Frank Warren Marshall: *Loafing* (c.1900)

WHO
WAS
WHO
IN
AMERICAN
ART
1564-1975

400 YEARS OF ARTISTS IN AMERICA

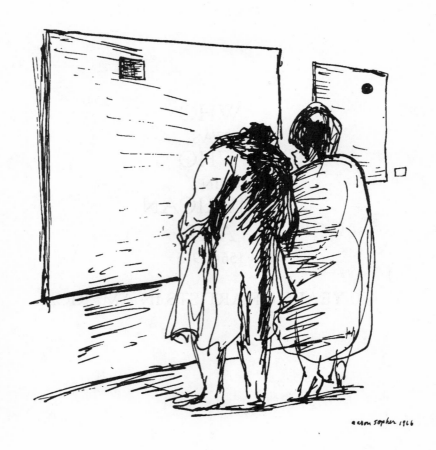

Aaron Sopher: *Couple Viewing Minimalist Paintings* (1966)

WHO
WAS
WHO
IN
AMERICAN
ART

1564-1975

400 YEARS OF ARTISTS IN AMERICA

Vol III: P-Z

Peter Hastings Falk
Editor-in-Chief

Audrey Lewis
Head of Research

Georgia Kuchen Veronika Roessler
Senior Editor Senior Editor

SOUND VIEW PRESS

AN AFFILIATE OF

INSTITUTE FOR ART RESEARCH & DOCUMENTATION
A NON-PROFIT ARTS EDUCATIONAL ORGANIZATION

1999

© 1999 by Sound View Press

Published in the United States of America by
Sound View Press
P. O. Box 833
Madison, CT 06443
Telephone: 203-245-2246 • Fax: 203-245-5116
email: info@falkart.com
Internet: www.falkart.com

ISBN 0-932087-55-8

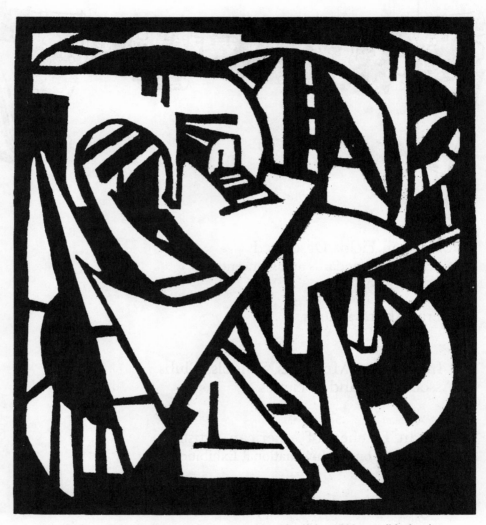

Natalie Van Vleck: *Architectonic abstract composition, New York,* c.1922; woodblock print.

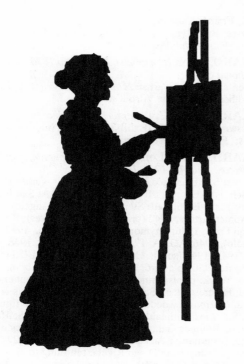

Silhouette of Anne Hall, the first and only woman
to be elected full membership in the
National Academy in the 19th century (1833)

P

PAALEN, Wolfgang *[Painter] early 20th c.*
Comments: Active in NYC during the 1930s.
Sources: PHF files.

W
J 40

PAAP, Hans *[Painter, illustrator] b.1894, Hamburg, Germany /
d.1966, on an island in the Pacific.*
Addresses: Berlin, Germany; Argentina; Brazil; Hollywood, CA;
Taos, NM. **Studied:** in Taos with Walter Ufer & Kenneth Adams,
1920s. **Exhibited:** Biltmore Salon, Los Angeles, 1928; Pasadena
Art Inst., 1929. **Work:** Van Vechten-Lineberry AM, Taos.
Comments: A portrait painter of Native Americans and Hispanics
of Taos, he also traveled to Mexico, Hawaii, and South America.
Position: art dir., motion picture industry, Berlin; painting teacher,
College de Belles Artes, Buenos Aires, Argentina. Illustr.: covers
for *Standard Oil Magazine.* **Sources:** Hughes, *Artists of
California,* 419; add'l info courtesy his daughter, Nancy Paap
(portrait of "Mable Dodge and Tony Luhan").

PAAS, Emilie See: **VAN DER PAAS, Emilie**

PABIAN, James Anthony *[Painter, animator] b.1909,
Rochester, NY.*
Addresses: Hollywood, CA; Ojai, CA. **Studied:** Mechanics Inst.,
Rochester, NY. **Exhibited:** Calif. WCS, 1935-36; P&S Los
Angeles, 1937. **Comments:** Position: animator, dir., animated car-
toon industry, Hollywood, CA, 45 years. **Sources:** Hughes,
Artists of California, 419.

PABLO, (Paul Burgess Edwards) *[Painter, art administra-
tor] b.1934, Moulton, IA.*
Addresses: Washington, PA. **Studied:** Iowa Wesleyan College
(B.A.) with S. Carl Fracassini; Wichita State Univ. (M.A.).
Member: Wichita Artists Guild (pres., 1961-62). **Exhibited:** 29th
Ann. Nat. Graphics Art Show, Wichita AA, 1960; Ann. Juror's
Award Show, Huntington (WV) Gal., 1965 (Juror's Best of Show

Award); 19th Ann. Nat. Decorative Arts Show, Wichita AA, 1966;
Max 24, Nat. Small Painting Show, Purdue Univ., Lafayette, IN,
1966; 2nd Nat. Polymer Exh., Eastern Mich. Univ., Ypsilanti,
1968. Awards: first prize in painting, Bethany College Ann. Show,
1964; first prize in summer show, Oglebay Inst., 1964. **Work:**
Wichita (KS) Art Mus.; Miami Beach (FL) Pub. Lib.; Iowa
Wesleyan College, Mount Pleasant; Wichita State Univ.; Citizen's
Lib., Wash., PA. **Comments:** Positions: chmn., Wash. &
Jefferson Nat. Painting Show, 1968-; pres., Arts Council, Wash.
Co., PA, 1969-72. Teaching:Wichita State Univ., summer 1962;
West Liberty State College, 1963-65; Wash. & Jefferson College,
1965-. **Sources:** WW73.

PABODIE, Charles A. *[Engraver] mid 19th c.*
Addresses: Providence, RI, active 1847-60. **Comments:** In 1857-
58 he was a partner with Daniel S. Parkhurst (see entry) in
Pabodie & Parkhurst. **Sources:** G&W; Providence CD 1847-60;
New England BD 1849-60.

PABODIE, Edwin A. *[Engraver] mid 19th c.*
Addresses: Providence, RI, 1850. **Sources:** G&W; Providence
CD 1850.

PABODIE & PARKHURST *[Engravers] mid 19th c.*
Addresses: Providence, RI, active 1857-58. **Comments:** Partners
were Charles A. Pabodie and Daniel S. Parkhurst (see entries).
Sources: G&W; Providence CD 1857-58.

PABST, Catherine J. (Mrs. Avery) *[Painter] early 20th c.*
Addresses: Seattle, WA. **Exhibited:** SAM, 1934. **Comments:**
Preferred medium: watercolor. **Sources:** Trip and Cook,
Washington State Art and Artists, 1850-1950.

PABST, Josef *[Painter] early 20th c.*
Exhibited: AIC, 1932. **Sources:** Falk, *AIC.*

PACE, Margaret Bosshardt *[Designer, painter] b.1919, San
Antonio, TX.*
Addresses: San Antonio, TX. **Studied:** Newcomb College
(B.F.A.); Trinity Univ.; Will Stevens; Etienne Ret; Xavier
Gonzalez. **Member:** San Antonio Art Lg. (bd. mem., 1967-68);
Texas FAA; Texas WCS; Contemp. Artists Group; San Antonio
Craft Guild. **Exhibited:** Texas Ann, 1958-59 & 1969; Invitational
Contemp. Artists Group, Mexico City Consulate, 1965 & 1968;
Religious Art, Hemisfair, 1968; Trinity Univ., San Antonio, 1969;
Artists Inst. Texas Cult., 1969. Awards: Henry Steinbomer Award,
Texas WCS, 1949 & 1966; Grumbacher Purchase Award, 1960;
Richard Kleberg Purchase Award, 1960. **Work:** Commissions:
murals, recreation room, Victoria Plaza, Golden Age Center, 1960;
mosaic murals, St. Lukes Episcopal Church, San Antonio, 1959,
Episcopal Diocesan Center, Diocese of West Texas, 1961 &
Episcopal Cathedral, 1965; designed & executed chalice, pattern
& pix, ordination of Father Braun, Pinckneyville, IL, 1969.
Comments: Positions: bd. mem. & vice-pres., San Antonio Art
Inst.; bd. mem., Friends of McNay Mus., San Antonio, 1967-72;
Southwest Craft Center, 1969-73. Teaching: Incarnate Word
College, 1964-65; San Antonio College, 1965-72. **Sources:**
WW73.

PACE, Stephen S. *[Abstract painter] b.1918, Charleston, MO.*
Addresses: NYC (1973); Wash., DC (1977). **Studied:** Inst.
Allende, San Miguel Allende, Mexico; Grande Chaumière, Paris;
Inst. Arte Statale, Florence, Italy; ASL with Cameron Booth &
Morris Cantor; Hans Hofmann Sch. **Exhibited:** WMAA, 1953-
1961; PAFA Ann., 1954; Carnegie Int., 1955; Int. Biennial, Japan,
selected by MoMA, 1957; Corcoran Gal. biennials, 1957, 1963;
Howard Wise Gal., NYC, 1964 (solo); "Abstract Watercolors by
14 Americans," MoMA, toured Europe, Asia & Australia, 1964-
66; Des Moines AC, 1970 (1960s retrospective). Other awards:
Dolia Lorian Award to promising painters, 1954; Hallmark Co.
Purchase Award, 1961. **Work:** WMAA; Univ. Calif., Berkeley;
James Michener Found., Univ. Texas, Austin; Walker AC,
Minneapolis, MN; Des Moines (IA) Art Center. **Comments:**
Active in Provincetown, MA, 1956-66. Preferred media: oils,
watercolors. Teaching: Washington Univ., spring-summer 1959;

Pratt Inst., 1961-68; Univ. Calif., Berkeley, spring, 1968.
Sources: WW73; Hubert Crehan, "A Change of Pace," *Art News* (April, 1964); Russell Arnold, "Paintings by Stephen Pace," *Crucible* (fall, 1965); Denver Lindley, "In a Landscape" (film), 1969-71; Provincetown Painters, 223; Falk, *Exh. Record Series.*

PACELLI, Vincent *[Painter] mid 20th c.*
Addresses: Brooklyn, NY. **Exhibited:** 48 Sts. Comp., 1939.
Sources: WW40.

PACH, Magda Frohberg (Mrs. Walter) *[Painter, portrait painter, lithographer, drawing specialist] b.1884, Dresden, Germany / d.1950, NYC.*
Addresses: NYC. **Studied:** Nat. Acad., Mexico City; J. Marchand in Paris; E. Stauffer. **Member:** S. Indp. A. (Dir.); NY Soc. Women Artists (pres.). **Exhibited:** S. Indp. A., 1923-29, 1931, 1933-44. **Sources:** WW47; add'l info. courtesy Peter C. Merrill, who cites 1864 as birth date.

PACH, Walter *[Etcher, mural painter, painter, writer, lecturer, critic] b.1883, NYC / d.1958, NYC.*
Addresses: NYC. **Studied:** CCNY; W.M. Chase & R. Henri at NY Sch. Art; L. Hunt; Paris. **Member:** S. Indp. A. **Exhibited:** Corcoran Gal. annual/biennials, 1908, 1945; Armory Show, 1913; S. Indp. A., 1917-42, 1944; WMAA, 1932-44; PAFA Ann., 1945-46. **Work:** MMA, WMAA; BM; CMA; PMG; CI; Newark Mus.; The Louvre, Paris; mural, CCNY; NYPL. **Comments:** Pach lived in Paris for a number of years and was one of the important early American writers on modernism. He also played a significant role in the choosing of modern French art for the Armory Show, accompanying Walt Kuhn and Arthur Davies in Paris (1912) to see the Steins' collection, and arranging introductions and visits to the studios of Brancusi, the Duchamp-Villons, Odilon Redon, and others. Davies and Kuhn hired Pach to act as European Representative and later as sales manager for the show. Teaching: Columbia; NYU. Positions: dir., "Masterpieces of Art," WFNY, 1939. Translator: *History of Art*, by Elie Faure (5 vols., 1921-30), *The Journal of Eugene Delacroix* (1937). Auth.: articles, *Scribner's; Century; Harper's; Gazette des Beaux Arts*; and books, including *The Masters of Modern Art; Georges Seurat; Modern Art in America; Ananias or the False Artist; R. Duchamp-Villon; An Hour of Art; Vincent van Gogh* (1936); *Queer Thing, Painting* (1938); *Ingres* (1939). **Sources:** WW47; Falk, *Exh. Record Series;* Brown, *The Story of the Armory Show,* 69-72, 77, 81.

PACHECO, Maximo *early 20th c.*
Exhibited: AIC, 1929. **Sources:** Falk, *AIC.*

PACHL, Delmar Max *[Sculptor, designer, graphic artist, teacher] mid 20th c.*
Addresses: Arlington, TX/Kansas City, MO. **Studied:** W. Rosenbauer; T.H. Benton; J. deMartelly; J. Meert; R. Braught; M.W. Hammond. **Member:** Co-op. AA, Kansas City. **Exhibited:** sculpture, Kansas City AI, 1938 (prize). **Comments:** Teaching: North Texas Agricultural College. **Sources:** WW40.

PACHNER, William *[Painter] b.1915, Brtnice, Czech.*
Addresses: Woodstock, NY.
Studied: Acad. Arts & Crafts, Vienna, Austria. **Exhibited:** Carnegie Int.; WMAA annual; Corcoran Gal. biennials, 1949-61 (4 times); PAFA Ann., 1951-53, 1960-62; U.S. FA Pavilion, New York World's Fair, 1965. Awards: AAAL & IIAL award, 1949; Ford Found. Awards, 1959-64; Guggenheim fellowship, 1960. **Work:** WMAA; Rose Gal., Brandeis Univ.; Butler Inst. Am. Art; Fort Worth AC; Iowa State Teacher's College. **Comments:** Preferred media: oils, watercolors, ink. Teaching: ASL, 1969-70. **Sources:** WW73; Kenneth Donahue, *William Pachner* (Am. Fed. Arts, 1959); Falk, *Exh. Record Series.*

PACHT, Sidney *[Painter] mid 20th c.*
Exhibited: S. Indp. A., 1938. **Sources:** Marlor, *Soc. Indp. Artists.*

PACINIO, Norberto Dal Pogetta *[Painter] early 20th c.*
Addresses: Chicago. **Exhibited:** AIC, 1902. **Sources:** Falk, *AIC.*

PACK, Frank *[Painter] b.1899.*
Addresses: Brooklyn, NY. **Exhibited:** Salons of Am., 1935, 1936.
Sources: Falk, *Exhibition Record Series.*

PACKARD, Alton *[Cartoonist, lecturer] b.1870 / d.1929, Oklahoma City.*
Comments: Cartoonist/artist: *Minneapolis Journal, Chicago Times,* other newspapers. Also a songwriter.

PACKARD, David C. *[Sculptor] mid 20th c.*
Addresses: Syracuse, NY. **Exhibited:** PAFA Ann., 1954.
Sources: Falk, *Exh. Record Series.*

PACKARD, Emmy Lou *[Painter, craftsperson, graphic artist, illustrator, writer] b.1914, Imperial Valley, CA.*
Addresses: San Francisco, CA. **Studied:** Univ. Calif., Berkeley; Calif. Sch. FA.; Europe. **Member:** San Fran. AA; San Fran. Women Artists. **Exhibited:** Stendahl Gal., Los Angeles, 1941; San Fran. Women Artists, 1942 (prize), 1955-56 (prizes); Rotunda Gal., San Fran., 1946; Raymond & Raymond Gal., 1942 (solo), 1945 (solo), 1946; AGAA, 1947; Calif. State Fair, 1948 (prize); SFMA, 1949, 1942 (solo); Oakland Art Festival, 1958 (prize). Other awards: Gump award, 1947; San Fran. Art Comn., 1951, 1953-54. **Work:** prints, Princess Kaiulani Hotel, Honolulu; mosaic mural, Hillcrest Elem. Sch., San Fran.; mural panels & woodcuts, S.S. *Mariposa;* woodcuts, S.S. *Monterey;* wood figures with mosaic, S.S. *Lurline;* inlaid linoleum back-bar for S.S. *Matsonia;* other work, Rotunda Gal., San Fran.; AGAA; Achenbach Found., San Fran. **Comments:** Packard lived in Mexico in 1927-28, receiving guidance from Diego Rivera, returning to his home there for a year in 1940, after she assisted him with his fresco at the GGE. Positions: writer, illustr., Richmond, CA, shipyard newspaper; graphic artist, Matson Navigation Co. **Sources:** WW59; Hughes, *Artists of California,* 419.

PACKARD, Fred C. *[Painter] b.1864.*
Addresses: Boston, MA. **Exhibited:** Boston AC, 1889; PAFA Ann., 1890. **Sources:** Falk, *Exh. Record Series.*

PACKARD, H. S. *[Engraver & lithographer of topographical views & portraits] late 19th c.*
Addresses: Boston, active 1875-1880. **Comments:** He worked for Haskell and Allen (see entry), in Boston and it is most likely that he was a professional printmaker in a variety of media. He may have worked in Philadelphia later in the century. He may also be responsible for the 1876 lithograph "City of Richmond, Virginia from Manchester." **Sources:** Pierce & Slautterback, 179.

PACKARD, Henrietta W. *[Painter] late 19th c.*
Addresses: Chicago. **Exhibited:** AIC, 1894. **Sources:** Falk, *AIC.*

PACKARD, Mabel *[Miniature painter] b.1873, Parkersburg, IA / d.1938, South Pasadena, CA.*
Addresses: Oak Park, IL; Pasadena, CA, from 1913. **Studied:** AIC; Acad. Colarossi, Paris; Acad. Julian, Paris, with Mme. Laforge; Munich. **Member:** Chicago SA. **Exhibited:** AIC, 1902-12; St. Louis Expo, 1904 (medal); Panama-Calif. Int. Expo, San Diego, 1915 (medal); Daniell Gal., Los Angeles, 1913; PPE, 1915; Ely Gal., Pasadena, 1917. **Sources:** WW33; Ness & Orwig, *Iowa Artists of the First Hundred Years,* 159; Hughes, *Artists of California,* 419.

PACKARD, R. G. (Mrs.) *[Painter] mid 19th c.; d.19.*
Addresses: Brooklyn, NY. **Studied:**

PACKARD, Rawson (Ross) *[Engraver] b.c.1813, New York State.*
Addresses: Albany, 1837 -46; NYC, by 1848 & still there in 1851. **Comments:** In 1850 he was in partnership with Joseph Prosper Ourdan (see entry) in NYC. **Sources:** G&W; 7 Census (1850), N.Y., XLVII, 774; Albany CD 1837-46; NYBD 1848-51; NYHS *Annual Report* for 1954.

PACKBAUER, Edward John *[Landscape & portrait painter] b.1862, Königsburg, Germany / d.1948, Detroit, MI.*
Addresses: Detroit, MI, 1880- past 1900. **Member:** Michigan AA; Art Club of Detroit; Detroit WCS; Soc. Assoc. Artists;

Scarab Club. **Exhibited:** Detroit Mus. Art, 1886, 1890-1911, 1912, 1918; Detroit AA, 1891, 1893, 1896; Soc. Assoc. Artists, 1894; Detroit Art Club, 1895; Detroit WCS, 1895. **Sources:** Gibson, *Artists of Early Michigan,* 185.

PACKER, A. S. *[Illustrator, portrait painter] b.1907, Chicago.* **Addresses:** Mt. Vernon, NY. **Studied:** AIC; Acad. Julian & Acad. Colarossi, Paris. **Member:** SI. **Comments:** Illustr.: *American Weekly.* **Sources:** WW47.

PACKER, Clair Lange (Mr.) *[Painter, writer] b.1901, Gueda Springs, KS / d.1978.* **Addresses:** San Antonio, TX; Tulsa, OK. **Studied:** Univ. New Mexico, Taos, with Millard Sheets & Barse Miller; J. Imhof; K. Adams; Harry Anthony De Young, San Antonio; Paul Barr, Grand Forks, ND. **Member:** Texas FAA; SSAL. **Exhibited:** Philbrook Mus., Tulsa; Houston Mus. FA, 1939; Gilcrease Mus., Tulsa; Elizabet Ney Mus., Austin, TX; Dallas (TX) Mus. **Awards:** hon. men. for watercolor, Houston Mus.; purchase prize for watercolor, Gilcrease Mus., Fourth Nat. Bank, Tulsa. **Work:** Gilcrease Mus., Tulsa, OK; Davis Gal., Tulsa; Alley Gal., Houston, TX; Glasser Gal., San Antonio; Seven Rays Gal., Taos. **Comments:** Preferred media: watercolors, oils, inks, crayons. Positions: artist, *San Antonio Express,* 1946-48; instr. art, Littlehouse Gal., San Antonio, 1947-48; artist, *Tulsa World,* 1948-65; cartoonist: *The Valley Morning Star.* Publications: auth./illustr., articles, *Western Publ.*; auth./illustr., articles, *Tulsa World Sunday Magazine*; auth./illustr., articles, *Tulsa World Ranch & Farm World*; auth., articles, *Lapidary Journal*; auth., articles, *Gun Report.* Teaching: private classes, San Antonio & Tulsa. Art interests: action sketches of rodeo contestants; landscapes, Indians, cowboys & marines. **Sources:** WW73; WW47.

PACKER, Francis H(erman) *[Sculptor] b.1873, Munich, Germany / d.1957.* **Addresses:** Rockville Center, NY. **Studied:** P. Martiny. **Exhibited:** AIC, 1916; PAFA Ann., 1916. **Work:** statues, Raleigh, Wilmington, both in NC; equestrian, Milwaukee, WI, Greensboro, NC; mem., Swope Park, Kansas City, MO; relief, Walt Whitman Bushwich H.S., Brooklyn, NY; Congressional medal to Byrd Antarctic Expedition. **Sources:** WW40; Falk, *Exh. Record Series.*

PACKER, Frederick L. *[Painter, illustrator, cartoonist] b.1886, Hollywood, CA / d.1956, Brightwaters, NY.* **Addresses:** San Francisco, CA; NYC. **Studied:** Los Angeles Sch. Art & Des.; AIC. **Member:** GFLA. **Comments:** Positions: illustr., Los Angeles *Examiner,* 1906; illustr., San Francisco *Call-Post,* c.1907-17; cartoonist, *American,* and *Daily Mirror.* **Sources:** WW27; Hughes, *Artists in California,* 419.

PACKER, George W. *[Painter] early 20th c.* **Addresses:** Paris, France. **Exhibited:** PAFA Ann., 1932. **Sources:** Falk, *Exh. Record Series.*

PACKMAN, Frank G. *[Painter, teacher, designer, lecturer, lecturer] b.1896, England.* **Addresses:** Huntington Woods, MI. **Studied:** Detroit Sch. FA; Paul Honore; J. P. Wicker. **Member:** Scarab Club, Detroit; Michigan Soc. Arts, Science & Letters. **Exhibited:** Scarab Club, Detroit; Detroit Inst. Art; Univ. Michigan. **Comments:** Teaching: Meinzinger Art Sch., Detroit, MI. Lectures: color. **Sources:** WW59; WW47.

PACKTMAN, I. *early 20th c.* **Exhibited:** Salons of Am., 1934. **Sources:** Marlor, *Salons of Am.*

PADBURG, Amanda *[Artist] late 19th c.* **Addresses:** Active in Michigan, c.1893. **Studied:** Maud Mathewson. **Sources:** Petteys, *Dictionary of Women Artists.*

PADDEN, Peggy Emily *[Painter] early 20th c.* **Addresses:** East Seattle, WA. **Sources:** WW24.

PADDOCK, Denise Emil *[Collector] mid 20th c.* **Addresses:** Bethpage, NY. **Comments:** Collection: Surrealist and geometric works. **Sources:** WW73.

PADDOCK, Ethel Louise *[Painter] b.1887, NYC / d.1975, NYC.* *E L Paddock.* **Addresses:** NYC. **Studied:** ASL; NY Sch. Art with Henri & J. Sloan. **Member:** Soc. Indep. Artists; NAWA, 1919; Pen & Brush Club; NYSWA; Salons of Am. **Exhibited:** Salons of Am.; Pen & Brush Club, 1934 (prize); NAWA, 1929 (prize), 1932 (prize); Soc. Indep. Artists, annuals, 1917-38. **Comments:** She and her sister Josephine often spent their summers painting and exhibiting together in Gloucester, MA. **Sources:** WW40; *Art by American Women:.the Collection of L. and A. Sellars,* 64.

PADDOCK, Jo(sephine) *[Painter, teacher, lecturer, writer, designer] b.1885, NYC / d.1964, NYC.* **Addresses:** NYC. **Studied:** ASL with Kenyon Cox, W.M. Chase, John Alexander; Barnard College (A.B.). **Member:** AWS; All. Artists Am.; CAFA; New Haven PCC; Grand Central Art Gal.; North Shore AA; AAPL; Easthampton Gld. Hall; Gloucester SA; Soc. Wash. Artists; Springfield Art Lg. **Exhibited:** Armory Show, 1913; Corcoran Gal. biennials, 1914, 1937; PAFA Ann., 1914-15, 1935-36; Salons of Am., 1933; BM, 1935 (prize); New Haven PCC, 1935 (prize); CAFA, 1937 (prize); AWCS, 1946 (prize); Fifteen Gal., NYC, 1937 (solo); NAD; AIC; All. Artists Am.; Wolfe AC, 1937 (prize); Paris Salon, 1951; Royal Inst., London, England, 1950; Berkshire MA, 1955 (solo); AAPL; Audubon Artists; CAFA; Guild Hall, Easthampton; North Shore AA; AAPL, 1960 (gold medal); Parrish Mus., Southampton, NY. **Work:** portraits, paintings, Barnard College Club, NY; Wesleyan College; Colgate Univ.; Dayton AI; Berkshire MA; Newport AM; Shelton College, NJ. **Comments:** Older sister of Ethel Paddock. She exhibited in New York, London, and Paris. **Sources:** WW59; WW47; Pisano, *One Hundred Years.the National Association of Women Artists,* 75 (w/repr.); Falk, *Exh. Record Series*; Brown, *The Story of the Armory Show.*

PADDOCK, Robert Rowe *[Theatrical designer, landscape painter] b.1914, Mansfield, OH.* **Addresses:** NYC; Mavis Glen, Greenwich, CT. **Studied:** Cleveland Sch. Art; Western Reserve Univ. (B.S.). **Exhibited:** Detroit Art Market, 1939; CGA, 1937; Butler AI, 1937; CMA, 1934-37. **Comments:** Positions: instr., Television Workshop, 1950; television des., CBS-TV, NYC, 1951-57; pres., United Scenic Artists, 1953-58; bd. of gov., Television Acad., 1955-58. Award for best live commercial, "Pillsbury's Xmas Show," 1957. Des. for theatrical productions: Ballet "Pinocchio," 1939; "Robin Hood," 1940; "Burlesque," 1946; "Alice in Wonderland," 1947; tech. dir., "Winged Victory;" Reading Bi-Centennial, 1949; J.L. Hudson's Fashionscope, 1948-50; "Macbeth," Met. Opera, 1959. **Sources:** WW59; WW47.

PADDOCK, Royce *[Painter] early 20th c.* **Addresses:** NYC. **Member:** Lg. AA. **Sources:** WW24.

PADDOCK, Thelma *[Painter, teacher] b.1898, Indiana.* **Addresses:** Los Angeles, CA. **Studied:** Otis AI; AIC; J. F. Smith. **Member:** ASL, Chicago; Southern Calif. AC. **Sources:** WW24.

PADDOCK, Willard D(ryden) *[Sculptor, painter] b.1873, Brooklyn, NY / d.1956, Brooklyn.* **Addresses:** South Kent, CT; Brooklyn; NYC. **Studied:** PIA Sch.; H. Adams; Courtois & Griardot in Paris. **Member:** ANA; Century Assn.; NSS, 1915; Artists Aid Soc. **Exhibited:** SNBA, 1896; Boston AC, 1900-01; PAFA Ann., 1900-36 (7 times); AIC; S. Indp. A., 1917. **Work:** New Milford (CT) H. S.; BM; Amherst College; Univ. Calif.; mem., Stratford, CT. **Sources:** WW47; Fink, *Am. Art at the 19th C. Paris Salons,* 377; Falk, *Exh. Record Series.*

PADELFORD, Morgan C. *[Painter, portrait painter, sculptor, teacher] b.1902, Seattle, WA.* **Addresses:** Pasadena, CA. **Studied:** Hopkinson; Isaacs; H. Hoffman, Univ. Calif., Berkeley; A. L'Hote, Paris; Paul Gustin; A. Patterson; E. Bush; J. Butler. **Member:** Seattle AI; Northwest PM. **Exhibited:** oil, Northwest Artists Exh., 1923 (prize); Seattle Art Dir. Assoc., 1925. **Work:** bas-relief in cast stone, Chamber of

Commerce Bldg.; Univ. Wash., Seattle. **Comments:** Positions: teacher, Scripps College; affiliated with art dept., Technicolor Motion Picture Corp., 25 years. **Sources:** WW40; Trip and Cook, *Washington State Art and Artists, 1850-1950.*

PADOVANO, Anthony John *[Sculptor, lecturer] b.1933, Brooklyn, NY.*
Addresses: Ancram, NY. **Studied:** Carnegie Inst. Tech.; Pratt Inst.; Columbia Univ. with Oronzio Maldarelli. **Member:** Sculptors Guild (vice-pres., 1968-69); Silvermine Guild Artists. **Exhibited:** Third Mostra Arte Figurative Int., Rome, Italy, 1961; Young Am., WMAA, 1965; Am. Sculpture, MoMA, 1966; Am. Express Pavilion, New York World's Fair, 1966; Inauguration of Nat. Coll. FA, Wash., DC, 1967; James Graham Gal., NYC, 1970s. **Awards:** Prix de Rome, Am Acad Rome, 1960; Guggenheim Found. fellowship, 1964; Ford Found. Purchase Award, 1966. **Work:** WMAA; Nat. Coll. FA, Wash., DC; Univ. Illinois; John Herron Art Inst.; Storm King AC, NY. Commissions: Sculpture In The Park, Parks Dept., New York, 1968; design, NY State Art Awards, NY State Council Arts, 1969; sculpture, World Trade Center, Port Authority NY & NJ, 1970; three arcs, donated by Trammel & Crow Co. for City of Dallas, 1972. **Comments:** Preferred media: metal, concrete. Positions: adv. mem. NJ State Council Arts, 1965-67. Publications: contrib., *Young America,* 1965. Teaching: Columbia Univ., 1964-; Univ. Conn., 1972; Queens Col lege(NY), 1972. **Sources:** WW73; "Young Talent," *Art Am.* (1965); James Mellow, article, *New York Times* Sunday Review, April, 1970.

PADUANE, Louis See: **PADUANI, Louis**

PADUANI, Louis *[Miniaturist, landscape painter, drawing teacher] early 19th c.*
Addresses: NYC in 1819; Richmond, VA, in 1821; Charleston, SC, in 1824. **Sources:** G&W; NYCD 1819; *Richmond Portraits;* Rutledge, *Artists in the Life of Charleston.*

PADUANY, Louis See: **PADUANI, Louis**

PAEFF, Bashka (Mrs. Samuel Waxman) *[Sculptor, teacher, lecturer] b.1893, Minsk, Russia / d.1979.*
Addresses: (Came to Boston as a child) Cambridge, MA. **Studied:** Mass. Normal Sch., with Cyrus Dallin; Boston Mus. Sch. FA with Bela Pratt, 1914; N. Aronson in Paris, France, 1930-32. **Member:** Cambridge AA (bd. mem.); Guild Boston Artists; Boston Soc. Arts & Crafts.; NSS (fellow). **Exhibited:** PAFA Ann., 1924, 1926-27; Paris Salon, early 1930s; Tercentenary Expo, Boston, 1933 (medal); Boston Guild Artists, 1959 (solo); NAD, 1969 (Daniel Chester French Medal); NSS; Johns Hopkins AC. **Work:** Hall of Fame, Mass. State House (Boston); "Boy and Bird Fountain," Boston Public Garden; bas-relief on War Mem. Bridge, Kittery (ME); fountains, Westbrook (ME), Ravina (IL), Stoughton (MA), and Chestnut Hill (MA); Birmingham, AL; MIT; bust, Univ. Buenos Aires; Grad. Center, Radcliffe College, Cambridge, MA; bust of A.J. Philpott, BMFA; Harvard Univ.; bas-relief, Rockefeller Inst., NY; Perkins Inst. for the Blind, Watertown (MA); bas-relief, Boston Psychopathic Hospital; bas-relief, Fernald State Sch., Waverly (MA), bas-relief, Princeton Inst. (N.J.); life size bas-relief, Justice Oliver Wendell Holmes, Harvard Law Library; bas-relief, Jane Addams, Hull House, Chicago and Addams House, Phila.; bronze reliefs, Dr. Southard, Harvard Medical Library; Dir. Augusta Bronmer, Judge Baker Foundation, Boston; Dr. Martin Luther King, Jr., Boston Univ., 1969; six-figure "Minute Man Memorial," Lexington, Mass. **Comments:** Specialized in realistic portraits, war memorials, fountains, and animals. Preferred media: bronze, marble. **Sources:** WW73; WW47; Rubinstein, *American Women Sculptors,* 199-200; Falk, *Exh. Record Series.*

PAEPCKE, Elizabeth H. (Mrs. Walter) *[Painter] mid 20th c.*
Addresses: Chicago area. **Exhibited:** AIC, 1935. **Comments:** Wife of Walter Paepcke, who was head of Container Corporation and a strong advocate of modern design in advertising. **Sources:** Falk, *AIC.*

PAGAN, Jack *[Painter] mid 20th c.*
Addresses: Houston, TX. **Exhibited:** watercolor, SSAL, 1936 (prize). **Sources:** WW40.

PAGANINI, Christophani *[Portrait & miniature painter, pastellist, teacher] mid 19th c.*
Addresses: New Orleans, active 1830. **Sources:** G&W; Delgado-WPA cites *Bee,* July 20, 1830. See *Encyclopaedia of New Orleans Artists.*

PAGAUD, Alice (Mrs. John) *[Painter, teacher] early 19th c.*
Addresses: Norfolk, VA, active 1822. **Comments:** Married to John Pagaud (see entry). **Sources:** Wright, *Artists in Virgina Before 1900.*

PAGAUD, John *[Portrait & miniature painter, teacher] early 19th c.*
Addresses: Norfolk, VA, active 1822. **Sources:** Wright, *Artists in Virginia Before 1900.*

PAGAZOZZI, Victor *early 20th c.*
Exhibited: Salons of Am., 1934. **Sources:** Marlor, *Salons of Am.*

PAGE, Addison Franklin *[Art administrator] b.1911, Princeton, KY.*
Addresses: Louisville, KY. **Studied:** Wayne State Univ. (B.F.A. & M.A.). **Member:** Mich. Sculpture Soc. (chmn., 1950); Mich. WCS (bd. mem., 1960); Assn. Art Mus. Dirs. **Comments:** Positions: jr. cur. educ., Detroit Inst. Arts, 1947-58; cur. contemp. art, 1958-62; dir., J.B. Speed Art Mus., 1962-. Teaching: Wayne State Univ, 1947-58; Cranbrook Acad. Art, 1958-62. Collections arranged: 19 Canadian Painters, 1962; Reg Butler; A Retrospective Exhibition, 1963; Treasures of Chinese Art, 1965; The Figure in Sculpture 1865-1965, 1965; Treasures of Persian Art, 1966; Indian Buddhist Sculpture, 1968; The Sirak Collection, 1968; Ciechanowiecki Collection of Gilt and Gold Medals and Plaquettes, 1969; 19th C. French Sculpture: Monuments for the Middle Class, 1971. Publications: auth., *Modern Sculpture: A Handbook,* 1950 & *Diego Rivera's Detroit Frescoes: A Handbook,* 1955, Detroit Inst. Arts. **Sources:** WW73.

PAGE, Alby *[Engraver] b.c.1838, Massachusetts.*
Addresses: Boston, 1860. **Sources:** G&W; 8 Census (1860), Mass., XXIX, 31.

PAGE, Charles *[Listed as "artist"] b.c.1818, England.*
Addresses: Spring Garden section of Philadelphia, PA, 1850. **Sources:** G&W; 7 Census (1850), Pa., LIV, 657.

PAGE, Charles Jewett *[Painter] d.1916.*
Addresses: Boston, MA. **Exhibited:** Boston AC, 1878-1907. **Sources:** WW08; *The Boston AC.*

PAGE, David *early 20th c.*
Exhibited: Salons of Am., 1929. **Sources:** Marlor, *Salons of Am.*

PAGE, Edward A. *[Marine painter] b.1850, Groveland, MA / d.1928, Swampscott, MA.*
Addresses: Lynn & Swampscott, MA. **Studied:** George Morse in Boston. **Exhibited:** Lynn GAR Exh., 1887; Boston AC, 1888-96, 1899, 1901, 1907-09; Providence AC; Worcester AM; Salamagundi Club; Lynn AC, 1909-28; Springfield Muf. FA. **Comments:** Worked in the leather business until he was thirty-five, while studying art and sharing a studio with Frederick Porter Vinton. He was also a friend of Thomas Robinson and J. Foxcroft Cole. In 1883, Page came to Lynn and became one of the group of local artists which included Chas. E.L. Green, Nathaniel Berry, Thomas C. Oliver, Charles Alley, Theodore N. Phillips and Charles H. Goodridge. In 1900, Page painted also with his good friend Charles H. Woodbury at Ogunquit, ME. Teaching: Lynn Evening Sch. Art, 1886-on. **Sources:** WW08; exh. cat., *Rediscovered Artists of Essex County, (1865-1915)* (Salem, Mass.: Essex Institute, 1971); D. Roger Howlett, *The Lynn Beach Painters* (Lynn Hist. Soc., 1998); add'l info. courtesy Selma Koss Holtz, Waban, MA.

PAGE, Elizabeth Amie *[Painter, lithographer, designer] b.1908, Brookline, MA.*

Addresses: Haverford, Phila., PA. **Studied:** ASL; BMFA Sch.; Alexander Brook. **Member:** Phila. Art All.; Phila. Pr. Club; ASL. **Exhibited:** S. Indp. A., 1938; Boston Indp. Exh., 1938; PAFA Ann., 1938-39; Butler AI, 1939-40, 1944; PAFA, 1943; NAD, 1943; Phila. Art All., 1943 (solo), 1954-58; LOC, 1943, 1944; Phila. Pr. Club, 1943 (prize); Northwest PM, 1944; NAWA. **Sources:** WW59; WW47; Falk, *Exh. Record Series.*

PAGE, Ethel N. *[Painter] late 19th c.*
Addresses: Phila., PA. **Exhibited:** PAFA Ann., 1891. **Sources:** Falk, *Exh. Record Series.*

PAGE, Grover *[Cartoonist, engraver] b.1892, Gastonia, NC / d.1958, Louisville, KY?.*
Addresses: Louisville, KY. **Studied:** AIC; Chicago Acad. FA. **Member:** SSAL; Southern PM; Indiana PM; Louisville AC; AFA; Louisville AA; Southern AA. **Exhibited:** SSAL, 1939 (prize), 1940 (prize). **Work:** Huntington Lib., San Marino, CA; Univ. Louisville. **Comments:** Positions: ed. cartoonist, *Nashville Tennessean* (1917-19), *Courier-Journal,* Louisville, (1919-). **Sources:** WW47.

PAGE, H. *[Illustrator] mid 19th c.*
Comments: Illustrated *The Life of Rev. David Brainard* (N.Y., c. 1833). His landscape designs for this work were engraved by Alexander Anderson (see entry). **Sources:** G&W; Hamilton, *Early American Book Illustrators and Wood Engravers,* 99, 427.

PAGE, H. *[Profile cutter] early 19th c.*
Addresses: Active 1816, location unknown. **Comments:** There is only one known example of his work: a profile of "Gen. Harris." **Sources:** G&W; Gillingham, "Notes on Philadelphia Profilists," 518 (repro.).

PAGE, H. C. *[Marble cutter, carver, engraver] mid 19th c.*
Addresses: Charleston, SC, active 1830. **Sources:** G&W; Rutledge, *Artists in the Life of Charleston.*

PAGE, Hollis Bowman *[Painter] late 19th c.*
Addresses: Boston, MA. **Exhibited:** NAD, 1890. **Sources:** Naylor, *NAD.*

PAGE, Horace Smith *[Painter] b.1913, Parowon, UT.*
Addresses: San Francisco, CA. **Studied:** Calif. College Arts & Craftswith Hamilton Wolf & Maurice Logan. **Member:** AWCS; Soc. Western Artists. **Exhibited:** Calif. State Fairs; Alameda County Fairs. **Sources:** Hughes, *Artists of California,* 419.

PAGE, Jacquelen Ann (Mrs.) See: **O'GORMAN, Jacqui (Mrs. Jacquelen Ann Page)**

PAGE, John Henry, Jr. *[Printmaker, painter] b.1923, Ann Arbor, MI.*
Addresses: Cedar Falls, IA. **Studied:** Minneapolis School Art; ASL; Univ. Michigan (B.Design); Univ. Iowa (M.F.A.). **Member:** College AA Am. **Exhibited:** Young Am. PM, MoMA, 1953; 10th Nat. Print Show, BM, 1956; 23rd Ann. Iowa Artists Show, Des Moines AC, 1971; Art USA, Northern Illinois Univ., DeKalb, 1971; Nine Iowa Artists, Govt. Exh., 1971-72; Percival Gals., Inc., Des Moines, IA, 1970s. Awards: Pennell Purchase Prize, LOC, 1964; purchase prize for prints, Sioux City AC, 1971; Younker Prize for Prints, Des Moines AC, 1971. **Work:** LOC; Walker AC, Minneapolis; Des Moines AC; Joslyn AM; Carnegie Inst. Commissions: Memberships Print, Des Moines AC, 1969. **Sources:** WW73.

PAGE, Josephine *[Painter] early 20th c.*
Addresses: Wash., DC, active 1912-32. **Studied:** PAFA. **Exhibited:** Soc. Wash. Artists, 1912-13; PAFA Ann., 1919-20. **Sources:** WW25; McMahan, *Artists of Washington, D.C.;* Falk, *Exh. Record Series.*

PAGE, Katherine S(tuart) *[Painter, miniature painter] mid 20th c.; b.Cambridge, MD.*
Addresses: Wash., DC, active 1931-41; Berryville, VA. **Studied:** Phila. Sch. Des. for Women; Margaretta Archambault. **Member:** Wash. SMPS&G. **Exhibited:** Wash. SMPS&G; Gr. Wash. Indep. Exh., 1935. **Sources:** WW40; McMahan, *Artists of Washington,*

D.C.

PAGE, Marie Danforth (Mrs. Calvin G.) *[Portrait & figure painter] b.1869, Boston, MA / d.1940.*
Addresses: Boston. **Studied:** Helen Knowlton (privately), Boston, 1886-89; BMFA Sch. with E. Tarbell & Frank Benson, 1890-96. **Member:** ANA, 1927; Guild of Boston Artists. **Exhibited:** Boston AC, 1892, 1894, 1905-07; PAFA Ann., 1903-40 (35 annuals, incl. prize, 1916); Corcoran Gal. biennials, 1907-37 (12 times); AIC, 1911-32 (15 annuals); Pan-Pacific Expo, San Fran., 1915 (bronze medal); NAD, 1916 (prize), 1923 (prize), 1928 (prize); Newport AA, 1916, 1921 (prizes); Duxbury AA, 1920 (prizes); Guild of Boston Artists, 1921 (1st solo); Sesqui-Centenn. Expo, Phila., 1926 (medal); Springfield AA (prize); Grand Central Gal.,1928 (prize). **Work:** George Walter Vincent Smith Mus., Springfield, MA; Mt. Holyoke College; Harvard Medical Sch.; Peter Bent Brigham Hospital (Boston); Brooklyn (NY) Medical Soc.; Lib. Sch., Univ. Wisconsin; Mus. and Art Gal., Reading, PA; Erie (PA) Mus. Art; Springfield (IL) AA; Montclair (NJ) Art Mus. **Comments:** Page was a popular and highly regarded portraitist, known for her portraits of children and young girls. She also frequently treated the theme of mother and child. Visited Europe after her marriage in 1896. Also known as Marie Danforth. **Sources:** WW38; *300 Years of American Art,* 626; Tufts, *American Women Artists, 1830-1930,* cat. no. 19; Falk, *Exh. Record Series.*

PAGE, Maxine *[Painter] early 20th c.*
Addresses: West Los Angeles, CA, 1932. **Exhibited:** Calif. WCS, 1931-32. **Sources:** Hughes, *Artists of California,* 419.

PAGE, Robert V. *[Artist] late 19th c.*
Addresses: Wash., DC, active 1893. **Sources:** McMahan, *Artists of Washington, D.C.*

PAGE, S. P. *[Pencil artist] mid 19th c.*
Addresses: Illinois. **Exhibited:** Illinois State Fair, 1855 (prize for pencil drawing). **Sources:** G&W; Chicago *Daily Press,* Oct. 15, 1855.

PAGE, Samuel *[Portrait painter] b.1823, Newburyport, MA / d.1852, Newburyport.*
Sources: G&W; Belknap, *Artists and Craftsmen of Essex County,* 11.

PAGE, Samuel Francis *[Painter] late 19th c.*
Addresses: Lexington, MA. **Exhibited:** NAD, 1878. **Sources:** Naylor, *NAD.*

PAGE, Sarah Nichols (Mrs.) See: **NICHOLS, Sarah**

PAGE, Walter Gilman *[Painter, portrait painter, writer] b.1862, Boston, MA / d.1934.*
Addresses: Nantucket, MA. **Studied:** BMFA Sch.; Acad. Julian, Paris, with Boulanger & Lefebvre, 1884. **Member:** Portland SA; Springfield AS; AFA; Mass. State Art Commission; Boston Comn. on Hist. Sites. **Exhibited:** Paris Salon, 1887-89; Boston AC, 1889-1907; NAD, 1890; AIC, 1911-12; PAFA Ann., 1927. **Work:** TMA; Art Mus., Portland, Maine; portraits, Mass. State House, Portland (ME) City Hall, Bowdoin College, Maine Hist. Soc., Colby College, Vermont State House, Worcester (MA) Pub. Lib., Fall River (MA) Pub Lib., Lowell (MA) City Hall, Dracut Pub. Lib., Tufts College. **Comments:** Organizer of the Public School Art Lg. **Sources:** WW33; Fink, *Am. Art at the 19th C. Paris Salons,* 377; Falk, *Exh. Record Series.*

PAGE, William *[Portraitist, painter of classical, literary and religious themes] b.1811, Albany, NY / d.1885, Tottenville, Staten Island, NY.* **WP. 1830.**
Addresses: NYC (until 1843); Boston (1844-49); Italy (1849-60); NYC (1866-on). **Studied:** James Herring in NYC, 1825; NAD with Samuel F.B. Morse, c.1826. **Member:** NA, 1837 (pres., 1871-73). **Exhibited:** NAD, 1827-85; PAFA, 1841-43, 1848; Brooklyn AA, 1868, 1912; Boston Athenaeum. **Work:** MMA; BMFA; NMAA; PAFA; Detroit IA; NY City Hall. **Comments:** He was a brilliant colorist and a leading exponent of classical figurative painting among the American Romantics. His best-known

work is the sensuous and controversial "Cupid and Psyche" (1843, MMA), which was rejected for the NAD exhibition of that year because of its unsettling eroticism. Page was brought up in NYC, working there (and in Northampton, MA; Albany, NY; and Rochester, NY) from 1829-32. He later spent long periods in Boston and Italy. In Italy, he worked mainly in Rome, where he was a prominent member of the Anglo-American colony. While abroad he painted portraits of many significant figures, including Robert Browning. Always interested in spiritualism, he also explored Swedensborgianism in these years. Returning to America in 1860, he lived for several years near George Inness at Eagleswood, NJ. In 1866 he moved to Tottenville, Staten Island, NY, where he lived until his death. **Sources:** G&W; Richardson, "Two Portraits by William Page;" Joshual C. Taylor, *William Page, The American Titian* (Chicago: Univ. of Chicago Press, 1957); DAB; Cowdrey, NAD; Naylor, NAD; Cowdrey, AA & AAU; Rutledge, PA; Swan, BA. More recently, see Baigell, *Dictionary; 300 Years of American Art*, vol. 1, 150.

PAGÈS, Jules Eugène *[Painter, illustrator; teacher] b.1867, San Francisco, CA / d.1946, San Fran.*
Addresses: Paris, France; San Fran. **Studied:** Calif. Sch. Des.; Acad. Julian, Paris, with Constant, Lefebvre & Robert-Fleury, 1890-95. **Member:** Int. Soc. Paris SP; Bohemian Club. **Exhibited:** AIC, 1900-01, 1909, 1913; Paris Salon, 1894-96 (prize, 1895), 1898-99 (med.), 1905 (med.); PAFA Ann., 1895; Corcoran Ga.l biennials, 1912, 1919; Pan-Pac Expo, 1915; Bohemian Club, 1924 (solo); CPLH, 1946 (mem.). **Award:** Knight of the Legion of Honor, 1910. **Work:** Mus. Pau, France; Mus. Toulouse, France; Luxembourg, Paris; Golden Gate Park Mus. & Art Inst., San Fran.; SFMA; Municipal Art Gal., Oakland, Calif.; CPLH. **Comments:** An expatriate Impressionist painter, he lived in France for 40 years, teaching a night class at the Académie Julian in Paris from 1902-on, and a life class there from 1907-on. He took many sketching trips in Europe, visiting Brittany, Spain and Belgium, also returning home to San Francisco for visits and exhibitions. At the outbreak of WWII he returned home permanently. **Sources:** WW40; Hughes, *Artists of California*, 420; Fink, *Am. Art at the 19th C. Paris Salons*, 377; *300 Years of American Art*, 612; Falk, *Exh. Record Series*.

PAGES, Jules Francois *[Engraver, painter] b.1833, NYC / d.1910, San Francisco, CA.*
Addresses: San Fran. from 1857. **Studied:** self-taught as a painter. **Work:** Oakland Mus. **Comments:** He had his own engraving business, painting in his leisure time. Pages never sold any of his works, giving them away as presents to friends and family. Specialty: still lifes, Chinatown genre, French scenes. **Sources:** Hughes, *Artists of California*, 420.

PAGET-FREDERICKS, Joseph Rous-Marten *[Illustrator, writer, designer, lecturer, painter, teacher] b.1905, San Francisco, CA / d.1963.*
Addresses: Berkeley, CA. **Studied:** Univ. Calif.; Europe; Leon Bakst; John Singer Sargent. **Member:** Los Angeles Mus. Assn.; Am. Soc. P&S; Grand Central Art Gal. **Exhibited:** Berlin, Germany, 1936 (prize); Stanford Univ., 1935 (prize); AIC; NYPL; Europe; South America; special mem. exh. of Pavlova Coll., San Fran., 1951, for Sadler's Wells Ballet. **Work:** Mills College, Oakland, CA; Univ. Calif.; coll. in London, Paris, Rome, Venice. **Comments:** Positions: instr., Color & Design, Calif. College Arts & Crafts; asst. dir., San Fran. AC. Autho./illustr.: *Green Pipes*, 1929; *Anna Pavlova*, published in Paris; *Pavlova's Impressions; Atlantis; The Human Body in Rhythmic Action; Red Roofs and Flowerpots; Miss Pert's Christmas Tree; The Paisley Unicorn; &* other books. Illustr.: *Selected Poems of Edna St. Vincent Millay*. 1929; *The Macaroni Tree; Sandra and the Right Prince*, 1951; *Gift of Merimond*, 1952. Auth./illustr.: *I Shall Always Love the West*, 1952 (memories of Pavlova in California), etc. Lectures: The Russian Ballet;" "La Loie Fuller" "Fortuny & Bakst." **Sources:** WW59; WW47.

PAGETT, (Mrs.) *[Teacher of drawing & painting in watercolors, needlework] late 18th c.*
Addresses: Charleston, SC. **Comments:** Taught at her husband's school in Charleston (SC) in 1794. **Sources:** G&W; Rutledge, *Artists in the Life of Charleston*.

PAGGATT, L. *[Engraver] b.c.1832, France.*
Addresses: San Francisco in 1860. **Sources:** G&W; 8 Census (1860), Cal., VII, 934.

PAGLINEA, Anthony *early 20th c.*
Exhibited: Salons of Am., 1934. **Sources:** Marlor, *Salons of Am.*

PAGON, Katherine Dunn *[Painter] b.c.1892, Chestnut Hill, PA / d.c.1985, Baltimore, MD.*
Addresses: Phila. (until 1920); Baltimore, MD (1920-on). **Studied:** PAFA with Hugh Breckenridge, 1910-18; Barnes Found., 1920s; C. Law Watkins, Wash., DC; Johns Hopkins Univ.; Maryland Inst.; Columbia Univ. **Member:** NAWA; Munic. Artists, Balt.; Friends of Art; "45 Group," Nantucket; Nantucket AA. **Exhibited:** PAFA Ann., 1918-21, 1928-36, 1962; Soc. Indep. Artists, 1923-24, 1931; Salons of Am., 1925, 1929, 1931; NAWPS, 1936 (prize); Alumni, Springside, Phila., 1936 (gold), 1939 (gold); BMA; NAD; Corcoran Gal. biennial, 1932; PMG; Baltimore SIA; Sweat Mem. Mus.; PC; Kenneth Taylor Gal., Nantucket, 1945-on. **Awards:** PAFA (4 study scholarships; Cresson Traveling scholarships, 1916, 1918). **Work:** PAFA; Nantucket Hist. Assn. **Comments:** She was active in Nantucket's summer art colony, c.1927-60s, painting in a Fauvist style. Teaching: Marine Hospital; Bryn Mawr School for Girls; Balt. Mus. Art; Homewood School, Baltimore. Also known as Mrs. William Watters. **Sources:** WW47; WW59; Falk, *Exh. Record Series;* add'l info. courtesy Nantucket Hist. Assn.

PAI-DOUNG-U-DAY See: **CANNON, Tommy Wayne (T. C.)**

PAICE, Philip Stuart *[Painter] early 20th c.*
Addresses: Denver, CO. **Exhibited:** AIC, 1917. **Sources:** WW17.

PAIER, Edward Theodore *[Painter, teacher, lecturer] b.1918, Hamden, CT.*
Addresses: West Haven 16, CT. **Studied:** Yale Univ. Sch. FA (B.F.A). &Dept. Educ.; Columbia Univ. Teachers College. **Comments:** Position: dir., Paier Sch. Art, Hamden, CT, 1946-. **Sources:** WW59.

PAIGE, Alvin *[Painter, sculptor] b.1934.*
Exhibited: Moscow Trade Fair. **Sources:** Cederholm, *Afro-American Artists.*

PAIGE, J. F. *[Engraver] mid 19th c.*
Addresses: San Francisco, 1859. **Comments:** Cf. Jules François Pages. **Sources:** G&W; San Francisco CD 1859.

PAIK, Nam June *[Video artist] b.1932, Seoul, Korea.*
Addresses: NYC. **Studied:** Univ. Tokyo (B.A., 1956). **Exhibited:** Fluxus Festival, Mus. Wiesbaden, Germany, 1962; Cybernetic Serendipity, Inst. Contemp. Art, London, 1968; The Machine as Seen at the End of the Mechanical Age, MOMA, 1968; Vision & Television, Rose Art Mus., Brandeis Univ., Waltham, Mass., 1969; St. Jude Video Intl, de Saisset Art Gal. & Mus., Univ. Santa Clara, Calif., 1971; MOMA, 1971 (solo), 1974 (Open Circuits: The Future of Television), 1977 (solo); The Kitchen, NYC, solos, 1973, 1976; Everson Mus., Syracuse, NY, 1973 (Circuit: a Video Invitational),1974 (solo); WMAA, solos, 1978, 1982; Tokyo Metrop. Mus. Art, solo, 1984; Holly Solomon Gal., NYC, solos, 1986, 1988-90; SFMoMA, solo, 1989. **Comments:** Teaching: artist-in-residence, WGBH-TV, Boston, 1969; GNET-TV, NYC, 1971. **Sources:** WW93.

PAIN, A. See: **PAIX, A.**

PAIN, Jacob *[Engraver] late 18th c.*
Addresses: Philadelphia, 1793. **Sources:** G&W; Brown and Brown.

PAIN, Louise (Carolyn) *[Sculptor] b.1908, Chicago.*
Addresses: Chicago, IL. **Studied:** E.R. Zettler. **Exhibited:** Artists Chicago & Vicinity, AIC, 1933 (prize). **Sources:** WW40.

PAIN, W. Boyse *[Painter] early 20th c.*
Addresses: Wash., DC. **Comments:** *Cf.* Painter W(illiam) Bowyer Pain. **Sources:** WW25.

PAIN, W(illiam) Bowyer *[Painter, teacher, illustrator, editor] b.1856, England / d.1930, Wash., DC.*
Addresses: Wash., DC. **Member:** Wash. Landscape Club. **Exhibited:** Wash. WCC; Wash. Landscape Club; Maryland Inst.; Soc. Wash. Artists; CGA; New York; Phila., PA. **Work:** Wash. Hist. Soc.; U.S. Nat. Arboretum (pomological watercolors). **Comments:** Could be painter W. Boyse Pain. Came to U.S. in 1903, and settled first in Wash., DC. Positions: illustr,, U.S. Dept. Agriculture.; instr., drawing, Georgetown Univ.; art ed., *Washington Life.* **Sources:** McMahan, *Artists of Washington, D.C.*

PAINE *[Decorative wall painter] mid 19th c.*
Addresses: Believed to have been active near Parsonfield, ME, during the 1830s. **Comments:** May have been working in collaboration with Jonathan Poor (see entry). His "signature" was an uprooted dead tree falling between the branches of another. **Sources:** G&W; *Art in America* (Oct. 1950), 165-66, 194 (repro.).

PAINE, A. B. *[Illustrator] 19th/20th c.*
Addresses: NYC. **Comments:** Affiliated with R.H. Russel & Co., NYC. **Sources:** WW01.

PAINE, Birdsall Douglass *[Painter] b.1858.*
Exhibited: PAFA Ann., 1880-92 (8 times); Boston AC, 1889. **Sources:** Falk, *Exh. Record Series.*

PAINE, Brooks *[Painter] mid 20th c.*
Addresses: Osprey, FL. **Exhibited:** PAFA Ann., 1942. **Sources:** Falk, *Exh. Record Series.*

PAINE, Edward S. *[Painter] mid 20th c.*
Studied: ASL. **Exhibited:** S. Indp. A., 1938. **Sources:** Marlor, *Soc. Indp. Artists.*

PAINE, Elizabeth *[Sculptor] mid 20th c.*
Exhibited: S. Indp. A., 1937. **Sources:** Marlor, *Soc. Indp. Artists.*

PAINE, Gerard L. *[Painter] mid 20th c.*
Exhibited: AIC, 1942. **Sources:** Falk, *AIC.*

PAINE, Helen See: **GOODWIN, Helen M.**

PAINE, Joseph Polley *[Painter, lithographer, engraver, etcher, designer, teacher] b.1912, Llano, TX.*
Addresses: Austin, TX. **Studied:** Texas A&I College; ASL; San Antonio AI; Kansas City AI; Univ. Texas; O'Hara Sch. **Member:** Bonner G. Art Club. **Exhibited:** S. Indp. A., 1934; PAFA, 1938; San Fran. AA, 1938; San Antonio, TX, 1946; Oakland Art Gal., 1946. **Sources:** WW47.

PAINE, Margaret Walker *[Sculptor] b.1896.*
Addresses: Everett, WA. **Studied:** Dudley Pratt; Avard Fairbanks; P.O. Tognelli. **Exhibited:** Henry Gal.; Western Wash. Fair. **Sources:** Trip and Cook, *Washington State Art and Artists,* 1850-1950.

PAINE, Marie Louise (Mattingly) *[Painter] b.1849, Pennsylvania.*
Studied: ASL of Wash., DC. **Member:** Soc. Wash. Artists; Wash. WCC. **Exhibited:** Cosmos Club, 1902; Wash. WCC, 1896-99. **Sources:** McMahan, *Artists of Washington, D.C.*

PAINE, May *[Painter] b.1873, Charleston, SC.*
Addresses: Charleston, SC. **Studied:** Leith Ross; F. Chase; Gruppe; A. Hutty; I. Summers. **Member:** SSAL. **Exhibited:** SSAL. **Sources:** WW33.

PAINE, Richard G. *[Sculptor] b.1875, Charleston, SC.*
Addresses: Wash., DC, until 1920; East Falls Church, VA, until 1935. **Studied:** L. Amateis; E. Kemeys. **Exhibited:** Soc. Wash. Artists, 1909-1916; PAFA Ann., 1914, 1917. **Sources:** WW21;

McMahan, *Artists of Washington, D.C.;* Falk, *Exh. Record Series.*

PAINE, Robert T. *[Museum curator] b.1900 / d.1965.*
Addresses: Boston, MA. **Comments:** Position: cur., Asiatic Art, Boston Mus. FA. **Sources:** WW66.

PAINE, Robert (Treat) *[Sculptor] b.1870, Valparaiso, IN / d.1946, Hollywood, CA.*
Addresses: West Hoboken, NJ (1893-1914); San Francisco, CA. **Studied:** AIC; ASL. **Member:** The Cornish (NH) Colony. **Comments:** He worked for Augustus St. Gaudens (see entry) and in 1924 he assisted A.P. Proctor (see entry) on sculpture projects. **Sources:** WW15; Hughes, *Artists of California,* 420.

PAINE, Susannah (or Susan) *[Portrait and landscape painter] b.1792, Rehoboth, MA / d.1862, Providence, RI.*
Addresses: Active in MA, CT, RI; her home was in Providence, RI, from mid-1840s until her death. **Comments:** Successful itinerant painter. Autobiography: *Roses and Thorns,* 1854. **Sources:** G&W; C.K. Bolton, "Workers with Line and Color in New England"; Providence CD 1847-60.

PAINE, T. O. *[Sculptor] b.c.1825, Maine.*
Addresses: Bangor, ME, 1850; Boston, 1852. **Sources:** G&W; 7 Census (1850), Maine, XIII, 307; Boston BD 1852.

PAINE, W. *[Primitive portraitist] mid 19th c.*
Addresses: New Bedford, MA, active c.1845. **Comments:** Worked in oil on cardboard. **Sources:** G&W; Lipman and Winchester, 178.

PAINTER, Ethel See: **HOOD, Ethel Painter**

PAINTER, James W. *[Engraver, photographer] early 20th c.*
Addresses: Wash., DC, active 1901-20. **Sources:** McMahan, *Artists of Washington, D.C.*

PAIPERT, Hannah *[Portrait painter] b.1911, Boston, MA.*
Addresses: Dorchester, MA/Sharon, MA. **Studied:** R. Lahey. **Sources:** WW40.

PAIRPONT, Thomas J. *[Painter] late 19th c.*
Addresses: Providence, RI. **Exhibited:** NAD, 1875. **Sources:** Naylor, *NAD.*

PAIST, Henrietta Barclay *[Painter] early 20th c.*
Addresses: St. Paul, MN. **Sources:** WW15.

PAIX, A. *[Landscape painter] mid 19th c.*
Exhibited: PAFA, 1854 ("View Near Pottsville, PA"), 1857 ("Woodland Scene"). **Sources:** G&W; Listed in G&W as "A. Pain;" see Rutledge/Falk, PA, under "A. Paix.".

PAJAMA *[Photographers] mid 20th c.*
Exhibited: DC Moore Gal., NYC, 1997. **Comments:** A group of three artists whose name is derived from the first two letters of each person's name: PAul Cadmus, JAred French, and MArgaret French. They collaborated primarily in photography, taking pictures on the beaches of Fire Island (NY), Provincetown, and Nantucket; and in their NYC studios in the winters.

PAJARAS, Alberto *[Lithographer] b.1877, Havana, Cuba / d.1924, New Orleans, LA.*
Addresses: New Orleans, active 1908-24. **Member:** Int. Assoc. of Amalgamated Lithographers Am. **Sources:** *Encyclopaedia of New Orleans Artists,* 290.

PAJAUD, William E. *[Painter, printmaker] b.1925, New Orleans, LA.*
Studied: Chouinard AI (Chrysler Scholarship); Xavier Univ. (B.A.). **Member:** Soc. Graphic Des.; Calif. WCS; Los Angeles AA. **Exhibited:** LACMA; Crocker Gal., Sacramento, CA; deYoung Mus., San Fran.; Esther Robles Gal., Los Angeles (solo); Univ. Iowa, 1972; Pasadena Art Mus.; Orange County (CA) Art Exh.; Los Angeles County Art Exh.; Atlanta Univ. (prize); Univ. Wisc.; Calif. WCS; Joseph Massa Gal. (solo); Emerson Gal. (solo); Heritage Gal. (solo). **Work:** Atlanta Univ.; Am. Artists Group. **Sources:** Cederholm, *Afro-American Artists.*

PAJOT, Louis E. *[Steel & medal engraver] early 19th c.*
Addresses: NYC, 1817-22. **Comments:** Cut the seal of the New-York Historical Society in 1821. The name also appears as Pigot and Parjeaux. **Sources:** G&W; NYCD 1817-22; Vail, *Knickerbocker Birthday*, 62.

PAL See: **PALEOLOGUE, Jean**

PALADIN, David Chethlahe See: **CHETHLAHE, (David Chethlahe Paladin)**

PALADINI, Antonio *[Sculptor] b.1854, Italy.*
Addresses: Wash., DC, active 1892-1922. **Comments:** He was employed in the studio of James F. Early, and modeled the death mask of assassinated President McKinley. **Sources:** McMahan, *Artists of Washington, D.C.*

PALANCHIAN, Enid See: **BELL, Enid Diack (Mrs E. B. Palanchian)**

PALANCHIAN, Missak *b.1898, Diarbekir, Armenia.*
Exhibited: Salons of Am., 1930, 1934. **Sources:** Marlor, *Salons of Am.*

PALANSKY, Abraham *[Painter, sculptor] b.1890, Lodz, Poland.*
Addresses: Los Angeles, CA. **Studied:** AIC. **Member:** Los Angeles WCS; No-Jury Soc., Chicago. **Exhibited:** AIC, 1940, 1941 (prize), 1942-44, 1945 (prize), 1949; Nat. Art Week, Chicago, 1940; Illinois State Mus., 1940; NJSA, Chicago, 1941-42; Oakland Art Gal., 1944; SFMA, 1944; Los Angeles Mus. Art, 1943, 1944 (solo), 1943, 1945, 1948-49, 1952; Riverside (CA) Mus., 1946, 1948; Pasadena AI, 1947-50, 1952 (prize); Madonna Festival, Los Angeles, 1949; Chicago Bd. Jewish Educ., 1950; Greek Theatre, Los Angeles, 1946-48, 1951. **Sources:** WW59; WW47.

PALAU, Marta *[Painter, weaver] b.1934, Albesa, Lerida, Spain.*
Addresses: Jalisco, Mexico. **Studied:** La Esmeralda, Inst. Nat. Bellas Artes, Mexico; San Diego State College, spec. study with Paul Lingren; Barcelona Escuela Artes Y Oficios, weaving with Grau Garriga. **Exhibited:** La Jolla Art Mus., 1964; San Diego FA, 1969; Univ. Texas Art Mus., 1970; Bienal Cali, Colombia, 1970; Bienal Santiago de Chile, Chile, 1970; Wenger Gal., San Ysidro, CA; Gal. Pecanins, Mexico City, Mexico, 1970s. **Work:** Univ. San Diego Medical Sch., La Jolla, CA; Hebrew Home for Aged, San Fran.; Club Indust., Mexico City; Center Arte Mod., Guadalajara, Mex. **Commissions:** mural, comn. by Miguel Aldana, Center Arte Mod., Guadalajara, 1971. **Comments:. Sources:** WW73.

PALAZZOLA, Guy *[Painter] mid 20th c.*
Addresses: Detroit & Ann Arbor, MI. **Exhibited:** PAFA Ann., 1951. **Sources:** Falk, *Exh. Record Series.*

PALAZZOLO, Carl *[Painter] b.1945.*
Addresses: Holliston, MA, 1975. **Exhibited:** WMAA, 1975. **Sources:** Falk, *WMAA.*

PALDI, Ange *[Battle scene artist] mid 19th c.*
Comments: Depicted the battles of Resaca de la Palma and Palo Alto during the Mexican War. He was with the 5th Infantry Regiment, U.S. Army. **Sources:** G&W; *Album of American Battle Art*, 129, pl. 55.

PALENSKE, Reinhold H. *[Etcher, painter, illustrator] b.1884, Chicago, IL / d.1954, Wilmette, IL?.*
Addresses: Woodstock, IL. **Studied:** AIC with W. Reynolds. **Member:** Chicago SE. **Exhibited:** Chicago SE, 1945 (prize); Smithsonian Inst. (solo); Munic. Art Gal., Oakland, CA; LOC. **Work:** LOC; NYPL; Royal Gal., London, England; Fort Worth AC Mus. **Comments:** Illustr.: *The Spur, Washington Star, Chicago Daily News.* **Sources:** WW47.

PALEOLOGUE, Jean *[Painter] b.1860, Romania / d.1942, Miami, FL.*
Studied: Paris. **Comments:** His birth date was possibly 1855. He

came to the U.S. in 1900, and was known as "Pal.".

PALESSARD, Louis *[Painter] mid 19th c.*
Addresses: New Orleans, active 1842-44. **Sources:** *Encyclopaedia of New Orleans Artists*, 290.

PALEY, Goldie *[Painter] mid 20th c.*
Addresses: Phila., PA. **Exhibited:** PAFA Ann., 1942. **Sources:** Falk, *Exh. Record Series.*

PALEY, Jeffrey *[Art dealer] b.1938, Chicago, IL.*
Addresses: NYC. **Studied:** Harvard College (B.A., 1960). **Comments:** Positions: co-dir., Paley & Lowe Gal. Specialty of gallery: contemp. American. Collection: contemp. American and Nepalese; Indian and Tibetan painting and sculpture. **Sources:** WW73.

PALEY, Lillian *[Painter] mid 20th c.*
Exhibited: Corcoran Gal. biennial, 1951. **Sources:** Falk, *Corcoran Gal.*

PALEY, Robert L. *[Illustrator] 19th/20th c.*
Addresses: Active in Colorado Springs, 1890s-1906; Boston, MA, 1923. **Comments:** Illustr.: *Saturday Evening Post;* "Myths and Legends of Colorado" by. L.M. Smith, 1906.

PALEY, Williams S. (Mr. & Mrs.) *[Collectors] b.1901, Chicago, IL / d.1990.*
Addresses: Manhasset, NY. **Studied:** Mr. Paley, Univ. Chicago, 1918-19; Univ. Penn. (B.S., 1922; L.L.D., 1967); Bates College (hon. L.L.D., 1963). **Comments:** Positions: Mr. Paley, trustee, MoMA, pres., 1968-. Collection: contemporary paintings. **Sources:** WW73.

PALFREY, Elizabeth Goelet Rogers (Mrs.) *[Craftsperson, designer, painter] b.1871, New Orleans, LA / d.1933, New Orleans.*
Addresses: New Orleans, active 1894-1918. **Studied:** Achille Perelli; Newcomb College, 1895-1902. **Exhibited:** Artist's Assoc. of N.O., 1894; NOAA, 1918. **Comments:** Designer of bookplates and jewellery, pottery decorator and metal worker. She reportedly was the first at Newcomb to design and craft a pierced brass lampshade, one of the school's distinctive crafts. **Sources:** WW19; *Encyclopaedia of New Orleans Artists*, 290.

PALFREY, Mary Harrison *[Craftsperson] b.1887, New Orleans, LA / d.1929, New Orleans.*
Addresses: New Orleans, active c.1907-16. **Studied:** Newcomb College, 1909-12. **Exhibited:** NOAA, 1911. **Sources:** *Encyclopaedia of New Orleans Artists*, 290.

PALING, John J. *[Painter] late 19th c.*
Exhibited: PAFA Ann., 1878. **Sources:** Falk, *Exh. Record Series.*

PALISSARD, Louis *[Engraver] mid 19th c.*
Addresses: New Orleans, 1842-44. **Sources:** G&W; New Orleans CD 1842; *Encyclopaedia of New Orleans Artists.*

PALITZ, Clarence Y. (Mrs.) *[Collector] mid 20th c.*
Addresses: NYC. **Sources:** WW73.

PALL, Augustin G. *[Portrait painter, mural painter] b.1882, Hungary.*
Addresses: Chicago, IL. **Studied:** E. Ballo, A. von Wagner & F. von Stuck in Munich; Acad. Julian, Paris, with Lefebvre. **Exhibited:** AIC, 1918-21. **Work:** murals, Church of St. Ignatius of Loyola, St. Sebastian Church, Solomon Temple, all in Chicago. **Sources:** WW24.

PALL, David B. (Dr. & Mrs.) *[Collectors] b.1914, Ft. William, Ontario.*
Addresses: Roslyn Estates, NY. **Studied:** Dr. Pall, McGill Univ. (B.Sc., 1936; Ph.D., 1939); Brown Univ., 1936-37. **Comments:** Collection: contemporary art. **Sources:** WW73.

PALLADINO, Miles *[Painter] b.1908, Cleveland, OH.*
Addresses: Cleveland, OH. **Studied:** E. Ballo, A. von Wagner, F. von Stuck, in Munich; Lefebvre, in Paris. **Exhibited:** CMA, 1933, 1939. **Work:** murals, Church of St. Ignatius of Loyola, St. Sebastian Church, Solomon Temple, all in Chicago. **Sources:**

WW40.

PALLAZO, Anthony *[Painter] mid 20th c.*
Addresses: Chicago area. **Exhibited:** AIC, 1937-38. **Sources:** Falk, *AIC*.

PALLENLIEF, Andrew *[Sculptor] b.c.1824, Switzerland.*
Addresses: San Francisco in July 1860. **Sources:** G&W; 8 Census (1860), Cal., VII, 756 (his wife was also Swiss, but their five-month-old daughter was born in California).

PALLESER, Robert *[Etcher] early 20th c.*
Addresses: Brooklyn, NY. **Sources:** WW27.

PALLET, Henrietta B. *[Painter] mid 20th c.*
Addresses: Chicago area. **Exhibited:** AIC, 1950. **Sources:** Falk, *AIC*.

PALLEY, Reese *[Art dealer] b.1922, Atlantic City, NJ.*
Addresses: NYC. **Studied:** London (England) Sch. Economics; New Sch. Social Res. **Comments:** Positions: owner, Reese Palley Gal., New York, San Fran., Atlantic City & Paris, France. Publications: auth., *The Boehm Experience*, Syracuse Univ. Press & Grosset & Dunlap, 1972. Specialty of gallery: avant-garde American art plus porcelain objet d'art. **Sources:** WW73.

PALM, Ansa *[Painter] early 20th c.*
Addresses: Great Neck, LI, NY. **Exhibited:** S. Indp. A., 1934. **Sources:** Marlor, *Soc. Indp. Artists*.

PALMATARY, James T. *[Townscape artist] mid 19th c.*
Addresses: Baltimore, active 1868-69. **Comments:** He may have received his introduction to viewmaking from Edwin Whitefield (see entry), since he served as his business agent for more than two years, beginning in 1850. Reps states that many of the views published by E. Sachse & Co., most notably a 1853 lithograph of Baltimore, did indeed have Palmatary as the artist. He went on to make views of Indianapolis (1854) and Washington (DC), and published a proposal to do a view of Columbus (OH) in 1854. **Sources:** G&W; Burnet, *Art and Artists of Indiana*, 65-66; Columbus, *Ohio Statesman*, Dec. 27, 1854 (courtesy J. Earl Arrington). Reps, 194-96 (pl.17).

PALMEDO, Lilian Gaertner (Mrs. Harold B.) *[Painter, mural painter, illustrator, decorator, designer] b.1906, NYC.*
Addresses: New Milford, CT. **Studied:** Viennese Kunsgewebeschule & Acad. with J. Hofmann & F. Schmutzer. **Member:** Arch. Lg. **Work:** murals, Montmartre Club, Palm Beach., FL; Ziegfeld Theatre, Maritime Exchange Bldg., Hotel Essex, Hotel Taft, Plaza Hotel, Pennsylvania Hotel, Paradise Night Club, all in NYC; Am. Asphalt Co., Chicago; Hotel Van Cleves, Dayton, OH; Standard Brands Pavilions, WFNY, 1939; Princeton Inn, NJ; Regal Theatre, Phila.; dec. fabrics, Patio Room, Radio City, NYC; sketches for Ziegfeld Theatre and costumes for Metropolitan Opera productions, Vienna Mus. Theatre Coll. **Sources:** WW40.

PALMER, A. Lucile *[Etcher, sculptor, lecturer, teacher] b.1910, NYC.*
Addresses: Reno, NV. **Studied:** F.V. Guinzburg; E. Fraser; M. Young; G. Lober; H. Paul; A. Picirilli, E. Morahan; M. Gage; G. Luken. **Member:** AAPL; Art Centre of the Oranges; San Fran. Soc. Women Artists; Santa Monica Art Soc. **Sources:** WW38.

PALMER, A. W. L. (Mrs.) See: **PALMER, Theresa Zmislow (Mrs. A. W. L.)**

PALMER, Adaline Osburn *[Portrait & miniature painter, teacher] b.1817, Rippon, VA (now WV) / d.1906, Rippon.*
Addresses: Fauquier County, VA; Mobile, AL; Richmond, VA. **Comments:** Married John P. Palmer, a Richmond journalist who died in 1879. **Sources:** G&W; Willis, "Jefferson County Portraits and Portrait Painters.".

PALMER, Adelaide C(oburne) *[Painter, teacher] b.c.1851, Orford, NH / d.1928.*
Addresses: Boston, MA/Piermont, NH. **Studied:** J.J. Enneking; Boston Mus. FA Sch., 1882. **Member:** Copley Soc., 1893.

Exhibited: Boston AC, 1880-1909; AIC, 1888; NAD, 1894; Poland Springs Art Gal., 1898; PAFA. Ann., 1913. **Comments:** Painter of flowers, fruit, still lifes, landscapes. She created the logo for "Fruit of the Loom." **Sources:** WW31; Petteys, *Dictionary of Women Artists;* Falk, *Exh. Record Series*.

PALMER, Allen Ingles *[Painter, illustrator, cartoonist] b.1910, Roanoke, VA / d.1950.*
Addresses: Roanoke, VA. **Studied:** PM Sch. IA; G. Demetrios; W. Biggs; H. Hensche; Corcoran Sch. Art. **Member:** AWCS; SC; Audubon Artists; NYWCC; Beachcombers' Club; Provincetown AA. **Exhibited:** New Britain Mus.; NYWCC, 1937; AWCS, 1939-46; Roanoke, 1940 (prize); AIC, 1940, 1945; MMA, 1941; Roanoke Art All., 1941 (prize); Audubon Artists, 1945; SC, 1942, 1946; VMFA. **Comments:** Contributor: *This Week, Rotarian.* **Sources:** WW47.

PALMER, Amelia *[Artist] late 19th c.*
Addresses: Active in Los Angeles, 1887-88. **Sources:** Petteys, *Dictionary of Women Artists.*

PALMER, Arthur C. *[Artist, decorator] b.c.1831, England.*
Addresses: NYC in 1850. **Comments:** Though listed as an artist in the census, he was listed in the directory as a decorator. **Sources:** G&W; 7 Census (1850), N.Y., XLIII, 129.

PALMER, Arthur W. *[Painter, etcher, teacher, craftsperson] b.1913, Chicago, IL / d.1982, Woodacre (Marin County), CA.*
Addresses: Woodacre, CA. **Studied:** Chouinard AI; F. Tolles Chamberlin. **Member:** Marin Soc. Art; Soc. Western Artists; Pasadena Soc. Art; Bohemian Club, San Fran. **Exhibited:** Los Angeles County Fair, 1933; San Diego FA Soc., 1934; Los Angeles AA, 1934 (prize); PAFA, 1933, 1935-36; P&S Los Angeles, 1935-37; Pasadena SA, 1935, 1938; LACMA, 1935; Miss. AA, 1944; AWCS, 1944; Oakland Art Gal., 1944; AWCS, 1944; Oakland Art Gal., 1944; Portland (OR) Mus. Art, 1944; Terry AI, 1952; Bohemian Club, 1952-1958; Marin Art & Garden Show, 1955-1958; de Young Mem. Mus., 1956. **Work:** portraits, Stanford Lane Hospital, Univ. Calif. Medical Sch., Univ. Calif. Dental College, Shriner's Hospital for Crippled Children, all in San Franc.; Evanston (IL) Hospital; Tulane Univ.; Bohemian Club. **Comments:** Positions: supervisor, effects animator, Walt Disney Studios, 1935-41. Teaching: Calif. College Arts & Crafts, 1952-53. **Sources:** WW59; WW47. More recently, see Hughes, *Artists of California*, 420.

PALMER, Benjamin C. *[Portrait & townscape painter] mid 19th c.*
Addresses: NYC, 1845-49. **Exhibited:** NAD, 1845-49 (as B.C. Palmer). **Comments:** Had a studio at New York University in 1845. Four views of Norwalk (CT) by B C. Palmer, presumably the same man, were lithographed by Jones & Newman about 1848. **Sources:** G&W; Cowdrey, NAD; NYCD 1845; *Portfolio* (Feb. 1951), 130 (repros.).

PALMER, Bertha Honoré (Mrs. Potter Palmer) *[Philanthropist, collector] b.1849, Louisville, KY / d.1918, Sarasota, FL.*
Addresses: Chicago, IL (1855-on). **Studied:** Visitation Convent Sch., Wash., DC, 1867. **Member:** Nat. Civic Fed.; Chicago Civic Fed. (first vice-pres.); Northwestern Univ. (trustee, 1892-96); appointed by Pres. McKinley as U.S. Comn. to Paris Expo, 1900, the only woman so honored; Legion of Honor, France, 1900. **Comments:** In 1890-93, she was pres. of the Board of Lady Managers, established by Congress, for the World's Columbian Exposition in Chicago. The board oversaw all issues related to women and the planning and decorations for the Woman's Building. She was the official spokeswoman for this branch of the Exposition, and her collection of speeches and reports may be found in *Addresses and Reports of Mrs. Potter Palmer, President of the Board of Lady Managers, World's Columbian Exposition* (Rand, McNally, 1894). She was the wife of one of the wealthiest men in America (of Palmer House fame), and was prominent herself as a philanthropist, becoming known as "the Mrs. Astor of the Middle West." With her husband (married 1870), and the advice

of Mary Cassat and Sara Tyson Hallowell, they assembled the first collection of Impressionist paintings in the Midwest. Her collection now forms the core of the AIC's Impressionist collection, and is comparable to that of the Havemeyer collection in the MMA (see Louisine E. Havemeyer). She maintained homes in Chicago, Newport, London, and Paris. In 1910 she built a winter home in Sarasota, FL where she owned 80,000 acres. **Sources:** PHF files courtesy Charlene G. Garfinkle, Ph.D.

PALMER, C. H. *[Portrait painter] early 19th c.*
Addresses: Pennsylvania, active c.1825. **Comments:** *Cf.* Ch. B.R. Palmer. **Sources:** G&W; Lipman and Winchester, 178.

PALMER, C. K. *[Portrait & miniature painter] mid 19th c.*
Addresses: Working probably in Connecticut, c.1840-42. **Sources:** G&W; Sherman, "Some Recently Discovered Early American Portrait Miniaturists," 295 (repro.); NYHS Cat. (1941); info cited by G&W as courtesy Mrs. T. Webster Nock, NYC.

PALMER, Celinda Ball Tucker *[Sketch artist] mid 19th c.*
Work: Shelburne (VT) Mus. **Comments:** Active in 1850s. **Sources:** Muller, *Paintings and Drawings at the Shelburne Museum,* 99.

PALMER, Ch. B. R. *[Portrait painter] early 19th c.*
Addresses: Pennsylvania, active 1826. **Comments:** *Cf.* C.H. Palmer **Sources:** G&W; *American Folk Art,* no. 17 and repro. p. 15.

PALMER, Delos, Jr. *[Painter] b.1891 / d.1961, Stamford, CT.*
Addresses: NYC. **Sources:** WW19.

PALMER, Drucilla *[Painter] mid 20th c.*
Addresses: Chicago area. **Exhibited:** S. Indp. A., 1936; AIC, 1937. **Sources:** Falk, *AIC.*

PALMER, Edmund *[Painter] late 19th c.*
Addresses: NYC. **Exhibited:** NAD, 1877. **Sources:** Naylor, *NAD.*

PALMER, Edmund Seymour *[Lithographer] b.England / d.1859, Brooklyn, NY.*
Addresses: Brooklyn, NY. **Exhibited:** Am. Inst., 1846 (independently as Seymour Palmer), 1848 (with Fanny Palmer under firm's name). **Comments:** Husband of Fanny Palmer (see entry). The couple married in the 1830's and arrived in NYC in the early 1840s from Leicester (England). It appears that he sometimes dropped his first name, identifying himself as Seymour Palmer. He and Fanny Palmer briefly worked together in a lithographic company called F. & S. Palmer (c.1846-49). He then became a tavern owner. The burden of supporting the family fell chiefly on Fanny Palmer, who was employed as an artist by Currier & Ives. He died in 1859, after a drunken fall in a Brooklyn hotel. **Sources:** G&W; Peters, *Currier & Ives,* 110-15; NYCD 1844-45 (as Edmund Palmer); NYCD 1846-47 (as Seymour Palmer); NYBD 1846, 1848 (as Seymour Palmer); Am Inst. Cat., 1846, 1848. Note: G&W listed him as Edward S. Palmer and also had a separate entry for Seymour Palmer but suggested that this might be Fanny's husband. It appears that these are the same person and that, in fact, his correct first name is Edmund. See Rubinstein, *American Women Artists,* 68-70, under entry for Fanny Palmer.

PALMER, Edward Seymour (Mrs.) See: **PALMER, Fanny (Frances) Flora Bond**

PALMER, Elizabeth See: **BRADFIELD, Elizabeth Palmer (Mrs.)**

PALMER, Erastus Dow E. D. PALMER FEC. '87.
[Sculptor, teacher] b.1817, Pompey, near Syracuse, NY / d.1904, Albany, NY.
Addresses: Albany, NY, 1846-1904. **Studied:** apprenticed to a carpenter; self-taught as sculptor. **Member:** NA (hon. mem., prof.); NSS. **Exhibited:** NAD, 1851-63; Phila. Centenn. Expo, 1876 (med.); PAFA Ann., 1851-77, 1894; Church of the Divine Unity, NYC, 1856 (a solo show titled the "Palmer Marbles," displaying Palmer's marble relief medallions). **Work:** Albany (NY) Inst.(portrait busts, reliefs :"Morning and Evening"); MMA ("The

Dawn of Christianity",1856,"White Captive," 1859) He made many ideal figures and, in 1874, executed the statue of Chancellor Robert R. Livingston, of New York, for the Capitol at Wash. **Comments:** Romantic sculptor. Began as a carpenter and in about 1840 married and moved to Utica, NY, where he built a home and worked as a patternmaker (carving wooden molds) for local industry. About 1845, he attempted cameo-cutting and soon achieved success, moving, In 1846, to Albany where he set up a studio and continued to produce cameo portraits. In 1848 he began modeling in clay and attempting marble pieces, and was soon producing portrait busts and ideal works. Palmer did quite well in Albany but also gained attention in NYC, where he began exhibiting in 1851 (NAD), receiving much critical praise. His most famous work, "The White Captive" (1859), which depicted a nude, young Christian woman tied to a post (in the captivity of American Indians), inspired much romantic, melodramatic prose in newspaper and magazines describing the plight of the chaste young woman who is said to have to endure the ungodly savagery of her captors. Throughout his career, Palmer also sold high-quality photographs of his sculpture; these sold well in the U.S. and in Europe and increased interest in his work, bringing him requests for replicas. Unlike most of his American sculptor contemporaries, he did not visit Europe until late in his career, traveling to France in 1873. Of his pupils at Albany, Launt Thompson (see entry) was probably the best known. His son, Walter Launt Palmer, was also an artist. **Sources:** G&W; DAB; Clement and Hutton; Gardner, *Yankee Stonecutters;* Cowdrey, NAD; Naylor, NAD; Cowdrey, AA & AAU; Rutledge, PA; Falk, PA, vol. 2; Swan, BA. More recently, see Baigell, *Dictionary;* Craven, *Sculpture in America* 158-66.

PALMER, F. & S. *[Lithographers, artists, draftsmen] mid 19th c.*
Addresses: NYC, active 1846-49. **Exhibited:** Am. Inst., 1848 (exhibited lithographs as firm). **Comments:** Partners were wife and husband Fanny and Edmund Seymour Palmer (see entries). **Sources:** G&W; NYCD 1846-49; Am. Inst. Cat., 1848.

PALMER, F. H. *[Painter] late 19th c.*
Addresses: Saranac Lake, NY. **Exhibited:** PAFA Ann., 1896-97 (landscapes). **Sources:** Falk, *Exh. Record Series.*

PALMER, Fanny (Frances) Flora Bond *[Landscape, townscape & still life painter, graphic artist, lithographer] b.1812, Leicester, England / d.1876, Brooklyn, NY.*
Addresses: active in NYC from 1844; Brooklyn, NY. **Studied:** Miss Linwood's School, London. **Exhibited:** Am. Inst., 1848 (lithographs shown under firm's name F. & S. Palmer); NAD, 1844, possibly 1868; Brooklyn AA, 1869. **Work:** Mus. of the City of New York has a large collection of Currier & Ives prints; NYHS; Mystic Seaport Mus. **Comments:** A leading artist for Currier & Ives. Born Frances Flora Bond, she and her husband, Edmund Seymour Palmer (see entry), came to NYC from Leicester (England) in the early 1840s. The couple briefly worked together in a lithographic company called F.&S. Palmer (c.1846-49, see entry). Fanny Palmer became the main support in the family and by 1849 was working for Nathaniel Currier's lithographic company (which became Currier & Ives in 1857). She was one of their most prolific artists, producing at least 200 documented lithographs for them. Specialized in country and farm scenes, images of trains traveling cross-country, and scenes of westward expansion. Between 1862-67, she created most of the firm's still lifes and, it is believed, a large number of the company's unsigned fruit and flower prints. Her designs were reproduced in calenders, greeting cards, and advertising. Fanny's sister and brother, Maria and Robert Bond were also artists (see entries). **Sources:** G&W; Peters, *Currier & Ives,* 110-15; Peters, *America on Stone;* Cowdrey, NAD; Naylor, NAD (listed as Flora L. Palmer); Am. Inst. Cat., 1846-48; NYCD 1846+. More recently, see Rubinstein, *American Women Artists,* 68-70; Baigell, *Dictionary;* Marlor, *Brooklyn Art Assoc.; Reps (includes many cat. entries and gives locations of prints);* BAI, courtesy Dr. Clark S. Marlor.

PALMER, Frances *[Artist] late 19th c.*
Addresses: Active in Alma, MI, 1897-99. **Sources:** Petteys, *Dictionary of Women Artists.*

PALMER, Frances Flora See: **PALMER, Fanny (Frances) Flora Bond**

PALMER, Frank (Mrs.) *[Painter] late 19th c.*
Addresses: NYC. **Exhibited:** NAD, 1880. **Sources:** Naylor, *NAD.*

PALMER, Fred Loren *[Collector, patron] b.1901, Richmond Hill, NY.*
Addresses: Summit, NJ. **Studied:** Hamilton College (A.B.). **Comments:** Positions: trustee, Am. Fed. Arts, 1955-63, mem. exec. comn., 1957-63; chmn. bd. adv., Edward W. Root AC, Hamilton College, 1958-; mem. adv. council, State Mus. NJ, 1960-63; trustee, Summit(NJ) Art Center, 1970-. Collection: watercolors by Robert Parker, Kingman, Fredenthal and others; drawings by Baskin, Kuniyoshi, Tam, Shahn, Hirsch, Liberman, Thomas George and others; oils by William Palmer, Rattner, Kerkam, Vernard, Meigs and others; prints and etchings by Isabel Bishop, Matisse, Picasso and Beckmann; sculpture by Maldarelli & Hardy. **Sources:** WW73.

PALMER, Frederick Woodbury *[Painter] early 20th c.*
Addresses: Phila., PA. **Sources:** WW04.

PALMER, Fredrikke S(chjöth) (Mrs.) *[Painter] b.1860, Drammen, Norway.*
Addresses: Honolulu, HI. **Studied:** K. Bergslien, in Chriatiana (now Oslo); C. Gussow, in Berlin. **Member:** New Haven PCC. **Exhibited:** S. Indp. A., 1917. **Comments:** Position: staff artist, *Woman's Journal.* **Sources:** WW29.

PALMER, George S. *[Patron] b.c.1890 / d.c.1930, Lake Wales, FL.*
Work: MMA. **Comments:** For nearly half a century he had been a collector of Colonial art and antiques. In 1928 he donated what is known as the Palmer Collection of Americana to the MMA.

PALMER, Hans P. *mid 20th c.*
Exhibited: S. Indp. A., 1931, 1934-36, 1938; Salons of Am., 1934, 1935. **Sources:** Falk, *Exhibition Record Series.*

PALMER, Hattie Virginia Young (Mrs. C. F.) *[Painter, teacher] early 20th c.; b.Ripley, OH.*
Addresses: Houston, TX. **Studied:** Cincinnati Art Acad. **Member:** Houston AL; Indiana AA; Indiana State Keramic Club; Texas FAA; AAPL; SSAL. **Sources:** WW33.

PALMER, Herbert Bearl *[Art dealer, art critic] b.1915, NYC.*
Addresses: Los Angeles, CA. **Studied:** NY Univ. (Carnegie scholarship, 1938; Michael Friedsam scholarship, 1939; Charles Hayden scholarship, 1940; B.A. & M.A.) with A.P. McMahon, Inst. FA; Univ. Southern Calif.; Univ. Calif., Los Angeles. **Member:** Ethnic Arts Council Los Angeles (bd. dirs., 1969-71); College AA Am.; Am. Assn. Mus.; Mayor's Radio & TV Comt., St. Louis (chmn., 1958-63); Int. Soc. Gen. Semantics. **Comments:** Positions: Western & contrib. ed., *Minicam Photography,* 1946-50; owner-consult., Herbert Palmer Assocs., 1950-58; art consult., Kalimar Inc., 1958-63; dir., Feigen-Palmer Gal., 1963-68; private dealer, 1968-. Lectures: Contemporary Art, Collecting and Investing in Art & Photography in the Arts, Univ. Calif., Los Angeles Exten. Collections arranged: The Film and Modern Art (designed, arranged & catalogued), Munic. Art Gal., Los Angeles, 1969. Research: problems in museum management and development. Publications: auth., "Art Museums Face Crisis of Identity," *Los Angeles Times;* auth., "Anti-educational Influence of Pictorial Communication," *Journal Secondary Educ.;* auth., "Perspective and Optical Illusions," *Design;* auth., "The Company Museum," *Boston Bus. Magazine;* auth., "The Mollusk in Art," *Nature Magazine.* **Sources:** WW73.

PALMER, Herbert James *[Illustrator] b.1910, Phila., PA.*
Addresses: Westmont, NJ. **Studied:** Phila. Public Indust. Art Sch. **Exhibited:** AIC, 1931. **Comments:** Position: affiliated with

Public Ledger, Phila. **Sources:** WW31.

PALMER, Herman *[Painter, sculptor, illustrator, etcher] b.1894, Farmingham, UT.*
Addresses: NYC. **Studied:** M. Young. **Member:** NYWCC. **Exhibited:** 1925-26, 1935-38. **Comments:** Illustr.: *Hidden Heroes of the Rockies.* **Sources:** WW29.

PALMER, Hermione *[Illustrator] mid 20th c.*
Addresses: Glendale, CA. **Member:** SI. **Sources:** WW47.

PALMER, J. *[Engraver] early 19th c.*
Comments: Engraver of illustrations for an edition of *The Bible* published in NYC in 1826. **Sources:** G&W; Stauffer.

PALMER, J. E. (Jr.) *[Painter] mid 19th c.*
Addresses: Brooklyn, NY. **Exhibited:** NAD, 1872. **Sources:** Naylor, *NAD.*

PALMER, Jane *[Painter] late 18th c.*
Comments: Known through a genre scene painted in watercolors, about 1780. **Sources:** G&W; Lipman and Winchester, 178.

PALMER, Jessie (Mrs. Carl E.) *[Painter, sculptor, teacher] b.1882, Lawrence, TX.*
Addresses: Dallas, TX. **Studied:** Dallas Tech. College; Broadmoor Art Acad.; J. Carlson; F. Reaugh; M. Simkins. **Member:** SSAL; Texas FAA; Amarillo AA. **Exhibited:** Frank Reaugh Art Exh., 1925-46; SSAL, 1928, 1934, 1944, 1945; Texas FAA (Nashville,TN), 1930-40; Texas State Fair, 1934; Elisabet Ney Mus., 1935 (solo); Dallas AA, 1940; New Orleans; Dudensing Gals., NYC. **Awards:** Dallas Woman's Forum, 1924 (medal); Texas-Oklahoma Fair, 1926 (prize), 1927 (prize). **Work:** Travis School, Dallas, TX; Dallas Woman's Forum. **Comments:** Position: secy., Frank Keaugh AC, Dallas, TX, 1944-46. **Sources:** WW59; WW47.

PALMER, Julia Ann *[Primitive painter] early 19th c.*
Addresses: Hallowell, ME, active 1820. **Comments:** Known through a genre scene painted in watercolors. **Sources:** G&W; Lipman and Winchester, 178.

PALMER, Julia B. *[Painter] 19th/20th c.*
Addresses: NYC. **Exhibited:** NAD, 1891. **Sources:** WW04.

PALMER, Lemuel *[Illustrator, designer, lecturer] b.1893, Portland, ME.*
Addresses: Springfield, MA. **Studied:** R. Andréws; Mass. Sch. Art. **Exhibited:** Springfield Art Gld., 1927 (prize), 1928 (prize). **Sources:** WW33.

PALMER, Leroy A. *[Painter] late 19th c.*
Addresses: Tacoma, WA, 1894-95. **Exhibited:** Interstate Fair, Tacoma, WA, 1894. **Sources:** Trip and Cook, *Washington State Art and Artists,* 1850-1950.

PALMER, Lucia A. *[Painter] early 20th c.; b.Dryden, NY.*
Addresses: Hudson, NY. **Member:** Woman's Nat. Press Assoc. **Exhibited:** Expo Universelle, Paris, 1900. **Sources:** Petteys, *Dictionary of Women Artists.*

PALMER, Lucie Mackay *[Painter, lecturer] b.1913, St. Louis, MO.*
Addresses: St. Louis, MO. **Studied:** Boston Mus. FA Sch.; St. Louis Sch. FA, Wash. Univ.; ASL with Rapheal Soyer, J.N. Newell & Robert Brackman. **Member:** NAWA; St. Louis Art Guild; Orlando AA; Art Lg. Orange County (corresp. secy.). **Exhibited:** St. Louis Artists Gld., 1934-46; Boston Mus. Nat. Hist., 1942; NAWA, 1944 (prize), 1945-46 (solos); AMNH, 1943 (solo) & 1958-59 (solo); Rochester Mus. Arts & Sciences, 1959 (solo); Chicago Nat. Hist. Mus., 1960 (solo); Calif. Acad. Sciences, San Fran., 1961 (solo); Art Lg. Orange County, 1961 (hon. men.). **Comments:** Lectures: painting above & below the sea. Research: underwater painting. **Sources:** WW73; WW47.

PALMER, Lucile See: **WYMAN, Lucile Palmer**

PALMER, M. DeForest *[Painter] mid 19th c.*
Addresses: NYC. **Exhibited:** NAD, 1873. **Sources:** Naylor, *NAD.*

PALMER, M. Ella *[Artist] late 19th c.*
Addresses: Active in Jackson, MI, 1887. **Sources:** Petteys, *Dictionary of Women Artists.*

PALMER, Margaret Allison See: **PALMER, Peggy**

PALMER, Margaret Longyear *[Sculptor, craftsperson, teacher] b.1897, Detroit, MI.*
Addresses: Groose Pointe Farm, MI. **Studied:** J. Wilson.
Member: Detroit SAC; Detroit Soc. Women P&S. **Exhibited:**
Michigan State Fair, 1921 (prize); Detroit, 1935 (prize, garden sculpture); Detroit Soc. Women P&S, regularly. **Sources:** WW40; Petteys, *Dictionary of Women Artists.*

PALMER, Mary *[Painter] late 19th c.*
Addresses: NYC. **Exhibited:** NAD, 1890. **Sources:** Naylor, *NAD.*

PALMER, Mary Frances White *[Miniature painter, watercolorist] b.1875, Davenport, IA / d.1943, Ottawa, IL.*
Addresses: Ottawa, IL; California. **Comments:** Mother of Peggy Palmer.

PALMER, May *[Painter] b.1870 / d.1941.*
Studied: in Paris with MacMonnies, c.1898-1901. **Comments:**
She was a friend of Mary Foote and the Emmet sisters. She had a long affair with MacMonnies at Giverny. **Sources:** PHF files.

PALMER, Mildred *early 20th c.*
Exhibited: Salons of Am., 1934. **Sources:** Marlor, *Salons of Am.*

PALMER, Mildred Trumbull *[Bookbinder, lecturer] b.1890, Cambridge, MA.*
Addresses: Cambridge, MA. **Studied:** H. Noulac, E. Maylandor, in Paris, France. **Member:** Boston Soc. Arts & Crafts; Book on Hand Gld., Boston. **Comments:** Lectures: bookbinding. **Sources:** WW59; WW47.

PALMER, Minette D. (Mrs.) *[Painter] early 20th c.*
Addresses: Cincinnati, OH. **Member:** Cincinnati Women's AC.
Sources: WW25.

PALMER, Pauline Lennards (Mrs. Albert E.) *[Landscape and portrait painter] b.1867, McHenry, IL / d.1938, Trondheim, Norway.*
Addresses: Chicago, IL/Provincetown, MA (1920s-30s). **Studied:**
AIC with W. M. Chase, R. E. Miller, C. W. Hawthorne; in Paris with Collin, Prinet, Courtois, Simon. **Member:** Chicago P&S;
Chicago AC; Chicago Gal. Assn.; Grand Central Gal.; Nat. Am.
Lg. Pen Women's ; Provincetown AA. **Exhibited:** PAFA Ann.,
1899, 1908, 1912-32; St. Louis Expo, 1904 (medal); AIC, 1907 (prizes), 1914 (portrait), 1916 (prizes), 1917 (prize), 1920 (prize);
1924 (prize), 1926 (prize), 1937 (prize); SWA, 1915 (prize);
Chicago AG, 1915 (prize); Corcoran Gal. biennials, 1916, 1926;
Chicago SA, 1920 (medal); Peoria, IL (medal); NAWPS, 1924 (prize); Chicago Gal. Assn., 1928 (prize), 1929 (prize), 1931 (prize), 1936 (gold); Findley Gal., 1935 (medal). **Work:** West End Women's Club; Munic. Art Lg. Collection; AIC Arche Club, Chicago; Decatur (IL) Pub. Sch. Collection; Muncie (IN) AA;
Chicago Municipal Comn.; Aurora (IL) Art Lg.; Aurora (IL) AA;
Rockford (IL) AA; Springfield (IL) AA; Delgado Mus. Art; San Diego Gal. FA; Acad. FA, Elgin, IL. **Sources:** WW38; Falk, *Exh. Record Series.*

PALMER, Peggy *[Illustrator, painter] b.1905, Ottawa, IL / d.1979, San Mateo, CA.*
Addresses: N. California, 1915-20s; Chicago, 1935-on. **Studied:**
her mother, Mary F. White Palmer. **Exhibited:** AIC, 1949.
Comments: Auth./illustr. of many childrens books, primarily for Rand McNally. Her work was principally in watercolor and of a humorous nature. Illustr.: *San Francisco Call Bulletin*, 1920s. In 1935, she married and lived in Chicago. **Sources:** info. courtesy P. Burrows, her son.

PALMER, Pierpont *[Painter] late 19th c.*
Addresses: NYC. **Exhibited:** NAD, 1896. **Sources:** Naylor, *NAD.*

PALMER, R. *[Painter] early 20th c.*
Addresses: NYC, 1915. **Sources:** WW15.

PALMER, R. D. *[Portrait painter] mid 19th c.*
Addresses: NYC (?), active 1841. **Sources:** G&W; FARL to George C. Groce, Jan. 6, 1948.

PALMER, Randolph *[Portrait painter] d.1845, Auburn, NY.*
Addresses: Active primarily in Auburn, NY, from 1838 until his death. **Comments:** Also worked in Albany (in the 1840s) and Seneca Falls, NY. In addition, he taught painting to several Auburn artists, including William E. McMaster and George E.
Clough (see entries). **Sources:** G&W; info from FARL. More recently, see Gerdts, *Art Across America*, vol. 1, 174, 190-91.

PALMER, Ruth *[Painter] early 20th c.*
Addresses: Active in NYC, c.1900-15. **Exhibited:** NAD, 1897-99. **Comments:** *Cf.* R. Palmer. **Sources:** Petteys, *Dictionary of Women Artists.*

PALMER, Samuel M. *[Painter] early 20th c.*
Addresses: Phila., PA. **Member:** Phila. AC. **Exhibited:** PAFA Ann., 1920; S. Indp. A., 1927. **Sources:** WW25; Falk, *Exh. Record Series.*

PALMER, Sarah *[Painter] early 20th c.*
Addresses: Phila., PA. **Sources:** WW06.

PALMER, Seymour See: **PALMER, Edmund Seymour**

PALMER, Solveig (Salveig) (S.) *[Painter] b.1894, Morris, MN / d.1982.*
Addresses: West Hempstead, NY. **Studied:** Barnard College, ASL; G. Luks; J. Sloan. **Member:** NAWPS; ASL. **Exhibited:**
Montross Gal., NY; S. Indp. A., 1925, 1934-35, 1938; Salons of Am., 1934-35. **Sources:** WW40.

PALMER, Sophia *[Portrait painter] b.1876, San Francisco, CA / d.1970, Palo Alto, CA.*
Addresses: San Fran.; Palo Alto, CA. **Studied:** Mark Hopkins Inst. **Exhibited:** San Fran. Sketch Club, 1898. **Sources:** Hughes, *Artists of California*, 421.

PALMER, Sylvanus *[Portrait painter] mid 19th c.*
Addresses: Albany, NY, active 1844-54. **Comments:** Artist of a lithographed portrait of his father, Rev. Sylvanus Palmer, dated March 1844. **Sources:** G&W; Peters, *America on Stone*; Albany CD 1847-54.

PALMER, Theresa Zmislow (Mrs. A. W. L.) *[Portrait painter] mid 19th c.*
Addresses: New Orleans, active 1834-46. **Sources:** G&W; New Orleans CD 1846; *Encyclopaedia of New Orleans Artists.*

PALMER, Walter Launt *[Landscape painter] b.1854, Albany / d.1932.*

- W·L·PALMER ·

Addresses: Albany, NY. **Studied:** Charles Elliott & F.E. Church, 1870; Carolus-Duran, in Paris, 1876.
Member: ANA, 1887; NA, 1897; SAA, 1881;
NYWCC; AWCS; SC, 1901; Pastel; Century Assoc.;
AFA; Union Int. des Beaux-Arts et des Lettres; NY State FA Comn. **Exhibited:** Brooklyn AA, 1881, 1884-86; PAFA Ann., 1882-1918; Boston AC, 1885-98; NAD (1872-1930) 1887 (prize);
Columbian Expo, Chicago, 1893 (med.); Phila. AC, 1894 (gold);
AWCS, 1895 (prize); Boston, 1895 (prize); Tenn. Centenn. Expo,
Nashville, 1897 (prize); Paris Expo, 1900 (prize); watercolors:
Pan. Am. Expo, Buffalo (medal,1901), Charleston Expo (medal, 1902), St. Louis Expo (medal, 1904); St. Louis Expo, 1904 (med. for oil); Phila., 1907 (med.); Corcoran Gal. biennials, 1907-12 (4 times); Buenos Aires Expo, 1910 (med.); AIC, 1919 (prize);
Wilmington, 1926 (prize), 1928 (prize). **Work:** NMAA; MMA;
BMFA; Buffalo FA Acad; Pub. Gal., Richmond, IN; Omaha (NE)
Art Soc.; Mem. Art Gal., Rochester, NY; MMA; Butler IA,
Youngstown, OH. **Comments:** The son of sculptor Erastus Dow Palmer, Walter won renown for his winter landscapes and scenes of Venice. He exhibited regularly at the NAD anuals for nearly 60 years. Except for a few years (1878-80) at the Tenth St. Studio

building in NYC, he lived in Albany. He traveled to Europe several times and produced numerous views of Venice in the early 1880s. In 1899 he and his wife visited Japan at the invitation of his Canadian patron Sir William Van Horne; the group traveled to Yokohama, Tokyo, Kobe, Nagasaki, Nagoya, Kyoto, also visiting Hong Kong, Canton, and Macao. Several works resulted from this trip. **Sources:** WW31; Gerdts, *Art Across America*, vol. 1: 177; Gerdts, *American Artists in Japan*, 10 and pl. 35; *300 Years of American Art*, vol. 1: 481; Falk, *Exh. Record Series.*

PALMER, William Charles *[Painter, educator] b.1906, Des Moines, IA / d.1987.*
Addresses: NYC; Utica, NY. **Studied:** ASL with Kenneth Hayes Miller, Boardman Robinson, Thomas Hart Benton; École des Beaux-Arts, Fontainebleau, France, with M. Baudouin. **Member:** NAD; Arch. Lg.; Am. Soc. PS&G; Am. Artists Congress; NSMP (secy., vice-pres.); Art Educ. Assn.; Am. Assn. Mus.; Audubon Artists; ASL; FA Fed. of NY (bd. dir.). **Exhibited:** Wash., DC, 1932 (solo); ASL, 1932 (solo); Des Moines, IA, 1932 (solo); Younkers Tea Room Gals., 1933 (solo); Salons of Am., 1934; CI, 1936; Paris Salon, 1939 (gold); PAFA Ann., 1940-53, 1958, 1964; NAD, 1946 (prize); Audubon Artists, 1947-48 (gold medal), 1957 (hon. men.); SC, 1948 (award); Cazenovia (NY) Junior College, 1949 (solo); Des Moines AA, 1949 (solo), 1962; Munson-Williams-Proctor Inst., 1952 (solo), 1956; Corcoran Gal. biennials, 1937-53 (6 times); VMFA; BM; AIC; TMA; WMAA; MoMA; Kansas City AI; "The Neglected Generation of Am. Realist Painters 1930-48," Wichita Art Mus., 1981; solos: Midtown Gals., New York, 1932, 1938, 1940, 1944, 1947, 1950, 1952, 1954, 1957, 1959, 1961, 1963-69; Two Decades of Painting, Munson-Williams-Proctor Inst. (solo) & Cummer Art Gal., Jacksonville, FL, 1971 (solo); Am. Acad. Arts & Letters grant, 1953. **Work:** Allied Maintenance Co.; Atlanta Univ.; BMA; Columbia, SC, Mus.Art; Columbus Gal. FA (Ohio); Continental Grain Co.; Dallas Muf. FA; Empire Trust Co.; Arlington (MA) Post Office; WMAA; MMA; AGAA; White House, Wash., DC; AAAL; Encyclopaedia Britannica Coll.; Des Moines AC; Munson-Wms.-Proctor Inst., Utica, NY; Cranbrook Acad. Art, Bloomfield Hills, MI; Univ. Texas, Austin; Nat. Mus. Sport, NYC; Phoenix Art Mus.; St. Lawrence Univ.; Sara Roby Found. Coll.; Utica Coll.; Syracuse Univ.; Univ. Club, NYC; The Upjohn Co. **Commissions:** WPA murals, USPO Bldg., Wash., DC, First Nati. City Bank New York, Mus. City of New York, Queens General Hospital, Jamaica, NY & Homestead Savings & Loan Assn., Utica, NY. **Comments:** Teaching: ASL; dir., Munson-Wms.-Proctor Inst. Sch. Art, 1941-70s. Contrib.: *American Artist* magazine. **Sources:** WW73; WW47; Ness & Orwig, *Iowa Artists of the First Hundred Years*, 159-60; Falk, *Exh. Record Series.*

PALMER, Winogene E. *[Painter] b.1873, Lewistown, IL.*
Addresses: Laguna Beach, CA. **Studied:** AIC; Anna Hills; George Brandriff. **Exhibited:** Laguna Beach Art Gal., 1930s; Calif. State Fair, 1937. **Sources:** Hughes, *Artists of California*, 421.

PALMER-PORONER, Margot *[Art dealer] late 20th c.; b.Quebec.*
Addresses: NYC. **Studied:** Montreal Art Sch. **Comments:** Positions: dir., East Hampton Gal., NYC. Also appears as Poroner. **Sources:** WW73.

PALMERTON, Don F. *[Marine & landscape painter] b.1899, Chicago, IL / d.1937.*
Addresses: Hollywood, CA. **Studied:** J.C. Abbott; A.C.M. La Farge & M.E. Davis in Paris. **Member:** Calif. AC. **Sources:** WW40.

PALMGREEN, Charles J. *[Painter] early 20th c.*
Addresses: Versailles, PA. **Member:** Pittsburgh AA. **Sources:** WW25.

PALMIE, Rosalie *[Painter] 19th/20th c.; b.Hamburgh, Germany.*
Addresses: Utica, NY. **Studied:** Acad. Julian, Paris, with Laurens & Constant; Berlin. **Exhibited:** Acad. Julian (prize); S. Indp.

A., 1917. **Sources:** WW01.

PALMORE, Tommy Dale *[Painter] b.1944.*
Addresses: Philadelphia, PA, 1972. **Exhibited:** WMAA, 1972. **Sources:** Falk, *WMAA.*

PALMQUIST, Robert *[Painter] mid 20th c.*
Addresses: Chicago area. **Exhibited:** AIC, 1940. **Sources:** Falk, AIC.

PALOWETSKI, C(harles) E. *[Painter] b.1885, New York.*
Addresses: Paris, France. **Studied:** Bonnât, in Paris. **Sources:** WW15.

PALTE, Walter *[Painter] mid 20th c.*
Addresses: NYC, 1959. **Exhibited:** WMAA, 1959. **Sources:** Falk, *WMAA.*

PALTENGHI, A. *[Sculptor] mid 19th c.*
Addresses: New Orleans, LA, 1854-56; San Francisco, CA, 1856-60. **Sources:** G&W; New Orleans CD 1854-56; San Francisco CD 1858-60.

PALUMBO, Alphonse *[Painter, sculptor] b.1890, Raito, Italy.*
Addresses: NYC. **Studied:** ASL; NAD; E. Spiecher; F.L. Mora; DuMond. **Member:** Art Fellowship, Inc. **Exhibited:** All. Artists Am.; NAD; Salons of Am.; S. Indp. A.

PALUMBO, Anthony *mid 20th c.*
Addresses: NYC, 1959. **Exhibited:** WMAA, 1959. **Sources:** Falk, *WMAA.*

PALUMBO, Dan *[Painter] mid 20th c.*
Addresses: Chicago, IL. **Exhibited:** Corcoran Gal. biennials, 1939. **Sources:** Falk, *Corcoran Gal.*

PANCHAK, William (Wasyl) *[Painter] b.1893, Czernica, Ukraine.*
Addresses: NYC. **Studied:** Canegie Inst.; PAFA; NAD; ASL. **Member:** Woodstock AA; AAPL. **Exhibited:** Soc. Indep. Artists, 1925, 1927, 1930-31, 1935; Salons of America; NAD; Soc. Indep. Artists, Buffalo; Newark Mus. Art (solo); Burr Gal., NY. **Work:** Newark Mus. Art; Skene Mem. Lib., Fleischmann, NY; churches in Pittsburgh, PA; McKeesport, PA; Rome, NY; Bridgeport, CT; NYC. **Sources:** WW59.

PANCOAST, Henry B(oller), Jr. *[Painter] b.1876, Phila.*
Addresses: Cornwells, Phila., PA. **Studied:** PAFA; Drexel Inst. **Member:** Phila. AC. **Exhibited:** PAFA Ann., 1903-09, 1924-25, 1930. **Sources:** WW25; Falk, *Exh. Record Series.*

PANCOAST, John *[Museum director] mid 20th c.*
Addresses: Portland, ME. **Sources:** WW66.

PANCOAST, Morris Hall *[Painter, illustrator, cartoonist] b.1877, Salem, NJ / d.1963, Rockport, MA.*
Addresses: Cambridge, MA/Lane's Cove, Rockport, MA (1945-on). **Studied:** Drexel Inst., Phila., 1895 (night courses); PAFA with Thomas Anshutz, 1897 (night courses); Acad. Julian, Paris, with Jean Paul Laurens, 1902-05. **Member:** CAFA; SC; PAFA; Phila. AA; Phila. Sketch Club; North Shore AA; Gloucester Soc. Artists. **Exhibited:** AIC, 1911, 1927; PAFA Ann., 1911-34; BM; Corcoran Gal. biennials, 1910-30 (6 times); S. Indp. A., 1920; NAD; Baltimore Charcoal Club; GGE, 1939; Gloucester SA; Rockport AA; Concord Pub. Lib., 1950 (solo). **Work:** PAFA; Reading (PA) Mus.; Williamsport (PA) Munic. Art Lg.; Williamsport (PA) Lib.; Speed Mem. Mus.; Mus. FA Houston; Milwaukee Al. **Comments:** After studying in Paris, he joined the art dept. of the *Philadelphia Inquirer*, 1905-07; then the *North American* as a cartoonist, 1907-19. Beginning in the early 1920s, he and his wife spent their summers in Rockport, MA, where she ran their "Studio Gallery by the Sea." The Great Depression caused them to move frequently until they finally settled in Cambridge, MA, in 1945. He is best known for his Cape Ann landscapes. **Sources:** WW59; Falk, *Exh. Record Series.*

PANDICK, John *[Painter] early 20th c.*
Addresses: NYC. **Exhibited:** S. Indp. A., 1917-25. **Sources:** WW15.

PANDOLFINI, Joseph Paul *[Painter, craftsperson, illustrator, teacher] b.1908, Italy.*
Addresses: NYC, 1912. **Studied:** NAD, 1925-30; Royal Acad. FA, Italy, 1933. **Exhibited:** Musée du Jeu de Paume, Paris, 1938; MoMA, 1938; MMA; CGA; AIC, 1939; WMAA, 1940; NAD, 1950; "NYC WPA Art" at Parsons Sch. Design, 1977. **Work:** Univ. Minnesota. **Comments:** Teaching: Brooklyn Mus. School, 1947-48. Represented by Julien Levy Gal., NYC, 1934-36; Downtown Gal., 1937-40. **Sources:** WW59; WW47; *New York City WPA Art,* 69 (w/repro.).

PANESIS, Nicholas *[Lithographer] b.1913, Middleboro, MA / d.1967, Los Angeles, CA.*
Comments: WPA printmaker in California, 1930s. **Sources:** exh. cat., Annex Gal. (Santa Rosa, CA, n.d., c.1988).

PANETH, Marie *[Painter] mid 20th c.*
Exhibited: S. Indp. A., 1939. **Sources:** Marlor, *Soc. Indp. Artists.*

PANETTY, Lewis *[Fresco painter] b.1805, Italy.*
Addresses: Wash., DC, active 1860. **Sources:** McMahan, *Artists of Washington, D.C.*

PANKE, Edith (Mrs. Felix Curt) *[Painter] mid 20th c.*
Addresses: NYC. **Exhibited:** S. Indp. A., 1933, 1937-41, 1944; NAWPS, 1935-38. **Sources:** WW40.

PANNASH, Adolph *b.1866 / d.1952, Flushing, LI, NY.*
Exhibited: S. Indp. A., 1926-27; Salons of Am., 1927. **Sources:** Falk, *Exhibition Record Series.*

PANOFSKY, Erwin *[Scholar, art historian] b.1892, Hanover, Germany / d.1968.*
Addresses: Moved to U.S. in 1933, settled in Princeton, NJ. **Studied:** Univ. Freiburg, Berlin & Munich; Ph.D.: Univ. Freiburg, Utrecht, Uppsala, Berlin; Litt. D.: Princeton Univ., Oberlin College, Rutgers Univ., Bard College; Arts D., Harvard Univ., NY Univ. **Awards:** Jurgius Medal, Hamburg; Haskins Medal, Mediaeval Acad. of Am., 1962. **Member:** British & Am. Acad. Arts & Sciences. **Comments:** Renowned art historian. Although Panofsky's research area was primarily Gothic and Renaissance art, his pioneering theories and methodologies of art interpretation had worldwide importance for the development of art history as a discipline. Teaching: Inst. for Advanced Study, Princeton (NJ) Univ., 1935-. **Auth.:** *Idea* (1924); *Studies in Iconology: Humanistic Themes in the Art of the Renaissance* 1939; *Gothic Art and Scholasticism* (1951); *Early Netherlandish Painting* (1953); *Meaning and the Visual Arts* (1970). **Sources:** WW66.

PANSING, Fred *[Marine painter, lithographer, photographer] b.1854, Bremen, Germany / d.1912, Jersey City, NJ.*

FRED PANSING

Studied: possibly inspired by James Bard, a neighbor in NYC; Hoboken Sketch Club, 1872. **Member:** Hoboken Sketch Club; NJ Arts Club. **Work:** Mariners' Mus.; Mystic Seaport Mus.; Peabody Mus., Salem. **Comments:** He came to NYC as a child, c.1865; by 1870 he was a sailor, sailing widely for five years. In 1872, he married and settled in Hoboken, NJ; then in Jersey City, 1890. He produced many ship portraits, which were published as chromolithographs for postcards, picture puzzles, sheet music, and prints; and he produced marine illustrations for *Harper's Weekly.* He also collaborated with Charles Parsons and Milton Burns. Most of his lithographs were made by Knapp & Co. and American Lithographic Co. In 1912, he produced his best-known series of ship portraits, being eighteen paintings of the fleet of the Nantasket Beach Steamboat Co. **Sources:** A.J. Peluso, article, *Maine Antique Digest* (April, 1985, 24D).

PANTILLA, Parker Elwood *[Painter] mid 20th c.*
Addresses: Chicago area. **Exhibited:** AIC, 1946. **Sources:** Falk, AIC.

PANTON, Henry *[Landscape painter] mid 19th c.*
Addresses: NYC, active 1850-72. **Member:** NA (hon. mem.). **Exhibited:** NAD, 1851-72; Am. Art-Union. **Sources:** G&W; Cowdrey, AA & AAU; Cowdrey, NAD; Naylor, NAD.

PANTON, M(alcolm) M., Jr. *[Painter] early 20th c.*
Addresses: Westfield, NJ, 1925. **Exhibited:** S. Indp. A., 1925. **Comments:** Possibly Rev. Malcolm McBride Panton, Jr., living in 1943. **Sources:** Marlor, *Soc. Indp. Artists.*

PANZARELL, Rose A. *[Painter] early 20th c.*
Addresses: Laurelton, LI, NY, 1931. **Exhibited:** S. Indp. A., 1931. **Sources:** Marlor, *Soc. Indp. Artists.*

PAOLI, J. *[Wax portraitist] mid 19th c.*
Addresses: Philadelphia, 1858. **Sources:** G&W; Phila. BD 1858.

PAOLO, Cartaino S(ciarrino) *[Sculptor] b.1882, Palermo, Italy.*
Addresses: NYC/Boston, MA. **Studied:** Am. Acad., Rome; FA Inst., Palermo. **Exhibited:** PAFA Ann., 1935. **Work:** busts, State House (Boston), Boston Cathedral; mem., Cathedral St. John the Divine, NYC; NYU; TMA; tablet, John Burroughs memorial field. **Sources:** WW21; Falk, *Exh. Record Series.*

PAOLO, Moro *early 20th c.*
Exhibited: Salons of Am., 1925. **Sources:** Marlor, *Salons of Am.*

PAONE, Peter *[Printmaker, painter] b.1936, Philadelphia, PA.*
Addresses: NYC. **Studied:** Phila. College Art (B.F.A., 1953). **Member:** SAGA. **Exhibited:** Brooklyn Mus., 1962 & 1964; Butler Inst. Am. Art, 1965; Contemp. Art Overseas; NY World's Fair, 1965; Otis Art Inst., Los Angeles, 1964 & 1966. **Awards:** Tiffany Found. grant, 1962 & 1964; purchase prize, Syracuse Univ., 1964; Guggenheim fellowship, 1965-66. **Work:** LOC; PMA; MoMA; Fort Worth AC Mus.; Victoria & Albert Mus., London, England. **Comments:** Auth./illustr.: *Paone's Zoo,* 1961; *Five Insane Dolls,* 1966 & *My Father,* 1968. **Sources:** WW73; Selden Rodman, *The Insiders* (Louisiana State Univ. Press, 1960).

PAPASHVILY, George *[Sculptor, writer] b.1898, Koblantkari, Georgia / d.1978.*
Addresses: Quakertown, PA. **Member:** Artists Equity Assn.; Audubon Artists; Phila. Art Alliance (sculpture comt., 1952-59). **Exhibited:** PAFA Ann., 1952-64 (6 times); Allentown (PA) Art Mus., 1951(solo); Lehigh Univ. Art Gal., Bethlehem, PA, 1957 (solo); Scripps College Art Gal., Claremont, CA, 1966 (solo); Reading (PA) Pub. Mus. & Art Gal., Pa, 1970 (solo); William Penn Mem. Mus., Harrisburg, PA, 1971(solo). **Work:** Woodmere Gal., Phila.; Reading (PA) Pub. Mus & Art Gal. Commissions: sculptures, Cascades Conf. Center, 1965 & walkway, 1967, Colonial Williamsburg, VA; sculptures, Fox Chase Branch Lib., 1969 & West Oak Lane Branch Lib., 1970, Free Lib. Phila.; sculpture, Balt. Co. Pub. Lib., Catonsville Maryland Branch, 1970; sculpture, Friends of Beverly Hills Lib. for Beverly Hills (CA) Pub. Lib., 1971. **Comments:** Preferred medium: stone. Publications: co-auth., *Anything Can Happen,* 1945, *Yes & No stories,* 1946, *Thanks to Noah,* 1950, *Dogs & People,* 1954 & *Russian Cooking,* 1969. **Sources:** WW73; D. Grafly, "Sculpture of George Papashvily" *Am. Artist Magazine* (Oct., 1955); A. Stenius, "Beauty in Stone" (film), Wayne State Univ., 1959; Falk, *Exh. Record Series.*

PAPASIAN, Jack (or Jacques) Charles *[Sculptor, writer] b.1878, Olympia, Greece / d.1957.*
Addresses: NYC. **Studied:** A.D. Zotto in Venice; E. Ferrari in Rome; Paris. **Member:** NSS. **Work:** Greek Government. **Sources:** WW47.

PAPAZIAN, George Cass See: **CASS-PAPAZIAN, George**

PAPE, Alice Monroe (Mrs. Eric) *[Painter, illustrator] b.Boston / d.1911, Manchester-by-the-Sea, MA.*
Addresses: Manchester-by-the-Sea. **Studied:** D. Bunker & G.H. Clements in Boston; Acad. Julian, Paris, with Bouguereau & T. Robert-Fleury; Ch. Lasar in Paris. **Comments:** She played the

piano and the double bass viol. Her sister was the wife of sculptor George Grey Barnard. Pape assisted her husband, Eric (see entry), at Cowles Art School & Eric Pape Art School, Boston. **Sources:** WW10; Petteys, *Dictionary of Women Artists.*

PAPE, Billie Kathleen *[Painter] mid 20th c.*
Addresses: Sacramento, CA. **Exhibited:** Calif. State Fair, 1937. **Sources:** Hughes, *Artists of California*, 421.

PAPE, Eric L. *[Painter, sculptor, illustrator, teacher] b.1870, San Francisco, CA / d.1938.*
Addresses: NYC, 1890s/Paris, France, 1893; Manchester-by-the-Sea, MA. **Studied:** E. Carlsen, Mark Hopkins Inst., San Fran.; École des Beaux-Arts, Paris, with Gérome; Acad. Julian, Paris, with Boulanger, Constant, Lefebvre, & Doucet, up to 1889; also in Paris with Delance, Whistler & Rodin. **Member:** United Arts Club, Royal Soc. Arts, Atlantic Union (all, of London); North British Acad.; Players Club, NYC. **Exhibited:** SNBA, 1890, 1892-94 (as Frederic Pape); World's Columbian Expo, 1893; PAFA Ann., 1893 (as Frederick L.M. Pape), 1894-1912 (5 times); Calif. Midwinter Fair, 1894; NAD, 1895-96, 1935; Boston AC, 1898-99 (Egyptian scenes); AIC, 1901-03, 1931; Pan-Pacific Expo, 1915. Awards: medals and diplomas, various exhs. **Comments:** After studying in Paris, Pape traveled to Germany and throughout Europe and North Africa before returning to the U.S. He established himself in NYC as a successful illustrator while continuing to paint figurative pieces, but spent most of his career in Boston. Position: founder/dir., Eric Pape Sch. Art, 1897-1913. Illustr.: *The Fair God; The Scarlet Letter; The Life of Napoleon Bonaparte; Life of Mahomet; Poetical Works of Madison Cawein; The Memoirs of Ellen Terry.* Designer: mon., Stage Fort Park, Gloucester, commemorating founding of Mass. Bay Colony, 1623. (He was born Frederic Pape.) **Sources:** WW38; *125 Years of American Watercolor Painting* (exh. cat., NYC: Spanierman Gal., 1998); Hughes, *Artists in California*; Fink, *Am. Art at the 19th C. Paris Salons*, 377 (as Frederic Pape); PHF files; Falk, *Exh. Record Series.*

PAPE, Frederic See: **PAPE, Eric L.**

PAPE, George K. *[Painter] early 20th c.*
Addresses: Chicago, IL. **Member:** Chicago NJSA. **Sources:** WW25.

PAPE, Gretchen Anna (Mrs.) *[Painter] b.1866 / d.1947, Evanston, IL.*
Addresses: Wilmette, IL.

PAPE, Paul C. *[Painter] late 19th c.*
Addresses: Cincinatti. **Exhibited:** AIC, 1898. **Sources:** Falk, AIC.

PAPO, Iso *[Painter] mid 20th c.*
Addresses: Allston, MA. **Sources:** WW66.

PAPPAS, Elaine *[Painter] mid 20th c.*
Addresses: Chicago area. **Exhibited:** AIC, 1947. **Sources:** Falk, AIC.

PAPPAS, George *[Painter] mid 20th c.*
Exhibited: Corcoran Gal. biennials, 1959, 1961; PAFA Ann., 1960. **Sources:** Falk, *Exh. Record Series.*

PAPPAS, James G. *[Painter, educator] b.1937, Syracuse, NY.*
Addresses: Buffalo, NY. **Studied:** NY State Univ., Buffalo (B.F.A., 1967; M.F.A., 1974); Albright Art School, Buffalo. **Member:** Buffalo SA; Patteran Soc., (pres.), 1979). **Exhibited:** Unitarian Universalist Church, Erie, PA; Buffalo, NY. Awards: Shirley Lidsey Curr Award, Rochester, NY; Univ. Buffalo Found. Award. **Comments:** Positions: co-founder, APS Creative AC, Inc., Buffalo, NY; co-founder/assoc. dir., Langston Hughes Center for the Visual-Performing Arts, Buffalo, 1970-73; exec. dir., 1974; bd. dir., Assoc. Arts Organization, 1975-80. NY State Univ., Buffalo; chmn., Cultural Section, Model Cities Program, Buffalo. Teaching: SUNY,1976-on. **Sources:** Cederholm, *Afro-American Artists*; Krane, *The Wayward Muse*, 193.

PAPPAS, John L. *[Painter] b.1898, Florina, Greece.*
Addresses: Detroit, MI. **Studied:** J.P. Wicker. **Member:** Scarab Club. **Exhibited:** Mich. Ann. Exh., 1929 (watercolor prize); Corcoran Gal. biennial, 1930; Mich. State Fair, 1930 (prize), 1932; PAFA Ann., 1932, 1934, 1964; Detroit AI, 1935 (prize); S. Indp. A., 1931; AIC, 1931-39; Scarab Club, 1939 (gold). **Work:** Detroit Inst. Art. **Sources:** WW40; Falk, *Exh. Record Series.*

PAPPAS, Marilyn *[Craftsman, educator] b.1931, Brockton, Mass.*
Addresses: Miami, FL. **Studied:** Mass. College Art (B.S.Ed.); Penn. State Univ. (M.Ed.). **Member:** Am. Crafts Council; Florida Craftsmen. **Exhibited:** "Young Americans," 1962 (prize)," Craftsmen of the Eastern States," 1963, "Fabric Collage," 1965 & "Craftsmen USA," 1966, Mus. Contemp. Crafts; "History of Collage," Kunstgewerbemuseum, Zurich, Switzerland, 1968. Awards: Florida Craftsmen Ann. Awards, 1966-67 & 1971; Miami AC Award, 1971-72. **Work:** Objects USA, Johnson Coll.; Viktor Lowenfeld Mem. Colle., Penn. State Univ.; Krannert Art Mus., Univ. Illinois; Dayton (OH) Traveling Mus. Commissions: wall covering, comn. by Lee Nordness, NYC, 1967; theater curtain, Temple Israel, Miami, 1968; fabric collage, Pan Am Int., 1970. **Comments:** Preferred medium: collage. Teaching: Penn. State Univ., 1959-64; Miami-Dade Jr. College, 1965-. Publications: contrib., *School Arts* magazine, 1962-67. **Sources:** WW73; Bartlett Hayes, *Drawings of the Masters: American Drawings* (Shorewood Publ., 1965); Nik Krevitsky, *Stitchery: Art and Craft* (Art Horizons, 1966); Lee Nordness, *Objects USA* (Viking Press, 1970).

PAPPEL, Edda See: **HEATH, Edda Maxwell (Miss)**

PAPPELENDAM, Laura van *[Painter] b.1883 / d.1974.*
Addresses: Active in New Mexico, 1925. **Studied:** AIC with Joaquin Sorolla y Bastida. **Comments:** Teaching: AIC, for over 50 years. **Sources:** Trenton, ed. *Independent Spirits*, 171 (w/repro.).

PAPPRILL, Henry *[Engraver] mid 19th c.*
Comments: Aquatint engraver of two views of NYC, 1846 and 1848. **Sources:** G&W; Stokes, *Historical Prints;* Stauffer.

PAPSDORF, Frederick *[Painter, etcher] b.1887, Dover, OH.*
Addresses: Detroit, MI. **Studied:** Detroit Inst. Art. **Member:** Progressive Art Club, Detroit. **Exhibited:** WMAA, 1940; PAFA Ann., 1944-47, 1950, 1958. **Work:** CAM; PAFA; MOMA; Detroit Inst. Art; Detroit Artists Market. **Comments:** Teaching: Northeastern YMCA, Detroit, MI. **Sources:** WW59; WW47; Falk, *Exh. Record Series.*

PAQUET, Anthony C. *[Engraver on wood, copper & steel] b.1814, Hamburg, Germany / d.1882, Philadelphia, PA.*
Addresses: worked in Phila. 1850-55; NYC 1856-58; Phila., permanently from 1859. **Exhibited:** PAFA, 1862 (military medal), 1864 (medallion). **Comments:** Came to America in 1848. He was an assistant engraver at the U.S. Mint from 1857-64 and engraved the first Congressional Medal of Honor. **Sources:** G&W; Stauffer; Thieme-Becker; Phila. BD 1851-55; NYBD 1856-58; Rutledge, PA; Loubat, *Medallic History of the U.S.*, plates 70, 72-73, 75-76; info. courtesy John R. Sinnot, Chief Engraver, U.S. Mint (1945); 7 Census (1850), Pa., L, 627 (as J. C. Paquet).

PAQUETTE *early 20th c.*
Exhibited: Salons of Am., 1934. **Sources:** Marlor, *Salons of Am.*Bibliography: Marlor, *Salons of Am.*

PARADISE, John *[Portrait painter] b.1783, Hunterdon County, NJ / d.1833, Springfield, NJ, at home of his sister.*
Addresses: Phila., active c.1803-09; NYC from 1810. **Studied:** briefly with Volozan in Phila., before 1803. **Member:** NA (founding mem., 1826). **Exhibited:** NAD, 1826-34. **Comments:** Began painting professionally c.1803. His son, John Wesley Paradise (see entry), was a portrait painter and engraver. **Sources:** G&W; Dunlap, *History*, II, 204-05; N.Y. *Evening Post*, Dec. 2, 1833, obit.; NYCD 1812-30; Cowdrey, NAD; Cummings, *Historic*

Annals of the NAD, 133 (death date erroneously given as June 16, 1834).

PARADISE, John Wesley *[Engraver, portrait painter]* b.1809, New Jersey / d.1862, NYC.
Addresses: NYC, active c.1828 to his death. **Studied:** engraving with Asher B. Durand in NYC. **Member:** ANA, 1833. **Exhibited:** NAD, 1828-49. **Sources:** G&W; Cummings, *Historic Annals of the NAD,* 308; Stauffer; Cowdrey, NAD; NYCD 1831-60; Durand, *Life and Times of A.B. Durand,* 90; Hamilton, *Early American Book Illustrators and Wood Engravers,* 96; 8 Census (1860), N.Y., LIII, 160.

PARADISE, Phil(ip) H(erschel) *[Painter, lithographer, craftsman, designer sculptor]* b.1905, Ontario, OR.
Addresses: Pasadena, CA, 1939; Cambria, CA in 1976. **Studied:** Chouinard AI, 1927; F. T. Chamberlin; C. Hinkle; R. Lebrun; L. Kroll. **Member:** ANA; Calif. WCS; Phila. WCC. **Exhibited:** GGE, 1939 (prize); Phila. WCC, 1939 (purchase award for "Goleta"), 1943 (Dana Medal for "Suburban Supper"); PAFA Ann., 1939, 1942; Denver Art Mus.; LACMA, 1940; San Diego FA Soc., 1940 (prize); PAFA, 1941 (medal); San Fran. Int. Exh., 1941 (purchase award for landscape); AV, 1943 (prize); CI, 1943-45; Corcoran Gal. biennials, 1941-49 (4 times); AIC, 1943; NAD; Pepsi-Cola, 1945 (prize); WMAA, 1945; SFMA. **Work:** Cornell Univ.; Univ. Calif.; Marine Hospital, Carville, LA; PAFA; Kansas State Univ.; LOC; Phila. WCC; San Diego FA Soc., CA; Spokane AA. **Comments:** Preferred medium: graphics. **Positions:** dir. fine arts, Chouinard Art Inst., 1936-40; art dir. & production des., Sol Lesser Prod., Paramount Studios, 1941-48; dir., Greystone Gal., 1962-70s. **Illustr.:** *Fortune; Westways; True,* and others, 1940-60. **Teaching:** Chouinard Art Inst., 1931-40; Univ. Texas, El Paso, 1952; Scripps College, 1956-57. **Sources:** WW73; WW47; Janice Lovos, "Guatemala Journey" (1950) & "Phil Paradise Serigraphs" (1969), *Am. Artist;* article by Beverly Johnson, *Los Angeles Times Home Magazine,* 1967; Falk, *Exh. Record Series.*

PARAMINO, John F. *[Sculptor, writer]* b.1888, Boston, MA.
Addresses: Wellesley Hills, MA. **Studied:** BMFA Sch. **Member:** Gld. Boston Artists; Copley Soc., Boston. **Exhibited:** PAFA Ann., 1918; Mass. Horticultural Soc., 1929 (medal). **Work:** sculpture, bas-reliefs, mem., monuments, busts: State House, Boston, MA; World War II Mem., Four Freedoms Mem., Boston; A. Platt Andrew Mem., Gloucester, MA; Plymouth, MA; Hall of Fame, NY; Boston Commons; Cambridge, MA; Boston Univ. Law Sch.; Harvard Univ.; Nantucket Island, MA; U.S. Army; New Suffolk County Court House, Boston; Northampton, MA; Wellesley College. **Comments:** Auth.:*Sculpture as a Medium of Expression,* 1945. **Sources:** WW59; WW47; Falk, *Exh. Record Series.*

PARAVICINI, Lizette *[Painter, craftsperson, teacher]* b.1889, Philadelphia, PA.
Addresses: Philadelphia, PA. **Studied:** Univ. Pennsylvania (A.B.; A.M.); PAFA; Frank Linton; Earl Horter; Arthur Carles. **Member:** Art All., Plastic Club, WCC, & Art Teachers Assoc., all of Phila.; Woodmere AA; fellow, PAFA. **Exhibited:** PAFA; Phila. WCC; Phila. Plastic Club; Woodmere Art Gal.; DaVinci All.; Phila. Art All. (solo); solos: Women's Club, Ardmore, Swarthmore & Phila. **Comments:** Teaching: Kensington H.S., Phila., 1921-55. **Sources:** WW59; WW47.

PARCELL, L. Evans *[Illustrator]* early 20th c.
Addresses: Washington, PA. **Member:** SI. **Sources:** WW31.

PARCELL, Malcolm Stephens *[Painter, educator]* b.1896, Claysville, PA.
Addresses: Washington, PA. **Studied:** CI; A.W. Sparks; George Sotter; Washington & Jefferson College. **Exhibited:** Assoc. Artists, 1918 (prize); NAD, 1919 (gold); Corcoran Gal. biennials, 1919-35 (4 times); PAFA Ann., 1920, 1928-33; MacBeth Gal., NYC, 1922; Carnegie Int., 1922, 1935 (solo), 1953 (prize); Gillespie Gal., Pittsburgh, 1923-24; AIC, 1924 (prize). **Work:** Butler AI; Carnegie Inst.; Univ. Pittsburgh; Foster Mem., Pittsburgh; Penn. State Univ.; Univ. Chicago; Northwestern Univ.

Comments: Contrib.: *International Studio; Harpers; Vanity Fair; Art and Archaeology; International Blue Book.* His mural, "Judgement of Paris," in the Continental Bar at the William Penn Hotel in Pittsburgh received much attention. Other decorative panel and mural commissions followed, and in 1937 he married Helen Louine Gallagher, the model of many of his paintings, including the award winning *Louine.* **Sources:** WW59; WW47. More recently, see, Chew, ed., *Southwestern Pennsylvania Painters,* 98-99; Falk, *Exh. Record Series.*

PARCELL, Mary C. *[Painter]* late 19th c.
Addresses: NYC. **Exhibited:** NAD, 1888, 1892. **Sources:** Naylor, *NAD.*

PARCHÉ, Gil See: **WILDER, Bert**

PARDEE, Lillian Minerva Magill *[Painter]* b.1859, Rock Island, IL / d.1936, Oakland, CA.
Addresses: Watsonville, CA. **Studied:** Wm. Keith. **Comments:** Specialty: watercolors. **Sources:** Hughes, *Artists of California,* 421.

PARDESSUS, E. V. *[Sculptor]* late 19th c.
Addresses: Brooklyn, NY. **Exhibited:** Brooklyn AA, 1877-78 (portrait busts). **Sources:** *Brooklyn AA.*

PARDE[E?], Phineas *[Listed as "artist"]* b.c.1819, Connecticut.
Addresses: New Haven, CT, 1850 (at the Assembly House Hotel). **Sources:** G&W; 7 Census (1850), Conn., VIII, 277.

PARDI, Justin Anthony *[Painter, teacher, lecturer]* b.1898, Castelli, Italy / d.1951.
Addresses: Overbrook, Phila., PA. **Studied:** BMFA Sch.; P. Hale; F. Bosley; McLellan. **Member:** Germantown Art Lg.; DaVinci All.; Phila. Art All.; Woodmere AA; Phila. Sketch Club. **Exhibited:** PAFA Ann., 1934-39; DaVinci All., 1937-39, 1940 (med.), 1941-44. **Work:** Fitzgerald Mercy Hospital, Darby, PA; North & Co.; College Physicians, Phila. **Comments:** Teaching: Business Men's AA (Phila.), PM Sch. IA (1927-32), PAFA (1932-39), Woodmere Art Gal. (1940). **Sources:** WW47; Falk, *Exh. Record Series.*

PARDO, Ambroise *[Portrait painter]* 18th/19th c.
Addresses: Active in Louisiana during the 1790s; specifically in New Orleans, LA, 1803-05. **Sources:** G&W; Van Ravenswaay, "The Forgotten Arts and Crafts in Colonial Louisiana," 195. See also *Encyclopaedia of New Orleans Artists.*

PARDO, Frank mid 20th c.
Exhibited: Salons of Am., 1936. **Sources:** Marlor, *Salons of Am.*

PARDOE, John *[Portrait painter]* mid 19th c.
Addresses: NYC. **Exhibited:** Am. Inst., 1848. **Sources:** G&W; Am. Inst. Cat., 1848; NYCD 1848-49, as "painter.".

PARDOE, J(onathan) B. *[Painter]* b.1873, Pennington, NJ / d.1944, Bound Brook, NJ.
Addresses: Bound Brook, NJ, 1925. **Exhibited:** S. Indp. A., 1925-26. **Sources:** Marlor, *Soc. Indp. Artists.*

PARDON, Earl B. *[Craftsman, educator]* b.1926, Memphis, TN / d.1991.
Addresses: Saratoga Springs, NY. **Studied:** Memphis Acad. Art (B.F.A.); Syracuse Univ. (M.F.A.). **Exhibited:** Mus. Contemp. Crafts; Wichita Craft Biennial; Syracuse Ceramics Nat.; Skidmore College; Schenectady Mus. Art. **Work:** Mus. Contemp. Crafts; St. Paul Mus. & Scoolh Art; Lows AC, Syracuse; Memphis Acad. Art; Skidmore College. **Commissions:** Mus. Contemp. Crafts & Prudential Life Ins. Co., Newark, NJ. **Comments:** Teaching: lecturer on painting, jewelry & design at art schools, craftsmens organizations & college alumni groups; prof. art & chmn. dept., Skidmore College. **Sources:** WW73.

PARDUCCI, Rudolph *[Sculptor]* b.1899, Pisa, Italy / d.1973, Los Angeles, CA.
Addresses: Los Angeles, 1938-73. **Exhibited:** LACMA, 1940. **Work:** Gardena Post Office. **Comments:** WPA artist. **Sources:**

Hughes, *Artists of California*, 421.

PAREDES, Diogenes *[Painter] mid 20th c.*
Exhibited: AIC, 1944. **Sources:** Falk, *AIC.*

PAREDES, Jose M. *[Mural painter, portrait painter, sculptor, lecturer, writer] b.1912, Uruapan, Michoacan, Mexico.*
Addresses: St. Louis, MO. **Studied:** St. Louis AL; E. Siebert.
Exhibited: sculpture, St. Louis AL (prize); Old Court House, 1913 (prize), 1932. **Sources:** WW40.

PARENTZ, Ernest *[Listed as "artist"] b.c.1832, France.*
Addresses: NYC, 1850. **Sources:** G&W; 7 Census (1850), N.Y., XLIV, 574.

PARHAM, Beverly See: **RANDOLPH, Beverly Parham (Mrs. Stephens)**

PARHAM, Frederick Duncan *[Sketch artist, architect] b.1893, New Orleans, LA / d.1971, New Orleans.*
Addresses: New Orleans, active 1915. **Exhibited:** NOAA, 1915.
Comments: Prominent architect who served on the first Vieux Carré commission and designed many N.O. buildings. **Sources:** *Encyclopaedia of New Orleans Artists*, 291.

PARHAM, Hilton L., Jr. *[Painter, illustrator] b.1930, Medford, MA.*
Addresses: Boston, MA. **Studied:** Vesper George Sch. Art, 1956-59. **Member:** Boston Negro AA. **Exhibited:** Cambridge, MA, 1968; Mus. Science, Boston, 1970 (award), 1972 (award); Int. Fair, Boston, 1971, 1972; Boston Negro AA, 1971, 1972; Boston Pub. Lib., 1973. **Sources:** Cederholm, *Afro-American Artists.*

PARHAM, Theophilus S. *[Engraver] d.1904, Wash., DC.*
Addresses: Wash., DC, active 1901. **Sources:** McMahan, *Artists of Washington, D.C.*

PARIS, Charles, Jr. *[Painter] mid 20th c.*
Studied: ASL. **Exhibited:** S. Indp. A., 1941. **Sources:** Marlor, *Soc. Indp. Artists.*

PARIS, Dorothy *[Painter] b.1899, Boston, MA.*
Addresses: NYC. **Studied:** Columbia Univ. Extension, 1920; Am. Acad. Dramatic Art, 1921; Acad. Grande Chaumière, Paris, France, 1926; Honolulu Acad. Art, 1945; Univ. Hawaii, 1945; ASL, 1947; Hans Hoffman, 1948. **Member:** NAWA (chairman, traveling oil exh., 1961- 63; vice-pres., 1972-74); Am. Soc. Contemp. Artists (chairman, Ways & Means comt., 1964-66; treas., 1965-66; lst vice- pres., 1965-67; pres., 1967-69; chmn. publicity, 1969-72); Int. Assn. Art (delegate, U.S. commt. & V.I. congress, 1969 ; treas., Florence flood fund, 1967; secy., 1969-72); Albert Gallatin Assoc., New York Univ. (fellow). **Exhibited:** Mus. des Belles Arts, Argentina; Mus. FA, Mexico; Sheldon Swope Mus. Art, 1964; Worlds Fair, 1965; NAWA Foreign Exh., Palazzo Vecchio, Florence, Italy, 1972; "NYC WPA Art" at Parsons Sch. Design, 1977. **Awards:** Jersey City Mus., 1957; Brooklyn Soc. Artists, 1958; Am. Soc. Contemp. Artists, 1970. **Work:** Mus. Cognac & Mus. Cannes, France; Purdue Univ.; Butler IA; Tufts College Art Coll. **Comments:** WPA artist. Preferred medium: oil. Positions: dir., two art galleries, New York, 1932-36; Ceramic Coop, Puerto Rico, 1936-38; chmn., art benefits, Visiting Nurse Service, New York; treas., Conf. Am. Artists, 1971. Teaching: Ceramic Workshop & Sch., NYC, 1939-41. **Sources:** WW73; *New York City WPA Art*, 69 (w/repros.).

PARIS, Harold Persico *[Sculptor] b.1925, Edgemere, LI, NY / d.1979, El Cerrito, CA.*
Addresses: Oakland, CA. **Studied:** Akad. Bildenden Kunst, Munich, Germany; Atelier 17, NYC. **Exhibited:** "Am. Sculpture in the Sixties," LACMA, 1967; "Human Concern & Personal Torment," WMAA, 1969; "L'Art Vivant aux Etats-Unis," Fondation Maeght, St. Paul, France, 1970; 3(e) Salon Int. de Galeries-Pilotes, Lausanne, Switz., 1970; "The California Years," Harold Paris 12 year Retrospective, Univ. Art Mus., Univ. Calif., Berkeley, 1972. **Awards:** Guggenheim fellowship, 1953-55; Creative Arts Inst. award, Univ. Calif., Berkeley, 1967; Linus Pauling Peace Prize, 1970. **Work:** PMA; MoMA; Univ Art Mus,

Univ. Calif., Berkeley; Milwaukee (WI) Art Center; AIC Commissions: fountain, Southridge, Taubman Indust., Milwaukee, WI, 1972. **Comments:** Preferred media: plastics, bronze, graphics. Teaching: Univ. Calif., Berkeley, 1960-. **Sources:** WW73; Peter Selz, "The Final Negation" (March-April, 1969) & John Fitzgibbons, "Paris in Berkeley" (May-June, 1972), *Art in Am.*; Robert Hughes, "Souls in Aspic," *Time* (May 22, 1972).

PARIS, Helen *[Painter] mid 20th c.*
Addresses: Elkins Park, IL. **Exhibited:** PAFA Ann., 1946.
Sources: Falk, *Exh. Record Series.*

PARIS, Jeanne C. *[Art critic, writer] 20th c.; b.Newark, NJ.*
Addresses: Glen Cove, NY. **Studied:** Newark Sch. FA; Tyler Sch. Art, Temple Univ.; Columbia Univ.; NY Univ. **Member:** NY Reporters Assn.; Newspaper Women's Club; Friends of Hofstra Mus. (bd. dir.); Friends of WMAA; AIC. **Comments:** Positions: assoc. dir., Valente Gal., New York; art critic, *Long Island Press*, 1963-. Teaching: lecturer art, universities, colleges, art leagues, women's clubs, museum assns., radio & NBC-TV series, "You're a Part of Art." Collections arranged: organized & directed "The Artist of the Month," providing lecturers & demonstrators in all the arts for organizations & schools; organized exhibs. of American art for Latin America, Italy & USA. Collection: 20th c. painting & sculpture. Publications: auth., articles, *Weekly Newspaper Chain, Record Pilot & Newsday* ; auth., "Art Feature," *Cue*, July, 1972. **Sources:** WW73.

PARIS, Lena B. *[Artist, teacher] b.1895, Gloversville, NY / d.1984, Wash., DC.*
Addresses: Wash., DC, 1922. **Studied:** New Palz Normal School; Am. Univ. **Member:** Soc. Wash. Artists; Artists Equity.
Exhibited: CGA; Studio Gal.; Balt. Mus. Art. **Comments:** She taught in public schools in Wash., D.C. from 1922-54. She studied at Am. Univ. after retiring. **Sources:** McMahan, *Artists of Washington, D.C.*

PARIS, Lucille M. (Lucille M. Bichler) *[Painter] b.1928, Cleveland, OH.*
Addresses: Wayne, NJ. **Studied:** Univ. Calif., Berkeley (B.A.; Taussig traveling fellowship, 1950-51; McEnerney graduate fellowship, 1952; M.A.); Atelier 17, Paris, France. **Exhibited:** Artist-Bay Area Graphics, 1964; Monmouth College, 1964-65, 1968 & 1972; Univ. Minnesota Art Gal., 1965; Aegis Gal., NYC, 1965 (solo); NJ State Mus., Trenton, 1968 & 1972. **Awards:** Ball State Univ., 1956 (purchase award); Argus Gal., NJ, 1963 (Bainbridge Award); Monmouth College Award, 1965. **Work:** Butterfield Coll.; Newark Mus. Coll. Contemp. Art. **Comments:** Teaching: Ball State Univ., 1955-57; William Paterson College, 1959-. **Sources:** WW73.

PARIS, Rosabelle *[Painter] early 20th c.*
Addresses: NYC, 1928. **Studied:** ASL. **Exhibited:** S. Indp. A., 1928. **Sources:** Marlor, *Soc. Indp. Artists.*

PARIS, Walter *[Painter, architect]*
b.1842, London, England / d.1906,
Washington, DC.
Addresses: London, England; Wash., DC. **Studied:** Royal Acad.; T.L. Rowbotham, Paul Naftel, Joseph Nash, in London (1870s). **Member:** Tile Club, NYC, 1876 (founder); Cosmos Club; Wash. AC; Wash. WCC. **Exhibited:** Wash. WCC; CGA, 1875; San Fran. AA, 1876; NAD, 1878; Brooklyn AA, 1877-84; AIC, 1897-1904; Boston AC, 1899; PAFA Ann., 1902; Veerhoff Gal., 1905 (solo).
Work: White House; NMAA; BMFA; CGA; Pioneers' Mus., Colorado Springs; State Dept. Diplomatic Reception Room.
Comments: After studying architecture at the Royal Acad., he left London for a 7-year architectural assignment for the British Crown in India. Upon returning to London, he became interested in art, and came to Colorado Springs, c.1872. He was the town's first resident artist, according to Samuels. He had a studio in NYC in 1876 and later moved to Wash., DC. Specialty: watercolors. Positions: architect, British government in India, 1863-70; teacher, lndscp. drawing, Royal Military Acad., Woolwich. He made a large and remarkably fine series of flower studies from nature as

aids to design. Also a violinist. **Sources:** WW06; Hughes, *Artists of California*, 422; P&H Samuels, 358; McMahan, *Artists of Washington, D.C.; Falk*, Exh. Record Series.

PARIS, W(illiam) Franklyn *[Mural painter, architect, writer, lecturer]* 20th c.; b.New York.
Addresses: NYC. **Studied:** ASL; Acad. Julian, Paris; Salvi in Rome. **Member:** Arch. Lg., 1898-1933; Century Assn.; Mus. French Art; Artists' Fellowship; Société Histoire d'Art Française; Société Gens de Lettres de France; Royal Acad. Arts & Sciences, Spain; MMA. **Exhibited:** Awards: Chevalier-Officer, Legion of Honor of France; Knight of the Crown of Belgium; Knight of the Crown of Italy, 1924; Knight of St. Michel; Hon. Knight of Malta. **Work:** Yale; Princeton; Oberlin College; Univ. Chicago; U.S. Supreme Court Bldg., Wash., DC; Senate Missouri State Capitol; Detroit Pub. Lib.; Supreme Courts State Capitol, both in WV; NY Life Ins. Bldg., NYC; Deanery, Cathedral of St. John the Divine, NYC; churches, Tulsa (OK), Grand Rapids (MI) & Watertown (NY). **Comments:** Auth.: *Decorative Elements in Architecture* (pub. in London, 1917), "An Italian Temple to Arts and Letters," *Architectural Forum*, 1925;"*Personalities in American Art; Rodin as a Symbolist; Biography of Albert Besnard; French Arts and Letters*. Positions: U.S. Comn. of Dec. Art., Paris Expo, 1900; dir., WFNY, 1939. **Sources:** WW40.

PARISEN, J. (Julien?) *[Portrait painter]* early 19th c.
Addresses: NYC, active 1821 to c.1830. **Member:** NA (founding mem., 1826). **Exhibited:** Am. Acad., 1821, 1823, 1827, 1828; NAD, 1827 (as J. Parisen), possibly in 1830 (as "-- Parisen"). **Comments:** J. Parisen was one of the founding members of the NAD. Exhibition records from the NAD in 1827 give his NYC address as William Street, which is also known to have been the address of William D. Parisen (see entry). As William had a brother named Julius, it is likely that J. Parisen was actually Julius Parisen. Dunlap mentions a portrait of Samuel Latham Mitchill as being painted by J. Parisen, but other than that nothing further is known of his career. **Sources:** G&W; Cummings, *Historic Annals of the NAD*, 28; Cowdrey, AA & AAU; Cowdrey, NAD; lithographed copy of will of Philip Parisen, Liber 57, pp. 414-15, at NYHS; NYCD 1827; Dunlap, *History*, I, 160; Clark, *History of the NAD*, 14.

PARISEN, (Mr.) *[Teacher of drawing & wax modelling]* mid 19th c.
Addresses: Charleston, SC, 1837. **Sources:** G&W; Rutledge, *Artists in the Life of Charleston*.

PARISEN, Otto *[Miniaturist, goldsmith, ornamental hairworker]* b.1723, Berlin, Germany / d.1811, New Rochelle, NY.
Addresses: Came to NYC, early 1760s, active there till c.1800; lived last years at New Rochelle, NY. **Comments:** He was the father of painter Philip and grandfather of painters J. and William D. Parisen (see entries on each). **Sources:** G&W; Kelby, *Notes on American Artists*, 49; Gottesman, *Arts and Crafts in New York*, I and II; Dunlap, *History*, I, 160.

PARISEN, Philip *[Miniature painter, silhouettist, hairworker, silversmith, drawing teacher]* b.probably NYC / d.1822, New Rochelle, NY.
Addresses: NYC, active c.1790 to 1815. **Studied:** probably with his father Otto Parisen. **Work:** NYHS. **Comments:** Son of Otto Parisen (see entry). Visited Charleston, SC, as a drawing teacher in 1795. Among his children were William (see entry) and Julian (who was probably the artist J. Parisen, see entry). **Sources:** G&W; N.Y. *Daily Gazette*, April 2, 1790 (citation courtesy Helen McKearin); Gottesman, *Arts and Crafts in New York*, II; NYCD 1797-1811; Rutledge, *Artists in the Life of Charleston*; Prime, II, 18-19; Dunlap, *History*, I, 160. More recently, see NYHS Catalogue (1974), cat. no. 1895.

PARISEN, William D. *[Portrait & miniature painter, drawing teacher]* b.1800, probably in NYC / d.1832.
Addresses: NYC. **Exhibited:** Am. Acad., 1816-; NAD, 1830 ("-- Parisen" of NYC exh. two portraits; this could have been either J. or William Parisen). **Work:** NYHS. **Comments:** A son of Philip

Parisen (see entry). He was in Charleston, SC, in 1818-19, and during the latter year ran a drawing academy with a Mr. Hinckley. He spent the remainder of his career in NYC, painting portraits and also working as a money-broker. According to Dunlap, he failed at both (Dunlap, vol. 1, 160), but he did exhibit at the American Academy. J. Parisen (see entry) was probably William's younger brother Julian; they were both living on William Street in 1827. **Sources:** G&W; N.Y. *Evening Post*, April 9, 1832, cited in Barber, "Deaths Taken from the N.Y. Evening Post;" Cowdrey, AA & AAU; Cowdrey, NAD; NYCD 1819-31; Rutledge, *Artists in the Life of Charleston;* Dunlap, *History,* I, 160. More recently, see NYHS Catalogue (1974), cat. no. 1104, 1109.

PARISH, A(nabelle) Hutchinson (Mrs.) *[Painter]* early 20th c.
Addresses: Portland, OR. **Sources:** WW06.

PARISH, Betty Waldo (Mrs.) *[Painter, writer, educator, lithographer]* b.1910, Cologne, Germany / d.1986, NYC.
Addresses: NYC. **Studied:** Acad. FA., Chicago, 1926 (at age 16); ASL with Kenneth Hays Miller & John Sloan; Columbia Univ.; New School Soc. Res.; Sternberg; S.W. Hayter; Grand Central School, NYC; Acad. Julian, Paris. **Member:** Audubon Artists (bd. dir., 1960-); Allied Artists Am. (bd. dir., 1965); NAWA (exec. bd., 1937-40; bd. dir., 1954-56); ASL (bd. dir., 1938-40); Pen & Brush Club (chmn. oil section, 1943-47, 1960-61; bd. dir., 1960-63); SAE; Dutchess County AA; Northwestern PM; NYWCC; Southern PM Soc.; FA Gld. NY. **Exhibited:** Salons of Am., 1934; PAFA Ann., 1935; NAWA, 1937, 1938, 1939 (prize), 1940-45, 1946 (prize); WFNY, 1939; Provincetown AA, 1939-40; PAFA, 1942-43; Argent Gal.; SAE, 1940-43 (prize), 1944-46; Pen & Brush Club, 1944 (prize); LOC, 1941-46; NAD, 1941, 1945-46; AIC; Southern PM; Albany Inst. Hist. & Art; Dutchess County AA; Collectors Am. Art; AAPL, 1964 (second prize); Nat. Arts Club, 1968-72; Allied Artists Am., 1972 (David Humprys Mem. Prize). Awards: Nat. Arts Graphic Prize, 1970. **Work:** MMA; LOC; SAM; AIC; Treasury Dept., Wash., DC; Brit Mus, London Eng; Musée d'Art, Brussels, Belgium; PAFA. **Comments:** Working in many print media, Parish is especially remembered for her woodcuts and wood engravings and as an important contributor to the revival of this medium. Auth./illustr.: *Rome*, 1958; *England Again*, 1959; *Paris*, 1960. Known also as Mrs. Richard Comyn Eames and Mrs. Whitney Darrow. **Sources:** WW73; WW47; Pisano, *One Hundred Years.the National Association of Women Artists*, 75; Falk, *Exh. Record Series*.

PARISH, Charles Louis See: **PARRISH, Charles Louis**

PARISH, Jean E. *[Painter, educator]* 20th c.; b.Oneonta, NY.
Addresses: Oneonta, NY. **Studied:** Ohio State Univ. (B.S.); Parsons Sch. Design; ASL with Kunyioshi, Zorach & Sidney Gross; Drake Univ. (M.F.A.); Arrowmont Sch. Crafts, Univ. Tenn.; MIT (summer scholarship & cert.). **Member:** Oneonta Community AC (gallery chmn., 1968); Upper Catskill Community Council Arts (exec. vice-pres., 1972); College AA Am.; Cooperstown AA; Berkshire AA. **Exhibited:** Art Today, 1967 & Graphics Nat., 1969, NY State Fair; 19th Ann. New England Exh., Silvermine Guild Artists, 1968; Nat. Exh. Contemp. Am. Painting, Soc. Four Arts, Palm Beach, 1969; Miss. Nat. Ann. AA, Jackson, 1970. Awards: purchase award, Munson-Williams-Proctor, 1967; Juror's Choice Award, 33rd Regional Artists Upper Hudson, 1968; first prize drawing, Roberson Center Ann., 1971. **Work:** Munson-Williams-Proctor Inst., Utica; Fox Hosp, Oneonta. Commissions: Paramonts and Cloths, United Methodist Church, Oneonta, 1971; murals, Goldman Theater, Phila. & Ritz Carleton, Montreal. **Comments:** Positions: designer, various interior design firms, New York, 1950-. Teaching: State Univ. NY College Oneonta, 1966-. **Sources:** WW73.

PARISH, W. D. *[Painter]* early 20th c.
Addresses: Providence, RI. **Studied:** Acad. Julian, Paris, 1895. **Member:** Providence WCC. **Sources:** WW19.

PARISH-WATSON, M. *[Art dealer]* d.1941.
Addresses: Fairfield, CT.

PARJEAUX See: **PAJOT, Louis E.**

PARK, A. E. (Betty) *[Painter, teacher] 20th c.*
Addresses: Anchorage, AK. **Exhibited:** Northwest Ann., SAM (several exhs.). **Sources:** WW59.

PARK, Agnes Helen *[Painter] early 20th c.*
Addresses: San Francisco, CA. **Exhibited:** San Fran. AA, 1923-24; Calif. Indust. Expo, San Diego, 1926. **Sources:** Hughes, *Artists of California*, 422.

PARK, Arthur Y. *[Painter] early 20th c.*
Addresses: Phila., PA, 1927. **Exhibited:** S. Indp. A., 1927. **Sources:** Marlor, *Soc. Indp. Artists.*

PARK, Asa *[Portrait & still life painter] b.Brighton or Newton, MA / d.1827, Lexington, KY.*
Addresses: Active primarily in Lexington, KY, from 1816. **Studied:** probably with John Ritto Penniman, Boston. **Work:** Georgetown (KY) College. **Comments:** (Jones and Weber report that Park was born in Virginia.) Painted in Boston in 1814; Burlington, VT, 1815. Advertised in Lexington, KY, in 1816, mentioning that he was of Boston and had the endorsement of Gilbert Stuart and John Ritto Penniman (who was likely his teacher). Was in Cincinnati in 1820 advertising his services as a portrait painter. Subsequently went back to Kentucky. Few of his portraits have been located; he was also apparently well-respected for his still lifes; however none are known today. Close friend of the artist William West (see entry) also of Lexington. *Cf.* Asa Parks [sic?], who may have been a relative. **Sources:** G&W; *Liberty Hall and Cincinnati Gazette*, April 20, 1820 (as A. Park); Price, *Old Masters of the Bluegrass*, 4-5 (says Park settled in Lexington before 1800); Gerdts, *Art Across America*, vol. 2, 156, with repro.; Hageman, 120; Jones and Weber, *The Kentucky Painter from the Frontier Era to the Great War*, 61 (w/repro.).

PARK, Carton Moore See: **MOORE-PARK, Carton**

PARK, Charles *[Painter] early 20th c.*
Exhibited: Younger Painters of Los Angeles, 1929. **Sources:** Hughes, *Artists of California*, 422.

PARK, Charlotte *mid 20th c.*
Addresses: NYC, 1953. **Exhibited:** WMAA, 1953. **Sources:** Falk, *WMAA.*

PARK, David *[Painter, teacher, lecturer] b.1911, Boston, MA / d.1960, Berkeley, CA.* *David Park*
Addresses: Berkeley, CA. **Studied:** Otis Art Inst. **Member:** San Fran. AA (bd. dir.). **Exhibited:** Oakland Mus., 1932; SFMA, 1935-36 (solo), 1939 (solo), 1940 (solo); San Fran. AA, 1935 (prize), 1951 (prize), 1953 (prize), 1957 (prize); AIC, 1936; CPLH, 1946; Univ. Illinois; MIT, 1953; Richmond AC, 1955; São Paulo, Brazil, 1955; Minneapolis Inst. Art, 1957; Oakland Art Mus., 1957 (gold medal); "Art:USA, 1958"; Richmond, VA, 1958; WMAA, 1959; Staempfi Gal., NYC, 1959, 1960, 1961, 1963, 1966 (all solo); PAFA Ann., 1960 (prize); Corcoran Gal. biennial, 1961; Univ. Art Gal., Berkeley, 1964 (solo); Maxwell Gal., San Fran., 1970 (solo), 1973 (solo), 1975 (solo), 1976 (solo); Oakland Mus., 1957, 1978 (solo). **Work:** WPA frescoes, John Muir Sch. (San Fran.), Cowell Mem. Hospital, Univ. Calif., Berkeley; SFMA. **Comments:** Teaching: Winsor Sch., Boston, MA, 1936-41; Calif. Sch. FA, San Fran., 1944-50s; Univ. Calif., Berkeley, 1955-on. **Sources:** WW59; WW47; Falk, *Exh. Record Series;* Hughes, *Artists of California*, 422.

PARK, Edwin Avery *[Painter, architect, teacher] b.1891, New Haven, CT / d.1978, Hanover, NH.*
Addresses: Bennington, VT. **Member:** Provincetown AA. **Exhibited:** WMAA, 1948; Salons of Am., 1922. **Comments:** Auth.: *New Backgrounds for a New Age*, 1926. Teaching: Bennington College. **Sources:** WW40.

PARK, Eirene See: **MUNGO-PARK, Eirene**

PARK, Hanes See: **PARK, (Hazel A.) Hanes**

PARK, Harrison *[Portrait painter] mid 19th c.*
Addresses: Cleveland & Ohio City, active 1837. **Comments:** Listed in the city directories. **Sources:** Hageman, 120.

PARK, (Hazel A.) Hanes *[Painter, craftsperson] b.1887, Waukee, IA / d.1975, Los Angeles, CA.*
Addresses: Los Angeles. **Studied:** Ortis AI; Cummings Art Sch., Des Moines; Paul Lauritz; Ralph Holmes, F. Tolles Chamberlin; Eduard Vysekal; John H. Rich; E. Roscoe Shrader. **Member:** Calif. AC; Southland AA; Artists of the Southwest; Whittier AA; Women Painters of the West; San Gabriel Artists Gld.; San Fernando Valley Prof. Artists Gld.; Southern Calif. Hand Weavers. **Exhibited:** Drusdale Gal., Van Nuys, CA, 1946 (solo); Signal Oil Bldg. lobby, Los Angeles, 1946; Long Beach, CA, 1953; Descanso Gardens, La Cañada, CA, 1957, 1958; Calif. AC, 1958. **Awards:** prizes, Whittier AA, 1942, 1943; San Fernando Valley Artists Gld., 1948; Calif. AC, 1952; Greek Theatre, Los Angeles, 1953; Ebell Club, 1955. **Sources:** WW59.

PARK, Helen C. *[Painter] early 20th c.*
Addresses: Englewood, NJ, 1917. **Studied:** ASL. **Exhibited:** S. Indp. A., 1917. **Sources:** Marlor, *Soc. Indp. Artists.*

PARK, Katherine B. *[Sculptor] late 19th c.*
Exhibited: NAD, 1884. **Sources:** Naylor, *NAD.*

PARK, L. W. *[Engraver] mid 19th c.*
Addresses: Boston, 1847. **Sources:** G&W; Boston CD and BD 1847.

PARK, Linton *[Primitive genre painter] b.1826, Marion Center (Indiana County), PA / d.1906, Erie, PA.*
Addresses: Active in western Pennsylvania. **Work:** NGA. **Comments:** Worked in furniture factory before joining the District of Columbia infantry regiment in 1864. After the Civil War he returned to Marion Center and painted signs and did decorative work on furniture. Began painting after 1870, producing a number of logging and farm scenes in Clearfield and Indiana Counties (PA). It is believed he painted his best work when he was about age 60. His most well-known painting, "Flax Scutching Bee" (painted on bed ticking, now at NGA), was found in 1939 and brought him to the attention of the art world. In his own day, his work was known only locally; especially of note was his "Johnstown Flood" (location unknown) which he showed to his neighbors several months after the 1889 disaster. He was also an inventor. **Sources:** G&W; "A Pennsylvania Primitive Painter," *Antiques* (Feb. 1939), 84-86, with 6 repros.; Lipman and Winchester, 178. More recently, see Chew, ed. *Southwestern Pennsylvania Painters*, repros.; Gerdts, *Art Across America*, vol. 1, 299.

PARK, Madeleine Fish (Mrs. Harold H.) *[Sculptor, lecturer, writer] b.1891, Mt. Kisco, NY / d.1960, Katonah, NY.*
Addresses: Katonah, NY. **Studied:** ASL; A. Phimister Proctor; Naum Los; Lawrence T. Stevens; F.V. Guinzburg. **Member:** Art Workers Club for Women; Chappaqua AG; NSS; NAWA; PBC; Soc. Medallists; AFA; Putnam County AA; Westchester Art & Crafts; NY Zoological Soc.; All. Artists Am.; Hudson Valley AA. **Exhibited:** S. Indp. A., 1927-28; PAFA Ann., 1931-42 (6 times); NAWA, 1933 (prize), 1940 (prize); Pen & Brush Club, 1938 (prize); Hudson Valley AA, 1944 (prize); Paris Salon; NAD; Arch. Lg.; AIC; SFMA; WMAA; MMA; NY Zoological Soc.; Brooks Mem. Art. Gal. (solo); Buie Mus., Oxford, MS; Mississippi AA; Univ. Florida; Converse College; Mint Mus.; J.B. Speed Mem. Mus.; Buffalo Mus. Science; Rochester Mem. Art Gal.; Erie Art Mus.; Utica Pub. Lib.; Cortland Free Lib.; Arnot Art Gal.; Illinois State Mus.; Wichita Mus. Art; Wustum Mus. FA; Kansas City State Teachers College; Univ. Wichita; Oklahoma AC; Massillon Mus. **Comments:** Specialty: wild and domestic animal sculptures. Went to India in 1948 to collect specimens for Hunt Bros. Circus. Lectures: "Experiences of a Sculptor." **Sources:** WW59; WW47; Falk, *Exh. Record Series.*

PARK, Malcolm S. *[Mural painter] b.1905, Helensburgh, Scotland.*

Addresses: Mt. Kisco, NY. **Studied:** NAD; École Americaine de Beaux Arts; Fontainebleau; Atelier des Fresques, Paris. **Member:** Princeton Arch. Assn.; Mural Painters. **Exhibited:** Fontainebleau Alumni Exh., 1934 (prize). **Comments:** Position: indust. des., Singer Mfg. Co., Elizabethport, NJ. **Sources:** WW40.

PARK, Richard Henry (or Hamilton) *[Sculptor] b.1832, NYC / d.After 1890.*
Addresses: Florence, Italy, 1890. **Exhibited:** NAD, 1862-65; Brooklyn AA, 1865, 1870 (bas-relief). **Work:** MMA. **Sources:** G&W; Gardner, *Yankee Stonecutters,* [74]; Thieme-Becker; Smith.

PARK, Rosemary *[Museum director] mid 20th c.*
Addresses: New London, CT. **Comments:** Position: dir., Lyman Allyn Mus. **Sources:** WW59.

PARK, S. *[Engraver] mid 19th c.*
Addresses: Rockport, IN, 1860. **Sources:** G&W; Indiana BD 1860.

PARK, William *[Stone, seal & cameo engraver] mid 19th c.*
Addresses: NYC, 1858. **Sources:** G&W; NYBD 1858.

PARKE, Jessie Burns *[Painter] b.1889, Paterson, NJ.*
Addresses: Arlington, MA. **Studied:** NY Sch. Applied Des. for Women; BMFA Sch. (Paige traveling scholarship, 1921); Philip Hale; William James; Frederick L. Bosley; M. Morgan in Paterson. **Member:** Penn. SMP; Min. PS&G, Wash., DC (assoc.). **Exhibited:** S. Indp. A., 1925, 1927-33, 1935; PAFA Ann., 1927-28; Penn. SMP, 1945 (med.), 1953 (Elizabeth Muhlhofer award), annually; Albright Art Gal.; Boston AC; Ogunquit AC; Paris Salon, 1924; Soc. Indep. Artists; Fed. Womens' Club, MA; Arlington (MA) Women's Club; PS&G, Wash., DC, 1953-55; Ogunquit (ME) Art Center. **Work:** portraits, miniatures, Northwestern Univ.; South Boston H.S.; PMA; Boston College H.S. **Sources:** WW59; WW47; Falk, *Exh. Record Series.*

PARKE, Josephine Dunham *19th/20th c.*
Exhibited: AIC, 1889, 1894; Salons of Am., 1923. **Sources:** Marlor, *Salons of Am.*

PARKE, Lucinda M. (or N.) *[Artist] 19th/20th c.*
Addresses: Wash., DC, active 1890-1905. **Exhibited:** Soc. Wash. Artists, 1892. **Sources:** McMahan, *Artists of Washington, D.C.*

PARKE, Mary *[Painter] early 19th c.*
Comments: Primitive watercolors of religious subjects, about 1825. **Sources:** G&W; Lipman and Winchester, 178.

PARKE, Nathaniel Ross *[Painter, teacher, designer] b.1904, Williamsport, PA.*
Addresses: West Hartford, CT. **Studied:** Trinity College; Yale Sch. (B.F.A.). **Member:** New Haven PCC; Assn. Conn. Artists; West Hartford Art Lg. (hon.). **Exhibited:** BAID, 1927 (med, prize); All. Artists Am., 1936; New Haven PCC, 1929; Williamsport Art Lg., 1929; Penn. State College, 1936; Hartford Women's Club, 1931; West Hatford Art Lg., 1935-41, 1945-56; CAFA, 1936; Indep. Artists Conn. 1938; Florida Southern College, 1952 (prize); Mansfield (CT) Fair, 1956 (prize); Glastonbury (CT), 1957 (prize). **Work:** Neuro-Psychiatric Inst. of Hartford Retreat; West Hartford (CT) Trust Co.; West Hartford Art Lg.; official bookplate, D.A.R.; restoration of dec., Congregational Church, Grafton, VT. **Comments:** Teaching: Conn. Gen. Life Ins. Co., 1954, 1956; Phoenix Mutual Life Ins. Co., 1956; Adult Educ., William Hall H.S., West Hartford, CT, 1951-. **Sources:** WW59; WW47.

PARKE, Sarah Cornelia *[Painter] b.1861, Houghton, MI / d.1937, Palo Alto, CA.*
Addresses: Detroit; NYC; Pacific Grove, CA. **Studied:** NYC. **Exhibited:** NAD, 1892; Mark Hopkins Inst., 1897-98; PAFA Ann., 1904; Berkeley Lg. FA, 1924; Salons of Am., 1927-29; S. Indp. A., 1927, 1930. **Work:** Monterey Pub. Lib. **Comments:** She painted adobes, landscapes, marines and coastal scenes, many of which were reproduced on post cards. **Sources:** Hughes, *Artists of California,* 422; Falk, *Exh. Record Series.*

PARKE, Walter Simpson *[Painter, illustrator] b.1909, Little Rock, AR.*
Addresses: Naperville, IL. **Studied:** AIC; Am. Acad. Art; Wellington Reynolds. **Member:** Brown Co. Art Guild; AAPL (local pres., 1968-); Palette & Chisel Acad.; Munic. Art Lg.; Oak Park Art Lg. **Exhibited:** Union Lg. Club Art Show, Chicago; Allied Artists Am. 52nd Ann., NYC; Munic. Art Lg., Chicago; AAPL, New York; Denver Art Mus. **Awards:** give purchase awards, Union Lg. Club Exh., 1955-69; gold medal, Chicago P&S, 1957; gold medal, Munic. Art Lg., 1971. **Work:** Univ. Illinois College Dentistry; Union Lg. Civic & Arts Found. **Comments:** Preferred medium: oils. Teaching: Palette & Chisel Acad., 1966-. **Sources:** WW73.

PARKER, A. *mid 19th c.*
Addresses: Iowa. **Comments:** Owner and exhibitor, though not necessarily the painter, of a temperance panorama shown at Davenport, IA, in December 1858. Parker's two brothers were residents of Davenport. **Sources:** G&W; Schick, *The Early Theatres of Eastern Iowa,* 279 (citation courtesy J. E. Arrington).

PARKER, Alan *mid 20th c.*
Addresses: Monterey, CA, 1951. **Exhibited:** WMAA, 1951. **Sources:** Falk, *WMAA.*

PARKER, Alfred *[Illustrator] b.1906, Saint Louis, MO / d.1985.*
Addresses: Westport, CT (1940s-60s); Carmel Valley, CA (1970s-on). **Studied:** St. Louis Sch. FA, Wash. Univ., 1923-28. **Member:** Int. Inst. Arts & Letters (fellow); SI (hon. mem.); St. Louis Art Dir. Club; Art Dir. & Artists Club of San Fran.; Westport Artists Group (founder & pres.). **Exhibited:** New Rochelle Pub. Lib.; Lotos Club; Illustration House, 1990s (retrospective). **Awards:** more than 25 gold medals and awards of excellence, including: Wash. Univ., 1953 (citation); Philad. Art Dirs Club, 1962 (award of hon.); Soc. Illustrators, 1965 (Hall of Fame). **Comments:** Best known for his idealized illustrations of the "Baby Boom" generation of the 1940s-60s, especially his mother & daughter covers for *Ladies Home Journal,* 1938-51. Illustr.: *Good Housekeeping, Town & Country, McCalls, Cosmopolitan* and others. Positions: founder, Famous Artists Sch., Westport, CT, 1947-. **Sources:** WW73; WW47; add'l info. courtesy Illustration House (NYC, essay #21); *Community of Artists,* 110.

PARKER, Angela Mary See: **HURD, Angela Mary (Parker)**

PARKER, Ann (Ann Parker Neal) *[Photographer, printmaker] b.1934, London, Eng.*
Addresses: North Brookfield, MA. **Studied:** RISD; Yale Univ. (B.F.A.). **Member:** Friends of Photography. **Exhibited:** Rubbings of New England Gravestones, Am. Embassy, London, 1965; Fenimore House, Cooperstown, NY, 1966; "Know Ye the Hour," Hallmark Gal., New York, 1968; "Ephemeral Image," Mus. Am. Folk Art, 1970; Mus. FA, Springfield, MA, 1972; Gal. Graphic Arts, NYC, 1970s. **Awards:** 50 Best Books Award, Am. Inst. Graphic Artists, 1957; grant in arts & humanities, Ford Found., 1962-63 & 1963-64. **Work:** MMA; LOC; Smithsonian Inst.; MoMA; Mus. Int. Folk Art, Santa Fe, NM. **Commissions:** ed. of 500 original rubbings (with Avon Neal), 1970 & ed. of 250 original rubbings (with Avon Neal), 1971, *Am. Heritage.* **Comments:** Publications: auth., *Eleven International Dinners,* 1956; co-auth., *What is American in American Art, Archaic Art of New England Gravestones,* 1963; co-auth., *A Portfolio of Rubbings from Early American Stone Sculpture,* 1964; photographer, *Ephemeral Folk Figures,* Potter, 1969; photographer, "When Shall We Three Meet Again," *Am. Heritage* (Vol. 21, No. 3.) Art interests: stone rubbings. **Sources:** WW73; M.J. Gladstone, "New Art from Early American Sculpture," *Collector's Quarterly Report* (1963) & "Pedestrian Art," *Art in Am.* (April, 1964); Stethen Chodorov, "Know Ye the Hour," produced on Camera Three, CBS-TV, Nov. 1968.

PARKER, A(nna) B(enedict) (Mrs. Neilson T.) *[Painter]* early 20th c.
Addresses: Woodstock, NY. Studied: ASL. Member: NAWPS; NAC. Exhibited: S. Indp. A., 1917-18. Sources: WW31.

PARKER, Anne Hoag *mid 20th c.*
Exhibited: Salons of Am., 1936. Sources: Marlor, *Salons of Am.*

PARKER, Arvilla *[Painter, illustrator] early 20th c.*
Addresses: San Francisco, CA, 1931-32. Exhibited: San Fran. Soc. Women Artists, 1931. Sources: Hughes, *Artists of California,* 422.

PARKER, Ben *[Painter] mid 20th c.*
Addresses: Seattle, 1937. Exhibited: SAM, 1937. Sources: Trip and Cook, *Washington State Art and Artists, 1850-1950.*

PARKER, Bill *[Painter] b.1924, Josephine, TX.*
Addresses: Paris 15, France. Studied: San Fran. Sch. FA; Acad. Grande Chaumière, Paris, France; Fred Hocks, La Jolla, CA & Hans Hoffman, NYC. Exhibited: "Five American Painters," Stedelijk Mus., Amsterdam, 1955; Salon Mai, Paris, 1956; Nat. Exh. Contemp. Am. P&S, Univ. Illinois, 1957; Summer Arts Festival Int.Exh., Univ. Maine, 1963; Chase Gal., NYC, 1970s. Awards: Burhle Prize, Gal. Kaganovitch, Paris, 1952. Work: MOMA, Paris; Stedelijk Mus., Amsterdam; WMAA; Moscow Mus., USSR; Univ. Maine, Orono Art Coll. Comments: Preferred Mmedium: acrylics. Sources: WW73; R. Nacenta, *School of Paris* (New York Graphic Soc., 1957); L. Durand, article, *Newsweek* (March 31, 1958); Y. Taillandier, "American in Paris," *Connaissance Arts* (March, 1958).

PARKER, C. E. (Mrs.) *[Painter] late 19th c.*
Exhibited: Calif. State Fair, Sacramento, 1881. Sources: Hughes, *Artists of California,* 422.

PARKER, C. R. *[Itinerant portrait and historical painter] mid 19th c.*
Addresses: travelled throughout the south. Exhibited: Royal Soc. British Artists, 1829 (portrait of Audubon). Comments: In 1826 his portraits of Washington, Jefferson, Lafayette, and Franklin were unveiled in the state legislative hall in New Orleans. Parker is next known to be in London in 1828, where he met and painted a portrait of John James Audubon (private collection); the two then traveled together to Paris and Versailles. By 1832, Parker was back in New Orleans announcing he had "lately returned from Europe." He would come back to New Orleans in 1838 and again from 1845-48. He also worked in Columbus, GA (1838); Natchez, MS (sometime in the 1830s-40s); Mobile (1840, 1843-44), Montgomery and Huntsville, AL; and Charleston, SC. Sources: G&W; Delgado-WPA cites *Argus,* Dec. 2, 1826, *Advertiser,* April 11, 1832, *True American,* July 2, 1838, *Picayune,* Dec. 4, 1845, and Feb. 3, 1846, and New Orleans CD 1846. See also *Encyclopaedia of New Orleans Artists;* Gerdts, *Art Across America,* vol. 2, 82, 87, 88, 92.

PARKER, Charles H. *[Script, map & ornamental engraver] b.c.1795, Salem, MA / d.1819, Philadelphia, PA.*
Addresses: Philadelphia, active 1812-19. Studied: Gideon Fairman, Phila. Sources: G&W; Stauffer.

PARKER, Charles Hadden *[Painter] early 20th c.*
Addresses: Santa Cruz, CA, 1932. Exhibited: AIC, 1905, 1909; San Fran. AA, 1924; Oakland Art Gal., 1930. Sources: Hughes, *Artists of California,* 422.

PARKER, Charles Schoff *[Sculptor, portrait painter] b.1870, NYC / d.1930.*
Addresses: Boston, MA. Studied: ASL; Acad. Julian, Paris, with Chapu & Puech, 1879-85; Gérôme, Delance & Callot in Paris. Member: NSS; Arch. Lg., 1898; NAC; BAC. Exhibited: Boston AC, 1883-1900. Sources: WW10; *The Boston AC* cites a birth date of 1860.

PARKER, Charles Stewart *[Architect, painter, teacher] d.1942.*
Addresses: Germantown, PA/New Hope, PA. Studied: Penn Sch.

Indust. Art; Univ. Penn.; C. Woodbury. Member: Germantown AL; AAPL. Exhibited: Germantown AL, 1937; Phillips Mill, New Hope. Comments: Teaching: Phila. public high schools, for 36 years. Sources: WW40; *Charles Woodbury and His Students.*

PARKER, Clarence G. *[Painter] late 19th c.*
Exhibited: NAD, 1881. Sources: Naylor, *NAD.*

PARKER, Cora *[Painter] b.1859, Kentucky / d.1944.*
Addresses: Lincoln, NE; Coral Gables, FL. Studied: Cincinnati Art Sch.; William M. Chase in NYC; Acad. Julian, Paris. Member: Greenwich SA. Exhibited: Trans-Mississippi Expo, Omaha, 1898; AIC,1905-06. Work: Kansas City AC; Nebraska AA, Lincoln; Bruce Mus., Greenwich, CT. Comments: Teacher & dir. of art program , Univ. Nebraska, 1893; in Kentucky, 1900-16; dir. of collections & exhibs., Bruce Mus., Greenwich, CT; WPA artist, Coral Gables, FL. Sources: WW40; Trenton, ed. *Independent Spirits,* 270; Petteys, *Dictionary of Women Artists.*

PARKER, Corinne *[Artist] early 20th c.*
Addresses: Wash., DC, active 1901. Sources: McMahan, *Artists of Washington, D.C.*

PARKER, Cushman *[Illustrator] b.1881, Boston, MA.*
Addresses: Woodstock, NY/Onset, MA. Studied: Acad. Julian, Paris, with J. P. Laurens, 1901-02; Carl Marr. Member: SI; Artists' Guild. Comments: Illustr.: covers for *Saturday Evening Post; McCall's; Colliers.* Sources: WW40.

PARKER, Dana (Mr.) *[Cartoonist] b.1891 / d.1933.*
Addresses: Port Washington, NY. Comments: Position: cartoonist, *Miami Herald; San Francisco Chronicle.*

PARKER, Edgar *[Portrait painter] b.1840, Framingham, MA / d.1892.*
Addresses: Spent most of his career in Boston, MA. Exhibited: Boston AC, 1873-89. Work: U.S. Capitol (Wash., DC). Comments: Among his prominent sitters were Nathaniel Hawthorne, J.G. Whittier, and Theodore Sedgwick. Sources: G&W; Fairman, *Art and Artists of the Capitol,* 280; Clement and Hutton; Thieme-Becker; *The Boston AC.*

PARKER, Edwin S. *[Painter] early 20th c.*
Addresses: NYC. Exhibited: S. Indp. A., 1930. Sources: Marlor, *Soc. Indp. Artists.*

PARKER, Edythe Stoddard *[Sculptor] early 20th c.; b.Winnetka, IL.*
Addresses: Winnetka, IL, active c.1903-09. Studied: AIC. Member: ASL, Chicago. Exhibited: AIC, 1903. Sources: WW10.

PARKER, Elizabeth *[Painter, teacher] b.1916, Edgefield, SC.*
Addresses: Beaufort, SC. Studied: M.H. Cabaniss; W.W. Thompson; Beaufort Art Sch. Member: Beaufort FAA; Carolina AA. Exhibited: Salons of Am., 1936. Comments: Teaching: Beaufort Art Sch. Sources: WW40.

PARKER, Elizabeth F. *[Landscape & floral painter] 19th/20th c.*
Addresses: Boston, MA. Exhibited: Boston AC, 1884, 1886, 1888, 1894-95; Brooklyn AA, 1885; PAFA Ann., 1894. Sources: Falk, *Exh. Record Series.*

PARKER, Emma Alice See: **NORDELL, Emma Alice (Polly) Parker (Mrs. Carl J.)**

PARKER, Ernest Lee *[Painter, teacher] 19th/20th c.*
Addresses: Phila., PA; London, England. Exhibited: AIC, 1898, 1902; PAFA Ann., 1936. Sources: WW13; Falk, *Exh. Record Series.*

PARKER, Evelyn Curry *[Painter] mid 20th c.*
Addresses: NYC, 1934. Studied: ASL. Exhibited: Salons of Am., 1934-36; S. Indp. A., 1934. Sources: Falk, *Exhibition Record Series.*

PARKER, Flora Burgess (Mrs.) *[Painter] early 20th c.*
Addresses: NYC, 1930. Studied: ASL. Exhibited: Salons of Am., 1934. Sources: Falk, *Exhibition Record Series.*

PARKER, Florence B. *[Painter] late 19th c.*
Addresses: NYC. **Exhibited:** NAD, 1878. **Sources:** Naylor, *NAD.*

PARKER, Frank F. *[Painter] early 20th c.*
Addresses: NYC. **Sources:** WW15.

PARKER, George *[Engraver] b.England / d.1868.*
Addresses: Boston, MA, active, late 1840s-50s. **Comments:** Active in London in 1832, Parker came to the U.S. about 1834 to work on Longacre and Herring's *National Portrait Gallery.* **Sources:** G&W; Stauffer; Boston CD 1847-55.

PARKER, George *[Painter] late 19th c.*
Addresses: Brooklyn, NY. **Exhibited:** NAD, 1895. **Sources:** Naylor, *NAD.*

PARKER, George Waller *[Painter, craftsperson, designer, lecturer, teacher, drawing specialist, decorator] b.1888, Gouverneur, NY / d.1957.*
Addresses: Summerville, SC. **Studied:** Brown Univ.; ASL; Grande Chaumière; Colarossi Acad. **Member:** SC; Portland SA; All. Artists Am.; Artists Fellowship; Audubon Artists; Société Coloniale des Artistes Françaises; FA Fed. NY; AAPL; Grand Central Art Gal. **Exhibited:** Strasbourg (prize); NAD; PAFA; AIC; Kansas City AI; Springfield Mus. Art; Paris Salon; Rochester Mem. Art Gal.; NYC (solo); Cincinnati; Cleveland; Chicago. **Work:** Rochester Mem. Art Gal.; Newark Mus.; Sweat Mem. Mus.; Lake Placid Club, NY; NY Hist. Soc.; Saranac Lake Pub. Lib.; U.S. Navy Bldg., Wash., DC; Trudue Sanitarium, Saranac Lake; BMA; AAPL; Reception Hospital, Saranac Lake. **Comments:** Teaching: Nantucket, 1940 (summer school). **Sources:** WW47.

PARKER, Gladys *[Cartoonist] mid 20th c.; b.Tonawanda, NY.*
Addresses: Hollywood, CA. **Member:** SI; Nat. Cartoonists Soc. **Comments:** Creator of syndicated cartoon "Mopsey." **Sources:** WW59; WW47.

PARKER, Gordena B. See: **JACKSON, Gordena Parker (Mrs.)**

PARKER, Harrison Magowan *[Painter] b.1907, Chicago, IL / d.1951, Southern California (suicide).*
Addresses: Southern California. **Studied:** Groton Sch., Massachusetts; Harvard Univ., 1931; Millard Sheets at Chouinard Art Sch. **Exhibited:** CI, 1941. **Comments:** Teaching: Polytechnic Sch., Pasadena. **Sources:** Hughes, *Artists of California,* 422.

PARKER, Harry Hanley *[Mural painter, sculptor, architect] b.1869, Phila., PA / d.1917.*
Addresses: Phila. **Studied:** PAFA. **Member:** Phila. Sketch Club; T Square Club. **Exhibited:** PAFA Ann., 1902-03, 1907. **Work:** Calvary Methodist Episcopal Church, Phila. **Sources:** WW15; Falk, *Exh. Record Series.*

PARKER, Harry S. III *[Museum educator] b.1939, St. Petersburg.*
Addresses: NYC. **Studied:** Harvard Univ. (B.A.); Inst. FA, NY Univ. (M.A.). **Member:** Am. Assn. Mus.; AFA; Int. Council Mus. **Comments:** Positions: asst. to dir., MMA, 1963-67, vice-dir. educ., 1968-. **Publications:** contrib., *Metrop. Mus. Art Bulletin.* Teaching: lectures mus. educ. **Sources:** WW73.

PARKER, Helen Mary *[Lecturer] mid 20th c.; b.Chicago.*
Addresses: Lake Bluff, IL. **Studied:** Univ. Chicago (Ph.B.); École du Louvre, Sorbonne, Paris. **Exhibited:** Award: citation, Univ. Chicago, 1952. **Comments:** Position: asst. mus. instr., 1914-26 & head dept. educ., 1926-53, AIC, Chicago (retired). Auth.: *Arno Art Studies,* 1930; "Art Quiz," 1939; *The Christmas Story in the Art Institute Collections,* 1949. Lectures: history of art; collections & exhibitions of the AIC. **Sources:** WW59.

PARKER, Helen Stockton *[Painter] early 20th c.*
Addresses: Baltimore, MD. **Member:** Baltimore WCC. **Sources:** WW24.

PARKER, J. *mid 19th c.*
Work: Western Reserve Hist. Soc., Cleveland, OH ("Cleveland Grays on Public Square," 1839). **Comments:** Hageman states, that the to him attributed painting was formerly thought to have been done by Sebastien Heine. **Sources:** Hageman, 120.

PARKER, James *[Painter] b.1933, Butte, MT.*
Addresses: NYC. **Studied:** Columbia College (B.A., 1955); independent study, Spain (1960-62). **Exhibited:** Salt Lake City (UT) Mus. Biennial, 1967; Structure of Color, WMAA, 1971; New Acquisitions, 1971 & Whitney Ann., 1972, WMAA; Aldrich Mus. Show, 1972. **Work:** WMAA; Aldrich Mus., Ridgefield, CT; Carnegie Inst., Pittsburgh, PA. **Comments:** Preferred media: acrylics, pencil, pastels. Positions: part-time mem dean's staff, Columbia Univ. Sch. Eng., 1967-. Publications: auth., "Pop's Ancestors," *Denver Quarterly,* 1967. Teaching: Metrop. State College, Denver, CO, 1965-67. **Sources:** WW73.

PARKER, James K. *[Painter] early 20th c.*
Addresses: Evanston, IL. **Sources:** WW08.

PARKER, James K. *[Painter] b.c.1880, probably in Hawaii / d.1963, Hawaii.*
Comments: Began painting at age 70. Specialty: primitive painting of Parker Ranch cowboy genre in Hawaii. (Different from previous James K.) **Sources:** P&H Samuels, 359.

PARKER, James Varner *[Art administrator, designer] b.1925, Senath, MO.*
Addresses: Phoenix, AZ. **Studied:** Phoenix Community College (A.A.); Arizona State Univ. (B.F.A. & M.A.). **Member:** Arizona AA (pres. & secy., 1960); Nat. Art Educ. Assn.; Arizona Watercolor Assn. (founder & pres., 1959). **Exhibited:** Tuscon AC, 1966; Phoenix Art Mus., 1966; Stanford Res. Inst., Palo Alto, CA, 1966; Yuma (AZ) AA, 1970; State Teachers College, MO, 1970; Thompson Gal., Phoenix, AZ, 1970s. Awards: Nat. Vet. Award, Santa Monica Recreation Dept., 1953; O'Brien Art Award, Arizona State Fair, 1960; UNICEF Award, 1968. **Work:** Southeast State Teachers College, MO; City of Phoenix Civic Art Coll.; Central H.S. Art Coll., MO; Alhambra H.S. Art Coll., AZ; Heard Mus., Phoenix. Commissions: Carl Hayden H.S. Student Body, Phoenix, 1960; Mr. & Mrs. Eugene Pulliam, Phoenix; Dr. & Mrs. Dean Nichols, Phoenix; Greater Arizona Savings Bank, Tucson, AZ Heard Mus. **Comments:** Preferred medium: collage. Positions: cur. educ., Heard Mus., 1958-68, cur. art, 1968-. Teaching: Phoenix College, 1968-70; Glendale Community College, 1971-72. Collections arranged: African Art, Heard Mus, 6 & 9/1972; Indian Art Collection, 1968 & 1972. Publications: illustr., *Heard Mus.,* 1958 & 1971; illustr., *The Story of Navaho Weaving,* 1961; illustr.,*Pima Basketry,* 1965; illustr., *Women in 1970,* 1970. **Sources:** WW73; "Design/Crafts/Education" (film), NAET-TV, Arizona State Univ., 1960.

PARKER, Jennie C. H. *[Painter, china decorator] mid 20th c.*
Addresses: Wash., DC, active 1917-39. **Sources:** McMahan, *Artists of Washington, D.C.*

PARKER, Jesse R. *[Artist] late 19th c.*
Addresses: Wash., DC, active 1896. **Sources:** McMahan, *Artists of Washington, D.C.*

PARKER, Jessie D. *[Still life painter] early 20th c.*
Addresses: Active in Los Angeles, 1903-16. **Exhibited:** Southern Calif. Painters, Blanchard Gal., Los Angeles, 1909. **Sources:** Petteys, *Dictionary of Women Artists.*

PARKER, John Adams, Jr. *[Landscape painter] b.1827, NYC / d.c.1905.*
Addresses: Brooklyn, NY; Adirondacks, NY, 1905. **Studied:** NY Univ. **Member:** ANA, 1864; Brooklyn AA (founder); Brooklyn AC. **Exhibited:** NAD, 1858-86; Brooklyn AA, 1861-86. **Comments:** Worked as a merchant from 1850-57 before turning to painting. Specialized in views of Long Island, and the Adirondack, Catskill, and White Mountains. **Sources:** G&W; CAB (gave November 29, 1829; *Who's Who in America,* 1903-05 (gave birth date as November 27, 1827); WW06; *Artists Year*

Book, 148; Cowdrey, NAD; Naylor, NAD; Campbell, *New Hampshire Scenery*, 125; Pisano, *The Long Island Landscape*, n.p.

PARKER, John Clay *[Painter] b.1907, McComb, MI.*
Addresses: New Orleans, LA. **Studied:** Sch. Indust. Art, NYC. **Member:** New Orleans AA. **Exhibited:** Mississippi AA; New Orleans AA. **Work:** portraits, Masonic Temple, Wash., DC; Medical Sch., Tulane Univ.; Univ. Mississippi Lib.; Boston Club, New Orleans; New Scottish Rite Bldg., Wash., DC; Medical Sch., Univ. Alabama; Louisiana Supreme Court, New Orleans; College of Surgeons Hdqtrs., Chicago; Ochsner Hospital, New Orleans; Eye, Ear, Nose & Throat Hospital, New Orleans; Mary Buck Health Center, New Orleans. **Sources:** WW59; WW47.

PARKER, John E. *[Painter] early 20th c.*
Addresses: Phila., PA. **Member:** SC. **Sources:** WW21.

PARKER, John F. *[Painter, sculptor] b.1884, NYC.*
Addresses: NYC. **Studied:** R. Henri in NYC; England; Acad. Julian, Paris, with J. P. Laurens, 1904; Steinlen in Paris. **Member:** Alliance; SC. **Exhibited:** AIC,1914; S. Indp. A., 1917, 1920-21. **Work:** NGA; Valley Forge Mus. **Sources:** WW25.

PARKER, John W. *[Lithographer] b.1862 / d.1930, NYC.*
Member: Poster Artists Assn. (pres.).

PARKER, John, Jr. *[Miniature painter, map maker] late 18th c.*
Comments: Made a survey and map of Portsmouth (NH) in 1778 and also painted miniatures. **Sources:** G&W; Lyman, "William Johnston," 70.

PARKER, Joseph *[Listed as "artist"] mid 19th c.*
Addresses: Baltimore, active 1856-57. **Sources:** G&W; Lafferty.

PARKER, Josephine *[Painter] late 19th c.*
Addresses: Chicago area. **Exhibited:** AIC, 1897. **Comments:** AIC.

PARKER, Katharine Susanne Oster *[Painter, teacher] b.1876, Valley, NE.*
Addresses: Omaha, NE. **Studied:** Laurie Wallace. **Exhibited:** Omaha AI, 1926-29. **Sources:** Petteys, *Dictionary of Women Artists*.

PARKER, Lawton S. *[Portrait, figurative, and landscape painter, teacher] b.1868, Fairfield, MI / d.1954, Pasadena, CA.* **L. Parker.**
Addresses: Chicago area, 1891-1916; Pailly-sur-Oise, France (until 1942). **Studied:** Acad. Julian, Paris, with J. P. Laurens, Constant, Bouguereau & Robert-Fleury, 1889-90, 1896-98; ASL with H. S. Mowbray & Wm. M. Chase, 1897; École des Beaux-Arts with Gérôme; Whistler in Paris; mural painting with P. Besnard in Paris. **Member:** ANA, 1916; Chicago SA; Paris AAA; NAC. **Exhibited:** PAFA Ann., 1899-21 (9 times); Paris Salon, 1900, 1902 (med.), 1913 (gold); St. Louis Expo, 1904 (med.); Int. Expo, Munich, 1905 (gold); CI, 1907; Chicago SA, 1908 (med.); AIC; 1909 (prize); NAD, 1909 (prize); Corcoran Gal. biennials, 1910-19 (3 times); Brooklyn AA, 1912; Pan-Pacific Expo, San Fran., 1915. **Work:** Chicago Univ.; U.S. Court of Appeals, Wash., DC; AIC; LACMA; Nat. Coll., France. **Comments:** A member of a group of American artists, who lived and worked for a time near Monet's studio-home at Giverny. **Teaching:** St. Louis Sch. FA, 1892; Beloit College, 1893; pres., NY Sch. Art, 1898-99; dir., Parker Acad., Paris, 1900; AIC, 1902; pres., Chicago Acad. FA, 1903. **Sources:** WW40; Gerdts, *Monet's Giverny: An Impressionist Colony*; Bruce Weber, *The Giverny Luminists: Frieseke, Miller, and Their Circle*; 300 Years of American Art, 622; Falk, *Exh. Record Series*.

PARKER, Lester Shepard *[Painter, writer, lecturer] b.1860, Worcester, MA / d.1925, Rochester, MN.*
Addresses: Jefferson City, MO. **Studied:** J. Ankeney; A. True; R. Miller, Colarossi Acad. Paris; J.G. Brown. **Comments:** Parker was largely instrumental in the movement to redecorate the Capitol at Jefferson City. **Sources:** WW25.

PARKER, Life, Jr. *[Sculptor, marble & stone engraver] b.c.1822.*
Addresses: Lowell, MA, active 1837-47. **Comments:** He is also said to have painted portraits. He was married to Hannah Lowe on February 8, 1845; their twin sons, Pliny and Preston, were born in Salem on March 17, 1846. **Sources:** G&W; *Vital Records of Lowell;* Belknap, *Artists and Craftsmen of Essex County*, 19; Lowell CD 1847; Lipman and Winchester, 178.

PARKER, Lillian M. *[Painter] early 20th c.*
Addresses: Stroudwater, ME. **Sources:** WW24.

PARKER, M. S. *[Portrait painter] mid 19th c.*
Addresses: Philadelphia, 1835-46. **Exhibited:** Artists Fund Soc., 1835-45; Apollo Assoc., NYC, 1838. **Comments:** Two watercolor portraits of Judge Richard Peters and his son Richard (Hist. Soc. of Penn.) were made in 1843 by an M. Parker, possibly the same as M.S. Parker. There was also an 1843 watercolor portrait reproduced in *Antiques* (Jan. 1939) as the work of M.J. [S.?] Parker. Cf. W.S. Parker. **Sources:** G&W; Rutledge, PA; Phila. CD 1839-46; information cited by G&W as being courtesy the late William Sawitzky; *Antiques* (Jan. 1939), repro.

PARKER, Margaret R. *[Painter] early 20th c.*
Addresses: Indianapolis, IN. **Sources:** WW15.

PARKER, Margery (Shale) *[Painter, teacher] b.1921, Sauk County, WI.*
Addresses: Stockton 3, CA. **Studied:** Univ. Wisconsin (B.S.); BM Sch. Art with Reuben Tam, Yonia Fain, Louis Grebenak; Marantz. **Exhibited:** NYC Center, 1955-56; Brooklyn Soc. Art, 1956; Panoras Gal., 1956 (solo). **Sources:** WW59.

PARKER, Marie (or May) A. *[Artist] early 20th c.*
Addresses: Wash., DC, active 1908-11. **Sources:** McMahan, *Artists of Washington, D.C.*

PARKER, Mary Elizabeth *[Painter] b.1881, Phila.*
Addresses: Phila, PA. **Studied:** Phila. Sch. Des. for Women with H.B. Snell, B. Foster, E. Daingerfield, W. Sartain; PAFA. **Exhibited:** AIC, 1904; PAFA Ann., 1912. **Sources:** WW13; Falk, *Exh. Record Series*.

PARKER, Mary Virgina *[Painter, teacher] early 20th c.*
Addresses: New Orleans, active c.1918-25. **Studied:** PAFA. **Exhibited:** NOAA, 1918; PAFA, 1922 (Thouron prize for composition); Arts & Crafts Club, N.O., 1920s. **Sources:** *Encyclopaedia of New Orleans Artists*, 293.

PARKER, Matthew S. *[Engraver] mid 19th c.*
Addresses: Chicago, IL, active 1858; Wash., DC, active 1865-72. **Sources:** G&W; Chicago CD 1858; McMahan, *Artists of Washington, D.C.*

PARKER, (Mr.) *[Listed as "artist"] b.c.1822, Maine.*
Addresses: Boston in 1850. **Sources:** G&W; 7 Census (1850), Mass., XXIV, 349.

PARKER, Nancy Wynne *[Engraver, mural painter, portrait painter] b.1908, Swampscott, MA.*
Addresses: Swampscott, MA. **Studied:** ASL. **Sources:** WW40.

PARKER, Nathaniel *[Decorative wall painter] b.1802, North Weare, NH.*
Addresses: Active Antrim, NH. **Comments:** Said to have decorated the Buchman house in Antrim (NH). **Sources:** G&W; Little, *American Decorative Wall Painting*, 101, 133.

PARKER, Neilson R. (Mrs.) See: **STEELE, Zulma (Mrs. Neilson T. Parker)**

PARKER, Paul *[Writer, painter, teacher] b.1905, La Grange, IL.*
Addresses: Vermillion, SD. **Exhibited:** AIC, 1931-40. **Comments:** Auth.: *The Modern Style in American Advertising Art*, Parnassus, 1937; *The Iconography of Advertising Art*, 1939. **Teaching:** Univ. South Dakota. **Sources:** WW40.

PARKER, Pauline *[Painter] mid 20th c.*
Addresses: Chicago area. **Exhibited:** AIC, 1943-44, 1946.
Sources: Falk, *AIC.*

PARKER, Phillips *[Painter] b.1896 / d.1935, Granada, Spain.*
Addresses: San Diego, CA.

PARKER, Phoebe *[Painter, portrait painter] b.1886, MN /
d.1986, Tacoma, WA.*
Addresses: Tacoma, WA. **Studied:** Annie Wright Seminary,
Tacoma; San Fran. **Exhibited:** Tacoma Art Lg., 1940, 1951.
Sources: Trip and Cook, *Washington State Art and Artists, 1850-
1950.*

PARKER, R. *[Painter] mid 20th c.*
Addresses: Chicago area. **Exhibited:** AIC, 1937. **Sources:** Falk,
AIC.

PARKER, Raymond *[Painter] b.1922, Beresford, SD / d.1990.*
Addresses: NYC. **Studied:** Univ. Iowa (B.A., 1946; M.F.A.,
1948). **Exhibited:** WMAA, 1950-73; Corcoran Gal. biennial,
1963 (Ford Found. purchase prize); Walker AC, Minneapolis,
MN, 1950 (solo); Kootz Gal., NYC, 1960-66 (solos);
Guggenheim Mus., 1961 (solo); Dayton (OH) Art Inst., 1965
(solo); SFMA,1967 (solo); Fischbach Gal., NYC, 1970s. Other
awards: Nat. Council on the Arts Award, 1967; Guggenheim fel-
lowship, 1967. **Work:** Solomon R. Guggenheim Mus.; MoMA;
WMAA; MMA; Tate Gal., London, England; LACMA.
Comments: An Abstract Expressionist painter of the NYC School
and accomplished jazz musician, he painted largely improvisation-
al works in vivid colors. Preferred media: oils. Auth.: "Student,
Teacher, Artist," College Art Journal, 1953; "Direct Painting,"
spring 1958 & "Intent Painting," fall 1958. Teaching: Hunter
College, 1955-70s; guest critic, Columbia Univ. and Bennington
College. **Sources:** WW73; L. Campbell, "Parker Paints a
Picture," *ArtNews* (Nov., 1962); G. Nordland, exhib. cat. (San
Fran. Mus. Art, 1967).

PARKER, Robert Andrew *[Painter, illustrator, teacher]
b.1927, Norfolk, VA.*
Addresses: Carmel, NY. **Studied:** AIC (B.A.E., 1952);
Skowhegan Sch. P&S with Jack Levine & Henry V. Poor; Atelier
17, New York, 1952-53. **Exhibited:** AIC, 1951; Atelier 17, NYC,
1952; Young American Printers, 1953; Roko Gal., 1954 (solo);
BM, 1955; WMAA, 1955-63; MoMA, 1957; Laon Mus., Aisne,
France, 1956; PAFA Ann., 1962; New School Social Res., NY,
1965; School Visual Arts, NY, 1965; Terry Dintenfass, Inc.,1970s;
Katonah Gal., NY, 1970s. Awards: Rosenthal Found. grant,
NIAL, 1962; Tamarind Lithography Workshop fellowship, 1967;
Guggenheim fellowship, 1969-70. **Work:** MoMA; WMAA ;
MMA; Morgan Lib., NYC; LACMA. Commissions: designer
sets, William Shuman Opera, MoMA, 1961. **Comments:** Illustr.:
hand colored limited edition poems, MoMA, 1962; poetry, *The
Days of Wilfred Owen,* (film), 1966; *Esquire* and other national
magazines. Teaching: RISD; Parsons Sch. Des., NYC. **Sources:**
WW73; W&R Reed, *The Illustrator in America,* 336; Falk, *Exh.
Record Series.*

PARKER, Roy Danford *[Painter] b.1882, Raymond, Iowa.*
Addresses: Middletown, NY. **Member:** Middletown Art Group;
Pocono Mountain Art Group. **Exhibited:** NYC, 1956-57 (3 solos);
Berkshire Mus., Pittsfield, 1958 (solo); Grout Hist. Mus.,
Waterloo, 1960 (solo); Minisink Gal., Wallpack, 1961 (solo); Hall
of Fame, Goshen, NY, 1962 (solo). Awards: 46 prizes. **Work:**
Berkshire Mus., Pittsfield, MA; Minisink Gal., Wallpack, NJ;
Grout Hist. Mus., Waterloo, IA; Everhart Mus., Scranton, PA;
Bridgeport (CT) Mus. **Comments:** Preferred medium: oils.
Sources: WW73.

PARKER, Sarah C. L. *[Painter] late 19th c.*
Addresses: NYC. **Exhibited:** NAD, 1885. **Sources:** Naylor,
NAD.

PARKER, Seymour D. *[Painter] early 20th c.*
Addresses: Northampton, MA, 1917. **Exhibited:** S. Indp. A.,
1917-18. **Sources:** Marlor, *Soc. Indp. Artists.*

PARKER, Stephen Hills *[Portrait painter] b.1852, New York
/ d.1925, Florence, Italy.*
Studied: C.-Duran, Paris. **Exhibited:** Paris Salon, 1876, 1878,
1879-81, 1885-88; NAD, 1886. **Sources:** Fink, *Am. Art at the
19th C. Paris Salons,* 377-78.

PARKER, Thomas H. *[Miniaturist] b.1801, Sag Harbor, NY /
d.1851.*
Addresses: Active in Hartford, CT; NYC; Vermont; and the
South. **Studied:** Matthew Rogers, NYC. **Comments:** He and one
of his pupils, Charles William Eldridge (see entry), worked in
partnership that was similar to Waldo & Jewett. After Eldridge
had studied for a year with Parker in Hartford, they joined togeth-
er and for the next nine years painted portraits in NYC, Vermont
(1833), and in the South, until Parker retired due to illness.
Sources: G&W; French, *Art and Artists in Connecticut,* 66 and
78; Bolton, *Miniature Painters;* Fielding; Eldridge, "Journal of a
Tour through Vermont to Montreal and Quebec in 1833.".

PARKER, Virginia *[Painter] b.1897, New Orleans, LA.*
Addresses: Charlottesville, VA. **Studied:** PAFA (Cresson
Travelling Scholarship, 1921). **Exhibited:** Salons of Am., 1926;
S. Indep. A., 1926-31; Morton Gal., NY, 1939 (solo); Int. WCC,
BM, 1939. **Comments:** Contrib.: *Dial,* 1927. **Sources:** WW40.

PARKER, W. L. (Mrs.) *[Painter] early 20th c.*
Addresses: Boston, MA. **Member:** Boston WCC. **Sources:**
WW24.

PARKER, W. S. *[Portrait painter] 19th c.*
Work: PAFA (oil portrait of W. C. Anderson). **Comments:** *Cf.*
M.S. Parker. **Sources:** G&W; WPA (Pa.), Hist. Records Survey,
"Catalogue of the Early American Portraits in the Penna. Acad."
(could be misspelling for M.S. Parker, who exhibited with Artists
Fund Society at PAFA from 1835-45).

PARKER, Walter H. *[Painter] early 20th c.*
Addresses: Hollywood, CA, 1932. **Exhibited:** Calif. Artists,
Golden Gate Mem. Mus., 1916. **Sources:** Hughes, *Artists of
California,* 423.

PARKER, Wentworth *[Painter, etcher] b.1890, Terre Haute,
IN.*
Addresses: Terre Haute, IN. **Studied:** W. Forsyth. **Exhibited:**
Salons of Am., 1931. **Sources:** WW29.

PARKER, William Gordon *[Illustrator] b.1875, Clifton, NJ.*
Addresses: Arkansas City, KS. **Studied:** ASL; Acad. Julian, Paris,
1895. **Sources:** WW10.

PARKES, Mary See: **ADELSPERGER, Mary P. (Mrs.)**

PARKES, W. *[Painter] mid 19th c.*
Exhibited: Cincinnati, 1857 (view of Washington's birthplace).
Sources: G&W; Cincinnati *Daily Gazette,* May 29, 1857 (cita-
tion cited by G&W as being courtesy J.E. Arrington).

PARKHOUSE, Stanley *[Illustrator, cartoonist] mid 20th c.*
Addresses: NYC. **Comments:** Contrib.: *Cosmopolitan,* 1939.
Sources: WW40.

PARKHURST, Anita (Mrs. Willcox) *[Painter, illustrator]
b.1892, Chicago, IL.*
Addresses: NYC. **Studied:** AIC. **Member:** Artist's Guild; SI.
Comments: Illustr.: covers, *Saturday Evening Post, Collier's.*
Sources: WW33.

PARKHURST, Anna M. *[Painter] early 20th c.*
Addresses: Wash., DC. **Member:** Soc. Wash. Artists, 1925.
Comments: In 1925 she resided with Burleigh Thomas S.
Parkhurst. **Sources:** WW25; McMahan, *Artists of Washington,
D.C.*

PARKHURST, Burleigh Thomas S. *[Painter, writer, lectur-
er] b.1854, Gloucester, MA.*
Addresses: Boston, MA (1917); Wash., DC (active mid 1920s);
Amherst, MA; Ogunquit, ME (1930s). **Studied:** Sartain; Acad.
Julian, Paris. **Member:** Providence AC; Soc. Wash. Artists; Wash.
AC. **Exhibited:** Soc. Wash. Artists; Wash. AC (solo); Soc. Indp.

A., 1917. **Comments:** He was also active in Utica, NY and Gloucster, MA. **Sources:** WW27; McMahan, *Artists of Washington, D.C.*

PARKHURST, Charles *[Art administrator, writer] b.1913, Columbus, OH.*
Addresses: Washington, DC. **Studied:** Williams College (B.A., 1935); Oberlin College (M.A., 1938); Princeton Univ. (M.F.A., 1941). **Member:** College AA Am. (pres.); Intermus. Conserv. Assn. Bd. (co-founder & pres.); Assn. Art Mus. Dirs. (vice-pres.); Am. Assn. Mus. (pres.). **Exhibited:** Awards: Chevalier, Legion of Honor, French Govt., 1947; Ford Found. fellowship, 1952-53; Fulbright res. fellowship, Univ Utrecht, 1956-57. **Comments:** Positions: dir., Allen Mem. Art Mus., Oberlin College, 1949-62; dir., Baltimore Mus. Art, 1962-70; asst. dir., Nat. Gallery Art, 1971-. Teaching: Princeton Univ., 1947-49; Oberlin College, 1949-62. Collections arranged: Good Design is Your Business, Albright-Knox Art Gal., 1947; Gorky & Watercolors by Max Beckmann, Princeton Art Mus., 1948; several exhs., Oberlin College, 1949-62; several exhs., Baltimore Mus. Art, 1962-71.Research: 16th & 17th c. scientific color theories and their relationship to visual arts. Publications: co-auth., *French Painting from the Chester Dale Collection* (catalogue), Nat. Gallery Art, 1941; auth., *Light and Color (Art Treasures of the World, New York and Toronto)*, Abrams, 1955; auth., *America's Museums: Prices and Priorities (the Belmont Report)*, Cultural Affairs, 1969; auth., *A Color Theory from Prague: Anselm de Boodt*, 1609 Allen Mem. Art Mus. Bulletin, 1971; auth., *Red-Yellow-Blue/A Color Triad in 17th Century Painting*, Baltimore Mus. Art Ann. IV, 1972. **Sources:** WW73.

PARKHURST, C(lifford) E(ugene) *[Illustrator] b.1885, Toledo.*
Addresses: NYC/Vails Gate, NY. **Studied:** Vanderpoel; Freer; Armstrong. **Member:** Arch. Lg. **Exhibited:** AIC, 1906. **Sources:** WW40.

PARKHURST, Daniel Burleigh *[Painter] late 19th c.*
Addresses: Phila., PA; Orange, NJ. **Exhibited:** NAD, 1883-90 (4 annuals); PAFA Ann., 1888, 1891; AIC, 1890. **Sources:** Falk, *Exh. Record Series.*

PARKHURST, Daniel S. *[Engraver, landscape painter] mid 19th c.*
Addresses: Providence, RI, active 1852-59. **Comments:** Partner with Charles Pabodie (see entry) in engraving firm of Pabodie & Parkhurst in 1857-58. An oil painting depicting the Franconia Mountains of New Hampshire was in a private collection as of 1985. **Sources:** G&W; Providence CD 1852-59; Campbell, *New Hampshire Scenery*, 125-26.

PARKHURST, Henry Landon *[Painter, teacher, architect, designer] b.1867, Oswego, NY / d.1921.*
Addresses: Chicago, 1901; NYC. **Studied:** NY Acad. FA. **Member:** NY Sketch Club. **Exhibited:** AIC, 1901. **Comments:** Teaching: CUA Sch. **Sources:** WW10.

PARKHURST, M. L. (Mrs.) *[Painter] late 19th c.*
Addresses: Alameda, CA. **Exhibited:** World's Columbian Expo, Chicago, 1893. **Sources:** Hughes, *Artists of California*, 423.

PARKHURST, Thomas Shrewsbery *[Landscape painter, illustrator] b.1853, Manchester, England / d.1923, Carmel, CA.*
Addresses: Toledo, OH; Carmel, CA. **Studied:** self-taught. **Member:** Toledo Tile Club; SC; NAC. **Work:** Toledo Mus.; Oakland AM; Lima, Ohio AL; Des Moines AC; Oklahoma AL. **Sources:** WW21.

PARKHURST, W. P. (Mrs.) *[Painter] late 19th c.*
Exhibited: Calif. Midwinter Int. Expo, 1894. **Comments:** This could be the same as M.L. Parkhurst (see entry). **Sources:** Hughes, *Artists of California*, 423.

PARKINS, J. (Sir) *[Painter] early 19th c.*
Exhibited: PAFA, 1828 (view of Philadelphia). **Sources:** G&W; Rutledge, PA.

PARKINSON, A. M. (Mrs.) *[Artist] late 19th c.*
Exhibited: Soc. Wash. Artists, 1892. **Sources:** McMahan, *Artists of Washington, D.C.*

PARKINSON, Donald B. *[Painter, architect] b.1895, Los Angeles, CA / d.1945, Santa Monica, CA.*
Addresses: Los Angeles, CA. **Studied:** Am. Acad., Rome, 1920-21. **Member:** Calif. AC. **Sources:** WW25; Hughes, *Artists of California*, 423.

PARKINSON, Elizabeth Bliss *[Patron, collector] b.1907, NYC.*
Addresses: NYC. **Comments:** Positions: trustee, MoMA, 1939-, pres. int. council, 1957-65, pres. mus., 1965-68. Collection: paintings and modern art. **Sources:** WW73.

PARKINSON, Grace Wells *[Painter, sculptor] mid 20th c.*
Addresses: Los Angeles, CA. **Member:** Calif. AC. **Exhibited:** Calif. Art Club, 1923-37; P&S Los Angeles, 1924-34. **Sources:** WW25; Hughes, *Artists of California*, 423.

PARKINSON, Helen Byrd *[Painter] early 20th c.*
Addresses: Chicago, IL. **Exhibited:** AIC, 1912-13, 1916. **Sources:** WW17.

PARKINSON, Ida J. *[Artist] 19th/20th c.*
Addresses: Active in Detroit, MI, 1899-1900. **Sources:** Petteys, *Dictionary of Women Artists.*

PARKINSON, Richard *[Portrait painter] mid 19th c.*
Addresses: Richmond, VA, in 1832. **Sources:** G&W; *Antiques* (Nov. 1929), 428, repro.

PARKINSON, William Jensen *[Painter, decorator, illustrator] b.1899, Hyrum, UT.*
Addresses: Salt Lake City, UT. **Studied:** essentially self-taught although he studied at Univ. Utah with A. B. Wright, 1924; R. Pearson, 1946. **Member:** Am. Artists Congress; Utah State Inst. FA. **Exhibited:** Utah State AC. **Work:** murals, McKinley Sch., Salt Lake City; Capitol, Utah; Hyrum City H.S.; Univ. Club, Salt Lake City. **Comments:** Ventured into surrealism; later work is largely portraiture. Teaching: Utah State AC; dept. store decorator, 1946. **Sources:** WW40.

PARKMAN, Polly *[Painter] mid 20th c.*
Addresses: NYC. **Studied:** J. Farnsworth. **Exhibited:** Corcoran Gal. biennial, 1939; Vendôme Gal., NYC, 1940. **Sources:** WW40.

PARKS, A. L. *[Artist] mid 19th c.*
Addresses: Wash., DC, active 1863. **Sources:** McMahan, *Artists of Washington, D.C.*

PARKS, Alonzo *[Portrait painter] early 19th c.*
Addresses: Corning, NY, 1817 and after. **Sources:** G&W; Sherman, "Unrecorded Early American Portrait Painters" (1933), 31.

PARKS, Asa *[Portrait painter] mid 19th c.*
Addresses: Boston, active 1858-59. **Comments:** Cf. Asa Park (d. 1827), who may have been a relative. **Sources:** G&W; Boston BD 1858-59.

PARKS, Billie (Miss) *[Painter] early 20th c.*
Addresses: Chicago, IL. **Member:** GFLA. **Sources:** WW27.

PARKS, Charles Cropper *[Sculptor] b.1922, Virginia.*
Addresses: Hockessin, DE. **Studied:** PAFA. **Member:** ANA; NSS (fellow); Allied Artists Am.; Delaware State Arts Council. **Exhibited:** NSS Ann., 1962-71 (gold med.); NAD, 1965-71; Allied Artists Am., 1967- 71. Awards: Wemys Found. travel grant, Greece, 1965; AAPL Gold Medal, 1970. **Work:** Commissions: "Joseph with the Body of Christ," Hockessin Methodist Church, DE, 1968; boy & dogs, H.B. Du Pont, Wilmington, DE, 1969; James F. Byrnes, Byrnes Found., Columbia, SC, 1970; "Father & Son, Mother" AUMP Church, Wilmington, 1971; "The Family," Phila. Redevelop. Auth., 1972. **Comments:** Positions: mem. adv. comt., John F Kennedy Center, 1968-. Publications: contrib.,"Sights & Sounds of Easter," TV

film produced by Wilmington Council Churches, 1964. **Sources:** WW73; Wayne Craven, *A Biography Mid Way,* catalog (Del Art Mus., 1971); Nancy Mohr, "The Parks Family," *Delaware Today Magazine* (1972).

PARKS, Christopher Cropper *[Sculptor, painter] b.1949, Wilmington, DE.*
Addresses: Hockessin, DE. **Studied:** Charles Parks. **Member:** NSS. **Exhibited:** NAD, 1968 (Helen Foster Barnett Prize); Allied Artists Am., New York, 1971 (Lindsey Morris Mem. Prize); NSS, 1972 (C. Percival Dietsch Prize). **Sources:** WW73.

PARKS, Eric Vernon *[Sculptor] b.1948, Wilmington, DE.*
Addresses: Chadds Ford, PA. **Studied:** Cornell Univ. (B.S.); PAFA; also sculpture with Charles Parks. **Member:** Brandywine Valley AA (mem. planning comt., spring 1972). **Exhibited:** Allied Artists Ann., NYC, 1970-71; NAD Ann., New York, 1972; NSS Ann., 1972; Three Sculptors of Am. Realism, Hewlett-Packard Instrument Div. Ann., Avondale, PA, 1972. Awards: hon. men., Allied Artists Ann., 1970; silver medal with patrons prize, Arts Atlantic Nat. Exh., Gloucester, MA, 1972. **Comments:** Preferred media: bronze, steel. **Sources:** WW73.

PARKS, Eva Allen *[Painter] b.1846, Buckfield, ME / d.1932.*
Addresses: Active in Mechanic Falls, ME. **Work:** Maine Hist. Soc. (painting of summer home in Center Minot, ME). **Sources:** Petteys, *Dictionary of Women Artists.*

PARKS, Frederick *[Engraver] mid 19th c.*
Addresses: Belleville, NJ, 1850. **Comments:** *Cf.* Richard Parks. **Sources:** G&W; N.J. BD 1850.

PARKS, Gordon *[Photographer, illustrator, author] b.1912, Kansas.*
Member: NY Newspaper Guild. **Exhibited:** Corcoran Gal., 1998 (retrospective, traveled to Mus. City of NY and Milwaukee AM, and 16 cities until 2003). **Work:** MoMA; MMA; largest collection (227 prints) at Corcoran Gal. **Comments:** Position: staff, *Life* and *Time* magazines, 1950-52. **Sources:** Cederholm, *Afro-American Artists;* article, *New York Times* (Sept. 30, 1998).

PARKS, J. *[Oil portraitist] mid 19th c.*
Addresses: Mohawk Valley, NY, c.1830. **Sources:** G&W; Lipman and Winchester, 178.

PARKS, James Dallas *[Painter, lithographer, sculptor, educator] b.1907, St. Louis, MO.*
Addresses: Jefferson City, MO. **Studied:** Bradley Univ. (B.S.); AIC; State Univ. Iowa (M.A.); Jean Charlot; Philip Guston. **Member:** Nat. Conf. Artists; College AA Am.; Missouri College Art Educ. Assn.; CAA. **Exhibited:** St. Louis Central Lib., 1928-31; Missouri State Fair, 1928, 1945 (prize), 1946; Harmon Found., 1929; CAM, 1946-47; Langston Univ., 1932; Atlanta Univ., 1942, 1944 (hon. men.), 1946, 1950-51, 1957-58; Kansas City AA, 1943 (prize); Springfield Mus. Art, 1946-47; Kansas City Mus., 1950; William Rockhill Nelson Gal. Art, 1951; West Virginia State, 1959 (solo); Howard Univ., 1961; Xavier Univ., 1963; Nat. Conf. Artists, 1964 (prize), 1965 (prize), 1969 (hon. men.); Alabama State, 1966 (solo); Savannah State Univ., 1967 (solo); Tuskegee Inst., 1967 (solo); Lincoln Univ. (solo); Joslyn Mus., Omaha, NE. **Work:** Atlanta Univ.; Springfield Mus. Art; Lincoln Univ.; State Univ. Iowa; Howard Univ.; Carver Sch. Kansas City, MO; mural, Lincoln Univ. **Comments:** Position: hd. art dept., Lincoln Univ., Jefferson City, MO, 1927-. Contrib.: *Design* magazine, *Everyday Art.* **Sources:** WW59; Cederholm, *Afro-American Artists.*

PARKS, Jarvin L. *mid 20th c.*
Addresses: Atlanta, GA, 1958. **Exhibited:** WMAA, 1958. **Sources:** Falk, *WMAA.*

PARKS, John D. *[Printmaker] mid 20th c.*
Addresses: Chicago. **Exhibited:** AIC, 1950. **Sources:** Falk, *AIC.*

PARKS, Louise Adele *[Painter] b.1945.*
Studied: Pratt AI (B.F.A.); Hunter College, NYC. **Exhibited:** Hunter College, 1969; Bowdoin College, 1970; Cinque Gallery,

NYC (solo); Franklin & Marshall College, Lancaster, PA, 1970 (solo); BMFA, 1970. **Sources:** Cederholm, *Afro-American Artists.*

PARKS, Lucille G. *[Painter, educator] b.1924, Buffalo, NY.*
Studied: Springfield (MA) College; self-taught as a painter. **Member:** Afro-Art Alliance, Springfield, MA. **Exhibited:** Am. Int. College, Springfield, MA, 1972; Afro-Art Alliance, Springfield, MA, 1972; plus other local exh. **Sources:** Cederholm, *Afro-American Artists.*

PARKS, Richard *[Steel plate engraver] mid 19th c.*
Addresses: Belleville, NJ, 1859-60. **Comments:** *Cf.* Frederick Parks. **Sources:** G&W; Essex, Hudson and Union Counties BD 1859; N.J. BD 1860.

PARKS, Robert Owen *[Painter, teacher] b.1916, Richmond, IN.*
Addresses: Lafayette, IN. **Studied:** Herron AI; Cape Sch. Art, Provincetown. **Member:** Fellow, Tiffany Fnd., 1938. **Exhibited:** Tiffany Fnd., 1938; Cincinnati Mus., 1938. **Comments:** Teaching: Purdue Univ. **Sources:** WW40.

PARKS, Robert Owens *[Museum director] mid 20th c.*
Addresses: Northampton, MA. **Sources:** WW59.

PARKS, Samuel Augustus *[Listed as "artist"] b.1822, probably Boston, MA / d.1877, Boston, MA.*
Addresses: Apparently spent his life in Boston. **Comments:** Son of Elisha Parks, merchant of Winchendon, MA, and Boston. **Sources:** G&W; Parks, *Parks Records,* III, 129; 7 Census (1850), Mass., XXVI, 575; 8 Census (1860), Mass., XXVII, 3; Boston CD 1851, 1860.

PARKYN, Maude M. *[Painter] early 20th c.*
Addresses: Chicago. **Exhibited:** AIC, 1905. **Sources:** Falk, *AIC.*

PARKYNS, George Isham *[Landscape & portrait painter, engraver] b.1749, Nottingham (England) / d.c.1820.*
Addresses: Brooklyn, NY, from 1794. **Exhibited:** London, 1772-1813 (engravings, landscapes). **Comments:** Came to U.S. c.1794 and, in association with James Harrison of NYC, published proposals to issue a series of 24 aquatints showing the principal cities and scenery of the United States. In January 1796 several of his drawings for this series, including the earliest view of Washington, DC, were on view at Harrison's in NYC and at Parkyns' residence in Brooklyn. One of his views of Mount Vernon, VA, was engraved by T. Milton and published by Richard Philips in London, 1804. Auth.: *Monastic Remains and Ancient Castles in Great Britain.* **Sources:** G&W; Thieme-Becker; Stauffer; Gottesman, *Arts and Crafts in New York,* II, nos. 119-20; Dunlap, *History,* II, 469; Stokes, *Historical Prints,* pl. 30a; *Antiques* (Feb. 1945), 103 (repro.); Wright, *Artists in Virginia Before 1900.*

PARLIN, Florence W. *[Painter] mid 20th c.*
Addresses: Rochester, MN. **Exhibited:** AIC, 1935; PAFA, 1936; NAWPS, 1938; Kansas City AI, 1937-39. **Sources:** WW40.

PARMELEE, Charles N. *[Wood engraver] b.c.1805, Connecticut.*
Addresses: Philadelphia, active 1837-54. **Sources:** G&W; 7 Census (1850), Pa., L, 825; Phila. CD 1837-54; Hamilton, *Early American Book Illustrators and Wood Engravers,* 280, 398.

PARMELEE, Elmer Eugene *[Portrait & landscape painter] b.1839, Middletown, VT / d.1861, Brandon, VT.*
Studied: NYC. **Exhibited:** NAD, 1857-61 (landscapes). **Comments:** Son of Syrena S. and Daniel S. (a Baptist preacher) Parmelee. In 1860 he was an instructor in drawing and painting in the Grammar School of New York University, along with Benjamin H. Coe (see entry). Examples of Parmelee's work are preserved in his family. **Sources:** G&W; info cited by G&W as being courtesy Mr. Cullen W. Parmelee, Urbana (IL), nephew of the artist; Cowdrey, NAD; 8 Census (1860), N.Y., LX, 149.

PARMELEE, Irene E. (or J.E.) See: **PARMELY, Irene E.**

PARMELEE, James Marcus *[Painter] d.1918, New Orleans, LA.*
Addresses: New Orleans, active c.1915-16. **Exhibited:** NOAA, 1915-16. **Comments:** Father of Marcus Sutton Parmalee (see entry). **Sources:** *Encyclopaedia of New Orleans Artists*, 292.

PARMELEE, Marcus Sutton *[Sketch artist, painter, commercial artist] b.1894, New Orleans, LA / d.1954, Metairie, LA.*
Addresses: New Orleans, active 1915-32. **Exhibited:** NOAA, 1915. **Comments:** Son of James M. Parmalee (see entry). **Sources:** *Encyclopaedia of New Orleans Artists*, 292.

PARMELEE, Mathilde *[Sculptor, teacher] b.1909.*
Addresses: Greenwich, CT. **Studied:** Kunstgewerbe Schule, Munich; Alfred Univ., Syracuse. **Exhibited:** Syracuse Mus., 1937 (prize). **Work:** Syracuse Mus. **Sources:** WW40.

PARMELEE, Olive Miriam Buchholz *[Painter] b.1913, Dubuque, IA.*
Addresses: Urbana, IL. **Studied:** Univ. Illinois, 1934; Andre Lhote; Acad. Julian; ASL,1934-35; Loen Kroll, PAFA, 1935-36; C.V. Donovan, Univ. Illinois. **Member:** NAWA. **Exhibited:** Univ. Illinois; PAFA, 1936; Pi Beta Phi Convention, 1936; Nat. Assoc. of Women P&S, 1936; Gardena H.S., Los Angeles, 1936; Dept. Educ., Office of Interior, Wash., DC, 1937; AIC, 1938. **Work:** Univ. Illinois; Sigma Chi & Pi Beta Phi, Champaign, IL. **Sources:** WW 43; Ness & Orwig, *Iowa Artists of the First Hundred Years*, 39.

PARMELEE, Theodore Davis *[Illustrator, animator] b.1912, New Jersey / d.1964, Los Angeles, CA.*
Addresses: Los Angeles, CA. **Comments:** Position: animator, movie industry. **Sources:** Hughes, *Artists of California*, 423.

PARMELY, Irene E. *[Artist] late 19th c.*
Addresses: Connecticut; Springfield, MA, 1875. **Studied:** Henry Bryant in Hartford; Nathaniel Jocelyn in New Haven. **Exhibited:** NAD, 1884-85, 1890-91. **Sources:** Petteys, *Dictionary of Women Artists*.

PARMENTER, Helen Caroline *[Artist, art administrator] b.c.1873, Elmira, NY / d.1915, NYC.*
Comments: Position: dir., art dept., Pittsburgh Training Sch. for Teachers. **Sources:** Petteys, *Dictionary of Women Artists*.

PARMENTER, Joel E. (Mrs.) *[Listed as "artist"] late 19th c.*
Addresses: Sacramento, CA. **Exhibited:** Calif. Agricultural Soc., 1883. **Sources:** Hughes, *Artists of California*, 423.

PARNELL, Eileen (Mrs. Gustav Bohland) *[Sculptor] b.1897, Belfast, Ireland / d.1987, Miami Beach, FL.*
Addresses: Miami Beach, FL. **Studied:** Europe; America. **Work:** medal design, Florida State College Women Alumnae Assn. **Sources:** WW40.

PARNELL, Joseph *[Etcher] late 19th c.*
Exhibited: Paris Salon, 1885. **Sources:** Fink, *Am. Art at the 19th C. Paris Salons*, 378.

PARNUM, Edward J. *[Architect, block printer] b.1901, Waco, TX.*
Addresses: Phila., PA. **Studied:** Univ. Penn.; Univ. Texas. **Member:** T Square Club. **Sources:** WW40.

PARR, Helen Sherwin (Mrs.) *[Amateur painter] b.1887, Sterling, CO / d.1970, Pueblo, CO.*
Addresses: Sterling. **Studied:** Univ. Colorado; Univ. Michigan; Mabel Landrum Torrey. **Sources:** Petteys, *Dictionary of Women Artists*.

PARR, James Wingate *[Painter] b.1923, Boston, MA / d.1969.*
Comments: Active in Provincetown, 1948-69. **Sources:** Provincetown Painters, 176.

PARR, Russell C. *[Painter, teacher, art administrator, lecturer] b.1895, Evansville, WI / d.c.1980, West Virginia.*
Addresses: Charles City, IA; Washington, DC, active 1933; NYC,

1944. **Studied:** Grinnell College; Univ. Illinois; Washington Univ.; AIC; George Washington Univ.; Acad. Colorossi; Greece; Paris, with Picart LeDoux, Dourananez; Oscar Gross; John Butler. **Member:** Nat. Soc. Indep. Artists; Wash. AL; Ten O'Clock Club; Artists Prof. Lg.; SI; Wash. Landscape Club; Wash. Arts Club. **Exhibited:** Nat. Soc. Indep. Artists; Wash. AL; AIC; Gr. Wash. Indep. Exh., 1935; Addison Gal., Andover, MA; Phillips Mem. Gall., Wash., DC; solos: Baltimore, Cincinnati, Grinnell; Iowa Artists Exh., Mt. Vernon, 1938. **Work:** Baltimore Pub. Lib.; Indust. Home Sch., Wash. **Comments:** Position: WPA dir./advisor, Region 1; chief, prof. training, Veterans Admin., NY, 1944. **Sources:** WW47; Ness & Orwig, *Iowa Artists of the First Hundred Years*, 160-161; McMahan, *Artists of Washington, D.C.*

PARRISEN See: **PARISEN, J. (Julien?)**

PARRISH, Alfred *[Painter] late 19th c.*
Exhibited: PAFA Ann., 1877. **Sources:** Falk, *Exh. Record Series*.

PARRISH, Anne *[Portrait painter] early 19th c.*
Work: Swarthmore (PA) College ("Edward Parrish").
Comments: Painted a portrait of Edward Parrish (1822-72), first pres. of Swarthmore College. The artist may have been his sister, Ann Cox Parrish (1824-1844). *Cf.* with Anne Lodge Parrish. **Sources:** G&W.

PARRISH, Anne Lodge Willcox (Mrs. Thomas) *[Portrait painter, etcher, teacher] b.c.1850, probably Phila.*
Addresses: Active Colorado Springs c.1880-1900. **Studied:** PAFA; etching with husband Thomas Parrish. **Exhibited:** "Woman Etchers of America," NYC, 1888; NY Etching Club, 1888; BAC, 1889; PAFA Ann., 1891. **Work:** Pioneers' Mus., El Paso Club & Cheyenne Mountain CC, all in Colorado Springs, CO. **Comments:** After marrying fellow artist Thomas Parrish in Philadelphia, she and her husband opened a studio in Colorado Springs, c.1880 and Anne established herself as a portrait painter. Her Colorado portraits are dated between 1880 and 1900. Although she also exhibited etchings, none of her prints have been found. Her daughter Anne, born in 1888, and son Dillwyn both became artists and writers. Parrish continued to paint in Colorado for a few years following her husband's death in 1899 but eventually returned to Philadelphia. **Sources:** P&H Samuels, 359. *Cf.* with Anne Parrish. Bibliography: P. Peet, *Am. Women of the Etching Revival*, 62-63; Falk, *Exh. Record Series*.

PARRISH, Charles Louis *[Townscape artist] b.c.1830, NYC / d.1902, NYC.*
Addresses: California, from 1850. **Studied:** apprenticed to builder-architect in New York; self-taught artist. **Work:** Bancroft Lib., Univ. Calif., Berkeley; Soc. Calif. Pioneers; Calif. Hist. Soc. **Comments:** Went to California in 1850 to seek gold, later settled in Jackson and manufactured rock crushers and quartz mills and carried on other businesses. Operated toll bridge at Big Bar in Amador County in 1850s and 1860s. His drawings of coastal cities in South America were dated 1852. Parrish made many pencil drawings of California towns, such as Jackson, Volcano, and Mokelumne Hill, c.1854. At least one was lithographed by Britton & Rey. About 1865 he moved to Oakland and died during a visit to relatives. **Sources:** G&W; Van Nostrand and Coulter, *California Pictorial*, 138-39; *Antiques* (Jan. 1954), 41-42 (repros.). More recently, see Hughes, *Artists in California;* P&H Samuels, 359.

PARRISH, Clara Weaver CLARA WEAVER PARRISH
(Mrs. Wm. P.) *[Painter, etcher, writer] b.1861, Selma, AL / d.1925, NYC.*
Addresses: NYC. **Studied:** ASL with W.M. Chase, H.S. Mowbray, K. Cox, J. S. Weir; in Paris with Collin, Mucha, Courtois. **Member:** NYWCC; AWCS; NAWA; NAC; Pen & Brush Club; SPNY; MacDowell Club; Lg. AA. **Exhibited:** Boston AC, 1891-1908; PAFA Ann., 1892-1902, 1906, 1921; World's Columbian Expo, Chicago, 1893; NAD, 1896, 1899; NY Women's AC, 1902 (prize), 1913 (prize); AIC, 1894-1919; Paris Expo, 1900; Corcoran Gal. annual/biennials, 1907, 1908, 1921; Appalachian Expo, Knoxville, 1910 (medal); Pan-Pacific Expo,

San Fran., 1915 (medal); NAC, 1924 (prize); SSAL, 1925.
Comments: Early on in her career she became interested in working with stained glass and she designed a number of windows with the Tiffany Studios during the 1890s, mostly for churches in the south. She also painted in oils and watercolors. In the later years of her life she traveled a great deal in Europe. **Sources:** WW24; Pisano, *One Hundred Years.the National Association of Women Artists*, 75; Falk, *Exh. Record Series.*

PARRISH, David Buchanan [Painter] b.1939, Birmingham, AL.
Addresses: Huntsville, AL. **Studied:** Univ. Alabama with Melville Price & Richard Brough (B.F.A.). **Exhibited:** Documenta & No. Documenta Realists, Gal. Gestlo, Hamburg, Germany, 1972; "Sharp Focus Realism," Sidney Janis Gal., NYC, 1972; "Painting & Sculpture Today," Indianapolis Mus. Art, 1972; "Phases of New Realism," Lowe Mus., Coral Gables, FL, 1972; "Realists Revival," AFA Traveling Show, 1972-73; French & Co, Inc., NYC, 1970s. Awards: award of merit, 23rd Southeastern Ann. Exh., High Mus., Atlanta, GA, 1968; top award, 61st Ann. Jury Exh., Birmingham Mus. Art, 1969; top award, Mid-South Ann., Brooks Mem. Art Gal., 1970. **Work:** Brooks Mem. Art Gal., Memphis, TN; Parthenon, Nashville, TN; Monsanto Chemical Co., Decatur, AL. **Comments:** Preferred medium: oils. **Sources:** WW73.

PARRISH, Frederick Maxfield See: **PARRISH, Maxfield**

PARRISH, Grace [Painter] early 20th c.
Addresses: St. Louis, MO. **Member:** St. Louis AG. **Sources:** WW25.

PARRISH, Jean [Landscape painter] b.c.1920, New Hampshire (or Windsor, VT).
Addresses: Albuquerque, NM 1973. **Studied:** self-taught. **Comments:** Daughter of Maxfield Parrish (see entry); moved to New Mexico in 1937 and began painting in 1948. **Sources:** P&H Samuels, 360.

PARRISH, Joseph Lee [Cartoonist] b.1905, Summertown, TN.
Addresses: Winnetka, IL. **Member:** Assn. Am. Ed. Cartoonists. **Comments:** Position: cartoonist, Chicago *Daily News.* **Sources:** WW59.

PARRISH, Mary E. [Painter] early 20th c.
Addresses: Newport, RI. **Sources:** WW19.

PARRISH, Maxfield
[Painter, illustrator] b.1870, Philadelphia, PA / d.1966, Plainfield, NH.
Addresses: Cornish, NH; Windsor, VT. **Studied:** his father, Stephen; Paris, 1884-86; architecture, Haverford College, 1888-91; PAFA, 1891-93; H. Pyle at Drexel Inst. **Member:** SAA, 1897; Phila. WCC; ANA, 1905; NA, 1906; Union Int. des Beaux Arts et Lettres;Cornish (NH) Colony, from 1898, where he designed and built his home "The Oaks.". **Exhibited:** PAFA Ann., 1894-1912 (8 times); Paris Expo, 1900 (prize); Pan-Am. Expo, Buffalo, 1901 (medal); Phila. WCC, 1908 (prize); Arch. Lg., 1917 (gold). **Work:** St. Louis AM; Brandywine River Mus., PA; Delaware AM, Wilmington; murals in hotels, clubs and public buildings. **Comments:** One of the great illustrators of the 20th century, his unique style set him apart. He mastered the mysterious effects of light and irridescent colors through a difficult glazing technique, enhanced by the invention of his luminous "Maxfield Parrish blue." He always worked from photographs rather than live models. His most famous painting, "Daybreak," sold millions of copies as a print (the original oil sold at auction for $4.3 million in 1996). During his long career, more than 20 million copies of his paintings were reproduced as color photolithographic prints. Earlier in his career, while recuperating from ill health, he painted in the Adirondacks and Arizona and Italy before settling in Vermont. He was the son of Stephen Parrish (see entry). Illustr.: covers for *Collier's* 1903-10; Edison Mazda calendars, 1918-34

(1,500,000 printed in 1925); Brown & Bigelow calendars, 1936-62; children's books. **Sources:** WW47; P&H Samuels, 360; Ivankovitch, 17-49; Falk, *Exh. Record Series.*

PARRISH, Samuel Longstreth [Patron] b.1849, Phila / d.1932, NYC.
Member: Parrish Art Mus., Southampton, NY (founder); Century; Archaeological Inst. Am. **Exhibited:** Award: Italian Govt., Order of the Crown of Italy. **Comments:** He was one of the pioneer golfers in the U.S.

PARRISH, Stephen (Maxfield)
[Etcher, painter] b.1846, Philadelphia, PA / d.1938, Plainfield, NH.
Addresses: Cornish, NH (1893-on). **Studied:** Th. P. Otter in Phila.; etching, privately with Peter Moran, 1879; Stephen J. Ferris and later, J. Pennell. **Member:** Royal Soc. Painter-Etchers, London, 1881; NY Etching Club; Phila. Sketch Club, 1879; Phila. SE; The Cornish (NH) Colony. **Exhibited:** PAFA Ann., 1876-97, 1905; NAD, 1879-96 (10 annuals); Louisville Indust. Expo, 1877, 1879; BMFA, 1880; Phila. Soc. Artists, 1881; Royal Soc. Painter-Etchers, London, 1881; Royal Canadian Acad. Arts, Montreal, 1882; Providence AC, 1882; SC, 1883; Boston AC, 1881-96; Brooklyn AA, 1882, 1891; NY Etching Club; Paris Salon, 1885-86; Portland Indust. Expo., 1892; World's Columbian Expo, Chicago, 1893 (15 etchings); Macbeth Gal., NYC (solo, 26 oils); AIC,1889-90; Albright-Knox AG, Buffalo, 1916; S. Indp. A., 1917, 1924; Saint-Gaudens Mus., Cornish, NH, 1965, 1970; Smithsonian Inst., 1974-77 (traveling exh. of 56 works to 11 museums); NY State Gallery Assn., 1977-78 (traveling exh. to 12 galleries); Vose Gal., Boston, 1982 (retrospective); Parrish AM, 1984 ("Painter-Etchers" exh.). **Work:** NMAA; Freer Gal.; Toledo Mus. Art; CI; Baltimore MA; Smithsonian. **Comments:** During the 1880s, he was one of the leading etchers in America. In 1867 he was in Paris, but as a coal merchant. By 1869 he owned a stationery store in Phila., which he sold in 1877. He then committed himself to painting. Around 1890, after the peak of Etching Revival, he returned to painting landscapes on Cape Cod and Cape Ann, and also traveled to Nova Scotia and New Brunswick. He stopped painting in the mid 1920s due to a stroke. He was the brother of Anne L. Parrish (see entry) and father of Maxfield Parrish (see entry). Illustr.: etching, in *Portfolio* magazine, 1885. **Sources:** WW38; exh. cat., Vose Gal., Boston (1982); *American Painter-Etcher Movement* 41; Fink, *Am. Art at the 19th C. Paris Salons*, 378; Falk, *Exh. Record Series.*

PARRISH, Thomas C. [Landscape painter, portrait painter, illustrator, etcher, teacher] b.1837, Philadelhia, PA / d.1899, Colorado Springs.
Addresses: Colorado Springs, CO (since 1870s). **Studied:** drawing in Philadelphia; etching with his brother, Stephen Parrish; PAFA, before 1880. **Exhibited:** PAFA Ann., 1893. **Comments:** Moved to Colorado Springs in 1871; returned to Philadelphia before 1880, after his first wife's death. He married painter Anne Lodge Willcox (see Anne Lodge Willcox Parrish) and returned to Colorado Springs about 1880, where they conducted an art studio. He was associated with Count Pourtales. Illustr.: "Legends & Myths of Pike's Peak Region." Specialty: watercolor. **Sources:** P&H Samuels, 360-61; Falk, *Exh. Record Series.*

PARRISH, Williamina [Painter] early 20th c.
Addresses: St. Louis, MO. **Member:** St. Louis AG. **Sources:** WW25.

PARROT, August [Painter] early 20th c.
Addresses: Jamaica, LI, NY, 1929. **Exhibited:** Salons of Am., 1924; S. Indp. A., 1929. **Sources:** Marlor, *Salons of Am.*

PARROT, William Samuel See: **PARROTT, William Samuel**

PARROTT, Allen [Museum curator] mid 20th c.
Addresses: Santa Fe, NM. **Comments:** Position: cur., Mus. Int. Folk Art. **Sources:** WW59.

PARROTT, William Samuel *[Landscape painter] b.1844, Missouri / d.1915, Goldendale, WA.*
Addresses: Portland, OR; Oakland, CA. **Comments:** Sketching already as a child, he had his first studio in Portland from 1867-c.1887. He left to spend several years in the wilds of Oregon, Washington and California, opening a studio in Oakland, CA, in 1906. After six years he returned to Oregon, and enjoyed international acclaim for his paintings of the Pacific Coast before his death. **Sources:** Hughes, *Artists of California,* 423; P&H Samuels, 361; Trip and Cook, *Washington State Art and Artists,* 1850-1950.

PARSE, Josephine L. *[Painter] b.1896, Seattle, WA / d.1987, Tacoma, WA.*
Studied: Wash.; Calif. **Member:** Tacoma Art Lg. **Comments:** Also appears as Buhr. **Sources:** Trip and Cook, *Washington State Art and Artists.*

PARSELL, Abraham *[Miniaturist] b.c.1792, New Jersey.*
Addresses: NYC, active 1820-56. **Comments:** Presumably the father of John H. Parsell (see entry), who shared the same address as Abraham (directory listings of 1844-48). **Sources:** G&W; 7 Census (1850), N.Y., XLVI, 644; NYCD 1820-56.

PARSELL, Florence (Abbey) *[Painter, illustrator, teacher] b.1892, Angola, IN.*
Addresses: Angola, IN. **Studied:** AIC. **Member:** Indiana AA. **Sources:** WW25.

PARSELL, John H. *[Miniaturist] mid 19th c.*
Addresses: NYC, active 1844-48. **Comments:** Living at the same address as Abraham Parsell, 1844-48. **Sources:** G&W; NYBD 1844, 1846; CD 1847-48.

PARSHALL, De Witt *[Landscape painter] b.1864, Buffalo, NY / d.1956, Santa Barbara, CA.*
Addresses: Santa Barbara, CA. **Studied:** Hobart College (B.S., 1885); Royal Acad., Dresden, Germany; Acad. Julian, Paris, 1887-88; Cormon & A. Harrison in Paris, 1886-92. **Member:** ANA, 1910; NA, 1917; Allied AA; SMPF West; Int. Soc. AL; Lotos Club; Century Assn.; NAC MacD. Club; Calif. Art Club; Painters of the West. **Exhibited:** World's Columbian Expo, Chicago, 1893; Boston AC, 1896, 1904; NAD, 1897, 1899; Corcoran Gal. biennials, 1908-37 (5 times); AIC, 1910-16; PAFA Ann., 1911-16 (4 times); Pan-Pacific Expo, 1915; LACMA, 1921; Painters of the West, Paris Salon, 1890, 1893, 1928 (gold); All-Calif. Exh., 1934 (prize); GGE, 1939. **Work:** MMA; TMA; Seattle AM; San Diego MFA; Syracuse Mus.; WMA; Detroit Inst. Art; Hackley Gal., Muskegon, MI; FA Gal., San Diego; Los Angeles Mus. History, Sciences & Art. **Comments:** Parshall had a studio in NYC in 1899, and became known for his Grand Canyon scenes. **Sources:** WW47; Hughes, *Artists of California,* 423; P&H Samuels, 361; Fink, *Am. Art at the 19th C. Paris Salons,* 378; Falk, *Exh. Record Series.*

PARSHALL, Douglas Ewell *[Painter, muralist, teacher] b.1899, NYC.*
Addresses: Santa Barbara, CA. **Studied:** ASL; Santa Barbara Sch. Arts; his father De Witt. **Member:** ANA, 1928; NA, 1969; Calif. AC; Calif. Nat. WCS; West Coast WCS; Painters of the West; Soc. Western Artists; Los Angeles AA; Santa Barbara AA. **Exhibited:** AIC, 1918, 1924-25; PAFA Ann., 1918-32 (6 times); LACMA, 1918, 1927; PAFA, 1924-41; NAD, 1924-27 (Hallgarten Prizes); Painters of the West, 1926 (gold); CI, 1924-34; Corcoran Gal. biennials, 1932, 1935; Chicago Inst. World's Fair, 1935; San Diego (CA) Expos, 1935; de Young Mus., 1935; GGE, 1939-40; Crocker Art Gal., Sacramento, 1942; Calif. WCS , 1958 (prize), 1962 (prize), 1964 -65 (purchase awards); Watercolor USA, 1969 (purchase award); Gal. de Silva, Santa Barbara & Challis Gal., Laguna Beach, CA, 1970s. **Work:** Warner Bros. Theatre, Hollywood (mural); Santa Barbara Jr. H.S. (murals); Syracuse Mus. FA; NGA; Reading (PA) Mus.; Kansas City AI; San Diego FA Soc.; de Young Mus., San Fran., CA; Santa Barbara (CA) Mus. Art; Richmond (VA) Mus. FA; Springfield (MO) Art Mus.; Detroit (MI) Mus. **Comments:** Preferred media: oils, watercolors.

Son of De Witt Parshall (see entry). Contrib.: *Am. Artist Magazine.* Positions: tech. illustr., Douglas Aircraft, 1942-44. Teaching: Santa Barbara Art Inst., 1967-70s. **Sources:** WW73; WW47; Falk, *Exh. Record Series.* More recently, see Hughes, *Artists of California,* 424; P&H Samuels, 361.

PARSLOW, Evalyn Ashley *[Painter, writer, teacher] b.1867, Westmorland, NY.*
Addresses: New York; Los Angeles, from 1923. **Member:** Women Painters of West. **Sources:** Petteys, *Dictionary of Women Artists.*

PARSON, George *[Painter] late 19th c.*
Addresses: Wash., DC. **Exhibited:** Wash. WCC, 1898; Omaha Expo, 1898. **Comments:** Could be artist George J. Parson. **Sources:** WW98.

PARSON, George J. *[Painter] b.1877, Japan.*
Addresses: Wash., DC, before 1880, active 1892-1905. **Exhibited:** Soc. Wash. Artists & Wash. WCC, 1892-99. **Comments:** He was born in Japan of American parents. Could be artist George Parson. **Sources:** McMahan, *Artists of Washington, D.C.*

PARSON, Lydia *[Painter] 19th/20th c.*
Addresses: Boston, MA. **Exhibited:** AWCS, 1898. **Sources:** WW01; Petteys, *Dictionary of Women Artists.*

PARSONS *[Wood engraver] mid 19th c.*
Comments: An example of his work appeared in *The Annals of San Francisco* (N.Y., 1855). Possibly Daniel Parsons (see entry). **Sources:** G&W; Hamilton, *Early American Book Illustrators and Wood Engravers,* 238.

PARSONS, A. A. (Mrs.) *[Amateur artist] late 19th c.*
Addresses: Active in Saginaw, MI. **Exhibited:** Michigan State Fair, 1875. **Sources:** Petteys, *Dictionary of Women Artists.*

PARSONS, Alfred *[Landscape painter] b.1830, England / d.1920, Broadway, England.*
Addresses: London, England. **Exhibited:** Boston AC, 1884-85; NAD, 1890; PAFA Ann., 1898-99. **Comments:** Lived for many years in the U.S. **Sources:** Falk, *Exh. Record Series.*

PARSONS, Antoinette de Forrest See: **MERWIN, Antoinette de Forrest Parsons (Mrs.)**

PARSONS, Arthur Jeffrey *[Museum director & curator] b.1856 / d.1915, Dublin, NH.*
Member: Wash. SFA (officer); AFA (dir.). **Comments:** Positions: cur. prints, LOC, 1900-15; dir., CGA.

PARSONS, Audrey Buller See: **BULLER, Audrey (Audrey Buller Parsons)**

PARSONS, Barbara *[Portrait painter] b.1910, New Britain.*
Addresses: New Britain, CT. **Studied:** Yale; New Britain AL; A. Brook; W. Adams; R. Brackman; R. Lahey. **Member:** CAFA; Hartford Soc. Women Painters; Conn. AA. **Exhibited:** New Haven PCC, 1932. **Sources:** WW40.

PARSONS, Betty Bierne *[Painter, sculptor, art dealer] b.1900, NYC / d.1982.*
Addresses: NYC. **Studied:** Renee Praha, NYC; sculptor Bourdelle, in Paris, France; sculpture with Archipenko & Zadkine; summers in Brittany studying watercolor with Arthur Lindsey. **Exhibited:** Gal. de Quatres Chemins, Paris, 1927 (1st solo); Midtown Gal., NYC (many solo shows of her watercolors, beginning 1936); WMAA biennials, 1952-57; PAFA Jury Meeting, 1957; Nat. Council Women of the U.S., 1959; Am. Abstract Artists, 1962; Soc. Four Artists, 1964; "Artists of Suffolk County, Part II: Abstract Tradition," Reckscher Mus., 1970; Montclair Art Mus., 1974 (retro.). **Work:** Montclair (NJ) Art Mus.; NMAA; WMAA. **Comments:** Owner & dir., Betty Parsons Gal., a gallery of seminal importance for the artists of the New York School emerging in the 1940s. When she opened her gallery in 1946 Parsons helped launch the careers of Jackson Pollock, Clyfford

Still, Mark Rothko, Barnett Newman, and other Abstract Expressionists. As a dealer, Parsons was noted for giving her gallery artists a great deal of freedom, allowing them, for example, to hang their own paintings for solo shows. Parsons was herself an artist and during the 1920s, while studying in Paris, associated with Man Ray, Gertrude Stein, Alexander Calder, and Tristan Tzara. On returning to the U.S. in 1933, she taught for several years in Santa Barbara, CA, before settling in NYC in 1936. She exhibited traditional watercolors during that decade and in the 1940s moved into abstraction. Parsons' sculptures are also abstract, and she tended to use natural materials such as driftwood and stone. Teaching: creativity seminar, Sarah Lawrence College, spring 1972. Specialty of her gallery: exclusively contemp. art. Collection: predominantly contemp. art. **Sources:** WW73; Rubinstein, *American Women Artists*, 276-78; E. Glazebrook, "One of the Early Birds," *The Times* (London), Dec. 16, 1968; N. Gosline, "Not a Time to Worship," *The Observer Rev.*, Nov. 24, 1968, Dora Z. Meilach, *Creating Art from Anything* (1968).

PARSONS, Charles H. *[Lithographer, marine and landscape painter in watercolors] b.1821, Rowland's Castle, Hampshire, England / d.1910, Brooklyn, NY.*
Addresses: Active in NYC, resided in Brooklyn, NY; then Montclair, NJ. **Studied:** NAD; apprenticed to George Endicott in 1833. **Member:** ANA, 1862; AWCS. **Exhibited:** NAD, 1851-98; Brooklyn AA, 1861-68, 1881-82; AIC, 1891-92. **Work:** Mystic Seaport Mus.; Peabody Mus., Salem; MIT. **Comments:** Brought to America at the age of nine; grew up in NYC. In 1835 he was apprenticed to the lithographer, George Endicott, where he mastered the medium. During 1854-62, he produced most of Endicott's marine lithos, as well as thirty for Currier & Ives. In 1863, he became the head art director for *Harper's,* and he held that position until his retirement in 1889. At *Harper's,* he assembled one of the most talented teams of illustrators in publishing history, including Winslow Homer, E. A. Abbey, C.S. Reinhart, H. Pyle; M.J. Burns, and many others. While at *Harper's,* he continued to do occasional work for Currier & Ives and for Endicott, was an accomplished painter, and an early champion of watercolor. **Sources:** G&W; Peters, *Currier & Ives,* 130-32; Peters, *America on Stone;* CAB; Clement and Hutton; Alden, "Charles Parsons;" Cowdrey, NAD; Naylor, NAD; Cowdrey, AA & AAU. Reps, 196 (pl.3,77). WW10.

PARSONS, Charles Richard *[Lithographer, painter] b.1844, Brooklyn, NY / d.1918, St. Ives, Cornwall, England (traveling).*
Studied: his father, Charles. **Exhibited:** NAD, 1863; Brooklyn AA, 1864, 1882-83; Boston AC, 1880, 1891. **Work:** Mystic Seaport; LOC; Franklin Delano Roosevelt Mus. **Comments:** He worked at Endicott & Co., and at Currier & Ives at the same time as his father, up to about 1885. Death date may be 1920. **Sources:** Brewington, 293.

PARSONS, Claude P. *[Painter, lecturer] b.1895, New York, NY.*
Addresses: Los Angeles 29, CA. **Studied:** Will Foster; William J. Harrison; Sam Hyde Harris. **Member:** P&S Los Angeles; Artists of the Southwest; Valley Art Gld.; Laguna Beach AA. **Exhibited:** Awards: prizes, P&S Club, Greek Theatre, Los Angeles, 1951, 1953, 1955; Artists of the Southwest, 1951-52, 1954; Valley Art Gld., 1953; Laguna Beach AA; Friday Morning Club, 1951, 1953. **Work:** Friday Morning Club; Calif. Bank, Hollywood. **Comments:** Lectures: "Color in Oil Painting;" "Painting in Europe;" "Art Appreciation," etc. **Sources:** WW59.

PARSONS, Daniel *[Engraver] mid 19th c.*
Addresses: NYC, active 1851. **Comments:** Probably the same as Mr. Parsons, 21, listed as an English-born engraver in NYC in the 1850 census of NYC. *Cf.* -- Parsons, engraver for *The Annals of San Francisco* (N.Y., 1855). **Sources:** G&W; NYCD 1851; 7 Census (1850), N.Y., XLI, 422.

PARSONS, David *[Listed as "artist"] mid 19th c.*
Addresses: NYC, active 1854. **Sources:** G&W; NYCD 1854.

PARSONS, David F. *[Painter] mid 20th c.*
Addresses: Chicago area. **Exhibited:** AIC, 1936. **Sources:** Falk, AIC.

PARSONS, David Goode *[Sculptor, teacher, painter, illustrator, lecturer] b.1911, Gary, IN.*
Addresses: Stoughton, WI. **Studied:** AIC; Univ. Wisc. **Member:** Hoosier Salon; Wisc. P&S; Wisc. Art Fed. **Exhibited:** Wisc. P&S, 1933, 1936-40, 1941 (prize); Wisc. Salon, 1934-41, 1938 (prize), 1943, 1944 (prize), 1945 (prize); AIC, 1935-46; VMFA, 1943 (prize); PAFA Ann., 1946, 1950. **Sources:** WW47; Falk, *Exh. Record Series.*

PARSONS, E. Gilman *[Sculptor] early 20th c.*
Addresses: NYC. **Exhibited:** PAFA Ann., 1935-36. **Sources:** Falk, *Exh. Record Series.*

PARSONS, Edith Barretto Stevens (Mrs.) *[Sculptor] b.1878, Houston, VA / d.1956.*
Addresses: NYC. **Studied:** ASL with Twachtman, French & Barnard, 1901-02 (won scholarships and sculp. prize). **Member:** NSS; NAWA, 1919. **Exhibited:** figures for the Liberal Arts Bldg., St. Louis Expo, 1904; NAD, 1908-33 (13 annuals); Arch. Lg., NYC; NSS; PAFA Ann., 1911-34 (16 annuals); "Duck Baby," Pan-Pacific Expo, San Francisco, 1915; AIC, 1916-24 (6 annuals); CPLH, 1929. **Work:** fountain, Memphis (TN) Pub. Park; "Frog Baby" fountain, Brookgreen Gardens, SC; "Turtle Baby," Cleveland Mus.; "Bird Baby," Brooks Mem. Art Gal., Memphis, TN; Library Arts Bldg., St. Louis, MO; mon., St. Paul, MO; MMA; WWI mem., Summit, NJ. **Comments:** (Mrs. Howard Crosby Parsons). Parsons specialized in sculptures of babies, usually featured in fountains. Parsons also produced busts and memorials. **Sources:** WW47; *Art by American Women:.the Collection of L. and A. Sellars,* 142; Petteys, *Dictionary of Women Artists;* Rubinstein, *American Women Sculptors,* 161-62; Falk, *Exh. Record Series.*

PARSONS, Edward Roy *[Painter] early 20th c.*
Addresses: Columbus, OH. **Member:** Columbus PPC. **Sources:** WW25.

PARSONS, Ernestine *[Painter, teacher, lecturer] b.1884, Booneville, MO / d.1967, Colorado Springs, CO.*
Addresses: Colorado Springs, CO. **Studied:** Colorado College (A.B.); Columbia Univ. (A.M.); Broadmoor Art Acad.; ASL; Colorado Springs FA Center; Randall Davey; Paul Burlin. **Member:** Colorado Springs Art Gld.; Colorado Springs FAC; AEA (vice-pres., Colorado Springs Chapt.). **Exhibited:** Broadmoor Art Acad., 1927 (prize); Albright Art Gal., 1927, 1930; Carnegie Inst., 1928; Denver Art Mus., 1933, 1942, 1951; S. Indp. A., 1934-35; Colorado State Fair, 1945 (prize); Pueblo, CO, 1953, 1962-64; Jewish Center, Denver, 1953; Wooster College (solo); Colorado Springs FA Center, 1944, 1945, 1948-64; Central City, CO, 1951, 1952, 1956-58; Ogunquit AC, 1952; Miami, FL, 1951; Canon City, CO, 1956-58; Rocky Ford, CO, 1956, 1958; Antler's Hotel, 1959-61; Colorado Springs FAC, 1952 (solo), 1956 (solo), 1958 (solo); Canon City, CO, 1953; St. Francis Hospital, Colorado Springs, 1954; First Nat. Bank, 1961 & Colorado College, 1961, both Colorado Springs. **Work:** Colorado Springs FAC; Colorado Springs H.S.; Fort Carson. **Comments:** Teaching: H.S., Colorado Springs. **Sources:** WW66; WW47.

PARSONS, Ethel M. See: **PAULLIN, Ethel M. Parsons (Mrs. Telford)**

PARSONS, Frank Alvah *[Educator, lecturer, writer] b.1866, Chesterfield, MA / d.1930, NYC.*
Studied: Wesleyan; Columbia; France; England; Italy. **Member:** Knight of the Legion of Honor, 1927. **Comments:** Position: pres., NY Sch. Fine & Applied Arts, 1905-30 (the old Chase Sch. Art). He developed the school so that by 1927 it numbered 800 students. In 1921 he established a branch in Paris, where, by 1927, pupils were registered from every state in the Union, Canada, and eighteen foreign countries.

PARSONS, George F. *[Painter] b.1844, Appleton, OH.*
Addresses: Youngstown, OH; San Francisco. **Studied:** F. Fehr, P. Nouen, in Munich. **Exhibited:** Omaha Expo, 1898. **Comments:** Nothing is known about him after the earthquake and fire of 1906 in San Francisco. **Sources:** WW04; Hughes, *Artists of California,* 424.

PARSONS, Henry *[Engraver] b.England? / d.1910, Richmond, VA.*
Addresses: Richmond, VA. **Comments:** Position: artist, engraver, Richmond newspapers, for over 25 years. **Sources:** Wright, *Artists in Virgina Before 1900.*

PARSONS, Isabella Hunner *[Designer, painter] b.1903, Baltimore.*
Addresses: Baltimore, MD. **Member:** Munic. Art Soc., Baltimore. **Sources:** WW40.

PARSONS, Ivy *[Painter] mid 20th c.*
Addresses: St. Luis Obispo, CA, 1930s. **Exhibited:** Calif. State Fair, 1937. **Sources:** Hughes, *Artists of California,* 424.

PARSONS, James Herbert *[Painter, engraver, medalist] b.1831 / d.1905, West New Brighton, NY.*
Comments: Worked for Tiffany & Co. for 23 years, and won the Beaconsfield gold medal in 1880. He won medals for his employers at the Paris and Chicago expositions. One of his best works was the marriage certificate of the Duke of Malborough and Miss Consuelo Vanderbilt.

PARSONS, Kitty (Mrs. Richard Recchia) *[Painter, writer] mid 20th c.; b.Stratford, CT.*
Addresses: Rockport, MA. **Studied:** PIA Sch.; Columbia; Boston Univ.; Univ. Chicago; Richard Recchia; life classes, Rockport AA. **Member:** NAWA; Rockport AA (bd. mem., 1927-60; chmn. arts & exhs. & entertainment, 1928-30; chmn. publicity, 1961-62); Copley Soc., Boston; NOAA; Palm Beach AL; Springfield AL; Authors Lg. Am.; North Shore AA; Nat. Lg. Am. Pen Women. **Exhibited:** Rockport AA Ann., 1931-; NAWA, 1931, 1941, 1944, 1960; North Shore AA, 1931-40, 1971; Ogunquit AC, 1935 (hon. men.); CGA, 1941; S. Indp. A., 1942; Portland SA, 1942, 1944; Audubon Artists; Springfield AL; Mint Mus. Art; Alabama WCS; Newport AA, 1944, 1945; Nat. Lg. Am. Pen Women, 1955 & 1956 (prizes); CAFA; J.B. Speed Mem. Mus.; Palm Beach AL; Doll & Richards (solo); Argent Gal. (solo); Bennington Mus. (solo); Whistler House, Lowell, MA (solo); Winchester, MA (solo) AA; Berkshire Mus., Pittsfield, MA, 1942 (solo); two-man show, Bennington (VT) Mus., 1939. **Work:** Syracuse Univ. **Comments:** Preferred medium: watercolors. Publications: ed., *Artists of the Rockport AA,* 1940. **Sources:** WW73; WW47; Beethold, "Kitty Parsons Watercolors Share Sense of Beauty," *Gloucester Times,* April 6, 1965; "If on Some Distant Day," *Prudential Center News* (Jan. 15, 1966); Virginia Bright, "Art, Mutual Respect Bind Talented Recchias Closer," *Boston Sunday Globe,* Aug. 30, 1970; *Artists of the Rockport AA,* (1956).

PARSONS, Laura Starr (Mrs. Fitzgerald) *[Miniature painter, designer] b.1915, Rockford, IL.*
Addresses: Nyack, NY. **Studied:** ASL; Mme. Brancour-Lenique, c.1908, Paris. **Member:** ASL; Young Am. AA. **Exhibited:** Rockland Fnd.; Munic. Gal. NYC, 1938; Georgetown Gal., Wash., DC, 1938, 1939; Young Am. Artists Exhib., R. H. Macy, NY, 1938; WFNY, 1939; ASL, 1939; Hudson River Artists, Nyack, NY, 1939. **Sources:** WW47.

PARSONS, Lelia (or Leila) *[Artist] late 19th c.*
Addresses: Active in Detroit, MI, 1898-99. **Sources:** Petteys, *Dictionary of Women Artists.*

PARSONS, Lloyd Holman *[Painter, designer, architect] b.1893, Montreal, Canada / d.1968, Little Compton, RI.*
Addresses: Little Compton, RI. **Studied:** McGill Univ. (B. Arch); ASL with Kenneth Hayes Miller, B. Robinson. **Member:** Providence Art Club. **Exhibited:** Corcoran Gal. biennial, 1935; AIC; NAD; PAFA Ann., 1935-37, 1943, 1949; CI.; WMAA; Salons of Am.; S. Indp. A. **Work:** WMAA. **Comments:** His wife

was artist Audrey Buller (see entry). **Sources:** WW66; WW47; Falk, *Exh. Record Series.*

PARSONS, Lydia *[Painter] d.1929.*
Addresses: Boston, MA. **Exhibited:** Boston AC, 1897. **Sources:** *The Boston AC.*

PARSONS, Margaret H. *[Painter] mid 20th c.*
Addresses: NYC, active 1900-40. **Member:** NAWA. **Exhibited:** Boston AC, 1900; NAWA, 1935-36. **Sources:** WW40; *The Boston AC.*

PARSONS, Marion Randall *[Painter, writer] b.1878, San Francisco, CA / d.1953, California.*
Addresses: San Fran. **Exhibited:** San Fran. Women Artists, 1942-48. **Award:** Medaille de la Reconnaissance Française. **Work:** Crocker Mus., Sacramento. **Comments:** She joined the Red Cross after her husband's death in 1918, and worked in France for two years. Auth.: *The Daughter of the Dawn,* 1923; *Old California Houses: Portraits and Stories,* 1952. Contrib.: articles to magazines and newspapers. **Sources:** Hughes, *Artists of California,* 424.

PARSONS, Mary Elizabeth *[Painter] b.1859, Chicago, IL / d.1947, Kentfield, CA.*
Addresses: Kentfield. **Studied:** L.P. Latimer, San Francisco. **Comments:** She was a friend and sketching partner of Alice Chittenden (see entry). Specialty: watercolors. Auth.: *Wild Flowers of California,* 1890s, illustr. by Margaret Warriner. **Sources:** Hughes, *Artists of California,* 424.

PARSONS, Maude B. *[Painter] early 20th c.*
Addresses: Seattle, WA. **Sources:** WW21.

PARSONS, Orrin Sheldon *[Portrait & landscape painter, museum director] b.1866, NYC (or Rochester) / d.1943, Santa Fe, NM.*
Addresses: Bronxville, NY; active in Santa Fe since 1913. **Studied:** NAD with W.M. Chase, Will Low & Edgar Ward. **Exhibited:** NAD, 1883-97 (6 annuals); PAFA Ann., 1892, 1899, 1901, 1915-18; AIC,1895, 1898, 1912; Corcoran Gal., 1907, 1919. **Work:** Mus. New Mexico; Univ. New Mexico. **Comments:** Parsons was a successful NYC portrait painter, 1895-12. Following his wife's death he painted impressionist landscapes in Santa Fe and was the first director of Mus. of New Mexico, 1918. **Sources:** WW40; P&H Samuels, 362; Falk, *Exh. Record Series.*

PARSONS, Phillip N. *[Painter] early 20th c.*
Addresses: Chicago, IL. **Studied:** ASL. **Member:** S. Indp. A. **Exhibited:** S. Indp. A., 1920-21. **Sources:** WW25.

PARSONS, S. F. (Mrs.) *[Miniature painter] early 20th c.*
Exhibited: Veerhoff Gal., Wash., DC, 1905. **Sources:** McMahan, *Artists of Washington, D.C.*

PARSONS, Theophilus *[Painter, writer] b.1876, NYC.*
Addresses: Wash., DC, active 1921-28; Paris, France, 1930s; Nonquit, MA. **Studied:** J. Carlson. **Member:** Soc. Wash. Artists; Wash. AC; Cosmos Club, 1943-52. **Exhibited:** Soc. Wash. Artists; Wash. AC (solo). **Sources:** WW33; McMahan, *Artists of Washington, D.C.*

PARSONS, Virginia *[Sculptor, painter] mid 20th c.*
Addresses: Los Angeles, CA. **Studied:** Chouinard Art Sch. **Exhibited:** Calif. WCS, 1933-34; Los Angeles County Fair, Pomona, 1935. **Comments:** Specialty: watercolors. **Sources:** Hughes, *Artists of California,* 424.

PARSONS, Walter Edward *[Painter] b.1890, Troy, PA / d.1962, Provincetown, MA?.*
Addresses: Provincetown, MA; Wellfleet, MA. **Studied:** Yale Univ.; CI.; NAD; ASL; Charles Hawthorne; Hans Hofmann; Jerry Farnsworth; Olinsky; Vytlacil; Schule für Bildende Kunst, Munich. **Member:** SC. **Exhibited:** S. Indp. A., 1932, 1934-35; PAFA Ann., 1934; SC, 1955; Provincetown AA, 1945-46, 1953-55; VMFA, 1946; Cape Cod AA, 1953-55. **Sources:** WW59; WW47; Falk, *Exh. Record Series.*

PARTCH, Virgil Franklin II
[Cartoonist, illustrator] b.1916, St. Paul Island, AK.
Addresses: Corona Del Mar, CA. **Studied:** Chouinard Art Inst., Los Angeles. **Exhibited:** Awards: first prize, Brussels Cartoon Exh., 1964. **Comments:** Positions: illustr., syndicated comic strip & daily panel, "Big George." Publications: auth., *It's Hot in Here;* auth./illustr., *Hanging Way Over;* auth./illustr., *VIP Tosses a Party,* S&S, 1959; auth./illustr., *New Faces on the Bar Room Floor,* 1961; contrib., cartoons, *Look & True.* **Sources:** WW73.

PARTEE, McCullough *[Sculptor, illustrator, teacher, designer, painter] b.1900, Nashville, TN.*
Addresses: Nashville, TN. **Studied:** Chicago Acad. FA; AIC; ASL; NAD; Grand Central Sch. Art; Hawthorne; Dunn; Carter; Reynolds; Bridgman. **Member:** Nat. Soc. Art Dir. **Exhibited:** Tenn. Art Exh., 1929 (prize). **Work:** port. plaques, Tenn. Agricultural Hall of Fame, Nashville, Greenville & Univ. Tennessee. **Comments:** Position: art dir., *Farm & Ranch and Southern Agriculturalist,* 1935-, Nashville, TN. Illustr. national magazines. **Sources:** WW59; WW47.

PARTIKEL, Alfred *[Painter] mid 20th c.*
Exhibited: AIC, 1937. **Sources:** Falk, *AIC.*

PARTIN, Robert (E.) *[Painter, educator] b.1927, Los Angeles, CA.*
Addresses: Fullerton, CA. **Studied:** Univ. Calif., Los Angeles, with Clinton Adarns, Gordon Nunes, S. Macdonald-Wright & BAP, 1950; Yale-Norfolk Art School, fellowship & study with Conrad Marea-Relli, 1955; Columbia Univ. with Andre Racz, John Heliker, Meyer Shapiro, Paul Tillich & MFA, 1956; Tamarind Lithography Workshop, Herron Art Sch., fellowship & study with Garo Antreasion, 1963. **Exhibited:** WMAA, 1963; 84th Ann. San Fran. Art Inst., SFMA, 1965; Calif. South 7, FA Gal. San Diego, 1969; San Fran. AA Centennial Exh., de Young Mus., 1971; Viewpoints 5, Dana AC, Colgate Univ., Hamilton, 1971. Awards: WMAA, 1963 (Ford Found. purchase prize); NC Mus. Art Ann., 1964 & 1965 (purchase prizes); Viewpoint 5, Colgate Univ., 1971 (purchase prize); Orlando Gal., Encino, CA, 1970s. **Work:** Solomon R. Guggenheim Mus. Art, NYC; NC Mus. Art, Raleigh; Picker Art Gal., Dana AC, Colgate Univ., Hamilton, NY; Jonson Gal., Univ. New Mexico, Albuquerque; Weatherspoon Art Gal., Univ. NC, Greensboro. **Comments:** Preferred media: oils, acrylics. Teaching: Univ. NC, Greensboro, 1957-66; Univ. New Mexico, 1963-64; Calif. State Univ., Fullerton, 1966-. **Sources:** WW73; Mortimer Gulney, "The Art of Robert Partin," Vol. 1 (1963), *Analects* (Univ. NC Press); Van Deren Coke, Robert Partin, *The Painter & the Photograph* (1965); William Wilson, "Review of Solo Show at Orlando Gallery, Encino, CA," *Art Walk* (Nov. 1971).

PARTINGTON, Gertrude See: **ALBRIGHT, Gertrude Partington**

PARTINGTON, John Herbert Evelyn *[Portrait painter] b.1844, Manchester, England / d.1899, East Oakland, CA.*
Addresses: Oakland, CA. **Studied:** England. **Exhibited:** Calif. Midwinter Int. Expo, 1894 (gold med); Mark Hopkins Inst., 1897; PPE, 1915. **Work:** de Young Mus.; Soc. Calif. Pioneers. **Comments:** Father of Gertrude Partington Albright and Richard Partington (see entries). The schooling of his children rested with him, since the family moved often. In 1891, he and Richard established the Partington Art School in San Francisco, where he taught until his death. **Sources:** Hughes, *Artists of California,* 424.

PARTINGTON, Richard Langtry *[Portrait and landscape painter] b.1868, Stockport, England / d.1919, Philadelphia, PA.*
Addresses: San Fran., CA; Phila. **Studied:** his father, J. H. Partington; Beaux-Arts Inst., Antwerp; Sir H. Herkimer, London. **Member:** San Fran. AA; Bohemian Club; Athenian-Nile Club, Oakland; Phila. Alliance. **Exhibited:** Calif. Midwinter Int. Expo, 1894; PAFA Ann., 1919. **Work:** Oakland Mus. **Comments:** Immigrated to California with his family in 1889 and in 1891 established the Partington Art School in San Francisco, together

with his father John H. Partington (see entry). He worked as a sketch artist for the San Francisco *Examiner,* and was curator for the Piedmont Art Gallery, Oakland. In 1916 a portrait commission took him to Philadelphia, where he remained for the rest of his life. **Sources:** WW27; Hughes, *Artists of California,* 424-425, who cites a death date of 1929; Falk, *Exh. Record Series.*

PARTON, Arthur *[Landscape painter] b.1842, Hudson, NY / d.1914.* *Arthur Parton N.A*
Addresses: Yonkers, NY. **Studied:** W.T. Richards in Phila.; PAFA. **Member:** ANA, 1871; NA,1884; AWCS; Artists Fund Soc. **Exhibited:** NAD, 1862-1914, 1896 (prize); Corcoran Gal., 1907-08, 1910; Brooklyn AA, 1866-85; Phila. Centennial Expo, 1876; Boston AC, 1882-1909; NYC, 1886 (gold); PAFA Ann., 1889 (Temple gold medal), 1891, 1896-97, 1905; Paris Expo, 1889; St. Louis Expo, 1904 (medal); AIC. **Work:** Brooklyn Inst. Mus.; Indianapolis AA; MMA. **Comments:** Best known for his landscapes of the Adirondack and Catskill mountains, Parton was a well-known figure in the New York art world who exhibited annually at the National Academy for more than half a century. From 1874-93, he kept his studio at the Tenth Street Studio (51 West 10th St.). He had visited Europe in 1869, and was influenced by the Barbizon style, but his work still retained a closer affinity to the second generation of Hudson River School painters. In 1872, his view on the Shenandoah River, VA, was published in Bryant's *Picturesque America.* He was one of the Parton brothers (see entries for Ernest and Henry). **Sources:** WW13; Wright, *Artists in Virgina Before 1900;* exh. cat. Columbia Cnty Hist. Soc. (Kinderhook, NY, 1998); Falk, *Exh. Record Series.*

PARTON, Arthur (Mrs.) See: **TAYLOR, Anna**

PARTON, Ernest *[Landscape painter] b.1845, Hudson, NY / d.1933, NY.*
Addresses: London, England, 1873. **Member:** Artists Fund Soc.; Royal Inst. Painters, London. **Exhibited:** NAD, 1866-97; Royal Acad., 1875, and annually through 1932; Paris Expo, 1889, 1900; Paris Salon, 1892, 1894 ; PAFA Ann., 1905. **Comments:** One of Parton brothers (see entries for Henry and Arthur). **Sources:** WW29; exh. cat. Columbia County Hist. Soc. (Kinderhook, NY, 1998); Fink, *Am. Art at the 19th c. Paris Salons,* 378; Falk, *Exh. Record Series.*

PARTON, Henry Woodbridge *[Landscape & marine painter] b.1858, Hudson, NY / d.1933, NYC.*
Addresses: NYC. **Member:** ANA, 1921; NA, 1929; P&S Gal. Assn.; SC, 1889; Century Assn.; AFA; NAC. **Exhibited:** NAD, 1881-1932; Brooklyn AA, 1882, 1884; Royal Acad., London; S. Indp. A., 1917; PAFA Ann., 1917; NAC, 1921 (purchase prize), 1928 (prize), 1929 (prize); AIC. **Work:** Univ. Nebraska; Reading (PA) Mus. **Comments:** Position: designer of rugs, Yonkers, for many years. One of Parton brothers (see entries for Ernest and Arthur). **Sources:** WW31; exh. cat. Columbia Cnty Hist. Soc. (Kinderhook, NY, 1998); Falk, *Exh. Record Series.*

PARTON, Hulda (Mrs. Daniel Day Walter, Jr.) *[Portrait painter] early 20th c.; b.Hudson, NY.*
Addresses: Yonkers, NY. **Studied:** ASL with K. Cox; Blanche in Paris; Sorolla in Madrid. **Work:** Sherman Mem. Dispensary, Yonkers. **Sources:** WW15.

PARTON, Nike *[Painter, sculptor] b.1922, New York, NY.*
Addresses: Sarasota, FL. **Studied:** Ringling Sch. Art (fine art cert.); sculpture with Lesley Posey; painting with Jay Connaway. **Member:** Florida Artist Group; Sarasota AA; Art Lg. Manatee Co.; Longboat Key AC. **Exhibited:** Southern Vermont AC, 1963 (solo); Westport (CT) Womens Club, 1965 (solo); Tampa Prof. Artist, 1968 (solo); Sarasota AA, 1969 (solo); Longboat AC, 1972 (solo); Ralph Wells, Bradenton, FL, 1970s. Awards: Award for "Thru the Trees" (watercolor), Sarasota AA, 1967; award for "Manatee" (watercolor), DeSoto Comt., 1968; award for "Ducks" (woodcut), Art Lg. Manatee Co., 1970. **Work:** Univ. Florida; Stetson Univ. **Comments:** Preferred medium: watercolors. Teaching: Art Lg. Manatee Co., 1954-62; instr. private studio,

1963-. **Sources:** WW73.

PARTRIDGE, Charlotte Russell *[Educator, lecturer, critic, painter] 20th c.; b.Minneapolis, MN.*
Addresses: Thiensville, WI. **Studied:** Northern Illinois Teachers College; Emma M. Church School Art; AIC; ASL; J. Carlson & abroad. **Member:** Oberlander Fellow, 1936; CAA; AFA; AAMus.; Wisc. P&S; Wisc. Des. Craftsmen; Western AA; EAA; Wisc. Soc. Applied Art. **Exhibited:** Awards: Oberlander Fellowship, 1936; Carnegie Grant, 1940. **Comments:** Teaching: Milwaukee-Downer College, 1914-22; Wisc. dir., FAP, 1935-39; Layton Sch. Art, 1920-54, dir., Layton Art Gal., Milwaukee, WI, 1921-50s. Lectures: Art in Contemporary Life; Enjoyment of Modern Art; How to Look at Paintings; Art Education. **Sources:** WW59; WW47.

PARTRIDGE, Esther E. (Mrs. Frank) *[Painter] b.1875, Union City, PA.*
Addresses: Spokane, WA. **Studied:** AIC; San Francisco; S.S. Nicolini; Art Center Sch., Los Angeles. **Member:** Spokane AA. **Exhibited:** Eastern Wash. Fair, 1921; Graham's, Spokane, 1928 (solo); Spokane Mus. Art. **Sources:** Trip and Cook, *Washington State Art and Artists, 1850-1950.*

PARTRIDGE, George Roy See: **PARTRIDGE, Roi**

PARTRIDGE, Imogene *[Painter] early 20th c.*
Addresses: Seattle, WA. **Member:** Seattle FAS. **Sources:** WW19.

PARTRIDGE, Joseph *[Miniaturist, marine painter] b.1792, England.*
Work: Mariners Mus., Newport News, VA. **Comments:** He was at Halifax, Nova Scotia, from 1819 -22; in Providence, RI, 1822-24 (where he painted a miniature of the Rev. Stephen Gano of that city); and enlistd in the U.S. Marines in Charletown, MA, 1825, as an anatomical painter. He served in the Mediterranean and made many scene paintings. He was discharged in 1830. **Sources:** G&W; Bolton, *Miniature Painters;* Stauffer, nos. 92 and 2443; Brewington, 293.

PARTRIDGE, Mary Elizabeth (Mrs. Daniel III) *[Painter, designer] b.1910, Ossining, NY.*
Addresses: Wash., DC. **Studied:** Sarah Lawrence; PMG Sch. Art. **Exhibited:** Studio House, 1938 (solo); Jr. Lg. Gal., 1939 (solo); PMG, 1940 (solo); Phila. Art All. (solo); Whyte Gal., Wash., DC (solo). **Work:** PMG. **Sources:** WW47.

PARTRIDGE, Nehemiah *[Itinerant portrait and decorative painter] b.1683, Portsmouth, NH / d.1737.*
Addresses: Active in Boston; NYC; Albany, NY; Virginia; possibly Rhode Island. **Work:** Albany Inst. Hist. & Art; Virginia Mus. FA, Richmond. **Comments:** Son of Mary Brown and Col. William Partridge, who later became lieutenant governor of New Hampshire (1696-1703). Nehemiah Partridge advertised in Boston in 1713 as a japanner and paint seller, and in 1715 as proprietor of "The Italian Matchean, or moving Picture." Partridge was admitted a freeman of NYC on April 22, 1718 and advertised as a limner in NYC, 1717-18. No portraits survive from either Boston or NYC but a body of work from subsequent years has emerged, however. Several discoveries by Mary Black led to Partridges' identification as the portraitist formerly known as the "Aetatis Suae Limner" (see entry) because of the unique inscription on each surviving portrait. He was also known as the "Schuyler Painter" because he had painted a number of members of the Schuyler family in Albany, NY. Partridge is believed to have been active in in Albany from c.1718 to sometime in 1721 and again in 1724 or 1725. He made about 50 portraits, many of which were of prominent citizens, including three future mayors and Colonel Pieter Schuyler (Albany Inst.). There are also additional attributions that would have him working in Jamestown (VA), 1722-23 (portraits of members of the Jaquelin and Brodnax families), and perhaps in Newport (RI). Partridge married Mary Halsey (daughter of Boston mathematician James Halsey) before 1732; he was dead by 1737, when his mother's will made reference to the chil-

dren of her "late son Nehemiah." **Sources:** G&W; Dow, *Arts and Crafts in New England,* 302; NYHS *Collections,* XLII, 122; Kelby, *Notes on American Artists,* 1; Flexner, *First Flowers,* 66; Barker, *American Painting,* 73. More recently, see Mary Black, "Contributions Toward a History of Early Eighteenth-Century New York Portraiture: The Identification of the Aetatis Suae and Wendell Limners," *American Art Journal* vol.12, no. 4 (Autumn 1980): 4-31; Saunders and Miles, 92-93, repro.; Craven, *Colonial American Portraiture,* 199-200; Gerdts, *Art Across America,* vol. 1, 172-73 and vol. 2, 11-12.

PARTRIDGE, Roi *[Etcher, educator, illustrator] b.1888, Centralia, WA Territory / d.1984, Walnut Creek, CA.*
Addresses: Oakland, CA. **Studied:** NAD; etching with Brockhoff in Munich, 1910-14. **Member:** ANA; SAE; Chicago SE; Am. Assn. Univ. Prof.; Calif. SE. **Exhibited:** Société des Artistes Françaises, Société Nat. des Beaux-Arts, both in France; Honolulu Acad. Art; CI; de Young Mus.; Smithonian Inst.; Toronto Art Gal.; MoMA; Alaska-Yukon-Pacific Expo, Seattle, 1909 (medals); NAD, 1910 (medal); PPE, 1915 (44 etchings); AIC, 1921 (medal); Brooklyn, 1921 (prize); San Fran., 1921 (prize); Los Angeles, 1922 (prize), 1925 (prize), 1929 (gold); Calif. Soc. PM, 1929 (gold medal); LOC, 1943 (prize); New York, 1947 (prize). **Work:** LOC; Calif. State Lib.; WMA; NYPL; Walker Art Gal.; Liverpool, England; Toronto Art Gal.; de Young Mem. Mus.; SFMA; AIC; MoMA; Los Angeles Mus. Art.; Honolulu Acad. Art; San Diego FA Soc.; Wells College, NY; BM; CI; NGA; Newark Pub. Lib.; TMA; Calif. State Lib., Sacramento; Milwaukee Art Gal.; Omaha AI; Haggin Mem. Mus., Stockton, CA; Crocker Art Gal., Sacramento; Nat. Coll. FA, Wash., DC; Mills College; Seattle Pub. Lib.; Univ. Nebraska; UCLA; Univ. Wash.; Scripps College; Prints of the Year, 1924-28, 1930-34; Hackley Art Gal., Muskegon, MI; Springfield (MA) Mus. Art. **Comments:** A master landscape etcher, he produced more than 200 etchings, being the subjects of his extensive travels throughout the Northwest, California, and the desert Southwest. He was the husband of photographer Imogen Cunningham. Illustr. of several books, including: *Creative Art; English Studio; Art and Archaeology; Prints;* and *Aesthetic Judgement.* Teaching: Mills College, Oakland, CA, 1920-54. **Sources:** WW59; WW47; Hughes, *Artists of California,* 425; catalogue raisonné of prints, Anthony R. White (Los Angeles, 1988).

PARTRIDGE, Sara *[Artist] late 19th c.*
Addresses: Active in Flushing, MI, 1887-89. **Sources:** Petteys, *Dictionary of Women Artists.*

PARTRIDGE, W(illiam) H. *[Painter] b.1858, Wheeling, WV.*
Addresses: Wellesley Hills, MA. **Studied:** Mass. Sch. Art; BMFA School. **Member:** Boston AC; Springfield AI; Gloucester SA; Business Men's AC of Boston. **Exhibited:** Boston AC, 1874. **Work:** lib., Wellesley, MA. **Sources:** WW40; *The Boston AC.*

PARTRIDGE, William Ordway *[Sculptor, writer, teacher] b.1861, Paris / d.1930.*
Addresses: NYC. **Studied:** Columbia Univ., NYC; Paris, Florence, Rome, 1882-?; he was a friend of Rodin, Bouguereau. **Member:** Arch. Lg.; Lotos Club; Royal SA, London; Cosmos Club, Washington, DC; AIA; SC, 1898; NSS. **Exhibited:** Boston AC, 1887, 1894; World's Columbian Expo. Chicago, 1893; NAD, 1899; PAFA Ann., 1899, 1907. **Work:** NHYS; marble "Peace Head," MMA; CGA; bust of Theodore Roosevelt, Republican Club. "Gen. Grant," Union Lg. Club, Brooklyn; "Pieta," St. Patrick's Cathedral, NYC; font, Cathedral of St. Peter and St. Paul, Washington, DC. Outdoor statues, "Alexander Hamilton" (Brooklyn); "Shakespeare" (Lincoln Park, Chicago); "Pocahontas" (Jamestown, VA); "Nathan Hale" (St. Paul, MN); "S. J. Tilden" (Riverside Drive, NYC); Schermerhorn Mem., Columbia Univ. (NYC); "Pocahontas"(Jamestown, VA). **Comments:** Sculptor of portrait memorials and busts. After studying in Europe, Partridge established a studio in Milton, MA, later moving to NYC. He first gained attention at the World's Columbian Expo. for his busts of Edward Everett Hale and James Russell Lowell, and his models for "Shakespeare" and "Alexander

Hamilton." These were praised for their naturalness and vitality. By the turn of the century he was working in a more spontaneous, impressionistic style, perhaps a result of his friendship with Rodin. About this time he made a series of busts of English authors, including Tennyson, Keats, Scott, Shelley, Milton, and others, in which the face was realistically modeled but the hair and clothing left in a rougher, unfinished state. Partridge also produced decorative pieces and religious subjects. He was also a poet, an actor, and a critic. **Auth.:** *Art for America; The Song of Life of a Sculptor; The Technique of Sculpture."* **Teaching:** Concord Sch. Philosophy; Stanford Univ.; George Washington Univ. **Sources:** WW29; Craven, *Sculpture in America,* 497-98; Falk, *Exh. Record Series.*

PARWIAN *[Painter] early 20th c.*
Exhibited: S. Indp. A., 1934. **Sources:** Marlor, *Soc. Indp. Artists.*

PASAVANT, Frederick Joseph *[Painter, illustrator] b.1887, Brandon, VT / d.1919.*
Addresses: NYC. **Studied:** ASL. **Member:** SI; Dutch Treat Club.

PASCAL, David *[Painter, cartoonist] b.1918, NYC.*
Addresses: Bethel, CT; NYC. **Studied:** Am Artists Sch. **Member:** Nat. Cartoonists Soc. (foreign affairs secy., 1964-); Mag. Cartoonists Guild; Int. Comics Org. (USA rep., 1970-). **Exhibited:** MMA, Cartoon Exh., 1951; Grand Central Art Gal.; CGA; Mus. Decorative Arts, Paris, France, 1967; Mus. Arte, São Paulo, Brazil, 1970; Lib. le Kiosque, Paris, 1965 (solo); Graham Gal., NYC, 1970s. **Awards:** United Seamen's Service, 1943, 1944; Dattero d'oro, Salone Internazionale dell Umorismo, Italy, 1963; award for illustr. excellence, 1969 & silver T-square, 1972, Nat. Cartoonists Soc. **Comments:** Preferred medium: inks. Teaching: Sch. Visual Arts, NYC. Toured Far East military installations, under the auspices of U.S. Army, 1958; int. rep., Newspaper Comics Council, New York, 1969-; U.S. rep. of *Phenix,* France, *Comics,* Italy & *RanTanPlan,* Belgium, 1970-. Publications: illustr., *The Art of Inferior Decorating, 1963;* illustr., *Best Cartoons of 1947-58; The Sale Begins When the Customer Says No,* 1953; *Fifteen Fables of Krylov,* 1965; auth./illustr., *The Silly Knight,* 1967; auth., *Comics: an American Expressionism,* Mus. Arts, Brazil, 1970; ed., *Graphis,* 1972. Contrib. of cartoons: *Punch; Saturday Evening Post; Sports Illustrated; New Yorker* and other national magazines. **Sources:** WW73.

PASCAL, Jeanne B. *[Painter] b.1891, France.*
Addresses: Wash., DC, 1898-1914. **Studied:** Corcoran Sch. Art. **Comments:** As a child, she watched her father, artist Paul Pascal, paint. When he died in 1905, she was placed in an orphan asylum. She pursued an interest in painting, persuading E.C. Messer to allow her to study at the Corcoran School of Art. She specialized, as her father had, in watercolors of orientalist scenes, some of which are almost indistinguishable from his. **Sources:** McMahan, *Artists of Washington, D.C.*

PASCAL, Paul B. *[Painter, teacher] b.1840, Toulouse, France / d.1905.*
Addresses: Wash., DC, 1898. **Studied:** École des Beaux Arts, Paris. **Exhibited:** Paris Salon, 1876-1880. **Comments:** Father of artist Jeanne B. Pascal. He offered art instruction in Wash., DC. Following a paralysis of his painting hand and a long illness, he died in poverty in 1905. Specialty: watercolor oriental scenes. **Sources:** McMahan, *Artists of Washington, D.C.*

PASCAL, Theo *[Painter, craftsperson, designer, illustrator] b.1915, Dallas, TX.*
Addresses: NYC. **Studied:** ASL; Howard Trafton. **Exhibited:** Worth Ave. Gal. Art, Palm Beach, 1945 (solo); Carstairs Gal., NY, 1946-47. **Awards:** Scholarship, Drake Univ. Sch. Journalism. **Comments:** Position: home ed., *Charm* magazine, 1946-50; J. Walter Thompson Agency, 1952-57; product merchandising mgr., *Good Housekeeping* magazine, 1958-59; dir., public relations, AFA, NYC, 1958-. Illustr.: *Johnny Groundhog's Shadow,* 1947. Contrib: *McCall's.* **Sources:** WW59.

PASCHKE, Ed *[Painter] late 20th c.*
Addresses: Chicago, IL, 1973-85. **Exhibited:** WMAA, 1973-85. **Sources:** Falk, *WMAA.*

PASCIN, Jules *[Painter] b.1885, Widdin, Bulgaria / d.1930, Paris, France.*

jascin

Addresses: Paris, France. **Studied:** Vienna; Munich. **Member:** Woodstock AA; Penguin Club. **Exhibited:** Armory Show, 1913; WMAA, 1928; PAFA Ann., 1929; Salon d'Automne, c.1908-12; Int. Exh. Modern Art, 1913; Berlin Photographic Co., NYC, 1915; Macbeth Gal., NYC; Salons of Am.; AIC. **Work:** MoMA; PAFA; Detroit IA; Minneapolis IA. **Comments:** His Mexican series of horses and riders is almost the only departure from his favorite theme: women, painted in rhythmic and delicate manner. Born Julius Pincas, he later adopted the name under which all his paintings are known. In 1914 he came to the U.S. to escape military service in France, and spent the next six years traveling FL, LA, NC, SC, TX, and the southwestern U.S. and Cuba. In 1920 he became a U.S. citizen, living in Brooklyn. He returned to Paris permanently, and on the eve of a prestigious solo show committed suicide by slitting his wrists and hanging himself. **Sources:** WW29; *Encyclopaedia of New Orleans Artists,* 292; Falk, *Exh. Record Series;* Woodstock AA; Brown, *The Story of the Armory Show.*

PASCOE, William *[Painter] early 20th c.*
Addresses: Detroit, MI. **Sources:** WW25.

PASCUAL, Nemesio A. *[Painter] b.1908, Jones, Isabelle, PI.*
Addresses: Seattle, WA, 1936-41. **Studied:** Cornish Art Sch., Seattle. **Exhibited:** SAM, 1936, 1937; Western Wash. Fair, 1937. **Sources:** Trip and Cook, *Washington State Art and Artists, 1850-1950.*

PASILIS, Felix *[Painter] b.1922, Batavia, IL.*
Addresses: NYC. **Studied:** Am. Univ., 1946-48, with William H. Calfee; Hans Hofmann Sch., 1949-52. **Exhibited:** Richard Brown Baker Coll., Staten Island, 1959; Yale Univ., 1961; R J. Gal., NYC, 1962 (solo); Greer Gal., New York, 1963 (solo); Great Jones Gal., New York, 1966 (solo). **Awards:** Longview Found. grant; Walter K. Gutman Found. grant. **Work:** Mint Mus., Charlotte, NC; MIT, Cambridge; Texas A&M Univ. **Comments:** Positions: co-founder, Hansa Gal., New York. **Sources:** WW73.

PASKAUKAS, Julius Alexander *[Sculptor] mid 20th c.*
Addresses: Chicago area. **Exhibited:** AIC, 1940, 1942, 1947. **Sources:** Falk, *AIC.*

PASKELL, William Frederick *[Landscape painter, marine painter] b.1866, Boston / d.1951.*
Addresses: Active around Cape Ann and Nantucket, 1930s. **Studied:** Th. Juglaris & F. de Blois in Boston; possibly in Paris as he traveled in Europe. **Exhibited:** Boston AC, 1887-1906. **Comments:** See discussion under T. Bailey. **Sources:** Brewington, 293; *The Boston AC.*

PASQUELLE, Frances M. L. *[Painter] early 20th c.*
Addresses: Glenbrook, CT. **Member:** S. Indp. A. **Exhibited:** S. Indp. A., 1917-19, 1921, 1923. **Sources:** WW25.

PASSAILAIGUE, Mary F. (Mrs. J. M.) *[Painter] mid 20th c.*
Addresses: Columbus, GA. **Studied:** W. Adams. **Exhibited:** Atlanta AG, 1938; Georgia AA, 1938; SSAL, Montgomery, AL, 1938; San Antonio, TX, 1939. **Sources:** WW40.

PASSALACQUA, David *[Illustrator, painter, teacher] b.1936, San Fran., CA.*
Addresses: NYC. **Studied:** Chouinard AI (Disney scholarship); Otis Art Sch.; County AI. **Work:** BMFA; Singer Coll.; Don Padilla Coll.; Celanese Co. **Comments:** Illustr.: paperback book covers, national advertising campaigns, magazines, such as *The Saturday Evening Post,* and many others. Teaching: Parsons Sch. Des., NYC; Pratt Inst.; Syracuse Univ. Lectures at universities and art schools in the U.S. and abroad.

PASSMORE, Deborah Griscom *[Painter] b.1840/50, Pennsylvania / d.1911, Wash., DC.*
Addresses: Phila., PA, 1881; Wash. DC., 1891. **Studied:** Phila., PA; Europe. **Exhibited:** Centennial Expo., Phila., PA, 1876; PAFA Ann., 1881, 1891; Columbian Expo., Chicago, IL, 1893 (award). **Work:** Nat. Agric. Lib., Beltsville, MD; SI; U.S. Nat. Arboretum. **Comments:** Encouraged by W.W. Corcoran, she opened a studio in Wash., DC in 1884. Illustr., U.S. Dept. Agriculture, 1892-1909. **Sources:** McMahan, *Artists of Washington, D.C.;* Falk, *Exh. Record Series.*

PASSUNTINO, Peter Zaccaria *[Painter, sculptor] b.1936, Chicago, IL.*
Addresses: NYC. **Studied:** AIC Schools (scholarships, 1954-58); Oxbow Sch. Painting, summer 1958; Inst. Art Archeologie, Paris, France, 1963; Fulbright fellowship, 1963-64; Guggenheim fellowship, 1971. **Exhibited:** Sherman Gal., Chicago, 1960-61; Zabriskie Gal., NYC, 1962; New Sch. Social Res., New York, 1970; Sonraed Gal., New York, 1971; Gal. B, Paris, 1972; Gal. Marc, Alexandria, VA & Gallery Bienville, New Orleans, LA, 1970s. **Work:** Walter P. Chrysler Mus., Provincetown, MA; Norfolk (VA) Mus. **Comments:** Positions: chmn., Momentum, Chicago, 1957-58. **Sources:** WW73; articles, *Art News* (Jan., 1971), *Artforum* (Feb., 1971), *Arts Magazine* (Jan., 1972) & *Humanism* (1972).

PASTEL, Esta V. *[Painter] early 20th c.*
Addresses: NYC, 1932. **Exhibited:** S. Indp. A., 1932. **Sources:** Marlor, *Soc. Indp. Artists.*

PASTERNACKI, Vetold Henry *[Painter] b.1896, Detroit, MI.*
Addresses: BIoomfield Hills, MI. **Studied:** John P. Wicker Art Sch., Detroit; Acad. Moderne, Paris; Marchand; Dufresne. **Member:** Scarab Club, Detroit. **Exhibited:** Salon d'Automne, Paris, 1929; AIC, 1938; Detroit Inst. Art, 1930-45, 1943 (prize); Detroit, 1932 (prize); Scarab Club, 1932 (prize), 1935 (gold medal); AIC, 1938; Pepsi-Cola, 1946; AFA traveling exh., 1956-58. **Work:** Wayne Univ.; Scarab Club. **Sources:** WW59; WW47.

PASTORIUS, Sallie W. *[Painter] late 19th c.*
Exhibited: PAFA Ann., 1879. **Sources:** Falk, *Exh. Record Series.*

PATAKY, Tibor *[Painter] mid 20th c.*
Addresses: Orlando, FL. **Exhibited:** SSAL, 1938; WFNY, 1939. **Sources:** WW40.

PATALANO, Frank Paul *[Designer, etcher, portrait painter, block printer, lithographer, jeweler] b.1914, Providence.*
Addresses: Providence, RI. **Studied:** RISD. **Comments:** Specialty: gowns and jewelry. **Sources:** WW40.

PATANIA, G. F. B. *[Portrait painter] mid 19th c.*
Addresses: NYC, active 1859-67. **Exhibited:** NAD, 1859, 1867. **Sources:** G&W; Cowdrey, NAD; NYBD 1860.

PATCH, Calista Halsey *[Wood carver] 19th/20th c.*
Member: Des Moines Art Soc. (founder of first art soc. in Des Moines). **Comments:** Catalogued art at Louisiana Purchase Expo, St. Louis, 1904. **Sources:** Petteys, *Dictionary of Women Artists.*

PATCH, Harriet N. *[Artist] early 20th c.*
Addresses: Wash., DC, active 1903. **Sources:** McMahan, *Artists of Washington, D.C.*

PATCH, Samuel, Jr. *[Listed as "artist"] b.c.1820, Massachusetts.*
Addresses: Weathersfield, VT, 1850 (at a hotel). **Sources:** G&W; 7 Census (1850), Vt., XII, 730.

PATE, William *[Engraver] mid 19th c.*
Addresses: NYC. **Comments:** Partner in Neal & Pate (see entry), active NYC in 1844. In 1854 he printed the Gollman-Doney engraving, "Distinguished Americans at a Meeting of The New-York Historical Society." **Sources:** G&W; NYBD 1844; Vail, *Knickerbocker Birthday*, 107.

PATEK, Joseph L. *[Painter] early 20th c.*
Addresses: Chicago, IL. **Exhibited:** AIC, 1912-13. **Sources:** WW15.

PATEMAN, Kim See: **LEVIN, Kim (Kim Pateman)**

PATERNOSTO, Cesar Pedro *[Painter] b.1931, Buenos Aires, Argentina.*
Addresses: NYC. **Studied:** Nat. Univ. La Plata, Sch. FA, 1957-59; Philos., 1961. **Exhibited:** Latin Am. Art Since Independence, Yale Univ., 1965; Third Biennial Am. Art, Cordoba, Argentina, 1966; The 1960s, MoMA, New York, 1967; Second Biennial Coltejer, Medellin, Colombia, 1970; First Biennial Am. Graphic Arts, Cali, Colombia, 1971; Galerie Denise René, NYC & Gal. Denise René, Dusseldorf, West Germany, 1970s. **Awards:** first prize, 3rd Biennial Am. Art, Cordoba, 1966; acquisition award, 15th Exh., Mar Del Plata, Argentina, 1966. **Work:** MoMA; Nat. FA Mus., Buenos Aires; Plastic Arts Mus., La Plata; MoMA, Buenos Aires; Albright-Knox Gal., Buffalo, NY. **Comments:** Preferred medium: acrylic paint on canvas. **Sources:** WW73; Sam Hunter, "The Cordoba Bienal," *Art Am.* (April, 1967); J.R. Mellow, "New York Letter," *Art Int.* (Nov, 1968); K. Kline, "Reviews," *Art News* (Jan., 1970).

PATERSON, Alice *[Painter] mid 20th c.*
Addresses: Daly City, CA. **Exhibited:** San Francisco AA, 1938. **Sources:** Hughes, *Artists of California,* 425.

PATERSON, Grace *[Painter] early 20th c.*
Addresses: Phila., PA. **Studied:** PAFA. **Sources:** WW19.

PATERSON, Hugh G. *[Painter] mid 20th c.*
Addresses: Chicago area. **Exhibited:** AIC, 1948. **Sources:** Falk, AIC.

PATERSON, Margaret *[Painter] early 20th c.*
Addresses: Boston, MA. **Member:** Women P&S. **Sources:** WW15.

PATERSON, Roy E. *[Painter] early 20th c.*
Addresses: Oakland, CA, 1930s. **Exhibited:** Oakland Art Gal., 1934, 1937. **Sources:** Hughes, *Artists of California,* 425.

PATERSON, Zama Vanessa Helder See: **HELDER, Zama Vanessa "Zelma" (Mrs. John S. Paterson)**

PATHY, Mariette *[Painter] mid 20th c.*
Addresses: Phila., PA. **Exhibited:** PAFA Ann., 1968. **Sources:** Falk, *Exh. Record Series.*

PATIGIAN, Haig *[Sculptor] b.1876, Armenia / d.1950, San Francisco, CA.*
Addresses: San Fran. **Studied:** self-taught; Mark Hopkins Inst; criticism from Marquet, in Paris. **Member:** NSS; AIAL; Soc. Sanity in Art; Société des Artistes Françaises; Jury of Awards, Pan-Pacific Expo, San Fran., 1915; Bohemian Club; Press Club, San Fran.; Family Club, San Fran.; NIAL. **Exhibited:** Salon des Artistes Françaises, Paris, 1906-1907; PPE, 1915; CPLH, 1929; SFMA, 1935; Soc. Sanity in Art (prize); GGE, 1939; AIC. **Work:** San Fran. City Hall; Golden Gate Park; McKinley Monument, Arcata, CA; Bohemian Club; CPLH, City Hall, Metropolitan Life Ins. Bldg., San Fran.; White House, Wash., DC; Seattle, WA; Mem. Mus., Civic Center, Olympic Country Club, San Fran.; mon., Fresno, CA; San Fran. Pub. Lib. **Comments:** He immigrated to California with his family at age 15 and worked as a laborer at first. In 1899 he enrolled at the Mark Hopkins Inst., and went on to become one of the most famous sculptors on the West Coast. **Sources:** WW47; Hughes, *Artists of California,* 425.

PATITZ, Martha *[Painter] b.1868, Germany / d.1937.*
Sources: info. courtesy Peter C. Merrill.

PATON, Joshua *[Marine painter] late 19th c.*
Work: Peabody Mus., Salem, MA. **Comments:** Actice c.1877. **Sources:** Brewington, 293.

PATON, William Agnew *[Writer] b.1848, NYC / d.1918, NYC.*
Member: Union Lg. C., NAC; Century Assn.; Nassau Club, Princeton. **Comments:** Auth.: *Down The Islands,* 1887 (illustr. by

M.J. Burns).

PATRI, Giacomo Giuseppe *[Graphic artist, illustrator, teacher] b.1898, Arquata Scrivia, Italy / d.1978, San Francisco, CA.*
Addresses: San Fran. **Studied:** Calif. Sch. FA. **Exhibited:** San Fran. AA, 1935; SFMA, 1937; AIC, 1935; Raymond & Raymond Gals., San Fran., 1940 (solo); San Fran. Arts Festival, 1946-65; Portrero Hill Artist's Show, 1968-78; Diablo Valley College, 1976 (solo); Marin Art and Garden Center, 1949; San Jose Mus., 1980 (solo). **Comments:** Position: illustr. San Francisco newspapers. Teaching: Presidio Hill Sch., 1931-32, Calif. Labor Sch., 1944-48; dir. of his own art school, San Fran., 1948-1966. He was also a champion fencer. **Sources:** Hughes, *Artists of California*, 425.

PATRICK, Dorothea *early 20th c.*
Exhibited: Salons of Am., 1925; S. Indp. A., 1935. **Sources:** Falk, *Exhibition Record Series.*

PATRICK, Genie H *[Painter] b.1938, Fayetteville, AR.*
Addresses: Iowa City, IA. **Studied:** Miss. State College Women, 1956-58; Univ. Georgia (B.F.A.); Univ. Illinois, Urbana-Champaign, 1960-61; Univ. Colorado (M.A., 1962). **Exhibited:** Mid-South Ann., Memphis, TN, 1959-60 & 1964; Walker Ann., Minneapolis, MN, 1966; Iowa Artist Exh., Des Moines AC, 1966, 1970 -71; Invitational Drawing Exh., Benedicta AC Gal., Saint Joseph, MN, 1970; Drawing & Painting, Coe College Gals., Cedar Rapids, IA, 1971. **Comments:** Preferred medium: oils. Positions: fellow-in-residence, Huntington Hartford Found., Pacific Palisades, CA, summer 1964. Teaching: Northeast Miss. Jr. College, Booneville, 1962-64; Radford College, VA, 1964-65; children's art classes, Cedar Rapids (IA) Art Center, 1965-70. **Sources:** WW73.

PATRICK, James H. *[Painter, lithographer, teacher, lecturer] b.1911, Cranbrook, BC, Canada / d.1944, Los Angeles, CA.*
Addresses: Los Angeles, CA. **Studied:** Chouinard AI with M. Sheets; C. Hinkle; L. Murphy; R. T. Chamberlin. **Member:** Calif. WCS; Found. Western Artists. **Exhibited:** AIC, 1936-43; Los Angeles County Fair, 1936 (prize), 1937 (prize); Calif. State Fair, 1938 (prize), 1939 (prize); GGE, 1939; Corcoran Gal. biennial, 1943; WMAA, 1944. **Work:** LOC; South Pasadena H.S. (frescoes, done with M. Sheets). **Comments:** Teaching: Chouinard AI, Los Angeles. **Sources:** WW40; Hughes, *Artists of California*, 425.

PATRICK, John Douglas *[Painter] b.1863, Hopewell, PA / d.1937.*
Studied: Acad. Julian, Paris, with Boulanger & Lefebvre, 1885-86, 1892; Merson, Chatrain, Glaize & Fremiet in Paris. **Exhibited:** Paris Salon, 1886, 1887; Acad. Julian (prizes); Paris Expo, 1889 (med.). **Work:** CAM. **Comments:** Teaching: St. Louis Sch. FA, Kansas City AI. **Sources:** Fink, *Am. Art at the 19th c. Paris Salons, 378.*

PATRICK, Joseph Alexander *[Painter, educator] b.1938, Chester, SC.*
Addresses: Iowa City, IA. **Studied:** Univ. Georgia (B.F.A., 1960); Univ. Colorado, Boulder (M.F.A., 1962). **Member:** Mid-Am. AA; College AA Am. **Exhibited:** Midwest Biennial, Joslyn Art Mus., Omaha, 1965; Nat. Small Painting Show, Univ. Nebraska, Omaha, 1966; Container Corp. Sixth Ann. FA Exh., Rock Island, IL, 1967; Dedication Exh., FA Center, State Univ. NY College Plattsburgh, 1970; Drawing Exh., Benedicta AC Gal., St. Joseph, MN, 1971. **Awards:** residence fellowship, Huntington Hartford Found., 1964; summer faculty fellowship, 1969 & faculty grant, 1973, Univ. Iowa Found. **Work:** Univ. Colorado, Boulder; Univ. Nebraska, Omaha; Davenport Munic. Art Gal. & Coe College, Cedar Rapids, IA; Fairfield Co. Hist. Soc., Winnsboro, SC; State Univ. NY College Plattsburgh. **Comments:** Preferred medium: oils. Positions: mus asst., Univ. Georgia Mus. Art, Athens, 1958-60; instr. art, Davenport (IA) Art Center, 1968, 1969 & 1972; instr. art, Keokuk (IA) AA, 1972. Teaching: Univ. Colorado, Boulder, 1960-62; Northeast Miss. Jr. College, Booneville, 1962-64; Radford College, 1964-65; Univ. Iowa, 1965-70s. **Sources:**

WW73.

PATRICK, Marcia A. *[Painter] b.1875, California / d.1964, Los Angeles, CA.*
Addresses: Los Angeles. **Exhibited:** P&S Los Angeles, 1936-37. **Sources:** Hughes, *Artists of California*, 426.

PATRICK, Ransom R. *[Educator, painter, historian, designer, commercial artist, lecturer, critic] b.1906, Santa Barbara, CA / d.1971.*
Addresses: Durham, NC. **Studied:** Univ. Washington (B.A.); Princeton Univ. (M.F.A.; Ph. D.). **Member:** CAA; Am. Soc. for Aesthetics (secy., 1950-55; trustee, 1955-58); AAUP; Int. Platform Assn. **Exhibited:** SAM, 1930-42. **Work:** mural, U.S. Naval Air Base, Sand Point, WA. **Comments:** Teaching: Oberlin College; Univ. Minnesota; Western Reserve Univ., 1949-54; Duke Univ., Durham, NC, 1954-60s. Contrib.: *Art Bulletin.* Position: bus. manager, *Journal of Aesthetics & Art Criticism,* 1950-55. Lectures: Aesthetic Criticism; Art History and The Humanities: 19th c. American Portrait Painting; Interrelationship of the Arts; History of Aesthetics and the Arts in a University Curriculum, and others, to art associations, art museums, college art conferences, etc., 1958-60. **Sources:** WW66.

PATRICK, William K. *[Cartoonist, sketch artist] b.St. Louis, MO / d.1936, San Antonio, TX.*
Addresses: New Orleans, active 1914-19. **Studied:** Crow Memorial Inst. **Comments:** Drew most of the cartoons for the book, *Club Men of Louisiana in Caricature,* 1917. **Sources:** *Encyclopaedia of New Orleans Artists,* 293.

PATRICOLA, Charles *[Painter] b.1899, Buffalo, NY / d.1982, Kenmore, lNY.*
Studied: Buffalo Sch. FA, 1914. **Member:** Buffalo SA. **Sources:** Krane, *The Wayward Muse,* 193.

PATRICOLA, Philip *[Painter] early 20th c.*
Addresses: Buffalo, NY. **Member:** Buffalo SA. **Sources:** WW25.

PATRUS, John *[Painter] early 20th c.*
Addresses: Peekskill, NY. **Exhibited:** S. Indp. A., 1931-32. **Sources:** Marlor, *Soc. Indp. Artists.*

PATTEE, David E. *[Painter] early 20th c.*
Addresses: NYC, 1923. **Exhibited:** S. Indp. A., 1923. **Sources:** Marlor, *Soc. Indp. Artists.*

PATTEE, Elmer Ellsworth *[Painter, sculptor] 20th c.*
Addresses: Paris, France. **Studied:** Bouguereau; Ferrier; Puech; Dampt. **Exhibited:** Paris Salon, 1895-99. **Comments:** Affiliated with Am. Art Co., Paris. **Sources:** WW10; Fink, *Am. Art at the 19th c. Paris Salons,* 378.

PATTEE, Elsie Dodge *[Painter, miniature painter, illustrator, teacher, writer, lecturer] b.1876, Chelsea, MA.*
Addresses: Old Lyme, CT; Mystic, CT. **Studied:** Acad. Julian, Paris. **Member:** ASMP; Grand Central Gal. Assn.; Mystic AA; Old Lyme AA; Brooklyn SMP. **Exhibited:** Pan-Pacific Expo, 1915 (medal); Concord AA, 1921; NAWPS, 1921; Calif. SMP, 1927 (prize), 1937 (prize); ASMP, 1930 (prize), 1936 (prize); Brooklyn SMP, 1935 (medal), 1939 (medal); Penn. SMP, 1935 (medal), 1939 (prize); AIC. **Work:** MMA; BM; PMA; PAFA. **Comments:** Illustr.: juvenile publications. **Sources:** WW59; WW47; Art in Conn.: Between World Wars.

PATTEE, Gertrude L. *[Artist] early 20th c.*
Addresses: Wash., DC, active 1901-10. **Sources:** McMahan, *Artists of Washington, D.C.*

PATTEN, Frances M. E. *[Painter] early 20th c.*
Addresses: Rockville Centre, NY. **Sources:** WW24.

PATTEN, Grace M. *[Artist] late 19th c.*
Addresses: Wash., DC, active 1896. **Sources:** McMahan, *Artists of Washington, D.C.*

PATTEN, Henry S. *[Painter] early 20th c.*
Addresses: NYC, 1923. **Exhibited:** S. Indp. A., 1923. **Sources:**

Marlor, *Soc. Indp. Artists.*

PATTEN, Joy *[Painter] mid 20th c.*
Addresses: Chicago area. **Exhibited:** AIC, 1940. **Sources:** Falk, AIC.

PATTEN, Mary C. *[Printmaker]; b.Bowdoinham, ME. 20th c.*
Addresses: Sacramento, CA. **Member:** Kingsley AC; Calif. PM; Calif. AC. **Exhibited:** Calif. State Fairs (gold, silver & bronze medals). **Comments:** Teaching: public schools, Sacramento, 1913-on. **Sources:** Hughes, *Artists of California,* 426.

PATTEN, Sarah E. *[Painter] early 20th c.*
Addresses: St. Paul, MN. **Sources:** WW15.

PATTEN, William *[Illustrator, art editor] b.1865, NYC / d.1936, Rhinebeck, NY.*
Studied: Acad. Julian, Paris, 1891. **Comments:** In 1888 (at age 23), he was the youngest art editor for *Harper's.* In 1932, he started in the "Cabinet of American Illustrators" at the LOC "to preserve for posterity the work of outstanding American illustrators.".

PATTEN, Zebulon S. *[Engraver and designer] mid 19th c.*
Addresses: Bangor (ME), 1855-60. **Sources:** G&W; *Maine and Register,* 1855-56; New England BD 1860.

PATTERSON, Alma V. A. *[Painter] early 20th c.*
Addresses: Phila., PA. **Exhibited:** PAFA Ann., 1932. **Sources:** Falk, *Exh. Record Series.*

PATTERSON, Ambrose McCarthy *[Painter, printmaker, educator] b.1877, Daylesford, Victoria, Australia / d.c.1966, Seattle, WA.*
Addresses: Seattle, WA, 1918-66. **Studied:** Nat. Gal. Art Sch., Melbourne, Australia; Acad. Julian, Paris, 1898; Lucien Simon, Andre Lhote & Maxime Maufra in Paris; École des Beaux-Arts; Acad. Colarossi; John Singer Sargent; fresco painting with Pablo O'Higgins in Mexico , 1934. **Member:** Le Cercle d'Artistique et Litteraire (co-founder); Australian AA (co-founder); Northwest PM; Seattle Art Mus.; Group of Twelve, Seattle, 1930s. **Exhibited:** Salon d'Automne, 1903; Paris Salon, 1903-08; Société Nat. des Beaux-Arts, 1903; Royal Acad., 1904 (solo); *Le Cercle d' Artistique et Litteraire,* Brussels, Belgium, 1907 (solo); Nat. Gal. Adelaide, c.1910 (solo); Univ. Club, Honolulu, c.1915 (solo); Laniakea Studio, Honolulu, c.1916 (solo); Hawaiian Soc. Artists, 1917; Blue Bird Restaurant, Carmel, 1917 (solo); Honolulu Art Soc., 1920; San Fran. AA, 1918 (solo), 1925; Seattle FA Soc. (predecessor to SAM), 1921 (solo); Western Painters, 1922-24; Montross Gal., New York, 1926; MoMA ("16 Cities"), 1933; Oakland Art Gal., 1932, 1936; SAM, 1934 (solo); WFNY (representing Wash. artists) 1939; Governor's Award, Wash. State, 1946; SAM, 1947 (solo, prize) (prizes also in 1944, 1959), 1961 (prize;joint retrospective with Walter Isaacs); World's Fair, Seattle, 1962; "Art of the Pacific Northwest," Smithsonian Inst., Nat. Coll. FA, 1974; "Northwest Traditions," SAM, 1978; Foster/White Gal., Seattle, 1979; "Seattle Painting 1925-85," Bumbershoot, Seattle Center, 1985; "Regional Painters of Puget Sound, 1970-1920," Mus. Hist. & Indust., Seattle, 1986-88; "School of Art 1920-60," SAFECO Ins. Cos., Seattle, 1988; Carolyn Staley FA, Seattle, 1989 (retrospective); SAM, 1990; Palm Springs (CA) Desert Mus., 1991; Woodside/John Braseth Gal., 1992 (retrospective); AIC. **Work:** Henry Art Gal., Seattle; Seattle Art Mus.; Tacoma Art Mus.; Musée d'Ixelles, Belgium; Honolulu AA; Phila. Mus. Art; LOC; SAFECO Ins. Co., Seattle; *The Seattle Times;* Seafirst Nat. Bank, Seattle; Miami-Dade Community College, FL ; Nat. Gal. Adelaide, Australia; Nat. Gal. NSW, Sydney, Australia; Australia Portrait Gal. (Canberra); Australian Commonwealth Government; Honolulu; Seattle, WA; mural, USPO, Mt. Vernon, WA. **Comments:** Modernist and WPA artist. Was in Honolulu in 1916, painting street scenes. Moved to Seattle in 1918, where he became the first professor at School of Art, University of Washington in 1919. Married painter Viola Hansen in 1922. In 1937 he moved to Laurelhurst studio (designed by Jack Sproule, architect). Teaching: Univ.

Washington, Seattle, WA, until 1947. **Sources:** WW59; WW47. More recently, see Hughes, *Artists of California,* 426; Trip and Cook, *Washington State Art and Artists,* 1850-1950; Forbes, *Encounters with Paradise,* 208; Trenton, ed. *Independent Spirits,* 113.

PATTERSON, Angelica Schuyler *[Painter] b.1864, Jersey City, NJ / d.1952.*
Addresses: Boston, MA. **Studied:** Cooper Union; New York, with D. Volk; Paris with A. Stevens & Colin; Boston with A. Thayer. **Member:** Copley Soc., 1895. **Exhibited:** SNBA, 1892; Boston AC, 1893-1904 ; NAD, 1894; PAFA Ann., 1894; Copley Gal., Boston (solo); Boston Art Dept., 1900 (solo). **Comments:** Specialty: church decorations. She exhibited as A.S., Angelica S., and Angelica Schuyler Patterson. **Sources:** WW10; Fink, *Am. Art at the 19th c. Paris Salons,* 378; Falk, *Exh. Record Series.*

PATTERSON, Anna Moore *[Painter] early 20th c.*
Addresses: Port Deposit, MD. **Sources:** WW08.

PATTERSON, B. F. *[Portrait painter] mid 19th c.*
Comments: Painted watercolor portraits in the Shenandoah Valley in the 1840s. **Sources:** Wright, *Artists in Virgina Before 1900.*

PATTERSON, Catherine Norris (Mrs. Frank T.)
[Miniature painter] late 19th c.; b.Phila.
Studied: PAFA; Plastic Club, Phila. **Comments:** Married Charles Leland Harrison in 1886 and Mr. Patterson in 1917. Positions: trustee, Phila. Mus. Art; bd. mem., Phila. Sch. Design for Women. **Sources:** Petteys, *Dictionary of Women Artists.*

PATTERSON, Charles Allen *[Painter] b.1922, Littleton, NC.*
Addresses: New York 28, NY. **Studied:** ASL with Reginald Marsh, Julien Levi, Morris Kantor. **Exhibited:** Hewitt Gal., 1953-58; Paris, France, 1951 (solo). **Sources:** WW59.

PATTERSON, C(harles) R(obert) *[Marine painter] b.1878, Southhampton, England / d.1958, NYC.*
Addresses: NYC. **Member:** NAC; SC; Allied AA; AWCS; NYSP; Explorers Club. **Exhibited:** PAFA Ann., 1915-25 (4 times). **Work:** BMFA; Mystic Seaport Mus.; Mariners Mus., Newport News, VA; Peabody Mus.; U.S. Naval Acad., Annapolis; Butler Art Inst., Youngstown, OH; Bath Marine Mus.; Mus., Trenton Mus. (Halifax, NS); Royal Victoria Mus., Halifax. **Comments:** Born into a family of shipbuilders, he went to sea at age 13 and sailed the seven seas aboard many types of vessels, and rounded Cape Horn four times. During the 1920s, he moved to NYC, concentrating his full efforts on painting. **Sources:** WW47; Brewington, 294; Falk, *Exh. Record Series.*

PATTERSON, Charles W. *[Painter, teacher] b.1870, Belle Vernon, PA / d.1938.*
Addresses: Pittsburgh, PA. **Studied:** PAFA. **Member:** Pittsburgh AA. **Exhibited:** Corcoran Gal. biennial, 1914; Pittsburgh AA, 1914 (prize); Pittsburgh AS, 1924 (prize); Friends Pittsburgh Art, 1929 (prize). **Work:** 100 Friends of Art, Pittsburgh. **Sources:** WW31.

PATTERSON, Claude A. *[Teacher and painter] mid 20th c.; b.Monmouth, IL.*
Addresses: Des Moines, IA. **Studied:** Charles Atherton Cumming, Cumming Art Sch.; Phila. Sch. Design; Monmouth College; Univ. Iowa; Harvard (M.A.); Columbia Univ. **Member:** Iowa Artists Club, 1929. **Exhibited:** Iowa Art Salon (prizes). **Comments:** According to Ness & Orwig, the "first artist in this country to receive a M.A. degree." Teaching: Monmouth College; Univ. Iowa; Univ. Illinois; Univ. Wisconsin; New Orleans. **Sources:** Ness & Orwig, *Iowa Artists of the First Hundred Years,* 161.

PATTERSON, Edward P. *[Engraver] mid 19th c.*
Addresses: Lowell, MA, 1834. **Sources:** G&W; Belknap, *Artists and Craftsmen of Essex County,* 4.

PATTERSON, Elizabeth G. *[Landscape, portrait and still life painter] 19th/20th c.*

Addresses: Richmond, VA, active 1899-1904. **Exhibited:** Richmond, VA. **Sources:** Wright, *Artists in Virgina Before 1900.*

PATTERSON, F. W. (Mrs.) *[Painter] 19th/20th c.*
Member: Tacoma Art Lg., 1891-92. **Exhibited:** Western Wash. Indust. Expo, 1891. **Sources:** Trip and Cook, *Washington State Art and Artists.*

PATTERSON, George W. Patrick See: **KEMOHA, (George W. Patrick Patterson)**

PATTERSON, Gertrude Hough *[Portrait painter, teacher]* b.1882, Norwich, CT.
Addresses: Granby, CT. **Studied:** PAFA; Yale; BMFA Sch.; ASL with R. Brackman; C. Woodbury; Norwich Sch. with Ozias Dodge; E. Pape; A.V. Tack. **Member:** West Hartford Art Lg.; Hartford Soc. Women Painters; Conn. Assn. Artists. **Comments:** Teaching: Sea Pines Sch., Brewster, MA. **Sources:** WW47; *Charles Woodbury and His Students.*

PATTERSON, H. *[Engraver] 19th c.*
Comments: Engraver of color plates of fish for the report of Matthew C. Perry's expedition to Japan. **Sources:** G&W; Perry, *Expedition to Japan.*

PATTERSON, Hedley V., Jr. *[Engraver, painter] early 20th c.; b.Boston, MA.*
Addresses: Wash., DC, active 1917-22. **Studied:** Mass. State Art Sch.; PAFA. **Exhibited:** Wash. Landscape Club, 1919.
Comments: Worked for Bureau of Engraving and Printing. He was also an engraver of Liberty Bonds. **Sources:** McMahan, *Artists of Washington, D.C.*

PATTERSON, Henry Stuart *[Painter]* b.1874, East Orange, NJ.
Addresses: NYC. **Studied:** R. Kent; F. Robinson; G.P. Ennis. **Member:** AWCS; SC; Century Assn.; Ramapo Arts & Crafts Center. **Exhibited:** Univ. Club, NY, 1939 (prize). **Sources:** WW47.

PATTERSON, Howard Ashman *[Painter, lithographer, designer, teacher]* b.1891, Philadelphia, PA.
Addresses: Phila., PA; Hopewell, NJ. **Studied:** PM Sch IA; ASL; PAFA (fellow) with Henry McCarter. **Member:** Am. Veterans Soc. Art. **Exhibited:** S. Indp. A.; PAFA Ann., 1913-16, 1920-23; NAD; AIC; F. PAFA; CI; CPLH; CMA; Mus. New Mexico, Santa Fe (solo); Chappel House, Denver, CO; Univ. Nebraska; Bethany College, Topeka; Highland Park Mus., Dallas; Ft. Worth Mus.; Chicago; Paris, France. **Work:** Luxembourg Mus., Paris. **Sources:** WW66; WW47; Falk, *Exh. Record Series.*

PATTERSON, I. M. (Mrs.) *[Artist] 19th/20th c.*
Addresses: Active in Los Angeles, 1891-1916. **Sources:** Petteys, *Dictionary of Women Artists.*

PATTERSON, J. M. (Mrs.) *[Painter] late 19th c.*
Addresses: Tacoma, WA, 1892. **Member:** Tacoma Art Lg., 1891, 1892. **Exhibited:** Western Wash. Indust. Expo, 1891. **Sources:** Trip and Cook, *Washington State Art and Artists, 1850-1950.*

PATTERSON, James S. *[Wood engraver]* b.1832 / d.1916, Hackensack, NJ.
Addresses: NYC, active from about 1858. **Sources:** G&W; *Art Annual,* XIII, obit.; NYBD 1858; Smith.

PATTERSON, Joseph *[Drawing master] early 19th c.*
Addresses: New Orleans, 1822. **Sources:** G&W; New Orleans CD 1822; *Encyclopaedia of New Orleans Artists* (suggests he could be the Joseph Patterson who died in New Orleans Sept. 28, 1822).

PATTERSON, Lawrence A. *[Illustrator] early 20th c.*
Addresses: San Francisco, 1925; San Mateo, 1932; Los Angeles, 1934. **Exhibited:** San Francisco AA, 1925. **Sources:** Hughes, *Artists of California,* 426.

PATTERSON, Lucile See: **MARSH, Lucile Patterson**

PATTERSON, Malvern C. (Mrs) *[Still life painter] 19th/20th c.*

Addresses: Richmond, VA, active 1896-1904. **Sources:** Wright, *Artists in Virgina Before 1900.*

PATTERSON, Margaret [handwritten: MARGARET PATTERSON ~ 1902 ~] **Jordan** *[Painter, block printer, teacher]* b.1867, at sea, off Soerabaija, Java / d.1950, Boston, MA.
Addresses: Boston, MA. **Studied:** possibly with with A.W. Dow in Boston, early 1890s; C.H. Woodbury, in Boston, Ogunquit, Maine & Europe; Pratt Inst., 1895; Castellucho & Augalada in Paris; woodblock printing with Ethel Mars in Paris, 1913; Hermann Dudley Murphy. **Member:** Boston SWCP (secy.); AFA; Copley Soc., 1900; Boston Guild Artists; Phila. WCC; Calif. PM; Providence WCC; Color Block PM; The Group (Boston), 1920s; NAWA. **Exhibited:** Boston AC, 1899, 1900-03, 1920; PAFA Ann., 1902; AIC, 1902-30 (15 annuals); Copley Gal., Boston 1910 (solo), 1912 (solo), 1914 (solo); Gal. Levesque, Paris, 1913 (solo); Gal. Barbazanges, Paris, 1913 (solo); H.D. Murphy's Copley Hall Studio, 1914 (solo); L. Katz Gal., NYC, 1914 (solo); Pan-Pacific Expo, San Fran., 1915 (hon. men. for woodcuts); Doll & Richards Gal., Boston, 1919; Worcester AM, 1919 (Paintings by "The Group"); Grace Horne Gal., Boston, 1920; Goodspeed's, Boston, 1922-24 (solos); Brown-Robertson Gal., NYC, 1923 (duo with Eliza D. Gardiner); Sesqui Centennial Int. Expo, Phila., 1926; Gld. Boston Artists, 1926 (solo), 1928 (solo); Brooklyn Mus., 1933; Phila. WCC, 1939 (Dawson medal); NMAA, 1983-84 ("Provincetown Printers" exh.); Steven Thomas, Woodstock, VT, 1986 (solo); Bakker Gal., Cambridge, MA, 1988, 1990 (retrospectives); "Charles H. Woodbury and His Students," Ogunquit Mus. Am. Art, 1998. **Work:** BMFA; LOC; Oakland (CA) Art Mus.; MMA; Univ. Calif.; Smith College; CMA; Mus.; Springfield (MA) Pub. Lib.; RISD; Victoria & Albert Mus., London; Print Coll., Mus., Genoa, Italy. **Comments:** Best known for her landscapes and floral still life works in color woodblock prints and gouache. Her work was strongly influenced by Japonisme. Patterson is remembered as an important figure in woodblock printing. She made her first color woodblock print in 1911, using only apple wood for her blocks and grinding her own natural and vegetable colors. She taught drawing in the Boston Public Schools, 1898-1915; then became head of the art dept., Dana Hall Sch., Wellesley, MA, 1915-40; also founded a summer school in Monhegan (ME). She traveled throughout Italy annually, 1922-29. She painted in Belgium, Holland, France, Spain, and at the artist colonies at Cape Ann (MA), Cape Cod (MA), Ogunquit (ME), and Monhegan Island (ME). Previous birth dates of 1868 and 1869 in various sources are incorrect. Signature note: Her earlier signature (c.1899-1919) tends to be precise, whether as initials or fully printed out in block letters; it becomes looser in the 1920s. **Sources:** WW40; exh. cat., Bakker Antiques (Cambridge, MA, 1988); *Charles Woodbury and His Students; Pisano, One Hundred Years.the National Association of Women Artists,* 76; Falk, *Exh. Record Series.*

PATTERSON, Marion L(ois) *[Educator, painter, lecturer]* b.1909, Knox County, IN.
Addresses: Vincennes, IN. **Studied:** Indiana State Teachers College (B.S.); Syracuse Univ. (M.F.A.). **Member:** Indiana State Teachers Assn.; NEA; Hoosier Salon; NAWA; Indiana Art Club; Vincennes Teachers Assn.; Western AA; Nat. Art Educ. Assn.; Indiana Art Educ. Assn.; Indianapolis AA; AAUW; Vincennes Teachers Fed. **Exhibited:** Hoosier Salon, 1942-58 (prizes, 1942, 1948; traveling exh., 1946); AWCS, 1941; NAWA, 1943-45, 1949-51; Hoosier Art Gal. Mexican Exh., 1942; Indiana Artists, 1942, 1944-45, 1951; Syracuse Univ., 1942 (solo); Vincennes Fortnightly Club, 1946 (solo); Swope Art Gal., 1948-51; Indiana Art Club, 1948; Syracuse Univ., 1942 (solo); Wabash Valley Artists, 1947, 1948 (prize), 1950 (prize), 1951; Ogunquit AC, 1954. **Comments:** Position: hd. art dept., Vincennes (IN) City Sch., 1936-; faculty, art dept., Vincennes Univ.; adult educ., Indiana Univ., 1951-; Western AA and NAEA mem. chmn. for State of Indiana, 1952-53, 1953-54; mem. adv. bd., So. Indiana Reg. Scholastic Art Exh., 1955-56; art critic, teacher, Indiana State Teachers College, 1957-58. **Sources:** WW59; WW47.

PATTERSON, Martha *[Painter, illustrator, teacher] b.1861, Chicago, IL.*
Addresses: San Francisco, CA. **Studied:** San Fran. with O. Kunath, W. Keith; ASL with K. Volk, W.M. Chase, I.R. Wiles, C. Carleton. **Member:** San Fran. AA. **Exhibited:** World's Columbian Expo, Chicago, 1893; Mechanics' Inst. Exh., 1888, 1893, 1897, 1899; Mark Hopkins Inst., 1897-98; Calif. State Fair, 1899 (prize). **Sources:** WW01; Hughes, *Artists of California,* 426.

PATTERSON, Mary Frances *[Designer, decorator, architect, craftsperson, lecturer, teacher, writer] b.1872, Niagara Falls, NY.*
Addresses: Berkeley, CA. **Studied:** T.H. Pond, H. Elliot, H.H. Clark & S. Burleigh at RISD; D. Ross at Harvard; museum study, Spain, France, Italy, England. **Member:** Providence AC; Friends Far Eastern Art; Mus. Assn., San Fran.; Needle & Bobbin Club, NY; Gld. Dec. Art, Univ. Calif. **Exhibited:** St. Louis Expo, 1904 (prize); Better Homes Program, Berkeley, 1929 (prize). **Comments:** Contrib.: articles on design, interior decoration, in educ. journals and magazines. Designed her home in Berkeley, which received hon. mention, permanent collection of prize houses, Better Homes Headquarters, Wash., DC, 1929. Teaching: Univ. Calif. **Sources:** WW40.

PATTERSON, Nellie (Nelle) *[Painter] mid 20th c.; b.Statesville, NC.*
Addresses: Wash., DC, active 1920-41. **Studied:** C. Hawthorne; D. Garber; R. Miller. **Member:** Wash. WCC. **Exhibited:** Wash. WCC; CGA, 1937, 1939; Gr. Wash. Indep. Exh., 1935. **Sources:** WW40; McMahan, *Artists of Washington, D.C.*

PATTERSON, Patty (Mrs. Frank Grass) *[Painter, craftsman, teacher, lecturer, designer] b.1909, Oklahoma City, OK.*
Addresses: Oklahoma City. **Studied:** Univ. Oklahoma (B.F.A.); École Beaux-Arts, Fontainebleau, France; Taos Sch. Art; ASL; Oklahoma State Univ.; Univ. Oklahoma; Emil Bisttraxn; Robert E. Wood; Milford Zarnes; George Post; Edgar Whitney. **Member:** Oklahoma AA (vice-pres. & secy.y); Oklahoma Art Lg.; Oklahoma Writers; Oklahoma Conserv. Artists; SWWCS; MacD. Club; Applied AC. **Exhibited:** MacD. Club, 1940 (medal), 1944 (medal); Oklahoma Art Lg., 1942 (prize); Fontainebleau School FA; Arch. Lg.; MIT; Oklahoma AA, 1932-58; Tulsa AA; YMCA, Oklahoma City AC, 1962-64. **Comments:** Teaching: lecturer, art trends, art & general, clubs & art organizations; art instructor, Oklahoma City Schools & Oklahoma City Univ., 1934-. **Sources:** WW73; WW47.

PATTERSON, Peter *[Painter] b.c.1834, Hawick, Roxburyshire, Scotland / d.1876, New Orleans, LA.*
Addresses: New Orleans, active 1860-76. **Sources:** *Encyclopaedia of New Orleans Artists,* 293.

PATTERSON, Rebecca Burd Peale *[Miniature painter] mid 20th c.; b.Phila., PA.*
Addresses: Phila., 1940. **Studied:** Penn. Mus.; Penn. Sch. Indus. Art, Phila.; Rebecca Van Trump; W.J. Whittemore in NY; A.M. Archambault. **Member:** Penn. SMP. **Sources:** WW40; WW10 (as Rebecca Burd Peale, miniature painter, residing in Holmesburg, PA); Petteys, *Dictionary of Women Artists.*

PATTERSON, Robert *[Illustrator] b.1898, Chicago, IL / d.1981.*
Addresses: Chicago, IL; NYC, 1922; Paris, France, c.1924-34. **Studied:** AIC; H. Dunn; Walt Louderback; Ralph Barton; P. Brissaud; Carl Ericson. **Work:** Cosmopolitan, 1939. **Comments:** Position: dir., Patterson Studios, Chicago (with his brother Loran). He was sent to Paris by *Judge* magazine, and stayed in France after the failure of *Judge,* illustrating for *Vogue.* Upon his return to the U.S., he obtained assignments for other magazines, as well as for advertising and books. **Sources:** WW40; W & R Reed, *The Illustrator in America,* 192.

PATTERSON, Russell *[Illustrator, landscape painter, designer] b.1896, Omaha, NE. / d.1977.*
Addresses: NYC. **Studied:** AIC; Acad. FA, Chicago; claimed to have studied with Monet. **Member:** SI; Artists Gld.; Am. Inst. Dec.; Artists & Writers. **Comments:** Illustr.: *American, Saturday Evening Post,* and *Liberty.* Costume & set designer, Ziegfield Follies, 1922, and other Broadway shows, also movies in Hollywood. Des., major department stores, hotel lobbies, restaurant interiors, Women's Army Corps uniforms in WWII. **Sources:** WW47.

PATTERSON, Viola (Mrs. Ambrose M.) *[Painter, sculptor, printmaker, teacher] b.1898, Seattle, WA / d.1984, Seattle.*
Addresses: Seattle. **Studied:** Univ. Washington (B.A., M.F.A.); in Paris with Andre L'Hote, Alexander Archipenko, Amedee Ozenfant. **Member:** Seattle Art Mus.; Northwest PM; Group of Twelve, Seattle; AEA (bd. mem., 1955-56). **Exhibited:** Phoenix, AZ, 1928 (prize); SAM, 1928, 1932 (prize), 1935 (solo), 1946 (prize), 1953-55, 1957 (solo); Women Painters of Wash., 1934-56; Oakland Art Mus., 1953; Henry Art Gal., Univ. Wash., 1953, 1964 (solo); Univ. Puget Sound, 1954, 1962 (solo); Univ. Washington, Sch. Art Faculty Exh., 1953-56; Zoe Dusanne Gal., 1954 (solo), 1958 (solo); Artists of Seattle Region, 1953-62 (prize 1955); Woessner Gal., 1955; Seattle World's Fair, 1962; Atrium Gal., 1964; Port Townsend Art Gal., 1964 (solo); Northwest Annuals, SAM, annually through 1965; Northwest WC Exh., 1952 (prize), 1954 (prize). **Work:** SAM. **Comments:** Married to Ambrose Patterson (see entry). Teaching: Univ. Washington, Seattle, WA. **Sources:** WW66; WW47; Trip and Cook, *Washington State Art and Artists, 1850-1950.*

PATTERSON, William *[Caricaturist, sketch artist] b.c.1820, Mississippi.*
Addresses: Came from Madison Parish, LA, to New Orleans, LA in 1849, still there in 1850. **Sources:** G&W; 7 Census (1850), La., VI, 61; Delgado-WPA cites *Delta,* July 22, 1849. See also *Encyclopaedia of New Orleans Artists.*

PATTERSON, William Whitfield *[Painter, architect] b.1914.*
Addresses: Danville, VA/Goose Rocks Beach, ME. **Studied:** E. O'Hara; Univ. Virginia. **Member:** Danville AC; Acad. Sc. & FA, Richmond, VA. **Sources:** WW40.

PATTI, P. *[Sculptor] b.c.1810, Italy.*
Addresses: NYC in 1860. **Sources:** G&W; 8 Census (1860), N.Y., LVI, 723.

PATTI, Peter *[Painter] mid 20th c.*
Addresses: NYC. **Studied:** Leonardo da Vinci Art Sch. (scholarship); NY Sch. Fine & Applied Arts (Parsons Sch. Design); Contemp. AC; ASL. **Member:** Am. Veterans Soc. Artists. **Exhibited:** Lynn Kottler Gal., NY; Leger Gal., White Plains, NY; The Little Studio & Art Gal., Pelham, NY; Madison Gal., NYC; Des Arts, NY; Raymond Duncan Gal., Paris; Southeast Mus., Brewster, NY; Bohman's Gal., Stockholm; Propersi Gal., Greenwich, CT; Salon of 50 States Competition (Prix de Paris in watercolor); Arnot Art Gal., Elmira, NY, 1962 (Director's Choice); "NYC WPA Art" at Parsons Sch. Design, 1977. **Comments:** Positions: WPA artist, New York City, 1938-42; art therapist, Veterans Admin., 1946-77. **Sources:** *New York City WPA Art,* 70 (w/repros.).

PATTISON, A. M. Gould *[Painter] 19th/20th c.*
Addresses: St. Louis, MO. **Sources:** WW01.

PATTISON, Abbott L. *[Sculptor, painter] b.1916, Chicago, IL.*
Addresses: Chicago, Winnetka, IL. **Studied:** Yale College (B.A., 1937), Yale Sch. FA (B.F.A., 1939). **Member:** Chicago Art Club. **Exhibited:** AIC, 1940-69; PAFA Ann., 1942, 1966; MMA, 1951-52; WMAA, 1953-59 (four exhs.); solos: Holbrook Mus., Univ. Georgia, 1954 & Sculpture Center, NY, 1956. **Awards:** First Logan Prize, AIC, 1942; prize, MMA, New York, 1950; prize, Bundy Mus., Vermont, 1967. **Work:** WMAA; Israel State Mus., Jerusalem; SFMA; Buckingham Palace, London, England; AIC. **Commissions:** sculpture, Central Nat. Bank, Cleveland, Mayo

Clinic, St. Thomas Acad., St. Paul, MN, New Trier West H.S., Chicago & U.S. State Dept. **Comments:** Teaching: AIC, 1946-52; sculptor-in-residence, Univ. Georgia, 1954; Skowhegan Sch. Art, 1955-1956. **Sources:** WW73; Falk, *Exh. Record Series.*

PATTISON, Carrie A. *[Painter] b.1877, Purchase Line, PA.* **Addresses:** Indiana, PA. **Member:** Pittsburgh AA; Johnstown (PA) AA. **Exhibited:** Pittsburgh AA Exh., CI, 1935 (prize); Johnstown AA, 1936 (prize), 1937 (prize). **Work:** One Hundred Friends of Pittsburgh Art Coll.; State College, PA. **Sources:** WW40.

PATTISON, Evelyn *[Painter] mid 20th c.* **Addresses:** Tacoma, WA, 1931; Enumclaw, WA, 1941. **Member:** Women Painters of Wash. (charter mem.). **Exhibited:** Women Painters of Wash. 1931. **Sources:** Trip and Cook, *Washington State Art and Artists,* 1850-1950.

PATTISON, Helen Searle (Mrs. James W.) See: SEARLE, Helen R. (or L.)

PATTISON, James William *[Painter, writer, lecturer, teacher] b.1844, Boston, MA / d.1915, Asheville, NC.* **Addresses:** Chicago, Park Ridge, IL. **Studied:** NY with J. M. Hart, Gifford Inness; Düsseldorf with Flamm; Paris with Chialiva. **Member:** Chicago SA; SWA; Chicago Municipal Art Lg.; Palette & Chisel Club; Attic Club; Cliff Dwellers; NAC. **Exhibited:** Paris Salon, 1879-81; Mass. Charitable Mechanic's Assn., Boston, 1881 (med.); Brooklyn AA, 1883, 1885; NAD, 1883-87; Boston AC, 1894; St. Louis Expo, 1904 (med.); Paris Salon; AWCS; PAFA Ann., 1908-09; AIC. **Work:** AIC. **Comments:** He married painter Helen Searle in 1876, and together they lived for the next six years at a small artists' colony in Ecouen, France. Lecturer: AIC. Position: dir., Sch. FA, Jacksonville, IL, 1884-96. Auth.: *Painters Since Leonardo.* Editor: *FA Journal,* Chicago. **Sources:** WW13; Fink, *Am. Art at the 19th c. Paris Salons,* 378; Falk, *Exh. Record Series.*

PATTISON, Robert J. *[Landscape painter, teacher] b.1838, NYC / d.1903, Brooklyn, NY.* **Addresses:** Active in NYC & Brooklyn, NY, from 1858. **Studied:** CCNY. **Member:** Brooklyn AA. **Exhibited:** NAD, 1858-86; Brooklyn AA, 1873-91; Yale Sch. FA, 1867 ("White Mountains from Shelboure"). **Sources:** G&W; *Art Annual,* IV; Cowdrey, NAD. More recently, see Naylor, NAD; Marlor, *History of the Brooklyn AA;* Campbell, *New Hampshire Scenery,* 126. WW01.

PATTISON, Sidney (Mrs.) See: MODJESKA, Marylka (Mrs. Sidney Pattison)

PATTON *early 20th c.* **Exhibited:** Salons of Am., 1931. **Sources:** Marlor, *Salons of Am.*

PATTON, Alice Vincent Corson *[Painter] b.Philadelphia, PA / d.1915?.* **Addresses:** Philadelphia, Drexel, PA; Paris. **Studied:** W.M. Chase; Rupert Bunny. **Member:** PAFA (fellow). **Exhibited:** Corcoran Gal. annual, 1908; PAFA Ann., 1909, 1930. **Work:** TMA. **Sources:** WW15; Petteys, *Dictionary of Women Artists;* Falk, *Exh. Record Series.*

PATTON, Bessie E. *[Artist] late 19th c.* **Addresses:** Active in Detroit, MI, 1890. **Sources:** Petteys, *Dictionary of Women Artists.*

PATTON, Katharine Maxey *[Painter] b.1866, Phila., PA / d.1941.* **Addresses:** Wheaton, IL; Phila., PA. **Studied:** ASL with K. Cox, C.W. Hawthorne, H.B. Snell; PAFA; W.M. Chase; A. Robinson in Venice; F. Brangwyn in London. **Member:** Phila. WCC; Phila. Alliance; AFA. **Exhibited:** AIC, 1908-15 (as Katherine Maxey); Knoxville (TN) Expo, 1913 (medal); PAFA Ann., 1915-38 (Mary Smith prize, 1921); Corcoran Gal. biennial, 1916; NAWPS, 1918 (prize); Nat. Art Exh., Springville, UT, 1926 (prize). **Work:** PAFA; Southern H.S., Phila.; Munic. Coll., Trenton, NJ; Penn. State Univ.; John Vanderpoel AA, Chicago; Community Center, Camden, NJ. **Comments:** Impressionist painter who often depict-

ed forest interiors. **Sources:** WW40; WW15; WW19; Danly, *Light, Air, and Color,* 60; Petteys, *Dictionary of Women Artists;* Falk, *Exh. Record Series.*

PATTON, M. C. (Mrs.) *[Painter] early 20th c.* **Addresses:** Sacramento, CA. **Member:** Calif. AC. **Sources:** WW25.

PATTON, Marion *[Painter] mid 20th c.* **Addresses:** Brookline, MA. **Studied:** G.E. Browne. **Member:** Copley Soc.; All. Artists Am. **Exhibited:** Am. Artists Group. Traveling Exh., AFA, 1939-40. **Sources:** WW40.

PATTON, Roy Edwin *[Painter, etcher, lecturer, teacher] b.1878, Springfiled, OH.* **Addresses:** Erie. **Studied:** Catlin; Ericson; Cross. **Member:** Erie AC; FA Palette Club; AAPL. **Sources:** WW40.

PATTON, William *[Lithographer] b.1824, Pennsylvania.* **Addresses:** Philadelphia in 1850-52. **Sources:** G&W; 7 Census (1850), Pa., XLIX, 5; Phila. CD 1850-52.

PATTY, William A(rthur) *[Painter, teacher, lecturer, blockprinter] b.1889, New Hartford, CT / d.1961, Laguna Beach, CA.* **Addresses:** Brooklyn, NY; North Hollywood, CA; Laguna Beach. **Studied:** Conn. ASL with C. Flagg and R. Brandegee; NAD with E. Ward; Acad. Julian, Paris. **Member:** Brooklyn SA; Brooklyn P&S; CAFA; AAPL; All. Artists Am.; Laguna Beach AA; Brooklyn WCC; Fifteen Gallery, NY. **Exhibited:** Salons of Am.; PAFA Ann., 1921, 1928; S. Indp. A.; NAD; Corcoran Gal. biennials, 1926, 1928; BM; CAFA; Wilmington Soc. FA; Witte Mem. Mus., San Antonio, 1957-58 (exhs. of blockprints & paintings). **Work:** murals, Trinidad, BWI; St. Petersburg, FL; Los Angeles, CA; Miami, FL; Phoenix, AZ. **Sources:** WW59; WW47; Falk, *Exh. Record Series.*

PATZIG, Edna *[Painter and teacher] b.1869, LeMars, IA / d.1961.* **Addresses:** Iowa City, IA. **Studied:** Cumming Sch. Art, 1909-14, with Charles Atherton Cumming; Frederick Bosley, Henry Hunt Clark, Boston MFA Sch.; Gorguet, Sch. FA, Fontainebleau, France; M. Prendergast. **Member:** Iowa Art Guild; Louis Comfort Tiffany Found.(painter & mem.); Iowa AG; Western AA. **Exhibited:** AWCS; NYWCC; Univ. Ohio, Columbus; Univ. Illinois; Joslyn Mem. Gal.; Munic. Gal.; Little Gal.; Iowa Art Guild; Iowa State Fair, 1925 (gold medal); Iowa Artists Exh., Mt. Vernon, 1938. **Work:** Montgomery (AL) Mus. FA. **Comments:** Position: assoc. prof., dept. graphic & plastic arts; hd., graphic & plastic arts, Univ. schools, Univ. Iowa, Iowa City. **Sources:** WWW40; Ness & Orwig, *Iowa Artists of the First Hundred Years,* 161-62.

PATZIG, Gretchen Jane *[Painter] b.1916, Des Moines, IA.* **Addresses:** Des Moines, IA. **Studied:** Cumming Sch. Art with Charles Atherton Cumming, Alice McKee Cumming; Univ. Iowa. **Exhibited:** Des Moines Women's Club; Univ. Iowa (award); Iowa Fed. Women's Clubs (hon. men.). **Sources:** Ness & Orwig, *Iowa Artists of the First Hundred Years,* 162.

PATZOLD, Oswald E. *[Sculptor] mid 20th c.* **Addresses:** Seattle, WA. **Exhibited:** SAM, 1939. **Sources:** Trip and Cook, *Washington State Art and Artists,* 1850-1950.

PAUL See: ACRUMAN, Paul

PAUL, Alfred E. *early 20th c.* **Exhibited:** Salons of Am., 1934. **Sources:** Marlor, *Salons of Am.*

PAUL, Andrew G. *[Painter] early 20th c.* **Addresses:** Los Angeles, CA. **Member:** Calif. AC. **Sources:** WW25.

PAUL, Bernard H. *[Craftsman] b.1907, Baltimore, MD.* **Addresses:** Linthicum Heights, MD. **Studied:** Maryland Inst., Baltimore. **Exhibited:** Maryland Inst., 1929 (prize), 1933 (prize), 1937 (prize); Art Soc., Baltimore, 1928 (prize). **Work:** Christmas

shows, Colonial Williamsburg, 1956-57 & 1960-; marionettes for opera, Peabody Conservatory Music, 1957; miniature model sets, Hutzler's Dept. Store's 100th Anniv., 1958; puppets used by U.S. Dept. Health, Educ. & Welfare for series of motion pictures for Social Security TV spots. **Comments:** Specialty: marionettes. Positions: dir., TV program, "Paul's Puppets," WBAL-TV, Baltimore, 1948-57, WMAR-TV, 1957-58. Teaching: instr. puppetry, Maryland Inst. College Art, 1929-47 & 1958-; puppet shows, Hutzler's Br. Store, 1958-. **Sources:** WW73; WW47.

PAUL, Charles R. *[Painter, illustrator, designer] b.1888, Indiana, PA / d.c.1945.*
Addresses: Phila., PA. **Studied:** W.M. Chase; T. Anschutz.; H. McCarter. **Sources:** WW40.

PAUL, David *[Mixed media artist] b.1943.*
Addresses: NYC, 1969. **Exhibited:** WMAA, 1969. **Sources:** Falk, *WMAA.*

PAUL, Eugène *[Mezzotint engraver] b.1830, France.*
Addresses: New Orleans in 1860. **Comments:** Engraved a portrait of Henry Clay in 1855 (Stauffer). Census of 1860 shows him living with his wife Marguerite, a native Louisianian, in the same house as daguerreotypist John H. Frobus. **Sources:** G&W; 8 Census (1860), La., VIII, 5; Stauffer. See also *Encyclopaedia of New Orleans Artists.*

PAUL, Gen *early 20th c.*
Addresses: NYC. **Sources:** WW25.

PAUL, Horace A. *[Painter] early 20th c.*
Addresses: Phila., PA. **Exhibited:** PAFA Ann., 1924-36 (5 times). **Sources:** Falk, *Exh. Record Series.*

PAUL, Irma Young *[Painter, teacher] b.1910, Kingman, KS.*
Addresses: Gilman, IA. **Studied:** Univ. Iowa (R.A.; M.A). **Exhibited:** Iowa Art Salon, 1937, 1938 (award); Central Iowa Fair, 1937, 1938 (prizes). **Comments:** Teaching: Newton, IA, 1934-35; Univ. elementary & junior h.s., 1932-33. **Sources:** Ness & Orwig, *Iowa Artists of the First Hundred Years,* 162.

PAUL, J. W. S. *[Painter] mid 19th c.*
Comments: Known through a theorem painting in watercolors, about 1840. **Sources:** G&W; Lipman and Winchester, 178.

PAUL, Jeremiah, Jr. *[Portrait, figure, and animal painter] b.probably Philadelphia, PA / d.1820, near St. Louis, MO.* **J. PAUL.**
Studied: fellow-pupil with Rembrandt Peale. **Member:** Columbianum (a founder, in Phila., 1794-95). **Exhibited:** Columbianum Exh. (1795); PAFA (1811-1819). **Comments:** Believed to be the son of a Philadelphia Quaker school teacher. In 1796 Paul joined with several other Philadelphia artists under the name of Pratt, Rutter & Co. (see entry). Matthew Pratt dropped out after a few months and the firm became Paul, Rutter & Clarke (see entry). Paul was still in Philadelphia in 1800, but by 1802 he had begun to travel. He was painting in Savannah (GA) in 1802; and during the winter of 1803 he was painting miniatures and tracing profiles at Charleston (SC). From 1806-08 he was in Baltimore (MD) and in 1811 he exhibited "Venus and Cupid" in Philadelphia. In 1814 he was at Pittsburgh (PA), painting portraits and signs. In Jan. of 1819 he advertised his services in Louisville (KY). Paul is also said to have painted theatrical scenery in the west during his last years. **Sources:** G&W; Sellers, *Charles Willson Peale,* II; Columbianum Cat.; Dunlap, *History;* Prime, II, 19, 31; Dickson, "A Note on Jeremiah Paul;" Rutledge, *Artists in the Life of Charleston;* Baltimore CD 1806-08; Rutledge, PA; *Connoisseur* (Jan. 1954), 184-85, repro.; Flexner, *The Light of Distant Skies,* biblio., 263. More recently, see Gerdts, *Art Across America,* vol. 1, 285, 315 and vol. 2, 63, 159.

PAUL, John *[Listed as "artist"] b.c.1806, Pennsylvania.*
Addresses: Frankford section of Phila., 1850. **Sources:** G&W; 7 Census (1850), Pa., LVI, 355.

PAUL, Joseph E. *[Painter] early 20th c.*
Addresses: Rockville Centre, LI, NY. **Studied:** ASL. **Exhibited:**

Salons of Am., 1930. **Sources:** Falk, *Exhibition Record Series.*

PAUL, Josephine *[Painter] mid 20th c.*
Addresses: Johnstown, PA. **Exhibited:** PAFA Ann., 1949, 1952-54; Corcoran Gal. biennial, 1951. **Sources:** Falk, *Exh. Record Series.*

PAUL, Julia S. *early 20th c.*
Exhibited: Salons of Am., 1934. **Sources:** Marlor, *Salons of Am.*

PAUL, Nade *[Painter] early 20th c.*
Addresses: NYC, 1929. **Exhibited:** S. Indp. A., 1929. **Sources:** Marlor, *Soc. Indp. Artists.*

PAUL, Seymour Holmes *[Painter] b.1912, Hollywood, CA.*
Addresses: Laguna Beach, CA; San Diego, CA. **Studied:** design with his father R.H. Paul; cartooning with E. Colburn. **Member:** Laguna Beach AA. **Work:** Students Lounge, Pan Pacific Club, Honolulu, 1935 (mural). **Sources:** Hughes, *Artists of California,* 427.

PAUL, W. S. (Mrs.) *[Artist] late 19th c.*
Addresses: Active in Flintsteel, MI, 1899. **Sources:** Petteys, *Dictionary of Women Artists.*

PAUL, William D., Jr. *[Museum director, painter] b.1934, Wadley, GA.*
Addresses: Athens, GA. **Studied:** Atlanta Art Inst. (B.F.A.); Univ. Georgia (A.B. & M.F.A.); Emory Univ.; Georgia State College; Univ. Rome, Italy. **Member:** AFA (trustee); College AA Am.; Am. Assn. Mus. **Exhibited:** Southeastern Ann., Atlanta; Virginia Intermont College, Bristol; Birmingham(AL) Ann.; Corcoran Gal. biennial, 1957; "Art of Two Cities," Macy's Ann., Kansas City, 1959, 1961, 1963-64 (prizes); Atlanta Paper Co. Ann., 1961 (prize); Mid-Am. Ann., 1962 (Hallmark Award); AFA traveling exh., 1965. **Work:** General Mills, Inc., Minneapolis, MN; Hallmark Cards, Kansas City, MO; Little Rock (AR) Art Center; Georgia Mus. Art, Atlanta; Univ. Georgia, Athens. **Comments:** Positions: dir. exh. & cur. study coll., Kansas City Art Inst., 1961-65; cur., Georgia Mus. Art, 1967-69; dir.r, Georgia Mus. Art, 1969-70s. Teaching: Kansas City AI, Park College, & Univ. Georgia. Collections arranged: sixty small original exhibs., incl Charlotte Crosby Kemper Gal, Kansas City AI, 1961-65; "Art of Two Cities," AFA traveling exh., 1965; "The Visual Assault," 1967; "Drawings by Richard Diebenkorn," "Selections: The Downtown Gallery," "Drawing and Watercolors by Raphael Soyer," "Recent Collages by Samuel Adler," "Twentieth Anniversary Exhibition & Art of Ancient Peru," "The Paul Clifford Collection," Georgia Mus. Art; "American Painting: the 1940s," 1968; "American Painting, the 1950s," 1968; "American Painting: the 1960s," 1969; "Philip Pearlstein, Retrospective Exhibition," 1970. **Sources:** WW73.

PAUL, William H., Jr. *[Illustrator] b.1880, Phila.*
Addresses: Phila., PA. **Studied:** PAFA. **Exhibited:** AIC, 1902-05; PAFA Ann., 1903-04, 1908-09. **Sources:** WW10; Falk, *Exh. Record Series.*

PAUL, William Wheeler *[Painter, printmaker] b.1913, Philadelphia, PA / d.1976, Altadena, CA.*
Addresses: Laguna Beach, CA. **Exhibited:** Laguna Beach AA Gal., 1938. **Sources:** Hughes, *Artists of California,* 427.

PAUL-FRÉDÉRIC-WILLIAM See: **WÜRTTEMBERG, Paul-Frederic-William (Duke of)**

PAUL, RUTTER & CLARKE *[Portrait, sign & ornamental painters] late 18th c.*
Addresses: Philadelphia, active 1796. **Comments:** The partners were Jeremiah Paul, George Rutter, and William Clarke. Earlier in the same year the firm had been organized as Pratt, Rutter & Co., but Matthew Pratt dropped out after only a few months. (See entries on each artist.) **Sources:** G&W; Prime, II, 19; Dickson, "A Note on Jeremiah Paul."

PAULDING, (Charles) Gouverneur *[Painter] b.1887, Calumet, MI / d.1965, NYC.*
Addresses: NYC, 1928. **Exhibited:** S. Indp. A., 1928. **Sources:**

Marlor, *Soc. Indp. Artists.*

PAULDING, John *[Sculptor]* *b.1883, Dark County, OH / d.1935, Chicago, IL.*
Addresses: Park Ridge, IL. **Studied:** AIC; Europe. **Member:** Chicago Gal. Art; Cliff Dwellers; Chicago P&S. **Exhibited:** AIC, 1910-27. **Work:** World War mem. in various Am. cities; McPherson, Kans., bronze equestrian statue of Gen. James B. McPherson, unveiled in 1917. **Sources:** WW33.

PAULDING, Richard A. *[Portrait & landscape painter] mid 19th c.*
Addresses: NYC, active 1841-54. **Exhibited:** NAD, 1841-53. **Sources:** G&W; Cowdrey, NAD (as Paulding); NYCD 1842, 1852 (listed in 1842 and 1852 as Richard A. Pauling, portrait painter, and assumed to be the Richard A. Paulding who was exhibiting at the NAD in these same years); NYBD 1854.

PAULEY, Floyd *[Block printer, drawing specialist, illustrator, mural & portrait painter] b.1909, Herington, KS / d.1935.*
Addresses: Milwaukee, WI/Herington, KS. **Studied:** G.V. Sinclair; M. Nutting; Layton Art Sch.; Osten; Sisson. **Member:** Daubers Club; Wisc. P&S. **Exhibited:** Kansas State Free Fair, Topeka, 1932-33 (prize); 1934 (prize); Wisc. P&S Exh., 1934 (prize); Int. WC Exh., Chicago, 1935 (prize); AIC, 1935. **Work:** Milwaukee pub. school. **Sources:** WW40.

PAULI, Clemens J. *[Topographic draftsman, lithograpic artist, printer] b.1835, Lübeck (Northern Germany) / d.1896, Milwaukee, WI.*
Addresses: Davenport, IA, active 1867; Milwaukee, WI, 1876 and after. **Comments:** Came to America in 1863 and first worked as a draftsman in Davenport. Met printers A. Hageboeck and C. H.Vogt (see entries) and followed Vogt to Milwaukee. There Pauli joined Adam Beck (see entry) to form a printing firm. Their partnership lasted from 1878-86 with Pauli putting on stone or zinc plates many of the drawings sent to them. A view artist himself, he had drawn views of towns in Iowa and Wisconsin in 1876-77. He reprised his artistic career in 1888, traveling the Midwest and south as far as Mississippi and Alabama. **Sources:** Reps, 198-99; Thomas Beckman, "The Beck & Pauli Lithographing Company," *Imprint* vol. 9, no. 1 (Spring 1984): 1-6.

PAULI, Corinne *[Illustrator] early 20th c.*
Addresses: Phila., PA. **Studied:** PAFA. **Sources:** WW25.

PAULI, Richard *[Landscape painter] 19th/20th c.*
Addresses: NYC. **Exhibited:** NAD, 1886-92; Boston AC, 1888-90; AIC. **Sources:** Falk, *Exhibition Record Series.*

PAULIN, Elise *[Painter] early 20th c.*
Addresses: Tompkinsville, NY. **Sources:** WW15.

PAULIN, Richard Calkins *[Museum director, teacher, craftsman] b.1928, Chicago, IL.*
Addresses: Rockford, IL, Eugene, OR. **Studied:** DePauw Univ. (B.A.); Univ. Denver (M.A.); Inst. FA, NY Univ.; Guadalajara, Mexico. **Member:** Rockford AA; Nat. Educ. Assn.; Nat. Council Art Educ.; Mus. Dir. Assn. North Am.; Western AA; Mid-Western Mus. Dir. Assn. **Exhibited:** Univ. Illinois, 1960; Rockford AA, 1961 (Canfield Award); Beloit College, 1961-63, 1965; Nat. College Educ., Evanston, IL, 1964. **Comments:** Positions: dir., Harry & Della Burpee Art Gal., Rockford, IL; asst. dir. art educ., Mus. Art, Univ. Oregon. Teaching: instr. arts & crafts, Roosevelt Jr. H.S., Rockford; instr., Rockford AA. Collections arranged: Teachers Who Paint. 1959; Chicago Painters, 1960; Six Chicago Painters. 1961; Picasso Preview, 1962; George Rouault-His Aquatints and Wood Engravings, 1963; Collectors Showcase, 1964; 30 Contemporary Living American Painters, 1964; First National Invitational Painting Exhibition: Fifty States of Art, 1965; Swedish Handcraft, 1961. **Sources:** WW73.

PAULIN, Telford See: **PAULLIN, Telford**

PAULIN, Thomas *[Engraver] mid 19th c.*
Addresses: Newark, NJ, 1859. **Sources:** G&W; Essex, Hudson, and Union Counties BD 1859.

PAULING *[Miniaturist] early 19th c.*
Addresses: Albany, NY in 1820. **Sources:** G&W; Sherman, "Some Recently Discovered Early American Portrait Miniaturists," 294 (repro.).

PAULING, Frederick *[Engraver] b.1871 / d.1939, Wash., DC.*
Addresses: Wash., DC, active 1910. **Member:** Wash. Soc. FA. **Work:** NMAH (etchings and aquatints). **Comments:** Worked for Bureau of Engraving and Printing starting in 1923. **Sources:** McMahan, *Artists of Washington, D.C.*

PAULING, Richard A. See: **PAULDING, Richard A.**

PAULL, Grace *[Illustrator, writer, lithographer] 20th c.; b.Cold Brook, NY.*
Addresses: NYC/Cold Brook, NY. **Studied:** PIA Sch.; Grand Central Art Sch.; George Bridgman; Alexander Archipenko. **Exhibited:** PAFA; CGA; Munson-Williams-Proctor Inst., Utica, NY. **Comments:** Auth./illustr.: *Raspberry Patch,* other juvenile books; illustr., *Peter by the Sea; County Stop;* contrib., *Story Parade.* **Sources:** WW47.

PAULLIN, Ethel M. Parsons (Mrs. Telford) *[Painter, engraver, textile designer] mid 20th c.; b.Chardon, OH.*
Addresses: NYC. **Studied:** BMFA Sch.; ASL. **Member:** NSMP. **Exhibited:** Salons of Am., 1934. **Work:** St. Bartholomew's Church, Church of St. Vincent Ferrer, NY; St. Stephen's Church, Stevens Point, WI; Fed. Bldg., Albany, NY; Mutual Casualty Ins. Bldg.; Stevens Point, WI; Christ Church, West Haven, CT; Trinity Church, Ft. Wayne, IN; Church of the Epiphany, Roslyn, LI, NY; Brooke General Hospital Chapel, U.S. Army, San Antonio, TX; stained glass windows: Dana Chapel, Madison Ave. Presbyterian Church, N.Y; St. John's Episcopal Church, Bernardsville, NJ, 1961; portrait, ex-pres., John Henry Barrows, Oberlin College, 1958; 30 religious triptychs for U.S. Armed Forces. 1962-64. **Comments:** Position: des., handwoven tapestries and decorations, Herter Looms, NYC. **Sources:** WW66; WW47.

PAULLIN, Telford *[Illustrator, painter] b.1885, Le Mars, IA / d.1933.*
Addresses: NYC. **Studied:** Chicago; J.M. Swan; F. Brangwyn in London. **Member:** NSMP. **Work:** St. Vincent Ferrer's, NYC; Chapel St. Bartholomew's, NYC. **Sources:** WW21.

PAULSON, George H. *[Painter] 19th/20th c.*
Addresses: Tacoma, WA. **Exhibited:** Tacoma Art Lg., 1915. **Sources:** Trip and Cook, *Washington State Art and Artists, 1850-1950.*

PAULUS, Christopher Daniel *[Sculptor, painter, illustrator, teacher] b.1848, Würtemberg, Germany / d.1936, Los Angeles County.*
Addresses: Newton, KS. **Studied:** E. Kähnel, Dresden. **Exhibited:** PAFA Ann., 1905. **Sources:** WW08; Falk, *Exh. Record Series.*

PAULUS, Francis Petrus *[Painter, sculptor, etcher, teacher] b.1862, Detroit, MI / d.1933, Detroit?.*
Addresses: Detroit. **Studied:** PAFA; Royal Acad., Munich, with Loefftz; école des Beaux-Arts, Paris, with Bonnat; Italy, Portugal, The Netherlands. **Member:** Chicago SE; NAC; Scarab Club; La Gravure Originale en Noir; Société Int. des Beaux-Arts et des Lettres. **Exhibited:** AIC, 1895, 1897, 1899, 1905; PAFA Ann., 1885, 1900, 1910-11. **Work:** Herron AI; Detroit AI; McGregor Lib., Highland Park, MI; NYPL; LOC; Oakland Mus.; Musée Moderne, Bruges; Royal Acad. FA, Munich. **Comments:** Positions: asst. dir., Detroit Acad. Art, 1895-1903; dir., Ann Arbor Art Sch., 1903-05; Bruges Sch. Art, 1905-c.1908. **Sources:** WW32; Falk, *Exh. Record Series.*

PAULUS, Gertrude *[Painter] b.1904, Germany.*
Sources: info. courtesy Peter C. Merrill.

PAUS, Aage (Seage) *[Painter] early 20th c.*
Addresses: Brooklyn, NY, 1927. **Studied:** ASL. **Exhibited:** S. Indp. A., 1927-28; Salons of Am., 1934. **Sources:** Falk,

Exhibition Record Series.

PAUS, Herbert *[Painter, illustrator, cartoonist]* b.1880, Minneapolis, MN / d.1946.

P A U S

Addresses: St. Paul, MN; Chicago, IL; Mamaroneck, NY. **Studied:** FA Sch., St. Paul, MN. **Member:** GFLA. **Work:** many magazines; des., WWI posters. **Comments:** Positions: cart., *St. Paul Pioneer Press;* staff, art studio, Chicago; adv. & magazine free-lance illustr., NYC. **Sources:** WW27.

PAUSAS, Francisco *[Painter]* early 20th c.; b.NYC.
Addresses: NYC, 1917. **Exhibited:** S. Indp. A., 1917-18. **Sources:** WW15.

PAUSCH, Eduard Ludwig Albert *[Sculptor]* b.1850, Copenhagen.
Addresses: Buffalo, NY/Westerly, RI. **Studied:** C. Conrads; K. Gerhart, Hartford; D. Mora, NYC. **Sources:** WW10.

PAUSON, Rose *[Painter, craftsperson]* b.1896, San Francisco, CA / d.1964, San Fran.
Addresses: San Fran. **Exhibited:** SFMA, 1935; San Fran. AA, 1937, 1942. **Sources:** Hughes, *Artists of California,* 427.

PAUTSCH, F. *[Painter]* early 20th c.
Exhibited: AIC, 1921. **Sources:** Falk, *AIC.*

PAVAL, Philip Kran *[Painter, craftsperson, lecturer, sculptor]* b.1899, Nykobing Falster, Denmark / d.1971, Los Angeles, CA.
Addresses: Sherman Oaks, CA.; Hollywood, CA. **Studied:** Borger Sch.; Tech. Sch. Des., Denmark. **Member:** Calif. Art Club (pres.); P&S Club; Los Angeles Mus. Art; Royal Numismatic Soc., London (fellow); AIFA (fellow); Scandinavian-Am. AA; Soc. Brasileira de Belas Artes, Brazil; Am. Artists Congress. **Exhibited:** Pomona, CA, 1934 (prize), 1935 (prize), 1936 (prize); Calif. State Fair, 1935-40 (prizes), 1955 (prize), 1957 (prize) ; Los Angeles Mus. Art, 1935 (prize), 1937 (prize), 1941 (med.), 1943-45 (solo) ; P&S Club, Hollywood Riviera Gal., 1936 (prize); Los Angeles, 1936 (prize); CPLH, 1938; GGE, 1939; State Expo., 1941 (gold medals); Santa Barbara Mus. Art, 1945; Wichita AA, 1946 (prize); Dalzell Hartfield Gal., Los Angeles; Ebell Club, Los Angeles, 1950; Calif. Art Club, 1953 (medal); Univ. Club, Los Angeles (gold medal); SAAS, Los Angeles (gold medal); Madonna Festival, Los Angeles, 1960 (prize). Awards: many hon. degrees and decorations from France, Sweden, Belgium, Italy, British India & U.S., incl. hon. Litt.D., Trinity Southern Bible College & Seminary, Mullins, SC; Jose Drudis Traveling Fellowship, 1959-60. **Work:** Lutheran Church, LA; Los Angeles Mus. Art; Philbrook AC; MMA; Pres. Palace, Quito, Ecuador; Devi Palace, Vizianagaram City, So. India; MMA; Wichita AA; Smithsonian Inst.; Newark Mus.; Pasadena AI; Royal Palace, Athens; Gov. Palace, Hawaii; Buckingham Palace, London; Mus. Am. Comedy, FL; Rosenborg Castle, Denmark; St. Martin of Tours, Brentwood, CA; Mataro Mus., Spain; Nat. Mus., Iceland; Nat. Mus., Copenhagen, Denmark; Nat. Mus., Oslo, Norway; Masonic Lodge, Hollywood & San Fran.; Frederikborg Castle, Denmark; museums in Sweden, France, Vienna, Austria, Portugal, Germany, England. **Comments:** Apprentice to a silversmith and student of art in Denmark. Immigrated to America in 1919 and first worked as a merchant seaman in New York. He moved to LA in the 1920s and established a silversmith shop. Paval became well known for his silver and gold sculptures and portraits in oil of Hollywood celebrities. **Sources:** WW66; Hughes *Artists in California,* WW47.

PAVIA, Phillip *[Sculptor]* b.1912.
Addresses: NYC, 1966. **Exhibited:** WMAA, 1966. **Sources:** Falk, *WMAA.*

PAVILLA, John Richard *[Painter]* b.1861, Yorkshire, England / d.1943, Nevada City, CA.
Addresses: Monterey, CA, 1920s-30s. **Exhibited:** Santa Cruz Art Lg., 1929-30. **Sources:** Hughes, *Artists of California,* 427.

PAVLOSKY, Vladimir *[Painter, decorator]* b.1884, Ukraine, Russia / d.1944.

Addresses: Boston, MA. **Studied:** with father, Gregiory Pavlosky, decorator of ecclesiastical interiors. **Member:** Boston WCS; Copley Soc.; Boston GA; Gloucester AA; Gloucester SA; Rockport AA, North Shore AA. **Exhibited:** Grace Horn Gal., 1922; Copley S., BMFA, 1923; Doll & Richards Gals., Boston (solos: 1924-29 annually; 1939, 1941, 1944); Carson Pirie & Scott, Chicago, 1928, 1931; AIC, 1928-29, 1931; Boston WCS; Gal. on the Moors; Gloucester SA; Gloucester AA; Rockport AA; North Shore AA; Carnegie Inst. Art; Vose Gals.; Ogunquit (ME) AC. **Work:** Commissions: interior, St. Mary's Polish Church & murals, Fenway Theater & Orpheum Theater, all in Boston; Strand Theater, Lynn, MA. **Comments:** Emigrated to America, age 20, to avoid conscription in the Tsar's Army. He came from a long line of Russian interior decorators who were well-trained painters, gilders, and carvers. Pavlosky was skilled as an allegorical painter but specialized in shore scenes depicting the life of Gloucester (MA) fishermen and the coast of Maine. Considered Winslow Homer his muse. **Sources:** biographical info courtesy of Selma Koss Holtz, Waban, MA.

PAVLOVICH, Edward *[Portrait painter, designer]* b.1915, NYC.
Addresses: NYC. **Studied:** H.E. Fritz; P. Moschowitz; W. Starkweather. **Member:** Kit Kat AC; Salart Club. **Sources:** WW40.

PAVON, Jose M. *[Etcher, lithographer]* 20th c.; b.Mexico City.
Addresses: NYC. **Exhibited:** AIC, 1931 (prize). **Work:** NYPL; AIC. **Sources:** WW32.

PAWLA, Frederick Alexander *[Painter, decorator]* b.1876, England / d.1964, Fort Ord, CA.
Addresses: NYC; Santa Barbara, CA. **Studied:** Europe. **Member:** Royal Art Soc., NSW; Santa Barbara AS; San Diego AS. **Exhibited:** Santa Cruz Art Lg., 1929. **Work:** Burlingame H.S. (murals); War Dept., Wash., DC; murals, Dept. Pub. Markets, NYC. **Sources:** WW40; Hughes, *Artists in California,* 427.

PAWLEY, James, Sr. *[Landscape & marine painter, teacher]* d.c.1857.
Addresses: Baltimore, MD. **Exhibited:** Maryland Hist. Soc. **Comments:** Taught painting in Baltimore from 1842-57. **Sources:** G&W; Baltimore CD 1842-56 (in 1858 directory Mrs. James and James Pawley, Jr., were listed, indicating that the elder James Pawley must have died in 1857 or 1858); Rutledge, MHS.

PAXON, Edgar Samuel *[Illustrator, muralist]* b.1852, East Hamburg, NY / d.1919, Missoula, MT.

E S Paxon 1906

Addresses: Buffalo, NY (until 1877); Deer Lodge, MT (1879-81); Butte, MT (1881-1905); Missoula, MT (1905-on). **Studied:** assisted his father as a sign painter & decorator. **Exhibited:** S. Indp. A., 1917. **Work:** Missoula County Court House (8 murals); Montana Capitol Bldg. (56 murals); Univ. Montana; Whitney Gal. Western Art, Cody, WY. **Comments:** Paxon's claim to fame was his 6' x 10' mural, "Custer's Last Battle," which took many years to paint, was exhibited nationally, and lauded for its accuracy of detail. He went West in 1877, and served as a scout in the Nez Perce war in Montana; thereafter, he specialized in painting Indians and pioneer life. **Sources:** WW19; P&H Samuels, 363.

PAXSON, Edgar Samuel See: **PAXON, Edgar Samuel**

PAXSON, Ethel Easton *[Landscape painter, teacher, writer, lecturer]* b.After 1885, Meriden, CT / d.1982.

Ethel Paxson

Addresses: Essex, CT; NYC. **Studied:** Lilla Yale in Meriden, CT; Corcoran Art Sch. with E. Messer, M. Mueden; PAFA with W. M. Chase, C. Beaux, T. Anschutz, H. Breckeridge, H. R. Poore; R. Johonnot in NYC. **Member:** AWCS; Allied Artists Am.; NAWA; Art Lg. Nassau County; Meriden Arts & Crafts Assn.; Wolfe Art Club; New Haven PCC; AAPL. **Exhibited:** S. Indp. A., 1921, 1923, 1925; NAD; NAWA; Allied Artists Am.; AWCS, 1945-46;

CAFA; Meriden Arts & Crafts Assn. (prize); Art Lg. Nassau County; AAPL; Wolfe Art Club; New Haven PCC, annually; Long Island Univ. Newhouse Gal.; Argent Gal.; Marquis Gal.; Grand Central AG, NYC; Marbella Gal., NYC, 1973 (and USA tour). **Work:** MMA; New Britain Mus. Am. Art; Heckscher Mus., Huntington, NY; Parrish Art Mus., Southampton, NY; Mattatuck Mus., Waterbury, CT; Meriden Hist. Soc.; Robert Hull Fleming Mus., Burlington, VT; Colby Art Mus.; Park Strathmore Gal., Rockford, IL; Marbella Gal.; Grand Central Art Gal.; Art Center, Florence Griswold Mus., both in Old Lyme, CT; Am. Embassy, Rio De Janeiro; Landmann Collection, São Paulo; Thomas Jefferson House, Brasilia; Florence Griswold Mus., Old Lyme, CT. **Comments:** One of the first American Impressionists to paint in South America, living in Brazil with her husband Clement Esmond Paxson, from 1916-21. When she returned to the United States she taught painting in Vermont and Connecticut. She traveled throughout her life and produced more than 2,000 paintings and continued to paint until the last year of her life. In 1971 she married Chester H. Du Clos. **Positions:** lecturer/instructor, NAD; NAWA; Frick Mus.; Nassau Inst. Art; "Highfields," Weston, VT (summers, 1936-41); Am. School, Rio de Janeiro; Bell Art Lg. (1948-49); Creative Arts School, New York; Art Classes, Central Park (1944-45); artist's studio, Kew Gardens, NY. **Writer/Illustr.:** *Brazilian American* (Rio de Janeiro). **Contrib.:** articles, *Woman's Home Companion, American Magazine.* She was also the author of five books, including *My Love Affair with Brazil* (1968); *Sonnets and Other Poems* (c.1969). **Sources:** WW59; WW47; Pisano, *One Hundred Years.the National Association of Women Artists,* 76.

PAXSON, Gordon *[Painter] mid 20th c.*
Exhibited: AIC, 1935. **Sources:** Falk, *AIC.*

PAXSON, Martha K. D. *[Miniature painter] b.1875, Phila.*
Addresses: Phila., PA. **Studied:** W. Sartain; Daingerfield. **Sources:** WW15.

PAXTON, Eliza *[Watercolor painter] early 19th c.*
Addresses: Philadelphia, 1814-16. **Comments:** Painted primitive still lifes in watercolor. **Sources:** G&W; Lipman and Winchester, 178.

PAXTON, Elizabeth Okie (Mrs. William M.) *[Painter] b.1877, Providence, RI. / d.1971.* *Elizabeth Paxton*
Addresses: Boston, Newton Centre, MA. **Studied:** W.M. Paxton. **Member:** Boston GA; North Shore AA. **Exhibited:** PAFA Ann., 1910-41; Corcoran Gal. biennials, 1912-41 (6 times); Pan-Pacific Expo, San Fran., 1915, North Shore AA, 1927 (prize); Jordan Marsh Gal., Boston, 1933; WFNY, 1939. **Sources:** WW40; Petteys, *Dictionary of Women Artists; Falk, Exh. Record Series.*

PAXTON, Fanny Leckey *[Landscape painter] late 19th c.*
Work: Univ. Virginia (view of Natural Bridge). **Sources:** Wright, *Artists in Virginia Before 1900.*

PAXTON, W(illiam) A. *[Painter, etcher] early 20th c.*
Addresses: Los Angeles, CA. **Member:** Calif. AC; P&S Los Angeles. **Sources:** WW25; Hughes, *Artists of California,* 427.

PAXTON, William McGregor *PAXTON-1908*
[Portrait, mural & genre painter, etcher, lithographer, teacher] b.1869, Baltimore, MD / d.1941.
Addresses: Newton Centre, MA. **Studied:** Cowles Art Sch., Boston, with D. M. Bunker; Tarbell, Benson & DeCamp in Boston; Acad. Julian, Paris, 1889-90, 1892; Ecole de Beaux-Arts, Paris, with Gérôme. **Member:** ANA, 1917; NA, 1928; SC; NAC; Copley Soc., 1894; Boston GA; St. Botolph Club, Boston; Phila. AC; Allied AA; AFA. **Exhibited:** Boston AC, 1895-1903; AIC, 1897-1926; PAFA Ann., 1898-1941 (prizes, 1915, 1921; gold medal, 1928); Pan-Am. Expo, Buffalo, 1901; St. Louis Expo, 1904 (medal); Corcoran Gal. biennials, 1907-41 (17 times); Pan-

Pacific Expo, San Fran., 1915; other Corcoran Gal. exhs., 1919 (prize), 1935 (prize); Indianapolis MA, 1979 (retrospective). **Work:** BMFA; PAFA; MMA; Army & Navy Club; CGA; Cincinnati Mus.; Detroit Inst. Art; Wadsworth Atheneum, Hartford, CT; St. Louis Art Mus.; El Paso (TX) Mus. Art; Butler AI, Youngstown, OH. **Comments:** One of the leading Boston School painters, along with Edmund Tarbell, Frank W. Benson, and Philip Leslie Hale. Paxton was particularly well-known for his extraordinary attention to the effects of light and to the details of flesh and fabric, as seen in his idealized paintings of young women in beautiful interiors. He also gained fame for his portraits, which included depictions of Grover Cleveland and Calvin Coolidge, and many Philadelphians (he was informally called the "court painter of Philadelphia"). Painted at Fenway Studios, Boston, 1906-15. **Teaching:** BMFA Sch., 1906-13. **Sources:** WW40; Baigell, *Dictionary;* Ellen Wardwellber, *William McGregor Paxton, 1869-1941* (exh. cat., Indianapolis Mus. of Art, 1979); Gerdts, *American Impressionism,* 207-14; Gammell, *The Boston Painters,* 109-22; Vose Galleries, *Mary Bradish Titcomb and Her Contemporaries,* 33; *300 Years of American Art,* 627; Falk, *Exh. Record Series.*

PAXTON-CAMPON, Frances (Miss) *[Painter] late 19th c.; b.Philadelphia, PA.*
Addresses: Paris, 1889. **Studied:** Bouguereau; Robert-Fleury; Benjamin-Constant. **Exhibited:** Paris Salon, 1889. **Sources:** Fink, *Am. Art at the 19th c. Paris Salons,* 378.

PAYANT, Felix *[Writer, lecturer, educator] b.1891, Faribault, MN.*
Addresses: Columbus, OH; Las Vegas, NV. **Studied:** Univ. Minnesota; PIA Sch.; Columbia Univ. (B.S.). **Comments:** Teaching: Ohio State Univ.; Syracuse Univ.; New Mexico Highlands Univ., to 1958. Conducts art study courses in Mexico each summer. Publications: ed., *Design* magazine, 1920-49; auth., *Our Changing Art Education,* 1935; *Design Technics; Create Something.* Lectures: "Design and People." **Sources:** WW59; WW47.

PAYEN, Cecile E. *[Painter] 19th/20th c.; b.Dubuque, IA.*
Addresses: Chicago, IL. **Studied:** NYC; Paris. **Exhibited:** Paris Salon, 1887; AIC, 1892-98; Columbian Expo, Chicago, 1893 (med.). **Sources:** WW01; Fink, *Am. Art at the 19th c. Paris Salons,* 378.

PAYETTE, Madeline See: **FERRARA, Madeline Payette**

PAYNE, Abigail Mason *[Primitive watercolorist] early 19th c.*
Addresses: Active in Granby, MA, 1802-08. **Sources:** Petteys, *Dictionary of Women Artists.*

PAYNE, Alfred *[Portrait painter] b.c.1815 / d.1893.*
Addresses: Active in Ohio, Wisconsin, and elsewhere for over forty years. **Studied:** Christopher P. Cranch. **Sources:** G&W; Barker, *American Painting,* 403.

PAYNE, Amy Gertrude *[Miniature painter] early 20th c.*
Addresses: Phila., PA. **Sources:** WW10.

PAYNE, Arthur H. *[Painter] early 20th c.*
Addresses: Chicago, IL. **Member:** Chicago NJSA. **Sources:** WW25.

PAYNE, Aurelia De Walt *[Painter] mid 20th c.*
Addresses: San Francisco & Los Angeles, CA. **Exhibited:** Los Angeles City Hall, 1932, 1935 (mem. exh.). **Sources:** Hughes, *Artists of California,* 427.

PAYNE, C. B. *[Painter] late 19th c.*
Exhibited: Mechanics' Inst., 1893. **Comments:** Specialty: watercolors. **Sources:** Hughes, *Artists of California,* 427.

PAYNE, Charles *[Engraver] mid 19th c.*
Addresses: Pawtucket, RI, 1857. **Comments:** In 1857 was in partnership with Jude Taylor in firm of Payne & Taylor. **Sources:** G&W; Pawtucket and Woonsocket BD 1857.

PAYNE, Edgar Alwin *EDGAR PAYNE*
[Landscape painter, muralist]
b.1882, Washburn, MO / d.1947, Hollywood, CA.
Addresses: Chicago, IL, 1921-25; NYC in 1934; Los Angeles, CA by 1941. **Studied:** chiefly self-taught; AIC. **Member:** SC; Allied AA; Int. Soc. AL; Calif. AC; Ten Painters of Los Angeles; Laguna Beach AA; Chisel Club, 1913; Chicago Soc. Artists; AAPL; Carmel AA. **Exhibited:** Calif. State Fairs, 1917 (prize), 1918 (prize); Sacramento State Fair, 1918 (gold); Sacramento, 1919 (medal); LACMA, 1919 (solo), 1926 (gold medal); AIC, 1920 (prize); Southwest Mus., 1921 (prize); PAFA Ann., 1921-22, 1925; Paris Salon, 1923; NAD, 1929 (prize); GGE, 1939; Calif. AC, 1947 (prize). **Work:** murals, Empress Theatre & Am. Theatre, both in Chicago; Clay County Court House, Brazil, IN; Hendricks County Court House, Danville, IN; Queen Theatre, Houston; Nebraska AA, Lincoln; Peoria Soc. Allied Artists; Herron AI; Mun. Art Comn.; Janesville (WI) AA; Southwest Mus., Los Angeles; Pasadena Art Mus.; Pasadena Art Inst.; Springville (UT) Mus. Art; Univ. Nebraska Gals.; NAD; AIC; Indianapolis Mus. **Comments:** He left home at age 14, traveling from the Ozarks through Mexico, earning his way by painting houses, stage sets and signs.His first visit to California was in 1909 and in 1917 he returned to Glendale, CA with a commission for a giant mural for the Congress Hotel in Chicago, which was fulfilled with the help of several of his friends. Payne traveled in Europe in the 1920s, where he won honorable mention at the Paris Salon. When he returned he wrote a book on landscape painting, and produced a color motion picture called *Sierra Journey*. A lake in the High Sierra is named for him. **Sources:** WW40; Hughes, *Artists of California*, 427-428; P&H Samuels, 363; Falk, *Exh. Record Series*.

PAYNE, Eloisa R. *[Engraver] early 19th c.*
Comments: One of the first American woman engravers.
Sources: G&W; Stephens, *The Mavericks*, 58.

PAYNE, Elsie Palmer (Mrs. Edgar A.) *[Painter, teacher, lecturer] b.1884, San Antonio, TX / d.1971, Minneapolis, MN.*
Addresses: Los Angeles, CA. **Studied:** Best's Art Sch., San Francisco; Chicago Acad. FA. **Member:** Laguna Beach AA (a founder); Women Painters of the West (a founder); Calif. Art Club; Calif. WCS; Artists of the Southwest; Soc. for Sanity in Art; Nat. Soc. Arts & Letters; AAPL. **Exhibited:** AIC, 1913, 1916; Paris, 1925; NAWA, 1930; NAD, 1930; Ebell Club, Los Angeles, 1932-42, 1943 (prize); Calif. WCS; Riverside Mus., 1944; 1941-43; Laguna Beach AA, 1951 (prize); LACMA, 1941, 1942 (prize) 1943, 1944 (prize); Calif. AC, 1943 (prize); Greek Theatre, Los Angeles, 1948 (prize), 1949 (prize); Pasadena AI, 1950 (prize); Laguna Beach Art Festival, 1952 (prize). **Work:** public schools in Laguna Beach, Los Angeles; bronze plaque, entrance to Laguna Beach Art Gal. **Comments:** Married Edgar Payne (see entry) in 1912; they lived on the East and West coast, traveling and exhibiting for two years in Europe, 1922-24. They permanently moved to Beverly Hills in 1932 and separated the following year. Publisher/distr.: *Composition of Outdoor Painting*, by Edgar A. Payne. Founder: Elsie Palmer Art Sch., Beverly Hills, 1934. **Sources:** WW59; WW47. More recently, see Hughes, *Artists of California*, 428; Trenton, ed. *Independent Spirits*.

PAYNE, Emma Lane (Mrs.) *[Painter, teacher] b.1874, Canada.*
Addresses: Euclid, OH. **Studied:** Cleveland Sch. Art; L. Ochtman. **Member:** Women's AC. **Exhibited:** Cleveland Art Mus. **Comments:** Specialty: animal portraits. **Sources:** WW40.

PAYNE, George Hardy *[Designer, craftsperson] b.1872 / d.1927.*
Addresses: Hawthorne, NJ. **Comments:** Founder: Payne Studios, one of the largest designers of stained glass in the U.S.

PAYNE, George Kimpton *[Designer, painter, graphic artist, sculptor, craftsperson, illustrator] b.1911, Springville, NY.*
Addresses: Arlington, VA. **Studied:** ASL with George Bridgman, Allen Lewis, Thomas Benton. **Exhibited:** Award: Int. Silk Assn.,

1958. **Work:** 200 animal drawings, U.S. Govt. **Comments:** Position: scientific artist, Nat. Zoo Park, Wash., DC, 1936; advertising artist, 1937-43; USNR terrain map model maker, 1943-45; mgr., displays, des., Woodward & Lothrop, Wash., DC, 1950-. Contrib.: *New Yorker*. **Sources:** WW59; WW47.

PAYNE, George N. *[Painter] mid 20th c.*
Exhibited: AIC, 1937. **Sources:** Falk, *AIC*.

PAYNE, Henry *[Crayon artist] mid 19th c.*
Addresses: NYC, 1844-48. **Exhibited:** Am. Inst., NYC, 1844. **Sources:** G&W; Am. Inst. Cat., 1844; NYCD 1847-48.

PAYNE, Henry Charles *[Landscape painter, critic] b.1850, Newburyport, MA / d.1916.*
Addresses: Chicago, IL. **Member:** Chicago SA; Chicago WCC. **Exhibited:** AIC, 1888-1915. **Comments:** Position: art critic, *Chicago Inter-Ocean*. **Sources:** WW15.

PAYNE, James *[Painter] early 20th c.*
Addresses: Phila., PA. **Sources:** WW04.

PAYNE, James *[Engraver] mid 19th c.*
Addresses: Lowell, MA, active 1834-37. **Sources:** G&W; Belknap, *Artists and Craftsmen of Essex County*, 4.

PAYNE, James A. *[Artist] late 19th c.*
Addresses: Wash., DC, active 1895. **Sources:** McMahan, *Artists of Washington, D.C.*

PAYNE, Jeanne See: **JOHNSON, Jeanne Payne (Mrs. Louis C.)**

PAYNE, John (B.) *[Painter, sculptor, graphic artist, educator] b.1932, Pontotoc, MS.*
Studied: Beloit (WI) College (B.A., 1959); Univ. Wisconsin (M.S., 1961; M.F.A., 1969); Univ. Kansas, 1965-66. **Member:** College AA Am.; Nat. Endowment for Humanities (dir., 1972). **Exhibited:** Atlanta Univ., 1959, 1963-64 (prize, graphics), 1965 (prize, watercolor), 1966 (sculpture); Beloit College, 1959 (also solo), 1968 (solo); Univ. Wisconsin, 1961 (solo), 1969; Langston Univ., 1961 (solo); Wisconsin State Fair, Milwaukee, 1961(award); Oklahoma AC, 1962; Bazza Gal., OK, 1962 (solo); Southern Univ., New Orleans, 1964 (solo), 1967; Baton Rouge Gal., 1967-71 (also solos); Louisiana State Univ., 1968 (solo); Stillman College, AL, 1970 (solo); Oklahoma City Univ. traveling show, 1962; Mulvane Arts Mus., Topeka, 1962; Masur Mus., Monroe, LA, 1964; Int. Exh. African Peoples Art, Los Angeles, 1968. **Awards:** Morse Found. Grants, 1958-59; Southern Fellowship Found. Grant, 1968. **Work:** Beloit College; Beloit State Bank; Univ. Wisconsin; Union College; Loyola Univ.; Stillman College; Atlanta Univ.; Kansas Univ.; Louisiana Nat. Bank; Fidelity Nat. Bank; Southern Univ.; Baton Rouge Gal.; Louisiana State Univ. **Sources:** Cederholm, *Afro-American Artists*.

PAYNE, John Barton *[Patron] b.1855, Prunytown, VA (now WV) / d.1935, Wash., D. C.*
Comments: The John Barton Payne Collection of Paintings presented to the Commonwealth of Virginia, consisting of fifty-one works by the Old Masters and the "Madonna of the Rappahannock" by Gari Melchers, is housed at Battle Abbey, Richmond. A contribution of one hundred thousand dollars from Judge Payne insured the building of the Virginia State Museum. He restored the historic St. John's Church in Washington. Among his bequests was the Payne collection of etchings and twenty-five thousand dollars to the University of Virginia.

PAYNE, John M. *[Listed as "artist"] b.c.1829, England.*
Addresses: NYC in 1860. **Sources:** G&W; 8 Census (1860), N.Y., XLVIII, 72.

PAYNE, Lan *[Painter] b.1948.*
Addresses: San Francisco, CA, 1975. **Exhibited:** WMAA, 1975. **Sources:** Falk, *WMAA*.

PAYNE, Leslie J. *[Sculptor] b.1907 / d.1981.*
Comments: African-American sculptor.

PAYNE, Lura M. *[Painter] early 20th c.*
Exhibited: Calif. State Fair, 1930; Kingsley AC, 1931-33.
Sources: Hughes, *Artists of California*, 428.

PAYNE, M. H. (Mrs.) *[Painter] late 19th c.*
Addresses: San Francisco, CA, 1880s. **Exhibited:** San Francisco AA, 1885; Calif. State Fair, 1888. **Sources:** Hughes, *Artists of California*, 428.

PAYNE, Paul T. (Mrs.) *[Sculptor, lecturer] mid 20th c.*
Addresses: Indianapolis, IN. **Member:** Indiana AC; PAFA (fellow); Indiana Fed. AC; Phila. Art All.; Indianapolis AA. **Exhibited:** Hoosier Salon, 1937 (prize); Indiana AC, 1938 (prize), 1939 (prize); Indiana Fed. AC, 1939 (prize). **Sources:** WW40.

PAYNE, Pauline *[Painter] early 20th c.*
Addresses: Los Angeles, CA. **Member:** Calif. AC. **Sources:** WW25.

PAYNE, Ruth See: **BURGESS, Ruth Payne (Mrs. John W.)**

PAYNE, William H. *[Critic] b.1834, Leicester, England / d.1905.*
Addresses: NYC. **Member:** Union Lg. Club. **Comments:** Came to U.S. in 1853 and is said to have become devoted to the advancement of American art.

PAYNE & TAYLOR *[Engravers] mid 19th c.*
Addresses: Pawtucket, RI, active 1857. **Comments:** Partners were Charles Payne and Jude Taylor. **Sources:** G&W; Pawtucket and Woonsocket BD 1857.

PAYNTER, G. J. *[Painter] late 19th c.*
Addresses: Phila., PA. **Exhibited:** PAFA Ann., 1892. **Sources:** Falk, *Exh. Record Series*.

PAYOR, Eugene *[Painter, designer, lecturer, comm a] b.1909, NYC.*
Addresses: NYC. **Studied:** Univ. California; ASL with John Stuart Curry, Jean Charlot, Raphael Soyer. **Exhibited:** All. Artists Am.; WMAA; Salons of Am.; S. Indp. A.; VMFA; SFMA; Univ. Georgia, 1944 (solo). **Awards:** prizes, Art Dir. Club, NY; Lithographers Nat. Assn.; Southampton Mus. Art. **Comments:** Teaching: Univ. Georgia, Athens,, 1943-45. **Sources:** WW59; WW47.

PAYSON, Charles S. (Mr. & Mrs.) *[Collectors] b.1898, Portland, ME.*
Addresses: Manhasset, NY. **Studied:** Yale Univ. (grad., 1921); Harvard Univ. (LL.B., 1924). **Comments:** Collection: contemporary art. **Sources:** WW73.

PAYZANT, St. George Charles *[Painter, illustrator] b.1898, Halifax, Canada / d.1980, Newport Beach, CA.*
Addresses: Los Angeles, CA. **Studied:** England; Canada; Chouinard Art Sch. **Member:** Calif. WCS; AWCS. **Exhibited:** P&S Los Angeles, 1931; Artists Fiesta, Los Angeles, 1931. **Comments:** Position: illustr., children's books. **Sources:** Hughes, *Artists of California*, 428.

PAZOLT, Alfred Joseph *[Painter] b.1872, Boston, MA.*
Addresses: Cornwall, England. **Studied:** P. Jansen in Düsseldorf, Germany. **Sources:** WW13.

PEABODY, Amelia ("Amy") *[Sculptor] b.1890, Marblehead Neck, MA / d.1984.*
Addresses: Boston, MA. **Studied:** BMFA Sch. with Charles Grafly; Archipenko Sch. Art; Northeastern Univ. (hon. D.F.A.). **Member:** Boston Sculpture Soc.; North Shore AA; Guild Boston Artists; AAPL; Boston AC; AFA; NAWA; NSS; New England Sculptors Assn.; Copley Soc. **Exhibited:** PAFA Ann., 1922-34; AIC, 1932; Boston Sculpture Soc.; Jr. Lg. Nat. Exh. (prize); Garden Club Am., (Mrs. Oakleigh Thorne Medal); WFNY, two years; WMAA, 1940; CI, 1941; NAWA, 1953; Guild Boston Artists, Boston, MA, 1970s. **Work:** End of an Era (marble), Mus. FA, Boston, MA; "Boy with Cat (stone), Children's Medical Center, Boston; plastic fox, Audubon Soc. Laughing Brook

Reservation. **Commissions:** Victory Medal, Joslin Clinic, Boston; baptismal font, church in Oxford, MA; portrait plaque of Dr. Hsein Wu, Harvard Medical Sch., Cambridge, MA; "Woodchucks & Pheasants", cast stone for entrance gate of Groton Mem. Park, MA; granite setter in animal graveyard for Mrs. Frank C. Paine, Wayland, MA. **Comments:** Preferred media: stone, bronze, ceramics. Teaching: chmn. arts & skills, Am. Red Cross, Boston. **Sources:** WW73; WW47; Falk, *Exh. Record Series*.

PEABODY, Elizabeth *[Painter] b.1885 / d.1974.*
Addresses: Active in Doylestown, PA; Baltimore, MD. **Exhibited:** Erwinna, PA. **Sources:** Petteys, *Dictionary of Women Artists*.

PEABODY, Emma Clara Peale (Mrs. James) See: **PEALE, Emma Clara**

PEABODY, Evelyn *[Sculptor] early 20th c.*
Addresses: Phila., PA. **Exhibited:** PAFA Ann., 1924, 1929-30. **Comments:** Affiliated with PAFA. **Sources:** WW25; Falk, *Exh. Record Series*.

PEABODY, Franklin Winchester *[Engraver, cameo cutter] b.1826, Whitehall, NY.*
Exhibited: PAFA, 1851 (cameos). **Comments:** Married in Blackwoodtown (NJ) in 1851. His children were born at Camden (NJ), 1852; Kingston (Ontario, Canada), 1854 and 1856; Springmills (NJ), 1858; Woodbury (N.J), 1861; Kingston (Ontario), 1863; Wilton (Ontario), 1868; and Toledo (OH), 1870. He served with the New Jersey Volunteers in the Civil War and was wounded at the siege of Richmond (VA). **Sources:** G&W; Peabody, *Peabody (Paybody, Pabody, Pabodie) Genealogy*, 348-49; Rutledge, PA.

PEABODY, Grace Allen *[Painter] 20th c.*
Addresses: NYC. **Member:** S. Indp. A. **Sources:** WW25.

PEABODY, Helen See: **GRANT, Helen Peabody (Mrs.)**

PEABODY, Helen Lee (Mrs. Robert S.) *[Painter] b.1879, NYC.*
Addresses: NYC. **Studied:** W. Chase; G. deF. Brush. **Member:** NAWPS; AWCS. **Exhibited:** Salons of Am., 1934; NAWPS, 1936, 1937, 1938; AWCS, 1939; NYWCC, 1939. **Sources:** WW47.

PEABODY, John O. (Mrs.) *[Artist] late 19th c.*
Addresses: Active in Hanover, MI. **Exhibited:** Michigan State Fair, 1875-77. **Sources:** Petteys, *Dictionary of Women Artists*.

PEABODY, L(ucy) L(effinwell) Johnson (Mrs.)
[Miniature painter] b.1855, Quincy, MA / d.1935, Monterey Peninsula, CA.
Addresses: Cambridge, MA, 1913; Toledo, OH, 1915-17; Quincy, MA, 1919; Monterey Peninsula, CA. **Exhibited:** AIC; Carmel Arts & Crafts Club, 1920; Ebell Club, 1927-29. **Awards:** Calif. SMP, 1927, 1929. **Sources:** WW19; Hughes, *Artists of California*, 428.

PEABODY, M. M. *[Stipple engraver] mid 19th c.*
Addresses: Utica, NY, 1835. **Sources:** G&W; Stauffer.

PEABODY, Marian Lawrence *[Painter, sculptor] b.1875, Boston.*
Addresses: Boston, MA/Bar Harbor, ME. **Studied:** Hale, Benson & Tarbell at Boston MFA Sch.; sculpture with Frederick Allen & Richard Recchia. **Exhibited:** NSS; Copley Gal., Boston, 1911, 1916 (solo); Doll & Richards, Boston, 1924-38 (five solos). **Work:** portrait head, Lawrence College, Appleton, WI; Groton (MA) Sch.; Episcopal Theological Sch., Cambridge, MA; portrait, Univ. Kansas, Lawrence. **Comments:** Preferred media: pastel, watercolor. Began sculpting after 1914. **Sources:** WW40; Petteys, *Dictionary of Women Artists*.

PEABODY, Mary E. *[Painter] early 20th c.*
Addresses: Phila., PA. **Exhibited:** PAFA Ann., 1925. **Sources:** WW25; Falk, *Exh. Record Series*.

PEABODY, Mary Jane (Mrs.) See: **DERBY, Mary Jane**

PEABODY, Mildred *early 20th c.*
Exhibited: Salons of Am., 1932. **Sources:** Marlor, *Salons of Am.*

PEABODY, Robert E. *[Marine painter] late 18th c.*
Comments: Active c.1797. **Sources:** Brewington, 295.

PEABODY, Ruth Eaton Colburn (Mrs.) *[Painter, sculptor, teacher] b.1898, Highland Park, IL / d.1966, Laguna Beach, CA.*
Addresses: Laguna Beach, CA. **Studied:** AIC (sculpture); with her mother, Elanor Colburn (see entry). **Member:** Calif. AC; San Diego AC; Laguna Beach AA. **Exhibited:** AIC, 1909 (at age 11, as Ruth Colburn); PPE, 1915; West Coast Artists, Los Angeles, 1926 (gold); Calif. State Fair, 1926 (prize), 1937 (prize); Laguna Beach AA, 1927 (prize), 1936 (prize), 1937 (prize); Riverside County Fair, 1928 (prize), 1930 (prize); San Diego FA Gal., 1928 (prize), 1929 (prize), 1931 (prize); Pasadena AI, 1930; Los Angeles County Fair, 1931 (prize); PAFA, 1931; Oakland Art Gal., 1932;Phila. Art All.; GGE, 1939; Crocker Art Gal., Sacramento; Calif. AC. **Work:** San Diego Mus.; Laguna Beach AA; drinking fountain opposite the Laguna Beach Art Gal.; monument, City of Laguna Beach; plaque, Anaheim H.S.; Hoag Memorial Hospital, Newport Beach, CA. **Comments:** She and her mother Elanor Colburn (see entry) moved to Laguna Beach in 1924 and opened a studio where they painted and taught. Peabody painted in oil and watercolor (portraits, abstracts, gardens) and sculpted fountains, memorial plaques, figures, and animals. Also known as Ruth Eaton Colburn. **Sources:** WW47; Hughes, *Artists in California* (provides death date of Oct. 22, 1966); P&H Samuels, 363-64; Trenton, ed. *Independent Spirits,* 75; Petteys, *Dictionary of Women Artists;* Falk,*AIC.*

PEABODY, Sophia Amelia *[Landscape painter, illustrator] b.1811, Salem, MA / d.1871, London, England.*
Studied: Boston; Washington Allston; Chester Harding; Thomas Doughty. **Comments:** Youngest of the famous Peabody sisters of Salem (MA). Began painting early in her life, as a diversion to illness; she later painted as a means of helping support her family. In 1842 she married Nathaniel Hawthorne, some of whose books she illustrated, as well as books by Bronson Alcott. **Sources:** G&W; Tharp, *The Peabody Sisters of Salem;* Hawthorne, *Nathaniel Hawthorne and His Wife;* Swan, BA; Petteys, *Dictionary of Women Artists.*

PEABODY, William F. *[Engraver] early 20th c.*
Addresses: Wash., DC, active 1905. **Sources:** McMahan, *Artists of Washington, D.C.*

PEABODY, William W. *[Craftsperson] b.1873, Gardner, MA.*
Addresses: Amesbury, MA. **Studied:** T. Resterich. **Member:** Boston SAC (master craftsman); Phila. ACG. **Comments:** Position: in charge of Peabody Craft Shop, hand-made solid silver flat ware, Amesbury, MA. **Sources:** WW40.

PEACE *[Engraver] mid 19th c.*
Comments: Engraver of one illustration in *A Universal History of the U.S.A.* (Buffalo, 1833). *Cf.* Pease. **Sources:** G&W; Hamilton, *Early American Book Illustrators and Wood Engravers,* 114.

PEACEY, Jess Lawson (Mrs.) *[Sculptor] early 20th c.*
Addresses: NYC. **Member:** NSS. **Exhibited:** PAFA Ann., 1927 (prize). **Sources:** WW47; Falk, *Exh. Record Series.*

PEACHEY, (Mrs.) *[Teacher] mid 19th c.*
Addresses: Charleston, SC. **Comments:** Teacher of the art of "imitating flowers. in wax," at Charleston in 1837. **Sources:** G&W; Rutledge, *Artists in the Life of Charleston.*

PEACOCK *[Portrait painter] 18th c.*
Addresses: Active in New England, 18th century. **Work:** Am. Antiquarian Soc., Worcester, MA, has two portraits "John Bush" and "Mrs. Charles Bush" which are attributed to Peacock. **Sources:** G&W; Fielding.

PEACOCK, Claude *[Illustrator, commercial artist, painter, teacher, cartoonist] b.1912, Selma, AL.*
Addresses: Montgomery, AL. **Studied:** Huntingdon College,

Montgomery, AL. **Member:** Alabama Art Lg. **Exhibited:** Army Artists Comp., Jefferson Barracks, MO, 1942 (prize); Army Artists Exh., Atlanta, GA, 1945; Alabama Art Lg., 1946 (prize). **Work:** Archives & History Dept., State of Alabama; WMAA; Montgomery Mus. FA; murals, Napier Field Army Air Base, Dothan, AL. **Comments:** Position: wild life artist, Dept. of Conservation, State of Alabama. Illustr.: covers for *Am. Druggist, Outdoorsman;* color work for *Life* magazine. **Sources:** WW59; WW47.

PEACOCK, Henry W. *[Painter] mid 20th c.*
Addresses: Bala-Cynwyd, PA. **Exhibited:** PAFA Ann., 1950-51. **Sources:** Falk, *Exh. Record Series.*

PEACOCK, Jean Eleanor (Mrs. Lewis M. Knebel) *[Painter, graphic artist, teacher] mid 20th c.; b.Norfolk, VA.*
Addresses: Arlington, VA. **Studied:** Longwood College (B.S.); Columbia Univ. (M.A.); State Teachers College, Farmville, VA; ASL; E. O'Hara; G. Cox; Arthur Young; Harry Wickey; B. Makielski; C. Martin; Edwin Ziegfeld. **Member:** AAPL; Virginia All. Artists; Richmond Acad. Artists; SSAL; Southern PM; NAWA; Virginia Educ. Assn.; NAEA; Eastern AA. **Exhibited:** NAWA, 1945-46; VMFA, 1945; Irene Leach Mem. Mus., 1945; Virginia Intermont College, 1945-46; SSAL, 1935 (prize). **Comments:** Her name sometimes appears as King (married to William C. King) and Knebel (when married to Lewis M. Knebel). Teaching: Pub. Sch., Norfolk & Richmond, VA; Fredericksburg, VA; summers, Radford College, William & Mary College, Wilson Teachers College; hd. dept., George Washington H.S., Alexandria, VA; Elementary Schs., Alexandria, VA. **Sources:** WW59; WW47.

PEACOCK, John *[Amateur artist] late 18th c.*
Addresses: Maryland. **Comments:** An English convict servant who twice ran away from Elk-Ridge, Anne Arundel County (MD) in 1775. Though a shoemaker by trade, he was described as "very officious in showing his skill in drawing pictures and making print letters, pretends to understand the painting business. " **Sources:** G&W; *Maryland Gazette,* March 30 and Sept. 21, 1775 (cited in "Sill Abstracts").

PEACOCK, Jon (Edward) *[Designer, etcher, illustrator] b.1908, NYC.*
Addresses: Hermosa Beach, CA. **Studied:** G. Ennis; Arshile Gorky; F. Monhoff; C. Cartwright. **Comments:** Position: set designer, 20th Century Fox. **Sources:** WW40.

PEACOCK, Sarah Brooks *[Portrait painter] 19th/20th c.; b.Phila., PA.*
Addresses: Wash., DC, 1892 until at least 1920. **Studied:** Acad. Julian, Paris; Corcoran Sch. Art. **Exhibited:** Paris; Munich; Florence; Rome. **Sources:** McMahan, *Artists of Washington, D.C.*

PEAK, Robert (Bob) *[Illustrator] b.1928, Colorado.*
Addresses: Kansas; California; NYC. **Studied:** Univ. Wichita (geology); AC Sch., Los Angeles. **Member:** SI (Hall of Fame, 1977). **Exhibited:** SI (gold medals); Art Dir. Club; Artists Guild, NYC, 1961 (Artist of the Year). **Comments:** Illustr.: *The Ladies' Home Journal, Esquire;* illustr., over 40 covers for *Time* magazine; adv. illustr., *Samsonite Luggage,* etc. he also did paintings for more than 100 movies, incl. *Apocalypse Now, My Fair Lady,* and others and designed the U.S. Olympic postage stamps. **Sources:** W & R Reed, *The Illustrator in America,* 303.

PEAKE, Channing *[Painter, muralist] b.1910, Marshall, CO / d.1989, Santa Barbara, CA.*
Addresses: Los Angeles, CA. **Studied:** Calif. College Arts & Crafts, 1928; Santa Barbara Sch. Art, 1929-31; ASL with Rico Lebrun, 1935-36. **Exhibited:** Univ. Illinois, 1953 & 1955; Santa Barbara Mus. Art, 1953 & 1956; PAFA Ann., 1954; Colorado Springs FA Center; Corcoran Gal. biennial, 1957; LACMA. **Work:** Santa Barbara Mus. Art. Commissions: murals (with Louis Rubenstein), Germanic Mus., Harvard Univ., 36 (with Rico Lebrun), Penn Station, NYC, 1936-38 (with Howard Warshaw), Santa Barbara Pub. Lib., 1958. **Comments:** Positions: founder,

Santa Barbara Mus. Art. **Sources:** WW73; Falk, *Exh. Record Series.*

PEAKE, Katherine *early 20th c.*
Exhibited: Salons of Am., 1932; S. Indp. A., 1932, 1933.
Sources: Falk, *Exhibition Record Series.*

PEALE, Anna Claypoole *[Miniaturist, portrait & still life painter] b.1791, Philadelphia / d.1878, Phila.*
Addresses: Phila. **Member:** PAFA, 1824 (she & her sister Sarah Miriam Peale were the first women elected academicians).
Exhibited: PAFA, 1811-42; Boston Atheneum, 1831; Centennial Exhs.: Louisville, KY, 1874, San Fran. & Phila., 1876. **Work:** Penn. Hist. Soc. ; Maryland Hist. Soc.; Cincinnati Art Mus.; MMA (Gloria Manney Coll.); Yale Univ. Art Gal.; Worcester Art Mus.; Montclair Art Mus. **Comments:** Daughter of James Peale (see entry) and granddaughter of James Claypoole (see entry). She specialized in romantic, sophisticated portrait miniatures and was in great demand in her lifetime. She advertised her services and traveled (often with her sister Sarah) to fulfill commissions in Boston, Baltimore, and New York. She occasionally worked in Wash., DC, where she painted Andrew Jackson (1819, now in Yale Univ. Art Gallery) and attended receptions with her uncle Charles Willson Peale at the White House. She also assisted her father James with his miniatures and backgrounds on canvases as his eyesight began to fail. She was married twice; in 1829, to the Rev. Dr. William Staughton (a scholar), who died just three months after they were married; and in 1841, to General William Duncan. Her work in miniature declined about 1841 and it is presumed that she turned her attention to painting on canvas. More than two hundred miniatures have been identified, most of them signed. **Sources:** G&W; DAB; Sellers, *Charles Willson Peale,* II, 416; Rutledge, PA; Swan, BA; Rutledge, MHS; Born, "Female Peales"; Pleasants, *250 Years of Painting in Md.,* 25. More recently, see Rubinstein *American Women Artists* 49; Miller, ed. *The Peale Family,* 228-237 (w/repros.). See Charles Willson Peale entry for archival information.

PEALE, Benjamin Franklin See: **PEALE, Franklin**

PEALE, Charles Willson *[Portrait & miniature painter, engraver, museum proprietor, scientist, inventor] b.1741, Chester, Queen Anne's County, MD / d.1827, Philadelphia, PA.*
Addresses: Phila. **Studied:** apprenticed to a saddler and wood carver in Annapolis, MD, 1761 (went into saddling business on his own in 1762); self instruction & 3 painting lessons with John Hesselius, Annapolis, MD; Benjamin West in London, 1767.
Member: Columbianum; Am. Philosophical Soc.; PAFA; Am. Acad. FA. **Exhibited:** Columbianum, 1795; PAFA, 1811-28, 1849, 1862, 1876-79, 1905; Brooklyn AA, 1872 (portraits); "The Peale Family: Creation of a Legacy," NPG, 1997. **Work:** Peale Mus., Baltimore; PMA; PAFA; Independence Hall portrait coll., now at Second Bank, Phila.; Princeton Univ.; MMA; NYHS; Wash. & Lee Univ. (Peale's first portrait of G. Washington, 1772); Brooklyn Mus.; Shelburne (VT) Mus.; State House, Annapolis, MD; DIA. **Comments:** Peale's interest in art began after 1761, when he bought himself several instruction books and art materials and took three art lessons from John Hesselius. In 1765, financial problems forced him to leave Annapolis briefly for Boston,where he met and was further encouraged by John Singleton Copley and John Smibert. On his return to Annapolis, his ambitions in art drew the attention of a group of planters who provided him with funds to study in England in 1767. After working in West's studio and studying the Italian masters, Peale returned to Annapolis in 1769. There he began fulfilling portrait commissions, also traveling to Baltimore, Philadelphia, and Williamsburg (VA) in 1774 and 1775; and in 1772 to Mount Vernon, where he painted the first of his many life portraits of Washington. Hoping to find more commissions, Peale moved to Philadelphia in 1775. Soon after, he joined the militia, serving for three years and fighting with Washington at the battles of Trenton and Princeton. During this period he also found time to produce a

series of miniatures of army personnel and leaders. Peale settled back in Philadelphia in 1778 and continued his portrait painting, traveling often to Baltimore and to Maryland's eastern shore. Among his most significant works during these years was his full-length "Washington After the Battle of Princeton, January 3, 1777" (now at Princeton Univ.), commissioned in 1779 by the Supreme Executive Council of Pennsylvania. Peale's cultural interests went beyond painting: he was concerned with natural science and history, and above all, with the education of the American public, believing this was of the utmost importance in the new democratic republic. In 1782, he opened a picture gallery in his home for the public; and in 1784, he founded his Philadelphia Museum (located first at Philosophical Hall; then moved to what is now Independence Hall, and finally to the "Arcade"), with the intention of showing to the public the "world in miniature" (quoted in Miller, ed., *The Peale Family: Creation of a Legacy,* p. 265) through the presentation of natural history specimens, special scientific exhibits, lectures, and concerts. The first of its kind in America, Peale displayed the specimens in open glass cases and situated the mounted and stuffed animals in front of painted backdrops that simulated their natual habitats (these were designed by Peale and his family). Included in the museum was a gallery of famous Americans featuring 250 portraits painted by Peale. The museum gained great notoriety and publicity in 1801 when Peale and family unearthed the bones of the pre-historic creature that came to be known as the mastedon (in Newburgh, NY, 1801). Among Peale's other endeavors were his failed attempt to establish an art academy in 1791; his founding, in 1794, of the first society of artists in U.S.—the short-lived Columbianum (the society held one exh. in 1795, at which Peale exhibited his famous trompe-l'œil "Staircase Group"); and, in 1805, his participation in establishing the Pennsylvania Academy of Fine Arts. From 1810-21, Peale lived as a gentleman-farmer on his estate "Belfield" outside of Philadelphia, although he still painted and consulted with his son Rubens, who was running the Phila. museum. Peale returned to Phila. in 1821 and took over management of the museum. Peale's interest in art education extended to teaching his children. From his three marriages—in 1762 to Rachel Brewer, in 1791 to Elizabeth DePeyster, and in 1805 to Hannah Moore—he fathered 17 children, including Raphaelle, Rembrandt, Rubens, Franklin, and Titian Ramsay Peale, all of whom became well-known artists. His brother James was also an artist. **Sources:** G&W; The earliest study is Charles Coleman Sellers, *Charles Willson Peale,* in 2 volumes (Phila., American Philosophical Society, 1947), which is supplemented by Sellers' 1952 checklist, *Portraits and Miniatures by. Charles Willson Peale,* published as Volume 42, Part 1, of the *Transactions* of the American Philosophical Society. The major archival manuscript source for Charles Willson Peale and family is the microfiche edition, with Guide and Index of *The Collected Papers of Charles Willson Peale and His Family,* ed., Lillian Miller (Millwood, NY: Kraus Microform, 1980); selections from this have been published in the seven-volume edition of the *Selected Papers of Charles Willson Peale and His Family* (four volumes had been published as of 1996). There have been many scholary studies devoted to the Peale family; an excellent bibliographical essay is included in the 1997 exhibition catalogue edited by Lillian B. Miller, *The Peale Family: Creation of a Legacy, 1770-1870* (Abbeville Press in association with The Trust for Museum Exhibitions and the National Portrait Gallery, Smithsonian Inst., 1997)

PEALE, Emma Clara *[Painter] b.1814.*
Exhibited: Am. Acad., 1835; Artists' Fund Soc. & at PAFA, 1840 ("View of the Wissahiccon," after Russell Smith, and "Head of a Terrier."). **Comments:** Daughter of Rembrandt Peale. She married James A. Peabody in 1838 and Caleb D. Barton in 1845.
Sources: G&W; Sellers, *Charles Willson Peale,* II, 419; Cowdrey, AA & AAU; Rutledge, PA; Rubinstein, *American Women Artists,* 50.

PEALE, Franklin *[Medallist, museum manager] b.1795, Philadelphia / d.1870, Phila.*

Addresses: Phila. **Studied:** apprenticed to machine factory; trained by his father in museum mangagement. **Exhibited:** Columbianum, 1795. **Comments:** Son of Charles Willson Peale, he was named Benjamin Franklin Peale, although he was later known as Franklin. He worked at an uncle's cotton mill in the Brandywine River Valley after the War of 1812. His marriage in 1815 to Eliza Greatrake was met with disdain by both families and soon after his wife was placed in the Pennsylvania Hospital (as a mental patient) for four years, after which Charles Willson Peale had the marriage annulled. He assisted his father and brothers at the Peale Museum for a number of years and was named manager by 1821. He lectured at the Franklin Inst. in Phila. from 1831-33. In the latter year Franklin Peale resigned his position as manager of his father's museum to take a position at the U.S. Mint in Philadelphia, serving first as assistant assayer and later (1840-54) as Chief Coiner. It was during this period that he executed President Polk's Indian medal (reproduced in Loubat). A musician and scientist, he also wrote songs and did experiments in steam. In his later years Franklin Peale served as President of the Hazleton Coal and Railroad Company, the Musical Fund Society, and the Pennsylvania Institution for Instruction of the Blind. He also published articles on coinage and minting issues, and archaeology. **Sources:** G&W; Sellers, *Charles Willson Peale*, II, 382-83, 415; Loubat, *Medallic History of the U.S.*, plate 59. More recently, see Miller, ed. *The Peale Family*, 25, 27, 39, 116-17, 189. See Charles Willson Peale entry for archival information.

PEALE, Harriet Cany (Mrs. Rembrandt) *[Portrait & still life painter]* *b.c.1800 / d.1869, Phila., PA.*

H. C. Peale.

Addresses: Phila., PA. **Exhibited:** Artists' Fund Soc., 1840; PAFA, 1840 (as Miss Harriet Cany), 1848-65 (as Mrs. Rembrandt Peale). **Comments:** Born Harriet Cany, she married Rembrandt Peale in November 1840 (she was his second wife). The couple established a studio in Philadelphia. Harriet Cany Peale painted portraits, figurative works, and still lifes, and, after her marriage, also made copies after her husband's work. **Sources:** G&W; 7 Census (1850), Pa., LI, 686 [age 50]; 8 Census (1860), Pa., LV, 793 [age 61]; Rutledge, PA; Sellers, *Charles Willson Peale*, II, 419; Born, "Female Peales: Their Art and Its Tradition"; *American Collector* (Dec. 1941), 3, repro; Petteys, *Dictionary of Women Artists;* Miller, ed. *The Peale Family*, 37. See Charles Willson Peale entry for archival information.

PEALE, Helen *[Painter, sculptor] early 20th c.* **Exhibited:** WMAA, 1920-1927. **Sources:** Falk, *WMAA.*

PEALE, J. M. (Miss) See: **PEALE, Sarah Miriam**

PEALE, James *[Miniature, portrait, still-life, and landscape painter] b.1749, Chestertown, MD / d.1831, Philadelphia.*

Jas Peale

Addresses: Philadelphia. **Studied:** apprenticed to a cabinetmaker-carpenter in Charlestown, Md., 1765; began studying in his brother Charles' studio in Annapolis, Md., by 1771. **Exhibited:** Columbianum, 1795; PAFA, 1811-62, 1911 (miniature exh.), 1923 (portraits by Charles W., James and Rembrandt Peale); BMA, 1823; Boston Athenaeum. **Work:** American Philosphical Society, Phila. (James Peale's Sketchbook); PAFA; Hist. Soc. Penn. Houston Mus. FA; Wash. Co. Mus. FA; Md. Hist. Soc.; Colonial Williamsburg Foundation, VA; Utah Mus.FA; CGA; J.B. Speed Mus., Louisville, KY; Cincinnati Art Mus.; AGAA; Worcester Art Mus. **Comments:** Younger brother of Charles Willson Peale. After serving with the Continental Army during the Revolution, he settled in Philadelphia in 1779 and married Mary Claypoole (daughter of painter James Claypoole) in 1782. For the next several years he and Charles attempted a working relationship in which they split their commissions; thereafter, however, they worked separately, still maintaining a close family relationship. James' career was rich and varied; he painted landscapes early in his career—his first known pure landscape ("Pleasure Party by Mill," Houston MFA) was painted about 1790—and he turned again to the subject late in his career when he and his brother Charles sketched together at various sites. In the 1780s James painted a number of can-

vases portraying historical scenes, most relating to the Revolution, including "The Generals at Yorktown" (Colonial Williamsburg). Peale's reputation, however, was built on his watercolor miniature portraits, for which he is considered among the best of his contemporaries. During his lifetime he produced over 200 portraits, receiving commissions from and for the social, political, and military elite. Peale also painted portraits in oil and is believed to have made about 75 in his career. After 1823, perhaps because of failing eyesight, Peale turned his focus from miniatures to still-life painting (he had exhibited his first in 1795, at the Columbianum), producing a notable body of fruit pieces which he showed frequently from 1823. Like his brother Charles, James involved his family in the art of painting. Of his six children, five are known to have painted: Maria, James, Anna Claypoole, Margaretta Angelica, and Sarah Miriam (see entries). **Sources:** G&W; Sellers, *Charles Willson Peale;* DAB; Rutledge, PA; Rutledge, MHS; Swan, BA; Brockway, "The Miniatures of James Peale," contains a checklist and 14 repros.; Sherman, "Two Recently Discovered Portraits in Oils by James Peale," with 4 repros. and checklist of oil portraits; Baur, "The Peales and the Development of American Still Life"; exhibition catalogues of the Peale exhibitions at the Penna. Academy (1923), Century Association (1953), and Cincinnati Museum of Art (1954, Flexner, *The Light of Distant Skies.* More recently, see Linda Crocker Simmons' chapter in "James Peale: Out of the Shadows," in Miller, ed. *The Peale Family;* Strickler, *American Portrait Miniatures*, 98-99. See Charles Willson Peale entry for archival information.

PEALE, James, Jr. *[Landscape, marine & still life painter] b.1789, Philadelphia / d.1876, Phila.* **Addresses:** Phila. **Exhibited:** PAFA, 1813-29, 1856-63. **Comments:** He was the only son of James Peale and, unlike his sisters, did not pursue art as a profession (he worked in a bank) although he did exhibit paintings throughout his life. In 1822 he married Sophonisba, daughter of Raphaelle Peale. **Sources:** G&W; CAB; Sellers, *Charles Willson Peale*, 338, 344, 416; Rutledge, PA; Miller, ed. *The Peale Family*, 13, 223. See Charles Willson Peale entry for archival information.

PEALE, John T. See: **PEELE, John Thomas**

PEALE, Margaretta Angelica *[Still life & portrait painter] b.1795, Philadelphia / d.1882, Phila.* **Addresses:** Phila. **Studied:** James Peale. **Exhibited:** Artists' Fund Soc. & PAFA, 1828-37, 1865; Boston Atheneum, 1830. **Work:** PAFA; Smith College Mus. Art, Northampton, MA; George Washington Univ. (several portraits). **Comments:** Daughter of James Peale (see entry). Began painting independent still lifes by c.1813, producing some illusionistic types ("Catalogue, A Deception," c.1813, in a private collection) as well as fruit compositions. Though few in number, her still lifes have been highly regarded by 20th century scholars. Peale also painted portraits beginning about 1828. She never married and at her death was sharing a home with her sister Sarah (see entry). **Sources:** G&W; Sellers, *Charles Willson Peale*, II, 416; Rutledge, PA; Phila. BD 1838; Born, "Female Peales: Their Art and Its Tradition"; McCausland. "American Still-life Paintings," repro. More recently, see Rubinstein *American Women Artists* 64; Miller, ed. *The Peale Family*, 224-27; Baigell, *Dictionary.* See Charles Willson Peale entry for archival information.

PEALE, Maria *[Still life painter] b.1787, Philadelphia / d.1866, Phila.* **Addresses:** Phila. **Exhibited:** PAFA, 1811 ("Fruit Piece," described as first attempt, now unlocated). **Comments:** Daughter of James Peale. No works have been located although there has been one attribution. **Sources:** G&W; Sellers, *Charles Willson Peale*, II, 416; Rutledge, PA; Miller, ed. *The Peale Family*, 224, 228, 297 (note 3). See Charles Willson Peale entry for archival information.

PEALE, Mary Jane *[Portrait painter, floral and fruit still life painter, studies of birds] b.1827,*

Mary J Peale

NYC / d.1902, Pottsville, PA.
Addresses: Spent most of her life in Phila. and on the family farm in Pottsville. **Studied:** Rembrandt Peale (her uncle); Thomas Sully; PAFA, 1856-58, and again in 1878 when she was given admission to life classes; Paris, late 1860s. **Work:** Univ. Penn.; Mead Art Mus., Amherst (MA) College; Southern Alleghenies Mus. Art. **Comments:** Daughter of Rubens Peale, whom she encouraged when he began painting late in his life (c.1855). The two are believed to have collaborated on some works (see Sellars, "Rubens Peale"). Mary Jane Peale had a greenhouse on the family farm and specialized in outdoor flower paintings but is also known for her richly textured fruit compositions. **Sources:** G&W; C. Sellars, "Rubens Peale: A Painter's Decade," *Art Quarterly* 43, no.4 (Summer 1960); C. Sellars, *Charles Willson Peale,* II, 420; Born, "Female Peales: Their Art and Its Tradition." More recently, see *Art by American Women:.the Collection of L.and A. Sellars,* 71; Miller, ed. *The Peale Family,* 169-70, 181, 183, 184; Tufts, *American Women Artists, 1830-1930,* cat. no. 86. See Charles Willson Peale entry for archival information.

PEALE, Raphaelle *[Still life, portrait & miniature painter] b.1774, Annapolis, MD / d.1825, Philadelphia.*
Exhibited: Columbianum, 1795; PAFA, 1811-52. **Work:** PMA; PAFA; Carpenters Co., Phila.; Hist. Soc. Penn.; MMA; Brooklyn MA; Newark Mus; Wadsworth Ath.; Nelson-Atkins Mus. Art, Kansa City, MO; Peale Mus., Baltimore; Monticello, Thomas Jefferson Memorial Found., Inc. (silhouette of Jefferson, 1804); Reading (PA) Public Mus.; Munson-Williams-Proctor Inst., Utica, NY; TMA; NMAA. **Comments:** Son of Charles Willson Peale. Began drawing and painting at an early age and by 1794 was receiving portrait commissions. During the 1790s he helped with his father's Phila. museum and collaborated with his brother Rembrandt on many portraits. He also posed with brother Titian in his father's famous "Staircase Group" (PMA) shown at the Columbianum exhibition in Philadelphia in 1795. Shortly thereafter, he and Rembrandt copied a number of their father's portraits of great leaders and took them on tour of Charleston (SC) and Savannah (GA), arriving in Baltimore (MD) in 1797. There the brothers attempted to establish a museum similar to their father's. When this failed several years later, the brothers parted ways; and Raphaelle went back to Philadelphia in 1800 to became his father's chief museum assistant. After a brief trip to England in 1802, Raphaelle returned to the U.S. and went into the profile-cutting business, touring much of the South and New England with the physiognotrace (a copying device) and fulfilling miniature commissions. After a period of financial success, he experienced a downswing, made worse by what apparently became a life-time problem with alcohol and mood swings. Beginning about 1811, Peale turned his focus away from portraiture toward still-life painting. This seemed to bring him much satisfaction despite his father's strong disapproval of his turning away from portraiture. Raphaelle soon achieved a mastery of the genre, especially in his "deceptions." ("Venus Rising from the Sea—A Deception," c.1822, Nelson-Atkins Mus.). His more typical still life, however, was a simple, careful arrangement of fruit, crockery, and sometimes a cake or a wineglass, on top of a shelf. Despite his talent, Peale achieved little commerical success with his still lifes. Peale suffered from gout and various other illnesses from about 1817, but continued to travel; visiting Norfolk, VA, in 1817, and Annapolis, Baltimore and the eastern shore of Maryland in 1820. **Sources:** G&W; Sellars, *Charles Willson Peale;* Bury, "Raphaelle Peale (1774-1825) Miniature Painter," with 8 repros. and checklist; Baur, "The Peales and the Development of American Still Life"; Rutledge, PA; Cowdrey, AA & AAU; Rutledge, *Artists in the Life of Charleston; Richmond Portraits;* DAB; McCausland, "American Still-life Paintings," repro.; Flexner, *The Light of Distant Skies.* More recently see Baigell, *Dictionary;* Gerdts, *Painters of the Humble Truth,* 51-60; Lillian B. Miller, "The Peales and their Legacy, 1735-1885," 29-34, and Brandon Brame Fortune, "A Delicate Balance: Raphaelle Peale's Still-Life Paintings and the Ideal of Temperance," both in Miller,

ed. *The Peale Family.* See Charles Willson Peale entry for archival information.

PEALE, Rebecca Burd See: **PATTERSON, Rebecca Burd Peale**

PEALE, Rembrandt *[Portrait, miniature and historical painter, lithographer, author] b.1778, on a farm in Bucks County, PA / d.1860, Philadelphia, PA.*
Addresses: Baltimore, 1814-20; Boston, 1825-28; Phila., from 1831 (made several trips to Europe). **Studied:** with his father; Royal Acad. with Benjamin West, London, 1802-03; Paris, 1807, 1808-10. **Member:** NA (founding mem., 1826-27, 1835-38; prof., 1828-34, 1838-60); PAFA (a founder). **Exhibited:** Columbianum, 1795; PAFA, 1811-65, 1905; NAD, 1826-60; Brooklyn AA, 1872, 1912 (portraits); PAFA, 1923 (mem. exh.). **Work:** Peale Mus., Balt.; PAFA; Hist. Soc. Penn.; NYHS; Detroit Inst. Art; BM; Old Dartmouth Hist. Soc.; Mead Art Mus., Amherst College, MA; NPG, Wash., DC; NMAA; LACMA; U.S. Senate Coll.; White House Coll. **Comments:** The son of Charles Willson Peale, he was probably the most ambitious of his father's children. He painted his first portrait at the age of thirteen; and in 1795, completed the first of his life portraits of George Washington (Hist. Soc. of Penn.). On his European sojourn, he lived in Paris 1808-10, studying the old masters and absorbing the lessons of neoclassicism from Jacques-Louis David. Filled with inspiration to become a history painter, Peale returned to Philadelphia and exhibited "The Roman Daughter" (1811, NMAA), which to his dismay drew criticism for being inappropriate subject matter. About the same time he tried and failed to establish an art gallery, the Apollodorian, in Philadelphia. Disappointed, Rembrandt moved to Baltimore and founded the Baltimore Museum in 1814, basing it on his father's model for a natural history museum and adding an art gallery of his own works as well. He concentrated his efforts there for several years, but after incurring severe financial losses from the panic of 1819, he returned to painting and began work on his grand, moralistic painting, "The Court of Death" (Detroit Inst.), a 12-foot by 24-foot canvas which warned of the consequences of giving in to earthly temptations (it was based on a poem by the English Bishop, Beilby Porteus). Rembrandt painted the work with the intention of touring the country and this proved extremely successful, drawing crowds in Baltimore, New York, Boston, Albany, Charleston, and Savannah between 1820-23, and taking in a profit of $4,000 in the first year alone. Peale publicized the work and advertised widely, even contacting ministers to urge their congregations to come to the exhibition. The elaborate painting was accompanied by a pamphlet explaining the meaning, but Peale believed it could be understood on its own terms because he had composed it using gestures, expressions, and physical attributes that would clearly convey the intended message to both the educated and uneducated. Calling this "metaphorical painting," he argued (in his essay, "Original Thoughts on Allegorical Painting," Philadelphia *National Gazette,* October 28, 1820) that other American artists should adapt this democratic theory, rather than using on sophisticated symbolism. Like his father, Peale made such efforts in order to appeal to a broad audience. His second major project in this regard was his long-time effort to establish what he called a national portrait and standard likeness of George Washington. In 1823, he painted the first of his well-known "porthole" portraits of the former president and tried to convince Congress to endorse this as the national image. Although this failed, the image had wide, enduring appeal and he would paint over 78 versions in his lifetime. In the last decade of his life, he delivered many lectures on Washington, illustrating them with his own paintings. It is for his portraits that Peale is most highly regarded; his attention to character and his rigorous study of coloring and glazing techniques resulted in luminous portraits of his contemporaries, most notably Thomas Jefferson (1805, NYHS). He painted close to a thousand portraits in his lifetime. Peale's contribution to art education was his popular pamphlet "Graphics: A Manual of Drawing and Writing, for the Use of Schools and Families" (1835) which was published in

many editions and used by high school teachers for many years. Peale published his memoirs, "Reminiscences," in *The Crayon* in 1855-56 (volumes 1-3). Other writings: "Notes on Italy" (Phila., 1832). **Sources:** G&W; Sellers, *Charles Willson Peale;* DAB; Rutledge, PA; Rutledge, MHS; Cowdrey, AA & AAU; Cowdrey, NAD; Swan, BA; Rutledge, *Artists in the Life of Charleston;* 7 Census (1850), Pa., LI, 686; 8 Census (1860), Pa., LV, 793; Flexner, *The Light of Distant Skies,* biblio., 264. More recently, see Lillian B. Miller, with an essay by Carol E. Hevner, *In Pursuit of Fame: Rembrandt Peale, 1778-1860* (Wash., DC and Seattle: Univ. of Washington Press for the National Portrait Gallery, 1992); Miller, ed. *The Peale Family;* Pierce & Slautterback, 179 (on Peale as a lithographer working for the Pendletons in Boston, 1825-28); Blasdale, *Artists of New Bedford,* 141-42 (w/repro.); *300 Years of American Art,* vol. 1, 84; Falk, *Exh. Record Series.* See Charles Willson Peale entry for archival information.

PEALE, Rosalba Carriera *[Painter]* b.1799 / d.1874.
Addresses: Philadelphia. **Member:** NA, 1828 (hon. mem., prof.). **Exhibited:** Artists' Fund Soc., PAFA, 1840 ("Italian Sunset" after Keyserman). **Comments:** Daughter of Rembrandt Peale (whose portrait of her, dated 1820, is at the NMAA). She married John A. Underwood in 1860. **Sources:** G&W; Sellers, *Charles Willson Peale,* II, 419; Rutledge, PA; Clark, *History of the NAD,* 266. See Charles Willson Peale entry for archival information.

PEALE, Rubens *[Museum manager, still life and animal painter]* b.1784, Philadelphia / d.1865, Phila.
Addresses: Pottsville (near Schuylkill Haven), PA; Phila. **Studied:** as a young man was trained by his father in museum mangagement, learning programming, taxidermy, and the painting of habitat scenery; studied painting and drawing with daughter, Mary Jane Peale, beginning about 1855; one of the Moran brothers (prob. Edward) later taught him some painting techniques. **Work:** Detroit Inst. Art; BMFA; Muson-Williams-Proctor Inst. Mus. Art, Utica, NY; Shelburne (VT) Mus.; Davenport (IA) Mus. Art. **Comments:** Son of Charles Willson Peale. There has been speculation that poor eyesight prevented him from becoming a professional painter, although this is unconfirmed. From 1810-22 he was in charge of the Philadelphia Museum founded by his father; from 1822-25 he ran the Baltimore Museum; and from 1825-37 he managed the Peale Museum in NYC, where he prospered until the panic of 1837 and the subsequent economic depression. Forced to relinquish the museum in 1842 (Phineas Barnum purchased the collection in 1849), he retired to his father-in-law's property in Pottsville, PA, and raised fruits and vegetables. He began painting about 1855 and was given instruction by his daughter Mary Jane Peale (see entry). Rubens produced about 135 paintings, mostly landscapes and still-lifes, some of which were of his own design but about one-third of which were copies after other family members (he also copied the work of contemporaries William E. Winner and Edward Moran). His own still lifes included fruit and floral subjects, but he is also recognized for his paintings of game birds in their natural settings (he made a series of fourteen bird pictures, 1860-65). In 1864, Rubens moved from his farm back to Philadelphia. **Sources:** G&W; C. Sellars, "Rubens Peale: A Painter's Decade," *Art Quarterly* 43, no. 4 (Summer 1960); C. Sellers, *Charles Willson Peale;* Karolik Cat., 446-48; Detroit Institute *Bulletin* (April 1944), 58; Muller, *Paintings and Drawings at the Shelburne Museum,* 100 (w/repro.); *300 Years of American Art,* vol. 1, 98; Paul Schweizer, "Fruits of Perseverance: The Art of Rubens Peale, 1855-1865," in Miller, ed. *The Peale Family,* See Charles Willson Peale entry for achival information.

PEALE, Sarah Miriam *[Portrait and still life painter]* b.1800, Philadelphia / d.1885, Phila.
Addresses: Phila. through 1831; Baltimore, MD, 1831-47; St. Louis, MO, 1847-77; Phila., 1877-on. **Studied:** James Peale, her father. **Member:** PAFA (she & her sister Anna Claypoole Peale were the first women elected academicians in 1824). **Exhibited:** PAFA, 1817-31; Missouri Bank, St. Louis, 1846 (Senator T.H. Benton, Congressman Caleb Cushing, Senator Lewis Fields Linn); Western Acad. Art, St. Louis, 1860; Missouri Sanitary Fair, 1864; frequently at the annual agricultural & mechanical fairs, St. Louis, 1850s-60s (prizes, 1859, 1861-62, 1866-67). **Work:** Nat. Portrait Gal., Wash., DC; Peale Mus., Baltimore; Brazilian Embassy Coll., Wash., DC; Missouri Hist. Soc., St. Louis; VMFA; San Diego Mus. Art; Nat. Mus. Women in the Arts. **Comments:** Daughter of James Peale (see entry) and niece of Charles Willson Pearle (see entry) who encouraged and sponsored her at important social events in Wash., DC. During the 1820s, she and her sister Anna traveled frequently from Phila. to Baltimore, fulfilling portrait commissions from leading families and political and military leaders in both cities. For a brief time the sisters worked on a collaborative venture in which Anna would complete the miniature portrait and Sarah the canvas version of the same person, but the two tired of this by the mid 1820s. Sarah moved to Baltimore about 1831, remaining there until about 1847 and rising to become one of that city's leading portraitists. She also painted in Wash., DC, in these years, producing a number of portraits of politicians and diplomats (Caleb Cushing, Thomas Hart Benton, Henry Alexander Wise) and gaining the respect and familiarity of the politicians by attending sessions of Congress. Peale excelled at still-life, usually choosing fruit as the subject, and her work was purchased by Robert Gilmor, then the most important collector in Baltimore. In 1847, partly because of ill health, Peale moved from the East to St. Louis, establishing a studio where she continued to paint partraits and still lifes (which received high praise and many prizes in exhibitions). She returned to Philadelphia about 1877 and spent the last years of her life there. **Sources:** G&W; Sellers, *Charles Willson Peale;* Born, "Female Peales: Their Art and Its Tradition"; Rutledge, PA; Rutledge, MHS; Phila. CD 1828; Baltimore CD 1831-45; St. Louis BD 1854; *Richmond Portraits;* Pleasants, *250 Years of Painting in Maryland.* More recently Rubinstein, *American Women Artists,* 46-49; Miller, ed. *The Peale Family,* 237-47; Tufts, *American Women Artists,* cat. nos. 1-5; *300 Years of American Art,* vol. 1, 124. See Charles Willson Peale entry for archival information.

PEALE, Titian Ramsay *[Naturalist, illustrator]* b.1799, Philadelphia / d.1885, Phila.
Studied: served a brief six-month apprenticeship at a spinning factory along the Brandywine (PA) owned by an uncle, 1814; Univ. Pennsylvania (anatomy, taxidermy, specimen drawing). **Member:** Acad. Natural Sciences, Phila. (1817). **Exhibited:** PAFA, 1822 (drawings & watercolors of buffaloes, squirrels, bears & butterflies). **Work:** Am. Philos. Soc., Phila.; Amon Carter Mus.; NGA; AMNH (including scrapbook); NPG, Wash., DC ("Sketch for a Self-Portrait"). **Comments:** Youngest son of Charles Willson Peale (see entry), he was born shortly after the death of his namesake (Titian Ramsay Peale, 1780-98). His career as an artist-naturalist began about 1817 when several of his colored plates were used in Thomas Say's *American Entomology.* He served as naturalist with Long's exploring expedition, 1818-21, to the upper Mississippi and the Rockies, sketching the landscape, plant, and animal life, as well as the native people of the region. On his return he was named assistant manager of the Peale Museum in Phila. (his younger brother Franklin was the manager), and arranged there a display of watercolor specimens from his expedition (these are now at the Am. Philos. Soc.). For the next decade he worked on drawings and paintings for several publications: for additional volumes of Say's *American Entomology* (1824-28); Charles Lucien Bonaparte's *American Ornithology.* (1825-33); and John Davidson Godman's *American Natural History* (1826-1828). As museum conservator, curator, and foreign correspondent, Peale traveled to Florida in 1823 and to the northern region of South America between the fall of 1830 and the spring of 1832 (visiting Columbia in 1831). In 1833, he succeeded his brother Franklin Peale as manager of the Peale Mus. From 1838-42 he traveled as an artist-naturalist with the Scientific

Corps of the Navy for the Charles Wilkes' expedition to the Pacific. Afterward he was sent to Washington, DC, to organize the expedition's collection, and he worked for the next several years writing a report with drawings and illustrations. It was finally published in 1848 (as *Mammalia and Ornithology,* volume 8 of *U.S. Exploring Expedition During the Years 1838, 1839, 1840, 1841, 1842. Under the Command of Charles Wilkes);* but, unfortunately, none of his plates were included and Wilkes determined that it was not scientific enough, pulling the publication and reassigning the task to John Cassin (whose volume was pub. in 1858, using many of Titian's drawings). From 1846-73 Peale worked as assistant examiner at the Patent Office in Wash., DC, and during those years took up photography (see Scrapbook at Am. Mus. of Natural History). He and his wife moved to Holmesburg, PA, in 1873, and finally to Philadelphia in 1877. He died shortly before completion of his important work (and long-term project) on American entomology, *The Butterflies of North America.* **Sources:** G&W; Sellers, *Charles Willson Peale;* DAB; Rutledge, *Artists in the Life of Charleston;* McDermott, "Early Sketches of T.R. Peale"; Rutledge, PA. More recently, see Miller, ed. *The Peale Family,* 38 and 187-201; P&H Samuels, 364-65; McMahan, *Artists of Washington, D.C.; 300 Years of American Art,* vol. 11, 21; Forbes, *Encounters with Paradise.* See Charles Willson Peale entry for archival information.

PEALE, Washington *[Landscape painter] b.1825, Philadelphia / d.1868.*
Addresses: NYC in 1860. **Exhibited:** NAD, 1860 (scene on the Delaware River). **Comments:** Son of James Peale, Jr. **Sources:** G&W; Sellers, *Charles Willson Peale,* II, 416; Cowdrey, NAD; NYCD 1860.

PEANO, Felix *[Sculptor] b.1863, Parma, Italy. / d.1949, Hawthorne, CA.*
Addresses: Hawthorne, CA. **Studied:** Tabacchi Acad. FA, Turin. **Member:** San Fran. AA. **Exhibited:** Mechanics' Inst., 1893; Mark Hopkins Inst., 1898; Calif. Liberty Fair, 1918; P&S Los Angeles, 1920. **Work:** interiors, Spreckels Theatre, San Diego; St. Vincent's Church, Los Angeles; Freeman Church, Inglewood; Quimby Bldg., Los Angeles; Catalina Island, CA busts, arch. sculpture, for many Calif. bldgs. **Comments:** Teaching: Mark Hopkins Inst., San Fran. Peano was a friend of Jack London, who is said to have written "Call of the Wild" in Peano's home in Oakland. **Sources:** WW40; Hughes, *Artists of California,* 429.

PEAR, Charles *[Illustrator] late 19th c.*
Addresses: NYC. **Comments:** Position: staff, *Illustrated American.* **Sources:** WW98.

PEARCE, Alice *[Painter] b.1919, NYC / d.1966, Los Angeles, CA.*
Exhibited: S. Indp. A., 1940. **Sources:** Marlor, *Soc. Indp. Artists.*

PEARCE, Charles Sprague
[Genre and figure painter]
b.1851, Boston, MA / d.1914.
Addresses: Paris, France/Auvers-sur-Oise, France (1884-on). **Studied:** L. Bonnât, in Paris, 1873. **Member:** SAA, 1886; ANA, 1906; Paris SAP; SC, 1900; NIAL. **Exhibited:** Centennial Expo, Phila., 1876; Brooklyn AA, 1877; Boston AC, 1877-1904; Paris Salon, 1876-77, 1879, 1881-96 (med., 1883) 1898-99; PAFA Ann., 1882-1909 (gold medal, 1885); NAD, 1883-92; AIC; Mechanic's Inst., Boston, 1878 (med.), 1884 (gold); Ghent, 1886 (gold); Munich, 1888 (gold); Berlin, 1891; San Fran., 1894 (gold); Atlanta Expo, 1895 (gold); Vienna Staats., 1898 (gold); Pan-Am. Expo, Buffalo, 1901 (med.); Corcoran Gal. annual, 1908. **Awards:** Chevalier of the Legion of Honor, France, 1894; Order of Leopold, Belgium, 1895; Order of the Red Eagle, Prussia, 1897; Order of Dannebrog, Denmark, 1899. **Work:** Buffalo FA Acad.; PAFA; AIC; MMA; LOC (6 lunette murals). **Comments:** Pearce was one of the leading American expatriate painters in Paris, along with J.S. Sargent, J.L. Stewart, M. Ramsey, E.H. Blashfield, and F. Bridgeman. In both style and subject matter, he was one of the most successful followers of Jules Bastien-Lepage and Jules

Breton. Signature note: He usually signed his full name in block letters, but occasionally signed in cursive or used his "CSP" within an inverted triangle monogram. **Sources:** WW13; Fink, *Am. Art at the 19th c. Paris Salons,* 378-79; *300 Years of American Art,* vol. 1, 509; Falk, *Exh. Record Series.*

PEARCE, Edgar Lewis *[Painter] b.1885, Phila., PA.*
Addresses: Phila., PA; Manasquan, NJ. **Studied:** PM Sch. IA; PAFA with W. Chase, C. Beaux, J.A. Weir. **Member:** Union Int. des Artes et Lettres, Paris; Manasquan River Group Artists. **Exhibited:** PAFA Ann., 1910, 1913; Spring Lake, NJ, 1945 (prize); AIC. **Sources:** WW47; Falk, *Exh. Record Series.*

PEARCE, Elizabeth J. *[Painter] early 20th c.*
Addresses: Baltimore, MD. **Sources:** WW25.

PEARCE, Ethel *[Painter] mid 20th c.*
Addresses: San Francisco, CA. **Exhibited:** GGE, 1939; San Fran. AA, 1940. **Sources:** Hughes, *Artists of California,* 429.

PEARCE, Fred E. *[Painter] early 20th c.*
Addresses: Chicago/Williamsburg, IN. **Sources:** WW10.

PEARCE, George E. *[Engraver, sketch artist, comm artist] b.1889, New Orleans, LA / d.1976.*
Addresses: New Orleans, active 1910-55. **Exhibited:** New Orleans Art Lg., NOAA, Arts & Crafts Club, 1920s-40s. **Comments:** Illustr. for Stanley C. Arthur's book "Old New Orleans", 1936. **Sources:** *Encyclopaedia of New Orleans Artists,* 293-94.

PEARCE, Glenn Stuart *[Painter, drawing specialist, teacher] b.1909, Erie, PA.*
Addresses: Erie, Chester Springs, Phila., PA. **Studied:** Ericson; Garber; Pearson; Harding; PAFA. **Exhibited:** Erie AC, 1929 (prize), 1930 (prize), 1931; PAFA Ann., 1930-34, 1943. **Sources:** WW40; Falk, *Exh. Record Series.*

PEARCE, Hart L. *[Engraver] mid 19th c.*
Addresses: Chicago, 1858-59; NYC, 1859. **Sources:** G&W; Chicago BD 1858-59; NYBD 1859. *Cf.* Hartell Pierce.

PEARCE, Helen Spang Ancona (Mrs. Thomas M.)
[Painter, designer, illustrator, teacher] b.1895, Reading, PA.
Addresses: Albuquerque, NM, in 1964. **Studied:** Phila. Sch. Des. for Women (now Moore Inst. Art, Science & Indust.); Univ. New Mexico, 1941, with Raymond Jonson, Kenneth Adams, Randall Davey; Pasadena City College with Kenneth Nack; George Bridgman; Henry B. Snell; Leopold Seyffert; Lucile Howard. **Member:** Las Artistas (a founder). **Exhibited:** Nat. Lg. Am. Pen Women, 1950, 1952; Terry AI, 1952; Roswell Mus. Art, 1953; P&S of the Southwest, 1943-54; New Mexico Artists, 1955; Mus. New Mexico traveling exh., 1948-50; New Mexico State Fair, 1942-54; Jonson Gal., 1942-55; All-Albuquerque Artists, 1950-55; Mus. New Mexico, 1943 (solo), 1946 (solo), 1951 (solo). **Awards:** prizes, New Mexico State Fair, 1942-45, 1957; Nat. Mus., Wash., DC, 1950, 1952. **Comments:** Illustr.: "Southwesterners Write," 1946. Work reproduced in *Art Digest* and *School Arts* magazines. **Sources:** WW59; Eldredge, et al., *Art in New Mexico, 1900-1945,* 205.

PEARCE, Jessica L. *[Artist, china painter] d.1909, Wash., DC.*
Addresses: Wash., DC, active 1897-1905. **Sources:** McMahan, *Artists of Washington, D.C.*

PEARCE, Mary Blake (Mrs. R. B.) *[Portrait painter, designer, illustrator] b.1890, Cuero, TX.*
Studied: Berlin & Paris, 1911-14; ASL. **Sources:** Petteys, *Dictionary of Women Artists.*

PEARCE, W. H. S. *[Painter] b.1864 / d.1935.*
Addresses: Newton, MA. **Exhibited:** Boston AC, 1891-1900. **Sources:** WW01; *The Boston AC.*

PEARCE, William See: **PIERCE, William, Jr.**

PEARL, Annie C. *[Painter] late 19th c.*
Exhibited: Calif. State Fair, 1888. **Sources:** Hughes, *Artists of*

California, 429.

PEARL, Julia *[Painter] mid 20th c.*
Addresses: NYC; Redwood City, CA. **Exhibited:** PAFA Ann., 1950, 1960. **Sources:** Falk, *Exh. Record Series.*

PEARL, Sarah Wood *[Portrait painter] early 19th c.*
Addresses: Active in Vermont, 1819. **Comments:** Painted a watercolor portrait of Park Wood in 1819, owned in 1941 by private collector in Rutland (VT). **Sources:** G&W; WPA (Mass.), *Portraits Found in Vermont.*

PEARLMAN, Henry *[Collector] b.1895, NYC / d.1974.*
Addresses: NYC. **Member:** Art Collectors Club. **Comments:** Collection: Impressionist and post-impressionist paintings, including works by Cezanne, Van Gogh, Lautrec, Modigliani, Soutine and Lipchitz. **Sources:** WW73.

PEARLSTEIN, Philip *[Painter, educator] b.1924, Pittsburgh, PA.*
Addresses: NYC. **Studied:** Carnegie Inst. with Sam Rosenberg, Robert Lepper & Balcomb Greene (B.F.A., 1949); Inst. FA, NY Univ. (M.A.) 1955. **Exhibited:** WMAA, 1955-72 (8 biennials), 1970 ("22 Realists"); Univ. Illinois, 1965, 1967, 1969; Corcoran Gal. biennial, 1967; Vassar College, 1968; Smithsonian, circulated Latin Am., 1968-70; "Aspects of A New Realism," Milwaukee AC, 1969; Univ. Georgia, 1970; Allan Frumkin Gal., NYC, 1970s. **Awards:** Fulbright fellowship to Italy, 1958-59; Nat. Endowment Arts grant, 1969; Guggenheim fellowship, 1971-72. **Work:** WMAA; MoMA; NY Univ.; Newark Mus.; Milwaukee (WI) AC; Hirshhorn Coll.; James Michener Found.; AIC; Speed Mus., Louisville, KY; Des Moines (IA) AC. **Comments:** Calling himself a "post-abstract realist," he is best-known for his monumental nudes. Pearlstein's nudes are usually shown under harsh lighting—as unidealized objects, and arranged in awkward, unsensuous poses or cut off in some way by the frame. Teaching: Pratt Inst., 1959-63; Brooklyn College, 1963-70s. **Sources:** WW73; Baigell, *Dictionary;* Linda Nochlin, *Philip Pearlstein* (exh. cat., Univ. Georgia, 1970); Allen S. Weller, *The Joys and Sorrows of Recent American Art* (Univ. Illinois Press, 1968); Udo Kultermann, *The New Painting* (1969); *Radical Realism* (1972, Praeger); Ellen Schwartz, "A Conversation with Philip Pearlstein," *Art in Am.* (Sept.-Oct., 1971).

PEARMAN, Katharine K. (Mrs. Arthur) *[Painter, lecturer, teacher] b.1893, Beloit, WI / d.1961, Rockford, IL.*
Addresses: Rockford, IL. **Studied:** Joseph A. Fleck; Hugh Breckenridge; Grant Wood; Francis Chapin. **Member:** Chicago SA; Rockford AA; Contemp. Art Group; Chicago AC. **Exhibited:** NAD, 1944; Grand Rapids, Mich., 1940; PAFA Ann., 1941; Corcoran Gal. biennial, 1941; Carnegie Inst., 1941, 1943; Rockford AA, 1927-46 (prizes: 1927, 1930-31, 1934-35, 1937, 1939, 1942-43) ; AIC, 1929, 1932, 1935, 1940-43, 1945, 1951(prize); Chicago AC, 1952; Burpee Art Gal., 1949, 1951; Wisc. Salon Art, 1939-40, 1942 (prize), 1943 (prize), 1944-45; Milwaukee, WI, 1946. **Work:** Burpee Art Gal., Rockford, IL; Wisc. Union; Abbott Laboratories Coll.; mural, St. Paul's Chapel, Camp Grant, IL. **Comments:** Teaching: Rockford (IL) College, 1943-45. Lectures: contemporary painting. **Sources:** WW59; WW47; Falk, *Exh. Record Series.*

PEARSALL, A. B. (Mrs.) *[Painter] early 20th c.*
Addresses: NYC. **Studied:** ASL. **Member:** S. Indp. A. **Exhibited:** S. Indp. A., 1921-22. **Sources:** WW24.

PEARSON, A. Gwynne *[Painter] early 20th c.*
Addresses: Long Island City, NY, 1930. **Exhibited:** S. Indp. A., 1930. **Sources:** Marlor, *Soc. Indp. Artists.*

PEARSON, Albert R. *[Portrait painter] b.1911.*
Addresses: Chicago, IL. **Studied:** E. Giesbert; AIC; L. Ritman. **Member:** Chicago NJSA. **Work:** White House, Wash., DC. **Sources:** WW40.

PEARSON, Alice Stoddard See: **STODDARD, Alice Kent**

PEARSON, Anton *[Craftsman, painter, portrait painter, sculptor] b.1892, Lund, Sweden.*
Addresses: Lindsborg, KS. **Studied:** Bethany College, Sweden; Lindsborg, KS; Birger Sandzen. **Member:** Smoky Hill AA. **Comments:** Contrib.: *Kansas* magazine; Lectures: woodcarving & hobbies. **Sources:** WW59; WW47.

PEARSON, Charles *[Painter] mid 20th c.*
Exhibited: S. Indp. A., 1935. **Sources:** Marlor, *Soc. Indp. Artists.*

PEARSON, Edwin *[Sculpfor, painter, craftsperson, designer, teacher] b.1889, Yuma County, CO.*
Addresses: Hyde Park,NY. **Studied:** Royal Acad. Art, Munich, Germany; AIC with Harry Wolcott; H. Hahn. **Exhibited:** Salons of Am., PAFA Ann., 1923, 1926-28; NAD; Arch. Lg.; Milwaukee AI (solo); AIC; Swedish-Am. Artists (prize). **Work:** sculpture, Nat. Mus., Wash., DC; Federal Hall, NY; Petersburg (VA) Mus.; Grand Canyon Nat. Park Mus.; Nat. Mus., Munich; State Lib., Weimar, Germany. **Comments:** Position: dir./teacher, Arts & Crafts Gld., New York; manager, San Jose Potteries, San Antonio, TX, 1944-45. Mus. exh. des. specialist & sculptor, Nat. Park Service, Wash., DC, 1950-57. **Sources:** WW59; WW447; Falk, *Exh. Record Series.*

PEARSON, Eleanor Weare *[Painter] 19th/20th c.*
Addresses: NYC; East Gloucester, MA, active 1899-1913. **Member:** NAC. **Exhibited:** Boston AC, 1899. **Sources:** WW13; *The Boston AC.*

PEARSON, Flora M. *[Artist] late 19th c.*
Addresses: Active in Los Angeles, 1891-94. **Sources:** Petteys, *Dictionary of Women Artists.*

PEARSON, Harry *[Engraver] b.c.1824, England.*
Addresses: NYC, 1860. **Sources:** G&W; 8 Census (1860), N.Y., LVII, 883 (his wife and children were all born in England or Scotland, the youngest about 1856).

PEARSON, Henry C. *[Painter] b.1914, Kinston, NC.*
Addresses: NYC. **Studied:** Univ. North Carolina (B.A., 1935); Yale Univ. (M.F.A., 1938); ASL, 1953-56. **Member:** Am. Abstract Artists. **Exhibited:** WMAA, 1960-67; "The Responsive Eye," MoMA, 1965; Corcoran Gal. biennials, 1965 (Kreeger purchase prize); PAFA Ann., 1964, 1968 (prize); "Contemporary Selections," Birmingham (AL) Mus. Art, 1971; Drawings USA 1971, Minnesota Mus. Art, St. Paul, 1971; Color Painting, Amherst (MA) College, 1972; Betty Parsons Gal., NYC, 1970s. Other awards: Tamarind Lithography Workshop, Ford Found., 1964. **Work:** MoMA; MMA; WMAA; Albright-Knox Art Gal., Buffalo; North Carolina Mus. Art, Raleigh. **Commissions:** World Univ. Service (poster); Sixth New York Film Festival, Lincoln Center (poster), List Art Posters, 1965, 1968; Five Psalms (book), Women's Committee, Brandeis Univ., 1969. **Comments:** Preferred media: acrylics, oils. Teaching: New Sch. Social Res., 1973; general critic, PAFA. **Sources:** WW73; Lippard, "Henry Pearson," *Art Int.* (1965); Falk, *Exh. Record Series.*

PEARSON, James Eugene *[Instructor, painter] b.1939, Woodstock, IL.*
Addresses: Ringwood, IL. **Studied:** Northern Illinois Univ. (B.S., educ., 1961; M.S., educ.; M.F.A., 1964); Tyler Sch. Art, Temple Univ.; Ithaca College. **Member:** College AA Am.; Illinois Art Educ. Assn.; Illinois Craftsmen's Council; AFA; Centro Studi E Scambi Internazionali, Rome. **Exhibited:** 21st Am. Drawing Biennial, Norfolk (VA) Mus. Arts & Sciences, 1965; 54th Ann. Exh., AA Newport, RI, 1965; 2 ème Salon Int. de Charleroi, Palais des Beaux Arts, Belgium, 1969; Fifth Int. Grand Prix Painting & Etching, Palais de la Scala, Monte Carlo, Monaco, 1969; 29th Illinois Invitational Exh., Illinois State Mus., Springfield, 1971. **Awards:** best of show award, William Boyd Andrews, 1961; purchase prize, Mr. & Mrs. Allen Leibsohn, 1963; Mary E. Just art award contest, Waukegan *News-Sun*, 1969. **Work:** Northern Illinois Univ., DeKalb; Palais des Beaux Arts, Charleroi, Belgium; Taft Field Campus, Northern Illinois Univ., Oregon, IL; Dixon (IL) State Sch.l; Sch. District 15, McHenry, IL.

Commissions: "Lorado Taft" (bronze relief plaque), Taft Field Campus, Northern Illinois Univ., 1967; "Vicki Unis" (oil portrait), Sarasota, FL, 1969; "Mae Stinespring" (oil portrait), comn. by Harry Stinespring, McHenry, IL, 1969; portraits in oils of Mr. & Mrs. Francis Hightower & Mrs. Nancy Langdon, Algonquin, IL, 1971. **Comments:** Publications: illustr., *McHenry County 1832-1968*, 1968; auth., "A Dream Never Realized," 1969 & auth., "Eagle's Nest Colony," 1970, *Outdoor Illinois*; auth., "Perspective: Outdoor Education from an Artists Point of View," *Journal Outdoor Educ.*, 1971; illustr., *The Rectangle*, 1972. Teaching: Woodstock (IL) H.S., 1961-; McHenry Co. College, Crystal Lake, IL, 1970-. **Sources:** WW73; F. Tramier, "James E. Pearson," *La Révue Moderne* (1965); Sally Wagner, "Volume Tells McHenry History," *Chicago Tribune*, 1969.

PEARSON, Jane (Mrs.) See: **MUMFORD, Jane Jarvis**

PEARSON, John *[Painter, instructor] b.1940, Boroughbridge, Yorkshire.*
Addresses: Oberlin, OH. **Studied:** Harrogate College Art, Yorkshire (nat. dipl. design, 1960); Royal Acad. Sch., London, England (cert., 1963) with Ernst Geitlinger; Northern Illinois Univ. (M.F.A., 1966). **Exhibited:** Four Young Artists, Inst. Contemp. Art, London, 1963; solos: Gal. Muller, Stuttgart, 1964, Gray Gal., Chicago, 1967-68; Paley & Lowe Gal., New York, 1971 & Pollock Gal., Toronto, Canada, 1971. Awards: Austin Abbey traveling fellowship, British Arts Council, 1963; Canadian Council grant, 1970; first prize for painting, CMA, 1972. **Work:** MoMA; Bochumer Mus., Stuttgart, Germany; Pasadena (CA) Mus. FA; Kleye Coll., Dortmund, Germany; Kunstverein, Hannover, Germany. **Comments:** Publications: contrib., "Art: The Measure of Man," *Directions 66/1967*, 1966; contrib., article, *Mus. Educ. Journal*, 1966. Teaching: Univ. New Mexico, 1966-68; NS College Art & Design, Halifax, 1968-70; Cleveland (OH) Inst. Art, 1970-72; Oberlin College, 1972-. **Sources:** WW73; Jock Wittet, Editorial, *Studio Int.* (March, 1968); Harry Bouras, "John Pearson," *Chicago Omnibus (May, 1966); Lizzie Borden: "John Pearson,"* Artforum (Feb., 1972).

PEARSON, Joseph *[Listed as "artist"] mid 19th c.*
Addresses: NYC, 1848. **Sources:** G&W; NYBD 1848.

PEARSON, Joseph O. *[Painter, engraver] d.1917, Little Falls, NJ.*
Addresses: Lived in Brooklyn, NY for twenty years. **Comments:** Specialty: music title pages. Pearson served in the Civil War.

PEARSON, Joseph Thurman, Jr. *[Painter, teacher] b.1876, Germantown, PA / d.1951, Huntington Valley, PA.*
Addresses: Germantown, Huntington Valley, PA. **Studied:** PAFA with W.M. Chase & J.A. Weir, 1897-1900. **Member:** ANA; NA, 1919; T Square Club. **Exhibited:** PAFA Ann., 1904-17, 1925-29, 1937, 1942 (Sesnan med., 1911; Temple gold and Stotesbury prize, 1916; Beck gold, 1917; Pennell med., 1933; mem., 1952); Buenos Aires Expo, Argentina, 1910 (bronze med.); Corcoran Gal. biennials, 1910-43 (8 times); St. Boltolph's Club, Boston, MA, 1911; NAD, 1911 (prize), 1915 (prize), 1918 (gold); Carnegie Inst., 1911 (med.); Pan-Pacific Expo, 1915 (gold); AIC, 1915 (med.), 1918 (prize); Sesqui-Centenn. Expo, Phila., 1926 (gold); Phila. WCC, 1933 (Pennell med.); Religious drawings traveled PAFA, CGA & Univ. NC, 1934; Germantown AA, 1934; Woodmere Art Mus., Chestnut Hill, PA, 1946; Albright Knox Art Gal., Buffalo, NY. **Work:** Univ. Club, Phila.; PAFA; Michener Mus. Art, Doylestown, PA; NAD; Nat. Trust for Hist. Preservation, Chesterwood; Stockbridge, MA; Villanova Univ. Art Coll.; Reading (PA) Mus.; Woodmere Art Mus, Chestnut Hill, PA. **Comments:** Teaching: PAFA, 1909-22, 1924-37, summers of 1929-35. **Sources:** WW47; Danly, *Light, Air, and Color*, 61; Falk, *Exh. Record Series.*

PEARSON, Lawrence E. *[Painter, illustrator] b.1900, Bay City, TX.*
Addresses: Houston, TX. **Studied:** Mus. FA Sch., Houston. F. Browne; A. MacDonald. **Member:** Art Gal., Houston; Sketch Club. **Exhibited:** Houston Mus. FA. **Comments:** Position:

painter, Matteson Southwest Inc., Houston. **Sources:** WW40.

PEARSON, Louis O. *[Sculptor] b.1925, Wallace, ID.*
Addresses: San Francisco, CA. **Exhibited:** Crocker Art Gal., Sacramento, CA, 1966; Joslyn Art Mus., Omaha, NE, 1966; Northern Arizona Univ. Art Gal., 1966. **Work:** Storm King AC, Mountainville, NY; Univ. New Mexico, Albuquerque. **Comments:** Preferred media: stainless steel. **Sources:** WW73.

PEARSON, Marguerite Stuber *[Painter, teacher]* MARGUERITE S PEARSON
b.1898, Philadelphia, PA / d.1978, Rockport, MA.
Addresses: Somerville, MA, through 1925; Rockport, MA (summers from 1920, built home/studio by 1941. **Studied:** BMFA Sch. with Frederick Bosley; privately with Edmund Tarbell, 1922-27; William James; Rockport Summer Sch.; landscape with Aldro T. Hibbard & Harry Leith-Ross; design with Henry Hunt Clark & Howard Giles; illustration with Harold N. Anderson & Chase Emerson. **Member:** Allied Artists Am.; Guild Boston Artists; North Shore AA; Rockport AA; Acad. Artists Soc.; Phila. Art All.; Sanity in Art; Ogunquit AA; SC; CAFA; AAPL; Wash. AC. **Exhibited:** PAFA Ann., 1924-36; Corcoran Gal. biennials, 1926-35 (3 times); NAD, 1925-29, 1931-32, 1934; Springville Art Gal., 1935-42, 1946; All. Artists Am., 1925-46, 1971; New Haven PCC (award), 1932, 1938; CAFA, 1925-32; Jordan Marsh Gal., 1930-46, 1972 (Ann. Exhib. of New England Artists); North Shore AA, 1926-46; Rockport AA, 1923-46 (many medals); Springville, UT, 1937 (prize); NAC, 1966 (prize); AAPL (gold); SC, 1941 (gold); North Shore AA, 1930 (prize), 1972 (mem. prize award); AAPL, 1961(gold medal for best oil painting); Wolfe Art Club, Council Am. Artists Soc., 1970 (award); Ogunquit AC (award); Springfield (MA) Art Mus. (Academic Art); Pierce Gal., Hingham, MA, 1980s. **Work:** Springville (UT) Art Mus.; New Haven Pub. Lib.; Beach Mem. Art Mus., Storrs, CT; Monson (MA) State Hospital; Gardiner (MA) H.S.; Boston Music Sch.; Brigham Young Univ.; Mechanics Bldg., Boston; Episcopal Diocesan House, Boston; Trade Sch. for Girls, and Wilson, Brooks, and Burke Sch., Boston; Grimmins and Chandler Sch., Somerville, MA; Somerville, Medford and Gloucester (MA) City Halls; Case Inst. Tech., Cleveland, Ohio; Draper (UT) School; Salem (MA) Court House; Bruckner Mus., Albion, MI; Case Inst. Technology, Cleveland, OH; Salem (MA) Court House Portrait Coll.; Somerville (MA) City Hall Portrait Coll. **Comments:** Best known for her floral still-lifes and interiors with figures. Confined to a wheelchair from her teenage years due to polio, she worked as a magazine and newspaper illustrator before turning to painting full time c.1922. Her interior genre scenes were reproduced as prints, and during the 1940s she became financially very successful. **Sources:** WW73; WW47; *300 Years of American Art*, vol. 2: 881; Vose Galleries, *Mary Bradish Titcomb and Her Contemporaries*, 46-47; Falk, *Exh. Record Series.*

PEARSON, Mary S. (Mrs.) *[Painter] 19th/20th c.*
Addresses: Saratoga, CA, 1890s-1905. **Exhibited:** Mark Hopkins Inst., 1896-97. **Sources:** Hughes, *Artists of California*, 429.

PEARSON, Molly *[Painter] early 20th c.*
Addresses: NYC, 1924. **Exhibited:** S. Indp. A., 1924. **Comments:** Possibly Pearson, Molly, b. 1896, Edinburgh, Scotland-d. 1959, Sandy Hook, CT. **Sources:** Marlor, *Soc. Indp. Artists.*

PEARSON, (Nils) Anton See: **PEARSON, Anton**

PEARSON, Paul *[Painter] mid 20th c.*
Exhibited: AIC, 1936. **Sources:** Falk, *AIC.*

PEARSON, Ralph M. *[Etcher, lecturer, writer, designer, teacher, critic] b.1883, Angus, IA / d.1958, South Nyack, NY.*
Addresses: Nyack, NY/East Gloucester, MA. **Studied:** AIC with C.F. Browne & Vanderpoel. **Member:** Chicago SE; Am. Artists Congress; ASL, Chicago; Chicago SE; New York SE; Calif. AC; Calif. PM; Calif. SE; Soc. Am. Etchers; Am. Soc. PS&G. **Exhibited:** Chicago SE, 1914 (prizes); Pan.-Pacific Expo, 1915 (medal); Am. Bookplate Soc., 1917 (medal); Calif. PM, 1922;

AIC. **Work:** NYPL; LOC; Mechanics Inst., Rochester; AIC; Los Angeles Mus. Art; Univ. Chicago Lib.; Columbia; Newark Pub. Lib.; Am. Antiquarian Soc. **Comments:** Author: "Experiencing Pictures" (1932), "The New Art Education" (1941), "Fifty Prints of the Year" (for the American Inst. of Graphic Arts, 1927), other books, "Woodcuts" (Encyclopaedia Britannica, 1929). Positions: dir., Design Workshop (School), New York & East Gloucester; art ed., *Forum*, 1936-40; columnist, *Art Digest*, 1945, 1946; **Sources:** WW47; Ness & Orwig, *Iowa Artists of the First Hundred Years* ,163-64.

PEARSON, Robert *[Landscape painter] d.1891, presumably Malden, MA.*
Addresses: NYC, 1860. **Exhibited:** NAD, 1860 ("Bay of New York"); Boston AC, 1877, 1881. **Comments:** Groce & Wallace suggested that this is probably the Robert Pearson who died at Malden (MA) February 12, 1891, and was described as an "artist of much repute" and a well-known resident of Malden. William Pearson (see entry) who lived at the same NYC address in 1860, was probably a relative. **Sources:** G&W; Cowdrey, NAD; Boston *Transcript*, Feb. 12, 1891; *The Boston AC.*

PEARSON, William *[Landscape painter] mid 19th c.*
Addresses: NYC, active 1857-80. **Exhibited:** NAD, 1857-60 (views of New Hampshire, Connecticut & upstate New York), 1877, 1881-82. **Comments:** In 1860 his address in NYC was the same as that given for Robert Pearson (see entry). **Sources:** G&W; Cowdrey, NAD; *The Boston AC.*

PEART, Caroline See: **BRINTON, Caroline Peart (Mrs. Christian)**

PEASE, Alonzo *[Portrait and landscape painter] mid 19th c.*
Addresses: Detroit, MI, 1853-c. 1859; Cleveland, OH, 1859; back to Detroit, 1860-61. **Exhibited:** NAD, 1870-80 (4 annuals); Detroit Art Loan Exh., 1883. **Comments:** Was a prominent portrait painter in Detroit; many of his paintings are still in that city. *Cf.* Hiram Alonzo Pease as cited in Hageman: it is possible they are the same artist because their times do coincide and they were both in Ohio, but more research must be done before that determination can be made. **Sources:** G&W; WPA (Ohio), *Annals of Cleveland;* information cited by G&W as being courtesy Donald MacKenzie, Wooster College (before 1957). More recently, see Gerdts, *Art Across America*, vol 2: 214, 234, 239; and Hageman (on Hiram Alonzo Pease), 120.

PEASE, Benjamin F. *[Wood engraver] b.1822, Poughkeepsie, NY.*
Addresses: NYC, active 1845-47; Peru. **Comments:** In 1846 was a partner in Pease & Baker (see entry). Sometime during the 1850s he went to Lima (Peru) where he married and was still living in 1869. **Sources:** G&W; Pease, *A Genealogical and Historical Record of the Descendants of John Pease*, 206; NYCD and NYBD 1846; Am. Inst. Cat., 1845-46; Hamilton, *Early American Book Illustrators and Wood Engravers*, 204, 207.

PEASE, C. W. *[Miniaturist] mid 19th c.*
Addresses: Providence, RI, 1844. **Sources:** G&W; Providence *Almanac*, 1844; Bolton, *Miniature Painters.*

PEASE, David G. *[Painter, educator] b.1932, Bloomington, IL.*
Addresses: Lansing, MI, 1960; Philadelphia, PA. **Studied:** Univ. Wisc-Madison (B.S., 1954; M.S., 1955; M.F.A., 1958). **Member:** College AA Am. **Exhibited:** PAFA Ann., 1960, 1964, 1968; Corcoran Gal. biennials, 1961, 1963 (4th hon. men.); Carnegie Inst., 1961; WMAA, 1963; Nat. Drawing Exh., SFMA, 1969; "Drawings USA," Minn. Mus. Art, St. Paul, 1971; Terry Dintenfass, NYC, 1970s. Other awards: Guggenheim fellowship, 1965-66; Childe Hassam Fund purchase award, Am. Acad. Arts & Letters, 1970. **Work:** WMAA; PMA; PAFA; Power Gal., Univ. Sydney, Australia; Des Moines (IA) Art Center. **Comments:** Preferred medium: acrylics. Teaching: Tyler Sch. Art, 1960-70s. **Sources:** WW73; Falk, *Exh. Record Series.*

PEASE, Ernest Sherman *[Painter] b.1846.*
Addresses: Utica, NY; Union Lakes & Caanan, CT; NYC.

Exhibited: NAD, 1874-86 (6 annuals). **Sources:** Naylor, *NAD.*

PEASE, Fred I. *[Painter] early 20th c.*
Addresses: Columbus, OH. **Member:** Columbus PPC. **Sources:** WW25.

PEASE, Henry E. (or Harry E.) *[Lithographer, engraver, stationer] mid 19th c.*
Addresses: Albany, NY, 1856-60. **Comments:** In 1856-57 he was employed by Abram J. Hoffman (see entry). He was a son of Richard H. Pease (see entry). **Sources:** G&W; Albany CD 1856-60; Pease, *A Genealogical and Historical Record of the Descendants of John Pease.*, 211.

PEASE, Joseph Ives *[Line engraver, watercolor & crayon artist] b.1809, Norfolk, CT / d.1883, Salisbury, CT.*
Studied: engraving with Oliver Pelton at New Haven, CT. **Comments:** Worked briefly with his younger brother Richard H. Pease at Albany, NY, in 1834, and Philadelphia in 1835; he remained in Philadelphia until 1850. Noted as an engraver for the annuals and for Godey's. In 1850 he moved to Stockbridge, MA, and later to a farm near Salisbury, CT. **Sources:** G&W; DAB; Stauffer; French, *Art and Artists in Conn.;* Rutledge, PA; Albany CD 1834; *Antiques* (April 1951), 301 (repro.); Pease, *A Genealogical and Historical Record of the Descendants of John Pease.*, 209-10 and plates.

PEASE, Julie J. *[Artist] mid 20th c.*
Addresses: Lansing, MI, 1960. **Exhibited:** PAFA Ann., 1960. **Sources:** Falk, *Exh. Record Series.*

PEASE, Lizzie V. *[Painter] late 19th c.*
Addresses: Phila., PA. **Exhibited:** PAFA Ann., 1885. **Sources:** Falk, *Exh. Record Series.*

PEASE, Lute (Lucius C.) *[Cartoonist, portrait painter, lecturer, writer] b.1869, Winnemucca, NV / d.1963, Maplewood, NJ.*
Addresses: Maplewood, NJ. **Studied:** self-taught; Malone (NY) Acad., 1887. **Member:** AAPL; AC of the Oranges. **Exhibited:** NAD. **Work:** Stenzell Coll. **Comments:** Positions: artist-corresp. in Alaska, 1897-1901 and Yukon-Nome correspondent for a Seattle newspaper; U.S. Comn. for Alaska, 1901-02; political cartoonist for the *Portland Oregonian*, 1902-5; ed./illustr. for *Pacific Monthly*, 1906-13. He moved to New Jersey and was an editorial cartoonist for more than 30 years, creating approximately 70,000 cartoons. **Sources:** WW40; P&H Samuels, 365.

PEASE, Marion Dietz *[Educator, craftsperson] b.1894, Huntington, MA.*
Addresses: Saratoga Springs, NY. **Studied:** PIA Sch.; Columbia Univ., Teachers College (B.S.; M.A.); special courses, Harvard Univ.; Univ. California with Millard Sheets & Glen Lukens; Chicago Sch. Des. with Moholy-Nagy; Cranbrook Acad. Art with Marianne Strengel. **Member:** CAA; NY State Craftsmen. **Exhibited:** Skidmore College Faculty Exhs.; Albany Inst. Hist. & Art; Schenectady Mus. Art; NY State Craftsmen. **Comments:** Teaching: Oklahoma College for Women, 1921-25; Skidmore College, Saratoga Springs, NY, 1926-. **Sources:** WW59.

PEASE, Nell Christmas McMullin (Mrs. Lute C.) *[Illustrator, portrait painter] b.1883, Steubenville, OH. / d.1958.*
Addresses: Maplewood, NJ in 1963. **Studied:** Corcoran Sch. Art; H. Helmick. **Member:** AC of the Oranges. **Comments:** Moved to New Jersey in 1914. Illustr.: *Pacific Monthly*, 1906-13. **Sources:** WW40; P&H Samuels, 365.

PEASE, Nell Christmas McMillan See: **PEASE, Nell Christmas McMullin (Mrs. Lute C.)**

PEASE, Richard H. *[Wood engraver, lithographer, printer] b.1813, Norfolk, CT / d.1869.*
Addresses: Active mostly in Albany, NY, through 1862. **Studied:** engraving in Conn. **Comments:** A younger brother of Joseph I. Pease (see entry). Worked in Albany, NY, in 1834, and then for a short time in Philadelphia, where he was married in 1835. He returned to Albany, however, and was active there until about

1862. He was still living in 1869. Henry (or Harry) E. Pease (see entry), his son, was working with him in the late 1850s. See also C. Kelsey and Ebenezer Emmons, Jr., two of several artists who did views and technical illustrations for Pease. **Sources:** G&W; Peters, *America on Stone;* Stauffer; Hamilton, *Early American Book Illustrators,* 100, 204, 207; Albany CD 1834-62; McClinton, "American Flower Lithographs," 363; Pease, *A Genealogical and Historical Record of the Descendants of John Pease.,* 211.

PEASE, Roland Folsom, Jr. *[Art critic, collector] b.1921, Boston, MA.*
Studied: Dartmouth College; Columbia Univ. (B.S.). **Comments:** Positions: reporter, United Press Int., 1952-55; exec. ed., *Art Voices,* 1952, assoc. ed., 1962-63, contrib. ed., 1963; managing ed., Harry N. Abrams, Inc., 1963-64; mem., Denhard & Stewart, Inc., NYC. Collection: works by Grace Hartigan, Larry Rivers, Robert Goodnough, Fairfield Porter, Jane Wilson, Sherman Drexler, Red Grooms, Gorchov, Jane Freilicher, George L.K. Morris and Diego Rivera. Publications: contrib., art criticisms, *Art Int., Metro, Pictures on Exh., Authors Guild Bulletin.* **Sources:** WW73.

PEASE & BAKER *[Engravers] mid 19th c.*
Addresses: NYC, active 1846. **Comments:** Their work appeared in a book published in NYC in 1846. Pease was Benjamin F. Pease (see entry); Baker has not been identified. **Sources:** G&W; Hamilton, *Early American Book Illustrators and Wood Engravers,* 204.

PEASE & WARREN *[Engravers, lithographers] mid 19th c.*
Addresses: Albany, active 1853. **Comments:** Partners were Richard H. Pease and George W. Warren (see entries). **Sources:** G&W; Albany CD 1853.

PEASLEE, Marguerite Elliott *[Painter, teacher] 20th c.; b.Hopkinton, MA.*
Member: Rockport AA; North Shore AA; Eastern AA. **Exhibited:** Rockport AA; North Shore AA; Boston AC; Worcester Art Mus.; Redding, CT. **Comments:** Positions: art supervisor, public schools in Mass. **Sources:** *Artists of the Rockport AA* (1946).

PEASLEY, A. M. *[Map & portrait engraver] early 19th c.*
Addresses: Newburyport, MA, 1804. **Sources:** G&W; Belknap, *Artists and Craftsmen of Essex County,* 4; Stauffer.

PEASLEY, Horatio N. *[Painter] b.1853, Milton, MA.*
Addresses: West Somerville, MA. **Studied:** J.J. Enneking, in Boston. **Exhibited:** Boston AC, 1891, 1892, 1905, 1907-08. **Sources:** WW10; *The Boston AC.*

PEASLEY-JOURDAN, Alda *[Painter] early 20th c.*
Addresses: Portland, OR, 1927. **Exhibited:** S. Indp. A., 1927. **Sources:** Marlor, *Soc. Indp. Artists.*

PEAT, (Miss) See: PITT, (Miss)

PEAT, Wilbur David *[Museum director, writer, lecturer] b.1898, Chengtu, China.*
Addresses: Indianapolis 8, IN. **Studied:** Ohio Wesleyan Univ.; Cleveland Sch. Art; NAD; ASL; Univ. Chicago. **Member:** AAMus.; Indiana Hist. Soc.; Midwest Mus. Conference; Indiana AC. **Exhibited:** Awards: hon. degrees, L.H.D., Hanover (IN) College, 1944; LL.D., Indiana Central College, Indianapolis, 1956. **Comments:** Position: dir., Akron, (OH) AI, 1924-29; dir. mus., John Herron AI, Indianapolis, IN, 1929-. Auth.: "Portraits and Painters of the Governors of Indiana" (Indiana Hist. Soc.), 1944; "Pioneer Painters of Indiana" (Art Assoc. Indianapolis), 1954; "Indiana Houses of the Nineteenth Century" (Indiana Hist. Soc.), 1962. Contrib.: bulletins of the Indianapolis AA;*Indiana Magazine of History; Art Quarterly.* Lectures: Pioneer Painters of Indiana. **Sources:** WW66.

PEAVY, Pauline White *[Sculptor] mid 20th c.*
Addresses: San Pedro, CA; Long Beach, CA, 1930s. **Exhibited:** SFMA, 1935; P&S Los Angeles, 1935, 1936. **Sources:** Hughes, *Artists of California,* 429.

PEBBLES, Frank Marion *[Portrait painter] b.1839, Wyoming County, NY / d.1928, Alameda, CA.*
Addresses: Chicago, IL; San Francisco, CA, 1875-1880; Chicago, IL, 1880-1915; California, 1915-28. **Studied:** Theodore B. Catlin before 1860; Edwin White at the NAD, one year; G.P.A. Healy in Chicago. **Member:** Bohemian Club (pres.); Chicago SA. **Exhibited:** Mechanics' Inst., 1876, 1877 (gold med.); World's Columbian Expo, Chicago, 1893; Mark Hopkins Inst., 1897-98; Pan-Pacific Expo, 1915; AIC. **Work:** Chicago Hist. Soc. **Comments:** Made his first attempts at portrait painting at 17 at Monroe (WI), but until after the Civil War did mostly sign and ornamental work. In the late 1860s he studied for a year in NYC, worked in Chicago, Detroit, San Francisco, and other Western cities, and eventually settled in Chicago, where he became known as "the gubernatorial and judicial portrait painter." Many of his early works were destroyed in the Chicago fire of 1871. He then spent five very productive years in San Francisco, where he fulfilled portrait commissions of Ulysses S. Grant, Charles Crocker and James Flood, among others. He returned to the Chicago area and was active in Oak Park, IL as late as 1915. He returned to San Francisco for the Pan-Pacific Expo, and stayed in California for the rest of his life, painting coastals and landscapes of Northern California. **Sources:** G&W; Andreas, *History of Chicago,* II, 561; *Artists Year Book,* 151; represented at Chicago Historical Society (info courtesy H. Maxson Holloway). More recently, see Hughes, *Artists in California.* 429.

PECHE, Dale C. *[Painter] b.1928, Long Beach, CA.*
Addresses: Laguna Beach, CA. **Studied:** Long Beach City College; AC College Design of Los Angeles; Reckless; Tyler; Legakes; Feitelson; Polifka; Williamaoski; Kramer. **Exhibited:** Indust. Graphics Int., 1956-71 (25 awards); NY Art Dir. Show, 1962 (prize); Los Angeles Art Dir. Show, 1962 (prize), 1970 (prize); West Coast Am. Realists, Muckenthaler Cultural Center, Fullerton, CA, 1972; Challis Gals., Laguna Beach, CA, 1972 (solo). **Work:** Commissions: paintings of San Fran. & Fishermans Wharf, Lezius Hiles Coll., Cleveland, OH, 1972. **Comments:** Preferred medium: gouache. Positions: graphic designer, North Am. Aviation, Inc., 1956- 60; art dir.-owner, Graphic Directions, 1960-68; art dir., Public Service Ltd., 1968-71; art dir., Design Vista Inc., 1971-. **Sources:** WW73.

PECHSTEIN, H. M. (Max Herman) *b.1881, Zwickau, Germany.*
Exhibited: Salons of Am., 1924; AIC. **Sources:** Marlor, *Salons of Am.*

PECK, Anita Walbridge *[Craftsperson] b.1882, Brooklyn, NY.*
Addresses: Bronxville, NY/South Egremont, MA. **Studied:** M. Robinson; V. Raffo; K. Illava; L. Jonas. **Member:** NY Soc. Ceramic Arts; Westchester Arts & Crafts. **Sources:** WW40.

PECK, Anna Gladys *[Illustrator] b.1884, Monmouth Beach, NJ.*
Addresses: Bayonne, NJ, 1913 ; NYC. **Studied:** Twachtman, Metcalf & Clinedinst in New York. **Exhibited:** AIC, 1913. **Sources:** WW17.

PECK, Anne Merriman (Mrs. Frank Fite) *[Illustrator, lithographer, writer, painter] b.1884, Piermont, NY.*
Addresses: NYC. **Studied:** R. Henri; I. Wiles; Hartford Art Sch.; NY Sch. Fine & Applied Art. **Member:** Am. Artists Congress. **Exhibited:** Weyhe Gal., NY; Tucson, AZ; S. Indp. A., 1917, 1919-22, 1926-27; PAFA Ann., 1918. **Work:** Newark Mus. **Comments:** Auth./illustr.: *Roundabout South America* (1940), *Young Mexico* (1934); illustr., *Steppin and Family* (1942). Position: illustr., *Harper's.* **Sources:** WW47; Falk, *Exh. Record Series.*

PECK, Augustus Hamilton *[Illustrator, teacher] b.1906, Frederick, MD / d.1975, Frederick, MD?.*
Addresses: Brooklyn, NY; Proctor, VT. **Exhibited:** drawing, CMA, 1931 (prize), illus., 1932 (prize); WMAA, 1942-1950. **Comments:** Position: supv., Brooklyn Mus. Art Sch. WPA print-

maker in NYC, 1930s. **Sources:** WW32; exh. cat., Annex Gal. (Santa Rosa, CA, n.d., c.1988); WW66.

PECK, Bradford *[Portrait painter] early 20th c.*
Exhibited: Mark Hopkins Inst., 1902. **Sources:** Hughes, *Artists of California*, 429.

PECK, Carmen *[Painter] mid 20th c.*
Addresses: Chicago area. **Exhibited:** AIC, 1942. **Sources:** Falk, *AIC.*

PECK, Clara Elsene
Williams *[Illustrator, painter, etcher] b.1883, Allegan, MI.*

Clara Elsene Peck

Addresses: Brooklyn, NY; Gettysburg, PA. **Studied:** Minneapolis Sch. FA; PAFA with William Chase. **Member:** NYWCC; AWS; Artists Gld.; SI; Women P&S Soc. **Exhibited:** AIC, 1913; PAFA Ann., 1913; Nat. Assoc. Women P&S; NY Women's P&S, 1921 (prize), poster, 1922 (prize); AWCS traveling exh.; MMA European traveling exh., 1956-57; Washington County Mus. Art, Hagerstown, MD, 1958; Gettysburg College (solo); York (PA) Art Center; New Canaan, CT, 1958. **Comments:** Specialty: drawings of women and children. Illustr. for national magazines; designed covers, text books and children's books, 1906-40. She was married to John Scott Williams (see entry) for a time. **Sources:** WW59; WW47; Falk, *Exh. Record Series.*

PECK, Cornelia M. Dawbarn *[Painter] early 20th c.*
Addresses: Rye, NY, 1920. **Exhibited:** S. Indp. A., 1920.

PECK, E. A. (Miss) *[Painter] late 19th c.*
Addresses: Hartford, CT. **Exhibited:** NAD, 1884. **Sources:** Naylor, *NAD.*

PECK, Edith Hogen *[Painter, etcher, lithographer] b.1884, Cleveland, OH / d.1957, Cleveland.*
Addresses: Cleveland. **Studied:** Cleveland Sch. Art; Henry G. Keller; Frank Nelson Wilcox. **Exhibited:** CMA, 1933-41 (prize), 1942-46; PAFA WC Ann., 1934-35, 1939; AWCS, 1946; Ohio PM, 1941-46; NAD, 1942-46; LOC, 1942-43; SAE, 1943-46; Northwest PM, SAM, 1945-46; Tri-State PM, 1945, 1946; Phila. Pr. Club, 1945; Laguna Beach Pr. Club, 1945; Am. Color Pr. Soc., 1946; CMA, 1933-46; Butler AI, 1937, 1940, 1942-43, 1946; SFMA. **Work:** CMA; Carville (LA) Mem. Hospital. **Comments:** Was introduced to intaglio printmaking methods by her son, artist James E. Peck; studied printmaking with Kalman Kubinyi (as did her son). Her most notable prints were color intaglio still lifes with landscapes in the background and were very painterly. **Sources:** WW47; additional info courtesy Martin-Zambito Fine Art, Seattle, WA & Anthony R. White, Burlingame, CA.

PECK, Edward S. *[Gallery director] d.1970.*
Addresses: Los Angeles, CA. **Comments:** Position: dir., Fisher Gal. Art, Univ. California. **Sources:** WW66.

PECK, Emily Ewing *[Sculptor] late 19th c.*
Addresses: Chicago area. **Exhibited:** AIC, 1898. **Sources:** Falk, *AIC.*

PECK, Esther *[Painter] early 20th c.*
Addresses: NYC, c.1913-23. **Member:** Lg. Am. Artists. **Sources:** WW24.

PECK, Glenna (Hughes) *[Painter, designer, ceramicist] 20th c.; b.Huntsburg, OH.*
Addresses: Syracuse, NY; Moravia, NY; Winter Park, FL. **Studied:** NY Sch. Fine & Applied Art; Syracuse Univ. (B.F.A.). **Member:** NAWA; Syracuse AA; Texas FAA; Orlando AA; Sarasota AA. **Exhibited:** Artists All., NY, 1931 (prize), 1932 (Thibaut prize); Syracuse AA, 1940 (prize), annually, Robineau Memorial Exh., Syracuse, 1934 (prize); Finger Lakes Exh., 1939; Syracuse Mus. FA, 1934; Bradenton (FL) AA. 1941; Orlando AA, 1958; Austin, TX, 1950 (solo); Vienna, VA, 1954. United Piece Dyeworks prize, 1932. **Sources:** WW59; WW47.

PECK, Grace Brownell *[Landscape painter, illustrator] b.1861, Moodus, CT / d.1931, Bristol, CT.*
Comments: Peck made black-and-white sketches for magazines.

PECK, Graham *[Illustrator, painter, writer] b.1914, Derby.*
Addresses: Derby, CT. **Studied:** Yale. **Exhibited:** Yale Gal. FA, 1939. **Comments:** Illustr.: "The Valley of the Larks," by Eric Purdon, 1939. Auth./Illustr.: "Through China's Wall," 1940. **Sources:** WW40.

PECK, Helen M. *[Painter] late 19th c.*
Addresses: Allegan, MI. **Exhibited:** Michigan State Fair, 1884-85 (prizes). **Comments:** Painted in oil, watercolor, & crayon. **Sources:** Gibson, *Artists of Early Michigan*, 191.

PECK, Henry J(arvis) *[Painter, illustrator, etcher, writer] b.1880, Galesburg, IL / d.1964.*

Henry J Peck

Addresses: Warren, RI, in 1941. **Studied:** E. Pape; H. Pyle; RISD. **Member:** Providence AC; Providence WCC; South County AA; North Shore AA. **Exhibited:** AIC, 1907. **Comments:** Illustr. of historic Western, rural and New England marine subjects. **Sources:** WW40; P&H Samuels, 364-65.

PECK, James Edward *[Painter, designer, illustrator, graphic artist] b.1907, Pittsburgh, PA.*
Addresses: Cleveland, OH; Seattle, WA; Botthel, WA, in 1998. **Studied:** Cleveland Inst. Art (cert.); John Huntington Polytechnic Inst.; H.G. Keller; R. Stoll; C. Gaertner; Hans Hoffman, Provincetown. **Member:** Guggenheim Found., 1942, 1945 (fellowship); Puget Sound Group Northwest Painters (pres.); Art Studio Owners Assn. **Exhibited:** CMA May Shows, 1933-49 (awards for watercolors1937-49); PAFA, 1934-35, 1937; AWCS, 1934-35, 1946; AIC, 1933-34, 1939, 1943, 1946; Dayton AI, 1942 (solo), 1943-45 (awards for watercolors1942-45); Cleveland Sch. Art, 1945; Cincinnati Mod. Art Soc., 1945; Little Art Center, Dayton, 1945; Ten-Thirty Gal., Cleveland, 1946; Butler AI, 1946; SAM, 1947, 1959; Henry Gal., 1950-51, 1954; AWCS, New York; SAM Northwest Ann.; Pepsi-Cola Drawing & WC Exh., MMAA; Nat. Gal.; award for painting, Guggenheim Found., 1942 & 1946. **Work:** CMA; U.S. Govt., Carville, LA; Dayton AI; Am. Acad. Arts & Letters, NYC; SAM. **Comments:** Preferred media: watercolors, enamels, woods. Positions: illustr., Fawn Art Studios, Cleveland, 1936-46; dir., art dept. at Cornish, 1947 (taught drawing, painting and advertising illustr.); art dir., Miller, McKay, Hoeck & Hartung, Seattle, 1954-60; graphic des., 1960-66; graphic des., Boeing Co, 1966-70. Publications: illustr., *Ford Times Magazine,* Teaching: Head dept art, Cornish Sch, Seattle, 1947-1952; Instr painting & graphic design, Burnley Sch Art, Seattle, 1966-. **Sources:** WW73; WW47. More recently, see Trip and Cook, *Washington State Art and Artists,* 1850-1950; addl info courtesy Martin-Zambito FA, Seattle, WA.

PECK, John *[Portrait, miniature & landscape painter] mid 19th c.*
Addresses: NYC, active 1839-50. **Exhibited:** Apollo Assoc.; Am. Inst.; NAD, 1839-45. **Sources:** G&W; Cowdrey, NAD; Cowdrey, AA & AAU; Am. Inst. Cat., 1842; NYCD 1840, 1846; NYBD 1849-50.

PECK, Joseph A(lanson) *[Painter] b.1874, Augusta, ME.*
Addresses: NYC/Middlebury, VT. **Member:** SC. **Sources:** WW33.

PECK, Judith S. *[Painter] mid 20th c.*
Addresses: Park Ridge, NJ. **Exhibited:** PAFA Ann., 1960. **Sources:** Falk, *Exh. Record Series.*

PECK, Julia *[Painter] early 20th c.*
Addresses: Active in Detroit, MI. **Member:** Detroit Soc. Women P&S, 1903 (charter mem.). **Exhibited:** Kraushaar Gals., NYC, 1920 (jointly with Edith Haworth). **Comments:** *Cf.* Julia E. Peck. **Sources:** Petteys, *Dictionary of Women Artists.*

PECK, Julia E. *[Painter] early 20th c.*
Addresses: Port Huron, MI. **Member:** Soc. Indep. Artists. **Exhibited:** WMAA, 1920-1922; Soc. Indep. Artists, 1920-21. **Sources:** WW25; Falk, *WMAA.*

PECK, M. L. (Mrs.) *[Artist] 19th/20th c.*
Addresses: Active in Los Angeles, 1891-1901. **Sources:** Petteys,

Dictionary of Women Artists.

PECK, Mary F. (Miss) *[Landscape & floral painter]* late 19th c.
Addresses: Newtown, CT. **Exhibited:** Boston AC, 1881-82; Brooklyn AA, 1881-85; PAFA Ann., 1882. **Comments:** Exhibited works indicate she painted flowers; also, landscapes in Barbizon, France. **Sources:** Falk, *Exh. Record Series.*

PECK, Natalie *[Painter]* b.1886, Jersey City, NJ.
Addresses: NYC, 1916-17. **Studied:** K.H. Miller; ASL. **Member:** Salons of Am.; Springfield AA; Soc. Indep. Artists. **Exhibited:** Corcoran Gal. biennial, 1916; PAFA Ann., 1916; Soc. Indep. Artists, 1917, 1921, 1926; Salons of Am., 1924, 1926-27. **Work:** PAFA. **Sources:** WW29; Falk, *Exh. Record Series.*

PECK, Nathaniel *[Primitive genre painter]* mid 19th c.
Addresses: Long Island, NY, active about 1827-30. **Sources:** G&W; Lipman and Winchester, 178; *Notes Hispanic* (1945), 25 (repro.).

PECK, Orin See: **PECK, Orrin**

PECK, Orrin *[Landscape & portrait painter]* b.1860, Delaware County, NY / d.1921, Los Angeles, CA. **O.P.**
Addresses: Pleasanton, CA. **Studied:** Gijsis & Loefftz in Munich. **Exhibited:** NAD, 1890, 1892; Columbian Expo, Chicago, 1893 (gold); Calif. Midwinter Int. Expo, 1894. **Work:** Bohemian Club; Univ. Calif.; Oakland Mus. **Comments:** Traveled to California at age two via the Isthmus of Panama. Phoebe Hearst, a passenger aboard the ship, liked the child. Later when Peck became an artist, he painted several portraits of the Hearst family, and was in charge of the artistic work planned for W.R. Heart's ranch in northern Calif. **Sources:** WW17; Hughes, *Artists of California,* 430.

PECK, Sara See: **FIELD, Sara Peck**

PECK, Sheldon *[Portrait painter]* b.1797, Cornwall, VT / d.1868.
Addresses: Vermont (until 1828); Jordan, NY (1828-45); Babcock's Grove, Lombard, IL (1845-on). **Studied:** self-taught. **Work:** Munson-Williams-Proctor Inst. **Comments:** An itinerant portrait painter, he primarily painted half-length portraits in subdued colors. After 1845, his palette brightened and he created his own trompe l'œil frames. He was also a farmer and school teaccher. **Sources:** G&W; *300 Years of American Art,* vol. 1, 119; G&W identified him as a painter of a pair of portraits on wood of Mr. and Mrs. Alanson Peck of Cornwall, VT, 1824)); WPA (Mass.), *Portraits Found in Vermont.*

PECK, Stephen Rogers *[Painter, teacher]* b.1912, Cortland, NY.
Addresses: Syracuse, NY. **Studied:** Syracuse Univ.; Acad. Julian, Paris. **Exhibited:** Syracuse AA, Mus. FA, Syracuse. **Comments:** Teaching: Syracuse Univ. **Sources:** WW40.

PECK, Verna Johnston (Mrs. W. C.) *[Painter, teacher]* b.1889, Hutchinson, KS.
Addresses: Kansas City 22, MO. **Studied:** Southwestern College; Wichita Univ.; Kansas City AI (B.F.A.); Independence, MO (B.F.A., M.A.); Grace Raymond; Clayton Henri Staples; Thomas Hart Benton. **Member:** Mid-Am. Artists; Community AA, Independence, MO. **Exhibited:** State Fair, Independence &, Sedalia, MO. **Awards:** prizes, Kansas State Fair, 1940, 1942; Kansas Artists, 1942; State Fair, Sedalia, MO, 1955. **Work:** Mid-Am. Art Gal. **Sources:** WW59.

PECK, William D. *[Painter]* late 19th c.
Addresses: Brooklyn, NY. **Exhibited:** NAD, 1878. **Sources:** Naylor, *NAD.*

PECKARD, William *[Engraver]* b.c.1825, England.
Addresses: Philadelphia in 1860. **Sources:** G&W; 8 Census (1860), Pa., LIII, 290.

PECKHAM, Anita (Mrs. George F.) *[Painter, weaver]* b.1917, Milwaukee, WI / d.1984, Seattle, WA.
Addresses: Seattle, WA. **Member:** Women Painters of Wash., 1948. **Sources:** Trip and Cook, *Washington State Art and Artists,* 1850-1950.

PECKHAM, Edward Lewis *[Painter]* b.1812, Providence, RI / d.1899, Providence, RI.
Addresses: Providence, RI. **Studied:** self-taught. **Work:** Rhode Island Hist. Soc. **Comments:** Preferred media: pencil, ink, watercolor. Between 1843-67 he created over 500 botanical studies of Rhode Island flora, some species of which no longer exist. He also produced approx. 60 works of pre-industrial Providence and surrounding areas. **Sources:** info. courtesy of Elinor Nacheman, Pawtucket, RI.

PECKHAM, F(elix) Augustus *[Portrait and still life painter]* b.1837, Middletown, RI / d.1876, Newport, RI.
Addresses: Newport, RI. **Studied:** self-taught. **Work:** Newport Hist. Soc. (portrait of Miss Ruth Franklin, 1868). **Comments:** Despite a spinal disease that robbed him of the use of his legs from childhood, he created skillful likenesses in crayon and on canvas; however, his infirmities caused his early death at age 38. **Sources:** add'l info from Redwood Lib., Newport, RI, courtesy Edward P. Bentley, Lansing, MI.

PECKHAM, Kate *[Painter]* late 19th c.
Studied: Acad. Julian, Paris, with Lefebvre. **Comments:** Sister of Rosa. **Sources:** Fehrer, The Julian Academy.

PECKHAM, Lewis (or Louis) *[Portrait painter, miniaturist]* b.1788, Newport, RI / d.1822, Vincennes, IN.
Addresses: moved from Boston to Vincennes after 1810 and worked there until his death. **Studied:** Boston, c.1810. **Work:** Indianapolis Mus. Art. **Comments:** Peckham was in the Battle of Tippecanoe under William Henry Harrison. Stationed in Boston in 1810, he was encouraged as a painter by Gilbert Stuart. Peckham worked in Vincennes in a studio partnership with C.D. Cook. **Sources:** G&W; Peckham, *Peckham Genealogy;* Burnet, *Art and Artists of Indiana,* 387; Peat, *Pioneer Painters of Indiana;* Gerdts, *Art Across America,* vol. 2: 253 (with repro.).

PECKHAM, Mary *[Painter, etcher]* mid 20th c.
Addresses: San Francisco, CA, 1920s-30s. **Exhibited:** San Fran. AA, 1927; San Fran. Soc. Women Artists, 1931; SFMA, 1935. **Sources:** Hughes, *Artists of California,* 430.

PECKHAM, Mary C. (Mrs. F. H.) *[Painter]* b.1861, Providence, RI.
Addresses: Providence, RI. **Studied:** M.C. Wheeler; R. Collin; A. Thayer. **Member:** Providence AC; Providence WCC; AFA; South County AA. **Sources:** WW40.

PECKHAM, Robert *[Portrait painter]* b.1785, probably at Westminster, MA / d.1877, Westminster, MA.
Comments: After his marriage he worked for a time at Northampton and Bolton (MA) but about 1821 he settled permanently in Winchester. Well-known locally as a portrait painter and a leader in the Congregational Church, Peckham was especially active in the temperance and abolition movements. **Sources:** G&W; Peckham, *Peckham Genealogy,* 399-400; Heywood, *History of Westminster,* 821-22.

PECKHAM, Rosa (Rose) *[Painter]* b.1842, Connecticut / d.1922, Conn.
Addresses: Providence, RI. **Studied:** Acad. Julian, Paris, with Lefebvre, 1875-78; Rolshoven. **Member:** Providence AC (founder, 1880; vice pres., 1883-85). **Exhibited:** NAD, 1872, 1880; Paris Salon, 1878, 1892; SNBA, 1893; Providence AC; Vose Gal.; Boston AC, 1878-80. **Work:** Phillips Acad., Exeter, NJ. **Comments:** While studying in Paris, with her sister Kate and May Alcott, she became friendly with G.P.A. Healy and Mary Cassatt. She painted portraits and still lifes. Fink gives birthplace as Boston. Also known as Rosa Peckham Danielson. **Sources:** C. Bert, *Sketches* (Providence, No.2, Dec. 1991); Fink, *Am. Art at the 19th c. Paris Salons,* 335, 379.

PECKHAM, William F. *[Wood engraver]* mid 19th c.
Addresses: NYC, 1838-48. **Sources:** G&W; NYCD 1838-48;

Hamilton, *Early American Book Illustrators and Wood Engravers,* 172.

PECKOVER, Edmund *[Painter] early 20th c.*
Exhibited: S. Indp. A., 1931. **Sources:** Marlor, *Soc. Indp. Artists.*

PECKWELL, Henry W. *[Wood engraver] b.1854, New York.*
Addresses: NYC. **Exhibited:** Pan-Am. Expo, Buffalo, 1901 (med.). **Sources:** WW06.

PECORINI, Margaret Bucknell (Comtessa) *[Painter, portrait painter] b.1879, Philadelphia, PA / d.1963, Guttenberg, NJ.*
Addresses: NYC/Paris, France. **Studied:** Acad. Julian, Paris. **Member:** Phila. Art Alliance. **Exhibited:** S. Indp. A., 1922-24; Salons of Am., 1923; Salon de la Soc. des Artistes Françaises. **Work:** BM. **Comments:** Specialty: portraits of children. **Sources:** WW33.

PEDDLE, Caroline C. See: **BALL, Caroline Peddle (Mrs.)**

PEDERSEN, Robert Holm *[Painter] b.1906, Hesselager, Denmark.*
Addresses: Montclair, NJ. **Studied:** self-taught; Denmark. **Member:** C of the Oranges; Asbury Park Soc. FA; AAPL. **Exhibited:** Newark AC, 1936 (prize); NJ Gal., 1936 (prize); Irvington (NJ) Municipal Exh., 1938 (prize); PAFA Ann., 1936, 1938; NAD, 1940; AIC, 1938-41; Montclair Art Mus., 1936-40; Newark Mus., 1937-38. **Sources:** WW47; Falk, *Exh. Record Series.*

PEDERSEN, Rubie C. See: **JOHNSON, Rubie C. Pederson**

PEDERSON, Andreas *[Painter] early 20th c.*
Addresses: Minneapolis, MN. **Sources:** WW24.

PEDERSON, Helen Pauline *[Painter] b.1915, Iowa City, IA.*
Addresses: Iowa City, IA. **Studied:** Univ. Iowa; Catherine Macartney, Edith Bell, Harry L. Stinson, Aden Arnold, Edna Patzig. **Exhibited:** Univ. FA Exh.; Iowa Art Salon, 1929-32; Iowa City Woman's Club (prize). **Work:** FA Bldg., Univ. Iowa. **Comments:** Position: photographic work, Scharf's Studio, Iowa City. **Sources:** Ness & Orwig, *Iowa Artists of the First Hundred Years,* 164.

PEDERSON, Jorgen *[Painter] b.1876, Denmark / d.1926.*
Addresses: Irvington, NJ. **Studied:** W.M. Chase; Henri. **Sources:** WW25.

PEDERSON, Molly Fay *[Painter, sculptor] b.1941, Waco, TX.*
Addresses: Richardson, TX. **Studied:** private study with Carl Cogar (Las Cruces, NM), James Woodruff (Houston), Mary Berry (McKinney, TX), Ramon Froman (Dallas, TX), Ken Gore (MA), Stewart Matthews, Arnold Vail & H.E. Fain (Dallas). **Member:** Texas FAA; Richardson Civic Arts Soc. (vice-pres., secy., treas., 1968-70); Arlington 200 (bd. mem.; show chmn.); Texas Starving Artists. **Exhibited:** Richardson (TX) Civic Arts Soc. Ann., 1968-70; Artists Market, Dallas, 1968-72; Bond's Alley Art & Craft Show, Hillsboro, TX, 1969-70; Texas FAA Exh., Dallas, 1970; Temple Emanu-El Ann Brotherhood Art Festival, Dallas, 1970-72. Awards: award for Manarola, Texans Assn. Art Show, 1968; Richardson Community Fair Award, 1969; award for black & white abstract, Bond's Alley Arts & Crafts Show, 1970. **Comments:** Preferred media: oils, acrylics, brass, copper. Positions: commercial artist, Goldstein-Migel Co., Waco, TX, 1958-59; layout artist, Sun Printing Co., El Paso, TX, 1960-64. Teaching: Richardson Recreation Center, 1972; Air Am. Sch., Udorn, Thailand, 1972-73. **Sources:** WW73; articles, *Dallas Morning News,* April 5, 1969, *Waco Citizen,* May 30, 1970 & *Richardson Daily News,* Dec. 3, 1971.

PEDON, Eugenio *[Sculptor] late 19th c.*
Addresses: Wash., DC, active 1887-89. **Sources:** McMahan, *Artists of Washington, D.C.*

PEDRETTI, Humberto J. *[Sculptor] b.1879, Brescia, Italy / d.1937, Hollywood, CA.*
Addresses: Los Angeles, CA, c.1922; Hollywood, CA. **Studied:** Milan, four years. **Exhibited:** P&S Los Angeles, 1923-25; PAFA Ann., 1926, 1928; San Diego FA Gal., 1927; Calif. AC, 1934. **Work:** Pershing Square, Los Angeles. **Comments:** Pedretti came to Los Angeles after working in Zurich, Munich and Mexico City. **Sources:** WW24; Bibliography: Hughes, *Artists of California,* 430; Falk, *Exh. Record Series.*

PEDROSE, Margaret Bjornson (Mrs. L. W.) *[Painter, writer] b.1893, Seattle, WA.*
Addresses: Seattle, WA. **Exhibited:** Western Wash. Fair, 1932-33. **Sources:** Trip and Cook, *Washington State Art and Artists, 1850-1950.*

PEEBLES, Frank (Francis) Marion *[Painter, portrait painter] b.1839, Wethersfield, NY / d.1928.*
Addresses: Alameda, CA. **Studied:** NAD; Edwin White in New York; G.P.A. Healy in Chicago. **Member:** Chicago SA; Chicago Art Gld; Chicago AD. **Exhibited:** San Fran., 1887 (med.). **Comments:** Peebles painted the first Pullman sleeper in Chicago, and in the fashion of the day painted the portraits of George Pullman and other railroad officials on engine headlights.Position: master painter, North Western Railroad. **Sources:** WW27.

PEEBLES, Nelson Childs *[Painter] early 20th c.*
Addresses: Cincinnati, OH. **Sources:** WW10.

PEEBLES, Roy B. *[Painter] b.1899, Adams, MA / d.1957, Adams, MA.*
Addresses: Adams, MA. **Studied:** C. Cimiotti; E. Watson; W. Taylor; C. Balmer; N. MacGilvary; L. Blake; A Bayard. **Member:** Pittsfield AL; Salons of Am.; Berkshire Business Men's Art Lg.; Deerfield Valley AA; Adams AA; AAPL. **Exhibited:** Salons of Am.; S. Indp. A., 1927-29, 1931, 1940; Williams College; Berkshire Mus.; Stockbridge AA; Deerfield Valley AA. **Sources:** WW47.

PEED, William B. *[Painter, landscape painter] mid 20th c.*
Addresses: Indianapolis, IN. **Exhibited:** PAFA Ann., 1937; Hoosier Salon, Chicago, 1937 (prize), 1938 (prize). **Sources:** WW40; Falk, *Exh. Record Series.*

PEEIFFER See: **VERHAEGEN & PEEIFFER**

PEEK, G. *[Engraver] mid 19th c.*
Addresses: Rockport, IN, 1860. **Sources:** G&W; Indiana BD 1860.

PEEKE, Grace N. Wishaar *[Portrait & miniature painter] b.1879, NYC.*
Addresses: NYC; Oakland, CA. **Studied:** NY Sch. Art with Wm. Chase. **Member:** San Fran. AA; San Fran. Guild of Arts & Crafts; Sequoia Club. **Exhibited:** Mark Hopkins Inst., 1904-06. **Sources:** WW04; Hughes, *Artists in California,* 613.

PEELE, John Thomas *[Genre & portrait painter] b.1822, Peterborough, England / d.1897, London, England.* ***J. T. Peele***
Member: ANA, 1846. **Exhibited:** NAD, 1840-85; PAFA, 1853-64; Brooklyn AA, 1862-81. **Comments:** He was brought to the U.S. as a child, and after a visit to England between 1841-44, opened a studio in NYC. He returned to England about 1852 and made his home there until his death; although he continued to exhibit in America and may have visited there a number of times. **Sources:** G&W; CAB; Cowdrey, NAD; Naylor, NAD; Cowdrey, AA & AAU; Rutledge, PA.

PEELER, Richard *[Potter, sculptor] b.1926, Indianapolis, IN.*
Addresses: Reelsville, IN. **Studied:** De Pauw Univ. (A.B., 1949); Indiana Univ. (M.A., 1960). **Member:** Nat. Council Educ. Ceramic Arts (vice-pres. & dir., 1966-70; pres., 1970-71); Indiana Art Educ. Assn.; Indiana Artist Craftsmen. **Exhibited:** Syracuse Nat. Ceramic Show, 1964; Ceramics USA 1966, Int. Minerals Corp., 1966; solos:, Indiana Central College, Goshen College & Univ. Evansville. **Work:** Int. Minerals, Skokie, IL; Armstrong

Cork Co.; Indiana State Univ.; Taylor Univ.; Indiana Central Univ. Commissions: sculpture in stone, Gobin Methodist Church, Greencastle, IN, 1963; portrait busts in stone, Pres. & Mrs. William Kerstetter, Greencastle, 1965; sculpture in fiberglass & epoxy, First Christian Church, Greencastle, 1968; portrait bust in ceramic, Harrison Johnson, Cleveland, OH, 1971; ceramic mural, De Pauw Univ., 1972. **Comments:** Preferred medium: ceramics. Publications: auth., 13 articles, *Ceramics Monthly Magazine*, 1962-65; film maker 8 films on ceramic art, McGraw, 1966-68. Teaching: Indianapolis Pub. Schools, 1951-58; De Pauw Univ., 1958-72; Kyoto City College FA, Japan, 1966. **Sources:** WW73.

PEELOR, Harold G. *[Painter] b.1856, NYC / d.1940, Milpitas, CA.*
Addresses: San Jose, CA. **Work:** LACMA. **Sources:** Hughes, *Artists of California*, 430.

PEERS, Florence Leif See: **LEIF, Florence (Mrs. Florence Leif Peers)**

PEERS, Frank W(agner) *[Mural painter, illustrator, block printer, engraver, lecturer, teacher, writer] b.1891, Topeka, KS.*
Addresses: NYC. **Studied:** J. Despujols; Fontainebleau. **Exhibited:** S. Indp. A., 1922; Salons of Am., 1934. **Work:** dec. panels, Am. Pro-Cathedral, Paris; prints, NYPL. **Comments:** Illustr.: "June Goes Down Town," by H. Dietz (1925), "Midnight Court," by P. Arla (1926), "Sarah Simon," by H. Allen (1929), "Light from Arcturus," by M. Walker (1933). **Sources:** WW40.

PEERS, Gordon Franklin *[Painter, educator, graphic artist] b.1909, Easton, PA / d.1988.*
Addresses: Cranston, RI; Providence, RI. **Studied:** RISD; ASL; BAID; John R. Frazier. **Member:** Providence Art Club; Provincetown AA. **Exhibited:** Providence Art Club, 1938; CI, 1942-43; VMFA, 1940; WFNY, 1939; GGE, 1939; Nat. Exh. Am. Art, NYC, 1936, 1938; Pepsi-Cola, 1946; WMA; PAFA Ann., 1948; Boston AC; Dept. Interior, Wash., DC; Univ. Illinois; Rockford AA; Mus., RISD; Newport AA (prize, 1958); Provincetown AA, 1958; Boston Art Festival, 1955 (prize),1958; Bert Gal., Providence, RI, 1995 (solo). **Work:** RISD Mus.; mural, Viking Hotel, Newport. **Comments:** During the 1950s, his tightly-rendered still life compositions gave way to a bright palette and heavier impastos, influenced by Cezanne. Positions: chief critic, RISD European Honors Program, Rome, 1961- 62. Teaching: RISD, 1934-70s. **Sources:** WW73; WW47; Falk, *Exh. Record Series*.

PEERS, Marion *[Painter] early 20th c.*
Addresses: Topeka, KS. **Comments:** Teaching: Topeka H.S. **Sources:** WW24.

PEET, Jeanie Spring *[Sculptor] b.1843, NYC / d.1921, Los Angeles, CA.*
Addresses: San Francisco & Los Angeles, CA. **Exhibited:** Mechanics' Inst. Fair, 1893. **Sources:** Hughes, *Artists of California*, 430.

PEET, Margot *[Painter] b.1903, Kansas City, MO.*
Addresses: Overland Park, KS; Kansas City, MO. **Studied:** Kansas City AI; Colorado Art Acad.; Randall Davey; E. Lawson; Thomas Hart Benton. **Member:** Mid-Am. Artists. **Exhibited:** Midwestern Exh., Kansas City, 1926, 1934, 1936 (prize), 1939; Jr. Lg. Exh., Kansas City, 1939 (prize); Jr. Lg. Regional Exh., Milwaukee, 1939 (prize); CGA, 1940; Mid-Am. Artists, 1950, 1953. **Comments:** Also known as Marguerite Munger Peet. **Sources:** WW59; WW40.

PEET, Marguerite Munger See: **PEET, Margot**

PEET, Martha Gertrude *[Craftsperson, jeweler] b.1880, Clinton, WI.*
Addresses: Cambridge, MA. **Studied:** BMFA Sch.; G. Hunt in London; R. Robert in Paris; H.H. Clark. **Member:** Springfield Art Lg.; Boston Soc. Arts & Crafts. **Exhibited:** Portland (ME) Arts & Crafts (med.); AIC, 1921 (prize), 1923 (prize), 1924 (prize), 1926 (prize); Boston Tercentenary Exh., 1930 (medals); Springfield Art Lg., 1936 (prize) 1938 (prize); jewelry BMFA; Phila. Art All.;

Dayton AI, SFMA; Handicraft Club, Providence; Omaha Soc. FA; Columbus Gal. FA; Paris Salon, 1938. **Sources:** WW47.

PEETS, Elbert *[Painter] early 20th c.*
Addresses: Cleveland, OH. **Sources:** WW25.

PEETS, Ethel Canby See: **CANBY, Ethel Poyntell (Mrs. Orville H. Peets)**

PEETS, Orville Houghton *[Painter, graphic artist, teacher] b.1884, Cleveland, OH / d.1968, Lewes, DE.*
Addresses: Millsboro, DE; Woodstock, NY. **Studied:** Acad. Julian, Paris, with J.P. Laurens & Baschet, 1902-03; École des Beaux-Arts, Paris. **Member:** Wilmington Soc. FA; Rehoboth (DE) Art Lg.; Woodstock AA; Wilmington Pr. Club. **Exhibited:** AIC; PAFA Ann., 1917; Int. PM Exh., Los Angeles, 1931 (gold medal); intaglio, CMA, 1932 (prize); WMAA, 1936-1938; Wilmington Soc. FA, 1942 (prize), 1943 (prize), 1944 (prize); Paris Salon, 1914 (prize); BMA, 1953 (prize). **Work:** Musée du Jeu de Paume, Paris; Hispanic Mus., NY; Delaware AC; State House, Dover, DE; NYPL; LOC; Calif. State Lib.; Los Angeles Mus. Art; PMA; CMA; Wilmington Soc. FA; BMA. **Comments:** Made 1954 Presentation Print for Printmakers of Calif. Married artist Ethel Poyntell Canby (see entry). **Sources:** WW59; WW47; Woodstock AA cites death date as 1964; Falk, *Exh. Record Series*.

PEETSCH, Charles *[Painter on glass] mid 19th c.*
Addresses: NYC, 1855. **Comments:** He offered for sale dissolving views and other kinds of paintings on glass, "on hand, or made to order." **Sources:** G&W; N.Y. *Herald*, March 23, 1855 (citation noted by G&W as being courtesy J.E. Arrington). *Cf.* Carl P. Pfetsch.

PEGRAM, Marjorie M. E. *[Painter] b.1883, NYC / d.1972, Carmel, CA.*
Addresses: Carmel, CA. **Studied:** Cooper Union with Emil Carlsen & Twachtman; Woodstock Art Colony; John Cunningham & Lee Randolph, Univ. Calif., Berkeley. **Member:** Carmel AA. **Sources:** Hughes, *Artists of California*, 430.

PEHL, J. Carl *[Artist] b.c.1873, Peoria, IL / d.1959, Maplewood, NJ.*
Addresses: Active in Brooklyn, NY, 1900-30. **Sources:** BAI, courtesy Dr. Clark S. Marlor.

PEHMOLLER, Alexander A. *early 20th c.*
Exhibited: S. Indp. A., 1926-28; Salons of Am., 1927, 1928, 1930. **Sources:** Falk, *Exhibition Record Series*.

PEI, Leoh Ming *[Architect-planner] b.1917, Canton, China.*
Addresses: NYC. **Studied:** MIT (B. Arch.); Harvard Grad. Sch. Design (M. Arch.). **Member:** NA; Am. Inst. Arch. (fellow); NIAL; Council of the Harvard Grad. Soc. Adv. Study & Research; AFA (trustee). **Exhibited:** Awards: MIT Traveling Fellowship, 1940; Harvard Wheelwright Fellowship, 1951; Arnold Brunner Award of the NIAL, 1961; "People's Architect" Award, Rice Univ., 1963; Medal of Honor, NY Chapt. Am. Inst. Arch., 1963. **Sources:** WW66.

PEINT, Girault *[Portrait painter] late 18th c.*
Addresses: NYC, active 1797. **Sources:** G&W; NYCD 1797 (cited by McKay).

PEIPERL, Adam *[Sculptor] b.1935, Sosnowiec, Poland.*
Addresses: Silver Spring, MD. **Studied:** George Washington Univ. (B.S., 1957); Penn. State Univ., 1957-59. **Exhibited:** CGA, 1968; solos: Marlborough-Gerson Gal., NYC, 1969, Baltimore Mus. Art, 1969, PAFA, 1969 & Nat. Mus Hist. & Tech., 1972-73; Marlborough Gal., NYC, 1970s. **Work:** Nat. Mus. Hist. & Tech., Wash., DC; Nat. Coll. FA, Wash., DC; John F. Kennedy Center Performing Arts, Wash., DC; PAFA; Boymans-Van Beuningen Mus., Rotterdam, Holland. **Comments:** Preferred media: light, water, plastics. **Sources:** WW73; Frank Getlein, "He Defied Tradition and Made It Work," *Sun Star,* Washington, July 21, 1968; Victoria Donohoe, "Two Solo Shows Look Off into Space," *Philadelphia Inquirer,* Nov. 23, 1969; Diane Chichura & Thelma Stevens, *New Directions in Kinetic Sculpture* (Van Nostrand-

Reinhild, 1973).

PEIRCE, Alzira *[Painter, lithographer, mural painter, teacher, sculptor]* b.1908, NYC.
Addresses: NYC. **Studied:** ASL,with B. Robinson; Bourdelle in Paris. **Member:** NSMP; Fed. Mod. P&S. **Exhibited:** PAFA Ann., 1940-41; WMAA, 1941; Salons of Am.; S. Indp. A.; CI; AIC; Dallas Mus. FA; Pan-Am. Exh.; Fed Mod. P&S. **Work:** USPOs, Ellsworth, South Portland, both in Maine; Indian Mountain Sch., Lakeville, CT. **Comments:** WPA artist. **Sources:** WW47; Falk, *Exh. Record Series.*

PEIRCE, Anna M. *[Painter, designer]* b.c.1846, Massachusetts / d.1913, New Orleans, LA.
Addresses: New Orleans, active 1880-1900. **Exhibited:** Tulane Dec. Art Lg. for Women, 1888; Art Lg. N.O., 1889. **Comments:** Daughter of Oliver Peirce (see entry), sister of Martha Peirce (see entry). **Sources:** *Encyclopaedia of New Orleans Artists*, 294.

PEIRCE, Dorothy Rice (Mrs. Waldo) *[Painter, sculptor]* early 20th c.
Addresses: NYC. **Exhibited:** S. Indp. A., 1917-22. **Sources:** WW24.

PEIRCE, Edith Loring See: **PIERCE, Edith Loring**

PEIRCE, Gerry *[Painter, etcher, illustrator, writer, teacher, lecturer]* b.1900, Jamestown, NY / d.1969, Tucson, AZ.
Addresses: Tucson, AZ in 1962. **Studied:** Cleveland Inst. Art; ASL. **Member:** SAGA; Chicago SE; AWS; Calif. PM; Phila. Print Club; Chicago Gal. Assn.; Cleveland PM. **Exhibited:** SAGA, 1935-1945. **Work:** Joslyn Art Mus.; IBM; BMFA; CMA; MMA; LOC; J. B. Speed Art Mus.; FMA; Arizona State Mus.; Denver Art Mus. **Comments:** Teaching: Gerry Peirce Sch., Tucson, AZ. Auth.: "How Percival Caught the Tiger" (1936), "How Percival Caught the Python" (1937). Illustr.: "Plants of Sun and Sand," 1939. **Sources:** WW59; WW40.

PEIRCE, H. T. (Miss) *[Artist]* mid 19th c.
Addresses: Boston, 1859. **Exhibited:** Boston Athenaeum , 1859. **Sources:** G&W; Swan, BA.

PEIRCE, H. Winthrop *[Painter, illustrator]* b.1850, Boston, MA / d.1936. *H Winthrop Peirce*
Addresses: Boston (until 1891); Revere, MA (1890s); West Newbury, MA (1927-36). **Studied:** apprenticed to a lithography firm, Boston, 1866; BMFA Sch. with Grundmann & Rimmer, 1877 (inaugural class); Acad. Julian, Paris, with Bouguereau & Robert-Fleury, 1881-82. **Member:** Copley Soc., 1879 (pres., 1879-88); Boston SWCP (pres.); North Shore AA; Springfield AA. **Exhibited:** Paris Salon, 1882-83; PAFA Ann., 1882, 1906; NAD, 1884-88; Doll & Richards Gal., Boston, 1884 (solo); Boston AC, 1879-1907; Corcoran Gal. annual, 1907; S. Indp. A., 1918-19; AIC; Vose Gal., Boston, 1936 (mem. exh.). **Work:** John-Esther Gal., Andover; AAA; Bowdoin College; Malden (MA) Pub. Lib.; Old Newburyport (MA) Hist. Soc. **Sources:** WW33; exh. cat., *Mirror of the Times* (Lepore FA, Newburyport, MA, 1995); Falk, *Exh. Record Series.*

PEIRCE, John R. *[Artist]* mid 20th c.
Addresses: Phoenixville, PA. **Exhibited:** PAFA Ann., 1937. **Sources:** Falk, *Exh. Record Series.*

PEIRCE, Joshua H. *[Miniaturist, lithographic artist]* b.1812, Charlestown, MA / d.1869, Boston, MA.
Addresses: Active Boston c.1835; NYC, 1841-42; Boston, 1843-49; San Francisco by 1850. **Exhibited:** Boston Athenaeum, 1843 (frame of miniatures). **Work:** Boston Athenaeum; Soc. Calif. Pioneers. **Comments:** Worked for William Pendleton in Boston, c.1835, and for George W. Lewis in NYC. Was partner in Sharp, Peirce & Co. (see entry) of Boston, 1846-49. Went to San Francisco in 1850 and was active throughout that decade, first in association with C.J. Pollard in 1850. He also drew on stone for Charles Peregoy and Benjamin Butler (see entries). There is no record of when he returned to Boston. **Sources:** G&W; NYBD 1841-42; Swan, BA [as John H.]; Peters, *America on Stone;*

Peters, *California on Stone*. The dates (c. 1801-1849) given in Swan are those of a John H. Peirce, laborer, who died at Chelsea (MA) in 1849. More recently, see Hughes, *Artists in California;* Pierce and Slautterback, 68 (repro), 154, 178, 179 (with obit. citation).

PEIRCE, Margaret S. *[Painter]* 19th/20th c.
Addresses: Boston, MA. **Exhibited:** Boston AC, 1902; PAFA Ann., 1912. **Comments:** Active 1902-19. At Fenway Studios, c.1913-19. **Sources:** WW19; Petteys, *Dictionary of Women Artists;* Falk, *Exh. Record Series.*

PEIRCE, Martha A. *[Designer]* b.c.1842, Salem, MA / d.1900, New Orleans, LA.
Addresses: New Orleans, active 1888-1900. **Exhibited:** Tulane Dec. Art Lg. for Women, 1888. **Comments:** Daughter of Oliver Peirce (see entry) and sister of Anna Peirce (see entry). **Sources:** *Encyclopaedia of New Orleans Artists*, 294.

PEIRCE, Oliver *[Listed as "artist"]* b.1807, Cambridge, MA / d.1893, New Orleans, LA.
Addresses: New Orleans, active 1890-91. **Comments:** Father of Anna and Martha Peirce (see entries). **Sources:** *Encyclopaedia of New Orleans Artists*, 294.

PEIRCE, Rex Barton *[Painter, wood carver]* b.1902, Sheldon, IL / d.1982, Tacoma, WA.
Addresses: Tacoma, WA. **Studied:** John Herron Art Inst., Indianapolis; Rex Brant; R.E. Wood; Perry Archer; George Post; May Marshall. **Member:** Pacific Gal; Artists. **Exhibited:** Pacific Gal; Artists; Frye Mus.; West Coast Oil Show; Wash. State Hist. Soc. **Sources:** Trip and Cook, *Washington State Art and Artists, 1850-1950.*

PEIRCE, Sylvia (Margaret) Stiastny (Mrs.) *[Painter, teacher]* b.1906, Lincoln, NE.
Addresses: Lincoln, NE. **Studied:** T.E. Besnon; H.J. Stellar; Univ. Nebraska. **Sources:** WW40.

PEIRCE, Thomas Mitchell *[Painter, illustrator]* b.1865, Grand Rapids, MI.
Addresses: NYC, 1917. **Exhibited:** S. Indp. A., 1917. **Sources:** WW06.

PEIRCE, Waldo *[Painter, illustrator, mural painter, writer]* b.1884, Bangor, ME / d.1970, Newburyport, MA. *WPeirce '40*
Addresses: Pomona, NY, 1947; Searsport, ME, 1966. **Studied:** Phillips Acad.; Harvard Univ. (A.B.); ASL in NYC; Acad. Julian, Paris, 1911. **Member:** Am. Soc. PS&G; Bangor SA; Salon d'Automne, Paris. **Exhibited:** PAFA Ann., 1915, 1934, 1939-60; Corcoran Gal. biennials, 1916-53 (10 times); S. Indp. A., 1924, 1934; AIC, 1926-46; WMAA, 1928-46; Salons of Am., 1934; Pomona, Calif., 1938 (prize); Pepsi-Cola, 1944 (prize); Carnegie Inst., 1944 (prize). **Work:** MMA; WMAA; AGAA; PAFA; BM; Farnsworth Mus. Art; Encyclopaedia Britannica; Pepsi-Cola Co.; The Upjohn Co.; Univ. Arizona; State House, Augusta, ME; Bangor (ME) Pub. Lib.; murals, USPO, Westbrooke, ME; Troy, NY; Peabody, MA; Am. Field Service Bldg., NYC 1961. **Comments:** WPA artist. Illustr.: "The Magic Bed Knob," 1943; "The Children's Hour," 1944; "Squawky and Bawky." **Sources:** WW47; WW66; Falk, *Exh. Record Series.*

PEIRCE, William J. See: **PIERCE, William J.**

PEIRCY, Frederick See: **PIERCY, Frederick**

PEIRSON, Alden *[Painter]* b.1873, Baltimore, MD.
Addresses: Philipse Manor, NY, 1917. **Exhibited:** S. Indp. A., 1917, 1921. **Sources:** Marlor, *Soc. Indp. Artists.*

PEIRSON, Katharine Gassaway *[Painter]* early 20th c.
Addresses: Philipse Manor, NY, 1917. **Exhibited:** S. Indp. A., 1917. **Sources:** Marlor, *Soc. Indp. Artists.*

PEIS, Lewis See: **PISE, Lewis**

PEISLEY, Wilfred J. *[Painter]* mid 20th c.
Addresses: NYC. **Exhibited:** PAFA Ann., 1950. **Sources:** Falk,

Exh. Record Series.

PEITER, Edith (Denham) *[Artist]; b.Livingston Parish, LA.*
Addresses: Orlando, FL, late 1950s. **Studied:** Louisiana State
Univ., 1916-19; Corcoran Sch. Art, 1949-53. **Member:** SMPS&G
Wash., DC; Wash. AC; Corcoran Alumni Assoc. **Exhibited:**
SMPS&G Wash., DC; Wash. AC; Corcoran Alumni Assoc.
Sources: McMahan, *Artists of Washington, D.C.*

PEIXOTTO, Ernest C(lifford)
*[Painter, illustrator, writer] b.1869,
San Francisco, CA / d.1940, NYC.* *E.C. Peixotto*
Addresses: San Francisco, CA; NYC/Paris France. **Studied:** San
Fran. Sch. of Design with Emil Carlsen; Acad. Julian, Paris, with
Constant, Lefebvre & Doucet, 1888-90, 1891-93. **Member:** ANA,
1909; Mural Painters; Arch. Lg., 1911; SI, 1906; Century Club;
MacD. Club; AIA; Beaux Arts Inst. Des.; AFA; NIAL; Société des
Artistes Françaises; Art Commission, City of New York; Cornish
(NH) Colony; Mystic AA. **Exhibited:** Paris Salon, 1890-91, 1895,
1921 (prize); Vicker's Gal, San Fran., 1892; Calif. Midwinter Int.
Expo, 1894; PAFA Ann., 1895, 1902, 1909; Guild of Arts &
Crafts, 1896; AIC; San Fran. AA, 1900, 1903; Pan-Pacific Expo,
1915. Awards: Chevalier of the Legion of Honor, 1921; Officer,
1924. **Work:** Nat. Gal., Wash., DC; Hispanic Soc. Am.; murals,
Seaman's Bank, Bank of New York, Embassy Club, all in NYC.
Comments: Illustr.: "Life of Cromwell," by Roosevelt,
"Wanderings," by Clayton Hamilton. Auth.: "By Italian Seas,"
"Romantic California," "Our Hispanic Southwest," "The American
Front." Consult.: mural painting, Board of Design, WFNY, 1939.
Positions: official artist, Ame. Expeditionary Forces (1918); dir.,
A.E.F. Art Training Center painting studio during WWI, Bellevue,
France (1919); dir., dept mural painting, Beaux Arts Inst., NYC
(1919-26); chmn., Am. Comt., Fontainebleau Sch. FA. **Sources:**
WW40; Hughes, *Artists of California,* 430; Fink, *Am. Art at the
19th c. Paris Salons,* 379; Falk, *Exh. Record Series.*

PEIXOTTO, Florian *[Painter] 19th/20th c.; b.San Francisco,
CA.*
Addresses: NYC. **Studied:** Acad. Julian, Paris, with J.P. Laurens
& Benjamin-Constant, 1893. **Exhibited:** Paris Salon, 1895, 1897;
PAFA Ann., 1900-01. **Sources:** WW01; Falk, *Exh. Record Series.*

PEIXOTTO, George Da Maduro *[Painter, sculptor] b.1862,
Cleveland, OH / d.1937, White Plains, NY.*
Addresses: Crestwood, NY. **Studied:** Meissonier & Munkacsy in
Europe; L. Pohle; J. Grosse. **Member:** Mystic AA. **Exhibited:**
Royal Acad., Dresden (med.); Acad. France; Paris Salon, 1882-83,
1885-86; NAD, 1887; SNBA, 1893-94; AIC, 1899; Salons of
Am., 1923, 1929, 1934; S.Indp.A., 1930. **Work:** Eastnor Castle,
England; CGA; NGA; Widener Mem. Lib., Harvard; Cleveland
Chamber of Commerce; New Amsterdam Theatre, NYC. **Sources:**
WW38; Fink, *Am. Art at the 19th c. Paris Salons,* 369, 379; Falk,
Exh. Record Series.

PEIXOTTO, Irma M. *[Painter] early 20th c.*
Exhibited: Wash. WCC, 1903-04. **Sources:** McMahan, *Artists of
Washington, D.C.*

PEIXOTTO, Mary H. (Mrs. Ernest) *[Painter, writer, lectur-
er] 20th c.; b.San Francisco, CA.*
Addresses: NYC/Seine et Marne, France. **Studied:** San Fran.
Sch. Des. with Emil Carlsen; Paris with Delecluse. **Member:**
NAWA; MacD. Club; French Inst. in U.S.; Chevalier, Legion of
Honor, 1934. **Exhibited:** San Fran. Sketch Club, 1894, 1896-97;
Marie Sterne Gal., NYC; Corcoran Gal. biennial, 1939; Grace
Horne Gal., Boston, 1939. **Work:** Montclair AM; BM.
Comments: Contrib.: articles, *Am. Magazine of Art,* Scribner's
London Studio. Married Ernest Peixotto (see entry) in 1897 in
New Orleans, LA. **Sources:** WW40; Hughes, *Artists of
California,* 430.

PEKENINO, Michele *[Stipple engraver] early 19th c.; b.Italy.*
Comments: Was employed by Asher B. Durand in NYC about
1820. Soon after moved to Philadelphia, and from there returned
to Italy. It is said that he raised money for his return by selling an

engraved portrait of Durand as a portrait of Simon Bolivar.
Sources: G&W; Durand, *Life and Works of Asher B. Durand,* 36;
Stauffer.

PELBY, (Mrs.) *[Wax modeller] mid 19th c.*
Comments: Her collection of scriptural wax statuary was shown
in NYC in 1848, in Boston in 1849, and in Philadelphia in 1851.
Sources: G&W; N.Y. *Herald,* Jan. 4, 1848; Boston *Evening
Transcript,* June 4, 1849; Phila. *Public Ledger,* Nov. 24, 1851
(citations courtesy J.E. Arrington).

PELENC, Simeon *[Painter, mural painter] b.1873, Cannes,
France / d.1935, San Francisco, CA.*
Addresses: San Fran. **Exhibited:** San Fran. AA, 1925; Oakland
Art Gal., 1934. **Work:** San Fran. State Univ.; Berkeley Pub. Lib.;
CPLH. **Comments:** Teaching: San Fran. State Univ. **Sources:**
Hughes, *Artists in California,* 431.

PELGRAM, Charles R. *[Illustrator] early 20th c.*
Addresses: NYC. **Member:** SI 1912. **Sources:** WW13.

PELHAM, Henry *[Portrait and miniature painter, engraver,
map-maker] b.1749, Boston / d.1806, drowned in the Kenmare
River, England.*
Addresses: Boston; later London. **Studied:** presumably with
Copley. **Exhibited:** Royal Academy, London, 1777 and 1778.
Work: MMA: miniature (watercolor on ivory) portrait of Stephen
Hooper. **Comments:** Youngest son of Peter Pelham and half-
brother of John Singleton Copley (see entries). He was the sitter
in Copley's "Boy with a Squirrel." While in his early twenties, he
painted miniatures and assisted Copley with some background
painting. In 1770 he engraved a depiction of the Boston Massacre
which Paul Revere allegedly copied and printed himself (excerpts
of an angry letter from Pelham to Revere are printed in Saunders
and Miles). Pelham was painting life-size portraits by 1774, when
he traveled to Philadelphia to complete several commissions. A
Loyalist, he left Boston in 1776 and rejoined the Copleys in
London. While there he exhibited one history painting ("The
Finding of Moses") and several miniatures. He later went to
Ireland as an engineer and map-maker, and served as estate agent
for Lord Lansdowne. **Sources:** G&W; DAB; DNB; Stauffer;
Letters & Papers of John Singleton Copley and Henry Pelham
(Mass. Hist. Soc., 1914); Slade, "Henry Pelham"; *Antiques* (Feb.
1942), 141 (repro.). More recently, see Saunders and Miles, 307-
08 (repro.).

PELHAM, Peter *[Mezzotint engraver, portrait painter, school-
master] b.1697, London, England / d.1751, Boston, MA.*
Addresses: To Boston in 1727, where he remained except for
brief time in Newport, RI, 1734-36. **Studied:** apprenticed in 1713
to John Simon, London (one of London's leading mezzotint
engravers). **Work:** National Portrait Gallery, Wash. DC (mez-
zotint print of Cotton Mather); American Antiquarian Soc.,
Worcester, MA (oil portraits of Cotton Mather and Mather Byles
and various mezzotints); Winterthur Museum, Winterthur, DE
(mezzotint of James Gibbs, c. 1720). **Comments:** Made at least
25 mezzotint portraits of prominent persons in London, between
1720 and 1726. After settling in Boston in 1727 he produced the
first mezzotint made in the colonies, a portrait of Reverend Cotton
Mather. He engraved the likeness from his own painted portrait of
Mather, a practice taken up because of what he perceived to be a
lack of distinguished painters in Boston at the time. Although he
followed this pattern again in his portrait of Mather Byles (c
1732), he, for the most part, worked in conjunction with John
Smibert once that artist arrived on the scene. Among Smibert's
works engraved and published by Pelham was Smibert's portrait
of the popular Louisbourg hero William Shirley (painting now
lost) who became governor in 1745. He also engraved portraits
after other artists, including John Greenwood (see entry) and the
English painter Joseph Highmore. In all, there are fifteen known
American mezzotint portraits by Smibert. As it was difficult to
make a living solely as an engraver, Pelham also taught school,
writing, painting on glass, and dancing. In 1748 Smibert married
the widowed mother of John Singleton Copley and gave the

young boy his first introduction to art. Pelham's own collection of mezzotints must also have been of influence. Henry Pelham, the youngest son of Peter Pelham, was also an artist (see entry). **Sources:** G&W; Allison, "Peter Pelham--Engraver in Mezzotinto"; DAB; DNB; Coburn, "More Notes on Peter Pelham"; Stauffer; Flexner, *John Singleton Copley*. More recently, see Saunders and Miles, 9, 19, 23, 30, 134-143; Craven, *Colonial American Portraiture*, 139-151.

PELIKAN, Alfred George *[Educator, writer, lecturer, painter, craftsperson]* b.1893, Breslau, Germany.
Addresses: Milwaukee, WI. **Studied:** CI. (B.A.); Columbia Univ. (M.A.); ASL; & in England; H.S. Hubbell; Hawthorne; Bicknell; E Savage. **Member:** Wis. P. & S. (hon.); Wis. Designer-Craftsman (hon.); Seven A. Soc. (hon.); A. Dir. Cl. (hon.). **Exhibited:** Wisconsin P. & S., 1958. **Awards:** F., Royal Soc. A., London; *Milwaukee Journal* prize, 1931, 1957; Helen F. Mears prize, 1936. **Comments:** Position: dir., Milwaukee AI, 1926-41; dir. a. edu., Milwaukee (Wis.) Pub. Sch., 1925-; ext. l., Univ. Wisconsin; exh. com., Milwaukee AI. Author: "The Art of the Child," 1931; "Fun With Figure Drawing," 1947. Co-author: "Simple Metalwork," 1940. Contributor to: School Arts, Design, Education, & other magazines. **Sources:** WW59; WW47.

PELL, Ella Ferris *[Painter, sculptor, illustrator]* b.1846, St. Louis MO / d.1922, Beacon, NY.
Addresses: NYC; Paris; Beacon, NY. **Studied:** CUA Sch.l with Rimmer; Académie Julian, Paris with J.P. Laurens; also with F. Humbert, G. St.-Pierre at École des Beaux-Arts, 1880s. **Exhibited:** NAD,1883-99, 1891 (prize); Brooklyn AA, 1883; Paris Salon, 1889, 1890; Boston AC, 1890, 1896; PAFA Ann., 1893; Black & White Clu, NYC, 1900. **Work:** "Salome," owned by BAC; "Andromeda," heroic statue. **Comments:** Pell took a trip to Europe, North Africa and the Near East with her sister and brother-in-law, which lasted from fall 1872 to spring 1878. She painted along the way: Algerian street scenes, landscapes in Normandy, etc.; and together with her sister drew maps of ancient Palestine for her brother-in-law's manuscript. Illus., Paul Tyner, *Through the Invisible,* 1897; also illustrator for Christmas cards, Easter designs and figures for Louis Prang. **Sources:** WW29; Tufts, *American Women Artists,* cat. no. 45; Petteys, *Dictionary of Women Artists;* Falk, *Exh. Record Series.*

PELL, Genevieve *[Painter]* mid 20th c.
Addresses: San Francisco, CA. **Exhibited:** P&S of Los Angeles, 1936; Calif. AC, 1936; GGE, 1939. **Comments:** Specialty: floral still lifes. **Sources:** Hughes, *Artists in California,* 431.

PELL, Jacob *[Painter, etcher]* b.1898, Ukraine / d.1991.
Addresses: Brooklyn, NY (1913-31); Marlboro, CT (1931-55); Los Angeles area, 1955-91. **Studied:** NAD, with L. Kroll, 1917-25; Educational Alliance; ASL, with J. Sloan, c.1925. **Member:** Am. Ar. Cong.; Am. Watercolorists. Nelson A. Gal., Kansas City; Nat. Training Sch., Wash., D. C.; Riverside Hospital, NYC. **Exhibited:** ACA, 1935 (first solo). **Work:** Wm. Rockhill Nelson Gal.; LACMA; Zimmerli AM, Rutgers Univ. **Comments:** He was painting in Paris, 1929-31, then returned to NYC where he was a muralist for the WPA. **Sources:** WW40; add'l info courtesy Mrs. Jacob Pell.

PELL, Olive (Mrs. Herbert) See: **BIGELOW, Olive Tilton (Mrs. Herbert Pell)**

PELL, Yack *[Painter]* b.1899, Russia.
Addresses: Provincetown, MA, 1936. **Exhibited:** S. Indp. A., 1936. **Sources:** Marlor, *Soc. Indp. Artists.*

PELLAN, (Alfred) *[Painter]* b.1926, Quebec City, Canada.
Addresses: PQ, Canada. **Studied:** Ecole des Beaux.Arts, Quebec City (grad., 1920). **Member:** Soc. Artistes Prof. Que.; assoc. Royal Can. Acad. Arts. **Exhibited:** Gal. Jeanne Bucher, Paris, 1939; solo show., Pellan, retrospective, Mus. Nat. d'Art Mod., Paris, 1955, Pellan, retrospective, Hall of Hon., Montreal, PQ, 1956; Alfred Pellan, retrospective, Nat. Gal. Can., Art Gal. Toronto & Montreal Mus. Fine Arts, 1960-61; Voir Pellan, Mus.

d'Art Contemporain, Montreal, 1969. **Awards:** first prize, First Gt. Exhib. Mural Art Paris, 1935; first prize for painting, 65th Ann. Spring Exhib., Montreal Mus. Fine Arts, 1948; first prize for painting, PQ Competition, 1948. **Work:** Mus. Nat. d'Art Mod., Paris, France; Mus. Grenoble, France; Que. Mus., Quebec City; Nat. Gal. Can., Ottawa; Montreal Mus. Fine Arts, PQ. **Commissions:** painting, Winnipeg Airport, Man., 1963; stained glass, La Place des Arts, Montreal, 1963; stained glass, Church Saint Theophile, Laval-Quest, PQ, 1964; two paintings, Nat. Libr. & Archives, Ottawa, 1967; polychromy of bldgs., Vt. Constructions Inc. Laval City, 1968. **Comments:** Preferred media: oils. Teaching: instr. painting, Ecole Beaux Arts, Montreal, 1943-52; instr. painting, Art Centre Sainte Adele, PQ, summer 1957. Publications: contribr., "Les iles de la nult," Parizeau Ed., 1944; contribr., "Le voyage d'Arlequin," Cahiers File Indienne, 1946. **Sources:** WW73; Donald W Buchanan, *Alfred Pellan* (McClelland & Stewart, 1962); Guy Robert, *Pellan* (Centre Psychologie Pedagogie, Montreal, 1963); "Voir Pellan," Nat. Film Bd. Can., 1969.

PELLEGRIN, Francis *[Engraver]* mid 19th c.
Addresses: NYC, 1852. **Sources:** G&W; NYBD 1852.

PELLEGRINI, Ernest (G.) *[Sculptor]* b.1889 / d.1955.
Addresses: East Boston, Boston, MA. **Studied:** Acad. Verona, Italy. **Member:** Boston Soc. S.; Copley S., Boston; North Shore AA; NSS. **Exhibited:** North Shore AA; PAFA Ann., 1928; Copley S.; Detroit Inst. A. **Work:** Nat. Shrine of the Immaculate Conception, Wash., DC, churches, Cambridge, Boston, Brighton, Lenox, all in Mass.; NYC; Chicago. Ill.; Portland, Maine; Miami, Fla.; New Milford, Conn.; Evanston, Ill.; Mattapan, Mass.; Concord, NH. **Sources:** WW47; Falk, *Exh. Record Series.*

PELLEN, John H. *[Engraver, draftsman]* 19th/20th c.
Addresses: Wash., DC, active 1890-1920. **Sources:** McMahan, *Artists of Washington, D.C.*

PELLEW, John C(lifford) *[Painter]* b.1903, Heamoor, England.
Addresses: Astoria, NY; Norwalk, CT. **Studied:** Penzance Sch. Art, Eng. **Member:** N.A.; AWCS; All. A. Am.; Southwestern WCS; SC. **Exhibited:** S. Indp. A., 1924-26, 1928-31, 1940-43; Salons of Am., 1934; Corcoran Gal biennials, 1935-51 (3 times); CI, 1943-46; PAFA, 1936-38; BM, 1935-36, 1939, 1943; CI, 1943-46; PAFA Ann., 1936-38, 1943, 1949; NAD, 1937, 1942, 1944, 1948-72 (1961, Adolph & Clara Obrig Prize); AIC, 1938-39, 1943; NYC (solo), 1934, 1938, 1944; WMAA, 1937-47; Butler Inst. Am. Art, 1964 (first award for watercolor); "200 Years of Watercolor Painting in America," MMA, 1967; "Landscape 1," De Cordova & Dana Mus., Lincoln, Mass., 1970; AWCS, 1970 (silver); Exchange Exhib., Canada, 1972; Grand Central Art Gal., NYC, 1970s. **Work:** MMA; BM; Newark Mus.; Butler Inst. Am. Art; Georgia MFA, Athens; Adelphi Col., Garden City, NY; New Britain Mus. Am. Art, CT. **Comments:** Preferred media: watercolor, oil. Author: *Acrylic Landscape Painting,* 1968; *Painting in Watercolor,* 1969; *Oil Painting Outdoors,* 1971. **Sources:** WW73; Norman Kent, *Watercolor Methods* (Watson-Guptill, 1955); Wendon Blake, *Complete Guide to Acrylic Painting* (Watson-Guptill, 1971); WW47; Falk, *Exh. Record Series.*

PELLICONE, William *[Painter]* b.1915, Philadelphia, PA.
Addresses: NYC. **Studied:** PAFA; Barnes Found., Merion, Pa. **Exhibited:** PAFA Ann., 1939; NAD, 1939; Woodmere Art Gal., Phila.; A. All., Phila.; group show, BMA, 1971; Capricorn Gallery, Bethesda, MD, 1970s; Allan Stone Gallery, NYC, 1970s. **Work:** work in public collections: BMFA; Smithsonian Inst.; Allan Stone Gals., NY & Purchase, NY; Philip Desind, Capricorn Gal., Bethesda, Md.; Am. Broadcasting Co., NY. **Commissions:** murals, Abraham & Strauss, Brooklyn, NY, 1969-70. **Comments:** Preferred media: oil. **Sources:** WW73; Falk, *Exh. Record Series.*

PELLIN, Irving *[Painter]* b.1934.
Addresses: NYC, 1973. **Exhibited:** WMAA, 1973. **Sources:** Falk, *WMAA.*

PELLISSIER, Charles *[Painter] b.c.1828, Ile-de -France / d.1878, New Orleans, LA.*
Addresses: New Orleans, active c.1874-78. **Comments:** Came to N.O. from Belgium. **Sources:** *Encyclopaedia of New Orleans Artists,* 295.

PELLOW, John C(lifford) See: **PELLEW, John C(lifford)**

PELLY, May G. *[Painter] early 20th c.*
Addresses: Phila., PA. **Exhibited:** Phila. WC Exhib, PAFA, 1905, 1907; AIC, 1907. **Sources:** WW08; Petteys, *Dictionary of Women Artists.*

PELOSO, Fred R. *[Painter] mid 20th c.*
Exhibited: Salons of Am., 1934. **Sources:** Marlor, *Salons of Am.*

PELS, Albert *[Painter, teacher, muralist, illustrator] b.1910, Cincinnati, OH / d.1998, NYC.*

Albert Pels

Addresses: NYC. **Studied:** Art Acad. Cincinnati, 1929-30; Cincinnati Art Mus. scholar, 1932; Univ. Cincinnati; BAID; ASL, 1933-37 (six scholarships and gold med.) with Thomas Hart Benton, Kenneth Hayes Miller, Geo. Bridgeman; Palmer; Brook; Am. School Art, NYC, 1934-35; Schackenberg scholar, 1949. **Member:** NSMP; Artists Union; Progressive AA; ASL; SC. **Exhibited:** S. Indp. A., 1941; Macbeth Gal., NYC, 1942-43; Babcock Gal., NYC, 1944-47; Laurel Art Gal., 1952; Pulitzer Gal., 1951; WMAA, 1938-39, 1942, 1944-47; CI, 1941-50; NAD, 1938, 1940-42, 1945-52; PAFA Ann., 1937-38, 1943, 1949; CM, 1932-38, 1940-42 (solo), 1943-46; Corcoran Gal biennials, 1945, 1951; Audubon Artists, 1946-48; Roerich Mus., NYC, 1944; AIC, 1946 (solo, traveled to St. Louis AM); Rochester Mem. Art Gal.; Nelson Gal.; Dayton AI; Riverside Mus.; Butler AI, 1945-55 (first prize for Sea Disaster, 1946); CAFA; Massillon Mus. Art.; Minneapolis Art Inst.; Butler Inst. Am. Art; CMA; SFMA; WFNY, 1939; VMFA; BAIC, 1936 (medal); Parkersburg, WV, 1942 (prize); Chicago Am., 1949; Babcock Gal, NYC, 1940s; Gorwit Gal., Roslyn, NY; "NYC WPA Art" at Parsons School Design, 1977; D. Wigmore FA, NYC (WPA retrospective); R. Davis FA, Shaker Heights, OH (solo); Rainone Gal., 1985. **Work:** Massillon Mus. Art; PMA. Commissions: "The Landing of the Swedes," Courthouse, Wilmington, DE, 1942; "Early History of Normal, Illinois," USPO; "Africa scene," North African Line, 1950; "History of Norfolk, VA," for naval base; "General History of Anniston, AL Area," YMCA. **Comments:** Preferred media: oils, watercolors, graphics. Positions: WPA Art Project, 1930s (four murals awarded); dir., Albert Pels School Art, Inc., 1972-on; demonstrator of oil painting on educ. TV. Publications: contrib., *Art News,* 1946; illustrator, "Easy Puppets," 1952 &" Water Pets," 1956. Teaching: instr., Jones Mem. School & Hessian Hills School; instr. of fine art, Albert Pels School Art, Inc., 1946-late 1980s when he sold the school to the Fashion Inst., NYC. Research: techniques of the old masters. Art interests: traditional art of the old masters. Collection: late 19th & early 20th century. **Sources:** WW73; WW47; *New York City WPA Art,* 70 (w/repros.); Falk, *Exh. Record Series.*

PELTIER, Olive *[Sculptor] 20th c.*
Addresses: Faribault, MN. **Sources:** WW15.

PELTO, George R. *[Painter] mid 20th c.*
Addresses: Detroit, MI, 1929. **Exhibited:** S. Indp. A., 1929. **Sources:** Marlor, *Soc. Indp. Artists.*

PELTON, Agnes *[Painter] b.1881, Stuttgart, Germany / d.1961, Cathedral City, CA.*
Addresses: NYC; Cathedral City, CA, 1931-61. **Studied:** Pratt Inst.; Rome; Arthur Wesley Dow; W.L. Lathrop; H.E. Field. **Member:** NAWA; AAPL; AFA; Riverside (CA) AA; Studio Guild, NYC; Transcendental Painters Group, Santa Fe (hon. mem.). **Exhibited:** S. Indp. A., 1917-18, 1920-21, 1923-30, 1933; Salons of Am.; PAFA Ann., 1930; PAFA, 1932 (solo); NAWA, annually until 1932; Armory Show, 1913; Knoedler Gal., 1917; WMAA, 1920-28; Frank Moore's Cross Roads Studio, 1924;

Montross Gal., 1929 (solo); BM, 1931; Argent Gal., 1931 (solo); Mus. New Mexico, Santa Fe, 1933; San Diego FA Center, 1934 (solo); Calif.-Pacific Int. Expo, San Diego, 1935; GGE, 1939; SFMA, 1943 (solo); Santa Barbara Mus. Art, 1934, 1943 (solo); Crocker Art Gal., Sacramento, CA, 1944 (solo), 1947 (solo); Laguna Beach AA, 1947 (solo); Pomona Col., 1947 (solo); Laguna Beach AA, 1947 (solo); Palm Springs (CA), 1950 (solo), 1955 (solo); Terry AI, 1952; El Mirador Hotel, Palm Springs, 1954 (solo); Desert Art Center, 1951-55 (solos); Univ. Redlands, 1951 (solo). **Work:** San Diego FA Soc.; Santa Barbara Mus. Art; H.L. Perry Mem. Lib.; First Nat. Bank, Louisville, GA; Univ. NM. **Comments:** Born in Germany of American parents. An avant-garde abstractionist, Pelton was a versatile and innovative artist, choosing from a wide range of subjects. She was in Honolulu in 1923 and 1924, where she executed portraits, still lifes, and flower studies from nature. In 1926 she visited the Near East, executing portraits, but had turned away from figurative art to an abstract symbolism by 1929, evident in her solo show at the Montross Gallery. Illustr.: "When I Was a Little Girl," by Z. Gale, Macmillan Co. Pettys reports an alternate birth date of 1888. **Sources:** WW59; WW47; Falk, *Exh. Record Series.* More recently, see Hughes, *Artists in California,* 431; Forbes, *Encounters with Paradise,* 243-44; Diamond, *Thirty-Five American Modernists* p.46; Petteys, *Dictionary of Women Artists;* Tufts, *American Women Artists,* cat. no. 80; *American Abstract Art,* 194; Trenton, ed. *Independent Spirits,* 75.

PELTON, Oliver *[Banknote and general engraver] b.1798, Portland, CT / d.1882, East Hartford, CT.*
Addresses: Active principally in Boston, MA. **Comments:** Partner with Terry, Pelton & Co. of Boston in 1836-37. **Sources:** G&W; Fielding, *Supplement to Stauffer;* Boston CD 1829-56.

PELTON, S. K. (Miss) *[Artist] early 20th c.*
Addresses: Active in Los Angeles, c.1915-16. **Sources:** Petteys, *Dictionary of Women Artists.*

PELTZMAN, Jacob *[Painter] early 20th c.*
Addresses: NYC, 1922. **Exhibited:** S. Indp. A., 1922, 1925. **Sources:** Marlor, *Soc. Indp. Artists.*

PELTZMANN, Jack *[Painter] 20th c.*
Addresses: NYC, 1927. **Exhibited:** S. Indp. A., 1927-28. **Sources:** Marlor, *Soc. Indp. Artists.*

PELZER, Mildred W. (Mrs. Louis) *[Painter] mid 20th c.; b.Dillon, MT.*
Addresses: Iowa City, IA. **Studied:** Montana State Normal Col.; Pratt Inst.; Columbia Univ.; Univ. Iowa; A.W. Dow, at Columbia. **Member:** Iowa Federation Women's Clubs (art chairman, 1935-37). **Exhibited:** Midwest Exhibition, Kansas City; Omaha A. Gal.; Iowa A. Salon, 1934 (award); Iowa State Col.; Biennial Exhibits, Iowa Federation Women's Clubs (awards). **Work:** Univ. Iowa; Iowa State Col.; WPA mural USPO, Waverly, Iowa; Jefferson Hotel, Iowa City. **Comments:** Organizer and director of first Iowa City Junior Flower Show and the Iowa Library of Art. Also published historical maps. Positions: art director, Bedford (IN) Public Schools; art dir., Teachers College, Madison, SD. **Sources:** WW40; Ness & Orwig, *Iowa Artists of the First Hundred Years,* 164-65.

PELZI, Robert *[Sculptor] d.1831, IN (automobile accident).*
Addresses: Chicago, IL. **Exhibited:** Ill. Acad. Show, 1931.

PEMBER, Ada Humphrey *[Painter] b.1859, Shopiere, WI.*
Addresses: Janesville, WI/Stoughton, WI; Santa Barbara, CA, 1932. **Studied:** W.M. Clute; F. Fursman. **Member:** Janesville AL; Wisc. PS. **Sources:** WW25; Petteys, *Dictionary of Women Artists.*

PEMBERTON, Anita Le Roy See: **LE ROY, Anita Pemberton**

PEMBERTON, Ida Hrubesky *[Painter] b.1890, Nebraska / d.1951.*
Studied: AIC. **Work:** Univ. Colorado Mus., Boulder (circulating collection of 50 paintings). **Comments:** Painted botanical por-

traits. **Sources:** Petteys, *Dictionary of Women Artists.*

PEMBERTON, John Peter *[Painter, illustrator, teacher, designer]* *b.1873, New Orleans / d.1914, Perpignan, France.*
Addresses: New Orleans, LA. **Studied:** Tulane Univ.; ASL; NY Sch. of Art; Andres Molinary; Paul Poincy; William Woodward; Académie Julian, Paris with Bouguereau and Ferrier, 1894-96; Acad. Colarossi. **Member:** Artist's Assoc. of N.O., 1896; NOAA (exec. commit.), 1904-05, 1907. **Exhibited:** Tulane U., 1893; Artist's Assoc. of N.O., 1896-97; Louisiana Historical Soc., 1903; NOAA, 1905, 1907-08; AIC, 1909; Nat. Assoc. of Newspaper Artists, 1905. **Award:** Académie Julian, first honor, concours. **Comments:** Position: t., Newcomb Col. Retired to France in 1908. **Sources:** WW10; *Encyclopaedia of New Orleans Artists,* 295.

PEMBERTON, Murdock *[Painter] mid 20th c.*
Addresses: NYC, 1925. **Exhibited:** S. Indp. A., 1925-27, 1929; WMAA, 1926. **Sources:** Falk, *WMAA.*

PEMBROOK, Theodore Kenyon *[Landscape painter]* *b.1865, Elizabeth, NJ / d.1917.*
Addresses: NYC. **Sources:** WW15.

PEN, Rudolph T. *[Painter] b.1918, Chicago, IL.*
Addresses: Chicago, IL. **Studied:** AIC (B.F.A.); also Europe, S. Am., Mex. & N. Africa. **Member:** AWCS; Arts Cl. Chicago; hon mem. Union League Civic & Arts Found. **Exhibited:** NAD, 1945 (prize); LOC, 1946; CI, 1946; AIC, 1939-51, 1961 (Contemp. Artists Exhib.); Milwaukee AI; Watercolor Print Exhib., PAFA; CGA; Joseph Welna, Chicago, IL, 1970s. **Awards:** Huntington Hartford Found. grant, 1958; Ryerson traveling fel., 1963. **Work:** Davenport Mus., Iowa; LOC; PMA; Vincent Price Coll.; AIC. **Comments:** Preferred media: oils, watercolors. Positions: pres., Alumni Assn., AIC, 1960-62; dir., Summer Sch. Painting, 1964-65. Publications: auth., "Whipping Boy or Cultural Spokesman," 1954 & auth., "The Tongue is Quicker than the Mind," 1966, Art League; auth., "Artist-Teacher blasts Tycoons & Pretenders," *Chicago Sun Times,* 1971. Teaching: asst. prof. painting, AIC, 1948-63; dir. pvt. sch., 1963-. **Sources:** WW73; Marilyn Hoffman, "Art," *Christian Sci. Monitor,* Jan. 3, 1951; Kay Loring, "Pen Named Director of Art School," July 24, 1964 & Edith Weigle, "Art Critic," *Chicago Tribune* (Nov. 28, 1965).

PENA, Alberto *[Painter, educator] b.1900, Havana, Cuba.*
Studied: San Alesandro Academy; PAFA. **Exhibited:** Club Atenas, Havana, 1934; Modern Cuban Art, Mexico City, 1937; Havana, 1935, 1937. **Awards:** Cresson scholarship, PAFA. **Sources:** Cederholm, *Afro-American Artists.*

PENA, Encarnacion *[Painter] mid 20th c.*
Addresses: San Ildefonso Pueblo, NM. **Exhibited:** S. Indp. A., 1932. **Sources:** Marlor, *Soc. Indp. Artists.*

PENA, Feliciano *[Painter] mid 20th c.*
Exhibited: AIC, 1941, 1943. **Sources:** Falk, *AIC.*

PENA, Tonita (Quah Ah) *[Painter, teacher, mural painter]* *b.1895, San Ildelfono Pueblo, NM / d.1949, San Ildefonso Pueblo.*
Addresses: Santa Fe, NM. **Studied:** San Ildefonso Pueblo Day Sch.; St. Catherine's Indian Sch.l, Santa Fe. **Exhibited:** Soc. Indep. Artists, 1932-34; First Nat. Exh. Am. Indian Painters, Philbrook AC, 1946. **Work:** AMNH; St. Louis AM; CG; Denver AM; Mus. Am. Indian; Mus. New Mexico. **Comments:** Specialty: watercolors of children and animals. She was the only successful Indian woman painter of the 1910-20s; an original participant in the watercolor movement with Awa Tsireh, Fred Kabotie and Oqwa Pi. Her murals were commissioned for the Soc. of Independent Artists, 1933, and for the Chicago World's Fair. Teaching: Indian Sch., Santa Fe NM, and Albuquerque, NM. **Sources:** WW47; P&H Samuels, 367; Trenton, ed. *Independent Spirits,* 157.

PENABERT, F. *[Portrait painter] mid 19th c.*
Addresses: Philadelphia, 1856. **Exhibited:** PAFA, 1856. **Sources:** G&W; Rutledge, PA.

PENCHARD, Charles *[Painter] mid 19th c.*
Addresses: NYC. **Exhibited:** NAD, 1861-70. **Sources:** Naylor, *NAD.*

PENCO, Andrew (Andrea) *[Painter] b.c.1841, Genoa, Italy / d.1889, New Orleans, LA.*
Addresses: New Orleans, active 1880-88. **Sources:** *Encyclopaedia of New Orleans Artists,* 295.

PENCZNER, Paul Joseph *[Painter] b.1916, Hungary.*
Addresses: Memphis, TN. **Studied:** Hungary & Austria. **Member:** Nat. Soc. Painters Casein. **Exhibited:** PAFA Ann., 1962; Brooks Mem. Art Memphis; Jersey City Mus.; Smithsonian Inst.; NOMA; Penczner's Round Corner Gal., Memphis, TN, 1970s. **Work:** Vatican, Rome; Capitol Bldg., Jefferson City; Univ. Tenn., Memphis; Univ. Mo., Cape Girardeau; Fla. State Univ., Talahassee. Commissions: works comn. by Mayor Walter Chandler, City of Memphis, Sen. McKinney, Capitol Bldg., Jefferson City, Univ. Tenn., Univ. Mo., & family of Virginia Churchill. **Comments:** Preferred media: oils, acrylics, ink. Teaching: owner & dir., Penczner Fine Art Sch., Memphis. **Sources:** WW73; Falk, *Exh. Record Series.*

PENDENNIS, Dorothy See: **BISSELL, Dorothy Pendennis (Mrs. Lloyd)**

PENDERGAST, John See: **PRENDERGAST, John**

PENDERGAST, Molly Dennett (Mrs. E. P.) *[Painter, teacher, designer, writer] b.1908, Belmont, MA.*
Addresses: Sacramento, CA. **Studied:** Univ. Calif. with H. Hofmann. **Member:** Kingsley AC; Northern Calif. Artists; San Fran. Soc. Women Artists. **Exhibited:** Kingsley AC, Sacramento, 1940-54; San Fran. AA, 1944-46; San Fran. Soc. Women Artists, 1944-46; Northern Calif. Artists; City of Paris, San Fran., 1943 (solo); Crocker Art Gal., 1946 (solo); Univ. Art Gal., Berkeley. **Comments:** Position: WPA artist/dir. **Sources:** Hughes, *Artists in California,* 431.

PENDLEBURY, Richard *[Painter] mid 20th c.*
Exhibited: Oakland Art Gal., 1929. **Sources:** Hughes, *Artists in California,* 431.

PENDLETON, Constance *[Painter, teacher, lecturer] 20th c.; b.Philadelphia, PA.*
Addresses: Bryn Athyn, PA. **Studied:** Columbia Univ. (B.S., M.A.); in Europe; & with Arthur Carles, Hugh Breckenridge, W. Grauer., Arthur Dow. **Member:** NAWA; Phila. Plastic C.; AFA; Phila. A. T. Assn.; Eastern AA. **Exhibited:** A. All., Plastic Cl., Sketch Cl., all of Phila., Pa.; S. Indp. A., 1936-37, 1939; Argent Gal; NAWPS, 1938. **Comments:** Position: hd. a. dept., Kensington H.S., Philadelphia, Pa. Retired, 1952. **Sources:** WW59; WW 47.

PENDLETON, Cross *[Artist] 19th/20th c.*
Addresses: Wash., DC, active 1901. **Sources:** McMahan, *Artists of Washington, D.C.*

PENDLETON, Elizabeth (Mrs. F.) *[Sculptor] early 20th c.*
Addresses: NYC. **Exhibited:** S. Indp. A., 1917. **Sources:** Marlor, *Soc. Indp. Artists.*

PENDLETON, Evelyn *[Sculptor] mid 20th c.*
Addresses: Bethel, CT, 1926. **Exhibited:** S. Indp. A., 1926. **Comments:** Married to artist William L. Marcy Pendleton. **Sources:** Marlor, *Soc. Indp. Artists.*

PENDLETON, John B. *[Lithographer] b.1798, NYC (of English parents) / d.1866, NYC.*
Addresses: Active Boston, MA. **Studied:** may have trained as engraver. **Comments:** Prior to becoming involved in lithography, John and his brother, William S. Pendleton, were employed in 1816 to rig up a system of gas lighting for the Peale Museums in Philadelphia and Baltimore; in 1820 they were in charge of the traveling exhibition of Rembrandt Peale's "Court of Death." In 1825 John went to France as agent for a bookseller and returned with lithographic stones, crayons, and transfer ink; and by February 1826 he and William had opened up Boston's first litho-

graphic shop. Their shop operated under the name of William and John Pendleton from 1826-30, although John left Boston in 1828. He spent a short time in Philadelphia (Pendleton, Kearney & Childs), and from 1829 to 1834 practiced lithography in NYC (on his own). In 1834 he sold this firm to a former pupil, Nathaniel Currier, and apparently abandoned lithography, although he remained in NYC and became involved in a number of occupations. From 1835 to 1851 he was listed as a carpenter and proprietor of a planning mill. William Pendleton continued operating the lithography shop in Boston until 1836 (see his entry for more complete discussion of the shop). **Sources:** G&W; Peters, *America on Stone;* Pendleton, *Brian Pendleton and His Descendants,* 750. More recently, see Reps, 27; Pierce and Slautterback, 146-47 (and repros.).

PENDLETON, Kate [Painter] mid 20th c.
Exhibited: S. Indp. A., 1940. **Sources:** Marlor, *Soc. Indp. Artists.*

PENDLETON, Walter [Painter] b.1866, Glenbrook, CT / d.1942, Islip, LI, NY.
Addresses: NYC, 1934. **Exhibited:** S. Indp. A., 1934. **Sources:** Marlor, *Soc. Indp. Artists.*

PENDLETON, William [Listed as "artist"] b.c.1832, New York.
Addresses: NYC in 1860. **Comments:** Both John B. and William S. Pendleton (lithographers) had sons of this name, but they are not known to have been artists. **Sources:** G&W; 8 Census (1860), N.Y., XLII, 955; Pendleton, *Brian Pendleton and His Descendants,* 750-51.

PENDLETON, William & John (Pendleton's Lithography) [Lithographers] mid 19th c.
Addresses: Boston, MA. **Comments:** More commonly known as Pendleton's Lithography Shop, active in Boston, 1826-36. See individual entries for John B. and William S. Pendleton.

PENDLETON, W(illiam) L(arned) Marcy [Painter] b.1865, Paris, of Am. parents.
Addresses: Bethel, CT; Phila., PA. **Studied:** C. Duran. **Member:** S. Indp. A.; Salons of America. **Exhibited:** Paris Salon, 1888; SNBA, 1893; PAFA Ann., 1895, 1904; Salons of Am.,1925, 1932-34; S. Indp. A., 1922-39. **Comments:** Husband of Evelyn Pendleton (see entry). **Sources:** WW33; Falk, *Exh. Record Series.*

PENDLETON, William S. [Engraver and lithographer] b.1795, NYC (of English parents) / d.1879, Staten Island, NY.
Addresses: Active Boston, MA. **Studied:** trained as an engraver. **Work:** Boston Athenaeum. **Comments:** In 1816, he and his younger brother John B. Pendleton (see entry) were hired to install gas fixtures in the Peale Museums at Philadelphia and Baltimore and in 1820 to exhibit Rembrant Peale's "Court of Death" in various cities and towns. By 1825 William was working as an engraver in Boston in partnership with Abel Bowen, but the following year he and his brother opened the first lithographic shop in Boston. William remained in Boston after John's departure in 1828 and operated the shop under his own name from 1831 to 1836, at which point he sold out to Thomas Moore, his bookkeeper. During these years William had also become involved in banknote engraving, founding the New England Bank Note Company in 1833; he continued in this venture until he moved to Philadelphia (date unknown) where he worked in the hardware business. After the Civil War he settled in Staten Island (NY). The Pendleton lithographic shop of Boston holds an important place in the development of lithography in America. It served as a training ground for a great number of artists who went on to make contributions to American art: among these are Nathaniel Currier, Fitz Hugh Lane, Benjamin Nutting, John W.A. Scott, and Moses Swett. The Pendletons also attracted accomplished artists like the painters Rembrandt Peale, Francis Alexander, John Ritto Penniman, and the architect Alexander Jackson Davis, all of whom tried their hand at lithography in the shop. The Pendleton shop produced a number of topographical views and views of Boston which have great historical value, among these are

Alexander Jackson Davis's "State House, Boston," of 1827; Eliza Ann Farrar's view of Lowell, Mass., of 1834; and Fitz Hugh Lane's view of Gloucester, Mass., c. 1835 (all at Boston Ath.). **Sources:** G&W; Peters, *America on Stone;* Pendleton, *Brian Pendleton and His Descendants,* 750; Baldwin, *Diary,* 331. More recently, see Pierce and Slautterback, 4-6, 146-48 (and repros.).

PENDLETON, KEARNEY & CHILDS [Lithographers] early 19th c.
Addresses: Philadelphia, 1829-30. **Comments:** Partners were John B. Pendleton, Francis Kearney, and Cephas G. Childs (see entries on each). **Sources:** G&W; Peters, *America on Stone;* Eckhardt, "Early Lithography in Philadelphia," 252.

PENDRELL, William P. [Painter, illustrator] early 20th c.
Addresses: Paris, France. **Studied:** Académie Julian, Paris with J.P. Laurens, 1901. **Exhibited:** NAD, 1886, 1895. **Sources:** WW10; Fehrer, The Julian Academy.

PENEAU, Alexander [Engraver] b.1887, New Hampshire / d.1963, Wash., DC.
Comments: Worked for the Bureau of Engraving and Printing, from 1924-57. **Sources:** McMahan, *Artists of Washington, D.C.*

PÈNE DU BOIS, Guy See: **DU BOIS, Guy Pène**

PÈNE DU BOIS, Yvonne See: **DU BOIS, Yvonne Pène**

PÉNÉLON, Henri Joseph [Portrait painter, photographer] b.1827, Lyon, France / d.1885, Prescott, AZ.
Addresses: Los Angeles, CA. **Work:** Bowers Mem. Mus. (Santa Ana, CA); Los Angeles County Mus. of Natural Hist. **Comments:** Settled in Los Angeles in 1850, and became the city's first resident artist-photographer. Painted portraits of some of the important ranchers in early California. Had daguerreotype studio in Los Angeles from 1853. He also painted frescoes in the Plaza Church in Los Angeles. His works are rare and of historical value. **Sources:** G&W; *Antiques* (Nov. 1953), 368 (repro.), 369; Hughes, *Artists in California,* 431; P&H Samuels, 367.

PENFIELD, Annie [Painter] late 19th c.
Addresses: Active in Detroit, MI. **Exhibited:** Detroit, 1875. **Sources:** Petteys, *Dictionary of Women Artists.*

PENFIELD, Edward [Painter, illustrator, writer, teacher] b.1866, Brooklyn NY / d.1925, Beacon, NY.
Addresses: Pelham Manor, NY. **Studied:** ASL. **Member:** WCS; GFLA; New Rochelle AA; SI, 1901; SC, 1905. **Work:** murals, Harvard and Rochester CC. **Comments:** He effectively combined the styles Art Nouveau, Japonisme, and Arts & Crafts to create some of the finest posters, advertisements, and magazine covers of the 20th c., especially for *Harper's.* His work also appeared in *Collier's, Sat. Eve. Post, Ladies Home Journal, Scribner's, Metropolitan magazine* and others. Author/illustrator: *Holland Sketches* (Scribner's, 1907), and *Spanish Sketches* (Scribner's, 1911). Position: art editor and illustrator, *Harper's,* 1891-1901. **Sources:** WW24; P & H Samuels, 367; add'l info. courtesy Illustration House (NYC, essay #20).

PENFIELD, Florence Bentz (Mrs.) [Painter, teacher] b.1895, Buffalo, NY.
Addresses: Reading, PA. **Studied:** Univ. Buffalo (Ph.C., B.S., M.S.); Buffalo Sch. FA; PAFA (f., PAFA); and with Florence Bach, Roy Nuse, Daniel Garber, F. Speight. **Member:** Buffalo Soc. Art; Woodmere Art Gal.; AAPL; AEA. **Exhibited:** Albright Art Gal., 1941 (prize); PAFA (prize); Parkersburg FAC; Reading Pub. Mus.; Miami, FL, 1952; Buffalo Soc. Art; Reading Art Gal.; traveling exhib., PA, MD, VA, GA. **Work:** Reading (PA) Pub. Mus. **Comments:** Teaching, private studio. **Sources:** WW59; WW47.

PENFIELD, George W. [Illustrator] 19th/20th c.
Addresses: NYC. **Sources:** WW01.

PENFOLD, Frank (Francis) C. *F.Penfold*
[Painter, teacher] b.1849, Lockport,
NY / d.1921, Concarneau, France.
Addresses: Buffalo, NY; Pont Aven, France. **Studied:** trained in
portraiture by his father; Académie Julian, Paris, 1884. **Member:**
Buffalo SA (pres., 1896). **Exhibited:** Brooklyn AA, 1882-83;
NAD, 1882-83; Paris Salon, 1882-84, 1889-91, 1893, 1899; Pan-
Am. Expo, Buffalo, 1901; PAFA Ann., 1901. **Work:** Buffalo FA
Acad. **Comments:** An expatriate painter, he was in France by
1879 and later kept a home in Pont Aven, Brittany. He returned to
Buffalo intermittently, and in 1891, on one of his longer visits, he
taught the first class in composition offered by School of Buffalo
Fine Arts Academy. He also participated in organizing Municipal
Art League in 1901. His father was William Penfold, a portrait
painter in Lockport and Buffalo. **Sources:** WW19; Krane, *The
Wayward Muse,* 194; Fink, *American Art at the Nineteenth-
Century Paris Salons,* 379-80; Falk, *Exh. Record Series.*

PENFOLD, William *[Portrait painter] mid 19th c.*
Addresses: Lockport, NY, 1859. **Sources:** G&W; N.Y. State BD
1859.

PENGEOT, George J. *[Painter] 20th c.*
Addresses: Buffalo, NY. **Sources:** WW17.

PENHALL, H. M. *[Painter] d.1913, Palermo, Italy (suicide).*
Addresses: His home was supposedly in San Fran.

PENHALLOW, Benjamin H. *[Lithographer and printer]*
mid 19th c.
Addresses: Lowell, MA, 1859. **Sources:** G&W; Lowell CD
1859.

PENIC, Dujam *[Painter] b.1890, Split, Yugoslavia.*
Addresses: NYC. **Exhibited:** S. Indp. A., 1917; WMAA, 1918-
1928. **Sources:** WW19.

PENKOFF, Ronald Peter *[Educator, printmaker] b.1932,*
Toledo, OH.
Addresses: Waukesha, WI. **Studied:** Bowling Green State Univ.
(B.F.A., 1954); Ohio State Univ. (M.A., 1956); Stanley William
Hayter's Atelier 1917, Paris, France, 1965-66. **Exhibited:** Pennell
Int. Exhib. Prints, LOC, 1955-57; Indiana Artists, John Herron Art
Mus., Indianapolis, 1960-64; CAFA Ann., Hartford, 1961-62; Soc.
Washington Printmakers, Smithsonian Inst., 1962; Nouvelles
Realities, Paris, 1966; Gallery 2111, Milwaukee, WI, 1970s.
Awards: first award in painting, NY State Fair, 1957; Munson-
Williams-Proctor Inst. award, Cent. NY Artists, 1958-59; first
award in painting, Eastern Ind. Artists, 1964. **Work:** LOC;
Columbus Gal. Art, Ohio; Munson-Williams-Proctor Inst.;
Montclair Mus., NJ; Ball State Art Gal., Muncie, Ind. **Comments:**
Preferred media: intaglio. Positions: vis. prof., Bath Acad. Art,
Corsham, Eng., summer 1966. Publications: auth., "The Eye &
the Object," *Forum,* (1962); auth., "Roots of the Ukiyo-E," 1965;
auth., "Sign, Signal, Symbol," 1970. Teaching: asst. prof. art,
State Univ. NY Col. Oneonta, 1956-59; asst. prof. art, Ball State
Univ., 1959-67; prof. art, Univ. Wis.-Waukesha, 1967-. **Sources:**
WW73; W. Fabricki, *Prints & Drawings of Ronald Penkoff,*
(Quartet, 1963); Donald Key, "Color Printing is an Elusive
Endeavor," *Milwaukee J.* (1971).

PENMAN, Edith *[Painter, etcher, craftsperson] b.1860,*
London, England / d.1929, NYC.
Addresses: NYC/Woodstock, NY. **Studied:** R.S. Gifford; H.B.
Snell; Cooper Union Sch. of Des. for Women, 1879-80. **Member:**
NAWPS (treasurer); SPNY; NYWCC; Alliance; Allied AA; NY
Soc. Ceramic Artists. **Exhibited:** NAD, 1886; "Women Etchers of
Am.," NYC, 1888; NY Etching Cl.,1889; Worlds Columbian
Expo, 1893; PAFA Ann., 1903; AIC, 1905-19, Boston AC, 1905-
08; Boston Soc. Artists; S. Indp. A.; Ft. Worth Mus. Art; Nebraska
AA; Women's AC; NAWPS, frequently; Corcoran Gal biennial,
1921. **Comments:** Specialties: flower pictures; pottery. In the sec-
ond decade of the 20th century she kept studios in the Van Dyck
Studio Building in New York and at Briarcliffe Manor, NY, where
she spent the summers. **Sources:** WW27; P. Peet, *Am. Women of*
the Etching Revival, 63; Falk, *Exh. Record Series.*

PENMAN, J. R. *[Painter] late 19th c.*
Exhibited: NAD, 1886. **Sources:** Naylor, *NAD.*

PENMORK *[Lithographer] mid 19th c.*
Work: LOC (lithograph of a view of the entrance of the First
Congregational Church on Broadway, NYC, dated 1845).
Sources: G&W; Peters, *America on Stone.* (lists him as
Penwork.).

PENN, Irving *[Photographer, painter] b.1917.*
Studied: Alexey Brodovitch, PMSchIA, late 1930s. **Work:**
MoMA; MMA; IMP/GEH; other major collections. **Comments:**
Fashion and portrait photographer for *Vogue.* He is best known
for his series of large and stark platinum print portraits of nota-
bles, tradespeople, foreigners. and cigarette butts. Early in his
career (1942) he was painting in Mexico, but in 1943 joined
Vogue. **Sources:** Witkin & London, 209.

PENN, Jennie *[Painter] b.1868, Batavia.*
Addresses: Batavia, OH. **Studied:** Cincinnati Art Acad., with
L.H. Meakin & V. Nowottny. **Member:** Cincinnati Womens Art
Cl. **Exhibited:** Cincinnati AM. **Sources:** WW10.

PENN, John W. *[Artist] 19th/20th c.*
Addresses: Wash., DC, active 1905. **Sources:** McMahan, *Artists
of Washington, D.C.*

PENNACHIO, Guy *[Painter] mid 20th c.*
Exhibited: Kingsley AC, Sacramento, 1940-50. **Sources:**
Hughes, *Artists in California,* 431.

PENNELL, Elizabeth Robins (Mrs. Joseph) *[Writer, crit-
ic] b.Philadelphia, PA / d.1936, NYC.*
Addresses: NYC. **Comments:** Wife of Joseph Pennell, she was
co-author with him of *The Life of Whistler* (1908) and *Whistler
Journal* (1921). Upon Joseph's death, she wrote *Joseph Pennell*
(1926) for the MMA's large memorial exhibition, and later wrote
Whistler, the Friend (1930) and *The Life and Letters of Joseph
Pennell* (1930).

PENNELL, Helen J. *[Artist] 19th/20th c.*
Addresses: Wash., DC, active 1900-05. **Sources:** McMahan,
Artists of Washington, D.C.; Petteys, *Dictionary of Women Artists.*

PENNELL, J. Helene See: **PENNELL, Helen J.**

PENNELL, Joseph *[Painter, etch-
er, lithographer, illustrator, writer]*
b.1860, Philadelphia, PA / d.1926,
Brooklyn Heights, NY.
Addresses: Germantown, PA; London, England; Brooklyn
Heights, NY. **Studied:** PAFA, 1878-80; Pa. Sch. Indust. A.; etch-
ing with Gerome Ferris, then Whistler. **Member:** ANA, 1907;
NA, 1909; NIAL; AAAL. 1922; Arch. Lg., 1894; Phila. SE; NY
Etching Cl; Intl. S. Painters, Sculp., Gravers, London; Royal
Belgian Acad. Assn., 1914; Paris SAP; T Square C.; Société des
Peintres-Graveures Français, Paris; A. Workers Gld. London; Pa.
Chapter AIA; Royal Inst. British Arch.; Chairman, Jury of
Awards, St. Louis, 1905; Rome, 1911; San Fran., 1915;
Commissioner, Milan, 1905; Leipzig, 1914. **Exhibited:** PAFA
Ann., 1879-84, 1893, 1899-1905, 1915; NAD, 1880; Boston AC,
1884; NY Etching Cl, 1884; Paris Expo, 1889, 1900 (gold); Phila.
AC, 1892 (med.); Columbian Expo, Chicago, 1893 (med.); Paris
Salon, 1901; Pan-Am. Expo, Buffalo, 1901; Dresden, 1903 (gold);
St. Louis (gold); St. Louis Expo, 1904; Liege, 1905 (gold); Milan,
1906 (prize); Barcelona, 1907; Brussels, 1910; Amsterdam, 1912
(gold); Florence, 1915 (prize); P. P. Expo, San Fran., 1915 (med.);
AIC; Concord AA, 1922; MMA, 1926 (mem. exh.); Davison Art
Cntr., Wesleyan Univ., 1979 (retrospective); Parrish AM, 1984
("Painter-Etchers" exh.). **Work:** Luxembourg Mus., Paris; Cabinet
des Estampes, Paris; Uffizi Gal., Florence; Mod. Gal., Venice;
Mod. Gal., Rome; British Mus., South Kensington Mus., both in
London ; LOC; AIC; BM; Berlin Gal.; Dresden Gal.; Munich Gal.
Comments: A close friend of Whistler, he carried on the master's
etching style and was regarded as one of the leading etchers in

America. He was also highly regarded for his pen & ink drawings. Author: *Life of James McNeill Whistler, The Whistler Journal*(with Mrs. Pennell), *Modern Illustration, The Graphic Art Series,* and *The Graphic Arts, Scammon Lectures.* His illustrations appeared in *Magazine of Art, Art Journal,* and *Century.* In all, he wrote or illustrated about 100 books. Taught at the ASL. **Sources:** WW25; *Encyclopaedia of New Orleans Artists,* 295; Baigell, *Dictionary;* Jane Allinson (exh. cat., Davison Art Cntr, Wesleyan Univ., 1979); *American Painter-Etcher Movement* 45; Falk, *Exh. Record Series.*

PENNER, David *[Painter] mid 20th c.*
Addresses: Chicago area. **Exhibited:** AIC, 1934. **Sources:** Falk, *AIC.*

PENNEY, Bruce Barton *[Painter] b.1929, Laconia, NH.*
Addresses: Kennebunkport, ME. **Studied:** Worcester Mus. Sch.; Cleveland Woodward, illusr.; with Eldon Rowland, Well Fleet, Mass.; NY Phoenix Sch. Design. **Exhibited:** Hanover Gal., NH; Southern Vt. Art Assn., Manchester, 1967; solo shows, Wiener Gal., NYC, 1968 (solo), 1970s; Center St. Gal., Winter Park, Fla., 1969 (solo); Gal. 2, Woodstock. Vt, 1969-71(solos). **Work:** Worcester Polytech Inst., Mass.; Stockholm Mus., Sweden; Dartmouth Col., Hanover, NH. **Comments:** Preferred media: oils. **Sources:** WW73.

PENNEY, Charles Rand *[Collector, patron] b.1923, Buffalo, NY.*
Addresses: Olcott, NY. **Studied:** Yale Univ. (B.A.); Univ. Va. (L.L.B. & J.D.). **Member:** Am. Fedn. Arts (trustee); Gal. Assn. NY (dir.); hon. life mem. Patteran Soc.; Buffalo Soc. Artists (trustee); Mem. Art Gal. Art Comt. **Comments:** Positions: dir. & trustee, The Charles Rand Penney Found., 1964-. Collections arranged: "Selected Works by Emil Ganso," Kenan Ctr., 1969; "Prints from The Charles Rand Penney Foundation", Niagara Co. Community Col. Mus., 1971; "Staffordshire Pottery Portrait Figures," Niagara Co. Hist. Soc., 1972. Collections: international contemporary art; works of Charles E. Burchfield & Emil Ganso; Western New York artists; Spanish-American Santos & Retablos; Victorian Staffordshire pottery portrait figures; American antique historic glass; American antique pressed glass. **Sources:** WW73.

PENNEY, Frances Avery See: **AVERY, Frances (Mrs. James Penney)**

PENNEY, Frederick Doyle *[Painter] b.1900, Fullerton, NE / d.1988, Coachella Valley, near Palm Springs.*
Addresses: Los Angeles, CA; Coachella Valley, near Palm Springs. **Studied:** AIC; ASL; Chouinard Art Sch., with Hinkle, Chamberlin and Pruett Carter. **Member:** Desert AC, Palm Springs; Laguna Beach AA; Calif. WC Soc.; Shadow Mountain Palette Cl. (co-founder). **Exhibited:** Calif. AC, 1930-33; Calif. WC Soc., 1930-35; GGE, 1939; Soc. for Sanity in Art, 1940. **Sources:** Hughes, *Artists in California,* 432.

PENNEY, James *[Painter, educator] b.1910, St Joseph, MO / d.1982.* **PENNEY**
Addresses: Utica, NY, 1955; Clinton, NY, 1959. **Studied:** Univ. Kansas (B.F.A., 1931) with Albert Bloch & Karl Mattern; ASL, 1931-34, with George Grosz, Von Schlegell, John Sloan & Thomas H. Benton. **Member:** NAD; Audubon Artists; Nat. Soc. Mural Painters; Munson-Williams-Proctor Inst. (life mem.); Am. Fed. Arts. **Exhibited:** Kansas City AI, 1931 (Midwestern Artists Ann., medal); S. Indp. A., 1934-36; 8th St Gal., 1935 (solo); Corcoran Gal biennials, 1937-53 (5 times); AIC, 1939, 1943; Denver Art Mus., 1939; BM, 1940-42; PAFA, 1940; PAFA Ann., 1951-68; WMAA, 1941; CI, 1942-43; MMA (AV), 1942; TMA, 1944; Audubon Artists, 1945, 1967 (prize); Nature in Abstraction Annuals, 1957, 1959, 1963; Hudson Walker Gal., 1938-40; Bonestell Gal., 1940; Marquire Gal., 1941; Kraushaar Gal., 1945-70s; Artists for Victory, MMA, 1941; Am. Inst. Arts & Letters Ann., New York, 1953, 1959 & 1971; NAD, 1972; Root Art Center, 1962, 1967, 1971, 1976; "NYC WPA Art" at Parsons School Design, 1977. Awards: medal & award, Paintings of the Year, Pepsi-Cola, 1948. **Work:** Fort Worth (TX) Mus.; Columbus

(OH) Gal. Fine Arts; Springfield (MA) Art Mus.; Wichita (KS) Art Mus.; New Britain (CT) Mus. Am. Art. WPA murals, Textile H.S.; Washington Market (Centennial); Green Point Hospital (with Moses Soyer); P.S. 42; Plans for Far Rockaway H.S.; Flushing H.S. Lobby, NY, 1938. WPA murals, USPOs in Union & Palmyra, MO, 1940-43. Other murals: "Hamilton Four Seasons" (mural), Dunham Hall, Hamilton College, Clinton, NY, 1959; "Nebraska Settlers" (three murals), Main Vestibule, Nebraska State Capitol, Lincoln, 1963; "Fields in Spring" (painting), commissioned by Omaha Nat. Bank for Joslyn Mus., 1966. **Comments:** Preferred media: oils. Positions: WPA mural artist, 1934-39; bd. control & vice pres., ASL, 1941-46; trustee, Am. Fine Arts Soc., 1941-48. Teaching: Bennington Col., 1946-47; Munson-Wms.-Proctor Inst., 1948-56; Hamilton Col., 1948-70s; Vassar Col., 1955-56; Yaddo fellowship, 1956 & 1961; Calif. Col. Arts & Crafts, 1960. Author: *Cross Section New York,* 1972; editor, *Charles Saxon Exhibition,* Hamilton Col., 1972; ed., *Mural designs —James Penney,* Utica Col., 1972. **Sources:** WW73; "James Penney Paints an Interior," *Oil Painting* (Watson Guptill, 1953); John I.H. Baur, *Nature in Abstraction* WMAA, 1958; "Nebraskaland Masterpiece," *Nebraska Land Magazine* (1964); *New York City WPA Art,* 71 (w/repros.); Falk, *Exh. Record Series.*

PENNEY, James (Mrs.) See: **AVERY, Frances (Mrs. James Penney)**

PENNEY, Joseph *[Portrait painter] 19th c.*
Addresses: Boston, 1845. **Sources:** G&W; Boston BD 1845; Bolton, *Miniature Painters.*

PENNIE, Robert M. *[Painter] b.1858, Albany, NY.*
Addresses: Paris, France. **Exhibited:** NAD, 1879, 1883; Paris Salon, 1882, 1883; PAFA Ann., 1883. **Sources:** Fink, *American Art at the Nineteenth-Century Paris Salons,* 380; Falk, *Exh. Record Series.*

PENNIMAN, E. Louise *[Painter] 20th c.*
Addresses: Phila. PA. **Sources:** WW15.

PENNIMAN, Ella A. *[Portrait and landscape painter] 19th c.*
Addresses: San Francisco, CA. **Exhibited:** San Francisco AA, 1885. **Sources:** Hughes, *Artists of California,* 432.

PENNIMAN, H(elen) Alison Fraser (Mrs.) *[Painter, writer] b.1882, NYC.*
Addresses: Baltimore, MD/Elkridge, MD. **Studied:** ASL with Twachtman, Beckwith, W. E. Whiteman, E.L. Bryant & Anshutz; in Germany. **Member:** Soc. Independent Artists. **Exhibited:** Munich Charcoal Club, Baltimore, 1912 (prize), 1913 (prize); S. Indp. A., 1918. **Sources:** WW25; Petteys, *Dictionary of Women Artists.*

PENNIMAN, John *[Lithographer] b.c.1817 / d.1850.*
Addresses: Baltimore, MD,1835-40; NYC, 1842 until his death. **Sources:** G&W; N.Y. *Spectator,* Feb. 28, 1850. obit.; Peters, *America on Stone;* Baltimore CD 1835-40; NYCD 1842-49; Stokes, *Iconography,* I, 432-33; Swan, "John Ritto Penninman," 248.

PENNIMAN, John Ritto **J.R.PENNIMAN.**
[Portrait & ornamental painter, lithographer, teacher] b.1782, Milford, MA / d.1841, Baltimore, MD.
Studied: apprenticed c.1792, probably to ornamental painter. **Member:** Mass. Charitable Mechanics Assoc.; Mason, 1810-21. **Exhibited:** Boston, 1819 (large glass painting depicting the fire at the Boston's Exchange Coffee House in 1818). **Work:** BMFA; Christ Church, Boston; Worcester (MA) Art Mus.; Essex Inst., Salem, MA; NMAA. **Comments:** In 1826, he was one of the first artists in America to produce a drawing on stone as a lithograph, for the Pendleton Lithographic Press in Boston (Bass Otis was the very first). A versatile artist, Penniman began his career as an ornamental painter at early age, and became one of the finest specialists in that field in America. At the same time, he also practicied portraiture and landscape painting. In 1805, he Married Susannah Bartlett in Boston, and became acquainted with Gilbert

Stuart, whose influence is seen in his portraits. His earliest work includes a self-portrait (pvt. collection), of c.1796, and "The Family Group," of 1798 (BMFA). In 1803, he opened a shop in the Roxbury section of Boston and continued his ornamental painting on clocks, frames, and mirrors. In 1819 he painted and exhibited a a 15-foot-square glass panel depicting the 1818 fire that had destroyed Boston's Exchange Coffee House. In 1826, he was working for Boston lithographers William S. and John B. Pendleton (see entries) as a designer and copyist. Debt and drinking problems put him in the Boston House of Correction at least twice, once in 1830. According to a fellow inmate (William J. Shelling, author of *The Rattrap*, 1837), Penniman agreed to serve as a draftsman on the frigate *Independence* from 1830-33. He is known to have lived for a time near Worcester, MA, and to have moved to Baltimore by 1837. He was the teacher of several early artists, including Alvan Fisher, Nathan Negus, Charles Bullard, and Charles Codman. **Sources:** G&W; Morgan, *Gilbert Stuart and His Pupils*, 33-34; Swan, "John Ritto Penniman"; Dunlap, *History*, II, 260 (erroneously states that Pennyman [sic] was already dead by 1833-34); Boston CD 1805-27. More recently, see Pierce and Slaatterback, 147; and *300 Years of American Art*, vol. 1, 94 (repro.).

PENNIMAN, Leonora Naylor *[Painter] b.1884, Minneapolis, MN / d.1957, Santa Cruz, CA.*
Addresses: Santa Cruz, CA/Brookdale, CA. **Studied:** E. Siboni in Chicago; Mills College Summer School with Lyonel Feininger. **Member:** Lg. Am. Pen. Women; San Fran. Soc. Women Artists; Women Painters of the West; Bay Region AA, Oakland; Santa Cruz AL. **Exhibited:** Stanford Univ.; Berkeley Art Gal.; Claremont Hotel, Berkeley; CPLH; Haggin Gal., Stockton (solo); Crocker Gal., Sacramento (solo); S. Indp. A., 1927-28; Santa Cruz Art Lg., 1928 (prize); Lg. Am. Pen Women, San Fran., 1931 (prize), 1935 (prize); Chicago, 1933; Santa Cruz County Fair, 1938 (prize), 1939 (prize). **Work:** Friendship House, Chicago. **Comments:** Penniman and her painting companions M. Rogers (see entry) and Cor DeGavere (see entry) were known as the "Santa Cruz Three." **Sources:** WW40; Hughes, *Artists of California*, 432.

PENNING, Tomas *[Sculptor] b.1905, Glidden, WI. / d.1982.*
Addresses: Saugerties, NY. **Studied:** Duluth, MN; AIC; Am. Acad. Art; E. Chassaing; Archipenko in Woodstock (scholarship); Kuniyoshi. **Member:** Sawkill PS; Woodstock AA. **Exhibited:** AIC, 1931; Salons of Am., 1934; WMAA, 1936; Ann Blanch Gal., Woodstock, 1978; James Cox Gal., Woodstock, NY, 1994 (solo). **Work:** Woodstock AA. **Comments:** Called the "Bluestone Master" for his bold carvings in Ulster Cnty (NY) bluestone. He and his wife established the Sawkill Gal. in Woodstock along with several other artist couples. Penning designed the craft-training center run by the Nat. Youth Admin. during the Depression, which later housed the Woodstock School of Art. **Sources:** WW40; addit. info. courtesy Woodstock AA.

PENNINGS, Thomas See: **PENNING, Tomas**

PENNINGTON, Harper *[Illustrator, painter] b.1855, Newport, RI / d.1920, Baltimore.*
Addresses: Baltimore, MD; London, England. **Studied:** Académie Julian, Paris; also with Gérome and Carolus-Duran. **Member:** Century A. **Exhibited:** PAFA Ann., 1879, 1885, 1893; Boston AC, 1889; NAD, 1891, 1896. **Sources:** WW19; Falk, *Exh. Record Series*.

PENNINGTON, Ruth Esther *[Painter, printmaker, craftsperson, teacher] b.1905, Colorado Springs, CO.*
Addresses: Seattle, WA. **Studied:** Univ. Wash.; Columbia; Univ. Oregon; with V. Vytlacil, E. Steinhof, A. Ozenfant. **Member:** Northwest PM; Southern PM S.; Seattle AM. **Exhibited:** Northwest PM, SAM, 1937 (prize); SAM, 1934. **Comments:** Position: prof. of art, Univ. of Wash., 1941. **Sources:** WW40; Trip and Cook, *Washington State Art and Artists;* Trenton, ed. *Independent Spirits*, 108-109.

PENNINGTON, T. Maurice *[Painter, illustrator, cartoonist, photographer] b.1923, Louisville, KY.*
Studied: Atlanta School of Art. **Member:** Nat'l Conference of Artists. **Exhibited:** Atlanta Univ., 1959-67; Clark Col., 1966; Tuskegee Inst., 1963-64; Piedmont Park Arts Festival, 1957-71; High Mus., Atlanta, 1971; Macon Mus. of Art, 1972. **Sources:** Cederholm, *Afro-American Artists*.

PENNOYER, A(lbert) Sheldon *[Painter, writer] b.1888, Oakland CA / d.1957, Madrid, Spain.*
Addresses: California; NYC; Europe; Litchfield, CT. **Studied:** Univ. Calif; Ecole des Beaux-Arts; Grande Chaumiere; H. Speed, in London; N. Los, at PAFA; Académie Julian, Paris, 1914; also with L. Simon and R. Ménard in Paris; with G. Casciaro and Carlandi in Rome, Italy. **Member:** AFA; San Francisco AA; AWCS; Century Assn.; NAC; Allied Artist of America; AAPL; Oakland AA; Kent (Conn.) AA. **Exhibited:** AIC; NAD; AWCS; Pan-Pac Expo, San Fra.,1915; Corcoran Gal biennial, 1923; Salons of Am., 1924, 1934. **Work:** Oakland Mus.; Henry Ford Mus., Dearborn, MI; CPLH; de Young Mus.; Santa Barbara Mus.;Smithsonian Inst.; U.S. Militiary Academy, West Point; MMA. **Comments:** Author: *This Was California*, 1938, and *Locomotives in Our Lives*, 1954. **Sources:** WW47; Hughes, *Artists of California*, 432.

PENNY, Aubrey John Robert *[Painter] b.1917, London, Eng.*
Addresses: Los Angeles, CA. **Studied:** UCLA (BA, art & art hist, 1953; MA, art, 1955); Dr Danes. **Member:** Contemp Art Soc, London; Victoria Inst, London; Am Soc Aesthetics & Art Criticism. **Exhibited:** LACMA, 1954-57; Corcoran Gal biennial, 1957; AWCS, 1957-58; PAFA, 1959; two-man shows, Madison Gal, NYC, 1963 & Int De Deauville, France, 1972. **Awards:** Prize for drawing, Emanual Sch, London, 1931; award of merit, Calif Nat Watercolor Soc, 1955; hon mention, Los Angeles City Art Festival, 1958. **Work:** Contemp Art Soc, London; Edward Dean Mus, Cherry Valley, Calif. **Comments:** In WW73, he is desribed as the "originator of the style, "No-osism" or mind-line, based on primacy of mind in the continuum, that chemical-electric relationships lead to neural energy, to feeling, to act." Preferred Media: acrylics. Positions: Owner, No-os Gal, Los Angeles, 1955-70s; mem art council, UCLA, 1955-70s. **Sources:** WW73.

PENNY, Carlton P. *[Painter] b.1896, Metuchin, NJ.*
Addresses: NYC. **Studied:** Columbia Univ.; Univ. Rochester; ASL; N.Y. Univ. **Member:** SC; Nat. Pastel Soc.; AAPL; Arch. Lg.; Audubon A. (Co-founder); Mun. A. Soc.; Nat. Soc. Painters in Casein (president). **Exhibited:** NAC, 1940, 1941; NAD, 1945; Harvard, 1945; Arch. Lg., 1943, 1944; Whistler Mus., 1945; Am. Acad. A. & Let. **Work:** Harvard; Whistler Mus., Lowell, Mass. **Comments:** Positions: Dir., AAPL; Town Hall Cl.; Chm., Town Hall Cl. A. Com.; Member-Delegate, FA Fed., NYC. **Sources:** WW59; WW47.

PENNY, Charles H. *[Engraver] b.c.1815, New York.*
Addresses: NYC, 1850. **Sources:** G&W; 7 Census (1850), N.Y., XLV, 494.

PENNY, Copra L. *[Painter] 20th c.*
Addresses: NYC, 1923. **Exhibited:** S. Indp. A., 1923-25. **Sources:** Marlor, *Soc. Indp. Artists*.

PENNY, Edward *[Portrait painter] b.1714 / d.1791.*
Sources: G&W; Neuhaus, *History and Ideals of American Art*, 14.

PENNY, Laura Annette *[Painter, teacher] 20th c.*
Addresses: San Luis Obispo, CA, 1932; Glendora, CA, 1939. **Exhibited:** GGE, 1939. **Sources:** Hughes, *Artists of California*, 432.

PENNY, Mary Frances *[Artist] late 19th c.*
Addresses: Active in Detroit, MI. **Exhibited:** Detroit AA, 1876. **Sources:** Petteys, *Dictionary of Women Artists*.

PENROD, Mabel Allen *[Painter, teacher] b.1889, Birmingham, MI.*

Addresses: Lansdowne, PA. **Studied:** J. F. Copeland; Univ. Penn.; PM Sch IA. **Member:** Wilmington SFA; Phila. Alliance. **Exhibited:** Wilmington (DE) SFA, 1934 (prize). **Sources:** WW40.

PENROD, Viola D. *[Painter] 20th c.*
Addresses: Dallas, TX. **Sources:** WW24.

PENROSE, Helen Stowe *[Painter] 20th c.*
Addresses: Baltimore, MD. **Member:** Baltimore WCC. **Sources:** WW25.

PENROSE, Margaret *[Illustrator] early 20th c.*
Comments: From 1914-16, she produced illustrations for juvenile series books, including *Motor Girls* for the Stratemeyer Syndicate. **Sources:** info courtesy James D. Keeline, Prince & the Pauper, San Diego.

PENROSE, Valeria F. *[Painter] b.1860.*
Addresses: Germantown, PA. **Exhibited:** PAFA Ann., 1885, 1887. **Sources:** Falk, *Exh. Record Series.*

PENT, Rose Marie (Mrs. Howard F.) *[Painter] b.St. Louis MO / d.1954.*
Addresses: Jenkintown, PA. **Studied:** PAFA; W. Chase; F. Wagner; H. Breckenridge. **Member:** Phila. Art All.; Phila. Plastic Club; Old York Road AG. **Exhibited:** PAFA; Phila. Plastic Club; Phila. Art All.; Phila. AC; Baltimore WCC; Chicago Soc. Min. Painters. **Sources:** WW47.

PENTEL, Jacob *[Sculptor] 20th c.*
Exhibited: S. Indp. A., 1938. **Sources:** Marlor, *Soc. Indp. Artists.*

PENTLARGE, Georginna *[Artist] 20th c.*
Exhibited: Salons of Am., 1926. **Sources:** Marlor, *Salons of Am.*

PENWORK See: **PENMORK**

PEN YO PEN See: **PIN, Pen Yo**

PEOLI, James J. *[Painter] 19th c.*
Addresses: NYC. **Exhibited:** NAD, 1866. **Sources:** Naylor, *NAD.*

PEOPLES, Augusta H. (Mrs. R. E.) *[Painter, teacher] b.1896, Philadelphia, PA.*
Addresses: Philadelphia, PA. **Studied:** Phila. Sch. Des. for Women; Spring Garden Inst.; PAFA. **Member:** Phila. Art All.; AAPL; Phila. Plastic Club; Germantown AL. **Exhibited:** PAFA, 1933-35; CGA, 1935-37, 1939; Phila. Art All., 1945 (solo); Phila. Plastic Club; Phila. Sketch Club; Woodmere Art Gal.; Newman's Gal.; Bala Cynwyd Women's Club, 1946 (solo); Delaware County Art Group, 1955; Women's City Club, Phila., 1957 (solo); Cape May AA, 1955-61. **Work:** Moore Inst., Phila. **Sources:** WW59; WW47.

PEPER, Meta A. *[Miniature painter] b.1887, New York.*
Addresses: NYC. **Studied:** Mrs. Ellis; A. Beckington. **Sources:** WW15.

PEPI, Vincent *[Designer, painter] b.1926, Boston, MA.*
Addresses: New York 17, NY; Massapequa, NY. **Studied:** Workshop Sch. Comm. A.; CUASch.; Pratt Inst.; Meschini Inst., Rome, and with Pericle Fazzini, Rome, Italy. **Exhibited:** Awards: Assn. Univ. Evening Col., 1952, 1954, 1958. **Work:** Mural, U.S. Naval Training Station, Sampson, N.Y. **Comments:** Positions: A., Sterling Adv. Agcy.; Asst. A. Dir., Batten, Barton, Durstine & Osborne, New York, N.Y.; A. Dir., Office of Publ. & Printing, A. Dir., N.Y. Univ. Press; Freelance A. Dir. & Des. as of 1959. **Sources:** WW59.

PEPITE, Joseph *[Scene painter] 19th c.*
Addresses: New Orleans, 1832. **Comments:** Active at The Orleans Theater in 1832. *Cf.* Louis Pepite. **Sources:** *Encyclopaedia of New Orleans Artists.*

PEPITE, Louis *[Scene painter, decorator] mid 19th c.*
Addresses: New Orleans, active 1827-35. **Studied:** Jean Baptiste Fogliardi, New Orleans. **Comments:** Black artist, described as "free colored male." Scene painter at The Orleans Theater in

1830. **Sources:** G&W; Delgado-WPA cites *La. Courier,* April 18, 1832, and New Orleans CD 1830, 1832, 1834. More recently, see *Encyclopaedia of New Orleans Artists* (also lists a Joseph Pepite, active at The Orleans Theater in 1832, perhaps they are the same person-or at least some relation).

PEPLOE, Fitzgerald Cornwall *[Sculptor] b.1861, England (came to U. S. in 1884) / d.1906, Purchase, NY.*
Studied: Paris; Rome. **Work:** statue, grounds of Mr. Chapman, at Dinard, Brittany; busts of women, in private art galleries of New York. **Sources:** WW04.

PEPLOW, Ralph *[Sculptor] 20th c.*
Exhibited: AIC, 1940. **Sources:** Falk, *AIC.*

PEPOON, Willis A. *[Painter] b.c.1860 / d.c.1940.*
Addresses: Wash., DC, active 1910-11. **Work:** Portraits: College of William and Mary; VA State Lib.; VA Military Inst. **Sources:** McMahan, *Artists of Washington, D.C.*

PEPPARD, Lorena *[Landscape & miniature painter, sculptor, teacher, writer] b.1864 / d.c.1939.*
Addresses: Wooster, OH. **Studied:** Oberline College; Cincinnati Art Acad., with Nowottny, Noble, Duveneck; BMFA Sch., with W. Paxton, P. Hale. **Member:** Cincinnati Women's AC. **Exhibited:** Cincinnati Women's AC; Cincinnati Art Mus.; Akron AI Am. Soc. Min. Painters. **Work:** portraits, Ohio Supreme Court; Wayne County Court House; Wooster (OH) Public Library. **Comments:** Contributor: articles, newspapers. **Sources:** WW38; Petteys, *Dictionary of Women Artists.*

PEPPER, Beverly Stoll *[Sculptor, painter] b.1924, Brooklyn, NY.*
Addresses: Rome, Italy, 1952-72; Perugia, Italy, 1972-on. **Studied:** Pratt Inst; ASL, New York; also with Fernand Léger & Andre L'Hôte, Paris, France, 1948; apprenticed with an ironmonger in Italy, 1962. **Exhibited:** Sculpture in the City, Festival dei due Mondi, Spoleto, Italy, 1962; Sculpture in Metallo, Turin, Italy, 1965; Plus by Minus, Today's Half Century, Albright-Knox Art Gallery, 1968; Outdoor Sculpture, Jewish Mus, New York, 1968; Sculpture, Mus Contemp Art, Chicago, Ill, 1969; Biennale, Venice, Italy, 1972; Marlborough Gallery, New York, NY, 1970s. Awards: Gold medal & purchase award for sculpture, XVII Mostra Int Fiorino, 1966; first prize & purchase award, Jacksonville Art Mus, 1970; Best Art in Steel, Iron & Steel Inst, 1970; Venice Biennale, 1972; Monumental Sculpture of the Seventies, Houston, TX; André Emmerich Gal., NYC (solo), 1975. **Work:** Albright-Knox Art Gallery, Buffalo, NY; Mass Inst Technol, Boston; Fogg Art Mus, Cambridge, Mass; Walker Art Ctr, Minneapolis, Minn; Galleria Civica Arte Mod, Turin, Italy. Commissions: Contrappunto (stainless steel), comn by William Kaufman Co, US Plywood Bldg, New York, NY, 1963; Kennedy Mem (stainless steel), Weizmann Inst, Israel, 1965; "Torre" (stainless steel), Flags Over Ga, Atlanta, 1969; "Sudden Presence" (Cor-ten), City of Boston, New Chardon St, 1971; "Land Canal & Hillside," site sculpture (Cor-ten, earth & sod), Dallas, TX, 1971-74; R D Nasher Co, North Park, Dallas, Tex, 1971; "Amphisculpture," built on the grounds of the A.T.&T. Long Lines Headquarters, Bedminster, NJ, 1974-77. **Comments:** Known for her monumental abstract steel sculptures and her environmental projects. She began her career working as an art director for several advertising agencies in NYC (1942-48), but moved to Europe in 1948 to study painting. Pepper painted in Europe for a number of years, also traveling to the Middle East and the Far East. In 1960 she began carving expressionistic sculptures out of olive, elm, and mimosa trees. Pepper became interested in welded sculpture in 1962 and moved away from expressionism to more geometric forms. By the 1970s she was producing monumental welded steel sculptures. Pepper has also created environmental projects incorporating elements of sculpture and nature, as in her "Amphisculpture" (see Works), which takes the form of an outdoor amphitheater made of concrete and set in grass. **Sources:** WW73; Rubinstein, *American Women Artists,* 361-65; Jan Van der Marck, *Beverly Pepper* (catalog), Marlborough Gallery, 1969;

Wayne Andersen, *Sculpture Today,* Mass Inst Technol Press, 1970; Vittorio Armentano, "BP Making Sculpture" (film), G Ungaretti, narrator, 1970.

PEPPER, Charles Hovey (Dr.) *[Painter] b.1864, Waterville, ME / d.1950, Brookline, MA.*
Addresses: NYC; Paris, France, 1898-99; Concord, MA, 1900-02; Boston, Jamaica Plain, & Brookline, MA. **Studied:** Colby College, Waterville, ME; ASL; Chase in NYC; Acad. Julian, Paris with J. P. Laurens & Constant, 1893-97; Aman-Jean in Paris. **Member:** NYWCC; Copley Soc., 1900; Boston AC; New Haven PCC; The Fifteen Gal; The Boston Five. **Exhibited:** SNBA, 1894; PAFA Ann., 1895-1902, 1909, 1932-34; Boston AC, 1896; Paris Salon, 1896-99; Armory Show, 1913; S. Indp. A., 1917-18; "Five Boston Artists," Vose Gal., Boston, 1930; Corcoran Gal. biennial, 1930; WMAA, 1933; AIC. **Work:** BMFA; WMA; Newark Mus.; FMA; RISD; Mills College, Oakland, CA; Colby College. **Comments:** Painted at Fenway Studios, Boston, 1906-31. He was one of the Boston Five (which also included Carl Gordon Cutler, Charles Hopkinson, Harley Manlius Perkins, and Marion Monks Chase), modernist watercolorists who created expressive landscapes. **Sources:** WW47; Vose Galleries, *Mary Bradish Titcomb and Her Contemporaries,* 37; Fink, *Am. Art at the 19th C. Paris Salons,* 380; Falk, *Exh. Record Series;* Brown, *The Story of the Armory Show.*

PEPPER, Edward *[Engraver] b.c.1828, Pennsylvania.*
Addresses: Philadelphia in 1850. **Sources:** G&W; 7 Census (1850), Pa., XLIX, 195.

PEPPER, Mary *[Wax portraitist] early 19th c.*
Comments: Active after 1800. **Sources:** G&W; Bolton, *American Wax Portraits,* 45.

PEPPER, Platt *[Patron] b.1837 / d.1907.*
Addresses: Phila., PA. **Comments:** One of the founders of thePennsylvania Museum School of Industrial Art (PMSchIA). In 1878 he headed a movement which led Congress to pass the act of admitting free of duty works of art to be exhibited in museums and art galleries.

PEPPER, Stephen Coburn *[Educator, writer, lecturer, critic] b.1891, Newark, NJ.*
Addresses: Berkeley, CA. **Studied:** Harvard Univ. (A.B., M.A., Ph.D.); Colby Col. (L.H.D.). **Member:** Am. Soc. for Aesthetics; CAA; Am. Philosophical Assn.; Am. Acad. A. & Sc. **Comments:** Position: Instr., 1919-20, Asst. Prof., 1923-27, Assoc. Prof., 1927-30, Prof., 1930-, Asst. Dean, Let. & Sc., 1939-47, Chm. A. Dept., 1938-51, Chm., Philosophical Dept., 1952-58, Emeritus, 1958-, Univ. California, Berkeley, Cal. Author: *Aesthetic Quality,* 1938; *World Hypotheses,* 1942; *The Basis of Criticism in the Arts,* 1945; *Principles of Art Appreciation,* 1949; *The Work of Art,* 1955; *The Sources of Value,* 1958, & others. Contributor to: *Journal of Philosophy, Philosophical Review, College Art Journal, Parnassus* magazines. **Sources:** WW59; WW47.

PERA, Benjamin *[Painter] 20th c.*
Addresses: Chicago area. **Exhibited:** AIC, 1935. **Sources:** Falk, *AIC.*

PERALLI, Achille See: **PERELLI, Achille**

PERALTA, Sophie Bendelari de See: **DE PERALTA, Sophie Bendelari**

PERAN, Marjorie *[Painter] 20th c.*
Exhibited: Santa Cruz Art League, 1935. **Sources:** Hughes, *Artists of California,* 432.

PERARD, Victor Seman *[Etcher, lithographer, illustrator, lecturer, teacher, writer] b.1870, Paris, France / d.1957, Bellport, L.I., NY.*
Addresses: NYC. **Studied:** NYU; ASL; NAD; Ecole des Beaux-Arts, Paris with Gérôme. **Member:** SI; SC. **Exhibited:** Boston AC, 1889; PAFA Ann., 1901; Salons of Am., 1934; AIC. **Work:** MMA; NYHS; CAD; NYPL; Newark Pub. Lib.; LOC; NGA;

Pittsfield Mus. A.; NYC Mus.; Vanderpoel AA, Chicago; Mariner's Mus., Newport News, VA; War Ministry, Paris, France. **Comments:** Teaching: Traphagen School. Illustrator of many books. Contributor: national magazines. Author: *Anatomy and Drawing; Drawing Horses; Faces and Expressions.* **Sources:** WW47; Falk, *Exh. Record Series.*

PERATEE, Sebastian *[Described as "image maker"] early 19th c.*
Addresses: NYC, 1819. **Sources:** G&W; NYCD 1819 (McKay).

PERAULT, L. *[Painter] 19th c.*
Exhibited: NAD, 1868. **Sources:** Naylor, *NAD.*

PERAZZINI, Guido *[Painter] 20th c.*
Addresses: Chicago area. **Exhibited:** AIC, 1947-48, 1950. **Sources:** Falk, *AIC.*

PERBANDT, Carl Adolf Rudolf Julius Von See: **VON PERBANDT, Carl Adolf Rudolf Julius**

PERCEL, de (Mme.) *[Portrait painter] mid 19th c.*
Addresses: New Orleans, active 1837. **Comments:** Newspapers of March and April, 1837, described her as recently arrived in New Orleans from Paris. **Sources:** G&W; *Bee,* March 30, 1837, and *Courier,* April 6, 1837. More recently, see *Encyclopaedia of New Orleans Artists.*

PERCELL, John *[Lithographer] mid 19th c.*
Addresses: Philadelphia, 1855. **Sources:** G&W; Phila. CD 1855.

PERCEVAL, Don Louis *[Illustrator, painter, author] b.1908, Woodford, Essex, England / d.1979, Santa Barbara, CA.*
Addresses: Altadena, CA; Tucson, AZ, 1954-59; Santa Barbara, CA in 1973. **Studied:** Chouinard Art Sch., with Nelbert Chouinard and F. T. Chamberlin; Heatherly Art Sch. and Royal College of Art, England. **Comments:** He came to the U.S. as a child, but returned to England after 1930 to study art. He visited Spain before serving in the Royal Navy during WWII, and returned to California after the war. In 1952 he was made a member of the Hopi tribe. Specialty: desert and western subjects. Position: teacher, Chouinard Art Sch. and Pomona College. **Sources:** Hughes, *Artists of California,* 432; Peggy and Harold Samuels, 367-68.

PERCH, John Dennis *[Landscape painter, teacher, writer] 20th c.; b.Olyphant, PA.*
Addresses: East Haven, CT. **Studied:** Yale Univ. **Comments:** Contributor: weekly art review, in *New Haven Journal Courier.* Teaching: YWCA Sketch C., New Haven. **Sources:** WW40.

PERCIVAL, Edwin *[Portrait, historical, and landscape painter] b.1793, Kensington, CT / d.Troy, NY.*
Addresses: Albany and Troy, NY. **Studied:** Hartford, CT, 1830. **Exhibited:** PAFA, 1832. **Comments:** Went to Albany (NY) in 1833 and began partnership with Henry Bryant. Groce & Wallace report that Percival later went to Troy (NY) where he became depressed and is said to have literally starved himself to death. Brother of James Gates Percival, poet and scholar. **Sources:** G&W; French, *Art and Artists in Connecticut,* 55; Rutledge, PA; Fielding, *Supplement to Stauffer,* no. 509.

PERCIVAL, H. *[Marine painter] 19th/20th c.*
Work: Peabody Mus., Salem, MA (watercolor). **Comments:** Active 1889-1905. **Sources:** Brewington, 297.

PERCIVAL, Henry *[Engraver and die sinker] b.c.1810, England / d.c.1872, Philadelphia, PA.*
Addresses: New York by 1851 (when his eldest son was born); Philadelphia from c. 1854 through c. 1872. **Work:** Various historical societies, usually in printed ephemera files; priv. colls. **Comments:** Best known as engraver and die sinker of brass dies for small advertising logotypes, now called cameo stamps. In New York, he was most likely partner with William Eaves (see entry), and in Philadelphia with William Barber (see entry), later with Jacob Maas and his son Charles (see entries on each). By 1863 Percival had begun to manufacture seal presses as well and had customers as far away as Virginia and Ohio. **Sources:** G&W; 8

Census (1860), Pa., LIII, 588; Phila. CD 1854-60+; add'l info. courtesy Thomas Beckman, Hist. Soc. of Delaware (author of "The Philadelphia Cameo Stamp Trade," *Nineteenth Century* Fall, 1998).

PERCIVAL, Olive May Graves *[Etcher, painter] b.1868, Sheffield, IL / d.1945, Los Angeles, CA.*
Addresses: Los Angeles, CA, 1919, 1932. **Member:** Calif. AC.
Sources: WW19; Hughes, *Artists of California*, 432.

PERCY, George R. (Mrs.) *[Painter] mid 19th c.*
Addresses: NY. **Exhibited:** NAD, 1871-72. **Sources:** Naylor, *NAD.*

PERCY, Isabelle Clark (Mrs. George Parsons West)
[Educator, designer, lithographer, painter, lecturer] b.1882, Alameda, CA / d.1976, Greenbrae, CA.
Addresses: Sausalito, CA. **Studied:** Hopkins AI, San Francisco; with A. Dow & Snell in NYC; F. Brangwyn and Alex Robinson in London. **Member:** San Francisco Sketch Cl.; San Francisco AA; Calif. SE; Marin County SA. **Exhibited:** Paris Salon, 1911-12; Pan-Pacific Expo, 1915 (med.); San Francisco AA, 1924-25; Calif. Col. Arts & Crafts, 1973 (solo); *House Beautiful* Cover Competition, 1930; Calif. Bookplate Competitions; NYC; Boston; Cleveland; San Francisco; Germany. **Work:** Calif. Hist. Soc.; Oakland Mus. **Comments:** Position: teacher/co-founder, Calif. College of Arts and Crafts, 1907-43. **Sources:** WW47; Hughes, *Artists in California*, 598.

PERCY, Ives *[Painter] late 19th c.; b.Detroit, MI.*
Studied: Lefebvre, Robert-Fleury.

PERDIKES, Nina *[Painter] mid 20th c.*
Addresses: Chicago area. **Exhibited:** AIC, 1935. **Sources:** Falk, *AIC.*

PERDUE, W. K. *[Painter, craftsperson, writer] b.1884, Minerva, OH.*
Addresses: Canton, OH. **Studied:** Dr. Esenwein. **Sources:** WW29.

PEREGOY, Charles E. *[Lithographer] mid 19th c.*
Addresses: San Francisco, CA, active in the early 1850s.
Comments: Known to have worked with Joshua Peirce and C.J. Pollard in early 1850's (see entries). **Sources:** G&W; Peters, *California on Stone;* Hughes, *Artists in California.*

PEREIRA, I(rene) Rice
[Painter, writer] b.1902, Boston, I. RICE PEREIRA
MA / d.1971, Marbella, Spain.
Addresses: NYC. **Studied:** ASL with Richard Lahey, Jan Matulka, 1927-30; Acad. Moderne, Paris, with A. Ozenfant, 1931. **Member:** American Abstract Artists, 1939; AEA. **Exhibited:** WMAA 1934-67 (biennials), 1953 (retrospective),1976 (retrospective); MoMA, 1944; San Fran. Conference, 1945; Critics Choice, NYC, 1945; Cincinnati Mod. AS; MMA; Pepsi-Cola, 1946 (prize); CI; PAFA Ann., 1947-60 (6 times); AIC; Musee d'Art Moderne, Paris; Tate Gal. A., Inst. Contemp. A., both in London; Brussels, Berlin, Antwerp, Vienna and other European cities; São Paulo, Brazil; Barcelona, Belgrade, Lille, Tours, Toulouse, etc.; Barnett Aden Gal., Wash., DC (solo); ACA Gal., 1933-35, 1949; SFMA, 1947, 1953; Phillips Acad., 1949; Corcoran Gal biennials, 1949-63 (5 times); Santa Barbara Mus. A., 1950; de Young Mem. Mus., 1950; Memphis Acad. A., 1951; Univ. Syracuse, 1951; BMA; 1951; Ball State T. Col., 1951; Durlacher Bros., 1951, 1953-54; PC, 1952; Dayton, AI, 1952; Des Moines A. Center, 1953; DMFA, 1953; Vassar Col., 1953; Adele Lawson Gal., 1954; Hofstra Col., 1954; Univ. Michigan, 1954; Phila. A. All., 1955; Wellons Gal., NYC, 1956; Nordness Gal., NYC, 1958, 1959, 1961; Rome-New York Fnd., Rome, Italy, 1960. **Work:** MoMA; MMA; WMAA; Newark Mus.; Univ. Arizona; Howard Univ.; Wadsworth Atheneum; TMA; SFMA; AIC; BMA; AGAA; DMFA; Detroit Inst. A.; Vassar Col.; NOMA; Walker A. Center; PMG; Smith Col.; Ball State T. Col.; Boston Univ.; Brandeis Univ.; Catholic Univ. Wash., DC; Goucher Col.; Atkins Mus., Kansas City; Univ. Iowa; Guggenheim Mus.; State T. Col., New

Paltz, N.Y.; Syracuse Univ.; WMA; Univ. Minnesota; Butler Inst. Am. A.; CM; Mus. A., Phoenix, Ariz.; Houghton Lib., Harvard Univ. (orig. mss. of "The Lapis"); Miller Coll., Meriden, Conn.; Dutch Ministry of Information. The Hague; Mus. Non-Objective Painting; WPA artist, 1935-39; Munson-Williams-Proctor Inst. **Comments:** Abstract painter whose work reflects her interest in light, space, and mysticism. She began experimenting with various nontraditional materials in the late 1930s, painting on plastic and glass, and adding such substances as marble dust to her pigments. Position: teacher at the WPA's Design Laboratory, 1935-39. Her sister Juanita was also an artist (see entry for Juanita Marbrook Guccione). Contributor to *The Palette; Mysindia; Western AA Bulletin.* Author: *Light and New Reality; The Transformation of Nothing and the Paradox of Space; The Nature of Space: A Metaphysical and Aesthetic Inquiry* (1956). **Sources:** WW66; WW47; *American Abstract Art,* 194; Karen A. Bearor, *Irene Rice Pereira: Her Paintings and Philosophy* (Austin, TX: Univ. of Texas Press, 1993); Baigell, *Dictionary;* Falk, *Exh. Record Series.*

PERELLI, Achille *[Sculptor, painter, crayon portraitist] b.1822, Milan, Italy / d.1891, New Orleans.*
Addresses: New Orleans, from 1850. **Studied:** Academy of Arts, Milan. **Member:** Southern Art Union, 1880-81 (founder, with Andres Molinary and Brors Anders Wikstrom); Artist's Assoc. of N.O., 1890; Cup and Saucer Club. **Exhibited:** In New Orleans: New Commercial Exchange (1850); Union Gallery of Fine Arts (1850); Charleville's gun store (1873); Wagener's (1877); Seebold's (1880, 1884); Southern Art Union (1881); American Expo. (1885-86); Artists Assoc. of New Orleans (1886-87, 1889-90); Tulane Univ. (1890). **Work:** New Orleans Mus. Art; Louisiana State Museum. Among his major New Orleans commissions: the statue of Stonewell Jackson for the top of the memorial tomb of the Louisiana Div. of the Army of Northern Virginia (Metairie Cemetery); the bronze insignia for the entrance of the tomb of the Army of Tenn. (Metairie Cemetery). Commissions outside New Orleans: sculp. for balustrade, U.S. Capitol, Wash., DC. **Comments:** Came to New Orleans after serving with Garibaldi in the Italian revolution of 1848. By 1851, he was known for his crayon portraits and for his sculpture. During his 40-year career in New Orleans, Perelli was commissioned to complete a number of the city's major monuments (see works), and also executed numerous busts and medallions. His busts of Robert E. Lee and Stonewell Jackson (1872) were utilized in the Monument to the Confederate Dead erected in 1874 at Greenwood Cemetery. He also sculpted the busts of notables Winfield Scott (1852), P. G. T. Beauregard (1861), and Abraham Lincoln. Perelli is said to have designed and executed the first heroic-sized bronze bust in New Orleans: the bust of Dante for the Dante Lodge of Masons in St. Louis Cemetery, III. Perelli was also recognized for his watercolors of bird, fish, and small game, as well as for his pictures of the Louisiana landscape, all of which he exhibited frequently. Teaching positions: prof. of drawing, Southern Art Union; taught modeling at the school of the Artists' Assoc. of New Orleans. Father of Albino J. and John A. Perelli, who were both hobby painters. Not to be confused with Achille Peretti (see entry), also a New Orleans artist. **Sources:** G&W; New Orleans *Daily Picayune,* Oct. 10, 1891, obit.; Delgado-WPA cites New Orleans CD 1852-54, 1858, 1867-91, *La. Courier,* May 5, 1851, obits. in *Times Democrat and Daily Item.* Oct. 10, 1891. More recently, see *Encyclopaedia of New Orleans Artists.* 296-97.

PERELLI, Cesar *[Sculptor] mid 19th c.*
Addresses: New Orleans, active 1853. **Comments:** Listed as being associated with Achille Perelli (see entry) in 1853.
Sources: G&W; New Orleans CD 1853 (as Peralli).

PERELMUTTER, Lillian *[Painter] mid 20th c.*
Addresses: New Haven, CT, 1934. **Studied:** ASL. **Exhibited:** Salons of Am., 1934; S. Indp. A., 1934. **Sources:** Falk, *Exhibition Record Series.*

PERENY, Andrew *[Designer, craftsperson] b.1908, NY.*
Addresses: Westerville, OH. **Studied:** Ohio State Univ. **Member:**

A. Ceramic S. **Exhibited:** Columbus AL, 1933 (prize). **Comments:** Contributor: Article, "What Price Ceramics?," *Design*, 1937. Position: pres., Pereny Pottery, Columbus. **Sources:** WW40.

PERENY, Madeline S. (Mrs. Steinfeld) *[Painter, illustrator, designer, teacher] b.1896, Hungary.* **Addresses:** Wash., DC; Woodstock, NY; California, 1950. **Studied:** Royal Acad. FA, Budapest; S. Hollosy, in Munich; K.H. Miller. **Member:** NAWPS. **Exhibited:** S. Indp. A.; AIC; CGA; PAFA; NAD; SFMFA; Argent Gal., NYC; NAWPS, 1939 (prize); Woodstock Art Gal.; Perls Gal., NYC, 1943 (solo); PAFA Ann., 1944; La Jolla Mus. Art, 1968 (solo). **Work:** City Hall, Budapest, Hungary. **Comments:** Illustr.: covers, *New Yorker*, 1929-31. Positions: designer/supervisor, animated cartoons., U.S. Govt., 1940s; teacher, California. **Sources:** WW40; McMahan, *Artists of Washington, D.C.;* Falk, *Exh. Record Series.*

PERERA, Gino Lorenzo *[Painter, sculptor, etcher] b.1872, Siena, Italy.* **Addresses:** Boston, MA. **Studied:** Royal Acad., Rome; BMFA Sch.; H.D. Murphy; B. Harrison; Ochtman. **Member:** Boston AC (pres.); St. Botolph C.; Copley S.; SC. **Exhibited:** St. Botolph C., Copley S.; Boston AC, 1908, 1909; Doll & Richards, Boston; S. Indp. A.; PAFA Ann., 1913, 1915. **Sources:** WW47; Falk, *Exh. Record Series.*

PERET, Marcelle *[Painter, teacher] b.1898, New Orleans.* **Addresses:** New Orleans, LA. **Studied:** Newcomb Sch. A.; H. Breckenridge; Chouinard Sch. **Member:** SSAL; NOAA; New Orleans ACC. **Comments:** Teaching: Newman Sch., New Orleans. **Sources:** WW40.

PERETTI, Achille *[Painter, sculptor] b.After 1857, or 1862 in Italy / d.1923, Chicago, IL.* **Addresses:** New Orleans, active 1884-1923; Chicago, IL. **Studied:** Art School of Rome; Bertini, Casnedi, Milan; Morelli, Naples; Isola, Barbino, Geneva; Ciseri, Massarini, Rome; Reale Academia di Belle Arte, Milan; Milan Academy of Arts. **Member:** French Assoc. of Artists, Rome, Chicago, New Orleans; Artist's Assoc. of N.O., 1905. **Exhibited:** Artist's Assoc. of N.O., 1894, 1897, 1901-1902; TN Cent. Expo, 1897. Award: Academical Study, Milan (1st silver medal). **Work:** several churches, New Orleans and Chicago; Historic New Orleans Collection. **Comments:** Born 1857 or 1862, he came to the U.S. in 1884. Became a citizen in 1890 and decorated churches along the Gulf coast as well as Chicago and New Orleans. He also exhibited portraits, landscapes, still lifes and miniatures. He carved in wood and did plaster sculptures. Not to be confused with Achille Perelli (see entry), also a New Orleans artist. **Sources:** *Encyclopaedia of New Orleans Artists*, 298; *Complementary Visions*, 36.

PEREZ, Paz *[Painter] mid 20th c.* **Exhibited:** AIC, 1941. **Sources:** Falk, *AIC.*

PEREZ, Ralph Austin (Tony) *[Painter, printmaker] mid 20th c.* **Addresses:** Seattle, WA. **Exhibited:** SAM, 1935. **Sources:** Trip and Cook, *Washington State Art and Artists.*

PERFIELD, John A. *[Painter] mid 20th c.* **Exhibited:** S. Indp. A., 1937. **Sources:** Marlor, *Soc. Indp. Artists.*

PERFILIEFF, Vladimir *[Painter] b.1895, Russia.* **Addresses:** Phila., PA. **Studied:** PAFA with H. Snell, D. Garber, H. Breckenridge, H. McCarter, Carrols, J. Pearson; Paris with Schouhaieff, Lhôte. **Member:** Phila. Alliance; Phila. Sketch C. **Exhibited:** Corcoran Gal biennial, 1923; PAFA Ann., 1923. **Sources:** WW33; Falk, *Exh. Record Series.*

PERI, Eve *[Textile designer, craftsperson] b.1898, Bangor, ME.* **Addresses:** New York 3, NY; Philadelphia 44, PA. **Member:** Home Fashion League. **Exhibited:** TMA, 1938; Arch. Lg., 1940; AGAA, 1948; Friends Lib. Germantown, Pa., 1952; solo: Phila. A. All., 1949; Hacker A. Gal., 1950; Everhart Mus., 1951. Awards: AID, 1952 (2 awards). **Work:** AGAA; Container Corp.

Am.; Swedish Airlines, and numerous priv. commissions. **Sources:** WW59.

PERIERA, Hubert *[Painter] mid 20th c.* **Addresses:** NYC, 1926. **Studied:** ASL. **Exhibited:** S. Indp. A., 1926. **Sources:** Marlor, *Soc. Indp. Artists.*

PERIERA, I(rene) Rica *[Painter] b.1907, Boston, MA / d.1971.* **Exhibited:** Salons of Am., 1934. **Sources:** Marlor, *Salons of Am.*

PERILLO, Gregory *[Painter] mid 20th c.; b.Staten Island, NY.* **Studied:** Pratt Inst.; ASL; School Visual Arts. **Work:** Denver MNH; Pettigrew Mus., SD; Mus. North Am. Indian, FL; St. Michael's College, NM. **Comments:** Son of an Italian immigrant, he worked an an artist for the State Dept.; traveled West and lived on Indian reservations. Considered to be an authority on Indian history. **Sources:** P&H Samuels, 368.

PERIN, Bradford *[Painter] mid 20th c.* **Addresses:** Salisbury, CT; NYC. **Exhibited:** PAFA Ann., 1951-52. **Sources:** WW24; Falk, *Exh. Record Series.*

PERINE, Eva Green (Mrs.) *[Painter] b.1846, Corunna, MI / d.1938, Laguna Beach, CA.* **Addresses:** San Francisco; Laguna Beach, CA, from 1920. **Studied:** Florence, Munich, Paris, with Danet; with Wm. Keith. **Member:** Laguna Beach AA. **Comments:** Her father went to California with the Gold Rush when she was three years old. He returned to Michigan in 1859 and the family traveled overland in a covered wagon. In the early 1870s, Eva and her sister Hattie Green (see entry) went to Europe to study art. **Sources:** WW25; Hughes, *Artists in California*, 433.

PERINE, George Edward *[Portrait engraver] b.1837, South Orange, NJ / d.1885, Brooklyn, NY.* **Addresses:** Active mainly in NYC. **Sources:** G&W; Stauffer.

PERINE, T. B. *[Engraver and plate printer] mid 19th c.* **Addresses:** Indianapolis, 1855-59. **Comments:** Partner in firm of Perine & Dexter (see entry) in 1858. **Sources:** G&W; Indianapolis CD 1855, 1858-59; Indiana BD 1858.

PERINE & DEXTER *[Engravers, plate printers, and stencil cutters] mid 19th c.* **Addresses:** Indianapolis, active 1858. **Comments:** T.B. Perine (see entry) was the engraver and plate printer in the company; nothing further is known of Dexter. **Sources:** G&W; Indiana BD 1858.

PERING, Cornelia *[Painter] late 19th c.* **Studied:** Mme. D. de Cool. **Exhibited:** Paris Salon, 1880 (drawing). **Sources:** Fink, *Ame. Art at the 19th c. Paris Salons*, 380.

PERING, Cornelius *[Landscape, portrait & miniature painter] b.1806, England / d.1881, Louisville, KY.* **Comments:** Established a "female seminary" at Bloomington (IN) In 1832. Moved to Louisville (KY) in 1849, where he founded an art school. **Sources:** G&W; Peat, *Pioneer Painters of Indiana.*

PERINI, Maxine Walker *[Painter, lecturer, teacher] b.1911, Houston, TX.* **Addresses:** Abilene, TX. **Studied:** Wellesley College; AIC; & with Boris Anisfeld. **Exhibited:** AIC, 1936, 1937, 1941; Texas Centennial Exhib., Dallas; Corpus Christi, TX. **Comments:** Position: director, Abilene MFA. **Sources:** WW59; WW47.

PERINOR, (Mr.) *[Portrait, landscape, and genre painter] early 19th c.* **Addresses:** New Orleans, 1825, 1835. **Studied:** Royal School of Fine Arts, Paris (according to newspaper). **Exhibited:** New Orleans: St. Philip Theatre in 1825; animated pictures at the Waterloo Panorama in 1835. **Comments:** Came to New Orleans in 1825 from Richmond (Va.), where he had been an entertainer. **Sources:** G&W; Delgado-WPA cites *La. Gazette*, April 5, 1825. More recently, see *Encyclopaedia of New Orleans Artists*, which

also cites *Bee,* Feb. 12, 21, 1835.

PERKINS, Abraham *[Engraver and goldsmith] b.1768, Newburyport, MA / d.1839, Newburyport.*
Addresses: Newburyport, MA, entire life. **Comments:** Brother of Jacob and father of Nathaniel Perkins (see entries). **Sources:** G&W; Perkins, *The Family of John Perkins,* III, 51; Belknap, *Artists and Craftsmen of Essex County,* 5.

PERKINS, Alexander Graves *[Marine painter, craftsman] b.1869 / d.1932.*
Addresses: Newburyport, MA. **Work:** Peabody Mus., Salem. **Comments:** A retired major from the Spanish-American War, Perkins produced watercolors and pen & ink drawings of Newburyport's old ships and waterfront scenes along the Merrimac River. He also practiced pyrography and furniture-making. **Sources:** C. L. Snow, exh. cat., "Newburyport Area Artists" (1981).

PERKINS, Angela L. *[Painter] b.1948, Chicago, IL.*
Studied: Los Angeles City Col.; self-taught as a painter. **Exhibited:** Watts Summer Festival, 1967, 1968; Art West Associated, Inc.; Independent Square Qualifying Exh., 1968. **Sources:** Cederholm, *Afro-American Artists.*

PERKINS, Ann *[Art historian] b.1915, Chicago, IL.*
Addresses: Champaign, IL. **Studied:** Univ. Chicago (A.B., 1935, A.M., 1936, Ph.D., 1940). **Member:** Archaeol. Inst. Am.; Col. Art Assn. Am. **Exhibited:** Awards: Guggenheim fel., 1954-55. **Comments:** Publications: auth., "The art of Dura-Europos." Teaching: res. assoc. ancient art, Yale Univ., 1955-65; assoc. prof. ancient art, Univ. Ill., Urbana, 1965-69, prof. ancient art, 1969-. Research: chiefly art of the Eastern Roman Empire. **Sources:** WW73.

PERKINS, Bell *[Still-life and landscape painter] 19th/20th c.*
Addresses: Richmond, VA, active 1896-1904. **Exhibited:** Richmond, VA, 1896-1904. **Sources:** Wright, *Artists in Virginia Before 1900.*

PERKINS, Charles Callahan *[Etcher and amateur painter, writer and lecturer on art] b.1823, Boston / d.1886.*
Addresses: Boston. **Studied:** Ary Scheffer and others, France. **Member:** Boston A. Cl. (pres.). **Exhibited:** Boston Athenaeum; Boston Art Cl., 1880-83. **Comments:** Author of books on Tuscan and Italian sculptors and a critical essay on Raphael and Michelangelo. Honorary director of the Boston Museum of Fine Arts. The plates in Perkins' books were etched by him, mainly from his own drawings. **Sources:** G&W; Swan, BA; Clement and Hutton; Chadbourne, Gabosh, and Vogel, 305.

PERKINS, Doris E. *[Painter] mid 20th c.*
Addresses: Oakland, CA, 1928-32. **Exhibited:** Oakland Art League, 1928. **Comments:** Teaching: Mills College. **Sources:** Hughes, *Artists in California,* 433.

PERKINS, E. G. *[Engraver] mid 19th c.*
Comments: Engraver of a portrait published in 1831 at Providence (R.I.). Jacob Perkins (see entry) had a son named Ebenleaf Greenleaf Perkins (born 1797, died 1842), but it is not known whether he also did engraving. **Sources:** G&W; Stauffer; Perkins, *The Family of John Perkins,* III, 51.

PERKINS, E. Stanley (Mrs.) *[Painter] b.1846.*
Addresses: Phila., PA. **Exhibited:** PAFA Ann., 1889. **Sources:** Falk, *Exh. Record Series.*

PERKINS, Edna L. *[Painter] b.1907, Jersey City, NJ / d.Kennebunk, ME.*
Addresses: NYC; Kennebunk Beach, ME. **Studied:** ASL, with Kenneth Hayes Miller. **Member:** NAWA; Maine WC Soc.; NY Soc. Women A.; Assoc. A. New Jersey. **Exhibited:** S. Indp. A., 1930; Salons of Am., 1934; PAFA Ann., 1934; NYSWA, 1936, 1939; WFNY 1939; Montclair AM, 1944 (certificate of award). **Sources:** WW59; WW47; Falk, *Exhibition Record Series.*

PERKINS, Elizabeth Ward *[Painter, educator, writer] b.1873, NYC / d.1954.*
Addresses: Boston, MA, and Ogunquit, ME. **Studied:** music in Europe; with Chas H. Woodbury, Ogunquit Sch. **Member:** AFA; Guild of Boston Artists; Women's City Cl. **Comments:** Partner with Charles Woodbury in Boston and Ogunquit (ME) schools, 1925-40. Perkins concentrated on the organization and operation of the school, allowing Woodbury time to develop his teaching philosophy into a more formal curriculum. In 1924 , the two changed the name of the Ogunquit school to the "Woodbury Training School in Applied Observation." Other positions: trustee, Children's Mus., Boston; president, Children's Art Centre, Boston. Publications: co-author with Charles Woodbury, *The Art of Seeing* (1925). **Sources:** *Charles Woodbury and His Students.*

PERKINS, Elizabeth Welles *[Painter] b.Brookline, MA / d.1928, Boston, MA.*
Addresses: Boston. **Studied:** self-taught and perhaps with W.M. Hunt; traveled in France, Switzerland, and Florence. **Sources:** Petteys, *Dictionary of Women Artists.*

PERKINS, Emily R. *[Painter] early 20th c.*
Addresses: Phila., PA. **Exhibited:** PAFA Ann., 1905. **Sources:** WW06; Falk, *Exh. Record Series.*

PERKINS, F. A. (Miss) *[Painter] late 19th c.*
Studied: Couture. **Exhibited:** NAD, 1875-86; Paris Salon, 1878-81. **Sources:** Fink, *American Art at the Nineteenth-Century Paris Salons,* 380.

PERKINS, Frederick Stanton *[Portrait and landscape painter] b.1832, Trenton , NJ / d.1899, Burlington , WI.*
Addresses: Burlington, WI. **Studied:** NYC. **Exhibited:** NAD, 1856-62; PAFA, 1858; Brooklyn AA, 1862. **Comments:** He was active in NYC through 1862, then moved to Wisconsin, settling first in Milwaukee and later in Burlington where he lived until his death. **Sources:** G&W; Perkins, *The Family of John Perkins,* III, 158; Cowdrey, NAD; Naylor, NAD; Rutledge, PA; NYBD 1857-60; Butts, *Art in Wisconsin,* 99; 8 Census (1860), N.Y., XLIII, 286.

PERKINS, George *[Painter] mid 20th c.*
Exhibited: Calif. Hist. Soc., 1970s. **Sources:** Hughes, *Artists in California,* 433.

PERKINS, George A. *[Marine painter] late 19th c.*
Work: Peabody Mus., Salem, MA (watercolor). **Comments:** He was a medical missionary to Africa, 1887. **Sources:** Brewington, 298.

PERKINS, Granville *[Landscape painter, scenery painter, book illustrator] b.1830, Baltimore, MD / d.1895, NYC.* **GP**
Addresses: NYC. **Studied:** Philadelphia, with James Hamilton. **Member:** AWCS. **Exhibited:** AIC; NAD, 1862-89; PAFA, 1856; Brooklyn AA, 1863-85; Boston AC, 1881-82. **Work:** Mystic Seaport Mus.; Peabody Mus., Salem, Mass. **Comments:** Active in Baltimore, Richmond, Philadelphia, and NYC. Illustrator: *Harper's Leslie's;* "Beyond the Mississippi," 1867. **Sources:** G&W; CAB; Rutledge, PA; Hamilton, *Early American Book Illustrators,* 431-32. More recently, see Campbell, *New Hampshire Scenery,* 126.

PERKINS, Harley Manlius *[Painter, writer, lecturer] b.1883, Bakersfield, VT / d.1964.*
Addresses: Brookline, MA; Magnolia, MA; Boston, MA. **Studied:** Brigham Acad.; Mass. Sch. A.; BMFA Sch. **Member:** The Boston Five (modernist watercolorists who created expressive landscapes: Carl Gordon Cutler, Charles Hopkinson, Charles Hovey Pepper, Harley Manlius Perkins, Marion Monks Chase). **Exhibited:** S. Indp. A., 1918; WMAA, 1926-50; AIC; BM; "Five Boston Artists," Vose Gal., Boston, 1930; Doll & Richards, Boston, 1945-46 (solo); Rehn Gal.; Montross Gal. **Work:** BMFA; WMAA; WPA artist/dir.; mural, Ala. State Bldg., Montgomery, Ala. **Comments:** Position: art ed., Boston Transcript, 1922-28; dir. Exh., Boston A. Cl., 1923-28; Mass. state dir., FAP, 1936-39;

tech. adv., Nat. A. Program, Wash., DC, 1940-41; pres., Boston Soc. Indp. A., 1940-54. Contributor to: *The Arts; Pictures on Exhibit;* Radio Art Commentator. **Sources:** WW59; WW47; Vose Galleries, *Mary Bradish Titcomb and Her Contemporaries,* 37.

PERKINS, Henry *[Banknote engraver] b.1803, Salem, MA.* **Addresses:** Philadelphia, from c.1835. **Comments:** Was a store clerk in Hanover (NH) and in Utica (NY), sold drugs in NYC, and finally settled permanently in Philadelphia before his marriage in 1835. In Philadelphia he was at first in the book trade, but about 1858 he became a member of the firm of Danforth, Perkins & Company and subsequently treasurer of the American Bank Note Company (see entries on both firms). **Sources:** G&W; Perkins, *The Family of John Perkins,* I, 110; Phila. CD 1859+; 8 Census (1860), Pa., LIII, 269.

PERKINS, Holmes G. *[Architect, educator] b.1904, Cambridge, MA.* **Addresses:** Philadelphia, PA. **Studied:** Harvard Univ. (A.B., 1926; M.Arch., 1929; L.L.D., 1972). **Member:** Am. Inst. Architects (fellow); Royal Inst. Architects Canada (hon. corresponding member). **Comments:** Positions: editor, *Journal Am. Inst. Planners,* 1950-52; chancellor college of fellows, Am. Inst. Architects, 1964-66. Publications: author, *Comparative Outline of Architectural History,* 1937; contributor, articles in professional journals. Teaching: chmn. dept. archit. & dean grad. school fine arts, Univ. Penn., 1951-71, prof. archit. & urbanism, 1971-. **Sources:** WW73.

PERKINS, Horace, Jr. *[Engraver] b.c.1833, New York.* **Addresses:** NYC in 1860. **Sources:** G&W; 8 Census (1860), N.Y., LVII, 960.

PERKINS, J. R. *[Landscape painter] mid 19th c.* **Addresses:** NYC in 1855. **Exhibited:** NAD, 1855; Md. Hist. Soc., 1856. **Sources:** G&W; Cowdrey, NAD; Rutledge, MHS.

PERKINS, Jacob *[Banknote engraver, die-cutter, and inventor] b.1766, Newburyport, MA. / d.1849, London, England.* **Studied:** apprenticed to a goldsmith, and learned also the art of engraving and sinking dies. **Comments:** Was associated with Gideon Fairman (see entry) in Newburyport and again in Philadelphia from 1816 to 1819. In 1819 he went to England with Fairman and others to seek a contract for banknote engraving from the Bank of England. This did not occur but Perkins remained in England and became a successful inventor. Among the inventions credited to him are a machine for making nails, stereotyping, and a propeller-driven steam boat. Abraham Perkins was a brother (see entry; see also E. G. Perkins, who may have been his son). **Sources:** G&W; Perkins, *The Family of John Perkins,* III, 49-51; Toppan, *100 Years of Bank Note Engraving,* 8-10; Stauffer; Bathe, *Jacob Perkins.*

PERKINS, John U(re) *[Painter] b.1875, Wash., DC / d.1968, Wash., DC.* **Addresses:** Wash., DC. **Studied:** Chase; Hawthorne; N. Brooke. **Member:** S. Wash. A.; Min. PS & G Soc. **Exhibited:** S. Wash. A., 1910-32; Wash. Lndscp. C.; Wash. WCC; Min. PS & G Soc.; MD Inst.; Gr. Wash. Indp. Exh., 1935. **Work:** CGA. **Comments:** He worked for the Smithsonian Inst. for 47 years, retiring in 1945. **Sources:** WW27; McMahan, *Artists of Washington, D.C.*

PERKINS, Joseph *[Banknote and letter engraver] b.1788, Unity, NH / d.1842, NYC.* **Addresses:** Phila., from c.1814 ; NYC, 1826 till his death. **Studied:** Williams College (grad., c.1814). **Comments:** From 1828-31 he was in partnership with Asher B. Durand in Durand, Perkins & Co. He had one son who could possibly be the lithographer Joseph Perkins (see entry). **Sources:** G&W; Stauffer; Perkins, *The Family of John Perkins,* II, 66; Rutledge, PA; NYCD 1826-42.

PERKINS, Joseph *[Lithographer] mid 19th c.* **Addresses:** NYC, 1851-53. **Exhibited:** Am. Inst., NYC, 1851. **Comments:** Possibly the son of engraver Joseph Perkins (see entry). **Sources:** G&W; NYCD 1851-53; Am. Inst. Cat., 1851.

PERKINS, Katherine Lindsay *[Painter] early 20th c.* **Addresses:** Topeka, KS. **Exhibited:** Mulvane Art Mus., Topeka, 1924. **Sources:** WW25; Petteys, *Dictionary of Women Artists.*

PERKINS, Lee See: **PERKINS, S. Lee**

PERKINS, Louella *[Artist, decorator] late 19th c.* **Addresses:** Cincinnati. **Comments:** Worked at Rookwood Pottery, Cincinnati, 1886-98. **Sources:** Petteys, *Dictionary of Women Artists.*

PERKINS, Lucy See: **RIPLEY, Lucy Fairfield Perkins (Mrs.)**

PERKINS, Lucy Fitch (Mrs. Dwight H.) *[Painter, illustrator, writer] b.1865, Maples, IN / d.1937, Pasadena, CA.* **Addresses:** Evanston, IL. **Studied:** BMFA Sch.; Robert Vonnoh. **Exhibited:** PAFA Ann., 1907, 1909. **Comments:** Auth./illustr.: *A Book of Joys; he Goose Girl; The Dutch Twins; The Scotch Twins; Dandelion Classics; Cornelia,* and other books for children. Perkins was an artist for Louis Prang & Co., c.1912 and also a teacher at Pratt Inst., Brooklyn, for many years. **Sources:** WW32; Petteys, *Dictionary of Women Artists;* Falk, *Exh. Record Series.*

PERKINS, Mabel H. *[Collector] b.1880, Grand Rapids, MI / d.1974.* **Addresses:** Grand Rapids, MI. **Studied:** Vassar College (B.A.). **Comments:** Positions bd. mem., sec., vice-pres. & pres., Grand Rapids Art Mus.; established print gallery in Grand Rapids Art Mus. Collection: fine prints of all categories, specializing in Dürer and Rembrandt. **Sources:** WW73.

PERKINS, Marion M. *[Sculptor] b.1908, Marche, AK / d.1961.* **Addresses:** Chicago. **Studied:** Cy Gordon. **Exhibited:** AIC (purchase prize, 1951); Howard Univ.; Evanston, IL, Country Club; Hull House, Chicago; American Negro Expo., Chicago, 1940; Rockford, IL, Col., 1965; Xavier Univ., 1963; South Side Community Art Center, Chicago, 1945. **Work:** AIC; priv. colls. **Sources:** Cederholm, *Afro-American Artists.*

PERKINS, Mary Smyth *[Landscape & portrait painter] b.c.1875, Phila. / d.1931, Germantown, PA.* **Addresses:** Lumberville, PA. **Studied:** PAFA with R. Henri; Phila. Sch. Des with W. Sartain; Lawton Parker Sch., Cottet, Simon, all in Paris; painted in Mexico, c.1910. **Member:** NAWPS. **Exhibited:** AIC; PAFA Ann., 1900-01, 1903-07 (prize), 1908-09, 1912-13; Paris Salon, 1909; Corcoran Gal biennial, 1910; NAWA (prize); S. Indp. A.; 1930. **Work:** portrait, City Hall, Phila. **Comments:** Specialty: hooked rugs in the form of wall panels. Position: hd. art dept. Converse College, Spartanburg, SC, 1907-11. Her name appears as Perkins and Taylor (Mrs. William F. Taylor). **Sources:** WW29; Petteys, *Dictionary of Women Artists;* Falk, *Exh. Record Series.*

PERKINS, (Miss) *[Portrait pastelist] late 18th c.* **Addresses:** Active in Connecticut, c.1790. **Work:** Conn. Hist. Soc. (portraits of Perkins family). **Sources:** Petteys, *Dictionary of Women Artists.*

PERKINS, Nathaniel *[Engraver] b.1803, Newburyport, MA / d.1847, Newburyport.* **Addresses:** Active in Boston 1836-47. **Comments:** Son of Abraham Perkins (see entry). He was an agent of the New England Bank Note Company from 1837 to 1847. **Sources:** G&W; Belknap, *Artists and Craftsmen of Essex County,* 5; Perkins, *The Family of John Perkins,* III, 51; Boston CD 1836-47.

PERKINS, Parker S. *[Marine painter] b.1862, Lowell, MA / d.1942.* **Addresses:** Rockport, MA. **Studied:** self-taught. **Member:** RAA; Gloucester SA; NSAA, 1927. **Exhibited:** Boston AC, 1885, 1891, 1894, 1898; AIC, 1911; Gal. on the Moors; Salons of Am., 1922. **Comments:** Active in Rockport his entire life. **Sources:** WW24; *The Boston AC;* add'l info. courtesy North Shore AA.

PERKINS, Philip *[Painter, portrait painter] b.1907, Waverly, TN / d.1970, Nashville, TN.*

Addresses: NYC, 1940-48; Nashville, 1948-55; Spain and France, 1955-61; Nashville, 1961-on. **Studied:** Vanderbilt Univ., 1925-26; AIC Sch., 1926-31; with J. Marchand and Louis Marcoussis in Paris, 1932-34; F. Leger in Paris, 1934-37. **Exhibited:** Salon d'Automne and Salon des Tuilleries, Paris, 1934; Marquie Gal., NYC, 1944 (solo), 1946 (solo), 1949 (solo); Gal. Maeght, Paris, 1947 (Intl Surrealist Exh.); Randall Gal., NYC (retrospective, 1978); Samuel Kootz Gal., NYC, 1951; Parthenon Mus., Nashville, TN, 1967, 1975 (posthumous). **Work:** Guggenheim Mus.; Butler Inst. Am. Art; de Saisset Mus., Santa Clara, CA; Parthenon Mus., Nashville, TN; Brooks Mem. AM, Memphis; Vanderbilt Univ.; Univ. Tenn.; Georgia MA; Univ. Georgia; NC Mus., Raleigh; Provincetown AA; Tenn. FA Cntr., Cheekwood. **Comments:** After living in Paris for eight years, he moved to NYC in 1940; from 1943-45 he shared a studio in Greenwich Village with Yves Tanguey. He moved to Nashville and taught at the Univ. Tenn. from 1948-53. He then lived in Spain, 1955-59; in Paris, 1959-61; finally returning to Nashville in 1961. There he taught at the Watkins Institute and the Fine Arts Center at Cheekwood. His surrealist painting "Debris of Summer," completed in 1943, was chosen by Emily Genauer as one of the fifty best contemporary paintings for her book *Best of Art*, and he had received acclaim for his portraiture as early as 1930. His mature work was in color field geometric abstraction. (His dates and certain aspects of his career are similar to those of Philip R. Perkins.) **Sources:** PHF files, info courtesy Stan Mabry; add'l info., Stanford Fine Art, Nashville, TN.

PERKINS, Philip R. *[Painter] b.1914, Chicago, IL / d.1968.*
Addresses: Chicago, IL. **Studied:** Am. Acad. Art, Chicago; Acad. de la Grande Chaumière, Paris. **Exhibited:** Salon d'Automne, Paris; Contemp. Artists, Los Angeles; AIC, 1955-56, 1958; Durand-Ruel, Paris, 1954 (Les Trois Prix); AIC, 1955 (Eisendrath Prize), 1958 (Renaissance Prize). **Work:** Joslyn Mem. Mus. **Sources:** WW66.

PERKINS, Prudence *[Primitive artist] early 19th c.*
Addresses: Active in Rhode Island, c.1810. **Comments:** Painted in watercolor and ink, adding pin pricks to resemble embroidery. **Sources:** Petteys, *Dictionary of Women Artists.*

PERKINS, Richard L. *[Painter] mid 20th c.*
Exhibited: AIC, 1946. **Sources:** Falk, *AIC.*

PERKINS, Robert Eugene *[Art administrator] b.1931, Pittsfield, MA.*
Addresses: Sarasota, FL. **Studied:** Sioux Falls Col., (B.A., 1956); Columbia Univ. (M.A., 1957); Univ. S. Dak. **Comments:** Positions: asst. prin., Canton High Sch., S. Dak., 1959-61; dir. admis., Sioux Falls Col., 1961-63, dean stud., 1963-70; pres., Ringling Sch. Art, Sarasota, Fla, 1971-. Publications: co-auth., *Profile of the South Dakota High School Graduate of 1968, 1969;* auth., *The Maestro,* 1970. **Sources:** WW73.

PERKINS, Ruth Appleton See: **SAFFORD, Ruth Appleton Perkins (Mrs.)**

PERKINS, Ruth Holmes *[Still life and landscape painter] b.1907 / d.1977.*
Addresses: Needham, MA, until 1970; Newburyport, MA, 1970-on. **Exhibited:** Needham and Boston, MA. **Sources:** C.L. Snow, exh. cat., "Newburyport Area Artists" (1981).

PERKINS, S. Lee *[Lithographer, engraver] b.1827, Connecticut.*
Addresses: NYC, active 1848-56. **Comments:** Was with Henry Serrell (see entry) in Serrel & Perkins, lithographers, from 1848 to 1852. In 1850 he was also operating an engraving firm under the name of Perkins & Co. The 1850 Census gives his age as 23 and birthplace as Connecticut. Groce & Wallace speculated that he might be Lee Perkins, son of Timothy Pitkin Perkins of West Hartford (Conn.); he was born in the mid-1820s and was mortally wounded in the second battle of Bull Run in 1862. **Sources:** G&W; NYCD 1848-56; NYBD 1850; 7 Census (1850), N.Y., LIV, 583; Perkins, *The Family of John Perkins,* III, 77.

PERKINS, Sarah (Miss) *[Pastel portraitist] b.1771, Plainfield, CT / d.1831.*
Addresses: Plainfield, CT, 1790s. **Studied:** may have studied with Joseph Seward of Hampton, CT, and at Plainfield Academy (where her father was teacher and proprietor). **Work:** Connecticut Hist. Soc. **Comments:** Painted pastel portraits, primarily of her family and mostly in the 1790s. Family responsibilities may have kept her from continuing with her artwork. The death of her mother in 1794 and her father (a physician and teacher) in 1799 left her to raise her seven younger siblings; and in c.1801 she married General Lemuel Grosvenor, a widower with five children. She had three children with Grosvenor. **Sources:** G&W (listed as Miss Perkins); Bolton, *Crayon Draftsmen.* (as Miss Perkins). More recently, see Rubinstein, *American Women Artists,* 43.

PERKINS, Sarah S. *[Painter, craftsperson] b.1864.*
Addresses: Brookline, MA, active 1899-1910. **Studied:** Boston Art Students Assn. **Member:** Copley Soc., 1899; Boston SAC. **Exhibited:** Boston AC, 1899, 1900; AIC, 1899. **Sources:** WW10; *The Boston AC.*

PERKINS, Stella Mary (Mrs. J. V.) *[Painter, writer, lecturer, teacher] b.1896, Winslow, IL.*
Addresses: Cedarville & Freeport, IL. **Studied:** Rockford Col.; Univ. Wisconsin; Marques Reitzel; Frederic Taubes; Briggs Dyer; Francis Shimer Sch. **Member:** Burpee AA; Daytona Beach AA; All-Illinois SA; Rockford AA; AIC. **Exhibited:** Burpee Art Gal., 1935 (prize), 1940 (prize)-41 (prize), 1953 (prize)-54 (prize), 1957 (prize); AIC traveling exh., 1938; Freeport Pub. Lib.; Freeport Hist. Mus.; CI; Colorado Springs FA Center; Denver AM; Springfield Mus., 1950-55; Decatur, IL, 1955; Art: USA, 1958; Rockford AA. **Work:** Freeport Pub. Lib.; Freeport Hist. Mus. **Comments:** Illustr.: *Better Homes and Gardens,* 1939, 1940. Contrib.: *American Home, Parent Teachers, Junior Home.* WW47 cites a birth date of 1891. **Sources:** WW59; WW47.

PERKINS, Susan E. H. (Mrs.) *[Patron] b.1929, Indianapolis, IN.*
Member: Women's AC (founder); Hoosier Salon Patrons Assn.; Indiana Fed. Art Clubs. **Comments:** For 30 years she conducted a class in art history in her home.

PERKINS, William Hubert *[Painter] mid 20th c.; b.Huntsville, MO.*
Addresses: Council Bluffs, IA. **Exhibited:** Iowa Art Salon, 1934 (hon. men.), 1935. **Work:** mural, Lincoln H.S., Council Bluffs; South Side Church, Council Bluffs; First Lutheran Church, Council Bluffs. **Comments:** WPA artist. **Sources:** Ness & Orwig, *Iowa Artists of the First Hundred Years,* 165.

PERKINS-RIPLEY, Lucy See: **RIPLEY, Lucy Fairfield Perkins (Mrs.)**

PERKINS & COMPANY *[Engravers] mid 19th c.*
Addresses: NYC, 1850. **Comments:** Headed by S. Lee Perkins (see entry). **Sources:** G&W; NYBD 1850.

PERKINSON, Rubye Henry *[Painter] mid 20th c.*
Exhibited: Salons of Am., 1930-31. **Sources:** Marlor, *Salons of Am.*

PERKY, Cheves West (Dr.) *[Painter] mid 20th c.*
Addresses: NYC, 1930. **Exhibited:** S. Indp. A., 1930. **Sources:** Marlor, *Soc. Indp. Artists.*

PERL, A. *[Sculptor] mid 19th c.*
Addresses: New Orleans, 1857. **Sources:** G&W; Delgado-WPA cites New Orleans CD 1857.

PERL, Esther *[Painter] 20th c.*
Addresses: NYC. **Sources:** WW24.

PERL, Francis *[Painter] late 19th c.*
Addresses: NYC. **Exhibited:** NAD, 1879. **Sources:** Naylor, *NAD.*

PERL, John *[Painter] mid 20th c.*
Addresses: Chicago area. **Exhibited:** AIC, 1942-43, 1946, 1948.

Sources: Falk, *AIC.*

PERL, Margaret Anneke *[Painter] b.1887, Duluth, MN / d.1956, Los Angeles County, CA.*
Addresses: Monterey Park, CA. **Studied:** AIC; with Henri; Much; Freer; Scarbina; Smith; Slinkard; Goldbeck; N. Fechin. **Member:** Calif. AC; San Gabriel AG. **Exhibited:** San Gabriel AG; Artists Fiesta, Los Angeles, 1931; AIC, 1940 (medal). **Sources:** WW47; Hughes, *Artists in California,* 433.

PERLE, Emilie F. *[Painter, sculptor] mid 20th c.*
Addresses: Berkeley, CA. **Exhibited:** San Francisco Soc. of Women Artists, 1931; San Francisco AA, 1936, 1937. **Sources:** Hughes, *Artists in California,* 433.

PERLE, Henry *[Painter] b.1872, Germany.*
Addresses: Brooklyn, NY. **Studied:** self-taught. **Member:** S. Indp. A. **Exhibited:** S. Indp. A., 1921, 1926-35. **Sources:** WW27.

PERLESS, Robert *[Sculptor] b.1938, NYC.*
Addresses: NYC. **Studied:** Univ. Miami. **Exhibited:** Bodley Gal., NYC, 1968 (solo); New Acquisitions Exhibit, WMAA, 1970; Kinetic Show, Hudson River Mus., 1970; Bernard Danenberg Galleries, NYC, 1972 (solo). **Work:** WMAA. Commissions: polished bronze kinetic sculptures, Eastern Airlines, Boston, Mass., Guggenheim Int., NY, Avon Co., NYC & Boone Co Nat Bank, Columbia, Mo; polished bronze hanging kinetic sculpture, Haskins & Sells, NY. **Comments:** Preferred media: bronze, stainless steel. **Sources:** WW73.

PERLIN, Bernard *[Painter, illustrator] b.1918, Richmond, VA.*
Addresses: NYC; Ridgefield, CT. **Studied:** NAD, with Leon Kroll, 1936-1937; ASL with Isabel Bishop, William Palmer & Harry Sternberg, 1936-37; also in Poland. **Exhibited:** PAFA Ann., 1948, 1952, 1960, 1966; Corcoran Gal biennials, 1953, 1959; AIC; Cincinnati Mis. Assn., 1958; Brussels World's Fair, 1958; Detroit Inst Art, 1960; WMAA, 1960; retrospective, Univ. Bridgeport, 1969. Awards: Fulbright fel., 1950; Guggenheim fel., 1954-55 & 1959; NIAL, 1964. **Work:** MoMA; Tate Gal., London; Springfield MFA, Mass; CPLH; Virginia MFA. Commissions: WPA mural, USPO Dept., 1940. **Comments:** During the late 1930s-40s, he painted in the style of "Magic Realism." Illustrations for *Life; Fortune* mags. Teaching: Wooster Community Art Ctr., Danbury, Conn., 1967-69. **Sources:** WW73; WW47; Lloyd Goodrich & John I.H. Baur, *American Art of Our Century* (WMAA, 1961); Daniel M. Mendelowitz, *A History of American Art* (Holt, Rinehart & Winston, 1961); Selden Rodman, *Conversations with Artists* (Capricorn Press, 1961); Falk, *Exh. Record Series.*

PERLIN, Rae *[Painter, collector] mid 20th c.; b.Saint John's, Newf.*
Addresses: Saint John's, Newfoundland. **Studied:** Samuel Brecher, 1941, 1942 & 1946 & Hans Hofmann, 1947 & 1948, NYC; Acad. de la Grande Chaumière, Paris, France; Acad Ranson, Paris. **Exhibited:** Mem Univ Newf Art Gallery, 1971; plus others from 1962-1972. Awards: Arts & lett, Newf. Govt., 1956 & 1962-67; Can. Coun. grant, 1970. **Work:** Mem. Univ. Newf. Permanent Collection, Can. **Comments:** Preferred medium: oils. Positions: art critic, *Saint John's Daily News,* 1960-71; art critic, *Saint John's Eve. Tel.,* 1964-67. Collection: contemp works of Can. artists; prints, drawings, constructions & paintings. Publications: contribr., "A History of Art in Newfoundland," In: *Book of Newfoundland,* Vol 4, 1967; illusr., *Spindrift & Morning Light,* 1968. **Sources:** WW73.

PERLMAN, Bennard B. *[Writer, painter, teacher] late 20th c.*
Addresses: Baltimore, MD, 1990s. **Studied:** Carnegie Inst. (B.F.A., painting); Univ. Pittsburgh (M.A., art history). **Member:** Royal Soc. Arts, London (fellow). **Exhibited:** Corcoran Gal biennial, 1951. **Work:** LOC; Peale Mus., Baltimore; Johns Hopkins Univ.; Univ. Ariz. **Comments:** Teaching: Community College, Baltimore, 1954-80s; Towson State Univ.; Morgan State Univ; Loyola College; Oxford Univ., England. **Auth.:** *The Immortal*

Eight North Light, 1979; *The Golden Age of A. Illustration: F. R. Gruger and His Circle* (1978); *1% Art in Civic Architecture* (1973); survey of Am. art for *New Catholic Encycl.* (1966).

PERLMAN, Herman *[Sculptor, caricaturist] b.1904, Roschist, Volyn, Poland.*
Addresses: Columbus, OH (immigrated 1914); Wash., DC (1927-on); Delray Beach, FL (1989). **Studied:** MD Inst. Art, c.1925-27; Corcoran Sch. A, 1927. **Exhibited:** primarily in Jewish community centers and temples throughout the U.S., 1963-on; NPG, 1982 (caricatures). **Work:** Renwick Gallery, Wash., DC (large entrance doors, 1972); Blair House, Wash., DC (8 interior doors). **Comments:** During the 1930s, he produced theatrical cartoons and political caricatures. In 1939, he founded the Mondell Inst. Art, a school of animation and cartooning, and published *Animated Cartooning* in 1946. In 1949, he changed course, and began carving glass, using a sandblasting technique for etching glass panels and murals. He made glass panels for bathrooms in the White House for Pres. Truman. **Sources:** Regina Greenspun, *Herman Perlman, His Life and Art* (Bartleby Press, MD, 1982).

PERLMAN, Joel *[Sculptor] b.1943.*
Addresses: NYC, 1973. **Exhibited:** WMAA, 1973. **Sources:** Falk, *WMAA.*

PERLMAN, Raymond *[Educator, illustrator] b.1923, Sheboygan, WI.*
Addresses: Mahomet, IL. **Studied:** Univ. Ill., Champaign (B.F.A., 1948, M.F.A., 1953); Art Ctr. Col. Design, Los Angeles (M.P.A., 1952). **Member:** Soc Typographic Arts, Chicago. **Exhibited:** Creativity on Paper, Mead Paper Co., NYC, 1965; Chicago 3, Ill., 1970; Art Dir. Cl. NYC 49th Ann., 1970; Printing Job of the Year, 3M Co, 1970; TDC 1917, Type Dir. Cl. New York, 1971. Awards: UN Int. Poster Competition, 1949; Eighth Ann. Watercolor & Drawing Exhib., Artists Guild Chicago, 1966; various cert. merit, design exhibs., 1965-on. **Work:** Watercolors, Univ. Ill., Champaign. **Comments:** Preferred media: watercolors, collage. Publications: illusr., *Our Wonderful World,* Grolier, 1953-59; illusr., Rocks & Minerals, 1957, illusr., *Fossils,* 1962, *Golden Nature Guide* & illusr., *Geology, Golden Sci. Guide,* 1972, Western Publ.; illusr., *World Book & Childcraft,* Field Enterprises, 1958-. Teaching: prof. art & in charge graphic design, Univ. Ill., Champaign, 1949-on. **Sources:** WW73.

PERLMUTTER, David *[Sculptor] b.1897, Warsaw, Poland / d.1947, Syracuse, NY.*
Addresses: Syracuse, NY. **Exhibited:** S. Indp. A., 1932, 1934, 1936-37, 1940, 1942. **Sources:** Marlor, *Soc. Indp. Artists.*

PERLMUTTER, Jack *[Painter, printmaker] b.1920, NYC.*
Addresses: Wash., DC. **Member:** Soc. Am. Graphic Artists; Cosmos Cl. (art comt., 1963-70s). **Exhibited:** Corcoran Gal biennials, 1949-65 (6 times); "American Prints Today," Print Council Am., exhibited in ten cities, 1959-60; "3rd & 4th Expos Gravure," Ljubljana, Yugoslavia, 1959 & 1961; First Int. Exhib. Fine Arts Saigon, 1962 (print prize); "Third Nat. Invitational Exhib. Printmaking," Univ. Wis., 1971; "Second Nat. Invitational Print Show," San Diego AM, 1971. Other awards: Fulbright grant in art & printmaking to Tokyo, Japan, 1959-60. **Work:** NGA; Phillips Coll.; Corcoran Gal; MMA; Nat MoMA, Tokyo, Japan. Commissions: "First Saturn Moon Rocket Launching" (painting), 1967 & "Saturn V, Apollo 6" (painting), 1968, NASA, Kennedy Space Ctr., Fla.; woodcuts for Apollo 1916, Mission Control Cntr., Houston, 1972. **Comments:** Positions: dir, Dickey Gal, DC Teachers Col, 1956-68. Teaching: chmn. dept. graphics, Corcoran Sch. Art, 1961-70s. Author: "Transactions of 5th International Conference of Orientalists" (Toho Gakkai) in *Japanese Prints Today,* July, 1960; "Western Art Influences in Japan," in *Today's Japan Orient/West,* Aug., 1960; "Painting in a Land of Transition" *Inst. Intl. Educ.* mag., Jan., 1961. **Sources:** WW73; "A Perlmutter Original," *Washington Star Sun. Mag.,* Nov., 1962; reproduction in *Art Today* (Holt, Rinehart & Winston).

PERLMUTTER, Victor Thor *[Painter] mid 20th c.*
Addresses: Chicago area. **Exhibited:** AIC, 1951. **Sources:** Falk,

AIC.

PERLS, Frank (Richard) *[Art dealer, collector] b.1910, Zehlendorf, Germany / d.1975.*
Addresses: Beverly Hills, CA. **Studied:** Univ. Vienna; Univ. Munich; Univ. Berlin. **Member:** Art Dealers Assn Am. **Comments:** Positions: dir., Frank Perls Gal., Beverly Hills, Calif. Publications: auth., various articles on art. Research: 15th- century Cologne School. Collection: Picasso, Braque, Matisse & Lautrec. **Sources:** WW73.

PERLS, Klaus G. *[Art dealer] b.1912, Berlin, Germany.*
Addresses: NYC. **Studied:** Univ. Basel, Switzerland (Ph.D., 1933). **Member:** Art Dealers AA (pres.; dir., 1966-68). **Comments:** Positions: partner, Perls Gals., 1937-. Auth.: *Complete Works of Jean Fouquet,* 1940; *Maurice de Vlaminck,* 1941. Specialty of gallery: modern masters. **Sources:** WW73.

PERNESSIN, Neomi *[Painter] early 20th c.*
Addresses: NYC. **Exhibited:** AIC, 1912. **Sources:** WW13.

PERO, Lorenzo *[Sculptor, "plaster image maker"] b.c.1837, Tuscany.*
Addresses: Philadelphia. **Comments:** Working and living with Lorenzo Hardie (see entry) in 1860. **Sources:** G&W; 8 Census (1860), Pa., LXII, 106.

PERONA, Elizabeth Henderson *[Painter, sculptor] b.1907, Minneapolis, MN / d.1967, New Jersey (auto accident).*
Addresses: Hollywood, CA; Sausalito, CA; New Jersey. **Studied:** Calif. Sch. of FA. **Exhibited:** SFMA, 1935. **Comments:** Married to Lucien Perona (see entry). Specialty: watercolors. **Sources:** Hughes, *Artists in California,* 433.

PERONA, Lucien A. *[Painter] b.1906, La Seyne, France / d.1971, Bernardsville, NJ.*
Addresses: Hollywood, CA; Sausalito, CA; New Jersey. **Studied:** Calif. Sch. of FA, with the Mackys, Ray Boynton, Ralph Stackpole, G. Albright; ASL. **Exhibited:** Explorer Gallery, NYC, 1962 (solo). **Comments:** Immigrated to California in 1910. Position: artist, Walt Disney Studios, San Francisco *Call Bulletin;* advert. dir., *Italian Swiss Colony* wines. Married to Elizabeth H. Perona (see entry). **Sources:** Hughes, *Artists in California,* 433.

PEROT, Annie Lovering *[Painter] b.1854, Phila., PA.*
Addresses: Phila, PA/East Gloucester, MA. **Studied:** PAFA, with Breckenridge, Anshutz, Chase, McCarter, Wagner. **Member:** Phila. Art Alliance; Plastic Cl. **Exhibited:** AIC, 1912; Plastic Club, Phila, 1913, 1916; PAFA Ann., 1913-14, 1918-19; PAFA, 1924; S. Indp. A., 1917-18. **Comments:** Preferred medium: watercolor. **Sources:** WW25; Petteys, *Dictionary of Women Artists;* Falk, *Exh. Record Series.*

PEROVANI, Joseph *[Portrait, historical, and landscape painter] b.Italy / d.1835, Mexico.*
Addresses: In U.S.: Philadelphia in 1795. **Comments:** Came to Philadelphia with Jacint Cocchi (see entry) in September, 1795; they advertised that they were from Venice and stated that they had worked in Rome as well as other Italian cities. Perovani was in Cuba in 1801 and died in Mexico. **Sources:** G&W; Thieme-Becker; Prime, II, 26.

PERRAM, Roy Gates *[Painter] b.1916, Paterson, NJ.*
Addresses: Hasbrouck Heights, NJ. **Studied:** Grand Cent Art Sch.; also with Frank V. Dumond & Frank J. Reilly. **Member:** Hackensack Art Cl. (pres., 1948); Bergen Co. Artists Guild. **Exhibited:** All. A. Am., 1966; Fairleigh Dickinson Univ., Rutherford, NJ, 1967; Fair Lawn Art Assn., NJ, 1968; Bergen Mall Exhib., Paramus, NJ, 1970; Portraits, Inc., NYC, 1970s. Awards: Purchase prize, Bergen Mall, 1964. **Work:** Americana Mus., Univ. SC; Plymoth Plantation, Plymouth, Mass.; Salisbury Pub. Libr., Md.; Maywood Pub. Libr., NJ. Commissions: portrait of Dr. O. Howard, D.D., by friends at Diocesan Col., McGill Univ., 1956; Jordan River (mural), Rutherford Baptist Church, NJ, 1957; portrait of Dr. Arthur Armitage, South Jersey Col., Rutgers Univ., Camden, 1961; portrait of Dr. Milton Hoffman, D.D., Cent Col., Pella, Iowa, 1966; portrait of H. Bruce Palmer, Conf. Bd.,

NYC, 1971. **Comments:** Preferred medium: oils. **Sources:** WW73.

PERRAULT, Ida Marie *[Painter] b.1874, Detroit, MI.*
Addresses: Paris; Detroit, MI. **Studied:** Detroit Mus. Art Sch.; Detroit School of Art, with John Dunsmore; Paris, The Hague, Brussels, for seven years. **Member:** Art clubs abroad. **Exhibited:** Trans-Mississippi Expo, Omaha, 1898; AIC, 1903; Detroit Mus. Art, 1911 (solo). **Comments:** Specialty: children. Made clay mannequins of mythological and historical characters. Also appears as Pervault. **Sources:** WW98; WW21; Gibson, *Artists of Early Michigan,* 191; Petteys, *Dictionary of Women Artists.*

PERRAULT, Marie (Mme.) See: **PERRAULT, Ida Marie**

PERRET, Andrew *[Engraver] mid 19th c.*
Addresses: Active Newark, NJ. **Comments:** Senior partner in Perret & Brother, engravers and "engine turners," Newark (N.J.), 1860 and after. **Sources:** G&W; Newark CD 1860-70; New Jersey BD 1860.

PERRET, Charles E. *[Engraver and die sinker] 19th c.*
Addresses: NYC, 1856-59. **Sources:** G&W; NYBD 1856-59.

PERRET, Ferdinand *[Art historian, painter, designer, graphic artist, illustrator, writer, lecturer] b.1888, Illzach, France / d.1960.*
Addresses: Los Angeles, CA. **Studied:** Ecole des Beaux-Arts, Paris, France with Jules Perret; Folkwang Mus., Germany, with Rohlfe and Weiss; London Sch. A., London, England, with C.P. Townsley; Stickney Mem. Sch. FA, Pasadena, Cal., with Jean Mannheim and Guy Rose; and with William Chase. **Member:** William Keith A., Berkeley, Cal.; Cal. A. Cl.; Los A. P.& S. Cl.; A. of the Southwest; Laguna Beach AA; AFA; Los Amigos Hist. S., Southern Calif.; Los Angeles AA; Santa Monica AA; P&S of Los Angeles. **Exhibited:** Pac. Intl. Expo., San Diego, 1935-36; Stickney Mem. Sch. FA; Los Angeles; Carmel, 1916; Awards: prize, Stickney Mem., Pasadena, 1917; medal, Int. Aero A. Exh., Los A., 1937; Los A. P. & S. Cl., 1949. **Work:** LACMA. **Comments:** Founder and Donor of the "Perret Art Reference Library," NCFA, Wash., DC. Lectures: The Arts and Crafts of the American Indian. Founder/owner/dir., Ferdinand Perett Research Lib. A. & Affiliated Sciences, Los Angeles, from 1906 , with all collected material for public use. Author and donor of the Perret Encyclopedia of Spanish Colonial Art (15 vols.) to the Museum of the Santa Barbara Hist. Soc., 1958. Contributor: California Arts & Architecture. Author: *California Artists of the First One Hundred Years.* **Sources:** WW59; WW47.

PERRET, George Albert *[Writer, lecturer] mid 20th c.; b.NYC.*
Addresses: Amagansett, NY. **Studied:** Munson-Williams-Proctor Inst, Utica, NY; Utica Col., Syracuse Univ.; ASL; NAD Sch. **Member:** Westbeth Graphic Artists Group (prog. dir.). **Comments:** Positions: dir., Parrish Art Mus., 1963-68; cur., Am. Contemp. Artists Gal., 1968-72; dir. publ., Assoc. Am. Artists, 1972-. Teaching: instr. art hist., Southampton Col., Long Island Univ., 1963-68. Collections arranged: Artists of the South Fork, 1965, The Wyeth Family, 1966 & Mary Cassat, 1967, Parrish Mus., Southampton, NY. Research: American painting, 1860-1950. Publications: contribr., "Art News and Reviews" (weekly column), *Suffolk Sun,* 1965-68; auth., *Levon West,* 1966; auth., *George Elmer Browne,* 1966; co-auth., *Tully Filmus Drawings,* 1971; auth., *Moses Soyer Drawings,* 1971. **Sources:** WW73.

PERRET, Henry *[Engraver] mid 19th c.*
Addresses: Active Newark, NJ. **Comments:** Junior partner in Perret & Brother, engravers and "engine turners," Newark (N.J.), 1860 and after. **Sources:** G&W; Newark CD 1860-70; New Jersey BD 1860.

PERRET, Nell Foster *[Painter] b.1916, Brooklyn, NY / d.1986.*
Addresses: NYC. **Studied:** Pratt Inst.; ASL; Design Lab. **Member:** East Hampton Guild Hall; Westbeth Graphic Artists

Workshop (publ. dir., 1970-72); Audubon Artists. **Exhibited:** St Mary's Univ., Md., 1971; Audubon Artists, Nat. Acad. Design Gal., 1971; Westbeth Graphics Workshop, Palacio Bellas Artes, Mex., 1971-72; East Hampton Guild Hall Ann.; Southampton Col. Ann. Awards: two awards, East Hampton Guild Hall, 1961 & 1962; three awards for graphics, Parrish Art Mus., 1963, 1964 & 1967. **Work:** Southampton Col.; Long Island Univ.; East Hampton Guild Hall; St Mary's Univ.; Wichita State Univ. **Comments:** Preferred media: graphics. Teaching: instr. graphics, Parrish Art Mus., Southampton, 1960-68; adj. prof. graphics, Southampton Col., 1968-70. **Sources:** WW73; Esther Greenwood, *Long Island Art* (Long Island Press, 1962); Jean Paris, "Review of My Work," *Newsday* (1963); Gordon Brown, "Review," *Arts Mag.* (summer, 1971).

PERRET, Paulin *[Engraver] mid 19th c.*
Addresses: New Orleans, active 1841-42. **Sources:** G&W; New Orleans CD 1841-42.

PERRET & BROTHER *[Engravers and engine turners] mid 19th c.*
Addresses: Newark, NJ, 1860 and after. **Comments:** Partners were Andrew and Henry Perret. **Sources:** G&W; Newark CD 1860-70; New Jersey BD 1860.

PERRETT, A. Louise *[Painter, illustrator, teacher] early 20th c.; b.Chicago.*
Addresses: Boston, MA. **Studied:** AIC; H. Pyle; J. Carlson. **Exhibited:** AIC, 1915, 1917. **Comments:** Teaching: AIC. *Cf.* Louise Perrett. **Sources:** WW40.

PERRETT, Galen Joseph *[Marine painter, etcher] b.1875, Chicago, IL / d.1949.*
Addresses: Laren, Holland (2 years); NYC; Rockport, MA, 1928 and after. **Studied:** U. of I.; AIC; ASL; Académie Julian, Paris; Nat. Acad., Munich, Germany; Colarossi Acad., Académie Julian, Paris, 1901. **Member:** SC; North Shore AA; Rockport AA(pres.). **Exhibited:** Paris Salon; St. Louis Expo.; PAFA Ann., 1905; AIC; NAD; NYC (solos). **Work:** Newark Mus.; Franklin (N. H.) Lib. **Sources:** WW47; *Artists of the Rockport Art Association* (1946); Falk, *Exh. Record Series.*

PERRETT, Louise *[Painter] 20th c.*
Addresses: Oak Park, IL. **Comments:** *Cf.* A. Louise Perrett. **Sources:** WW15.

PERRI, Frank S. *[Painter] mid 20th c.*
Addresses: Chicago area. **Exhibited:** AIC, 1939-51. **Sources:** Falk, *AIC.*

PERRIE, Bertha E(versfield) *[Painter, miniature painter, teacher] b.1868, Wash., DC / d.1921, Gloucester, MA.*
Addresses: Wash., DC. **Studied:** ASL (scholarship); ASL, Wash., DC. **Member:** Wash. WCC; Soc. Wash. Artists; ASL; Penn. Soc. Min. Painters; Wash. AC; Wash. Soc. FA; Wash. Handicraft Gld. **Exhibited:** AWCS, from c.1897; NYWCC; Wash. WCC, 1891-1921, (second Corcoran prize, 1900, first Corcoran prize, 1904); Boston AC, 1892-94; AIC; PAFA Ann., 1895, 1898-1901, 1919; Corcoran Gal biennials, 1908-21 (6 times); NAD; Appalachian Expo., 1910 (silver med.). **Work:** NMAA; Wash. AC. **Comments:** Teaching: CGA; ASL, Wash., DC; Gunston Hall School. **Sources:** WW19; McMahan, *Artists of Washington, D.C.;* Petteys, *Dictionary of Women Artists;* Falk, *Exh. Record Series.*

PERRIGARD, Hal Ross *[Painter, designer] b.1891, Montreal, Canada.*
Addresses: Rockport, MA, 1923 and after. **Member:** Royal Canadian Academy; Arts Club, Pen & Pencil, Montreal. **Exhibited:** U.S.A.; Canada; England; Scotland; France; Belgium; British Empire Exh., Wembley, England; NYWF, 1939. **Work:** internationally. **Sources:** *Artists of the Rockport Art Association* (1946).

PERRIN, Beranger *[Listed as "artist"] mid 19th c.*
Addresses: New Orleans, 1837. **Sources:** G&W; Delgado-WPA cites New Orleans CD 1837.

PERRIN, C. Robert *[Painter, illustrator] b.1915, Medford, MA.*
Addresses: Nantucket Island, MA. **Studied:** School Practical Art, scholarship, also with John Whart & Lester Stevens, four years. **Member:** AWCS; Boston WCS; AA Nantucket; Rockport AA; Guild Boston Artists; North Shore AA. **Exhibited:** Boston Soc. Independent Artists, 1952 (purchase prize); Rockport AA, 1953 (prize); North Shore AA, 1954 (prize); AWCS, 1958-; U.S. Info Agency World Tour, 1959; Boston WCS, 1955 (prize),1960-; NAD; Boston Arts Festival; 32nd Ann. Exhib. Painting by Contemp New England Artists, 1961 (Richard Mitlou Mem. Award); Copley Soc., 1965 (first award); Grand Central Art Gals., NYC, 1970s. **Work:** Ford Motor Co. Coll. Am. Watercolors; Lyman Allyn Mus., New London, CT. **Comments:** Preferred medium: watercolors. Positions: free lance illustrator, Boston, MA, 1939-42 & 1946-68. Teaching: artist, lecturer & demonstrator, Boston & Nantucket Island, MA, 1950. **Sources:** WW73; James S. Geggis, *Art Studio on Wheels* (United Press, 1947); Patricia Boyd Wilson, "The Home Forum," *Christian Science Monitor,* 1966; Norman Kent, *100. Publications:* co-author, "Watercolor Page," 1959 & co-author, "Making a Rug Mural,'"1966, Am. Artist Magazine; contributor, *The Folk Arts & Crafts of New England,* 1965; contributor, *Creating Art from Anything,* 1968.

PERRIN, Dorothy M. *[Painter] mid 20th c.*
Addresses: Seattle, WA, 1949. **Exhibited:** SAM, 1949. **Sources:** Trip and Cook, *Washington State Art and Artists.*

PERRIN, Inez *[Artist] 19th/20th c.*
Addresses: Active in Detroit, MI. **Sources:** Petteys, *Dictionary of Women Artists.*

PERRIN, Joseph S. *[Painter] mid 20th c.*
Addresses: Atlanta, GA. **Exhibited:** PAFA Ann., 1958. **Sources:** Falk, *Exh. Record Series.*

PERRINE, Edith Eva Elliott *[Painter, block printer] b.1886, Des Moines, IA / d.1946, Riverside, CA.*
Addresses: Riverside, CA. **Member:** Calif. WC Soc.; Laguna Beach AA. **Exhibited:** Oakland A. Gal., 1937. **Comments:** Specialty: watercolors. **Sources:** Hughes, *Artists in California,* 433.

PERRINE, Van Dearing *[Painter, writer, lecturer, teacher] b.c.1868, Garnett, KS / d.1955, Stamford, CT.*
Addresses: Maplewood, Englewood, NJ. **Studied:** CUA Sch.; NAD. **Member:** ANA; NA, 1931; Nat. AA; Millburn-Shore Hills AA; Am. Soc. PS&G; Woodstock AA. **Exhibited:** NAD, 1898-1900, 1930 (prize); PAFA Ann., 1900-37; Charleston Expo, 1902 (med.); Boston AC, 1902-03; CI, 1903; Corcoran Gal. biennials, 1907-35 (9 times); Armory Show, 1913; Pan.-Pac. Expo., 1915 (medal); S. Indp. A., 1917-20; P&S Los Angeles, 1927; AIC. **Work:** PMG; BM; CI; Newark Mus.; Montclair AM; WMAA. **Comments:** Auth.: *Let the Child Draw.* Experiments with color music. **Sources:** WW47; Falk, *Exh. Record Series;* add'l. info. courtesy Woodstock AA; Brown, *The Story of the Armory Show.*

PERRING, Cornelia S. *[Painter] b.1840, Bloomington, IN / d.Louisville, KY.*
Addresses: Louisville, KY. **Member:** Louisville AL. **Sources:** WW01; Petteys, *Dictionary of Women Artists.*

PERRODIN, Antoine *[Painter] late 19th c.; b.Louisiana.*
Exhibited: Paris Salon, 1890. **Sources:** Fink, *American Art at the Nineteenth-Century Paris Salons,* 380.

PERRONE, Ben (Benedict) *[Painter] late 20th c.; b.Pittston, PA.*
Addresses: Buffalo, NY. **Studied:** Yale Summer Sch. of Art and Music, Norwalk, Ct., 1959; Univ. of Buffalo (B.F.A., 1960); with Lawrence Calcagno, Edward Millman, Bernard Chaet, Calvin Harlan, Don Nichols and Philip Elliott, c.1973. **Comments:** Founded and directed Zuni Gallery in Buffalo, 1962, with Adele Cohen. Dir., Workshop Theatre, Buffalo, c. 1967. Designed sets for black comedies, *Orison* and *Fando and Lis* by Fernando

Arrabal, Albright-Knox Art Gallery, 1967. Teaching: instr., State Univ. College at Buffalo. **Sources:** Krane, *The Wayward Muse,* 194.

PERROT, Paul N. *[Art administrator, lecturer] b.1926, Paris, France.*
Addresses: Wash., DC. **Studied:** Inst. Fine Arts, New York Univ., 1946-52. **Member:** Am. Assn. Mus. (council mem., exec. committee, vice-pres.); U.S. Int. Council Mus. (chmn.); College AA Am.; Am. Archaeology Inst.; Special Lib. Assn. **Comments:** Positions: assts., The Cloisters, MMA, 1948-52; asst. to dir., Corning Mus. Glass, 1952-55, asst. dir., 1955-60, dir., 1960-72; ed., *Journal of Glass Studies,* 1959-72; asst. sec. mus. progams, Smithsonian Inst., 1972-. Teaching: instr. glass history, Corning Community College & Alfred Univ. Collections arranged: Three Great Centuries of Venetian Glass, 1958; most exhibs. shown at The Corning Mus. Glass, 1960-72. Publications: auth., *Three Great Centuries of Venetian Glass,* 1958; author, articles, *Antiques, Apollo, Arts in Virginia, College Art Journal* & others. **Sources:** WW73.

PERROTT, James Stanford *[Art administrator, educator] mid 20th c.*
Addresses: Calgary, Canada. **Studied:** Alta Co.1 Art, Calgary; Banff Sch. Fine Arts, Alta.; Hans Hofmann Sch. Art, Provincetown, Mass.; ASL; PAFA. **Member:** Alta. Soc. Artists (pres., 1965). **Exhibited:** Alta. Soc. Artists, Edmonton, 1955-70; Western Ont. Ann., London, Ont., 1962; Art Inst. Ont. Touring Exhib., 1965. Awards: scholarship ann. award. **Work:** Univ. Calgary; Glenbow-Alta Inst., Calgary. **Comments:** Preferred media: watercolors. Teaching: instr. hist., drawing, design & anat., Alta Col. Art, 1946-67, hd. dept., 1967-. Collection: paintings, prints, sculpture, antiques, glass, ceramics & pottery. **Sources:** WW73.

PERRY, Annette *[Painter, teacher] b.1872, Patch Grove, WI / d.1965, Los Angeles, CA.*
Addresses: Los Angeles, CA. **Studied:** Newcombe School of Art, Indianapolis; with M. DeMandeville, Tacoma, WA. **Comments:** Founder, dir., Perry Art Studio, Los Angeles. She taught members of the film industry at her school. **Sources:** Hughes, *Artists in California,* 433.

PERRY, Bart *[Painter, teacher] b.1906, Boston, MA.*
Addresses: New York 11, NY. **Studied:** Harvard Univ.; N.Y. Univ. (grad. work); Calif. Sch. FA. **Member:** Woodstock AA; AEA. **Exhibited:** SFMA, 1946 (solo); San F. AA, 1953 (prize); Woodstock AA, 1958; Labaudt Gal., San F., 1954; Camino Gal., N.Y., 1957; Corcoran Gal biennial, 1961. **Comments:** Teaching: art history, Univ. Pittsburgh, 1933-34; Mills Col., 1948. **Sources:** WW59.

PERRY, C. H. *[Wood engraver] mid 19th c.*
Addresses: Cincinnati, 1853. **Sources:** G&W; Ohio BD 1853.

PERRY, Carrie (Miss) *[Painter] mid 19th c.*
Addresses: Troy, NY. **Exhibited:** NAD, 1868. **Sources:** Naylor, NAD.

PERRY, Charles Owen *[Sculptor] b.1929, Helena, MT.*
Addresses: Rome, Italy. **Studied:** Columbia Univ., 1954; Yale Univ., with J. Albers, 1954-58 (B.Arch., 1958). **Exhibited:** WMAA Sculpture Biennial, 1964-66; Science Age Totems, SFMA, 1965; Directions 1: Options 1968, Milwaukee Art Ctr., Wis. & Mus. Contemp. Art, Chicago, 1968; Superlimited, Books, Boxes & Things, Jewish Mus., 1969; Venice Biennial, Italy, 1972; Waddell Gal., NYC, 1970s. Awards: Prix de Rome, Am. Acad. Rome, 1964 & 1966; design in steel award, Am. Iron & Steel Inst., 1970 & 1971; premio for Emelia, Circolo della Stampa, Bologna, 1971. **Work:** MoMA; AIC; Mus. Contemp. Art, London, Eng.; SFMA; Joseph Hirshhorn Coll. Commissions: aluminum sculpture, Torrington Mfg., 1969; bronze sculpture, Harvard Bus. Sch., 1971; chrome sculpture, Equitable Assurance, St. Louis, Mo., 1971; painted steel sculpture, Fed. Reserve Bank, Minneapolis, Minn., 1972; aluminum sculpture, Embarcadero Ctr.,

San Francisco, 1972-73. **Comments:** Preferred media: metals, plastics. Positions: sculptor-in-residence, Am. Acad. Rome, 1970-71. **Sources:** WW73; L.B. Jackson, "Return to a Rome Prize Winner," *Am. Inst. Architects J.* (Apr., 1968); "Charles Perry & Solid Geometry," *Archit. Forum* (Apr., 1972).

PERRY, Clara Fairfield (Mrs. Walter Scott) *[Painter] b.Brooklyn, NY / d.1941, Stoneham, MA.*
Addresses: Stoneham, MA. **Studied:** W.S. Perry; H.B. Snell; E. Caser. **Member:** Meridian Club; Brooklyn SA; Brooklyn P&S; Marblehead AA. **Exhibited:** Pratt Inst., Brooklyn, 1917, 1926 (solo); Nat. Women P&S, 1924; S. Indp. A., 1931; Salons of Am., 1934. **Sources:** WW40; Petteys, *Dictionary of Women Artists.*

PERRY, Clara Greenleaf *[Landscape painter, sculptor, lecturer] b.1871, Long Branch, NJ / d.1960.*

Clara G. Perry 19

Addresses: Dedham, Boston, MA; Wash., DC. **Studied:** R. Henri; BMFA Sch., with E. Tarbell, Frank Benson; M.R. Collins in Paris. **Member:** Copley S.; NAWA, 1922; Wash. AC; Soc. of Ind. Artists. **Exhibited:** PAFA Ann., 1901, 1915, 1923; Exh. of Independent Artists, 1910; AIC, 1913; Bakker Gal., Boston, 1978. **Comments:** Her paintings are marked by broad broken brushwork. She painted at Ogunquit, Bermuda, Madrid, England (Surrey), and France (Loire). **Sources:** WW33; exh. cat., Bakker Gal., Boston (1978); *Art by American Women:.the Collection of L. and A. Sellars,* 87; Falk, *Exh. Record Series.*

PERRY, Edith Dean Weir (Mrs.) See: **WEIR, Edith Dean (Mrs. J. DeWolf Perry)**

PERRY, Edward *[Engraver] mid 19th c.*
Addresses: NYC, 1845. **Exhibited:** Am. Inst., NYC, 1845 (frame of wood engravings). **Sources:** G&W; Am. Inst. Cat., 1845.

PERRY, Edward *[Painter] mid 20th c.*
Addresses: Canton, NY, 1927. **Exhibited:** S. Indp. A., 1927-28. **Sources:** Marlor, *Soc. Indp. Artists.*

PERRY, Emilie S(tearns) *[Sculptor, illustrator] b.1873, New Ipswich, NH / d.1929, Ann Arbor, MI.*
Addresses: Los Angeles, CA, 1909-16; Ann Arbor, MI. **Studied:** BMFA Sch.; Mass. Normal Art Sch.; M. Broedel. **Member:** Ann Arbor AA. **Exhibited:** YWCA, Los Angeles, 1910; Pan-Calif. Int. Expo, San Diego, 1915 (silver & bronze medals); Oakland Art Gal., 1917. **Work:** panel, The Women's Club, Hollywood; Hollywood Lib.; College of Garvanza, Los Angeles. **Comments:** Position: medical illus., Univ. of Michigan. **Sources:** WW29; Hughes, *Artists in California,* 433; Petteys, *Dictionary of Women Artists.*

PERRY, Emma E. *[Artist] late 19th c.*
Addresses: Active in Ann Arbor, MI, 1891-95. **Comments:** President, Ann Arbor Art School, 1895. *Cf.* Emilie S. Perry. **Sources:** Petteys, *Dictionary of Women Artists.*

PERRY, Enoch Wood, Jr. *[Genre, portrait, and landscape painter] b.1831, Boston, MA / d.1915, NYC.*

E.W. Perry. N.A. 1874

Addresses: NYC. **Studied:** Leutze in Düsseldorf, 1852-54; Couture in Paris, 1854-55. **Member:** ANA, 1869; NA, 1869; AWCS; Artists Aid Soc.; Century Assoc. **Exhibited:** NAD, 1867-1915; AIC; PAFA Ann., 1858-60, 1885; Brooklyn AA, 1867-82; World's Industrial and Cotton Centennial Expo, 1884-85; Boston AC, 1877. **Work:** Oakland Mus.; MMA; Louisiana State Mus.; Bishop Mus., Honolulu; Buffalo FA Acad.; Shelburne (VT) Mus. **Comments:** After working in a New Orleans grocery store from 1848-52, Perry earned enough to study painting in Düsseldorf and Paris. He also visited Rome and Venice, serving as U.S. Consul in the latter city from 1856-58. Returning to America, he settled briefly in Philadelphia and New Orleans; but in 1863 began traveling extensively in the West. He lived in San Francisco for about three years, where he became a friend of Albert Bierstadt, accompanying him on a tour of Yosemite. He was in Hawaii 1864-65, fulfilling portrait commissions and painting landscapes. In Utah

he painted leaders of the Mormon church. In 1866 he opened a studio in NYC and remained there, aside from later trips to California and Europe, until his death. Although he was extremely successful as a portraitist, he achieved even wider popularity through his genre pictures, which he exhibited at the National Academy for nearly 50 years. **Sources:** G&W; WW15; Cowdrey, "The Discovery of Enoch Wood Perry," with 9 repros.; DAB; CAB; Clement and Hutton; Cowdrey, NAD; Naylor, NAD; Rutledge, PA; Falk, PA, vol. 2; Cline, "Art and Artists in New Orleans"; Swan, BA. See also Baigell, *Dictionary; Encyclopaedia of New Orleans Artists.* 299; Campbell, *New Hampshire Scenery,* 127; Hughes, *Artists in California,* 434; Muller, *Paintings and Drawings at the Shelburne Museum,* 100 (w/repro.); Forbes, *Encounters with Paradise,* 92, 155-59; Falk, *Exh. Record Series.*

PERRY, Florence *[Artist] late 19th c.*
Addresses: Wash., DC, active 1890. **Sources:** McMahan, *Artists of Washington, D.C.*

PERRY, Frank Chester *[Marine painter, landscape painter, teacher] b.1859, Swansea, MA.*
Addresses: Westerley, RI. **Exhibited:** Boston AC, 1895, 1898, 1907. **Sources:** WW10; *The Boston AC.*

PERRY, Franklin *[Engraver] b.c.1836, Vermont.*
Addresses: Boston, 1860. **Sources:** G&W; 8 Census (1860), Mass., XXVII, 522.

PERRY, Frederick *[Painter] mid 20th c.*
Exhibited: BMA, 1939; Augusta Savage Studio, 1939; American Negro Expo., Chicago, 1940. **Work:** Nat'l Archives. **Sources:** Cederholm, *Afro-American Artists.*

PERRY, George F. *[Listed as "artist"] mid 19th c.*
Addresses: Cincinnati, 1850. **Sources:** G&W; Cincinnati CD 1850 (courtesy Edward H. Dwight, Cincinnati Art Museum).

PERRY, Glenn *[Painter] b.1880, Corning, NY.*
Addresses: Buffalo, NY. **Member:** The Patteran; Buffalo SA. **Exhibited:** Albright A. Gal.; Riverside Mus., NYC; Am. Fed. A., 1939. **Sources:** WW40.

PERRY, Ione H. *[Figure painter] b.1839, NYC.*
Addresses: Active in NYC. **Studied:** Cooper Institute; Henry Loop. **Exhibited:** NAD, 1867-83 (5 annuals). **Comments:** Specialized in literary subjects. Some of her paintings were reproduced in lithographs and widely circulated. **Sources:** G&W; Clement and Hutton.

PERRY, Isabella C. *[Painter] early 20th c.*
Addresses: NYC. **Exhibited:** AIC, 1907. **Sources:** Falk, *AIC.*

PERRY, J. Daniel *[Sculptor] late 19th c.*
Exhibited: NAD, 1870. **Sources:** Naylor, *NAD.*

PERRY, James DeWolf (Mrs.) See: **WEIR, Edith Dean (Mrs. J. DeWolf Perry)**

PERRY, J(ames) R(aymond) *[Painter] b.1863, Northfield, MA.*
Addresses: Chicago, IL. **Studied:** self-taught. **Member:** South Side AA; All-Ill. SFA; AIC; AAPL. **Exhibited:** AIC; South Side AA, 1929 (prize). **Work:** Chicago pub. schs.; Harper Mem. Lib., Chicago Univ.; Beals Mem. Lib; Winchendon, Mass.; John H. Vanderpoel AA, Chicago. **Sources:** WW40.

PERRY, Jerry *[Sculptor] b.1947.*
Addresses: NYC, 1975. **Exhibited:** WMAA, 1975. **Sources:** Falk, *WMAA.*

PERRY, Kenneth F. *[Educator, writer] b.1902, Pueblo, CO.*
Addresses: Greeley, CO. **Studied:** Colorado State Col. (A.B., A.M.); Columbia Univ. (Ph.D.). **Comments:** Position: chm., Division of the Arts, Colorado State College, Greeley, Colo. Author: *A Diversified Art Program; The Binding of Books* (with Baab); contributor of articles to magazines. **Sources:** WW66.

PERRY, Lelia *[Landscape and still life painter] late 19th c.*
Addresses: Norfolk, VA. **Exhibited:** Norfolk, VA, 1885-86. **Sources:** Wright, *Artists in Virginia Before 1900.*

PERRY, Lilla Cabot (Mrs. Thomas S.) *[Portrait, genre and landscape painter, writer] b.1848, Boston, MA / d.1933, Hancock, NH.*
Addresses: Boston, MA/Hancock, NH. **Studied:** Cowles Art Sch., with D.M. Bunker, R.W. Vonnoh, c.1885-88; Académie Julian, Paris; Académie Colarossi, Paris; privately with A. Stevens, Paris, 1888. **Member:** Boston GA (co-founder, 1914); Allied AA, London; Société des Artistes Indépendants, Paris; Int. Soc. AL; Women's Int. AC, Paris, London; Nippon Bijitsu-in, Tokyo Concord AA; CAFA. **Exhibited:** Boston AC, 1891-1904, 1933 (memorial); PAFA Ann., 1892-1907, 1912-13, 1918-30 (total 21 annuals); Paris Salon, 1889; SNBA, 1895-97; NAD, 1890-91, 1921; AIC, 8 annuals, 1890-1904; Boston, 1892 (medal); Corcoran Gal biennials, 1914-28 (5 times); Boston AG (solos); World's Columbian Int. Expo, Chicago, 1893; St. Louis Expo, 1904 (bronze med.); Pan-Pac. Expo, San Francisco, 1915 (bronze med.); S. Indp. A., 1917-18; Salons of Am., 1925, 1929; Sesqui-Centennial Int. Expo, Phila, 1926. **Work:** BMFA; NYPL; Am. Fed Women's Club, Wash., DC; Carolina AA, Charleston. **Comments:** Descended from a wealthy Boston family, Perry was both a poet and a painter. Although she began seriously studying painting rather late (around age 30), she earned a good reputation for her Impressionist portraits and figurative works. Ultimately, however, she stands out for her tireless efforts to promote Claude Monet, next door to whom she purchased a home in Giverny. In her role as an ambassador for Impressionism, she was more important for establishing cultural ties between the Boston painters and Giverny than for her own paintings. Her article "Reminiscences of Claude Monet from 1889-1909" (*Am. Magazine of Art,* Mar. 1927) is based upon her years at Giverny and is perhaps the most accurate account of Monet's method and nature of plein-air painting. In 1898 her husband took a teaching position in Japan, where she continued her painting, creating mainly landscapes and a few portraits. From 1911 until her death, she painted at Fenway Studios in Boston and at her farm in Hancock, NH. Author (poetry): "The Heart of the Weed," "From the Garden of Hellas," "Impressions," "The Jar of Dreams." **Sources:** WW27; Vose Galleries, *Mary Bradish Titcomb and Her Contemporaries,* 47; Tufts, *American Women Artists,* cat. nos. 50-51, 65; Fink, *American Art at the Nineteenth-Century Paris Salons,* 380; Falk, *Exh. Record Series.*

PERRY, Maeble C(laire)(Mrs. Edwards) *[Sculptor, painter, decorator, designer, lecturer, teacher] b.1902, Idaho.*
Addresses: Chicago, Evanston, IL; Cos Cob, CT. **Studied:** AIC, A. Polasek. **Member:** Chicago Art Gal.; AIC; Chicago P&S. **Exhibited:** Alliance, 1931 (prize); Evanston Woman's Cl., 1933-34, 1936-37 (prizes); PAFA Ann., 1934; AIC, 1939 (prize); PAFA, 1941. **Work:** AIC. **Sources:** WW40; Falk, *Exh. Record Series.*

PERRY, Marie E. *[Sculptor] mid 20th c.*
Exhibited: S. Indp. A., 1936. **Sources:** Marlor, *Soc. Indp. Artists.*

PERRY, Mary Chase See: **STRATTON, Mary Chase Perry (Mrs. Wm. H.)**

PERRY, Michael Kavanaugh *[Painter, printmaker] b.1940, Los Angeles, CA.*
Studied: Otis AI (B.F.A., M.F.A., 1967). **Exhibited:** Otis AI; Los Angeles City Hall, 1968. **Work:** Golden State Mutual Life Ins. Co. **Comments:** Position: instr., Albany State Col., Albany, GA. **Sources:** Cederholm, *Afro-American Artists.*

PERRY, Minnie Hall (Mrs. William) See: **MURPHY, Minnie B. Hall**

PERRY, Oliver Hazard *[Painter, water colorist] b.1842.*
Addresses: Newtown, NY. **Exhibited:** PAFA Ann., 1885, 1887. **Sources:** Falk, *Exh. Record Series.*

PERRY, Ollie Montgomery *[Painter] b.1881, Missouri / d.1964, San Diego, CA.*
Addresses: San Diego, CA. **Studied:** Alfred R. Mitchell, in San Diego. **Member:** San Diego Art Guild; Los Surenos Art Center.

Exhibited: San Diego FA Gal., 1927; Calif. Pac. Int'l Expo, San Diego, 1935. **Sources:** Hughes, *Artists in California*, 434.

PERRY, Oma Alice *[Painter] b.1880, Illinois / d.1961, San Jose, CA.*
Addresses: Carmel, CA. **Member:** Carmel AA. **Exhibited:** Calif. State Fair, 1937. **Sources:** Hughes, *Artists in California,*434.

PERRY, P. Vincent *[Painter] early 20th c.*
Exhibited: AIC, 1906. **Sources:** Falk, *AIC*.

PERRY, Raymond *[Painter, illustrator, designer, lecturer, writer] b.1876, Sterling, IL / d.1960, NYC.*
Addresses: NYC. **Studied:** AIC. **Member:** AWCS; SC, 1908; NYWCC. **Exhibited:** S. Indp. A., 1921. **Work:** windows, St. Andrew's Church, Pittsburgh, Pa.; Mem. Lib., Hanover, Pa.; portraits, 7th Regiment Armory, Fraunces Tavern, NY; Press Cl., Baltimore, Md.; Poe Cottage, Phila., Pa. **Sources:** WW59; WW47, which gives date of birth as 1886.

PERRY, Raymond W. *[Educator, block printer, painter, writer] b.1883, Natick, MA.*
Addresses: West Dennis, MA. **Studied:** Mass. Sch. Art; Rhode Island College Educ.; W.D. Hamilton; V. Preissig; A.K. Cross; Andréws. **Member:** Providence AC; Providence WCC; Cape Cod AC; EAA. **Exhibited:** AIC, 1918-26. **Comments:** Contrib.: *Am. Vocational Journal, School Shop*. Position: state supervisor, Indust. Educ., RI. Auth./illustr.: *Block Printing Craft*, 1930, *Blackboard Illustration*. **Sources:** WW47.

PERRY, Regenia Alfreda *[Art historian] b.1941, Virgilina, VA.*
Addresses: Richmond, VA. **Studied:** Va. State Col. (B.S., 1961); Case Western Reserve Univ., VMFA Out of State fel., 1961-62 (M.A., 1962); Yale Univ., 1963-64; Univ. Pa. (Ph.D., art hist., 1966). **Member:** Col. Art Assn. Am.; Am. Assn. Mus.; Soc. Archit. Historians; Am. Assn. Univ. Prof. **Exhibited:** Awards: Danforth Found. post-doctoral fel., 1970-71. **Comments:** Positions: spec. res. asst., Cleveland MA, 1964-65; vis. scholar, Piedmont Univ. Ctr., Winston-Salem, NC, 1971-72. Teaching: asst. prof. art hist., Howard Univ., 1965-66; asst. prof. art hist., Ind. State Univ., Terre Haute, 1966-67; assoc. prof. art hist., Va. Commonwealth Univ., 1967-. Publications: auth., *A History of Afro-American Art 1619-1972*, Holt, Rinehart & Winston, 1973; auth., *James Van Derzee--Photographer*, 1973. **Sources:** WW73.

PERRY, R(oland) Hinton *[Portrait painter, sculptor] b.1870, NYC / d.1941.*
Addresses: NYC/Richmond, MA. **Studied:** Acad. Julian, Paris with Chapu and Puech, 1891; Ecole des Beaux-Arts with Gérome; Acad. Delecluse; also with Delance and Callot in Paris. **Member:** Grand Central A. Gal. **Exhibited:** AIC, 1895, 1916; Paris Salon, 1892; SNBA, 1894, 1897; PAFA, 1894; PAFA Ann., 1901, 1911-12. **Work:** LOC; Buffalo Hist. Soc.; New Amsterdam Theatre, NYC; Capitol dome, Harrisburg, Pa.; Gettysburg; Ogdensburg; Louisville; Chattanooga; Conn. Ave. Bridge, Wash. DC; Syracuse, NY. **Comments:** He appeared also as Hinton and Hinton-Perry. **Sources:** WW40; Fink, *American Art at the Nineteenth-Century Paris Salons*, 356, 380; Falk, *Exh. Record Series*.

PERRY, Saidee W. *[Painter] late 19th c.*
Exhibited: Soc. Washington Artists, 1892. **Sources:** McMahan, *Artists of Washington, D.C.*

PERRY, Shirley *[Painter] 19th/20th c.*
Addresses: NYC. **Exhibited:** NAD, 1900. **Comments:** Position: affiliated with Carnegie Studios. **Sources:** WW01.

PERRY, Walter Scott *[Painter, sculptor, teacher, writer, lecturer] b.1855, Stoneham, MA / d.1934.*
Addresses: Brooklyn, NY/Stoneham, MA. **Studied:** Langerfeldt; Higgins; P. Millet; Mass. Normal A. Sch.; Europe; Egypt; India; China; Japan. **Member:** NAD, Alliance; Eastern AA; Western AA; AFA; Rembrandt C.; Egypt Exploration Fund. **Comments:** Author: *Egypt, the Land of the Temple Builders; With Azir Girges in Egypt*, textbooks on art education. Positions: supv., dr./a. edu., schools, Fall River, Mass., 1875-79, Worcester, Mass., 1979-87;

dir., PIA Sch., 1887-28. **Sources:** WW31.

PERRY, William H. H. *[Drawing teacher] mid 19th c.*
Addresses: In New Bedford, MA in 1849. **Comments:** In *New Bedford City Director*, 1849. **Sources:** Blasdale, *Artists of New Bedford*, 142.

PERRY, W(inifred) A(nnette) *[Painter] early 20th c.; b.Wasepi, MI.*
Addresses: Oakland, CA. **Studied:** Calif. School of FA; with W.V. Cahill; J. Rich. **Exhibited:** San Francisco AA, 1918. **Sources:** WW25; Hughes, *Artists in California*, 434, who states, that this may be the same as Mrs. William Perry, who exhibited at the Oakland Art Gallery in 1922.

PERSAC, Adrien See: **PERSAC, (Marie) Adrien**

PERSAC, (Marie) Adrien *[Landscape and architecture painter, lithographer, teacher, architect] b.1823, Lyons, France / d.1873, Manchac, LA (at family picnic).*
Addresses: active New Orleans, 1857-72. **Exhibited:** Louisiana Grand State Fair (1867-71, prizes); Paris Expo (1868); at Laurent Uter's store in New Orleans (1872). **Work:** La. State Museum ("Olivier Plantation"); Shadows-on-the-Teche, New Iberia, La. **Comments:** Specialized in architectural, estate, and city scenes, as well as maps and charts. In 1858 his detailed renderings of plantation lines, names, owners, and landmarks were published in *Normans's Chart of the Lower Mississippi River*. From 1860-69 painted watercolors of New Orleans buildings and sites that were used in real estate transactions. Some of these were done in partnership with Eugene Surgi. Also known through gouache paintings of Louisiana plantations such as "Olivier," "Shadows-on-the-Teche," and "Ile Copal," of 1860-61. Made lithographs of city scenes and business establishments (a series of the latter were pub. by Benedict Simon, c.1870). **Sources:** G&W; *American Processional*, 246. More recently, see *Encyclopaedia of New Orleans Artists*. 299-300.

PERSEVEAUX, Alphonse *[Lithographer] b.1876, New Orleans, LA / d.1950, New Orleans.*
Addresses: New Orleans, active 1895-1935. **Comments:** Brother of William G. and Walter P. Perseveaux, who were also lithographers. **Sources:** *Encyclopaedia of New Orleans Artists*, 301.

PERSHING, Elizabeth Heifenstein *[Painter] 20th c.*
Addresses: Phila., PA. **Sources:** WW13.

PERSHING, Louise *[Figure, portrait and landscape painter, sculptor, lecturer] b.1904, Pittsburgh, PA.*
Addresses: New Hope, Dermont, Pittsburgh, PA. **Studied:** PAFA; Carnegie-Mellon Univ.; Univ. Pittsburgh, with Philip Elliot; also with Hans Hofmann; A. Kostellow; G. Romanoglie. **Member:** Pittsburgh WC Soc.; Assoc. A. Pittsburgh; NAWPL. **Exhibited:** Pittsburgh AA, 1930-72 (12 prizes); Salons of Am., 1932, 1934; PAFA Ann., 1934-36, 1939, 1964; NAWA, 1936 (prize); Wichita Mus., 1936 (prize); ; CI, 1931 (prize), 1932 (prize), 1937, 1942 (solo), 1943-49 (Painting in the US), 1950; CM, 1936-40; Corcoran Gal biennial, 1939; GGE, 1939; VMFA, 1942; NAD, 1934; AIC, 1933, 1938, 1942; Springfield, Mus. A.,1944-45; Butler AI, 1936-50; Contemp. A. Gal., 1943, 1944 (solo),1947, 1950; WMAA, 1950; John Herron AI, 1949; Sao Paulo, Brazil, 1948; solo shows, Argent Gal., 1937; Chautauqua, NY, 1943; Contemp. A. Gal., NYC ; Cleveland One Thirty Gal., 1949; Chatham Col., 1950; Univ. Ohio, 1953; Westinghouse Corp, Pittsburgh, 1965; Gulf Oil Corp, Pittsburgh, 1966; Univ. W. Va.; Art Alliance, Phila.; King Gal, Pittsburgh, 1970s. Other awards: Artist of the Year, Pittsburgh Chamber Commerce, 1966; Nat. Soc. Arts & Letters Award of Merit, 1969; Artist of the Year, Pittsburgh Arts & Crafts Ctr., 1972. **Work:** Earle Ludwig Coll., Chicago, Ill.; Indiana State T. Col.; Gulf Oil Corp., Pittsburgh; Penn. State Col.; Pittsburgh Pub. Sch. Coll.; Univ. W. Va.; murals, Dormont (Pa.) Pub. Sch.; Shadyside Hospital, Pittsburgh. **Comments:** Preferred media: oils, stainless steel, brass, aluminum, Cor-ten steel. A versatile artist, her mural, titled *Education Versus Crime* was rejected by the Hillsdale School PTA

in 1932, and later exhibited at the Gulf Galleries. In her industrial paintings of the Gulf Oil Refineries in Newark, NJ, exhibited in 1966, she transformed machinery into strong, abstract designs, to much acclaim of the public. Position: dir., New Hope , PA, Progressive Gal., 1953-55; Des., Mark Cross, NY, 1954-56. **Sources:** WW73; WW47; Falk, *Exh. Record Series.* More recently, see, Chew, ed., *Southwestern Pennsylvania Painters,* 103-104.

PERSICO, E. Luigi *[Sculptor, miniature and portrait painter, teacher] b.1791, Naples, Italy / d.1860, Marseilles, France.*
Addresses: Pennsylvania, 1818-25; Wash., DC, 1825-c.1855.
Exhibited: Boston Athenaeum; PAFA and Artists' Fund Society, Phila., 1825-64 (portrait busts). **Work:** Am. Philosophical Soc. (bust of Nathaniel Chapman, exhibited at PAFA in 1825; bust of Nicholas Biddle, c.1837); sculp. work, U.S. Capitol, Wash., DC.
Comments: (Known as Luigi Persico) One of the leading neo-classical Italian sculptors to work on the U.S. Capitol project. Came to America from Naples in 1818 and for the next several years worked in the Pa. cities of Lancaster, Harrisburg, and Philadelphia, painting miniatures and teaching drawing. In 1824, he gained attention for his bust of Lafayette, which was shown during the General's farewell tour of the United States. The following year, Persico was living in Wash., DC, and for the next twenty years worked on fulfilling several presitigious commissions for the sculptural program of the U.S. Capitol. These included the colossal figures of "War" and "Peace" (1829-35) for the niches under the east portico; the figural group, "The Genius of America" (1825-28), for the east pediment; and the group for the great stairs, for which he chose the subject, "The Discovery," showing the figure of Columbus flanked by a crouching, semi-nude Indian Maiden. The latter work, when shown for the first time in 1844, was not received favorably by Congress and Persico lost further chances at government commissions. He continued to exhibit his sculptural busts in Boston and Philadelphia, however, returning to Europe in 1855. Gennaro Persico was his brother (see entry). **Sources:** G&W; Thieme-Becker; Lancaster County (Pa.) Hist. Soc., *Papers,* XVI, 67-107; Scharf and Westcott, *History of Philadelphia,* II, 1067; Fairman, *Art and Artists of the Capitol,* 48, 77-78; Nagler, *Neues Allgemeines Künstler-Lexikon,* II, 131; Rutledge, PA; Swan, BA; More recently, see Baigell, *Dictionary;* Craven, *Sculpture in America,* 64-66; McMahan, *Artists of Washington, D.C.*

PERSICO, Gennaro *[Miniaturist and crayon artist, drawing and painting teacher] b.Naples, Italy / d.c.1859, said to have died at sea.*
Addresses: Primarily Richmond, VA. **Exhibited:** PAFA, 1822-31; Md. Hist. Soc. **Work:** Shelburne (VT) Mus. **Comments:** Brother of E. Luigi Persico, he came to America from Naples, c.1820, and worked in the Pa. cities of Lancaster, Philadelphia, and Reading throughout the decade. He and his wife ran an English and French Academy for young women at Richmond (VA) in the 1830s, and from 1837-40 he was a vestryman of an Episcopal church in that city. After his wife's death in 1842 he returned to Naples. He was back in Richmond in 1852 and worked as an artist there until c.1859 at which time he is believed to have died at sea. **Sources:** G&W; *Richmond Portraits,* 226-28; Montgomery, *Berks County,* 808; Lancaster County Hist. Soc., *Papers,* XVI, 93-94; Rutledge, PA; Rutledge, MHS; Swan, BA; Muller, *Paintings and Drawings at the Shelburne Museum,* 101 (w/repro.).

PERSICO, Luigi See: **PERSICO, E. Luigi**

PERSKIN, Israel H. *[Artist] 19th/20th c.*
Addresses: Wash., DC, active 1905. **Sources:** McMahan, *Artists of Washington, D.C.*

PERSON, Beverly *[Painter] mid 20th c.*
Exhibited: AIC, 1946. **Sources:** Falk, *AIC.*

PERSONS, Geraldine *[Painter] mid 20th c.*
Addresses: Worcester, MA. **Member:** NAWPS. **Exhibited:** Am. WCC, 1934, 1936-38; NAWPS, 1935,1937, 1938. **Sources:** WW40.

PERSONS, Simmons *[Painter] b.1906, Norfolk, VA.*
Addresses: NYC. **Studied:** ASL, with Frank DuMond, George Bridgman, Kimon Nicolaides. **Exhibited:** AIC, 1943-44; WMAA, 1938-39, 1941, 1945-46, 1949, 1951, 1953; PAFA, 1945; VMFA, 1941; Rehn Gal., 1950, 1955 (solo). **Award:** F., Huntington Hartford Fnd., 1952. **Work:** WMAA. **Comments:** Teaching: instr. drawing, Hunter Col., NYC, 1950-54. **Sources:** WW59; WW47.

PERSSON, Fritiof *[Painter] b.1897, Sweden / d.1957, San Bernardino County, CA.*
Addresses: Los Angeles, CA. **Studied:** ASL. **Member:** P&S Los Angeles; Soc. for Sanity in Art. **Exhibited:** Acad. Western Painters, 1938; GGE, 1939; Scandinavian-Am. Soc., 1939. **Comments:** Came to U.S. after serving in the Canadian army in WWI. Specialty: the Mojave and Colorado deserts. **Sources:** Hughes, *Artists in California,* 434.

PERUANI, Joseph See: **PEROVANI, Joseph**

PERUL, de (Mme.) See: **PERCEL, de (Mme.)**

PERVAULT, Ida Marie See: **PERRAULT, Ida Marie**

PESCHERET, Leon Rene *[Etcher, craftsperson, designer, illustrator, writer, lecturer] b.c.1891, Chiswick, England / d.1961.*
Addresses: Whitewater, WI. **Studied:** Battersea Polytechnic, London; AIC; Royal Col. of Engraving, Kensington, England; Malcolm Osborn & Roger Hebbelinck. **Member:** Chicago Soc. Etchers; Printmakers Soc. of California; Am. Color Print Soc.; Soc. Am. Printmakers; Palette & Chisel Cl., Chicago; Print Council of Am.; Calif. Soc. Etchers. **Exhibited:** Younker Bros. Tea Room Galleries, 1935 (solo); Smithsonian Inst.; Chicago SE, 1935 (prize), 1936 (prize); Southern PM Soc., 1936 (prize)-37 (prize); Buck Hills AA, 1948-49; Chicago Galleries Assn., 1951. **Awards:** Lila Mae Chapman award, 1936, 1937; Grand Central Galleries, 1937 (award). **Work:** designs, interior, Mem. Union Bldg., Univ. Wisconsin; Peoria Country Cl.; Kenyon Col. Union Bldg., Gambier, Ohio; British Mus.; LOC; Cabinet du Roi, Brussels; Nat. Collection FA, Wash., DC; NYPL; AIC; presentation prints for Am. Color Print Soc., 1943; Buck Hills AA, 1947; Chicago Soc. Etchers, 1956; Printmakers Soc. of California, 1958. **Comments:** Author/illustrator, *Principle and Practice of Interior Decorating; An Introduction to Color Etching.* Illustrator, *The Spirit of Vienna,* 1935; *Chicago Welcomes You,* 1933. Contributor of color etchings to American Artist and *Arizona Highways* magazines. **Sources:** WW59; WW40; Ness & Orwig, *Iowa Artists of the First Hundred Years,* 165-66.

PESMAN, Judith *[Painter] mid 20th c.*
Addresses: Chicago area. **Exhibited:** AIC, 1942; PAFA Ann., 1942. **Sources:** Falk, *Exh. Record Series.*

PESSEL, Esther *[Illustrator, painter, drawing specialist] b.1903, Phila.*
Addresses: Phila., PA. **Studied:** Phila. Sch. Des for Women; PAFA. **Comments:** Illustrator: daily newspapers. **Sources:** WW40.

PESSEL, Leopold *[Painter] mid 20th c.*
Addresses: Phila., PA. **Exhibited:** PAFA Ann., 1934. **Sources:** Falk, *Exh. Record Series.*

PESSOU, Louis Lucien *[Lithographer] b.1825, New Orleans, LA / d.1886, New Orleans.*
Addresses: New Orleans, active 1853-68. **Comments:** Black artist (contemporary references described him as "colored"). Was a partner with Benedict Simon in Pessou & Simon, 1855 -67. In 1870 he was registrar of births and deaths. **Sources:** G&W; Delgado-WPA cites New Orleans CD 1853-66; CD 1870. More recently, see *Encyclopaedia of New Orleans Artists,* 301.

PESSOU & SIMON *[Lithographers, printers, publishers] mid 19th c.*
Addresses: New Orleans, 1855-67. **Comments:** Partners were Louis Pessou and Benedict Simon (see entries on each). **Sources:** G&W; Delgado-WPA cites New Orleans CD 1855-60. More

recently, see *Encyclopaedia of New Orleans Artists.*

PETEK, Poko *[Painter] d.1972.*
Work: Mus. New Mexico, Read Mullan Gallery. **Comments:** She painted a series of Indian ceremonial dances. **Sources:** P&H Samuels, 369.

PETER, Armistead III *[Painter, historian, horticulturalist, gentleman farmer] mid 20th c.; b.Cambridge, NY.*
Addresses: Wash., DC. **Exhibited:** New York; CGA; Cosmos Cl. **Work:** CGA; NMAA. **Comments:** He devoted much time to taking care of the Tudor Place in Georgetown, where his family had lived since 1805. In between serving in World Wars I and II, he studied art in Paris and Nice. **Sources:** McMahan, *Artists of Washington, D.C.*

PETER, George *[Mural painter, designer] b.1860 / d.1943.*
Addresses: Milwaukee, WI. **Studied:** Munich; Vienna. **Exhibited:** AIC, 1902. **Work:** painted panorama scene for film "Gone with the Wind.".

PETERDI, Gabor F. *[Painter, printmaker] b.1915, Pestujhely, Hungary.*
(handwritten: Peterdi 1945)
Addresses: (Came to America in 1939) Rowayton, CT. **Studied:** Hungarian Acad. FA, 1929; Acad. Belle A., Rome, 1930; Académie Julian, Paris, 1931; Acad. Scandinave, Paris, 1931; W. S. Hayter's Atelier 17, Paris 1933-39, NYC, 1947. **Member:** Silvermine Guild Artists (v. pres., 1965-70s); Florentine Acad. Des.; Nat. Drawing Soc. **Exhibited:** WMAA biennials, 1949-67; PAFA Ann., 1951-53, 1958 (medal for best landscape), 1962; Brooklyn Mus, 1959 (retro.), CMA, 1962 (retro.); Corcoran Gal biennials, 1949, 1963; Corcoran Gal (retro.), 1964; Yale Univ. Art Gal, 1964 (retro.); Mus. Western Art, Tokyo, 1964 (prize); Honolulu Acad. Arts, 1968 (retro.); Grace Borgenicht Gal, NYC, 1970s. Other awards: Prix du Rome, 1930; Guggenheim fellow, 1964-65. **Work:** WMAA; MoMA; MMAA; AIC; BMFA. **Comments:** Best known for his engravings and intaglio prints. Teaching: Brooklyn Mus. Art Sch., 1948-52; Hunter Col., 1952-59; Yale Univ., 1960-70s. Author: *Printmaking* (Macmillan, 1959); *Great Prints of the World* (Macmillan, 1969); "Printmaking," in *Encyclopaedia Britannica.* **Sources:** WW73; Baigell, *Dictionary;* V. Johnson, *Graphic Work 1934-1969* (Touchstone, 1969); Una Johnson, *Gabor Peterdi* (exh. cat., Brooklyn Mus., 1959); Falk, *Exh. Record Series.*

PETERS, Albert Edward *[Landscape painter] b.c.1865, London, Ontario / d.1939, Birmingham, MI.*
Addresses: Detroit, MI. **Studied:** AIC; with Joseph Gies. **Member:** Hopkin Club, Scarab Club, both Detroit. **Exhibited:** locally in Michigan. **Sources:** Gibson, *Artists of Early Michigan,* 195.

PETERS, Bernard E. *[Mural painter, designer, teacher, writer, lecturer] b.1893.*
Addresses: St. Louis, MO. **Studied:** England; France; St. Louis Univ.; Harvard; Univ. Mo.; F. Mulhaupt. **Member:** St. Louis Indst. AC; North Shore AA; St. Louis A. Gld.; 2 x 4 Soc., St. Louis. **Exhibited:** Mo. State Fair, 1933 (prize); PAFA; St. Louis A. Gld., annually; Barn Gal., 1946 (solo); All-Mo. Ar. Exh. **Comments:** Teaching: Cleveland H. S., St. Louis. **Sources:** WW47.

PETERS, Betty *[Painter] 20th c.*
Addresses: NYC. **Sources:** WW15.

PETERS, C. *[Primitive watercolor painter] mid 19th c.*
Addresses: Massachusetts, c.1835. **Comments:** Painted watercolor memorials. **Sources:** G&W; Lipman and Winchester, 178.

PETERS, C. Merriman *[Illustrator, painter] early 20th c.*
Addresses: NYC. **Studied:** Sacramento (Calif.) Art Sch. **Comments:** Specialty: comic subjects. **Sources:** WW06.

PETERS, Carl William *[Painter, teacher] b.1897, Rochester, NY / d.1980.*
Addresses: Fairport, NY/Rockport, MA (summers, from 1925). **Studied:** Rochester Inst. Tech., 1914; ASL, 1919; ASL Summer School, Woodstock, NY with Charles Rosen, Harry Leith-Ross, 1921; John F. Carlson in Woodstock, 1922. **Member:** AWCS; Buffalo SA; Springfield AA; AFA; Rockport AA; Woodstock AA; Rochester Art Cl.; Academic Artists; Genesee Group (the Rationalists); NSAA 1929-52. **Exhibited:** NAD, 1926-45 (first, second & third Hallgarten Prizes, 1926, 1928 & 1932); Univ. Rochester, 1924 (prize); Rochester AC, frequently (medal, 1925; prizes, 1927-28); Buffalo SA, 1927 (prize); PAFA Ann., 1927-28, 1933; Corcoran Gal biennials, 1930-35 (3 times); AIC; AWCS; Milwaukee AI; North Shore AA (prize, 1931); Rockport AA (frequently, prizes: 1951-52, 1954-55, 1960-61; gold medal,1971); Springfield Mus. Art; Rochester Mem. Art Gal, 1932 (prize); Univ. Rochester, 1924 (Fairchild gift); Albright Art Gal.; Syracuse Mus. FA, 1930 (solo); Fort Worth Mus. Art. **Work:** NMAA and other public collections. Commissions: "Evolution of Contemporary Commerce in Rochester" (mural), Genessee Valley Trust headquarters, Rochester, 1930; "From Painting Man to Modern Lines" (mural), Madison H.S., Rochester (mural), 1937; "Settling of Genessee Valley" (mural), West H.S., Rochester, U.S. Govt., 1938; Charlotte H.S. (mural),1940; Fairport Public Library, Rochester (mural); "Tribute to Devotion" (mural), Rochester Acad. of Medicine, 1941. **Comments:** Impressionist landscape painter who focused on New York's Genesee Valley and Massachusett's Cape Ann area (in particular Rockport, 1925-on). He was a muralist during the WPA era for Rochester- area buildings. In the 1940s, he joined an association of Rochester artists called the Genesee Group (or Rationalists) who believed that art should advance not by revolution but more slowly, through evolution. Teaching: life class, Univ. Rochester; Rochester Memorial A. Gal. **Sources:** WW73; WW47; *Artists of the Rockport Art Association* (1956); Christian Title, *Carl W. Peters, 1897-1980,* exh. cat. (Los Angeles: De Ville Gal, 1986); Falk, *Exh. Record Series;* add'l info. courtesy Spaniermann Gal, NYC; North Shore AA; Woodstock AA.

PETERS, Charles F. *[Illustrator] early 20th c.*
Addresses: Dover, NJ. **Member:** SI, 1911. **Sources:** WW13.

PETERS, Charles Rollo *[Painter] b.1862, San Francisco, CA / d.1928, San Francisco.*
Addresses: San Francisco. **Studied:** Calif. Sch. Design, with Virgil Williams, 1870s; San Francisco, with J. Tavernier, 1885; Académie Julian, Paris with Boulanger and Lefebvre, 1886-88; Ecole des Beaux-Arts with Gérôme; also with Cormon in Paris. **Member:** San Fran. AA; Bohemian Cl., San Fran.; SC; Lotos Cl.; Carmel Colony. **Exhibited:** Munich, 1888 (hon. men.); Paris Salon, 1889; Union League Cl. of NYC, 1899; San Francisco AA, annuals 1891-1923; Mechanics Inst.; Pan-Am. Expo, Buffalo, 1901 (bronze med.); PAFA Ann., 1902; St. Louis Expo, 1904 (silver); Lotos Cl., 1904 (prize); SC, 1904 (med.); Alaska-Yukon Expo., 1909; Bohemian Cl., to 1923; Del Monte Gal., Monterey, from 1907; Golden Gate Park Mus., 1915; Colton Hall, Monterey, 1968 (solo); Oakland Mus., 1972. **Comments:** Member of a wealthy San Francisco pioneer family. In 1886 he went to Paris to study and was greatly influenced by Alexander Harrison and James McNeil Whistler (see entries). Married to Constance Peters (see entry) with whom he spent later years in Europe. Specialty: nocturnal landscapes. **Sources:** WW24; Hughes, *Artists in California,* 434-435; P&H Samuels, report alternate deathdate of 1927, p.369; Falk, *Exh. Record Series.*

PETERS, Charles Rollo III *[Portrait painter, scenic designer] b.1892, France / d.1967, Monterey, CA.*
Addresses: Monterey, CA; NYC. **Studied:** with his father, Charles Rollo Peters; Paris, London, Munich, for five years. **Exhibited:** Santa Barbara Mus. of Art, 1966; Colton Hall, Monterey, CA, 1968. **Work:** Monterey Peninsula Mus. of Art; City of Monterey. **Comments:** He was born overseas, where his father Charles R. Peters (see entry) was studying art. In 1914 he opened a studio in NYC, worked as a Shakespearian actor and designed sets for productions in which he played. **Sources:** WW17; Hughes, *Artists in California,* 435.

PETERS, Clinton See: **PETERS, (Dewitt) Clinton**

PETERS, Constance Mabel Easley *[Painter] b.1878, South Africa / d.1935.*
Addresses: San Francisco, CA; Monterey, CA; Europe. **Studied:** Paris, France, with Courtois. **Exhibited:** Golden Gate Park Mem. Mus., 1916; Berkeley League of FA, 1924; Colton Hall Mus., Monterey, 1968. **Work:** Monterey Peninsula Mus. of Art; City of Monterey. **Comments:** She became the second wife of Charles R. Peters (see entry), living in California and Europe. Her world travels are reflected in her paintings. **Sources:** WW17; Hughes, *Artists in California*, 435.

PETERS, DeWitt Clinton III *[Painter, teacher] b.1902, Monterey, CA / d.1966, Palisade, NY.*
Addresses: Monterey, CA; Pomona, NY; Haiti. **Studied:** with his father, Charles Rollo Peters; ASL; Paris, with Leger and Sterner. **Exhibited:** 1930s in Monterey. **Work:** City of Monterey, CA. **Comments:** Named for a great uncle and a cousin, he was the son of Charles Rollo Peters (see entry) and brother of Charles Rollo Peters III (see entry). As a young man he worked as a writer in NYC for several years, however he gave up writing for painting. In 1944, after serving in WWII, he established a free art school in Port-Au-Prince, Haiti, which launched the Haitian art movement. Among his students were Hector Hyppolite, Philome Obin, Rigaud Bemoit, and Tousaint Auguste. **Sources:** PHF files.

PETERS, (Dewitt) Clinton *[Painter, illustrator] b.1865, Baltimore, MD / d.1948, Newtown, CT.*
Addresses: NYC. **Studied:** Académie Julian, Paris with Lefebvre, Boulanger,1886-88; Ecole des Beaux-Arts with Gérome; also with Collin in Paris. **Exhibited:** Paris Expo, 1889 (med); Paris Salon, 1888, 1889, 1891; SNBA, 1894-96; NAD, 1899; S. Indp. A., 1917. **Work:** portraits, City Hall, Boy's School, both in Baltimore; Yale; Harvard; Rutgers Univ., Hist. Soc. and H. S., Albany. **Comments:** Illustrator: *Tutti Fruitti; Children of the Week; Madame Daulnoy's Fairy Stories; St. Nicholas, Harper's, Young People, Wide Awake, New York Life*. **Sources:** WW40; Fink, *American Art at the Nineteenth-Century Paris Salons*, 380.

PETERS, Donald A. *[Lithographer] b.1901.*
Addresses: Roslyn, NY. **Exhibited:** WMAA, 1933-1936. **Sources:** Falk, *WMAA*.

PETERS, Edith Macausland *[Painter] early 20th c.*
Addresses: Phila., PA, c.1905-10. **Studied:** PAFA. **Member:** PAFA (fellowship). **Exhibited:** PAFA Ann., 1905. **Sources:** WW10; Falk, *Exh. Record Series*.

PETERS, Eric A. *[Painter, graphic artist, cartoonist, commercial artist, lecturer] b.1909, Vienna, Austria.*
Addresses: New York 23, NY. **Studied:** with Prof. Schmutzer, Vienna, Austria; Acad. A., and with Profs. Orlik, Balushek, Steinhard, all Berlin, Germany; Acad. A., Naples, Italy. **Exhibited:** MMA, 1943; solo in Vienna and Berlin. **Awards:** USO, 1942. **Work:** Gr. A. Col., Albertina Mus., and State Lib. of Austria, Vienna. **Comments:** Illus., *Matadore der Politik*, 1932. Contributor cartoons to *Sat. Eve. Post; Colliers* and other magazines. Cartoonist for newspapers in Berlin, Vienna and Naples. **Sources:** WW59.

PETERS, Francis Charles *[Painter] b.1902, Dunkirk, NY / d.1977.*
Addresses: Wash., DC. **Studied:** Albright A. Sch., Buffalo; ASL. **Member:** AAPL (adv. bd.); Am. A. Lg., Wash. DC (pres.). **Exhibited:** AAPL, 1956-58; CGA, 1956; Metropolitan Exh., 1954-57; Wash. A. Cl., 1952-58. **Awards:** prizes, AAPL, 1955-56; Wash. Landscape Cl., 1957; Wash. A. Cl., 1957. **Sources:** WW59.

PETERS, G. W. *[Painter] 19th/20th c.*
Addresses: Leonia, NJ. **Sources:** WW01.

PETERS, Helen *[Painter] mid 20th c.*
Addresses: NYC. **Exhibited:** Salons of Am., 1925; S. Indp. A., 1925. **Sources:** Falk, *Exhibition Record Series*.

PETERS, J. *[Cartoonist] mid 19th c.*
Addresses: Philadelphia, 1843. **Sources:** G&W; Peters, *America on Stone*.

PETERS, J. *[Primitive painter] mid 19th c.*
Addresses: Active in Vermont, 1840. **Comments:** Specialized in genre subjects in oils. **Sources:** G&W; Lipman and Winchester, 178.

PETERS, J., Sr. *[Painter] early 19th c.*
Comments: Painter of a landscape with Mennonite figures, probably set in the Delaware Water Gap (Pa.), early 19th century. **Sources:** G&W; Born, *American Landscape Painting*, 126, fig. 84; *Antiques* (May 1941), 259.

PETERS, John E. *[Fresco painter] b.1827, Osnabrück, Germany.*
Addresses: Wash., DC, active 1860-77. **Sources:** G&W; 8 Census (1860), D.C., I, 823; McMahan, *Artists of Washington, D.C.*

PETERS, Joy Ballard *[Painter, educator] late 20th c.*
Studied: Howard Univ.; Wash., DC Teachers Col. **Exhibited:** State Armory, Wilmington, DE, 1971; Howard Univ.; Margaret Dickey Gallery; DCAA, Anacostia Neighborhood Mus.-Smithsonian Inst. **Sources:** Cederholm, *Afro-American Artists*.

PETERS, Leslie H. *[Landscape painter] b.c.1916, Great Falls, MT.*
Addresses: Great Falls, MT in 1974. **Studied:** Univ. Montana; Univ. Oregon, sculpture; ASL and Central Park School Art, 1945; with Charlie Beil in Fanff. **Comments:** Served with cavalry on Mexican border, 1940-42 and with 13th Armored Div. in Europe. Favorite subjects: selk, mule deer, moose, buffalo and mountain sheep. **Sources:** P&H Samuels, 369-70.

PETERS, Louis W. *[Sculptor, architect] d.1924.*
Addresses: NYC. **Work:** sculptural des. for addition to Times Annex; carvings on several bldg. at West Point.

PETERS, Maryella *[Painter] early 20th c.*
Addresses: NYC. **Member:** Lg. AA. **Exhibited:** S. Indp. A., 1922-23. **Sources:** WW24.

PETERS, Paul *[Painter] mid 20th c.*
Exhibited: AIC, 1942. **Sources:** Falk, *AIC*.

PETERS, Pearl L. *[Portrait painter] 19th/20th c.*
Addresses: San Francisco, CA, 1870s, 1880s; San Jose, CA, 1896-1911. **Exhibited:** Mechanics' Inst. Fair, 1871; San Francisco AA, 1883. **Sources:** Hughes, *Artists in California*, 435.

PETERS, Robert B. (Mrs.) *[Painter] mid 20th c.*
Addresses: Southern California. **Exhibited:** Riverside Public Lib., 1927. **Sources:** Hughes, *Artists in California*, 435.

PETERS, Rollo See: **PETERS, Charles Rollo III**

PETERS, Ruth *[Painter] mid 20th c.*
Addresses: Los Angeles, CA. **Exhibited:** P&S of Los Angeles, 1932 (prize). **Sources:** Hughes, *Artists in California*, 435.

PETERS, S. A. (Miss.) See: **GROZELIER, Sara Peters (Mrs. Leopold)**

PETERS, Sara See: **GROZELIER, Sara Peters (Mrs. Leopold)**

PETERS, Verda V. (Mrs. W. A.) *[Painter] mid 20th c.*
Addresses: Seattle, WA, 1941. **Exhibited:** SAM, 1939. **Comments:** Preferred medium: watercolor. **Sources:** Trip and Cook, *Washington State Art and Artists*.

PETERS, W. T. *[Topographical artist] mid 19th c.*
Comments: Artist of several Yokohama scenes published with Commodore Matthew C. Perry's report on his expedition to Japan in 1853-54. *Cf.* W.T. Feters. **Sources:** G&W; Perry, *Expedition*, I, list of illustrations.

PETERS, Walt *[Artist] b.1894 / d.1985.*
Member: Woodstock AA. **Sources:** Woodstock AA.

PETERS, William *[Engraver] b.c.1831, Pennsylvania.*
Addresses: Philadelphia in 1860. **Sources:** G&W; 8 Census
(1860), Pa., L, 608.

PETERS, William Thompson, Jr. *[Engraver] b.1828,*
Cheshire, CT.
Addresses: New Haven in 1850. **Comments:** Son of William
Thompson Peters (1805-85) and Etha L. Town (1809-71), daugh-
ter of the New Haven architect Ithiel Town. William, Jr. had a
younger brother, Ithiel Town Peters, 16, who was listed in 1850 as
a painter. William, Jr. is said to have died in a Soldiers' Home in
New York State. **Sources:** G&W; Peters, *Peters of New England,*
165-66; 7 Census (1850), Conn., VIII, 391.

PETERS-BAURER, Pauline *[Artist, decorator] late 19th c.*
Addresses: Cincinnati. **Comments:** Worked at Rookwood
Pottery, 1893-94. **Sources:** Petteys, *Dictionary of Women Artists.*

PETERSEN, August H. M. *[Engraver, stencil cutter] b.1819,*
Russia, or Hamburg, Germany / d.1882, New Orleans.
Addresses: New Orleans, active 1859-79. **Sources:** G&W; New
Orleans CD 1860. See also *Encyclopaedia of New Orleans Artists.*

PETERSEN, Bernhof *[Painter] mid 20th c.*
Addresses: Brooklyn, NY. **Exhibited:** Salons of Am., 1929,
1930; S. Indp. A., 1930, 1935. **Sources:** Marlor, *Salons of Am.*

PETERSEN, Christian *[Sculptor, medalist, teacher] b.1885,*
Dybbol, North Slesvig, Denmark / d.1973, Calimesa, CA.
Addresses: immigrated to Attleboro, MA, 1909. **Studied:** Newark
Tech. School (die cutting); ASL; RISD; Henry Hudson Kitson.
Member: Attleboro Chapter, AFA; Chicago Gal. Assoc.; East
Orange AA. **Exhibited:** PAFA Ann., 1917, 1930; Younkers Tea
Room Galleries, 1934 (solo); Iowa Art Salon. **Work:** Boston
Conservatory of Music; New Bedford, MA; Newport, RI; St.
John's College, Brooklyn, NY; State of Iowa; group of reliefs with
Fountain, Dairy Industries Bldg.; relief and statue, Veterinary
Quadrangle; reliefs on Gymnasium, several portrait busts, Iowa
State College; Fountain of the Blue Heron, Decatur, IL; Bukh's
School, Ollerup, Denmark; Old Dartmouth Hist. Soc. **Comments:**
Came to the U.S. at age nine. Was a jeweler for 15 years in MA
and designed two pieces of sculpture for New Bedford. WPA
artist. Teaching: Iowa State College, 1937-61. **Sources:** WW40;
Ness & Orwig, *Iowa Artists of the First Hundred Years,* 166-67;
Blasdale, *Artists of New Bedford,* 142 (w/repro.); Falk, *Exh.*
Record Series.

PETERSEN, Einar Cortsen *[Painter, mural painter] b.1885,*
Copenhagen, Denmark / d.1986, Los Angeles, CA.
Addresses: Los Angeles, CA, 1916-1986. **Studied:** Copenhagen;
Paris , Rome, Munich. **Member:** Calif. AC; P&S of Los Angeles.
Work: murals: University Club, Hotel Rosslyn, Roos Brothers
Cafeteria, Los Angeles; First National Bank, El Paso, TX;
Honolulu City Hall. **Comments:** Immigrated to the U.S. in 1912
and worked in Nebraska, Oregon and Washington, before settling
in California. **Sources:** Hughes, *Artists in California,* 435.

PETERSEN, Eugen H. *[Educator, painter, designer, commer-*
cial artist, illustrator, lecturer] b.1892, Bluefields, Nicaragua.
Addresses: Bluefields, Nicaragua; Manhasset, NY. **Studied:**
PIASCh.; NY Univ. (B.A.); & with John Carlson, George Elmer
Browne, George Bridgman. **Member:** Brooklyn SA; Swedish-
Am. Ar.; SC; PS. **Exhibited:** MMA; PMA; NAD; BM; SC.
Comments: Teaching: prof. art, PIASch, Brooklyn, N.Y., 1921-.
Lectures: Perspective & Free Hand Drawing. **Sources:** WW59;
WW47.

PETERSEN, Ida Eldora *[Painter] b.1875, Calamus, IA.*
Addresses: Calamus, IA. **Exhibited:** DeWitt Fairs (11 awards);
Iowa State Fiar; World's Contest (honor). **Work:** Church and
school, Calamus; church in Chicago. **Sources:** Ness & Orwig,
Iowa Artists of the First Hundred Years, 167.

PETERSEN, Johan Eric See: **PETERSEN, John E. C.**

PETERSEN, John *[Painter] mid 20th c.*
Exhibited: S. Indp. A., 1939-40. **Sources:** Marlor, *Soc. Indp.*

Artists.

PETERSEN, John E. C.
[Marine painter] b.1839, *John E. C. Petersen.*
Copenhagen, Denmark /
d.1874, Melrose, MA.
Studied: D.H. Anton Melbye & Niels C.F. Dahl, 1860.
Exhibited: Brooklyn AA, 1873; Boston AC, 1887. **Work:** Mystic
Seaport Mus.; Nahant (MA) Pub. Lib. **Comments:** He opened a
studio in Boston in 1865 and was listed in that city's directories,
1866-73. His illustrations appeared in *Harper's Weekly* in 1868.
Sources: Brewington, 299.

PETERSEN, Lucy C. M. *[Painter] late 19th c.*
Addresses: Chicago area. **Exhibited:** AIC, 1896. **Sources:** Falk,
AIC.

PETERSEN, Martin *[Painter, etcher] b.1867, Denmark /*
d.1956.
Addresses: NYC. **Studied:** NAD. **Member:** NYWCC; SC, 1906;
ANA, 1943; AWCS; SAE. **Exhibited:** SAE (prize); LOC (prize);
NAD, 1890, 1895 (silver med. & Hallgarten prize), 1898-99, 1905
(Hallgarten prize), 1907, 1940; PAFA Ann., 1899, 1904-10; CI,
1905-08, 1911, 1943; NYWCC, 1906 (prize), SC, 1906, 1907
(Inness prize); Corcoran Gal annual, 1907; Salons of Am., 1934;
SAE, 1938 (Talcott prize); WFNY, 1939; Venice Biennial, 1940;
H.V. Allison Gal., NYC, 1942 (solo); Am. for Victory traveling
exh., 1943; LOC, 1944 (1st purchase prize); Am.-Swedish Inst.,
1959 (memorial); Kramer Gal., St.Paul, MN, c.1992, (retrospec-
tive); AIC. **Work:** AIC; LOC; Newark Pub. Lib. (NJ); BMFA;
Rochester MFA. **Comments:** Painter-etcher of the American
scene, in the tradition of John Sloan and Reginald Marsh.
Sources: WW47; catalogue raisonné of 225 prints, Kramer Gal.
(St.Paul, MN, c.1992); Falk, *Exh. Record Series.*

PETERSEN, Otto A. A. *[Engraver] b.1857, Louisiana /*
d.After 1940.
Addresses: New Orleans, active 1877-86. **Comments:** Son of
August H. M. Petersen (see entry). **Sources:** *Encyclopaedia of*
New Orleans Artists, 302.

PETERSEN, Per Edward August *[Engraver] b.1826,*
Denmark / d.1906, Wash., DC.
Addresses: Wash., DC, active 1860-92. **Comments:** Worked for
the U.S. Coast Survey. **Sources:** McMahan, *Artists of*
Washington, D.C.

PETERSEN, Philip *[Painter] mid 20th c.*
Addresses: Los Angeles, CA. **Member:** P&S of Los Angeles.
Exhibited: Artists Fiesta, Los Angeles, 1931. **Sources:** Hughes,
Artists in California, 435.

PETERSEN, Roland Conrad *[Painter, printmaker] b.1926,*
Endelave, Denmark.
Addresses: Davis, CA. **Studied:** UC Berkeley (A.B., 1949, M.A.,
1950); San Fran. AI, 1951; Calif. Col. Arts & Crafts, summer
1954; Atelier 17, Paris, France, 1950, 1963 & 1970, with Stanley
W. Hayter. **Member:** Intercontinental Biog. Assn.; Calif. Soc.
Etchers; SFMA. **Exhibited:** Illinois Biennial, Urbana, 1961-69;
Carnegie Int., Pittsburgh, Pa., 1964; 25th Ann. Exhib. Contemp.
Art, AIC, 1965; American Painting, VMFA, 1966-70; Trois
Graveurs et Un Sculpteur, Ctr. Cult. Am., Paris, France, 1971;
Staempfli Gal., NYC & Bednarz Gals., Los Angeles, CA, 1970s.
Awards: Guggenheim fel., 1963; appointee, Inst. Creative Arts,
Univ. Calif., 1967 & 1970; Fulbright travel award, 1970. **Work:**
MoMA; WMAA; PMA; Nat. Collection Fine Arts, Wash., DC; De
Young Mem. Mus. **Commissions:** Dams of the West (portfolio of
25 color prints), US Dept. Interior, Bur. Reclamation, Wash., DC,
1970. **Comments:** Positions: mem. educ. process, Col. Lett. &
Sci., Univ. Calif., Davis, 1965, mem. exec. comt., 1965-66.
Teaching: instr. painting, Washington State Univ., 1952-56; assoc.
prof. painting & printmaking, UC Davis, 1956-; instr. printmak-
ing, UC Berkeley, summer 1965. **Sources:** WW73; Philip Leider,
rev., in: *Art in Am.* (1963); Michael Benedikt, rev., in: *Art News*
(1967); James Mellow, rev., in: *Art Int* (1967).

PETERSEN, Thomas Ferrier *[Marine painter] b.1861, Norway / d.1926, Noank, CT.*
Work: Mystic Seaport Mus. **Comments:** At one time a sailor, he was self-taught. **Sources:** Brewington, 300.

PETERSHAM, Maud Feller *[Illustrator, writer] b.1889, Kingston, NY.*
Addresses: Woodstock, NY. **Studied:** Vassar College; NY School Fine & Applied Art. **Member:** Woodstock AA. **Exhibited:** Awards: Caldecott Medal, 1946. **Comments:** Publications: author/illustrator, "Bird in Hand," 1967 & "David, " 1967; co-author, "American ABC," 1967 & co-author, "Rooster Crows," 1971, Macmillan; author/illustrator, "Let's Learn about Sugar, Harvey, " 1969; co-author/illustrator, "Miki," "Ark of Mother and Father Noah," "Bible Story Series," and other children's books. **Sources:** WW73; WW47; Woodstock AA lists this artist as Maude Fuller Petersham as does Pettys.

PETERSHAM, Maud Fuller See: **PETERSHAM, Maud Feller**

PETERSHAM, Miska *[Illustrator, writer] b.1888, Torokszentmiklos, Hungary / d.1959, Alexandria, VA.*
Addresses: Woodstock, NY. **Studied:** Royal Acad., Budapest, Hungary. **Member:** Woodstock AA. **Exhibited:** Awards: Caldecott medal, 1946. **Work:** children's books in libraries. **Comments:** Author/illustrator (with Maud Petersham, see entry) of children's books, text books. **Sources:** WW59; WW47; Woodstock AA cites death date as 1960.

PETERSON, A. E. S. *[Painter] b.1908, Northampton, MA / d.1984.*
Addresses: East Providence, RI. **Studied:** Herman Itchkawich, Providence, RI; C. Gordon Harris, Lincoln, RI. **Member:** AWCS; Nat. Soc. Painters Casein & Acrylic (dir., 1970-); All. Artists Am.; Catharine Lorillard Wolfe A. Cl.; Providence A. Cl.; Providence WCC (treasurer, 1962-70; recording secy., 1971-). **Exhibited:** AWCS, NAD Gallery, 1968-72; Audubon Artists, 1969, 1970 & 1972; Painters & Sculptors Soc. NJ, Jersey City Mus., 1969-72; Butler IA, 1970; Knickerbocker Artists, NAC, New York, 1971-72. Awards: Naomi Lorne Mem. Medal for Old Barn, Nat. Soc. Painters Casein, 1968; Sadle & Max Tesser Award for Old Barn, Audubon Artists, 1969; gold medal for Cabanas, Catharine Lorillard Wolfe A. Cl., 1971. **Work:** Nat. Shawmut Bank Boston, MA; Grant Capitol Management Corp., Providence; Tillinghast Stiles, Inc., East Providence, RI. **Comments:** Preferred media: watercolors, casein, graphics. **Sources:** WW73; R. Stevens, "Nobody Home," *La Rev. Mod.* (Nov. 1, 1965); Ralph Fabri, "Old Barn," *Syndicate Magazine* (June, 1969) & "Cabanas," *Today's Art Magazine* (May, 1972).

PETERSON, C. See: **PETERSON, Niss C.**

PETERSON, Daniel (Roy) *[Craftsman] b.1909, Campbellsville, KY.*
Addresses: Louisville 8, KY. **Studied:** Cranbrook Acad. A.; Univ. Indiana; Univ. Louisville. **Member:** Kentucky A. Edu. Assn.; Midwest Des-Craftsmen; Louisville A. Center Assn. **Exhibited:** Am. Jewelry Exh., 1955; Phila. A. All., 1950, 1951; Cranbrook Alumni Ex., 1954; Louisville A. Center, 1948-1958; 2-man exh. (with Nelle Peterson) A. Center Gal., 1953, 1957. Awards: prizes, Louisville A. Center, 1949, 1951, 1955. **Sources:** WW59.

PETERSON, E. C. *[Marine painter] mid 19th c.*
Addresses: Boston, MA. **Exhibited:** NAD, 1871. **Sources:** Naylor, *NAD;* listed incorrectly in Brewington as Petersen.

PETERSON, Elna Charlotte *[Painter] b.1916 / d.1937.*
Addresses: Minneapolis, MN. **Studied:** Mitchell; Kopietz; Mosely; Winchell. **Exhibited:** Kansas City AI, 1935 (prize).

PETERSON, Elsa Kirpal (Mrs. R. M. T.) *[Painter] b.1891, NYC.*
Addresses: Flushing, NY. **Studied:** E.W. Burroughs; J.E. Fraser. **Member:** Alliance; ASL. **Exhibited:** PAFA Ann., 1918. **Sources:** WW33; Falk, *Exh. Record Series.*

PETERSON, Eric A. *[Painter] early 20th c.*
Addresses: Tubercular Sanitorium, Columbus, OH. **Studied:** Académie Julian, Paris. **Member:** Columbus PPC. **Sources:** WW25.

PETERSON, G. *[Painter] 19th/20th c.*
Addresses: San Francisco, CA, active ca.1890-1910. **Exhibited:** Mechanics Inst. Fair, 1893. **Comments:** Specialty: floral still lifes and scenes of the San Francisco Bay area. **Sources:** Hughes, *Artists in California,* 436.

PETERSON, Garland Burruss See: **BURRUSS, Garland**

PETERSON, George D. *[Sculptor] late 19th c.; b.Wilmington, DE.*
Studied: Académie Julian, Paris with Chapu, 1888-90; also with Falguière and Bartholdi in Paris. **Exhibited:** Paris Salon, 1892. **Sources:** Fink, *American Art at the Nineteenth-Century Paris Salons,* 380.

PETERSON, H. *[Portrait painter] mid 19th c.*
Addresses: Active in New Hampshire, after 1845. **Comments:** Painter of portraits of Col. Joseph Wentworth (1818-1901) and his wife (1823-97) of Sandwich (NH), who were married c.1845. **Sources:** G&W; WPA (Mass.), *Portraits Found in N.H.,* 26.

PETERSON, Helen *[Artist] early 20th c.*
Comments: Active c.1914. **Sources:** Petteys, *Dictionary of Women Artists.*

PETERSON, Hulda Hook *[Landscape painter] 19th c.*
Work: In collection of Mrs. c. Henry Wyberk, Massachusetts. **Sources:** Petteys, *Dictionary of Women Artists.*

PETERSON, Ida Eldora *[Painter] b.1875, Calamus, IA.*
Addresses: Calamus. **Studied:** Calamus. **Exhibited:** DeWitt Fairs; Iowa State Fair (11 awards). **Sources:** Petteys, *Dictionary of Women Artists.*

PETERSON, Jane (Jeanne) JANE PETERSON
[Painter, designer] b.1876, Elgin, IL / d.1965, Leawood, Kansas (home of a niece).
Addresses: Paris, France; NYC/Ipswich, MA. **Studied:** PIA Sch. with A.W. Dow, 1895-1901; ASL with B. Harrison, F.V. DuMond, and H.B. Snell; F. Brangwyn, in London, 1907; in Paris with J.E. Blanche, Ch. Cottet, C. Castelucho, Lhote, and Friesz; in Madrid with Sorolla, 1909. **Member:** AWCS; NAWA; Audubon Artists; PBC; Wash. WCC; Phila. WCC; NY Soc. Painters; AFA; All.Artists Am.; Art Lg. Am.; Miami Art Lg.; Soc. Four Arts, Palm Beach, FL; NYWCC; CAFA; NAC; Hartford Artists; Fed. Française des Artistes, Paris. **Exhibited:** Soc. des Artistes Français, 1908; St. Botolphe Cl., Boston, 1909; Knoedler Gal., NYC, 1909; Bendann Gal., Balt., 1909; NAD, 32 annuals, 1908-32; AIC, 1910 (solo, 87 paintings), 1914 (solo of 20 garden paintings), 1915-28; PAFA, 12 annuals, 1910-29; Brooklyn AA, 1912; Corcoran Gal biennials, 1914-37 (5 times); Girls AC, Paris, 1915 (prize); Pan.-Pac. Expo, San Fran., 1915; CAFA, 1916 (prize)-17 (prize); S. Indp. A., 1917; NAWA,1919 (prize), 1927 (prize); Erich Gal., NYC, 1925 (29 Turkish paintings); Florida SA, 1938 (prize); Wash. WCC, 1940 (prize); Soc. Four Arts; Florida Fed. Artists, 1937 (prize); Newhouse Gals., NYC, 1946 (solo, flower paintings); All. A. Am., 1952 (Testimonial Award); Gloucester Soc. Artists, 1955 (prize); AAPL, 1955 (prize); North Shore AA, 1960; Phila. WCC; AWCS; NY Soc. Painters; CAFA; Buffalo Mus. Sc.; Cayuga Mus. Hist. & Art; Chautauqua Women's Cl.; Binghamton Mus. Art; Arnot Art Gal.; Montclair Art Mus.; Rutgers Univ.; Audubon Artists; Princeton Univ.; Everhart Mus.; Mint Mus. Art; High Mus. Art; Chattanooga AA; Brooks Mem. Art Gal.; Speed Mem. Mus.; Butler AI; Ball State Teachers Col.; Kenosha Hist. & Art Mus. (solo); Oshkosh Pub. Mus. (solo); Wustum Mus. (solo); Syracuse Mus. FA (solo); Davenport Mun. Art Gal. (solo); Springfield Art Mus. (solo); Philbrook Art Center (solo); Thayer Mus. (solo); Wichita AA (solo); Joslyn Mem. (solo); Crocker Art Gal., Sacramento, CA (solo); Haggin Mem. Gal., Stockton, CA (solo); Santa Barbara Mus. Art (solo); San Jose State College; Hirschl and Adler Gal., NYC, 1970 (solo);

Hickory MA, 1987 (retrospective). **Work:** BM; Grand Rapids AA; Boise City (ID) Art Collection; Sears Art Gal., Elgin, IL; Syracuse Mus. FA; Richmond (IN) Art Mus.; Frances Shimer College; Soc. Four Arts, Palm Beach, FL; Wesleyan College, Macon, GA; Wichita Art Mus.; Brooklyn Athletic Cl.; Pub. Sch., Evanston, IL; Country Cl., Torrington, CT; YMCA, Elgin, IL; Speed Mus.; Boise Pub. Lib.; Rollins Col., Winter Park, FL. **Comments:** One of the leading women post-impressionist painters of the 1910s-30s, she worked in both oils and gouache, and had more than 100 exhibitions in those years alone. In 1909, after her first success, she changed her birth name from Jennie Christine Peterson to simply Jane Peterson. Many of her New England beach and pier scenes date from c.1916-18. After WWI she resumed her annual trips to Europe, spending six months in Turkey in 1924. She also painted in Bermuda. In 1925 she married a lawyer, M. Bernard Philipp; thereafter, she worked almost exclusively in her studio, painting large floral works (mostly zinnias, petunias, and peonies). Position: teacher, watercolor, ASL, 1913-19. Author: *Flower Painting.* **Sources:** WW66; WW47; J. Jonathan Joseph, *Jane Peterson, An American Artist* (Boston, 1981); biography in *Prominent Women of New York* (1945); Rubinstein, *American Women Artists,* 179-80; Tufts, *American Women Artists,* cat. nos. 72-73; Falk, *Exh. Record Series.*

PETERSON, John Douglas *[Art administrator, designer] b.1939, Peshtigo, WI.*
Addresses: Bloomfield Hills, MI. **Studied:** Layton Sch Art (cert. indust. design, B.F.A.); Cranbrook Acad. Art (M.F.A.). **Member:** Arts Coun. Triangle (chmn., 1971-); Cranbrook Acad. Art Alumni Assn. (bd. mem., 1969-70, v. pres., 1971-72); Am. Assn. Mus.; Mich. Mus. Assn. **Exhibited:** Made of Plastic, Bloomfield Art Assn., 1970; Detroit Artists, Mkt., 1971. **Comments:** Positions: pres., Romaine Gal., 1964-65; asst. dir., Cranbrook Acad Art/Gals., 1968-70, assoc. dir., 1970-71, dir. & dean stud., Acad., 1971-. Teaching: instr. exhib. design, Cranbrook Acad. Art, 1970-72. Collections arranged: Dr. & Mrs. Hilbert De Lawter-African Collection, 1967; Miava Grottel Retrospective-Ceramics, 1967; Wallace Mitchell Retrospective-Painting, 1971. **Sources:** WW73.

PETERSON, Josephine *[Painter] mid 20th c.*
Addresses: Chicago area. **Exhibited:** AIC, 1937. **Sources:** Falk, AIC.

PETERSON, Kay *[Etcher, painter, drawing specialist, teacher] b.1902, Oak Hill, PA.*
Addresses: Newton Lower Falls, MA. **Studied:** Cleveland Sch. A. **Member:** Boston AC; Rockport AA. **Comments:** Positions: dir., A. Dept., Lasell Jr. Col., Auburndale, Mass.; Hobby Studio, Newton Lower Falls. **Sources:** WW40.

PETERSON, Larry D. *[Painter, educator] b.1935, Holdrege, NE.*
Addresses: Kearney, NE. **Studied:** Kearney State College (B.A., 1958); Northern Colorado Univ. (M.A., 1962); Univ. Kansas, 1972-. **Member:** Nat. Art Educ. Assn.; Nebraska Art Teachers Assn. (pres.); Assn. Nebraska Art Clubs (pres.); Nebraska State Educ. Assn., Kappa Pi (pres., Beta Beta Chapter). **Exhibited:** Five State Exhib., Washburn Univ., Topeka, KS, 1965; 26th Nat. WC Exhib., Jackson, MS, 1967; 5th Nat. Art Exhib., New Orleans, 1969; Kansas Univ. Ann., Lawrence, 1971; Nat. Art Exhib., Rock Springs, WY, 1971; Ware House Gal., Grand Island, NE, 1970s. Awards: Chadron State Col. First Award, 1963; Nebraska Art Teachers Assn. Distinguished Service Award, 1969; award of excellence, Nat. Art Exhib., Rock Springs, 1971. **Work:** Univ. Minnesota; The Gallery, Kearney, NE; 250 works in private collections. Commissions: oil paintings, Trenton H.S., 1959; watercolor, ATO Fraternity, Kearney State College, 1967; acrylic & oil paintings, First Methodist Church, Kearney, 1972. **Comments:** Preferred media: watercolors, acrylics. Publications: contributor, "Art in Action," Nat. Art Publ., 1962-64; co-author, "Nebraska Art Guide K-6," Elementary Art Curriculum, State Nebraska, 1966. Teaching: art instr., North Platte Public Schools, 1958-65; art instr., North Platte College, 1966-67; asst. prof. art, Kearney State College, 1967-; graduate asst., Univ. Kansas, Lawrence, 1970-71.

Sources: WW73; Nancy Kalis, solo review, *Art Review,* (Des Moines, IA, 1968); Reva Remy, "One-man Review," *Rev. Mod. Art* (Paris France, 1968.).

PETERSON, Lily Blanche See: **RHOME, Lily Blanche Peterson (Mrs. Byron)**

PETERSON, M. *[Painter] early 20th c.*
Addresses: NYC. **Exhibited:** PAFA Ann., 1929. **Sources:** Falk, *Exh. Record Series.*

PETERSON, Maelia *[Artist] 19th/20th c.*
Addresses: Active in Grand Rapids, MI, 1897-1900. **Sources:** Petteys, *Dictionary of Women Artists.*

PETERSON, Margaret *[Painter, illustrator] b.c.1903, Seattle, WA.*
Addresses: Berkeley, CA; Victoria, B.C., Canada, 1956. **Studied:** UC Berkeley (M.A.); with Hans Hofmann and V. Vytacil; with Andre Lhote in Paris. **Member:** American Abstract Artists. **Exhibited:** CPLH, 1933 (solo), 1960 (solo); San Fran. Women A., 1935 (prize)-36 (prize); GGE, 1939; SFMA, 1939 (solo), 1973 (solo); Univ. of British Columbia, 1961 (solo). **Comments:** A Cubist early in her career. Illustrator: "The Man on the Flying Trapeze,", 1934. Position: teacher, Univ. Calif., 1928-1950. She was married to a Canadian writer and moved to Canada, spending eleven years on the Island of Salina in Italy. **Sources:** WW40; Hughes, *Artists in California,* 436; Trenton, ed. *Independent Spirits,* 32, cites birth date of 1902.

PETERSON, Mary C. *[Painter] mid 20th c.*
Addresses: Chicago area. **Exhibited:** AIC, 1930-31, 1934, 1940. **Sources:** Falk, AIC.

PETERSON, Millie *[Artist] late 19th c.*
Addresses: Active in Jackson & Grand Rapids, MI, 1887-95. **Sources:** Petteys, *Dictionary of Women Artists.*

PETERSON, Nelle Freeman *[Teacher, craftsperson] b.1903, LaGrange, KY.*
Addresses: Louisville 8, KY. **Studied:** Univ. Louisville (B.A., M.A.); Cranbrook Acad. A.; Univ. Indiana. **Member:** A. Cl. of Louisville; Midwest Des-Craftsmen; CAA; Western AA; Ky. Edu. Assn.; Ky. A. Edu. Assn.; A. Center of Louisville. **Exhibited:** Am. Jewelry Exh., 1955; Univ. Nebraska, 1952; Cranbrook Alumni Exh., 1954; A. Center, Louisville, 1948-1955; 2-man (with Daniel Peterson) A. Center Gal., 1953. **Comments:** Position: instr., crafts, A. Center Assn. and Univ. Louisville, Ky. Lectures: Color in Weaving; Kentucky Crafts. **Sources:** WW59.

PETERSON, Niss C. *[Landscape painter] mid 19th c.*
Addresses: NYC, active 1859-60. **Comments:** The name is variously given as Niss C. Peterson, Ness C. Pettersen, C. Petersen, and simply Peterson. **Sources:** G&W; NYCD and NYBD 1859-60.

PETERSON, Perry *[Illustrator] b.1908, Minneapolis, MN / d.1958, NYC (following a fire in his studio).*
Addresses: Chicago, IL; NYC. **Studied:** Federal School correspondence course; AIC (briefly). **Comments:** Illus., catalogs for *Montgomery Ward,* and other advertising; *Liberty* and other national magazines. **Sources:** W & R Reed, *The Illustrator in America,* 231.

PETERSON, Robert Baard *[Painter, draughtsman] b.1943, Elmhurst, IL.*
Addresses: Albuquerque, NM. **Studied:** Gallaudet Col., 1960-62; Univ. N. Mex., 1962-65, with Lez Haas, Ralph Lewis, Sam Smith, Walther Kuhlmann, Norman Zammitt & John Kacere. **Exhibited:** Second Nat. Painting Show, Washington & Jefferson Col., Pa., 1969; Southwest Fine Arts Biennial, Santa Fe, 1970; Fuller Lodge Competition, Los Alamos, N. Mex., 1970; solo shows, Unitarian Church, Albuquerque, N. Mex, 1970 & Willard Gal., NYC, 1972. Awards: Hon mention & purchase award, Southwest Fine Arts Biennial, 1970; purchase prize, Fuller Lodge Competition, 1970; Wurlitzer Found grant, 1970. **Work:** Sim Hunter, NYC; Northern

Trust, Chicago; First City Bank Chicago, Brussels, Belg.; Mus. N. Mex., Santa Fe; Wurlitzer Found., Taos, N. Mex. **Comments:** Preferred media: oils. **Sources:** WW73; "Eye on New York," *Art Gallery Mag.*, (Jan, 1972); David L Shirley, Review, *New York Times,* Jan 8, 1972; Bruce Wolmer, "Reviews & previews," *Art News* (Feb., 1972).

PETERSON, Roger Tory
[Illustrator, writer, lecturer, photographer] b.1908, Jamestown, NY. / d.1996, Old Lyme, CT.
Addresses: Alexandria, VA (1940s); Old Lyme, CT. **Studied:** ASL, 1927; NAD, 1929-31; with Wm. D. von Langereis, John Sloan, and K. Nicolaides. **Exhibited:** bird paintings in natural history museums in Buffalo, Detroit, Los Angeles, Boston, New York, Toronto, Charlotteville, and Charleston. Awards: eleven honorary degrees; NY Zoological Soc. (gold med); World Wildlife Fund (gold med); U.S. Humane Soc. (med); Swedish Acad. of Science, (Linnaeus gold med); French Natural Hist. Soc. (gold med); Explorers Club, 1974 (med); Presidential Medal of Freedom, 1980. **Comments:** The best known ornithologist of the 20th century, he was author/illustrator of *A Field Guide to the Birds* which was revised four times since 1934, the year it was published and won the Brewster Award of the Am. Ornithologists Union. By the time of his death in 1996, about 4 million copies of the book had sold, and Peterson had garnered numerous international awards. He wrote and illustrated many other natural history books, including a 31-vol. series of field guides, including one for wildflowers. In 1961, *Audubon Magazine* said that "as a naturalist, he has the soul of an artist and as an artist he has the soul of a naturalist." His 100,000-mile trip across the U.S. in 1953 with British naturalist, James Fisher, resulted in their book, *Wild America* (1955). Positions: t., Rivers Sch., Brookline, Mass., c.1931-34; asst. editor, *Audubon Magazine,* 1935-42. **Sources:** WW47; biography by John Devlin and Grace Naismith (1977); obit., *New York Times* (July 30, 1996, p.D1).

PETERSON, Roland *[Painter] mid 20th c.*
Exhibited: PAFA Ann., 1966. **Sources:** Falk, *Exh. Record Series.*

PETERSON, Ruth Jordan (Mrs. Sterling) *[Sculptor, craftsperson] b.1901, Denver, CO.*
Addresses: Seattle, WA. **Studied:** Univ. of Wash. **Member:** Women Painters of Wash., 1938-1943. **Exhibited:** Wash. State Arts and Crafts, 1935; NYWF, 1939. **Sources:** Trip and Cook, *Washington State Art and Artists.*

PETERSON, Thomas (Capt.) *[Painter] mid 20th c.*
Addresses: Noank, CT, 1920. **Exhibited:** S. Indp. A., 1920, 1923. **Sources:** Marlor, *Soc. Indp. Artists.*

PETERSON, Vivian K. *[Painter] 20th c.*
Addresses: Minneapolis, MN, c.1913-23. **Sources:** WW24.

PETETIN, Sidonia *[Painter] late 19th c.; b.France.*
Comments: Known in San Francisco in 1861 and again, 1870s-1880s. **Sources:** Petteys, *Dictionary of Women Artists.*

PETHEO, Bela Francis *[Painter, educator] b.1934, Budapest, Hungary.*
Addresses: Collegeville, MN. **Studied:** Univ. Budapest (M.A., 1956); Acad. Fine Arts, Vienna, 1957-59, with A.P. Guetersloh; Univ. Vienna, 1958-69; Univ. Chicago, (M.F.A., 1963). **Member:** Col. Art Assn. Am.; Int. Platform Assn. **Exhibited:** Hamline Univ., 1966; Coffman Gal., Univ. Minn, 1968; Moorhead State Col., 1969; Biennale Wis. Printmakers, 1971; Rochester Art Ctr., 1972. Awards: Belobende Anerkennung, Acad. Fine Arts, Vienna, 1958; graphic prize, Univ. Chicago, 1962. **Work:** Hungarian State Mus. Fine Arts, Budapest; Kunstmus., Basel, Switz.; Univ. Minn. Permanent Coll., Minneapolis; Carleton Col. Permanent Coll., Northfield, Minn. Commissions: Kindliche Untugenden (mural), Assn. Austrian Boy Scouts, Vienna, 1958; The History of Handwriting (exhib. panel), Noble & Noble Publ. for Hall of Educ., WFNY, 1964. **Comments:** Preferred media: oils, acrylics, graphics. Teaching: instr. art, Univ. Northern Iowa, 1964-66;

assoc. prof. art & artist-in-residence, St John's Univ., 1966-. Publications: auth., "Rembrandt's Pupils in the Museum of Fine Arts in Budapest," *Szabad Muveszet,*June, 1956; auth., "Creativity Versus Convention: an Illustrator's Challenge," *Rec.*, winter 1967; auth., "Polymer-coated Lithographic Transfer Paper," In: "Five Artists--Their Printmaking Methods," *Artists Proof*, 1968; auth., "The College Art Gallery," *Art J.*, summer 1971. **Sources:** WW73.

PETICOLAS, Alfred Brown *[Lawyer and amateur artist] b.1838, Richmond, VA / d.1915, Victoria, TX.*
Addresses: Petersburg, VA; Victoria, TX. **Work:** Virgina Hist. Soc. (series of drawings of canals, bridges, and railways in Virginia). **Sources:** Wright, *Artists in Virginia Before 1900.*

PETICOLAS, Arthur Edward *[Painter] b.c.1825, probably in Richmond, VA.*
Addresses: Richmond, VA. **Exhibited:** Richmond (Va.), 1847. **Comments:** Son of Edward F. and Jane Pitfield Braddick Peticolas (see entries on each). He later studied medicine and became professor of anatomy at the Medical College of Virginia. **Sources:** G&W; *Richmond Portraits,* 151.

PETICOLAS, Edward F.
[Portrait, miniature & landscape painter] b.1793, Pennsylvania / d.c.1853, probably Virginia.
Studied: Thomas Sully, Richmond; England, France, and Italy, 1815-20. **Work:** Valentine Mus. (Richmond, VA). **Comments:** Son of Philippe Abraham Peticolas (see entry). Brought to Richmond (VA) by his parents in 1804. Was taking miniature likenesses there as early as 1807 and, in 1810, was teaching at Mrs. Byrd's School. Began painting in oil during his 1815 trip to Europe. Returned to Virginia in 1820, and soon became Richmond's leading portrait painter. His full-length, grand manner "Portrait of Lafayette" (Valentine Mus.), painted in 1824-25 for the Richmond City Hall, received especially high praise. He made a second trip to Europe about 1825 and a third in 1830-33. After 1840 he suffered from severe rheumatism which led to his giving up painting about 1845. His wife Jane Pitfield Braddick Peticolas was also an artist, as was their son Arthur Edward Peticolas (see entries). Also appears as F. Petticolas Edward. **Sources:** G&W; *Richmond Portraits,* 150-51, 228-30; Swan, BA. More recently, see Gerdts, *Art Across America,* vol. 2:14-16; P&H Samuels, 370.

PETICOLAS, Edward F. *[Wood engraver] mid 19th c.*
Addresses: Cincinnati, active 1857-61. **Comments:** In 1863 he was listed as assistant librarian of the Young Men's Mercantile Library Association. He may have been a son of Theodore V. Peticolas (see entry) who was working in Cincinnati in the 1830s and early 1840s and living in Clermont County (OH) in the 1850s. **Sources:** G&W; Cincinnati CD 1857-63.

PETICOLAS, Jane Pitfield Braddick *[Portrait copyist] b.1791, probably Scotland / d.1852, Richmond, VA.*
Addresses: Richmond, VA. **Comments:** She was living in Richmond (Va.) when she married painter Edward F. Peticolas (see entry) in 1822. Their son, Arthur Edward Peticolas, was also an artist for a time. **Sources:** G&W; *Richmond Portraits,* 229-30.

PETICOLAS, Philippe Abraham *[Miniature painter, teacher of drawing and music] b.1760, Meziers (France) / d.1841, Petersburg, VA.*
Exhibited: Brooklyn AA, 1866 (min. portrait of Geo. Washington, 1796). **Comments:** Served eight years in the army of the King of Bavaria before moving to St. Domingo about the time of the slave revolts in 1790. He left the island shortly after the birth of his first son Augustus, and came to Philadelphia where he lived for a few years as a miniature painter and print seller. Later worked in Lancaster, PA; and, in 1797, at Winchester, VA. In 1804 he moved to Richmond, VA, where he became the city's leading miniaturist. He remained there the rest of his career. Died at the home of a son in Petersburg, VA. Of his four sons, two were artists: Edward F. and Theodore V. Peticolas (see entries). **Sources:** G&W; *Richmond Portraits,* 228-29; Prime, II, 26, 52;

Lancaster County Hist. Soc., *Papers,* XVI, 69; *Antiques* (Dec. 1942), 277, repro. of his miniature of Washington. More recently, see Gerdts, *Art Across America,* vol 2: 14.

PETICOLAS, Sherry *[Sculptor, teacher] b.1904, Waterloo, IA / d.1956, Los Angeles, CA.*
Addresses: Los Angeles, CA. **Member:** Calif. AC; P&S of Los Angeles. **Work:** Frank Wiggins Trade School, Los Angeles; Inglewood, San Fernando, Colton Post Offices; Newman Park, Riverside; Memorial Park, Redlands. WPA artist. **Sources:** Hughes, *Artists in California,* 436.

PETICOLAS, Theodore V. *[Miniature and portrait painter, drawing teacher] b.1797, PA, probably in Lancaster.*
Exhibited: Artists' Fund Society, Phila., 1840. **Comments:** Youngest son of Philippe Abraham Peticolas (see entry). Brought up in Richmond (Va.), he was active there as a miniature painter from 1819 to 1820. After this he is went to Cincinnati (Ohio), where he married in 1824, but by 1833 he was working in Huntsville (Ala.). From 1836 to at least 1842 he was painting miniatures in Cincinnati, but by 1851 he had retired to live in Clermont County (Ohio) as a farmer. The Cincinnati engraver Edward F. Peticolas (see entry) may have been his son. **Sources:** G&W; *Richmond Portraits,* 229; WPA (Ala.) Hist. Records Survey cites Huntsville *Southern Advocate,* July 2, 1833; Cincinnati CD 1836-42 [as T. V. or Thomas V. Peticolas]; Rutledge, PA; Cist, *Cincinnati in 1841* and *Cincinnati in 1851.* More recently, see Hageman, 120-21; Gerdts, *Art Across America,* vol 2: 14, 181.

PETIGRU, Caroline (Mrs. William A. Carson) *[Portrait and miniature painter] b.1819, Charleston , SC / d.1893, Rome.*
Addresses: NYC, 1860s-80s; Rome, Italy, 1880s-93. **Studied:** Charleston, SC. **Exhibited:** Carolina AA Bazaar, Charleston, 1883. **Comments:** In 1840 she married William A. Carson; and in 1860 moved to NYC because of her Unionist sympathies. During the 1880s she moved to Rome. Her father was James Lewis Petigru (1789-1863), a noted Charleston lawyer and Unionist. *Cf.* Mrs. C. Carson, who exhibited floral works and one portrait at the NAD in the 1860s; it is very possible they are the same person. **Sources:** G&W; CAB; Carolina Art Association Catalogues, 1935, 1936. More recently, see Gerdts, *Art Across America,* vol 2: 56.

PETIT, Don *[Sculptor] mid 20th c.*
Addresses: Chicago area. **Exhibited:** AIC, 1951. **Sources:** Falk, *AIC.*

PETITE, Jena Wolverton *[Painter, illustrator] b.1892, Tacoma, WA / d.1974, Seattle, WA.*
Studied: Reed College; Central Wash. College; with Paul Immel, Helen Everett. **Comments:** Primarily a wildlife illustrator, she illustrated books, written by her son Irving. Her bird paintings were made into slides for public schools, and in the mid 1940s, she illustrated a booklet on the most important birds of Point Lobos, CA. **Sources:** Trip and Cook, *Washington State Art and Artists.*

PETITT, William R. *[Engraver] 19th/20th c.*
Addresses: Wash., DC, active 1905. **Sources:** McMahan, *Artists of Washington, D.C.*

PETO, John Frederick *[Painter] b.1854, Philadelphia, PA / d.1907.*
Addresses: Philadelphia (until 1889); Island Heights, NJ (1889-on). **Studied:** PAFA, 1878. **Exhibited:** PAFA Ann., 1879-81, 1885, 1887-88; Brooklyn Mus., 1950; NGA, Wash., DC, 1983 (traveling exhib., went to Amon Carter Mus.). **Work:** BMFA; MMA; NMAA; Brooklyn Mus.; Carnegie Inst.; Cleveland MA; Wadsworth Atheneum, Hartford, CT; New Britain Mus. Am. Art; Ariz. State Univ. Art Collection; Minneapolis IA; LACMA; Shelburne (VT) Mus.; Smith College MA. **Comments:** A major trompe l'œil still-life painter, he produced an important series of "rack" paintings (cards, papers, letters, and photographs pinned, often behind ribbons, against an illusionistic wooden wall or back-

board) dating from 1879-1904, some of which were painted for Philadelphia business establishments (1879-85). Peto greatly admired William Harnett, whom he became acquainted with in Phila. before the latter's trip to Europe in 1880. Although Peto exhibited at PAFA, most of his career was spent in relative obscurity and he often traveled from Phila. to Island Heights, NJ, where he was able to supplement his income by playing the cornet at camp meetings. Peto moved there permanently in 1889 and thereafter did not exhibit at PAFA. He did however, sell his paintings to wealthy tourists who spent summers on the Island. In 1905, a Phila. dealer who had purchased a number of Peto's paintings began affixing the signature of the more famous William Harnett on many of Peto's works. In the late 1940s Alfred Frankenstein became aware of the extent of the forgery problem after visiting Peto's Island Heights studio; he then did a systematic study of Peto's work, thus disentagling the works of Peto from those of Harnett, and in so doing showed that their styles differed greatly. **Sources:** John Wilmerding, *Important Information Inside: The Art of John F. Peto and the Idea of Still-Life Painting in Nineteenth-Century America* (exh. cat., National Gal. of Art, Wash, DC, 1983); Baigell, *Dictionary;* Alfred Frankenstein, *After the Hunt,* 13-23, 99-111; Gerdts, *Painters of the Humble Truth,* 179-86; Gerdts and Burke, *American Still-Life Painting,* 142-44, 156-57, and 248-49 (notes 1 and 2); Brooklyn Mus.; *John Peto* (exh. cat., 1950); Muller, *Paintings and Drawings at the Shelburne Museum,* 101 (w/repro.); Falk, *Exh. Record Series.*

PETOW, Edward T. *[Painter] b.1877, Russia.*
Addresses: Providence, RI. **Studied:** Acad. A., Odessa; Munich Acad. **Member:** Soc. A. & Letters, Geneva, Switzerland. **Exhibited:** Odessa (med); St. Petersburg (med). **Sources:** WW10.

PETRAGLIA, Peter F. *[Painter, illustrator, graphic designer, cartoonist, photographer] b.1928, NYC.*
Addresses: Newtown, PA. **Studied:** PMA Sch., 1948-52; with Sol Mednick, Arthur Williams, Morris Berd, Paul Froelich, Ben Eisenstat, Gertrude Schell. **Member:** Phila. Sketch Cl., since 1972 (bd. of dir., 1983-85); Artsbridge, Lambertville, NJ; AEA. **Exhibited:** Philadelphia Sketch Cl., 1970s,1979; widely thereafter. Awards: Philadelphia Art Dir. Cl., 1960s-86, numerous awards for illustrations and design; second prize for photograph, Photo Review. **Comments:** Preferred media: acrylic, oil, pastel, watercolor, pen & ink. Creator, syndicated character, *Thumbody,* used in marketing programs, 1970s-80s; creator, cartoon strip, *Delaware Valley Advance,* 1970-73. A conceptual thinker, his work reflects an ease of movement between photography, painting and the use of different media. Positions: inst., part time, Philadelphia Col. of Art, 1958, 1959, 1960-61; art dir., CEO, Princeton Partners, Inc, ad agency, Princeton, NJ, 1971-86. **Sources:** info. courtesy of the artist.

PETRANECK, George *[Lithographer] b.c.1867, New Orleans, LA / d.1901, New Orleans.*
Addresses: New Orleans, active 1884-1901. **Sources:** *Encyclopaedia of New Orleans Artists,* 302.

PETRASCHEK-LANGE, Helene *[Painter] b.1875.*
Exhibited: AIC, 1924-25. **Sources:** Falk, *AIC.*

PETRAVICIUS, Viktoras A. *[Painter/printmaker] mid 20th c.*
Addresses: Chicago area. **Exhibited:** AIC, 1951 (prize).

PETREMONT, Clarice Marie *[Painter, craftsperson, designer, block printer, painter, teacher] b.Brooklyn, NY / d.1949.*
Addresses: Shelton, CT, from 1913. **Studied:** M. Fry; P. Cornoyer. **Member:** AAPL; Boston SAC; New Haven PCC; Bridgeport Art Lg. **Comments:** Teaching: Bridgeport Art Lg. **Sources:** WW47.

PETRENCS, Jules A. *[Artist] mid 20th c.*
Addresses: Pittsburgh, PA. **Exhibited:** PAFA Ann., 1954. **Sources:** Falk, *Exh. Record Series.*

PETRI, Richard *[Portrait, figure, and genre painter] b.1824, Dresden,* *R. Petri.*
Germany / d.1857, either Fredericksburg or(Austin, 1858).
Addresses: Texas. **Studied:** Dresden Academy, 1838-44 with Richter and Hübner. **Comments:** Following his involvement in the 1848 Revolution, he and his brother-in-law Hermann Lungkwitz (see entry) came to America as political exiles in 1850, stopping briefly at West Virginia and then joining the German colony at New Braunfels (TX) in 1851 to suit Petri's health. While there Petri painted portraits using crayon, watercolor, and tempera. The Petri and Lungkwitz families moved to Fredericksburg (TX) in 1854 and Petri continued to make portraits, focusing on individuals from local tribes whom he befriended. He also painted genre scenes picturing his fellow settlers. He drowned at the age of 34. Also appears as Petrie. **Sources:** G&W; "Texas in Pictures," 456 (repros.); Gideon, "Two Pioneer Artists of Texas." More recently see P&H Samuels, 296 and 370.

PETRIC, Lubin *[Painter] d.1978, Seattle, WA.*
Addresses: Seattle, WA. **Exhibited:** SAM, 1934. **Work:** in priv. colls.; WPA artist. **Comments:** Son of a Yugoslav immigrant, he was an important part of the Northwest School of Painters, but not an official member of the "Group of Twelve." **Sources:** Trip and Cook, *Washington State Art and Artists.*

PETRIE, Ferdinand Ralph *[Painter, designer] b.1925, Hackensack, NJ.*
Studied: Parsons Sch. Design, NYC (cert. advert., 1949); ASL, with Frank Reilly; Famous Artists Course Illus. (cert., 1959). **Member:** Rutherford, NJ. **Exhibited:** Audubon Naturalists Soc., 1970 (solo); All. A. Am., NAD Gal., 1971; NJ WC Soc., Mus. Arts & Sci., Morristown, 1971-72; Am. Artists Prof. League Grand Nat., New York, 1971 & 1972; San Clemente White House Loan Exhib. from Smithsonian Inst., 1970-72; Callahan-Petrie Gal., Rockport, MA & Grand Central Gals., NYC, 1970s. Awards: first prize for watercolor, Atlantic City Boardwalk Show, 1969; Salmagundi Cl. Purchase Prize, 1970; Grand Nat. Award, Am. Artists Prof. League, 1971. **Work:** Nat. Coll. Fine Art, Smithsonian Inst.; Audubon Naturalists Soc., Chevy Chase, Md.; Hammond Mus., North Salem, NY; US Navy Combat Art Gal., Wash., DC. **Comments:** Preferred medium: watercolors. Positions: illus., J. Gans Assoc. Studio, New York, 1950-69. Teaching: instr. painting & drawing, Fairleigh Dickinson Univ., Rutherford, 1969-70; instr. watercolor, Annex Gal., Montclair, NJ, 1970-72; pvt. instr. watercolor, 1972-. Publications: illusr., New York Life Ins. Calendar, 1970 & 1972; illusr., Provident Mutual Life Ins. Co. Calendar, 1971; illusr., educ. poster, Educ. Syst. & Publ., 1972; illusr., Becton-Dickinson Co. Publ., 1972. **Sources:** WW73.

PETRIE, Frederick Richard See: **PETRI, Richard**

PETRINA, Charlotte Kennedy (Carlotta) *[Painter, illustrator, graphic artist, teacher] b.1901, Kingston,NY.*
Addresses: Brooklyn, NY; Naples, Italy. **Studied:** ASL; CUA Sch.; Robinson; Bridgman; Miller; Savage. **Member:** Artists Gld.; SI; ASL. **Exhibited:** Salon d'Automne, Salon des Artistes Francais, Paris; AIC; PAFA; Phila. Pr. Cl.; BM; WMAA; Dudensing Gal.; AIGA; Capri, Italy, 1950; solo: Galleria "La Finestra," Rome, 1952; Crespi Gal., N.Y., 1957; AIC. Awards: Guggenheim F., 1933, 1934. **Work:** NY Pub. Lib.; Brooklyn Mus. **Comments:** Illus. (Limited Ed. Cl.) *South Wind; Paradise Lost; The Aeneid; Henry VI.* **Sources:** WW59; WW40.

PETRINA, John Antonio *[Painter, illustrator, lithographer, lecturer, writer, teacher] b.1893, Venice, Italy / d.1935, Evanston, WY (automobile accident).*
Addresses: San Francisco, CA; Roslyn, Brooklyn, NY. **Studied:** ASL, with Volk; Cox; Bridgman; Henry; Woodstock Colony. **Member:** Artists Gld.; Woodstock AA. **Exhibited:** Calif. Artists, Golden Gate Park Mem. Mus., 1916; San Francisco AA, 1919; AIC; Paris Salons; PAFA Ann., 1930. **Work:** lithographs, Fifth Ave. Library, NYC; Brooklyn Mus.; French Gov. **Comments:** Position: hd. of graphic arts, Pratt Inst. Author/illustrator: *Art*

Work, How Produced, How Reproduced. Illustrator: *Ports of France; Trails of the Troubadours,* pub. Century. **Sources:** WW33; Hughes, *Artists in California,* 436; Woodstock AA; Falk, *Exh. Record Series.*

PETRO, Joseph (Victor), Jr. *[Painter, illustrator] b.1932, Lexington, KY.*
Studied: Transylvania College with Victor Hammer; Cincinnati Med. Sch. (grad. sch.; art as applied to medicine). **Member:** Lexington, KY. **Exhibited:** solos: Transylvania College, 1963, Univ. Kentucky, 1965, Abercrombie-Fitch, NY, 1968, Bass Gals., Louisville, 1968 & Clossons, Cincinnati, OH, 1969. **Work:** commissions: covers, *Family Weekly* magazine, NY; Brown & Bigelow calendars; Brown-Forman Distillers, Louisville, KY; 32 horse paintings, Keeneland Coll., Keeneland Racing Assn., Lexington, KY; 27 portraits of pres. of Transylvania Col., 1794-, pres. room, Transylvania Col. **Comments:** Positions: publ., series ltd number collector prints horses, 1954-69; consult., Spindletop Res., Inc., Lexington, 1965-68. Publications: illlustr., *Cincinnati Pictorial Enquirer, Thoroughbred Rec., Nat. Geographic, Holiday, Better Homes & Gardens.* **Sources:** WW73.

PETROFF, Gilmer *[Painter, designer, educator] b.1913, Saranac Lake, NY.*
Addresses: Taylors, SC; Columbia, SC. **Studied:** Yale Univ.; Univ. Wis. Summer Sch.; Cape Cod Sch. Art; also with Richard E. Miller. **Member:** Phila. WCC; Atlanta AA; Greenville (SC) A. Lg.; Staten Island AA; Beach Combers C., Provincetown, Mass; SC Art Assn (pres., 1955); Columbia Artists Guild (pres., 1957). **Exhibited:** San Diego Art Guild, 1936; PAFA, 1937-38; AIC, 1939; Atlanta AA; Greenville (SC) A. Lg.; Mint Mus. A., 1946 (prize). AWCS (prize 1946); Girls H.S., Atlanta, Ga., 1947 (prize); High Mus Art, Atlanta, Ga, 1947 (purchase award); Saranac Lake AA.; Saint Paul Mus., 1939; Columbia Mus Art, SC, 1951 (purchase award 1965); Carolina AA, 1951(prize); Sears Roebuck, 1954 (prize); Florence Mus Art, SC, 1969; Staten Island Mus Art, NY. **Work:** Dongan Hills, NY, Savings Bank; O'Hara Collection; High Mus., Atlanta, Ga.; Columbia Mus., SC; Florence Mus., SC; Staten Island Hist Soc., NY; Saranac Lake AA. Commissions: murals, Colonial Bldg. & Loan Assn., Staten Island, NY, Clemson House, Clemson Univ, 1951, Tapps Dept Store, Columbia. 1954, SC Hwy. Dept., Columbia, 1956 & Yachtsman Motel, Myrtle Beach, SC, 1971. **Comments:** Preferred media: watercolors, acrylics. Positions: designer, Lyles, Bissett, Carlisle & Wolfe, Architects, Columbia, 1950-60; chief designer, Stanley Smith & Sons, Builders, 1960-. Teaching: assoc. prof. archit., Clemson Univ., 1946-50; instr., Richland Art Sch., Columbia, 1950-60. Publications: illusr., *Textile Leaders of the South,* 1964. **Sources:** WW73; WW47.

PETRONZIO, Frank *[Portrait painter, painter, etcher] mid 20th c.; b.Beverly, MA.*
Studied: Cleveland Inst. of Art; Mass. School of Art; BMFA Sch.; ASL, with Yashuo Kuniyoshi; Romano Sch. of Art, Gloucester. **Exhibited:** CMA (prize in etching). **Sources:** *Artists of the Rockport Art Association* (1956).

PETROV, Basil *[Art dealer] 20th c.*
Addresses: NYC. **Sources:** WW66.

PETROV, Dimitri *[Painter, printmaker] b.1919, Philadelphia, PA / d.1986.*
Addresses: Philadelphia, 1940s; Mount Washington, MA, 1977. **Studied:** PAFA; with Hayter at Atelier 17 Workshop. **Member:** Woodstock AA. **Exhibited:** Hugo Gal., NYC; Stravinsky Gal.; Maeght Gal.; CI; AIC; PAFA Ann., 1944; Iris Clert; Corcoran Gal biennial, 1947; WMAA, 1951. **Work:** Woodstock AA; Indiana Univ.; Rutgers Univ.; Swarthmore; Brandeis; Pace; Phila. Mus.; Penn. State; Reading Mus.; Wm. Penn Mus., Harrisburg, PA; MoMA; PAFA; Phila. Print Club; Pasadena Mus.; Oklahoma Mus.; Bridgeport Univ. Mus.; Containier Corp. Collection; AVX Corp. Collection; Lake Placid AC; St. Peters Col.; Syracuse Univ.; Cornell; Grand Rapids Mus.; Norfolk Mus.; New Jersey State; State Univ. NY, Col. at New Paltz; Ulster County CC; New

Britain Mus. AA. **Comments:** A Dada-Surrealist painter, he grew up in an anarchist colony in New Jersey. Publications: co-editor: *Prospero* series of poet-artist books and *Instead,* a surrealist newspaper; co-publisher/editor, *Letter Edged in Black;* a series of portfolios, *S.M.S.* **Sources:** Wechsler, 31; Falk, *Exh. Record Series;* addit. info. courtesy Woodstock AA.

PETROVIC, Milan V. *[Painter, etcher, teacher] b.1893, Pancevo, Serbia.*
Addresses: Cincinnati, OH. **Studied:** N. Kouznjezoff; E. Singer. **Member:** MacD. Soc., Cincinnati. **Work:** Hispanic Mus., Hispanic Society Am., NY. **Sources:** WW40.

PETROVITS, Milan *[Painter, drawing specialist, illustrator, teacher] b.1892, Vienna, Austria. / d.1944, Pittsburgh, PA.*
Addresses: Verona, PA. **Studied:** CI with A.C. Sparks. **Member:** Pittsburgh AA. **Exhibited:** S. Indp. A., 1917-18; Pittsburgh AA, 1922 (prize), 1923 (prize), 1924 (prize), 1932 (prize); PAFA Ann., 1923, 1934-35; Pittsburgh Art Soc., 1938 (prize). **Work:** Public Sch. Coll., Pittsburgh. **Comments:** Came to the U.S. in 1905. A versatile painter who worked with a number of subjects, styles and techniques, from nostalgic Hungarian genre scenes to abstract landscapes. Teaching: AI Pittsburgh. **Sources:** WW40; Chew, ed., *Southwestern Pennsylvania Painters,* 103, 104; Falk, *Exh. Record Series.*

PETROVITS, N. Paul *[Portrait painter] b.1811, Hungary / d.c.1882, Australia.*
Addresses: NYC; San Francisco, CA, 1874-75; Los Angeles, CA, 1876; Virginia City, NV, 1878. **Comments:** He was a successful artist, but was executed by hanging for the murder of his wife. **Sources:** Hughes, *Artists in California,* 436.

PETRTYL, August *[Painter/sculptor] early 20th c.*
Addresses: Chicago, IL. **Exhibited:** AIC, 1904-05, 1912. **Sources:** WW13.

PETRUCCELLI, Antonio *[Designer, illustrator] b.1907, Fort Lee, NJ. / d.1994.*
Addresses: MT Tabor, NJ. **Studied:** M.M. White. **Exhibited:** Corona Mundi, NY, 1925 (prize)-26 (prize); A. All. of Am. for Intl. Press Exh., Cologne, 1927 (prize); Am. Soc. for Control of Cancer, 1928 (prize); Stehli Silk Corp., 1928 (prize); Johnson and Faulkner, NY, 1933 (prize); *House Beautiful* Cover Comp., 1928 (prize), 1929 (prize), 1931 (prize), 1933 (prize). **Work:** mural dec., Hotel Winslow, NY. **Comments:** Designer: covers, *New Yorker, Collier's, Today, Fortune,* 1932-37. **Sources:** WW40; add'l info. courtesy Robert Reed, Short Hills, NJ.

PETRUCCI, Carlo Albert *[Painter] 20th c.*
Addresses: NYC. **Sources:** WW13.

PETRUNKEVITCH, Wanda *[Painter] early 20th c.*
Addresses: Pittsburgh, PA. **Studied:** ASL. **Exhibited:** S. Indp. A., 1927. **Sources:** Marlor, *Soc. Indp. Artists.*

PETRY, Mildred *[Painter] early 20th c.*
Addresses: NYC. **Studied:** ASL. **Exhibited:** S. Indp. A., 1922, 1929. **Sources:** Marlor, *Soc. Indp. Artists.*

PETRY, Victor *[Painter, illustrator, etcher, teacher] b.1903, Phila.*
Addresses: Douglaston, NY/Ogunquit, ME. **Studied:** F. Waugh. **Member:** NYWCC; Seven Arts Club. **Exhibited:** AIC,1929. **Work:** BM. **Sources:** WW40.

PETT, Helen Bailey *[Sculptor, teacher] b.1908, East Liverpool, OH. / d.1996, Natick, MA.*
Addresses: Jackson, MI. **Studied:** With A.T. Fairbanks; Univ. Mich.; with A. Laessle; PAFA. **Member:** AAPL. **Exhibited:** PAFA, 1935 (as Helen Bailey). **Work:** medal for Mich. Horticultural Soc. **Comments:** Her sculpture was reproduced in *American Magazine of Art.* **Sources:** WW40.

PETT, John *[Painter] late 18th c.*
Comments: Painter on glass of a picture of the death of General Wolfe, dated 1772 (according to Groce & Wallace, the signed and dated painting was on consignment at NYHS, 1950). **Sources:**

G&W.

PETTE, John Phelps *[Painter] early 20th c.*
Addresses: Trenton, NJ; NYC. **Exhibited:** PAFA Ann., 1906; S. Indp. A., 1917, 1922. **Sources:** WW08; Falk, *Exh. Record Series.*

PETTEE, John (Mrs.) *[Painter] late 19th c.*
Exhibited: Mechanics Inst., San Francisco, 1896. **Sources:** Hughes, *Artists in California,* 436.

PETTENGILL, Ernest Eugene *[Portrait photographer, painter] b.1886, Farmington, NJ / d.1951, New Bedford, MA.*
Member: New England Photographers Assoc.; New Bedford Art Club. **Exhibited:** Morris Plan Bank, New Bedford, 1950; Swain Free School Design, c.1940. **Work:** Old Dartmouth Hist. Soc. **Comments:** Instructor, Swain Free School Design, 1936. **Sources:** Blasdale, *Artists of New Bedford,* 143 (w/repro.).

PETTERSON, John P. *[Silversmith] b.1884, Gothenburg, Sweden / d.1949.*
Addresses: Park Ridge, IL. **Studied:** Royal Sch. A. & Crafts; D. Anderson. **Member:** Boston Soc. A. & Crafts. **Exhibited:** AIC, 1922 (prize), 1923 (prize); Boston Soc. A. & Crafts, 1929 (prize), 1936 (prize); Paris Salon, 1937 (prize); Boston SAC, 1932 (prize), 1936 (med); MMA; SFMA; Joslyn Mem.; CMA; BMFA; AIC. **Work:** Passavant Hospital Mem. Fund Trophy, Chicago; Trophy, Lake Geneva, Wis.; sword presented to King of Italy by Italian War Veterans of Chicago, 1928. **Sources:** WW47.

PETTERSON, Ness C. See: **PETERSON, Niss C.**

PETTET, William *[Painter] b.1942.*
Addresses: Los Angeles, 1967; NYC, 1973. **Exhibited:** WMAA, 1967, 1969, 1973. **Sources:** Falk, *WMAA.*

PETTETTE, C. S. (Mrs.) *[Artist] late 19th c.*
Addresses: Active in Bay City, MI, 1897. **Sources:** Petteys, *Dictionary of Women Artists.*

PETTIBONE, Daniel *[Artist and edge-tool maker] early 19th c.*
Addresses: Philadelphia, 1811-20. **Sources:** G&W; Brown and Brown.

PETTINGELL, Lilian Annin (Mrs. C. K.) *[Painter, teacher] b.1871, LeRoy, NY.*
Addresses: La Crosse, WI; Seattle, WA, active 1908, 1924. **Studied:** I.R. Wiles; L.M. Wiles; R.H. Nicholls, Chase Sch.; ASL. **Exhibited:** Seattle Fine Arts Soc., 1908; Alaska-Yukon Pacific Expo, 1909. **Sources:** WW33; Trip and Cook, *Washington State Art and Artists.*

PETTINGELL, Robert Clyde, Jr. *[Painter] mid 20th c.*
Addresses: Wash., DC. **Exhibited:** Wash. WCC, 1939; Am. Fed. A., 1939. **Sources:** WW40.

PETTINGELL, Lillian G. See: **PETTINGELL, Lilian Annin (Mrs. C. K.)**

PETTIS See: **PITTIS, Thomas**

PETTIS, Mary Fancher *[Landscape painter] b.1848, Saratoga, NY / d.1930, Marin County, CA.*
Addresses: Oakland, CA. **Studied:** San Francisco, CA, with Mary Curtis Richardson; San Francisco Sch. of Des. **Exhibited:** San Francisco AA, 1902. **Sources:** Hughes, *Artists in California,* 436.

PETTIT, Evelyn M. *[Painter, teacher] b.1870, Lisbon, OH.*
Addresses: Lisbon, OH. **Studied:** Cleveland School Art; A. Dow, PIA School. **Comments:** Teaching: NY School Decorative & Applied Art. **Sources:** WW06.

PETTIT, George W. *[Painter] d.1910.*
Addresses: Phila., PA. **Member:** Phila. AC. **Exhibited:** NAD, 1871; PAFA Ann., 1876-87 (6 times). **Sources:** WW10; Naylor, *NAD;* Falk, *Exh. Record Series.*

PETTIT, Grace *[Painter] mid 20th c.*
Addresses: NYC. **Exhibited:** AIC, 1935; Kansas City AI, 1938; Contemp. A. Gal., NYC, 1938. **Sources:** WW40.

PETTRICH, Ferdinand See: **PETTRICH, Ferdinand Friedrich August**

PETTRICH, Ferdinand Friedrich August *[Sculptor]*
b.1798, Dresden (Germany) / d.1872, Rome (Italy).
Studied: Thorwaldsen in Rome; Ecole des Beaux-Arts, Dresden, 1916 and with his father. **Exhibited:** PAFA, 1843-45, 1865. **Work:** NMAA; American Philosophical Society, Philadelphia, PA; Newberry Lib., Chicago. **Comments:** Came to U.S. in 1835, on commission from Pope Pius IX to model North American Indians. He settled first in Philadelphia, where he executed portrait busts for several years, before relocating to Washington, DC. In the latter city, Pettrich hoped to gain the commission for two large statues that were to be placed on the great stairway at the western front of the U.S. Capitol. But although he submitted and was paid for his models, his proposal was eventually rejected. Despite this, he kept a studio in DC until the early 1840s, producing a number of works in stone, such as "Fisher Girl" and "Dying Tecumse" (both at NMAA). He was helpful in getting Emmanuel Leutze a copy of Houdon's life mask of Washington (for Leutze's "Washington Crossing the Delaware"). The U.S. government's commission of Pettrich (in 1841) to design the base of Greenough's colossal Washington statue pushed the German-born sculptor into the controversy over the government's employment of foreign artists. This and an attempt on his life led him to leave DC and by 1847 he was listed (in Pennsylvania Academy catalogue) as residing in Rio de Janeiro (Brazil), where he became court sculptor to Emporer Dom Pedro II. Pettrich eventually returned to Rome. In 1865, Pettrich's life-size marble "Dying Tecumseh" was brought from Brazil to the U.S. and displayed in the Capitol rotunda where President Lincoln's body lay in state. According to Samuels, when he returned to Rome, the Pope granted him a pension. **Sources:** G&W; Thieme-Becker; Holmes, *Catalogue of the National Gallery of Art;* Fairman, *Art and Artists of the Capitol,* 76; Rutledge, PA; 7 Census (1850), Pa., Phila., p. 893 (note: G&W thought it possible that the Rowland Petrich, 52, sculptor, listed in this Philadelphia census might be Ferdinand Pettrich); *Antiques* (Aug. 1948), 100 (repro.). More recently, see Craven, *Sculpture in America,* 68-69; McMahan, *Artists of Washington, D.C.;* P&H Samuels, 371.

PETTY, George *[Illustrator, cartoonist]*
b.1894 / d.1975.
Addresses: NYC. **Studied:** Académie Julian, Paris with J.P. Laurens, 1914. **Comments:** Contributor: *Esquire,* 1939. **Sources:** WW40.

PETTY

PETTY, Jessie W. *[Painter, etcher, teacher] 20th c.;*
b.Navasota, TX.
Addresses: San Antonio, TX/Douglas, AZ. **Studied:** Arpa; Gonzalez; de Young; Piazzoni. **Member:** SSAL; San Antonio AL; Palette and Chisel Club; Texas FA. **Sources:** WW33.

PETTY, Mary *[Illustrator, cartoonist]*
b.1899, Hampton, NJ / d.1976, Paramus, NJ.
Addresses: NYC, 1929. **Studied:** self-taught. **Exhibited:** Salons of Am., 1929; S. Indp. A., 1929; Cincinnati AM, 1940; Syracuse Univ., 1979. **Comments:** Contributor, covers, *New Yorker,* 1927-76. also appears a Mrs. Alan Cantwell Dunn. **Sources:** Marlor, *Salons of Am.;* Petteys, *Dictionary of Women Artists.*

Mary Petty

PETZOLD, Adolph *[Painter] 20th c.*
Addresses: Philadelphia, PA. **Sources:** WW15.

PEUGEOT, George I(ra) *[Painter, craftsperson] b.1869, Buffalo.*
Addresses: Buffalo, NY. **Studied:** P. Gowans. **Member:** Buffalo SA. **Sources:** WW29.

PEVSNER, Naum Nemia See: **GABO, Naum**

PEW, Gertrude L. (Mrs. Frederic G. Robinson)
[Miniature painter] b.1876, Niles, OH.
Addresses: NYC. **Studied:** E. Carlsen; L. Simon; Menard. **Exhibited:** PAFA, 1925. **Work:** War Dept., Wash., DC. **Sources:** WW40.

PEW, James *[Engraver] b.1822, England.*
Addresses: New Orleans, 1850. **Comments:** Listed as living in the Charity Hospital of Orleans Parish (LA), in December 1850. **Sources:** G&W; 7 Census (1850), La., IV, 719; *Encyclopaedia of New Orleans Artists.*

PEW, Susan (Margaret) *[Painter] mid 20th c.*
Exhibited: Salons of Am., 1934. **Sources:** Marlor, *Salons of Am.*

PEYRAUD, Elizabeth K. (Mrs. F. C.) *[Painter, illustrator]*
early 20th c.; b.Carbondale, IL.
Addresses: Highland Park, IL. **Studied:** AIC; F.C. Peyraud. **Member:** Chicago P&S; Chicago WCC; Cordon Club; Chicago Gal. Assn. **Exhibited:** AIC, 1900-28; Pan-Pac. Expo, San Francisco, 1915. **Sources:** WW33; Petteys, *Dictionary of Women Artists.*

PEYRAUD, Frank Charles *[Painter] b.1858, Bulle, Switzerland. / d.1948.*
Addresses: Highland Park, IL. **Studied:** AIC; École de Beaux-Arts, Paris; Bonnât; Friburg. **Member:** Chicago P&S; Chicago WCC; NAC. **Exhibited:** AIC, 1890 (prize), 1921 (prize); NAD, 1892; PAFA Ann., 1898, 1911-15, 1921-27; Corcoran Gal. biennial, 1910; Pan-Pacific Expo, San Fran, 1915 (medal); Hamilton Cl., Chicago, 1920 (medal); Chicago P&S, 1935 (gold); Chicago SA (prize). **Work:** Union Lg. Cl., Chicago; AIC; fresco, Peoria Pub. Lib.; Munic. Art Coll., Phoenix, AZ; Friends Am. Art, Chicago; Mus., Bulle, Switzerland. **Sources:** WW40; Falk, *Exh. Record Series.*

PEYTON, Alfred Conway *[Painter, illustrator, etcher]*
b.1875, Dera Doon, British India / d.1936, Gloucester, MA?.
Addresses: Came to U. S. c.1906, settled in Chicago; NYC, c. 1917-24; Gloucester, MA, 1924-36. **Studied:** South Kensington Sch., London, England. **Member:** AWCS; NYWCC; North Shore AA. **Exhibited:** Bombay (medal); Madras (medal); AIC, 1911-29; S. Indp. A., 1917; Corcoran Gal biennial, 1930. **Work:** Coll. Friends of Art. **Comments:** Married artist Bertha Menzler Peyton. Illustrator: magazines in England, U.S. **Sources:** WW32.

PEYTON, Ann Douglas Moon (Mrs. Philip B.) *[Painter, illustrator] b.1891, Charlottesville, VA.*
Addresses: Phila., PA. **Studied:** G. Bellows; R. Henri; W.M. Chase. **Member:** Richmond AC. **Sources:** WW25.

PEYTON, Bertha Sophia Menzler (Mrs. Alfred C.)
[Landscape and still-life painter, teacher, writer] b.1871, Chicago, IL / d.1947.
Addresses: Chicago, c. 1890-1912 (in Paris, 1896-96); NYC; 1912-24; Gloucester, MA, 1921-47. **Studied:** AIC (grad., 1893); Aman-Jean, Paris, until 1896; Collin & Merson, also in Paris. **Member:** North Shore AA (dir.); NAWPS; NYWCC; AWCS; Allied AA; SPNY; Grand Central AG. **Exhibited:** Paris Salon, 1895, 1896; AIC, 1895-1929 (name appears as Menzler, Dressler & Peyton); PAFA Ann., 1896-1913 (as Menzler), 1918-36 (as Peyton); NAWPS, 1926 (prize); Paris Salons, 1895-96 (as Bertha Menzler); Pan-Am. Expo, Buffalo, 1901; Corcoran Gal. biennials, 1910-27 (6 times); NAD, 1913-18; Pan.-Pac. Expo, San Fran., 1915; Detroit IA; Macbeth Gal. & Grand Central Gal., NYC, after 1921; North Shore AA, 1930 (prize); CI; AWCS; Syracuse Mus. FA. **Work:** Union Lg. Cl., Chicago; Nike Cl., Klio Cl., West End Women's Cl., all in Chicago; Evanston Women's Cl.; BM; Chicago FA Bldg.; Addison Gilbert Hosp., Gloucester, MA; AFAA; BM. **Comments:** Born Bertha Sophia Menzler, she traveled out West and painted landscapes after her marriage to artist Edward Dressler. In 1903 her "San Francisco Peaks" was the first painting purchased by the Santa Fe Railroad for their collection (she was listed in their cat. as Bertha Dressler). After a divorce and a second marriage to artist Albert Peyton (c.1912), her name appears as Peyton and Menzler-Peyton. **Sources:** WW47; Fink, *American Art at the Nineteenth-Century Paris Salons,* 371; Pisano, *One Hundred Years.the National Association of Women Artists,* 71; Trenton, ed. *Independent Spirits,* 154; Falk, *Exhibition Record Series.*

PEYTON, Ida *[Painter, designer, photographer] b.New Orleans, LA / d.1898, New Orleans.*
Addresses: New Orleans, active 1884-98. **Studied:** Paris.
Exhibited: World's Industr. and Cotton Cennt. Exh., 1884-85.
Sources: *Encyclopaedia of New Orleans Artists,* 303.

PEZET, Alice (Mrs. A. Washington) See:
ARMSTRONG, Alice (Mrs. A. Washington Pezet)

PEZZA, Stephanie *[Painter] b.1864, Torino, Italy / d.1951, El Cerrito, CA.*
Addresses: San Fran.; El Cerrito. **Exhibited:** San Fran. AA, 1916. **Comments:** Position: owner, Roman School of Fine Arts, San Fran. Teaching: Grant School, El Cerrito, CA, after 1921. Also appears as Stefania Pezza Hendricks. **Sources:** Hughes, *Artists in California,* 436.

PEZZATI, Pietro (Peter) *[Painter] b.1902, Boston, MA.*
Addresses: Boston, MA. **Studied:** Child-Walker School Art; Charles Hopkinson; also in Europe. **Exhibited:** Corcoran Gal biennials, 1930-37 (3 times); PAFA Ann., 1930, 1932-33; WFNY, 1939. **Work:** Medical Sch. & Business School, Harvard Univ.; Sch. Medicine & School Educ., U.Penn; Mass. General Hosp.; Yale Sch. Medicine; Mass. Hist. Soc. **Comments:** Teaching: schools & private classes; also history of portraiture. **Sources:** WW73; WW40; Falk, *Exh. Record Series.*

PEZZOLI, Silvio, Sr. *[Painter]* *S. PEZZOLI.*
mid 20th c.
Exhibited: S. Indp. A., 1927-29;
Salons of Am., 1936. **Sources:** Marlor, *Salons of Am.*

PF, Ogwa *[Painter] mid 20th c.*
Exhibited: S. Indp. A., 1935. **Sources:** Marlor, *Soc. Indp. Artists.*

PFAFF, Ethel C. *[Painter] mid 20th c.*
Addresses: Manhasset, LI, NY, 1927. **Exhibited:** S. Indp. A., 1927. **Sources:** Marlor, *Soc. Indp. Artists.*

PFAFF, Judy *[Sculptor] b.1946.*
Addresses: Columbus, OH, 1975; NYC, 1987. **Exhibited:** WMAA, 1975, 1981, 1987. **Sources:** Falk, *WMAA.*

PFAHL, Charles Alton III *[Painter] b.1946, Akron, OH.*
Addresses: Brooklyn, NY. **Studied:** Robert Brackman, Madison, CT; John Koch, NYC; Jack Richard, Cuyahoga Falls, OH. **Member:** Salmagundi Cl.; Nat. Arts Cl.; Hudson Valley Artists. **Exhibited:** All. A. Ann., 1969-71, Am. WC Ann., 1970 & 1971 & Audubon Artists Ann., 1970-72, NAD; solo show, Harbor Gal., Long Island, NY, 1971; Butler Inst. Am. Art Ann., 1972. **Awards:** Green Shields grant, Canada, 1971; John F. & Anna Lee Stacy grant, 1972; Hudson Valley Gold Medal of Honor, 1972. **Comments:** Preferred media: pastels, oils. **Sources:** WW73.

PFALTZGRAF, R. *[Painter] 20th c.*
Addresses: Columbus, OH. **Member:** Pen and Pencil Club, Columbus. **Sources:** WW25.

PFAU, Gustavus *[Lithographer: topographical views and portraits] b.1808, Germany / d.1884, Springfield, IL.*
Addresses: Active in NYC and Boston, 1848-51. **Studied:** Germany. **Comments:** Worked at the Royal Art Gallery in Dresden before emigrating to U.S. in 1838 as part of a group of German Lutherans (known as the Stephanites) seeking religious freedom. Settled with the group at Dresden, MO, and for the next 10 years he farmed and did some occassional sketching of the local landscape. In 1848 Pfau began working in NYC and Boston. In NYC he produced a battle scene for Sarony and Major and also did work for Nagel and Weingartner. In Boston he made views and portraits for Tappan and Bradford. Returned to Missouri in 1851 and appears to have given up his artistic activity, perhaps because of failing eyesight. **Sources:** G&W; 7 Census (1850), Mass., XXV, 88; *Album of American Battle Art,* pl. 64; Stokes, *Historical Prints,* 106; NYCD 1848-50. More recently, see Reps, 374; Pierce and Slautterback, 179-80.

PFEFFER, F. *[Landscape painter] mid 19th c.*
Addresses: NYC, 1848. **Exhibited:** American Institute, NYC

(1848: a view of Castle "Stoltzerfels," presumably in Germany). **Sources:** G&W; Am. Inst. Cat., 1848.

PFEIFER, Bodo *[Painter, sculptor] b.1936, Düsseldorf, Germany.*
Addresses: Vancouver, BC. **Studied:** Ecole des Beaux Artes, Montreal; Acad. Fine Arts, Hamburg, Germany; Vancouver School Art, BC (diploma). **Exhibited:** Canada 101, Edinburgh Int. Festival, 1968; Survey 1968, Montreal Mus. Fine Art, 1968; Can. Artist, Art Gal. Ontario, 1968; The New Art of Vancouver, Newport Harbour Art Mus., Seventh Biennial Exhib., Nat. Gal. Canada, Ottawa, 1968; The New Art of Vancouver, Newport Harbour Art Mus., 1969. **Awards:** Canadian Council grants, 1966-71; Can. Group Painters Award in Painting, 1967; award in painting, Survey 1968, Montreal Mus. Fine Art, 1968. **Work:** Vancouver Art Gal.; Nat Gal., Ottawa, Ont.; Art Gal. Ont, Toronto; Montreal Mus. Fine Art, PQ; Can. Coun., Ottawa, Ont. Commissions: mural, Dept. Transport, Ottawa, Vancouver Int. Airport, 1968; mural, McCarter Nairne & Partners, Architects for Moore's Off. Bldg., Vancouver, 1968. **Comments:** Teaching: sessional instr. painting & drawing, Univ. Calgary, 1971-. **Sources:** WW73; Thomas H. Garver, *The New Art of Vancouver* (Newport Harbour Art Mus., 1969); W. Townsend, "Canadian Art Today" *Studio Int.* (1970); "Artists of Pacific Canada," Nat. Film Bd. Can., 1971.

PFEIFER, Clara Maria See: **GARRETT, Clara Pfeifer (Mrs. Edmund A.)**

PFEIFER, Herman *[Painter, illustrator]* ⊞
b.1879, Milwaukee, WI / d.1931.
Addresses: NYC/Staten Island, NY. **Studied:** Royal Acad., Munich; Wilmington, DE, with H. Pyle (1903-04). **Member:** SI. **Exhibited:** Salons of Am., 1934. **Work:** SI. **Comments:** Illustrator: *Harper's, Century, McClure's, Ladies Home Journal, Good Housekeeping,* and other national magazines. He also did some advertising illustrations. **Sources:** WW40.

PFEIFFEN, Justus *[Painter] early 20th c.*
Addresses: NYC. **Exhibited:** PAFA Ann., 1910, 1913. **Sources:** WW15; Falk, *Exh. Record Series.*

PFEIFFER See: **VERHAEGEN & PEEIFFER**

PFEIFFER, Carl *[Painter] late 19th c.*
Addresses: NYC. **Exhibited:** NAD, 1870, 1875. **Work:**. **Sources:** Naylor, *NAD.*

PFEIFFER, Fritz *[Painter, teacher, lecturer] b.1889, Gettysburg, PA / d.1960.*
Addresses: Massillon, OH; Provincetown, MA. **Studied:** PAFA with Hugh Breckenridge, T. Anshutz; William M. Chase; Robert Henri; Académie Julian, Paris, 1907. **Member:** Provincetown AA (hon. v. pres., 1938-56); Artist and Writers U., Provincetown; Am. A. Cong.; AEA. **Exhibited:** PAFA Ann., 1924, 1933; Detroit IA, 1946 (solo); AIC; Harvard, 1940 (solo); Mich. State Normal Col., 1941 (solo); Newhouse Gal. (solo); solo: Gordon Beer Gal., Detroit, 1940, 1942, 1944; Boris Mirski Gal., Boston, 1944; Adams Gal., Buffalo; Hall of Fame, Miami, 1952; Wellons Gal., NY, 1955. **Work:** Springfield Mus. A;.Falmouth, Mass. Pub. Lib.; stage sets, Provincetown Town Hall. **Comments:** Position: instr., Albright A. Gal., Buffalo, N.Y., 1944-49. **Sources:** WW59; WW47; Falk, *Exh. Record Series.*

PFEIFFER, Grace *[Artist] mid 20th c.*
Exhibited: PAFA Ann., 1947. **Sources:** Falk, *Exh. Record Series.*

PFEIFFER, Heinrich *HARRY PFEIFFER*
Herman (Harry R.)
[Painter] b.1874, Hanover, PA / d.c.1960.
Addresses: St. Augustine, FL.; Provincetown, MA. **Studied:** ASL, with John Carlson; PAFA, with Hugh Breckenridge, Henry McCarter. **Exhibited:** PAFA Ann., 1920, 1926, 1932-37; Corcoran Gal biennial, 1926; AIC; S. Indp. A., 1922; Salons of Am., 1926, 1927. **Sources:** WW59; WW47; Falk, *Exh. Record Series.*

PFEIFFER, Homer F. *[Painter] mid 20th c.*
Exhibited: AIC, 1942. **Sources:** Falk, *AIC*.

PFEIFFER, Hope (Mrs. Fritz) See: **VOORHEES, Hope Hazard**

PFEIFFER, Jacob *[Lithographer] b.c.1816.*
Addresses: Philadelphia in 1850. **Sources:** G&W; 7 Census (1850), Pa., L, 627.

PFEIFFER (PFEIFER), Gordon E. *[Painter] mid 20th c.*
Addresses: Quebec, Canada. **Exhibited:** S. Indp. A., 1931, 1934, 1942; Salons of Am., 1934. **Sources:** Falk, *Exhibition Record Series*.

PFEIL, Adolph H. *[Watercolor painter] late 19th c.*
Addresses: Phila., PA. **Exhibited:** PAFA Ann., 1890-91.
Comments: *Cf.* G. H. Pfeil of Philadelphia. **Sources:** Falk, *Exh. Record Series*.

PFEIL, G. H. *[Painter] 20th c.*
Addresses: Phila., PA. **Comments:** *Cf.* Adolph H. Pfeil of Philadelphia. **Sources:** WW06.

PFENNINGER, Jacob *[Portrait painter] mid 19th c.*
Addresses: Cleveland, OH, 1857-59. **Sources:** G&W; Cleveland BD 1857; Ohio BD 1859.

PFETSCH, Carl P. *[Portrait and genre painter] b.1817, Blankenburg, Germany / d.1898, Indianapolis, IN.*
Addresses: Indianapolis, IN. **Exhibited:** NAD, 1852.
Comments: Came to U.S. soon after 1848, worked in NYC until c.1855. Traveled West, first to Cincinnati, Oh., then to New Albany, Ind., where he lived from 1856 to 1870. From 1870 until his death his home was at Indianapolis. **Sources:** G&W; Peat, *Pioneer Painters of Indiana* [as Fetsch]; NYBD 1850-55; Cowdrey, NAD. *Cf.* Charles Peetsch.

PFINGSTEN, Clara Ella *[Block printer, craftsperson, sculptor] b.1897, Elberfeld, Germany.*
Addresses: Westport, CT. **Studied:** H. Heath. **Comments:** Affiliated with Art Extension Press, Westport, Conn. **Sources:** WW40.

PFIRMAN, George *[Painter] b.1869.*
Addresses: Phila., PA. **Exhibited:** PAFA Ann., 1889-90. **Sources:** Falk, *Exh. Record Series*.

PFISTER, Grace Anna *[Miniature painter] b.1883, California / d.1969, Oakland, CA.*
Addresses: Oakland, CA. **Exhibited:** Oakland Art Gal., 1917. **Sources:** Hughes, *Artists in California*, 437.

PFISTER, Jean Jacques (Mr.) *[Painter, teacher, lecturer] b.1878, Basel, Switzerland / d.1949, NYC.*
Addresses: San Francisco, CA; NYC; Laguna Beach, CA; Coral Gables, FL. **Studied:** Hopkins Sch. FA; ASL; with Wayman Adams; Art Sch., Bremen, Germany. **Member:** AWCS; Laguna Beach AA; Carmel AA; New Rochelle AA; Palm Beach A. Lg.; NAC; SC; Blue Dome Fellowship. **Exhibited:** Golden Gate Park Memorial Mus., 1916; Gump's, San Francisco; S. Indp. A., 1925-26; Stendahl Gal., Los Angeles, 1930; Palm Beach AL, 1938 (prize), 1940 (prize); Miami, Fla., 1942 (prize). **Work:** Rollins Col., Winter Park, Fla.; Ohio Wesleyan Univ.; Vt. Hist. Mus., Old Bennington; Butterworth Hospital, Grand Rapids, Mich.; Normal Sch., Lander, Wyo.; Columbia Univ. Chapel; Palm Beach Women's C.; Elks Temple, Passaic, NJ; Montanans, Inc., Helena, Mont.; State T. Col., Lander, Wyo.; Knowles Mem. Chapel, Winter Park, Fla.; Christian Science Bldgs., WFNY (1939), GGE (1939). **Comments:** Teaching: assoc. prof., Rollins Col., 1932-, Miss Harris' Col. Prep. School, Coral Gables, FL, 1937-. Illustrator: American hist. textbooks. His best known work records the trans-Atlantic flight of Charles Lindbergh and has been reproduced in many publications. Some of his works relate to Bermuda. **Sources:** WW47; Hughes, *Artists in California*, 437.

PFLAGER, Dorothy Holloway (Mrs. Henry R.) *[Painter] b.1900, Los Angeles, CA.*
Addresses: St. Louis, MO. **Studied:** Wellesley Col. (B.A.); Washington Univ. (M.A.). **Member:** St. Louis A. Gld.; St. Louis Studio Group; AEA; NAWA;. **Exhibited:** BMA, 1942 (prize); Baltimore WCC, 1942; Loring Andrews Gal., Cincinnati, 1945; CAM, 1945, 1946; St. Louis AG, 1946, 1957 (solo); St. Louis 1944 (solo); 8th St. Gal., NY, 1951 (solo). **Sources:** WW59; WW47.

PFLAUMER, Paul Gottlieb, 2nd *[Painter, illustrator, craftsperson] b.1907, Phila.*
Addresses: Phila, PA. **Studied:** T. Oakley; L. Spizziri; J. Dull. **Member:** Phila. Alliance. **Sources:** WW40.

PFOHL, William F. *[Painter] 20th c.*
Addresses: Winston-Salem, NC. **Work:** WPA mural, USPO, Wilmington, NC. **Sources:** WW40.

PFOTZER, Edmond *[Painter] late 19th c.*
Addresses: Phila., PA. **Exhibited:** PAFA Ann., 1891. **Sources:** Falk, *Exh. Record Series*.

PFRIEM, Bernard A. *[Painter, teacher, designer] b.1914, Cleveland, OH.*
Addresses: NYC. **Studied:** John Huntington Polytech Inst., 1934-36; Cleveland Inst. Art, 1936-40; Europ. study, 1950-52. **Exhibited:** AIC; CI, 1942; CMA, 1938-40, 1943; Butler AI, 1939-40; Western Reserve Univ., 1940 (prize); six shows, Iolas Gal., NY, 1949-63; WMAA, 1952 & 1965; retrospective, Cleveland Inst. Art, 1963; Richard Feigen Gal., Chicago, Ill., 1967; also in France, Ger. & Italy Awards: Mary Ranney traveling scholar, Western Reserve Univ.; Copley Award painting, 1959; prize drawing, Norfolk Mus. Arts & Sci. **Work:** MoMA; Chase Manhattan Bank, NY; Dorado Beach Hotel, PR; Columbia Banking, Savings & Loan Assn., Rochester, NY; MMA. Commissions: murals, Guerrero & Mexico City, Mex. **Comments:** Positions: dir., studio arts sessions in Southern France for Sarah Lawrence Col. Teaching: instr. drawing & painting, Peoples Art Ctr., MoMA, 1946-51; instr. drawing, Cooper Union Sch. Art & Archit.; instr. Silvermine Col. Art, New Canaan, CT; instr. Sarah Lawrence Col., 1969-70. **Sources:** WW73; Patrick Waldberg, *Bernard Pfriem*, monogr. (William & Noma Copley Found., 1961 & *Main et Marvielles*, Mercure, France, 1961; Patricia Allen Dreyfus, "The Inward Journey," monogr., *Am. Artist* (Sept., 1972).

PHAIR, Ruthe (Mrs. Harold) *[Painter] b.1898, Buffalo, NY.*
Addresses: Spokane, WA. **Studied:** Spokane Art Center. **Exhibited:** SAM, 1934; PAM, 1935; Spokane Art Center, 1935. **Sources:** Trip and Cook, *Washington State Art and Artists*.

PHALAN, Charles T. See: **PHELAN, Charles T.**

PHARES, Frank *[Painter] 20th c.*
Addresses: MT Holly, NJ. **Studied:** PAFA. **Sources:** WW25.

PHARR, Mr & Mrs Walter Nelson *[Collectors] mid 20th c.; b.Greenwood, Miss; Detroit, MI.*
Addresses: NYC. **Studied:** Mr. Pharr, Washington & Lee Univ.; Mrs. Pharr, Garland Jr. Col., Boston, Mass. **Comments:** Born in 1906 and 1923 respectively. Collection: International modern art; marine paintings including 18 by J. E. Butterworth, others by R. Salmon & T. Birch. **Sources:** WW73.

PHELAN, Charles T. *[Landscape painter] b.1840, NYC.*
Exhibited: Brooklyn AA, 1879 (views of White Mountains, NH), 1882; NAD, 1880-82. **Sources:** G&W; Champlin and Perkins.

PHELAN, Elizabeth *[Painter] mid 20th c.*
Addresses: St. Louis, MO. **Exhibited:** PAFA Ann., 1951, 1953-54. **Sources:** Falk, *Exh. Record Series*.

PHELAN, Harold L(eo) *[Painter, teacher] b.1881, NYC.*
Addresses: NYC. **Studied:** H.W. Ranger; ASL; Académie Julian, Paris, 1902-03. **Exhibited:** S. Indp. A., 1917; Salons of Am., 1925, 1929, 1931, 1934. **Sources:** WW25.

PHELAN, Linn Lovejoy *[Designer, educator, lecturer]*
b.1906, Rochester, NY / d.1992.
Addresses: Alfred/Almond, NY. **Studied:** Rochester Inst.
Technol. (dipl., 1928); Ohio State Univ. (B.F.A., ceramic art,
1932); Alfred Univ. (M.S., educ., 1955); L.S. Backus; A.E. Baggs;
F. Payant; F. Trautman. **Member:** N.H.Lg. A. & Cr.; Maine Craft
Gld. **Exhibited:** Phila A. All., 1937-42, 1945-46; Syracuse MFA,
1932-36; NY S. Ceramic A., 1934, 1936; N Y Decorators C.,
1938; WMA, 1943; Rochester Mem. A. Gal., 1928-58; Bangor
(Maine) SA, 1939-40; Boston SAC, 1938; Wichita AA, 1946;
Dartmouth, 1945; Everson Mus., Syracuse, NY, 1932-50;
Albright-Knox Mus, Buffalo, NY, 1951; York State Craftsman,
Ithaca Col., NY, 1954-71; NY State Fair, Syracuse, 1960-70.
Work: Cranbook Acad. A.; Dartmouth; mem., YWCA, Lewiston,
Maine. **Comments:** Preferred media: ceramics. Contributor:
Design Craft Horizons. Positions: owner, Linwood Pottery, Saco,
Maine, 1940-43; mgr. fair, York State Craftsmen, Inc, 1957-59;
exec. comt., NY State Art Teachers, Albany, 1958-61, pres., 1960-
61. Teaching: instr. pottery, Sch. Am. Craftsman, 1944-50; instr.
art, Alfred-Almond Cent. Sch., 1950-67; lectr. art, State Univ. NY
Col. Ceramics, Alfred Univ., 1967-. **Sources:** WW73; WW47.

PHELIPS, Emily Bancroft (Mrs.) *[Painter]* b.1869,
England.
Addresses: Kimmswick, MO. **Studied:** St. Louis Sch. FA; H.
Breckenridge. **Member:** Artists Guild. **Exhibited:** Portland (OR)
Expo, 1905 (hon. men.); Sedalia, MO, 1913 (gold), 1918 (gold).
Sources: WW31.

PHELPS, Adele C. *[Painter]* b.1866, Lockport, NY / d.1945,
Los Angeles, CA.
Addresses: Laguna Beach, CA. **Sources:** WW25; Hughes,
Artists in California, 437.

PHELPS, Albert Carruthers *[Sketch artist, cartoonist,
painter, writer]* b.1875, New Orleans, LA / d.1912, New
Orleans.
Addresses: New Orleans, c.1897-1912. **Member:** Tulane Sketch
Cl.; Artist's Assoc. of N.O., 1897; Arts Exhibition Cl., 1901.
Comments: Pos.: editor, New Orleans Item, 1907-12 (also contr.
cartoons and illustrations). His drawings and watercolors date
from the early 1900 and possibly as early as 1897. **Sources:**
Encyclopaedia of New Orleans Artists, 303.

PHELPS, Dorothy *[Painter]* 20th c.
Addresses: Highland Park, IL. **Sources:** WW27.

PHELPS, E. *[Engraver]* mid 19th c.
Addresses: Northampton, MA, 1849-56. **Sources:** G&W; New
England BD 1849, 1856.

PHELPS, Edith Catlin (Mrs. Stowe) *[Painter, etcher]*
b.1875, NYC / d.1961, Santa Barbara, CA.
Addresses: Connecticut; NYC; Providencetown, MA; Santa
Barbara, CA. **Studied:** Charles Hawthorne; William M. Chase;
Académie Julian, Paris. **Member:** CAFA; All. A. Am.; Santa
Barbara AA; San Diego FAS. **Exhibited:** S. Indp. A., 1925;
Salons of Am., 1925, 1926; Corcoran Gal biennial, 1921; PAFA
Ann., 1924-25; AIC; GGE 1939; LACMA; San Diego FAS, 1938
(prize); Sacramento State Fair, 1938 (prize), 1941 (prize);
Oakland Art Gal.; Santa Cruz AL, 1935; Santa Barbara Mus. Art,
1945 (solo); CAFA (prize); Madonna Festival, Los Angeles, 1951
(prize), 1956 (prize). **Work:** NYC Court House; Wilshire
Presbyterian Church. **Sources:** WW59; WW47. More recently,
see Hughes, *Artists in California,* 437; Petteys, *Dictionary of
Women Artists,* cites alternate birth date of 1879; Falk, *Exh.
Record Series.*

PHELPS, Edwin Forman *[Painter, sketch artist]* b.1796,
Aurora, NY / d.1863, Chadron, OH.
Addresses: New Orleans, active 1822-26; Chadron, OH c.1830s
and after. **Comments:** Itinerant portrait and miniature painter
whose family came from New York State to the Western Reserve.
He traveled down the Mississippi River to N. O. on two painting
and sketching expeditions, the first from KY (1822-23) and the

second from OH (1825-26). It is believed that he worked with
John James Audubon (see entry) and William Bamborough during
his visits to the South. By 1850/60 he had become a farmer.
Sources: *Encyclopaedia of New Orleans Artists,* 303; Hageman,
121.

PHELPS, Helen Watson *[Painter]* b.1864, Attleboro, MA /
d.1944.
Addresses: Providence, RI, 1886-on; NYC, 1899-1906, and
c.1930s-on). **Studied:** Académie Julian, Paris with Collin, T.R.-
Fleury, Bouguereau, Giacomotti, and Deschamps, 1884-86.
Member: NAWPS; Providence AC; SPNY; Yonkers AA; Newport
AA; PBC; NAC. **Exhibited:** Paris Salon, 1886; Soc. Am. Artists,
1898; Boston AC, 1888-1908; NAD, 1892-95; PAFA Ann., 1899,
1906; Pan-Am. Expo, Buffalo, 1901 (prize); NY Women's AC,
1907 (prize), 1909 (prize); Corcoran Gal annual/biennial, 1907,
1910; NAWPS, 1914 (prize), 1915 (prize); AIC. **Work:** NGA;
RISD; NAC. **Comments:** She painted portraits of elegant society
notables as well as immigrant children and European fisherfolk.
Sources: WW40; C. Bert, *Sketches* (Providence, No.2, Dec.
1991); Fink, *American Art at the Nineteenth-Century Paris
Salons,* 380; Petteys, *Dictionary of Women Artists,* cites alternate
birth date of 1859; Falk, *Exh. Record Series.*

PHELPS, Julia M. *[Painter]* mid 20th c.
Addresses: NYC, 1934. **Studied:** ASL. **Exhibited:** S. Indp. A.,
1934. **Sources:** Marlor, *Soc. Indp. Artists.*

PHELPS, Katherine Elisabeth *[Painter]* late 19th c.; b.New
York.
Exhibited: SNBA, 1898-99. **Sources:** Fink, *American Art at the
Nineteenth-Century Paris Salons,* 380.

PHELPS, Mary C. (Mrs. Wm. M.) *[Painter]* b.c.1833 /
d.1899.
Addresses: Detroit, MI, 1890s. **Member:** Detroit WC Soc.
Exhibited: Detroit WC Soc., 1895. **Sources:** Gibson, *Artists of
Early Michigan,* 195.

PHELPS, Nan Dee *[Painter, photographer]* b.London, KY /
d.1990.
Addresses: Hamilton, OH. **Studied:** self-taught; scholar to
Cincinnati AM. **Exhibited:** All-American Fine Art Show,
Cincinnati, Ohio; Cincinnati AM, 1942-56. Awards: first place,
Ford Motor Co., 1960; first place mag. cover, Kiwanis Cl.,
Cincinnati, Ohio, 1960; award from Greater Hamilton A. Cl.
Work: The Henry Ford Coll., Dearborn, Mich.; Chamber of
Commerce, Pulaski, Va; also in pvt. collections. Commissions:
Water Along Autumn Path, Emanuel Baptist Church, Hamilton,
Ohio, 1948; The Coming of the Lord, First Church of God,
Middletown, Ohio, 1949; Sunset on Water, First Church of God,
New Miami, Ohio; Country Scenery, Mr. & Mrs. Steve
Derdourski, Gary, Ind., 1952; The Shepherd & Sheep, Orphanage,
Trinidad Island, 1965. **Comments:** Preferred media: oils.
Publications: auth., "Self-Taught Artist," *Ford Times News* (1958);
auth., "Christmas Shopping Through the Windshield," 1972-73.
Sources: WW73; Della Hicks, *Never, Never Land.*

PHELPS, Pauline Elizabeth *[Painter, sculptor]* b.1906,
Independence, IA.
Addresses: Newton, IA. **Studied:** Iowa State Teachers Col.;
Ferguson Practical Art School; Stone City Art Colony; Otis Art
Inst. **Exhibited:** Iowa Art Salon, 1932 (hon. men.); Iowa Artists
Cl., 1933. **Comments:** Position: art supervisor, Streator (IL)
Elementary Schools. **Sources:** Ness & Orwig, *Iowa Artists of the
First Hundred Years,* 167.

PHELPS, R. S. *[Painter]* mid 20th c.
Addresses: NYC, 1932. **Exhibited:** S. Indp. A., 1932. **Sources:**
Marlor, *Soc. Indp. Artists.*

PHELPS, S. L. *[Painter]* late 19th c.
Addresses: NYC. **Exhibited:** NAD, 1879. **Sources:** Naylor,
NAD.

PHELPS, Sophia Throop *[Painter]* b.1875, Chicago.
Addresses: Chicago, IL. **Studied:** AIC. **Exhibited:** AIC, 1897.

Sources: WW01.

PHELPS, W(illiam) P(reston)
[Painter] b.1848, Dublin, NH / d.1923, Chesham, NH. *W.P Phelps*
Addresses: Lowell, MA, c.1882-89; Chesham, NH, 1889-on. **Studied:** Lowell; Boston; with Velten, Meissner, and Barth in Munich, 1875-78; Paris, 1879. **Exhibited:** Boston AC, 1878, 1884; NAD, 1878, 1880; Int'l Exh. at Glass Place, Munich. **Work:** Keene (NH) Pub. Lib.; New Hampshire Hist. Soc.; Shelburne (VT) Mus.; priv. colls. **Comments:** Phelps was known for his landscapes of the Merrimack River valley around Lowell, the New England coast. However, he ventured West in 1886, painting a 7' x 12' mural on site at the Grand Canyon (location unknown). After moving to New Hampshire, he became well-known for his landscapes of the region around Mount Monadnock. **Sources:** WW17; Campbell, *New Hampshire Scenery*, 127-28; Muller, *Paintings and Drawings at the Shelburne Museum*, 102 (w/repro.); *300 Years of American Art*, vol. 1, 430.

PHILASTRE, Eugene *[Painter, decorator] b.1828, Paris, France / d.1886, New Orleans, LA.*
Addresses: New Orleans, active 1871-85. **Comments:** Scenic and fresco painter who decorated several hotels, restaurants and private residences in New Orleans. **Sources:** *Encyclopaedia of New Orleans Artists*, 304.

PHILBIN, Clara *[Sculptor] early 20th c.*
Addresses: Cincinnati, OH. **Studied:** Cincinnati Art Acad., 1897-1908. **Member:** Cincinnati Woman's AC. **Exhibited:** PAFA Ann., 1908-09, 1911; NSS. **Sources:** WW27; Petteys, *Dictionary of Women Artists*; Falk, *Exh. Record Series.*

PHILBRICK, Allen Erskine *Allen Philbrick*
[Painter, etcher, engraver, educator, lecturer, teacher] b.1879, Utica, NY / d.1964, Alexandria, VA.
Addresses: Winnetka, IL. **Studied:** AIC; Académie Julian, Paris with J.P. Laurens, 1904; Ecole des Beaux-Arts. **Member:** affiliated with AIC, 1940; Chicago SE; Chicago PS. **Exhibited:** NAD, 1942-46; LOC, 1942-44, 1946; AIC, 1922 (prize)-23 (prize); Evanston Women's C., 1937 (prize); Chicago Soc. Etchers, 1953 (prize). **Work:** murals, Juvenile Court, Chicago, Ill.; People's Trust & Savings Bank, Cedar Rapids, Iowa; portrait, Iowa State Hist. Mus.; Lake View H. S., Chicago; Univ. Iowa. **Sources:** WW59; WW47.

PHILBRICK, Elisabeth A. *[Painter] mid 20th c.*
Addresses: Boston, MA. **Exhibited:** PAFA Ann., 1941-42. **Sources:** Falk, *Exh. Record Series.*

PHILBRICK, Jane W. *[Painter, teacher] b.1911, Chicago, IL.*
Addresses: Winnetka, IL/Wiscasset, ME. **Studied:** AIC. **Member:** Wis. Fed. Ar. **Exhibited:** AIC, 1937; Milwaukee AI, Wiscasset AG. **Comments:** Position: t., Milwaukee-Downer Col. **Sources:** WW40.

PHILBRICK, Margaret Elder *[Printmaker, painter] b.1914, Northampton, MA.*
Addresses: Westwood, MA. **Studied:** Mass. Col. Art (grad.); De Cordova Mus. Workshop, with Donald Stoltenberg. **Member:** SAE; Chicago SE; Boston Printmakers (exec. bd., 1972); Boston WC Soc.; Soc. Am. Graphic Artists; NAD; Am. Color Print Soc. **Exhibited:** SAE, annually; Chicago SE, annually; NAD, 1944, 1946; Northwest PM, 1946; Albany Pr. C., 1945; Buffalo Pr. C., 1940, 1943; LOC, 1944-45; CI, 1944 ; US Info. Agency Serv. Exhib. to Far East, 1958-59; Second Int. Miniature Print Exhib., Pratt Graphic Art Ctr., NYC, 1966; Boston Printmakers 23rd Nat. Exhib., De Cordova Mus., Lincoln, Mass., 1971; Soc. Am. Graphic Artists 51st Nat., Kennedy Gals., NYC, 1971; Margaret Philbrick--A Retrospective Exhib., Ainsworth Gal., Boston, 1972; Westwood Gallery, Westwood, MA, 1970s. **Awards:** Carl Zigrosser Multum in Parvo Award, Pratt Graphic Art Ctr., 1966; Alice Standish Buel Mem. purchase award, Soc. Am. Graphic

Artists, 1971; John Taylor Arms Mem. Prize, NAD, 1972. **Work:** LOC; Wiggin Coll., Boston Pub. Libr., Mass.; Nat. Bezalel Mus., Jerusalem; First Nat. Bank, Boston; New Britain Mus., Conn. **Comments:** Preferred media: intaglio, mixed media. Publications: illusr., "On Gardening," 1964 & illusr., "In Praise of Vegetables," 1966,*Scribners;* illusr., "Natural Flower Arrangements," Doubleday, 1972; illusr., "West Dedham & Westwood 300 Years," 1972. **Sources:** WW73; WW47.

PHILBRICK, Mary *[Painter] 19th/20th c.*
Addresses: Grundman Studios, Boston, MA. **Exhibited:** Boston AC, 1900. **Sources:** WW01.

PHILBRICK, Otis W. *[Painter, printmaker] b.1888, Mattapan, MA / d.1973, Westwood, MA?.*
Addresses: Westwood, MA. **Studied:** Mass. Sch. Art, Boston. **Member:** Boston Soc. WC Painters; Soc. Am. Graphic Artists; Boston Printmakers (pres.); Copley Soc. **Exhibited:** PAFA Ann., 1918, 1925, 1928; Corcoran Gal. biennial, 1928; NMAA, 1946 (solo); NAD, 1943-44, 1946; Albany Pr. C., 1945; Buffalo Pr. C., 1940, 1943; LOC, 1943-46; CI, 1944-45; Jordan Marsh Gal, 1963 (prize).; Boston WC Soc. Ann.; Cambridge Art Assn., 1954 (prize), 1959 (prize); Boston Art Festival, 1953-55, 1958, 1961; Am. Exhibs. in France, Israel, Italy & Eng.; US State Dept. traveling exhib., Far East; AIC; Mohawk Paper Co. purchase award, 1963. **Work:** BPL; LOC; Bezalel Mus., Jerusalem; Amherst Col.; Fogg Mus. Art. **Comments:** Teaching: Mass. College of Art. **Sources:** WW73; WW47; Falk, *Exh. Record Series.*

PHILBRICK, Stacey *[Painter] early 20th c.*
Work: Anschutz Collection. **Comments:** Painter of "Grand Canyon," 1915. **Sources:** P&H Samuels, 371 (illus. 225).

PHILBROOK, E. Ada *[Painter] late 19th c.; b.Boston, MA.*
Studied: A. Herst. **Exhibited:** Paris Salon, 1870. **Comments:** Exhibited a drawing at the Paris Salon. **Sources:** Fink, *American Art at the Nineteenth-Century Paris Salons*, 380.

PHILBROOK, Emily H. *[Painter] mid 20th c.*
Addresses: Laguna Beach, CA. **Exhibited:** Artists Fiesta, Los Angeles, 1931. **Sources:** Hughes, *Artists in California*, 437.

PHILIP, Elsie Harvey (Mrs.) *[Painter] b.1893, New Jersey.*
Exhibited: S. Indp. A., 1937. **Sources:** Marlor, *Soc. Indp. Artists.*

PHILIP, Frederick William *[Portrait, landscape, and figurative painter] b.1814, Brooklyn, NY / d.1841, Brooklyn, NY.*
Addresses: NYC. **Studied:** Europe, 1833. **Member:** ANA, 1833. **Exhibited:** American Academy , 1833; NAD, 1833, 1840; Apollo Assoc., 1840. **Sources:** G&W; Thieme-Becker; Cummings, *Historic Annals*, 168; NYBD 1840; Cowdrey, NAD; Cowdrey, AA & AAU; BAI, courtesy Dr. Clark S. Marlor.

PHILIP, Helen *[Portrait and landscape painter] 19th/20th c.*
Addresses: San Francisco, CA, 1880s. **Exhibited:** San Francisco AA, 1885, 1887. **Sources:** Hughes, *Artists in California*, 437.

PHILIP, William H. *[Portrait sculptor] mid 19th c.*
Addresses: NYC, 1858-59. **Exhibited:** Brooklyn AA, 1869. **Sources:** G&W; NYCD 1858-59; NYBD 1858.

PHILIPP, Jane Peterson (Mrs. M. Bernard) See: **PETERSON, Jane (Jeanne)**

PHILIPP, Robert *[Painter] b.1895, NYC / d.1981, NYC.* *Philipp*
Addresses: NYC. **Studied:** ASL with F.V. DuMond & G. Bridgman, 1910-14; NAD with Volk & Maynard, 1914-17. **Member:** ANA, 1934; NA, 1945; Lotos C., 1945; Intl. Soc. AL, 1959; Benjamin Franklin fel. Royal Soc. Art London, 1965. **Exhibited:** NAD, 1922 (prize), 1947 (prize), 1951 (prize); Corcoran Gal biennials, 1923-53 (11 times, incl. silver med., 1939); PAFA Ann., 1923-58; AIC, 1936 (med.); CI, 1937 (prize); WMAA, 1937; All. A. Am., 1958 (bronze med.); AWCS, 1967 (W.C. Osborne Award). **Work:** WMAA; MMA; BM; Houston MFA; Dallas Mus.; High Mus., Atlanta; CGA; Norton Gal. Art; Columbus MFA; Univ. of Ill., Urbana. **Comments:** Finding success and recognition early on in his career, he painted portraits of

celebrities, also landscapes and nudes. Married to Shelley Post, he often used her as a model. Teaching: Univ. Ill., 1940; High Mus. Art, 1946; ASL. **Sources:** WW73; *300 Years of American Art,* 866; Falk, *Exh. Record Series.*

PHILIPP, Werner *[Painter, mural painter] b.1897, Breslau, Germany / d.1982, San Francisco, CA.*
Addresses: San Francisco, CA. **Studied:** Academy of FA, Berlin; with Oskar Kokoschka in Dresden; Yves Brayer in Paris. **Exhibited:** GGE, 1939; Oakland Art Mus. (solo); SFMA (solo); Corcoran Gal biennial, 1941; de Young Mus., 1943 (solo); Calif. State Fair, 1949 (prize); Arizona State Fair, 1949 (prize), 1950 (prize); CPLH, 1965 (solo); West Berlin, Germany, c.1971 (retrospective). **Work:** Mural: Temple House of Congregation Beth Sholom, San Francisco. **Sources:** Hughes, *Artists in California,* 437.

PHILIPPOTEAUX, Paul Dominick *[Historical and genre painter] mid 19th c.; b.France.*
Addresses: Active New Orleans, c.1848-?. **Comments:** Listed by Groce & Wallace as coming to Louisiana not long after the French Revolution of 1848. In February 1850 his "Proclamation of the French Republic" was shown in New Orleans. A cotton-picking scene painted before the Civil War is also known. There was a Paul Dominique Philippoteaux (1846-1923, see entry) active in New Orleans in 1885. **Sources:** G&W; New Orleans *Daily Picayune,* Feb. 5, 1850; *Antiques* (April 1944), 161 (repro.).

PHILIPPOTEAUX, Paul Dominique *[History painter] b.1846, Paris, France / d.1923, Paris, France.*
Addresses: Active New Orleans 1885; possibly in NYC in 1891. **Studied:** with his father Félix Emmanuel Philippoteaux; Cabanel and Léon Cogniet, c.1862; Ecole des Beaux Arts, Paris. **Exhibited:** Paris Salon, 1866-67; NAD, 1891. **Work:** "Battle of Gettysburg," Gettysburg (PA) National Military History Park. **Comments:** French painter who traveled to New Orleans in 1885 in order to marry Marie Bechet. While in the U.S. he painted a panorama of Niagara Falls, a cyclorama of the Battle of Gettysburg (which traveled to Chicago), and a diorama of the life of Ulysses S. Grant. In 1891, he exhibited a painting at the NAD and gave a NYC address. There was a Paul Dominick Philippoteaux (see entry) active in New Orleans in 1848-50. Whether they were related is not known. **Sources:** *Encyclopaedia of New Orleans Artists,* 304; Gerdts, *Art Across America,* vol. 2: 301; Naylor, *NAD.*

PHILIPS *[Portrait painter] mid 19th c.*
Comments: Known as painter of a portrait of Anna Noxon, September 1837. *Cf.* Ammi Phillips. **Sources:** G&W; Sherman, "Unrecorded Early American Painters" (1934), 149.

PHILIPS, Charles See: **PHILLIPS, Charles**

PHILIPS, Emily (Mrs.) *[Painter] 20th c.*
Addresses: St. Louis, MO. **Member:** St. Louis AG. **Sources:** WW25.

PHILIPS, Katherine Elizabeth *[Painter] 19th/20th c.; b.NYC.*
Addresses: Paris, France, 1900-03. **Exhibited:** Salon de la Soc. Nat. des Beaux-Arts, Paris, 1898. **Sources:** WW01; Petteys, *Dictionary of Women Artists.*

PHILIPSE, Margaret Gouverneur *[Painter] 19th/20th c.*
Addresses: NYC. **Exhibited:** AWCS, 1898. **Sources:** WW01; Petteys, *Dictionary of Women Artists.*

PHILIPSE, Mary *[Amateur artist] b.1730, Philipse Manor, NY / d.1825, Yorkshire, England.*
Work: her self-portrait hangs in the Octagon Room of the Morris-Jumel Mansion, NYC. **Comments:** Married Roger Morris of NYC in 1765. For ten years they lived in what is now known as the Morris-Jumel Mansion in NYC (the oldest residence in Manhattan). During the Revolution they emigrated to England and settled in Yorkshire. **Sources:** G&W; *Antiques* (March 1951), 217 (repro.); DAB under Roger Morris.

PHILLENE, Ferdinand J. *[Engraver] b.c.1834, Jamaica.*
Addresses: Philadelphia in 1860. **Sources:** G&W; 8 Census (1860), Pa., LII, 87.

PHILLIBROWNE, Thomas *[Engraver] mid 19th c.; b.London.*
Exhibited: American Institute, 1856. **Comments:** Working in London in the 1830's. Came to the U.S. before 1851 when he engraved a portrait of Kossuth for a Boston firm. Active in NYC from 1856. **Sources:** G&W; Stauffer; NYCD 1856-60; Am. Inst. Cat., 1856.

PHILLING, Irving *[Painter] mid 20th c.*
Exhibited: Salons of Am., 1934. **Sources:** Marlor, *Salons of Am.*

PHILLIPP, Robert *[Painter] b.1895, NYC / d.1981, NYC.*
Addresses: NYC. **Exhibited:** AIC, 1923, 1932-45 (prize, 1936). **Sources:** Marlor, *Salons of Am.*

PHILLIPS *[Portrait painter] mid 19th c.*
Comments: Groce & Wallace listed this artist as the painter of likenesses of a number of members of the Ten Broeck family of New York State between 1832 and 1834. This may be Ammi Phillips. **Sources:** G&W; Runk, *Ten Broeck Genealogy,* 112, 155, 187, 189-90; WPA (Mass.), *Portraits Found in New York.*

PHILLIPS, A. G. *[Painter] early 20th c.*
Addresses: Phila., PA. **Exhibited:** PAFA Ann., 1917. **Sources:** Falk, *Exh. Record Series.*

PHILLIPS, Abraham *[Etcher] 20th c.*
Addresses: NYC. **Sources:** WW27.

PHILLIPS, Abram *[Painter] b.1896.*
Addresses: Brooklyn, NY. **Exhibited:** S. Indp. A., 1931; PAFA Ann., 1932. **Comments:** *C.f.* Abraham. **Sources:** Falk, *Exh. Record Series.*

PHILLIPS, Agda *[Painter] 20th c.*
Addresses: Excelsior, MN. **Sources:** WW24.

PHILLIPS, Ammi *[Itinerant portrait painter] b.1788, Colebrook, CT / d.1865, Curtisville (now Interlaken), MA.*
Studied: self-taught. **Work:** Fogg Art Mus., Harvard Univ.; Princeton Univ.; Conn. Hist. Soc., Hartford; Shelburne (VT) Mus.; Rockefeller Folk Art Cntr., Williamsburg, VA; Albany Inst.; AIC; Berkshire Mus., Pittsfield, MA; MMA; Senate House, Kingston, NY. **Comments:** Son of Samuel and Milla Phillips of Colebrook, CT. His earliest known work dates from 1811. Some of his work had been previously identified as the work of two artists known as the Border Limner and the Kent Limner. However, in 1958, researchers looking closely at geneological and stylistic evidence concluded that the work of the Border Limner was actually an early phase of the Kent Limner (see Barbara and Larry Holdridge) and that the artist responsible for these paintings was Phillips. It appears that Phillips established himself as a portraitist in Albany, NY, by 1813. After marrying in Nassau, NY, he and his wife moved to Troy, NY. From there he made painting trips all along what was called the Border Country (the border of CT and NY) until c.1819, painting in a primitive style. During the 1820s, he made trips down the west side of the Hudson, down to Orange County, NY and east through Dutchess County, NY. His works became increasingly more expressive and stylized. In the 1830s, he was painting the wealthy families of Kent, CT. In later years he lived in the Dutchess County towns of Poughkeepsie, Amenia, and Northeast. Late in his life, he moved to the Berkshires and resided in Curtisville, MA. Phillips was a prolific artist, painting until the end of his life. Approx. 500 portraits have been assigned and/or attributed to him. In 1998, his portrait, "Girl in Red" was selected by the U.S. Postal Service to be featured as a new postage stamp. *Cf.* ---- Philips and ---- Phillipa. **Sources:** G&W; Barbara & Larry Holdridge, *Ammi Phillips: Portrait Painter* (NY, 1968); Muller, *Paintings and Drawings at the Shelburne Museum,* 102 (w/repro.); Baigell, *Dictionary; 300*

Years of American Art, vol. 1, 104.

PHILLIPS, Amos *[Painter] mid 20th c.*
Addresses: NYC, 1925. **Exhibited:** S. Indp. A., 1925-26.
Sources: Marlor, *Soc. Indp. Artists.*

PHILLIPS, Anita See: **JORDAN, Anita Phillips**

PHILLIPS, Ann Cole (Mrs. W. Phillips) *[Painter] b.1911, NYC.*
Addresses: New York 21, NY. **Studied:** NAD; ASL; in France, Italy and Spain, and with Jose Clemente Orozco. **Member:** Silvermine Gld. A.; Brooklyn Soc. A.; NY Soc. Women A. (bd. dir.); NAWA (bd. dir.); AEA (bd. dir.). **Exhibited:** PAFA Ann., 1946, 1951; WMAA, 1950; NAD, annually since 1945; Riverside Mus., annually since 1945; Union Col., 1957; Canton AI; Massillon Mus. A.; Georgia Mus. A.; Columbia, SC; Univ. Nebraska; NY Univ.; in Bern and Lugarno, Switzerland; Argent Gal., NY; Paris, France; solo: Vendome Gal., 1946; Schaefer Gal., 1952; Galerie Andre Weil, Paris, 1957; Chase Gal., NY, 1958. Awards: Karasink award, 1947; NAD, 1955; Lehman award, 1956. **Work:** Union Col., Schenectady, NY; NY Univ.; Georgia Mus. A., Athens; Columbia (S.C.) Mus. A.; Washington County Mus., Hagerstown, Md.; High Mus. A., Atlanta. **Sources:** WW59; Falk, *Exh. Record Series.*

PHILLIPS, Benjamin R. *[Artist, photographer] b.c.1821, New York.*
Addresses: NYC. **Comments:** In 1860 he was listed as an artist, in 1863 as a photographer. **Sources:** G&W; 8 Census (1860), N.Y., XLIV, 417.

PHILLIPS, Bert Greer *[Painter, teacher, illustrator] b.1868, Hudson, NY / d.1956, San Diego, CA.* *Phillips.*
Addresses: 1890s, NY; Taos, NM. **Studied:** NAD, c.1889; ASL, c.1889; Académie Julian with Laurens, Constant, 1895. **Member:** Taos SA (founder, 1912); SC; Chicago Gal. Art. **Exhibited:** NAD, 1890, 1903-23 (7 times); AIC, 1896, 1899, 1918; PAFA Ann., 1898, 1918-19; Corcoran Gal biennials, 1923, 1935; Calif.-Pac. Int. Art Expo, 1935. **Work:** murals, Polk County Court House, Des Moines; San Marcos Hotel, Chandler, AZ; capitol, Jefferson City, MO; Courthouse, Taos; Mus. New Mexico; Philbrook Art Center; Gilcrease Inst. **Comments:** An established artist by 1889, he painted landscapes in England in 1894, and shared a studio with Blumenschein, whom he had met in France, in NYC in 1898. That same year the two made a sketching trip to Colorado. On their way to Mexico they broke down near Taos, leading to the founding of the art colony there. Specialty: Indian subjects. **Sources:** WW40; P&H Samuels, 371; Eldredge, et al., *Art in New Mexico, 1900-1945,* 205-06; *300 Years of American Art,* 620; Falk, *Exh. Record Series.*

PHILLIPS, Bertrand D. *[Painter, graphic artist, educator] b.1938, Chicago, IL.*
Studied: AIC (B.F.A.); Northwestern Univ. (M.F.A.). **Member:** Nat'l Conference of Artists. **Exhibited:** Kover Gal., Chicago, 1969; Univ. of Chicago, 1971; Southern Ill. Univ., 1972. Awards: George C. Brown Foreign Traveling Fellowship, AIC, 1961; Ponte Dell'Arte, AIC, 1961. **Sources:** Cederholm, *Afro-American Artists.*

PHILLIPS, Blanche (Howard) *[Sculptor] b.1908, MT Union, PA.*
Addresses: Upper Nyack, NY. **Studied:** CUASch.; ASL; Stienhofs Inst. Des.; Cal. Sch. FA, and with Zadkine, Hofmann. **Member:** S. Gld.; Chrysler Mus., Provincetown; Norfolk Mus. A. & Sciences; All Faith Temple, Val Moren, Canada, 1965. **Exhibited:** SFMA, 1942-43, 1945-47, 1949; Oakland A. Mus., 1946, 1948; LACMA, 1949; WMAA, 1952, 1957; BMFA, 1958; Mus. FA of Houston, 1958; Riverside Mus., 1958, 1962; Art: USA, 1958; Stable Gal., NY, 1959-60; Claude Bernard Gal., Paris, France, 1960; Holland-Goldowsky Gal., Chicago, 1960; Silvermine Gld. A., 1963, 1964; Museo de Bellas Artes, Argentina, 1962; solo: SFMA, 1943, 1949; Crocker A. Gal.,

Sacramento, Cal., 1949; RoKo Gal., NY, 1955, 1957; New Gal., Provincetown, Mass., 1961; East Hampton Gal., LI, 1963-64; Silvermine Gld. A., 1963; Mari Gal., Woodstock, 1964; Galerie Internationale, NY, 1962, and in Mexico, 1951. Award: NAWA, 1963, 1964. **Sources:** WW66.

PHILLIPS, C. B. *[Painter] 19th/20th c.*
Addresses: Julian, CA. **Work:** Bancroft Library, UC Berkeley. **Sources:** Hughes, *Artists in California,* 437.

PHILLIPS, C. Holmead See: **PHILLIPS, Holmead**

PHILLIPS, Caroline *[Artist] 19th/20th c.*
Addresses: Active in Detroit, MI, 1897-1900. **Sources:** A.; Petteys, *Dictionary of Women Artists.*

PHILLIPS, Caroline King *[Miniature painter, illustrator] early 20th c.*
Addresses: Active in Waban & Boston, MA, c.1907-23. **Exhibited:** Boston AC, 1908; AIC. **Sources:** WW24; Falk, *Exhibition Record Series;* Petteys, *Dictionary of Women Artists.*

PHILLIPS, Charles *[Engraver] mid 19th c.; b.England.*
Addresses: NYC, 1842. **Exhibited:** NAD, 1842 (as Charles Philips, an engraving after Joshua Reynolds). **Sources:** G&W; Stauffer; Cowdrey, NAD.

PHILLIPS, Charles C. *[Engraver] b.c.1830.*
Addresses: Philadelphia in 1850. **Sources:** G&W; 7 Census (1850), Pa., LV, 220.

PHILLIPS, Charlotte *[Painter] mid 20th c.*
Exhibited: San Diego Art Guild, 1936. **Sources:** Hughes, *Artists in California,* 437.

PHILLIPS, Claire Donner *[Landscape painter, etcher] b.1887, Los Angeles, CA / d.1960, Prescott, AZ.*
Addresses: Prescott, AZ. **Studied:** Stanford Univ. (A.B.); Teachers Col., Columbia Univ., with Arthur Dow. **Member:** Calif. AC; Women Painters of the West; Laguna Beach AA. **Exhibited:** Arizona State Fair, 1928 (prize); Mus. Northern Arizona,1930; Yavapai County Fair (prizes). **Work:** Prescott (AZ) Public School, Arizona Fed. Women's Cl. **Sources:** WW59; WW47.

PHILLIPS, Clarence Coles See: **PHILLIPS, Coles**

PHILLIPS, Coles *COLES PHILLIPS*
[Illustrator] b.1880, Springfield, OH / d.1927.
Addresses: New Rochelle, NY. **Studied:** Chase A. Sch. **Member:** New Rochelle AA. GFLA; Author's Lg. America. **Comments:** Illustrator best known for his "Fadeaway Girl," so-named for his posterizing technique of linking select dress parts of a young woman to a background of identical color, thereby creating an intriguing design of shapes. Beginning in 1908, variations of his "Fadeaway Girl" appeared in *Saturday Evening Post, Good Housekeeping, Ladies' Home Journal, Life, Liberty, McCall's, Woman's Home Companion.* **Sources:** WW25; add'l info. courtesy Illustration House (NYC, essay #8).

PHILLIPS, Dale See: **PHILLIPS, S. D. (Dale)**

PHILLIPS, Dorothy See: **SKLAR, Dorothy (Mrs. Phillips)**

PHILLIPS, Dorothy W. *[Art administrator, writer] b.1906, Camden, NY / d.1977.*
Addresses: Wash., DC. **Studied:** Wellesley College (B.A.); New York Univ. (Grad. Inst. Fine Arts); Inst. Art & Archéologie, Sorbonne, Paris. **Comments:** Positions: asst. curator, Egyptian dept., MMA, 1930-48; curator collections & researcher & editor & compiler, miscellaneous catalogues for loan exhibs. of American art, Corcoran Gal., 1959-. Publications: contributor, ancient Egyptian art articles in *Metropolitan Mus. Art Bulletin,* 1941-48 & author, "Ancient Egyptian Animals," MMA picture book with text, 1948; contributor, American art articles in *Corcoran Gallery Bulletin & Nat. Retired Teachers Assn. Journal,* 1963-72; co-author & editor, "A Catalogue of the Collection of American Paintings in the Corcoran Gallery of Art," Vol. I, 1966,

Vol. II. **Sources:** WW73.

PHILLIPS, Duncan *[Museum director, collector, writer, lecturer, critic, painter] b.1886, Pittsburgh, PA / d.c.1968.*
Addresses: Wash., DC. **Studied:** Yale Univ. (B.A., hon. degree, M.A.); Kenyon Col., 1951 (D.H.L.); (D. Let.), Am. Univ., 1955 (D.H.L.), Yale Univ., 1959; officer, Legion of Honor, 1948; (D.F.A.), Windham Col., 1963. **Member:** AFA; Hon. F., Berkeley Col., Yale Univ.; AAMus.; NGA, (trustee, mem.). **Comments:** Founder and director of the Phillips Memorial Collection (first formed in 1918 in honor of Duncan Phillip's brother and father), the first museum devoted to modern art in the U.S. His wife Majorie Acker Phillips was Associate Director and also an artist (see entry) Other positions: trustee & member, Acquisitions Com., (from its opening to 1960), NGA, Wash., DC; chm., Com. for Modern American Paintings, Tate Gal., London, England, 1946. Ed. & contributor to: PMG publications & catalog introductions to exhibitions of Graves, Tomlin, Knaths, Dove and other painters. Contributor essays to *Kenyon Review, Art, Art News* and other magazines. Author: "Collection in the Making," 1926; "The Artist Sees Differently," 1931; "The Leadership of Giorgione," 1937; co-author: "Daumier," 1923. **Sources:** WW66; WW47.

PHILLIPS, Elizabeth Shannon *[Painter] b.1911, Pittsburgh, PA.*
Addresses: NYC. **Studied:** CI, Pittsburgh; ASL; Tiffany Fnd. Schol. **Exhibited:** CI; 48 Sts. Comp., 1939. **Work:** WPA mural, USPO, West Haven, Conn. **Sources:** WW40.

PHILLIPS, Ellen A. *[Painter] 19th c.*
Sources: Petteys, *Dictionary of Women Artists.*

PHILLIPS, Florence A. (Mrs.) *[Painter] mid 20th c.*
Addresses: Los Angeles, CA, 1913-23; Berkeley, CA, 1923-24. **Exhibited:** Berkeley League of Fine Art, 1924. **Sources:** Hughes, *Artists in California,* 437.

PHILLIPS, George W. *[Portrait and landscape painter] b.1822, Wash., DC.*
Addresses: Cincinnati, OH, 1843-60; Louisville, KY, 1867-69. **Sources:** G&W; 7 Census (1850), Ohio, XXI, 314; Cincinnati CD 1850-60; Whitley, *Kentucky Ante-Bellum Portraiture.* More recently see, Hageman, 121.

PHILLIPS, Gertrude *[Painter, teacher] early 20th c.*
Addresses: NYC, c.1909. **Sources:** WW10.

PHILLIPS, Gifford *[Collector, writer] b.1918, Wash., DC.*
Addresses: Los Angeles, CA. **Studied:** Stanford Univ., 1936-38; Yale Univ. (B.A., 1942). **Member:** MoMA (trustee, 1966-); Phillips Collection (trustee); Pasadena Art Mus. (trustee, 1967-); MoMA Int. Coun. (bd. dirs.); LACMA Contemp. Art Coun. **Comments:** Publications: auth.," Arts in a Democratic Society," 1966; auth., articles, in: "Art News, Artforum & Art in Am." Collection: contemporary American painting and sculpture. **Sources:** WW73.

PHILLIPS, Gordon *[Painter, sculptor, illustrator] b.1927, Boone, NC.*
Addresses: Crofton, MD, 1976. **Studied:** Corcoran School Art. **Exhibited:** Kennedy Gal., NYC (solo). Awards: 2 gold medals for his pewter and bronze sculptures, Franklin Mint. **Work:** Buffalo Bill Mus., Cody, WY. **Comments:** Noted Western painter, who depicts landscapes and people in realistic detail. He collected impressions and artifacts during annual trips West, but rarely sketched or painted on the spot. Illustrator for *Look, Time, Life, Newsweek* and Western magazines. **Sources:** P&H Samuels, 372.

PHILLIPS, Grace H. *[Painter] mid 20th c.*
Addresses: NYC. **Member:** S. Indp. A. **Exhibited:** S. Indp. A., 1917-18, 1920-21, 1931; WMAA, 1921-22. **Sources:** WW25.

PHILLIPS, Harper Trenholm *[Painter, educator] b.1928, Courtland, AL.*
Exhibited: Xavier Univ., 1963; WVa. State Col., 1968 (best in show); Howard Univ., 1961, 1970. **Comments:** Position: prof., Grambling College, LA. **Sources:** Cederholm, *Afro-American*

Artists.

PHILLIPS, Harriet Sophia *[Painter, craftsperson] b.1849, Delta or Rome, NY / d.1928, NYC.*
Addresses: NYC/Hague-on-Lake George. **Studied:** Fehr, Munich; Simon, Paris; NYC. **Member:** Künstlerinnen Verein, Munich (hon. mem.); NAC; NYSC; SPNY; PBC; Mun. AC. **Exhibited:** Armory Show, 1913; Munich; Paris; S. Indp. A., 1917-21. **Work:** Univ. Akron. **Sources:** WW27; Brown, *The Story of the Armory Show.*

PHILLIPS, Helen Elizabeth *[Sculptor, printmaker] b.1913, Fresno, CA.*
Addresses: San Francisco, CA; NYC/Paris, France. **Studied:** Calif. Sch. FA, 1931-36, with Stackpole and Piazzoni. **Member:** affiliated with San Fran. AA. **Exhibited:** internationally; AIC; Calif. Sch. of FA, 1932 (Walter prize); WMAA, 1948; SFMA, 1936 (prize); San Francisco AA, 1936 (purchase prize), 1948 (donor prize). Award: Copley Foundation award, 1958. **Work:** St. Joseph's Church, Sacramento, Calif.; SFMA. **Sources:** WW40; Hughes, *Artists in California,* 438.

PHILLIPS, Henry J. *[Engraver] mid 19th c.*
Addresses: NYC, 1854-57. **Sources:** G&W; NYBD 1854-57.

PHILLIPS, Holmead *[Painter] b.1889, Shippensburg, PA.*
Addresses: NYC. **Exhibited:** Salons of Am., 1922, 1926; AIC; PAFA Ann., 1926, 1928; S. Indp. A., 1934. **Work:** Jeu de Paume Museum, Paris; BM. **Sources:** WW40; Falk, *Exh. Record Series.*

PHILLIPS, Irving W. *[Cartoonist, illustrator] b.1905, Wilton, WI.*
Addresses: Phoenix, AZ. **Studied:** Chicago Acad. Fine Arts. **Member:** Writers Guild Am.; Dramatists Guild; Nat. Cartoonists Soc.; Magazine Cartoonists Guild; Newspaper Cartoon Council. **Exhibited:** Awards: Int. first prize & cup, Salone dell'Umorismo of Bordighera, Italy, 1969. **Work:** Commissions: stage play adaptations, "One Foot in Heaven," "Gown of Glory," "Mother was a Bachelor" & "Rumple," Alvin Theatre, NYC, 1955. **Comments:** Positions: cartoon humor editor, *Esquire Magazine,* 1937-39; cartoon staff, *Chicago Sun-Times* Syndicate, 1940-52; motion picture assignments with Warner Bros., RKO, Charles Rodgers Prod. & United Artists. Publications: author/illus., syndicated strip appearing internationally in 180 papers in 22 countries, "The Strange World of Mr. Mum;" author, "The Twin Witches of Fingle Fu," 1969; author, "No Comment by Mr. Mum," Popular Library, 1971; author & co-author, 260 TV scripts; contributor, scripts & animation to ABC-TV children's program, "Curiosity Shop"; contributor, *Saturday Evening Post.* **Sources:** WW73.

PHILLIPS, J(ay) Campbell *[Painter] b.1873, NYC / d.1949, NYC.*
Addresses: NYC. **Studied:** W.M. Chase; ASL with H.S. Mowbray; Clinedinst; MMA Sch. A. **Member:** AAPL; Lotos C.; Ar. Funds; Ar. of Carnegie Hall. **Exhibited:** NAD, 1895; Corcoran Gal biennials, 1908-14 (3 times); S. Indp. A., 1917; Salons of Am., 1934. **Work:** MMA; CMA; Albright A. Gal.; High Mus. A.; U.S. Treasury Dept., Wash. DC; Capitols, Trenton (N. J.), Harrisburg (Pa.); Lotos C., NYC; NAD; Cornell; Colgate; CCNY; Phila. Bar Assn.; Supreme Court Pa.; Nat. Democratic C., NYC; New York City Hall; DAR, Wash., DC; Acad. Medicine, NYC; Bronx County Court House, NYC; Real Estate Bd., NYC; NY Supreme Court. **Sources:** WW47.

PHILLIPS, Jessie W. *[Painter] 20th c.*
Addresses: Seattle, WA. **Sources:** WW24.

PHILLIPS, John *[Portrait painter] b.1822, Paisley, Scotland.*
Studied: Spain, Italy, and France, 1852-54. **Exhibited:** NAD, 1853-77; Brooklyn AA, 1875-77; PAFA, 1856. **Work:** Chicago Hist. Soc. **Comments:** He came to U.S. about 1837 and took up portrait painting about 1842. In 1847 he was at Albany, NY, painting the governor and many legislators. He worked in Puerto Rico c.1849-52. By 1854 he had returned from study in Europe and opened a studio in NYC. In 1858-59 he was in Cuba and in 1861 he went to Montreal. After a failed business venture, he moved to

Chicago in 1868 and resumed his painting. He made occasional trips to New York State but Chicago remained his home at least into the mid-1880s. **Sources:** G&W; Andreas, *History of Chicago*, II, 561-62; Ulp, "Art and Artists in Rochester"; NYCD 1853-60; Cowdrey, NAD; Naylor, NAD; Rutledge, PA.

PHILLIPS, John E. *[Painter] mid 20th c.*
Addresses: Chicago, IL. **Member:** Chicago PS. **Exhibited:** AIC, 1913-31,1931 (prize). **Sources:** WW25.

PHILLIPS, John Goldsmith *[Museum curator] b.1907, Glens Falls, NY.*
Addresses: NYC. **Studied:** Harvard Univ. (A.B.). **Exhibited:** Awards: Guggenheim fel., 1957. **Comments:** Teaching: lectr. var. aspects Europ. art & new installations, MMA. Positions: former chmn. Western Europ. arts, MMA, chmn. emer. Western Europ. arts, 1971-. Publications: auth., "Early Florentine Designers and Engravers," MMA, 1955; auth., "China-Trade Porcelain," 1956. **Sources:** WW73.

PHILLIPS, J(ohn H(enry) *[Etcher, teacher] b.1876, Sun Prairie, WI.*
Addresses: Babylon, NY. **Member:** SC. **Exhibited:** Chicago Arch. C., 1903. **Work:** Elizabethan Theatre, Upper Montclair, NJ; Babylon Theatre, Babylon, NY; Ringling Mus., Sarasota, Fla. **Sources:** WW27.

PHILLIPS, Josephine Neall *[Miniature painter, painter] mid 20th c.*
Addresses: Orange, NJ. **Exhibited:** Pa. SMP, PAFA, 1934-36; ASMP, 1938; Calif. SMP, 1938. **Sources:** WW40.

PHILLIPS, Leonard H. *[Painter] 20th c.*
Addresses: Columbus, OH. **Member:** Columbus PCC. **Sources:** WW25.

PHILLIPS, Lois A.B. *[Artist] early 20th c.*
Addresses: Active in Los Angeles, 1911-25. **Sources:** Petteys, *Dictionary of Women Artists*.

PHILLIPS, Margaret McDonald *[Painter, educator] 20th c.; b.NYC.*
Addresses: NYC. **Studied:** Hunter Col. (B.A.); Grand Cent. Sch. Art (M.A.); with Eric Pape, Frank Schwartz & Edmund Greacen; Wayman Adams Sch. Portraiture; Univ. Paris, scholar, 1942; St Andrews Col. (Ph.D.). **Member:** The 50 Am. Artists (pres., 1954-); Royal Soc. Arts, London; Acad. Artists, W. Springfield, Mass.; Palm Beach Art League; Rockport Art Assn. **Exhibited:** Gal. Int., NY, 1960; 50 Am. Artists, Schoeneman Art Gal., NYC, 1965; NAC 23rd Ann., NY, 1969; Ogunquit Art Ctr., Maine, 1969; Academic Artists, W. Springfield, Mass., 1970; Rembrandt Art Gal., NYC, 1970s. Awards: Nancy Ashton Prize, 1942; citation, Fla. Southern Col., 1969. **Work:** Indira Ghandi (portrait), Indira Ghandi Coll., New Delhi, India; portrait of a mountaineer, Fla. Southern Col.; Muskingum Col., Ohio; St Luke's Hosp., New York. Commissions: portrait of Mme. V. Pandil commissioned by UN, hanging in New Delhi, 1954; portrait of Mme. Paul Marfort, Berlitz Sch. Language, Paris, France, 1965; portrait of John S. Bennell, Fifth Ave Presby. Church, NYC, 1967; portrait of Walter H. Aldridge, Columbia Univ., NYC, 1969; portrait of Pres. Richard M. Nixon, commissioned by Pres. Heritage Cl., Republican Cl. Hdq., 1972. **Comments:** Preferred media: oils. Publications: illusr., "King of Siam & Queen of Persia," NY Graphic Soc., 1947; auth., "You & Your Portrait," 1955; auth., "Judging an Art Exhibition," 1960; auth., "Aesthetic Enjoyment," 1968. Teaching: mem. admin. staff, New York Phoenix Sch. Design, 1954-, hd. portrait painting dept., 1968-; instr. pvt. classes. **Sources:** WW73; Su San, *Artist Captures the Essence* (Sun, 1969); Wagsan, "She Paints the Greats," *J. Am.*; Lesley Kuhn, *Psychosomatic painting* (Int. Press Assn., 1969).

PHILLIPS, Marguerite See: **SHAFER, Marguerite (Phillips) Neuhauser**

PHILLIPS, Marjorie Acker (Mrs.) *[Museum director, painter] b.1894,*

MARJORIE PHILLIPS

Bourbon, IN / d.1985, Wash., DC.
Addresses: Assening, NY; Wash., DC. **Studied:** ASL with Kenneth Hayes Miller & Boardman Robinson, 1915-18; with her uncle Gifford Beal. **Member:** Soc. Wash. Artists; AFA.
Exhibited: Soc. Wash. Artists (hon. men., 1923); Wash. AC; Soc. Indep. Artists; Corcoran Gal biennials, 1921-59 (17 times); PAFA Ann., 1925, 1933, 1944-45, 1954; CI, 1934-46; AIC, 1931, 1940-41; WMAA; Century of Progress Exh., Chicago, 1933; MoMA, 1933; WFNY, 1939; GGE, 1939; Exhibition of American Painting, Tate Gal., London, 1946; Denver Art Mus., 1941; PMG, 1941; Kraushaar Gal., 1941 (solo); Durand-Ruel Gal., NYC, 1941 (solo); Santa Barbara Mus. Art, 1945 (solo); CPLH, 1950 (solo); Corcoran Gal, solo, 1955; Edward Root AC, Munson-Williams-Proctor Inst., Utica, NY, 1965 (solo); Hamilton Col, 1965 (retro.); Marlborough Gal., London, 1973 (retro.); Franz-Bader Gal., 1977. Awards: Penn. Mus. Sch. Art, 1959 (award of merit). **Work:** WMAA; BMFA; CGA; Yale Univ. Art Gal., New Haven, CT; Phillips Coll., Wash., DC; WPA mural, USPO, Bridgeville, PA. **Comments:** In 1921 she met and later married Duncan Phillips, founder of the Phillips Collection, the first museum devoted to modern art in the U.S. Positions: assoc. dir., Phillips Collection, 1925-66, dir., 1966-72. Collections arranged: Seymour Lipton's Sculpture, 1964; Giacomotti Sculpture and Painting, 1965; Alexander Calder Sculpture, 1967; Contemporary Sculpture, 1968; Cezanne Exhib. (with AIC & BMFA), to celebrate 50th Anniversary of Phillips Collection opening, 1971; Forty Paintings by Wash., DC, Artists, 1971-72. In addition to her work at the Phillips Col., Marjorie Phillips painted throughout her life. Phillips worked in a post-impressionist style inspired by Pierre Bonnard, choosing as her subject matter intimate interiors, still lifes, and landscapes. Publications: auth., *Duncan Phillips and His Collection* (Atlantic Monthly Press, Little, 1971). **Sources:** WW73 puts birthdate at 1894; WW47 puts birthdate at 1895; Rubinstein, *American Women Artists*, 236-238 puts birthdate at 1895; McMahan, *Artists of Washington, D.C.* puts birthdate at 1894; Falk, *Exh. Record Series*.

PHILLIPS, Martha (Mrs J. Campbell) *[Painter] mid 20th c.; b.Stockholm, Sweden.*
Exhibited: Salons of Am., 1934. **Sources:** Marlor, *Salons of Am.*

PHILLIPS, Matthew "Matt" *[Painter] b.1927, NYC.*
Addresses: Annandale-on-Hudson, NY. **Studied:** Univ. Chicago (M.A.); Stanford Univ.; Barnes Found. **Exhibited:** Galerie Mareel Bernheim, NYC, 1962-65; Peter Deistsch, NY, 1962 & 1965; Princeton Gal. Fine Art, 1971; Smithsonian Inst. Traveling Exhib., 1972; William Zierler Gal., NYC, 1972. **Work:** MMA; Nat. Gal. Art; PMA; New Brit. Mus. Am. Art. **Comments:** Preferred media: watercolors, oils. Teaching: hd. dept. art, Bard Col., 1964-. Publications: auth., "Maurice Prendergast: The Monotypes" (catalog), 1967 & "Milton Avery: Works on Paper" (catalog), 1971, Bard Col.; auth., "The Monotype Today," *Artist's Proof* 1969; "The Monotype: An Edition of One," Smithsonian Inst. Traveling Exhib., 1972. **Sources:** WW73.

PHILLIPS, Mel(ville) (A.) *[Painter, teacher, comm, illustrator] b.1893, NYC.*
Addresses: New York 19, NY; Lynbrook, LI, NY. **Studied:** NAD, and with George Maynard, Ivan Olinsky. **Member:** SI.
Exhibited: Awards: NAD; Motion Picture award for Poster, 1938; AIC, 1930 (prize). **Work:** NAD; many portraits of prominent persons. **Comments:** Contribut. illus. to *Coronet; American Legion; Womans Home Companion* and others. Advertising illus. to many national magazines. **Sources:** WW59.

PHILLIPS, (Mrs.) *[Teacher of embroidery, music, drawing and painting] late 18th c.*
Addresses: Charleston, SC, active 1795. **Sources:** G&W; Rutledge, *Artists in the Life of Charleston*.

PHILLIPS, Patricia *[Painter, etcher] b.1916, NYC / d.1946.*
Addresses: NYC. **Studied:** Sarah Lawrence Col.; W.S. Hayter. **Exhibited:** Bonestell Gal., NYC; Pinacotheca Gal., NYC; CPLH.

PHILLIPS, R. L. (Mrs.) *[Painter] late 19th c.*
Addresses: NYC. **Exhibited:** NAD, 1871. **Sources:** Naylor, *NAD*.

PHILLIPS, Robert Francis *[Illustrator] d.1902, NYC.*
Comments: Brother of Stephen Francis. Died of scarlet fever.

PHILLIPS, Roberta G. *[Artist] late 19th c.*
Addresses: Wash., D.C., active 1882-84. **Sources:** McMahan, *Artists of Washington, D.C.*

PHILLIPS, S. D. (Dale) *[Painter, teacher, lithographer]* b.1904, Elmo, MO.
Addresses: Ames, IA. **Studied:** Minneapolis School Art; Ecole de Art under Alexander Archipenko; Brown School Lithography under Bolton Brown. **Exhibited:** Minneapolis Art Inst.; Joslyn Mem.; Carson Pirie Scott; California; Iowa Art Salon, 1936 (award), 1937 (award); All Iowa Exhibit, Carson Pirie Scott, 1937 (hon. men.). **Work:** Iowa State College and in priv. colls. **Comments:** Position: t., architectural engineering dept., Iowa State College. Professional printer of lithographs and etchings for other artists, including Jean Charlot, Dewey Albinson, Lowell Houser, etc. **Sources:** Ness & Orwig, *Iowa Artists of the First Hundred Years,* 167.

PHILLIPS, S. George *[Painter, illustrator] b.c.1890 / d.1965.*
Addresses: NYC, 1913; studio in Phila., PA/home in Atlantic City, NJ. **Studied:** PAFA. **Member:** Phila. AC. **Exhibited:** PAFA Ann., 1913, 1920-24, 1932, 1937. **Comments:** Worked as a magazine illustrator early in his career. He was primarily a portraitist but also produced some landscapes. **Sources:** WW25; clipping from *Phila. Inquirer,* June 20, 1965; Falk, *Exh. Record Series.*

PHILLIPS, S. J. *[Sign and ornamental painter] mid 19th c.*
Addresses: Cleveland, 1840. **Sources:** G&W; Knittle, *Early Ohio Taverns,* 43.

PHILLIPS, Sara J. *[Craftsperson, block printer] b.1892, Brooklyn, NY.*
Addresses: Tully, NY. **Studied:** PIA School; Columbia Univ. **Member:** NY Soc. Craftsmen. **Sources:** WW40.

PHILLIPS, W(alter) J(oseph) *[Painter, block printer, etcher, craftsperson, writer, teacher, lecturer] b.1884, Barton-on-Humber, England / d.1963, Calgary, Alberta, Canada.*
Addresses: Winnipeg, Canada, 1913-on. **Studied:** Birmingham Art School with E.R. Taylor. **Member:** ARCA, 1921; RCA, 1933 (as the only engraver recognized); Calif. PM; Boston SAC. **Exhibited:** Salons of Am., 1924; Los Angeles, 1926 (prize); Graphic Arts Cl., Toronto, 1926 (prize); Boston SAC (med.); AIC. **Work:** Nat. Gal., Canada; AIC; Mus. New Mexico; Toronto Gal.; British Mus.; Victoria and Albert Mus.; LACMA; Calif. State Libr.; LOC; Natal, South Africa. **Comments:** Author: "The Technique of the Color Wood-Cut," "The Canadian Scene," "Essays in Wood." Positions: teacher, Univ. Wisconsin, Univ. Alberta, Univ. Manitoba, Banff School FA. **Sources:** WW31; P&H Samuels, 372.

PHILLIPS, Walter Shelley *[Illustrator, writer] b.1867 / d.1940.*
Addresses: Active in Chicago before 1900. **Comments:** Author/illustrator: "Totem Tales," 1896. **Sources:** P&H Samuels, 372.

PHILLIPS, Wilber E(lmer) *[Painter] b.1907, Bogard, MO.*
Addresses: Kansas City/Bogard, MO. **Studied:** St. Louis Sch. FA; PAFA. **Member:** St. Louis AG. **Exhibited:** St. Louis AG, 1932 (prize); Mo. State Fair, 1934 (prize), 1935 (prize), 1937 (prize); Midwestern Ar., Kansas City AI, 1939 (prize). **Work:** Carrollton (Mo.) Baptist Church; Lib., Southeast H.S., Kansas City; Paseo H.S., Jackson County Court House, Detention Home, both in Kansas City. **Sources:** WW40.

PHILLIPS, William *[Engraver] b.1817, England.*
Addresses: Wash., D.C., active 1860-65. **Comments:** Worked for the U.S. Coast Survey. **Sources:** McMahan, *Artists of Washington, D.C.*

PHILLIPS, William Arthur *[Painter, teacher, writer] b.1916, Los Angeles, CA / d.1989, Seattle, WA.*
Addresses: Tacoma, WA. **Studied:** Calif., 10 years; Univ. of Wash. **Member:** Puget Sound Group of Northwest Painters; Pacific Gallery Artists. **Exhibited:** Western Wash. State. **Comments:** Position: teacher, Tacoma school system. **Sources:** Trip and Cook, *Washington State Art and Artists.*

PHILLIPS, William G. *[Engraver] 19th/20th c.*
Addresses: Wash., D.C., active 1892-1905. **Comments:** Could be the William Phillips active in Wash., D.C. from 1860-65. **Sources:** McMahan, *Artists of Washington, D.C.*

PHILLIPS, Winifred Estelle *[Craftsperson, designer, painter, teacher] b.1880, Clay Banks, WI / d.1963.*
Addresses: Wauwatosa, WI. **Studied:** F. Fursman; G. Moeller; G. Oberteuffer; H.B. Snell; PIA Sch.; AIC; Wisconsin Sch. Art; State College Milwaukee; State Sch. Certificate, Alfred, NY. **Member:** Wisc. Art Fed.; NAWPS; Milwaukee AI. **Exhibited:** Milwaukee AI (prize), 1936 (prize), 1937 (prize), 1938 (prize). **Comments:** Specialty: ceramics. Position: ceramics teacher, Milwaukee State Teachers College. **Sources:** WW40.

PHILLIPS & BOWEN *[Painters] mid 19th c.*
Addresses: New Orleans, active 1854. **Comments:** Partners were A.L. Phillips and O.F. Bowen. **Sources:** *Encyclopaedia of New Orleans Artists,* 304.

PHILP, J. B. *[Painter] late 19th c.*
Member: Wash. AC, 1876-77. **Comments:** Could be James B. Philip listed in the 1877 *Washington City Directory.* **Sources:** McMahan, *Artists of Washington, D.C.*

PHILP, William H. *[Portrait and ornamental painter] mid 19th c.*
Addresses: NYC, 1850's. **Exhibited:** American Institute, 1850 (Hose Co. No. 3's fire engine with painted panels [by Philp] depicting the battle of Bunker Hill and Washington at the battle of Monmouth). **Sources:** G&W; NYCD 1850-60; Smith, "Painted Fire Engine Panels," 246.

PHILPOT, S. H. *[Painter, teacher, illustrator] 20th c.*
Addresses: Baltimore 1, MD. **Studied:** Maryland Inst.; ASL; PIA Sch.; & with Henry Roben, George Bridgman, Frederick Goudy, Anna Fisher, Jacques Maroger. **Exhibited:** Maryland Inst.; BMA; CGA; Ogunquit A. Center; Hagerstown, Md. **Work:** Fed. Land Bank, Baltimore, Md. **Comments:** Position: freelance art dir. **Sources:** WW59.

PHILPOT, Samuel H. *[Painter, teacher, illustrator] 20th c.*
Addresses: Baltimore, MD. **Studied:** Md. Inst.; ASL; PIA Sch.; H. Roben; G. Bridgman; F. Goudy; A. Fisher. **Exhibited:** Md. Inst.; BMA; CGA; Ogunquit A. Ctr.; Hagerstown, Md. **Work:** Fed. Land Bank, Baltimore, Md. **Comments:** Position: T., Md. Inst. **Sources:** WW47.

PHILPS, Katherine Elisabeth See: **PHILIPS, Katherine Elizabeth**

PHIMISTER-PROCTOR, A. See: **PROCTOR, A(lexander) Phimister**

PHINNEY, Alta H. *[Artist] late 19th c.*
Addresses: Active in Tecumseh, MI, 1887-91. **Sources:** Petteys, *Dictionary of Women Artists.*

PHINNEY, Anita *[Landscape painter] 19th/20th c.*
Addresses: Newport, RI. **Member:** Newport AA. **Exhibited:** New Haven PCC, 1900 (charter exh.). **Sources:** WW25.

PHINNEY, Deidamia *[Drawing teacher] early 19th c.*
Addresses: Philadelphia, 1818. **Sources:** G&W; Brown and Brown.

PHINNEY, Emma Elisabeth *[Sculptor] late 19th c.; b.Boston, MA.*
Studied: Negrett. **Exhibited:** Paris Salon, 1881. **Sources:** Fink, *American Art at the Nineteenth-Century Paris Salons,* 380.

PHIPPEN, George *[Painter, sculptor] b.1916, Iowa / d.1966, probably Skull Valley, AZ.*
Studied: self-taught; with Henry Balink. **Member:** CAA (first pres.). **Work:** Phoenix AM. **Comments:** Taught himself to paint while serving in WWII. Began oil painting in 1948 and also sculpted. His widow wrote a book about him. **Sources:** P&H Samuels, 372-73.

PHIPPEN, John (Jonathan) *[Painter] late 18th c.*
Addresses: Salem, MA, 1790-93. **Work:** Peabody Mus., Salem, Mass. **Sources:** G&W; Robinson and Dow, *Sailing Ships of New England*, I, 62 (identified as John Phippen); Brewington, 301 (listed as Jonathan Phippen).

PHIPPS, Cynthia *[Collector] 20th c.*
Addresses: NYC. **Sources:** WW73.

PHIPPS, Edgar Eugene *[Photographer] b.1887, Kingston, British West Indies.*
Exhibited: Harmon Fnd., 1933; Buckingham Palace, London. **Work:** Nat'l Archives. **Sources:** Cederholm, *Afro-American Artists.*

PHIPPS, Ella *[Painter] late 19th c.*
Addresses: probably Missouri. **Exhibited:** St. Louis Expo, 1891 (prize). **Comments:** A fanciful, somewhat naive painter. **Sources:** exh. cat., *Missouri Artists* (Th. McCormick, 1984).

PHIPPS, G. W. *[Listed as "artist"] b.c.1805, Massachusetts.*
Addresses: New Haven, CT in 1850. **Sources:** G&W; 7 Census (1850), Conn., VIII, 279.

PHIPPS, Ogden (Mr. & Mrs.) *[Collectors] 20th c.*
Addresses: NYC. **Member:** Art Collectors Cl. **Sources:** WW73.

PHIPPS, William C. *[Engraver] b.1820, London, England / d.1892.*
Addresses: Wash., DC, active from 1840s. **Comments:** Established own firm in 1878; still active in 1892. **Sources:** G&W; Washington and Georgetown CD 1855, 1858, 1860; McMahan, *Artists of Washington, D.C.*

PHISTER, Jean Jacques *[Painter, sculptor] b.1878, Bern, Switzerland.*
Addresses: San Fran., CA. **Sources:** WW17.

PHOEBUS, Natalie *[Painter] mid 20th c.*
Exhibited: S. Indp. A., 1937. **Sources:** Marlor, *Soc. Indp. Artists.*

PHOENIX, Bertha E. *[Painter] 19th/20th c.*
Addresses: Wash., DC, active c.1900. **Sources:** WW01; McMahan, *Artists of Washington, D.C.*

PHOENIX, Florence Bingham (Mrs. Lauros Monroe) *[Designer, craftsperson] d.1920.*
Studied: AIC.

PHOENIX, Frank *[Painter] b.1858, Illinois / d.1924, Glendale, CA.*
Addresses: Chicago, IL, until c.1910; Glendale, CA. **Studied:** Académie Julian, Paris, 1896. **Member:** Chicago SA. **Exhibited:** AIC, 1900-10. **Comments:** Teaching: AIC. **Sources:** WW13.

PHOENIX, Lauros Monroe *[Painter, educator, designer, lecturer] b.1885, Chicago, IL.*
Addresses: NYC; Bronxville, NY. **Studied:** AIC; & with John Vanderpoel, Thomas Wood Stevens, Louis W. Wilson, J.F. Carlson, at Woodstock Summer Sch. **Member:** NSMP; New Rochelle AA; ASL, Chicago; Alpha Delta Sigma; Quill Cl. **Work:** murals, St. Paul Hotel and Lowry Doctors' Bldg., St. Paul, Minn.; Donaldson Bldg., Elks Cl., Minneapolis, Minn. **Comments:** Position: pres., dir., instr., N.Y.-Phoenix Sch. Des., NYC; adjunct prof., NY Univ. (emeritus). **Sources:** WW66; WW47.

PHOUTRIDES, Evan(gelos) (Stephanos) *[Painter] b.1922 / d.1955.*
Addresses: Seattle, WA, 1949. **Exhibited:** SAM, 1949; Henry Gal., 1950, 1951. **Sources:** Trip and Cook, *Washington State Art and Artists.*

PHYSICK, W. *[Lithographer] mid 19th c.*
Comments: Lithographer of painting (by S. Walter) of the New York packet ship *Roscius,* launched in 1839, lost in the Atlantic in 1860. It is not known for certain if Physick was American. **Sources:** G&W; *Portfolio* (Feb. 1947), 138 (repro.).

PI, Oqwa (Opwa) *[Painter] mid 20th c.*
Exhibited: S. Indp. A., 1932-34; AIC, 1935-36. **Sources:** Falk, *AIC.*

PIAI, Pietro *[Sculptor] b.1857, Vittorio, Treviso, Italy.*
Addresses: NYC. **Studied:** Vittorio, with Stella; Acad., Turin, with C. Tabacchi. **Sources:** WW04.

PIATEK, Francis John *[Painter] b.1944, Chicago, IL.*
Addresses: Chicago, IL. **Studied:** AIC Sch. (BFA & MFA.). **Exhibited:** Chicago & Vicinity Shows, 1967-1969 & 1971 & Soc. Contemp. Art Exhib., 1970 & 1971, AIC; WMAA Ann. Exhib. Contemp. Am. Painting, 1968; solo shows, Hyde Park Art Ctr., 1969 (solo); Phyllis Kind Gal., 1972 (solo), 1970s. **Awards:** AIC traveling fel., Francis Ryerson, 1967; Pauline Potter Palms award, 1968 & John G. Curtis Prize, 1969, Chicago & Vicinity Shows. **Work:** AIC. Commissions: mural, Main State Bank Chicago, 1972. **Comments:** Preferred media: oils, acrylics. Teaching: inst.r painting, AIC, 1970-71. **Sources:** WW73.

PIATELLI, Aldo S. *[Sculptor] early 20th c.*
Addresses: NYC, 1917. **Exhibited:** S. Indp. A., 1917. **Sources:** Marlor, *Soc. Indp. Artists.*

PIATT, Howard H. *[Painter] mid 20th c.*
Exhibited: S. Indp. A., 1936. **Sources:** Marlor, *Soc. Indp. Artists.*

PIATT, Ida F. *[Painter] late 19th c.*
Addresses: Napa, CA. **Exhibited:** Calif. Agricultural Soc., 1883. **Sources:** Hughes, *Artists in California*, 438.

PIATT, Nadeen *[Landscape painter] mid 20th c.*
Addresses: Los Angeles, CA, 1931-33. **Exhibited:** Artists Fiesta, Los Angeles, 1931. **Sources:** Hughes, *Artists in California*, 438.

PIATTI, Anthony *[Sculptor] mid 19th c.*
Addresses: NYC, 1849-57. **Exhibited:** NAD, 1850. **Sources:** G&W; NYBD 1849-57; Cowdrey, NAD.

PIATTI, Emilio Fernando *[Sculptor] b.1859, NYC / d.1909.*
Addresses: Englewood, NJ. **Studied:** CUA Sch, with his father Patrizio; asst. to Saint-Gaudens. **Work:** mausoleum of George Wescott; statue of Gen. Spinola; bust of Bertha Galland. **Sources:** WW04.

PIATTI, Patrizio *[Sculptor] b.1824, near Milan, Italy.*
Addresses: NYC. **Comments:** Specialty: statuary. Father of Emilio. Came to NYC in 1850. **Sources:** G&W; NYBD 1857-60. WW04.

PIAZZONI, Gottardo Fidel Ponziano *[Painter, etcher, sculptor, draftsperson, decorator, teacher, writer] b.1872, Intragna, Switzerland / d.1945, Carmel, CA.*
Addresses: San Fran., CA. **Studied:** San Fran. Sch. of Des. with Mathews and Yelland; Acad. Julian, Paris, 1894; Ecole des Beaux-Arts, Paris. **Member:** San Fran. AA; Calif. Soc. of Etchers (cofounder); Beaux Arts Cl.; Bohemian Cl.; Calif. Soc. Mural A.; Chicago SE. **Exhibited:** San Fran. AA annuals, 1898-1919 (prize), 1920-24 (gold), 1925-26, 1927 (med.), 1928-35; Louisiana Purchase Expo., St. Louis, 1904 (hon. men.); Int'l Expo, Rome, 1906; Paris Salon, 1907; Corcoran Gal biennial, 1912; Paul Elder Gal, San Fran, 1914 (solo); PPE, 1915; Bohemian Cl., 1923 (solo); Ariz. State Fair, 1924 (prize); San Diego SFA, 1927 (prize); Calif. Soc. of Etchers, Stanford U., 1928; Adams-Danysh Gal., San Fran., 1934 (solo); SFMA, 1935; GGE, 1939; Labaudt Gal, San Fran., 1946 (solo); Calif. Hist Soc., 1959 (solo). **Work:** Calif. Hist. Soc.; Oakland Mus.; CPLH; de Young Mus.; The Walter Coll., San Fran. AA; Golden Gate Park Mus., San Fran.; Municipal Gal., Phoenix, Ariz.; Mills Col. A. Gal., Calif.: 5 murals, San Fran. Pub. Lib. **Comments:** Joined his father in California at age 14, who had started a dairy farm on an old Spanish land grant. While studying art in Paris, he lived with

Douglas Tilden (see entry) and Granville Redmond (see entry), from 1915-25 he shared a studio in San Francisco with Arthur Putnam (see entry). Position: t., Calif. Sch. of FA, San Francisco, 1919-35. Served on the SFMA Advisory Board. **Sources:** WW40; Hughes, *Artists in California,* 438.

PICARD, August *[Sculptor] early 20th c.*
Addresses: Wash., D.C., active 1903. **Sources:** McMahan, *Artists of Washington, D.C.*

PICARD, Lil *[Painter, sculptor] mid 20th c.; b.Landau, Germany.*
Addresses: NYC. **Studied:** Col. Strassbourg, Alsace-Loraine; study in Vienna, Austria & Berlin, Ger.; ASL, with Jevza Modell. **Exhibited:** Parnass Gal., Wupperthal, Ger., 1962; Insel Gal., Hamburg, Ger., 1963; Smolin Gal., NYC, 1965; Kunsthalle, Baden-Baden, Ger.; Stedelijk Mus., Holland. **Work:** Schniewind Coll., Nevege, Ger.; Hahn Coll., Cologne, Ger. **Comments:** Positions: art critic, *Kunstwerk,* Baden-Baden & *Die Welt,* Hamburg. Publications: contrib. ed., *Inter/View.* Art interests: self performances in personal realism style. **Sources:** WW73.

PICARD, Peter *[Engraver] early 19th c.*
Addresses: Philadelphia, 1816-17. **Sources:** G&W; Brown and Brown.

PICARD, Peter M., Jr. *[Engraver] early 19th c.*
Addresses: Philadelphia, 1818-19. **Sources:** G&W; Brown and Brown.

PICCARD, Ira *[Portrait painter] 20th c.; b.Webster City, IA.*
Addresses: Webster City, IA. **Studied:** AIC and with Sholte, Wash., DC. **Member:** Chicago Artists Cl. **Comments:** Head of Webster City group of PWA workers. **Sources:** Ness & Orwig, *Iowa Artists of the First Hundred Years,* 167.

PICCHI, Frederick *[Sculptor, molder, gilder] b.c.1795, Italy.*
Addresses: New Orleans, active 1856-61. **Sources:** G&W; Delgado-WPA cites New Orleans CD 1860-61. More recently, see *Encyclopaedia of New Orleans Artists.*

PICCILLO, Joseph *[Painter] b.1941, Buffalo, NY.*
Addresses: Buffalo, NY. **Studied:** State Univ. Col. at Buffalo (B.S., 1961; M.S., 1964). **Exhibited:** Awards: purchase award, Am. Acad. of Arts and Letters, 1968; CAPS grant, New York State Council on the Arts, 1972; National Endowment for the Arts Grant, 1979. **Comments:** Position: teacher, art education at State University College at Buffalo from 1967 on.

PICCIRILLI, Attilio *[Sculptor] b.1866, Massa, Italy / d.1945, NYC.*
Addresses: NYC. **Studied:** Academia San Luca, Rome. **Member:** ANA, 1909; NA, 1935 Arch. Lg., 1902; Allied AA. **Exhibited:** Pan-Am. Expo, Buffalo, 1901 (med.); PAFA Ann., 1902-18, 1933 (gold 1917); St. Louis Expo, 1904 (med.); Paris Salon, 1912 (prize); P.P. Expo, San Fran., 1915 (gold); NAD, 1926 (gold); Grand Central Gal., N.Y. 1929 (prize); AIC. **Work:** "Maine Memorial," NYC; glass panel/entrance, Palazzo d'Italia; sculpture/glass panel/entrance, Intl. Bldg., Rockefeller Center, NYC; MacDonough Mon., New Orleans; FA Acad., Buffalo; bust of Jefferson, Va. Capitol; USPO Dept. Bldg. Wash., DC; USPO, Whitman, Mass. WPA Artist. **Comments:** Came to the U. S. in 1888 and settled in NYC. In 1898 he went to New Orleans to submit his design for the John McDonogh monument in Lafayette Square. It was chosen and the same year he returned for the official unveiling. He later created numerous other monuments, including the national monument to the sinking of the battleship "Maine". Son of Guiseppe and brother of Furio Piccirilli, sculptor who also submitted a design for the John McDonogh monument. **Sources:** WW40; *Encyclopaedia of New Orleans Artists,* 305; Falk, *Exh. Record Series.*

PICCIRILLI, Bruno *[Sculpto, teacher] b.1903, NYC.*
Addresses: Poughkeepsie, NY. **Studied:** NAD; BAID; Am. Acad. in Rome. **Member:** NSS; Arch. Lg.; Dutchess County AA. **Exhibited:** San Fran., 1929; NAD, 1930-32; Arch. Lg., 1945; Albany Inst. Hist. & A., 1942, 1945; MMA; San Francisco Nat.

Exh.; Am. Acad. in Rome; Dutchess County AA, Poughkeepsie, NY; IBM; F.D. Roosevelt Lib., Hyde Park, NY. **Work:** Exterior and interior sculpture, Riverside Church, N.Y.; WPA artist; mural, USPO, Marion, N.C.; sculpture, Mount Carmel Church, Poughkeepsie, N.Y.; statue, Brookgreen Gardens, S.C.; Priscilla G. L. Plimpton Memorial, Wheaton College; All Saints Episcopal Church, Baldwin, N.Y.; many portraits, fountains, etc., in priv. colls. **Comments:** Position: instr., sc., Vassar College. **Sources:** WW66; WW47.

PICCIRILLI, Furio (Ferruccio) *[Sculptor] b.1868, Massa, Italy / d.1949.*
Addresses: NYC. **Studied:** Acad. San Luca, Rome. **Member:** ANA; NA, 1936; Arch. Lg., 1914. **Exhibited:** Pan-Am. Expo, Buffalo, 1901 (prize); St. Louis Expo, 1904 (med); PAFA Ann., 1904-12 (4 times); P.-P. Expo, 1915 (prize); AIC. **Comments:** Came to NYC in 1888; son of Guiseppe, brother of Attilio Piccirilli. **Sources:** WW47; WW25 (as Ferruccio); Falk, *Exh. Record Series.*

PICCIRILLI, Guiseppe *[Sculptor] b.1843 / d.1910.*
Addresses: NYC. **Work:** marble dec., new Customs House, NY; Chamber of Commerce; County Court House; NY Stock Exchange. **Comments:** With his six sons, all sculptors, he opened a studio adjoining his home.

PICCIRILLI, Horatio *[Sculptor] b.1872, Massa Italy (came to NYC in 1888) / d.1954, Riverdale, NY.*
Addresses: NYC. **Exhibited:** NAD, 1926 (prize). **Comments:** Son of Guiseppe. **Sources:** WW33.

PICCIRILLI, Maso *[Sculptor] 20th c.; b.Massa, Italy.*
Addresses: NYC. **Comments:** Came to NYC in 1888. Son of Guiseppe. **Sources:** WW29.

PICCIRILLI, Orazio *[Sculptor] 20th c.; b.Massa, Italy.*
Addresses: NYC. **Comments:** Came to NYC in 1888. Son of Guiseppe. **Sources:** WW29.

PICCIRILLI, Vivian Lush See: **LUSH, Vivian R. (Mrs. V. L. Piccirilli)**

PICCOLI, Girolamo *[Sculptor] b.1902, Palermo, Sicily.*
Addresses: NYC; Milwaukee, WI. **Studied:** Wis. Sch. A; F. Vittor; L. Taft. **Member:** Am. A. Cong. **Exhibited:** Milwaukee AI, 1922 (med); Wis. PS, 1924 (prize); PAFA Ann., 1925; AIC. **Work:** sculpture of the Eagles Club Bldg.; fountain, Lake Park, Milwaukee. WPA artist. **Sources:** WW40; Falk, *Exh. Record Series.*

PICHON, Arthur *[Painter] b.1857, LA.*
Addresses: New Orleans, active 1875-1922. **Sources:** *Encyclopaedia of New Orleans Artists,* 305.

PICIKEIT, Joseph *[Primitive painter] b.1848, New Hope / d.1918.*
Addresses: New Hope, PA. **Work:** MoMA; WMAA (few works survive).

PICK, John *[Educator, art administrator] b.1911, West Bend, WI.*
Addresses: Milwaukee, WI. **Studied:** Univ. Notre Dame (B.A.,1929); Univ. Wis. (M.A.,1934, Ph.D., 1938); grad. study at Harvard & Oxford. **Member:** Am. Assn. Univ. Prof.; Mod. Lang Assn. Am.; Eng.-Speaking Union; fel. Royal Soc. Arts, London. **Work:** Milwaukee Art Ctr.; Marquette Univ. Art Coll. **Comments:** Positions: chrmn., Univ. Comt. Fine Arts, Marquette Univ., 1951-; cultural attaché, Embassy of Malta, Wash., DC, 1968-. Teaching: Fulbright lectr., Royal Univ. Malta, 1955-56. Collections arranged: Marquette Univ. Art Collection including editing two catalogues. Research: brochures on icons, Spanish colonial art and others. Publications: auth., "Gerard Manley Hopkins: Priest and Poet," (Word Univ. Press, 1942); "A Hopkins Reader," (Oxford Univ. Press, 1952); "Hopkins--the Windhover," (Merrill, 1968). **Sources:** WW73.

PICKARD, Dorothy *[Painter] mid 20th c.*
Exhibited: AIC, 1938. **Sources:** Falk, *AIC.*

PICKARD, Thomas W. *[Painter] 20th c.*
Addresses: Columbus, OH. **Member:** Columbus PPC. **Sources:** WW25.

PICKEN, A. *[Lithographer] mid 19th c.*
Addresses: NYC, active c. 1835. **Sources:** G&W; Peters, *America on Stone.*

PICKEN, George Alexander pic
[Painter, printmaker, teacher]
b.1898, NYC / d.1971, Tyringham, MA.
Addresses: NYC; Tyringham, MA. **Studied:** ASL, 1924; & in Europe. **Member:** An Am. Group; Nat. Soc. Mural Painters; Am. Artists Congress; Fed. Modern Painters & Sculptors; Soc. Am. Graphic Artists; Am. Assn. Univ. Prof.; "The Islanders," Audubon Artists; Am. Soc. Painters, Sculptors and Gravers. **Exhibited:** Salons of Am.; ASL, 1922, 1923, 1925, 1929, 1933, 1934, 1936, 1939; Montross Gal., NYC, 1923; NYPL, 1924, 1928, 1932; Wanamaker Gal., NYC, 1924, 1935, 1939; S.S. Carvalho Gal., Plainfield, NJ, 1924; Neumann Gal., NYC, 1928; G.R.D. Studio, NYC, 1928, 1929; Salons America, 1929, 1932, 1934, 1936; WMAA, 1932-34, 1936, 1938, 1940, 1942-46, 1947, 1949, 1955, 1960; College Art Assoc., NYC, 1932; Brownell-Lambertson Gal., NYC, 1931; Am. Print Makers, Inc., NYC, 1931, 1933-34, 1936; Milch Gal., NYC, 1932-36; Eighth St. Gal., NYC, 1932; PAFA Ann., 1932-64; Union Library, Schnectady, NY, 1932; First Municipal Art Exhib., R.C.A. Bldg., NYC, 1934; Corcoran Gal biennials, 1935-61 (10 times, incl. 4th prize, 1943); Mural Painters Soc., NYC, 1935; Roerich Mus., NYC, 1935; Gillespie Gal., Pittsburgh, PA,. 1936; New School Soc. Res., 1936; WFNY, 1939; Am. Soc. PS &G, NYC, 1939; Marie Harriman Gal., NYC, 1940; AIC, 1941-45; VMFA, 1942, 1944, 1946; Frank Rehn Gal., NYC, 1942, 1945, 1947, 1949, 1952, 1954, 1960, 1963, 1967, 1971; WMA, 1943; An Am. Group, NYC, 1944; Pepsi Cola Co., Los Angeles, 1948; Herron AI, 1944, 1945; MMA, 1943; Kalamazoo Inst. Art, 1943; LACMA, 1945; BM, 1944-46; CI, 1944-46; Iowa State Univ., 1946; Berkshire Mus.; NAD, 1947. **Work:** CGA; Newmark Mus.; NYPL; Dartmouth; IBM Collection; Univ. Arizona; Lowe Art Center, Syracuse Univ.; Lowe Art Gal, Miami Univ.; Hudson River Mus.; WMAA. **Commissions:** murals, U.S. Post Office, Fort Edward & Hudson Falls, NY & Chardon, OH; St. Ambrose Church, Brooklyn, NY; Hawthorne (NY) Public School. **Comments:** Teaching: ASL; Berkshire Mus., Pittsfield, Mass; Brooklyn Mus. School, Brooklyn, NY; Cooper Union Art School, 1943-64; Columbia Univ., 1943-64; Hofstra Univ., 1965-66; Kansas City Art Inst., 1965-66; Univ. Hartford, 1967-68; Lenox School Boys, MA, 1967-68. **Sources:** WW73; WW47; *American Scene Painting and Sculpture,* 62 (w/repro.); Falk, *Exh. Record Series.*

PICKENS, Alton *[Painter, educator] b.1917, Seattle, WA / d.1991.*
Addresses: Poughkeepsie, NY. **Studied:** Reed Col., Portland, Oreg.; Seattle AI; Portland (Oreg.) A. Mus. Sch.; L. Reynolds. **Exhibited:** MMA, 1942; MoMA, 1943; CAM, 1945; AIC, 1945; Cl, 1945; WMAA, 1946-55; Corcoran Gal biennial, 1951; PAFA Ann., 1952, 1958. **Work:** MoMA. **Comments:** Magic Realist painter. Teaching: Univ. IN, 1946-47; Vassar Col., 1956-70s. **Sources:** WW73; Wechsler, 39; Falk, *Exh. Record Series.*

PICKENS, Lucien Alton See: **PICKENS, Alton**

PICKENS, Vinton Liddell *[Painter] mid 20th c.; b.Charlotte, NC.*
Addresses: Ashburn, VA. **Studied:** Corcoran Art Sch. with Eugene Weisz; Am. Univ. with Ben L. Summerford. **Member:** AEA (Wash., DC Chapt.). **Exhibited:** Corcoran Gal. biennial, 1951; Soc Wash. Artists; Irene Leach Mem. Exhibs., Norfolk, Va.; Va. Artists Biennial, Richmond; NC Artists Biennial, Raleigh. **Work:** Butler Inst. Am. Art; Watkins Gal., Wash, DC; Miami MoMA, Fla.; Univ. Maine; Art-in-the-Embassies Prog., State Dept. **Comments:** Auth & illustrator: "Paint an Elephant," *Atlantic,* 1958; article in *Serendipity.* **Sources:** WW73.

PICKERING, Ernest *[Educator] 20th c.*
Addresses: Cincinnati, OH. **Comments:** Position: dean, College of Applied Art, Univ. of Cincinnati. **Sources:** WW59.

PICKERING, Hal *[Illustrator] 20th c.*
Addresses: Salt Lake City, UT. **Comments:** Position: affiliated with Deseret News. **Sources:** WW15.

PICKERING, James H. *[Designer] b.1904, Kansas City, MO.*
Addresses: NYC. **Studied:** M. van der Rohe; H. Bayer; E Reich, Berlin. **Comments:** Specialty: store interiors, displays, exhibitions. **Sources:** WW40.

PICKERING, Mabel Lisle (Mrs. H.B.) See: **DUCASSE, Mabel Lisle (Mrs. Curtis John)**

PICKERING, Phoebe See: **JENKS, Phoebe A. Pickering Hoyt (Mrs. Lewis E.)**

PICKERING, S(imon) Horace *[Painter, illustrator, lecturer, commercial artist, historian, writer] b.1894, Salt Lake City, UT.*
Addresses: NYC. **Studied:** AIC; Grand Central A. Sch.; & with Wayman Adams, Dean Cornwell; Summer Sch. of P., Saugatuck, Mich. **Member:** S. Indp. A.; Nat. Parks Assn.; Acad. Allied A.; AAPL; Am. Mus. Natural Hist.; Am. Veterans Soc. A. **Exhibited:** Soc. Indp. A., 1927-1946; Salons of Am.; Am. Veterans Soc. A., annually; AIC; Greenwich Village A. Center; Barbizon-Plaza A. Gal., NY; Acad. Allied A., NY ,1955; Jersey City, NJ, 1956. **Work:** Nat. Park Service. **Comments:** Position: color photographer, Nat. Parks Service; tour leader supv., Statue of Liberty, NYC. Contributor: maps & illus. to Nat. Park Service periodicals. **Sources:** WW59; WW47.

PICKETT, Byron M. *[Sculptor] mid 19th c.*
Addresses: NYC. **Exhibited:** NAD, 1867-68, 1875. **Sources:** Naylor, *NAD.*

PICKETT, Frederick Augustus *[Miniature painter] d.1904, Newport (RI) Hospital.*
Addresses: NYC. **Exhibited:** PAFA Ann., 1903 (last work publicly shown). **Sources:** Falk, *Exh. Record Series.*

PICKETT, J. H. R. *[Painter] 20th c.*
Addresses: Richmond, VA. **Work:** USPOS, Lewisburg, Term., Virginia Beach, Va. WPA artist. **Sources:** WW40.

PICKETT, James Tilton *[Painter, photographer] b.1857, Bellingham, WA / d.c.1888, Portland, OR.*
Addresses: Portland, OR. **Studied:** San Francisco, CA. **Exhibited:** Festival of the Arts Expo., State Capitol Mus., Olympia, 1971. **Comments:** Son of the Confederate Army General G. E. Pickett and a Native American woman of the Haida tribe, he began drawing at an early age, using charcoal, berry juices and other natural pigments on wood. Position: staff, *Seattle Post Intelligencer* and *Portland Oregonian.* **Sources:** Trip and Cook, *Washington State Art and Artists.*

PICKETT, Joseph *[Painter]*
b.1848, New Hope, PA / d.1918, JOE PICKETT
New Hope.
Addresses: New Hope, PA. **Work:** MoMA; WMAA. **Comments:** "Primitive" painter. He did not begin painting until the late 1890s, while operating a general store in New Hope. His subjects included local historical events, such as George Washington's activities at New Hope. He would work on his paintings for years and few of his works survive. **Sources:** Gerdts, *Art Across America,* vol. 1: 276 (w/repro.).

PICKFORD, Rollin Jr. *[Painter] b.1912, Fresno, CA.*
Addresses: Fresno, CA. **Studied:** Fresno State Col.; Stanford Univ. (B.A.); also with Alexander Nepote, Ralph DuCasse, James Weeks & Joseph Mugnaini. **Member:** West Coast WC Soc.; Carmel AA; Fresno Arts Ctr.; Old Bergen Art Guild; Calif. WC Soc. **Exhibited:** All-Calif. Invitational, Laguna Beach, 1960 (best of show); Watercolor USA, Springfield, Mo., 1962 (first prize and purchase award), 1965 & 1966; Calif State Fair, 1963 (first prize & purchase award); Mainstreams '1968, Marietta, OH, 1968; Calif. Nat. WC Soc. Traveling Show, Riverside Mus., New York

& VMFA; Austrian-Am. Exchange Exhib., Linz, Salzburg & Vienna, Austria, 1972. **Work:** Springfield Art Mus., Mo.; State of Calif. Coll., Sacramento; Ford Motor Co., Dearborn, Mich.; Fresno Arts Ctr.; City of Santa Paula, Calif. **Comments:** Preferred media: watercolors, oils, acrylics. Positions: pres., Fresno Art League, 1946-47. Teaching: instr. art, Fresno State Col., 1948-62. Publications: illusr., stories by William Saroyan, Lincoln-Mercury Times & Ford Times, 50's; auth., "A Philosophical Approach to Watercolor," *Am. Artist* (1969). **Sources:** WW73.

PICKHARDT, Carl E., Jr. *[Painter, educator, lithographer]* b.1908, Westwood, MA.
Addresses: Cambridge, MA; Sherborn, MA. **Studied:** Harvard Univ. (A.B., 1931); study with Harold Zimmerman, 1930-35. **Exhibited:** WWAA, 1936; NAD.,1936, 1942 (Schope Prize); McDonald Gal., NY, 1937; Inst. Mod. A., Boston, 1939; Int. Biennial of Color Lithography, 1951; CI,1952; Int. Exhib., Japan, 1952; Am. Drawing Biennial, Norfolk, Va., 1966; PAFA Ann., 1968; Doris Meltzer, NYC, 1970s. **Work:** NYPL; AGAA; PMA; FMA; MOMA; BMFA; Newark Art Mus, NJ; LOC; BM. **Comments:** Teaching: instr. printmaking, Worcester Mus. Art Sch., 1949-50; instr. printmaking, ASL, 1951; instr. painting, Fitchburg Art Mus., 1951-62. **Sources:** WW73; Parker Tyler, *Carl Pickhardt* (Horizon, 1972); Falk, *Exh. Record Series.*

PICKHIL, Alexandre See: **PICKIL, Alexander**

PICKIL, Alexander *[Portrait painter]* d.c.1840.
Addresses: New Orleans. **Comments:** African-American artist. Known through secondary sources. He is said to have destroyed all or nearly all his paintings because of "disillusionment with his environment and the attitude of critics and friends toward his art" (Porter). **Sources:** G&W (as Pickil); James Porter, "Versatile Interests of the Early Negro Artist," 21. More recently, see *Encyclopaedia of New Orleans Artists* (as Alexandre Pickhil).

PICKMAN, Vivian W. *[Painter]* mid 20th c.
Addresses: Boston, MA, 1933. **Exhibited:** S. Indp. A., 1933. **Sources:** Marlor, *Soc. Indp. Artists.*

PICKNELL, George W.
[Landscape painter] b.1864, Springfield, VT / d.1943, Silvermine, CT.
Addresses: Pas-de-Calais, France; Freehold, NJ; Silvermine, CT. **Studied:** Académie Julian, Paris with J.J. Lefebvre and B. Constant, 1887-90; ASL. **Member:** Am. Artists Ass'n of Paris (founder); SC; AFA; Springfield (IL) AA; Silvermine Artists Gld. (founder). **Exhibited:** Salon des Artistes Français; in Nice and Toulouse, France; PAFA Ann., 1909, 1912; Herron AI, Indianapolis, 1911 (solo); AIC; S. Indp. A.; Silvermine Artists Gld.; Bridgeport AL, 1934 (prize). **Work:** Detroit Inst. Art; New England Baptist Hosp., Boston; YMCA, Norwalk, CT. **Comments:** After his studies in Paris, he was briefly an illustrator in Boston and New York. He returned to Paris for about fifteen years, painting throughout the country. He returned to the U.S. around 1911, and was active in Freehold, NJ before settling in Silvermine, CT, in 1912. During WWI, he and his wife opened the Fine Arts Theatre in Westport, CT. He is best known for his landscapes of Connecticut and rural France. **Sources:** WW40; Falk, *Exh. Record Series.*

PICKNELL, William Lamb
[Landscape painter] b.1853, Vermont / d.1897, Boston, MA.
Addresses: Boston, MA, until c.1873; Europe, c.1873-82; Boston, 1882-89; France, 1889-97; Boston, 1897. **Studied:** Geo Inness in Italy, c.1873; École des Beaux-Arts with with Gérôme, 1874; with Robert Wylie in France. **Exhibited:** Paris Salon, 1876, 1878-81, 1884, 1888, 1893-98; NAD, 1879-98; Corcoran Gal, 1880 (prize for "Road to Concarneau"); PAFA Ann., 1881-83, 1891-98, 1902; Boston AC, 1896, 1901; AIC. **Work:** BMFA; MMA; NMAA; PAFA; Musée d'Orsay, Paris; Walker AG, Liverpool, England. **Comments:** From 1873-on, Picknell was largely an expatriate painter who traveled throughout France, living at the artists

colonies in Pont-Aven (1876-80) and Concarneau, later traveling to Grez, Moret, and Antibes. He did return to Massachusetts for part of the 1880s, painting along the coast at Annisquam, and traveling widely from Florida to California. In poor health, he died at age 43. He was commemorated by Augustus St. Gaudens on a portrait medallion. His brother was George W. Picknell. **Sources:** Fink, *American Art at the Nineteenth-Century Paris Salons,* 380-81; *300 Years of American Art,* vol. 1, 465; Falk, *Exh. Record Series.*

PICKUP, Ernest A. *[Etcher, engraver]* b.1887, Shelbyville, TN / d.1970, Nashville, TN?.
Addresses: Nashville, TN. **Member:** Woodcut Soc.; Southern Pr.M.; SSAL; Studio Cl. **Exhibited:** Delgado Mus. A., 1937 (prize); AIC, 1937 (prize), 1938, 1939 (prize), 1940; PAFA, 1933-35; SAE Inti. Exh., 1937-39; Centenn. C., Nashville, 1939, 1945 (solo). **Work:** Nashville Park Commission; Delgado Mus., New Orleans. **Comments:** I., "Man Upon Earth," 1945 (7 wood engravings). **Sources:** WW53; WW47.

PICOT, Joseph-Pierre See: **CLORIVIÈRE, Joseph-Pierre Picot de Limoëlan de**

PIECK, Phillip (Father) *[Painter]* b.1881, Holland.
Addresses: Philippines; NYC. **Exhibited:** Contemporary Arts, NYC, 1941, 1943, 1946 (solos); PAFA Ann., 1944. **Comments:** Served in the Philippines as a member of the St. Joseph's Missionary Fathers for 32 years before coming to NYC. He returned there after WWII, in 1946. **Sources:** Falk, *Exh. Record Series;* info. courtesy of Charles Semowich, Rensselaer, NY.

PIELAGE, Jozef *[Painter]* b.1901.
Addresses: Orange, NJ. **Exhibited:** S. Indp. A., 1933. **Sources:** Marlor, *Soc. Indp. Artists.*

PIELICE, Rolfe *[Illustrator]* 20th c.
Addresses: San Fran., CA. **Sources:** WW211.

PIELKE, Rolf *[Painter, commercial artist]* b.1886, Poland / d.1957, Crescent City, CA.
Addresses: San Francisco, CA. **Exhibited:** City of Paris, San Francisco, 1924. **Sources:** Hughes, *Artists in California,* 438.

PIENOVI *[Scene painter]* early 19th c.
Addresses: NYC, active 1811. **Studied:** identified in NY *Evening Post,* as "from the Academy of Rome". **Comments:** Painted a drop curtain showing NYC scenes for a NYC theater, 1811. **Sources:** G&W; N.Y. *Evening Post,* Aug. 1, 1811 (citation cited by G&W as being courtesy J.E. Arrington).

PIEPER, Hugo J. *[Painter]* mid 20th c.
Addresses: Chicago area. **Exhibited:** AIC, 1948 (prize), 1949, 1950 (prize). **Sources:** Falk, *AIC.*

PIEPER, Joseph *[Painter]* mid 20th c.
Exhibited: AIC, 1938. **Sources:** Falk, *AIC.*

PIER, Rosamond See: **HUNT, Rosamond Pier (Mrs William Morris Hunt)**

PIERCE *[Portrait painter]* early 19th c.
Addresses: Portsmouth, NH, 1819. **Comments:** Advertised at Portsmouth in February 1819. He also ran a gallery in Portsmouth for a time. **Sources:** G&W; *Antiques* (Sept. 1944), 158. More recently, see Gerdts, *Art Across America,* vol. 1: 31.

PIERCE *[Portrait painter]* early 19th c.
Addresses: Vermont, active 1821. **Comments:** Known through portraits of Mr. and Mrs. Matthew Perkins, dated 1821(owned in 1941 by private collector in Burlington, VT). **Sources:** G&W; WPA (Mass.), *Portraits Found in Vermont.*

PIERCE, A. B. , Jr. *[Painter]* 20th c.
Addresses: Houston, TX. **Exhibited:** Houston Artists Arm., Houston MFA, 1938, 1939. **Sources:** WW40.

PIERCE, Alice B. *[Painter]* late 19th c.
Addresses: NYC. **Exhibited:** NAD, 1893. **Sources:** Naylor, *NAD.*

PIERCE, Anna Harriet *[Painter, drawing specialist, teacher]*
b.1880, Southbury, CT.
Addresses: Southbury, CT, 1947; New Haven, CT, 1953.
Studied: NAD; NY Sch. Art; Yale Univ. (B.F.A.); F. Luis Mora;
J.H. Niemeyer; F.C. Jones; G. Maynard; K.H. Miller; J.F. Weir;
E.C. Taylor; Commonwealth Colony, Boothbay Harbor, Maine.
Member: New Haven Paint & Clay Cl.; Brush & Palette Cl.
Exhibited: CAFA, 1932, 1935; Brush & Palette Cl., 1927-36,
1948-52; New Haven Paint & Clay Cl., 1910-36, 1948-52.
Awards: Yale Sch. FA (prize); Brush & Palette Cl. **Sources:**
WW47; WW53.

PIERCE, Anne Honsley *[Painter, printmaker]* b.1877, San
Diego, CA / d.1951, San Diego.
Addresses: San Diego, CA. **Studied:** Cora Timken Burnett.
Member: San Diego AA (co-founder 1904); San Diego Art Guild.
Exhibited: San Diego AA, 1905; Panama-Calif. Int'l Expo, 1916;
San Diego FA Gal., 1927, 1952 (retrospective); Calif.-Pac. Int'l
Expo, San Diego, 1935. **Sources:** Hughes, *Artists in California*,
438.

PIERCE, Antoinette A. (Mrs.) *[Painter]* 19th/20th c.
Addresses: Detroit, 1899-1900; Cincinnati, OH. **Studied:** BMFA.
Member: Copley Soc., 1895; Cincinnati Women's A. Cl.;
Cincinnati Women's Press Cl.; Detroit WCS. **Exhibited:** AIC,
1899-1900. **Comments:** Specialty: roses. **Sources:** WW10;
Petteys, *Dictionary of Women Artists*.

PIERCE, Bruce Wellington *[Lithograper, painter]* b.1858,
Broome County, NY / d.1947, Los Angeles.
Addresses: San Francisco, 1884-c.87; Los Angeles, 1887-1947.
Work: Sherman Library, Newport Beach, CA; Huntington
Museum, San Marino, CA; de Young Museum; Soc. of Calif.
Pioneers. **Comments:** Married to Clara Elliott, either the daughter
or niece of Wallace William Elliot (see entry). He drew ten views
of California towns between 1886-94. He also painted landscapes
in oil and watercolor. **Sources:** Reps, 199; Hughes, *Artists in
California*, .

PIERCE, Charles F(ranklin) *Charles F. Pierce*
[Landscape painter] b.1844,
Sharon, NH / d.1920, Brookline, MA.
Addresses: Boston, Brookline, MA. **Studied:** Boston; Europe.
Member: Boston AC; Boston SWCP; New Haven PCC.
Exhibited: Boston AC, 1875-1909; PAFA Ann., 1881-1901 (6
times); Corcoran Gal annual, 1907; AIC. **Sources:** WW19;
Campbell, *New Hampshire Scenery*, 128; Falk, *Exh. Record
Series*.

PIERCE, Danny *[Painter, educator, etcher, engraver, writer]*
b.1920, Woodlake, CA.
Addresses: Kent, WA. **Studied:** Am. A. Sch.; Brooklyn Mus.
Sch. A.; Chouinard AI; University of Alaska, 1963 (B.A.).
Member: Soc. Indp. A., Boston; CAFA; AEA (pres., Seattle
Chapter, 1958); Am. Color Pr. Soc.; F., I.A.L. **Exhibited:**
LACMA; Oakland A. Mus.; BMFA; Springfield A. Mus.; SAM;
Portland (Ore.) A. Mus.; BM; Munson-Williams-Proctor Inst.;
Corcoran Gal biennial, 1951; Carnegie Inst.; Erie Pub. Mus.;
Milwaukee AI; Butler AI; New Britain Mus. A.; Avery Mem.;
Univ. Maine; Clearwater Mus. A.; Bradley Univ.; Univ.
Mississippi; Creative Gal. (solo); Contemporaries (solo); Univ.
So. Cal.; DMFA; Denver A. Mus.; MoMA; Sanford-Tiel Mem.
Mus., Cherokee, Iowa; PAFA; Nat. Mus., Stockholm; Sao Paulo,
Brazil, Biennial Art Exh, 1954; Barcelona, Spain; Modern Masters
of Intaglio, Queens Col., NY, 1964; USIS Graphic Exhs. to
Prague, Yugoslavia, India, 1965; Northwest Printmakers, Henry
Gal., Seattle, 1964, SAM, 1965. One-man: (prints) Univ. of
Alaska, 1959-63, 1973-74; Tacoma A. Mus., 1964; Hanga Gal.,
Seattle, 1964; Gonzaga Univ., Spokane, Wash., 1964; Central
Washington Col. Edu., 1965; Univ of Oregon, Eugene, Or., 1964;
Oregon State Univ at Cornvallis, Or., 1964; Tacoma Art Mus
(Wash.), 1964; Expo 70, Osaka, Japan (representing State of
Washington artists, one of twelve artists); Bradley Gal,
Milwaukee, 1966-68, 1970, 1972, 1974, 1976, 1978, 1980, 1982;

Kohler Gal., Seattle, 1974; Oshkosh Public Mus., Wisc., 1976,
1984-85; Univ. of Maine, Orono, Me., 1978; Wisconsin State
Univ at Stevens Point (Wisc.), 1978; Cushing Gal., Dallas Tx.,
1978; Tahir Gal., New Orleans, La., 1980; City Hall Gal,
Oostduinkerke, Belgium, 1981; Univ. of Wisc.-Milwaukee Mus.
FA (Milwaukee, Wisc.), retrospective upon retirement, 1985;
Awards: prizes, BM, 1952 (purchase); Bradley Univ., 1952; LOC,
1952, 1953, 1958 (purchase); Univ. So. California, 1952; SAM,
1952; Western Washington State Fair, 1954 (prize); Henry Gal.,
1955; CAFA (prize, best oil landscape); So. Illinois Art Assoc.
(first prize in oil); Northwest Printmakers International, Seattle,
1955, 1964, 1968; Bradley Univ. Print Assoc., Peoria, Il., 1952.
Work: BM; NYPL; LOC; MoMA; Clearwater Mus. A.; Bradley
Univ.; Univ. So. California; Princeton Univ.; SAM; Sweat Mem.
Mus.; Nat. Mus., Stockholm, Sweden; Nat'l. Lib., Paris France;
Bradley Univ., Peoria, Il.; Univ. So. Calif., Los Angeles; Univ of
Wash., Henry Gal., Seattle, Wash.; Clearwater Mus. (Fla.); Univ.
of Minnesota (Minneapolis); National Fisheries Mus.,
Oostduinkerke, Belgium; Oshkosh Public Mus. (Wisc.); Rahr-
West Mus., Manitowoc, Wisc.; Univ. of Wisc., Madison and
Milwaukee; Johnson Wax Foundation, Racine, Wisc.; General
Mills Coll. of Art, Minneapolis, Minn.; USIS Offices in the Near
East and in Europe; Smithsonian Inst.; Huntington Lib., San
Marino, Calif.; William and Mary Col., Williamsburg, Va.
Comments: With a Carnegie Found. grant, he established the art
dept. at Univ. of Alaska, 1960-63, artist-in-res., 1964-65; visiting
instr., graphics, Univ. Wisconsin, Milwaukee, 1965; hd., art dept.,
Cornish Sch. of All. A., 1964-65; Univ. of Wisconsin-Milwaukee,
Sch. of Fine Arts. He retired from teaching in 1984 as Professor
Emeritus. Publications: published limited edition books: *Little No
Name*, 1959; *The Bear That Woke Too Soon*, 1963; *Little
Ezukvuk*, 1964; *Washington's Dilemma: Sack Cloth and
Butternut, 1775-83*, 1973; *Edge of the Sea*, 1974; *A Day on the
Norma A.*, 1975; *Cattle Drive '76*, 1976; *Shepherdess of
Monument Valley*, 1977; *Man, Horse and Sea*, 1979, 1982; *Sea
Wrack*, 1980; *Birds*, 1981; *Joe Friebert*, 1976; *Golden Seas*, 1987.
Sources: WW66; addl info courtesy Martin-Zambito Fine Art,
Seattle, Wash.

PIERCE, David *[Portrait painter, daguerreotypist]* b.c.1819,
Massachussetts.
Addresses: Detroit, MI, active 1860-61. **Comments:** Was listed
in 1860 as portrait painter, in 1861 as daguerreotypist. **Sources:**
G&W; 8 Census (1860), Mich., XX, 919; Detroit CD 1861.

PIERCE, Delilah W(illiams) *[Painter, educator]* b.1904,
Wash., DC / d.1992.
Addresses: Wash., DC. **Studied:** Wash., DC Teachers Col. (dipl.);
Howard Univ. (B.S.); Columbia Univ. (M.A.); also with Lois
Jones, Céline Tabary, Ralph Pearson, James Lesene Wells & Jack
Perlmutter. **Member:** Soc Wash. Artists (treas., 1969-); AEA;
Wash. WC Assn. (mem. chmn., 1972); Nat. Conf. Artists (regional
chmn., 1970-72); DC Art Assn. (chmn. exhib. comt., 1970-72).
Exhibited: Margaret Dickey Gal., 1949-69; Atlanta Univ. Art
Show, 1952 & 1953; Area Show, 1957-59 & Travel Exhib., 1960-
61, CGA; BMA Area Show, 1959; Artists Mart, 1963, 1965, 1968,
1970, 1972; Howard Univ., 1970; Smithsonian Inst.; Wash. WC
Soc.; Soc. of Wash. Artists; American Federation of Arts, NYC,
1964 (mus. donor prog. purchase award); Martha's Vineyard
Island Show; Rehoboth Art League; Smith-Mason Gal. Nat.
Exhib., 1971 (prize); State Armory, Wilmington, DE, 1971;
Trenton Mus., 1972. **Awards:** Agnes Meyer summer fel., 1962;
award for achievement in field of art & art educ., Phi Delta
Kappa, 1963. **Work:** Howard Univ. Gal. Art, Wash., DC; DC
Teachers Col., Wash.; Anacostia Mus., Smithsonian Affil.
Commissions: portrait of Dr. Eugene A. Clark comn. by family for
Eugene A. Clarke Pub. Sch., Wash., DC, 1969. **Comments:**
Preferred media: oils, acrylics. Teaching: instr. art, secondary pub.
schs., Wash., DC, 1925-52; instr. art & art educ., DC Teachers
Col., 1952-56, prof. art & art educ., 1956-69, vis. prof. art educ.,
1970-71; vis. prof. art educ., Howard Univ. Sch. Educ., 1964-67.
Publications: auth., "Can Art Serve as a Balance Wheel in
Education?" *Educ. Arts Assn. J.* (1949); auth., "The Significance

of Art Experiences in the Education of the Negro," *J. Negro Life & Hist.* **Sources:** WW73; Cedric Dover, *American Negro Art,* (New York Graphic Soc., 1960); J.E. Atkinson, *Black Dimensions in Contemporary American Art,* (Carnation Co., 1971); Cederholm, *Afro-American Artists.*

PIERCE, Donald *[Painter] mid 20th c.*
Exhibited: Corcoran Gal biennial, 1951. **Sources:** Falk, *Corcoran Gal.*

PIERCE, E. *[Painter] late 19th c.*
Exhibited: San Francisco AA, 1885 (still life of grapes). **Sources:** Hughes, *Artists in California,* 439.

PIERCE, E. C. (Mrs.) *[Artist] early 20th c.*
Addresses: Active in Los Angeles, 1905-09. **Sources:** Petteys, *Dictionary of Women Artists.*

PIERCE, Edgar A. (Mrs.) *[Painter] 20th c.*
Addresses: Westboro, MA. **Sources:** WW24.

PIERCE, Edith Loring *[Etcher] b.1855, Philadelphia / d.1940.*
Addresses: Phila., PA. **Exhibited:** PAFA Ann., 1882-85; NAD, 1883-84; Boston AC, 1883-86; Paris Salon, 1885. **Comments:** Bibliography; Fink, *Am.n Art at the 19th c. Paris Salons,* 379; Falk, *Exh. Record Series.*

PIERCE, Elijah *[Sculptor, carver, painter] b.1892, near Baldwin, MS.*
Studied: self-taught. **Exhibited:** Ohio State Univ., 1971; Univ. of Ill., 1972; MoMA, 1972; Bernard Danenberg Galleries, NYC, 1972. **Work:** priv. colls. **Sources:** Cederholm, *Afro-American Artists.*

PIERCE, Elizabeth R. (Mrs. Vernon L.) *[Painter] mid 20th c.; b.Brooklyn, NY.*
Addresses: Bayside, NY; Yarmouth, NS. **Studied:** ASL, with John Groth, John Stewart Curry & Ame Goldthwaite; Art League Long Island, New York, with Edgar A. Whitney; Columbia Univ. Exten.; Hunter Col. **Member:** NAWA; life mem. ASL; Douglaston A. Lg.; Nat. Lg. Am. Pen Women; A. Lg. Long Island; AAPL; New Jersey Soc. P. & S. **Exhibited:** Douglaston A. Lg., 1946 (prize), 1950 (prize); BM, 1942; Studio Gal., 1945, 1946; Graitt Studios, NY, 1937; ASL, 1989; Jersey City Mus.; A. Lg. Long Island, 1946 (prize); Nat. Assn. Women Artists Ann., NAD Galleries; Argent Gal.; Hudson Valley AA; NAC; Nova Scotia Soc. Artists, Halifax; Nat. Mus., Wash., DC; Crowell's Downeaster Gal., Yarmouth, NS; Women's Int. Exp., 1947. **Work:** Children's room, Jamaica Pub. Libr., NY. **Comments:** Preferred media: oils. Teaching: instr. adult educ. oil painting, Nova Scotia Dept. Educ., Yarmouth, 1959-67. **Sources:** WW73; WW47.

PIERCE, Ethel *[Painter] mid 20th c.*
Addresses: San Francisco, CA. **Exhibited:** Oakland Art Gal., 1939. **Sources:** Hughes, *Artists in California,* 439.

PIERCE, Florence Miller *b.1919.*
Addresses: Active in New Mexico. **Comments:** Along with her husband, Ahorace Towner Pierce, a founder of the Transcendetal Painting Group, 1938. **Sources:** Trenton, ed. *Independent Spirits,* 171 (w/repro.).

PIERCE, Frances B. *[Landscape painter] b.1868, NJ.*
Addresses: Dunkirk, NY. **Studied:** M. Waiter; H.B. Snell; J. Lie; N. Fechin; S. Bredin. **Member:** Buffalo SA; Buffalo Guild Allied Artists; Nat. Lg. Am. Pen Women. **Work:** Public School No.19, Corona, NY. **Sources:** WW40.

PIERCE, Glenn M. *[Illustrator] 20th c.*
Addresses: Brooklyn, NY. **Member:** SI. **Sources:** WW33.

PIERCE, H. Winthrop *[Painter] late 19th c.; b.Boston, MA.*
Studied: Bouguereau, Robert-Fleury. **Exhibited:** Boston AC, 1881; Paris Salon, 1882-83. **Sources:** Fink, *American Art at the Nineteenth-Century Paris Salons,* 379.

PIERCE, Hannah Bradford See: **MYRICK, Hannah Bradford Pierce**

PIERCE, Harry *[Painter] 20th c.*
Addresses: Hyde Park, MA. **Member:** Boston AC. **Sources:** WW25.

PIERCE, Hartell *[Engraver, marine artist] b.1832, New York.*
Addresses: NYC in 1860. **Work:** Mariners Mus., Newport News, VA. **Comments:** *Cf.* Hart L. Pearce. **Sources:** G&W; 8 Census (1860), N.Y., LIV, 1; listed as living with his Irish wife and two children; Brewington, 301, lists him as still active in 1889.

PIERCE, Herbert Stanton *[Painter] b.1916, East Orange.*
Addresses: South Orange, NJ. **Studied:** Newark Pub. Sch. Fine & Indus. A.; Grand Cen. Sch. A. **Member:** Am. Ar. Prof. Lg.; N.J. WC Soc.; Essex WCC. **Exhibited:** Newark AC, 1936 (prize); NJ Gal., 1937 (prize); Asbury Park, Soc. A., 1938 (prize). **Sources:** WW40.

PIERCE, Horace Towner *[Painter, filmmaker] b.1914 / d.1958.*
Addresses: Meeker, CO; Baltimore, 1925-36; Taos, NM, 1936-39; NYC, 1939-42; Los Angeles, 1942; Santa Fe. **Studied:** MD Inst. Art, 1935; in Taos with E. Bisttram, 1936-39. **Member:** Transcendental Painting Group, 1938-41. **Exhibited:** MoMA, 1940. **Comments:** In 1938, he began to film a short movie, "The Spiral Symphony, " which used images of his abstract paintings. The movie was never completed but the paintings were exhibited at MoMA in 1940. **Sources:** *American Abstract Art,* 195; Diamond, *Thirty-Five American Modernists.*

PIERCE, J. Lee *[Painter] 20th c.*
Addresses: Chicago, IL. **Member:** Chicago NJSA. **Sources:** WW251.

PIERCE, James W. (Mrs.) *[Painter] 19th c.*
Addresses: Sacramento, CA. **Exhibited:** Calif. Agricultural Soc., 1883 (painted plaques). **Sources:** Hughes, *Artists in California,* 439.

PIERCE, Joseph W. *[Marine painter] late 19th c.*
Work: Peabody Mus., Salem, MA; Marblehead Hist. Soc. (MA). **Comments:** Active 1865-89, he was probably painting in the Far East in the 1860s; then in Boston and Marblehead. **Sources:** Brewington, 301.

PIERCE, Joshua See: **PEIRCE, Joshua H.**

PIERCE, Josiah, Jr. *[Artist, teacher] d.1902, Wash., D.C.*
Addresses: Wash., DC. **Comments:** Professor of drawing at Columbian Univ. (now George Wash. Univ.). **Sources:** McMahan, *Artists of Washington, D.C.*

PIERCE, Kate F. *[Painter] 19th/20th c.*
Addresses: Weymouth, MA. **Exhibited:** Boston AC, 1900. **Sources:** WW01; *The Boston AC.*

PIERCE, Lenora *[Painter] b.1872, Carthage, MO / d.1961, Tacoma, WA.*
Addresses: Tacoma, WA. **Studied:** self-taught. **Exhibited:** Western Wash. Fair; Pacific Gal. Artists; Wash. State Hist. Soc., 1954. **Sources:** Trip and Cook, *Washington State Art and Artists.*

PIERCE, Lucy Valentine *[Landscape painter; printmaker] b.1887, San Francisco, CA / d.1974, La Jolla, CA.*
Addresses: Berkeley, CA. **Studied:** Xavier Martinez; BMFA Sch.; Calif. Col. of A. & Cr.; San Fran. Inst. Art, & with Armin Hansen in Monterey. **Exhibited:** Pan-Pacific Expo, San Francisco, 1915; San Francisco AA, 1916, 1923, 1925; Hotel Oakland, Benefit for the Calif. College Arts & Crafts, 1924; Calif. State Fair, 1930; GGE, 1939. **Sources:** WW19; Hughes, *Artists in California,* 439.

PIERCE, Margaret Serena *[Painter] b.1867, New Bedford, MA / d.1952, Boston, MA.*
Studied: Friends Acad., BMFA School; Paris and Holland. **Exhibited:** New Bedford Art Club Loan Exhib., 1908. **Work:** New Bedford (MA) Free Pub. Lib. **Comments:** Had a studio in Boston. **Sources:** Blasdale, *Artists of New Bedford,* 144 (w/repro.).

PIERCE, Marion L. *[Painter] 20th c.*
Addresses: Rumson, NJ. **Member:** AWCS. **Sources:** WW47.

PIERCE, Martha *[Landscape painter, teacher] b.1873, New Cumberland, WV.*
Addresses: Wayne, NE/Lincoln, NE in 1941. **Studied:** Chicago Acad. FA with J.W Reynolds, J. Norton, L. Welson, C. Werntz; AIC; NYU, with J.P. Haney. **Member:** Nebraska Art Teachers Assn.; Western AA; NAAE. **Work:** Wayne State Teachers College. **Comments:** Position: head art dept., Wayne State Teachers College. **Sources:** WW40; P&H Samuels, 373.

PIERCE, Mildred *[Painter] 20th c.*
Addresses: Laguna Beach, CA. **Sources:** WW25.

PIERCE, Minerva Lockwood (Mrs.) *[Painter] b.1883, Trinidad, CO / d.1972, San Diego, CA.*
Addresses: San Francisco, CA; Reno, NV. **Member:** Latimer Club, Reno, NV. **Exhibited:** Lg. Am. Pen Women, de Young Mus., 1928; GGE, 1939. **Comments:** Position: house chairman, Nevada Art Gallery. Specialty: historical buildings, desert scenes and landscapes of the Sierra and Lake Tahoe. **Sources:** Hughes, *Artists in California,* 439.

PIERCE, Nicholas *[Artist] mid 19th c.*
Addresses: Newburyport, MA in 1850. **Sources:** G&W; Belknap, *Artists and Craftsmen of Essex County,* 11.

PIERCE, Rowena Elizabeth *[Sculptor] 20th c.*
Addresses: Providence, RI. **Member:** Providence AC. **Sources:** WW25.

PIERCE, W. J. *[Wood engraver] mid 19th c.*
Addresses: NYC, 1847. **Exhibited:** American Institute Fair, 1847. **Comments:** Probably William J. Pierce, wood engraver of Boston (see entry). **Sources:** G&W; Am. Inst. Cat., 1847.

PIERCE, Waldo See: **PEIRCE, Waldo**

PIERCE, William H. C. *[Painter, teacher] b.1858, Hamilton, NY / d.1940, San Diego, CA.*
Addresses: San Diego, CA. **Studied:** Lowell Sch. Des.; MIT; Paris. **Member:** San Diego AG. **Exhibited:** Pan-Calif Expo, San Diego, 1915 (bronze med.); World's Columbian Expo., Chicago, 1893; Calif.-Pac. Int'l Expo, San Diego, 1935. **Comments:** Position: hd. of art dept., Chaffey College of USC, Ontario, CA. **Sources:** WW40; Hughes, *Artists in California,*439.

PIERCE, William J. *[Engraver] b.c.1828, Vermont.*
Addresses: Burlington, VT in 1850. **Comments:** Cf. William J. Pierce of Boston. **Sources:** G&W; 7 Census (1850), Vt., IV, 597.

PIERCE, William J. *[Wood engraver] mid 19th c.*
Addresses: Boston, 1851 until c.1870. **Comments:** He was with Worcester & Pierce in Boston in 1851 and 1852. Cf. W.J. Pierce and William J. Pierce (of Vermont). **Sources:** G&W; Boston CD 1851-60+; Hamilton, *Early American Book Illustrators.*

PIERCE, William, Jr. *[Portrait painter] late 18th c.; b.Virginia.*
Addresses: Virginia, active from August 1775. **Studied:** Charles Willson Peale at Annapolis (MD) and Baltimore (MD) in 1774-75. **Sources:** G&W; Sellers, *Charles Willson Peale,* I, 119-20; *Virginia Gazette,* August 11, 1775; *William and Mary Quarterly,* II (1893-94), 35).

PIERCY, Frederick *[Portrait & landscape painter] b.1830, Portsmouth, England / d.1891, London, England.*
Exhibited: London, 1848-80. **Comments:** Began painting portraits in England about 1848. In 1853 he left Liverpool for the U.S., arriving in New Orleans in March and traveling to St. Louis (MO), Nauvoo (IL), and westward to Salt Lake City (UT), sketching scenes and portraits along the way at the behest of the Mormon Church. After his return to England in 1854 he wrote and illustrated an account of his journey, *Route from Liverpool to Great Salt Lake Valley* (1855). Continued to exhibit portraits in London as late as 1880, when he became paralyzed. **Sources:** G&W; Arrington, *Nauvoo Temple,* Chapter 8; Piercy, *Route from*

Liverpool to the Great Salt Lake Valley; Jackson, *Gold Rush Album,* repros.; Powell, "Three Artists of the Frontier." More recently, see *Encyclopaedia of New Orleans Artists;* P&H Samuels, 373.

PIERI, Pompeo L. *[Painter] early 20th c.*
Addresses: NYC. **Exhibited:** S. Indp. A., 1929, 1932. **Sources:** Marlor, *Soc. Indp. Artists.*

PIERIE, William See: **PIERRIE, William**

PIERNE, Jean *[Painter] early 20th c.*
Exhibited: AIC, 1926. **Sources:** Falk, *AIC.*

PIEROTTI, John *[Cartoonist] mid 20th c.; b.NYC.*
Addresses: NYC. **Studied:** ASL; Cooper Union; Mechanics Inst. **Member:** Nat. Cartoonists Soc. (pres., 1957-59); Artists & Writers. **Exhibited:** Man & this World, Montreal, Can.; Yugoslavia; MMA. **Awards:** five Silurian Awards for best ed. cartoon, 1965-71; Page One Award for best sports cartoon, 1965-68; Page One Award for best ed. cartoon, 1968 & 1970-72. **Work:** Collection of All Works, Syracuse Univ.; Wayne State Univ.; Univ. Wis. Numerous commissions. **Comments:** Publications: illusr., sports & ed. cartoonist, New York Post in 1973. **Sources:** WW73.

PIERPONT, Clarence S. *[Painter] 20th c.*
Addresses: Providence, RI. **Member:** Providence AC. **Sources:** WW25.

PIERRE, Joseph Horace Jr. (Joe) *[Cartoonist, commercial artist] b.1929, Salem, OR.*
Addresses: Salem, OR. **Studied:** Famous Artists School; Advertising Art School, Portland, Ore. **Member:** Northwest Cartoonists & Gagwriters Assn. (fndr.); Nat. Agricultural Comic Strip Artists Assn. **Work:** mural, Mardi Gras Restaurant, Salem, Ore. **Comments:** Positions: ed. & publ., "The Pro Cartoonist & Gagwriter," professional weekly for cartoonists and writers, 1961; pres., Illustrators' Workshop, 1960-61. Vocational instr., Graphic Arts, Oregon State Correctional Institution, Salem, Ore., 1963-65. Author, illus., ed., "Survival Program for Farmers" (cartoon booklet); author, ed., (work book) "An Introductory Course in Screen Process" (publ. by Ore. State Corr. Inst., 1964). Contributor cartoons to: *Saga; Male; Travel; Flying; Humorama; Master Detective* and other national magazines. Creator of "Fabu" comic strip for "Oregon Agriculture." **Sources:** WW66.

PIERRE-NOEL, Lois Mailou Jones See: **JONES, Lois Mailou (Mrs V. Pierre-Noel)**

PIERRIE, William *[Landscape and townscape painter] mid 18th c.*
Comments: Officer in the British Royal Artillery stationed in America. In 1768 (as Lt. Pierie) he drew a view of Niagara Falls; in 1774 another view of the Falls was published, this one after a painting by a Mr. Wilson. Made views of NYC and Boston in 1775 and 1776. He was promoted to Captain some time after 1768. **Sources:** G&W; Dow, *Niagara Falls,* I, 80; Stokes, *Historical Prints;* Stokes, *Iconography,* VI, pl. 88a; Kelby, *Notes on American Artists,* 11.

PIERROT, Henriette *[Painter] early 20th c.*
Addresses: NYC. **Exhibited:** S. Indp. A., 1924-27; Salons of Am., 1925. **Sources:** Falk, *Exhibition Record Series.*

PIERSALL, Zella Kay *[Painter] mid 20th c.*
Addresses: San Francisco, CA; Reno, NV. **Exhibited:** GGE, 1940; Soc. for Sanity in Art, CPLH, 1945. **Sources:** Hughes, *Artists in California,* 439.

PIERSON, Alden *[Illustrator] b.1874, Baltimore / d.1921.*
Addresses: NYC. **Member:** SI, 1912. **Comments:** Position: art dir., *American Magazine.* **Sources:** WW19.

PIERSON, Elizabeth G. (Mrs.) *[Painter] mid 20th c.*
Addresses: NYC. **Exhibited:** NAWPS, 1935-38. **Sources:** WW40.

PIERSON, Gaston *[Painter] mid 20th c.*
Exhibited: S. Indp. A., 1937-38. **Sources:** Marlor, *Soc. Indp. Artists.*

PIERSON, J. A. (Mrs.) *[Painter] late 19th c.*
Addresses: Active in Kalamazoo, MI. **Exhibited:** Michigan State Fair, 1884. **Sources:** Petteys, *Dictionary of Women Artists.*

PIERSON, John C. *[Painter] 20th c.*
Addresses: Hartford, CT. **Member:** CAFA. **Sources:** WW25.

PIERSON, John C. (Mrs.) *[Painter] 20th c.*
Addresses: Hartford, CT. **Member:** Hartford AS. **Sources:** WW25.

PIERSON, Lydia Jane Wheeler (Mrs.) *[Watercolorist, poet] 19th c.; b.Middletown, CT.*
Addresses: Active in Pennsylvania. **Studied:** self-taught. **Comments:** Created a book of poetry, illustrated with engravings of flowers. **Sources:** Petteys, *Dictionary of Women Artists.*

PIERSON, N. *[Painter] 20th c.*
Addresses: Alexandria, VA. **Sources:** WW04.

PIERSON, Paul R.B. *[Engraver] mid 19th c.*
Addresses: Boston, 1855-58. **Comments:** In 1855-56 of Smith & Pierson (see entry). **Sources:** G&W; Boston CD 1855-58, BD 1855-56.

PIERSON, Pauline *[Painter] mid 20th c.*
Addresses: Oakland, CA. **Member:** Carmel AA. **Exhibited:** Oakland A. Gal., 1939. **Sources:** Hughes, *Artists in California,* 439.

PIERSON, Sarah *[Genre painter] early 19th c.*
Comments: Her "Fulton Street, New York, 1821" was shown at the Corcoran Gallery in 1950. **Sources:** G&W; *American Processional,* 240.

PIERSON, Susan E. *[Painter, teacher] early 20th c.*
Addresses: Wash., DC, active 1902-09; Huntley, VA, 1909. **Member:** Wash. WCC, 1902-21. **Exhibited:** Wash. WCC, 1902-03. **Comments:** Instructor of art at the Friends Sch., Wash. D.C. **Sources:** WW06; McMahan, *Artists of Washington, D.C.*

PIERSON, Victor *[Painter] late 19th c.; b.England or France.*
Addresses: Came to New Orleans via Mexico c.1865, active through 1873 when he is said to have left for Mexico. **Exhibited:** Wagener's New Orleans, 1868, 1870; Seebold's New Orleans, 1884; Grand State Fair, 1870-71. **Work:** Fair Grounds Race Track, New Orleans ("Life on the Metairie"); Louisiana State Mus., New Orleans ("Volunteer Firemen's Parade"). **Comments:** Partner with John Genin (see entry) in Pierson & Genin (1871-72); and with Paul Poincy (see entry) in Pierson & Poincy (1872-73). He specialized in horse paintings but also collaborated on several large paintings. In 1868 he and Theodore Sydney Moise (see entry) collaborated on the grand "Life on the Metairie", an historical painting which won best prize at the Grand State Fair. In 1872 he and Paul Poincy worked together to create "Volunteer Firemen's Parade," which was over 12 feet long and included portraits of over 126 firemen. **Sources:** G&W; Gerdts, *Art Across America,* vol. 2: 95, 105; *Encyclopaedia of New Orleans Artists* (under Victor Pierson, and Pierson & Poincy).

PIERUCCI, Massimo *[Sculptor] mid 20th c.*
Addresses: Phila., PA. **Exhibited:** PAFA Ann., 1968. **Sources:** Falk, *Exh. Record Series.*

PIETERSZ, Bertus L. *[Painter, writer, teacher] b.1869, Amsterdam, Holland / d.1938.*
Addresses: Springfield, MA. **Studied:** Rotterdam, with H.W. Ranger. **Exhibited:** Jordan Marsh Art Gal., 1894-96. **Work:** Springfield, Mass., Art Mus. **Sources:** WW38; Campbell, *New Hampshire Scenery,* 128.

PIETERSZ, John C. *[Painter] 20th c.*
Addresses: Springfield, MA. **Sources:** WW17.

PIETRI, Hortensia *[Painter] early 20th c.*
Addresses: NYC, 1929. **Exhibited:** S. Indp. A., 1929. **Sources:** Marlor, *Soc. Indp. Artists.*

PIETRI, Louisa *[Painter] early 20th c.*
Addresses: NYC, 1929. **Exhibited:** S. Indp. A., 1929. **Sources:** Marlor, *Soc. Indp. Artists.*

PIETRO, Cartaino di Sciarrino *[Sculptor] b.1886, Palermo, Italy / d.1918.*
Addresses: Pelham, NY; NYC. **Studied:** Rome; mostly self-taught. **Member:** Boston AC. **Exhibited:** PAFA Ann., 1913, 1919 (deceased); P.-P. Expo, San Fran., 1915 (prize); AIC, 1916. **Work:** busts, Am. Mus. Natural Hist., NY; bust, Hamilton Col., Hamilton, Ohio; bust, Pan-Am. Union, Wash., DC; bust, Univ. Wis., Madison; bust, Hague Peace Palace, Hague, Holland; bust, Memorial col., Phila.; marble fountain, Hackensack (N.J.) Court House. **Comments:** Founder/director: Friends of Young Artists. **Sources:** WW17; Falk, *Exh. Record Series.*

PIETRO, S. C. (Mrs.) *[Sculptor] 20th c.*
Addresses: NYC. **Sources:** WW21.

PIETZ, Adam *[Sculptor, engraver, medalist] b.1873, Germany / d.1961, Phila., PA.*
Addresses: Phila., Drexel Hill, PA. **Studied:** PAFA; AIC; & in Germany. **Member:** Phila. Sketch Cl.; Phila. A. All. **Exhibited:** AIC; PAFA Ann., 1901-05, 1910-16, 1930-38, 1943-44; S. Indp. A., 1917. Award: bronze medal, Madrid, Spain, 1951. **Work:** Mem. Hall, Navy Yard, U.S. Mint, Univ. Pennsylvania, PAFA, PMA, Acad. Music, Sketch Cl., all in Phila., Pa.; Am. Numismatic Soc.; Nat. Mus., Wash., DC; AIC; Vanderpoel Coll.; British Mus., London; reverse, Congressional Med. Honor; Iowa Statehood (Centennial) Half-Dollar, 1946. **Comments:** Position: asst. engraver, U.S. Mint, 1927-46. **Sources:** WW53; WW47; Falk, *Exh. Record Series.*

PIGAL *[Engraver] late 18th c.; b.France.*
Addresses: NYC in 1795. **Sources:** G&W; NYCD 1795 (McKay); Dunlap, *History* (1918), II, 199, and III, 327.

PIGALLE See: **PIGAL**

PIGATT, Anderson J. *[Sculptor] b.1928, Baltimore, MD.*
Studied: self-taught. **Exhibited:** BM, 1969; Columbia Univ., 1969. **Sources:** Cederholm, *Afro-American Artists.*

PIGGOT, Joseph *[Painter] late 19th c.*
Addresses: New Orleans, active 1872-87. **Studied:** Italy. **Comments:** Listed as scenic painter for several theatres and opera houses. **Sources:** *Encyclopaedia of New Orleans Artists,* 306.

PIGGOT, Robert *[Stipple engraver] b.1795, NYC / d.1887, Sykesville, MD.*
Addresses: Philadelphia, active 1817-22. **Studied:** apprenticed to Philadelphia engraver David Edwin. **Exhibited:** PAFA, 1817-20 (prints). **Comments:** Went into partnership about 1816 with a fellow pupil, Charles Goodman (see entry). The firm (Goodman & Piggot) did considerable work for periodicals and annuals until the early twenties. Piggot became an Episcopal deacon in 1823 and was ordained two years later. He continued to do a little engraving after his ordination. From 1869 on he was rector of Christ Church in Sykesville (Md.). **Sources:** G&W; DAB; Stauffer; Baker, *American Engravers.*

PIGGOTT, George W. *[Painter] late 19th c.*
Addresses: NYC. **Exhibited:** NAD, 1883, 1886. **Sources:** Naylor, *NAD.*

PIGOT See: **PAJOT, Louis E.**

PIGOTT, Frank E. *[Painter] 20th c.*
Addresses: NYC. **Member:** Rochester AC. **Comments:** Affiliated with Steck & Speirein Lithographic Co., NYC. **Sources:** WW24.

PIGUET, M(arguerite) S. *[Painter] mid 20th c.*
Addresses: NYC, 1921. **Studied:** ASL. **Exhibited:** S. Indp. A., 1921, 1923, 1925-29, 1932. **Sources:** Marlor, *Soc. Indp. Artists.*

PIHL, Kai H. *[Painter] mid 20th c.*
Addresses: NYC. **Exhibited:** S. Indp. A., 1925-26; Salons of Am., 1928. **Sources:** Falk, *Exhibition Record Series*.

PIKE, Alice See: **BARNEY, Alice Pike (Mrs. Albert C.)**

PIKE, Charles J. *[Sculptor, painter] 19th/20th c.*
Addresses: NYC. **Studied:** Académie Julian, Paris, 1891; also with Falguière and A. Saint-Gaudens in Paris. **Member:** Arch. Lg., 1902. **Exhibited:** Paris Salon, 1892-94. **Sources:** WW10; Fink, *American Art at the Nineteenth-Century Paris Salons*, 381.

PIKE, Emily S. *[Painter] late 19th c.*
Exhibited: Calif. Midwinter Int'l. Expo, 1894. **Sources:** Hughes, *Artists in California*, 439.

PIKE, Harriet A. *[Painter] 19th/20th c.*
Addresses: Fryeburg, ME. **Comments:** Possibly Hattie A. Pike, who exhibited an oil painting at the Boston AC in 1890. **Sources:** WW24; *The Boston AC*.

PIKE, John *[Illustrator, painter] b.1911, Boston, MA / d.1979.*
JOHN PIKE//
Addresses: Woodstock, NY. **Studied:** Hawthorne School Art, 1928-31; also with Richard Miller. **Member:** Provincetown AA; Old Lyme AA; Woodstock AA; NYWCC; Am. Artists Group, Jamaica, BWI; NA; AWCS; Soc. Illustrators; Salmagundi Cl. **Exhibited:** AIC; Ferargil Gal., NY (solo); Grace Home Gal., Boston (solo); WC Arm., PPFA; Am. WCC-NYWCC, 1939; Grand Central Art Gal.; SC, 1941 (Black & White Prizes); NAD, 1945 (Halgarten Prize); Saint Petersburg (FL) Art Club; Oklahoma City Mus. Conserv. Art; Great Plains Mus., Lawton, OK; San Diego Fine Arts Festival, 1960-61. **Awards:** AWCS Award, 1942. **Work:** Woodstock AA. Commissions: paintings, USAP Historical Foundation, France, Germany, Greenland, Ecuador, Columbia, Panama & others; advertisement for Lederle Labs, Alcoa, Standard Oil & Falstaff. **Comments:** Publications: contributor, illustrations & covers, *Colliers, Reader's Digest, Life, Fortune , True*. Teaching: instr., John Pike Watercolor School, Woodstock, NY, summers. **Sources:** WW73; WW47; Woodstock AA cites birth date of 1917.

PIKE, Jos(eph) *[Lithographer] b.c.1837, Pennsylvania.*
Addresses: Philadelphia in 1860. **Sources:** G&W; 8 Census (1860), Pa., LVII, 489; living with his father, David Pike, merchant.

PIKE, Mary H. *[Painter] d.1893, Wash., DC.*
Addresses: Wash., DC, active 1887-1892. **Sources:** McMahan, *Artists of Washington, D.C.*

PIKE, S. *[Illustrator] early 19th c.*
Comments: Illustrator of *Lessons for Children* (Phila., 1818); the cuts were engraved by Alexander Anderson (see entry). **Sources:** G&W; Hamilton, *Early American Book Illustrators*, 434.

PILBROW, Edward *[Engraver] mid 19th c.*
Addresses: NYC, 1829-36. **Comments:** Partner with Thomas Illman (see entry), in Illman & Pilbrow until 1836. **Sources:** G&W; NYCD 1829-36.

PILDOS, Max *[Painter] mid 20th c.*
Addresses: NYC, 1940. **Exhibited:** S. Indp. A., 1940-41, 1944. **Sources:** Marlor, *Soc. Indp. Artists*.

PILGRIM, Earle Montrose *[Painter] b.1923, NYC / d.1976.*
Comments: Abstract figurative painter active in Provincetown, MA, 1951-57. **Sources:** Provincetown Painters, 235.

PILGRIM, James *[Listed as "artist"] b.c.1818, England.*
Addresses: Philadelphia in 1860. **Sources:** G&W; 8 Census (1860), Pa., L, 358; he and his wife's two children, 5 and 2, were born in Massachusetts.

PILIE, Joseph (Gil Joseph) *[Scenic painter, designer, and teacher of figure, landscape, and flower painting] b.c.1789, Mirbalis, Santo Domingo / d.1846, New Orleans.*
Addresses: New Orleans, active 1808-34. **Comments:** Decorated the Grand Hall of the Terpischore (1813) with Jean Hyacinthe Laclotte (see entry). Scenic painter, 1816-17, for St. Philip Street Theatre, Orleans Theatre, and the Olympic Circus. Responsible for design of several (temporary) public monuments, including a triumphal arch to celebrate the visit of Lafayette in 1825 and a centotaph memoralizing the deaths of Thomas Jefferson and John Adams in 1827. Directed the decoration of St. Louis Cathedral for the memorial service in honor of Gen. Lafayette (July 26, 1834). **Sources:** G&W; Delgado-WPA cites *Moniteur*, March 26, 1808. More recently, see *Encyclopaedia of New Orleans Artists*.

PILKINGTON, Adam *[Amateur artist] b.1810, Lancaster (England) / d.1856.*
Comments: Worked as a bleacher in England before emigrating to America in the early 1840's. He settled in Nauvoo (Ill.) and helped build the Mormon Temple, of which he made a drawing some time before his death. **Sources:** G&W; Arrington, "Nauvoo Temple," Chapter 8.

PILKINGTON, James E. *[Engraver and die sinker] mid 19th c.*
Addresses: Albany, NY, 1856-57; Baltimore in 1858. **Comments:** Partner with Daniel True (see entry) in True & Pilkington, active in Albany, 1856-57. **Sources:** G&W; Albany CD 1856-57; Baltimore CD 1858.

PILLAN, Galya *[Painter] mid 20th c.*
Addresses: Chicago area. **Exhibited:** 1947 (prize). **Sources:** Falk, *AIC*.

PILLARS, Charles Adrian *[Sculptor, teacher] b.1870, Rantoul, IL / d.1937, Clifton, FL.*
Addresses: Sarasota, FL. **Studied:** AIC; Taft; French; Potter. **Member:** FA Soc., Jacksonville. **Work:** mem., Jacksonville; Bryan Mem., Battleship, Fla.; Mem. Flag Staff Standard, St. Augustine; statue, U.S. Capitol, Wash., DC; statue, Barnett Nat. Bank, Jacksonville. **Comments:** Position: t., Ringling Sch. A., Sarasota. **Sources:** WW33.

PILLARS, Murray De See: **DEPILLARS, Murray N.**

PILLIN, Polia *[Painter, craftsperson] b.1909, Poland / d.1992.*
Addresses: Santa Fe, NM; Los Angeles, CA. **Studied:** Hull House, Chicago; Todros Geller; Jewish People's Inst., Chicago. **Member:** So. California Des. Assn. **Exhibited:** Oakland A. Gal.; Cincinnati AM; N. Mex. Mus., Santa Fe; WC Arm., San Fran. A. Assn., 1939; AIC, 1947-48; SFMA, 1948; Wichita AA, 1947-49, 1951; Denver A. Mus., 1952; Oakland A. Mus., 1950; LACMA, 1948, 1950, 1952; Los A. County AI, 1949 (ceramics prize); Syracuse Mus. FA, 1950 (prize); Cal. State Fair, 1951 (prize); Landau Gal., 1952; The Willow, NY, 1948-56. **Work:** ceramics: DMFA; Long Beach Mun. A. Gal.; Syracuse Mus. FA; Los A. AI. **Comments:** Contributor to *Arts & Architecture; The Arts; American Artist* magazines. **Sources:** WW59; WW40, cites birthdate of 1905.

PILLINER, C. A. *[Landscape painter] mid 19th c.*
Addresses: Cambridge, MA, 1860. **Comments:** Painter of a landscape in oils on tin. **Sources:** G&W; Lipman and Winchester, 178.

PILLINER, Frederick J. *[Lithographer and wood engraver] mid 19th c.*
Addresses: Boston,1853-54; Philadelphia 1856-60 and after. **Comments:** In Boston he was junior partner in Schenck & Pilliner (see entry), 1853-54. The name occasionally appears as Pillner or Pittner, though Pilliner is most common. **Sources:** G&W; Boston CD 1853-54; Phila. CD 1856-60+; Hamilton, *Early American Book Illustrators*, 216.

PILLNER, George *[Lithographer] mid 19th c.*
Addresses: Philadelphia, 1860. **Sources:** G&W; Phila. CD 1860.

PILLOW, George *[Lithographer] mid 19th c.*
Addresses: NYC, 1837. **Comments:** Partner in firm of Hayward & Pillow, active 1837. The other partner was George Hayward (see entry). **Sources:** G&W; NYCD and BD 1837.

PILLSBURY, Thomas *[Painter, etcher, printmaker] mid 20th c.*
Addresses: Chicago, IL; NYC; Laguna Beach, CA, 1930s.
Member: Laguna Beach AA. **Exhibited:** locally in Laguna Beach, CA. **Comments:** Active in Chicago and NYC as a scenic designer for various theatrical enterprises. **Sources:** Hughes, *Artists in California*, 439.

PILLSBURY, Tom C. *[Painter] b.c.1915, Enid, OK.*
Addresses: Truth or Consequences, NM in 1975. **Studied:** Phillips Univ., Enid; Nebraska Univ.; Chicago art schools; in Taos with Emil Bisttram in the 1930s; Fred Brandrif, Laguna Beach, CA. **Sources:** P&H Samuels, 373. *Cf.* Thomas Pillsbury.

PILSBURY, Anne *[Artist] early 20th c.*
Addresses: Wash., D.C., active 1905. **Sources:** McMahan, *Artists of Washington, D.C.*

PILSBURY, Emma J. *[Painter] 19th/20th c.*
Addresses: NYC. **Exhibited:** Boston AC, 1905. **Sources:** WW06; *The Boston AC.*

PIM, William Paul *[Cartoonist] b.1885, Armstrong County, PA.*
Addresses: Birmingham, AL. **Studied:** Huntington Polytech. Inst. **Member:** Birmingham AC. **Work:** Huntington Lib., San Marino, Calif Cartoonist: "Telling Tommy," educational newspaper strip. **Sources:** WW40.

PIMAT, P. Mignon *[Portrait painter] early 19th c.*
Addresses: Massachusetts, active 1810. **Sources:** G&W; Lipman and Winchester, 178.

PIMENTEL, Palmyra *[Painter] mid 20th c.*
Exhibited: S. Indp. A., 1935, 1937. **Sources:** Marlor, *Soc. Indp. Artists.*

PIMSER, R. See: **PINSLER, R.**

PIN, Pen Yo *[Painter] mid 20th c.*
Exhibited: S. Indp. A., 1932; AIC, 1936. **Sources:** Falk, *Exh. Record Series.*

PINAC, Anna V. *[Painter, teacher] b.1863, New Orleans, LA / d.1929, New Orleans.*
Addresses: New Orleans, active 1885-1920. **Sources:** *Encyclopaedia of New Orleans Artists*, 307.

PINARDI, Enrico Vittorio *[Sculptor, painter] b.1934, Cambridge, MA.*
Addresses: Hyde Park, MA. **Studied:** apprentice with Pelligrini & Cascieri, five yrs.; Boston Archit. Ctr.; BMFA Sch., Boston; Mass. Col. Art (B.S., educ); RI Sch. Design (M.F.A.). **Exhibited:** New England Art Part IV Sculpture, 1964 & Surrealism, 1970, De Cordova Mus.; 21 Sculptors & Painters, Boston Univ., 1964; New England Art Today, Northeastern Univ., 1965; 10 Sculptors, Nashua, NH, 1968; Sidney Kanegis Gal., Boston, MA, 1970s. **Work:** Worcester Art Mus., Mass.; De Cordova Mus., Lincoln, Mass.; Inst. Contemp. Art, Boston, Mass.; Chase Manhattan Bank, NYC; Kanegis Gal., Boston. **Comments:** Preferred media: wood. Teaching: instr. sculpture, Worcester Art Mus. Sch., 1963-67; asst. prof. sculpture, RI Col., 1967-. **Sources:** WW73.

PINCKNEY, Stanley *[Painter, mosaic artist] b.1940, Boston, MA.*
Studied: The Famous Artists School, Westport, CT; BMFA Sch., 1967 (traveling scholarship, Africa). **Exhibited:** BMFA, 1970. **Work:** Nat'l Center of Afro-American Artists, Boston, MA. **Sources:** Cederholm, *Afro-American Artists.*

PINCOVITZ, H. A. *[Painter] 20th c.*
Addresses: Phila., PA. **Studied:** PAFA. **Sources:** WW25.

PINCUS, Jeanette *[Painter] mid 20th c.*
Exhibited: AIC, 1939. **Sources:** Falk, *AIC.*

PINCUS-WITTEN, Robert A *[Art historian, writer] b.1935, NYC.*
Addresses: Flushing, NY. **Studied:** Cooper Union, Emil

Schweinburg grant, 1956; Univ. Chicago, dept. fel., 1961-63 (M.A. & Ph.D.); Univ. Paris exchange fel., Sorbonne, 1963-64. **Comments:** Positions: assoc ed., *Artforum.* Teaching: asst. prof. art hist., Queens Col., 1966-. Publications: auth.,"Les Salons de la Rose & Croix" (Picadilly Gal., London, 1968); auth., "The Konography of Symbolist Art," *Artforum* (Jan., 1970); auth., "Against Order: Poetical Sources of Chance Art," in: *Against Order, Chance and Art* (Inst. Contemp. Art, Univ. Pa., 1970); auth., "The Disintegration of Minimalism: five Pictorial Sculptors," In: *Materials and Methods, a New View* (Katonah Gal., 1971); auth., "White on White: from Tonalism to Monochromism," in: *White on White* (Mus. Contemp. Art, Chicago, 1972). Research: Symbolism; the history of contemporary art. **Sources:** WW73.

PINDELL, Howardena Doreen *[Painter, art administrator] b.1943, Phila., PA.*
Addresses: NYC. **Studied:** Boston Univ. (B.F.A., 1965); Yale Univ. (M.F.A., 1967). **Exhibited:** twenty-six Contemporary Women Artists, Larry Aldrich Mus., Ridgefield, Conn., 1971; Contemporary Black Artists in America, 1971 & Whitney Ann., 1972, WMAA; Oversize Drawings, NY Univ., 1972; American Women Artists, Kunsthaus Hamburg, Ger., 1972. **Awards:** Nat. Endowment Arts Found. Award, 1972. **Work:** WMAA; priv. colls. **Comments:** Positions: asst. cur. prints & illustrated bks., MoMA, 1971-on. Teaching: guest lectr. mus. & the printmaker, Pratt Inst., NYC, 1972- ; guest lectr. women artists, Hunter Col., NY 1972-. Publications: auth., "Mary Quinn Sullivan, Notable American Women," *Harvard Univ. Press, 1971;* auth., "California Prints," *Arts Mag.* (May, 1972); auth., "Jan Groth: The Constructed Line," *Craft Horizons* (August, 1972); auth., "Ed. Ruscha: Interview," *Print Collectors News Letter* (fall 1972). **Sources:** WW73; Hans Bhalla, "Exhibition at Spellman Col" (Nov, 1971); Carter Ratcliff, "Whitney Annual," *Artforum* (April, 1972); Lucille Naimer, "The Whitney Annual," *Arts Mag.* (March, 1972).

PINDER *[Landscape painter, teacher] early 19th c.*
Addresses: Norfolk, VA, active 1810. **Comments:** He sought subscriptions for engraved copies of his views of the Norfolk harbor and offered his services as a teacher of painting, architecture, and French. **Sources:** Wright, *Artists in Virgina Before 1900.*

PINE, Geri (Geraldine) (Mrs. Werner) *[Painter] b.1914, NYC.*
Addresses: NYC. **Studied:** NY School of Design (scholarship) with Paul T. Frankl; ASL, with Nicolaides and John Sloan (scholarship). **Member:** Am. Artists Congress; Am. Contemporary Artists. **Exhibited:** Salons of Am., 1934; Uptown Gal.; WMAA, 1943; ACA Gal., 1936, 1940, 1941, 1949 (all solo); BM, 1938; Bonestell Gal., 1945; Easthampton Guild Hall; Parrish Mus.; Artisans Gal., 1954 (solo); La Tausca Pearls Exhib., 1947; Benson Gal., Bridgehampton, 1975; "NYC WPA Art" at Parsons School Design, 1977. **Work:** Queens (NY) Pub. Lib. **Comments:** Worked with WPA Art Project, beginning in 1934 as mural designer, teacher at Settlement Houses and on the Easel Project. Pine worked from nature although later the forms became abstracted. **Sources:** WW59; WW47; *New York City WPA Art*, 71 (w/repros.).

PINE, James *[Portrait painter] early 19th c.*
Addresses: NYC, 1834 -45; Newark, NJ, 1846-50, NYC and Sing Sing (now Ossining, NY), 1852-57; Phila., 1859. **Exhibited:** NAD, 1839-47. **Work:** NYHS. **Comments:** Began his career about 1830 in NYC, living in Newark, NJ, from 1846 until 1850. Between 1852 and 1858 he was assisted by his son, Theodore E. Pine (see entry) in NYC and Sing Sing, NY. **Sources:** G&W; Cowdrey, NAD; NYBD 1844-57; N.J. BD 1850; Rutledge, PA; Stillwell, "Some 19th Century Painters," 85-86; NYHS Catalogue (1974), cat. nos. 1614, 1965.

PINE, Robert Edge *[Portrait and historical painter] b.1730, London, England / d.1788, Philadelphia.*
Addresses: Philadelphia, PA, 1784-88. **Member:** Royal

Academy, London (founding mem., 1769). **Exhibited:** Royal Acad., London; Independence Hall, Phila., 1784 (this may have been the first solo show in America); Brooklyn AA, 1872; National Port. Gal., Wash., DC, 1979 (retrospective). **Work:** Pa. Hist. Soc., Phila.; National Port. Gal., Wash., DC; Washington and Lee Univ.; Mount Vernon Ladies' Association; NYHS. **Comments:** Son of engraver John Pine, brother of miniature painter Simon Pine, brother-in-law of landscape painter Alexander Cozens. Before coming to America, Robert E. Pine was a well-respected grand-manner painter of portraits and historical subjects in London and a rival of Sir Joshua Reynolds. A supporter of the American colonies during the war, Pine came to America with the idea of painting the subject of the Revolution. Arriving in Philadelphia in 1784, he exhibited 27 of his paintings at Independence Hall and two years later opened an exhibition hall in his Phila. home. His ambition of recording events surrounding the Revolution was only partially realized in his "Congress Voting Independence," left incomplete at his death and finished by Edward Savage (Pa. Hist. Soc.). Pine made several life portraits of Washington (while staying at Mount Vernon) and was commissioned to paint portraits of Martha Washington's four grandchildren and her niece Frances Bassett. He also completed portraits of other well-known Americans. Pine's paintings were sold by lottery and were exhibited for a number of years in Philadelphia, NYC, and Boston, by Daniel Bowen. **Sources:** G&W; DAB; DNB; Whitley, *Artists an Their Friends in England;* Prime, , 7, and II, 26-29; Morgan and Fielding, *Life Portraits of Washington,* 83-88; Peale, "Reminiscences"; Dunlap, *History;* Flexner, *The Light of Distant Skies;*More recently, see Robert Stewart, *Robert Edge Pine* (exh. cat., National Portrait Gal., Wash., DC, 1979); Baigell, *Dictionary; 300 Years of American Art,* 47; Wright, *Artists in Virginia Before 1900;* NYHS Catalogue (1974), cat. nos. 568, 995.

PINE, Rose *[Painter] mid 20th c.*
Addresses: NYC, 1931. **Studied:** ASL. **Exhibited:** S. Indp. A., 1931; Salons of Am., 1934. **Sources:** Falk, *Exhibition Record Series.*

PINE, Theodore E. *[Portrait painter and engraver] b.1828 / d.1905, Ogdensburg, NY.*
Addresses: NYC, active 1847-66; Chicago, IL, 1867-?; NYC, 1881-85; MT Vernon, NY, 1886; Chicago, 1895. **Studied:** under his father, James Pine; Paris, Rome, and Munich, beginning 1860. **Exhibited:** NAD, 1847-86; AIC, 1895. **Work:** NYHS. **Comments:** From 1847, he worked in and around NYC, but his home was in Newark until about 1855 and then at Sing Sing (now Ossining, NY). From 1862 he worked in the Tenth St. Studio, NYC. He moved to Chicago in 1867 and soon joined the council of the Chicago Academy of Design. During the 1880s, his address was listed (in NAD exhibition catalogues) as NYC; but in 1895 he had a Chicago address (AIC exhibition catalogue). He also worked in St. Louis (Mo.); Manitou (Colo.); and Asheville (NC). **Sources:** G&W; *Art Annual,* V, obit.; Cowdrey, NAD; Naylor, NAD; NYBD 1850-60; Stillwell, "Some 19th Century Painters," 88-93. More recently, see Gerdts, *Art Across America,* vol. 2: 291; NYHS Catalogue (1974), cat. no. 1615; Falk, *AIC.*

PINEDA, Marianna (Marianna Pineda Tovish) *[Sculptor] b.1925, Evanston, IL.*
Addresses: Brookline, MA. **Studied:** Cranbrook Acad. Art, 1942, with Carl Milles; Bennington Col., 1942-43, with Moselsio; UC, Berkeley, 1943-45, with R. Puceinelli; Columbia Univ., 1945-46, with Maldarelli; also with Ossip Zadkene, Paris, France, 1949-50. **Member:** AEA (secy., Boston Chap., 1957-59); Sculptors Guild; NA; Boston Visual Artists Union. **Exhibited:** MMA, 1951; four WMAA Ann., 1954-59; AIC, 1957 & 1961; Carnegie Int., Pittsburgh, Pa., 1960; MoMA, 1960; Alpha Gal., Boston, MA., 1970s Awards: Mather Prize for Sculpture, AIC, 1957; grand prize, Boston Arts Festival, 1960; Radcliffe Inst. Independent Study scholar, 1962-64. **Work:** Walker Art Ctr., Minneapolis, Minn.; BMFA; Munson-Williams-Proctor Inst., Utica, NY; Addison Gal. Am. Art, Andover, Mass.; Dartmouth Col., NH. Commissions: medallion for Jan Veen Mem. Libr., Boston

Conserv. Music. **Comments:** Preferred media: bronze, wood, stone, ivory, wax. Publications: contribr. & illusr., *Art in Am.* (Feb., 1955); *Audience Mag.* (winter 1960). Teaching: instr. sculpture, Newton Col., Mass., 1972-. **Sources:** WW73.

PINELES, Cipe (Miss) *[Painter, illustrator]*
b.1908, Vienna, Austria.
Addresses: Brooklyn, NY. **Studied:** A. Fisher.
Sources: WW29.

CP.

PINES, Ned L *[Collector] b.1905, Malden, MA.*
Addresses: NYC. **Comments:** Collection: modern art. **Sources:** WW73.

PINFOLD, Frank C. See: **PENFOLD, Frank (Francis) C.**

PINGREE, E. A. (Miss) *[Artist] early 20th c.*
Addresses: Active in Los Angeles, 1900-03. **Sources:** Petteys, *Dictionary of Women Artists.*

PINHEY, Robert Spottiswoode (Mrs.) *[Landscape painter]*
b.NYC / d.1931, Geneva, Switzerland.
Addresses: NYC; Paris, active from the 1880s; Wash., DC, 1915. **Studied:** Paris. **Exhibited:** Paris Salon, 1880s; Wash. WCC, 1915. **Sources:** McMahan, *Artists of Washington, D.C.*

PINI DI SAN MINIATO, Arturo *[Collector] b.1923, Falconara, Italy.*
Addresses: NYC. **Studied:** Instituto Tecnico-Commerciale, Ancona, Italy. **Exhibited:** Awards: honorary president, Committee for Festivities, 1966-1967, of the City of San Miniato, Italy. **Comments:** Positions: national president, National Society on Interior Designers, 1964-65. Collection: 19th century furniture, porcelain, decorative arts. **Sources:** WW66.

PINISTRI, S. *[Sketch artist, architect, cartographer] early 19th c.*
Addresses: New Orleans, active 1833. **Comments:** Made a sketch of New Orleans from the West bank of the Mississippi River, which was engraved as a vignette on his map "New Orleans General Guide & Land Intelligence", 1841. **Sources:** *Encyclopaedia of New Orleans Artists,* 307.

PINK, Harry *[Painter] mid 20th c.*
Addresses: Chicago, IL. **Exhibited:** Ar. Chicago Vicinity Ann., 1934-38; AIC. **Sources:** WW40.

PINKERSON, Ian *[Painter] mid 20th c.*
Addresses: NYC. **Exhibited:** PAFA Ann., 1962. **Sources:** Falk, *Exh. Record Series.*

PINKERTON, Clayton (David) *[Painter] b.1931, San Fran., CA.*
Addresses: Richmond, CA. **Studied:** Calif. Col. A. & Cr. (B.A.ED., M.F.A.); Harwood Found., Univ. N. Mex. **Member:** San Fran. Art Inst. **Exhibited:** Recent Painting USA: The Figure, MoMA, 1963; Contemp. Am. Painting & Sculpture, Univ. Ill., 1967 & 1969; Violence in Recent American Art, Mus. Contemp. Art, Chicago, 1969; Human Concern, WMAA; Three Centuries of Am. Painting, CPLH, 1971. Awards: Fulbright scholar, 1957-58; James Phelan Award, 1957 & 1961; San Francisco Art Assn. **Work:** De Young Mus., San Fran.; CPLH; Ill. Bell Tel., Chicago. **Comments:** Teaching: prof. fine arts, Calif. Col. Arts & Crafts, 1960-; dir. grad. div. **Sources:** WW73; Joan Mondale, *Politics in art.*

PINKERTON, E. J. *[Lithographer and polychrome engraver] mid 19th c.*
Addresses: Philadelphia, active 1840-46. **Comments:** Partner in Pinkerton, Wagner & McGuigan, 1844-45 (see entry). His work was published in the *U.S. Military Magazine* in 1840. **Sources:** G&W; Peters, *America on Stone;* Todd, "Huddy & Duval Prints"; *American Collector* (July 1946), 12 (repro.).

PINKERTON, Lucile Wilkinson *[Painter] mid 20th c.*
Addresses: Wash., DC. **Exhibited:** Corcoran Gal biennial, 1945. **Sources:** Falk, *Corcoran Gal.*

PINKERTON, WAGNER & MCGUIGAN
[Lithographers] mid 19th c.
Addresses: Philadelphia, active 1844-45. **Comments:** Partners were E.J. Pinkerton, Thomas Wagner, and James McGuigan (see entries). In 1846 it became Wagner & McGuigan. **Sources:** G&W; Phila. CD 1844-46; Peters, *America on Stone.*

PINKHAM, Marjorie Stafford *[Block printer, painter, teacher] b.1909, Tarkio, MO.*
Addresses: Saint Helens, OR. **Studied:** F.C. Trucksess; M.V. Sibell; V. True; F.H. Trucksess. **Comments:** Position: teacher, Cordova Indian School, Seward, Alaska. **Sources:** WW40.

PINKNEY, Edward J. *[Wood engraver] mid 19th c.*
Addresses: NYC, 1854. **Sources:** G&W; NYBD 1854.

PINKNEY, Helen Louise *[Art administrator, art historian] mid 20th c.; b.Decatur, IL.*
Addresses: Dayton, OH. **Studied:** Dayton Art Inst. Sch. (grad.). **Member:** Am. Assn. Mus.; Spec. Libr. Assn., Mus. Div. **Comments:** Positions: registrar of collections, Dayton Art Inst., 1936-45, cur., 1945-59, librarian, 1945-, assoc. cur. textiles, 1959-. Collections arranged: The Camera the Paper & I, collection of photographs by Jane Reece, 1952; The Wonderful World of Photography: Jane Reece Memorial Exhibition, 1963; Oriental & European Textiles Exhib., 1972. Research: extensive research on Jane Reece Photographic Collection; general research as curator on collections, including textiles; bibliographic research as librarian for museum & school.Publications: auth., articles & catalogues on Jane Reece Collection, in: *Dayton Art Inst. Bulletin,*1952 & 1963. **Sources:** WW73.

PINKNEY, Jerry *[Illustrator, designer] b.1939, Phila., PA.*
Addresses: Croton-on-Hudson, 1971-on. **Studied:** Phila. Mus. Col. of Art. **Member:** Kaleidoscope (founder). **Exhibited:** SI (awards); Brandeis Univ., 1969; BMFA, 1970; Nat'l Center of Afro-American Artists, 1969; American Inst. of Graphic Arts; NY, NJ, Boston and Providence Art Dir. Shows (gold, silver & bronze medals); North Florida State Univ. Awards: Aiga Award. **Comments:** Illus., *American Home, Essence,* and other national magazines, book publishers and advertisers. **Sources:** Cederholm, *Afro-American Artists;* W & R Reed, *The Illustrator in America,* 337.

PINKNEY, Louis Mortimer *[Painter] b.1903, NY / d.1940, Brooklyn, NY.*
Addresses: Brooklyn, NY. **Exhibited:** S. Indp. A., 1930. **Sources:** Marlor, *Soc. Indp. Artists.*

PINKNEY, Samuel J. *[Wood engraver] mid 19th c.*
Addresses: Active in NYC, 1848-65 (while living in Brooklyn). **Exhibited:** American Institute (1848, as S.J. Pinkney; 1850 as J.J. Pinkney). **Comments:** Listed in the business directories as Samuel Pinkney, Jr. **Sources:** G&W; Am. Inst. Cat., 1848, 1850; NYBD 1854, 1858; NYCD 1853-65; advertisement in Print Collection, Cooper Union (cited in G&W as courtesy of Miss Elizabeth Marting).

PINKOVITZ, H. A. *[Painter] early 20th c.*
Addresses: Phila., PA. **Exhibited:** PAFA Ann., 1921. **Sources:** Falk, *Exh. Record Series.*

PINKOWSKI, Emily Joan *[Painter, instructor] mid 20th c.; b.Chicago, IL.*
Addresses: Riverwoods, IL. **Studied:** Mundelein Col. (scholar); Univ. Chicago (Ph.B.); Am. Acad. Art (com. art cert.). **Member:** North Shore A. League; Deerpath A. League; Northbrook A. League; Soc Polish Arts & Lett.; Polish Arts Cl. **Exhibited:** Butler Inst. Am. Art, 1969-72; New Horizons in Art, Ill. Competition, Chicago, 1970-72; A Styka Mem. Exhib. Nat. Show, Am. Artists Polish Descent, Am. Coun. Polish Cult. Clubs, Doylestown, Pa, 1971; Women '1971, Northern Ill. Univ., DeKalb, 1971; Mainstreams '1972, Marietta Col. Int. Exhib., Ohio, 1972. Awards: Second prize, New Horizons in Art, Ill Competition, North Shore Art League, 1971; second prize, Styka Show, Am. Coun. Polish Cult. Clubs, 1971; Borg-Warner purchase award,

1972. **Comments:** Preferred media: acrylics. Teaching: instr. painting, Northbrook Art League, Ill., 1968-; instr. painting, North Shore Art League, Winnetka, Ill., 1970-; instr. painting, Deerpath Art League, Lake Forest, Ill, 1971-. **Sources:** WW73; Ann Feuer, "Artist in the News," *Hollister Papers,* 1969; Robert Glauber, *The Mechanical Image,* monograph for solo show, 1971.

PINKUS, Sara M. *[Painter] mid 20th c.*
Addresses: NYC, 1930; Hemstead, NY. **Exhibited:** S. Indp. A., 1930; Salons of Am., 1934; PAFA Ann., 1936. **Sources:** Falk, *Exhibition Record Series.*

PINNEO, Gustav M. *[Painter] b.1892, NYC.*
Addresses: NYC. **Exhibited:** S. Indp. A., 1917. **Sources:** Marlor, *Soc. Indp. Artists.*

PINNER, Philip *[Painter, designer, lithographer] b.1910, San Francisco, CA / d.1977, San Fran., CA.*
Addresses: San Fran., CA. **Studied:** Cal. Sch. FA; A. Center Sch., Los A.; Schaeffer Sch. Des., San F.; & with Maynard Dixon, Joseph Sinel. **Member:** San F. AA.; United Am. Artists; San Fran. Ar. Coop. **Exhibited:** San F. AA, 1931-32, 1935-36, 1939, 1941, 1943-45; GGE 1939; SFMA, 1935, 1945-46; CPLH, 1945-46; Stanford Univ. A. Gal., 1946; SFMA traveling exh., 1944. **Work:** SFMA. **Sources:** WW53; WW47. More recently, see Hughes, *Artists in California,* 439.

PINNES, S. M. *[Painter] mid 20th c.*
Exhibited: Salons of Am., 1934. **Sources:** Marlor, *Salons of Am.*

PINNEY, Eunice Griswold (Mrs.) *[Painter] b.1770, Simsbury, CT / d.1849, Simsbury.*
Addresses: active primarily in Windsor & Simsbury, CT. **Studied:** self-taught. **Work:** NYHS ("Two Women," c.1815); NGA, Wash., DC. **Comments:** Watercolorist who worked in a primitive style. Born Eunice Griswold, married twice, first to Oliver Holcombe and second to Butler Pinney (in 1797). She began painting about 1809 and was active until about 1826, signing her work "Eunice Pinney." She was very well-read and a leader in her Episcopalian church. Her more than 50 recorded works (signed by or attributed) include genre scenes, landscapes and buildings, figure pieces, memorials, allegories, religious, historical, and literary subjects. **Sources:** G&W; Lipman, "Eunice Pinney--An Early Connecticut Watercolorist," with checklist and 5 repros., *Art Quarterly* (Summer 1943); Lipman and Winchester, chapter III, 4 repros.; Warren, "Richard Brunton" (1953). More recently, see Rubinstein, *American Women Artists,* 32 (with repro.); Baigell, *Dictionary.*

PINNINGTON, Jane *[Painter] b.1896, Kansas.*
Addresses: Active in Santa Fe, NM, from 1942. **Sources:** Petteys, *Dictionary of Women Artists.*

PINOLI, A. (Mr.) *[Portrait and fresco painter] mid 19th c.; b.Italy.*
Addresses: New Orleans, 1838-44. **Comments:** Partner in Ceresa & Pinoli, 1838 (see entry). In 1841, he and Dominique Canova painted frescoes on the interior of St. Louis Exchange Hotel. **Sources:** G&W; New Orleans CD 1838 (lists him as Pirroli), New Orleans CD 1841-42; Delgado-WPA cites *Commercial Bulletin,* April 5, 1841. More recently, see *Encyclopaedia of New Orleans Artists.* 307.

PINSKY, Alfred *[Painter, educator] b.1921, Montreal, PQ.*
Addresses: Montreal. **Studied:** Montreal Mus. Fine Arts; also with Anne Savage. **Exhibited:** Can. Soc. Graphic Art; Can. Group Painters; Montreal Mus. Fine Arts. Awards: scholar, Montreal Mus. Fine Arts, 1938-39. **Comments:** Positions: former chmn. dept. fine arts, Sir George Williams Univ.; auth. critical rev. of exhibs., CBC, Montreal. Teaching: prof. fine arts, Sir George Williams Univ. **Sources:** WW73.

PINSLER, R. *[Painter] mid 20th c.*
Addresses: E. Islip, NY. **Exhibited:** S. Indp. A., 1926.

PINSON, Paul *[Painter] mid 20th c.*
Addresses: Chicago area. **Exhibited:** AIC, 1946, 1949. **Sources:**

Falk, *AIC*.

PINSON, Solomon M. *[Painter] early 20th c.*
Addresses: Philadelphia, PA. **Exhibited:** PAFA Ann., 1925.
Sources: WW25; Falk, *Exh. Record Series.*

PINT, Joseph *[Engraver and die sinker] mid 19th c.*
Addresses: NYC, 1858. **Sources:** G&W; NYBD 1858.

PINTAO, Manuel Martinez *[Painter] early 20th c.*
Addresses: Mexico, 1923. **Exhibited:** S. Indp. A., 1923. **Sources:** Marlor, *Soc. Indp. Artists.*

PINTNER, Dora *[Painter, craftsperson, designer] mid 20th c.; b.Edinburgh, Scotland.*
Addresses: Cambridge, MA. **Studied:** Glasgow Col. A., Scotland; Radcliffe Col. (A.A.); Boston Univ. (M.A.). **Member:** Watertown (Mass.) AA; Copley Soc., Boston; Cambridge AA; Pa. Soc. Min. P. **Exhibited:** PAFA, 1924-46; AIC; AWCS, 1933; Nat. Mus., Wash., DC, 1943, 1952; CGA, 1944-46; ASMP, 1934, 1940, 1942; Los Angeles County Fair, 1941; Portland SA, 1934-42; Boston AC, 1932-33, 1935; Copley S., 1937-58; Calif Soc. Min. P., 1937-38, 1941; Chicago Soc. Min. P., 1938, 1940, 1942; Contemp. New England A., 1942-46; Cambridee AA. 1944-58; Jordan Marsh Gal.; Pillsfield Mus. A., 1951. **Work:** stained glass windows, Angell Mem. Hospital, Boston; Nat. Mus. **Comments:** Lectures on stained glass. **Sources:** WW59; WW47.

PINTO, Angelo Raphael *[Mural painter, drawing specialist, block printer] b.1908, Casal Velino, Salerno, Italy. / d.1994, NYC.*
Addresses: Phila., PA; NYC. **Member:** Phila Pr. C.; Phila. A. All.; Phila. WCC; Un. Scenic Ar. Am. **Exhibited:** PAFA Ann., 1929, 1936-37, 1943; Barnes Fnd., Merion, Pa., 1931-33; WMAA, 1936; Contemp. Am. P., Four AC, Palm Beach,FL 1937 (prize); Corcoran Gal biennials, 1937, 1939; AIC. **Work:** PAFA; Barnes Fnd.; MMA; NYPL; WMAA. **Comments:** Came to U.S. in 1909. **Teaching:** Barnes Fnd. **Sources:** WW40; Falk, *Exh. Record Series.*

PINTO, Biagio *[Mural painter, drawing specialist] b.1911, Phila., PA / d.1989, Venice, FL.*
Addresses: Phila., PA; NYC. **Exhibited:** Bames Fnd. Scholarship, Merion, Pa., 1932-33; Phila. AC, 1932 (prize); PAFA Ann., 1932, 1937-38, 1943; AIC; WMAA, 1937; Corcoran Gal biennials, 1937-43 (3 times). **Work:** PAFA; PMA; Barnes Fnd., Merion; Mus. Allentown, Pa. **Sources:** WW40; Falk, *Exh. Record Series.*

PINTO, James *[Painter, sculptor] b.1907, Bijelina, Yugoslavia.*
Addresses: San Miguel de Allende, Mexico. **Studied:** Univ. Zagreb, Yugoslavia; Chouinard Art Inst., Angeles, Calif.; mural painting with David Alfaro Siqueiros; also with Jean Charlot. **Exhibited:** American Painting Today, MMA, 1952; 15th Ann. Contemp. Art, AIC, 1955; Instituto Nacional Bellas Artes, Mexico City, Mex., 1958; 62nd Ann. Western Artists, Denver Art Mus., Colo., 1962; 1st Anual de Escultura, Museo Arte Moderno, 1971-72; Galeria de Arte Misrachi, Mexico, DF, 1970s. **Awards:** first prize, First Nat. Vet. Exhib., Santa Monica, Calif., 1947; first prize, Nat. Univ. Mex. & US Embassy, Mexico City, 1949; purchase prize, Life-Day Exhib. Contemp. Art, Fargo, N. Dak., 1957. **Work:** Witte Mem. Mus., San Antonio, Tex.; Mus. Contemp. Art, Belgrad, Yugoslavia; Berg Art Ctr., Concordia Col., Moorehead, Minn.; Mala Umetnicka Galeria, Sarajevo, Yugoslavia; Univ. Art Gal., Univ. N. Mex., Albuquerque. **Commissions:** regional fiesta mural, Inst. Allende, San Miguel, 1951 & 1954; co-worker with Rico Lebrun on Genesis Mural, Pomona Col., Calif., 1960; outdoor sculpture mural, Nell Fernandez Harris, San Miguel, 1968; indoor mural, Hotel Inst. Allende, 1970. **Comments:** Preferred media: acrylics, bronze. **Teaching:** instr. painting, Escuela Univ. Bellas Artes, San Miguel, 1948-50; dean faculty, Inst. Allende, 1950-. **Sources:** WW73; Felipe Cossio del Pomar , *Critica de Arte de Baudelaire a Malraux* (Fondo de Cultura Economica, 1956); Brooks, *Painting & understanding of Abstract Art* (1964) & Baldwin, *Contemporary Sculpture Techniques* (1967,

Reinhold).

PINTO, Salvatore *[Mural painter, etcher, block printer, drawing specialist] b.1905, Casal Velino, Salerno, Italy. / d.1966, Philadelphia, PA.*
Addresses: Phila., PA. **Studied:** Barnes Fnd. Scholarship, Merion, Pa., 1931-33. **Member:** United Scenic Ar. Am.; Phila. Pr. C. **Exhibited:** PAFA Ann., 1920, 1930, 1943; Corcoran Gal biennials, 1930-43 (4 times); Phila. Print C., 1932 (prize); Phila. AC, 1934 (gold); AIC; WMAA, 1934, 1936. **Work:** MMA; NYPL.; WMAA.; AIC; Barnes Fnd., Merion, PA. **Comments:** Came to U. S. in 1909. **Sources:** WW40; Falk, *Exh. Record Series.*

PIOT, Adolphe *[Painter] mid 19th c.*
Addresses: NYC. **Exhibited:** NAD, 1864. **Sources:** Naylor, *NAD.*

PIOTROWSKA, Irena Glebocka *[Writer, critic, lecturer] b.1904, Poznan, Poland.*
Addresses: NYC. **Studied:** Univ. Poznan, Poland (Ph.D.); Ecole du Louvre, Paris; Columbia Univ. **Member:** Am. Soc. for Aesthetics; CAA; Polish Inst. A. & Sc. in Am.; Am. Soc. for Expansion of Polish Art Abroad; Kosciuszko Assn. **Exhibited:** Univ. Poznan, 1929 (medal). **Comments:** Position: art sec., Polish Inst. A. & Let., Roerich Mus., NYC, 1932-35; Delegate to America, Soc. for the Expansion of Polish Art Abroad, 1938-39; sec., treas., Kosciuszko Assn., 1940-42; ed. bd., co-author (art), "Slavonic Encyclopaedia," 1949. Author: "Problems of Polish Contemporary Painting," 1935; "The Art of Poland," 1947; co-author: "Poland," the United Nations series, 1945; contributing ed., "Encyclopaedia of the Arts," 1945. Contributor to: *Journal of Aesthetics & Art Criticism; Art & Industry,* London; *Liturgical Arts;* & other publications. **Sources:** WW53; WW47.

PIOUS, Robert Savon *[Painter, commercial artist] b.1908, Meridian, MS.*
Studied: AIC; NAD (scholarship). **Exhibited:** Smithsonian Inst., 1930; Urban League, 1932; Harlem Businessmen's League; Harmon Fnd., 1930-31, 1933 (Spingarn prize), Touring Exh., 1934-35; Harlem Art Committee, 1935; American Negro Expo, Chicago, 1940; NY Federal Arts Project, 1936-39; Atlanta Univ., 1942; Augusta Savage Studio, 1939; City College of NY, 1967; "NYC WPA Art" at Parsons School Design, 1977. **Awards:** Nat. Poster Competition Prize. **Work:** Nat. Archives, Smithsonian Inst. **Comments:** Positions: WPA artist; illustrator, U.S. Office War Info., during WWII; illustrator, *Bronzeman Magazine* and *Opportunity.* **Sources:** Cederholm, *Afro-American Artists; New York City WPA Art,* 72 (w/repros.).

PIPE, Eric *b.1870, San Fran., CA / d.1938.*
Addresses: Manchester-by-the Sea, MA. **Studied:** E. Carlsen, in New York; Ecole des Beaux-Arts, Paris, with Gérôme, Constant, Lefebvre, Doucet, Delance. **Member:** United Arts Cl., Royal Soc. Arts, Atlantic Union, all of London; North British Acad.; Players Cl., NYC. **Exhibited:** Awards: medals and diplomas, various exh. **Comments:** Position: dir., Eric Pape Sch. Art, 1898-1913. Illustrator: "The Fair God," "The Scarlet Letter," "The Life of Napoleon Bonaparte," "Life of Mahomet," "Poetical Works of Madison Cawein." Contributor: portraits, "The Memoirs of Ellen Terry." Designer: mon., Stage Fort Park, Gloucester, commemorating founding of Mass. Bay Colony, 1623. **Sources:** WW38.

PIPER, George H. *[Painter, sculptor] 19th/20th c.*
Addresses: Chicago, IL. **Studied:** Académie Julian, Paris, 1887, 1894. **Member:** Chicago SA. **Exhibited:** AIC, 1901-02, 1905. **Sources:** WW06.

PIPER, Jane *[Painter] mid 20th c.*
Addresses: Phila., PA. **Exhibited:** PAFA Ann., 1945-68 (5 times). **Sources:** Falk, *Exh. Record Series.*

PIPER, John *[Painter] mid 20th c.*
Exhibited: AIC, 1935. **Sources:** Falk, *AIC.*

PIPER, Natt A. *[Painter, architect, blockprinter, wood engraver] b.1886, Pueblo, CO. / d.1969, Butte County, CA.*
Addresses: Long Beach, CA. **Studied:** Fanshaw and Richter.

Member: P&S of Los Angeles; AAPL; Long Beach AA; State Assn. Calif. Arch.; Santa Monica AA; Long Beach Arch. C.; Spectrum C. **Exhibited:** Southwest Expo., 1929 (med). **Work:** Ashton Coll. Wood-Engravings, Springfield, Mass.; NYPL; LOC. **Comments:** Illustrator: "American Architect," "California Arts and Architecture." Contributor: articles, Pencil Points, Arts and Decoration, Architect and Engineer. **Sources:** WW40; Hughes, *Artists in California*, 440.

PIPER, Van D. *[Painter] 19th c.*
Addresses: NYC. **Exhibited:** NAD. **Sources:** WW98.

PIPPENGER, Robert *[Sculptor, designer, craftsperson]* *b.1912, Nappanee, IN.*
Addresses: New Hope, PA. **Studied:** John Herron A. Sch. (B.F.A.). **Exhibited:** Prix de Rome, 1938 (prize); Am. Acad., Rome (prize); Herron AI, 1938 (prize); Ind. State Fair; Grand Central A. Gal., 1937-39; PAFA Ann., 1942; NJ State Mus., Trenton, 1945. **Work:** S., Plymouth (IN.) Lib.; Brookgreen Gardens, SC. **Sources:** WW53; WW47; Falk, *Exh. Record Series.*

PIPPIN, Horace *[Primitive painter, sculptor] b.1888, West Chester, PA / d.1946.*

H.PiPPIN.

Addresses: West Chester, PA. **Studied:** self-taught. **Exhibited:** West Chester Community Center, 1937; "Masters of Popular Painting," MoMA, 1938; Carlen Gal., Phila., 1940 (solo); Bignou Gal, NYC, 1940; American Negro Expo., Chicago, 1940; Downtown Gal, NYC, 1941; Arts Cl. of Chicago, 1941; South Side Community Art Center, Chicago, 1941; SFMA, 1942; CI, 1944 (hon. men.); Corcoran Gal biennials, 1943, 1945; AIC, 1943, 1945; PAFA Ann., 1943-47 (prize 1946); Atlanta Univ., 1944; Howard Univ., 1945; Knoedler Gal, NYC, 1947; Walker Art Center, c.1950; WMAA, 1943-45; NY City Col., 1967; James A. Porter Gal, 1970; Newark Mus., 1971; PAFA, 1993 (retrospective) Awards: J. Henry Scheidt Memorial Prize. **Work:** PAFA ("John Brown Going to his Hanging;" Brandywine River Mus., Chadds Ford, PA; Barnes Collection, Merion, PA; MoMA; MMA; WMAA; BMFA; Albright-Knox Gal., Buffalo, NY; PMA; Phillips Memorial Gal., Wash., DC; Nat'l Archives; Wichita Mus., Kansas; Rhode Island Mus.; Encyclopedia Britannica Coll.; Archives of American Art. **Comments:** The first African-American primitive painter to achieve widespread critical recognition, during the 1930s-40s. After serving in WWI and losing much of the use of his right arm, Pippin began making burnt-wood panels, taking up oils in the late 1920s. In the 1930s his work came to the attention of local Brandywine artists Christian Brinton and N.C. Wyeth who in turn introduced the work to the president of the Chester County Art Association. A solo exhibition at the Association's gallery in 1937 led to a showing of his work at MoMA in 1938. This led to numerous other exhibitions and the patronage of Phila. collector Albert Barnes (see entry). Pippin's subject matter included images of African-American life, historical, military, and biblical themes, and still lifes. Although he worked in a primitive style, his treatment of subject matter (as in his "John Brown" series) was often complex and psychologically and emotionally moving. **Sources:** WW40; Judith Stein, *I Tell My Heart: The Art of Horace Pippin*, with essays by Richard Powell, Cornel West, and Judith Wilson (exh. cat., PAFA, 1993); Baigell, *Dictionary;* Driskell, *Hidden Heritage*, 43, 47; Brandywine River Museum, *Catalogue of the Collection*, 223; Cederholm, *Afro-American Artists;* Falk, *Exh. Record Series.*

PIQUET, M. S. *[Painter] 20th c.*
Addresses: NYC. **Member:** S. Indp. A. **Sources:** WW25.

PIQUET, Rudolphe E. *[Painter] late 19th c.*
Exhibited: NAD, 1866-67, 1878. **Sources:** Naylor, *NAD.*

PIROTZO, Daniel *[Engraver] b.c.1877, OH.*
Addresses: New Orleans, active 1910. **Sources:** *Encyclopaedia of New Orleans Artists*, 307.

PIRROLI, A. See: **PINOLI, A. (Mr.)**

PIRRSON, James W. *[Landscape painter] mid 19th c.*
Addresses: NYC, active 1856-68. **Exhibited:** NAD, 1859-68. **Sources:** G&W; NYCD 1856; NYBD 1857; Cowdrey, NAD; Naylor, NAD.

PIRSON, Elmer (William) *[Painter, illustrator] b.1888.*
Addresses: Buffalo, NY. **Studied:** G. Bridgman; J.E. Fraser. **Member:** GFLA.

PIRSSON, J. Emily *[Painter] 20th c.*
Addresses: Wyoming, NJ. **Member:** Lg. AA. **Sources:** WW24.

PIRSSON, James W. *[Marine painter, architect] d.1888, NYC.*
Addresses: NYC (1856-on). **Exhibited:** NAD, 1862-68. **Work:** Mystic Seaport Mus. **Sources:** Brewington, 302.

PIRSSON, R. I. *[Painter] late 19th c.*
Addresses: NYC, 1881. **Exhibited:** PAFA Ann., 1881 ("Moonlight on the Ocean"). **Sources:** Falk, *Exh. Record Series.*

PISANI, Francesco *[Painter] mid 20th c.*
Exhibited: Salons of Am., 1934. **Sources:** Marlor, *Salons of Am.*

PISANI BROTHERS, (F. and C.) *[Sculptors] mid 19th c.*
Addresses: San Francisco, active 1860. **Sources:** G&W; San Francisco BD 1860.

PISCHIUTTI, Luigi *[Sculptor, painter] mid 20th c.*
Addresses: NYC. **Exhibited:** S. Indp. A., 1930. **Sources:** Marlor, *Soc. Indp. Artists.*

PISCIOTTA, Anthony T. *[Painter] b.1913.*
Addresses: NYC. **Exhibited:** S. Indp. A., 1937-42, 1944. **Sources:** Marlor, *Soc. Indp. Artists.*

PISE, Lewis *[Miniature & landscape painter, teacher] 18th/19th c.; b.Italy.*
Addresses: Active Philadelphia , 1795 & 1797; Baltimore, 1800-01 & 1807-08; Alexandria, VA, 1810-11. **Comments:** He offered drawing instruction. **Sources:** G&W; Prime, II, 29; Baltimore CD 1800-01, 1807-08 (Mayo).

PISE, Louis See: **PISE, Lewis**

PISHBOURNE, Robert See: **FISHBOURNE, R(obert) W.**

PISSIS, Emile M. *[Landscape and portrait painter] b.1854, San Francisco, CA / d.1934, San Fran.*
Addresses: San Francisco. **Studied:** Académie Julian, Paris, four years. **Member:** San Fran. AA (co-founder, 1871). **Exhibited:** Mechanics' Inst. Fair, 1896. **Work:** Soc. of Calif. Pioneers; Calif. Hist. Soc. **Comments:** His wealth allowed him to rarely exhibit and never sell any of his paintings, many of which were lost in the earthquake and fire of 1906. **Sources:** Hughes, *Artists in California*, 440.

PISTCHAL, Julius *[Painter] mid 20th c.*
Addresses: NYC, 1928. **Studied:** ASL. **Exhibited:** S. Indp. A., 1928, 1938. **Sources:** Marlor, *Soc. Indp. Artists.*

PISTER, Rudolph *[Painter] late 19th c.*
Addresses: NYC. **Exhibited:** NAD, 1878-85; PAFA Ann., 1881. **Sources:** Naylor, *NAD;* Falk, *Exh. Record Series.*

PISTEY, Joseph Jr. *[Painter] 20th c.*
Addresses: Bridgeport, CT. **Work:** USPO, Haynesville, La. WPA artist. **Sources:** WW40.

PISTOR, Rudolphe See: **PISTER, Rudolph**

PITARD, Robert C. *[Painter, sketch artist, copyist] b.c.1876, New Orleans, LA.*
Addresses: New Orleans, active 1884-87. **Studied:** William Warrington, 1887. **Member:** NOAA, 1905. **Exhibited:** American Expo., 1885-86; W. Warrington's Studio, 1887. **Comments:** Child prodigy who taught himself to paint and draw at the age of eight by copying other works. He later became a noted violinist at Belhaven College. **Sources:** *Encyclopaedia of New Orleans Artists*, 308.

PITCHER, Samuel H. *[Painter]* 20th c.
Addresses: Worcester, MA. **Sources:** WW24.

PITCHFORT, R. V. *[Painter]* mid 20th c.
Exhibited: AIC, 1932. **Sources:** Falk, *AIC.*

PITFIELD, Florence Beatrice *[Painter]* early 20th c.
Addresses: Brooklyn, NY, c.1913-23. **Exhibited:** AIC, 1911.
Sources: WW13.

PITKIN, Anna Denio *[Portrait and animal painter]* d.1929,
Tyron, NC.
Addresses: Detroit, MI. **Exhibited:** Michigan State Fair, 1879;
Great Art Loan, 1883; Detroit Mus. Art, 1886. **Comments:**
Preferred media: watercolor, crayon. **Sources:** Gibson, *Artists of
Early Michigan,* 197.

PITKIN, Caroline W. *[Painter, craftsperson]* b.1858, NYC /
d.1937.
Addresses: NYC. **Studied:** William Merritt Chase; Dumond;
Birge Harrison; Charles Woodbury, Ogunquit School; Brenner.
Member: PBC; Allied AA; NAWA. **Exhibited:** NAD, 1891;
PAFA Ann., 1892-93; Soc. Indep. Artists; PBC; Allied AA;
NAWA. **Sources:** WW33; *Charles Woodbury and His Students;*
Falk, *Exh. Record Series.*

PITKIN, E. Josephine See: **PITKIN, Josephine**

PITKIN, Joseph Lowell *[Engraver]* b.1878, New Orleans, LA
/ d.1939, Charlotte, NC.
Addresses: New Orleans, active 1900. **Comments:** Brother of
Robert G. Pitkin (see entry). **Sources:** *Encyclopaedia of New
Orleans Artists,* 308.

PITKIN, Josephine *[Painter]* early 20th c.
Addresses: NYC, c.1905-10. **Member:** NAWA, 1909. **Exhibited:**
AIC, 1909. **Comments:** Most likely the same as Josephine Pitkin
Newton of Scarsdale, NY (see entry). **Sources:** WW10.

PITKIN, Robert Graham *[Cartoonist]* b.1880, New Orleans,
LA / d.1970, East Islip, NY.
Addresses: New Orleans, active 1896-1900. **Comments:** Brother
of Joseph L. Pitkin (see entry). **Sources:** *Encyclopaedia of New
Orleans Artists,* 308.

PITMAN, Agnes *[Woodcarver, ceramist, china painter, art
teacher]* b.1850, Sheffield, England / d.1946, Cincinnati, OH.
Studied: with her father, Benn Pitman; Cincinnati School Design.
Exhibited: Phila. Centennial Expo, 1876; Cincinnati Loan Exhib.,
1878; Columbian Expo, Chicago, 1893. **Comments:** Art teacher,
Cincinnati School Design. **Sources:** Petteys, *Dictionary of
Women Artists.*

PITMAN, Elizabeth S. *[Painter]* 20th c.
Addresses: Wallingford, CT. **Member:** New Haven PCC.
Sources: WW25.

PITMAN, Harriette Rice (Mrs. Stephen M.) *[Painter,
teacher]* 19th/20th c.; b.Stetson, ME.
Addresses: Providence, RI. **Studied:** Pratt Inst. **Member:**
Providence WCC; Providence AC. **Comments:** Positions: circuit
supervisor/teacher, Corning, Ithaca, Jamestown, all in NY, 1891-
92; teacher, Providence Public School 1894-1904; RISD Mus.,
1926. **Sources:** WW31.

PITMAN, Sophia L. *[Painter, teacher]* b.1855, Providence, RI
/ d.1943.
Addresses: Providence, RI. **Studied:** Mass. Normal Art Sch.,
Boston; W.M. Chase, F.V. DuMond, J. Twachtman, and J.A. Weir
in NYC. **Member:** Providence AC (charter mem., 1880);
Providence WCC; Copley Soc. (charter mem., 1879). **Comments:**
Teaching: Moses Brown Sch., 1878-1931. **Sources:** WW33.

PITMAN, Theodore B. *[Painter, illustrator, sculptor]* b.1892 /
d.1956.
Studied: Harvard. **Comments:** Served in both WWI and WWII.
Illustrator: "The Frontier Trail," 1923, "Firearms in the Custer
Battle," 1953. **Sources:** P&H Samuels, 373.

PITMAN, Thomas *[Ship portrait painter]* b.1853,
Marblehead, MA / d.1911, Marblehead.
Addresses: Marblehead, MA, c.1850. **Work:** Peabody Mus.,
Salem, Mass. **Comments:** He was also a sign, carriage, and house
painter. **Sources:** G&W; Robinson and Dow, *Sailing Ships of
New England,* I, 62; F.J. Peters, *Paintings of the Old `Wind-
Jammer,'* 32; Brewington, 302.

PITNER, Dora *[Painter]* mid 20th c.
Exhibited: 1926-27, 1930. **Sources:** Falk, *AIC.*

PITSHKE, Evelyn *[Painter]* mid 20th c.
Exhibited: Salons of Am., 1934. **Sources:** Marlor, *Salons of Am.*

PITT, Donald A. *[Lithographer, illustrator]* b.1906, Colorado /
d.1954, San Francisco, CA (suicide).
Addresses: San Francisco, CA. **Exhibited:** San Francisco AA,
1935. **Sources:** Hughes, *Artists in California,* 440; add'l info.
courtesy Anthony R. White, Burlingame, Ca., who supplied a
death date of 1952.

PITT, Joseph B. *[Engraver]* mid 19th c.
Addresses: NYC, 1859. **Sources:** G&W; NYBD 1859.

PITT, (Miss) *[Potrait painter & copyist]* early 19th c.
Addresses: Newport, RI. **Comments:** Referred to in Russian
traveler Paul Svinin's book about his visit to America, 1811-13.
He described meeting a young girl, Miss Pitt, who was a talented
painter. **Sources:** G&W; Yarmolinsky, ed., Svinin's *Picturesque
United States of America,* 38.

PITTAR, Barry *[Painter]* early 20th c.
Exhibited: AIC, 1926-28. **Sources:** Falk, *AIC.*

PITTFIELD, William *[Engraver]* b.c.1825, France.
Addresses: Philadelphia in 1850. **Sources:** G&W; 7 Census
(1850), Pa., LII, 906.

PITTIS, Henry *[Engraver]* mid 19th c.
Addresses: NYC, active 1844-49. **Exhibited:** American Institute
(1844-47, jointly with Thomas Pittis). **Comments:** Working with
his brother Thomas Pittis from 1844 to 1849. **Sources:** G&W;
NYCD 1844-49; Am. Inst. Cat., 1844-47.

PITTIS, Thomas *[Engraver]* b.c.1807, Isle of Wight (England).
Addresses: NYC, active 1842-68. **Exhibited:** American Institute
(1844 -51, jointly with Henry Pittis through 1847). **Comments:**
From 1844 to 1849 he was in partnership with his brother Henry
Pittis. **Sources:** G&W; 8 Census (1860), N.Y., LVI, 995 [as
Thomas Pettis]; NYCD 1842-68; Am. Inst. Cat., 1844-51.

PITTIS BROTHERS See: **PITTIS, Henry**

PITTIS BROTHERS See: **PITTIS, Thomas**

PITTMAN, Hobson *[Painter,
printmaker, lecturer, critic,
teacher]* b.1899, Tarboro, NC /
d.1972, Bryn Mawr or Upper
Darby, PA.
Addresses: Phila.; Manoa section of Upper Darby; Bryn Mawr,
PA. **Studied:** Rouse Art Sch., Tarboro, NC; Cl; Penn. State
College; Columbia Univ.; Woodstock Art Sch., summers, 1920s;
Europe, 1928; E. Walters; A. Heckman; D. Rosenthal. **Member:**
Woodstock AA; Audubon Artists; NA; Phila. WCC; F.I.A.L.; Int.
Platform of Lecturers; Phila. Artists All.; AEA. **Exhibited:** Salons
of Am., 1929-30, 1934; S. Indp. A., 1929-31; PAFA Ann., 1929-
68 (1943 prize; 1960 faculty exhib., solo); WMAA biennials,
1933-46; Corcoran Gal biennials, 1935-67 (12 times, incl. 4th
prize, 1947, and silver med., 1953); VMFA, 1938, 1940, 1942,
1944, 1946; AIC; WMA; Phila. WCC, annually; Cl, annually from
1940, 1949 (prize); CMA; CPLH, 1947 (prize); Herron AI; Santa
Barbara MA; MoMA; GGE, 1939; Butler AI, 1950 (prize), 1955
(prize & purchase); NAD, 1953 (gold med.), 1959-61; McNay AI,
1959-61; Columbia Univ., 1960 (Brevoort prize); North Carolina
MA (retrospective), 1963; Paris; London; Venice; Cairo; and other
European art centers; Guggenheim fellow, 1955. **Work:** MMA;
PAFA; WMAA; BM; PMG; VMFA; Nebraska AA; John Herron

AI; Butler AI; CMA; CI; Brooks Mem. Art Gal.; AGAA; Florence (SC) Mus. Art; PMA; NIAL; Cranbrook Acad. Art; PMA; Herron AI; Santa Barbara Mus. Art; Wilmington Soc. FA; IBM; Penn. State Univ.; Encyclopedia Britannica; TMA; Montclair Art Mus.; Abbott Laboratories. **Comments:** During the 1930s his mature stye began to emerge in his impressionistic domestic interiors, and through the 1950s he painted numerous still lifes and floral pieces. His late style included dreamlike passages. Pittman was also a printmaker; he started making linoleum cuts and woodcuts in 1930 (producing about 50 blocks) and in 1931 began etching (eventually making about 20 etchings). Lectures: "American Painting Today," "Portrait and Figure Painting Today;" "International Contemporary Painting;" "The Artist's Vision;" "Influences in Art;" "Chardin and Picasso;" and many others given 1956-65, at PAFA, Univ. Virginia, Mary Washington Col., Univ. Richmond, Randolph-Macon Col., PMA, and William & Mary Col. Teaching: Friends' Sch., Overbrook, PA; PAFA; PMA; Penn. State Univ. Illustrator: *Fortune.* **Sources:** WW66 cites 1900 birth date but WW47 cites 1899; Baigell, *Dictionary; Hobson Pittman: Retrospective Exhibition from 1920* (exh. cat., North Carolina Mus., 1963); Falk, *Exh. Record Series.*

PITTMAN, Kitty Butner (Mrs. James T.) *[Painter, teacher, sculptor]* b.1914, Philadelphia, PA.
Addresses: Atlanta, GA; NYC. **Studied:** Oglethorpe Univ.; & with Fritz Zimmer, Robert Dean, Maurice Seiglar. **Member:** NAWA; Atlanta A. Exhibitors. **Exhibited:** SSAL, 1935-1940; Assoc. Georgia A., 1933-36, 1938, 1940; Atlanta Studio Cl., 1932-40; Atlanta AA, 1936, 1938; Atlanta A. Exhibitors, 1940-42; Chicago North Shore A. Lg., 1937; NAWA. **Work:** port., The Memminger Mem. Study, All Saints Church, Atlanta, Ga. **Sources:** WW59; WW47.

PITTNER, F. J. See: **PILLINER, Frederick J.**

PITTS, Fred L. *[Painter]* b.1842, MD.
Addresses: Phila., PA. **Studied:** PAFA; McMicken, Cincinnati. **Exhibited:** PAFA Ann., 1892-95, 1900-03; AIC, 1896, 1902. **Comments:** Position: affiliated with Phila. Sketch Club. **Sources:** Falk, *Exh. Record Series.*

PITTS, Henry S. *[Painter];* b.Phila., PA.
Member: Providence AC. **Sources:** WW17.

PITTS, Kate *[Painter, etcher, illustrator, drawing specialist]* b.1896, Aberdeen, MS.
Addresses: NYC. **Studied:** G.B. Bridgman; ASL; Studio Workshop, Boston and Rockport, MA; Lhote, in Paris. **Member:** Artists All. Am.; Studio Club. **Exhibited:** Studio Club, 1922 (prize), 1923 (prize), 1939 (prize for watercolor). **Comments:** Illustrator: covers, *Arts and Decoration,* Oct. 1935, 1937. **Sources:** WW40.

PITTS, Lendall *[Portrait and landscape painter, etcher]* b.1875, Detroit, MI / d.1938, Boston, MA.
Addresses: Detroit, MI/Paris, France. **Studied:** France, Germany, Switzerland; Paris, with Jean Paul Laurens and Benjamin-Constant. **Member:** Paris AAA. **Exhibited:** AIC, 1906; Corcoran Gal annual, 1908; PAFA Ann., 1913. **Work:** Museums in the U.S. and France. **Comments:** Developed a color print without lines called "pastelographs." Married to Elizabeth McCord (see entry) in 1921 and lived in Paris for many years, returning to Detroit frequently. **Sources:** WW25; Gibson, *Artists of Early Michigan,* 197; Falk, *Exh. Record Series.*

PITTS, Lendall (Mrs.) See: **MCCORD, Elizabeth S.**

PITTWOOD, Ann *[Painter, sculptor, graphic artist]* b.1895, Spokane, WA.
Addresses: Seattle, WA. **Studied:** NAD; ASL; Otis Art Inst., Los Angeles; Cornish Art School. **Exhibited:** Los Angeles, CA, 1927 (solo); Women's Prof. League, Aberdeen, WA, 1935-36. **Sources:** Trip and Cook, *Washington State Art and Artists.*

PITZ, Henry Clarence *[Painter, writer, lithographer, illustrator, educator]* b.1895, Philadelphia, PA / d.1976, Phila.
Addresses: Norristown, Plymouth Meeting, PA; Phila., PA. **Studied:** PMA Sch. (grad); Spring Garden Inst. (grad.). **Member:** Phila. A. All. (v. pres. in charge art, 1933-59, bd. dirs., 1942-); AWCS; Phila. Sketch C.; Phila. Pr. C.; Audubon A.; A. Lg. Am.; Folio C.; Phila. WCC; Southern PM Soc.; NAD; hon. mem. Soc. Illustrators; Woodmere A. Gal. (bd. trustees, 1968-); Philobiblon Cl. **Exhibited:** LACMA, 1932 (med); PAFA, 1930-69, (1934, Dana gold med.); PAFA Ann., 1936, 1943, 1954; PM Sch IA, 1934 (prize); Paris Salon, 1934 (prize); Phila. Pr. C., 1937 (prize); NAD, 1950-72; AIC; Stockholm, Sweden; PMA; AWCS, 1932 (prize), 1933-37, 1944, 1946-68; BM; BMA; Wilmington Soc. FA; Ogunquit A. Center, 1932-32 (prize); Denver A. Mus., 1934 (prize); Southern PM Soc., 1937 (prize); Int. Expo, Paris, 1938 (bronze med.); WFNY, 1939; Phila. A. All., 1941 (prize); Nat. Gal. Art, Wash., DC,1970 (Exhib. of Space Artists); Philadelphia Athenaeum,1970 (literary award med.); Phoenix Art Mus., Ariz., 1972 (Exhib. Western Artists). **Work:** PAFA; NGA; PMA; NAD; LOC; LACMA; NYPL; Denver A. Mus.; Allentown Mus.; Franklin Inst., Phila.; West Phila. H.S.; Woodrow Wilson Jr. H.S., Phila.; Miami Univ.; Vanderpoel Coll., Chicago; Artist Gld., Denver. Commissions: three mural panels commissioned by Smithsonian Inst. for Chicago World's Fair; illusr. for five classics, Limited Ed. Club, 1952-67; off. NASA artist, Apollo 10 Flight, 1969; off. artist, US Environ. Protection Agency, 1972. **Comments:** Preferred media: watercolors, oils, acrylics. Positions: pres., Philadelphia Sketch Club, 1936-39; assoc. ed., *Am. Artist,* 1942-; bd. ed., Am. Artist Bk. Club, 1968-. t., PM Sch. IA (1934-46), PAFA (summer session, 1938-), Univ. Pa. (1941) Publications: auth., "Treasury of American Book Illustrations,' 1941; auth., "Ink Drawing Techniques," 1957; co-auth.," Early American Dress," 1962; auth., "The Brandywine Tradition," 1969; auth., "Charcoal Drawing," 1971. Teaching: prof. decoration & illus. & dir. dept., Philadelphia Col. Art, 1934-60; instr. drawing, & watercolor, PAFA, summers 1937-42; vis. lectr. art, Univ. Pa., 1942. Research: artists of Brandywine Valley, Pa; art techniques. **Sources:** WW73; Ernest W. Watson, *Forty illustrators;* add'l info. courtesy Anthony R. White, Burlingame, CA; Falk, *Exh. Record Series.*

PITZ, Molly Wood (Mrs. Henry C.) *[Painter]* b.1913, Ambler, PA.
Addresses: Plymouth Meeting, PA; Philadelphia, PA. **Studied:** Philadelphia Mus. Sch. Indust. Art. **Member:** Phila. A. All.; Phila. WC; Bryn Mawr Art Ctr., Art Teachers Workshop; Allen Lane Art Ctr.; Phila. Mus. Sch. Art Alumni Assn. **Exhibited:** Ann. Small Oil Exh., Phila. Sketch C., 1935 (prize), 1936-45; Phila. WC Cl., 1939-45 & 1963; Woodmere Art Gal., 1943-46 & 1948-52; William Jeanes Mem. Libr., 1948-55 & 1959-69; Phila. Mus. Col. Art, 1959; Phila. A. All., 1965. Awards: Hartford Found. fel., 1964. **Work:** Pa State Univ; pvt. colls. **Sources:** WW73; WW47.

PITZELL, Adelyn *[Painter]* mid 20th c.
Addresses: NYC. **Exhibited:** S. Indp. A., 1927. **Sources:** Marlor, *Soc. Indp. Artists.*

PIXLEY, Emma Catherine O'Reilly *[Painter]* b.1836, Rochester, NY / d.1911, Oakland, CA.
Addresses: San Francisco, CA. **Studied:** San Francisco Sch. of Des., with Irwin, Mathews and Sparks; Cooper Union, NYC. **Member:** San Francisco AA. **Exhibited:** Calif. State Fairs; San Francisco AA, 1885. **Comments:** Specialty: landscapes of Marin County. **Sources:** Hughes, *Artists in California,* 440.

PIZZELLA, Edmundo *[Portrait painter]* b.1868, Naples, Italy / d.1941, San Francisco, CA.
Addresses: San Francisco, CA. **Exhibited:** Soc. for Sanity in Art, CPLH, 1940 (gold). **Comments:** He came to San Francisco from his native Italy at the turn of the century. **Sources:** Hughes, *Artists in California,* 440.

PIZZINI, Irene *[Artist] mid 20th c.*
Addresses: NYC. **Exhibited:** PAFA Ann., 1946. **Sources:** Falk, *Exh. Record Series.*

PIZZITOLA, Vincent *[Painter, teacher] b.1890, Alcamo, Italy.*
Addresses: New York 11, NY. **Studied:** Acad. of Rome, with Spinetti; and with Cellini, Ferrari, Atanasia. **Member:** Soc. Indp. A.; NAC. **Exhibited:** Soc. Indp. A.; Montross Gal. (solo); All. A. Am.; Burr Gal. (2-man). **Awards:** prize and medal, Acad. of Rome. **Work:** paintings and murals in private colls. **Comments:** Position: instr., City Island Sch. A., NYC. **Sources:** WW59.

PIZZUTI, Michele *[Painter] b.1882.*
Addresses: NYC. **Studied:** D. Morelli. **Sources:** WW29.

PLACE, A. *[Painter] 19th c.*
Addresses: NYC. **Exhibited:** PAFA Ann., 1881 (water color, "Spanish Gypsy"). **Sources:** Falk, *Exh. Record Series.*

PLACE, Graham *[Illustrator] 20th c.*
Addresses: Larchmont, NY. **Member:** SI. **Sources:** WW47.

PLACE, Vera Clark (Mrs.) *[Painter] b.1890, Minneapolis.*
Addresses: Minneapolis, MN. **Studied:** Minneapolis Sch. Art; Chase; Difner; R. Miller; A. de la Gandere. **Member:** Attic Club, Minneapolis; Minneapolis SFA. **Exhibited:** Minnesota State Art Exh. (prize); P&S Los Angeles, 1924. **Comments:** Also known as Vera I. Clark. **Sources:** WW33.

PLAGEMANN, Antonio *[Painter] b.1900.*
Addresses: NYC. **Exhibited:** NAD, 1861. **Sources:** Naylor, *NAD.*

PLAGENS, Peter *[Painter, instructor] b.1941, Dayton, Ohio.*
Addresses: New York, NY. **Studied:** Univ Southern Calif, BFA, 1962; Syracuse Univ, MFA, 1964. **Exhibited:** Wide White Space, Antwerp, Belg. 1968; Contemp Am Drawings, Oakland Art Mus, Calif, 1969; First Ann Drawing Exhib, St John's Univ, NY, 1970; Nat Drawing Invitational, Southern Ill Univ, Carbondale, 1971; Twenty-Four Los Angeles Artists, Los Angeles Co Mus Art, Calif, 1971; WMAA, 1972. **Comments:** Positions: Cur, Long Beach Mus, Calif, 1965-1966; contribr ed, Artforum. Publications: Auth, A meditation on painting, 3/1971 & West coast blues, 2/1971, Artforum; auth, Zip: Barnett Newman, Art in Am, 11/1971. auth, Some problems in recent paintings, Art J, winter 1971. Teaching: Instr art, Calif State Univ, Northridge. **Sources:** WW73.

PLAIN, Bartholomew *[Listed as "picture maker"] early 19th c.*
Addresses: NYC, 1802-18. **Sources:** G&W; NYCD 1802-18.

PLAISTED, Mary Tirzah *[Painter] 20th c.*
Addresses: Chicago area. **Exhibited:** AIC, 1940. **Sources:** Falk, *AIC.*

PLAISTED, Zelpha (or Zepha) M. (Miss) *[Painter] 19th/20th c.; b.Maine.*
Addresses: Boston, MA, active 1891-1915. **Studied:** Boston; England; Paris. **Member:** Copley Soc., 1891. **Exhibited:** PAFA Ann., 1899; Boston AC, 1902, 1904, 1906, 1907, 1909; AIC, 1905. **Sources:** WW15; Falk, *Exh. Record Series.*

PLAISTRIDGE, Philip *[Painter, etcher] 20th c.*
Addresses: Winchester, NH. **Sources:** WW33.

PLAMONDON, Marius Gerald *[Sculptor, craftsman] b.1919, Quebec, PQ.*
Addresses: PQ. **Studied:** Ecoles Beaux-Arts, Quebec; also in Prance & Italy. **Member:** Sculptors Soc Can; Stained Glass Asn Am; Royal Can Acad. **Exhibited:** Exhibited nationally & int. **Awards:** Scholar to Europe, 1938-1940; Royal Soc fel, 1955-1956. **Work:** Commissions: Stone carvings, stained glass, numerous churches, univ bldgs, hotels & hosps. **Comments:** Positions: Pres, Ecoles Beaux Arts, Quebec; pres, Soc Sculptors Can, 1959-1961; v pres, Int Asn Plastic Arts, UNESCO. **Sources:** WW73.

PLANCHER, Arnold *[Painter] 20th c.*
Addresses: NYC. **Studied:** ASL. **Exhibited:** S. Indp. A., 1933-

34;1936-43. **Sources:** Marlor, *Soc. Indp. Artists.*

PLANK, Esther Rae *[Painter] 20th c.*
Addresses: NYC. **Member:** GFLA. **Sources:** WW27.

PLANK, G. Wolfe *[Illustrator] 20th c.*
Addresses: Wyebrooke, PA. **Exhibited:** AIC, 1913. **Sources:** WW15.

PLANT, Olive *[Painter] 20th c.*
Addresses: Wash., D. C., active 1919-24. **Member:** S. Wash. A.; Wash. AC. **Sources:** WW25; McMahan, *Artists of Washington, D.C.*

PLANT, S. *[Painter] 19th c.*
Addresses: NYC. **Exhibited:** AWCS, 1898. **Sources:** WW98.

PLANTE, George *[Painter] b.1914.*
Exhibited: S. Indp. A., 1943. **Sources:** Marlor, *Soc. Indp. Artists.*

PLANTOU, Julia (Mme. Anthony) *[Historical and religious, landscape and portrait painter] early 19th c.; b.France.*
Addresses: Philadelphia, active c.1816 to c.1825 (with some travel); Washington, DC, until 1837. **Studied:** in Paris, possibly with Renaud or Jean-Baptiste Regnault; Jacques-Louis David. **Exhibited:** PAFA, 1818-22 (a view near Paris, a miniature of Pius VII, and copies after Mignard and Raphael, done in 1802); "Peace of Ghent" travelled to Washington, DC,1817, 1819-20; Philadelphia; New Orleans, 1819; Charleston, SC, 1823. **Comments:** Emigrated to America from France, about 1816. She was noted for her large (7 x 11 feet) allegorical painting "Peace of Ghent, 1814, and Triumph of America," first exhibited at Washington, DC, in December 1817 and shown subsequently in several other cities over the next six years. She and her second husband, Anthony Plantou, a Philadelphia dentist, traveled with the painting and made prints of the work. (Her first husband was Nicholas Barrabino). She was back in Philadelphia by 1825 and was painting portraits in Washington, DC, until at least 1837. **Sources:** G&W; Scharf and Westcott, *History of Philadelphia,* II, 1053; Rutledge, PA; Phila. CD 1818; Delgado-WPA cites *La. Gazette,* Jan. 20 and 29, 1819; Dunlap, *History;* Rutledge, *Artists in the Life of Charleston;* Washington *Daily National Intelligencer,* Dec. 13 and 23, 1817 (courtesy J. Earl Arrington); Robert Smith, "The Peace of Ghent," *Art Quarterly* 12 (Autumn 1949), 366-70. More recently, see McMahan, *Artists of Washington, D.C.; Encyclopaedia of New Orleans Artists* (indicates she studied with Renaud and David); and Gerdts, *Art Across America,* vol. 1: 343 (suggests she may have studied with Jean-Baptiste Regnault).

PLAQUE, R. *[Painter]*
Addresses: New Orleans, active ca.1867. **Exhibited:** Grand State Fair, 1867 (best southern landscape in oil, best head in oil, best composition in oil). **Sources:** *Encyclopaedia of New Orleans Artists,* 308.

PLASCHKE, Paul A. *[Landscape and portrait painter, cartoonist] b.1880, Berlin, Germany / d.1954, Louisville, KY.*
Addresses: Chicago, IL. **Studied:** CUA School, 1897; ASL with G. Luks. **Member:** Assn. Chicago PS; Louisville Art Club. **Exhibited:** Richmond (IN) AA, 1917 (prize); PAFA Ann., 1917, 1929; S. Indp. A., 1918; Nashville AA, 1925 (prize); Hoosier Salon, 1929 (prize), 1934 (prize); Louisville AA, 1932 (prize); SSAL, 1936 (prize); AIC. **Work:** Attica (IN) Library; Lexington (KY) Library; Speed Mem. Mus., Children's Free Hospital, both in Louisville; Vanderpoel Art Assn.; Univ. Kentucky Art Mus., Lexington. **Comments:** Came to the U.S. at age four and was raised in New Jersey. Moved to Louisville, KY in 1899 and to Chicago in 1937. Illustrator: humorous drawings, *Life, Puck, Judge,* other magazines. Positions: cartoonist, *New York World; Louisville Times; Chicago Herald American,* until 1950; *Sunday Courier-Journal,* 1913-36. Began to paint landscapes in 1905, working in oil, pastel and watercolor and monotype medium. He was a founder of the Louisville Art Acad., where he later taught and was also active in the founding of the J. B. Speed Art Mus. **Sources:** WW40; Jones and Weber, *The Kentucky Painter from*

the Frontier Era to the Great War, 62 (w/repro.); Falk, *Exh. Record Series.*

PLASSMANN, Ernst *[Sculptor and wood carver] b.1823, Sondern, Westphalia (Germany) / d.1877, NYC.*
Addresses: Emigrated to U.S. in 1853, settling in NYC. **Studied:** Germany and Paris, before 1853. **Comments:** In 1854 established in NYC an art school which he conducted until his death. Also executed many statues and monuments for public and private patrons, especially in NYC. Author of two books: *Modern Gothic Ornaments* (1875) and *Designs for Furniture* (1877). **Sources:** G&W; CAB; NYBD 1856-60+.

PLATE, Walter ("Bud") *[Painter, designer, craftsman, educator] b.1925, Woodhaven, NY / d.1972.*
Addresses: Woodstock, NY. **Studied:** Grand Central School Art, NY, 1942-43; École Beaux-Arts & Grande Chaumière, and Léger, Paris, France, 1947-50. **Member:** Woodstock AA. **Exhibited:** WMAA, 1955-58; AIC, 1959; 1961; Corcoran Gal biennials, 1959-63 (3 times, inclgold med, 1959); PAFA Ann., 1960; Walker AC, Minneapolis, MN, 1960; Albany Inst. History & Art, 1961 (prize). Other awards: Woodstock Klienert Award, 1961. **Work:** CGA; WMAA; Woodstock AA; Johnson Foundation Collection; also in private collections. **Comments:** Abstract artist whose work made use of expressionist and cubist idioms at different points in his painting career. Teaching: ASL, summers, 1959-65; assoc. prof. archit., Rensselaer Polytech Institute, Troy, NY, 1964-70s. **Sources:** WW73; *Woodstock's Art Heritage,* 120; Woodstock AA; Falk, *Exh. Record Series.*

PLATEN, C. *[Lithographer] mid 19th c.*
Addresses: Charleston, SC, 1853. **Sources:** G&W; Rutledge, *Artists in the Life of Charleston.*

PLATFOOT, A. J. *[Painter] 20th c.*
Exhibited: S. Indp. A., 1937. **Sources:** Marlor, *Soc. Indp. Artists.*

PLATH, Iona *[Designer, writer] b.1907, Dodge Center, MN.*
Addresses: Woodstock, NY. **Studied:** Westmoreland Col; ASL New York; Art Inst Chicago. **Comments:** Positions: Free lance designer, 1947-. Publications: Auth & illusr, Decorative arts of Sweden, Scribner's, 1948 & Dover, 1965; auth & illusr, Hand weaving, Scribner's, 1964 & 1972. Teaching: Instr art & design, 1930-. **Sources:** WW73.

PLATH, Karl *[Painter, illustrator, writer] 20th c.; b.Chicago.*
Addresses: Chicago, IL. **Studied:** AIC; Acad. FA; Grant. **Member:** Chicago PS; All-Ill. Soc. FA; Chicago Gal. A. **Exhibited:** AIC. **Sources:** WW33.

PLATKY, Ethel Mantell *[Painter] 20th c.*
Exhibited: S. Indp. A., 1942. **Sources:** Marlor, *Soc. Indp. Artists.*

PLATT, Alathea (or Alethea) Hill *[Landscape painter, miniature painter] b.1861, Scarsdale, NY / d.1932, White Plains, NY.*
Addresses: Sharon, CT; NYC. **Studied:** ASL; B. Foster; H. B. Snell; Delecluse Acad., Paris. **Member:** AFA; NYWCC; AWCS; NAWPS; NAC; Pen and Brush Club; SPNY; Yonkers AA; Allied AA; CAFA. **Exhibited:** PAFA Ann., 1900-01, 1903NY Women's AC, 1903 (prize); Boston AC, 1900-03, 1906-08; Minnesota AA, Faribault, 1909 (prize); S. Indp. A., 1917; Salons of Am., 1922; Nat. Lg. Am. Pen Women, 1928 (prize); AIC. **Work:** Faribault (MN) Public Library; Anderson (IN) Art Gal.; Court House, White Plains, NY; Mus. St. Joseph, MO; Nat. Art Club, NY. **Comments:** Although previously listed as Alethea, she is known to have signed her paintings Alathea. Marlor has birthdate as 1860. **Sources:** WW31; *The Boston AC;* Falk, *Exh. Record Series;* add'l info. courtesy Steve Brennan, St. Cloud, FL.

PLATT, Charles Adams *[Painter, architect, etcher, writer] b.1861, NYC / d.1933, Cornish, NY.*
Addresses: NYC. **Studied:** NAD, 1879; etching with Stephen Parrish, 1880; ASL; Académie Julian, Paris with Boulanger and Lefebvre, 1882-89 (Fehrer cites 1884-85). **Member:** SSA, 1888, ANA, 1897; NA, 1911; Am Acad. AL; AWCS; NY Etching Cl.; London Soc. P. & E.; AIA; Century; AFA; Am. Acad., Rome;

Cornish (N. H.) Colony. **Exhibited:** PAFA Ann., 1881-83, 1889, 1894-99; NY Etching Cl., 1884; Brooklyn AA, 1882-86; Boston AC, 1884-96; SAA, 1894 (prize); Paris Expo, 1900 (med); Pan-Am Expo, Buffalo, 1901 (med); Arch. Lg., 1913 (med); NAD, 1882-97; Paris Salon 1883-86; Parrish AM, 1984 ("Painter-Etchers" exh.); Corcoran Gal biennials, 1919-32 (6 times); AIC. **Work:** AGAA; Albright-Knox, Buffalo; Montclair AM; Freer Gal.; CGA. **Comments:** Began working as professional architect in 1916, through the patronage of William Astor. His building designs include the Freer Gallery, Wash., DC, and the Lyman Allyn Mus., New London, Conn. **Sources:** WW31; Pisano, The Long Island Landscape, n.p.; *American Painter-Etcher Movement* 45; Fink, *American Art at the Nineteenth-Century Paris Salons,* 381; Falk, *Exh. Record Series.*

PLATT, Charles H., Jr. *[Painter] 20th c.*
Addresses: Yonkers, NY. **Exhibited:** S. Indp. A., 1920. **Sources:** WW21.

PLATT, Eleanor *[Sculptor, teacher] b.1910, Woodbridge, NJ / d.1974.*
Addresses: Santa Barbara, CA; NYC. **Studied:** ASL; A. Lee. **Member:** NAD; NSS. **Exhibited:** PAFA Ann., 1939, 1941. Awards: Chaloner scholar, 1939-41; Am Acad Arts & Lett grant, 1944; Guggenheim fel, 1945. **Work:** BMFA; MMA; NY Bar Assn.; Traman Library; Hebrew Univ., Jerusalem; CI; Harvard Univ. Law School Library. Commissions: bas-reliefs, Louis Brandeis Wehle, Samuel J. Tilden & Arthur T. Vanderbilt; plaques, Orison Marden & Charles S. Whitman, NY School Law; busts, Arnold Grant, Syracuse Univ. Law School. **Comments:** Positions: teacher, Fine & Indust. School Art, NYC; member, NYC Art Commission, 1964-67. Also known as Eleanor Platt Flavin. **Sources:** WW73; WW47; Falk, *Exh. Record Series.*

PLATT, Ella M. *[Artist, photographer] 19th/20th c.*
Addresses: Wash., D.C., active 1897-1926. **Sources:** McMahan, *Artists of Washington, D.C.*

PLATT, Elsie H. *[Landscape painter] late 19th c.*
Addresses: Active in Port Huron, MI, 1885-91. **Sources:** Petteys, *Dictionary of Women Artists.*

PLATT, George *[Listed as "artist"] mid 19th c.*
Addresses: NYC, active 1846-48. **Sources:** G&W; NYBD 1846, 1848.

PLATT, George W. *[Still-life, landscape, and portrait painter] b.1839, Rochester, NY / d.1899, Denver, CO.*
Addresses: Denver, CO. **Studied:** PAFA, probably c.1871-76 (same time as Peto); Italy and Munich, before 1878. **Member:** Denver AC. **Exhibited:** PAFA Ann., 1876-78; St. Louis (MO) Exposition of 1888. **Comments:** Graduated from the University of Rochester about 1860 and then spent several years out West as draftsman with John Wesley Powell's geological surveys (which included exploration of canyons in Colorado). Returned from study in Europe and worked in Davenport (Iowa) and Rock Island (IL) in 1878. By 1881, he had opened a studio in Chicago. Lived in Denver (CO) during the 1890's. Teacher at Univ. of Denver. His game and barn door still-lifes often made use of Western objects and shared the illusionistic sensibility of the works of Harnett and Peto. Platt's trompe l'oeil "Vanishing Glories" (unlocated) created quite a sensation when exhibited at the St. Louis Exposition of 1888. Newspaper accounts recounted the excitement created by the tricky illusionism of the painting, which depicted a peg on a barn door, on which was hung a buffalo skull, cowboy outfit, revolver, saddle, sombrero, and rifle, and a bowie knife that appeared to be actually stuck into the canvas. **Sources:** G&W; Frankenstein, *After the Hunt,* 128-31, plates 71, 113, 116. See also P&H Samuels, 374; Gerdts, *Art Across America,* vol. 2: 305, and vol. 3: 118-20, with repro. WW48; Falk, *Exh. Record Series.*

PLATT, H. *[Portrait painter, engraver] mid 19th c.*
Addresses: Active in Boston, 1832; Columbus, OH, active 1839. **Work:** Ohio State Museum, Columbus, OH (Portrait of James Kilbourne, 1838). **Comments:** Engraver and painter of a portrait

published in Boston in 1832. **Sources:** G&W; Stauffer. Hageman, 121.

PLATT, Harold *[Painter] 19th/20th c.*
Addresses: Brooklyn, NY. **Sources:** WW01.

PLATT, Harriet R. *[Painter] late 19th c.*
Exhibited: NAD, 1884. **Sources:** Naylor, *NAD*.

PLATT, Harry *[Artist] late 19th c.*
Addresses: Wash., D.C., active 1882. **Sources:** McMahan, *Artists of Washington, D.C.*

PLATT, J. B. *[Painter] 20th c.*
Addresses: NYC. **Sources:** WW19.

PLATT, James C. *[Portrait, landscape, and still-life painter] d.1882, Brooklyn, NY.*
Exhibited: NAD, 1861,1868-69, 1873; PAFA, 1869; Brooklyn AA, 1862-78. **Comments:** Advertised in Charleston, SC, in 1846 and was at Chicago in 1859, but most of his career (from 1850 until his death) was spent in or near NYC and Brooklyn. **Sources:** G&W; Thieme-Becker; Cowdrey, NAD; NYBD 1854-60; Rutledge, *Artists in the Life of Charleston;* Rutledge, PA; Chicago BD 1859.

PLATT, John Franklin *[Painter]*
Addresses: NYC, 1945. **Exhibited:** WMAA, 1945. **Sources:** Falk, *WMAA*.

PLATT, Joseph B. *[Painter] early 20th c.*
Exhibited: WMAA, 1926. **Sources:** Falk, *WMAA*.

PLATT, Julian *[Painter] mid 20th c.*
Studied: ASL. **Exhibited:** S. Indp. A., 1935. **Sources:** Marlor, *Soc. Indp. Artists.*

PLATT, Juliette P. *[Artist] early 20th c.*
Addresses: Active in Los Angeles, 1914-20. **Sources:** Petteys, *Dictionary of Women Artists.*

PLATT, Katherine *[Painter] 19th/20th c.*
Addresses: Brooklyn, NY. **Exhibited:** NAD, 1895. **Sources:** Naylor, *NAD*.

PLATT, Livingston *[Painter] 19th/20th c.*
Addresses: Brooklyn, NY. **Exhibited:** NAD, 1894-95. **Sources:** WW01.

PLATT, M. B. (Miss) *[Painter] late 19th c.*
Exhibited: NAD, 1884. **Sources:** Naylor, *NAD*.

PLATT, Marie Starbuck *[Watercolorist] early 20th c.*
Exhibited: Alumni Assn., School Industrial Arts, Phila., 1903. **Sources:** Petteys, *Dictionary of Women Artists.*

PLATT, Martha A. *[Painter, teacher] 19th/20th c.; b.New Haven, CT.*
Addresses: Boston, MA, active 1896-1931. **Studied:** F.D. Williams. **Member:** Copley Soc. **Exhibited:** Boston AC, 1896, 1900; Poland Springs Art Gal., Boston, 1898; AIC. **Sources:** WW10; Falk, *Exh. Record Series.*

PLATT, Mary Cheney *[Painter, designer, teacher] b.1893, NYC / d.1977, NYC.*
Addresses: NYC. **Studied:** Parsons School Des.; NY School Fine & Applied Art; ASL; NAD; & with George Bridgman, Arthur Crisp, Charles Hawthorne. **Member:** NAWA. **Exhibited:** Salons of Am., 1924; S. Indp. A., 1924; NAWA, 1934-42, 1946; Montclair Art Mus., 1932; Contemporary Artists, 1933; Mun. Art Com. Exhib., 1936; Montclair Women's Cl., 1954 (solo). **Work:** murals, Russell Sage Fnd.; Spanish House, Columbia Univ.; General Fed. Women's Clubs. **Comments:** Position: hd., art dept., Chapin School, NYC, 1935-. **Sources:** WW59; WW47.

PLATT, (Mrs.) See: **WRIGHT, Elizabeth**

PLATT, Ward C. *[Painter] mid 20th c.*
Addresses: Chicago area. **Exhibited:** AIC, 1951. **Sources:** Falk, *AIC.*

PLATTENBERGER *[Painter] mid 19th c.*
Addresses: Active in Pennsylvania. **Comments:** Known by a Biblical scene painted in oils, c.1860. **Sources:** G&W; Lipman and Winchester, 178.

PLAU, Eleanor Walls *[Painter, teacher] b.1878, San Fra., CA.*
Addresses: San Fran., CA; Long Beach, CA. **Studied:** San Francisco Sch. of Des., with Arthur Mathews. **Exhibited:** San Francisco AA, 1904; Mark Hopkins Inst., 1905. **Comments:** Position: t., public schools in San Francisco and Los Angeles, CA. **Sources:** Hughes, *Artists in California*, 440.

PLAUCHE, Leda Hincks *[Painter] b.1887, New Orleans, LA / d.1980, New Orleans.*
Addresses: New Orleans. **Studied:** Newcomb Col.; G.L. Viavant; E. Woodward. **Exhibited:** Nat. Farm and Live Stock Show, New Orleans, 1916 (prize); NOAA, 1917. **Comments:** Specialty: carnival and pageant costume design. Worked for Rex and Atlanteans (carnival organizations). She illustrated her own book, "Old New Orleans Characters", 1931 and Stanley Arthur's " Old New Orleans," 1937. **Sources:** WW21; *Encyclopaedia of New Orleans Artists,* 309.

PLAUT, James S *[Art administrator, writer] b.1912, Cincinnati, OH.*
Addresses: Chestnut Hill, MA. **Studied:** Harvard Univ. (A.B., 1933, A.M., 1935). **Member:** Art Vis. Comt. of Wheaton Col. (chmn.); MacDowell Colony; Coun. Arts, Mass. List. Technol. **Exhibited:** Awards: Chevalier, Legion of Honor, Fr. Govt., 1946; Off., Royal Order St. Olav, Norway, 1950; Comd.r, Royal Order of Leopold, Belg. Govt., 1958. **Comments:** Positions: asst. cur. paintings, BMFA, 1935-39; dir., Inst. Contemp. Art, Boston, 1939-56; v. pres., Old Sturbridge Village, 1959-62; secy. gen., World Crafts Coun., 1967-; adv., NJ State Mus. & Pac. Northwest Arts Ctr. Teaching: lectr. hist. art, Harvard Univ., 1934-35, 1937-38; lectr. hist. art, New Eng. Conserv. Music, 1938-39. Collections arranged: int. exhibs. for Inst. Contemp. Art, Boston, 1939-56; in charge of all exhib. planning, US Pavilion, Brussels World's Fair, 1958, New York World's Fair, 1964, Montreal, 1967 & Osaka, 1970. Publications: auth., "Oskar Kokoschka," 1948; auth., "Steuben Glass," 1948, 1951 & 1972; auth., "Assignment in Israel," 1960. **Sources:** WW73.

PLAVCAN, Catharine Burns (Mrs. Joseph M.) *[Critic, teacher, painter, lecturer] b.1906, Springfield, IL.*
Addresses: Erie, PA. **Studied:** Col. William & Mary; PAFA; Mercyhurst Col., Erie (B.A.). **Member:** A. Cl. of Erie; Fed. Erie A. **Exhibited:** Indiana, Pa., 1943; Butler AI, 1943; Ohio Valley Exh., Athens, Ohio, 1944; A. Cl. of Erie, 1931 (prize), 1936 (prize), 1948 (prize), Fed. Erie A., 1950-55 (prize 1952). **Work:** mural asst., Press Cl., Treacy Sch., St. Vincent Hospital, all Erie, Pa.; church decorations, Lorain, Ohio, Meadville and DuBois, Pa. **Comments:** Position: a. instr., Erie Day Sch., 1937-42; Erie Pub. Schs., 1946-; a. cr., *Erie Dispatch,* 1937-57; *Erie Sunday Times-News,* 1957-; sec., Fed. Erie A. Lectures: Children's Art. **Sources:** WW59; WW47.

PLAVCAN, Joseph Michael *[Painter, teacher, lecturer] b.1908, Braddock, PA / d.1981.*
Addresses: Erie, PA. **Studied:** PAFA with D. Garber, J. Pearson (Cresson traveling scholarship, 1928); Univ. Pittsburgh. **Member:** Am. Fed. T.; Am. Vocational Assn.; Erie A. Cl.; Fed. Erie A. **Exhibited:** PAFA Ann., 1929-36, 1941, 1951-52; Soc. Wash. A., 1929 (med.); Corcoran Gal. biennials, 1930 (4th prize), 1932, 1951; Parkeburg FA Cen., 1943-44 (prize); CI, 1930; AIC, 1931, 1935-36; NAD, 1943-44, 1950, 1952; Pepsi-Cola, 1946; Indiana, Pa., 1943-44; Butler AI, 1938-39, 1942, 1944 (prize)-45, 1949, 1951; Ohio Valley Exh. Athens, Ohio, 1943-54; Erie, Pa., 1928-55; AC of Erie, 1935 (prize); Parkersburg FA Center, 1943-44; Edinboro, Pa., Slippery Rock, Pa., 1955 (solo); Thiel Col., 1958 (solo). **Work:** murals, Press Cl., Art C., Erie Women's Cl, Acad. H. S. Treacy Sch., St. Vincent's Hospital, Erie, Pa.; Church of Nativity, Lorain, Ohio; St. Agatha's, Meadville, Pa.; DuBois, Pa. **Comments:** Teaching: dir. art, Erie Tech. H.S., Erie, Pa., 1932-

50s; Erie Veteran's Sch., 1946-50s. **Sources:** WW59; WW47; Falk, *Exh. Record Series.*

PLEADWELL, Amy Margaret *[Painter] b.1875, Taunton, MA.*
Addresses: Boston, MA. **Studied:** Mass. Sch. Art; Grande Chaumière, École Moderne, Acad. Colarossi, in Paris. **Member:** NAWA; Copley Soc., Boston; AFA; Lyceum Cl., Paris; Boston Soc. Contemp. Artists. **Exhibited:** AIC, 1915, 1920; numerous watercolor exhibitions. **Sources:** WW59; WW47.

PLEADWELL, Theodora *[Sculptor] mid 20th c.*
Addresses: NYC?. **Exhibited:** PAFA Ann., 1950. **Sources:** Falk, *Exh. Record Series.*

PLEASANTS, Albert C. *[Topographic artist] mid 19th c.*
Addresses: Richmond, VA. **Comments:** Artist of a view of Richmond (Va.) [that had previously been] erroneously dated 1798. Son of Archibald and Mary (Brend) Pleasants who were married in Richmond in November 1812; the family were Quakers. He was living in Richmond in 1836. **Sources:** G&W; Information courtesy Mrs. Ralph Catterall, Valentine Museum, Richmond.

PLEASANTS, Frederick R *[Collector, patron] b.1906, Upper Montclair, NJ.*
Addresses: Tucson, AZ. **Studied:** Princeton Univ. (B.S.); Harvard Univ. (M.A.). **Comments:** Positions: cur., Brooklyn Mus., 1950-58; cur., Ariz. State Mus., 1958-64. Teaching: lectr., Ariz. State Mus., 1960-64. Collection: primitive art of Africa, Oceania and pre-Columbian America. Research: primitive art, problems of anthropology in relation to museums in America. **Sources:** WW73.

PLEASURE, Pauline *[Painter] mid 20th c.*
Exhibited: S. Indp. A., 1935. **Sources:** Marlor, *Soc. Indp. Artists.*

PLECKER, D. A. *[Topographic artist] mid 19th c.*
Addresses: Active California, c.1855. **Comments:** Artist of "A Correct View of the Mammoth Tree Grove" in California, lithographed by R.W. Fishbourne (see entry) and published in 1855. **Sources:** G&W; Peters, *California on Stone.*

PLEIMLING, Winifred (Mrs. Herald O.) *[Painter] mid 20th c.; b.Jackson, MI.*
Addresses: Chicago, IL. **Studied:** AIC; F.V. Poole; G. Oberteuffer; L. Ritman. **Member:** Women's Art Salon, Chicago (pres. & founder); Chicago SA; All-Ill. SA; FA Guild, Chicago; South Side AA; Chicago AC; Assn. Chicago P&S; AIC Alumni Assn. (vice-pres.). **Exhibited:** South Side AA (prize); AIC, 1936, 1941, 1942, 1944; Chicago A. Cl. (prize); Illinois State Mus. **Sources:** WW59; WW47.

PLEIN, Charles M. *[Painter] b.Alsace-Lorraine / d.1920, Omaha, NE.*
Comments: An authority on Indian history, he had a collection of rare Indian curios. **Sources:** WW47.

PLEISSNER, Ogden Minton *[Painter, illustrator, educator] b.1905, Brooklyn, NY / d.1983, London, England.*
Pleissner
Addresses: NYC; Dubois, WY, 1976. **Studied:** Brooklyn Friends School; ASL with F.J. Boston, G. Bridgman, and F.V. DuMond. **Member:** NA, 1940 (vice-pres.); SAE; All. Artists Am.; AWCS; Brooklyn SA; Century Assn.; Phila. WCC; Baltimore WCC; SC; CAFA; Lyme AA; Audubon Artists; Southern Vermont Artists; Royal Soc. Arts. **Exhibited:** Salons of Am., 1923-25, 1928, 1934; S. Indp. A., 1923-25, 1928; PAFA Ann., 1928, 1933-49, 1952-53; Corcoran Gal biennials, 1928-53 (9 times); CI; AIC; NAD, 1959 (Altman Prize); AWCS; MMA; NAC, 1928-31 (prizes); SC, 1935 (prize), 1938 (prize); WMAA, 1938-56; WCC, 1954 (Joseph Pennell Medal); AWCS, 1956 (gold); Hirschl & Adler Gal., NYC, 1970s. **Work:** Amon Carter Mus.; MMA; Nat. Collection Fine Arts; PAFA; PMA; BM; TMA; WMAA; LACMA; Minneapolis Inst. Art; Swope Gal. Art; New Britain Mus.; Canajoharie Mus.; NYPL; LOC; Reading Mus. Art; Univ. Nebraska; Univ. Idaho; High Mus. Art; Shelburne (VT) Mus.; Cincinnati AM.

Comments: In 1932, the MMA purchased one of his oils, making him the youngest artist in its collection. But he went on to become best known for his watercolors of New England scenes. During WWII, he painted for the U.S. Air Force and also for *Life.* After the war his subject matter were urban scenes in France, Italy and Spain. Preferred media: oils, watercolors. Positions: mem., Fine Arts Commission, Nat. Collection Fine Arts; director & trustee, Tiffany Foundation; trustee, Shelburne Mus. Also active in WY; painted in Bermuda c.1950. Signature note: early paintings a fully signed, but from c.1950-on they are almost always signed simply as "Pleissner" in a cursive style, and are undated. **Sources:** WW73; Alexander Eliot, *American Painting*; Norman Kent, articles in *American Artist;* WW47; P&H Samuels, 374; Muller, *Paintings and Drawings at the Shelburne Museum,* 103 (w/repros.); Falk, *Exh. Record Series.*

PLETCHER, Gerry *[Painter, printmaker] mid 20th c.; b.State College, PA.*
Addresses: Nashville, TN. **Studied:** Edinboro State Col. (B.S.Art Educ.); Pa. State Univ. (M.A.); also with Montenegro, Carol Summers, Harold Altman, Nelson Sandgren & Shobaken. **Member:** Tenn. A. League. **Exhibited:** 31st Southeastern Competition & Exhib., Gal. Contemp. Art, Winston-Salem, NC, 1969; Cent. South. Art Exhib., Nashville, 1969-71; Graphics USA 1970, Nat. Art Exhib., Dubuque, Iowa, 1970; Ark. Nat. Art Exhib., Ark. State Univ., 1970; NAD 145th Ann., NYC 1970; The Gal. Upstairs, Inc, Nashville, TN, 1970s; Gal. Artist-Centre, Switz., 1970s. Awards: first prize purchase award in graphics, 9th Ann. Tenn. All-State Artists Exhib., Nashville, 1969; graphics purchase award, 22nd Ann. Mid-States Art Exhib., Evansville Mus. Arts & Sci., 1969; 7 purchase prizes, Tenn Arts Comn., 1972. **Work:** Evansville Mus. Arts & Sci., Ind.; Fisk Univ., Nashville, Tenn.; Jacksonville State Univ., Ala; Watkins Art Inst., Nashville; Tenn. Arts Comn., Nashville. **Comments:** Preferred media: etchings, woodcuts, acrylics, oils. Teaching: instr. printmaking, Univ. Tenn., Nashville, 1968-. **Sources:** WW73; "Gerry Pletcher," *La Rev. Mod.* (Feb., 1971); "Zweimal drei," *Aufbau* (March, 1971).

PLETSCH, Ethel Emma Wetzler *[Painter] b.1888, Pittsfield, ME / d.1943, Pasadena, CA.*
Addresses: Pasadena, CA. **Exhibited:** Calif. State Fair, 1930; Pasadena Soc. of Artists, 1934-37. **Sources:** Hughes, *Artists in California,* 440.

PLEUTHNER, Walter Karl *[Designer, painter, lecturer] b.1885, Buffalo, NY.*
Addresses: NYC; Scarsdale, NY. **Studied:** ASL, Buffalo & NYC; NAD; DuMond; Mora. **Member:** Scarsdale AA; AIA; Arch. Lg.; Westchester Soc. Arch. **Exhibited:** Armory Show, 1913; S. Indp. A., 1917; PAFA Ann., 1923. **Comments:** Lectures: inter-relationship of design. **Sources:** WW53; WW47; Falk, *Exh. Record Series;* Brown, *The Story of the Armory Show.*

PLICATOR, Frank *[Engraver] b.1838, New Orleans.*
Addresses: New Orleans, active 1860. **Sources:** G&W; 8 Census (1860), La., VI, 847.

PLIMPTON, Cordelia Bushnell *[Artist, pottery decorator] b.1830, Palmyra, OH / d.1886, Cincinnati, OH.*
Studied: Berlin, 1881. **Member:** Cincinnati Pottery Cl, 1879 (founding mem.). **Exhibited:** Columbian Expo, Chicago, 1893. **Sources:** Petteys, *Dictionary of Women Artists.*

PLIMPTON, Fannie E. *[Artist] late 19th c.*
Addresses: Wash., DC, active 1877-92. **Comments:** Had a studio in the Corcoran Building in 1892. **Sources:** McMahan, *Artists of Washington, D.C.*

PLIMPTON, Russell A. *[Art administrator] b.1891, Hollis, NY.*
Addresses: Palm Beach, FL. **Studied:** Princeton Univ. (A.B., 1914); Univ. Minn. (hon. M.A., 1956); pvt. study art hist., Europe. **Member:** Assn. Art Mus. Dirs. (pres., 1956); Am. Assn. Mus.; Am. Fedn. Arts. **Comments:** Positions: asst. cur. decorative arts dept., MMA, 1916-21; dir., Minneapolis Art Inst., 1921-56; dir.,

Soc. Four Arts Palm Beach, Fla, 1956-69; dir. emer. 1969-. Publications: contribr., *Minneapolis Art Inst. Bulletin.* Teaching: lectr. painting & decorative arts, radio & TV, Minneapolis, Minn. Collections arranged: increased collections & arranged many exhibs., Minneapolis Art Inst. **Sources:** WW73.

PLIMPTON, William E. *[Landscape and figure painter] late 19th c.*
Addresses: NYC. **Exhibited:** Brooklyn AA, 1876-86, 1891; NAD, 1882-1900 (7 annuals); PAFA Ann., 1890. **Sources:** WW01; *Brooklyn AA; Falk, Exh. Record Series.*

PLIMPTON, William P. *[Painter] late 19th c.*
Studied: Gérome. **Exhibited:** Paris Salon, 1894. **Sources:** Fink, *American Art at the Nineteenth-Century Paris Salons,* 381.

PLIMSOLL, Fanny G. *[Painter] 19th/20th c.*
Addresses: Paris, France. **Sources:** WW01.

PLOCHER, Jacob J. *[Engraver] d.1820, Philadelphia.*
Addresses: Philadelphia, active from 1815 until his death. **Sources:** G&W; Stauffer.

PLOCHMANN, Carolyn Gassan *[Painter] b.1926, Toledo, OH.*
Addresses: Carbondale, IL. **Studied:** TMA Sch. Design, 1943-47; Univ. Toledo (B.A., 1947); State Univ. Iowa (M.F.A., 1949); with Alfeo Faggi, 1950; South. Ill. Univ., 1951-52. **Member:** Silvermine Guild Artists; Woodstock Art Assn.; Phila. WC Cl.; Toledo Fedn. Art Socs. **Exhibited:** Witte Mus, San Antonio, Tex, 1968 (solo); TMA, 1968 (solo); PAFA Ann., 1962; 164th Prints & Drawings Ann., PAFA, 1969; 52nd Ann. Mem. Exhib., Phila. WC Cl., 1969; Woodstock Artists Assn. 50th Ann., NY, 1969; Kennedy Galleries, Inc, NYC, 1970s. **Awards:** George W. Stevens fel., TMA, 1947-49; Tupperware Art Fund First Award, 1953; Emily Lowe Found. Competition Award, 1958. **Work:** Selden Rodman Coll., Oakland, NJ; Evansville Mus. Arts & Sci., Ind.; Fleishmann Found. Coll., Cincinnati, OH; Butler Inst. Am. Art, Youngstown, OH. Commissions: mural, North Side Old Nat. Bank, Evansville, 1953. **Comments:** Preferred media: oils, acrylics, graphics. Teaching: supvr. art, Allyn Training Sch., South. Ill. Univ., Carbondale, 1949-50. Publications: auth., *University Portrait: Nine Paintings by Carolyn Gassan Plochmann* (South. Ill. Univ. Press, 1959); auth., bk. rev., in: *The Egyptian;* auth., cover article, in: *Prize-Winning Graphics,* 1966. **Sources:** WW73; Louise Bruner, "Art notes," *Toledo Blade,* Oct 10, 1965; Donald Key, rev., In: *Milwaukee J.,* June 18, 1969; Falk, *Exh. Record Series.*

PLOGER, Benjamin John *[Painter, teacher] b.1908, New Orleans.*
Addresses: Houston, TX. **Studied:** Acad. de la Grande Chaumière, Paris; Acad. Colarossi, Paris; De L'Ecole la Fresque, Paris; W. Adams; E. Woodward. **Member:** SSAL; NOAA; NOAL; Houston Ar. Gal. **Exhibited:** P. W. A. exh., NOMA, 1935 (prize); Houston artist exh., 1936 (rize). **Work:** Flowers Sch., New Orleans; U. S. Gov. **Comments:** Position: t., Mus. FA, Houston. **Sources:** WW40.

PLONSKI, Walter D. *[Sculptor] mid 20th c.*
Exhibited: AIC, 1930. **Sources:** Falk, *AIC.*

PLONTKE, Paul *[Painter] mid 20th c.*
Exhibited: AIC, 1924-25. **Sources:** Falk, *AIC.*

PLOTKIN, Edna See: **HIBEL, Edna**

PLOWDEN, T. M. (Mrs) See: **MCCULLOUGH, Suzanne (Mrs. T. M. Plowden)**

PLOWMAN, George T(aylor) *[Illustrator, etcher, writer] b.1869, Le Suer, MN / d.1932, Cambridge, MA.*
Addresses: Cambridge, MA. **Studied:** Douglas Volk, in Minneapolis; Eric Pape, in Boston, 1910; F. Short at Royal College of Art, London, 1911-13. **Member:** Chicago SE; NY SE; Boston SE; Calif. SE; Calif. PM; Soc. Am. E.; F., Royal Soc. Arts. **Exhibited:** P. P. Expo, San Fran., 1915 (med); AIC. **Work:** etchings, BMFA; NYPL; LOC; British Mus.; South Kensington Mus.;

Nat. Mus., Washington; Luxembourg Mus.; Newark Pub. Lib.; Sacramento (Calif.) State Mus.; Albany A. Mus.; Southport Mus., England; MMA; Minneapolis Mus. A. **Comments:** Author: "Etchings and Other Graphic Arts," 1914, "Manual of Etching," 1924. Trained as an architect, he turned to etching at age 42 and was considered to have immortalized New England's covered bridges in his work. **Sources:** WW31.

PLUFF, Frank N. *[Painter] mid 20th c.*
Exhibited: P&S of Los Angeles, 1930. **Sources:** Hughes, *Artists in California,* 441.

PLUGGE, Frederick W. *[Engraver, lithographer] 19th/20th c.*
Addresses: Wash., D.C., active 1890-1901. **Sources:** McMahan, *Artists of Washington, D.C.*

PLUMB *[Portrait painter] mid 19th c.*
Addresses: Active in Maryland before 1868. **Comments:** Painter of a portrait of Francis Thomas of Maryland which was engraved by Alfred Sealey (Sealey died c.1868, see entry). **Sources:** G&W; Stauffer.

PLUMB, George T. *[Painter] early 20th c.*
Exhibited: PPE, 1915 (med.). **Comments:** Specialty: watercolors. **Sources:** Hughes, *Artists in California,* 441.

PLUMB, Grant *[Painter] mid 20th c.; b.NYC.*
Addresses: Los Angeles, CA. **Studied:** with his father; with Wm. Paxton in Los Angeles; Académie Julian, Paris, with Laurens, Lhote, Charles Blanc; Acad. Belli Arti, Florence, with Baccio Bacci. **Exhibited:** Laguna Beach AA, 1936 (first prize). **Sources:** Hughes, *Artists in California,* 441.

PLUMB, Helen G. *[Painter] late 19th c.*
Addresses: NYC. **Exhibited:** PAFA Ann., 1880. **Sources:** Falk, *Exh. Record Series.*

PLUMB, H(enry) G(rant) *[Genre and landscape painter, teacher] b.1847, Sherburne, NY / d.1930, NYC.*
Addresses: NYC/Sherburne, NY. **Studied:** NAD; Ecole des Beaux-Arts, Paris, with Gérome. **Member:** SC; A. Fund. S.; AFA. **Exhibited:** NAD, 1879-92; Brooklyn AA, 1879-86; PAFA Ann., 1881-82, 1888-92, 1898; Boston AC, 1886-1900; Paris Expo., 1889 (prize); Paris Salon, 1878; S. Indp. A., 1918-19, 1923-24; Salons of Am.,1925-26; AIC. **Comments:** Exhibited works indicate he also painted in Brittany. Position: t., Cooper Union, 1882-1916. **Sources:** WW29; Fink, *American Art at the Nineteenth-Century Paris Salons,* 381; Falk, *Exh. Record Series.*

PLUMBE, John, Jr. *[Daguerreotypist] b.1809, Wales / d.1857, Dubuque, IA.*
Work: LOC. **Comments:** He is best known for taking the earliest photographs of buildings and monuments in Wash., DC (1846). From 1832-38 he was a railroad surveyor in Virginia, but took up the daguerreotype process in 1840 in Wash., DC. He soon set up daguerreotype galleries in Boston (1841-46), Baltimore (1841-?), NYC (1843-47), Philadelphia (1842-45), Lexington, KY (1845-?), Saratoga, Louisville, New Orleans, Dubuque, St. Louis —all crowned by his "National Daguerreian Gallery" in Wash., DC (1846-50). He also published *Plumbeian* (1846) and *National Plumbeotype Gallery* (1846). However, financial problems soon forced him sell his interest in the galleries to his employees. Plumbe moved West to Dubuque, then California, and tried to interest the U.S. government in his scheme for surveying a Southern railroad route across the country. The government chose a Northern route, and in 1857 Plumbe slit his throat. **Sources:** Newhall, *The Daguerreotype in America,* 150.

PLUMBER, Nan D. *[Painter] 19th/20th c.*
Addresses: Boston, MA, active 1899-1906. **Exhibited:** Boston AC, 1890-1905. **Sources:** WW06; *The Boston AC,* (under Plumer).

PLUMER, Harrison Lorenzo *[Portrait and genre painter] b.1814, Haverhill, MA.*

Addresses: London, 1837-45; New Orleans, active 1859-66. **Exhibited:** Boston Athenaeum, 1837; Royal Academy, London (between 1837 and 1845, as H.L. Plummer); Victorin Guette's store, 1859. **Comments:** While in New Orleans he advertised (1859) that he could paint an oil portrait in five hours. **Sources:** G&W; Perley, *The Plumer Genealogy*, 185; Swan, BA; Graves, *Dictionary;* Delgado-WPA cites *Bee*, March 2, 1859. More recently, see *Encyclopaedia of New Orleans Artists* (under Harrison Lorenzo Plummer).

PLUMER, Jacob P. *[Engraver] mid 19th c.*
Addresses: Boston, 1855-60 and after. **Comments:** Was in partnership with Nathaniel Evans, Jr., in firm of Evans & Plumer, 1855-56. **Sources:** G&W; Boston CD 1855-60+; Perley, *The Plumer Genealogy,* 157 (G&W speculated that engraver Plumer may be Jacob P. Plumer, son of Avery and Elizabeth (Paul) Plumer, born March 26, 1819).

PLUMER, Nan D. See: **PLUMBER, Nan D.**

PLUMMER, Adrian *[Portrait painter] mid 19th c.*
Addresses: Boston, active 1837. **Exhibited:** Boston Athenaeum (1837). **Sources:** G&W; Boston Athenaeum Cat., 1837.

PLUMMER, Alice Gertrude *[Painter, teacher] b.1892, NYC / d.1957, Oakland, CA.*
Addresses: Oakland, CA. **Studied:** Univ. Calif. (M.A.). **Member:** Pacific AA; AFA. **Exhibited:** Oakland Art Gal., 1927; League of American Pen. Women, de Young Mus., 1928; Bay Region AA, 1935. **Comments:** Position: assist. prof., UC, 1914-17; t., high schools, 1917-1941. **Sources:** Hughes, *Artists in California,* 441.

PLUMMER, Arrie Elizabeth (Mrs. L.L.) *[Painter, teacher] b.1884 , LA Grange, GA.*
Addresses: Birmingham, AL. **Studied:** C. Hill; M. Armstrong; I. Lauder; S. W. Woodward; H. Leech; J.K. Fitzpatrick. **Member:** Birmingham AC; Alabama AL; Dixie Art Colony; SSAL; Sarasota AA. **Work:** Mus. FA, Montgomery; Birmingham Public School; Seton Hall, Decatur, AL. **Sources:** WW40.

PLUMMER, E. (Mrs.) *[Painter] late 19th c.*
Exhibited: NAD, 1881. **Sources:** Naylor, *NAD.*

PLUMMER, Edward *[Miniaturist] mid 19th c.*
Addresses: Connecticut, active c. 1850. **Comments:** Known through a watercolor miniature. **Sources:** G&W; Lipman and Winchester, 178.

PLUMMER, Edwin *Edwin Plummer*
[Portrait painter] mid 19th c.
Addresses: Salem, MA, 1828; Boston, 1841-46. **Sources:** G&W; Belknap, *Artists and Craftsmen of Essex County,* 12; Boston BD 1841, 1844, 1846.

PLUMMER, Elmer (Ginzel) *[Painter, etcher, mural painter, graphic artist, teacher] b.1910, Redlands, CA / d.1987.*
Addresses: Hollywood, CA. **Studied:** Chouinard Sch. A., Los Angeles, with L. Murphy; M. Sheets; P. Carter; D. Alfaro; C. Hinkle; Siqueiros. **Member:** Calif. WC Soc. **Exhibited:** Los Angeles Country Fair, 1932 (prize); Los Angeles AA., 1934 (prize); Calif. State Fair, 1938 (prize); WC Ann., PAFA, 1938; PAFA Ann., 1940; Int. WC Ann., AIC, 1939; GGE, 1939. **Work:** YMCA, Pasadena; Oxnard A. Assn., Calif.; FA Gal., San Diego; White House, Wash., DC. **Comments:** Position: artist, Walt Disney Studios. **Sources:** WW40; Falk, *Exh. Record Series.*

PLUMMER, Ethel McClellan *[Painter, illustrator] b.1888, Brooklyn, NY / d.1936, NYC.*
Addresses: NYC. **Studied:** Henri; Mora. **Member:** Soc. Illustrators (officer). **Exhibited:** WMAA, 1922-26. **Comments:** Illustrator: *Vanity Fair, Vogue, Life, Woman's Home Companion, New York Tribune.* Specialty: portrait sketches. Married Jacobson and Frederick E. Humphreys. **Sources:** WW38; Petteys, *Dictionary of Women Artists,* 568.

PLUMMER, Harrison Lorenzo See: **PLUMER, Harrison Lorenzo**

PLUMMER, John H *[Art administrator, educator] b.1919, Rochester, MN.*
Addresses: Blauvelt, NY. **Studied:** Carleton Col. (A.B.); Columbia Univ. (Ph.D.). **Comments:** Positions: res. assoc., Pierpont Morgan Libr., NYC, 1955-56; cur., mediaeval & renaissance, 1956-66, res. fel. for art, 1966-. Teaching: instr. & lectr., Columbia Univ., instr., Barnard Col., 1952-56; vis. prof., univ., 1961; vis. lectr., Harvard Univ., 1963; adj. prof., Columbia Univ., 1964-. Research: mediaeval and modern art. Publications: auth., "Liturgical Manuscripts," 1964 & "The Glazier Collection of Illuminated Manuscripts," 1968 (Pierpont Morgan); auth., "The Hours of Catherine of Cleves," Pierpont Morgan, Boston Bk. & Braziller, 1966. **Sources:** WW73.

PLUMMER, Leander Allen II *[Painter, sculptor] b.1857, New Bedford, MA / d.1914, New Bedford.*
Studied: Friends Acad.; Harvard, 1879; Lawrence Scientific Sch. (civil and mining engineering); Académie Julian, 1883-84, with Gustave Boulanger and Jules Lefebvre; Carl Von Gydingsvard. **Exhibited:** Doll and Richards Gal., Boston, 1903; New Bedford A. Cl., 1907-12. **Work:** New Bedford (MA) Free Pub. Lib.; Old Dartmouth Hist. Soc. **Comments:** Combined his talent in painting and wood carving to do "relief painting"; subjects were fish and marine birds. Also produced some furniture. **Sources:** Blasdale, *Artists of New Bedford,* 144-45 (w/repros.).

PLUMMER, R. *[Painter] mid 19th c.*
Addresses: Maine, active c.1860. **Comments:** Landscape in oils. **Sources:** G&W; Lipman and Winchester, 178.

PLUMMER, Thomas Rodman *[Painter] b.1862, New Bedford, MA / d.1918, France.*
Addresses: Active in New Bedford, MA, 1884-1916. **Studied:** Harvard, 1884; École des Beaux-Arts, Paris (architecture). **Exhibited:** New Bedford Art Cl., 1907. **Comments:** Served in WWI; became ill and died in France. **Sources:** Blasdale, *Artists of New Bedford,* 146 (w/repro.).

PLUMMER, W. H. *[Marine painter] late 19th c.*
Work: Mariners Mus., Newport News, VA (oil). **Comments:** Active c.1872-76. **Sources:** Brewington, 304.

PLUMMER, William *[Painter of miniature profiles in watercolors] mid 19th c.*
Addresses: Massachusetts, active first quarter of the 19th century. **Studied:** said to have studied under Allston (see Sherman). **Sources:** G&W; Sherman, "American Miniatures by Minor Artists."

PLUNDER, Franz *[Painter] mid 20th c.*
Addresses: NYC. **Exhibited:** PAFA Ann., 1925; Salons of Am., 1930; AIC. **Sources:** WW25; Falk, *Exh. Record Series.*

PLUNGUIAN, Gina R. (Mrs.) *[Painter, sculptor, teacher, lecturer] d.1962, Newark, DE.*
Addresses: Newark, DE. **Studied:** Ecole des Beaux-Arts, Montreal, Canada; Dayton AI. **Member:** AEA; NAWA; Assoc. A., New Jersey; CAA; Council of Del. A. **Exhibited:** PAFA Ann., 1958; Butler AI; All. A. Am.; WMAA; Lighthouse A. Exh., NY; Newark Mus. A.; Montclair A. Mus.; New Jersey WC Soc.; New Jersey State Mus., Trenton; S. Indp. A.; Columbus Gal. FA; Dayton AI; Hunter Gal., Chattanooga; solo: Princeton Group A. (2); Princeton Present Day Cl.; New Brunswick A. Center; Oglethorpe Univ., Georgia; Argent Gal., N.Y.; Univ. Delaware, 1958; Lincoln Univ., 1959; Octorara (Pa.) AA, 1957. **Awards:** prizes, Hunter Gal., 1954, 1955; Delaware A. Center, 1958. **Work:** Kirkman Vocational H.S., Chattanooga; Tel-Aviv Mus., Israel; Southern Missionary Col., Tenn.; portraits in many priv. colls. **Comments:** Position: instr., Delaware A. Center, Wilmington, Del. Lectures on art to clubs, teacher's organizations, college and art groups. **Sources:** WW59; Falk, *Exh. Record Series.*

PLYMPTON, Cordelia Bushnell See: **PLIMPTON, Cordelia Bushnell**

PLYMPTON, D. Della *[Painter] b.1874, Brooklyn, NY.*
Addresses: Brooklyn, NY. **Studied:** J. Francis Murphy, H.B. Snell, & F. Luis Mora. **Exhibited:** PAFA Ann., 1903; AIC, 1911. **Sources:** WW15; Petteys, *Dictionary of Women Artists;* Falk, *Exh. Record Series.*

PNEUMAN, Mildred Young (Mrs. Fred A.) *[Painter, serigrapher] b.1899, Oskaloosa, IA.*
Addresses: Gary, IN; Boulder, CO; Walnut Creek, CA. **Studied:** Univ. Colorado (B.A. & B.Ed., 1921; M.F.A., 1947); J. Rennell. **Member:** Boulder Artists Guild (pres., 1969-70); AAPL; Hoosier Salon Assn.; Gary PPC; Boulder Art Assn. **Exhibited:** Gary Civic Art Fnd., 1937 (prize); Phila. Color. Print Soc., 1945; Hoosier Salon, 1928-40; Marshall Field's, Chicago, IL, 1928-40; Denver Art Mus., 1944; Boulder Art Guild, 1954-61; Mus. New Mexico; Univ. Wyoming; Am. Color Print Soc.; Colorado State Fairs, 1965-68 (award 1944); Denver Metrop., 1969; Northern Colorado Exhibs., Boulder Art Assn., 1970; Tri Kappa Prizes, 1937, 1965-66. **Work:** Univ. Colorado Mus.; Univ. Colorado Faculty Cl.; PEO Mem. Library, Des Moines, IA. **Comments:** Preferred media: oils. Positions: bd. mem., Boulder Pub. Lib. A. Gal., 1967-70. Teaching: art instr., Los Angeles Public Schools, 1921-23; instr., Gary Public Schools, 1923-25. Collection: 130 prints, woodcuts, lithographs, etchings, serigraphs and others, from the United States, Europe and Asia. Publications: auth., "A Study of the Mountain Form in Painting," Univ. Colorado, 1947. **Sources:** WW73; WW47; Ness & Orwig, *Iowa Artists of the First Hundred Years,* 168.

PO-TSU-NU See: **MONTOYA, Gerónima Cruz (Po-Tsu-Nu)**

POATS, William W. (Mrs.) *[Artist] late 19th c.*
Addresses: Active in Benton Harbor, MI, 1887-89. **Sources:** Petteys, *Dictionary of Women Artists.*

PODA, Louis *[Painter] mid 20th c.*
Exhibited: S. Indp. A., 1936. **Sources:** Marlor, *Soc. Indp. Artists.*

PODALADALTE See: **ZOTOM, Paul Caryl**

PODCHERNIKOFF, Alexis (Angelo) *[Painter, lithographer] b.1912, San Francisco, CA / d.1987, San Fran.*
Addresses: San Francisco. **Studied:** Hopkins Sch. FA, San Fran.; A.M. Podchernikoff; Ossip de Perelmaof. **Work:** WPA artist. **Sources:** WW40.

PODCHERNIKOFF, Alexis Matthew *[Landscape painter] b.1886, Vladimir, Russia / d.1933, Pasadena, CA.*
Addresses: San Francisco, CA; Santa Barbara, CA. **Studied:** with his grandfather Dmitri Zolotarieff, Ilya Repin, Verestchagin, in Russia. **Work:** Oakland Mus.; Royal Art Commission, Moscow. **Comments:** He immigrated to the U.S. and settled in San Francisco in 1905. Specialty: Calif. landscapes in the manner of Corot. **Sources:** Hughes, *Artists in California,* 441.

PODCHERNIKOFF, Ida Maria Working *[Painter] b.1868, Belle Plaine, MN / d.1944, San Francisco, CA.*
Addresses: Northern California. **Work:** Comisky-Roche Funeral Home, San Francisco. **Comments:** She was married to Alexis M. Podchernikoff (see entry). Specialty: oil paintings. her work is rare and often unsigned. **Sources:** Hughes, *Artists in California,* 441.

PODESTA, Stephen *[Sculptor listed as "plaster image maker"] b.c.1810, Italy.*
Addresses: Boston in 1860. **Comments:** Pedro Groppi (see entry) was listed as boarding with the family. **Sources:** G&W; 8 Census (1860), Mass., XXVI, 402 (he and his wife had four children all born in Massachusetts since 1843).

PODOLSKY, Henry W. *[Sculptor] mid 20th c.*
Addresses: Baltimore, MD. **Exhibited:** PAFA Ann., 1921-23, 1937. **Sources:** WW25; Falk, *Exh. Record Series.*

PODSZUS, Carl O. *[Painter] mid 20th c.*
Addresses: NYC, 1948. **Exhibited:** S. Indp. A., 1944; WMAA, 1948. **Sources:** Falk, *WMAA.*

POE, Alexander *[Painter] mid 20th c.*
Addresses: NYC, 1941. **Exhibited:** S. Indp. A., 1941-42, 1944. **Sources:** Marlor, *Soc. Indp. Artists.*

POE, Elisabeth E. *[Painter, writer, critic] b.1888, Philadelphia, PA / d.1934, Wash., DC.*
Addresses: Wash., DC, 1902-34. **Studied:** primarily self-taught; C. Law Watkins. **Member:** Wash. WCC; AFA. **Exhibited:** solos: PAFA; Syracuse Mus. FA; Wash. AC; CGA, 1938; Phillips Mem. Gal., Wash., DC, 1939, 1946-47 (memorial); MMA; Cincinnati Art Mus.; Am. AC Soc.; Gr. Wash. Indep. Exhib., 1935. **Work:** PMG; PAFA; CGA. **Comments:** Positions: art critic, *Washington Times-Herald; Washington Post.* Co-auth. (with her sister, Vylla Wilson, see entry): "Half Forgotten Romances of American History," 1924; "Edgar Allan Poe, High Priest of the Beautiful," 1932. **Sources:** WW53; WW47; McMahan, *Artists of Washington, D.C.;* Petteys, *Dictionary of Women Artists,* cites alternate birth date of 1886.

POE, Hugh M. *[Painter] b.1902, Dallas, TX.*
Studied: R.L. Mason; Forsyth; C. Hawthorne. **Member:** Knoxville Sketch C.; Ind. AC; East Tenn. SFA; Hoosier Salon. **Exhibited:** Art Assn., Herron AI, 1923 (prize)-24 (prize); Hoosier Salon, Marshall Field's. Chicago, 1925 (prize). **Work:** Herron AI; Knoxville (Tenn.) Sketch C. **Sources:** WW33.

POE, Lucy A. *[Painter] early 20th c.*
Addresses: NYC. **Exhibited:** NAD, 1874-75. **Sources:** WW06.

POE, Vylla See: **WILSON, Vylla (Poe)**

POEHLER, John *[Painter] 20th c.*
Addresses: NYC. **Work:** WPA mural, USPO, Riverside, NJ. **Comments:**. **Sources:** WW40.

POESCHE, Ilya *[Artist] late 19th c.*
Addresses: Wash., D.C., active 1884. **Sources:** McMahan, *Artists of Washington, D.C.*

POFFINBARGER, Paul *[Painter] 20th c.*
Addresses: Des Moines, IA. **Comments:** WPA artist. **Sources:** WW40.

POGANY, William Andrew (Willy) *[Designer, painter, illustrator, graphic artist, sculptor, etcher] b.1882, Szeged, Hungary / d.1955, NYC.*
Addresses: NYC. **Studied:** Budapest, Hungary. **Member:** Arch. Lg.; SC; Calif. AC; Beaux-Art Inst.; fellow, Royal Soc. Artists, London, England; Woodstock AA. **Exhibited:** Pan-Pac. Expo., 1915 (gold); New York Soc. Arch., 1923 (prize); Leipzig Expo (gold); Budapest Expo (gold) ; AIC. **Work:** Heckscher Children's Theatre, NY; Niagara Falls Power Co; W.R. Hearst's Wyntoon Village; Park Sheraton Hotel, NY; Hungarian National Gal., Budapest; Ritz Towers, NY; St. George Hotel, Brooklyn. **Comments:** Positions: stage designer for Broadway productions and Metropolitan Opera Co.; motion picture art dir., 1930-40. Auth./illus., numerous books, including Willy Pogany's "Drawing Lessons," 1946; "Water Color Lessons," 1950; "Oil Painting Lessons," 1952. Illustrator: *American Weekly.* **Sources:** WW53; WW47; Woodstock AA.

POGREBYSKY, William *[Painter] mid 20th c.*
Addresses: Stelton, NJ. **Exhibited:** Salons of Am., 1924; S. Indp. A., 1924-28, 1930. **Sources:** Falk, *Exhibition Record Series.*

POGSON, Annie L. (Willfong) (Mrs.) *[Landscape & flower painter] b.1857, New Hampshire / d.1931, Los Angeles, CA.*
Addresses: Hawaii, 1912; Hollywood, 1912-24; Los Angeles, CA. **Member:** Calif. AC. **Exhibited:** Hollywood, 1919; Kanst Gal., Los Angeles, 1920. **Sources:** WW25; Hughes, *Artists in California,* 441; Petteys, *Dictionary of Women Artists.*

POGUE, Stephanie E. *[Graphic artist, educator] b.1944, Shelby, NC.*
Studied: Syracuse Univ.; Howard Univ. (B.F.A., outstanding grad.); Cranbrook Academy of Art, Bloomfield Hills, MI. **Exhibited:** Fisk Univ., 1966; Rhode Island Col.; Young

Printmakers AA of Indianapolis; Rubiner Gal., Royal Oaks, MI, 1967; Univ. of North Dakota; MI Assn. of Printmakers, London Arts Gal., Detroit; Okla. Art Center, 1968; Peabody Mus., Nashville, TN; WMAA; Xavier Univ. (solo); CI, 1972; Alabama State Univ., 1972. **Work:** Fisk Univ.; WMAA; Xavier Univ.; Tennessee Arts Commission, Nashville; Univ. of the South, Swanee, TN. **Comments:** Position: assist. prof., Fisk Univ. **Sources:** Cederholm, *Afro-American Artists.*

POGZEBA, Wolfgang *[Painter, etcher, sculptor] b.1936, Planegg, Germany.*
Addresses: Denver, CO in 1975. **Work:** Mus. New Mexico; Lubbock Chamber Commerce. **Sources:** P&H Samuels, 374.

POHI, Marsimiliano *[Woodcarver] late 19th c.*
Exhibited: Mechanics' Inst., San Francisco, 1896. **Sources:** Hughes, *Artists in California,* 441.

POHL, Augusta E. *[Painter] mid 20th c.*
Addresses: Brooklyn, NY. **Exhibited:** S. Indp. A., 1929-31, 1934; Salons of Am., 1930-32, 1934. **Sources:** Falk, *Exhibition Record Series.*

POHL, Edward *[Engraver] b.c.1841, Pennsylvania.*
Addresses: Philadelphia in 1860. **Sources:** G&W; 8 Census (1860), Pa., LIII, 202.

POHL, Ernest Henry *[Landscape painter] b.1874, Michigan / d.1956, San Diego, CA.*
Addresses: San Diego, CA. **Work:** Univ. of Notre Dame, South Bend, IN. **Comments:** Founded the La Jolla Art Center, together with his wife. **Sources:** Hughes, *Artists in California,* 441.

POHL, Hugo David *[Painter, etcher, teacher] b.1878, Detroit, MI / d.1960, San Antonio, TX.*
Addresses: San Antonio, TX. **Studied:** J. Melchers (at age 11); Detroit Inst. Art, with J. Giles; ASL; Académie Julian, Paris with J.P. Laurens. **Member:** Texas FAS; AAPL; Mural Painters; Washington Art Lg. **Exhibited:** NAD; Scarab Club, Detroit; Palette & Chisel Club, Chicago; S. Indp. A. **Work:** San Antonio (TX) Auditorium; murals, Int. Harvester Co., Chicago; Union Pacific R.R. **Comments:** Pohl built a traveling studio to tour and paint the West, including Colorado, New Mexico, Arizona and California. He also painted in France, Germany, Holland, Spain, and Italy before settling in Texas and joining the San Antonio art colony. Position: dir., Washington Art League; dir., San Antonio Acad. Art. **Sources:** WW59; WW47; P&H Samuels, 375.

POHL, Lavera Ann (Mrs. William) *[Painter, writer, lecturer, historian] b.1901, Port Washington, WI.*
Addresses: Milwaukee, WI; Red Bank, NJ. **Studied:** Univ. Bonn (Ph.D.); Univ. Cologne, Germany; Wis. Sch. FA; Milwaukee State T. Col.; Milwaukee AI.; Saugatuck Sch. P., Mich. **Member:** Wis. P. & S.; Wis. Designer-Craftsmen; CAA; AFA; AAUW; NAWA. **Exhibited:** Wis. P. -S., 1918-42 (prize), 1943-46; NAWA, 1944-45; Milwaukee AI, 1946; Beloit Col., 1940, 1942, 1946; Col. Women's C., Milwaukee, 1940, 1946 (solo); Argent Gal., 1945; Barbizon Plaza Gal., 1946. **Awards:** Marquette Univ. Matrix Award, 1953; Senior Lg. Service Cl. of America Award, 1954. **Work:** des. Women's Army Corps med.; murals, Milwaukee Univ.; Grace Baptist Church. **Comments:** Author: "American Painting," 1938. Contributor to: newspapers & college year books. Lectures on art topics; art advisor. Position: dir., Milwaukee AI, Milwaukee, Wis., 1950-55; dir., Laylon A. Gal., 1953-55. **Sources:** WW59; WW47.

POHL, Louis G *[Painter, printmaker] b.1915, Cincinnati, OH.*
Addresses: Honolulu, HI. **Studied:** Cincinnati Art Acad. **Member:** Hawaii P&S League; Honolulu Printmakers. **Exhibited:** Butler Inst. Am. Art, 1939 & 1944; Art of Cincinnati, 1940-42; Cincinnati Mus. Assn., Contemp. Art Ctr., 1961 (solo) & Honolulu Acad Art (solo). **Awards:** four prizes, Honolulu Acad Art, 1947-57; McInerny Found. grant, 1954-55; Printmaker of the Year, 1965. **Work:** Cincinnati Mus. Assn.; Honolulu Acad Art. **Comments:** Positions: cartoonist, daily cartoon "School Daze," *Honolulu Advertiser.* Teaching: instr., Univ. Hawaii, 1953-56;

instr., Honolulu Sch. Art; instr. drawing, painting & illus., Honolulu Acad. Art. **Sources:** WW73.

POHL, Lydia D. *[Painter] 20th c.*
Addresses: Chicago, IL. **Sources:** WW15.

POHL, Minette T. See: **TEICHMUELLER, M. (Mrs. Minette T. Pohl)**

POHLMANN, Theodore *[Lithographer] late 19th c.*
Addresses: New Orleans, active 1882-86. **Sources:** *Encyclopaedia of New Orleans Artists,* 309.

POIDIMANI, Gino *[Sculptor, teacher] b.1910, Rosolini, Italy.*
Addresses: Rome, Italy; Brooklyn, NY. **Studied:** Royal Sch. A., Siracuse, Italy; Royal Liceo Artistico of Rome; Royal Acad. FA, Rome. **Member:** Int. Artistic Assn., Rome; Artistic & Cultural Cl., Siracuse, Italy; NSS; All. A. Am. **Exhibited:** Florence, 1942; San Remo prize exh., 1937, 1939, 1940; Venice Biennale, 1941; Rome, 1947 (solo); Audubon A., 1947, 1950-52; PAFA Ann., 1948; Fairmount Park, Phila., 1949; NSS, 1951-52; Argent Gal., 1951; All. A. Am., 1951. **Awards:** Gov. scholarship to Royal Acad. FA, Rome; gold medal, for sculpture, Tripoli, 1929. **Work:** statues, bas-reliefs, Cathedral of Messina, Rome; St. Joseph's Catholic Church, Rosolini, Italy; Monumental Cemetery, Milan; numerous portrait busts in priv. colls. **Sources:** WW59; Falk, *Exh. Record Series.*

POILLON, Clara Louise (Mrs. Cornelius) *[Craftsperson] b.1851, NYC / d.1936.*
Addresses: NYC, c.1907. **Exhibited:** Salons of Am., 1923. **Sources:** WW24.

POINCY, Paul E. *[Portrait, religious, landscape, and genre painter] b.1833, New Orleans / d.1909, New Orleans.*
Addresses: New Orleans. **Studied:** Académie Julian, Paris, c.1852-58; École des Beaux-Arts; also with Marc-Gabriel-Charles Gleyre and Léon Cogniet in Paris. **Member:** Southern Art Union , 1880-81(founder); Artists' Assoc. of New Orleans, 1885-97 (an organizer, treasurer, secretary, teacher of perspective drawing). **Exhibited:** frequently in New Orleans: Seebold's, 1879-80; Lilienthal's, 1883; Tulane Univ.,1892; Artists' Assoc. of New Orleans, 1886-1901; Moses & Son, 1901; also at Tenn. Centennial Expo, Nashville, 1897. **Work:** Louisiana State Mus., New Orleans ("Volunteer Firemen's Parade," 1872, painted in collaboration with Victor Pierson); Historic New Orleans Collection. **Comments:** After studying in Paris, he returned to New Orleans in January of 1859, and remained active there until his death, although he also briefly worked in Alabama (1859). He shared a studio with Richard Clague (see entry) in New Orleans before entering the Confederate Army. After the war, he was a partner with Victor Pierson (see entry) in Pierson & Poincy (1872-73). He specialized in children's portraits but also painted street scenes and religious-themed works. **Sources:** G&W; G&W also included an entry for a portrait painter named A. Poincy, based on Delgado-WPA citation from *Bee,* Jan. 18, 1859; this must, however, be the Paul Poincy who studied in Paris and returned to New Orleans in 1859: see references in *Encyclopaedia of New Orleans Artists* under entries for Paul Poincy, and Pierson & Poincy). See also WPA (Ala.), Hist. Records Survey; Cline, "Art and Artists in New Orleans;" Gerdts, *Art Across America,* vol. 2: 105; *Complementary Visions,* 35.

POINDEXTER, Elinor Fuller *[Art dealer] 20th c.; b.Montreal.*
Addresses: NYC. **Member:** Art Dealers Assn Am. **Comments:** Positions: dir, Poindexter Gallery. Specialty of gallery: contemporary painting & sculpture, especially American. Collection: contemporary works. **Sources:** WW73.

POINDEXTER, James Thomas *[Portrait painter] b.1832, Christian County, KY / d.1891, Eddyville, KY.*
Addresses: Active primarily in Evansville, IN. **Studied:** may have studied in Cincinnati. **Work:** Evansville (IN) A. Gal.; New Harmony (IN) Lib.; Univ. Kentucky Art Mus., Lexington. **Comments:** Began his career in Kentucky as an itinerant.

Working at Evansville (IN) as early as 1852-c.1860 and established himself as a leading resident portrait painter. Returned there after the Civil War, during which he had served as a telegraph operator, and remained until 1882; also worked in New Orleans 1870-71 and in Granada, MS. He traveled to New York and Boston and was in Italy. He eventually returned to Kentucky and is listed in the Louisville City Directory in 1889. **Sources:** G&W; Peat, *Pioneer Painters of Indiana*; Burnet, *Art and Artists of Indiana*. More recently, see *Encyclopaedia of New Orleans Artists*; Gerdts, *Art Across America*, vol. 2: 257; Jones and Weber, *The Kentucky Painter from the Frontier Era to the Great War*, 62-63 (w/repro.).

POINDEXTER, Julia *[Painter] late 19th c.*
Addresses: Wash., DC. **Exhibited:** Boston AC, 1888. **Sources:** *The Boston AC.*

POINDEXTER, Vernon Stephensen *[Illustrator, commercial artist] b.1918, Roanoke County, VA.*
Studied: ASL. **Exhibited:** ACA Gallery, NYC; LOC (award); BM; Phila. Print Club; NAD. **Sources:** Cederholm, *Afro-American Artists.*

POINT, Nicholas S.J. (Father) *[Amateur painter] b.1799, Rocroy (near Belgium), France / d.1868, Quebec, Canada.*
Work: Jesuit Provincial House in St. Louis (MO) owns over 100 of his sketches; work also located in Jesuit Archives (Rome, Italy). **Comments:** Jesuit priest who served in France, Switzerland, and Spain before being sent to St. Mary's, KY, in 1835. After serving in Louisiana and Westport, MO, he joined Father de Smet's missionary group in 1841, acting as a diarist on their journey to the Rockies (arriving at the Flathead area, in what is now Montana). Point spent the winter with the Indians, giving religious instruction and also making paintings and sketches of their daily lives. In 1842 he designed and built a short-lived mission among the Coeur d'Alene Indians (in region that is now part of Northern Idaho). In 1845 he worked to establish a mission among the Blackfeet but when this failed he requested a transfer to Canada, which he received in 1847. He soon retired to Windsor, Ontario, and in 1859 wrote *Wilderness Kingdom* which he illustrated with hundreds of his paintings depicting the lives of the Rocky Mountain Indians. Some of his sketches also formed the basis for lithographs illustrating Father de Smet's *Oregon Missions and Travels over the Rocky Mountains in 1845-46.*
Sources: G&W; Rasmussen, "Art and Artists in Oregon, 1500-1900," cite also Cody, *History of the Coeur d'Alene Mission of the Sacred Heart* and Wagner, *The Plains and the Rockies.* More recently, see P&H Samuels, 375.

POINTEL, J.B. See: **POINTEL DU PORTAIL, J. B.**

POINTEL DU PORTAIL, J. B. *[Portrait, landscape, and flower painter; lithographer; teacher; daguerreotypist] mid 19th c.; b.France.*
Addresses: New Orleans, active 1836-before 1844; Baton Rouge, LA, by 1844. **Studied:** Jacques-Louis David, Léon Cogniet, and Redouté, Paris. **Exhibited:** Louisiana Grand State Fair, 1844 (cert. for portraits). **Comments:** Active in Paris from c. 1820. Was described in 1836 New Orleans newspaper as having come from France. Produced lithographic portraits of many leading New Orleans residents, was lithographer at New Orleans *Bee*, and one of the earliest daguerreotypists in New Orleans (1840). *Cf.* M.L. de Pontelli. **Sources:** G&W; G&W had separate listings for J.B. Pointel and M. Pontel du Portail; however *Encyclopaedia of New Orleans Artists* shows him as one artist, and includes references: New Orleans CD 1838; *Bee*, Nov. 11, 1836; Apr. 5, Nov. 22, 1837; Feb. 11, April 9, 1840; *Courier*, June 11, 1838, Mar. 7, 1839; and *Picayune*, Jan. 14, 1844. See also Benezit, vol. 8 (under Pointel Du Portail).

POINTER, Augusta L. *[Sculptor] b.1898, Durango, CO.*
Addresses: NYC; Lincoln Park, NJ. **Studied:** H. Hering; Cooper Union; George Bridgman, ASL. **Exhibited:** Arch. Lg., 1928 (prize); NSS; PAFA Ann., 1929. **Sources:** WW33; Petteys, *Dictionary of Women Artists*; Falk, *Exh. Record Series.*

POINTER, Priscilla *[Painter] mid 20th c.*
Exhibited: Salons of Am., 1934. **Sources:** Marlor, *Salons of Am.*

POISSON, Julien *[Drawing teacher] early 19th c.*
Addresses: Richmond, VA, active 1810-12. **Sources:** G&W; *Richmond Portraits.*

POITIAUX, Michael Benoit *[Amateur artist, teacher] b.1771, Brussels, Belgium / d.1854, Richmond, VA.*
Addresses: Charleston, SC, 1787-98; Richmond, VA. **Comments:** A successful businessman at first, he lost much of his wealth in 1819 and taught painting and music during his later years. **Sources:** Wright, *Artists in Virginia Before 1900.*

POLAKOV, Lester *[Painter] mid 20th c.*
Exhibited: Salons of Am., 1934. **Sources:** Marlor, *Salons of Am.*

POLAN, Lincoln M. *[Collector] b.1909, Wheeling, WVA.*
Addresses: Huntington, WV. **Studied:** New York Univ.; Univ. Va.; Ohio State Univ. **Member:** MMA. **Comments:** Positions: mem. bd. dirs., Huntington Galleries, WVa. Collection: line and wash drawings by Rodin; drawings by French impressionists; American paintings, predominantly of the Ash-Can School; Renaissance portraits of men; Renaissance prints and engravings. Collections exhibited at Huntington Galleries Art Museum, University of West Virginia Art Museum, Museum of Fine Arts, Houston, Texas & Phoenix Art Museum, Arizona. **Sources:** WW73.

POLAN, Nancy Moore *[Painter] mid 20th c.; b.Newark, OH.*
Addresses: Huntington, WV. **Studied:** Marshall Univ. (A.B.); Huntington Galleries; also with Fletcher Martin, Hilton Leech, Paul Puzinas & Al Schmidt. **Member:** NAC; assoc. All. A. Am.; Acad. Internazionale Leonardo de Vinci Roma (corresp., 1972); Int. Platform Assn. (art comt.), 1967-72); Am. Fedn. Arts. **Exhibited:** AWCS, 1961, 1966 & 1972 & traveling exhib., 1972-73; Nat. Arts Cl., New York, 1962-72; Joan Miro Graphics, Barcelona, 1970 & traveling exhib., Spain & USA, 1970-71; 21st Contemp. Art La Scala, Florence, Italy, 1971; solo show, New York World's Fair, 1965. **Awards:** Ralph & Elizabeth C. Norton Mem. Award, Third Nat. Jury Show Am. Art, Chautauqua, NY, 1960; Nat. Arts Cl. WC Award, NYC, 1969; bronze medal, Centro Studi e Scambi Internazionali, Rome, 1971. **Work:** Huntington Galleries, WVa; Admiral House, Naval Observ, Wash., DC. **Comments:** Preferred media: watercolors. Positions: hon. rep., Centro Studi e Scambi Internazionali, Rome, Italy, 1968-1972. Publications: contribr., *La Rev Mod.*, 1961 & 1966. **Sources:** WW73; Pierre Mornand, "Portrait," *La Rev. Mod.* (1966).

POLAND, Howard *[Painter] late 19th c.*
Addresses: NYC. **Exhibited:** PAFA Ann., 1878-79. **Sources:** Falk, *Exh. Record Series.*

POLAND, Lawrence *[Painter] 20th c.*
Addresses: Cincinnati, OH. **Member:** Cincinnati AC. **Sources:** WW06.

POLAND, Reginald *[Museum director, writer, lecturer, teacher, critic] b.1893, Providence, RI.*
Addresses: West Palm Beach, FL. **Studied:** Brown Univ. (B.A., hon. D.F.A.); Princeton Univ. (A.M.); Harvard Univ. (A.M.). **Member:** AAMus.; Assn. A. Mus. Dir., and of Western Assn. A. Mus. Dir. (hon.); Norton Gal. & School of Art, West Palm Beach (hon.); Atlanta AA; San Diego FA Soc. (hon.); Atlanta WC Cl. (hon.); AAPL (vice-pres. Atlanta chptr.); hon. memb., Chattahoochee Hand-Weavers Gld. **Exhibited:** Awards: f., Am. Acad. in Rome, 1916; traveling f., Carl Schurz Fnd., 1936; Royal Order of Spain, 1931; gold medal, Intl. Expo., San Diego, 1935; Guest of West German Republic, Mus. Dirs. Group, summer 1958. **Comments:** Position: dir., Denver AA, 1919-21; edu. dir., Detroit Inst. A., 1921-26; dir., San Diego FA Gal., 1926-50; dir., Norton Gal. & Sch. A., West Palm Beach, Fla., 1952-54; dir., Museums, Atlanta, Ga., AA 1954-63, emeritus, 1963-; bd. memb., Atlanta Civic Ballet (exec. vice-pres., 1962-65); Atlanta Festival of Arts. Contributor to art magazines. Lectures: Spanish art; French decorative art. **Sources:** WW66.

POLAND, William Carey *[Educator, writer] b.1846, Goffstown, NH / d.1929, Providence, RI.*
Studied: Brown; Berlin; Leipzig; France; Italy. **Member:** Providence AC. **Comments:** Author: several notable books on the history of art. Position: t., Brown Univ., 1892-1915.

POLASEK, Albin *[Sculptor, teacher] b.1879, Frenstat, Czechoslovakia.*
Addresses: Chicago ; Winter Park, FL. **Studied:** Am. Acad. in Rome; PAFA; & with Charles Grafly. **Member:** Arch. Lg.; Assn. Chicago P.&S.; Bohemian AC; AFA; ANA; NA, 1933; NSS, 1914; SW Soc.; Cliff Dwellers; Board of A. Advisors, State of Illinois. **Exhibited:** PAFA Ann., 1908-44 (gold 1915, prize 1925); Prix de Rome, 1910 (prize); AIC, 1917 (prize), 1922 (prize); Milwaukee AI, 1917 (med.); Chicago SA, 1922 (prize); Chicago Gal. Assn., 1937 (prize); Paris Salon, 1913 (prize); P. P. Expo, San Fran., 1915 (med.); Assn. Chicago P&S, 1933 (med.). **Award:** Order of the White Lion, awarded by the Government. **Work:** MMA; PAFA; AIC; Detroit Inst. A.; Ball State T. Col., Muncie, Ind.; mem., Springfield, Ill.; Hartford, Conn.; Chicago, Ill.; Vincennes, Ind.; St. Cecelia's Cathedral, Omaha, Neb.; Masaryk Mem., Chicago; mem., Prague, Czechoslovakia, 1928; bronze statues, mountain top in Frenstat pon Radhostem, Czechoslovakia. **Comments:** Positions: hon. prof., Am. Acad., Rome, 1930-31; t., AIC, 1940. **Sources:** WW59; WW47; Falk, *Exh. Record Series.*

POLDEMAN, William F. *[Listed as "artist"] b.c.1827, Baden, Germany.*
Addresses: NYC in 1860. **Sources:** G&W; 8 Census (1860), N.Y., XLIV, 356 (living with his wife and son, age 12, both born in Germany).

POLELONEMA, Otis *[Painter] b.1902, Shungopovi, AZ.*
Addresses: Second Mesa, AZ in 1967. **Studied:** Santa Fe Indian Sch., 1914-20. **Exhibited:** S. Indp. A., 1932; AIC, 1935. **Work:** Denver AM; Mus. Am. Indian; Mus. New Mexico; Philbrook Art Center; Gilcrease Inst. **Comments:** WPA artist and early Hopi painter who began painting in 1917. **Sources:** P&H Samuels, 375.

POLESKIE, Stephen Francis *[Painter, printmaker] b.1938, Pringle, PA.*
Addresses: Ithaca, NY. **Studied:** Wilkes Col. (B.A., econ., 1959); New Sch. Social Res., 1961. **Exhibited:** Contemporary American Printmakers, S. London Mus., Eng., 1967; Word & Image-Posters and Typography (1879-1967), MoMA, 1968; Recent Acquisitions: Prints and Drawings, MMA, 1969; Oversize Prints, WMAA, 1971; Primera Bienal Americana de Artes Graficas, Mus. Tertulia, Carton Colombia, S. Am., 1971; Associated American Artists, NYC, 1970s; Fendrick Gallery, Wash., DC, 1970s. **Work:** WMAA; MMA; MoMA; Walker Art Ctr., Minneapolis, Minn.; Fort Worth Art Ctr., Tex. **Commissions:** seven ed. silk-screen prints, Assoc. Am. Artists, 1965-72; Seagansett-Patchogue (ed. silk-screen prints), Int. Graphic Arts Soc., 1972. **Comments:** Teaching: asst. prof. silk-screen & drawing, Cornell Univ., 1968-. **Sources:** WW73.

POLEY, Margaret F. *[Painter] late 19th c.*
Addresses: Colorado Springs, CO. **Exhibited:** PAFA Ann., 1890. **Sources:** Falk, *Exh. Record Series.*

POLGREEN, John *[Illustrator, cartoonist] mid 20th c.*
Addresses: NYC. **Comments:** Illus.: *Red Book,* 1939. **Sources:** WW40.

POLHEMUS, Charlotte *[Painter] mid 20th c.*
Addresses: Franklin, MI. **Exhibited:** PAFA Ann., 1960. **Sources:** Falk, *Exh. Record Series.*

POLIFKA, Bernyce *[Painter] mid 20th c.*
Exhibited: Kingsley Art Cl., Sacramento, 1932-33; P&S of Los Angeles, 1935. **Sources:** Hughes, *Artists in California,* 441.

POLIN, Hal *[Painter, wood block printer] b.1927, Philadelphia, PA / d.1983.*
Studied: ASL. **Exhibited:** widely on the East Coast. **Work:** Wm. A. Farnsworth Lib. and A. Mus, Rockland, Me. **Comments:**

Originally began as an abstractionist, but later painted in a more representational manner. Known for his woodcuts. Painting locations include Monhegan Island (ME). **Sources:** Curtis, Curtis, and Lieberman, 104, 185.

POLISHER, Regina K. *[Miniature painter]*
Exhibited: Calif. Soc. of Miniature Painters, 1938. **Sources:** Hughes, *Artists in California,* 441.20.

POLITI, Leo *[Painter, sculptor, illustrator, cartoonist] b.1908, Fresno, CA.*
Addresses: Los Angeles, CA, from the 1930s. **Studied:** Milan (Italy) AI, 1924 (scholarship). **Member:** P&S of Los Angeles. **Exhibited:** AI, Milan, 1924; WC Ann. PAFA, 1937; S. Indp. A., 1937; PS Ann., IAC, 1937; Delphic Studios, NY (solo); AIC. **Awards:** three Caldecott Book Awards; Catholic Library Assoc. (medal). **Work:** murals, theatre, Univ. Fresno (CA). **Comments:** Illustrator: "Little Pancho," 1938, Jack & Jill, weekly, 1939. Position: art editor, Viking Press. **Sources:** WW40; Hughes, *Artists in California,* 442; P&H Samuels, 375-76.

POLITINSKY, F. Augusta (Flora) *[Painter, sculptor] mid 20th c.; b.Paterson, NJ.*
Addresses: Paterson, NJ. **Studied:** Am. Art Sch., NYC; NAD; Newark Mus.; ASL. **Member:** Paterson Art Assn.; Burr Artists; Fair Lawn Assn.; Gotham Painters, New York (treas., 1963); Composers, Authors & Artists Am. **Exhibited:** Nat Acad Sch, Gotham Painters, New York, 1960; Paterson Mus., 1963; Ahda Artzt Gallery, New York, 1967-1969; Burr Artists, Jersey City Mus., 1969; Empire Savings, Hannover Trust, New York, 1971. **Awards:** Best in show, Gotham Painters, 1965; hon mention, Composers, Auth, Artists Am, 1972. **Work:** pvt colls. **Comments:** Preferred media: wax, watercolors, casein, oils, papier maché, copper, aluminum wire. **Sources:** WW73.

POLK, Charles Peale *[Portrait and general painter] b.1767, Annapolis, MD / d.1822, Richmond County, VA.*
Studied: Charles Willson Peale. **Work:** CGA; Abby Aldrich Rockefeller Coll. of American Folk Art (Williamsburg, VA); BMA; Md. Hist. Soc.; Am. Antiq. Soc. (Worcester, MA). **Comments:** Nephew of Charles Willson Peale, Polk was orphaned in 1777 and grew up in the Philadelphia home of his artist uncle. After first advertising as a portrait painter in Baltimore in 1785, he moved back and forth between that city and Philadelphia in the years following. In 1787 he advertised in Philadelphia as a house, ship, and sign painter, but from 1791 to 1793 he was again offering to paint portraits in Baltimore. About 1796 he was working in Hagerstown and elsewhere in Frederick County, Md. He became known for his portraits of George Washington, Benjamin Franklin, and Gen. Lafayette. He would make and sell copies of these and other artists' portraits and is known to have sold over 50 likenesses of Washington, all copied form Charles Willson Peale's portrait of 1787. From 1799 through at least 1800, he was in Virginia, where in Nov. of 1799, he painted (at Monticello) his most well-known work, a portrait from life of Thomas Jefferson (now in private coll.). He also painted at Richmond during the winter of 1799-1800 and worked in Winchester (Va.). Was unable to support himself with his painting and by 1802 had moved to Wash., D.C., and taken a job as a clerk for the U.S. Treasury Dept., a position he held until 1819. He then moved to Richmond County, Va., where he was again painting portraits, this time on glass, in a method (verre eglomise) that had been popularized in France. **Sources:** G&W; Sellers, *Charles Willson Peale;* Prime, I, 7, and II, 29-31, 52; Kimball, "Life Portraits of Jefferson"; Morgan and Fielding, *Life Portraits of Washington; Richmond Portraits;* Pleasants, *250 Years of Painting in Maryland.* More recently, see Gerdts, *Art Across America,* vol. 1: 314-315; *300 Years of American Art,* vol. 1: 74.

POLK, Charlotte Payne (Mrs.) *[Craftsperson, designer] d.1963.*
Addresses: New Orleans, active 1895-1905. **Studied:** Newcomb Coll., 1895, 1902-05. **Exhibited:** Louisiana Purchase Exh., St. Louis, MO, 1904. **Comments:** Distingushed pottery designer who

also prepared enormous maps of N.O. and the Mississippi River together with Jennie Wilde (see entry). **Sources:** *Encyclopaedia of New Orleans Artists*, 311.

POLK, Frank *[Sculptor] b.1909, Arizona.*
Addresses: Mayer, AZ in 1976. **Comments:** Cowboy and rodeo personality, first known as a whittler. Later he became a sculptor in bronze. **Sources:** P&H Samuels, 376.

POLK, Mary Alys *[Painter, illustrator, teacher] b.1902, Greenwood, IN.*
Addresses: Indianapolis, IN. **Studied:** W. Forsyth. **Member:** Ind. AC. **Exhibited:** Hoosier Salon, 1927 (prize). **Sources:** WW33.

POLKES, Alan H. *[Collector, patron] b.1931, NYC.*
Addresses: NYC. **Studied:** Brooklyn College; College of the City of NY. **Comments:** Collection: Old Masters and Modern Art. Presented works of art for the first lobby devoted to original art (333 E. 79th St., NYC). These included: fountain by Milton Hebald; mural, Sason Soffer, Ivan Mosca; tapestry, Jan Yoors; and works by Xanti Schwanski, Sam Goodman and Sironi. **Sources:** WW66.

POLKINGHORN, George *[Painter] b.1898, Leadville, CO / d.1967, Los Angeles, CA.*
Addresses: Hollywood, CA; Encino, CA. **Studied:** Univ. Calif. (A.B.); Otis Art Inst., with Vysekal and Shrader. **Member:** San Diego Art Guild; Cal. A. Cl.; Cal. WC Soc.; Laguna Beach AA. **Exhibited:** Cal. WCC; Laguna Beach AA; San Diego FA Center; LACMA; Santa Cruz A. Lg.; Cal. A. Cl, 1952 (prize & gold medal); AWCS. **Sources:** WW59; WW47.

POLKY, Olaf H. *[Painter] 20th c.*
Addresses: Chicago, IL. **Member:** Chicago NJSA. **Exhibited:** AIC. **Sources:** WW25.

POLL, Ella *[Painter] mid 20th c.*
Addresses: Brooklyn, NY. **Exhibited:** S. Indp. A., 1932. **Sources:** Marlor, *Soc. Indp. Artists.*

POLLACK, Lou H. *[Painter] mid 20th c.*
Addresses: Martins Ferry, OH. **Exhibited:** PAFA Ann., 1954. **Sources:** Falk, *Exh. Record Series.*

POLLACK, Louis *[Art dealer] b.1921, NYC / d.1970.*
Addresses: NYC. **Member:** Art Dealers Association of America. **Comments:** Positions: founder, Peridot Gal., 1948; pres., Collectors Graphics, 1961. Specialty of gallery: contemporary American paintings and sculpture. Presented the first exhibition in America of sculptures by Medardo Rosso. **Sources:** WW66.

POLLACK, Peter *[Photographer, writer] b.1911, Wing, ND / d.1978.*
Addresses: NYC. **Studied:** AIC; Inst. Design, Chicago, Ill. **Work:** (Photographs) AIC; Worcester Art Mus.; WMAA. **Comments:** Positions: cur. photog., AIC, 1945-57; dir., Am. Fedn. Arts, 1962-64; hon. cur. photog., Worcester Art Mus., 1964-; dir. art, WJ Sloane, New York, 1965-70; dir. photog., Harry N. Abrams, Inc, 1970-; ed., series of facsimile editions publ. by Amphoto Press, 1971-. Publications: auth., "Understanding Primitive Art (Sula's Zoo)," 1968; auth., "The Picture History of Photography," rev. ed., 1970. **Sources:** WW73.

POLLACK, Reginald Murray *[Painter, writer] b.1924, Middle Village, NY.*
Addresses: Great Falls, VA. **Studied:** apprentice to Moses Soyer, 1941; Wallace Harrison, 1946-47; Acad. de la Grande Chaumière, Paris, 1948-52. **Exhibited:** Peridot Gal., NYC, 1949-69 (12 solos); WMAA, 1953-63; PAFA Ann., 1962, 1966; Corcoran Gal biennial, 1963; "Mixed Emotions," Long Beach Mus., Calif., 1969; "The Artist Collects," Lytton Art Cntr., Los Angeles, 1969; "Collectors Choice," Hall Gal., Miami Beach, Fla., 1972. Awards: Prix Othon Friesz-V., Paris, 1956; Prix des Peintres Etrangers-Laureate, Paris, 1958; Ingram-Merrill Fndn. grants in painting, 1964, 1970-71. **Work:** WMAA; MoMA; Brooklyn Mus.; Collection de l'Etat, France; Tel Aviv Mus., Jerusalem Mus. & Haifa Mus., Israel. Commissions: ed. of color lithography, Intl.

Council, MoMA, 1959; "Peace" (greeting card), Jewish Mus., NYC, 1961; painting for "Great Thoughts of Western Man" series, Container Corp. Am., 1964; cover for State of NY Dir., Bell Tel. Co., 1968-69; Chinese animal destiny calendar, Colgate-Palmolive Co., 1972. **Comments:** He developed an improved technique for producing original lithographs from high speed offset presses. Preferred media: oils. Illustrator: "O is for Overkill" (Viking Press, 1968); "The Willow Tree," (Holt, Rinehart & Winston, 1972). Auth.-illus.: "The Magician and the Child," (Atheneum, 1971). Auth.: "To Artists With Love" & "Brancusi's Sculpture versus his Home," in *ArtNews*. Teaching: vis. critic art, Yale Univ., 1962-63; Cooper Union, 1963-64; Human Relations Training Ctr., UCLA at Lake Arrowhead, 1966; Quaker Half-Way House, Los Angeles, 1968. **Sources:** WW73; Falk, *Exh. Record Series.*

POLLACK, Theresa *[Painter] b.1899, Richmond, VA.*
Exhibited: Corcoran Gal biennial, 1930; Salons of Am., 1933-34. **Sources:** Falk, *Exhibition Records Series.*

POLLAK, Augusto *[Painter] 20th c.*
Addresses: NYC. **Sources:** WW10.

POLLAK, Charlotte L. (D.) *[Painter] early 20th c.*
Addresses: Cullman, AL. **Exhibited:** S. Indp. A., 1918-19. **Sources:** Marlor, *Soc. Indp. Artists.*

POLLAK, Frances (Francis) M. *[Painter] mid 20th c.*
Exhibited: S. Indp. A., 1938-39, 1941. **Sources:** Marlor, *Soc. Indp. Artists.*

POLLAK, Mary See: **REGENSBURG, Mary (Pollak)**

POLLAK, Max *[Etcher, landscape and portrait painter] b.1886, Prague, Czechoslovakia / d.1970, Sausalito, CA.*
Addresses: Sausalito, CA. **Studied:** Vienna Academy of Art. **Member:** Chicago SE; Cal. SE. **Exhibited:** Gump's, San Francisco, 1934; Cincinnati AM, 1939; GGE, 1939; CPLH, 1940 (solo); Chicago SE, 1942 (prize); Calif. SE, 1942, 1944 (prize), 1945 (prize). **Work:** MMA; NYPL.; deYoung Mem. Mus.; Cal. State Lib.; LOC; SFMA; British Mus., London; Albertina Mus., Vienna; A. Mus., Prague; Mus. der Stadt Wien. **Comments:** I., "My City," 1929. **Sources:** WW59; WW47.

POLLAK, Theresa *[Painter, educator, graphic designer] b.1899, Richmond, VA.*
Addresses: Richmond, VA. **Studied:** Richmond A. Cl.; Westhampton Col., Univ. Richmond (B.S.); ASL; Fogg Mus., Harvard Univ., Carnegie Fellowship; Steiger Paint Group, Edgertown, MA; with Hans Hofmann, Provincetown, MA; Tucker; Miller; M. Weber Bridgman; B. Robinson; Nicolaides. **Member:** Richmond AA (vice-pres., 1958-59); Assn. Preservation Virginia Antiquities; ASL; Marquis Biographical Library Soc.; VMFA; Valentine Mus., Richmond. **Exhibited:** S. Indp. A., 1931; Tiffany Fnd., 1932; Carnegie Fellowship, 1933; Studio Cl., NY, 1926 (prize); Richmond Artists, 1931 (prize), 1938 (prize), 1939 (prize); CGA, 1930 (12th Biennial Exhib. Contemporary Am. Painting); WMAA, 1932 (lst Biennial Contemporary Am. Painting); BMFA, 1933 (New England Soc. Contemporary Art); Rockefeller Center, NY, 1936, 1938; Oakland Art Gal., 1941-43; Richmond Women's Cl., 1928-30; Richmond Acad. Art, 1931-38; VMFA, 1938, 1939, 1940 (solo), 1941-46, 1971(Virginia Artists 1971); Virginia Intermont Exhib., 1944; Westhampton Col., 1940 (solo); Univ. Virginia, 1940 (solo); Randolph-Macon Col. for Women, 1940 (solo); Farmville State Teachers Col., 1941 (solo); Richmond Jewish Community Center, 1960; Chrysler Mus. Norfolk, 1968 (9th Irene Leache Mem. Regional Painting Exhib.). Awards: distinguished alumna award, Westhampton College, 1964; certif. of distinction, VMFA, 1971; Theresa Pollak Bldg. of Fine Arts, Virginia Commonwealth Univ., 1971. **Work:** Virginia Commonwealth Univ., Richmond; VMFA; Chrysler Mus. Norfolk, VA; Univ. Virginia, Charlottesville; Washington & Lee Univ., Lexington, VA. **Comments:** Preferred media: oils, ink. Publications: contrib., art criticisms, *Richmond Newsleader* & *Richmond Times Dispatch*, 1931-49. Teaching: instr., drawing & painting, Virginia Commonwealth Univ., 1928-35, prof., drawing

& painting, 1935-69, faculty chmn., 1942-50; instr., drawing & painting, Westhampton Col., Univ. Richmond, 1930-35; teacher, Col. William & Mary, Richmond, VA, 1935-46. **Sources:** WW73; WW47.

POLLAK, Virginia Leigh King (Morris) *[Sculptor, lecturer, teacher] b.1898, Norfolk, VA / d.1967.*
Addresses: Norfolk, VA; New York 22, NY; Kearny, NJ; Wash., D.C., active 1924. **Studied:** Harriet W. Frishmuth; ASL; Borglum Am. Sch. Sculpture; Yale Univ. Dept. FA; abroad. **Member:** Norfolk SA; Soc. Wash. Artists; Wash. AC; SSAL; Am. Soc. Archaeology; Nat. Acad. Pathology; AFA; Montclair Woman's Club; Horticultural Soc. NY; Nat. Council of Women of U.S. **Exhibited:** Soc. Wash. Artists, 1924; Wash. AC; Soc. Indp. A.; NSS; CGA; PAFA; VMFA; Norfolk Mus. Arts & Sciences; Birmingham, AL; U.S. Armed Forces Mus. Awards: Norfolk SA, 1921, 1926; Florence K. Sloan prize, 1920, 1922; Elsie Stegman prize, 1921; Pres.l Citation & Distinguished Service Citation for establishing Medical Moulage Lab. & assisting in developing Tantalum Lab., Halloran Hospital, U.S. Army. **Work:** U.S. Armed Forces Medical Mus., Wash., DC; Robert E. Lee Mansion Mus., Arlington, VA; mem., Henry A. Wise; Road Markers for State of Virginia. **Comments:** Established a gallery at the Lighthouse, NYC, for educating sighted and blind people through the use of 3-dimensional art objects. Positions: chief, Medical Moulage Lab., Halloran Hospital, Wash., DC; asst. chief, Tantalum Lab., U.S. Army, Halloran; co-founder, Alva Studios (museum reproductions); Educ. for the Blind through Art and Historical Museums; consult., Smithsonian Inst.; consult., Armed Forces Medical Mus.; chmn., Science Comt., Norfolk Botanical Gardens; mem., Advisory Comt. on Arts for Nat. Cultural Center, Wash., DC; consult., Norfolk Mus. Arts & Sciences; mem., Adv. Comn. on Art, John F. Kennedy Cultural Center, Wash., DC; advisor on art, President's Comt. on Employment of the Handicapped, Wash., DC; dir., Arthur Morris Coll. Contrib.: *Popular Gardening; Quest Magazine; Int. Medical Bulletin.* Lectures: contemporary and Greek sculpture; Near East, French & English interiors; porcelain & glass at museums, colleges, women's clubs, etc. **Sources:** WW66; McMahan, *Artists of Washington, D.C.*

POLLARD, Alice Esther *[Painter] 19th/20th c.; b.Chillicothe, MO.*
Addresses: St. Louis, MO. **Studied:** St. Louis Sch. FA. **Exhibited:** St. Louis Expo, 1898. **Sources:** WW98.

POLLARD, C. J. *[Lithographer] mid 19th c.*
Addresses: San Francisco, 1850-52. **Comments:** Between 1850 and 1852 worked with Joshua H. Peirce and Charles E. Peregoy (see entries). In 1852, as a partner with Joseph Britton in Pollard & Britton, lithographed several views of California. **Sources:** G&W; Peters, *California on Stone;* San Francisco BD 1850; More recently, see Reps, 188 (note 3) and cat. entries 76, 268, 417 for Pollard & Britton.

POLLARD, Calvin *[Architect and draftsman] b.1797, New Braintree, MA / d.1850.*
Addresses: NYC, active 1818-50. **Work:** Belknap Coll. at the NYHS has a watercolor by him of the residence of Henry Remsen, NYC. **Comments:** Prominent architect and builder in NYC. Older brother of John Pollard (see entry). **Sources:** G&W; Underwood, *The Ancestry and Descendants of Jonathan Pollard,* 12-13; *Catalogue of the Belknap Collection.*

POLLARD, Donald Pence *[Designer, painter] b.1924, Bronxville, NY.*
Addresses: NYC. **Studied:** pvt. study with Harriet Lumis; RI Sch. Design (B.F.A.); Brown Univ. **Exhibited:** Conn. Nat. Acad., 1942; all major Steuben Exhibs., 1953-; Phillips Mall Ann., 1972. **Work:** Eisenhower Mus.; Kennedy Coll.; Govt. of Can., Ottawa, Ont.; also in pvt. collections in the US, Europe, Asia & the Far East. Commissions: design of the Great Ring of Canada (with Alexander Seidel); other comns. as assigned by Steuben Glass. **Comments:** Preferred media: crystal, oils. Positions: sr. des., Steuben Glass, 1950-. **Sources:** WW73.

POLLARD, Henry *[Engraver] mid 19th c.*
Addresses: Boston, 1849. **Sources:** G&W; Boston CD 1849.

POLLARD, Henry G. See: **BALL & POLLARD**

POLLARD, Henry (Mrs.) *[Painter] 20th c.*
Addresses: Savannah, GA. **Member:** Savannah AA. **Sources:** WW25.

POLLARD, John *[Painter, especially of flower pieces] b.1802, New Braintree, MA / d.1885, East Wilson, Niagara County, NY.*
Studied: trained as a carver. **Comments:** Worked as a carver in Albany (N.Y.) during the 1820's. Moved further South because of illness and married at Philadelphia in 1831. Lived in NYC until 1835, then moved to a farm at East Wilson, Niagara County (NY) where he spent the rest of his life. He worked in pencil, oils, and watercolors. Calvin Pollard (see entry) was his brother. **Sources:** G&W; Underwood, *The Ancestry and Descendants of Jonathan Pollard,* 14.

POLLARD, John H. *[Painter] mid 20th c.*
Addresses: Cascadia, Seattle, WA, 1938. **Exhibited:** SAM, 1937. **Comments:** Preferred medium: watercolor. **Sources:** Trip and Cook, *Washington State Art and Artists.*

POLLARD, Luke *[Portrait painter] mid 19th c.*
Addresses: Harvard, MA in 1845. **Sources:** G&W; Lipman and Winchester, 178; Sears, *Some American Primitives,* 5-7, 14-15 (repros.).

POLLARD, William *[Marine painter, restorer] mid 19th c.*
Addresses: Boston, active from at least 1854. **Work:** Penobscot Mus. (Searsport, Maine); State Street Trust Company (Boston, Mass.). **Comments:** Known through ship picture dated 1851. Listed in Boston directories 1854-65 as restorer. **Sources:** G&W; F.J. Peters, *Paintings of the Old `Wind-Jammer',* 32 (repro.); Brewington, 305.

POLLARD & BRITTON *[Lithographers] mid 19th c.*
Addresses: San Francisco, active 1852. **Comments:** Partners were C.J. Pollard and Joseph Britton (see entry). Lithographed several views of California in 1852. **Sources:** G&W; Peters, *California on Stone.* More recently, see Reps, 188 (note 3) and cat. entries 76, 268, 417 for Pollard & Britton.

POLLARO, Paul *[Painter] mid 20th c.; b.Brooklyn, NY.*
Addresses: Brooklyn, NY. **Studied:** Flatiron Sch. Art, NYC; ASL. **Exhibited:** PAFA Ann., 1964; Am. Acad. Arts & Lett., 1966 & 1972; NIAL, 1969 & 1972; Artists of the 20th Century, Gallery Mod. Art, NYC, 1970; Artists at Work, Finch Col. Mus., 1971; Babcock Galleries, NYC, 1970s. Awards: second prize, Jersey City Mus., 1962; fel., MacDowell Colony, 1966, 1968 & 1971; Tiffany Found. grant, 1967. **Work:** Finch Col. Mus., NY; Notre Dame Univ., Ind.; Manhattanville Col., Purchase, NY; Wagner Col., Staten Island, NY; MacDowell Colony Coll., Peterborough, NH. **Comments:** Preferred media: acrylics, oils, collage. Teaching: instr. painting, New Sch. Soc. Res., 1964-69; asst. prof. painting, Wagner Col., 1969-; vis. artist, Notre Dame Univ., summers 1965 & 1967. **Sources:** WW73; Falk, *Exh. Record Series.*

POLLET, Joseph (C.) *[Painter, graphic artist, writer, lecturer, teacher] b.1897, Albbrück, Germany / d.1979, NYC.*
Addresses: NYC/Woodstock, NY. **Studied:** ASL with John Sloan, Robert Henri (1920-22), Homer Boss (1923); Paris, Munich, and Amsterdam, 1930 (Guggenheim Fellowship, 1930-31). **Member:** ASL (life mem., 1932); Soc. Indep. Artists; Woodstock AA; Am. Soc. P. S. & Gravers; Ind. Artists' Cl.; Eighth Street Cl., 1948 (with DeKooning, Jack Levine, Calder, and Stuart Davis). **Exhibited:** Whitney Studio Cl., 1924-29 (duo with Reginald Marsh, 1924; solo in 1927); S. Indp. A., 1925-31; Corcoran Gal biennials, 1928-51 (4 times); PAFA Ann., 1929-34, 1942; Salons of Am., 1930-33, 1936; WMAA, 1932-37, 1940, 1944-48, 1951; Downtown Gal., NYC, 1926 (solo); Dudensing Gal., NYC, 1925-28; Albright Art Gal., Buffalo, 1928-32; Cleveland MA, 1928-32; Woodstock AA, 1931, 1933-34, 1944, 1979 (memorial); PAFA, 1926-44; MoDA, 1930; CI, 1929-45 (hon. mem., 1929, annual intl. exh.); AIC, 1929-36; NY Mun. Exh., 1933; VMFA; Newark

Mus., 1944; WFNY 1939; WMAA, 1923-46; Midtown Gal., 1950; Schoelkopf Gal., NYC, 1964-65, 1967 (solos); Brusson il Principio, Val d'Aosta, Italy, 1967, 1981 (memorial); ACA Gal., NYC, 1986; James Cox Gal., Woodstock, NY, 1995 (solo). **Work:** Newark Mus.; WMAA; LACMA; Dartmouth Col.; NYU; PMG; WPA mural in USPO, Pontotoc, MS; Woodstock AA. **Comments:** Emigrated to NYC in 1911, and at age 21 had a promising career as advertising copywriter. At the same time, he studied painting and his landscapes were immediately successful in NYC galleries. From 1954-61, he lived in Paris and Italy. In 1971, a fire in his Greenwich Village studio destroyed 100-150 of his paintings. Position: teacher at Byrdcliffe Arts & Crafts Center, Woodstock, 1929; dir., Sawkill Sch. Art, Woodstock, NY, 1935-42 (dir.); instructor of painting, New York Univ., 1946-47. **Sources:** WW59; WW47; Falk, *Exh. Record Series.* More recently, see *Woodstock's Art Heritage,* 120-121; and exh. cat., *Joseph Pollet, A Knowing Inocence* (James Cox Gal., Woodstock, 1995); Woodstock AA.

POLLEY, Frederick *[Painter, etcher, illustrator, writer, teacher] b.1875, Union City, IN / d.1958, Indianapolis, IN?.* **Addresses:** Indianapolis, IN. **Studied:** Indiana Univ.; Corcoran Sch. A.; & with James R. Hopkins; Herron A. Inst., Indianapolis, with W. Forsyth. **Member:** Indiana AC; Indiana Soc. Pr. M. (pres.); Chicago SE; SC; New Orleans A. Lg. **Exhibited:** Salons of Am., 1924; Hoosier Salon, 1925 (prize) 1926-29, 1930 (prize) 1931-32 (prize) 1933-36 (prize), 1937-40, 1942 (prize), 1943 (prize), 1944 (prize); 1945-52 (prizes 1945 & 1951); Indiana Fed. A., 1945 (prize); Ind. AC, 1939 (prize), 1943 (prize), 1945 (prize), 1950 (prize); New Orleans A. Lg., 1943 (prize); John Herron A. Inst., 1900-46 (1934 prize), 1952; LOC, 1944-45; CI, 1945; Delgado Mus. A., annually. **Work:** John Herron AI; Nat. Mus., Wash., DC. **Comments:** T., Arsenal Tech. Sch. I., "Indianapolis, Old and New"; & other books. Author/illus., "Our America"; "Historic Churches in America." Positions: ed., art feature, *Indianapolis Sunday Star,* since 1924. **Sources:** WW53; WW47.

POLLIA, Joseph P. *[Sculptor] b.1893, Italy / d.1954.* **Addresses:** NYC. **Studied:** BMFA Sch. **Member:** NSS; Arch. Lg. **Exhibited:** PAFA Ann., 1940-41, 1944-45, 1948. **Work:** statues, mem., figures, monuments, Commonwealth of Virginia; Indiana Univ.; Pontifical Col., Worthington, Ohio; Sheridan Square, NY; San Juan Hill, Santiago, Cuba; City of Orange, Mass.; Court House, Elizabeth. NJ; West Side Park, Jersey City, NJ; others in White Plains, Utica, Gloversville, Lake Placid, Richmond Hill, Glencove, Tarrytown, Troy, all in New York; Greenfield, Stoneham, Lynn, Franklin, and Barre, Mass.; Marshalltown & Storm Lake,Iowa; Milford, Conn.; Manassas, Va. **Comments:** Position: affiliated with VMFA, 1940. **Sources:** WW53; Falk, *Exh. Record Series.*

POLLITZER, Anita L. *[Painter] 20th c.* **Addresses:** NYC. **Sources:** WW17.

POLLOCK, A(braham) L. *[Painter] mid 20th c.* **Addresses:** Chicago, IL. **Exhibited:** AIC, 1928; S. Indp. A., 1929-32. **Sources:** Falk, *Exhibition Record Series.*

POLLOCK, Adele A. *[Painter] early 20th c.* **Addresses:** NYC, 1917. **Exhibited:** S. Indp. A., 1917. **Sources:** Marlor, *Soc. Indp. Artists.*

POLLOCK, C. *[Lithographer] mid 20th c.* **Addresses:** NYC, 1936. **Exhibited:** WMAA, 1936. **Sources:** Falk, *WMAA.*

POLLOCK, Charles (Cecil) *[Painter, teacher] b.1902, Denver, CO.* **Addresses:** NYC; Detroit, Okemos, MI. **Studied:** Otis AI; ASL. **Exhibited:** Salons of Am., 1934; PAFA Ann., 1934, 1941; Corcoran Gal biennials, 1935, 1967; AIC, 1937, 1942; SAE, 1937; SFMA, 1939; WFNY 1939; Colorado Springs FA Center, 1937-38; Detroit Inst. A., 1939-40, 1945; WMAA, 1963. **Work:** murals, Mun. Water Plant, Lansing, Mich.; Mich. State Col., East Lansing; WMAA. **Comments:** The brother of Jackson Pollock.

Teaching: graphic design, painting, lettering, etching, Michigan State Univ., East Lansing, Mich., 1942-50s. **Sources:** WW59; WW47; Falk, *Exh. Record Series.*

POLLOCK, Charlotte L. See: **POLLAK, Charlotte L. (D.)**

POLLOCK, Courtnay *[Sculptor] early 20th c.* **Addresses:** NYC. **Exhibited:** PAFA Ann., 1911, 1915. **Sources:** WW17; Falk, *Exh. Record Series.*

POLLOCK, Elizabeth R. *[Sculptor] mid 20th c.* **Addresses:** Phila., PA. **Exhibited:** PAFA Ann., 1938, 1941. **Sources:** Falk, *Exh. Record Series.*

POLLOCK, George H. *[Artist] 19th/20th c.* **Addresses:** Wash., D.C., active 1877-1920. **Sources:** McMahan, *Artists of Washington, D.C.*

POLLOCK, Jackson *[Painter] b.1912, Cody, WY / d.1956.* **Addresses:** East Hampton, NY. **Studied:** Los Angeles Manual A. Sch., 1925-27; ASL with T.H. Benton (with whom he had a close relationship), J. Sloan, R. Laurent, 1929-32. **Exhibited:** Art of This Century, 1943 (his first major exh.), organized by Peggy Guggenheim), 1944; MMA (AV), 1943; AIC, 1947, 1949; WMAA,1946-54; PAFA Ann., 1947-56 (5 times); Chicago (solo); San Fran. (solo); New York (solo); Venice (solo); Milan (solo); Paris (solo); Zurich (solo), all in the 1950's; MoMA, 1967 (retrospective), 1998 (retrospective, traveled to the Tate Gal., London, 1999). **Work:** MoMA; MMA; WMAA; AIC; BM; PMA; NMAA; Guggenheim Mus.; SFMA; LACMA; Univ. Iowa; Dallas MA; Kunstsammlung Nordrhein Westfalen, Düsseldorf, Germany. **Comments:** The most important of the first generation of Abstract Expressionist painters who emerged from the WPA era (employed, 1938-42). He set out to obliterate his artistic ancestors, and succeeded through his famous "drip action paintings" (created 1947-51). Although he was not the very first drip-action painter, he quickly adapted and personalized the technique, becoming the central figure of the New York School (joined by Kline, De Kooning, and others) which won the battle of the American avant-garde over the Paris School, thereby making New York the new center of the contemporary art world. At the same time, he also succeeded in angering traditionalist art lovers and became more ridiculed by the public than any other painter of the 20th century. Key catalysts of his fame were friendships with the influential art critic, Clement Greenberg (his most staunch supporter) as well as the art dealers Peggy Guggenheim, Betty Parsons, and Sidney Janis. In 1950, photographer Hans Namuth captured Pollock in action, recording in still photographs and on film, the rhythmic energy of his dripping technique — an event that was lauded as the founding of "Happening" art. Pollock soon returned to a more figurative (although still gestural) style. He also returned to alcohol, and his unending bouts with drinking led to his death in a car crash on Long Island — thereby serving to further reinforce his myth and ensure his iconic status in American art history. His wife, Lee Krasner (see entry), was also an abstract painter. **Sources:** WW53; WW47; the Namuth photographs were first published in *Portfolio* magazine (1951); the best known contemporary account is Harold Rosenberg's "The American Action Painters" in *ArtNews* (1952); Francis V. O'Connor and Eugene V. Thaw, eds., *Jackson Pollock: Catalogue Raisonné of Paintings, Drawings and other Works* (New Haven: Yale Univ. Press, 1978); Ellen Landau, *Jackson Pollock* (New York: Abrams, 1989); Naifeh & G.W. Smith, *Jackson Pollock: An American Saga* (1989); Erika Doss, *Benton, Pollock, and the Politics of Modernism: From Regionalism to Abstract Expressionism* (Chicago: Univ. of Chicago Press, 1991); Deborah Solomon, *Jackson Pollock, A Biography* (Simon & Schuster, NY); J. Gardner, "This Cowboy Rode Alone" *Art & Antiques* (Dec. 1998, p.98); Sarah Boxer, "The Photos that Changed Pollock's Life" *New York Times* (Dec. 15, 1998); K. Varnedoe & P. Karmel, *Jackson Pollock* (exh. cat. MoMA, 1998); Falk, *Exh. Record Series.*

POLLOCK, Jackson (Mrs.) See: **KRASNER, Lee (Lenore)**

POLLOCK, James Arlin *[Painter, craftsperson] b.1898, Salt Lake City / d.1949.*
Addresses: Essex, CT. **Studied:** Univ. Pa.; J.G. McManus; G. Wiggins. **Member:** CAFA. **Exhibited:** NAD, 1943; CAFA, 1938-43; Lyme AA, 1939-43. **Sources:** WW47.

POLLOCK, L. S. (Mr. and Mrs.) *[Collectors] 20th c.*
Addresses: Dallas, Texas. **Sources:** WW66.

POLLOCK, Mabel Clare Hillyer *[Painter, block printer, teacher] b.1884, Ashtabula, OH.*
Addresses: Salem, MA. **Studied:** Pratt Inst.; Henry Keller at Cleveland Sch. A. **Comments:** Specialty: block printing on textiles. **Sources:** WW40.

POLLOCK, Merlin F. *[Painter, educator, graphic artist] b.1905, Manitowoc, WI.*
Addresses: Chicago, IL; Fayetteville, NY. **Studied:** Ecole Beaux Arts, Paris, France; Fountainebleau, Paris; AIC (B.F.A., M.F.A.). **Exhibited:** AIC, 1930 (James Nelson Raymond fel.); Fontainebleau Sch. Fa., 1931; Michigan Invitational, Flint Inst. Art, Mich., 1957; Dr. Vance Inaugural Invitational, Wesleyan Univ., Lincoln, Nebr., 1958; Rocky Mountain Nat. Invitational Art Exhib., Utah State Univ., Logan, 1958; One Hundred Twenty-Five Years of New York State Painting & Sculpture Invitational, NY State Fair, 1966; Mich. State Univ., East Lansing, 1959 (solo); Everson Mus., Syracuse, 1966 (solo); Syracuse Ann, Everson Mus, 1950 (prize), 1960 (prize), 1964 (prize) & 1966 (prize); Finger Lakes Ann., Rochester Mem. Mus., 1956-58 (prizes),1960 (prize). **Work:** Syracuse Univ, NY; Munson-Williams-Proctor Inst, Utica, NY; Everson Mus, Syracuse; State Univ NY Col Forestry, Syracuse. Commissions: Steel (fresco), Tilden Tech High Sch, Chicago, Ill; Lincoln H. S., Manitowoc (mural); Wright Jr. Col.,IL (mural); First mural, USPO, O'Fallon, IL, comn. by US Treas. Dept. WPA artist. **Comments:** Preferred media: acrylics, watercolors. Positions: supvr. mural painting, Ill. Art Proj., Works Proj. Admin., 1940-43; chmn. grad. prog., Syracuse Univ. Sch. Art, 1947-71; acting dean sch. art, Syracuse Univ., 1960-61, 1967-68 & 1969-70. Teaching: instr. mural painting, fresco & drawing, AIC Sch., 1935-43; prof. painting, Syracuse Univ., 1946-71. **Sources:** WW73; WW40.

POLLOCK, Thomas *[Engraver] mid 19th c.; b.Edinburgh, Scotland.*
Comments: From 1832-33 he was at New Orleans; 1834-35, at Boston; 1839 at Providence (RI); 1840-57, at NYC. While in Boston he may have been a partner in Pollock and Wilson (1834); while in NYC he was senior partner in the firms of Pollock & Smith (1840, see entry) and Pollock & Doty (1841, see entry). **Sources:** G&W; *Encyclopaedia of New Orleans Artists* cites *Bee*, Dec. 20-Jan. 7, 1833 (advs.); Stauffer; Boston CD 1835; NYCD 1840-41; NYBD 1840-57.

POLLOCK, Uila (or Wellesca or Ulla A.) *[Artist]*
Addresses: Wash., D.C., active 1890-1921. **Sources:** McMahan, *Artists of Washington, D.C.*

POLLOCK & DOTY *[Engravers] mid 19th c.*
Addresses: NYC, 1841. **Comments:** Partners were Thomas Pollock and Warren S. Doty (see entries). **Sources:** G&W; NYCD 1841.

POLLOCK & SMITH *[Engravers] mid 19th c.*
Addresses: NYC, 1840. **Comments:** Thomas Pollock (see entry) was the senior partner; no further information on Smith is recorded. **Sources:** G&W; NYBD and CD 1840.

POLLOCK & WILSON *[Engravers] mid 19th c.*
Addresses: Boston, 1834. **Comments:** Partners were most likely Thomas Pollock and William W. Wilson (see entries). **Sources:** G&W; Stauffer.

POLO, "El Kezer" August *[Painter] mid 20th c.*
Addresses: Bronx, NY. **Exhibited:** S. Indp. A., 1932. **Sources:**

Marlor, *Soc. Indp. Artists.*

POLONSKY, Arthur *[Painter, educator] b.1925, Lynn, MA.*
Addresses: Newtonville, MA. **Studied:** BMFA Sch., with Karl Zerbe, 1943-48, dipl. (with honors), 1948, European traveling fel., 1948-50. **Exhibited:** AIC, 1949; Salon des Jeunes Peintres, Paris, France, 1949; Art Today-1950, MMA, 1950; Exhib. Am. Art, Stedelijk Mus., Amsterdam, Holland, 1950; Carnegie Int. Expos, Pittsburgh, Pa., 1951; View, Inst. Contemp. Art, Boston, 1960; Boris Mirski Gallery, Boston, MA, 1970s. Awards: Tiffany Found. grant for painting, 1951-52; first prize, Boston Arts Festival, 1954. **Work:** Fogg Mus., Harvard Univ., Cambridge, Mass.; BMFA; Addison Gal. Am. Art; Brandeis Univ., Waltham, Mass.; Stedelijk Mus., Amsterdam, Holland. Commissions: portrait of Dr. William Dameshek, Tufts-New England Med. Ctr., Boston, 1966; Stone with the Angel (portfolio of ten original lithographs), Impressions Workshop, Inc, Boston, 1969; portrait of Dr. Sidney Farber, Harvard Med. Sch. for Boston Children's Hosp., 1971. **Comments:** Preferred media: oils, tempera. Positions: mem. & dir., AEA, 1948-67. Teaching: instr. painting & hd. dept., BMFA Sch., 1950-60; from instr. to asst. prof. painting & drawing, Brandeis Univ., 1954-65; assoc. prof. painting, drawing & design, Boston Univ. Sch. Fine & Applied Arts, 1965-. **Sources:** WW73; article on young artists, In: *Life Mag.* (Dec., 1948); reviews of exhibs., In: *Art News* (1948 & 1965); microfilm records of papers, documents, letters, reviews & tape recorded interviews, In: *Archives Am Art.*

POLONY, Elemer *[Painter, teacher] b.1911, Zomba, Hungary.*
Addresses: New York 11, NY. **Studied:** Royal Acad. FA, Budapest, with Gyula Rudnay; Acad. FA, Rome, Italy; and with Aba-Novak. **Member:** Arch. Lg.; NSMP. **Exhibited:** in Budapest, 1939-43; Intl. Exh. Sacred Art, Vatican, 1950; Intl. Exh., Rome, Italy, 1949; William Rockhill Nelson Gal. A., Kansas City, 1953; CMA, 1955, 1957; solo: Budapest, 1939, 1941-43; Czechoslovakia, 1948; Rome, Italy, 1949; Florence, Italy, 1950; Kansas City AI, 1952; Arch. Lg., 1957. Awards: gold, Budapest, 1938; Grand Prix and traveling scholarship, Budapest, 1939; Ministry of Edu. traveling F., 1941; F., Rome, 1946; prize, Henry Street Settlement mural comp., 1958. **Work:** Univ. Kansas City, and in Hungary, Czechoslovakia. Fresco and mosaics, churches in Europe; murals, Univ. Kansas City. **Sources:** WW59.

POLONYI, John *[Painter] early 20th c.*
Addresses: NYC. **Studied:** ASL. **Member:** S. Indp. A. **Exhibited:** Salons of Am., 1922; S. Indp. A., 1921-22. **Sources:** WW25.

POLOS, Theodore C. *[Painter, lithographer, teacher] b.1902, Mytelene(Lesbos), Greece / d.1976, Oakland, CA.*
Addresses: Oakland, CA. **Studied:** Calif. Col. A. & Cr.; Cal. Sch. FA; Xavier Martinez, Constance Macky; S. Mackay. **Member:** A. Cen. San Fran.; San F. AA. **Exhibited:** SFMA, 1935; San Fran. AA, 1937 (prize), 1938 (prize), 1953 (Gerstle prize); SFMA, 1939 (prize); WFNY, 1939; GGE, 1939; Rosenberg F., 1940; Richmond, Va., 1942 (med.); MoMA, 1942, 1943, 1948; CI, 1943-46; AIC, 1943, 1945; Corcoran Gal biennial, 1943; Corcoran Gal (solo); VMFA, 1942; Fnd. Western A.; CPLH; Crocker A. Gal.; Riverside Mus., NY, 1948; Phillips Mem. Gal., Wash., DC, 1948; de Young Mus., 1968 (solo); San Fran. Art Commission Gal., 1976. **Work:** SFMA; VMFA; Mills Col.; Crocker A. Gal. **Comments:** He came to the U.S. in 1917, and during the 1930s was a WPA printmaker in California. Teaching: Acad. Advertising Art, San Fran.; Cal. Col. A. & Crafts, Oakland; Cal. Sch. FA, San Fran. **Sources:** WW59; WW47; exh. cat., Annex Gal. (Santa Rosa, CA, n.d., c.1988).

POLOTTI, L(ouis) *[Painter] early 20th c.*
Exhibited: Salons of Am., 1929-30. **Sources:** Marlor, *Salons of Am.*

POLOUSKY, Julie (Raymond) *[Painter] b.1908, Phila., PA / d.1976, Long Beach, CA.*
Addresses: Long Beach, CA. **Studied:** ASL; NY Evening Sch. Indst. A.; & with Vanessa Helder, Sam Hyde Harris, Loren

Barton. **Member:** Laguna Beach AA; Long Beach AA; Cal. WC Soc.; Women Painters of the West. **Exhibited:** Long Beach AA, 1935 (prize), 1936, 1942-45 (prizes); Laguna Beach AA, 1944 (prize), 1946 (prize); Huntington Beach, Calif., 1945 (prize); Calif. WC Soc., 1945 (prize)-48; Honolulu Acad. A., 1941; SFMA, 1946; LACMA, 1945; Riverside Mus., 1946; Los Angeles Pub. Lib., 1946; Bakersfield, Calif., 1946. **Sources:** WW53; WW47.

POLOWETSKI, C(harles) Ezekiel *[Painter] b.1884, Russia.*
Addresses: NYC. **Studied:** R. Blum; L. Bonnât. **Member:** Paris AAA; SC; Allied AA. **Exhibited:** Corcoran Gal biennial, 1914; S. Indp. A., 1917-18, 1925-26, 1931; Salons of Am., 1925, 1934; PAFA Ann., 1932. **Work:** State Normal Sch., Brockport, NY; Bezalel Col., Palestine; City Hall, Paterson, NJ; Barnett Hospital, Paterson, NJ; NYC Pub. Sch.; Summit Park Sanatorium, Pomona, NY; Administration Bldg, Floyd Bennett Airport, NY. **Sources:** WW40; Falk, *Exh. Record Series.*

POLSKY, Cynthia *[Painter] b.1939, NYC.*
Addresses: NYC. **Studied:** ASL, with Will Barnet, New Sch. Social Res., with Julian Levy; Columbia Univ. **Exhibited:** Benson Gal., Bridgehampton, LI, NY, 1968 (solo), 1970s; Comara Gal., Los Angeles, 1969 (solo), 1972 (watercolor exh.); Artisan Gal., Houston, Tex., 1970 (solo); Palm Springs Desert Mus., 1972-73 (solos); Laguna Beach Art Assn. Exhib. 1910, 1971. **Work:** Palm Springs Desert Mus., Calif.; Hirshhorn Collection; Rand Corp. Off., Los Angeles, Calif. **Commissions:** wooden painted murals, Manhattanville Col. Music Festival, 1966; rec. jacket, UNICEF, 1966. **Comments:** Preferred media: acrylics, watercolors. **Sources:** WW73; Henry Seldio, catalogue preface for exhib. (Palm Springs Desert Mus., 1972-1973).

POLTER See: **POTTER, Samuel**

POLVOGT, Carl William, Jr. (Bill) *[Cartoonist, comm a, designer] b.1929, Dallas, TX.*
Addresses: Dallas, TX. **Studied:** Southern Methodist Univ., Dallas; Univ. Texas, Austin (B.S.). **Member:** Nat. Professional Adv. Fraternity. **Comments:** Position: art dir., Tech. Publications, Chance Vought Aircraft Co., 1951-54; dir., Chas. B. Russell & Assoc., Dallas, Tex., 1954-. Contributor cartoons to *Sports Illustrated; Sat. Eve. Post* and other national magazines. **Sources:** WW59.

POMAREDE, Edouard *[Portrait and sign painter] b.c.1809, Ponpegrive, France / d.1879, New Orleans.*
Addresses: New Orleans, active 1859-74. **Sources:** G&W; *Encyclopaedia of New Orleans Artists* cites New Orleans CD 1859-61, 1870, 1874; *Bee*, Sept. 24, 1879.

POMAREDE, Leon *[Panoramist, landscape-, miniature-, scene-, and religious painter] b.1807, Tarbes, France / d.1892, St. Louis, MO.*
Addresses: Active in New Orleans, LA and St. Louis, MO. **Studied:** Paris; Germany; Italy; with Mr. Findelles (?); received further instruction in New Orleans (c. 1830) from theatrical painters Antoine Mondelli (whose daughter he eventually married) and Louis Dominique Grandjean Develle. **Exhibited:** "Pomarede's Original Panorama of the Mississippi River and Indian Life" was shown in St. Louis in Sept. 1849; New Orleans at Armory Hall (Nov. 1849-Jan. 13, 1850); other cities included Mobile, AL; NYC; and Newark, NJ (Nov. 1850). **Comments:** Arrived in U.S. about 1830 and was soon living in New Orleans where, in Jan. of 1832, he advertised that he could ornament rooms in oil and fresco. That same year he moved to St. Louis (MO) and painted one of the earliest views of the town. In 1834 he decorated the Cathedral in St. Louis with oil paintings, frescoes, and transparent window paintings. He returned to New Orleans in 1837, opened a studio, and in 1841 completed a commission for three religious pictures at St. Patrick's Church. For these paintings, which were first shown to the public in June 1841, he received assistance from Mondelli (in painting the ceiling) and from George David Coulon (for "Transfiguration"). By October of 1843 he had gone back to

St. Louis where he settled permanently. He went into partnership with T.E. Courtenay (see entry) as plain and ornamental painters. In 1848 Pomarede collaborated for a short time with Henry Lewis (see entry); but the association soon was dissolved and each set out to produce his own version. Pomarede reportedly had the assistance of Charles Wimar (see entry) in making the sketches and paintings that eventually were used to complete his panorama. With his partner Courtenay, Pomarede took the Mississippi panorama on tour to St. Louis, New Orleans, and several other cities until it was destroyed by fire at Newark (NJ) in November 1850. After this loss Pomarede returned to St. Louis, reopened his studio and spent the rest of his life painting religious and genre pictures and murals for churches, theaters, and public buildings. He died at the age of 85, from injuries received in a fall from a scaffold in a church he was decorating at Hannibal (MO). Aappears also as De Pomarede, or De la Pomarede. **Sources:** G&W; McDermott, "Leon Pomarede, 'Our Parisian Knight of the Easel,'" with seven repros.; Arrington, "Leon D. Pomarede's Original Panorama of the Mississippi River"; Arrington, "Nauvoo Temple," Chapter 8; Delgado-WPA cites *Courier*, Nov. 9, 1841, and *Daily Picayune*, Nov. 27, 1849. More recently, see *Encyclopaedia of New Orleans Artists*, 311-12.

POMERANCE, Leon *[Collector, patron] b.1907, NYC.*
Addresses: Great Neck, NY. **Studied:** NY Univ. (B.S.), Law Sch. (LL.B. & LL.M.). **Comments:** Positions: trustee, Archaeol. Inst. Am., 1965-, pres., NY chapt., 1968-70; co-sponsor excavations, Kato Zakro, Crete, Greece. Collection: ancient pre-Greek, Greek and Near Eastern art. **Sources:** WW73.

POMERANZ, Mildred H. *[Painter] mid 20th c.*
Addresses: NYC, 1930. **Exhibited:** S. Indp. A., 1930-32. **Sources:** Marlor, *Soc. Indp. Artists.*

POMEROY, Ella Celeste *[Sculptor] late 19th c.*
Addresses: Chicago area. **Exhibited:** AIC, 1899. **Sources:** Falk, AIC.

POMEROY, Elsie Lower *[Painter, illustrator, teacher] b.1882, New Castle, PA / d.1971.*
Addresses: Mill Valley, CA. **Studied:** Corcoran Sch. Art; & with Phil Dike, Millard Sheets, Eliot O'Hara. **Member:** Calif. WC Soc.; San Francisco AA; Laguna Beach AA; Riverside FA Gld.; FA Soc., San Diego; Los Angeles AA; Wash. WCC; San Francisco Women Artists; Marin Soc. Art. **Exhibited:** Oakland Art Gal., 1932; Art Lg., Wash., DC, 1935 (prize); AIC, 1938, 1939; GGE, 1939; NGA, 1941; Butler AI, 1942 (prize); AWCS, 1942; Chicago AC, 1943; Riverside (CA) FA Gld., 1946 (prize); Marin Soc. Art, 1948 (prize); Calif. WCC; Wash. WCC; San Francisco Women Artists, 1955; Mill Valley, CA, 1957 (prize). **Work:** Los Angeles AA; Butler AI; San Francisco Mun. Coll.; Carville, LA; Riverside (CA) H.S. **Comments:** Preferred media: oil, watercolor. Painted cactus, California missions, flowers, scenes of Mexico. Position: art instructor, Y.W.C.A., San Francisco, CA; illustrator, botanical illus. for U.S. Dept. Agriculture (her series "Save the Citrus Crop" won numerous awards); contributing artist, SFMA rental library; instructor, Adult Educ., Tamalpais H.S. **Sources:** WW59; WW47.

POMEROY, Florence Walton (Mrs. Ralph B.) *[Painter] b.1889, East Orange, NJ.*
Addresses: West Orange, NJ; Isle-au-Haunt, ME. **Studied:** George Bellows; J. Johansen; B.J.O. Nordfeldt; H. Boss; A. Goldthwaite. **Member:** NAWA; SIA; NYSC. **Exhibited:** Soc. Indep. Artists, 1917-22, 1924; Salons of Am.; NAD, 1942, 1944; NAWA, annually; Bonestell Gal., 1947 (solo); 460 Park Ave., NY, 1942 (solo). **Sources:** WW53; WW47.

POMEROY, Grace V. *[Painter] d.1906.*
Addresses: NYC. **Member:** NYWCC. **Exhibited:** Boston AC, 1890-98; AIC, 1891; PAFA Ann., 1893. **Sources:** WW06; Falk, *Exh. Record Series.*

POMEROY, Laura Skeel (Mrs.) *[Sculptor] b.1833, NYC / d.1911, NYC.*
Addresses: NYC; Poughkeepsie, NY. **Work:** bust of Matthew

Vassar, Vassar College.

POMEROY, Mary Agnes *[Painter] b.1869.*
Addresses: NYC, c.1900; Cleveland, OH, 1904. **Exhibited:** AIC, 1904. **Sources:** WW01.

POMEROY, Ralph *[Painter] mid 20th c.*
Exhibited: AIC, 1945-48. **Sources:** Falk, *AIC.*

POMEROY, Sanford B. *[Painter] late 19th c.; b.New York.*
Exhibited: SNBA, 1894, 1898. **Sources:** Fink, *American Art at the Nineteenth-Century Paris Salons,* 381.

POMFRET, John *[Art library director] mid 20th c.*
Comments: Position: dir., Henry E. Huntington Lib. & Art Gal., San Marino, CA. **Sources:** WW59.

POMMAYRAC, Pierre Paul Emmanuel De *[Miniaturist, art teacher] b.1807, Puerto Rico / d.1880, Paris, France.*
Addresses: New Orleans, active 1832-35. **Studied:** Gros; Mme. Lizinka de Mirbel. **Exhibited:** Boimare's Bookstore, New Orleans, 1832; Salon, Paris, 1833-35. **Sources:** G&W; Delgado-WPA cites *Courier,* Dec. 5, 1833, and New Orleans CD 1834-35. *Encyclopaedia of New Orleans Artists.* 312.

POMMER, Julius John *[Painter, lithographer, etcher] b.1895, San Francisco, CA / d.1945, San Fran.*
Addresses: San Francisco. **Studied:** Calif. Sch. of FA, with Otis Oldfield. **Member:** San Francisco AA; Calif. Soc. of Etchers (dir.). **Exhibited:** San Francisco Modern Gal., 1926; Oakland A. Gal., 1932; Gump's, San Francisco, 1935; SFMA, 1935; GGE, 1939. **Work:** SFMA; Calif. Hist. Soc.; San Francisco Pub. Lib. **Sources:** Hughes, *Artists in California,* 442.

POMMER, Mildred Newell *[Painter, graphic artist, designer, craftsperson, teacher] b.1893, Sibley, IA / d.1963, San Francisco, CA.*
Addresses: San Francisco. **Studied:** Otis AI; Chouinard AI; Calif. Sch. FA, and with Beniamino Bufano. **Member:** San Francisco AA; San Francisco Women Artists; Contemporary Handweavers of Calif. **Exhibited:** Oakland A. Gal., 1932; San Francisco AA, annually, 1939 (prize); SFMA, 1939, 1943 (prize); deYoung Mem. Mus., 1952; Wash. State Fair, Puyallup; Calif. Hist. Soc.; CPLH; San Francisco Art Festival, annually. **Work:** SFMA; Calif. Hist. Soc.; CPLH. **Comments:** WPA printmaker in California, 1930s. **Sources:** WW59; WW47; exh. cat., Annex Gal. (Santa Rosa, CA, n.d., c.1988).

PONCE DE LEON, Michael *[Printmaker, painter] b.1922, Miami, FL.*
Addresses: NYC. **Studied:** Univ. Mex. (B.A.); ASL; NAD; Brooklyn Mus. Art Sch.; also in Europe. **Member:** Soc. Am. Graphic Artists (treas., 1968); Assn. Am. Univ. Prof. **Exhibited:** Mus. Arte Mod., Paris, France; Victoria & Albert Mus., London, Eng.; Venice Bienale, 1970; MoMA; MMA; Jane Haslem Gallery, Wash., DC, 1970s Awards: Tiffany Found. grant, 1955; Fulbright grant, 1956; Guggenheim Found. grant, 1967. **Work:** MoMA; Nat. Gal. Art, Wash., DC; Smithsonian Inst.; MMA; Brooklyn Mus, NY. Commissions: many print editions, 1960-; 10 prints, US State Dept, 1966; glass sculpture Steuben Glass, 1971. **Comments:** Positions: Int. Cult Exchange, US State Dept., lect. & travel Yugoslavia, 1965, India & Pakistan, 1967-1968 & Spain, 1971. Teaching: instr. printmaking, Hunter Col., 1959-66; instr. printmaking, ASL, 1966- ; prof. printmaking Columbia Univ., 1972. Publications: contribr., "Experiments in three Dimensions," *Art in Am.* (1968); auth., "Artist proof," 1971; auth., "The Collage Intaglio," 1972. **Sources:** WW73; J. Ross & C. Romano *The Complete Printmaker* (Macmillan, 1972); J. Heller, *Prints* (Holt Rinehart & Winston, 1972); G. Peterdi, *Printmaking* (Macmillan, 1972).

PONCHON, Anthony *[Landscape artist] b.c.1820, France.*
Addresses: NYC, 1850's. **Sources:** G&W; 7 Census (1850), N.Y., XLIII, 2; NYBD 1858-59.

PONCIA, Antonio *[Sculptor, "statuary and moulder"] b.c.1793, Italy.*

Addresses: Baltimore, active 1859-60. **Sources:** G&W; Baltimore CD 1859; 8 Census (1860), Md., III, 915.

POND, Allen Bartlit *[Architect, painter] 20th c.*
Addresses: Chicago, IL. **Sources:** WW06.

POND, Clayton *[Painter, printmaker] b.1941, Long Island, NY.*
Addresses: NYC. **Studied:** Carnegie Inst. Technol. (B.F.A., 1964); Pratt Inst. (M.F.A., 1966). **Member:** Am. Color Print Soc.; Print Coun. Am.; Boston Printmakers; Phila. Print Cl. **Exhibited:** WMAA Ann., 1967; solo exhibs., paintings, Martha Jackson Gal., NYC, 1968 & 1972 & paintings & prints, De Cordova Mus, Lincoln, Mass, 1972; Int. Exhib. Colored Graphics, MoMA, Paris, France, 1970; US Pavilion, World's Fair, Osaka, Japan, 1970. Awards: State Dept grant, Smithsonian Inst. Int. Art Prog. & Abby Gray Found., 1967; Boston Mus. Purchase Award, Boston Printmakers 20th Ann., 1968; Color Print USA Purchase Award, W. Tex. Mus., 1969. **Work:** Nat. Collection Fine Arts, Wash., DC; MoMA; BMFA; PMA; AIC. **Comments:** Teaching: instr. photog. & printmaking, CW Post Col., Long Island Univ., 1966-68; adj. instr. serigraphy, Sch. Visual Arts, New York, 1968-1970; guest lectr., Univ. Wis.-Madison, spring 1972. **Sources:** WW73; Richard S. Field, "Silkscreen, the Media Medium," *Art News* Jan, 1972; Jules Heller, *Printmaking Today* (Holt, Rinehart & Winston, 1972); Marshall B. Davidson, "Artists' America," *Am. Heritage* (1973).

POND, Dana *[Painter] b.1881 / d.1962.*
Addresses: NYC. **Member:** NA. **Sources:** WW47.

POND, David F. *[Crayon artist] mid 19th c.*
Addresses: Hartford, CT, active 1851. **Sources:** G&W; Hartford BD 1851.

POND, Elizabeth Keith *[Painter] b.1886, Berkeley, CA / d.1955, Berkeley.*
Addresses: Berkeley, CA. **Studied:** Wm. Keith. **Comments:** Daughter of Admiral Charles and Emma Pond (see entry). She was named after Wm. Keith and stayed his pupil until he died. She later compiled items in his estate, which are now held in the Bancroft Lib. at UC Berkeley. **Sources:** Hughes, *Artists in California,* 443.

POND, Emma McHenry *[Painter, teacher] b.1857, Temescal Rancho (now Emeryville), CA / d.1934, Berkeley, CA.*
Addresses: Berkeley, CA. **Studied:** W. Keith. **Member:** San Francisco AA; San Fran. S. Women A. **Exhibited:** Mechanics' Inst., San Francisco, 1871. **Comments:** First pupil of Wm. Keith, whose sister Mary later became his wife. Specialty: landscapes and portraits. **Sources:** WW33; Hughes, *Artists in California,* 443.

POND, Florence A. *[Instructor, artist] late 19th c.*
Comments: Instructor: ASL of Wash., DC, 1892-93. **Sources:** McMahan, *Artists of Washington, D.C.*

POND, George D. *[Painter] 20th c.*
Addresses: Leonia, NJ. **Sources:** WW15.

POND, Harold Woodford *[Painter, designer, teacher] b.1897, Appleton, WI.*
Addresses: East Orange, NJ. **Studied:** Lawrence Col., Appleton, Wis.; PIA Sch. **Member:** SC; A. Center of the Oranges; AAPL; Irvington A. & Mus. Assn.; Millburn Short Hills A. Center. **Exhibited:** A. Center of the Oranges, 1945 (prize); PAFA, 1939; Irvington A. & Mus. Assn.; Millburn-Short Hills A. Center; Montclair A. Mus.; AAPL. **Work:** murals, Wellesley, Mass.; Princeton, N.J.; war mem., East Orange, NJ. **Sources:** WW53; WW47.

POND, Irving K. *[Painter] early 20th c.*
Exhibited: AIC, 1913. **Sources:** Falk, *AIC.*

POND, Mabel E. Dickinson (Mrs.) *[Painter] 20th c.*
Addresses: Spencer, MA. **Sources:** WW24.

POND, Theodore Hanford *[Painter, craftsperson, writer, lecturer, teacher] b.1873, Beirut, Syria / d.1933, near Kutztown,*

PA.
Addresses: Akron, OH; Boston, MA. **Studied:** Pratt Inst.
Member: Boston SAC; Alliance; Am. Assn. Mus.; Assn. Art Mus.
Dir.; AFA; College AA. **Exhibited:** Boston AC, 1898, 1899;
PAFA Ann., 1900. **Comments:** Specialty: design of textiles, wallpaper, stained glass, silverware, jewelry. Positions: t., RISD, Md.
Inst.; dir., Dayton AI, Akron AI. **Sources:** WW31; Falk, *Exh.
Record Series.*

POND, Willi Baze (Mrs. Charles E.) *[Painter, writer, lecturer, teacher] b.1896, Mason, TX / d.1947.*
Addresses: Spokane, WA. **Studied:** Oklahoma Col. for Women;
Am. Sch. Research, Santa Fe, NM; Broadmoor A. Acad.; K.
Chapman; Norfeldt. **Member:** Okla. A. Lg.; Okla. AA.
Exhibited: Denver A. Mus.; Colorado Springs FA Cen.; Okla.
AA; Marshall Field; Anderson Gal., NY. **Work:** murals, Christian
& Baptist churches, Chickasha, Okla. **Comments:** Author: "The
Rhythm of Colour"; "Six Great Moderns." Position: dir., Indian
A., Anadarko Reservation, 1922-27; Creative A., Women's C.,
Spokane, 1944-45. **Sources:** WW47.

PONDER, Lou *[Portrait, figure and mural painter] mid 20th c.*
Studied: Colorado Univ. (grad. 1951); CGA, with Edmund
Archer; Inst. Allende, Mexico, with James Pinto (mural painting).
Member: Rockport AA. **Exhibited:** VMFA, 1953, 1955; PAFA,
1954; NAD, 1955. **Comments:** Positions: teacher, CGA, 1953,
Virginia high school, 1954. **Sources:** *Artists of the Rockport Art
Association* (1956).

PONNET, Charles *[Sculptor] early 20th c.*
Addresses: Phila., PA. **Exhibited:** PAFA Ann., 1908. **Sources:**
WW10; Falk, *Exh. Record Series.*

PONS, Valentine William *[Painter] late 19th c.*
Addresses: New Orleans, active 1888-89. **Sources:**
Encyclopaedia of New Orleans Artists, 312.

PONSEN, Tunis *[Painter, teacher, lecturer] b.1891,
Wageningen, Holland / d.1968, Chicago, IL.*
Addresses: Chicago, IL. **Studied:** AIC with K. Buehr;
Oberteuffer; and abroad. **Member:** Chicago P.& S.; Chicago Soc.
A.; Chicago Gal. Assn.; Renaissance Soc., Univ. Chicago.
Exhibited: AIC, 1927-28 (prize); 1929-35; TMA; PAFA Ann.,
1931; Chicago P.&S.; Chicago Soc. A.; Ill. Soc. A., 1954 (prize);
Chicago Gal. Assn., 1950-55 (solo); Hefner Gal., 1985 (solo);
Button Gal., Douglas, MI, 1988 (solo); Muskegon Mus. A, c.1993
(solo). **Work:** Hackley A. Gal.; Flint Inst. A.; City of Chicago
Coll.; Chicago Pub. Schs.; Vanderpoel A. Assn.; Northwestern
Univ. Lib. **Sources:** WW59; WW47; Falk, *Exh. Record Series.*

PONT, Charles Ernest *[Printmaker, painter, illustrator, lecturer, craftsperson, writer] b.1898, St. Julien, France / d.1971.*
Addresses: NYC; Wilton, CT. **Studied:** Shelton Col.; PIA Sch.;
CUA Sch.; ASL. **Member:** AWCS; Soc. Typophiles; Southern Pr.
M.; AI Graphic A. **Exhibited:** Southern Pr. M., 1941 (prize);
SAE, 1937 (prize); Mineola Fair, 1934-36 (prize, each yr.); Int.
Wood Engr. Exh., Warsaw, 1937; NAD, 1933-40; MMA, 1941;
AIC, 1936-37; PAFA, 1932, 1940; Warsaw, Poland, 1935; Phila.
Pr. C., 1932, 1939; Phila. A. All., 1930-31; LOC, 1943; SFMA;
WFNY, 1939; Southern Pr. M.; New Haven Paint & Clay Cl.;
Kent AA; Bridgeport Art Lg.; CAFA; AWCS; CMA; AAPL, 1957
(prize); Wm. Greenbaum Gal., Gloucester, 1989. **Work:** LOC.;
MMA; Syracuse Mus. FA; NY Pub. Lib.; Newark Pub. Lib.;
Peabody Mus.; Appalachian Mus., Mt. Airy, Ga.; Staten Island
Inst. A.&Sc.; Pub. Lib., Hasbrouck Heights, NJ; Pub. Lib., Mt.
Vernon, NY. **Comments:** Position: art dir., *Magazine Digest,* 1951-52; asst. a. dir., *Grosset & Dunlap,* 1954-. Author/illus., des.,
"Tabernacle Alphabet," 1946; "The World's Collision," 1956. llustrator: "Whalers of the Midnight Sun," "Head Wind," "Down
East," many other books. Lectures: Art and Theology. **Sources:**
WW59; WW47.

PONTALBA, Gaston De *[Sketch artist, musician] b.1828,
France / d.1875.*
Addresses: New Orleans, active 1848-51. **Comments:** Both his

parents, Joseph Xavier Célestin Delfau de Pontalba and Micaela
Leonarda Almonester, were born in Louisiana of prominent families. After they divorced (1838) Gaston lived in Paris with his
mother, until the 1848 Revolution forced them to leave France.
Madame Pontalba and her sons Gaston and Alfred fled to London
and then returned to New Orleans. They stayed until 1851, and
their trip was recorded by Gaston in a diary and sketchbook that
was eventually published as *Voyage à la Nouvelle Orléans du Fev.
1848 au 7 Mai 1851.* Included were city views, primarily of the
Place d'Armes (now Jackson Square). This famous site consists of
two rows of apartment buildings, facing each other across a
square, which were constructed by Gaston's mother (to this day
known as the Pontalba Buildings). He returned to Paris in the
spring of 1851 and continued to pursue his interest in art, publishing prints of French estates and castles. **Sources:** G&W;
Encyclopaedia of New Orleans Artists. 312-13.

PONTELLI, M. L. de *[Portrait painter and teacher] mid 19th
c.*
Addresses: New Orleans, 1842-44. **Comments:** *Cf.* J.B. Pointel
du Portail. **Sources:** G&W; Delgado-WPA cites *Bee,* Dec. 10,
1842, and New Orleans CD 1843-44.

PONTICKAU, Robert *[Engraver] b.1846, Germany / d.1920,
Wash., DC.*
Addresses: Hudson County, NJ; Wash., DC. **Comments:** Worked
for the Bureau of Engraving and Printing from 1893-1920.
Sources: McMahan, *Artists of Washington, D.C.*

POOCK, Fritz (Carl Rudolph Frederick) *[Painter, designer, draftsperson, etcher, illustrator] b.1877, Halberstadt,
Germany / d.1945, Los Angeles, CA.*
Addresses: Los Angeles, CA. **Studied:** Francisco del Marmol, in
Granada, Spain; Germany. **Member:** Calif. AC. **Work:** Santa
Monica H. S. **Comments:** Specialty: technical illus. **Sources:**
WW40; Hughes, *Artists in California,* 443.

POOK, G. C. *[Marine sketch artist] b.1804, Boston, MA /
d.1878, Brooklyn, NY.*
Work: FDR Lib., Hyde Park, NY (pen & ink and watercolor).
Comments: From 1841-66, he was in U.S. Navy Construction,
building several ships including the U.S.S. Merrimac. **Sources:**
Brewington, 306, says this may be Samuel More Pook.

POOK(E), Harriett E.F. *[Artist] early 20th c.*
Addresses: Wash., DC, active 1923-24. **Sources:** McMahan,
Artists of Washington, D.C.

**POOKE, Marion Louise
(Mme. Bernard S. Duits)** *Marion L Pooke*
*[Painter, illustrator, teacher]
b.1883, Natick, MA. / d.1975, Paris, France.*
Addresses: Natick, Boston, MA; Paris, France, 1923 and after.
Studied: Smith Col.; Mass. Normal Art Sch., Boston; BMFA Sch.
with Frank W. Benson and Edmund Tarbell; DeCamp; Charles
Woodbury, Ogunquit Sch. **Member:** CAFA. **Exhibited:** AIC,
1913-16; PAFA Ann., 1913, 1918, 1921-23; Abbot Acad.,
Andover, MA, 1914 (with Gertrude Fiske and Beatrice Whitney
Van Ness); Corcoran Gal biennial, 1914; NAD, 1915 (solo); Pan.-
Pac. Expo, San Fran., 1915 (med.); CAFA, 1917 (prize); NAWA,
1921 (prize); Fenway Studios, Boston, 1922 (solo); "Charles H.
Woodbury and His Students," Ogunquit Mus. of Am. Art, 1998.
Work: Walnut Hill Sch.; Danforth Mus., Framingham, MA.
Comments: Teaching: Abbot Acad., Andover, MA; Walnut Hill
Sch. (Natick, MA, 1915-23). She painted at Fenwick Studios,
1918-20, and 1922-24. **Sources:** WW31; Vose Galleries, *Mary
Bradish Titcomb and Her Contemporaries,* 48-49; *Charles
Woodbury and His Students;* Falk, *Exh. Record Series.*

POOL, Eugenia Pope *[Painter] 19th/20th c.; b.Cameron, TX.*
Addresses: Active in Big Springs, TX, from 1899. **Studied:** Santa
Fe, NM with Olive Rush; Frederick Browne, Houston; Dawson-
Watson and Anthony De Young, San Antonio; Grand Central
School, NYC. **Exhibited:** Santa Fe Mus.; SSAL; Dallas, Ft.
Worth, & San Antonio; Snyder & Abilene, TX (solos). **Sources:**

Petteys, *Dictionary of Women Artists.*

POOL, John C. *[Amateur painter] b.1898, England.*
Addresses: Canada, 1912. **Comments:** Came to U.S. in 1945. He was a valet, handyman, nurseryman, cook, bartender, and assistant restaurant manager before he moved to Wash., DC in 1961, and taught himself to paint at the age of 77. Pool painted landscapes, used ordinary house paints on matboard, glass, driftwood, and made designs for postcards and calendars. He was said to have had a solo exhibition in 1977, where 20 of his works were shown. **Sources:** McMahan, *Artists of Washington, D.C.*

POOL, Mary *[Painter] early 20th c.*
Addresses: Brooklyn, NY, 1922. **Exhibited:** S. Indp. A., 1922. **Sources:** Marlor, *Soc. Indp. Artists.*

POOLE, Abram *[Painter] b.1883, Chicago / d.1961, Old Lyme, CT.*
Addresses: Chicago, IL; NYC; Old Lyme, CT. **Studied:** Académie Julian, Paris, 1908; Royal Acad., Munich, with Von Marr, 1905-12; L. Simon in Paris, 1912-15. **Member:** ANA, 1933; NA, 1938; Chicago SA. **Exhibited:** Paris Salon; PAFA Ann., 1920-41 (prize 1930); CI; Corcoran Gal biennials, 1923-43 (9 times, incl. 4th prize, 1926); AIC, 1926 (prize); Salons of Am., 1934; NAD, 1938 (prize); Royal Acad., Munich (med.); Concord, Mass., 1926 (med.). **Work:** AIC; PAFA. **Sources:** WW47; Falk, *Exh. Record Series.*

POOLE, Albert (Bert) F. *[Landscape painter, sketch artist, lithograper, printer, illustrator, writer] b.1853, North Bridgewater (now Brockton), MA / d.1939, Massachussetts.*
Addresses: Lived in Massachssetts all his life and maintained a studio on Monhegan Island. **Studied:** T. Juglaris, in Boston. **Member:** Quincy AL; Am. APL. **Exhibited:** Boston AC, 1896-1906; PAFA Ann., 1912. **Work:** Boston Pub. Lib.; City Hall, Boston; City Hall, Cambridge, Mass.; Monhegan Mus.; Maine Historic Preservation Commission, Augusta, Me. **Comments:** He worked as a clerk and then as a school principal but decided on an artistic career by 1880. His first city view was a lithograph of Bar Harbor, ME, printed in 1880 by J.J. Stoner (see entry). After a brief partnership in 1883 with George Norris (see entry), who seems to have served as business agent while Poole did the sketches and drawings, he published his own (lithographic) work, mainly panoramic views of Massachussetts. He sometimes signed his name as "Bert" Poole. From 1905-19 he was listed in the Boston Directories as "bird's eye view specialist." He also made many drawings of Monhegan Island. **Sources:** WW33; Reps, 199-200 (pl.4); Curtis, Curtis, and Lieberman, *Monhegan: The Artist's Island,* 19, 29, 31, 146, 185; Falk, *Exh. Record Series.*

POOLE, Bert See: **POOLE, Albert (Bert) F.**

POOLE, Burnell *[Marine painter] b.1884 / d.1933, Englewood, NJ.*
Studied: MIT. **Work:** U. S. Naval Acad., Annapolis; official artist to the British fleet (WWI). An interesting commission received by the artist was for a painting of the old "Corsair" (the yacht of the late J. P. Morgan) which hangs in one of the cabins of the new "Corsair," owned by J.P. Morgan, Jr.

POOLE, Earl L(incoln) *[Former museum director, illustrator, graphic artist, sculptor, painter, educator, lecturer] b.1891, Haddonfield, NJ / d.1972.*
Addresses: West Reading, PA. **Studied:** PMSchIA; PAFA; Univ. Pennsylvania and abroad. **Member:** Reading T. Assn.; Berks A. All. (vice-pres., 1958-61); Pa. State Edu. Assn.; Nat. Edu. Assn.; AAMus.; Phila. Sketch C. **Exhibited:** PAFA Ann., 1930, 1932; Univ. Michigan; LOC; LACMA; Harrisburg (Pa.) AA; CAM; Am. Mus. Natural Hist. **Awards:** F., PAFA; Hon. degree, Sc. D., Franklin and Marshall Col., 1948. **Work:** Univ. Michigan; s. Reading Mus. Park, Reading, Pa.; State Capitol, Harrisburg, Pa.; Muhlenberg College. **Comments:** Position: dir. art edu., Reading Sch. District, 1916-39, asst. dir., 1926-39, dir., 1939-57, Reading (Pa.) Pub. Mus. I., "Birds of Virginia," 1913; "Mammals of Eastern North America," 1943; & 45 other books. Lectures:

Symbolism in Art. **Sources:** WW66; WW47; Falk, *Exh. Record Series.*

POOLE, Eugene Alonzo *[Painter, sculptor] b.c.1841, Pooleville, MD / d.1912, Pittsburgh, PA.*
Addresses: Wash., DC, active 1874; Pittsburgh, PA, 1887-1912. **Studied:** PAFA; in Paris with Bonnât. **Member:** Soc. Wash. Artists; Pittsburgh AA (dir., 1900). **Exhibited:** NAD, 1880; Soc. Wash. Artists, 1891; Corcoran Gal annual, 1907 (landscape, Mystic, Conn.); Louvre, Paris. **Work:** Butler Inst. of Am. Art; Rockville Hist. Soc.; Westmoreland County Mus. **Comments:** He received early recognition for his sculpted busts of Robert E. Lee, Generals Stonewall Jackson and Joseph E. Johnson, as well as portraits, which where exhibited at the Corcoran Gallery and the Louvre. Beginning 1887, he specialized in landscapes, especially in autumn, in the Barbizon style. His landscapes have been compared to those of George Inness. **Sources:** WW13; Chew, ed., *Southwestern Pennsylvania Painters,* 104, 106, 107, 108; McMahan, *Artists of Washington, D.C.*

POOLE, Flora *[Artist] late 19th c.*
Addresses: Active in Grand Rapids, MI, 1889. **Sources:** Petteys, *Dictionary of Women Artists.*

POOLE, Frederic Victor *[Painter, teacher, craftsperson, teacher] b.1865, Southampton, Hants, England / d.1936.*
Addresses: Chicago, IL. **Studied:** Académie Julian, Paris, 1890-91; London, with F. Brown. **Member:** Chicago SA; Chicago PS; Chicago Gal. A. **Exhibited:** PAFA Ann., 1922; AIC, 1928 (prize). **Work:** Toronto Univ. **Comments:** Teaching: AIC. **Sources:** WW33; Falk, *Exh. Record Series.*

POOLE, (Horatio) Nelson *[Painter, etcher, lithographer, teacher] b.c.1883, Haddonfield, NJ / d.1949, San Francisco, CA.*
Addresses: Hawaii; San Francisco, CA. **Studied:** PAFA, with Thomas Anshutz. **Member:** Calif. SE; San Francisco AA.; Chicago SE; Calif. Book Plate Soc. **Exhibited:** Hawaiian Soc. Artists, 1917; San Francisco AA, 1921-22 (prize), 1923-27 (prize), 1928-49; Calif. SE, 1927 (prize), 1929 (prize); Galerie Beaux Arts, San Francisco, 1929; SFMA, 1935; GGE, 1939. **Work:** Honolulu Acad. Art; Mills College; SFMA; WPA murals, Roosevelt Jr. H.S., San Francisco. **Comments:** Position: art instr., Calif. Sch. FA, San Francisco, CA, 1927-42. **Sources:** WW53; WW47. More recently, see Hughes, *Artists in California,* 443; Forbes, *Encounters with Paradise,* 208.

POOLE, John *[Etcher] 20th c.*
Addresses: Honolulu, HI. **Member:** Calif. SE. **Comments:** Position: affiliated with *Star Bulletin.* **Sources:** WW27.

POOLE, Lynn D. (Mr.) *[Educator] b.1910, Eagle Grove, IA.*
Addresses: Baltimore 10, MD. **Studied:** Western Reserve Univ. (A.B., M.A.). **Member:** NEA; Am. Soc. for Aesthetics; Eastern AA; CAA; Am. Pub. Relations Assn.; Pub. Relations Soc. of Am.; Nat. Assn. Edu. Broadcasters; Am. College Pub. Relations Assn. (pres., 1956-57). **Exhibited:** Awards: 19 national awards for educational television, including George Foster Peabody award, 1950, 1952. **Comments:** Position: dir. edu. Activities, Walters A. Gal., Balt., Md., 1938-42; dir., Pub. Relations, Johns Hopkins Univ., Baltimore, Md., 1946-. Contributor to *America, School Arts, Eastern Arts Bulletin* and others, with articles on art education and public relations. **Sources:** WW59.

POOLE, Nelson See: **POOLE, (Horatio) Nelson**

POOLE, William H. *[Engraver] mid 19th c.; b.New York.*
Addresses: NYC, active 1857 and after. **Comments:** He was with John Lathrop in Lathrop & Poole, NYC, 1857-58. **Sources:** G&W; NYBD 1857-59; 8 Census (1860), N.Y., XLV, 841.

POOLEY, A. *[Painter] mid 18th c.*
Addresses: Active Annapolis, MD, 1752. **Comments:** Advertised in October 1752 at Annapolis (Md.) stating that he was prepared to paint "either in the Limning Way, History, Altar Pieces for Churches, Landskips, Views of their own Houses and Estates, signs or any other Way of Painting and also Gilding." **Sources:**

G&W; *Maryland Gazette,* Oct. 12, 1752, cited by Prime, I, 7.

POONS, Larry *[Painter] b.1937, Tokyo, Japan.*
Addresses: NYC. **Studied:** BMFA Sch., 1958. **Exhibited:** AIC, 1966; Corcoran Gal biennial, 1967; Carnegie Inst., 1967; Documenta IV, Kassel, Ger., 1968; WMAA, 1968, 1972. **Work:** MoMA; Albright-Knox Art Gal; Stedelijk Mus, Holland; Woodward Fndn, Wash., DC. **Sources:** WW73; Lawrence Alloway, *Systemic Painting* (Guggenheim Mus., 1966); Gregory Battcock (ed.), *Minimal Art: A Critical Anthology* (Dutton, 1968); E.C. Goosen, *The Art of the Real USA, 1948-1968* (MoMA, 1968).

POOR, Alfred Easton *[Painter] b.1899, Baltimore, MD.*
Addresses: NYC. **Studied:** ASL. **Member:** AWCS. **Exhibited:** AIC, 1924; S. Indp. A., 1933. **Sources:** WW47.

POOR, Anne *[Painter, muralist] b.1918, NYC.*
Addresses: New City, NY. **Studied:** Bennington Col.; ASL with Alexander Brook, William Zorach, and Yasuo Kuniyoshi; Acad. Julian, Paris, with Jean Lureat & Abraham Rattner; assistant to Henry Varnum Poor on fresco murals. **Member:** AEA. **Exhibited:** "Artists For Victory," MMA, 1942; Am. Brit. Art Cntr., NYC, 1944-45 & 1948; PAFA Ann., 1944-52, 1958-60, 1964-66; AIC, 1945-46; WMAA, 1946-59; Corcoran Gal. biennial, 1947; NAD 1970 (first prize for landscape painting); Maynard Walker Gal, NYC, 1950; Graham Gal, NYC, 1957-71 (solos). Other awards: Edwin Austin Abbey Mem. fellowship for mural painting from the NAD, 1948; NIAL grant in art, 1957. **Work:** WMAA; BM; AIC; Des Moines Art Ctr. Commissions: WPA murals, 1937; murals in true fresco, comn. by Nathaniel Saltonstall, Wellfleet, Mass., 1951-52, Skowhegan Sch. Painting & Sculpture, 1954, South Solon Free Meeting House, Maine, 1957 & Mr. & Mrs. Robert Graham, Stamford, Conn., 1958. **Comments:** The daughter of Henry Varnum Poor. In 1944, she and Marion Greenwood were appointed the first two female artist war-correspondents. Teaching: Skowhegan Sch. Painting & Sculpture, 1947-61, gov. & trustee, 1963-on. Illustrator: *Greece* (Viking Press, 1964). **Sources:** WW73; Alan Gussow, *A Sense of Place, Friends of Earth* (Sat. Rev. Press, 1972); Falk, *Exh. Record Series.*

POOR, Charles H. *[Painter] d.1910, Wash., DC.*
Addresses: Wash., DC, active 1872-1910. **Member:** Wash. SA; Wash. WCC. **Exhibited:** Wash. WCC, 1897-1904; Wash. SA. **Comments:** Career officer in the U.S. Navy. Works consisted mostly of seascapes and coastal scenes. **Sources:** WW98; McMahan, *Artists of Washington, D.C.*

POOR, H. V. (Mrs.) See: **THOMPSON, Dorothy Ashe**

POOR, Henry Varnum *[Painter, mural painter, illustrator, craftsperson, lithographer] b.1888, Chapman, KS / d.1970, probably New City, Rockland County, NY.*

H V Poor '60

Addresses: Kansas City, MO, 1913; San Francisco, CA, 1914-19; Rockland County, NY, 1919-on. **Studied:** Stanford Univ. (A.B., 1910); Slade Sch., London with Walter Sickert; Académie Julian, Paris with Laurens, 1911. **Member:** NA, 1963; San Francisco AA; San Francisco Soc. A.; Calif. AC; AEA; NIAL. **Exhibited:** PAFA Ann., 1913-14, 1927-66 (gold for best portrait, 1951); Pan.-Pac. Expo, 1915; San Francisco AA, 1918 (prize); NAD; AIC, 1932 (prize); CI, 1934 (prize); WMAA, 1932-53; Corcoran Gal biennials, 1935-59 (11 times); Rehn Gal., NYC, 1961 (solo), 1964 (solo). **Work:** MMA; MoMA; WMAA; PMG; NIAL; SFMA; CGA; CMA; Columbus Mus. A.; AGAA; BM; Newark Mus.; PMA; Kansas City AI; Wichita Art M., Kansas; LACMA; Dallas Mus. FA; WMA; San Diego Mus.; frescoes, Dept. Justice and Dept. of Interior Bldg., Wash., DC (WPA project); "The Land Grant Frescoes," Pennsylvania State Univ.; "Kentucky," lobby, Courier-Journal Bldg., Louisville, KY; ceramic mural, Mt. Sinai Hospital; ceramic mural, exterior H.S., Flushing, NY; Traveler's Ins. Bldg., Boston; Deerfield Acad., MA. **Comments:** Realist painter and muralist. His early career was spent primarily as a designer and craftsperson. After moving to Rockland County, NY,

in 1919 he designed and built his home/studio "Crow House" and focused on the applied arts, gaining popularity for his painted pottery and handcrafted bathrooms during the 1920s. Poor returned to painting in 1929, traveling to the Mediterranean and to Paris and producing a group of paintings that brought him high praise when exhibited in NYC (1931). During the 1930s Poor ventured into fresco painting, gaining major mural commissions as a WPA artist. His easel paintings, whether of lone individuals or landscapes, are expressive in brushwork and often somber in mood. Poor was the founder and first president of the Skowhegan (Maine) School of Painting and Sculpture. Other positions: teacher, Mark Hopkins AI (1917-19), Stanford, Columbia. Author/illus., "Artist Sees Alaska," 1945; "A Book of Pottery," 1958; illustrator, Jack London's "Call of the Wild" (Limited Editions Club). **Sources:** WW66; WW47; P&H Samuels, 377; *300 Years of American Art,* 828; Baigell, *Dictionary;* Falk, *Exh. Record Series.*

POOR, Henry Warren *[Painter, lecturer, writer] b.1863, Boston, MA / d.1938.*

Henry. W. Poor.

Addresses: Medford, MA. **Studied:** Mass. Normal A. Sch.; Paris. **Member:** Boston AC. **Exhibited:** Boston AC, 1907. **Sources:** WW27.

POOR, Jonathan D. *[Wall painter] mid 19th c.*
Addresses: active in Maine and Eastern Massachusetts, 1830s. **Studied:** perhaps with Rufus Porter. **Comments:** The nephew of Rufus Porter (see entry), he may also have worked in collaboration with a muralist named Paine (see entry). Signed murals by Poor have been uncovered, and his style is very similar to that of Rufus Porter (see entry). **Sources:** G&W; Little, *American Decorative Wall Painting,* 127, 132; *Art in America* (Oct. 1950), 164-65, 173-78, 194 (repro.).

POOR, Robert John *[Art historian] b.1931, Rockport, IL.*
Addresses: Minneapolis, MN. **Studied:** Boston Univ., (B.A. art hist., 1953 (M.A., art hist., 1957); Univ. Chicago, with Ludwig Bachhofer (Ph.D. art hist., 1961). **Comments:** Positions: consult. Asian art, Minneapolis Inst. Art; cur. Asian art, Minn. Mus. Art, Saint Paul. Collections arranged: Art of India (exhibition catalogue), 1969 & Far Eastern Art in Minnesota Collections (exhibition catalogue), 1970, Univ. Minn. Gallery; Hanga, The Modern Japanese Print (exhibition catalogue), Minn Mus. Art, Saint Paul, 1972. Research: Chinese bronzes. Publications: auth., "Notes on the Sung," archaeological catalogs, 1965 & auth., "Some Remarkable Examples of I-Hsing ware, 1966-1967," Archives of Chinese Art Soc. Am.; auth., "Ancient Chinese Bronzes," *Inter-Cult Arts Press* (1968); auth., "Evolution of a Secular Vessel-Type," 1968 & auth., "On the Mo-tzu-Yu," 1970, *Oriental Art.* Teaching: asst. prof. Asian art, Dartmouth Col., 1961-65; assoc. prof. Asian art, Univ. Minn., Minneapolis, 1965-. **Sources:** WW73.

POORE, Henry R(ankin) *[Genre and landscape painter, illustrator, writer, teacher] b.1859, Newark, NJ / d.1940, Orange, NJ.*
Addresses: Philadelphia, PA; Orange, NJ/Lyme, CT. **Studied:** U.Penn.; PAFA with Peter Moran: NAD; Académie Julian, Paris with Bouguereau, 1883-85, 1892; Luminais in Paris. **Member:** ANA, 1888; Phila. Sketch C.; AC Phila. SC; Lotos C.; Union Inter des Beaux-Arts et des Lettres; Phila. Alliance; Art Center of the Oranges; AAPL; NAC; Am. Soc. Animal P.&S.; AFA; Lyme AA. **Exhibited:** PAFA Ann., 1878-1936; NAD,1882-1900, 1888 (prize); Brooklyn AA, 1882; Paris Salon, 1884, 1892; Am. AA (prize); Boston AC, 1885-1909; AIC, 1888-1922; Pan-Am. Expo, Buffalo, 1901 (med.); St. Louis Expo, 1904 (med.); Am. A. Soc., Phila., 1906 (gold); Corcoran Gal. biennials, 1907-30 (7 times); Buenos Aires, 1910 (gold); Pan.-Pac. Expo, San Fran., 1915 (med.). **Work:** FA Acad., Buffalo; City Mus. of St. Louis; A. Assn., Indianapolis; Worcester Mus.; Phila A. C.; Rittenhouse Cl.; Madison A. Assn.; Tacoma AC; Mills Col. A. Gal., Calif.; Gov. purchase, Brazil; Nat. Mus., New Zealand. **Comments:** Poore returned to Paris in 1891, and was sketching foxhunting in

England in 1892. He also visited and worked in the West. Author: "Pictorial Composition," "The Pictorial Figure," "The Conception of Art," "Art Principles in Pratice," "Modern Art: Why, What and How," "Thinking Straight on Modern Art." Teaching: PAFA, 1890s. **Sources:** WW40; P&H Samuels, 377; Fink, *American Art at the Nineteenth-Century Paris Salons,* 381; *300 Years of American Art,* 544; Falk, *Exh. Record Series.*

POP CHALEE *[Painter] b.1908, Castle Gate, UT.*
Pop-Chalee
Addresses: Manhattan Beach, CA in 1968. **Studied:** Santa Fe Indian School. **Work:** Gilcrease Inst.; Mus. Northern Arizona; Mus. New Mexico; Stanford Univ.; murals, Albuquerque Airport Terminal. **Comments:** Active in radio work in the 1950s. Also known as Merina Lujan Hopkins. **Sources:** P&H Samuels, 377-78.

POPE, Alexander, Jr. *[Still-life and portrait painter, sculptor] b.1849, Boston, MA / d.1924.*
ALEXANDER POPE-98
Addresses: Boston, Brookline, MA/Hingham, MA. **Studied:** Wm. Rimmer. **Member:** Copley S., 1893; Boston AC. **Exhibited:** Boston AC, 1875-77, 1880, 1889-98; AIC; PAFA Ann., 1919. **Work:** Brooklyn Mus.; M.H. de Young Mus; PAFA. **Comments:** Painter of animal subjects (also sculptures) and still life. During the 1860s-70s, Pope worked in his father's lumber business. In 1875, he began to exhibit his carved and painted wood trophies of live and dead game birds. He became well known as an animal portraitist, painting famous horses and champion dogs and cats. During the late 1880s, he turned to painting large trompe l'oeil still lifes (hunting pictures and compositions of military paraphernalia), and is considered Boston's leading representative of that school. He also painted trompe l'oeil pictures showing dogs, chickens, even lions, enclosed within a wooden crate covered with chicken wire or a cage. After 1912, he was chiefly a portrait painter of people and their animals. He published two portfolios of lithographs entitled *Upland Game Birds and Water Fowl of the United States* and *Celebrated Dogs of America.* **Sources:** WW24; Baigell, *Dictionary;* Alfred Frankenstein, *After the Hunt,* 67, 139-41; Gerdts, *Painters of the Humble Truth,* 153, 157, 193, 196; Gerdts and Burke, *American Still-Life Painting,*133-34, 142; Falk, *Exh. Record Series;* add'l info. courtesy Janice Chadbourne, Boston Pub. Lib.

POPE, Alfred Atmore *[Patron] b.1842, Maine / d.1913, Farmington, CT.*
Comments: He made his fortune as president of the Cleveland Malleable Iron Co., and by the late 1880s emerged as one of the earliest serious collectors of Impressionist paintings. Although Pope was friendly with Cassatt, Whistler, and Monet, he relied on his own judgment in selecting their works as well as those by Manet, Degas, and other important artists. He once wrote to his fellow Connecticut collector, Harris Whittemore, about his decision not to buy a particular painting: "I don't 'rise to it' as I am bound to do to any and every picture before I purchase it." Pope's daughter, Theodate Pope Riddle, was among the earliest women architects in America. She designed a retirement home for her parents in Farmington, CT, which housed her father's collection. When she died in 1946, she bequeathed the home and its exceptional collection to become the Hill-Stead Museum, which remains unchanged today. **Sources:** info courtesy archivist, Hill-Stead Mus.

POPE, Annemarie Henle *[Art administrator] 20th c.; b.Dortmund, Germany.*
Addresses: Wash., DC. **Studied:** Heidelberg Univ. (Ph.D., 1932); Radcliffe Col., Harvard Univ., exchange fel., 1933-34. **Member:** Am. Assn. Mus.; Washington Friends of Am. Mus. Bath, Eng. (chmn.); Am. Fedn. Arts; Master Drawings Assn.; Corcoran Gal. **Exhibited:** Awards: Royal Swedish Order of Polar Star, 1957; Order of Merit, First Class, Ger., 1964. **Comments:** Positions: asst. dir., Portland Art Mus., Ore., 1941-42; dir. in charge exhibs., Am. Fedn. Arts, 1947-51; chief traveling exhibs., Smithsonian Inst., 1951-64; pres., Int. Exhibs. Found., 1965-. Publications: auth., acknowledgments for catalogues publ. by Int. Exhibs.

Found. in connection with traveling exhibs. **Sources:** WW73.

POPE, Arthur *[Painter, teacher, lecturer] 19th/20th c.*
Addresses: Cambridge, MA, active 1889-1927. **Exhibited:** Boston AC, 1889, 1891. **Comments:** Position: t., Harvard. **Sources:** WW27; *The Boston AC.*

POPE, Celestine Johnston *[Educator, painter] b.1911.*
Studied: Boston Univ. **Exhibited:** Harmon Fnd., 1930; Smithsonian Inst., 1930. Award: 1st prize, Ivory Soap Contest, 1934. **Comments:** Position: t., Episcopal City Mission, Boston; Palmer Memorial Inst., Sedalia, NC; Hillside Park School. **Sources:** Cederholm, *Afro-American Artists.*

POPE, Collett S. *[Painter] 20th c.*
Addresses: Duluth, MN. **Comments:** Position: affiliated with Duluth Acad. FA. **Sources:** WW24.

POPE, David S. (or I.) *[Painter] late 19th c.*
Addresses: NYC. **Exhibited:** NAD, 1883-86. **Sources:** Naylor, *NAD.*

POPE, John *[Portrait, landscape, and genre painter] b.1820, Gardiner, ME / d.1880, NYC.*
Studied: Boston, c.1836; several years in Rome and Paris before 1857. **Member:** A.N.A., 1859. **Exhibited:** NAD, 1857-65; PAFA, 1859-69; Boston Art Assoc., 1868; Brooklyn AA, 1861-81. **Comments:** Raised as a farmer but went to Boston about 1836 to pursue art. In 1849 he joined the rush to California, stayed a few years, returned to Boston briefly, and then went to Europe. By 1857 he had returned and established himself in NYC, where he maintained a studio until his death. Best-known work: full length portrait of Daniel Webster, painted for the town of Charlestown (Mass.). Possibly related to Mrs. Mary S. Pope (see entry.) **Sources:** G&W; Pope, *A History of the Dorchester Pope Family,* 221-22; *American Art Review,* II, Part I (1881), 169, obit.; Swan, BA; Boston BD 1844-49, 1853+; Cowdrey, NAD; Rutledge, PA; Hart, "Life Portraits of Daniel Webster." More recently, see Campbell, *New Hampshire Scenery,* 129.

POPE, John Alexander *[Museum director] b.1906, Detroit, MI / d.1982.*
Addresses: Wash., DC. **Studied:** Yale Col. (B.A., 1930); Harvard Univ. (M.A., 1940, Ph.D., 1955). **Member:** Am. Oriental Soc.; Oriental Ceramic Soc., London; Assn. Asian Studies; Asia Soc.; Japan Soc. **Comments:** Positions: assoc. in res., Freer Gal.Art, Wash., DC, 1943-46, asst. dir., 1946-62, dir., 1962-71; co-chmn., Manila Trade Pottery Sem., Manila, 1968. Publications: compiler, "A Descriptive and Illustrative Catalogue of Chinese Bronzes," 1946; auth., "Fourteenth Century Blue and White: A Group of Chinese Porcelains in the Topkapu Sarayi Müzesi, Istanbul," Freer Gal. Art Occasional Papers, Vol 2, No 1; auth., "Chinese Porcelains from the Ardebil Shrine, Freer Gal. Art, 1956; sr. co-auth., "Freer Chinese Bronzes," Freer Gal. Art Oriental Studies, Vol 1, No 7; contribr., *Harvard J. Asiatic Studies.* Teaching: lectr. Chinese art, Columbia Univ., 1941-43; res. prof. oriental art, Univ. Mich., 1962-71; lectr., US, Europe & Far East, 1966-69. **Sources:** WW73.

POPE, Louise *[Painter] early 20th c.*
Addresses: NYC, c.1907-15. **Sources:** WW15.

POPE, Marion Holden *[Painter, etcher, lithographer, portrait & mural painter, illustrator] b.c.1872, San Francisco, CA / d.1958, San Fran.*
Addresses: Los Angeles; Sacramento, CA. **Studied:** Mark Hopkins Sch. Art; A. Matthews; Whistler at Colarossi Acad. **Member:** Calif. SE; Laguna Beach AA; San Francisco AA; Northern Calif. AA; Kingsley AC, Sacramento, CA. **Exhibited:** Steckel Gal., Los Angeles, 1906; LACMA, 1915; Mark Hopkins Sch. Art (medal); Oakland A. Gal., 1927; Calif. State Fair, 1930; Crocker Art Gal., Sacramento, 1944. **Work:** Calif. SE; LOC; SFMA; Crocker Art Gal.; SAM; Carnegie Lib., Oakland, CA; Calif. State Capitol; Calif. State Lib. **Sources:** WW53; WW47. More recently, see Hughes, *Artists in California,* 443; Petteys, *Dictionary of Women Artists.*

POPE, Mary Ann Irwin *[Painter] b.1932, Louisville, KY.*
Addresses: Huntsville, AL. **Studied:** Art Ctr., Louisville; Univ. Louisville; Cooper Union. **Member:** Huntsville Art League & Mus. Assn.; Ala. WC Soc. **Exhibited:** Soc 4 Arts, Palm Beach, Fla., 1969; Frontal Images, Jackson, Miss., 1970; Mid-South, Brooks Art Gal., Memphis, Tenn., 1971 & 1972; 38th Ann. Nat. Exhib. Miniature Artists, Wash., DC, 1971; Piedmont Painting & Sculpture Exhib., Mint Mus., Charlotte, NC, 1972. Awards: Shaw Warehouse Award, 32nd Nat. Watercolor Exhib., 1972; Mint Mus. Purchase Award, Piedmont Painting & Sculpture Exhib., 1972. **Work:** Nat. Collection Fine Art, Wash., DC; Mint Mus., Charlotte, NC; Quarter Print Collector, New Orleans, La. **Comments:** Preferred media: acrylics. Teaching: instr. painting, Art Ctr., 1959; instr. painting, Huntsville Art League, Ala., 1966-, dir., adult classes, 1967-. **Sources:** WW73.

POPE, Mary S. *[Painter] mid 19th c.*
Addresses: NYC. **Exhibited:** NAD, 1866-68. **Sources:** Naylor, *NAD.*

POPE, Maud Mary *[Amateur painter] b.1867, Watertown, NY.*
Addresses: Active in Quebec. **Studied:** Wickenden, Quebec. **Exhibited:** Montreal AA, 1908-14. **Sources:** Petteys, *Dictionary of Women Artists.*

POPE, Minga *[Painter] late 19th c.*
Addresses: NYC. **Exhibited:** NAD, 1892-93. **Sources:** Naylor, *NAD.*

POPE, (Mrs.) *[Portrait painter] mid 19th c.*
Addresses: Milwaukee, WI in September 1847. **Sources:** G&W; Butts, *Art in Wisconsin,* 84-85.

POPE, Richard Coraine *[Painter, designer] b.1928, Spokane, WA.*
Addresses: Huntsville, AL. **Studied:** Univ. Louisville (B.A. & M.A.); Cincinnati Art Acad., with Noel Martin. **Member:** Huntsville Art League & Mus. Assn. (dir., 1970-72); Huntsville Mus. Bd. **Exhibited:** work has been widely exhibited in regional shows. **Comments:** Preferred media: opaque watercolor. Positions: art dir., Staples Advert., Louisville, 1957-64. Teaching: instr. graphic design, Univ. Louisville, 1965-66; assoc. prof. graphic design, Univ. Ala., Huntsville, 1966-. **Sources:** WW73.

POPE, Sara Foster *[Painter, illustrator, craftsperson, teacher] b.1880, Boston.*
Addresses: Phila., PA. **Studied:** Indust. Art Sch., Drexel Inst.; F. Lesshafft, in Phila. **Member:** Plastic Club. **Exhibited:** AIC, 1907-08. **Sources:** WW10.

POPE, Sarah *[Listed as "artist" (census)] b.1820, Massachusetts.*
Addresses: Philadelphia in 1860. **Exhibited:** a "Miss Pope" exhibited crayon portraits of dogs at the Pennsylvania Academy in 1851. **Sources:** G&W; 8 Census (1860), Pa., LVI, 494; Rutledge, PA.

POPE, Thomas *[Architect, artist, and engineer] early 19th c.*
Addresses: Philadelphia, active 1812-17. **Exhibited:** Society of Artists at PAFA (1812: "Design of alterations and additions for State-House buildings, Chestnut St., Phila."). **Sources:** G&W; Brown and Brown; Rutledge, PA; Yarmolinsky, *Picturesque United States of America,* 41.

POPE, Thomas Benjamin *[Landscape, genre, and still life painter] b.New York or New Jersey / d.1891, Fishkill Landing, NY (killed by a train).*
Addresses: Newburgh, NY. **Studied:** Am. Inst., 1845, 1849. **Exhibited:** American Institute, NYC, 1845 and 1849 (showed several crayon drawings). **Work:** New York State Mus., Albany. **Comments:** Worked as a liquor dealer in Newburgh, NY, before becoming a painter. After serving in the Civil War, he returned to Newburgh where he painted landscapes and fruit still lifes from which color advertisements were made. **Sources:** G&W; Am. Inst. Cat., 1845, 1849; Alfred Frankenstein, *After the Hunt,* 159-60.

POPE, William Frederick *[Painter, sculptor] b.1865, Fitchburg, MA / d.1906, Boston, MA.*
Addresses: Paris, France. **Studied:** Académie Julian, Paris, 1901; Ecole des Beaux-Arts, Paris. **Exhibited:** Paris Salon; Boston AC, 1894-1897; PAFA Ann., 1905. Award: Grand Prix de Rome, Ecole des Beaux-Arts. **Work:** portrait in relief of Mrs. Mary Baker G. Eddy. **Sources:** WW06; Falk, *Exh. Record Series.*

POPENOT *[Painting and dancing master] late 18th c.*
Addresses: Baltimore, 1786. **Sources:** G&W; Prime, II, 52.

POPIEL, Antoni *[Painter] early 20th c.*
Addresses: Chicago, IL. **Exhibited:** AIC, 1909. **Sources:** WW10.

POPINI, Alexander *[Painter, illustrator] mid 20th c.*
Addresses: NYC. **Member:** SC. **Exhibited:** Salons of Am., 1933. **Sources:** WW25.

POPINSKY, Arnold Dave *[Sculptor, educator, graphic artist] b.1930, NYC.*
Addresses: Beloit, WI. **Studied:** N.Y. State Univ., Col. for T. (B.S.); Albright A. Sch.; Univ. Wisconsin (M.S.). **Comments:** Position: prof. s., Beloit College, Beloit, Wis., 1959-on. **Sources:** WW59.

POPKIN, Mark *[Painter] 20th c.*
Addresses: NYC. **Sources:** WW06.

POPOFF, Andrew P. *[Painter] early 20th c.*
Addresses: Flushing, NY. **Member:** S. Indp. A. **Exhibited:** S. Indp. A., 1921. **Sources:** WW25.

POPOFF, Olga See: **MULLER, Olga Popoff (Mrs.)**

POPOLIZZIO, Vincent J. *[Painter] mid 20th c.*
Addresses: Fort Terry, 1942. **Exhibited:** S. Indp. A., 1942. **Sources:** Marlor, *Soc. Indp. Artists.*

POPPE, H. *[Sculptor] mid 20th c.*
Exhibited: S. Indp. A., 1936. **Sources:** Marlor, *Soc. Indp. Artists.*

POPPE, Vera *[Painter] early 20th c.*
Addresses: NYC. **Exhibited:** AIC, 1919. **Sources:** WW19.

POPPEL, John *[Engraver] mid 19th c.*
Comments: Engraver of two illustrations for Dana's *United States Illustrated* (c. 1855). **Sources:** G&W; Dana, *The United States Illustrated.*

PORAY, Stan(islaus) P(ociecha) *[Painter, designer, craftsperson, illustrator, lecturer, teacher] b.1888, Krakow, Poland / d.1948, NYC.*
Addresses: Los Angeles, CA. **Studied:** Acad. FA, Poland; Paris. **Member:** San Diego AS; Société des Artistes Polonais en France; Los Angeles AA; Calif. AC. **Exhibited:** Stendahl Gal., Los Angeles, 1929 (solo); Springville, Utah 1929 (prize); LACMA, 1938 (prize); GGE, 1939; Detroit Inst. A., 1945; SFMA; San Diego FA Soc.; Dallas Mus FA; Salt Lake City AA; Calif. AC; Los Angeles P & S. Cl.; Los Angeles AA. **Work:** LACMA; Good Samaritan Hospital, Bd. Educ., both in Los Angeles; Gardena (CA) H.S.; Radcliffe Col.; Polish Nat. All. Mus., Chicago; Polish Embassy, Wash., DC; IBM Coll.; Detroit Inst. Art; FMA; Imperial Red Cross, Tokyo. **Comments:** Of noble birth, he was art director of a theatre in Tomsk, Russia, when he was forced out by the Russian Revolution and came to Los Angeles via China. Specialty: still lifes. **Sources:** WW47; Hughes, *Artists in California,* 444.

PORCHER, (Miss) *[Portrait painter] mid 19th c.*
Addresses: Advertised oil paintings at Charleston, SC in 1850. **Sources:** G&W; Rutledge, *Artists in the Life of Charleston.*

PORGES, Suzanne F. *[Painter] mid 20th c.*
Exhibited: S. Indp. A., 1943. **Sources:** Marlor, *Soc. Indp. Artists.*

PORONER, Margot Palmer See: **PALMER-PORONER, Margot**

PORSMAN, Frank O. *[Painter, decorator, teacher] b.1905, Worcester, MA / d.c.1958.*

Addresses: Worcester, MA. **Studied:** WMA Sch. **Member:** Worcester Gld. A. & Craftsmen. **Exhibited:** Critics Choice, CM, 1945; Nat. Gal., Ottawa, Canada, 1934, 1935; WWA, 1934, 1937, 1939. **Work:** Town Hall, Boylston, Mass. **Sources:** WW53; WW40.

PORTAIL, J. B. Pointel du See: **POINTEL DU PORTAIL, J. B.**

PORTANOVA, Giovanni B. *[Sculptur, teacher] b.1875, Misilmeri, Palermo, Italy. / d.1956, Sonoma County, CA.*
Addresses: San Francisco, CA. **Studied:** Sch. FA, Palermo; Sch. FA, Rome; Inst. FA, Paris. **Exhibited:** Indst. AM, Rome, 1895 (prize); San Fran. Expo, 1915; San Francisco AA, 1916, 1924; Soc. of Western Artists, 1949. **Work:** St. Mary's College Chapel, Moraga, CA; Bank of Am., San Fran.; Pantages, Fox theaters, San Fran. **Comments:** Position: t., Univ. Calif. **Sources:** WW40; Hughes, *Artists in California*, 444.

PORTANOVA, Joseph Domenico *[Sculptor, designer] b.1909, Boston, MA / d.1979, Riverside County, CA.*
Addresses: Pacific Palisades, CA. **Studied:** Boston Trade School; with Cyrus E. Dallin. **Member:** Calif. A. Cl. (second v. pres. & bd. dirs., 1963); fel. Am. Inst. Fine Arts (v. pres., 1964). **Exhibited:** GGE, 1939; LACMA, 1958; Laguna Beach Art Assn., Calif., 1960; Calif. A. Cl., Los Angeles, 1962; Calif. State Fair, Sacramento, 1963; NAD, 1964; Laguna Beach Art Assn., 1960 (first prize); Calif. A. Cl., 1962 (first prize); Calif. State Fair, 1963 (gold). **Work:** Dr. Lee de Forest (sculpture), Smithsonian Inst.; Dr. Robert A. Millikan (sculpture), Calif. Inst. Technol., Pasadena; Dr. Fabien Sevitzky (sculpture), Dade Co. Auditorium, Miami, Fla.; Richard Bard (sculpture), Lake Bard, Ventura Co., Calif.; J.B (Cap.) Haralson (sculpture), Amateur Athletic Union, Indianapolis, Ind. Commissions: Dr. Charles LeRoy Lowman (sculpture), Orthopaedic Hosp., Los Angeles, Calif., 1962; Leo M. Harvey (sculpture), Harvey Aluminum Co., Torrance, Calif., 1962; ten bas-relief tablets, Los Angeles Mem. Coliseum, 1963-; John E. Longden (bust), 1966, Santa Anita Park, 1966 & William Shoemaker (bust), Areadia, Calif., 1971, Los Angeles Turf Cl. **Comments:** Preferred media: bronze. Positions: v. pres. design, Hoffman Electronics Corp., 1944-65; dir. design, Teledyne-Packard Bell, 1965-. **Sources:** WW73; "Clay & Bronze," *Saturday Night* (Jan., 1939); Janice Lovoos, "The Portrait Sculpture of Joseph Portanova," *Am. Artist* (Jan., 1965).

PORTE CRAYON See: **STROTHER, David Hunter**

PORTER, Agnes *[Painter] mid 20th c.; b.Hartford, CT.*
Addresses: Rockport, MA. **Studied:** Yale Art Sch.; Eliot O'Hara, Stanley N. Phillips. **Member:** Rockport AA; North Shore AA; Cambridge AA; Copley Soc., Boston. **Sources:** *Artists of the Rockport Art Association* (1956).

PORTER, Beata Beach See: **BEACH, Beata (Mrs. Vernon C. Porter)**

PORTER, Benjamin Curtis *[Painter] b.1845, Melrose, MA / d.1908.*
Addresses: Boston, through 1872; NYC, from 1883. **Studied:** W. Rimmer and A. H. Bicknell in Boston; Académie Julian, Paris, 1881-83. **Member:** NA, 1880; SAA, 1903; NSS; NAC; NIAL. **Exhibited:** NAD, 1867-1900 (15 annuals); Boston AC, 1882-83; Paris Expo, 1900 (med.); Pan-Am. Expo., Buffalo, 1901 (med.); PAFA Ann., 1903; St. Louis Expo, 1904 (med.); Corcoran Gal. annual, 1907. **Comments:** Known especially for his portraits, he also painted figural works. He traveled to Europe 1872 and in 1875, visiting Venice and Paris, and again in the early 1880s. **Sources:** WW08; Clement and Hutton; Falk, *Exh. Record Series.*

PORTER, Bernice S. *[Painter] mid 20th c.*
Exhibited: Salons of Am., 1934. **Sources:** Marlor, *Salons of Am.*

PORTER, Bruce *[Mural painter, designer, writer] b.1865, San Francisco, CA / d.1953, San Fran.*
Addresses: San Fran. **Studied:** England, France, Italy. **Member:** Bohemian Club; Am. PS. **Exhibited:** San Francisco AA, 1916. **Award:** Chevalier Legion of Honor, France. **Work:** Stevenson

mem., San Fran.; stained glass/murals, churches and pub. bldgs. of Calif. **Comments:** Author: "The Arts in California.". **Sources:** WW40.

PORTER, Charles Ethan *C. E. Porter.*
[Painter] b.1847, Hartford, CT / d.1923.
Addresses: NYC, active 1869-78; intermittently in Hartford, CT, 1878-89; Rockville, CT, in 1921. **Studied:** NAD, beginning 1869; Paris, 1881-84. **Member:** CAFA. **Exhibited:** NAD, 1871, 1876, 1885-86. **Work:** Lyman Allyn Art Mus., New London, CT. **Comments:** One of the first African American to exhibit at the NAD, he specialized in still-lifes, particularly of fruits and flowers. Returned to Hartford in 1884 and was active in art community; also a friend of Mark Twain. **Sources:** WW21; Gerdts, *Art Across America*, vol. 1: 109-11 (repro.); Art in Conn.: Early Days to the Gilded Age.

PORTER, David *[Painter] mid 20th c.*
Exhibited: Corcoran Gal biennial, 1959. **Sources:** Falk, *Corcoran Gal.*

PORTER, David *[Amateur artist, military officer, diplomat] b.1780, Boston / d.1843, Constantinople (now Istanbul, Turkey).*
Comments: Entered U.S. Navy as a midshipman in 1798, served (with distinction) as captain of several ships during the War of 1812. Sketches by Porter were used to illustrate his *Journal of A Cruise Made in the Pacific Ocean in the Years 1812, 1813 and 1814.* Eventually resigned from the service in 1826 to become Commander-in-Chief of the Mexican Navy. In 1830 he was named U.S. Consul at Algiers; a little over a year later he became American Chargé d'Affaires at Constantinople and in 1839 Minister to Turkey. **Sources:** G&W; DAB; rare books, Library of Congress; Stauffer (under William Strickland).

PORTER, David See: **PORTER, (Edwin) David**

PORTER, Doris Lucille (Mrs. Donald J. McLean) *[Painter, lecturer, teacher, sculptor, lecturer] b.1898, Norfolk, VA.*
Addresses: Norfolk, VA; Burlington, NJ. **Studied:** H. Breckenridge; Hans Hofmann in Munich and Capri, Italy, 1928; Cleveland Sch. Art; PAFA, 1933; Wayne State Univ. (B.A. & M.A. art educ.), 1937; Univ. Michigan (M.F.A., 1942); also with Zoltan & Vaclav Vytlacil. **Member:** Norfolk Art Corner; Portrait Assn., Detroit; North Shore AA; Grosse Pointe Artists; SSAL; Norfolk SA; Redford AC; AFA; Ann Arbor AA; Michigan WCS; Ann Arbor Women Painters (pres.); Detroit Soc. Women P&S (life mem.; vice-pres., 1941); Women Painters of Ann Arbor (pres. & hon. founder, 1950); Palette & Brush, Detroit (founder & hon. pres., 1934). **Exhibited:** Norfolk SA, landscapes, 1925-27 (3 prizes), portrait/landscape, 1929 (prize); S. Indp. A., 1927; Grosse Pointe Artists Award, 1933-34, 1937, 1950; NAD, 1933 (Lambert Award), 1934; PAFA Ann., 1933; VMFA, 1934; Detroit IA, 1939, 1941, 1943, 1946, 1948, 1953, 1955-56; Argent Gal., 1939 (solo); Mus. Arts & Sciences, Norfolk, 1940; Corcoran Gal. biennial, 1941; Detroit Soc. Women P&S, 1947 (prize), 1949 (prize), 1962-64; Michigan Artists, Toledo, 1949; Detroit Mus., 1950; Flint MA, 1950 (solo); Scarab Club, 1950; Palette & Brush Cl., 1951-52; Terry AI, 1952; Michigan WCS, 1952; VMFA, 1952; Univ. Michigan; Ann Arbor Women Painters, 1962-64; Ann Arbor Artists, 1962-64; Michigan Acad. Arts & Sciences. **Work:** portrait, Wythe House, Williamsburg, VA; TMA; Cranbrook Acad. Art; murals PAFA, Ford Sch., Highland Park, MI, 1935.; Norfolk Col. Commerce; Wayne Univ.; Michigan State Normal Col., Ypsilanti; Dearborn Hist. Soc.; Phila.; Cranbrook Mus., Bloomfield Hills, MI; Univ. Michigan. Commissions: mural, St. Mary's Hall, Burlington, VT, 1933; mural, Sweitzer (bust), Sweitzer School, Wayne, MI, 1965. **Comments:** Painted portraits, landscapes, murals, still lifes in oils & watercolors. Teaching: Michigan State Normal College, 1939-41; Univ. Michigan, 1945; Wayne Public Schools, 1950-56; chmn., Art Section, Mich. Acad. Arts, Sciences & Letters, 1962-63. Owner & dir., Olde Towne Gal., Portsmouth, VA, 1970; hd.,

Frederick Col., Dartsmouth, VA. **Sources:** WW73; WW47; WW66; Falk, *Exh. Record Series;* articles in newspapers reports of Michigan Acad. Arts, Sciences & Letters.

PORTER, E. T. *[Painter] mid 19th c.*
Exhibited: NAD, 1867. **Sources:** Naylor, *NAD.*

PORTER, (Edwin) David *[Painter, sculptor] b.1912, Chicago, IL.*
Addresses: Wainscott, NY; NYC, 1951. **Exhibited:** WMAA, 1951; Corcoran Gal biennial, 1959; "Editions in Plastic," Jewish Mus., NYC, 1969; Outdoor Sculpture, Artists of the Region, Guild Hall, NY, 1970; "Artists at Dartmouth," City Hall, Boston, Mass., 1971; Hemisphere Cl., Time-Life Bldg., NYC, 1971; Artists of Suffolk County, Part V, New Directions, Heckscher Mus., Huntington, NY, 1971. Awards: gold medal of Pres. Gronchi of Italy, Sassoferrato, Italy, 1961; Beaux Arts Award in painting, Beaux Arts Cl., 1969; grant, NIAL, 1970. **Work:** WMAA; Miami-MoMA; Chrysler Art Mus.; Norfolk Mus. Arts & Sci.; Parish Art Mus., Southampton. **Comments:** Author: "Why I Ran Away," *Am Weekly* (July, 1960). Teaching: artist-in-residence, Dartmouth Col., 1964-65; artist-in-residence, Cooper Union, 1967-68; lecturer, Corcoran Gal., 1968-69. **Sources:** WW73; "Today's Living," *New York Herald Tribune,* 1956; "The making of a construction" (TV film interview), Voice Am., 1957; articles on work in newspapers in Norway & Sweden, 1960.

PORTER, Eleanor S. *[Painter] mid 20th c.*
Addresses: Great Neck, LI, NY. **Exhibited:** S. Indp. A., 1934. **Sources:** Marlor, *Soc. Indp. Artists.*

PORTER, Eliot Furness *[Photographer, writer] b.1901, Winnetka, IL. / d.1990.*
Studied: Harvard. Medical Sch., 1929 (where he taught biochemistry until 1939). **Exhibited:** An American Place, NYC 1938-39. **Work:** MMA. **Comments:** Widely known for his bird and nature photographs in color, his name is firmly linked with the Sierra Club and its promotion of conservation causes. He was encouraged by Ansel Adams and Alfred Stieglitz, and the latter's exhibition of his work in 1938-39 sparked him to devote his full time to photography. **Sources:** Witkin & London, 216.

PORTER, Elmer Johnson *[Painter, educator, designer] b.1907, Richmond, IN.*
Addresses: Cincinnati, OH; Terre Haute, IN. **Studied:** AIC, 1926-29 (B.A.E.); Ohio State Univ. (M.A.); Earlham Col.; Univ. Cincinnati; Univ. Colorado; Butler Univ.; San Carlos Univ., Guatemala. **Member:** Cincinnati Crafters; Western AA; Am. Soc. Bookplate Collectors & Des.; Art Educ. Assn. Indiana (pres., 1952-1953, secr.-treas., 1954-67); Kappa Pi (int. secr., 1970-); Nat. Art Educ. Assn.; Am. Soc. Bookplate Collectors & Designers; Pen & Brush Cl. **Exhibited:** Iowa Artists Exhibit, Mt. Vernon, 1938; Indianapolis AA, 1929 (applied arts prize); Hoosier Salon, 1939 (Bonsib. purchase prize); 1940 (prize); Columbus Art League, 1938 (watercolor award).; Richmond, IN., 1929 (prize); Cincinnati; Indiana Exh., Herron AI, 1929 (prize); NYC. **Work:** Richmond (IN) H.S. Collection; murals, Shrine Temple dining-room, Cedar Rapids, IA. **Comments:** Preferred media: watercolors. Publications: auth., "Bookplates of Ernest Haskel," *Bookplate Ann.* (1951). Teaching: instr. art, McKinley High School, Cedar Rapids, Iowa, 1930-37; instr., Hughes H.S., Cincinnati, 1938-46; prof. art, Indiana State Univ., Terre Haute, 1946-. **Sources:** WW73; WW47; Ness & Orwig, *Iowa Artists of the First Hundred Years,* 168.

PORTER, Fairfield *[Painter, lecturer, writer] b.1907, Winnetka, IL / d.1975, Southampton, NY.* *Fairfield Porte* [signature]
Addresses: Southampton, Long Island, NY, from 1949. **Studied:** Harvard Col. (B.S., 1928); ASL, with Boardman Robinson & Thomas Hart Benton, 1928-30. **Member:** Int. Assn. Art Critics. **Exhibited:** PAFA Ann., 1934, 1962, 1966; AIC, 1935-38; five biennials, WMAA, 1959-67; Univ. Ala., 1964; Univ. Southern Ill., 1964; Purdue Univ., 1966 (purchase prize); Cleveland MA, 1967 (retrospective); Colby Col., 1969; M. Knoedler & Co, NYC,

1970s: Hirschl and Adler Gals., NYC, 1974 (retrospective). **Work:** MoMA; WMAA; MMA; BM; CGA; Hirshhorn Mus.; Cleveland Mus.; Wadsworth Atheneum; Univ. Nebr.; Purdue Univ.; Mus. of N. Mex., Santa Fe. **Comments:** Realist painter. Known for his intimate interior scenes, landscapes, and portraits (including ones of artist Larry Rivers and poet John Ashbery). Painted on Monhegan Island (Me.) and was a longtime summer resident of Spruce Head Island, Me. As a young man Porter studied art history with Bernard Berenson, and later, during the 1950s, wrote wrote art reviews and a book on Thomas Eakins (1959). Awards: Longview Found. Award for criticism in *The Nation,* 1959. Teaching: adj. prof. art, Southampton Col., Long Island Univ.; instr., Queens Col., NY, 1969; prof. & artist-in-residence, Amherst Col., 1969-70. Positions: ed. assoc., *Art News,* 1951-58; art critic, *The Nation,* 1959; also contributed articles to *Art in Am., Art & Lit.,* and others. Author: *Thomas Eakins* (Braziller, 1959). **Sources:** WW73; John Spike, *Fairfield Porter: An American Classic* (NYC: Abrams, 1992); John W McCoubrey, *American Tradition in Painting* (Braziller, 1963); Baigell, *Dictionary;* Curtis, Curtis, and Lieberman, 185; Falk, *Exh. Record Series.*

PORTER, Frank *[Painter] early 20th c.*
Addresses: Kansas City, MO. **Sources:** WW17.

PORTER, Franklin *[Silversmith] b.1869 / d.c.1936.*
Addresses: Danvers, MA. **Studied:** RISD. **Work:** eucharistic vessels, Chapel of the Resurrection, Nat. Cathedral, Wash., DC, sanctuary lamp, St. John's Church, Portsmouth, NH. **Sources:** WW35.

PORTER, George Edward *[Illustrator] b.1916, Perry, FL.*
Studied: Ringling Sch. A., Sarasota, FL; Phoenix AI, NYC, with Lucille Blanche, Th. Fogarty, Sr., Franklin Booth, L. Phoenix; BM, with Reuben Tam. **Member:** SI. **Exhibited:** SI annuals; Art Dir. Cl., NYC and Baltimore. **Comments:** Illus., *Good Housekeeping, The Saturday Evening Post,* and other national magazines. **Sources:** W&R Reed, *The Illustrator in America,* 272.

PORTER, George Taylor *[Painter] 19th/20th c.*
Addresses: Paris, France. **Studied:** Académie Julian, Paris, 1897. **Exhibited:** PAFA Ann., 1901. **Sources:** WW04; Fehrer, The Julian Academy; Falk, *Exh. Record Series.*

PORTER, Isabel See: **COLLINS, Isabel Margaret Porter**

PORTER, J. Erwin *[Painter] b.1903, Medina, NY.*
Addresses: Tucson, AZ. **Studied:** Rochester Inst. Tech. **Member:** fellow, Rochester Mus. & Science Center; AWCS; All. A. Am.; Rochester A. Cl.; Genesee Group. **Exhibited:** AWCS, 1961-68 (four shows); NAD, 1963 & 1965; All. A. Am., 1963-71 (six shows); Smithsonian Inst., 1967 (solo); Nat. Arts Cl. Ann., 1967-70. Awards: Rochester A. Cl. Awards, 1964, 1965, 1968 & 1969; Widmer Wine Co. Award, Mem. Art Gal. Finger Lakes Exhib., 1968. **Work:** Marine Midland Bank; Monroe Co. Savings Bank; Rochester Savings Bank; New Paltz Savings Bank; Charles Rand Penny Foundation. **Sources:** WW73; article, *Am. Artist,* (June, 1966).

PORTER, J. T. *[Engraver] early 19th c.*
Addresses: Middletown, CT, 1815. **Sources:** G&W; Stauffer.

PORTER, James A. *[Art historian, writer, painter, illustrator, designer, educator] b.1905, Baltimore, MD / d.1970, Wash., DC.*
Addresses: Wash., DC. **Studied:** Howard Univ. (B.S.); ASL, with George Bridgman and Dimitri Romanovsky; NY Univ. (MA.); Sorbonne, Paris, France (Medieval Art Study); Cuba and Haiti, 1945-46; Rubens House, Brussels, Belgium, summer 1955; Instituto Allende, Mexico, summer 1961 (fresco painting); West and North Africa,1963-64 (African Art and Arch.). **Member:** Arts Council of Wash., DC; CAA; Am. A. Cong.; Belgian-American Art Seminar; United Negro College Fund Comm.; Museum of African Art (charter mem.). **Exhibited:** Wash. WCC, 1926-28;

Harmon Exh., 1928-1929 (hon. men.), 1930, 1933 (prize); Nat. Exh. Negro Art, 1928-45; Smithsonian Inst., Exh. of Paintings and Sculpture of American Negro Artists, 1929, 1930, 1933; Howard Univ. Gal., 1930, 1938, 1965, 1992-93 (all solos); 13th annual Philadephia WC Exh., 1932; AWCS, 1931; Dept. Labor Auditorium, 1942; A. Week Exh., 1942, 1944; Atlanta Univ., 3rd annual exh., 1944; Barnett-Aden Gal., Wash., DC, 1948 (solo); Dupont Theater Art Gal., Wash., DC, 1948 (solo) Calif. Arts Commission, The Negro in American Art, 1966-67 (traveling); LACMA, 1976 (Two Centuries of Black American Art); Bellevue, WA, Art Mus., Hidden Heritage, 1986-87 (traveling). Awards: fellowship, Institut d'Art et d'Archéologie, Université de Paris, Sorbonne, 1935; second prize, best review, *Journal of Negro History*, 1937, 1941; Rockefeller Found. Travel Grant, Cuba & Haiti, 1945-46; fellowship, Belgian American Educational Found. and the Belgian Ministry of Education, Belgium, 1955; Achievement in Art, Pyramid Cl., Phila., 1955; Evening Star Faculty Research Grant, Howard Univ., 1964 (Brazil); America's Outstanding Men of the Arts, National Gal., 1965. **Work:** DuSable Mus. of African Am. History, Chicago, IL; Fisk Univ.; Hampton Inst.; Howard Univ. Gal. A.; Lincoln Univ., Jefferson City, Mo.; Harmon Fnd., NY; Mus. of African Am. Art, Tampa, FL; National Afr.-Am. Mus. and Cultural Center, Wilberforce, OH; National Portrait Gal.; IBM; murals, 12th Street Branch, YMCA, Wash., DC, Rankin Chapel, Wash., DC. **Comments:** His publication, "Modern Negro Art," 1943, laid the foundation for the study of African-American, African, and African-Brazillian art history. His numerous other publications include "The Negro Artist and Racial Bias," *Art Front* (March 1936), 8-9; "Robert S. Duncanson, Midwestern Romantic-Realist," 1951; *Ten Afro-American Artists of the Nineteenth Century* (Wash., DC: Howard Univ. Gal. of Art, 1967). Contributor to *Art in America, Art Quarterly, Encyclopedia of the Arts.* Position: prof. and chairman in the Dept. Art at Howard Univ., Wash., DC. 1953-70. Illus., "Playsongs of the Deep South"; "Talking Animals." **Sources:** WW59; WW47; *James A. Porter, Artist and Art Historian: The Memory of the Legacy* (Wash., DC: Howard Univ. Gal. of Art, 1992); Bearden and Henderson, *A History of African-American Artists;* Driskell, *Hidden Heritage*, 41, 61 (repro. fig. 43); Cederholm, *Afro-American Artists* (cites a death date of 1971); add'l info. courtesy Jacqueline Francis, New Haven, Conn.

PORTER, James Tank *[Sculptor] b.1883, Tientsin, China / d.1962, La Mesa, CA.*
Addresses: La Mesa, CA. **Studied:** Pomona Col. (B.A.); ASL; & with George Bridgman, Robert Aitken, Gutzon Borglum. **Member:** San Diego FA Soc.; Spanish Village A. Center; San Diego A. Gld.; Contemporary A. San Diego. **Exhibited:** San Diego FA Soc., 1923-24 (prize), 1924-41; AIC; NAD; PAFA Ann., 1925, 1933; GGE, 1939. **Work:** Beloit Col.; San Diego FA Soc.; Yale Univ. A. Gal.; San Diego Mus. Natural Hist.; Am. Legion Hall, La Mesa; Ellen B. Scripps Testimonial, La Jolla; portrait busts, Pomona Col., Methodist Episcopal Church of North China, Peking; bronze portrait relief, Mercy Hospital, San Diego. **Sources:** WW59; WW47; Falk, *Exh. Record Series.*

PORTER, Jennie C. *[Artist] 19th/20th c.*
Addresses: Active in Grand Rapids & Jackson, MI, 1878-1900. **Sources:** Petteys, *Dictionary of Women Artists.*

PORTER, John *[Portrait painter] mid 19th c.*
Addresses: Believed to have been active 1853, probably in Virginia. **Sources:** G&W; Willis, "Jefferson County Portraits and Portrait Painters."

PORTER, John J (ames) *[Landscape and portrait painter] b.1825, Beaver County, PA.*
Addresses: NYC; Culpeper, VA, c.1853 and after. **Studied:** NYC; Europe. **Exhibited:** NAD, 1848; American Art-Union, 1848-50 (included a scene in Schoharie County, NY). **Work:** Virginia Polytechnic Inst.; Virgina State Lib. **Sources:** G&W; Cowdrey, NAD; Cowdrey, AA & AAU. More recently, see Wright, *Artists in Virginia Before 1900.*

PORTER, John L. *[Patron] b.1868, Meadville, PA / d.1937, Clifton Springs, NY.*
Addresses: Pittsburgh, PA. **Member:** mem./founder: One Hundred Friends of Pittsburgh Art, 1916; CI FA Committee. **Comments:** Position: vice pres., Carnegie Inst.

PORTER, John S. *[Miniaturist] early 19th c.*
Addresses: Boston from 1822 to 1833 and at Lowell, MA in 1834. **Exhibited:** Boston Athenaeum, 1833. **Comments:** Possibly the John Porter of Massachusetts listed in Lipman and Winchester. **Sources:** G&W; Swan, BA; Belknap, *Artists and Craftsmen of Essex County,* 12; Bolton, *Miniature Painters; cf. Antiques,* XXIII, 13-14.

PORTER, Julia S. Gunnison *[Painter] b.1867, Glendale, OH / d.1952.*
Addresses: San Diego County, CA. **Studied:** ASL; NAD; Académie Julian, Paris; Mc Gill Univ., Montreal, Canada. **Exhibited:** San Diego Fine Art Gal., 1927; San Diego Art Guild, 1941. **Sources:** Hughes, *Artists in California,* 444.

PORTER, Katherine *[Painter] b.1941.*
Addresses: Boston, MA, 1969; Santa Fe, NM, 1973; Lincolnville, ME. **Exhibited:** WMAA, 1969, 1973, 1981. **Sources:** Falk, *WMAA.*

PORTER, Katherine Anne (Miss) *[Painter] b.1890, Indian Creek, TX / d.1980, Silver Spring, MD.*
Addresses: NYC. **Exhibited:** S. Indp. A., 1927. **Sources:** Marlor, *Soc. Indp. Artists.*

PORTER, L(aura) Schaefer (Mrs.) *[Painter, educator] b.1891, Fort Edward, NY.*
Addresses: Gainesville, GA; Fort Edward, NY. **Studied:** NY Sch. Art; ASL; Skidmore Col.; and with Robert Henri, William M. Chase, Kenneth Hayes Miller, Wayman Adams. **Member:** ASL; Southeastern AA; Georgia Artists; AAPL; Phila. Arts & Crafts Gld.; Syracuse AA. **Exhibited:** NYWCC, 1939.; Phila. Arts & Crafts Gld., 1932-33; MMA; Glens Falls Lib., 1953 (solo); Ogunquit AC, 1953; Town Hall, NY; Mill Artists Colony, Elizabethtown, NJ, 1953; Fort Edward (NY) Art Center, 1953-55; Syracuse Mus. FA, 1954-55; Manchester (VT) FA Center; Syracuse Univ., 1954. **Work:** Pittsburgh Lib.; Brenau Col., Gainesville, GA; Simmons Col. Chapel; Walter Reed Hospital, Wash., DC; Fort Edward Art Center; Labor Union offices, Fort Edward; Kappa Pi Coll. **Comments:** Position: art professor, Fort Edwards, NY. **Sources:** WW66; WW47.

PORTER, Lenora B. *[Painter] 20th c.*
Addresses: La Mesa, CA. **Exhibited:** San Diego Art Guild, 1936. **Sources:** Hughes, *Artists in California,* 444.

PORTER, Louis H., Jr. *[Painter] mid 20th c.*
Studied: ASL. **Exhibited:** S. Indp. A., 1942. **Comments:** Possibly Louis H. Porter, Jr, b.1904-living, 1946. **Sources:** Marlor, *Soc. Indp. Artists.*

PORTER, Love (Miss) *[Painter] b.1876, Maryland / d.1960, Laguna Beach, CA.*
Addresses: NYC; Laguna Beach, CA. **Exhibited:** S. Indp. A., 1917, 1920-21, 1927-30, 1940; Salons of Am., 1928, 1934; NAWA, 1935-38. **Sources:** WW40.

PORTER, M. *[Portrait painter] mid 19th c.*
Addresses: Active in Vermont, c.1830. **Comments:** Painter of a portrait of Philip Crosby Tucker (1800-61) of Vergennes (VT), dated 1830. **Sources:** G&W; WPA (Mass.), *Portraits Found in Vermont.*

PORTER, Mardi *[Portrait painter] mid 20th c.*
Exhibited: P&S of Los Angeles, 1938; Calif. AC, 1939. **Sources:** Hughes, *Artists in California,* 444.

PORTER, M(ary) K(ing) *[Miniature and landscape painter] b.1865, Batavia, IL / d.1938, Wash., DC.*
Addresses: Wash., DC/Charmain, PA. **Studied:** Volk, in Chicago; ASL, Wash., DC; B. Perrie; Snell. **Member:** Wash. WCC; Wash. AC. **Exhibited:** Wash. WCC; Cosmos Cl., 1902; Maryland Inst.,

1930; Gr. Wash. Indep. Exhib., 1935. **Comments:** She was well known for her drawings and watercolors of houses and other Wash., DC places of historic importance. **Sources:** WW38; McMahan, *Artists of Washington, D.C.*

PORTER, Mary S. *[Amateur artist] late 19th c.*
Addresses: Active in Detroit, MI, 1879-93. **Sources:** Petteys, *Dictionary of Women Artists.*

PORTER, Mary Weber *[Painter] b.1904, Olney, IL.*
Addresses: Fairfield, IL, 1998. **Studied:** AIC, c.1922-24; Rend Lake, IL., art seminars, Univ. of Illinois, 1970-80. **Member:** Mitchell Mus. A., Mt. Vernon, IL. **Exhibited:** has received recognition and awards from the mid-1970s onward. **Work:** Mitchell Mus. A., Mt. Vernon, IL. **Comments:** Work reproduced on covers of *Outdoor Illinois* in Aug.-Sept., 1976 and Oct., 1977. **Sources:** info. courtesy Mary Gillaspy, Oley, PA.

PORTER, Priscilla Manning *[Craftsman, teacher, lecturer, educator, writer] b.1917, Baltimore, MD.*
Addresses: NYC; Wash., CT. **Studied:** Bennington Col. (BA, 1940). **Member:** Soc. Conn. Craftsmen; Artist-Craftsmen New York. **Exhibited:** Syracuse Mus. FA, 1953; NY Soc. Ceramic A., 1947-55; NY Soc. Craftsmen, 1954-55; San Jose State Col. Glass Exhib., 1964; Craftsmen of the Eastern States, sponsored by Smithsonian Inst., 1966. **Awards:** cert. of merit, Artist-Craftsmen New York, 1968. **Work:** bowl in collection of Pottery Sch., Faenza, Italy; fused & epoxied glass panel, New Britain Mus., Conn.; fused glass animal in permanent collection of Corning Mus. Glass, NY. **Commissions:** fused glass cross, St John's Episcopal Church, Wash., Conn., 1962; fused weed-ash cross, Emmanuel Episcopal Church, Baltimore, Md., 1963 and mosaic triptych; First Unitarian Church, Balt., Md.(mosaic triptych); Noah's Ark (fused glass epoxied to plate glass panels), North Shore Unitarian Soc., Plandome, Long Island, 1971. **Comments:** Teaching: instr. ceramics, dept educ., MoMA, 1952-61. **Sources:** WW73.

PORTER, Raymond A(verill) *[Sculptor, teacher] b.1883, Hermon, NY / d.1949, Boston, MA.*
Addresses: Chicago ,1904; thereafter in Chelmsford, Watertown, Boston, all MA. **Member:** Boston SS; Cambridge AI. **Exhibited:** AIC, 1904; PAFA Ann., 1913, 1916. **Work:** Pres. Tyler Mem., Richmond, Va.; statue, Rutland, Vt.; Victory Mem., Salem, Mass.; mem., Commonwealth Armory, Boston; mem., Leominster, Mass.; mon., Somerville, Mass.; mon., State House, Boston. **Comments:** Teaching: BMFA Sch. **Sources:** WW40; Falk, *Exh. Record Series.*

PORTER, Rebecca T. *[Painter] late 19th c.*
Addresses: New Haven, CT. **Exhibited:** NAD, 1891 (poss., 1869). **Sources:** Naylor, *NAD.*

PORTER, Rufus *[Itinerant portrait and mural painter, silhouettist, author, editor, inventor] b.1792, West Boxford, MA / d.1881, New Haven, CT (visiting one of his sons).*
Work: Maine State Mus. (wall fresco from private house in Winthrop, Maine); Rockefeller Folk Art Ctr., Williamsburg, VA. **Comments:** One of America's most fascinating artists of the 19th-century, Porter was also a brilliant inventor. He was brought up in Maine, beginning around 1800. About 1810, he began his career there as a house and sign painter, shoemaker, and farmer. In 1816, he became a portrait painter in New Haven, CT, where he also made fiddles. He worked as an itinerant portrait painter throughout New England and the Mid-Atlantic states until c.1823, traveling as far South as Virginia. In 1823, he began to paint landscapes as well as portrait miniatures (on ivory and paper). He also created silhouettes using a camera obscura of his own design, and could complete an exacting silhouette in 15 minutes. Porter continued his itinerant ways, and from 1824-45 traveled about, painting the landscape murals for which he is best known. His more than 150 murals usually featured New England country scenes and included such motifs as steamboats and barns; they were often painted either over mantelpieces or around the entire room. In 1840, in NYC, he started the magazine, *New York Mechanic,*

soon changing its name to *American Mechanic* which, in turn, became *Scientific American.* By 1845, he had quit painting his murals in favor of editing the magazine. He also continued his work as an inventor and was the author of several books, including *A Select Collection of Valuable and Curious Arts and Interesting Experiments* (1825-26). Despite the lack of a formal education, Porter was a brilliant and meticulous inventor. To name a few of his numerous inventions: he was the first person to engineer the moving of an entire 3-story home in Connecticut; he invented modular housing; built his own steam auto in 1830, and a steam engine that is the precursor to modern automotives; he invented the revolving-barrel rifle; plus, a small dirigible airship with pointed ends. Although his portraits were as precise as those of Saint-Mémin, his murals reveal his joy in paining scenes of whimsy and fantasy rather than the accute observation of nature one might come to expect from an inventor who was always mechanically precise. He even published a series of essays about his mural paintings in *Scientific American.* He is even known to have experimented with deliberately abstract woodcuts, anticipating modern art by nearly a century. Despite his genius and prolific production, Porter was a maverick with little financial sense, and was never rewarded with wealth or status. The artist Stephen Twombly Porter was his son, and Jonathan D. Poor was his nephew (see entries). **Sources:** G&W; Lipman, *Rufus Porter, Yankee Wall Painter,* contains a checklist and 25 repros.; see also: Lipman and Winchester, 57-66; Little, *American Decorative Wall Painting,* 132; DAB. More recently see Baigell, *Dictionary;* Lipman, *Rufus Porter Rediscovered,* exh. cat., Hudson River Museum, Yonkers, NY, 1980; *300 Years of American Art,* vol. 1, 110; add'l info courtesy Porter lecturer, Gregory Smart (Lexington, MA).

PORTER, S. C. See: **PORTER, S(uzanne) C.**

PORTER, Stephen Twombly *[Wall painter] b.1816, Portland, ME / d.1850, Billerica, MA.*
Addresses: NYC. **Comments:** The son of Rufus Porter (see entry), he worked with his father as a wall painter and later (1841-42) on his father's magazine, *New York Mechanic* (later *Scientific American*). **Sources:** G&W; Little, *American Decorative Wall Painting,* 132.

PORTER, S(uzanne) C. *[Painter] late 19th c.; b.Hartford, CT.*
Studied: Gladwin and Seth Cheney and NYC, 1859; Wheeler, in Hartford, 1863; Tissier, Paris, 1873. **Exhibited:** Paris Salon, 1875; Centennial Exh., Phila., 1876. **Sources:** Petteys, *Dictionary of Women Artists;* Fink, *American Art at the Nineteenth-Century Paris Salons,* 381.

PORTER, Vernon Carroll *[Director, painter, designer] b.1896, Cleveland, OH.*
Addresses: Tompkins Corners, NY; NYC; Putnam County, NY. **Studied:** ASL; Grand Central Sch. A.; Mechanics Inst.; Brooklyn Polytechnic Inst. **Member:** AA Mus.; Am. FA Soc. **Comments:** Position: dir., Am. FA Soc. (1937-38), Riverside Mus., 1938-; dir., NAD, 1950-. Husband of Beata Beach Porter. **Sources:** WW66; WW47.

PORTER, Vernon Carroll (Mrs.) See: **BEACH, Beata (Mrs. Vernon C. Porter)**

PORTER, Veva *[Painter] mid 20th c.*
Addresses: Modesto, CA. **Exhibited:** San Francisco AA, 1937-38. **Comments:** Specialty: watercolors. **Sources:** Hughes, *Artists in California,* 444.

PORTER, Vida L. *[Amateur painter] b.1889, Sherman, TX / d.1985, Wash., DC.*
Studied: Howard Univ.; Corcoran Sch. A. **Comments:** Teacher: Wash., DC public schools, 1920-early 1960s. **Sources:** McMahan, *Artists of Washington, D.C.*

PORTER, Vivian Forsythe *[Painter] b.1880 / d.1982.*
Addresses: New England. **Comments:** See mention under T. Bailey.

PORTER, William Arnold *[Decorator, landscape painter, teacher]* b.1844, Worcester, England / d.1909.
Addresses: Phila., PA. **Studied:** South Kensington Mus., London. **Member:** Phila. Sketch Cl.; Phila. SA; Phila. AC; Pen Cl. **Exhibited:** PAFA Ann., 1887. **Comments:** His first work on coming to New York was to decorate a service of china for Pres. Grant. Position: t., Spring Garden Inst., Phila., for more than 36 years. **Sources:** WW10; Falk, *Exh. Record Series*.

PORTER, William E. *[Engraver]* mid 19th c.
Addresses: Warren, Ohio, active 1853. **Exhibited:** NAD, 1867, 1873. **Sources:** G&W; Ohio BD 1853.

PORTER, William T. *[Painter]* mid 19th c.
Addresses: New Orleans, active 1866-67. **Comments:** Worked at Pike's Opera House, Cincinnati, OH and then at the Varieties Theatre and Academy of Music in New Orleans. **Sources:** *Encyclopaedia of New Orleans Artists*, 313.

PORTEUS, C. R. *[Mural painter, sculptor]* b.1868 / d.1940.
Addresses: Milwaukee, WI. **Studied:** NYC. **Comments:** Sculpted all figures for French Pavillion at the St. Louis Centennial.

PORTINARI, Candido *[Painter]* mid 20th c.
Exhibited: AIC, 1941. **Sources:** Falk, *AIC*.

PORTLOCK, Nathaniel *[Amateur sketch artist]* b.c.1748, England / d.1817.
Comments: British naval officer who visited the Northwest coast of the present United States in 1786-87 and made some sketches which were used to illustrate *A Voyage Round the World; But More Particularly to the North-West Coast of America: Performed in 1785, 1786, 1787, and 1788, in the King George and Queen Charlotte, Captains Portlock and Dixon.* **Sources:** G&W; Rasmussen, "Art and Artists in Oregon," cited by David C. Duniway; DNB.

PORTMANN, Frieda Bertha Anne *[Painter, sculptor, teacher, designer, writer]* b.1895, Tacoma, WA / d.1976, Seattle, WA.
Addresses: Seattle, WA. **Studied:** Univ. Wash.; Oreg. State Col.; AIC; Univ. Chicago; Calif. Col. A. & Crafts; Cornish Sch.; Fernand Leger, Glenn Lukens, Clifford Still, Norman Lewis Rice, Peter Camfferman, Edward Du Penn, Julius Heller, Hayter, Lasansky & H. Matsumoto. **Member:** NAWPS; Northwest Printmakers (pres.); Women Painters Wash. (secy.). **Exhibited:** Women P. of Wash., 1940 (prize), 1943 (prize), 1946 (prize); Puyallup (Wash.) Fair, 1946 (prize); Northwest Pr. M., 1936-46; NAWA, 1936-39; SAM, 1937-46; Prints, BMFA; paintings, prints, sculpture & crafts, SAM; sculpture, Denver Mus. Art; painting & print, Oakland Mus. Art; paintings, Argent Gal., NY. **Work:** Calif. Col. A. & Cr.; St. Joseph's Sch., Seattle; Univ. Southern Calif., Los Angeles; AIC; Calif. Col. Fine Arts, Oakland. **Commissions:** Sacajewea (wooden garden sculpture), Seattle, Wash; Beer & Skittles (mural), pvt. home, Seattle; Pioneer Teacher (oils), Pioneer Assn., Seattle; Lily Madonna (ceramics), in garden, Catholic Sch., Seattle; numerous portraits in oils, Seattle. **Comments:** Contributor: educational magazines, newspapers. Teaching: art dir., Walla Walla Pub Schs., Wash.; instr. art & orchestra, Aberdeen Pub. Schs., Wash.; instr. jr. & high sch. art, Seattle Pub. Schs. **Sources:** WW73; WW47.

PORTNER, Edward *[Engraver]* b.c.1835, Pennsylvania.
Addresses: Philadelphia, active 1850-60. **Sources:** G&W; 7 Census (1850), Pa., LV,100; 8 Census (1860), Pa., LI, 44.

PORTNER, Leslie Judd (Mrs.) *[Art critic, writer]* mid 20th c.; b.NYC.
Addresses: Wash. 8, DC. **Studied:** PAFA, with Henry McCarter. **Member:** Women's Nat. Press Cl. **Exhibited:** Awards: Cresson traveling fellowship, PAFA, 1936; Nat. Art Critics award, CAA, 1954, 1955. **Comments:** Positions: sec. to dir., MoMA, 1939-43; specialist, Exhibits Branch, U.S. Office of Education, Wash., DC, 1943-44; specialist, Visual Arts Div., Pan Am. Union, 1944-45; art critic, *Washington Post*, Wash., DC, 1951-. Contributor to *Washington Post; Christian Science Monitor; USIA; Pan American Union Bulletin.* **Sources:** WW59.

PORTNOFF, Alexander *[Sculptor, painter, teacher]* b.1887, Russia / d.1949, Phila., PA.
Addresses: Phila., PA. **Studied:** PAFA; C. Grafly. **Member:** NSS; Intl. Group. **Exhibited:** PAFA Ann., 1913-25, 1929-31; P. P. Expo San Fran., 1915 (prize); AIC; S. Indp. A., 1917. **Work:** Milwaukee AI; BM; PMA; Mus. Western A., Moscow. **Sources:** WW47; Falk, *Exh. Record Series*.

POSCH, Paul Hermann *[Painter, decorator]* b.1877, Berlin, Germany / d.1975, Union City, CA.
Addresses: St. Helena, CA. **Exhibited:** Soc. for Sanity in Art, CPLH, 1945. **Sources:** Hughes, *Artists in California*, 445.

POSEN, Stephen *[Painter]* b.1939, St. Louis, MO.
Addresses: NYC. **Studied:** Washington Univ. (B.F.A., Milliken traveling scholar, 1964-65); Fulbright grant, Italy, 1964-66; Yale Univ. (M.F.A.). **Exhibited:** Highlight of the 1971 Season, Aldrich Mus. Contemp. Art, Ridgefield, Conn., 1971; The New Realists, Chicago Mus. Contemp. Art, 1971; Relativating Realism, Stedelijk Van Abbe Mus., Eindhoven, Holland, 1972; WMAA Ann., 1972; Documenta 5, Kassel, Ger., 1972. **Work:** VMFA; Chase Manhattan Coll. **Comments:** Teaching: instr. drawing, Cooper Union. **Sources:** WW73; David Shirey, "Downtown Art Scene," *NY Times*, Apr. 3, 1971; Ivan Karp, "Rent is the Only Reality," *Arts Mag.* (Jan., 1972); John Canaday, "Whitney Annual," *NY Times*, Feb. 6, 1972.

POSES, Mr & Mrs Jack I. *[Collectors]* b.1899, Russia.
Addresses: NYC. **Studied:** Mr Poses, NY Univ. (B.C.S., 1923, M.B.A., 1924); Brandeis Univ. (LL.D., 1968). **Exhibited:** Awards: Mr. Poses, Chevalier, Legion Hon., 1958; citation distinguished & exceptional serv. to City New York, Mayor Lindsay, 1967. **Comments:** Positions: Mr. Poses, v. chmn., NYC Bd. Higher Educ., 1963-; mem. bd. trustees, mem. educ. & budget comts., founder Poses Inst. Fine Arts & chmn. coun. fine arts, Brandeis Univ.; founder, Einstein Med. Sch. Art interests: established numerous scholarships at many leading universities, as well as devoting active support to major art museums. Collection: French and American. **Sources:** WW73.

POSEY, Leslie Thomas *[Sculptor, educator, architect, decorator]* b.1900, Harshaw, WI.
Addresses: Sarasota, FL. **Studied:** Wis. Sch. Fine & Appl. Arts, with Ferd. Koenig, 1919-23; PAFA, scholar, 1923, also with Albert Laessle; C. Grafly; AIC, 1924 & with Albin Polasek, 1929-30. **Member:** Indianapolis Arch. Cl.; Hoosier Salon; Longboat Key Art Ctr.; Sarasota Art Assn. (dir., 1971-73). **Exhibited:** Milwaukee AI, 1923 (Wisconsin Sculptors & Painters, med, prize), 1930 (Lincoln Int.); Fla. Fed. A., 1940-44, 1945 (prize); Sarasota AA, 1940-46 (first prize, 1940); Ind. Arch. Assn., 1928 (med.); Am. Artists Exhib., AIC, 1930; Hoosier Salon, Marshall Field's Gal., Chicago, Ill, 1930 (Katherine Barker Hickox, first prize); Fla. Int., Lake Land, 1950. **Work:** Walker Theater; Granada Theater; Brightwood Community Bldg., Indianapolis; Manatee Art League, Bradenton, Fla; Contemp. Arts Gal., Pinellas Park, Fla.; Longboat Key Art Ctr., Fla. **Commissions:** Beethoven (limestone), Dr. O. Seivert, Wildwood Park, Wis., 1933; decorative cast stone, Church of the Redeemer, Sarasota, Fla, 1952; garden figure in cast stone, Nat. Coun. Garden Clubs, Athens, Ga., 1954; Kellogg portrait (stone), Dept. Fire Control, Oneco, Fla., 1958; Terry portrait (bronze), Longboat Key Art Ctr., 1970. **Comments:** Preferred media: stone. Positions: sculptor, Am. Terra-Cotta Co., Chicago, 1925-26; hd. sculpture & design, Indianapolis Terra-Cotta Co., Ind., 1926-29. Teaching: dir. sculpture, Posey Sch. Sculpture, 1937-; instr. sculpture, Manatee Art League, Bradenton, Fla., 1952-61; instr. sculpture, Longboat Key Art Ctr., 1961-71. **Sources:** WW73; WW47.

POSNER, Donald *[Art historian]* b.1931, NYC.
Addresses: NYC. **Studied:** Queens Col. (A.B., 1956); Harvard Univ. (A.M., 1957); NY Univ. (Ph.D., 1962). **Member:** Col. Art Assn. Am. (dir., 1970-74); Renaissance Soc. Am.; Am. Soc. 18th-

Century Studies. **Exhibited:** Awards: Phi Beta Kappa award, 1956; Rome prize fel., Am. Acad. Rome, 1959-61; ACLS grant, 1965. **Comments:** Positions: art hist.-in-res., Am. Acad. Rome, 1968-69; ed.-in-chief, *Art Bulletin,* 1968-71. Teaching: instr. art hist., Queens Col., 1957; asst. prof. art hist., Columbia Univ., 1961-62; prof. art hist., NY Univ. Inst. Fine Arts, 1962-. Research: Italian painting in 18th-through 16th-century; French painting of 18th-century. Publications: auth., "Annibale Carracci," 1971; auth., "Caravaggio's homo-erotic early works," *Art Quart.* (1971); co-auth., "17th & 18th Century Art," 1972; auth., "The True Path of Fragonard's Progress of Love," *Burlington Mag.,* (1972); auth., "Watteauls Lady at her Toilet," 1973. **Sources:** WW73.

POSNER, John David (Dr.) *[Painter] b.1889 / d.1965, NYC.*
Addresses: NYC, 1931. **Exhibited:** S. Indp. A., 1931. **Sources:** Marlor, *Soc. Indp. Artists.*

POSNER, Michael *[Painter] early 20th c.*
Exhibited: S. Indp. A., 1918. **Sources:** Marlor, *Soc. Indp. Artists.*

POSSELWHITE, George W. *[Engraver] b.c.1822, England / d.After 1899.*
Addresses: Came to U.S. in 1850, worked mainly in NYC and Philadelphia and was living in New York in 1899. **Sources:** G&W; Stauffer.

POST, Charles Johnson *[Portrait painter, etcher, cartoonist, lecturer, writer] b.1873.*
Addresses: Bayside, NY. **Studied:** J. C. Beckwith; K. Cox. **Comments:** Illustrator: *Harper's, American Legion Monthly, Century, Cosmopolitan,* 1900-36. **Sources:** WW40.

POST, Cornelia S. *[Painter, wood engraver] late 19th c.; b.Montpelier, VT.*
Exhibited: NAD, 1863, 1865. **Comments:** Painted in oil, watercolor, crayon, pen & ink (portraits). Illustrator, Phebe A. Hanaford's "Daughters of America: or Women of the Century," 1883. **Sources:** Petteys, *Dictionary of Women Artists.*

POST, Edward C. *[Landscape painter] mid 19th c.*
Addresses: NYC, 1853; Catskills, NY, 1855-56; Düsseldorf (Germany) in 1860. **Exhibited:** NAD, 1852-56; PAFA, 1856,1860. **Sources:** G&W; Cowdrey, NAD; Rutledge, PA.

POST, Edwina M. *[Painter] 19th/20th c.*
Addresses: NYC, active 1887-1901. **Studied:** Chase at Shinnecock Summer School Art. **Member:** NY Women's AC. **Exhibited:** NAD, 1887; Boston AC, 1890-91. **Comments:** Position: affiliated with Carnegie Studios, NYC. **Sources:** WW01; Falk, *Exh. Record Series.*

POST, George B. *[Painter] mid 19th c.*
Addresses: NYC. **Exhibited:** NAD, 1861-62, 1864. **Sources:** Naylor, *NAD.*

POST, George (Booth) *[Painter, muralist, educator, graphic artist] b.1906, Oakland, CA / d.1997.*
Addresses: San Francisco, CA. **Studied:** Calif. School Fine Arts. **Member:** AWCS; SFAA; Calif. WCS; Int. Inst. Arts & Letters; West Coast WC Soc. **Exhibited:** SFMA, 1935-36 (prize), 1941(solo); Calif.-Pac. Int. Expo, San Diego, 1935; Oakland A. Gal.,1936 (prize), 1947 (prize); San Francisco AA, 1936 (prize); LACMA, 1936, 1945 (prize); AIC, 1936; CPLH, 1936, 1940 (solo), 1945 (solo), 1960 (solo), 1965 (solo, retrospective); Calif. WC Soc., 1947 (prize), 1953 (prize); MMA; DeYoung Mem. Mus.; SAM; San Diego Fine Arts Gal.; Challis Gal., Laguna Beach, 1980s (solo); Mother Lode Exhib., 1955 (prize), 1958 (prize),1960 (prize); Watercolor USA, Springfield (MO) Mus. Art, 1966 (purchase award); Jack London Square Art Festival, 1968 (purchase award); Zellerbach Show, San Francisco, 1975 (first prize); Soc. Western Artists, 1979 (best of show). **Work:** SFMA; SAM; CPLH; San Diego FA Soc.; MMA; Sonora (CA) H.S. **Comments:** Publications: contributor of illustrations, *Fortune, Calif. Arts & Architecture, Art Digest, Am. Artist, Ford Times.* Teaching: instr., Stanford Univ., 1940; prof. fine arts, Calif. Col. A. & Cr., 1947-; instr., San Jose Col., 1951-52. **Sources:** WW73.

POST, Herman *[Painter] mid 20th c.*
Exhibited: Salons of Am., 1934, 1936. **Sources:** Marlor, *Salons of Am.*

POST, Joseph (Mrs.) See: **BRETZFELDER, Anne**

POST, Lou MacLean *[Painter] mid 20th c.*
Addresses: San Francisco, CA, 1932. **Exhibited:** San Francisco Soc. of Women Artists, 1931. **Sources:** Hughes, *Artists in California,* 445.

POST, (Mary) May Audubon *[Painter, illustrator] b.NYC / d.1929.*
Addresses: Phila., PA; Larren & Volendam, Holland, from 1901. **Studied:** PAFA, with Chase, Beaux, Grafly, Breckenridge; Drexel Inst., with H. Pyle; L. Simon, in Paris. **Member:** Phila. WCC; Plastic Club; S. Indp. A. **Exhibited:** PAFA (traveling scholarships); PAFA Ann., 1903-05, 1913-15; Paris Salon, 1902; Phila. AC, 1903 (gold); AIC, 1902-14; S. Indp. A., 1917-20. **Comments:** Active 1903-29. **Sources:** WW27; Petteys, *Dictionary of Women Artists;* Falk, *Exh. Record Series.*

POST, Mildred Anderson (Mrs. A. Kerigan, Jr.) *[Painter, illustrator] b.1892, Wayne / d.1921.*
Addresses: Wayne, PA. **Studied:** W. Everett; T. Oakley. **Member:** Phila. WCC. **Sources:** WW19.

POST, Nellie A. *[Artist] late 19th c.*
Addresses: Active in Alpena, MI, 1897-99. **Sources:** Petteys, *Dictionary of Women Artists.*

POST, William *[Art materials supplier, painter, glazier] b.1720 / d.c.1800.*
Addresses: NYC. **Comments:** Beginning in 1754, he sold paint supplies and brushes in NYC. His sons, William and Gerardus, continued the business until the mid 1830s. The company's successor was the F.W. Devoe Co. **Sources:** Katlan, vol. I, 25.

POST, W(illiam) Merritt *[Landscape painter] b.1856, Brooklyn, NY / d.1935, NYC.* *W.MERRITT POST*
Addresses: Millburn, NJ, 1884; S. Orange, NJ, 1885; NYC, 1888; W. Morris, CT, 1911-on. **Studied:** Samuel F. Johnson, 1880; ASL, with J.C. Beckwith, 1881-82. **Member:** ANA, 1910; AWCS; NYWCC; A. Fund S.; SC, 1900; CAFA; NYSP; Barnard Cl., 1910. **Exhibited:** NAD, 1883-1935, 1910 (prize); Brooklyn AA, 1884, 1886, 1891; Soc. Am. Artists, 1886-1905; Boston AC, 1889-94, 1896-1903, 1905-08; Gill's Art Gal. (Boston, and later Springfield) 1889-1921; AIC, 1890-1919; NYWCC and AWCS, 1890-1919; PAFA Ann., 1892-99; Pan-Am. Expo, Buffalo, 1901 (prize); Corcoran Gal., 1907; St. Louis AM, 1914; Salons of Am., 1934; Salmagundi Cl.; Mattatuck Mus., Waterbury, CT, 1998 (retrospective). **Work:** Newark Mus.; Heckscher Mus.; Mattatuck Mus. **Comments:** A Tonalist known for his landscapes often centering on country streams in autumn. **Sources:** WW33; exh. cat., Mattatuck Mus. (Waterbury, CT, 1998); Falk, *Exh. Record Series.*

POSTGATE, Margaret J. *[Painter, sculptor, designer, teacher, writer] mid 20th c.; b.Chicago, IL.*
Addresses: NYC. **Studied:** AIC; ASL; R. Ryland; M. Young. **Member:** College AA; Ill. Acad. FA. **Exhibited:** Beaux Arts, 1924 (med.); Nat. Small Sculpture Competition, 1924 (prize), 1927 (prize)-28 (prize), NYC; AIC, 1928-30; PAFA Ann., 1929; Harper's Sketch Contest, 1931. **Work:** BM. **Sources:** WW40; Falk, *Exh. Record Series.*

POSTMA, Robert C. *[Painter] late 20th c.*
Addresses: Brooklyn, NY. **Exhibited:** PAFA Ann., 1968. **Sources:** Falk, *Exh. Record Series.*

POTAMKIN, Meyer P *[Collector] b.1909, Phila., PA.*
Addresses: Phila., PA. **Studied:** Dickinson Col. (Ph.B., 1932); Temple Univ. (M.Ed., 1941). **Comments:** Collection: American art, heavy 1880 to 1915 from Hicks to Levine. **Sources:** WW73.

POTEAT, Ida I(sabella) *[Painter, craftsperson, teacher] b.1856, Yanceyville, NC.*
Addresses: Raleigh, NC/Wake Forest, NC. **Studied:** Mounier;

Chase; Parsons. **Comments:** Position: affiliated with Meredith Col., Raleigh. **Sources:** WW25.

POTIN, Emilie *[Sculptor] late 19th c.*
Addresses: Phila., PA. **Exhibited:** PAFA Ann., 1880. **Sources:** Falk, *Exh. Record Series.*

POTRON, Rita *[Painter] late 19th c.; b.San Francisco, CA, to Fr. parents.*
Studied: Mlle. Tirad; Cuyer; Lefebvre; Mme Hortense Richard; Serre; Robert-Fleury. **Exhibited:** Paris Salon, 1892-99. **Comments:** Exhibited drawings at the Paris Salons. **Sources:** Petteys, *Dictionary of Women Artists;* Fink, *American Art at the Nineteenth-Century Paris Salons,* 381.

POTRON DE LA MARLIERE, Rita See: **POTRON, Rita**

POTTENGER, Mary L. *[Painter] mid 20th c.*
Addresses: Los Angeles, CA, 1920s, 1930s. **Member:** Calif. AC; P&S of Los Angeles. **Exhibited:** LACMA, 1927; Pasadena Art Inst., 1930; Artists Fiesta, Los Angeles, 1931; Oakland Art Gal., 1932. **Sources:** Hughes, *Artists in California,* 445.

POTTENGER, Zeb *[Painter] 20th c.*
Addresses: Richmond, IN. **Sources:** WW25.

POTTER, Agnes Squire *[Painter, teacher] b.1892, London.*
Addresses: Chicago, IL. **Studied:** NY Sch. F. & Appl. A.; Minneapolis AI; Hawthorne; Breckenridge. **Member:** Chicago AC; Cordon C.; Chicago SA; Cor Ardens. **Exhibited:** AIC, 1922 (prize), 1929 (prize); Chicago W. Aid, 1932. **Work:** Chicago schools. **Sources:** WW40.

POTTER, Anne W. *[Painter] early 20th c.*
Addresses: Chicago, IL, c.1909-13. **Exhibited:** AIC, 1909-10. **Sources:** WW13.

POTTER, B. *[Artist] early 20th c.*
Addresses: Active in Los Angeles, 1916-23. **Sources:** Petteys, *Dictionary of Women Artists,* reports that this may be Blanche Potter, active in Los Angeles, 1923-30.

POTTER, Bertha Herbert (Mrs. Edward, Jr.) *[Painter, graphic artist, lithographer, muralist] b.1895, Nashville, TN / d.1949, Santa Fe, NM.*
Addresses: Nashville, TN; Santa Fe, NM. **Studied:** Pearl Saunders, E.A. Webster, Breckenridge, Van D. Perrine, & Edmund Greacen; Sch. Art & Applied Des., NYC; Ringling Sch. Art. **Member:** NAWPS; Boston AC; North Shore AA; SSAL; Nashville Studio Cl.; Sarasota AA; Centennial Club, Nashville (chairman). **Exhibited:** PAFA Ann., 1933; Salons of Am., 1934. **Work:** portrait of Gov. Henry H. Horton for Tennessee; Tennessee State Mus. **Comments:** Started an art school in Nashville along with P. Saunders and C.P. Byrns, 1932. Spent her last years in Santa Fe, NM. Marlor puts date of death at 1944. **Sources:** WW40; Kelly, "Landscape and Genre Painting in Tennessee, 1810-1985," 109 (w/repro.); Falk, *Exh. Record Series.*

POTTER, Bessie See: **VONNOH, Bessie (Onahotema) Potter (Mrs.)**

POTTER, Crowell *[Miniaturist] early 19th c.*
Addresses: Active in NYC, c.1825. **Comments:** Painted miniatures of Cornelius Leverich Brower and John J. Brower of NYC, c.1825. **Sources:** G&W; WPA (Mass.), *Portraits Found in N.Y.;* FARL Photo Negatives 19191, 19193.

POTTER, Edna E. *[Painter] 20th c.*
Addresses: Brooklyn, NY. **Sources:** WW24.

POTTER, Edward Clark *[Portrait painter] b.1800 / d.1826, NYC.*
Addresses: NYC in 1826. **Member:** N.A., founding mem., 1826. **Exhibited:** NAD (1826). **Sources:** G&W; N.Y. *Evening Post,* December 5, 1826, obit.; Cummings, *Historic Annals,* 28, 76; Cowdrey, AA & AAU; Cowdrey, NAD.

POTTER, Edward C(lark) *[Sculptor] b.1857, New London, CT / d.1923, New London.*

Addresses: Greenwich, CT. **Studied:** Académie Julian, Paris with A. Mercié, 1878-81; Daniel Chester French. **Member:** SAA, 1894; NSS, 1893; ANA, 1905, NA, 1906; Arch. Lg. 1898; NIAL. **Exhibited:** Boston AC, 1886; Paris Salon, 1887-88; NAD, 1889; St. Louis Expo, 1904 (gold); AIC; PAFA Ann., 1913, 1918. **Work:** with D.C. French, "Gen. Grant," Fairmount Park, Phila.; "George Washington," Paris, Chicago; LOC; Lansing, Mich.; Gettysburg; AIC; equestrian statue, Arlington Cemetery, Wash., DC; "Lions," NYPL; "Lions," Morgan Lib., NYC; Piedmont Park, Atlanta, Ga.; Brookline, Mass.; Mem., Greenwich, Conn. **Comments:** Specialty: animals. **Sources:** WW21; Fink, *American Art at the Nineteenth-Century Paris Salons,* 381-82; Falk, *Exh. Record Series.*

POTTER, Edwin Tuckerman *[Architect] mid 19th c.*
Addresses: Philadelphia. **Exhibited:** PAFA (1860-62: architectural sketches and designs); NAD, 1867. **Comments:** He was a son of Alonzo Potter, Protestant Episcopal Bishop of Pennsylvania. **Sources:** G&W; Rutledge, PA.

POTTER, (George) Kenneth *[Painter, designer] b.1926, Bakersfield, CA.*
Addresses: Madera, CA. **Studied:** Acad. Art, San Francisco, 1947 & 1948; Acad. Frochot, Paris, France, with Jean Metzinger (theoretician of cubism), 1950-52; Inst. Statale dei Belli Arte, Florence, Italy, summer 1951; study in Sicily, 1953; Col. Marin, AA, 1972. **Member:** West Coast WC Soc. (pres., 1968-70); AEA (bd. dirs., Northern Calif. chap., 1972-73); East Bay Artists Assn. (v. pres., 1970); San Francisco Soc. Communicating Arts. **Exhibited:** Phelan Awards Competition, SFMA, 1949; 94th Ann. AWCS, NAD Gal., & Nat. Travel Show, 1961; A City Buys Art, CPLH 1963; Fukuoka, Japan Exchange Show, Oakland, Calif., 1964; solo show, Brazilian-Am. Inst., Rio de Janeiro, 1955; Maxwell Galleries, Ltd, San Francisco, CA, 1970s. Awards: purchase award for watercolor, San Francisco Art Comn., 1958; non-purchase award for watercolor, Calif. State Fair & Expos, 1958 & 1972; first award for watercolor, Delta Ann., Antioch, Calif., 1969. **Work:** City San Francisco Art Comn., Calif., 1958; Univ. San Francisco Coll., 1965; Fed. Housing & Urban Development, regional off., San Francisco, 1969; Col. Marin, Kentfield, Calif., 1972. Commissions: Golf Match (egg tempera), Olympic Club Lakeside Lobby, San Francisco, 1960; mural (acrylic on wallboard), Macy's--Stockton, Sacramento, 1963; mural (acrylic on canvas), Macy's--Stockton, 1965; hist mural (ink & acrylic on canvas), Corte Madera Town Council-Town Hall, 1968; two murals (ink & acrylic on canvas), Regional Off. Moore Bus. Forms, 1969. **Comments:** Preferred media: watercolors, oils, acrylics. Positions: art dir., McCann-Erikson Advert., Rio de Janeiro, 1954-55; art dir., Johnson & Lewis Advert., San Francisco, 1957; art dir., Michelson Advert., Palo Alto, Calif., 1959-60; Teaching: instr. watercolor, Civic Art Ctr., Walnut Creek, Calif, 1968-70; instr. watercolor, Acad. Art, San Francisco, 1970.Publications: contribr., "Golden Gate Bridge," May, 1962; "A Walk in Chinatown," June, 1962; "A Walk in the Art World," Oct., 1963, *Bonanza, San Francisco Chronicle;* contribr., "Mission San Antonio," *Calif. Automobile Assn.* (Sept., 1967); contribr., "Marin Portfolio," *Image Mag.* (Oct.,1967). **Sources:** WW73; Harold Rogers, "Color out of the West," *Christian Science Monitor* (Feb., 1949); Mabel Greene, "I Began to Draw,then to Talk," *San Francisco News* editorial (Nov., 1952); Milton Goldring, "O Pintor Americano Kenneth Potter," *Correio da Manha* (Rio de Janeiro, June, 1955).

POTTER, Gertrude B. *[Painter] 19th/20th c.*
Addresses: NYC. **Sources:** WW01.

POTTER, H(arry) S(pafford) *[Illustrator, painter] b.1873, Detroit, MI.*
Addresses: NYC. **Studied:** Académie Julian, Paris with J.P. Laurens and Constant, 1890; also with L. Simon in Paris. **Member:** SI 1910. **Exhibited:** AIC, 1911. **Sources:** WW40; Gibson, *Artists of Early Michigan,* 198. Gibson states a birth date of 1870.

POTTER, Henry *[Portrait painter]* mid 19th c.
Addresses: Brooklyn, NY, 1857. **Sources:** G&W; Brooklyn BD 1857.

POTTER, Horace E. *[Designer, craftsperson, teacher]* b.1873, Cleveland, OH.
Addresses: Cleveland, OH; Gates Mills, OH. **Studied:** Cleveland Sch. A.; Cowles Sch. A., Amy M. Sacker Sch. of Des.; England. **Member:** Cleveland S.A. **Exhibited:** CMA, 1920 (prize)-21 (prize); P. P. Expo, 1915 (gold); AIC, 1917 (prize). **Comments:** Position: instr., Historic Ornament, Cleveland Sch. A., Cleveland, Ohio. **Sources:** WW53; WW47.

POTTER, Jack *[Illustrator]* b.1927.
Addresses: California; NYC. **Studied:** Art Center Sch., Los Angeles; Jepson Art Sch., with Rico Lebrun. **Comments:** Illus., major national magazines, adv. campaigns for Coca Cola, and others. Position: t., Art Center School, Los Angeles (3 years); t., School of Visual Art, NYC. **Sources:** W & R Reed, *The Illustrator in America*, 301.

POTTER, John Briggs *[Painter]* b.1864, Lansing, MI.
Addresses: East Lansing, MI; Boston, MA. **Exhibited:** Detroit Mus. of Art, 1886; Michigan State Fair, 1886; SNBA, 1892, 1894, 1899; PAFA Ann., 1896-97, 1901. **Sources:** Gibson, *Artists of Early Michigan*, 198; Fink, *American Art at the Nineteenth-Century Paris Salons*, 382; Falk, *Exh. Record Series*.

POTTER, Kenneth See: **POTTER, (George) Kenneth**

POTTER, Larry *[Painter]* mid 20th c.; b.New Jersey.
Addresses: Paris. **Studied:** CUA Sch.; Graphic Workshop, NYC. **Exhibited:** 44th Street Gallery, NYC; Galerie St. Luc, Paris; Galerie Libraire Anglaise, Paris. **Sources:** Cederholm, *Afro-American Artists*.

POTTER, Lillian Brown *[Painter, writer, lecturer]* b.1892, NYC.
Addresses: Caldwell, NJ. **Studied:** G. Bridgman: A. Tucker; B. Robinson; D. Smith; ASL. **Member:** S. Indp. A. **Exhibited:** S. Indp. A., 1924. **Sources:** WW25.

POTTER, Linn E. *[Artist]* 19th/20th c.
Addresses: Wash., D.C., active 1899. **Sources:** McMahan, *Artists of Washington, D.C.*

POTTER, Louis McClellan
[Sculptor, etcher] b.1873, Troy, NY / d.1912, Seattle, WA.
Addresses: NYC. **Studied:** Hartford with C.M. & M. Flagg; Paris with L.O. Merson & J. Dampt. **Member:** NY Mus. Art Soc. **Exhibited:** AIC; SNBA, 1899; PAFA Ann., 1905, 1908-09; Armory Show, 1913 (catalogued but not received). **Award:** Officier du Nicham Iftikar from Bey of Tunis, 1900. **Work:** des., mem. to Horace Wells, Hartford; busts, prominent persons. **Comments:** Specialty: Indian groups. **Sources:** WW10; Fink, *Am. Art at the 19th C. Paris Salons*, 382; Falk, *Exh. Record Series*; Brown, *The Story of the Armory Show.*

POTTER, M. Helen *[Painter]* 20th c.
Addresses: Providence, RI. **Member:** Providence WCC. **Sources:** WW25.

POTTER, Margaret Ann See: **HARMON, Margaret Ann**

POTTER, Martha J(ulia) *[Painter, teacher]* b.1864, Essex, CT.
Addresses: New Haven, CT. **Studied:** J.H. Niemeyer; J.F. Weir; A.W. Dow; M. Fry. **Member:** New Haven PCC; CAFA; AFA. **Sources:** WW33.

POTTER, Mary Knight *[Painter, writer]* 20th c.; b.Boston.
Addresses: Boston, MA. **Studied:** MMA Sch.; ASL; Cowles Art Sch., Boston; Académie Julian, Paris. **Member:** Copley Soc.; AFA. **Comments:** Author: "Love in Art," "Art of the Louvre," "Art of the Vatican," "Art of the Venice Academy." **Sources:** WW21.

POTTER, Mathilde *[Painter]* b.1880, Phila.
Addresses: Santa Barbara, CA/Phila., PA. **Studied:** D. Garber; V. Garber; Woodbury. **Member:** Plastic Club; Print Club, Phila.; PAFA fellow. **Sources:** WW33 (puts birth date at 1880); *Charles Woodbury and His Students* (puts her birth date at 1889).

POTTER, Miriam Clark *[Illustrator]* b.1886, Minnesota / d.1964, Carmel, CA.
Addresses: Carmel, CA. **Comments:** Second wife of Zenas Potter (see entry). **Sources:** Hughes, *Artists in California*, 445.

POTTER, Muriel Melbourne (Mrs. E. M.) *[Painter, illustrator, cartoonist]* b.1903, Brooklyn, NY.
Addresses: Brooklyn, NY. **Studied:** ASL; NY Sch. F. & Appl. A.; O'Hara Sch., Maine; PIA Sch. **Member:** NAWPS. **Exhibited:** NAWPS, 1937, 1938; AIC; S. Indp. A., 1941-42. **Sources:** WW40.

POTTER, Nathan D(umont) *[Painter, sculptor]* b.1893, Enfield, MA / d.1934.
Addresses: Lyne, Greenwich, CT; NYC. **Studied:** D.C. French; E.C. Potter. **Exhibited:** PAFA Ann., 1916, 1923. **Work:** WWI Mem. Column, Westfield, NJ; equestrian statue, Colorado Springs; des., WWI medal for men of Greenwich, Conn. **Sources:** WW33; Falk, *Exh. Record Series*.

POTTER, Pearl See: **ETZ, Pearl Potter (Mrs.)**

POTTER, Ralph *[Painter]* mid 20th c.
Exhibited: S. Indp. A., 1936. **Sources:** Marlor, *Soc. Indp. Artists*.

POTTER, Rose L. *[Painter, illustrator, teacher]* 20th c.
Addresses: Phila., PA; in Phoenix, AZ, from c.1921. **Studied:** PAFA. **Exhibited:** PAFA Ann., 1908; AIC, 1908, 1911. **Comments:** Painted miniatures on ivory in watercolor. **Sources:** WW17; Petteys, *Dictionary of Women Artists*; Falk, *Exh. Record Series*.

POTTER, Ruth Morton *[Craftsperson, designer]* b.1896, Enfield, MA.
Addresses: New London, CT. **Studied:** M.M. Atwater. **Member:** Boston SAC (Master Craftsman); Soc. Conn. C. **Comments:** Illustrator: *Handicrafter*. **Sources:** WW40.

POTTER, Samuel *[Engraver]* b.c.1820, Pennsylvania.
Addresses: Northern Liberties section of Philadelphia, 1850. **Sources:** G&W; 7 Census (1850), Pa., XLIX, 266.

POTTER, Ted *[Painter, art administrator]* b.1933, Springhill, KS.
Addresses: Winston-Salem, NC. **Studied:** Univ. Kans.; Univ. Calif. Grad. Sch., Berkeley; Calif. Col. A&Cr. (M.F.A., 1962). **Member:** NC State Arts Soc. (adv. coun., 1969-72); Nat. Endowment for the Arts (individual artist fel. panel, visual arts div., 1971-72); NC State Arts Coun. (bd. mem.). **Work:** Salem Col., Winston-Salem, NC; NC Nat. Bank, Charlotte; Arts Coun. Winston-Salem; Glide Found., San Francisco, Calif.; Calif. Col. A&Cr. **Comments:** Positions: dir. art, Glide Found., 1965-67; dir., Gallery Contemp. Art, Winston-Salem, 1968-72; dir., Tampa Bay Art Ctr., Fla., 1972-. Specialty of gallery: Contemporary American Art. **Sources:** WW73.

POTTER, Ursula Yeaworth (Mrs.John M.) *[Painter, teacher]* mid 20th c.; b.York, PA.
Addresses: Atlanta, GA. **Studied:** Md. Inst.; Johns Hopkins Univ. **Member:** SSAL; Southeastern AA (founder). **Exhibited:** High MA, Atlanta; SSAL, 1938. **Comments:** Position: dir., Yeaworth-Potter A. Sch., Atlanta. **Sources:** WW40.

POTTER, V. G. *[Painter]* 20th c.
Addresses: Camden, OH. **Sources:** WW06.

POTTER, W. C. *[Landscape painter]* mid 19th c.
Addresses: Elmira, NY; NYC, 1862-65. **Exhibited:** NAD, 1856, 1862-65. **Sources:** G&W; Cowdrey, NAD; Naylor, NAD.

POTTER, William Gage *[Amateur painter]* b.1864, South Dartmouth, MA / d.1919, South Dartmouth, MA.
Addresses: Active in South Dartmouth, 1889-1919. **Studied:**

Friends Acad.; NYU (medicine), 1888. **Exhibited:** New Bedford A. Cl., 1907-16. **Sources:** Blasdale, *Artists of New Bedford*, 146-47 (w/repro.).

POTTER, William J. *[Landscape painter, teacher] b.1883, Bellefonte, PA / d.1964, Greenwich, CT.*
Addresses: Phila., PA; Boston, MA; Colorado Springs, CO, 1921-22; NYC; Greenwich, CT/West Townshend, VT. **Studied:** PAFA; W. Sickert in London. **Member:** CAFA; SC. **Exhibited:** PAFA Ann., 1909, 1917-22, 1927-32; Salons of Am., 1922; Corcoran Gal biennial, 1932, 1937; Allied AA, 1934; AIC. **Work:** Brooklyn Mus.; Hispanic Mus., NYC; Mem. Art Gal., Rochester, NY; Herron AI; Sidney Australia Mus.; Cincinnati Mus.; Expo Park Mus., Los Angeles; Mus. Rouen, France; Museo Nacionale d'el Arte Modero, Madrid. **Comments:** Teaching: Broadmoor Acad. Art, Colorado Springs, 1920s. **Sources:** WW40; P&H Samuels, 378; Falk, *Exh. Record Series.*

POTTER, Zenas Lemuel *[Painter] b.1886, Minneapolis, MN / d.1958, Monterey, CA.*
Addresses: French Riviera, 1930s; Mexico, 1937; Carmel, CA. **Studied:** Univ. of Minnesota; Columbia Univ. **Member:** Carmel Art Assoc. **Exhibited:** Mexico City (first solo). **Comments:** A wealthy businessman and government official in WWII, he painted in his spare time. **Sources:** Hughes, *Artists in California*, 445.

POTTERVELD, Burton Lee *[Designer, painter, educator, graphic artist, writer] b.1908, Dubuque, IA.*
Addresses: Milwaukee, WI; Dubuque, IA. **Studied:** Layton Sch. A.; Univ. Dubuque; Univ. Wisconsin; Univ. Iowa. **Member:** Wis. PS. **Exhibited:** AIC, 1931, 1937-39; Am. A., 1935; Wis. PS, 1932-46; Madison Salon, 1940-43. **Work:** Oshkosh State T. Col. **Comments:** Position: t., Layton Sch. A., Milwaukee; assoc. prof., Univ. Wisconsin, Milwaukee, Wis. Contributor to Standard Edu. Soc., Chicago. **Sources:** WW59; WW47.

POTTHAST, Edward H(enry) ***E Potthast***
[Landscape painter, illustrator] b.1857, Cincinnati, OH / d.1927, NYC.
Addresses: NYC, c.1892-on. **Studied:** McMicken School Design, 1869, 1873, 1879-82 and 1885-87; a lithography apprentice to Ehrgott Krebs Co.; Antwerp, 1882; Munich, 1882 and 1887; with Cormon in Paris, 1887. **Member:** SAA, 1902; ANA, 1899; NA, 1906; AWCS; NYWCC; SC, 1895; Lotos Club; Allied AA; Cincinnati AC; P & S Gal. Assn.; SPNY. **Exhibited:** PAFA Ann., 1895-1927; NAD, 1897-1927, 1899 (prize); Boston AC, 1896-1909; Paris Salon, 1889-91; AIC, 1896-1925; AWCS, 1901 (prize) 1914 (prize); SC, 1904 (prizes), 1905 (prize); Corcoran Gal biennials, 1907-23 (8 times); Pan-Pac. Expo, San Fran., 1915 (med.). **Work:** Cincinnati Art Mus.; Brooklyn Inst. Mus.; Hackley Art Gal., Muskegon, MI; AIC. **Comments:** Potthast is best known for his Impressionist beach scenes featuring women and children playing in the surf. After studying in Paris, he settled in NYC, working as an illustrator for *Harper's* and *Scribner's* (many of his subjects were Africa American). In the mid 1890s, he turned seriously to painting figures, landscapes, and seascapes. Around 1914, he began to exhibit the beach scenes for which he became so well known. Executed in bold brushwork, they were painted along the New England coast, often at the artists' colonies at Rockport, MA, or at Ogunquit, ME. **Sources:** WW25; *Cincinnati Painters of the Golden Age*, 92-93 (w/illus.); Fink, *American Art at the Nineteenth-Century Paris Salons*, 382; Falk, *Exh. Record Series.*

POTTHOFF, Charles *[Fresco painter] b.1824, Emden, Germany / d.1879, New Orleans, LA.*
Addresses: New Orleans, active 1854-68. **Exhibited:** Grand State Fair (1868, firm of Potthoff & Knight won hon. men. for best display of medallions in plaster). **Comments:** Decorated the ceiling of Trinity Episcopal Church in New Orleans (1854). Was partner with George F. Knight in firm of Potthoff & Knight (painters, sculptors, art suppliers), 1857-68. **Sources:** G&W; *Encyclopaedia of New Orleans Artists*. 313.

POTTINGER, Zeb *[Painter] 20th c.*
Addresses: Richmond, IN. **Sources:** WW24.

POTTS, Don *[Painter, educator] b.1936, San Francisco, CA.*
Addresses: San Francisco, CA. **Studied:** San Jose State Col. (B.A., 1936, M.A., 1965); Univ. Iowa, 1963. **Exhibited:** Los Angeles Munic. A. Gal., Calif., 1968; Excellence, Univ. Calif. Art Mus., Berkeley, 1970; Recent Acquisitions, SFMA, 1971; What is Technological Art?, Calif. State Univ., Hayward, 1971; solo shows, Hansen Fuller Gal., San Francisco, 1964, 1966 & 1970. **Awards:** first prize, Print Sculpture Ann., Richmond Art Ctr., Calif., 1966; Nat. Coun. Arts fel., Nat. Endowment Arts, 1970; Adeline Kent Award, SFMA, 1970. **Work:** Univ. Iowa, Iowa City; Joslyn Art Mus., Omaha, Nebr.; La Jolla Mus. Art, Calif.; Pasadena Art Mus., Calif.; SFMA. **Comments:** Teaching: asst. prof. art, UCalif., Berkeley in 1973. **Sources:** WW73.

POTTS, Gertrude Early *[Landscape painter] late 19th c.*
Addresses: Active in Detroit, 1896-99. **Studied:** Detroit and Boston. **Sources:** Petteys, *Dictionary of Women Artists*.

POTTS, Jean G. *[Fresco and trompe l'oeil painter] mid 19th c.*
Addresses: Pennsylvania. **Comments:** Visited and advertised his services in Acomac, VA, 1838-39, Norfolk, VA, 1851. **Sources:** Wright, *Artists in Virginia Before 1900.*

POTTS, W(illiam) Sherman *[Portrait painter, miniature painter] b.1876, Millburn, NJ / d.1930, Stonington, CT.*
Addresses: NYC/Noank, CT. **Studied:** C.N. Flagg, Hartford; PAFA; Académie Julian, Paris with J.P. Laurens and Constant, 1899. **Member:** CAFA; ASMP; Mystic SA (pres.); American A. Prof. L. (founder). **Exhibited:** PAFA Ann., 1905; S. Indp. A., 1917-18; Salons of Am., 1922; CAFA, 1929 (prize); AIC. **Sources:** WW29; Falk, *Exh. Record Series.*

POTTS, William Stephens *[Engraver] b.1802, near the present Bloomfield, PA / d.1852, St. Louis, MO.*
Studied: apprenticed to a Philadelphia printer; possibly to Peter Maverick, Newark (NJ). **Comments:** Brought up in Trenton (NJ). In 1824 he was working in NYC with William Chapin (see entry). Entered Princeton Theological Seminary in 1825 and in 1828 took charge of a church at St. Louis. In 1837 he became president of Marion College in Missouri and from 1839 to 1852 he was pastor of the Second Presbyterian Church in St. Louis. **Sources:** G&W; Potts, *Historical Collections Relating to the Potts Family*, 175; Fielding; Stephens, *The Mavericks*, 42.

POU, Miguel *[Painter] mid 20th c.; b.Ponce, PR.*
Addresses: Ponce, PR. **Studied:** ASL. **Exhibited:** S. Indp. A., 1926-27, 1929, 1941; Salons of Am., 1927. **Sources:** Falk, *Exhibition Record Series.*

POUCHER, Edward A. *[Painter] 20th c.*
Addresses: NYC. **Member:** GFLA. **Sources:** WW27.

POUCHER, Elizabeth Morris *[Sculptor, lithographer] mid 20th c.; b.Yonkers, NY.*
Addresses: Bronxville, NY. **Studied:** Vassar Col. (A.B.); NY Univ.; Columbia Univ.; ASL; Alexander Archipenko; Acad. Grande Chaumière, Paris, France; Ecole Animalier, Paris; also with Andre Lhote. **Member:** Nat. Sculpture Soc.; All. A. Am.; Pen & Brush (bd. dirs., 1969-72); Hudson Valley Art Assn. **Exhibited:** PAFA Ann., 1933, 1939, 1942; Salons of Am., 1934; WMAA, 1940; All. A. Am., 1941-43,1968-72; 1945; MMA (AV), 1942; NAD, 1944; Fifteen Gal., 1940-41; Bronxville Women's C., 1940; WFNY, 1939; Bronxville, NY Ann., 1968-71 (first prize for sculpture); Hudson Valley Art Assn., White Plains, NY, 1968-71, (1970 hon. men.); Pen & Brush, New York, 1968-72 (1970 silver medal for sculpture); Nat. Sculpture Soc. Exhibs., 1968-72. **Work:** Nat. Portrait Gal., Smithsonian Inst.; Taylor A. Gal., Vassar Col., Poughkeepsie, NY; Mus. City NY; portraits for pvt. commissions, 1970-72. **Comments:** Preferred media: graphics. Position: staff, W.D. Teague Co., NYC, 1944-46. **Sources:** WW73; WW47; Falk, *Exh. Record Series.*

POUCHER, Emily Rollinson *[Painter] mid 20th c.*
Addresses: Bronxville, NY. **Exhibited:** NAWPS, 1935-38. **Sources:** WW40.

POUCHER, Emma Eggleston *[Painter] late 19th c.; b.New York.*
Exhibited: Paris Salon, 1891. **Comments:** Exhibited a drawing at the Paris Salon. **Sources:** Fink, *American Art at the Nineteenth-Century Paris Salons,* 382.

POUCHER, William Eggleston *[Painter] late 19th c.; b.New York.*
Addresses: Glenside, PA. **Studied:** Lefebvre, Constant. **Exhibited:** Paris Salon, 1890; NAD, 1893, 1895; PAFA Ann., 1894. **Sources:** Fink, *American Art at the Nineteenth-Century Paris Salons,* 382; Falk, *Exh. Record Series.*

POUGIALIS, Constantine *[Painter, educator] b.1894, Corinth, Greece.*
Addresses: Chicago, IL. **Studied:** AIC; George Bellows, Wellington Reynolds, Leopold Seyffert; also in Greece, France and Italy. **Exhibited:** AIC, prizes & medals: 1925, 1931, 1935-36, 1950, also solo; PAFA Ann., 1933-34, 1937-38; GGE, 1939; Corcoran Gal biennials, 1937-41 (3 times); CI; WFNY, 1939; WMAA; Rehn Gal.; MoMA; Univ. Minn; Union Lg. Cl., Chicago, 1955 (prize); Chicago Artists Exh., France, 1957-58; LACMA; TMA; DMFA; Mun. A. Gal., Jackson, Miss.; Albright A. Gal., Buffalo; CM; Robinson's Gal., Chicago; Rehn Gal., NY; Nat. Mus. Gal, Athens, Greece; *Chicago Sun-Times,* 1960. **Work:** AIC; Univ. Minnesota; John Vanderpoel A. Gal., Chicago; *Chicago Sun-Times;*Evanston (Ill.) Pub. Lib. **Comments:** Teaching: AIC, 1938-60s; trustee, MoMA. **Sources:** WW66; WW47; Falk, *Exh. Record Series.*

POULBOT *[Painter] mid 20th c.*
Addresses: Chicago area. **Exhibited:** AIC, 1936. **Sources:** Falk, *AIC.*

POULL, Mary B. *[Painter, muralist, teacher] mid 20th c.; b.Port Washington, WI.*
Addresses: Chicago, IL. **Studied:** AIC; C.W. Hawthorne; J.C. Johansen; G. Oberteuffer; H. Luyten, in Belgium. **Member:** Chicago Women's Salon; AIC; North Shore AG, 1935; Detroit Sco. Women P&S, from 1910. **Exhibited:** North Shore AG, 1935 (prize); Detroit Soc. Women P&S; AIC. **Work:** Gay and Sturgis, Houghton, MI. **Sources:** WW40.

POUNIAN, Albert K. *[Printmaker] mid 20th c.*
Exhibited: AIC, 1936. **Sources:** Falk, *AIC.*

POUPARD, James *[Portrait painter and engraver, jeweller and goldsmith] 18th/19th c.*
Addresses: Philadelphia, 1769-1807; NYC in 1814. **Comments:** Came to U.S. from Martinique and had been an actor early in his life. **Sources:** G&W; Hamilton, *Early American Book Illustrators;* Stauffer; Prime, I, 26-27; Brown and Brown; *Portfolio* (Jan. 1952), 117 (repro.).

POUPELET, Jane *[Sculptor] mid 20th c.*
Addresses: Paris, France. **Member:** NAWPS. **Exhibited:** AIC, 1930-35. **Sources:** WW25.

POURGEE, Aimee L. *[Painter] late 19th c.*
Addresses: Mayville, NY. **Exhibited:** PAFA Ann., 1891. **Sources:** Falk, *Exh. Record Series.*

POURTAN, Leon *[Painter] late 19th c.*
Addresses: Roxbury, MA. **Exhibited:** PAFA Ann., 1896-97. **Sources:** Falk, *Exh. Record Series.*

POUSETTE-DART, Joanna *[Painter] b.1947.*
Addresses: NYC, 1973. **Exhibited:** WMAA, 1973. **Sources:** Falk, *WMAA.*

POUSETTE-DART, Nathaniel J. *[Painter, designer, etcher, teacher, writer, lecturer] b.1886, St. Paul, MN / d.1965, Valhalla, NY.*
Addresses: Valhalla, NY; Nantucket, MA. **Studied:** ASL; PAFA, 1909-10 (2 Cresson Traveling Scholarships, PAFA, 1911, 1912); W. Chase; R. Henri; H.R. Poore; St. Paul A. Sch.; MacNeil, in NYC; Anshutz. **Member:** Fed. Mod. P. & S.; Arch. Lg.; Mural P.; A. Dir. Cl. (life); Nat. A. Dir. Cl.; Westchester A. & Crafts Gld.;

Am. Soc. for Aesthetics; Div. on Aesthetics, Am. Psychological Assn. **Exhibited:** PAFA Ann., 1915; Minn. State A.Soc., 1913-16 (prize, each yr.); St. Paul Inst., 1915; WMAA; MMA; S. Indp. A., 1927-31, 1934; Anderson Gal., NY, 1928; WFNY, 1930; Pinacotheca, 1943; Am.-British A. Ctr., 1943; Westchester A. & Crafts Gld., 1953 (prize). Awards: certif. merit, A. Dir. Cl.; A. Dir. Exh., 1954; F., PAFA. **Comments:** Father of Richard Pousette-Dart (see entry). Lecturer, PIA Sch., Columbia Univ., and many lectures on television. Author: *Ernst Haskell, His Life and Work;* series of six books: *Distinguished American Artists Series,* 1924-30; *American Painting Today, 1950-1956,* 1956; *Art Directing; The Techniques of Visual Communication and Selling,* 1956. Contributor to *Art News; American Artist,* and other art magazines. **Sources:** WW59; WW47; Falk, *Exh. Record Series.*

POUSETTE-DART, Richard *[Painter] b.1916, Saint Paul, MN / d.1992.*
Addresses: Suffern, NY. **Studied:** mostly self-taught as artist, although did learn from his father Nathaniel Pousette-Dart; Bard Col. (hon. D.H.L., 1965). **Exhibited:** Artists Gal., NYC, 1941 (first solo); "Abstract Painting & Sculpture in America," 1944 & traveling exhibs., 1969 & 1971, all at MoMA; PAFA Ann., 1946-64 (5 times); Peggy Guggenheim's Art of This Century Gal., NYC, 1947 (solo); "The New Decade," 1955, 1959, 1963 (retrospective); "New York School," LACMA; Documenta 2, Kassel, Germany, 1959; "American Abstract Expressionists & Imagists," Guggenheim Mus., 1961; Corcoran Gal biennials, 1959, 1965 (silver); AIC, 1965 (Comstock Prize); WMAA biennials, 1949-73. Other awards: Nat Arts Council Award, 1966. **Work:** MoMA; WMAA; NMAA; AGAA; Albright-Knox Art Gal.; Johnson Wax Coll. **Comments:** A first-generation Abstract Expressionist, he was one the group of young radical artists, along with Pollock and de Kooning, who were called the "The Irascibles" in the famous *Life* magazine article of 1951. Pousette-Dart's early style, of the 1930s, combined elements of cubism and surrealism. About 1940 he began producing works in which the painting surface was cluttered and heavily encrusted with small biomorphic forms set off by thin webs of lines meandering throughout the canvas. By the 1950s the biomorphic forms were replaced by small, more abstract clusters of color, and by the 1960s form was further abstracted and dematerialzed so that the entire surface of his canvas appeared as a constellation of rich texture and color. Throughout his career, Pousette-Dart's work was driven by his interest in the spiritual and mystical aspects of the self and the universe. Teaching: BMFA Sch., 1959; New Sch. Social Res., 1959-61; Sch. Visual Arts, NYC, 1965; Minneapolis Inst. FA, 1965; Columbia Univ., 1968; Sarah Lawrence Col., 1971, 1973; ASL, 1980-92. **Sources:** WW73; Baigell, *Dictionary; The Spiritual in Art,* 351, 415; *300 Years of American Art,* 959; *Richard Pousette-Dart: Transcendental Expressionist* (1961); John Gordon, *Richard Pousette-Dart* (exh. cat., WMAA, 1963); Lawrence Campbell, *Pousette-Dart: Circles and Cycles* (1963); Charlotte Willard, *Yankee Vedanta* (1967); Falk, *Exh. Record Series.*

POUTASSE, Harriet B. *[Painter] early 20th c.*
Addresses: New Brighton, SI, NY. **Exhibited:** S. Indp. A., 1929. **Sources:** Marlor, *Soc. Indp. Artists.*

POVLICH, Robert *b.1937.*
Addresses: NYC, 1972-73. **Exhibited:** WMAA, 1972-73. **Sources:** Falk, *WMAA.*

POW, Miguel See: **POU, Miguel**

POWEAS, Mary S. *[Painter] mid 20th c.*
Exhibited: Salons of Am., 1934. **Sources:** Marlor, *Salons of Am.*

POWEL, Samuel, Jr. *[Painter, water colorist] late 19th c.*
Addresses: Phila., PA. **Exhibited:** PAFA Ann., 1887 (landscapes). **Sources:** Falk, *Exh. Record Series.*

POWELL, Arthur James Emery *[Painter] b.1864, Vanwert, OH / d.1956,*

Poughkeepsie.
Addresses: NYC, Dover Plains, NY. **Studied:** San Fran. Sch. Design; St. Louis Sch. FA; Académie Julian, Paris with Toudouse and Ferrier, 1903. **Member:** ANA, 1921; NA, 1937; SC, 1904; Paris AA; Artists Fund Soc.; Allied AA; NAC; NYWCC; Kent AA; Dutchess County AA. **Exhibited:** PAFA Ann., 1910, 1922; SC, 1913 (prize), 1928 (prize), 1931 (prize); Corcoran Gal biennials, 1914, 1921; All. Artists Am., 1930 (prize); NAD, 1921 (prize); NAC, 1930 (prize); New Rochelle, 1930 (prize); AIC. **Work:** Milwaukee AI; Boise Library; NAC (NYC); murals, Methodist Church, St. James Church, Dover Plains, NY; Bowen Hospital, Poughkeepsie. **Sources:** WW53; WW47; P&H Samuels, 378; Falk, *Exh. Record Series.*

POWELL, Asa L. *[Genre painter, writer] b.1912, Tulerosa, NM.*
Addresses: Yakima, WA, 1946; Kalispell, MT in 1973. **Studied:** Montana State Univ.; self-taught artist. **Comments:** Began sketching and painting in 1938. Author/illustrator, "The Ace of Diamonds," 1965. **Sources:** P&H Samuels, 379.

POWELL, Caroline A(melia) *[Engraver, illustrator] b.1852, Dublin, Ireland / d.1935, Boston.*
Addresses: Trenton, NJ; Boston, MA; Santa Barbara & Santa Monica, c.1920-35. **Studied:** W.J. Linton; T. Cole; Cooper Union Art School; NAD. **Member:** Soc. Am. Wood Engravers (first female mem.). **Exhibited:** Columbian Expo, 1893 (med.); PAFA Ann., 1894; Pan-Am. Expo, Buffalo, 1901 (silver). **Work:** BMFA; NYPL; CI; Springfield Pub. Lib.; Santa Barbara (CA) Pub. Lib.; New Bedford (MA) Pub. Lib. **Comments:** Specialty: wood engraving. Illustrator for *Century Magazine.* **Sources:** WW32; Hughes, *Artists in California*, 445; Petteys, *Dictionary of Women Artists;* Falk, *Exh. Record Series.*

POWELL, Doane *[Craftsperson, lecturer, cartoonist, sculptor] b.1881, Omaha, NE / d.1951.*
Addresses: NYC. **Studied:** AIC; Académie Julian, Paris with J.P. Laurens, 1906; Académie Grande Chaumière; W. J. Reynolds. **Member:** SI. **Exhibited:** Arch. L.; Lotos C. (solo). **Comments:** Specialty: portrait masks. **Sources:** WW47.

POWELL, Eleanor Mason *[Painter] mid 20th c.*
Addresses: NYC. **Exhibited:** S. Indp. A., 1929. **Sources:** Marlor, *Soc. Indp. Artists.*

POWELL, Ella May (Mae) *[Painter] b.1879, Davenport, IA.*
Addresses: Chicago, IL. **Studied:** Edwin Scott; Acad. Colarossi, Paris, with Collin, Courtois. **Exhibited:** AIC, 1902, 1916. **Sources:** WW21; Petteys, *Dictionary of Women Artists.*

POWELL, Eugene M. *[Painter] mid 20th c.*
Addresses: NYC. **Exhibited:** PAFA Ann., 1950-51; Corcoran Gal biennial, 1951. **Sources:** Falk, *Exh. Record Series.*

POWELL, Fannie (Miss) *[Painter] late 19th c.*
Addresses: NYC. **Exhibited:** NAD, 1862-63, 1876. **Sources:** Naylor, *NAD.*

POWELL, Fay Barnes (Mrs.) *[Painter] early 20th c.*
Addresses: Chicago, IL. **Member:** Chicago SA. **Exhibited:** AIC, 1918-19. **Sources:** WW27.

POWELL, Gabriel M. *[Painter, craftsperson, designer] 20th c.*
Addresses: NYC. **Studied:** ASL; Acad. All. A.; & with Gregoriere. **Member:** A.Lg.A.m.; S. Indp. A.; Un. Scenic A. **Exhibited:** A.Lg.Am.; S. Indp. A.; Acad. All. A.; Vendome Gal.; Barbizon Plaza Gal. **Work:** wall decorations, French Sch., NY. **Sources:** WW53; WW47.

POWELL, Georgette Seabrook *[Painter, art therapist] 20th c.; b.Charleston, SC.*
Studied: Harlem Art Workshop; CUA Sch.; Turtle Bay Music School; Dept. of Agriculture; DC Teachers College. **Exhibited:** Smith-Mason Gal., 1971; NJ State Mus.; Atlanta Univ.; Dillard Univ. (prize); Smithsonian Inst.; Margaret Dickey Gal.; Wash. DC; DCAA, Anacostia Neighborhood Mus.-Smithsonian Inst.; CI.

Awards: prize, American Art League; Award, DC Public Health Dept. **Work:** Harmon Fnd.; Johnson Pub. Co. **Sources:** Cederholm, *Afro-American Artists.*

POWELL, Georgiana J. *[Painter, sculptor, graphic artist, illustrator] b.1936, Boston, MA.*
Studied: Boston Univ. **Member:** Boston Negro Artists Assn.; Cambridge AA. **Exhibited:** Unitarian Laymens League Art Exh., Boston, 1961 (prize); NAACP Convention, 1963 (prize); Boston Pub. Lib., 1964-65, 1973; Internat'l Book Exhibit, Leipzig, Germany, 1965; Boston Negro Artists Assn., 1966; Tufts Univ., 1970; Salem State Col., 1970; Gordon Col., Wenham, MA, 1971; Whole World Celebration, Commonwealth Armory, Boston, 1971, and many churches in the area. Awards: Peace Cup, Women's Internat'l League for Peace & Freedom. **Comments:** Position: medical illus., New England Center Hospital. **Sources:** Cederholm, *Afro-American Artists.*

POWELL, Goldie See: **HARDING, G(oldie) Powell (Mrs.)**

POWELL, H. M. T. *[Townscape and portrait painter, writer, illustrator] mid 19th c.*
Addresses: Active in California in the 1850s. **Work:** Huntington Library, San Marino, CA. **Comments:** Traveled west from Illinois to San Diego, arriving in that city December, 1849. Over the next several weeks he made drawings of the missions at San Diego and San Luis Rey and did one of the earliest views of Los Angeles. He then moved on to Northern California where he was active until 1860. His diary *Santa Fe Trail to California* was edited and published in 1931. **Sources:** G&W; Taft, *Artists and Illustrators of the Old West*, 267; *American Processional*, 158. More recently, see Hughes, *Artists in California;* P&H Samuels, 379.

POWELL, J. S. *[Painter] early 20th c.*
Addresses: Logan, UT. **Studied:** Académie Julian, Paris, 1908. **Comments:** Affiliated with Utah Agricultural College. **Sources:** WW15.

POWELL, J. T. *[Lithographer] b.c.1823, Canada.*
Addresses: Boston in 1850. **Comments:** Living with Daniel Barry, Thomas Barry, and -- Comri (see entries). **Sources:** G&W; 7 Census (1850), Mass., XXV, 311.

POWELL, Jennette M. *[Painter, etcher, craftsperson, teacher] b.c.1871, Kingston, Nova Scotia / d.1944, NYC.*
Addresses: Norton, MA/Camp Hill, PA. **Studied:** Columbia; Chase; Henri; Hawthorne; Parsons; Sandzen; and in Paris. **Comments:** Positions: teacher, Iowa State College & Univ. Washington, Seattle. **Sources:** WW33.

POWELL, Leslie (Joseph) *[Painter, designer, lithographer, teacher] b.1906, Minneapolis, KS.*
Addresses: NYC. **Studied:** Okla. Univ., 1922-23; Chicago Acad. FA, 1924-25; ASL, fall 1927; New Orleans Sch. A.; Columbia Univ., 1949-51 (B.F.A., 1952; M.F.A., 1954). **Member:** Southwestern AA; AEA; Audubon Soc. **Exhibited:** S. Indp. A.; Okla. Art Ctr., Oklahoma City; WMAA, 1941; Philbrook Mus. Art, Tulsa; Charles Morgan Gal., NYC, 1938-39 (solos); Norlyst Gal., NYC, 1957 (solo); Bodley Gal., NYC, 1960 (solo); Art for Industry Gal., NYC, 1970s. Awards: Blanche Benjamin Award for best landscape, 1931. **Work:** BM; Newark Mus. Art, NJ; Univ. Ga Mus. Art; Univ. Ariz.; Mus. NM Gal. Art, Santa Fe; Okla. Art Ctr. Commissions: Power (with Boyd Cruise), Industry, Communication & others, Samuel L. Peters HS Commerce, New Orleans, La, 1930 & 1931; Town & Country (painting), Security Bank & Trust Co., Lawton, Okla., 1948. **Comments:** Preferred media: oils, watercolors, pastels. Positions: des., Richard Hudnut Co., 1927-47; free lance designer, various firms, 1927-on. Teaching: Fort Sill I & E Ctr., Okla, 1926; Arts & Crafts Club, New Orleans, 1926; Tulane Univ. Sch. Arch., 1929-30. Research: Chinese art. Art interests: Modern art-abstract interpretations of classical & modern music; ballet paintings. Author: reviews in *Villager*, 1967-69. **Sources:** WW73; WW47.

POWELL, Lucien Whiting
[Painter] b.1846, Levinworth Manor, Upperville, VA / d.1930, Wash., DC.
Addresses: Round Hill, VA; Wash., DC. **Studied:** Phila. with T. Moran; PAFA; London Sch. Art with Fitz, c.1875; Rome; Venice; Paris with Bonnât. **Member:** Soc. Wash. Artists; Wash. WCC; Wash. Lndscp. C.; Wash. Soc. FA. **Exhibited:** Soc. Washington Artists (Parsons Prize, 1903); PAFA Ann., 1906; Corcoran Gal annuals, 1907-08; Washington WCC; Veerhoff's Gal. (solo, 1907); Wash. AC (solo, 1922). **Work:** NMAA; CGA; NGA; High Mus. Art, Atlanta; Am. Univ.; Georgetown Univ.; Hist. Soc. of Wash., D.C.; State Dep. Reception Room; Cosmos Cl.; Congressional Cl. **Comments:** Powell was best known for his landscapes of both Venice and the Grand Canyon. He had served in the Virginia cal-valry during the Civil War, after which he studied in Philadelphia. In 1875, while studying in London, his subject matter and paint-ing style were influenced by the works of J.M.W. Turner. He returned to Europe in 1890 and became known for his scenes of Venice. In 1901, he made a trip to the West, painting in the Grand Canyon. In 1910, he traveled throughout the Middle East, painting landscapes of the Holy Land. **Sources:** WW29; P & H Samuels, 379; McMahan, *Artists of Washington, D.C.; 300 Years of American Art,* vol. 1, 413; Falk, *Exh. Record Series.*

POWELL, Mary E. *[Painter] early 20th c.*
Addresses: Hempstead, NY, c.1909. **Sources:** WW10.

POWELL, Pauline *[Portrait painter] b.1876, Oakland, CA / d.1912, Oakland, CA.*
Addresses: Oakland, CA, 1890s. **Studied:** self-taught. **Exhibited:** Oakland, CA, 1890 (said to be first black artist to exhibit in Calif.). **Work:** Oakland Museum. **Comments:** A painter as well as a musician. **Sources:** Hughes, *Artists in California,* 446; Trenton, ed. *Independent Spirits,* 12, cites birth date as 1872, as does Pettys.

POWELL, Ralph Williford *[Painter] b.1908, Hanford, CA.*
Addresses: Hanford, CA. **Studied:** Calif. College FA, Oakland; Calif Sch. FA, San Fran. **Member:** San Fran. AA. **Exhibited:** San Francisco AA, 1937. **Work:** CMA; San Fran. AA; Arnot Gal., Elmira, NY.; Ft. Dodge, IA, Fed. A. **Sources:** WW40.

POWELL, Roscoe *[Artist] early 20th c.*
Addresses: Wash., D.C., active 1909. **Sources:** McMahan, *Artists of Washington, D.C.*

POWELL, Samuel See: **FOLWELL, Samuel**

POWELL, Violet (Louise) (Mrs. Willard B., Sr.)
[Painter] b.1902, Philadelphia, PA.
Addresses: Miami 43, FL. **Studied:** PIA Sch.; ASL, and with James Lunnon. **Member:** Blue Dome A. Fellowship; Miami A. Lg.; Coral Gables A. Cl.; Palm Beach A. Lg.; AAPL; Coral Gables Woman's Cl. **Exhibited:** PIA Sch.; ASL; Miami A. Lg., 1947-51 (prize, 1949); Poinciana Festival, 1948 (prize); A. & Writers, 1948-1952 (prizes, 1948, 1951, 1952); AAPL, 1950 (prize), 1951; Blue Dome, 1951; Miami Beach A. Center; Miami Springs Woman's Cl.; Coral Gables Woman's Cl.; solo: Musicians Cl. of Am., Colony Theatre, both in Miami. **Sources:** WW59.

POWELL, William H. *[Art dealer] b.1865 / d.1916.*
Addresses: NYC. **Comments:** Active in NYC, 1881-99, as an art dealer; also sold artists' materials and picture frames. **Sources:** info. courtesy Eli Wilner Co., NYC.

POWELL, William Henry *[Portrait and historical painter] b.1823, NYC / d.1879, NYC.*
Addresses: Cincinnati, c.1831-37; New Orleans, 1842; NYC. **Studied:** James H. Beard and Frederick Franks, Cincinnati, before 1837; Henry Inman, NYC, c.1840; Paris; Florence, Italy. **Member:** ANA, 1843. **Exhibited:** NAD, 1838-78; Wash., DC, 1847; Armory Hall, New Orleans, 1854; Brooklyn AA, 1861, 1877. **Work:** U.S. Capitol (rotunda and Senate wing), Wash., DC; State House, Columbus, OH; Cincinnati AM; NYHS. **Comments:** Powell grew up in Cincinnati, and in 1837 went East with the help

of Cincinnati art patron Nicholas Longworth. For a short time in 1842 he had a portrait studio in New Orleans, but worked primari-ly in NYC with summer visits to Cincinnati. After his historical painting "Columbus before the Council of Salamanca" (unlocated) was shown in Wash., DC, in 1847, he won the commission to paint the last panel for the rotunda of the U.S. CapitoI building, a project he worked on in Paris from 1848-53. His completed work, "De Soto Discovering the Mississippi" (Rotunda, U.S. Capitol), was exhibited in New Orleans in 1854 and thereafter installed in the Capitol. Most of Powell's remaining career was spent in NYC, but with strong ties to Ohio. In 1857 he received a commission from that state to paint "Perry's Victory on Lake Erie" for the State House in Columbus. Other commissions: "The Battle of Lake Erie," for the Senate wing of the U.S. Capitol, completed in 1873. **Sources:** G&W; DAB; Cowdrey, AA & AAU; Cowdrey, NAD; Naylor, NAD; New Orleans CD 1842; NYCD 1852, 1854; Cist, *Cincinnati in 1841* and *Cincinnati in 1859;* Delgado-WPA cites New Orleans *Bee,* Jan. 7, 1842, and *Commercial Bulletin,* Feb. 18, 1842; Fairman, *Art and Artists of the Capitol;* 7 Census (1850), N.Y., LII, 398. See also *Encyclopaedia of New Orleans Artists;* Gerdts, *Art Across America,* vol. 2: 180, 184 (and notes); *Cincinnati Painters of the Golden Age,* 93-94 (w/illus.); NYHS Catalogue (1974).

POWELLE, Pauline See: **POWELL, Pauline**

POWER, (Frederick) Tyrone (Edmund) *[Painter] b.1969, London, England / d.1931.*
Addresses: NYC. **Exhibited:** S. Indp. A., 1922. **Sources:** WW25; Marlor, *Soc. Indp. Artists.*

POWER, John *[Lithographer] b.c.1830, Prussia.*
Addresses: Baltimore in 1860. **Sources:** G&W; 8 Census (1860), Md., V, 510.

POWER, Maurice J. *[Sculptor, foundry owner] b.1838, County Cork, Ireland / d.1902.*
Studied: learned the trade of stonecutting. **Comments:** Came to the U. S. with his parents. In 1863 he stablished the National Fine Arts Foundry, which cast many notable pieces of sculpture includ-ing battle monuments at Trenton and Monmouth, NJ, Albany and Buffalo, NY.

POWER, Ralph E. *[Painter] early 20th c.*
Exhibited: AIC, 1927-28. **Sources:** Falk, *AIC.*

POWER, Tyrone (Mrs.) *[Painter] 20th c.* **Sources:** WW25

POWER-O'MALLEY, Michael Augustin See: **O'MALLEY, Power**

POWERS, Alenson G. *[Portrait and historical painter] b.1817, NY or VA.*
Addresses: New Orleans, active 1848-54 and 1856-60; Madison Parish, LA, 1860-c.1867; New Orleans, 1867. **Studied:** Paris, 1855; Florence, Italy, 1856. **Exhibited:** Hewlett's Exchange, New Orleans, 1848 ("Gen. Zachary Taylor"); Paris Salon, 1855. **Comments:** Began painting in Northern Ohio, c.1842; was paint-ing portraits in Cincinnati durign the summer of 1844. In 1848 he painted an equestrian portrait of Gen. Zachary Taylor at Baton Rouge (La.). Went on to New Orleans and remained there until 1854, returning in 1856 after study in Europe. Painter of some of New Orleans most notable citizens. Nothing is known of him after March 1867. Fink gives birthplace as New Orleans and spells his first name 'Alanson.' **Sources:** G&W; Delgado-WPA cites the fol-lowing: *Picayune,* Nov. 2, 1848; New Orleans CD 1849, 1851, 1853-54, 1858, 1860-61; *Delta,* March 12 and May 17, 1854; *Picayune,* June 27, 1854, March 25, 1856, and Jan. 4, 1859; and *Commercial Bulletin,* Dec. 22, 1856; Fink, *American Art at the Nineteenth-Century Paris Salons,* 382. More recently, see *Encyclopaedia of New Orleans Artists.*

POWERS, Asahel Lynde *[Itinerant portrait painter] b.1813, Springfield, VT / d.1843, probably in Olney, IL.*
Work: New York State Hist. Assoc., Cooperstown; Fogg Art Mus., Harvard

Univ., Cambridge, MA; NGA, Wash., DC; Abby Aldrich Rockefeller Folk Art Collection, Williamsburg, VA; Shelburne (VT) Mus. **Comments:** An enigmatic itinerant portrait painter, he is believed to have begun painting about age 18, traveling throughout Vermont, New Hampshire, and Massachusetts. In 1831, he painted nine portraits of one family (Cobb-Harris family) in Windham, VT. These New England travels continued to about 1839, when he is known to have moved to New York state. A pair of portraits dated October 1839 survive from Ogdensburg, and works dated 1840 show that he worked in Malone and in Plattsburgh (where a group of 20 portraits have been identified). Sometime after this he and his wife made their way to Olney, IL, where Asahel's brother had settled several years later. No paintings survive from his time in Illinois. Powers painted on wood early in his career but later switched to canvas. Signature note: From 1831-c.35, he signed as "Ashael Powers," and from c.1835-40 as "A. Powers" or "A.L. Powers." He often included the name and age of the sitter as well as the date of the portrait, but some works are unsigned. **Sources:** G&W; Powers, *The Powers Family*, 88; Sherman, "Unrecorded Early American Painters" (1934), 149; information cited by G&W as being courtesy Harry Stone Gal.; Lipman and Winchester, 178. More recently, see Nina Fletcher Little, "Asahel Powers, Painter of Vermont Faces," *Antiques* Nov. 1973; *300 Years of American Art*, vol. 1: 156; Muller, *Paintings and Drawings at the Shelburne Museum*, 104 (w/repro.).

POWERS, Daniel W. *[Patron] b.1818, Batavia, NY / d.1898.* **Addresses:** Rochester, NY. **Comments:** The Powers Art Gal. was known throughout the U.S. and Europe; besides containing the works of old masters, many celebrated American and European artists were represented. **Sources:** WW47.

POWERS, Elizabeth C. *[Artist] mid 20th c.* **Addresses:** Kansas City, MO. **Exhibited:** PAFA Ann., 1960. **Sources:** Falk, *Exh. Record Series.*

POWERS, Gorman *[Painter] mid 20th c.* **Exhibited:** Corcoran Gal biennial, 1951. **Sources:** Falk, *Corcoran Gal.*

POWERS, Grant J. *[Painter] mid 20th c.* **Addresses:** NYC, 1931. **Studied:** ASL. **Exhibited:** S. Indp. A., 1931. **Sources:** Marlor, *Soc. Indp. Artists.*

POWERS, Harriet *[Folk artist, quiltmaker] b.1837, near Athens, GA / d.1911, near Athens.* **Addresses:** near Athens, GA. **Comments:** Born as a slave, she lived on a small farm with her husband and children after the Civil War. Her quilts combine Bible stories with astronomical events and local legends. **Sources:** Dewhurst, MacDowell, and MacDowell, 169.

POWERS, Hiram *[Sculptor] b.1805, on a farm near Woodstock, VT / d.1873, Florence, Italy.* **Studied:** Frederick Eckstein, Cincinnati, c.1823-24. **Member:** honorary NA, 1837. **Exhibited:** The "Greek Slave" toured London and the United States, 1847; NAD, 1867; PAFA Ann., 1878. **Work:** BMFA, PAFA, Cincinnati AM; MMA; NMAA; VMFA; State House, Boston; his "Franklin" and "Jefferson,"are at the Capitol Bldg., Wash., DC; copies of the "Greek Slave" can be found at CGA, Brooklyn Mus., Newark Mus., and Yale Univ. Art Gal. **Comments:** As a child, his family moved to Ohio, settling near Cincinnati, where his father soon died. In 1822, Powers went to work as a mechanic at the Luman Watson clock and organ factory. About the same time he began experimenting with sculpture, executing a small wax medallion of Aaron Corwin (1823) and learning clay modeling and plaster casting from Eckstein. About 1828, he was put in charge of the mechanical section at Dorfeuille's Western Museum in Cincinnati; among his projects was an animated tableau of Dante's Inferno which was made by placing clockwork mechanisms in a group of old wax figures which were remodeled by Powers. He began making portrait busts

of friends, attracting the attention of Nicolas Longworth, a wealthy art patron. Believing in Powers' talent and realizing that the East coast offered more possibilities for commissions, he helped finance Powers' move to Wash., DC, in 1834. Powers' career was soon given a powerful boost by his first major work, a portrait bust of President Andrew Jackson, modeled from life in the White House in 1835. This encouraged other portrait commissions and for several years he modeled the busts of many of the leading men of Washington, including Chief Justice John Marshall, Daniel Webster, Martin Van Buren, and John Quincy Adams. He also traveled to Boston and New York City to fulfill portrait requests. In 1837 he sailed for Italy with his family and, after a few months in Paris, settled in Florence, where he was to spend the rest of his life. Commissions were difficult to come by at first, even with the help of Horatio Greenough, but by 1842 Powers had gained tremendous respect as a portraitist, recognized for his naturalism and his ability to capture the essense of his sitter. Between 1842 and 1855 he completed about 150 busts, sometimes receiving up to $1000 for one. Like other sculptors of his day, including Greenough, he was interested in undertaking ideal subject and began executing "ideal" busts in the early 1840s, and in 1845 produced the popular "Persephone." In October 1842 he began work on his first full-length ideal sculpture to be put into marble, his "Greek Slave." The international success of this work, completed in 1843, established Powers as the leading American sculptor of his day. Although the exhibition of nudes in America had previously caused controversy, a brilliant promotional effort by Powers agent, Miner Kellogg, pursuaded the American audience to look at the work as a Christian morality tale, and to sympathize with the plight of the young girl and see her nudity as an emblem of her innocence and chasteness. When it toured the United States in 1847, the sculpture was a phenomenal success, bringing $23,000 in ticket sales. The original work was sold in London and Powers sold six marble copies for about $4000 each, as well as many small replicas. For the rest of his career, Powers continued to make both portraits and ideal sculpture. He was among the sculptors commissioned to create works for the Capitol in Washington, DC, completing statues of Benjamin Franklin and Thomas Jefferson for the Senate and House wings. His last full-size sculpture, "The Last of the Tribe" (1872) depicts a Native American woman running and looking over her shoulder. **Sources:** G&W; DAB; Taft, *History of American Sculptor;* Gardner, *Yankee Stonecutters;* Swan, BA; Rutledge, PA; Cowdrey, NAD; Lee, *Familiar Sketches of Sculpture and Sculptors;* Rutledge, MHS; Craven, *Sculpture in America*, 111-123; Baigell, *Dictionary;* P&H Samuels, 380; Falk, *Exh. Record Series.*

POWERS, J. *[Portrait painter] b.c.1815, Philadelphia.* **Addresses:** New Orleans in 1860. **Sources:** G&W; 8 Census (1860), La., VII, 37.

POWERS, James T. *[Lithographer and engraver] b.c.1826, Boston / d.1899, Boston.* **Addresses:** Boston, active 1851-76. **Work:** Boston Athenaeum (see Powers & Weller). **Comments:** Partner in following firms: Swett & Powers, 1851 (see entry); J.T. Powers & Co., 1852-53; Powers & Weller (see entry), 1854-62; Powers & Co., 1863; Powers & St. John, 1867; J.T. Powers, 1868-69. After giving up his business, Powers worked for J.H. Bufford and J.H. Bufford's Sons from 1872-75. He was at same address as Charles H. Baker in 1876 but had no business address (in Boston directories) after that year. **Sources:** G&W; Boston CD 1852-60+. More recently, see Pierce and Slautterback, 148.

POWERS, Jane Gallatin *[Painter] b.1868, Sacramento, CA / d.1944, Rome, Italy.* **Addresses:** Monterey Peninsula, CA; Rome, Italy. **Studied:** A. Lhote, in Paris. **Member:** San Francisco Spinner's Cl. (cofounder); San Francisco Sketch Cl.; San Francisco AA; Carmel AA; Carmel Arts and Crafts Cl. **Exhibited:** San Francisco Sketch Cl., 1890s; Paris; Rome. **Sources:** Hughes, *Artists in California,* 446.

POWERS, John M. *[Illustrator] 20th c.*
Addresses: NYC. **Member:** SI. **Sources:** WW33.

POWERS, Longworth *[Sculptor] b.1835, Cincinnati / d.1904.*
Addresses: Florence, Italy. **Studied:** his father, Hiram (1805-73) in Florence. **Sources:** WW04.

POWERS, Marilyn *[Painter] b.1925, Brookline, MA / d.1976.*
Addresses: Brookline, MA. **Studied:** Mass. Col. Art, 1942-45; Boston Mus. Sch., 1945-49, with Karl Zerbe. **Exhibited:** Boston Art Festival, 1952-1958; View, Inst. Contemp. Arts, Boston, 1962; BMFA, 1969; Providence Art Festival, RI, 1970; Direct Vision, Boston City Hall, 1972; Joan Peterson Gal., Boston, MA, 1970s. Awards: awards, Fleming Mus., Univ. Vt., 1952 & Silvermine, Conn., 1953. **Work:** Fleming Mus., Univ. Vt. Commissions: portraits of Mrs. Jane Stahl, comn. by Frederick T. Stahl, 1965, Mrs. John Deknatel, comn. by John Deknatel, Boston, 1969 & family portraits, comn. by Warren Bennis, pres., Univ. Cincinnati, 1970; plus other portraits, Boston. **Comments:** Preferred media: oils. Publications: contribr., painting reproduced, *Art News*, 1952, drawings reproduced, *Audience Mag.*, 1958 & 1959, *Christian Sci. Monitor*, 1965 & *New Boston Renaissance,*1969. Teaching: instr. painting, Harriet Tubman Settlement House, 1953-54; instr. painting, Boston & Brookline Adult Educ., 1963; instr. painting, Direct Vision Art Sch., 1969-, pres., Direct Vision Inc., 1972-. **Sources:** WW73; Neil Hansen, *This Mighty Space* (New Renaissance, 1968); P. Boyd Wilson, "Marilyn Powers," *Christian Science Monitor* (1969); Edgar Driscoll, "Review," *Boston Globe* (1969).

POWERS, Marion (Mrs. W.A.B.Kirkpatrick) *[Painter] 19th/20th c.; b.London, England.*
Addresses: Waldoboro, ME/Friendship, ME, active 1897-1940. **Studied:** Garrido in Paris; also in London. **Member:** NAWA, 1918; Copley Soc., Boston; Artists' Guild, NYC. **Exhibited:** Boston AC, 1897, 1900, 1908-09; Paris Salon, 1906; Royal Academy, and Walker Art Gal., both London; NAD, 1906-29 (11 annuals); PAFA Ann., 1907 (prize), 1908-29 (13 annuals); Corcoran Gal. annuals/biennial, 1907-08, 1910; AIC, 1908-21 (5 annuals); Buenos Aires Expo, 1910 (silver); Pan.-Pac. Expo., San Fran., 1915 (gold); Doll & Richards, Boston, 1919 (solo). **Work:** Luxembourg, Paris; Can. Pac. Railway, Hotel Vancouver, BC; RISD. **Comments:** Born in England of American parents, she married the British painter W.A.B. Kirkpatrick. **Sources:** WW40; Falk, *Exh. Record Series.*

POWERS, Mary Swift (Mrs.) *[Painter] b.1885, Leeds, MA / d.1959, NYC.*
Addresses: Tenafly; Manchester, VT; NYC. **Studied:** Framingham (MA) Normal Sch. **Member:** Southern Vermont Artists. **Exhibited:** NAD; PAFA Ann., 1934; AWCS; AIC; Salons of Am.; Syracuse Mus. FA; Macbeth Gal.; Marie Sterner Gal. (solo); Grace Horne Gal., Boston (solo). **Work:** Williams Col.; Wood Gal. Art, Montpelier, VT; WMAA; AGAA. **Sources:** WW59; WW47; Falk, *Exh. Record Series.*

POWERS, Oliver *[Sign and ornamental painter] early 19th c.*
Addresses: Warren, OH, 1820. **Sources:** G&W; Knittle, *Early Ohio Taverns.*

POWERS, Preston *[Painter] b.1843.*
Exhibited: Boston AC, 1874. **Sources:** *The Boston AC.*

POWERS, Richard Gorman *[Artist] mid 20th c.*
Addresses: Ridgefield, CT, 1960. **Exhibited:** WMAA, 1960 (drawing). **Sources:** Falk, *WMAA.*

POWERS, Richard M. *[Illustrator] b.1921, Chicago, IL.*
Studied: Loyola Univ.; AIC; Univ. of IL.; New Sch. for Social Research, NYC, with Julian Levi; with Jay Connaway in Maine and Vermont. **Exhibited:** New Talent Exh., MoMA, 1952; MMA; CGA; NAD; WMAA; Rehn Gal., NYC (solos) Awards: Frank R. Paul Award, 1983. **Comments:** Illus., children's books, cover designs for poetry and literature, "Major Cultures of the World,"World Publ. Co.; illus., *Esquire, Life, The Saturday Evening Post,* and others. Executed over 400 science fiction and fantasy paintings, 16 of which were published by Doubleday in a portfolio, *Time Warp.* **Sources:** W & R Reed, *The Illustrator in America*, 304.

POWERS, Robert A. *[Landscape painter] mid 19th c.*
Addresses: Brooklyn, NY. **Exhibited:** Apollo Association; American Art-Union; NAD, 1840-49; Brooklyn AA, 1863. **Comments:** Specialized in scenes of various parts of New York State. **Sources:** G&W; Cowdrey, AA & AAU; Cowdrey, NAD, NYCD 1840-45.

POWERS, S. *[Listed as "artist"] b.c.1820, New York.*
Addresses: New Orleans in 1850. **Sources:** G&W; 7 Census (1850), La., V, 8.

POWERS, Stephen R. *[Painter] early 20th c.*
Addresses: Brooklyn, NY. **Exhibited:** S. Indp. A., 1925-27. **Sources:** Marlor, *Soc. Indp. Artists.*

POWERS, T. E. *[Painter] d.1939.*
Addresses: Norwalk, CT. **Comments:** Landscapes by Powers were catalogued for exhibit at the Armory Show in 1913 but not received. **Sources:** WW17; Brown, *The Story of the Armory Show.*

POWERS, Thomas *[Portrait painter] d.1859, Sandusky, OH.*
Addresses: Norwalk, OH. **Comments:** Firelands Museum has oil portraits that are possibly done by him. He painted the Timothy Baker family. **Sources:** Hageman, 121.

POWERS & WELLER *[Lithographers and engravers] mid 19th c.*
Addresses: Boston, active 1854-62. **Work:** Boston Athenaeum: views of several buildings in Boston; the tomb of Daniel Webster; and a view of birthplace of Benjamin Franklin that was drawn by Joseph Foxcroft Cole who made several drawings for the firm. **Comments:** Partners were James T. Powers and Edwin J. Weller (see entries on each); prior to this the two were associated under the name of J.T. Powers & Co. (1852-53). **Sources:** G&W; Boston CD 1852-60+, BD 1852-60. More recently, see Pierce and Slautterback, 148.

POWNALL, Thomas *[Topographical artist] b.1722, Lincoln, England / d.1805, Bath, England.*
Addresses: In American colonies, 1753-60. **Comments:** Graduated from Cambridge in 1743 and in 1753 came to America as private secretary to Sir Danvers Osborn, Governor of New York. From 1757 to 1759 he was Governor of Massachusetts. Returned to England in 1760 and was active in Parliament during the Revolution. A number of his American views were engraved and published in England. **Sources:** G&W; DNB; DAB; *Portfolio* (March 1948), 152; *Art Quarterly* (1945), 41.

POWRIE, Robert *[Sculptor, painter] b.1843 / d.1922.*
Work: Mem., Gen. John Gibbons, Arlington Cemetery.

POYNTON, Arthur M. *[Artist] late 19th c.*
Addresses: Wash., D.C., active 1885-88. **Sources:** McMahan, *Artists of Washington, D.C.*

POZZATTI, Rudy O. *[Printmaker, painter, sculptor] b.1925, Telluride, CO.*
Addresses: Lincoln, NE; Bloomington, IN. **Studied:** Univ. Colo. (B.F.A. & M.F.A., 1950), with Max Beckmann & Ben Shahn; also with Wendell H. Black. **Member:** Soc. Am. Graphic Artists; Boston Printmakers; Print Coun. Am. (adv. bd.). **Exhibited:** PAFA Ann., 1951, 1954, 1962; Work of Rudy Pozzatti, Cleveland Mus. Art, 1955; Young Americans, WMAA, 1961; Stampe di Due Mondi: Prints of Two Worlds, Tyler Sch. Art, Rome, Italy, 1967; 20 Year Retrospective, Sheldon Mem. A. Gal., Univ. Nebr., 1969; Artists Abroad, Inst. Int. Educ., Am. Fedn. Arts, New York, 1969; Joan Peterson Gal., Boston, MA, 1970s Awards: Assoc. Am. Artists Prize, 1962; 100 Prints of the Year Exhib., 1962; Guggenheim fel., 1963-64; George Norlin Silver Medal, Assoc. Alumni of Univ. Colo., 1972. **Work:** MoMA; LOC; AIC; Sheldon Mem. Art Gal., Lincoln, Nebr.; CMA. Commissions: (Spec. Print Editions) Cleveland Print Cl.,

CMA, 1954; Int. Graphic Arts Soc., New York, 1958-61 & 1963; Conrad Hilton Hotel, NYC, 1961; Clairol, Inc., for WFNY, 1963; Ferdinand Roten Gals., Baltimore, Md, 1967-68. **Comments:** First traveled to Italy in 1952 and has since then often chosen Italian-related subjects (such as ancient and modern Roman scenes, and religious themes common to Renaissance art). Has worked in all print media, but made his first lithographs in 1963 at the Tamarind Workshop, Los Angeles. Teaching: asst. prof. printmaking & painting, Univ. Nebr., 1950-56; prof. printmaking, Indiana Univ., 1956-72, distinguished prof., 1972-. **Sources:** WW73; Norman Geske, *Rudy Pozzatti: American Printmaker* (Univ. Kans. Press, 1971); Baigell, *Dictionary;* Richard Taylor, "Pozzatti" (film), Artists in America, NETV, 1971; Nancy Carroll, *A Visit with Rudy Pozzatti* (North Shore Art League, 1972); Falk, *Exh. Record Series.*

PRADOS, (Mme.) *[Miniaturist] early 19th c.*
Addresses: New Orleans, c.1800-24. **Exhibited:** America Expo, 1885-86. **Sources:** G&W; Fielding. More recently, see *Encyclopaedia of New Orleans Artists.* 314-15.

PRAEGER, Frederick A *[Collector, publisher] b.1915, Vienna, Austria.*
Addresses: Herrsching near München, Germany. **Studied:** Univ. Vienna. **Comments:** Positions: pres., Frederick A. Praeger, Publ., New York, 1950-68; chmn., Phaidon Publ., Ltd., London, 1967-68; gen. mgr., Ed. Praeger, Munich. 1969-. Collection: Contemporary art. **Sources:** WW73.

PRAGER, David A *[Collector] b.1913, Long Branch, NJ.*
Addresses: NYC. **Studied:** Columbia Univ. (B.A. & L.L.D.); also with Jack Tworkov. **Member:** Century Assn. **Comments:** Positions: asst. secy., Friends of WMAA, 1959-63, secy., 1963-67; mem. acquisitions comt., WMAA, 1960-61, 1967-68 & 1970-71; bd. trustees, Am. Fedn. Arts, 1967-, treas., 1969-; treas., Munic. Art Soc., 1967-69, bd. dirs., 1969-, pres., 1972-. Collection: contemporary American painting. **Sources:** WW73.

PRAGER, G. Joseph *[Sculptor] b.1907.*
Addresses: Amelia, OH. **Studied:** C.J. Barnhorn; E. Bruce Haswell. **Member:** Cincinnati Assn. Prof. A.; Contemporary A.; Jewish AC. **Exhibited:** Cincinnati Women's C., 1930; Jewish AC, 1931-35 (prizes). **Comments:** Position: t., Cincinnati Col. **Sources:** WW40.

PRAGLER, Estella J. *[Artist] late 19th c.*
Addresses: Active in Grand Rapids, MI, 1883. **Sources:** Petteys, *Dictionary of Women Artists.*

PRAGUE, Mary Brice See: **BRICE, Mary B. (Mrs. Albert G.)**

PRAHAR, Renée (Irene) *[Sculptor, teacher] b.1880, NYC / d.1963, New London, CT.*
Addresses: NYC. **Studied:** Bourdelle, Injalbert, Beaux-Arts, all in Paris. **Member:** NAWPS. **Exhibited:** Paris Salon; NAWPS; NSS; PAFA Ann., 1916; S. Indp. A., 1917; Kingore Gals., NYC, 1922 (solo); Salons of Am., 1923; AIC; WMAA, 1918, 1922, 1923. **Work:** MMA. **Sources:** WW33; Petteys, *Dictionary of Women Artists;* Falk, *Exh. Record Series.*

PRAHOR, Renee See: **PRAHAR, Renée (Irene)**

PRALL, Robert M. See: **PRATT, Robert M.**

PRAND, Edmond *[Painter] late 19th c.*
Addresses: Phila., PA. **Exhibited:** PAFA Ann., 1881. **Sources:** Falk, *Exh. Record Series.*

PRANG, Louis *[Lithographer, wood engraver, publisher] b.1824, Breslau, Germany / d.1909, Los Angeles, CA.*

December 1851.~
Louis Prang

Addresses: NYC (emigrated, 1850); Boston, MA, 1856-on. **Studied:** with his father, a calico printer. **Work:** Boston Public Lib. (major collection); American Antiquarian Soc. (Worcester, Mass.); Boston Athenaeum. **Comments:** Active in Germany, Austria, France and England until 1848, when, due to his involvement in the Revolution of 1848, he was forced to flee first to Bohemia, then to Switzerland, and finally to America, arriving in NYC in April of 1850. He settled in Boston, taught himself wood engraving and worked at it until 1856 when he went into the lithographic business in Boston with Julius Mayer (see entry). In 1860 Prang established his own firm, Louis Prang & Co. (Roxbury, MA) which soon became extremely successful. During the Civil War he published items relating to the war including battle plans and maps, but also card portraits of Union officers, sheet music, and Winslow Homer's popular *Campaign Sketches* and album cards (entitled *Life in Camp* and issued in two sets). In 1866, Prang began issuing chromolithographs of oil paintings, marketed under the name of "Prang's American Chromos" and advertised as "dining room pictures." Prints of works by American artists such as Carducius Ream, Lilly Martin Spencer, and Martin Johnson Heade, became extremely popular among the general American public and satisfied Prang's desire to bring knowledge and appreciation for art to a larger audience. Among his other accomplishments was his introduction of the Christmas Card in the 1870s and the colored pictorial business card (trade card). After 1875, with the aid of John S. Clark, Dana Hicks, and John S. Smith, the company designed a series of drawing textbooks and a line of school art materials and teaching aids that proved influential in the development of art education in the U.S. **Sources:** G&W; Rushford, "Louis Prang"; DAB; *Art Annual*, VII, obit.; Peters, *America on Stone;* Boston CD 1852 and after. More recently, see Katharine M. McClinton. *The Chromolithographs of Louis Prang* (New York: Clarkson N. Potter, 1973); Pierce and Slautterback, 148-49 (and repros.); Baigell, *Dictionary.*

PRANG, Robert L. *[Painter] late 19th c.*
Addresses: NYC. **Exhibited:** NAD, 1890. **Sources:** Naylor, *NAD.*

PRANG & MAYER *[Lithographers] mid 19th c.*
Addresses: Boston 1856-60. **Work:** Boston Athenaeum. **Comments:** Partners were Louis Prang and Julius Mayer (see entries). Produced a variety of work, mostly tinted lithographs. After 1860 Mayer established the firm of Mayer & Stetfield and Prang continued as Louis Prang & Co. **Sources:** G&W; Boston CD 1856-60; Rushford, "Lewis Prang." More recently, see Pierce and Slautterback, 149 (and repros.).

PRANKE, Earl Frederick *[Designer, illustrator, painter] b.1914, Cleveland, OH.*
Addresses: Cleveland, OH. **Studied:** Ohio Univ.; Cleveland School Art (B.A.); with Daniel Boza. **Exhibited:** CMA, 1938, 1939, 1940. **Comments:** Position: art director, Wolf Envelope Co., Cleveland, Ohio, 1939-41, 1946- U.S. Army. 1941-46. **Sources:** WW53; WW47.

PRAPPAS, George *[Painter] mid 20th c.*
Addresses: NYC, 1927. **Exhibited:** S. Indp. A., 1927. **Sources:** Marlor, *Soc. Indp. Artists.*

PRASH (OR PRASCH), Richard John, Jr. *[Painter] b.1919, Seattle, WA / d.1986, Portland, OR.*
Studied: Univ. of Wash.; Calif. Col. of A. &Cr., Oakland; Art Center School, Los Angeles. **Member:** Tacoma Art League; Puget Sound Group of Northwest Painters, 1955. **Exhibited:** Univ. of Puget Sound, 1938; Wash. State Hist. Soc., 1945; SAM, 1946. **Comments:** Position: t., Univ. of Oregon, 1949; t., Portland State Univ., 28 years. **Sources:** Trip and Cook, *Washington State Art and Artists.*

PRASSE, Leona E. *[Museum associated curator] mid 20th c.; b.Cleveland, OH.*
Addresses: Cleveland 6, OH; Lakewood 7, OH. **Studied:** Flora Mather Col., Western Reserve Univ. (B.S., B.A.); Cleveland Inst. A. **Exhibited:** Award: Guggenheim F., 1956. **Comments:** Position: assoc. cur., 1930- Dept. Prints & Drawings, CMA; sec., Print Club of Cleveland, 1947-. Contributor to CMA Bulletin, with numerous articles on prints and drawings. Assembled exhibitions and compiled catalogues of: Sesquicentennial Exhibition of

the The Art of Lithography, 1948; The Work of Lyonel Feininger, 1951; Work of Antonio Frasconi, 1952; Drawings of Charles E. Burchfield, 1953; Prints and Drawings by Walter R. Rogalski, 1954; Work of Rudy Pozzatti, 1955; Recent Work of Peter Takal, 1958; Shiko Munakata, 1960; Prints and Drawings of Werner Drewees, 1961. Granted visa by East Germany to travel there, 1959-60, for research on graphic art of Lyonel Feininger. **Sources:** WW66.

PRASUHN, John G. *[Sculptor] b.1877, near Versailles, OH.*
Addresses: Indianapolis, IN. **Studied:** Mulligan; Taft; AIC. **Member:** Ind. AC; Indianapolis AA. **Exhibited:** Hoosier Salon, 1938 (prize); AIC. **Work:** Northern Ill. State Normal Sch., De Kalb; Field Mus. Nat. History; Lincoln Park, Chicago; lions, Columbus Mem. Fountain, Wash., DC. **Comments:** Contributor: article "Cement," *Scientific American* (1912). Associated with the Field Mus. of Nat. History, Chicago. **Sources:** WW40.

PRATHER, Ralph Carlyle *[Illustrator, writer] b.1889, Franklin, PA.*
Addresses: Philadelphia, PA. **Comments:** I., "Yellow Jacket"; numerous children's stories, magazine covers, *Nature, Boy's Life, Child Life, St. Nicholas.* Contributor to national magazines. **Sources:** WW53; WW47.

PRATHER, Winifred Palmer (Mrs. Clark) *[Painter] b.1912, Plainfield, NJ.*
Addresses: New Orleans, LA/Fort de France, Martinique. **Studied:** Newcomb Col., New Orleans; Grand Central A. Sch.; ASL. **Member:** NOAA. **Exhibited:** NOAA, 1938 (prize); Delgado AM; SSAL, Montgomery, 1938, San Antonio, 1939. **Sources:** WW40.

PRATJE, Eugene *[Painter] late 19th c.; b.Batavia, Java, to Am. parents.*
Studied: Beaux-Arts Academy of Düsseldorf. **Exhibited:** Paris Salon, 1891. **Sources:** Fink, *American Art at the Nineteenth-Century Paris Salons,* 382.

PRATOR, Ernest *[Illustrator] 19th c.*
Addresses: NYC. **Comments:** Position: staff, *Illustrated American.* **Sources:** WW98.

PRATT, A. S. *[Painter] 20th c.*
Addresses: Phillips, ME. **Sources:** WW15.

PRATT, Ann See: **SPENCER, Ann Hunt**

PRATT, Bela L(yon) *[Sculptor, medalist, teacher] b.1867, Norwich, CT / d.1917, Boston, MA.*
Addresses: Jamaica Plain, Boston, MA/Bartlett's Harbor, North Haven, ME. **Studied:** Yale School FA, with Niemeyer and J.F. Weir, 1884-88; ASL with Saint Gaudens, F.E. Elwell, W.M. Chase, K. Cox, 1888-90; Académie Julian, Paris with H. Chapu, 1880-82, 1891; École des Beaux-Arts, Paris, with A. Falguière, 1890-92 (won several medals and prizes at the École and finished first in his class). **Member:** NSS 1899; ANA 1900; Arch. League, 1911; Guild Boston Artists, 1914 (founder); NIAL; CAFA; Tavern Club, Boston, 1894; The Country Cl., Brookline, MA, 1910. **Exhibited:** Paris Salon, 1892, 1897, 1898 (hon. men.); Pan-Am. Expo, Buffalo, 1901 (silver); PAFA Ann., 1902-13; St. Louis Expo, 1904 (gold); AIC, 1912-16; Pan.-Pac. Expo, 1915 (gold). **Awards:** Yale Univ. (hon. B.F.A., 1899); Harvard Univ. (hon. M.F.A., 1915). **Work:** BMFA; Harvard Univ.; Trinity Church, Boston; Boston Pub. Lib.; LOC; Yale Univ. AG; Portland MA; Johnson Mus. Art, Cornell Univ.; Houston MFA; U.S. Naval Acad.; State House, Boston; monument, Malden, MA; Andersonville, GA; St. Paul's School, Concord, NH; Brooklyn Inst. Mus.; New Bedford (MA) Free Pub. Lib. Architectural Sculpture: numerous decorations for LOC, including some for the Congressional Lib.(spandrel figures, entrance; bas-relief medallions for the pavillion). **Comments:** He returned from Paris in 1892, commissioned by Saint-Gaudens to produce two colossal groups for the World's Columbian Expo in Chicago. In 1893, he was appointed sculpture professor at the BMFA Sch., a position he held for the rest of his life. He had many commissions for

medals and medallions, and in 1908 produced the quarter and half-eagle Indian Head gold coins for the Roosevelt administration. 1909 was his most active year in medal work. The bulk of his 180 works, however, were portrait reliefs, portrait busts (such as the portrait bust of his good friend, Frank Benson), colossal groups, statues, and ideal figures, and monuments (such as his memorial to the "Titantic"). He was also known for his decorative architectural sculpture (for the Liberal Arts Bldg., Buffalo Expo. and for LOC). **Sources:** WW15; Cynthia P.K. Sam, "Bela Lyon Pratt: Medals, Medallions, and Coins" (conference paper, Am. Numismatic Soc., NY, 1988); Pratt Family Paper, Archives of Am. Art; Blasdale, *Artists of New Bedford,* 147-48 (w/repro.); Craven, *Sculpture in America,* 496-97; Fink, *American Art at the Nineteenth-Century Paris Salons,* 382; Falk, *Exh. Record Series.*

PRATT, Catherine H.B. *[Primitive watercolorist] mid 19th c.*
Addresses: Active in Stillwater, NY, 1828. **Comments:** Known for a mourning picture in memory of John and Mary Foot. **Sources:** Petteys, *Dictionary of Women Artists.*

PRATT, Charles H. *[Engraver] b.c.1836, Vermont.*
Addresses: Boston in 1860. **Sources:** G&W; 8 Census (1860), Mass., XXVI, 862.

PRATT, Dallas *[Patron, collector] b.1914, NYC.*
Addresses: NYC. **Studied:** Yale Univ. (B.A.); Columbia Univ. (M.D.). **Comments:** Positions: ed., Columbia Libr. Columns, 1951-; co-founder & trustee, Am. Mus. Britain, 1959-; ed., Am. in Britain, 1963-64; founder, John Judkyn Mem., Bath, Eng., 1964-. Collection: Renaissance maps & manuscripts. Publications: auth., "Discovery of a World-Early Maps of America," *Antiques Mag.* Dec., 1969 & Jan., 1970; auth, "Angel-Motors," Columbia Libr. Columns, May, 1972. **Sources:** WW73.

PRATT, David (Foster) *[Painter, craftsperson, designer] b.1918, Ithaca, NY.*
Addresses: Buffalo, NY; Holland, NY. **Studied:** AI of Buffalo; & with William B. Rowe; C. Bredemiere. **Member:** The Patteran. **Exhibited:** Albright A. Gal., 1939 (prize), 1940-46; Syracuse MFA, 1941 (prize); 20th Century C., 1940 (solo); AIC. **Sources:** WW53; WW47.

PRATT, Dudley *[Sculptor, lecturer, teacher] b.1897, Paris, France / d.1975.*
Addresses: Seattle, WA; Croton Falls, NY; Guanajuato, Mexico. **Studied:** Yale Univ.; BMFA Sch., with Charles Grafly; Acad. Grande Chaumière, with Emile Antoine Bourdelle; Univ. Wash., with Archipenko. **Member:** Pac. Northwest Acad. A. **Exhibited:** SAM, 1929-41, 1935 (solo), 1936 (prize), 1939 (prize); Oakland A. Gal., 1940; WFNY 1939. Sculpture Center, NY, 1957-58; PAFA Ann., 1958; Detroit Inst. A., 1958; Pennsylvania-Detroit, 1958; Art USA, 1958, Madison Square Garden, NYC, 1958; Mount Kisco Ann., Mount Kisco, NY, 1960, Northern Westchester, 1964; Audubon Artists 18th Ann., 1960; solo show, Sculpture Ann., New York, 1959. **Work:** SAM (three works); Civic Auditorium, Henry A. Gal., Doctors Hospital, Seattle, Wash.; IBM Coll.; Park Ave Gal., Mount Kisco, NY; Galeria San Miguel, San Miguel Allende, Mex. Commissions: 12 over life-size groups, Univ. Wash. Med. Sch., 1948; Gold Star Mother, War Mem. on Pub. Safety Bldg., City of Seattle, Wash., 1949; The Student (limestone), Holland Libr., Wash. State Univ., Pullman, 1950; Womens' Gymnasium, Social Science Bldg., Univ. Washington; Hoquiam (Wash.) City Hall; Bellingham City Hall; Washington State Col. Lib., Pub. Lib., Everett, Wash.; Seattle Surgical S., medals. **Comments:** Position: t., Univ. Wash. Seattle, 1925-432; ed-in-chief handbooks, from 1942, Boeing Aircraft Co., Seattle. **Sources:** WW73; WW47; Falk, *Exh. Record Series.*

PRATT, Eliza See: **GREATOREX, Eliza Pratt (Mrs. Henry M.)**

PRATT, Elizabeth Southwick (Mrs. R. Winthrop) *[Portrait painter, lithographer] b.NYC / d.1964.*
Addresses: New York 3, NY. **Studied:** Mass. Sch. Art; Cleveland Sch. Des.; and in Paris, London, Florence and Rome. **Member:**

Washington Square Assn. (bd. mem.); NAWA (pres.); Pen & Brush Club (1st vice- pres.); Engineering Woman's Club (bd. mem.). **Exhibited:** Studio Guild, NYC, 1940 (solo); NAWA, 1947-56, 1957 (medal), 1958-60; Pen & Brush Club, 1945-61; Argent Gal., NYC. **Work:** many portraits in U.S. and abroad. **Comments:** Lectures on art for women's clubs, museums and art groups. **Sources:** WW59.

PRATT, Emmett A. *[Painter] 20th c.*
Addresses: Hanford, CT. **Sources:** WW25.

PRATT, Frances (Frances Elizabeth Usui) *[Painter, art dealer] b.1913, Glen Ridge, NJ.*
Addresses: NYC. **Studied:** New York Sch. Applied Design for Women; ASL with Richard Lahey; Hans Hofmann Sch. Art. **Exhibited:** Layton A. Gal., 1941; Denver A. Mus., 1942; Denver AM annual, 1942; Mun. A. Gal., Jackson, Miss., 1943, 1946; Marquie Gal., 1943 (solo); AGAA 1945; Am.-British A. Ctr., 1945 (solo); Mint Mus., 1946; CMA, 1947; Brooklyn Mus. Watercolor Int., 1947, 1949 & 1951; Corcoran Gal. biennial, 1949; NAWA Ann., 1946; prize for oil, NAWA Ann., 1946 (prize), 1950 (Anne Payne Robertson Prize); Audubon Artists annual, 1952 (prize for crayon mixed media). **Work:** Brooklyn Mus, NY; VMFA. **Comments:** Positions: owner-dir., Frances Pratt, Inc, Gal. Teaching: YWCA, NYC, 1940s; Ballard Sch., NYC, 1942-59; Parsons Sch Des., 1948-51. Collections arranged: "Ancient Mexico in Miniature," AFA, 1964-66; "Guerrero, Stone Sculpture from the State of Guerrero," Mex., Finch Col. Mus. Art, 1965. Research: pre-classic cultures of Mexico (1500 BC - AD 200). Specialty of gallery: antiquities; Oriental pottery; modern paintings. Collection: paintings, prints, Japanese tea bowls. Publications: co-author, "Encaustic, Methods and Materials," 1949. Illustrator: *Mezcala Stone Sculpture: the Human Figure*, Mus. Primitive Art, 1967; *Chalcacingo: Akademische Drucke* U. Verlagsanstalt, Graz, Austria, 1971; *Paleolithic and Megalithic Traits in the Olmec Tradition of Mexico*, Institutum Canarium, Graz, Austria, 1972. **Sources:** WW73; WW47 (as Mrs. Chris Ritter).

PRATT, Fred S. *[Painter] late 19th c.*
Addresses: Worcester, MA. **Exhibited:** PAFA Ann., 1896-97. **Sources:** Falk, *Exh. Record Series.*

PRATT, George Dupont *[Patron] b.1869, Brooklyn, NY / d.1935.*
Addresses: Glen Cove, NY. **Studied:** Amherst Col., 1893. **Member:** MMA (trustee); financed American Art Show, 1932, Intl. Art Exh., Venice; PIA Sch.; Am. Fed. A.; Soc. Medalists (founder); Cosmos C.; Century. **Comments:** Son of Charles M. who founded PIA Sch.

PRATT, Georgia B. *[Painter] early 20th c.*
Addresses: Denver, CO. **Exhibited:** S. Indp. A., 1922. **Sources:** Marlor, *Soc. Indp. Artists.*

PRATT, Harry E(dward) *[Painter, illustrator, teacher] b.1885, North Adams.*
Addresses: North Adams, MA/Jacksonville, VT. **Sources:** WW29.

PRATT, Helen L. (Mrs. Bela L.) *[Sculptor] b.1870, Boston, MA.*
Addresses: Jamaica Plain, MA. **Studied:** BMFA Sch. **Exhibited:** Paris Salon, 1897; PAFA Ann., 1912. **Sources:** WW17; Fink, *American Art at the Nineteenth-Century Paris Salons*, 382; Falk, *Exh. Record Series.*

PRATT, Henry Cheever *[Portrait and miniature, landscape and panorama painter] b.1803, Orford, NH / d.1880, Wakefield, MA.*
Studied: S.F.B. Morse, beginning c.1817. **Exhibited:** Boston Athenaeum; San Diego (1852, this is the first known art exhibition in California). **Work:** Orford, NH, Mus.; Peabody Mus. (Salem, MA); MMA; Univ. of Texas at Austin; LACMA; de Young Museum. **Comments:** Was fourteen years old and working on a New Hampshire farm (c.1817) when S.F.B. Morse noticed

his drawings on a barn door and encouraged his parents to let him come to Boston for study. He became Morse's assistant for a number of years, traveling with him to Charleston in 1819 and 1820, to Washington, DC, in 1821, and again to Charleston in 1822. By 1825 Pratt was established in his own studio in Boston, painting portraits. He also was interested in landscape and made sketching trips, once traveling to Maine with his friend Thomas Cole (1845). From 1851-53 he was survey artist with John Russell Bartlett's expedition to explore the Mexican boundary. He made many oil sketches along the way and in later years turned some into major canvases. He lived in Charlestown, MA, until 1860 when he moved to Montrose (part of Wakefield, MA). **Sources:** G&W; Karolik Cat., 449-51; Mabee, *The American Leonardo;* Larkin, *Samuel F.B. Morse and American Democratic Art;* Rutledge, *Artists in the Life of Charleston;* Boston BD 1841-60+; Swan, BA; Cowdrey, NAD; Rutledge, PA; Boston *Transcript*, Nov. 30, 1880, obit.; Boston *Transcript*, June 5, 1849, and March 1, 1850, and Baltimore *Sun*, July 12, 1852 (citations courtesy J.E. Arrington); *American Processional*, 149; *Panorama* (Jan. 1949), 53, 55. More recently, see P&H Samuels, 380-81; Hughes, *Artists in California.*; Campbell, *New Hampshire Scenery*, 129-130.

PRATT, Henry Cheeves See: **PRATT, Henry Cheever**

PRATT, Herbert William *[Painter, screenprinter] b.1904, Leicester, England.*
Addresses: NYC. **Studied:** NAD; ASL with J. Matulka, S. Hawthone, H. Hofmann. **Member:** Nat. Serigraph S. **Exhibited:** NAD, 1928; Phila. WCC, 1929; Wilmington SFA, 1929; AWCS, 1928; Roerich Mus., 1933; SFMA, 1945; Oakland A. Gal., 1944; MoMA, 1940; BM, 1944, 1945; Intl. Pr. S., 1944; Rochester Pub. Lib., 1945. **Sources:** WW47.

PRATT, Inga *[Painter, commercial artist, illustrator] b.1906, Brookings, SD.*
Addresses: Highlands, NJ. **Studied:** Acad. Colarossi, Paris; ASL. **Member:** ASL; SI. **Exhibited:** Lotos Cl., 1953. **Award:** Direct Mail Adv. Assn., 1946. **Comments:** Contributor illus. to Harpers magazine. Freelance for various advertising agencies. **Sources:** WW59.

PRATT, J. *[Painter] early 19th c.*
Exhibited: American Academy, 1825 (view of Boston Common). **Sources:** G&W; Cowdrey, AA & AAU.

PRATT, John *[Painter] mid 20th c.*
Addresses: Chicago, IL. **Exhibited:** AIC, 1936-37, 1939. **Sources:** WW40.

PRATT, Joseph (Mrs.) *[Painter] late 19th c.*
Addresses: Active in Chicago. **Exhibited:** Interstate Indus. Expo, Chicago, 1878. **Sources:** Petteys, *Dictionary of Women Artists.*

PRATT, Julia D. *[Painter, lecturer] early 20th c.; b.North Collins, NY.*
Addresses: Buffalo, NY/North Collins, NY. **Studied:** O. Scheider, Buffalo FA Acad.; CUA Sch.; NY Indst. A. Sch. **Member:** Buffalo Ind. A.; Buffalo Allied AA; Chicago NSA; S. Indp. A.; Buffalo SFA. **Exhibited:** S. Indp. A., 1922, 1924-25. **Sources:** WW33.

PRATT, Katharine *[Craftsman] b.1891, Boston, MA.*
Addresses: Dedham, MA. **Studied:** BMFA Sch.; & with George C. Gebelein. **Member:** Boston Soc. Arts & Crafts (master craftsman & medalist). **Exhibited:** BMFA; Paris Salon 1937; Boston SAC, 1932 (medal); Tercentenary Exh., Boston, 1930 (medal). **Comments:** Position: instructor, silversmithing, Boston Sch. Occupational Therapy, 1943-. **Sources:** WW59; WW47.

PRATT, Katherine *[Printmaker] early 20th c.*
Exhibited: Printmakers Soc., LACMA, 1916. **Sources:** Petteys, *Dictionary of Women Artists.*

PRATT, Kenneth *[Painter] mid 20th c.*
Addresses: San Leandro, CA. **Exhibited:** Oakland A. Gal., 1938-39. **Sources:** Hughes, *Artists in California*, 446.

PRATT, Lorus *[Portrait painter, landscape painter, mural painter]* b.1856, Salt Lake City / d.c.1923.
Addresses: Salt Lake City, UT. **Studied:** Deseret Univ. with Weggeland, Ottinger; NYC, 1876; Académie Julian, Paris with Constant and Doucet, 1890-92 (sponsored by Church of LDS). **Work:** LDS temples. **Comments:** Pratt was in England in 1879. After studying in Paris, he returned to Salt Lake City in 1892 and painted in LDS temples, although he found his art career unprofitable. **Sources:** WW15; P&H Samuels, 381; Trenton, ed. *Independent Spirits,* 216.

PRATT, M. S. *[Painter]* 19th/20th c.
Addresses: NYC. **Member:** NY Womens AC. **Sources:** WW01.

PRATT, M. T. (Mrs.) *[Painter]* late 19th c.
Addresses: Active in Bridesburg, Phila. **Exhibited:** PAFA Ann., 1879. **Sources:** Petteys, *Dictionary of Women Artists;* Falk, *Exh. Record Series.*

PRATT, Marcus D. *[Painter]* mid 20th c.
Addresses: Buffalo, NY. **Exhibited:** Bibliography: 1950-51. **Sources:** Falk, *Exh. Record Series.*

PRATT, Matthew *[Portrait painter, decorative painter, teacher]* b.1734, Philadelphia, PA / d.1805, Philadelphia.
Studied: apprenticed with his uncle, James Claypoole, Sr.,1749-55 (James Claypoole, Jr., had previously been identified as Pratt's teacher but subsequent research has shown that Pratt finished his apprenticeship in 1755. Given that James, Jr., was born about 1743, producing his first known work c.1761, it is not feasible that James, Jr. was the teacher); Benjamin West in London. **Exhibited:** Soc. Artists of Great Britain, 1766 ("The American School"); Williamsburg, VA, 1773. **Work:** MMA; Nat. Port. Gallery, Wash., DC; Colonial Williamsburg Coll.; Shelburne (VT) Mus.; PAFA; NY Chamber of Commerce. **Comments:** After his apprenticeship, he set up his trade (see Hart) with Francis Foster (of whom nothing further is recorded). Pratt spent six months in Jamaica, 1757-58, and on his return to Philadelphia began painting portraits. In 1764 he traveled to London with his cousin Betsy Shewell, who was Benjamin West's fiancée, and West's father. Pratt lived with West from 1764-66 and while there made his best-known painting, "The American School" (MMA), a conversation piece depicting five artists in the studio of Benjamin West. After his London stay, Pratt painted portraits in Bristol, England for a year and a half, returning to Philadelphia in 1768. Over the next several years, Pratt painted in Philadelphia and also traveled to NYC in 1772 and Virginia. In 1773 he had an exhibition in Williamsburg, showing portraits and still-lifes, as well as copies after West. After 1785, Pratt seems to have remained primarily in Philadelphia. While he continued to paint portraits, he also worked as a sign painting, achieving high distinction for his craftsmanship in that field. Pratt was also a teacher. **Sources:** G&W; Older sources include: Sawitzky, *Matthew Pratt, 1734-1805,* chronology and checklist, 43 plates; Flexner, *The Light of Distant Skies,* biblio., 265; Charles Henry Hart, "Autobiographical Notes of Matthew Pratt, Painter," *Pennsylvania Magazine of History and Biography* vol.19 (1896): 460-67. More recently, see Saunders and Miles, 32, 265-68, 311-13 (who identify Claypoole, Sr., as Pratt's teacher); and Baigell, *Dictionary.*

PRATT, Philip H(enry) *[Designer, decorator, lecturer, teacher]* b.1888, Kansas City, MO.
Addresses: Brooklyn, NY. **Studied:** St. Louis Sch. FA; Phila.Indst. A. Sch.; South Kensington, London. **Work:** murals, Wis. State Capitol. **Sources:** WW40.

PRATT, Ralph Farman *[Painter]* 19th/20th c.
Addresses: Warner, NH. **Exhibited:** Boston AC, 1909. **Sources:** *The Boston AC.*

PRATT, Robert M. *[Painter]* mid 20th c.
Addresses: NYC, 1954. **Exhibited:** PAFA Ann., 1954 ("Lilac Garden"). **Sources:** Falk, *Exh. Record Series.*

PRATT, Robert M. *[Portrait, figure, and flower painter]* b.1811, Binghamton, NY / d.1880, NYC.
Addresses: NYC, 1845-1858 and c. 1865-80. **Studied:** Paris, 1859 (was in Europe until before 1865). **Member:** A.N.A., 1849; N.A., 1851. **Exhibited:** NAD, 1833-81; Brooklyn AA, 1863-80; PAFA, 1865-67. **Sources:** G&W; *American Art Review,* I (1880), 552, obit.; Cowdrey, NAD; Naylor, NAD; Swan, BA; Rutledge, PA; NYCD 1845+; *Stranger's Guide* to NYC, 1847 (as Robert M. Prall).

PRATT, Rosalind Clark *[Painter]* b.c.1857 / d.1932, Branford, CT.
Studied: NAD. **Member:** AFA; Nat. Educ. Assn.; Conn. Forest & Park Assn.; World Peace Lg. **Exhibited:** NAD, 1893.

PRATT, Ruth *[Painter]* 20th c.
Addresses: Fenway Studios, Boston, MA. **Sources:** WW13.

PRATT, Samuel B. *[Painter]* mid 20th c.
Addresses: Arlington, VA. **Exhibited:** Corcoran Gal biennials, 1945, 1951. **Sources:** Falk, *Corcoran Gal.*

PRATT, V(irginia) Claflin (Mrs. Dudley) *[Sculptor, teacher]* b.1902, Littleton, MA.
Addresses: Seattle, WA; Deer Harbor, MA. **Studied:** C. Grafly; E. A. Bourdelle; BMFA Sch.; Grande Chaumière, Paris. **Member:** Pac. Northwest Acad. A. **Exhibited:** Northwest Ann., 1934 (prize); SAM, 1937. **Work:** numerous portrait heads. **Comments:** Position: hd. art dept., Helen Bush Sch., Seattle, Wash. 1926-38. Married to Dudley Pratt (see entry). **Sources:** WW53; WW47.

PRATT, RUTTER & CO. *[Portrait and ornamental painters]* late 18th c.
Addresses: Philadelphia, 1796. **Comments:** The firm was composed of Matthew Pratt, George Rutter, William Clarke and Jeremiah Paul (see entries). Pratt dropped out after a few months, however, and the firm became known as Paul, Rutter & Clarke. **Sources:** G&W; Prime, II, 31.

PRATVIEL, Louis *[Portrait painter]* mid 19th c.
Addresses: St. Louis, 1854-59. **Sources:** G&W; St. Louis BD 1854, 1859.

PRAUS, H(arry) J. *[Painter]* early 20th c.
Addresses: Astoria, LI, NY. **Exhibited:** S. Indp. A., 1918. **Sources:** Marlor, *Soc. Indp. Artists.*

PREBLE, Donna Louise *[Painter, illustrator]* b.1882, Reno, NV / d.1979, Vista, CA.
Addresses: Hawaii; San Diego, CA; Pasadena, CA. **Studied:** Partington School of Illustration, San Francisco. **Comments:** Position: illustr., ad. agencies. Author, illustr., *Tomar of Siba,* and *Yamino Kwiti,* children's books on Southern Calif. Indians. **Sources:** Hughes, *Artists in California,* 446.

PREBLE, Marie (Mrs.) *[Miniature painter]* 19th/20th c.; b.Boston, MA.
Addresses: Paris, France. **Studied:** Mrs. Hortense Richard. **Exhibited:** Paris Salon, 1879, 1893, 1894, 1896-99; NAD, 1887. **Comments:** Exhibited drawings at the Paris Salons. **Sources:** WW04; Fink, *American Art at the Nineteenth-Century Paris Salons,* 382.

PRECHT, Fred A. *[Painter]* mid 20th c.
Addresses: NYC. **Exhibited:** S. Indp. A., 1917-18, 1921-22, 1925-30; PAFA Ann., 1929. **Sources:** WW21; Falk, *Exh. Record Series.*

PRECHT, Fritz *[Painter]* 20th c.
Addresses: NYC. **Sources:** WW06.

PRECOUR, Peter (Mme.) *[Drawing teacher and fan-painter]* mid 18th c.
Addresses: Charleston, SC, 1732. **Sources:** G&W; Rutledge, *Artists in the Life of Charleston.*

PRECOURT, Virginia Strom *[Painter, graphic artist, designer, sculptor, illustrator]* b.1916, Duluth, MN.
Addresses: Shaker Heights, OH, until 1927, summers later; Chicago, IL; Boothbay Harbor, ME, 1940-56; Dover, MA. **Studied:** Stuart School, Boston; BMFA School; Radcliffe Col.,

Cambridge, MA; Cleveland School of Art; Child Walker Art School, Florence, Italy; AIC; also in England, Egypt (tomb-restoration techniques), France, Spain, Bulgaria, Rumania, Iran, Mongolia, China. **Member:** Copley Soc., Boston. **Exhibited:** Boston Symphony Hall, 1969 (solo); Boston A. Center, 1970; Arvest Gals., 1973-75; Copley Soc., Boston (Master's Medallion); "100 Best Artists in America", competition and tour. **Work:** DeCordova Mus., Lincoln, Mass; Weyerhauser Mus., Duxbury, Mass; Bank of Boston, in Boston, London, and NYC; Gillette Corp., Boston; Marrott Corp., Los Angeles, Cal.; Art for Industry, Boston and NYC; Caps Cities/ABC, NYC; corporate and priv. colls. **Comments:** Positions: prior to 1964, worked as fashion artist, clothing designer, in Chicago, IL, and also as commercial artist and product designer. Her art work has been characterized as having an air of mystery, achieved by the layering of plastics, pigment and stone as well as the use of abrasives, knives, needles and razors, clothes and solvents to create various effects. Out of her interest and concern for the preservation of art works, she invented several techniques for incorporating synthetic materials into art work that helps ensure their preservation. **Sources:** info., including clippings and exh. materials, courtesy Arline E. Vogel, NYC.

PREDLOVE See: **PRETLOVE, David**

PREDMORE, Jessie *[Primitive painter]* b.1896, Osco, IL. **Studied:** self-taught. **Exhibited:** Hagen Art Gal., Stockton, CA; Crocker Art Gals., Sacramento. **Comments:** Painted Indians on the Nez Percés reservation in Idaho. Took up painting at age 44. **Sources:** Petteys, *Dictionary of Women Artists.*

PREHN, Hans Ernst *[Sculptor, painter, craftsperson]* b.1895, Philadelphia, PA. **Addresses:** New York 14, NY. **Studied:** Acad. FA, Budapest; CUA Sch.; BAID. **Member:** Artist-Craftsmen of NY. **Exhibited:** Medallic A. Soc., 1950; Arch. Lg.; SC (NSS exh.), 1951, 1952, 1954; NY Soc. of Craftsmen, 1953-1957. Awards: prizes, CUA Sch., 1927, 1931, bronze medal, 1933. **Work:** paintings, Marble Collegiate Church, NY; bas-relief panel, USPO, Bishopville, SC; work also in church in Csepa, Hungary. **Sources:** WW59.

PREIBISIUS, Hilda Elma *[Graphic artist]* b.1901, Ohio / d.1981, San Diego, CA. **Addresses:** San Diego, CA. **Exhibited:** San Diego FA Gal., 1927. **Work:** WPA artist. **Sources:** Hughes, *Artists in California,* 447.

PRELL, Walter *[Painter]* b.1857. **Studied:** Académie Julian, Paris with J.P. Laurens and Constant, 1891. **Sources:** Fehrer, The Julian Academy.

PRELLWITZ, Edith Mitchill (Mrs. Henry) *[Painter, designer]* b.1865, South Orange, NJ / d.1944, East Greenwich, RI. **Addresses:** Peconic, NY, from 1899; NYC. **Studied:** ASL with Brush, Cox; Académie Julian, Paris with Bouguereau and T. Robert-Fleury; also with Courtois. **Member:** SAA, 1898; ANA, 1906; NAWA. **Exhibited:** PAFA Ann., 1888, 1892-93 (as Mitchell), 1896-97, 1930 (as Prellwitz); Paris Salon; NAD, 1891-94 (prize), 1895, 1929 (prize); SAA, 1895 (prize); Atlanta Expo, 1885 (med.); Pan-Am. Expo, Buffalo, 1901 (med.); AIC; P&S of Los Angeles, 1930. **Work:** mural, Universalist Church, Southhold, NY. **Comments:** Member of the Cornish (NH) colony from 1895-98. Contributor: article, "Tempset in Paint Pots," *American Magazine of Art.* **Sources:** WW40; Pisano, *One Hundred Years.the National Association of Women Artists,* 76; Falk, *Exh. Record Series.*

PRELLWITZ, Henry *[Painter]* b.1865, NYC / d.1940, East Greenwich, RI. **Addresses:** NYC/Cornish, NH/Peconic, NY. **Studied:** P.T. Dewing; ASL; Académie Julian, Paris with J.P. Laurens, 1887-89. **Member:** SAA 1897 (sec.); ANA 1906, NA 1912 (treasurer); Century Assn.; Cornish Colony. **Exhibited:** NAD , 1892-93 (third Hallgarten Prize), 1894-97, 1907 (Clarke Prize); PAFA Ann.,

1893-94, 1898, 1903-04; Pan-Am. Expo, Buffalo, 1901 (bronze med.); St. Louis Expo 1904 (med.); AIC. **Comments:** Known for his idealistic paintings, he was part of the artists' colony in Peconic, which included E.A. Bell, Irving Wiles and B. Fitz. His wife Edith was also an accomplished painter. Teacher: drawing and life classes, Pratt AI; dir., ASL, 1894-98. **Sources:** WW40; Pisano, *The Long Island Landscape,* n.p.; Falk, *Exh. Record Series.*

PRENDERGAST, Ana M(argarita) *[Painter]* mid 20th c. **Addresses:** NYC. **Studied:** ASL. **Exhibited:** S. Indp. A., 1929, 1930, 1932, 1938. **Sources:** Marlor, *Soc. Indp. Artists.*

PRENDERGAST, Charles E. *[Craftsman, painter, sculptor, framemaker, teacher]* b.1863, Boston, MA / d.1948, Norwalk, CT. **Addresses:** Westport, CT, 1925-on. **Member:** Am. Soc. P S & G.; ANA, 1939. **Exhibited:** S. Indp. A., 1917-18, 1921, 1936, 1941; Salons of Am., 1923; AIC; WMAA, 1934-48; Corcoran Gal. biennial, 1939; PAFA Ann., 1939, 1945-46. **Work:** PMG; AGAA; RISD; Barnes Fnd.; International House, NY. **Comments:** Early in his career, he became known for his exotic hand-carved and painted frames, often of gold or silver leaf over incised plaster, with color. In 1903, he and H. Dudley Murphy founded the Carrig-Rohane Frame Shop (see separate entry) in Winchester, Mass. It was not until he was about age 50 that Prendergast turned more fully to painting. Charles's more famous brother was Maurice Prendergast, for whom he created many frames. Signature note: The backs of his paintings or frames are often inscribed with sketches of animals, and his frames typically bear his carved monogram. **Sources:** WW47; *Community of Artists,* 76 (cites an 1863 birth date); Marlor, *Salons of Am.* (puts date of birth at 1863); Falk, *Exh. Record Series.*

PRENDERGAST, Eugenia Van Kemmel *[Patron]* b.1894 / d.1994. **Comments:** For half a century, she was the protector and promoter of the works of both her husband, Charles, and her brother-in-law, Maurice Prendergast. Her gifts to the Williams College Museum of Art formed an aggregate of $32-million, including 379 works by the Prendergast brothers (the largest collection of their work) and a trust to support the museum. **Sources:** press release, Williams College (Williamstown, MA, Oct. 1996).

PRENDERGAST, James Donald (Mrs.) See: **ULLRICH, B(eatrice) (Mrs. J. D. Prendergast)**

PRENDERGAST, James Donald *[Painter, etcher, lithographer, writer]* b.1907, Chicago, IL. **Addresses:** Ann Arbor, MI; New Orleans, LA. **Studied:** AIC; Univ. Chicago (B.F.A.); UCLA; & with Boris Anisfeld, Edward Weston. **Member:** Laguna Beach AA; Calif. WCS; San F. AA; Audubon A.; CAA; Am. Assn. Univ. Prof. **Exhibited:** WFNY 1939; GGE, 1939; MMA; SFMA, 1939-43; PAFA, 1939; PAFA Ann., 1942; AIC, 1933, 1935, 1942; BMA, 1939; Rockford AA, 1939; San Diego FA Soc., 1940; LACMA, 1938-40; CGA, 1941; Louisiana A., 1941; VMFA, 1942; Univ. Arizona, 1943; Audubon A., 1945; La Tausca Pearls Exh., 1946; Central American traveling exh.; Detroit Inst. A., 1944, 1945. Awards: John Quincy Adams traveling Fellowship, 1931-32. **Work:** Univ. Arizona. **Comments:** Position: visiting instr., Univ. Southern California, 1937-40; instr., New Orleans A. & Crafts Sch., 1940-42; asst. prof., Univ. Arizona, 1942-44; asst. prof., Dept. Drawing & Painting, Col. Arch. & Des., Univ. Michigan, Ann Arbor, Mich., 1944-48; assoc. prof., 1948-. **Sources:** WW59; WW47; Falk, *Exh. Record Series.*

PRENDERGAST, John *[Amateur painter, sketch artist]* b.1815, England. **Addresses:** Came to San Francisco from Hawaii in July 1848, active 1848-51. **Work:** a number of his drawings survive at: Soc. of Calif. Pioneers. **Comments:** During his three years in California, made many watercolors and drawings (in crayon and

pencil). Four of his paintings were used to illustrate Theodore T. Johnson's *California and Oregon, 1850* (2nd ed.), while some other works were lithographed and appeared in *Procession at San Francisco in Celebration of the Admission of California, 1850.* **Sources:** G&W; Van Nostrand and Coulter, *California Pictorial,* 150-51; Peters, *California on Stone;* Jackson, *Gold Rush Album,* 118 (as Pendergast). More recently, see Hughes, *Artists in California;* P&H Samuels, 381; Forbes, *Encounters with Paradise,* 122-23.

PRENDERGAST, Maurice *Prendergast* **B(razil)** *[Painter, illustrator, graphic artist]* b.1858, St. John's, Newfoundland / d.1924, NYC. **Addresses:** family came to Boston in 1861; Winchester, MA; NYC, 1914-on. **Studied:** early training was as a letterer and showcard painter; Acad. Julian, Paris, with J.P. Laurens, 1887-89; Acad. Colarossi with Blanc, 1891-95; J. W. Morrice (Canadian) in Paris. **Member:** NYWCC; Copley Soc., 1898; Boston WCC; Boston GA; Am. P&S; S. Indp. A.; Lg. AA; New SA. **Exhibited:** Boston AC, 1895-1906; PAFA Ann., 1896-1903, 1915, 1918-19; AIC,1897-1939, 1932 (prize); Pan-Am. Expo, Buffalo, 1901 (med.); Corcoran Gal. biennials, 1907-23 (7 times, incl. bronze med., 1923); Armory Show, 1913; with "The Eight" (although his work is neo-impressionist rather than "Ash Can"); S. Indp. A., 1917-21, 1925, 1936, 1941; Salons of Am., 1923; Univ. Maryland, 1976 (retrospective); WMAA, 1920, 1928. **Work:** Williams College Mus. Art (including archival material); MMA; WMAA; BFMA; PMG; Worcester Art Mus.; CI; CGA; Detroit Inst. Art; Lehigh Univ., Bethlehem, PA; Munson-Williams-Proctor Inst., Utica, NY. **Comments:** Modernist painter best known for his lively beach and park scenes combining bold contoured forms with decorative surface patterning and bright, prismatic color. For much of his career he worked primarily in watercolor but in the mid-teens began to focus more on oils. He also made over 200 monotypes between 1892 and 1905. Traveled abroad six times: England, 1886; France, 1891 to c.1895; Italy, 1898-99; Paris, 1909-10; Italy, 1911-12; Paris, 1914. **Sources:** WW24; Baigell, *Dictionary;* Susan E. Strickler, ed., *American Traditions in Watercolor: The Worcester Art Museum Collection* (New York: Worcester Art Museum with Abbeville Press, 1987); Carol Clark et al., catalogue raisonné (Prestel); Mecklenburg, Zurier, and Snyder, *Metropolitan Lives: the Ashcan Artists and their New York; 300 Years of American Art,* 532; Falk, *Exh. Record Series.*

PRENDERGAST, Molly (Mrs. E. P.) *[Painter]* b.1908, Belmont, MA. **Addresses:** Sacramento 15, CA. **Studied:** Univ. California (A.B., M.A.), and with Hans Hofmann. **Member:** San F. Soc. Woman A.; Nat. Ser. Soc. **Exhibited:** San F. AA, 1944-46; San F. Soc. Women A., 1944-46, 1948-52; Northern Cal. A.; Cal. State Fair; Crocker A. Gal.; Cal. State Lib.; solo: City of Paris, San F.; Crocker A. Gal.; Sacramento City Lib., 1952. **Sources:** WW53.

PRENNER, Raya G. *[Jewelry maker]* mid 20th c. **Exhibited:** S. Indp. A., 1942. **Sources:** Marlor, *Soc. Indp. Artists.*

PRENTICE, David Ramage *[Painter, designer]* b.1943, Hartford, CT. **Addresses:** NYC. **Studied:** Hartford Art Sch. **Exhibited:** Teuscher Gallery, 1966 (solo); Sonnabend Gallery, NYC, 1970 (solo); Other Ideas, Detroit Inst Fine Arts, Mich., 1969; Prospect, Düsseldorf, Ger., 1969; WMAA, 1969, Ann.,1970; Sonnabend Gallery, NYC, 1970s. **Work:** Wadsworth Atheneum, Hartford; Yale Univ., New Haven, Conn.; MoMA. **Comments:** Preferred media: acrylics. Teaching: guest instr. painting, Hartford Art Sch., Univ. Hartford, fall 1970. **Sources:** WW73.

PRENTICE, George W. *[Ornamental painter]* b.c.1813, Rhode Island. **Addresses:** Philadelphia in 1850. **Sources:** G&W; 7 Census (1850), Pa., LIII, 26; living with his wife, and their three children, ages 1 to 6, all born in Pennsylvania.

PRENTICE, Levi Wells *[Painter]* **L.W.Prentice.** b.1851, Harrisburg, NY / d.1935,

Philadelphia, PA. **Addresses:** Syracuse, NY, 1870s-83; Buffalo, NY, 1883-late '80s; Brooklyn, late '80s-?; NYC; CT; NJ; Phila. **Member:** Brooklyn AA. **Exhibited:** Adirnondack Mus., Blue Mountain Lake, NY, 1993 (retrospective). **Work:** Adirondack Mus., Blue Mountain Lake, NY; Shelburne (VT) Mus. **Comments:** Grew up on a farm in Lewis County, NY, and was listed as a landscape painter in Syracuse by 1872. For the next several years he traveled through the region, painting the Adirondack mountains and surrounding area. Both he and his father were listed as residents of Buffalo, NY, in 1879, 1880, and 1884. During these years, when his landscapes were bringing him recognition, he also painted portraits, decorated ceilings in homes, and designed furniture and houses. After moving to Brooklyn in 1884, Prentice began painting still lifes, focusing on fruit — especially apples and plums —shown either piled high in pots in an interior or set into a natural setting. In the latter type Prentice typically presented the fruit: 1) tumbling out of a basket onto the grass or 2) growing on the tree (shown in a close-up, cropped view) with the natural landscape behind. Prentice moved often after leaving Brooklyn in 1903, living in NYC, Connecticut, and New Jersey before settling in Philadelphia (probably by 1907 when his son graduated from Philadelphia High School). Prentice's sharply linear and simple yet realistic renderings of fruit did not gain much attention with historians until the 1970s. **Sources:** Gerdts, *Painters of the Humble Truth,* 205-06 (with repro.); Gerdts and Burke, *American Still-Life Painting,* 159-62 (with repro.); *300 Years of American Art,* vol. 1: 454 (with repro.); Muller, *Paintings and Drawings at the Shelburne Museum,* 248 (with repro.); *Nature Staged: The Landscape and Still Life Paintings of Levi Wells Prentice* (exh. cat., Adirnondack Mus., Blue Mountain Lake, NY, 1993); *American Paintings from the Masco Corporation* (auction cat., Sotheby's, NYC, Dec. 3, 1998), 62-66.

PRENTIS, Edmund Astley *[Craftsperson]* b.1856, Long Island City, NY. / d.1929. **Member:** NY SAC (pres.). **Comments:** Specialty: illuminated Spanish leather.

PRENTISS, Addison *[Wood engraver]* mid 19th c. **Addresses:** Worcester, MA, 1852-60. **Sources:** G&W; Worcester CD 1852-60.

PRENTISS, Dorothea *[Painter]* mid 20th c. **Exhibited:** Salons of Am., 1935. **Sources:** Marlor, *Salons of Am.*

PRENTISS, Grace Leonie *[Painter]* 19th/20th c. **Addresses:** South Norwalk, CT, active 1898-1900. **Exhibited:** Boston AC, 1898. **Sources:** *The Boston AC.*

PRENTISS, Lillian *[Painter]* mid 20th c. **Exhibited:** Salons of Am., 1928-30; AIC; PAFA Ann., 1934. **Sources:** Falk, *Exh. Record Series.*

PRENTISS, Nathaniel Smith *[Engraver?]* mid 19th c. **Addresses:** NYC. **Comments:** Prentiss is listed as a perfumer in NYC directories from 1818 to 1838, but from 1835 to 1838 he seems to have been associated with Charles Cushing Wright in the NYC firm of Wright & Prentiss, xylographic (wood) and copperplate engravers and printers (see entry). **Sources:** G&W; NYCD 1818-38.

PRENTISS, Sarah J(ane) *[Flower, figure, and still-life painter]* b.1823, Paris, ME / d.1877, Bangor, ME. **Addresses:** Paris, ME; Wakefield, MA; Bangor, ME. **Studied:** School of Des., Boston, 1859-1961 with Tuckerman; Europe, Munich, Bavarian and Italian Alps, 1874-75. **Comments:** Preferred medium: oil. During the Civil War she served as a nurse at hospitals in Maryland. **Sources:** G&W; Simpson, *Leaflets of Artists.*; add'l info. courtesy of Edward P. Bentley, Lansing, MI.

PRENTISS, Thomas *[Painter]* mid 20th c. **Addresses:** NYC. **Exhibited:** Corcoran Gal biennial, 1959; WMAA, 1962 (goldpoint); PAFA Ann., 1962. **Sources:** Falk, *Exhibition Records Series.*

PRENTISS, Tina *[Artist] mid 20th c.*
Addresses: Somerville, MA. **Exhibited:** PAFA Ann., 1953.
Sources: Falk, *Exh. Record Series.*

PRENTISS-LINGAN, V. D. See: **LINGAN, Violetta D. Prentiss**

PRESBREY, E. Wiley *[Painter] b.c.1858 / d.1931.*
Exhibited: Boston AC, 1879-80. **Sources:** *The Boston AC.*

PRESBY, C. B. *[Painter] late 19th c.*
Addresses: Taunton, MA. **Exhibited:** AIC, 1892. **Sources:** Falk, *AIC.*

PRESCOTT, Ada M. *[Painter] 20th c.*
Exhibited: Salons of Am., 1934. **Sources:** Marlor, *Salons of Am.*

PRESCOTT, Edward *[Artist] late 19th c.*
Addresses: Wash., D.C., active 1881. **Exhibited:** NAD, 1876.
Sources: McMahan, *Artists of Washington, D.C.*

PRESCOTT, Katherine T. Hooper (Mrs. Harry L.)
[Sculptor] 19th/20th c.; b.Biddeford, ME.
Addresses: Active 1893-1917 in Boston, Chicago, NYC.
Studied: E. Boyd, Boston; F.E. Elwell, NYC. **Member:** Copley Soc., 1893. **Exhibited:** NAD, 1890, 1898; Boston AC, 1890-1900; PAFA Ann., 1896-99, 1913; AIC, 1897, 1908-09; NSS.
Sources: WW17; Petteys, *Dictionary of Women Artists;* Falk, *Exh. Record Series.*

PRESCOTT, Louise See: **CANBY, Louise Prescott**

PRESCOTT, Plumer *[Portrait painter] b.1833, Franklin, NH / d.1881, Springfield, IL.*
Addresses: Buffalo, NY, active in 1855. **Sources:** G&W;
Runnels, *History of Sanbornton, N.H.,* II, 591; Buffalo BD 1855.

PRESCOTT, Preston Lorraine *[Sculptor, teacher, designer] b.1898, Ocheydan, IA.*
Addresses: Los Angeles, CA; Santa Cruz County, CA. **Studied:** Minneapolis Inst. Art; Otis AI; ASL; & with Gutzon Borglum, David Edstrom; Robert Aitken; Julia Bracken Wendt. **Member:** California AC; Laguna Beach AA. **Exhibited:** MMA (AV), 1942; MMA, 1942; LACMA, 1935 (prize)-36 (prize), 1937; California AC, 1935 (prize)-36 (prize); Ebell Salon, 1935-37; Stendahl Gal., Los Angeles, 1937; Laguna Beach AA, 1936 (prize), 1937-38; Los Angeles Chamber of Commerce, 1927-29 (prizes); Riviera Gal., Hollywood, 1936; Carmel Library, 1950, 1952; deYoung Mem. Mus.; Los Gatos AA, 1954-55; Santa Cruz Art Lg., 1955; de Saisset Art Gal., Univ. of Santa Clara, 1956, 1957 (solo); Marin Art & Garden Show, 1958; Montalvo AA, 1958. **Work:** bust of John Marshall, California State Exposition Bldg., Los Angeles; monument, Arcadia, CA; fountain, Acacia Lodge, Ojai and in many priv. colls. **Comments:** WPA artist. Position: teacher, Sheriden Mem. School Art, Ben Lomond, CA; pres., dir., Bridge Mt. Fnd., Ben Lomond, CA. **Sources:** WW59; WW47; Ness & Orwig, *Iowa Artists of the First Hundred Years,* 169.

PRESCOTT, William Linzee *[Painter] b.1917, NYC.*
Addresses: Tuxedo, NY. **Studied:** Chouinard Sch. A., Los Angeles; Galvan, Mexico. **Member:** NSMP; Portraits, Inc.
Exhibited: Morgan Gal., NYC, 1940 (solo); NSMP, Arch. Lg., 1956; Madrid, Spain, 1958 (solo). **Work:** murals. N.Y. Hospital; Metropolitan Life Ins. Co., and in private homes and restaurants.
Sources: WW59; WW40.

PRESNAL, William Boleslaw *[Painter, teacher] b.1910, New Bedford, MA.*
Addresses: Rockport, MA. **Member:** Rockport AA; North Shore AA. **Exhibited:** Newport AA; North Shore AA; Rockport AA; S. Indp. A. **Sources:** WW40.

PRESS, Esther See: **PRESSOIR, Esther E(stelle)**

PRESSER, Josef *[Painter, educator, lecturer, teacher, graphic artist, illustrator] b.1911, Lublin, Poland / d.1967, Paris, France.*
Addresses: Phila., PA; NYC. **Studied:** BMFA Sch.; & in Europe.
Member: Phila. WCC; New Haven PCC; Woodstock AA.
Exhibited: PAFA Ann., 1934, 1943-44, 1951-52; PAFA, 1937-46; CI, 1941-46; AIC, 1938-46; Contemporary Artists; Assoc. Am. Artists; Weyhe Gal.; Nierndorf Gal.; MoMA; New Haven PCC, 1935 (prize), 1939 (prize); Toledo AA, 1944 (prize); WMAA, 1950-51. **Work:** Royal Mus., Florence, Italy; MMA; Newark Mus.; PMA; AGAA; Syracuse Mus. FA; WMAA; Smith College; murals, Bristol, PA; USPO, Southern Pines, NC; Print Club, Art Alliance, Phila.; BMFA; Allentown (PA) Mus.; Woodstock AA.
Comments: Position: instructor, lecturer, painting, CUA Sch., NYC; instructor, painting, North Shore Art Center, Roslyn, LI, NY. Illustrator, jacket design, "Soul of the Sea," 1945. **Sources:** WW59; WW47 puts date of birth at 1907; Woodstock AA; Falk, *Exh. Record Series.*

PRESSEY, Helen Adelaide *[Painter] 19th/20th c.*
Exhibited: Boston AC, 1882-1893; PAFA Ann., 1888-91.
Sources: Falk, *Exh. Record Series.*

PRESSLER, Gene (Mr.) *[Illustrator] 20th c.*
Addresses: NYC. **Sources:** WW19.

PRESSLEY, Daniel *[Sculptor] late 20th c.; b.Wasamasaw, SC.*
Studied: self-taught. **Exhibited:** BM, 1969; Columbia Univ., 1969. **Sources:** Cederholm, *Afro-American Artists.*

PRESSOIR, Esther E(stelle) *[Painter, craftsperson, illustrator, teacher, cartoonist] b.1902, Philadelphia, PA / d.1986, Brooklyn, NY.*
Addresses: Mt. Bethel, PA; NYC. **Studied:** RI Sch. Des.,1919-23 (grad.); ASL, 1924-28; with Hawthorne; K. Miller; Kuhn; B. Robinson; Kunstgewerbeschule, Munich, Germany, 1927.
Member: AEA; Mt. Bethel Art Colony; American Craftsmen's Cooperative Council; Cal. WC Soc.; College AA of America.
Exhibited: RISD, 1921 (hon. men.); Vose Gal., Boston, 1927; S. Indp. A., 1927; PAFA Ann., 1927-29, 1937-38; Delphic Studios, NYC, 1930 (solo), 1931; Salons of Am., 1932, 1934; Cronyn & Lowndes Gal., NYC, 1934 (solo); Uptown Gal., NYC, 1934; AIC, 1935; LACMA; WFNY 1939; NGA, 1941; CAA; Rockefeller Center, NYC (solo); Morton Gal., NYC (group & solo shows); Arthur Newton Gal., NYC; Ten Dollar Gal., NYC; G.R.D. Studio, NYC; MacBeth Gal., NYC; Brown Univ. (College AA); NAWA.
Work: PAFA; LACMA; Syracuse Univ.; BM. **Comments:** In 1930, she and Helen MacAusland were the first women to bicycle across Europe, on a five-month trip. She returned to Providence and Woodstock (NY) and was active on Block Island (RI) and was a member of the progressive Mt. Bethel Art Colony in Penn. Position: instr., Crafts, Hospitals and Art Centers. Illustrations in: *Fiction Parade, New Yorker,* and *Tomorrow* magazines. Books illustrated: *Jews Are Like That;* and *A Calendar in Song-For Voice & Piano.* **Sources:** WW59; WW47; Marlor, *Salons of Am.* (gives birthdate of 1905); Falk, *Exh. Record Series;* add'l info. courtesy of Gert C. Wirth, Northfield, MA.

PRESTELE, William Henry *[Painter, illustrator] late 19th c.; b.Germany.*
Addresses: Illinois, 1869; Iowa, 1870s; Wash., D.C., active 1887-95. **Work:** Horticultural Science Inst., Beltsville, MD (29 paintings of N. Am. wild grapes); Hunt Inst., Carnegie-Mellon Univ.; U.S. Ntl. Arboretum. **Comments:** His father, Joseph, and his brothers were all artists and lithographers, specializing in botanical art. Illustrator with the U.S. Dep. of Agr. in 1887. He prepared a series of 29 paintings of North American species of wild grapes for a projected monograph. In 1893, photographs of these paintings were exhibited at the Columbian Expo. in Chicago. **Sources:** McMahan, *Artists of Washington, D.C.*

PRESTINI, James Libero *[Sculptor, designer] b.1908, Waterford, CT.*
Addresses: Chicago, IL; Berkeley, CA. **Studied:** Yale Univ. (B.S., 1930), Sch. Educ., 1932; Univ. Stockholm, 1938, with Carl Malmsten; Inst. Design, Chicago, 1939, with L. Moholy-Nagy; also study in Italy, 1953-56. **Member:** MMA (life fel.).
Exhibited: AGAA; Albany Inst. Hist. & A., Albright A. Gal.; BMA; Butler AI; CMA; Dallas Mus. FA; Dayton AI; Denver A. Mus.; de Young Mem. Mus.; Lyman Allyn Mus.; Milwaukee AI;

Neville Pub. Mus., Green Bay, Wis.; Portland Ore. A. Mus.; Russell Sage Fnd.; Smithsonian Inst.; Joslyn Mem.; TMA; Walker A. Ctr.; Phila. A. All.; Wash. County Mus. FA; MIT; Currier Gal. A.; James Prestini, Sculpture from Structural Steel Elements, SFMA, 1969; James Prestini, AIC , 1969; Contemporary American Painting & Sculpture, Univ IL, Champaign, 1969; Excellence: Art from the University, Univ. Calif., Berkeley, 1970; MoMA,1949 (best res. report prize, Int. Competition for Low-Cost Furniture Design), 1972 (International Collection of 20th Century Design); Am. Iron & Steel Inst., New York, 1971 (award for excellence in fine art in steel); Triangle Gallery, San Francisco, CA, 1970s Staempfli Gallery, NYC, 1970s. **Awards:** Guggenheim fel. for sculpture, 1972-73. **Work:** Albright A. Gal.; Ball State T. Col.; CMA; Northwestern Univ.; Russell Sage Fnd.; Univ. Minn.MoMA & MMA; AIC; Nat Collection Fine Arts, Smithsonian Inst.; SFMA. Commissions: aluminum sculpture, RS Reynolds Mem. Sculpture Award, Richmond, Va., 1972. **Comments:** Preferred media: steel, aluminum, wood. Teaching: instr. des., Lake Forest Academy, 1933-42; Inst. of Des., Chicago, 1939-46; assoc. prof., N. Texas State Univ., 1942-43; instr., Inst. Design, Chicago, 1952-53; prof., UC Berkeley, 1956-on; res. prof., Creative Arts Inst., 1967-68. Publications: co-auth., "The Place of Scientific Research in Design," 1948; co-auth., "Research in Low-Cost Seating for Homes," 1948; co-auth., "Survey on Construction Materials Demonstration & Training Center," 1951; auth., "Survey of Italian Furniture Industry (Milan)," 1954; auth., "Proposed Policy Statement on Architectural Research for the College of Architecture of the University of California," Berkeley, 1958. **Sources:** WW73; Edgar Kaufmann, "Prestini's Art in Wood," *Pantheon* (1950); Gerald Nordland, "James Prestini, Sculpture from Structural Steel Elements," SFMA, 1969; George Staempfli, "James Prestini, Recent Sculpture," Staempfli Gal., 1971.

PRESTLOVE See: **PRETLOVE, David**

PRESTON, Alice Bolam (Mrs. Frank I.) *[Illustrator, designer, craftsperson] b.1889, Malden, MA / d.1958, Beverly Farms, MA.*
Addresses: Beverly Farms, MA. **Studied:** Mass. Sch. Art; & with Vesper George, Felicie Waldo Howell, Henry Snell; A. A. Munsell; A.K. Cross. **Member:** PBC; Copley Soc., Boston; Rockport AA; Boston AC; North Shore AA; Gld. Beverly Artists; Soc. for Preservation New England Antiquities. **Exhibited:** Boston AC; Copley Soc.; PBC; Speed Mem. Mus.; Rockport AA; North Shore AA; *House Beautiful* Cover Competition, 1925-58 (prizes,1925-26, 1927, 1928). **Comments:** Illustrator: "The Green Forest Fairy Book" (1920), "Whistle for Good Fortune" (1940), "The Valley of Color Days," "Adventures in Mother Gooseland," "Peggy in her Blue Frock," "Humpty Dumpty House," pub. Houghton Mifflin. **Sources:** WW53; WW47.

PRESTON, Alice M. *[Painter] early 20th c.*
Addresses: Active in NYC, c.1905-10. **Member:** Boston AC. **Sources:** WW06.

PRESTON, Alice Roberts (Mrs. Frank) *[Painter] 20th c.*
Addresses: Auburndale, MA. **Member:** Concord AA. **Sources:** WW24.

PRESTON, Blanche (Mrs.) *[Painter, designer] early 20th c.; b.Fayetteville, WVa.*
Addresses: New Orleans, active 1910-16. **Studied:** Cincinnati AM; ASL. **Exhibited:** NOAA, 1913. **Comments:** Painted portraits, landscapes and miniatures and also designed carnival floats in New O. After 1916 she returned to West Va. **Sources:** WW17; *Encyclopaedia of New Orleans Artists*, 315.

PRESTON, Charles E. *[Painter] mid 20th c.*
Exhibited: S. Indp. A., 1940-41. **Sources:** Marlor, *Soc. Indp. Artists.*

PRESTON, Frank Loring *[Painter] 20th c.*
Addresses: Auburndale, MA. **Member:** Concord AA. **Sources:** WW25.

PRESTON, Harriet Brown *[Painter, teacher, critic] b.1892, Hackensack, NJ / d.1961.*
Addresses: Tenafly, NJ/Rockport, MA. **Studied:** Trenton Normal Col.; NY Univ.; Columbia Col.; Parsons Sch. Des.; and with Harvey Dunn. **Member:** Bergen County Artists Gld.; New Jersey Soc. P&S; Rockport AA; North Shore AA; AAPL. **Exhibited:** New Jersey Soc. P&S, 1950-58; All. Artists Am., 1951, 1953, 1955-56; AWCS, 1951; AAPL, 1953-56; NAC, 1952-53; Knickerbocker Artists, 1957; Academic Artists, 1956-58; Bergen County Artists, 1943-58; Rockport AA, 1949-58; North Shore AA, 1949-58; NJWCS, 1951; Trenton Mus., 1951, 1954, 1956; Montclair Art Mus., 1952, 1953, 1955, 1956; Wolfe Art Cl., 1954-55; Silvermine Gld. Artists, 1954; Art Center of the Oranges, 1955-56. **Awards:** prizes, NJ Women's Cl., 1950-51; Art Council of New Jersey, 1951; Bergen County Artists Gld., 1953-54; Pascack Valley Regional, 1955; gold certificate, NJ Soc. P&S, 1955. **Work:** Tenafly (NJ) H.S.; Rockport (MA) H.S. **Sources:** WW59.

PRESTON, James M(oore) *[Illustrator, painter] b.1874, Roxborough, PA / d.1962, Easthampton, NY.*
Addresses: Bellport, NY (until 1935); East Hampton, NY, thereafter. **Studied:** PAFA, 1891-94, 1897-98; Acad. Colarossi, Paris, 1898. **Member:** GFLA. **Exhibited:** PAFA Ann., 1909-17; Armory Show, 1913; Ann. Exh. Advertising Art, 1921-27 (medals, 1924, 1927); Montross Gal., NYC, 1927 (solo); Westmoreland Mus. Art, 1990 (retrospective); Altman-Burke FA, NYC, 1990. **Comments:** Although he was a classmate and close friend of the artists of the "Ashcan Group," he painted landscapes in the Post-Impressionist style with soft and subtle colors. He produced a cover for *Saturday Evening Post* (April, 1905) but was most active in illustration during the 1920s. He and his wife (May Wilson Preston) traveled frequently to Paris. **Sources:** WW27; Richard J. Boyle, exh. cat., Westmoreland Mus. Art (1990); Falk, *Exh. Record Series;* Brown, *The Story of the Armory Show.*

PRESTON, Jessie Goodwin (Mrs.) *[Painter] b.1880, East Hartford, CT.*
Addresses: East Hartford, CT. **Studied:** W.M. Chase; Henri; W. Griffin. **Member:** CAFA; Hartford SWP; North Shore AA; New Haven PCC; Springfield AL. **Exhibited:** CAFA, 1924; Salons of Am., 1929. **Sources:** WW40.

PRESTON, Malcolm H *[Art critic, painter] b.1919, West New York, NJ.*
Addresses: Truro, MA. **Studied:** Univ. Wis. (B.A.); Columbia Univ. (M.A. & Ph.D.). **Exhibited:** Wis. Salon; PAFA; Audubon Artists; Art USA; Provincetown Art Assn. **Awards:** Joe & Emily Lowe Found. educ. res. grant, 1950; Ford Found. grant, 1956 -57; Shell Oil res. grant, 1964. **Work:** Hofstra Univ. Coll.; Dayton Art Inst.; Portland Mus. **Comments:** Preferred media: oils. Positions: dir., Inst. of the Arts, Hofstra Univ., 1960-64; art critic, *Newsday,*1968-; art critic, *Boston Herald Traveler*, 1970-. Teaching: asst. instr. fine arts, New Sch. Social Res., 1940-41; instr. fine arts, Adelphi Univ., 1947-48; prof. fine arts, Hofstra Univ., 1949-. **Sources:** WW73.

PRESTON, May (Mary) Wilson (Mrs. James M.) *[Illustrator] b.1873, NYC / d.1949, Easthampton, NY.*
Addresses: East Hampton, NY. **Studied:** ASL with Wm. Merritt Chase, Robert Henri & John H. Twachtman, 1892-97; NAD; Whistler Sch., Paris, 1899; Chase's New York Sch. Art. **Member:** Women's AC, NYC (founder at age 16; later became known as NAWA); SI (co-founder, 1904); Assoc. Am. P&S (co-founder, 1912; sponsored the Armory Show of 1913. **Exhibited:** PAFA Ann., 1903 (as Watkins); 1906-11 (4 annuals); NAD, 1907-11 (4 annuals); AIC, 1907; Armory Show, 1913; Pan.-Pac. Expo, San Francisco, 1915 (med.); London & Paris. **Comments:** Her husband Thomas H. Watkins died in 1900, just two years after they were married. She then began a career in New York City as an

illustrator while continuing her studies at Chase's New York School of Art. In 1903 she married James Moore Preston, with whom she co-founded the Society of Illustrators. For years she was the only woman member of this group, and her illustrations appeared in popular magazines and books by F. Scott Fitzgerald and P.G. Wodehouse. Her easel paintings were primarily genre studies and figure pieces in the same realistic spirit as artists of the Ashcan School. The Prestons moved to a remodeled barn in South Hampton, NY, at the beginning of the Depression, where she developed a skin infection that prevented her from painting. **Sources:** WW27; Pisano, *One Hundred Years.the National Association of Women Artists,* 76; Falk, *Exh. Record Series.*

PRESTON, N. A. (Mrs.) *[Painter] early 20th c.*
Addresses: Active in Avilla, IN, c.1921. **Studied:** Philadelphia. **Sources:** Petteys, *Dictionary of Women Artists.*

PRESTON, William E. *[Painter] b.1930, Cleveland, OH.*
Addresses: Santa Fe, NM. **Studied:** Institute of Des., Chi., Ill.; AIC.; UCLA. **Exhibited:** Boston WCS, 1965-1969; Knickerbocker Artists, NYC, 1965; All. A. of Am.,1966; Am. WCS,1967; NAD, 1967; Witte Mus., San Antonio, Tx., 1967; Boston Arts Festival, 1971; De Cordova Mus., Lincoln, Me., 1971. Awards: All. A. of Am., Chandler Prize, 1967; NAD, Obrig Prize, 1967, & medal of honor for watercolor, 1968; purchase prize, Watercolor USA, Springfield, Mo. **Work:** Fisher Scientific, Pittsburgh, Pa. Rockefeller Mus., Williamsburg, Va.; Ogunquit Mus. of Am. Art, Ogunquit, Me.; La Jolla Mus, La Jolla, Calif. **Comments:** Taught watercolor at Art League of Houston (Tx.), Portsmouth Art Assn. and York Art Assn. Also a guitarist. **Sources:** Info. courtesy Selma Koss Holtz, Waban, Mass.; *Ogunquit, Maine's Art Colony, A Century of Color, 1886-1986* (exh. cat., Ogunquit: Barn Gallery Assoc., Inc., 1986); Moody, *Synthetic Media;* Allied Artists, *Prize-Winning Watercolors;* Schmaltz, *Watercolor Your Way.*

PRESTON, William Gibbons *[Painter, architect] b.1844, Boston, MA / d.1910, Boston.*
Addresses: Boston. **Studied:** his father; Ecole Des Beaux Arts, Paris. **Member:** Boston AC. **Exhibited:** Boston AC, 1875-98. **Sources:** WW10; Campbell, *New Hampshire Scenery,* 130; *The Boston AC.*

PRESTOPINO, Gregorio *[Painter, teacher] b.1907, NYC.*
Addresses: Brooklyn, NYC, NY; Roosevelt, NJ. **Studied:** NAD. **Member:** MacDowell Colony (dir., 1971). **Exhibited:** Corcoran Gal. biennials, 1937-59 (4 times); WMA, 1938; WFNY, 1939; GGE, 1939; WMAA, 1938-65; AIC, 1941, 1943; CAM, 1945; Albright A. Gal., 1946; Pepsi-Cola, 1946 (prize); MoMA; PAFA Ann., 1946-53, 1958, 1966 (Temple Gold Medal 1946, prize 1952); AGAA; NAD, 1972 (Altman Figure Painting Award); Lerner-Heller Gal., NYC, 1970s. Other Awards:NIAL grant, 1961. **Work:** WMAA; MoMA; Walker Art Ctr., Minneapolis; Hirshhorn Coll.; AIC; Rochester Mem. A. Gal.; NJ State Mus, Trenton. Commissions: mosaic, commn. by Dr. Rebecca Notterman, Prof. Bldg., Princeton. **Comments:** Preferred media: oils, watercolors. Teaching: artist (painting), Brooklyn Mus. Sch., 1946-51; artist (painting), New Sch. Social Res., 1950-67; artist-in-residence, Mich. State Univ., 1960. **Sources:** WW73; J. Hubley, "Harlem Wednesday" (film), Storyboard, Inc., 1956; JG Smith, "Watercolors of Gregorio Prestopino," *Am. Artist* (Oct., 1957); WW47; Falk, *Exh. Record Series.*

PRETLOVE, David *[Engraver of cylinders for embossing] mid 19th c.*
Addresses: NYC, active 1846-48. **Exhibited:** American Institute, NYC, 1846-47. **Comments:** The name appears also as Predlove and Prestlove. **Sources:** G&W; NYCD 1846-48; NYBD 1847-48; Am. Inst. Cat., 1846, 1847.

PRETSCH, John Edward *[Cartoonist, illustrator] b.1925, Philadelphia, PA.*
Addresses: Philadelphia, PA. **Comments:** Positions: sunday supplement artist, news artist & promotional layout artist, *Philadelphia Eve Bulletin,* news artist, 1966-; advert. layout artist,

Sears Roebuck & Co. Publications: illusr., "Five Years, Five Countries, Five Campaigns with the 141st Infantry Regiment," 1945; contribr., cartoons, in: *Colliers, Sat. Eve. Post & Philadelphia Eve. Bulletin.* **Sources:** WW73.

PRETYMAN, William *[Painter] late 20th c.*
Addresses: Natucket, MA. **Exhibited:** NAD, 1881. **Sources:** WW17.

PREU, John D. *[Teacher craftsman, landscape painter, illustrator] b.1913, Hartford, CT.*
Addresses: Newington, CT; Cape Cod, MA. **Studied:** PIA Sch.; NY Univ.; Dixon Sch. Metalcraft; Hartford A. Sch.; W. Starweather; A. Fisher; A. Jones. **Member:** CAFA; New Haven Paint & Clay Cl.; Conn. WC Soc.; Meriden A. & Crafts; West Hartford A. Lg.; Springfield AL. **Exhibited:** Salons of Am., 1934; NYWCC, 1934-40; AWCS, 1935-40; All. A. Am., 1935; CAFA, 1936-46; Conn. WCS; AIC; Springfield AL, 1936-39; CAA Traveling Exh., 1935; New Haven PCC; Berkshire Mus.; Pittsfield A. Lg., 1949-52; Avery Mem., 1949; Wadsworth Atheneum Jewelry exh., 1955; Osterville Fair, Cape Cod, 1955; New Haven Paint & Clay Cl.; Glastonbury Lib. (solo). **Work:** Biro-Bidjan Mus., Russia. **Comments:** Position: instr., Weaver H.S., Hartford, Conn., 1937-46; chm. a. dept., 1949-; instr., metal & jewelry, West Hartford (Conn.) A. Lg., 1937-46; dir., Soc. Conn. Craftsmen, 1949-; instr., jewelry and enameling classes for Hartford YWCA, Conn. General Ins. Co., and Newington, Conn. Adult Classes; A. Com., Newington Lib. A. Exhs. **Sources:** WW59; WW47.

PREUSS, Charles *[Topographical artist] d.1853, near Wash., DC.*
Comments: Artist and map-maker on several early Western surveys, including John Frémont's second expedition, which began in May 1843 at the Missouri River, followed the Oregon trail to the Columbia River, turned South through Oregon, into Nevada and then crossed the Sierras into California (by mid-winter of 1844). Preuss's sketch of Ft. Laramie (WY) and other Western scenes were included with Frémont's 1845 *Report.* Preuss was living in Wash., DC in 1850 and 1853. Jessie Benton Frémont stated that his death was by suicide. **Sources:** G&W; Frémont, *Report of the Exploring Expedition to the Rocky Mountains in the Year 1842, and to Oregon and North California in the Years 1843-44.;* G&W also cited information courtesy of Robert Taft, Lawrence (Kans.); Washington CD 1850, 1853. More recently, see P&H Samuels, 381.

PREUSS, Roger *[Painter, writer] mid 20th c.; b.Waterville, MN.*
Addresses: Minneapolis, MN. **Studied:** Minneapolis Col. Art & Design. **Member:** Soc. Animal Artists; fel., Int. Inst. Arts; Minn. Artists Assn. (dir. & past v. pres., 1953-56); Am. Artists Prof. League; Minneapolis Soc. Fine Arts. **Exhibited:** Contemp. Bird Painting Biennial, Joslyn Art Mus., Omaha, Nebr., 1948; Kerr's Gal., Beverly Hills, Calif., 1948; Nat. Wildlife Art Exhib., Milwaukee, Wis., 1954; Gal. Western Art, Mont. Hist. Soc., Helena, 1964; 13th Int. Exhib., Galerie Int., NYC, 1971; Gokey Gal., Saint Paul, MN, 1970s; Merrill's Gal., Taos, NM, 1970s. Awards: Fed. duck stamp design award, US Fish & Wildlife Serv., 1949; Audubon Soc. art award, 1959; art-print-of-the-year award, Nat. Wildlife Fedn., 1964. **Work:** Mont. Hist. Mus., Helena; Brigham Young Univ., Harris Fine Arts Ctr., Provo, Utah; Smithsonian Hall Philately; Mont. State Univ. Inabnit Coll., Missoula; US Fed. Bldg. & Minn. State Capitol, Saint Paul; also in European pub. collections. Commissions: 1949-50 Fed. Duck Stamp Design, US Dept. Interior, Wash., DC, 1948; 16 painting wildlife series, Shedd-Brown Coll., Minneapolis, Minn., 1950; 150 paintings of wildlife, Thos. D. Murphy Co., Red Oak, Iowa, 1954; 20 paintings, Michael's Restaurant Preuss Coll., Golden Valley, Minn., 1955; Minnesota Wildlife (12 painting panel), Greater Minneapolis C. of C., 1968. **Comments:** Preferred media: oils, watercolors. Publications: auth. & illusr., "The Official Wildlife of America Calendar," 1955-; auth. & illusr., "Outdoor Horizons," 1957; contribr., "National Wildlife," 1963; co-auth. &

illusr., "Minnesota Today," 1968; illusr., "Twilight Over the Wilderness," 1971. Teaching: sem. lectr. wildlife painting, Minneapolis Col. Art; consult., Art & Educ. Assn. **Sources:** WW73; "Black Ducks Along the Border" (film), produced by Lane Film Studios, Inc, 1962; Marion McKinley, "Roger Preuss – Artist," *S. Dak. Conserv. Digest* (Jan., 1970); Dean Durken, *Preuss, Master of Wildlife Painting* (Saint Paul Pioneer Press, Nov. 1970).

PREUSSER, Robert Ormerod *[Painter, educator] b.1919, Houston, TX.*
Addresses: Houston, TX; Cambridge, MA. **Studied:** McNeill Davidson in Houston, 1930-39; Inst. Design, Chicago, 1939-40, 1941-42 with Moholy-Nagy and Rbt. J. Wolff; Newcomb Sch. Art, Tulane Univ., 1940-41; Art Ctr. Sch., Los Angeles, 1946-47. **Exhibited:** Nat. Exh. Am. A., NYC, 1939; CI, 1941 ("Directions in American Painting"); AIC, 1942, 1947 ("Abstract and Surrealist American Exhibition"), 1951 (Am. Artists Ann.); VMFA, 1946; Houston MFA., 1940 (purchase prize, 16th Ann. Houston Artists Exhib.); Contemp. Arts Mus., 1952 (Purchase Prize, 27th Ann. Houston Artists Exhib.); San Antonio AL, 1941 (prize); Kansas City AI, 1936; Southeast Texas Exh., 1937-39; Texas General Exh., 1940-45; SSAL, 1941; Dallas MFA, 1938; Rockefeller Cts., 1938; Corcoran Gal biennial, 1953; "Survey of American Painting," AFA trav. exhib., 1957-58; "Texas Painting & Sculpture, The 20th Century," Owens Arts Ctr. trav. exhib., Dallas, 1971-72; Joan Peterson Gal., Boston, MA, 1970s. Awards: nominated Promising New Talent in USA, *Art in Am. Rev.,* 1956. **Work:** Houston MFA; Contemp Arts Mus, Houston; Witte Mem Mus, San Antonio; Texas Christian Univ., Fort Worth; AGAA. **Comments:** Preferred media: mixed media. Positions: art ed., *Texas Cancer Bulletin,* 1948-50; co-dir., Contemp. Arts Mus., Houston, 1949-51; stage set designer, Texas Stage, Houston, 1950-51; assoc. cur. educ., Houston MFA, 1952-54. Author: "Visual education for science and engineering students," in *Education of Vision,* George Braziller, 1965, Fr. & Ger. ed., 1967; "Art and the Engineer," *Mech. Eng.,* 12/1967. Teaching: Houston MFA Sch., 1947-54; Univ. Houston, 1951-54; M.I.T., 1954-70s; Harvard Univ. Grad. Sch. Design, 1955-56. **Sources:** WW73.

PREUSSL, Carl C. *[Painter] mid 20th c.*
Addresses: Chicago, IL. **Exhibited:** AIC, 1924-34; PAFA Ann., 1927. **Sources:** Falk, *Exh. Record Series.*

PREVAL, Juanita *[Painter] 20th c.*
Addresses: Milwaukee, WI. **Sources:** WW24.

PREVOST, André *[Painter] mid 20th c.*
Exhibited: AIC, 1930, 1934. **Sources:** Falk, *AIC.*

PREVOST, Victor *[Lithographer, painter, photographer] b.1820, France.*
Addresses: Came to America about 1847/48 and became active in NYC. **Work:** NYHS; Calif. Hist. Soc. (San Francisco); Chicago Hist. Soc.; Bancroft Lib. at Univ. of Calif., Berkeley. **Comments:** Working for the NYC firm of Sarony & Major (see entry), he traveled twice to California in 1847 and 1849. Drew several views of San Francisco on stone that were printed by Sarony & Major. He later returned to France for further study and there developed a wax film which he used successfully as a photographer in NYC. Also worked as a chemist and a teacher. **Sources:** G&W; Van Nostrand and Coulter, *California Pictorial,* 54; Stokes, *Iconography,* III, 710-11, pl. 142a and 142b; NYBD 1850-51. More recently, see Reps, cat. nos. 234-38; Hughes, *Artists in California.*

PREVOST, William S. *[Listed as "artist"] b.c.1835, New Jersey.*
Addresses: Philadelphia in 1860. **Sources:** G&W; 8 Census (1860), Pa., LV, 56.

PREVOT, M. J. *[Painter] 20th c.*
Addresses: NYC. **Sources:** WW13.

PREVOT, Rose Frankfort *[Painter] early 20th c.*
Exhibited: AIC, 1925-27. **Sources:** Falk, *AIC.*

PREW, John D. See: **PREU, John D.**

PREYER, David C. *[Writer] b.1862, Amsterdam, Holland (came to U. S. in 1883) / d.1913.*
Addresses: NYC. **Studied:** New Brunswick Theological Seminary. **Comments:** Author: "The Art of the Netherlands," "The Art of the Berlin Galleries," "The Art of the Metropolitan Museum," "The Art of the Vienna Gallery." Position: ed., *Collector and Art Critic,* from 1900-02.

PREZAMENT, Joseph *[Painter] b.1923, Winnipeg, Canada.*
Addresses: PQ, Canada. **Studied:** Winnipeg Sch. Art; Montreal Mus. Fine Arts; Ecole des Beaux Arts. **Member:** Can. Soc. Graphic Artists. **Exhibited:** Royal Can. Acad., Montreal Mus. Fine Arts, 1967; Burnaby Art Soc., BC, 1967; Can. Painters & Engravers, Toronto, 1968; Can. Soc. Graphic Artists, Toronto, 1968; Canadian Printmakers Showcase, Toronto, 1969; Waddington Galleries, PQ, Can., 1970s. **Comments:** Preferred media: oils. **Sources:** WW73.

PREZZI, John J. *[Painter] mid 20th c.*
Exhibited: S. Indp. A., 1935. **Sources:** Marlor, *Soc. Indp. Artists.*

PREZZI, Wilma Maria *[Painter, sculptor, teacher] b.1915, Long Island City, NY / d.c.1964.*
Addresses: NYC. **Studied:** New York State Edu. Dept.; Metropolitan A. Sch.; ASL. **Member:** Life F., Am. Intl. Acad.; Life F., Intl. Inst. A. & Lets.; Arch. Lg.; Intl. FA Council; Chinese A. Soc. Am. **Exhibited:** CI, 1946; All. A. Am., 1942-44; Nelson Gal. A., 1944 (solo); Norfolk Mus. A.& Sc., 1945 (solo); de Young Mem. Mus., 1945; Knoedler Gal., 1945; China Inst. Am.,1947 (solo). Awards: F. grant, Intl. FA Council, 1949, gold medal, 1954; Hon. degree, Doctor of Humanities, Philathea Col., Canada; Dame d'Honneur, Ordre de Lion des Ardennes, de Luxembourg, Paris, 1955; Dama Commendatrice Orden Militar de S.S. Salvador y Santa Brigida de Svecia, Spain, 1955; Membre d'Honneur, Les Violetti Picards et Normands, Paris, France, 1957; Membre d'Honneur, Club des Intellectuels, Français, Paris, 1957; Croix de Commandeur, Ligue Universelle de Bien Public, Paris; Hon. Ph.D., St. Andre's Ecumenical Univ., London, England, 1957; Byzantine Gold Medal, Biblioteca Partenopea, Naples, Italy, 1956; Medaille D'Or an Merite, Institut Nord Africain D'Etudes Metapsychiques, Tunis, North Africa, 1957; Medaille d'Argent, Prix Thorlet de L'Academie Franáais, Arts-Sciences-Lettres, Paris, 1958; Medaille d'Argent, Switzerland; Palma Academica, Argentina; Gran Premio de Honor, Sociedad Gente de Arte deI Sur. Buenos Aires; Benediction Scroll, Pope Pius X. **Work:** sculp., murals, paintings: Rickshaw Restaurant, Boston; Mus. Religious A., Utrecht, Netherlands; St. Gregory's Seminary, Cincinnati; Fla. State Univ., Olin Downs Music Lib.; Elmhurst Col., Illinois; NY Univ. Music Lib.; Xavier Univ., Albers Hall; Hermitage Fnd., Norfolk, Va.; many sculptured portraits of prominent persons; 25 are in Wisconsin Hall of Fame, Milwaukee and 9 in Baseball Hall of Fame, Cooperstown, NY, executed by Prezzi-Kilenyi Assoc. **Comments:** Contributor: Asia magazine. **Sources:** WW59; WW47.

PRIBBLE, Easton *[Painter, lecturer, educator] b.1917, Falmouth, KY.*
Addresses: Lawrenceburg, IN; Utica, NY. **Studied:** Univ. Cincinnati; Cincinnati Sch. of Appl. Arts; three fellowships at Yaddo, Saratoga Spgs. Fl. **Exhibited:** CM, 1941, 1943, 1947; AIC, 1948; MoMA; Whitney Ann. Am. Painting, WMAA, 1949-50, 1954-55; BMA, 1955; Walker A. Center, 1953; Brandeis Univ., 1954; Alan Gal., NY, 1955 (solo), 1956-57; Univ. Nebr. Ann., Lincoln, 1954-58; Everson Mus, Syracuse, NY, 1963 (Painting award,1960 &1964. Awards: Munson-Williams-Proctor Inst., 1957 (solo), 1958, 1963 (award); Ill. Wesleyan Univ., 1956; Des Moines A. Center, 1957. **Work:** WMAA; NY; Munson-Williams-Proctor Inst., Utica, NY; Joseph Hirshhorn Coll.; Parrish Mus., Southampton, NY; Utica Col., NY. Commissions: painted wood relief mural, Munson-Williams-Proctor Inst. Sch. Art, 1961; painted wood relief mural, Oneida Co. Off. Bldg., NY, 1969. **Comments:** Preferred media: oils, acrylics, pastels. Painting loca-

tions include Monhegan Island (ME). Teaching: instr. painting, Munson-Williams-Proctor Inst. Sch. Art, 1957-59; instr. hist. art, Utica Col., 1960-. Publications: contribr., "New Talent in America," *Art in Am.,* 1956. **Sources:** WW73; Curtis, Curtis, and Lieberman, 69, 79,185.

PRICE, Alice Hendee (Mrs. Chester B.) *[Painter] b.1889, Arcadia, Iowa.*
Addresses: Bronxville 8, NY. **Studied:** Kansas City AI; NAD; NY Sch. Fine & Applied Art (scholarship); with Wayman Adams, Jerry Farnsworth. **Member:** Hudson Valley AA; Pen & Brush Club. **Exhibited:** WFNY, 1939; Arch. Lg. (solo); Pen & Brush Cl. (solo); NAC; Hudson Valley AA; Westchester County Art Project; Bronxville Women's Cl., 1956 (solo). Awards: prizes, Hudson Valley AA, 1946; Westchester County Art Project, 1949, 1954-55; Crestwood, 1952; Pen & Brush Club, 1955; Bronxville Women's Cl., 1956 (solo). **Work:** NAD; murals, triptych, Chapel, Christ Church, Bronxville. **Sources:** WW59.

PRICE, Anna G. *[Painter, teacher] 20th c.; b.NYC.*
Addresses: Forest Hills, NY. **Studied:** ASL; NY Sch. A. **Member:** NAWPS; PBC. **Sources:** WW40.

PRICE, Charles Douglas *[Craftsperson, sculptor, teacher] b.1906, Newark, NJ.*
Addresses: Newark, NJ. **Studied:** PIA Sch.; Cranbrook Acad.; W. Zorach; ASL. **Work:** Cranbrook Mus. **Comments:** Position: t., Cranbrook Acad. A. **Sources:** WW40.

PRICE, Charles Matlack *[Painter] 20th c.*
Addresses: NYC. **Comments:** Position: staff, Arts and Decoration. **Sources:** WW24.

PRICE, Chester B. *[Illustrator, etcher, architect] b.1885, Kansas City, MO / d.1962, Bronxville, NY.*
Addresses: NYC; Bronxville, NY. **Studied:** ASL; Washington Univ., St. Louis, Mo.; Royal Col. A., London, England; & with Malcolm Osborne, Robert Austin; Umbdenstock, in Paris; D. Barber, in NYC. **Member:** AIA; Arch. L.; SAGA; Chicago Soc. Et.; SC. **Exhibited:** Arch. L., 1915-1937 (prize 1928); NAD; SAGA; WFNY 1939; Chicago SE. **Work:** NYPL.; Nat. Mus., Wash., DC; Univ. Nebraska; Fine Prints of the Year, 1931, 1932, 1935; Fifty Prints of the Year, 1933; Cranbrook Mus. **Comments:** Position: assoc. in arch., Columbia Univ., NYC, 1942-44; pres., Arch. Lg., 1949-50. I., 14th Ed., Encyclopaedia Britannica, article on architecture. Illus. for national magazines. Lectures: Architectural Illustration. **Sources:** WW59; WW47.

PRICE, Clayton S(umner) *[Painter, illustrator, mural painter] b.1874, Bedford, IA / d.1950, Portland, OR.*

C S Price.

Addresses: Portland, OR. **Studied:** St. Louis Sch. FA, 1905; with Armin Hansen in Monterey, CA. **Exhibited:** San Francisco AA, 1915-24; Galerie Beaux Arts, San Francisco, 1925 (solo), 1927; Berkeley League of FA, 1927 (solo); 48 States Comp., 1939; de Young Mus., 1939; Portland AM, 1942 (solo), 1949 (solo), 1951 (solo), 1976 (solo); Detroit IA, 1944; MoMA, 1943, 1946; Valentine Gal., NYC, 1945 (solo); PAFA Ann., 1945; AIC, 1947; Reed College, OR, 1948 (solo); Willard Gal., NYC, 1949 (solo); Downtown Gal., NYC, 1958 (solo); Fine Arts Patrons of Newport Harbor, CA, 1967 (solo); SAM; LACMA; BMA; Walker Art Ctr.; CPLH; Santa Barbara MA, 1951-52; SFMA, 1976; Oakland Mus., 1981. **Work:** LACMA; MMA; MoMA; Portland AM; Detroit IA. **Comments:** Illustrator: *Pacific Monthly,* 1909-10. Specialty: Western scenes. Active in Wyoming, 1888-c.1908. **Sources:** WW40; Hughes, *Artists in California,* 447; Falk, *Exh. Record Series.*

PRICE, Edith Ballinger *[Illustrator painter, writer] b.1897, New Brunswick, NJ.*
Addresses: Wakefield, RI; Newport, RI. **Studied:** BMFA Sch.; NAD; ASL, with Alexander R. James; P.L. Hale; H. Sturtevant; G. Maynard; Thomas Fogarty. **Member:** Newport AA; South County AA. **Exhibited:** Newport AA; South County AA. **Comments:**

Author/illustrator: "Garth Able Seaman," "Ship of Dreams," "A Citizen of Nowhere," "Lubber's Luck;" also numerous short stories. **Sources:** WW59; WW47.

PRICE, Eleanore (Mrs. William F.) *[Painter] 20th c.*
Addresses: Newport, RI. **Member:** Newport AA. **Sources:** WW25.

PRICE, Elizabeth D. *[Painter] late 19th c.*
Addresses: Pottstown, PA, 1879-85. **Exhibited:** PAFA Ann., 1879, 1885. **Sources:** Falk, *Exh. Record Series.*

PRICE, Elizabeth Freedly See: **FREEDLY, Elizabeth C. (Mrs. R. Moore Price)**

PRICE, Elizabeth M. See: **PRICE, M. (Mary) Elizabeth**

PRICE, Esther Prabel *[Portrait painter] b.1904.*
Addresses: Chicago, IL. **Studied:** AIC. **Member:** John H. Vanderpoel AA; Chicago NJSA. **Exhibited:** AIC, 1937-38, 1940. **Comments:** Position: t., Morgan Park Military Acad. **Sources:** WW40.

PRICE, Eugenia *[Miniature & landscape, teacher] b.1865, Beaumont, TX / d.1923, Los Angeles, CA.*
Addresses: San Antonio, TX. **Studied:** St. Louis Sch. FA; AIC; Académie Julian, Paris. **Member:** Chicago AC; Texas FAS; Chicago SMP; San Antonio AL; SSAL. **Exhibited:** AIC, 1905-06, 1917; ASMP; NAD; San Antonio Art Lg., regularly. **Sources:** WW21; Petteys, *Dictionary of Women Artists.*

PRICE, Frank C. *[Painter] 20th c.*
Addresses: Columbus, OH. **Member:** Columbus, PPC. **Sources:** WW25.

PRICE, Frederic Newlin *[Museum director, gallery owner, writer, lecturer] b.1884, Philadelphia, PA / d.1963.*
Addresses: New Hope, PA; most of his career was spent in NYC. **Studied:** Swarthmore Col. **Member:** SC. **Comments:** Position: dir., Benjamin West Mus., Swarthmore, Pa.; dir., Ferargil Gal., New York, N.Y. Ferargil Galleries handled the work of American artists, including Ryder, Davies, and H. Walker. Contributor to: *International Studio* magazine. Lectures: Benjamin West. Author: "Arthur Davies" 1930; "Albert P. Ryder," 1932; "Horatio Walker"; "Ernest Lawson"; & other books. **Sources:** WW59; WW47; also discussed in William I. Homer and Lloyd Goodrich, *Albert Pinkham Ryder, Painter of Dreams*(New York: Harry N. Abrams, 1989).

PRICE, Garrett *[Illustrator, cartoonist] b.1896, Bucyrus, KS / d.1979, Norwalk, CT.*

Garrett Price

Addresses: Westport, CT. **Studied:** Univ. WY; AIC. **Member:** SI. **Exhibited:** MMA; PAFA; AIC; AWCS. **Comments:** Best known as an illustrator for the *New Yorker,* for which he produced 50 covers and many cartoons. **Sources:** WW66; WW47; *Community of Artists,* 89.

PRICE, George *[Cartoonist, painter, illustrator] b.1901, Coytesville, NJ / d.1995, Tenafly, NJ.*

Geo. Price

Addresses: Tenafly, NJ. **Studied:** George (Pop) Hart. **Comments:** For more than six decades, he contributed more than 1,200 eccentric cartoons, enlivened by a cast of odd characters, to *The New Yorker* magazine. With his friends, Charles Addams, Peter Arno, and William Steig, he shaped the look of the magazine from the 1930s-on. Author & illustrator: *We Buy Old Gold,* 1952; *George Price's Characters,* 1955; *My Dear Five Hundred Friends, 1963;* People Zoo, 1971. Illustrator: *The Strange Places,*1939; during the 1920s, his work appeared in *Life, Judge, Collier's,* and *Sat. Eve. Post.* **Sources:** WW73; WW40; *The World of George Price: A 55-Year Retrospective* (1988); obit., *New York Times* (Jan. 14, 1995, p.30).

PRICE, George *[Engraver] b.1826, England.*
Addresses: NYC, active 1860 and after. **Sources:** G&W; Stauffer; 8 Census (1860), N.Y., XLVII, 311.

PRICE, Gray See: **MERRELS, Gray Price (Mrs.)**

PRICE, Gwynne C. *[Painter]* *19th/20th c.*
Addresses: Chicago, IL. **Exhibited:** AIC, 1891, 1894, 1898-99; Chicago Artists, 1898; NY State Fair, 1898. **Sources:** WW01.

PRICE, H. B. *[Portraitist, daguerrotypist, miniature painter]* *mid 19th c.*
Addresses: Ohio, active 1844. **Comments:** Advertised in the *Ohio Sun* in 1844. **Sources:** Hageman, 121.

PRICE, Harold F. *[Painter, lithographer]* *b.1912, Portland, OR.*
Addresses: Los Angeles, CA; Carmel, CA, 1960s. **Studied:** Univ. of Oregon; ASL, 1936-39; Mexico City. **Exhibited:** Artists Fiesta, Los Angeles, 1931; P&S of Los Angeles, 1932-36. **Sources:** Hughes, *Artists in California*, 447.

PRICE, Harry *[Painter]* *early 20th c.*
Addresses: Tappan, NY. **Exhibited:** S. Indp. A., 1920. **Sources:** Marlor, *Soc. Indp. Artists.*

PRICE, Hattie Longstreet *[Illustrator]* *b.1891, Germantown, PA.*
Studied: PAFA (European travel scholarship); Paris. **Comments:** Illustrator of children's books. **Sources:** Petteys, *Dictionary of Women Artists.*

PRICE, Helen F. *[Painter, writer, lecturer]* *b.1893, Johnstown, PA / d.1960, Johnstown, PA.*
Addresses: Johnstown. **Member:** All. Artists Johnstown; NAWA; Pittsburgh AA. **Exhibited:** Salons of Am., 1933-35; S. Indp. A., 1933-36, 1940-42; All. Artists Am., 1936-37, 1939; Pittsburgh AA, annually; All. Artists Johnstown, annually (prizes:1940, 1942, 1944, 1948, 1950); Western Penn. Hist. Soc., 1940 (solo); Butler AI, 1945-47; NAWA; Argent Gal.; Univ. Pittsburgh; Mountain Playhouse, Jennertown, PA (4 solos). **Work:** Somerset (PA) Public School; Lutheran Col., Gettysburg, PA; Bethlehem Steel Gen. Offices; Somerset Bank; Johnstown Bank; Univ. Pittsburgh. **Sources:** WW59; WW47.

PRICE, Henry *[Sculptor]* *early 20th c.*
Addresses: London, England. **Exhibited:** St. Louis Expo, 1904 (med.). **Sources:** WW06.

PRICE, Irene Roberta *[Portrait painter]* *b.1900, Savannah, GA.*
Addresses: Winston-Salem, NC; Blowing Rock, NC. **Studied:** Duke Univ. (A.B.); Corcoran Sch. A.; & with Charles Hawthorne, Robert Brackman. **Member:** SSAL; AAPL; N.C. State A. Soc. **Exhibited:** SSAL; Piedmont Festival A., 1944; N. C. Fed. Women's C., Charlotte, 1937. **Work:** City of New Bern, NC; Duke Univ.; Virginia Military Inst.; many portraits. **Sources:** WW59; WW47.

PRICE, John *[Portrait painter]* *mid 19th c.*
Addresses: NYC. **Exhibited:** NAD, 1844. **Sources:** G&W; Cowdrey, NAD.

PRICE, John M. *[Art director, designer, cartoonist, film producer]* *b.1918, Plymouth Meeting, PA.*
Addresses: Philadelphia, PA. **Studied:** Pa. State Univ. (B.A.). **Member:** A. Dirs. Cl., Philadelphia. **Exhibited:** Phila. WC Soc., 1940; Greenwich Soc. A., 1949-52; Ferargil Gal., 1952. **Awards:** Intl. Broadcasting Award of the Hollywood Advertising Club for Best Use of Color and for TV Animation, 1961; Silver Medal and 2 Gold Medals, Phila. A. Dirs. Club for audio-visual shows, 1959, 1962, 1964. **Comments:** Position: des., a. dir., for television, 1954-62; Producer of films for advertising and industry, 1962-; designer, photographer & producer of three 80-minute film presentations, consisting of still color photography and art synchronized to stereophonic sound: "Who Says the Danube Isn't Blue?" (1959) and "There Grows the Alpenrose" (1961), "Alpine Fantasy" (1965). Author, illus., ed., "Don't Get Polite With Me!" 1952. (A collection of Price cartoons reprinted from *Sat. Eve. Post, New Yorker* and other publications). Contributor cartoons to *Sat. Eve. Post; Esquire; New Yorker; American; Ladies Home Journal;* King Features Syndicate; Marshall Field Sundicate and many others. Work represented in Art Directors' Annual, 1957. **Sources:** WW66.

PRICE, Kenneth *[Printmaker, sculptor]* *b.1935, Los Angeles.*
Addresses: Los Angeles, CA. **Studied:** Univ. Calif.; Otis Art Inst.; Chouinard Art Inst.; Univ Southern Calif. (B.F.A., 1956); State Univ. NY Albany (M.F.A., 1958). **Exhibited:** Fifty Calif. Artists, SFMA, 1962; New American Sculpture, Pasadena Art Mus., 1964; two-man show, 1966 & American Sculpture of the Sixties, 1967, LACMA; Ten from Los Angeles, SAM, 1966; solo show, 1969 & ann. group show, 1972, WMAA. **Awards:** Tamarind fel., 1968-69. **Work:** LACMA. **Sources:** WW73; Peter Selz, *Funk* (Univ. Calif. Press, 1967).

PRICE, Leslie *[Painter, graphic artist, educator]* *b.1945, NYC.*
Studied: School of Visual Art, NYC; Pratt Inst.; Mills College, Oakland. **Member:** Art West Associated North; Renaissance Universal. **Exhibited:** Oakland Mus.; Col. of Marin; Pacific Grove Art Center, CA; Group One, NYC; Univ. of Iowa, 1971-72; Illinois Bell Tel., Chicago, 1971; Black Figures in History, Berkeley, CA, 1972. **Work:** Oakland Mus.; Mills Col.; Ill. Bell Tel.; Johnson Pub. Co.; priv. colls. **Sources:** Cederholm, *Afro-American Artists.*

PRICE, Lida Sarah *[Painter, miniature painter, teacher]* *b.1865, Iowa / d.1954.*
Addresses: Paris, France; Los Angeles, CA, 1906-32. **Studied:** Académie Julian, Paris with Mme. Laforge; also in Paris with R.E. Miller and Collin. **Exhibited:** AIC, 1905; Steckel Gal., Los Angeles, 1907. **Sources:** WW08; Hughes, *Artists in California*, 448; Petteys, *Dictionary of Women Artists.*

PRICE, Lottie *[Still-life painter]* *19th/20th c.*
Addresses: Richmond, VA. **Exhibited:** Richmond, VA, 1897-99. **Sources:** Wright, *Artists in Virgina Before 1900.*

PRICE, Luxor *[Painter]* *mid 20th c.; b.Wales.*
Addresses: Dutchess Co., NY. **Exhibited:** S. Indp. A., 1931. **Sources:** Marlor, *Soc. Indp. Artists.*

PRICE, M. (Mary) Elizabeth *[Painter, lecturer, teacher, craftsperson]* *b.1877, Martinsburg, WV / d.1965.*
Addresses: Phila., 1914-17; NYC, 1918-32; New Hope, Bucks County, PA, 1933-on. **Studied:** PM School IA; PAFA with William L. Lathrop and H. Breckenridge. **Member:** New Hope AA; Poland Springs Art Gal.; NAWPS; Arkansas FAS; Phila. Art All.; Ten Philadelphia Painters; Plastic Cl.; Whitney Studio Cl.; Lg. of NY Artists ; Fellowship, PAFA. **Exhibited:** Ten Philadelphia Painters; NAWA, 1920-on; S. Indp. A., 1917, 1919, 1924; WMAA, 1918-28; Salons of Am., 1927; NAD, 1932-34; PAFA Ann., 1914-18, 1923-43; Corcoran Gal. biennials, 1914-39 (7 times); Ferargil Gal.; CI; Phillips Mill, New Hope, PA; Grand Central Art Gals. (solo), Anderson Gal, NYC (solo); Fifty-Fifth Street Gal., NYC. (solo); NJ State Mus., 1934; Moore Col. of Art & Des., Phila., PA, 1998 (retrospective, "The Philadelphia Ten"). **Work:** Swarthmore Col.; Smith Col.; Dickinson Col. **Comments:** Sister of the prominent art dealer, Frederick Newlin Price (of Ferargil Gal., NYC). She specialized in decorative, modernist landscapes in the Pennsylvania impressionist style, and floral pieces with backgrounds of metal leaf which were Japanese-inspired. She became director of the Neighborhood Art School of Greenwich House. She collaborated with Edith Lucille Howard in 1931 on the murals for the American Women's Association Clubhouse, in New York City. **Sources:** WW59; WW47; Pisano, *One Hundred Years.the National Association of Women Artists*, 76 (gives birth/death dates as 1875-1960); Talbott and Sidney, *The Philadelphia Ten* (gives birth/death dates as 1877-1965); Falk, *Exh. Record Series.*

PRICE, Margaret Evans (Mrs.) *[Illustrator, writer, painter]* *b.1888, Chicago, IL / d.1973, East Aurora, NY.*
Addresses: East Aurora, NY. **Studied:** Mass. Normal Art Sch. 1907; & with Joseph De Camp, Vesper George; Major. **Exhibited:**

Boston AC; Albright Art Gal.; Grand Central Art Gal., 1953-56; Bermuda AA, 1956, 1957; numerous exh. of book illus. **Work:** NY Hist. Soc.; NY Hist. Mus.; Bermuda AA; Bermuda Cathedral. **Comments:** Traveled extensively, studying subjects for her work. Author/illustrator: "Legends of the Seven Seas"; "Down Comes the Wilderness"; "Mirage," 1955; "Myths and Enchantment Tales," 1954-1958. Illustrator: "Bounty of Earth"; "West Indian Play Days"; & other books. Contributor: *Woman's Home Companion, Nature, Child Life* magazines. **Sources:** WW59; WW47.

PRICE, Mary Roberts Ball (Mrs. Joseph) *[Painter] early 20th c.*
Addresses: Phila., PA. **Studied:** PAFA. **Member:** Plastic Cl. **Exhibited:** Plastic Cl., 1913, 1916. **Sources:** WW25.

PRICE, Mary S. (Mrs. Charles Gray) *[Painter] 19th/20th c.*
Addresses: Chicago, IL. **Member:** Louisville AL. **Sources:** WW01.

PRICE, May (or Mary) A. *[Artist] early 20th c.*
Addresses: Wash., DC, active 1902-05. **Sources:** McMahan, *Artists of Washington, D.C.*

PRICE, Minnie *[Painter, teacher] b.1877, Columbus, OH / d.1957, Las Vegas, NV.*
Studied: Columbus School Art; with Edgar Littlefield, Hawthorne, Raymond Ensign, & Ernest Watson. **Exhibited:** Carnegie Library, Columbus; Greek Theatre, Los Angeles, 1950; San Fernando (CA) Prof. Artists, 1954, 1956; Las Vegas Auditorium & Las Vegas Pub. Lib., 1953-55. **Sources:** Petteys, *Dictionary of Women Artists.*

PRICE, Norman (Mills) *[Illustrator] b.1877, Brampton, Ontario / d.1951.*
Addresses: NYC, 1911-on. **Studied:** Ontario Sch. Art; W. Cruikshank, in England, c.1901; Westminster Sch. A., Goldsmith's Inst., London; Académie Julian, Paris with J.P. Laurens; R.E. Miller in Paris. **Member:** SI; AG; Mahlstick Cl.; Little Billee Sketch Cl. **Exhibited:** SI, 1921-46; Rockefeller Center, 1946 (prize); Illustration House, NYC, c.1990. **Comments:** Best known for his illustrations of adventure featuring pirates and vikings. In London, he was the founder of Carlton Studios. He did freelance work in Paris until an assignment in Belgium for *Century* brought him to the attention of other American publishers. In 1911, he had a studio in NYC, and worked for *Harper's, Cosmopolitan,* and *Liberty.* He also illustrated novels, including *The Lamb's Tales from Shakespeare* (1905), *The Rogue's Moon* (1929), *Leif Erikson the Lucky* (1939), *Treasure Island,* and other books. **Sources:** WW47; Samuels, 382; exh. flyer, Illustration House (n.d., c.1990).

PRICE, Porter B. *[Painter] mid 20th c.*
Addresses: Chicago area. **Exhibited:** AIC, 1931-32, 1934, 1938. **Sources:** Falk, *AIC.*

PRICE, Richard Kimmell *[Painter] mid 20th c.*
Addresses: San Jose, CA, 1930s. **Exhibited:** Calif. State Fair, 1937. **Sources:** Hughes, *Artists in California,* 448.

PRICE, Robert *[Wood engraver and lithographer] mid 19th c.*
Addresses: Albany, NY, 1859. **Sources:** G&W; Albany CD 1859.

PRICE, Robert G. *[Painter] mid 20th c.*
Addresses: NYC, 1954. **Exhibited:** WMAA, 1954. **Sources:** Falk, *WMAA.*

PRICE, Rosalie Pettus (Mrs. William A.) *[Painter] b.1913, Birmingham, AL.*
Addresses: Birmingham, AL. **Studied:** Birmingham-Southern Col. (A.B.); Univ. Ala. (M.A.), and with Hanuah Elliott, A. L. Bairnsfather, Wayman Adams. **Member:** Calif. Nat. WC Soc.; WC Soc. Ala. (secy., 1948-49); Mobile WC Soc.; New Orleans AA; Louisiana WC Soc.; Long Beach AA; Birmingham Art Assn. (pres., 1947-49); Nat. Soc. Painters Casein & Acrylic. **Exhibited:** Calif. WCS, 1945-48, (traveling exh., 1947-48), 1954; Riverside

Mus., 1946, 1948; SSAL, 1936, 1943, 1946; Long Beach AA, 1944, 1945; Los Angeles Nat. A. Week, 1945; Phila. WC & Print Exh., 1948; Alabama WC Soc., 1948 (prize), 1949; AWCS, 1947; Mobile WC Soc., 1948; New Orleans AA, 1947-48 (prize); Mississippi AA, 1947; Newport AA, 1946; High Mus. A., 1947-49; SSAL, 1936, 1943, 1946; Long Beach AA, 1944, 1945; Birmingham AA, 1934-35, 1944 (prize)-45 (prize), 1947, 1950 (prize),1951, 1968 (Little House on Linden purchase award); Pen & Brush Cl., 1949-50 (prize); Watercolor USA, Springfield, 1968, 1971-72; 35th Ann Mid-year Show, Butler Inst. Am. Art, Youngstown, OH, 1970; 50th Ann. Exhib., Calif. Nat. WC Soc., Laguna Beach, Calif., 1970; WC Invitational, Chico State Col., Calif., 1972; 18th Ann. Drawing & Small Sculpture Show, Ball State Univ., Muncie, Ind., 1972. W. Alden Brown Mem. Prize, Nat. Soc. Painters Casein, 1970; purchase award, WC USA, 1972. **Work:** Birmingham Mus. Art; Springfield Art Mus., Mo.; Spain Ctr. Coll., Univ. Ala., Birmingham; Samford Univ., Birmingham; Birmingham Trust Nat. Bank. **Comments:** Preferred media: acrylics, oils, ink. Teaching: instr. drawing & watercolor, Birmingham Mus. Art, 1967-70; instr. art appreciation, color & design, Samford Univ., 1969-70. **Sources:** WW73; Martin Hames (interviewer), "The Implacable Abstraction of Objects," Ala. Educ. TV, 1/13/1972.

PRICE, Ruth Seeling (Mrs. Dean T.) *[Painter and commercial designer] b.1912, Syracuse, NY.*
Addresses: Des Moines, IA. **Studied:** Charles A. Cumming, Cumming Art School; Mabel Dixon & Lowell Houser. **Exhibited:** Iowa Art Salon, 1929 (first award), 1930 (first award), 1933-34; Des Moines Women's Cl., 1934-36. **Comments:** Position: commercial designer of lamps, 1930-33. **Sources:** Ness & Orwig, *Iowa Artists of the First Hundred Years,* 169.

PRICE, Samuel Woodson *[Portrait and figure painter; historian] b.1828, Nicholasville, KY / d.1918, St. Louis, MO.*
Addresses: St. Louis, MO. **Studied:** 1847, Nicholasville, KY, with William Reddin; Lexington, KY, with Oliver Frazer; briefly at NAD. **Exhibited:** NAD, 1879-80. **Work:** Univ. Kentucky Art Mus., Lexington. **Comments:** After studying in NYC returned in 1849 to Kentucky and painted portraits there and in Tennessee until the outbreak of the Civil War. He served as Colonel in the Union Army and was wounded at the battle of Kennesaw Mountain. After the war he painted portraits for a time in Washington, DC; served as postmaster at Lexington, 1869-76; and continued to paint portraits and figure paintings until he went blind in 1881. Lived in Louisville from 1878 to 1906 and then moved to St. Louis, MO. In his later years, he devoted himself to history, writing *Old Masters of the Bluegrass* (pub. in 1902 by Filson Club of Louisville), an early historical account of Kentucky art which focused on six artists. **Sources:** G&W; Coleman, "Samuel Woodson Price, Kentucky Portrait Painter," with checklist; information courtesy Mrs. W.H. Whitley, Paris (KY); Naylor, NAD. More recently, see Gerdts, *Art Across America,* vol. 2: 156, 162; WW17; Jones and Weber, *The Kentucky Painter from the Frontier Era to the Great War,* 63 (w/repros.).

PRICE, Susana Martin *[Miniature painter] early 20th c.*
Addresses: Moylan, PA. **Sources:** WW15.

PRICE, Vincent *[Collector, art dealer] b.1911, St Louis, MO.*
Addresses: Beverly Hills, CA. **Studied:** Yale Univ. (B.A., 1933); Univ. London, 1934-35; Ohio Wesleyan (hon. LL.D.); Calif. Col. Arts & Crafts (hon. D.F.A.); Columbia Col. (hon. D.F.A.). **Member:** Indian Arts & Crafts Bd., Dept. Interior (chmn., 1968-72). **Comments:** Positions: founder, Mod. Inst. Art, 1945; pres., Univ. Calif., Los Angeles Art Coun.; dir., Vincent Price A. Gal.; art consult., Sears Roebuck & Co. Publications: auth., Vincent Price on art, syndicated column, Chicago Tribune, 3 yrs.; auth., many articles on art in nat. magazines & newspapers; auth., "I Like What I Know"; "The Book of Joe"; "Treasury of American Art.". **Sources:** WW73.

PRICE, William Henry *[Landscape and marine painter] b.1864, Pittsburgh, PA / d.1940, Pasadena, CA.*

Addresses: Pasadena, CA. **Studied:** a few lessons with E. Forester, and for a short time with Edgar Payne. **Member:** Calif. AC; Acad. Western Painters (cofounder); P.&S. C. **Exhibited:** Nat. P& S Exh., LACMA 1931 (popular prize); Gardena A. Gal., 1933 (second prize); Clearwater Gal., 1934 (first prize); Calif. State Fair, Sacramento, 1934 (hon. men.), 1935 (hon. men.); Pasadena SA, 1936 (first prize) Civic A. Exh., Pasadena, 1937 (popular prize). **Sources:** WW40; Hughes, *Artists in California,* 448.

PRICE, William L. *[Painter, watercolorist, architect]* late 19th c.
Addresses: Phila., PA. **Exhibited:** PAFA Ann., 1881-85, 1890, 1894. **Sources:** Falk, *Exh. Record Series.*

PRICE, Williard Bertram *[Painter]* b.1872, Newark.
Addresses: Newark, NJ. **Studied:** NAD; ASL; W.M. Chase. **Exhibited:** NAD, 1880; AIC, 1902-03, 1905. **Sources:** WW06.

PRICHARD, Helen Bobo (Mrs. Fred) *[Painter]* b.1910, Colfax, IA.
Addresses: Fontanelle, IA. **Studied:** Iowa State Teachers Col. (B.A., 1927-31); Charles A. Cumming, 1926. **Exhibited:** Iowa Art Salon, 1935 (medals); Joslyn Mem.; Southern Iowa Fair, Oskaloosa, IA. **Work:** De Sota M.E. Church; Seymour M.E. Church; Jordan M.E. Church, Des Moines; Avondale Church; Church of Christ, East Des Moines. **Comments:** Positions: teacher, Cumberland, IA; Bridgewater, IA; specialized in religious painting, 1935-. **Sources:** Ness & Orwig, *Iowa Artists of the First Hundred Years,* 169.

PRICHARD, J. Ambrose See: **PRITCHARD, J. Ambrose**

PRICHARD, Theodore Jan *[Designer, educator, architect]* b.1902, Thief River Falls, MN.
Addresses: Moscow, ID. **Studied:** Univ. Minnesota (B.A.); Harvard Univ. (M.Arch.). **Member:** AIA; Pacific AA. **Exhibited:** watercolor, SAM; Boise (Idaho) AM. **Comments:** Position: prof., hd. a. dept., Univ. Idaho, Moscow, Idaho. **Sources:** WW53; WW47.

PRICKETT, Helen *[Painter]* mid 20th c.
Addresses: Chicago area. **Exhibited:** AIC, 1949-50. **Sources:** Falk, *AIC.*

PRICKETT, Rowland Pierson *[Painter, writer, teacher, illustrator]* b.1896, Springfield, MA.
Addresses: Hampden, MA, 1947; Monterey, MA, 1959. **Studied:** Cornell Univ. (B.S.); Lumis A. Acad., with Harriet Randall Lumis; PAFA. **Member:** SC; Springfield A. Gld. **Exhibited:** BMFA, 1926 (prize); Springfield A. Lg., 1945-46; Springfield A. Gld., 1945-46; Royal Inst., Jamaica, B.W.I., 1943-44; Westfield (Mass.) Atheneum; San Juan, Puerto Rico, 1951; Ogunquit A. Center, 1958; solo: Hotel Grant, San Diego, 1940; Witherle Mem., Castine, Me., 1954; Hotel Floridian, Miami Beach, 1955; Bar Harbor, Me., 1956; Juneau, Alaska, 1957. **Work:** CAFA; Travelers Ins. Co.; Jamaica, B.W.I. Railways; Mexican Nat. Railways; U.S. Army Air Force Tactical Color Research, 1943. Color Indexing, 1948; Lincoln Mem. Lib., Brimfield, Mass; Parrish A. Mus. **Comments:** Dir./co-instr.: Prickett-Montague Studio of Painting, Monterey, Mass. (with wife Ruth DuBarry Montague). Originator, instr., 5 home study courses via airmail; Prickett Simplified Palette of Colors; leader of nationwide Happy Painters Guild for Skillful Art; writer of "Paint and Be Happy" column of instructions and art comments for American weekly newspapers; author of published monographs on various phases of oil painting. **Sources:** WW59; WW47, puts birth at 1906.

PRICKETT, Ruth (Mrs. Roland Pierson Prickett) See: **MONTAGUE, Ruth DuBarry (Criquette)**

PRIDE, Joy (Mrs. Tom Scott) *[Painter, writer]* mid 20th c.; b.Lexington, KY.
Addresses: NYC; Boston, MA. **Studied:** Univ. KY (B.A., M.A.); Barnes Found., Merion, Pa; ASL; New Sch. Soc. Res.; Académie Julian, Paris; Acad. Andre Lhote, Paris; Acad. Scandinave, Paris;

also with Stuart Davis. **Member:** NAWA; Pen & Brush; Newburyport Art Assn. (pres.). **Exhibited:** CAA, 1931; CGA, 1933; NAWA, 1943-60 (hon. men., 1952); PBC, 1947; Speed Mem. Mus.,1929-33; Univ. Ky., 1932 (solo); Circle Gal., Hollywood, Calif., 1943; Pen & Brush, 1945-66; solo shows, Lexington, Ky, 1935, Los Angeles, Calif., 1945 & Newburyport, Mass., 1972. Awards: Am. Inst. Graphic Arts Fifty Bks. of Yr. Award. **Work:** home of Henry Clay-Ashland; Senate Off. Bldg., Washington, DC; Lexington Pub. Schs. Commissions: Hist. Ky. Landmarks, Ky. Schs. **Comments:** Preferred media: oils, graphics. Positions: art di.r gen. publ., Christian Sci. Publ. Soc.; art dir.-prod. ed., McCormack Mathers Publ. Co.; sr. art ed., Macmillan Co. Research: influences on modern schools of painting other than painting traditions. Publications: auth., "Songs of America," Crowell; auth., "America Sings," Hansen; designer, "Psychology;" designer, "Story of American Freedom;" designer, "World History," Macmillan. Teaching: hd. dept. art, Barmore Sch., NYC; hd. dept. art, Murray State Teachers Col.; Univ. KY. **Sources:** WW73; WW47.

PRIDHAM, Henry *[House and sign painter, glass stainer]* mid 19th c.
Addresses: Cincinnati, active 1850 and possibly earlier.
Comments: This may be the Pridham of Wicher & Pridham (see entry), sign, ornamental, and steamboat painters at Cincinnati in 1844. **Sources:** G&W; Cincinnati CD 1850; Knittle, *Early Ohio Taverns.*

PRIEBE, Elizabeth *[Painter]* 19th/20th c.
Exhibited: Wash. State Arts and Crafts, 1909. **Sources:** Trip and Cook, *Washington State Art and Artists.*

PRIEBE, Karl *[Painter, teacher, lecturer]* b.1914, Milwaukee, WI / d.1976.
Addresses: NYC.; Milwaukee, WI. **Studied:** Layton Sch. A.; AIC. **Exhibited:** Perls Gal., 1943 (solo)-44 (solo), 1946 (solo); AIC, 1936, 1938-39, 1949 (prize); Milwaukee AI, 1943-45 (prizes); WMAA, 1944-45; PAFA Ann., 1944, 1948-50; Corcoran Gal biennials, 1947, 1949; Paris, France. 1951; Hammer Gal., NYC, 1956; Univ. Wisconsin, 1958. **Work:** Layton Gal. A.; Milwaukee AI; Encyclopaedia Britannica Coll.; VMFA; Barnes Fnd.; IBM Coll.; Detroit Inst. A.; Fisk Univ.; Marquette Univ.; Reader's Digest Coll. **Comments:** Position: asst. in Ethnology, Milwaukee Pub. Mus., 1938-42; dir., Kalamazoo AI, Kalamazoo, Mich., 1944; instr. painting, Layton Sch. A., Milwaukee, WI. **Sources:** WW59; WW47; Falk, *Exh. Record Series.*

PRIES, Lionel H. *[Educator, painter, etcher, architect]* b.1897, San Francisco, CA / d.1968, Seattle, WA.
Addresses: Seattle, WA. **Studied:** Univ. California (A.B.); Univ. Pennsylvania (M. Arch.); & with Paul Cret, Dawson, Gumaer. **Member:** Puget Sound Group of Northwest Painters, 1933. **Exhibited:** Arch. L., 1921; Am. Acad. In Rome, 1921 (prize); Bohemian Cl., San Francisco, 1922; CPLH; SAM, 1935; Univ. Washington. Awards: LeBrun traveling F., 1922. **Work:** mem. Univ. California; SAM. **Comments:** Position: dir., SAM,1929-30; assoc. prof. arch., Univ. Washington, Seattle, 1928-. Lectures: Ornament; Architecture; Textiles. **Sources:** WW59; WW47. More recently, see Hughes, *Artists in California,* 448; Trip and Cook, *Washington State Art and Artists.*

PRIEST, Alan *[Former museum curator]* b.1898, Fitchburg, MA / d.1968.
Addresses: NYC. **Studied:** Harvard Univ. (B.A.). **Exhibited:** Awards: Carnegie F., China, 1925; Sachs F., China, 1926-27. **Comments:** Position: tutor, lecturer, Harvard Univ., 1922-23; asst. prof., Harvard Univ., 1927; cur., Far Eastern A., MMA, 1928-63. Author: "Chinese Sculpture in the Metropolitan Museum of Art," 1943; "Costumers from the Forbidden City" (monograph), 1945; "Aspects of Chinese Painting," 1954; various other monographs & catalogs. Contributor to: Bulletin of the MMA. Lectures: Oriental art. **Sources:** WW66; WW47.

PRIEST, Francis I. *[Sign and ornamental painter]* b.c.1792, NY.

Addresses: Steubenville (Ohio), 1830-60. **Sources:** G&W; Knittle, *Early Ohio Taverns;* Hageman, 121.

PRIEST, Hartwell Wyse (Mrs.) *[Painter, printmaker, teacher] b.1901, Brantford, Ontario.*
Addresses: Charlottesville, VA. **Studied:** Smith Col., 1924; Paris-Atelier, with Andre Lhote; ASL; also with Hans Hofmann. **Member:** NAWA (mem. jury, 1955, exten. comt., 1970-72); Summit AA; Soc. Am. Graphic Artists; Washington WC Cl. **Exhibited:** NAWA Ann., 1944-(award); Soc. Am. Graphic Artists Ann., 1956-; Artistes Feminins, Exhib. Les Services Americans d'information, Ostende & Brussels, Berne, 1956; Audubon Artists, 1968; NAWA Foreign Exhib., Palazzo Vechio, Florence, Italy, 1972; Current Scene Gal., Charlottesville, VA, 1970s **Awards:** medal of honor, 1953, Alice S. Buell Mem. Award for graphics, 1970 & John Carl Georgi Mem. Award, 1972, award, Pen & Brush, 1972. **Work:** etching, LOC; etching, Newark Pub. Libr., NJ; lithograph, Norton Gal., West Palm Beach, Fla.; lithograph, Longwood Col., Farmville, Va.; Univ. Maine. Commissions: murals in children's ward, Univ. Va. Hosp., Charlottesville, 1955; flowers & woodland scene for ann. report, Hunt. Bot. Libr., Pittsburgh, Pa., 1971. **Comments:** Preferred media: graphics. Illustrator: "The New Wood Cut," by M.C. Salaman. Positions: pres., Summit, NJ Art Assn., 1945-1946. Teaching: instr. graphics, Va. Art Inst., 1967-. **Sources:** WW73; WW40.

PRIEST, Joseph *[listed as "artist"] b.c.1820, England.*
Addresses: NYC in 1850. **Sources:** G&W; 7 Census (1850), N.Y., XLVIII, 279; he and his wife had a one-year-old son who was also born in England.

PRIEST, Joseph *[Listed as "artist"] b.c.1832, Virginia.*
Addresses: NYC in 1860. **Sources:** G&W; 8 Census (1860), N.Y., LIV, 445.

PRIEST, Lucia Mead *[Artist, craftsworker] early 20th c.*
Exhibited: Doll & Richards, 1913. **Sources:** Petteys, *Dictionary of Women Artists.*

PRIEST, Richard E. *[Painter] mid 20th c.*
Addresses: NYC, 1944. **Exhibited:** S. Indp. A., 1944. **Sources:** Marlor, *Soc. Indp. Artists.*

PRIEST, William *[Engraver and publisher] late 18th c.*
Addresses: Philadelphia, 1794-95. **Sources:** G&W; Brown and Brown.

PRIEST, William *[Ornamental painter] late 18th c.*
Addresses: Baltimore in 1796. **Comments:** Advertised in Baltimore in 1796 "paintings in imitation of paper hangings by a mechanical process," as well as "laying plain grounds in distemper, with plain or festoon borders." **Sources:** G&W; Little, "Itinerant Painting in America, 1750-1850," 208.

PRIESTMAN, B. Walter *[Painter] b.1868, Kewanee, IL. / d.1951.*
Addresses: NYC; Boston, MA. **Studied:** Chicago; Boston; NYC; Paris. **Exhibited:** NAD, 1894-1900; Boston AC, 1899; AIC. **Sources:** WW04.

PRILIK, Charles Raphael *[Illustrator, etcher, craftsperson] b.1892, Odessa, Russia.*
Addresses: Gary, IN/Miller, IN. **Studied:** Forsberg; Philbrick. **Member:** Gary AL. **Sources:** WW25.

PRIME, H. F. *[Portrait painter] mid 19th c.*
Addresses: Hudson, NY. **Exhibited:** NAD, 1839-40. **Sources:** G&W; Cowdrey, NAD.

PRIME, William Cowper *[Educator, writer] b.1825, Cambridge, NY / d.1905.*
Addresses: NYC. **Studied:** Princeton, 1843. **Member:** Grolier C.; MMA (trustee). **Comments:** Author: books dealing with art and travel. Position: t., Princeton.

PRIMERANO, Joan Walton *[Painter] b.1926, Buffalo, NY.*
Addresses: Buffalo, NY. **Studied:** Albright Art Sch., Buffalo; Art Inst. Buffalo. **Exhibited:** Benedictine Art Awards, NYC, 1970;

Audubon Artists Exhib., NYC, 1971-72; Mainstreams '1972, Marietta Col., Ohio, 1972; All. A. Exhib., 1972. **Awards:** Harold J. Cleveland Mem. Award, 14th Nat. Juried Show, Chautauqua, NY, 1971. **Comments:** Preferred media: oils. **Sources:** WW73.

PRIMUS, Nelson A. *[Portrait and religious painter] b.c.1842, Hartford, CT / d.1916, San Francisco, CA.*
Addresses: Hartford, until c.1865; Boston, c.1865-at least 1895; San Francisco, CA. **Studied:** at Hartford, CT, apprenticed to George Francis in Hartford, also received instruction from Elizabeth Gilbert Jerome in Hartford. **Work:** de Young Mus.; Oakland Mus. **Comments:** African-American artist. Primus worked as a portrait and carriage painter in Hartford, later moving to Boston where he painted religious subjects and portraits. In 1895 he made his way to California via the Isthmus of Panama. In San Francisco he worked at a delicatessen and lived in Chinatown, painting in his spare time. **Sources:** G&W (cite birthdate as '1843); Porter, *Modern Negro Art,* 52-53; French, *Art and Artists in Connecticut,* 155; Hughes, *Artists in California,* 448 (cites a birth date of 1866); Art in Conn.: Early Days to the Gilded Age (gives birth-date of 1842).

PRINCE, Arnold *[Sculptor, educator] b.1925, Basseterre, St. Kitts, British West Indies.*
Studied: ASL, 1957-61(scholarships); North Adams State Col. (M.A.). **Member:** Sculptor's Guild, NYC. **Exhibited:** Barbados Mus., 1949; British Council Inter-Island Art Exh., 1949-53; St. Thomas Pub. Lib., 1955; Phoenix Gal., NYC, 1961-62; Internat'l A. Gal., 1961; Arlington, PA., Mus., 1961; Jersey City Mus., 1961; St. Marks on the Bauverie Episcopal Church, 1963; St. Peters Episcopal Church, NYC, 1964; Temple Emmanuel, NYC, 1964; Capricorn Gal., NYC, 1966; Lever House, 1967; Norwich Univ., VT., 1969; Sculptor's Guild, NYC, 1969-70, 1972; North Adams State Col., MA, 1971. **Work:** ASL. **Sources:** Cederholm, *Afro-American Artists.*

PRINCE, E. G. (Mrs.) *[Painter] 20th c.*
Addresses: Weldon, PA. **Sources:** WW04.

PRINCE, Ethel T. *[Painter, teacher] mid 20th c.*
Addresses: Wash., DC, active 1905-35; Hudson, NY, 1941. **Member:** Soc. Wash. Artists; Wash. AC (charter mem.). **Exhibited:** Soc. Wash. Artists, 1912-13, 1920. **Sources:** WW27; McMahan, *Artists of Washington, D.C.*

PRINCE, George *[Lithographer] late 19th c.*
Addresses: Wash., D.C., active 1877. **Sources:** McMahan, *Artists of Washington, D.C.*

PRINCE, Kenneth *[Printmaker] mid 20th c.*
Exhibited: South Side Community A. Center, Chicago, 1941. **Sources:** Cederholm, *Afro-American Artists.*

PRINCE, Lottie D. *[Artist] mid 20th c.*
Addresses: Wash., D.C., active 1920-35. **Exhibited:** Gr. Wash. Indp. Exh., 1935. **Sources:** McMahan, *Artists of Washington, D.C.*

PRINCE, Luke, Jr. *[Portrait painter] mid 19th c.*
Addresses: Haverhill, MA, c.1840. **Sources:** G&W; Lipman and Winchester, 179.

PRINCE, Roger *[Sculptor] mid 20th c.*
Addresses: Westport, CT, 1960. **Exhibited:** WMAA, 1960. **Sources:** Falk, *WMAA.*

PRINCE, Suzanne *[Painter] mid 20th c.*
Addresses: NYC, 1930. **Exhibited:** S. Indp. A., 1930. **Sources:** Marlor, *Soc. Indp. Artists.*

PRINCE, William Meade *[Illustrator, painter, lecturer] b.1893, Roanoke, VA / d.1951.*
Addresses: Westport, CT, 1920s; Chapel Hill, NC, 1930s-on. **Studied:** New York Sch. Fine & Appl. Art. **Member:** SI; SC; North Carolina State AS; A. & W. Assn.; Artist Gld. **Exhibited:** SI. **Comments:** During the 1920s, the Dodge Motor Co. wanted his vivid and atmospheric style of

illustration, but in his reluctance to take the job, he quoted an out-rageous fee. Dodge accepted, and Prince went on to live like a prince with his Arabian horses. Illustrator: *Cosmopolitan, Collier's, Saturday Evening Post, American,* other publications. Position: teacher, Univ. North Carolina, 1939-46. **Sources:** WW47; *Community of Artists,* 75.

PRINDEVILLE, Mary *[Painter] b.1876.*
Addresses: NYC/Chicago, IL. **Studied:** ASL. **Exhibited:** PAFA Ann., 1917-18; Buffalo FA Acad., 1919; AIC, 1920; S. Indp. A., 1931; WMAA,1934. **Sources:** WW19; Petteys, *Dictionary of Women Artists;* Falk, *Exh. Record Series.*

PRINDLE, Mary V. *[Artist] late 19th c.*
Addresses: Active in Grand Rapids, MI, 1889. **Sources:** Petteys, *Dictionary of Women Artists.*

PRINGLE, Bertha Hemphill *[Painter] early 20th c.*
Addresses: San Francisco, CA. **Exhibited:** San Francisco AA, 1923, 1924; Berkeley League of FA, 1924; S. Indp. A., 1925. **Sources:** Hughes, *Artists in California,* 448.

PRINGLE, Burt Evins *[Graphic artist, designer] b.1929, Savannah, GA.*
Addresses: Jacksonville, FL. **Member:** Am. Fedn. Arts. **Exhibited:** Jacksonville Arts Festival, 1961-64; solo show, Norton Gal. & Sch. Art, West Palm Beach, Fla., 1968. Awards: Soc. L'Exploition Brussels World's Fair, Pan. Am. Airways, 1958; 1 bronze & 2 gold medals, Display World Mag., 1958-59; 16 hono-rariums, UN Postal Admin., 1966-72. **Work:** Hall of Fame Portraits, Gator Bowl, Jacksonville, Fla. Commissions: murals, USA, Stuttgart, Ger., 1954; Migratory Bird Treaty Commemorative Postage Stamp, 1966 & VI Commemorative Postage Stamp, 1967, US Post Off. **Comments:** Preferred media: tempera, acrylics, gouaches. Positions: display dir., Retail stores, 1946-. **Sources:** WW73; Lily Freed, article, In: *Scotts Monthly J* (1966-1967); Belmont Faries,"Stamp design," *SPA Jour.* (1967); A. Beltramo , "La personate filatelico," *Collezionista* (Italy, 1968).

PRINGLE, James Fulton *[Marine painter, portrait and land-scape painter] b.1788, Sydenham, Kent, England / d.1847, Brooklyn, NY.*
Addresses: Brooklyn, NY (immigrated 1828). **Studied:** with his father James Pringle. **Exhibited:** NAD, 1832-44; Apollo Assoc.; Clinton Hall, NY; 333 Broadway, NYC , 1837 (60 works). **Work:** New York State Hist. Assoc., Cooperstown, NY; Mariners Mus., Newport News, VA; Mus. City of New York; Mystic (CT) Seaport Mus.; Peabody Mus., Salem, MA; Shelburne (VT) Mus. **Comments:** A leading painter who documented the clipper-ship era. He painted marine scenes for the British Admiralty before coming to U.S. where he gained a strong reputation for his highly-detailed ship portraits, shipbuilding scenes, and scenes of marine disasters. **Sources:** G&W; Information courtesy Miss M.L. Pringle, granddaughter of the artist; Cowdrey, NAD; Cowdrey, AA & AAU; Brooklyn CD 1833-46; *American Processional,* 120 (with repro.); *Portfolio* (March 1943), frontis.; *American Collector* (Aug. 1943), frontis. More recently, see Brewington, 309; and *300 Years of American Art,* vol. 1, 103 (with repro.); Muller, *Paintings and Drawings at the Shelburne Museum,* 113 (with repro.); *300 Years of American Art,* vol. 1, 103; BAI, cour-tesy Dr. Clark S. Marlor.

PRINGLE, Joseph *[Marine painter] mid 19th c.*
Comments: Active 1849-1860's. **Sources:** G&W; Peters, "Paintings of the Old `Wind-Jammer,'" 32.

PRINGLE, Miriam *[Painter] early 20th c.*
Exhibited: San Francisco AA, 1920 (watercolor). **Sources:** Hughes, *Artists in California,* 448.

PRINGLE, William *[Engraver] b.c.1832, New York.*
Addresses: NYC in 1860. **Sources:** G&W; 8 Census (1860), N.Y., LVIII, 812.

PRINGLE, William, Jr. *[Journeyman engraver] b.c.1834, New York.*

Addresses: NYC in 1860. **Sources:** G&W; 8 Census (1860), N.Y., LIX, 284; NYCD 1862; living in with his father William Pringle, Sr., whose property was valued at $35,000.

PRINS, Benjamin Kimberly *[Illustrator] b.1904, Leiden, Holland / d.1980.*
Addresses: Wilton, CT. **Studied:** NY Sch. F. & App. A.; PIASch.; ASL. **Member:** Westport AA; Wilton Hist. Soc. **Exhibited:** Awards: gold medal, A. Dir. Cl., NY. **Comments:** History and photographs of work included in "Illustrating for the Saturday Evening Post," 1951. Contributor covers and illus. to *Sat. Eve. Post;* illus. for *McCalls, Good Housekeeping; Woman's Home Companion, Nations Business, Readers Digest,* and other national magazines. **Sources:** WW66.

PRINS, (J.) Warner *[Painter, illustrator] b.1901, Amsterdam, Holland.*
Addresses: NYC. **Member:** AEA. **Exhibited:** solo shows, Carlebach Gal., NY, 1950, Archit. League, NY, 1952, The Contemporaries, NY, 1953 & Juster Gal., NY, 1959. **Work:** MMA; Jewish Mus., NY; Munson-Williams-Proctor Inst., Utica, NY. Commissions: ceramic murals, pub. bldg., NY & Int. Hotel, Airport, NYC. **Comments:** Publications: illusr., "An Old Faith in the New World;" illusr., "Phedre," 1968; illusr., "Haggadah," A.S. Barnes, 1969. **Sources:** WW73.

PRINS, Warner See: **PRINS, (J.) Warner**

PRINZ, A. Emil *[Painter] late 19th c.*
Addresses: Brooklyn, NY. **Exhibited:** NAD, 1896. **Sources:** Naylor, *NAD.*

PRIOR, Ariadne *[Painter] mid 20th c.*
Addresses: Chicago area. **Exhibited:** AIC, 1935. **Sources:** Falk, *AIC.*

PRIOR, Charles M. *[Painter, etcher, decorator, teacher] b.1865, NYC.*
Addresses: NYC. **Studied:** E.M. Ward, NAD. **Member:** Salons of Am.; EAA; AAPL; AFA. **Exhibited:** S. Indp. A., 1921, 1923-25, 1927-28, 1931, 1933; Salons of Am., 1934-36. **Sources:** WW40.

PRIOR, Harris King *[Art administrator, educator] b.1911, Hazardville, CT / d.1975.*
Addresses: Rochester, NY. **Studied:** Trinity Col. (B.S., 1932, M.A., 1935); Harvard Univ.; Yale Univ.; Univ. Paris; Univ. Brussels; Inst. Fine Arts, New York Univ.; Calif. Col. Arts & Crafts (hon. D.F.A., 1959). **Member:** Assn. Art Mus. Dirs. (v. pres., 1968, secy., 1971, treas., 1972); Am. Assn. Mus.; Col. Art Assn. Am.; Century Assn.; Rotary Cl. **Comments:** Positions: dir. community arts prog., Munson-Williams-Proctor Inst., 1947-56; dir. Am. Fedn. Arts, 1956-62; dir. Mem. Art Gal., Univ. Rochester, 1962-. Publications: auth., "Ten Painters of the Pac. Northwest," (exhib. catalog), 1948; auth., "Paintings of Arthur B. Davies" (exhib. catalog, WMAA), 1962; auth., articles, in: *Italian Encycl., Mus. News, Ore. Hist. Quart., Art in Am. & ASL Quarterly.* **Sources:** WW73.

PRIOR, J. (Mr.) *[Painter] b.c.1795, England.*
Addresses: New Orleans, active 1848. **Sources:** *Encyclopaedia of New Orleans Artists,* 315.

PRIOR, Jane Otis *[Amateur painter] mid 19th c.*
Addresses: Bath, ME, c.1922-40. **Studied:** probably at Miss Tinkham's School, Wiscasset, ME. **Comments:** Painted on boxes. Sister of William M. Prior (see entry). **Sources:** Petteys, *Dictionary of Women Artists.*

PRIOR, M. B. *[Portrait painter] mid 19th c.*
Comments: According to F.F. Sherman, he painted the likenesses of a Mr. and Mrs. Ford of South Paris (Me.) in 1834. **Sources:** G&W; *Art in America* (March 1935), 82.

PRIOR, Ruby See: **ADAIR, Ruby (Mrs.)**

PRIOR, W. H. *[Illustrator] mid 19th c.*
Comments: Illustrated *Our World, or, The Slaveholder's Daughter,* an anti-slavery novel published in NYC in 1855.
Sources: G&W; Hamilton, *Early American Book Illustrators,* 437.

PRIOR, William Henry *[Marine painter] b.1806, Bath, ME / d.1873, Boston, MA.*
Addresses: Portland, ME, 1831-40; Boston, MA, 1841-45; East Boston, 1846. **Comments:** He also visited New Bedford, MA, Newport, RI, and Baltimore, MD. **Sources:** Brewington, 309.

PRIOR, William Matthew *[Itinerant portrait, landscape, and commercial painter, painter on glass] b.1806, Bath, ME / d.1873, (East) Boston.*
Studied: self-taught. **Exhibited:** Athenaeum, Boston, 1831.
Work: Mus. Am. Folk Art, NYC; Corcoran Gal., Wash., DC; BMFA; Fruitlands and the Wayside Museums Inc., Harvard, Mass.; Old Dartmouth Hist. Soc.; Shelburne (VT) Mus.
Comments: Folk artist whose earliest known portrait was painted in 1824 at Portland, ME. He lived in Portland from about 1831-40, part of the time with his brothers-in-law, the Hamblens (see entries). By 1841 he was settled in Boston and he maintained a studio there until 1846 and thereafter in East Boston. As an itinerant painter he also visited New Bedford, MA, c.1845; Newport, RI; and Baltimore. Prior varied his style to fit the price paid by the sitter; in 1831 he advertised that "persons who wished a flat picture can have a likeness whithout shade or shadow at one-quarter price" (from *Maine Inquirer,* 1831, quoted in Little). These primitive works are the ones for which he has become best known, but he also painted in a more sophisticated manner. In addition, he painted on glass, many copies of Gilbert Stuart's "Athenaeum" portrait of Washington. In his later years he was assisted by his sons, Gilbert and Matthew Prior. Prior called his studio "The Painting Garret," and some works from the studio were signed "Painted in Prior's Garret." He painted Dr. Leonard Hanna of Columbiana County, OH around 1829. He was also the author of several religious books. **Sources:** G&W; Little, "William Matthew Prior," in Lipman and Winchester, 80-89; Little, "William Matthew Prior, Traveling Artist, and His In-Laws, the Painting Hamblens;" Lyman, "William Matthew Prior, the 'Painting Garret' Artist"; Karolik Cat., 452-55; Sears, *Some American Primitives,* 32-49; 7 Census (1850), Mass., XXIV, 203; Swan, BA; Flexner, *The Light of Distant Skies.* More recently, see *300 Years of American Art,* vol. 1:135; Hageman, 121; Blasdale, *Artists of New Bedford,* 148 (with repro.); Muller, *Paintings and Drawings at the Shelburne Museum,* 114-15 (with repros.).

PRISBREY, Tressa (Grandma) *[Primitive sculptor] b.1895, Minot, ND.*
Addresses: Santa Susana, CA. **Comments:** Over about 20 years, she created an assemblage of 13 buildings and other structures around her trailer in Santa Susana. "Bottle Village," as it is called, represents a rare environmental work done by an American woman. **Sources:** Dewhurst, MacDowell, and MacDowell, 169-170.

PRISCILLA, Louis *[Illustrator, cartoonist] mid 20th c.*
Addresses: NYC. **Comments:** Illustrator: *Collier's Weekly,* 1937; *New Yorker,*1939. **Sources:** WW40.

PRISLAND, Theodore *[Sculptor] mid 20th c.*
Addresses: Chicago area. **Exhibited:** AIC, 1941. **Sources:** Falk, AIC.

PRITCHARD, Caspar *[Listed as "shade painter"] b.1835, Philadelphia.*
Addresses: Philadelphia in 1860. **Sources:** G&W; 8 Census (1860), Pa., LI, 311.

PRITCHARD, George Thompson *[Painter, lecturer, teacher] b.1878, Havelock, New Zealand / d.1962, Reseda, CA.*
Addresses: San Francisco, CA; Milwaukee, WI; Europe; Canada; NYC; Richmond, VA; Southern California. **Studied:** New Zealand: Aukland Academy of Art; Elam School of Art; Melbourne Academy of FA; Académie Julian, Paris; Vanderheldt Academy, Amsterdam, 1911-14. **Work:** Springville Mus., UT; Gardena High School, CA. **Sources:** Hughes, *Artists in California,* 448.

PRITCHARD, J. Ambrose .AMBROSE PRICHARD.
[Landscape and marine painter] b.1858, Boston, MA / d.1905, Roxbury, MA.
Addresses: Boston, MA. **Studied:** Académie Julian, Paris with Boulanger and Lefebvre, 1881-87; also with Gérome, pooosibly until 1889. **Member:** Boston AC; Boston SWCP. **Exhibited:** Boston AC, 1881-1904; Paris Salon, 1887, 1888; MA Charitable Mech. Assoc., 1881; PAFA Ann., 1892. **Sources:** WW04; Campbell, *New Hampshire Scenery,* 130; Fink, *American Art at the Nineteenth-Century Paris Salons,* 382; Falk, *Exh. Record Series.*

PRITCHARD, Theodore Jan *[Designer, educator] b.1902, Thief River Falls, MN.*
Addresses: Moscow, ID. **Studied:** Univ. Minnesota (B.A.); Harvard Univ. (M. Arch.). **Member:** AIA. **Comments:** Position: prof., hd. art dept., Univ. Idaho, Moscow, ID. **Sources:** WW59.

PRITCHARD, Walter Howlison *[Painter] early 20th c.; b.Madras, India.*
Addresses: Tahiti; Los Angeles, CA. **Studied:** Scotland. **Exhibited:** American Mus. of Natural History, 1916; Galeries George Petit, Paris, 1921; Palace Hotel, Rio de Janeiro, 1922; Grace Nicholson Gals., Pasadena, CA, 1926. **Work:** Cleveland Mus. of Natural Hist.; Scripps Inst., La Jolla, CA. **Comments:** Specialty: underseas scenes. In c.1909 he changed his first name to Zarh. **Sources:** Hughes, *Artists in California,* 448-449.

PRITCHETT, Eunice Clay (Mrs. John W. Squire) *[Painter, drawing specialist, lecturer, teacher] mid 20th c.; b.Keeling, VA.*
Addresses: Danville, VA. **Studied:** B. Baker; J. Harding; R. Meryman; L. Stevens; J. Pearson; E. Nye; Garber; Nuse; O'Hara; Adams. **Member:** Danville AC; SSAL; Virginia Art Alliance; Richmond Acad. Science & FA. **Exhibited:** Wash. SA; Danville AC; Richmond Acad., 1936; Wash. SA; VMFA; Ogunquit AC. **Work:** Danville Armory; Whitmell Farm Life Sch., VA; portrait, Danville, VA; Virginia Military Inst.; Danville Mem. Hospital; Stuart (VA) Court House; Averett College, Danville, VA; Chapel, Ft. Story, VA. **Sources:** WW53; WW47.

PRITZLAFF, Mr. & Mrs. John, Jr. *[Collectors] b.1925, Milwaukee, WI.*
Addresses: Phoenix, AZ. **Studied:** Princeton Univ. (B.A., 1949). **Comments:** Positions: US Ambassador to Malta, 1969-; bd. dir., Heard Mus. **Sources:** WW73.

PRIZER, Agnes I. *[Painter] 20th c.*
Addresses: Dayton, KY. **Member:** Cincinnati Women's AC. **Sources:** WW25.

PRIZER, J. Neville (Mrs. Chas. S.) *[Painter] early 20th c.*
Addresses: NYC, 1917. **Exhibited:** S. Indp. A., 1917. **Sources:** Marlor, *Soc. Indp. Artists.*

PRIZER, Tillie Neville See: **SPANG, Tillie Neville (Mrs C.S. Prizer)**

PRIZES, Charles (Mrs.) *[Painter] 20th c.*
Addresses: NYC. **Member:** NAWPS. **Sources:** WW19.

PROBASCO *[Painter] early 19th c.*
Comments: Reputed to have painted a "portrait" of "Uncle Sam" in 1816. **Sources:** G&W; San Francisco *Chronicle,* May 11, 1902 (G&W listed citation as being courtesy Clarence S. Brigham, American Antiquarian Society).

PROBASCO, Edwin A. *[Engraver] b.c.1839, Pennsylvania.*
Addresses: Philadelphia in 1860. **Sources:** G&W; 8 Census (1860), Pa., LVI, 563.

PROBERT, Sidney W. *[Painter] b.1865, Paterson, NJ / d.1919, Paterson, NJ.*

Addresses: Paterson, NJ. **Studied:** Silver Lake A. Sch.; ASL; France; Italy. **Member:** SC; S. Indp. A. **Exhibited:** S. Indp. A., 1917, 1918. **Work:** Paterson Pub. Lib. **Comments:** Position: t., Pub. Sch., Paterson. **Sources:** WW19.

PROBST, Joachim *[Painter] b.1913, NYC.*
Addresses: NYC. **Exhibited:** Grace Cathedral, San Francisco, 1962; St. Louis Univ., Mo., 1966; Chrysler Mus., Norfolk, 1970; St. Petersburg Mus., Fla., 1971; Probus Rex Gal., NY, 1971-72. **Awards:** Sullivan Co. Art Show, 1961-1962 & New York State Exhib., 1963, Greer Gal. **Work:** St. Petersburg Mus., Fla.; Chrysler Mus., Norfolk, Va.; Delgado Mus., La.; Grace Cathedral, San Francisco, Calif.; Fairleigh Dickinson Univ., Madison, NJ. **Comments:** Preferred media: oils. **Sources:** WW73; Bermett Schiff, "In the Art Galleries," *New York Post* Nov. 10, 1957; Roger Ortmayer, "Frontiers of Faith Presents the Art of Joachim Probst," produced on NBC-TV, July 15, 1962; *The Horizon History of Christianity* (Am. Heritage Publ. Co., 1964).

PROBST, John *[Lithographer] b.c.1805, Germany.*
Addresses: NYC, active c. 1838 to 1850. **Comments:** In 1844 he was a partner with William R. Willis (see entry) in Willis & Probst. **Sources:** G&W; 7 Census (1850), N.Y., XLIV, 424; NYCD 1844-50.

PROBST, Thorwald (A.) *[Painter, illustrator, teacher] b.1886, Warrensburg, MO. / d.1948, Los Angeles, CA.*
Addresses: Los Angeles, CA. **Studied:** I. Olsen; V. Langer. **Member:** Calif. AC; Laguna Beach AA; Artland C.; P&S of Los Angeles (pres., 1940-41). **Exhibited:** Kanst Gal., Los Angeles, 1916; Los Angeles City Hall, 1938; CPLH, 1945. **Work:** Laguna Mus. of Art. **Comments:** Illustrator: "Poems of California Missions," 1923, by his wife Leeta. Owner: Beverly Hills Art Gal., 1926-. **Sources:** WW33; Hughes, *Artists in California*, 449.

PROCHOWNIK, Walter *[Painter, teacher] b.1923, Buffalo, NY.*
Addresses: Buffalo, NY. **Studied:** Art Inst. of Buffalo, 1945-47; ASL, 1947-49. **Member:** Patteran Soc. **Comments:** Raised in Poland. Returned to Buffalo c.1939. Teaching: State Univ. of New York at Buffalo since 1963; Empire State College, Buffalo, 1975-85. **Sources:** Krane, *The Wayward Muse*, 194.

PROCTER, Burt *[Painter] b.1901, Gloucester, MA / d.1980.*
Addresses: Oak Park, IL; Wyoming; Pasadena, CA; NYC; Southern California, since 1938. **Studied:** AIC; Stanford Univ.; Chouinard Art Inst., Otis Art Inst., with Chamberlin and Lawrence Murphy; with Harvey Dunn and Pruett Carter in NYC. **Member:** Pasadena AA; Palm Springs AA; Ebell Club; Laguna Beach AA; Hudson Valley AA. **Exhibited:** Nat'l Academy of Western Art, 1973; Southwest Mus., Los Angeles, 1974 (solo). **Comments:** Position: commercial artist, Pasadena, CA, 1920s; art dir., advertising agency, NYC, late 1920s; mining engineer, Western U.S., 1930s. **Sources:** Hughes, *Artists in California*, 449.

PROCTOR *[Illustrator] early 20th c.*
Addresses: Wash., DC. **Comments:** Illustrator with the U.S. Dep. of Agr., 1900. **Sources:** McMahan, *Artists of Washington, D.C.*

PROCTOR, A(lexander) Phimister *[Sculptor, painter, etcher] b.1862, Bozanquit, Ontario / d.1950, Palo Alto, CA.*
Addresses: Seattle, WA; Studios in NYC and the Hollywood Hills, CA. **Studied:** NAD, 1887; ASL, 1887; assistant to Saint-Gaudens in Paris for one year; Académie Julian, Paris with Puech, 1894; Acad. Colarossi with Injalbert, 1895. **Member:** Bohemian Cl.; ANA, 1901, NA, 1904; SAA, 1895; AWCS; Arch. Lg. 1899; NSS, 1893; NIAL; A. Aid Soc.; Century Assn.; NAC; Am. Soc. Animal P.& S. **Exhibited:** NAD, 1889-90, 1895; Boston AC, 1890-1903; PAFA Ann., 1890-1912, 1920-23, 1930; Columbian Expo, Chicago, 1893 (med.); SNBA, 1896-98; Paris Expo, 1900 (gold); St. Louis Expo, 1904 (gold), (med.); Arch. Lg., 1911 (med.); Pan.-Pac. Expo, San Francisco, 1915 (gold); LACMA, 1924; AIC. **Work:** Prospect Park, Brooklyn, NY; MMA; BM; Princeton; bridges, Wash., DC; CI; Univ. Oregon, Eugene; mon., Buffalo; statue, Portland, OR; State House, Salem House, OR; Portland, OR; Minot, ND; Civic Center, Denver; Lake George, NY; Kansas City; mem., Wichita, KS; Pendleton, OR; Dallas. **Comments:** He spent summers in the Northwest, hunting and making studies. Many of his monuments were recast in small sizes by *Roman Bronze* and *Gorham Bronze*. Specialty: Western animal sculpture. Fink gives birthplace as New York. **Sources:** WW47; Hughes, *Artists in California*, 449; P&H Samuels, 384; Fink, *American Art at the Nineteenth-Century Paris Salons*, 380; Falk, *Exh. Record Series.*

PROCTOR, Aurion M. *[Painter] mid 20th c.*
Exhibited: Salons of Am., 1934. **Sources:** Marlor, *Salons of Am.*

PROCTOR, Burt See: **PROCTER, Burt**

PROCTOR, Charles *[Museum curator] 20th c.*
Addresses: Tulsa, OK. **Comments:** Position: curator, Gilcrease Institute of American History & Art. **Sources:** WW59.

PROCTOR, Charles E. *[Painter] 20th/21st c.*
Addresses: NYC. **Member:** SC, 1891; A. Fund. S. **Exhibited:** NAD, 1890-1900, 1897 (prize); Syracuse State Fair (prize); SC, 1900 (prize). **Sources:** WW10.

PROCTOR, Ernest L. *[Painter] d.1925.*
Addresses: Boston, MA. **Exhibited:** Boston AC, 1900. **Sources:** WW01.

PROCTOR, Florence (Mrs. A. H. C.) *[Painter] mid 20th c.*
Exhibited: S. Indp. A., 1937. **Sources:** Marlor, *Soc. Indp. Artists.*

PROCTOR, Gifford MacGregor *[Sculptor, designer] b.1912, NYC.*
Addresses: NYC; Wilton, CT; Menlo Park, CA. **Studied:** Yale Univ. (B.F.A.); Am. Acad. in Rome, Prix de Rome fel., 1935; apprentice to A. Phimister Proctor (father); study & travel abroad, 5 yrs. **Member:** Nat. Sculpture Soc.; Arch. Lg. **Exhibited:** Arch. Lg., 1938; WFNY, 1939; 48 Sts. Comp., 1939. **Award:** Prix de Rome, 1935. **Work:** commissions: four heroic granite eagles, US Govt., Fed. Off. Bldg., New Orleans, La.; 1940; first spec. serv. force mem., Helena, Mont., 1948; two portrait statues, comn. by State of Ore., Nat. Capitol Bldg., Wash., DC, 1953; relief globe of moon, Washington Plaza Hotel, Seattle, Wash., 1969; many medals, portrait busts, garden & decorative sculpture. WPA artist. **Comments:** Preferred media: bronze. Positions: asst. to pres., Chandler Cudlipp Assts. NY, NY Interior Planning & Design, 1958-65; coordr. planning & design, Stud. Union, San Fernando Valley State Col., Northridge, Calif., 1969-. Teaching: artist-in-residence, Beloit Col., 1940-42. **Sources:** WW73; WW40; Clement Morro, "The Valley Forge Washington," *La Rev. Mod.* (1938); sci. ed., "Want to buy a moon?," *Life Mag.* (Nov. 30, 1962).

PROCTOR, John A. (Mrs.) See: **WHITING, Gertrude McKim (Mrs. John A. Proctor)**

PROCTOR, Joseph *[Listed as "artist"] b.c.1786, Maryland.*
Addresses: NYC in 1860. **Comments:** African-American artist. **Sources:** G&W; 8 Census (1860), N.Y., LI, 166: listed as age 74, living with wife.

PROCTOR, Mehetabel Cummings See: **BAXTER, Mehetabel Cummings Proctor**

PROCTOR, Romaine *[Painter, teacher] b.1899, Birmingham, AL.*
Addresses: Springfield, IL. **Studied:** AIC; Chicago AFA. **Member:** Am. Bookplate S. **Sources:** WW25.

PROCTOR, Sherry *[Sculptor] mid 20th c.*
Addresses: Chicago area. **Exhibited:** AIC, 1951. **Sources:** Falk, *AIC.*

PROCTOR, William James *[Draftsman] early 19th c.*
Addresses: Active in NYC, 1814. **Comments:** In 1814 he made watercolor drawings of NYC fortifications. **Sources:** G&W; Stokes, *Iconography,* III, 551, and pl. 82a.

PROEBSTING, Dewey *[Illustrator, cartoonist, painter]*
b.1898, Burlington, KS / d.1979, near Crystal Lake, IL.
Comments: Creator: "Buckskin Lad" cartoon series for Chicago Sun. Designer: International Havester logo during 1930's, as a commercial artist in Chicago. Specialties: country and farm life; cowboys and Indians.

PROETZ, Victor *[Painter]* *20th c.*
Addresses: St.Louis, MO. **Sources:** WW25.

PROHASKA, Frank C. *[Painter]* *mid 20th c.*
Studied: ASL. **Exhibited:** S. Indp. A., 1942. **Sources:** Marlor, *Soc. Indp. Artists.*

PROHASKA, R(aymond) J. *[Painter, illustrator]* *b.1901, Muo, Yugoslavia / d.1981.*
Addresses: Bridgehampton, NYC, NY. **Studied:** Calif. Sch. Fine Art, San Fran. **Member:** SI (pres., 1959-60). **Exhibited:** Salons of Am., 1934; PAFA Ann., 1949, 1954, 1964; Springfield Art Mus., 1962 (John Marin Mem. Award); Guild Hall, East Hampton, NY (gold for painting, 1963; Hall of Fame & Soc. Medal of Hon., 1972, solo show award,1963); VMFA Biennial, 1965-69; NC Mus. Art, 1971; Benson Gal., Bridgehampton, NY; Southampton Col., NY; AIC; WMAA, 1952. **Work:** Butler Inst. Am. Art, Youngstown, OH; Krannert Art Gal., Univ. Ill., Champaign; Guild Hall, East Hampton, NY; Int. Tel. & Tel. Co., New York; New Britain Mus., Conn. Commissions: communications (mural), Washington & Lee Univ., Lexington, Va., 1967. **Comments:** Teaching: instr. illus., ASL, 1961-62; artist in res., Washington & Lee Univ., Lexington, VA, 1964-69; artist in res., Wake Forest Univ., 1969-73. Illustrator: *Good Housekeeping,* 1939. Illustrator: *Eddie-No-Name* (1963); *Who's Afraid* (1963); author of *A Basic Course in Design, Introduction to Drawing & Painting* (1971). **Sources:** WW73; Falk, *Exh. Record Series.*

PROOM, Al *[Painter, designer]* *b.1933, Nevada City, CA.*
Addresses: San Francisco, CA. **Exhibited:** CPLH, 1962-64; Oakland Art Mus., 1962 & 1964; Butler Inst. Am. Art, 1964; Rochester Mem. Art Gal., 1964; McNay A. Inst., San Antonio, 1965. Awards: purchase prize for City Beautification, San Francisco, 1967; purchase prize, Butler Inst. Am. Art, 1969. **Sources:** WW73.

PROPER, Ida Sedgwick *[Painter]* *b.1873, Proper's Corner, Bonaparte, IA / d.1957.*
Addresses: Paris, France; NYC; Monhegan Island, ME. **Studied:** ASL; Thor in Munich; Richard Miller, Castolucchio, Collin, Primet, Steinlin in Paris. **Member:** Soc. Painters of NY. **Exhibited:** Salon Francais, Paris; Salon des Beaux Arts, Paris; PAFA Ann., 1910-12; S. Indp. A.; Buffalo, NY; Penn. Acad. FA. **Work:** New Jersey State House; Iowa Hist. Gal.; Mrs. Marshall Fields Collection. **Comments:** Art editor, suffragist journal, *The Woman Voter.* **Sources:** WW17; Ness & Orwig, *Iowa Artists of the First Hundred Years,* 170; Falk, *Exh. Record Series.*

PROPHET, Nancy Elizabeth *[Sculptor, teacher]* *b.1890, Warwick, RI / d.1960, Providence, RI.*
Addresses: Atlanta, GA, 1933-44; Providence, RI, 1944-60. **Studied:** RISD, 1918; École des Beaux-Arts with Ségoffio (Prophet spent 10 years in Paris, 1922-32). **Member:** Newport AA; College AA; Salon d'Automne; Salon des Artistes Français. **Exhibited:** Salon d'Automne, 1924, 1927; Paris August Salons, 1925-26; Salon des Artistes Françaises, Paris, 1929; Work of Negro Artists, 1929 (prize); Harmon Fnd.,1929 (Otto Kahn award), 1930-31, 1936; Salons of Am., 1930; Boston Soc. Indep. Artists, 1932; Vose Gal., Boston, 1932; Newport AA, 1932 (Greeenough Prize); Whitney Sculpture Biennial, 1935, 1937. **Work:** RISD Mus.; WMAA; National Archives. **Comments:** Carved simplified, sometimes abstract figures (in stone and wood) of African Americans during the 1920s and 30s. She received critical praise while living in France in the 1920s and was befriended by poet Countee Cullen and painter Henry O. Tanner. Returning to the U.S. in 1932, Prophet lived in Providence, RI, and showed her work successfully, receiving much favorable publicity but barely earning a living. With the Depression on, she moved to Atlanta, GA, in 1933 where she taught at Atlanta University and eventually became the head of the sculpture department of Spelman College (until 1944). Described by Fort as "flamboyant, but private," Prophet suffered a mental breakdown about 1944 and returned to Providence. She produced little work in the years following and died in obscurity and poverty. Author, article in *Phylon,* Atlanta Univ., 1940. **Sources:** WW40; Cederholm, *Afro-American Artists;* Fort, *The Figure in American Sculpture,* 218 (w/repro.); Rubinstein, *American Women Sculptors,* 243-46; add'l info courtesy of Elinor Nacheman, Pawtucket, RI.

PROSCH, Charles *[Portrait and figure painter]* *late 19th c.*
Addresses: San Francisco, CA, 1870s, 1880s. **Member:** San Francisco AA. **Exhibited:** Calif. State Fair, 1880, 1888. **Work:** de Young Mus. **Sources:** Hughes, *Artists in California,* 449.

PROSCHWITZKA, Janet *[Painter]* *mid 20th c.*
Exhibited: S. Indp. A., 1940. **Sources:** Marlor, *Soc. Indp. Artists.*

PROSKAUER, Nancy See: **DRYFOOS, Nancy Proskauer**

PROSPER See: **FOY, Rene Prosper**

PROSPER, Henri *[Portrait painter]* *mid 19th c.*
Addresses: NYC. **Exhibited:** NAD, 1857-58. **Sources:** G&W; Cowdrey, NAD.

PROSPERI, Gabriel *[Sculptor]* *early 20th c.*
Addresses: Wash., D.C., active 1922. **Sources:** McMahan, *Artists of Washington, D.C.*

PROSPERO, Amabar *[Sculptor]* *early 20th c.*
Addresses: Wash., D.C., active 1923. **Sources:** McMahan, *Artists of Washington, D.C.*

PROSS, Lester Fred *[Educator, painter]* *b.1924, Bristol, CT.*
Addresses: Berea, KY. **Studied:** Oberlin Col. (B.A., 1945, M.A., 1946); Ohio Univ., with Ben Shahn, summer 1952; Skowhegan Sch. Painting & Sculpture, summer 1953; also with Simon, Zorach, Levine, Hebald & Bocour. **Member:** College Art Assn. Am.; Mid-Am. College Art Assn.; Kentucky Guild Artists & Craftsmen (pres, 1961-63); Assn. Asian Studies; Asia Soc. **Exhibited:** Louisville A. Center Ann., 1961-1964; Midstates Ann., Evansville, 1964; Face of Kentucky I & II Traveling Exhib., 1968-70; Appalachian Corridors II Traveling Exhib., 1970-71; Preview '1971, 1971. Awards: Haskell traveling fellowship, Oberlin College, 1957-58. **Comments:** Preferred media: oils, watercolors, acrylics. Positions: pres., Kentucky Art Education Assn., 1955; chairman advisory board, Appalachian Mus., Berea Col., 1969-. Teaching: prof. art, Berea Col., 1946-, chairman dept., 1950-; Fulbright lecturer painting & art history, Univ. Panjab, 1957-58; visiting assoc. prof. art education & history, Union Col., summer 1961; visiting prof. art, Am. Univ. Cairo. Publications: illustrator, "Mountain Life & Work.". **Sources:** WW73.

PROSSER, Allison Margaret See: **ALLISON, Margaret Prosser**

PROSSER, Percy J. *[Sculptor, decorator]* *b.c.1871, England.*
Addresses: New Orleans, active 1908-27. **Comments:** In 1912-13 he worked with Percy J. Prosser, Jr. **Sources:** *Encyclopaedia of New Orleans Artists,* 315.

PROTAS, Julius *[Painter]* *d.1964, Sarasota, FL.*
Addresses: Whitestone, LI, NY. **Exhibited:** S. Indp. A., 1930. **Sources:** Marlor, *Soc. Indp. Artists.*

PROTEAU, Helene *[Sculptor]* *mid 20th c.*
Exhibited: PAFA Ann., 1966. **Sources:** Falk, *Exh. Record Series.*

PROTIN, Victor See: **PROTIN & MARCHINO**

PROTIN & MARCHINO *[Sculptors and carvers]* *mid 19th c.*
Addresses: NYC, 1850. **Comments:** Partners were Victor Protin and Frederick Marchino (see entry). **Sources:** G&W; NYCD and BD 1850.

PROTZ, W. F. *[Painter] 19th/20th c.*
Addresses: NYC. **Exhibited:** NAD, 1899. **Sources:** WW01.

PROTZMANN, George *[Painter] early 20th c.*
Addresses: NYC. **Studied:** ASL. **Exhibited:** S. Indp. A., 1917. **Sources:** WW21.

PROUDMAN, William *[Engraver] b.1826, Dover, NH.*
Addresses: Manchester, NH; known to have married (in 1849) at Lynn, MA. **Sources:** G&W; Belknap, *Artists and Craftsmen of Essex County*, 5.

PROUFE, Suzanne *[Painter] late 19th c.*
Studied: Edmond Yon. **Exhibited:** Paris Salon, 1889. **Sources:** Fink, *American Art at the Nineteenth-Century Paris Salons*, 382.

PROUT, George Morton *[Painter, graphic artist, illustrator] b.1913, St. Francisville, IL.*
Addresses: Columbus, IN. **Studied:** Herron AI; PAFA. **Member:** Indianapolis AA; Ind. AC. **Exhibited:** Grand Central Gal., 1938; GGE 1939; AIC. **Work:** Herron AI. **Sources:** WW40.

PROUT, V. A. *[Scene painter] mid 19th c.*
Addresses: Active in Boston, 1853. **Comments:** Painter of "chromatrope views" for a performance of *Uncle Tom's Cabin* at Ordway Hall, Boston, in January 1853. **Sources:** G&W; Boston *Evening Transcript*, Jan. 10, 1853 (citation provided G&W courtesy J.E. Arrington).

PROUTY, John Donald *[Painter] mid 20th c.*
Addresses: Chicago area. **Exhibited:** AIC, 1941, 1943, 1946. **Sources:** Falk, *AIC*.

PROVAN, Sara *[Painter] mid 20th c.*
Addresses: NYC, 1951-54; Eatontown, NJ. **Exhibited:** WMAA, 1951-54; PAFA Ann., 1951-52, 1958. **Sources:** Falk, *Exh. Record Series*.

PROVAN, Shirley *[Painter] mid 20th c.*
Addresses: NYC. **Exhibited:** PAFA Ann., 1949. **Sources:** Falk, *Exh. Record Series*.

PROVIGNI, Guseppe (or Josh) *[Ornamental artist] late 18th c.*
Addresses: Wash., D.C., active mid 1790s. **Comments:** Last name could also be Provine or Provini. He worked at the U.S. Capitol, and was adept at a type of plastering used in the Pantheon in Rome. **Sources:** McMahan, *Artists of Washington, D.C.*

PROVO, Charles H. *[Painter] early 20th c.*
Addresses: NYC. **Exhibited:** S. Indp. A., 1927. **Sources:** Marlor, *Soc. Indp. Artists*.

PROVOST, Merele *[Painter] mid 20th c.*
Exhibited: S. Indp. A., 1939. **Sources:** Marlor, *Soc. Indp. Artists*.

PROW, Hallie P(ace) (Mrs.) *[Painter] b.1868, Salem, IN / d.1945.*
Addresses: Bloomington, IN. **Studied:** John Herron AI; L.O. Griffith; C. Graft; W. Forsyth. **Member:** Ind. AC; AAPL; Ind. A. Fed. **Work:** Salem, Ind. Pub. Lib. **Sources:** WW40.

PROWN, Jules David *[Art historian] b.1930, Freehold, NJ.*
Addresses: New Haven, CT. **Studied:** Lafayette Col. (A.B., 1951); Harvard Univ. (A.M., fine arts, 1953); Univ. Del. (A.M.,early Amer. culture, 1956); Harvard Univ. (Ph.D., fine arts, 1961). **Comments:** Positions: cur., Garvan & Related Collections of Am Art, Yale Univ., 1963-68; dir., Yale British Art Ctr, 1968-76. Teaching: Yale Univ., from 1961-. Publications: auth, *John Singleton Copley* (2 volumes, Harvard Univ. Press, Cambridge, Mass., 1966); *American Paintings: From Its Beginnings to the Armory Show* (Cleveland, World Publishing, 1969); "Style as Evidence," *Winterthur Portfolio* (Autumn 1980); "Mind in Matter," *Winterthur Portfolio* (Spring 1982); "Thomas Eakins' Baby at Play," *Studies in the History of Art*, Nat Gal Art, Wash. DC. (Vol. 18, 1985); "Benjamin West's Family Picture: A Nativity in Hammersmith," in John Wilmerding, ed., *Essays in Honor of Paul Mellon* (Washington, DC., 1986); "Winslow Homer in His Art," *Smithsonian Studies in American Art* (Spring, 1987);

"Charles Willson Peale in London," in *Charles Willson Peale: New Perspectives* (Univ. Pittsburgh Press, 1991); and others.

PRUCHA, Robert *[Painter] early 20th c.*
Addresses: Chicago, IL. **Exhibited:** AIC, 1919-20, 1924. **Sources:** WW19.

PRUDEN, Daniel R. *[Engraver] mid 19th c.*
Addresses: Boston, 1852-55. **Sources:** G&W; Boston BD and CD 1852-55.

PRUD'HOMME, John Francis Eugene *[Engraver] b.1800, St. Thomas Island, Virgin Islands / d.1892, Georgetown section of Washington, DC.*
Studied: apprenticed to his brother-in-law, engraver Thomas Gimbrede, 1814. **Member:** A.N.A., 1838; N.A., 1846. **Comments:** Brought to NYC by his parents in 1807. By 1821 he had embarked on his own, engraving portraits and illustrations for many books and periodicals, including a number for the *National Portrait Gallery of Distinguished Americans* (1831). Prud'homme served as Curator of the National Academy from 1845 to 1853. From 1852 to 1869 he was designer and engraver for a NYC banknote firm. Moving to Washington (D.C.) in 1869, he took employment with the Bureau of Engraving and Printing, retiring in 1885. **Sources:** G&W; DAB; NYCD 1819-52; Cowdrey, NAD; Cowdrey, AA & AAU; Stauffer; Hamilton, *Early American Book Illustrators*, 233; Cummings, *Historic Annals*. More recently, see McMahan, *Artists of Washington, D.C.*

PRUITT, A. Kelly *[Painter, sculptor, illustrator, author] b.1924, Waxahachie, TX.*
Addresses: Ranchos de Taos, NM; living in Presidio, TX in 1976. **Exhibited:** Guest artist, Texas State Fair, Dallas, 1969; 19th Ann. Tucson Festival Exhib., Tucson Art Center, AZ, 1969; solo exhib, Oklahoma Mus. Art at Red Ridge, Oklahoma City, 1972; Cross Gals., Fort Worth, TX, 1970s; Spanish Steps Gal., Taos, NM, 1970s. **Work:** Mus. New Mexico, Santa Fe; Diamond M Mus., Snyder, TX. Commissions: The Plainsman (bronze), Frank Phillips Collection, Borger, TX, 1967. **Comments:** Preferred media: oils, bronze. Publications: illus., *The Cattleman*, 1966 & 1968; illustrator, *The Paint Horse J.*, 1967; illus. & auth., article in *The Paint Horse Journal*, 1967. **Sources:** WW73; "A Lamp Out of the West," Chyka Carey Productions, 1964; Jane Pattie, "A. Kelly Pruitt: Cowboy with a Paint Brush," *Cattleman Magazine* (1966); Ed Ainsworth, *The Cowboy in Art* (World, 1968); P&H Samuels, 384.

PRUNIER, Arthur William *[Painter, teacher, designer, comm a] b.1905, Lynn, MA.*
Addresses: Nuestro Rancho, Vista, CA. **Studied:** Mass. Normal A. Sch.; Washington State T. Col.; ASL of Los A.; San Diego Sch. A. & Crafts, and with S. MacDonald-Wright; Everett Jackson, Nicolas Brigante. **Member:** Vista A. Gld. (Fndr.); Carlsbad-Oceanside A. Lg. **Exhibited:** Oceanside, Cal., 1945; Vista A. Gld., 1946-57; Coronado AA, 1951; A.T. Exh., Los A., 1952; Oceanside-Carlsbad, 1952-57; Escondido, Cal., 1957; San Diego County Fair, 1952-55; solo: Contemp. Gal., Hollywood; Carlsbad Hotel, 1948, 1953; San Diego Sch. A. & Crafts, 1952; Palomar Col., 1957-58; Santa Fe, 1958. Awards: prizes, Carlsbad-Oceanside A. Lg., 1952, 1954, 1957; Vista A. Gld., 1952, 1954, 1955; San Diego County Fair, 1952. **Work:** murals, Hayward Hotel, Los A.; Sunkist Bldg., Los A.; Coast Grinding Co., Los A., and numerous cafes and private homes. **Sources:** WW59.

PRURNACKÉ, Charles *[Listed as "artist"] 19th c.*
Addresses: New Orleans in 1838. **Sources:** G&W; New Orleans CD 1838.

PRUSHECK, Harvey Gregory *[Painter] b.1887, Yugoslavia.*
Addresses: Cleveland, OH. **Member:** AAPL; Ill. Acad. FA; Chicago SA; AFA. **Exhibited:** S. Indp. A., 1922; AIC, 1930 (prize); Corcoran Gal biennial, 1932; Cleveland A. & Craftsmen, 1933. **Work:** Milwaukee AI; Pub. Libs., Chisholm, Minn., Boise, Idaho; Cleveland Pub. Libs.; Mun. A. Coll., Cleveland; CMA; Nat. Gal., Yugoslavia. **Comments:** Position: dir., Arts & Crafts,

Div. Recreation, Cleveland. **Sources:** WW40.

PRUSS, Boris *[Painter] b.1863, Wiikomir, Russia.*
Addresses: Hammonton, NJ. **Studied:** Munich, with W. Diez; F. von Lenbach; Bonnât, Paris. **Member:** SC, 1900; Munich A.; Universal German AA; SC, 1900. **Exhibited:** Paris Salon; 1880 (med)-81 (med), 1883 (med)-84, 1886. **Sources:** WW04.

PRUSS, Ella *[Sculptor] mid 20th c.*
Addresses: Chicago area. **Exhibited:** AIC, 1947. **Sources:** Falk, *AIC.*

PRUYN, M. L. (Miss) *[Painter] 19th/20th c.*
Addresses: NYC. **Exhibited:** NAD, 1899. **Sources:** Naylor, *NAD.*

PRUYN, Samueletta R. *[Painter] 19th/20th c.*
Addresses: Chicago. **Exhibited:** AIC, 1898, 1900. **Sources:** Falk, *AIC.*

PRYCE, Al *[Painter] 20th c.*
Addresses: Canton, OH. **Member:** Artklan. **Comments:** Affiliated with Canton Advertising. **Sources:** WW25.

PRYCE, Edward L. *[Sculptor, muralist, painter, landscape arch.] b.1914, Lake Charles, Louisiana.*
Studied: Tuskegee Inst., AL (B.S.); Ohio State Univ. (B.L.A.); Univ. of CA, Berkeley (M.L.A.). **Exhibited:** Atlanta Univ. (sculpture award, 1968); Tuskegee Inst. **Work:** Atlanta Univ.; Tuskegee Inst. **Sources:** Cederholm, *Afro-American Artists.*

PRYDE, James *[Painter] b.1866 / d.1941.*
Exhibited: Armory Show, 1913. **Work:** AIC. **Sources:** Brown, *The Story of the Armory Show.*

PRYIBIL, Albert *[Painter] mid 20th c.*
Exhibited: S. Indp. A., 1941. **Sources:** Marlor, *Soc. Indp. Artists.*

PRYOR, George *[Engraver] b.c.1824, England.*
Addresses: Frankford section of Philadelphia, 1850. **Sources:** G&W; 7 Census (1850), Pa., LVI, 302.

PRYOR, Roger *[Painter] mid 20th c.*
Exhibited: Salons of Am., 1934. **Sources:** Marlor, *Salons of Am.*

PRYOR, Warrant *[Painter] 20th c.*
Addresses: Rochester, NY. **Member:** Cleveland SA. **Sources:** WW27.

PRYOR, Yvonne L.D *[Painter] mid 20th c.*
Addresses: Chicago, IL. **Exhibited:** AIC, 1937, 1939, 1949. **Sources:** WW40.

PSOTTA, Charles *[Painter] 19th/20th c.; b.Philadelphia, PA.*
Addresses: Paris, France; Phila., PA. **Studied:** Paris, with Lauren, Constant, A. Roll. **Exhibited:** PAFA Ann., 1891; SNBA, 1896-98; AIC. **Sources:** WW01; Fink, *American Art at the Nineteenth-Century Paris Salons,* 382; Falk, *Exh. Record Series.*

PUCCI, Albert John *[Painter] mid 20th c.*
Exhibited: Corcoran Gal biennial, 1951. **Sources:** Falk, *Corcoran Gal.*

PUCCI, Gigi F. *[Artist] mid 20th c.*
Addresses: Brooklyn, NY. **Exhibited:** PAFA Ann., 1950. **Sources:** Falk, *Exh. Record Series.*

PUCCINELLI, Dorothy Wagner See: **CRAVATH, Dorothy Puccinelli (Mrs.)**

PUCCINELLI, Raimond(o) *[Sculptor, wood carver, teacher, lecturer] b.1904, San Francisco, CA / d.1986, Florence, Italy.*
Addresses: California; NYC; Florence, Italy. **Studied:** Calif. Sch. Fine Arts, San Francisco; Rudolph Schaeffer Sch. Design, San Fran.; apprentice to woodcarvers, stone cutters & masters of plaster; UC Berkeley. **Member:** NSS; San Fran. AA; Art Center San Fran.; Florentine Acad. (hon. mem.). **Exhibited:** SFMA, 1935-46; Calif.-Pacific Int'l Expo, San Diego, 1935; San Fran. A. Center, 1936 (solo); Oakland A. Gal., 1938 (prize), 1939-40, 1941 (prize)-42 (prize); LACMA, 1939 (sculpture award); San Fran. AA, 1937 (prize)-38 (prize); GGE, 1939; WMAA, 1940, 1948-49 (

Contemporary American Sculpture); WFNY, 1939; Crocker A. Gal., 1941; PAFA Ann., 1942, 1950-53, 1960-62; CM, 1941; NSS; Arch. Lg., 1941, 1945; Portland A. Mus., 1939; CGA, 1942, 1962 (Modern Sculpture); CPLH, 1946 (solo); Mills Col., 1945; Univ. Calif., 1945; de Young Mem. Mus., 1944 (solo); Santa Barbara Mus. A., 1946; Scripps Col., 1941; Twenty Contemporary Sculptors, Grand Cent. Gals., NYC, 1946; Sculpture Exhib., Nat. Inst. Arts & Lett., NY, 1953, 1955 & 1957; Palazzo Strozzi, Florence, Italy, 1966 (medaglio d'oro for "Il Fiorino"); Bienniale Int. del Bronzetto, Padova, Italy, 1967; plus numerous solo exhibs. in the USA, Latin America & Europe. **Work:** Phelan Bldg., San Jose; Pacific Nat. Bank Bldg., San Fran.; wood panels, furniture, San Fran. Stock Exchange; Corpus Christi Church, Piedmont, Calif.; Marconi Mon., Telegraph Hill, San Fran. Maria (terracotta), SFMA; Seated Figure (bronze), Museo d'Arte Moderna, Florence, Italy; Edgard Varese (granite portrait), Columbia Univ. Music Libr., NYC; Mother & Child (porphyry), Fresno Mall, Calif.; Hans Rothe (bronze portrait), Stadt Theater Mus., Schleswig, Ger. Commissions: Panther (polished diorite), Salinas Col., Calif., 1940; Polar Bear (polished marble), Mills Col., Oakland, Calif., 1941; Bear (diorite), UC Berkeley, 1944; San Franciscan Saints, 1957-58, bronze doors, 1958 & St. Bernadette & Virgin, (terra-cotta), 1958, House of Theology, Franciscan Monastery, Centerville, Ohio; Cross (bronze), St. Andrew's Church, Mayo, Md., 1960. **Comments:** Positions: cult. envoy for Latin Am., US Dept. State, 1956. Teaching: instr. sculpture & drawing, Mills Col., 1938-47; prof. sculpture & drawing, Univ. Calif., Berkeley, 1942-47; asst. prof. sculpture & drawing, Univ. NC, Chapel Hill, 1947-48; instr. design & art hist., Queens Col., NYC, 1948-51; dean sculpture & drawing, Rinehart Sch. Sculpture, Peabody Inst. & Md. Inst. Col. Art, 1958-60; prof. sculpture, Int. Univ. Arts, Florence. Publications: auth., "Bronze Sculpture," *Arts & Archit.* (1939); auth., "Sculpture, A Visual Language," *Architects' Report* (winter 1961). **Sources:** WW73; Falk, *Exh. Record Series.*

PUCCIO, Antonio *[Sculptor, designer, cabinetmaker, carver] 19th/20th c.; b.Palermo, Sicily.*
Addresses: New Orleans, active 1909. **Sources:** *Encyclopaedia of New Orleans Artists,* 315.

PUCCIO, Gaspar[te] *[Painter] early 20th c.*
Addresses: NYC. **Exhibited:** S. Indp. A., 1924. **Sources:** Marlor, *Soc. Indp. Artists.*

PUCKER, Bernard H. *[Art dealer] b.1937, Kansas City, MO.*
Addresses: Boston, MA. **Studied:** Columbia Univ. (B.A., 1959); Hebrew Univ. Jerusalem, 1960; Brandeis Univ. (M.A., 1966). **Comments:** Positions: dir, Pucker Salrai Gal., Boston, Mass. Specialty of gallery: contemporary artists; Chagall graphics; Israeli artists; New England artists. **Sources:** WW73.

PUCKETT, Henry Frank *[Portrait painter, block printer, teacher] b.1941, Chicago.*
Addresses: Chicago, IL. **Studied:** W. Reynolds; A. Sterba. **Member:** Chicago NJSA; All.-Ill.Soc.FA; Hoosier Salon; Soc. Ar., Inc. **Work:** St. Procopius Abbey, Lisle, Ill.; Juvenile Court Bldg., Cook County, Ill.; state of Ill. **Comments:** Position: t., Austin Evening H.S., Chicago. **Sources:** WW40.

PUDOR, H. *[Portrait painter] mid 19th c.*
Addresses: Lawville, NY, active c. 1860. **Comments:** Specialized in family group portraits in oil. **Sources:** G&W; Lipman and Winchester, 179.

PUGH, Effie *[Painter] 20th c.*
Addresses: Chicago, IL. **Member:** Chicago NJSA. **Sources:** WW25.

PUGH, Elizabeth Worthington (Mrs.) *[Painter] 20th c.*
Addresses: Cincinnati, OH. **Member:** Cincinnati Women's AC. **Sources:** WW25.

PUGH, Grace Huntley *[Painter] mid 20th c.*
Studied: Wellesley Col.; Barnard Col.; NAD; ASL; Parsons Sch. Design. **Exhibited:** CI Summer Show, Pittsburgh; Pittsburgh AA;

Butler AI; Nassau County Art Lg.; Contemporary Art Gal., NYC; New Rochelle AA (prize); Rockport AA (Ernest Longfellow Prize & hon. men.); Westchester Arts & Crafts; East Hampton Guild Hall. **Work:** Pittsburgh Schools; Mamaroneck Free Lib.; Princeton Univ. (mural). **Comments:** Positions: art dir., Briarcliffe Jr. College, 4 years; sales information, CI, 3 years; asst. art dir., Young & Rubicam. **Sources:** *Artists of the Rockport Art Association* (1946, 56).

PUGH, (Sarah) Mabel (Miss) *[Educator, painter, graphic artist, illustrator, writer, lecturer]* b.1891, Morrisville, NC / d.1986, Raleigh, NC.
Addresses: Raleigh, NC; Morrisville, NC; NYC. **Studied:** ASL; PAFA (Cresson traveling scholarship, 1919; fellowship, PAFA); Columbia Univ.; North Carolina State Col., and with Hawthorne, Adams, Martin; NAWA; SSAL. **Member:** CAA; NC State Art Soc. **Exhibited:** NC State Fair, 1922 (prize); S. Indp. A., 1929; SSAL, 1930 (prize); Southern Printmakers (prize); Mint Mus. Art (prize); Plastic Cl., Phila., 1926 (gold); NC State Fed. Women's Cl., 1937-39 (prize, each yr.); NAD, 1932; PAFA Ann., 1933; LOC, 1943-44; NAWA, 1934-35 (prize), 1939; AAPL; NC Artists; Kansas City AI. **Work:** LOC; NC State Garden Cl.; Waynesville Court House; Peace Col. Lib.; portraits Franklin Community Center; Dir. Room, Insurance Bldg., Raleigh; White Mem. Presbyterian Church, Raleigh; John Marshall House, Richmond; Chatham Hospital; Cary H.S. Agricultural Com. Room, House of Representatives, Wash., DC; Marine & Fisheries Committee Room, House Representatives, Wash., DC; Warren County Mem. Lib., Queens College, Charlotte, NC. **Comments:** Position: head, art dept., Peace College, Raleigh, NC, 1936-. Author/illustrator: "Little Carolina Bluebonnet", 1933; Illustrator: Century Co., Thomas Crowell Co., Doubleday Doran, E.P. Dutton Co., Ginn Co. **Sources:** WW59; WW47; Falk, *Exh. Record Series;* add'l info. courtesy Anthony R. White, Burlingame, CA.

PUGLIESE, Anthony *[Etcher, teacher, lecturer]* b.1907, NYC.
Addresses: NYC. **Studied:** NYU. **Work:** NYU. **Comments:** Position: t., Brooklyn Col. Illustrator: *Herald Tribune, Harper's, Redbook.* **Sources:** WW40.

PUGNI, Louis *[Listed as "artist,"1860]* b.c.1827, Italy.
Addresses: Wash., DC, early 1860s. **Comments:** In 1862 he was listed as a grocer. **Sources:** G&W; 8 Census (1860), D.C., I, 703.

PUGSLEY, Clarence Gordon *[Painter, illustrator]* b.1888, Missouri / d.1917, Los Angeles, CA.
Addresses: Los Angeles, CA. **Studied:** Jean Mannheim.
Exhibited: Press Artist's Assoc. of Los Angeles, 1906. **Sources:** Hughes, *Artists in California,* 450.

PUHALA, Albert (V.) *[Painter]* mid 20th c.
Addresses: Yonkers, NY. **Exhibited:** S. Indp. A., 1934-36.
Sources: Marlor, *Soc. Indp. Artists.*

PULCHER, Theresa (Essie) S. *[Artist]* 19th/20th c.
Addresses: Active in Grand Rapids, MI, 1894-1901; Chicago.
Sources: Petteys, *Dictionary of Women Artists.*

PULFREY, Dorothy Ling *[Painter]* b.1901, Providence, RI.
Addresses: Sheffield, England. **Studied:** J. Sharman; A. Heintzelman. **Member:** Providence WCC. **Sources:** WW33.

PULGAR, Jacques *[Painter]* early 20th c.
Addresses: NYC. **Exhibited:** S. Indp. A., 1923. **Sources:** Marlor, *Soc. Indp. Artists.*

PULIAFITO, Tomaso *[Mixed media artist]* b.1933.
Addresses: NYC, 1975. **Exhibited:** WMAA, 1975. **Sources:** Falk, *WMAA.*

PULITZER, Joseph, Jr. *[Collector]* b.1913, Saint Louis, MO.
Addresses: Saint Louis, MO. **Studied:** Harvard Univ. (A.B., 1936). **Comments:** Collection: contemporary art, paintings.
Sources: WW73.

PULITZER, Muriel *[Sculptor]* mid 20th c.
Addresses: Los Angeles, CA. **Exhibited:** LACMA, 1940.

Sources: Hughes, *Artists in California,* 450.

PULLINGER, Herbert *[Printmaker, painter, illustrator, teacher]* b.1878, Philadelphia, PA / d.1961, Philadelphia.
Addresses: Philadelphia. **Studied:** PM Sch. IA; Drexel Inst.; PAFA (F., PAFA), with McCarter, Anshutz. **Member:** Phila. Pr. Cl.; Phila. Sketch Cl.; Phila. WC Cl. **Exhibited:** PAFA Ann., 1913-14, 1918-20; PAFA, 1925 (gold); Sesqui-Centenn. Expo, Phila., 1926 (med); AIC. **Work:** NYPL.; Luxembourg Mus., Paris; Springfield (Mass.) Lib.; PAFA; Phila. Pub. Lib.; PMA; CMA; Newark Mus.; LOC; Honolulu Acad. FA; TMA.
Comments: Position: instr., Graphic A., PM Sch A., Philadelphia, Pa. Author, illus., "Washington, the Nation's Capitol," 1921; "Old Germantown." Illus. for national magazines. **Sources:** WW59; WW47; Falk, *Exh. Record Series.*

PULLMAN, Margaret MacDonald *[Landscape painter, author, illustrator]* b.Pennsylvania or Camden, IN / d.1892, Baltimore, MD.
Addresses: Camden & Logansport, IN; Chicago area, from 1881.
Studied: PAFA. **Exhibited:** NAD, 1888; AIC, 1889, 1891.
Sources: Falk, *AIC;* Petteys, *Dictionary of Women Artists.*

PULLOCH, William A. *[Painter]* mid 20th c.
Exhibited: Salons of Am., 1929. **Sources:** Marlor, *Salons of Am.*

PULSIFER, J(anet) D. *[Painter]* 20th c.; b.Auburn, ME.
Addresses: Buffalo, NY/Scituate, MA. **Studied:** ASL; Delance, Courtois, Aman Jean, in Paris. **Sources:** WW29.

PULSIFER, Wilhelmina Schutz ("Mina") *[Portrait painter, lithographer]* b.1899, Leavenworth, KS / d.1989, Chula Vista, CA. MINA PULSIFER—
Addresses: San Diego, CA. **Studied:** Kansas City Art Inst.; San Diego Academy of Fine Arts, with DeVol and Schneider; with N. Fechin and F. Taubes. **Member:** San Diego Art Guild (pres. 1944). **Exhibited:** Calif.-Pacific Int'l. Expo, San Diego, 1935; GGE, 1940; lithographs in two European traveling shows organized by the Boston Pub. Lib. **Work:** Boston Pub. Lib.; Bibliotheque Nationale, Paris; National Bezalel Mus., Jerusalem.
Sources: Hughes, *Artists in California,* 450.

PUMA, Fernando *[Painter, writer, critic, educator]* b.1919, NYC / d.1955, NYC.
Addresses: NYC. **Studied:** NY Univ.; Columbia Univ.
Exhibited: S. Indp. A., 1941-42, 1944; Albany Inst. Hist. & A., 1943-44; Detroit Inst. A., 1944; Critics Show, NY, 1945; PMG; Adelphi Col.; Randolph-Macon Col.; Minneapolis Inst. A.; Univ. Illinois, 1952; solo: New York City; SFMA; Santa Barbara Mus. A.; in Paris, France, 1949; Gallery D., 1939-47. **Work:** PMG; Detroit Inst. A.; Randolph-Macon Col. **Comments:** Art Review radio program, 1942-43. Author: "Modern Art Looks Ahead," 1947; "Love This Horizontal World," 1949; "7 Arts," 1953, 3rd ed., 1955. **Sources:** WW59; WW47.

PUNCHATZ, Don Ivan *[Painter, illustrator]* b.1936, Hillside, NJ.
Addresses: Arlington, TX. **Studied:** School of Visual Arts, NY (scholarship), with Burne Hogarth, Bob Gill, Francis Criss; SVA (evening); Cooper Union. **Exhibited:** Art Dir. Clubs (awards in several cities); SI (awards); Soc. of Publication Des. (awards).
Work: Dallas Mus.; George Eastman House, Rochester, NY; many priv. colls. **Comments:** Positions: art dir., Pittsburgh, PA, c. five years; t., Texas Christian Univ., 1970-on; t., East Texas State Univ. A full-time free-lance illus. since 1966, he formed his own studio in 1970, and counted among his clients most major magazines, as well as national companies and book publishers.
Sources: W & R Reed, *The Illustrator in America,* 337.

PUNDERSON, E. M. *[Painter]* mid 19th c.
Addresses: Active in Maryland, 1850. **Exhibited:** Md. Hist. Soc., 1850 (monochromatic paintings titled "Fancy Piece" and "Scene on the Ohio"). **Sources:** G&W; Rutledge, MHS.

PUNDERSON, Hannah *[Folk painter]* b.1776 / d.1821.
Addresses: Connecticut. **Work:** Conn. Hist. Soc. **Comments:**

Creator of a watercolor mourning picture, she was the sister-in-law of Prudence Punderson Rossiter. **Sources:** Dewhurst, MacDowell, and MacDowell, 170; Petteys, *Dictionary of Women Artists.*

PUNDERSON, Lemuel S. *[Engraver] mid 19th c.*
Addresses: Active in NYC during the early 1850's and thereafter in New Haven, CT. **Sources:** G&W; Stauffer; New England BD 1856-60; New Haven CD 1859.

PUNDERSON, Prudence Geer *[Folk painter] b.1735, Groton, CT / d.1822, Preston, CT.*
Addresses: Connecticut. **Work:** Connecticut Hist. Soc.
Comments: Married to Ebenezer Punderson, Jr. in 1757, she was the mother of eight, including Prudence Punderson Rossiter (see entry). **Sources:** Dewhurst, MacDowell, and MacDowell, 170.

PUNDERSON, Prudence (Mrs. T. Rossiter) *[Needlework artist] b.1758 / d.1784.*
Addresses: Connecticut. **Work:** Connecticut Hist. Soc.
Comments: Daughter of Ebenezer and Prudence Geer Punderson (see entry), she was married to Dr. T. Rossiter. Created remarkable needlework pictures "Mortality Scene" and the set of "Twelve Disciples." **Sources:** Dewhurst, MacDowell, and MacDowell, 170.

PURCELL, Edward B. *[Painter, wood engraver, and designer] mid 19th c.*
Addresses: NYC and Brooklyn, active 1835-70. **Exhibited:** NAD. between 1835 and 1844. **Comments:** Exhibited religious, historical, landscape, and genre paintings between 1835 and 1844 but during the fifties and sixties was primarily a designer and engraver on wood. He also published several art textbooks. He may have been the Purcell who was a partner with Albert H. Jocelyn (see entry) in the wood engraving firm of Jocelyn and Purcell, active in NYC in 1851. Groce & Wallace speculated that he might be the miniaturist Edward Purcell who exhibited in Dublin (Ireland) in 1812 and 1815, spent some time in England, returned to Dublin in 1831 as a drawing professor and of whom nothing further is known. **Sources:** G&W; NYCD 1835-70; NYBD 1851; Cowdrey, NAD; Stokes, *Historical Prints;* Drepperd, "American Drawing Books"; Am. Inst. Cat., 1842, 1844, 1845; Hamilton, *Early American Book Illustrators,* 209 and 438; Strickland, *Dictionary of Irish Artists.*

PURCELL, Edward B., Jr. *[Painter] mid 19th c.*
Addresses: NYC, active 1836. **Exhibited:** NAD, 1836 ("Hector Dragged by Achilles Round the Walls of Troy"). **Comments:** His address in NYC, 1836, was the same as that of Edward B. Purcell (see entry), presumably his father. **Sources:** G&W; Cowdrey, NAD.

PURCELL, Hazel *[Painter] 20th c.*
Addresses: Alliance, OH. **Sources:** WW25.

PURCELL, Henry *[Engraver] late 19th c.*
Addresses: NYC, 1774-75 (and possibly later in Philadelphia).
Comments: Advertised in NYC in 1774 and 1775 as Henry Purcell, engraver. In Philadelphia, in the years 1783-84, a Henry D. Pursell advertised as an engraver. These two may be the same man. **Sources:** G&W; Gottesman, *Arts and Crafts in New York,* I, 13; Kelby, *Notes on American Artists,* 12-13; Prime, I, 27.

PURCELL, John Wallace *[Sculptor, craftsperson, teacher, writer] b.1901, New Rochelle, NY.*
Addresses: Evanston, IL. **Studied:** Cornell Univ. (A.B.); AIC.
Exhibited: AIC, 1925-46; Evanston & North Shore A., 1933-34, 1935 (prize), 1936-38, 1939 (prize), 1940-46; WFNY 1939; AIC, 1933-46. **Awards:** Ryerson traveling scholarship, 1930. **Work:** AIC. **Comments:** Position: instr. s., AIC, 1925-44; Evanston (Ill.) A. Center, 1944-46. **Sources:** WW53; WW47.

PURCELL, Joseph William *[Painter, sculptor, craftsperson] b.1904, Kentucky / d.1974, La Mesa, CA.*
Addresses: Pasadena, CA. **Exhibited:** P&S of Los Angeles, 1928-29; Artists Fiesta, Los Angeles, 1931. **Sources:** Hughes, *Artists in California,* 450.

PURCELL, Norah *[Painter, illustrator] early 20th c.*
Addresses: Active in San Gabriel, CA, 1903-07. **Exhibited:** Craig Gal., Pasadena, CA, 1907. **Sources:** Petteys, *Dictionary of Women Artists.*

PURCELL, Rosanna *[Painter] mid 19th c.*
Addresses: NYC, 1836. **Exhibited:** NAD, 1837 ("The Cottage Door" and "The Literary Retreat"). **Comments:** Listed at the same address as Edward B. Purcell and Edward B. Purcell, Jr., in 1837. **Sources:** G&W; Cowdrey, NAD.

PURDIE, Evelyn *[Miniature painter] b.1858, Smyrna, Asia Minor / d.1943, Cambridge, MA.*
Addresses: Cambridge, MA. **Studied:** BMFA Sch., with Grundmann; Carolus-Duran, Henner, Mme. Debillemont-Chardon, in Paris. **Member:** Penn. Soc. Min. Painters; Boston Gld. Artists. **Exhibited:** Boston AC, 1906-07; Penn. Soc. Min. Painters, 1929 (medal); AIC. **Sources:** WW40.

PURDIN, William A. *[Painter] mid 19th c.*
Addresses: NYC. **Comments:** The painter of Olin's "Grand Moving Panorama of the Laying of the Atlantic Cable," 1858. **Sources:** G&W; Indianapolis, *Indiana State Sentinel,* Oct. 4, 1858 (courtesy J. Earl Arrington).

PURDUE, Chris(tine) M. *[Craftsman, sculptor, teacher] b.1902, New Haven, CT / d.1978.*
Addresses: New Haven 14, CT. **Studied:** Greenwich House, NY; ASL; Univ. Pa.; Whitney A. Sch., New Haven; Alfred Univ. (summer); Worcester (Mass.) Craft Center; Silvermine Gld.; in France, Italy and England, and with Paul Manship. **Member:** New Haven Paint & Clay Cl.; NY Soc. Ceramic A.; Silvermine Gld. A.; Soc. Conn. Craftsmen. **Exhibited:** New Haven Paint & Clay Cl., 1951-52, 1955; Whitney A. Sch., 1950-51; Silvermine Gld. A., 1954-55, 1958; NY Soc. Ceramic A., 1953-54; Essex AA, 1952. **Awards:** prizes, Silvermine Gld. A., 1954; New England Exh., 1955; Essex AA. **Comments:** Contributor to *Ceramic Monthly.* **Sources:** WW59.

PURDUE, Ellen *[Painter] early 20th c.*
Exhibited: S. Indp. A., 1925. **Sources:** Marlor, *Soc. Indp. Artists.*

PURDUM, M. Bertha *[Painter] mid 20th c.*
Addresses: Los Angeles, CA, 1930s. **Exhibited:** P&S of Los Angeles, 1935. **Sources:** Hughes, *Artists in California,* 450.

PURDY, Albert J. *[Portrait painter] b.c.1835 / d.1909, Ithaca, NY.*
Sources: G&W; *Art Annual,* VII, obit.

PURDY, Donald R. *[Painter, art dealer] b.1924, CT.*
Addresses: Wilton, CT. **Studied:** Univ. Conn. (B.A.); Boston Univ. (M.A.). **Member:** Am. Fedn. Arts; All. A. Am.; Silvermine Guild Artists. **Exhibited:** USA Int. Show; Silvermine Guild Artists; Audubon Artists; All. A. Am.; Schoneberg Gals.,NYC. **Awards:** gold medal, All. A. Am.; first prize, Silvermine Guild Artists; Jane Peterson Award, Audubon Artists. **Work:** New Britain Mus.; Colby Col.; Chase Manhattan Bank Coll.; Kansas Univ.; Chrysler Mus. **Comments:** Preferred media: oils. Collection: American & Barbizon. **Sources:** WW73; F Whitaker, article, In: *Am Artist.*

PURDY, Earl *[Mural painter, architect, etcher] 20th c.*
Addresses: Larchmont, NY. **Member:** AIA. **Work:** murals, Hotel Washington, DC; etchings, Cushing Mem. Gal., Newport, RI. **Sources:** WW40.

PURDY, Helen *[Painter] late 19th c.; b.New York.*
Studied: Bouguereau, Robert-Fleury. **Exhibited:** Paris Salon, 1891. **Comments:** Exhibited a drawing at the Paris Salon. **Sources:** Fink, *American Art at the Nineteenth-Century Paris Salons,* 382.

PURDY, Lydia See: **HESS, Lydia Purdy**

PURDY, Maud H. *[Illustrator, miniature painter] b.1873, Philadelphia, PA.*
Addresses: NYC; Spring Valley, NY. **Studied:** PIA School;

Adelphi College; A. Cogswell; Whittaker. **Member:** Brooklyn AS. **Exhibited:** PAFA; and in NYC. **Comments:** Illustrator: "Fundamentals of Botany," by Dr. Gager; "Families of Dicotyledons"; "Illustrated Guide to Trees and Shrubs"; "All About African Violets." Position: illustrator, Brooklyn (NY) Botanical Gardens, 1911-. **Sources:** WW59; WW47, which puts date of birth 1874.

PURDY, Robert Cleaver [Painter, mural painter] mid 20th c. **Addresses:** Louisville, KY/Goose Rocks Beach, ME. **Studied:** Herron AI Sch. **Exhibited:** WC Ann., PAFA, 1938; AIC. **Work:** WPA murals, USPOs, Princeton, Ky., New Albany, Miss. **Sources:** WW40.

PURDY, W. Frank [Sculpture expert] b.1865 / d.1943. **Addresses:** New Canaan, CT. **Member:** Art All. Am.; Antique and Decorative Art Dealers Assn. **Comments:** Position: hd., sculpture dept., Gorham Co.

PUREFOY, Heslope [Miniature painter] b.1884, Chapel Hill, NC. **Addresses:** Asheville, NC. **Studied:** A. Beckington; L.F. Fuller. **Member:** Pa. Soc. Min. P. **Sources:** WW33.

PURER, John [Painter] mid 20th c. **Addresses:** Floral Park, NY. **Exhibited:** S. Indp. A., 1934. **Sources:** Marlor, Soc. Indp. Artists.

PURIFOY, Noah [Sculptor] b.1917, Snow Hill, AL. **Studied:** Alabama State Teachers Col.; Atlanta Univ.; Chouinard AI. **Member:** Joined for the Arts, Inc. **Exhibited:** UC Santa Cruz; Nordness Galleries, NYC; Long Beach Mus.; Lang Art Gal., Claremont, CA; Brockman Gal., Los Angeles; Watts Renaissance of the Arts, Los Angeles; Negro Art Traveling Exh., CA; Pasadena Mus.; Orlando Gals., Encino, CA; Municipal Art Gals., Barnsdall Park, Los Angeles; Bowman Mann Galleria, Los Angeles; Univ. of South. CA; WMAA, 1971; Univ. of Iowa, 1971-72; LACMA; Oakland Mus.; IL. Bell Tel.; Huntington Gals., TN; Dickson Art Center, 1966. **Work:** Cowell Col., Santa Cruz; Oakland Mus. **Sources:** Cederholm, Afro-American Artists.

PURINTON, J. See: **PURRINGTON, J.**

PURINTON, Virginia R. [Painter] mid 20th c. **Exhibited:** AIC, 1938. **Sources:** Falk, AIC.

PURKISS, Myrton N. [Painter, ceramic artist] b.1912, Canada / d.1978, Fullerton, CA. **Addresses:** Southern California. **Studied:** USC; Chouinard Art School, Los Angeles. **Exhibited:** San Diego FA Gal., 1937; Muckenthaler Cultural Center, Fullerton, 1977 (retrospective). **Sources:** Hughes, Artists in California, 450.

PURRINGTON, Caleb Pierce [Painter, decorator] b.1812, Mattapoisett, MA / d.1876. **Exhibited:** Panorama: first showing in December, 1848 in New Bedford, MA. It later toured Boston (1849), Cincinnati, Louisville, St. Louis, Baltimore and NYC; second showing in New Bedford, 1960 on Popes Island. **Work:** Old Dartmouth Hist. Soc. **Comments:** Had a business in Fairhaven, MA with B. Taber. Appears to have collaborated with Benjamin Russell (see entry) on a panorama of a whaling voyage, shown in Boston in 1849, and subsequently, without mention of Purrington, at NYC and Cincinnati. **Sources:** G&W; Boston Evening Transcript, Jan. 3, 1849; information provided G&W courtesy J.E. Arrington; Blasdale, Artists of New Bedford, 149 (w/repro.).

PURRINGTON, Henry J. [Ship carver] b.1825, Mattapoisett, MA. **Addresses:** New Bedford, MA, act. 1848 to 1900. **Comments:** He was also a musician and amateur actor. Still living in the 1920's. **Sources:** G&W; Pinckney, American Figure-heads and Their Carvers, 147-50, pl. 28.

PURRINGTON, J. [Miniaturist] early 19th c. **Addresses:** Active in Salem, MA in 1802; NYC in 1807 and after. **Work:** NYHS (Portrait of Richard (?) Sears). **Comments:** In 1802, he advertised at Salem (Mass.), where he was apparently

associated with William Verstille (see entry) **Sources:** G&W; Belknap, Artists and Craftsmen of Essex County, 12; NYCD 1807; Felt, Annals of Salem, II, 79; Bolton, Miniature Painters. See also NYHS Catalogue (1974), cat. no. 1854.

PURRMAN, Hans [Painter] mid 20th c. **Exhibited:** AIC, 1932. **Sources:** Falk, AIC.

PURSELL, Henry D. See: **PURCELL, Henry**

PURSELL, Mary C. See: **PARCELL, Mary C.**

PURSER, Mary May (Mrs. Stuart R.) [Painter, designer, educator, illustrator, craftsperson] b.1913, Chicago, IL. **Addresses:** Chattanooga, TN; Gainesville, FL. **Studied:** AIC; Louisiana Col.; Univ. Mississippi (A.B.); Univ. Florida (M.F.A.), and study abroad; E. Zettler; M. Artingstall; N. Cikovsky. **Member:** Southeastern AA; Fla. A.T. Assn.; NAEA. **Exhibited:** AIC, 1941; New Orleans AA, 1942; Delgado Mus. A. (solo); Mississippi AA (solo); Soc. Four Arts, 1955; Fla. Fed. A., 1952 (prize), 1955 (prize); Birmingham Mus. A., 1955; Fla. State Fair, 1958 (purchase prize). **Work:** murals, USPO, Clarksville, Ark. **Comments:** Positions: t., AIC; Louisiana Col.; Univ. Chattanooga; A. Supv., Gainesville, Fla., 1955-57; asst. prof., San Fernando Valley State Col., Los Angeles. Cal., 1958-59. Illus. for "Supervision for Better Schools" (2nd ed.). **Sources:** WW59; WW47 has birthdate as 1914.

PURSER, Stuart R. [Painter, educator] b.1907, Stamps, AR / d.1986. **Addresses:** Chattanooga, TN; Gainesville, FL. **Studied:** Louisiana Col. (A.B.); AIC (B.F.A.; M.F.A.); A. Anisfeld; & abroad. **Member:** SSAL. **Exhibited:** New Orleans AA (prize); Miss. AA, 1942 (prize); PAFA Ann., 1946-47, 1950-52; AIC, 1936, 1938; WFNY, 1939. **Work:** murals, USPO, Leland, Miss.; Gretna, Ferriday, La.; Carrollton. Ala. WPA artist. **Comments:** Position: hd. dept. A., Louisiana Col., Pineville, La., 1935-45; Univ. Chattanooga, Tenn., 1946-49; hd. dept. a., Univ. Mississippi. Oxford, Miss., 1949-51; hd. dept. Florida, 1951-56; prof. a., Univ. Florida. 1916-56; prof., San Fernando Valley State Col., Los Angeles, Cal., 1958-59. **Sources:** WW59; WW47; Falk, Exh. Record Series.

PURSSELL, Marie Louise [Painter, illustrator, craftsworker] mid 20th c. **Addresses:** Newark, NJ; NYC. **Studied:** Fawcett School Art with Ida W. Stroud. **Exhibited:** Lefevre Gal., Newark, NJ, 1915; NAWPS, 1935-38. **Sources:** WW40.

PURVES, Austin, Jr. [Painter, sculptor, designer, teacher] b.1900, Phila., PA. **Addresses:** Litchfield, CT. **Studied:** PAFA with Daniel Garber; Académie Julian, Paris; Am. Conservatory at Fontainebleau, France, with Paul Baudoin. **Member:** Gld. of Louis Comfort Tiffany Fnd.; Century Assn.; Natl Soc Mural Painters (pres., 1955); Arch. League NY (v. pres., 1930). **Exhibited:** Arch. Lg., 1926 (prize). **Work:** Litchfield Hist. Soc.; Waterbury Mus. Illuminated Litany Service, St. Paul's Church, Phila.; coats-of-arms, St. Michael's Church, Jersey City; mosaic ceiling, Bricken Bldg., NY; mem., Wash., DC; fresco, St. Michael's Church, Torresdale, Pa.; S.S. America; murals, Folger Shakespeare Mem. Lib.; Nat. Mus., Wash., DC. Commissions: altar painting, comn. by William Olcott, St. Paul's Church, Duluth, Minn., 1927; altar painting, comn. by Byron Miller, Grace Church, Honesdale, Pa, 1948; mosaic chapel, Am. Battle Monument, Draguignan, 1948; aluminum has reliefs, US Lines, SS United States, 1950; East apse mosaics, Nat. Shrine Immaculate Conception, Wash., DC, 1960. **Comments:** Preferred media: tempera, aluminum casting. Positions: dir., Design Studio, R.H. Macy, NYC, 1927-29. Teaching: Yale Univ., 1927-28; dir. Cooper Union Art Sch., 1931-38; Bennington Col., 1946-47. **Sources:** WW73; WW47.

PURVIANCE, Cora Louise [Painter, teacher] b.1904, Phila. **Addresses:** NYC; Phila., PA. **Studied:** PAFA with H. Breckenridge. **Member:** NAWPS. **Exhibited:** PAFA, 1930 (gold);

PAFA Ann., 1936, 1941-45, 1948; Plastic Cl., 1931 (gold), 1932 (med); Corcoran Gal biennials, 1939-43 (3 times); AIC. **Sources:** WW40; Falk, *Exh. Record Series*.

PURVIANCE, Florence V. *[Painter, educator] mid 20th c.; b.Baltimore, MD.*
Studied: Univ. of Pennsylvania; Columbia Univ.; Pennsylvania State Col. **Exhibited:** BMA, 1938-40. **Sources:** Cederholm, *Afro-American Artists*.

PURVIS, R. Murray *[Painter] 19th/20th c.*
Addresses: Boston, MA. **Sources:** WW01.

PURVIS, William G. *[Painter] early 20th c.*
Addresses: Maywood, IL. **Member:** Chicago SA. **Exhibited:** AIC, 1899-1911. **Sources:** WW21.

PURWIN, Sigmund F. *[Painter] mid 20th c.*
Addresses: Chicago area. **Exhibited:** AIC, 1943, 1948. **Sources:** Falk, *AIC*.

PURYEAR, B. , Jr. (Mrs.) *[Painter] mid 20th c.*
Addresses: Wash., DC, active 1920-35. **Exhibited:** Gr. Wash. Indp. Exh., 1935. **Sources:** McMahan, *Artists of Washington, DC*.

PUSEY, John *[Painter] mid 20th c.*
Addresses: Council Bluffs, IA. **Studied:** France. **Exhibited:** Iowa Art Salon, 1934. **Comments:** WPA artist, under Grant Wood. **Sources:** Ness & Orwig, *Iowa Artists of the First Hundred Years*, 171.

PUSEY, Mavis *[Printmaker, painter] b.1931, Jamaica, West Indies.*
Studied: ASL. **Exhibited:** ASL; Treasure Gallery, NYC; Dickson Art Center, 1966; UC Los Angeles, 1966; WMAA, 1971. **Work:** Oakland Mus.; priv. colls. **Sources:** Cederholm, *Afro-American Artists*.

PUSHMAN, Hovsep *[Painter] b.1877, Armenia / d.1966, NYC.*
Addresses: Paris, France; Mission Inn, Riverside, CA, 1916-19; NYC, 1919-on. **Studied:** Imperial Art School, Constantinople (by age 11); AIC, before 1900; traveled in China for several years, studying Chinese art; Académie Julian, Paris with J.P. Laurens, Lefebvre, Robert-Fleury, and Déchenaud, 1912. **Member:** Calif. AC; Paris AAA; SC.
Exhibited: PAFA Ann., 1913, 1942-44; Paris Salon, 1914 (med.), 1921 (med.); Calif. AC, 1918 (prize); Corcoran Gal biennials, 1921-39 (4 times); LACMA, 1916, 1918, 1921 (solos); Grand Central A. Gal., 1930 (prize), 1932 (solo). **Work:** Milwaukee AI; Layton Art Gal., Milwaukee; Minneapolis Art Mus.; MMA; DIA; Rockford (Ill.) Art Gld.; Norfolk (Va.) Art Assn.; University Cl., Milwaukee; Univ. Ill., Springfield; BMFA; Dallas A. Assn.; Amherst Col.; Montclair (N.J.) Art Mus.; Canajoharie A. Gal.; Detroit Inst. A.; New Britain (Ct.) Mus. Amer. A.; Philbrook AM, Tulsa; Houston AM; San Diego Fine Arts Soc.; SAM.
Comments: Best known for his mystical still lifes of oriental objects. He was well-received in his lifetime; at his 1932 solo show at the Grand Central A. Galleries, his 16 paintings were sold by the end of the opening day. **Sources:** WW40; *300 Years of American Art*, vol. 2:743; Hughes, *Artists in California*; Falk, *Exh. Record Series*.

PUSTERLA, Attilio *[Mural painter] b.1862, Milan, Italy (came to U.S. in 1899) / d.1941.*
Addresses: Woodcliff, NJ. **Work:** murals: Lewis and Clark Mem. (Astoria, Wash.), Parliament Bldg. (Ottawa), NY County Court House.

PUTHUFF, Hanson (Duvall)
[Landscape and portrait painter] b.1875, Waverly, MO / d.1972, Corona del Mar, CA.
Addresses: La Crescenta, Eagle Rock, CA. **Studied:** AIC; Univ. Art School, Denver, 1893. **Member:** Calif. AC; Laguna Beach AA; Los Angeles WC Soc.; P.&S. Club, Los Angeles; Berkeley Lg. FA; Pasadena Soc. Artists; San Fran. AA; Palette & Chisel,

Chicago; SC; Southern States Art League. **Exhibited:** AIC, 1907-15; Alaska-Yukon Expo, Seattle, 1909 (prize); Paris Salon, 1914 (med.); LACMA, 1914 (solo), 1917 (solo), 1929; Pan-Calif. Expo, San Diego, 1916 (2 medals); Calif. AC, 1916 (prize); San Francisco AA, 116; State Fair, Sacramento, 1918 (gold), 1919 (med.); PAFA Ann., 1919; Laguna Beach AA, 1920 (prize), 1921 (prize); Southwest Mus., Los Angeles, 1921 (prize); Springville, Utah, 1924 (prize), 1926-28 (prize, each yr.); Painters of the West, 1925 (med.), 1927 (gold), 1930 (med.); Riverside, CA, 1927 (prize); Pac. Southwest Expo, 1928 (med.; Chicago Gal. Assn., 1930; GGE, 1939. **Work:** Hackley Mus., Muskegon, MI; Municipal Coll., Denver; Springville MA, Utah; Los Angeles County Coll., LACMA; Laguna Beach MA; Pasadena AI; Municipal Art Gal., Phoenix; Los Angeles public schools. **Comments:** Realistic Calif. landscape painter. Specialty: Southern California deserts. He worked as a commercial artist until after 1926, when he devoted all his time to fine art and exhibitions. **Sources:** WW40; Hughes, *Artists in California*, 451; *300 Years of American Art*, 723; Falk, *Exh. Record Series*.

PUTMAN, Donald *[Painter] b.1927, State of Washington.*
Addresses: Hermosa Beach, CA in 1973. **Studied:** Los Angeles Art Center College of Des. **Comments:** Positions: teacher, Los Angeles Art Center of Des., 1962; scenery design, MGM. **Sources:** P&H Samuels, 384.

PUTNAM, Alice Elizabeth *[Painter] b.1909, Omaha, NE.*
Addresses: Piedmont, CA. **Studied:** Mills College (M.A., 1935); with Cora Boone. **Member:** Art League of the East Bay; San Francisco Women Artists. **Exhibited:** Oakland A. Gal., 1932. **Comments:** Position: t., Mills College, 1936-52; t., Alameda public schools, 1951-52; dir. of admissions, Calif. Col. of Arts and Crafts, 1956-63; dean of adm., San Francisco Art Inst., 1969-80. **Sources:** Hughes, *Artists in California*, 451.

PUTNAM, Amy (Miss) *[Painter] late 19th c.*
Addresses: NYC. **Exhibited:** NAD, 1882. **Sources:** Naylor, *NAD*.

PUTNAM, Arion *[Painter, photographer] b.1870, NYC / d.1949, Los Angeles, CA.*
Addresses: Los Angeles, CA. **Member:** Calif. AC. **Sources:** WW25; Hughes, *Artists in California*, 451.

PUTNAM, Arthur *[Sculptor] b.1873, Waveland, MS / d.1930, Ville Davray, near Paris.*
Addresses: Bohemian Club, San Francisco, CA/Paris, France. **Studied:** San Fran. with R. Schmidt & Julie Heyneman, 1894; Chicago with E. Kemeys, 1897-98; bronze casting in Europe, 1905. **Member:** NSS, 1913; San Fran. AA; Bohemian Cl. **Exhibited:** Rome, 1906; Paris, 1907; PAFA Ann., 1909, 1921; AIC, 1912, 1924; Armory Show, NYC, 1913; PPE, 1915; San Fran. AA, 1916; Calif.-Pacific Int. Expo, San Diego, 1935; SFMA, 1935; GGE, 1939; CPLH, 1930 (solo), 1932 (solo), 1940 (solo), 1956 (solo), 1958 (solo); Oakland Mus., 1978 (solo). **Work:** groups of animal sculptures, CPLH, San Diego FA Soc.; MMA; BMFA; Oakland Mus.; Bank of Calif., San Fran. (pumas); de Young Mus. (sphinxes); St. Francis Hotel, San Fran. (puma drinking fountain); Crocker Bank, San Fran. (animal frieze); Unitarian Church of San Fran. (angels); Junipero Serra in Mission Dolores garden; Sloat Mon., Monterey (collab. with Earl Cummings); Pacific Union Cl. of San Fran. (ceiling and newel post); Presidio Park, San Diego; San Fran. City Cl.; Bohemian Cl. **Comments:** Putnam's father was a civil engineer and the family led a somewhat itinerant life, until they bought a lemon ranch near San Diego when Arthur was 18 years old. He was sketching wild animals in his late teens and while studying art in San Francisco, supported himself by working at a slaughter house, where he learned much about animal anatomy. He later shared a studio with Gottardo Piazzoni (see entry) and Earl Cummings (see entry). A major portion of his work was created from 1901-05. In 1905 he and his wife Grace Storey Putnam (see entry) went to Paris, where he exhibited and observed Rodin. Returning to San Francisco in 1907, the Putnams found their studio in ruins, as a result of the

earthquake and fire, and for a while they lived in a tent. His career ended in 1911, when brain surgery left him partially paralyzed. Specialty: Western animals, esp. mountain lions. Established foundry (1909), casting bronzes by the cire-perdue method (lost-wax process). **Sources:** WW29; Hughes, *Artists in California,* 451; P&H Samuels, 385; Fort, *The Figure in American Sculpture,* 218-19.

PUTNAM, Brenda *[Sculptor, writer, teacher] b.1890, Minneapolis, MN / d.1975.*
Addresses: Wash., DC, active 1911-13; NYC; Wilton, CT.
Studied: BMFA Sch., 1905-07, drawing, with Paxton and Hale, modeling with Mary E. Moore and Bela Pratt; Corcoran Sch. Art; ASL, with James Earle Fraser, Charles Grafly, and later with Archipenko (1920s); Corcoran Sch., Wash., DC, with E.C. Messer; in Florence, Italy with Libero Andreotti, 1920s. **Member:** NIAL; ANA; NA, 1936; NSS; NAWA; NAC. **Exhibited:** PAFA Ann., 1910, 1913-15, 1919-32, 1940-44 (gold 1923); Int. Exhib., Rome, 1911; AIC, 1917 (prize); Arch. Lg., 1924 (Avery prize); Grand Gal., 1930 (prize), 1939 (prize); NAD, 1922, (Barnett prize), 1929 (medal), 1935 (Watrous gold medal); NAWA, 1923 (prize), 1928 (prize); Grand Central Art Gals., NYC (retrospective); NSS; Ferargil Gal., NYC, 1947 (solo). Other awards: Competition for Congressional Medal, presented to Fleet Admiral King, 1947. **Work:** Syracuse University Art Collection (archival material is located in the University's Carnegie Lib.); Dallas Mus. FA; NIAL; Hispanic Mus.; "Puck," in front of the Folger Shakespeare Lib., Wash., DC; Norton Gal. Art; Brookgreen Gardens, SC; Lynchburg, VA; West Palm Beach, FL; Acad. Arts & Letters; Hall of Fame, NY; Detroit Inst. A.; Lynchburg, VA; South Orange, NJ; mural reliefs: USPO, Caldwell, NJ; USPO, St. Cloud, MN; marble fig., Norton Gal. Art; 3 plaques, doorway over the visitor's gallery, House of Representatives, Wash., DC; Rock Creek Cemetery, Wash., DC; portrait bust of Harriet Beecher Stowe, Am. Hall of Fame; bust of Susan B. Anthony for Hall of Fame, 1952. **Comments:** WPA artist. Best known for her garden figures, portraits busts, bas reliefs, and small statuettes. She actively exhibited her work from 1910 on. To further develop her style around 1927, she worked with Libero Andreotti in Florence and Archipenko in New York. She retired in 1952. In 1964, at the request of Syracuse University, all pertinent data relating to the artist's fifty years of creating and teaching sculpture, was collected, and in 1965 was deposited at the University's Carnegie Library. Author: *The Sculptor's Way,* 1939; *Animal X-rays,* 1947. **Sources:** WW66; WW47; McMahan, *Artists of Washington, DC;* Pisano, *One Hundred Years.the National Association of Women Artists,* 78; Rubinstein, *American Women Artists,* 248-49; Falk, *Exh. Record Series.*

PUTNAM, Charlotte Ann *[Etcher] b.1906, Red Wing, MN.*
Addresses: Bronxville, NY. **Studied:** ASL; H. Wickey.
Exhibited: Nat. Jr. Lg. Exh., Cincinnati Mus., 1931 (prize); Nat. Jr. Lg. Exh., Los Angeles, 1932 (prize). **Sources:** WW32.

PUTNAM, Claude George, Sr. *[Illustrator, painter] b.1884, Michigan / d.1955, Newport Beach, CA.*
Addresses: Newport Beach, CA. **Member:** Commercial Artist's Assoc. of Southern Calif. **Comments:** Author/illustrator: "Log Book," "Harbors & Islands," "California Coast." The signature on his paintings is often "PUT." **Sources:** Hughes, *Artists in California,* 452.

PUTNAM, David A. *[Portrait painter] b.c.1816, Pernambuco (Brazil) / d.1840.*
Addresses: Salem, MA. **Comments:** He was an adopted son of David Putnam of Salem (Mass.). **Sources:** G&W; Belknap, *Artists and Craftsmen of Essex County,* 12.

PUTNAM, Edmund *[Engraver] b.c.1800, Massachusetts.*
Addresses: Boston, active c. 1843 to 1860. **Sources:** G&W; 8 Census (1860), Mass., XXVI, 639; Boston CD 1843-60.

PUTNAM, Elizabeth D. *[Painter] early 20th c.*
Addresses: Wash., DC. **Exhibited:** Wash. WCC, 1911. **Sources:** WW13; McMahan, *Artists of Washington, DC.*

PUTNAM, Florence N. *[Painter] late 19th c.*
Studied: Hitchcock; Tarbell; Cox; Chase. **Exhibited:** Paris Salon 1898. **Sources:** Fink, *American Art at the Nineteenth-Century Paris Salons,* 382.

PUTNAM, George W. *[Portrait painter] b.c.1812, Salem, MA.*
Addresses: Nashua, NH, in 1844 (at the time of his marriage).
Exhibited: Boston Athenaeum, 1841. **Sources:** G&W; Belknap, *Artists and Crafstmen of Essex County,* 12; Swan, BA.

PUTNAM, Grace Storey *[Painter, sculptor] b.1877, San Diego, CA / d.1947, Malibu, CA.*
Addresses: San Francisco, CA; Malibu, CA. **Studied:** Maud McMullan in San Diego. **Exhibited:** San Francisco AA, 1900; Oakland Art Gal., 1917; WMAA, 1923. **Comments:** Married to Arthur Putnam (see entry) from 1899 to 1915, after which time she supported herself and her children by giving painting and drawing lessons. She began sculpting doll's heads and copyrighted the famous "Bye-Lo Baby" in 1922. She was married to sculptor Eugene Morahan (see entry) from 1927-1941. **Sources:** Hughes, *Artists in California,* 452.

PUTNAM, John B. (Mrs.) *[Collector] b.1903, Cleveland, OH.*
Addresses: Cleveland, OH. **Member:** Art Collectors Cl.
Comments: Collection: paintings and modern art. **Sources:** WW73.

PUTNAM, L. J. (Jaynes) (Mrs.) *[Genre painter] late 19th c.*
Addresses: Active in Los Angeles, 1884-90. **Sources:** Petteys, *Dictionary of Women Artists.*

PUTNAM, Louis S. *[Sculptor] mid 20th c.*
Exhibited: AIC, 1932. **Sources:** Falk, *AIC.*

PUTNAM, Marion See: **WALTON, Marion Putnam (Mrs.)**

PUTNAM, Sarah G(ould) *[Portrait painter] 19th/20th c.*
Addresses: Boston, MA. **Studied:** Boston; NYC with J.B. Johnston, Duveneck, & Chase. **Exhibited:** Boston AC, 1890-93; J. Eastman Chase Gal., Boston, 1895 (solo); Doll & Richards, 1898 (solo); Charles E. Cobb Gal., 1908 (solo). **Sources:** *The Boston AC;* Petteys, *Dictionary of Women Artists.*

PUTNAM, Stephen G(reeley) *[Wood engraver] b.1852, Nashua, NH.*
Addresses: Queens, NY. **Studied:** Brooklyn Art Assn.; ASL; H.W. Herrick; F. French; E.J. Whitney. **Exhibited:** Paris Expo, 1889 (med.), 1900 (med.); Columbian Expo, Chicago, 1893 (med.); Pan-Am. Expo, Buffalo, 1901 (med). **Sources:** WW31.

PUTNAM, Thorington *[Painter] mid 20th c.*
Addresses: Hollywood, CA, 1930s and 1940s. **Exhibited:** Calif. WC Soc., 1935-42. **Sources:** Hughes, *Artists in California,* 452.

PUTNAM, Wallace (Bradstreet) *[Painter, writer, illustrator] b.1899, West Newton, MA / d.1989.*
Addresses: Yorktown Heights, NY. **Studied:** Boston. **Exhibited:** "Int. Exhib. Mod. Art, Société Anonyme," Brooklyn Mus., 1926; Salons of Am., 1927; S. Indp. A., 1927-30, 1940-42; "Fantastic Art, Dada, Surrealism," MoMA, 1936; Bignou Gal., 1945 (solo); Chinese Gal., 1948; Passedoit Gal., 1951, 1953-54; PAFA Ann., 1960. **Work:** MoMA; Yale Univ. Société Anonyme Coll.; Univ. Southern Ill.; Roy Nenberger Coll. **Comments:** Preferred media: oils. Publications: auth. & illusr., *Manhattan Manners,* 1935; and *Miracle Enough,* 1968. **Sources:** WW73; WW47; Falk, *Exh. Record Series.*

PUTTEMANS, Viviane *[Painter] mid 20th c.*
Addresses: Brooklyn, NY, 1933. **Exhibited:** S. Indp. A., 1933.
Sources: Marlor, *Soc. Indp. Artists.*

PUTTERMAN, Florence Grace *[Painter, collector] b.1927, Brooklyn, NY.*
Addresses: Selinsgrove, PA. **Studied:** NY Univ. (B.S.); Bucknell Univ.; Pa. State Univ. **Member:** Am. Fedn. Arts; Hunterdon Co. Art Ctr.; Art All. Cent. Pa.; Mid-State Artists (treas., 1970-).

Exhibited: Butler Inst. Am. Art, 1965; Northwest Printmakers Ann., Seattle, Wash.; Images 1970, Miss. State Art Festival, Jackson, 1970; 3rd Nat. Print Ann., Ga. State Univ., Atlanta, 1972; Colorprint USA, Tex. Tech. Univ., Lubbock, 1972. **Awards:** 1st prize, graphics, Berwick Art Ctr, 1966-67; best-in-show award, Everhart Mus., Scranton, Pa., 1968. **Work:** Bucknell Univ., Lewisburg, Pa.; Lycoming Col., Williamsport, Pa. **Comments:** Positions: founder & pres., Arts Unlimited, Selinsgrove, Pa, 1965-; cur., Milton Shoe Co. Print Collection, Pa., 1970-. Teaching: artist in residence, Federal title III program, 1967-70. Collection: African & Indian art. **Sources:** WW73.

PUTZEYS, Edward *[Painter]* late 19th c.
Addresses: NYC. **Exhibited:** NAD, 1881. **Sources:** Naylor, *NAD.*

PUTZKI, Dorothy *[Artist]* early 20th c.
Addresses: Wash., D.C., active 1912-17. **Comments:** Daughter of artists Kate and Paul Putzki. **Sources:** McMahan, *Artists of Washington, D.C.*

PUTZKI, Kate *[Artist]* early 20th c.
Addresses: Wash., DC, active 1911-15. **Comments:** Wife of artist Paul A. Putzki and mother of artist Dorothy Putzki. **Sources:** McMahan, *Artists of Washington, DC.*

PUTZKI, Paul Adoplh *[Painter]* b.1858, Germany (came to U.S. in 1879) / d.1936, Wash., DC.
Addresses: Illinois; Indiana; Wash., DC, 1890. **Exhibited:** Soc. Wash. Artists; Wash. WCC. **Comments:** Husband of artist Kate Putzki and father of artist Dorothy Putzki. Taught watercolor and china painting in Chicago and Indianapolis prior to opening a studio in Wash., DC, at the invitation of the wife of Pres. Harrison. **Sources:** WW01; McMahan, *Artists of Washington, DC.*

PUZINAS, Paul *[Painter, educator]* b.1907, Riga, Latvia.
Addresses: New York 19, NY. **Studied:** A. Acad., Latvia (M.A.); and in Belgium. **Member:** A. Lg. of Long Island; AAPL; All. A. Am., and many art organizations in California. **Exhibited:** Art: USA, 1958; Audubon A.; All. A. Am., 1957; Butler Inst. Am. A., 1958; All-City A. Exh., Los A., 1950-52; Intl. Flower Show A. Exit., 1951; Am. Traditional A. Exh., Los A., 1955; A. Lg. of Long Island, 1956, 1958; AAPL, 1957; Hudson Valley AA, 1958. **Awards:** prizes, Lithuania Nat. award, 1938 and others; Greek Theatre, Los Angeles. 1950; Madonna Festival, Los Angeles, 1951; Intl Flower Show A. Exh., 1951; Am. Traditional A. Exh., Los A., 1955; AAPL, Grand Nat. award, 1956; Emily Lowe Fnd., NY, 1957; Lockman award, NY, 1957; Huntington award, 1958; A. Lg. of Long Island, 1958. **Work:** Nat. Mus., Kaunas and in Vilnius, Lithuania; State A. Mus., Riga, Latvia mural, Paneveszy Cathedral, Lithuania. **Sources:** WW59.

PYE, Fred *[Painter, teacher]* b.1882, Hebden Bridge, Yorkshire, England.
Addresses: Des Moines, IA; Cincinnati, OH. **Studied:** Academy Julian, Acad. Colarossi, both in Paris; Lavrens, Dechanaud, Henri Royer, Jules Pages and R. E. Miller. **Member:** SC; Cincinnati Men's AC; Cincinnati Assoc.Professional Artists. **Exhibited:** Salons of Am.; CM; France; New York, Philadelphia, Washington, Cincinnati; Canada. **Work:** Luxembourg Mus., Paris; Mus. Art, Edmonton, Canada; Ainslie Galleries, NY. **Sources:** WW59; WW47; Ness & Orwig, *Iowa Artists of the First Hundred Years,* 171.

PYLE, Arnold *[Painter and teacher]* b.1908, Cedar Rapids, IA.
Addresses: Cedar Rapids, IA. **Member:** Cooperative Mural Painters of Iowa. **Exhibited:** Iowa Art Salon, 1930-32 (awards), 1933 (hon. men.), 1934-37, 1936 (award) 1938 (first prize); AIC, 1934-39; PAFA Ann., 1934, 1936; Midwestern Exhibition, 1935; Chicago Expo, 1935; J. N. Darling, Des Moines, IA, purchase prize; watercolor, Midwestern Artists Exh., Kansas City AI, 1936 (prize). **Work:** McKinley Jr. H.S., Cedar Rapids; priv. colls. **Comments:** Assisted Edward Rowan in Little Gallery, Cedar Rapids; assisted Grant Wood, WPA, 1934. **Sources:** WW40; Ness & Orwig, *Iowa Artists of the First Hundred Years,*171; Falk, *Exh.*

Record Series.

PYLE, Clifford C(olton) *[Painter, illustrator, block printer, craftsperson, designer, drawing specialist, etcher, teacher, writer]* b.1894, MO.
Addresses: Oakland, CA. **Studied:** P. Lemos; L. Randolph; G. Albright; R. Schaeffer. **Work:** MMA. **Comments:** Author: "Leathercraft as a Hobby," 1939. **Sources:** WW40.

PYLE, Ellen Bernard Thompson (Mrs.) *[Painter, illustrator]* b.c.1881, Germantown, PA / d.1936, Greenville, DE.
Addresses: Wilmington, DE. **Studied:** Drexel Inst., with Howard Pyle (also attended his first summer school in Chadds Ford, 1898). **Member:** Wilmington Soc. FA. **Comments:** Specialty: child portraits. She married H. Pyle's brother Walter in 1904, and interrupted her career to raise a family. She returned to illustrating after her husband's death in 1919, doing covers for the *The Saturday Evening Post.* **Sources:** W & R Reed, *The Illustrator in America,* 141. Reed cites a birth date of 1876.

PYLE, Frank Wilkes (Mrs.) *[Artist, writer]* b.1878, San Sabo, TX.
Addresses: Wash., DC, active 1916-30. **Studied:** Corcoran Sch. Art; PAFA. **Exhibited:** Ntl. Lg. Am. Pen Women (prize 1925). **Sources:** McMahan, *Artists of Washington, DC.*

PYLE, Howard *[Illustrator, painter, writer, teacher]* b.1853, Wilmington / d.1911, Florence, Italy.
Addresses: Wilmington, DE/Chadds Ford. **Studied:** Philadelphia, with Van der Weilen, 1869-72. **Member:** ANA, 1905; NA, 1907; SC, 1876; NIAL; Century; Intl. Soc. SPG. **Exhibited:** Boston AC, 1886-87; NAD, 1890; PAFA Ann., 1893, 1902; Columbian Expo, Chicago, 1893 (med); Pan-Am. Expo, Buffalo, 1901 (gold); Paris Expo, 1900 (med). **Work:** Pyle Mem. Gal., Wilmington Inst. Lib., DE; Brandywine River Mus., Chadds Ford, PA; St. Louis AM. **Comments:** Pyle had studio in New York, 1876-80 and in Wilmington from 1880. He is best known for his illus. of early Am. historical characters and events. A highly important and influential illustrator and teacher, he was the founder of the "Brandywine School" and is often referred to as the "Father of American Illustration." Among his many famous students were V. Oakley, N.C. Wyeth, M. Parrish, and H. Dunn. He was the author/illustrator of 24 books, including "The Merry Adventures of Robin Hood" (1883), "Within the Capes," "Pepper & Salt," "The Wonder Clock" (1888), "The Rose of Paradise," "Twilight Land" (1895), "Stolen Treasure" (1907), "Otto of the Silver Hand." He illustrated more than 100 books, and his works appeared in every major magazine from 1876 on, including *Scribner's, St. Nicholas, Harper's* (in black & white from 1876-87). Positions: Drexel IA, 1894-1900; director, Pyle Sch. Art ,1900-06. Specialty: pen-and-ink drawings. **Sources:** WW06; P&H Samuels, 385; Falk, *Exh. Record Series.*

PYLE, Katherine *[Portrait painter, illustrator, writer]* b.1863, Wilmington, DE / d.c.1938.
Addresses: Wilmington, DE. **Studied:** Women's Indust. Sch.; Drexel Inst., with H. Pyle; ASL; Phila. School Design. **Member:** Wilmington Soc. FA. **Exhibited:** Columbian Expo, Chicago, 1893. **Comments:** Sister of Howard Pyle. Author: "Wonder Tales Retold," "Tales of Folk and Fairies," "Heroic Tales from Greek Mythology," "Heroic Tales from the Norse Mythology," "Charlemagne and His Knights," & other books. **Sources:** WW38; Petteys, *Dictionary of Women Artists.*

PYLE, Margery Kathleen *[Painter, landscape painter]* b.1903, Wilmington, DE.
Addresses: Wilmington , DE. **Studied:** PAFA (F. PAFA, 1936); Univ. Delaware; D. Garber; R. Braught; F. Cannon; A. Doragh. **Member:** Wilmington Soc. FA; Rehoboth (Del.) A. Lg.; Studio Group of Wilmington; Wilmington Pr. Cl.; Wilmington A. Cl. **Exhibited:** Wilmington AC, 1934 (prize); Rehoboth A. Lg. 1937 (prize), 1939 (solo), 1947 (solo); PAFA, 1936; Wilmington Soc. FA, annually. **Sources:** WW59; WW47.

PYLE, Richard T. *[Painter] mid 20th c.*
Addresses: Dallas, TX, 1952. **Exhibited:** WMAA, 1952.
Sources: Falk, *WMAA.*

PYLE, Walter, Jr. *[Painter, mural painter, illustrator, teacher]*
b.1906, Wilmington.
Addresses: Greenville, DE. **Studied:** PMSchIA; PAFA. **Member:**
Wilmington A. Cl. **Exhibited:** Wilmington Soc. FA 1935 (prize),
1937 (prize), 1938 (prize); Wilmington A. Cl., 1937 (prize); WC
Ann., PAFA, 1938. **Work:** murals, Special Sch. District,
Georgetown, Del. **Comments:** Position: Del. state supv., WPA.
Sources: WW40.

PYLE, William Scott *[Painter] b.1888, Monmouth Beach, NJ*
/ d.1938, The Hague, Holland.
Addresses: NYC. **Member:** SC. **Exhibited:** AIC, 1915-16, S.
Indp. A., 1917; PAFA Ann., 1917, 1920; Corcoran Gal biennial,
1919. **Sources:** WW25; Falk, *Exhibition Records Series.*

PYLES, Charles C. (Conrad) *[Painter] b.1846, LA or KY.*
Addresses: New Orleans, active 1870-81. **Sources:**
Encyclopaedia of New Orleans Artists, 315.

PYLES, Minnie Louise See: **RAUL, Minnie Louise**
Briggs (Mrs. Harry Lewis)

PYLES, Virgil E. *[Illustrator, painter] b.1891, La Grange, KY.*
Addresses: NYC. **Studied:** AIC; ASL; Grand Central A. Sch.; SI
Sch. for Veterans. **Member:** Am. Veterans Soc. A. **Exhibited:**
Lotos Cl.; Am. Veterans Soc. A. L., Am. Legion. **Comments:**
Illustrator: *Ladies Home Journal, American, Adventure,* other
magazines. **Sources:** WW53; WW47.

PYNE, Crawford Christopher *[Painter] late 19th c.*
Addresses: NYC. **Exhibited:** NAD, 1862-63; PAFA Ann., 1884.
Sources: Naylor, *NAD;* Falk, *Exh. Record Series.*

PYNE, Robert Lorraine *[Landscape painter] b.1836.*
Addresses: NYC. **Exhibited:** NAD, 1856-97; Brooklyn AA,
1867-82, 1891; PAFA Ann., 1883-84, 1888-90; AIC, 1896,1899.
Comments: Exhibited works indicate he painted in Long Island
and New Jersey, up the Hudson River, and in the Catskills (NY)
and the Berkshires (MA). **Sources:** G&W; Cowdrey, NAD;
NYBD 1859-60; Falk, *Exh. Record Series.*

PYTLAK, Leonard *[Serigrapher, lithographer, painter,*
teacher, lecturer] b.1910, Newark, NJ.
Addresses: NYC. **Studied:** Newark Sch.
Fine & Industrial Arts; ASL (life mem.).
Member: Artists Lg. Am.; Nat. Serigraph
Soc (founder; twice pres.); Audubon Artists; Phila. Color Pr. Soc.
Exhibited: Salons of Am., 1934; AIC, 1941-42; MMA, 1942
(prize); AV, 1943 (prize); Phila. Pr. Club (prize); Phila. Color Pr.
Soc. (prize); NAD, 1946 (prize); LOC, 1944-46 (prize); SAM
(prize); Guggenheim Fellowship, 1941; "NYC WPA Art" at
Parsons School Design, 1977; WMAA, 1942. **Work:** MMA; BM;
CI; Denver Art Mus.; SAM; BMFA; NYPL; PMA; Newark
Library; MoMA; Contemporary Artists; Nat. Serigraph Soc.
Comments: Lectures: silkscreen process. WPA printmaker in
NYC, 1930s. **Sources:** WW59; exhib. cat., Annex Gal. (Santa
Rosa, CA, n.d., c.1988); WW47; *New York City WPA Art,* 72
(w/repro.).

Symbol of the Architectural League, New York, 1912.

Q

QUABIUS, Kempert *[Printmaker] mid 20th c.*
Addresses: Chicago area. **Exhibited:** AIC, 1951. **Sources:** Falk, *AIC.*

QUACKENBUSH, Ethel H. *[Painter] early 20th c.*
Addresses: NYC, c.1913-19. **Exhibited:** AIC, 1915. **Comments:** Lived at the same address as Grace M. Quackenbush. **Sources:** WW19; Petteys, *Dictionary of Women Artists.*

QUACKENBUSH, Grace M. *[Painter] early 20th c.*
Addresses: NYC, c.1913. **Comments:** Lived at same address as Ethel Quackenbush. **Sources:** WW13; Petteys, *Dictionary of Women Artists.*

QUAGLION, Louis (Prof.) *[Painter] mid 20th c.*
Exhibited: S. Indp. A., 1935, 1939. **Sources:** Marlor, *Soc. Indp. Artists.*

QUAH AH See: **PENA, Tonita (Quah Ah)**

QUAINTANCE, Helen M. (Yocum) *[Painter] early 20th c.*
Addresses: Wash., DC, active 1915-29. **Member:** Wash. AC; Soc. Wash. Artists, 1915; Wash. WCC. **Sources:** McMahan, *Artists of Washington, DC.*

QUALIA, Anthony *[Painter] mid 20th c.*
Addresses: Wash. DC. **Exhibited:** Corcoran Gal biennial., 1951; PAFA Ann., 1952. **Sources:** Falk, *Exh. Record Series.*

QUALLEY, Lena *[Painter] early 20th c.; b.Decorah, IA.*
Addresses: Hillsdale, MI, c.1905-10. **Studied:** AIC; Paris with MacMonnies, de la Gandara, Simon & Cottet. **Exhibited:** AIC, 1902-05. **Sources:** WW10.

QUALTIERI, Joseph P. *[Abstract painter] 20th c.*
Member: Mystic AA. **Exhibited:** Mystic AA. **Work:** PAFA. **Sources:** PHF files, Mystic AA.

QUAM, Mylo *[Painter, actor, costume designer] b.1941, Cooperstown, ND / d.1996, Kingston, NY.*
Addresses: Shokan, NY, 1965. **Studied:** Concordia Univ., Portland, OR; Brandeis Univ. (scholarship); Boston College. **Member:** Woodstock AA. **Exhibited:** Boatman Gal., NYC (first solo); Runyon Winchell; Waverley; San Fran.; Desmond/Weiss Gal.; Ann Leonard Gal., Woodstock. **Comments:** During his career Quam created 761 paintings and collages. **Sources:** Woodstock AA.

QUAN, Mun S. *[Painter] b.1917, Canton, China.*
Addresses: Jacksonville 5, FL. **Studied:** Canton Acad. Art, China; Ko-Kim Fu, Canton; Nicholas Volpe, Jacksonville, FL. **Member:** Sarasota AA; New Orleans AA; Florida Fed. Artists; Florida Artists Group. **Exhibited:** Florida Fed. Artists; Florida Artists Group; Delgado MA; Sarasota AA; Jacksonville AM, 1952, 1953, 1956, 1957 (all solos); Jacksonville Univ., 1957; Daytona AA, 1953; Univ. Florida, 1958. Awards: prizes, Canton, China, 1948; Governor's award, Macao, 1949; Florida Fed. Artists, 1952, 1953; Jacksonville AM, 1951-58; St. Augustine AA, 1951, 1953-56. **Work:** Jacksonville AM; Univ. Florida. **Comments:** Teaching: watercolor, Jacksonville AM, Florida. **Sources:** WW59.

QUANCHI, Leo William *[Painter] b.1892, NYC / d.1974, Kent, CT.*
Addresses: NYC; Maywood, NJ; Kent, CT. **Studied:** CCNY; NAD; ASL; Parsons Sch. Design; G. deF. Brush; F.C. Jones; D. Volk. **Member:** Audubon Artists; Artists Lg. Am.; Lg. Present-Day Artists; Soc. Independent Artists; College AA; AAPL. **Exhibited:** S. Indp. A., 1917, 1922, 1932, 1940, 1942-44; Salons of Am., 1922, 1931, 1932, 1934; NAD, annually; PAFA Ann., 1922-24, 1948-49, 1953; Pepsi-Cola, 1944, 1946; Corcoran Gal. biennials, 1951-59 (3 times); Montclair AM, annually; WMAA; Des Moines AC; MMA; Monmouth College, NJ, 1961; New Jersey Art Today, Fairleigh Dickinson Univ., 1965; Salmagundi Club prize, 1968; first prize, NAUW, 1970; ann. exhib., State NJ. **Work:** WMAA; Newark (NJ) Art Mus.; PAFA; Bloomfield College Coll., NJ. **Sources:** WW73; WW47; Falk, *Exh. Record Series.*

QUANDT, Russell Jerome *[Restorer] b.1919, New London, CT / d.1970.*
Addresses: Washington 6, DC; Washington 8, DC. **Studied:** Yale College. **Member:** Int. Inst. for Cons. of Mus. Objects (fellowship). **Work:** restoration commissions for Phillips Gal., J.B. Speed AM, Colonial Williamsburg. **Comments:** Positions: restorer, Corcoran Gal. Art, 1950-; conservator, Abby Aldrich Rockefeller Folk Art Coll., Williamsburg, VA, 1954-. **Sources:** WW66.

QUARRÉ, Frederick *[Steel & aquatint engraver] mid 19th c.*
Addresses: Active in NYC; Philadelphia. **Exhibited:** Franklin Inst., Phila., 1849 (decorated lamp shades). **Comments:** Working in NYC as early as 1839 as an engraver for *Godey's Lady's Book* and other fashion magazines and in 1842 he edited and published his own magazine entitled *Artist.* Subsequently moved to Philadelphia where he was active as an engraver and lampshade maker until about 1849. Quarré's most distinctive productions were flower aquatints embellished with engraved white lace, in the manner of the later valentine. **Sources:** G&W; Waite, "Pioneer Color Printer: F. Quarré."

QUARTLEY, Adele *[Painter] late 19th c.*
Addresses: NYC. **Exhibited:** NAD, 1886. **Sources:** Naylor, *NAD.*

QUARTLEY, Arthur
[Marine painter, landscape painter, engraver, decorator] b.1839, Paris, France / d.1886, NYC.
Addresses: Peekskill, NY; Baltimore, MD; NYC. **Studied:** with his father Frederick W.; apprenticed to a sign-painter in NYC prior to 1862; Europe, before 1886. **Member:** ANA, 1879; NA, 1886; Tile Club. **Exhibited:** NAD, 1875-87; Brooklyn AA, 1875-86; PAFA Ann., 1879-80, 1883; Boston AC, 1880-85;London, 1884-85; Paris Intl., 1876. **Work:** Baltimore MA; Brooklyn MA; Cincinnati MA; Salem, Mass.; Md. Hist. Soc.; NYHS. **Comments:** Son of Frederick William Quartley. Spent his childhood in France and England; but after his mother's death in 1851 he was taken to America by his father and they settled in Peekskill, NY. At the beginning of his career, Quartley worked as

an engraver in Peekskill and as a sign-painter in NYC. From 1862-75 he was associated with the decorating firm of Emmart & Quartley in Baltimore; however, in 1873, he established his own painting studio and began producing marines. By about 1876 he had given up the interior design business and opened a studio in NYC; thereafter, Quartley spent his summers painting on the Isle of Shoals, off the coast of New Hampshire. He also painted on Long Island, at East Hampton and Cold Spring Harbor. His life was cut short by his untimely death soon after his return from a year's visit to Europe. **Sources:** G&W; DAB; CAB; Clement and Hutton; G.W. Sheldon, *American Painters* (NY, 1879); "The Tile Club at Play," *Scribner's Monthly* (February, 1879); "The Tile Club Ashore" *Century Magazine* (February, 1882); Gerdts, *Art Across America*, vol. 1: 148, 334; Pisano, *The Long Island Landscape, 1865-1914*, introduction; Benezit; Falk, *Exh. Record Series*.

QUARTLEY, Frederick William *[Engraver, landscape painter]* b.1808, Bath, England / d.1874, NYC.
Studied: took up wood engraving at the age of 16; Wales; Paris. **Comments:** After the death of his wife in 1851 he came to America with his son, Arthur Quartley (see entry), and settled at Peekskill, NY. He was a popular engraver for several publishers. Best known work: illustrations for *Picturesque America* (1872) and *Picturesque Europe* (1875). **Sources:** G&W; CAB; Clement and Hutton; Hamilton, *Early American Book Illustrators*.

QUARTON, G. *[Painter]* mid 20th c.
Exhibited: S. Indp. A., 1936. **Sources:** Marlor, *Soc. Indp. Artists*.

QUASTHOFF, Donna E. *[Sculptor]* mid 20th c.
Addresses: Chicago area. **Exhibited:** AIC, 1948. **Sources:** Falk, AIC.

QUASTLER, Gertrude Panek (Mrs. Henry) *[Printmaker, painter]* b.1909, Vienna, Austria / d.1963, Brookhaven, NY.
Addresses: Brookhaven, NY. **Studied:** Columbia Univ.; Univ. Illinois; Chicago Inst. Des. **Member:** Boston PM; Print Council Am. **Exhibited:** PAFA, 1949-55; BM; LC; Audubon Artists; Univ. Nebraska; Springfield, IL; Denver AM; Univ. Indiana; solos: Chicago, 1950, 1952, 1953; Decatur, 1955; Boston, 1955; Philadelphia, 1953; Stonybrook, NY, 1958. **Work:** MoMA; Farnsworth MA; AIC; BMFA; FMA; Boston Pub. Lib.; Phila. Free Lib.; RISD; Univ. Delaware, Maryland & Nebraska. **Comments:** Immigrated to U.S. in 1940. **Sources:** WW59.

QUAT, Helen S. *[Printmaker, painter]* b.1918, Brooklyn, NY.
Addresses: Great Neck, NY. **Studied:** Skidmore College; Columbia Univ.; ASL; Raphael Soyer; Joseph Solman; Leo Manso. **Member:** NAWA; Long Island AA; Print Club, Phila.; fellow, MacDowell Colony. **Exhibited:** Pratt Graphics Center 3rd Int. Miniature Print Exh., 1968; PAFA 164th Ann., 1969; Int. Exh. Women Artists, Ontario & France, 1969; State Univ. NY, Potsdam 10th Print Ann., 1969-70; Nat. Exh. Prints & Drawings, Oklahoma AC, 1969-72. **Awards:** Vadley Art Co. Award for Graphics, Wolfe Art Club, 1967; purchase prize, Hunterdon AC, NJ, 1970; Mr. & Mrs. Benjamin Ganeles Prize, NAWA, 1971; Alonzo Gal., NYC, 1970s. **Work:** Univ. Massachusetts, Amherst; NJ State Mus., Trenton. **Sources:** WW73.

QUAT, Judith Gutman *[Painter, graphic artist, teacher]* b.1903, Radom, Poland.
Addresses: Lewisburg, PA. **Studied:** Hunter College; ASL; R. Laurent. **Member:** United Am. Artists; Young Am. Artists; ASL. **Exhibited:** Salons of Am., 1933; 8th St. Playhouse, NYC (solo); ACA Gal., NYC, 1939; WFNY 1939; S. Indp. A., 1941-42. **Work:** Temple Rodeph Shalom, NYC; ASL. **Sources:** WW40.

QUATTROCCHI, Edmondo *[Sculptor]* b.1889, Sulmona, Italy / d.1966.
Addresses: Long Island City, NY. **Studied:** CUA Sch.; ASL; in Paris; Philip Martiny; D.C. French; C.C. Rumsey; F. MacMonnies. **Member:** NA; All. Artists Am.; NSS; AAPL; Int. Inst. Arts & Letters. **Exhibited:** Salon des Artistes Françaises, Paris; Bossuet Mus., Meaux, France; Sheldon Swope MA, Terre Haute, IN; MMA; NSS (prize); NAD; IBM; All. Artists Am. (prize); AAPL, 1958 (prize). Other awards: Chevalier, Legion d'Honneur, France. **Work:** bronze tablet, Clock Tower Square and statue, Roslyn, NY; statue, Pelham Bay Park, NY; portrait busts, NYPL; Council on Foreign Relations, NY; NYU Hall of Fame. Also many bas-reliefs and medals. In France, monument (des. by Mac Monnies) commemorating the Battle of the Marne, gift from America to France. **Sources:** WW66; WW47.

QUAVER, Paul J. *[Painter]* mid 20th c.
Addresses: Chicago area. **Exhibited:** AIC, 1941. **Sources:** Falk, AIC.

QUAW, John C. *[Portrait painter]* mid 19th c.
Addresses: Albany, NY in 1852. **Sources:** G&W; Troy and Albany BD 1852.

QUAYTMAN, Harvey *[Painter]* b.1937, Far Rockaway, NY.
Studied: Syracuse Univ.; Tufts Univ.; BMFA School (B.F.A.; J.W. Paige traveling fellowship, 1960-61). **Exhibited:** Inst. Contemp. Art, Houston, TX, 1967; WMAA, 1969 & 1972; L'Art Vivant Aux États Unis, Fondation Maeght, St. Paul de Vence, France, 1970; Structure of Color, WMAA, 1970; AIC Biannual, 1972; Paula Cooper Gal., NYC, 1970s. **Work:** Pasadena AM; WMAA; Dartmouth College; Houston Mus. FA; Mus. Modern & Experimental Arts, Santiago de Chile. **Comments:** Teaching: BMFA Sch; Middlebury College; Essex College Art, Colchester, England; Sch. Visual Arts, NY; Cooper Union in 1973. **Sources:** WW73.

QUEBY, John *[Sculptor]* b.c.1808, Florida.
Addresses: NYC in 1850. **Sources:** G&W; 7 Census (1850), N.Y., XLIII, 22.

QUEEN, James *[Lithographer]* b.1824, Philadelphia / d.c.1877.
Addresses: Philadelphia. **Studied:** lithography with Wagner & McGuigan, Phila. **Comments:** Produced much work for P.S. Duval (see entry) in Philadelphia. A number of the illustrations for the *U.S. Military Magazine* (1840-42) were drawn and lithographed by him. **Sources:** G&W; Peters, *America on Stone*; Todd, "Huddy & Duval Prints"; Stokes, *Historical Prints*; *American Collector* (June 1942), 14 (repro.); Perry, *Expedition to Japan*; 7 Census (1850), Pa., LV, 194.

QUELY, John See: **QUEBY, John**

QUERIDO, Zita *[Painter, teacher, lecturer]* b.1917, Vienna, Austria.
Addresses: NYC. **Studied:** Hans Hofmann Sch. FA. **Member:** AFA; Nat. Comm. Art Educ. **Exhibited:** Miami MOMA, 1964; Provincetown Group, 1958; São Paulo, Brazil, 1965; Bodley Gal., NY, 1957(solo), 1961(solo), 1962(solo). **Work:** MOMA, São Paulo, Brazil; MOMA, Rio de Janeiro; MoMA, New York (lending); Rose AM, Brandeis Univ.; Arkansas AC; Smith College Mus.; Andrew Dickson White, Mus., Cornell Univ.; Peabody College; Ft. Lauderdale MA; Jewish Mus., NY. **Comments:** Position: dir./instr., Riverdale FA Soc., NY. Work presented on ABC-TV and NBC-TV; also, broadcast on work over "Voice of America." **Sources:** WW66.

QUESENBURY, William *[Portrait & topographical painter, cartoonist]* b.1822, Fayetteville, AR / d.1888, Fayetteville.
Addresses: Fayetteville. **Comments:** Quesenbury (pronounced "Cushenbury") was well known throughout Arkansas as an editor of the *Arkansian* to which he also contributed cartoons under the name of "Bill Cush." He also made views of Fayetteville buildings. In 1851 he was editor of the *Sacramento Union*, Sacramento, CA. That same year he joined J. Wesley Jones (see entry) and others on a sketching trip in Nevada, Utah and California. **Sources:** G&W; WPA Guide, *Arkansas*, 313; Hughes, *Artists of California*, 453.

QUESNAY DE BEAUREPAIRE, Alexander-Marie (Chevalier) *[Teacher of painting & drawing]* b.1755, Saint-Germain-en-Viry, France / d.1820, Saint Maurice (Seine), France.

Comments: Born into nobility, Quesnay entered the *Gendarmes de la Garde du Roi* when he was a young man. In April 1777 he arrived in Virginia to serve under Lafayette, but in the fall of 1778 had to retire because of illness. He spent the next two years in Gloucester County, VA, at the home of John Peyton. In 1780 he went to Philadelphia and ran a school there for four years. In 1784 he moved to NYC where he advertised as a teacher of French, drawing, and dancing. In 1785 he returned to Virginia and conceived of a plan to establish in Richmond an Academy of Arts and Sciences, a "universal academy" of science, natural history and the fine arts, with branches in other American cities and affiliations abroad. He offered his first classes in the fine arts in the fall of 1785 and the cornerstone of what was to be the main building was laid in June of 1786. Quesnay went back to France at the end of 1786 hoping to raise money for this project but his efforts were not successful, in great part because of the coming of the French Revolution. Quesnay spent the remainder of his life in France, except for a brief exile during the Revolution. **Sources:** G&W; DAB; Kelby, *Notes on American Artists*, 18-24. More recently, see Gerdts, *Art Across America*, vol. 2: 13-14.

QUEST, Charles Francis *[Painter, educator, etcher, engraver, sculptor] b.1904, Troy, NY / d.1993, Tryon, NC.*
Addresses: St. Louis, MA/Webster Groves, MO; Tryon, NC, 1971-on. **Studied:** Wash. Univ. Sch. FA, 1924-29; advanced study in Paris, France, 1929; summer study, Spain, France & England, 1960; Fred Carpenter; Edmund Wuerpel. **Member:** St. Louis AG; SAGA; Missouri State Teachers Assn. **Exhibited:** Les Peintres Graveurs Actuels Aux États-Unis, Bibliothèque Nat., Paris, 1951; Am. Watercolor, Drawings & Prints Exh., MMA, New York, 1952; Art in the Embassies Program, Dept. of State, Washington, DC, 1967; 51st Exh., SAGA, New York, 1971; NGA; MoMA, 1933; CGA; CI; NAD; SFMA; CAM, 1932-46, 1944 (prize; AIC, 1942; 1942; WFNY 1939; Swope Art Gal.; SAM; Springfield MA, 1945 (prize); Kansas City AI, 1932 (medal); CAFA; Smith College; San Diego FAS; CM; CMA; LOC 1945, 1946; St. Louis AG, 1923 (prize), 1924, 1925 (prize), 1926, 1927 (prize), 1928, 1929, 1930 (prize), 1932 (prize,) 1933, 1937, 1942, 1945, 1946. Additional awards: purchase prize, 3rd Ann. Nat. Print Exh., BM, 1949; purchase prize, Nat. Print Exh., LOC, 1952; purchase prize, 51st Ann. Print Exh., SAGA, 1971. **Work:** British Mus., London, England; Victoria & Albert Mus., London; Bibliothèque Nat., Paris; MoMA; MMA; U.S. War Dept., Wash., DC; Univ. Wisconsin; Munson-Williams-Proctor Inst.; CAM; Springfield MA; LOC; Carpenter Branch Lib.; St. Mary's Church, Helena, AR; Hotel Chase, St. Louis; Pub. Sch., University City, Munic. Auditorium, St. Louis; baptistry murals, St. Michael & St. George Episcopal Church, St Louis, MO, 1934; altar painting, Trinity Episcopal Church, St. Louis, 1935; altar painting, Old Cathedral, St. Louis, 1959-60. **Comments:** Preferred medium: oils. Teaching: St. Louis Public Schools, 1929-44; Wash. Univ. Sch. FA, 1944-70s. **Sources:** WW73; WW47; article, *St Louis Post Dispatch*, 1960; demonstration of printmaking, 1968 & demonstration of figure drawing, 1968, "Art in St Louis," (program produced on KMOX-TV, St. Louis).

QUEST, Dorothy (Mrs. Chas. F. Johnson) *[Painter, instructor, sculptor, lecturer] b.1909, St. Louis, MO.*
Addresses: Tryon, NC. **Studied:** St. Louis Sch. FA; Wash. Univ. Sch. FA, 1928-33; study in Europe, 1929; Columbia Univ., summer 1937; C.F. Quest; E. Wuerpel; F.G. Carpenter; G. Goetch. **Member:** St. Louis AG; Tryon Painters & Sculptors, Inc. (chmn. exhibs. out-of-town artists, 1970-); Spartanburg AA. **Exhibited:** CAM, 1932, 1934, 1938-40; St. Louis AG, 1935, 1938, 1940; 7 solos: 1933, 1939, 1940, 1943, 1945, 1951, 1955; Tryon FA Center, NC, 1972 (solo). **Work:** Olin Library, Wash. Univ., St. Louis; St. Louis Univ. Medical Sch.; Univ. Eastern Illinois, Charleston; Eden Seminary, St. Louis; Washington & Lee Univ., VA. Commissions: sixteen murals for sanctuary, Church of Epiphany, St. Louis, 1948; assisted C.F. Quest, Helena, AR, St. Louis, MO, church murals; twelve mem. portraits, Dodge Mem. Hall, Boston, MA, 1957; Mrs. Clay Jordan, philanthropist, Mem. home, St. Louis, 1963; John Lilly, pres., St. Louis Co. Nat. Bank,

1963; Pierre Laclede, Pierre Laclede Bldg., St. Louis, 1964; plus over 600 portraits, 1931-72. **Comments:** Preferred media: oils. Position: teacher, Community Sch., Clayton, MO, 1936-38; Sacred Heart Acad., St. Louis, 1939-41; Maryville College, St. Louis, 1945. **Sources:** WW73; Eloise Lang, article, *St Louis Post Dispatch*, 1965; Walter Orthwein, article, 1967 & Lynn Hawkins, article, *St Louis Globe Democrat*, 1969.

QUEST, E. Eloise *[Painter] early 20th c.*
Addresses: Brooklyn, NY/Columbus, OH. **Sources:** WW25.

QUESTY, Jacob *[Sculptor, marble cutter] b.c.1843, Louisiana.*
Addresses: New Orleans, active 1880. **Comments:** "Mulatto" artist, working with Joseph Llulla. **Sources:** *Encyclopaedia of New Orleans Artists,* 316.

QUICK, Birney MacNabb *[Painter, educator] b.1912, Proctor, MN.*
Addresses: Minneapolis, MN. **Studied:** Vesper L. George Sch., Boston; Minneapolis College Art & Design; Louis Comfort Tiffany & Chaloner fellowships, 1938. **Exhibited:** Am. P&S Show, AIC; Minnesota Biennial, Minneapolis AI, 1960 (award in drawing); Independent Artist's Show, Boston; Walker AC (solo); Minneapolis AC (solo); Tweed Gal., Univ. Minnesota, Duluth; Martin Gal., Minneapolis, 1970s. **Work:** Minneapolis AI; Univ. Minnesota Art Coll.; General Mills Coll.; Int. Multifood Corp. Coll.; Northwestern Nat. Life Coll.; Medical Arts Bldg., Duluth, MN, 1946; Minnesota Mutual Life Ins. Co., Saint Paul, 1958; Minnesota Fed. Savings Loan, St. Paul, 1960; Grand Marais St. Bank, MN, 1968; St. John's Catholic Church, Grand Marais, 1972. **Comments:** Preferred media: oils, watercolors. Positions: dir., studies abroad, Am. College Art, 1970-71. Teaching: Minneapolis Sch. Art, 1946-. **Sources:** WW73.

QUICK, H. B. *[Engraver] mid 19th c.*
Addresses: New Orleans, 1856. **Sources:** G&W; Delgado-WPA cites New Orleans CD 1856.

QUICK, Isaac *[Portrait painter] 19th c.*
Addresses: Active in New Jersey. **Comments:** Painter of a portrait of Jacob Throckmorton owned in 1940 by a descendant (of the sitter) in Watchung, NJ. **Sources:** G&W; WPA (N.J.), Historical Records Survey.

QUICK, Israel *[Portrait painter, photographer, teacher] b.c.1830, New York / d.1901.*
Addresses: NYC in 1850; Cincinnati, active 1857 to c.1897. **Member:** Cincinnati AA; Cincinnati Sketch Club. **Exhibited:** Cincinnati AA Ann. Exh., 1866-67; Wiswell's Art Gal., 1867; Cincinnati Indust. Expo, 1870. **Work:** Cincinnati MA. **Comments:** Known primarily as a portrait painter, he was listed in 1862 as a photographic artist in a firm called Hoag and Quick. **Sources:** G&W; 7 Census (1850), N.Y., L, 381; Gerdts, *Art Across America*, vol. 2: 194, 196, 197; *Cincinnati Painters of the Golden Age*, 94-95 (w/illus.).

QUICK, William *[Wood engraver] b.c.1843, New York.*
Addresses: NYC in 1860. **Sources:** G&W; 8 Census (1860), N.Y., XLVIII, 1063.

QUIDOR, George W. *[Engraver, music publisher] b.c.1817, New York.*
Addresses: Active in NYC in the early 1850s. **Sources:** G&W; 7 Census (1850), N.Y., LV, 891; NYBD 1854; Peters, *America on Stone*.

QUIDOR, John *[Painter of literary & genre scenes] b.1801, Tappan, NY / d.1881, Jersey City, NJ.*
Studied: briefly apprenticed to John Wesley Jarvis, sometime between 1814-22. **Exhibited:** NAD, 1828-39, 1847 ; PAFA, 1857-58; Boston Athenaeum. **Work:** Yale Univ. Art Gal.; Brooklyn Mus.; BMFA; NGA; Shelburne (VT) Mus.; Detroit IA; Munson-Williams-Proctor Inst., Utica, NY. **Comments:** Best known as a painter of romantic and literary-inspired subjects, particularly drawn from the stories of Washington Irving and James Fenimore Cooper. He grew up in Tappan and NYC, and spent his career in

NYC, except for a period in Quincy, IL, from 1837-c.1850. Early in his career he worked painting signs and fire engine panels but is also known to have painted a scene from "Don Quixote" in 1823. By the late 1820s, after an apprenticeship with J.W. Jarvis, he listed himself as a portrait painter in the NYC directories. However, no portraits by him are known; instead, he earned his reputation for his literary subjects such as the famous "Ichabod Crane Pursued by the Headless Horseman" (1828, Yale); "The Money Diggers" (1832, Brooklyn Mus.); as well as scenes from the tale of Rip Van Winkle. While living in Illinois, Quidor continued to pursue his fascination with stories by Irving, especially Rip Van Winkle ("Return of Rip Van Winkle," NGA). He also received a commission from a Mr. R.E. Smith (in 1844) to paint a series of seven religious paintings (all are unlocated today). These were intended to be taken on tour and some actually were shown in New York in 1847, but Smith eventually broke the agreement and Quidor left Quincy and returned to NYC. He retired in 1868 to his daughter's home in Jersey City. Quidor's romantic and often visionary treatment of literary themes was out of step with the mid-nineteenth century taste for realism, and his career as an artist, although promising at first, was not a very successful one. He was virtually forgotten until the 1940s when a show at the Brooklyn Museum (1942) revived interest in his work. **Sources:** G&W; Baur's *John Quidor,* was the text for the 1942 Brooklyn Mus. exhibition and contains many illustrations and a catalogue of his work. See also; Cowdrey, NAD: Cowdrey, AA & AAU; Rutledge, PA; Swan, BA; 7 Census (1850), N.Y., L, 653. More recently, see Baigell, *Dictionary,* Gerdts, *Art Across America,* vol 2: 282-83; David Sokol, *John Quidor, Painter of American Legend* (exh. cat., Wichita Art Mus., 1973); Muller, *Paintings and Drawings at the Shelburne Museum,* 117 (with repro.); *300 Years of American Art,* vol. 1, 128.

QUIGLEY, Edward B. ("Quig") *[Painter, illustrator, sculptor, mural painter] b.1895, Park River, ND / d.1986.*
Addresses: Portland, OR in 1968. **Studied:** AIC; Chicago Acad. FA. **Work:** Merrhill MFA, Goldendale, WA; Nat. Cowboy Hall of Fame. **Comments:** Specialty: animals & cowboy genre. Positions: art dir., Chicago publishing companies. **Sources:** P&H Samuels, 386; The Cœur d'Alene Art Auction, July 25, 1998.

QUIGLEY, Ellen Louise *[Painter] mid 20th c.*
Addresses: Manchester, NH/East Gloucester, MA. **Studied:** E. Gruppe; Manchester Inst. Arts & Sciences; ASL. **Member:** North Shore AA; Gloucester SA; Merrimack Valley AA. **Work:** Tufts College, Boston. **Sources:** WW40.

QUIGLEY, W. S(mithson) *[Painter] early 20th c.*
Addresses: NYC. **Exhibited:** S. Indp. A., 1929, 1930. **Comments:** Possibly Quigley, Wirt S., b. Montour Falls, NY, 1874-d. 1944, NYC. **Sources:** Marlor, *Soc. Indp. Artists.*

QUILLAUMIN, Armand *early 20th c.*
Exhibited: Salons of Am., 1923. **Sources:** Marlor, *Salons of Am.*

QUILLIAM, John *[Engraver] mid 19th c.*
Addresses: New Orleans, active 1858-77. **Sources:** G&W; Delgado-WPA cites New Orleans CD 1859; additional references are cited in *Encyclopaedia of New Orleans Artists.*

QUILLIN, Ellen S. (Mrs.) *[Museum director] mid 20th c.*
Addresses: San Antonio, TX. **Sources:** WW59.

QUIMBY, Fred(erick) G. *[Marine painter] b.1863, Sandwich, NH / d.1923, Arlington, MA.*
Addresses: Boston, MA. **Member:** Boston AC. **Exhibited:** Boston AC, 1908-09; S. Indp. A., 1917. **Sources:** WW21; *The Boston AC.*

QUIMBY, Helen Ziehm *[Sculptor] mid 20th c.*
Addresses: Chicago area. **Exhibited:** AIC, 1944, 1946. **Sources:** Falk, *AIC.*

QUINAN, Henry B(rewerton) *[Art director] b.1876, Sitka, AK.*
Addresses: NYC. **Studied:** Acad. Julian, Paris, with J.P. Laurens, 1901-02. **Member:** SC; SI; Art Dir.; AFA. **Comments:** Position:

art dir., Crowell Publishing Co. **Sources:** WW31.

QUINAN, Henry R. *[Illustrator] mid 20th c.*
Addresses: Glenbrook, CT. **Member:** SI. **Sources:** WW47.

QUINBY, Josephine *[Painter] late 19th c.*
Addresses: Active in Wash., DC. **Exhibited:** Soc. Wash. Artists, 1892. **Sources:** Petteys, *Dictionary of Women Artists.*

QUINCKE, Julie *[Lithographer] early 19th c.*
Work: Avery Coll., NYPL. **Comments:** Known for a litho dated 1820. **Sources:** Petteys, *Dictionary of Women Artists.*

QUINCY, C. B. *[Painter] early 20th c.*
Addresses: Norwood, OH. **Member:** Cincinnati AC. **Sources:** WW17.

QUINCY, Edmund *[Painter, drawing specialist] b.1903, Biarritz, France.*
Addresses: Boston 14, MA. **Studied:** Harvard College; Albert Herter, Georges Degorce, George Noyes, F. Whiting; ASL. **Member:** Newport AA; Contemp. Artists. **Exhibited:** Salon d'Automne, 1928-29, 1935-36, 1951-53; Springfield AL, 1929; Salons of Am., 1929-31; Salon des Tuileries, 1938; PAFA Ann., 1932, 1937 (prize), 1942, 1945; Syracuse AA, 1940 (prize); Corcoran Gal. biennials, 1951-59 (3 times); AIC, 1937, 1943; Carnegie Inst., 1941-45; WMA, 1936; Newport AA, 1941-45; Ogunquit AC, 1941; NY State Exh., 1941; Ars Sacra, Naples, 1951; Bordighera, 1952; Venice, 1950; Turin, 1951; Gal. Lucy Krogh, Paris, 1955; Gal. Marcel Bernheim, Paris, 1955; Boston Atheneum, 1955 (solo); Gal. La Bussola, Turin, 1951; Gal. Marseille, Paris, 1953; Gal. de l'Institut, Paris, 1955. **Work:** Musée de Grenoble, France; Univ. Arizona; PAFA. **Sources:** WW59; WW47; Falk, *Exh. Record Series.*

QUINCY, Henrietta S. *[Painter] late 19th c.*
Addresses: Active in Los Angeles, 1884-92. **Comments:** Painted scenes of San Pedro, CA. **Sources:** Petteys, *Dictionary of Women Artists.*

QUINER, Joanna *[Portrait sculptor] b.1801 / d.1873.*
Addresses: Beverly, MA. **Exhibited:** Boston Athenaeum, 1846-48. **Sources:** G&W; Swan, BA; Petteys, *Dictionary of Women Artists,* reports alternate birth date of 1796 and a death date of 1869.

QUINLAN, Patricia *[Artist] mid 20th c.*
Addresses: Detroit, MI. **Exhibited:** PAFA Ann., 1960. **Sources:** Falk, *Exh. Record Series.*

QUINLAN, Will J. *[Painter, etcher] b.1877, Brooklyn, NY.*
Addresses: Yonkers, NY. **Studied:** Adelphi College with J.B. Whittaker; NAD with Maynard and E. Ward. **Member:** SAE; Yonkers AA. **Exhibited:** AIC, 1911, 1915-19; SC, 1913 (prizes), 1914 (prize); Pan-Pacific Expo, 1915; PAFA Ann., 1915, 1917-18; Corcoran Gal. biennials, 1916-21 (3 times); S. Indp. A., 1917-18; Los Angeles PM, 1920; Yonkers AA, 1932 (prize); Yonkers Mus. Science & Art, 1939. **Work:** NYPL; Oakland Public Mus.; Yonkers Mus. Science & Art. **Comments:** Quinlan enjoyed sketching in shipyards, but during the WWI period was arrested as a spy. He made at least one trip to the West Coast, c.1914. It has been noted that the artist was hearing-impaired. **Sources:** WW40; Art in Conn.: The Impressionist Years; Falk, *Exh. Record Series.*

QUINN, Anne Kirby *[Painter] early 20th c.; b.Hillsborough, OH.*
Addresses: Paris, France. **Studied:** R. Miller in Paris, c.1913. **Exhibited:** AIC, 1912; PAFA Ann., 1912. **Sources:** WW15; Falk, *Exh. Record Series.*

QUINN, Edmond T. *[Sculptor, painter] b.1868, Phila., PA / d.1929.*
Addresses: Phila., PA; NYC. **Studied:** T. Eakins in Phila.; Injalbert in Paris. **Member:** ANA; NSS, 1907; Arch. Lg., 1911 NIAL; Newport AA; New SA; Art Comm. Assoc., NY. **Exhibited:** NAD, 1891, 1893; PAFA Ann., 1891-1930; AIC, 1895-1928; Boston AC, 1899; Corcoran Gal. annual, 1907; Pan-Pacific Expo, San Fran., 1915. **Work:** Statue, Williamsport, PA;

Brooklyn Inst. Arts & Sciences; King's Mountain Battle Mon., SC; E.A. Poe bust, Poe Park, Fordham, NY; Pittsburgh Athletic Club; MMA; Vicksburgh, Mississippi Nat. Military Park; Gramercy Park, NYC; busts, BM; New Rochelle, NY; bust, Hall of Fame; Gov. Venezuela. **Sources:** WW27; Falk, *Exh. Record Series.*

QUINN, Henrietta Reist *[Collector] b.1918, Lancaster, PA.*
Addresses: Cornwall, PA. **Studied:** Edgewood Park Jr. College. **Comments:** Collection: Am. primitive paintings; 18th c. porcelain; 18th c. miniature memorabilia; 18th c. Am. & English furniture. **Sources:** WW73.

QUINN, John *[Patron] b.1870 / d.1924, NYC.*
Comments: He conducted the campaign which resulted in the removal of all duty on modern works of art brought into this country. He was also one of the founders of the AAPS, which organized the 1913 Armory Show in NYC, and was a benefactor of the MMA.

QUINN, John C. *[Painter] early 20th c.*
Addresses: St. Paul, MN. **Sources:** WW13.

QUINN, Lawrence *[Painter] mid 20th c.*
Exhibited: S. Indp. A., 1941. **Sources:** Marlor, *Soc. Indp. Artists.*

QUINN, Lucille *[Listed as "artist"] early 20th c.*
Addresses: New Orleans, active c.1916. **Exhibited:** NOAA, 1916. **Sources:** *Encyclopaedia of New Orleans Artists,* 316.

QUINN, M. Hayes *[Painter] early 20th c.*
Addresses: Chicago. **Exhibited:** AIC, 1920. **Sources:** Falk, *AIC.*

QUINN, Noël Joseph *[Painter, illustrator, educator] b.1915, Pawtucket, RI / d.1993, Los Angeles, CA.*
Addresses: Los Angeles. **Studied:** RISD (grad., 1936; fellowship, Paris, France); Parsons Sch. Fine & Applied Arts, Paris & Italy (cert. dipl.); École des Beaux-Arts; Andre Lhote & Andre Cassandre; Nat. Gal. & Kaiser Frederick Mus., Berlin, Germany. **Member:** Calif. Nat. WCS (pres., 1962-63); Soc. Motion Picture Illustr. (pres., 1963-65). **Exhibited:** Am. Paintings & Prints, MMA, 1952; Hallmark Int. Show, Wildenstein Gals., NYC, 1953; Southwest WCS. Show, Southern Methodist Univ., 1969; Yoseido Gal., Tokyo, Japan, 1955 (solo). Awards: State Agric. Comt., Calif. State Fair, 1949 (first prize); Hallmark Int. Award, 1952; Watercolor USA, Springfield AM, 1964 (prize). **Work:** Butler AI, Youngstown, OH; Air Force Acad.; Pentagon, LOC & House of Representatives; Calif. State Agriculture Coll., Sacramento; Los Angeles Turf Club, Santa Anita Park, Arcadia, CA. Commissions: Santa Anita Portfolio, Los Angeles Turf Club, 1960. **Comments:** Preferred media: watercolors. Teaching: Otis Art Inst., 1953-; Los Angeles City College, 1972. Art interests as stated in 1973: "Part of each year devoted to educating the blind in terms of their sight by their study and active participation in art work; creator of new language of symbols for color and value in bas-relief; paintings reproduced in the language overlay provide the pertinent clues which enable them to complete the picture." Auth.: article, *Am. Artist Magazine,* (May, 1963); "Scene," *Southwestern Watercolor Soc. Magazine.* **Sources:** WW73; add. info courtesy Helen R. Quinn, Los Angeles, CA.

QUINN, Robert Hayes *[Illustrator, graphic artist, writer, commercial artist] b.1902, Waterford, NY / d.1962, Biddeford, ME.*
Addresses: Mechanicville, NY. **Studied:** Syracuse Univ.; PIA Sch., Albany, Schenectady & Troy, NY. **Exhibited:** Cooperstown, NY, 1953, 1954; Schenectady MA, 1953; Kennedy Gal., NY, 1953. **Comments:** Positions: mem., Young Adult Council, YMCA; bd. dir., secy., Mechanicville YMCA; instr., Adult Educ. Classes, Mechanicville H.S.; staff artist, *Trails* magazine, Esperance, NY, 1935-46. Contrib.: *Yankee; Rural New Yorker; New England Homestead.* **Sources:** WW59; WW47.

QUINN, Stephen J. *[Commercial artist, painter] early 20th c.*
Addresses: San Francisco, CA, 1922-35. **Exhibited:** East West Art Soc., San Fran., 1922. **Sources:** Hughes, *Artists of California,* 453.

QUINN, Thomas *[Painter, illustrator] b.1939, Honolulu, HI.*
Addresses: Point Reyes (Marin County), CA. **Studied:** College of Marin; AC College of Design, Los Angeles, 1958-63. **Exhibited:** Many exhibitions since 1975, including the annual Birds in Art exhs. at the Leigh Yawkey Woodson Art Mus., Wausau, WI; Frederic Remington AM, Ogdensburg, NY, 1988 (retrospective); "Natural Habitat: Contemp. Wildlife Artists of North Am., " Spanierman Gal., NYC, 1998. **Comments:** Wildlife watercolorist, well known for his paintings depicting Canadian geese. Began as illustrator in NYC, contributing to *Saturday Evening Post, Readers Digest, Argosy, Field and Stream,* and other popular magazines. While recovering from a serious accident in 1966, he began painting the Canada geese near his home in Connecticut. After moving to Marin County, CA, he made painting his full-time endeavor by 1974. **Sources:** William H. Gerdts and David J. Wagner, *Natural Habitat: Contemporary Wildlife Artists of North America* (exh. cat., NYC: Spanierman Gallery, 1998).

QUINN, Vincent Paul *[Painter, cartoonist] b.1911.*
Addresses: Chicago, IL. **Studied:** AIC; Univ. Chicago. **Exhibited:** AIC, 1936. **Work:** Coll. Chicago Public School AS. **Sources:** WW40.

QUINONES, Albert J. *[Landscape painter] early 20th c.*
Addresses: Oakland, CA, 1920s-30s. **Exhibited:** Oakland Art Gal., 1929. **Sources:** Hughes, *Artists of California,* 453.

QUINT, Bernard *[Painter] mid 20th c.*
Exhibited: S. Indp. A., 1940. **Sources:** Marlor, *Soc. Indp. Artists.*

QUINT, Louis H. *[Engraver] b.c.1824, Maine.*
Addresses: Philadelphia in 1850. **Sources:** G&W; 7 Census (1850), Pa., LI, 836 (living with his wife, also from Maine, and infant son, Silas H., born in Pennsylvania).

QUINTANA, Ben *[Painter, muralist] b.1923, Cochiti Pueblo, NM / d.1944, WWII Pacific Theater at Leyte.*
Studied: Santa Fe and Cochiti Pueblo Indian schools; Tonita Pena & Geronima Montoya. **Work:** Gilcrease Inst.; Mus. Am. Indian; Philbrook AC. **Comments:** A Native American, he won a poster contest at age 15 and again at 17 vs. 52,000 entries. **Sources:** P&H Samuels, 386.

QUINTANA, Joe *[Painter] mid 20th c.; b.Cochiti Pueblo, NM.*
Work: Mus. Northern Arizona, Katherine Harvey Coll., Flagstaff. **Sources:** P&H Samuels, 386.

QUINTANILLA, Luis *[Painter, graphic artist, lecturer] b.1895, Santander, Spain.*
Addresses: New York 11, NY. **Studied:** Jesuit Univ. Deusto, Spain; Gov. Travelling Fellowship, Italy. **Exhibited:** WFNY 1939; Pierre Matisse Gal., 1934 (solo); MoMA, 1938; All. Artists Am., 1939; New Sch. Social Research, 1940; Corcoran Gal. biennial, 1941; Knoedler Gal., 1944; de Young Mem. Mus., 1944; WMAA, 1942. **Work:** MOMA Madrid; MOMA Barcelona; Musée d'Art Decoratif, Paris; MoMA; MMA; AIC; Princeton Univ.; BM; Univ. Kansas City, MO; Spanish Consulate, Hendaye, France. **Comments:** Illustr.: "All the Brave," 1939; "Franco's Black Spain," 1945; "Gulliver's Travels," 1947; "Three Exemplary Novels," 1950. **Sources:** WW59; WW47.

QUINTIN, Audrey *[Artist] early 20th c.*
Addresses: Wash., DC, active 1909. **Sources:** McMahan, *Artists of Washington, DC.*

QUINTIN, D. S. *[Lithographer] mid 19th c.*
Studied: Alfred Hoffy in Philadelphia, c.1841. **Sources:** G&W; Peters, *America on Stone.*

QUINTMAN, Myron *[Painter, etcher] b.1904, NYC.*
Addresses: Brooklyn 13, NY. **Studied:** CUA Sch.; Educ. All., NY; Brooklyn Art Sch.; William Auerbach-Levy. **Exhibited:** LOC, 1945-46; NAD, 1946; SAE, 1945; Laguna Beach AA, 1945; Newport AA, 1945; Northwest PM, 1946. **Sources:** WW53; WW47.

QUINTON *[Miniaturist] early 19th c.*

Comments: Reputed to have painted a Mrs. Burroughs, aged 92, in 1804. **Sources:** G&W; Sherman, "Some Recently Discovered Early American Portrait Miniaturists," 294.

QUINTON, Cornelia Bentley Sage See: **SAGE, Cornelia Bentley**

QUINTON, W. W. (Mrs.) See: **SAGE, Cornelia Bentley**

QUIRK, Francis Joseph *[Painter, museum director, designer, teacher, writer, lecturer] b.1907, Pawtucket, RI / d.1974.*
Addresses: Rydal, PA; Bethlehem, PA. **Studied:** RISD (grad., 1929); Univ. Penn., 1942; Provincetown Sch. Art; Woodstock, NY; Italy, France; Germany; Czechoslovakia; J.R. Frazier; F. Sisson. **Member:** Phila. AC; Univ. Club; AAPL; Art All. Phila.; Am. Assn. Mus.; AFA. **Exhibited:** PAFA; PMA; NAD; CGA; Buffalo & Syracuse, NY; Newport, RI; Portland, ME; Providence, RI; Phoenix Gal., NYC, 1970s; Ogunquit Gal., ME, 1970s. Awards: RISD (prize); Providence AC (prize); Tiffany Found. fellowship, 1940; Lineback Award, 1965; Ossabaw Island Project, 1968 & 1972. **Work:** NPG; Canton (OH) Art Inst.; Georgia MA, Athens; Univ. Notre Dame, Inc. Commissions: portrait of Pres. Strider, Colby College Alumni, ME; portrait of Dr. John Leitner, bd. dir., Monroe Co. Medical Center; portrait of pres., Lehigh Univ.; portrait of Carl Sandberg, commissioned by Pres. Abby Sutherland Brown, Ogontz College, PA; portrait of Edgar Lee Masters, commissioned by Writers Guild PA. **Comments:** Preferred media: oils, acrylics, watercolors, charcoal, pastel, ink. Teaching: Montgomery Sch., 1930-35, 1938-45; Ogontz College, PA, 1935-50; Hussian Sch. Arts, Philadelphia, 1943-50; chmn. fine arts, Lehigh Univ., 1950-69. Position: dir. exhs., Lehigh Univ., 1950-; cur. permanent coll., 1959-. Publications: "These Our Own" (TV program), WFIG TV, 1959-61; "Art & Us" (TV & radio program), Lehigh Valley & Easton, 1961; auth., "Maurice Prendergast," Arizona State Univ., 1965. Art interests: library and art collection of the Ossabaw Island Project. Collection: Oriental prints; contemp. Am. prints; primitive Am. paintings. **Sources:** WW73; WW47.

QUIRK, Thomas Charles, Jr. *[Painter, educator] b.1922, Pittsburgh, PA.*
Addresses: Kutztown, PA. **Studied:** Edinboro State College (B.S., 1948); Univ. Pittsburgh (M.Ed., 1964). **Member:** Phila. WCC. **Exhibited:** PAFA Ann., 1958, 1960; PAFA, 1969; NAD, 1971; Am. Drawing Biennial XXIV, Norfolk, VA, 1971; Drawing & Small Sculpture Ann., Ball State Univ., 1971; Phila. WCC Ann., 1972; Larcada Gal., NYC. Awards: Phila. WCC Ann., 1970 (hon. men.); Drawing Ann., Ball State Univ., 1971 (prize). **Work:** Butler IA, Youngstown, OH; Chatham College, Pittsburgh; Pittsburgh Public Schools. **Comments:** Preferred media: watercolors, oils. Positions: artist-in-residence, Everhart Mus, Scranton, PA, 1972-. Teaching: Kutztown State College, 1966-. **Sources:** WW73; Falk, *Exh. Record Series.*

QUIROT, Charles *[Lithographer] mid 19th c.*
Addresses: San Francisco, 1850s. **Work:** Bancroft Lib., Univ. of Calif., Berkeley. **Comments:** Partner in Justh, Quirot & Co. (see entry for Justh) in 1851 and from 1851-53 had his own company. Specialized in views of California. **Sources:** G&W; Peters, *California on Stone;* Reps, cat nos. 66, 83, 150, 410.

QUIRT, Walter W.
[Painter, lecturer, teacher, etcher] b.1902, Iron River, MI / d.1968, Minneapolis, MN.
Addresses: NYC, 1930s-44; Michigan & Minneapolis, MN, c.1945-. **Studied:** Layton Sch. Art, 1921-23. **Member:** An Am. Group; Am. Artists Congress; Artists Union. **Exhibited:** AIC, 1926, 1929, 1947; Julian Levy Gal., NYC, 1936 (solo), 1937; WMAA, 1936-58; Pinacotheca Gal., NYC, 1942; DMFA (purchase award); Minneapolis Univ. Gal., Univ. Minnesota, 1980 (retrospective). **Work:** MoMA; Walker AC; WMAA; Newark Mus.; Wadsworth Atheneum; Univ. Minnesota; Univ. Iowa;. **Comments:** Social surrealist during the 1930s. Friend of James Guy (see entry). Passionate supporter of social content and

Surrealism in art as an effective combination for encouraging radical social change, in 1937 he spoke at the MoMA Symposium "Surrealism and Its Political Significance." He also wrote an essay "Wake Over Surrealism: With Due Respect to the Corpse" (c.1940, Pinacotheca Gal., NYC), in which he strongly criticized Dali and other Surrealists whose work he felt had degenerated into negativism and decadence. His own style moved through phases of figuration, fantasy, and abstraction, but always expressed his social and personal convictions. Teaching: Layton Sch. Art, 1924-29; Am. Artists Sch., NYC, 1940; Michigan State College, 1940s; Univ. Minnesota, 1945-66. WPA artist in NYC. **Sources:** WW47; WW66; P&H Samuels, 386; Wechsler, 42-43 and cat. nos. 107-110; *Walter Quirt: A Retrospective* (exh. cat., Univ. of Minn., 1980).

QUISGARD, Liz Whitney *[Painter, sculptor] b.1929, Philadelphia, PA.*
Addresses: Baltimore, MD. **Studied:** Maryland Inst. College Art (1949, B.F.A., summa cum laude); Morris Louis, 1957-60; Rinehart Sch. Sculpture (M.F.A., 1966). **Exhibited:** Baltimore Mus. Regional Exhib., 1958 (prize); Corcoran Gal biennial, 1963; Univ. Colorado Invitational Show, 1963; PAFA annual, 1964; Loyola College Invitational, 1966 (best in show); AIC, 1965; Univ. Maryland, 1969 (solo). Other awards: Rinehart fellowship, Maryland Inst., 1964-66. **Work:** Univ. Arizona Gallagher Mem. Coll., Tucson; Lever House, NYC; Univ. Baltimore; Hampton School, Towson, MD. Commissions: two murals, Belfort, Baltimore, 1954. **Comments:** Positions: theatre designer, Goucher College, Theatre Hopkins & Center Stage, Baltimore, 1966-; art critic, *Baltimore Sun*, 1969-70; area reviewer, *Craft Horizons Magazine*, 1969-70s. Teaching: Baltimore Hebrew Congregation, 1962-70s; Maryland Inst., Baltimore, 1965-; Goucher College, 1966-69; Univ. Maryland, Catonsville, 1969-70. Auth.: "Baltimore's Top Twelve," *Baltimore Magazine* (May, 1969); auth./illustr., "An Artist's Travel Log" (series of 3 articles), *Baltimore News Am.* (1971). **Sources:** WW73; Barbara Rose, review, *Art Int.* (Nov., 1962); review, *Arts Magazine* (Nov., 1962); Falk, *Exh. Record Series.*

QUISPEZ, Carlos *[Painter] mid 20th c.*
Exhibited: P&S Los Angeles, 1935. **Sources:** Hughes, *Artists of California*, 453.

QUIST, Elizabeth *[Painter, china painter] 19th/20th c.*
Addresses: Tennessee. **Comments:** Step-daughter of Thomas Campbell (1834-1914, see entry), she finished most of her step-father's paintings after his death. She also painted landscapes and did some china painting. **Sources:** Kelly, "Landscape and Genre Painting in Tennessee, 1810-1985," 80-81 (w/repro.).

QUISTGAARD, Harold Ivar de Rehling *[Painter] b.1914, NYC.*
Addresses: NYC. **Studied:** École de l'État, Acad. Colarossi & Grande Chaumière, all in Paris, France; NAD; Leonardo da Vinci Art Sch., NY; Colorado Springs FAC, with Boardman Robinson; ASL; New Orleans Art Acad. **Member:** Pirate's Alley Artists Group, Chartres St. AA, Assoc. Art Gal., Delgado MA, all in New Orleans, LA. **Exhibited:** École de l'État, Paris, 1931; École des Arts Decoratifs, Paris, 1932; Savannah AI, 1936; U.S. Nat. Exh., 1937; Schofield Barracks, Oahu, HI, 1940; Christmas Island, 1943; ASL, 1945; Assoc. Artists, New Orleans, 1951; Louisiana State Fair, 1952; Pirate's Alley, New Orleans, 1953; Delgado MA, 1954; Greenwich Village AC, 1961. Awards: prizes, Louisiana State Fair, 1952; Pirate's Alley Exh., 1953. **Work:** Bourbon House & Assoc. Artists Studio, both New Orleans; murals, Officer's Club, Christmas Island; Newport, NY. **Sources:** WW66.

QUISTGAARD, Johann Waldemar de Rehling *[Portrait painter] b.1877, Orsholtgaard, Denmark / d.1962, Copenhagen, Denmark.*
Addresses: NYC. **Studied:** Denmark. **Member:** Chicago AC; NY Genealogical & Biographical Soc.; SC. **Exhibited:** St. Louis World Fair, 1904; Arthur Tooth & Son Gal., N.Y., 1906; Guildhall A. Gal., London, 1907; French Miniature Soc., 1907, Royal

Acad., London, 1908; Walker A. Gal., Liverpool, 1908, 1924; Salon des Artistes Francais, 1907-1909, 1924-26; Royal Acad., Copenhagen, 1910; ASMP, 1912; Int. Exh. Miniatures, Ghent, Belgium, 1913; Reinhardt Gal., 1914; John Levy Gal., 1921; Durand-Ruel, Paris, 1925; Durand-Ruel, NY, 1927; Union League, NY, 1929; Salons of Am.; Decorator's Art Gal., 1935-37; Woman's Club, Charlotte, NC, 1935; Colorado Springs FAC, 1938; Denver AM, 1938; Roullier Gal., Chicago, 1942; Woman's Club, Rockford, IL, 1942, Chicago Art Club, 1943-46; Arthur Newton Gal., NY, 1944; Flint, MI, 1947; Newcomb-Macklin Gal., NYC, 1949. **Awards:** Knighthood of Danneborg, Denmark, 1919; Chevalier French Legion of Honor, 1926; Distinguished award, Art Dir. Club, 1944. **Work:** Mus. of the Kings of Denmark, Copenhagen; Christiansborg Castle and King's private coll. at Amalienborg Castle, Denmark; St. John's Cathedral, Denver; Washington Univ., St. Louis; NY Genealogical & Biographical Soc.; U.S. Dept. Agriculture & Treasury; Brookings Found., Wash., DC; many portraits of prominent persons. **Sources:** WW47.

QUITZOW, Bernard de *[Painter] late 19th c.*
Exhibited: Paris Salon, 1879 (drawing). **Sources:** Fink, *Am. Art at the 19th c. Paris Salons,* 382.

QUORTRUP, Earl *[Painter] early 20th c.*
Addresses: Delhi, NY. **Exhibited:** S. Indp. A., 1929-30. **Sources:** Marlor, *Soc. Indp. Artists.*

Aaron Sopher: *Connoisseur* (pen & ink, 1930s)

R

RAAB, Ada Dennett Watson (Mrs. Sidney Victor)
[Painter, writer] b.London, England / d.1950.
Addresses: NYC. **Studied:** London Univ.; F. Brown; W. Steer; Alice Fanner. **Member:** NAC; Wolfe AC. **Exhibited:** 1903-c.1940, Royal Soc. Artists, Birmingham, London Salon, New English AC; Royal Acad., Royal Hibernian Acad., Soc. Women Artists. **Work:** Royal Acad., London. **Sources:** WW47; Petteys, *Dictionary of Women Artists.*

RAAB, Ferdinand *[Portrait painter] mid 19th c.*
Addresses: NYC, 1850-62. **Comments:** This may be the Frederick Raab who exhibited "The Shepherd Boy" at the American Art-Union in 1849. **Sources:** G&W; NYCD 1850-62; Cowdrey, AA & AAU; represented in a private collection, NYC (1957).

RAAB, Francis *[Lithographer] b.1813, Germany.*
Addresses: NYC, 1848-54. **Sources:** G&W; 7 Census (1850), N.Y., XLIV, 251; NYBD 1848-54.

RAAB, George *[Painter, block printer, teacher, museum curator] b.1866, Sheboygan, WI / d.1943, Milwaukee.*
Addresses: Decatur, Il. **Studied:** Weimar Acad., Germany, with R. Lorenz; G. Courtois in Paris. **Member:** Wis. PS; Milwaukee AI (founder). **Exhibited:** AIC, 1902-03, 1909-11; Corcoran Gal annual, 1907; Milwaukee AI, 1917. **Work:** St. Paul Inst.; Milwaukee AI. **Comments:** Position: curator, Layton A. Gal., 1902-22. **Sources:** WW40.

RAABE, Alfred *[Illustrator] b.1872 / d.1913.*
Addresses: NYC.

RAASCH, Helen K. *[Artist] 20th c.*
Addresses: Ridgewood, NJ. **Exhibited:** PAFA Ann., 1942. **Sources:** Falk, *Exh. Record Series.*

RABB, Irving W. (Mr. & Mrs.) *[Collectors] 20th c.*
Addresses: Cambridge, MA. **Studied:** Mr. Rabb, Harvard Univ, AB, Harvard Bus Sch; Mrs. Rabb, Smith Col, AB, Radcliffe Col, AM. **Comments:** Collection: Twentieth century sculpture, including Henry Moore, Giacometti, Maillot, Arp, Lipshitz, Calder, Neuelson & Laurens; twentieth century drawings and collages, with emphasis on Cubism and sculpture drawings. **Sources:** WW73.

RABB, J. E. *[Painter] 20th c.*
Exhibited: S. Indp. A., 1935. **Comments:** Possibly Robb, J.E. **Sources:** Marlor, *Soc. Indp. Artists.*

RABBETH, James, Jr. *[Landscape painter] b.1824, London (England) / d.c.1858, Glastonbury, CT.*
Addresses: Glastonbury, CT, active c.1855-58. **Comments:** Painted a view of Curtisville (now Naubuc, part of Glastonbury, CT), c.1855. He died soon after his marriage in 1858 in Glastonbury. **Sources:** G&W; Conn. Hist. Soc. *Bulletin* (April 1947), 12-13.

RABILLON, Léonce *[Sculptor] b.1814 / d.1886.*
Addresses: Baltimore, MD. **Comments:** For many years a teacher of modern languages at Baltimore, he executed two portrait busts for the Peabody Institute in the early 1870s. **Sources:** G&W; Peabody Institute Cat. (1949), 3; Baltimore CD 1856+.

RABIN, Bernard *[Art restorer] b.1916, New York, NY.*
Addresses: Newark, NJ. **Studied:** Newark Art Sch; New Sch Social Res; Brooklyn Mus, with Sheldon & Caroline Keck; also restoration at the Uffizi, Florence, Italy. **Member:** Am Asn Mus; fel Int Inst Conserv. **Work:** (Restoration Works) Montclair Art Mus, Princeton Univ Art Mus, Carnegie-Mellon Mus, NJ Hist Soc, & in pvt collections. Commissions: Restoration of Monet's Water Lilies, MoMA, New York, 1959. **Comments:** Positions: Official restorer, Newark Mus, Montclair Art Mus Princeton Univ Art Mus, Carnegie-Mellon Mus & NJ Hist Soc; head Am restorers, Comt Rescue Ital art, 1967. Publications: Auth, articles, J Int Inst Conserv, 1959-1970. Teaching: Lectr, Int Conf Conservators, Lisbon, 1972. **Sources:** WW73.

RABIN, Jack *[Painter] 20th c.*
Addresses: Los Angeles, CA, 1930s. **Exhibited:** Painters and Sculptors of Los Angeles, 1933. **Sources:** Hughes, *Artists of California,* 454.

RABINEAU, Francis *[Miniaturist, crayon portraitist, painter] late 18th c.*
Addresses: Active in NYC, 1791-92; Newark and New Brunswick, NJ, 1795-96. **Comments:** In 1795 he also painted standards and colors for the New Jersey militia regiments. **Sources:** G&W; NYCD 1791-92; Gottesman, II, nos. 36-37; Prime, II, 32; *The Guardian, or New Brunswick Advertiser,* May 19, 1795; *American Collector,* Aug. 23, 1934, 5.

RABINO, Saul Jacob *[Painter, sculptor, lithographer] b.1892, Odessa, Russia / d.1969, Los Angeles, CA.*
Addresses: Los Angeles, CA, 1932-1969. **Studied:** Russian Imperial A. Sch.; Ecole des. A. Decoratifs, Paris. **Exhibited:** Los Angeles Mus. Hist. Sc. A.; Laguna Beach AS; WFNY, 1939. **Work:** Los Angeles Pub. Lib. **Comments:** Born Rabinowitz. WPA printmaker in California, 1930s. **Sources:** WW40; exh. cat., Annex Gal. (Santa Rosa, CA, n.d., c.1988).

RABINOVICH, Raquel *[Painter, sculptor] b.1929, Buenos Aires, Argentina.*
Addresses: Huntington, NY. **Studied:** Univ. Córdoba, Arg; Univ Edinburgh; Atelier André Lothe, Paris, France. **Exhibited:** Soc Scottish Artists, Edinburgh, 1957; Salón Art Visuales Contemp, Arg, 1961; Salón Premio Honor Ver y Estimar, Buenos Aires, 1963; Primer Salón Artistas Jóvenes Latin Am, Mus Art Mod, Arg, 1965; New Directions (Artists of Suffolk Co), Hecksher Mus, Huntington, NY, 1971. Awards: Salón munic prize, Arg, 1954; Salon Parques Nac Prize, 1963; Fondo Nac Art fel, 1964. **Work:** MOMA, Buenos Aires; Genaro Perez Mus., Córdoba; Fondo Nac Art, Buenos Aires. **Comments:** Preferred Media: Oils,

Glass. Dealer: Lerner-Heller Galleries, New York, NY **Sources:** WW73; E Rodriguez, *Raquel Rabinovich* (Exposiciones, 1962); J Barnitz, "Raquel Rabinovich," *Arts Mag* (New York, 1970); M Preston, "Raquel Rabinovich," *Newsday* (New York, 1972).

RABINOVITCH, Ira *[Painter] 20th c.*
Addresses: NYC, 1920. **Exhibited:** S. Indp. A., 1920-21, 1924, 1932-34, 1937, 1944; Salons of Am., 1932-35. **Sources:** Marlor, *Soc. Indp. Artists;* Marlor, *Salons of Am.* (lists as Rabinovitch with no first name).

RABINOVITCH, William Avrum *[Painter] b.1936, New London, CT.*
Addresses: Monterey, CA. **Studied:** Worcester Polytech Inst, BSME; Boston Mus Sch Fine Arts; San Francisco Art Inst, MFA; also with Tom Holland. **Exhibited:** Monterey Peninsula Mus Art, 1965 (solo); Am Embassy & Asn Cult Hisp Norteamericano, 1968 (solo); Silvermine Competitive, Conn, 1969; New York City Ann, Avanti Gallery, 1970; Large Paintings, Monterey Jazz Festival, 1971 (solo). Awards: First prize, Monterey Peninsula Mus Art & Monterey Jazz Festival, 1965 & first prize, Monterey Co Fair, 1970; Maxwell Gallery, San Francisco, CA, 1970s. **Work:** Monterey Peninsula Col, CA. **Comments:** Preferred Media: Oils, Acrylics, Watercolors. **Sources:** WW73.

RABINOVITZ, Harold *[Painter] b.1915, Springfield, MA.*
Addresses: NYC. **Studied:** Yale Univ. **Member:** Artists U. of Western Mass. **Exhibited:** Springfield AL, 1936 (prize); Corcoran Gal biennial, 1939; PAFA Ann., 1939-41;WMAA, 1940. **Sources:** WW40; Falk, *Exh. Record Series.*

RABINOWITZ, Numa *[Painter] 20th c.*
Addresses: Bronx, NY, 1925. **Studied:** ASL. **Exhibited:** S. Indp. A., 1922. **Sources:** WW25.

RABINOWITZ, Saul See: **RABINO, Saul Jacob**

RABJOHN, Thomas Henry *[Landscape painter] b.1852, Milwaukee, WI / d.1943, Glendale, CA.*
Addresses: Oakland, CA; Glendale, CA. **Exhibited:** Oakland Art Fund, 1905. **Comments:** William Keith (see entry) bought supplies at his art store and often gave him painting instructions. His paintings are rare. **Sources:** Hughes, *Artists of California,* 454.

RABKIN, Leo *[Sculptor, painter] b.1919, Cincinnati, Ohio.*
Addresses: New York, NY. **Studied:** Univ Cincinnati; NY Univ; also with Iglehart, Tony Smith & Baziotes. **Member:** Am Abstr Artists (pres, 1964-); US Comn Int Asn Art (secy, 1968-1970); Fine Arts Fedn New York (mem bd dirs, 1970-); Sculptors Guild; Fedn Mod Painters & Sculptors. **Exhibited:** Seven Painting & Sculpture Biennials, Whitney Mus Am Art, 1959-1969; three-man show, New Talents, MOMA, 1960; Light/Motion/Space, Walker Art Ctr, Minneapolis, Minn, 1967; A Plastic Presence, San Francisco Mus Art, Milwaukee Art Ctr & Jewish Mus, 1970; Retrospective, Storm King Art Ctr, Mountainville, NY, 1970. Awards: Ford Found Award for Watercolor, 1961; First prize for watercolor, Silvermine Guild Artists, 1961; popular award for sculpture, First Ann Westchester, 1967. **Work:** MOMA, New York, NY; Whitney Mus Am Art, New York; Solomon R Guggenheim Mus, New York; NC Mus Art, Raleigh; Brooklyn Art Mus, NY. **Comments:** Preferred Media: Sculptural Constructions. Publications: Ed, American Abstract artists, 1936-1966. Collection: Whirligigs; Shaker furniture and tools; American primitive toys and dolls. **Sources:** WW73.

RABORG, Benjamin (or BOF) *[Painter] b.1871, Missouri / d.1918, San Francisco, CA.*
Addresses: Chicago, IL; California, c.1880; active in San Fran., from c.1895. **Work:** Stenzel collection. **Comments:** Specialized in portraits, Indian scenes, and landscapes. He fulfilled many decorative and painting commissions for wealthy San Franciscans after the earthquake and fire of 1906. By 1913 his work was no longer in demand and he was living in a small hotel in downtown San Francisco. Raborg died from his injuries after being hit by a cable car. Samuels report that his work varied in both quality and style. **Sources:** Hughes, *Artists of California,* 454; Peggy and Harold Samuels, 387.

RABOUIN, Edna *[Painter] 20th c.*
Exhibited: S. Indp. A., 1941. **Sources:** Marlor, *Soc. Indp. Artists.*

RABOY, Emanuel ("Mac") *[Painter, cartoonist, graphic artist, craftsperson] b.1914, NYC / d.1967, NY (Bronx), NY.*
Addresses: NYC. **Studied:** NY Sch. Indst. A.; PIA Sch. **Member:** United Am. A. **Exhibited:** AIC, 1937; NA, 1938; WMAA, 1938-1941; WFNY, 1939. **Work:** MMA (wood engravings). **Comments:** He produced wood engravings under the WPA, then created "Captain Marvel, Jr." for Fawcett Publications, and was art director for Spark Comics. In 1948, he signed with King Features Syndicate to draw "Flash Gordon." **Sources:** WW40; *Famous Artists & Writers* (1949; add'l info. courtesy Anthony R. White, Burlingame, Ca.).

RABUS, Carl *[Painter] 20th c.*
Exhibited: AIC, 1941. **Sources:** Falk, *AIC.*

RABUSKI, Theodore *[Portrait, landscape, and decorative painter, drawing teacher, painter on glass, and lithographer] mid 19th c.; b.Posen (Poland).*
Addresses: Charleston, SC, 1848-49, 1853; NYC, 1856. **Studied:** C.W. Wach, Berlin, Germany. **Comments:** Worked in Charleston (SC) as an artist in varied media, and in NYC as a lithographer and publisher of prints. Position: advertisement in Charleston indicated he had been professor of drawing at the Military Academy of Posen (Poland). **Sources:** G&W; Thieme-Becker; Rutledge, *Artists in the Life of Charleston;* Peters, *America on Stone;* Hamilton, *Early American Book Illustrators; Portfolio* (March 1948), 160 (repro.).

RABUT, Paul L. PAUL RABUT
[Illustrator, painter, designer] b.1914, NYC / d.1983.
Addresses: NYC; Westport, CT in 1976. **Studied:** CCNY; NAD; ASL; also with Jules Gottlieb, Harvey Dunn & Lewis Daniel. **Member:** SI; Westport Artists. **Exhibited:** NAD, 1932 (medal), 1950; PAFA, 1941; SI, 1941-46; Soc. Illustrators, 1941-1972; MMA (AV), 1942; Art Dir. Club, 1942-1953, 1942 (medal), 1943 (medal), 1946 (medal), 1951 (prize); AIC, 1943; State Dept. Traveling Exhib. Advertising Art, Europe & South Am., 1952-1953. **Work:** USA Med. Mus., Washington, DC; US Postal Service Collection; General Electric Collection. Commissions: Designed 6 cent Natural Hist Commemorative US Postage Stamp, Haida Ceremonial Canoe, 5/6/1970 & 11 cent Airmail Commemorative US Postage Stamp, City of Refuge, National Park Service, 4/3/1972. **Comments:** Positions: consultant, primitive art, galleries & collectors; art director & stylist animated films, Fed. Aeronaut Admin., US Army, US Navy & French Govt. Publications: Author/Illustrator, "Paul Rabut Visits the Tall Timber," *True Magazine,* 1949; Author/Illustrator, "My Life as a Head Hunter, *Argosy Magazine,* 1953; Illustrator, leading national magazines. Teaching: lecturer illustration, photography, primitive arts of Africa & Northwest coast & South Seas. Collection: primitive art, especially Africa, oceanic, pre-Colombian America & American Indian. **Sources:** WW73; WW47; Peggy and Harold Samuels, 387.

RACHELSKI, Florian W. *[Painter, sculptor] 20th c.; b.Poland.*
Addresses: New York, NY. **Studied:** École Nat Beaux Arts, Paris, France. **Member:** Syndicat Nat des Artistes Createur Prof, 1953; fel Nat Sculpture Soc. **Exhibited:** Salon Nat Beaux Arts, Paris; Salon des Artistes Francais, Paris; Salon d'Hiver, Paris; Nat Acad Design, New York, NY; Nat Sculpture Soc, New York. Awards: Salon des Artistes Francais (bronze medal, 1955 & silver medal, 1956); Prix Bingguely le Jeune, Winter Salon, Paris, 1958. **Work:** Commissions: Monument of Christ, St Mary's Church, Paris, 1953; monument of the Madonna, St Trinity Church, Osining, NY, 1959. **Comments:** Preferred Media: Wood, Stone, Bronze, Marble. Publications: Auth articles in, *J l'Amateur d'Art, La Rev Mod, Masque et Visages, Nat Sculpture Rev & Le Livre D'Or Sculpture.* **Sources:** WW73.

RACHMAN, Paul *[Painter] 20th c.*
Exhibited: S. Indp. A., 1941-42, 1944. **Sources:** Marlor, *Soc. Indp. Artists.*

RACHMIEL, Jean *[Painter, etcher] b.1871, Haverstraw, NY.*
Addresses: NYC. **Studied:** ASL with Geo. Brush; Académie Julian, Paris with J.P. Laurens and Lefebvre, 1890-92; also with Bonnât. **Exhibited:** Paris Salon, 1898, 1912 (med); PAFA Ann., 1904-05; Corcoran Gal biennial, 1912; AIC. **Sources:** WW17; Fink, *American Art at the Nineteenth-Century Paris Salons*, 383; Falk, *Exh. Record Series.*

RACHOTES, Matene (Mrs. Jo Cain) *[Painter, teacher, lithographer] b.1905, Boston, MA.*
Addresses: Brighton, MA; NYC; Kingston, RI. **Studied:** Mass. Normal A. Sch.; BMFA Sch.; Child Walker Sch. FA; Harvard Univ.; F.; Fogg AM; F., Tiffany Fnd. **Member:** Contemp. A. Group; South County A.; Am. A. Cong. **Exhibited:** PMA; CGA; AIC; Providence Mus. A.; South County AA; Salons of Am.; PAFA Ann., 1933-34, 1938. **Comments:** Position: Instr. art, Mary Wheeler Sch., Providence, RI & asst. prof. art, co-dir., with Jo(seph) Cain. Summer Art Workshop, Univ. Rhode Island, Kingston, R.I. **Sources:** WW59; WW47; Falk, *Exh. Record Series.*

RACINE, Albert (Apowmuckon) *[Woodcarver, sign painter, gallery owner] b.1907, Browning, MT.*
Addresses: Browning, MT, 1969. **Studied:** Haskell Inst., Lawrence, KS, 1921-22; W. Reiss; E.E. Hale, Jr.; A. Voision (French); C. Hutig (German); Puget Sound College, c.1945. **Work:** Mus. of the Plains Indian, Browning; Methodist Mission, Browning. **Comments:** Blackfoot Indian painter from 1926; woodcarver from 1936. Worked in Seattle, 1940-42 and served in WWII. Racine was an illustrator for the US Navy for six years and then returned to Montana in 1960, settling in Browning in 1961. **Sources:** Peggy and Harold Samuels, 387.

RACITI, Cherie *[Sculptor] b.1942.*
Addresses: San Francisco, CA, 1975. **Exhibited:** WMAA, 1975. **Sources:** Falk, *WMAA.*

RACKLE, William *[Sculptor, marble cutter, decorator] b.1842, Germany.*
Addresses: New Orleans, active 1899-1909. **Sources:** *Encyclopaedia of New Orleans Artists*, 317.

RACKLEMAN, George *[Painter, commercial artist and restorer] 20th c.; b.Germany.*
Addresses: Des Moines, IA, 1915. **Studied:** Nürnberg, Germany; Munich Academy. **Comments:** Came to U.S. in 1910; painted murals in South Carolina; traveled over U.S. painting; settled in Des Moines and engaged in commercial work. **Sources:** Ness & Orwig, *Iowa Artists of the First Hundred Years*, 172.

RACKLEY, Mildred (Mrs. Mildred Rackley Simon) *[Serigrapher, painter, craftsperson] b.1906, Carlsbad, NM Territory / d.1992, Lafayette, CA.*
Addresses: Lafayette, CA. **Studied:** Univ. Texas; New Mexico Normal Univ., A.B.; Kunstgewerbe Schule, Hamburg, Germany; and with Walter Ufer, George Grosz. **Member:** Nat. Ser. Soc. **Exhibited:** Denver Art Mus.; Oakland Art Gal.; Gump's, San Francisco; AIC; Mus. New Mexico; Salons of Am., 1934; MoMA, 1940; Springfield Art Lg., 1944-46, 1948; Newport AA, 1945, 1946, 1948; Laguna Beach AA, 1946; SAM; Mint Mus. Art, 1946; Nat. Ser. Soc., 1948-52; Audubon Artists, 1948; Phila. Pr. Club, 1948; LC, 1948; Carnegie Inst., 1948; Northwest Printmakers 1949; Diablo Art Festival, 1958 (prize); Concord, CA, 1958 (prize). **Work:** MoMA; MMA; PMA; Springfield Art Mus.; Princeton Pr. Club. **Comments:** Position: vice pres., Valley Art Center, 1957-58; instructor, mosaic, silk screen, Valley Art Center, Lafayette, CA, 1956-58. **Sources:** WW59; WW47; article by M. Lee Stone, *Journal of the Print World* (Fall, 1991).

RACKOW, Leo *[Illustrator] 20th c.*
Addresses: NYC. **Member:** SI. **Sources:** WW47.

RACZ, Andre *[Painter, educator, engraver] b.1916, Cluj, Romania.*
Addresses: Demarest, NJ; NYC. **Studied:** Univ Bucharest, BA, 1935. **Member:** Soc Am Graphic Artists; Am Asn Univ Prof. **Exhibited:** NYC, 1943 (solo); Art of this Century, 1944; MOMA Traveling Exh., 1944-46; LOC, 1945, 1946; NAD, 1945; Phila., 1945 (solo); WMAA, 1949, 1962; PAFA Ann., 1953; 50 Yrs Am Art, MOMA, Paris, London, Belgrade & Barcelona, 1955; First Int Biennial, Mex, 1958; First Biennial Relig Art, Salzburg, Austria, 1958; Int Watercolor Biennial, Brooklyn Mus, 1961; Nat Inst Arts & Lett, New York, 1968. **Awards:** Guggenheim fel printmaking, 1956; Fulbright res scholar, Chile, 1957; Ford Found fel, 1962. **Work:** MOMA; WMAA; NYPL; LOC; Bibliot Nat, Paris. **Comments:** Teaching: Prof painting & chmn div painting & sculpture, Columbia Univ, 1951-. Publications: Auth, *The Reign of Claws*, 1945; *XII Prophets of Aleijadinho*, 1947; *Via Crucis,* 1948; *Mother and Child*, 1949; *Canciones Negras*, 1953. **Sources:** WW73; WW47; Carmen Valle, *Poets on Painters and Sculptors* (Tiger's Eye, 1949); Rosamel del Valle, "Una Tarde con el Pintor Andre Racz," *Nacion* (1949); Antonio Romera, *Andre Racz Pintor y Grabador* (Ed Pacifico, 1950); Falk, *Exh. Record Series.*

RADBOURNE, William H *[Landscape painter] b.1838, Brooklyn, NY / d.1914, Orleans, NY.*
Addresses: Brooklyn, NY, until 1905.

RADCLIFFE, Charles *[Portrait and vignette engraver] b.c.1777 / d.1807, Salem, MA.*
Addresses: Philadelphia, 1805. **Comments:** He claimed to be the son of the English novelist, Mrs. Ann Radcliffe. **Sources:** G&W; Belknap, *Artists and Craftsmen of Essex County*, 5; Stauffer.

RADCLIFFE, T. B. *[Still life painter] mid 19th c.*
Addresses: Philadelphia. **Exhibited:** PAFA (1849). **Sources:** G&W; Rutledge, PA.

RADDATZ, Ralph Louis *[Painter] 20th c.*
Addresses: Chicago area. **Exhibited:** AIC, 1948, 1951. **Sources:** Falk, *AIC.*

RADDEN, Thomas M. *[Lithographer] b.c.1831, Massachusetts.*
Addresses: Boston, 1850. **Sources:** G&W; 7 Census (1850), Mass., XXV, 415.

RADEKE, Eliza Green (Mrs) *[Educator, patron] b.1855, Augusta, GA / d.1931.*
Addresses: Providence, RI. **Member:** Bd. Dir., Am. Fed. Arts, since 1914. **Comments:** Her pictures, early Am. Furniture and a wide variety of objets d'art constitute an important part of the collections of the Eliza G. Radeke Mus., which was a gift to RISD. Position: Trustee, RISD (since 1889), Pres. (1913-31).

RADENKOVITCH, Yovan *[Portrait painter, mural painter, architect, lecturer, teacher, writer] b.1903.*
Addresses: NYC/Gloucester, MA. **Exhibited:** AIC, 1935. **Work:** BM; Yugoslav Legation, Wash., D.C.; SFMA; TMA.; Mattatuck Mus., Waterbury, CT. **Comments:** Expressionist landscape and figurative painter. Contributor: articles about art to newspapers; Belgrade, Paris mags. **Sources:** WW40.

RADENSKI, Emmanuel See: **RAY, Man**

RADER, Elaine Myers *[Painter, block printer, teacher] b.1902, Ponca City, OK.*
Addresses: Wichita, KS. **Studied:** Kopietz; Sandzen; Taft. **Member:** Wichita AG; Wichita AA; Kansas City AG. **Exhibited:** S. Indp. A., 1932. **Sources:** WW33.

RADER, Isaac *[Painter] b.1906, Brooklyn, NY.*
Addresses: Detroit, MI; Phila., PA. **Studied:** Abramovsky; Kappes; Niles; Wicker; J. Marchand; Lhote. **Member:** Detroit AC. **Exhibited:** Toledo P., 1921 (prize); Detroit AI, 1926 (prize); TMA, 1930; S. Indp. A., 1930; PAFA Ann., 1940. **Sources:** WW33; Falk, *Exh. Record Series.*

RADER, Marcia A. *[Painter, drawing specialist, lecturer, teacher, writer] b.1894, St. Louis, MO / d.1937.*
Addresses: Sarasota, FA/Highlands, NC. **Studied:** F. Oakes Sylvester; J.K. Wangelin; St. Louis Sch. FA. **Member:** Florida Fed. Arts (pres.); AAPL; SSAL. **Comments:** Position: art editor, New State Course of Study for Florida; art director, Sarasota H.S.; teacher, Ringling Jr. College. **Sources:** WW38.

RADER, Virginia Baker (Mrs. Melvin) *[Painter, sculptor] b.1906, Denver, CO.*
Addresses: Seattle, WA. **Studied:** Univ. of Wash.; PAM Art School; Tiffany Foundation, NY. **Exhibited:** SAM, 1934. **Sources:** Trip and Cook, *Washington State Art and Artists,* 1850-1950.

RADFORD, Colin (Mrs) *[Painter] b.1885, Auburn, CA / d.1948, Seattle, WA.*
Addresses: Seattle, WA. **Studied:** Univ. of Wash. **Exhibited:** Western Wash. Fair, 1925; SAM, 1934-38. **Sources:** WW24; Trip and Cook, *Washington State Art and Artists,* 1850-1950.

RADFORD, Zilpha (Mrs. Colin O.) See: **RADFORD, Colin (Mrs)**

RADICE, Canio *[Painter] 20th c.*
Addresses: Chicago area. **Exhibited:** AIC, 1941, 1948. **Sources:** Falk, *AIC.*

RADICE, Date Donato *[Painter] 20th c.*
Exhibited: AIC, 1942. **Sources:** Falk, *AIC.*

RADICH, Stephen *[Art dealer] 20th c.*
Addresses: New York, NY. **Sources:** WW66.

RADIN, Cecile *20th c.*
Exhibited: Salons of Am., 1934. **Sources:** Marlor, *Salons of Am.*

RADIN, Dan *[Painter] b.1929, New York, NY.*
Addresses: Norwich, CT. **Studied:** High Sch Music & Art; Queens Col; Cranbrook Acad Art, BFA & MFA. **Exhibited:** Butler Inst Am Art 26th Ann, 1961; Painting Part II, 1963 & Landscape II, 1971, De Cordova Mus; Am Acad Ann, Rome, 1964; Contemp Surv, J B Speed Mus, Louisville, Ky, 1966. **Awards:** Louis Comfort Tiffany Found awards in painting, 1962 & 1964; second purchase award, Lowe Gallery, 1963. **Work:** Cranbrook Mus, Bloomfield Hills, Mich; Detroit Inst Arts, Mich; Butler Inst Am Art, Youngstown, Ohio; Lowe Gallery, Univ Miami, Coral Gables, Fla. **Comments:** Preferred Media: Oils, Acrylics. Teaching: Instr painting, Swain Sch Design, New Bedford, Mass, 1964-71; instr painting & drawing, Univ Conn, 1972; instr drawing, R I Sch Design, 1972. **Sources:** WW73.

RADITZ, Lazar *[Portrait painter, teacher] b.1887, Drinsk, Russia. / d.1956, Spartanburg, SC.*
Addresses: Phila., PA, for many years; New York; Bristol, RI; Spartanburg, SC, 1950s. **Studied:** PAFA, with W.M. Chase, 1904-10; (won Cresson Traveling Scholarshipos, 1907-08); Tarbell. **Member:** Phila. Alliance. **Exhibited:** The Art Club of Phila., 1913 (solo); PAFA Ann., frequently, 1908-45; Pan-P. Expo, San Fran., 1915 (med); NAD, 1918 (prize); AIC, 1925; McClees Galleries, Phila., solos: 1934-35; S. Indp. A., 1942; Ogunquit (Me.) Art Ctr, solos: 1947-48. **Work:** PAFA; Am. Philosophical S.; Dropsie Col.; Univ. Pa.; Baugh Inst. Anatomy; Acad. Nat. Sch.; Franklin Inst.; Col. Physicians; Temple Univ.; Free Lib.; Germantown Friends Sch.; Graphic Sketch C., Mercantile Lib., Phila.; Brown Univ.; Yale Univ.; State Capitol, Harrisburg; convent, Cornwalls Heights, Pa.; Rollins Col.; Fla.; Wesleyan College. Raditz's coll. was given to Greenville Mus. A. (S. Carolina) by his widow. The National Portrait Gallery has hundreds of photos of Raditz's portraits, plus his appointment and account books. **Comments:** Prominent portraitist. He portrayed such notables as Rockefeller, DuPont, Madame Chiang-Kai-Shek, and many philanthropists, doctors and judges. Teaching positions: Graphic Sketch C., Phila.; Spartanburg, SC, 1950s. His daughter Violetta C. Raditz was also an artist (see entry). **Sources:** WW40; Falk, *Exh. Record Series;* add'l info. courtesy of his grandson, Jonathan Flaccus, Putney, VT.

RADITZ, Violetta C(onstance) *[Painter, mural painter, printmaker, designer] b.1912, Phila. / d.1998, NYC.*
Addresses: Phila., 1912-32; Ireland, 1933-35; NYC, 1936-98. **Studied:** self-taught (daughter of portrait artist-teacher Lazar Raditz). **Member:** Phila. Print Club; Phila. Art Alliance; NAWA. **Exhibited:** PAFA, drawing & watercolor exhibs., 1920-26, 1930, 1932-34; Phila. Art Alliance, 1922 (solo); Warwick Galleries, Phila., 1931 (solo); Beaux-Arts Inst. Des., 1933 (medal for an ocean liner mural design); Delphic Studios, NYC, 1936 (solo); Converse College, Spartanburg, SC, 1953 (solo); Greenville (SC) Mus. Art, 1959 (solo); Janet Fleisher Gallery, Phila.a, 1986 (solo); Moore College Art, Phila., 1991. **Work:** Greenville (SC) Mus. Art. **Comments:** A child prodigy, her whimsical drawings were exhibited at PAFA when she was eight years old. She moved to Ireland with her first husband William Flaccus and designed theater sets there. After returning to NYC, she opened her own design agency and exhibited her etchings and lithographs. In 1945, after a divorce, she took a trip to Haiti, where she painted, using pastels as her medium. Remarried in 1947 to Bernard Glemser, a novelist. Her childhood work was rediscovered by the art world beginning in 1959. Worked as a designer in the bridal departments of Lord & Taylor and Bergdorf Goodman in the 1960s. Appears also as Flaccus. **Sources:** WW25; info courtesy of her son, Jonathan Flaccus, Putney, VT.

RADLEY, Rose Burr *[Painter] 20th c.*
Addresses: Wash., DC. **Exhibited:** Corcoran Gal biennial, 1937. **Sources:** Falk, *Corcoran Gal.*

RADLIFF, R. P. *[Landscape painter] 20th c.*
Addresses: San Francisco, CA. **Exhibited:** Soc. for Sanity in Art, CPLH, 1940. **Sources:** Hughes, *Artists of California,* 454.

RADNITSKI, Emmanuel See: **RAY, Man**

RADO, Ilona *[Painter] late 19th c.; b.Budapest, Hungary / d.Leonia, NJ.*
Addresses: NYC, active 1887-1929. **Studied:** Académie Colarossi, with R. Collin and Courtois. **Exhibited:** Salon de la Soc. des Artistes Francais, 1887-92; 1929; Salon de la Soc. National des Beaux-Arts, 1890; Boston AC, 1892; NAD, 1893; also Budapest and Vienna. **Comments:** Specialty: portraits and nudes. She came to America in 1891. Married to architect Frederick West. **Sources:** Petteys, *Dictionary of Women Artists;* Fink, *American Art at the Nineteenth-Century Paris Salons,* 383; *The Boston AC.*

RADOCZY, Albert *[Painter] b.1914, Stamford, CT.*
Addresses: Cresskill, NJ. **Studied:** Parsons Sch Design; Cooper Union, grad. **Exhibited:** N J State Mus Ann, Trenton, 1961; WMAA, 1962; Brooklyn Mus Nat Print Exhib, NY, 1962; MOMA Lending Collection. 1965. **Awards:** Purchase award, Ball State Teachers Col, 1959. **Work:** Brooklyn Mus, NY; Ball State Teachers Col, Ind; Lyman Allyn Mus, Conn. **Commissions:** Tapestry murals, Allegheny Col, Meadville, Pa, 1966. **Comments:** Preferred Media: Oils. Teaching: Lectr drawing, Cooper Union, 1950-55; prof design, City Col New York, 1955-70s. **Sources:** WW73.

RADOSLAVOV, Theodore *[Painter] 20th c.*
Exhibited: S. Indp. A., 1941. **Sources:** Marlor, *Soc. Indp. Artists.*

RADUE, Josephine Watt Lee (Mrs. Edward C.) *[Painter] b.1910, Denver, CO.*
Addresses: Wash., DC/Blue Ridge Summit, PA. **Studied:** A. Otis; G.S. Foster. **Member:** So. County AA. **Sources:** WW40.

RADULOVIC, Savo *[Painter, craftsman, graphic artist, teacher, lecturer] b.1911, Montenegro, Yugoslavia.*
Addresses: New York, NY. **Studied:** Saint Louis Sch Fine Arts, Wash Univ, 1930-32; Fogg Mus Art, Harvard Univ, Carnegie fel, 1937; Acad Belle Arte, Rome, Italy, Fulbright fel, 1949-50. **Member:** Artists Equity Asn. **Exhibited:** NAD; PAFA Ann., 1949; WMAA; City Art Mus Saint Louis; Wildenstein Gal., N.Y.; Philadelphia Mus Art; Washington Irving Gal., N.Y.; Park Ave. Gal., Mt. Kisco, N.Y., and in museums throughout U.S.; Rome,

Italy. **Awards:** Carnegie F. to Fogg Mus. A., Harvard Univ., 1937; Purchase prize, City Art Mus Saint Louis, 1941; Fulbright F., Rome, Italy, 1949-50. **Work:** City Art Mus Saint Louis; Univ Ariz; Hist Sect, War Dept, Pentagon, Washington, DC; Col William & Mary, Williamsburg, Va; MOMA, Miami Beach, Fla; also in pvt collections US & abroad. **Comments:** Positions: Owner & dir, Artists Little Gallery, New York, NY, 1946-70s. **Sources:** WW73; Falk, *Exh. Record Series.*

RADVILLE, Ann *[Painter] 20th c.*
Addresses: Chicago area. **Exhibited:** AIC, 1935-43. **Sources:** Falk, *AIC.*

RAE, Edwin C *[Art historian, educator] b.1911, New Canaan, CT.*
Addresses: Champaign, IL. **Studied:** Harvard Col, BA, 1933, Harvard Univ, MA, 1934, PhD, 1943. **Member:** Soc Archit Historians (asst ed jour, 1941); Col Art Asn Am; Archaeol Inst Am; Royal Soc Antiquaries Ireland. **Exhibited:** Awards: Legion Honneur scholars & res grants. **Comments:** Teaching: Instr hist art, Brown Univ, 1938-39; instr hist art, Univ Ill, Urbana, 1939-42, prof hist art, 1947-70s. Research: Gothic architecture and sculpture, particularly in Ireland. Publications: Auth, "The Education of the Artist," *Art Journal,* 1961; auth, "The Sculpture of the Cloister of Jerpoint Abbey," 1966 & "Irish Sepulchral Monuments of the Later Middle Ages," 1970-71, *Journal Royal Soc Anti-quaries Ireland;* auth, "The Rice Monument in Waterford Cathedral," *Royal Irish Acad Proceedings,* 1970. **Sources:** WW73.

RAE, Frank B *[Painter] 20th c.*
Addresses: Cleveland, OH. **Member:** SC. **Sources:** WW25.

RAE, John *[Illustrator, painter, lecturer, writer] b.1882, Jersey City, NJ / d.1963, Houston, TX.*
Addresses: North Stonington, CT in 1954. **Studied:** PIA Sch., 1900; ASL with H. Pyle, K. Coz, F.V. DuMond. **Member:** SI, 1912. **Exhibited:** S. Indp. A., 1919, 1926. **Work:** LOC. **Comments:** Rae painted portraits of celebrities. He began to author/illustrate books in 1916. Author/illustrator: "The Big Family," "The Pies and the Pirates," "Grasshopper Green and the Meadow Mice," "New Adventures of Alice," "Granny Goose," "Lucy Locket," "Why?". Illustrator: many books published by Harper's, Macmillan, and others. Position: teacher, portrait painting, Cateau-Rose IA; teacher, design and painting, Rollins College, Florida. **Sources:** WW40; Peggy and Harold Samuels, 387-88.

RAEDER, Marjorie *[Painter] 20th c.*
Addresses: Oceanside, L.I., NY, 1932. **Exhibited:** S. Indp. A., 1932. **Sources:** Marlor, *Soc. Indp. Artists.*

RAEMISCH, Ruth (Mrs. Waldemar) *[Enamel painter] b.1893, Berlin, Germany.*
Addresses: Providence, RI. **Studied:** Germany. **Exhibited:** CGA, 1943 (solo); BMA, 1944; R.I.Sch.Des., 1945; WMA; Syracuse MFA, 1941 (prize). **Work:** enamels: MMA; R.I.Sch.Des. Mus.; IBM Coll. **Comments:** Married to Waldemar Ramisch (see entry). **Sources:** WW53; WW47.

RAEMISCH, Waldemar *[Sculptor, teacher] b.1888, Berlin, Germany / d.1955.*
Addresses: Providence, RI. **Studied:** Germany. **Member:** NSS; Providence AC. **Exhibited:** AIC, 1942; PAFA Ann., 1946 (medal), 1949-54; Phillips Acad., Andover, Mass., 1941; WMA, 1942; Buchholz Gal., 1941, 1945; WMAA, 1951-54. **Work:** Cranbrook Acad. A.; FMA; Providence A. Mus. **Comments:** Married to Ruth Raemisch (see entry). Position: Instr. S., R.I.Sch.Des., Providence. R.I., 1939-. **Sources:** WW53; WW47; Falk, *Exh. Record Series.*

RAEN, Isaac See: **RAIN, Isaac**

RAFFAEL, Joseph *[Painter] b.1933, Brooklyn, NY.*
Addresses: San Geronimo, CA. **Studied:** Cooper Union Art Sch; Yale Univ (BFA). **Exhibited:** Corcoran Gal biennial, 1967; Ninth Sao Paulo Bienial, Brazil, 1968; "Human Concern, Personal Torment," WMAA, 1970; "American Painting," Richmond AM,

Va, 1970; Darmstadt Biennial, Ger, 1970; 70th Am Exhib, Art Inst Chicago, 1972. **Awards:** Fulbright award, 1958-60; Tiffany Fndn fellow, 1960. **Work:** MMA; San Francisco MA, Calif; AIC; LACMA; Univ Art Mus, UCal, Berkeley. **Comments:** Preferred Media: oils. Teaching: Sch Visual Arts, 1966-69; UCal, Berkeley, 1969; Saeramento State Univ, 1969-70s. **Sources:** WW73; Pincus-Witten, "A Conversation with Joe Raffael," *Artforum,* 12/1966; Grace Glueck, "O to be Born Under Pisces," *NY Times,* 1/1969; Gloria Smith, "The Eyes Have it: Joseph Raffael" (film), NBC-TV, 1972.

RAFFAELLI, Gino *[Painter] 20th c.*
Addresses: Los Angeles, CA. **Member:** Calif. AC. **Sources:** WW25.

RAFFEL, Alvin Robert *[Painter, educator] b.1905, Dayton, OH.*
Addresses: Dayton, OH. **Studied:** Chicago Acad Fine Arts; AIC, with F. DeForest Schook. **Member:** Am Assn Univ Prof; Dayton Soc Painters & Sculptors. **Exhibited:** Pepsi-Cola, 1945; Ohio Ann, Dayton Art Inst, 1933, 1935-45 (1945, First purchase prize for Fellaheen); Cincinnati Ann, Cincinnati Art Mus, Ohio, 1945; Portrait of America, New York, NY, 1946; Carnegie Ann, Pittsburgh, Pa, 1946-48; Magnificent Mile Exh., Chicago, 1955; Provincetown Arts Festival, Mass, 1958. **Awards:** for Holiday on the Ice, Mrs G S Weng, 1948; award for The Lesser Light to Rule the Night, Jefferson Patterson, 1951. **Work:** Dayton Art Inst; Canton Art Mus, Ohio. Commissions: Seascape (oil), George E Morris, Chicago, Ill, 1933; portrait of A H Allen, comn by Mrs A H Allen, Chicago, 1934; portrait of Karl Koeker, comn by Karl Koeker, Dayton, 1935; portrait of S H McCoy, Springfield H S, Ohio, 1956; landscape (oil), Widow's Home, Dayton, 1958. **Comments:** Preferred Media: Oils, Watercolors. Teaching: Prof painting & life drawing, Sch of Dayton Art Inst, 1946-70s. Position: Instr., Dayton AI, Dayton, Ohio. Publications: Auth, "Art," *Exponent,* 1961. **Sources:** WW73; WW47.

RAFFO, Steve *[Artist] mid 20th c.*
Addresses: NYC. **Exhibited:** Corcoran Gal biennials, 1947, 1951; WMAA, 1947-51; PAFA Ann., 1948 (prize), 1949, 1953, 1962. **Sources:** Falk, *Exhibition Records Series.*

RAFILSON, Sidney G. *[Artist] 20th c.*
Addresses: Chicago, IL. **Exhibited:** PAFA Ann., 1952. **Sources:** Falk, *Exh. Record Series.*

RAFOSS, Kaare *[Painter] b.1941.*
Addresses: NYC, 1975. **Exhibited:** WMAA, 1975. **Sources:** Falk, *WMAA.*

RAFSKY, Jessica C *[Collector] b.1924, New York, NY.*
Addresses: New York, NY. **Studied:** George Washington Univ; New York Univ. **Member:** Assoc Guggenheim Mus; sustaining mem MOMA; assoc MMA; Friend of Whitney Mus; Mus Primitive Art. **Comments:** Collection: Contemporary art. **Sources:** WW73.

RAFTERY, J. H. *[Painter] 20th c.*
Exhibited: AIC, 1935. **Sources:** Falk, *AIC.*

RAGAN, Henry (Mrs.) See: **WALDVOGEL, Emma (Mrs. Henry Ragan)**

RAGAN, Leslie Darrell *[Painter, illustrator] b.1897, Woodbine, IA / d.1972, Portland, OR.*
Addresses: Pebble Beach, CA. **Studied:** Cumming Sch. A.; AIC; Chicago Acad. FA. **Member:** Allied Ar. Am.; SI; A. Gld.; Carmel AA; SC; AAPL; A. Fellowship. **Exhibited:** Salons of Am., 1927-28; WFNY, 1939; AIC, 1940 (award); Phila. A. All., 1940 (certificate of merit), NAD; All. A. Am., 1939.; Boston AC; SC; SI; Carmel AA. **Work:** Posters, N.Y. Central R.R., Norfolk & Western R.R. **Sources:** WW59; WW47.

RAGAN, Nannie *[Artist] early 20th c.*
Addresses: Active in Los Angeles, 1905-07. **Sources:** Petteys, *Dictionary of Women Artists.*

RAGER, Edward *[Artist] 20th c.*
Addresses: NYC, 1950. **Exhibited:** WMAA, 1950 (work on paper). **Sources:** Falk, *WMAA.*

RAGIUDA, Shinyo *[Painter] 20th c.*
Addresses: NYC. **Member:** S.Indp.A. **Sources:** WW25.

RAGLAND, Jack Whitney *[Painter, printmaker] b.1938, El Monte, CA.*
Addresses: Indianola, IA. **Studied:** Ariz State Univ, BA & MA, with Dr Harry Wood, Arthur Jacobson & Ben Goo; Univ Calif, Los Angeles, with Dr Lester Longman, Sam Amato & William Brice; Akad Angewandte Kunst; Akad Bildenden Künste; Graphische Bundes-Lehr-und Versuchsanstalt, Vienna. **Member:** Col Art Asn; Mid-Am Col Art Asn. Awards: Grand purchase prize, Ariz Ann, Phoenix Art Mus, 1961; painting selected as one of top representational painting in USA, Allied Publ, 1962. **Exhibited:** Ariz Ann Exhib, Phoenix, Ariz, 1961; Tucson Southwest Exhib, Ariz, 1961; Exhib Nat Recognized Artists, Scattle, Wash, 1963 & Fort Lauderdale, Fla, 1964 -65; Iowa Ann Exhib, Des Moines, 1970 & 1972. **Work:** Albertina Mus, Vienna, Austria; Phoenix Art Mus, Ariz; Graphische Bundes-Lehr-und Versuchsanstalt, Vienna; Kunsthaus, Basel, Switz. **Comments:** Preferred Media: Acrylics, Serigraphy. Teaching: Grad asst drawing & painting, Univ Calif, Los Angeles, 1961-1964; instr drawing & painting, Ariz State Univ, summer, 1963; assoc prof drawing, printmaking & art history, Simpson Col, 1964-. Publications: Contribr, statement, In: *Prize-Winning Paintings Book II,* Allied, 1962; auth, "Works of Wilhelm Jarushka," *Graphische-Lehr-und-Versuchsanstalt Mag,* 1971. **Sources:** WW73; "Applause" *NY Mag Arts* (Nov 3, 1971).

RAGSDALE, William *[Painter] 20th c.*
Addresses: Chicago area. **Exhibited:** AIC, 1939. **Sources:** Falk, *AIC.*

RAGUSA, Joseph *[Sculptor, designer, builder] b.1848, Palermo, Italy / d.1921, New Orleans, LA.*
Addresses: New Orleans, active 1882-1920. **Comments:** Came to the U.S. in 1872 and created floats for the Rex carnival organization,1882-1920. He designed floats in N.O. for ca. 40 years and also worked for the Hudson-Fulton celebration in NYC, 1908, the Gasparilla Parade in FL and the Memphis, TN Centenary Celebration, 1918. **Sources:** *Encyclopaedia of New Orleans Artists,* 317.

RAGUSA, (Signor) *[Artist] mid 19th c.; b.Italy.*
Exhibited: showed sixteen European views at Mobile (Ala.),1844. **Sources:** G&W; Mobile *Register and Journal,* Nov. 26-Dec. 25, 1844 (courtesy J. Earl Arrington).

RAHJA, Virginia Helga *[Painter, educator] b.1921, Aurora, MN.*
Addresses: St Paul, MN. **Studied:** Hainline Univ, BA, 1944; Sch Assoc Arts, DFA, 1966. **Member:** Minn Art Educators Asn; Nat Asn Interior Designers; Am Asn Univ Women; Midwest Col Art Conf. **Exhibited:** Many exhibs & ann, Walker Art Ctr, Minn Art Inst, St Paul Gallery, Minn State Fair & Hamline Galleries. **Comments:** Positions: Asst supt fine arts, Minn State Fair, 1944-48. Teaching: Assoc prof painting, Hamline Univ, 1943-48 & dir, Hamline Galleries, 1945-48; prof painting, Sch Assoc Arts, St Paul, 1948-65, dean, 1948-70s. **Sources:** WW73.

RAHLSON, Lydia *[Painter] 20th c.*
Exhibited: Sculptor, 1926; Salons of Am., 1927. **Sources:** Falk, *Exhibition Record Series.*

RAHMER, Louis *[Painter] 20th c.*
Addresses: Rockville Centre, L.I., NY. **Exhibited:** S. Indp. A., 1920. **Sources:** Marlor, *Soc. Indp. Artists.*

RAHMING, Norris *[Painter, educator, etcher, lecturer] b.1886, NYC / d.1959.*
Addresses: Gambier, Cleveland, OH. **Studied:** NAD; ASL; N.Y. Sch. A.; Emil Carlsen; W. M. Chase; Robert Henri; H.G. Keller. **Member:** CAA; Cleveland SA; Columbus A. Lg. **Exhibited:** PAFA Ann., 1927, 1930-32; Corcoran Gal biennial, 1930; CMA,

1925, 1926-29 (prizes), 1930-37; Great Lakes Exh., 1937; Columbus A. Lg., 1938-39. **Work:** CMA; Newark Mus.; City of Cleveland Coll.; Cleveland YMCA; Senate Office Bldg., Wash., D.C.; Am. Embassy, Paris; WPAmurals, USPO, Gambier, Ohio; Rocky River (Ohio) Pub. Lib.; Bb. Ed. Bldg., Cleveland. **Comments:** Position: dir., dept. art, Kenyon Col., Gambier, Ohio, 1936-52 (retired); Study and Research: Mexico and the Southwest, 1953-59. **Sources:** WW59; WW47; Falk, *Exh. Record Series.*

RAHN, A Donald *[Painter] 20th c.*
Addresses: Brooklyn, NY. **Member:** GFLA. **Sources:** WW27.

RAHN, Irving *[Painter] 20th c.*
Addresses: Milwaukee, WI. **Member:** Wis. PS. **Sources:** WW25.

RAHR, Frederic H *[Collector, patron] b.1904, Malden, Mass.*
Addresses: New York, NY. **Studied:** Harvard Col; Famous Artists Sch; Nat Acad Sch Fine Arts; also with Francis Scott Bradford. **Comments:** Collection: Paintings, prints, engravings. **Sources:** WW73.

RAHTJEN, Fitzhugh *[Painter] 20th c.*
Addresses: San Francisco, CA. **Comments:** Possibly Elizabeth Fitzhugh Rathjen (see entry). **Sources:** WW17.

RAIGUEL, Marjorie *[Painter] 20th c.*
Addresses: Chicago area. **Exhibited:** AIC, 1941. **Sources:** Falk, *AIC.*

RAIKEN, Leo *[Painter] 20th c.*
Addresses: Brooklyn, NY. **Studied:** ASL. **Exhibited:** 48 States Comp., 1913; S. Indp. A., 1941. **Sources:** WW40.

RAILEY, Laura *[Sketch artist, teacher]*
Addresses: New Orleans, active 1892-1913. **Studied:** Newcomb Coll., 1892. **Exhibited:** Tulane U., 1892. **Sources:** *Encyclopaedia of New Orleans Artists,* 317.

RAIN, Charles (Whedon) *[Painter] b.1911, Knoxville, TN.*
Addresses: New York, NY. **Studied:** AIC, 1931-33; private study in Berlin, Vienna, and Paris, 1933-34. **Exhibited:** AIC, 1936, 1942, 1947; WMAA, 1941, 1949; Corcoran Gal biennials, 1947, 1959, 1963; Springfield MFA, 1947 (purchase prize), 1963; Univ Ill, 1949-57 (5 solos; purchase prize in 1950); Los Angeles Mus Art, 1951, 1956; Denver Art Mus, 1957; PAFA Ann., 1958; Albright-Knox Art Gallery, Buffalo, 1961; FAR Gal., NYC, 1970s; "Surrealism and American Art," Rutgers Mus., New Brunswick, NJ, 1977. **Work:** Springfield MFA; Univ Ill; Ariz State Univ, Tempe; DeBeers Mus, Johannesburg, S. Africa; Virginia MFA. **Comments:** Magic Realist. **Sources:** WW73; Wechsler, 38; Falk, *Exh. Record Series.*

RAIN, Isaac *[Listed as "artist"] b.c.1816, Pennsylvania.*
Addresses: Philadelphia in 1850. **Sources:** G&W; 7 Census (1850), Pa., LIV, 780.

RAINE, Earl Thomas *[Painter] b.1911, Penns Grove, NJ.*
Addresses: Thiensville, WI. **Studied:** Marquette Univ.; Univ. Arizona; Layton Sch. A. **Member:** Wis. P. & S.; Wis. Ar. Fed. **Exhibited:** 48 States Comp., 1939; WFNY, 1939; Grand Rapids A. Gal., 1940; PAFA, 1940-41, 1946; AIC, 1936, 1938-40, 1948, 1952; Denver A. Mus., 1936-38, 1939 (solo),1940, 1944, 1946, 1949; CM, 1940-41; Wis. P. & S., 1935-42, 1946, 1949-53, 1957; Layton A. Gal., 1936, 1938, 1940, 1946 (solo), 1949; Univ. Wisconsin, 1935-40; Milwaukee AI, 1949; Minn. Centennial, 1949; Wisconsin Centennial, 1948; Gimbel's Wis. Centennial, 1948; Ozaukee County Exh., 1948-58. **Work:** Layton A. Gal.; WPA artist. **Comments:** Position: Chm., Ozaukee County A. Com., 1949-56, 1958. **Sources:** WW59; WW47.

RAINES, Minnie *[Painter] 20th c.*
Addresses: Memphis, TN. **Sources:** WW25.

RAINEY, Bennett *[Painter] 20th c.*
Addresses: Wash. DC. **Exhibited:** PAFA Ann., 1939. **Sources:** Falk, *Exh. Record Series.*

RAINEY, Catherine (Kate) Scott (Mrs. Wm. J.) *[Painter]* *19th/20th c.*
Addresses: Detroit, MI, 1880- after 1900. **Exhibited:** Detroit Art Assoc., 1875-76; Angell's Gallery, Detroit, 1877; Detroit Inst. of Arts, 1883, 1886; Michigan State Fair, 1880. **Sources:** Gibson, *Artists of Early Michigan,* 199.

RAINEY, Froelich Gladstone *[Art administrator, writer, lecturer]* *b.1907, Black River Falls, WI.*
Addresses: Valley Forge, PA; Philadelphia, PA. **Studied:** Univ Chicago, PhB, 1929; Am Sch in France, 1930; Yale Univ, PhD, 1935. **Member:** Am Asn Mus (pres, 1961-63, exec comt, 1963-70s); Int Coun Mus; Mus Coun Philadelphia; Soc Am Archaeol; Soc Pa Archaeol. **Exhibited:** Awards: Grants for res, Am Mus Natural Hist, 1934-42; Comdr., Order of Merit, Italian Repub. **Comments:** Positions: Asst in anthrop, Peabody Mus, Yale Univ, 1931-35; anthrop res in West Indies, 1933-35; Prof Anthropology, 1935-42; Consultant, State Dept, 1948-52; dir, Univ Mus, Univ Pa, 1947-70s, dir, Applied Sci Ctr for Archaeol, 1960-70s, archaeol res in Italy, 1961-70s, supvr archaeol res, Univ Mus expeds all over the world. Teaching: Asst prof anthrop, Univ Puerto Rico, 1935; prof anthrop, Univ Alaska, 1935-42; prof anthrop, Univ Pa, 1947-70s. Publications: Auth, "Archaeology,"1970, "Dating the Past," 1971 & "Archaeology," 1972, *Encycl Britannica Yearbk Sel & The Future;* auth, *The Ipiutak Culture. Excavations at Point Hope, Alaska,* Addison-Wesley, 1971; auth, "Looting of Archaeological Sites," *Sci Yr.* **Sources:** WW73.

RAINEY, Robert E. L. (Réni) *[Painter, screenprinter, designer, teacher]* *b.1914, Jackson, MI.*
Addresses: North Canton, OO. **Studied:** Univ. Chicago; AIC (M.F.A.); Francis Chapin; Boris Anisfeld. **Member:** Am. Soc. for Aesthetics; Vanguard PM Group. **Exhibited:** AIC, 1938-46 (5 annuals); Providence AC, 1945; Massillon Mus., 1945; Canton AI, 1946 (solo); Northwest PM, 1945 (prize); Canton AI, 1946 (prize). **Work:** SAM. **Comments:** Position: dir., Little Art Gal. of the North Canton (OH) Lib. **Sources:** WW59; WW47.

RAINSFORD, (Miss) *[Landscape artist]* *19th c.*
Addresses: NYC. **Exhibited:** NAD, 1843-44 (several English views and pencil drawings). **Comments:** Possibly one of the Misses Rainsford, one of whom was named Lydia, who ran a school for young ladies in NYC 1842-54. **Sources:** G&W; Cowdrey, NAD; NYCD 1842-54.

RAISBECK, J J *[Painter]*
Addresses: Swissvale, PA/Pittsburgh, PA. **Sources:** WW25.

RAJE, Pauline Cairns *[Painter]* *b.1899, California / d.1986, San Gabriel, CA.*
Addresses: Oakland, CA; Los Angeles, CA. **Exhibited:** Oakland Art League, 1928. **Comments:** Position: T., Mills Coll., 1928; T., Santa Paula public schools. **Sources:** Hughes, *Artists of California,* 454.

RAKEMANN, Carl *[Painter, illustrator, decorator, designer, educator]* *b.1878, Washington, DC / d.1965, Fremont, OH.*
Addresses: Chevy Chase, MD, 1928; Fremont, OH, 1960. **Studied:** Royal Academies in Munich and Düsseldorf; Paris. **Member:** Ten Painters of Wash. **Exhibited:** Corcoran Gal biennial, 1910; Soc. Wash. A.; Wash. WCC; Sesqui-Centennial Expo, 1926 (gold medal); MD Inst., 1930; Gr. Wash. Indp. Exh., 1935; Golden Gate Expo, San Francisco; General Motors Bldg., WFNY, 1939; GGE, 1939. **Work:** U.S. Capitol Bldg., Wash., D.C.; Hayes Mem., Fremont, Ohio; U.S. Dept. Commerce; Kenyon Col., Gambier, OH; U.S. Soldiers Home, TN; State House, Columbus, OH; murals, U.S. Court House, Dallas, TX; Bureau of Public Roads, Wash., DC; Wash. Hist. Soc. (portrait of father, 1905). **Comments:** Son of painter Joseph Rakemann. Contributor to *Highways of History.* **Sources:** WW59; WW47; McMahan, *Artists of Washington, DC.*

RAKEMANN, Joseph *[Fresco painter, decorative artist]* *b.1832, Melle, Germany / d.1917, Wash., DC.*
Addresses: Wash., DC. **Work:** White House; Patent Office; State

Dep. **Comments:** Came to the U.S. in 1856, first settling in Wash., DC, where he assisted Brumidi with decorations at the U.S. Capitol. **Sources:** McMahan, *Artists of Washington, DC.*

RAKHIT, Jane Kende *20th c.*
Studied: ASL. **Exhibited:** Salons of Am., 1931; S. Indp. A., 1931. **Sources:** Falk, *Exhibition Record Series.*

RAKOCY, William (Joseph) *[Painter, educator]* *b.1924, Youngstown, Ohio.*
Addresses: El Paso, TX. **Studied:** Butler Inst Am Art, with Clyde Singer, 1939-41; Am Acad Art, 1944; Kansas City Art Inst, with Ross Braught, Ed Lanning & Bruce Mitchell, MFA, 1951. **Member:** Kansas City Area Artists Asn; El Paso Art Asn; Mogollon Artists Asn (pres); Western Asn Art Schs & Univ Mus; El Paso Hist Soc. **Exhibited:** Butler Inst Am Art Ann, 1955; Nancy Crook International Gallery, El Paso, TX. Awards: Art travel grant to study in Italy, Italian Businessmen, Kansas City, Mo, 1953; first award in watercolor, Butler Inst Am Art, 1956. **Work:** Mural, U S N T S, Gt Lakes, Ill; mural, YMCA, Youngstown; watercolor, Butler Inst Am Art, Youngstown; drawings & prints, El Paso Mus Art, Tex. Commissions. Mural, Woodrow Wilson High Sch, Youngstown, 1946; four murals (with Robert Sonoga & Chet Kwiecinski), MeSorleys Colonial Rest, Pittsburgh, Pa, 1955; three murals, YMCA, Youngstown. **Comments:** Preferred Media: Oils, Watercolors, Acrylics. Teaching: Instr painting & drawing, Mohn Sch Art, 1954-56; asst prof painting & drawing, Col Artesia, 1966-67, assoc prof painting & drawing, 1967-71. Art Interests: Promoter of art auctions to assist artists via sales and scholarships. Publications: Auth, *Sketches on Mogo Uon,* 1964; auth, *A Western Portfolio,* 1965; auth, "Art Reporter, El Paso, Texas," *Painting Place Art News,* 1972; auth, *Sketches & Observations,* 1972; auth, "Art Look," *South West Gallery Mag.* **Sources:** WW73.

RALEIGH, Charles Sidney *[Marine painter]* *b.1830, Gloucester, England / d.1925, Bourne, MA.*
c.S.Raleigh 1881
Studied: self-taught. **Work:** Kendall Whaling Mus.; Mariner's Mus.; Mystic Seaport Mus.; Peabody Mus.; Old Dartmouth Hist. Soc.; Bourne Town Hall, Bourne, MA; Kendrick House, Wareham, MA; Shelburne, VT; MMA. **Comments:** A merchant seaman since boyhood, he settled in New Bedford, MA by 1870s where he first worked with a painting contractor, William H. Caswell and later set up a studio for work as a commercial marine artist. He executed a huge panorama depicting scenes from a whaling voyage. He and his family moved to Monument Beach, MA, 1881, where he established himself as a decorative house and carriage painter, although he continued to do works on canvas as well. **Sources:** Blasdale, *Artists of New Bedford,* 150-51 (w/repros.).

RALEIGH, Henry *[Illustrator, etcher, lithographer, painter]* *b.1880, Portland, OR / d.1944, NYC.*
RALEIGH
Addresses: San Francisco, CA; NYC/Westport, CT. **Studied:** Mark Hopkins Inst., San Fran. **Member:** Alliance; Artists G.; SC; SI; Coffee House C. **Exhibited:** Mark Hopkins Inst., 1897, 1900; SC, 1916 (prize); Ad. Art in America Comp., 1927 (gold); Illustration House, NYC, 1991 (first solo); AIC. **Work:** New Britain Mus. Am. Art. **Comments:** He was at his peak during the 1920s, illustrating elegant high society, and for four decades his works appeared in *Saturday Evening Post* and *Cosmopolitan.* In the 1920s, Everett Shinn called him "the best illustrator in this country today." In Westport, he lived near Arthur Dove, who he helped financially. However, he was also a hard drinker, and died after falling from the window of a run-down hotel in NYC. **Sources:** WW40; Hughes, *Artists of California,* 454; exh. pamphlet, Illustration House (1991); *Community of Artists,* 27.

RALEIGH, Sheila *[Painter]* *b.1913, NYC.*
Addresses: Westport, CT. **Exhibited:** S. Indp. A., 1932, 1934; Salons of Am., 1934. **Sources:** Falk, *Exhibition Record Series.*

RALL, (Mrs) *[Painter] 20th c.*
Addresses: Los Angeles, CA. **Member:** Calif. AC. Affiliated with Evening Express. **Sources:** WW25.

RALPH, John A. *[Engraver] b.c.1798, England.*
Addresses: NYC in 1850. **Sources:** G&W; 7 Census (1850), N.Y., LVI, 4.

RALPH, Lester *[Painter, etcher, illustrator] b.1877, NYC / d.1927.*
Addresses: NYC. **Studied:** ASL; Slade Sch., London; Académie Julian, Paris, 1895. **Comments:** Illustrator of Mark Twain's *Eve's Dairy.* **Sources:** WW25.

RALPH, W. *[Engraver] 18th/19th c.*
Addresses: Philadelphia, active 1794-1808. **Sources:** G&W; Stauffer.

RALSTON, C. W. *[Painter] 20th c.*
Addresses: Oakland, CA, 1930s. **Exhibited:** Oakland Art Gallery, 1934. **Sources:** Hughes, *Artists of California*, 454.

RALSTON, George Washington *[Portrait painter] b.1819 / d.1843.*
Comments: His early years were spent at Strasburg, Lancaster County (Pa.); he later moved to Columbia (Pa.) **Sources:** G&W; Letter of Jack Wilson to FARL, Dec. 8, 1946.

RALSTON, J(ames) K(enneth) *[Painter, illustrator, sculptor, writer] b.1896, Choteau, MT / d.1987.*
Addresses: Billings, MT in 1976. **Studied:** AIC, 1917, 1920; hon. D.F.A., Rocky Mountain College, 1971. **Member:** Montana Inst. Arts; Billings Arts Assn.; Yellowstone Art Center (chairman annual art auction). **Exhibited:** Yellowstone Gal., 1944; Billings; Cheyenne, WY; Noble Hotel, Lander, WY; Wort Hotel, Jackson, WY; Gainsborough Gallery, Calgary, Alberta, 1959; Charles M. Russell Gallery, Great Falls, 1962 & 1971; Montana Hist. Soc., 1964; Galeries Lafayette, Paris, France, 1966; Yellowstone Art Center, Billings, 1967 & 1971. His 4''' x 18' "After the [Custer] Battle," exhibited nationally and in Europe. **Work:** Jefferson Nat. Expansion Mem., Saint Louis, MO; Custer Battlefield Nat. Monument, Montana; Montana Hist. Soc. Mus. & Galleries, Helena; Buffalo Bill Hist. Center, Whitney Gallery Western Art, Cody, WY; Western Heritage Mus. Treasures of West Collection, Billings, MT. **Commissions:** murals, The Crossing, Jordan Hotel, Glendive, MT, 1952 & Billings Municipal Airport, Logan Field, 1958; paintings, After The Battle, Treasures of West Collection, 1955, Into The Unknown, Jefferson Nat. Expansion Monument, 1964 & The Return, First West. Nat. Bank, Great Falls, MT, 1971. WPA murals, USPO, Sturgis, SD & Sidney, MT. **Comments:** A cowboy-artist, Ralston began painting in oil at age 14 and was receiving landscape commissions by 18. Ran his father's ranch until 1935. Preferred media: oils, ink, watercolors. Publications: author/illustrator, *Rhymes of a Cowboy*, Rimrock Publ., 1969. **Sources:** WW73; Michael Kennedy, "Man Who Avoids Footprints of CMR," *Montana Magazine Western Hist.* (1961); R. W. Fenwick, "J. K. Ralston and His Art," *Empire Magazine* (1967); Ed Ainsworth, *The Cowboy in Art* (Book World Publ., 1968.); WW47; Peggy and Harold Samuels, 388; The Coeur d'Alene Art Auction, July 25, 1998.

RALSTON, Louis *[Dealer] b.1928, Point Pleasant Beach, NJ.*
Member: Lotos C.; Sons of the Am. Revolution. He had been an art dealer for thirty years, specializing on old masters, Barbizon and English paintings.

RALSTON, Robert *[Engraver] mid 19th c.*
Addresses: Providence, RI, active 1856. **Comments:** In 1856, was partner with James Wood (c. 1803-67, see entry) in Wood & Ralston, engravers for calico printers. **Sources:** G&W; Providence CD 1856.

RAMAGE, John *[Miniaturist] b.c.1748, Ireland / d.1802, Montreal, Canada.*
Studied: Dublin School of Artists, 1763. **Work:** NYHS.
Comments: He left Ireland at an unknown date and was living in Halifax (N.S.) in 1772 and 1774. He was working as a miniaturist in Boston by 1774, but with the outbreak of Revolution he joined the loyalist troops and went with his regiment to Halifax in April 1776. The following year his regiment went to NYC, where he remained until 1794 and achieved considerable success as a miniaturist. In 1794 he left NYC for Montreal because of financial difficulties. **Sources:** G&W; Morgan, *A Sketch of the Life of John Ramage, Miniature Painter;* Morgan and Fielding, *Life Portraits of Washington*, 139-42. More recently, see NYHS Catalogue (1974), index (for list of cat. entries).

RAMAIZEL, Fr. *[Painter] 20th c.*
Exhibited: S. Indp. A., 1938. **Sources:** Marlor, *Soc. Indp. Artists.*

RAMBEAU, J. Calhoun *[Painter, commercial artist] 20th c.*
Addresses: Los Angeles, CA, 1928-31. **Exhibited:** Artists Fiesta, Los Angeles, 1931. **Sources:** Hughes, *Artists of California*, 454.

RAMBERG, Christina (Christina Ramberg Hanson) *[Painter] b.1946, Camp Campbell, KY.*
Addresses: Chicago, IL. **Studied:** Sch Art Inst Chicago, BFA, 1968. **Exhibited:** Famous Artists, 1969 & Chicago Imagist Art, 1972, Mus Contemp Art, Chicago, Ill; Spirit of the Comic in the 50's & 60's, Univ Pa, Philadelphia, 1969; False Image H, Hyde Park Art Ctr, Chicago, 1969; WMAA, 1972-79; Phyllis Kind Gallery, Chicago, IL. **Comments:** Preferred Media: Acrylics. Teaching: Vis artist-instr painting, Univ Colo, Boulder, 1972. **Sources:** WW73.

RAMBERG, Lucy Dodd (Mrs.) *[Painter] d.1929, Florence.*
Addresses: Florence, Italy. **Comments:** Position: head, Lucy Dodd Sch. for American Girls.

RAMBO, James I *[Museum curator] b.1923, San Jose, CA.*
Addresses: San Francisco, CA. **Studied:** San Jose State Col, BA, 1948; Calif Sch Fine Arts; Tex A&M Univ. **Comments:** Positions: Mem staff, Cooper Union Mus, New York, NY, keeper decorative arts, 1950-52; mem staff, Calif Palace of Legion of Honor, San Francisco, Calif, 1953-70s, cur collections, 1955-66, chief cur, 1966-70s. Publications: Contribr, articles in prof publ & catalogues. **Sources:** WW73.

RAMBO, Ralph *[Commercial artist, cartoonist] b.1894, San Jose, CA.*
Addresses: San Jose, Ca; Palo Alto, CA. **Member:** San Jose Historical Mus. Assoc.; DeAnza College History Center. **Comments:** Position: Art dir., Muirson Label Co., fifty years. Auth./illus., 12 books in pen and ink on the history of the Santa Clara Valley. **Sources:** Hughes, *Artists of California*, 454.

RAMBUSCH, Frode C W *[Painter, decorator] b.1860, Denmark / d.1924, Brooklyn, NY.*
Exhibited: Award: knighted by the King of Denmark, 1916. **Work:** Cathedrals in Baltimore, Md., Scranton, Pa., Erie, Pa., Buffalo, N.Y.

RAMÉE, Joseph Jacques *[Architect and landscape architect] b.1764, Charlemont, France / d.1842, Beaurains, near Noyons, France.*
Studied: trained as an architect in France. **Exhibited:** Society of Artists, Philadelphia (1814: architectural drawing). **Comments:** Came to America in 1811, worked in Philadelphia and Baltimore, designed Union College and its grounds at Schenectady (N.Y.), and then returned to Europe about 1816. After working in Belgium and Germany he settled in Paris in 1823. **Sources:** G&W; DAB; Rutledge, PA; *Architectural Review* (Feb. 1947), 57-62; Thieme-Becker.

RAMER, Nat *[Artist] 20th c.*
Addresses: NYC. **Exhibited:** Salons of Am., 1934; PAFA Ann., 1934; Corcoran Gal biennial, 1935. **Sources:** Falk, *Exhibition Records Series.*

RAMEY, George *[Painter] 20th c.*
Addresses: Atlanta, GA. **Exhibited:** SSAL, 1937, 1939; WFNY, 1939. **Sources:** WW40.

RAMIREZ, Eduardo Villamizar *[Sculptor] b.1923, Pamplona, Colombia.*

Addresses: New York, NY. **Studied:** Nat Univ Colombia Archit Sch; Nat Univ Colombia Art Sch. **Exhibited:** The Classic Spirit, Sidney Janis Gallery, New York, 1964; White on White Show, De Cordova Mus, Lincoln, Mass, 1965; Art of Latin America Since Independence, Yale Univ, New Haven, Conn, 1966; Tenth Sao Paulo Biennial, Brazil, 1968; Am Acad Arts & Letters, 1972. Awards: Guggenheim Int Award, 1958; first award, Salon Artistas Colombianos, Bogota, 1964; second int prize, Tenth Sao Paulo Biennia, 1968. **Work:** MOMA; Chase Manhattan Bank, New York; MIT Art Collection, Cambridge, Mass. Bogota, Colombia; Notre Dame Univ Art Collection, Ind. Commissions: Wood relief & gold leaf, Banco Bogota, Colombia; precast concrete walk, Gaseosas Lux, Cali, Colombia; sculpture & wood panels, American Bank, New York; sculpture in concrete, Fort Tryon, New York. **Comments:** Preferred Media: Metal Constructions, Concrete Constructions. **Sources:** WW73.

RAMM, John Henry *[Landscape painter] b.1879, Antioch, CA / d.1948, San Francisco, CA.*
Addresses: San Francisco, CA. **Studied:** self-taught. **Comments:** Son of German immigrants, whose father had been a duke. Ramm accompanied Manuel Valencia (see entry) on sketching trips, but never exhibited or sold his paintings. **Sources:** Hughes, *Artists of California,* 455.

RAMM, John Milton *[Painter, mural painter] b.1904, San Francisco, CA / d.1984, Alameda, CA.*
Addresses: San Francisco, CA; Alameda, CA. **Studied:** with his father; Calif. Sch. of FA. **Exhibited:** Oakland Art Gallery, 1933. **Work:** WPA artist. **Comments:** Son of John H. Ramm (see entry). He painted watercolors on his many trips to places around the world, as well as murals in San Francisco and Hollywood. He also painted backdrops for Hollywood movies. **Sources:** Hughes, *Artists of California,* 455.

RAMM, Louis A. *[Landscape painter, engraver, lithographer] mid 19th c.*
Addresses: Richmond, VA, active 1850s. **Comments:** Position: lithographer, Ritchie and Dunnavant, Richmond. **Sources:** Wright, *Artists in Virginia Before 1900.*

RAMM (OR RANN), Henry G. A. *[Artist]*
Addresses: Wash., DC, active 1887-95. **Sources:** McMahan, *Artists of Washington, DC.*

RAMON See: **KELLEY, Ramón**

RAMON, A. A. *[Etcher, landscape painter] 20th c.*
Addresses: Los Angeles, 1932, San Francisco, 1938, Sausolito, 1941. **Member:** Soc. for Sanity in Art; Calif. Soc. of Etchers. **Exhibited:** GGE, 1940; Soc. for Sanity in Art, CPLH, 1941. **Work:** Oakland Mus. **Sources:** Hughes, *Artists of California,* 455.

RAMON, Adolpho *[Sculptor] 20th c.*
Addresses: NYC. **Studied:** Mrs. H.P. Whitney. **Sources:** WW19.

RAMOS, Anthony *[Videographer] b.1944.*
Addresses: Providence, RI (1975), NYC, (1979). **Exhibited:** WMAA, 1975-79. **Sources:** Falk, *WMAA.*

RAMOS, Carlos *[Artist] b.1940.*
Addresses: NYC, 1968. **Exhibited:** WMAA, 1968 (fiberglass). **Sources:** Falk, *WMAA.*

RAMOS, Mel(vin) John *[Painter, educator] b.1935, Sacramento, CA.*
Addresses: Oakland, CA. **Studied:** Sacramento Jr Col, 1954, with Wayne Thiebaud; San Jose State Col, 1955; Sacramento State Col, 1955-58 & MA. **Exhibited:** Pop Art USA, Oakland Mus & Six More, Los Angeles Co Mus, Calif, 1963; Human Concern, Personal Torment, WMAA & Pop Art Revisited, Hayward Gallery, London, Eng, 1969; Looking West, Joslyn Art Mus, Omaha, Nebr, 1970; French & Co, New York, NY. **Work:** MOMA; Neue Galerie, Aachen, Ger; Oakland Art Mus, Calif; San Francisco Art Mus, Calif; Univ Mus, Potsdam, NY. Commissions: Paintings, Time Inc, New York, 1968 & Syracuse

Univ, NY, 1970. **Comments:** Preferred Media: Oils. Teaching: Assoc prof painting, Calif State Univ, Hayward, 1966-70s. Publications: Contribr, *History of Modern Art,* 1969, *Erotic Art 2,* 1970, *Art Now/New Age,* 1971, *The High Art of Cooking & Art as Image and Idea,* 1972. **Sources:** WW73; R Skelton, "The Art of Mel Ramos," *Art Int* (Switz, 1968); S Suzuki, *Mel Ramos-1935-* (Mizue, Tokyo, 1970); "Pops Girls" (pictorial), *Playboy* (1972).

RAMSAY, David *[Engraver] mid 19th c.*
Addresses: NYC, 1854. **Sources:** G&W; NYBD 1854.

RAMSAY, Hallie See: **CONGER, Hallie Ramsay (Mrs. Clement)**

RAMSAY, Milne See: **RAMSEY, Milne**

RAMSAYE, Fern Forester (Mrs) *[Illustrator] b.1889, Poplar Bluffs, AR / d.1931, South Norwalk, CT.*
Studied: St. Louis Sch. FA; Phila. Sch. FA; Art Inst., Versailles, France. **Comments:** Illustrator: adv. agencies, NY magazines.

RAMSDELL, Fred Winthrop *[Landscape painter, portrait painter] b.1865 / d.1915.*
Addresses: Manistee, MI. **Studied:** ASL, with C. Beckwith; Paris, with R. Collin. (After several years spent in France and Italy he returned to join the colony of painters at Lyme, Conn.). **Exhibited:** Paris Salon, 1891-94, 1897, 1898. **Sources:** Fink, *American Art at the Nineteenth-Century Paris Salons,* 383.

RAMSDELL, Katherine D. *[Painter] 19th/20th c.*
Addresses: Woburn, MA. **Exhibited:** Boston AC, 1898-99. **Sources:** WW01; *The Boston AC.*

RAMSDELL, M. Louise (Lee) *[Painter] 20th c.; b.Housatonic, MA.*
Addresses: Housatonic, MA. **Studied:** Univ. California; Smith Col., B.A.; ASL; Grand Central Sch. A.; in Vienna; and with Wayman Adams, George Luks, Jerry Farnsworth, and others. **Member:** All. A. Am.; Audubon A.; NAWA; Pen & Brush Cl.; NAC; Berkshire AA.; Pittsfield AL; Springfield AL. **Exhibited:** Grand Central Sch. A., 1930; Ringling Sch. A., 1931; St. Petersburg A. Cl., 1936-37 (prizes); NAD, 1941, 1943; NAWA; All. A. Am., 1941-46; Portraits, Inc., 1942; NAC, 1943-46; Pittsfield AL, 1934-46; Berkshire Mus. A., 1942 (solo); Pen & Brush Cl., 1941, 1943, 1944 (solo), 1951 (prize), 1954 (prize); New Jersey P. & 5., 1948; Albany Inst. Hist. & A., 1955 (prize); Academie A., 1954 (prize). **Comments:** Position: Bd. Dir., Berkshire AA, 1953-. **Sources:** WW59; WW47.

RAMSDEN, Elizabeth *[Painter] 19th c.*
Addresses: Lansdale, PA. **Exhibited:** PAFA Ann., 1890. **Sources:** Falk, *Exh. Record Series.*

RAMSEUR, Mary D *[Painter] 20th c.*
Addresses: Spartanburg, SC. **Sources:** WW24.

RAMSEY, Alice Harvey *[Illustrator, painter] b.1894, Chicago, IL / d.1983, Westport, CT.*
Addresses: Westport, CT (1920s-on). **Studied:** AIC; ASL with Wallace Morgan and Howard Giles. **Comments:** Illustrator: *Judge, McCall's, Scribner's, Harper's Bazaar, Sat. Eve. Post,* and other magazines. She later became a central figure in the *New Yorker* group of illustrators. **Sources:** *Community of Artists,* 88.

RAMSEY, Charles Frederic *[Abstract painter] b.1875, Pont-Aven, Brittany, France / d.1951, New Hope, PA.*
Addresses: Phila. (1898-c.1905); New Hope, PA. **Studied:** PAFA (Cresson Trav. Scholarship, 1896); Académie Julian, Paris with J.P.Laurens and B. Constant, 1896-98. **Exhibited:** PAFA Ann., 1902-03, 1910-12; Phila. Art Alliance, 1940; Michener Mus., Doylestown, PA, 1991 ("New Hope Modernists"). **Comments:** Son of still-life painter, Milne Ramsey (see entry). In 1898 he lived in Philadelphia, and around 1905, he established a studio at New Hope, PA. In 1906 he became ass't curator at PAFA, and in 1911 became curator of the Carnegie Inst., Pittsburgh. In 1916 he became Director of the Minneapolis Sch. FA but was soon fired for being a socialist and member of the IWW ("Wobblies"). After serving as a camouflage artist during WWI, in 1918 he took up

permanent residence at New Hope and became an abstract painter. By the 1930s, he had led a secessionist movement known as "The Independents" or "The New Group" in reaction to the traditional landscape painters of New Hope. He taught privately and at the Solebury Sch. in New Hope. He also did wood-carving with Morgan Colt and large batik designs with a student, Ethel Wallace. **Sources:** WW13; *American Abstract Art,* 195; PHF files; Falk, *Exh. Record Series.*

RAMSEY, Dorothy *[Painter, mural painter] 20th c.; b.Santa Ana, CA.*
Addresses: Santa Ana, CA. **Studied:** self-taught. **Comments:** A midget, she opened a studio in Santa Ana in 1934. Specialty: Mexican and Hawaiian genre. **Sources:** Hughes, *Artists of California,* 455.

RAMSEY, Edith *[Sculptor] b.1889, Ogden, UT.*
Addresses: Brooklyn, NY. **Studied:** K.H. Gruppe. **Member:** NAWPS; Allied AA. **Exhibited:** Palm Beach AC, 1935. **Sources:** WW40.

RAMSEY, John *[Artist] 20th c.*
Addresses: NYC, 1933. **Exhibited:** WMAA, 1933 (drawing). **Sources:** Falk, *WMAA.*

RAMSEY, Lewis A. *[Landscape, portrait and mural painter, illustrator, sculptor] b.1873, Bridgeport, IL / d.1941, Hollywood, CA.*
Addresses: Hollywood, CA. **Studied:** Utah, with J. Hafen; AIC, 1890; D. Volk; Académie Julian, Paris with J.P. Laurens and Bouguereau, 1897-03. **Member:** Laguna Beach AA; Southern Calif. Artists; Soc. of Utah Artists. **Exhibited:** AIC, 1906; S. Indp. A., 1931. **Work:** murals, Latter Day Saints Temple, Hospital and State Capitol (Salt Lake City), Mun. Art Collection (Ogden), Brigham Young Univ. (Provo), churches, all in Utah; Ohio State Univ., Columbus; Latter Day Saints Temple, Laie, Hawaii. **Comments:** Traveled in Europe before teaching at LDS Univ. Was in Chicago until 1908 when he settled in Utah. Decorated a temple in Hawaii in 1916. Moved to Hollywood in the early 1930s, where he painted portraits of movie stars. Positions: teacher of penmanship, BYU, 1889; calligrapher and photo retoucher, Boston and NYC; teacher, Latter Day Saints Univ., 1903-05. **Sources:** WW40; Hughes, *Artists of California,* 455; P&H Samuels, 388.

RAMSEY, Lucy C. *[Artist]*
Addresses: Wash., DC, active 1881-85. **Sources:** McMahan, *Artists of Washington, DC.*

RAMSEY, Milne *[Still life, figure, and landscape painter] b.1847, Philadelphia, PA / d.1915, Philadelphia, PA.*
Studied: PAFA; with Leon Bonnat, in Paris, c.1871-76. **Exhibited:** Paris Salon, 1868-69, 1876, 1878-80; Brooklyn AA, 1871, 1882; NAD, 1872-90 (4 annuals); PAFA ann., 1877-92, 1903; Boston AC, 1881, 1888-92. **Work:** Mint Mus., Charlotte, NC. **Comments:** Ramsey is best known for his still lifes. He spent a decade in France, and his son, Charles Frederic Ramsey (see entry), was born at the artists colony of Pont-Aven, Brittany. Upon Milne's return c.1881, he apparently kept studios in Philadelphia, NYC, and a home in Atlantic City, NJ; finally living in Philadelphia for the last years of his life. **Sources:** WW04; Fink, *American Art at the Nineteenth-Century Paris Salons,* 383; Falk, *Exh. Record Series.*

RAMSEY, N. (Miss) *[Artist] late 19th c.*
Addresses: Active in Los Angeles, 1891. **Sources:** Petteys, *Dictionary of Women Artists.*

RAMSEY, Rachel (Miss) *[Amateur painter] b.c.1832.*
Addresses: Albany, NY. **Exhibited:** American Institute, 1849 (volume of paintings of flowers and other subjects). **Sources:** G&W; Am. Inst. Cat., 1849.

RAMSIER, John *[Miniature painter] b.1861, Switzerland / d.1936.*
Addresses: New Albany, IN; Louisville, KY. **Studied:** trained as a photographer. **Work:** Univ. Kentucky Art Mus., Lexington. **Comments:** Came to the U.S. in 1883. Worked as a photographer and set up a shop with a partner, W. A. Johnston, in 1893. When fire destroyed their equipment, Ramsier turned to miniature painting. He also did silhouettes, commercial lettering, tinted postcards and photographs. **Sources:** Jones and Weber, *The Kentucky Painter from the Frontier Era to the Great War,* 63-64 (w/repro.).

RAMUS, Charles Frederick *[Block printer, drawing specialist, engraver, illustrator, lithographer, painter, lecturer, teacher, writer] b.1902, Denver, CO / d.1979, Englewood, CO.*
Addresses: Denver, CO. **Studied:** J.E. Thompson; Denver Acad. Appl. A. **Member:** Cleveland PC. **Work:** CMA; Denver AM; Denver Pub. Lib.; Columbus Gal. FA; Allen Mem. AM, Oberlin Col.; CAM; Conn. Col.; Dayton AI; Cincinnati AM. **Comments:** Contributor: *Rocky Mountain News, Cleveland Year Book.* **Sources:** WW40.

RAMUS, Michael *[Painter] 20th c.*
Addresses: San Francisco, CA, 1930s and 1940s. **Exhibited:** 48 States Comp., 1939. **Sources:** WW40.

RANBY, Edwin F. *20th c.*
Exhibited: S. Indp. A., 1922, 1924-28; Salons of Am., 1925. **Comments:** *Cf.* Randby, Edwin F. **Sources:** Falk, *Exhibition Record Series.*

RANCH, Mildred *[Painter] 20th c.*
Addresses: Cincinnati, OH. **Member:** Cincinnati Women's AC. **Sources:** WW21.

RANCON, Victor *[Listed as "artist"] early 19th c.*
Addresses: New Orleans, active 1824. **Sources:** G&W; Delgado-WPA cites New Orleans CD 1824.

RAND, Daisy A. *[Painter] late 19th c.*
Addresses: Cambridge, MA. **Exhibited:** Boston AC, 1880, 1893. **Sources:** *The Boston AC.*

RAND, Ellen Emmet (Mrs. William B.) *[Portrait painter] b.1875, San Francisco, CA / d.1941, NYC.*
Addresses: NYC; Salisbury, CT. **Studied:** Boston, drawing with Dennis Miller Bunker (at age 12); ASL, 1889-93; Chase School at Shinnecock, c.1892; Paris, where she met Sargent and studied with MacMonnies, from 1896. **Member:** ANA, 1926; NA, 1934; NAWA; Portrait Painters. **Exhibited:** Durand-Ruel Gal., NYC, 1902 (solo); St. Louis Expo, 1904 (silver medal); PAFA, 10 annuals, 1904-41 (gold medal, 1922); Copley Hall, Boston, 1906 (first solo by a woman); William MacBeth Gal., NYC, 1907; Corcoran Gal biennials, 1907, 1923, 1930, 1935; NAD, 1908-38; AIC, 1909-28 (8 annuals); Pan-Pacific Expo, San Fran., 1915 (gold medal); Buenos Aires Expo, 1910 (bronze medal); NAWA, 1927 (prize); NYWF, 1939; Wm. Benton MA, Univ. Connecticut, 1984. **Work:** MMA; Roosevelt Library and Mus., Hyde Park (official portrait of Pres. Franklin D. Roosevelt, 1934); William Benton Mus. Art, Univ. Conn.; her portraits are in many public and private institutions. **Comments:** Born Ellen Gertrude Emmet. One of the leading women portrait painters at the turn-of-the-century, she set up her studio in NYC in 1900 and painted the portraits of many prominent American artists and writers; among them Henry James, William James, Stanford White, and Frederick MacMonnies. Her other sitters included many leaders of business, politics, education, and society. She was the cousin of Henry James and came from a family of women artists that included her cousins Rosina Emmet Sherwood, Lydia Emmet, and Jane Emmet De Glehn. She married Wm. Rand in 1911 and supplied the major part of her family's income through her work. Her close friends, such as Mary Foote, called her "Bay." Signature note: Her early works (1890s-c.1902) tend to be signed "E.G. Emmet." From c.1903 until she married in 1911, she tended to sign as "Ellen

Emmet Rand." **Sources:** WW40; Martha J. Hoppin, *The Emmets: A Family of Women Painters* (The Berkshire Museum, Pittsfield, Mass., 1982); Tufts, *American Women Artists*, cat. nos. 17, 18; Art in Conn.: The Impressionist Years; Falk, *Exh. Record Series.*

RAND, F. *[Portrait painter] 19th c.*
Addresses: Boston. **Exhibited:** Boston Athenaeum (1829). **Comments:** Groce & Wallace thought it possible this might be John Goffe Rand (see entry), who was in Boston at this time. **Sources:** G&W; Boston Athen. Cat., 1829.

RAND, Helen *[Sculptor, drawing specialist, teacher] b.1895, NYC.*
Addresses: NYC. **Studied:** S. Borglum, Bourdelle & R. Laurent. **Work:** Vassar College. **Sources:** WW40.

RAND, Helen Appleton *[Artist] b.1887 / d.1974, Brooklyn, NY.*
Addresses: Active in Brooklyn, NY, 1918. **Studied:** With Wm. M. Chase. **Comments:** Founder, Portraits, Inc., NYC. **Sources:** BAI, courtesy Dr. Clark S. Marlor.

RAND, Henry Ashbury *[Painter] b.1886, Phila., PA / d.1961.*
Addresses: Holicong, Phila., PA. **Studied:** PAFA, with Chase, Anshutz, Breckenridge. **Member:** Phila. Sketch C. **Exhibited:** PAFA Ann., 1909-31; CGA; AIC; Phila. Sketch C., 1965 (mem. exh.). **Work:** PAFA. **Comments:** Bucks County impressionist. Created an outdoor studio at his family farm "Shadowbrook;" he was also a horticulturist, specializing in orchids. **Sources:** WW40; Danly, *Light, Air, and Color*, 64; Falk, *Exh. Record Series.*

RAND, John Goffe *[Portrait painter] b.1801, Bedford, NH / d.1873, Roslyn, Long Island, NY.*
Addresses: Roslyn, Long Island, NY. **Studied:** apprenticed to a furniture painter; took up portraiture about 1825 and received some instruction from Samuel F.B. Morse, who was working in the vicinity of Manchester (N.H.). **Member:** A.N.A., 1833. **Exhibited:** Boston Athenaeum (1828-29); NAD (1833, 1859-60); Royal Academy, London (1840). **Work:** NYHS (portrait of William Cullen Bryant). **Comments:** Rand was in Boston in 1828 and 1829. In March and April 1831 he was at Charleston (S.C.). He moved to NYC about 1833 and the following year he went abroad, settled in London for a number of years and there developed the screw-top compressible paint tube. Rand was back in NYC in 1840, but appears to have made a second visit to England in the forties. He opened a studio in NYC about 1848 and firmly established himself as a portrait painter. **Sources:** G&W; "Art and Artists in Manchester," 110-11; Swan, BA; Cowdrey, NAD; NYBD 1840, 1851; Rutledge, *Artists in the Life of Charleston; cf.* Lipman and Winchester, 179; Barber, "Deaths Taken from the N.Y. Evening Post." NYHS Catalogue (1974).

RAND, Margaret A(rnold) *[Painter, teacher] b.1868, Dedham, MA / d.1930.*
Addresses: Cambridge, MA. **Studied:** with E.D. Norcross, C. Goodyear, G.H. Smillie; H.W. Rice. **Member:** Copley Soc., 1894. **Exhibited:** Boston AC, 1898-1901; Phila.; NYC. **Work:** Boston AC. **Sources:** WW29; *The Boston AC.*

RAND, Paul *[Painter, designer, teacher, writer] b.1914, NYC.* *Paul Rand*
Addresses: Weston, CT. **Studied:** Pratt Inst; ASL, with George Grosz; Parsons Sch Design. **Member:** Art Dirs Club New York; AIGA; Alliance Graphique Int, Paris; Benjamin Franklin fel, Royal Soc Arts & Sci, London. **Exhibited:** AIGA, 1938 (prize), 1942, 1958 (solo), 1966 (gold medal); A. Dir. C. 1936-44, 1945 (medal), 1946; Composing Room, 1947 (solo), IBM Gallery, 1971 (solo); Brooklyn Mus, 1972 (solo); Awards: Citation, Philadelphia Col Art, 1962; Art Dirs Hall of Fame, 1972. **Work:** MOMA; NYPL; Smithsonian Inst, Washington, DC. **Comments:** Positions: Art dir, Esquire Apparel Arts, 1937-41; art dir, Weintraub Advert Agency, 1941-54; design consult, IBM Corp & Westinghouse Elec Corp, 1956-70s. Teaching: Instr design, Cooper Union, 1942; instr graphic design, Pratt Inst, 1946-47; prof graphic design, Yale Univ, 1956-69. **Publications:** Auth, *Thoughts on Design,* Wittenborn, 1947 & Van Nostrand Reinhold, 1970; auth, *Black in the Visual Arts,* Harvard Univ Press, 1949; illusr, *I Know a Lot of Things,* 1956, *Sparkle & Spin,* 1957, *Little 1,* 1962 & *Listen, Listen,* 1970, Harcourt; auth, *The Trademarks of Paul Rand,* Wittenbron, 1960. **Sources:** WW73; Georgine Oeri,"Paul Rand," *Graphis Mag.*

RANDALL, A. G. See: **RANDALL, Asa Grant**

RANDALL, Albertine See: **WHEELAN, Albertine Randall (Mrs.)**

RANDALL, Alice *[Painter] late 19th c.*
Studied: with L.-O. Merson, R. Collin; Aman Jean. **Exhibited:** Paris Salon 1895; AIC. **Sources:** Fink, *American Art at the Nineteenth-Century Paris Salons*, 383.

RANDALL, Anne W. *[Painter, illustrator] 20th c.*
Exhibited: SAM, 1940. **Comments:** Position: illustr., Boeing Aircraft Co. **Sources:** Trip and Cook, *Washington State Art and Artists, 1850-1950.*

RANDALL, Arne *[Painter] 20th c.*
Addresses: Seattle, WA, 1941. **Exhibited:** SAM, 1940. **Sources:** Trip and Cook, *Washington State Art and Artists, 1850-1950.*

RANDALL, Asa Grant *[Painter, illustrator, block printer, teacher] b.1869, Waterboro, ME / d.1948.*
Addresses: Providence, RI; Boothbay Harbor, ME. **Studied:** PIA Sch., with A. Dow; ASL of Wash., DC; H. Helmick; A.H. Munsell. **Member:** Providence AC; Providence WCC; RI Assn. Teachers Drawing and Manual Arts; Quinsnicket Painters; Commonwealth Art Colony, Boothbay Harbor, ME (founder); Wash. WCC. **Exhibited:** Wash. WCC, 1896-98. **Comments:** Positions: teacher, Classical H.S., Providence, A.K. Cross Sch. **Sources:** WW40; WW98 (lists as A.G. Randall, living in Wash., DC, 1898); McMahan, *Artists of Washington, DC.*

RANDALL, Byron *[Painter, engraver, teacher] b.1918, Tacoma, WA.*
Addresses: Seattle, WA, 1944; San Francisco, CA. **Studied:** Salem Fed. A. Ctr.; with C.V. Clear; L. Bunce. **Member:** San F. A. Gld.; San F. AA; Council All. A. Los A.; AEA; Marin County.Soc. A. **Exhibited:** BMA, 1939; SFMA, 1946, 1950-51; John Herron AI, 1946; AIC, 1949; London, England, 1952; Los A., Cal., 1948; Toronto, Canada, 1948; solo: Univ. Oregon, 1942; Los A. City Col., 1942; ACG Gal., Los A., 1945; Raymond & Raymond, San F., 1943, 1945; Little Gal., Los A., 1944; SAM, 1941; Whyte Gal., 1939; Three Arts Gal., Poughkeepsie, N.Y., 1956; solo sponsored by City of Montreal, 1956. **Work:** SFMA; PMG; mural, YM-WHA, Montreal, Canada. **Sources:** WW59; WW47.

RANDALL, Corydon Chandler *[Painter, photographer] 19th/20th c.*
Addresses: Detroit, MI, 1861- after 1900. **Exhibited:** Detroit Art Assoc., 1875-76; Michigan State Fair, 1880. **Sources:** Gibson, *Artists of Early Michigan*, 199.

RANDALL, D Ernest *[Painter, illustrator] b.1877, Rush County, IN.*
Addresses: San Francisco, CA. **Studied:** AIC, with Vanderpoel, Hubble. **Member:** ASL, Chicago; Art Workers' G., St., Paul; Minn. State Art S. **Exhibited:** AIC, 1909. **Sources:** WW24.

RANDALL, Darley (Mrs.) See: **TALBOT, Grace Helen**

RANDALL, Eleanor Elizabeth *[Painter, educator] 20th c.; b.Holyoke, MA.*
Addresses: Boston, MA; Hartford, CT. **Studied:** Wheaton Col., A.B., Hon. A.M., 1957; BMFA Sch.; Boston Univ., M.A. **Member:** CAA; Rockport AA; North Shore AA. **Exhibited:** Boston AC; Springfield AL; Rockport AA; North Shore AA; Jordan Marsh Gal. **Comments:** Position: Asst. Prof. A., Wheaton Col., Norton, Mass., 1926-42; Senior Instr., Div. Edu., BMFA, Boston, Mass., to 1964; Cur., Education, Wadsworth Atheneum, Hartford, Conn., 1964-70s. **Sources:** WW66.

RANDALL, Emma F. Leavitt *[Portrait painter] 19th/20th c.*
Addresses: Phila., PA. **Studied:** PAFA with W.M. Chase & W. Sartain. **Exhibited:** PAFA Ann., 1885-92 (as Leavitt), 1895-97 (as Randall). **Sources:** WW13; Falk, *Exh. Record Series.*

RANDALL, Florence *20th c.*
Addresses: Providence, RI. **Member:** Commonwealth Colony of Art, Boothbay, ME. **Comments:** She taught with her husband, Asa, at the Commonwealth Colony of Art, Boothbay, ME, from 1905-c.1940. **Sources:** info courtesy C.E. Burden.

RANDALL, G. H. *[Etcher, engraver]*
Addresses: Wash., DC, active early 1900s. **Comments:** Contributor: etching, "The Old Stone Bridge" for the 1904 *Washington Evening Star* calendar. **Sources:** McMahan, *Artists of Washington, DC.*

RANDALL, George *[Scene painter] mid 19th c.*
Comments: Scene painter for *Uncle Tom's Cabin,* presented at Ordway Hall, Boston, in January 1853. **Sources:** G&W; Boston *Evening Transcript,* Jan. 10, 1853 (citation courtesy J.E. Arrington).

RANDALL, George Archibald *[Illustrator, printmaker] b.1887, Berkeley, CA / d.1941, Ventura, CA.*
Addresses: Ventura, CA. **Studied:** UC Berkeley, B.S., 1910. **Exhibited:** GGE, 1939; Bachman Gal., Los Angeles, 1939. **Comments:** Illustrator: "Spur," 1939. Specialty: horses, Indian and western subjects. **Sources:** WW40; Hughes, *Artists of California,* 455.

RANDALL, George C. *[Painter] 20th c.*
Addresses: Ellensburg, WA. **Exhibited:** SAM, 1938. **Sources:** Trip and Cook, *Washington State Art and Artists,* 1850-1950.

RANDALL, Harlan Elmer *[Painter] b.1880 / d.1965.*
Studied: apprenticed to an engraver; painting with Sam Sargent. **Member:** Newburyport AA (charter mem). **Exhibited:** Newburyport AA; Rockport AA; Ogunquit AA; Marblehead AA. **Sources:** C.L. Snow, exh. cat., "Newburyport Area Artists (1981).

RANDALL, James *[Painter] 19th/20th c.*
Addresses: Syracuse, NY. **Sources:** WW01.

RANDALL, Jessie Louise See: **MINDELEFF, Jessie Louise (Randall)**

RANDALL, L. C. *[Painter] 20th c.*
Addresses: Columbus, OH. **Member:** Pen and Pencil Club, Columbus. **Sources:** WW25.

RANDALL, Leslie *20th c.*
Exhibited: Salons of Am., 1933. **Sources:** Marlor, *Salons of Am.*

RANDALL, (Lillian) Paula *[Sculptor, designer] b.1895, Plato, MN / d.1985.*
Addresses: Sierra Madre, CA. **Studied:** Minneapolis Inst Arts; Univ Southern Calif; Otis Art Inst, Los Angeles. **Member:** Pasadena Soc Artists (secy-treas publicity, 1962-72); Pasadena Artist Assocs; Laguna Beach Art Mus; Los Angeles Co Art Gallery. **Exhibited:** All Calif Exhib, Laguna Beach Art Mus, Calif, 1964; Univ Taiwan, Formosa, 1964; Calif Inst Technol, Dabney Hall, Pasadena, 1965; Brandeis Univ Exhib, Granada Hills, Calif, 1967; Form and the Inner Eye Tactile Show, Calif State Univ, Los Angeles & Pierce Col, San Fernando, Calif, 1972. Awards: Laguna Beach Art Mus Award, All Calif Show, 1964; spec achievement award, All Calif Exhib, Indio, 1966; Pasadena Soc Artists Spec Award, 1971. **Work:** Western Div Nat Audubon Soc, Sacramento, Calif; Off Tournament Roses, Pasadena, Calif. **Comments:** Preferred Media: Wood, Stone, Plastics, Welded Metals. Teaching: Instr sculpture, pvt studio, 1969-70s; instr sculpture, Pasadena Sch Fine Arts, 1970. **Sources:** WW73; Russ Leadabrand, "Meet Artist Paula Randall," *Pasadena Star-News,* 1969; Don Ham (dir), "The Art of Age" (film), privately produced, 1971; Jim Norris, "An Artist Who Perseveres with a Blowtorch," *Pasadena Union,* 1971.

RANDALL, Loveta See: **HIBSCH, Loveta Randall**

RANDALL, Mary J. *[Painter] 19th c.*
Addresses: Chicago area. **Exhibited:** NAD, 1881; AIC, 1892. **Sources:** Falk, *AIC.*

RANDALL, Paul A. *[Landscape painter] b.1879, Warsaw, Poland / d.1933.*
Addresses: Indianapolis, IN. **Studied:** W. Forsyth; C.A. Wheeler. **Member:** Indiana AC; Brown County Gal. Assn. **Sources:** WW13.

RANDALL, Paula See: **RANDALL, (Lillian) Paula**

RANDALL, Ruth Hunie *[Designer, educator, teacher] b.1896, Dayton, OH.*
Addresses: Port Charlotte, FL. **Studied:** Cleveland Art Inst., design & art educ.; Syracuse Univ., B.F.A., M.F.A.; State Univ. NY College Ceramics, Alfred Univ.; Kunstgewerbe Schule, Vienna; also with Ruth Reeves, R. Obsieger & Ivan Mestrovic. **Member:** Am. Ceramic Soc.; Lg. Am. Pen Women; Syracuse AA; Syracuse Daubers; Southwest Florida Craft Guild; NY State Craftsmen (board directors, 1958-60); Syracuse Ceramic Guild (pres., 1956). **Exhibited:** Syracuse MFA, 1932-42, 1937 (prize), 1938 (prize); Cranbrook Acad. Art, 1946; WFNY, 1939; GGE, 1939; Paris Salon, 1937; MMA; Phila. Art All.,1936, 1942-45; Finger Lakes Exh., Rochester, Utica, NY; Youngstown, OH, Kansas City, MO, ceramic exh., Scandinavian countries; Syracuse AA, 1939 (prize); Robineau Mem. Exh., 1932; San Francisco; NYC; Paris Decorative Arts; Nat. Ceramic Exh., 1930-62, (second prize awards: 1930, 1936 & 1956); , Rochester (NY) Mus.,1962 (first prize for ceramic sculpture); Artizan Shop, Sanibel, FL. **Work:** IBM Collection; Syracuse MFA; San Antonio MA; Everson Mus., Syracuse, NY; Walker Art Mus., Youngstown, OH; San Antonio Mus.; Syracuse Univ. Commissions: ceramic sculpture relief, exterior branch library, Syracuse Board Educ. Bldg. Committee, 1960. **Comments:** Preferred media: ceramics. Publications: illustrator, ceramics page, *Craft Horizons,* 1939; author, "Ceramic Sculpture," Watson Guptill, 1946. Teaching: prof. design & crafts, Syracuse Univ. School Art, 1930-62. Collection: Japanese Mingei ceramics & Peruvian ceramics for Syracuse Univ. Art School Collection. **Sources:** WW73; article on personal ceramic collection, *Syracuse Mus. Bulletin,* 1960. WW47.

RANDALL, Theodore A *[Sculptor, educator, illustrator] b.1914, Indianapolis, IN.*
Addresses: NYC; Alfred, NY. **Studied:** Herron AI; Am. Acad., Rome; Yale Univ, BFA, 1938; State Univ NY Col Ceramics, Alfred Univ, MFA, 1949. **Member:** Fel Am Ceramic Soc; fel Acad Int Ceramics; fel Nat Coun Educ for Ceramic Arts (past pres); fel Nat Asn Schs Art (pres); SUNY Coun Art Dept Chmn. **Exhibited:** Yale; Grand Ctr. A. Gal.; Va. Bldg., WFNY, 1939. Awards: Prizes, Albright Art Gallery, Smithsonian Inst & York State Craftsmen. **Work:** Commissions: Pottery, Syracuse Mus Fine Arts & St Stephens Church, Albany, NY. **Comments:** Teaching: Lectr motives & meaning in art & ceramics today; instr State Univ NY Col Ceramics, Alfred Univ, 1952-53, asst prof, 1953-56, head div art, 1956-70s, prof ceramics, 1960-70s. Publications: Auth, "Notions about the Usefulness of Pottery," *Pottery Quart,* 1961; contribr, articles, In: *Am Ceramic Soc J & Bull, Ceramic Age, Ceramic Indust & Ceramics Monthly.* **Sources:** WW73; WW40.

RANDALL, Virna See: **HAFFER, Virna (Mrs. Norman B. Randall)**

RANDALL, William George *[Painter] b.North Carolina / d.1905, Blowing Rock, NC.*
Work: Universities of North Carolina in Chapel Hill and Greensboro. **Comments:** He spent most of his life in North and South Carolina, but moved to Wash., DC in 1893. He then moved to Arizona, and thereafter returned to North Carolina, where he died in Blowing Rock in 1905. **Sources:** McMahan, *Artists of Washington, DC.*

RANDBY, Edwin F. *20th c.*
Exhibited: Salons of Am., 1926. **Comments:** *Cf.* Ranby, Edwin F. **Sources:** Marlor, *Salons of Am.*

RANDEL, Elias, Jr. See: **RANDELL, Elias, Jr.**

RANDELL, Abraham R. *[Wood engraver] b.c.1822, New York State.*
Addresses: NYC, 1844-58. **Sources:** G&W; 7 Census (1850), N.Y., XLV, 43; NYBD 1844, 1858.

RANDELL, Elias, Jr. *[Engraver] b.c.1828, New York State.*
Addresses: NYC in 1850. **Sources:** G&W; 7 Census (1850), N.Y., L, 753 [as Randell].

RANDELL, Richard K *[Sculptor] b.1929, Minneapolis, MN.*
Addresses: New York, NY. **Exhibited:** Walker Art Ctr Biennial, 1956, 1958, 1962 & 1966; PAFA Ann., 1960; Ohio State Univ, 1966; Univ Ill, 1967; American Sculpture of the Sixties, Los Angeles Co Mus Art, 1967; Southern Ill Univ, 1967. **Awards:** Purchase prizes, Walker Art Ctr Biennial, 1956, 1962 & 1966; first prize & purchase prize, 1957 & hon mention, 1959, Minneapolis Art Inst; purchase prize, Saint Paul Art Gallery, 1961. **Work:** Minneapolis Art Inst; Univ Minn; Saint Paul Gallery; Walker Art Ctr, Minneapolis. **Comments:** Teaching: Instr, Hamline Univ, 1954-61; instr, Macalester Col, 1961; instr, Univ Minn, 1961-65; instr, Sacramento State Col, 1966. **Sources:** WW73; Maurice Tuchman, *American Sculpture of the Sixties* (Los Angeles Co Mus Art, 1967); Falk, *Exh. Record Series.*

RANDELS, Katherine *[Painter, mural painter] b.1916, Los Angeles, CA.*
Addresses: Michigan; California; Wisconsin; Battle Creek, MI. **Studied:** Mills College; Calif. Sch. of FA. **Exhibited:** SFMA, 1937, 1941; GGE, 1939. **Work:** Calhoun County Bldg., Marshall, MI; Battle Creek Art Center. **Sources:** Hughes, *Artists of California*, 455-456.

RANDLE, Frederic *[Painter] b.1808 / d.1886.*
Addresses: Phila., PA. **Exhibited:** NAD, 1875-75; PAFA Ann., 1876-79. **Sources:** Naylor, *NAD;* Falk, *Exh. Record Series.*

RANDOLPH, Beverly Parham (Mrs. Stephens) *[Sketch artist, teacher] 19th/20th c.; b.Biloxi, MS.*
Addresses: New Orleans, active 1901. **Studied:** Newcomb College, 1898, 1900-02. **Sources:** *Encyclopaedia of New Orleans Artists,* 317.

RANDOLPH, Dorothy See: **BYARD, Dorothy Randolph (Mrs. John)**

RANDOLPH, Edward Washburn *[Portrait painter] mid 19th c.*
Addresses: Active in Vermont, 1855. **Comments:** Painter of a portrait in oil, dated 1855 (private collection in Barre, Vt., as of 1941). **Sources:** G&W; WPA (Mass.), *Portraits Found in Vt.*

RANDOLPH, Elizabeth See: **GARDNER, Elizabeth Randolph (Mrs.)**

RANDOLPH, Gladys Conrad *[Painter, writer] 20th c.; b.Whitestone, NY.*
Addresses: Miami, FL. **Studied:** NY Sch Fine & Appl Art; Terry Art Inst; Portland Art Mus, Ore; Univ Pa; New York Univ; also with Hobson Pittman & Revington Arthur. **Member:** Fla Fedn Artists; Miami Watercolor Soc; Artists Equity Asn; Arts Coun, Inc, Miami (art chmn); Fla Art Group. **Exhibited:** League Am Pen Women, 1950; Fla Southern Col, 1952; Ringling Mus Art, Fla; Miami Art League; Am Artists Prof League. **Awards:** Prizes, Miami Art League, Blue Dome & Fla Fedn Artists. **Work:** Lowe Gallery Art; Columbus Mus Art, Ga. **Comments:** Publications: Contribr, articles, In: *Mineralogist, Portland Oregonian, Ore J, Am Boy* & other publ & newspapers. **Sources:** WW73.

RANDOLPH, Grace Fitz See: **FITZ-RANDOLPH, Grace**

RANDOLPH, Innes *[Amateur painter; Portrait sculptor] b.1837, Frederick County, VA / d.1887, Baltimore, MD.*
Addresses: Baltimore, MD. **Studied:** Hobart College. **Work:** Peabody Institute, Baltimore, Md. **Comments:** Randolph was active in Wash., DC, North Carolina, Virginia, and Baltimore. He was a journalist by profession, but also wrote poetry, painted in oil and watercolor, and executed cast bronze sculptures. About 1873 he modelled a bust of George Peabody, founder of the Peabody Institute. **Sources:** G&W; Randolph, *The Randolphs of Virginia*, 25; Peabody Institute Cat. (1949); McMahan, *Artists of Washington, DC.*

RANDOLPH, James Thompson *[Wood carver and portrait sculptor] b.1817, Bound Brook, NJ / d.1874.*
Addresses: Baltimore (for most of his life and all of his career). **Comments:** In 1839 he was a partner in Harold & Randolph, ship carvers (see entry), and from 1853 to 1860 he headed the firm of Randolph & Seward (with William E. Seward). Randolph executed a bust of Congressman John T. Randolph in 1858 and the McDonough Monument in Greenmount Cemetery in 1865. **Sources:** G&W; Gardner, *Yankee Stonecutters,* 70; Pinckney, *American Figureheads,* 120-21, 199; Baltimore CD 1842-60.

RANDOLPH, John W. *[Educator, painter, lithographer] b.1920, Ada, OK.*
Addresses: Enid, OK. **Studied:** Univ. Oklahoma, B.F.A., M.F.A. **Comments:** Position: Hd., A. Dept., Phillips Univ., Enid, Okla. **Sources:** WW59.

RANDOLPH, Lee F(ritz) *[Landscape and portrait painter, etcher, teacher] b.1880, Ravenna, OH / d.1956, Salinas, CA.*
Addresses: San Francisco, CA. **Studied:** Cincinnati A. Acad.; ASL with K. Cox; Ecole des Beaux Arts; Académie Julian, Paris; with Bonnat, Merson, and with A. Lhote in Paris. **Member:** Chicago Soc. of Etchers; San Fran. AA; Bohemian C.; Calif. S.E. **Exhibited:** Pan-P. Expo, San Fran., 1915 (med); San Fran AA, 1916, 1919 (med); Del Monte Art Gallery; Oakland Art Gallery, 1916; Beaux Arts Gallery of San Francisco, 1926-31; Bohemian Club, 1928, 1932, 1935; AIC; Paris Salon; SFMA, 1935. **Work:** SFMA; de Young Mus.; Oakland Mus.; Paris MoMA; Utah State Univ.; Luxembourg Mus. **Comments:** Position: T., UC Berkeley, 1915-16; Dir., Calif. Sch. FA., 1917-42. **Sources:** WW40.

RANDOLPH, Leila Pierce *[Craftsperson, teacher] b.1891, New Orleans, LA / d.1956.*
Addresses: New Orleans, active ca. 1915-16. **Exhibited:** NOAA, 1916-17. **Sources:** *Encyclopaedia of New Orleans Artists,* 317.

RANDOLPH, Mary *[Sculptor] 20th c.*
Addresses: Chicago, IL. **Exhibited:** AIC, 1911. **Sources:** WW13.

RANDOLPH, Virginia *[Painter] 20th c.*
Exhibited: AIC, 1928-29. **Sources:** Falk, *AIC.*

RANDOLPH & SEWARD *[Ship carvers] mid 19th c.*
Addresses: Baltimore, 1853-60. **Comments:** Partners were James T. Randolph (see entry) and William E. Seward. **Sources:** G&W; Pinckney, *American Figureheads,* 121, 199; Baltimore CD 1853-60.

RANEY, Grace *[Painter] 20th c.* **Addresses:** NYC, 1951. **Exhibited:** WMAA, 1951. **Sources:** Falk, *WMAA.*

RANGER, Henry Ward *[Landscape painter] b.1858, Syracuse, NY / d.1916, NYC.*
Addresses: Old Lyme, CT, 1899-1904; Noank, CT, c.1905-16; winter studio in NYC. **Studied:** Syracuse Univ.; self-taught; in Europe. **Member:** AWCS; ANA, 1901; NA, 1906; Lotos Club; NAC; Rochester AC. **Exhibited:** Brooklyn AA, 1882-92; Boston AC, 1883-1902; NAD, 1887-1916; Paris Salon, 1888-89; Paris Expo, 1900 (medal); AIC, 1889-1939; PAFA Ann., 1895-1905; Pan-Am. Expo. Buffalo,1901 (medal); Charleston Expo, 1902 (gold); AAS, 1907 (gold); Corcoran Gal annuals, 1907-08; Florence Griswold Mus., Old Lyme, CT, 1999 (retrospective).

Work: NMAA; Florence Griswold Mus., Old Lyme, CT; MMA; CGA; CI; TMA; Buffalo FA Acad.; NGA; PAFA; Brooklyn Mus.; Montclair (NJ) AM. **Comments:** One of the leading "Tonalists" of his day. In the late 1890s, he discovered the beauty of Old Lyme, CT, attracted other artists there, and it soon became one of the most important artists colonies in America. In 1902, he started spending time along the Mystic River and established a studio in Noank by 1905. He bequeathed his entire collection and estate to NAD for the establishment of the "Ranger Fund" to buy paintings to be donated to U.S. museums. **Sources:** WW15; Jack Becker, *Henry Ward Ranger and the Humanized Landscape* (exh. cat., Florence Griswold Mus., Old Lyme, 1999); *Connecticut and American Impressionism* 169-70 (w/repro.); *Art and Artists of the Mystic Area* (exh. cat., Mystic AA, 1976); Fink, *American Art at the Nineteenth-Century Paris Salons*, 383; *Art in Conn.: The Impressionist Years*; Falk, *Exh. Record Series.*

RANIERI, Robert *[Sculptor] 20th c.*
Addresses: NYC. **Exhibited:** PAFA Ann., 1968. **Sources:** Falk, *Exh. Record Series.*

RANK, Kathryn K. *[Painter] 20th c.*
Addresses: Collegeville, PA. **Exhibited:** PAFA Ann., 1950, 1952-54. **Sources:** Falk, *Exh. Record Series.*

RANKEN, William B E *[Painter] 20th c.*
Addresses: NYC. **Sources:** WW17.

RANKIN, Don *[Painter] b.1942.*
Addresses: Homewood, AL. **Studied:** Famous Artists' Sch; also with Bill Yeager; Samford Univ, BA (fine art & psychol). **Member:** Ala Watercolor Soe (past v pres, bd dirs); charter mem La Watercolor Soc (reporter-at-large); assoc Am Watercolor Soc. **Exhibited:** Ala Watercolor Soc, 1967-71; Birmingham Art Asn Ann, 1968 & Ala Centennial Show, 1971, Birmingham Mus Art. **Work:** Numerous collections in southeast & New England states. Commissions: Birmingham Centennial Seal, 1969; Birmingham Centennial commemorative coins, Arlington Shrine, 1970, Univ Ala Med Complex, 1971 & Birmingham Jefferson, 1971. **Sources:** WW73.

RANKIN, Dorothy Taylor *[Painter] 20th c.*
Addresses: Wash., DC, active 1919-23. **Exhibited:** Soc. Wash. Artists, 1922. **Sources:** WW24; McMahan, *Artists of Washington, DC.*

RANKIN, Ellen (Helen) Houser *[Sculptor] b.1853, Atlanta, IL.*
Addresses: Chicago, IL. **Studied:** AIC; Fehr Sch. Munich. **Exhibited:** AIC, 1889, 1891, 1894-97; Columbian Expo, Chicago, 1893; PAFA, 1896-97. **Comments:** Married W.P. Copp in 1874 and lived in Loda and Pullman, IL. **Sources:** WW01; WW04; Petteys, *Dictionary of Women Artists*; Falk, *Exh. Record Series.*

RANKIN, Grace *[Listed as "artist"] late 19th c.*
Addresses: Detroit, MI, 1875-77. **Exhibited:** Detroit Art Assoc., 1875-76; Angell's Gallery, 1877. **Sources:** Gibson, *Artists of Early Michigan*, 199.

RANKIN, Mary Kirk (Mrs. W.H.) *[Painter] b.1897, El Paso, TX.*
Addresses: San Marino 9, CA. **Studied:** Chouinard AI, and with Loren Barton, James Couper Wright. **Member:** Women Painters of the West; Pasadena Soc. Art; Laguna Beach AA; Nat. Soc. Arts & Letters; Artists of the Southwest; Nat. Lg. Am. Pen Women. **Exhibited:** Pasadena AI, 1949-52; Greek Theatre, Los Angeles, 1948-51; Laguna Beach AA, 1947-51; Ebell Club, Los Angeles, 1948-51. Awards: prizes, Hollywood Lib.; Women Painters of the West, 1952. **Sources:** WW59.

RANKIN, Myra Warner (Mrs. Leonard) *[Painter, sculptor, designer, craftsperson, illustrator, block printer, teacher] b.1884, Roca, NE.*
Addresses: New Hartford, CT. **Studied:** AIC; W. Reiss; H. Riess; Univ. Nebr. **Member:** S. Conn. Craftsmen. **Comments:** Position: teacher, Hartford YWCA Craft Workshop; ceramic and design teacher, New Hartford, CT; medical illustrator for Mayo Clinic,

Northwestern Univ., and medical publications. **Sources:** WW40; Petteys, *Dictionary of Women Artists.*

RANKIN, R. H. M. *[Painter] 20th c.*
Exhibited: AIC, 1930. **Sources:** Falk, *AIC.*

RANKINE, V. V. *[Sculptor, painter] mid 20th c.; b.Boston, MA.*
Addresses: New York, NY. **Studied:** Amedée Ozenfant School, NYC; Black Mountain College with Alberts & De Kooning. **Exhibited:** Jefferson Pl Gal, Wash., DC, 1963-72 (6 solos); Betty Parsons Gal, NYC, 1966, 1969-70; Corcoran Gal biennial, 1967; Four Americans, Axiom Gal, London, 1968; "Painting & Sculpture Today," Indianapolis Mus, 1969. Awards: painting prize, Corcoran Gallery ann. exhib., 1955. **Work:** NMAA; CGA; Oklahoma City Mus.; Indianapolis MA; Woodward Fndn, Wash., DC. Commissions: altar painting, Robert Owen Shrine, New Harmony, IN, 1965. **Comments:** Preferred media: plexiglas. Teaching: director, art dept., Madeira School, Greenway, VA, 1967-70; artist-in-residence, Inst. Man & Science, Rensselaer, NY, summer 1968; humanities art instructor, Hunter College H.S., New York, 1970-71. **Sources:** WW73; Leslie Judd Ahlander, article, *Art Int.* (Nov., 1964); Lawrence Campbell, article, *Art News* (March, 1969); Legrace Benson, article, *Art Int.* (Dec., 1969).

RANN, Vollian Burr *[Painter] b.1897, Wilmington, NC / d.1956.*
Addresses: Provincetown, MA (1922-56). **Studied:** Corcoran Sch. A.; NAD; & with Charles Hawthorne. **Member:** Provincetown AA (Hon. V. Pres.). **Exhibited:** Corcoran Gal biennials, 1928, 1937; PAFA Ann., 1928, 1937; NAD, 1930, 1931; Phila. A. All.; All. A. Am.; Provincetown AA, 1923-1946; Piedmont Festival, NC.; Univ. Illinois. **Sources:** WW53; WW47; Provincetown Painters, 144; Falk, *Exh. Record Series.*

RANNELLS, Edward Warder *[Writer, educator, lecturer, painter] b.1892, Osceola, MO.*
Addresses: Lexington, KY. **Studied:** Ohio State Univ., A.B.; FMA, Harvard Univ.; Univ. Chicago, M.A. **Member:** AFA; CAA; Nat. Edu. Assn.; Mid-Western Col. A. Conference. **Exhibited:** Columbus, Ohio; Louisville, Lexington, Ky. Contributor to: College Art Journal, Design, School Review, Gazette des Beaux-Arts, Journal of Aesthetics, with articles on art education & art criticism. **Comments:** Position: Assoc. Dean, AIC, 1926-29; Prof., Hd. Dept. A., Univ. Kentucky, Lexington, Ky., 1929-51; Prof. A., 1951-. **Sources:** WW59.

RANNELLS, Will *[Illustrator, painter, teacher] b.1892, Caldwell, OH.*
Addresses: Westerville, OH; Columbus, OH. **Studied:** Cincinnati A. Acad. **Member:** Artists G.; Columbus AL; Ohio WCS; NYWCC. **Exhibited:** Phila. WC Cl.; AWCS. **Comments:** I., "Dog Stars." 1916; "Waif, the Story of Spe," 1937; "Animals Baby Knows," 1938; "Farmyard Play Book," 1940; "Jack, Jock and Funny," 1938; "Timmy," 1941; Author, I., "Animal Picture Story Book," 1938; I., "Just a Mutt," 1947. Illus. for Life, Judge, McCall's, Country Gentleman magazines. Position: Assoc. Prof. FA, Ohio State Univ., Columbus, Ohio. **Sources:** WW59; WW47.

RANNEY, E. H. (Mrs.) *[Painter] 19th c.*
Addresses: Kalamazoo, MI. **Exhibited:** Michigan State Fair, 1884. **Sources:** Gibson, *Artists of Early Michigan*, 199.

RANNEY, Glen Allison *[Painter, teacher] b.1896, Hustler, WI / d.1959, Minneapolis, MN?.*
Addresses: Minneapolis, MN. **Studied:** Minneapolis Sch. Art; ASL; & with A. Angarola, Richard Lahey, Cameron Booth, George Luks. **Member:** Minnesota AA. **Exhibited:** CM, 1937-38; PAFA, 1937, 1941; PAFA Ann., 1938; Corcoran Gal biennial, 1939; AIC, 1925, 1937, 1938; Kansas City AI, 1938 (prize)-1940; Davenport, Iowa, 1940; Minnesota Inst. Art, 1923 (prize), 1935 (prize), 1936-46, 1937 (prize), 1943 (prize); Minnesota State Fair, 1923 (prize), 1936 (prize), 1937-38, 1939 (prize), 1940-42, 1943 (prize), 1944 (prize), 1946 (prize), 1949 (prize); Minneapolis Women's Club, 1935-57 (prizes); St. Paul Art Gal., 1940-46; No.

10 Gal., NY, 1941 (solo),1942 (solo); Kilbride-Bradley Gal., Minneapolis, 1957 (solo). **Work:** Minneapolis Inst. Art; Cape May (NJ) Court House; Univ. Minnesota; U.S. Marine Hospital, Carville, LA. **Comments:** WPA artist. **Sources:** WW59; WW47; Falk, *Exh. Record Series.*

RANNEY, William Tylee *W. R ANNEY*
[Genre, history, sporting and portrait painter] b.1813, Middletown, CT / d.1857, West Hoboken, NJ.
Studied: studied painting and drawing in Brooklyn, NY, beginning c.1833. **Member:** ANA, 1850. **Exhibited:** NAD, 1838-57. **Work:** North Carolina MA, Raleigh; J. B. Speed AM, Louisville; NAD; BMFA; Corcoran Gallery of Art; Thomas Gilcrease Inst., Tulsa, OK. **Comments:** An important genre and historical painter, particularly of the Southwest. He lived in Middletown, CT, until his apprenticeship as a tinsmith began in 1826 (at age of 13) in Fayetteville, NC. By 1833, he was studying art in Brooklyn,and in 1836 he enlisted with the Texan Army in the war against Mexico. On his return to Brooklyn, about 1838, he painted portraits before opening his studio in NYC, which he kept from 1843-47. He then moved to more rural areas: in 1848 he was living in Weehawken, NJ and by 1850 he was living in neighboring West Hoboken, NJ, which was then developing as a rural artist colony. Ranney's time in Texas had put him in contact with trappers, guides, and hunters, and this became the recurring subject matter for his art from about 1846 (when he exhibited several western scenes at the NAD). His Hoboken studio, with its large accumulation of western objects, was said to resemble a pioneer's cabin. In addition to his western paintings, he also became known for his history pictures, a number of which related to George Washington and the Revolutionary War, and for his pictures of duck hunting in the Hoboken marshes. Ranney was well-respected by his fellow painters, in particular by William Sydney Mount who, after Ranney's death, helped arrange a memorial exhibition to benefit the artist's family. Mount also completed paintings that had been left unfinished in Ranney's studio. Ranney's works were also reproduced as engravings and distributed widely by the Am. Art-Union. **Sources:** G&W; DAB; Cowdrey, NAD; Cowdrey, AA & AAU; NYCD 1843; NYBD 1844-50; Rutledge, PA; Rutledge, MHS; Karolik Cat., 462-64; *Crayon*, V (1858), 26, obit. More recently, see P & H Samuels, 389; Baigell, *Dictionary;* Gerdts, *Art Across America,* vol. 1: 232, 233 (repro.); *300 Years of American Art,* vol. 1, 157.

RANNIT, Aleksis *[Art historian, educator] b.1914, Kallaste, Estonia.*
Addresses: New Haven, CT. **Studied:** Tartu State Univ, dipl art hist; Columbia Univ, MS. **Member:** Int Asn Art Critics; Int Pen Clubs, London (exec comt); Asn Ger Art Historians; Estonian Lit Soc (pres); academician Acad Int Sci & Lett, Paris; plus others. **Exhibited:** Awards: Olsen Found fel res & writing on Coptic art & symbolism, 1955. **Comments:** Positions: Chief cur prints & rare bks, Lithuanian Nat Libr, Kaunas, 1941-44; sci secy, div fine arts, Fr High Comn, Ger, 1950-53; art ref librn & cataloger prints, art & archit div, New York Pub Libr, 1953 & 1961. Teaching: Prof art hist, Ecole Superieure Arts et Metiers, Freiburg, Ger, 1946-50; prof art hist, res assoc & cur Slavic & E Europ collections, Yale Univ,1970s. Publications: Auth, *Eduard Wiiralt* (monogr), 1943 & 1946 & *V K Jonynas* (monogr), 1947; auth, *V K Jonynas* (monogr), UNESCO, 1949; auth, *Honegger, Swiss Purist Artist* (monogr), 1971; contribr, *Brockhaus Encycl & Schweizer Lexicon.* **Sources:** WW73.

RANNUS, Woldemar (Waldemar) A. *[Painter] b.1880, Estonia / d.1944, NYC.*
Addresses: NYC. **Member:** Soc. Independent Artists. **Exhibited:** S. Indp. A., 1919-27, 1929, 1936, 1940; Salons of Am., 1929, 1934. **Sources:** WW25; Falk, *Exhibition Records Series*

RANSOM, Alexander *[Portrait painter] mid 19th c.*
Addresses: Active 1842-65. **Exhibited:** NAD, 1853-57; PAFA, 1865; Boston Athenaeum, 1842-55. **Work:** Tennessee State Mus. **Comments:** Relatively little is known about Ranson. He was active in Boston and Lowell (MA) in the 1840's, in London in

1850, in Boston in 1851-52, in NYC from 1853-55, and again in Boston from 1856 at least until 1865. Taught Aaron Draper Shattuck in Boston and moved with him jto NYC. **Sources:** G&W; Swan, BA; Boston BD 1844-46, 1851-52, 1857-60; Lowell *Courier,* April 23, 1845, Jan. 3 or 31, 1850 (citations courtesy C.C. Leach); Lowell BD 1848; Cowdrey, NAD; Rutledge, PA; Kelly, "Landscape and Genre Painting in Tennessee, 1810-1985," 50-51 (w/repro.).

RANSOM, Caroline L. Ormes *[Portrait and landscape painter, teacher] b.1826, Newark, OH / d.1910, Washington, DC.*
Addresses: Washington, DC, from mid 1870's until her death. **Studied:** Oberlin College; NYC, 1853, landscape with Asher B. Durand, portraiture with Thomas Hicks and Daniel Huntington; Wilhelm von Kaulbach in Munich, c.1857; Jarvis Hanks. **Member:** Daughters of Am. Revolution (a founder); Classical Club of Washington, DC (a founder. **Exhibited:** NAD, 1854-64. **Work:** U.S. Capitol; U.S. Treasury Dept.; Western Reserve Hist. Soc. (Cleveland, OH). **Comments:** Graduated from Grand River Institute in Austinburg, OH in 1845/46 and worked there as an art teacher until c.1849. After further study, was active in Sandusky (OH) from 1858 until she opened up a portrait studio in Cleveland in 1861. There she became the city's leading portraitist, particularly after her portrait of Ohio Senator Joshua R. Giddings was purchased in 1867 for the U.S. Capitol in Washington, DC. She left Cleveland and settled in Washington, DC, in 1875, where she produced portraits of many notable statesmen, including Thomas Jefferson, James Garfield, and Alexander Hamilton. **Sources:** G&W; Fairman, *Art and Artists of the Capitol;* 251; Cowdrey, NAD; Sandusky CD 1858; *Museum Echoes* (March 1951), cover. More recently, see McMahan, *Artists of Washington, D.C.,* who cites references giving birth date as 1826; Gerdts, *Art Across America,* vol. 2: 214-15 (and notes). Hageman, 121; Petteys, *Dictionary of Women Artists,* cites birth date of 1838.

RANSOM, Fletcher C *[Illustrator, portrait painter] b.1870, Kalamazoo, MI / d.1943.*
Addresses: NYC. **Studied:** AIC; NY Acad.FA. **Member:** SI, 1903. **Comments:** He shared a NYC apartment with baseball legend, Cy Young while illustrating for *Collier's, Woman's Home Companion*and *Youth's Companion.* He also produced calendars for Brown & Bigelow, and was commissioned by the Chicago Midland Railroad to paint 20 portraits of Pres. Lincoln. Ransom completed 14 of them before his death. **Sources:** WW19; add'l info courtesy Dr. Wm. F. Heatly, the artist's grand-nephew.

RANSOM, Louis Edward *[Painter] 20th c.*
Addresses: Chicago area. **Exhibited:** AIC, 1939, 1942-46. **Sources:** Falk, *AIC.*

RANSOM, Louis Liscolm *[Portrait, historical, and religious painter] b.1831, Salisbury Corners, NY / d.c.1926, Cuyahoga Falls, OH.*
Addresses: Akron, OH. **Studied:** Henry Peters Gray, NYC, 1851. **Work:** Oberlin (OH) College. **Comments:** During the late 1850's and early 1860's worked chiefly in up-state New York towns, including Utica, Rome, and Lansingburg. In 1884 he settled in Akron (OH). Two years later he donated his best-known work, "John Brown on His Way to Execution," to Oberlin College because of that school's anti-slavery stance. **Sources:** G&W; Information cited by G&W as being courtesy Mr. Fordan Ransom of Washingtonville (NY), son of the artist; Fletcher, "Ransom's John Brown Painting"; Rome CD 1859. More recently, see Gerdts, *Art Across America,* vol. 2: 225.

RANSOM, Ralph *[Painter] b.1874, St. Joseph.*
Addresses: St. Joseph, MI. **Studied:** AIC; Chicago Art Acad., with J.F. Smith; Acad. Delecluse, Paris. **Sources:** WW06.

RANSOM, William A *[Dealer, patron] b.1856, Rochester, NY / d.1919.*
Addresses: Los Angeles, CA.

RANSON, Nancy Sussman (Mrs.) *[Painter, serigrapher]* 20th c.; b.NYC.
Addresses: Brooklyn, NY. **Studied:** Pratt Inst. Art School, cert; NY School Fine & Applied Art; ASL; Brooklyn Mus. Art School; also with Alexander Brook; Robert Laurent & Jean Charlot; Brook. **Member:** Brooklyn AS; New York Soc. Women Artists (vice-pres., 1968-69); Am. Soc. Contemporary Artists (pres., 1969-71); NAWA (chmn. for exhibs., 1963-67; chmn. admission, 1969-71); Audubon Artists (director, graphics, 1970-73); Am. Color Print Soc. **Exhibited:** AWCS, 1940, 1942-43; NAWA, 1943-46, 1956 (Medal of Honor in Graphics); Brooklyn SA, 1941-46; "Tomorrow's Masterpieces" Exh., 1943; Long Island Art Festival,1946; Argent Gal.; Feragil Gal; Critics Choice Show, Grand Central Galleries, New York, 1946; WMAA, 1951; Nat. Exhib. Contemporary Artists US, Pomona, CA, 1956; PAFA, 1957; Color Prints of Americas, NJ State Mus., 1970; Am. Soc. Contemporary Artists, 1970 (first prize in graphics). Awards: MacDowell Foundation fellowship, 1964. **Work:** Fogg Mus. Art, Harvard Univ., Cambridge, MA; Mus. City of New York; Philadelphia Free Library; Nat. Art Gallery New South Wales, Sydney, Australia; Nat. MOMA, New Delhi, India. **Comments:** Preferred media: oils, acrylics, silkscreen. **Sources:** WW73; WW47.

RANTZ *[Painter]* 20th c.
Exhibited: AIC, 1930. **Sources:** Falk, *AIC.*

RAOUL, Louis *[Miniaturist, physician, and author]* early 19th c.
Addresses: Charleston, SC, 1816. **Sources:** G&W; Carolina Art Assoc. Cat. (1935).

RAOUL, Margaret Lente (Mrs.) *[Block printer, drawing specialist, lecturer, teacher, writer]* b.1892, Saratoga, NY.
Addresses: Navesink, NJ. **Studied:** B. W. Clinedinst; F.Dielman; D. Rivera; A. Lewis. **Comments:** Contributor: articles, *American Magazine of Art, Pamassus, The Bookman.* Illustrator: *The London Mercury.* **Sources:** WW40.

RAPER, B. W. *[Xylographic wood engraver]* mid 19th c.
Addresses: NYC, 1841. **Sources:** G&W; NYBD 1841.

RAPER, Edna *[Painter]* 20th c.
Addresses: Pleasant Ridge, OH. **Member:** Cincinnati Women's AC. **Sources:** WW25.

RAPETTI, John *[Sculptor]* b.1862, Como, Italy / d.1936.
Addresses: Weehawken, NJ. **Studied:** Milan; Paris, assisted Bartholdi casting the Statue of Liberty. **Comments:** Came to U.S. in 1889 to assist W.O. Partridge on exhibits for the Columbian Expo, 1889.

RAPHAEL, Frances (Mrs. Nicholas D Allen) *[Painter]* b.1913, San Angelo, TX.
Addresses: San Angelo, TX/Brooklyn, NY. **Studied:** X. Gonzalez; R. Staffel. **Member:** SSAL. **Sources:** WW40.

RAPHAEL, Joseph M.
[Painter] b.1872, Jackson, CA. / d.1950, San Francisco, CA. **JOE RAPHAEL**
Addresses: San Francisco, CA/Uccle, Belgium; Laren, Holland. **Studied:** San Francisco Sch. of Des. with Arthur Mathews and Douglas Tilden; Académie Julian, Paris with J.P. Laurens, 1894; École des Beaux-Arts. **Exhibited:** San Francisco AA 1896-1918 (gold medal), 1919-39; Mark Hopkins Inst., 1900 (gold med); Paris Salon, 1904, 1905 (hon. mention), 1906, 1915 (hon. mention); PAFA Ann., 1909; Del Monte Art Gallery; Calif. SE, 1913; Pan-Pacific Expo, San Francisco, 1915 (gold medal); Oakland Art Gallery, 1924, 1933 (solo); Gump's, 1941 (solo); SFMA, 1910 (solo), 1935, 1939 (solo), 1940 (solo), 1951 (solo); GGE, 1939; AIC; Calif. Hist. Soc., 1960 (solo); Stanford Univ., 1980 (solo); Oakland Mus., 1981. **Work:** Mills College, Oakland, CA; San Diego Mus.; SFMA; Oakland Mus.; de Young Mus.; Stanford Univ. Mus.; LACMA; Golden Gate Park Mus.; San Francisco AA. **Comments:** An expatriate painter, in 1894 he went to study in Paris and remained in Europe until 1939, at the outbreak of

WWII. While his early works show the influence of Dutch genre paintings, by 1905 he began painting large figure paintings, single figures and complex groups, in a naturalist light with Symbolist overtones. His life's work also includes watercolors, etchings, pen-and-ink drawings and woodcuts. **Sources:** WW40; Hughes, *Artists of California,* 456; Falk, *Exh. Record Series.*

RAPHAEL, LeRoy Lindenmuth See: LINDENMUTH, Tod

RAPHAEL, Samuel *[Painter]* 20th c.
Addresses: NYC. **Member:** GFLA. **Sources:** WW27.

RAPIN, George *[Painter]* 20th c.
Exhibited: Salons of Am., 1935-36; S. Indp. A., 1935-37. **Sources:** Falk, *Exhibition Record Series.*

RAPOPORT, Nathan *[Sculptor]* 20th c.
Addresses: NYC. **Exhibited:** PAFA Ann., 1960 (prize). **Sources:** Falk, *Exh. Record Series.*

RAPOZA, Francisco *[Painter, teacher, lecturer]* b.1911, New Bedford, MA.
Addresses: South Dartmouth, MA. **Studied:** Boston Univ.; New Bedford Textile Inst., B.S.; Swain Sch. Des., and with Harry Neyland. **Member:** Providence Art Club; New Bedford AA; Nat. Congress P.T.A.; Eastern AA; Dartmouth Teachers Assn. **Exhibited:** Boston, MA, 1948; New Bedford AA, 1952-55; New Bedford Art Group, 1948-52. Awards: New Bedford Centennial prize, 1947; New Bedford AA, 1954. **Work:** Old Dartmouth Hist. Soc.; Crapo Gal., New Bedford; murals, New Bedford Mun. Airport; Bass River Bank, Hyannis, MA. **Comments:** Position: art instructor, Swain Sch. Des., New Bedford, MA, 1943-55; also part-time, Tabor Acad., Marion, MA, 1948-52; art instructor, Dartmouth (MA) H.S., 1955-. Lectures: Art Appreciation; Color Theory: Impressionism to Present Day Art. **Sources:** WW59.

RAPP, Ebba (Mrs. McLauchlan) *[Painter, sculptor, print-maker, teacher]* b.1909, Seattle, WA / d.1985, Seattle.
Addresses: Seattle. **Studied:** Cornish A. Sch., Seattle; Univ. of Wash. with A. Archipenko summers of 1935-36. **Member:** Women Painters of Wash. **Exhibited:** Women Painters, Wash., 1937 (prize); Northwest PM, SAM, 1937 & Northwest Annuals, 1944 (solo); WFNY, 1939; University of Puget Sound, 1954; Frye AM, 1955 (solo); Denver AM; Grand Rapids Art Gal. (Michigan). **Work:** sculpture commissions: Seattle Pub. Lib., Magnolia Branch; Univ. of Washington Law Sch.; St. Barnabas Church, Bainbridge Island; Holy Trinity Lutheran Church, Mercer Island. **Comments:** Successful portraitist who made a transition into sculpture. Rapp executed portraits in oil of such people as Nellie Cornish, former governor Rosellini, and writer Mary McCarthy. Subject matter included female forms and compositions based on Northwest Indian motifs. Position: teacher, Cornish Art School Sculpture Dept, 1939-41 (instr., anatomy, drawing and sculpture) and Edison Voc. School. **Sources:** WW40; Trip and Cook, *Washington State Art and Artists;* addl. info courtesy Martin-Zambito Fine Art, Seattle, WA.

RAPP, George *[Illustrator]*
Addresses: NYC. **Member:** SI.

RAPP, Grant 20th c.
Exhibited: Salons of Am., 1934. **Sources:** Marlor, *Salons of Am.*

RAPP, Lois *[Painter, educator, illustrator, drawing specialist, teacher]* b.1907, Norristown, PA.
Studied: Philadelphia College Art, diploma teacher's training & certificate illus., 1925-29; also with Earl Horter. **Member:** Am. Watercolor Soc.; Woodmere Art Gallery (exhib. committee, 1965-69); Philadelphia Watercolor Club (board directors, 1968-70). **Exhibited:** S. Indp. A., 1942; Lansdale Art League, 1952 (gold medal for Along the Schuylkill River); Am. Drawing Ann. XV, Norfolk, VA, 1957; Am. Watercolor Soc. 91st Ann., NYC, 1958; Regional Exhib., Philadelphia Mus Art, Pa, 1959; Philadelphia Watercolor Club, Pa, 1971; Woodmere Art Gallery, Phila., 1960 (award for Meeting House Interior), 1963 (Falls of the Potomac), 1972. **Work:** Woodmere Art Gallery, Phila.; Valley Forge Mem.

Chapel, PA; Gwynedd-Mercy College, Gwynedd Valley, PA; Norristown (PA) Public Library; Montgomery Hospital, Norristown. **Comments:** Preferred media: watercolors, oils, pastels. Teaching: art instructor, Mater Misericordiae Acad., Merion, PA, 1933-45; instr art, Collegeville Trappe Public Schools, 1935-48; art instructor, Conshocken Art League, PA, 1935-57. **Sources:** WW73; WW40.

RAPPAPORT, Maurice I. *[Collector, critic, art dealer]* b.1899, Russia.
Addresses: Cleveland Heights, OH. **Studied:** ASL, with Henri, Bridgman, Neilson. **Member:** Soc. Independent Artists; Cleveland Art Directors' Club, 1952-70s. **Exhibited:** S. Indp. A., 1921. **Comments:** Positions: president, Rappaport Exhibits, Inc., 1932-70s; director, Circle Gallery, 1961-70s. Collection: 19th and 20th century traditional art. Specialty of gallery: contemporary realist art. **Sources:** WW66; WW25.

RAPPÉ, Mary *[Primitive watercolorist]* b.c.1776.
Addresses: Eastern Ohio, c.1790. **Sources:** G&W; Lipman and Winchester, 179.

RAPPIN, Adrian *[Painter]* b.1934, New York, NY.
Addresses: New York, NY. **Studied:** Acad. Fine Arts, Rome, Italy; Brandeis Univ., B.A.; Art Acad. Cincinnati; ASL. **Member:** Allied Artists Am.; 50 Am. Artists; Intercontinental Artists; Am. Artists Prof. League. **Exhibited:** Allied Artists Am., Nat.Acad. Design Galleries, 1961-72; solo exhibs, Barzansky Gallery, 1964, 1966 & 1969; 50 Am. Artists, New York, 1965-69; UNICEF Int., Monaco, 1965-67; Kalamazoo, MI, 1970. **Work:** Staten Island Mus., New York; Gibbes Gallery, Charleston Mus., SC; Lincoln Univ., Oxford, PA; Randolph Macon College, Lynchburg, VA; Kellogg Foundation, Battle Creek, MI. **Comments:** Preferred media: oils. Publications: "Reproductions Painting," Christmas Fund, *New York Times,* 1967-70, "Songs of our Times," Hansen, 1973 & "The Bookshelf for Boys & Girls," Univ. Soc. Press, 1973-74. **Sources:** WW73.

RAPPLEYE, Eva *[Painter, designer, teacher]* 20th c.; b.Interlaken, NY.
Addresses: Jersey City, NJ; Orr's Island, ME. **Studied:** Metropolitan Sch. Art; ASL; & with Kenyon Cox, Bryson Burroughs, G. Bridgman, G.P. Ennis, O. Julius. **Member:** PBC; Gotham Painters; Wolfe AC. **Exhibited:** WFNY 1939; PBC, 1944-46; Wolfe AC, 1944-46; Gotham Painters, 1944-46; Wolfe AC, 1936, 1937. **Sources:** WW53; WW47.

RASARIO, Ada See: CECERE, Ada Rasario

RASCHE, Mary Walcot See: RICHARDSON, Mary Walcot (Mrs. W. Rasche)

RASCHEN, Carl Martin *[Painter, illustrator, etcher, teacher]* b.1882.
Addresses: Rochester, NY. **Studied:** Rochester Atheneum; and with Gilbert Gaul; Mechanics Inst. **Member:** Rochester Art Club; Brush & Pencil Club; Beach Combers, NJ; Woodstock AA. **Work:** Univ. Rochester. **Comments:** Illustrator of magazines, newspapers, books. **Sources:** WW59; WW47.

RASCHEN, Henry *[Painter, teacher]* b.1854, Oldenburg, Germany / d.1937, Oakland, CA.
Addresses: Oakland, CA (1906-on).

H. RASCHEN 1886

Studied: with Joseph Harrington; San Francisco Sch. of Design, with V. Williams; with Charles Christian Nahl; Munich, with Loefftz, Streihuber, Barth, Dietz, 1875-83. **Member:** San Francisco AA; Bohemian Club. **Exhibited:** Mechanics' Inst., San Francisco, 1871 (medal); Calif. State Fair, 1894 (medal), 1896 (medal), 1898 (medal); Mark Hopkins Inst., San Francisco, 1897-1898; Munich Expo,1898 (gold medal); Lewis and Clark Expo, Portland, OR, 1905 (medal); Alaska-Yukon Expo, 1909 (gold medal). **Work:** Frye Mus., Seattle; Bohemian Club, San Francisco; Anschutz, Kahn, Harmsen collections. **Comments:** Raschen immigrated with his parents to Ft. Ross, CA in 1868. He returned from his studies in Europe in 1883, and while living in

San Francisco he often visited the family ranch in Sonoma County where he painted the Pomo Indians. In 1886, he served as a volunteer scout and sketch artist with the U.S. Army, in pursuit of Geronimo. In 1890, he returned to Munich to teach for four years. In 1894, he visited the captured Geronimo and painted portraits of him. A popular and successful painter, he continued recording the life and customs of the Southwest Indians, and was able to buy a large home in Oakland, CA after the San Francisco fire. **Sources:** Hughes, *Artists of California,* 456; P & H Samuels, 389-90, cites Merton Hinshaw's report of alternate birthdates (1856 or 1857), alternate birthplace (Mendocino County, CA) and an alternate deathdate(1938).

RASCOE, Stephen Thomas *[Painter, educator]* b.1924, Uvalde, TX.
Addresses: Arlington, TX. **Studied:** Univ. Texas, Austin; AIC, B.F.A., M.F.A. **Member:** Dallas AA; Fort Worth AA; Mus. South Texas, Corpus Christi; South Texas Art Lg. (pres., 1960-61); Arlington AA (pres., 1967-68). **Exhibited:** Longview Invitational Ann., Texas, 1957-72; Artists West of the Mississippi, Denver, CO, 1967; San Antonio (TX) Hemisphere, 1968; Mary Nye Contemporary Art, Dallas, TX, 1970s. **Awards:** Houston Mus. Fine Arts purchase award, Texas Show, 1956; first prize, Texas Painting & Sculpture Show, Dallas Mus., 1957; D.D. Feldman award, 1958. **Work:** Houston Mus. Fine Arts; Dallas Mus. Fine Arts,; Southern Methodist Univ., Dallas; Ford Motor Co., Dearborn, MI; Ling-Temco-Vought Research Center, Grand Prairie, TX. **Commissions:** Rancho Seco Land & Cattle Co, Corpus Christi, TX, 1967; Texas Instruments Corp., Dallas, 1967; Arlington (TX) Bank & Trust Co., 1969; First Nat. Bank Dallas, 1969; Lakewood Bank, Dallas, 1971. **Comments:** Preferred media: oils. Teaching: asst. professor art, Univ. Texas, Arlington, 1964-70s. **Sources:** WW73.

RASCOVICH, Robert(o) Benjamin(e) *[Painter, wood carver]* b.1857, Spalata, Dalmatia / d.1905, Chicago, IL.
Addresses: Tacoma, WA, 1903; Chicago, IL. **Studied:** Imperial Acad., Vienna; Royal Acad., Venice; École des Beaux-Arts, Paris; Rome. **Member:** Int. S., Rome; WCS, Rome. **Exhibited:** Brooklyn AA, 1885; AIC; Rome WCS (medal); Western Wash. Indust. Expo, 1891; Chicago, 1897 (prize); Columbian Expo, 1893 (prize). **Work:** Tacoma Pub. Lib., WA. **Sources:** WW01; Trip and Cook, *Washington State Art and Artists,* 1850-1950.

RASER, John Heyl *[Painter]* b.1824, Mobile, AL / d.1901.
Addresses: Phila., Reading and Williamsport, PA. **Studied:** art, science and music from an early age. **Member:** Art Exhibition Gallery; Phila. Art Club. **Exhibited:** PAFA Ann., 1876, 1889-90. **Comments:** Raser came to Reading, PA in 1851, where he opened two successful drug stores. He painted in his spare time and in 1871 sold his stores to paint full-time in a studio. He focused on portraits but also pursued landscape, marine and still life painting. He visited Europe in 1875, and sketched the countryside. In 1884 he opened a studio in Philadelphia and continued painting until his death in Williamsport, PA. **Sources:** Malmberg, *Artists of Berks County,* 22; Falk, *Exh. Record Series.*

RASEY, Rose *[Artist]* late 19th c.
Addresses: Active in Nashville, MI, c.1887-99. **Sources:** Petteys, *Dictionary of Women Artists.*

RASKIN, Joseph *[Painter, etcher, teacher, writer]* b.1897, Nogaisk, Russia.
Addresses: NYC. **Studied:** NAD. **Member:** Am. Artists Congress;Woodstock AA; Audubon Artists; AEA. **Exhibited:** Salons of Am., 1925; S. Indp. A., 1930; PAFA Ann., 1930, 1936, 1938; Tricker Gal., 1939; Schneider-Gabriel Gal., 1941; Steinway Hall, 1942; Assoc. Am. Artists, 1945; Corcoran Gal biennials, 1935, 1937; CI; Miami Beach AC, 1956 (solo); VMFA; NAD; SAGA; Schervee Gal., Boston, 1927; Hebraica Gal., NY, 1958 (solo). **Awards:** European scholarship, NAD, 1921; Fellowship, Tiffany Fnd., 1921. **Work:** Dept. Labor Bldg., Wash., DC; Dartmouth College Lib.; Harvard Law Sch. Lib.; Ain-Harod Mus., Israel. **Comments:** Author, "Portfolio of Etchings of Harvard

University"; co-illustrator, "Home-Made Zoo," 1952. **Sources:** WW59; WW47; Falk, *Exh. Record Series.*

RASKIN, Milton W. *[Painter] b.1916, Boston, MA.*
Addresses: Burbank, CA. **Studied:** BMFA Sch.; Sch. of Practical Arts, Boston, with Philip Martin, W. Lester Stevens, John Whorf, Harold Rotenberg and others; privately in Los Angeles with Leon Franks, Nicolai Fechin, G. Thompson Pritchard and Will Foster. **Member:** Calif. Art Club; San Fernando Valley Art Club; San Fernando Valley Prof. Artists Gld. **Exhibited:** Awards: prizes, Greek Theatre, Los Angeles, 1953; San Fernando Valley Art Club, 1953; San Fernando Valley Prof. Artists Gld., 1953. **Sources:** WW59.

RASKIN, Saul *[Etcher, lithographer, painter, illustrator, writer, lecturer] b.1878, Nogaisk, Russia / d.1966, New York, NY.*
Addresses: NYC. **Member:** AWCS; SAE; Audubon Artists; NYWCC. **Exhibited:** AIC (prize); Phila. Pr. Club (prize); PAFA Ann., 1930; SAE (prize). **Work:** MMA; BM; AIC; Pittsfield Mus. Art; CAM; VMFA; NYPL; LOC; Mus. FA of Houston; Brooks Mem. Art Gal.; Newark Mus., Lib.; Charleson (SC) Mus. **Comments:** Author: "Palestine in Word and Picture." Illustrator: "The Genesis," "The Book of Psalms," "The Hagadah." **Sources:** WW59; WW47; Falk, *Exh. Record Series.*

RASKO, Maximilian Aurel Reinitz *[Portrait painter, teacher, lecturer, graphic artist] b.1883, Budapest, Hungary / d.1961, Spring Valley, NY.*
Addresses: NYC. **Studied:** Royal Acad., Munich, Germany; Dresden Acad. Des. & Painting; Royal Indust. Acad., Transylvania; Normal Sch., Budapest; Académie Julian, Paris; Acad. FA, Vienna; Acad. FA, Rome, Italy. **Member:** Audubon Artists; AAPL; AAPL. **Exhibited:** Audubon Artists; Budapest, 1903 (prize); Int. Expo, Bordeaux, France, 1927 (prize); Civil Order of Merit, Bulgaria; Little Cross of Portugal; Cross from Ordinis Sanctae Maria de Bethlehem, 1951; Commendatorem Gratia, 1952; Senior Citizenship Certificate, from Gov. Harriman, New York State, 1958. **Work:** Nat. Democratic Club; U.S. Treasury Dept., Wash., DC; The Vatican, Rome Italy; Phillips Exeter Acad., Exeter, NH; U.S. Stamp printed, 1958, from portrait of Louis Kossuth, liberator. **Comments:** Illustrator: "The Mysteries of the Rosary." **Sources:** WW59; WW47.

RASKOB, Joseph *[Painter] b.1908.*
Addresses: NYC. **Exhibited:** S. Indp. A., 1941, 1944. **Sources:** Marlor, *Soc. Indp. Artists.*

RASMUSEN, Henry N. *[Painter, writer, educator, sculptor, graphic artist] b.1909, Salt Lake City, UT.*
Addresses: Austin, TX; Salt Lake City, UT; Mill Valley, CA. **Studied:** AIC; Am. Acad. Art, Chicago. **Member:** Utah State Inst. FA; Am. Artists Congress; San Francisco AA; AEA. **Exhibited:** Utah State Fair, 1937 (prize), 1939 (prize), 1943 (prize), 1948 (prize); WFNY 1939; AIC, 1939-40; CGA, 1940; MoMA, 1940; Am. Artists Congress, 1939; Utah State AC, 1939, 1941; Denver AM, 1940, 1947; Portland AM; San Diego FA Soc.; Oakland Art Gal.; Texas Western College; deYoung Mem. Mus.; CPLH; Albright Art Gal.; Vancouver (BC) Art Gal.; Wash. State College; Kansas City AI; Dallas MFA; MFA of Houston. Solos: Witte Mem. Mus.; Ft. Worth AA; Texas FAA; Corpus Christi AA; Texas State Teachers College; NYPL; Santa Barbara MA; Denver AM; SFMA. Awards: prizes, Utah State Inst. FA, 1944; IBM, 1939; Texas FAA; San Francisco AA, 1952, 1955-56. **Work:** Utah State Fair Assn.; Utah State Inst. FA; Brigham Young Univ.; Denver AM; SFMA; IBM; murals, Utah State AC; Utah State Capitol Bldg. (in collaboration). **Comments:** Positions: instructor, Univ. Texas; FAC of Houston; Utah State AC; Albright Art Sch., Buffalo, NY. Author: "Art Structure," 1950; "The Painters Craft" (chapter in "The Book of Knowledge"). **Sources:** WW59; WW47.

RASMUSSEN, Bertrand *[Painter] b.1890, Arendal, Norway.*
Addresses: Brooklyn, NYC. **Studied:** Acad. Julian, Paris, with J.P. Laurens, 1910. **Member:** Brooklyn WCC. **Exhibited:** Armory Show, 1913; S. Indp. A., 1917-20. **Sources:** WW25; Brown, *The Story of the Armory Show.*

RASMUSSEN, John *[Folk painter] b.1828, Germany / d.1895, Shillington, PA.*
Studied: self-taught. **Exhibited:** Rockefeller Folk Art Center, 1968 (retrospective with Hofmann and Mader). **Work:** Rockefeller Folk Art Center, Williamsburg, VA; Reading Mus., PA. **Comments:** Along with Charles Hofmann and Louis Mader (see entries), he was one of the three "Pennsylvania Almshouse Painters," so-named because they were committed to the Berks County Almshouse in Shillington, PA. Rasmussen immigrated in 1865, was committed to the poorhouse in 1879, and imitated Hofmann's style, as did Mader. **Sources:** *300 Years of American Art,* vol. 1, 226.

RASMUSSEN, John Harry *[Sculptor] 20th c.*
Addresses: Chicago area. **Exhibited:** AIC, 1945, 1951. **Sources:** Falk, *AIC.*

RASMUSSEN, Nils *[Landscape painter] mid 19th c.*
Addresses: Chicago, 1859. **Comments:** Partner with Henry Kleinofen in Kleinofen & Rasmussen, landscape painters, active 1859. **Sources:** G&W; Chicago CD 1859.

RASMUSSON, Daniel *[Painter] 20th c.*
Addresses: Philadelphia, PA, (1938). **Exhibited:** S. Indp. A., 1936; WMAA, 1938-45; AIC, 1943. **Sources:** Falk, *AIC.*

RASSAU, J. H. *[Lithographer] mid 19th c.*
Addresses: Charleston (SC), active 1845. **Comments:** Believed to be the first lithographer in Charleston. **Sources:** G&W; Rutledge, *Artists in the Life of Charleston,* 167 and fig. 43.

RASSIAT, James *[Painter] 20th c.*
Exhibited: AIC, 1930. **Sources:** Falk, *AIC.*

RASSIM, Mihride (Madame) *[Painter] 20th c.*
Addresses: NYC, 1932. **Exhibited:** S. Indp. A., 1932. **Sources:** Marlor, *Soc. Indp. Artists.*

RASZENSKI, Alexandre *[Miniaturist] mid 19th c.*
Addresses: NYC, active 1853-54. **Exhibited:** NAD, 1853. **Sources:** G&W; Cowdrey, NAD; NYBD 1854.

RASZEWSKI, Alexandre See: **RASZENSKI, Alexandre**

RATCLIFF, Blanche Cooley (Mrs. Walter B.) *[Painter] b.1896, Smithville, TX.*
Addresses: Atlanta, GA. **Studied:** O.B. Jacobson; D.B. Cockrell. **Member:** Les Beaux-Arts, Norman, OK; Ft. Worth Painter. **Work:** Univ. Oklahoma. **Comments:** Also known as Blanche Marshall Cooley. (Alternate spelling: Ratliff.). **Sources:** WW33.

RATCLIFF, William *[Painter] 20th c.*
Exhibited: AIC, 1927-28. **Sources:** Falk, *AIC.*

RATELLE, Arthur William *[Lithographer] b.1879, New Orleans, LA / d.1926, New Orleans, LA.*
Addresses: New Orleans, active 1898-1900. **Sources:** *Encyclopaedia of New Orleans Artists,* 317.

RATELLIER, Francis *[Lithographer] mid 19th c.*
Addresses: NYC, 1859. **Sources:** G&W; NYBD 1859.

RATH, Frederick L., Jr. *[Historian, museum director, lecturer, writer] b.1913, New York, NY.*
Addresses: Cooperstown, NY. **Studied:** Dartmouth College, B.A.; Harvard Univ., M.A. (Am. Hist.). **Member:** Am. Hist. Assn.; Am. Assn. for State & Local Hist.; AA Mus. **Exhibited:** Awards: Certificate of Merit, Am. Scenic & Historic Preservation Soc.; fellowship, Rochester Mus. Arts & Sciences. **Comments:** Positions: historian, Nat. Park Service, 1937-42, 1946-48; exec. secretary, Nat. Council for Historic Sites & Bldgs., 1948-50; director, Nat. Trust for Historic Preservation, 1950-56; vice-dir., New York State Hist. Assn., Cooperstown, NY, 1956-; pres., Am. Assn. for State & Local History, 1960-62; council, 1954-60s; editor, "FDR's Hyde Park" (with Lili Rethi); comm. of admin., Cooperstown Graduate Programs (History Museum Training and American Folk Culture). Teaching: adjunct prof., State Univ. College at Oneonta. Lectures: New Trends in Historic

Preservation. **Sources:** WW66.

RATH, Hildegard *[Painter, lecturer] b.1909, Württemberg, Germany.*
Addresses: Kings Point, NY. **Studied:** Atelier House, Stuttgart, Germany, with Adolf Senglaub; Kunstgewerbe Schule, Stuttgart; Akad. Bildenden Kunste, Berlin, Germany; also with Otto Manigk, Berlin. **Member:** Int. Platform Assn.; Württembergischer Kunstverein, Stuttgart; Southern Vermont AA; Knickerbocker Artists; Artists Equity Assn. NY. **Exhibited:** Weissenhof Ausstellung Stuttgart Int., 1927; Allied Artists Am., Nat. Acad. Design Galleries, New York, 1951; Artists Equity Bldg. Fund Exhib., WMAA, 1951; Artists Equity Assn., 1952; 15th Nat. Print Exhib., Library Congress, 1957; Galerie Internationale, NYC, 1970s; Weintraub Gallery, NYC, 1970s. Awards: Dr. Blaicher Award, 1927; Grumbacher Award, 1952; Prix de Paris, 1963. **Work:** Württembergische Kultministerium, Stuttgart; MMA; NYPL; BM; LOC, Washington, DC; over 800 works in museum & private collections. Commissions: oil paintings, portraits & landscapes, commissioned by Willi Eiselen, Ulm, Donau, Germany, 1932; portraits, landscapes & still lifes, commissioned by Waiter Freudenberg, Baden, Germany, 1946; Triplets, commissioned by Mrs. Sig. Buchmeyer, Paris, France, 1948; Mrs. Siegtraut Gauss-Glock, Württemberg, Germany, 1954; Madonna, commissioned by Klaus Heuck, Frankfurth, Germany, 1959. **Comments:** Preferred media: oils, pastels, watercolors, charcoal. Publications: author, articles, *Art Digest,* 1952, *Schwarzwald Zeitung,* 1959 & *Am. Artist,* 1963; contributor, "Enciclopedia int degli artisti," 1970-71. Teaching: director of painting, European School Fine Art, 1949-54; lecturer history of art, Great Neck Public Schools, 1961-62; lecturer serigraphy, North Shore Art Center, 1961-62. **Sources:** WW73; Hennemann-Bayer, "Zur Ausstellung," *Schwarzwälder Bote Stuttgart,* 1959; Dannecker, "Von Werken," *Stuttgarter Nachrichten,* 1959; P.H. Buhner, "HIldegard Rath im Kunsthaus Schaller," *Stuttgarter Zeitung,* 1959.

RATHBONE, Augusta Payne *[Painter, etcher, illustrator] b.1897, Berkeley, CA.*
Addresses: San Francisco, CA. **Studied:** Univ. California, B.A.; Grande Chaumière, Paris, France, and with Claudio Castelucho, Lucien Simon. **Member:** NAC; AAPL; Calif. Soc. Etchers; San Francisco Women Artists. **Exhibited:** Paris Salons; Oakland Mus.; BM, 1933; Calif. Soc. Etchers,1947 (purchase),1950, 1953; San Francisco Art Festival, 1951 (prize); deYoung Mem. Mus., 1954; Calif. State Lib., 1952; Raymond & Raymond Gal.; CPLH, 1958; SFMA. **Work:** deYoung Mem. Mus.; Calif. State Lib.; BM. **Comments:** She made many trips to NYC and France. Illus., "French Riviera Villages." **Sources:** WW59; Hughes, *Artists of California,* 457.

RATHBONE, Charles H. , Jr. (Mrs.) See: **MOORE, Martha**

RATHBONE, Charles Horace, Jr. *[Painter, etcher, teacher, writer] b.1902, NYC / d.1936, Miami Beach, FL.*
Addresses: NYC/Concameau, France. **Studied:** ASL; H. Lever. **Member:** NAC; "The Fifteen" (founder); SC; Artists Fellowship Assn.; Union Artistique de la Bretagne, France; Allied Artists of America. **Exhibited:** S. Indp. A., 1926-27; Salons of Am., 1927, 1928, 1934; Corcoran Gal biennial, 1930; PAFA Ann., 1931. **Work:** BM. **Comments:** Author: "It's the Climate," 1936, illustrated with linoleum cuts by his wife, Martha Moore (see entry). **Sources:** WW33; Falk, *Exh. Record Series.*

RATHBONE, Edith P. *[Sculptor] 20th c.*
Addresses: NYC. **Member:** S. Indp. A. **Exhibited:** S. Indp. A., 1917-18, 1921; WMAA, 1920-21. **Sources:** WW24.

RATHBONE, Eleanor *[Sculptor] 20th c.*
Addresses: Los Angeles, 1930s. **Studied:** Chouinard Art School. **Exhibited:** Los Angeles County Fair, Pomona, 1935. **Sources:** Hughes, *Artists of California,* 457.

RATHBONE, J. L. (Mrs.) *[Painter] 19th/20th c.*
Addresses: San Francisco, CA. **Exhibited:** San Francisco AA, 1885. **Sources:** Hughes, *Artists of California,* 457.

RATHBONE, Martha See: **MOORE, Martha**

RATHBONE, Mary P. (Mrs.) *[Portrait and still life painter, etcher] late 19th c.*
Addresses: NYC. **Exhibited:** Brooklyn AA, 1867, 1873-78. **Sources:** *Brooklyn AA.*

RATHBONE, Perry Townsend *[Museum director] b.1911, Germantown, PA.*
Addresses: NYC; Cambridge MA. **Studied:** Harvard College, A.B., 1933, Harvard Univ., 1933-34; Wash. Univ., hon. D.F.A., 1958; Northeastern Univ., hon. D.H.L., 1960; Bates College, hon. D.F.A., 1964; Suffolk Univ., hon. D.H.L., 1969; Williams College, 1970; Boston College, hon. D.F.A., 1970. **Member:** Am. Assn. Mus. (vice-pres., 1960-; council member); Assn. Art Mus. Dirs. (pres., 1959-60, 1969-70); Benjamin Franklin fellowship, Royal Soc. Arts, London. **Exhibited:** Awards: Chevalier, Legion of Honor. **Comments:** Positions: curator, Detroit IA, 1936-40; secretary & director, masterpieces of art, NY World's Fair, 1939; director, City Art Mus. Saint Louis, 1940-55; director, Boston Mus. Fine Arts, 1955-72; exec. vice-pres. & mus. liaison for Christies, 1985; member, Mayor of Boston's Art Advisory Committee, 1969-; chmn. board, Metrop. Boston Art Center; trustee, New England Conservatory Music; Inst. Contemporary Art, Boston; Boston Art Festival; vice-chmn., committee to visit fine arts dept., Harvard Univ.; trustee, RISD; Int. Exhibs. Foundation, Washington, DC; member, fine arts visiting committee, RISD; member, visiting committee, art & archeology, dept. fine arts, Wash. Univ.; member, art advisory committee, Chase Manhattan Bank, New York; trustee, Am. Fed. Arts. Publications: author, "Max Beckmann, "1948; "Mississippi Panorama," 1949; "Westward the Way," 1954; "Lee Gatch," 1960 & "Handbook for the Forsyth Wickes Collection, "1968; contributor, art magazines & museum bulletins. **Sources:** WW73; WW47.

RATHBONE, Richard Adams *[Painter, educator, lecturer, writer] b.1902, Parkersburg, WV.*
Addresses: New Haven, CT. **Studied:** Yale Sch. FA, B.F.A.; NY School Fine & Applied Art, Paris, France. **Member:** New Haven PCC; Parkersburg AC; Assn. Conn. Artists. **Work:** Yale Univ. Art Gal. **Comments:** Position: asst. Prof., drawing & painting, Yale Univ. Sch. FA, New Haven, CT. Lectures: History of Painting, Sculpture, Ornament. Author: "Introduction to Functional Design," 1950. **Sources:** WW59; WW47.

RATHBUN, Charles (Mrs,) *[Painter] 20th c.*
Addresses: Chicago. **Exhibited:** AIC, 1910. **Sources:** Falk, *AIC.*

RATHBUN, D. R. *[Portrait painter] mid 19th c.*
Addresses: Berlin, NY in 1859. **Sources:** G&W; N.Y. State BD 1859.

RATHBUN, Helen R. *[Painter] 20th c.*
Addresses: St. Louis, MO. **Member:** Soc. Women Artists. **Exhibited:** AIC, 1908; PAFA Ann., 1913. **Sources:** WW15; Falk, *Exh. Record Series.*

RATHBUN, Richard *[Museum director, writer] b.1852, Buffalo, NY / d.1918.*
Addresses: Wash., DC. **Studied:** Cornell; Harvard, with Agassiz. **Comments:** Position: director, Nat. Mus., 1898-18.

RATHBUN, Seward Hume *[Painter, illustrator, teacher, writer, architect] b.1886, Washington, DC / d.1965, Wash., DC.*
Addresses: Washington, DC. **Studied:** Harvard College, A.B.; Harvard Univ., M.A. **Member:** AWCS; Wash.,WCC; AIA; Cosmos Club. **Exhibited:** AWCS; Wash.,WCC, annually; Stanford Univ. (solo); Gr. Wash. Indep. Exhib., 1935. **Comments:** " Teaching: instructor of architecture, Western High School. Author: "A Background to Architecture," 1926. Illustrator: "The Charm of Old Washington," by Ada Rainey, 1932. Contributor to *Encyclopaedia of Social Sciences;* "Pencil Points," "Classic Art," "Near Eastern. **Sources:** WW59; WW47; McMahan, *Artists of*

Washington, DC.

RATHJEN, Elizabeth Fitzhugh *[Painter] b.1885, California / d.1965, San Francisco, CA.*
Addresses: San Francisco, CA. **Exhibited:** Golden Gate Park Memorial Mus., 1916. **Sources:** Hughes, *Artists of California,* 454.

RATHMAN, Helen See: **BISSELL, Helen Rathman (Mrs.)**

RATHOD, Kantilal *[Painter] 20th c.*
Addresses: Chicago, IL. **Exhibited:** PAFA Ann., 1954. **Sources:** Falk, *Exh. Record Series.*

RATHSACK, Lawrence Paul *[Painter] 20th c.*
Addresses: Chicago area. **Exhibited:** AIC, 1943, 1948-49. **Sources:** Falk, *AIC.*

RATKAI, George *[Painter, sculptor, illustrator] b.1907, Budapest, Hungary.*
Addresses: NYC. **Member:** Artists Equity Assn.; Audubon Artists; fellow, Int. Inst. Arts & Letters; AFA; Nat. Soc. Painters in Casein. **Exhibited:** Pepsi-Cola, 1945-46; Springfield Mus. Art, 1946; Assn. Am. Artists, 1945, 1947; Art Lg. Am., 1944; Hungarian Artists in Am., 1944; WMAA, 1949-58; PAFA Ann., 1948-53; Corcoran Gal biennials, 1953-63 (5 times); Audubon Artists, 1955-65 (gold medals, 1953 & 1965 & mem medal, 1956); Provincetown AA, 1956-64; Relig Art Exhib., Univ. Nebraska, 1965; Mansfield State College, PA, 1965; Bass Mus. Art, Miami, 1965. **Awards:** Art of Dem. Living, 1951 (prize); Childe Hassam Award, 1959. **Work:** Tel-Aviv Mus., Israel; Abbott Labs Collection; Univ. Illinois; Butler IA; Univ. Nebraska. **Comments:** Illustrator: *Collier's, Good Housekeeping.* **Sources:** WW73; WW47; Falk, *Exh. Record Series.*

RATKAI, Helen *[Painter] b.1914, NYC.*
Addresses: NYC. **Studied:** ASL, with Yasuo Kuniyoshi. **Member:** Art Lg. Am. **Exhibited:** PAFA Ann., 1942, 1949; SFMA, 1942; AV, 1942; MoMA, 1942; AIC, 1943; "Tomorrow's Masterpieces" Exh., 1943; Wildenstein Gal., 1941-42; Marquie Gal., 1943; Peiken Gal., 1944; Assoc. Am. A., 1943-45; New-Age Gal., 1945-46; NYPL, 1944; Pepsi-Cola, 1946; Corcoran Gal biennial, 1947; Salpeter Gal., 1949-50; New Sch. for Social Research, 1953; WMAA, 1951; Provincetown AA, annually. **Work:** Abbott Laboratories (Booklets). **Sources:** WW59; WW47; Falk, *Exh. Record Series.*

RATLIFF, Blanche See: **RATCLIFF, Blanche Cooley (Mrs. Walter B.)**

RATLIFF, Floyd *[Educator, author] b.1919, La Junta, CO / d.1999, Santa Fe, NM.*
Studied: Colorado College (BA); Brown Univ. (MA & PhD, psychology). **Comments:** For 31 years, he taught at Rockefeller Univ., NYC, and was the leading authority on the pyschophysiological bases of optical effects and color contrasts in Pointillist and Neo-Impressionist paintings, best exemplified by his book, *Paul Signac and Color in Neo-Impressionism* (Rockefeller Univ., 1992). **Sources:** *NY Times* (16 June 1999).

RATLIFFE, M. Francis *[Painter] 20th c.*
Addresses: Norman, OK. **Exhibited:** PAFA Ann., 1950. **Sources:** Falk, *Exh. Record Series.*

RATSEP, Hilda *[Painter] 20th c.*
Exhibited: S. Indp. A., 1939. **Sources:** Marlor, *Soc. Indp. Artists.*

RATTERMAN, Walter G. *[Painter] b.1887 / d.1944.*
Addresses: NYC/ Woodstock, NY, 1930s. **Member:** AG. **Comments:** Specialized: landscapes, illustration, portraits. **Sources:** WW31; add'l info. courtesy Peter Bissell, Cooperstown, NY.

RATTI, Gino A *[Sculptor] b.1882, Carrara, Italy (came to U.S. ca. 1907) / d.1937, Wash., DC.*
Studied: stonecarving, Carrara, Italy. **Work:** figures on Supreme Court and Archives Bldgs., Wash., DC; Roosevelt Mem. Bldg.,

NYC; Michigan Ave. Bridge, Chicago. **Sources:** McMahan, *Artists of Washington, DC.*

RATTI, Joseph *[Sculptor] b.1888, Carrara, Italy / d.1955, Wash., DC.*
Work: Nat. Cathedral, P.O. Bldg., NGA, Tomb of the Unknown Soldier in Arlington Cemetery, all in Washington, DC. **Comments:** He came to the U.S. around 1910, and worked in Vermont, New York, Louisiana, Wisconsin, and Illinois before settling in Wash., DC, where he worked on the sculptural decoration of many churches and public buildings. He worked at the Cathedral from around 1943-55, when he fell to his death from the western nave of the church. **Sources:** McMahan, *Artists of Washington, DC.*

RATTI, Reima Victor *[Painter] 20th c.*
Addresses: Chicago area. **Exhibited:** AIC, 1941-46. **Sources:** Falk, *AIC.*

RATTNER, Abraham
[Painter] b.1895, Poughkeepsie, NY / d.1978, NYC.
Addresses: NYC. **Studied:** Corcoran School Art, 1913-15; George Washington Univ, 1913-14; PAFA, 1915-17; Académie Julian, Paris; Écoles Beaux Arts, Paris, 1921-23; Acad. Ransom, Paris, 1923-24; Acad. Grande Chaumière, 1924-25; Sorbonne, 1925-26. **Member:** NIAL. **Exhibited:** PAFA Ann., 1929, 1939-66 (medal 1945); CI, 1943-46; Corcoran Gal biennials, 1941-65 (10 times, incl. gold med., 1953); AIC; BMFA; MoMA, 1945; WMAA; SFMA; Santa Barbara Mus. Art; Pepsi-Cola 1946 (prize); La Tausca Pearls Exhib., 1947 (prize); Phila. Art All.; BMA; CPLH; New Orleans Arts & Crafts; Chicago AC; NGA; VMFA; CAM; Iowa State Univ.; Salon d'Automne, Salon des Tuileries, Salon des Independants, Paris; Univ. Illinois, 1948 (prize), 1952 (retrospective); Temple Univ., Phila. 1955 (citation & gold medal, solo show); Art Directors Club, Phila., 1956 (gold medal); AFA Traveling Exhib., 1960-61; Downtown Gal.; Kennedy Gals., NYC, 1970s. **Work:** U.S. State Dept.; MoMA; WMAA; PAFA; Albright-Knox Art Gallery, Buffalo; AIC; BMA; Ft. Worth AA; Encyclopaedia Britannica Collection; Pepsi-Cola Collection; Clearwater Art Mus.; PMG. **Commissions:** mosaic mural, St. Francis Monastery, Chicago, 1956; mosaic columns & tapestry murals, Fairmount Temple, Cleveland, OH, 1957; stained glass facade, Loop Synagogue, Chicago, IL, 1958; De Waters AC, Flint, MI, 1958; facade, St. Leonard's Friary & College. **Comments:** Expressionist artist. Rattner joined the army in WWI and was sent to France as a camouflage artist. He returned to Europe after the war on scholarship and remained there until the outbreak of WWII in 1939, when he had to leave most of his work behind. He soon after took an extended road-trip through the U.S. with his novelist friend Henry Miller, whom he knew from Paris (Miller later wrote an account of the trip, with illustrations by Rattner). Teaching: instructor, Skowhegan School Art, summers 1949-50; artist-in-residence, Am. Acad. in Rome, 1951; teacher, Yale (1952-53), New School, NYC (1947-55), BM (1950-51), ASL (1954) visiting prof., PAFA, 1955; visiting prof., Columbia Univ., 1955-56; instructor & artist-in-residence, many leading schools & universities. **Sources:** WW73; WW47; Lloyd Goodrich & John I.H. Baur, *Four American Expressionists,* WMAA, 1949; Baigell, *Dictionary;* S.W. Hayter, *About Prints,* Oxford Univ. Press, 1962; *Archives of American Art Journal,* vol.27, No. 2, 1987, p.36; *300 Years of American Art,* 865; Falk, *Exh. Record Series.*

RATTRAY, Annie L. *[Artist] early 20th c.*
Addresses: Wash., DC. **Comments:** Painted mostly still lifes. **Sources:** McMahan, *Artists of Washington, DC.*

RATTROY, Robert *[Painter] 19th c.*
Addresses: NYC. **Exhibited:** NAD, 1885. **Sources:** Naylor, *NAD.*

RATZKA, A(rthur) L(udwig) *[Portrait painter] b.1869, Andrejova, Hungary / d.c.1958.*
Addresses: NYC. **Studied:** Acad. FA, Vienna and Munich; S.

Hollosi, Munich. **Member:** All. Artists Am.; AAPL. **Exhibited:** S. Indp. A., 1927; Salons of Am., 1927; NAD, 1930 (prize), 1931, 1945; All. Artists Am., 1932-51; AAPL, annually, 1948 (prize). **Comments:** Contributor of articles on pastel and portrait painting to *Werkstatt der Kunst*. **Sources:** WW59; WW47.

RATZKER, Max *[Sculptor] mid 20th c.*
Addresses: NYC. **Member:** WFNY, 1939. **Exhibited:** S. Indp. A., 1926. **Sources:** WW40.

RAU, Jacob *[Engraver, printer] b.c.1821, Holstein, Germany.*
Addresses: NYC, from c.1851 to at least 1870. **Comments:** From c.1860 to c.1870, he was active as a printer for lithographers. **Sources:** G&W; 8 Census (1860), N.Y., LI, 285; NYCD 1851-60; NYBD 1859. More recently, see Reps, cat. nos. 577, 599, 602, 2505 (as printer, under name of J. Rau, at 381 Pearl St., NYC).

RAU, V B *[Painter] 20th c.*
Addresses: Brooklyn, NY/Provincetown, MA. **Sources:** WW25.

RAU, William *[Painter, illustrator] b.1874, NYC. / d.1956, Richmond Hill, L.I., NY.*
Addresses: Kew Gardens, Jeffersonville, NY. **Studied:** NAD with E.M. Ward; W.M. Chase. **Member:** Intl SAL; AAPL; Nassau County SA. **Exhibited:** Corcoran Gal annual, 1907; AIC, 1907-11; PAFA Ann., 1913; S. Indp. A., 1917. **Work:** Douglas Co. C.H., Omaha, NE; St. Matthews' Church, Hoboken, NJ; panels, Melrose Pub. Lib., NYC; High Bridge Pub. Lib., NYC; Patio Theatre, Brooklyn, NY; Keith Theare, Richmond Hill, NY; Pt. Wash. (NY) Theatre; Fantasy Theatre, Rockville Center, NY; Bliss Theatre, Woodside, NY; Bushrock Savings Bank, Brooklyn. **Sources:** WW40; Falk, *Exh. Record Series.*

RAU, William H *[Photographer] b.1855 / d.1920.*
Addresses: Philadelphia, PA. **Comments:** A pictorialist landscape photographer, he also participated in the U.S. expedition which circled the earth in 1874 to observe the transit of Venus.

RAUCH, John G *[Collector, patron] b.1890, Indianapolis, IN.*
Addresses: Indianapolis, IN. **Studied:** Harvard College, A.B., 1911; Harvard Law School, 1911-12; Butler Univ., hon. L.L.D., 1968. **Comments:** Positions: trustee, Indianapolis AA, 1940-62, pres., board of trustees, 1962-; chmn., board trustees, Indiana Hist. Soc., 1950-. **Sources:** WW73.

RAUCH, William *[Listed as "artist"] b.c.1817, Bavaria.*
Addresses: NYC in 1860. **Sources:** G&W; 8 Census (1860), N.Y., LVII, 206; his three children, the oldest 6 years, were all born in New York.

RAUCHFUSS, Marie See: **MACPHERSON, Marie (Mrs.)**

RAUDBY See: **RANBY, Edwin F.**

RAUGHT, John Willard *[Landscape painter] b.1857, Dunmore, PA / d.1931.*
Addresses: Dunmore, Scranton, PA. **Studied:** NAD; Académie Julian, Paris with Lefebvre and Boulanger, 1886-87. **Member:** SC, 1902; AFA. **Exhibited:** PAFA Ann., 1885, 1904; NAD, 1891-1901; Paris Salon, 1889; Brooklyn AA, 1891; Boston AC, 1892-1903; SNBA, 1897; AIC. **Comments:** A memorial to him was established in the Everhart Mus., Scranton, PA. **Sources:** WW31; Fink, *American Art at the Nineteenth-Century Paris Salons,* 383; Falk, *Exh. Record Series.*

RAUH, Florence *[Painter] 20th c.*
Addresses: NYC. **Exhibited:** S. Indp. A., 1917. **Sources:** Marlor, *Soc. Indp. Artists.*

RAUH, Fritz *[Painter] b.1920, Wuppertal, Germany.*
Addresses: San Anselmo, CA. **Studied:** Art School, Braunschweig, Germany. **Exhibited:** Solos: De Young Mus., San Francisco, 1956, San Francisco MA, 1967, William Sawyer Gallery, San Francisco, 1971 & Oakland Art Mus., 1971; Int. Show, Expo '1970, Osaka, Japan, 1970; William Sawyer Gallery, San Francisco, 1970s. **Sources:** WW73.

RAUH, Ida *[Artist] b.1877 / d.1970.*
Member: Woodstock AA. **Sources:** Woodstock AA.

RAUL, Harry Lewis *[Sculptor, museum administrator, lecturer, designer, printmaker] b.1883, Easton, PA / d.1960, Wash., DC.*
Addresses: Washington, DC. **Studied:** NY Sch. Art; ASL; PAFA; Lafayette College; with William Chase, Frank DuMond, Charles Grafly, F.E. Elwell & others. **Member:** AAPL; Assn. Am. Mus.; Min. PS&G Soc., Wash., DC; Art Center of the Oranges; Montclair AM; Fellowship, Royal SA, London, England; Soc. Wash. Etchers. **Exhibited:** NAD; Arch. Lg.; CGA; Pan-Pacific Expo, 1915; PAFA Ann., 1922; Hispanic Soc., NY; BMA; Montclair Art Mus., 1931 (medal); Newark Mus.; Ferargil Gal.; Newark AC; Art Center of the Oranges, 1930 (prize). **Awards:** Fellowship, Royal SA, London, England; medal, U.S. Dept. Interior, 1949. **Work:** sculpture, mem., statues, reliefs: NMAA; International Mus., Asbury Park, NJ; Montclair Art Mus.; Lafayette College, Easton, PA; West Chester, PA; Lincoln Trust Co. Bldg., Scranton, PA; Englewood, NJ; Orange, NJ; Yonkers, NY; Jersey City, NJ; Morristown, NJ; Berea College, KY; Univ. of the South, Sewanee, TN; Richmond, VA; statue, Northampton Co., PA; portrait, Phila.; World War mon., Wilson Borough, PA; mem., Sea Girt, NJ, War Mothers' Mem., Phila; mem. tablets, First Congregational Church, Oak Park, IL; mem., Panzer College, East Orange; bronze portrait tablet of Philip Murray in Blantyre, Scotland; Allan Haywood portrait tablet, Yorkshire, England; B.B. Burgunder portrait tablet, Wash., DC. **Comments:** Painted portraits of Pres. F.D. Roosevelt, Thomas Edison, Phillips Murray, and Supreme Court Justice Charles Evans Hughes. He married artist Minnie Louise Briggs in 1943. ; WMAA, 1949-58. Lectures: "The Technique of Sculpture." Author: "The Celtic Cross for Modern Usage." Position: sdministrator, Mus. of the U.S., Dept. of the Interior, Washington, DC, 1938-58. **Sources:** WW59; WW47; McMahan, *Artists of Washington, DC;* Falk, *Exh. Record Series.*

RAUL, Josephine Gesner (Mrs. Harry L.) *[Painter, block printer, teacher] 20th c.; b.Linden, NJ.*
Addresses: Orange, NJ/Groton, CT. **Studied:** NAD; ASL; G.A. Thompson. **Member:** AAPL; Art Center of the Oranes; NAWPS. **Exhibited:** NAWPS, 1930 (prize); Nat. Lg. Am. Pen Women, 1930 (prize); Art Center of the Oranges, 1931 (prize); Kresge Art Exhib., 1933 (prize). **Sources:** WW40.

RAUL, Minnie Louise Briggs (Mrs. Harry Lewis) *[Painter, teacher, etcher, writer, illustrator, lecturer] b.1890, Temple Hills, MD / d.1955.*
Addresses: Wash., DC, 1906. **Studied:** Hill Sch. Art; Corcoran Sch. Art; with Benson B. Moore, William Mathews. **Member:** Wash. WCC; Soc. Wash. Artists; Wash. SE; Min. PS&G Soc.; Lg. Am. Pen Women; Gr. Wash. Indep. Exh., 1935. **Exhibited:** Contemporary Club, Newark, NJ, 1941; Alexandria (VA) Lib., 1942; Mem. Pier Gal., Bradenton, FL, 1940; CGA, 1930-46; U.S. Nat. Mus., 1935, 1939 (prize), 1946; Lg. Am. Pen Women, 1930-46 (prizes: 1933-34, 1936, 1941); Maryland State Fair, 1941 (prize); LOC, 1945; Wash. AC. Solo shows: CGA; NYC; Chicago, Baltimore; San Francisco. **Work:** CGA; Johns Hopkins Univ.; Keats Mus., Wentworth House, London; Warm Springs, GA. **Comments:** She married sculptor Harry Raul in 1943. Instructor: etching and drypoint, ASL of Wash., DC; also operated her own school in Wash., DC. Contributor: articles and etchings to *Washington Sunday Star, Cathedral Age, Am. Forestry Magazine.* Author/illustrator: *Wild Flowers of the Holy Land,* 1949. **Sources:** WW53; WW47; McMahan, *Artists of Washington, DC.*

RAULSTON, Marion Churchill McCartney (Mrs. Burrell O.) *[Portrait painter] b.1886, Sunriver, MT / d.1955.*
Addresses: Los Angeles, CA. **Studied:** PIASch.; Otis AI; Los Angeles AI; in Germany with Skarbina. **Member:** Calif. A. Cl.; Women Painters of the West; Los Angeles AA; NAWA; Pasadena AI; Council All. Artists, Los Angeles; Laguna Beach AA; Friday Morning Cl., Los Angeles; Soc. for Sanity in Art. **Exhibited:**

CGA, 1930-46; Calif. State Fair, 1930; LACMA, 1934 (prize), 1937 (prize), 1939 (prize); GGE, 1939; Women Painters of the West (prize); Los Angeles AI (prize); CPLH, 1945; Calif. A. Cl. (solo); Stendahl Gal., Los Angeles, 1937 (solo); Los Angeles City Hall (solo); Ebell Cl. (solo); Hollywood Women's Cl. (solo); Univ. Southern Calif. (solo); Friday Morning Cl. (solo); Beverly Hills Women's Cl. (solo). **Work:** Univ. Southern Calif.; Los Angeles AA. **Comments:** Author: *O.H. Churchill and His Family.* 1950 (now in Calif. State Lib., Huntington Lib., and others). **Sources:** WW53; WW47. More recently, see Hughes, *Artists in California,* 457.

RAUSCH, Stella Jane (Mrs. Henry G.) *[Painter, craftsperson, designer, teacher]* b.1876, Monroe County, MI.
Addresses: Cleveland, OH. **Studied:** Cleveland Sch. Art; & with Hawthorne, Johonnot, & others. **Member:** Cleveland Women's AC. **Exhibited:** CMA (prize); Cleveland Sch. Art (prize). **Work:** Cleveland Pub. Lib.; Cleveland Hospital. **Comments:** WPA artist. **Sources:** WW53; WW47.

RAUSCHENBERG, Robert *[Painter, printmaker, assemblage-maker, collagist]* b.1925, Port Arthur, TX.
Addresses: NYC. **Studied:** Kansas City Art Inst & Sch Design, 1946-47; Acad Julian, Paris, 1948; Black Mt Col, with Josef Albers, 1948-49; ASL with Vaclav Vytlacil & Morris Kantor, 1949-52. **Exhibited:** Leo Castelli Gal., NYC; MoMA, "Art of Assemblage," 1961, "Dada, Surrealism and Their Heritage," 1968, 1976 (solo); Venice Biennale, 1964 (prize); Corcoran Gal biennials, 1959, 1963, 1965 (gold medal); WMAA, 1961-1973; AIC, 1966 (award); "Directions I: Options," Milwaukee Art Ctr, 1968; Arts Council Gt Brit, 1968; PAFA Ann., 1968; Guggenheim Mus, 1972. **Work:** Albright-Knox Art Gallery; WMAA; MOMA; MMA; PMA; SFMA; National Mus., Wash., DC; White Mus, Cornell Univ; Tate Gallery, London, Eng; Goucher Col.; Wadsworth Atheneum, Hartford, CT. **Comments:** One of the most important post-WWII American artists; his works strongly influenced pop art and neo-dadaism in the 1960s. In his collages of the early 1950s and his innovative combine-paintings (beginning c.1953) Rauschenberg incorporated non-artistic objects from his own past as well as materials that had no personal connection. He began making lithographs and silkscreens in the early 1960s, often juxtaposing a number of disparate images (from newspapers and magazines for example) within one print. In the 1970s he used various materials, including cardboard and fabric, in the making of relief and three-dimensional assemblages. Always open to new expression, Rauschenberg has also used his works in conjunction with music and performance. He worked as a mangager, designer, and performer in Merce Cunningham's dance company for many years and also produced designs for Paul Taylor's dance company. **Sources:** WW73; Roni Feinstein, *Robert Rauschenberg: The Silkscreen Paintings 1962-1964* (New York, 1990); Barbara Rose, *Robert Rauschenberg* (Avedon Edition, Vintage Books, 1987); Calvin Tomkins, *Off the Wall: Robert Rauschenberg and the Art World of our Time* (New York, 1980); *Robert Rauschenberg* (exh. cat., MOMA, 1976); Baigell, *Dictionary; 300 Years of American Art,* 989; Dore Ashton, *The Unknown Shore* (Little, 1962); Tracy Atkinson, *Directions I: Options 1968* (Milwaukee Art Ctr, 1968); Gregory Battcock (ed), *Minimal Art: A Critical Anthology* (Dutton, 1968); Lawrence Alloway, Falk, *Exh. Record Series.*

RAUSCHERT, J. Karl *[Painter]* 20th c.
Exhibited: AIC, 1930. **Sources:** Falk, *AIC.*

RAUSCHNABEL, Marianne *[Painter, weaver]* b.Belgium / d.1964, Germany (on a visit).
Addresses: San Francisco, CA; Marin County, CA. **Studied:** Stuttgart Art School; Calif. Sch. of FA. **Exhibited:** GGE, 1939. **Comments:** Came to the U.S. with her husband William Rauschnabel (see entry). **Sources:** Hughes, *Artists of California,* 457.

RAUSCHNABEL, W (illiam) F(redrick) *[Painter, printmaker]* b.1883, Stuttgart, Germany / d.1947, Sierra City, CA.
Addresses: San Francisco, CA. **Member:** San Francisco AA;

Calif. SE; Marin Soc. of Artists, 1927 (cofounder). **Exhibited:** Calif. State Fair, 1930; Oakland Art Gallery, 1932; SFMA, 1935; GGE, 1939. **Work:** Mills College, Oakland. **Comments:** Immigrated to California in 1905. Position: head, art dept., College of Marin, CA, 20 years. Specialty: landscapes in oil and watercolor, wood block prints. **Sources:** WW17; Hughes, *Artists of California,* 457.

RAUSCHNER, Henry *[Wax miniaturist]* early 19th c.
Addresses: Charleston, SC, active 1810-11. **Comments:** Advertised in Charleston (SC) in November 1810 and April 1811, described as being "from the northward." Groce & Wallace speculated that this may have been John Christian Rauschner (see entry) who was working in Massachusetts and Pennsylvania in these years and is known to have traveled as far south as Virginia making wax portraits. **Sources:** G&W; Rutledge, *Artists in the Life of Charleston,* 128, 216.

RAUSCHNER, John Christian *[Wax portraitist]* b.1760, Frankfurt, Germany.
Addresses: Lived in NYC and travelled to Massachusetts, Pennsylvania, and Virgina. **Work:** Essex Institute, Salem, MA; NYHS; Am. Antiq. Soc., Worscester, MA; Maryland Hist. Soc.; Shelburne (VT) Mus. **Comments:** Son of Christian Benjamin Rauschner, modeller and stucco worker in Germany, he was originally named Johann Christoph, but became John Christian in America. Rauschner had a NYC address from 1799 to 1808, but also traveled extensively, working from Massachusetts down to Virginia and possibly South Carolina. He was at Philadelphia in 1801 and 1810-11 and at Boston and Salem (MA) in 1809-10. His career is undocumented after 1811. Specialized in colored wax bas-relief profile portraits on glass. Over 100 works of this type have been identified. *Cf.* Henry Rauschner. **Sources:** G&W; Bolton, *American Wax Portraits,* 24-29, 46-60 (checklist); NYCD 1799-1808; notes by Homer Eaton Keyes in *Antiques* (Sept. 1936), 100, and (1937), 186-87; Brown and Brown [as Rawschnor]. See also Craven, *Sculpture in America;* and NYHS Catalogue (1974), cat. entries 1306, 1674, 1844-46, 2133, with several repros.; Muller, *Paintings and Drawings at the Shelburne Museum,* 117 (with repro.).

RAUTENBERG, Robert *[Sculptor]* 19th c.
Addresses: Phila., PA. **Exhibited:** PAFA Ann., 1892 (plaster relief). **Sources:** Falk, *Exh. Record Series.*

RAUWOLF, R. V. *[Etcher]* 20th c.
Addresses: Chicago area. **Exhibited:** AIC, 1950. **Sources:** Falk, *AIC.*

RAVEL, Edouard *[Painter]* 19th c.
Exhibited: Mark Hopkins Inst., 1897. **Sources:** Hughes, *Artists of California,* 457.

RAVELEON, Albert L. *[Painter]* 20th c.
Exhibited: San Francisco AA, 1924. **Sources:** Hughes, *Artists of California,* 457.

RAVELL, Henry *[Painter]* 20th c.
Addresses: Laguna Beach, CA. **Member:** Laguna Beach AA. **Exhibited:** LACMA, 1919. **Sources:** WW25.

RAVELLI, (Father) *[Carver and painter]* mid 19th c.
Addresses: Active in Montana, c.1850. **Work:** St. Mary's Mission, Stevensville, MT. **Sources:** G&W; WPA Guide, Montana.

RAVENEL, Pamela Vinton Brown *[Painter, miniature painter, illustrator]* b.1888, Brookline, MA.
Addresses: Woodstock, NY. **Studied:** Maryland Inst.; in Paris, France, with Collin, Courtois; E. Whiteman, in Baltimore. **Member:** ASMP; NOAA; Phila. Min. Painters Soc.; SSAL; New Orleans Min. Painters Soc. **Exhibited:** Am. Woman's Work, Paris, 1914; Baltimore WCC, 1920; PAFA, 1922-25; AIC. **Work:** BM; CMA, BMA. **Comments:** Listed in 1917 as Mrs. Vinton-Strunz in Roland Park, MD. **Sources:** WW53; WW40; WW47; Petteys, *Dictionary of Women Artists.*

RAVENEL, St. Julien, Jr. *[Painter] 20th c.*
Addresses: NYC. **Exhibited:** S. Indp. A., 1927. **Sources:** Marlor, *Soc. Indp. Artists.*

RAVENEL, William de Chastignier *b.1859 / d.1933.*
Comments: He assisted the American Red Cross in organizing its museum and was instrumental in establishing the headquarters of the American Assoc. of Museums at the Smithsonian. **Position:** director, U.S. Nat. Mus., Wash., DC.

RAVENNA MOSAIC, INC. *20th c.*
Exhibited: Salons of Am., 1924. **Sources:** Marlor, *Salons of Am.*

RAVENOLD, Bruce *[Painter] 20th c.*
Addresses: NYC. **Sources:** WW25.

RAVENSCROFT, Ellen *[Painter, lithographer, craftsperson, teacher] b.1876, Jackson, MS / d.1949, NYC.*
Addresses: St. Louis, MO, early 1920s; NYC/Provincetown, MA from 1926. **Studied:** NAD; Chase Sch. Art; Castellucho, Paris; E.A. Webster in Provincetown. **Member:** NYSWA; Municipal Artists Com. of 100, NYC; NYSWA; Provincetown AA; St. Louis AG. **Exhibited:** Wolfe AC, 1908 (prize), 1915 (prize); S. Indp. A., 1917, 1922, 1924-27, 1930, 1935-36, 1940; Salons of Am., 1922-24, 1934; Kansas City AI, 1923; Nat. Assoc. Women P&S; Provincetown AA; 1924-28. **Comments:** Marlor gives birthdate of 1885, as does Pettys. **Sources:** WW47; Marlor, *Salons of Am.;* Petteys, *Dictionary of Women Artists.*

RAVESON, Sherman H(arold) *[Painter, writer, designer, illustrator] b.1907, New Haven, CT / d.1974.*
Addresses: Hastings, NY; Franklin, NC. **Studied:** Cumberland Univ. (A.B., 1927; L.L.B., 1929); ASL; V. Mundo. **Member:** Am. Watercolor Soc.; Philadelphia Watercolor Club; Grand Central Art Gallery. **Exhibited:** Salons of Am., 1934; Art Dir. Club, 1934 (medal), 1939 (medal); Nat. Adv. Award, 1941; Corcoran Gal biennials, 1935; PAFA Ann., 1935, 1938; NAD, 1935, 1937, 1939; TMA, 1938; AWCS, 1934-45, 1956 (Hans Obst purchase prize); CI, 1936, 1965; Iowa State Fair, 1936; Wash. State Fair, 1936; AIC 1935-36, 1938-40; WFNY, 1939; Assn. Am. Artists, 1941 (solo), 1966-67; Am. Watercolor Soc., NYC, 1934-58; Eleven paintings of NY Racetracks, New York World's Fair, 1964-65; Grand Central Art Gallery, New York, 1965-67; Grand Central Art Galleries, NYC, 1970s. Other awards: Nat. Arts Club Medal of Honor, 1961; first recipient of John Hervey Citation for distinguished contribution in harness racing art, Harness Tracks Am., 1964. **Work:** Nat. Mus Racing, Saratoga, NY; Hall of Fame of Trotter, Goshen, NY; Sporting Gallery, NY; Hialeah Race Course Clubhouse, FL; Saratoga Raceway, NY. **Comments:** Preferred media: oils. **Positions:** art editor, *Vanity Fair,* 1929-34; art director, *Life* (1935-37), *Esquire* (1936), Petingell & Fenton, Inc. (1937-41); vice-pres. & art director, Sterling Advertising, New York, 1951-58; publ., *Classified Boating Dir.,* 1967-68; pres., *Mountain Living Magazine,* 1970-. **Publications:** author, *Literary America,* 1950. **Designer:** stage sets for "If Booth Had Missed," "That Is To Say," "Decision Reserved," "Dearly Beloved," "Show Business." **Sources:** WW73; WW47; Falk, *Exh. Record Series.*

RAVLIN, Grace *[Painter] b.1885, Kaneville, IL / d.1956.*
Addresses: Chicago, IL; Kaneville, IL in 1943. **Studied:** AIC; PAFA with W.M. Chase; L. Simon and Menard in Paris. **Member:** Associée, Société Nationale des Beaux-Arts, Paris, 1912; Peintres Orientalists Français; Sociétaire Salon d'Automne. **Exhibited:** Amis des Arts, Toulon, 1911 (medal); Pan-Pacific Expo, San Fran., 1915; PAFA Ann., 1916-17; Corcoran Gal biennials, 1916, 1926; Carsons Gals., Chicago, 1917; Santa Fe Art Mus., 1917; Minneapolis; Macbeth Gal., NYC, 1924; Rockford (IL) College, 1927; AIC, 1918 (prizes), 1922 (prize). **Work:** AIC; Luxembourg, Paris; French Gov.; City of Chicago; Arché Club, Chicago; Newark Art Mus.; Los Angeles Mus. Art; Vanderpoel AA Collection. **Comments:** Her work is largely European in subject. She visited Taos in 1934. **Sources:** WW40; P&H Samuels, 390; Petteys, *Dictionary of Women Artists,* cites alternate birth date of 1873; Falk, *Exh. Record Series.*

RAW, Jacob See: **RAU, Jacob**

RAWDON, Freeman *[Engraver] b.c.1801, Tolland, CT or Pennsylvania / d.1859, NYC.*
Addresses: NYC. **Comments:** Brother of Ralph Rawdon. Active as an engraver and businessman in NYC from 1833-59. During most of this time he was connected with the firm of Rawdon, Wright & Hatch [& Edson after 1847] (see entries). He was the father of Henry M. Rawdon (see entry). **Sources:** G&W; NYCD 1833-60; N.Y. *Evening Post,* Sept. 22, 1859, obit. (cited in Barber, "Deaths Taken from the N.Y. Evening Post"); Stauffer (says he was born in Tolland, Conn.); 7 Census (1850), N.Y., LV, 434 (states he was born in Pennsylvania.).

RAWDON, Henry M. *[Engraver] b.c.1833, NYC.*
Addresses: NYC, active 1850. **Comments:** He was a son of Freeman Rawdon (see entry). He was listed in 1863 and 1865 as a clerk. **Sources:** G&W; 7 Census (1850), N.Y., LV, 434; NYCD 1863, 1865.

RAWDON, Horace *[Painter] mid 19th c.*
Addresses: Trumbull County, OH, 1850. **Comments:** Listed in 1850 Trumbull County census. *Cf.* H. Rodden. **Sources:** Hageman, 121.

RAWDON, John *[Painter] 20th c.*
Addresses: Providence, RI, 1932. **Exhibited:** S. Indp. A., 1932-33. **Sources:** Marlor, *Soc. Indp. Artists.*

RAWDON, Nell *[Painter] 20th c.*
Studied: Calif. College Arts & Crafts. **Exhibited:** San Francisco AA, 1917; 1923; Hotel Oakland, 1924. **Sources:** Hughes, *Artists of California,* 457.

RAWDON, Ralph *[Engraver] 19th c.; b.Tolland, CT.*
Comments: Brother of Freeman Rawdon. Was associated with Thomas Kensett (see entry) at Cheshire, CT, as early as 1813 and in 1816 was working with Asaph Willard (see entry) at Albany, NY. In 1822 he was a partner in Balch, Rawdon & Co. (see entry) at Albany and from 1826 to 1834 he headed the firm of Rawdon, Clark & Co. (see entry), also at Albany. In 1828 he founded the NYC firm of Rawdon, Wright & Co. (see entry), but he apparently did not move permanently to the city until 1835. For the next three years he was in mercantile business with Warren S. Kellogg, but by 1841 he had rejoined his brother Freeman in Rawdon, Wright & Hatch. He remained with that firm and its successor, Rawdon, Wright, Hatch & Edson (see entry), until its merger with the American Bank Note Company in 1858. Rawdon continued to remain active as an engraver and made his home in Brooklyn at least until 1877. **Sources:** G&W; Stauffer; Grolier Club, *The United States Navy, 1776-1815,* 82; Bowditch, notes on American engravers of coats of arms; Albany CD 1816-34; NYCD 1828-32, 1835-46, 1850-55, 1857-62, 1864-66; Brooklyn CD 1860-77.

RAWDON, Richard *[Painter] mid 19th c.*
Addresses: Warren and Trumbull Counties, OH. **Comments:** Brother of Horace Rawdon (see entry). Bibliography, Hageman, 121.

RAWDON-HASTINGS, Francis *[Amateur battle artist] b.1754, England / d.1826, at sea off Naples, Italy.*
Comments: 1st Marquis of Hastings and 2nd Earl of Moira. Came to America as a lieutenant in 1773 (he was then known as Rawdon) and served during most of the American Revolution. Groce & Wallace indicated that several watercolors from his own collection (later dispersed) were believed to be by his hand; they portray scenes of the Revolution around NYC. After he returned to England in 1781 he served in Parliament, both in England and Ireland; he also rose to the rank of general, served as commander-in-chief of the forces of Scotland, and finished his career by serving ten years (1813-1823) as Governor-General of India. **Sources:** G&W; DNB; Stokes, *Iconography,* I, 362-63, pl. 49.

RAWDON, CLARK & CO. *[Engravers] mid 19th c.*
Addresses: Albany, NY, 1826-34. **Comments:** Main partners were Ralph Rawdon and Asahel Clark (see entries). This was a predecessor in Albany for Rawdon, Wright, Hatch & Co. in 1835;

and for Rawdon, Wright, Hatch & Edson in 1835 and 1847-58. **Sources:** G&W; Albany CD 1826-34.

RAWDON, WRIGHT & CO. *[Engravers] early 19th c.*
Addresses: NYC, active 1828-31. **Comments:** Partners were Ralph Rawdon and Neziah Wright (see entries). Forerunner of Rawdon, Wright & Hatch (see entry). **Sources:** G&W; NYCD 1828-31.

RAWDON, WRIGHT & HATCH [& CO.] *[Banknote engravers] mid 19th c.*
Addresses: NYC, 1832-34, 1836-46; with a branch at Albany in 1835 and at Boston from 1843-47. **Exhibited:** American Academy, NYC, 1833 (specimens of banknote engraving). **Comments:** Partners were Ralph Rawdon, Freeman Rawdon, Neziah Wright, and George W. Hatch (see indiv. entries). The firm had several geneses: in 1835 and after 1847 as Rawdon, Wright, Hatch & Edson (see entry) and in 1842 it was known as Rawdon, Wright, Hatch & Smillie (see entry). **Sources:** G&W; NYCD 1832-46; Albany CD 1835; Boston CD 1843-47; Cowdrey, AA & AAU.

RAWDON, WRIGHT, HATCH & SMILLIE *[Banknote engravers] mid 19th c.*
Addresses: NYC, 1842. **Comments:** Partners were Ralph Rawdon, Freeman Rawdon, Neziah Wright, and George W. Hatch and James Smillie (see individual entries). **Sources:** G&W; NYCD 1842.

RAWDON, WRIGHT, HATCH & EDSON *[Banknote engravers] mid 19th c.*
Addresses: NYC, 1835, 1847-58; with branches in Albany, Boston, Cincinnati, and New Orleans. **Comments:** Partners were Freeman Rawdon, Ralph Rawdon, Neziah Wright, George W. Hatch, Tracy R. Edson (see individual entries). In 1858 it was merged with the newly-formed American Bank Note Company. **Sources:** G&W; NYCD 1835, 1847-58; Albany CD 1835; Boston CD 1848-49; Cincinnati BD 1850-59; New Orleans BD 1859; Toppan, *100 Years of Bank Note Engraving*, 12.

RAWLINGS, Henry *[Die sinker] b.c.1830, England.*
Addresses: Philadelphia in 1860. **Comments:** Lewis Tomkins, lithographer (see entry), lived in the same house. **Sources:** G&W; 8 Census (1860), Pa., LII, 252.

RAWLINSON, Elaine *[Painter] b.1911, NYC.*
Addresses: NYC. **Studied:** NAD; PAFA Country Sch. **Member:** NAC; NAWPS. **Exhibited:** Salons of Am., 1932; Awards: winning design for one-cent stamp, U.S. Govt. **Sources:** WW40.

RAWLS, James *[Illustrator painter, comm a] b.1894, Molino, Tenn.*
Addresses: Falls Church, VA; Hyattsville, MD. **Studied:** Watkins Inst., ASL; Clinton Peters Portrait Painting School, NY. **Member:** SI; Art Dir. Club; Nat. Soc. Art Dir.; Wash. Film Council; Soc. Fed. Art & Des.; Nat. Press Club. **Comments:** Position: art director & director of public relations, Creative Arts Studio, Washington, DC. **Sources:** WW59; WW47.

RAWSCHNOR See: **RAUSCHNER, John Christian**

RAWSKI, Conrad Henry *[Educator, lecturer] b.1914, Vienna, Austria.*
Addresses: Cleveland, OH. **Studied:** Univ Vienna, PhD; Western Reserve Univ, MS in LS; Harvard Univ; Cornell Univ. **Member:** Am Soc Aesthet; Mediaeval Acad Am; Am Libr Asn; Ohio Libr Asn; Am Musicol Soc. **Exhibited:** Awards: Ford Found fel, 1952-53. **Comments:** Positions: Head fine arts dept, Cleveland Pub Libr, 1957-62. Teaching: Prof, Ithaca Col, 1940-56; lectr, Schenectady Mus, 1946-48; lectr hist of the bk, lit of humanities & fine arts librarianship; assoc prof libr sci, sch libr sci, Case Western Reserve Univ, 1962-65; prof libr sci & coordr PhD prog, 1965-70s. Publications: Auth, *Petrarch: Four Dialogues for Scholars*, Case Western Reserve Univ Press, 1967; contribr, criticisms, articles & rev in publ on art, music & medieval aesthet. **Sources:** WW73.

RAWSON, Albert Leighton *[Landscape painter, engraver, author, philologist] b.1829, Chester, VT / d.1902, NYC.*
Addresses: Weedsport, NY in 1858; NYC, 1867-71. **Exhibited:** NAD, 1858-79; Brooklyn AA, 1866-78. **Comments:** After studying law, theology and art, he traveled extensively in the United States, Latin America, and the Orient. His publications, which he also illustrated, include a "Bible Dictionary," "Antiquities of the Orient," and dictionaries of Arabic, German, English and the Bedouin languages. In addition he executed more than 3,000 engravings. **Sources:** G&W; *Art Annual*, IV, obit.; Cowdrey, NAD; Naylor, NAD.

RAWSON, Carl W(endell) *[Painter] b.1884, Des Moines, IA.*
Addresses: Minneapolis, MN. **Studied:** Cumming Art School; NAD; Minneapolis Sch. Art. **Member:** Minneapolis AS; Minn. State AS; Attic Club; Palette & Chisel Club of Chicago. **Exhibited:** Des Moines Hoyt Sherman Place, 1929 (solo), 1930. **Work:** Minneapolis IA; Minneapolis Golf Club Gal.; Winona Country Club; Library, Douglas School and Northwestern Bank Bldg., Minneapolis; Capitol, Bismark, ND; State Hist. Dept., Library, Des Moines, IA; Univ. Minnesota; Public Library, Mayo Clinic, Univ. Club, Rochester, MN; College Surgeons, Chicago, IL; State College, Ames, IA; Univ. Wisconsin; Minnesota Hist. Bldg. **Comments:** Specialty: portraits and landscapes. **Sources:** WW40; Ness & Orwig, *Iowa Artists of the First Hundred Years*, 173.

RAWSON, E. M. *[Engraver, die sinker, and stencil cutter] mid 19th c.*
Addresses: Troy, NY in 1859. **Sources:** G&W; Troy CD 1859.

RAWSON, Eleanor *[Watercolor painter] early 19th c.*
Addresses: Vermont, active c.1820. **Comments:** Specialized in genre scenes. **Sources:** G&W; Lipman and Winchester, 179.

RAWSON, Julius A. (Mrs.) *[Portrait and landscape painter]*
Addresses: San Francisco, CA, 1870s, 1880s. **Exhibited:** Arriola Relief Fund Exhib., San Francisco, 1872. **Sources:** Hughes, *Artists of California*, 457.

RAWSON, Maurice 20th c.
Exhibited: Salons of Am., 1930. **Sources:** Marlor, *Salons of Am.*

RAWSON, Nairne *[Painter] 19th c.*
Addresses: Albany, NY. **Exhibited:** AIC, 1892; NAD, 1892. **Sources:** Falk, *AIC*.

RAWSTHORNE, John W. *[Painter, engraver] b.1881, Manchester, England / d.1942, Pittsburgh, PA.*
Addresses: Pittsburgh, PA. **Studied:** Stevenson Art School, Pittsburgh. **Member:** Pittsburgh AA (founding member, 1910; director, 1914). **Exhibited:** Pittsburgh AA annuals, until c.1926. **Comments:** Position: co-owner & operator, graphics studio, from 1917. **Sources:** WW25; Chew, ed., *Southwestern Pennsylvania Painters*, 109, 111.

RAWSTORNE, Edward (or Edwin) *[Landscape painter] mid 19th c.*
Addresses: NYC, active 1859-99. **Exhibited:** NAD, 1859-62; Brooklyn Art Assoc., 1862. **Sources:** G&W; NYBD 1858; Cowdrey, NAD; Naylor, NAD.

RAY, Alice *[Painter] 20th c.*
Addresses: Ft. Worth, TX. **Sources:** WW24.

RAY, Clary *[Illustrator, painter] b.1865, Wash., DC.*
Addresses: Wash., DC, active 1890-1912. **Studied:** ASL, Wash. DC (scholarship); Académie Julian, Paris, 1895; Acad. Delecluse, Paris. **Exhibited:** Wash. WCC, 1899; Soc. Wash. Artists, 1900-04; PAFA Ann., 1901. **Work:** U.S. Naval Acad. Mus., Annapolis, MD (watercolor ship portraits). **Sources:** WW06; McMahan, *Artists of Washington, DC*; Falk, *Exh. Record Series*.

RAY, Joseph Johnson *[Painter, illustrator] b.1879, Philadelphia, PA.*
Addresses: Riverside, CA, active 1906-08. **Exhibited:** Blanchard Gallery, Los Angeles. **Sources:** Hughes, *Artists of California*, 457; P&H Samuels, 390.

RAY, Mamie *[Painter] late 19th c.*
Exhibited: San Francisco AA, 1883. **Sources:** Hughes, *Artists of California*, 457.

RAY, Man *[Photographer, painter, film-maker, sculptor, writer] b.1890, Phila., PA / d.1976, Paris, France.*
man Ray
Addresses: NYC, 1908-21; Paris, 1921-40; Hollywood, CA, 1940-51; Paris, 1951-on. **Studied:** mostly self-taught; NY Acad. Art, 1908-12; Ferrer School, 1911. **Member:** Sociéte Anonyme (proto-Dada Group), NYC, 1920 and in Paris, 1921. **Exhibited:** S. Indp. A., 1917-18, 1941; AIC, 1944, 1947; Getty Mus., 1998 (retrospective); Int. Center of Photography, NYC, 1998 (retrospective). **Work:** MoMA; RISD; Yale; AIC; IMP; NOMA; WMAA; Getty Mus., Los Angeles, CA (one of the world's largest collections). **Comments:** (Born Emmanuel Radnitski) The only American artist to be a member of both the Dadaists and the Surrealists. At the beginning of his career in NYC he painted in Cubist and Expressionist styles. In 1913, he befriended Max Weber and began visiting Stieglitz's Little Galleries of the Photo-Secession (he also painted a portrait of Stieglitz in 1913). In 1915, Man Ray was introduced to a Marcel Duchamp by Walter Arensberg, and soon after he helped stake roots for the Dada movement in NYC. In 1921, he moved to Paris, joining Duchamp's Surrealist group which had replaced the Dadaists. Here, he created the cameraless light photos, called "rayographs," for which he is best known. He also painted surrealist images, worked in collage and constructions, and painted many portraits of artists. **Sources:** WW21; Wechsler, 26; *Photography and Its Double* (Gingko, 1998); Baigell, *Dictionary*; Arturo Schwarz, *Man Ray* (1977); A. Davidson, *Early American Modernist Painting*, 111-15.

RAY, Melvin Brown *[Portrait and landscape painter] b.1853, Lewis County, NY / d.1937, Utica, NY.*
Addresses: Martinsburg, NY; Utica, NY. **Studied:** Academy of Design, NY; Cooper Union Art School. **Member:** Central NY Soc.Artists. **Work:** portraits, Court House, Baggs Hotel, Munson-Williams Memorial, Mayor's Office, Hotel Utica, Calvary Church, Church of the Holy Cross, Park Baptist Church, First & Second National Bank, all Utica, NY. **Comments:** Position: teacher, Utica Sketch Club. His works include portraits of Vice President James S. Sherman and Governor Horatio Seymour. The *New York Times* obituary of Jan. 7, 1938 mistakenly cites his first name as Melville. **Sources:** info. courtesy of Peter Bissell, Cooperstown, NY.

RAY, Robert (Donald) *[Painter, sculptor, printmaker, gallery owner] b.1924, Denver, CO.*
Addresses: Taos, NM (1952-on). **Studied:** Drake Univ.; Univ. Southern California, B.F.A.(cum laude), 1950; Centro Estudios Universitarios, Mexico City, Mexico, M.A.(magna cum laude) with J. Fernández. **Member:** Taos Art Assn. **Exhibited:** The West--80 Contemporaries, Univ. Arizona Art Gallery, Tucson, 1967; solo show, Colorado Springs Fine Arts Center, CO, 1968; Three Cultures--Three Dimensions, 1969 & Southwestern Artists Biennial, 1970, Mus. New Mexico; 73rd Ann. Exhib. Western Art, Denver Art Mus., 1971. **Awards:** Purchase award, Ball State Teachers College, 1959; first prize for sculpture, Mus. New Mexico, 1969; graphics award, Taos Art Assn., NM, 1972. **Work:** Baltimore Mus. Art, MD; Brooklyn Mus. Art, NY; Denver Art Mus., CO; Mus. New Mexico, Santa Fe; Columbia Mus. Art, SC. **Comments:** Served in WWII. A grant from the Wurlitzer Foundation brought him to Taos in 1954. Dealer: Mission Gallery, Taos, NM. **Sources:** WW73; Peggy and Harold Samuels, 390. Bibliography: Fels, *Compression and expansion in the works of Blackburn and Ray* (1972); Harmsen, *Harmsen's Western Americana* (Northland, 1972); Bibliography: article, "La Galeria Escondida" in *Artforum* (n.d.).

RAY, Rudolf *[Painter] mid 20th c.*
Addresses: New York, NY. **Exhibited:** WMAA, 1955; Corcoran Gal biennial, 1963. **Sources:** WW66; Falk, *Exhibition Records Series.*

RAY, Ruth (Mrs John Reginald Graham) *[Painter] b.1919, New York, NY / d.1977.*
Addresses: Darien, CT. **Studied:** Swarthmore Col; ASL New York, with Bridgeman, Corbino & Kantor. **Member:** NAD (coun, 1969-72); Silvermine Guild Artists; Allied Artists Am; Grand Cent Art Gallery, New York. **Exhibited:** NAD; Carnegie Inst; WMAA; PAFA Ann., 1960; Allied Artists Am, New York; Grand Central Art Gallery, NYC. **Awards:** Purchase prize, Springfield Mus, 1946; medal of hon, Am Artists Mag, 1953; bronze medal, Allied Artists Am, 1957. **Work:** NAD; Columbus Art Mus, Ga; Springfield Mus Fine Arts, Mass; Norfolk Mus Art, Va; Nat Art Mus Sport, New York. **Comments:** Preferred Media: Oils, Gouache, Pencil. Positions: V pres, Nat Asn Women Artists. **Sources:** WW73; Falk, *Exh. Record Series.*

RAY, S(ilvey) J(ackson) *[Cartoonist] b.1891, Marceline, MO.*
Addresses: Kansas City, MO.; Gashland, MO. **Studied:** F.R. Gruger, ASL. **Exhibited:** Awards: citation, U.S. Treasury Dept., 1942; Christopher Medal award, 1954; Freedom Foundation awards, 1951, 1954. **Work:** Huntington Library, San Marino, CA. **Comments:** Position: cartoonist, *The Kansas City Star.* **Sources:** WW59; WW40.

RAYDON, Alexander R *[Art dealer, collector] 20th c.*
Addresses: New York, NY. **Studied:** Tech. Univ. Munich, grad. engineer. **Comments:** Positions: director, Raydon Gallery. Research: American art of the nineteenth and early twentieth centuries. Specialty of gallery: paintings, sculpture, prints and drawings from the Renaissance to the present, with emphasis on the nineteenth and early twentieth centuries. Publications: editor, "America's Vanishing Resource" (1970), "America the Beautiful" (1971), "Americans Abroad" (1972) &" Charles Burchfield-Master Doodler" (1972). **Sources:** WW73.

RAYEN, James Wilson *[Painter, instructor] b.1935, Youngstown, Ohio.*
Addresses: Wellesley, MA. **Studied:** Yale Univ., B.A., B.F.A. & M.F.A.; also with Josef Albers, Sewell Sillman & Rico Lebrun. **Exhibited:** Durlacher Brothers Gallery, NYC, 1966 (solo); Young New England Painters, Ringling Mus., Sarasota, FL, 1969;Eleanor Rigelhaupt Gal., Boston, 1968 (solo); Landscape II, De Cordova Mus., Lincoln, MA, 1971; 10 Year Retrospective, Brockton (MA) Art Center, 1973 (solo). **Awards:** Italian Govt. grant in painting, 1959-60; Ford Foundation grant in the humanities, 1969-70. **Work:** Addison Gallery Am. Art, Andover, MA; Yale Univ., New Haven, CT; Wellesley College, MA; First Nat. Bank, Boston. **Comments:** Preferred media: acrylics. Teaching: assoc. professor, Wellesley College, 1961-70s. **Sources:** WW73.

RAYMOND, A. D. *[Painter] 20th c.*
Exhibited: Oakland Art Gallery, 1928. **Sources:** Hughes, *Artists of California*, 457.

RAYMOND, Albert M. *[Artist]*
Addresses: Wash., DC, active 1892-1901. **Sources:** McMahan, *Artists of Washington, DC.*

RAYMOND, Alex(ander) (Gillespie) *[Cartoonist, illustrator] b.1909, New Rochelle, NY / d.1956.*
Addresses: Stamford, CT. **Studied:** Notre Dame Univ.; Grand Central Sch. Art. **Member:** SI; Artists & Writers Club (exec. board); Nat. Cartoonists Soc. (pres., 1950-52). **Exhibited:** Awards: Billy DeBeck award, 1949. **Comments:** In 1934, he created the comic strip, "Flash Gordon," followed by "Jungle Jim" and "Rip Kirby" (c.1947). He was also co-creator of "Secret Agent X9," all King Features Syndicate. **Sources:** WW53; WW47; *Famous Artists & Writers* (1949).

RAYMOND, E. Launitz *[Painter] 19th c.*
Addresses: Brick Church, NJ. **Exhibited:** PAFA Ann., 1882. **Sources:** Falk, *Exh. Record Series.*

RAYMOND, Edith *[Graphic artist] mid 20th c.*
Addresses: Baltimore, MD. **Exhibited:** Maryland Inst., 1940 (solo). **Sources:** WW40.

RAYMOND, Elizabeth *[Painter, teacher] b.1904, New Orleans.*
Addresses: New Orleans, LA. **Studied:** E. Woodward. **Member:** SSAL; Mississippi AA; NOAA. **Sources:** WW33.

RAYMOND, Eugenia *[Art librarian, educator] 20th c.; b.Toledo, Ohio.*
Addresses: Seattle 4, Wash.; Seattle 5, Wash. **Studied:** Mt. Holyoke College, B.A.; Lib. School, NYPL. **Member:** Washington AA; Am. Lib. Assn.; Pacific Northwest Lib. Assn.; Pacific AA. **Comments:** Position: librarian, Cincinnati Mus. Art, 1930-37; reference asst., AIC, 1938-39; art librarian, Seattle (WA) Pub. Lib., 1940-60s. Contributor to: *Bulletin of Cincinnati Mus. Art,* with articles on early and contemporary book illustration. **Sources:** WW59.

RAYMOND, F. *[Painter] 19th c.*
Exhibited: NAD, 1878. **Sources:** Naylor, *NAD.*

RAYMOND, Flora Andersen *[Painter, illustrator] 20th c.; b.Pewaukee Lake, WI.*
Addresses: Chicago, IL. **Studied:** AIC; Hyde Park Peoples College; E. Giesbert; F. Grant. **Member:** Lg. Am. Pen Women; All-Illinois AA; North Shore AA; South Side AA. **Exhibited:** AIC, 1937, 1942; Evanston Women's Club; Blackstone Lib., Chicago. **Comments:** Illustrator: books & book jackets. **Sources:** WW47.

RAYMOND, Frank Willoughby *[Etcher, painter] b.1881, Dubuque, IA.*
Addresses: Chicago, IL. **Studied:** AIC. **Member:** California SE; Chicago SE; Palette and Chisel Club; Artists Guild; Illinois Acad. FA; Chicago Gal. Assn. **Exhibited:** Palette & Chisel Club; Art Inst. Chicago; Toledo Art Mus.; California Etchers Soc. Exhibits; Brooklyn Mus.; Corcoran Mus. **Work:** AIC; TMA; Brooklyn Mus.; Lincoln Mem.; Washington, DC. **Sources:** WW40; Ness & Orwig, *Iowa Artists of the First Hundred Years,* 173.

RAYMOND, George H. *[Lithographer] b.c.1825, New York.*
Addresses: NYC in 1850. **Sources:** G&W; 7 Census (1850), N.Y., XLVIII, 433.

RAYMOND, Grace Russell *[Painter, lithographer, lecturer, teacher] b.1876, Mount Vernon, OH.*
Addresses: Wash., DC, active 1910-mid 1920s; Winfield, KS. **Studied:** Southwestern College, Ph.B., D.F.A.; AIC; Corcoran Sch. Art; N.Y. Sch. Applied Des.; MMA Sch., NYC; PAFA; Heatherleys Sch. FA, London, England, Paris; Rome; Belgium; Mexico and with Henry Snell, George Elmer Browne, Guy Wiggins, Mrs. Gertrude Massey, & others. **Member:** AFA; Wash. WCC. **Exhibited:** Wash. WCC; Soc. Wash. Artists; AIC, 1938, 1942; Evanston Women's Club; Hilton, Drake, Bismarck and Swiss Chalet Hotels, Chicago; Women's Club, Chicago, 1938 (solo); Hyde Park Hotel, 1940; Normal Park Lib., 1939. **Awards:** prizes, Parent-Teacher Assn., Springfield, IL, 1933 (2); Fed. Women's Club, 1938; Highland Park, IL, 1938; Lg. Am. Pen Women, 1948-50, 1953. **Work:** Winfield (KS) H.S. Art Gallery; Newton Mem. Hospital; Douglass (KS) Pub. Lib. **Comments:** Lectures: "Giotto's Influence Today"; "Japanese Influence in Western Painting." Position: instr., drawing & painting, lecturer, art history & appreciation, Southwestern College, Winfield, KS, 1930-45. She also taught privately until at least 1962. **Sources:** WW59; WW37; McMahan, *Artists of Washington, DC.*

RAYMOND, Julie E. *[Painter] b.1859, Brooklyn, NY / d.1955, Santa Ana, CA (rest home).*
Addresses: Laguna Beach, CA. **Studied:** Pratt Inst.; Adelphi College. **Member:** Laguna Beach AA. **Exhibited:** Kanst Gallery, Los Angeles, 1912; Calif. Art Club, 1915; Los Angeles Pub. Lib., 1920; Calif. WC Soc., 1927; LACMA, 1927; Calif. State Fair, 1930; Oakland Art Gallery, 1932; Laguna Beach AA annuals; NYC; Boston. **Work:** Laguna Mus. **Comments:** Traveled to England, France, Sweden and Norway during her student years. She settled in California in 1906, and taught outdoor classes in Laguna Beach. Her paintings were inspired by her travels as well as the California landscape. **Sources:** WW25; Hughes, *Artists of California,* 458.

RAYMOND, Kathryn Tileston *[Painter] 19th/20th c.*
Addresses: Grundmann Studios, Boston, MA, active 1884-1913. **Member:** Boston Art Students Assn., 1884. **Exhibited:** Boston AC, 1898-99; AIC; NYWCC; PAFA Ann., 1899, 1901. **Comments:** Specialty: watercolors. **Sources:** WW13; *The Boston AC;* Petteys, *Dictionary of Women Artists;* Falk, *Exh. Record Series.*

RAYMOND, L(eone) Evelyn *[Sculptor, lecturer, teacher] b.1908, Duluth, MN.*
Addresses: Minneapolis, MN. **Studied:** Minneapolis Sch. Art; & with Charles S. Wells. **Member:** Minnesota AA; Minnesota Sculptors Group. **Exhibited:** Minnesota State Fair, 1941 (prize), 1943 (prize), 1944 (prize); Minneapolis IA., 1944 (prize); Walker AC, 1944 (prize), 1945 (prize). **Work:** bas-relief, International Falls (MN) Stadium; wood carvings, Sebeka (MN) H.S.; Farmer's Exchange Bldg., St. Paul; Hall of Statuary, Wash., DC, for the State of Minnesota; marble sculpture, Lutheran Church of Good Shepherd, Minneapolis; relief, Church of St. Joseph, Hopkins, MN; interior of St. George's Episcopal Church, including sconces, font, etc., and two crucifixes, St. Louis Park, MN. **Comments:** Contributor to: *School Arts* magazine. Position: director, Evelyn Raymond Clay Club, Minneapolis, MN; head, sculpture dept., Walker AC, 1940-51. **Sources:** WW59; WW47.

RAYMOND, Norman O. Samuel *b.1861, New Orleans, LA / d.1897, New Orleans, LA.*
Sources: *Encyclopaedia of New Orleans Artists,* 318.

RAYMOND, William Asa *[Drawing specialist] b.1819 / d.1853.*
Addresses: Detroit, MI, 1852-53. **Exhibited:** Gallery of FA, Detroit Firemen's Hall, 1852, 1853. **Comments:** A merchant, who executed several drawings of early Detroit and its surroundings. **Sources:** Gibson, *Artists of Early Michigan,* 199.

RAYMONO, Antonin A *[Painter] 20th c.*
Addresses: NYC. **Sources:** WW15.

RAYMUNDO, Francisco V. *[Painter, sculptor, teacher] b.1897, Manila, Philippines.*
Addresses: Attleboro MA. **Studied:** Académie Julian, Paris; NY School Fine & Applied Art; ASL; Columbia. **Exhibited:** Attleboro Mus. Art & Hist., 1939 (prize); Boston Soc. Indep. Artists. **Work:** Attleboro Mus. Art & Hist.; Peoples Inst., Attleboro. **Sources:** WW40.

RAYNARD, Louis See: **RAYNAUD, Louis F.**

RAYNAUD, Louis F. *[Painter, teacher] b.1905, New Orleans, LA.*
Addresses: Chicago, IL. **Member:** Soc. for Sanity in Art. **Exhibited:** San Antonio AL, San Antonio, 1929 (prize); S. Indp. A., 1931; NOAL, 1933 (prize); NOAA, 1934 (prize); AIC. **Work:** WPA murals, USPOs, St. Louis, MO & Abbeville, LA. **Sources:** WW40.

RAYNER, Ada (Mrs. Rayner Hensche) *[Painter] b.1901, London, England / d.c.1984.*
Addresses: Provincetown, MA. **Studied:** ASL; Cape Sch. Art; Henry Hensche. **Member:** Provincetown AA. **Exhibited:** Provincetown AA; Chrysler Mus. Art, Provincetown; Ft. Wayne Mus. Art; Miles Standish Gal., Boston. **Sources:** WW59; WW47.

RAYNER, John *[Painter] 20th c.*
Addresses: NYC, 1929. **Exhibited:** S. Indp. A., 1931. **Sources:** Marlor, *Soc. Indp. Artists.*

RAYNER, Robert J. *[Portrait and landscape painter, engraver, and lithographer] b.c.1818, England.*
Addresses: NYC, 1844-56 and Newark, NJ, 1859. **Exhibited:** NAD, 1854 (crayon portraits). **Comments:** In 1848 he was listed with Thomas W. Rayner (see entry), as a lithographer. **Sources:** G&W; 7 Census (1850), N.Y., LII, 433 [as engraver]; NYBD 1844-50; NYCD 1856; Essex, Hudson & Union Counties BD

1859; Cowdrey, NAD; Stokes, *Historical Prints,* pl. 71b.

RAYNER, Thomas W. *[Lithographer] mid 19th c.*
Addresses: NYC, active 1848. **Comments:** Associated with Robert J. Rayner (see entry) in 1848. **Sources:** G&W; NYCD and BD 1848.

RAYNERD, D. *[Portrait and sign painter] early 19th c.*
Addresses: Cincinnati, active c.1809. **Comments:** Advertised in Cincinnati "that he intends to practice his business of portrait painting for one month in this town", in *Liberty Hall and Cincinnati Mercury* **Sources:** Hageman, 121.

RAYNES, Joseph F. *[Painter] b.1876, Boston.*
Addresses: Boston, MA/West Wareham, MA. **Studied:** ASL. **Exhibited:** S. Indp. A., 1917, 1919, 1925-29. **Sources:** WW25.

RAYNES, Sidney *[Painter] b.1907, Melrose, MA.*
Addresses: Rockport, MA; NYC. **Studied:** H.H. Breckenridge; ASL. **Member:** Am. Artists Congress. **Exhibited:** PAFA Ann., 1933; S. Indp. A., 1935; Northwest PM, SAM, 1936 (prize); AIC. **Sources:** WW40; Falk, *Exh. Record Series.*

RAYNESS, Gerard (Mathiassen) *[Painter, illustrator, designer] b.1898, Slater, IA / d.1946.*
Addresses: Ames, IA. **Studied:** C.A. Cumming; Iowa State College; Cumming School Art. **Member:** Iowa AG. **Exhibited:** Iowa Art Guild; Norske Klub, Chicago; Iowa State Fair, 1929 (honorable mention), 1931 (prize), 1932 (prize); All Iowa Exhibit, Carson Pirie Scott, 1937. **Comments:** Position: teacher, drawing, design & lettering, Cumming School Art, 1926-31. **Sources:** WW40; Ness & Orwig, *Iowa Artists of the First Hundred Years,* 173-74.

RAYNESS, Velma Wallace *[Painter, illustrator, teacher] b.1896, Davenport, IA.*
Addresses: Ames, IA. **Studied:** Cumming School Art. **Member:** Iowa Artists Gld. **Exhibited:** CGA, 1934; Joslyn Mem., 1939, 1946; Iowa Fed. Women's Club, 1919-31 (prizes).; Univ. Iowa; Cornell College; Mt. Vernon; Davenport Mus. Art; Sioux City Art Center; Des Moines Art Center; Corcoran Gallery, 1934; Iowa Art Guild; Iowa State Fair, Des Moines, 1924-26 (prizes), 1935 (prize); Des Moines Women's Club, 1919-31, 1924 (prize), 1926 (prize); Carson Pirie Scott. **Work:** Collegiate Presbyterian Church, Ames, IA; St. John's Methodist Church, Van Buren, AR; U.S. Govt.; portrait, Botany Hall, Iowa State College, Ames, IA. **Comments:** Painting instructor, Cumming School of Art, 1926-31. Illustrator: "The Corn is Ripe," 1944. Author: "Campus Sketches of Iowa State College," 1949. **Sources:** WW59; WW47; Ness & Orwig, *Iowa Artists of the First Hundred Years,* 174.

RAYNOLDS, Emanuel See: **REYNOLDS, Emanuel**

RAYNOR, E. Webster *[Painter] 19th/20th c.*
Addresses: NYC. **Sources:** WW01.

RAYNOR, Ethel *[Painter] 20th c.*
Addresses: NYC, 1931. **Exhibited:** S. Indp. A., 1931. **Sources:** Marlor, *Soc. Indp. Artists.*

RAYNOR, Grace Horton *[Sculptor] b.1884, NYC.*
Addresses: NYC. **Member:** Art Workers Club. **Work:** plaque, Pub. Lib., Glen Ridge, NJ; fountain, Cherry Valley Club, NY. **Comments:** Specialties: portraits; statuettes and heads. **Sources:** WW29.

RAYO, Omar *[Printmaker] b.1928.*
Addresses: NYC, 1966. **Exhibited:** WMAA, 1966. **Sources:** Falk, *WMAA.*

RAZALLE, Teresa (Tess) S. *[Sculptor] 20th c.*
Addresses: Los Angeles, CA, 1911-20; Santa Monica, CA, 1932. **Exhibited:** Artists Fiesta, Los Angeles, 1931. **Comments:** Her mother Emma Razalle was also an artist (see entry). **Sources:** Hughes, *Artists of California,* 458.

RAZELLE, Tess S. See: **RAZALLE, Teresa (Tess) S.**

REA, Daniel, Jr. *[Painter] b.1743.*
Addresses: Boston, active c.1768-1803. **Studied:** learned his trade in the shop of his father-in-law, Thomas Johnston. **Comments:** He was chiefly a house, ship, and sign painter, but may also have done some portrait work. He was the brother-in-law and partner of John Johnston (see entry). **Sources:** G&W; Coburn, "The Johnstons of Boston," Part II, 132-36; Boston CD 1789.

REA, Dorothy (Mrs. Gardner) *[Painter] mid 20th c.*
Addresses: Brook Haven, NY. **Exhibited:** NAWPS, 1935-38. **Sources:** WW40.

REA, Gardner *[Cartoonist] b.1892, Ironton, OH.*
Addresses: Brookhaven, NY. **Studied:** Ohio State Univ. (A.B.); Columbus Art Sch.; Albert Fauley; Malcolm Fraser. **Member:** Am. Acad. Political Science. **Exhibited:** nationally & internationally. **Comments:** Auth.: "The Gentleman Says It's Pixies;" "Gardner Rea's Side Show." Contrib.: *Judge, New Yorker, Saturday Evening Post, Colliers, Look,* and other national magazines. **Sources:** WW66.

REA, James Edward *[Painter, sculptor, designer, lecturer, teacher, illustrator] b.1910, Forsyth, MT.*
Addresses: St. Paul, MN; San Bernardino, CA. **Studied:** St. Paul Sch. Art; Am. Acad. Art, Chicago; Univ. Minnesota (B.S.); Univ. Redlands; Claremont College. **Member:** Twin City Puppetry Gld. **Exhibited:** Grumbacher Exh., 1935; Minn. State Fair, 1933 (prize), 1934 (prize), 1935 (prize); Minneapolis Inst. Art, 1932-1942; Nat. Orange Show. Other awards: San Bernardino, CA, 1957. **Work:** Custer State Park Mus., SD; Hotel Lenox, Duluth, MN; Lowry Medical Arts Bldg., Harding H.S., both in St. Paul; murals, Holy Rosary Church, Arrowhead Motel, both San Bernardino. **Comments:** Teaching: San Bernardino Polytech. H.S., 1946-. Lectures: art history. **Sources:** WW59; WW47.

REA, John L(owra) *[Painter, sculptor, writer] b.1992, Beekmantown, NY.*
Addresses: Plattsburg, NY. **Studied:** H.A. MacNeil; J.E. Fraser; DuMond. **Member:** Plattsburg AG. **Exhibited:** S. Indp. A., 1922; PAFA Ann., 1925. **Work:** tablet, George H. Hudson State Normal Sch., Plattsburg; figures, Miner School, Chazy, NY. **Comments:** Contrib.: *House Beautiful, House and Garden, Am. Home.* **Sources:** WW40; Falk, *Exh. Record Series.*

REA, Louis Edward *[Landscape painter] b.1868, Flint, MI / d.1927, San Francisco, CA.*
Addresses: Placer County, CA. **Studied:** Methodist College, Napa, CA. **Exhibited:** Calif. State Fair, 1881, 1925 (special award), 1926; Kanst Gal., Los Angeles, 1927, 1937. **Work:** Calif. Hist. Soc. **Comments:** On his painting excursions he was often accompanied by E.A. Burbank (see entry). Specialty: hills of Sonoma and Marin Counties. **Sources:** Hughes, *Artists of California,* 458.

REA, Marian *[Illustrator] 20th/21st c.*
Work: U.S. Nat. Arboretum; Herbarium Lib., Univ. Michigan; Mycology Lab., Beltsville, MD. **Comments:** Illustr. with the U.S. Dept. of Agriculture. **Sources:** McMahan, *Artists of Washington, DC.*

REA, Pauline De Vol *[Painter, designer, teacher, educator, illustrator] b.1893, Chicago, IL / d.1974, San Diego, CA.*
Addresses: San Diego, CA. **Studied:** Chicago Acad. FA; Rudolph Schaeffer; Cyril Kay-Scott; others. **Member:** San Diego Artists Gld.; La Jolla AC; San Diego Adv. Club. **Exhibited:** AIC, 1918; Los Angeles; La Jolla AC; Laguna Beach AA; Cedar City, UT; San Diego FA Soc., 1941 (prize). **Work:** San Diego FA Soc. **Comments:** Positions: dir., San Diego Acad. FA, 1929-41; dir., La Jolla AC Children's Class, 1941-58; dir./instr., Casa Manana, La Jolla, CA. **Sources:** WW59; WW47.

REA, Samuel *[Patron] b.1855, Hollidaysburg, PA / d.1929.*
Member: PM Sch. IA (patron, 1928).

REABURN, Maude Lightfoot (Mrs. DeWitt) *[Artist] early 20th c.*
Addresses: Washington, DC; Los Angeles, c.1914. **Sources:** Petteys, *Dictionary of Women Artists.*

READ See: **REID, John**

READ, Adele Von Helmold *[Painter] b.1858, Phila. / d.1905.*
Addresses: Lansdowne, Phila., PA. **Studied:** Chase; Anshutz; PAFA. **Member:** Phila. Art Alliance; Plastic Club; AFA. **Exhibited:** PAFA Ann., 1883-1904 (as Von Helmold), 1927 (as Read); Boston AC, 1894, 1898, 1902; AIC, 1901;. **Sources:** WW40; WW06 (as Helmold); Falk, *Exh. Record Series.*

READ, Christina M. *[Painter] late 19th c.*
Addresses: Chicago. **Exhibited:** AIC, 1895, 1897. **Sources:** Falk, *AIC.*

READ, Donald F. *[Wood engraver, artist] mid 19th c.*
Addresses: NYC, active 1845-60. **Exhibited:** Am. Inst., NYC. **Comments:** He and his brother James A. Read worked together as illustrators for a number of magazines, especially *Yankee Doodle,* but they are remembered principally for their comic *Journey to the Gold-Diggins by Jeremiah Saddlebags* (1849), republished in facsimile in 1950 with an introduction by Joseph Henry Jackson. **Sources:** G&W; J.A. and D.F. Read, *op. cit.;* Am. Inst. Cat., 1845-47; NYCD 1848, 1851-52.

READ, E(lmer) J(oseph) *[Painter] b.1862, Howard, Steuben County, NY.*
Addresses: Palmyra, NY. **Studied:** Syracuse Univ.; Fremiet in Paris. **Exhibited:** NAD, 1892, 1894; AIC, 1913

READ, F. W. *[Illustrator] late 19th c.*
Studied: Acad. Julian, Paris, 1891. **Comments:** Illustrator associated with *Munsey's Magazine.* **Sources:** WW98.

READ, Frank E. *[Painter, teacher, writer] b.1862 / d.1927, Seattle, WA.*
Addresses: Seattle, WA. **Studied:** W.M. Hunt. **Member:** Seattle FA Soc. **Sources:** WW25; Trip and Cook, *Washington State Art and Artists, 1850-1950.*

READ, Franklin *[Engraver] mid 19th c.*
Addresses: Wash., DC, active 1865. **Sources:** McMahan, *Artists of Washington, DC.*

READ, George *[Engraver] b.c.1800, Ireland.*
Addresses: New Haven, CT, in September 1850. **Sources:** G&W; 7 Census (1850), Conn., VIII, 398 (suggests that he must have been living in NYC by c.1831: of his six sons, the eldest (19) was listed as having been born in New York, the second (17) in Ireland, and the rest (13 to 1) in Connecticut.)

READ, Helen Appleton *[Art historian, art critic] b.1887, Brooklyn, NY / d.1974.*
Addresses: NYC. **Studied:** Smith College (A.B., 1908) with Alfred Vance Churchill; Frank Vincent Dumond, William Chase; Robert Henri, Henri Sch. Art; Charles Frieseke & Richard Miller. **Member:** Arch. Am. Art; AFA; Brooklyn Mus.; WMAA; Cosmopolitan Club. **Exhibited:** Awards: Salmagundi Club Medal, 1967; Smith College Medal, 1968. **Comments:** Research: Am. art; German art; Romantic art. Positions: art critic, *Brooklyn Daily Eagle,* 1922-38; assoc. art ed., *Vogue Magazine,* 1923-31; dir., Art Alliance Am., 1924-30; dir. (1943-57) & pres. (1957-), at Portraits, Inc. (gallery specializing in contemp. portraiture). Publications: auth., *Robert Henri* (1929), *500 Years of German Art* (1936) & *Caspar David Friedrich, Apostle of Romanticism* (1939). **Sources:** WW73.

READ, Helen M. *[Landscape painter] 19th/20th c.*
Addresses: Allegan, MI. **Exhibited:** Michigan State Fair, 1884. **Sources:** Gibson, *Artists of Early Michigan,* 200.

READ, Henry *[Painter, writer, teacher, lecturer, designer] b.1851, Twickenham, England / d.1935.*
Addresses: Denver, CO. **Member:** Nat. Acad. Art; Colorado Chapt. AIA; AFA, 1909. **Exhibited:** AIC, 1900. **Work:** Denver Mus. **Comments:** Position: dir., Denver Students Sch. Art. **Sources:** WW29.

READ, James Alexander *[Wood engraver, artist] mid 19th c.*
Addresses: NYC, active 1845-60. **Exhibited:** Am. Inst., NYC,

1847. **Comments:** With his brother Donald F. Read (see entry), James did engraving and illustrating for several magazines, especially *Yankee Doodle,* but he is best known for the comic *Journey to the Gold-Diggins by Jeremiah Saddlebags* (1849), illustrated by the Read brothers. **Sources:** G&W; J.A. and D.F. Read, *op. cit.;* NYCD 1845-49; Am. Inst. Cat., 1847.

READ, James B. *[Portrait painter] b.c.1803, Pennsylvania / d.c.1870.*
Addresses: NYC, 1849-50; Philadelphia, 1859-on. **Comments:** Best known for his oil, "Burning of the Steamer California, 1837." **Sources:** G&W; 7 Census (1850), N.Y., XLVIII, 302; NYCD 1849-50; Phila. CD 1859-70; Brewington, 317.

READ, John *[Engraver] mid 19th c.*
Addresses: NYC, 1855-56. **Sources:** G&W; NYCD 1855-56.

READ, Mary See: **SHERMAN, Mary Read**

READ, Mary Gerard See: **GERARD-RÉAD, Mary**

READ, Nicholas *[Engraver] b.1841, Pennsylvania.*
Addresses: Philadelphia, active in 1860, 1871. **Sources:** G&W; 8 Census (1860), Pa., LIX, 493.

READ, Ralph (Miner) *[Painter] b.1890, New Haven, CT.*
Addresses: Higganum, CT. **Studied:** Yale Univ. (Ph.B.); Columbia Univ.; Guy Wiggins; in Paris. **Member:** Lyme AA; Essex AA; Studio Gld., West Redding, CT. **Exhibited:** Hudson River Mus., Yonkers, NY, 1957; in museums and other exhs. in Oswego, Cortland & Rochester, NY; Brockton, Amherst, MA; Portland, ME; Florence, SC; Kansas City, MO; Waterloo, IA; Peoria, IL; Easton, PA; Morgantown, WV; Milwaukee, WI (1951-58); Lyme AA, annually; Essex. **Sources:** WW59.

READ, Thomas Buchanan
[Portrait & historical painter, illustrator, sculptor, poet] b.1822, near Guthriesville, Chester County, PA / d.1872, NYC.

T. Buchanan Read
Frascati·
·1869

Exhibited: PAFA Ann.,1847-66, 1876-78; NAD, 1841-59; Cincinnati, OH, 1864; Brooklyn AA, 1869. **Work:** Cincinnati Art Mus.; PAFA; Peabody Inst., Baltimore, MD; Detroit Inst. Art; State Capitol, Trenton, NJ ("Sheridan's Ride;" Read wrote a poem of the same title). **Comments:** Shortly after apprenticing with a tailor, c. 1835, Read left for Philadelphia, where he worked in several stores before taking off for Cincinnati in 1837. There he worked as a ship and sign painter and, for a short time, served as Shobal Clevenger's assistant. By 1840 he had gained enough recognition as a painter to win a commission for a portrait of William Henry Harrison. In 1841 Read moved to Boston, where he befriended Allston and Longfellow. In 1845 his first book of poems was published and from that point until his death he devoted himself to both his painting and poetry. In 1846 he moved to Philadelphia. In 1850 Read made the first of several trips to Europe where he spent much of his time during the next two decades. While there, he developed friendships with the English Pre-Raphaelites and with the American sculptors living in Italy. Read was back in the U.S. during the Civil War, working for the Union cause on the staff of General Lew Wallace (as a lecturer and propagandist). In 1865 he briefly established a studio in New Orleans to paint a portrait of General Philip H. Sheridan. He then returned to Italy and lived in Rome and Florence until shortly before his death in 1872. Read painted many portraits in his lifetime but was more famous for his historical and literary paintings; these reflected ideal and romantic themes under titles such as a "A Painter's Dream" (Detroit Inst.) and "Hiawatha's Wooing." He was considered one of America's leading poets at the time of his death. **Sources:** G&W; Keller, "Thomas Buchanan Read"; Pleasants, *Four Great Artists of Chester County;* Borneman, "Thomas Buchanan Read"; DAB; Swan, BA; Rutledge, PA; Cowdrey, NAD; Boston BD 1842-46; Phila. CD 1850; Rutledge, MHS; Cowdrey, AA & AAU. More recently, see Baigell, *Dictionary;* Peggy and Harold Samuels, 390-91; *Encyclopaedia of New Orleans Artists;* and Gerdts, *Art Across America,* vol. 1: 283;

Cincinnati Painters of the Golden Age, 95-97 (w/illus.); Falk, *Exh. Record Series.*

READ, Walter *[Artist] b.c.1863, England / d.c.1950, Brooklyn, NY.*
Addresses: Active in Brooklyn, 1905-50. **Sources:** BAI, courtesy Dr. Clark S. Marlor.

READ & BROTHER *[Engravers] mid 19th c.*
Addresses: NYC, 1848. **Comments:** Partners were James A. and Donald F. Read (see entries). **Sources:** G&W; NYBD and CD 1848; Hamilton, *Early American Book Illustrators,* 295-96; J.A. and D.F. Read, *Journey to the Gold-Diggins by Jeremiah Saddlebags.*

READE, John See: **REID, John**

READE, Roma (Mabel Kelley Aubrey) *[Painter, writer, teacher] b.1877, Skaneateles, NY / d.1958.*
Addresses: Pasadena, CA. **Studied:** Univ. College, Toronto; Donalda-McGill College, Montreal; Columbia Univ. **Member:** Theatre Artists Gld.; Westchester Artists Gld.; Contemp. Art Club; Calif. Art Club; Glendale AA; Laguna Beach AA; New England Painters; Canadian Art Lg.; Southland AA; Painters of the Southwest; Illustrators, Inc. **Exhibited:** PAFA; AIC; Pasadena Mus. Art; Laguna Beach, CA; Nat. Soc. Arts & Letters, Washington, DC; WFNY 1939; Pasadena Soc. Artists; CPLH; Paul Metcalfe Gal., Los Angeles. **Work:** murals, paintings in theatres. **Comments:** Contrib. to magazines on theatre and art. Auth.: "Scene Painting and Art". **Sources:** WW53; WW47; Petteys, *Dictionary of Women Artists.*

READER, George W. *[Engraver] b.c.1825.*
Addresses: Philadelphia in 1850, 1860. **Sources:** G&W; 7 Census (1850), Pa., XLIX, 285; 8 Census (1860), Pa., LIV, 874.

READER, Samuel J. *[Amateur sketcher] 19th/20th c.*
Addresses: North Topeka, KS. **Comments:** He illustrated a diary he kept at North Topeka (KS) from 1855 to 1909. **Sources:** G&W; WPA Guide, *Kansas,* 137.

READING, Alice Matilda *[Portrait painter] b.1859, Shasta County, CA / d.1939, Shasta, CA.*
Addresses: Wash., DC, active 1896-1920; Shasta County, CA. **Studied:** ASL, Wash., DC; Corcoran Sch., Wash., DC. **Exhibited:** Cosmos Club, 1902. **Work:** Fairfax County, VA; Shasta Hist. Soc.; Redding, CA; Soc. Calif. Pioneers, San Fran.; State Capitol, Sacramento, CA. **Sources:** WW19; Hughes, *Artists of California,* 458; McMahan, *Artists of Washington, DC;* Petteys, *Dictionary of Women Artists,* cites birth date of 1858.

READING, William *[Portrait painter] mid 19th c.*
Addresses: Active in Louisville & elsewhere in Kentucky. **Comments:** While painting at Nicholasville (KY) in the fall of 1847 he gave lessons to Samuel Woodson Price (see entry). *Cf.* William H. Redin. **Sources:** G&W; Coleman, "Samuel Woodson Price, Kentucky Portrait Painter," 6.

READIO, Wilfred A. *[Painter, lithographer, educator] b.1895, Northampton, MA / d.1961, Pittsburgh, PA.*
Addresses: Pittsburgh, PA. **Studied:** Carnegie Inst. Tech. (B.A.) with A.V. Churchill, Arthur W. Sparks. **Member:** Pittsburgh AA. **Exhibited:** Pittsburgh AA, annually, since1921 (prize),1940 (prize); Rocky Mountain PM 1935 (prize); SFMA, 1935, 1955; Cleveland Pr. Club, 1935; Calif. PM, 1935, 1936; Phila. Pr. Club, 1934-45, 1951, 1953, 1957; Buffalo Pr. Club, 1938-43; AIC, 1934, 1935, 1937, 1940; Wichita AA, 1934-38; Laguna Beach AA, 1945, 1946,1951-5; LOC, 1944, 1945-52, 1957, 1958; CI, annually since 1934; SAGA, 1950, 1951. **Work:** Pittsburgh Pub. Sch.; Latrobe (PA) H.S.; Carnegie Inst.; Penn. State College. **Comments:** Positions: chmn., Dept. Painting & Design, 1929-39, dept. hd., 1939-55, prof., 1955-, Carnegie Inst. Tech., Pittsburgh, PA. Specialty: scenes of Pittsburgh and the Am. West. **Sources:** WW59; WW47. More recently, see, Chew, ed., *Southwestern Pennsylvania Painters,* 109, 110.

READY *[Architect, draftsman] early 19th c.*
Exhibited: Charleston, SC, 1822 (design for a memorial tablet). **Sources:** G&W; Rutledge, *Artists in the Life of Charleston.*

REAGH, Bill *[Painter] mid 20th c.*
Exhibited: P&S Los Angeles, 1937. **Sources:** Hughes, *Artists of California,* 458.

REALE, Frank *[Sculptor] mid 20th c.*
Exhibited: S. Indp. A., 1937. **Sources:** Marlor, *Soc. Indp. Artists.*

REALE, Nicholas Albert *[Painter] b.1922, Irvington, NJ.*
Addresses: Hillside, NJ. **Studied:** Newark Sch. FA; Pratt Inst.; ASL. **Member:** AWS; All. Artists Am.; NJWCS; New Jersey P&S; New Jersey AA. **Exhibited:** AWCS, 1959-65; NAD, 1964, 1965; Audubon Artists, 1959-65; Watercolor: U.S.A., 1962, 1963, 1965; New Jersey P&S, 1959-65; Montclair Mus. Art, 1957-65 (prizes, 1957, 1961-62); New Jersey WC Ann., 1957-64; Westfield AA, 1963-65; Monmouth College Festival of Arts, 1960-65. **Awards:** Newark Mus., 1959; Jersey City Mus. purchase, 1960; NJWCS, 1957, 1962; Medal of Honor, 1960; Audubon Artists, Grumbacher purchase, 1963. **Work:** Newark Mus.; Jersey City Mus.; Monmouth College. **Comments:** Teaching: Newark (NJ) Sch. Fine & Indust. Art. **Sources:** WW66.

REAM, Carducius Plantagenet *[Painter, illustrator] b.1837, Lancaster, OH / d.1917, Chicago, IL.* *C.P.Ream*
Addresses: Chicago. **Studied:** Paris; London; Munich; NYC. **Member:** Chicago Acad. Design; AIC. **Exhibited:** Brooklyn AA, 1872-79, 1883; Royal Academy, London , 1892, 1898; AIC, 1894-1909 (solo), 1910-17. **Work:** AIC, "Purple Plums" (or "Just Gathered"), the first work by a Chicago artist to enter their permanent coll.; Brandywine River Mus., Chadds Ford, PA. **Comments:** Worked in New York and Cincinnati before moving to Chicago in 1878, becoming that city's most successful still-life painter and achieving national and international recognition. He was known especially for his fruit pictures, some of which were reproduced as chromolithographs by Louis Prang (see entry) and advertised as "dining-room pictures." He produced tabletop studies, in which the fruit is displayed in a glass or china dish, and he also painted more Ruskinian interpretions in which a group of plums or peaches is shown in its natural setting, as if having been just gathered after falling from a tree. Ream was a master at rendering the color and sensuous texture of fruit by bathing his subjects in soft but dramatic light. He also painted landscapes, portraits, and figure studies. Brother of Morston Constantine Ream (see entry). Gerdts noted various spellings of Ream's first name: Cadorsus, Carducis, Cardurcis, and Carducius. There has been some conflict over his year of birth. Groce & Wallace had reported it as 1836; more recent publications (including Gerdts) have revised the date to 1837. **Sources:** G&W; *Art Annual,* XIV, obit. More recently, see Gerdts, *Painters of the Humble Truth,* 28, 113; Gerdts, *Art Across America,* vol. 2: 294-95; *300 Years of American Art,* vol. 1: 296; Falk, AIC; *For Beauty and for Truth,* 83 (w/repro.).

REAM, Morston Constantine *[Still life painter] b.1840, Lancaster, OH / d.1898, NYC.* *Morston Ream*
Addresses: NYC (1872-c.1883); Chicago, IL (c.1888-97). **Exhibited:** Moore's Art Rooms, NY; Cleveland, OH; Brooklyn AA, 1873-83, 1892; PAFA Ann., 1876, 1881; Toledo Loan Exh., 1885; San Fran.; NAD, 1872-83; AIC, 1888-97. **Comments:** A specialist in fruit and dessert still lifes and brother of Carducius Plantagenet Ream (see entry). Morston learned daguerreotyping in 1860 and was a photographer's apprentice until he found the process detrimental to his health and turned to painting, c.1868. He also produced some landscapes and genre paintings. **Sources:** G&W; Gerdts, *Painters of the Humble Truth,* 113; Naylor, NAD; Falk, AIC; *For Beauty and for Truth,* 84 (w/repro.); Falk, *Exh. Record Series.*

REAM, Vinnie (Mrs. Richard L. Hoxie) *[Sculptor] b.1847, Madison, WI / d.1914, Wash., DC.*

Addresses: Iowa City, IA/Wash., DC. **Studied:** C. Mills, Wash., DC, age 15; Majoli, Rome, 1869; Bonnét, Paris. **Exhibited:** Centennial Exh., Phila., 1876; St. Louis Expo., c. 1875; Woman's Bldg., World's Columbian Expo., Chicago, 1893 ("The West" and "Miriam's Song of Triumph"). **Work:** "Lincoln," "Samuel Kirkwood," "Sequoyah," U.S. Capitol, Wash., DC; NYHS; NMAA. **Comments:** Ream was working on a statue of Pres. Lincoln (which she sketched and modeled from life over a period of six months at the White House) when he was assassinated (she had sketched him that very day), and when Congress made an appropriation for a marble statue of Lincoln, she won the $10,000 prize. She went to Europe in 1869 to put the work into marble and was welcomed by the American artists living in Rome. While abroad, she modeled likenesses of Cardinal Antonelli (in Italy) and Liszt (in Paris). In addition to the Lincoln statue, which is in the rotunda of the Capitol, the U.S. government commissioned her for a bronze sculpture of Admiral Farragut (she received $20,000), which is also in Wash., DC (at K Street between 16th and 17th St., N.W.). She was the first woman to sculpt for the U.S. Government, but put aside her career in 1878 when she married Lt. Richard L. Hoxie, and became a popular Wash., DC, hostess and social leader. In 1912, however, she received two commissions for bronze statues to be placed in the Capitol building and was at work on both ("Samuel Kirkwood" and "Sequoyah") at the time of her death in 1914. She and her husband are buried in Arlington National Cemetery, where their tomb is marked with a copy of Ream's "Sappho." **Sources:** WW13; Richard Hoxie, *Vinnie Ream* (1908); NYHS Catalogue (1974), cat. no. 1225; Ness & Orwig, *Iowa Artists of the First Hundred Years*, 107; Tufts, *American Women Artists, 1830-1930*, cat. no. 108; Rubinstein, *American Women Artists*, 83-85; Baigell, *Dictionary*.

REAMER, Maude *[Painter, teacher] early 20th c.*
Addresses: Buffalo NY. **Sources:** WW21.

REANEY, Thomas A. *[Painter] b.1916, Valjean, Sask., Canada.*
Addresses: Colorado Srings, CO, in 1971. **Studied:** Zoltan Sepeshy, Cranbrook Acad. Art, 1930s. **Work:** Cranbrook AA; Princeton Univ.; Colorado Springs FAC. **Sources:** P&H Samuels, 391.

REAPSOMER, William R. *[Artist] 19th/20th c.*
Addresses: Wash., DC, active 1890-1905. **Sources:** McMahan, *Artists of Washington, DC.*

REARDON, Mary A. *[Painter, educator, lithographer, illustrator] b.1912, Quincy, MA.*
Addresses: Boston, MA. **Studied:** Radcliffe College (A.B.); Yale Univ. School FA (B.F.A.); Eugene Savage; Jean Charlot; David Siqueiros. **Member:** North Shore AA; Boston Liturgical Art Group; Nat. Soc. Mural Painters; Cambridge AA; North Shore AA; Copley Soc.; BMFA (mem., ladies comt.). **Exhibited:** Northwest PM, 1940; Inst. Mod. Art, Boston; North Shore AA, 1940-46; Quincy, MA (solo); First & Second Int. Exhs. Religious Art, Trieste, Italy, 1961 & 1966 (President's Medal); Seventh Centennial Exh., Basilica St. Anthony, Padua, Italy, 1963; Trieste, 1971 (solo). **Work:** murals, De Cordova Mus., Lincoln, MA; Radcliffe College, Cambridge, MA. Commissions: mosaic chapel, "Our Lady of Guadalupe," 1965 & mosaic ceilings, "Last Judgment & Creation," Nat. Shrine Immaculate Conception, Wash., DC, 1972; fresco, "Formation of a Priest," St. Johns Sem., Brighton, MA; Maryknoll & Brookline Chapel, Boston; dec., St. Raphael's Hall, Newton, MA; tryptych, U.S.S. *Wasp*; altarpiece & figures, Baltimore Cathedral, MD, 1967. **Comments:** Preferred media: oils, watercolors, acrylics, charcoal. Publications: co-auth., "Pope Pius XII—Rock of Peace"; illustr., "Snow Treasure," "They Came from Scotland," "Bird in Hand" &" Grenfell." Teaching: adult educ., BMFA; Emmanuel College, Boston, 1951-70. **Sources:** WW73; WW47.

REARICK, Janet (Mrs.) *[Scholar] mid 20th c.*
Addresses: NYC. **Sources:** WW66.

REASE, William H. *[Lithographer, printer] b.1818, Pennsylvania.*
Addresses: Philadelphia, active 1844-c.1872. **Work:** Mariners Mus., Newport News, VA; Atwater Kent Mus., Phila.; Hist. Soc. Penn. (Phila.); Penn. Hist. and Mus. Commission (Bureau of Archives & History, Div. of History, Harrisburg, PA); Colorado State Hist. Soc., Denver. **Comments:** Lithographer of a view of "Jersey Shore Looking South West Lycoming Co., Pa. 1854." As W.H. Rease & Co., he printed a view of Central City, Colorado (not dated, located at Colorado State Hist. Soc.). He apparently stopped working in 1872. **Sources:** G&W; 7 Census (1850), Pa., LII, 171; Phila. CD 1844-60+; Peters, *America on Stone*. More recently, see Reps, 469, 3461; Brewington, 318.

REASER, Wilbur (Aaron) *[Portrait painter, lecturer] b.1860, Hicksville, OH / d.1942, Minneapolis, MN.*
Addresses: NYC. **Studied:** Mark Hopkins Inst., San Fran.; Acad. Julian, Paris, with B. Constant, Lefebvre, Doucet, 1888-89. **Member:** San Fran. AA. **Exhibited:** Paris Salon, 1890, 1893; California Expo, 1894 (gold medal); NAD, 1897 (first Hallgarten prize), 1900; PAFA Ann., 1898, 1900; AIC. **Work:** Des Moines Woman's Club; Carnegie Gallery, Pittsburgh; Art Gallery, Des Moines; portraits, U.S. Senate Lobby, Capitol (Montpelier, VT), Capitol (Charleston, WV), Iowa State Hist. Soc. (Des Moines, IA). **Comments:** Specialty: portraits; pastel. **Sources:** WW40; Ness & Orwig, *Iowa Artists of the First Hundred Years*, 174; Fink, *Am. Art at the 19th c. Paris Salons*, 383; Falk, *Exh. Record Series*.

REASON, Henry J. *[Engraver] mid 19th c.*
Addresses: NYC, 1856. **Sources:** G&W; NYBD 1856.

REASON, Joseph T., Jr. *[Painter] early 20th c.*
Exhibited: PAFA Ann., 1908. **Sources:** Falk, *Exh. Record Series.*

REASON, Patrick Henry *[Engraver, lithographer] b.1817 / d.1850.*
Addresses: Active in NYC from 1837-66. **Member:** Anti-Slavery Soc. **Exhibited:** Howard Univ., 1967. **Work:** Howard Univ. Coll. **Comments:** African-American artist who, according to Stauffer, was a clever engraver of portraits in stipple, but in the 1850s was forced to give up engraving for other work because of race prejudice. Gaither writes that Reason made lithographic portraits of many prominent abolitionists. **Sources:** G&W (cites death date of 1852); Porter, *Modern Negro Art*, 35-38; NYCD 1845-66; David Stauffer (gives artist's name as *Philip H. Reason*); Art in America (1936), repro. opp. p. 22. More recently, see Edmund Barry Gaither, "The Spiral of Afro-American Art" in *300 Years of American Art*, vol. 1: 381; Cederholm, *Afro-American Artists* (cites a death date of 1850).

REASON, Philip H. See: **REASON, Patrick Henry**

REASONER, David *[Painter] mid 20th c.*
Exhibited: San Diego Art Guild, 1937. **Sources:** Hughes, *Artists of California*, 458.

REASONER, Gladys Thayer (Mrs. David) *[Painter, teacher] b.1886, Woodstock, CT.*
Addresses: Woodstock, NY. **Studied:** A.H. Thayer. **Exhibited:** AIC, 1906; WMAA, 1920-21; Vose Gal., Boston, 1924; Knoedler Gal., NYC, 1919; San Diego FAA, 1938; Grand Central Gals., NYC, 1906 (solo), 1935 (solo); Macbeth Gal., NYC, 1906; Copley Gal., Boston, 1906. **Comments:** Daughter of A.H. Thayer and his first wife Kate Bloede. **Sources:** WW25; Petteys, *Dictionary of Women Artists*.

REASONER, Grace Dredge (Mrs. Lyman H.) *[Portrait painter and designer] b.1895, Des Moines, IA.*
Addresses: Belmont, MA. **Studied:** Cumming Art Sch. with Charles Atherton Cumming; Boston Mus. FA Sch., 1917-20; Elizabeth Shippen Geren, William James; Abbott H. Thayer. **Member:** Copley Soc. **Exhibited:** Copley Soc. Show, Boston Mus. FA; Jordan Marsh, Boston (hon. men.); Providence Art Club; Grace Horne Gal., Boston. **Awards:** Des Moines Women's Club scholarship, 1909, 1910; Des Moines Lib. Bd. scholarship,

1914, 1915-17. **Comments:** Specialty: children, although not exclusively. Teaching: Milton Acad., 1921-22; Belmont Day Sch., 1929-33; Modern Sch. Art, Boston, 1937-38. Designer & interior decorator, 1930s. **Sources:** Ness & Orwig, *Iowa Artists of the First Hundred Years,*174-75.

REASOR, Robert Alden *[Painter] early 20th c.*
Comments: Possibly the son of William A. Reasor, also a pastellist. **Sources:** PHF files, Impressionist pastel landscape dated 1928.

REAUGH, Charles Franklin See: **REAUGH, F(rank)**

REAUGH, F(rank) *[Painter, teacher] b.1860, near Jacksonville, IL / d.1945, Dallas, TX.*
Addresses: Terrell, TX, 1875; Dallas in 1903; Oak Cliff, TX. **Studied:** St. Louis Sch. FA, 1883; Acad. Julian, Paris, with Constant, Doucet, 1888-91. **Member:** Dallas AA; AFA. **Exhibited:** AIC, 1895-1902; PAFA Ann., 1895; NAD, 1896. **Work:** Dallas AA; Dallas Pub. Lib.; Univ. Texas; Dallas Mus. FA; Fort Worth AM; Texas Tech. Lib., Lubbock; Panhandle Plains Hist. Mus, Canyon. **Comments:** Organized a school in Terrell. Positions: dir., Outdoor Summer Sketching Sch.; teacher, Baylor Univ. Specialty: Texas cattle and western landscapes. Epic cycle: "Twenty-four Hours with the Herd." **Sources:** WW40; P&H Samuels, 391; Falk, *Exh. Record Series.*

REAVES, Angela Westwater *[Art editor, writer] b.1942, Columbus, OH.*
Addresses: NYC. **Studied:** Smith College (B.A.); NY Univ. (M.A.). **Comments:** Positions: asst. dir., Center Int. Studies, NY Univ., 1967-69; research assoc., Inst. Govt., Univ. Georgia; ed., *Georgia Govt. Rev.,* 1969-71; managing ed., *Artforum,* 1972-. **Sources:** WW73.

REAVIS, Esma Jacobs *[Painter, craftsperson, teacher] b.1900, Corinth, MS.*
Addresses: Greenville, TX. **Studied:** M. Simpkins; M. Marshall; Reaugh; Klepper. **Member:** SSAL; Reaugh AC, Dallas. **Exhibited:** Prof. Exh., Texas State Fair, 1928 (prize), 1930 (prize); SSAL, 1931 (prize); Texas Fed. Women's Club, 1931 (prize); Frank Reaugh AC, 1932 (prize). **Work:** Greenville (TX) H.S. **Sources:** WW40.

REAY, Martine R. *[Painter, illustrator] b.1871, New York.*
Addresses: NYC. **Studied:** ASL. **Exhibited:** Corcoran Gal. annual, 1908. **Sources:** WW10.

REBAJES, Francisco *[Craftsman, designer, teacher] b.1907, Puerto Plata, Dominican Republic.*
Addresses: NYC; Malverne, NY. **Studied:** in Dominican Republic & Spain. **Member:** Soc. Designer-Craftsmen; Fellow, Royal Soc. Art, London. **Exhibited:** Paris Salon, 1937 (medal); MMA, 1937; BM, 1938. **Work:** WMAA. **Comments:** Position: pres., Copper Craftsmen, Inc., NYC; pres., Rebajes, Fifth Ave., NYC. **Sources:** WW59; WW47.

REBAJES, Ramon (Torres) *[Painter] b.1899, Spain / d.1933.*
Addresses: NYC. **Exhibited:** S. Indp. A., 1929-33; Salons of Am., 1932. **Sources:** Marlor, *Salons of Am.*

REBAY, Hilla *[Painter, writer, museum director, collector, lecturer] b.1890, Strasbourg, Alsace, France / d.1967.*
Addresses: Greens Farms, CT. **Studied:** Academies in Düsseldorf and Munich; Acad. Julian, Paris, with J.P. Laurens, G. Royer &Laparra. **Exhibited:** Salon des Indépendants, Paris, 1911; Freie Secession, Berlin, 1913; Secessions, Munich, 1912; Worcester MA, 1928; Bernheim Jeune, Charpentier Gals., Paris; Marie Sterner, Wildenstein Gals., NYC; Salon des Tuileries, Salon d'Automne, Salon Nouvelles Réalités, Paris, France, since 1929; CPLH; GGE 1939. **Work:** in museums in U.S., France, Italy, Switzerland, Germany. **Comments:** An important promoter of modern art in America, she immigrated to the U.S. in 1926 and beginning in 1935 became Solomon R. Guggenheim's first director of the Mus. Non-Objective Painting, which later became the Guggenheim Museum, NYC (of which she was director until 1952). In 1915, she was greatly influenced by Hans Arp in Paris, who introduced her to many of the modern painters. Later, Rudolph Bauer also provided introductions to the leading modernists, and Guggenheim's collection grew in importance. Other positions: trustee, Mid-Fairfield County Youth Mus., Westport, CT Auth.: "Wassily Kandinsky"; "Kandinsky Memorial"; "Moholy-Nagy Memorial." Contrib.: *Southern Literary Digest, Carnegie Inst. Magazine, New Age, Realities,* and other publications. Her full name was Baroness Hildegard Rebay von Ehrenwiesen. **Sources:** WW66; WW47; *American Abstract Art,* 195.

REBECHINI, Ferdinand *[Sculptor] mid 20th c.*
Addresses: Elmwood Park, IL. **Exhibited:** PAFA Ann., 1950; AIC, 1951. **Sources:** Falk, *Exh. Record Series.*

REBECHINI, Guido *[Sculptor] early 20th c.*
Addresses: Chicago, IL. **Exhibited:** AIC, 1915-16. **Sources:** WW17.

REBECHINI, Marcello *[Sculptor] early 20th c.*
Addresses: Chicago. **Exhibited:** AIC, 1921, 1923, 1940. **Sources:** Falk, *AIC.*

REBECK, Steven Augustus *[Sculptor, medalist] b.1891, Cleveland, OH / d.1975, Cleveland Heights, OH.*
Addresses: Cleveland Heights. **Studied:** Karl Bitter; Cleveland Sch. Art with Carl Heber. **Member:** NSS; Cleveland SA. **Exhibited:** CMA, 1922-23 (awards & medals for portraits & busts); PAFA Ann., 1924. **Work:** CMA; Commissions: Shakespeare (bust in stone), for garden, Cleveland; Soldiers Mem., Alliance, OH; Spanish War Veteran (bronze); Lincoln (bronze); sphinx statue, Masonic Temple, Saint Louis, MO; Civil Court House, St. Louis, MO. **Comments:** Art interests: portraits & memorial tablets. **Sources:** WW73; WW47; Falk, *Exh. Record Series.*

REBER, Alfred A. *[Painter] early 20th c.*
Addresses: Dormont, PA. **Member:** Pittsburgh AA. **Sources:** WW24.

REBER, Elsie *[Painter] mid 20th c.*
Addresses: Phila., PA. **Exhibited:** PAFA Ann., 1948-49, 1951. **Sources:** Falk, *Exh. Record Series.*

REBER, L. O. *[Painter] 19th/20th c.*
Addresses: Jackson, MI. **Exhibited:** Michigan State Fair, 1886. **Sources:** Gibson, *Artists of Early Michigan,* 200.

REBERT, Jo Liefeld *[Painter, lecturer] b.1915, Detroit, MI.*
Addresses: Los Angeles, CA. **Studied:** Detroit Soc. Arts & Crafts, grad; Detroit Inst. Musical Art (artists dipl.); Joseph Canzanni. **Member:** Calif. Nat. WCS (treas. & historian, 1964-67); Pasadena Soc. Artists; Los Angeles Women's Art Council. **Exhibited:** Watercolor USA (Arches Paper Award; total of 94 awards); Calif. Nat. WCS (7 awards, 1958-70); Calif. State Fair (prizes, 1966-71); solo matted traveling show, U.S. univs., 1970-971; Brand AC, Glendale, 1971 (solo) & Palos Verdes Mus., 1972 (solo); Jacqueline Anhalt Gal., Los Angeles, CA, 1970s. **Work:** Eastland Bank, Anaheim; Lytton S&L, Los Angeles; Mus Belles Artes, Mexico City; Calif. State Fair Coll.; Brentwood S&L, Hollywood, CA. **Comments:** Positions: juror, Calif. Nat. WCS, Calif. State Fair & other shows. Teaching: Downey (CA) Mus. Art Sch., 1960-69; Chouinard Art Inst., Los Angeles, 1966-67; Univ. Southern Calif. at Idyllwild, 1972; demonstrated lectures for art groups in the West. Publications: auth., "Handbook on Copper Enameling," *Ceramics Monthly Magazine,* 1955; auth., *The Challenge of Painting* 1970. **Sources:** WW73.

REBETY, Victor *[Listed as "artist"] mid 19th c.*
Addresses: New Orleans, active 1860-66. **Sources:** G&W; Delgado-WPA cites New Orleans CD 1860-61, 1865. Additionally, New Orlean CD 1866 is cited in *Encyclopaedia of New Orleans Artists.*

REBICHON, Emile *[Designer] b.c.1827, France.*
Addresses: Frankford, near Philadelphia, in 1850. **Comments:**

Living with his father, Theodorus Rebichon, engraver. **Sources:** G&W; 7 Census (1850), Pa., LVI, 316.

REBICHON, Theodorus *[Engraver] b.c.1801, France.* **Addresses:** Frankford, near Philadelphia, in 1850. **Comments:** Living with his son, designer Emile Rebichon. **Sources:** G&W; 7 Census (1850), Pa., LVI, 316.

REBISSO, Louis T. *[Sculptor] b.1837, Genoa, Italy / d.1899, Cincinnati, OH.* **Addresses:** Came to U.S. and settled at Boston in 1857; Cincinnati. **Comments:** Was associated with Thomas Dow Jones (see entry) in Cincinnati and for many years a professor of sculpture at Cincinnati Art School. Among his students was Solon Borglum, who also worked in Rebisso's studio for a time. **Sources:** G&W; *Art Annual,* I (Supp.), obit.; Boston *Transcript,* May 4, 1899, obit.; Gardner, *Yankee Stonecutters.* See also, Craven, *Sculpture in America,* 525.

REBOLE, Henry *[Fresco painter] b.c.1821, Germany.* **Addresses:** Pittsburgh, PA, in 1850. **Comments:** Listed as living with his wife and Frederick Lotz (see entry). **Sources:** G&W; 7 Census (1850), Pa., III, 96.

REBOLI, Joseph John *[Painter, illustrator] b.1945, Port Jefferson, NY.* **Addresses:** Stony Brook, NY. **Studied:** Paier Sch. Art, New Haven, CT. **Member:** Salmagundi Club. **Exhibited:** Conn. Classic Art Exh., Trumbull, CT, 1964 (best in show); Nat. Benedictine Art Awards, NYC, 1965; 23rd New England P&S Exh., Silvermine, CT, 1972; Barney Kane Inc., NYC, 1970s. Other awards: purchase award, New Haven PCC, 1965; first prize, White Plains Art Festival, 1972. **Work:** New Haven PCC; Awixa Pond AA, Bay Shore, NY. **Comments:** Preferred medium: oils. Illustr.: *Guideposts Magazine,* 11/1971; *Ralston's Ring,* Ballentine, 1971; *Good Housekeeping Magazine,* 7/1972 & 9/1972; *Clothes Magazine,* 5/1972. **Sources:** WW73.

RECCA, J. George *[Painter, commercial artist] b.1899, Palermo, Italy.* **Addresses:** Elmhurst, NY. **Studied:** PIA Sch. **Member:** AWCS; SC; All. Artists Am.; Audubon Artists; Grand Central Art Gal; Brooklyn SA; NYWCC; NY Soc. Painters; AAPL.; Springfield (MA) Art Lg. **Exhibited:** NAD, 1935, 1940, 1942; Exh. Religious Art, Grant Studios, Brooklyn, 1936 (prize); PAFA, 1940-41, 1944; Ogunquit AC, 1938 (prize), 1939 (prize); All. Artists Am., 1941-43. **Sources:** WW59; WW47.

RECCHIA, Kitty (Mrs. Richard H.) See: **PARSONS, Kitty (Mrs. Richard Recchia)**

RECCHIA, Richard (Henry) *[Sculptor] b.1885, Quincy, MA / d.1983, Rockport, MA.* **Addresses:** Rockport, MA, 1928. **Studied:** BMFA School; Acad. Julian, France; in Italy. **Member:** NAD; NSS; Copley Soc.; Boston SS (founder); Boston AC; Phila. Alliance; CAFA; Gld. Boston Artists; North Shore AA; Rockport AA; AAPL. **Exhibited:** PAFA Ann., 1910-12, 1919-20, 1926-29, 1936; Pan-Pacific Expo, 1915 (medal); Guild Boston Artists, 1923 (solo), 1934 (solo); St. Botolph Club, 1926 (solo); CGA, 1928; BMFA Sch. (prize; solos); NSS, 1939 (prize), 1940-49 (Lindsay Morris Mem. Prize for Bas Relief, 1949); AIC; New York World's Fair, 1942; NAD, 1942 (gold medal), 1944 (prize), annually; Int. Expo, auspices Italian Gov., Bologna, Italy, 1931 (Gold Cross & Medal of Honor); S. Indp. A., 1944. **Work:** bas reliefs on bldg., Boston Art Mus. & replica, Purdue; Boston State House; Somerville Pub. Lib.; Red Cross Mus., Wash., DC; Buffalo Mus. Art & Science; Boston Psychoanalytical Inst.; J.B. Speed Mus., Louisville, KY; Brookgreen Gardens Mus., SC. Commissions: bas reliefs, Gov. Curtis Guild, Boston Common, 1916; Sam Walter Foss, Brown Univ., 1916; Phi Beta Kappa, Harvard Univ., 1917; Gov. Oliver Ames Mem., Northeaston, MA, 1921; portrait tablet, Davenport Sch., Malden, MA; Gov. John Stark equestrian statue, State of NH, Manchester, 1948. **Comments:** Son of an Italian immigrant stonecutter. Modeled idealized figures expressing emotional

states, and, later, small modernist bronzes of birds and other animals. Preferred media: bronze, marble. **Positions:** founder, Boston Soc. Sculptors. **Publications:** illustr., "Down to Earth," 1964. **Sources:** WW73; "Richard Recchia Creates Heroic Aize Equestrian," *Am. Art* (June, 1950); Meara, "A Garden Where Statues Grow," *North Shore Magazine* (1968); Stickler, "Stark Holds Symbol of Freedom High," *New Hampshire Sun News,* Sept. 27, 1970; WW47; Fort, *The Figure in Am. Sculpture,* 219 (w/repro.); Falk, *Exh. Record Series.*

RECKENDORF, J. Angelika *[Craftsman, educator] b.1893, Freiburg, Germany.* **Addresses:** Pembroke, NC. **Studied:** Cranbrook Acad. Art; CI; Univ. North Carolina (M.A.); in Europe with Hans Ehmke, Heinrich Wölfflin. **Member:** CAA; Southeastern AA; Southeastern Art Educ. Assn.; NC State Art Soc. **Exhibited:** North Carolina Aeriara, 1940, 1944; Wichita AA, 1952, 1954; Greensboro Textile Exh., 1950, 1954; in Europe. **Comments:** Teaching: hd. art dept., Pembroke (NC) College, 1942-; Crafts Workshop, Univ. North Carolina, Chapel Hill, NC, 1943-44. Contrib.: "High School Journal," with articles on art education in the public schools. **Sources:** WW59; WW47.

RECKHARD, Gardner Arnold *[Landscape painter] b.1858, Poughkeepsie, NY / d.1908.* **Addresses:** Poughkeepsie. **Studied:** New York. **Member:** Vassar Arts & Crafts Soc. **Exhibited:** NAD, 1886, 1888. **Comments:** Position: A. Dir., Vassar Inst.

RECKLESS, Stanley L(awrence) *[Painter, teacher] b.1892, Philadelphia, PA / d.1955, Los Angeles, CA.* **Addresses:** Los Angeles. **Studied:** PAFA; Acad. Julian, Paris. **Member:** Graphic Sketch Club, Phila.; Paris AAA. **Exhibited:** PAFA, 1916 (prize); PAFA Ann., 1923-24; Corcoran Gal. biennials, 1919-23 (3 times); Artists Fiesta, Los Angeles, 1930 (gold), 1932 (prize). **Work:** Wood Art Gal., Montpelier, VT. **Comments:** Teaching: Chouinard Art Sch.; Art Center Sch., Los Angeles. **Sources:** WW40; Hughes, *Artists of California,* 458; Falk, *Exh. Record Series.*

RECKLINGHAUSEN, Max Von *[Painter] early 20th c.* **Addresses:** NYC. **Exhibited:** S. Indp. A., 1917, 1920-23, 1926. **Sources:** Marlor, *Soc. Indp. Artists.*

RECKNAGEL, John H., Jr. *[Painter, teacher] b.1870, Brooklyn, NY.* **Addresses:** Finistère, Paris, France. **Studied:** Acad. Julian, Paris, 1891. **Exhibited:** SNBA, 1897-99; PAFA Ann., 1899, 1903; Salons of Am., 1924, 1925; AIC. **Sources:** WW10; Fink, *Am. Art at the 19th c. Paris Salons,* 383; Falk, *Exh. Record Series.*

RECOLEY, Julius *[Listed as "artist"] mid 19th c.; b.Germany.* **Addresses:** Philadelphia in 1850. **Sources:** G&W; 7 Census (1850), Pa., LI, 149 (last name is difficult to read).

RECORDS, Elizabeth *early 20th c.* **Exhibited:** Salons of Am., 1934. **Sources:** Marlor, *Salons of Am.*

RECTOR, Anne E. *[Painter] early 20th c.* **Addresses:** NYC. **Studied:** ASL. **Exhibited:** Salons of Am., 1923; WMAA, 1924-26. **Comments:** Also appears as Mrs. Duffy. **Sources:** WW21; Marlor, *Salons of Am.*

RED, John *[Sculptor] 19th/20th c.; b.Boston, MA.* **Studied:** Chapu. **Exhibited:** Paris Salon, 1889-97. **Sources:** Fink, *Am. Art at the 19th c. Paris Salons,* 383.

REDCORN, James See: **RED CORN, James (Jim) Lacy**

RED CORN, James (Jim) Lacy *[Painter, teacher, textile designer] b.1938, Pawhuska, OK / d.1994.* **Addresses:** Pawhuska, OK. **Studied:** Univ. Oklahoma, 1958-61; Univ. Arizona (Southwest Indian Art Project, scholarships, summers 1961-62); Northeastern State Univ. (1965, B.A.). **Exhibited:** Am. Indian Expo, Annuals, Anadorka, OK (prizes, 1967-68); Inter-Tribal Indian Ceremonials, Gallup, NM, 1964 (award); Ann. Indian Art Exh., Philbrook Mus. Art, Tulsa, OK (awards, 1968-69); Scottsdale (AZ) Nat. Indian Art Exh.; Univ. Arizona, Tucson,

Univ. Oklahoma, Norman; Assn. Interior Decorators & Des., Chicago; Pacific Art Conf., Seattle, WA, 1961; State Univ. Iowa, Iowa City; Heard Mus., Phoenix, 1963 (solo; prize); Southern Plains Indian Mus. & Craft Center, Anadarko, OK (solo). **Work:** Arizona State Mus.; Heard Mus.; U.S. Dept. Interior, Wash., DC; Mus. Northern Arizona, Flagstaff; Osage Tribal Mus., Pawhuska, OK; Univ. Oklahoma Lib., Norman; Philbrook Mus. Art, Tulsa. **Comments:** Member of the Osage tribal nation, his native name was Walankee (No Sense); Ha-Pah-Shu-Tse. Preferred media: oil, watercolor, textile. **Sources:** info. courtesy of Donna Davies, Fred Jones Jr. Mus. Art, Univ. Oklahoma.

REDD, Lucy T. *[Painter] late 19th c.*
Addresses: Richmond, VA. **Exhibited:** PAFA Ann., 1888.
Sources: Falk, *Exh. Record Series.*

REDDEN, Alvie Edward *[Painter, instructor] b.1915, Hamilton, TX.*
Addresses: Grand Junction, CO. **Studied:** West Texas State College (B.S., 1940); Univ. Colorado (M.F.A., 1951); Ohio State Univ.; Columbia Univ.; Mexico City College; Latin-Am Cultural Workshop; Grant Reynard. **Member:** Mesa Co. FA Center (trustee, 1953-63); Nat. Art Educ. Assn.; Colorado Art Educ. Assn.; Pacific AA. **Comments:** Teaching: Samnorwood Elem Sch., 1940-42 & 1945; West Texas State Univ., 1946; Mesa College, 1947-, chmn div. fine arts, 1964-; Univ. Colorado, 1949-.
Sources: WW73.

REDDING *[Portrait painter] mid 19th c.*
Comments: Active in 1833. *Cf.* William H. Redin, W. Reding, and William Reading. **Sources:** G&W; FARL question file.

REDDING, George Herbert Huntington *[Painter] b.1857, Sacramento, CA / d.1910, San Francisco, CA.*
Addresses: San Fran. **Studied:** Bellevue College, NY (M.D.).
Exhibited: San Fran. AA, 1891; Calif. Midwinter Int. Expo, 1894. **Comments:** A practicing physician, he painted in his spare time and was active in the local art scene. **Sources:** Hughes, *Artists of California*, 458.

REDDING, J. Y. *[Painter] 19th/20th c.*
Addresses: Brooklyn, NY. **Comments:** *Cf.* John Y. Redding.
Sources: WW01.

REDDING, John Y. *[Painter] early 20th c.*
Addresses: Kent, CT, 1923. **Exhibited:** S. Indp. A., 1923.
Sources: Marlor, *Soc. Indp. Artists*; *Cf. J.Y. Redding.*

REDDING, Julia See: **KELLY, J(ulia) Redding**

REDDING, Kelly J. See: **KELLY, J(ulia) Redding**

REDDING, (Mr.) *[Landscape painter] mid 19th c.*
Addresses: Charleston, SC, active in 1851. **Comments:** Several of his views of Cannonsborough and vicinity were sold at a benefit fair in Charleston, 1851. **Sources:** G&W; Rutledge, *Artists in the Life of Charleston.*

REDDING, Walter *[Painter] mid 20th c.*
Exhibited: PAFA Ann., 1951. **Sources:** Falk, *Exh. Record Series.*

REDDING, William *[Engraver] b.c.1840, Maryland.*
Addresses: Baltimore in 1860. **Sources:** G&W; 8 Census (1860), Md., V, 304 (living with his father, William Redding, oyster packer).

REDDING, William See: **READING, William**

REDDINGTON, George M. *[Painter, lithographer, screenprinter] b.1905, Blue Rapids, KS.*
Addresses: NYC. **Studied:** Univ. Kansas; Kansas City AI; ASL; Angarola; Kostellow; Barnet. **Exhibited:** Ft. Dix, NJ,1945 (prize); Armed Services Exh., NY Soc. Arts & Crafts, 1945 (prize); LOC,1943; Topeka, Kans.,1940; Oklahoma AC; Springfield Mus. Art, 1940-43; Riverside Mus.,1945; NYC, 1938 (solo), 1940 (solo); ASL; Kansas City AI; NYC,1938 (solo), 1940 (solo).
Sources: WW53; WW47.

REDDISH, Joan *[Painter] early 20th c.*
Addresses: Plainfield, NJ, 1931. **Exhibited:** S. Indp. A., 1931.

Sources: Marlor, *Soc. Indp. Artists.*

REDDISH, John *[Painter] early 20th c.*
Addresses: NYC, 1933. **Exhibited:** S. Indp. A., 1933. **Sources:** Marlor, *Soc. Indp. Artists.*

REDDIX, Roscoe C. *[Painter, educator] b.1933, New Orleans, LA.*
Studied: Southern Univ. New Orleans (B.A.); Indiana Univ. (M.S.); Xavier Univ. **Member:** Nat. Conf. Artists. **Exhibited:** Indiana Univ.; Prof. Artists Show, State of Louisiana; Black Artists Show, Dillard Univ.; Atlanta Univ., Ann.; Civil Liberties Union, Savannah, GA; Expo '72, Chicago; Southern Univ., New Orleans, 1972; Savannah State Univ.; NJ State Mus. **Work:** Southern Univ., New Orleans; Education Bldg., Louisiana State Capitol. **Sources:** Cederholm, *Afro-American Artists.*

REDEIN, Alex *[Painter, teacher] b.1912, Bridgeport, CT.*
Addresses: NYC, Fire Island, NY. **Studied:** Yale Univ. Sch. FA; ASL; Mexico City. **Member:** AEA. **Exhibited:** PAFA Ann., 1947; NAD, 1950; AWS, 1950; Butler AI, 1955, 1958; Farnsworth Mus., 1950; Phila. Art All., 1951, 1958; CMA, 1956; Minn. State Fair, 1949; Pinacotheca Gal., 1944 (solo); John Heller Gal., NY (10 solos). **Work:** Butler AI; Albany Inst Hist. & Art; Phila. Art All.; Ain Harod Mus., Israel. **Sources:** WW59; Falk, *Exh. Record Series.*

REDELIUS, F. H. *[Painter] mid 20th c.*
Addresses: Baltimore, MD. **Exhibited:** PAFA Ann., 1953.
Sources: Falk, *Exh. Record Series.*

REDELL, Raymond *[Painter] mid 20th c.*
Addresses: Wauwausota, WI. **Exhibited:** 48 Sts. Comp., 1939.
Work: USPOs, Middlebury (IN) & Berlin (WI). **Comments:** WPA artist. **Sources:** WW40.

REDER, Bernard *[Sculptor, etcher, engraver, lithographer] b.1897, Czernowitz, Roumania / d.1963.*
Addresses: Florence, Italy. **Studied:** Acad. FA, Prague, with Sturza. **Exhibited:** PAFA, 1949; PAFA Ann., 1960, 1962; PMA, 1949; MoMAA, 1951, 1953, and prior; BM; NGA; WMAA; Weyhe Gal., NY; Phila. Art All.; Phila. Pr. Club; Borgenicht Gal., NY; Wildenstein Gal., Paris; Tel Aviv Mus.; Dominion Gal., Montreal, 1953; Univ. Illinois, 1953; European traveling exh., MoMA, 1955; Gal. d'Arte Moderna L'Indiano, Florence, Italy, 1956-57. **Work:** MoMA; PMA; Tel Aviv Mus., Israel; BMA; FMA; NYPL; NGA; AIC; MMA; Museu d'Arte Moderna, São Paulo, Brazil. **Sources:** WW59; Falk, *Exh. Record Series.*

REDERER, Franz *[Painter] b.1899, Zürich, Switzerland.*
Addresses: Berkeley, CA. **Exhibited:** Caracas, Venezuela, 1940 (prize); Pal. Leg. Honor, 1946 (med); Corcoran Gal biennial, 1941; CI, 1944; AIC, 1940, 1942; BM, 1941; LOC, 1944; de Young mem. Mus., 1943; SFMA. **Work:** de Young Mem. Mus.; SFMA; Santa Barbara Mus. Art; SAM; Caracas Mus. Art.
Sources: WW53; WW47.

REDERUS, S. F. *[Painter, writer, lecturer] b.1854, Netherlands.*
Addresses: Dubuque, IA. **Studied:** Bridgeport, CT, with R. Wynkoop. **Member:** Milwaukee AI; Dubuque AS. **Work:** Presbyterian Church, Nortonville, KS. **Sources:** WW21.

REDETT, B(oyd) M(cCay) *[Painter, designer] b.1885, Fredericksburg.*
Addresses: Toledo, OH/Fredericksburg, OH. **Sources:** WW17.

REDFERN, Charles K. *[Artist] mid 20th c.*
Addresses: Phila., PA. **Exhibited:** PAFA Ann., 1942. **Sources:** Falk, *Exh. Record Series.*

REDFERN, Joseph Louis *[Painter] d.1909, Wash., DC.*
Addresses: Wash., DC, active 1865-96. **Exhibited:** Soc. Wash. Artists, 1891-92. **Sources:** McMahan, *Artists of Washington, DC.*

REDFIELD, Alfred C. *[Painter] early 20th c.*
Addresses: Readville, MA. **Sources:** WW25.

REDFIELD, Edward W(illis) *E.W.Redfield. 1937.*
[Painter, teacher] b.1869, Bridgeville, DE / d.1965.
Addresses: Center Bridge, PA, 1898-; New Hope, PA/Boothbay Harbor, ME. **Studied:** PAFA, 1886-90 (where he developed a close friendship with classmate Robert Henri), with Anshutz, Hovenden, James Kelley; Acad. Julian, Paris, with Bouguereau, Robert-Fleury & Ferrier, 1889. **Member:** NA; SAA, 1903; Phila. AC; SC; Nat. Inst. Artists Lg.; AFA; PAFA (fellow). **Exhibited:** Centennial Expo, Phila., 1876 (at the age of 7 he submitted a study of a cow); PAFA Ann., 1888-1946 (gold, 1903, 1905; prize, 1912); Paris Salon, 1891, 1893, 1908 (prize), 1909 (med.); AC Phila., 1896 (med.); Paris Expo, 1900 (med.); Pan-Am. Expo, Buffalo, 1901 (med.); NAD, 1895-96, 1904 (prize), 1918 (prize), 1919 (prize), 1922 (prize), 1927 (med.); SAA, 1904 (prize), 1906 (prize); St. Louis Expo, 1904 (med.); CI, 1905 (med.), 1914 (gold); Boston AC, 1904-07; Corcoran Gal. biennials, 1907-57 (21 times, incl. gold medal, 1908); AIC, 1909 (med.), 1913 (gold); Buenos Aires Expo, 1910 (gold); Wash. SA, 1913 (gold); Pan-Pacific Expo, San Fran., 1915 (hors concours [jury of awards]); Wilmington Soc. FA, 1916, (prize); Calendar Comp., New York, 1926 (prize); Springfield AA, 1930 (prize); Newport AA, 1912 (innaugural), 1933 (prize); Buck Hill AA, 1936 (prize); WMAA,1932. **Work:** Luxembourg Mus., Paris; CGA; Cincinnati Mus.; CI; Boston Mus.; PAFA; PMA; Brooklyn Art Inst.; Indianapolis; Detroit Inst.; AIC; Buffalo FA Acad.; Minneapolis IA; RISD; MMA; Brooks Mem. Art Gal., Memphis; NGA; Cooke Coll., Honolulu; Telfair Acad. Savannah, GA; Delgado Mus.; Butler Art Inst.; Harrison Gal., Los Angeles Mus. Art; Boston Art Club; Kansas City Art Mus.; Dallas Pub. Art Gal.; Mem. Art Gal., Rochester; St. Louis Art Mus.; Grand Rapids Art Gal.; Assoc. FA, Des Moines; Phila. Art Club; Pub. Sch. Coll., Gary, IN; Nat. Gal., Buenos Aires, Argentina; Montclair (NJ) Mus. **Comments:** A New Hope (Bucks County) Impressionist and acknowledged leader of the group that included Daniel Garber, Walter Schofield, and Robert Spencer. He was especially known for his Delaware River area winter scenes. Redfield began as an academic figure and portrait painter but during his time in France in the 1890s began painting outdoors at Barbizon and Pont-Aven. A very spontaneous, vigorous plein-air painter, he was able to start and finish a painting all at "one go." Later in life, in a concern for his reputation, Redfield burned hundreds of paintings that he deemed to be of lesser quality. He won numerous awards and was extremely successful in his own time but was neglected during the decade following his death. He is now recognized as one of the leading American Impressionists. Signature note: Until c.1893, he signed as "E. Willis Redfield." From c.1893-c.1905, he signed as "E.W. Redfield" in upper/lower case letters; thereafter in block letters. His worked was often faked during his lifetime. Teaching: PAFA. **Sources:** WW59; WW47; Danly, *Light, Air, and Color;* Baigell, *Dictionary;* Fink, *Am. Art at the 19th c. Paris Salons,* 383; Falk, *Exh. Record Series.*

REDFIELD, Grace Chapman *[Painter] early 20th c.*
Addresses: Wilmette, IL. **Member:** Chicago WCC. **Exhibited:** AIC, 1914-24. **Sources:** WW24.

REDFIELD, Heloise Guillou *[Miniature painter] b.1883, Phila.*
Addresses: Barnstable, MA/Wayne, PA. **Studied:** PAFA with W.M. Chase, C. Beaux; Acad. Julian, Paris, with Mme. Laforge; Acad.Delecluse, Paris. **Member:** ASMP; Penn. SMP. **Exhibited:** Copley Gal., Boston, 1911 (solo); Buffalo SA (prize); Pan-Pacific Expo, San Fran., 1915 (silver medal). **Sources:** WW33.

REDFIELD, L. C. *[Painter] late 19th c.*
Exhibited: NAD, 1884. **Sources:** Naylor, *NAD.*

REDFIELD, Mary Bannister *[Painter] b.1883, Newark, NJ.*
Addresses: Wash., DC, active 1917. **Studied:** ASL; B. Harrison. **Member:** Wash. AC; Wash. WCC. **Exhibited:** Soc. Wash. Artists, 1917; Wash. AC; Wash. WCC. **Sources:** WW17; McMahan, *Artists of Washington, DC.*

REDFIELD, William D. *[Engraver] mid 19th c.*
Addresses: NYC. **Exhibited:** NAD, 1836. **Comments:** Did engravings for a number of books published in the early 1850s. **Sources:** G&W; Cowdrey, NAD; Hamilton, *Early American Book Illustrators.*

REDIN, Carl *[Painter] b.1892, Sweden / d.1944, Los Gatos, CA.*
Addresses: Chicago, IL, 1913-1916; Albuquerque, NM; Palomar Mountain, CA, late 1930s. **Exhibited:** Macbeth Gal., NY; Broadmoor Art Acad, Colorado Springs; Herron AI. **Work:** Royal Acad., Stockholm; Dept. of Labor, Wash., DC. **Comments:** He had some art training in his native country but started painting in earnest during a stay in a sanitarium in New Mexico. Teaching: Univ. New Mexico; summer classes in Lubbock, TX. **Sources:** WW40; Hughes, *Artists in California,* 459.

REDIN, Richard Wright *[Artist] 19th c.*
Studied: Princeton Univ. **Work:** Peabody Room, Georgetown Pub. Lib. (1830 oil painting "Little Falls of the Potomac"). **Comments:** Probably the son of William Redin, from Lincolnshire, who came to the U.S. around 1817, and lived in Georgetown. It is said that Richard died of cholera shortly after his graduation from Princeton Univ. **Sources:** McMahan, *Artists of Washington, DC.*

REDIN, W. See: REDING, W.

REDIN, William H. *[Portrait painter, photographer, architect] mid 19th c.*
Addresses: NYC in 1848-49; Louisville, KY, 1843, and again beginning in late 1850s. **Exhibited:** NAD, 1848-49 (as W.H. Redin). **Comments:** In 1843 he was working as brewery clerk in Louisville (KY) and returned there in the late 1850s. In 1865 he was listed as a photographer and in 1870 as an architect. *Cf.* William Reading, and W. Reding. **Sources:** G&W; Cowdrey, NAD; NYCD 1849; Louisville CD 1843, 1848, 1859, 1865, 1870.

REDING, W. *[Portrait painter] mid 19th c.*
Addresses: NYC in 1852. **Exhibited:** NAD, 1852 (as W. Redin). **Comments:** *Cf.* William H. Redin. **Sources:** G&W; Cowdrey, NAD.

REDINGTON, N. M. (Mrs.) *[Painter] 19th/20th c.*
Addresses: Tacoma, WA, 1909. **Exhibited:** Alaska Yukon Pacific Expo, 1909. **Comments:** Preferred media: oil, watercolor. **Sources:** Trip and Cook, *Washington State Art and Artists,* 1850-1950.

REDKA, Eugenia *[Painter, teacher, lithographer, craftsperson, designer] 20th c.; b.NYC.*
Addresses: Bronx, NY. **Studied:** Hunter College; Columbia. **Member:** Art Teachers Assn.; Progressive Educ. Assn. **Exhibited:** Hunter College (prize); AIC, 1935, 1936; LOC, 1944; Phila. WCC, 1941; Wash. WCC, 1942; MMA (AV), 1942; Northwest PM, 1944; 8th Street Gal., 1942. **Comments:** Teaching: College St. Rose, Albany (1933-36); H.S. Music & Art, NYC, 1936-. **Sources:** WW47.

REDKIN, Rudolph *[Lithographer] b.c.1880, Louisianna.*
Addresses: New Orleans, active 1905-10. **Sources:** *Encyclopaedia of New Orleans Artists,* 319.

REDLINGER, Frank *[Block printer] b.1885, Missouri / d.1951, Los Angeles, CA.*
Addresses: Los Angeles, CA. **Exhibited:** Artists Fiesta, Los Angeles, 1931. **Sources:** Hughes, *Artists of California,* 459.

REDMAN, Alban *[Painter] late 19th c.*
Addresses: Baltimore, MD. **Exhibited:** NAD, 1875. **Sources:** Naylor, *NAD.*

REDMAN, Harry Newton *[Painter, sculptor, lithographer, screenprinter, teacher] b.1869, Mount Carmel, IL.*
Addresses: Boston, MA. **Member:** New England Mod. Art Soc.; Copley Soc. **Exhibited:** PAFA Ann., 1926; CI, 1928, 1930. **Work:** BMFA. **Comments:** Position: affiliated with New England Conservatory of Music, Boston. **Sources:** WW47; Falk, *Exh.*

Record Series.

REDMAN, Herbert L. *[Painter] b.1888, Plymouth, England / d.1951, La Grangeville, NY.*
Exhibited: S. Indp. A., 1940. **Sources:** Marlor, *Soc. Indp. Artists.*

REDMAN, Joseph Hodgson *[Cartoonist, illustrator, writer] d.1914.*
Addresses: Brooklyn, NY. **Comments:** Illustr.: books, including one onf Bermuda. Position: cartoonist, *Daily News,* 16 years; hd. art dept., an evening paper, 10 years.

REDMAN, William H. *[Lithographer and wood engraver] b.c.1833, Ireland.*
Addresses: NYC. **Exhibited:** Am. Inst., 1850-51 (pencil & crayon drawings). **Sources:** G&W; 8 Census (1860), N.Y., XLVI, 305; Am. Inst. Cat., 1850-51; NYBD 1858, 1860.

REDMAYNE, Robert *[Military draftsman, map maker] b.1826, Yorkshire, England.*
Addresses: Active while in California, 1856. **Comments:** After coming to U.S. (date unknown), enlisted in the U.S. Army at Philadelphia in September, 1853; was assigned to Battery I, 32 U.S. Artillery, and was discharged at Benecia (CA) in October, 1856. In March 1856 he made some pen-and-ink maps and views of the military camp at Benecia. **Sources:** G&W; Adjutant-General's office, Dept. of the Army; Cartographic Records, National Archives.

REDMOND, Frieda Voelter (Mrs. John J.) *[Painter] b.1857, Thun, Switzerland.*
Addresses: NYC (Switzerland, 1915). **Exhibited:** Boston AC, 1889-1900; NAD, 1891, 1897; Columbian Expo, Chicago, 1893 (med.); PAFA Ann., 1895. **Sources:** WW17; Falk, *Exh. Record Series.*

REDMOND, Granville *[Painter] b.1871, Philadelphia, PA / d.1935, Los Angeles, CA.*
Addresses: San Jose, CA, c.1874; Los Angeles, CA, 1898. **Studied:** Berkeley Sch. Deaf, 1879-90, with Theophilus Hope D'Estrella; San Fran. Sch. Des. with Mathews & Joullin; Acad. Julian, Paris, with J.P. Laurens & Constant, 1893. **Member:** Bohemian Club; San Fran. AA; Calif. AC; Laguna Beach AA. **Exhibited:** Paris Salon, 1895; Louisiana Purchase Expo, 1904 (med.); Alaska-Yukon-Pacific Expo, Seattle, 1909 (med.); Del Monte Gal., Monterey, 1911, 1913; PPE, 1915; San Fran. AA (gold, prize); Oakland Mus., 1989 (retrospective). **Work:** Bancroft Lib., Univ. Calif., Berkeley; Calif. Sch. Deaf, Fremont; Laguna Mus.; LACMA; NYC Mus.; Mills College Art Gal.; Oakland Mus.; Stanford Univ. Mus.; Springville (UT) Mus. Art; Nat. Center Deafness; Calif. State Univ.; de Young Mus.; Capitol, Olympia, WA; Jonathan Club, Los Angeles. **Comments:** Born Grenville Richard Seymour Redmond, he changed his first name to Granville c.1889. Deaf from scarlet fever at age three, Redmond received lessons in art and encouragement to pursue art studies from Theophilus Hope D'Estrella (at Berkeley School for the Deaf), who himself was a deaf-mute and a pupil of Virgil Williams (see entry). Position: affiliated with the Charlie Chaplin Film Co., Los Angeles. He became good friends with Charlie Chaplin and helped him perfect his pantomime technique for the movies. Chaplin in turn cast him in his movies, most notably as the sculptor in *City Lights.* Specialty: tonal landscapes and bright, colorful renderings of wildflowers. Realistic in his approach, he believed that nature changed constantly and quickly, and a painting should reflect the artist's conception of form, design and color. **Sources:** WW33; Hughes, *Artists in California,* 459; *300 Years of American Art,* 641.

REDMOND, Grenville Richard Seymour See: **REDMOND, Granville**

REDMOND, James McKay *[Painter, lithographer] b.1900 / d.1944, WWII, Battle of the Bulge.*
Addresses: Los Angeles, CA. **Studied:** Macdonald-Wright. **Exhibited:** Los Angeles P&S, 1936 (prize). **Work:** murals, USPOs, Compton and Santa Paula, Calif.; San pedro High School,

CA; Phineas Banning Jr. H.S., Wilmington, CA; FA Gal., San Diego. **Comments:** WPA artist. **Sources:** WW40; Hughes, *Artists in California,* 459.

REDMOND, John J. *[Painter] b.1856, Salem, MA. / d.1929.*
Addresses: Salem, MA; NYC; Gruvers, Switzerland. **Studied:** BMFA Sch. **Member:** NYWCC; SC, 1891. **Exhibited:** Boston AC, 1888-1908; NAD, 1888-97 (4 annuals); PAFA Ann., 1893, 1898-1904,1909-11; AIC. **Sources:** WW25; Falk, *Exh. Record Series.*

REDMOND, Lydia *[Painter] 19th/20th c.; b.New York.*
Addresses: NYC, 1895-1900; Newport, RI. **Studied:** Bouguereau; Robert-Fleury; Chase at Shinnecock Summer Sch., Long Island, NY. **Member:** Newport AA. **Exhibited:** Paris Salon, 1891; NAD, 1895, 1897; PAFA Ann., 1895, 1900. **Sources:** WW25; Fink, *Am. Art at the 19th c. Paris Salons,* 383; Petteys, *Dictionary of Women Artists;* Falk, *Exh. Record Series.*

REDMOND, Margaret *[Craftsperson, designer, decorator, painter] b.1867, Phila., PA / d.1948.*
Addresses: Boston, MA/Chesham, NH. **Studied:** PAFA; J. Twachtman; L. Simon, R. Mènard, in Paris. **Member:** Copley Soc.; Boston SAC; Phila. WCC; Assn. Stained Glass of Am. **Exhibited:** S. Indp. A.; NAD; NYWCC; PAFA Ann., 1895-1904; Phila. Art Club, 1898; Tercentenary FA Exh., Boston, 1930 (gold); AIC. **Work:** windows, Trinity Church (Boston), St. Paul's Church (Englewood, NJ), Children's Room, Pub. Lib. (Englewood), St. Peter's Episcopal Church (Beverly, MA); stained glass medallion, Elliot Hospital (Keene, NH); St. Paul's Church, North Andover, MA; All Saints Church, Petersborough, NH. **Sources:** WW40; Petteys, *Dictionary of Women Artists;* Falk, *Exh. Record Series.*

REDNICK, Eugenia *[Painter, teacher, graphic artist, designer] mid 20th c.; b.NYC.*
Addresses: Bronx 70, NY. **Studied:** Hunter College (B.A.); Teachers College, Columbia Univ. (M.A.). **Exhibited:** LOC; Phila. WCC; Wash. WCC; MMA; Northwest PM; 8th St. Gal.; Bradley Univ. **Awards:** prize, Hunter College; 2 awards for photography from Popular Photography Int. Photo Comp.; prizes for photos, *World Telegram & Sun, Travel, Flower Grower* magazines. **Comments:** Teaching: Teachers College, Columbia Univ., NYC. Photographs in *Popular Photography Las Americas; Travel; The Priest; Pictures* and other publications. **Sources:** WW59.

REDNICK, Herman *[Painter, lithographer] b.1902, Philadelphia, PA.*
Addresses: Grantwood, NJ; Taos, NM. **Studied:** NAD; Hawthorne. **Exhibited:** NAD; PAFA Ann., 1927; Corcoran Gal. biennial, 1930; Albright Art Gal.; Morton Gal., NYC, 1936-38 (solos); Francis Webb Gal., Los Angeles, 1942; Ojai (CA) Gal., 1946; Mus. New Mexico, 1950, 1953, 1955. **Sources:** WW59; WW31; Falk, *Exh. Record Series.*

REDWINE, Emma Luehrmann *[Painter] b.1879, Germany / d.1968, Ukiah, CA.*
Addresses: Ukiah, CA. **Comments:** Came to California in 1883. Specialty: watercolor landscapes. **Sources:** Hughes, *Artists of California,* 459.

REDWOOD, Allen C(arter) *[Illustrator, writer] b.1844 / d.1922, Ashebille, NC.*

A. C. Redwood - '84

Addresses: Asheville, NC. **Exhibited:** PAFA Ann., 1880-81, 1893; NAD, 1882. **Work:** Md. Hist. Soc. **Comments:** Magazine illustrator of the Civil War, the West and the Spanish-American War. Auth./illustr.: article, Jackson's Foot-Cavalry at 2nd Bull Run, in "Battles and Leaders of the Civil War" (1884). A major in the Confederate Army. Important for his war illustrations from the Confederate side, which appeared in *Leslie's, Harper's,* and *Century.* After the war, he opened a studio in Baltimore, later moving to NYC, Bayonne, NJ, and Port Conway, NJ. **Sources:** P&H Samuels, 391; Falk, *Exh. Record Series.*

REDWOOD, Junius *[Painter] b.1917, Columbus, OH.*
Exhibited: Newark Mus., 1971; MoMA; State Univ. Albany, NY; Long Island Art Teachers Assn.; Acts of Art Gal., NYC. **Work:** MoMA. **Sources:** Cederholm, *Afro-American Artists.*

REE, Max Emil *[Art director, designer, cartoonist, architect] 20th c.; b.Copenhagen, Denmark.*
Addresses: Beverly Hills, CA. **Studied:** Royal Univ., Copenhagen (dipl. in arch.). **Member:** Un. Scenic Artists; Soc. Motion Picture Art Dir. **Comments:** Awards: best art direction, "Cimarron," Acad. Motion Picture Arts & Sciences, 1931. Designer of costumes & stage sets for motion picture & stage productions, including productions of Max Reinhardt, MGM, Radio Pictures Studio, Von Stroheim, San Fran. Opera House. Cartoonist/illustr. for *New Yorker* magazine. **Sources:** WW53; WW47.

REECE, Dora *[Painter] mid 20th c.; b.Philipsburg, PA.*
Addresses: Philadelphia, PA. **Studied:** Phila. Sch. Des.; PAFA; Europe; Daingerfield; Snell; Seyffert; Breckenridge; Hale, Pearson; Garber. **Member:** Penn. SMP; Plastic Club; Phila. Alliance; AFA; PAFA (fellow). **Exhibited:** Phila. Sch. Des. (prize); Rittenhouse Flower Market, Phila. (prize). **Work:** PMA; Mem. Lib., Philipsburg, PA. **Sources:** WW59; WW47.

REED, Abner *[Engraver, painter, printer] b.1771, East Windsor, CT / d.1866, Toledo, OH.*
Comments: Working in NYC in 1797. He was at Hartford (CT) from 1803 -10 and is listed there again from 1821-24 as a partner with Samuel Stiles (see entry) in the firm of Reed, Stiles & Co. He subsequently worked in NYC and published a penmanship book illustrated with his own plates. William Mason was his pupil (see entry). **Sources:** G&W; Fielding's supplement to Stauffer; Swan, "Early Sign Painters," 403; Grolier Club, *The United States Navy, 1776 to 1815,* 78; Toppan, *100 Years of Bank Note Engraving,* 10; Dunlap, *History,* II, 47; Fielding.

REED, Addie M. *[Portrait painter] early 20th c.*
Addresses: Seattle, WA, 1931. **Member:** Women Painters of Wash. (charter mem.). **Exhibited:** Women Painters of Wash., 1931. **Comments:** Position: artist, Western Engraving and Colortype Co., Seattle. **Sources:** Trip and Cook, *Washington State Art and Artists, 1850-1950.*

REED, Adine *[Painter, sketch artist, teacher] late 19th c.*
Addresses: New Orleans, active 1893-97. **Studied:** George D. Coulon. **Comments:** Opened an art school and studio in 1893 with Carrie Trost (see entry). He was later listed as a music teacher. **Sources:** *Encyclopaedia of New Orleans Artists,* 318.

REED, Anna Baughn *[Painter] early 20th c.*
Studied: Paris. **Member:** Detroit Soc. Women P&S, 1905. **Exhibited:** Paris Salon. **Sources:** Petteys, *Dictionary of Women Artists.*

REED, Bertha M. *[Painter] early 20th c.*
Addresses: Worcester, MA. **Sources:** WW24.

REED, Booth *[Painter] mid 20th c.*
Exhibited: S. Indp. A., 1935. **Sources:** Marlor, *Soc. Indp. Artists.*

REED, Burton I. *[Painter] early 20th c.*
Comments: Affiliated with St. Paul's School, Concord, NH. **Sources:** WW19.

REED, C. W. *[Painter] late 19th c.*
Addresses: Boston, MA. **Exhibited:** Boston AC, 1891. **Sources:** *The Boston AC.*

REED, Charles H. *[Engraver] late 19th c.*
Addresses: Phila., PA. **Exhibited:** PAFA Ann., 1883-93 (4 times). **Sources:** Falk, *Exh. Record Series.*

REED, Charles L. *[Landscape painter] mid 20th c.*
Addresses: San Francisco, CA, active 1937-41. **Exhibited:** Soc. for Sanity in Art, CPLH, 1941. **Sources:** Hughes, *Artists of California,* 459.

REED, Charles W. *[Combat artist] mid 19th c.*
Comments: Several of his sketches of Civil War scenes were used as illustrations in J.D. Billing's *Hardtack and Coffee,* 1887. **Sources:** Wright, *Artists in Virgina Before 1900.*

REED, Charlotte A. *[Painter, teacher, ceramic artist] b.1876, Marshalltown, IA / d.1966, Ontario, CA.*
Addresses: Marshalltown, IA; Ontario, CA. **Studied:** Cincinnati Art Acad.; Corcoran Gal. Sch., Wash., DC; Univ. Calif., Berkeley with Hans Hofmann; Chouinard Art Sch.; Univ. So. Calif. **Member:** Pacific AA; Calif. Art Teacher's Assoc. **Exhibited:** Laguna Beach & Pasadena, CA, 1930s. **Comments:** Teaching: Iowa public schools, until 1910; Chaffey H.S. & College, Ontario, CA, until 1946. **Sources:** Hughes, *Artists in California,* 459.

REED, Chester A. *[Illustrator] early 20th c.*
Addresses: Worcester, MA. **Sources:** WW15.

REED, David *[Painter] b.1946.*
Addresses: NYC, 1975-89. **Exhibited:** WMAA, 1975-89. **Sources:** Falk, *WMAA.*

REED, Doel (Mr.) *[Painter, educator, teacher, lecturer] b.1894, Logansport, IN / d.1985, Taos, NM.*
Addresses: Stillwater, OK; Taos, NM in 1976. **Studied:** Art Acad. Cincinnati, 1916-17; L.H. Meaken, James R. Hopkins & H.H. Wessel, 1919-20; France; Mexico. **Member:** NAD; Allied Artists Am.; Audubon Artists; SAE; Chicago SE; Phila. WCC; Indiana PM; Prairie PM; Calif. PM; SSAL; Nat. Soc. Painters Casein. **Exhibited:** S. Indp. A., 1927, 1929; SAE, 1930-46; Kansas City AI, 1932 (med.); "100 Etchings of the Year," 1932-44; AIC, 1934, 1937, 1939; NAD, 1934-46, 1965 (Samuel Morse Medal); Tulsa AA, 1935 (prize); Paris Salon, 1937; Rome, Italy, 1937; Sweden, 1938; Chicago SE, 1938 (prize); CGA, 1940; Phila. Print Club, 1940 (prize); Venice, Italy, 1940; CI, 1941; Currier Gal. Art, 1942 (prize); MMA, 1942; WMAA, 1942; Northwest PM, 1942 (prize), 1944 (prize); Herron AI, 1943; LOC, 1944-46; PAFA, 1944-45; Philbrook AC, 1944 (prize); Laguna Beach AA, 1944 (prize); SSAL, 1944 (prize); "50 American Prints,"1944; Oakland Art Gal., 1945 (prize); Audubon Artists, 1945, 1951 (Gold Medal of Honor), 1954 (John Taylor Arms Mem. Medal); Albany Inst. Hist. & Art, 1945; Pasadena AI, 1946; London; Allied AA; Nat. Soc. Painters Casein; Mission Gal., Taos, NM & Blair Gals., Ltd., Santa Fe, NM, 1970s. **Work:** Bibliothéque Nat., Paris; Victoria & Albert Mus., London; MMA; Rosenwald Coll., Phila.; PAFA; PMA; LOC; CI; SAM; Honolulu Acad. Art; NYPL; Philbrook AC; Mus. FA, Houston; Univ. Montana; Univ. Tulsa; Grinnell College; Southern Methodist Univ.; Oklahoma AC; Oklahoma Art Lg.; Commissions: six murals, Oklahoma State Off. Bldg., Oklahoma City, 1941. **Comments:** Settled in Taos in 1959 where he had previously spent summers. Preferred media: graphics. Teaching: Oklahoma State Univ., 1924-59. **Sources:** WW73; *Doel Reed Makes an Aquatint* (Mus. New Mexico Press, 1965); WW47; P&H Samuels, 392.

REED, Dorothy H. *[Artist] early 20th c.*
Addresses: Active in Los Angeles, 1916-20. **Sources:** Petteys, *Dictionary of Women Artists.*

REED, Earl H(owell) *[Etcher, writer] b.1863, Geneva, IL / d.1931, Chicago, IL.*
Addresses: Chicago, IL. **Studied:** self-taught. **Member:** Chicago SA. **Exhibited:** Memorial exh., Marshall Field Gal., Chicago; AIC. **Work:** TMA; LOC; AIC; NYPL; St. Louis Art Mus.; Milwaukee AI; Detroit AI. **Comments:** Auth.: "Etching; A Practical Treatise," "The Voices of the Dunes and Other Etchings," "The Dune Country," "Sketches in Jacobia," "Sketches in Duneland," "Tales of a Vanishing River," "The Silver Arrow." Became a prime mover in a campaign that resulted in the establishment of the Dunes State Park by the Indiana Legislature. **Sources:** WW29.

REED, Earl Meusel *[Painter, illustrator, teacher] b.1895, Milford, NE.*
Addresses: Casper, WY; Mills, WY in 1974. **Studied:** Univ.

Nebraska; AIC; Univ. Wyoming; PAFA with Garber, Seyffert, G. Harding, 1923-25. **Member:** Swedish-Am. Artists Soc.; Wyoming AA; Teton Artists. **Exhibited:** PAFA; Oakland Art Gal.; Milwaukee AI; Springville, UT; Swedish-Am. Exh., Chicago; Kansas City AI; Univ. Nebraska; Denver Art Mus.; Joslyn Mem.; Harwood Gal., Taos, NM; Wyoming AA; Teton Artists; etc. **Work:** Univ. Nebraska; Rawlins (WY) Pub. Lib.; Queens College, NYC; PAFA; Univ. Wyoming; USPO, Rawlins, WY; Casper College Lib., WY. **Comments:** Painter of Indian subjects, Western scenes, waterfalls, wildflowers. Moved to Wyoming in 1933 and was partner of Olaf Moller, sharing a studio in the Tetons, 1940-41. Positions: commercial artist, Chicago, until WWI; commercial artist, Milwaukee after the war. Teaching: Natrona County H.S. & Casper Jr. College, Casper, WY, 1953-58. **Sources:** WW53; WW47; P&H Samuels, 392.

REED, Ed [Illustrator, cartoonist] mid 20th c.
Addresses: Des Moines, IA. **Comments:** Creator: cartoon, "Off the Record". **Sources:** WW40.

REED, Edwin O. [Map & general engraver] b.c.1824, Ohio.
Addresses: Cincinnati, active during the 1850s. **Comments:** Living with his brother Erastus (see entry) and parents Samuel and Jane Reed in 1850. **Sources:** G&W; 7 Census (1850), Ohio, XXI, 295; Cincinnati CD and BD 1850-56.

REED, Eleanor [Painter] b.1913, Fort Sill, OK.
Addresses: Haverford, PA. **Studied:** Moore Inst., Phila. **Member:** Phila. Art All.; Provincetown AA; AAPL; Key West Soc. Artists. **Exhibited:** PAFA Ann., 1939; Wash. WCC, 1939. **Sources:** WW40; Falk, Exh. Record Series.

REED, Erastus R. [Engraver] b.1827, Ohio.
Addresses: Cincinnati, OH. **Comments:** Living with his brother Edwin (see entry) and parents Samuel and Jane Reed in 1850. **Sources:** G&W; 7 Census (1850), Ohio, XXI, 295.

REED, Esther Silber [Painter, illustrator, teacher] b.1900, St. Louis.
Addresses: Pasadena, CA. **Studied:** St. Louis Sch. FA; ASL; Breckenridge Sch. Painting. **Member:** St. Louis AG; St. Louis Indep. Artists. **Exhibited:** St. Louis AG, 1939 (prize), 1931 (prize). **Work:** St. Louis Post-Dispatch. **Sources:** WW40.

REED, Ethel [Painter, illustrator] b.1876, Newburyport, MA.
Addresses: Boston, MA. **Studied:** Laura C. Hills; Cowles Art Sch., Boston, 1893. **Exhibited:** Boston AC, 1896. **Comments:** Illustr. for books by Charles Knowles Bolton, Gertrude Smith and Louise Chandler; and for St. Nicholas. Designed for Boston Herald, Louis Prang and Boston publishers. **Sources:** The Boston AC; Petteys, Dictionary of Women Artists.

REED, Fishe P. See: **REED, Peter Fishe**

REED, Florence Robie (Mrs. Holway) [Painter, graphic artist, teacher, lecturer] b.1915, Belmont, MA.
Addresses: West Acton, MA; Hyannis, MA. **Studied:** Mass. Sch. Art; ASL; Mass. General Hospital Medical Arts Course. **Member:** Cape Cod AA; Boston Art Club. **Exhibited:** Watertown Pub. Lib.; Boston Art Club, 1938, 1939; Jordan Marsh Gal.; 1938, 1943; Chatham, MA,1938, 1939; Dongan Hills, Staten Island, NY, 1940 (solo); Vose Gal., 1941; Marblehead, MA, 1941; South Yarmouth (MA) Lib., 1941 (solo), 1956; Hyannis, MA; Barnstable Fair, 1954. **Work:** Acton (MA) Pub. Lib.; Mass. General Hospital. **Sources:** WW59; WW47.

REED, George Wilkie [Painter] late 19th c.
Addresses: Kalamazoo, MI. **Exhibited:** AIC, 1896. **Sources:** Falk, AIC.

REED, Geraldine See: **MILLET, Geraldine R. (Mme. François)**

REED, Gervais See: **REED, (Truman) Gervais**

REED, Grace Adelaide [Painter, teacher] b.1874, Boston, MA.
Addresses: Boston, MA. **Studied:** Charles Woodbury; Denman

Ross; Francis Hodgkins; Delecluse & Ménard in Paris; Mass. Normal Art Sch. **Member:** Copley Soc.; AAPL. **Exhibited:** AIC, 1914-15. **Sources:** WW33; Charles Woodbury and His Students.

REED, Grace Corbett (Mrs. Harold Whitman) [Weaver, teacher, lecturer] 20th c.; b.Brattleboro, VT.
Addresses: Reading, MA. **Studied:** M.M. Atwater. **Member:** Boston SAC; Weavers' Gld., Boston; Reading Soc. Craftsmen. **Exhibited:** Boston SAC, 1933 (medal). **Work:** Raleigh Tavern (table linens), House of Burgesses (upholstery), both in Williamsburg, VA. **Comments:** Auth.: "Raised Weaving," "Luncheon Sets in Two-harness Weaving," both pub. The Handicrafter, 1928, 1930. Co-designer: Reed-Macomber Ad-A-Harness and Foldaway Looms. Teaching: Boston Sch. Occupational Therapy. **Sources:** WW40.

REED, Hal [Painter, sculptor] b.1921, Frederick, OK.
Addresses: Reseda, CA. **Studied:** Trade Tech. College Los Angeles; AC Sch. Design; Art Lg. San Fran.; Nicolai Fechin. **Member:** Council Traditional Artists Socs. (pres., 1971-72); AAPL (fellow); Am. Inst. FA (fellow); Valley Artists Guild, Los Angeles (pres. & past pres., 1958-72); Calif. Art Club. **Exhibited:** Nat. Open, SMPS&G, Wash., DC, 1972; Nat. Open, Miniature Art Soc. NJ, 1972; AAPL, New York, 1972; Calif. State Fair, Sacramento, 1972; Olive Hyde AC Second Ann., Fremont, CA, 1972. Awards: first award in sculpture, portrait, seascape & graphics, San Fernando Art Guild, 1969; first in sculpture & McLeod Award, Miniature Painters, Sculpture Soc., Washington, 1972; first in sculpture & purchase award, Miniature Art Soc. NJ, 1972. **Work:** State of Calif. Gov. Off., Sacramento; Los Angeles City Hall Permanent Coll. Commissions: Robert Fulton Medal, Nat. Commemorative Soc., 1971; Eleanor Roosevelt Medal, Soc. Commemorative Femmes Célèbres 1971; Atomic Age Medal, Soc. Medalists, 1971. **Comments:** Preferred media: oils, acrylics, bronze. Positions: founder, Art Lg. Los Angeles, 1965-. Publications: auth., How to Compose Pictures & Achieve Color Harmony, Walter Forter Publ., 1969-72. Teaching: Art Lg. Los Angeles, 1965-. **Sources:** WW73.

REED, Harold [Art dealer] b.1937, Newark, NJ.
Addresses: NYC. **Studied:** Stanford Univ. (B.A.); ASL. **Comments:** Positions: dir., Harold Reed Gal., NYC. **Sources:** WW73.

REED, Helen [Painter, sculptor]
Addresses: Active in Boston. **Studied:** sculpture with Preston Powers, Florence. **Exhibited:** Boston; New York. **Comments:** Made portraits in crayon and sculpted bas-reliefs. **Sources:** Petteys, Dictionary of Women Artists. Cf. Helen A. Reed.

REED, Helen A. [Painter] early 20th c.
Addresses: Manchester, MA. **Sources:** WW19.

REED, Helen C. (Mrs.) [Painter] early 20th c.
Addresses: NYC, c.1912-23. **Member:** Lg. Am. Artists. **Sources:** WW24.

REED, I. L. (Mrs.) [Artist] 19th/20th c.
Addresses: Active in Los Angeles, c.1897-1902. **Sources:** Petteys, Dictionary of Women Artists.

REED, I. N. (Mrs.) [Painter] late 19th c.
Addresses: Active in Kalamazoo, MI. **Exhibited:** Michigan State Fair, 1885. **Sources:** Petteys, Dictionary of Women Artists.

REED, Izah B. [Listed as "artist"] b.c.1825, Philadelphia.
Addresses: Philadelphia in 1860. **Sources:** G&W; 8 Census (1860), Pa., LII, 131.

REED, Jennie A. [Painter] late 19th c.
Addresses: New Haven, CT. **Exhibited:** NAD, 1882; PAFA Ann., 1882, 1884. **Sources:** Naylor, NAD; Falk, Exh. Record Series.

REED, John See: **REID, John**

REED, John B. [Artist, sign painter] early 19th c.
Addresses: Lancaster, OH, in 1817. **Sources:** G&W; Knittle, Early Ohio Taverns.

REED, John S. *[Engraver] b.c.1831, Pennsylvania.*
Addresses: Philadelphia. **Comments:** Living in 1860 with his parents, Mr. and Mrs. Elias Reed. The father was a cabinet-maker and the mother ran a boarding house. **Sources:** G&W; 8 Census (1860), Pa., LIV, 257.

REED, Lillian R. *[Painter, teacher] 19th/20th c.; b.Phila.*
Addresses: Phila. PA, active 1900-40. **Studied:** PAFA; Phila. Sch. Des. for Women; Lathrop; Daingerfield. **Member:** Plastic CIub; Phila. Art Teachers Assn.; Phila. Art All. **Exhibited:** PAFA Ann., 1899-1904, 1908-10; Plastic CIub (gold); Boston AC, 1908; Corcoran Gal. biennial, 1910; AIC. **Sources:** WW40; Falk, *Exhibition Records Series.*

REED, Margaret Wilkins (Mrs. David A.) *[Portrait painter] b.1892, Boston, MA / d.1983, Norwich, VT.*
Studied: BMFA Sch. with J.S. Sargent, F. Benson, William Paxton. **Comments:** Specialty: children in bright colors. Active in Boston, Cohasset, both in MA; Walpole, NH; Brevard, NC. **Sources:** obit., *Boston Globe* (Feb. 27, 1983).

REED, Marion Tufts See: **TUFTS, Marion**

REED, Marjorie *[Painter, illustrator] b.1915, Springfield, IL.*
Addresses: Los Angeles, CA; Tombstone, AZ, in 1975. **Studied:** Chouinard Art Sch.; Art Center Sch.l, Los Angeles; Jack W. Smith. **Exhibited:** Biltmore Salon, Los Angeles, 1937. **Comments:** Early in life she assisted her father in designing Christmas cards and was employed by Walt Disney at age 14. After her marriage to a Hollywood film sound director, she worked for 40 years on researching and recording artistically the Butterfield Overland Stage route and its men. Illus., *Colorful Stage.* Specialty: horses and western genre. **Sources:** Hughes, *Artists in California,* 460.

REED, Mary Taylor *[Painter] early 20th c.*
Addresses: Boston, MA. **Exhibited:** PAFA Ann., 1913. **Sources:** WW15; Falk, *Exh. Record Series.*

REED, Mary Williams (Mrs. John A.) *[Still life, landscape & portrait painter] b.c.1870, San Francisco.*
Addresses: St. Helena, CA, early 1890s; San Fran., 1899; NYC and London; France, 1929. **Studied:** San Fran. Sch. Design, late 1880s; Chase Sch., NY; Acad. Colarossi, Paris; Mark Hopkins IA; Univ. Calif. **Exhibited:** World's Columbian Expo, Chicago, 1893; Calif. Midwinter Int. Expo, 1894; Salon des Artistes Françaises, 1924, 1928. **Comments:** Williams first married S C. Davison, who died in 1896; then H. Kellett Chambers of Australia in 1901; by 1929 she was Mrs. John A. Reed and living in the South of France. She did caricatures of famous people and worked as a newspaper artist for the *San Francisco Examiner* and the *New York World,* using the name "Kate Carew." When in England, she worked as a cartoonist for the *Tatler.* **Sources:** Hughes, *Artists in California,* 136; Petteys, *Dictionary of Women Artists.*

REED, Melton *[Painter] 19th/20th c.*
Addresses: Jackson, MI. **Exhibited:** Michigan State Fair, 1882 (prize). **Sources:** Gibson, *Artists of Early Michigan,* 200.

REED, Myra *[Portrait painter] b.1905, Cincinnati, OH.*
Addresses: Phila., PA. **Member:** Phila. Art All. **Exhibited:** Hotel Rittenhouse, Phila., 1937; S. Indp. A., 1941, 1943-44. **Sources:** WW40.

REED, Olga Geneva (Mrs. M. Daley) *[Painter] b.1873.*
Studied: Cincinnati Art Acad. **Comments:** Painter & decorator for Rookwood Pottery, Cincinnati, 1890-1909. Married Matthew A. Daly after the death of her first husband, Joseph Pinney. **Sources:** Petteys, *Dictionary of Women Artists.*

REED, P. *[Portrait painter] mid 19th c.*
Addresses: Leominster, MA, active c.1840. **Sources:** G&W; Sears, *Some American Primitives,* 287; Lipman and Winchester, 179.

REED, Paul Allen *[Painter, educator] b.1919, Washington, DC.*
Addresses: Arlington, VA. **Studied:** San Diego State College;

Corcoran Sch. Art. **Exhibited:** 25th Ann. Soc. Am. Art, AIC, 1965; Wash. Color Painters, Wash., DC, Texas, Calif., Mass. & Minn., 1965-66; 250 Years Am. Art, CGA, 1966; Jackson Pollock to the Present, Steinberg Gal., Wash. Univ., St. Louis, MO, 1969; Washington 20 Yrs, Baltimore Mus. Art, 1970; Bertha Schaefer Gal., NYC, 1970s. **Work:** CGA; Nat. Coll. FA, Wash., DC; Detroit (MI) Inst. Art; Walker AC, Minneapolis, MN; Albright-Knox Art Gal., Buffalo, NY. **Comments:** Preferred medium: acrylics. Teaching: Art L. Northern Virginia, 1971-; Corcoran Sch. Art, 1971-. **Sources:** WW73; Barbara Rose, "The Primacy of Color" (May, 1964) & Legrace Benson, "The Washington Scene" (1969), *Art Int.*; Walter Hopps, *The Vincent Melzac Collection,* (Corcoran Gallery Art, 1971).

REED, Peter Fishe *[Landscape & figure painter, teacher of painting & drawing, critic, poet] b.1817, Boston / d.1887, Burlington, IA (at home of a son).*
Member: Chicago Acad. Des. (mem. Acad. council). **Exhibited:** U.S. Sanitary Comn. Ladies' North-Western Fair, Chicago, 1863. **Comments:** Was in Cincinnati in 1844 as a house and sign painter, but about 1850 he went to Indiana, settling first at Vernon and then, from 1860-63, in Indianapolis. During one of those years (1861) he taught English, painting and drawing at Whitewater College in Centerville, IN. Reed went to live in Chicago about 1863; from there he also made frequent sketching trips to New England, particularly Vermont. In addition to his landscapes, he painted literary figurative compositions, including scenes from John Bunyan's *Pilgrim's Progress.* **Sources:** G&W; Burnet, *Art and Artists of Indiana,* 104-08; Peat, *Pioneer Painters of Indiana.* More recently, see Gerdts, *Art Across America,* vol. 2: 260-61, 287, 291.

REED, Robert *[Artist] b.1938.*
Addresses: New Haven, CT, 1972. **Exhibited:** WMAA, 1972. **Comments:** *Cf.* Robert J. Reed. **Sources:** Falk, *WMAA.*

REED, Robert J. *[Painter] mid 20th c.*
Addresses: Minneapolis, MN, 1966. **Studied:** Morgan State College (B.S.); Yale Univ. (B.F.A.; M.F.A.). **Exhibited:** Minnesota Press Club, WAC Biennial, 1964. **Comments:** Positions: asst. prof. & chairman, Div. Found. Studies, Minneapolis Sch. Art. **Sources:** WW66.

REED, Robert K. *[Painter] b.1906, Cadillac, MI.*
Addresses: San Antonio 8, TX. **Studied:** Univ. Texas; Frederick Taubes; Xavier Gonzales; Jacob Getlar Smith; Minna Citron. **Member:** Texas WCS; Texas FAA; Craft Gld. of San Antonio. **Exhibited:** San Antonio Artists, 1946-55 (prize, 1947); Texas FAA, 1947-55 (prize, 1950); Texas WCS, 1949-55 (prizes, 1950, 1954). Other awards: River Art Group, 1951, 1955. **Work:** Witte Mem. Mus. **Sources:** WW59.

REED, Roland *[Photographer] b.1864 / d.1934.*
Studied: apprenticed to Daniel Dutro in Havre, MT, 1880s. **Comments:** Became a partner to Dutro and opened his own studios in Minnesota and Montana. In 1897 he photographed the Alaska Gold Rush and c.1907 began a photographic study of Indian peoples. **Sources:** Witkin and London, *The Photograph Collector's Guide,* 373; Pacific Book Auction Galleries, 1998.

REED, Ruth S. *[Painter] mid 20th c.*
Exhibited: S. Indp. A., 1941. **Sources:** Marlor, *Soc. Indp. Artists.*

REED, Samuel *[Painter] early 19th c.*
Addresses: Cincinnati in 1819. **Sources:** G&W; *Antiques* (March 1932), 152.

REED, Sarah I. *[Painter] early 20th c.*
Exhibited: PAFA Ann., 1905. **Sources:** Falk, *Exh. Record Series.*

REED, Thomas Harrison *[Sculptor] mid 20th c.; b.NYC.*
Studied: Carnegie Tech.; AIC; Univ. Michigan. **Exhibited:** GGE, 1939. **Comments:** Teaching: San Jose State College, 1939-41. **Sources:** Hughes, *Artists in California,* 460.

REED, (Truman) Gervais *[Assistant museum director, teacher] b.1926, Wichita, KS.*

Addresses: Southeast, Bellevue, WA. **Studied:** Yale Univ. (B.A.). **Member:** Western Assn. Art Mus.; Wash. Arts & Crafts Assn.; Archaeological Inst. Am.; Seattle All. Artists. **Comments:** Positions: ed. asst., *Magazine of Art*, NY, 1949-50; acting dir., Film Center, Univ. Washington, 1950-52; supt., art dept., Western Washington Fair, 1952-57; asst. dir., Henry Gal., Univ. Washington, Seattle, 1952-. **Sources:** WW59.

REED, Veda *[Painter, craftsman]* b.1934, Granite, OK.
Addresses: Memphis, TN 1952. **Studied:** Memphis Acad. Arts, 1956; Siena College, Memphis; Illinois Inst. Tech., Chicago; England, 1960-61. **Exhibited:** solos: Memphis, Washington, NY. **Work:** several Memphis museums, corporate & private collections; Tennessee State Mus. **Comments:** Reed's subject matter varied, but was later mostly landscapes. In 1978-79 She painted scenes in Oklahoma, New Mexico, Texas and the Dakotas; and since 1980, also painted in and around Memphis. Teaching: Memphis Acad. Arts, 1962- & chmn., painting dept., 1977-80. **Sources:** Kelly, "Landscape and Genre Painting in Tennessee, 1810-1985," 148-49 (w/repro.).

REED, William *[Painter]* late 19th c.
Addresses: New Orleans, active 1873-85. **Sources:** *Encyclopaedia of New Orleans Artists*, 319.

REED, STILES & CO. *[Engravers]* early 19th c.
Addresses: Hartford, CT, 1821-24. **Comments:** Partners were Abner Reed and Samuel Stiles (see entries). **Sources:** G&W; Grolier Club, *The United States Navy, 1776 to 1815*, 78; Hamilton, *Early American Book Illustrators and Wood Engravers*, 94.

REEDER, Alexander See: **RIDER, Alexander**

REEDER, Benjamin F. *[Artist, decorator]* b.c.1834, Pennsylvania.
Addresses: NYC in 1860. **Sources:** G&W; 8 Census (1860), N.Y., L, 323.

REEDER, Clarence M. *[Sketch artist, commercial artist, painter, photographer]* b.1894, New Orleans, LA / d.After 1962.
Addresses: New Orleans, active 1910-32. **Exhibited:** NOAA, 1917. **Sources:** *Encyclopaedia of New Orleans Artists*, 319.

REEDER, Dickson *[Painter, etcher, engraver, designer, teacher]* b.1913, Ft. Worth, TX.
Addresses: Fort Worth, TX. **Studied:** ASL; New Sch. Social Research; Europe; Wayman Adams; William S. Hayter. **Exhibited:** SSAL, 1934, 1938, 1939, 1944 (prize); Corcoran Gal. biennials, 1939, 1941; Fort Worth AA, 1940 (prize), 1942 (prize), 1944 (prize), 1945 (prize); Texas General Exh., 1945 (prize), 1942 (prize); AIC; CI; PAFA; Colorado Springs FA Center; Weyhe Gal.; AV; Pepsi-Cola; >*Caller-Times* Exh., Corpus Christi, TX, 1945 (prize); Dallas Pr. Soc., 1945 (prize). **Work:** Dallas Mus. FA; Ft. Worth AA; Colorado Springs FA Center. **Sources:** WW53; WW47.

REEDER, Flora Blanc MacLean (Mrs. Harold L.) *[Painter, teacher]* b.1887, Saginaw, MI.
Addresses: Columbus, OH. **Studied:** Ohio State Univ. (B.A., B.Sc. in FA); Univ. Kansas; Columbus Art Sch.; San Fran. Sch. Art; Charles Hawthorne; J.R. Hopkins; Maurice Sterne; John Caroll; E. Thurn. **Member:** Columbus Gal. FA; Columbus Art Lg. **Exhibited:** Ohio State Fair, 1924 (prize); Columbus Art Lg., 1925-36, 1937 (prize), 1938, 1939 (prize), 1940-46, 1956-57; Ohio State Journal, 1940 (prize); Everyman's Exh., Columbus, 1938 (prize); Ohio State Univ., 1928, 1929; Columbus Gal. FA, 1954, 1955; Ohio WCS (prizes).; Ohio Valley Exh., 1955 (prize). **Work:** Columbus Gal. FA. **Sources:** WW59; WW47; Petteys, *Dictionary of Women Artists*, cites birth date of 1888 and reports that she was the wife of artist, Dickson Reeder.

REEDER, J. H. *[Portrait painter]* mid 19th c.
Addresses: Cincinnati, 1850. **Sources:** G&W; Cincinnati CD 1850 (courtesy Edward H. Dwight, Cincinnati Art Museum).

REEDER, Lydia Morrow (Mrs. Charles Wells) *[Painter]* b.1885, Martinsville, OH.
Addresses: Columbus, OH. **Studied:** Ohio State Univ.; A. Schille; J.R. Hopkins; C.W. Hawthorne; L. Seyffert; L. Van Pappendam; AIC. **Member:** Columbus Art Lg.; Ohio WCS. **Exhibited:** Columbus Art Lg. Exh., 1935 (prizes); AIC. **Sources:** WW40.

REEDU, Clarence M. *[Painter]* early 20th c.
Addresses: New Orleans, LA. **Comments:** Affiliated with New Orleans Item. **Sources:** WW17.

REEDY, Leonard Howard *[Painter]* b.1899, probably Chicago, IL / d.1956, probably Chicago. **LEONARD H. REEDY**
Addresses: Chicago. **Studied:** AIC; Chicago Acad. FA. **Work:** Adams Coll.; Santa Fe Ry Coll. **Comments:** Spent much of his youth in the West. Specialties: Western scenes, cowboys. **Sources:** P&H Samuels, 393.

REEHILL, John A. *[Painter]* early 20th c.
Addresses: Jersey City, NJ. **Exhibited:** S. Indp. A., 1925. **Sources:** Marlor, *Soc. Indp. Artists*.

REEN, Charles *[Artist, lithographer]* b.c.1827, Germany.
Addresses: Philadelphia, by 1850-57; Chicago, by 1858. **Comments:** In 1850 he and his wife shared a house with Mr. and Mrs. Lee Elliott and Morris Levly. In 1857 Reen was in partnership with Charles Shober and the following year Reen & Shober were in Chicago (see entry). **Sources:** G&W; 7 Census (1850), Pa., LI, 657; Phila. CD 1856-57; Chicago CD 1858. *Cf.* Charles Ruen.

REEN & SHOBER *[Engravers and lithographers, printers]* mid 19th c.
Addresses: Active in Philadelphia in 1857; Chicago by 1858. **Work:** Chicago Hist. Soc. **Comments:** Partners were Charles Reen and Charles Shober (see entries). **Sources:** G&W; Phila. CD 1857; Chicago CD 1858. More recently, see Reps, cat. nos. 921, 4327.

REENTS, Henry A. *[Painter]* b.1892, Chicago, IL.
Addresses: Michigan City, IN; Chicago, IL. **Studied:** AIC; Albert Fluery; E.J.F. Timmons; Carl Buhr. **Member:** Indiana Art Club; Hoosier Salon. **Exhibited:** Hoosier Salon, 1935-1938. **Work:** high schools in Hartford, Michigan, Rockford, IL. **Sources:** WW53; WW47.

REEP, Edward Arnold *[Painter, educator, lithographer]* b.1918, Brooklyn, NY.
Addresses: Huntington Beach, CA; Greenville, NC; Bakersfield, CA. **Studied:** Art Center College Design with Barse Miller (cert., 1941); E.J. Bisttram; Stanley Reckless; Willard Nash. **Member:** Los Angeles AA; Nat. WCS; Calif. Nat. WCS (pres.), 1951-52); San Diego Art Guild; Calif. Parent-Teachers Assoc.(hon. life mem.). **Exhibited:** GGE, 1939; Carmel AA, 1942 (first prize); WMAA annuals,1946-48; San Diego Mus., 1948 (first prize), 1950 (first prize); Los Angeles County Fair, 1948; Corcoran Gal. biennial, 1949; LACMA Ann., 1946-1951 (first purchase prize for watercolor), 1952-1960; Los Angeles All City Ann., 1963 (first prize in oil painting) NAD; NGA; Garden Gal., Raleigh, NC, 1970s. Other awards: Guggenheim Found. fellowship, 1946. **Work:** LACMA; 66 works, US War Dept., Pentagon; Grunwald Graphic Arts Coll., Univ. Calif., Los Angeles; Lytton Coll., Los Angeles; State of Calif. Colle., Sacramento. Commissions: three panels of early conquests in Calif., South Am. & U.S. (with Gordon Mellor), USA Private's Club, Fort Ord, CA, 1941; Painter's Impression of Int. Airports (10 pages in full color), *Life Magazine*, 6/1956. **Comments:** Preferred medium: oils. Positions: coord. art chmn., Los Angeles City Art Festival Exhs., 1951. Publications: auth., *The Content of Watercolor*, Van Nostrand Reinhold, 1969. Teaching: Art Center College Design, Los Angeles, 1946-50; Chouinard Art Inst., Los Angeles, 1950-70; chmn. dept., East Carolina Univ., 1970-70s. **Sources:** WW73;

Niece, *Art, an Approach* (William C. Brown, 1959); Schaad, *Realm of Contemporary Still-Life* (1962).

REES, Lewis (Mrs.) *[Listed as "hair painter"] mid 19th c.*
Addresses: Philadelphia in 1857. **Sources:** G&W; Phila. CD 1857 (her husband, Lewis Rees, was a professor of classics).

REES, Lonnie *[Painter, illustrator] b.1910, San Antonio, TX.*
Addresses: San Antonio, TX. **Studied:** ASL; Nat. Acad. **Member:** SSAL; San Antonio Art Lg. **Exhibited:** S. Indp. A., 1937; SSAL, 1938-39 (prize); All Texas Ann., Houston Mus. FA, 1940 (prize); Allied Artists Am., 1937; Nat. Acad., 1938. **Work:** City Council Chamber, San Antonio. **Comments:** Illustr.: "The Texas Rangers," 1935. **Sources:** WW40.

REES, Rosalie L. (Mrs. Hugo) *[Painter, engraver] b.1897, NYC.*
Addresses: NYC/Neponsit, NY. **Studied:** NAD with G. Maynard; Cooper Union with J.C. Chase. **Member:** NAWPS; Am. Artists Group. **Exhibited:** S. Indp. A., 1932; Salons of Am., 1934. **Comments:** Designer: cover, *Nature Magazine.* **Sources:** WW40.

REESE, Charles Chandler *[Illustrator, cartoonist] b.1862, Pittsburgh / d.1936, Glendale, CA.*
Comments: Affiliated with newspapers in New York, Pittsburgh, Phila.

REESE, David Mosley *[Museum director, painter, teacher] b.1915, Newnan, GA.*
Addresses: Savannah, GA. **Studied:** Atlanta AI; ASL; Florida State Univ. **Member:** Am. Assn. Mus. Dirs.; Southeastern Mus. Dirs. Assn.; Macdowell Fellowship. **Exhibited:** Southeastern Ann., 1946-50, 1952, 1953 (prize), 1955-56; Am. Assn. Mus. Exh., 1958; Georgia AA, 1955-57 (prize, 1955). Other awards: Carnegie Grant, 1952. **Work:** Atlanta AA Gal.; Columbus (GA) Mus. Arts & Crafts; Ford Motor Co., Dearborn, MI; mural, Union Bag-Camp Paper Corp., Savannah, GA. **Comments:** Position: dir., Telfair Acad. Arts & Sciences. Savannah, GA. Arranged exh.: "Masterpieces in Georgia Collections" for Telfair Acad. Arts & Sciences, 1958. **Sources:** WW59.

REESE, Emily Shaw *[Painter] early 20th c.*
Addresses: NYC. **Sources:** WW19.

REESE, W. R. *[Painter] early 20th c.*
Addresses: St. Louis, MO. **Sources:** WW25.

REESE, Walter Oswald *[Painter, sculptor, teacher, illustrator] b.1889, Pana, IL / d.1943, Seattle, WA.*
Addresses: Seattle, WA. **Studied:** Chicago Acad. FA; Univ. Wash; A. Archipenko. **Member:** Seattle Art Inst.; Puget Sound Group of NW Painters. **Exhibited:** Northwest PM Ann., SAM, 1937; WFNY, 1939; AIC. **Comments:** Position: hd. art dept., Cornish Art Sch. **Sources:** WW40; Trip and Cook, *Washington State Art and Artists,* 1850-1950.

REESEMAN, Howard *[Painter] mid 20th c.*
Addresses: Chicago area. **Exhibited:** AIC, 1935-36. **Sources:** Falk, *AIC.*

REESER, Eugene Samuel *[Painter, photographer] b.1862, Leesport, PA.*
Addresses: Reading, PA. **Comments:** The son of the successful photographer William Reeser, he showed talent in art from the age of six. Beginning at nineteen years of age, he pursued a career in several galleries in Reading, PA, working in all aspects of photography and art. In 1894 he started in business for himself in portraiture. He is also known for his brightly hued landscapes and animal paintings. **Sources:** Malmberg, *Artists of Berks County,* 23.

REESER, Lillian *[Painter, craftsperson, teacher] b.1876, Denver.*
Addresses: Denver, CO. **Studied:** BMFA; H. Rice, in Boston. **Member:** Artists Club, Denver; Mineral Art Club, Denver; Int. Lg. Mineral Painters. **Exhibited:** Omaha Expo, 1898 (prizes). **Sources:** WW01.

REESOR, Emily Woodham *[Painter] b.1863, Michigan / d.1942, Oakland, CA.*
Addresses: Oakland. **Exhibited:** Oakland Art Gal., 1929. **Sources:** Hughes, *Artists of California,* 460.

REESOR, Goronwy Buchan *[Painter, cartographer, commercial artist] b.1898, Nelson, BC, Canada / d.1982, Berkeley, CA.*
Addresses: Berkeley, CA. **Studied:** Calif. College Arts & Crafts; Univ. Calif., Berkeley. **Comments:** Position: ed. artist, San Fran. *Chronicle,* 25 years. Specialty: maps, landscapes, sporting events and figure studies. **Sources:** Hughes, *Artists in California,* 460.

REEVE, John Sebastian *[Sculptor] b.1943, Oakland, CA.*
Addresses: Santa Barbara, CA. **Studied:** Arizona State Univ. (B.F.A., 1967; M.F.A., 1971). **Exhibited:** Pacific Northwest Arts & Crafts Fair, Bellevue, WA, 1967 & 1968; First Four Corners Biennial, 1971 & Invitational Show, 1972, Phoenix Art Mus.; North-West Ann., SAM, 1971; Arizona State Univ., 1971. Awards: hon. men., Phoenix Art Mus., 1971. **Comments:** Preferred media: mixed media. **Sources:** WW73.

REEVE, Myrtle A. *[Painter] early 20th c.*
Addresses: Jacksonville, FL. **Sources:** WW25.

REEVES, Benjamin (Mr. & Mrs.) *[Collectors] mid 20th c.*
Addresses: NYC. **Sources:** WW73.

REEVES, Edward T. *[Painter] 19th/20th c.*
Addresses: NYC; Boston, MA. **Exhibited:** Boston AC, 1893-94, 1906. **Sources:** *The Boston AC.*

REEVES, Franklin A. *[Sculptor, marble cutter] b.c.1841, NYC / d.1915, New Orleans, LA.*
Addresses: New Orleans, active 1871-1910. **Sources:** *Encyclopaedia of New Orleans Artists,* 319.

REEVES, George M. See: **REEVS, George M.**

REEVES, Joseph Mason, Jr. *[Portrait painter] b.1898, Washington, DC / d.1973, Los Angeles, CA.*
Addresses: NYC; Norfolk, VA; Los Angeles. **Studied:** PAFA; Corcoran Gal. Sch., Wash., DC; Paul Albert Edmund Tarbell; Acad. Julian, Paris, with P.A. Laurens, Dechenaud & Royer; S. Meyer in Rome. **Member:** Artists of the Southwest (pres.,1960-61); Laguna Beach AA; Am. Inst. FA; Los Angeles AA; Calif. AC; P&S Club, Los Angeles; Bohemian Club; Soc. for Sanity in Art (pres., So. Calif. Chapt.). **Exhibited:** Arizona State Fair, 1932 (hon. men.); Paris Salon, 1934; Los Angeles AA, 1934 (award of merit); Biltmore Salon, 1934; Bohemian Club, 1935; NAD; Société des Artistes Françaises, Paris; Calif. AC (prize); P&S Club (prize); Artists of the Southwest; Sacramento, CA, 1927 (prize), 1931 (prize); Coronado, CA, 1932 (prize); Santa Cruz, CA, 1933 (prize); Los Angeles AA, 1934 (prize); Greek Theater, Los Angeles, 1962. **Work:** U.S. Navy Dept.; Univ. Calif.; Ebell Club, Los Angeles, CA; Serpell Coll., Norfolk, VA; Bohemian Club; State of Calif.; LA County St. Francis Hospital. **Comments:** Son of Adm. Joseph M. Reeves. Teaching: The Art Center School, Los Angeles. Associated with MGM Studios from 1928-34. **Sources:** WW53; WW47; Hughes, *Artists of California,* 460.

REEVES, Louise See: **HERRESHOFF, Louise C. (Mrs. Charles E. Eaton)**

REEVES, Maude Cooper *[Painter] b.1873, Columbus, IN.*
Studied: Herron AI with J. Ottis Adams. **Sources:** Petteys, *Dictionary of Women Artists.*

REEVES, Ruth *[Designer, craftsperson, painter, writer, lecturer, teacher] b.1892, Redlands, CA / d.1966, New Delhi, India.*
Addresses: NYC. **Studied:** PIA Sch.; San Fran. Sch. Design; ASL; in Paris with Fernand Leger; K.H. Miller. **Member:** Art Lg. Am.; AEA; NAWA (Comn. on Art Educ.); Needle & Bobbin Club. **Exhibited:** Soc. Indep. Artists, 1917; Am. Des. Gal., 1929; BM, 1931; Minneapolis IA; MMA, 1929, 1931; BMFA, 1930, 1931; PMA, 1930; AIC, 1930; CAM, 1930; CI, 1930; Dayton AI, 1930; CM, 1930; BMA, 1930; Toledo MA, 1931; CMA, 1931; Arch. Lg., 1931; State Teachers College, Farmville, VA; Univ. Chicago;

Phila. Art All.; AGAA; Kansas City AI; Denver AM; U.S. State Dept. traveling exh., 1952. Awards: Gardner Grant, 1931; Carnegie traveling fellowship, 1934-35; Guggenheim fellowship, 1940-42. **Work:** textile designs, wall coverings, Radio City Music Hall, NY; hangings, Children's Room, Mt. Vernon (NY) Pub. Lib.; murals, St. Albans (NY) H.S.; textiles, Victoria & Albert Mus., London, England. **Comments:** Illustr.: "Daphnis and Chloe," pub. Limited Editions Club, 1934. Position: first superintendent, Index of Am. Design, Wash., DC; instr., Textile Design, CUA Sch., NYC; lecturer, Sch. Painting & Sculpture, Columbia Univ., 1952-; art teacher, Children's Workshop classes, AEA, NYC, 1952-53; instr., Cleveland IA, 1954 (summer); lecturer, Colby College, Detroit IA & Cleveland IA, 1955. Contrib. to university brochures, art bulletins & magazines. **Sources:** WW59; WW47.

REEVES, W. H. *[Listed as "artist"] b.1823, England.*
Addresses: New Orleans, LA, in 1850. **Comments:** Possibly the same as the H. Reeves listed as a printer in New Orleans, 1851-53. **Sources:** G&W; 7 Census (1850), La., IV(1), 660; *Encyclopaedia of New Orleans Artists.* 319.

REEVES, Walter Henry *[Painter] early 20th c.*
Addresses: NYC. **Sources:** WW15.

REEVS, George M. *[Portrait painter] b.1864, Yonkers, NY / d.1930, NYC.*
Addresses: NYC. **Studied:** ASL; Acad. Julian, Paris, with J.P. Laurens & Constant, 1891-93; Gérôme. **Member:** SC; Artists Fund Soc. **Exhibited:** NAD, 1890, 1897; Paris Salon, 1894; PAFA Ann., 1895-99, 1902; SC, 1906 (prize); S. Indp. A., 1917. **Comments:** Last name appears as Reevs and Reeves. **Sources:** WW29 (as Reevs); Fink, *Am. Art at the 19th c. Paris Salons,* 383-84 (as Reevs); Naylor, *NAD* (as Reeves); Marlor, *S. Indp. A.* (as Reevs); Falk, *Exh. Record Series.*

REEVS, J. Graham *[Painter] early 20th c.*
Addresses: Shelter Island, NY. **Member:** SC. **Sources:** WW25.

REFREGIER, Anton L. *[Painter, designer, teacher, writer] b.1905, Moscow, Russia / d.1979, Moscow, Russia.*
Addresses: Woodstock, NY. **Studied:** Marie Vassilief, Paris, 1920; RISD, 1920-25; Hans Hoffman in Munich, Germany, 1927; ASL. **Member:** Art Lg. Am.; San Fran. AG; AEA; Nat. Soc. Mural Painters; Woodstock AA. **Exhibited:** S. Indp. A., 1930; WFNY, 1939; WMAA, 1940-57; PAFA Ann., 1943-53; CPLH, 1948; Corcoran Gal. biennials, 1951-55 (3 times); Hallmark Competition, 1953 (prize); Phila. Art All., 1962; Moscow Mus. FA, Leningrad, 1966; AIC; Awards: "NYC WPA Art" at Parsons Sch. Design, 1977. **Work:** MMA; MoMA; Walker AC; Univ. Arizona; WPA murals USPO, San Fran.; Mus. Mod. Western Art, Moscow; USSR. Mus. Art, Univ. Wyoming; CGA; Smithsonian Inst., Wash., DC; St. Laurence Univ., Canton, NY; Encyclopaedia Britannica Coll. Commissions: glass constructs, Burlington Mills, NYC; mural, lobby, Gracie Square Hosp., New York; mural, lobby, psychiatric addition, Metrop. Hosp., New York, 1970; mosaic mural, 1199 Hosp. Workers Union, 1970; paintings, Grand Coulee Dam, U.S. Dept. Interior, 1971; Woodstock AA. **Comments:** Came to U.S. in 1909. Refregier had a professional career as designer for interior decorators and architects in NYC, 1928. About that time, he began to produce works on social issues but never completely gave up his commercial projects. His WPA post office murals in San Francisco cover 2,400 square feet, depicting the history of the city in a socialist light. They were begun in 1941 and not finished until after WWII. Teaching: Univ. Arkansas, 1952; Cleveland Sch. FA; Bard College, 1962-64. Artist-corresp., *Fortune Magazine,* U.N. Original Conf., San Fran., CA. Publications: auth., *Natural Figure Drawing,* 1949; *An Artist's Journey,* 1965; *We Make our Tomorrow,* 1965; contrib., *Fortune, What's New* & other magazines. **Sources:** WW73; WW47; Falk, *Exh. Record Series.* More recently, see *Woodstock's Art Heritage,* 122-123; Hughes, *Artists in California,* 461; *New York City WPA Art,* 73 (w/repros.); add'l info. courtesy Woodstock AA.

REGALADO, Manuel Rivera *[Painter, lithographer, mural painter, caricaturist] b.1886, Mexico City / d.1964, Los Angeles, CA.*
Addresses: NYC, 1909; Europe; Los Angeles, CA. **Studied:** Indust. Sch., Acad. San Carlos, 1902-04; Acad. San Fernando, Madrid. **Exhibited:** Oakland Art Gal., 1942. **Work:** Smithsonian Inst. **Sources:** Hughes, *Artists in California,* 461.

REGAN, Lillian Levins *[Painter] early 20th c.*
Addresses: Brooklyn, NY. **Exhibited:** S. Indp. A., 1918. **Sources:** Marlor, *Soc. Indp. Artists.*

REGAT, Mary E. *[Sculptor] b.1943, Duluth, MN.*
Addresses: Anchorage, AK. **Studied:** Univ. Alaska. **Member:** Alaska Artist Guild; Anchorage FA Mus. Assn. **Exhibited:** All Alaska Juried Art Show, Anchorage; Design I, Anchorage; Color Center Gal., 1970-71 (solos); Artique Gal., 1972 (solo). Awards: sculpture award, Design I, 1971; purchase award, Anchorage FA Mus., 1971. **Work:** Anchorage (AK) FA Mus.; Pfeils Prof. Travel Agency, Anchorage; Post Oak Towers Bldg., Alaska Interstate Corp., Houston, TX; Anchorage Natural Gas. **Comments:** Preferred medium: stone. **Sources:** WW73; Voula Crouch, "Carving a Canoe," *Alaska Sportsman* (1971) & "Sam—Sculpture in Soapstone," *Alaska Journal* (winter, 1972).

REGENSBURG, Mary (Pollak) *[Painter] mid 20th c.*
Addresses: NYC. **Studied:** ASL. **Exhibited:** Salons of Am., 1934; S. Indp. A., 1934-39, 1942-43. **Comments:** Appears also as Mrs. Leonard Feist. **Sources:** Marlor, *Salons of Am.*

REGENSBURG, Sophy Pollak *[Folk painter, collector] b.1885, NYC / d.1974.*
Addresses: NYC. **Studied:** NY Sch. Art with W.M. Chase & Robert Henri. **Exhibited:** Nat. Amateur Painters Competition, 1952 (gold & bronze medals), 1953 (silver medal); Parrish Art Mus., Southampton, NY, 1956, 1972; Nat. Soc. Painters Casein, NYC, 1956, 1958; Guild Hall East Hampton, 1960-71; St. Louis Art Mus., 1967; Butler Inst. Am. Art Mid-Year Ann., 1972; Babcock Gal., NYC, 1970s. **Work:** Guild Hall East Hampton, NY; Smith College Mus. Art, Northampton, MA. **Comments:** Preferred media: acrylics. Collection: contemporary Am. paintings & drawings. **Sources:** WW73.

REGENSTEINER, Else F(riedsam) *[Educator, designer] b.1906, Munich, Germany.*
Addresses: Chicago, IL. **Studied:** Univ. Munich; Inst. Design, Chicago; Black Mountain College with Moholy-Nagy, Marli Ehrman & Anni & Josef Albers. **Member:** Am. Crafts Council; Handweavers Guild Am. (bd. dirs., 1971-72). **Exhibited:** Designer-Craftsmen USA, circulated by Smithsonian Inst., 1953; Designer-Craftsmen Illinois, Illinois State Mus., Springfield, 1966; Decorative Arts Nat., Wichita, KS, 1970; Textiles for Collectors, AIC, 1971; Fabrications, Cranbrook Acad. Art, 1972. Awards: first prize for drapery & upholstery, Int. Textile Exh., Univ. NC, 1946; five citations of merit, Am. Interior Design, 1947, 1948 & 1951; hon. men., State Mus. Art, Springfield, 1966. **Work:** Cooper Union Mus., NYC; AIC; Illinois State Univ. **Comments:** Publications: contrib., "Craftsmen in Illinois," *Directions 1965,* 1965 & "Weaving in Illinois," *Directions 1970,* 1970, Illinois Art Educ. Assn. & articles, *Handweaver & Craftsman,* 1965 & 1969; auth., *The Art of Weaving,* Van Nostrand Reinhold, 1970; contrib., articles, *Shuttle, Spindle & Dyepot,* 1971-72. Teaching: Hull House, Chicago, 1941-45; Inst. Design, Chicago, 1942-46; Sch. Art Inst. Chicago, 1945-71. **Sources:** WW73.

REGESTER, Charlotte *[Painter, sculptor, craftsperson, designer, teacher] b.Baltimore, MD / d.1964, Rockport, MA.*
Addresses: Rockport, MA. **Studied:** Albright Art Sch.; ASL; Columbia Univ.; Greenwich House with R. Henri, M. Robinson, A. Piccirilli; R. Clark; U. Wilcox; Buffalo ASL. **Member:** Clay Club; Cape Ann Gld. Craftsmen; NAWA; Pen & Brush Club; NY Ceramic Soc. **Exhibited:** NAWA, 1942 & prior; Argent Gal., 1943; PBC, 1939 (award);1954-1958: Cape Ann Art Festival; Pen & Brush Club; ceramics, Cape Ann Gld. Craftsmen; Rockport

AA. **Comments:** Positions: hd. art dept., Todhunter Sch., NY, 1927-39; art dept., Dalton Sch., NY, 1939-45; Westchester Workshop of Arts & Crafts, White Plains, NY, 1945-52; Ceramics, City College NY, 1951-52; Studio Workshop for Painting & Ceramics, Rockport, MA, 1952-. **Sources:** WW59; WW47.

REGINATO, Peter [Sculptor] b.1945, Dallas, TX.
Addresses: NYC. **Studied:** San Fran. Art Inst., 1963-66. **Exhibited:** Park Place Invitational, 1967; WMAA Sculpture Ann., 1970; Highlights of the Season, Aldrich Mus., 1970-71; Tibor de Nagy Gal., NYC, 1971(2 solos). **Comments:** Preferred medium: steel. Teaching: Hunter College, 1971-. **Sources:** WW73; Pincus-Witten, "Peter Reginato," Artforum (1971); Shireley, "Joe Lo Guidio Gallery," NY Times, 1972.

REGISTER, Emmasita See: **CORSON, E(mmasita) R(egister) (Mrs. Walter)**

REGLI, Alver [Painter] b.1867, Italy / d.1939, Los Angeles, CA.
Addresses: Los Angeles, CA, from 1889. **Work:** WPA artist. **Comments:** Owner: Florence Art Sch., Los Angeles, 1931. He fled his native country because of the killing of a nobleman over the love of the girl who posed for Stella, the picture of a reclining nude exhibited at the PPE of 1915. The famous painting has also been attributed to several other artists. **Sources:** Hughes, Artists of California, 461.

REHAG, Lawrence J. [Designer, illustrator, cartoonist] b.1913, San Antonio, TX.
Addresses: Oakland, CA. **Studied:** Calif. College Arts & Crafts; Prof. Ehmcke in Munich. **Exhibited:** Calif. College Arts & Crafts; GGE, 1939. **Comments:** Position: staff artist, Velvetone Poster Co., San Fran.; Calif. College Arts & Crafts. **Sources:** WW40.

REHBER, J(oseph) C. [Painter] early 20th c.
Addresses: Westport, CT. **Exhibited:** S. Indp. A., 1926, 1928. **Sources:** Marlor, Soc. Indp. Artists.

REHBERGER, Gustav [Painter, educator] b.1910, Riedlingsdorf, Austria.
Addresses: NYC. **Studied:** AIC, scholar; Art Instr. Sch., Minneapolis (scholarship). **Exhibited:** AIC, 1941, 1943, 1946. **Comments:** Teaching: Am. Art Sch., NYC, 1969-; ASL, 1972-. **Sources:** WW73.

REHBOCK, Lillian Fitch (Mrs. Ralph H.) [Painter, block-printer] b.1907, Wilmette, IL.
Addresses: Seattle, WA. **Studied:** Northwestern Univ.; AIC; Univ. Wash.; PAFA; Acad. Lhote, Paris; Univ. Calif., Berkeley; Hans Hoffman; Eliot O'Hara. **Member:** Women Painters of Wash.(charter member); Northwest PM; Artists Equity Assoc., Seattle. **Exhibited:** AIC; Frye Mus., Seattle; SAM; shows and solo shows in and around Seattle, 1932-58. **Sources:** WW40; Trip and Cook, Washington State Art and Artists, 1850-1950.

REHDER, Julius Christian [Portrait painter, lithographer] b.1861, Flensburg, Germany / d.1955, Germany.
Studied: F. Keller in Karlsruhe; A. von Werner in Berlin. **Comments:** Although he was a German artist, he lived and painted in the U.S. for fifteen years. **Sources:** info courtesy C. Richard Becker, via the artist's niece.

REHLING, Zelda [Painter] early 20th c.
Addresses: Indianapolis, IN. **Sources:** WW10.

REHM [Painter] mid 20th c.
Addresses: Dannemora, NY. **Exhibited:** S. Indp. A., 1936. **Sources:** Rehm; Marlor, Soc. Indp. Artists.

REHM, Wilhelmine (Willie) [Craftsperson, designer, lecturer] b.1899, Cincinnati, OH / d.1967.
Addresses: Cincinnati. **Studied:** Smith College; Sch. Applied Art, Univ. Cincinnati; Art Acad., Cincinnati. **Member:** Crafters Co.; Cincinnati Women's AC; Cincinnati Ceramics Gld. **Comments:** Positions: painter/decorator, Rookwood Pottery, Cincinnati, 1927-35 & 1943-48; designer, etched glass, Sterling Glass Co., Cincinnati; art teacher. **Sources:** WW40; Petteys, Dictionary of

Women Artists.

REHMAN, Harriet H. [Painter] mid 20th c.; b.NYC.
Exhibited: S. Indp. A., 1935. **Sources:** Marlor, Soc. Indp. Artists.

REHN, F. M. R. [Painter] early 20th c.
Addresses: NYC. **Sources:** WW24.

REHN, F(rank) K(nox) M(orton) [Marine painter] b.1848, Phila. / d.1914, Magnolia, MA. *F.K.M. Rehn*
Addresses: Philadelphia (until 1881); NYC/Magnolia, MA (1881-on). **Studied:** PAFA, 1866, with Christian Schussell. **Member:** ANA, 1899; NA, 1908; SAA, 1903; AWCS; NYWCC; SC, 1883; Lotos Club. **Exhibited:** PAFA Ann., 1876-92, 1898-1906; NAD, annually, 1879-1914; Brooklyn AA, 1881-86, 1891; St. Louis, 1882 (prize); Boston AC, 1882-1909; Water Color Comp., NYC, 1885 (prize); Prize Fund Exh., NYC, 1886 (gold); Paris Expo, 1900; Pan-Am. Expo, Buffalo, 1901 (med.); Charleston Expo, 1902 (med.); St. Louis Expo, 1904 (med.); SC, 1905 (prize), 1906 (prize); AAS, 1907 (gold); Corcoran Gal. biennials, 1907-12 (4 times); AIC. **Work:** Buffalo FA Acad.; Detroit Mus.; Corcoran Gal. **Comments:** Although he painted a wide variety of subjects early in his career, by the 1870s he had focused upon the coastal scenes for which he is best known. Many of his paintings are of the coasts of Massachusetts and Maine. Rehn was among the very few who did not study in Europe. A popular artist, he exhibited annually at the National Academy for thirty-five years. **Sources:** WW13; 300 Years of American Art, vol. 1, 428; Falk, Exh. Record Series.

REHN, Isaac [Painter, photographer, lithographer] mid 19th c.
Addresses: Philadelphia. **Comments:** Listed as painter (1845-48), photographer (1849-59), and lithographer (1860 and after). **Sources:** G&W; Phila. CD 1845-60+.

REHN, John [Listed as "artist"] b.1836, Pennsylvania.
Addresses: Philadelphia in 1860. **Sources:** G&W; 8 Census (1860), Pa., LIX, 475.

REHN, Michael [Listed as "artist"] b.1820, Germany.
Addresses: Boarding in New Orleans in 1850. **Sources:** G&W; 7 Census (1850), La., V, 82; Encyclopaedia of New Orleans Artists. 319.

REIBACK, Earl M. [Sculptor, painter] b.1938, NYC.
Addresses: NYC. **Studied:** Lehigh Univ. (B.A. & B.S., eng. physics); MMIT (M.S., nuclear eng.). **Exhibited:** Light and Motion Show, Worcester (MA) Art Mus., 1967; Milwaukee (WI) Art Center, 1967; Experiments in Light and Tech., BM, 1968; Bienal de Arte, Coltejer Medellin, Colombia, South Am., 1971; U.S. Info. Service Exh., 15 European & Middle Eastern countries, 1971-73. **Work:** WMAA; PMA; Milwaukee AC; New Orleans (LA) Mus. Art; Wichita (KS) Art Mus. Commissions: three light sculptures & projects, Coty Show, MMA, 1966; lumia light wall, Int. Hotel, Las Vegas, NV, 1969; lumia light sculpture, Mus. North Carolina, Raleigh, 1970. **Comments:** Publications: auth., articles, House and Garden, 1/1969 & Electronics Age, spring 1970. Teaching: lecturer, New York Univ., Columbia Univ., City College New York, Univ. Denver & Northwood College. Art interests: lumia, kinetic light, light projections. **Sources:** WW73; articles, Time, Fortune & House & Garden; color plates, Encyclopedia Britannica Ann. (1971).

REIBEL, Bertram [Sculptor, graphic artist, engraver] b.1901, NYC.
Addresses: Chicago, IL; Chappaqua, NY. **Studied:** AIC; Alexander Archipenko. **Member:** Int. PM; Northwest PM; Am.-Jewish AC; Am. Artists Congress; Southern PM; Chicago SA; Artists Equity Assn.; Assn. Int. Arts Plastiques. **Exhibited:** MMA; NAD; Int. PM; MMA; CM; Oakland Art Gal.; AIC; Kansas City AI; Detroit Inst. Art; Southern PM; PAFA; Northwest PM; LOC. **Comments:** Preferred media: wood, bronze, stone. **Sources:** WW73; WW47.

REIBER, Cora Sarah (Mrs. Charles F. Rothweiler) [Painter, designer] b.1884, NYC.

Addresses: Plainfield, NJ. **Studied:** NY School Applied Des. for Women; ASL; Charles Jeltrup; Alphonse Mucha; J. Mayer. **Work:** mural, Wadsworth Ave. Baptist Church, NYC. **Comments:** Lectures: perspective. Positions: designer, wallpaper & fabrics for leading manufacturers; instr., NY School Des. for Women & Traphagen School, NYC. **Sources:** WW59; WW47.

REIBER, R(ichard) H. *[Painter, etcher, sculptor, designer, lecturer, teacher, architect, writer] b.1912, Crafton, PA.*
Addresses: Pittsburgh, PA. **Studied:** Cornell Univ.; Kenneth Washburn; Olaf Brauner; Walter Stone. **Member:** Pittsburgh AA; Pittsburgh Arch. Club; Pittsburgh Print Club. **Comments:** Lectures: "Process of Etching." Teaching: Shady Side, Pittsburgh, PA. **Sources:** WW59; WW47.

REICH, Jacques *[Etcher] b.1852, Hungary / d.1923, Dumraven, NY.*
Addresses: Phila., PA, 1878-81; New Dorp, NY. **Member:** Budapest; Paris; NYC; PAFA. Chicago SE; Calif. PM. **Exhibited:** PAFA Ann., 1877-78, 1881. **Work:** portraits of famous Americans; etchings, AIC; MMA; NYPL; NY State Lib.; Cornell. **Comments:** Came to U.S. in 1873. Illustr.: pen portraits, "Cyclopedia of Painters and Paintings" (pub. Scribner's), Appleton's "Cyclopedia of American Biography," Mace's "History of the United States," Cordy's "History of the United States". **Sources:** WW21; Falk, *Exh. Record Series.*

REICH, Jean Heyl *[Ceramic craftsman] 20th c.; b.Columbus, OH.*
Addresses: Cincinnati, OH; Tryon, NC. **Studied:** Cincinnati Art Acad.; Univ. Cincinnati; Harold S. Nash; H.H. Wessel; James Hopkins. **Member:** Woman's AC, Crafters, Ceramic Gld., Cincinnati Prof. Artists, all of Cincinnati. **Exhibited:** Syracuse Mus. FA, 1939-41, traveling exh., 1939-41; Woman's AC, Cincinnati, 1939-45; Nat. Art Week, Wash., DC, 1940; CM, 1939-42; NAC, 1940; Cincinnati Crafters, 1941; Ceramic Gld., 1943; CM, 1944 (solo); Dayton AI, 1945 (solo). **Work:** IBM Coll. **Comments:** Teaching: CM, Cincinnati, OH, 1949-57; Jean & Fred Relch Studio, Tryon, NC. **Sources:** WW59; WW47.

REICH, Johann Mathias See: **REICH, John Matthias**

REICH, John Matthias *[Die-sinker, medallist] b.1768, Furth (Bavaria) / d.1833, Albany, NY.*
Studied: with his father, the German die-sinker Johann Christian Reich. **Member:** Soc. Artists (1811, a founder; one of the first group of Penn. Academicians, 1812). **Exhibited:** PAFA, 1811. **Comments:** Studied and worked in Germany some years, but about 1800 came to Philadelphia. Between 1801-13 he executed several medals for the U.S. Government and in 1807 he was made Assistant Engraver at the Mint. He is said to have gone West for his health soon after 1813, but he died in Albany in 1833. **Sources:** G&W; Chamberlain, "John Reich, Assistant Engraver to the United States Mint"; Loubat, *Medallic History of the U.S.,* 133 ff. and plates XXII-XXV; Stauffer; Dunlap, *History,* II, 469; Phila. CD 1803-08; Scharf and Westcott, *History of Philadelphia,* II, 1064; Rutledge, PA.

REICH, Murray *[Painter] b.1932.*
Addresses: NYC, 1969-72. **Exhibited:** WMAA, 1969-72. **Sources:** Falk, *WMAA.*

REICH, Nathaniel E. *[Painter] 20th c.; b.Brooklyn, NY.*
Addresses: Brooklyn, NY. **Studied:** ASL; Pratt Inst.; Brooklyn Inst. Arts & Science. **Member:** Artists Equity Assn. **Exhibited:** Eighth Serv. Command Competition USA, 1944; Fourth Har Zoin Temple Art Show, Phila., 1966; Prospect Park Centennial Invitational, 1966; MOMA, Paris, 1970; Boston Inst. FA, 1971. **Awards:** St Gaudens Medal, 1923; first prize, Eight Serv. Command Competition, USA, 1944. **Work:** Huntington Hartford Coll., Gallery Mod. Art, New York; Joe & Emily Lowe Mus., Univ. Miami, FL; Wash. Co. Mus. FA, Hagerstown, MD; Evansville (IN) Mus. Arts & Science; NY Heart Assn. **Comments:** Preferred medium: oils. **Sources:** WW73.

REICHADT, S. See: **REICHARDT, John**

REICHARD, Gustave *[Art dealer] b.1843, Germany / d.1917.*
Addresses: Cedarhurst, NY. **Comments:** Came to NYC as young man and was long prominent in NYC art life, being a close friend of Winslow Homer and other American artists.

REICHARD, Theodore P. See: **REICHARD, Theophele (Theophilus)**

REICHARD, Theophele (Theophilus) *[Painter, photographer] b.1855, Fürth, Germany / d.1948, Hayward, CA.*
Addresses: NYC; San Francisco, CA; Alameda, CA. **Exhibited:** Boston AC, 1883; NAD, 1884; PAFA Ann., 1888; World's Columbian Expo, Chicago, 1893; Calif. Midwinter Int. Expo, 1894; San Fran. AA, 1896. **Work:** Calif. Hist. Soc. **Comments:** Specialty: oil portraits from photographs. Developed a patent for a device for making photographic prints on wood, 1895. He also executed a chromolithograph of the San Francisco fire in 1906. **Sources:** Hughes, *Artists of California,* 461; Falk, *Exh. Record Series.*

REICHARDT, Ferdinand See: **RICHARDT, (Joachim) Ferdinand**

REICHARDT, John *[Landscape painter] mid 19th c.*
Addresses: NYC, 1858. **Exhibited:** NAD, 1858 (recorded as John [or S.] Reichardt). **Comments:** *Cf.* Joachim Ferdinand Richardt. **Sources:** G&W; Cowdrey, NAD; NYCD 1857, 1860.

REICHARDT, Theophele See: **REICHARD, Theophele (Theophilus)**

REICHART, Donald *[Painter, designer, teacher, block printer, lecturer] b.1912, Chicago, IL.*
Addresses: Springfield, MA. **Studied:** blockprints with E. Zweybruck, Vienna; O.E. Smith. **Member:** Springfield AL; Artists Union of Western Mass.; CAFA; Am. Artists Congress; Grand Central Art Gal.; Stockbridge AA. **Exhibited:** Springfield AL, 1937 (prize); Stockbridge AA, 1939 (prize). **Work:** Berkshire Mus., Pittsfield, MA; Springfield Mus. Art; G.W. Vincent Smith Art Mus.; Springfield (MA) Pub. Lib.; Mt. Hermon Sch., Northfield (MA) Pub. Lib.; Mt. Hermon Sch., Northfield, MA. **Comments:** Teaching: G.W.V. Smith Art Mus., Springfield. **Sources:** WW47.

REICHART, Joseph Francis, Jr. *[Painter] early 20th c.*
Addresses: NYC. **Member:** S. Indp. A. **Exhibited:** S. Indp. A., 1921. **Sources:** WW25.

REICHE, F. (or J. F.) *[Wood engraver] 18th/19th c.*
Addresses: Philadelphia, 1794-1804. **Comments:** His woodcuts appeared chiefly in German books published in Philadelphia and Maryland. The Philadelphia directories list him as Frederick Richie in 1794, as Frederick Reiche or Reicke in 1795-96, and as Francis Reiche in 1798, while his woodcuts are signed F. or J.F. Reiche. **Sources:** G&W; Phila. CD 1794-96, 1798; Stauffer; Hamilton, *Early American Book Illustrators and Wood Engravers,* 71, 440.

REICHEK, Jesse *[Printmaker, painter] b.1916, Brooklyn, NY.*
Addresses: Berkeley, CA. **Studied:** Inst. Design, Chicago, 1941-42; Acad. Julian, Paris, 1947-51. **Exhibited:** MoMA, 1962, 1965 & 1969; solos: Am. Cultural Center, Florence, Italy, 1964 & Univ. New Mexico Mus., 1966; Univ. Southern Calif. Art Mus., 1967 (retrospective); SFMA 1969; Betty Parsons Gal., NYC, 1970s. **Awards:** co-partic., Graham Found. grant, 1962; res. travel grant, Creative Arts Inst., Univ. Calif., summer 1963. **Work:** Amon Carter Mus. Western Art, Fort Worth, TX; AIC; Bibliothèque Nat., Paris, France; Grunwald Graphic Arts Found., Univ. Calif., Los Angeles; La Jolla Art Mus. **Comments:** Publications: auth., *Jesse Reichek-Dessins,* Ed. Cahiers Art, Paris, 1960; auth., *La Montée de la Nuit,* 1961 & *Fontis,* 1961, P.A. Benoit, Alex; auth., "Etcetera," *New Directions,* 1965; auth., *The Architect and the City,* MIT Press, 1966. Teaching: Univ. Calif, Berkeley, 1958-60s; Tamarind Lithography Workshop, Los Angeles, 1966; Creative Arts Inst., Univ. Calif., 1966-67. **Sources:** WW73.

REICHEL, Hans *[Painter] mid 20th c.*
Exhibited: AIC, 1939. **Sources:** Falk, *AIC*.

REICHELL, William Cornelius *[Painter] b.1824, Salem, NC, / d.1876.*
Addresses: Bethlehem and Lititz, PA. **Studied:** Gustavus Grunewald at Bethlehem, PA. **Comments:** Became a Moravian minister and taught in Moravian schools at Bethlehem and Lititz (PA). He was also noted as a historian and naturalist. **Sources:** G&W; Levering, *History of Bethlehem.*

REICHERT, Donald O. *[Painter, art administrator, designer, teacher, craftsman, serigrapher] b.1912, Chicago, IL.*
Addresses: Springfield, MA. **Studied:** Am. Int. College; Emmy Zweybruck; Paval Tchelitchew; Owne Smith; Attingham, Nat. Trust, England. **Member:** Conn. WCS; Am. Assn. Mus. **Exhibited:** Awards: Barstow Award; Springfield Art Lg. Award, 1937; Fitchburg Award; Stockbridge AA, 1939. **Work:** Berkshire Mus., Mus. FA, Springfield, MA; Pittsfield (MA) Mus. Art; Fitchburg (MA) Mus. Art; Olsen Found., Leete's Island, CT; George Walter Vincent Smith Art Mus.; Springfield (MA) Pub. Lib. **Comments:** Preferred media: watercolors, collage. Positions: asst dir., Yale Univ., 1951-54; asst. dir., Olsen Found., Leetes Island, 1954-55; cur., instr. art, adult educ. , George Walter Vicent Smith Art Mus., Springfield, MA, 1955-70, dir., 1970-. Publications: co-auth., *Maxfield Parrish Tetrospect*, 1966; co-auth., *The George Walter Vincent & Belle Townsley Smith Collection of Islamic Rugs*, 1971; auth. of catalogues of mus. exhs. Collections arranged: Maxfield Parrish Retrospect, 1966; David Bumbeck, 1966; Michael Skop-George Harrington, 1968; Otto & Gertrud Natzler, 1970. **Sources:** WW73.

REICHERT, Oscar Alfred *[Painter, designer, architect] mid 20th c.; b.Germany.*
Addresses: Reading, PA. **Studied:** Frankfurt AI & Sch. Des.; Offenbach Inst. Tech.; Düsseldorf Acad. FA, Germany. **Member:** Knickerbocker Artists; Am. Veteran's Artists Soc. **Exhibited:** Knickerbocker Artists, 1949-52, 1954; Am. Veteran's Soc. Artists, 1949-55; AWCS, 1950; Audubon Artists, 1950; Acad. in Rome, 1950; Reading Mus. Art, 1930-57; Berks County Arch. Soc., Reading Mus., 1958. Awards: Nat. German Comp., Mem. Monument, City of Beckum, 1927; Olympic Comp. Arch. Sec. (U.S. Team). Berlin, 1936 (medal); Regional Art Comp., 1940; Jersey City Mus. Art, 1955. **Work:** Reading Mus. Art. **Comments:** Contrib. to *Sports Afield; La Révue Moderne; Vanity Fair; Reading Times.* Arch. & art advisor, Hist. Section of City of Friedberg & Budingen, 1923-24; arch., des., art advisor, Hist. Section, City of Pirmasens, 1925; studio prof., Emil Fahrenkamp; arch., ces., Düsseldorf, 1927-28; textiles, Wyomissing, PA, arch., des., 1931-. **Sources:** WW59.

REICHMAN, Agatha *[Painter] mid 20th c.*
Addresses: NYC. **Exhibited:** S. Indp. A., 1941-42, 1944. **Sources:** Marlor, *Soc. Indp. Artists.*

REICHMAN, Fred(Rick) (Thomas) *[Painter] b.1925, Bellingham, WA.*
Addresses: San Francisco, CA. **Studied:** Univ. Calif., Berkeley (B.A., cum laude; M.A.); San Fran. Art Inst. **Exhibited:** PAFA Ann., 1960; AIC 64th Ann., 1961; 50 Calif. Artists, WMAA, 1962; SFMA, 1969 (solo); Expo 1970, Osaka, Japan, 1970; 7 Bay Area Artists, Oakland Mus., 1971; Silvan Simone Gal., Los Angeles, CA & Rose Rabow Gals., San Fran, 1970s. Awards: Artist's Council Prize, San Fran. AA Ann., 1954; San Fran. Art Festival, 1964 (purchase award); Art Festival City & Co. San Fran., 1968 (award of merit). **Work:** SFMA; Oakland (CA) Mus., Art Div.; Oklahoma AC, Oklahoma City; City & Co. San Fran.; Bank Am. World Hdqtrs., San Fran. Commissions: murals, Stanford Univ. Med. Sch., Palo Alto, CA, 1961 & San Fran. Art Festival, Civic Center, 1968. **Comments:** Preferred media: oils, acrylics. Teaching: Univ. Calif. Exten., San Fran., 1966-. **Sources:** WW73; Gerald Nordland, *Catalogue* (SFMA, April, 1969); Falk, *Exh. Record Series.*

REICHMAN, Gerson *[Collector] mid 20th c.*
Addresses: Portchester, NY. **Sources:** WW73.

REICHMANN, Josephine Lemos (Mrs.) *[Painter] b.1864, Louisville, KY / d.1939.*
Addresses: Chicago, IL. **Studied:** AIC; ASL; NY Art Inst.; Hawthorne. **Member:** Chicago SA; Chicago AC; North Shore AA; NAWPS; SSAL. **Exhibited:** ASL, 1912; AIC, 1909-32; S. Indp. A., 1924; PAFA Ann., 1924; Salons of Am., 1925; Illinois State Mus.; Vanderpoel AA; Chicago Gals. Assoc., 1927 (solo). **Comments:** Worked for FAP. **Sources:** WW38; Falk, *Exh. Record Series.*

REICHMANN, Lewis Sam *[Artist] mid 20th c.*
Addresses: NYC, 1952. **Exhibited:** WMAA, 1952. **Sources:** Falk, *WMAA.*

REICHMANN, Rudoplh *[Portrait painter, photographer] mid 19th c.*
Addresses: Wash., DC, active 1866-77. **Comments:** During part of his residence in Wash., DC, he was in partnership with Albert Siebert as Reichmann & Seibert. **Sources:** McMahan, *Artists of Washington, DC.*

REICK, William A. *[Sculptor] mid 20th c.*
Addresses: Wash., DC. **Member:** NSS. **Comments:** Affiliated with War Dept., Wash., DC. **Sources:** WW47.

REID, Albert Turner *[Painter, lecturer, illustrator, cartoonist, teacher, writer] b.1873, Concordia, KS / d.1955.*
Addresses: NYC. **Studied:** NY Sch. Art; ASL; L.C. Beckwith; W.V. Clark: Kansas State Univ.; Wesleyan Univ., Salina, KS (hon. degree, M.A.). **Member:** AAPL; Cart. Club; Art Gld.; SI; FA Fed. NY. **Exhibited:** Pan-Pacific Expo, 1915 (prize). **Work:** Ft. Hays Kansas State College; State House, Topeka, KS; murals, USPO, Sabetha, Olathe, KS; Sulphur, OK; des./builder, Kans. Semi-Centenn. Expo, Topeka, 1911; des., medal Wash. Bicentennial Comt. **Comments:** Contrib./illustr.: national magazines; books; newspapers. **Sources:** WW53; WW47.

REID, Aurelia Wheeler *[Painter, craftsperson, sculptor, writer] b.1876, Beeckman, Dutchess County, NY / d.1969, Los Angeles, CA.*
Addresses: San Pedro, CA; Los Angeles, CA. **Studied:** CUA Sch.; Teachers College, Columbia Univ.; Winthrop College, SC; Univ. Calif., Los Angeles; Los Angeles County AI; Otis AI; Delecluse Acad., Paris; W. Metcalf; H.C. Christy. **Member:** Penn. SMP; Calif. SMP; AAUW; San Pedro AA; W. Gld.; San Pedro Art Patrons. **Exhibited:** Boston AC, 1905; CGA; Smithsonian Inst.; LACMA.; San Diego FAS; San Pedro AA, 1939 (prize); Santa Barbara Mus. Art; Pasadena AI; Pomona, CA; San Pedro Writers Guild, 1936 (prize); Aeronautical Exh., 1939 (medal); Terry AI; Madonna Festival, Los Angeles; Greek Theatre, Los Angeles; PAFA; San Pedro Fair (prize); El Serene, CA; Cabrillo Hall, San Pedro (solo). **Work:** sculpture, Los Angeles State Bldg.; LACMA; miniature, PMA. **Sources:** WW59; WW47; *The Boston AC.*

REID, C(elia) Cregor (Mrs. J. M. T.) *[Engraver, painter, craftsperson, printer] mid 20th c.; b.Springfield, KY.*
Addresses: St. Augustine, FL. **Studied:** Univ. Kentucky (B.S.); AIC; Maryland Inst.; CI. **Member:** St. Augustine AC; SSAL; Lg. Am. Pen Women. **Exhibited:** NAD, 1943; WFNY 1939; Albright Art Gal., 1943; Phila. Print Club, 1943; SSAL, 1933, 1937 (prize), 1940, 1943 (prize); St. Augustine AC, 1930-46. Award: Florida Fed. Artists, 1933. **Work:** Illinois State Mus. **Sources:** WW53; WW47.

REID, Christian *[Sculptor] late 19th c.*
Addresses: New Orleans, active 1871-86. **Sources:** *Encyclopaedia of New Orleans Artists, 320.*

REID, Christine (C.) W. *[Painter] early 20th c.*
Addresses: NYC. **Exhibited:** S. Indp. A., 1927. **Sources:** Marlor, *Soc. Indp. Artists.*

REID, Dan Terry *[Painter] mid 20th c.; b.Chicago, IL.*
Studied: Howard Univ.; Wicker Sch. FA, Detroit; AIC.
Exhibited: 3rd Ann. All-Negro Showing of Chicago Artists' Guild (1st prize); Harmon Found., 1931, 1933; Chicago Outdoor Show, 1934; West Side Alley, PWAP, 1934; Harmon College AA Trav. Exh., 1934-35; Texas Centennial, 1936; South Side Community Art Center, Chicago, 1945. **Sources:** Cederholm, *Afro-American Artists.*

REID, Donald A. *mid 20th c.*
Exhibited: Harmon Found., 1931, 1933; Chicago Artists' Outdoor Sgow, 1934; Westside Gal., 1934; PWAP Exh., Washington & Richmond, 1934; Harmon Found. College Art Assn. Touring Exh., 1934-35. **Sources:** Cederholm, *Afro-American Artists.*

REID, Donald Redevers *b.1902, British Guiana.*
Studied: ASL; private instruction. **Exhibited:** NYPL; ASL; Harmon Found., 1931, 1933; Am. Negro Expo, 1940 (hon. men.). **Work:** NYPL. **Sources:** Cederholm, *Afro-American Artists.*

REID, E. C. (Mrs.) *[Painter] late 19th c.*
Addresses: Active in Allegan, MI. **Exhibited:** Michigan State Fair, 1884. **Sources:** Petteys, *Dictionary of Women Artists.*

REID, Edith A. *[Painter] early 20th c.*
Addresses: Chicago, IL. **Exhibited:** AIC, 1917. **Sources:** WW17.

REID, Estelle Ray *[Painter] early 20th c.*
Addresses: Appleton, WI. **Exhibited:** AIC, 1902. **Sources:** WW04.

REID, Florence Sims (Mrs. R. S.) *[Miniature painter] b.1891, Birmingham, AL.*
Addresses: New Haven, CT. **Studied:** Yale Univ. (B.F.A.) with Kendall Taylor. **Member:** New Haven PCC; Penn. SMP. **Exhibited:** PAFA, 1933-36, 1938, 1941, 1943, 1945; Smithsonian Inst., 1944, 1945; ASMP, 1933, 1935-38, 1941; Calif. SMP, 1936, 1941; Penn. SMP, 1951 (prize). **Sources:** WW59; WW47; Petteys, *Dictionary of Women Artists.*

REID, Helen Hunt *[Painter] b.1901, Kansas City, MO / d.1969, San Luis Obispo, CA.*
Addresses: Los Angeles, CA; Laguna Beach, CA. **Studied:** Univ. Calif., Los Angeles; Univ. So. Calif. **Work:** Laguna Mus. **Comments:** Teaching: Paasadena city schools, CA, 38 years. Position: bd. dir., Laguna Mus. Art. **Sources:** Hughes, *Artists of California,* 461.

REID, H(enry) Logan *[Painter] early 20th c.*
Addresses: NYC. **Member:** S. Indp. A. **Exhibited:** S. Indp. A., 1921. **Sources:** WW21.

REID, J. J. *[Portrait painter] mid 19th c.*
Addresses: NYC in 1846. **Sources:** G&W; NYBD 1846.

REID, James Colbert *[Block printer, illustrator] b.1907, Philadelphia, PA / d.1989, Newton, PA.*
Addresses: Trevose, PA. **Studied:** Oakley; Pullinger; PM Sch. IA. **Member:** Phila. Print Club. **Comments:** Illustr.: "The Life of Christ," and "The Song of Solomon," in wood cuts; "Mijjkel Fonhus," "Miss Tiverton," "This Wooden Pig Went With Dora," and "Swords against Carthage," mystery books by S.S. Smith; "Ringtail," by A.C. Gall; "Pogo," by J. Berger; "Wonders of Water," by M.E. Baer; "Lost Island," by N. Burglon; "Not Really," by L. Frost. **Sources:** WW40.

REID, J(ane) B(rewster) *[Painter, etcher] b.1862, Chicago, IL / d.1966, Rochester, NY.*
Addresses: Rochester, NY (1882-on). **Member:** Rochester AC. **Exhibited:** Boston AC, 1907; Rochester AC Ann., Mem. AG, 1914-17; AIC. **Work:** Nantucket Hist. Assn. **Comments:** Known for her watercolors, she was an active member of Nantucket's summer artist colony, and may have been painting on the island as early as 1891. Also known for her flower garden paintings. She lived to be 103. **Sources:** WW13; *The Boston AC;* add'l info. courtesy Nantucket Hist. Assn.; and Palmer Leroy Fine Art, Lyme, CT.

REID, Janet Kellogg *[Painter] b.1894, Merrill, WI.*
Addresses: Wilton, CT. **Studied:** AIC with G.E.Browne, G.P.Ennis; Acad. de la Grande Chaumière, Paris. **Member:** Allied Artists Am.; AAPL; Yonkers AA; AWCS. **Exhibited:** AIC; Nat. Acad. (prize); Paris Salon; AWCS-NYWCC, 1939; Milwaukee AI, 1929 (med). **Sources:** WW40; *Art by American Women:.the Collection of L.and A. Sellars,* 59.

REID, Jean Arnot *[Miniature painter, painter] b.1882, Brooklyn, NY.*
Addresses: NYC/Monterey MA. **Studied:** R. Brandegee; Am. Sch. Min. Painting; ASL. **Member:** NAWPS; ASMP; Yonkers AA. **Exhibited:** AIC, 1915. **Sources:** WW47.

REID, John *[Portrait & genre painter] b.c.1832, Ireland.*
Addresses: NYC from 1858-62; possibly in Wash., DC, in 1872.
Exhibited: NAD, 1858 (as John Reed or Reade), 1861-62 (as John Reid). **Comments:** In 1872 he published in Washington, D.C., a lithograph by Duval & Hunter of his painting, "St. Patrick's Day in America." **Sources:** G&W; 8 Census (1860), N.Y., LI, 699 [as Reed]; Cowdrey, NAD [as Reed or Reade]; Naylor, NAD [as Reid]; N.Y. State BD 1859 [as Read]; NYBD 1859 and NYCD 1860-62 [as Reid]; *Portfolio* (March 1952), 159 [as Reid].

REID, John See: **READ, John**

REID, Lorna (Fyfe) *b.1887, London, Ontario, Canada.*
Exhibited: Salons of Am., 1922, 1923. **Sources:** Marlor, *Salons of Am.*

REID, Marie C(hristine) W(estfeldt) *[Floral still life painter] 19th c.; b.NYC.*
Addresses: NYC/South Bristol, ME, active 1883-1934. **Studied:** J.A. Weir; D. Volk; G.W. Edwards; F.E. Elwell. **Member:** NAWPS; Salons of Am. **Exhibited:** Brooklyn AA, 1882-85; PAFA Ann., 1882, 1892, 1901-02, 1910; NAD, 1883-92; Boston AC, 1884-1902; Salons of Am.; AIC. **Sources:** WW40; Falk, *Exh. Record Series.*

REID, Mary Augusta Hiester (Mrs. George) *[Painter] b.1854, Reading, PA / d.1921, Toronto, Ontario.*
Addresses: Reading, PA; Toronto, Ontario from c.1886. **Studied:** PAFA with Thomas Eakins; Dagnan-Bouveret, Rixens, Blanc, & Courtois in Paris; Phila. Sch. Des. **Exhibited:** NAD, 1890-91, 1895; Montreal AA; Columbian Expo., Chicago, 1893; Pan-Am. Expo, Buffalo, 1901; St. Louis Expo., 1904; Ontario Soc. Artists; Royal Canadian Acad.; Art Gal.Toronto, 1922 (mem. exh.). **Comments:** Painted flowers, still lifes, miniatures, murals, and landscapes, married to George Reid. **Sources:** WW25; Petteys, *Dictionary of Women Artists.*

REID, Mary M. *[Painter] early 20th c.*
Addresses: Chicago, IL. **Sources:** WW19.

REID, O(liver) Richard *[Painter, teacher] b.1898, Eaton, GA.*
Addresses: NYC. **Studied:** PAFA; with D. Garber. **Member:** Graphic Sketch Club, Phila.; Salons of Am. **Exhibited:** S. Indp. A., Anderson Gal., NYC; Salons of Am.; Harmon Found., NYC, 1928-31; Indp. Artists Lg.; Urban Lg., NY; Howard Univ., 1932. **Work:** NYPL; Nat. Archives. **Sources:** WW40; Cederholm, *Afro-American Artists.*

REID, Peggy *[Painter, sculptor] b.1910, Liverpool, England.*
Addresses: NYC/Skowhegan, ME. **Studied:** R.J. Kuhn. **Exhibited:** AIC, 1929; PAFA Ann., 1933, 1935-36. **Sources:** WW33; Falk, *Exh. Record Series.*

REID, Robert Dennis
[Painter, instructor] b.1924, Atlanta, GA.
Addresses: NYC. **Studied:** Clark Col, 1941-1943; AIC, 1943-1946; Parson Sch Design, New York, NY, 1948-1950. **Exhibited:** Center Gallery, NYC, 1959; James Gallery, NYC, 1961; Mortimer Brandt Gallery, 1962; Osborne Gallery, 1963; Barnard Col., 1965; 1st World Festival of Negro Artists, Dakar, Senegal, 1965; Bucknell Univ., 1965; Grand Central Moderns, 1965 (solo), 1966,

1967; UCLA Art Galleries, 1966; City Col. of NY; Baruch Col.; Arts in the American Embassies State Dept. Program, 1967; Minneapolis Inst. of Arts; Studio Mus. Harlem, 1968-69; Am Acad Arts & Lett, 1967-1969 (Childe Hassam Purchase Award); Lehigh Univ., 1969; Beson Gallery, Bridgehampton, NY, 1970; Summit, NJ, Art Center, 1970; US Info Serv Tour, Paris, Brest, Vannes & Tours, 1971; Black Artists: Two Generations, 1971 & Recent Acquisitions, 1971, Newark Mus; Black Artists Am, WMAA, 1971; Alonzo Gallery, 1971 (solo) & NC Cent. Univ, Durham, 1972 (solo); IL. Bell Tel., 1972; Lobby Gallery, Chicago; Univ. of Wisc.; Sloan Galleries, Valparaiso, IN; Peoria IL, Art Guild; Burpee Gallery, Rockford , IL; Davenport, IA, Municipal Gallery; St. Paul's Col., Lawrenceville, CA; WMAA, 1971; Newark Mus., 1971; Univ. of Iowa, 1971-72; Dickson Art Center, 1966; US Information Service, Wash., DC, 1971. **Work:** Myers Col, Birmingham, Ala; Mus African Art, Washington, DC; Laura Musser Mus, Muscatine, Iowa; Univ Notre Dame, South Bend, Ind; Cornell Univ, Ithaca, NY; Newark Mus.; Syracuse Univ.; Univ. of PA; Drew Univ. **Comments:** Preferred media: oils. Teaching: Instr painting, Summit Art Ctr, NJ, 1970-1971; asst prof drawing, RI Sch Design, 1970-. **Sources:** WW73; Cederholm, *Afro-American Artists;* Many articles & reviews.

REID, Robert (Lewis) *[Painter, mural painter, craftsperson, teacher] b.1862, Stockbridge, MA / d.1929, Clifton Springs, NY.* **Addresses:** NYC, 1889-c.1920; Colorado Springs, CO, c.1920-27; Clifton Springs, NY, 1927-29. **Studied:** BMFA Sch., 1880-84; ASL, 1885; Académie Julian, with Boulanger and Lefebvre, 1886-89. **Member:** ANA, 1902; NA, 1906; SAA; Ten Am. Painters (founder); NIAL. **Exhibited:** Paris Salon, 1887-89; Boston AC, 1889, 1890; SAA, 1889-97; PAFA Ann., 1889-1913, 1920-22, 1966; Pastelists, 1890; murals, Liberal Arts Bldg., and easel ptgs., Columbian Expo, Chicago, 1893 (medal); Ten Amer. Painters, 1898-1918; NAD, 1889 (autumn exh.), 1890, 1891 (autumn exh.), 1892, 1897 (prize), 1898 (prize); U.S. Pavilion, Paris Expo, 1900 (gold); Pan-Am. Expo, 1901 (medal); St. Louis Expo, 1904 (medal); Corcoran Gal biennials, 1907-28 (10 times, incl. bronze medal, 1908); Newport AA, 1912 (innaugural); murals, Palace of Fine Arts, Pan-Pacific Expo, San Fran., 1915; AIC. >mond (IN) AA; Cincinnati Art Mus.; Omaha Mus.; Detroit Inst. Arts; Minneapolis Inst. Art; Harrison Gal., LACMA; Ft. Worth Mus.; Akron Art Gal. Murals and Decorative Commissions: Mass. State House, Boston, 1901; LOC, 1897; Appellate Court, NYC, 1899; altar piece, Church of St. Paul the Apostle, NYC; stained glass windows, H.H. Rogers Mem. Church, Fair Haven, Mass., 1901-05; Central H.S., Springfield, MA. **Comments:** Muralist and Impressionist painter. Founding member of the Ten American Painters. Reid spent summers painting in Normandy while studying in France in the late 1880s. Returning to NYC in 1889, Reid exhibited easel paintings and in 1892 received the commisssion to decorate one of the eight entrance pavilion domes in the Liberal Arts Building for the Worlds Columbian Expo. After the Chicago fair, Reid received several important mural commissions in NYC, including one for a reception-room ceiling in the Fifth Avenue Hotel (demolished c.1908), and decorations for the Imperial Hotel (also demolished). Reid continued to receive major decorative commissions throughout his career, but also contributed his easel works annually to the SAA and the NAD, and, beginning in 1898, to the exhibitions of the Ten. His Impressionist paintings from the late 1890s and into the twentieth century typically depicted idealized young women set in landscapes and holding or carrying flowers. About 1910 he began a group of paintings showing women dressed in Japanese kimonos set in brilliantly colored interiors decorated with mirrors and Oriental screens. Reid moved to Colorado Springs about 1920, joining the faculty of Broadmoor Academy. In his Colorado years, he concentrated more on portraiture, creating what he called "portrait impressions," by quickly painting in only the essential forms and features in broad, vigorous brush strokes. Reid was partially paralyzed by a stroke in 1927 and spent the last two years of his life in a New York State sanitorium where he learned to paint with his left hand. Teaching: BMFA Sch. (assistant) 1881-84; ASL and CUASch., 1890s;

Broadmoor Art Acad. 1920-27. **Sources:** WW27; H. Barbara Weinberg, "Robert Reid," in *Ten American Painters* (exh. cat., Spanierman Gal., NYC, 1990), pp. 113-15; Gerdts, *American Impressioniom,* 181-85; Baigell, *Dictionary;* Fink, *American Art at the Nineteenth-Century Paris Salons,* 383; Naylor, *NAD;* Falk, *Exh. Record Series.*

REID, Victor E. *[Painter] 20th c.* **Addresses:** Los Angeles, CA. **Studied:** Otis Art Inst. **Member:** Calif. AC. **Exhibited:** Calif. AC, 1924. **Sources:** WW25.

REID, William See: **REED, William**

REIDENER, Oscar *early 20th c.* **Exhibited:** Salons of Am., 1929. **Sources:** Marlor, *Salons of Am.*

REIDER, David H. *[Designer, photographer] b.1916, Portsmouth, OH.* **Addresses:** Ann Arbor, MI. **Studied:** Univ. Buffalo; Cleveland Sch. Art. **Member:** Am. Assn. Univ. Prof.; MoMA (comt. on art educ.); Soc. Photography Educ. **Exhibited:** Milwaukee Art Inst.; Albion College; Univ. Michigan; Saarbrucken, Germany; AFA Exh., 1959-61. **Work:** Milwaukee Art Inst.; Mus. Saarbrucken, Germany. **Comments:** Publications: contrib., numerous arch. & indust. publications. Teaching: Buffalo State Teachers College, 1942; Univ. Buffalo, 1942-46; Albright Art Sch., 1942-47; Univ. Michigan, Ann Arbor, 1947-60s. **Sources:** WW73.

REIDY, Jeannette Sprague *[Painter] early 20th c.; b.Iowa.* **Addresses:** Chicago, IL. **Studied:** AIC, c.1907. **Member:** ASL, Chicago. **Exhibited:** AIC, 1906. **Sources:** WW08.

REIF, Rubin *[Painter, educator] b.1910, Warsaw, Poland.* **Addresses:** Fayetteville, AR. **Studied:** Cooper Union Art Sch.; ASL; Has Hofmann Sch. FA; Acad. FA, Florence, Italy. **Exhibited:** AFA Traveling Exh., 1948-49 & 1967-69; Cincinnati Mus. Assn.; Arkansas AC, Little Rock, 1960-61 & 1967-69; Springfield (MO) Art Mus., 1967-69; Oklahoma AC, 1967-69. Awards: prizes, Ohio State Fair, 1952, Arkansas Festival Arts, 1962-63 & Oklahoma Ann., 1964. **Work:** Ohio Univ.; ASL; Cooper Union Coll.; Arkansas Indust. Development Comn. **Comments:** Teaching: Univ. Arkansas, Fayetteville, 1970s. **Sources:** WW73.

REIFF, Robert Frank *[Art historian, painter] b.1918, Rochester, NY / d.1982.* **Addresses:** Rochester, NY; Middlebury, VT. **Studied:** Univ. Rochester(A.B., 1941); Colorado Springs FA Center, 1942, with Boardman Robinson & Adolf Dehn; Columbia Univ. (M.A., 1950; Ph.D., 1960); Hans Hofmann, 1951. **Member:** College AA Am.; Am. Assn. Univ. Prof. (pres., local chapt., 1971-72). **Exhibited:** NGA, 1942; MMA (AV), 1942; Syracuse Mus. FA, 1941; Grand Central Art Gal., 1941; Rochester Mem. Art Gal., 1936-69 (awards, 1941, 1945, 1958 & 1962; solo, 1945); Rundel Art Gal., 1939 (solo); de Young Mem. Mus., 1944 (solo); Santa Barbara Mus. Art, 1944 (solo); Pasadena AI, 1944 (solo); Albright-Knox Art Gal., Buffalo, 1952, 1956 (award for "Before Processing"); Walker AC, 1952 (award) 1957; Berkshire AA, 1958; Stratton Mountain (VT) Summer Exh., 1971. **Work:** Rochester Mem. Art Gal.; Pasadena Art Inst.; Middlebury College; Allen Mem. Art Gal., Oberlin, OH. **Comments:** Preferred media: oils, acrylics. Positions: trustee, Sheldon Mus., Middlebury, VT, 1960-. Publications: auth., *Indian Miniatures; The Rajput Painters,* Tuttle, 1959 & *Renoir,* McGraw, 1968; contrib., *McGraw-Hill Dictionary Art,* 1969 & *Encyclopedia World Art,* Vol. 1914, 1970; auth., articles, *College Art Journal,* winter 1970-71 & winter 1971-72. Teaching: Muhlenberg College, 1947-49; sculpture & design, Oberlin College, 1950-55; Univ. Chicago, 1955-56; Saint Cloud (MN) State College, 1956-57; Middlebury College, 1958-. Research: late painting of Arshile Gorky; modern art; 19th c. European and Far Eastern art. **Sources:** WW73; WW47.

REIFFEL, Charles *[Landscape painter, lithographer] b.1862, Indianapolis, IN / d.1942, San Diego, CA.*

Charles Reiffel

Addresses: Buffalo, NY; Silvermine, CT; settled in San Diego, CA, 1925 & living there in 1942. **Studied:** mostly self-taught, but did study portrait painting with Carl Marr in Munich. **Member:** Allied AA; Contempotary; Int. Soc. Art Lgl; Conn. SA; SC; CAFA; Buffalo SA; Silvermine GA; Wash. AC; North Shore AA; Hoosier Salon; Chicago Gal. Art; San Diego AG; Calif. AC; Laguna Beach AA. **Exhibited:** Buffalo SA, 1908 (prize); PAFA Ann., 1910, 1917-24, 1930; Corcoran Gal. biennials, 1910-28 (6 times); Pan-Pacific Expo, 1915; AIC, 1917 (med.); S. Indp. A., 1917-18; CAFA, 1920; Int. Expo, Pittsburgh, 1922; Hoosier Salon, 1925 (prize), 1926 (prize), 1927 (prize), 1928 (prize), 1931 (prize), 1938 (prize); LACMA, 1926 (prize), 1929 (prize); San Diego FA Gal., 1926 (prize), 1927 (prize); Calif. AC, 1928 (gold); Sacramento AC, 1928 (prize), 1930 (prize); Phoenix, AZ, 1928 (prize), 1930 (prize); Santa Cruz, 1929 (prize); John Herron AI, 1929 (prize); Richmond (IN) AA, 1930 (prize); Painters of the West, 1930 (gold); Pasadena Art Gal., 1930 (prize); Los Angeles Exh., 1932 (prize). **Work:** CGA; San Diego FA Gal.; Santa Cruz AL; Municipal Gal., Phoenix; Wood Art Gal., Montpelier, VT; LACMA; Herron AI; Admin. Bldg., San Diego. **Comments:** Position: lithographer, Stowbridge Lithography Company, Cincinnati. After six years in Europe, he continued in the lithography business until c.1921, when he started devoting all his time to painting, particularly Southern California landscapes. **Sources:** WW40; Hughes, *Artists of California,* 462; P&H Samuels, 394; Falk, *Exh. Record Series.*

REIGART, Henry *[Miniaturist] early 19th c.*
Comments: Painter of a miniature of John Landis (1776-1850) of Lancaster (PA). **Sources:** G&W; Lancaster County Hist. Soc., *Portraiture in Lancaster County,* 135.

REIGEL, Henry *[Painter] early 20th c.*
Comments: Landscape paintings dating in the 1920s by this artist have surfaced. **Sources:** Malmberg, *Artists of Berks County,* 26.

REILLY, Elvira M. (Mrs. Harold) *[Painter] b.c.1899 / d.1958, Oak Ridge, NJ.*
Addresses: Key West, FL. **Studied:** ASL. **Member:** NAWA; All. Artists Am. **Exhibited:** S. Indp. A., 1924; Key West, FL, 1951; Miami Beach AC, 1953; Argent Gal., 1949; Galerie Bosc-Petrides, Paris, France; NAD; NY Hist. Mus.; NAC; Martello Gal., Key West; High MA; Ridgewood AA; Hudson Valley AA; Cape May, NJ (solo). **Comments:** Position: program dir., Martello Tower Gal., Key West, FL. **Sources:** WW53.

REILLY, Frank Joseph *[Painter, educator, lecturer, writer, illustrator, teacher] b.1906, NYC / d.1967.* *Frank Reilly*
Addresses: NYC; Woodstock, NY. **Studied:** ASL; G. Bridgman; F. DuMond; D. Cornwell. **Member:** ANA; NSMP; SC; Century Assn.; All. Artists Am.; Inter-Color Soc.; SI; AAPL; Artists & Writers; Int. Platform Assn.; Artists Fellowship; Woodstock AA. **Exhibited:** NAD; AAPL (award); All. Artists Am.; SI; Liberty Hall, Phila., PA; Hudson Valley AA, (gold medal); Ogunquit AA (Public Award). **Work:** murals, in NYC schools, Bronx H.S. of Science; Johnson City, TN. **Comments:** Made 12 full color, sound motion pictures on artists. Teaching: Grand Central Sch. Art; Moore Inst. Art; Pratt Inst.; Art Assoc.; ASL. Positions: vice-pres., ASL; pres., Council of Am. Artists Soc.; dir., Nat. Inst. of Art & Design; art comn., City of New York; trustee, FA Fed., NY; pres., Frank Reilly Sch. Art. Lectures on all phases of art to art schools, museums and clubs; 14 yearly lectures at ASL. Auth.: weekly art column of Newhouse Syndicate. Contrib. to major art publications. **Sources:** WW66; WW47; Woodstock AA.

REILLY, John G. *[Painter] early 20th c.*
Addresses: Cincinnati, OH. **Member:** Cincinnati AC. **Sources:** WW15.

REILLY, John Louis *[Painter] late 19th c.; b.New York.*
Exhibited: Paris Salon, 1880. **Sources:** Fink, *Am. Art at the 19th c. Paris Salons,* 384.

REILLY, John W. *[Painter] 20th c.*
Addresses: Phila., Radnor, PA. **Exhibited:** PAFA Ann., 1958, 1960, 1966 (prize). **Sources:** Falk, *Exh. Record Series.*

REILLY, Joseph *[Portrait & landscape painter] b.1809, Butler County, OH / d.1849.*
Addresses: Active mostly in Hamilton, OH. **Studied:** Miami Univ. **Exhibited:** Cincinnati Acad., 1841; Fireman's Fair Exh., 1845. **Sources:** Hageman, 121.

REILLY, Mildred A. *[Painter] b.1902, Milwaukee, WI.*
Addresses: Jackson Heights, LI, NY. **Studied:** Milwaukee Art Sch.; Layton Sch. Art; ASL with Robert Brackman, Robert Philipp, Howard Trafton. **Member:** NAWA. **Exhibited:** Levittown, NY, 1951; Contemp. Art Gal., 1952; NAWA, 1954. Awards: prizes, North Shore Hospital Benefit, Levittown, NY, 1951. **Comments:** Position: freelance fashion ilustr. for leading stores and fashion magazines. Teaching: Layton Sch. Art, Milwaukee, WI, 1945-48. **Sources:** WW59.

REILLY, Paul H. *[Portrait & landscape painter, illustrator, cartoonist] b.Pittsburgh / d.1944, Westport, CT.*
Addresses: Pittsburgh, PA. **Studied:** Pittsburgh. **Member:** Pittsburgh AA. **Sources:** WW19.

REILLY, Peter *[Painter] mid 20th c.*
Exhibited: S. Indp. A., 1941. **Sources:** Marlor, *Soc. Indp. Artists.*

REILY, Joseph *[Listed as "artist"] mid 19th c.*
Addresses: Hamilton (OH) in 1841. **Sources:** G&W; info cited by G&W as being courtesy Edward H. Dwight, Cincinnati Art Museum.

REIM, Eimrich See: **REIN, Einrich**

REIMANN, Carl *[Mural painter, decorator, designer, illustrator] b.1873, Milwaukee, WI.*
Addresses: Milwaukee. **Studied:** R. Lorenz; M. Thedy, Royal Acad., Weimar, Germany. **Work:** stained glass windows, St. John's Episcopal Church, Charlestown, WV; Milwaukee AI. **Sources:** WW40.

REIMANN, William P(age) *[Sculptor, educator] b.1935, Minneapolis, MN.*
Addresses: Cambridge, MA. **Studied:** Yale Univ. (B.A., 1957; B.F.A., 1959; M.F.A., 1961); Josef Alberts; Rico Lebrun; Robert M. Engman; James Rosati; Gilbert Franklin; Seymour Lipton; Gabor Peterdi; Neil Welliver; Bernard Chaet. **Exhibited:** Structured Sculpture, Gal. Chalette, New York, 1961-68; Sculpture Ann., 1964-65 & Young Americans, 1965, WMAA; Int. Exh. Contemp. P&S, Carnegie Inst., Pittsburg, 1967-68; Transformations, Carpenter Center Visual Arts, Harvard Univ., 1972. **Work:** MoMA; Boston Mus. FA; WMAA; Rockefeller Univ., New York. Commissions: sculpture, Yale Univ. Dept. Art & Arch., 1964; suspended sculptures, Endo Labs, Garden City, NY, 1965 & Rockefeller Univ., 1970-71; countyard sculpture, Harvard College Observ., Cambridge, MA, 1972; sculpture, "Transformation of a Rectangle," Revere Copper & Brass Corp., New York. **Comments:** Preferred media: plexiglass, stainless steel, pencil. Teaching: Old Dominion College, 1961-64; Harvard Univ., 1964-, Carpenter Center Visual Arts, spring 1971. **Sources:** WW73.

REIMER, Cornelia (Mrs. E. K.) *[Painter, teacher] b.1894, San Jacinto, CA.*
Addresses: Sierra Madre, CA. **Studied:** Pomona College; Univ. California (A.B.; M.A.); Univ. Panama with Cedeño; Pasadena Sch. FA with Ejnar Hansen, Frode Dann, Orrin White. **Member:** Canal Zone Art Lg.; Nat. Lg. Am. Pen Women; Pasadena AA. **Exhibited:** Nat. Lg. Am. Pen Women, 1949, 1952, 1957; Las Vegas, NV, 1957, 1958 (solo); Tivoli Gal., Canal Zone, 1950, 1951 (solo); Altadena (CA) Lib., 1954; Sierra Madre, CA, 1953-58; Pasadena Art Fair, 1957-58; San Gabriel, CA, 1958. Awards: Nat. Lg. Am. Pen Women, 1949 (Canal Zone Br.), 1957 (Pasadena Br.). **Sources:** WW59.

REIMERS, Johannes *[Painter] b.1856, Norway / d.1953, San Leandro, CA.*
Addresses: San Francisco, CA. **Exhibited:** San Fran. AA, 1916-17. **Work:** Oakland Mus. **Sources:** WW19; Hughes, *Artists of California*, 462.

REIMERS, Marie Arentz *[Painter] b.1859, Bergen, Norway / d.1946, Berkeley, CA.*
Addresses: Berkeley, CA. **Studied:** self-taught. **Exhibited:** locally. **Comments:** Married Johannes Reimers (see entry) in 1883 in Oakland, CA. She began painting at age 69. **Sources:** Hughes, *Artists of California*, 462.

REIMS, Salvatore *[Sculptor] early 20th c.*
Addresses: NYC. **Sources:** WW21.

REIN, Einrich *[Painter] b.1827 / d.1900.*
Addresses: Providence, RI. **Exhibited:** NAD, 1873, 1880; Boston AC, 1880. **Sources:** *The Boston AC.*

REIN, Harry R. *[Painter, screenprinter, decorator, craftsperson] b.1908, NYC.*
Addresses: Pomona, CA. **Studied:** ASL. **Member:** Western Serigraph Inst., Los Angeles; Pasadena AA. **Exhibited:** MMA, 1935; New Haven PCC, 1936; MoMA, 1939; WFNY 1939; Laguna Beach AA, 1946; Jepson AI, 1950; Pomona College, 1951. **Work:** MMA; murals, Greenpoint Hospital, Brooklyn, NY; Westwood Hills Christian Church, Westwood, CA; First Christian Church, Whittier, CA; Pasadena Child Guidance Clinic; Hollywood-Beverly Christian Church, Los Angeles. **Comments:** Position: dir., Western Serigraph Inst., Los Angeles, 1951. Contrib.: cartoons, *New Yorker*. WPA printmaker in NYC, 1930s. **Sources:** WW59; WW47; exh. cat., Annex Gal. (Santa Rosa, CA, n.d., c.1988; wherein birth date is cited as 1892).

REINA, Horace *[Painter] mid 20th c.*
Addresses: Honduras, 1939. **Exhibited:** S. Indp. A., 1939. **Sources:** Marlor, *Soc. Indp. Artists.*

REINA, Salvatore *[Sculptor] b.1895, Girgenti, Italy.*
Addresses: NYC/South Beach, Staten Island, NY. **Studied:** BAID. **Member:** Salons of Am.; Soc. Med.; Staten Island AA. **Exhibited:** Salons of Am.; S. Indp. A., 1925-26, 1928, 1930; PAFA Ann., 1931-32; Staten Island AI Soc., 1937-38; Studio Guild, Inc., NYC, 1939-40. **Work:** Lake View Cemetery, East Hampton, CT; Gate of Heavenly Rest Cemetery, NY. **Sources:** WW40; Falk, *Exh. Record Series.*

REINAGLE, Hugh *[Scene painter, landscape, historical, biblical & portrait painter, drawing teacher] b.1788, Philadelphia, PA / d.1834, New Orleans, LA.*
Addresses: Phila.; NYC; Albany, NY, 1815-17; Phila., 1818; Richmond, VA, 1819; NYC, 1820s; New Orleans, 1832-34. **Studied:** John J. Holland, Phila., before 1813. **Member:** NA (founding mem.). **Exhibited:** PAFA, 1811-1830; NAD, 1831; Peale's Museum, NYC, 1830 (large painting of "Belshazzar's Feast" or "Daniel Interpreting the Handwriting on the Wall"); same work again in New Orleans, Mariner's Church, 1832 & winter-spring of 1833-34. **Comments:** Son of Alexander Reinagle who had been the musical director at the New Theater in Phila. from c.1790 until his death in 1809. It may have been at the New Theater that Hugh learned scenery painting. By 1807 he was a scenic painter at the New Theatre in NYC, remaining in that city until about 1813. Reinagle worked in Albany from 1815 to 1817, painting theater scenery and running a drawing academy. He opened a short-lived academy in Phila. in 1818, and in 1819 visited and decorated the Richmond Theater, Richmond, VA. Returning to NYC for the 1820s, he became the leading scenic designer in that city and the chief painter at the Park Theatre. He moved to New Orleans in 1832 and worked as head scene painter at the American Theatre. Reinagle was also a painter of biblical scenes and landscapes, and while in New Orleans painted at least one bayou scene. He died of cholera in that city in May of 1834. **Sources:** G&W; New Orleans *Bee* and *Argus*, May 24, 1834, obituaries (cited by Delgado-WPA); DAB [under Alexander

Reinagle]; Odell, *Annals of the New York Stage;* NYCD 1813, 1826-33; Rutledge, PA; Albany CD 1815-16; Cowdrey, AA & AAU; Prime, II, 32; Cummings, *Historic Annals;* Cowdrey, NAD; Kendall, *The Golden Age of the New Orleans Theater*, 76; *Harper's Magazine*, LX (May 1883), 861; New Orleans *Bee*, Jan. 14 and May 17, 1834 (cited by Delgado-WPA); Peters, *America on Stone*, pl. 107; Stokes, *Historical Prints*; Stokes, *Iconography*. More recently, see *Encyclopaedia of New Orleans Artists;* and Gerdts, *Art Across America*, vol. 2: 96; Wright, *Artists in Virgina Before 1900.*

REINAGLE, T. *[Scene painter] early 19th c.*
Addresses: NYC, 1826. **Comments:** Working as scene painter at the Park Theatre in 1826. May have been Hugh Reignagle's (see entry) brother Thomas. **Sources:** G&W; Odell, *Annals of the New York State*, III, 231; DAB [under Alexander Reinagle].

REINBERGER, Joseph *[Sketch artist] mid 19th c.; b.Germany.*
Addresses: Nauvoo, IL. **Comments:** Settled at Nauvoo in 1850 and made a drawing of the ruined city the following year. This was owned in 1947 by a private collector in Nauvoo. **Sources:** G&W; Arrington, "Nauvoo Temple," Chap. 8.

REINDEL, Edna *[Painter] b.1900, Detroit, MI.*
Addresses: NYC; Santa Monica, CA. **Studied:** PIA Sch. **Exhibited:** Corcoran Gal. biennials, 1930, 1937; Salons of Am.; Art Dir. Club, 1935 (medal); PAFA Ann., 1935-38, 1941; Beverly Hills Art Festival, 1939 (prize); GGE, 1939; WMAA, 1937-38, 1940, 1949; Carnegie Inst., 1937-38, 1944-46, 1947-49; AIC, 1934-35, 1945, 1948; Macbeth Gal., 1934, 1937, 1940, 1949; Stendhal Gal., Los Angeles, 1939-40; Francis Taylor Gal., Beverly Hills, 1941-42, 1945; LACMA, 1940; Dallas, TX; Balt., ME; Vigaveno Gal., Los Angeles, 1953. **Awards:** Tiffany Found. fellow, 1926, 1932. **Work:** MMA; DMFA; WMAA; Ball State Teachers College; Canajoharie Art Gal.; *Life* magazine coll.; New Britain AI; Labor Bldg., Wash., DC; murals, Fairfield Court, Stamford, CT; Gov. House, St. Croix, Virgin Islands; WPA mural, USPO, Swainsboro, GA. **Sources:** WW59; WW47; Falk, *Exh. Record Series.*

REINDEL, William George *[Painter, etcher, engraver, lecturer] b.1871, Fraser, MI / d.1948, Cleveland, OH.*
Addresses: Cleveland, OH. **Studied:** largely self-taught; America; Europe. **Exhibited:** S. Indp. A., 1919. **Work:** British Mus., Victoria & Albert Mus., Both in London; MMA; NYPL; Detroit Inst. A.; CMA; Butler AI. **Sources:** WW47.

REINDORF, Samuel *[Painter, engraver, lithographer, instructor] b.1914, Warsaw, Poland / d.1988.*
Addresses: NYC; Westport, CT. **Studied:** Central Tech. Sch. Toronto; Am. Artists Sch., NYC (scholarship) with Saul Wilson & Nahum Tscacbasov; Sol Baiserman. **Member:** Artists Equity Assn New York; Art Lg. Am. **Exhibited:** Toronto Art Gal., 1934-38; Riverside Mus., 1939-40, 1945; WFNY, 1939, 1963-65; Butler Inst. Am. Art, 1963-65; 26th Ann. Exh. Contemp. Am. Painting, Palm Beach, 1964 (first prize); CAFA,1968 (hon. men. for "Clown"); Washington Irving Gals., NYC & Agra Gal., Wash., DC, 1970s. **Work:** Fairfield (CT) Mus.; Toronto (Ontario) Art Gal.; Riverside Mus., New York; Hall of Art, New York; Tygeson Gal., Toronto. **Comments:** Preferred media: oils, pastels, watercolors. Publications: auth., articles, *Art News*, 1964, *Toronto Star,* 1965, *Toronto Globe & Mail,* 1966, *Excelsior,* Mexico City, 1967 & *Dallas Morning News,* 1967. Illustr.: "The Land of the Whip," 1939; "I Came Out Alive," 1941. **Sources:** WW73; WW47; Emily Genauer, article, *Herald Tribune,* 1963; Lotta Dempsey, article, *Toronto Daily Star,* 1966; Richard Ray, article, *Bridgeport Post,* 1970.

REINEKING, James *[Sculptor] b.1937.*
Addresses: San Francisco, CA, 1968; NYC, 1973. **Exhibited:** WMAA, 1968, 1973. **Sources:** Falk, *WMAA.*

REINER, Joseph *[Sculptor] early 20th c.*
Addresses: Union Hill, NJ; NYC. **Member:** NSS. **Exhibited:**

Garden Club Am., 1929 (prize); PAFA Ann., 1943. **Sources:** WW31; Falk, *Exh. Record Series.*

REINER, Jules (Mr. & Mrs.) *[Collectors, patrons] b.1918, NYC.*
Addresses: NYC. **Studied:** Mr. Reiner, St. Johns Univ. (LL.B.); Mrs. Reiner, NY Univ. (B.A.). **Member:** Friends WMAA; Solomon R. Guggenheim Mus. (assoc.); MoMA (contrib.); MMA; Friends Hofstra Univ. Mus. **Comments:** Collection: late 19th-20th c. art. **Sources:** WW73.

REINFORT, Mary *[Craftsperson] b.c.1845, Austria / d.1916, Pass Christian, MS.*
Addresses: New Orleans, active 1889-1902. **Studied:** Newcomb College, 1886-87, 1891-94. **Member:** Art League of N.O., 1889; Art Lg. Pottery Club, 1892. **Exhibited:** Art League of N.O., 1889; Tulane Univ., 1892. **Sources:** *Encyclopaedia of New Orleans Artists,* 320.

REINHARDT, Ad(olph) F. *[Painter, educator, lecturer] b.1913, Buffalo, NY / d.1967, New York, NY.*
Addresses: NYC. **Studied:** Columbia Univ. (B.A., 1930-35), studied aesthetics with Meyer Shapiro; NAD with K. Anderson & John Martin, 1936; privately with C. Holty & F. Criss in NYC, 1936; NYU; Inst. FA; abroad. **Member:** Am. Abstract Artists, 1937; CAA; Chinese Art Soc.; Asia Soc. **Exhibited:** AIC, 1942, 1947, 1949; Corcoran Gal. biennials, 1947-47 (3 times); WMAA, 1947-65. Solos: BM, 1946; Columbia Univ., 1943; Betty Parsons Gal., 1946-56; PAFA Ann., 1951, 1954; Iris Clert Gal., Paris, 1960, 1963; ICA Gal., London, 1964; Dwan Gal., Los Angeles, 1963; Graham Gal., NY, 1965; Stable Gal., NY, 1965; M. Diamond FA, 1980 (solo of small collage drawings). **Work:** WMAA; CI; MoMA; BMA; Mus. Living Artists; LACMA; TMA; PMA; Yale Univ.; Dayton AI; Nelson-Atkins Mus.; SFMA; Albright-Knox Art Gal., Buffalo, NY. **Comments:** Abstract painter, devoted to the idea of pure painting. He worked in the WPA Easel Div., 1936-41, and in 1940 organized a picket of MoMA. By the mid 1950s, he became known for his large works incorporating broad fields of single colors with subtle tonal changes. He is perhaps best remembered for his completely black paintings (5 ft.-square), from 1960. Teaching: Brooklyn College, 1947-; Calif. Sch. FA, 1950; Univ. Wyoming, 1951; Yale Univ., 1952-53; NY Univ., 1955; Syracuse Univ., 1957; Hunter College, 1960. Lectures: Modern Art; Asiatic Art. Contrib. of cartoons to *Picture News,* and the radical newspaper *PM* in the 1940s. Illustr.: "The Good Man and His Good Wife," 1944, "Races of Mankind," 1944. Co-ed.: "Modern Artists in America," 1952. Auth.: "Art-as-Art Dogma," *Art News,* 1960, 1964, and *Art International,* 1962; *Art-as-Idea: the Selected Writings of Ad Reinhardt* (New York: Viking, 1975). **Sources:** WW66; WW47; Martin James, "Artists Today — Ad Reinhardt," *Portfolio & ArtNews Annual,* 1960; Priscilla Colt, "Notes on Ad Reinhardt" by *Art Int.,* Oct., 1964; *Am. Abstract Art,* 196; Baigell, *Dictionary;* Falk, *Exh. Record Series.*

REINHARDT, Henry *[Dealer] b.1858 / d.1921.*
Addresses: NYC. **Member:** Lotos Club. **Comments:** He had galleries in Milwaukee, Chicago, NYC and Paris, and was instrumental in organizing and building art museums. Through him the Toledo Museum of Art acquired the famous "Moonlight," by R.A. Blakelock.

REINHARDT, Siegfried Gerhard *[Painter, designer] b.1925, Eydkuhnen, Germany.*
Addresses: Kirkwood, MO. **Studied:** Wash Univ. (A.B.). **Member:** St. Louis Art Guild. **Exhibited:** CAM St. Louis, 1943-61 (14 exhs.); AIC, 1947; WMAA, 1951-55 & 1960; Cincinnati AC, 1955, 1958 & 1961; PAFA Ann., 1958, 1962, 1964; PAFA, 1960-61; Midtown Galleries, NYC & Albrecht Gal. Art, St. Joseph, MO, 1970s. Awards: six awards, St. Louis Art Guild, 1951-58; awards, Cincinnati Contemp. AC, 1958 & Int. Exh. Sacred Art, Trieste, Italy, 1961. **Work:** Am. Acad. Arts & Letters; CAM St. Louis; Concordia Teachers College; Southern Illinois Univ.; WMAA. Commissions: murals, Rand McNally, Skokie, IL,

Edison Bros. Shoe Co., St. Louis, Teamsters Local 88, Med. Bldg. & Nooter Corp., St. Louis. **Comments:** Positions: designer & executor stained glass windows, Emil Frei, Inc., 1948-; painted "Man of Sorrows," weekly TV show, 1955, 1957 & 1958. Teaching: Wash. Univ., 1955-70. **Sources:** WW73; Nathaniel Pousettte-Dart (ed.), *American Painting Today* (Hastings, 1956); Lee Nordness (ed.), *Art: USA: Now* (C.J. Bucher, 1962); Falk, *Exh. Record Series.*

REINHART, Albert Grantley *[Painter, illustrator] b.1854, Pittsburgh, PA / d.1926.*
Addresses: Brielle, NJ. **Studied:** Munich; Venice; Paris, with Bonnat. **Exhibited:** Paris Salon, 1882; NAD, 1885; PAFA Ann., 1890. **Comments:** Brother of Charles S. Reinhart. **Sources:** WW01; Fink, *Am. Art at the 19th c. Paris Salons,* 384 (as Reinhard); Falk, *Exh. Record Series.*

REINHART, Benjamin Franklin *[Portrait, historical, genre & landscape painter] b.1829, near Waynesburg, PA / d.1885, Philadelphia, PA.*
Addresses: New Orleans; London, England; NYC. **Studied:** received a few lessons in Pittsburgh, c.1844; NAD, 1847-49; Düsseldorf, Paris & Rome, 1850-53. **Member:** ANA, 1871. **Exhibited:** NAD, 1847-84; PAFA Ann., 1868-80; Brooklyn AA, 1868-76. **Work:** CGA. **Comments:** Reinhart began painting portraits at age 16. In 1853 he opened a portrait studio in NYC, but also made a number of extensive trips into the Midwest and South. He went to New Orleans in 1859 and entered into a partnership with Theodore Sidney Moise (see entry). In 1861 (or early 1862) he left for London, where for the next seven years he had great success as a painter of portraits and genre scenes. He returned to NYC in 1868 and lived there for most of his remaining years, although he died in Philadelphia. During these years, Reinhart concentrated his efforts on genre and historical subject pictures, many of which were reproduced as chromolithographs. His most popular works were anecdotal scenes with little girls. Pittsburgh artist, Charles Stanley Reinhart (see entry), was his nephew. **Sources:** G&W; DAB; CAB; Clement and Hutton; Cowdrey, NAD; Ohio BD 1859; New Orleans CD 1860-61 (cited by Delgado-WPA); Rutledge, PA; Falk, PA (vol. 2); Graves, *Dictionary;* Fleming, *History of Pittsburgh,* III, 626. More recently, see *Encyclopaedia of New Orleans Artists;* Edwards, *Domestic Bliss,* cat. no. 68 (with repro.); P&H Samuels, 394; *300 Years of American Art,* vol. 1, 231; Falk, *Exh. Record Series.*

REINHART, Charles Stanley *[Illustrator, painter] b.1844, Pittsburgh, PA / d.1896, NYC.*
Addresses: NYC; Paris, France; NYC. **Studied:** Paris, 1867; Royal Acad., Munich, with Streyhuber, Otto, 1868. **Member:** Tile Club. **Exhibited:** NAD, 1874-94; Brooklyn AA, 1879-82; Boston AC, 1879, 1881; PAFA Ann., 1879-95 (6 times; gold, 1888); Paris Salon, 1884-89; Paris Expo, 1889 (med.). **Work:** CGA. **Comments:** He worked as illustrator for *Harpers* and took summer sketching trips to Long Island with other Tile Club members (1878, 1881). Painted landscapes at Cold Spring Harbor and East Hampton, Long Island. **Sources:** "The Tile Club at Play," *Scribner's Monthly* (February, 1879); Gerdts, *Art Across America,* vol. 1: 148, 298; Pisano, *The Long Island Landscape, 1865-1914,* introduction; Fink, *Am. Art at the 19th c. Paris Salons,* 384; Falk, *Exh. Record Series.*

REINHART, Lester C. *[Landscape painter] b.1908, Lower Lancaster County, PA.*
Addresses: Lancaster, PA. **Studied:** Wilmington (DE) Acad. Art. **Member:** Wilmington SFA; Wilmington AC; Chester County AA; Lancaster Sketch Club. **Work:** bas-relief, Watt & Shand Bldg., Lancaster. **Sources:** WW40.

REINHART, Stewart *[Painter, sculptor, etcher] b.1897, Baltimore, MD.*
Addresses: Mt. Kisco, NY. **Studied:** E. Berge; M. Miller; ASL. **Exhibited:** S. Indp. A., 1919; WMAA, 1920. **Sources:** WW25.

REINHOLD, Caspar *[Die sinker and engraver] early 19th c.*
Addresses: NYC, 1829-32. **Sources:** G&W; NYCD 1829-32; *Am. Advertising Directory,* 1832, p. 147.

REINHOLD, Rudolph *mid 19th c.*
Addresses: NYC, active 1859-60. **Comments:** Partner with Leonard Hieronimus in Hieronimus & Reinhold, lithographers, NYC, 1859-60. **Sources:** G&W; NYCD 1859-60; NYBD 1859.

REINICKE, Clara See: **DRIPPS, Clara Reinicke (Mrs.)**

REINICKE, Walter E. *[Painter] early 20th c.*
Addresses: Brooklyn, NY. **Exhibited:** S. Indp. A., 1920.
Sources: Marlor, *Soc. Indp. Artists.*

REINIKE, Charles Henry *[Painter, etcher, teacher] b.1906, New Orleans, LA.*
Addresses: New Orleans. **Studied:** Gredhan Art Sch., New Orleans; Chicago Acad. FA. **Member:** NOAL; New Orleans AA; SSAL. **Exhibited:** PAFA; NAD; Delgado Mus. Art (solo); Munic. Art Gal., Jackson, MS (solo); Eastman Mem. Mus., Laurel, MS (solo); Louisiana Art Comm. Gal., Women's Club, Shereveport, LA (solo); SSAL, 1936 (prize), 1940 (prize); NOAL,1941 (prize), 1945 (med.); Mid-South Fair, Memphis (gold); Outdoor Show, New Orleans, 1941 (prize); High Mus., Atlanta, 1937 (prize); New Orleans AA, 1937 (prize), 1940 (prize), 1941 (prize), 1945 (prize); Mid-South Fair, Memphis, TN (medal); Outdoor Show, New Orleans, 1941 (prize). **Work:** Mint Mus. Art; Mus. Science & Indust., Chicago. **Comments:** Position: dir., Reinike Acad. Art. **Sources:** WW53; WW47.

REININGHAUS, Ruth (Ruth Reininghaus Smith)
[Painter, instructor] mid 20th c.; b.New York, NY.
Addresses: New York, NY. **Studied:** Hunter Co, 1944-46 & 1950-52; NAD (Nell Boardman scholarsh) with Morton Roberts, 1962; Frank Reilly Sch. (Robert Lehman scholarship) with Frank Reilly, 1963; ASL with Robert Phillips & Robert Beverly Hale, 1966; NY Univ. (scholarship, 1968). **Member:** All. Artists Am.; AAPL; Hudson Valley AA; Berkshire AA. **Exhibited:** Catharine Lorillard Wolfe AA Ann., Nat. Arts Club, NY, 1966; Hudson Valley AA Ann., Westchester Community Center, NY, 1969-72; AAPL Ann., Lever House, NY, 1969-72; Allied Artists Am. Ann., NAD, 1971; Berkshire AA, Pittsfield (MA) Mus., 1972; Hammer Galleries Inc., NYC, 1970s. Awards: Nell Boardman Award, NAD, 1962; Robert Lehman Award, Frank Reilly Sch., 1963. **Comments:** Preferred medium: oils. Positions: free lance artist & fine arts comns.; tech. illustr., Sound Publ. Co., 1966-. Publications: tech. illustr., *Telephony for the Sound Contractor,* 1972. Teaching: Kittredge Club Women, New York, 1964-; Bankers Trust Co., New York, 1971-. **Sources:** WW73; Lucien Mandosse, "58th Ann. Exh. of Allied Artists of Am.," *La Révue Moderne* (1972).

REINKE, Amadeus Abraham *[Amateur artist] b.1822, Lancaster, PA / d.1889, Herrnhut, Germany.*
Comments: Artist of a view of Bethlehem (PA) about 1853. Son of Samuel Reinke (see entry). After attending and teaching in the Moravian schools at Nazareth and Bethlehem from 1830-44 and three years as a missionary in Jamaica, Reinke was ordained in 1848. His ministry was spent at Salem (NC), Graceham (MD), Staten Island (NY), Philadelphia, and after 1865 in NYC. He was made a bishop of the Moravian Church in 1870. **Sources:** G&W; Rice, *In Memoriam: Amadeus Abraham Reinke;* Levering, *History of Bethlehem,* 648, 700, 710.

REINKE, Florence Stratton *[Painter] b.1907, Baltimore, MD.*
Addresses: Berkeley, CA. **Studied:** Univ. Calif. (B.A.); Acad. Julian, Paris. **Member:** Carmel AA; Mendocino AA. **Sources:** Hughes, *Artists of California,* 462.

REINKE, Ottilie *[Painter] early 20th c.*
Addresses: Milwaukee, WI. **Member:** Wisc. P&S. **Sources:** WW25.

REINKE, Samuel *[Portrait painter] b.c.1790.*
Comments: Portrait painter in his youth, subsequently a minister

and bishop of the Moravian Church. After graduating from Moravian College in Bethlehem about 1811, Reinke taught school in Bethlehem, Lancaster, and Lititz. From 1844-47 and 1853-54 he was pastor of a church in Bethlehem. He was still living in 1870 at the age of 80. Amadeus A. Reinke was his son (see entry). **Sources:** G&W; Levering, *History of Bethlehem,* 588, 602-03, 676, 687, 709; Rice, *In Memoriam: Amadeus Abraham Reinke.*

REINMAN, Paul *[Painter, illustrator, cartoonist, commercial artist] b.1910, Germany.*
Addresses: Brooklyn 29, NY. **Member:** Nat. Cartoonists Soc.; New Jersey P&S. **Exhibited:** Nechemia Glezer Gal., NY, 1957; Viennese Art Gal., NY, 1957. **Comments:** Illustr.: *Harwyn's Picture Encyclopedia,* 1958. **Sources:** WW59.

REINSEL, Walter Newton *[Painter, designer, etcher] b.1905, Reading, PA / d.1979.*
Addresses: Philadelphia, PA. **Studied:** PAFA with Arthur B. Carles; Andre Lhote, Paris; Mirmade, France. **Member:** Artists Equity Assn., Phila. Chapt.; Phila. WCC; PAFA; Phila. Art All. (mem. oil comt.). **Exhibited:** Salons of Am.; S. Indp. A., 1927; Wanamaker Regional, Phila., 1934; PAFA Ann., 1939-54; PAFA, 1948 (solo); Reading Mus. Art, 1945; Phila. WCC Ann., 1950-72; AWCS, 1958-62; Audubon Artists, 1953-55; Phila. Art All. (3 solos); Dubin Gal., Phila., 1951 (solo); Butler AI, 1954-58. Awards: several medals for layout design & typography; medal, Phila. Sketch Club, 1952; Harrison Morris Prize, PAFA Fellowship, 1953-57; Phila. WCC Medal & Award, 1967 & T. Oakley Mem. Prize, 1968. **Work:** PMA; Reading (PA)Pub. Mus.; Woodmere Art Gal., Phila.; Container Corp., Chicago; oil, Capehart Farnsworth. **Comments:** Worked for a time as a stained glass artist. Positions: art dir. & supervisor, N.W. Ayer & Son, 1930-65. Specialty: layout design, typography. Known for his watercolors as well, his painting locations included Monhegan Island (ME). **Sources:** WW73; WW47; Curtis, Curtis, and Lieberman, 100, 186; Falk, *Exh. Record Series.*

REIS, Bernard J. (Mrs.) *[Collector, patron] b.1900, NYC.*
Addresses: NYC. **Studied:** Univ. Michigan. **Comments:** Positions: trustee, Jewish Mus., New York; mem. arts comt., Brandeis Univ., Watham, MA. **Sources:** WW73.

REISAPFEL, Berthold *[Painter, designer] b.1911, Chicago, IL.*
Addresses: Chicago, IL. **Studied:** AIC. **Member:** United Scenic Artists. **Exhibited:** AIC, 1933-34, 1948. **Comments:** Theatrical des., Chicago Opera; Lake Shore Theatre, Westford, MA. **Sources:** WW40.

REISINGER, Hugo *[Patron, dealer] b.1856, Langeschwalbach, near Weisbaden, Germany (settled / d.1914, Langeschwalbach.*
Comments: He arranged an exhibit of German art shown during 1908-09 at the MMA, the Copley Soc., Boston and AIC. In 1910 he sent to Berlin and Munich a collection of about 200 paintings by American artists, some lent by the MMA and PAFA, but most of them from his private collection. In 1914 he was appointed honorary commissioner to the Anglo-American Expo in London and arranged the American art section and published its illustrated catalogue. He bequeathed $100,000 to Columbia, $50,000 to the MMA, $50,000 to the Germanic Mus. at Harvard, and similar amounts to the art museums in Berlin and Munich.

REISMAN, Frances *[Painter] mid 20th c.*
Exhibited: Corcoran Gal. biennial, 1951. **Sources:** Falk, *Corcoran Gal.*

REISMAN, Philip *[Painter, illustrator, educator] b.1904, Warsaw, Poland / d.1992.*
Addresses: NYC. **Studied:** ASL, illustration & composition with Wallace Morgan; life drawing with George Bridgeman; also etching & composition with Harry Wickey. **Member:** An Am. Group; Artists Lg. Am.; Am. Artists Congress; Artists Equity Assn. New York (vice pres.; pres.).

Exhibited: Roerich Mus. (solo); P&S (solo); Assoc. Am. Artists (solo); FAR Gal. (solo); Guild Gal., Warwick, OH (solo); The Hudson Guild (solo); Beaux Arts Gal., Denver (solo); Storm King AC, Mountainville, NY (solo); Harbor Gal., Cold Spring Harbor, NY (solo); AIC, 1932, 1944; PAFA Ann., 1933-34, 1946; MoMA, 1932; Nat. Print Exh.; Pepsi-Cola, 1944 (prize); WMAA; NAD, 1956 (Joseph Isidor Gold Medal); Art USA, 1959; Michiewitz Centennial Committee Prize, 1955; Childe Hassam Found. Purchase Prize, 1968; Yaddo Fellowship; "NYC WPA Art" at Parsons Sch. Design, 1977; ACA Gal., NYC, 1970s. **Work:** MMA; NYPL (print coll.); MoMA; Bibliothèque Nat., Paris; Syracuse (NY)Univ. Coll.; Bates College, ME; Wadsworth Atheneum, Hartford, CT; Norfolk (VA) Mus. Commissions: WPA mural, Bellevue Psychiatric Hospital, New York, 1938. **Comments:** Preferred media: oils, watercolors. Publications: illustr., "Anna Karenina," Vols. I & II, 1940 & "Crime and Punishment," 44 Random. Teaching: Workshop Sch. Advertising Art, New York, 1954-56; Five Towns Arts Found., 1968-70; Educ. Alliance, New York, 1971-72. **Sources:** WW73; Lincoln Kirstein, *Philip Reisman* (Hound & Horn, 1933); Henry Goodman, *Philip Reisman* (AD, 1941); illustrations reproduced by *Life* (1941); WW47; *New York City WPA Art*, 73 (w/repros.); Falk, *Exh. Record Series.*

REISNER, Irma (Victoria) (Mrs. Ferd. Betzlmann)
[Portrait painter] b.1889, Budapest, Hungary.
Addresses: Wilmette, IL. **Studied:** Max Klinger; Leipzig; Audubon Tyler. **Member:** North Shore AL; Chicago NJSA; All-Illinois SFA; AAPL; AFA. **Sources:** WW33.

REISNER, Martin A. *[Landscape, panorama & scenery painter] mid 19th c.; b.Russia.*
Addresses: Brooklyn in 1850; Germantown, PA in 1859. **Exhibited:** Philadelphia, 1848 (panorama of Taylor's campaigns in Mexico); NAD, 1850; PAFA, 1859. **Comments:** Came to America about 1848 after having been for some years in charge of scene painting at the Imperial Theatre in St. Petersburg (Russia). In 1849 he sold a landscape to the American Art-Union. **Sources:** G&W; Phila. *Public Ledger*, July 3 and 13, Nov. 27, Dec. 2, 1848, and Jan. 18, 1849 (cited by J.E. Arrington); Cowdrey, AA & AAU; Cowdrey, NAD; Rutledge, PA.

REISS, F(ritz) Winold *[Painter, mural painter, designer, decorator, teacher] b.1886, Karlsruhe, Germany / d.1953, Carson City, NV.*
Addresses: NYC; Woodstock, NY; Glacier Park, Montana. **Studied:** Bavaria with his father; Munich Royal Acad. with Von Stuck; Munich Art Sch. with Diez. **Member:** Arch. Lg.; AWCS; NSMP; SI. **Exhibited:** AWCS; AIC; NAD; Munich; Paris; Stockholm. **Work:** dec., Apollo Theatre, South Sea Island Ballroom of Hotel Sherman, Chicago; Restaurants Crillon; Hotel St. George, Brooklyn; Longchamps Restaurants, NYC; Cincinnati Union Terminals; murals, Steuben Tavern; WFNY, Music Hall, 1939. collection of portraits of 81 Indians for Great Northern R.R., Minneapolis IA; Woolaroc Mus., OK. **Comments:** Came to the U.S. in 1913 and went West to the Blackfoot Reservation in 1919, delayed by WWI. He returned many times over and painted portraits, mainly in pastels. His subjects included native Americans as well as blacks and western landscapes. His paintings showed the individuals, rather than a stereotype. Illustr.: "Blackfeet Indians," 1935. Teaching: NYU. **Sources:** WW47; *Woodstock's Art Heritage*, 124; P&H Samuels cite alternate birthdate (1888).

REISS, Hans Egon Friederick *[Sculptor, teacher] b.1885, Lahr, Baden, Germany.*
Addresses: NYC. **Studied:** Acad. Bildenden Künste, Karlsruhe, Baden, Germany. **Exhibited:** PAFA Ann., 1936, 1938. **Comments:** Teaching: NYU, Winold Reiss Art Sch. **Sources:** WW40; Falk, *Exh. Record Series.*

REISS, Henriette *[Painter, teacher, designer, lecturer] b.1890, Liverpool, England.*
Addresses: NYC; Woodstock, NY. **Studied:** Switzerland, England & with Schildknecht in Germany. **Member:** AEA. **Exhibited:** Salons of Am.; S. Indp. A.; MMA; WMAA; AIC; BMFA; BM; CMA; AFA; Am. Mus. Natural Hist.; Newark Mus.; PMA; CAM; CI; Dayton AI; CM; BMA; Am. Des. Gal.; Anderson Gal.; Grand Central Art Gal.; Rochester Mem. Gal., 1946; Am. Woman's Assn.; MoMA; Toledo Mus. Art (solo); CMA (solo); Univ. Nebraska (solo); Univ. Kentucky (solo); Univ. Delaware (solo); Hackley Art Gal. (solo); Fashion & Indust. Exh.; (music paintings) 58th St. Music Lib., NY, 1956-65; extensively in Europe, notably in Paris, Geneva, Zurich. **Comments:** Contributor to national magazines. Lectures: design correlating music with art, to art organizations, universities and art groups U.S. and abroad. Positions: taught special classes in design for supervisors, public & H.S. teachers of Board Educ., NYC; instructor, lecture, consultant, Fashion Inst. Tech., (Br. State Univ.), Textile Design Dept., NYC. **Sources:** WW66; WW47.

REISS, Lee *[Painter] mid 20th c.; b.New York, NY.*
Addresses: Flushing, NY. **Studied:** Art Alliance Sch.; ASL; Am. Art Sch.; Queens College; Cornell Univ. **Member:** Allied Artists Am.; Nat. Art Lg., Long Island; NAWA (chmn. traveling oil shows) >es. **Work:** Washington Co. Mus, Hagerstown, MD; Norfolk Mus. **Comments:** Teaching: Nat. Art Lg., Long Island. **Sources:** WW73.

REISS, Lionel S. *[Painter, lithographer, illustrator, etcher, designer] b.1894, Austria.* *LIONEL S. REISS*
Addresses: NYC. **Studied:** self-taught; ASL. **Member:** AWS; Audubon Artists; Art Lg. Am. **Exhibited:** AIC; BM; CM; Los Angeles Mus. Art; WMAA; PAFA; AWS; NAD; S. Indp. A.; Midtown Gal., 1939 (solo); MoMA, 1940 (prize); CI, 1941; Am. Artists Group (prize); Assn. Am. Artists, 1943 (prize), 1946 (solo); Assoc. Am. Artists Gal., 1946 (solo). Award:"Artists as Reporter" Comp. **Work:** BM; Jewish Mus., NY; Jewish Theological Seminary, NY; Sinai Center, Chicago; Tel-Aviv Mus., Israel; Bezalel Mus.; Columbia Univ. **Comments:** Auth.: "My Models Were Jews," 1938; "New Lights and Old Shadows," 1954. Illustr.: "A Golden Treasury of Jewish Literature". **Sources:** WW59; WW47.

REISS, Louis H. *[Painter, illustrator, teacher] b.1873, Newark.*
Addresses: Newark, NJ. **Studied:** J.W. Stimson; Diehl; Ward. **Sources:** WW10.

REISS, Roland *[Sculptor] b.1929.*
Addresses: Venice, CA. **Exhibited:** WMAA, 1975. **Sources:** Falk, *WMAA.*

REISS, Wallace *[Painter] mid 20th c.*
Addresses: NYC, 1951; Astoria, NY, 1955. **Exhibited:** WMAA, 1951-55; PAFA Ann., 1952; Corcoran Gal. biennial, 1953. **Sources:** Falk, *Exhibition Records Series.*

REISS, Winold *[Painter, designer] b.1886, Karlsruhe, Germany / d.1953, NYC.* *WINOLD REISS*
Addresses: New York 11, NY. **Studied:** in Germany. **Member:** AWCS; NSMP; Arch. Lg.; Woodstock AA. **Exhibited:** Salons of Am.; S. Indp. A.; AWCS; AIC; NAD; Anderson Gal. (solo); Europe; Shepherd Gal., NYC, 1988; Cox Gal., Woodstock, NY, 1991; Smithsonian Inst. traveling solo, 1991 ("To Color America"). **Work:** Cincinnati Union Terminal; Woolaroc Mus., Bartlesville, OK; Minneapolis Inst. Art; Grand Central Art Gal.; Browning (MT) Mus.; Woodstock AA. **Comments:** During the 1920s-30s, he documented the American Indian, the Harlem Renaissance, and the working class. In 1939, he produced the nation's largest mural for the WFNY, and he was well-known for his Art Deco designs for Longchamps and Crillon in France. He ran art schools in NYC, Woodstcok, and Glacier Nat. Park. His illustrations appeared in many national magazines as well as his book, *Blackfeet Indians* (1935). Lectures: color; mural painting. **Sources:** WW53; addit. info. courtesy Woodstock AA.

REISSNER, Martin A. See: **REISNER, Martin A.**

REISZ, Frank *[Painter]* early 20th c.
Comments: Affiliated: Art Acad., Cincinnati. **Sources:** WW17.

REITER, Freda Leibovitz (Mrs.) *[Painter, graphic artist, illustrator, etcher, lithographers] b.1919, Philadelphia, PA.*
Addresses: Camden, NJ. **Studied:** Moore Inst. Des.; PAFA; Barnes Found.; San Carlos Acad., Mexico, D.F. **Member:** AEA; Nat. Lg. Prof. Women Artists; Phila. Pr. Club. **Exhibited:** PAFA, 1936, 1938, 1941, 1942, 1954; Graphic Sketch Club, 1938 (prize), 1940 (prize); NAD, 1941, 1944-46, 1957, 1958; CI, 1943; MMA, 1943, 1949; Carlen Gal., 1942 (solo); Phila. Pr. Club, 1944 (solo); Phila. YW-YMHA, 1954. **Work:** LOC.; CI; drawings, *Phila. Inquirer.* **Comments:** Lectures: Mexican Art. Illystr. of numerous books. **Sources:** WW59; WW47.

REITHERMAN, Wolfgang *[Painter] b.1909, Germany / d.1985, Los Angeles, CA.*
Addresses: Los Angeles, CA. **Exhibited:** Calif. WCS, 1933. **Comments:** Position: dir., prod., Walt Disney Studios. **Sources:** Hughes, *Artists of California*, 462.

REITMAN, Joseph *[Lithographer] b.c.1830, Bavaria.*
Addresses: Philadelphia in 1860. **Sources:** G&W; 8 Census (1860), Pa., LXII, 323.

REITZ, Jackson *[Painter] mid 20th c.*
Addresses: NYC. **Exhibited:** S. Indp. A., 1934-35. **Sources:** Marlor, *Soc. Indp. Artists.*

REITZ, R. *[Painter] mid 20th c.*
Exhibited: AIC, 1940. **Sources:** Falk, *AIC.*

REITZEL, Joseph *[Painter] mid 20th c.*
Addresses: San Francisco, CA. **Exhibited:** Soc. for Sanity in Art, CPLH, 1941. **Sources:** Hughes, *Artists of California*, 462.

REITZEL, Marques E. *[Painter, educator, graphic artist, lecturer, teacher, illustrator] b.1896, Fulton, IN / d.1963, Pescadero, CA.*
Addresses: Rockford, IL; San Jose, CA; Pescadero, CA. **Studied:** AIC (B.F.A.); Ohio State Univ. (M.A.; Ph.D.); Cleveland Col., Western Reserve Univ.; Geo. Bellows; L. Kroll; Hopkins; C. Buehr; Foster. **Member:** Press & Union Lg. Club, San Fran.; Commonwealth Club, San Fran.; Chicago SA; Chicago P&S; Chicago Gal. Art; Hoosier Salon; Am. Coll. S. Print Collectors; Cliff Dwellers; Pacific AA; Western College AA; Soc. Western Artists; Indiana Soc. Chicago. **Exhibited:** CI, 1929; Corcoran Gal. biennial, 1930; PAFA Ann., 1929, 1931-32; AIC, 1927 (prize) 1928 (prize), 1929, 1931, 1934; CMA, 1931; Hoosier Salon, 1928, 1929 (prize), 1930-31, 1940, 1942, 1944-45; All-California Exh., 1940-41, 1944; Oakland Art Gal., 1941-43; Century of Progress, Chicago, 1934 (gold); GGE, 1939; San Jose AL, 1940 (prize), 1941 (prize); Chicago Gal. Assn., 1937 (prize), 1943 (prize). **Work:** Chicago Mun. Coll. for pub. schs.; Chicago Pub. Schs. AS; Hobart (IN) H.S.; Rockford College; Dakota Boys Sch.; H.S., Rockford, IL., Lafayette, IN; AA, Belvidere Women's Club; Colorado State Teachers College. **Comments:** Teaching: San Jose (CA) State College (emeritus, 1956); pres., acting dir., Pescadero Summer Sch. Art. **Sources:** WW59; WW47; Falk, *Exh. Record Series.*

RELF, Clyde Eugenia *[Painter] early 20th c.*
Addresses: Seattle, WA. **Sources:** WW24.

RELF, Richard *[Photographer, printer, colorer] b.1883, New Orleans, LA.*
Addresses: New Orleans, active c.1900-79. **Comments:** Noted portrait photographer who retired at age 90. **Sources:** *Encyclopaedia of New Orleans Artists*, 321.

RELIS, Rochelle R. *[Painter] 20th c.; b.Lwow, Poland.*
Addresses: Long Island City, NY. **Studied:** Theatre Acad., Lwow; Art Sch., Lwow; Herman Frenkiel, Paris, France. **Member:** Berkshire AA; Texas Fine AA; Nat. Acad. TV Arts & Sciences; Am. Guild Variety Artists; Am. Fed. TV & Radio Artists. **Exhibited:** Int. Arts Exh., New York; Spring Arts Festivals, New York; Atlantic City (NJ) Arts Shows; Gal. Int., New York; numerous selected nat. & regional juried shows. **Awards:** hon. M.F.A., Univ. Eastern Florida, 1971. **Work:** Synagogue Mus., Graz, Austria; over 50 private collections in U.S., Europe & Israel. Commissions: Jewish Folklore Albume Series, "Fiddler on the Roof," 1972. **Comments:** Preferred media: oils, ink, watercolors. Teaching: summer resorts, 1970-71. **Sources:** WW73.

RELYEA, Charles Mark *[Illustrator, painter] b.1863, Albany, NY / d.1932.*
Addresses: Phila., PA; Flushing, LI, NY. **Studied:** PAFA with T. Eakins; F.V. Du Mond in NYC; Paris. **Member:** SC; Allied AA; Alliance; Player's Club; Artists Gld. **Exhibited:** PAFA Ann., 1888; S. Indp. A., 1929-30. **Sources:** WW31; Falk, *Exh. Record Series.*

REMAHL, Frederick *[Painter, teacher] b.1901, Sweden.*
Addresses: Chicago, IL. **Studied:** Minneapolis Sch. Art; A Angarola. **Member:** Chicago SA; AAPL. **Exhibited:** AIC, 1927-49; Corcoran Gal. biennials, 1928, 1935; PAFA Ann., 1929. **Work:** Mus. Gothenburg, Sweden; Chicago Bd. Trade; twelve WPA paintings in State Inst., IL. **Sources:** WW40; Falk, *Exh. Record Series.*

REMARU, Hla *[Painter] early 20th c.*
Addresses: Lima, Peru. **Exhibited:** S. Indp. A., 1924. **Sources:** Marlor, *Soc. Indp. Artists.*

REMBERT, Catharine Philip (Mrs.) *[Designer, painter, teacher] b.1905, Columbia.*
Addresses: Columbia, SC. **Studied:** Art Dept., Univ. South Carolina; Maryland Inst.; A. Lhote, Paris. **Member:** Columbia AA; Columbia Sketch Club; SSAL; State Fair, 1931 (prize), 1932 (prize), 1936 (prize). **Comments:** Teaching: Univ. South Carolina. Specialty: lampshade & textile design, stagecraft. **Sources:** WW40.

REMBSKI, Stanislav *[Portrait painter, writer, teacher, lecturer] b.1896, Sochaczew, Poland. / d.1998, Baltimore, MD.*
Addresses: NYC, c.1925-40; Baltimore, MD, 1940-on; Deer Island, ME (summers). **Studied:** ASL; Tech. Inst., Warsaw, Poland; Ecole Beaux Arts, Paris, Francek; Royal Acad. FA, Berlin, Germany, 1923; E. Wolfsfeld, Berlin. **Member:** SC; All. Artists Am.; Nat. Soc. Mural Painters; AAPL; Charcoal Club, Baltimore. **Exhibited:** Dudensing Gals., NYC, 1927 (solo); S. Indp. A., 1931, 1936; Carnegie Hall Gal., NYC, 1934 (solo), Arthur Newton Gal., NYC, 1935 (solo); BMA, 1947; Baltimore Inst. Art, 1950; Calvert Gal., Wash., DC, 1990 (solo). **Work:** Columbia Univ.; Kent Sch., CT; Adelphi College; Brooklyn Polytechnic Inst.; NAD; St. John's Hospital, Brooklyn; Mus. Osage Indian, Pawhuska, OK; Johns Hopkins Univ.; Goucher College; Loyola College; Bd. Educ., Baltimore; State House, Annapolis, MD; Church of the Neighbor; Univ. NC; Beth Israel Hospital, Newark; Pres. Woodrow Wilson, Woodrow Wilson House, Wash., DC; Pres. Frankin D. Roosevelt, FDR Mem. Lib., Hyde Park, NY; Lawrence Cardinal Shehan, Archbishop's House, Baltimore, MD; Fleet Admiral William D. Leahy, Hist. Soc., Madison, WI; Leon Dabo. Commissions: mural, "Conversion of William Duke of Acquitaine," Trustees of St. Bernard's Sch., Gladstone, NJ, 1931; mural, "I Am the Life," Mem. Episcopal Church, 1962. **Comments:** A self-described "painter of people," he completed more than 1,500 portraits. Positions: critic, Maryland Inst. Art, 1952-55. Auth.: "Mysticism in Art" and other lectures, published by Rembski's Leonardo da Vinci Art School in 1936; *Freedom, New Age*, 1972; articles, "Art and Religion," and "Reflections on Symbolism," *New Church Messenger.* **Sources:** WW73; WW47; catalogue, *Stanislav Rembski Portraits* (Baltimore, 1967); PHF files, add'l info from the artist, 1993.

REMECKE, Adolphe *[Listed as "artist"] b.c.1823, Germany.*
Addresses: Philadelphia in 1850. **Sources:** G&W; 7 Census (1850), Pa., LII, 893.

REMENEYE, Edward *[Listed as "artist"] mid 19th c.; b.Hungary.*

Addresses: NYC in 1850. **Sources:** G&W; 7 Census (1850), N.Y., XLI, 494.

REMENICK, Seymour *[Painter] b.1923, Detroit, MI.*
Addresses: Philadelphia, PA. **Studied:** Tyler Sch. FA, 1940-42; Hans Hofmann Sch., 1946-48. **Exhibited:** Am. Painting, Rome, Italy, 1955; 4 Young Americans, RISD, 1956; 11 Contemp. Am. Painters, Paris, France, 1956; AIC Ann., 1961; Drawing Show, PMA, 1965; PAFA Ann., 1968; Pearl Fox Gal., Melrose Park, PA, 1970s. **Awards:** Louis Comfort Tiffany Found. grant; 1955; Benjamin Altman Landscape Prize, NAD, 1960; Hallmark Purchase Award, 1960. **Work:** PMA; PAFA; RISD; Phoenix Art Mus.; Dallas Mus. Contemp. Art. **Comments:** Preferred medium: oils. **Sources:** WW73; Falk, *Exh. Record Series.*

REMFREE, Helen F. *[Painter] early 20th c.; b.San Diego, CA.*
Addresses: San Diego, CA. **Studied:** Ed Northridge; San Diego Acad. FA. **Exhibited:** San Diego FA Gal., 1927. **Sources:** Hughes, *Artists in California,* 463.

REMICK, Christian *[Marine & townscape painter in watercolors] b.1726, Eastham, MA.*
Addresses: Active in Boston, 1768-69; said to have lived on Cape Cod after the Revolution. **Work:** Yale Univ. Art Gal. , New Haven, CT; Essex Inst., Salem, MA. **Comments:** A master mariner, Remick was apparently at Boston in the fall of 1768 when he made several views of the harbor and the Common, showing the landing and the encampment of the British regiments quartered on the town. In October 1769 he was again in Boston, described as having come lately from Spain. He advertised that he could do "sea pieces, perspective views, geographical plans of harbors, seascapes, etc." Remick is also known to have done some heraldic painting. **Sources:** G&W; Cunningham, *Christian Remick;* Bowditch, "Early Water-Color Paintings of New England Coats of Arms," 183-84 and fig. 5; Dow, *Arts and Crafts in New England,* 2; Stokes, *Historical Prints,* 23. More recently, see Brewington, 321, who cites *Boston Gazette,* October 16, 1769.

REMINGTON, Alice Maud *[Painter] early 20th c.*
Addresses: NYC. **Exhibited:** S. Indp. A., 1919. **Sources:** Marlor, *Soc. Indp. Artists.*

REMINGTON, Deborah Williams *[Painter] b.1930, Haddonfield, NJ.*
Addresses: NYC. **Studied:** Calif. Sch. FA, San Fran. (cert., 1952); San Fran. Art Inst. (B.F.A., 1955); Asia, 1955-58. **Exhibited:** WMAA Painting Ann., 1965, 1967 & 1972; Art Vivant Am., Fond Maeght, Saint Paul de Vence, France, 1970; Bykert Gal., NYC & Pyramid Gals., NW, Wash., DC, 1970s. **Work:** WMAA; Mus. XXème Siècle, Paris, France; Addison Gal. Am. Art, Andover, MS; Van Boymans Mus., Rotterdam, Holland. **Comments:** Preferred medium: oils. **Sources:** WW73; Knute Stiles, "The Mysterious Machine," *Artforum* (Feb., 1966); Simon Watson-Taylor, "Space Machines," *Art & Artists* (August, 1967); Sabine Marchand, "Deborah Remington," *Cimaise* (February, 1972).

REMINGTON, Edith Liesee *[Painter] early 20th c.*
Addresses: Phila., PA. **Sources:** WW19.

REMINGTON, Elizabeth H. *[Flower painter] b.1825 / d.1917, Flushing, NY.*
Addresses: NYC. **Exhibited:** Brooklyn AA, 1869-79; NAD, 1869-79. **Comments:** Her work was published by Louis Prang & Co. **Sources:** G&W; Petteys, *Dictionary of Women Artists.*

REMINGTON, Frederic Sackrider *[Painter, illustrator, sculptor, writer] b.1861, Canton, NY / d.1909, Ridgefield, CT.*

Frederic Remington

Addresses: New Rochelle, NY; Ridgefield, CT. **Studied:** Vermont Episcopal Inst.; Yale Art Sch., 1878-79; ASL, c.1885, otherwise self-taught. **Member:** ANA, 1891; NIAL. **Exhibited:** NAD, 1887-99; Boston AC, 1890, 1891, 1909; Paris Expo, 1889, (med.); PAFA Ann., 1892-93, 1906-10; Corcoran Gal. annuals, 1907-08;

AIC. **Work:** Amon Carter Mus. (major coll.); Remington AM, Ogdensburg, NY (major coll.); NMAA; MMA; AIC; Gilcrease Inst.; Ogdensburg (NY) Pub. Lib.; NYPL; Shelburne (VT) Mus.; other major museums. **Comments:** Lauded as the most important painter documenting life in the vanishing West. His paintings were based on first-hand experiences, and everything that happened on the plains or in the mining camps served as his subject matter. He made numerous trips to the West and became skilled as a cowboy. He also prospected for gold in the Apache country of the Arizona Territory, and in Kansas operated a ranch and worked in a saloon. He spent winters in NYC, writing and painting, and winters in the West, Canada, or Mexico. His first commission was for *Harper's Weekly* in 1882, when he drew a picture of Geronimo's campaign. He began creating bronzes of western subjects in 1895, winning immediate attention with his first work, "The Bronco Buster." His bronzes became very popular and were reproduced in multiple series. In his lifetime, Remington produced about 25 bronzes, plus 3,000 paintings and drawings, and eight books. He also traveled to North Africa, Russia, Germany, England, Mexico, and Cuba as an artist-correspondent. One of his last sculptures was the cowboy statue erected in Fairmount Park, Philadelphia. From c.1886 he occupied a large studio which he had built at New Rochelle, NY; but about six months before his death he sold it and moved to Ridgefield, CT. Remington died of appendicitis a the age of forty-eight. **Sources:** WW10; Peter H. Hassrick, *Frederic Remington: Paintings, Drawings, and Sculpture in the Amon Carter Museum and the Sid W. Richardson Collections* (1973); Bruce Wear, *The Bronze World of Frederic Remington* (Tulsa, OK, 1966); Baigell, *Dictionary;* P&H Samuels, 395; Muller, *Paintings and Drawings at the Shelburne Museum,* 118 (w/repros.); Eldredge, et al., *Art in New Mexico, 1900-1945,* 206; Falk, *Exh. Record Series.*

REMINGTON, M. (Mrs.) *[Painter] mid 19th c.*
Addresses: Active in Detroit, MI. **Exhibited:** Michigan State Fair, 1855. **Sources:** Petteys, *Dictionary of Women Artists.*

REMINGTON, S. J. (Mr.) *[Painter] late 19th c.*
Addresses: Tacoma, WA, 1895. **Exhibited:** Tacoma Art Lg., 1895. **Comments:** Preferred medium: watercolor. **Sources:** Trip and Cook, *Washington State Art and Artists, 1850-1950.*

REMINGTON, Schuyler *[Illustrator] early 20th c.*
Addresses: New Rochelle, NY. **Studied:** Acad. Julian, Paris, 1910. **Member:** New Rochelle AA. **Sources:** WW24.

REMINICK, Harry *[Sculptor] b.1913, Cleveland, OH.*
Addresses: Cleveland. **Work:** Valley View Housing Proj., Cleveland. **Comments:** Specialty: animals. **Sources:** WW40.

REMLINGER, Joseph (J.) *[Painter, illustrator] b.1909, Trenton, NJ.*
Addresses: Trenton, NJ. **Studied:** Trenton Sch. Indust. Art; PAFA. **Member:** Morrisville-Trenton Art Group; PAFA. **Exhibited:** PAFA, 1933 (prize), 1948; PAFA Ann., 1941; AIC, 1941; Salons of Am., 1934; NAD, 1941-42; Montclair Art Mus., 1937-40; Kresge Exh., NJ, 1938-41; NJ State Mus., Trenton, 1939-45, 1950, 1954; NJ Gal., 1938 (prize), 1939 (prize), 1941 (prize) Asbury Park Soc. FA, 1938; South Jersey Soc. Art, 1936; Univ. Iowa, 1941; Joslyn Art Mus., 1941; Denver Art Mus., 1941; Morrisville-Trenton Art Group, 1949-55; 1952. **Awards:** PAFA Fellowship; prizes: Trenton Art Lg., 1929, 1931, 1935; Plainfield Art Group, 1938; Westfield, NJ, 1939; Shore & River Art Group, 1941. **Sources:** WW59; WW47; Falk, *Exh. Record Series.*

REMMEY, Charles H. *[Engraver] mid 19th c.*
Addresses: NYC, 1844-58. **Sources:** G&W; NYBD 1844-58.

REMMEY, Paul Baker *[Painter, designer, illustrator, teacher, comm a] b.1903, Philadelphia, PA / d.1958.*
Addresses: Philadelphia, PA. **Studied:** PM Sch. IA. **Member:** Phila. WCC; Phila. Sketch Club; Woodmere AA. **Exhibited:** PAFA, 1931-32, 1934-46; Phila. Art All., 1939-46; AIC, 1938, 1946; Woodmere Art Gal., 1940-46; Chicago Art Dir. Club, 1948 (gold medal); Terry AI, 1951 (prize);. **Work:** PM Sch. IA;

Fleisher Mem.; Gimbel Coll.; many Phila. H.S.; Woodmere Art Gal. **Comments:** Contrib. to national magazines with advertising paintings; *Phila. Record; Phila. Inquirer.* **Sources:** WW53; WW47.

REMMLEIN, Jules *[Sculptor] early 20th c.*
Addresses: Phila., PA. **Exhibited:** PAFA Ann., 1906. **Sources:** WW10; Falk, *Exh. Record Series.*

REMOUIT, L. *[Miniaturist, profilist] early 19th c.*
Addresses: Active Richmond, VA, August 1807 (with John McConachy, see entry); Charleston, SC, Nov. 1808. **Sources:** G&W; *Richmond Portraits;* Rutledge, *Artists in the Life of Charleston.*

REMPEL, Dietrich *[Sculptor] early 20th c.*
Addresses: Bluffton, OH. **Exhibited:** PAFA Ann., 1930. **Sources:** Falk, *Exh. Record Series.*

REMPEL, Helen H. *[Painter] mid 20th c.*
Addresses: Burbank, CA. **Exhibited:** GGE, 1939. **Sources:** Hughes, *Artists of California,* 463.

REMQUIT, Carl *[Painter] early 20th c.*
Addresses: Brooklyn, NY. **Sources:** WW08.

REMSEN, Helen Q. *[Sculptor, teacher] b.1897, Algona, IA.*
Addresses: Sarasota, FL. **Studied:** Univ. Iowa; Northwestern Univ. (B.A.); Grand Central Sch. Art; Georg Lober; John Hovannes. **Exhibited:** NAD, 1936; PAFA Ann., 1937; All. Artists Am., 1944, 1955; SSAL, 1944 (prize), 1945-46; Soc. Four Arts, 1942 (prize), 1943-45; Norton Gal. Art, 1944 (prize); Florida Fed. Art, 1939, 1941 (prize), 1942 (prize), 1943, 1944 (prize), 1945; Dallas Mus. FA, 1944 (prize); Nat. Sculpture Exh., Sarasota, 1953 (prize); Berkshire Sc. Group, 1954; Smithsonian Inst., 1954 (prize); New Orleans AA, 1954, 1955 (prize), 1956, 1957 (prize); Wash. Sculptors, 1954; Silvermine Gld. Artists, 1955; Sarasota AA, 1957, 1958; Florida Sculptors, 1958, 1960, 1961; Manatee (FL) AC, 1958 (solo); NSS, 1961. **Work:** fountains: Jungle Gardens, Sarasota; St. Boniface Church, Sarasota; Three Marys (marble) dedicated 1964, Grace and Holy Trinity Cathedral, Kansas City, MO. **Comments:** Teaching: Sarasota, FL, 25 years. **Sources:** WW66; WW47; Falk, *Exh. Record Series.*

REMSEN, Ira M. *[Painter] b.1876, NYC / d.1928, Carmel, CA.*
Addresses: NYC; Monterey Peninsula, CA. **Studied:** Acad. Julian, Paris, with J.P. Laurens & B. Constant, 1898. **Member:** Bohemian Club; Carmel AA; Paris AAA; Mural Painters. **Exhibited:** Santa Cruz Statewide, 1928. **Work:** Occidental College, Los Angeles. **Sources:** WW17; Hughes, *Artists of California,* 463.

REMSING, Gary See: **REMSING, (Joseph) Gary**

REMSING, (Joseph) Gary *[Painter, sculptor] b.1946, Spokane, Wash.*
Addresses: Modesto, CA. **Studied:** San Jose State Univ. (B.A. & M.A.). **Exhibited:** Solos: de Saisset Mus., 1969, Atherton Gal., Menlo Park, CA, 1970 & 1972, William Sawyer Gal., San Fran., 1971 & 1973 & Gerard John Hayes Gal., Los Angeles, 1972; Selection of Young Contemp. Calif. Artists, 1969 & 1970; Looking West 1970, Joslyn Art Mus., Omaha, NE, 1970; Gerard John Hayes Gallery, Los Angeles, CA. **Awards:** Walnut Creek Civic Arts Center Gal., 1969, Maryville College, TN, 1970 & Calif. Arts Comn., 1970. **Work:** De Saisset Mus., Univ. Santa Clara, CA. **Comments:** Publications: auth., articles, *San Francisco Chronicle,* 9/8/1969 & 5/7/1971; auth., article *West Art,* 9/1969; auth., articles, *Art-Forum,* 11/1969; auth., articles *Art Week,* 5/1971 & 4/1972. Teaching: Modesto Jr. College, 1971-. **Sources:** WW73.

REMUS, Peter *[Sculptor] b.c.1824, France.*
Addresses: Pittsburgh, PA, 1850. **Sources:** G&W; 7 Census (1850), Pa., III(2), 208.

RENADA *[Painter] early 20th c.*
Exhibited: S. Indp. A., 1932, 1934. **Sources:** Marlor, *Soc. Indp.*

Artists.

RENAUD, R. E. (or R. N.) *[Painter] late 19th c.*
Exhibited: Wash. WCC, 1899. **Sources:** McMahan, *Artists of Washington, DC.*

RENAUD, R. N. See: **RENAUD, R. E. (or R. N.)**

RENAULT, Antoine (Anthony or Antonio) *[Painter, gilder, varnisher] b.Paris, France / d.1829.*
Addresses: NYC, 1794 to c.1801; New Orleans, active 1803-27. **Comments:** Scenic interior painter and carriage painter. Also designed public firework displays that included large balloons as part of the spectacle. **Sources:** G&W; Gottesman, *Arts and Crafts in New York,* II, nos. 453-54; NYCD 1799-1801; New Orleans CD 1822-23. More recently, see *Encyclopaedia of New Orleans Artists.* 321.

RENAULT, Giorgio *[Sculptor] early 20th c.*
Addresses: Chicago, IL. **Exhibited:** AIC, 1914-18. **Sources:** WW17.

RENAULT, John Francis *[Allegorical & historical painter] late 18th c.*
Work: copy of "The Triumph of Liberty" was at NYHS in 1957. **Comments:** Renault claimed to have been at the Battle of Yorktown in 1781 as assistant secretary to Count de Grasse and Engineer to the French Army. His "Triumph of Liberty" was advertised in NYC in 1795 by D.F. Launy and again in 1797 by Renault and Verger. In 1819, he published an engraving of the British officers surrendering their arms to Washington at Yorktown, describing himself as a U.S. citizen. **Sources:** G&W; *Album of American Battle Art,* 47; Gottesman, *Arts and Crafts in New York,* II, nos. 99-101.

RENCH, Polly (Mary) See: **WRENCH, Polly (Mary)**

RENFREW, Evelyn Feader *[Painter] b.1893, San Francisco, CA / d.1974, Los Angeles, CA.*
Exhibited: FAP, Southern Calif., 1936. **Comments:** Specialty: watercolors. **Sources:** Hughes, *Artists of California,* 463.

RENFROW, Gregg *[Sculptor] b.1948.*
Addresses: San Francisco, 1975. **Exhibited:** WMAA, 1975. **Sources:** Falk, *WMAA.*

RÉNI, Bob See: **RAINEY, Robert E. L. (Réni)**

RENICK, Claribel H. *[Painter] early 20th c.*
Addresses: Los Angeles, CA. **Exhibited:** P&S Los Angeles, 1928. **Sources:** Hughes, *Artists of California,* 463.

RENIER, Joseph Emile *[Sculptor, teacher] b.1887, Union City, NJ / d.1966, NYC.*
Addresses: NYC. **Studied:** ASL with G. Bridgman, K. Cox & H. MacNei; studios of A.Weinman, A. Piccirilli; Acad. de la Grand Chaumière & Acad. Colarossi, Paris; studio asst. of V. Rousseau in Brussels, 1910-12; Am. Acad. in Rome (F.A.A.R.), 1915; interrupted by WWI; completed 1921). **Member:** ANA,1937; NSS; Medallic Art Soc.; Arch. Lg.; New Haven PCC; NAC. **Exhibited:** Newark Mus.; Arch. Lg.; NSS; Montclair Art Mus.; Garden Club Am., 1928 (prize), 1929 (prize).; PAFA Ann., 1931-33, 1937, 1942; Mattatuck Mus., Waterbury, CT, 1935; New Haven PCC, 1935; WFNY, 1939; Nat. Comp. for medal depicting 50th anniversary of the Medallic Art Co.,1949 (prize); AAPL, 1959 (med.); NAC, 1960 (med.); NAD, 1962 (Samuel Morse Medal),1965 (Elizabeth N. Watrous Gold Medal), 1966 (D.C. French med.); **Awards:** Prix de Rome, 1915. **Work:** Brookgreen Gardens, SC; Mattatuck Mus., Waterbury, CT; med., for Medallic Art Soc.; des., Omar Bradley medal, awarded by Veterans of Foreign Wars; Merit Award medal; Al Jolson medal, both awarded by the Veterans of Foreign Wars; Young Mem. medal, Monarch Life Ins. Co., 1951; Ross Mem. medal, for Am. Tuberculosis Assn., 1952; des., Civil War Centennial Medal; triptych, Citizens Comt. for the Army and Navy, 1945; bronze war mem. plaque, P.S. No. 45, Ozone Park, NY, 1947; the Great Star of Texas (25') for State of Texas Bldg., Dallas, 1936; 4 metopes repeated 7 times for Postal Administration Bldg., Wash., DC, 1933; WFNY,

"Speed" equestrian statue for Court of Communications, 1939; panels, entrance to Domestic Relations Court, Brooklyn, NY; medals, S.S. "United States"; submarine "Nautilus," 1954; Pangborn Bros.; 75th Anniversary medal for Am. Soc. Mech. Engineers, 1955; Nat. Heart Assn. award medal, 1958; Seley Fnd. medal, 1958; Daniel C. Gainey tablet, 1958; Charles E. Howard mem. medal, 1956; mem. plaques of Charles Henry & May Hanford MacNider, 1955; Arthur T. Galt, 1956; Robt. H. Gore & M. A. Hortt Mem. tablet, 1956; designed Mark Hopkins Medal in Hall of Fame Series, 1964 (NY Univ.); numerous portraits, reliefs & statuettes. **Comments:** Teaching: Yale Univ. Sch FA, 1927-41. **Sources:** WW66; add'l info. courtesy the artist's son, M.R. Donner; WW47; Falk, *Exh. Record Series.*

RENIERS, Peter *[Sculptor] mid 19th c.*
Addresses: Philadelphia, 1857. **Work:** NYHS: plaster bust of Elisha Kent Kane M.D. (1820-1857), signed and dated at Philadelphia 1857. **Sources:** G&W; NYHS Catalogue (1941) and NYHS Catalogue (1974), cat. no. 1084.

RENISON, Paula (Mrs. Herbert) See: **GERARD, Paula (Mrs. Herbert Renison)**

RENK, Merry (Merry Curtis) *[Designer, sculptor] b.1921, Trenton, NJ.*
Addresses: San Francisco, CA. **Studied:** Sch. Indust. Arts, Trenton, NJ; Inst. Design, Chicago. **Member:** Metal Arts Guild (pres., 1953). **Exhibited:** Nordness Gals., NYC, 1970 (solo); Objects USA Traveling Exh., USA & Europe, 1970-72; De Young Mem Mus., San Fran., 1971 (solo) & Mus. Hist. & Tech., Smithsonian Inst., 1971-72 (solo). Awards: San Fran. Art Comn. Awards, 1954 & 1959; San Fran. Women Artists Award, 1965. **Work:** San Fran. (CA) State College Lib.; San Fran. Art Comn.; Univ. Wisc.; Johnson's Wax Coll., Objects USA; Oakland (CA) Mus. Art. Commissions: "Wedding Crown," Johnson's Wax Coll., Objects USA, 1970. **Sources:** WW73; Uchida, "Jewelry by Merry Renk," *Craft Horizons* (Nov.-Dec., 1961); C. McCann, "Three Fine Craftsmen," *Artweek* (Feb., 1971); A. Fried, article, *San Francisco Examiner,* March, 1971.

RENNELL, J(ohn) W(atson) *[Painter, sculptor, illustrator, lecturer, teacher] b.1876, Foo Chow, China.*
Addresses: Boulder, CO. **Studied:** PAFA; H. Pyle. **Comments:** Teaching: Univ. Colorado. **Sources:** WW25.

RENNELS, F. M. *[Sculptor] b.1942, Sioux City, IA.*
Addresses: Elgin, IL. **Studied:** Eastern Illinois Univ. (B.S.); Stanford Univ., summer grad. study sculpture; Cranbrook Acad. Art, Bloomfield Hills, MI (M.F.A.). **Exhibited:** Kent (OH) State Blossom Summer Outdoor Sculpture Show, 1971; Mich. Artist Show, Detroit Art Inst., 1971; Multiples USA, Kalamazoo, MI, 1971; group & solo show, Spectrum Gal., NYC, 1972. Awards: Cranbrook Acad. Art Ann. Founders Award, 1970; Multiples USA Award, Kalamazoo, 1970; Troy (MI) Sculpture Comp. Award, 1971. **Work:** Elgin (IL) Civic Plaza; Judson College, Elgin. **Comments:** Preferred media: steel, aluminum. **Sources:** WW73.

RENNER, Otto (Hermann) *[Painter, etcher] b.1881, San Francisco, CA. / d.1950, San Bernardino County, CA.*
Addresses: Paso Robles, CA. **Studied:** C.H. Robinson; A. De Milhau; H. Wolf. **Exhibited:** Calif. State Fair, 1937. **Sources:** WW33; Hughes, *Artists of California,* 463.

RENNICK, Charles *[Painter] mid 20th c.*
Addresses: NYC. **Exhibited:** S. Indp. A., 1944. **Sources:** Marlor, *Soc. Indp. Artists.*

RENNIE, Frank *early 20th c.*
Exhibited: WMAA, 1924-1928; Salons of Am., 1934. **Sources:** Marlor, *Salons of Am.*

RENNIE, Helen (Sewell) *[Painter, designer, cartoonist] 20th c.; b.Cambridge, MD.*
Addresses: Arlington, VA; Washington, DC. **Studied:** Corcoran Sch. Art (honors); NAD; Charles W. Hawthorne. **Member:** AWCS; Soc Wash. Artists (vice-pres.); Artists Equity Assn.; Women in the Visual Arts. **Exhibited:** Corcoran Gal. biennials,

1959; other Corcoran Ga.l exhs., 1931, 1933; PAFA, 1934; MoMA, 1946; MMA, 1946, "Recent Drawings USA," 1956; Soc. Wash. Artists, 1948-71 (5 awards from various donors); Baltimore Mus. Regional, 1959-60 (prizes), 1964; "Washington Artists," PMG, 1971-72; Franz Bader Gal., Wash., DC, 1970s. **Work:** PMG; Am. Univ. College Law Watkins Coll., Wash., DC; U.S. Dept. Commerce, Wash., DC; U.S. Dept. State, Wash. DC; Clarendon Trust Co., Arlington, VA. Commissions: WPA mural design, Roosevelt H.S., Wash., DC, 1933-34. **Comments:** Preferred media: oils, acrylics. Positions: artist-des., War Food Admin., Wash., DC, 1940-45; art dir., U.S. Navy Dept., Wash., DC, 1948-51; visual info officer, U.S. Office Price Stabilization, Wash., DC, 1951-53. Teaching: PMG Sch.; Wash. ASL. **Sources:** WW73; WW47.

RENNINGER, Katharine S. *[Artist] mid 20th c.*
Addresses: Newtown, PA. **Exhibited:** PAFA Ann., 1962. **Sources:** Falk, *Exh. Record Series.*

RENNINGER, Paul *[Painter] early 20th c.*
Addresses: Newark, NJ. **Sources:** WW04.

RENNINGER, Wilmer Brunner *[Painter] b.1909, Boyettown, PA / d.1935.*
Studied: T. Oakley; H. Pullinger. **Work:** Reading Mus.

RENNO, Louis *[Artist] early 20th c.*
Addresses: Wash., DC, active 1905. **Sources:** McMahan, *Artists of Washington, DC.*

RENO, James *[Artist] mid 20th c.*
Addresses: New Castle, IN. **Exhibited:** PAFA Ann., 1951. **Sources:** Falk, *Exh. Record Series.*

RENO, Mary Bailey (Mrs.) *[Painter] 19th/20th c.*
Addresses: Oakland, CA, 1893-1903. **Exhibited:** Mechanics Inst., San Francisco, 1893. **Sources:** Hughes, *Artists of California,* 463.

RENO, Max *[Painter, etcher, commercial artist] early 20th c.*
Addresses: Los Angeles, CA. **Studied:** Royal Acad., Munich. **Exhibited:** Indep. Artists Los Angeles, 1923. **Comments:** Immigrated to the U.S. c.1922. He and his brother Louis opened the Reno Art School in 1924 in Los Angeles. **Sources:** Hughes, *Artists of California,* 463.

RENO, May Bayley *[Painter] late 19th c.*
Exhibited: Mechanics Inst., 1893. **Sources:** Hughes, *Artists of California,* 463.

RENO-HASSENBERG *early 20th c.*
Exhibited: Salons of Am., 1925. **Sources:** Marlor, *Salons of Am.*

RENOIR, Alexander *[Painter, silhouettist, engraver, restorer, museum proprietor, goldsmith, gilder, teacher] early 19th c.*
Addresses: New Orleans, 1819-32. **Comments:** In 1819 he was listed as a portraitist (in plaster), seal engraver, painting restorer, and hairworker; in 1820 he opened a museum that featured objects from around the world; in 1822, he advertised as a jeweller, engraver, and keeper of the Commercial Coffee-House and Museum; in 1827, as an engraver. In 1828, fire destroyed most of the objects in his museum. From 1829-32, he advertised as artist, hairworker, silhouettist, painting teacher, and engraver. **Sources:** G&W; Delgado-WPA cites *La. Gazette,* Oct. 27, 1819, New Orleans CD 1822, 1827, 1830, and New Orleans *Bee,* July 29, 1830. More recently, see *Encyclopaedia of New Orleans Artists,* 321, which contains additional contemporary references.

RENOUARD, George A. *[Graphic artist, painter] b.1885 / d.1954.*
Addresses: NYC. **Exhibited:** AIC, 1936; CAFA, 1938; 15 Gal., NYC, 1940 (solo). **Comments:** Birth date possibly 1884. **Sources:** WW40.

RENOUF, Edward Pechmann *[Painter, sculptor] b.1906, Hsiku, China.*
Addresses: East St. Washington, CT. **Studied:** Phillips Andover Acad., 1924; Harvard Univ., 1928; Columbia Univ., 1936-46;

drawing & painting with Carlos Merida, Mexico, 1941. **Member:** Sculptors Guild; Fed. Mod. P&S. **Exhibited:** WMAA Sculpture Ann., 1960 & 1964; threeman show, Zabriskie Gal., New York, 1960; CAFA Show, Wadsworth Atheneum, Hartford, 1961 (hon. men.); PAFA Ann., 1966; Spectrum Gal., NYC, 1970s. Other awards: second prize for sculpture, Sharon Creative Arts Found., 1964. **Work:** Commissions: steel sculpture, 1965 & mural painting, 1967, Horace Mann Sch., Riverdale, NY. **Comments:** Preferred media: acrylics, steel. Publications: contrib., Dyn, Mexico, 1942. Teaching: Akad. Bildenden Künste, Munich Germany, fall 1970. **Sources:** WW73; John Canaday, "Art; An Image is Created," *New York Times,* January 5, 1960; Brian O'Doherty, article, *New York Times,* March 31, 1962; Stuart Preston, article, *New York Times,* February 27, 1965; Falk, *Exh. Record Series.*

RENOUF, Emil *[Painter] late 19th c.*
Addresses: NYC. **Exhibited:** NAD, 1888. **Sources:** Naylor, *NAD.*

RENOUF-WHELPLEY, A. Vincent *[Painter] late 19th c.; b.New York.*
Exhibited: NAD, 1886; SNBA, 1892. **Sources:** Fink, *Am. Art at the 19th c. Paris Salons,* 384.

RENSHAW, Dagmar Adelaide (Mrs. E. J. Le Breton) *[Teacher, designer, illustrator] b.1891, New Orleans, LA.*
Addresses: New Orleans, active 1917-39. **Studied:** Newcomb College, 1908-12, 1914. **Exhibited:** Delgado Mus. Art, 1939. **Comments:** Illustr.: "France Amérique", 1932. Also an author and teacher of French and Italian. Cousin of Lea McLean Renshaw (see entry). **Sources:** *Encyclopaedia of New Orleans Artists,* 322.

RENSHAW, Lea McLean *[Painter] b.1887, New Orleans, LA / d.1973, New Orleans.*
Addresses: New Orleans, active c.1901-72. **Studied:** Elmire M. Villere, 1900-01. **Exhibited:** Artist's Assoc. of N.O., 1901; Grunewald's Music Store, N.O., 1901. **Comments:** Amateur painter of portraits, still lifes and historical subjects. **Sources:** *Encyclopaedia of New Orleans Artists,* 322.

RENSHAW, Linda *[Painter] mid 20th c.*
Addresses: Phila., PA. **Exhibited:** PAFA Ann., 1968. **Sources:** Falk, *Exh. Record Series.*

RENSHAWE, John Henry *[Painter, topographer, geographer] b.1852 / d.1934, Wash., DC.*
Addresses: Wash., DC, active 1877-1934. **Member:** Cosmos Club, 1880-1934. **Exhibited:** Wash. WCC, 1911-12. **Work:** Nat. Park Service, Yellowstone Nat. Park. **Comments:** Worked for U.S. Geological Survey, and was involved in many of its western expeditions. **Sources:** WW13; McMahan, *Artists of Washington, DC.*

RENSIE, Florine (Mrs. William J. Eisner) *[Painter] b.1883, Philadelphia, PA / d.1974, NYC.*
Addresses: NYC. **Studied:** ASL with Alexander Brook, Sidney Laufman; G. Picken. **Member:** NAWA; Studio Guild; Woodstock AA. **Exhibited:** Salons of Am., 1936; S. Indp. A., 1937-44; PAFA Ann., 1937; Corcoran Gal. biennial, 1941; VMFA, 1942; "Masterpieces of Tomorrow" Exh., Terry AI, 1952 (award); NAWA; Woodstock, NY (solo); City Center Gal. **Work:** Woodstock AA. **Comments:** Her brush name, "Rensie," is Eisner spelled backward. **Sources:** WW59; WW47; Woodstock AA; Falk, *Exh. Record Series.*

RENTERIA, Philip *[Painter] b.1947.*
Addresses: Houston, TX, 1975. **Exhibited:** WMAA, 19, 1975. **Sources:** Falk, *WMAA.*

RENTSCHLER, Fred *[Painter] early 20th c.*
Addresses: Cleveland, OH. **Exhibited:** AIC, 1931. **Sources:** WW25.

RENWICK, Edward A. *[Landscape painter] mid 20th c.*
Exhibited: Womens' Club, Evanston, IL, late 1930s. **Comments:** Painted in Calif. and New Mexico in the early 1930s. **Sources:**

info courtesy James E. Myers (1995).

RENWICK, Gladys W. *[Painter] b.1905, St. Louis, MO.*
Member: Acts of Art Gal., NYC. **Exhibited:** Lincoln Univ., 1950, 1966; Atlanta Univ., 1951(award); BMFA, 1954; NAD; PAFA, 1957; Chester City Fed. S&L, 1960; Beach Theatre, Cape May, 1961; Post House, NY; Bird Cage Gal., NYC. **Work:** Atlanta Univ.; Lincoln Univ. **Sources:** Cederholm, *Afro-American Artists.*

RENWICK, Howard Crosby *[Illustrator, painter] mid 20th c.*
Addresses: NYC. **Member:** SI; Allied AA. **Sources:** WW47.

RENWICK, James *[Amateur landscape painter] b.1792, Liverpool (England) / d.1863, NYC.*
Addresses: NYC. **Member:** Am. Acad. (bd. dir., 1817-20; mem., 1825); NAD (hon. amateur, 1842-60). **Exhibited:** Am. Acad., 1820 (frame of English and Am. views in 1820 [as I. Renwick]). **Comments:** Brought to America as a child and graduated from Columbia College, NYC, in 1807. Travelled in Europe with Washington Irving and was in business in NYC for several years. From 1820-53 he was professor of natural philosophy and experimental chemistry at Columbia and a widely respected consulting engineer. He was the father of James Renwick, the architect. **Sources:** G&W; DAB; Cowdrey, AA & AAU; Cowdrey, NAD.

RENWICK, William Whetten *[Architect, sculptor, painter,] b.1864, Lenox, MA / d.1933.*
Addresses: Short Hills, NJ. **Member:** SC; AIA, 1901; NSS. **Work:** Roman Catholic Church of All Saints, NYC; one of the towers of St. Patrick's Cathedral; pulpit, corner plot of Grace Episcopal Church, NYC. **Comments:** Inventor: "fresco-relief" in mural dec. Specialty: ecclesiastical arch./des. **Sources:** WW25.

RENZ, Belle *[Artist] late 19th c.*
Addresses: Wash., DC, active 1890. **Comments:** Probably the Bell Renz who painted the 1897 watercolor, "Sitting Bull, Chief of the Sioux," which is in the collection of the Buffalo Bill Memorial Mus. in Golden, CO. **Sources:** McMahan, *Artists of Washington, DC.*

RENZETTI, Aurelius *[Sculptor] early 20th c.*
Addresses: Phila., PA. **Studied:** PAFA. **Exhibited:** PAFA Ann., 1915-25, 1938. **Sources:** WW25; Falk, *Exh. Record Series.*

RENZI, Clement *[Sculptor] mid 20th c.*
Exhibited: PAFA Ann., 1964, 1966. **Sources:** Falk, *Exh. Record Series.*

REOPEL, Joyce *[Sculptor] b.1933, Worcester, MA.*
Addresses: NYC. **Studied:** Ruskin Sch. Drawing & FA, Oxford Univ., England; Yale-Norfolk Art Sch. (fellowswhip); Worcester Mus. Art Sch. (grad.). **Exhibited:** Boston Arts Festival; NIAL; Worcester Mus. Art; De Cordova & Dana Mus., Licoln, MA; Victoria & Albert Mus., London, England. **Awards:** NIAL; Wheaton College for research; Ford Found. grant. **Work:** Ohio State Univ., Columbus; Fogg Art Mus., Cambridge, MA; PAFA; Addison Gal. Am. Art, Andover, MA; Univ. Mass., Amherst. **Sources:** WW73.

REPETTO, Antonio *[Sculptor, teacher] b.1837, Genoa, Italy / d.1902, New Orleans, LA.*
Addresses: New Orleans, active 1876-1902. **Comments:** Member of the chorus of the French opera, he turned to sculpting when his dwarfism kept him from an operatic career. He created portraits in bust, statue and cameo, as well as vases and statues in plaster and cement. He did statues for carnival floats and his bust of philanthropist John McDonogh was reproduced for each of the McDonogh schools. **Sources:** *Encyclopaedia of New Orleans Artists,* 322.

REPPETO, John D. *[Painter] mid 20th c.*
Addresses: Kirkland, WA, 1946-47. **Member:** Puget Sound Group of NW Painters, 1946. **Exhibited:** SAM, 1946-47. **Comments:** Preferred medium: oil. **Sources:** Trip and Cook, *Washington State Art and Artists,* 1850-1950.

RESIKA, Paul *[Painter] b.1928, NYC.*
Addresses: NYC. **Studied:** Sol Wilson, 1940-44; Hans Hofmann, 1945-47, in New York; Venice & Rome, 1950-54. **Exhibited:** George Dix Gal., 1948 (solo); Peridot-Washburn Gal., NYC, 1964-65 & 1967-71 (solos); NAD, 1961, 1972; "Am. Landscape," Smithsonian Inst., 1968; "Hassam Exh.," Am. Acad. Arts & Letters, 1969-71 (Hassam Purchase Prize, 1971); Washburn Gal., NYC, 1970s. Other awards: Louis Comfort Tiffany Found. grant, 1959; Ingram Merrill Prize, 1969. **Work:** Indianapolis Mus. Art; Sheldon Mem. Gal., Univ. Nebraska, Lincoln; Hirshhorn Coll., Wash., DC; Sara Roby Found.; Mus. Contemp. Art, Bordighera, Italy. **Comments:** Positions: artist-in-residence, Dartmouth College, spring 1972. Teaching: Cooper Union, 1966-70s; ASL, 1968-69. **Sources:** WW73; Claire Nicholas White, "Resika's Mountains," *Art News* April, 1967; Mimi Shorr, "Passions in Balance," *Am. Artist* (Dec. 1972); also numerous reviews & articles, *New York Times; Time; Arts; Art News; Art Int.; Am. Artist.*

RESKO *[Painter] 20th c.*
Exhibited: S. Indp. A. **Sources:** Marlor, *Soc. Indp. Artists.*

RESLER, George Earl *[Etcher] b.1882, Waseca, MN.*
Addresses: St. Paul, MN. **Member:** Chicago SE. **Exhibited:** Minn. Art Comn., 1913 (prize), 1923 (prize), 1914 (prize); St. Paul Inst., 1918 (med.). **Work:** AIC; Smithsonian Inst., Wash., DC; Munic. Art Gal., Tampa; St. Paul Inst. **Sources:** WW40.

RESNICK, Milton *[Painter] b.1917, Bratslav, Russia.*
Addresses: NYC. **Studied:** Paris, France & NYC. **Exhibited:** DeYoung Mem. Mus., San Fran., 1955 (solo); WMAA, 1957-67 (4 exhs.); PAFA Ann., 1962, 1966; SFMA, 1963; Univ. Texas Art Mus., 1964 & 1968; Jewish Mus., NY, 1967; Howard Wise Gal., NYC, 1970s. **Work:** Calif. Mus. FA, Berkeley; MoMA; WMAA; Wadsworth Atheneum; Wake Forest College, Winston-Salem, NC. **Comments:** Teaching: Pratt Inst., Brooklyn; visiting lecturer & critic, RI, Yale Summer Sch., Wagner College & Silvermine; Univ. Calif., Berkeley, 1955-56; NY Univ., 1964-; NY Studio Sch., 1965-; Univ. Wisc.-Madison, 1966-67. **Sources:** WW73; Falk, *Exh. Record Series.*

RESNIKOFF, Isaac *[Painter] early 20th c.*
Addresses: NYC. **Exhibited:** S. Indp. A., 1925-29. **Sources:** Marlor, *Soc. Indp. Artists.*

RESNIKOFF, Mischa *early 20th c.*
Exhibited: Salons of Am., 1929. **Sources:** Marlor, *Salons of Am.*

RESSINGER, Paul M. *[Painter] early 20th c.*
Addresses: Chicago, IL. **Member:** GFLA. **Sources:** WW27.

RESTEIN, Edmund P. (or B.) *[Lithographer] b.1837, France / d.1891.*
Addresses: Philadelphia. **Comments:** Came to America c.1852. His father, James Restein [Reston in 1860 Census], was a "fancy card maker." Edmund and his younger brother Ludwig (see entry) were employed for a time by P.S. Duval (see entry), but in 1868 they went into business for themselves. **Sources:** G&W; Peters, *America on Stone;* 8 Census (1860), Pa., L, 252; *Portfolio* (Feb. 1954), 126 (repro.).

RESTEIN, Ludwig *[Lithographer] b.c.1838, France.*
Addresses: Philadelphia. **Comments:** Came to America c.1852. First employed by P.S. Duval (see entry) but after 1868 worked with his older brother, Edmund Restein (see entry). **Sources:** G&W; 8 Census (1860), Pa., L. 252; Peters, *America on Stone; Portfolio* (Feb. 1954), 126 (repro.).

RET, Etienne (Mr.) *[Painter, writer, lecturer] b.1900, Bourbonnais, France.* *Etienne*
Addresses: Hollywood. CA. **Studied:** Ecole des Arts Décoratifs, Paris; Maurice Dents; Georges Desvallieres. **Exhibited:** de Young Mus., 1943; PAFA Ann., 1947; London; Paris; NYC; Los Angeles; AIC. **Work:** de Young Mem. Mus.; Santa Barbara Mus. Art; Pasadena AI; San Diego FA Soc.; Witte Mem. Mus.; State Mus., France; Encyclopaedia Britannica Coll. **Comments:** Teaching: Chouinard Art Sch. Auth.: "Blindman's Bluff," 1929. **Sources:**

WW59; WW47; Falk, *Exh. Record Series.* More recently, see Hughes, *Artists of California,* 463.

RETHI, Lili (Elizabeth) *[Industrial artist, illustrator, lithographer] b.1894, Vienna, Austria.*
Addresses: NYC. **Studied:** Vienna Acad. with Otto Friedrich; Von Larisch. **Member:** Royal Soc. Arts, London, England (fellow). **Exhibited:** Berlin; Vienna; Stockholm; Arch. Lg. (solo); MMA, 1942; Am. Soc. Civil Engineers, 1942; 46 pictures of the Verrazano-Narrows Bridge construction, NY, at Smithsonian Inst., 1965; NY Worlds Fair, 1965. "The Bridge" (40 construction pictures) publ. 1965, Harper & Row. **Work:** Sperry Gyroscope Co., Turner Construction Co., Spencer, White & Prentis, Merritt, Chapman & Scott, Lever Bros., Walsh Construction Co., all of NY; S.C. Bliss Co., Canton, OH; Eastern Stainless Steel Corp., Balt., MD; Cities Service Co.; Bd. Water Supply, New York City (painting); Gibbs & Hill's "50 Years of Engineering Accomplishment," 1961 (painting); *New York Times* and *Esquire Magazine* (drawings); Surveyor, Nenninger & Chànevert, Montreal, Canada; Moran Towing & Transportation, NY; Am. Soc. Mech. Engineers; New York World's Fair Corp., 1964; construction pictures of the dam at Manicouagan, in the Arctic Circle. **Comments:** Illustr.: "U.S. Naval Dry Dock Construction," 1941, 1943; "Builders for Battle," 1946; "Tanker Construction," 1946; "The White House Reconstruction," 1950; illustr. for Encyclopaedia Americana, NY and Chicago; illustr., "Big Bridge to Brooklyn," 1956. Contrib. drawings to *New York Times Magazine* on construction of U.N. Building; Brooklyn Bridge; The White House, etc. Autobiography over Radio Salzburg in series "Culture & Science," 1955; illustr.: "St. Thomas More"; "Panama Canal," 1958; "Italy," 1958; "Man Against Earth," 1961. **Sources:** WW66; WW47.

RETHLAW, Orrin *[Sculptor] mid 20th c.*
Exhibited: S. Indp. A., 1937. **Sources:** Marlor, *Soc. Indp. Artists.*

RETTICH, Klara *[Painter] b.1860, NY / d.1916, Stuttgart, Germany.*
Studied: Robert Haug. **Comments:** Painted portraits, flowers, animals. **Sources:** Petteys, *Dictionary of Women Artists.*

RETTIG, John *[Painter, designer] b.c.1855, Cincinnati, OH / d.1932, Cincinnati.*
Addresses: Cincinnati. **Studied:** McMicken Sch. Design, 1873-81, with Duveneck, Potthast; Paris with Collin, Courtois, Prinet. **Member:** SC; Cincinnati AC; AFA. **Exhibited:** PAFA Ann., 1896-1910 (4 times); Boston AC, 1902; AIC; S. Indp. A., 1917. **Work:** Cincinnati Art Mus. **Comments:** Much of his life was spent in Holland, among the fishing villages. He also decorated and modeled Rookwood pottery. Afterwards he painted theatrical scenery; produced pageants in Cincinnati and NYC; and went to North Africa, Mexico and the Southwest. **Sources:** WW31; Samuels, 396; *Cincinnati Painters of the Golden Age,* 97 (w/illus.); Falk, *Exh. Record Series.*

RETTIG, John (Mrs.) *d.1919, Cininnati, OH.*
Member: Cincinnati Women's Club (hd. art dept.); Cincinnati MacDowell Soc.

RETTIG, Martin *[Painter] early 20th c.; b.Cincinnati.*
Addresses: Cincinnati, OH. **Studied:** F. Duveneck. **Member:** Cincinnati AC. **Sources:** WW31.

RETTSTATT, E. Myrna *[Artist] early 20th c.*
Addresses: Wash., DC, active 1920-35. **Exhibited:** Gr. Wash. Indp. Exh., 1935. **Sources:** McMahan, *Artists of Washington, DC.*

RETZ, Philip *[Painter, architect, designer, craftsperson, teacher] b.1902, Berlin, CT.*
Addresses: Omaha, NE. **Studied:** T.R. Kimball; A. Dunbier. **Sources:** WW40.

REUHL, George Albert *[Painter] early 20th c.*
Addresses: NYC. **Exhibited:** S. Indp. A., 1924-25. **Sources:** Marlor, *Soc. Indp. Artists.*

REUL, Alexander *[Sculptor] b.1874 / d.1937, White Plains, NY.*

REUM, Maxine *[Painter, sculptor] mid 20th c.*
Addresses: Chicago area. **Exhibited:** AIC, 1947, 1950. **Sources:** Falk, *AIC.*

REUSCH, Helen *[Painter] 19th/20th c.*
Addresses: Cambridge, MA. **Exhibited:** Boston Art Club, 1898. **Sources:** WW01.

REUSCH, Helga *[Painter] 19th/20th c.*
Addresses: Cambridge, MA, active 1898-1901. **Exhibited:** Boston Art Club, 1898. **Comments:** *Cf.* Helen Reusch. **Sources:** *The Boston AC.*

REUSING, Fritz *[Painter] early 20th c.*
Exhibited: AIC, 1925. **Sources:** Falk, *AIC.*

REUSSNER, Robert *[Engraver] mid 19th c.*
Addresses: NYC, 1859. **Sources:** G&W; NYBD 1859.

REUSSWIG, William *[Illustrator, writer] b.1902, Somerville, NJ. / d.1978, NYC.*
Addresses: NYC. **Studied:** Amherst College; ASL. **Member:** SI. **Comments:** Illustr. of adventure, the Old West, sports. Auth./illustr.: *A Picture Report of the Custer Fight.* Illustr.: *Collier's, True.* **Sources:** WW47; Samuels, 396.

REUTER, George *[Engraver] late 19th c.*
Addresses: Wash., DC, active 1877. **Sources:** McMahan, *Artists of Washington, DC.*

REUTER, Herman *[Painter, etcher] b.1888, Santa Ana, CA / d.1965, Los Angeles County, CA.*
Addresses: Los Angeles County, CA. **Member:** Calif. AC. **Comments:** Position: rep., *Santa Ana Register*; ed., *Hollywood Citizen News.* **Sources:** Hughes, *Artists of California,* 463.

REUTER, William *[Artist] late 19th c.*
Addresses: Wash., DC, active 1892-93. **Sources:** McMahan, *Artists of Washington, DC.*

REUTERDAHL, Henry *[Painter, illustrator, writer] b.1871, Malmo, Sweden / d.1925, Wash., DC.*
Addresses: NYC; Weehawken, NJ; Wash, DC. **Studied:** self-taught. **Member:** Arch. Lg., 1911; Assn. U.S. Naval Arch. Eng.; Artists Fund Soc.; Mural Painters; AG, Authors Lg. Art. **Exhibited:** PAFA Ann., 1901, 1908-21; Corcoran Gal. biennials, 1907-19 (5 times); Armory Show, 1913; Pan-Pacific Expo, San Fran., 1915 (med.); S. Indp. A., 1917; Phila. WCC, 1919 (prize); AIC. **Work:** U.S. Naval Acad., Annapolis; Navy Dept., Wash., DC; Nat. Mus., Wash., DC; Naval War College, Newport; TMA; Kalamazoo AA; Culver Military Acad.; Capitol, Jefferson City, MO. **Comments:** He specialized in naval, marine, and industrial subjects, and earned his reputation as an artist-correspondent during Spanish-Am. War. Later, he became best known for his dramatic illustrations as an official artist for the U.S. Navy during WWI, 1917-18. **Sources:** WW25; Falk, *Exh. Record Series;* Brown, *The Story of the Armory Show.*

REUTHER, Richard G. *[Sculptor, wood carver] b.1859 / d.1913, Detroit, MI.*
Addresses: Detroit, MI, 1876-1913. **Comments:** Associated with Edward O. Wagner in Wagner & Reuther, sculptors, 1885-87; Reuther & Co., wood carvers, 1888; the Wilton, Reuther C., arch. sculptors and carvers, 1899-1900+. **Sources:** Gibson, *Artists of Early Michigan,* 201.

REVA *[Painter, illustrator, designer] b.1925, Coney Island, NY.*
Addresses: New York 11, NY. **Studied:** ASL with Robert Hale (Carnegie Scholarship, 1942). **Exhibited:** Colorado Univ., 1958; Carnegie Inst., 1958; Corcoran Gal. biennial, 1959; Salzburg Biennale, 1959; traveling exh., Europe, 1958-59. **Comments:** Specialist in advertising illustration and design during the 1940s-50s. **Sources:** WW59.

REVALEON, Albert LaMartine *[Painter, printmaker] b.1903, San Francisco, CA / d.1944.*
Addresses: San Fran. **Exhibited:** San Fran. AA, 1924. **Sources:** Hughes, *Artists in California,* 463.

REVENAUGH, Aurelius O. *[Portrait painter] b.1840, Zanesville, OH / d.1908.*
Addresses: Jackson, MI, 1871-87; Louisville, KY in 1880-1908. **Studied:** Univ. Michigan (medical degree); John Mix Stanley. **Exhibited:** Michigan State Fair, 1876. **Work:** Univ. Kentucky Art Mus., Lexington. **Comments:** Following the Civil War, he returned to Ann Arbor, MI, where he became an artist. In partnership with William H. McCurdy as Revenaugh & McCurdy, 1879. **Sources:** Gibson, *Artists of Early Michigan,* 201; Jones and Weber, *The Kentucky Painter from the Frontier Era to the Great War,* 64 (w/repro.).

REVERE, C. H. *[Landscape painter] mid 19th c.*
Addresses: San Francisco, 1859. **Sources:** G&W; San Francisco BD 1859.

REVERE, Joseph Warren *[Topographical artist, writer] b.1812, Boston / d.1880, Hoboken, NJ.*
Comments: Grandson of Paul Revere (see entry). Entered the Navy as a midshipman in 1812; was well-traveled and rose to lieutenant before his retirement in 1850. From 1845-48 he was assigned to California and commanded the party which raised the American flag at Sonoma in July 1846. He was back in California for the Gold Rush in 1949. Revere's *Tour of Duty in California* (1849), is illustrated by a number of California views from sketches by him. Served during the Civil War as a colonel and brigadier-general in the New Jersey Volunteers. Later settled in Hoboken, NJ. **Sources:** G&W; DAB; Van Nostrand and Coulter, *California Pictorial,* 52-53; Jackson, *Gold Rush Album,* 4-7; P&H Samuels, 396.

REVERE, Paul *[Engraver, printer, silversmith] b.1735, Boston, MA / d.1818, Boston.*
Addresses: spent his entire life in Boston. **Studied:** silversmithing with his father, Apollos Rivoire. **Work:** John Singleton's portrait of Paul Revere is at the BMFA. **Comments:** Trained as a silversmith, Revere took up engraving about 1765 and throughout his career engraved bills, money, musical scores, political prints, cartoons, portraits, and views. He was also a copper worker, bell caster, and watercolorist. His best-known engraving, the "Boston Massacre," was actually based on a depiction made by Henry Pelham (see entry). Revere is most famous for his activities as a patriot before and during the American Revolution. **Sources:** G&W; Goss, *The Life of Colonel Paul Revere;* Forbes, *Paul Revere and the World He Lived In.* More recently, see Clarence S. Brigham, *Paul Revere's Engravings* (1969); Baigell, *Dictionary;* Saunders and Miles, 307-08 (which reprints excerpts of an angry letter from Pelham to Revere regarding Revere's engraving of "The Boston Massacre").

REVEREND, J. See: **REVEREND, T.**

REVEREND, M. M. *[Painter] early 20th c.*
Addresses: Kansas City, MO. **Sources:** WW17.

REVEREND, T. *[Sculptor] mid 19th c.*
Addresses: Philadelphia. **Exhibited:** PAFA, 1859. **Sources:** G&W; Rutledge, PA.

REVESZ-FERRYMAN, Francis See: **FERRYMAN, F(rancis) Revesz**

REVIERE *[Scene painter] mid 19th c.*
Addresses: Active in NYC, 1858. **Comments:** Working at Wallack's Theatre, NYC, in 1858. Painted a number of Utah scenes for the production of *Deseret Deserted, or the Last Days of Brigham Young.* It is likely he is actually Edward Riviere (see entry). **Sources:** G&W; N.Y. *Herald,* May 24, 1858.

REVINGTON, George D. III *[Collector] 20th c.*
Addresses: West Lafayette, IN. **Comments:** Collection: modern Am. painting and sculpture, exhibited at the AFA, MoMA and at

various galleries and art shows. **Sources:** WW73.

REVOR, Remy Ssnd *[Designer, educator] b.1914, Chippewa Falls, WI.*
Addresses: Milwaukee, WI. **Studied:** Mt. Mary College (B.A.); Sch. AIC (B.F.A. & M.F.A.). **Member:** Wisc. Designer Craftsmen (publ. chmn., 1966-68); College AA Am. **Exhibited:** Wisc. Designer Craftsmen Ann., 1953-72; Mus. Contemp. Crafts, New York, 1962, 1963 & 1966-68; Wichita AA, 1964; Chicago Pub. Lib., 1964. Awards: Louis Comfort Tiffany Found. Award For Textiles, 1962; Am. Inst. Architects Gold Medal Award For Craftsmanship, 1967; Fulbright Award res. textile design, Finland, 1969-70. **Work:** Milwaukee AC; St. Paul (MN) AC; Mus. Texas Tech. Univ.; Objects USA, Johnson Coll. Contemp. Crafts. **Comments:** Teaching: Mt. Mary College, 1952-70s; Arrowmont Sch. Arts & Crafts, Gatlinburg, TN, summers 1969-72. **Sources:** WW73.

REVZAN, Daniel *[Painter] b.1908, Chicago, IL / d.1996.*
Addresses: Woodstock, NY, 1950. **Studied:** John Norton, 1926. **Member:** Woodstock AA. **Exhibited:** Chicago No Jury; Romany Club; Gaulois Gal.; AIC; MMA; Paradox Gal., Woodstock; Woodstock AA. **Comments:** Painter of portraits and nudes. WPA artist, sponsored by the Whitney Mus. Revzan also worked for Buckminster Fuller. **Sources:** Woodstock AA.

REWALD, John *[Art historian, educator] b.1912, Berlin, Germany.*
Addresses: NYC. **Studied:** Univ. Hamburg, 1931; Univ. Frankfurt-Am-Main, 1931-32; Sorbonne (Ph.D., 1936). **Member:** CAA. **Exhibited:** Awards: Prix Charles Blanc, Acad. Française, 1941; Knight, Legion of Hon., 1954. **Comments:** Positions: cur. private coll., John Hay Whitney; assoc. MoMA, 1943-. Teaching: Princeton Univ., 1961; Univ. Chicago, 1964-71; City Univ. NY, 1971-. **Auth.:** *The History of Impressionism* (MoMA, 1946, 62, 69), *Post-Impressionism-from Van Gogh to Gauguin* (MoMA, 1956, 62); auth., *Paul Cezanne: A Biography* (Schocken, 1968); auth., books on Bonnard, Pissaro, Seurat, Manzu, Degas and Maillol. **Sources:** WW73.

REXACH, Alberto *[Painter] early 20th c.*
Addresses: NYC. **Comments:** Affilated with Caldwell & Co. **Sources:** WW24.

REXFORD, Blanch *[Painter] late 19th c.*
Exhibited: Detroit AA, 1876. **Sources:** Petteys, *Dictionary of Women Artists.*

REXROTH, Andrée Schafer (Mrs.) *[Painter] b.1902, Chicago, IL / d.1940, San Francisco, CA.*
Addresses: San Fran. **Studied:** Acad. FA, Chicago. **Exhibited:** CPLH, 1930; Santa Monica Pib. Lib., 1932 (solo); San Fran. AA, 1932; Oakland Art Gal., 1932; Paul Elders Gal., 1935; Downtown Gal., NYC, 1937; AIC, 1938; de Young Mus., 1939. **Comments:** WPA artist. **Sources:** WW40; Hughes, *Artists of California,* 464.

REY, H(ans) A(ugusto) *[Illustrator, writer, lithographer, cartoonist] b.1898, Hamburg, Germany. / d.1977.*
Addresses: NYC; Cambridge, MA. **Studied:** Univ. Munich; Univ. Hamburg. **Member:** Am. Craftsmans Council; AIGA. **Exhibited:** 1946 Books by Offset Lithography Exh., NYC; 1946 Best Picture Books; AIGA, 1941 for "Curious George". **Work:** Kerlan Coll.; Univ. Southern Miss.; Univ. Oregon. **Comments:** Preferred media: gouache, india ink, crayon. Publications: numerous illustrated childrens books, Harper, 1941-62 & including "Curious George" series & others, Houghton, 1941-66. Auth./illustr.: "Curious George," 1941; "Cecily G.," 1942; "Look for the Letters," 1945 & numerous others, mainly for children. Illustr.: "Park Book," 1944; "Spotty," 1945; comic trip "Pretzel." **Sources:** WW47; WW73.

REY, Jacques Joseph *[Lithographer, printer] b.1820, Bouxviller (Alsace) / d.1892, San Francisco, CA.*
Addresses: San Fran. from 1852. **Studied:** art & lithography in France. **Work:** Work produced by Britton & Rey (and Britton, Rey & Co.) is represented at the Soc. of Calif. Pioneers (San

Fran.); Univ. Lib. at UCLA, Special Coll. Div.; Calif. Hist. Soc. (San Fran.), and other locations (see Reps). **Comments:** As a young man went to Russia as companion, secretary, and interpreter to a nobleman. Joined the Gold Rush to California in 1852, settling in San Francisco. For the next three decades was associated in lithography with his brother-in-law Joseph Britton (see entries for Joseph Britton and Britton & Rey). The Britton & Rey partnership was extremely successful, printing numerous views of California towns. **Sources:** G&W; Peters, *California on Stone;* 8 Census (1860), Cal., VII, 587; San Francisco BD 1856; 1858; Howells, *California in the Fifties.* More recently, see Reps, 188 (note 3) and many cat. entries under Britton & Rey and Britton, Rey, & Co.; Hughes, *Artists in California,* 464.

REY, Lopez *[Painter] mid 20th c.*
Exhibited: AIC, 1947. **Sources:** Falk, *AIC.*

REY, Louis Martin *[Portrait painter] b.1886, San Francisco, CA / d.1908.*
Addresses: San Fran.; New Mexico. **Studied:** Mark Hopkins Inst.; Ecole des Beaux-Arts, Paris. **Comments:** He developed tuberculosis in Paris and died at age 21. **Sources:** Hughes, *Artists of California,* 464.

REY, Marie See: **SANDER, Marie Rey**

REY, Sylvia Jura *[Painter] b.1864, San Francisco, CA / d.1941, Berkeley, CA.*
Addresses: San Fran.; Berkeley. **Member:** San Fran. Sketch Club. **Comments:** Daughter of Jacques Rey (see entry). **Sources:** Hughes, *Artists of California,* 464.

REYAM, David *[Painter, designer] b.1864, NYC / d.1943, Wilmington, DE.*
Addresses: Phila., PA; Wilmington, DE. **Studied:** NAD; Acad. Julian, Paris, with Lefebvre & Bouguereau. **Exhibited:** PAFA Ann., 1898, 1900; S. Indp. A., 1939. **Sources:** WW40; Falk, *Exh. Record Series.*

REYBURN, William F. *[Painter] 19th/20th c.*
Addresses: Wash., DC. **Exhibited:** Soc. Wash. Artists, 1898. **Sources:** WW01; McMahan, *Artists of Washington, DC.*

REYDER, William S. *[Painter] late 19th c.*
Exhibited: Mechanics Inst., San Francisco, 1893. **Sources:** Hughes, *Artists of California,* 464.

REYFF, Louis *[Engraver, jeweler, watchmaker] late 19th c.*
Addresses: New Orleans, active 1888-91. **Sources:** *Encyclopaedia of New Orleans Artists,* 323.

REYNAL, Adele *early 20th c.*
Exhibited: Salons of Am., 1928, 1933. **Sources:** Marlor, *Salons of Am.*

REYNAL, Jeanne *[Mosaic artist] b.1903, White Plains, NY.*
Addresses: Calif., 1939-46; NYC thereafter. **Studied:** Atelier, Paris, France, apprentice with Boris Anrep, 1930-38. **Exhibited:** San Fran. AA, 1945 (Emmanuel Walter purchase prize for Yuba, a mosaic); Iolas Gal., 1947 (with A. Gorky & W. Lam); WMAA, 1951-57; Loeb Gal., NY Univ., 1961; PVI Gal., NYC, 1964; SFMA traveling exh. to Boston, Montreal, Lincoln (NE), Amarillo (TX), 1964; Betty Parsons Gal., 1971 & Newport (RI) AA, 1971. **Work:** MoMA; WMAA; Ford Found., White Plains; Walker AC, Minneapolis; Rockefeller Univ. Commissions: Ford Found. Program Adult Educ., White Plains, 1959; Our Lady of Florida, Palm Beach, 1962; Cliff House, Avon, CT, 1962; Nebraska State Capital, Lincoln, 1965-66; S.S. *Joachim* & Ann Church, Queens Village, NY, 1967. **Sources:** WW73; Hans Unger, *Practical Mosaic* (1965); Barbara Poses Kafka, "Art & Architecture," *Craft Horizons* (Jan.-Feb., 1968); Paul Falkenberg (producer & ed.), "Mosaics: The Work of Jeanne Reynal" (film), 1968; Wechsler, 30.

REYNAL, Louis *[painter] early 20th c.*
Exhibited: Salons of Am., 1933. **Sources:** Marlor, *Salons of Am.*

REYNARD, Carolyn Cole *[Painter, instructor] b.1934, Wichita, KS.*
Addresses: Poughkeepsie, NY. **Studied:** Wichita State Univ. (B.F.A.; Ohio Univ. (M.F.A.). **Member:** NY State Art Teachers Assn.; Dutchess Co. AA. **Exhibited:** Air Capitol Ann., Wichita (KS) Art Mus., 1956; Exh. 1980, Huntington WV) Gals., 1957-59; Santa Barbara (CA) Art Mus., 1960; Artists of Santa Barbara, Faulkner Gal., Santa Barbara, 1960-62; Artists of Central New York, Munson-Williams-Proctor Inst. Mus Art. Utica, NY, 1964-65 & 1967. **Work:** Wichita State Univ. **Comments:** Publications: auth.," I Can't Draw," *School Arts,* 1971. Teaching: Ohio Univ., 1958-59; State Univ. NY College Oswego, 1963-69; Wappingers Central Sch. District, NY, 1969-. **Sources:** WW73.

REYNARD, Grant (Tyson) *[Painter, etcher, lithographer, illustrator, lecturer, writer] b.1887, Grand Island, NE / d.1967, NYC.*
Addresses: Leonia, NJ. **Studied:** AIC; Chicago Acad. Art; Harvey Dunn; Harry Wickey; Mahonri Young; Baldwin-Wallace College (hon. deg., LH.D., 1955). **Member:** ANA; AWCS (council, 1958-61); SAGA; Audubon Artists; New Jersey AA; New Jersey WCS; All. Artists Am.; Am. Artists Group; Prairie PM;.Phila. SE. **Exhibited:** Salons of Am.; WFNY, 1939; AGAA (solo); LOC, 1944 (prize); AAPL, 1934 (prize); WMAA, 1938; SC, 1939 (prize); Joslyn Mem.; Univ. Nebraska; Univ. Tulsa; AIC; PAFA; NAD; SC (prize); Kennedy & Co. (solo); Clayton Gal. (solo); Grand Central Art Gal. (solo); Assn. Am. Art (solo); McD. Club (solo); Bucknell Univ., 1946 (solo); Montclair Art Mus., 1958 (solo). **Work:** Montclair Art Mus.; Norton Gal. Art; Newark Mus.; FMA; Univ. Tulsa; MMA; NYPL; LOC; AGAA; de Young Mem. Mus.; Univ. Nebraska; NJ State Mus., Trenton; panels, Calvary Episcopal Church, NY; murals, St. John's Church, Leonia, NJ, First Baptist Church, Hackensack, NJ. **Comments:** Teaching: Millbrook Sch. (NY), Palo Duro Sch. Art (Canyon, TX). Position: pres., Montclair (NJ) Art Mus. Illustr.: "Rattling Home for Christmas," 1941 (Am. Artists Group). Contrib. to *Scribner's*; biographical article by Norman Kent, *Am. Artist* magazine, 1961; contrib. of articles to *Am. Artist,* including "Lithographs, Childe Hassam", and on the Barnes Coll. **Sources:** WW66; WW47.

REYNEAU, Betsy Fraves (Mrs.) *[Portrait painter] b.1888, Battle Creek, MI / d.1964, Camden County, NJ.*
Studied: Boston Mus. Sch. FA with Duveneck; Paris; Rome. **Exhibited:** Nat. Coll. FA, 1944 (joint with L. Waring, portraits of distinguished black leaders; also toured U.S.). **Work:** Nat. Portrait Gal. **Comments:** Cf. Mrs. Paul O. Reyneau. **Sources:** Petteys, *Dictionary of Women Artists.*

REYNEAU, Paul O. (Mrs.) *[Painter] early 20th c.*
Addresses: Detroit, MI. **Comments:** Cf. Mrs. Betsy Fraves Reyneau. **Sources:** WW21.

REYNERSON, June *[Painter, sculptor, craftsworker, educator] b.1891, Mound City, KS.*
Addresses: Terre Haute, IN. **Studied:** Indiana State Normal Sch.; PIA Sch.; Indiana State Teachers College (B.S.); Columbia Univ. (M.A.); Robert Henri; Joseph Pennell. **Member:** AAPL; Pen & Brush Club. **Comments:** Teaching: Indiana State Teachers College, Terre Haute, IN. Lectures: "Contemporary Trends in Painting"; "Architecture of Today and Yesterday." **Sources:** WW59.

REYNES, Polyxene Mazureau (Mrs. Joseph Reynes)
[Miniaturist] b.1808, New Orleans / d.1879, New Orleans.
Addresses: New Orleans, active 1831. **Studied:** Louis François Aubry. **Work:** New Orleans Mus. Art. **Sources:** G&W; *Bee,* March 4, 1879; *Encyclopaedia of New Orleans Artists,* 323; Petteys, *Dictionary of Women Artists,* cites birth date of 1805.

REYNOLDS, Alice *[Painter] mid 20th c.*
Addresses: Albany, TX. **Exhibited:** 48 Sts. Comp., 1939. **Sources:** WW40.

REYNOLDS, Alice M. *[Painter] early 20th c.; b.Olcott, NY.*
Addresses: Denver, CO, 1902; NYC, 1905-08. **Studied:** ASL; Paris with Merson, Collin, Aman-Jean. **Exhibited:** AIC, 1902, 1907. **Sources:** WW08.

REYNOLDS, Catherine *[Amateur landscape artist in pencil, crayon, sepia wash, and watercolors] b.c.1782, Detroit, MI / d.1864, Amherstburg, Ontario, Canada.*
Addresses: Amherstburg, Ontario (near Detroit, MI), 1796-1864. **Studied:** self-taught. **Work:** Detroit Inst. Arts; Hiram Walker Hist. Mus. (Windsor, Ontario); Fort Malden Mus. (Amherstburg, Ontario). **Comments:** One of the earliest artists of the Detroit River region. Born in Detroit (then Upper Canada) while her father was British Commissary there, she lived there until 1796 and thereafter at Amherstburg, where her father was Deputy Commissary. She lived in Amherstburg the rest of her life. About thirty works have been attributed to her, dating from about 1810-20 and consisting primarily of landscapes and scenes along the Detroit River and Lake Erie. **Sources:** G&W; Robinson, "Early Houses on the Detroit River and Lake Erie in Workings by Catherine Reynolds;" McDonald, *Dictionary of Canadian Artists,* vol. 7.

REYNOLDS, Charles H(enry) *[Painter] b.1902, Kiowa, OK.*
Addresses: Taos, NM. **Studied:** AIC; John Eliot Jenkins. **Member:** Taos AA. **Exhibited:** CAFA, 1940; Tulsa AA, 1936-46; Oakland Art Mus., 1943, 1948; El Paso AA, 1948; Mus. New Mexico, 1947-53; Oklahoma AA, 1949; Harwood Lib. & Art Mus., Taos, 1947-52; Springville H.S., 1951-52; Terry AI, 1952; Louisiana State Mus., 1952; Philbrook Mus. Art, 1943-50 (solos); Raton AA, 1949; San Angelo AA, 1949; Oklahoma AC, 1949; Phillips Univ., Enid, OK, 1949; Tulsa Art Gld., 1950; Amarillo College, 1950; Oklahoma City Univ., 1951; Phoenix FAA, 1952; Tri-State Fair, Amarillo, TX, 1953, 1955; Texas FAA, 1954; Manhattan (KS) Pub. Lib., 1955; Mus. New Mexico; Louisiana State Mus.; Laguna Gloria Mus. **Work:** Koshare Mus., La Junta, CO; Gilcrease Found., Tulsa; Southwestern Univ., Georgetown, TX. **Sources:** WW59.

REYNOLDS, Clara W. (Mrs.) *[Mural & portrait painter, designer, decorator, printmaker, drawing specialist, illustrator, teacher, writer] b.1899, East Poultney, VT.*
Addresses: Rutland, VT. **Studied:** Syracuse Univ.; Boston, Vesper George Sch. Art; Fontainebleau Sch. FA. **Member:** Rutland AC (director). **Work:** illumination, Rutland Pub. Lib. **Comments:** Teaching: Meldon Sch., Rutland, VT. **Sources:** WW40.

REYNOLDS, Depew Robert *[Artist] b.1936 / d.1985.*
Member: Woodstock AA. **Sources:** Woodstock AA.

REYNOLDS, Douglas Wolcott *[Painter, educator, lecturer, illustrator, engraver] b.1913, Columbus, GA.*
Addresses: Georgetown, TX; Newtonville, MA. **Studied:** Ringling Sch. Art; Univ. Miami; Columbia Univ. (M.A.; F.A. in Educ.); North Carolina State College, Sch. Des.; Yale Univ. (B.F.A.). **Member:** Florida Fed. Art; Texas FAA; Am. Soc. for Aesthetics; Boston Regional Council Art Educ. **Exhibited:** North Carolina State College Union; Columbia Art Gal.; Fla. State Expo, 1930; Rome, Italy, 1941; Florida Fed. Art, 1934-36; New Haven, T, 1941-42 & 1946 (solo); North Carolina, 1947-55; NYC, 1949 (solo); Virginia, 1952; Akron, OH, 1959; Massillon, OH, 1959; Tufts Univ. 1964, World Art Gal., Newton, MA, 1965 (solo). **Awards:** Yale Univ., 1941-42 (fellowship); Beaux-Arts Comp., 1940; Southern F. Fund grant, 1955. **Work:** Southwestern Univ. **Comments:** Teaching: Southwestern Univ., Georgetown, TX, 1943-46; Meredith College, Raleigh, N.C., 1946-57; Kent (OH) State Univ., Sch. Art, 1957-59; Wheelock College, Boston, 1959-64; Tufts Univ., Medford, MA, 1960-; consult., Oriental Art Hist., Lexington (MA) Public Sch., 1964, 1965; faculty, Boston Mus. FA Sch., 1960-.Lectures: Oriental Art and Philosophy; "On Bringing Criticism of Southern Sung Painting Up to Date," (College Art Conf., Cleveland), 1958; "Sincerity & Decadence in

Art," Am. Soc. Aesthetics Conf., Cincinnati, 1959;"Development of Modern Painting," Inst. Contemp. Art, Boston, 1960; "Art and Society", Boston Mus. FA, 1965. **Sources:** WW66; WW47.

REYNOLDS, Edith (Miss) *[Painter] b.1884 / d.1964, Wilkes-Barre, PA.*
Addresses: Wilkes-Barre, PA, c.1915-19. **Exhibited:** S. Indp. A., 1917-19; Salons of Am., 1922. **Sources:** WW19; Marlor, *Salons of Am.*

REYNOLDS, Elizabeth *[Painter] 19th/20th c.*
Addresses: Boston, MA, active 1895-1901. **Exhibited:** Boston AC, 1895-96; PAFA Ann., 1895-97; NAD, 1896. **Sources:** WW01; Falk, *Exh. Record Series.*

REYNOLDS, Emanuel *[Portrait & miniature painter] mid 19th c.*
Addresses: Active in NYC, 1836-37. **Exhibited:** NAD , 1836-37. **Sources:** G&W; Cowdrey, NAD; NYCD 1836-37; Sherman, "Unrecorded Early American Portrait Painters" (1933), 29, repro.

REYNOLDS, Florence (Miss) *[Floral painter] late 19th c.*
Addresses: Brooklyn, NY. **Exhibited:** Brooklyn AA, 1874-78. **Sources:** *Brooklyn AA.*

REYNOLDS, Frances Burr See: **BURR, Frances**

REYNOLDS, Frederick (Thomas) *[Etcher, craftsperson, lecturer, teacher] b.1882, London, England.*
Addresses: NYC. **Studied:** London. **Member:** SAE; SC. **Exhibited:** Salons of Am. **Sources:** WW33.

REYNOLDS, George H. *[Painter] late 19th c.*
Addresses: NYC. **Exhibited:** Brooklyn AA, 1879-82; NAD, 1879-82; PAFA Ann., 1881, 1883. **Sources:** *Brooklyn AA;* Falk, *Exh. Record Series.*

REYNOLDS, George W. *[Painter] early 20th c.*
Addresses: Los Angeles, CA. **Member:** Calif. AC. **Exhibited:** locally, 1916-25. **Sources:** WW25.

REYNOLDS, Gordon L. *[Educator, lecturer, craftsperson, painter] b.1907, Lynn, MA.*
Addresses: Boston 15, MA; Waban 68, MA. **Studied:** Mass. Sch. Art (B.S. in Educ.); Harvard Univ.; Columbia Univ.; Univ. Montana; Boston Univ. **Member:** Nat. Art Educ. Assn.; Eastern AA; Am. Soc. for Aesthetics; AEA. **Exhibited:** Awards: Carnegie award, Harvard Univ.; Honor award, Mass. Sch. Art Educ., 1949 Year Book, Eastern AA, "Art in General Education." **Comments:** Positions: exec. bd., Nat. Assn. Sch. Design; Adv. Council, Art Dept., Pub. Sch., City of Boston; instr., State Teachers College Bridgewater, MA, 1932-38; pres., Mass. Sch. Art, Boston, MA, 1939-; State Dir. Art Educ. for Massachusetts, 1939-. **Sources:** WW59.

REYNOLDS, H. C. *early 20th c.*
Exhibited: Salons of Am., 1923. **Sources:** Marlor, *Salons of Am.*

REYNOLDS, H. C. (Miss, Mrs.) *[Painter] early 20th c.*
Addresses: Brooklyn, NY. **Exhibited:** S. Indp. A., 1924-26. **Sources:** Marlor, *Soc. Indp. Artists.*

REYNOLDS, Harry Reuben *[Art historian, photographer, painter, critic, teacher] b.1898, Centerburg, OH / d.1974, Utah.*
Addresses: Logan, UT. **Studied:** AIC; State Univ. Iowa, 1939-40; Brooks Inst. Photography, 1961; Sandzen; B.J.O. Norfeldt; G. Wood; L. Randolph; O. Oldfield; R. Stackpole. **Member:** Utah AI. **Exhibited:** SFMA, 1931; Oakland Art Gal., 1928-29, 1932; Utah State Fair, 1936 (prize); Salt Lake City AC(solo); AIC, 1923 (med.). **Work:** Bethany College, Lindsborg, KS; Utah State Fair Coll.; Ogden Pub. Sch.; Branch Agriculture College, Cedar City, UT; Logan (UT) H.S.; Polk Sch., Odgen; photo murals, College Hill & Logan LDS Temple, Cache Co., UT, 1947 & Cache Co. scenes, Bluebird Candy Co., Logan, 1947. **Comments:** Teaching: Utah State Univ., 1923-, cur. galleries, 1967-. Collections arranged: Faculty Show Multimedia, 1967, Concrete & Abstract, 1968, Ansel Adams Photog Exh., 1968 & Forms Upon The Frontier, Folk Life and Folk Arts, 1968. **Sources:** WW73;

WW47.

REYNOLDS, Helen Baker *[Craftsperson] b.1896, Ojai, CA.*
Addresses: San Francisco. **Studied:** Calif. Sch. FA; R. Schaeffer Sch. Des.; Kunstgewerbe Schule, (Arts & Crafts Sch.) Vienna. **Member:** San Fran. AA; San Fran. Soc. Women Artists; San Fran. AC. **Sources:** WW40.

REYNOLDS, Henry W. W. *[Portrait painter, draftsman, engineer] b.1833, New Orleans, LA / d.1911.*
Addresses: New Orleans, active 1860. **Comments:** A merchant who was an amateur painter. Cousin of Frederic E. Church (see entry). **Sources:** *Encyclopaedia of New Orleans Artists, 323.*

REYNOLDS, James E. *[Painter, illustrator] b.1926, Taft, CA.*
Addresses: Oak Creek Canyon, AZ in 1976. **Studied:** Allied Arts Sch., Glendale, with Arthur Beaumont, Charles Payzant and Stan Parkhouse. **Member:** CAA, 1969. **Work:** The Arizona Bank. **Comments:** Was an illustrator for the movie studios for 15 years, traveling in the West in his spare time. He moved to Arizona in 1968 and summered in Montana. **Sources:** P&H Samuels, 397.

REYNOLDS, John *[Seal engraver] mid 19th c.*
Addresses: NYC, active 1851-52. **Exhibited:** Am. Inst., 1851 (jointly with Charles Craske jointly, several specimens of a "new process of seal engraving"). **Comments:** Partner with Charles Craske (see entry) in Craske & Reynolds, seal engravers, active as a firm in 1852. **Sources:** G&W; NYCD 1852 (as Craske & Reynolds); Am. Inst. Cat., 1851.

REYNOLDS, John *[Engraver, copperplate printer] b.c.1826.*
Addresses: Boston in 1850. **Sources:** G&W; 7 Census (1850), Mass., XXV, 83; Boston CD 1851-52.

REYNOLDS, John W., Jr. *[Artist] late 19th c.*
Addresses: Wash., DC, active 1881-93. **Sources:** McMahan, *Artists of Washington, DC.*

REYNOLDS, Joseph Gardiner, Jr. *[Designer, craftsman, writer, lecturer, cartoonist] b.1886, Wickford, RI.*
Addresses: Belmont, MA. **Studied:** RISD. **Member:** Medieval Acad.; Copley Soc., Boston; Marblehead AA; Boston SAC (master craftsmen); AFA. **Exhibited:** Boston SAC, 1929 (medal); Boston Tercentenary Expo, 1930 (gold); Paris Salon, 1937 (medal); U.S. Pavilion, Paris, France; Mus. FA, NYC; Providence Art Club. **Work:** stained glass windows, Washington Cathedral; Mem. Chapel & Am. Church, Paris, France; Wellesley (MA) Mem. Chapel; St. George's School Chapel, Newport, RI; Princeton Chapel; churches in Pittsburgh, PA; Glens Falls, NY; Mercersburg, PA; Belleau, France;Winston-Salem, NC; Litchfield, CT; Laconia, NH; Hudson Falls, NY; Colorado College; Riverside Church, NYC; Florence Nightingale Window, Nat. Cathedral; Cathedral of St. John the Divine; church, Springfield, IL. **Comments:** Preferred media: stained glass. Research: medieval cathedrals; medieval stained glass. Contrib.: articles, *Cathedral Age, Am. Architect, Creative Design, Stained Glass Magazine.* **Sources:** WW73; WW47.

REYNOLDS, Joshua W. *[Engraver] b.c.1835, Boston.*
Addresses: Boston in 1860. **Sources:** G&W; 8 Census (1860), Mass., XXIX, 8; Boston CD 1860.

REYNOLDS, Lloyd J. *[Painter] b.1902, Bemidji, MN / d.1978, Portland, OR.*
Addresses: Portland, OR. **Exhibited:** SAM, 1937, 1938 (prize). **Sources:** WW40.

REYNOLDS, Margaret Melvina *[Painter, teacher] b.1913, Salt Lake City, UT.*
Addresses: Storm Lake, IA. **Studied:** Buena Vista College, Storm Lake, IA; Ringling Sch. Art; AIC. **Exhibited:** Buena Vista College; Sioux City, Iowa Fed. Women's Clubs (hon. men.); Ringling Sch. Art (prize). **Comments:** Teaching: Clarion College; Buena Vista College. Free lance artist. **Sources:** Ness & Orwig, *Iowa Artists of the First Hundred Years, 175-76/.*

REYNOLDS, Mary A. *[Artist] b.c.1825.*
Addresses: Wash., DC, active 1860. **Sources:** McMahan, *Artists*

of Washington, DC.

REYNOLDS, May E *[Painter] early 20th c.*
Addresses: Put-In-Bay, OH. **Sources:** WW04.

REYNOLDS, Nancy Du Pont *[Sculptor] b.1919, Greenville, DE.*
Addresses: Greenville, DE. **Member:** Nat. Lg. Am. Pen Women (Diamond State Br.); Burr Artists; Delaware Art Mus.; Rehoboth Art Lg.; Wolfe Art Club. **Exhibited:** CGA; NAD; Delaware Art Mus., Wilmington; Rehoboth(DE) Art Lg. (solo) & Caldwell's Wilmington (solo). **Work:** Commissions: lucite carving on copper bases, Stevenson Center Natural Science, Vanderbilt Univ., Nashville, TN; lucite carving for meditation chapel, Lutheran Towers Bldg., Wilmington; lucite carvings, Wilmington Trust Co.; bronze statue of a child (in memory of Dr. Warren), Childrens Bur., Wilmington. **Comments:** Preferred media: bronze, lucite. **Sources:** WW73.

REYNOLDS, Oakley *[Illustrator] mid 20th c.*
Addresses: Rockville Center, NY. **Member:** SI. **Sources:** WW47.

REYNOLDS, Ralph William *[Educator, painter, lithographer] b.1905, Albany, WI / d.1991.*
Addresses: Indiana, PA. **Studied:** AIC, 1925-27 & 1931; Beloit College (B.A., 1938); State Univ. Iowa (M.A., 1939); Grant Wood; Jean Charlot; Eliot O'Hara; Charles Burchfield; William Thon; Clarence Carter; Millard Sheets. **Member:** Indiana (PA) AA (pres., 1942); Johnstown (PA) AA; Pittsburgh WCS (vice-pres., 1952); Pittsburgh AA; AAPL (fellow). **Exhibited:** over 100 exhs. incl. Oklahoma AC, 1939; Phila Art All., 1939; Am. Color Pr. Soc., 1942; Iowa State Fair, 1939-40; Kansas City AI, 1940; Butler AI, 1941-42; Pittsburgh AA, 1942-46; Athens, OH, 1945-46; Parkersburg FA Center, 1945-46. Pittsburgh WCS, Arts & Crafts Center, 1951-72, AWCS, NAD Gals., 1959 & AAPL Grand Nat., Lever House, New York, 1972; over 20 solo shows incl. Univ. Club Pittsburgh & Westminster College, 1968. **Awards:** 20 awards, Ann. Allied Artists Johnstown, PA, 1951-72; 5 Ida Smith Mem. Awards & First Prize, Pittsburgh WCS, 1951-63; 7 purchase awards, Penelec & U.S. Bank Shows, 1960-69. **Work:** Indiana Univ. PA; Westminster College, New Wilmington, PA; One Hundred Friends Pittsburgh Art, PA; Univ. Club, Pittsburgh; also many pub. schools, banks & indust. concerns in western PA. Commissions: many portraits, PA, 1942-72. **Comments:** Positions: commercial artist, various studios, Chicago & Cleveland, OH, 1927-33. Teaching: Beloit College, 1933-38; South Dakota State Univ., 1940-41; Indiana Univ., PA, 1941-70s. **Sources:** WW73; WW47.

REYNOLDS, Richard *[Painter] b.1827, England / d.1918, Cincinnati.*
Comments: A descendant of Sir Joshua Reynolds who came to U.S. as a young man.

REYNOLDS, Richard (Henry) *[Sculptor, painter] b.1913, NYC.*
Addresses: Stockton, CA. **Studied:** San Bernardino Valley College (A.A., 1933); Univ. Calif., Berkeley (B.A., 1936; cert., 1939); Univ. Calif., Los Angeles (S.S., 1939); Mills College (S.S., 1940) with Moholy-Nagy; Univ. of the Pacific (M.A., 1942); Rudolph Schaefer Sch.; Oregon State Univ. (Shell grant.). **Member:** Int. Inst. Arts & Letters (life fellow); College AA Am.; Pacific AA (ed., *Journalette*; pres., Northern Calif. Sect., 1951-52; chmn. nat. mem. comt., 1952-53); San Fran. Art Inst.; Stockton Art Lg. (hon. mem.; pres., 1952-53). **Exhibited:** West Coast Sculptors, Eric Locke Gal., San Fran., 1960; Painting in May 1966, Purdue Univ., 1966; Northern Calif. Arts Painting Open, Sacramento, 1970; Da Vinci Int., New York Coliseum, 1970; Post-Sabbatical Exh., Stockton FA Gal., 1972. **Awards:** second prize for sculpture, *Sexology Magazine*, 1957; Transparent Painting Award, Northern Calif. Spring Art Festival, 1968; purchase award for painting, Lodi-Acampo Open, 1970. **Work:** Commissions: wall sculpture, steel tiger, Women's Dorm, Univ. of the Pacific, 1964; metal Bengal tiger, Class of 1950, Univ. of the Pacific,

1965; cast stone buffalo, Manteca (CA) Union H.S., 1965; bronze relief, New Wing Stockton Rec. Bldg., Stockton, 1966. **Comments:** Publications: auth. & contrib., *Art & Arch.*, 1/1948; auth., "The Shell and the Kernel," *Pacific Review,* 10/1951; auth., "A Plea for Wider Distribution of Art Values," *College Art Journal,* winter 1951-52; auth., *Aspects of Creativity*, Univ. of the Pacific Press, 1960; auth.," A Buffalo Sculpture for a California High School," 1/1966. Teaching: Stockton College, 1938-48; Univ. of the Pacific, 1948-; guest prof. art educ., summer 1954; guest lecturer, Alaska Methodist Univ., spring 1962. Research: art education; sculpture. **Sources:** WW73.

REYNOLDS, Robert F. *[Portrait painter, lithographer] b.c.1818.*
Addresses: Philadelphia, active 1841 until after 1868. **Exhibited:** Artists' Fund Soc., 1841 (portrait after Henry Inman); PAFA Ann., 1868, 1878 (as R.F. Reynolds). **Sources:** G&W; 7 Census (1850), Pa., LII, 725; Rutledge, PA; vol. 1; Falk, PA, vol. 2; Phila. CD 1843-60+.

REYNOLDS, Stephanie (Mrs.) *[Painter] early 20th c.*
Addresses: NYC. **Studied:** ASL. **Exhibited:** S. Indp. A., 1928, 1931; Salons of Am., 1931. **Sources:** Falk, *Exhibition Record Series.*

REYNOLDS, Theodocia *[Artist] b.c.1826.*
Addresses: Wash., DC, active 1860. **Sources:** McMahan, *Artists of Washington, DC.*

REYNOLDS, Thomas *[Stone seal engraver, heraldic engraver] 18th/19th c.; b.England or Ireland.*
Addresses: Philadelphia, act. 1785 until c.1788; NYC, 1804-5. **Comments:** From London and Dublin, he opened a seal manufacturing company Philadelphia in 1785. **Sources:** G&W; Prime, II, 72; Gottesman, *Arts and Crafts in New York,* II, nos. 238-39; Kelby, *Notes on American Artists;* Phila. CD 1785; NYCD 1804 (McKay), 1805.

REYNOLDS, Virginia (Mrs.) *[Miniature painter] b.1866, Chicago, IL / d.1903.*
Addresses: Chicago, IL. **Studied:** C. Von Marr & Heterick in Munich; Ch. Lasar in Paris. **Member:** SBA; ASMP. **Exhibited:** Miniature Exh., NYC, 1896, SNBA, 1897-99; PAFA Ann., 1903. **Sources:** WW01; Fink, *Am. Art at the 19th c. Paris Salons,* 384; Falk, *Exh. Record Series.*

REYNOLDS, Wellington Jarard *[Painter, teacher] b.1869, New Lenox, IL.*
Addresses: Chicago, IL. **Studied:** Royal Acad., Munich; Acad. Julian, Paris, with J.P. Laurens & Constant, 1894-96; École des Beaux-Arts, Paris. **Member:** Societe des Artistes Françaises; Cliff Dwellers. **Exhibited:** Chicago, 1908 (med.); Chicago SA, 1910 (med.); PAFA Ann., 1922-30 (5 times); Paris Salon, 1925 (med.); Sesqui-Centenial Expo, Phila, 1926 (med.); AIC, 1921 (prize); Corcoran Gal. biennial, 1928. **Work:** Univ. Chicago; Piedmont Gal., Oakland, CA; Springfield Mus. FA; City Mus., Laurel, MS; Univ. Illinois; Univ. California; Golden Gate Park Mus., San Fran.; Riverside (IL) H.S.; Hotel, Castle Park, MI; Lake Shore Athletic Club, Chicago. **Comments:** Teaching: Chicago Acad. FA. **Sources:** WW53; WW47; Falk, *Exh. Record Series.*

REYNOLDS, William H. (Mrs.) *[Painter] early 20th c.*
Addresses: Providence, RI. **Member:** Providence AC. **Sources:** WW25.

RHANA *early 20th c.*
Exhibited: Salons of Am., 1934. **Sources:** Marlor, *Salons of Am.*

RHEAD, Frederick Hurten *[Ceramicist, craftsperson] mid 20th c.; b.Hanley, Staffordshire, England.*
Addresses: East Liverpool, OH. **Studied:** F.A. Rhead, Taxile Doat; L.V. Solon. **Member:** Arch. L.; Art Ceramic Soc. **Exhibited:** San Diego Expo, 1915 (gold), 1934 (med.). **Work:** dec., theatres, hotels, etc., in collaboration with L.V. Solon. **Comments:** Auth.: "Studio Pottery," 1910. Contrib.: articles on ceramics, *Collier's Nat. Encyclopedia*. Positions: art dir., Homer Laughlin China Club, Newell, WV. Teaching: West VIrginia Univ.

Sources: WW40.

RHEAD, George W. *[Illustrator] late 19th c.*
Addresses: NYC. **Comments:** Affiliated with R.H. Russell & Co., NYC. **Sources:** WW98.

RHEAD, Lois Whitcomb *[Sculptor, ceramic artist] b.1892, Chicago, IL.*
Addresses: East Liverpool, OH/Santa Barbara, CA. **Studied:** F.H. Rhead; L.V. Solon. **Member:** NAWA; Am. Ceramic Soc. **Exhibited:** Nat. Assoc. Women P&S, 1924. **Sources:** WW29; Hughes, *Artists of California,* 464.

RHEAD, Louis J. *[Illustrator, painter, writer] b.1857, Etruria, Staffordshire, England / d.1926.*
Addresses: Amityville, NY. **Studied:** E.J. Poynter; A. Le Gros in London. **Member:** Arch. Lg., 1902; NYWCC. **Exhibited:** NAD, 1886, 1892; Paris Salon, 1891; Boston AC, 1888, 1902, 1905; Boston, 1895 (gold); Pan-Am. Expo, Buffalo, 1901; PAFA Ann., 1903; St. Louis Expo, 1904 (gold). **Comments:** Auth./Illustr.: "Robin Hood"; several works on angling. Illustr.: Harpers' Juvenile Classics. **Sources:** WW25; Fink, *Am. Art at the 19th c. Paris Salons,* 384; Falk, *Exh. Record Series.*

RHEAL, Ronda *[Painter, drawing specialist, illustrator] b.1891, Baltimore, MD / d.c.1945.*
Addresses: Boston, MA. **Member:** Gloucester SA; Boston Soc. Indep. Artists. **Comments:** Illustr.: volume of Emerson's Essays, accepted by Harvard Univ. for Emerson College, Widener Lib. **Sources:** WW40.

RHEEM, Royal Alexander *[Illustrator] b.1883, Omaha, NE.*
Addresses: Minneapolis, MN. **Studied:** Minneapolis Sch. Art with R. Koehler. **Exhibited:** Minn. State Art Soc. (prize). **Sources:** WW10.

RHEES, Morgan J. *[Painter] late 19th c.*
Addresses: Wheeling, WV, 1883; Boston, MA, active 1886-93. **Exhibited:** PAFA Ann., 1883; Boston AC, 1886; NAD, 1890, 1893. **Sources:** Falk, *Exh. Record Series.*

RHEIN, R(uth) V(an) W(yck) *[Painter] b.1892, NYC.*
Addresses: NYC/Jamestown, RI. **Studied:** H.W. Ranger. **Sources:** WW17.

RHETT, Antoinette (Francesca) *[Etcher, painter] b.1884, Baltimore, MD.* *Antoinette Rhett*
Addresses: Charleston, SC. **Studied:** Alfred Hutty. **Member:** Charleston EC; Carolina AA; Mississippi AA; Charleston Sketch Club; NOAA; SSAL. **Exhibited:** SSAL (prize); South Carolina State Fair. **Sources:** WW40.

RHETT, Hannah McC(ord)(Miss) *[Painter, teacher] b.1871, Columbia, SC.*
Addresses: Brevard, NC. **Studied:** ASL; Acad. Julian, Paris, with J.P. Laurens; Collin in Paris. **Member:** Carolina AA; Soc. Indep. Artists; ASL. **Exhibited:** Am. Art Soc. (bronze & silver medals); Salons of Am.; S. Indp. A., 1924-28, 1930, 1931-33; Appalachian Expo, 1911. **Sources:** WW31.

RHIND, C. *[Sketch artist] early 19th c.*
Comments: An Erie Canal sketch by this artist appears in Colden's *Memoir* (1825). **Sources:** G&W; Colden, *Memoir.*

RHIND, John Massey *[Sculptor] b.1860, Edinburgh, Scotland / d.1936, NYC.*
Addresses: NYC. **Studied:** his father, John Rhind (R.S.A.); Royal Acad.; Paris with Dalou. **Member:** NSS, 1893 (fellow); Arch. Lg., 1894; New York Munic. AS; NAD; SC; Allied AA; Brooklyn SA; Royal Scotch Acad., 1933. **Exhibited:** NAD, 1890-91, 1899; PAFA Ann., 1895, 1904, 1931; St. Louis Expo, 1904 (gold). **Work:** Trinity Church, NYC; equestrian, "George Washington," Newark, NJ; statues in Philadelphia; "Peter Stuyvesant," Jersey City; McKinley mem., Niles, OH; Butler AI; numerous decorations for fed. and mun. bldgs. His portrait bust of Carnegie is in many libraries. **Comments:** Immigrated to the U.S. in 1889. **Sources:** WW33; P&H Samuels, 397; Falk, *Exh. Record Series.*

RHINDESBERGER, Peter See: **RINDISBACHER, Peter**

RHINEHART, Charles Stanley See: **REINHART, Charles Stanley**

RHINELANDER, W. H. *[Listed as "artist"] mid 19th c.*
Addresses: Baltimore, 1858. **Sources:** G&W; Baltimore BD 1858.

RHOADES, Catherine N. See: **RHOADES, Katherine Nash**

RHOADES, John Harsen *[Patron] d.1906.*
Addresses: NYC. **Member:** Soc. of Collectors (pres.). **Comments:** Had a notable collection of paintings by American artists.

RHOADES, K. N. *[Painter] 20th c.*
Addresses: NYC, 1915. **Comments:** Probably Katherine Nash Rhoades (see entry). **Sources:** WW15.

RHOADES, Katherine Nash *[Painter] b.1885, NYC / d.1965, NYC.*
Addresses: NYC. **Studied:** Isabelle Dwight Sprague-Smith; in Paris, 1908-10 (traveled there with Marion Beckett and Malvina Hoffman). **Exhibited:** Armory Show, NYC, 1913; NAC, 1914; 291 Gallery, NYC, 1915 (two-person show with Marion Beckett); Soc. Indep. Artists, 1917; Salons of Am., 1934; Delphic Studios, NYC, 1935 (solo). **Comments:** Early American Modernist, part of the Stieglitz Group. Her first name has appeared as both Katherine and Catherine, and her last name appears variously as Rhoades and Rhoads. Her birth, death, and residence have been confused with those of another artist, Katherine Rhoads (see entry), who was born in 1885 and died in 1938. Katherine Nash Rhoades painted Fauvist-style portraits and landscapes, many of which she later destroyed. A friend of Stieglitz, Steichen, Picabia, and other modernists, her work appeared in *Camera Work* and *291*. The Mexican artist Marius De Zayas made a caricature of her in 1914 (MMA, Alfred Stieglitz Collection). She became associated with Charles Freer after 1915 and was involved in the opening of the Freer Gallery in Wash., DC. She also co-founded the religious library now part of the Jessie Ball DuPont Library at the Univ. of the South in Sewanee, TN. Auth.: "An Appreciation of Charles Lang Freer," *Art Orientalis,* vol. 2 (1957). **Sources:** Brown, *The Story of the Armory Show* (listed as Catherine N. Rhoades, b. 1895, d. c.1938); Petteys, *Dictionary of Women Artists;* Marlor, *Salons of Am.* (as Katherine Nash Rhoads, b. 1885, d. 1965); Marlor, *Soc. Indp. A.*(as Katherine Nash Rhoades, b. 1885, d. 1965); Davidson, Early American Modernist Painting, 15, 77, 79 (repro. of De Zayas' caricature).

RHOADES, William H. *[Listed as "artist"] mid 19th c.*
Addresses: Philadelphia, 1860 and after (according to Phila. CD 1860+). **Comments:** *Cf.* William Rhoads and William H. Rhodes. **Sources:** G&W; Phila. CD 1860+.

RHOADS, Eugenia Eckford *[Painter] b.1901, Dyesburg, TN.*
Addresses: Wilmington, DE. **Studied:** Miss. State College Women (A.B., 1923); Columbia Univ. (M.A., 1924); Am. Beaux Art Sch., Fontainbleau, summer 1932; Robert Brackman; Francis Speight; Walter Stuemig; Helen Sawyer; Henry Pitz. **Member:** Nat. Lg. Am. Pen Women (pres., Diamond State Br., 1954); Wilmington Soc. FA (secy. bd., 1969-); Phila. Art All.; Allied Artists Am.; AWCS; Rehoboth Art Lg., (mem. adv. comn., 1936-). **Exhibited:** Brooks Mem. Art Gal., Memphis, TN, 1955; Nat Coll., Smithsonian Inst., Wash., DC, 1956-68; Birmingham (AL) Art Mus., 1962; Allied Art, NAD, 1966; AWCS, 1967; Warehouse Gal., Arden, DE, 1970s. **Awards:** Fresh Flowers Today Award, Wilmington Soc. FA, 1946; The Trio Award, Birmingham Mus. Art, 1962; Breath of Spring Award, Nat. Lg. Am. Pen Women, 1963. **Work:** Delaware Art Mus., Wilmington; Miss. State College Art Coll., Columbus; Univ. Delaware Art Coll.n, Newark; Du Pont Co. Coll., Wilmington & Atlanta; Wilmington Trust Co. **Comments:** Positions: chmn. educ. council, Wilmington Art Mus., 1940-48; mem. visual art council, Delaware State Arts Council, 1969-. Publications: auth., *Wonder Windows,* Dutton

1931. Teaching: NC College Women, 1924-26; Univ. NC, summers 1929 & 30; dir., Tower Hill Sch., Wilmington, 1927-35. **Sources:** WW73.

RHOADS, George *[Artist] mid 20th c.*
Addresses: NYC. **Exhibited:** PAFA Ann., 1964. **Sources:** Falk, *Exh. Record Series.*

RHOADS, Harry Davis *[Block printer, designer, drawing specialist, etcher, engraver, illustrator] b.1893, Phila., PA.*
Addresses: Barberton, OH. **Studied:** H.G. Keller. **Comments:** Position: art dir., Firestone Tire Co., Akron, OH. **Sources:** WW40.

RHOADS, Katherine *[Painter] b.1895 / d.1938, Richmond, VA.*
Addresses: Richmond, VA, 1933. **Studied:** O. Gieberich; A. Fletcher; J. Slavin. **Member:** Richmond Acad. Art (founding mem.); possibly NAWA. **Exhibited:** VMFA, 1939 (mem. exh.); frequently in Richmond, VA. **Comments:** She has been confused with Katherine Nash Rhoades (see entry). Rhoads painted florals, landscape, and figural works and was also an actress. She was a founding member and trustee of the Virginia Museum of Fine Art (VMFA). **Sources:** WW33 (as Katherine Rhoads, b. 1895); Petteys, *Dictionary of Women Artists;* Pisano, *One Hundred Years.the National Association of Women Artists,* 93 (lists Katherine Nash Rhoades, not Katherine Rhoads, but Petteys indicates that it was Katherine Rhoads who was a member of NAWA).

RHOADS, Katherine Nash See: **RHOADES, Katherine Nash**

RHOADS, William *[Portrait and figure painter] b.c.1828, Pennsylvania.*
Addresses: Pittsburgh, PA, active 1850s. **Studied:** Oregon Wilson in Pittsburgh. **Comments:** Could be the William H. Rhoades (see entry) active in Philadelphia from 1860. There is also a William H. Rhodes, active in Cincinnati about the same time. They could all be the same person. **Sources:** G&W; 7 Census (1850), Pa., III, 257. More recently, see Gerdts, *Art Across America,* vol. 1: 290.

RHODE, Sarah See: **CAROTHERS, Sarah Pace (Mrs. W. Allen Rhode)**

RHODEN, John W. *[Sculptor] b.1918, Birmingham, AL.*
Addresses: Brooklyn, NY. **Studied:** Richmond Barthe, 1938; Columbia Univ. Sch. Painter & Sculpture with Oronzio Maldarelli, Hugo Robus & William Zorach. **Member:** Munic. Art Soc. (life mem.); Am Soc. Contemp. Artists. **Exhibited:** Columbia Univ. (3 prizes for sculpture); Howard Univ., 1951(Medal Pro Sculptura Egregia); Fisk Univ.; Frick Mus.; Atlanta Univ. Ann. (prize. 1955); MMA; Audubon Ann; PAFA Ann., 1950; NAD; Am. Acad. Arts; AIC; Brooklyn College, 1969; BMFA, 1970; WMAA, 1971; Univ. Pittsburgh, 1971; Nat. Acad. Arts & Letters; Schneider Gal., Rome; Fairweather-Harden Gal., Chicago; Saidenberg Gal., NYC; Audubon Ann.; British-Am. Gal.; Univ. Illinois Ann.; Howard Univ. Mus.; Am. Acad., Rome; Camino Gal. **Awards:** Rosenwald Fellowship, 1947-48; Prix de Rome Fellowship, 1952-54; New Jersey P&S Award; Rockefeller grant, 1959; Tiffany Award; Guggenheim fellowship, 1961. **Work:** Stockholm Mus; Carl Milles Coll.; Heinz Coll., Pittsburgh, PA; Steinberg Coll., Saint Louis, MO; Delaware Mus. Commissions: zodiacal structure and curved wall (metals & jewel glass), Sheraton Hotel, Phila., 1957; "Monumental Bronze," Harlem Hospital, 1966; "Monumental Abstraction," Metrop. Hospital, 1968; Clifton Sr. H.S., Baltimore, MD, 1971. **Comments:** Positions: specialist, U.S. Dept. State Tour Iceland, Europe & Northern Africa, 1955-56; mem. artist delegation, U.S. Dept. State Tour, USSR, Poland & Yugoslavia, 1959 & Asia, 1960; consult., Seni-Rupa Inst. Tek., Bandung, Indonesia, 1962. **Sources:** WW73; Cederholm, *Afro-American Artists;* Falk, *Exh. Record Series.*

RHODES, Charles Ward *[Painter, teacher] d.1905, Buffalo, NY (suicide?).*

Addresses: St. Louis, MO; Pittsburgh, PA; Boston, MA; Buffalo, NY. **Comments:** Taught at St. Louis MFA; CI gallery business manager, 1902; moved to Boston, and finally to Buffalo.

RHODES, Daniel *[Mural painter, craftsman, painter, teacher, designer, lecturer] b.1911, Fort Dodge, IA.*
Addresses: Menlo Park, CA. **Studied:** Univ. Chicago (Ph.B.); Alfred Univ. (M.A.); AIC; ASL; Stone City; J.S. Curry; Edmond Giesbert; Grant Wood. **Member:** Iowa Artists Club, 1933; Am. Ceramic Soc.; Munic. Art Forum, Des Moines. **Exhibited:** AIC, 1938; Toledo Art Inst.; Corcoran Gal.; Phillips Gal.; Nat. Gal.; Iowa Artists Exh., Mt. Vernon, 1938; SFMA, 1940; CPLH, 1941 (solo); Iowa State Fair Art Salon, 1931, 1938-40 (prizes); Iowa Artists Club (prize); Cornell (award). **Work:** Blanden Gal.; ceramics, Walker AC; murals, USPO, Glen Ellyn, IL; Clayton, MO; Marion, IA; Piggott, AR, Storm Lake, IA; Navy Dept. cafeteria, Wash., DC; Agricultural Bldg., Iowa State Fair Grounds, 1938. **Comments:** According to Ness & Orwig, "The Des Moines *Register* carried the story that the Iowa State Fair Board objected to a left-handed sower in the mural for the Agricultural Building, and after changing to a right-handed sower, Mr. Rhodes found it weakened his composition, so changed back. Many left-handed farmers of Iowa rose to his defense through the press and in personal letters." Teaching: Art Student's Workshop, Des Moines (1940); Stanford Univ., Palo Alto, CA (1946). Lectures: modern art. *Cf.* Daniel Rhodes, professor in the College of Ceramics, at Alfred, NY in 1959. **Sources:** WW53; WW47; Ness & Orwig, *Iowa Artists of the First Hundred Years,* 176.

RHODES, Daniel *[Educator, craftsperson] mid 20th c.*
Addresses: Alfred, NY, 1959. **Exhibited:** WMAA, 1956-1966. **Comments:** Teaching: College of Ceramics, Alfred, NY. This is most likely the Daniel Rhodes born in Iowa in 1911 (see entry). **Sources:** WW59.

RHODES, Ethen van Linschoten *[Craftsperson, teacher] b.1882, Maidstone, England.*
Addresses: Woodstock, VT. **Studied:** Conn. College with O.W. Shere & A. Watrous; W. Walden. **Member:** Boston SAC. **Comments:** Teaching: Vermont State Bd. Health. **Sources:** WW40.

RHODES, George F. *[Engraver, die sinker]*
Addresses: Cincinnati. **Comments:** In 1857 he headed the firm of G.F. Rhodes & Co.; in 1858-59 he was with the Cincinnati Type Foundry. **Sources:** G&W; Cincinnati CD 1857-59, BD 1857.

RHODES, George W. *[Painter] b.1850, KS / d.1937, Seattle, WA.*
Addresses: Tacoma, WA. **Exhibited:** Wash. State Hist. Soc. **Comments:** Went to the Puyallup Valley in the mid 1880s with his brother Seth. They later opened a store in Tacoma, but in 1897 were both committed to a mental hospital. George painted in a primitive style, and is said to have destroyed many of his paintings upon completion. **Sources:** Trip and Cook, *Washington State Art and Artists,* 1850-1950.

RHODES, Helen N. *[Painter, blockprinter, lithographer, illustrator, teacher] b.1875, Milwaukee, WI / d.1938, Seattle, WA.*
Addresses: Seattle, WA/Ellisport, WA. **Studied:** Univ. Wash.; NAD; A.W. Dow; Columbia Univ.; Cowles Art Sch., Boston. **Member:** SAM; Northwest PM; Pacific AA. **Exhibited:** Alaska Yukon Pacific Expo, 1909; Seattle AI, 1923 (prize), 1924 (prize), 1925 (prize); AIC, 1928; Int. Salon Water Colors, Provincial Exh., New Westminster, BC, 1928 (medal, prize), 1929 (medal, prize); NW Artists Ann. Exh., Seattle, 1930 (prize), 1932; State Fair, 1932 (prize); SAM, 1934, 1939 (posthumous solo); Henry Gal., Seattle, 1939 (posthumous solo). **Comments:** Publications: auth. of articles on univ. problems in design; ed./pub., *Northwest History in Block Print;* illustr., "Paul Bunyan Comes West," pub. Houghton Mifflin. Teaching: Univ. of Oregon; Univ. Wash. **Sources:** WW38; Trip and Cook, *Washington State Art and Artists,* 1850-1950.

RHODES, La Verne E. *[Printmaker] mid 20th c.*
Addresses: Chicago area. **Exhibited:** AIC, 1949. **Sources:** Falk, AIC.

RHODES, Lillyan (Mrs. Daniel) *[Sculptor] b.1915, Des Moines, IA.*
Addresses: Alfred, NY. **Studied:** Univ. Iowa; AIC; Alfred Univ. **Exhibited:** Awards: prizes, Western NY Artists, 1957; Syracuse Mus. FA, 1958. **Sources:** WW59.

RHODES, Naomi *[Portait painter] b.1899, Lynn.*
Addresses: Lynn, MA. **Studied:** Hale; James; Meryman; Tarbell. **Member:** Wash. AC. **Sources:** WW25.

RHODES, Reilly Patrick *[Art museum director, medical illustrator] b.1941, Bloomington, IL.*
Addresses: Canton, OH. **Studied:** Kansas City Art Inst. (B.F.A., 1966); Wichita State Univ. (M.F.A., 1968); Sterling Inst., Boston (art gallery management, 1969); Syracuse Univ. (mus. management, 1970); Univ. Missouri-Columbia (public relations, 1970). **Member:** College AA Am.; Am. Assn. Mus.; Council of the Arts (assoc.). **Exhibited:** Raydon Gal., NYC. Awards: Macy's Ann. Exh. Award, 1965. **Work:** General Mills, Inc., Minneapolis, MN; Macy's Inc., Kansas City, MO; Wichita State Univ.; Albrecht Gal. Mus. Art, St. Joseph, MO. **Comments:** Positions: medical illustrator (film making), Kansas City Gen. Hospital & Medical Center, 1966; mem. staff, Longstreet Art Gal., Wichita, KS, 1967-68; dir., Albrecht Gal., Saint Joseph, MO, 1968-71; dir., Canton (OH) Art Inst., 1971-. Publications: auth., "Public Relations Catalogue, Albrecht Gal.; auth., introductions to various catalogues incl. "L.E. Shafer Bronzes, An Ehibition of Sculpture and Drawings by O.V. Shaffer," "Moses Soyer: A Selection of Paintings 1960-1970" & "Moses Soyer: A Human Approach," "The Art of Irving Ramsey Wiles (1861-1948)" & "All Ohio" (Canton Art Inst Ann). Teaching: drawing, Missouri Western College, 1969-70. Collections arranged: 12 collections for Mus. Art, Albrecht Gal., 1968-71; William Grooper: Fifty Years of Drawing 1921-71 (200 works); Moses Soyer: A Human Approach; Jack Zajac Sculpture; Viviane Woodard Corp. Coll. (French Impressionists); Charles Burchfield: Master Doodler; Alexander Archipenko: The Am. Years; Joseph Gotto; Drawings & Sculpture; Gaston Lachaise: Drawings & Sculpture; Lamar Dodd: Retrospective; Bruno Lucchesi: Sculpture; Paintings by Greg Rossi; Ohio University Alumni invitational Exh.; Robert Wick: Sculpture; all for the Canton Art Inst., 1971-. **Sources:** WW73.

RHODES, Rowland *[Sculptor] late 19th c.*
Addresses: Concord, NH. **Exhibited:** PAFA Ann., 1899. **Sources:** Falk, *Exh. Record Series.*

RHODES, Walter R. *early 20th c.*
Exhibited: Salons of Am., 1926, 1928. **Sources:** Marlor, *Salons of Am.*

RHODES, William B. *[Painter] b.1860.*
Addresses: Paris, France. **Studied:** Courtois; Collin. **Exhibited:** Paris Salon, 1886; PAFA Ann., 1889. **Sources:** Fink, *Am. Art at the 19th c. Paris Salons*, 384; Falk, *Exh. Record Series.*

RHODES, William H. *[Listed as "artist"] b.c.1842, Pennsylvania.*
Addresses: Cincinnati in June 1860. **Comments:** *Cf.* William Rhoads and William H. Rhoades. **Sources:** G&W; 8 Census (1860), Ohio, XXV, 255.

RHOME, Lily Blanche Peterson (Mrs. Byron) *[Miniature painter] b.1874, Phila.*
Addresses: Asbury Park, NJ. **Studied:** James Wood; Breckenridge; Anshutz; Chase; Beaux. **Exhibited:** PAFA Ann., 1903; ASMP, 1938; Wash. SMPS&G, 1939. **Sources:** WW40; Petteys, *Dictionary of Women Artists;* Falk, *Exh. Record Series.*

RHONIE, Aline H. *b.1909, York, PA / d.1963, Sands Point, LI, NY.*
Exhibited: S. Indp. A., 1931-35, 1939; Salons of Am., 1932. **Sources:** Marlor, *Salons of Am.*

RIAL, John *[Engraver] b.c.1800, England.*
Addresses: Frankford section of Philadelphia, 1850. **Sources:** G&W; 7 Census (1850), Pa., LVI, 271.

RIBA, Paul F. *[Painter, illustrator] b.1912, Cleveland, OH / d.1977.*
Addresses: Cleveland, OH; West Palm Beach, FL. **Studied:** PAFA; Cleveland Inst Art, grad, 1936. **Member:** Artists Guild of Palm Beach Art Inst (mem bd, 1972-). **Exhibited:** CMA, 1937-1955 (Spec awards & first prizes); CI, 1947-1949 & 1952; NAD, 1953; Am Inst Interior Designers, 1962 (Best Wallcovering Yr Int Award); Flint Invitational, Mich, 1966; Art in USA, New York. Awards: best of show award, Ziuta & JJ Akston Found, 1972. **Work:** White House, Washington, DC; Smithsonian Inst, Washington; Cleveland Mus Art, Ohio; Cleveland Pub. Lib.; Rochester Mus Art, NY; Ohio State Capitol, Columbus. Commissions: Elements off Aviation (mural), Cleveland Airport, Ohio, 1937; Travel (mural), Cleveland Auto Club; 1947; Industrial Products (mural), Warner & Swasey Co, Cleveland, 1953; illustration of Jack London's Call of the Wild, Harris-Intertype Corp, Cleveland, 1962; African Scene (mural), bd rm for Apcoa Corp, 1967. **Comments:** Dealer: Brian Riba, Palm Beach, FL. Teaching: Instr drawing & illus, Cleveland Inst Art, 1949-1962. **Sources:** WW73; Ernest W Watson, "The paintings of Paul Riba," *Am Artist Mag* (Nov, 1953) & *Composition in landscape & still life* (Watson-Guptill, 1959); Kenneth Bates, *Principles of basic design* (World); WW40.

RIBAK, Louis Leon *[Painter, teacher] b.1902, Russian Poland / d.1979, Taos, NM.* *ribak*
Addresses: Taos, NM (after WWII-on). **Studied:** PAFA with Daniel Garber; ASL with John Sloan; Educ. Alliance Artists Sch., NYC. **Member:** AEA; An. Am. Group; Am. Soc. PS & GR; Am. Artists Cong. **Exhibited:** S. Indp. A., 1925; PAFA Ann., 1933, 1946, 1950, 1953; AIC; WFNY 1939; GGE, 1939; WMAA; WMA; Walker Art Center; VMFA; MMA; Springfield Mus. FA; BM; Corcoran Gal biennial, 1947; Newark Mus.; numerous traveling exhibits. **Work:** WMAA; Univ. Arizona; Newark Mus.; BM; WPA mural, USPO, Albemarle, NC. **Comments:** Position: director and instructor, Taos Valley Art Sch., Taos, NM, 1959. His wife Beatrice Mandelman was also an artist (see entry). **Sources:** WW59; WW47; P&H Samuels, 397; Falk, *Exh. Record Series.*

RIBCHESTER, John *[Amateur painter] b.1866, England / d.1931, New Bedford, MA.*
Addresses: Acative in New Bedford, MA, 1905-31. **Exhibited:** New Bedford Art Club, 1916. **Sources:** Blasdale, *Artists of New Bedford*, 151.

RIBCOWSKY, Dey de *[Marine painter] b.1880, Rustchuk, Bulgaria. / d.1936.*
Addresses: Los Angeles, CA. **Studied:** Paris; Florence; Petrograd. **Member:** Newport AA; Buenos Aires SFA. **Exhibited:** Petrograd, 1902 (medal); Uruguay Expo, Montevideo, 1908 (medal); Rio de Janeiro Expo, 1909 (medal); Odessa, 1909 (prize); Moscow, 1910 (prize); Sofia Nat. Gal., 1910 (prize). **Work:** Mus. Alexander III, Petrograd; Tretiacof Gallery, Moscow; Odessa Mus.; Uruguay Mus., Montivideo; Buenos Aires Mus.; Nat. Palace, Montevideo; Nat. Palace, Rio de Janeiro; Governor's Palace, Barbadoes; Manchester (NH) Mem. **Comments:** Specialty: inventor of the Medium "Reflex." **Sources:** WW25; Sloan's, January, 1999.

RIBERA, Lucien *[Painter] 20th c.*
Addresses: NYC. **Exhibited:** S. Indp. A., 1944. **Sources:** Marlor, *Soc. Indp. Artists.*

RIBLET, Grace E. *20th c.*
Exhibited: Salons of Am., 1922, 1923. **Sources:** Marlor, *Salons of Am.*

RIBLEY, De Forrest F. *[Painter] 20th c.*
Addresses: Norristown, PA; NYC. **Exhibited:** PAFA Ann., 1947, 1954. **Sources:** Falk, *Exh. Record Series.*

RIBONI, Giacinto *[Portrait and figure painter]* *mid 19th c.;*
b.Piacenza (Italy).
Addresses: Settled in Philadelphia by 1835. **Exhibited:** Artists
Fund Society, Phila. (1835-38). **Work:** Hist. Soc. of Pa.
Comments: Active in Rome between 1819 and 1828. His death
date is unconfirmed: Thieme-Becker gives 1838 but the Historical
Society of Pennsylvania owns four portraits by him of the Boker
family, one of which is signed and dated 1839. **Sources:** G&W;
Thieme-Becker; Rutledge, PA; information cited by G&W as
being courtesy the late William Sawitzky; Phila. BD 1838, CD
1839.

RICARBY, George *[Engraver]* *b.1828, England.*
Addresses: New Orleans, active 1850. **Comments:** This may be
the George D. Rickarby listed in city directories 1852-53.
Sources: G&W; 7 Census (1850), La., V, 91; NOCD 1852-53;
Encyclopaedia of New Orleans Artists. 323.

RICARDO, Arnold *[Painter]* *20th c.*
Addresses: Brooklyn, NY, 1923. **Exhibited:** S. Indp. A., 1923.
Sources: Marlor, *Soc. Indp. Artists.*

RICARDO, R. J. (Mrs.) *[Music and drawing teacher]* *early*
19th c.
Addresses: Charleston, SC in 1810; Norfolk, VA. **Sources:**
G&W; Rutledge, *Artists in the Life of Charleston.*

RICCARD, George *[Painter]* *late 19th c.*
Addresses: Los Angeles, CA. **Exhibited:** Calif. Agrticultural
Soc., 1883. **Comments:** Specialty: watercolors. **Sources:**
Hughes, *Artists of California,* 465.

RICCARDI, Robert *[Painter]* *20th c.*
Addresses: NYC, 1922. **Exhibited:** S. Indp. A., 1922. **Sources:**
Marlor, *Soc. Indp. Artists.*

RICCARDO, Richard *[Painter]* *20th c.*
Addresses: Chicago area. **Exhibited:** AIC, 1934, 1938, 1945.
Sources: Falk, *AIC.*

RICCI, Jerri *[Painter]* *20th c.; b.Perth Amboy, NJ.*
Addresses: Rockport, MA. **Studied:** NY Sch Appl Design for
Women, 1935; ASL New York, with Scott Williams, George
Bridgman, Mahonri Young & others, 1935-1938. **Member:** Am
WC Soc; Allied Artists Am; A.N.A.; Philadelphia WCC; Audubon
Artists; Rockport AA; NYWC Soc. **Exhibited:** TMA; PAFA;
AIC; Dayton Art Inst; Addison Gallery Am Art; plus others.
Awards: Silver medal, Catharine Lorrillard Wolfe Art Club, 1954;
Clara Obrig Award, NAD; gold medal, Audubon Artists, 1955;
plus many others. **Work:** Fairleigh Dickinson Col; Parrish Mus,
Southampton, NY; Am Acad Arts & Lett; Clark Univ, Butler Art
Inst; Addison Gallery Am Art, Andover, Mass; plus others.
Sources: WW73; *Artists of the Rockport Art Association* (1956).

RICCI, Ulysses Anthony *[Sculptor]* *b.1888, NYC / d.1960,*
Rockport, MA.
Addresses: NYC. **Studied:** CUA Sch; ASL; & with George
Bridgeman, James Earle Fraser. **Member:** ANA; Am. Numismatic
Soc.; NSS; All. A. Am.; SC; Arch. L.; Audubon Artists; AA Prof.
League; Guild of Boston Artists; Rockport AA; North Shore AA.
Exhibited: PAFA Ann., 1915, 1920; Rome, Italy, 1926 (medal);
MMA (AV), 1942; NAD; All. A. Am (prizes); Arch. L.; SC
(prizes); Rockport AA (prizes); North Shore AA (prizes). **Work:**
medals, Am. Numismatic Soc.; s., Plattsburg, N.Y.; Bowery
Savings Bank; Rundel Mem. Lib.; Rochester Univ.; Arlington
Mem.; Am. Pharmaceutical Bldg., Wash., D.C.; Dept. Commerce
Bldg., Wash., D.C.; Meuse -Argonne Memorial. **Sources:** WW59;
WW47; *Artists of the Rockport Art Association* (1956); Falk, *Exh.*
Record Series.

RICCIARDI, Cesare A. *[Painter]* *b.1892, Italy.*
Addresses: Phila., PA. **Studied:** PAFA. **Member:** Phila. Sketch
C.; Phila. Alliance. **Exhibited:** PAFA Ann., 1916-20, 1927-31;
Corcoran Gal biennials, 1921, 1926; AIC. **Sources:** WW25; Falk,
Exh. Record Series.

RICCITELLIE, D(omenico) *[Painter]* *b.1881, Italy.*
Addresses: Providence, RI. **Studied:** RISD. **Sources:** WW27.

RICCO, Roger *[Artist]* *20th c.*
Addresses: Milwaukee, WI. **Exhibited:** PAFA Ann., 1964.
Sources: Falk, *Exh. Record Series.*

RICE, Anne Estelle (Mrs. O. R. Drey) *[Illustrator, painter]*
b.1879, Phila. / d.1959.
Addresses: Phila., PA; Paris from 1906; England from 1913.
Studied: Phila. Acad. FA;. **Exhibited:** AIC, 1909; Salon des
Indépendants; Salon d'Automne, Paris; London, 1911-27 (several
solo exhib. at Baillie Gal.); London Salon; Leicester Gals.;S. Indp.
A., 1917; Wildenstein Gal.; Carnegie Inst. 24th Ann. Int. Exhib.,
1925; Univ. Hull & Arts Council Gal., Cambridge and London,
1969 (posthumous). **Comments:** Fauvist painter of landscapes,
coastal scenes, portraits, figures. Contributor, *Rhythm* magazine.
Sources: WW10; Petteys, *Dictionary of Women Artists.*

RICE, Burton *[Painter]* *20th c.*
Addresses: Chicago, IL. **Exhibited:** AIC, 1915. **Sources:**
WW15.

RICE, Calvin L. *[Engraver]* *mid 19th c.*
Addresses: Worcester, MA, 1859-60. **Sources:** G&W; Worcester
CD 1859; New England BD 1860.

RICE, Charles Edward *[Sculptor]* *b.1843, New Orleans, LA /*
d.1902, New Orleans, LA.
Addresses: New Orleans, active ca.1891-92. **Exhibited:** Artist's
Assoc. of N.O., 1891-92. **Comments:** Insurance broker who was
an amateur artist. **Sources:** *Encyclopaedia of New Orleans*
Artists, 323.

RICE, Charles H. *[Painter]* *20th c.*
Addresses: Sea Bright, NJ. **Member:** S. Indp. A. **Exhibited:** S.
Indp. A., 1921. **Sources:** WW25.

RICE, Dan *[Painter, instructor]* *b.1926, Long Beach, CA.*
Addresses: East Hampton, CT. **Studied:** Univ Calif, Los Angeles;
Black Mountain Col, BA; UC, Berkeley; MIT, MA(arch); also
with De-Kooning, Kline, Shahn, Motherwell, Stamos, Tworkov,
Guston, Albers, Bolotowski & Rothko. **Exhibited:** Catherine
Viviano Gallery, NYC, 1970s. Awards: Longview Found grant,
1962. **Work:** Wadsworth Atheneum, Hartford, Conn; Albright-
Knox Art Gallery, Buffalo, NY; MoMA; Princeton Univ Mus, NJ;
Dillard Univ Mus, New Orleans, LA. **Comments:** Preferred
media: oils. Positions: consult, Franz Kline Estate, New York,
1963-; cataloguer works of Mark Rothko, New York, 1969-1970.
Publications: illusr, *The Dissolving Fabric,* 1955; illusr, *All That*
is Lovely in Men, 1956; illusr, *The Dutiful Son,* 1960; illusr,
Corrosive Sublimate, 1971; illusr, *The Plum Poems,* 1972.
Teaching: Instr painting & drawing, Black Mountain Col, NC,
1956-1957; instr painting, ASL, 1968-69; visit. prof., State Univ.
NY, Buffalo, summer 1970; instr. life drawing, Univ. Conn., 1971-
72. **Sources:** WW73; Jonathan Williams, *Dan Rice, Painter* (Art
Int. Magazine, 1960).

RICE, Dorothy See: **PEIRCE, Dorothy Rice (Mrs.**
Waldo)

RICE, E. A. *[Portrait engraver in mezzotint]* *mid 19th c.*
Addresses: Working for Baltimore engravers about 1845.
Sources: G&W; Stauffer.

RICE, Emery *[Decorative painter]* *mid 19th c.*
Addresses: Active in and around Hancock, NH before 1850.
Sources: G&W; Little "Itinerant Painting in America, 1750-
1850," 209.

RICE, Emma Deuel *[Painter]*
Addresses: Wash., DC, active 1906-35. **Studied:** Corcoran
School Art. **Member:** Wash. WCC; Wash. AC. **Exhibited:** Wash.
WCC, 1906-27; Wash. AC; Maryland Inst.; Greater Wash. Indep.
Exh., 1935. **Comments:** Specialty: watercolor. Position: instruc-
tor, Wash. Art Lg. **Sources:** WW25; McMahan, *Artists of*
Washington, DC.

RICE, Ettie L. (Mrs.) *[Painter] 19th c.*
Addresses: NYC. **Exhibited:** NAD, 1873. **Sources:** Naylor, *NAD.*

RICE, Franklin Albert *[Miniature painter, portrait painter]* b.1906, Cleveland, MO.
Addresses: Cleveland, MO. **Studied:** A. Bloch; K. Mattern; R.J. Eastwood; Univ. Kans.,. **Comments:** Position: staff, Thayer MA, Lawrence, Kans. **Sources:** WW40.

RICE, Gerret S. *[Portrait and still life painter] mid 19th c.*
Addresses: Warren, OH (active 1843); Ashtabula County, OH (active beginning 1850). **Comments:** Advertised portrait painting in the *Western Reserve Chronicle* and was listed as painter in Ashtabula County. **Sources:** Hageman, 121.

RICE, Harold Randolph *[Educator, writer, critic, designer, graphic artist]* b.1912, Salineville, OH / d.1987.
Addresses: Cincinnati, OH. **Studied:** Univ Cincinnati, BSAA & BS(art educ), 1934, MEd, 1942; Columbia Univ, Arthur Wesley Dow scholar, 1943-1944, EdD, 1944; Moore Col Art, hon LHD, 1963. **Member:** Southwestern AA; SSAL; Birmingham A. Lg.; Ala. WCC; AFA; Ala. A. Lg.; Fel & life mem Nat Assn Schs Art (secy, 1950-1955, pres, 1955-1957); life mem Eastern Arts Assn (v pres, 1956-1958, pres, 1958-1960); Nat Art Educ Assn (coun mem, 1960-1963); hon mem Cincinnati Art Club; Int Coun Fine Arts Deans. **Exhibited:** Columbia, 1943-44 (prize). **Comments:** Positions: Chmn comt on art, Ohio Elem Educ Policies Comt, 1940-1942; chmn arts & skills corps, Am Red Cross, Ala, 1944-1946; dir, Philadelphia Art Alliance, 1947-1963; nat scholar juror, Scholastic Arts Awards, seven yrs, 1949-1971; adv art ed, Bk Knowledge, 1950-1963; mem bd dirs, Contemp Arts Ctr, 1964-1969, mem adv bd, 1969-. Publications: Auth, numerous articles for prof mag & jour, 1929-; contrib art ed, Arts & Activities, 1937-1946; plus others. Teaching: Art supvr, Wyoming Pub Schs, Ohio, 1934-1942; adj instr, Univ Cincinnati, 1940-1942; teaching fel, Columbia Univ, 1942-1944; head dept art, Univ Ala, 1944-1946; dean, Moore Inst Art, 1946-1962, first pres, 1951-1962; pres & dean, Moore Col Art, 1962-1963; dean, Col Design, Archit & Art, Univ Cincinnati, 1963-. **Sources:** WW73; WW47.

RICE, Henry Webster *[Painter, teacher]* b.c.1853, Pownal, ME. / d.1934, Watertown, MA.
Addresses: Watertown, MA. **Studied:** Ross Turner. **Exhibited:** Boston AC, 1888-1907; AIC. **Comments:** He painted at Fenwick Studios, 1906-34 and took painting trips to Bermuda from 1913 on. **Sources:** WW25; Vose Galleries, *Mary Bradish Titcomb and Her Contemporaries,* 47.

RICE, James R. *[Line engraver]* b.1824, Syracuse, NY.
Addresses: Settled in Philadelphia in 1851, active as late as 1876. **Studied:** W.W. Rice (his brother) in NYC before 1851. **Sources:** G&W; Stauffer; Phila. CD 1856-60+.

RICE, John E. *[Sketch artist] 19th c.*
Addresses: Made sketches in Kansas before the Civil War. **Sources:** G&W; WPA Guide, *Kansas.*

RICE, John J. *[Sketch artists] 19th/20th c.*
Addresses: Detroit, MI. **Exhibited:** Michigan State Fair, 1883. **Sources:** Gibson, *Artists of Early Michigan,* 201.

RICE, Joseph R. *[Engraver] mid 19th c.*
Addresses: Philadelphia, 1859. **Comments:** *Cf.* James R. Rice. **Sources:** G&W; Phila. CD 1859.

RICE, Juanita See: **GUCCIONE, Juanita (Rice) Marbrook**

RICE, Julia Hall *[Wood carver; pottery decorator] late 19th c.*
Studied: Cincinnati School Design, 1971-75. **Exhibited:** Phila. Centennial, 1976; Cincinnati Loan Exhib., 1878; Columbian Expo, Chicago, 1893. **Sources:** Petteys, *Dictionary of Women Artists.*

RICE, Kathryn Clark (Mrs.) *[Designer, craftsperson, painter]* b.1910, Frankfort, KY.
Addresses: Gambier, OH. **Studied:** Univ. Cincinnati; Cincinnati

Art Acad; Ohio State Univ. **Member:** Columbus Art Lg. **Sources:** WW40.

RICE, Lee Marvin *[Painter, illustrator, writer, saddlemaker]* b.1892, ranch near Fresno, CA / d.1984.
Addresses: San Francisco, CA. **Studied:** Heald College, San Francisco; Calif. College of Arts and Crafts, 1916-20. **Sources:** Hughes, *Artists of California,* 465.

RICE, Lucy Wilson (Mrs. C. D.) *[Portrait painter]* b.1874, Troy, AL.
Addresses: Austin, TX. **Studied:** G.E. Browne; W. Adams; Grand Central Sch. Art; Acad. Colarossi, Grande Chaumière, Acad. Delecluse, all in Paris. **Member:** SSAL; Texas FAA; Austin Art Lg.; AAPL. **Work:** portraits: State of Texas; Univ. Texas; Univ. Men's Club, Austin; Baylor Univ.; Texas College Art & Indust., Kingsville; Texas Capitol; State Univ.; federal Bldg., Austin; Pub. Lib., San Antonio; Theological Seminary, Rochester, NY; Scottish Rite Dormitory, Univ. Texas; Baylor College, Belton; State Teachers College, San Marcos; Texas Centenn. Expo, Dallas; Southwestern Univ., Georgetown, TX; Univ. Texas Medical Sch., Galveston. **Sources:** WW40.

RICE, Maegeane Ruble *[Painter, sculptor, teacher, lecturer]* b.1911.
Addresses: Muskogee, OK/Fayetteville, AR. **Studied:** I. Gador; C. Batthyany; S. Pekary in Budapest. **Member:** Arkansas WCC. **Exhibited:** Oklahoma AA, Oklahoma City, 1935 (prize), 1937 (prize); ceramics, Oklahoma State Fair, 1939 (prize); S. Indp. A., 1941. **Work:** Arkansas State Lib. **Sources:** WW40.

RICE, Margaret A. *[Painter]* b.1901, Canada.
Addresses: Seattle, WA. **Studied:** Leon Derbyshire; Alma Lorraine. **Exhibited:** Western Wash. Fair, 1936. **Sources:** Trip and Cook, *Washington State Art and Artists,* 1850-1950.

RICE, Marghuerite Smith (Mrs. Fred Jonas Rice) *[Sculptor]* b.1897, St. Paul.
Addresses: Buffalo, NY. **Studied:** E. Pausch. **Member:** Buffalo SA; Gld. Allied Artists; Lg. Am. Pen Women. **Work:** portrait bust, Bishop Charles Harry Brent, mem. in Philippines. **Sources:** WW40.

RICE, Matthew A. *[Lithographer, printer]* b.1879, New Orleans, LA / d.1924, New Orleans.
Addresses: New Orleans, active 1904-10. **Sources:** *Encyclopaedia of New Orleans Artists,* 323.

RICE, Maude Anita *[Painter]* b.1875, Iowa / d.1966, San Diego, CA.
Addresses: San Diego, CA. **Exhibited:** San Diego FA Gal., 1927. **Sources:** Hughes, *Artists of California,* 465.

RICE, Mervyn A. *[Painter] early 20th c.*
Addresses: Wash., DC. **Sources:** WW25.

RICE, Myra M. *[Painter] early 20th c.*
Addresses: Newfane, NY. **Member:** Buffalo SA. **Sources:** WW25.

RICE, Nan (Mrs. Hugh) *[Painter, lecturer]* b.1890, Winnipeg, Canada / d.1955, Stockton, CA.
Addresses: Chicago 37, IL. **Studied:** Winnipeg Sch. Art; Wesley College, Winnipeg; AIC; Univ. Chicago; Alexander Musgrove. **Member:** Chicago SA; Chicago P&S Assn.; South Side AA; Ridge AA; All-Illinois Soc. FA; Hyde Park AC; Chicago AC. **Exhibited:** Wawasea Art Gal., Syracuse, IN, 1944 (prize), 1945 (prize); All-Illinois Soc. FA, 1944 (prize); South Side Artists, 1942-45 (prizes); AIC, 1933, 1942, 1944; Milwaukee AI, 1944. **Work:** Univ. Chicago; Vanderpoel Coll. **Comments:** Lectures: portrait painting. **Sources:** WW53; WW47.

RICE, Norman Lewis *[Painter, educator, graphic artist]* b.1905, Aurora, IL.
Addresses: Pittsburgh, PA. **Studied:** Univ. Illinois (B.A., 1926); AIC, 1926-30. **Member:** Cliff Dwellers, Chicago; Nat. Assn. Sch. Art (fellow); Am. Council Arts in Educ. (fellow). **Comments:** Teaching: Sch. Art Inst. Chicago, 1928-1943; Syracuse Univ.,

1946-54; Carnegie-Mellon Univ., 1954-. **Sources:** WW73; WW47.

RICE, Philip *[Painter] early 20th c.*
Addresses: Staten Island, NY. **Exhibited:** S. Indp. A., 1933, 1935. **Sources:** Marlor, *Soc. Indp. Artists.*

RICE, Philip Somerset *[Painter, art administrator] b.1944, Mobile, AL.*
Addresses: Springfield, IL. **Studied:** Mid Tenn. State Univ. (B.S., art, 1967); Pratt Contemp. PM Center with Jurgen Fischer, 1967; Southern Illinois Univ., Carbondale (M.F.A., 1971). **Member:** College AA Am.; AFA. **Exhibited:** The Print in Am., Peabody Mus., Nashville, TN, 1966; Wabash Valley Ann., Terre Haute, 1971; Chapel Hill (NC) Nat. PM, 1971; Brooks Goldsmith's Ann., Memphis, TN, 1972; Quincy (IL) Art Ann., 1972. **Work:** Rose Human Inst. Tech., Terre Haute, IN; univ. gals., Southern Illinois Univ., Carbondale; Mid Tenn. State Univ. Gals., Murfreesboro. Commissions: historical oil painting, Murfreesboro C of C, 1966. **Comments:** Preferred medium: acrylics. Positions: exec. dir., Springfield AA, 1971-72. Teaching: dir. art, Issac Litton Jr. H.S., Nashville, 1967-70; Pratt Contemp. PM Center, 1967; Southern Illinois Univ., Carbondale, 1970-71; Springfield AA, 1971-72. **Sources:** WW73; *Parisian Arts Int.*

RICE, Richard Austin *[Curator, teacher] b.1846, Madison CT / d.1925.*
Addresses: Wash., DC. **Studied:** Yale; Univ. Berlin; other foreign univ. and technical schools. **Comments:** Teaching: Univ. Vermont, 1875-81; Wlliams College, for 25 years; chief, Div. of Prints, LOC.

RICE, Robert *[Steel engraver] b.c.1833, Vermont.*
Addresses: Boston in 1860. **Sources:** G&W; 8 Census (1860), Mass., XXVI, 304.

RICE, Robert Creighton *[Artist, photographer] 19th/20th c.*
Addresses: Wash., DC, active 1892-1920. **Sources:** McMahan, *Artists of Washington, DC.*

RICE, Shirley R. (Lourie) *[Painter, teacher] b.1923, NYC.*
Addresses: Corona del Mar, CA. **Studied:** Columbia Univ. with Frank Mechau; Colorado Springs FA Center with Mangravite, Britton, Vander Sluis, Barrett; Univ. Calif., Los Angeles with Laura Andreson; Claremont College; Howard Cook; Mexico City College; San Miguel de Allende, Mexico; Long Beach State College (M.A.). **Member:** NAEA; Pacific AA; Orange County Art Teachers Assn.; Laguna AA. **Exhibited:** Northwest PM, 1948; Newport Harbor Exh., 1949; Laguna Beach Art Festival, 1952-61; Long Beach Municipal Exh., 1957-58; Long Beach State College, 1960 (solo). **Comments:** Teaching: Newport Harbor H.S., Newport Beach, CA; Orange Coast College, Costa Mesa, CA. **Sources:** WW66.

RICE, Susanne C. *[Miniature painter] 19th/20th c.*
Addresses: NYC, active 1898-1901. **Exhibited:** Boston AC, 1898; NYWCC, 1898. **Sources:** WW01; *The Boston AC.*

RICE, W. W. *[Line engraver] mid 19th c.*
Addresses: NYC. **Comments:** Employed by Rawdon, Wright, Hatch & Co., and by Rawdon, Wright, Hatch & Edson (see entries), of NYC in 1846 and after. He was engraving under his own name as late as 1860. James R. Rice was his brother and pupil. *Cf.* Rice & Buttre. **Sources:** G&W; Stauffer.

RICE, William *[Sign painter] mid 19th c.*
Addresses: Hartford, CT in 1844. **Sources:** G&W; *Magazine of Art* (April 1943), 129, repro. of tavern sign.

RICE, William C(larke), Jr. *[Mural painter, sculptor, illustrator, craftsperson, writer, teacher] b.1875, Brooklyn, NY / d.1928, NYC.*
Addresses: NYC/Center Lovell, ME. **Studied:** CCNY, 1897; G. DeF. Brush; ASL. **Member:** NY Arch. Lg.; Mural Painters. **Exhibited:** S. Indp. A., 1917. **Work:** murals; Pub. Sch., NYC; Jonas Bronck Sch.; Missouri Theare, St. Louis; Nat. Gal., Wash.; 20-panel mural, Park Central Hotel, NYC. **Comments:** Teaching:

NYC Pub. Sch. **Sources:** WW27.

RICE, William M(orton) J(ackson) *[Portrait painter] b.1854, Brooklyn, NY / d.1922, NYC.*
Addresses: NYC. **Studied:** NYC with C. Beckwith; Carolus-Duran in Paris. **Member:** ANA, 1900; SAA, 1886; Century Assn.; Lg. of AA. **Exhibited:** NAD, 1885-1900; PAFA Ann., 1894; Pan-Am. Expo, Buffalo, 1901 (med.); S. Indp. A., 1917-18; Corcoran Gal. biennial, 1907; Salons of Am., 1922; AIC. **Sources:** WW24; Falk, *Exh. Record Series.*

RICE, William Seltzer *[Block printer, etcher, teacher, painter, designer, illustrator, writer] b.1873, Manheim, PA / d.1963, Oakland, CA.*
Addresses: Oakland, CA. **Studied:** PM Sch. IA; College Arts & Crafts, Oakland, CA (B.F.A.); Drexel Inst. with Howard Pyle. **Member:** San Fran. AA; Oakland Art Lg.; Pacific AA; Bay Region AA; Northwest PM; Calif. SE; Calif. Soc. PM; Prairie PM. **Exhibited:** PM Sch. IA, 1904 (prize); PPE, 1915; S. Indp. A., 1918; Brooklyn Mus.; WFNY, 1939; CPLH, 1918; San Fran. AA, 1916, 1925; GGE, 1939; Phila. Print Club, 1943, 1944, 1946; Calif. SE, annually since 1912, 1943 (prize), 1945 (prize); LOC, 1943, 1944, 1946; Stanford Univ. AG; Calif State Lib., Sacramento; Cleveland AM; Wichita AM; Oakland College Arts & Crafts; LACMA; Oakland Mus.; SAM; Portland MA; UCLA; Gump's, San Fran.; Annex Gal., Santa Rosa, CA, 1984 (retrospective). **Work:** prints: NMAA; BPL; Calif. State Lib.; Oakland H.S.; Calif. College Arts & Crafts; Golden Gate Park Mus., San Fran.; LOC; NYPL; Mills College AG; Oakland AM; PMA; Stockton AM. **Comments:** Best known for his color woodblock prints which he produced in small editions. His bright colors and brush-blended backgrounds reflect the Japanese influence while his bold dark outlines show the Western, or English, infuence. Teaching: Fremont H.S., 1914-30; Castlemont H.S., Oakland, CA, 1930-40; Univ. Calif. Ext. Dept., 1932-43. Auth.: *Block Printing in the School* (1929); *Portfolio of Block Prints* (1932); *Block Prints — How to Make Them* (1941). Contrib.: *School Arts* and *Design* magazines; *Christian Science Monitor.* Lectures: Block Print Making. **Sources:** WW59; WW47; Hughes, *Artists of California,* 465; Samuels, 398; exh. cat., Annex Gal. (Santa Rosa, CA, 1984).

RICE-KELLER, Inez (Mrs.) *[Sculptor, painter, writer] b.Kenosha County, WI / d.1928, Mt. Vernon, NY.*
Studied: Maryland AI; Paris; J. Dampt; M. Antokolski. **Member:** NAC. **Exhibited:** Paris Salon; London; New York; Baltimore.

RICE-MEYEROWITZ, Jenny See: **MEYEROWITZ, Jenny Delony Rice (Mrs. Paul A.)**

RICE-PEREIRA, Irene See: **PEREIRA, I(rene) Rice**

RICE & BUTTRE *[Engravers] mid 19th c.*
Addresses: NYC, 1849-50. **Comments:** Junior partner in this firm was John Chester Buttre (see entry); Rice has not been firmly identified. Groce & Wallace suggest Rice may have been W.W. Rice (see entry) who was working for Rawdon, Wright, Hatch & Co. in NYC about this time. **Sources:** G&W; NYBD 1849-50; Stauffer [under Buttre].

RICH, A. H. *[Engraver] 19th c.*
Comments: Engraver of a print of F.O.C. Darley's painting of the Battle of Concord. **Sources:** G&W; *American Collector* (April 1943), cover.

RICH, A. P. *[Painter] late 19th c.*
Exhibited: PAFA Ann., 1879. **Sources:** Falk, *Exh. Record Series.*

RICH, Daniel Catton *[Art administrator, lecturer] b.1904, South Bend, IN / d.1976.*
Addresses: NYC. **Studied:** Univ. Chicago (Ph.B.); Harvard Univ. **Member:** Int. Council Mus.; Am. Inst. Design; Am. Inst. Arch. (hon. mem., Chicago Chapt.); Assn. Art Mus. Dirs.; Am. Assn. Mus. **Exhibited:** Awards: Officer, Legion Hon.; Officer, Order or Orange Nassau; Knight of Merit, Italy. **Comments:** Positions: ed., *Bulletin,* AIC, 1927-32, asst. cur. painting & sculpture, 1929-31, assoc. cur., 1931-38, dir. fine arts, 1938-43, cur., 1938-70, dir. fine

arts, 1943-58, trustee, 1955-58, hon. gov. life mem.; dir., Worcester (MA)Art Mus., 1958-70; trustee, Guggenheim Mus., NYC, 1961-; vice-chmn., Mass. Bd. Higher Educ., 1969-70. **Publications:** auth., *Seurat and the Evolution of La Grande Jatte,* 1935, "Charles H. and Mary F.S. Worcester Coll. Catalogue," 1938 & *Degas,* 1951; contrib., *Atlantic Monthly* & art journals. Teaching: lectures on Degas, the two Tiepolos, all phases of painting & sculptures, especially in 17th, 18th & 19th century painting; visiting lecturer, Harvard College, 1960. Collections arranged: The Two Tiepolos; Toulouse-Lautrec, 1931; Rembrandt and His Circle, 1935; The Art of Fr Goya, 1941; Hogarth, Constable & Turner, 1946; Henri Rousseau, 1946; Chauncey McCormick Memorial Exhibition, 1955; Georges Seurat, 1958. **Sources:** WW73.

RICH, Ethel *[Painter] mid 20th c.*
Addresses: Oakland, CA. **Exhibited:** Bay Region AA, 1940. **Sources:** Hughes, *Artists of California,* 465.

RICH, Frances L. *[Sculptor, photographer] b.1910, Spokane, WA.*
Addresses: Santa Barbara, CA; Palm Desert, CA. **Studied:** Smith College (B.A., 1931); sculpture with Malvina Hoffman & frescoes with Angel Zarraga, Paris, France, 1933-35; Beaux Art Acad.; Boston Mus. Sch., 1935-36, with Alexander Jacovleff; Cranbrook Acad. Art, 1937-40, sculpture with Carl Mills; Claremont College, 1946, with Millard Sheets. **Member:** Arch. Lg. NY; Cranbrook Acad. Art (alumna). **Exhibited:** WFNY, 1939; Am. Acad. Des., NY, 1936; Cranbrook Acad. Art, 1938-39; Santa Barbara Mus. Art, 1941-42, 1952 (solo); Greek Theatre, Los Angeles, 1946; CPLH, 1955 (solo & retrospective); Palm Springs Desert Mus., 1969 (solo); Calif. Religious Artist, De Young Mem. Mus., 1952 (solo); Lenten Exh. Liturgical Arts, Denver Art Mus., 1955 (solo). **Work:** Purdue Univ.; Santa Barbara Mus. Art; Smith College; marble portrait bust of Alice Stone Blackwell, Boston Pub. Lib.; "Nude Bronze," Palm Springs (CA) Desert Mus.; St Catherhine of Sienna, lib. entrance, Santa Catalina Sch., Monterey, CA; "Christ Crucified," Coll. Father Edward Boyle, Holy Trinity Church, Bremerton, WA. **Commissions:** Army Navy Nurse, Arlington (VA) Nat. Cemetery, 1938; bronze bas relief Nunc Dimittis, comn. by Mr. & Mrs. James Coonan, St. Peters Episcopal Church, Redwood City, CA, 1955; bronze Our Lady of Combermere, Madonna House, Ontario, 1956; bronze bust of Katherine Hepburn, Am. Shakespeare Festival Theatre, Stratford, CT, 1960; bronze St. Francis of Assisi, St Margarets Episcopal Church, Palm Desert, 1970 & Pierce College, Athens, Greece, 1971. **Comments:** Preferred medium: bronze. **Sources:** WW73; WW47; articles, *Liturgical Arts Quarterly;* also in newspapers.

RICH, Garry Lorence *[Painter] b.1943, Newton County, MO.*
Addresses: NYC. **Studied:** Kansas City Art Inst. (B.F.A.); NY Univ. (M.A.). **Exhibited:** Max Hutchinson Gal., NYC, 1970s. **Awards:** Max Beckman fellowship, Brooklyn Mus., 1966; Nat. Council Arts Nat. Endowment, 1967; Anderson fellowship, NY Univ. 1968; WMAA, 1969. **Work:** WMAA; Aldrich Mus. Contemp. Art, Ridgefield, CT; Phoenix (AZ) Art Mus.; Nelson Gal. Art, Kansas City, MO; Miami (FL) Art Center. **Comments:** Teaching: NY Univ., 1965-70; Hofstra Univ., 1971-72; Bard College, 1972-. **Sources:** WW73; Domingo, "Color Abstractionism" (December, 1970) & Bowling, "Color and Recent Painting" (1972), *Arts Magazine;* Ratcliff, "Young New York Painters," *Art News* (1970).

RICH, George *[Painter] early 20th c.*
Addresses: Chicago, IL. **Member:** Chicago NJSA. **Exhibited:** AIC, 1923-26; PAFA Ann., 1925. **Sources:** WW25; Falk, *Exh. Record Series.*

RICH, Grace Ellingwood *[Artist] b.1872 / d.1959, Bennington, VT.*
Addresses: Active in Brooklyn, NY, 1929-48. **Exhibited:** Salons of Am.; S. Indp. A., 1929. **Sources:** BAI, courtesy Dr. Clark S. Marlor.

RICH, Harvey J. *[Artist] mid 19th c.*
Addresses: NYC. **Exhibited:** Am. Inst., NYC, 1849-50 ("Moonlight View"). **Sources:** G&W; Am. Inst. Cat., 1849-50.

RICH, Jack C. *[Sculptor] mid 20th c.*
Exhibited: S. Indp. A., 1941. **Sources:** Marlor, *Soc. Indp. Artists.*

RICH, James Rogers *[Landscape painter] b.1847, Boston, MA / d.1910.*
Addresses: Boston. **Studied:** Harvard, 1870; chiefly self-taught. **Exhibited:** NAD, 1880-86; Boston AC, 1880-1889; Paris Salon, 1883; New Orleans Expo, 1885 (prize); Simla (India) FA Expo, 1902 (med). **Comments:** He traveled extensively in Europe, Egypt, the Orient and in India, where he lived seven years, returning to the U.S. c.1902. He was wealthy and his pictures were seldom for sale. **Sources:** WW10; Fink, *Am. Art at the 19th c. Paris Salons,* 384.

RICH, John Hubbard *[Painter, teacher] b.1876, Boston, MA / d.1954, Los Angeles, CA.* *John H Rich*
Addresses: Boston, MA; Hollywood, CA. **Studied:** ASL; BMFA Sch.; Europe. **Member:** Calif. AC (pres., 1944-45); Laguna Beach AA; Calif. WCS (1st vice-pres., 1942-43); Council All. Artists; SC. **Exhibited:** BMFA, 1905-07 (traveling scholarship); PAFA Ann., 1905, 1912-14, 1923; San Diego Expo., 1915 (med.); San Fran. AA, 1916; Calif. AC, 1916 (prize), 1917 (prize), 1919 (prize); Pan.-Calif. Expo, San Diego, 1916 (med.); LACMA, 1915, 1917, 1922 (prize), 1926, 1927, 1929, 1937, 1939; Calif. State Fair, 1928 (prize); Phoenix, AZ, 1928 (prize); Sacramento, CA, 1928 (prize); FAS, San Diego, 1932 (prize); Santa Monica AA, 1932 (prize); GGE, 1939; NAD; Acad. FA, NY; AIC; Pasadena AI; Laguna Beach AA; Fnd. Western Artists; Los Angeles P&S; SC (prize). **Work:** LACMA; Utah State Inst. FA; Univ. Club, San Diego; Fed. Bldg., Los Angeles; Good Samaritan Hospital, Los Angeles; Pomona College; Scripps College; BMFA; USC. **Comments:** Teaching: Groton Sch., Boston; Otis AI, Los Angeles, CA, 28 years. **Sources:** WW53; WW47; Falk, *Exh. Record Series.* More recently, see Hughes, *Artists of California,* 465; *The Boston AC,* states, that he possibly exhibited as J.H.Rich at the Boston AC in 1905.

RICH, Roger L. *[Illustrator] 19th/20th c.*
Addresses: NYC. **Studied:** Acad. Julian, Paris, 1880-89. **Sources:** WW19; Fehrer, The Julian Academy.

RICH, Waldo Leon *[Illustrator] b.1853, Schuylerville, NY / d.1930, Saratoga Springs, NY.*
Studied: Williams College. **Comments:** Banking was his life work, but he did the illustrations for a limited edition of the "Arabian Nights Tales." He had collected a fine library, specializing in first editions of rare old books and had made notable collections of birds and butterflies.

RICHARD, Betti *[Sculptor] b.1916, NYC.*
Addresses: NYC. **Studied:** ASL; Paul Manship. **Member:** NSS (fellow; secy., 1971-); Arch. Lg. NY (vice-pres. sculpture, 1961-63); All. Artists Am.; Nat. Arts Club; Audubon Artists. **Exhibited:** All. Artists Ann., 1942-71; S. Indp. A., 1942-43; NAD Ann., 1944-71; NSS Ann., 1947-72; Third Int. Exh., PMA, 1949; PAFA Ann., 1949; Fall Exh. Künstlerhaus, Vienna, Austria, 1954. **Awards:** Barnett Prize, NAD, 1947; gold medal for sculpture, All. Artists Am., 1956; John Gregory Award, NSS, 1960. **Work:** Phoenix (AZ) Art Mus.; San Joachin Pioneer Mus. & Haggin Art Gals., Stockton, CA; Melick Lib., Eureka (IL) College; Hackley Sch., Tarrytown, NY; Rosary Hill College, Buffalo, NY. **Commissions:** St. Francis Statue, St. Francis of Assisi Church, New York, 1957; marble statue of Our Lady, House Theology, Centerville, OH, 1958; St. John Baptiste de la Salle, St. John Vianney Sem., E. Aurora, NY, 1963; busts of Mozart & Wagner, Metrop. Opera, New York, 1963 & 1970; Cardinal Gibbons Mem., Baltimore, MD, 1967. **Comments:** Preferred medium: bronze. **Sources:** WW73; Jacques Schnier, *Sculpture in Modern America* (Univ. Calif. Press, 1949); Norman Kent, "The Sculpture of Betti Richard," *Am. Artist Magazine;* Falk, *Exh. Record Series.*

RICHARD, Dick *[Painter] early 20th c.*
Addresses: Chicago area. **Exhibited:** AIC, 1930, 1932. **Sources:** Falk, *AIC.*

RICHARD, Edna Vergon *[Painter] b.1890, Alturas, CA / d.1985, Carmel, CA.*
Addresses: Carmel, CA. **Member:** Carmel AA; Soc. for Sanity in Art. **Exhibited:** GGE, 1940. **Sources:** Hughes, *Artists of California,* 465.

RICHARD, Gerald *[Painter, designer] b.1910, NYC.*
Addresses: Arlington, VA. **Studied:** Europe. **Work:** Fr. Naval Club, Paris; Nat. Naval Mem. Mus., Wash., DC; Adm. Jerauld Wright Bldg., Norfolk Naval Base; Lyndon B. Johnson Ranch; Sam Rayburn Lib., TX. Commissions: large oil painting, The (PT) 109, Kennedy Lib. **Comments:** Art interests: portrayal of nautical, sportscar, and air activities, historical combat scenes and all-subject murals. **Sources:** WW73.

RICHARD, Henri (E. H.) *[Painter] early 20th c.*
Addresses: Paterson, NJ. **Member:** Soc. Indep. Artists. **Exhibited:** Soc. Indep. Artists, 1920-23, 1925-28. **Sources:** WW25.

RICHARD, Jacob *[Painter, teacher] b.1883, Ukrania.*
Addresses: Chicago, IL. **Studied:** H. Walcott. **Member:** Chicago SA; All-Illinois SFA; Illinois Acad. FA; Chicago P&S. **Exhibited:** AIC, 1912 (prize), 1917 (prize). **Work:** City of Chicago; Illinois State Mus., Springfield; John H. Vanderpoel AA, Chicago. **Comments:** Teaching: Peoples Univ., Chicago. **Sources:** WW40.

RICHARD, John H. See: **RICHARDS, John H.**

RICHARD, Louis *[Architect, sculptor] b.1869, France / d.1940.*
Addresses: West Nyack, NY. **Work:** mansions in NY and Newport. **Comments:** Came to the U.S. in 1891.

RICHARD, Paul *[Art critic] b.1939, Chicago, IL.*
Addresses: Washington, DC. **Studied:** Harvard College (B.A., 1961); Univ. Penn. Grad. Sch. FA. **Comments:** Position: art critic, *Washington Post,* Wash., DC, 1968-. **Sources:** WW73.

RICHARD, Stephen *[Listed as "artist"] b.c.1819, Maryland.*
Addresses: Baltimore in 1850. **Sources:** G&W; 7 Census (1850), Md., IV, 236 (living with V.P. Richard, M.D., 25).

RICHARDS, Anna Mary See: **BREWSTER, Anna Mary Richards**

RICHARDS, Benjamin *[Landscape painter] mid 19th c.*
Addresses: Philadelphia in 1860. **Sources:** G&W; Phila. CD 1860.

RICHARDS, Bill *[Sculptor] b.1936.*
Addresses: Philadelphia, PA, 1975. **Exhibited:** PAFA Ann., 1968; WMAA, 1975. **Sources:** Falk, *Exh. Record Series.*

RICHARDS, Charles *[Illustrator, painter, etcher] b.1906 / d.1992.*
Work: Historic New Orleans Coll. **Comments:** Drew illustrations for newspapers in Memphis and New Orleans. Also painted and etched scenes of the French Quarter in New Orleans in an Impressionist style. **Sources:** *Complementary Visions,* 53, 89.

RICHARDS, Charles K. *[Painter] early 20th c.*
Addresses: Columbus, OH. **Member:** Columbus PPC. **Sources:** WW25.

RICHARDS, Charles Russell *[Educator] b.1865, Boston / d.1936.*
Addresses: NYC. **Studied:** MIT. **Member:** French Legion of Honor. **Exhibited:** U.S. rep., Int. Expo Mod. Dec. & Indus. Art, Paris, 1925. **Comments:** Positions: dir., Am. Assn. Mus., 1923-26; dir., General Educ. Board; dir., Cooper Union, 1908-23; teacher, Pratt Inst., Brooklyn.

RICHARDS, David *[Portrait & genre sculptor, portrait painter in oils & crayon] b.1828, Abergwynolwyn , Wales / d.1897, Utica, NY.*
Addresses: Utica, NY; NYC. **Studied:** NYC for 7 years (after 1850). **Exhibited:** NAD, 1859-78 (as resident of NYC). **Work:** NYHS; NYPL (includes archival material as well). **Comments:** Came to the U.S. c.1847 and found work as a stone cutter at Utica (NY). About 1850 he carved a portrait bust of Utica political leader Horatio Seymour (NYHS). During the course of Richards' career he worked in NYC (1859-78), Chicago (IL), and Woodside, Long Island (NY). Specialized in portrait busts and medallions, many of which depicted clergymen. His "President Grant," "General Harding," and "The Confederate Soldier," at Savannah, GA, are among his best. Richards' bas-relief portraits were especially popular and affordable. He also made small portrait busts of prominent figures which were mass-produced in plaster, copyrighted, and sold to the general public for a few dollars; one such example is his bust of the popular American actress Charlotte Saunders Cushman (c.1870, NYHS). **Sources:** G&W; Utica *Daily Press,* Nov. 29, 1897, obit.; *Art Annual,* I (1898), 28, obit.; Cowdrey, NAD; Naylor, NAD; NYCD 1859-60. More recently, see NYHS Catalogue (1974), cat. nos. 440, 879, 880, 1866.

RICHARDS, E. M. *[Painter] 19th/20th c.*
Addresses: NYC; Newark, NJ (act. 1877-c.1909). **Member:** SC, 1878. **Exhibited:** Brooklyn AA, 1877-83; Boston AC, 1881-82; PAFA Ann., 1881-82. **Sources:** WW10; Falk, *Exh. Record Series.*

RICHARDS, Edythe (Miss) *[Drawing specialist] 20th c.*
Addresses: Tacoma, WA. **Studied:** Univ. Wash. **Exhibited:** Cooper Union Art Inst., 1931 (first prize). **Sources:** Trip and Cook, *Washington State Art and Artists,* 1850-1950.

RICHARDS, Elizabeth L(undborg) *[Painter] early 20th c.*
Addresses: NYC. **Exhibited:** S. Indp. A., 1920. **Sources:** Marlor, *Soc. Indp. Artists.*

RICHARDS, E(lla) E. *[Portrait and genre painter] b.1899, Virginia.*
Addresses: NYC; Baltimore, MD. **Studied:** ASL with R. Henri; Acad. Julian, Paris, with Lefebvre & Fleury; R. Collin in Paris. **Member:** PBC. **Exhibited:** Omaha Expo, 1899 (medal); Paris Salon, 1899; PAFA Ann., 1901-03; Charleston Expo, 1902 (medal); Salons of Am.; AIC; S. Indp. A., 1917. **Sources:** WW40; Fink, *American Art at the Nineteenth-Century Paris Salons,* 384; Falk, *Exh. Record Series.*

RICHARDS, Emelyn *[Artist] late 19th c.*
Addresses: Wash., DC, active 1892. **Sources:** McMahan, *Artists of Washington, DC.*

RICHARDS, Frances *[Painter] late 19th c.*
Addresses: NYC. **Exhibited:** NAD, 1884, 1886-87. **Sources:** Naylor, *NAD.*

RICHARDS, Frederick DeBourg *[Landscape painter, etcher] b.1822, Wilmington, DE / d.1903, Philadelpha, PA.*
Addresses: NYC, 1844-45; Philadelphia, from 1848-66; Paris in 1868. **Member:** Artists Fund Soc.; Phila. Soc. Artists; Phila. AC. **Exhibited:** Am. Inst.; Am. Art-Union; NAD,1845-76; PAFA Ann.,1848-95; Brooklyn AA,1874-79; Boston AC, 1883, 1891; Art Loan Exh., Pub. Lib., Tacoma (WA) Art Lg., 1891; AIC, 1896-1902. **Comments:** Richards spent most of career in Philadelphia but had a Paris address in 1868. On his return to Philadelphia (before 1870) he began showing views of Venice. Between 1875-78 he exhibited scenes of Colorado and California, suggesting he had visited those places as well. The majority of his landscapes were set in Pennsylvania and New Jersey. **Sources:** G&W; Am. Inst. Cat., 1844; Cowdrey, AA & AAU; Cowdrey, NAD; Naylor, NAD; Rutledge, PA; Falk, PA (vol. 2); Phila. BD 1850, 1853; *Portfolio* (Dec. 1946), 92, repro.; Marlor, *Brooklyn Art Assoc.* More recently, see Gerdts, *Art Across America,* vol. 3: 203; P&H Samuels, 398; WW01.

RICHARDS, Frederick De Berg See: **RICHARDS, Frederick DeBourg**

RICHARDS, F(rederick) T(hompson) *[Cartoonist, illustrator, writer] b.1864, Phila. / d.1921.*
Addresses: Phila., PA. **Studied:** PAFA, with Eakins, E.B.

Bensell; ASL. **Member:** Phila. Sketch Club; Players Club.
Comments: Author: "Color Prints from Dickens," "The Blot Book." Positions: staff, *Life,* since 1888; cartoonist, *New York Herald, Times, Philadelphia North American.* **Sources:** WW19.

RICHARDS, George M(ather) *[Painter, illustrator] b.1880, Darien, CT.*
Addresses: New Canaan, CT. **Studied:** D.J. Connah; R. Henri; E. Penfield. **Member:** SC; Silvermine Gld.; Arch. Lg. **Exhibited:** S. Indp. A., 1917-19; WMAA, 1921-1925. **Comments:** Illustrator: "The Golden Book". **Sources:** WW33.

RICHARDS, Gertrude L(undborg) *[Painter] early 20th c.*
Addresses: Richmond, SI, NY. **Exhibited:** S. Indp. A., 1917-20; WMAA, 1920-26. **Sources:** WW17.

RICHARDS, Glenora *[Miniature painter] b.1909, New London, Ohio.*
Addresses: New Canaan, CT. **Studied:** Cleveland Sch. Art. **Member:** ASMP; NAWA. **Exhibited:** ASMP, 1947-56; NAWA, 1953-56; Smithsonian traveling exh. of miniatures, 1966. **Awards:** medal, ASMP, 1947; Penn. SMP, 1947; medal, NAWA, 1953; Wash. SMP&S, 1956-57. **Work:** PMA. **Sources:** WW59.

RICHARDS, Harriet R(oosevelt) *[Painter, illustrator] b.Hartford, CT / d.1932.*
Addresses: New Haven, CT, c.1905-37. **Studied:** Yale Univ.; Frank Benson in Boston; H. Pyle, in Wilmington, DE; Académie Julian, Paris. **Member:** New Haven PCC; Phila. Plastic Club. **Exhibited:** AWCS; Plastic Club; New Haven PCC, 1900 (charter exh.); AIC. **Comments:** Illustrator: holiday editions of books by Louisa M. Alcott and W.D. Howells; *Harper's Monthly, Century Co., Women's Home Companion.* **Sources:** WW33.

RICHARDS, J. R. *[Itinerant portrait painter] mid 19th c.*
Addresses: Logansport (IN) and other Indiana towns, 1837-45, and perhaps into the 1850s. **Sources:** G&W; Peat, *Pioneer Painters of Indiana;* Burnet, *Art and Artists of Indiana,* 389 [as -- Richards].

RICHARDS, Jeanne Herron *[Etcher, painter] 20th c.; b.Aurora, IL.*
Addresses: Alexandria, VA. **Studied:** Univ. Iowa (B.F.A., 1952; M.F.A., 1954) with Mauricio Lasansky; Fulbright grant, Paris, 1954-55; Atelier 1917 in Paris, 1954, with Stanley William Hayter. **Member:** College AA Am.; Soc. Wash. DC PM; Print Club Albany; Northern Virginia FAA. **Exhibited:** LOC Pennell Exhs. Prints, 1947-61 (5 exhs.); Prints From Brooklyn Mus. Nat., AFA US Tour, 1956; Intaglio Prints USA, U.S. Info Agency Tour South Am., 1959; prints, Univ. Illinois, Champaign, 1969 (solo); Olga N. Sheldon Coll., Univ. Nebraska Gals., Lincoln, 1970; Mickelson Gal., Wash., DC, 1970s. **Awards:** purchase award & mem., CGA, 1957; purchase award, Print Club Albany 13th Nat., 1969. **Work:** Lessing J. Rosenwald Coll., Nat Gal. Art; Prints & Photographs, LOC; Nat. Coll. FA, Wash., DC; Nelson-Atkins Gal. Art, Kansas City, MO; Sheldon Mem. Art Gals., Univ. Nebraska, Lincoln. **Comments:** Teaching: Univ. Iowa, 1955-56; Univ. Nebraska, Lincoln, 1957-63. **Sources:** WW73.

RICHARDS, John *[Painter] b.1831 / d.1889.*
Addresses: NYC. **Comments:** American painter whose "Battle of Gettysburg," painted about 1870, was owned by Nelson A. Rockefeller in the 1950s. **Sources:** G&W; *American Processional,* 177, 246-47; WW01.

RICHARDS, John H. *[Draftsman, lithographer, engraver] b.c.1807, Germany.*
Comments: While working with P.S. Duval of Phila. between 1841-43, the two experimented with "lithotinting." The result was "Grandpapa's Pet," said to be the first true lithotint produced in America, and published in *Miss Leslie's Magazine* in April 1843. Richards appeared as an engraver in Philadelphia directories in 1843 and 1844, as an artist in the 1850 Census, and as an employee at the U.S. Mint in 1851-52. From 1852-55 an artist named J.H. Richard was hired by the Smithsonian Institution to produce drawings of specimens of mammals, fish, and reptiles that were

collected by western surveying expeditions; the resulting engravings appeared in the official reports published between 1855-60. The same artist also contributed drawings to Duval's series of turtle prints and eight steel plates appearing in T.W. Harris's *Treatise on Some of the Insects Injurious to Vegetation* (Boston, 1862). An artist named J. Richards contributed a drawing for at least one of John Hart's 1868 series of prints of Germantown (PA). Groce & Wallace noted that it was very probable that John H. Richards, J.H. Richard, John Richard or Richards, and J. Richard were one artist. **Sources:** G&W; 7 Census (1850), Pa., LIII, 217 [as John Richards]; "The New Art of Lithotint," *Miss Leslie's Magazine,* April 1843, 113-14 [as Richards]; Peters, *American on Stone,* under Duval; Waite, "Beginnings of American Color Printing," 15 [as John C. Richards]; Phila. CD 1843-44 [as John Richards], 1851-52 [as John Richard]; Marcy, *Exploration of the Red River of Louisiana;* U.S. War Dept., *Reports of Explorations and Surveys,* vols. VI-VIII, X, XII; Hamilton, *Early American Book Illustrators and Wood Engravers,* 401; Peters, *America on Stone,* under J. Richards. More recently, see Marzio, *The Democratic Art;* also, Pierce and Slautterback, 10, regarding William Sharp's color lithograph experiments of 1840.

RICHARDS, Karl Frederick *[Educator, painter] b.1920, Youngstown, OH.*
Addresses: State University, AR. **Studied:** Cleveland Inst. Art (dipl., 1944); Western Reserve Univ. (B.S.Ed., 1944); State Univ. Iowa (M.A., 1947); Ohio State Univ. (Ph.D., 1956). **Comments:** Preferred medium: oils. Teaching: Bowling Green State Univ., 1947-56; Texas Christian Univ., 1956-71; Arkansas State Univ., 1971-. **Sources:** WW73.

RICHARDS, Lee Greene *[Portrait painter, sculptor, illustrator] b.1878, Salt Lake City, UT / d.1950, Salt Lake City.*
Addresses: Salt Lake City. **Studied:** Salt Lake City with J.T. Harwood, c.1895; Académie Julian, Paris with J.P. Laurens, 1901-02; Ecole des Beaux-Arts with Bonnât, 1902. **Member:** Salon d'Automne; Paris AAA; Utah SA; NAC. **Exhibited:** Paris Salon, 1904 (prize); PAFA Ann., 1905; AIC. **Work:** Utah State Capitol; Univ. Utah; BYU. **Comments:** A popular Utah portrait painter who was in Paris from 1901-04, 1908-09, 1920-23. He was one of the "20th Ward Group" of artists. Teaching: Univ. Utah, 1938-47. **Sources:** WW31; P&H Samuels, 398; Falk, *Exh. Record Series.*

RICHARDS, Lucy Currier (Mrs. F. P. Wilson) *[Sculptor] early 20th c.; b.Lawrence, MA.*
Addresses: Boston; Norwalk, CT, active 1906-1933. **Studied:** BMFA School; Kops in Dresden; Eustritcz in Berlin; Académie Julian, Paris. **Member:** Copley Soc.; Boston GA; NAWPS; MacD. Club. **Exhibited:** Boston AC, 1906, 1907; PAFA Ann., 1907-17 (7 times); AIC; Portland (OR) AA (solo); Guild Boston Artists, 1919 (solo). **Sources:** WW33; Petteys, *Dictionary of Women Artists;* Falk, *Exh. Record Series.*

RICHARDS, Margaret A. (Mrs. Samuel D.) *[Painter] 19th/20th c.*
Addresses: Detroit, MI, 1871-1905; Ypsilanti, MI from 1905. **Studied:** John Owen in Detroit; Smiley in NYC. **Member:** Detroit WCS; Detroit AC. **Exhibited:** Detroit, 1893, 1895, 1897. **Sources:** Gibson, *Artists of Early Michigan,* 201.

RICHARDS, Marjorie Lorraine *[Painter] early 20th c.*
Addresses: W. Haven, CT. **Exhibited:** S. Indp. A., 1933. **Sources:** Marlor, *Soc. Indp. Artists.*

RICHARDS, Myra R(eynolds) *[Sculptor, painter, teacher] b.1882, Indianapolis / d.1934, NYC.*
Addresses: Indianapolis, IN. **Studied:** John Herron AI with O. Adams, Forsyth, R. Schwartz, G.J. Zolnay; Paris. **Member:** Hoosier Salon. **Exhibited:** AIC, 1923; PAFA Ann., 1928; NSS. **Work:** statue, Greenfield, IN; bust, Indiana State Lib.; Columbus (IN) H.S.; fountain figures, Univ. Park, Indianapolis; group symbolic of women's achievement, presented by the Women's Press Club of Indiana to Turkey Run State Park. **Comments:** Teaching: John Herron AI. **Sources:** WW29; Falk, *Exh. Record Series.*

RICHARDS, Nellie *[Landscape painter] early 20th c.*
Work: Old Mint, San Francisco, (Mt. Shasta, 1914). **Sources:** Hughes, *Artists of California*, 465.

RICHARDS, Newton *[Stone cutter, sculptor, engraver, art teacher, sketch artist] b.1805, New Hampshire / d.1874, New Orleans.*
Addresses: New Orleans from 1831, active until 1873. **Studied:** apprenticed to Abner Joy, stoneworker in Boston. **Comments:** After apprenticeship, was put in charge of Abner Joy's stoneworking business in NYC; worked in Philadelphia before going to New Orleans in Dec., 1831. Owned granite and marble yard in New Orleans, providing stone for architectural facades and tombs. Designed pedestal for monument to Andrew Jackson in Jackson Square (1852) and many other family and individual tombs. Position: prof. drawing, design, engraving, artisan sketching, New Orleans Polytechnic & Indust. Inst., 1873. **Sources:** G&W; New Orleans CD 1841-42, 1846. More recently, see *Encyclopaedia of New Orleans Artists*. 323-324.

RICHARDS, Samuel *[Figure painter] b.1853, Spencer, IN / d.1893, Denver, CO.*
Addresses: Munich, Germany; Davos Platz, Switzerland. **Studied:** Europe with Steele; Theobald Lietz, Indianapolis, 1871; Indiana Univ. **Exhibited:** Boston AC, 1888, 1890; PAFA Ann., 1891. **Work:** Detroit Inst. Arts ("Evangeline Discovering Her Affianced in the Hospital"). **Comments:** Richards was born in Indiana and traveled to Munich like many other Indiana artists of that time. There he was an expressive figure painter of momumental and literary subjects. He became ill in Europe and returned home in 1891 and moved to Denver where he directed the Denver Art League. Richards died shortly thereafter; his obituary was written by longtime friend, James Whitcomb Riley. **Sources:** Gerdts, *Art Across America*, vol. 2: 265-66 (with repro.); Falk, *Exh. Record Series*.

RICHARDS, T(homas) Addison *[Landscape, floral, fruit, and portrait painter, illustrator, teacher] b.1820, London, England / d.1900, Annapolis, MD.*
Addresses: NYC. **Studied:** NAD, 1844-46. **Member:** ANA, 1848; NA, 1851 (corresponding secretary, 1852-92); AWCS. **Exhibited:** NAD, 1846-99; Brooklyn AA, 1863-86; PAFA Ann., 1864, 1881; Boston AC, 1881; AIC, 1888. **Work:** Shelburne (VT) Mus. **Comments:** Painter of the Hudson River landscape and the South. After coming to America with his family in 1831, he grew up in Hudson, NY, and Penfield, GA. In 1838 (at age 18), he published an illustrated guide to flower painting. At the time, Richards was living in Augusta, GA, where he offered instruction in landscape, fruit, flower, and marine painting, and also contributed travel pictures to local periodicals. In 1842, he illustrated a book on Georgia, containing what are among the earliest landscapes of that state. He painted and taught in Charleston, SC, 1843-44, and later in 1844 went to study in NYC. Richards established a studio in that city but also began painting in the Hudson River Valley, and by 1848 was part of the growing art colony in Palenville, NY, at the southern end of the Kaaterskill Cove near Catskill. Others painting there included Asher B. Durand, John Frederick Kensett, David Johnson, and Richard William Hubbard. Richards also painted in the area of Lake George, NY, and traveled widely in the U.S. and Europe. In 1857 he published an illustrated handbook of American travel. He also contributed illustrated travel articles to several American magazines. Teaching: NY Univ., 1867-87. **Sources:** G&W; DAB; *Art Annual*, II, obit.; Rutledge, *Artists in the Life of Charleston*; NYCD 1845, 1860; Cowdrey, NAD; Naylor, NAD; Rutledge, PA; 8 Census (1860), N.Y., XLIX, 1038; Peters, *America on Stone; Home Authors and Home Artists*; Falk, *Exh. Record Series*. More recently, see Muller, *Paintings and Drawings at the Shelburne Museum*, 119 (w/repro.); *300 Years of American Art*, vol. 1, 189; Gerdts, *Art Across America*, vol. 1:159 and vol. 2: 68.

RICHARDS, Thomas W. *[Architect and painter] b.1836 / d.1911.*
Addresses: Philadelphia, 1858-60; Baltimore, MD, 1861;

Philadelphia in 1862. **Exhibited:** PAFA, 1854-62 (oriental scenes and Moorish architectural views), 1862 (a view by Richards and John Murdock showing the interior of St. James R.C. Church, Baltimore). **Sources:** G&W; Rutledge, PA (under "Thomas W. Richards" and under "Murdock and Richards"); Phila. CD 1858.

RICHARDS, Walter DuBois *[Illustrator, designer] b.1907, Penfield, OH.*
Addresses: New Canaan, CT. **Studied:** Cleveland Sch. Art. **Member:** SI; Cleveland PM; AWCS; Conn. WCS; Westport Artists; Fairfield WC Group. **Exhibited:** CMA, 1933-37 (prizes); AIC; WMAA, 1938-1940. **Work:** Cleveland Pub. Lib.; CMA. **Comments:** Affiliated with Charles E. Cooper Studios, NY. **Sources:** WW47.

RICHARDS, William Coolidge *[Painter] b.1914., Columbus, MS.*
Addresses: Ocean Springs, MS. **Studied:** Univ. Virginia; Tulane Univ. (B.A.); Cincinnati Art Acad.; ASL with Brook, Kuniyoshi, Laurent & Zorach. **Exhibited:** Gal. Raspall, France, 1948; Little Studio, 1952, 1955 (solo); Jackson (MS) Art Mus.; Mobile AA, 1957; Telfair Acad., Savannah, 1957. **Sources:** WW59.

RICHARDS, William Trost
[Marine, landscape painter] *Wm.T.Richards.1890.*
b.1833, Philadelphia / d.1905, Newport, RI.
Addresses: Phila., PA; Newport, RI, from 1890. **Studied:** Phila. with Paul Weber, 1850; maybe at PAFA, c.1852; Florence, Rome, Paris, all during 1853-56 (traveling with William Stanley Haseltine & Alexander Lawrie). **Member:** PAFA, 1853; Assn. Advancement of Truth in Art, 1868; Royal Acad., London; NA, 1871; AWCS. **Exhibited:** PAFA Ann.,1852-1905 (silver medal, 1885); NAD, 1858-1905; Brooklyn AA, 1863-85; Paris Salon, 1873; Centenn. Exhib., Phila., 1876 (medal); Boston AC, 1878, 1882-86, 1898; Paris Expo, 1889 (medal); Royal Acad., London; AIC. **Work:** Brooklyn Mus.; Bowdoin College, Brunswick, ME; Cooper-Hewitt Museum, NYC; CGA; MMA; Newark (NJ) Mus.; Shelburne (VT) Mus. **Comments:** While studying painting privately with Paul Weber, he worked as an illustrator for a Philadelphia company producing gas lamp fixtures and exhibited his first landscapes at PAFA in 1852. In 1855, he traveled with Wm. S. Haseltine and Paul Weber to Dusseldorf, studying, and meeting Leutze and Bierstadt. He also traveled to France and Italy before returning to Philadelphia in 1856, marrying and settling in Germantown (until 1881). From 1856-66, he was preoccupied with landscapes, and his attention to detail reveals a Ruskinian concern with truth to nature and the influence of the Pre-Raphaelites (whose work was exhibited in Phila. in 1858). Richards visited Britain in 1866-67 and by the 1870s he had increasingly turned to the marine paintings (in oils and watercolors) for which he is now best known. In 1874 he bought his first of several houses in Newport, and painted around Aquidneck and Conanicut until his death. During his later years he also made frequent trips to the British Isles and the Channel Islands. **Sources:** G&W; Morris, *Masterpieces of the Sea: William T. Richards, a Brief Outline of His Life and Art;* DAB; *Art Annual*, VI, obit.; Rutledge, PA; Cowdrey, NAD; Rutledge, MHS; Phila. CD 1854-60+; *Portfolio* (April 1945), 190-91; WW04; Baigell, *Dictionary;* Muller, *Paintings and Drawings at the Shelburne Museum*, 119 (w/repro.); Rbt. Workman, *The Eden of America* (RISD, 1986, p.58); Fink, *American Art at the Nineteenth-Century Paris Salons*, 384; Falk, *Exh. Record Series*.

RICHARDSON, Alexander *[Painter] early 20th c.*
Addresses: NYC. **Exhibited:** S. Indp. A., 1922; Salons of Am., 1934. **Sources:** Falk, *Exhibition Record Series*.

RICHARDSON, Andrew *[Landscape painter] b.1799, Scotland / d.1876, NYC.*
Addresses: NYC. **Member:** ANA, 1832; NA, 1833 (retired from NAD in 1858). **Exhibited:** Am. Acad.; NAD, 1831-76; Brooklyn AA, 1869-70; Apollo Assoc.; Am. Art-Union. **Comments:** Came to NYC c.1831. His landscapes were primarily Scottish, English,

and New York or Pennsylvania scenes. According to exhibition records, Richardson was back in Scotland in 1844 but by 1848 he was again in NYC; in 1852 he was in Scotland but by 1868 had returned to the U.S. **Sources:** G&W; Cowdrey, NAD; Cowdrey, AA & AAU; Smith; Mallet; Thieme-Becker; Fielding.

RICHARDSON, Anna M. (Mrs.) *[Landscape painter]* 19th/20th c.
Addresses: Boston, MA, c.1904-10. **Studied:** ASL with G. de Forest Brush and W.H. Foote; Boston with L. Kronberg, S.C. Carbee. **Member:** Copley Soc., 1904. **Exhibited:** Boston AC, 1905; PAFA Ann., 1910. **Sources:** WW10; Falk, *Exh. Record Series.*

RICHARDSON, Arloa F. *[Artist]* late 19th c.
Addresses: Wash., DC, active 1889. **Comments:** He had a studio in the Corcoran Building. **Sources:** McMahan, *Artists of Washington, DC.*

RICHARDSON, Benjamin J. *[Etcher, photographer, painter]* b.1835, London / d.1926.
Addresses: Brooklyn, NY. **Exhibited:** NAD, 1882, 1885; Boston AC, 1890. **Sources:** WW06; *The Boston AC.*

RICHARDSON, Billie (Miss) *[Painter]* mid 20th c.
Addresses: NYC. **Exhibited:** S. Indp. A., 1944. **Sources:** Marlor, *Soc. Indp. Artists.*

RICHARDSON, Caroline Schetky See: **SCHETKY, Caroline (Mrs. Sam. Richardson)**

RICHARDSON, Catherine Priestly *[Painter]* b.1900, NYC.
Addresses: Cambridge, Brookline, MA. **Studied:** P.L. Hale. **Member:** NAWPS. **Exhibited:** Boston, 1921 (prize); PAFA Ann., 1921-27; S. Indp. A., 1935. **Sources:** WW40; Falk, *Exh. Record Series.*

RICHARDSON, Cherry E(mma)(Mrs.) b.1859.
Exhibited: Salons of Am., 1924. **Sources:** Marlor, *Salons of Am.*

RICHARDSON, Clara Virginia *[Painter, etcher, illustrator, teacher]* b.1855, Phila., PA / d.1933.
Addresses: Phila., PA; Portland, ME after 1927. **Studied:** Phila. Sch. Des. Women (William J. Horstmann Scholarship) with Ferris, Peter Moran (etching), Daingerfield, Snell. **Member:** Plastic Club (recording secy., 1914-15); Phila. Art All. **Exhibited:** PAFA Ann., 1885, 1887; PAFA, 1885-1913; Union Lg. Club, 1888; "Women Etchers of Am.," Boston & NYC; Columbian Expo, 1893; Plastic Club, 1909-22. **Comments:** Painter of landscapes, flowers, views of Europe and New England. Richardson taught pen and ink for photo-engraving at Phila. Sch. Des. Women in 1885/86 and 1886/87. None of her etchings have been located. **Sources:** WW31; P. Peet, *Am. Women of the Etching Revival,* 63; Petteys, *Dictionary of Women Artists;* Falk, *Exh. Record Series.*

RICHARDSON, Constance Coleman (Mrs. E. P.) *[Painter]* *Constance Richardson* b.1905, Indianapolis, IN.
Addresses: Detroit, MI, 1931-62; Philadelphia, PA, from c.1962. **Studied:** Vassar; PAFA, 1925-28. **Exhibited:** Michigan Artists Ann., 1937 (prize); Detroit IA, 1938 (prize), 1945, 1959; Schaeffer Gal., NYC, 1938; Golden Gate Expo, 1939; WFNY, 1939; AIC, 1940-41, 1945; MacBeth Gal., NYC, 1940s-50s; PAFA, 1940-64 (7 times); CI, 1941, 1943-45; de Young Mem. Mus., 1943, 1947 (solo); WMAA, 1944, 1945; Corcoran Gal. biennials, 1945-53 (3 times); Critics Choice, CM, 1945; "Am. Painting Today," MMA, 1950; Kennedy Gals., NYC (1960s-70s); "Am. Landscape, A Changing Frontier," Nat. Coll. FA, 1966; AFA, 1967-68 ("Fifty Artists from Fifty States" trav. exhib.); "Am. Paintings of Ports & Harbor, 1774-1968," Jacksonville-Norfolk, 1969; "Remnants of Things Past," Jacksonville-St. Petersburg, 1971. **Work:** WMAA; Detroit IA; PAFA; Indianapolis MA; John Herron AI, Indianapolis; Detroit IA; Santa Barbara MA; Columbus (OH) Gal. FA; PAFA. **Commissions:** "This Land is Ours" (painting), Omaha (NE) Nat. Bank, 1966. **Comments:** An acclaimed landscape painter from the 1930-70s, she painted in Vermont, New York State (through 1931), and the Great Lakes

area (after her move to Detroit); and traveled frequently to Wyoming and other western locations. She used classic fifteenth-century Flemish painting techniques which she learned from museum conservators. She was married to the art historian (and museum director) Edgar P. Richardson. **Sources:** WW73; WW47; Louise Bruner, "Constance Richardson," *Am. Artist* (Jan., 1961); Alan Gussow, *A Sense of Place, the Artist & the American Land* (Saturday Rev. Press, 1971); Tufts, *American Women Artists, 1830-1930,* cat. no. 78; Rubinstein, *American Women Artists,* 238-39; Falk, *Exh. Record Series.*

RICHARDSON, Cora *[Painter]* late 19th c.
Addresses: NYC. **Exhibited:** NAD, 1875-80. **Sources:** Naylor, *NAD.*

RICHARDSON, Dean mid 20th c.
Addresses: possibly Boston. **Exhibited:** WMAA, 1959; Corcoran Gal. biennial, 1961; PAFA Ann., 1962. **Sources:** Falk, *Exhibition Records Series.*

RICHARDSON, E. A. (Ellen A.) *[Pottery decorator]* late 19th c.
Exhibited: Columbian Expo, Chicago, 1893. **Comments:** Created plate designs, Louis Prang & Co., 1890. **Sources:** Petteys, *Dictionary of Women Artists.*

RICHARDSON, Earl Wilton *[Painter]* b.c.1912, NYC / d.1935.
Addresses: NYC. **Studied:** NAD. **Member:** Artists Union; Negro Artists Gld. **Exhibited:** NAD (prize); Harmon Found. Exh., 1933 (prize)-35, touring exh., 1934-35; CGA, 1934; Texas Centennial, 1936; Howard Univ., 1937; Am. Negro Expo, Chicago, 1940; NY Fed. Arts Project, 1934-45; Urban Lg.; City College NY, 1967. **Work:** painting and supervising a Negro hist. mural on a WPA project. **Sources:** Cederholm, *Afro-American Artists.*

RICHARDSON, Ed *[Illustrator, commercial artist]* b.1927, Springfield, MA.
Studied: RISD; Thurston Munson. **Exhibited:** Norwich (CT) Rose Festival. **Comments:** Illustrator: Merriam Webster dictionaries. **Sources:** Cederholm, *Afro-American Artists.*

RICHARDSON, E(dgar) P(reston) *[Historian, administrator]* b.1902, Glens Falls, NY / d.1985, Philadelphia, PA.
Addresses: Detroit, MI, 1931-62; Phila., from c.1962. **Studied:** Williams College, 1925; PAFA, 1925-28; Univ. Penn. **Member:** Archives Am. Art (co-founder/dir., 1954); Am Philos. Soc; Hist. Soc. Penn.; Nat. Portrait Gal. Comn. **Comments:** Best known as a co-founder of the Archives of American Art and for his books, *The Way of Western Art* (1939 & 1967), *American Romantic Painting* (1944), *Washington Allston* (1948 & 1967), *Painting in America, The Story of 450 Years* (1956 & 1965), *A Short History of Painting in America* (1963). Positions: ed., *Art Quarterly,* 1938-64; dir., Detroit Inst. Arts, 1945-62; dir., H.F. du Pont Winterthur Mus., 1962-66; chmn., Smithsonian Art Comn., 1963-66; pres., PAFA, 1968-70. He was married to painter Constance Coleman Richardson. **Sources:** WW73; WW47.

RICHARDSON, Esther Ruble (Mrs.) *[Painter, teacher, lecturer]* b.1895, Nevada, MO.
Addresses: Joliet, IL; Lockport, IL. **Studied:** Univ. Chicago (Ph.B.); AIC; Chicago Acad. FA; Millard Sheets; Frederic M. Grant; W. Sargent. **Member:** Joliet Art Lg.; Nat. Educ. Assn.; Illinois Educ. Assn.; All-Illinois SFA; Chicago Gal. Assn.; Hoosier Salon. **Exhibited:** Illinois Soc. FA, 1936 (gold); AIC, 1934-41; PAFA, 1935; Hoosier Salon, 1931-41 (including several solos); Chicago Gal. Assn. ; O'Briens Gals., Chicago; Tower Town Gal., Chicago. **Work:** Illinois Pub. Sch.; Iola (KS) Lib. **Comments:** Position: head, art dept., Joliet Township H.S. & Jr. College Joliet, IL. Contrib.: *School Arts* magazine. **Sources:** WW53; WW47.

RICHARDSON, Evans T. (Mrs.) *[Etcher]* late 19th c.
Addresses: Active in Detroit, MI, 1893. **Sources:** Petteys, *Dictionary of Women Artists.*

RICHARDSON, F. *[Teacher, sketch artist] mid 19th c.* **Addresses:** New Orleans, active 1857-61. **Comments:** Drew an illustrated advertisement engraved by Charles J. Stevens that appeared in the *Weekly Mirror,*1859. **Sources:** *Encyclopaedia of New Orleans Artists,* 324.

RICHARDSON, Fanny McClatchy *[Painter] b.1861, Sacramento, CA / d.1948, Sacramento.* **Addresses:** Sacramento. **Studied:** Notre Dame Convent, San Jose. **Member:** Kingsley AC. **Exhibited:** Calif. State Lib., 1945 (solo). **Work:** De Saisset Mus., Univ. Santa Clara. **Comments:** Specialty: watercolors of California wildflowers. *Cf.* M. McClatchy. **Sources:** Hughes, *Artists of California,* 466.

RICHARDSON, Florence Isabelle Wilson *[Painter] b.1879, San Francisco, CA / d.1973, San Fran.* **Addresses:** San Fran. **Studied:** Mattie A. Terry. **Comments:** Specialty: portraits, still lifes, moody landscapes, many on silk. **Sources:** Hughes, *Artists of California,* 466.

RICHARDSON, Florence Wood *[Potter] mid 20th c.* **Addresses:** Columbus, OH. **Exhibited:** Columbus AL, 1937 (prize). **Sources:** WW40.

RICHARDSON, Francis H(enry) *[Painter] b.1859, Boston, MA / d.1934, Ipswich, MA.* **Addresses:** Ipswich. **Studied:** Boston with W.M. Hunt; Académie Julian, Paris, with Boulanger, Lefebvre; Doucet; Constant; Laurens. **Member:** SC, 1901; Gloucester SA. **Exhibited:** Paris Salon, 1889, 1890, 1894-99 (prize, 1899); Harcourt Studios Gal., 1890; Boston AC, 1891 (solo), 1892-1903 (purchase prize), 1904-09; PAFA Ann., 1891-1904; AAS, 1902 (med.); NAD, 1892-93, 1896; AIC; Detroit IA; Phila. AC; AWCS; S. Indp. A., 1930. **Work:** BAC; Lasell Seminary, Auburndale, MA; Town Hall, Braintree, Mass.; Roxbury Latin Sch., Boston. **Comments:** During his years in Paris, he also painted in Étaples, and Concarneau, and traveled with C.C. Cooper to Italy, N. Africa, and Spain. **Sources:** WW33; exh. cat., *Painters of the Harcourt Studios* (Lepore FA, Newburyport, MA, 1992) Bibliography: Fink, *American Art at the Nineteenth-Century Paris Salons,* 384; Falk, *Exh. Record Series.*

RICHARDSON, Frederick *[Listed as "artist"] b.c.1822, England.* **Addresses:** Philadelphia. **Comments:** Living with Richard Richardson (see entry) and family in Philadelphia, July 1860. He owned real estate valued at $30,000. **Sources:** G&W; 8 Census (1860), Pa., LII, 64.

RICHARDSON, Frederick *[Illustrator, painter, teacher] b.1862, Chicago / d.1937, NYC.* **Addresses:** NYC/Chicago, IL. **Studied:** St. Louis Sch. FA; Académie Julian, Paris with Doucet & Lefebvre, 1887-90. **Member:** Paris Salon, 1890; Century Assn.; SI, 1905; AFA; Cliff Dwellers, Chicago; MacD. Club. **Exhibited:** AIC. **Comments:** Illustrator: books; magazines; *Chicago Daily News.* **Sources:** WW33; Fink, *American Art at the Nineteenth-Century Paris Salons,* 384.

RICHARDSON, George *[Painter] early 19th c.* **Addresses:** Active in NYC, 1824. **Comments:** Painter of a watercolor view of the East River with a distant view of the seat of Joshua Waddington, Esq., NYC, 1824. **Sources:** G&W; *Antiques,* May 1942, 308 (repro.).

RICHARDSON, Gretchen (Gretchen Rose Freelander) *[Sculptor] 20th c.; b.Detroit, MI.* **Addresses:** NYC. **Studied:** Wellesley College (B.A.); Acad. Julian, Paris, France; ASL with William Zorach & Jose de Creeft. **Member:** Audubon Artists (sculpture jury, 1971); NAWA (exec. comt., 1952-55; sculpture jury, 1969-71); NY Soc. Women Artists; Artists Equity Assn. NY. **Exhibited:** Int. Arts Club, London, England; PAFA Ann., 1953, 1960; Audubon Artists; Knickerbocker Artists; NAD. Awards: IAR Wylie prize 1952, Amelia Peabody prize, 1955 & Mary Kellner Mem. prize, 1959, NAWA; Bodley Gal., NYC, 1970s. **Comments:** Preferred media:

stone, marble, alabaster. **Sources:** WW73; Falk, *Exh. Record Series.*

RICHARDSON, Harold B. *[Painter] early 20th c.* **Addresses:** Oak Park, IL. **Sources:** WW19.

RICHARDSON, Harry S. *[Sculptor, craftsperson] mid 20th c.* **Exhibited:** Cleveland & Youngstown (OH) Mus.; San Fran., 21st Ann. Festival; Philippines AA, Ann.; Mead's Gal., San Fran.; Acad. Sciences, Golden Gate Park, San Fran.; Mills College. **Sources:** Cederholm, *Afro-American Artists.*

RICHARDSON, Helen E. *[Sculptor] early 20th c.* **Addresses:** Detroit, MI. **Exhibited:** PAFA Ann., 1924. **Sources:** Falk, *Exh. Record Series.*

RICHARDSON, Henrietta P. *[Painter] late 19th c.* **Addresses:** Providence, RI. **Exhibited:** NAD, 1878. **Sources:** Naylor, *NAD.*

RICHARDSON, Henry *[Painter] mid 19th c.* **Addresses:** New Orleans, active 1836-42. **Comments:** Partner in painting firm of Richardson and Watson (see entry). 1836-37. He was listed on his own 1841-42. **Sources:** G&W; *Encyclopaedia of New Orleans Artists* cites NOCD 1841-42.

RICHARDSON, Henry *[Engraver] b.c.1817, New York.* **Addresses:** NYC. **Comments:** Living in 1850 with a wife and three children, all born in New York. **Sources:** G&W; 7 Census (1850), N.Y., XLVI, 614.

RICHARDSON, Henry C. *[Painter] early 20th c.* **Addresses:** NYC. **Member:** GFLA. **Sources:** WW27.

RICHARDSON, Isa (Louise) Cabot See: **DREIER, Isa (Louisa) Cabot Richardson (Mrs.)**

RICHARDSON, J. F. *[Wood engraver] mid 19th c.* **Addresses:** Portland, ME, 1860. **Sources:** G&W; Portland BD 1860.

RICHARDSON, Jacob *[Engraver] late 19th c.* **Addresses:** Wash., DC, active 1877. **Sources:** McMahan, *Artists of Washington, DC.*

RICHARDSON, James B. *[Painter] early 20th c.* **Addresses:** Wash., DC, active 1909-35. **Member:** Soc. Wash. Artists. **Exhibited:** Soc. Wash. Artists; Gr. Wash. Indep. Exh., 1935; Wash. Landscape Club. **Comments:** His works were primarily watercolors. **Sources:** WW27; McMahan, *Artists of Washington, DC.*

RICHARDSON, James H. *[Wood engraver] mid 19th c.* **Addresses:** NYC, 1848-80. **Comments:** He was associated with the firms Orr & Richardson,1848, and Richardson & Cox, 1853-59 (see entries). **Sources:** G&W; NYCD 1848-59; Hamilton, *Early American Book Illustrators and Wood Engravers,* 527.

RICHARDSON, John Frederick *[Painter, teacher] b.1906, Nashville, TN / d.1998, Knoxville.* **Addresses:** Nashville, TN, 1906-41; Chicago, IL, 1942-72; Nashville, 1973-98. **Studied:** Vanderbilt Univ., 1929; Watkins Inst., 1931, with C. Cagle & M. Partee; PAFA, 1932; Univ. Chicago (M.A., 1942). **Member:** Tennessee WCS; Nashville AG; Tennessee Art Lg. **Exhibited:** PAFA Ann., 1936; AIC. **Awards:** SSAL, 1935; Univ. Chicago (first prize); Union Lg. Club, Chicago (Van Auken Purchase Prize); PAFA (Ramborger Prize; Henry R. Poor Prize); Gal. Science & Art, San Fran; (IBM Hon. Award); Central South Exh., Nashville (Richards & Southern Award, Capitol Engraving Co. Award); Tennessee All-State Exh. (Purchase Award); Vanderbilt Univ. (Purchase Award); Tennessee WCS. **Work:** PAFA; IBM; Boston Soc. Nat. History; Calumet Sch., Hammond, IN; Dekalb College; Albion College; Shenendehowa Central Sch., Elnora, NY; The Parthenon, Nashville, TN; Am. Lib. Color Slides; Watkins Inst., Nashville, TN. **Comments:** Preferred media: watercolor, oil, acrylic, pastel, pen and ink. Richardson explored a wide variety of styles and media interpreting landscapes from Tennessee to Arizona to

Washington State. **Teaching:** Watkins Inst., Nashville, 1938-42; Univ. Illinois, Chicago Circle, 1946-69. **Sources:** WW40; Falk, *Exh. Record Series;* addit. info courtesy Jean Richardson Hilten, Walland, TN.

RICHARDSON, Judith Heidler *[Art administrator, art dealer]* b.1942, Newport, RI.
Addresses: NYC. **Studied:** Swarthmore College; Bennington College (B.A.); Sorbonne Univ. Paris, Ecole des Lettres.
Comments: Positions: asst. dir., Pace Gal., NYC, 1966-69; dir., Sonnabend Gal., New York, 1969-. Specialty of gallery: Contemporary painting & sculpture; art deco & art moderne.
Sources: WW73.

RICHARDSON, L. C. *[Portrait painter]* early 19th c.
Work: In 1956, the Wentworth Gardiner House, Portsmouth, NH, had oil portraits of Jacob Sheafe (1754-1829) and Mrs. Jacob Sheafe (1751-1833). **Sources:** G&W; WPA (Mass.), *Portraits Found in N.H.,* 20.

RICHARDSON, Louis H. *[Painter]* b.1853, New Bedford, MA / d.1923, New Bedford.
Addresses: New Bedford/Salters Point, South Darmouth, MA.
Studied: self-taught. **Member:** New Bedford Art Club (charter mem.); New Bedford FA Soc. (organizer, 1921). **Exhibited:** Arlington Gal., New York (with Clifford Ashley), 1917; Swain Free Sch. Design, New Bedford, 1923; New Bedford Art Club, 1907-20; Thumb Box Exh., 1910, 1911; New Bedford Soc. FA, 1921. **Work:** Old Dartmouth Hist. Soc. **Comments:** Preferred medium: oils and oil pastels; sometimes painted on asbestos. Was also a well-known local baseball player ("Home Run King of 1870"). **Sources:** WW17; info. courtesy of George Gray, Westport, MA; Blasdale, *Artists of New Bedford,* 152 (w/repro.).

RICHARDSON, M. M. *[Artist]* early 20th c.
Addresses: Wash., DC, active 1917. **Exhibited:** Wash. AC, 1917 (at the Willard Hotel, to benefit the Am. Red Cross). **Sources:** McMahan, *Artists of Washington, DC.*

RICHARDSON, Marcella *[Painter]* mid 19th c.
Addresses: Pontiac, MI, 1854-55. **Exhibited:** Michigan State Fair, 1854-55. **Comments:** Preferred medium: watercolor.
Sources: Gibson, *Artists of Early Michigan,* 201.

RICHARDSON, Margaret Foster *[Portrait painter]* b.1881, Winnetka, IL. / d.c.1945.
Addresses: Boston, MA. **Studied:** Mass. State Normal Art Sch. with J. DeCamp & E.L. Major; BMFA Sch. with E.C. Tarbell; study tour in Europe. **Exhibited:** Corcoran Gal. biennials, 1908-16 (5 times); PAFA Ann., 1910-30; Copley Gal., 1910 (solo); Carnegie Inst.; Boston AC, 1909; AIC, 1911 (Harris bronze medal & prize); NAD, 1913 (prize). **Work:** portraits: MIT; Boston Univ.; Admin. Bldg., Boston; U.S.S. *Phelps;* T. Roosevelt Sch., Boston; Mechanic Arts H.S., Boston; Boston Pub. Sch.; Am. Legion Post, Lynn, MA; Pub. Lib., Lawrence, MA. **Comments:** Her subjects included many Boston notables such as Mary Baker Eddy, the founder of the Christian Science Church, university scholars and presidents, as well as Admiral Phelps. Earlier works show the strong influence of her Boston teachers. **Sources:** WW40; Tufts, *American Women Artists,* cat. no. 16; Falk, *Exh. Record Series.*

RICHARDSON, Maria *[Watercolorist]* mid 19th c.
Addresses: Active in Pontiac, MI. **Exhibited:** Michigan State Fair, 1855. **Sources:** Petteys, *Dictionary of Women Artists.*

RICHARDSON, Marion *[Painter, lithographer, etcher]* b.1877, Brooklyn, NY. / d.1952, NYC.
Addresses: NYC/Adelynrood, South, Byfield, MA. **Studied:** Chase; DuMond; Senseney. **Member:** Calif. PM; NAWPS; AFA.
Exhibited: S. Indp. A., 1917. **Work:** mural block prints on linen, Mass. Gen. Hospital, Boston; Parish House, Grace Church, Amherst, MA; St. Anne's Church, Murray Bay, Quebec, Canada; St. Luke's Hospital, NY. **Sources:** WW40.

RICHARDSON, Mary Curtis (Mrs.) *[Woodcarver, portrait painter]* b.1848, NYC / d.1931, San Francisco, CA.
Addresses: NYC; San Fran. **Studied:** San Fran. Sch. of Des. with Virgil Williams; CUA.Sch.; ASL with B. Irwin, W. Sartain.
Member: SFAA; AFA. **Exhibited:** NAD, 1885-86,1887 (prize), 1894; San Fran. AA, 1895-97, 1900, 1901; Calif. State Fair, 1887 (medal), 1916 (prize), 1917 (prize), 1919 (prize); Indust. Expo, San Fran., 1893 (medal); Mark Hopkins Inst., 1897-98; Vickery, Atkins & Torrey, San Fran., 1909 (solo); Macbeth Gal., NY, 1910; Corcoran Gal. biennial, 1910; PAFA Ann., 1911, 1913; Pan-Pacific Expo, San Fran., 1915 (medal); CPLH, 1932 (mem.).
Work: Golden Gate Park Mus., San Fran.; de Young Mus.; Univ. Calif.; SFMA; Mills College, Oakland; AIC; Oakland Mus.; St. Mary's College, Oakland; Music & AA, Pasadena, CA; CPLH; Stanford Univ. **Comments:** Daughter of Lucien Curtis (see entry), she was born on the trip via Panama to San Francisco. She and her sister Leila Curtis (see entry) learned engraving and drawing from their father; and in 1866 the sisters made the overland trek to NYC, where they studied wood engraving and drawing. Together they opened a wood engraving business upon their return to San Francisco. An Impressionist painter, she became nationally known as "The Mary Cassat of the West", because of her mother-and-child themes. **Sources:** WW29; Hughes, *Artists of California,* 466; Falk, *Exh. Record Series.*

RICHARDSON, Mary Nest See: **RICHARDSON, Mary Nettie N(eal)**

RICHARDSON, Mary Nettie N(eal) *[Portrait painter]* b.1859, Mt. Vernon, ME / d.1937.
Addresses: Boston, MA/Canton, ME. **Studied:** BMFA Sch.; Colarossi Acad., Paris; A. Koopman, Paris; Chas. Woodbury, Ogunquit Sch. **Member:** Copley Soc., 1897; AAPL; AAA.
Exhibited: Boston AC, 1896-1907, 1917 (solo); Paris Salons, 1897; AIC, 1898; W.J. Gardner & Co., Boston, 1909 (solo); PAFA; Poland Spring (ME); Portland (ME) Mus. Art. **Work:** Walker Art Gal., Bowdoin College Mus., Brunswick, ME; Farnsworth Mus. **Comments:** Also painted some landscapes.
Sources: WW33; *Charles Woodbury and His Students;* Fink, *American Art at the Nineteenth-Century Paris Salons,* 384; *The Boston AC;* Petteys, *Dictionary of Women Artists.*

RICHARDSON, Mary Walcot (Mrs. W. Rasche) *[Craftsperson]* 19th/20th c.
Addresses: New Orleans, active 1901-05. **Studied:** Newcomb College, 1897-1901. **Member:** Art's Exh. Club. **Sources:** *Encyclopaedia of New Orleans Artists,* 324.

RICHARDSON, Pattie See: **EAST, Pattie Richardson (Mrs.)**

RICHARDSON, Rachel Madeley (Mrs. Frank K. Ominsky) *[Mural painter, textile designer]* b.1896, London, England / d.1941, Port Jervis, NY.
Addresses: NYC. **Studied:** London; NYC; ASL. **Exhibited:** S. Indp. A., 1930.

RICHARDSON, Richard *[Listed as "artist"]* b.c.1827, England.
Addresses: Philadelphia. **Comments:** Living in in 1860 with his English wife and brother (?), Frederick Richardson (see entry), and a daughter Ellen, 3, born in Pennsylvania. **Sources:** G&W; 8 Census (1860), Pa., LII, 64.

RICHARDSON, Rome K. *[Painter, craftsperson]* b.1877, Candor, Tioga Co., NY.
Addresses: NYC. **Studied:** Pratt Inst., Brooklyn; NY Sch. Art.
Exhibited: book cover design, Pan-Am. Expo, Buffalo, 1901 (prize). **Sources:** WW10.

RICHARDSON, S. *[Sculptor]* early 20th c.
Addresses: Philadelphia, PA, 1925. **Exhibited:** PAFA Ann., 1925 (portrait sculpture). **Comments:** *Cf.* Sarah Richardson of Philadelphia. **Sources:** Falk, *Exh. Record Series.*

RICHARDSON, Sam *[Painter, educator]* b.1934, Oakland, CA.
Addresses: San Francisco, CA. **Studied:** Calif. College Arts & Crafts (B.A., 1956 & M.F.A., 1960). **Exhibited:** Paints Behind

the Painters, CPLH, 1967; Illinois Biennial, Univ. Illinois, 1967; WMAA, 1968; Plastic as Plastic, Mus. Contemp. Crafts, NYC 1969; New Methods & Materials, MoMA, 1969; Reed College Invitational, OR, 1969. **Comments:** Teaching: Oakland City College, 1960-1961; art dir., Mus. Contemp. Crafts, New York, 1961-63; San Jose State College, 1963-70s. **Sources:** WW73.

RICHARDSON, Sarah [Painter] early 20th c.
Addresses: Phila., PA. **Studied:** PAFA. **Comments:** Cf. S. Richardson of Philadelphia in 1925. **Sources:** WW25.

RICHARDSON, Theodore Scott [Painter] early 20th c.
Addresses: Chicago, IL. **Exhibited:** AIC, 1908, 1910-11.
Sources: WW13.

RICHARDSON, Theodore J.
[Landscape painter] b.1855,
Readfield, ME / d.1914,
Minneapolis, MN.
Addresses: Netley Corners, MN; Monterey, CA. **Studied:** abroad, 1896-1902. **Member:** SC. **Work:** Anchorage Hist. & FA Mus.; Fogg Mus.; Burlingame Northern, Inc. **Comments:** Teaching: Minneapolis public schools. After his marriage to a Monterey artist, he often spent winters there and summers in Alaska. Specialty: Alaskan scenery. **Sources:** WW13; Hughes, Artists of California, 466.

RICHARDSON, V(olney) A(llan) [Painter, teacher] b.1880, Attica, NY. / d.Houston TX.
Addresses: Houston, TX. **Studied:** Sch. FA, Albright Art Gal.with W. M. Chase; E. Dufner; F.V. DuMond; C.W. Hawthorne.; ASL. **Member:** Buffalo SA. **Exhibited:** Albright Art Gal., Buffalo, 1927 (prize), 1931 (prize); Buffalo SA, 1935 (prize). **Sources:** WW40; Krane, The Wayward Muse, 194.

RICHARDSON, William H. [Painter, portrait painter] early 20th c.
Addresses: Phila., PA, 1902. **Exhibited:** PAFA Ann., 1902.
Sources: Falk, Exh. Record Series.

RICHARDSON, Z. B. (Mrs.) [Artist] 19th/20th c.
Addresses: Active in Los Angeles, c.1897-1918. **Comments:** Cf. Zetta Behne. **Sources:** Petteys, Dictionary of Women Artists.

RICHARDSON, Zetta (Mrs.) See: **BEHNE, Zetta**

RICHARDSON-JONES, C(hristina) (Miss) [Painter] early 20th c.
Addresses: Hempstead, LI, NY. **Studied:** ASL. **Exhibited:** S. Indp. A., 1931. **Sources:** Marlor, Soc. Indp. Artists.

RICHARDSON-JONES, Gladys (Miss) [Sculptor] early 20th c.
Addresses: Hempstead, LI, NY. **Exhibited:** S. Indp. A., 1931; Salons of Am., 1934. **Sources:** Falk, Exhibition Record Series.

RICHARDSON & COX [Wood engravers] mid 19th c.
Addresses: NYC, 1853-59. **Comments:** Partners were James H. Richardson and Thomas Cox, Jr. (see entries on each). **Sources:** G&W; NYCD 1853-59; Hamilton, Early American Book Illustrators and Wood Engravers, 528.

RICHARDSON & WATSON [Portrait, historical, landscape, miniature & fancy painters] early 19th c.
Addresses: New Orleans, active 1836-37. **Comments:** Partners were Henry Richardson and James Watson (see entries). **Sources:** G&W; Delgado-WPA cites New Orleans Commercial Bulletin, Dec. 12, 1836, and New Orleans CD 1837. More recently, see Encyclopaedia of New Orleans Artists.

RICHARDT, Ferdinand Joachim See: **RICHARDT, (Joachim) Ferdinand**

RICHARDT, (Joachim) Ferdinand [Landscape painter] b.1819, Brede(Seeland), Denmark / d.1895, Oakland, CA.
Studied: Royal Acad., Copenhagen. **Exhibited:** Niagara Gal., NYC, 1856-57; San Fran. AA, 1876. **Work:** NY State Hist.

Soc.(fourteen paintings); NYPL; Oakland Mus.; Calif. Hist. Soc. San Fran.; White House, Wash., DC; Thorwaldsen Mus., Copenhagen, Denmark. **Comments:** Arrived in NYC about 1855 having already achieved success in Denmark through the sale of paintings to the King of Denmark, the Russian Czar, and British royalty. In the U.S. he gained the attention of wealthy patrons who responded to his views of Virginia, New York, and Pennsylvania. He became noted for his paintings of Niagara Falls, especially after William Vanderbilt commissioned him to paint a view of the falls for $14,000. May have returned to Europe in the early 1860s but had moved to San Francisco by 1875. There he continued to paint Niagara but also began recording views of Yosemite and its waterfalls. In the late 1870s he was active on the Monterey Peninsula, joining Jules Tavernier and other painters who had formed an art colony there. Also made trips into the mountains of Santa Cruz and northern California. Last studio was in Oakland. Cf. John (or S.) Reichardt who exhibited at the NAD in 1858. **Sources:** G&W; info cited by G&W as being courtesy Janet R. MacFarlane, dir., Albany Inst.; N.Y. Herald, Nov. 19, 1856, and Jan. 11, 1859 (courtesy J. Earl Arrington); Art Journal, 1863. More recently, see Hughes, Artists in California; Gerdts, Art Across America, vol. 3: 245.

RICHELIEU, Elise [Painter] early 20th c.
Addresses: Brooklyn, NY. **Exhibited:** S. Indp. A., 1931.
Sources: Marlor, Soc. Indp. Artists.

RICHENBURG, Robert Bartlett [Painter, sculptor] b.1917, Boston, Mass.
Addresses: Ithaca, NY. **Studied:** George Washington Univ.; Boston Univ.; Corcoran Sch. Art; ASL; Ozenfant Sch. Art; Hans Hofmann Sch. FA. **Member:** Art Educ. Assn. (comt. Int. Cultural Relations); Am. Assn. Univ. Prof.; College AA; ASL (life mem.). **Exhibited:** Tibor de Nagy Gal., NYC, 1959-64 (solos); AFA traveling exhs., 1960-61, 1964-65, 1968-69; WMAA annuals, 1961, 1964, 1968 (sculpture); Corcoran Gal. biennial, 1963; Dana AC, Colgate Univ., 1970 (solo); Ithaca College Mus. Art, 1971 (solo). **Awards:** AFA award, 1964. **Work:** Chrysler Mus.; Univ. Texas Art Mus., Austin; Univ. Calif., Berkeley Mus. Art; WMAA; MoMA. **Comments:** Teaching: City College NY; Pratt Inst.; Cooper Union; NY Univ.; Cornell Univ., 1964-67; Hunter College, 1967-70; Aruba Res. Center, City Univ. Program, 1970; Ithaca College, 1970s. **Sources:** WW73.

RICHERT, Charles H. [Painter, teacher] b.1880, Boston, MA / d.1974. **C·H·RICHERT-**
Addresses: Arlington, Belmont, MA. **Studied:** Mass. Normal Art Sch.; Joseph De Camp; Ernest L. Major; R. Andrew. **Member:** Boston Soc. WC Painters; Painters Gld., Boston Artists; AWCS. **Exhibited:** Boston AC, 1906-07; PAFA Ann., 1912; BAID, 1919 (prize), 1920 (prize); NAD; AIC; BMFA. **Comments:** Teaching: Rindge Tech. Sch. (Cambridge, MA), Mass. Sch. Art. **Sources:** WW59; WW47; Falk, Exh. Record Series.

RICHES, [W. ?] [Engraver] mid 19th c.
Addresses: Columbus, OH. **Comments:** Of Felch & Riches, copper, steel, and seal engravers of Columbus (Ohio), 1856-57. **Sources:** G&W; Columbus BD 1856; Ohio BD 1857.

RICHEY, Oakley E. [Painter, teacher, lecturer, craftsman, writer] b.1902, Hancock County, IN.
Addresses: Indianapolis, IN. **Studied:** John Herron AI (M.A.E.); Grand Central Sch. Art; ASL; DuMond; Purves; Pogany; S. Walker; G. Bridgman. **Member:** Nat. Educ. Assn.; Indiana State Teachers Assn.; Indianapolis Fed. Pub. Sch. Teachers; Indianapolis AA; Richmond AA; Hoosier Salon; Indiana Artists Club; Indiana PM; Portfolio Club, Indianapolis. **Exhibited:** Indianapolis, 1935 (prize); Hoosier Salon, 1948 (prize), 1950 (prize), 1953 (prize); Indiana State Fair, 1950 (prize). **Work:** Richmond (IN) AA; murals, Connersville (IN) H.S.; West Lafayette (IN) Pub. Sch.; Pittsburgh (KS) Pub. Lib.; FERA Bldg., Indianapolis. **Comments:** Teaching: John Herron Art Sch., 1924-35; Arsenal Technical Schools, Indianapolis, 1935-50s; Indiana

Univ. Ext., Indianapolis, 1932-. **Sources:** WW59; WW47.

RICHIE, Georgia Alice *[Sculptor] b.1877, Kansas / d.1961, Los Angeles, CA.*
Addresses: Los Angeles. **Exhibited:** P&S Los Angeles, 1933.
Sources: Hughes, *Artists of California,* 467.

RICHMAN, Robert M. *[Art administrator, writer] b.1914, Connersville, IN.*
Addresses: Washington, DC. **Studied:** Western Mich. Univ. (A.B. Eng.; A.B., hist.); Univ. Mich. (A.M.). **Member:** Am. Assn. Mus. Dirs; Am. Assn. Mus.; Int. Inst. Arts & Letters (fellow); College AA Am.; Artists Equity Assn. **Exhibited:** Awards: Hopwood Awards, 1942-44; Comdr. Brit. Empire, 1959. **Comments:** Positions: founder & pres., Inst. Contemp. Arts, Wash., DC, 1947, trustee, mem. exec. comt. & bd. trustees, 1947-; lit. & art ed., *New Republic Magazine,* 1951-54; mem., President's FA Comt., 1956-, chmn., 1960-; mem., Washington Festival, 1957-, dir., 1958; mem., Am. Nat. Theatre & Acad., 1958-; trustee, Nat. Culture Center, 1959-; trustee, Opera Soc. Washington, 1959-; trustee, Meridian House Found., 1960-; trustee, Arena Stage, Washington Drama Soc., 1960-; consult. arts, Dept. State, 1961; trustee, Center Arts of Indian Am., 1965-. Publications: publ., *The Potter's Portfolio,* 1950; ed., *The Arts at Mid-Century,* 1954; auth., *Nature in the Modern Arts;* contrib., *New Republic & Kenyon Review.* Teaching: Univ. Mich., 1938-45; Adelphi College, 1945-47; Nat. Gal. Art, Phillips Gal. & LOC. Collections arranged: over 90 exhs. of recent work by contemporary artists from Europe, Asia and the Americas. **Sources:** WW73.

RICHMOND, Agnes M. *[Painter] b.1870, Alton, IL / d.1964, Brooklyn, NY.* AMRichmond
Addresses: Brooklyn, NY/Mountainville, NY. **Studied:** St. Louis Sch. FA; ASL with Twachtman, Appleton, Clark & Kenyon Cox. **Member:** Allied AA; Fifty Am. Artists; NAWA; Brooklyn SA; Brooklyn PS; AAPL. **Exhibited:** NAWA, 1911 (prize), 1922 (prize), 1924, 1933 (prize), 1936-37, 1946, 1948, 1950; PAFA Ann., 1912, 1922-23, 1927, 1937; Corcoran Gal. biennials, 1914, 1919; Pan-Pacific Expo, San Fran., 1915; Soc. Indep. Artists, 1917-22, 1925, 1928; AIC, 1920, 1922; Salons of Am.; Sesqui Cent. Int. Expo., Phila., 1926; Brooklyn Soc. Artists, 1932, 1934-36, 1942-46, 1949; The Fifteen Gal., 1939 (solo); New Rochelle, NY, 1932 (prize); CGA; NAD, 1922, 1924, 1927-28; Phila. WCC, 1927; Toronto; Montreal; CI; Newport AA; San Diego FA Soc.; AAPL; All. Artists Am, 1947 (prize),1952 (prize), 1953 (prize); J. Allen Gal., NYC, 1981 (solo); Hickory Mus. Art, NC. **Work:** San Diego FA Soc.; Hickory (NC) Mus. Art. **Comments:** Teaching: ASL, 1910-14. Specialty: portraits of women. **Sources:** WW59; WW47; Falk, *Exh. Record Series.*

RICHMOND, Almond *[Painter] early 20th c.*
Addresses: Meadville, PA. **Comments:** He and his brother James (see entry) were lawyers by profession. Almond painted genre scenes of local people and events, often with humor. **Sources:** WW21; Gerdts, *Art Across America,* vol. 1: 301.

RICHMOND, Evelyn K. *[Painter] b.1872, Boston, MA / d.1961, Santa Barbara, CA.*
Addresses: Santa Barbara, CA. **Studied:** Henry B. Snell.
Member: NAWA; Providence WCC; Santa Barbara Art Lg.; Calif. WCS. **Comments:** *Cf.* Evelyn N. Richmond. **Sources:** WW59; WW47.

RICHMOND, Evelyn N. (Mrs. Harold A.) *[Painter] early 20th c.*
Addresses: Providence, RI. **Member:** Providence WCC.
Comments: *Cf.* Evelyn K. Richmond. **Sources:** WW25.

RICHMOND, Frederick W. *[Collector, patron] b.1923, Boston, Mass.*
Addresses: Brooklyn, NY. **Studied:** Harvard Univ., 1942-43; Boston Univ. (A.B., 1945); Pratt Inst. (LL.D.). **Comments:** Positions: chmn. bd., Carnegie Hall Corp., 1961; mem., NY State Council Arts; chmn., NY Comt. Young Audiences; co-chmn.,

Mayor's Comt. Scholastic Achievement; bd. mem., NY Studio Sch. Collection: modern art. **Sources:** WW73.

RICHMOND, Gaylord D. *[Painter, designer, craftsperson, teacher] b.1903, Milan, MO.*
Addresses: Woodbridge, CT; Palm Springs, CA. **Studied:** Otis AI; Yale Univ. (B.F.A.; M.F.A.); E. Rescue Shrader; E.C. Taylor; E. Savage. **Member:** Calif. AC; New Haven PCC; CAFA. **Exhibited:** New Haven PCC, 1931 (prize), 1938 (prize); Los Angeles AA, 1934 (prize); Calif. State Fair, 1934 (prize). **Comments:** Positions: teacher, Yale, 1936-46; art dir., Allied Corp., 1942-46; Flintridge Sch., Pasadena, 1940; dir., Richmond Gal., Palm Springs, CA; pres., Desert AC. **Sources:** WW59; WW47.

RICHMOND, James *[Painter] 19th/20th c.*
Addresses: Meadville, PA. **Comments:** Like his brother Almond (see entry), he was a lawyer by profession. James painted humorous and topical scenes of local life around Meadville (Erie County). **Sources:** Gerdts, *Art Across America,* vol. 1: 301.

RICHMOND, Leo Lorraune *[Painter] early 20th c.*
Exhibited: AIC, 1931. **Sources:** Falk, *AIC.*

RICHMOND, Maude See: **FENNER, Maude Richmond (Mrs. Albert)**

RICHMOND, R(obert) C. *[Painter] b.1867, Baltimore.*
Addresses: Washington, DC. **Exhibited:** Corcoran Gal. biennials, 1916, 1919. **Sources:** WW27.

RICHMOND & WHITTLE *[Sign painters] 19th c.*
Addresses: Active in Massachusetts. **Comments:** Painters of a sign at Barnstable (MA), the reverse of which shows a harbor with a steam packet and three-masted schooner. **Sources:** G&W; *American Collector* (March 6, 1934), 3.

RICHTER, Catherine Moore *[Painter, craftsperson] b.1888, LA Veta, CO.*
Addresses: Grand Junction, CO; Long Beach, CA. **Studied:** Colorado State Teacher's College; AIC. **Member:** Long Beach AA; Laguna Beach AA; Nat Lg. Am. Pen Women. **Comments:** Position: teacher, Long Beach H.S.; des., mechanisms for the Douglas Aircraft plant. Illustr.: *Bibi the Baker's Horse,* and *Two Young Corsicans,* 1940s. **Sources:** Hughes, *Artists of California,* 467.

RICHTER, Emil H. *[Painter] b.1869 / d.1929.*
Addresses: Newton Centre, MA. **Member:** Boston AC.
Exhibited: Boston AC, 1897-98. **Sources:** WW19; *The Boston AC.*

RICHTER, Frank C. *[Painter] b.1845.*
Addresses: Ashbourne, PA. **Exhibited:** PAFA Ann., 1880-83.
Sources: Falk, *Exh. Record Series.*

RICHTER, George A. *[Painter] early 20th c.*
Addresses: Providence, RI. **Sources:** WW24.

RICHTER, George Martin *[Writer, lecturer] b.1875, San Francisco, CA / d.1942, Norwalk, CT.*
Studied: Germany. **Comments:** Authority on Giorgione and Renaissance art.

RICHTER, Gisela Marie Augusta *[Museum curator, writer, lecturer, craftsperson] b.1882, London, England / d.1972.*
Addresses: NYC; Rome, Italy. **Studied:** Girton College, Cambridge; British Sch. Archaeology, Athens, Greece; Trinity College, Dublin (Litt. D.); Cambridge Univ., England (Litt. D.; Hon. F.); Somerville College, Oxford; Girton College, Cambridge (Hon. F.); Smith College, 1935 (hon. degress, L.H.D.);Rochester Univ., 1940 D.F.A.); Univ. Oxford, 1952; Basel Univ. (Ph.D.). **Member:** Am. Numismatic Soc. (fellow); Archaeological Inst. Am.; Accademia, Napoli; Pont. Accademia Romana; Am. Acad. in Rome; Hellenic & Roman Soc., London;. **Exhibited:** Am. Assn. Univ. Women, 1944 (prize). **Comments:** Positions: asst., Classical Dept., 1906-10, asst.cur., 1910-22, assoc. cur., 1922-25; cur., 1925-48, hon. cur., 1948-, MMA, NYC; assoc. ed., *Am. Journal of*

Archaeology; pres., NY Soc. of the Archaeological Inst. Am., 1941-46; lecturer, Yale Univ., 1938, Bryn Mawr College, 1941, Oberlin College, 1943; Dumbarton Oaks, 1949; Univ. Michigan, 1952; Am. Acad. in Rome, 1952; Somerville College, Oxford, 1954; Roman Soc., London, 1957; visiting lecturer, Columbia Univ. Auth.:"The Craft of Athenian Pottery," 1923; "Ancient Furniture," 1926; "Animals in Greek Sculpture," 1930; "Handbook of the Etruscan Collection," 1940, "Attic Red-figured Vases, A Survey," 1946"Kouroi," 1942, 2nd ed. 1960. **Sources:** WW66; WW47.

RICHTER, H. Davis *[Painter] early 20th c.*
Exhibited: AIC, 1928-29. **Sources:** Falk, *AIC.*

RICHTER, Henry L. *[Painter] b.1871, Saxony, Germany / d.1960, Rolling Hills, CA.*
Addresses: Chicago, IL; Gunnison, CO; Des Moines, IA; Long Beach, CA, 1919; Rolling Hills, CA, 1939-60. **Studied:** AIC; A.E. Burbank; Art Acad., Munich, with Prof. Knirr. **Member:** Denver AA; Calif. WCS; Laguna Beach AA; P&S Los Angeles; Palos Verdes AA; San Pedro AA; Long Beach AA. **Exhibited:** AIC; TMA; Denver Lib.; Boston AC, 1908; Laguna Beach AA annuals (many awards); Calif. State Fairs (many awards); LACMA, 1927, 1937 (bronze medal); Pacific Southwest Expo, 1928 (silver med.); GGE, 1939. **Work:** Laguna Beach Mus.; First Methodist Church, Long Beach; Religious Science Church of Redondo Beach; several H.S., Southern Calif.; Children's Mus., Colorado Springs; mural, Colorado State Normal Sch., Gunnison. **Comments:** Immigrated to the U.S. in 1887. Teaching: Drake Univ.; Gunnison, CO, 1911-18; studio work. **Sources:** WW21; Ness & Orwig, *Iowa Artists of the First Hundred Years,*176-77; *The Boston AC;*Hughes, *Artists of California,* 467. Hughes varies from other sources in stating 1870 as the birth year, and Plumenau, Austria as the place of birth; yet another source cites 1862 as the birth year.

RICHTER, Horace *[Collector] b.1918, Ossining, NY.*
Addresses: NYC; Sands Point, NY. **Studied:** Univ. North Carolina (B.A.). **Comments:** Position: bd. gov., Jewish Mus. Collection: NY school, second generation; primitive art-African, pre-Columbian. **Sources:** WW66.

RICHTER, Irma *early 20th c.*
Exhibited: Salons of Am., 1923, 1924. **Sources:** Marlor, *Salons of Am.*

RICHTER, Julius *[Painter, engraver, lecturer, etcher] b.1876, Allegheny, PA.*
Addresses: Buffalo, NY. **Studied:** Volney A. Richardson; Mildred C. Green; Emile Gruppe; J. Rummell. **Member:** Buffalo SA; Buffalo Pr. Club; Am. Physicians AA. **Exhibited:** Am. Physicians Exh., annually; Buffalo SA, annually, 1945 (medal); Albright Art Gal., 1946; City AM, St. Louis. Awards: "Print of the Year," 1950. **Comments:** Position: lectures, anatomy in art, Albright Art Sch., Buffalo, NY, 1924-34. **Sources:** WW59; WW47.

RICHTER, Lillian *[Painter, lithographer, illustrator, writer, teacher] b.1915, Newport, RI.*
Addresses: NYC. **Studied:** K. Nicolaides E. Fitsch & G. Picken at ASL. **Exhibited:** AIC; WFNY 1939; ACA Gal.; G-R-D Gal.; Contemp Women Artists, 1935-39; PAFA, 1940; CAFA, 1940. **Comments:** Teaching: Sch. for Art Studies, NYC, 1946. **Sources:** WW53; WW47.

RICHTER, Louise C. (Mrs. William F.) *[Designer educator] b.1918, Akron, OH.*
Addresses: Richmond Heights, MO; Washington, MO. **Studied:** CI (B.F.A.). **Work:** Univ. West Virginia; Granite City Steel Co., Granite City, IL.; designed Univ. medallion, Washington Univ., St. Louis, MO. **Comments:** Position: des. instr., Washington Univ. Sch. FA, St. Louis, MO, 1941-; des. consult., Wrought Iron Range Co., St. Louis, 1944-; Master Plastic Molding Corp., St. Louis, 1945-. **Sources:** WW59; WW47.

RICHTER, Mischa *[Painter, illustrator, cartoonist, teacher] b.1910, Russia.*

Addresses: Darien, CT. **Studied:** Boston MFA Sch.; Yale Sch. FA, 1934; Kozloff in Russia. **Member:** Boston Soc. Indep. Artists; Am. Artists Congress. **Exhibited:** Rockefeller Center, NYC; ACA Gal., NYC. **Work:** mural, Burroughs Newsboys Found., Boston. **Comments:** After painting social realism under the WPA, during the 1940s he became best known for his strip, "Strictly Richter" (King Features Syndicate). He also illustrated for *Esquire, Collier's Liberty, Saturday Evening Post, Am. Magazine.* **Sources:** WW40; *Famous Artists & Writers* (1949).

RICHTER, Richard *[Sketch artist] mid 19th c.*
Addresses: Active in CT, c.1855. **Comments:** Drew a view (in colored charcoal) of Naubuc (then Curtisville), CT, in 1855 or 1856. **Sources:** G&W; Conn. Hist. Soc. *Bulletin* (April 1947), 9.

RICHTER, Wilmer Siegfried *[Illustrator, painter, designer, lithographer, teacher] b.1891, Phila.*
Addresses: Havertown, PA. **Studied:** PM Sch. IA; PAFA; W.H. Everett; D. Garber; J. Pearson; G. Oberteuffer. **Member:** Phila. Sketch Club; Phila. WCC. **Exhibited:** AIC, 1927, 1929. **Work:** Phila. Pub. Sch. **Sources:** WW47.

RICKARD, Marjorie Rey *[Artist] b.1893, Belvedere Island, CA / d.1968.*
Addresses: Active in Tiburon, CA. **Sources:** Petteys, *Dictionary of Women Artists.*

RICKER, Grace *[Painter] early 20th c.*
Addresses: Milwaukee, WI. **Sources:** WW17.

RICKERT, Irwin *[Painter] early 20th c.*
Addresses: Jackson Hieghts, LI, NY. **Exhibited:** S. Indp. A., 1932. **Sources:** Marlor, *Soc. Indp. Artists.*

RICKERT, J. *[Sketch artist] early 19th c.*
Comments: Drew a view of Nazareth (PA) which was engraved about 1831 by E.W. Mumford. **Sources:** G&W; Stauffer.

RICKERT, William H., Jr. *[Painter] mid 20th c.*
Exhibited: AIC, 1936. **Sources:** Falk, *AIC.*

RICKET, Thomas *[Engraver] early 19th c.*
Addresses: Philadephia, 1805. **Sources:** G&W; Brown and Brown.

RICKETSON, Louisa D. *[Painter] b.1869, Boston, MA / d.1958, Atlantic City, NJ.*
Exhibited: Nonquitt Casino Show, 1900; New Bedford Art Club Loan Exh., 1908. **Work:** New Bedford (MA) Free Pub. Lib.; Old Dartmouth Hist. Soc. **Comments:** Spent much of her life abroad and is known to have painted at the Acad. Julian. **Sources:** Blasdale, *Artists of New Bedford,* 153 (w/repro.).

RICKETSON, Mary Elizabeth Bliss (Mrs. Arthur) *[Painter] b.1843, England / d.1926, New Bedford, MA.*
Addresses: Active in New Bedford, MA, 1915-26. **Exhibited:** New Bedford Art Club Loan Exh., 1908. **Comments:** Adopted c.1847 and became Louise Dolben Bliss. Later she renamed herself Mary Elizabeth. **Sources:** Blasdale, *Artists of New Bedford,* 153.

RICKETSON, Walton *[Sculptor] b.1839, New Bedford, MA / d.1923, New Bedford.*
Addresses: Active in New Bedford, 1870-1923. **Studied:** Friends Acad. **Member:** New Bedford AC, 1907 (a founder along with Herbert Bryant); Quittacas Club. **Exhibited:** NAD, 1874, 1880, 1882, 1891; Lawton's Book Store & Art Gal., New Bedford, 1878; Boston AC, 1880, 1882; New Bedford AC, 1907-14, 1917. **Work:** portrait busts of Louisa M. Alcott, Henry D. Thoreau, R.W. Emerson, others in pub. lib., New Bedford; Brown Univ.; Friends Acad., New Bedford; Concord (MA) Lib.; Gosnold Mem. Tower, Island of Cuttyhunk, MA; Old Dartmouth Hist. Soc. **Comments:** Specialties: intaglios; basreliefs; busts. Collab. with his sister, Anna, in the editing of three books. **Sources:** WW25; Blasdale, *Artists of New Bedford,* 154 (w/repro); *The Boston AC.*

RICKETTS, Agnes Fairlie *[Painter, teacher] mid 20th c.; b.Glasgow, Scotland.*

Addresses: Jackson, MS. **Studied:** Wellesley College (B.A.); Univ: Iowa (M.A.); PAFA; Univ. Georgia. **Member:** Miss. AA; SSAL. **Exhibited:** SSAL, 1945 (prize), 1946; Miss. AA, 1942, 1943; Delgado Mus. Art, 1944-46. **Sources:** WW53; WW47.

RICKEY, George W. *[Sculptor, painter, writer, teacher] b.1907, South Bend, IN.*
Addresses: Grew up in Scotland; East Chatham, NY, from 1960. **Studied:** Trinity College, Scotland; Balliol College, Oxford Univ (B.A., 1929/M.A. in art history, 1941); Ruskin Sch. Drawing, Oxford Univ., 1928-29; Acad. Andre Lhote, Paris, 1929; Acad. Mod. with Leger & Ozenfant, Paris, 1929-30; Knox College (hon. D.F.A., 1970). **Member:** United Am. Artists; Am. Artists Congress. **Exhibited:** WMAA biennials, 1952-70; PAFA Ann., 1952-54, 1966-68; CGA, 1966 (retrospective); Directions in Kinetic Sculpture, Univ. Calif., Berkeley, 1966; Sculpture from Twenty Nations, Guggenheim Mus., NYC, 1967; Plus by Minus, Albright-Knox Art Gal., 1968; Int. Sculptors' Symposium, Osaka, Japan, 1969; Kinetic Art, Arts Council Great Britain, Hayward Gal., London, 1970; Staempfli Gal., NYC, 1970s; Mich. Art Ann., Detroit AI; Kalamazoo AI; Am. Artists Congress. **Awards:** Nat. FA Honor Award, Am. Inst. Arch., 1972. **Work:** WMAA; MoMA; MMA; Albright-Knox Art Gal., Buffalo, NY; CGA; Mus. Boymans-van Beuningen, Rotterdam, Neth.; Neue Nationalgalerie, Berlin, Germany. WPA murals: USPO, Selinsgrove, PA, and Olivet (MI) College. Commissions for kinetic sculpture: Joseph H. Hirshhorn Coll., 1962; Kunsthalle, Hamburg, Germany, 1963; Rijksmuseum Kroller-Muller, Otterlo, Neth., 1965; Nordpark, Düsseldorf, Germany, 1965; NMAA, Wash., DC, 1967. **Comments:** Best known for his kinetic sculpture after 1949, especially the wind-driven works after 1959. He began as a fresco and mural painter but made his first mobile sculpture in 1945 while serving in the Air Force. Preferred medium: stainless steel. Teaching: Groton Sch., MA, early 1930s; artist-in-residence, Olivet(MI) College; chmn., art dept., Muhlenberg College, Allentown, PA, 1941-48. Publications: auth., *Constructivism: Origins and Evolution,* Braziller, 1967. **Sources:** WW73; WW40; Baigell, *Dictionary;* Nan Rosenthal, *George Rickey* (1977); *Two Hundred Years of American Sculpture,* 301-02; Robert Coates, "The Art Galleries/Innovations," *New Yorker* (Oct., 21, 1961); "Engineer of Movement," *Time Mag* (Nov 4, 1966); Peter Riedl, "George Rickey: Kinetische Objekte," *Philipp Reclam Journal* (Stuttgart, 1970); Falk, *Exh. Record Series.*

RICKLY, Jessie Beard *[Painter, graphic artist, lecturer, cartoonist, teacher] b.1895, Leeper, MO / d.1975.*
Addresses: Webster Groves, MO. **Studied:** St. Louis Sch. FA; Harvard Univ.; Charles Hawthorne; O. Berninghaus; E. Wuerpel. **Member:** Missourians; St. Louis Artists Gld; SSAL; New Hats; Shikari. **Exhibited:** St. Louis Artists Gld., 1927 (prize) 1931 (prize), 1932 (prize), 1945 (prize), 1957; Missouri State Fair, 1917 (prize), 1932 (prize); Kansas City AI, 1929, 1934 (medal), 1940; CAM, 1928, 1939; SSAL, 1933, 1934; Carroll Knight Gal., St. Louis, 1948; Joslyn Art Mus., 1949; Monticello College, Godfrey, IL, 1952; State College, Cape Girardeau, MO, 1950; Henry George Sch., NY, 1951. Awards: Carnegie scholarship to Harvard Univ., 1940; Aaron Gal., Chicago. **Work:** Flynn Park Sch. & Jr. H.S., University City, MO; Executive Mansion, Jefferson City, MO; Butler County Court House; Hodgens Sch., Maplewood; University City Sr. H.S. **Comments:** Founder of St. Genevieve (MO) Artists Colony. Teaching: Washington Univ. Sch. Art, 1951. **Sources:** WW59; WW47; Petteys, *Dictionary of Women Artists.*

RICKNER, Louis *[Lithographer] b.1826, Germany.*
Addresses: Pittsburgh, PA in August 1850. **Sources:** G&W; 7 Census (1850), Pa., III(2), 75.

RICKS, Percy *[Painter, educator] b.1923, Wash., DC.*
Exhibited: Howard Univ., 1961; BMFA, 1970; James A. Porter Gal., 1970; Smith-Mason Gal., Wash., DC, 1971; Phila. Civic Center Mus.; State Armory, Wilmington, DE, 1971. **Sources:** Cederholm, *Afro-American Artists.*

RICKSON, Gary A. *[Painter, writer, musician] b.1942.*
Studied: Moorish Science Temple, Inc. **Exhibited:** BMFA, 1970; Boston Pub. Lib., 1973. **Awards:** Nat. Endowment Fed. Grant. **Sources:** Cederholm, *Afro-American Artists.*

RICO, Donato ("Dan" or "Don") *[Painter, engraver, illustrator, lithographer] b.1912, Rochester, NY / d.1985, Hollywood, CA.*
Addresses: NYC. **Studied:** Cooper Union; NY Evening Sch. Indust. Art; Am. Artists Sch. **Member:** United Am. Artists; Am. Artists Congress. **Comments:** Contrib.: *The Nation, New Masses.* WPA printmaker in NYC, 1930s. **Sources:** WW40; exh. cat., Annex Gal. (Santa Rosa, CA, n.d., c.1988; wherein birth date is cited as 1910).

RIDA, Julius A. *[Painter] b.1854.*
Addresses: New Haven, CT. **Exhibited:** PAFA Ann., 1891. **Sources:** Falk, *Exh. Record Series.*

RIDABOCK, Ray(mond) (Budd) *[Painter, instructor] b.1904, Stamford, CT / d.1970.*
Addresses: Redding Ridge, CT. **Studied:** Williams College, 1922-24; Columbia Univ. Exten., 1928-29; Amy Jones; Anthony di Bona; Peppino Mangravite; Xavier Gonzalez. **Member:** AWCS; Artists Equity Assn; Audubon Artists; CAFA; Silvermine Guild Artists (fellow; bd. dirs.). **Exhibited:** Portland SA, 1943, 1946; New Haven PCC, 1943-45; Saranac Lake Art Lg., 1942-44; Irvington Art Mus. Assn., 1943; State Teachers College, PA, 1946; Mint Mus. Art, 1946; Mid-Vermont Artists, 1943-45; Utica, NY, 1946; Lake Placid, NY, 1944, 1945; AWCS Traveling Exhs., 1962-64; Audubon Artists; Boston Arts Festival, Baltimore Mus.; Butler Inst. Am. Art; PAFA. **Awards:** Conn. WCS Awards, 1963-67 & 1968; Painters in Casein Medal of Merit, 1965; award, Greenwich Art Soc., 1967. **Work:** New Britain Art Mus.; Munson-Williams-Proctor Inst.; State Teachers College, Indiana, PA; U.S. Embassy, Lima, Peru; Norfolk Mus. Arts & Sciences. **Comments:** Teaching: Silvermine Guild Artists, 1958-; Greenwich Art Soc., 1962-. **Sources:** WW73; WW47.

RIDDELL, Annette Irwin (Mrs.) *[Painter] early 20th c.; b.Oswego, NY.*
Addresses: Chicago, IL; Laguna Beach, CA. **Studied:** AIC with Vanderpoel and Freer; Académie Julian, Paris, with Royer; Collin, Courtois, Girardot & Prinet in Paris. **Member:** Laguna Beach AA; Alumni AIC. **Sources:** WW33.

RIDDELL, Annie *[Miniature painter, painter] 19th/20th c.*
Addresses: Boston, Nantucket, Jamaica Plain, MA, active 1889-1915. **Exhibited:** Boston AC, 1897-1908. **Sources:** WW15; *The Boston AC.*

RIDDELL, William Wallace *[Painter] b.1877, Chicago, IL / d.1948, Laguna Beach, CA.*
Addresses: Chicago, IL; Laguna Beach, CA. **Studied:** AIC; Académie Julian, Paris with J.P. Laurens & Constant, 1900. **Member:** Laguna Beach AA; Palette & Chisel Acad. FA, Chicago; AFA; P&S Los Angeles. **Comments:** Husband of Annette I. Riddell (see entry). **Sources:** WW53; WW47.

RIDDER, Arthur *[Painter] early 20th c.*
Addresses: Chicago, IL. **Member:** Chicago SA. **Sources:** WW21.

RIDDERHOFF, Phyllis *[Painter] mid 20th c.*
Addresses: Los Angeles, CA. **Exhibited:** LACMA, 1940. **Sources:** Hughes, *Artists of California,* 467.

RIDDLE, Alice (Mrs. Hans Kindler) *[Painter, craftsperson, lithographer, teacher] b.1892, Germantown, PA / d.1980, London, England.*
Addresses: Phila., PA; Baltimore, MD; Wash., DC, 1931; Senlis, France, 1960; London, England, 1978. **Studied:** PAFA; Phila. Sch. Des. for Women; Académie Julian, Paris. **Exhibited:** PAFA Ann., 1915 (as Riddle) 1920, 1931-33, 1951 (as Kindler); Corcoran Gal. biennials, 1941, 1951; NAD; AIC; BMA; S. Indp. A.; Paris (solo); New York (solo), Phila. (solo); Baltimore (solo); Phila. AC, 1933 (prize); Denver Mus. Art, 1933 (prize); Gr. Wash.

Indep. Exh., 1935. **Work:** PAFA; Balt. Mun. Mus.; murals, West Phila. H.S.; USPO, Ware Shoals, SC. **Comments:** She was married to Hans Kindler, the founder and conductor for 18 years of the Nat. Symphony Orchestra. Teaching: St. Timothy's Sch., Catonsville, MD, 1945-46. **Sources:** WW53; WW47; McMahan, *Artists of Washington, D.C.;* Falk, *Exh. Record Series.*

RIDDLE, C. W. *[Painter] early 20th c.*
Addresses: Jamaica Plain, MA. **Member:** Boston AC. **Sources:** WW25.

RIDDLE, Hannah *[Folk artist] mid 19th c.*
Addresses: Woolwich, ME, active c.1870. **Exhibited:** Woolwich Fair, 1870 (1st prize for felt coverlet, brightly colored against a dark background, resembling the brilliance of stained glass). **Sources:** Dewhurst, MacDowell, and MacDowell, 170.

RIDDLE, John T. *[Printmaker, sculptor] b.1933, Los Angeles, CA.*
Studied: Los Angeles City College; Calif. State College, Los Angeles. **Member:** Black Arts Council, Los Angeles. **Exhibited:** Brockman Gal., 1958; Watts Art Festival, 1965-71 (3 first prizes); Heritage Gal., 1969; Calif. State College, Retrospective in Black; Ankrum Gal., 1970; Univ. Iowa, 1971-72; San Jose State College, 1972. Awards: Emmy Award for " Renaissance in Black, " KNBC-TV, 1971. **Work:** Oakland Mus.; Golden State Mutual Life Ins. Co. **Sources:** Cederholm, *Afro-American Artists.*

RIDDLE, Mary Althea *[Sculptor] early 20th c.; b.Chicago.*
Addresses: Chicago, IL. **Studied:** AIC; BMFA Sch. **Exhibited:** AIC, 1916, 1926; Corcoran Gal. biennial, 1926. **Sources:** WW17.

RIDDLE, Mary M. (Mrs. J. W.) *[Mural painter, portrait painter, lecturer] b.1876, New Albany, IN.*
Addresses: Lawrenceburg, IN. **Studied:** W. Chase; F. Duveneck. **Member:** Cincinnati Women's AC; Soc. Western Artists; Indiana Fed. of C. (art dept.). **Work:** murals, Lawrenceburg (IN) Pub. Sch. **Sources:** WW47.

RIDDLE, Theodate Pope See: **POPE, Alfred Atmore**

RIDDLE, William R. *[Lithographer] mid 19th c.*
Addresses: Milwaukee, WI. **Comments:** In partnership with Louis Lipman (see entry) in Milwaukee (WI), 1857. **Sources:** G&W; Kent, "Early Commercial Lithography in Wisconsin," 249.

RIDDLESBARGER, Sara K. *[Painter, sculptor, teacher] b.1869, near Dubuque, IA.*
Studied: Jennie James of Dubuque & Charles Russel of Montana. **Sources:** Petteys, *Dictionary of Women Artists.*

RIDELSTEIN, Maria *[Painter] b.1884, Germany / d.1970.*
Sources: info. courtesy Peter C. Merrill.

RIDEOUT, Alice *[Sculptor] b.1872, Marysville, CA.*
Studied: Rupert Schmid in San Francisco; San Fran. Sch. Design. **Comments:** Designed large figures to decorate the Women's Bldg. at Colmbian Expo, Chicago, 1893. **Sources:** Petteys, *Dictionary of Women Artists.* Schmidt Index cites 1872 birth date.

RIDEOUT, William Ernest *[Painter, etcher] b.1891, San Francisco, CA / d.1947, Oakland, CA.*
Addresses: Oakland, CA. **Studied:** Calif. College Arts & Crafts with Perham Nahl. **Exhibited:** Oakland Art Gal., 1939. **Comments:** Active as an artist until he died; he was also a dentist. Subjects: landscapes, nudes, portraits and figure studies. **Sources:** Hughes, *Artists of California,* 468.

RIDER, Alexander *[Figure, genre, landscape, portrait & miniature painter] early 19th c.*
Addresses: Philadelphia, 1810-34. **Exhibited:** PAFA , 1811-30 (scenes from literature & some genre). **Comments:** Came to Philadelphia from Germany with John Lewis Krimmel (see entry) in 1810 and worked there until 1834. He also visited Charleston (SC) in 1819 and Washington (DC) in 1814. **Sources:** G&W; Bolton, *Miniature Painter;* Rutledge, PA; Scharf and Westcott, *History of Philadelphia;* Rutledge, *Artists in the Life of Charleston;* Dunlap, *Diary,* III, 705, 714, 760.

RIDER, Arthur Grover *[Painter, designer, graphic artist, etcher, teacher] b.1886, Chicago, IL / d.1975, Pasadena, CA.*

A.G.RIDER

Addresses: Los Angeles, CA, since 1924. **Studied:** Acad. FA, Chicago; Académie de la Grande Chaumière, Académie Colarossi; Werntz Acad. FA, Valencia, Spain. **Member:** Palette & Chisel Club, Chicago; Chicago Gal. Assn.; Calif. AC; P&S Los Angeles; Acad. Western Painters; Hispanic Soc.; Laguna Beach AA. **Exhibited:** AIC, 1917 (prize), 1923 (prize), 1925-29; Calif. State Fair, Sacramento, 1936 (prize); Chicago Gal. Assn., 1929 (solo); Laguna Beach AA; GGE, 1939; Calif. Art Club, 1940 (first prize); P&S Los Angeles, 1950. 1954 (first prize), 1959; Circullo des Bellas Artes, Spain. **Work:** City of Chicago. **Comments:** As a student he painted for the Lyric Opera in Chicago, and then in London, England for the Opera House at Covent Garden. He painted in Spain for nine summers, and became friends with Joaquin Sorolla, who greatly influenced his work. Position: scenic artist, Metro-Goldwyn-Mayer and Twentieth Century-Fox Studios, Los Angeles, for over 30 years. **Sources:** WW40; Hughes, *Artists of California,* 468.

RIDER, Charles Joseph *[Painter, sculptor, bookplate designer, teacher] b.1880, Trenton, NJ.*
Addresses: San Pedro, Pasadena, CA. **Studied:** W.M. Chase; S. Macdonald-Wright. **Member:** Am. Soc. Bookplate Collectors & Des. **Exhibited:** PAFA Ann., 1919; LACMA, 1928 (solo). **Sources:** WW33; Hughes, *Artists of California,* 468; Falk, *Exh. Record Series.*

RIDER, Henry Orne *[Painter, teacher, lecturer] b.1860, Salem, MA.*
Addresses: Auburndale, MA. **Studied:** D.W. Champney at BMFA Sch.; École des Beaux-Arts with M. Duval; Académie Julian, Paris, Boulanger & J. Lefebvre, 1885-88; P. Schmitt, L.G. Pelouse, L. Joubert & E. Petitjean in Paris. **Member:** BAC. **Exhibited:** Paris Salon, 1889-91; NAD, 1897; Boston AC, 1890-99; PAFA Ann., 1930; Gloucester Soc. Art, 1935, 1936; S. Indp. A., 1938. **Work:** dec., U.S. Destroyer *Phelps;* U.S. Destroyer *Charles V. Gridley;* mem., MacKay Jr. H.S., East Boston; Brooklyn Inst. Art & Science; Bowdoin College; Harrison Gray Otis House, Univ. Women's Bldg., Boston; Virginia Pub. Utilities Bldg., Alexandria; Florida Power & Light Co., St. Petersburg; Seigle Bldg., Boston; Plymouth (MA) H.S. **Sources:** WW40; Campbell, *New Hampshire Scenery,* 135, and WW08 both spell the name as "Ryder;" however, he reappears in WW40 with a much larger listing as "Rider;" Fink, *American Art at the Nineteenth-Century Paris Salons,* 387; Falk, *Exh. Record Series.*

RIDER, J. V. (Mrs.) *[Listed as "artist"] late 19th c.*
Addresses: Grass Valley, CA. **Exhibited:** Calif. Agricultural Soc., 1883 (pen-and-ink drawing). **Sources:** Hughes, *Artists of California,* 468.

RIDER, Myra Bell Chamberlain (Mrs. W. F.) *[Miniature painter] b.c.1839, Middletown, CT.*
Addresses: Detroit, MI, 1870-98. **Member:** Detroit WCS. **Sources:** Gibson, *Artists of Early Michigan,* 201.

RIDGELY, Frances Summers (Mrs. J. A.) *[Museum curator, writer, lecturer, painter, illustrator] b.1892, Curran, IL.*
Addresses: Springfield, IL. **Studied:** Syracuse Univ.; AIC. **Member:** Springfield AA; Nat. Lg. Am. Pen Women (state art chmn.). **Exhibited:** Springfield AA; Illinois State Mus. **Comments:** Positions: cur. art, Illinois State Mus., Springfield, IL, 1941-. Contrib.: *Child Life Magazine; The Living Museum.* Painter of backgrounds for habitat groups. **Sources:** WW59; WW47.

RIDGELY, Mildred *[Painter] mid 20th c.*
Addresses: NYC, 1942. **Studied:** ASL. **Exhibited:** AIC, 1942; S. Indp. A., 1942-44. **Sources:** Falk, *Exhibition Record Series.*

RIDGEWAY, Ethelina *[Painter] mid 20th c.*
Exhibited: S. Indp. A., 1940. **Sources:** Marlor, *Soc. Indp. Artists.*

RIDGEWAY, Frank Edward, Jr. *[Cartoonist] b.1930, Danbury, CT.*
Addresses: Sarasota, FL. **Studied:** ASL; Cartoonists & Illustrators Sch., NY. **Work:** comic strip "Mr. Abernathy" for King Features Syndicate. **Comments:** Teaching: Famous Artist Schools, Westport, CT. **Sources:** WW59.

RIDGWAY, John Livzy *[Draftsman, illustrator] d.1926, Wash., DC.*
Addresses: Wash., DC, active 1884-1926. **Member:** Cosmos Club, 1895-1926. **Work:** watercolor sketches, U.S. Nat. Arboretum. **Comments:** He was an illustrator under W.H. Holmes in the Division of Illustration of the U.S. Geological Survey. From 1894-99 he executed illustrations for the U.S. Dept. of Agric. **Sources:** McMahan, *Artists of Washington, DC.*

RIDGWAY, Mary G. *[Painter] 19th/20th c.*
Exhibited: Wash. WCC, 1899. **Sources:** McMahan, *Artists of Washington, DC.*

RIDGWAY, W. *[Line engraver] mid 19th c.*
Addresses: NYC, 1854 and after. **Sources:** G&W; Stauffer.

RIDLEY, Essex *[Profile portraitist] late 18th c.*
Comments: Painter of a profile of a daughter of John Jay, 1797. **Sources:** G&W; Jackson, *Silhouette,* 139.

RIDLEY, Gregory D., Jr. *[Sculptor, painter, educator] b.1925, Smyrna, TN.*
Studied: Fisk Univ.; A&I State Univ.; Tennessee State Univ. (B.S.); Univ. Louisville (M.A.). **Member:** Nat. Conf. Artists (founder). **Exhibited:** Fisk Univ., 1945-72; Atlanta Univ.; Summer Festival of Art Exh. of Am. Vet. Soc. Artists, NYC (award); Xavier Univ., 1963; Sheraton Hotel, Phila., 1968; BMFA, 1970; Univ. Iowa, 1971-72; Smith-Mason Gal., Wash., DC, 1971. **Work:** Fisk Univ.; Winston-Salem State College. **Comments:** Teaching: Grambling College, LA. **Sources:** Cederholm, *Afro-American Artists.*

RIDLON, James A. *[Sculptor, educator] b.1934, Nyack, NY.*
Addresses: Cazenovia, NY. **Studied:** Syracuse Univ. (B.A., 1957); San Fran. State College, 1958-59; Syracuse Univ. (M.F.A., 1965). **Member:** Nat. Art Educ. Assn.; NY State Art Teachers Assn.; Syracuse AA; Cooperstown AA. **Exhibited:** Solos: Wells College, Aurora, NY & Schuman Gal., Rochester, 1971; Mirrors, Motors, Motion, Albert-Knox Art Gal., Buffalo, NY, 1970; Graphics 1971, Nat. Print & Drawing Exh., Western New Mexico Univ., 1971; Lubin House Gal., NYC, 1971. Awards: purchase prize, 32nd Ann. Exh., Munson-Williams-Proctor Mus., 1968; Graphics 1969 Award, NY State Fair, 1969; first prize in sculpture, 10th Ann. Westchester Art Soc. Exh., 1970. **Work:** Munson-Williams-Proctor Mus., Utica, NY; State Univ. NY Agric. & Tech. College Morrisville; Rochester (NY) Mem. Gal.; Everson Mus., Syracuse, NY. Commissions: sculptured mural C&U Broadcasting, 1958; Bert Bell Mem. Trophy, Long Island Athletic Club, 1968; assemblage, Merchants Nat. Bank Bldg., Rochester, 1971. **Comments:** Publications: contrib., *Synaesthetic Education,* Syracuse Univ. Press, 1971. Teaching: San Francisco State College, 1958; Syracuse Univ., 1965-70s. **Sources:** WW73.

RIEBER, Winifred Smith *[Portrait painter] b.1872, Carson City, NV / d.1963, Sonoma, CA.*
Addresses: Berkeley, CA. **Studied:** San Francisco Sch. Des.; Boston Sch. FA; Europe. **Work:** Rieber Hall, UCLA; Mills College; Stanford, Columbia, Northwestern & Atlanta Universities; Boston Unitarian Soc. **Comments:** She painted portraits of many intellectuals, including Albert Einstein, author Thomas Mann, poet Edwin Markham, university presidents and professors, as well as notables like Mrs. Herbert Hoover and Phoebe Hearst. **Sources:** Hughes, *Artists of California,* 468.

RIECKE, George *[Painter] 19th/20th c.*
Addresses: New Orleans, active c.1887-1902. **Exhibited:** NAD, 1900; Artist's Assoc. of N.O., 1902. **Sources:** *Encyclopaedia of New Orleans Artists,* 324.

RIEDELL, Clifford H. *[Painter, teacher] b.1882 / d.After 1925.*
Addresses: Active in New Bedford, MA area, 1907-19. **Studied:** Swain Free Sch. Design, 1907. **Exhibited:** New Bedford Art Club, 1907-19; Swain School Design, 1917; Nat. Lapel Button Contest, 1916 (first prize). **Comments:** Teaching: Swain Free Sch. Design, 1907-20; Smith College, Northampton, MA; operated a school of design and landscape painting, Boothbay Harbor, ME, in the summer. **Sources:** Blasdale, *Artists of New Bedford,* 155.

RIEDY, Lorene M. *[Designer, decorator, painter] b.1900, Lisle, IL.*
Addresses: Chicago, IL. **Studied:** AIC; Sch. Applied Art, Chicago; Am. Acad. Art, Chicago. **Member:** All Illinois Soc. FA; Am. Des. Inst. **Exhibited:** Cook County (IL) Fair,1935 (prize); Navy Pier, Chicago. **Sources:** WW40.

RIEFSTAHL, Rudolf Meyer (Dr.) *[Educator, writer] b.1880, Germany / d.1936, NYC.*
Addresses: NYC. **Studied:** Germany. **Member:** Guggenheim Found. (fellow). **Comments:** Expert on Moslem art, antiquities of the Middle Ages. Led a number of expeditions into Asia Minor. Author of books on Islamic and Near Eastern art. Teaching: NYU, for fifteen years; advisor, Penn. Mus. Art.

RIEGELMAN, Lillian White *[Painter] mid 20th c.*
Exhibited: S. Indp. A., 1937. **Sources:** Marlor, *Soc. Indp. Artists.*

RIEGGER, Hal *[Craftsman, educator, sculptor] b.1913, Ithaca, NY.*
Addresses: Gridley, CA; Mill Valley, CA. **Studied:** NY State Ceramic College, Alfred Univ. (B.S.); Ohio State Univ. (M.A.). **Member:** San Fran. Potters Assn.; Florida Craftsmen Assn. **Exhibited:** Syracuse Mus. FA, 1934-38, 1939 (prize), 1940-41, 1949 (prize); Robineau mem. exh., Syracuse, 1936 (prize); GGE, 1939; WFNY, 1939; WMAA, 1936; CAD; Phila. Art All., 1940 (solo); West Coast Ceramic Annual, 1948 (prize); European traveling exh. ceramics; AFA traveling exh. "California Crafts"; Tampa A (solo)I; Norton Gal. Art, West Palm Beach; Phila. ; Portland, OR; Long Beach, CA; San Fran. Potters Assn., 1956 (prize); Calif. State Fair, 1956 (prize). **Work:** Syracuse Mus. FA; MMA; MoMA. **Comments:** Contrib.: *Ceramic Industry; Ceramics Monthly.* Architectural commissions: New Orleans, LA, Tampa & Clearwater, Fzzl. TV series, 1959. Teaching: PM Sch. IA, 1939-42; Oregon Ceramic Studio, Portland, 1946-. **Sources:** WW66; WW47.

RIEHL, Otto *[Painter] early 20th c.*
Addresses: Oakland, CA, active 1920s. **Exhibited:** Oakland Art Gal., 1928. **Sources:** Hughes, *Artists of California,* 468.

RIEHLE, William J. *early 20th c.*
Exhibited: Salons of Am., 1934. **Sources:** Marlor, *Salons of Am.*

RIEKARTS, Frederick *[Engraver] b.c.1831, Germany.*
Addresses: Philadelphia in 1850. **Sources:** G&W; 7 Census (1850), Pa., L, 860.

RIEKE, George *[Painter] b.1848, Sheboygan, WI.*
Addresses: Brooklyn, NY. **Studied:** CUA Sch. **Sources:** WW06.

RIEKER, Albert George *[Sculptor] b.1889, Stuttgart, Germany / d.1959, Clermont Harbor, MI.*
Addresses: New Orleans, LA. **Studied:** Univ. Munich; Royal Acad. FA, Munich; Royal Acad. FA, Stuttgart. **Member:** New Orleans Art Lg.; SSAL: New Orleans AA. **Exhibited:** Stuttgart, 1910 (prize); Nuremberg, 1911 (prize); St. Württemberg, Stuttgart, 1921; NOAA, 1934 (prize), 1940 (prize), 1941 (prize); SSAL, 1938 (prize); Louisiana State Exh., 1939 (prize); AIC, 1929; PAFA Ann., 1929-30, 1937; New Orleans Art Lg. **Work:** monuments, mem., figures: Vicksburg (MS) Nat. Park; State Capitol, Baton Rouge, LA; Courthouse, Pascagoula, MS; Jackson, MS; Mente Park; Masonic Temple, New Orleans; Temple, Sinai; State College Lib., Starkville, MS; St. Augustine Seminary, St. Louis, MS; Jackson, MS; bas-reliefs, Vacarro Mausoleum, Metairie Cemetery; First Nat. Bank, Port Arthur, TX; Miltenberger-Lapeyre

Convalescent Home; Mem. Playground; busts, Touro Infirmary, New Orleans; Delgado Mus.; Louisiana State Mus.; Elementary Sch., East Baton Rouge; Court House, St. Bernard, LA; First Baptist Church; crucifix, Lutheran Church, sculpture, Civic Center, all New Orleans, LA. **Sources:** WW59; WW47; Falk, *Exh. Record Series.*

RIEMAN, Paul *[Painter] mid 19th c.*
Addresses: Albany, NY. **Exhibited:** NAD, 1868. **Sources:** Naylor, *NAD.*

RIEMANN, William *[Sculptor] b.1935.*
Addresses: Galerie Chalette, NYC. **Exhibited:** WMAA, 1966. **Sources:** Falk, *WMAA.*

RIENECKE, W. *early 20th c.*
Exhibited: Salons of Am., 1928. **Sources:** Marlor, *Salons of Am.*

RIEPE, Don J. *[Painter] mid 20th c.*
Addresses: Seattle, WA, 1951. **Exhibited:** SAM, 1945, 1946; Henry Gal., Seattle, 1950, 1951. **Sources:** Trip and Cook, *Washington State Art and Artists, 1850-1950.*

RIEPPEL, Ludwig *[Sculptor] b.1861 / d.1960.*
Addresses: NYC. **Comments:** Died at age 99. **Sources:** WW21.

RIES, Enryp *[Painter] early 20th c.*
Addresses: Seattle, WA, 1934. **Exhibited:** SAM, 1934. **Sources:** Trip and Cook, *Washington State Art and Artists, 1850-1950.*

RIES, Gerta (Gertraut) *[Painter] early 20th c.*
Addresses: Brooklyn, NY. **Studied:** ASL. **Exhibited:** S. Indp. A., 1926. **Sources:** WW25; Marlor, *Soc. Indp. Artists.*

RIES, Helen W. *[Painter] mid 20th c.*
Addresses: Baltimore, MD. **Exhibited:** PAFA Ann., 1952. **Sources:** Falk, *Exh. Record Series.*

RIES, Martin *[Painter, art historian] b.1926, Washington, DC.*
Addresses: Scarsdale, NY. **Studied:** Corcoran Gal. Sch., 1940-44; Am. Univ. (B.A., 1950) with Jack Tworkov & Leo Steppat; Hunter College (M.A., 1968) with Leo Steinberg, William Rubin, Ad Reinhardt. **Exhibited:** Corcoran Gal. biennial, 1957; Inst. Hispanic Culture, Univ. Madrid, 1955; MoMA, 1956; TMA, 1957; Paul Gal., Tokyo, 1968; NIAL at CGA, 1957 (prize); Whyte Gal., 1957 (Critics Choice prize); Mann Gal., NYC, 1970s. **Work:** Pace College Mus., Pleasantville, NY; Riverside Mus. Coll., Rose Art Mus., Brandeis Univ.; Inst. Cult. Hisp., Madrid, Spain. **Comments:** Positions: asst. dir. public relations, Nat. Congress Comt., 1951; asst. dir., Hudson River Mus., Yonkers, NY, 1957-67; ad.v, Westchester Cultural Center, 1965-67. **Auth.:** "Elusive Goya," *New Repub,* 1957; monthly articles, *Hudson River Mus. Bulletin,* 1957-67; "Hudson River Art,Past & Present," 1959; "Endowments for Great Society," *Art Voices,* 1965 & *New Art,* 1966. Teaching: Marymount College, 1959; Hunter College, 1963-67; LI Univ., 1968. Research: Minotaur in Western art, from ancient Greek myth to contemporary art. **Sources:** WW73.

RIES, Solomon *[Teacher, sketch artist] b.c.1805, Obernai, France / d.1875, New Orleans, LA.*
Addresses: New Orleans, active 1858. **Sources:** *Encyclopaedia of New Orleans Artists,* 325.

RIESE, Alfred *[Painter] early 20th c.*
Addresses: NYC. **Exhibited:** Salons of Am., 1932; S. Indp. A., 1932-33. **Sources:** Falk, *Exhibition Record Series.*

RIESENBERG, Sidney H. *[Painter, illustrator, teacher] b.1885, Chicago, IL / d.1971.*
Addresses: Yonkers, NY; Hastings-on-Hudson, NY in 1962. **Studied:** AIC. **Member:** Allied Artists Am.; SC; Yonkers AA; Rockport AA. **Exhibited:** Yonkers AA, 1930 (prize); Westchester Art Gld., 1940 (prize), 1941 (prize), 1951 (prize); NAD, 1930, 1931, 1933, 1938, 1940, 1941; Allied Artists Am., 1936, 1938-45; WFNY, 1939; NYWCC, 1940, 1941; Montclair Art Mus.; Hudson Valley AA; New Rochelle AA; Rockport AA (prize); Currier Gal. Art ; S. Indp. A. **Work:** Hudson River Mus.; Vanderpoel Collection; Central Nat. Bank, Yonkers, NY. **Comments:**

Specialized in Western subjects. Teaching: Westchester Workshop, White Plains, NY. Illustr.: "With Whip and Spur," 1927; "Pioneers All." 1929. Contrib.: illus. to national magazines, incl. *Harper's, Collier's, Scribner's, Saturday Evening Post.* **Sources:** WW59; WW47; P&H Samuels, 399-400.

RIESER, Marianne *[Painter] mid 20th c.*
Addresses: NYC. **Exhibited:** S. Indp. A., 1944. **Sources:** Marlor, *Soc. Indp. Artists.*

RIESS, Lore *[Painter, printmaker] 20th c.; b.Berlin, Germany.*
Addresses: NYC. **Studied:** Art Acad., Contempora (Bauhaus Sch.), Berlin; Sumi Drawing & Calligraphy, Tokyo, Japan; ASL. **Exhibited:** Solos: Nihon Bashi Gal., Tokyo, 1965, NAWA, 1969 (M.J. Kaplan Prize) , P&S Soc. Nat., Old Jaffa Nora Gal., Israel, 1970, P&S Soc. Nat., 1971 & Int. Miniature Print Exh., 1971 (Gal. Graphic Art Award); Phoenix Gal., NYC, 1970s. Other awards: William McNulty Merit Award, ASL, 1964. **Work:** CGA; Israel Mus., Jerusalem; Tel-Aviv Mus., Israel; U.S. Embassy, Tokyo; Rutgers Univ., NJ. Commissions: edition of etchings, Mickelson Gal., Wash., DC, 1971. **Comments:** Preferred medium: oils. **Sources:** WW73; T. Ichinose, "Colorful Abstract Oils by Lore Riess," *Mainichi Daily News,* 1965; articles, *Art News* (May, 1966), *Washington Post,* Jan., 1967 & *Jerusalem Post,* July, 1970 & March, 1971.

RIESS, Paul *[Sculptor, molder] b.1843, Berlin, Germany / d.1926, New Orleans, LA.*
Addresses: New Orleans, active 1882-86. **Studied:** Berlin. **Exhibited:** Grunewald's Music Store, N.O., 1882; Washington Artillery Hall, N.O.,1883; Am. Expo, 1885-86. **Comments:** Worked in association with Rudolph Thiem (see entry). **Sources:** *Encyclopaedia of New Orleans Artists,* 325.

RIESS, William *[Painter] b.1856, Berlin / d.1919.*
Addresses: Indianapolis, IN, 1884. **Studied:** Berlin Art Acad.; Von Werner. **Exhibited:** Pan-Pacific Expo, San Fran., 1915 (gold, med.). **Work:** John Herron AI, Indianapolis. **Comments:** Specialties: Western and Indian life. Died suddenly at his temporary studio in Chicago. **Sources:** WW10.

RIETHMULLER, Aloise D. *[Artist] early 20th c.*
Addresses: Active in Los Angeles, c.1912. **Studied:** ASL, Los Angeles. **Comments:** Went around the world, 1910-12. **Sources:** Petteys, *Dictionary of Women Artists.*

RIFFINBURG, William *[Listed as "artist"] b.c.1820, Germany.*
Addresses: Philadelphia in 1850. **Sources:** G&W; 7 Census (1850), Pa., LII, 970.

RIFFLE, Elba Louisa (Mrs. Vernon) *[Illustrator, comm a, painter] b.1905, Winamac, IN.*
Addresses: Indianapolis, IN. **Studied:** John Herron AI; Indiana Univ.; Purdue Univ.; Myra Richards; Forsythe. **Member:** Hoosier Salon; Indiana AC. **Exhibited:** Northern Indiana Artists, 1931 (prize); Midwestern Exh., Wichita, KS, 1932 (prize); Hoosier Salon, 1934 (prize); Indiana State Fair, 1930-32 (prizes), 1934 (prize), 1935 (prize), 1938 (prize). **Work:** Christian Church, H.S., Pub. Lib., Winamac, IN; Tipton (IN) Pub. Lib.; Indiana Univ.; Woman's Club House, Clay City, IN. **Comments:** Illustr.: "Cats Magazine"; "Our Dumb Animals Magazine"; "One Hundred Years of Service" (history of YMCA in Indianapolis). **Sources:** WW59; WW47.

RIFKA, Judy *[Painter] b.1946.*
Addresses: NYC, 1975-83. **Exhibited:** WMAA, 1975-83. **Sources:** Falk, *WMAA.*

RIFKIN, Harold (Dr. & Mrs.) *[Collectors] 20th c.*
Addresses: NYC. **Comments:** Collection: Am. art of the early 20th c. **Sources:** WW73.

RIGACCI, Lola *[Sculptor] mid 20th c.*
Addresses: Chicago area. **Exhibited:** AIC, 1950 (prize). **Sources:** Falk, *AIC.*

RIGALI, G. *[Sculptor] mid 19th c.*
Addresses: NYC, 1856. **Sources:** G&W; NYBD 1856.

RIGBY, F. G. (Mrs. Harold) *[Illustrator, portrait painter]*
19th/20th c.; d.New York.
Addresses: NYC. **Sources:** WW01; Petteys, *Dictionary of Women Artists.*

RIGBY, Harold See: **RIGBY, Harroke B.**

RIGBY, Harroke B. *[Illustrator] b.c.1852 / d.1907.*
Addresses: NYC. **Exhibited:** NAD, 1887, 1899

RIGBY, Ivan *[Sculptor] mid 20th c.*
Addresses: Pratt Institute, Brooklyn, NY. **Exhibited:** WMAA,
1953. **Sources:** Falk, *WMAA.*

RIGBY, Joseph P. *[Illustrator] early 20th c.*
Member: Pittsburgh AA. **Comments:** Affiliated with Pres
Publishing Co., Pittsburgh. **Sources:** WW21.

RIGELE, Edward *[Painter] mid 20th c.*
Exhibited: S. Indp. A., 1935, 1940. **Sources:** Marlor, *Soc. Indp.
Artists.*

RIGER, Robert *[Illustrator, writer] b.1924, NYC.*
Addresses: Living in NYC in 1971. **Studied:** H.S. of Music and
Art, NYC; Pratt Inst. until 1947. **Comments:** Positions: layout
artist, *The Saturday Evening Post;* commercial artist; sports
writer, 1960-; auth., "Run to Daylight," with Vince Lombardi,
1963; dir.-prod., ABC Sports, 1964; illustr., "Riders of the Pony
Express," by Ralph Moody, 1958. **Sources:** P&H Samuels, 400.

RIGG, Margaret *[Painter] mid 20th c.*
Exhibited: Florida Creates, 1971-72; Univ. Turku, Finland;
Yamada Gal., Kyoto, Japan; Trend House, Tampa, FL; Botolph
Group Gal., Boston; Wash. Fed. Gal., Miami; Nashville Artists
Guild; Florida Artist Group Ann.; Contemp. Gal., St. Petersburg;
Krannert Art Mus., Urbana, IL; Ringling Mus., FL; CBS-TV,
1968; Florida Gulf Coast AC. **Comments:** Specialty: mixed
media. **Sources:** Cederholm, *Afro-American Artists.*

RIGGS, Katherine G. *[Artist] early 20th c.*
Addresses: Wash., DC, active 1904. **Sources:** McMahan, *Artists
of Washington, DC.*

RIGGS, Katherine Louise *[Painter, teacher] d.1828, New
Orleans, LA.*
Addresses: New Orleans, active 1892-1928. **Member:** Artist's
Assoc. of N.O., 1896; Arts Exh. Club, 1901; NOAA, 1905.
Exhibited: Tulane Univ., 1893; Artist's Assoc. of N.O., 1892-94,
1896-97, 1899. **Comments:** Born in Iberia Parish, LA, her year of
birth varies between 1859-68 in the census and voter registration
cards. **Sources:** *Encyclopaedia of New Orleans Artists,* 325.

RIGGS, Robert *[Painter, lithograph-* ROBERT RIGGS
er, illustrator] b.1896, Decatur, IL /
d.1970, Philadelphia, PA.
Addresses: Philadelphia, PA. **Studied:** Académie Julian, Paris,
1919. **Member:** ANA, 1938; NA; Phila. Art All.; Phila. WCC.
Exhibited: AIC; Phila. WCC, 1932 (med.); WMAA, 1933-1942;
PAFA, 1934 (med.); PAFA Ann., 1939, 1945-46; Phila. Pr. Club,
1936 (prize), 1937 (prize), 1938 (prize); Century of Progress
Expo., 1934 (prize); NY Art Dir. Club (medal six times). **Work:**
Phila. WCC; AIC; BM; WMAA; NYPL; Dallas Mus. FA; LOC;
MMA; Nat. Mus., Copenhagen, Denmark; Modern Art Gal; all
lithographic work (73 prints) in LOC Congress, Pennell Fund.
Comments: Teaching: Phila. Mus. Sch. Indust. Art. **Sources:**
WW66; WW47; Falk, *Exh. Record Series.*

RIGHTER, Alice L. *[Painter] 19th/20th c.; b.Monroe, WI.*
Addresses: Lincoln, NE. **Studied:** AIC; ASL: DuMond; Castaign;
Lasar; Duprè, in Paris. **Sources:** WW01.

RIGHTER, Mary L. *[Painter] 19th/20th c.*
Addresses: Lincoln, NE. **Sources:** WW01.

RIGNEY, Francis J(oseph) *[Drawing specialist, illustrator,
writer] b.1882, Waterford, Ireland.*

Addresses: NYC. **Studied:** Metropolitan Sch. Art. **Member:**
NAC. **Work:** WFNY, 1939. **Comments:** Illustr.: "The Clipper
Ship," "Ships of the Seven Seas," "What's the Joke?,"
"Landlubbers Afloat," "Games and Game Leadership," "Elements
of Social Science," "Johnny Round the World." Position: art ed.,
Boys' Life. **Sources:** WW40.

RIGNY, Alfred *early 20th c.*
Studied: Académie Julian, Paris with J.P. Laurens, 1908-11.
Exhibited: Salons of Am., 1922, 1925-26. **Sources:** Marlor,
Salons of Am; Fehrer, The Julian Academy.

RIGOULOT, Helene *[Painter] early 20th c.*
Addresses: Elgin, IL. **Exhibited:** AIC, 1910. **Sources:** WW13.

RIGSBY, Clarence S. *[Cartoonist, illustrator] d.1926, Seattle,
WA.*
Comments: He was the originator of the animated cartoon, and
comic strip, including "Major Ozone" and "Ah Sid, the Chinese
Kid." Contrib.: *Life, Judge;* Sam Lloyd Syndicate. Positions: staff
artist, *New York Herald, New York World, Brooklyn Eagle.*

RIGSBY, John David *[Painter] b.1934, Tallassee, AL.*
Addresses: Beaufort, SC. **Studied:** Univ. Alabama (B.F.A. &
M.S., urban studies); Southern Conn. State College; Columbia
Univ. with Leon Goldin. **Member:** Guild SC Artists; Nat. Art
Educ. Assn.; College AA Am. **Exhibited:** Alabama Artists Ann.,
Birmingham, 1962; Artists of Southeast & Texas, New Orleans,
LA, 1963; solos: Delgado Mus., New Orleans, 1964, Galerie
Munic., Tunis, 1967, Telfair Acad., 1969 & Columbia (SC) Mus.,
1971; Am. Artists Tunisia, U.S. Info Service, 1966; Guild SC
Artists Ann., 1971; Neikrug Gal., NYC, 1970s. Awards: merit
award, Artists of Southeast & Texas, Delgado Mus., 1963; merit
award, Guild SC Artists Exh., 1971; Springs Mills Traveling Exh.
Award, 1972. **Work:** Telfair Acad Arts & Sciences, Savannah,
GA; Univ. Alabama Gal. Coll.; Beaufort (SC) Mus.; U.S.
Embassy, Tunis, Tunisia; Brit. Counsel, Tunis. Commissions:
sculpture, Mobile (AL) Art Center, 1963. **Comments:** Preferred
media: oils, acrylics. Positions: consult. art, Center Urban Educ.,
NYC, 1968-69; dir., Volunteer Community Servcie Program,
Action Bridgeport(CT) Community Development, 1968-69.
Teaching: Nat.Endowment Arts artist-in-residence, Beaufort (SC)
Pub. Sch. System, 1970-73. Research: design of cultural enrich-
ment programs as a basis for community participation. **Sources:**
WW73; Al Wardi, "Dans le Tournoi de l'Art avec John David
Rigsby," *L'Action,* March 29, 1967; Gaynor Pearson, "The One-
Room School Now has Wheels," *Conn. Educ.* (Feb., 1968); Oliver
& Sisk, "Artist-in-Residence—a First for South Carolina," *SC
Educ. Journal* (winter, 1971).

RIHL, Martha Landell *[Painter] b.1863.*
Addresses: Phila., PA. **Exhibited:** PAFA Ann., 1887-88, 1891.
Sources: Falk, *Exh. Record Series.*

RIIS, Anna M. *[Craftsperson, teacher] early 20th c.;
b.Norway.*
Addresses: Cincinnati, OH. **Studied:** Royal & Imperial Sch. Art
& Indsut., Vienna; Royal Art Sch., Christiania. **Member:**
Cincinnati Women's AC; Crafters; Cincinnati Ceramic Club.
Comments: Teaching: Cincinnati Art Acad. **Sources:** WW31.

RIIS, Jacob August *[Photographer, writer] b.1849, Ribe,
Denmark / d.1914.*
Addresses: NYC. **Comments:** Came to NYC in 1870. America's
earliest social reform photographer, he first illustrated slum and
sweatshop conditions for the New York *Tribune* (1877-88) and the
Evening Sun (1888-on). His influential books are: *How the Other
Half Lives* (1890), *Children of the Poor* (1892), *Out of Mulberry
St.* (1898), *The Making of an American* (1901), and *Children of
the Tenements* (1903). His work was continued by Jessie T. Beales
and Lewis Hine. The three all influenced the "Ashcan school" of
painters. **Sources:** Welling, 308-10.

RILEY, Agnes (Miss) *[Painter] early 20th c.*
Addresses: NYC. **Member:** S. Indp. A. **Exhibited:** S. Indp. A.,
1921-22. **Sources:** WW25.

RILEY, Anita B. *[Sculptor, painter]* b.1928, New Bedford, MA.
Studied: Swain School Des. **Member:** Phila. AA; AEA, Phila.,
PA. **Exhibited:** Woodmere Gal., 1970; Tempel Univ., 1971; Phila.
Civic Center Mus.; Holyoke College, 1972; Storelli Gal., 1972.
Sources: Cederholm, *Afro-American Artists.*

RILEY, Ann Maverick See: **MAVERICK, Ann Anderson (Mrs.)**

RILEY, Art (Arthur Irwin) *[Painter, photographer]* b.1911,
Boston, MA.
Addresses: Burbank, CA. **Studied:** Art Center Sch. Los Angeles.
Member: Acad. Motion Picture Arts & Science; AWCS.
Exhibited: AWCS, NYC; Calif. WCS, LACMA; Springfield
(MO) Art Mus.; Youngstown (OH) Art Mus.; Pacific Grove, Calif.
Art Mus (solo). **Awards:** AWCS award; Laguna Beach AA award;
Butler Inst. Am. Art award. **Comments:** Preferred media: water-
colors, oils. Positions: artist, MGM Studios, five years; artist, Walt
Disney Studios, 1937-65. **Sources:** WW73.

RILEY, Bernard J. *[Painter]* mid 20th c.
Addresses: Phila., PA; Fairfield, New Canaan, CT. **Exhibited:**
PAFA Ann., 1946, 1952, 1958. **Sources:** Falk, *Exh. Record
Series.*

RILEY, Bill *[Cartoonist, illustrator]* b.1921., Charleston, SC.
Addresses: New York 31, NY. **Studied:** Cartoonist & Illustrators
Sch. with Bume Hogarth. **Comments:** Contrib. cartoons to *New
Yorker; Sat. Review; Reporter,* and others. Positions: art dir.,
Cartoonist Workshop, NYC. **Sources:** WW59.

RILEY, Chapin *[Collector]* mid 20th c.
Addresses: Worcester, MA. **Member:** Art Collectors Club.
Comments: Collections: modern painting and sculpture.
Sources: WW73.

RILEY, Charles Valentine *[Artist, illustrator, entomologist]*
b.1843, London, England / d.1894.
Addresses: Illinois; Missouri. **Studied:** Paris, France. **Member:**
Cosmos Club, 1878 (one of founders). **Work:** U.S. Nat.
Arboretum; Cooper-Hewitt Mus., NYC. **Comments:** He came to
the U.S. in 1860 to earn a living, first as a reporter, artist and edi-
tor on the *Prairie Farmer,* a leading agricultural journal. After
serving in the Civil War, he was an entomologist for the state of
Missouri for 9 years. In 1877, he was appointed chief of the U.S.
Entomological Commission in Wash., DC. From 1878-94 he
worked for the U.S. Dept. of Agric. He took an honorary position
at the U.S. Nat. Mus. in 1894, and died the following year of
injuries received in a bicycle fall. **Sources:** McMahan, *Artists of
Washington, DC.*

RILEY, Frank E. *[Painter]* early 20th c.
Addresses: Chicago, IL. **Member:** GFLA. **Sources:** WW27.

RILEY, Frank H. *[Painter]* b.1894, St. Joseph, MO.
Addresses: Highland Park, IL. **Studied:** L. Ritman; J. Marchand;
A. Lhote. **Exhibited:** AIC, 1923-24, 1933-35. **Sources:** WW33.

RILEY, Garada Clark *[Painter]* b.1894, Chicago, IL.
Addresses: Highland Park, IL. **Studied:** J. Marchand; Lhote; L.
Kroll. **Exhibited:** AIC, 1923-50. **Sources:** WW33.

RILEY, Gerald Patrick *[Designer, instructor]* b.1941,
Oklahoma City, OK.
Addresses: Oklahoma City. **Studied:** Univ. Oklahoma (B.F.A.,
1964; M.A., art educ., 1971). **Member:** Nat. Art Educ. Assn.
(states assembly, 1967-71); Oklahoma Art Educ. Assn. (pres.,
1969-71); Oklahoma City Art Educ. Assn. (pres., 1967-68); Am.
Crafts Council; Oklahoma Designer Craftsman Assn. (vice-pres.,
1969-71). **Exhibited:** Ann. Eight-State Exh. P&S, 1969 & 1970;
Oklahoma Biennial Exh., 1971, Oklahoma AC, Oklahoma City;
Ann. Oklahoma Designer Craftsman Exh., Philbrook AC, Tulsa,
1971 (jewelry award); Ann. Prints, Drawings & Crafts Exh.,
Arkansas AC, Little Rock, 1971 (purchase award). **Work:**
Arkansas AC, Little Rock; Contemp. Arts Found., Oklahoma City.
Comments: Positions: educ. dir., Oklahoma AC, Oklahoma City,
1967-69; dir. creative educ. lab., Oklahoma City Arts Council,

1971-72. Teaching: Oklahoma AC, Oklahoma City, 1966-71; John
Marshall H.S., Oklahoma City, 1968-. **Sources:** WW73;
"Exhibitions," (March-April, 1969; Jan.-Feb., 1970; Nov.-Dec.,
1971) *Craft Horizons.*

RILEY, Jennie Little (Mrs. R. M.) *[Painter]* b.1867, Ohio.
Addresses: Illinois; Webster City, IA. **Studied:** mainly self-
taught. **Exhibited:** County Fair, Hamilton, OH; Iowa State Fair.
Work: Lincoln H.S., Methodist Church, County Hospital, all in
Webster City, IA. **Sources:** Ness & Orwig, *Iowa Artists of the
First Hundred Years,* 177.

RILEY, Jeremiah H. *[Engraver, die sinker]* mid 19th c.
Addresses: NYC, 1854-59. **Sources:** G&W; NYBD 1854-59.

RILEY, John *[Listed as "artist"]* b.c.1830, Ireland.
Addresses: NYC in 1860. **Sources:** G&W; 8 Census (1860),
N.Y., LX, 1046.

RILEY, Ken(neth) Pauling *[Illustrator]* b.1919, Missouri.
Addresses: Danbury, CT; Tombstone, AZ in 1973. **Studied:**
Kansas City AI with Thomas Hart Benton; ASL with Frank
DuMond; Grand Central Sch. with Harvey Dunn. **Member:** SI;
Westport Artists; Nat. Acad. Western Art. **Work:** war paintings,
U.S. Coast Guard; West Point Mus.; White House Coll.; Air Force
Acad.; Custer Mus. **Comments:** Illustr.: "The Eustace Diamonds,"
1951; "The Greatest Story Ever Told," 1950. Contrib. illus. to
*Saturday Evening Post, Cosmopolitan, Readers Digest, McCalls,
Wornans Home Companion, True, Redbook, Esquire, Coronet.*
Sources: WW59; P&H Samuels, 400.

RILEY, Lillian Irene *[Painter]* mid 20th c.
Addresses: Seattle, WA, 1946. **Exhibited:** SAM, 1946; Henry
Gal., 1951. **Comments:** Position: staff, Boeing Aircraft Co., 1944.
Sources: Trip and Cook, *Washington State Art and Artists,* 1850-
1950.

RILEY, Marguerite *[Painter]* mid 20th c.
Addresses: Germantown, MD. **Exhibited:** 48 States Comp.,
1939. **Sources:** WW40.

RILEY, Mary Gine (or Grimes) *[Landscape painter]*
b.1883, Washington, DC / d.1939, Wash., DC.
Addresses: Wash., DC. **Studied:** B. Harrison & H.B. Snell in
NYC; Corcoran Sch. Art, 1907-08, 1910-11, 1913. **Member:** Soc.
Wash. Artists; NAWPS; Wash. AC; NAC; AFA; Wash. WCC;
SSAL. **Exhibited:** Corcoran Gal. biennials, 1919, 1926; PAFA
Ann., 1924, 1928, 1933; Maryland Inst.; Wash. AC; AWCS; Soc.
Wash. Artists, (medals 1923, 1932); NAC, 1928 (prize); NAWPS,
1930 (prize); NAD, 1931; Gr. Wash. Indep. Exh., 1935. **Work:**
CGA. **Sources:** WW38; P&H Samuels, 400; McMahan, *Artists of
Washington, DC; Falk, Exh. Record Series.*

RILEY, Maude Kemper *[Critic, writer, teacher, illustrator]*
b.1902, Franklin, LA.
Addresses: Los Angeles, CA. **Studied:** Newcomb College,
Tulane Univ. (B.F.A.); CUA Sch.; Yale Univ. (M.F.A.); Ellsworth
Woodward; Will H. Stevens; William Brewster. **Exhibited:**
Award: Mexican Govt. Fellowship for field and school study of
Pre-Columbian Art. **Comments:** Positions: ed. asst., illustr., *Revue*
magazine, 1937-38; art critic, *Cue* magazine, 1938; assoc. ed., *Art
Digest,* 1943-45; columnist, *Progressive Architecture,* 1945-46;
publ. & ed., *MKR's Art Outlook & MKR's Art Weekly,* 1945-48; art
adv., assoc., Magazine Contrib,, Inc., 1946., art critic, assoc. ed.,
Fortnight Magazine, 1952-. **Sources:** WW53; WW47.

RILEY, Nicholas F. *[Illustrator, cartoonist, teacher]* b.1900,
Brooklyn, NY / d.1944.
Addresses: Brooklyn, NY. **Studied:** ASL; PIA Sch., 1921.
Member: SI; SC; Lotos Club. **Exhibited:** Paris Salon, 1925.
Comments: Illustr.: *Saturday Evening Post,* 1939. Teaching: PIA
Sch., 1927-44. **Sources:** WW40.

RILEY, Olive *[Educator]* mid 20th c.
Addresses: Brooklyn, NY. **Comments:** Position: treas., Sch. Art
Lg. NYC. **Sources:** WW66.

RILEY, Roy John *[Painter, designer]* b.1903, Independence, KS.
Addresses: Phoenix, AZ. **Studied:** Calif. Arts & Crafts; Detroit Art Sch.; Huettles Art Sch., Chicago; Univ. Tulsa with Franz Vanderlachen; Merlin Enabnet. **Exhibited:** Philbrook AA, Tulsa, OK; Ruskin Club, Tulsa; Verdigris Valley Art Exh., Independence, KS; Scottsdale (AZ) Artist Lg.; Philbrook Art Gal. Tulsa (2 solos); La Galeria, Sedona, AZ, 1970s. Awards: awards for South of the Border (painting), Philbrook Art Gal., 1945 & Ruskin Club, 1945; award for The Boulders (painting), Scottsdale Artist Lg., 1969. **Work:** Commissions: mural, Travel & Transport Bldg., Chicago World's Fair, 1933. **Comments:** Preferred medium: oils. Positions: demonstrator, Artist in Action shows, Philbrook Art Gal., Tulsa & AA's in Bartlesville (OK), Fort Smith (AR), civic groups in Scottsdale (AZ)& univs. Art interests: sculpture compositions in primitive art; light plastics representative of stone. **Sources:** WW73.

RIMANCCZY, A. W. *[Painter]* early 20th c.
Addresses: Cleveland Heights, OH. **Member:** Cleveland SA. **Sources:** WW27.

RIMMEL, E. P. Grebe See: **GREBE, (E. P. Grebe Rimmel)**

RIMMER, Caroline Hunt *[Sculptor, writer]* b.1851, Randolph, MA. / d.1918, Boston, MA.
Addresses: Belmont, MA. **Studied:** her father, Dr. William Rimmer. **Exhibited:** PAFA Ann., 1888, 1898-99, 1901; Boston AC, 1896, 1899; AIC. **Comments:** Auth./illustr.: "Figure Drawing for Children," 1893. **Sources:** WW13; Falk, *Exh. Record Series.*

RIMMER, William (Dr.) *[Sculptor, portrait & figure painter, teacher, author]* b.1816, Liverpool, England / d.1879, South Milford, MA.

W. Rimmer 1872

Exhibited: NAD, 1866; Boston AC, 1876; BMFA, 1879 (memorial); Armory Show, 1913 (lent by Miss Rimmer); WMAA, 1946 (solo). **Work:** BMFA (best collection); MMA. **Comments:** A richly imaginative and unique painter and sculptor, and an important teacher. Rimmer's father was an expatriate who believed (as had Audubon) that he was the lost dauphin to the French crown. The family emigrated to Nova Scotia in 1818, and moved to Boston in 1826. Rimmer was interested in art from a young age and by 1830 had become familiar with stonecutting techniques (there was a stoneyard near his home) and completed his first work, called "Despair" (11" high, in gypsum, at BMFA). Rimmer would not return seriously to sculpture until the 1850s, but instead focused on painting and drawing, helping to support his family from c. 1831 to 1835 by painting portaits and signs, and drawing on stone at the Boston lithography shop of Thomas Moore from 1835 to 1840. Rimmer married in 1840 and over the next several years earned a living by painting portraits in the Boston vicinity. By 1845, Rimmer and his wife had settled in Randolph, MA, where he worked as a cobbler, occasionally painting portraits. He also began studying medicine at this time, teaching himself through books borrowed from the vast library of his friend Dr. A.W. Kingman. In 1855 Rimmer moved to East Milton, MA, where he practiced medicine full time (after being awarded a medical degree by the Suffolk County Medical Society). During these years he also turned his attention to sculpture, working first in granite, later in clay and marble. One of his pieces came to the attention of a Boston art patron, Stephen H. Perkins, who subsequently encouraged Rimmer and provided funds so that the artist could start a full-length statue of the "Falling Gladiator." When it was cast in plaster in 1861 (it was not put in bronze until 1906), Perkins showed it in Boston and Europe, bringing Rimmer a small degree of recognition. His powerful treatment of anatomical form and the emotionialism expressed in the "Falling Gladiator," and also seen in his "Dying Centaur" (1871, BMFA) and the "Fighting Lions" (1871, MMA), did not fit in with the prevailing taste for neoclassicism in Rimmer's day (although it evokes and pre-dates the style of Rodin). Rimmer's figurative paintings were rarely seen in his lifetime but show the same romantic impulse as his sculptures. His most famous painting, "Flight and Pursuit" (1872, BMFA) is both mysterious and dreamlike, and has evoked many interpretations since his death. In his own lifetime, however, Rimmer gained more notice for his lectures on art anatomy, which he began giving in 1861 in Boston. As his reputation spread, he was invited to give a series of ten lectures on art anatomy at Lowell Institute in 1863/64, and gave instruction to artists at the Boston Athenaeum. From 1864 to 1866 he conducted his own school of drawing and modeling in Boston. Rimmer moved to NYC in 1866 in order to serve as director of the School for Design for Women at the Cooper Institute in NYC. He returned to Boston in 1870, reopened his school and taught there until 1876, and during the last three years of his life taught in the art school of the Boston Museum of Fine Arts. An influential teacher of many Boston artists, Rimmer is particularly important for encouraging many women to pursue professional careers in art. Note: like W.M. Hunt, Rimmer lost most of his work in the Boston fire of 1872. Auth.: *Elements of Design* (Boston, 1864) and *Art Anatomy* (Boston, 1877). **Sources:** G&W; Truman H. Bartlett *The Art Life of William Rimmer* (1882); DAB; Gardner, "Hiram Powers and William Rimmer;" Lincoln Kirstein, *William Rimmer* (WMAA, 1946); Pierce and Slautterback, 144; Craven, *Sculpture in America*, 346-57; Charles A. Sarnoff, "The Meaning of William Rimmer's "Flight and Pursuit,"" *American Art Journal* vol.6, no.1 (May 1973): 18-19; Marcia Goldberg, "William Rimmer's "Flight and Pursuit": An Allegory of Assassination," *Art Bulletin* vol.58, no.2 (June 1976): 234-40; *300 Years of American Art*, vol. 1, 171; *The Boston AC;* Brown, *The Story of the Armory Show.*

RIMONOCZY, A. W. *[Painter]* late 19th c.
Exhibited: AIC, 1897. **Sources:** Falk, *AIC.*

RIMPRECHT, Johann Baptist See: **RIMPRECHT, John**

RIMPRECHT, John *[Genre & portrait painter]* b.1801, Triberg, Germany / d.1877, Triberg.
Addresses: Brooklyn, NY, 1857. **Comments:** Came to U.S. in 1843 and returned to Triberg after the Civil War. **Sources:** G&W; Thieme-Becker Becker; Brooklyn BD 1857.

RINCICOTTI, J. H. *[Painter]* mid 20th c.
Exhibited: Mystic AA. **Work:** Mystic AA. **Sources:** PHF files, Mystic AA postcard.

RINCK, A(dolph) D. *[Portrait and miniature painter, teacher]* b.c.1810, France.
Addresses: New Orleans (active between 1840-72, with frequent travel). **Studied:** Royal Acad., Berlin; Paul Delaroche, Paris (1835-40). **Exhibited:** Salon, Paris, 1835-40; lecture hall, Monsieur Bravo's in New Orleans, 1846; Brooklyn AA, 1873. **Work:** NYHS (miniature portrait of John Woodhouse Audubon, c.1845). **Comments:** Came to New Orleans in 1840 and worked winters there until 1846 at which time he seems to have made that city his permanent residence. Gave painting and drawing lessons from 1846 while still painting portraits and traveling (Brazil in 1851). An advocate of scientific agriculture, he wrote a pamphlet on the subject, proposed a school devoted to its teaching, and bought a farm in Algiers, LA, in 1859. His whereabouts from 1861 and 1869 are unknown; however, he once again advertised his services as portraitist in New Orleans in 1871. One portrait survives from 1872. A number of portraits have been found in Norwich, CT, suggesting this as one of the places he traveled over the years. **Sources:** G&W; Delgado-WPA cites *Bee*, Dec. 9, 1840, Jan. 8, 1842, Jan. 3, 1843, March 30, 1858, Feb. 17, 1871, *Picayune*, Jan. 9, 1851, and New Orleans CD 1841-42, 1846; cf. Seebold, *Old Louisiana Plantation Homes and Family Trees*, I, 23. More recently, see *Encyclopaedia of New Orleans Artists;* Gerdts, *Art Across America*, vol. 2: 95.

RINDISBACHER, Peter *[Genre, landscape, animal & miniature painter]* b.1806, Upper Emmenthal, Canton Bern (Switz.) / d.1834, St. Louis, MO.

Peter Rindisbacher

Studied: at age 12 (1818) spent summer studying with Jacob S. Weibel in Swiss Alps. **Work:** Public Canadian Archives; Royal

Ontario Mus. (Toronto, Canada); Gilcrease Inst. (Tulsa, OK); Amon Carter Mus. (Fort Worth, TX); Denver (CO) Art Mus.; Peabody Mus., Harvard Univ. (Cambridge, MA); U.S. Military Acad. Mus. **Comments:** Early specialist in (watercolor) scenes of frontier life and Indians (according to Samuels, "the first pioneer artist recording genre of Western Indians," 400). Accompanied his family in 1821 to the Earl of Selkirk's Red River colony in western Canada. Sketched scenes along the way (icebergs, Eskimos, landscape); and during the five years spent in the frontier settlement Peter helped support his family by selling drawings and watercolors of prairie life. About 1822-23 he was asked by Andrew Bulger (gov. of the Red River colony) to record scenes at some of the British forts in the area. Subsequently, he became known in England and some of his works were lithographed in London. After severe weather and other factors in 1826 forced Red River settlers off their farms, the Rindisbachers moved south into Wisconsin (Gratiot's Grove), where Peter continued to paint. In 1829 Indian Commissioner Caleb Atwater hired him to record the Indians attending the Prairie du Chien treating meeting in Wisconsin. About this time he settled permanently in St. Louis and began to contribute western, Indian, and sporting scenes to *The American Turf Register and Sporting Magazine.* He was gaining national recognition for his pictures when he died at age twenty-eight. **Sources:** G&W; McDermott, "Peter Rindisbacher: Frontier Reporter," 10 repros., biblio.; Nute, "Peter Rindisbacher, Artist" and "Rindisbacher's Minnesota Water Colors"; Alice E. Smith, "Peter Rindisbacher: A Communication." More recently, see P&H Samuels; Gerdts, *Art Across America,* vol. 3: 30 (with repro); MacDonald, *Dictionary of Canadian Artists.*

RINDLAUB, M. Bruce Douglas (Mrs.) *[Miniature painter]* early 20th c.
Addresses: Fargo, ND. **Sources:** WW19.

RINDSKOPF, Alex C. *[Painter]* early 20th c.
Addresses: Chicago, IL. **Member:** GFLA. **Sources:** WW27.

RINDY, Dell Nichelson *[Painter]* b.1889 / d.1962.
Addresses: Madison, WI. **Studied:** AIC; Yankton College, SD. **Member:** Madison AG (pres.). **Sources:** WW24.

RINEHART, Frank A. *[Photographer]* b.1861, Lodi, IL / d.1928.
Comments: Traveled to Denver in 1880, possibly working with Wm. H. Jackson. In 1885, he opened his portrait studio in Omaha, NE. In 1898, he became official photographer for the 1898 Trans-Miss. & Int. Expo, where he photographed 500 delegates from 36 tribes of the U.S. Indian Congress, including Geronimo, Red Cloud, and White Swan. Later, he traveled to the reservations and made more than 1,200 portraits in 8"x 10" size as platinum prints. **Sources:** PHF files.

RINEHART, William Henry *[Sculptor]* b.1825, near Union Bridge, MD / d.1874, Rome, Italy.
Addresses: Rome, Italy, permanently from 1858. **Studied:** apprenticed to a Baltimore firm of stonecutters, c.1846; Maryland Inst. Mechanic Arts, Baltimore, 1851; Florence & Rome Italy, 1855-57. **Exhibited:** NAD, 1866. **Work:** Peabody Inst., Baltimore; MMA; Corcoran Gal.Art; outdoor works: doors for the House of Rep. wing, Capitol building, Wash., DC; many statues in Baltimore cemeteries and parks. **Comments:** Neoclassical sculptor whose earliest works included a genre piece "The Smokers" (for which he won a prize in 1851 at the Md. Inst. of Mechanic Arts) and portrait busts. After studying two years in Italy he returned to Baltimore briefly in 1857 but was back in Italy in 1858. He settled in Rome, remaining there until his death, although he visited the U.S. briefly in 1866 and 1872. A measure of the high esteem in which Rinehart was held can be seen in his selection to complete and execute Thomas Crawford's designs for the bronze doors on the U.S. Capitol building in Washington, DC. (Crawford had died in 1857). Rinehart completed the doors for the Senate wing in 1863-65 (these were cast in 1868); and in 1866 he completed the models for the House of Representatives doors, using Crawford's iconographic program but executing the panels

in his own style (these were not cast until 1905). Rinehart was especially praised for his ideal and classical figures, such as his "Clytie" (1872, Peabody Institute), the reliefs "Morning" and "Evening" (1858, Peabody Institute), and "Latona and Her Daughters" (1874, MMA). He produced over twenty versions of his popular "Sleeping Children" between 1861 and 1874 (Corcoran Gallery and elsewhere). **Sources:** G&W; William S. Rusk, *William Henry Rinehart* (Baltimore, 1939); DAB; Gardner, *Yankee Stonecutters;* Taft, *History of American Sculpture;* "New Rinehart Letters," *Maryland Historical Magazine,* XXXI, 225-42. More recently, see Baigell, *Dictionary;* Craven, *Sculpture in America,* 288-95.

RINER, Florence Furst (Mrs.) See: **FURST, Florence Wilkins**

RINES, Frank M. *[Painter, teacher]* b.1892, Dover, NH.
Addresses: Jamaica Plain, MA; Rockport, MA. **Studied:** Eric Pape Sch. Art, Boston; Mass. Sch. Art. **Member:** Wash. WCC; North Shore AA; Copley Soc., Boston. **Exhibited:** Wash. WC Cl.; North Shore AA, 1938-1958; Copley Soc., 1946, 1955, 1958; Jordan Marsh Gal., 1932-58; North Shore AA; Logan Airport, Phila.; Ogunquit AC. **Comments:** Teaching: Boston Univ., 1939-46; Boston Center of Adult Educ., 1937-; Mass. Univ. Extension, 1937-47; Boston Y.M.C.A., 1947-58. Auth./illustr.: "Drawing in Lead Pencil," 1929; "Pencil Drawing," 1939; "Tree Drawing," 1946. **Sources:** WW59; WW47.

RING, Alice Blair *[Painter, miniature painter]* b.1869, Knightville, MA. / d.1947, Pomona, CA.
Addresses: Pomona, CA. **Studied:** Oberlin College; ASL; ASL Wash., DC; Académie Julian, Paris with J.P. Laurens & Mme. Laforge; J. Dupré in Paris; Geo. Hitchcock; G. Melchers. **Member:** Cleveland Woman's AA; Laguna Beach AA; Calif. SMP; Women Painters of the West; AFA. **Exhibited:** AIC, 1905-06; Paris Salon, 1905-07, 1909; Acad. Julian Portrait Competition, 1908 (2 bronze medals); Pan-Pacific Expo, 1915; Pomona, 1922 (first prize), 1936 (first prize); Long Beach, CA, 1928 (hon. men.); Century of Progress Expo, Chicago, 1933; LACMA, 1936 (hon. men.). **Work:** Pilgrim Congregational Church, Pomona, CA. **Comments:** She made 16 trips around the world before 1930. **Sources:** WW40; Hughes, *Artists of California,* 469.

RING, David *[Engraver]* mid 19th c.
Addresses: Baltimore, active 1856-57. **Comments:** In partnership with Edwin Ruthven (see entry) in engraving firm of Ruthven and Ring, Baltimore, active 1856-57. **Sources:** G&W; Baltimore CD 1856, BD 1857.

RING, Edward Alfred *[Collector, art dealer]* 20th c.; b.NYC.
Addresses: Titusville, NJ. **Member:** AFA; MMA; MoMA; Los Angeles Mus. Art; NJ State Council Arts (1967-; chmn., 1971-). **Comments:** Owner of Carter Gallery. Collections arranged: Focus On Light, sponsored, NJ State Mus. Trenton, 1967. **Sources:** WW73.

RING, Elizabeth C. *[Painter]* 19th/20th c.
Addresses: Urbana, OH. **Sources:** WW01.

RINGELKE, H. *[Sculptor]* early 20th c.
Addresses: NYC. **Sources:** WW10.

RINGGOLD, Cadwalader *[Topographical draftsman, cartographer]* b.1802, Maryland / d.1867.
Comments: Entered the U.S. Navy as a midshipman in 1819, retired in 1864 as a commodore, and was made a rear-admiral, retired, the year before his death. In 1849-50, as Commander Ringgold, he commanded a surveying expedition to the California coast. A sketch of the entrance to San Francisco Bay, made at this time, appeared in his report, titled *Series of Charts, with Sailing Directions.* (1852). He was declared insane in 1854 and went to China to recover. He retired as a Commodore in 1864. **Sources:** G&W; DAB; Brewington, 324; Peters, *California on Stone.*

RINGGOLD, Faith *[Painter, craftsperson, sculptor, performance artist, educator]* b.1934, NYC.
Addresses: NYC. **Studied:** City College NY, with Yasuo

Kuniyoshi & Robert Gwathmey (B.S., 1955; M.F.A., 1959).
Member: Women Students & Artists for Black Art Liberation;
CAA; Women's Caucus Art. **Exhibited:** Spectrum Gal., NYC,
1967, 1970 (solo); Univ. Iowa, 1971-72; Carroll Reece Mus.,
Johnson City, TX; MoMA (Martin Luther King, Jr. Exh.); Harlem
Cultural Council; Metropolitan Applied Research Co., NYC;
Lever House Gal., NYC; Nat. Acad. Art; Phila. Civic Center
Mus.; NC A&T Univ.; Martha Jackson Gal., NYC, 1970; NY
Shakespeare Festival Pub. Theatre, 1970; Illinois Bell Tel. Co.,
1971-72; NY State Dept. Educ., 1971 (solo); State Armory,
Wilmington, DE, 1971; Illinois State Mus., Springfield, 1971-72;
Sloane Gals., Valpariaso, IN, 1971-72; Peoria (IL) Art Guild,
1971-72; Burpee Gallery, Rockford, IL, 1971-72; Davenport
Munic. Gal., 1971-72; Kalamazoo (MI) College, 1971-72; Mus.
Nat. Center Afro-Am. Artists, Boston, 1971; Univ. New
Hampshire, 1971; Currier Gal. Art, Manchester, NH, 1971; Bank
St. College, NYC, 1971; Acts of Art Gal., NYC, 1971; NY
Cultural Center, 1971; Finch College, 1971; Kunsthaus, Hamburg,
Germany, 1972; Louisiana State Univ., 1972 (solo); Rutgers
Univ., 1973 (solo). **Work:** Chase Manhattan Bank, NYC; Studio
Mus., Harlem; High Mus. of Art, Atlanta, GA; MMA;
Guggenheim Mus.; BMFA; MoMA; NY State Council Arts; Bank
St. College Educ., NYC; mural, Riker's Island Women's House of
Detention, NYC (1971). **Comments:** Ringgold began addressing
civil rights and political themes in her painting in 1967, looking to
Africa for design sources. In the early 1970s, as she became
increasingly community-minded and active, she began making
works that could be easily transported to her performances at lec-
ture halls and college campuses. In these cloth hangings and soft
sculptures she drew on African forms and craft techniques, using
the works express social messages. Throughout the 1970s,
Ringgold was an important figure in organizing protests against
the exclusion of women artists from exhibitions and museums,
particulary focusing attention on the lack of black women artists
represented. **Sources:** Rubinstein, *American Women Artists*, 425-
26; Baigell, *Dictionary;* Cederholm, *Afro-American Artists;*
Cassandra L. Langer and Joanna Frueh, co-eds., *Feminist Art
Criticism: An Anthology* (1988).

RINGHOUSE, C. L. *[Painter] late 19th c.*
Addresses: Phila., PA. **Exhibited:** PAFA Ann., 1892, 1895.
Sources: Falk, *Exh. Record Series.*

RINGIUS, Carl *[Painter, writer, craftsperson, designer, block
printer] b.1879, Bostad, Sweden / d.1950.*
Addresses: Hartford, CT. **Studied:** Sweden; C.N. Flagg; R.B.
Brandegee. **Member:** Soc. Graphic Artists, Stockholm, Sweden;
Chicago AG; SC; Springfield AA; North Shore AA; New Haven
PCC; Audobon Artists; Conn. Lg. Art Students; Scandinavian-
Am. Artists; Swedish-Am. Artists; Southern PM; Mid-Vermont
Artists; Gloucester SA; Illinois Acad. FA; AAPL; Hartford
Salmagundanians; Studio Guild. **Exhibited:** CAFA, 1935 (prize),
1941-46; Studio Guild, 1937 (prize); State of Conn., 1929 (med.);
North Shore AA, 1941-46; New Haven PCC, 1938 prize, 1941-46,
1945 (prize); All. Artists Am., 1944; Hartford Salmagundians,
1941-46; Mid-Vermont Artists, 1946; Scan.-Am Exh., Chicago,
1929 (prize). **Work:** Vanderpoel Coll.; Illinois State Mus.; Art
Mus; Gothenburg, Sweden; Vexjo Mus., Sweden; Upsala College,
East Orange, NJ; Springfield (IL) AA. **Comments:** Auth.: "The
Swedish People in Connecticut," (published for the Century of
Progress Expo). Position: dir., CAFA, from 1935.

RINGIUS, Lisa (Mrs. Carl) *[Craftsperson] mid 20th c.;
b.Bergunda, Sweden.*
Addresses: Hartford, CT. **Studied:** Sweden. **Member:** North
Shore AA. **Comments:** Specialty: tapestry, weaving, needlework.
Sources: WW40.

RINGLING, John *[Patron] d.1936, NYC.*
Comments: Ringling bequeathed his entire estate to Florida,
forming the John and Mable Ringling Mus. Art in Sarasota. His
collection was strong in pre-1800 Italian art and Flemish and
Dutch paintings, 1400-1900. The paintings remain in his home
"Ca'd'Zan" which reflected the opulent lifestyle of the 1920s.

RINGLING, John (Mrs.) *[Patron] b.Ohio / d.1929, NYC.*
Comments: Her art collection consisted of many fine works
secured during foreign travel. (See entry for John Ringling).

RINGWALT, Katherine H. *[Painter, teacher] early 20th c.;
b.Phila., PA.*
Studied: PAFA. **Sources:** WW25.

RINGWOOD, Joseph E. *[Painter] early 20th c.*
Addresses: Poughkeepsie, NY. **Exhibited:** S. Indp. A., 1926,
1930-31; Salons of Am., 1934. **Sources:** Falk, *Exhibition Record
Series.*

RINIKER, George L. *[Painter] mid 20th c.*
Exhibited: AIC, 1936-37. **Sources:** Falk, *AIC.*

RINK, John J. *[Portrait painter] mid 19th c.*
Addresses: NYC, 1857. **Sources:** G&W; NYBD 1857.

RINNE, Christine Hillka *[Painter] 20th c.*
Addresses: Berkeley, CA, active 1930s. **Exhibited:** SFMA, 1935.
Sources: Hughes, *Artists of California*, 469.

RINNE, Leah I. *[Painter] mid 20th c.*
Addresses: San Francisco; Berkeley, CA. **Exhibited:** Oakland Art
Gal., 1932; SFMA, 1935. **Sources:** Hughes, *Artists of California*,
469.

RINTELMAN, Charles D. *[Portrait painter] b.1868,
Cadarburg, WI / d.1938, Los Angeles, CA.*
Addresses: Los Angeles, CA. **Comments:** Popular portrait artist
until the stock market crash of 1928. **Sources:** Hughes, *Artists of
California*, 469.

RION, Hanna (Mrs. Alpheus B. Hervey) *[Painter, illustra-
tor, writer] b.1875, Winnsborough, SC / d.1924.*
Addresses: Active in Cornwall, England, Bermuda, Port Ewen,
NY & Columbia, SC. **Studied:** F. Ver Beck. **Exhibited:** Boston
AC, 1905-07. **Comments:** Auth. "Let's Make a Flower Garden";
"The Garden in the Wilderness." **Sources:** WW24.

RIOR, Irving *[Cartoonist] b.1907, Austria.*
Addresses: New York 62, NY. **Studied:** CUA Sch.; NAD; ASL
with William McNulty & George Bridgman. **Member:** Nat.
Cartoonists Soc. **Comments:** Contrib. cartoons to King Features;
Chicago Tribune; NY News Syndicate; *Esquire; Saturday Evening
Post; Colliers; American* and other national magazines. **Sources:**
WW66.

RIORDAN, G. C. *[Painter] early 20th c.*
Addresses: Newport, KY. **Member:** Cincinnati AC. **Sources:**
WW25.

RIORDAN, Roger *[Illustrator, writer, critic] d.1904, NYC.*
Exhibited: NAD, 1877; PAFA Ann., 1879-81. **Comments:**
Contrib.: leading American magazines. Illustr.: Solomon's "Song of
Songs." Positions: art ed., *Harper's, Drama Critic, The Sun*; art
juror, Paris Expo, 1900; asst. chief, applied arts, Buffalo Expo,
1901. **Sources:** Falk, *Exh. Record Series.*

RIOS See: **DE LAS RIOS**

RIOS, John Fidel *[Lithographer, screenprinter, painter, educa-
tor, lecturer, writer] b.1918, San Marcos, TX.*
Addresses: NYC. **Studied:** Southwest Texas Teachers College
(B.A.); Univ. Texas; Teachers College, Columbia Univ.(M.A.).
Exhibited: CGA, 1944; LOC, 1945; CAFA, 1946; Mint Mus. Art,
1946; ACA Gal., 1943; Southwest Texas Teachers College Mus.,
1943, 1945; Int. House, NY, 1944; William Rockhill Nelson Gal.,
1944. Awards: Inst. Int. Educ., 1942-44 (fellow). **Comments:**
Lectures: "Art in the Social Studies"; "The Art of Lithography";
etc. Teaching: The Tutoring Sch., NYC, 1944-45. **Sources:**
WW53; WW47.

RIOU, Louis *[Painter] early 20th c.*
Exhibited: AIC, 1934. **Sources:** Falk, *AIC.*

RIPIN, Paula *[Photographer] early 20th c.*
Addresses: NYC, 1932. **Exhibited:** S. Indp. A., 1932. **Sources:**
Marlor, *Soc. Indp. Artists.*

RIPLEY, A(iden) Lassell *[Painter, etcher] b.1896, Wakefield, MA / d.1969, Lincoln, MA.*
Addresses: Lexington, Boston, MA. **Studied:** Fenway Sch. Illus., 1917; BMFA Sch. with Philip Hale and F. Benson, 1919-24 (awarded Paige Traveling Fellowship, 1924-25). **Member:** ANA; AAPL; Audubon Artists; All. Artists Am.; NSMP; Gld. Boston Artists, 1926-69 (pres., 1959-60); AWCS; Boston WCS Painters; NSAA, 1958-62. **Exhibited:** AIC, 1926 (Logan prize for water-color),1927-32, 1934-45 (1928, 1936, prize & medal); Gld. Boston Artists, 1926 (solo: foreign scene paintings), 1930 (solo, sporting paintings), 1942, 1972 (commemorative), 1974 (Boston paintings), 1975 (Foreign scene paintings), 1978; PAFA Ann., 1928, 1930; PAFA, 1936-37, 1939, 1945; Boston WCS, 1929 (prize),1954 (prize), 1955 (prize), 1960 (prize); Boston AC, 1929 (prize); Boston Tercentenary Exh. 1930 (medal); AWCS, 1939-58 (prizes, medal, 1945, 1947, 1952, 1954); NYWCC, 1933 (Obrig prize); TMA, 1938; BMFA, 1938; AGAA, 1939; WFNY, 1939; WMA, 1940; Baltimore WCC, 1940-42; MMA (AV), 1942; NJ State Mus., Trenton; Currier Gal. Art; Boston SWCP; Grand Central Gal., 1949 (solo); *Am. Artist Magazine,* 1952 (prize); NAD, 1953 (prize), 1964 (Mason prize); AAPL, 1954 (gold medal), 1955 (prize), 1959; Boston Art Festival, 1955 (prize); All. Artists Am., 1957 (prize); Concord AA, 1955 (prize & medal); Jordan Marsh, 1955 (award & medal), 1958, 1961; Worcester AM, 1965 (Paul Revere historical paintings); DeCordova Mus., 1977 (retrospective); Coe Kerr Gal., NYC, 1982 (retrospective). **Work:** AIC; BPL; BMFA; Davenport Mun. Art Gal.; Atlanta AA; Beaverbrook Art Gal., Fredericton, NB, Canada; murals, Winchester (MA) Pub. Lib.; USPO, Lexington, MA. **Comments:** Best known for his watercolors of New England and sporting scenes. Auth.: chapt., *Water Color Methods* (1955). Teaching: Harvard Sch. Arch., 1929. **Sources:** WW66; WW47; Falk, *Exh. Record Series;* add'l info. courtesy North Shore AA.

RIPLEY, Lassell See: **RIPLEY, A(iden) Lassell**

RIPLEY, Lucy Fairfield Perkins (Mrs.) *[Sculptor, ceramicist, medalist] b.Winona, MN / d.1949, NYC.*
Addresses: Active in NYC. **Studied:** ASL with Saint-Gaudens; Daniel French; Paris with Rodin, Despiau, Lhote. **Exhibited:** St. Louis Expo, 1904 (bronze med.); Plastic Club, Phila, 1916; S. Indp. A., 1918; NAWA, 1919 (prize); Milch Gals., NYC, 1921; Salon de la Soc. Nat. des Beaux-Arts; Salon d'Automne; Artistes Décorateurs; Gal. Georges Petit; Soc. de la Gravure; Salons of Am., 1922-23; AIC; NSS, 1928. **Work:** WMA. **Comments:** Appears as Ripley and Perkins-Ripley. Known for her garden sculptures which reflect her interest in Assyrian, Egyptian, and Archaic Greek art. Her patrons included Stanford White, Mrs. Payne Whitney, and Mrs. E.H. Harriman. **Sources:** WW47; Nat. Sculpture Soc., *Exh. of Am. Sculpture Cat., 1928,* 206; Petteys, *Dictionary of Women Artists;* Rubinstein, *American Women Sculptors,* 251-52; Marlor, *Salons of Am.*

RIPLEY, Robert L. *[Illustrator, cartoonist] b.1893 / d.c.1950.*
Addresses: Mamaroneck, NY. **Member:** SI. **Comments:** In 1919, he created "Believe It or Not" and by the 1940s it was syndicated in hundreds of newspapers around the world. He was, himself, material suitable for his own daily drawing: he drew upside-down; he never played a card game; he owned five cars but could not drive; he was the first artist ever to send a cartoon by radio (London to NYC, 1927); and was the first to broadcast worldwide simultaneously (1934). **Sources:** WW47; *Famous Artists & Writers* (1949).

RIPLEY, Thomas Emerson *[Painter, writer] b.1865, Rutland, VT / d.1956, Tacoma, WA.*
Addresses: Santa Barbara, CA; Tacoma, WA. **Studied:** Yale Univ.; Belmore Browne; Roy Brown. **Exhibited:** Santa Barbara Mus. Aty. **Comments:** Began his career as a writer and painter after being financially ruined in the stock market crash of 1929. Auth.: "A Vermont Boyhood," 1937, and *Green Timber,* 1968. Contrib. *Atlantic Monthly.* **Sources:** WW53; WW47. More recently, see Trip and Cook, *Washington State Art and Artists, 1850-1950.*

RIPORTELLA, Anthony *[Artist] b.1883, Menfi, Sicily / d.1969, Old Tappan, NJ.*
Addresses: Active in Brooklyn, NY, 1927-31. **Studied:** ASL. **Exhibited:** S. Indp. A., 1927-34, 1936-44. **Sources:** BAI, courtesy Dr. Clark S. Marlor.

RIPPER, Art D. *early 20th c.*
Exhibited: Salons of Am., 1925. **Sources:** Marlor, *Salons of Am.*

RIPPETEAU, Hallie Crane *[Painter] late 19th c.*
Addresses: Active in El Paso, TX. **Studied:** Baylor College, 1870s, with McArdle; R.J. Onderdonk; Eva Fowler. **Sources:** Petteys, *Dictionary of Women Artists.*

RIPPEY, Clayton *[Painter, educator] b.1923, La Grande, OR.*
Addresses: Bakersfield, CA. **Studied:** Northwestern Univ.; Stanford Univ. (B.A. & M.A.) with Daniel Mendelowitz, Ray Faulker & Anton Refrigie; San Jose State College with George Post; Inst. Allende, Mexico, with James Pinto & Fred Samuelson. **Member:** Taft AA (hon. life mem.); Bakersfield AA (vice-pres., 1954); Calif Art Educ. Assn. **Exhibited:** Lucian Labaudit Gal., San Fran., 1955; Cunningham Mem. Mus., Bakersfield, 1958, 1961 & 1966; Circulo de Belles Artes, Palma, Spain, 1960; Pioneer & Haggen Mus., Stockton, CA, 1964; Port Townsend (WA) AC (festival guest exh.), 1965; Gal. Yves Jaubert, France, 1970s; plus 32 solo shows. Awards: 13 awards (single painting), traveling show, Kern Co., 1960; best of show, Kern Co. Fair Assn., 1963, 1965 & 1967; best of show, Taft AA, 1972. **Work:** Cunningham Mus., Bakersfield, CA; Wakayama Castle, Japan. Commissions: pylon design & mural, Bakersfield (CA) College, 1958; two murals, Porterville (CA) College, 1966; two murals, Valley Plaza Mall, Bakersfield, 1967; mural, Monache H.S., Porterville, 1968; three dimensional, Tenneco Corp. Hdqtrs., Bakersfield, 1969. **Comments:** Preferred medium: acrylics. Positions: dir exhs., Cunningham Mus., Bakersfield, 1954-55; dir. exh., Bakersfield College Gal., 1961-62. Teaching: Bakersfield College, 1949-72; Maui Community College, Univ. Hawaii, 1967-68. **Sources:** WW73.

RISDON, Richard P. *[Wood engraver] mid 19th c.*
Addresses: NYC, 1858-60. **Sources:** G&W; NYBD 1858-60.

RISEMAN, William *[Mural painter, designer, decorator] b.1910, Boston, MA.*
Addresses: Short Hills, NJ. **Studied:** Yale. **Member:** Mural Painters. **Work:** WPA murals, USPO, Lynn, MA; Lafayette Hotel, Brunswick Hotel, Boston; Lafayette Hotel, Portland, ME. **Sources:** WW40.

RISHELL, Robert *[Painter, mural painter] b.1917, Oakland, CA / d.1976, Oakland, CA.*
Addresses: Oakland, CA. **Studied:** Calif. College Arts & Crafts with Xavier Martinez; Univ. Calif., Berkeley. **Member:** Nat. Acad. Western Artists; Oakland Citizen Art Council; Soc. Western Artists; Bohemian Club. **Exhibited:** Soc. for Sanity in Art, CPLH, 1945; de Young Mus. (many awards); Calif. State Fairs (awards). **Work:** Calif. State Capitol (portrait of Ronald Reagan); Palm Springs Desert Mus.; Nat. Cowboy Hall of Fame, OK; Treasure Island Naval base; West Point Mus.; Naval Acad. Mus., Annapolis; Indianapolis Mus.; Univ. Calif., Berkeley; Univ. Chicago; Bohemian Club; Oakland Pub. Lib.; murals: World Trade Center, San Fran.; Oakland Mus.; Bank of Calif., Oakland. **Comments:** Specialty: horses, portraits, scenes of the Indian country of Utah, New Mexico and Arizona. **Sources:** Hughes, *Artists in California,* 469-470; Pe&H Samuels, 401, report alternate birthdate of c.1925.

RISHER, Anna Priscilla *[Painter] b.1875, Dravosburgh, PA. / d.1946, Los Angeles County.*
Addresses: La Crescenta, CA. **Studied:** Pennsylvania College for Women; New England Conservatory of Music; Anna A. Hills; D. Schuster. **Member:** Laguna Beach AA. **Comments:** Specialty: landscapes and coastals. She also composed 350 published musical works. **Sources:** WW40; Hughes, *Artists of California,* 470.

RISING, Adelaide *[Portrait painter]* b.1847, NYC / d.c.1904, Oakland, CA.
Addresses: San Francisco, CA. **Exhibited:** Mechanics Inst. Fair, 1896. **Comments:** Married to William Hahn (see entry) in 1882. **Sources:** Hughes, *Artists of California,* 470.

RISING, C. P. *[Painter]* early 20th c.
Exhibited: WMAA, 1920. **Sources:** Falk, *WMAA.*

RISING, Dorothy Milne *[Painter, instructor, teacher, writer, craftsperson, lecturer]* b.1895, Tacoma, WA / d.1992, Mukilteo, WA.
Addresses: Seattle, WA. **Studied:** Pratt Inst. (dipoma, 1916); Cleveland Sch. Art with Henry Keller, 1920; Univ. Washington (B.F.A., 1932; M.F.A., 1933); R. Ensign. **Member:** Royal Soc. Art, London (fellow); Nat. Lg. Am. Pen Women (pres., Seattle branch, 1970-72); Women Painters Wash. (pres., 1949); Northwest WCS (co-founder); Artists Equity Assn.; AAPL; Northwest PM. **Exhibited:** Massillon Mus. Art, 1945; Lg. Am. Pen Women, 1946 (prize); Northwest WCS, 1940-46; Women Painters of Wash., 1941-46; Pacific Northwest Ann. Exh., Spokane, WA, 1945, 1946; Studio Gal., 1944, 1945 (solo), 1946; SAM, 1946 (solo); Ferry Mus. Art, Seattle, 1946 (solo); Tacoma, 1945 (solo); Pacific Coast Artists & Sculptors Assn., 1932 (prize), 1933 (prize); Western Wash. Fair, Puyallup, 1933-38 (prizes); Spokane Womens Club, 1949 (purchase prize); Henry Gal., 1950 (Music & Art Foundation First Prize); Nat. Lg. Am. Pen Women, Smithsonian, 1955 (best watercolor in show); Northwest Ann., 1969 & Northwest WCS, Art Mus. Pavilion, 1969; West Coast Exh., 1969 & Puget Sound Area Exh., 1969; Frye Art Mus., 1971; Erb Mem. Art Gal., Eugene, OR, 1972. **Work:** SAM; Frye Art Mus., Seattle; Pac. Nat. Bank Wash., Tacoma; Three Grumbacher Coll.; Lakeside Sch.; Cheney Cowles Mus., Spokane. **Comments:** Preferred media: oils, watercolors. Publications: auth./illustr., " Contemporary versus Academic Art," *Town Crier,* 1934; auth., "The Silver Bible," *Christian Science Monitor,* 1964; auth./illustr., "Vanished Landmarks," 1971, "Preserving Our Open Spaces," 1971 &"Great Snow Mountain," 1972, "Age of Achievement." Teaching: Broadway Evening Sch., Seattle; Univ. Puget Sound, 1916-17; Western Wash. College, 1917-19; Seattle High Schools, 1933-66. **Sources:** WW73; "Around the World through an Artist's Eyes," *Pen Woman,* 1967; Edna Daw, "A Word about Dorothy Rising, *Age of Achievement* (1971); additional info courtesy Martin-Zambito Fine Arts, Seattle, WA.

RISING, Ruth *[Painter]* mid 20th c.
Addresses: Tacoma, WA. **Member:** Tacoma Art Lg. **Exhibited:** Wash. State Hist. Soc., 1945. **Sources:** Trip and Cook, *Washington State Art and Artists,* 1850-1950.

RISLEY, Donald *[Artist]* mid 20th c.
Addresses: Phila., PA. **Exhibited:** PAFA Ann., 1953. **Sources:** Falk, *Exh. Record Series.*

RISLEY, John Hollister *[Sculptor, educator]* b.1919, Brookline, MA.
Addresses: Middletown, CT. **Studied:** Amherst College (B.A., cum laude); RISD (B.F.A.); Cranbrook Acad. Art (M.F.A.). **Exhibited:** Awards: first prize for furniture, U.S. Designer Craftsman, 1953; Drakenfield Prize, 18th Ceramic Ann., 54: New Haven Arts Festival Sculpture Prize, 1966. **Work:** Wesleyan Univ., CT; Henry E. Hunnington Art Gal., CA; Fred Olsen Found., CT; Hartford (CT) Jewish Community Center; Rose Art Gal., Brandeis Univ. Commissions: reliefs, wood & metal, IBM Hdqtrs., New York, 1965, wrought iron, Cleveland (OH) Garden Center, 1966 & copper, Nat. Bank, Quarryville, PA, 1971; sculptures, wood & metal, Brookside Elementary Sch., Waterville, ME & bronze, Univ. Maine, Portland, 1970. **Comments:** Teaching: Wesleyan Univ., 1954-70s. **Sources:** WW73.

RISLEY, Mary Kring *[Craftsman, teacher]* b.1926, Detroit.
Addresses: Middletown, CT. **Studied:** Univ. Michigan (B. Des.); Cranbrook Acad. Art (M.F.A.) with Maija Grotell. **Member:** Soc. Connecticut Craftsmen (bd. dir.). **Exhibited:** Wichita Ceramic Exh., 1949-52, 1954-55; Syracuse Mus. FA, 1949-54 & traveling exh.; Des.-Craftsmen, U.S.A., 1953 & traveling exh.; Los Angeles County Fair, 1949; Walker AC, 1951-54; Detroit Inst. Art, 1948-52; Cranbrook Acad. Alumni, 1953; Sweat Mem. Mus., 1954; New Britain Mus. Art, 1955; WMA, 1955; Slater Mus. Art, Hartford, 1955. Awards: prizes, Cranbrook Acad. Art, 1951; Wadsworth Atheneum, 1955; Craft Fair, Hartford, 1955. **Comments:** Teaching: Ox Bow Summer Sch., Saugatuck, MI; Toledo Mus. Art; Potter's Gld., Arm Arbor; U.N. technician in ceramics, Manila, PI; Haystack Summer Sch. of Crafts, Liberty, ME. Auth.: *U.N. Report on Ceramics in the Philippines.* Lectures on ceramics to museums, art groups, church groups. **Sources:** WW59.

RISLING, Edloe Johnson *[Painter, etcher]* b.1899, Sacramento, CA.
Addresses: San Francisco, CA. **Studied:** Calif. Sch. FA. **Exhibited:** Kingsley Art Club, Sacramento, 1932; SFMA, 1935. **Sources:** Hughes, *Artists of California,* 470.

RISLING, Jay *[Painter, mural painter, photographer]* b.1896, Orleans, CA.
Addresses: San Francisco, CA. **Studied:** Stanford Univ.; Calif. Sch. FA; Armin Hansen in Monterey; Denver Acad. Art. **Exhibited:** San Fran. AA, 1924, 1925, 1935; Art Center Gal., 1930s; SFMA, 1935. **Work:** WPA mural, USPO, Guymon, OK. **Comments:** Married artist Edloe J. Risling (see entry) in 1925. **Sources:** WW40; Hughes, *Artists of California,* 470.

RISQUE, Caroline Everett *[Sculptor, teacher]* b.1886, St. Louis, MO.
Addresses: St. Louis, Clayton, MO/Santa Fe, NM. **Studied:** St. Louis Sch. FA with Zolnay; F. Rhead, Laurent, at ASL; Colarossi Acad., Paris, with Injalbert, P. Bartlett. **Member:** St. Louis AG; Shikari; Soc.Indep. Artists. **Exhibited:** Paris Salon, 1912; PAFA Ann., 1914-31 (6 times); St. Louis AG, 1914 (prize), 1922 (prize), 1924 (prize); NSS, 1923; AIC. **Work:** Mus., New Orleans; St. Louis AG; Stone Group, Catholic Church, Helena, AR; St. Louis Medical Soc.; Dental Dept., Northwestern Univ. Medical Center. **Comments:** Specialized in decorative work and small bronzes. Position: head, John Burroughs Country Day Sch.; teacher, Adult Study Center, St. Louis. **Sources:** WW40; Nat. Sculpture Soc., *Exhib. of Am. Sculpture Cat., 1928,* 207; Falk, *Exh. Record Series.*

RISSER, J. Hemley *[Painter]* early 20th c.
Addresses: NYC. **Sources:** WW10.

RISSLAND, Edwin F. (E.) *[Painter]* early 20th c.
Addresses: Newark, NJ, 1934. **Exhibited:** S. Indp. A., 1934.

RISSMAN, Arthur Henry Louis *[Painter, teacher, lecturer]* b.1920, Chicago, IL.
Addresses: Chicago, IL. **Studied:** Univ. Southern California; Northwestern Univ. (B.S. in Educ.); Chicago. Acad. FA; AIC; ASL. **Member:** AEA; Chicago Art Club; Univ. Chicago Renaissance Soc. **Exhibited:** AIC; Layton Gal. Art; Springfield Art Mus.; Pensacola AC; Delagado Mus. Art, New Orleans; Atlanta AA; Frye Mus. Art, Seattle; Mint Mus.; Philbrook AC, Tulsa; Feingarten Gal., Chicago; Renaissance Soc., Chicago; Chicago Art Club; Old Orchard Exh., Winnetka, IL; Werbe Gal., Detroit;M. Singer & Son, Chicago, 1958 (solo); Exh. A, Chicago, 1959; Blackhawk Restaurant, 1964; Chicago Pub. Lib., 1964. **Comments:** Positions: lecturer, Contemp. Art, Adult Educ. Council of Chicago, 1959-; assoc., Contemp. Art Workshop, Chicago, 1960-; founding & directing chmn., The Arts Assembly of the Adult Educ. Council, Chicago, 1959-, vice-pres., 1960-; instr., School, AIC, 1963-65; nat. project dir., arts & crafts Program, Pres. Comt. on Employment of the Handicapped and Nat. Soc. for Crippled Children and Adults. Res. Artist, Wheaton College, 1964. **Sources:** WW66.

RISSO, Charles *[Lithographer]* mid 19th c.
Addresses: Active in NYC, 1832 to c.1837; New Orleans, 1837-47; NYC, 1849 to c.1850. **Comments:** In partnership with William R. Browne (firm of Risso & Browne, see entry) in NYC from 1832 to c.1837, although in 1837 he apparently moved to New Orleans. His employer there, Dominique Theuret (see entry),

called Risso the "oldest lithographer in the Union" and stated that he could speak English, French, Spanish, and Portuguese. Risso remained in New Orleans until 1847. He returned to NYC and was in partnership with George E. Leefe (see entry), from 1849 until about 1850. **Sources:** G&W; Peters, *America on Stone;* NYCD 1833-36, 1849; NYBD 1850; Delgado-WPA cites *Courier,* April 6, 1837, New Orleans CD 1838, 1841-42. More recently, see *Encyclopaedia of New Orleans Artists.* 326.

RISSO & BROWNE *[Lithographers] mid 19th c.*
Addresses: NYC, 1832-38. **Work:** Natchez Hist. Soc.; Stokes Coll., NYPL. **Comments:** The partners were Charles Risso and William R. Browne (see entries on each). They printed a view of Natchez, MS (by artist James Tooley), sometime between 1833-36. **Sources:** G&W; NYCD 1833-35; Peters, *America on Stone.* More recently, see Reps, cat. no. 1974.

RISSO & LEEFE *[Lithographers] mid 19th c.*
Addresses: NYC, active c.1850. **Comments:** Partners were Charles Risso and George E. Leefe (see entries on each). **Sources:** G&W; NYCD 1849, BD 1850; Peters, *America on Stone.*

RIST, Louis G (Luigi) *[Graphic artist] b.1888, Newark, NJ / d.1959, Nottingham, PA.*
Addresses: Newark, NJ. **Studied:** Newark Tech. Sch. with S. Skou. **Member:** Am. Color Pr. Soc. **Exhibited:** LOC; NAD; Phila. Pr. Club; Am. Color Pr. Soc., 1941 (prize); Northwest PM, 1946 (prize); Albany Pr. Club; Montclair Art Mus.; Irvington (NJ) Lib.; Princeton Pr. Club. **Work:** NYPL; MMA; CM; Newark Lib.; Springfield Art Mus. **Sources:** WW47.

RISWOLD, Gilbert P. *[Sculptor] b.1881, Sioux Falls, SD. / d.1938, Hollywood, CA.*
Addresses: Oak Park, IL; California, 1930s. **Studied:** L. Taft & C. Milligan in Chicago. **Exhibited:** AIC, 1909-20. **Work:** Springfield, IL; Salt Lake City, UT. **Sources:** WW24; Hughes, *Artists of California,* 470.

RITCHIE, Alexander *[Painter] b.1863, Scotland.*
Addresses: Hicksville, NY. **Studied:** RISD. **Member:** Brooklyn SA. **Exhibited:** S. Indp. A., 1917-21. **Sources:** WW33.

RITCHIE, Alexander Hay *[Engraver, etcher; genre, portrait & figure painter] b.1822, Glasgow, Scotland / d.1895, New Haven, CT.*
Addresses: NYC and Brooklyn, through at least 1891; during his last years he lived in New Haven, CT. **Studied:** in Edinburgh with Sir William Allan, before 1841. **Member:** NA, 1871. **Exhibited:** NAD, frequently, 1848-91; Paris Salon, 1859; Brooklyn AA, 1861-72; PAFA, 1863; Boston AC, 1887. **Comments:** Emigrated to America in 1841, worked for a few years in Canada, and settled in NYC about 1847. He established a prosperous engraving business in NYC and also became known as a painter of portraits and genre scenes. **Sources:** G&W; DAB; Cowdrey, NAD; Naylor, NAD; Rutledge, PA; NYCD 1847+; Clement and Hutton; Fink, *American Art at the Nineteenth-Century Paris Salons,* 384.

RITCHIE, Andrew C. *[Art administrator, art historian, lecturer, writer] b.1907, Bellshill, Scotland / d.1978.*
Addresses: Buffalo, NY; New Canaan, CT. **Studied:** Univ. Pittsburgh (B.A.; M.A.); Yale Univ. (hon. M.A.); Univ. London (Ph.D.). **Member:** College AA Am.; Assn. Am. Mus. Dir. **Exhibited:** Awards: Decorated Cross Legion of Hon., France, 1946; Order of Orange Nassau, Netherlands, 1948; Officer Cross of Order of Merit, Fed. Repub. Germany, 1957. **Comments:** Positions: dir., Albright-Knox Art Gal., Buffalo, NY, 1942-49; dir., dept. painting & sculpture, MoMA, 1949-57; dir., Yale Univ. Gal., New Haven, CT, 1957-70, emer. dir., 1970-. Teaching: lect. and res. assist., Frick Coll., NYC, 1935-42; visiting lecturer art, NYU, 1936-40; lecturer, British Art, French and Spanish Post-Renaissance painting & modern art. Publications: auth., *English Painters, Hogarth to Constable,* 1942; *Abstract Painting and Sculpture in America,* 1951,1970; *Edouard Vuillard,* 1954, 1970; *Three American Precisionist Painters;* co-auth., *Selected Paintings & Sculpture from the Yale Univ. Art Gallery* (Yale Univ.

Press, 1972). **Sources:** WW73.

RITCHIE, Andrew, Jr. *[Painter of landscapes & battle pieces] b.1782 / d.1862.*
Addresses: Active in Boston in 1836. **Exhibited:** Boston Athenaeum, 1836. **Sources:** G&W; Swan, BA.

RITCHIE, E. H. *[Painter] b.1854.*
Addresses: Santa Fe, NM. **Exhibited:** PAFA Ann., 1883; NAD, 1884. **Sources:** Naylor, *NAD;* Falk, *Exh. Record Series.*

RITCHIE, Henrietta *[Etcher] late 19th c.*
Addresses: Phila., PA, 1891. **Exhibited:** PAFA Ann., 1891. **Sources:** Falk, *Exh. Record Series.*

RITCHIE, John M. *[Portrait painter] mid 19th c.*
Addresses: NYC, 1844. **Sources:** G&W; NYBD 1844.

RITCHIE, Mary D. Bladen (Mrs. George S.) *[Landscape painter] 20th c.; b.Phila.*
Addresses: Phila., PA, c.1903-09. **Member:** Plastic Club. **Exhibited:** PAFA Ann., 1903. **Sources:** WW10; Falk, *Exh. Record Series.*

RITCHIE, Richard S. *mid 20th c.*
Exhibited: Salons of Am., 1936. **Sources:** Marlor, *Salons of Am.*

RITCHIE, S. *early 20th c.*
Exhibited: Salons of Am., 1934. **Sources:** Marlor, *Salons of Am.*

RITCHIN, Elsie E. *[Painter] early 20th c.*
Addresses: Brooklyn, NY, 1932. **Exhibited:** S. Indp. A., 1932. **Sources:** Marlor, *Soc. Indp. Artists.*

RITER, Carl Frederick *[Painter, educator] b.1915, Carroll, IA.*
Addresses: Des Moines, IA; Milwaukee, WI. **Studied:** Univ. Wisconsin; NY Univ. Inst. FA; Univ. South Dakota; Ohio State Univ.; Univ. Iowa. **Exhibited:** Parkersburg FA Center, 1941, 1946; Joslyn Mem., 1945; Athens, OH; Gainesville, FL; Des Moines, IA. **Comments:** Teaching: Univ. Florida, Gainesville, 1944-45; Drake Univ., Des Moines, IA, from 1945; Milwaukee-Downer College, Milwaukee, WI. **Sources:** WW59; WW47.

RITMAN, Anna Laufer *[Painter] early 20th c.*
Addresses: Chicago area. **Exhibited:** AIC, 1926. **Sources:** Falk, AIC.

RITMAN, Julius *[Painter] early 20th c.*
Exhibited: AIC, 1930 (prize). **Sources:** Falk, AIC.

RITMAN, Louis *[Painter, educator] b.1889, Russia / d.1963.*

L. Ritman (signature)

Addresses: Paris, France, 1913-14; Chicago, IL. **Studied:** AIC with J. Vanderpoel; W.M. Chase; W.J. Reynolds; École des Beaux-Arts, Paris. **Member:** Am. Artists Assn., Paris; ANA; Am. Soc. PS&G; Assoc. Nat. Beaux-Arts, Paris. **Exhibited:** PAFA Ann., 1913-16, 1924-44, 1952; Pan-Pacific Expo, 1915 (med.); NAD, 1918 (prize; medal), 1951 (prize); AIC, 1930 (gold), 1932 (med.), 1939 (prize), 1940 (med.), 1941 (med.); Chicago AG, 1915 (prize); Corcoran Gal. biennials, 1919-45 (6 times). **Work:** Chicago Munic. Art Lg.; Des Moines AC; PAFA. **Comments:** One of the leading Post-Impressionists working at Giverny. Teaching: AIC Sch., 1930s. **Sources:** WW59; WW47; Bruce Weber, *The Giverny Luminists: Frieseke, Miller, and Their Circle;* Falk, *Exh. Record Series;* PAFA, vol. II and WW15 cite his address as Paris in 1913-14.

RITMAN, Maurice *[Painter, writer, lecturer, teacher] b.1906, Chicago, IL.*
Addresses: Chicago, IL. **Studied:** W. Reynolds; L. Ritman; AIC. **Member:** Chicago SA; Am. Artists Congress. **Exhibited:** AIC, 1938 (prize), 1940 (prize), 1944 (prize). **Comments:** Position: art dir., Jewish Peoples Inst., Chicago. **Sources:** WW59; WW47.

RITSCHEL, Nora Havel *[Sculptor, painter] b.1897, Dryad, WA / d.1975, Carmel, CA.*
Addresses: Carmel, CA. **Exhibited:** Bay Region AA, 1935. **Comments:** She was the secretary of William Ritschel (see entry) and became his third wife in 1930. Specialty: wax sculptures. **Sources:** Hughes, *Artists of California,* 470.

RITSCHEL, William (or Wilhelm) (Frederick) *[Painter]* W· RITSCHEL *b.1864, Nürnberg, Bavaria, Germany / d.1949, Carmel, CA.*
Addresses: NYC, 1895-1929; Carmel, CA. **Studied:** Royal Acad., Munich, with F. Kaulbach and C. Raupp. **Member:** ANA, 1910; NA, 1914; NYWCC; AWCS; SC, 1901; Artists Fund Soc.; NAC, Kunstverein, Munich; Allied AA; Calif. WCS; Bohemian Club; Société Int. des Beaux Arts et des Lettres, Paris. **Exhibited:** Boston AC, 1903, 1905, 1908, 1909; PAFA Ann., 1903-29; Corcoran Gal. biennials, 1907-37 (11 times); San Fran. AA, 1911; CI, Pittsburgh, 1912; NAD, 1913 (prize), 1921 (prize), 1926; NAC, 1914 (gold); Pan-Pacific Expo, 1915; Sacramento State Fair, 1916 (gold), 1936 (prize); Phila. AC, 1918 (gold); SC, 1923 (med.), 1930; AIC, 1923 (prize); Paris Salon, 1926 (hon. men.); Pomona, CA, 1930 (prize); Dallas, TX, 1930 (prize); Los Angeles, 1934 (prize); Springfield H.S. AA, 1935 (prize); Acad. West. Painters, 1936 (prize), 1937 (prize); Santa Cruz AL, 1936 (prize). **Work:** PAFA; Ft. Worth Mus.; AIC; Detroit AC; CAM; Smithsonian; Monterey Peninsula Mus. Art; LACMA; Albright Art Gal.; Minneapolis AM. **Comments:** Plein-air painter who came to U.S. in 1895 and settled in California in 1911, while continuing to exhibit on the East Coast and in Europe. He won international acclaim for his sea paintings and took many trips throughout the world, especially the South Seas. **Sources:** WW47; Hughes, *Artists of California,* 470; P&H Samuels, 401-02; Falk, *Exh. Record Series.*

RITTAS(S)E, Roger M. *[Painter, teacher] b.1899, Littlestown, PA / d.1975, Lebanon, PA.*
Addresses: Phila., PA; Wash., DC, 1936. **Studied:** AIC; PAFA; Corcoran Sch. Art. **Member:** Soc. Wash. Artists; Wash. Landscape Club. **Exhibited:** PAFA Ann., 1924, 1936; Gr. Wash. Indep. Exh., 1935; Soc. Wash. Artists, (hon. men., 1936); Burlington Hotel (solo, 1939); Wash. AC (solo, 1961); Wash. Landscape Club. **Comments:** Teaching: U.S. Dept. of Interior; his studio. He was hospitalized in 1971 at the Veterans Hospital in Lebanon, PA, where he died 4 years later. **Sources:** WW40; McMahan, *Artists of Washington, DC;* Falk, *Exh. Record Series.*

RITTENBERG, Henry R. *[Painter, teacher] b.1879,* Rittenberg· *Libau, Latvia / d.1969.*
Addresses: Phila., PA, 1906-18; NYC, 1921-. **Studied:** PAFA (Cresson traveling scholarship, 1904); Bavarian Acad., Munich; Shinnecock Summer Sch. with William M. Chase. **Member:** NA, 1927; P&S Assn.; AAPL; NY Soc. Painters; Audubon Artists; Phila. AC; NAC; Allied AA; Wash. AC; MacD. Club; Alliance; Artists Fund Soc.; BAID (hon.); SC (hon.); PAFA Fellowship. **Exhibited:** PAFA Ann., 1906-22, 1932-34; Corcoran Gal. biennials, 1910-35 (7 times); NAD, 1920 (prize), 1926 (prize); AIC, 1925 (prize); NAC, 1938 (prize); AC Phila., 1906. **Work:** NY Hist. Soc.; Columbia Univ; Butler AI; Dept. Justice, Wash., DC; State Capitol, Harrisburg, PA; Univ. Pennsylvania; Fed. Court, Phila.; Phila. Bar Assn.; Univ. Panama; Panama Republic; Jefferson Medical College; Univ. Virginia; NY Chamber of Commerce; NY Acad. Medicine; Franklin Marshall College; Skidmore College; College of Physicians, Union Lg.; Phila. AC; Hahnemann College; Poor Richard's Club; College of Pharmacy; Phila. Pub. Lib.; H.S., Phila.; NY Produce Exchange; NY County Bar Assn.; Masonic Lodge, St. Louis, MO; Nat. Arts Club, Salmagundi Club; Pub. Lib., Greenville, SC; portrait, still life, ASL; NAD; Rutgers Univ.; Phila Free Lib.; Am. Acad. Arts & Letters; Hall of Am. Artists, NY Univ. **Comments:** He was primarily a portrait painter, but considered painting still lifes an integral part of his art. He is known to have painted portraits in Panama. Teaching: life class, BAID; NAD; ASL. **Sources:** WW66; WW47; Pisano, *The Students of William M. Chase,* 21; Falk, *Exh. Record Series.*

RITTENHOUSE, George Annette *[Portrait painter, painter] b.1871, Pennsylvania / d.1953, San Diego, CA.*
Addresses: San Diego, CA. **Studied:** NYC with Wayman Adams. **Member:** San Diego Art Guild; Contemp. Artists of San Diego. **Work:** San Diego Hist. Soc. **Sources:** Hughes, *Artists of California,* 470.

RITTENHOUSE, Hazel Scriver *[Painter] b.1910, South Shore, SD / d.1973, Santa Cruz, CA.*
Addresses: Santa Cruz, CA. **Studied:** Claude Buck; San Jose State Univ. **Exhibited:** Santa Cruz State-Wide annuals; Soc. for Sanity in Art, 1945, 1949; Nat. Art Exh., Oakland; CPLH, 1946 (first prize). **Sources:** Hughes, *Artists of California,* 471.

RITTER, Alice Bickley *[Painter, teacher] early 20th c.*
Addresses: Phila., PA. **Studied:** PAFA. **Sources:** WW25.

RITTER, Alonzo W. *[Painter] b.1898, Hagerstown, MD.*
Addresses: Hagerstown, MD; Wash., DC, active 1929-40. **Studied:** D.M. Hyde. **Member:** Hagerstown SA. **Exhibited:** S. Indp. A., 1924; Cumberland Valley Artists, Hagerstown Mus. FA, 1932, 1936 (prize); Soc. Wash. Artists; AAPL. **Work:** murals, Jr. H.S., hotel, Hagerstown. **Sources:** WW40; McMahan, *Artists of Washington, DC.*

RITTER, Anne Louise Lawrence Gregory (Mrs. E. A.) *[Painter, craftsperson, teacher] b.1868, Plattsburgh, NY. / d.1929.*
Addresses: Denver, CO; NYC. **Studied:** C.M. Dewey; R. Reid; Colarossi Acad. with Prinet, Girardor; Victoria Lyceum, Berlin. **Member:** Boston SAC; AFA; NSC; NY Women's AC. **Exhibited:** NAD, 1893, 1897; PAFA, 1893; Boston AC; Paris Salon, 1895, 1896 (as Gregory); Trans-Mississippi Expo, 1898; Phila. Art Club; St. Louis Expo, 1904 (medal) Boston SAC, 1907 (prize); Colorado Springs, 1912-19; S. Indp. A., 1917-18; Denver AM, 1920. **Work:** Broadmoor Art Acad.; Denver AM. **Comments:** Married artist Artus Van Briggle in 1902 and Etienne Ritter in 1908. Positions: organizer, Broadmoor Art Acad., Colorado Springs; art instr., Univ. Denver; pres./art dir., Van Briggle Pottery Co., 1904-. **Sources:** WW31; Fink, *Am. Art at the 19th c. Paris Salons,* 348; *The Boston AC;* Petteys, *Dictionary of Women Artists;* Falk, *Exh. Record Series.*

RITTER, Charles H. *[Painter] early 20th c.*
Addresses: Bloomingburg, NY. **Studied:** ASL. **Exhibited:** S. Indp. A., 1918-19, 1924. **Sources:** WW21.

RITTER, Chris *[Painter] b.1908, Iola, KS / d.1976, Maine.*
Addresses: NYC; Ogunquit, ME. **Studied:** Univ. Kansas (B.A.); ASL; Columbia Univ; BM Sch. Art; G. Grosz; M. Kantor. **Exhibited:** Salons of Am.; AIC, 1938, 1940, 1942-46; BM, 1939, 1941, 1943, 1945; Corcoran Gal. biennial, 1939; Denver AM, 1938 (prize), 1939-42; MMA; CM; Oakland Art Gal.; Jackson (MS) Mus. FA; Kansas City AI; NGA, 1941, 1945.; Oakland Art Mus.; Boston Art Festival, 1961; AWCS, 1960; Uptown Gal., 1939 (solo), 1942 (solo); Marquie Gal., 1943 (solo); Nat. Army Art Exh., 1945 (prize); Am.-British Gal., 1945 (solo); Laurel Gal., 1948 (solo), 1950 (solo), all in NY; Mississippi AA, 1947 (prize); Phila. Art All., 1948; Phila. Pr. Club, 1948 (prize); PAFA Ann., 1949; BM, 1949 (prize); Univ. Maine, 1964; Pinetree Designs Gal., Ogunquit, ME, 1964. **Work:** BM; Univ. Georgia Mus.; U.S. Govt.; WMA; Ogunquit (ME) Mus. Art; Univ. Maine; NYPL; LOC; Everhart Mus. Art. **Comments:** Positions: dir., Laurel Gal., NYC, 1946-51; dir., Pinetree Designs Gal., Ogunquit, ME; pres., Ogunquit AA, 1957-61. Teaching: Hunter College, 1939-41; Cornell Univ., 1947; Ballard Sch., 1947-53; Midland (TX) AC, 1954; York & Kittery (ME) AA; York Adult Educ. program; Portsmouth (NH) AA. Contrib.: *Display World* magazine. **Sources:** WW66; WW47; *Ogunquit, Maine's Art Colony, A Century of Color, 1886-1986* (exh. cat., Ogunquit: Barn Gallery Assoc., Inc., 1986); Falk, *Exh. Record Series;* add'l info. courtesy Selma Koss Holtz, Waban, MA.

RITTER, Chris (Mrs.) See: **PRATT, Frances (Frances Elizabeth Usui)**

RITTER, Ernest Walter *[Landscape painter, commercial artist] b.1891, Colorado / d.1949, Los Angeles, CA.*

Addresses: Los Angeles, CA. **Sources:** Hughes, *Artists of California*, 471.

RITTER, Julian *[Painter, mural painter]* b.1909, Hamburg, Germany.
Addresses: Chicago, IL; Los Angeles, CA; Maui, HI. **Studied:** Art Center School, Los Angeles, 1932-34. **Work:** Silver Slipper, Las Vegas. **Comments:** He worked for several film studios as well as painted portraits of prominent citizens in California. **Sources:** Hughes, *Artists of California*, 471.

RITTER, Louis *[Landscape painter, lithographer]* b.1854, Cincinnati, OH / d.1892.
Addresses: Cincinnati; Boston. **Studied:** McMicken Sch. Design, 1873-74; Florence with Duveneck; Paris with Lefebvre, Boulanger. **Exhibited:** Acad. Munich, 1878 (silver med.); Boston AC, 1884; Paris Salon, 1887; St. Botolph Club, 1890; Louis Ritter's Studio Exh., 1890; NAD, 1891; Cincinnati Art Mus., 1904. **Work:** Cincinnati Art Mus. **Comments:** One of the "Duveneck Boys." **Sources:** *Cincinnati Painters of the Golden Age*, 97-100 (w/illus.). Bibliography: Fink, *Am. Art at the 19th c. Paris Salons*, 384; *The Boston AC*.

RITTER, M. Antoinette *[Painter, teacher]* mid 20th c.
Addresses: Baltimore, MD. **Studied:** Maryland Inst., Baltimore; Johns Hopkins Univ. **Exhibited:** Friends of Art, Baltimore (solo); Baltimore Mus. Art, 1939 (prize); WFNY, 1939. **Sources:** WW40.

RITTER, Paul *[Painter]* b.1829 / d.1907.
Sources: Campbell, *New Hampshire Scenery*, 134.

RITTER, Robert *[Painter]* mid 20th c.
Addresses: Chicago area. **Exhibited:** AIC, 1949. **Sources:** Falk, AIC.

RITTERBUSH, William *[Sketch artist]* b.1835, New Hampshire / d.1880, Weaverville, CA.
Addresses: Weaverville, CA, early 1850s-80. **Work:** Weaverville Mus., CA. **Comments:** He made several sketches of the area around his home. In the 1860s-70s he worked as a miner and served as a justice of the peace. **Sources:** Hughes, *Artists of California*, 471.

RITTERHOFF, Amalie *[Illuminator]* b.c.1864 / d.1903, New York.
Work: King Edward of England and the Russian czar. **Sources:** Petteys, *Dictionary of Women Artists*.

RITTERSON, George H. *[Painter]* early 20th c.
Addresses: Bridgeport, NJ. **Exhibited:** S. Indp. A., 1924-25. **Sources:** Marlor, *Soc. Indp. Artists*.

RITTIS, J. Frank *[Painter]* early 20th c.
Addresses: Elgin, IL. **Exhibited:** AIC, 1910. **Sources:** WW13.

RITTMAN, L. See: **RITMAN, Louis**

RITZ, Madeline Gateka *[Educator, painter]* b.1903, Chickasha, OK.
Addresses: Brookings, SD. **Studied:** Oklahoma College for Women (A.B.); Columbia Univ. (M.A.); AIC; Penn. State Univ. (Ed. D.); Univ. Iowa; Ohio State Univ.; Univ. Chicago; Univ. Wisconsin; J. Despujols; C. Martin; A. Strauss. **Member:** AAUW; SD State Art Educ. Assn.; NAEA. **Exhibited:** Oklahoma AA. **Comments:** Teaching: South Dakota State College; Oklahoma College for Women, 1940; South Dakota State Univ., Brookings. **Sources:** WW66; WW47.

RIU, Victor *[Sculptor]* b.1887, Italy / d.1974.
Addresses: Coopersburg, PA. **Studied:** Italy. **Member:** Lehigh Artists; Woodmere Art Gal.; Allentown Art Mus.; PAFA. **Exhibited:** PAFA Ann., 1958 (prize), 1960; PAFA, 1964, 1971; Phila. Art. All. Solos: Lehigh Univ., Woodmere Art Gal.& Allentown Art Mus. **Awards:** Charles K. Smith Award, 1966; Philip Mills Award, New Hope, PA, 1971-72; Lehigh Art All. Gold Medal Award, 1972. **Work:** PAFA; Lehigh Univ.; Woodmere Art Gal., Phila.; Fed. Reserve S&L Pub. Art Coll.,

Phila.; Mus. Civico, Trieste, Italy. **Comments:** Preferred medium: granite. **Sources:** WW73; Falk, *Exh. Record Series.*

RIVARDE, Victor *[Painter]* late 19th c.; b.New York.
Studied: Hebert; Boulanger. **Exhibited:** Paris Salon, 1887. **Sources:** Fink, *Am. Art at the 19th c. Paris Salons*, 384.

RIVARDI, John Jacob Ulrich *[Sketch artist]* d.1808.
Addresses: Detroit, MI, 1797. **Comments:** A major in the Corps of Artillerists and Engineers, he made a watercolor manuscript map of the old fort and settlement of Detroit, dated March 29, 1799. **Sources:** Gibson, *Artists of Early Michigan*, 202.

RIVAS, Paul George *[Painter, gallery dir, teacher, critic, lecturer, writer, etcher]* b.1930, Mexico City, Mexico.
Addresses: Los Angeles, CA; Malibu, CA. **Studied:** Univ. Calif., Los Angeles (M.A.); Univ. Calif., Berkeley; College Arts & Crafts, Oakland, CA. **Exhibited:** SAM, 1955; Los Angeles AA, 1955; 1956; LOC, 1955; Newport Beach, 1955; Texas Western College, 1955; Long Beach Art Mus. 1955; Oakland Art Mus., 1955; Wichita AA, 1956; Santa Barbara Mus. Art, 1956; CPLH, 1956; Smithsonian Inst., 1956; UCLA, 1956; Nat. Orange Show, 1956-57; BM, 1956; Chaffey College, 1959; Denver Art Mus., 1957; Los Angeles Valley College, 1964; Newport Beach, 1964; Chateau Lascombes, Margaux (Gironde), France, 1964, 1965; Comara Gal., Los Angeles, 1965. **Awards:** purchase awards, Nat. Orange Show, 1957; Newport Harbor Exh., 1958; prizes, Nat Orange Show, 1958 and Newport Harbor, 1958. **Work:** Phoenix Art Mus; La Jolla Mus. Art; Mus. FA of Houston; Univ. Calif., Los Angeles; Newport Harbor H.S.; Nat. Orange Show Coll. Commissioned by ABC-TV, Los Angeles, for a painting in conjunction with TV Special "The Young Man from Boston" dealing with the life of John F. Kennedy, 1965 (painting to be placed in the Kennedy Lib.). **Comments:** Teaching: UCLA, 1954-52; Los Angeles Munic. Art Dept., City of Los Angeles, 1957-59; Downey Mus. Art, 1963; Otis AI, 1963-. Position: art ed., *Beverly Hills Times*; columnist for *Artforum*; dir., Paul Rivas Gal., Los Angeles, 1959-. **Sources:** WW66.

RIVE, Leon *[Portrait painter]* b.c.1809, France.
Addresses: New Orleans, 1849-50; Louisville, KY in 1850. **Sources:** G&W; 7 Census (1850), Ky., XI, 160; New Orleans CD 1849-50; *Encyclopaedia of New Orleans Artists* cites *Courier*, Aug. 1, 1849.

RIVERA, Diego *[Painter, mural painter]* b.1886, Guanajuato, Mexico / d.1957, Mexico City, Mexico.
Addresses: San Francisco, CA, 1930; Detroit, MI, 1933; NYC, 1934; San Fran., 1940. **Studied:** San Carlos Acad. with Santiago Rebull and José Maria Velasco; Europe, 1908 (on stipend from the Veracuz govt.). **Exhibited:** S. Indp. A., 1917-18, 1923; Salons of Am., 1923, 1924, 1930; CPLH, 1930 (first American solo); GGE, 1940; "Crosscurrents of Modernism: Four Latin Am. Pioneers: Diego Rivera, Joaquín Torres-Garcia, Wilfredo Lam, and Matta," Hirshhorn Mus., Wash., DC, 1992. **Work:** murals: San Fran. Stock Exchange, San Fran. Art Inst.; Detroit Art Inst.; Rockefeller Center, NYC (destroyed); frescoe: Little Theatre, San Fran. City College ("Culture of the Americas," painted for the GGE, 1940); SFMA; Mills College; CPLH; Mexican Mus., San Fran.; de Young Mus.; San Fran. General Hospital; many murals in Mexico City. **Comments:** Noted Mexican painter, founder of the Mexican Muralist Movement, with Orozco and Siqueiros. Rivera fulfilled many mural commissions in the U.S. (on the west and east coasts and in Detroit); he also influenced the careers of many American artists of the 1930s. His mural for Rockefeller Center in NYC was destroyed because of Rockefeller's objections to Rivera's inclusion of a portrait of Lenin. **Sources:** Jean Charlot, *The Mexican Mural Renaissance: 1920-25* (New Haven: Yale Univ. Press, 1963); Hughes, *Artists of California*, 471.

RIVERA, Frank *[Painter]* b.1939.
Addresses: NYC, 1968; New Brunswick, NJ, 1975. **Exhibited:** PAFA Ann., 1968; WMAA, 1975. **Sources:** Falk, *Exh. Record Series*.

RIVERA, Jose de See: **DE RIVERA, Jose**

RIVERA, Rolando *[Illustrator] mid 20th c.*
Addresses: NYC. **Member:** SI. **Sources:** WW47.

RIVERON, Enrique *[Painter] mid 20th c.*
Exhibited: S. Indp. A., 1936. **Sources:** Marlor, *Soc. Indp. Artists.*

RIVERS, Albert *[Painter] mid 20th c.*
Addresses: Brooklyn, NY. **Exhibited:** Salons of Am., 1934, 1936; S. Indp. A., 1934. **Sources:** AIC.

RIVERS, Cornelia McIntire *[Painter, teacher] b.1912, Savannah, GA.*
Addresses: Savannah, GA. **Studied:** Vassar College (A.B.); Univ. Georgia; ASL; Am. Art Sch.; Robert Brackman. **Member:** Am. Portrait Artists; Georgia AA; Savannah Art Club; St. Augustine AA. **Exhibited:** Portraits, Inc., 1949, 1951; Audubon Artists, 1949; Hallmark Awards, 1950; Am. Portrait Artists, 1950; Terry AI, 1952; Creative Gal., 1952; Savannah Art Club, 1935; Manchester, VT, 1947; Southeastern exh., 1952; St. Augustine AA, 1952; Quantico, VA, 1947 (solo); Telfair Acad., 1947. Awards: Univ. Georgia, 1935; Savannah Art Club, 1942; ASL, 1946; Manchester, VT, 1947. **Work:** Woodville H.S., Savannah; Ericson Mem. Hall, Savannah. **Sources:** WW59.

RIVERS, Georgie Thurston (Mrs. William W.) *[Painter, designer, block printer, teacher, lecturer, writer] b.1878, Tunica, MS.*
Addresses: Montgomery, AL. **Studied:** G. Bridgman, ASL; AIC with E.P. Timmons, C. Wilson; W. Titze; H. Peterson; Huntingdon College; Europe. **Member:** SSAL; Alabama AL; Mississippi AA; NOAA. **Exhibited:** Tri-State WC Exh., Jackson, MS, 1926 (prize). **Work:** Montgomery (AL) Fine Art. **Comments:** Contrib.: articles, *Art Digest, School Arts,* Alabama newspapers. Teaching: Huntington College. **Sources:** WW40; Petteys, *Dictionary of Women Artists.*

RIVERS, Haywood Bill *[Painter] b.1922, Morven, NC.*
Studied: ASL, 1946-49; Ecole du Musée du Louvre, Paris, 1949-52. **Exhibited:** BMA, 1948 (annual & solo); CI, 1949; Paris Salons, 1950; City College NY, 1967; Univ. Wisc., Stout, 1970; BMFA, 1970; Rebuttal to the Whitney Mus. Exh., 1971; Newark Mus., 1971. Awards: Gretchen Hutzler Award, 1948; Rosenwald Fellowship, 1948; Whitney Fellowship, 1952; BMA Ann, 1948 (prize). **Work:** BMA; Le Musée d'Art Moderne, Paris; NYPL. **Sources:** Cederholm, *Afro-American Artists.*

RIVERS, Jack Stuart *[Painter] early 20th c.*
Addresses: NYC. **Studied:** Académie Julian, Paris, 1910. **Sources:** WW13; Fehrer, The Julian Academy.

RIVERS, James *[Artist] mid 19th c.*
Addresses: Active in Maine, 1855. **Comments:** Made a drawing of the Academy and Congregational Church at Thomaston (ME) for a map of 1855. **Sources:** G&W; *Journal of the Society of Architectural Historians,* X (Dec. 1951), 27.

RIVERS, James S. *[Lithographer, engraver] b.Mississippi / d.1885, New Orleans, LA.*
Addresses: New Orleans, active 1876-85. **Comments:** Executed and several views of the World's Industrial and Cotton Cent. Expo, 1884-85. **Sources:** *Encyclopaedia of New Orleans Artists,* 327.

RIVERS, Larry *[Painter, sculptor, designer, illustrator] b.1923, NYC.*
Addresses: Southampton, NY. **Studied:** Hans Hofmann Sch. FA, 1947-48; NY Univ., with William Baziotes. **Exhibited:** WMAA biennials, 1954-64 (9 shows); Corcoran Gal. biennials, 1955 (bronze medal), 1957; PAFA Ann., 1964; Jewish Mus., NY, 1965 (retrospective); Marlborough Gal., NYC, 1968; Gotham Gal., NYC, 1968; AIC, 1970 (retrospective); Indianapolis Mus. Art, 1980. **Work:** MMA; NMAA; BM; BMA; WMAA; Guggenheim; Dallas MA; AIC; Kansas City AI; Minneapolis IA; CGA; Hirshhorn Mus.; NGA, Wash, DC; MoMA; LACMA; SFMoMA; North Carolina Mus. of Art, Raleigh. Commissions: first NY Film Festival, 1963 (outdoor billboard). **Comments:** One of the first artists in the 1950s to respond to Abstract-Expressionism by re-exploring figuration and employing the imagery of popular culture and American folklore. Rivers became an important part of the NYC avant-garde scene beginning in the 1950s, designing sets for a Frank O'Hara play in 1954, and for Igor Stravinsky's *Oedipus Rex* in 1966. He began sculpting in 1953, producing works in welded metal, plexiglas and wood. Illustr.: *When the Sun Tries To Go On.* Teaching: Slade Sch. FA, London, 1964. **Sources:** WW73; Baigell, *Dictionary;* Lucy R. Lippard, *Pop Art* (Praeger, 1966); Sam Hunter, *Larry Rivers,* (Abrams, 1970); Provincetown Painters, 254; Falk, *Exh. Record Series.*

RIVERS, Rosetta Raulston *[Painter, block printer, craftsperson, drawing specialist, lecturer, teacher, writer] mid 20th c.*
Addresses: Macon, GA. **Studied:** ASL; AIC; Hawthorne; E. Thurn; C. Woodbury; Modern Art Acad., Paris. Macon AA; Georgia AA; SSAL. **Exhibited:** Georgia AA, block printed wall drapery (prize). **Comments:** Teaching: Wesleyan College and Conservatory, Macon, GA. **Sources:** WW40.

RIVERS, Walter G. *[Painter] b.1914, California.*
Addresses: Larkspur, CA. **Studied:** Univ. Calif., Berkeley; George Demont Otis. **Exhibited:** Soc. for Sanity in Art, CPLH, 1945. **Sources:** Hughes, *Artists of California,* 471.

RIVES, Amelie See: **TROUBETZKOY, Amelie Rives**

RIVES, Frances E. *[Painter] b.1890, Nevada / d.1968, Carmel Valley, CA.*
Addresses: Monterey Peninsula, CA. **Studied:** San Fran. Art Inst.; Helen Forbes; Wm. Chase; Armin Hansen. **Exhibited:** East Bay Artists Exh., 1917. **Comments:** Married to Armin Hansen (see entry) in 1922, she abandoned her own career to support her husband's. **Sources:** Hughes, *Artists of California,* 471.

RIVES, Sarah Landon *[Portrait, still life & genre painter] b.1874, Albemarle County, VA / d.1958, Albemarle County.*
Work: Virginia Hist. Soc. **Sources:** Wright, *Artists in Virgina Before 1900.*

RIVET, Grace Clement *[Lithographer] mid 20th c.*
Addresses: San Francisco, CA. **Exhibited:** WPA artists, de Young Mus., 1939. **Sources:** Hughes, *Artists of California,* 471.

RIVIERE, Edward *[Listed as "artist" in census] b.c.1804, France.*
Addresses: NYC, active 1858-60. **Comments:** Groce & Wallace speculated that he was probably the scene painter, Reviere (see entry), who was working at Wallack's Theatre in 1858 and designed scenery for *Deseret Deserted, or the Last Days of Brigham Young.* **Sources:** G&W; 8 Census (1860), N.Y., LIII, 507; NYCD 1858-59; N.Y. *Herald,* May 24, 1858 (courtesy J. Earl Arrington).

RIVIERE, Peter *[Miniaturist] late 18th c.*
Addresses: Philadelphia, active 1784. **Sources:** G&W; Prime, I, 8.

RIVOIRE, Julien Emile *[Sketch artist, painter, photographer]*
Addresses: New Orleans, active 1885-1903. **Exhibited:** New Orleans, 1892. **Comments:** Primarily a portrait artist he added photography to his skills c.1894. He first was the editor of the *Franco-Louisianais* newspaper until c.1889, when he left the city. Upon his return in 1892 he exhibited portraits in his studio. **Sources:** *Encyclopaedia of New Orleans Artists,* 327.

RIVOLTA, Jack *early 20th c.*
Exhibited: Salons of Am., 1934. **Sources:** Marlor, *Salons of Am.*

RIX, Julian Walbridge *[Landscape painter, illustrator, etcher] b.1851, Peacham, VT / d.1903, NYC.*
Addresses: Patterson, NJ; NYC, from 1891.
Studied: briefly a student of Virgil Williams at Calif. Sch. Design, San Fran., after 1868, but was mostly self-taught; Europe, 1889. **Member:** SC, 1888; Bohemian Club; Lotos Club.
Exhibited: Mechanics Inst., San Fran, 1878-87; PAFA Ann.,

1882, 1887-88; San Fran. AA, 1883 (solo show, 200 paintings); NAD, 1884-86, 1891, 1894; Boston AC, 1886-1894; World's Columbian Expo, Chicago, 1893; AIC. **Work:** CGA; Minneapolis AM; TMA; Oakland Mus. Art; Crocker Mus., Sacramento; de Young Mus., San Fran.; Soc. Calif. Pioneers. **Comments:** During the last quarter of the 19th century, Rix was a prominent landscape painter. He was raised in Vermont, and in 1869 joined his family in San Francisco and attended school there. In 1876, he joined the art colony at Monterey (CA), then returned to San Francisco in 1879. He shared a studio with Jules Tavernier and, as a member of the Bohemian Club, actually led a "bohemian" lifestyle. In 1881, he moved to Paterson, NJ; then NYC in 1891. Illustr.: "Picturesque California," 1888. **Sources:** WW03; Hughes, *Artists in California*, 471-72; P&H Samuels, 402; Falk, *Exh. Record Series.*

RIXFORD, Carrie (Caroline) *[Portrait painter] b.1873, San Francisco, CA / d.1961, Stockton, CA.*
Addresses: Lifelong resident of San Fran. **Studied:** Mark Hopkins Inst. with Arthur Mathews; Acad. Julian, Paris, with Laurens; Whistler. **Member:** San Fran. Sketch Club; Palo Alto Art Club; SFAA; San Fran. Soc. Women Artists (pres., 1913-15). **Exhibited:** San Fran. Sketch Club, 1894-1903; Calif. State Fair, 1899; GGE, 1939. **Work:** Oakland (CA) Mus.; de Young Mus., San Fran.; Haggin Mus., Stockton, CA. **Sources:** WW17; WW13 (under Carrie Rixford Johnson); Hughes, *Artists in California*, 472 (under Caroline Rixford).

RIXINGER, Francis *[Lithographer] mid 19th c.*
Addresses: NYC, 1859. **Sources:** G&W; NYBD 1859.

RIXSON, Eleanor *[Painter] early 20th c.*
Addresses: NYC. **Exhibited:** S. Indp. A., 1922. **Sources:** Marlor, *Soc. Indp. Artists.*

RIZEK, Emil *[Painter] mid 20th c.*
Addresses: San Francisco, CA, 1930s. **Exhibited:** Oakland Art Gal., 1938. **Sources:** Hughes, *Artists of California*, 472.

RIZK, Romanos *[Painter, instructor] b.1927, Providence, RI.*
Addresses: Provincetown, MA. **Studied:** Vesper George Sch. Art, Boston, MA; Butera Sch. Art, Boston; Cape Sch. Art, Provincetown, MA, with Henry Hensche. **Member:** Provincetown AA (trustee, 1967-). **Exhibited:** Cape Cod AA & Provincetown AA Juried shows, 1953-72; Cape Cod AA Invitational, Hyannis, MA, 1963, 1965 & 1972; Bristol (RI) Art Mus., 1970 (solo); Provincetown AA Invitational, 1971-72; Arwin Gals., Detroit, MI, 1972 (solo). Awards: girst prize, Falmouth Artist's Guild, 1965, Cape Cod AA, 1965, 1968 & 71 AA Nantucket, 1966. **Work:** Mus. FA, Mobile, AL; State St. Bank Bldg. Gal., Boston. **Comments:** Preferred media: acrylics, polymer, collage. Positions: mem. gov. bd., FA Work Center, Provincetown, 1968-70, mem. adv. comt., 1970-. Publications: print ed. painting, Int. Art Publ. Co. 1970. Teaching: Romanos Rizk Sch. Painting, Provincetown, 1962-. **Sources:** WW73.

ROACH, Arthur (Rev.) *[Painter] b.1935, Perth Amboy, NJ.*
Studied: Newark State Col.; Newark School of Fine and Ind. Arts; School of Visual Arts; Collegiate Bible Inst. **Exhibited:** Newark Community Art Show, 1969 (prize); Newark Mus., 1971; West Orange, NJ; Purdue Univ., 1972. **Work:** Newark Mus. **Sources:** Cederholm, *Afro-American Artists.*

ROACH, Mariana *[Craftsperson, bookbinder] b.1908.*
Addresses: Dallas, TX. **Studied:** Southern Meth. Univ.; E, Diehl; Gerlach, Columbia. **Exhibited:** Allied Arts exh., Dallas Mus. FA, 1933 (prize); Allied Arts craft exh., 1935 (prize). **Comments:** Illustrator: "Fine Bindings in Dallas," (S. Chokla, Publisher's Weekly, 1935.) Position: t., Dallas Evening Sch. **Sources:** WW40.

ROACH, William A. *[Designer] b.1888.*
Addresses: Wash., DC, active 1938-47; Milford, DE, 1956. **Comments:** Worked for the Bureau of Engraving and Printing from 1938-47. **Sources:** McMahan, *Artists of Washington, DC.*

ROACHMAN, Emily F. *[Painter] mid 20th c.*
Addresses: NYC. **Exhibited:** S. Indp. A., 1928-29. **Sources:** Marlor, *Soc. Indp. Artists.*

ROAN-HORSE, Ralph *[Painter] mid 20th c.*
Addresses: Los Angeles, CA. **Studied:** Otis Art Inst. **Exhibited:** Artists Fiesta, Los Angeles, 1931. **Sources:** Hughes, *Artists in California,* 472.

ROARK, Helen Willis (Mrs. Aiden) *[Painter, writer, designer] b.1906, Centerville, CA.*
Addresses: San Francisco, CA. **Studied:** Eugen Neuhaus, Univ. Calif.; Calif. Sch. FA. **Comments:** Auth.: "Tennis," "Fifteen-Thirty," (1928, 1937). Contrib.: articles, *Sat. Eve. Post; Cosmopolitan; Scribner's; Liberty*; drawings, *Sat. Eve. Post; Forum; Vanity Fair; London Sketch.* **Sources:** WW40.

ROATS, Tatiana M. (Mrs.) *[Painter] 20th c.*
Addresses: Bainbridge Island, WA, 1982. **Exhibited:** SAM, 1945; Henry Gallery, 1951. **Sources:** Trip and Cook, *Washington State Art and Artists.*

ROBANE, Bernice *[Painter] mid 20th c.*
Exhibited: AIC, 1942. **Sources:** Falk, *AIC.*

ROBB, David M. *[Educator, art historian] b.1903, Tak Hing Chau, China.*
Addresses: Merion Station, PA. **Studied:** Oberlin Col. (A.B., 1926, A.M., 1927); Carnegie Found. fel. fine arts, 1927-30; Princeton Univ. (A.M., 1931, M.F.A., 1935), Inst. Advan. Study fel., 1938-39 (Ph.D., 1941). **Member:** Col. Art Assn. Am. (pres., 1960-62); Soc. Archit. Historians; Phila. A. All. **Exhibited:** Awards: Fulbright & Guggenheim fel. **Comments:** Publications: Co-auth., "Art in the Western World," 1935 & 1962; auth., "Harper History of Painting," 1952; auth., "Art of the Illuminated Manuscript," 1973. Teaching: assoc. prof. hist. art, Colgate Univ., 1930-35; assoc. prof. hist. art, Univ. Minn., 1935-39; prof. hist. art, Univ. Pa., 1939-. Research: Medieval art. **Sources:** WW73.

ROBB, Elizabeth B. *[Painter] mid 20th c.*
Addresses: Emsworth, PA, from c.1912. **Member:** Pittsburgh AA; AFA. **Exhibited:** PAFA Ann., 1913; Pittsburgh AA, 1914 (prize), 1915 (prize); S. Indp. A., 1920-22, 1932. **Sources:** WW33; Falk, *Exh. Record Series.*

ROBB, Juliet E. (S.) *[Painter] mid 20th c.*
Addresses: Radburn, NJ. **Exhibited:** S. Indp. A., 1936-43; PAFA Ann., 1936-37, 1942. **Comments:** *Cf.* Raabb, J.E. **Sources:** Falk, *Exh. Record Series.*

ROBB, Russell *[Painter] 20th c.*
Addresses: Concord, MA. **Member:** Concord AA. **Sources:** WW25.

ROBB, Sidney R. (Mr. & Mrs.) *[Collector] b.1900, Boston, MA.*
Addresses: Boston, MA. **Studied:** Mr. Robb, Harvard Univ.; Tufts Univ. (hon. L.L.D., 1961); Harvard Univ. (hon. M.A., 1962); Boston Col. (hon. L.H.D., 1964); Suffolk Univ. (hon. D.C.S., 1966). **Exhibited:** Awards: Mr. Robb, hon. alumni, Hebrew Univ. Jerusalem, 1965. **Comments:** Positions: Mr Robb, trustee, BMFA. Collections: Impressionists, primarily Degas, Pissarro, Vuillard Mary Cassatt, Bonnard and Moore; sculptures--Degas, Maillol, Lehmbruck & Moore. **Sources:** WW73.

ROBBER, Samuel K. *[Painter] mid 20th c.*
Exhibited: Salons of Am., 1934. **Sources:** Marlor, *Salons of Am.*

ROBBIN, Anthony Stuart *[Painter, writer] b.1943, Wash., DC.*
Addresses: NYC. **Studied:** Columbia Col. (B.A.); Yale Univ. Sch. Art (B.F.A. & M.F.A.). **Exhibited:** group shows, Bykert Gallery, NYC, 1971 & Paley & Lowe Inc., NYC, 1972; guest exhib., Tyler Sch. Art, Temple Univ., 1972; WMAA Ann., 1972. **Work:** Addison Gallery Am. Art, Andover, Mass. **Comments:** Preferred media: acrylics. Author: "Smithson Sites & Non-Sites," *Art News*, 1969; "Two Ocean Projects," *Arts Mag.*, 1969; "A Protein Sensibility," *Arts Mag.*, 1971; "Hutchison Ecological Art,"

Art Int., 1970. **Sources:** WW73.

ROBBINS, Bianca Ann Barker (Mrs.) *[Painter] b.1853, near Watkins Glen, NY / d.1926, Watkins Glen, NY.* **Addresses:** Active in Corning and Rochester, NY. **Studied:** Self-taught. **Comments:** Specialty: landscapes, flowers, seascapes. **Sources:** Petteys, *Dictionary of Women Artists.*

ROBBINS, Catherine *[Painter] 19th c.* **Comments:** Painted still lifes on velvet. **Sources:** Petteys, *Dictionary of Women Artists.*

ROBBINS, Charles D. *[Painter] late 19th c.* **Addresses:** Active in California (probably San Francisco), 1880s. **Sources:** P&H Samuels, 402.

ROBBINS, Daniel J. *[Educator, art historian] b.1933, New York.* **Addresses:** Cambridge, MA. **Studied:** Univ. Chicago (B.A.); Yale Univ. (M.A.); NY Univ. Inst. Fine Arts; Univ. Paris. **Exhibited:** Awards: French Govt. fel., Paris, 1958; Fulbright grant, 1958-59. **Comments:** Positions: cur., Nat. Gal. Art, Wash., DC, 1959-60; cur., Guggenheim Mus., 1961-64; dir., Mus. Art, RI Sch. Des., 1964-71; dir., Fogg Art Mus., Harvard Univ., 1971-. Teaching: instr., Ind. Univ., 1955; prof., Brown Univ, 1965-71; lectr., Harvard Univ. Collections arranged: Cezanne & Structure, 1963 & Albert Gleizes Retrospective, 1964-65, Guggenheim Mus.; Contemp. Wall Sculpture, 1963-64 & Decade of New Talent, 1964-65, Am. Fedn. Arts.Publications: auth., "Painting Between the Wars," 1965; auth., "Joaquin Torres Garcia," Guggenheim Mus., 1971; contribr., *Art J., Art France, Art Int., Art News, Apollo, Studio Int. & Bulletin,* Baltimore Mus Art. **Sources:** WW73.

ROBBINS, Dorothy *[Artist] mid 20th c.* **Addresses:** Cincinnati, OH; Levittown, NY. **Exhibited:** PAFA Ann., 1950, 1953. **Sources:** Falk, *Exh. Record Series.*

ROBBINS, Douglas *[Painter] early 20th c.; b.Springfield, OH.* **Addresses:** NYC. **Exhibited:** AIC, 1916. **Sources:** WW17.

ROBBINS, Ellen *[Watercolor painter; teacher] b.1828, Watertown, MA / d.1905, Boston, MA.* *E. Robbins*
Addresses: Boston, MA. **Studied:** mostly self-taught as watercolorist; New England School of Design, Boston, one year with Stephen Tuckerman; Merrimac Printworks. **Exhibited:** Boston AC, 1873-88; Centennial Exh., Phila., 1876. **Work:** Worcester (MA) Art Museum. **Comments:** Early in her career she gained attention selling bound albums of her watercolors of autumn leaves. She became recognized as a teacher of watercolor and as a flower painter (advertising in Boston newspapers: "Miss Robbin's Flower and Autumn Leaf Painting Classes"). Robbins often painted on the Island of Shoals off the coast of New Hampshire, where she began spending summers as early as 1850. A special draw there, for Robbins and other artists and writers, was the garden (and home) of poet Celia Thaxter. Some of her wildflower watercolors were reproduced as chromolithographs by Louis Prang and Co. and were popular in England. **Sources:** G&W; Worcester Art Museum, *Catalogue;* Fielding; Ellen Robbins, "Reminiscences of a Flower Painter," *New England Magazine* 14, no. 4 (June 1896), 440-51 and no. 5 (July 1896), 532-45; Tufts *American Women Artists 1830-1930,* cat. no. 90-91; *Things of Beauty: Floral Still-Lifes Selected from the Collection of Louise and Alan Sellars* (exh. brochure, Brenau College, Gainesville, Ga., 1992), 12; Strickler, ed. *American Traditions in Watercolor,* 216.

ROBBINS, Frank G. *[Mural painter, block printer, craftsperson, etcher, engraver] b.1886, Jefferson County, KY.* **Addresses:** Louisville, KY. **Member:** SSAL; Kentucky Sketch Club. **Sources:** WW40.

ROBBINS, Frank(lin) *[Cartoonist, illustrator, painter, writer] b.1917, Boston, MA.* **Addresses:** NYC. **Studied:** BMFA Sch.; NAD. **Member:** Nat Cartoonist Soc.; A.Lg.Am. **Exhibited:** AIC, 1936; NAD, 1936

(prize)-37, 1938, 1957-58; Roerich Mus., 1945; WMAA, 1955-56; Corcoran Gal. biennial, 1957 & 1958; TMA, 1957 & 1958; Audubon Artists, 1957 & 1958. **Work:** Commissions: portrait, Polyclinic Hosp., NY. **Comments:** He created the comic strip, "Scorchy Smith" (1939-44) and became best known for his strip of the hell-for-leather aviator, "Johnny Hazard" (King Features Syndicate). He also illustrated for *Life, Look, Cosmopolitan* and other national magazines. **Sources:** WW73; WW47, where he appears as Franklin; *Famous Artists & Writers* (1949).

ROBBINS, Frederick Goodrich *[Portrait painter, etcher, lecturer, teacher, writer] b.1893, Oak Park, IL / d.1974, New Hampton, NH?.* **Addresses:** Los Angeles, CA, 1929; Berkeley, CA, 1936; Westboro, MA. **Studied:** C.N. Werntz; H. McCarter; Breckenridge; Pierson; Calif. Sch. of FA, with S. Mackey; L. Randolph; J. Laan, Amsterdam. **Member:** Calif. Min. Painters; Calif. SE; Calif. PM. **Work:** etchings, for Pres. Roosevelt, Queen of Holland and others. **Sources:** WW40; Hughes, *Artists in California,* 472.

ROBBINS, Horace Wolcott, Jr. *[Landscape painter] b.1842, Mobile, AL / d.1904, NYC.* **Addresses:** NYC/summers in Simsbury and Farmington, CT. **Studied:** James M. Hart in NYC, 1859; Paris, 1865-66; Columbia Univ. (law), 1890; T. Rousseau, in Europe. **Member:** ANA, 1864, NA, 1878; AWCS; Artists Fund Soc.; NY Sch. Applied Des. for Women (trustee); MMA (fellow). **Exhibited:** NAD, 1863-94; PAFA, 1862-64; Boston Art Assoc.; Brooklyn Art Assoc., 1862-83; AIC. **Work:** Adirondack Mus. **Comments:** After graduating from a Baltimore College, he went to NYC, opening his own studio in 1860. In Connecticut he often worked with James Hart and Worthington Whittredge. He was also friends with F.E. Church and in 1864 went with him to Jamaica , then on to England, France, and Switzerland. He returned to NYC in 1867 and was on Long Island the summer of 1880. He was best known for his watercolors, but also painted in oils, including landscapes of the White Mountains. In the Adirondacks of Northern New York State, he had a studio near William Hart. In his fifties he became a lawyer. **Sources:** G&W; WW04; Cowdrey, NAD; Rutledge, PA; French, *Art and Artists in Connecticut,* 153-55; Century Association, *Yearbooks,* 1894-04. More recently, see Campbell, *New Hampshire Scenery,* 134; *Keene Valley: The Landscape and Its Artists; East Hampton: The 19th Century Artists' Paradise;* Art in Conn.: Early Days to the Gilded Age.

ROBBINS, Hulda D. *[Painter, printmaker] b.1910, Atlanta, GA.* **Addresses:** Ventnor, NJ. **Studied:** Pa. Mus. Sch. Indust. Art, Phila.; Prussian Acad., Berlin, with Ludwig Bartning; Barnes Found., Merion, Pa. **Member:** Am. Color Print Soc. **Exhibited:** Portrait of America, New York & Tour, 1945-46, Current Am. Prints, Carnegie Inst., Pittsburgh, Pa., 1948; Nat. Print Ann., Brooklyn Mus. & Tour, 1948-49; Nat. Exhib. Prints, LOC, 1956; US Info Agency Print Exhib. Europ. Tour, 1972-. Awards: purchase award, Prints For Children, MoMA, 1941; Paintings by Printmakers Award, 1947 & Babette S. Kornblith Purchase Prize, 1949, Nat Serigraph Soc. **Work:** MMA; Victoria & Albert Mus., London, Eng.; Bibliot. Nat., Paris; Art Mus. Ont.; Smithsonian Inst. **Comments:** Teaching: instr., basic & advan. serigraphy, Nat. Serigraph Soc. Sch., 1954-60; instr. creative painting, Atlantic Co. Jewish Community Ctr., Margate, NJ, 1960-67. **Sources:** WW73.

ROBBINS, Jennie *[Painter] 19th/20th c.* **Addresses:** Louisville, KY. **Member:** Louisville AL. **Sources:** WW01.

ROBBINS, John C. *[Etcher] 20th c.* **Addresses:** Farmington, CT. **Sources:** WW17.

ROBBINS, John Williams *[Lecturer, painter, writer, etcher] b.1856, Windham, CT / d.1939.* **Addresses:** Boston, MA. **Studied:** Mass. State Normal A. Sch.; Cowles A. Sch., Boston. **Member:** CAFA. **Exhibited:** Boston AC, 1881; Salons of Am. **Work:** Windham Pub. Lib.; Otis House,

Boston; AIC; NGA; Bibliothèque Nationale, Paris. **Comments:** Author: "The Witch of Tunthorne Gore," White Mts. Legends. Specialty: inventor, brule print and mezzo brule etchings. **Sources:** WW38.

ROBBINS, Luke See: **ROBINS, Luke**

ROBBINS, Marvin S. *[Portrait painter] b.1813, Middlefield, MA.*
Addresses: Active in Middlefield and Beckett, MA, until c.1872. **Sources:** G&W; Sears, *Some American Primitives,* 290; *Vital Records of Middlefield: Births.*

ROBBINS, R. (Mrs.) *[Listed as 'artist"] late 19th c.*
Addresses: San Jose, CA. **Exhibited:** Calif. Agricultural Soc., 1883 (pencil drawing). **Sources:** Hughes, *Artists in California,* 472.

ROBBINS, Raisa *[Painter] mid 20th c.*
Exhibited: AIC, 1942. **Sources:** Falk, *AIC.*

ROBBINS, Raymond Francis *[Painter, teacher] b.1912, Boston, MA.*
Addresses: Plainville, CT. **Studied:** Mass. Sch. A.; South Boston Sch. A.; G. Bjareby. **Exhibited:** VMFA, 1938; New Britain A. Mus., 1945; Ogunquit A. Ctr., 1938. **Sources:** WW47.

ROBBINS, Richard Smith *[Painter] late 19th c.; b.Solon, OH.*
Addresses: Chicago, IL. **Studied:** Académie Julian, Paris with Lefebvre, Constant, and L. Doucet, 1890. **Exhibited:** Chicago A. Exh., 1898; Omaha Expo, 1898; Louisville A. Lg., 1898. **Sources:** WW98.

ROBBINS, Royal *[Painter] early 20th c.*
Addresses: Brookline, MA. **Exhibited:** S. Indp. A., 1917-18. **Sources:** Marlor, *Soc. Indp. Artists.*

ROBBINS, Theresa Reynolds *[Painter] b.1893, Boston, MA.*
Addresses: Boston, MA/Nantucket, MA. **Studied:** P.L. Hale; R. Smith. **Exhibited:** S. Indp. A., 1917-18. **Sources:** WW31.

ROBBINS, Warren M. *[Art administrator, educator] b.1923, Worcester, MA.*
Addresses: Wash., DC. **Studied:** Univ. NH (B.A., eng., 1945); Univ. Mich. (M.A., hist., 1949). **Comments:** Positions: founder/dir., Mus. African Art, 1964-. Publications: auth., "African Art in American collections," Praeger, 1966; contrib., article, In: *Art in Society,* Vol 5, No 3; ed., "The Art of Henry O. Tanner" (exhib catalogue), 1969; auth., "The Language of African Art" (exhib. catalogue), 1970; auth., "The Impact of African Sculpture on Modern Western Art," Praeger, (in prep). Teaching: lectr., African Art, Mus. African Art, Wash., DC, 1964-; lectr. influence of African sculpture on mood Western art, mus. & univs. in USA, 1968-. Collections arranged: Traditional African Art from the Peabody Museum, 1966; The Heritage of African Art, 1967; Edward Mitchell Bannister, 1967; Ben Shahn on Human Rights, 1968; The Art of Henry O. Tanner, 1969; The Language of African Art 1970; African Art--The De Havenon Collection, 1971; African Art in Washington Collections, 1972. Research: influence of African sculpture on modern Western art. **Sources:** WW73.

ROBBINS-LEE, Lucy *[Painter] 19th/20th c.; b.NYC.*
Addresses: Paris, France. **Exhibited:** Paris Salon, 1887. **Sources:** WW04.

ROBERDS, Gene Allen *[Printmaker] b.1935, Cole Camp, MO.*
Addresses: St. Augustine, FL. **Studied:** Eastern Ill. State Col. (B.S., 1957); Univ. Ill. (M.F.A., 1961). **Member:** Intercontinental Biog. Assn. **Exhibited:** Minnesota Artists, Walker Art Ctr., 1966; Art of Two Cities, NYC, 1966; Nat. Invitational Print Show, San Diego, Calif., 1971. **Work:** Jacksonville Art Mus., Fla; Jacksonville Jr. Col. Gal.; Carver Orgn., Evansville, Ind. Commissions: Vignette for stock cert., Dayton Corp., Minneapolis, Minn., 1967. **Comments:** Positions: owner-artist, St. Augustine Prints, 1970-. Teaching: instr. printmaking, Murray

State Col., 1961-64; asst. prof. printmaking, Minneapolis Sch. Art, 1964-68; asst. prof. printmaking, Jacksonville Univ., 1968-71. Publications: illusr., Minn. Rev., 1966; illusr., "The Metaphysical Giraffe," 1967. **Sources:** WW73.

ROBERG, Patricia *[Painter] mid 20th c.*
Addresses: Bellingham, WA. **Exhibited:** SAM, 1945. **Sources:** Trip and Cook, *Washington State Art and Artists.*

ROBERSON, Edith T. *[Painter] mid 20th c.*
Addresses: Wilmington, DE. **Exhibited:** PAFA Ann., 1958. **Sources:** Falk, *Exh. Record Series.*

ROBERSON, Lee B. *[Painter] b.1916, Ames, IA.*
Addresses: Ames, IA. **Studied:** Freehand Drawing Dept., Iowa State Col.; AIC; S.D. Phillips, Lowell Houser, Giesberg, Chapin, Hoeckner, Phipps, Ropp. **Member:** Catalog Assoc. **Exhibited:** Iowa Art Salon (award); Memorial Union, Iowa State Col. (hon. men.); Industrial Arts Bldg.; AIC (hon. men.). **Work:** priv. colls. **Sources:** Ness & Orwig, *Iowa Artists of the First Hundred Years,* 177.

ROBERSON, Rose *[Sculptor] mid 20th c.; b.Ames, IA.*
Addresses: Ames, IA. **Studied:** AIC; Chicago School Sculpture; Lorado Taft. **Exhibited:** Chicago, 1931; Iowa Art Salon; Great Hall, Iowa State Col. **Work:** Memorial Union, Iowa State Col. **Comments:** Specialty: portrait busts. **Sources:** Ness & Orwig, *Iowa Artists of the First Hundred Years,* 177-78.

ROBERT *[Painter, designer, graphic artist, sculptor, craftsperson, teacher] b.1909, NYC.*
Addresses: NYC. **Studied:** Leonard Garfinkel, Albert Jahr, Sylvia DeG. Coster. **Exhibited:** Am. Mus. Natural Hist., 1939; GGE 1939; Vendome Gal., 1938; Salons of Am., 1932; Weyhe Gal., 1943; 8th St. Playhouse, N.Y. (solo). **Work:** Mun. Mus., Winston-Salem, N.C.; Carolyn Aid Soc., Savings Bank, Bronx, NY. **Sources:** WW53; WW47.

ROBERT, Alexander *[Lithographer] b.c.1832, Prussia.*
Addresses: NYC in 1860. **Sources:** G&W; 8 Census (1860), N.Y., XLIII, 618.

ROBERT, C. E. (Mrs.) See: **MCCULLOUGH, Lucerne (Mrs. C.E. Robert)**

ROBERT, James H. *[Artist] late 19th c.*
Addresses: Wash., DC, active 1880. **Sources:** McMahan, *Artists of Washington, DC.*

ROBERT, Lulu *[Artist] late 19th c.*
Addresses: Wash., DC, active 1891. **Sources:** McMahan, *Artists of Washington, DC.*

ROBERT, Oscar *[Painter] b.1829, Copenhagen, Denmark / d.c.1901, Wash., DC.*
Addresses: Wash., DC, 1864, active 1865-1901. **Comments:** Robert shared a studio and gallery with artist Earl Keyser in the late 1860s. He worked in oils, watercolor and crayon. **Sources:** McMahan, *Artists of Washington, DC.*

ROBERTI, Romolo *[Painter] b.1896, Montelanico, Italy.*
Addresses: Chicago, IL. **Studied:** Cornell Univ.; AIC; & with Antonin Storba, Albert Krehbiel. **Member:** Ill. Acad. FA; All-Ill. SA; Chicago SA. **Exhibited:** AIC, 1923, 1928, 1932, 1940; solo exh.: Findlay Gal. (solo); DaVinci A. Gal., NY (solo); Allerton, Harding, Barker Gal., Los A., CA (solo). **Work:** State T. Col., Malcolm, IL. **Comments:** Illustrator: "Art of To-Day," by J.Z. Jacobson. **Sources:** WW53; WW47.

ROBERTO, Frank P. *[Painter] mid 20th c.*
Exhibited: S. Indp. A., 1936. **Sources:** Marlor, *Soc. Indp. Artists.*

ROBERTS, A. L. (Miss) *[Artist] early 20th c.*
Addresses: Active in Los Angeles, 1911-15. **Sources:** Petteys, *Dictionary of Women Artists.*

ROBERTS, Abby *[Painter] mid 20th c.*
Exhibited: Salons of Am., 1930. **Sources:** Marlor, *Salons of Am.*

ROBERTS, Adam *[Listed as "artist"] b.c.1836, France.* **Addresses:** Baltimore, MD, in 1860. **Sources:** G&W; 8 Census (1860), Md., III, 981.

ROBERTS, Alice Mumford See: **CULIN, Alice Mumford Roberts**

ROBERTS, Alice Turner (Mrs. G. Brinton) *[Painter] b.1876, Philadelphia, PA / d.1955.* **Addresses:** Philadelphia, PA. **Studied:** PAFA with Henry McCarter. **Member:** Phila. Plastic Cl.; NY Soc. Women Artists; NAWA (as Alice T. Roberts, as of 1938). **Exhibited:** PAFA Ann., 1933-53 (as Alice T. Roberts, prizes in 1936 & 1952); S. Indp. A., 1937, 1940; Corcoran Gal biennial, 1939; Phila. Plastic Cl. (medal); Woodmere Art Gal.; Hobson Pitman Gal., Toledo. **Work:** PAFA. **Comments:** Not to be confused with Alice Mumford Roberts Culin (see entry). **Sources:** WW53 (as Alice T. Roberts); WW47 (as Alice T. Roberts); Falk, *PAFA*, vol. 3; Petteys, *Dictionary of Women Artists.*

ROBERTS, Allen *[Engraver] b.c.1828, New York.* **Addresses:** NYC. **Comments:** Living, in 1850, in the home of Robert Roberts (see entry). **Sources:** G&W; 7 Census (1850), N.Y., XLVI, 555.

ROBERTS, Alton True (Mrs.) *[Painter] 20th c.* **Addresses:** Marquette, MI. **Member:** Soc. Detroit Women Painters. **Sources:** WW25.

ROBERTS, Arnold *[Painter] mid 20th c.* **Studied:** ASL. **Exhibited:** S. Indp. A., 1937. **Sources:** Marlor, *Soc. Indp. Artists.*

ROBERTS, Betty Repine *[Painter] b.c.1905, Clifton, NJ.* **Addresses:** Clifton, NJ; Pasadena, Ca; Laguna Beach, CA; Yucaipa, CA. **Studied:** Galen W. Doss, Eleanor Colburn, Ruth Peabody. **Member:** Laguna Beach AA; San Diego FA Soc.; Laguna Festival of Arts. **Exhibited:** Laguna Festival of Arts; Laguna Beach AA; San Diego FA Soc.; throughout Southern Calif. **Sources:** Hughes, *Artists in California,* 472.

ROBERTS, Bishop *[Painter, engraver] d.1739, Charleston, SC.* **Addresses:** Charleston, SC, active 1735-39. **Work:** Colonial Williamsburg Foundation, Williamsburg, VA. **Comments:** At Charleston, he advertised that he could undertake portrait painting and engraving, heraldic and house painting, landscapes for chimney pieces, drawings of houses in colors or india ink, and instruction in drawing. Roberts' only known surviving work is a watercolor view of Charleston from about 1737-38, which was also engraved by W.H. Toms of London in 1739. Roberts' wife, Mary Roberts (see entry), was also an artist, although she did not advertise her services until after her husband's death. **Sources:** G&W; Rutledge, "Charleston's First Artistic Couple"; Wilson, "Art and Artists of Provincial South Carolina," 139; Prime, I, 8; Stokes, *Historical Prints,* pl. 14a. More recently, see Gerdts, *Art Across America,* vol. 2: 42-43 (repro.). Note: There is some confusion over his death date: Groce & Wallace give death date as October 1739 while Saunders & Miles give death year as 1740.

ROBERTS, Blanche Gilroy *[Sculptor] b.1871, Phila.* **Addresses:** Phila., PA/NYC. **Exhibited:** PAFA Ann., 1907-15, 1930. **Sources:** WW19; Falk, *Exh. Record Series.*

ROBERTS, Casey *[Painter] mid 20th c.* **Exhibited:** AIC, 1931. **Sources:** Falk, *AIC.*

ROBERTS, Charles M. *[Sculptor] late 19th c.* **Addresses:** Wash., DC, active 1877. **Sources:** McMahan, *Artists of Washington, DC.*

ROBERTS, Clyde Harry *[Painter, educator] b.1923, Sandusky, OH.* **Addresses:** Hagerstown, MD. **Studied:** Cleveland Inst. Art (dipl., 1946); Columbia Univ. (M.A., 1949); also with John Pike & Robert Brackman. **Member:** Baltimore WC Cl.; Md. Art Assn. (secy., 1962-64); Nat. Art Educ. Assn.; Wash. Co. Arts Coun. **Exhibited:** many exhibs., Baltimore Watercolor Open, Cumberland Valley Exhib., Miss. Art Assn. Open & Cleveland Mus. May Show; Artists Unlimited, Silver Spring, MD, 1970s. **Awards:** first award, Miss. Art Assn., 1950; popular prize, Cumberland Valley Artist, 1971; Artists Members Award, Baltimore WC Cl., 1971. **Work:** Washington Co. Mus. Fine Arts, Hagerstown, Md.; Ford Times Gal., Dearborn, Mich.; Hill Top House, Harpers Ferry, WVa.; Artists Unlimited, Wash., DC. **Comments:** Preferred media: watercolors. Teaching: instr. painting, Wash. Co. Mus. Art, Hagerstown, 1949-70; dir. Sch., 1968-70; instr. painting, Hagerstown Jr. Col., 1957-; supvr. art, Wash. Co. Bd. Educ., 1968-. Publications: illusr., *Ford Times Mag.,* 1958; contribr., *Sch. Arts,* 1968 & Artists News Unlimited, 1971. **Sources:** WW73; Jerome Palms, article, In: *Ford Times Mag.* (1958); G. Horn, article, In: *Art Today* (1968).

ROBERTS, Colette (Jacqueline) *[Art critic, art administrator] b.1910, Paris, France / d.1971.* **Addresses:** NYC. **Studied:** Sorbonne (M.A.); Acad. Ranson, with Roger Bissiere, 1925-31; Ecole Louvre, 1928-37; Inst. Art & Archeol., with Henri Focillon. **Exhibited:** exhibited extensively throughout France. **Awards:** Palmes Academiques, 1960; McDowell Colony fel., 1960. **Comments:** Positions: directed & organized meet the artist prog., New York Univ.; gallery dir., Nat. Assn. Women Artists, New York, 1947-49; secy. to cur. Far Eastern Art, MMA, 1950-51; dir., Grand Cent. Mod. Gal., NY, 1952-68; assoc. dir., Sachs Gal., New York 1968-. Publications: auth.," Mark Tobey," 1960, "Louise Nevelson, Sculptor," 1964 & Pocket museum, 1964; contribr., art ed., In: Fr.-Am., 1953-. Teaching: The road to mod. art summer lect. series, Coun. Int. Educ. Exchange, 1951-; instr., Queens Col., NY, 1960; instr., New York Univ., 1960, adj. asst. prof. art hist., 1968-. Collections arranged: organized exchange cult. exhibs., sponsored by Am. & Fr. Embassies. Specialty of gallery: modern American art. **Sources:** WW73.

ROBERTS, Cornelia Howard (Mrs. Robert E.) *[Painter] 19th/20th c.* **Addresses:** Detroit, MI. **Member:** Detroit WC Soc. **Exhibited:** Michigan State Fair, 1879; Detroit Mus. Art, 1886; local galleries, 1886-90. **Comments:** Preferred medium: watercolor. **Sources:** Gibson, *Artists of Early Michigan,* 202.

ROBERTS, Dean (Mrs. Stanley H. Wolcott) *[Decorator, designer, drawing specialist, etcher] b.1899, Chelsea, MA.* **Addresses:** Manhasset, NY. **Studied:** Corcoran Sch. Art; Calif. Art Sch. **Member:** Douglaston Art Lg. (pres.). **Work:** Univ. Nebraska. **Comments:** Illustrator: *Herald Tribune Magazine.* **Sources:** WW40.

ROBERTS, Donald H. *[Painter] late 20th c.* **Exhibited:** Atlanta Univ., 1951; BMFA, 1970. **Sources:** Cederholm, *Afro-American Artists.*

ROBERTS, Dwight V. *[Portrait painter] b.1908, Kansas City, MO.* **Addresses:** Kansas City 5, MO. **Studied:** Kansas City AI; ASL, with Frank Reilly, and in Europe. **Member:** Kansas City AI Alum.; Mid-Am. A. **Exhibited:** Midwestern Exh., 1941; solo: Woman's City Cl., Kansas City, 1951; Junior Lg., Houston, 1952. **Work:** portraits, Nat. Bank of Am., Salina, Kans.; First Baptist Church, Tulsa, Okla.; Town House Hotel, Kansas City, Kans.; Planters State Bank, Salina, Kans.; Kehilath Israel Synagogue, Kansas City. **Sources:** WW59.

ROBERTS, Edith A. *[Craftsperson, designer, painter] b.1887, Germantown, PA.* **Addresses:** Woodstock, NY. **Studied:** NY Sch. Fine & Applied Art; PAFA. **Member:** Boston SAC; Nat. AAI. **Exhibited:** WMAA, 1921-1928. **Sources:** WW40.

ROBERTS, (Edith) Lucille See: **HOWARD, (Edith) Lucille (Mrs. Herbert Allen Roberts)**

ROBERTS, Edward *[Painter] mid 20th c.* **Addresses:** Englewood, NJ. **Exhibited:** S. Indp. A., 1928. **Sources:** Marlor, *Soc. Indp. Artists.*

ROBERTS, Elizabeth *[Painter] mid 20th c.*
Addresses: Wash., DC. **Member:** Soc. Wash. Artists. **Exhibited:** Soc. Wash. Artists, 1936. **Comments:** *Cf.* Elizabeth Bohannan Roberts. **Sources:** WW40.

ROBERTS, Elizabeth Bohannan *[Artist] mid 20th c.*
Exhibited: Salons of Am., 1935. **Comments:** *Cf.* Elizabeth Roberts of Wash., DC. **Sources:** Marlor, *Salons of Am.*

ROBERTS, Elizabeth W(entworth) *[Painter] b.1871,*
Phila., PA / d.1927, Concord, MA.
Addresses: Concord, MA/Hopkinton, NH/Coffen's Beach, West Gloucester, MA. **Studied:** Phila. with E. Bonsall, H.R. Poore; Académie Julian, Paris with Bouguereau, Robert-Fleury, and Lefebvre; also with Merson. **Member:** Int. SAL; Ten Phila. Painters; Provincetown AA; Concord AA (founder); NAWA; North Shore AA, 1923-27; Allied AA. **Exhibited:** PAFA Ann., 1887-89 (Mary Smith prize), 1898-1911, 1919-23 ; Paris Salon, 1892, 1894, 1897, 1898; Soc. Indep. Artists, 1917, 1919; Concord AA, 1922; AIC; SAA; Corcoran Gal biennial, 1919; Cincinnati AM; Munich Int. Expos of Antwerp and and Budapest; Moore College Art & Design, Phila., PA, 1998 (retrospective, "The Philadelphia Ten."). **Work:** PAFA; Asllo San Giovanni, Bragora, Venice, Italy; Public Library, Concord, MA; Fenway Court, Boston. **Comments:** Specialized in landscapes and seascapes. **Sources:** WW25; info. courtesy North Shore AA and Annisquam Hist. Soc.; Talbott and Sidney, *The Philadelphia Ten;* Fink, *American Art at the Nineteenth-Century Paris Salons,* 384; Falk, *Exh. Record Series.*

ROBERTS, Ella A. *[Painter] b.1866, Farmington, NH /*
d.1930, Farmington.
Addresses: Active in Providence, early 1900s; and in Farmington. **Exhibited:** Provincetown AA, 1916. **Comments:** Married Ralph E. Davis. **Sources:** Petteys, *Dictionary of Women Artists.*

ROBERTS, Ellen T. *[Painter] late 19th c.*
Addresses: Phila., Jenkintown, PA. **Exhibited:** PAFA Ann., 1881-85. **Sources:** Falk, *Exh. Record Series.*

ROBERTS, Emeline Marie *[Painter] early 20th c.*
Addresses: New Orleans, active c.1918. **Exhibited:** NOAA, 1918. **Sources:** *Encyclopaedia of New Orleans Artists,* 327.

ROBERTS, Erling *[Painter] b.1902, Surrey, England.*
Addresses: California, 1930s. **Studied:** Slade School, London. **Work:** Interior Department, Washington DC. **Sources:** Hughes, *Artists in California,* 472.

ROBERTS, Frances *[Painter, craftsperson] mid 20th c.*
Addresses: San Diego, CA, 1932-35. **Exhibited:** Calif.-Pacific Int'l Expo, Long Beach, 1935. **Sources:** Hughes, *Artists in California,* 472.

ROBERTS, (Frederick) George *[Marine painter] b.c.1808.*
Addresses: Brooklyn, NY, 1867. **Work:** FDR Lib., Hyde Park, NY. **Comments:** He was in the U.S. Navy, 1846-48 as a gunner during the Mexican War, and served in the Civil War (1861-64). Later, he opened a paint and hardware store in Brooklyn but it failed. **Sources:** Brewington, 325.

ROBERTS, George See: **ROBERTS, (Frederick) George**

ROBERTS, George *[Artist] mid 20th c.*
Addresses: Moscow, ID. **Exhibited:** PAFA Ann., 1958. **Sources:** Falk, *Exh. Record Series.*

ROBERTS, George W. *[Painter] 20th c.*
Addresses: Alden, NJ. **Sources:** WW17.

ROBERTS, Georgia *[Painter] early 20th c.*
Exhibited: Calif. WC Soc., 1924. **Sources:** Hughes, *Artists in California,* 472.

ROBERTS, Georgina Wooton *[Painter, teacher] b.1891,*
Auburn, IN.
Addresses: Hays, KS. **Studied:** De Pauw Univ.; AIC; Church Sch. Art. **Exhibited:** Kansas-Oklahoma-Missouri Exh., 1923 (medal). **Sources:** WW25.

ROBERTS, Gilroy *[Sculptor, medalist] b.1905, Phila., PA /*
d.1992.
Addresses: Phila., Newton Square, PA. **Studied:** Frankford High Sch. Eve. Art Class, Phila., Pa.; Corcoran Gal. Art Sch.; also with John R. Sinnock & Heinz Warnsks. **Member:** Fel. Nat. Sculpture Soc.; Franklin Inst.; Rittenhouse Astron. Soc.; Phila. Sketch Cl. **Exhibited:** PAFA Ann., 1930, 1934, 1945-48; PAFA, 1936-37; Corcoran Gal. Art, Wash., DC, 1942; Nat. Sculpture Soc., NYC; Madrid, Spain, 1951; Rome, Italy, 1961. **Awards:** hon men., Nat. Sculptors Soc., 1951; gold medal & citation, Int. Exhib. Coins & Medals, Madrid, Spain, 1951; gold medal, Numismatic Assn., 1951. **Work:** US Mint, Philadelphia; Smithsonian Inst., Wash., DC; Franklin Mint, Franklin Ctr., Pa. Commissions: portrait of Anthony Drexel, Drexel Inst., Philadelphia, 1938; Kennedy half dollar, US Mint, Philadelphia, 1963; portrait of Albert Einstein, Inst. Advan. Study, Princeton, NJ; portrait of David Sarnoff, RCA Corp.; portrait of Ernie Pyle, Scripps Howard News Alliance. **Comments:** Positions: picture engraver, Bur. Engraving & Painting, Wash., DC, 1938-44; chief sculptor & engraver, US Mint, Philadelphia, 1948-64 (best known for the Roosevelt dime and Kennedy half dollar); chmn. & chief sculptor, Franklin Mint, 1964-on. Author: "Birth of a Dime Design," 10/1967; "Creating Designs in Circles," 5/1968, *Coins Mag.* **Sources:** WW73; Willard Garvin, "The Suburb that has its Own Mint," *Sunday Bulletin Mag.* (Jan., 1951); Thomas Baker, "The Creation of the Kennedy Half Dollar," *Coin Assn. Mag.* (Jun., 1972); Falk, *Exh. Record Series.*

ROBERTS, Gloster E. *[Artist] 19th/20th c.*
Addresses: Wash., DC, active 1905-20. **Sources:** McMahan, *Artists of Washington, DC.*

ROBERTS, Goodridge See: **ROBERTS, (William) Goodridge**

ROBERTS, H. K. *[Engraver] mid 19th c.*
Addresses: NYC, 1832. **Sources:** G&W; NYCD 1832; *Am. Adv. Directory,* 1832, 148.

ROBERTS, Harold G. *[Artist] mid 20th c.*
Addresses: South Orange, NJ. **Exhibited:** PAFA Ann., 1935. **Sources:** Falk, *Exh. Record Series.*

ROBERTS, Hazel Lavina *[Painter] mid 20th c.*
Addresses: San Francisco, CA, active 1927; Los Angeles, CA, active until at least 1942. **Exhibited:** Los Angeles County Fair, 1929. **Sources:** Hughes, *Artists in California,* 472.

ROBERTS, Helen *[Painter] early 20th c.*
Addresses: Wash., DC. **Exhibited:** Wash. WCC, 1917. **Comments:** She may be the Helen Roberts whose oil painting of a farm scene, c.1910, is in a private collection in Hudson, MA, and who worked for the Bureau of Engraving and Printing in 1905. **Sources:** WW19; McMahan, *Artists of Washington, DC.*

ROBERTS, Helen M. *[Painter] early 20th c.*
Addresses: Chicago area. **Exhibited:** AIC, 1917-18, 1920, 1925. **Sources:** Falk, *AIC.*

ROBERTS, Henry G. *[Painter] mid 20th c.*
Exhibited: AIC, 1942. **Sources:** Falk, *AIC.*

ROBERTS, Hermine (Matilda) *[Graphic artist, painter,*
teacher] b.1892, Cleveland, OH.
Addresses: Billings, MT. **Studied:** W. Forsyth; E. Steinhof; Univ. Indiana. **Member:** Southern PM; Indiana Soc. Printmakers; Hoosier Salon. **Exhibited:** S. Indp. A., 1939. **Comments:** Author of course of art study for Jr. H.S., state of Montana, 1934. Position: teacher, Eastern Montana State Normal Sch. **Sources:** WW40.

ROBERTS, Howard *[Sculptor] b.1843, Phila., PA / d.1900,*
Paris.
Addresses: Bryn Mawr, PA. **Studied:** PAFA; Ecole des Beaux-Arts, Paris, with Dumont, Gumery, 1860s. **Exhibited:** Paris Salon, 1869; Centenn. Expo, Phila., 1876 (gold for his "La Première Pose"); PAFA Ann., 1876, 1905. **Work:** PMA ("La Première

Pose"); "Robert Fulton," Capitol, Wash., DC. **Comments:** During the 1870s he was considered the best contemporary American sculptor. One of the first Americans to adopt the Parisian Beaux-Arts sculptural style. Lived in Paris, 1873-74. Specialties: ideal figures; statuettes; busts; portraits. **Sources:** WW98; Baigell, *Dictionary;* Fink, *American Art at the Nineteenth-Century Paris Salons,* 385; Falk, *Exh. Record Series.*

ROBERTS, I. H. *[Portrait painter] mid 19th c.*
Comments: Groce & Wallace included I.H. Roberts based on an inscription reading "Painted by I.H. Roberts 1850" which was found on the back of a portrait owned in 1938 by private collector of Richmond (Va.). The authors speculated that this might be the artist listed in Ohio directories as J.H. Roberts (see entry for J.H. Roberts of Ohio). **Sources:** Groce & Wallace.

ROBERTS, J. H. *[Artist] late 19th c.*
Addresses: Wash., DC, 1879. **Comments:** May be the same artist listed as J.H. (or J.M.?) Roberts, active in Ohio from 1853-59. **Sources:** McMahan, *Artists of Washington, DC.*

ROBERTS, J. H. (possibly J. M.) *[Portrait and landscape painter] mid 19th c.*
Addresses: Active in Ohio, 1852-59. **Comments:** J.H. Roberts was listed in the Ohio business directory of 1853 as a portrait painter in Springfield, OH, and in the 1859 directory as a portrait and landscape painter at Woodstock, OH. Hageman, citing the Springfield, OH, City Directory of 1852, listed a portrait painter named J.M. Roberts. They are likely the same artist. **Sources:** G&W; Ohio BD 1853, 1859 (as J.H. Roberts); Hageman, 122.

ROBERTS, Jack *[Painter, illustrator] b.1920, Oklahoma City, OK.*
Addresses: Carbondale, CO in 1975. **Studied:** Univ. Oklahoma; Am. Acad. Art, Chicago; Grand Central School Art with Harvey Dunn. **Comments:** Specialty: historical Westerns, particularly mountain men and hunters. **Sources:** P&H Samuels, 402.

ROBERTS, James *[Copper engraver] b.c.1831, England.*
Addresses: Philadelphia in 1860. **Sources:** G&W; 8 Census (1860), Pa., LX, 709.

ROBERTS, Jessie Macy *[Painter] mid 20th c.*
Addresses: Cincinnati, OH. **Exhibited:** Cincinnati AM, 1934, 1936, 1939. **Sources:** WW40.

ROBERTS, John *[Portrait and miniature painter, engraver (also inventor and amateur musician)] b.1768, Scotland / d.1803, NYC.*
Addresses: Came to America c.1793, settling in NYC but also traveling throughout the South. **Comments:** Active in NYC, he also visited Charleston, SC, in the winter of 1796-97; Norfolk, VA, 1797-99; Petersburg, VA, 1798; and possibly Portsmouth, NH, in March 1801. **Sources:** G&W; Dunlap, *History,* I, 427-29; Bolton, *Miniature Painters;* NYCD 1795-1803; Rutledge, *Artists in the Life of Charleston;* Prime, II, 32; Hamilton, *Early American Book Illustrators and Wood Engravers,* 86; *Antiques* (Sept. 1944), 158; Wright, *Artists in Virginia Before 1900.*

ROBERTS, John *[Painter] mid 20th c.*
Addresses: La Verne, CA. **Exhibited:** S. Indp. A., 1925-26. **Sources:** Marlor, *Soc. Indp. Artists.*

ROBERTS, John M. *[Painter] mid 19th c.*
Addresses: Peoria, OH. **Comments:** Peoria's first artist, he painted several local views, 1831-32. **Sources:** Gerdts, *Art Across America,* vol. 2: 283.

ROBERTS, John Taylor *[Sculptor] b.1878, Germantown, PA.*
Addresses: Phila., PA; NYC, 1917-. **Studied:** C. Grafly. **Exhibited:** PAFA Ann., 1907-12, 1917-18. **Sources:** WW19; Falk, *Exh. Record Series.*

ROBERTS, Joseph Lincoln *[Painter] b.1815, Gloucester, MA.*
Addresses: Pittsburgh, PA, active ca. 1863-1865. **Member:** Pittsburgh Art Soc. **Exhibited:** Cosmopolitan Art Assoc., Sandusky, OH, 1857, 1860; Pittsburgh AA, 1860; Pittsburgh

Sanitary Fair, 1864. **Comments:** Specialty: still lifes, landscapes, nature morte. **Sources:** info. courtesy of Edward P. Bentley, Lansing, MI.

ROBERTS, Josephine Howard *[Painter] early 20th c.*
Addresses: Coytesville, NJ. **Exhibited:** S. Indp. A., 1917. **Sources:** Marlor, *Soc. Indp. Artists.*

ROBERTS, Josephine Seaman *[Painter, writer, lecturer, teacher] mid 20th c.; b.Los Angeles, CA.*
Addresses: Los Angeles/Idyllwild, CA. **Member:** S. Calif. WCS; Calif. PS; Pacific AA. **Exhibited:** Artists Fiesta, Los Angeles, 1931. **Comments:** Preferred medium: watercolors. **Sources:** WW33; Hughes, *Artists in California,* 472.

ROBERTS, Lawrence Drane *[Amateur painter] b.1893, Nelson County, VA / d.1988, Berryville, VA.*
Addresses: Wash., DC, 1915; Berryville, VA. **Comments:** He painted landscapes in oil for his own enjoyment. **Sources:** McMahan, *Artists of Washington, DC.*

ROBERTS, Louise Smith (Mrs. William A.) *[Illustrator, designer] b.1887, Phila., PA / d.1936, Fox Chase, PA.*
Studied: Phila. Mus. School Indust. Arts; ASL. **Comments:** Illustrator: *Philadelphia Record,* 15 years. Position: staff designer for several women's magazines. Co-founder, Roberts Press, Rose Valley, PA.

ROBERTS, Lucille D. (Malkia) *[Painter, educator] 20th c.; b.Wash., DC.*
Addresses: Hyattsville, MD. **Studied:** Howard Univ.; Univ. Michigan, A.M.; NY Univ.; Acad. de la Grande Chaumière, Paris, France; Univ. Ghana; also with Jose Gutierriez, Mexico City, Mexico. **Member:** Nat. Conf. Artists; Black Acad. Arts & Letters; Soc. Washington Artists; Wash. DC Art Assoc. **Exhibited:** Nat. Exhib. Black Artists, Smith-Mason Gal., Wash., DC, 1971; Black Artists Exhib., Afro-Am. Cultural Center, Cleveland State Univ., 1972;1st World Festival of Negro Arts, Dakar, Senegal; Smithsonian Inst.; Porter Gallery, Howard Univ., 1971 (solo); College Mus., Hampton Inst., 1972(solo). **Awards:** first prize, mem. show, 1965 & Evening Star Award, 1966, Soc. Wash. Artists; James A. Porter Award, Cleveland State Univ., 1972. **Work:** Atlanta Univ. Coll.; West Virginia State Col. Coll.; Jefferson Community Coll., Water Town, NY. **Comments:** Preferred media: oils, acrylics. Teaching: asst. prof. art, DC Teachers Col., Wash., 1965-; visiting assoc. prof. African & Afro-Am. art, State Univ. NY College Oswego, 1970-71. **Sources:** WW73; Lewis & Wadday, *Black Artists on Art* (1969); J. Edwin Atkinson, *Black Dimensions in Contemporary Art* (Carnation Co., 1970); Cederholm, *Afro-American Artists.*

ROBERTS, M. E. *[Painter] 19th/20th c.*
Addresses: Minneapolis, MN, 1894-95; NYC. **Exhibited:** PAFA Ann., 1894-95 (still-life paintings). **Sources:** WW01; Falk, *Exh. Record Series.*

ROBERTS, M. (Miss) *[Portrait painter] late 19th c.*
Exhibited: San Francisco AA, 1873. **Sources:** Hughes, *Artists in California,* 472.

ROBERTS, Malcom M. *[Painter] b.1913.*
Addresses: Seattle, WA. **Studied:** Univ. of Wash.; AIC; Europe. **Exhibited:** SAM, 1934; Northwest Artists, 1939. **Comments:** Local newspapers referred to him as the "Seattle Surrealist." **Sources:** Trip and Cook, *Washington State Art and Artists;* Wechsler, 32.

ROBERTS, Margaret Lee (Mrs. De Owen N., Jr.) *[Painter, teacher] b.1911, Oklahoma City, OK.*
Addresses: Norman, OK. **Studied:** Chouinard AI. **Member:** Oklahoma AA. **Work:** YWCA, Univ. Oklahoma. **Sources:** WW40.

ROBERTS, Marie C. *[Watercolorist] early 20th c.*
Addresses: Wash., DC, 1911. **Exhibited:** Wash. WCC, 1911. **Sources:** WW13; McMahan, *Artists of Washington, DC;* Petteys, *Dictionary of Women Artists.*

ROBERTS, Marvin S. See: **ROBBINS, Marvin S.**

ROBERTS, Mary *[Miniaturist] d.1761, Charleston (buried in St. Philip's Parish).*
Addresses: Charleston, SC. **Work:** Carolina Art Assoc./Gibbes Art Gallery, Charleston, SC. **Comments:** Earliest woman miniaturist to work in the colonies. After the death of her husband, Bishop Roberts (see entry) in 1739, Mary's name appears several times in the *South Carolina Gazette*, advertising her services as a face painter and offering her husband's printing press for sale. Three signed miniatures (watercolor on ivory) are the only works to survive. Based on clothing and hair styles, they are believed to have been painted in the 1740s. **Sources:** G&W; Rutledge, "Charleston's First Artistic Couple"; Prime, I, 8. More recently, see Craven, *Colonial American Portraiture*, 357, who cites *South Carolina Gazette*, February 2 and 9, 1740; and Saunder and Miles, 163 (repro.).

ROBERTS, Mary R. *[Painter] 19th/20th c.*
Addresses: Philadelphia, PA. **Exhibited:** PAFA Ann., 1900. **Sources:** WW01; Falk, *Exh. Record Series.*

ROBERTS, Maurine Hiatt (Mrs. Arthur K.) *[Painter, illustrator, teacher] b.1898, Kansas City, MO.*
Addresses: Seattle, WA. **Member:** Seattle FAS. **Sources:** WW25.

ROBERTS, Mills *[Artist] late 19th c.*
Addresses: Wash., DC, active 1895. **Sources:** McMahan, *Artists of Washington, DC.*

ROBERTS, Milnora de B. *[Painter] mid 20th c.*
Addresses: Seattle, WA. **Exhibited:** PAFA Ann., 1934. **Sources:** WW24; Falk, *Exh. Record Series.*

ROBERTS, Morton *[Painter, illustrator, teacher] b.1927, Worcester, MA / d.1964.*
Addresses: Harrison, NY. **Studied:** Yale Univ. Sch. FA (B.F.A.). **Member:** NA; AWCS; All. A. Am.; Copley Soc., Boston; Rockport AA. **Exhibited:** Milch Gal.; Butler Inst. Am. A.; NAD, 1954-58; Audubon A.; Boston A. Festival; AWCS; All. A. Am.; Parrish Mus.; Phila. A. All., 1956 (solo); Childs Gal., Boston, 1955 (solo); Traveling group shows, 1951. **Awards:** Abbey F., NAD, 1950; prizes, Yale Univ., 1947; State of Mass., 1953; Pinanski prize, 1952; NAD, 1954-57; AWCS, 1953, 1955, silver medal, 1956; citation and medal, American Artist magazine, 1955. **Work:** NAD; Yale Univ.; Parrish Mus., Southampton, and in priv. colls. **Comments:** Commissioned paintings for *Readers Digest; Life magazine; Sports Illustrated,* and others. Work reproduced in 1957 ed. Encyclopedia Britannica. Positions: instr., PIA Sch., Brooklyn, NY, 1951-55. **Sources:** WW59.

ROBERTS, Nat (Mrs.) See: **WALLACE, Ethel A.**

ROBERTS, Nathan B. *[Portraitist] mid 19th c.*
Addresses: NYC in 1856. **Exhibited:** American Institute (1856: pencil portraits). **Sources:** G&W; Am. Inst. Cat., 1856.

ROBERTS, Nellie H. *[Artist] 19th/20th c.*
Addresses: Wash., DC, active 1908. **Sources:** McMahan, *Artists of Washington, DC.*

ROBERTS, Nelson L. (Mrs.) *[Artist] late 19th c.*
Addresses: Active in Port Huron, MI, 1889-91. **Sources:** Petteys, *Dictionary of Women Artists.*

ROBERTS, Norman L. *[Painter] b.1896, Ironia, NJ.*
Addresses: NYC. **Studied:** H.G. Keller. **Work:** Jr. Lg. Club, Cleveland, OH; Cleveland (OH) Pub. Lib. **Sources:** WW29.

ROBERTS, P. Gigby *[Painter] mid 20th c.*
Addresses: Seattle, WA, 1945. **Exhibited:** SAM, 1945. **Sources:** Trip and Cook, *Washington State Art and Artists.*

ROBERTS, Priscilla Warren *[Painter] b.1916, Glen Ridge, NJ.*
Addresses: Wilton, CT. **Studied:** ASL; NAD. **Member:** NA, 1957; Catharine Lorillard Wolfe Assn. (hon. mem.). **Exhibited:** S. Indp. A., 1944; Carnegie Int., Pittsburgh, 1950 (3rd prize); NAD,

1947 (Hallgarten prizes & Proctor Portrait Prize), 1969; Corcoran Gal. biennial, 1947; Univ. Ill., Urbana; All. Artists, NYC; Grand Central Gal., NYC, 1970s. **Work:** MMA; Dallas MFA; Walker Art Ctr, Minneapolis, Minn; Butler Inst. Am. Art; IBM Collection, NYC. **Comments:** Preferred media: oils. Publications: contribr., *Pictures, Painters, and You,* by Ray Bethers. **Sources:** WW73.

ROBERTS, Randal(l) H. (Sir) *[Painter] late 19th c.*
Addresses: Boston, MA. **Exhibited:** NAD, 1880; PAFA Ann., 1882. **Sources:** Naylor, *NAD;* Falk, *Exh. Record Series.*

ROBERTS, Rebekah Evens *[Painter] late 19th c.*
Addresses: Phila., PA. **Exhibited:** PAFA Ann., 1887-90. **Sources:** Falk, *Exh. Record Series.*

ROBERTS, Robert *[Wood engraver] b.c.1821, Wales.*
Addresses: NYC, active from 1841 to 1850. **Studied:** said to have been a pupil of Joseph Alexander Adams. **Comments:** In 1850 he lived with Allen Roberts (see entry), probably his brother. **Sources:** G&W; 7 Census (1850), N.Y., XLVI, 555; NYCD 1841-49; Am. Inst. Cat., 1842; Hamilton, *Early American Book Illustrators and Wood Engravers,* 78.

ROBERTS, Sarah Pickens *[Painter] 20th c.; b.Louisville, KY.*
Addresses: Chevy Chase, MD. **Studied:** Corcoran Sch. A.; George Wash. Univ.; H.B. Snell; C. Critcher; Radcliffe Col. **Comments:** Position: t., Highland Hall. **Sources:** WW40.

ROBERTS, Spencer *[Painter] 20th c.*
Addresses: Phila., PA. **Member:** AC Phila. **Sources:** WW25.

ROBERTS, Sydney A. *[Illustrator, graphic artist] b.1900, FL.*
Addresses: Des Moines, IA; Erie, PA, 1950. **Studied:** Cummings Sch. Art, Des Moines. **Member:** Co-op Artists, State of Iowa. **Exhibited:** Iowa State Fair; Des Moines Art Gal.; PAFA Ann., 1950. **Comments:** Specialty: cowboy subjects. WPA artist. **Sources:** WW40; Falk, *Exh. Record Series.*

ROBERTS, Thomas (Kieth) *[Painter] b.1909, Toronto, Ontario.*
Addresses: Port Credit, Ontario. **Studied:** Cent. Tech. Sch., Toronto; Ont. Col. Art, Toronto. **Member:** Royal Can. Acad.; Ont. Soc. Artists. **Exhibited:** many Ann., Royal Acad. Arts, Montreal & Toronto, Montreal Mus. Fine Arts & Ont. Soc. Artists, Toronto, 1929-; Eaton's Fine Art Galleries, Toronto, Ont., 1970s Awards: Ralph Clarke Stone Award, 1949. **Work:** Ford Motor Co.; Rio-Algom; Seagrams. **Comments:** Preferred media: oils, watercolors, acrylics. **Sources:** WW73.

ROBERTS, Violet K(ent) (Mrs.) *[Painter, illustrator, designer] b.1880, The Dalles, OR / d.c.1958.*
Addresses: Wash., DC, 1920-47. **Studied:** PIA Sch.; BMFA Sch.; & with Frank Benson, George Eggers, Beck; Moschcowtiz; Prellwitz. **Exhibited:** with Wash. DC groups from 1921 including Wash. WCC, 1945; Wash. Min. Soc., 1945, 1952-54; Wash. AC, 1946 (solo); Wash. Area Exhib., 1951. **Comments:** Position: staff, CGA, Wash., DC, 1944-. Illustrator, *First Book of Religion.* **Sources:** WW53; WW47; McMahan, *Artists of Washington, DC;* Petteys, *Dictionary of Women Artists.*

ROBERTS, Virginia *[Painter] mid 20th c.*
Addresses: Berkeley, CA, late 1930s. **Member:** San Francisco AA. **Exhibited:** SFMA, 1935, 1939 (solo); GGE, 1939. **Sources:** Hughes, *Artists in California,* 473.

ROBERTS, William *[Engraver] b.c.1809, England or Germany.*
Addresses: Philadelphia, active c. 1839-60. **Comments:** According to the 1850 Census he was born in England about 1809, while the 1860 Census states that he was born in Germany about 1811. His wife was English and their two children were born in Pennsylvania about 1839 and 1845. **Sources:** G&W; 7 Census (1850), Pa., LII, 273; 8 Census (1860), Pa., LII, 898; Phila. CD 1851-52.

ROBERTS, William *[Wood engraver] b.c.1829, New York.*
Addresses: NYC, active 1846-76. **Exhibited:** American Institute,

1846-51. **Comments:** In 1846 he was a junior partner in Butler & Roberts (see entry) of NYC **Sources:** G&W; NYCD 1846-76; NYBD 1846; Am. Inst. Cat., 1846-49, 1851; Sears, *Description of the U.S.,* frontis.; Hamilton, *Early American Book Illustrators and Wood Engravers,* 446, 528; 7 Census (1850), N.Y., XLVIII, 232 [as William E.].

ROBERTS, W(illiam) *[Landscape painter] mid 19th c.; b.England?.*
Work: Mus. of Early Southern Decorative Art. **Comments:** Came to Virginia c.1805. Delineator of a view of Natural Bridge (Va.), engraved by William Main who was working in NYC between 1820 and 1837. **Sources:** G&W; Stauffer. More recently, see Wright, *Artists in Virginia Before 1900.*

ROBERTS, (William) Goodridge *[Painter] b.1904, Barbados, BWI.*
Addresses: Montreal, PQ. **Studied:** Beaux-Arts, Montreal, 1924-26; ASL, 1927-29; Univ. NB (L.L.D., 1960). **Member:** Can. Group Painters; Can. Soc. Graphic Art; Can. Soc. Painters in Water Colour; Contemp. Arts Soc., Montreal; Royal Can. Acad. **Exhibited:** Carnegie Inst., 1952 & 1955; Valencia Int., 1955; Mexico City, Mex., 1958; Brussels, Belg., 1958; Tate Gal., London, Eng., 1964. Awards: prizes, Montreal Mus. Fine Arts, 1948 & 1956 & Winnipeg Art Gal., 1957; Glazebrook Award, 1959. **Work:** Nat. Gal. Can.; Montreal Mus. Fine Arts; Vancouver A. Gal.; Winnipeg A. Gal.; Bezalel Mus., Israel. Commissions: painting of Quebec landscape presented to Queen Elizabeth by Royal Can. Air Force Assn., 1954. **Comments:** Positions: official war artist, RCAF, 1943-1945. Teaching: vis. fel., Univ. NB, 1959-60. **Sources:** WW73.

ROBERTS, William J. *[Portrait painter] mid 19th c.*
Addresses: Newark, NJ, 1857-60. **Exhibited:** NAD, 1865. **Sources:** G&W; Newark CD 1857, 1860.

ROBERTSON, Alexander *[Miniaturist and landscape painter, painting teacher] b.1772, Aberdeen, Scotland / d.1841, NYC.*
Addresses: NYC. **Studied:** London. **Member:** American Academy (member from 1817, secretary from 1817 to 1825 and keeper from 1820 to 1835). **Exhibited:** American Academy (frequently). **Comments:** Younger brother of Archibald (1765-1835, see entry), whom he followed to America in 1792. Both established themselves in NYC where for many years they conducted the Columbian Academy of Painting. Alexander was better known as a teacher than as a painter, although he was very active in the American Academy. His drawing of Mount Vernon was engraved by Francis Jukes and published in London in 1800. **Sources:** G&W; Robertson, *Letters and Papers of Andrew Robertson,* 1, 2, 9, 285; Bolton, *Miniature Painters;* Cowdrey, AA & AAU; NYCD 1793+; Stokes, *Historical Prints;* Flexner, *The Light of Distant Skies,* biblio., 265; Wright, *Artists in Virgina Before 1900.*

ROBERTSON, Alexander *[Lithographer] mid 19th c.*
Addresses: NYC, 1852-60. **Comments:** Partner in Robertson & Seibert (1854-57, see entry), of Robertson, Seibert & Shearman (1859-60 see entry). **Sources:** G&W; NYCD 1852-58; NYBD 1854, 1857-60.

ROBERTSON, Anne MacKinne *[Sketch artist, designer] b.1887, Augusta, Georgia / d.1959, New Orleans, LA.*
Addresses: New Orleans, active 1906-23. **Studied:** Newcomb Col., 1905-07; Ellsworth Woodward. **Exhibited:** Newcomb Art Alum. Assoc., 1910; NOAA, 1910; Delgado Museum, 1940. Awards: Mary L.S. Neill Medal, 1906; Architectural Art and its Allies, cover design competition, 1906 (hon. men.). **Comments:** Came to New Orleans in 1897. She was best known for her bookplates and prints. Active in city planning until retirement in 1953. **Sources:** *Encyclopaedia of New Orleans Artists,* 327-28.

ROBERTSON, Archibald *[Miniature and portrait painter, teacher of painting] b.1765, Money-Musk, Scotland / d.1835, NYC.*
Addresses: NYC, from 1791. **Studied:** Aberdeen; Edinburgh; and

in London received instruction from Joshua Reynolds and Benjamin West (before 1791). **Member:** American Academy (mem. and dir.). **Exhibited:** American Academy, NYC. **Work:** NYHS. **Comments:** Grew up in Aberdeen, Scotland, where his father was an architect. Came to NYC in 1791 on the invitation of Dr. John Kemp of Columbia College. One of his first works made in America was a portrait from life of General George Washington (NYHS). For the next thirty years Robertson enjoyed a successful career as a miniaturist. He was also a teacher of drawing and painting, and, with his brother Alexander (see entry), operated the Columbian Academy of Painting (one of the earliest art schools in the U.S.). Robertson published a book on drawing (C. 1802) and also wrote on miniature painting. His wife, Eliza Abramse (see entry) of NYC, was also an artist. **Sources:** G&W; DAB; Robertson, *Letters and Papers of Andrew Robertson,* 1, 9, ll-16, 21-40, 285; Stillwell, "Archibald Robertson, Miniaturist"; Morgan and Fielding, *Life Portraits of Washington;* Dunlap, *History;* Flexner, *The Light of Distant Skies,* biblio., 265-66; NYHS Catalogue (1974), cat. nos. 109, 1716-20, and 2192 (repros.).

ROBERTSON, Archibald *[Topographical draftsman while in military] b.c.1745 / d.1813, at his estate "Lawers" (Scotland).*
Work: NYPL owns a portfolio of 54 drawings made by him in Cuba and North America between 1762 and 1780. **Comments:** Entered the British army in 1759, serving at the siege of Havana in 1762, and later in America (1775-80) as officer of the Royal Engineers and Deputy Quartermaster General during the Revolution. After retiring from the service in 1786, Major (later Lt. General) Robertson spent the rest of his life on his estate, "Lawers," near Comrie, Perthshire (Scotland). **Sources:** G&W; Robertson, *Archibald Robertson,. His Diaries and Sketches in America;* Stokes, *Iconography,* V, 994.

ROBERTSON, Bryan *[Writer] mid 20th c.*
Addresses: NYC. **Comments:** Positions: staff mem., *Arts Mag.* Publications: ed., "Jackson Pollock," In: *Library of Modern Master Ser.* (Abrams, 1960). **Sources:** WW73.

ROBERTSON, Cecile Walton *[Painter] b.1891 / d.1956.*
Exhibited: AIC, 1922. **Sources:** Falk, AIC.

ROBERTSON, D. Hall *[Painter] b.1918, Wash., DC.*
Addresses: Leesburg, VA. **Studied:** Corcoran Sch. Art, Wash.; ASL. **Member:** Am. Fedn. Arts. **Exhibited:** Two biennials, 1939 and1945 & solo show, 1947, Corcoran Gal.; Carnegie Inst. Print Exhib., 1952; "Best American Art During Last Five Years," MMA, 1954. Awards: first prize in oils, 1959 & first prize in watercolors, 1969, Northern Va. Fair. **Work:** commissions: mural, US Govt. Post Off., Miss., 1940. **Comments:** Preferred media: oils. Positions: art dir., US Army Hq. Mil. Dist., Washington, 1954-. Teaching: instr. oil painting, US Army, Pentagon, Washington, 1969-. **Sources:** WW73.

ROBERTSON, David D. *[Painter, landscape painter] 19th/20th c.*
Addresses: Detroit, MI; NYC, 1890. **Exhibited:** Michigan Artists' Assoc., Angell's Gal., 1878. **Comments:** Position: scenic painter, Pullman passenger coaches. **Sources:** Gibson, *Artists of Early Michigan,* 202.

ROBERTSON, Donald *[Painter] b.1925, Springfield, IL / d.1984, Buffalo, NY.*
Addresses: Urbana, IL. **Studied:** Indiana Univ, Bloomington (B.A., 1950); John Herron AI, Indianapolis, In., 1952; Univ. of Illinois, Carbondale (M.F.A., 1955). **Exhibited:** PAFA Ann., 1954. **Comments:** Moved to Buffalo in 1967. Teaching: Univ. of Illinois, 1955-60; Fundacion Rodriguez, Acosta Granda, Spain, 1959-60; Dayton Art Inst., Ohio, 1961-63; Rochester Inst. of Technology, New York, 1963-67; State Univ. of New York at Buffalo, 1967-84. **Sources:** Krane, *The Wayward Muse,* 194; Falk, *Exh. Record Series.*

ROBERTSON, Don(ald) H. *[Painter] mid 20th c.*
Addresses: Wash., DC. **Exhibited:** Corcoran Gal biennials, 1941,

1947; PAFA Ann., 1954. **Sources:** Falk, *Exh. Record Series.*

ROBERTSON, Donald J. *[Painter] b.1933, Mt. Vernon, NY.* **Studied:** School of Visual Arts, NY; NAD (scholarship). **Member:** New Rochelle Artists Guild; Mt. Vernon Artists Guild; Mamaroneck Artists Guild. **Exhibited:** Smith-Mason Gal., 1971; River View Gals., NYC; Studio Workshop Gal., NYC; Mary Tucker Gal., NY; Six-Month Gal., New Rochelle, NY; Acts of Art Gal., NYC; Northpoint Gal., LI; Sindin-Harris Gal., Hartsdale, NY; Afro-Leito Gal., White Plains, NY; CI; National Print-Drawing-Photography Show. **Work:** priv. colls. **Sources:** Cederholm, *Afro-American Artists.*

ROBERTSON, Eliza (Mrs. Archibald) See: **ABRAMSE, Eliza (Mrs. A. Robertson)**

ROBERTSON, Ethel Burt *[Miniature painter] b.1872, Cincinnati.* **Addresses:** Cincinnati, OH. **Studied:** Cincinnati Art Acad.; J.W. Dunsmore. **Sources:** WW08.

ROBERTSON, Fred E. *[Painter] b.1878, NYC.* **Addresses:** Savannah, NY. **Studied:** Cornell Univ. (B.S.A.). **Exhibited:** Albright A. Gal.; Rochester Mem. A. Gal.; Saranac Lake A. Lg.; Auburn Mus.; State T.Col., Indiana, Pa.; Gal. St. Etienne, 1945 (solo). **Sources:** WW53; WW47.

ROBERTSON, George J. *[Portrait, landscape, and town-scape painter, teacher] late 19th c.; b.Scotland.* **Addresses:** Milwaukee, WI, 1846-60; Rockford, IL, 1860 to at least 1885. **Studied:** Royal Academy, London. **Exhibited:** Royal Academy, London, 1827-36. **Comments:** Robertson was in Cleveland, OH, by September 1845 and the following year moved to Milwaukee, WI. He drew a view of Milwaukee that was lithographed by D.W. Moody and published in NYC in 1854. Robertson later moved to Rockford, IL, where he taught painting, drawing, and graphics at the Young Ladies Seminary (later Rockford College) from 1860 until 1885. **Sources:** G&W; Butts, *Art in Wisconsin*, 80; Graves, *Dictionary; Portfolio* (Jan. 1952), 100. More recently, see Gerdts, *Art Across America*, vol. 2: 324.

ROBERTSON, H. O. *[Painter, printmaker, illustrator] b.1887, Marion, IL / d.1970.* **Addresses:** Dallas, TX. **Member:** Lone Star Printmakers. **Exhibited:** WFNY, 1939; GGE, 1939; Dallas MFA, 1930-37 (prize); Texas Centennial, 1936; Phila. Art Alliance; SSAL, 1941-44; LOC (Pennell exhib.); NAD; AFA, 1943-44 (Texas Panorama); Texas-Oklahoma General Expo, 1942 (hon. men.); Texas Print Soc., 1943 (prize)-44 (prize); All. AA, 1945 (prize). **Work:** Dallas MFA. **Comments:** A regionalist painter who was also a illustrator for *Ladies' Home Journal.* His works were illustrated in *Life* and *London Studio.* **Sources:** WW40; Dallas MFA Library artist files; Stewart, *Lone Star Regionalism*, 184-85 (w/repros.).

ROBERTSON, Harriet C. (Mrs. James P.) *[Painter] mid 20th c.* **Addresses:** Seattle, WA. **Exhibited:** SAM, 1945. **Sources:** Trip and Cook, *Washington State Art and Artists.*

ROBERTSON, J. *[Painter] mid 20th c.* **Exhibited:** Salons of Am., 1934. **Sources:** Marlor, *Salons of Am.*

ROBERTSON, J. Milton *[Ceramicist] b.1890, Readville, MA.* **Addresses:** Dedham, MA. **Studied:** Hugh C. Robertson. **Member:** Boston SAC; Phila. ACG. **Work:** Dept. Agriculture, Quebec. **Comments:** Position: supervisor, Dedham Pottery, Dedham, MA. **Sources:** WW40.

ROBERTSON, Jane Porter *[Painter] early 20th c.* **Addresses:** Denver, CO, c.1915-19. **Member:** Denver AA; Denver Artists Cl. **Sources:** WW19.

ROBERTSON, John *[Marine painter] mid 19th c.* **Comments:** Known for a ship painting in oils and watercolors on paper, c.1845. **Sources:** G&W; Lipman and Winchester, 179.

ROBERTSON, John Ewart *[Portrait painter] b.1820 / d.1879.* **Addresses:** Liverpool (England) in 1853 &1858; Baltimore in 1860; NYC in 1869. **Exhibited:** Royal Academy, 1844-65; PAFA, 1853-69. **Comments:** Probably some relation to John Roy Robertson; both were in Baltimore about the same time: John Roy lists 20 Mulberry St., Baltimore, in 1859 (NAD); John Ewart lists 11 Mulberry St., Baltimore, in 1860 (PAFA). **Sources:** G&W; Rutledge, PA; Graves, *Dictionary.*

ROBERTSON, John Roy *[Portrait and figure painter] d.After 1884.* **Addresses:** Baltimore, MD, & Wash., DC, active c. 1857-59; NYC, 1869-84. **Studied:** Ary Scheffer. **Member:** Wash. A. Assoc. **Exhibited:** Md. Hist. Soc.; Wash. A. Assoc., 1857-59; NAD, 1859-84; Paris Salon, 1866. **Work:** Md. Hist. Soc.; Chicago Hist. Soc. **Comments:** In 1863 he painted the portrait of Jefferson Davis. He may be some relation to John Ewart Robertson as both were in Baltimore about the same time: John Roy lists 20 Mulberry St., Baltimore, in 1859 (NAD); John Ewart lists 11 Mulberry St., Baltimore, in 1860 (PAFA). **Sources:** G&W; Cowdrey, NAD; Naylor, NAD; Baltimore BD 1859; Lafferty; Rutledge, MHS; Graves, *Dictionary;* repro., Met, Mus., *Life in America*, no. 199; Washington Art Association Cat., 1857, 1859. More recently, see Fink, *American Art at the Nineteenth-Century Paris Salons*, 385; McMahan, *Artists of Washington, D.C.*

ROBERTSON, John Tazewell *[Painter, graphic artist, teacher] b.1905, NYC.* **Addresses:** NYC/Millington, NJ. **Studied:** ASL; Tiffany Fnd., F., 1933. **Exhibited:** CGA. **Work:** WPA. **Comments:** Murals: Hunt C., Omaha, Nebr.; USPO, Nashville (Ark.); Joslyn Mem.; Omaha; McKinley H.S., Cedar Rapids, Iowa. **Sources:** WW40.

ROBERTSON, L. H. *[Painter] early 20th c.* **Exhibited:** Salons of Am., 1927. **Sources:** Marlor, *Salons of Am.*

ROBERTSON, Madeleine Nixon *[Painter, sculptor, teacher] b.1912, Vancouver, BC, Canada.* **Addresses:** Philadelphia, PA. **Studied:** Moore Inst. Des. for Women; PAFA; Graphic Sketch C. **Exhibited:** PAFA, annually; PAFA Ann., 1939; Moore Inst. Des. for Women; Alum. Am. Acad., Rome, 1943 (prize); Phila. A. All. **Awards:** Cresson traveling scholarship, PAFA, 1942; Ware F., 1943. **Work:** Swedish Mus., Phila.; Phila. Sketch Cl.; Stevens Inst., Hoboken, NJ. **Sources:** WW53; WW47; Falk, *Exh. Record Series.*

ROBERTSON, Mary Kemble *[Painter] late 19th c.* **Addresses:** Salem, MA, 1891. **Work:** Peabody Mus., Salem, MA (marine watercolor). **Sources:** Brewington, 327.

ROBERTSON, Mittie Newton (Mrs. Jerome) *[Designer] b.1893, Grandview, TX.* **Addresses:** NYC. **Studied:** Schotz, in Dresden, Germany; D. Wier, NYC. **Exhibited:** All. Artists Am., 1930 (prize). **Comments:** Specialty: textile design. **Sources:** WW40.

ROBERTSON, Nellie B. *[Painter] late 19th c.* **Addresses:** Cleveland, OH. **Exhibited:** NAD, 1886. **Sources:** Naylor, *NAD.*

ROBERTSON, Paul Chandler *[Painter, designer] b.1902, St. Paul, MN / d.1961.* **Addresses:** NYC. **Studied:** Univ. Calif.; Cal. Sch. F. & App. A.; NY Sch. F. & App. A.; & abroad. **Member:** NSMP; A.I.D.; Arch. Lg. **Exhibited:** Anderson Gal.; Gal. Mus. French A., 1932; Kimball, Hubbard & Powell, 1933; Putnam County AA, 1936; Parsons Sch. Des., 1937; Decorators Cl., 1937-39; Decorator's War Relief Exh., 1941; Arch. L., 1946, 1956; NY Coliseum, 1958; Design Center, NY, 1958; Office Emergency Management traveling exh., 1942. **Awards:** prizes, House Beautiful Cover Comp.,1933; Office Emergency Management, 1942. **Work:** murals, Aluminum Corp.; Grace Lines; Claridge Hotel, Atlantic City; Dempsey Hotel, Macon. Ga.; Bowery Savings Bank; Farrell Lines; Atlantic Rayon Co.; Cities Service Oil Co.; Sulgrave Cl., Wash. DC; Alpha Cement Co., Easton, Pa.; Watertown Fed.

Savings & Loan Co.; Lord & Taylor, James McCreery, W.&J. Sloane, R.H. Macy, NY; & in numerous hotels. **Comments:** Contributor to: *House Beautiful, House & Garden, New Yorker,* & other national magazines. Lectures, Mural Painting as a Profession. Fed. FA, NYC. **Sources:** WW59; WW47.

ROBERTSON, Paula M. *[Painter] mid 20th c.*
Exhibited: Salons of Am., 1934. **Sources:** Marlor, *Salons of Am.*

ROBERTSON, Persis Weaver (Mrs. Albert J.)
[Lithographer, painter] b.1896, Des Moines, IA / d.1992, Wash., DC?.
Addresses: Des Moines, IA; Wash., DC. **Studied:** Stone City Art Colony, 1934; Art Students Work Shop, Des Moines; Adrian Dornbush & Lowell Houser; Wells College, Columbia (grad., 1917). **Member:** Audubon Artists. **Exhibited:** AIC; CGA; BM; PAFA; Iowa Art Salon, 1934 (prizes), 1935 (hon. men.), 1936-38; Carson Pirie Scott, 1937 (hon. men.); Iowa Artists Exhibit, Mt. Vernon, 1938; Younker Brothers; Little Gal., 1936; Minnesota State Fair, 1936; AIC, 1935, 1937, 1939; Northwest PM, 1937, 1939-40; Five States Exhibition, 1936; Santa Fe Art Mus., 1936; Carl Freund Gallery, 1937; Philadelphia Print Cl., 1936-37, 1939-40; Phila. A. All., 1936, 1939; Washington WCC, 1939-40; Phila. WCC, 1940; Buffalo Print Cl., 1938, 1940; Boston Soc. Indep. Artists, 1941; Southern PM, 1938; Oakland Art Gal., 1938-39, 1941; Oakland Art Center, 1940-41; LOC, 1945; Audubon Artists, 1945; Joslyn Mem., 1936, 1938, 1940, 1941; Kansas City AI, 1936-41, 1940 (prize); Wichita, KS, 1938-40; Ferargil Gal., 1939 (solo); Hanley Gal., Minneapolis, 1939 (solo); Denver Art Mus., 1939 (solo); W.R. Nelson Gal., 1940 (solo); SAM, 1937; SI, 1955 (solo); Des Moines Art Center, 1951. **Work:** NMAA. **Sources:** WW47; Ness & Orwig, *Iowa Artists of the First Hundred Years,*178; McMahan, *Artists of Washington; DC.*

ROBERTSON, Ralph F. *[Painter] 20th c.*
Addresses: New Rochelle, NY. **Member:** New Rochelle AA. **Sources:** WW25.

ROBERTSON, Rhodes *[Etcher, teacher] b.1886, Somerville, MA.*
Addresses: Minneapolis, MN. **Sources:** WW24.

ROBERTSON, Stewart *[Portrait painter, etcher] b.1887, Dundee, Scotland / d.1970, Los Angeles, CA.*
Addresses: Los Angeles, CA, 1924. **Studied:** Nat'l Gal., London. **Member:** P&S of Los Angeles (pres., 1933-35). **Exhibited:** P&S of Los Angeles, 1926, 1929; Calif. State Fair, 1930; Academy of Western Painters, Los Angeles, 1936-39. **Sources:** Hughes, *Artists in California,* 473.

ROBERTSON, Thomas *[Painter] mid 19th c.*
Addresses: NYC. **Exhibited:** American Art-Union (1847: "Pleasure Yacht"). **Sources:** G&W; Cowdrey, AA & AAU.

ROBERTSON, Thomas *[Sculptor, architect] late 19th c.*
Addresses: Phila., PA. **Exhibited:** PAFA Ann., 1887, 1891-92. **Sources:** Falk, *Exh. Record Series.*

ROBERTSON, Thomas Arthur *[Portrait painter, mural painter, miniature painter, craftsperson] b.1911, Little Rock, AR.*
Addresses: Little Rock, AR. **Studied:** A.L. Brewer. **Exhibited:** PAFA Ann., 1935. **Comments:** Specialty: carved frames. **Sources:** WW40; Falk, *Exh. Record Series.*

ROBERTSON, Walter *[Miniature painter] b.c.1750, Dublin, Ireland / d.1802, Futtehpore.*
Addresses: In America: NYC, 1793-94, Philadelphia, 1795; India thereafter. **Studied:** Dublin, from c.1765. **Comments:** Brother of Irish miniaturist Charles Robertson. He was active in Dublin until 1784, working thereafter in London until 1792 when he returned to Dublin bankrupt. Left for America in 1793, sailing there with his friend, Gilbert Stuart. After about a year in NYC, he moved with Stuart to Philadelphia. There he lived with artists J.J. Barralet and Robert Field and concentrated primarily on making miniature copies of Stuart portraits, although he also painted miniatures of his own, including several from life of Washington.

He left America toward the end of 1795 and went to India. **Sources:** G&W; Strickland, *Dictionary of Irish Artists;* Cone, "The American Miniatures of Walter Robertson"; NYCD 1795-96; Morgan and Fielding, *Life Portraits of Washington,* 195-98; Dunlap, *History;* Thieme-Becker; Benezit.

ROBERTSON, William *[Engraver] mid 19th c.*
Addresses: NYC, 1832. **Comments:** There could possibly be two engravers of this name, since their addresses, as listed in the directories (see references), are different. **Sources:** G&W; *Am. Advt. Directory* 1832, p. 148; NYCD 1832.

ROBERTSON, William *[Ceramicist, craftsperson] b.1864, East Boston / d.1929, Dedham, MA.*
Member: Boston SAC. **Exhibited:** Paris Expo (prize); Buffalo Expo (prize); San Fran. Expo (prize). **Work:** BMFA; Isabella Stewart Gardner Mus., Boston. **Comments:** After mining in the West he returned to his father's pottery, known as the Chelsea Pottery Co. Upon the death of his father he changed the name to the Dedham Pottery, where the well-known blue and white crackle was made, with glaze in imitation of old Chinese pottery. The Twin Stars of Chelsea, vases glazed in rich ox-blood, are perhaps the most notable.

ROBERTSON, William A. *[Marine painter, ship carver] b.1911 / d.1968.*
Work: Peabody Mus., Salem, MA. **Comments:** He was a member of the crwe of "Bear of Oakland" on the 2nd Byrd Expedition to the Antarctic, 1933-35. **Sources:** Brewington, 326.

ROBERTSON, William R. See: **ROBERTSON, William**

ROBERTSON & SEIBERT *[Lithographers] mid 19th c.*
Addresses: NYC, 1854-57. **Comments:** Partners were Alexander Robertson and Henry Seibert (see entries). Succeeded by Robertson, Seibert & Shearman (with addition of James Shearman, see his entry), active 1859-60. **Sources:** G&W; NYBD 1854, 1857-60.

ROBERTSON, SEIBERT & SHEARMAN
[Lithographers] mid 19th c.
Addresses: NYC, active 1859-60. **Comments:** Firm succeeding Robertson & Seibert; the partners were Alexander Robertson, Henry Seibert, and James A. Shearman (see entries). **Sources:** G&W; NYBD 1859-60.

ROBESON, Edna Amelia *[Miniature painter] b.1887, Davenport, IA.*
Addresses: Bettendorf, IA; Woodstock, NY. **Studied:** Frank Phoenix; ASL. **Member:** Pennsylvania Soc. Min. Painters. **Exhibited:** AIC, 1916-18. **Sources:** WW33; Ness & Orwig, *Iowa Artists of the First Hundred Years,* 179.

ROBILLARD, Victor H. *[Listed as "artist"] 19th/20th c.*
Addresses: Working in New Bedford, MA, area, 1896-1900. **Comments:** Listed in *New Bedford City Directory,* 1899-1900; an artist for Am. Art Studio, 1899. **Sources:** Blasdale, *Artists of New Bedford,* 155.

ROBIN, Augustus *[Portrait, historical, and landscape engraver] mid 19th c.*
Addresses: NYC, active c. 1846 and after. **Comments:** Said to have been an employee of J.C. Buttre (see entry) for about 40 years. **Sources:** G&W; NYBD 1846; Stauffer.

ROBIN, Cassie *[Painter] late 19th c.; b.Baltimore, MD.*
Studied: Mlle. Bricou. **Exhibited:** Paris Salon, 1881, 1882. **Comments:** Exhibited drawings at the Paris Salon. **Sources:** Fink, *American Art at the Nineteenth-Century Paris Salons,* 385.

ROBIN, Edward See: **ROBYN, Eduard (Edward)**

ROBIN, Fanny *[Painter] b.1888, Philadelphia, PA.*
Addresses: Philadelphia, PA. **Studied:** Moore Inst. Des.; PAFA; & with Breckenridge, Snell, Horter. **Member:** Woodmere Art Gal.; PAFA; Plastic Club, Art All., Art Teachers Assn., all of Phila. **Exhibited:** PAFA, 1936, 1939; Phila. Art All., 1943 (solo); DaVinci All., 1942 (prize); Phila. Plastic Club, 1943(medal),

1955 (gold). **Sources:** WW59; WW47.

ROBIN, Nathaniel *[Painter] mid 20th c.*
Addresses: NYC. **Exhibited:** S. Indp. A., 1931; Salons of Am., 1934. **Sources:** Falk, *Exhibition Record Series.*

ROBINEAU, Adelaide (Mrs) *[Craftsperson, teacher] b.1929, Syracuse, NY.*
Comments: Position: t., Col. of FA, Syracuse Univ. Her porcelains won nat. and intl. awards.

ROBINEAU, Francis See: **RABINEAU, Francis**

ROBINEAU, BERTHAUT & CO. *[Engravers] mid 19th c.*
Addresses: NYC, active 1860. **Comments:** Robineau is not listed separately in the directories; Berthaut is Tony Berthaut (see entry), engraver and die sinker, 1856-59. **Sources:** G&W; NYBD 1860; NYCD 1856-60.

ROBINOR, Rudolph *[Painter] mid 20th c.*
Addresses: NYC. **Exhibited:** S. Indp. A., 1931. **Sources:** Marlor, *Soc. Indp. Artists.*

ROBINS, Hugo *[Painter] 20th c.*
Addresses: NYC. **Exhibited:** Salons of Am. **Sources:** WW21.

ROBINS, John L. *[Listed as "artist"] early 19th c.*
Addresses: NYC, 1818-21. **Comments:** *Cf.* Luke Robins. **Sources:** G&W; NYCD 1818-21.

ROBINS, Louisa Winslow (Mrs. Thomas) *[Painter, illustrator] b.1898, Dedham, MA / d.1962, Darien, CT.*
Addresses: Buffalo, NY, 1920-49; Darien, CT, 1949-on. **Studied:** George Luks (summer); Albright-Knox Gal. Sch. Art, Buffalo; Silvermine Gld., after 1949. **Member:** Patteran Soc. (founding mem., 1933); New Haven PCC, 1957. **Exhibited:** Artists Western NY (prize); Albright Art Gal., Buffalo, 1936 (prize), 1940 (prize); AIC, 1940; Bonestell Gal., NYC, 1944 (solo); New Haven PCC, 1950s. **Work:** MoMA; Albright-Knox Gal.; Wadsworth Atheneum. **Sources:** WW40; Krane, *The Wayward Muse,* 194.

ROBINS, Luke *[Scene painter, teacher of painting] 18th/19th c.*
Addresses: Philadelphia, until c.1796; Petersburg, VA, 1796-c.1810; Philadelphia, c.1810-on. **Comments:** Robins was a scene painter at the New Theatre in Philadelphia before moving to Petersburg, VA, where it was announced in July 1796 that he had been hired as scene painter at a new theater to be opened in that city. At the time it was also reported that he had future projects in Richmond and Norfolk (VA). Robins returned to Philadelphia about 1810 where he taught landscape, architectural, and flower painting. *Cf.* John L. Robins. **Sources:** G&W; Prime, II, 33; Brown and Brown.

ROBINS, Mary Ellis *[Painter, teacher] b.1860, Ashwood Plantation, MS. / d.1949.*
Addresses: Phila., PA. **Studied:** Phila. Sch. Des. for Women; PAFA; with Stephen Ferris, James R. Lambdin, and Chase. **Member:** Plastic Club; Soc. Arts & Letters. **Work:** Phila. Hist. Soc. **Sources:** WW10; Petteys, *Dictionary of Women Artists.*

ROBINS, Seymour *[Illustrator, painter] 20th c.*
Addresses: New York 36, NY. **Sources:** WW59.

ROBINS, Susan P.B. *[Painter] b.1849, Boston. / d.c.1922.*
Addresses: Boston, MA. **Studied:** J.Johnston; R.Turner; F. Crowninshield; BMFA Sch., with P. Hale. **Member:** Copley Soc., 1894. **Exhibited:** Boston AC, 1888, 1901, 1905, 1907, 1908; AIC, 1902-11, 1918, 1920; PAFA Ann., 1903. **Sources:** WW25; Falk, *Exh. Record Series.*

ROBINS, William P. *[Painter] mid 20th c.*
Exhibited: AIC, 1946. **Sources:** Falk, *AIC.*

ROBINSON, A. A. (Mrs.) *[Painter] late 19th c.*
Addresses: Active in Detroit, MI. **Exhibited:** Great Art Loan, Detroit, 1895 (flowers). **Sources:** Petteys, *Dictionary of Women Artists.*

ROBINSON, Adah Matilda *[Painter, designer, lecturer, educator] b.1882, Richmond, IN.*
Addresses: San Antonio, TX. **Studied:** Earlham College; AIC; & with Charles Hawthorne, George Elmer Browne, John Carlson, A. Woelfle. **Member:** San Antonio Art Lg.; Southwestern AA; Prairie Printmakers (hon.); CAA. **Exhibited:** Awards: Univ. Tulsa, 1936 (hon. degree, D.A.). **Work:** Oklahoma City Art Lg.; Philbrook AC; designed interior, First Church of Christ Scientist, Tulsa, OK; mem. fountain, Tulsa; Second Church of Christ Scientist, Tulsa; Christian Science Church, Bartlesville, OK; Tulsa Pub. Lib.; Boston Ave. Methodist Church, Tulsa. **Comments:** Positions: chmn., art dept., Tulsa (OK) Univ., 1927-45; Trinity Univ., San Antonio, TX, 1945-. Lectures: Historical & Modern Art Periods. **Sources:** WW59; WW47.

ROBINSON, Alexander Charles *[Painter, teacher] b.1867, Portsmouth, NH. / d.1940.*
Addresses: NYC; Boston, MA/London, England & Paris, France. **Studied:** Lowell Sch. Des.; Académie Julian, with Doucet and Constant. **Member:** NYWCC; Phila. WCC; Chicago WCC; AWCS; SC; Société Nationale des Aquarellistes; Société des Artistes Coloniale in Paris; Cercle d'Art, Tournai and Bruges, Belgium; United Arts C., London. **Exhibited:** Boston AC, 1894, 1899, 1905; PAFA Ann., 1894, 1900-02, 1910; SNBA, 1899; P.-P. Expo, San Fran., 1915 (med); AIC. **Work:** TMA; Rockford (Ill.) AA; Miss. AA, Jackson; PAFA; NOMA; Newcomb Gal., Tulane Univ.; D. Fitzgerald A. Gal., Brookline, Mass.; Museum d'Ixelles; Moscow, Russia; Glasgow, Dundee, both in Scotland; London, Manchester, both in England. **Sources:** WW40; Fink, *American Art at the Nineteenth-Century Paris Salons,* 385; Falk, *Exh. Record Series.*

ROBINSON, Alexandre *[Painter] mid 20th c.*
Exhibited: PAFA Ann., 1948. **Sources:** Falk, *Exh. Record Series.*

ROBINSON, Alfred *[Amateur sketcher] b.1806, Massachusetts / d.1895, probably California.*
Addresses: Active in California, 1829-42. **Comments:** Went to California in 1829 and remained for eight years as agent for Bryant & Sturgis, Boston merchants. In 1837 he returned East with his wife, but he was in California again in 1840-42 as agent for Bryant & Sturgis, and after 1849 as representative of the Pacific Mail Steamship Company. In 1846 he published anonymously *Life in California,* containing seven lithographs based on his own sketches made between 1829 and 1842. **Sources:** G&W; Van Nostrand and Coulter, *California Pictorial,* 36; P&H Samuels, 403.

ROBINSON, Alice *[Landscape painter, lecturer, teacher, writer] 20th c.; b.Westmoreland Co., PA.*
Addresses: Columbia, OH. **Studied:** Miami Univ.; Columbia; C. Hawthorne; H.B. Snell; Cincinnati Art Acad.; ASL. **Member:** College AA; Columbus Gal. FA; Friends of Art, Columbus; Ohio WCS. **Comments:** Position: teacher, Ohio State Univ. **Sources:** WW40.

ROBINSON, Allan *[Painter] mid 20th c.*
Exhibited: Hemingway Gals., NYC, 1969. **Sources:** info. courtesy of Charles Semowich, Rensselaer, NY.

ROBINSON, Alonzo Clark *[Writer, sculptor] b.1876, Darien, CT.*
Addresses: Paris, France. **Member:** SBA. **Sources:** WW31.

ROBINSON, Amy R. *[Painter] 20th c.*
Addresses: Brooklandville, MD. **Sources:** WW25.

ROBINSON, Ann *[Painter] 20th c.*
Addresses: Laguna Beach, CA. **Member:** Laguna Beach AA. **Sources:** WW25.

ROBINSON, Birdy (Susanne) Antrobus See: **ANTROBUS, Birdy (Susanne)**

ROBINSON, Boardman *[Painter, mural painter, illustrator, cartoonist, teacher] b.1876, Somerset, Nova Scotia, Canada / d.1952,*

Colorado Springs, CO.
Addresses: NYC, 1904-30; Colorado Springs, CO, 1930-52.
Studied: Boston Normal Art Sch. with E.W. Hamilton, 1894-97; Acad. Julian, Paris, 1898-1900; Acad. Colarossi & École des Beaux-Arts, 1901-04. **Member:** SI; AIAL. **Exhibited:** Armory Show, 1913; Pan-Pac. Expo, 1915; S. Indp. A., 1922; PAFA Ann., 1926, 1939, 1944, 1950; Arch. Lg., 1930 (gold); AIC; WMAA, 1923-47; Corcoran Gal. biennials, 1947, 1949. **Work:** Colorado Springs FA Center; NMAA; MMA; Dallas MFA; Amon Carter Mus.; Mus. New Mexico; AIC; LOC; Harvard Univ.; LACMA; Wichita Mus. Art; Fogg Mus. Art; NYU; Denver AM; Univ. Arizona. **Murals:** Rockefeller Center, NYC; Dept. Justice, Wash., DC; USPO, Englewood, CO ("Horse Show") **Comments:** Came to the US in 1894. After studying and painting in Paris and San Francisco, he went to work as a cartoonist for the New York *Morning Telegraph,* 1907-10 and the New York *Tribune,* 1910-14. He went to Russia with John Reed in 1915 to cover the Kerensky Revolution for *Metropolitan Magazine,* and from 1915-20 worked for *The Masses, Liberator,* and *Harper's Weekly.* Robinson was also an important muralist, the ones he designed for Kaufmann's Dept. Store in Pittsburgh (1927-29) are considered by many the first modern American murals. In 1930 he settled in Colorado Springs where he taught and served as director at the Art Academy of the Colorado Springs FA Center, drawing many prominent artists to teach at the school (among them George Biddle, Thomas Hart Benton, Henry Varnum Poor, Adolf Dehn, arnold Blanch, Edgar Britton). Positions: teacher, ASL, 1924-30; teacher and later dir., Broadmoor Art Acad. (absorbed into the Colorado Springs FA Center in 1936), 1930-. Illustr.: *Cartoons of the War* (Dutton, 1915); *Spoon River Anthology; Moby Dick; The Brothers Karamazov; The Idiot;* also, *Rhymes of If and Why,* by Betty Sage (Duffield); *The War in Eastern Europe,* by John Reed. **Sources:** WW47; Baigell, *Dictionary;* Albert Christ-Janer, *Boardman Robinson* (1946); *Colorado Springs Fine Arts Center: A History and Selections From the Permanent Collections* (1986); P&H Samuels, 403; Falk, *Exh. Record Series.*

ROBINSON, C. B., Jr. *[Painter] mid 20th c.*
Addresses: NYC. **Exhibited:** S. Indp. A., 1929, 1934. **Sources:** Marlor, *Soc. Indp. Artists.*

ROBINSON, Carrie B(rown) *[Painter, craftsperson] b.1867, Johnstown, PA.*
Addresses: Cleveland, OH/Gates Mill, OH. **Studied:** PAFA; Cleveland SA. **Member:** Womans AC, Cleveland. **Sources:** WW25.

ROBINSON, Charles Aral *[Commercial artist] b.1905, Pennsylvania.*
Studied: NYC; Canada; Buffalo. **Exhibited:** Harmon Fnd., 1924, 1929, 1930; Studio 1, Berkeley; S. Indp. A., 1937. **Sources:** Cederholm, *Afro-American Artists.*

ROBINSON, Charles Dormon *[Landscape and marine painter, illustrator] b.1847, E. Monmouth, ME / d.1933, San Rafael, CA.*
Addresses: San Francisco, CA; San Rafael, CA. **Studied:** with Wm. Bradford, 1862; G. Inness, M.F.H. de Haas, 1863; R. Gignoux, Cropsey, Newport, VT, 1866-67; Paris, with Boudin, 1899-01. **Member:** Palette Club, San Fran.; San Fran. AA; Bohemian Cl.; San Fran. Sketch Cl. **Exhibited:** Mechanics Fair, San Fran., 1860 (diploma, best marine drawing by a juvenile); San Francisco AA, 1876; Sacramento State Fair, 1878 (prizes); NAD, 1891; NGA, 1891; Calif. Midwinter Int'l Expo, 1894; Mark Hopkins Inst., 1897; Calif. State Fair, 1930. **Work:** Calif. Hist. Soc.; San Francisco Maritime Mus.; Soc. Calif. Pioneers; Crocker Mus., Sacramento; Oakland Art Mus.; Bohemian Cl.; de Young Mus.; Sierra Nevada Mus., Reno; 84 works in British collections. **Comments:** Active in Vermont, 1861-73; in Iowa, 1873-74; then returned to and settled in San Francisco. He began as a photo retoucher and wrote and illustrated for *Overland Monthly* and *Century.* He made his first trip to Yosemite in 1880 and returned there for 24 summers. He played a significant part in making Yosemite a national park and became a leading interpreter of the

area, painting in the tradition of the Hudson River School. After his 50 x 400 foot, 50 ton painting of Yosemite was rejected by the Paris Expo in1900, he cut it into pieces for sale to finance his trip home. Robinson published an article about the panorama, its inspiration and progress. In 1906, much of his earlier work was destroyed in the San Francisco earthquake and fire. **Sources:** WW17; Hughes, *Artists in California,* 473; P&H Samuels, report alternate birthplace of Vermont, 403.

ROBINSON, Charles H(oxsey) *[Painter, teacher] b.1862, Edwardsville, IL. / d.1945, Morro Bay, CA.*
Addresses: Morro Bay, CA. **Studied:** Washington Univ.; St. Louis School of Arts; with J. Fry, C. Von Salza, E. Wuerpel. **Member:** Calif. WCS; AAPL. **Exhibited:** St. Louis Expo; Calif. State Fairs. **Comments:** Position: art dir., WPA Recreation Center, Morro Bay. **Sources:** WW33; Hughes, *Artists in California,* 473.

ROBINSON, Charles W *[Painter] 20th c.*
Addresses: Rochester, NY. **Member:** Rochester AC. **Sources:** WW25.

ROBINSON, Charlotte *[Painter] 19th/20th c.*
Addresses: Detroit, M, 1879-83I. **Exhibited:** Michigan State Fairs, 1879, 1883. **Comments:** Preferred media: watercolor, pastels. **Sources:** Gibson, *Artists of Early Michigan,* 202.

ROBINSON, Clemens Tanquary (Mrs.) *[Painter] mid 20th c.*
Addresses: NYC. **Exhibited:** S. Indp. A., 1928-30, 1933-35. **Sources:** Marlor, *Soc. Indp. Artists.*

ROBINSON, David *[Painter, illustrator] b.1886, Warsaw, Poland.*

David Robinson 1910

Addresses: Chicago , 1907; Silvermine, CT. **Studied:** America; France; Germany. **Member:** SI, 1910; SC; S.Indp.A.; Artists' G.; Silvermine GA; AFA. **Exhibited:** AIC, 1907; S. Indp. A., 1917-20, 1922. **Sources:** WW40.

ROBINSON, Delia Mary *[Painter, etcher, teacher, illustrator] mid 20th c.; b.Waterloo, NE.*
Addresses: Waterloo, NE; Los Angeles, CA, 1920s, 1930s. **Studied:** Forsberg; E. Church; Chichester. **Member:** Laguna Beach AA; Omaha AG. **Exhibited:** P&S of Los Angeles, 1922; Los Angeles County Fair, 1929. **Work:** dec. study, Jr. H.S., Kearney; Masonic and Eastern Star Home, Plattsmouth, Nebr. **Sources:** WW40; Hughes, *Artists in California,* 474.

ROBINSON, Dent *[Painter] 20th c.*
Addresses: NYC. **Sources:** WW19.

ROBINSON, Dorothy (Mrs. Gardiner S.) See: **VOLTZ, Dorothy (Mrs. Gardiner S. Robinson)**

ROBINSON, Edward *[Museum director] b.1858 / d.1931.*
Addresses: NYC. **Studied:** Harvard, 1879; Europe, 1879-84. **Member:** American Acad., Rome (trustee); Am. Fed. A. (Dir.); Mus. City of N.Y. (trustee). **Comments:** Also selected and arranged collections in the Slater Mem. Mus., Springfield (Mass.) AM. Position: dir., MMA, 1910-31.

ROBINSON, Elizabeth See: **HAWES, Elizabeth Eppes Osborn (Robinson)**

ROBINSON, Elizabeth Bradbury Stanton (Mrs.) *[Painter] b.1832 / d.1897.*
Work: Bowdoin (ME) College Mus. Art (pastel landscape). **Sources:** Petteys, *Dictionary of Women Artists.*

ROBINSON, Florence H. *[Educator] mid 20th c.; b.San Luis Obispo, CA.*
Addresses: Sweet Briar, VA. **Studied:** Univ. California (B.A., M.A.); Am. Acad. in Rome (F.A.A.R.); Columbia Univ. (Ph.D.). **Member:** CAA; Archaeological Inst. Am.; Am. Assn. Univ. Prof.; Am. Assn. Univ. Women; Soc. Arch. Historians; Southeast Col. A. Conference. **Exhibited:** Awards: Drisler F., Columbia Univ., 1922-24; Jesse Benedict Carter F., Am. Acad. in Rome, 1924-25. **Comments:** Positions: instr., Mt. Holyoke Col., 1925-26; asst.

prof., 1927-30, assoc. prof., 1930-37, prof., 1937- , hd. dept. a., 1936-, Sweet Briar Col., Sweet Briar, Va. Contributor to "Memoirs of the American Academy in Rome." Lectures on Greek & Roman Art; History of Architecture; Medieval Art; Art of the Americas. **Sources:** WW53.

ROBINSON, Florence V(incent) *[Painter] b.1874, Boston, MA / d.1937.*
Addresses: Boston, MA; NYC. **Studied:** Vignal, Dagman-Bouveret, Whistler, and Harpignies in Paris. **Member:** Société des Aquarellistes, Paris; AWCS. **Exhibited:** Boston AC, 1893, 1898, 1900, 1905-08; PAFA Ann., 1895; Paris Salon, 1899; AIC; Royal Acad., London; Boston Art Dept. , 1982-96; J. Eastman Chase Gal., 1907; Charles E. Cobb Gal., 1911-15; Chicago; Phila.; St. Louis. **Work:** Harvard; Cleveland Sch. Art; Govt. Collection, France; BMFA; Hispanic Mus., NYC; BM. **Comments:** Specialty: watercolor. **Sources:** WW38; Fink, *American Art at the Nineteenth-Century Paris Salons,* 385; Petteys, *Dictionary of Women Artists,* cites alternate birth date of 1864; Falk, *Exh. Record Series.*

ROBINSON, Frank *[Marine painter] mid 19th c.*
Comments: Known through one ship picture in watercolor and pencil, dated c.1860. **Sources:** G&W; Lipman and Winchester, 179.

ROBINSON, Frederick B. *[Art administrator] b.1907, Boston, MA.*
Addresses: Longmeadow, MA. **Studied:** Harvard Univ., Fogg Art Mus. fellowship for study in Europe (B.S.); Western New England College (hon. L.H.D., 1962). **Exhibited:** Awards: Outstanding Servant Public, WWLP TV, 1964; Benjamin Franklin fellowship, Royal Soc. Encouragement Arts, London, England, 1968. **Comments:** Positions: dir., Mus. Fine Arts, Springfield, MA. Publications: contributor, museum bulletins, art magazines & newspapers. Teaching: prof. art history, Springfield Tech. Community College, 1969-. **Sources:** WW73.

ROBINSON, Gertrude (Mrs. Frederic G.) See: **PEW, Gertrude L. (Mrs. Frederic G. Robinson)**

ROBINSON, G.H. D. *[Painter] mid 20th c.*
Exhibited: S. Indp. A., 1935. **Sources:** Marlor, *Soc. Indp. Artists.*

ROBINSON, Godfrey Harding *[Painter] 19th/20th c.*
Addresses: Boston, active 1899. **Exhibited:** Boston AC, 1895, 1899. **Sources:** Campbell, *New Hampshire Scenery,* 134.

ROBINSON, Grace A. *[Painter] 19th/20th c.*
Addresses: San Francisco, CA. **Exhibited:** Mark Hopkins Inst., 1898. **Sources:** Hughes, *Artists in California,* 474.

ROBINSON, Granville S. *[Painter] mid 20th c.*
Exhibited: S. Indp. A., 1941. **Sources:** Marlor, *Soc. Indp. Artists.*

ROBINSON, H. L. *[Sculptor, painter] 20th c.*
Addresses: Columbus, OH. **Member:** Pen and Pencil Club, Columbus. **Sources:** WW25.

ROBINSON, Hal *[Landscape painter] b.1875 / d.1933.*
Addresses: NYC. **Exhibited:** NAD, 1896; Corcoran Gal biennial, 1910. **Comments:** He also painted at Old Lyme, CT. **Sources:** WW15; *The Boston AC,* which states that he is possibly the H.H. Robinson who exhibited at the Boston AC in 1881 and 1884.

ROBINSON, Harriette Wood *[Painter] 20th c.*
Addresses: Auburn, ME. **Sources:** WW08.

ROBINSON, Harry A. *[Painter] 19th/20th c.*
Addresses: New Orleans, active 1888-1900. **Comments:** Came to N.O. from Cleveland, OH. **Sources:** *Encyclopaedia of New Orleans Artists,* 328.

ROBINSON, Helen Avery *[Sculptor] mid 20th c.; b.Louisville, KY.*
Addresses: NYC. **Studied:** Solon Borglum; ASL. **Exhibited:** PAFA Ann., 1922; NSS, 1928; S. Indp. A., 1929. **Sources:**

WW24; Natl. Sculp. Soc., *Exh. of Amer. Sculpture Cat.,* 1928, 207; Falk, *Exh. Record Series.*

ROBINSON, Henry R. *[Carver, gilder, caricaturist, and lithographer] mid 19th c.*
Addresses: NYC. **Exhibited:** American Institute. **Comments:** Listed as a carver and gilder in 1833-34, caricaturist 1836-43, lithographer and print publisher 1843-51. **Sources:** G&W; Peters, *America on Stone;* NYCD 1836-51; Am. Inst. Cat., 1842, 1847; *Portfolio* (Jan. 1954), 116, repro.; *Antiques* (Sept. 1940), 120, and (July 1945), 34, repros.

ROBINSON, Hilyard Robert *[Architect, designer] b.1899, Wash., DC.*
Studied: Pennsylvan. Mus. of Indus. Arts, 1917; Univ. of Pennsylvania; Columbia Univ. (B.Arch., 1924, M.Arch., 1931); Univ. of Berlin, 1931-32. **Exhibited:** Harmon Fnd., 1928. Awards: Magazine of Arch., medal & prizes, 1928; Wash. Board of Trade, 1943 (prize), 1952 (merit award). **Comments:** Positions: hd. of dpt. of arch., Howard Univ.; senior arch., consultant, Government Housing Agencies, 1934-35, 1939. **Sources:** Cederholm, *Afro-American Artists.*

ROBINSON, Howard W. *[Painter] mid 20th c.*
Addresses: NYC. **Exhibited:** S. Indp. A., 1933-34. **Sources:** Marlor, *Soc. Indp. Artists.*

ROBINSON, Imogene See: **MORRELL, Imogene Robinson**

ROBINSON, Increase *[Painter, lecturer] b.1890, Chicago, IL.*
Addresses: Chicago, IL. **Member:** Chicago SA; Chicago AC. **Exhibited:** AIC, 1927-35. **Comments:** Position: asst. to Natl. Dir., WPA. **Sources:** WW38.

ROBINSON, Ione *[Painter, illustrator, etcher, writer] b.1910, Portland, OR.*
Addresses: NYC. **Studied:** Otis AI; PAFA; Paris, France, 1927-29. **Exhibited:** LACMA, 1929; Marie Harriman Gal., 1931; Delphic Studios, 1931; Julian Levy Gal., 1938; Univ. Mexico: 1938; PAFA Ann., 1939, 1941; Bonestell Gal., 1940; Bellas Artes, Mexico, D.F. 1944. Awards: Guggenheim F., 1931. **Comments:** Author: "A Wall to Paint On," 1946; I., "Impressions of South America," 1933. Contributor to: *Saturday Review of Literature, California Arts & Architecture* magazines. **Sources:** WW53; WW47; Falk, *Exh. Record Series.*

ROBINSON, Irene Bowen (Mrs. W.W.) *[Illustrator, painter] b.1891, South Bend, WA / d.1973, Santa Monica, CA.*
Addresses: Los Angeles, CA. **Studied:** Drury College (A.B.); Univ. Chicago; Broadmoor Art Acad.; with J.F. Carlson; Otis AI. **Member:** Calif. WC Soc.; Calif. AC; Laguna Beach AA; Progressive Painters of Southern California; Contemporary Painters, 1931(a founder). **Exhibited:** LACMA, 1930-35 (prize), 1936 (prize)-43 (solo), 1944-45, 1950; San Diego FAS, 1927 (prize); Calif. AC, 1931 (prize); GGE, 1939; Ebell Salon, 1934 (prize), 1942 (prize), 1945 (prize), 1951 (prize); Glendale AA, 1945 (prize). **Work:** Pasadena AI. **Comments:** Modernist painter, who illustrated books by her husband, W.W. Robinson. Illus., "At the Zoo," 1940; "Picture Book of Animal Babies," 1946; "The Forest and the People," 1946, "Land in California," 1948, "The Malibu," 1958, and others. **Sources:** WW59; WW21; WW47. More recently, see Hughes, *Artists in California,* 474; Trenton, ed. *Independent Spirits,* 76.

ROBINSON, Isabel See: **ROBINSON, (Virginia) Isabel**

ROBINSON, Isabel Dauchy *[Painter, craftsperson, etcher] b.1896, San Diego, CA / d.1982, Monterey, CA.*
Addresses: Pacific Grove, CA. **Studied:** night classes in Los Angeles. **Member:** Las Artistas Cl. of Los Angeles; Women Painters of the West. **Work:** Pacific Grove Women's Club; Monterey Civic Cl. **Sources:** Hughes, *Artists in California,* 474.

ROBINSON, J. C. *[Portrait painter] mid 19th c.*
Work: NGA (Garbisch Collection). **Comments:** Painter of portraits of an old man and an old woman, 1848. **Sources:** G&W;

Garbisch Collection catalogue, 94-95, repros.

ROBINSON, J. H. D. *[Painter] mid 20th c.*
Studied: Brooklyn Art School; ASL; NY Univ.; College AA.
Exhibited: Harmon Fnd., 1931, 1935; NY Pub. Lib.; American Negro Expo., Chicago, 1940; Roerich Mus., 1934; Soc. of Independent Artists, 1935; Harmon Col. Trav. Exh., 1934-35; Texas Centennial, 1936; WPA, 1934; Atlanta Univ., 1944. **Sources:** Cederholm, *Afro-American Artists.*

ROBINSON, James *[Art & antiques dealer] b.1936.*
Addresses: NYC. **Comments:** Head of the antique silver establishment in NYC which bears his name today. An authority on old English silver, his hobby was the collection of china. He established offices in London, Palm Beach, Newport and Southampton.

ROBINSON, Jay *[Painter] b.1915.*
Exhibited: PAFA Ann., 1948-49, 1952; Corcoran Gal biennial, 1949. **Sources:** Falk, *Exh. Record Series.*

ROBINSON, Jay Thurston *[Painter, designer] b.1915, Detroit, MI.*
Addresses: NYC; Pleasantville, NY. **Studied:** Yale Col. (BA); Cranbrook Acad. Art (M.F.A.), with Zoltan Sepeshy. **Member:** AEA. **Exhibited:** Detroit IA, 1941-42; Pepsi-Cola, 1944 (purchase prize); Audubon Artists, NYC; CI; CGA Biennial; NAD ,1945; PAFA. **Awards:** RKO Comp., 1944; Louis Comfort Tiffany Found. fel, 1949; seven purchase awards, Childe Hassam Fund, Am. Acad. Arts & Lett. **Work:** U.S. Govt.; Pepsi-Cola Coll.; Cranbrook Mus, Bloomfield Hills, Mich; Detroit Inst Art, Mich; Houston Mus Fine Arts, Tex; Speed Mus., Louisville, Ky.; Philbrook Art Ctr., Tulsa, Okla. **Comments:** Art Interests: non-objective; semi-abstract on human themes; portraits. **Sources:** WW73; WW47.

ROBINSON, Jean A. *[Painter] 20th c.*
Addresses: Charleston, SC. **Sources:** WW21.

ROBINSON, John *[Wood engraver] b.c.1835, (in U.S.).*
Addresses: Boston in 1860. **Sources:** G&W; 8 Census (1860), Mass., XXVIII, 100.

ROBINSON, John *[Portrait and miniature painter] b.England / d.1829, Philadelphia.*
Addresses: Philadelphia. **Exhibited:** PAFA, 1816-24. **Comments:** Friend of Benjamin West; his *A Description of and Critical Remarks on the Picture of Christ Healing the Sick in the Temple Painted by Benjamin West, Esq.* appeared in February 1818 (West's critically acclaimed painting had been completed in 1811). Robinson's miniature of West was shown at PAFA in 1817. **Sources:** G&W; Rutledge, PA; Robinson, *op. cit.;* Scharf and Westcott, *History of Philadelphia,* II, 1053; Dunlap, *History.*

ROBINSON, John *[Engraver and die sinker] b.c.1832, New York.*
Addresses: NYC, from c. 1856. **Sources:** G&W; 8 Census (1860), N.Y., XLIX, 1028; NYBD 1856-59.

ROBINSON, Kate *[Painter] 19th/20th c.*
Addresses: Jackson, MI, 1876-82. **Exhibited:** Michigan State Fair, 1876-77, 1882. **Sources:** Gibson, *Artists of Early Michigan,* 202.

ROBINSON, Kathleen See: **INGELS, Kathleen Beverley Robinson (Mrs.)**

ROBINSON, L. S. Mona *[Painter] early 20th c.*
Addresses: Paoli, PA. **Exhibited:** PAFA Ann., 1924. **Sources:** WW25; Falk, *Exh. Record Series.*

ROBINSON, Leo *[Painter] late 20th c.*
Studied: Howard Univ.; Cranbrook Academy of Art (M.F.A.). **Exhibited:** James A. Porter Gal., 1970; Barnet Aden Gal., Wash., DC; Howard Univ. (award); Smithsonian Inst.; Dreyer Gal., Houston; Fisk Univ.; George Wash. Univ.; Wash. Gal. of Modern Art; Talladega Col.(solo, award); Dartmouth Col. (award); Sheraton Hotel, Phila., 1968. **Sources:** Cederholm, *Afro-American Artists.*

ROBINSON, Louis A. *[Painter] mid 20th c.*
Addresses: San Francisco, CA. **Exhibited:** San Francisco AA, 1936. **Sources:** Hughes, *Artists in California,* 474.

ROBINSON, M. E. *[Painter] d.1928.*
Addresses: Brooklyn, NY. **Exhibited:** Boston AC, 1888; Brookly AC, 1898; NAD, 1886, 1893. **Sources:** WW01; Petteys, *Dictionary of Women Artists.*

ROBINSON, Marcus J. *[Painter] b.1858, New Orleans, LA / d.1930, New Orleans.*
Addresses: New Orleans, active 1879-1902. **Sources:** *Encyclopaedia of New Orleans Artists,* 328.

ROBINSON, Margaret Frances *[Landscape painter, designer] b.1908, Hull, MA.*
Addresses: New Orleans, LA. **Studied:** W. Adams; R. Davey; L. Randolph. **Member:** NOAA; SSAL. **Comments:** Position: a. dir., Civic Theatre Players, New Orleans. **Sources:** WW40.

ROBINSON, Mary (Mrs. Arthur) See: **CANE, Mary (Mrs. Arthur Robinson)**

ROBINSON, Mary P. *[Painter] early 20th c.*
Exhibited: Salons of Am., 1925. **Sources:** Marlor, *Salons of Am.*

ROBINSON, Mary Turlay *[Painter, lecturer] b.1887, South Attleboro, MA.*
Addresses: NYC. **Studied:** Vassar Col. (A.B., 1910); ASL; Fontainebleau, France; Dumond; Luks; Beaudoin; Despujols. **Member:** AFA; French Fresco Soc.; Officer of French Acad., 1933; Nantucket AA (jury committee, 1970); Smithsonian Assocs. (nat. mem.); AEA (bd. of dirs.); ASL (life mem.; woman's vice-pres., 1922-23); Fontainebleau Alumni Assn. (liaison officer, 1928). **Exhibited:** WMAA, 1922-1923; NAWA, 1929-36; S. Indp. A., 1930; Am. Woman's Assn., 1932-38, 1937 (prize); Anderson Gal., 1930 (solo); Nantucket AA, 1933-45; Bignous Gal., 1941, 1942; Salons of Am.; Salon d'Automne, 1925; Les Indépendents, Paris, France, 1926; Kraushaar Gal. Shows; Fontainebleau Alumni Assn.; Arch. League; Cooper Union Mus.; Anderson Gals., 1930 (solo); Binet Gal., NYC, 1950 (solo). **Awards:** best in show, Am. Woman's Assn.; Jurors Choice, Nantucket AA, 1971. **Work:** CUA School. **Commissions:** fresco (with La Montagne St. Hubert), Expos Arts Decoratifs, 1925. **Comments:** Preferred media: oils. Publications: author, articles in art magazines & college publications, 1971. Teaching: lecturer, Background In Art, MMA & other museums & galleries, New York; lecturer, Forming Collections, Jr. League New York. Collection: American and French artists' paintings of the 19th-and 20th-centuries. **Sources:** WW73; WW47, puts birth at 1888; Petteys, *Dictionary of Women Artists.*

ROBINSON, Mary Yandes *[Painter, illustrator] 19th/20th c.; b.Milwaukee, WI.*
Addresses: Indianapolis, IN, c.1900-20. **Studied:** Indiana Art School; ASL; and with Chase, K. Cox, Sue Ketcham, and Rhoda Nichols. **Member:** SWA (associate). **Sources:** WW01; Petteys, *Dictionary of Women Artists.*

ROBINSON, Maude *[Craftsman, lecturer, teacher] b.1880, Corning, NY / d.Before 1976.*
Addresses: NYC; Sharon, CT. **Studied:** ASL, 1903; Newcomb Col., Tulane Univ.; NY State Ceramic Sch.; & with Charles Binns, Arthur Dow, John Twachtman, J.F. Carlson; H.S. Mowbray; K. Cox; Newcomb Pottery; A. Baggs. **Member:** NY Keramic Soc. (hon.). **Exhibited:** MMA; AIC; Sharon, CT. **Comments:** Positions: dir., Greenwich House Pottery, NYC, 1911-41; consultant in Ceramic Technique, MMA; dir., owner, Maude Robinson Pottery, NY, 1917-56. Author: "Technique of Terra Cotta Sculpture," 13th ed., Encyclopaedia Britannica; chapter on "Pottery" in "Careers for Women"; "Pottery and Porcelain" in the World Book Encyclopaedia. Lectures: Technique of Pottery. Des. and executed medal for Millbrook (NY) Garden Club, 1954-55. **Sources:** WW59; WW47; *Encyclopaedia of New Orleans Artists,* 328.

ROBINSON, May E *[Teacher, writer] b.Vincennes, IN / d.1928, Bloomington, IN.*

Studied: Pratt Inst.; St. Louis Sch. FA; John Herron A. Sch. **Member:** Allied Arts Section of Ind. Teachers Assn.; Ind. AC; Ind. Fed. AC (dir.). **Comments:** Positions: t., Washington (Ind.) Pub. Sch., Boothbay Studios (Boothbay Harbor, Maine).

ROBINSON, (Miss) *[Painter]* 20th c.
Addresses: St. Joseph, MO. **Sources:** WW24.

ROBINSON, Nancy B(ell) *[Painter, teacher]* 20th c.; b.Big Cove, PA.
Addresses: Phila., PA. **Studied:** PMSchIA. **Member:** Phila. Alliance; Plastic C. **Sources:** WW33.

ROBINSON, Oliver D. *[Painter]* early 20th c.
Addresses: Rockville Center, LI, NY. **Member:** S. Indp. A. **Exhibited:** S. Indp. A., 1921. **Sources:** WW25.

ROBINSON, Paul *[Cartoonist]* b.1898, Kenton, OH.
Addresses: Essex Fells, NJ, 1949. **Comments:** He was a cartoon film animator until 1925, when he created the popular comic strip, "Etta Kett" (King Features Syndicate). **Sources:** *Famous Artists & Writers* (1949).

ROBINSON, Pauline (Mrs.) *[Listed as "artist"]* mid 19th c.
Addresses: New Orleans in 1846. **Sources:** G&W; Delgado-WPA cites New Orleans CD 1846.

ROBINSON, Peter L., Jr. *[Painter]* b.1922, Wash., DC.
Studied: Howard Univ. (B.A.). **Exhibited:** James A. Porter Gal., 1970; Smith-Mason Gal., Wash., DC, 1971; CGA; Collectors Corner; Artists Mart; Atlanta Univ.; Barnet Aden Gal.; Potter's House Gal.; Howard Univ.; DCAA, Anacostia Neighborhood Mus.-Smithsonian Inst.; State Armory, Wilmington, DE, 1971. **Work:** "Art for Embassies Program" for US embassies in Costa Rica & Ceylon. **Comments:** Position: visual infor. officer, National Aeronautics & Space Administration. **Sources:** Cederholm, *Afro-American Artists.*

ROBINSON, R. I. *[Painter]* mid 20th c.
Exhibited: San Diego FA Gallery, 1927. **Sources:** Hughes, *Artists in California,* 474.

ROBINSON, Ralph V. *[Painter]* mid 20th c.
Exhibited: Corcoran Gal biennial, 1943. **Sources:** Falk, *Corcoran Gal.*

ROBINSON, Robert *[Illustrator]* 20th c.
Addresses: NYC. **Sources:** WW19.

ROBINSON, Robert B(yron) *[Painter]* b.1886, Wilkes-Barre, PA / d.1952, Douglaston, LI, NY.
Addresses: NYC. **Studied:** ASL. **Member:** Lg. AA. **Exhibited:** S. Indp. A., 1917, 1920, 1922-23, 1925, 1927, 1929-30, 1932; Salons of Am. **Sources:** WW24.

ROBINSON, Robert Doke *[Painter, educator]* b.1922, Kansas City, KS.
Addresses: Castleton, VT. **Studied:** Minneapolis Sch. Art; Walker Art Ctr. Sch.; Univ. Minn., with S. Chatwood Burton (B.A., B.S.& M.A.); Okla. State Univ., with Ivan Doseff & Schaefer-Simmern (cert.). **Member:** Delta Phi Delta; Nat. Art Educ. Assn.; Eastern Art Assn. **Exhibited:** S. Vt. Art Ctr., Manchester, 1961. **Work:** Chaffee Art Mus., Rutland, Vt.; Lawrence Recreation Ct., Rutland. **Comments:** Positions: owner & pres., R.D Robinson Advert. Co, 1951-58; art dir., Grubb-Clealand Advert. Agency; pres., Mid-Vt. Artists, 1963-65. Publications: contrib illus., nat. & int. mod. med. publ. & others. Teaching: lectr. art & the community & art educ., art clubs, gallery groups, high schs. & cols.; asst. prof. art & chmn. dept., Castleton State Col., 1960-. **Sources:** WW73.

ROBINSON, Russell R. *[Painter]* mid 20th c.
Addresses: Phila., PA. **Exhibited:** PAFA Ann., 1948. **Sources:** Falk, *Exh. Record Series.*

ROBINSON, Ruth C(arroll) See: **TREGANZA, Ruth Robinson (Mrs.)**

ROBINSON, Ruth M. *[Painter, designer, teacher]* b.1910, Philadelphia, PA.

Addresses: Upper Darby, PA; Drexel Park, PA. **Studied:** Moore Inst. A., Sc. & Indst. (B.S. in A.Edu.); PAFA; & with Earl Horter, Umberto Romano. **Member:** A. All., Plastic Cl., WC Cl., all of Phila., Pa., Bryn Mawr A. Center. **Exhibited:** Moore Inst. Des., 1930 (prize); AIC, 1936-37; Phila. Plastic C., 1932 (prize), 1941 (med.); Cape May AL, 1940 (prize); Grand Central A. Gal.; Contemp. A. Gal.; Phila. A. All.; Mortimer Levitt Gal.; Phila. WC Cl., 1930-1946; PAFA, 1940; GGE 1939; numerous solo exh., Phila., N.Y. Awards: F., PAFA. **Work:** Marine Hospital, Carville, La.; Ft. Knox, Ky.; Carnegie Corp. **Comments:** Positions: instr., Occupational Therapy, A., Pub. Schs. **Sources:** WW59; WW47.

ROBINSON, Sally *[Sculptor]* early 20th c.
Exhibited: WMAA, 1922. **Sources:** Falk, *WMAA.*

ROBINSON, Samuel *[Painter]* early 20th c.
Addresses: NYC. **Exhibited:** S. Indp. A., 1925. **Sources:** Marlor, *Soc. Indp. Artists.*

ROBINSON, Sarah (Center) Whitney (Mrs. Boardman) *[Sculptor]* early 20th c.
Addresses: Oakland, CA; NYC, c.1905-13. **Studied:** Mark Hopkins Inst.; with Rodin in Paris. **Exhibited:** Mark Hopkins Inst., 1898; Paris Salon, 1903. **Comments:** Married Boardman Robinson (see entry) in 1903. **Sources:** WW13; Hughes, *Artists in California,* 602.

ROBINSON, Snowden *[Lithographer]* b.1828, Maryland.
Addresses: Wash., DC, active 1850-1905. **Sources:** G&W; 7 Census (1850), D.C., I, 234; McMahan, *Artists of Washington, DC.*

ROBINSON, Theodore *[Painter, teacher, designer]* b.1852, Irasburg, VT / d.1896, NYC.
Addresses: NYC. **Studied:** AIC, 1870; NAD, 1874; Acad. Julian, Paris, with Constant; Carolus-Duran & Gérôme, 1876-90. **Member:** ASL (founder). **Exhibited:** Paris Salons, 1877, 1880, 1887-90; NAD, 1881-96; Brooklyn AA, 1881-83; Boston AC, 1881-96; PAFA Ann., 1882, 1891-95, 1905; SAA, 1888, 1890 (Webb Prize); BM, 1946 (retrospective); Armory Show, 1913 (posthumous); BMA, 1973 (retrospective); AIC. **Work:** MMA; NMAA; CGA; AGAA; PAFA; Randolph-Macon Col., Lynchburg, VA; BMA; Scripps Col., Claremont, CA; Art Mus., Princeton (NJ) Univ.; Phillips Coll., Wash., DC. **Comments:** Robinson was one of the earliest and most important of the American Impressionists. He was active in France 1876-79, returned there in 1884, and spent 1887-92 mostly at Giverny where Monet welcomed him into his inner circle of friends. Like Monet, Robinson chose particular landscape scenes as series, painted at different times of the day. Upon his return, he settled in Greenwich, CT, 1893-95 (Cos Cob, 1894), but died young owing to the asthma that had plagued him since childhood. Designer: stained-glass and mosaics, 1879-c.1884. Positions: helped form the Arts Students' League (whose name he suggested); teacher of landscape painting, Brooklyn Art School (summers of 1893-94), PAFA (from 1894). **Sources:** E. Clark, *Theodore Robinson, His Life & Art;* Baigell, *Dictionary; Connecticut and Am.n Impressionism* 170 (w/repro.); Fink, *Am. Art at the 19th C. Paris Salons,* 385; Falk, *Exh. Record Series;* Brown, *The Story of the Armory Show.*

ROBINSON, Thomas *[Landscape, genre, and animal painter]* b.1834, Pictou, Nova Scotia, Canada / d.1888, Providence, RI.
Addresses: Active in NYC by 1856 and thereafter divided his time between NYC and Providence, RI. **Member:** Providence AC. **Exhibited:** RIAD Mus., NAD, 1862-1877; PAFA Ann., 1876; Boston Athenaeum; Providence AC. **Work:** Worcester A. Mus. **Comments:** Along with G.W. Whitaker, he actively promoted the Barbizon style of landscape painting in Providence, RI. In 1856 he was active in NYC, but thereafter moved to Providence where he painted and was a buying agent of French Barbizon paintings for the Vose Galleries. **Sources:** G&W; Arnold, *Art and Artists of Rhode Island;* Cowdrey, NAD; Swan, BA; NYCD 1856; *Antiques* (March 1942), 170, repro.; Worcester Art Museum Cat.; C. Bert,

Sketches (Providence, No.1, Dec. 1990); Falk, *Exh. Record Series.*

ROBINSON, Thomas *[Wood engraver] mid 19th c.*
Addresses: Troy, NY, active 1857. **Comments:** Partner with
Thomas McKeon in Robinson & McKeon, wood engravers, Troy
(N.Y.), active 1857. **Sources:** G&W; Troy BD and CD 1857.

ROBINSON, Thomas *[Art dealer, collector] b.1938, Fort
Worth, TX.*
Addresses: Houston, TX. **Studied:** Tex. Christian Univ.; Tex.
Wesleyan Col. **Comments:** Positions: dir., Robinson Galleries,
Inc., 1969-. Specialty of gallery: Art of the 19th & 20th centuries
in America; American sculpture, paintings & graphics. **Sources:**
WW73; Brochure (Jan, 1971); article, In: *SW Art Gallery Mag.*
(Jun, 1971).

ROBINSON, Virginia C(arolyn) *[Painter, historian, illustra-
tor] mid 20th c.; b.Maryville, MO.*
Addresses: Columbus, MS. **Studied:** William Woods Col. (A.A.);
Northwest Missouri State Col. (A.B.); Columbia Univ. (B.S. in
L.S.). **Member:** Am. Lib. Assn.; AAUW; Long Beach (Cal.) AA;
New Orleans AA; Miss. Lib. Assn.; Miss. AA; Miss. Hist. Assn.;
Miss. Edu. Assn.; Laguna Beach AA; Nat. Audubon Soc.; Palette
& Brush Cl. **Exhibited:** Mun. A. Gal., Jackson, Miss., 1950-51;
Brooks Mem. A. Gal., 1955, 1957; AAUW exh., Maryville, Mo.,
1953-55; Delgado Mus. A., 1957; One-man: Miss. State Col. for
Women, 1955; Delta AA, Greenwood, Miss., 1955; Meridan AA,
1955; Lauren Rogers Mem. Mus., Laurel, Miss., 1956; Youth
Center, Starkville, Miss., 1955; Allison's Wells, Way, Miss., 1957;
Miss. Hist. Soc., 1958; Wm. Carey Col., 1958; Clarksdale, Miss.,
Pub. Lib., 1956; Mary Buic Mus., Oxford. Miss., 1956. **Awards:**
Kappa Pi (hon.), 1955. **Work:** Miss. Dept. Archives & Hist.,
Jackson, Miss.; Miss. State Col. for Women; Blue Ridge
Assembly, Black Mountain, NC; U.S.S. Everett Larson.
Comments: Positions: asst. catalog dept., Kansas City Pub. Lib.,
1926-27; circ. dept., Grinnell Col. Lib., 1928-29; assoc. Librarian
& Cataloger, Miss. State Col. for Women, Columbus, Miss., 1929-
. Illus., "Somebody Might Come," 1958. **Sources:** WW59.

ROBINSON, (Virginia) Isabel *[Educator, painter, craftsper-
son, graphic artist, designer, writer] b.1894, Eagle Ranch,
Adair County, MO.*
Addresses: Canyon, TX. **Studied:** Cranbrook Acad. Art;
Chouinard AI; Kirksville (MO) State Teachers Col.; Univ.
Missouri (B.S.); Columbia Univ. (M.A.); Otis AI; & with Millard
Sheets; Martin; Northrup; Allen Staples; Monhoff; Vysekal.
Member: Texas State Teachers Assn.; Assoc. Art Instr., Texas;
NAAI; College AA; SSAL. **Exhibited:** SSAL; All. Art & Indust.,
NY; Texas Centennial Exh., Dallas, 1936; Dallas Mus. FA; Ft.
Worth, Austin, San Antonio, Houston, TX; Michigan State Col.,
1937 (solo); Texas Fed. Women's Cl., 1946 (prize); Contemp.
Hand Weavers of Texas, 1955 (prize); Col. Lib., Canyon, TX,
1958 (solo). **Work:** Columbia Univ.; Amarillo, Texas Pub. Lib.;
Hist. Soc. Mus., Canyon, TX. **Comments:** Positions: art instr.,
Ohio Univ., Athens, OH, 1924-25; hd., art dept., assoc. prof., West
Texas State Col., Canyon, TX, 1927-58. Lectures: "Early and
Contemporary Art & Artists of Texas." **Sources:** WW59; WW47.

ROBINSON, Wahneta Theresa *[Curator, art historian] mid
20th c.; b.Adrian, MI.*
Addresses: Long Beach, CA. **Studied:** Long Beach City Col.
(A.A.); Long Beach State Univ. (B.A. & M.A.); Univ. Calif., Los
Angeles, with Dr. E. Maurice Bloch. **Member:** Col. Art Assn.; Art
Historians Southern Calif.; Am. Assn. Univ. Women. **Comments:**
Positions: cur., Long Beach Mus. Art, Calif., 1966-. **Publications:**
auth. catalogues, Nineteenth century American landscape painting,
1966, Seven decades of design, 1967, Alexander Calder's
Gouaches, 1970, American portraits--old & new, 1971 & Masuo
Ikeda--paints, 1971. Collections arranged: Nineteenth Century
American Landscape Painting, 1966; Seven Decades of Design,
1967; African Art, 1968; Alexander Calder's Gouaches, 1970;
American Portraits--Old & New, 1971; Masuo Ikeda--Prints,
1971; Hans Burkhardt--Retrospect, 1972; William Gropper--
Paintings & Graphics, 1972. Research: essential historical data

gathered about artists and art works for exhibition, publication and
lectures. **Sources:** WW73.

ROBINSON, Walter Paul *[Painter] b.1903.*
Addresses: Chicago, IL. **Studied:** AIC. **Member:** Chicago NJSA;
Chicago Artists U. **Exhibited:** AIC, 1934-41. **Work:** U.S. Govt.
Sources: WW40.

ROBINSON, Watson (Mrs.) *[Painter] mid 20th c.*
Exhibited: S. Indp. A., 1935. **Sources:** Marlor, *Soc. Indp. Artists.*

ROBINSON, William *[Engraver] early 19th c.*
Addresses: Philadelphia, c. 1815-18. **Comments:** Groce &
Wallace speculated that he might be the Robinson who engraved
the illustrations for Parson Weems' *Life of Washington* (Phila.
1815). **Sources:** G&W; Brown and Brown.

ROBINSON, William *[Engraver] b.c.1810, New York.*
Addresses: NYC in 1850. **Comments:** May be the William
Robinson who exhibited pencil drawings and crayon sketches at
the American Institute in 1844 and 1845. **Sources:** G&W; 8
Census (1860), N.Y., XLI, 623; Am. Inst. Cat., 1844, 1845.

ROBINSON, William Murray *[Landscape painter] late 19th
c.*
Addresses: Richmond, VA, active, 1830s; Petersburg, VA, active
1850s, 1860s. **Work:** Mariners' Mus.; priv. colls. **Comments:**
Also a musician. *Cf.* William Robinson, engraver of NYC.
Sources: Wright, *Artists in Virginia Before 1900.*

ROBINSON, Will(iam) S. \NM. S. ROBINSON
*[Landscape painter, marine
painter] b.1861, East Gloucester, MA / d.1945, Biloxi, MS.*
Addresses: Phila., PA; NYC, 1895-1922; Old Lyme, CT (sum-
mers, c.1905-22; permanently, c.1923-37). **Studied:**
Massachusetts Normal Art Sch., Boston; Académie Julian, Paris
with Constant and Lefebvre, 1889. **Member:** ANA, 1907; NA,
1911; AWCS 1897 (pres., 1914-21); NYWCC, 1891; SC, 1896;
Lotos Club; Artists Fund Soc., 1889; NAD; Allied AA, 1919;
Lyme AA (charter mem., pres.); NAC. **Exhibited:** Boston AC,
1885-1904; PAFA Ann., 1892-1924; Paris Expo, 1900 (hon.
men.); Pan-Am. Expo, Buffalo, 1901 (hon. men.); SC, 1901
(prize), 1917 (prize), 1922 (prize); St. Louis Expo, 1904 (bronze
med.); NAD, 1891,1910 (prize), 1929 (prize); Corcoran Gal bien-
nials, 1907-23 (9 times, incl. 4th prize, 1919); Buenos Aires Expo,
1910 (silver med.); Pan-Pac. Expo, San Francisco, 1915 (silver
med.); Dallas Exhib., 1915 (med.); S. Indp. A., 1917; Lyme AA,
1925 (prize), 1927 (prize), 1928 (prize); AIC; NAD, 1891-1900.
Work: CI; Dallas AM; NGA; CMA. **Comments:** A member of
the colony at Old Lyme, he also painted at Monhegan Island
(Maine) and Bermuda. Teaching: in Boston, 1880s; Maryland
Inst., 1885-89; Drexel AI, 1890s; PAFA, 1890s; Columbia Univ.
Teachers Col., 1890s; NAD, 1920-34; Connecticut Col., 1928-34.
Sources: WW40; Curtis, Curtis, and Lieberman, 94, 186;
Connecticut and American Impressionism 171 (w/repro.); Art in
Conn.: The Impressionist Years; Falk, *Exh. Record Series.*

ROBINSON, W(illiam) T. W.T.Robinson.
[Painter] b.1852, Somerville, MA.
Addresses: Malden, MA. **Studied:** G.N. Cass, in Boston;
Académie Julian, Paris with Bouguereau; École des Beaux-Arts;
École de Medecine; Gobelin Tapestry Sch.; Diogene Maillart, all
in Paris. **Work:** Henry Gal., Seattle; Roswell R. Robinson,
Malden Pub. Lib. **Sources:** WW40.

ROBINSON & BATES *[Portrait and landscape painters] mid
19th c.*
Addresses: Bellefontaine, OH, 1859. **Comments:** Nothing further
is known of either artist. **Sources:** G&W; Ohio BD 1859.

ROBINSON & MCKEON *[Wood engravers] mid 19th c.*
Addresses: Troy, NY, 1857. **Comments:** Partners were Thomas
Robinson and Thomas McKeon (see entries). **Sources:** G&W;
Troy BD and CD 1857.

ROBISON, Ann(a) Dorothy *[Painter, etcher, teacher] mid
20th c.; b.Palmyra, IL.*

Addresses: Los Angeles, CA. **Studied:** UCLA (B.A.); Oils AI; & with John Hubbard Rich, Paul Clemens. **Exhibited:** LOC., 1944; San Gabriel A. Gld., 1942; Fnd. Western A., 1932-1944; CPLH, 1933; Women's Univ. Cl., Los A., 1955 (solo). **Comments:** Positions: art t., 1931-, chm. dept., 1944-, Franklin H.S., Los Angeles, Cal. **Sources:** WW59; WW47.

ROBISON, Jessie Howe *[Painter] mid 20th c.*
Addresses: Los Angeles, CA. **Exhibited:** Calif. Art Club, 1937-38; GGE, 1940. **Sources:** Hughes, *Artists in California*, 474.

ROBISON, Laura Lee *[Painter] b.1914, Walla Walla, WA.*
Addresses: Walla Walla, WA. **Studied:** Whitman Col., Walla Walla; Pratt Inst.; ASL. **Exhibited:** Whitman Conservatory, 1932-39; ASL, 1938. **Comments:** Position: teacher, Whitman College. **Sources:** Trip and Cook, *Washington State Art and Artists.*

ROBISON, Rae *[Painter] mid 20th c.*
Exhibited: S. Indp. A., 1941. **Sources:** Marlor, *Soc. Indp. Artists.*

ROBITCHER, Bianca (Mrs.) *[Painter] late 19th c.*
Addresses: NYC, 1882. **Exhibited:** NAD, 1882. **Sources:** Naylor, *NAD.*

ROBITSCHER, Bianca Bondi (Mrs) *[Wood engraver] b.1844, Dresden / d.1924, Elmhurst.*
Studied: CUA Sch. **Comments:** Position: t., CUA Sch.

ROBLER, Samuel K. *[Painter] mid 20th c.*
Exhibited: Salons of Am., 1934. **Sources:** Marlor, *Salons of Am.*

ROBLES, Esther Waggoner *[Art dealer, collector] 20th c.; b.Sacramento, CA.*
Addresses: Los Angeles, CA. **Studied:** Cumnock Sch. Girls & Sch. Expression, Los Angeles; UCLA; Univ. Paris; toured art monuments in Europe. **Member:** LACMA (graphic arts coun. & contemp. art coun.); Western Assn. Mus.; Pasadena Mus.; Univ. Calif., Los Angeles, Alumni Assn. **Comments:** Positions: adv, Fed Arts Proj., Calif Arts Comn.; art corresp., Los Angeles newspapers, Venice Biennale & Documenta 4, Kassel, Ger.; v. pres., Southern Calif. Art Dealers Assn., 1970-72; hon. mem. art adv. panel, Comn. Internal Revenue, 1970-72; organizer & pres., Art Sponsors, Inc.; ed., *The Lively Arts;* dir. exhibs., Esther Robles Gal. Teaching: lectr., Development of La Cienega and Los Angeles as a Major Art Center & Current Materials of Art: Light/Sound/Movement/Plastics. Collections arranged: Co-organizer & catalog, Karel Appel West Coast Exhib., La Jolla Art Mus., Pasadena Mus., Phoenix Art Mus., SFMA & Santa Barbara Art Mus., 1961-62; Robert Cremean Sculpture Exhib. with catalog, Sheldon Mem. Art Gal., Univ. Nebr., Univ. Tex., Univ. Colo., Fort Worth Art Ctr., State Univ. Iowa, Krannert Art Mus. of Univ. Ill. & Munic. Art Dept., Barnsdalle Gals., Los Angeles, 1964-66; Robert Cremean Sculpture Tour with catalog, Calif. Arts Comn., 1966-67. Specialty of gallery: 20th century and vanguard painting and sculpture. Collection: American & European artists, toured by Western Association of Art Museums; works by Appel, Bissier, Capograossi, Davie, Ehrenhalt, Frost, Hartung, Hofmann, Matta, Jenkins, Robles, Scott, Magritte, Seuphor, Falkenstein, Hayter, Tapies, Feininger, Giacometti, Battenberg, Cremean and Hajdu. **Sources:** WW73.

ROBLES, Glenn (Waggoner) *[Printmaker, painter] mid 20th c.; b.Los Angeles, CA.*
Addresses: Los Angeles, CA. **Studied:** Seong Moy Graphic Sch.; Los Angeles City Col.; UCLA. **Exhibited:** West Side Jewish Community Ctr., Los Angeles, 1963; La Jolla Mus. Art, Calif., 1964; Long Beach Mus. Art, Calif., 1964; LACMA, 1964; NY/LA Drawings of the 60's, 1966. **Work:** many pvt. colls. **Sources:** WW73.

ROBLES, Julian *[Painter, sculptor] b.1933, Bronx, NY.*
Addresses: Taos, NM. **Studied:** NAD, with Robert Phillip; ASL, with Sidney Dickinson. **Exhibited:** N.Mex State Fair Art Exhib., Albuquerque, 1971. Awards: first award-purchase prize, N. Mex. State Fair, 1971; second prize (pastels), N. Mex. Fine Art Award, 1972. **Work:** N. Mex. State Fair Gal., Albuquerque; Diamond M. Mus., Snyder, Tex. Commissions: portraits, Haruke Fujita, wife of

Consul Gen. Japan, 1967, Adm. Edward O. McDonnell, Lincoln Family, Oyster Bay, LI, 1968, Ernestine Evans, Secy. State N. Mex., 1969, Margaret Jamison, Santa Fe, N. Mex., 1970 & Jean & Merle Rosenbaum, Santa Fe, 1971. **Comments:** Research: researching and recording authentic Western Indian life and ceremonials. **Sources:** WW73.

ROBOTHAM, Edward W. *[Painter] mid 20th c.*
Addresses: NYC. **Exhibited:** S. Indp. A., 1927. **Sources:** Marlor, *Soc. Indp. Artists.*

ROBSON, (Gerson) Adele May *[Designer] b.1908, Phila., PA.*
Addresses: Springfield, PA. **Studied:** Phila. Sch. Des. for Women. **Exhibited:** Alliance, 1929 (prize). **Work:** mural: St. Joseph's Convent, Chestnut Hill, Phila. (in collaboration with Mrs. P.H. Bolano). **Comments:** Also known as Gerson, Adele. Specialty: heraldic plaques and historical coats of arms. **Sources:** WW40.

ROBUS, Hugo *[Sculptor, teacher, painter] b.1885, Cleveland, OH / d.1964, NYC.*
Addresses: NYC, 1915-64. **Studied:** Cleveland Sch. Art, 1904-08; NAD, 1910-11; Bourdelle, at Grande Chaumière, 1912-14. **Member:** Sculptors Gld.; An Am. Group; Shilling Fund Jury. **Exhibited:** Gage Gal., Cleveland, 1913 (solo, paintings); S. Indp. A., 1917, 1940; WMAA biennials, 1933-62; PAFA Ann., 1934, 1945-62 (Widener gold med. 1950; Steel Mem. prize 1954); WFNY, 1939; MoMA, 1939; CI, 1941; MMA (AV), 1942 (prize); Grand Central Art Gal., solos, 1946, 1949; Munson-Williams-Proctor Inst., Utica, 1948 (first museum solo); Sculptors Gld., annually; Bucholz Gal.; CGA, 1958 (solo); WMAA, 1960 (retrospective); Forum Gal., NYC, solos, 1963, 1966; Natl. Coll. of Fine Arts (now NMAA), 1980 (solo). Additional awards: Shilling Fund prize, 1946; citation and grant, NIAL, 1957. **Work:** MMA; MoMA; WMAA; NMAA; IBM; Munson-Williams-Proctor Inst.; CMA; Rockefeller Center, NYC; CGA. **Comments:** First a craftsman of jewelry, tableware, and ivories at the Cleveland Sch. Art (until 1910), he then focused on painting until 1920 when he took up sculpture. Robus worked in isolation over the next 12 years, supporting his family through the sale of his crafts. During these years he experimented with simplified forms and smoothly modeled surfaces and by the early 1930s his sculpture had achieved the sweeping contours and highly polished sleekness of his mature style. His sculpture was not seen publicly until 1933 when "Dawn" was shown at the Whitney annual; and athough he exhibited regularly after that year he was not able to live off the sales of his work until the 1950s. Robus participated in federal art projects beginning in 1937. Teaching: Modern Art Sch., NYC; summer sessions at Columbia Univ.,1940s and 1950s; Brooklyn Mus. Art Sch.; Hunter Col., NYC. **Sources:** WW59; WW47; *Fort*, The Figure in American Sculpture, 220 (w/repro.); Roberta Tarbell, *Hugo Robus* (exh. cat., NMAA, 1980); Baigell, *Dictionary;* Craven, *Sculpture in America*, 594-96; *Two Hundred Years of American Sculpture*, 303-304; Falk, *Exh. Record Series.*

ROBY, Helen E. *[Painter, teacher] 19th/20th c.*
Addresses: Detroit, MI, 1881-99; Meriden, CT, 1900. **Studied:** Paris, three years; with Mlle. Greatorex. **Member:** Detroit WC Soc.; Rembrandt Etching Club; Soc. of Western Artists. **Exhibited:** Detroit, 1886, 1890, 1893-98; Paris Salon, 1889; NYC, 1896; Cleveland & Cincinnati, OH; Soc. Western Artists, 1898; NAD, 1890. **Comments:** Specialty: flowers, landscapes, marines, interiors. **Sources:** WW01; Gibson, *Artists of Early Michigan*, 203; Fink, *American Art at the Nineteenth-Century Paris Salons*, 385.

ROBY, Sara (Mary Barnes) *[Patron, collector] 20th c.; b.Pittsburgh, PA.*
Addresses: NYC. **Studied:** Pennsylvania Academy of Fine Arts; ASL, and with Kenneth Hayes Miller, Reginald Marsh. **Comments:** Positions: founder, director & treasurer, The Sara Roby Foundation, 1956-; director & chairman of the Visual Arts Committee at Goddard-Riverside Community Center, NYC,

1965-. Collections: contemporary American art including paintings, sculpture, watercolors and drawings, with particular emphasis on the elements of form and craftsmanship in painting and sculpture. This collection is of the Sara Roby Foundation. The collection was shown at the Whitney Museum of American Art in 1959. It was then exhibited in leading museums in the United States Tour, 1960 to 1962. Between 1962 and 1963, the Collection, under the sponsorship of the U.S. Information Agency, was shown in eleven countries in Latin America. In April 1965, the Collection was shown at the Stephen Wise House, a public housing project in NYC under the sponsorship of the Goddard-Riverside Community Center. In March, 1966 the Collection was shown at the Hartford Art School of the University of Hartford in Connecticut. The American Federation of Arts planned to circulate the Sara Roby Foundation Collection throughout the United States from September 1966 through June 1968. **Sources:** WW66.

ROBYN, Charles *[Lithographer] mid 19th c.; b.Westphalia.*
Addresses: St. Louis, MO, 1846-47; Philadelphia, 1848-50; St. Louis, 1850-56. **Comments:** Worked with his brother Eduard (see entry). **Sources:** G&W; Missouri Hist. Soc., *Bulletin,* IV (Jan. 1948), 103, and VI (Oct. 1949), 102.

ROBYN, Eduard (Edward) *[Lithographer, engraver, portrait and landscape painter] b.1820, Emmerich, Westphalia / d.1862, near Hermann, MO.*
Addresses: St. Louis, MO, 1846-47; Philadelphia, 1848-50; St. Louis, 1850-56; Hermann, MO, c.1856-62. **Work:** Missouri Hist. Soc., St. Louis (including several lithographic views, a self-portrait, a sketch-book and ledger, and his panorama of the Eastern and Western hemispheres); Missouri State Mus., Jefferson City. **Comments:** One year after arriving in St. Louis from Westphalia in 1846, Eduard and his brother Charles moved to Philadelphia, where they worked as lithographers until 1850 (in the firm of Dreser & Robyn, see entry). In 1850 they moved back to St. Louis and established their own lithographic business, specializing in views. In 1853 Eduard drew, printed and published with his brother a large view of St. Louis. The firm was bought out by Theodor Schrader (see entry) in 1857, but Eduard continued to work for him, drawing four more views c.1860, all of which were published by Schrader. Robyn's other major project in these years was his a large (8 feet by 350 feet) panorama "An Artist's Travels in the Eastern Hemisphere," which he did in association with Ferdinand Welcker. He moved to a farm near Hermann (Mo.) about 1856. **Sources:** G&W; Missouri Hist. Soc., *Bulletin,* III (Oct. 1946), 27; *ibid.,* IV (Jan. 1948), 103; *ibid.,* VI (Oct. 1949), 102; *ibid.,* VII (April 1951), 382-83; Phila. CD 1848-50; St. Louis CD 1853, BD 1854; WPA Guide, *Missouri. More recently, see Reps, 200-01, and cat. nos. 1989, 1996, 2000, 2042, 2076.*

ROBYNSON, Bernie Haynes *[Graphic artist] b.1900, Paris, Kentucky.*
Studied: Knoxville Col.; YMCA School of Art; NAD; Associated Art School; ASL; with Mort Burger, Charles Hinton, Augusta Savage. **Exhibited:** Harmon Fnd., 1933; NY Pub. Lib.; Teachers College Lib., Columbia Univ., 1932; Art Students Cl., NYC. **Sources:** Cederholm, *Afro-American Artists.*

ROC *[Painter] early 20th c.*
Exhibited: S. Indp. A., 1929. **Sources:** Marlor, *Soc. Indp. Artists.*

ROCA, Claude M. *[Artist] mid 20th c.*
Addresses: Wash., DC, active 1923-28. **Sources:** McMahan, *Artists of Washington, DC.*

ROCA, Stella McLennan *[Portrait and landscape painter] b.1879, Nebraska City, NE / d.1954.*
Addresses: Tucson, AZ. **Studied:** AIC, and with John C. Johannson. **Member:** Tucson FAA (exec. board); Palette & Brush Club, Tucson (a founder); Nebraska AA; Lincoln Art Gld.; Tucson WC Gld. **Exhibited:** Phoenix Expo, 1923 (prize), 1926 (prize), 1931 (prize), 1932 (prize); Mus. Northern Ariz., 1933 (prize); Tucson, 1942 (prize); Lincoln, NE; Los Angeles; Phoenix, Tucson, 1948-52; Carnegie Inst., Pittsburgh; Palette & Brush Club, Tucson. **Work:** Dept. Interior, Wash., DC; Union H.S.,

Yuma, AZ; Woman's Club, Tucson. **Sources:** WW53; WW47; Petteys, *Dictionary of Women Artists.*

ROCENBERG *[Painter] late 19th c.; b.Philadelphia, PA.*
Exhibited: Paris Salon, 1886. **Sources:** Fink, *American Art at the Nineteenth-Century Paris Salons,* 385.

ROCH, Anna *[Painter] mid 20th c.*
Addresses: NYC. **Exhibited:** S. Indp. A., 1925-26. **Sources:** Marlor, *Soc. Indp. Artists.*

ROCHARD, Pierre *[Painter, illustrator, writer, lecturer, teacher] b.1869, Lyon, France.*
Addresses: Salt Lake City, UT. **Studied:** Paris, with Gérôme, Ecole des Beaux-Arts. **Work:** murals, frescoes: Metropolitan Opera House; Waldorf Astoria Hotel, NYC. **Sources:** WW19.

ROCHE, David *[Lithographer] b.c.1835, Pennsylvania.*
Addresses: Philadelphia in 1860. **Sources:** G&W; 8 Census (1860), Pa., LV, 111.

ROCHE, Jim *[Sculptor, painter] b.1943, Jackson Co, FL.*
Addresses: Irving, TX. **Studied:** Fla. State Univ. (B.A.); Univ. Dallas (M.A. & M.F.A.). **Exhibited:** Whitney Sculpture Ann., WMAA, 1970; Project: South/Southwest, Fort Worth Art Ctr. Mus., Tex., 1970; Six Major Pieces by Six Young Sculptors, A Clean Well Lighted Place, Austin, Tex., 1971; Drawings 1971-72, Janie C. Lee Gallery, Dallas, Tex, 1971-72; Interchange, Dallas Mus Fine arts & Walker Art Ctr., Minn., 1972-73; Dave Hickey, NYC, 1970s. Awards: exhib. awards, Fort Worth Art Ctr. Mus., 1970-71. **Comments:** Preferred media: ceramic, wire, plastic, ink. **Sources:** WW73; Martha Utterback, "Texas," *Artforum* (Jan, 1971); Janet Kutner, "Texas/A New Environment," *Art Gallery Mag.* (July, 1972); Kent Biffle, "Art/Big D.," *Newsweek* (Aug., 1972).

ROCHE, Leo Joseph *[Cartoonist] b.1888, Ithaca, NY.*
Addresses: Kenmore, NY; Buffalo, NY. **Studied:** Syracuse Univ. Sch. FA. **Exhibited:** Awards: Nat. Safety Council; Disabled Veterans Soc. **Work:** LOC; Henry Huntington Mus. A.; F. D. Roosevelt and Harry S. Truman libraries. **Comments:** Positions: ed. cart., *Buffalo Courier-Express,* Buffalo, NY, 1934-. Contributor: cartoons, *Sat. Eve. Post; Collier's* etc. **Sources:** WW59; WW47.

ROCHE, M. Paul *[Painter, etcher, lithographer, sculptor, lecturer] b.1888, Cork, Ireland.*
Addresses: Brooklyn, NY, 1917; Baltimore, MD. **Studied:** St. John's Col.; PIASch.; NAD, with Charles Hawthorne. **Exhibited:** NAD (prize); Brooklyn SE (prize); NAC (prize); AIC (prize). **Work:** BM; CMA; LOC.; Cal. State Lib.; NYPL.; murals, Washington Col., Chestertown, Md.; Enoch Pratt Lib., Catholic Cathedral, St. Joseph's Church, all of Balt., Md.; AIC; Detroit AI. **Comments:** Lectures: American mural painting. **Sources:** WW59; WW47.

ROCHE, Rena M. *[Painter] 19th/20th c.*
Addresses: Seattle, WA. **Exhibited:** Alaska Yukon Pac. Expo., 1909. **Comments:** Preferred medium: watercolor. **Sources:** Trip and Cook, *Washington State Art and Artists.*

ROCHE, Thomas C. *[Landscape photographer] d.1895.*
Comments: A prominent photographer who began his career making hundreds of large photographs during the Civil War and thousands of stereoviews of war scenes for Edward Anthony's company. After the war he continued to work for Anthony, producing about 15,000 negatives of landscapes throughout the country, including some of the earliest views of the Far West. He was also an inventor, and his breakthrough development in 1886 was the gelatine-bromide photographic paper which gradually displaced the old albumen print paper. **Sources:** Welling, 295.

ROCHELEAU, George A. *[Painter] mid 20th c.*
Addresses: Chicago, IL. **Exhibited:** AIC, 1945-47; PAFA Ann., 1948. **Sources:** Falk, *Exh. Record Series.*

ROCHELLE, Eugene *[Illustrator] b.1876 / d.1914, NYC, suicide.*
Addresses: Flushing, Queens, NY.

ROCHON, Julius *[Portraitist]*
Comments: Groce & Wallace included him but noted that it wasn't known whether he was American. He is known only through a wax portrait of Washington which was based on the work of other artists. **Sources:** G&W; Bolton, *American Wax Portraits*, 60.

ROCHON, Marie Louise See: **HOOVER, Marie Louise Rochon (Mrs.)**

ROCHOW, Elizabeth Moeller (Mrs. A. M.) *[Museum director, painter, educator]* b.1906, Davenport, IA.
Addresses: Davenport, IA. **Studied:** State Univ. of Iowa (B.A., M.A.); PAFA. **Exhibited:** Awards: prizes, Davenport Mun. A. Gal., 1934, 1936; Laura Spellman Rockefeller Grad. F., State Univ. Iowa. **Work:** Rock Island (Ill.) Pub. Sch. **Comments:** Position: instr., Univ. Iowa Experimental Sch., 1928-31; chm. a. dept., Shimer Col., Mt. Carroll, Ill., 1934, 1936-38; instr., Montana State Normal Col., Dillon, 1934-36; visiting instr., Augustana Col., Rock Island, Ill., 1955-62; gal. dir. & lecturer in art hist., Davenport Mun. A. Gal., 1938-. **Sources:** WW66.

ROCK, Howard See: **WEYAHOK, Sikvoan**

ROCK, John *[Painter]* mid 20th c.
Addresses: NYC. **Exhibited:** S. Indp. A., 1928. **Sources:** Marlor, *Soc. Indp. Artists.*

ROCK, John Henry *[Educator, painter, lithographer]* b.1919, Tillamook, OR.
Addresses: Corvallis, OR. **Studied:** Oregon State Col. (B.S.), with Gordon Gilkey; Cal. Col. A. & Crafts (M.F.A.), with Leon Goldin, Nathan Oliveira. **Member:** Portland AA. **Exhibited:** print and lith. exhs., BM, 1956; Bordighera, Italy, 1957; SAM, 1956-57; Wichita, Kans., 1958; CM, 1958; New Canaan, Conn., 1958; Oakland A. Mus., 1956, 1958; Portland A. Mus., 1951-52, 1955-56; Denver A. Mus., 1953; Northwest Pr. M., Seattle, 1951, 1955, 1957; DMFA, 1958; Northwest A., 1958. Awards: prizes, Portland A. Mus., 1955 (purchase)-56; Univ. Washington, 1955 (purchase); Oregon State Fair, 1957-58. **Work:** Portland A. Mus.; Henry Gal., Univ. Washington; U.S. Information Agency. **Comments:** Positions: prof. drawing, painting, a. hist., Midwestern Texas Univ.; prof. drawing, graphics, Oregon State College, Carvallis, Ore. as of 1959. **Sources:** WW59.

ROCKBURNE, Dorothea *[Sculptor]* b.1934, Verdun, PQ, Canada.
Addresses: NYC. **Studied:** Black Mountain Col. (B.A.). **Exhibited:** Sonnabend Gal., Paris, 1971 (solo); MoMA, 1971; solo show, Bykert Gallery, New York, 1970, 1972 & 1973; WMAA, 1970-79; Documenta 5, Kassel, W. Ger., 1972. Awards: Guggenheim fel., 1972-73. **Work:** MoMA; Walker Art Ctr., Minneapolis, Minn. **Comments:** Teaching: instr. art theory, Sch. Visual Arts, New York, 1970-. **Sources:** WW73; Robert Pincus-Witten, article, In: *Artforum* (Feb. 1971); Gregoire Muller, "Materialith Painterlines," *Arts Mag.* (Nov., 1971); cover photo & three articles, *Artforum* (Apr., 1972).

ROCKE, Gilbert *[Painter]* mid 20th c.
Addresses: Chicago area. **Exhibited:** AIC,1927-40. **Sources:** Falk, *AIC.*

ROCKEFELLER, David (Mr. & Mrs.) *[Collectors]* b.1915, NYC.
Addresses: NYC. **Studied:** Mr. Rockefeller, Harvard Univ. (B.S., 1936); Univ. Chicago (Ph.D., 1940); Columbia Univ. (L.L.D., 1954); Bowdoin Col., 1958; Jewish Theological Sem., 1958; Williams Col., 1966; Wagner Col., 1967; Harvard Univ., 1969; Pace Col., 1970. **Comments:** Positions: trustee & chmn. board trustees, MoMA. Collections: Paintings, modern art. **Sources:** WW73.

ROCKEFELLER, John D., Jr. (Mrs.) *[Collector]* late 20th c.
Addresses: NYC. **Sources:** WW66.

ROCKEFELLER, John Davidson III *[Collector, patron]* b.1906, NYC / d.1978.
Addresses: NYC. **Studied:** Princeton Univ. (BS, 1929). **Member:** Asia Soc. (press & trustee, 1956-1964, chmn., 1965-); Am. Assn. Mus.; life mem. Brooklyn Mus. & MMA; corp. mem. MoMA; Mus. Primitive Art. **Comments:** Positions: bd. mem., Am. Mus. Natural Hist., 1933-55; dir., Lincoln Ctr. Performing Arts, Inc., chmn., 1961-70, hon. chmn., 1970-; emer. trustee, Princeton Univ. Collection: emphasis on Asian art. **Sources:** WW73.

ROCKEFELLER, Laurance S. (Mrs) *[Collector]* late 20th c.
Addresses: NYC. **Sources:** WW73.

ROCKEFELLER, Nelson Aldrich *[Collector, patron]* b.1908, Bar Harbor, ME / d.1979.
Addresses: Albany, NY. **Studied:** Dartmouth Col. (AB, 1930). **Member:** Am. Assn. Mus.; Asia Soc.; Assocs. Guggenheim Mus.; life mem. Col. Art Assn. Am.; Coun. Nat. Mus. France. **Comments:** Positions: trustee, MoMA, 1932-, pres., 1939-41 & 1946-53, chmn., 1957-58; founder, trustee & pres., Mus. Primitive Art, 1954-; hon. trustee, MMA. **Sources:** WW73.

ROCKEFELLER, Winthrop (Mr. & Mrs.) *[Collectors]* b.1912, NYC / d.1973.
Addresses: NYC. **Studied:** Mr. Rockefeller, Yale Univ., 1931-34; Univ. Ark. (hon. L.L.D.); Hendrix Col., Col. William & Mary, Col. Ozarks, NY Univ. (L.H.D.); Univ. San Francis Xavier, Suere, Bolivia (H.H.D.); Southwestern at Memphis (D.C.L.). **Comments:** Positions: chmn. bd., Colonial Williamsburg & Williamsburg Restoration. Collection: paintings and furniture. **Sources:** WW73.

ROCKER, Fermin *[Painter]* mid 20th c.
Addresses: Crompound, NY, 1942. **Exhibited:** AIC, 1943; WMAA, 1942. **Sources:** Falk, *AIC.*

ROCKER, Nicholas *[Sculptor or portraitist (listed as "image maker")]* b.c.1812.
Addresses: NYC in 1860. **Comments:** Living with John Mollinari (also image maker, see entry). **Sources:** G&W; 8 Census (1860), N.Y., XLIV, 159.

ROCKE (ROCKLE), Marius R(omain) See: **ROCLE, Marius R(omain)**

ROCKEY, Abraham B. *[Portrait painter]* b.1799, Mifflinsburg, PA / d.After 1860.
Addresses: Philadelphia, active c. 1848 until after 1860. **Exhibited:** Artists' Fund Society snd PAFA (1828-53). **Comments:** Also painted some portraits in Delaware. **Sources:** G&W; Smith; Rutledge, PA; Phila. CD 1829-60+; *Portraits in Delaware, 1700-1850*, 63, 64; 7 Census (1850), Pa., L, 254 [aged 48].

ROCKLIN, Raymond *[Sculptor, lecturer]* b.1922, Moodus, CT.
Addresses: Peekskill, NY; NYC, 1960-62. **Studied:** Educ. Alliance, NYC, with Abbo Ostrovsky; Cooper Union Art Sch., with Milton Hebald & John Hovannes. **Member:** Sculptors Guild; Am. Abstr. Artists; Fedn. Mod. P&S. **Exhibited:** Young Am., WMAA, 1956; Oakland Art Mus., 1959; Galleria Tiberina, Rome, 1959; Univ. Calif., Berkeley, 1960; Claude Bernard Gal., Paris, 1960; WMAA, 1960-62; Sculptors Guild, NYC, 1970s. Awards: Cooper Union Art Sch. scholar to Skowhegan Sch. Painting & Sculpture, 1951; Fulbright grant, Italy, 1952-53; Yaddo Found. fel., 1956. **Work:** WMAA; Provincetown Mus. Art, Mass.; Temple Israel, Saint Louis; Skowhegan Sch. Painting & Sculpture. Commissions: wall brass, comn. by Mrs. Beskind, New York, 1962 & Mrs. Nina Waller, Baltimore, 1963. **Comments:** Preferred media: bronze, steel, wood. Teaching: guest artist, Am. Univ., 1956; asst. prof. art, UC Berkeley, 1959-60; guest artist, Ball State Teachers Col., summer 1964. **Sources:** WW73; M. Seuphor, *Raymond Rocklin, The Sculpture of this Century* (1961); F. Hazan, article, In: *Dictionary of Modern Sculpture.*

ROCKMORE, M. Gladys *[Painter] 20th c.*
Addresses: Chicago, IL. **Member:** AG of Authors Lg. A.
Sources: WW25.

ROCKMORE, Noel *[Painter] b.1928, NYC.*
Addresses: New Orleans, LA. **Exhibited:** CMA; NOMA; Butler Inst. Am. Art; WMAA, MoMA & MMA; PAFA; plus solo shows. Awards: Hallgarten prize, 1956 & 1957 & Wallace Truman prize, 1959, NAD; Tiffany Found. fels, 1956 & 1963; Ford Found. & Am. Fedn. Arts grant, 1964. **Comments:** Publications: auth., *Preservation Hall Portraits,* 1968. **Sources:** WW73.

ROCKWELL, Augustus *[Landscape painter] mid 19th c.*
Addresses: Buffalo, NY, active c 1852-c. 1860. **Work:** Beloit (WI) College owns "Valley of the Au Sable [NY]," painted in 1866. **Sources:** G&W; Buffalo BD 1855-60; Krane, *The Wayward Muse,* 30.

ROCKWELL, Bertha *[Painter] b.1874, Junction City, KS.*
Addresses: NYC, c.1908-09. **Exhibited:** Boston AC, 1902, 1907; AIC; PAFA Ann., 1908. **Sources:** WW10; Falk, *Exh. Record Series.*

ROCKWELL, Cleveland (Salter) *[Landscape and marine painter] b.1837, Youngstown, OH / d.1907, Portland, OR.*
Addresses: San Francisco, CA, 1868-78; Portland, OR, 1878-on. **Studied:** Troy (NY) Polytechnic; Univ. New York; in England. **Member:** Oregon AA; Sketch Cl. of Portland. **Exhibited:** San Francisco AA, from 1873. **Work:** Flavel Mus., Astoria, OR; Portland Art Mus. **Comments:** Rockwell was a descendant of Governor Bradford of the Plymouth colony and of Moses Cleveland, who laid out the city of Cleveland in 1796. Beginning in 1857, he worked as a surveyor and mapmaker for the U.S. Coast Geodetic Dept., charting NY harbor, the Southern coast during the Civil War, and the Magdalena River, Colombia (1867). From 1868-92, he surveyed the Northern California and Oregon coasts. He does not appear to have begun painting until after the Civil War, but was active painting scenes along the coast that he surveyed, as well as ship portraits. He retired from the U.S.G.S. in 1892. **Sources:** WW06; Hughes, *Artists in California,* 474-475; P&H Samuels, 404; *300 Years of American Art,* vol. 1, 285.

ROCKWELL, Edwin Amasa *[Writer, critic] b.1846 / d.1919.*
Addresses: Brooklyn, NY. **Comments:** Position: art and musical ed., Brooklyn Eagle, twenty yrs.

ROCKWELL, Elizabeth A. *[Painter] b.1836, NYC / d.1911, Los Angeles, CA.*
Addresses: NYC; San Francisco, CA, 1873- c.1908; Los Angeles, CA, c.1908-11. **Studied:** Troy Academy, Fulton, VT; with Professor François in Brussels, 1868. **Member:** San Francisco AA. **Exhibited:** San Francisco AA annuals; Mechanics Fair, 1876. **Work:** San Mateo County Hist. Mus; Soc. Calif. Pioneers; de Young Mus.; San Francisco Maritime Mus. **Comments:** Specialty: portraits, landscapes. **Sources:** Hughes, *Artists in California,* 475.

ROCKWELL, E(lizabeth) T. (Mrs.) *[Animal painter] late 19th c.*
Addresses: Brooklyn, NY (1870s); South Woodstock, CT. **Exhibited:** Brooklyn AA, 1874-77; Boston AC, 1893-94. **Sources:** *Brooklyn AA; The Boston AC.*

ROCKWELL, Etta Maia Reubell *[Painter] b.1874, Kentucky.*
Studied: F.B. Aulich in Chicago; H.H. Bagg in Lincoln, NE. **Exhibited:** Nebraska fairs. **Sources:** Petteys, *Dictionary of Women Artists.*

ROCKWELL, Evelyn Enola *[Painter] b.1887, Chicago, IL / d.1933.*
Addresses: Kew Gardens, NY/Ogunquit, ME (summers). **Studied:** PAFA; ASL; W.M. Chase; C. Beaux; C. Woodbury, Ogunquit Sch.; E.G. Baker. **Member:** Queensborough SAC. **Exhibited:** S. Indp. A. 1921; Doll & Richards, Boston, 1921 (solo); Ehrich Gals., NYC, 1925 (solo). **Comments:** Specialty: children's portraits and "cosmic portraits" in pastel. **Sources:**

WW40; Petteys, *Dictionary of Women Artists; Charles Woodbury and His Students.*

ROCKWELL, Frederick (Frye) *[Sculptor, painter] b.1917, Brooklyn, NY.*
Addresses: NYC; East Boothbay, ME. **Studied:** Columbia Univ.; NAD; Tiffany Fnd.; & with Oronzio Malderelli, Arnold Blanch, George Grosz, William Zorach. **Member:** Audubon A.; Kennebec Valley AA.; Lincoln Country Hist. Assn. **Exhibited:** WFNY 1939; AWCS, 1939, 1942-43; AIC, 1940, 1943-44; S. Indp. A., 1941-44; Morton Gal., 1941 (solo), 1943; NGA, 1941; WMAA, 1941; PAFA, 1943, 1946; PAFA Ann., 1947; Portland Mus. A., 1944, 1956; Ogunquit A. Center, 1945, 1957, 1958; Audubon A., 1945, 1949-52; MMA, 1952; Farnsworth Mus., 1949; Univ. Maine, 1956 (solo); NSS, 1956-57; Five Islands annual, 1957; Art: USA, 1958; Wiscasset, Me., 1958, 1959-61; Bowdoin Col., 1960 (solo); Maine State A. Festival, Augusta, 1960-61. **Award:** F., Tiffany Fnd., 1948. **Work:** U.S. Marine Hospital, Carville, LA; Chrysler Mus., Provincetown, MA. **Comments:** *Cf.* Fritz Rockwell, who could possibly be the same artist. Fritz Rockwell was listed (in WW40) as exhibiting at WFNY in 1939; AWCS, 1939; he also is listed in AIC exh. records as exhibiting there in 1944. These are all venues at which Frederick Frye Rockwell also exhibited. **Sources:** WW66; WW47; Falk, *Exh. Record Series.*

ROCKWELL, Fritz *[Painter] 20th c.*
Addresses: NYC. **Exhibited:** S. Indp. A., 1938-40; AWCS/NYWCC, 1939; WFNY, 1939; AIC. **Comments:** *Cf.* Frederick Frye Rockwell, who could possibly be the same artist. **Sources:** WW40.

ROCKWELL, Horace *[Portrait painter] b.1811, possibly in Philadelphia / d.1877, Roanoke, IN.*
Addresses: Philadelphia, as of 1835; settled in Fort Wayne, IN c. 1836; later moved to Roanoke, IN. **Exhibited:** Artists Fund Soc., 1835. **Work:** The Newark Mus. **Comments:** Provincial but not primitive portraitist; painted several major multifigured family groups. Also painted scriptural pictures and experimented with a flying machine. **Sources:** G&W; Peat, *Pioneer Painters of Indiana,* 109-11, 237; Rutledge, PA; *Antiques* (Nov. 1950), 383; Gerdts, *Art Across America,* vol. 2: 255 (with repro.).

ROCKWELL, Jennie *[Portrait painter] late 19th c.; b.U.S.*
Addresses: Active in Bay City, MI, 1893-99. **Comments:** Partner of Anna Carrier in the firm of Carrier and Rockwell, 1897-99. **Sources:** Petteys, *Dictionary of Women Artists.*

ROCKWELL, Lucy Twyman (Mrs. Frederick Wm.) *[Craftsperson, lecturer] mid 20th c.; b.Chicago, IL.*
Addresses: Phila., PA. **Studied:** Boston SAC; AIC; Acad. Colarossi, Paris. **Member:** Phila. Art All.; AC Gld., Phila. **Exhibited:** Phila. Art All.; Pan-Pacific, Expo, San Francisco, 1915 (medal); AC Gld., Phila.; Int. Expo, Paris, 1937. **Work:** jeweled book, Nat. Cathedral. Wash., DC. **Comments:** Specialty: jewelry. **Sources:** WW40.

ROCKWELL, Mary C. *[Painter] mid 20th c.*
Addresses: Chicago area. **Exhibited:** AIC, 1934. **Sources:** Falk, AIC.

ROCKWELL, Maxwell Warren *[Illustrator] b.1876 / d.1911, NYC.*
Studied: Académie Julian, Paris with J.P. Laurens and Constant, 1900-01. **Comments:** Illustrator: *Life,* and other humorous publications. **Sources:** Fehrer, The Julian Academy.

ROCKWELL, Norman (Percevel) *[Illustrator, muralist] b.1894, NYC / d.1978, Stockbridge, MA.*
Addresses: New Rochelle, NY; Arlington, VT; Stockbridge, MA, since 1950s. **Studied:** Chase Sch. Art c.1908; NAD, c.1909; ASL, also with George Bridgeman & Thomas Fogarty; Univ. Vermont (D.F.A., 1949); Middlebury College (H.H.D., 1954); Univ. Mass. (D.F.A., 1961). **Member:** Soc. Illustrators; Salmagundi Cl.; Artists' Guild of the Authors' League of America;

Work: MMA; Delaware Art Mus., Wilmington; Soc. of Illus., NYC: Norman Rockwell Mus. **Comments:** Frequently acclaimed as America's greatest illustrator capturing the heart of America's family values, he created 322 covers for *Sat. Eve. Post* from 1916-63. His work also appeared in Brown & Bigelow calendars from 1924-76 as well as every major magazine. His illus. for Twain's *Tom Sawyer* and *Huckleberry Finn* became classics. During World War I, while serving in the Navy, he painted official portraits. During the 1950s, he executed murals related to the Four Freedoms for the Nassau Tavern in Princeton, NJ. Author: *Norman Rockwell, Illustrator* (1946); *The Norman Rockwell Album* (1961); Autobiography: *My Adventures as an Illustrator*(1959). **Sources:** WW73; WW47; *300 Years of American Art*, vol. 2: 862; P&H Samuels, 404.

ROCKWELL, Rena Victoria *[Marine painter, lecturer] b.1890.*
Addresses: Wilkinsburg, PA/S. Wellfleet, MA. **Studied:** Bradley Polytech. Inst. **Member:** Pittsburgh AA; AAPL. **Exhibited:** Pittsburgh AA, 1937 (prize). **Work:** Forest Hills (PA) Public Schools. **Sources:** WW40.

ROCKWELL, Robert H(enry) *[Sculptor] b.1886, Laurens, NY.*
Addresses: Brooklyn, Yonkers, NY. **Exhibited:** BM (small bronzes of animals); S. Indp. A., 1917; PAFA Ann., 1941. **Sources:** WW29; Falk, *Exh. Record Series.*

ROCKWOOD, Katherine C. *[Landscape painter] 19th/20th c.*
Addresses: Durham, CT. **Studied:** Wedworth Wadsworth in Durham, CT. **Comments:** She painted watercolor landscapes around Durham, CT, and signed them as "K.C. Rockwood." **Sources:** PHF files.

ROCKWOOD, Paul Clark *[Lithographer] b.1895, Monrovia, CA / d.1972, Kailua, Oahu, HI.*
Addresses: San Francisco, CA, active 1932-39. **Exhibited:** de Young Mus., 1939. **Sources:** Hughes, *Artists in California*, 475.

ROCKWOOD, Roy *[Illustrator] early 20th c.*
Comments: From 1913-15, he produced illustrations for juvenile series books, including *Speedwell Boys* for the Stratemeyer Syndicate. **Sources:** info courtesy James D. Keeline, Prince & the Pauper, San Diego.

ROCLE, Margaret (Margot) K(ing) (Mrs. Marius) *[Painter, lithographer] b.1897, Watkins Glen, NY / d.1981, Ramona, CA.*
Addresses: Chula Vista, CA, from 1928. **Studied:** PAFA; with R. Henri; Bredin; Wiles. **Member:** Soc. of Independent Artists; San Diego FAS; San Fran. AA; Laguna Beach Progressives; San Fran. Soc. of Women Artists; San Diego Modern Painters. **Exhibited:** Salons of Am.; S. Indp. A., 1928-29; Calif. State Fair, 1930; Southern Calif. Artists, 1931 (hon. men.), 1933 (hon. men.); Oakland Art Gal., 1932; Santa Cruz Ann., 1932 (prize); PAFA Ann., 1932; Century of Progress Expo, Chicago, 1933; San Diego Ann., 1933; Calif.-Pac. Int. Expo, San Diego, 1935; SFMA, 1935; GGE, 1939; San Diego AG, 1939 (prize); Faulknew Gal., Santa Barbara, 1939. **Work:** BMA; FA Gal., San Diego. **Comments:** She began as a barefoot dancer in the tradition of Isadora Duncan and appeared in vaudeville shows until the outbreak of WWI, when she became a nurse and was sent to France. There she met her husband Marius Rocle (see entry), whom she married in 1918. By 1921 they had moved to California and she seriously turned to art in the mid-1920s. **Sources:** WW40; Hughes, *Artists in California*, 475; Trenton, ed. *Independent Spirits*, 75; Falk, *Exh. Record Series.*

ROCLE, Marius R(omain) *[Painter, lithographer] b.1897, Brussels, Belgium / d.1967, Ramona, CA.*
Addresses: Chula Vista, CA from 1928. **Member:** San Diego FAS; San Fran. AA; Laguna Beach AA; Soc. of Independent Artists. **Exhibited:** S. Indp. A., 1928-29; Salons of Am., 1929; San Diego AG, 1931 (prize); Calif.-Pacific Int'l Expo, San Diego,

1935; GGE, 1939. **Work:** BMA; FA Gal., San Diego. **Comments:** He served in WWI as a U.S. citizen and he and his wife Margaret Rocle (see entry) settled permanently in California c. 1921. **Sources:** WW40; Hughes, *Artists in California*, 475; Marlor, *Salons of Am.* (under Rocke or Rockle).

RODART, George *[Painter] b.1943.*
Addresses: Venice, CA, 1975-83. **Exhibited:** WMAA, 1975-83. **Sources:** Falk, *WMAA.*

RODDA, Dorothy (Mrs. Paul) See: **COOK, Dorothy W. (Mrs. Paul Rodda)**

RODDA, Stewart *[Painter] mid 20th c.*
Addresses: Drexel Hill, PA. **Exhibited:** PAFA Ann., 1931, 1933. **Sources:** Falk, *Exh. Record Series.*

RODDEN, H. *[Portrait painter] mid 19th c.*
Addresses: Warren, OH, 1853. **Comments:** *Cf.* Horace Rawdon. **Sources:** G&W; Ohio BD 1853.

RODDIS, Mary Augusta *[Painter] b.Troy, NY / d.1925, New Orleans, LA.*
Addresses: New Orleans, active 1889-1910. **Member:** Arts Exh. Club, 1901. **Exhibited:** Artist's Assoc. of N.O., 1894. **Sources:** *Encyclopaedia of New Orleans Artists*, 328.

RODDY, Edith Jeannette *[Painter, etcher, teacher, lecturer] b.Meadville, PA / d.c.1960.*
Addresses: Sarasota, FL. **Studied:** BMFA Sch.; in Europe; & with Charles Hawthorne, George Pearse Ennis; Nat. Lg. Am. Pen Women; Syracuse AA; SSAL. **Member:** NAWA; Florida Fed. Art; Sarasota AA; Clearwater AA. **Exhibited:** Florida AA; Sarasota AA; Sarasota Fed. Art (citation); Clearwater AA, 1946 (prize); Palm Beach Art Lg.; Wash. WCC; Gulf Coast Group; Florida Fed. Art, 1938 (medal). **Work:** Meadville (PA) AA; Syracuse Mus. FA. **Comments:** Contributor: *School Arts League, Design*, & other magazines; covers for *Literary Digest, Keramic Studio.* **Position:** teacher, Ringling Sch. Art, Sarasota, FL. **Lectures:** Art History & Art Appreciation. **Sources:** WW59; WW47.

RODERICK, C(harles) E. D(uncan) *[Painter] 20th c.; b.Nova Scotia.*
Addresses: Allston, MA. **Studied:** C.K. Fox. **Member:** Portland AS. **Sources:** WW25.

RODERICK, Harry T. *[Painter] 20th c.*
Addresses: Columbus, OH. **Member:** Columbus PPC. **Sources:** WW25.

RODERICK, John M. *[Painter, mural painter, decorator, designer] b.1877, Wilmington, DE.*
Addresses: Harrisburg, PA.; Philadelphia, PA. **Member:** Wilmington SFA. **Exhibited:** PAFA Ann., 1937-38. **Work:** PAFA; Wilmington Soc. FA; mural decorations in churches in Cambridge, Md.; Easton, Md.; Wilmington, Del.; Pendleton, Ore.; Collegeville, Pa.; Riverton, NJ; Church, Ridgely, Md; Sacred Heart Church, Delphi, Pa; Harrisburg and Philadelphia, Pa. **Sources:** WW59; WW47, puts birth at 1878; Falk, *Exh. Record Series.*

RODERICK, Lulu Zita (or Rita) (Mrs. H. P. Jeffries) *[Painter, writer, teacher, illustrator] mid 20th c.; b.Nova Scotia.*
Addresses: Sussex Comers, New Brunswick, 1925-29. **Studied:** P. Moschowitz; PIA Sch. **Member:** Newport AA. **Sources:** WW29 (as Lulu Rita Jeffries); WW25 (as Lulu Zita Roderick).

RODERTSON, Persis W. (Mrs.) *[Lithographer] b.1896, Des Moines, IA.*
Addresses: Des Moines, IA. **Studied:** Wells Col. (B.A.); Columbia Univ. **Member:** Audubon A. **Exhibited:** AIC, 1935, 1937, 1939; Northwest Pr. M., 1937, 1939-40; Phila. Pr. Cl., 1936-37, 1939- 40; Phila. A. All., 1936, 1939; Wash. WC Cl., 1939-40; Phila. WC Cl., 1940; Buffalo Pr. Cl., 1938, 1940, 1951; Boston Soc. Indp. A., 1941; Southern Pr. M., 1938; Oakland A. Gal., 1938 -39, 1941; Okla. A. Center, 1940-41; LOC, 1945, 1950; Audubon A., 1945, 1951; Joslyn Mem., 1936, 1938, 1940-

41; Silver Springs (Md.), 1955; Kansas City AI, 1936-40 (prize), 1941; Wichita, Kan., 1938-40; solo exh.: Ferargil Gal., 1939; Hanley Gal., Minneapolis, 1939; Denver A. Mus., 1939; William Rockhill Nelson Gal., 1940; Iowa A., 1950-51; Des Moines A. Center, 1951 (solo); Hanley Gal., Minneapolis; Old Town A. & Crafts, Southold, LI; Smithsonian Inst., 1955. **Comments:** Lectures: Lithography. **Sources:** WW59.

RODEWALD, Fred C. *[Illustrator] mid 20th c.*
Addresses: Active in NYC, 1930s. **Comments:** Worked for Macmillan Co., 1948; contributed "The Flaming Frontier" for *Real Western* magazine. **Sources:** P&H Samuels, 405.

RODGERS *[Portrait painter] early 19th c.*
Comments: Painter of a portrait of Joseph Rodman Drake (1795-1820), engraved by T. Kelly. Groce & Wallace noted the possibility that this artist may have been Nathaniel Rogers. **Sources:** G&W; Stauffer, II, no. 1600.

RODGERS, Isabel Frances *[Painter] b.1890, Fort Worth, TX.*
Addresses: Lumberville, PA. **Studied:** Moore Inst. Des. for Women; & with George Elmer Browne. **Member:** All. Artists Am.; NAC; NAWPS. **Exhibited:** NAD, 1931, 1932, 1934, 1937, 1938; NAWA, 1937-38. **Sources:** WW53; WW47.

RODGERS, Joshua *[Listed as "artist"] b.c.1839, Pennsylvania.*
Addresses: Philadelphia in 1860. **Sources:** G&W; 8 Census (1860), Pa., LV, 794.

RODGERS, M. C. *[Painter] 20th c.*
Addresses: Pittsburgh, PA. **Member:** Pittsburgh AA. **Sources:** WW21.

RODGERS, Maria Sanchez *[Painter] mid 20th c.*
Addresses: Santa Cruz, CA. **Exhibited:** Calif. Statewide Exh., Santa Cruz AL, 1937 (prize). **Sources:** WW40.

RCDIER, Marie *[Painter] early 20th c.*
Addresses: NYC, 1924. **Exhibited:** S. Indp. A., 1924. **Sources:** Marlor, *Soc. Indp. Artists.*

RODIER, P. Louis *[Artist] b.1859, Wash., DC.*
Addresses: Wash., DC, active 1901. **Sources:** McMahan, *Artists of Washington, DC.*

RODINA, K. Michaloff *[Sculptor] early 20th c.*
Addresses: NYC. **Exhibited:** PAFA Ann., 1915. **Sources:** WW15; Falk, *Exh. Record Series.*

RODINE, Mary Louise *[Sculptor] b.1914, Stratford, IA.*
Addresses: Des Moines, IA. **Studied:** Drake Univ.; Art Students Work Shop; Florence Sprague Smith, Oma Strain, Lowell Houser. **Member:** Delta Phi Delta Art Fraternity. **Exhibited:** Iowa Art Salon, 1934, 1936 (award), 1937 (award); All Iowa Woodsculpture Exhibit, Ames, 1936; Third Nat. Exhibition Am. Art, 1938; All Iowa Exhibit, Carson Pirie Scott, 1937; Delta Phi Delta, 1933 (first award). **Work:** Iowa State College, 1936. **Sources:** Ness & Orwig, *Iowa Artists of the First Hundred Years,* 179.

RODMAN, Edmund *[Sketch artist] b.1824, New Bedford, MA / d.1902, New Bedford.*
Addresses: New Bedford, MA, 1860-1902. **Work:** New Bedford (MA) Free Pub. Lib. **Comments:** Worked first for a photography firm and later had a studio of his own. **Sources:** Blasdale, *Artists of New Bedford,* 155-56 (w/repros.).

RODMAN, H. Purcell *[Painter] mid 20th c.*
Addresses: Alliance, OH. **Exhibited:** NYWCC, 1936-37; Wash. WCC, 1939; AWCS-NYWCC, 1939. **Sources:** WW40.

RODMAN, Selden *[Writer, collector] b.1909, NYC.*
Addresses: Oakland, NJ. **Studied:** Yale Univ., 1931. **Comments:** Positions: art comnr., State NJ, 1964-65. Publications: auth., "The Eye of Man," 1956, "Conversations with Artists," 1957 & "The Insiders," 1959. Collection: contemporary figurative painting and sculpture; collection has been widely show in the United States

and Mexico, and has been catalogued by Vanderbilt University and by San Carlos Academy, Mexico. Art Interests: initiated and directed tempera murals by eight self-taught artists in Cathedral St-Trinité, Port-au-Prince, Haiti, 1949-1951; comn. three murals by Seymour Leichman and sculpture by James Kearns, 1960-68. **Sources:** WW73.

RODNITZKY, Emmanuel See: **RAY, Man**

RODRIGUEZ, Alfred C. *[Landscape painter] b.1862, California / d.1890, San Francisco, CA.*
Addresses: San Fran. **Studied:** San Francisco School of Des.; with Jules Tavernier. **Exhibited:** Calif. State Fair, 1888; San Francisco AA, 1890; Calid.-Midwinter int'l Expo, 1894; Oakland Art Fund, 1904. **Comments:** He had his own studio at age 18 in Oakland, and took many sketching trips together with George Redding (see entry) and his pupil Harry Cassie Best (see entry). Rodriguez died of consumption and his works are rare. **Sources:** Hughes, *Artists in California,* 476.

RODRIGUEZ, Loranzo M. *[Painter] early 20th c.*
Addresses: Mexico. **Exhibited:** S. Indp. A., 1923. **Sources:** Marlor, *Soc. Indp. Artists.*

RODRIGUEZ LUNA, Antonio *[Painter] b.1910, Montoro, Spain.*
Addresses: Francisco, CA. **Studied:** Sch. Fine Arts, Seville, 1923-27; Royal Acad. San Fernando, Madrid, 1927-29. **Exhibited:** solo shows, Venice Biennial (representing Spain), 1934, Nat. Mus., Wash., DC, 1941, Retrospective, Nat. Palace Fine Arts, Mexico DF, 1959, Fine Arts Gal. San Diego, 1967 & Wenger Gal., San Fran., Calif., 1970. Awards: first prize for painting, Nat. Contest Painting & Design, Barcelona, 1938; Guggenheim fel., 1941-43, first prize for painting, Nat. Inst. Fine Arts Ann., Mex., 1963. **Work:** Nat. MoMA, Madrid, Spain; Fine Arts Gal. San Diego, Calif.; Nat. MoMA, Mexico City, Mex. **Comments:** Preferred media: oils. Teaching: prof. painting, San Carlos Acad., Nat. Univ. Mex, 1949-69. **Sources:** WW73; M. Nelkin, *El Expressionismo Mexicano* (Inst. Nac. Bellas Artes, 1964); "Image of Mexico," *Tex. Quart.* (1969); Juan Rejano, *Antonio Rodriguez Luna* (Nat. Univ. Mex.).

RODRIQUEZ, Eloisa See: **SCHWAB, Eloisa (Mrs. A. H. Rodriguez)**

RODWAY *[Presumably lithographer and engraver] mid 19th c.*
Addresses: Chicago, 1853. **Comments:** Partner with Henry Acheson (see entry) in Acheson & Rodway, lithographers and engravers, active in Chicago, 1853. Nothing further is known of Rodway. **Sources:** G&W; Chicago CD 1853.

RODYENK, Peter de *[Painter] mid 20th c.*
Addresses: NYC. **Exhibited:** S. Indp. A., 1923, 1927. **Sources:** Marlor, *Soc. Indp. Artists.*

ROE, Emil *[Painter] mid 20th c.*
Exhibited: Salons of Am., 1931, 1934. **Sources:** Marlor, *Salons of Am.*

ROE, Julia See: **STOHR, Julie**

ROE, Nicholas *[Listed as "artist"] b.c.1819, New York.*
Addresses: NYC in 1850. **Sources:** G&W; 7 Census (1850), N.Y., XLI, 539.

ROEBLING, Mary G *[Collector, patron] b.1905, Collingswood, NJ.*
Addresses: Trenton, NJ. **Exhibited:** Awards: American AA; Arch. Am. Art; Philadelphia Print Cl.; NJ Cult. Ctr. Adv. Coun. (first chmn.); MMA. **Comments:** Collection: paintings, sculpture, fine porcelain and glass. **Sources:** WW73.

ROECKER, H(enry) Leon *[Painter] 19th/20th c.; b.Burlington, IA.*
Addresses: Chicago, IL; Winthrop Harbor, IL. **Studied:** Acad. Des., Chicago; Royal Acad., Munich. **Member:** Chicago SA; Chicago WCC; Cliff Dwellers; Cor-Ardens. **Exhibited:** Munich, 1889 (hon. men.); PAFA Ann., 1892, 1909, 1928; AIC, 1894

(Yerkes prize), 1897 (prize), 1911 (prize), 1931 (prize); Chicago SA, 1909 (med.). **Sources:** Ness & Orwig, *Iowa Artists of the First Hundred Years,* 179; Falk, *Exh. Record Series.*

ROECKER, Julia (Mrs.) *[Museum director] b.1887 / d.1988, Saginaw, MI?.*
Addresses: Saginaw, MI. **Sources:** WW66.

ROEDER, Elsa *[Illustrator] b.c.1885, Baltimore, MD / d.1914.*
Addresses: Orange, NJ. **Studied:** H. Pyle, Wilmington; E. Penfield; Sch. Indust. Art, Phila. **Member:** Sketch Club, Wilmington. **Exhibited:** *Life Magazine* contest, 1908 (prize); theatrical poster exh., (prize). **Comments:** Illustrated books by her father, Rev. Adolph Roeder. Lecturer, YWCA and Woman's Club; assisted with drawing and painting classes, Orange Valley Social Settlement, Orange, NJ. **Sources:** Petteys, *Dictionary of Women Artists.*

ROEDER, Emy *[Painter] mid 20th c.*
Exhibited: AIC, 1936. **Sources:** Falk, *AIC.*

ROEDER, John *[Sculptor, painter] b.1877, Luxembourg / d.1964, Richmond, CA.*
Addresses: Richmond, CA, 1909. **Studied:** self-taught. **Exhibited:** Richmond Art Center, 1961 (solo), 1963 (solo); Oakland Mus., 1986. **Work:** Richmond Art Center. **Comments:** He worked in several professions and painted and sculpted in his free time in a primitive style. **Sources:** Hughes, *Artists in California,* 476.

ROEDER, Norbert *[Museum director] 20th c.*
Addresses: Kenosha, WI. **Sources:** WW59.

ROEDING, Frances *[Painter] b.1910, San Francisco, CA.*
Addresses: Berkeley, CA. **Studied:** Calif. Sch. FA, San Fran.; ASL. **Member:** San Fran. AA; Soc. of Western Artists. **Exhibited:** Salons of Am.; San Fran. Soc. of Western Artists, 1936 (prize); San Francisco AA, 1937; Women A., Wichita, Kans., 1938 (prize); Fnd. Western A., Los Angeles, 1938 (prize); All Calif. Exh., LACMA, 1939 (prize). **Work:** SFMA; Mills Col. Gal., Calif.; LACMA; Oakland A. Gal. **Sources:** WW40; Hughes, *Artists in California,* 476.

ROEHLK, Ernst *[Painter] early 20th c.*
Addresses: Chicago, IL. **Member:** Chicago SA. **Exhibited:** AIC, 1916. **Sources:** WW29.

ROEHNER, Wilhelm *[Portrait and genre painter] mid 19th c.*
Addresses: NYC in 1854 and Newark, NJ in 1859. **Comments:** Groce & Wallace noted the possibly that this might be the Wilhelm Roehner who worked in Vienna, 1839-42, and Berlin, 1842-46. *Cf.* -- Rohner. **Sources:** G&W; NYBD 1854; Newark CD 1859; Thieme-Becker.

ROEHRICH, Lucy Turner *[Painter] mid 20th c.*
Addresses: NYC. **Studied:** ASL. **Exhibited:** S. Indp. A., 1933, 1935; Salons of Am., 1934. **Sources:** Marlor, *Salons of Am.*

ROELOFS, Richard, Jr. (Mrs.) *[Collector] 20th c.*
Addresses: NYC. **Sources:** WW73.

ROEN, Irma *[Painter] early 20th c.*
Addresses: Rock Island, IL. **Member:** NAWPS. **Exhibited:** AIC, 1924-25. **Sources:** WW25.

ROERICH, Nicholas K(onstantin) *[Painter, theatrical designer] b.1874, St. Petersburg, Russia / d.1947.*
Studied: Acad. of Art, St. Petersburg. **Exhibited:** London, 1920; Carnegie Inst.; AIC. **Work:** Roerich Museum, NYC. **Comments:** After study in St. Petersburg, Roerich traveled to Paris and later to Italy and London. While in Paris, Roerich designed the sets and costumes for Stravinski's "Sacre du Printemps" for Diaghilev's Ballet Russe. When invited to show his paintings in the United States in 1920 at the Art Institute of Chicago, his work caused a sensation. Subsequently the work was shown in many cities in the United States. Roerich spent the summer of 1921 on Monhegan Island, Maine, completing a series of painings called the "Ocean Series" (Roerich Mus., NYC). He spent many years in India, portraying the people and mountains of Tibet. Established the Roerich Foundation, a world peace movement, in 1932. **Sources:** Benezit; Curtis, Curtis, and Lieberman, 99, 167, 186.

ROESCH, Kurt Albert (Ferdinand) *[Painter, teacher, illustrator] b.1905, Berlin, Germany / d.1984, New Canaan, CT.*
Addresses: Bronxville, NY; New Canaan, CT. **Studied:** Acad. Art, Berlin, with K. Hofer. **Member:** Am. A. Cong; NH Art Assn. **Exhibited:** AIC; VMFA; four exhibs. at CI, 1941-58; WMAA, 1945-63; PAFA Ann., 1947, 1950-53; Corcoran Gal biennial, 1947; Documenta, Kassel, Ger, 1955; solo shows, Curt Valentin Gal., NYC, 1949-53; Currier Gal., 1955. **Work:** MoMA; Albright-Knox Art Gal., Buffalo, NY; MMA; Currier Gal., Manchester, NH; Univ. Minn; Univ Nebr. **Comments:** Teaching: Sarah Lawrence Col. Illustrator: "The Metaphysical Poets," 1945; "Sonnets to Orpheus," 1944. **Sources:** WW73; WW47; Falk, *Exh. Record Series.*

ROESEN, Severin *[Still-life painter, painter on porcelain and enamel] b.1815, probably near Cologne, Germany / d.1871.* S. Roeseu.
Addresses: Williamsport, PA, c.1862- c.1871. **Studied:** unknown. **Exhibited:** Cologne, Germany, 1847; PAFA, 1863. **Work:** Delaware Art Museum, Wilmington; Amon Carter Mus., Fort Worth, TX; Shelburne (VT) Mus. **Comments:** Roesen began painting porcelain, enamelware and still-lifes in Germany, then emigrated to America about 1848. His still-lifes brought him recognition, and in 1848-50 he sold eleven works to the American Art-Union. He lived in NYC until about 1857, after which he spent several years working in a number of central Pennsylvania towns before settling down in rural Williamsport, PA, then a wealthy lumbering town, about 1862. There he achieved considerable success. His still life paintings (he painted 300-400) are influenced by the Dutch tradition, and typically consist of a large, elaborate arrangements of fruits (or flowers), usually surrounded by leaves and accompanied by a small bird's nest or a half-filled wine glass, all piled high on a marble table top. His signature is often devised as a grape vine's tendril. **Sources:** G&W; Maurice A. Mook, "S. Roesen, `The Williamsport Painter,'" Allentown (Pa.) *Morning Call,* Dec. 3, 1955; Thieme-Becker; Cowdrey, AA & AAU; R.B. Stone, "Not Quite Forgotten, A Study of the Williamsport Painter, S. Roesen," Lycoming Co. Hist. Soc., *Proceedings and Papers,* No. 9, 1951; NYC 1850-57; Born, *Still Life Painting in America;* Frankenstein, *After the Hunt,* 32 and pl. 30; *Portfolio* (Aug. 1944), cover and p. 15; *ibid.* (Jan. 1954), 118; *Williamsport Sun and Banner,* June 27, 1895. More recently, see Baigell, *Dictionary;* Gerdts, *Art Across America,* vol. 1: 271-72 and note 12; Gerdts and Burke, *American Still-Life Painting,* 61, 66; *For Beauty and for Truth,* 85 (w/repro.); Muller, *Paintings and Drawings at the Shelburne Museum,* 120 (w/repro.);.

ROESLER, Nep *[Sketch artist] 19th c.*
Comments: Served as a corporal in the 47th Ohio Division during the Civil War. He made several sketches of war scenes in Western Virginia. **Sources:** Wright, *Artists in Virginia Before 1900.*

ROESLER, Norbert Leonhard Hugo *[Collector] b.1901, Plankenberg, Austria.*
Addresses: NYC. **Member:** Drawing Society; fellow, Pierpont Morgan Library. **Comments:** Collection: drawings by Dutch, French, Italian, English and others. **Sources:** WW73.

ROESNER, Lester R. *[Painter] mid 20th c.*
Exhibited: AIC, 1937. **Sources:** Falk, *AIC.*

ROESSLE, Sigmund G. *[Painter, fresco painter] b.c.1854, New Orleans, LA / d.1907, New Orleans.*
Addresses: New Orleans, active 1879-1906. **Comments:** (Sigmond Russell) **Sources:** *Encyclopaedia of New Orleans Artists,* 329.

ROESSLER, Pauline *[Artist] early 20th c.*
Addresses: Active in Los Angeles, c.1908-10. **Sources:** Petteys, *Dictionary of Women Artists.*

ROESTEL, A. *[Painter] late 19th c.*
Addresses: Venice. **Exhibited:** NAD, 1883. **Sources:** Naylor, *NAD.*

ROETH, Esther *[Painter] mid 20th c.*
Addresses: Chicago, IL. **Exhibited:** AIC, 1922-24, 1926. **Sources:** WW25.

ROETHE, Louis Henry *[Painter] b.1860, Shasta, CA / d.1928, San Francisco, CA.*
Addresses: San Fran. **Studied:** San Francisco School of Des.; with Kunath, Williams and Yelland; Munich, Germany, 1880-85. **Exhibited:** ASL of San Francisco, 1886; Calif. State Fair, 1888. **Work:** Soc. of Calif. Pioneers (bird's -eye view of Placerville, CA, 1888, published by W.W. Elliott Co.). **Sources:** Hughes, *Artists in California,* 476.

ROETTER, Paulus *[Landscape and botanical painter] b.1806, Nürnberg, Germany or Thun, Switzerland / d.1894, St. Louis, MO.*
Addresses: St. Louis, MO, 1845-c. 1860; Cambridge, MA, c. 1865-84; St. Louis, MO, 1884-94. **Studied:** Nürnberg, Düsseldorf, Munich, and possibly Paris, prior to 1825. **Exhibited:** St. Louis Agric. and Mechanical Soc. Fair, 1858-59; Sanitary Fair, 1864. **Work:** Missouri Hist. Soc., St. Louis; Univ. Texas, Austin; Missouri Botanical Gardens, St. Louis. **Comments:** Active in Switzerland from 1825 to 1845, painting miniature landscapes for tourists and teaching at Thun and Interlaken. He immigrated to America in 1845 to join a utopian community in Dutzow, MO, but soon settled in St. Louis, where he and became an Evangelical pastor, and first instructor in drawing at Washington University (through 1861). Beginning in the late 1850s he became known for his romantic scenes along the Mississippi. He also produced drawings used as illustrations in Engelmann's "The Cactaceae of the Boundary" in *Report of the U.S. and Mexican Boundary Survey* (1859). After serving with the Home Guard during the Civil War, he became an associate of Louis Agassiz at Harvard. He returned to St. Louis in 1884. **Sources:** G&W; Powell, "Three Artists of the Frontier," 38-41; WPA Guide, *Missouri; Gazette des Beaux Arts* (Oct. 1946), 303, repro.; Thieme-Becker. More recently, see P&H Samuels, 405; Gerdts, *Art Across America,* vol. 3: 42, 44, 46.

ROGALL, Wilhelmine *[Painter] early 20th c.*
Addresses: NYC. **Member:** NAWPS. **Exhibited:** S. Indp. A., 1918. **Sources:** WW29.

ROGALSKI, Anton Harry *[Painter] mid 20th c.*
Exhibited: AIC, 1935, 1938, 1943. **Sources:** Falk, *AIC.*

ROGALSKI, Walter R. *[Printmaker, lecturer] b.1923, Glen Cove, NY.*
Addresses: Locust Valley, NY. **Studied:** Brooklyn Mus. Sch., with Xavier Gonzalez, Arthur Osver, C. Seide & Gabor Peterdi, 1947-51. **Member:** Soc Am. Graphic Artists. **Exhibited:** six shows, Brooklyn Mus., 1951-68; WMAA, 1966; Soc Am Graphic Artists, 1966 & 1969; Cincinnati Mus. Assn., 1968; Am. Fedn. Arts Traveling Exhib., 1969; Nat. Print Exhib., Potsdam, NY, 1969. Awards: prizes, DeCordova & Dana Mus., 1961 & Yale Gal. Fine Arts, 1961; purchase prize, Assoc. Am. Artists, 1966. **Work:** MoMA; Brooklyn Mus; CMA; Fogg Mus. Art; SAM. **Comments:** Teaching: lectr. etching, engraving, lithography & photo silk-screening; assoc. prof. graphic art, grad. sch. art & design, Pratt Inst. Publications: auth., "Prints and Drawings by Walter R. Rogalski" (catalogue), Print Club Cleveland & Cleveland Mus. Art, 1954; contribr., *Artists Proof* mag. **Sources:** WW73.

ROGER, Franz *[Fresco painter] mid 19th c.*
Addresses: Wash., DC, active 1865. **Sources:** McMahan, *Artists of Washington, DC.*

ROGERS *[Panorama painter] mid 19th c.*
Comments: Painter of a Mississippi River panorama for a production of *Uncle Tom's Cabin* at the National Theatre, NYC, March 1854. *Cf.* Charles H. Rogers. **Sources:** G&W; N.Y. *Herald,* March 22, 1854 (citation in G&W courtesy J.E. Arrington).

ROGERS *mid-19th c.*
Exhibited: Charleston, SC, Nov., 1835 (bird and flower paintings). **Sources:** G&W; Rutledge, *Artists in the Life of Charleston.*

ROGERS, A. E. *[Painter] late 19th c.*
Studied: Laurens, Constant. **Exhibited:** Paris Salon, 1893 (drawing). **Sources:** Fink, *American Art at the Nineteenth-Century Paris Salons,* 385.

ROGERS, A. Edith *[Painter, teacher] 20th c.*
Addresses: Camden, NJ. **Studied:** PAFA. **Sources:** WW25.

ROGERS, A. H. *[Painter] 20th c.*
Addresses: Phila., PA. **Sources:** WW06.

ROGERS, Adele *[Painter, designer, etcher, illustrator, teacher, lithographer] b.1861, Mount Vernon, NY.*
Addresses: Provincetown, MA; East Palatka, FL. **Studied:** CUA Sch.; with William Chase; Charles Hawthorne; George de Forest Brush; D. Volk; R. Henri; G.E. Browne. **Member:** Provincetown AA; St. Augustine AC; PAFA. **Exhibited:** CUA Sch. (prize). **Comments:** Married to Mr. Shrenk. **Sources:** WW53; WW47.

ROGERS, Agnes *[Painter] early 20th c.*
Addresses: Chicago. **Exhibited:** AIC, 1919. **Sources:** Falk, *AIC.*

ROGERS, Annah Barkeley Wright (Mrs. Philip) *[Painter, drawing specialist] 19th/20th c.; b.Seattle, WA.*
Addresses: Seattle. **Studied:** AIC. **Member:** Seattle FAA. **Exhibited:** Seattle FAA Annuals, 1929, 1932. **Sources:** Trip and Cook, *Washington State Art and Artists.*

ROGERS, Annette Perkins *[Painter] b.1841, Boston, MA / d.1920.*
Addresses: Boston, MA. **Studied:** W.M. Hunt, 1868; traveled Europe, 1881. **Exhibited:** Boston AC, 1887; Noyes & Blakeslee Gal., Boston; Williams & Everett Gal., Boston, 1888. **Comments:** Specialties: landscapes, still-life. **Sources:** Petteys, *Dictionary of Women Artists.*

ROGERS, Augustus D. *[Painter] b.1820, Salem, MA / d.1896, Salem.*
Work: Peabody Mus., Salem, MA (marine pen & ink, signed "A.D.R."). **Sources:** Brewington, 328.

ROGERS, Barksdale (Miss) *[Illustrator, painter] early 20th c.; b.Macon, GA.*
Addresses: NYC. **Studied:** Steinlen, in Paris; Munich. **Member:** SI. **Exhibited:** S. Indp. A., 1921. **Work:** portrait masks. **Comments:** Illustrator: *Saturday Evening Post; Scribner's.* **Sources:** WW40.

ROGERS, Bruce *[Book designer] b.1870, Lafayette, IN / d.1957.*
Addresses: Danbury, CT. **Studied:** Purdue Univ. (B.S., L.H.D.). **Member:** AIGA. **Exhibited:** Awards: Am. Acad. Arts & Letters (gold medal). **Work:** books in major libraries; Oxford Lectern Bible; World Bible; Frick Coll. Catalogue; Carl H. Pforzheimer Catalogue; many important books for Grolier and other book clubs. **Comments:** Positions: designer, Riverside Press, Cambridge, MA, 1895-1912; Cambridge Univ. Press, Cambridge, England, 1917-19; W.E. Rudge, Mt. Vernon, NY, 1920-28; Harvard Univ. Press, 1920-34. Author/designer, articles on printing, "The Centaur Types.". **Sources:** WW53.

ROGERS, C. M. *[Painter] late 19th c.*
Addresses: NYC, 1881. **Exhibited:** NAD, 1881. **Sources:** Naylor, *NAD.*

ROGERS, Champ B. *[Sculptor] mid 20th c.*
Addresses: Williamsport, PA. **Exhibited:** PAFA Ann., 1931. **Sources:** Falk, *Exh. Record Series.*

ROGERS, Charles *[Miniaturist] mid 19th c.*
Addresses: Boston, 1844-46. **Sources:** G&W; Boston BD 1844;
Bolton, *Miniature Painters*.

ROGERS, Charles Albert *[Landscape painter, painter]*
b.1840, New Haven, CT / d.1913, Los Angeles, CA.
Addresses: NYC; active San Francisco from 1860s; Los Angeles,
1906 and still in 1913. **Studied:** NYC; Munich; Paris; Rome.
Member: P&S of Los Angeles; Calif. AC; San Francisco AA.
Exhibited: Mechanics' Inst. Fair, 1895, 1897, 1899; Mark
Hopkins Inst., 1897; Calif. State Fair, 1902; Alaska-Yukon Pacific
Expo, Seattle, 1909 (bronze medal); Blanchard Gal., Los Angeles,
1911. **Work:** Calif. Hist. Soc. **Comments:** Moved to Los Angeles
after the 1906 fire destroyed his studio. Also painted scenes of
Chinatown and sketched in Yosemite in 1911. P&H Samuels
report that he may be Charles Rogers who painted a San
Francisco panorama in 1856 and worked at the Lyceum Theater in
1859. **Sources:** Hughes, *Artists in California*, 476; Samuels, 405-
06.

ROGERS, Charles B. *[Painter, museum director, etcher, litho-*
grapher, teacher] b.1911, Great Bend, KS / d.1987, Ellsworth,
KS?.
Addresses: Gread Bend, KS; Ellsworth, KS. **Studied:** NAD; fel-
lowship, Tiffany Fnd., 1937; Bethany Col. (B.F.A.); Calif. College
Arts & Crafts (M.F.A.); with Dong Kingman; Jay Connaway
School Art. **Member:** SAE; Prairie PM; Calif. Soc. PM; Chicago
NJSA; Northwest PM; Soc. Indep. Artists; Progessive AA; Soc.
Am. Graphic Artists; Carmel AA; Prairie WC Painters; Kansas
Fed. Art (vice-pres., bd. mem., 1971-). **Exhibited:** NAD;
LACMA; Phila. Pr. Cl.; NOAA; Oakland Art Gal.; SAE; Wash.
WCC; Gumps, San Francisco;S. Indp. A., 1936-38; Wichita AA;
WFNY, 1939; Kansas City AI, 1928 (prize), 1939 (prize);
Northwest PM; Alabama AA; CM; Alameda, CA, 1945 (prize);
Vendôme Gal. (solo); Mus. New Mexico (solo); Thayer Mus.
(solo); Kansas State Agric. Col. (solo); Bethany Col., 1941
(prize), 1943 (prize) (solo); Univ. Oklahoma (solo); Telenews
Gal., San Francisco (solo); Kansas State Fair, 1931-32 (prize),
thirteen awards in four years; LOC, 1943 (prize). Solos: U.S. Nat.
Mus., Smithsonian Inst., Inst. Mex. Norteamericano, Mexico City,
Munic. Tower Galleries, Los Angeles, Galleries de Arte,
Monterrey, Mexico & Inst. Technology, Rochester, NY. Awards:
over 130 art awards including, Am. Inst. Fine Arts & Mikami
Award. **Work:** Thayer Mus., Lawrence, KS; Kansas Univ.;
Kansas State Women's Cl.; Smoky Hill, Kansas Col.; Hutchinson
(KS) Jr. Col.; LOC Pennell Coll., Wash., DC; MMA Arms Coll.,
NYC; Inst. Mex. Notreamericanos, Mexico City; PMA; Boston
Pub. Libr. Commissions: mural, U.S. Govt. Post Office, Council
Grove, KS, 1940; Smoky Valley Landscape, Citizens Bank Mem.,
Ellsw., KS, 1969; Splitter Farm, Dr. Stan Splitter, Oakland, KS,
1971; Autumn in Kansas, C.L. Clark Law Offices, Salina, KS,
1972. **Comments:** Positions: manager & asst. dir., Huntington
Hartford Foundation, 1954-66; dir., Rogers House Mus.-Gal.,
1967-. Teaching: hd. school art, Bethany Col., 1947-53; hd. school
art, Kansas Wesleyan Univ., 1966-67. Collections arranged: The
Great West-Paintings & Prints by Charles B. Rogers; Paintings of
the Southwest by Peter Hurd, Bethany College. Specialty of
gallery: paintings & prints of the great West. Publications: auth.,
"Painting the American West," *Artists Magazine*, London; auth.,
"Charles B. Rogers Pleads for the Spirit in Art," *Am. Artist*
Magazine, (August, 1963); auth., "Heart of Art," *Art & Artists*,
1965; auth., *Quill of the Kansan*, privately published, 1970.
Sources: WW73; WW47; Ed. Smith, *Charles B. Rogers--Artist*
(Kansas State Publishing, 1968); *Art Professor Charles B. Rogers*
(Kansas State Univ., 1969).

ROGERS, Charles H. *[Scene and landscape painter,*
panoramist] mid 19th c.
Addresses: New Orleans in 1849; San Francisco, c. 1856-72.
Exhibited: Calif. A. Union (1865: landscapes). **Comments:**
Active at the American Theater in New Orleans, 1849. He also
made a sketching trip along the Mississippi to gather material for
Henry Lewis' (see entry) mammoth panorama. By 1856 he was in

San Francisco and associated with John W. Fairchild (see entry),
artist at the American Theatre, in preparing a panorama of scenes
of the California Vigilance Committee. In 1859 he was at the
Lyceum Theater. Later he was listed simply as "artist." Not to be
confused with Charles Albert Rogers (1848-1918). *Cf.* also, --
Rogers, scene painter in NYC in 1854. **Sources:** G&W;
MacMinn, *The Theatre of the Golden Era in California*, 226 (cita-
tion courtesy J.E. Arrington); San Francisco CD 1859-1902. More
recently, see *Encyclopaedia of New Orleans Artists;* Hughes,
Artists in California.

ROGERS, Clara *[Artist] mid 20th c.*
Addresses: Detroit, MI. **Exhibited:** PAFA Ann., 1960. **Sources:**
Falk, *Exh. Record Series*.

ROGERS, D. *[Portrait painter] mid 19th c.*
Comments: Painted profile portraits of Joseph and Hyram Smith,
Mormon leaders, at Nauvoo (Ill.) in 1842. **Sources:** G&W;
Josephson, "What Did the Prophet Joseph Smith Look Like?",
313-14.

ROGERS, David *[Portrait painter] mid 19th c.*
Addresses: NYC, active 1829-58. **Exhibited:** NAD, 1829-31.
Sources: G&W; Cowdrey, NAD; NYCD 1829-58.

ROGERS, E. *[Miniature painter] early 19th c.*
Addresses: Alexandria, VA, active early 1800s. **Sources:**
McMahan, *Artists of Washington, DC*.

ROGERS, E. E. (Mrs.) *[Artist] 19th/20th c.*
Addresses: Active in Los Angeles, c.1889-1913. **Sources:**
Petteys, *Dictionary of Women Artists*.

ROGERS, Edward *[Wood engraver] mid 19th c.*
Addresses: Philadelphia, 1855-60 and after. **Sources:** G&W;
Phila. CD 1855-60+.

ROGERS, Edward A. (Mrs.) *[Painter] 19th/20th c.*
Addresses: San Francisco, CA, 1880s-1906. **Exhibited:** Calif.
State Fair, 1888. **Comments:** Position: artist, San Francisco *Call*
newspaper. **Sources:** Hughes, *Artists in California*, 476.

ROGERS, Effie *[Printmaker] mid 20th c.*
Exhibited: AIC, 1939. **Sources:** Falk, *AIC*.

ROGERS, Eleanor Gale (Mrs.) *[Painter] early 20th c.*
Addresses: Los Angeles, CA, 1917-25. **Member:** Calif. AC.
Sources: WW25.

ROGERS, Elizabeth A. *[Artist] 19th/20th c.*
Addresses: Wash., DC, active 1897. **Sources:** McMahan, *Artists*
of Washington, DC.

ROGERS, Elnora D. *[Painter] 20th c.*
Addresses: New Haven, CT. **Sources:** WW17.

ROGERS, Elva *[Painter] mid 20th c.*
Exhibited: Salons of Am., 1934. **Sources:** Marlor, *Salons of Am.*

ROGERS, Frances Elizabeth *[Painter, illustrator, writer]*
b.1886, Grand Rapids, MI.
Addresses: NYC/Bearsville, Ulster County, NY. **Studied:** H.
Pyle; AIC. **Exhibited:** S. Indp. A., 1917. **Comments:** Co-
author/illustrator (with Alice Beard) "Heels, Wheels, and Wire,"
"Fresh and Briny," "5000 Years of Glass," 1935.

ROGERS, Franklin Whiting *[Painter] b.1854 / d.1917.*
Addresses: Hingham, MA. **Exhibited:** Boston AC, 1876-1906;
Corcoran Gal biennial, 1910. **Sources:** WW15; Falk, *Exhibition*
Records Series.

ROGERS, George *[Sculptors] b.1930, Rutledge, AL.*
Studied: Cleveland Inst. of Art, 1955-59; Cranbrook Academy,
1959-60. **Exhibited:** Waden Gal., Cleveland 1959; Detroit Inst. of
Arts, 1960, 1971; Cranbrook Academy, 1959. **Sources:**
Cederholm, *Afro-American Artists*.

ROGERS, George F. *[Mural painter] b.1841 / d.1863, North*
Carolina.
Addresses: Active in New Bedford, MA, 1859-60. **Sources:**
Blasdale, *Artists of New Bedford*, 157 (w/repro.).

ROGERS, George H. *[Listed as "artist"] b.1826, Connecticut.*
Addresses: New London, CT in 1850. **Sources:** G&W; 7 Census (1850), Conn., X, 236.

ROGERS, Gertrude (Mrs. Roy W.) *[Primitive painter] b.1896, Ionia County, MI.*
Addresses: Dearborn, MI/Arcadia, FL. **Member:** Friends of Art. **Exhibited:** European tour of Am. Primitive Paintings; Smithsonian Tour of Am. Primitive Painters; Western Art Mus. Director's tour; Des Moines Art Center; Galerie St. Etienne, NY, 1952; Am-British Art Gal., 1950 (solo), 1952 (solo); Grand Rapids Art Gal., 1950 (prize), 1951, 1955 (prize); Erie Pub. Mus., 1952; Erie Art Gal., 1952 (prize); Huntington Gal., WV, 1953 (prize). **Comments:** Rogers began painting at age 49, when she developed arthritis. Much of her subject matter centers around growing up on a farm. **Sources:** WW59; Dewhurst, MacDowell, and MacDowell, 171.

ROGERS, Gretchen (Margaret) Woodman *[Painter] b.1881, Boston, MA / d.1967, New Haven, CT.*
Addresses: Boston, MA, c.1913-33. **Studied:** BMFA Sch., 1900-107. **Member:** Boston GA. **Exhibited:** PAFA Ann., 1910-30 (11 times); AIC, 1911, 1914; Corcoran Gal biennials, 1914-26 (4 times); Pan-Pac. Expo, San Fran., 1915 (silver); Boston GA, 1917, 1928 (solo); Vose Gals., 1998. **Work:** pastel figurative work, Everette James Coll. of American portraiture. **Comments:** Painted at Fenway Studios, 1909-32. It is not clear whether there is any relationship between this artist and the craftsperson/designer/painter named Margaret Rogers (see entry). **Sources:** WW33; Rubinstein, *American Women Artists*, 200; Petteys, *Dictionary of Women Artists;* Vose Galleries, *Mary Bradish Titcomb and Her Contemporaries,* 49; PHF files; Falk, *Exh. Record Series.*

ROGERS, Henry W. *[Portrait and miniature painter] late 18th c.*
Addresses: Salem, MA, October 1782. **Sources:** G&W; Belknap, *Artists and Craftsmen of Essex County,* 12; Bolton, *Miniature Painters.*

ROGERS, Henry Whittingham *[Portrait and miniature painter] b.1824 / d.1855.*
Addresses: Active in Salem, MA, 1846-55. **Exhibited:** at the age of eight (1833) exhibited a drawing at the Boston Athenaeum. **Comments:** He was the son of Nathaniel L. Rogers, merchant of Salem. **Sources:** G&W; Swan, BA; BA Cat., 1833; Salem CD 1846-56; Belknap, *Artists and Craftsmen of Essex County,* 12.

ROGERS, J. *[Artist] 19th c.*
Work: Mariners' Mus., VA. **Comments:** Drew a lithograph of the pilot boat "Ann of Norfolk," getting underway. **Sources:** Wright, *Artists in Virginia Before 1900.*

ROGERS, James B. *[Painter] late 20th c.; b.Detroit, MI.*
Addresses: Los Angeles, CA. **Studied:** Univ. Ill.; Univ. Miami; Md. Inst. Art (B.F.A.). **Member:** Provincetown Art Assn. **Exhibited:** All Maryland, BMA, 1956; Conn. Biennial, Wadsworth Atheneum, Hartford, 1965; Newport Ann., RI, 1966; Jersey City Ann., Jersey City Mus. Art, 1967; Hortt Mem., Fort Lauderdale Mus. Art, Fla, 1971; McKenzie Gallery, Los Angeles, CA, 1970s. **Awards:** Contemp. Am. Art-World Tour, US State Dept., 1964; travel exhib. award, Salmagundi Cl., 1968. **Work:** Long Beach Mus. Art, Calif.; Douglas Col., New Brunswick, NJ; Founder's Collection, Calif. State Col. Syst.; New Brunswick Pub. Libr., NJ; US NATO Hq., Brussels, Belgium. **Commissions:** series of industrial paintings, Chem Bank World Hq., NYC; series of paintings, Kidder-Peabody Corp World Hq., New York, 1970. **Comments:** Preferred media: acrylics. **Sources:** WW73.

ROGERS, Jane *[Painter] b.1896, NYC.*
Addresses: NYC/Woodstock, NY. **Studied:** S. Halpert; M. Weber. **Member:** NAWPS; Woodstock AA. **Exhibited:** S. Indp. A., 1926-31; Salons of Am.; PAFA Ann., 1933-34; WMAA, 1936. **Sources:** WW40; Falk, *Exh. Record Series;* addit. info. courtesy Woodstock AA.

ROGERS, Janet-Tran *[Artist] mid 20th c.*
Addresses: Princeton, NJ. **Exhibited:** PAFA Ann., 1960. **Sources:** Falk, *Exh. Record Series.*

ROGERS, John *[Sculptor] b.1829, Salem, MA / d.1904, New Canaan, CT.*
Addresses: NYC, active 1859-94; New Canaan, CT (after his retirement in 1894). **Studied:** Went abroad in the fall of 1858, first going to Paris, where he studied with Dantin, and then to Rome, where he briefly entered the atelier of a British sculptor named Spence. **Member:** N.A., 1863; NSS. **Exhibited:** Chicago Fair, 1859 ("Checker Players," was a huge success); Brooklyn AA, 1862-74; PAFA, 1864; NAD, 1860-92; Paris Salon, 1865; Centenn. Expo, Phila., 1876 (29 works); World's Columbian Expo, Chicago 1893 (gold); NAD, 1861-92. **Work:** An almost complete collection of Rogers' "published" work (his groups) is at the NYHS, which also owns his papers. **Comments:** Best known for his "Rogers Groups" (small figural sculpture groups of historical and literary notables, and genre). Rogers grew up in Cincinnati, OH, and Northampton and Roxbury, MA. He went to work at age 16 as clerk; worked as draftsman and mechanic in Mass., N.H., and Missouri, 1848-57. He began modelling small groups in clay as early as 1849, but it was not until 1858 that he decided to become a professional sculptor. While studying in Rome, he met the Americans Richard Greenough, William Wetmore Story, Harriet Hosmer, and others. He became convinced that the simplicity and restraint of the neoclassical style was not for him and that he instead preferred a naturalistic style, rich in detail, that could help tell the stories he wanted his scupture to convey. Returned to the U.S. (Roxbury, Mass.) by spring of 1859 and soon took a drafting job in Chicago, but within a few months he had won notice for his little clay grouping, "Checker Players," the first of the type that came to be known as the "Rogers Groups." This praise encouraged him to make a career out of these small-scale genre works. Moving to NYC in the fall of 1859, he opened a studio and over the next thirty-five years created over 80 works of the "Rogers Groups" type. Reproduced as small (from 13" to 22" high) plaster works painted a neutral (tan or gray) color, over 80,000 replicas were sold in Rogers' lifetime. His work was affordable, usually about ten or fifteen dollars each, and easily available through Rogers' own catalogue mail-order business. Anecdotal and often humorous in nature, his subject matter was taken largely from everday life ("Coming to the Parson," 1870; and "Weighing the Baby," 1876; "Checkers up at the Farm," 1877). He also created narratives out of contemporary issues and events, including slavery and the Civil War ("The Slave Auction," 1859; "Wounded to the Rear--One More Shot," 1864; and "The Fugitive's Story," 1869) and portrayed colorful scenes from literature (such as Washington Irving's Rip Van Winkle). Rogers made some small portrait sculptures, including likenesses of Abraham Lincoln, George Washington, and Henry Ward Beecher. **Sources:** G&W; WW04; Smith, *Rogers Groups;* Barck, "John Rogers;" DAB; David Wallace, *John Rogers, the People's Sculptor* (1967); Craven, *Sculpture in America,* 357-366; Baigell, *Dictionary;* Fink, *American Art at the Nineteenth-Century Paris Salons,* 385.

ROGERS, John *[Engraver] b.c.1808, England / d.c.1888.*
Addresses: NYC. **Comments:** Came to NYC about 1850 and was chiefly employed by book publishers. **Sources:** G&W; Stauffer; NYBD 1856+; Hamilton, *Early American Book Illustrators and Wood Engravers,* 133.

ROGERS, John *[Painter, lecturer, teacher] b.1906, Brooklyn, NY / d.1985.*
Addresses: Brooklyn, NY; Elmont, NY. **Studied:** ASL. **Member:** AWCS (exhib. chmn., 1968); Brooklyn Soc. A.; Am. A. Group; Am. Artists Prof. League; SC; Art League Nassau Co. (pres., 1966); ASL. **Exhibited:** AWCS, 1939-46 (silver med., 1942, med., 1944), 1947-72; BM, 1941, 1946; Brooklyn SA, 1940-55 (medal, 1950); A. Dir. C., 1938; Long Island A. Festival, 1945-46; Watercolor USA, Springfield, Mo, 1962; St. Botolph Cl., Boston, 1947; SC, 1950-65 (award, 1956), 1970 (first prize in watercol-

or); NAC, 1952, 1965; Grand Central A. Gal., 1954, 1955-65; Bohne Gal., 1943-65; Academic A., 1955, 1961, 1965; WC Soc., London, 1963, 1965; NAD,1970; Am. Artists Prof. League (gold); Baltimore WC Cl., 1959 (award); Operation Democracy, 1960 (1st prize); A. Lg. of Long Island, 1961 (prize); Locust, Va., 1964 (prize);Garden City Gal., Garden City, NY, 1970s. **Comments:** Preferred media: watercolors. Specialty: landscapes, marines. Positions: artist, *New York Times,* 1928-30; artist & illusr., *New York Post,* 1950-55. Teaching: Instr watercolors, Garden City Adult Sch., 1955-70; instr. watercolors, Elmont Adult Prog., 1957-70. Publications: auth., articles, In: *Am. Artist,* 1948, *Design Mag.,* 1951, *Artist's Mag.,* London, 1952 & *Watercolor Simplified,*1965. **Sources:** WW73; WW47; Norman Kent, "John Rogers, Watercolorist," *Am. Artist* (1948).

ROGERS, John A(rthur) *[Architect, etcher, painter, teacher]* *b.1870, Louisville, KY / d.1934, Daytona, FL.*
Addresses: Daytona Beach, FL. **Studied:** AIC; MIT; R. Seymour. **Member:** Am. Art. Prof. Lg.; Fla. Fed. A.; SSAl. **Exhibited:** S. Indp. A., 1932. **Sources:** WW33.

ROGERS, John H. *[Sculptor, educator] b.1921, Walton, KY.*
Addresses: Atlanta, GA. **Studied:** Eastern Ky. Univ.; Tyler Sch. Art, Temple Univ. (B.F.A. & M.F.A.). **Member:** Nat. Assn. Schs. Art (del., 1971-72); Southeastern Col. Art Conf. (del., 1972); Col. Art Assn. (1971-72). **Exhibited:** Minneapolis Womens Cl. Ann. Print Show, Minn., 1966; Armed Forces of US as Seen by the Contemporary Artist, Smithsonian Inst., 1968; Artists in Vietnam, Smithsonian Traveling Exhib. Serv., 1968-70; Atlanta Sch. Art Faculty Exhib., High Mus. Art, Ga., 1972. **Awards:** Mem. Award, Minneapolis Womens Cl., 1966. **Work:** Ala. Archives, Montgomery; Marine Corps Combat Art Coll., Marine Corps Mus., Wash., DC; Auburn Univ., Ala. **Commissions:** bust of Gen. H.M. Smith USMC, Ala. Archives, Montgomery, 1969. **Comments:** Preferred media: bronze, wood. Positions: acad. dean, Minneapolis Col. Art & Design, 1964-68; asst. hd., Marine Corps Combat Art Prog., Washington, 1968-69, hd., 1969-70; dean, Atlanta Sch. Art, Ga., 1970-on. Teaching: sr. seminar humanities, Atlanta Sch. Art, 1970-71. Publications: auth., *Minn. Educ. Assn. J.,* 1967. **Sources:** WW73.

ROGERS, Julia Brincombe *[Painter, sculptor] late 19th c.*
Addresses: New Orleans, active c.1894. **Studied:** Achille Perelli. **Exhibited:** Artist's Assoc. of N.O., 1894. **Comments:** Sister of Elizabeth Goelet Rogers Palfrey (see entry). **Sources:** *Encyclopaedia of New Orleans Artists,* 329.

ROGERS, Julie Homberger *[Painter, graphic artist] b.1908, San Fran., CA.*
Addresses: San Francisco, CA; NYC; Connecticut/Tobago, West Indies. **Studied:** Calif. School of FA; NYC, with Rico Lebrun and George Grocz. **Member:** San Francisco Artists & Writers Union; Norwich AA; Columbia Art Soc. **Exhibited:** San Francisco AA annuals. **Sources:** Hughes, *Artists in California,* 477.

ROGERS, Kate J. *[Portrait painter] late 19th c.*
Addresses: Active in Ann Arbor, MI, 1886-99. **Sources:** Petteys, *Dictionary of Women Artists.*

ROGERS, Katherine M. *[Designer, illustrator, teacher] b.1908, Pueblo, CO.*
Addresses: San Leandro, CA. **Studied:** Calif. College Arts & Crafts; J. Paget-Fredericks. **Comments:** Specialty: designer of theatrical costume, sets, posters. **Sources:** WW40.

ROGERS, Laura (Mrs.) *[Painter] 19th/20th c.*
Addresses: Ballard, WA. **Studied:** Lottie Lovejoy. **Exhibited:** Wash. State Arts and Crafts, 1909. **Sources:** Trip and Cook, *Washington State Art and Artists.*

ROGERS, Laussant Richter *[Painter] mid 20th c.*
Addresses: Phila., PA; New Castle, DE. **Studied:** ASL. **Member:** Wilmington SFA. **Exhibited:** PAFA Ann., 1899; Salons of Am.; S. Indp. A., 1930-31, 1934. **Sources:** WW25; Falk, *Exh. Record Series.*

ROGERS, Leo M. *[Collector] b.1902, Boston, MA.*
Addresses: Sarasota, FL. **Studied:** Columbia Col. (B.A., 1923); Columbia Univ. (Ch.E., 1925). **Comments:** Collection: Cezanne, Manet, Degas, Soutine, Modigliani, Sisley, Signac, Roualt, Vuillard, Picasso, Pascin, Lautrec, Cassat, Renoir, Pisarro, Van Gogh, Morisot, Daumier, Brach, Homer & Ryder. **Sources:** WW73.

ROGERS, Leore Corrin (Mrs.) *[Painter] b.1897, Oconomowoc, WI.*
Addresses: Buffalo, NY. **Studied:** Mrs. W.E. Forbush; Mrs. H. Beecher. **Member:** Richmond AC; York (PA) Art Cl. **Exhibited:** York Art Cl.; Grand Central Art Gal., NY, 1939; S. Indp. A., 1939. **Sources:** WW40.

ROGERS, Louise De Gignilliet *[Portrait painter, etcher] mid 20th c.; b.Macon, GA.*
Addresses: Greenwich, CT. **Studied:** Steinlen, in Paris; R. Henri; Munich; ASL. **Member:** Brooklyn SE; Conn. SA. **Exhibited:** S. Indp. A., 1917, 1921, 1923. **Work:** portrait, Vice-Pres. Marshall; William Jennings Bryan; Senator Tillman. **Sources:** WW29.

ROGERS, Margaret *[Painter, designer, craftsperson] mid 20th c.; b.Boston, MA.*
Addresses: Boston/Barnstable, MA, 1940. **Studied:** A. Munsell; V. George; Mass. Sch. Art. **Member:** Boston SAC (master craftsman; Dean, Guild of Jewelers). **Exhibited:** Boston SAC (med); AIC (prize). **Comments:** Not clear whether there is any relationship between this artist and Gretchen (Margaret) Woodman Rogers (see entry). **Sources:** WW40.

ROGERS, Margaret Esther *[Painter, teacher] b.1872, Birmingham, England / d.1961, Santa Cruz, CA.*
Addresses: Santa Cruz, CA. **Studied:** F.L. Heath, L.P. Latimer, Alexander Bower. **Member:** Santa Cruz AL; Soc. Western Artists; Bay Region AA; Berkeley Lg. FA; Salinas FAA; Women Painters of the West. **Exhibited:** Santa Cruz AL; Los Angeles; San Francisco; S. Indp. A., 1927-28; Santa Cruz Statewide Exh., 1928 (prize), 1937 (prize), 1938 (prize); Oakland Art Gal., 1932; Watsonville, CA, annually (prizes); Calif. State Fair, Sacramento, 1934, 1936-38 (prize), 1939 (prize), 1941 (prize); GGE, 1939; NYC; Chicago; Portland, OR; Boise, ID. **Comments:** Her family owned a prosperous sheep ranch in California, and Margaret was known as one of the finest horsewomen in the West in her youth. She moved to Santa Cruz in 1905 and became known as one of the "Santa Cruz Three", together with her painting companions Cornelia DeGavere (see entry) and Leonora Penniman (see entry). **Sources:** WW59; WW47. More recently, see Hughes, *Artists in California,* 477.

ROGERS, Margaret Woodman See: **ROGERS, Gretchen (Margaret) Woodman**

ROGERS, Mary *[Painter] mid 20th c.*
Exhibited: S. Indp. A., 1936. **Comments:** Possibly Rogers, Miss Mary Gamble, b. 1870, Bryan's Station, KY-d.1951, NYC. **Sources:** Marlor, *Soc. Indp. Artists.*

ROGERS, Mary *[Painter, sculptor] b.1882, Pittsburgh / d.1920, NYC.*
Addresses: NYC. **Studied:** R. Henri; Paris, with Simon, Ménard. **Member:** Soc. Independent Artists (dir.). **Sources:** WW19.

ROGERS, Mary C. *[Painter] b.c.1882, Pittsburgh, PA / d.1920, NYC.*
Addresses: NYC. **Exhibited:** Armory Show, 1913; S. Indp. A., 1917-20, 1923, 1941. **Sources:** Marlor, *Soc. Indp. Artists;* Brown, *The Story of the Armory Show.*

ROGERS, Mary G. *[Painter, writer, lecturer, teacher] mid 20th c.*
Addresses: NYC/Wequetonsing, MI. **Studied:** Chase; Despujols, France. **Member:** NAWPS; NAC; AWCS; PBC. **Exhibited:** NAD, PAFA; Pan.-Pac. Expo; NAWPS. **Comments:** Position: t., NY Tranining Sch. for Teachers. **Sources:** WW40.

ROGERS, Mary J. *[Painter] 19th/20th c.*
Exhibited: Boston AC, 1876-77. **Comments:** Active 1877-1920.
Sources: *The Boston AC.*

ROGERS, Mary Lupen *[Painter] early 20th c.*
Addresses: Everett, WA, 1931. **Exhibited:** Everett Drama
League, 1930-31. **Sources:** Trip and Cook, *Washington State Art
and Artists.*

ROGERS, Mary (Mrs. Richard) See: **BEAN, Mary
(Mrs. Richard Rogers)**

ROGERS, Meyric Reynold *[Museum curator, educator,
writer, lecturer] b.1893, Kings Norton, England / d.1972.*
Addresses: Chicago, IL; Hendersonville, NC. **Studied:** Harvard
Univ. (A.B., M. Arch.). **Member:** AA Mus.; CAA. **Exhibited:**
Awards: Legion of Honor, 1948; Star of Italy, 1952. **Comments:**
Author: "Carl Milles, Sculptor," 1940; "American Interior
Design," 1947; "Handbook, Italy at Work," 1950. Co-author:
"Handbook to the Pierpont Morgan Wing," MMA, 1923;
"Handbook to the Lucy Maud Buckingham Medieval Collection,"
1945. Contributor to: Encyclopaedia Britannica with article on
Am. Interior Dec. & Am. Furniture, 1956; museum bulletins & art
periodicals. Position: asst., asst cur., Decorative A. Dept., MMA,
1917-23; prof., Smith Col., 1923-26; assoc. prof., Harvard Univ.,
1927; dir., BMA, 1928-29; dir., CAM, 1929-39; cur. Decorative
A. & Indst. A., AIC, Chicago, Ill., 1939-59 (leave 1958-59); orga-
nizing sec., Italy at Work" Exh., 1950; l., Am. Art, Yale Univ.,
1956; trustee, Am. Craftsmen's Edu. Council, NY; cur. Garvan and
related Collections, Yale Univ. A. Gal., New Haven, Conn., 1958-
64, Emeritus, 1964-. **Sources:** WW66; WW47.

ROGERS, Michael G. *[Portrait painter] b.c.1805, Ohio /
d.1832, Indianapolis, IN.*
Addresses: Indianapolis, IN, as of 1831. **Sources:** G&W; Peat,
Pioneer Painters of Indiana, 149-50; Burnet, *Art and Artists of
Indiana,* 61.

ROGERS, Millard Buxton *[Art historian] b.1912, Danville,
IL.*
Addresses: Seattle, WA. **Studied:** AIC (M.F.A.); Univ. Chicago
(M.A., Ph.D. 1935). **Member:** CAA, Oriental Ceramic Soc.; Far
Eastern Assn. **Exhibited:** Awards: F., AIC, 1935; F., Univ.
Chicago 1938-40; Rockefeller grant, travel and study in the
Orient, 1948-49. Contributor of articles to *Artibus Asiae;* reviews
to *Journal of Asiatic Studies; Far Eastern Ceramic Bulletin,* and
others. Lectures: Oriental Art. **Comments:** Positions: instr.,
Humanities, Univ. Chicago, 1940-43; hd. art dept., Univ. So.
California, 1946-47 and visiting l., 1947; asst. prof., Stanford
Univ., 1947-50, visiting l., 1952; l. in art history, Univ.
Washington, 1952-; asst. in Anthropology, Field Mus. Nat. Hist.,
Chicago, 1941-43; assoc. dir., SAM, 1952-61; director of the
Center for Asian Arts and lecturer in the School of Art, Univ.
Washington, 1961-. **Sources:** WW66.

ROGERS, Millard Foster, Jr. *[Art administrator, art histori-
an] b.1932, Texarkana, TX.*
Addresses: Madison, WI. **Studied:** Mich. State Univ. (B.A.
(hon.), 1954); Univ. Mich. (M.A., 1958); Victoria & Albert Mus.,
London, 1959, with John Pope-Hennessy. **Member:** Assn. Art
Mus. Dirs.; Am. Assn. Mus. **Exhibited:** Awards: Gosline fel.,
TMA, 1958-59. **Comments:** Positions: asst. to dir., TMA, 1959-
63, cur. Am. art, 1964-67; dir., Elvehjem Art Ctr., Univ. Wis.-
Madison, 1967-. Teaching: assoc. prof. mus. training & connois-
seurship, Univ. Wis.-Madison, 1967-. Collections arranged: New
Eng. Glass Co., 1818-80, TMA, 1963; Indian Miniature Painting,
1971 & Canadian Landscapes, 1973, Univ. Wis. Research: Junius
Brutus Stearns, 1815-85. Publications: auth., "La Pintura Espanola
en el Museo de Arte de Toledo," Goya, Aug., 1962; "The
Salutation of Beatrice by Dante Gabriel Rossetti," *Connoisseur*
(July, 1963); "Benjamin West and the Caliph: two paintings for
Fonthill Abbey," *Apollo* (June,1966); "Ivydia, Popular Victorian
Image," *Antiques* (March, 1970) & Randolph Rogers, "American
Sculptor in Rome," *Univ. Mass. Press* (1971). **Sources:** WW73.

ROGERS, Minnie M. *[Painter] late 19th c.*
Addresses: NYC, 1883. **Exhibited:** NAD, 1883. **Sources:**
Naylor, *NAD.*

ROGERS, Nathaniel *[Miniature painter] b.1788,
Bridgehampton, Long Island, NY / d.1844, Bridgehampton.*
Addresses: It is believed he painted in Conn. before establishing
studio in NYC, where he was active 1811-39. **Studied:**
"Mysterious" Brown, NYC; Joseph Wood, NYC, 1811. **Member:**
American Academy; N.A. (founding mem.). **Exhibited:** NAD,
1826-30; Worcester Art Mus., 1976-77. **Work:** NYHS; Md. Hist.
Soc.; Worcester Art Mus. **Comments:** One of the founders of the
National Academy, his work as a miniaturist was considered high-
ly in his day. From c.1811 to 1840, he was one of the most prolif-
ic miniature painters in NYC, typically using a dark palette of
greys, greens and browns. **Sources:** G&W; Frederic Sherman,
"Nathaniel Rogers and His Miniatures," *Art in America* 23
(October 1935): 158-62, incl. five repros. and checklist; NYCD
1812-39; Cowdrey, AA & AAU; Cowdrey, NAD; Cummings,
Historic Annals; Bolton, *Miniature Painters;* NYHS Catalogue
(1974), cat. entries 975, 1300, 1459, 1697+; Strickler, *American
Portrait Miniatures,* 100-101.

ROGERS, Oliver A. *[Painter] mid 20th c.*
Addresses: Los Angeles, CA, 1925-32. **Member:** Calif. AC.
Sources: WW25; Hughes, *Artists in California,* 477.

ROGERS, Otto Donald *[Painter, educator] b.1935,
Kerrobert, Canada.*
Addresses: Saskatoon, Sask. **Studied:** Sask. Teacher's Col.
(teacher cert., 1953); Univ. Wis. (B.Sc., Art educ., 1958, M.A.,fine
art, 1959). **Member:** Assoc. Royal Can. Acad. Art. **Exhibited:**
Biennial, 1966 & Royal Can. Acad. Art Exhib., 1970, Nat. Gal.
Can.; Directors Choice Exhib., sponsored by Can. Coun.,
Confedn. Art Gal. & Mus., Charlottetown, Prince Edward Island,
1968; Art in Saskatchewan, Waddington Fine Arts Gal., Montreal,
1969; Art Bank Can. Exhib., Mendel Gal., Saskatoon, 1972.
Awards: sr award for study in Europe, Can. Coun., 1967-68.
Work: Nat. Gal. Can., Ottawa; Montreal Mus. Fine Arts; Nat.
Mus. Iceland, Reykjavik; Fredericton A. Gal., NB; Windsor A.
Gal., Ont. Commissions: sculpture in steel (with George Kerr,
architect), Prince Albert Regional Libr., 1965. **Comments:**
Preferred media: acrylics. Positions: mem. acquisitions comt.,
Mendel Gal., 1972-73. Teaching: assoc. prof. painting, Univ.
Sask., 1959-, hd. art dept., 1973-. **Sources:** WW73; R. Harper,
History of Canadian Painting (1966); W. Townsend, "Canadian
Art Today," *Studio Int.* (1970); C. McConnell, "Otto Rogers," *Arts
Can.* (1971)-.

ROGERS, P. J. *[Printmaker, painter] b.1925, Rochester, NY.*
Addresses: Akron, OH. **Studied:** Wells Col., Aurora, NY (B.A.);
Univ. Buffalo Grad. School; Acad. Fine Arts, Vienna; ASL; also
with Victor Hammer, Lazlo Szabo & Robert Brackman. **Member:**
Women's Art Lg. Akron (corresponding secy., 1968-70).
Exhibited: Big Bend Nat., Tallahassee, FL, 1968; Akron First
Inst. May Show, 1969; 34th Ohio Artists & Craftsmen Show,
Massillon (OH) Mus., 1970; Canton Art Inst. Ann. All-Ohio Fall
Show, 1970 & 1971; Summerfield Gal., Dobbs Ferry, NY, 1970s;
Drawing Room Gal., Peninsula, OH, 1970s. Awards: second
prize, Univ. Akron, 1969; hon. award, Ohio Print Show, Cuyahoga
Valley Art Ins., 1969. **Comments:** Preferred media: graphics.
Positions: art preparator, Buffalo Mus. Science, 1952-55.
Teaching: painting instr., Buffalo Mus. Science, 1956; instr., arts-
crafts, Univ. Akron Special Programs, 1958. **Sources:** WW73.

ROGERS, Peter Wilfrid *[Painter] b.1933, London, England.*
Addresses: San Patricio, NM. **Studied:** St. Martins Sch. Art,
London, Eng. **Exhibited:** Royal Soc. Brit. Artists, 1957-59;
Religious Paintings, Birmingham Mus. Art, Ala., 1967; Biennial,
Santa Fe, N.Mex, 1970; Artium Orbis Gallery, Santa Fe, NM,
1970s. **Work:** Bristol A. Gal., Eng; Roswell Mus., N. Mex;
Macnider Mus., Mason City, Iowa; Mus. of Southwest, Midland,
Tex. Commissions: mural, Tex. State Archives & Libr., Austin,
1964; 48 paintings & drawings of Alaska, Atlantic Richfield Co.,

NYC, 1970-71. **Comments:** Preferred media: oils, acrylics, ink. Publications: auth. & Illusr., "The quest.". **Sources:** WW73.

ROGERS, Ralph
Comments: Three unsigned portraits, painted about 1800, at the Sheldon Museum and Middlebury College, Middlebury (Vt.), have been attributed to this artist, who is said to have been the son of a portrait painter of the same name. Groce & Wallace noted that there was speculation that these portraits may have been painted by Ralph E.W. Earl (c. 1785-1838, see entry), son of Ralph Earl (see entry), and that the two Ralph Rogerses never existed. **Sources:** G&W; Frankenstein and Healy, "Two Journeyman Painters," 15.

ROGERS, Randolph *[Sculptor] b.1825, Waterloo, NY / d.1892, Rome, Italy.*
Addresses: Most of his career was spent in Rome. **Studied:** Lorenzo Bartolini, Florence, Italy, 1848-51. **Exhibited:** NAD, 1852; PAFA Ann., 1867-68, 1878; Phila. Centennial, 1876 ("Nydia"); Mark Hopkins Inst., 1903. **Work:** MMA; PAFA; TMA; Newark (NJ) Mus. Art; Buffalo and Erie County Hist. Soc.; the Univ. of Mich. in Ann Arbor had most of his casts at one time, but few are extant today. Public works: "John Adams," Memorial Hall, Harvard Univ.; "Columbus Doors," Eastern entrance to Rotunda, U.S. Capitol, Wash., DC; Soldier and Sailors' Monument, Detroit, Mich.; Soldier and Sailors' Monument, Providence, RI; "Lincoln," Fairmount Park, Phila. **Comments:** Grew up in Ann Arbor, MI. Went to NYC about 1843 and spent the next five years as a clerk in Stewart's dry-goods store. During this time he began modeling portrait busts and so impressed his employers that, in 1848, they helped finance a trip for him to study in Italy. After three years in Florence he established his studio in Rome, and began executing ideal pieces in a neoclassical style, including "Ruth" (1853, Toledo Mus.) and his most famous work, "Nydia, the Blind Flower Girl of Pompeii" (1855-56, MMA, PAFA, and elsewhere), of which almost 100 copies were made. Rogers came back to the U.S. in 1853-55, during which time he was awarded several major commissions, the most important of which was for a set of bronze doors, illustrating the life of Columbus, for the Rotunda of the U.S. Capitol. He returned to Rome in 1855 in order to complete them (they were installed in 1862) and remained there for the rest of his life, although he made many professional visits to the U.S. During those years, Rogers continued to make some ideal figures, including "The Lost Pleiad", but he was mostly busy with portrait busts and public monuments. Among his major achievements were his completion of Thomas Crawford's "Washington Monument (1861, Richmond, VA) and two post-Civil War Soldiers' and Sailors' Monuments (Providence, RI, 1871, and Detroit, MI, 1873). "The Last Arrow" (MMA) a bronze equestrian group showing an American Indian on a rearing horse shooting his last arrow, was modeled in 1880. Just two years later, Rogers was paralyzed and no longer able to work. Before his death, he shipped the casts of most of his works to the University of Michigan (see works). **Sources:** G&W; DAB; Taft, *History of American Sculpture;* Fairman, *Art and Artists of the Capitol.* More recently, see Baigell, *Dictionary;* Millard F. Rogers, Jr., *Randolph Rogers: American Sculptor in Rome* (1971); Craven, *Sculpture in America,* 312-19; Hughes, *Artists in California,* 477; Falk, *Exh. Record Series.*

ROGERS, Rebecca *[Painter] b.c.1847, Springfield, OH / d.1920, San Diego, CA.*
Addresses: Dayton, OH, c.1880; San Diego, CA, ca. 1901-1920. **Studied:** Cincinnati Art Academy, with Charles T. Weber; South Kensington Art School, London; BMFA School. **Member:** San Diego Art Guild (charter mem., 1915). **Exhibited:** Panama-Calif. Expo., San Diego, 1915. **Comments:** Specialty: flowers. Positions: teacher, Springfield, Dayton, OH; dir., art dept., Bishop's School, La Jolla, CA. Sister of William Allen Rogers (see entry). **Sources:** Hughes, *Artists in California,* 477.

ROGERS, Richard *[Painter] mid 20th c.*
Addresses: Norristown, PA. **Exhibited:** S. Indp. A., 1930. **Sources:** Marlor, *Soc. Indp. Artists.*

ROGERS, Robert *[Engraver and die sinker] mid 19th c.*
Addresses: NYC, 1854-59. **Sources:** G&W; NYBD 1854, 1856-59.

ROGERS, R(obert) B(ruce) *[Painter, writer, engraver, lithographer, illustrator] b.1907, Girard, KS.*
Addresses: Los Angeles, CA; NYC. **Studied:** ASL; G. Bridgman; Frank DuMond; Amedee Ozenfant; Hans Hofmann. **Member:** AFA; Newspaper G.; Provincetown AA; Am. A. gong.; Beachcombers' Cl.; United American Artists. **Exhibited:** Provincetown AA, 1933-37; FAP traveling exh., 1935-37; Phila. A. All., 1935; S. Indp. A., 1936; Am. A. Cong., 1936-40; Grand Central A. Gal., 1936; A. Union, 1936 (prize); WFNY 1939; Riverside Mus., 1941. **Work:** Court House, USPO, Boston; Barnstable H.S., Hyannis; Pub. Sch., Falmouth; Pub. Sch., Eastham; Pub. Lib., Provincetown, Mass.; priv. colls. **Comments:** Positions: dir., Garret Gal. & A. Classes, NY, to 1950. Producer, writer & consultant cineplastic composition. Produced animated films: "Toccata Manhatta" and "Round Trip in Modern Art, "1948; "Beethoven Fantasy,"1949; "Motion Painting III-Rhapsody,"1950-51. **Sources:** WW47; WW53.

ROGERS, Robert Stockton *[Painter, teacher, lecturer] b.1896, Burton, KS.*
Addresses: Atlanta, GA. **Studied:** Fairmount Conservatory, Wichita (grad.); AIC; Am. Acad. A., Chicago, and with A. Oberteuffer; A. Philbrick; H. Timmons; F. Young. **Member:** A. Dir. Cl. of Atlanta; Assn. Georgia A.; Atlanta WC Cl; SSAL; Artists' G., Atlanta. **Exhibited:** VMFA, 1938; MoMA, 1930; PAFA, 1932; Rockefeller Ctr., 1932; SSAL, 1939 (prize); Assn. Georgia A.; IBM, 1941 (prize); High Mus. A., 1941 (prize); Atlanta AA; BMFA; Vose Gal., Boston; Mint Mus. A.; Dayton AI; Tupper Ware Nat. traveling exh., 1956; Birmingham, Ala., 1954; Southeastern annual, Atlanta; Atlanta A. Dir. Cl., 1954-56 (awards); Atlanta WC Cl., 1955 (award); Painting of the Year, Atlanta, 1956-58; Audubon A., 1958; Knickerbocker A., 1958; Shreveport A. Gal (solo); Gertrude Herbert Mus. A., Augusta (solo); Brenau Col (solo); Mint Mus. A (solo); Stevens-Gross Gal., Chicago (solo) Awards: Carnegie grants, 1947, 1949. **Work:** Univ. Georgia; Brown Univ., Providence, RI; IBM; Atlanta AA; Rich's, Inc., Atlanta. **Comments:** Positions: instr., Atlanta Art Inst., 1929-; dir., Atlanta Art Inst., 1942-52. **Sources:** WW59; WW47.

ROGERS, Roy D. *[Landscape painter] 19th/20th c.*
Addresses: Seattle, WA, 1925, 1934. **Comments:** Preferred medium: watercolor. **Sources:** WW24.

ROGERS, S. D. *[Painter] 20th c.*
Addresses: Memphis, TN. **Sources:** WW13.

ROGERS, Sarah (Sally) *[Painter] early 19th c.*
Exhibited: NYC, 1807; Charleston, 1808; Baltimore, MD, 1809; Alexandria, VA, 1809; PAFA,1811, 1813. **Comments:** Armless painter who was exhibited as a prodigy in NYC in 1807 and Charleston (with Martha Anne Honeywell-see entry) in 1808. It was said that, using only her mouth, she painted flowers and landscapes with a brush; cut paper and cloth with scissors; and threaded a needle. **Sources:** G&W; Jackson, *Silhouette,* 139; Rutledge, *Artists in the Life of Charleston;* Rutledge, PA; Wright, *Artists in Virginia Before 1900.*

ROGERS, Simeon Douglas *[Painter] late 19th c.; b.St. Louis, MO.*
Studied: with Bouguereau, Robert-Fleury. **Exhibited:** Paris Salon 1889, 1990. **Sources:** Fink, *American Art at the Nineteenth-Century Paris Salons,* 385.

ROGERS, Walter S. *[Illustrator] early 20th c.*
Comments: From 1912-31, his produced more than 670 illustrations in more than 310 juvenile series books, including *The Hardy Boys, Tom Swift, Honey Bunch, The Bobbsey Twins* and many others (most for the Stratemeyer Syndicate). **Sources:** info courtesy James D. Keeline, Prince & the Pauper, San Diego.

ROGERS, W(illiam) A(llen) *W. A. Rogers.*
[Painter, illustrator, cartoonist, engraver, writer] b.1854, Springfield, OH / d.1931, NYC.
Addresses: NYC, 1893; Wash., DC, 1923. **Studied:** Worcester Polytechnic Inst. **Member:** Century Assoc., 1894; SI; GFLA; SC, 1872 (founder); Cosmos Cl.; Soc. Illustrators. **Exhibited:** Brooklyn AA, 1883; Boston AC, 1886; PAFA Ann., 1893; Gordon Dunthorne Gal., 1926 (solo). **Work:** LOC; Smithsonian; White House; NMAH. **Comments:** From 1870-77 Rogers was an engraver and artist in various cities. From 1877 he was on the staff of *Harper's Weekly* and *Harper's* magazine (where his illustrations appeared between 1879-1900), as well as *Life, St. Nicholas, The Century, Washington Post,* and *New York Herald,* the latter for 19 years (following T. Nast). His illustrations appeared in Samuel Adams Drake's *Heart of the White Mountain.* His friends included many important civic and government officials, such as Presidents Theodore Roosevelt and Grover Cleveland. He made many trips to the West and other parts of the U.S. from 1878-98; also visited Canada. On a visit to New Orleans, he made watercolor sketches of Jackson Square, Canal St., and the Sugar Exchange, which were reproduced in *Harper's* in 1899-1900. Author of "World Worth While," "Danny's Partner," and "A Miracle Man," and "America's Black and White Book" (one of two volumes of his cartoons). Because of one of his anti-German war cartoons published in the *Herald* during World War I, the French decorated him as a Chevalier of the Legion of Honor, 1921. **Sources:** WW39; *Encyclopaedia of New Orleans Artists,* 329; Campbell, *New Hampshire Scenery,* 134; P & H Samuels, 406, and McMahan, *Artists of Washington, DC* gives death place as Wash., DC; Falk, *Exh. Record Series.*

ROGERS, William F. *[Artist] 19th/20th c.*
Addresses: Wash., DC, active 1892. **Comments:** Active in Wash., DC as "Gedney [Albert G. Gedney] and Rogers, engravers, printers and lithographers." **Sources:** McMahan, *Artists of Washington, DC.*

ROGERT, Alene (Mrs) *[Painter] mid 20th c.; b.Springfield, OH.*
Addresses: Wyoming, OH. **Exhibited:** Ohio State Fair, 1935; PAFA, 1936; Cincinnati M., 1939; AIC. **Work:.** **Sources:** WW40.

ROGO, Elsa (Mrs. Stefan Hirsch) *[Painter] mid 20th c.*
Exhibited: Salons of Am., 1929-31, 1934. **Sources:** Marlor, *Salons of Am.*

ROGOVIN, Howard Sand *[Painter] b.1927, Ashville, NC.*
Addresses: NYC. **Studied:** Northwestern Univ. (B.S.); ASL, with Kantor & Grosz; Univ. Colo. (M.F.A.). **Exhibited:** Babcock Gallery, NYC, 1970s. Awards: Yaddo, 1960; Nat. Coun. Arts, 1969; Old Gold Metal, Univ. Iowa, 1970. **Comments:** Teaching: vis. artist, Kansas City Art Inst., Mo., 1968-69; assoc. prof. drawing, Univ. Iowa, 1969-72. **Sources:** WW73.

ROGOWAY, Alfred *[Painter] b.1905, Portland, OR.*
Addresses: Ranchos de Taos, NM. **Studied:** Univ. So. Calif. at Los A.; UC Berkeley; Univ. Mexico; Cal. Sch. FA, San F.; Cal. Col. A. & Crafts; Mills Col., with Leger, Feininger. **Exhibited:** nationally and internationally, 1925-56. **Work:** Mus. New Mexico, Santa Fe.; Galerie le Mage, Vence, France; Galerie Grimaldi, Cannes, France. **Sources:** WW59.

ROHAN-CHANDOR, Emilie (Countess) See: HERZFELD, Emy (O.)

ROHDE, Arendt *[Painter] b.1862, Movstrop, Denmark / d.1942, Burlingame, CA.*
Addresses: San Francisco, CA. **Exhibited:** Mechanics' Inst. Fair, 1899; GGE, 1940. **Comments:** Worked as a housepainter together with his brother Peter Rohde (see entry). In his spare time he painted landscapes and Chinatown subjects. **Sources:** Hughes, *Artists in California,* 477.

ROHDE, Gilbert *[Designer, craftsperson] mid 20th c.*
Addresses: NYC. **Exhibited:** MoMA, Wash., DC, 1939. **Comments:** Position: hd., WPA Program, NY Des. Lab. Des., modern furniture. **Sources:** WW40.

ROHDE, Peggy Ann (Mrs. Gilbert) *[Designer, writer, painter, lecturer, teacher, craftsperson] b.1911, NYC.*
Addresses: NYC; Huntington, NY. **Studied:** PIA Sch.; NY Univ.; Columbia Univ.; Univ. California; Univ. Washington. **Member:** Arch. Lg.; Soc. Indst. Des. **Exhibited:** NAC, 1940; Soc. Indst. Des. traveling exh., 1948-50. **Comments:** Author: "Making Built-In Furniture," 1950. Contributor to *Interiors, Home Furnishings,* and other publications. Lectures on Industrial Design as a Career for Students. **Sources:** WW53; WW47.

ROHDE, Peter H. *[Landscape painter, etcher] b.1879, Odense, Denmark / d.1949.*
Addresses: San Francisco, CA, 1893; Santa Clara, CA, c.1920. **Studied:** Mark Hopkins Inst.; Calif. Sch. of FA with Piazzoni and Stackpole. **Exhibited:** San Francisco AA, 1912-20; PPE, 1915; Calif. Industrial Expo, San Diego, 1926. **Comments:** Worked as a housepainter with his brother Arendt (see entry), before studying art. Specialty: portraits, landscapes and still lifes. **Sources:** Hughes, *Artists in California,* 477.

ROHDE, William F. *[Artist, possibly painter] mid 19th c.*
Addresses: NYC. 1859-69. **Sources:** G&W; NYCD 1859-69.

ROHDENBURG, G. L. *[Painter] mid 20th c.*
Exhibited: S. Indp. A., 1938. **Sources:** Marlor, *Soc. Indp. Artists.*

ROHL, John *[Sculptor] late 19th c.*
Addresses: NYC, 1890. **Exhibited:** NAD, 1890. **Sources:** Naylor, *NAD.*

ROHL-SMITH, Carl *[Sculptor, teacher] b.1848, Roskilde, Denmark / d.1900, Copenhagen, Denmark.*
Addresses: Wash., DC. **Studied:** Acad. FA, Copenhagen; Germany; Austria; Italy. **Member:** NSS. **Exhibited:** NSS; NAD; AIC. **Work:** bronze monument to William W. Belknap (1891), Arlington Ntl. Cemetery; monument to William T. Sherman, in front of the Treasury Bldg, Wash., DC; Fort Dearborn Monument, Chicago; bust of Chief Mano Warnataka, Copenhagen Mus.; Soldiers' Mon., Des Moines, IA. **Comments:** Professor at the Acad. FA in Copenhagen, 1885. In 1886 he came to the U.S., living in St. Louis, Chicago, and New York before settling in Wash., DC, where he had a studio in the 1890s. His monument to William T. Sherman, located in front of the Treasury Building, was incomplete at the time of his death (visiting Copenhagen in 1900), and his wife, Sara, directed its completion by other sculptors. **Sources:** WW98; McMahan, *Artists of Washington, DC.*

ROHLAND, Caroline Speare *[Painter, lithographer, etcher] b.1885, Boston, MA / d.1965, Woodstock, NY?.*
Addresses: Sierra Madre, CA. **Studied:** BMFA Sch.; ASL; Andrew Dasburg. **Member:** Woodstock AA. **Exhibited:** WMAA 1928-1942; VMFA, 1941; Corcoran Gal biennial, 1937; CI; LOC; AIC; NAD, 1945-46; Mus. New Mexico, Santa Fe, 1944, 1945; New Mexico State Fair. **Work:** WMAA; Honolulu Acad. Arts; WPA murals, USPO, Bunkie, LA; Sylvania, GA; Fulton, NY; Woodstock AA. **Sources:** WW53; WW47; Woodstock AA cites death date as 1964.

ROHLAND, Lillian *[Painter] mid 20th c.*
Addresses: Detroit, MI. **Exhibited:** S. Indp. A., 1928. **Sources:** Marlor, *Soc. Indp. Artists.*

ROHLAND, Paul *[Painter, screenprinter] b.1884, Richmond, VA / d.1953.*
Addresses: Woodstock, NY; Sierra Madre, CA. **Studied:** ASL; Robert Henri. **Member:** Chicago NJSA; Woodstock AA. **Exhibited:** Armory Show, 1913; Salons of Am.; S. Indp. A., 1918, 1920, 1925-26, 1930; WMAA, 1927-42; VMFA; Corcoran Gal biennials, 1935, 1937; CI; AIC; PAFA; Mus. New Mexico; Pasadena AI; Dallas Mus. FA, 1946. **Work:** WMAA; Syracuse Mus. FA; Davenport Munic. Art Gal.; Honolulu Acad. Arts; Barnes Found.; WPA murals, USPO, Union, PA; Mus. New

Mexico; Woodstock AA. **Comments:** Specialty: still life and landscape. **Sources:** WW25; P&H Samuels, 407; Woodstock AA & Marlor cite death date as 1949; Marlor, *Soc. Indp. Artists;* Falk, *Exh. Record Series;* Brown, *The Story of the Armory Show,* cites death date as c.1950.

ROHLFING, Christian *[Art administrator, curator] b.1916, Philadelphia, PA.*
Addresses: NYC. **Studied:** Univ. Chicago. **Comments:** Positions: bd. dirs. & adv. bd., Four Winds Mus. Theatre; adminr. & cur. exhibs., Cooper-Hewitt Mus. Design, NYC. **Sources:** WW73.

ROHLFS, Charles *[Designer] b.1853 / d.1936, Buffalo, NY.*
Addresses: NYC. **Member:** Royal Soc. of Arts, London. **Exhibited:** Turin, Italy (furniture; only American invited). **Comments:** In 1890 began manufacturing furniture, being credited with having orginated mission furniture. **Sources:** WW47.

ROHLFS, Christian *[Painter] mid 20th c.*
Exhibited: AIC, 1929, 1931, 1938-41. **Sources:** Falk, *AIC.*

ROHM, Robert *[Sculptor] b.1934, Cincinnati, OH.*
Addresses: Birmingham, MI; Brooklyn, NY, 1962; Wakefield, RI, 1970-73. **Studied:** Pratt Inst. (B.ID., 1956); Cranbrook Acad. Art, Bloomfield Hills, Mich. (M.F.A., 1960). **Exhibited:** PAFA Ann., 1960 (prize); Anti-illusion: Procedures/Materials, 1969 & Sculpture Ann., 1962-1973, WMAA; 955,000, Vancouver Art Mus., BC, 1970; solo exhib, O.K. Harris, Works of Art, NYC, 1970 & 1971; US Sect., Triennial, New Delhi, India, 1971. Awards: Guggenheim Found. fel., 1964; Cassandra Found. Award, 1967. **Work:** MoMA; Kunsthalle, Zurich, Switz.; Finch Col. Mus., NY; Columbus Gal. Fine Art, OH; Allen Art Mus., Oberlin Col., OH. **Comments:** Teaching: instr. sculpture, Columbus Col. Art & Design, 1956-59; instr. sculpture, Pratt Inst., 1960-65; assoc. prof. sculpture, Univ. RI, 1965-, res. grant-in-aid, 1965, 1966 & 1969. **Sources:** WW73; Ralph Pomeroy, "An interview with Robert Rohm," *Artforum* (Apr. 1970) & "Robert Rohm," *Arts Can.* (Apr. 1970); Kenneth Baker, "The Way Works of Art Behave," *Christian Sci. Monitor,* (Dec. 14, 1970); Falk, *Exh. Record Series.*

ROHN, Ray *[Illustrator, cartoonist] b.1888, Defiance, OH / d.1935.*
Addresses: Phila., PA. **Member:** SI. **Comments:** Illustrator: *Harper's, Judge, Life.* Position: art dept., *Phila. Public Ledger.* **Sources:** WW33.

ROHNER, (Mr.) *[Listed as "artist"] mid 19th c.*
Addresses: Hartford, CT in 1860. **Comments:** *Cf.* Wilhelm Roehner. **Sources:** G&W; Hartford CD 1860.

ROHNSTOCK, J Henry *[Craftsperson] b.1879, Denmark.*
Addresses: West Somerville, MA/Scituate, MA. **Member:** Boston SAC (master craftsman). **Exhibited:** Tercentenary FA Exh., Boston (gold). **Work:** Riverside Church, NYC; Cathedral St. John the Divine, NYC; East Liberty Presbyterian Church, Pittsburgh, Pa.; Chapel of Colorado Col., Colorado Springs; Westminster Presbyterian Church, Springfield, Ill.; Princeton Univ. Chapel; Mercersberg Acad. Chapel, Pa.; Pres. Church, Glens Falls, NY; National Cathedral, Wash., DC; Wellesley Col. Chapel; Am. Mem. Chapel, Belleau Wood, Belleau, France. **Comments:** Position: partner, Reynolds, Francis and Rohnstock, craftsmen in stained glass, Boston, Mass. **Sources:** WW40.

ROHOWSKY, Meyers *[Painter, sculptor] b.1900, Connecticut / d.1974, New Jersey.*
Addresses: NYC. **Studied:** Hartford Art Soc.; Acad. Julien, Paris; Graphisch. Lehr., Vienna. **Member:** New Jersey Artists Equity (pres.). **Exhibited:** ZAK Gal, Paris; Wildenstein Gal.; ACA Gal.; Whitney Mus.; "NYC WPA Art" at Parsons School Design, 1977. **Work:** WPA murals, De Witt Clinton H.S., Bronx, NY and U.S. Naval Reserve, Whitestone, NY; Albertina Mus., Vienna; Montclair (NJ) Art Mus.; New Jersey State Mus. **Comments:** WPA artist, first in Newark and then in New York. Met Picasso and Roualt in Europe after WWII, returned to New York in 1950

and in 1954 moved to New Jersey following a devasting studio fire. Began sculpting in 1960 and returned to painting only in 1974. **Sources:** *New York City WPA Art,* 74 (w/repros.).

ROHR, Doris Estelle *[Painter] b.1896, Bellingham, WA / d.1987, Carmel, CA.*
Addresses: Carmel, CA. **Studied:** Western Washington College; with Abel Warshawsky and Frank Myers. **Member:** Carmel AA. **Sources:** Hughes, *Artists in California,* 478.

ROHR, Nora Lee (Mrs. F. V.) *[Museum curator, critic, writer, lecturer, teacher] b.1901, Munich, Germany.*
Addresses: San Francisco 2, CA. **Studied:** Harvard Univ.; & in Germany, Italy. **Member:** Am. Soc. for Aesthetics; Buffalo SA; The Patteran. Lectures: American Folk Art; Sculpture, Ancient & Modern; etc. Position: dir. edu., Albright A. Gal., 1931-34; art cr., *Buffalo Evening News,* 1936-44; asst. cur. edu., SFMA, San Francisco, Cal. **Sources:** WW53.

ROHRBACH, Charles *[Commercial artist, designer, painter, craftsperson] b.1892, Berne, Switzerland / d.1962, Buffalo, NY.*
Addresses: Buffalo, NY; East Aurora, NY. **Studied:** Switzerland; Fed. Sch. Commercial Des, Minneapolis, Mn. **Member:** Buffalo Soc. A.; Buffalo AG; Aurora A. Cl. **Exhibited:** Soc. for Sanity in A., 1937-38; Buffalo, Rochester, Auburn, Binghamton, East Aurora, NY; Buffalo SA, 1927 (prize), 1934 (prize), 1936 (prize), 1946 (med). **Work:** Buffalo Mus. Science; WBEN-TV Reception Room. Cover illus., Buffalo Courier-Express Pictorial Magazine; illus., textbooks for NY State Edu. Dept., Bureau of Vocational Training. **Comments:** Arrived in U.S. in 1915; came to Buffalo in 1916. Position: art dir., Larking Col, Inc. **Sources:** WW59; WW47; Krane, *The Wayward Muse,* 194-195.

ROHRBECK, Frank *[Painter] early 20th c.*
Addresses: Milwaukee, WI. **Exhibited:** AIC, 1902. **Sources:** Falk, *AIC.*

ROHRBOUGH, Herbert Levi *[Painter] b.1876, Hamilton, MO / d.1952, Palm Springs, CA.*
Addresses: Long Beach, CA. **Member:** Spectrum Club; P&S of Los Angeles. **Sources:** Hughes, *Artists in California,* 478.

ROHRER, Joseph *[Sculptor, carver] b.c.1820, Alsace / d.1893, New Orleans, LA.*
Addresses: New Orleans, active 1870-92. **Sources:** *Encyclopaedia of New Orleans Artists,* 329.

ROHRER, Ross *[Painter] mid 20th c.*
Addresses: Chicago area. **Exhibited:** AIC, 1947. **Sources:** Falk, *AIC.*

ROHRER, Warren *[Painter] mid 20th c.*
Exhibited: PAFA Ann., 1968. **Sources:** Falk, *Exh. Record Series.*

ROHRHEIMER, Louis *[Sculptor] 19th/20th c.*
Addresses: Cleveland, OH. **Studied:** Académie Julian, Paris, 1893. **Comments:** Affiliated with Cleveland Sch. A. **Sources:** WW04.

ROHRIG, Frits *[Sculptor] b.1878, Benshausen, Germany.*
Addresses: Glenmont, NY. **Studied:** G.A. Sartorio, Rome, Italy; Acad., Weimar, Germany. **Sources:** WW40.

ROINE, Jules Edouard *[Sculptor] b.1857 / d.1916.*
Addresses: NYC. **Member:** NSS, 1907. **Exhibited:** PAFA Ann., 1913; Armory Show, 1913. **Work:** MMA. **Sources:** WW15; Falk, *Exh. Record Series;* Brown, *The Story of the Armory Show.*

ROITMAN, Beatrice *[Painter] mid 20th c.*
Addresses: Chicago area. **Exhibited:** AIC, 1947. **Sources:** Falk, *AIC.*

ROJANKOVSKY, Feodor Stepanovich *[Illustrator] b.1891, Mitava, Russia / d.1970.*
Addresses: Bronxville, NY. **Studied:** Acad. FA, Moscow. **Exhibited:** Award: Caldecott Award, 1956 for illus. in "Frog Went A-Courtin'." **Comments:** I., "Daniel Boone"; "Jacques Cartier"; "Tall Mother Goose"; "Treasure Trove of the Sun"; "Frog Went A-Courtin'," and many other children's books. **Sources:** WW66.

ROJAS, Francisco *[Painter] mid 20th c.*
Exhibited: S. Indp. A., 1936. **Sources:** Marlor, *Soc. Indp. Artists.*

ROJO, Vicente *[Painter] b.1932, Barcelona, Spain.*
Addresses: Mexico DF 21, Mexico. **Exhibited:** Sixth Biennial Sao Paulo, Brazil, 1961; Second Biennial De Jovenes, Paris, France, 1961; Mexico: The New Generation, traveled throughout the USA, 1966; Expo '1967, Montreal, PQ, 1967; First Triennial India, New Delhi, 1968; Galeria Juan Martin, Mexico DF 6, Mex., 1970s. **Work:** MoMA, Mex.; Banco Cedulas Hipotecarias SA, Mex.; Casa de las Americas, Havana, Cuba; Biblioteca Luis Arango, Bogota, Colombia. Commissions: portfolio of five lithographs, Lublin Inc., NYC, 1969. **Sources:** WW73; J.J. Gurrola (producer), "Rojo" (film), Nat. Univ. Mex., 1966; Octavio Paz, *Discos Visuales* (Ediciones Era, 1968); J Garcia Ponce, *Vicente Rojo* (Nat. Univ. Mex., 1971).

ROJTMAN, Marc B. (Mr. & Mrs.) *[Collectors] 20th c.*
Addresses: NYC. **Sources:** WW66.

ROJTMAN, Marc B. (Mrs.) *[Collector] 20th c.*
Addresses: NYC. **Member:** Art Collectors Cl.; Drawing Soc.; fel. in perpetuity MMA; Inst. Fine Arts, NY Univ. (mem. bd. adv.); Cooper Hewitt Mus., Smithsonian Inst. (mem. adv. coun.). **Comments:** Positions: bd. gov., New York Cult Ctr.; fel., Morgan Libr.; pres. Rojtman Found Inc. **Sources:** WW73.

ROKUS, Bert *[Painter] mid 20th c.*
Addresses: Glendale, LI, NY, 1934. **Exhibited:** S. Indp. A., 1934. **Sources:** Marlor, *Soc. Indp. Artists.*

ROLAND, Conrad *[Painter] 20th c.*
Addresses: Norristown, PA. **Sources:** WW25.

ROLAND, Edward *[Painter, sculptor, teacher] b.1911, St. Louis, MO.*
Addresses: Los Angeles, CA. **Studied:** Wash. Univ., St. Louis; A. Katchamakoff. **Member:** Calif. WCS; Correlated A. Group, Los Angeles. **Exhibited:** Los Angeles Mus. Hist. Sc. A.; Ebell C., Los Angeles. **Comments:** Author: "Science or Art," "Through the Looking Glass," 1939. **Sources:** WW40.

ROLAND, Jay *[Painter] b.1904, NYC / d.1960, Brewster, NY.*
Addresses: NYC. **Studied:** NAD; ASL; Grand Central A. Sch. **Member:** AWCS; Audubon A.; Phila. WC Cl.; Brooklyn SA; Arch. L. **Exhibited:** NY WC Cl., 1934-1937; AWCS, 1933-46; AIC, 1935, 1941, 1946; BM, 1943-44 (prize); CA, 1933-34, 1936; MMA (AV), 1942; Phila. WC Cl., 1940-46; Audubon A., 1944-45 (prize); Brooklyn SA, 1941-46 (prize, 1944); Am.-British A. Center, 1942-44; Wash. WC Cl., 1942 -43; NAD, 1943; Marie Sterner Gal., 1941 (solo); Campbell-Ewald Co. Gal., 1941 (solo). **Work:** BM. **Comments:** His wife, listed as Mrs. Jay Roland Linton, was also an artist. **Sources:** WW59; WW47.

ROLAND, Jay (Mrs.) See: **LINTON, (Mrs. Jay Roland)**

ROLAND, John See: **RUHLAND, John**

ROLAND, Linton See: **LINTON, (Mrs. Jay Roland)**

ROLANDO, Paolo Emilio (Paul E.) *[Painter, sculptor] b.1884, Rome, Italy.*
Addresses: Wash., DC, 1927; NYC, 1940; North East, PA. **Studied:** Mariani and Sartorio, in Italy; PAFA; Corcoran Sch. Art. **Member:** Soc. Wash. Artists. **Exhibited:** Soc. Wash. Artists, 1927-37; Wash. Landscape Club; Gr. Wash. Indep. Exh., 1935. **Comments:** He was married to artist Virginia Moorhead Rolando (see entry). **Sources:** WW40; McMahan, *Artists of Washington, DC.*

ROLANDO, Virginia Moorhead (Mrs. Paul E.) *[Painter] b.1898, North East, PA.*
Addresses: Wash., DC, active 1933-40; NYC, active 1940-53. **Studied:** Corcoran Sch. Art; Otis AI; with Roscoe Shrader, L. Grace Woodward; D. Woodward; L.C. Catlin. **Member:** Soc. Wash. Artists. **Exhibited:** Soc. Wash. Artists, until 1937; CGA, 1933, 1934, 1936; Wash. Art Lg., 1933; Gr. Wash. Indep. Exh., 1935; Erie (PA) Pub. Libr.; Chautauqua, NY. **Work:** Presbyterian

Home & Hospital, Cambridge Springs, PA. **Comments:** Wife of artist Paul E. Rolando (see entry). **Sources:** WW53; WW47; McMahan, *Artists of Washington, DC.*

ROLF, Emma (Miss) See: **ROLFE, Emma (Miss)**

ROLFE, Edmund B. *[Painter, craftsperson] b.1877, Detroit, MI / d.1917, near Woodstock, NY.*
Addresses: Shady, NY. **Studied:** AIC; ASL; CGA. **Exhibited:** Michigan State Fair, 1916; AIC. **Comments:** He died in an automobile accident. **Sources:** WW15.

ROLFE, Emma (Miss) *[Painter] mid 19th c.*
Addresses: Brooklyn, NY, in 1839. **Exhibited:** Apollo Gal., NYC, 1839 (portrait and a landscape sketch). **Comments:** She may have been a daughter or sister of John A. Rolph (see entry), whose name appears variously as Rolfe or Rolph and who also exhibited at the Apollo. **Sources:** G&W; Cowdrey, AA & AAU.

ROLFE, H. Parker *[Painter] late 19th c.*
Addresses: Phila., PA. **Exhibited:** PAFA Ann., 1884-85. **Sources:** Falk, *Exh. Record Series.*

ROLFE, John See: **ROLPH, John A.**

ROLFE, Kate Da C. *[Painter] late 19th c.*
Addresses: Phila., PA. **Exhibited:** PAFA Ann., 1885. **Sources:** Falk, *Exh. Record Series.*

ROLFE, Mary See: **ALLEN, Mary Rolfe (Mrs.)**

ROLFF, Cateau *[Painter] early 20th c.*
Addresses: Chicago. **Exhibited:** AIC, 1923. **Sources:** Falk, *AIC.*

ROLICK, Esther G. *[Painter] mid 20th c.*
Addresses: Shown as Jacques Seligmann Galleries, NYC (1948). **Exhibited:** WMAA, 1948. **Sources:** Falk, *WMAA.*

ROLLE, Albert *[Engraver] b.1816, Prussia.*
Addresses: Washington, DC active 1860-70. **Comments:** Employed in the U.S. Coast Survey. **Sources:** G&W; 8 Census (1860), D.C., II, 428; McMahan, *Artists of Washington, DC.*

ROLLE, August Herman Olson *[Painter, printmaker, graphic artist] b.1875, Sibley County, MN / d.1941, Wash., DC.*
Addresses: Wash., DC, 1900. **Studied:** Corcoran Sch. A., under Messer, Brooke, and Moser, beginning in 1905. **Member:** S. Wash. A.; Wash. WCC; Min. PS & G Soc. of Wash., DC; Wash. Ldscp. C. (founder, 1915); AFA; Wash. AC; Soc. Wash. Et. **Exhibited:** S. Wash. A.; Wash. WCC; CGA; Ntl. Gal.; MD Inst.; Min. PS & G Soc. of Wash., DC; Wash. Lndscp. C.; Venable's Gal. (joint exh., 1924); Gr. Wash. Indp. Exh., 1935;. **Work:** LOC; CGA; Wash. Hist. Soc.; Wash. AC; Calvert Marine Mus., Solomons, MD. **Comments:** After serving in the Spanish-American War, he came to Wash., DC in 1900, where he was a forestry expert with the Bureau of the Census for over 40 years. Specialty: land and seascapes in oil and watercolor. **Sources:** WW40; McMahan, *Artists of Washington, DC.*

ROLLER, Janet Worsham (Mrs. S.K.) *[Painter, illustrator] 20th c.; b.Lynchburg, VA.*
Addresses: NYC/Cobalt, CT. **Studied:** CUA Sch.; C. Hawthorne; R. Henri; K.H. Miller. **Sources:** WW40.

ROLLER, Kay See: **ROLLER, (Samuel) K.**

ROLLER, Margaret J.R. *[Artist] early 20th c.*
Addresses: Wash., DC, active 1920-24. **Sources:** McMahan, *Artists of Washington, DC.*

ROLLER, Marion Bender *[Sculptor, painter] b.1925, Boston, MA.*
Addresses: NYC. **Studied:** Vesper George Sch. Art (dipl.); ASL, with John Hovannes; Greenwich House, with Lu Duble; also watercolors with Edgar Whitney. **Member:** Nat. Sculpture Soc.; All. A. Am. (asst. corresp. secy., 1966-71); Pen & Brush (co-chmn., 1967-); Catharine Lorillard Wolfe A. Cl.; Hudson Valley Art Assn. **Exhibited:** AWCS; Albany Inst. Hist. & Art; Pittsfield Mus.; Great Barrington Exh.; All. A. Am., 1959-72: NAD, 1962-69; Am. Artists Prof. League, 1965-66 & 1968; Audubon Artists,

1966; Nat. Sculpture Soc., NYC, 1969-72. Awards: anonymous prize, 1959 & hon. men., 1965, All. A. Am.; Mrs. John Newington Award, 1965 & Archer Milton Huntington Award, 1968, Am. Artists Prof. League, gold medal, Pen & Brush, 1971; Knickerbocker A.; Great Barrington Exh.; AAPL; Archer Huntington award, Hudson Valley AA. **Work:** Commissions: hd. of child, Nassau Ctr. for Emotionally Disturbed Children, Woodbury, NY, 1968; plus others. **Comments:** Preferred media: terra-cotta, bronze, watercolors. Teaching: instr. art, Fashion Inst. Technol., 1967. **Sources:** WW73; G. Kramer, "Profile," *Hudson Register Star* (1965).

ROLLER, Samuel K. (Kay Roller) *[Painter, etcher, teacher, illustrator] mid 20th c.; b.New Market, VA.*
Addresses: Lynchburg, VA. **Studied:** CGA; NY Sch. Art; Chicago Acad. Art; Univ. Virginia; Robert Henri; George Ennis; Brooks; Otis Art Sch.; F. Grant. **Member:** AAPL; Cooperstown AA; Lynchburg Art Cl.; Lynchburg Art Center; Studio Guild. **Exhibited:** S. Indp. A., 1929-30; Salons of Am.; Morton Gal., 1935 (solo), 1936 (solo), 1939 (solo), 1940 (solo); Soc. Four Arts, West Palm Beach, FL, 1937 (solo); Argent Gal., 1939 (solo)-40 (solo); Lynchburg Woman's Cl., 1942 (solo); Leach Mem., 1943 (solo)-44 (solo); VMFA, 1942-44; Norfolk Mus. Art, 1944-53; Lynchburg Art Cl., 1941-58, 1964 (solo); Lynchburg Art Center, 1954-58 (solo, 1950, 1956); Cooperstown AA, 1953-55; Norton Gal. Art, Palm Beach, FL, 1942; Huckleberry Mountain Workshop, 1950 (solo); Lake Charles, LA, 1950 (solo); DeRidder, LA, 1950 (solo). **Work:** NY Hist. Soc.; Am. Art Group; Hickory Grove Inn, Cooperstown, NY. **Comments:** Contributor covers to *Richmond Times Dispatch Magazine*. Position: instr., Cooperstown, NY, 1951-(summers).Illustrator: *McCall's;* Pierce Lithographer Corp. **Sources:** WW66; WW47.

ROLLIN, H. J. *[Painter] late 19th c.*
Addresses: Ohio, 1876-1877. **Exhibited:** NAD, 1876-77; PAFA Ann., 1877. **Sources:** Naylor, *NAD;* Falk, *Exh. Record Series.*

ROLLIN, Kate C. *[Artist] early 20th c.*
Addresses: Wash., DC, active 1914-20. **Sources:** McMahan, *Artists of Washington, DC.*

ROLLINGS, A. Sydney *[Craftsperson, designer, teacher] b.1880, Knoxville, TN.*
Addresses: Providence, RI. **Studied:** RISD. **Member:** Boston SAC. **Comments:** Position: teacher, RISD. Specialty: jewelry. **Sources:** WW40.

ROLLINS, Carl Purlington *[Book designer, craftsperson, lecturer, teacher, writer] b.1880, West Newbury, MA / d.1960, Hamden, CT.*
Addresses: Hamden, CT. **Studied:** Harvard Univ., hon. deg., M.A., L.H.D., Yale Univ. **Member:** AIGA; Columbiad Cl. of Conn.; Grolier Cl. (hon.); Century Assn.; Club of Odd Volumes, Boston (hon.); Double Crown Cl., London. **Exhibited:** "Fifty Books of the Year," annually; AIGA, 1926 (med), 1941 (gold medal); Dartmouth Col., 1946; retrospective exhs., Yale Univ., 1948, Grolier Cl., 1948. **Comments:** Positions: des., Yale Univ. Press. 1918-48 (retired); Printer, Yale Univ., New Haven, Conn., 1920-48, Emeritus, 1948-. Print Consultant, Rutgers Univ. Des. books for Grolier Cl., MMA, Limited Editions Cl., Yale Univ., Yale Univ. Press. Contributor to: Saturday Review; Dolphin; Print; and other trade publications. Lectures: History and Practice of Printing. **Sources:** WW59; WW47.

ROLLINS, Helen Jordan (Mrs.) *[Painter, craftsperson, jeweler, teacher] b.1893, Hayward, CA.*
Addresses: Los Angeles, CA; La Crescenta, CA. **Studied:** Los Angeles Sch. Art & Design, and with J.E. McBurney, J. Francis Smith, Theodore Lukits. **Work:** Southwest Mus., Los Angeles; Los Angeles Public School; mural, Educ. Bldg., San Diego. **Comments:** Authority on early California-Spanish historical subjects. Positions: chmn., Hist. & Landmarks Committee, Los Compadrinos de San Gabriel Club. **Sources:** WW59; WW47.

ROLLINS, Henry C. *[Sculptor] b.1937.*
Addresses: San Anselmo, CA, 1968. **Studied:** RISD. **Exhibited:** WMAA, 1968, 1971; Oakland Mus., 1970. **Sources:** Cederholm, *Afro-American Artists.*

ROLLINS, Josephine Lutz *[Painter, mural painter, lithographer, teacher, educator] b.1896, Sherburne, MN / d.1989.*
Addresses: Minneapolis, MN. **Studied:** Cornell Col., Mt. Vernon, IA; Univ. Minnesota (B.A., M.A.); Corcoran Sch. A.; Minneapolis Sch. A.; & with Hans Hofmann, Cameron Booth, Edmund Kinsinger. **Member:** Minn. Assn. A. **Exhibited:** Nelson Gal., Kansas City, 1935 (prize), 1936 (prize), 1939 (prize); AWCS, 1936, 1946; AIC, 1937; Sacramento, Calif, 1941; All. A. Am., 1946; Minn. State Fair, annually; All. A. Am., 1946; Newport AA, 1946; Sacramento, Cal., 1941; Minneapolis Inst. A., annually; Twin City Exh. (prize); St. Paul Gal., 1956; Oakland A. Gal.; solo traveling exh., 1958; Monterey, Cal., 1958. Awards: (2) purchase prizes, WAC. **Work:** Univ. Minn.; Virginia (Minn.) Lib.; Owatonna (Minn.) Lib.; Crosby-Tronton H.S. (Minn.); mural, University H.S., Minneapolis. **Comments:** Positions: assoc. dir., Stillwater A. Colony; prof., painting, drawing, Univ. Minnesota, Minneapolis, Minn. Founder, West Lake Gal., Minneapolis, 1964-. **Sources:** WW66; WW47.

ROLLINS, Warren Eliphalet — W. E. Rollins —
[Painter, teacher] b.1861, Carson City, NV / d.1962, Winslow, AZ.
Addresses: San Diego, 1887; Tacoma, WA, 1890s; Valley, AZ; Baltimore, MD in the 1940s. **Studied:** San Fran. Sch. Design, with V. Williams. **Member:** Tacoma A. League, 1892; early member of the Santa Fe Colony, 1915. **Exhibited:** Western Wash. Industrial Expo, 1891; Santa Fe, before 1910; Mus. New Mexico, Santa Fe; Am. Artists Assn., Los Angeles; Calif. Sch. Des (medal); Maryland Inst.; Barbizon Plaza, NY; Gunnison, CO; Delmonico's, NYC, Sheraton Belvedere Hotel, Baltimore, MD, 1947 (solo). **Work:** Santa Fe Railroad; triptychs, Bishops' Lodge, Santa Fe, NM; Tower Bldg., Baltimore, DC; murals, USPO, Gallup, NM; Harvey House, Gallup, NM; Mus. New Mexico, Santa Fe; hotel, Arrowhead Springs, CA; Nat. Bank, Phoenix, AZ; Huntington Gal., Los Angeles;. **Comments:** WPA artist. Position: assistant director, Calif. Sch. Design, San Francisco. About 1900 he was one of the first painters admitted to the ceremonies of the Hopi, Crow and Blackwell Indians and had a studio near El Tovar at the Grand Canyon. Specialty: Southwestern scenes, marines. **Sources:** WW59; WW47. More recently, see Hughes, *Artists in California,* 478; P&H Samuels, 407; Trip and Cook, *Washington State Art and Artists.*

ROLLINSON, Charles *[Painter] 20th c.*
Addresses: Elizabeth, NJ. **Sources:** WW19.

ROLLINSON, Charles *[Engraver] b.c.1793 / d.1833, Boston.*
Addresses: NYC. **Comments:** Probably a son of William Rollinson (see entry), with whom he worked in NYC from c. 1808 to 1832. In 1846 Charles's widow, Maria, was living at the same address as S.O. Rollinson (see entry), and Joseph R. Rollinson, merchant. **Sources:** G&W; Sawyer, "Deaths Published in The Christian Intelligencer," Jan. 26, 1833; Stauffer; NYCD 1816-33, 1846.

ROLLINSON, S. O. *[Sketch artist] mid 19th c.*
Addresses: NYC in 1846. **Exhibited:** American Institute (1846: pencil sketches). **Comments:** He or she lived at the same NYC address as Maria Rollinson, widow of Charles Rollinson (see his entry). **Sources:** G&W; Am. Inst. Cat., 1846.

ROLLINSON, William *[Engraver, miniaturist] b.1762, Dudley, England / d.1842, NYC.*
Addresses: Emigrated to America in 1788, settling in NYC February 15, 1789. **Comments:** One of Rollinson first jobs in America was the chasing of silver buttons for Washington's inaugural suit. He took up engraving c.1791 and his work was appeared in books published thereafter. He he also worked as a

banknote engraver with William S. Leney (see entry). Charles Rollinson, who may have been a son of William, was also an engraver (see entry); another Charles, great-grandson of William, was a noted illuminator in the late 19th and early 20th centuries in NYC. **Sources:** G&W; DAB; Reid and Rollinson, *William Rollinson, Engraver;* Decatur, "William Rollinson, Engraver"; NYCD 1790-1842; Stokes, *Historical Prints;* Dunlap, *History.*

ROLLO, Jo(seph) *[Painter] b.1904, Ragusa, Italy.*
Addresses: NYC; Woodstock, NY. **Studied:** AIC; ASL; Leon Kroll; John Carroll; George Luks. **Exhibited:** WMAA, 1919, 1933, 1936; S. Indp. A., 1928; Corcoran Gal biennial, 1939; CI, 1929, 1931, 1936; AIC, 1930, 1934, 1936-38; Detroit Inst. A., 1951-52; TMA, 1951; Terry AI, 1952. **Work:** WMAA; CAA. **Sources:** WW59; WW47.

ROLOFF, John Scott *[Sculptor] b.1947.*
Addresses: Lexington, KY, 1975. **Exhibited:** WMAA, 1975. **Sources:** Falk, *WMAA.*

ROLOFF, Louis *[Engraver] mid 19th c.*
Addresses: NYC, 1852-60 and after. **Sources:** G&W; NYCD 1852-60+.

ROLPH, John A. *[Engraver and painter] b.1799, Essex (England) / d.1862, Brooklyn, NY.*
Addresses: NYC and Brooklyn, NY. **Exhibited:** Apollo Association; NAD, 1839-42 (as John A. Rolph), 1843-44 (as John Rolfe). **Comments:** Came to NYC about 1839. His name appears as John A. Rolph or John Rolfe in exhibitions and in the directories. exhibited portraits, historical compositions, landscapes, and engravings between 1839 and 1844. In the NYC directories various occupations are given: 1839, baskets; 1840-52, engraver; 1853, toys; 1854, fancy store; 1855, varieties; 1856, toys; 1857-60 [Brooklyn CD], engraver; 1861-62 [Brooklyn and NYC], engraver. In 1864 his widow, Emma, is listed as "toys" in NYC. *Cf.* Emma Rolfe of Brooklyn, 1839. **Sources:** G&W; Smith; Cowdrey, NAD; Cowdrey, AA & AAU; NYCD 1839-64; Brooklyn CD 1857-61; Stokes, *Iconography,* III, 628-29; Stauffer; BAI, courtesy Dr. Clark S. Marlor.

ROLSHOVEN, Julius *[Painter, teacher]* J.R
b.1858, Detroit, MI / d.1930, NYC.
Addresses: Paris, France; London, England; NYC/Florence, Italy. **Studied:** Cooper Union Art School, 1877; Hugo Crola in Düsseldorf, 1878; Loefftz in Munich, 1879; Duveneck in Florence; Académie Julian, Paris with T. Robert-Fleury, 1886-89. **Member:** ANA, 1926; Soc. Nat. des Beaux-Arts, Paris; Secession, Munich; Detroit FAS; Intl. Artists Congress; Paris SAL; Scarab Cl., Detroit; Foreign AC, Florence; Bene Merensa Societa di Belle Arte, Florence; Taos SA, 1917 (assoc.), 1918 (active mem.); NAC. **Exhibited:** NAD, 1885, 1889; Paris Salon, 1888-91; SNBA, 1892-95,1898-99; PAFA Ann., 1893, 1898-1902, 1905, 1928; AIC; Detroit, 1912 (North African paintings); S. Indp. A., 1918; Taos SA, 1922; Paris Expo, 1889 (medal), 1900; Pan-Am. Expo, Buffalo, 1901 (medal); medals, Munich, Berlin, Brussels, Chicago; St. Louis Expo, 1904 (medal); Société Française, Paris; Corcoran Gal biennials, 1907-26 (4 times). **Work:** Cincinnati AM; Detroit Inst. Art; Minneapolis Mus.; BM; Detroit Athletic Cl.; Bohemian Cl.; Union Lg. Cl., Chicago; BMA; Montclair Mus.; Mus. New Mexico. **Comments:** One of the "Duveneck Boys" in Venice. He visited North Africa in 1910, the West in 1913 and honeymooned in New Mexico in 1916, where he stayed two years before returning to Florence. Teaching: life classes in Paris, 1890-95, and in London, 1896-1902. **Sources:** WW29; P & H Samuels, 408; Eldredge, et al., *Art in New Mexico, 1900-1945,* 206; Fink, *American Art at the Nineteenth-Century Paris Salons,* 385-86; Falk, *Exh. Record Series.*

ROMAN, Amelie *[Painter] 20th c.*
Addresses: New Orleans, LA. **Sources:** WW24.

ROMAN, Ann *[Painter] mid 20th c.*
Addresses: Chicago area. **Exhibited:** AIC, 1949. **Sources:** Falk,

AIC.

ROMAN, Eric *[Painter] early 20th c.*
Addresses: Corona, LI, NY. **Exhibited:** S. Indp. A., 1918, 1920. **Comments:** It is possible that Eric Roman also participated in the 1917 S. Indp. A. exhibition--Marlor included a listing for a Mr. Roman (no first name) who sold a work through the Society in 1917. **Sources:** Marlor, *Soc. Indp. Artists.*

ROMAN, Marie Desiree *[Craftsperson, teacher, sketch artist] b.1867, St. James Parish, LA / d.1950, New Orleans, LA.*
Addresses: New Orleans, active c.1885-1939. **Studied:** Arthur Dow, Ipswich, MA, 1904; Newcomb Col., 1885-87, 1889-91, 1896-1905 Award: New England Scholarship, 1904. **Comments:** Member of the first graduating class of Newcomb. Sister of Marie J. Roman (see entry). **Sources:** *Encyclopaedia of New Orleans Artists,* 329-30.

ROMAN, Marie Jeanne Amelie *[Craftsperson, teacher, sketch artist] b.1873, St. James Parish, LA / d.1955, New Orleans, LA.*
Addresses: New Orleans, active 1895-1939. **Studied:** Newcomb Col., 1895-1901; Arthur Dow, Ipswich, MA, 1901; John Carlsen, Woodstock, NY, 1914; Julien Towdonze and Baschet, Paris, 1909. **Member:** Artist's Assoc. of N.O.; Louisiana Art Teacher's Assoc. (treasurer,1903-04). **Exhibited:** Artist's Assoc. of N.O., 1897; Louisiana Purchase Exhib., 1904; NOAA, 1917-18. **Work:** Historic New Orleans Collection. **Comments:** Member of the first Newcomb class in pottery decoration. She joined the faculty after graduation and stayed until retirement in 1939. Sister of Marie D. Roman (see entry). **Sources:** *Encyclopaedia of New Orleans Artists,* 330; *Complementary Visions,* 89.

ROMAN, Nathan *[Painter] mid 20th c.*
Addresses: Chicago area. **Exhibited:** AIC, 1942-43. **Sources:** Falk, *AIC.*

ROMANACH, Leopoldo *[Painter] 19th/20th c.; b.Cuba.*
Addresses: NYC. **Studied:** F. Pardillo. **Member:** Associazione Artestica Internazionale di Roma. **Exhibited:** Paris Expo, 1900 (med). **Sources:** WW01.

ROMANDY, Gounod *[Painter] b.1893, Coronado Beach, CA / d.1942, Los Angeles, CA.*
Addresses: Los Angeles, CA. **Member:** Laguna Beach AA; Calif. AC; P&S of Los Angeles. **Exhibited:** LACMA, 1936 (first prize); Soc. for Sanity in Art, CPLH, 1940; Laguna Beach AA. **Comments:** A musician, as well as a painter, he was a solo violinist with the Walt Disney Studios, 1935-40. **Sources:** Hughes, *Artists in California,* 478.

ROMANELLI, Carlo (Alfred) *[Sculptor] b.1872, Florence, Italy / d.1947, Los Angeles, CA.*
Addresses: Chicago, IL; Los Angeles, CA. **Studied:** France and Italy. **Exhibited:** Detroit Inst. of Arts, 1908-12. **Sources:** WW24; Hughes, *Artists in California,* 478; Gibson, *Artists of Early Michigan,* 206.

ROMANELLI, Frank *[Painter, sculptor, illustrator] b.1909, Italy.*
Addresses: Buffalo, NY. **Studied:** The Patteran. **Exhibited:** Albright A. Gal, Buffalo, 1938 (prize). **Work:** State T. Col., Buffalo; murals, Buffalo Marine Hospital; panels, City of Buffalo. **Sources:** WW40.

ROMANES, Elizabeth *[Portrait and still-life painter] late 19th c.*
Addresses: San Francisco, CA, 1868-77. **Exhibited:** Arriola Relief Fund, San Francisco, 1872. **Sources:** Hughes, *Artists in California,* 478.

ROMANO, Clare Camille *[Printmaker, painter] b.1922, Palisade, NJ.*
Addresses: Englewood, NJ. **Studied:** CUA Sch., 1939-43; Ecole Beaux-Arts, Fontainebleau, France, 1949; Inst. Statale Arte, Florence, Italy, Fulbright grant, 1958-59. **Member:** Soc. Am. Graphic Artists (pres., 1970-72); Print Cl. Phila.; Boston

Printmakers; Mod. Painters & Sculptors; A.N.A. **Exhibited:** Invitational of American Prints, South London A. Gal., Eng., 1967; Cincinnati Mus. Art Print Invitational 1968; First Biennial Am. Graphic Art, Columbia, S. Am., 1971; Second Triennial Int. Exhib. Woodcuts, Ugo Carpi Mus., Italy, 1972; American Prints, US Info Agency Invitational, Australian Nat. Mus., Canberra, 1972; Assoc. Am. A., NYC, 1970s. Awards: Tiffany grant, 1952; Fulbright grant, 1958; citation for pr. of achievement, CUA Sch., 1966. **Work:** MoMA, WMAA & MMA; LOC & Nat. Collection Fine Arts, Wash., DC. Commissions: tapestry, Hanover Bank, NY, 1969. **Comments:** Teaching: instr. printmaking, New Sch. Social Res., 1960-; adj. asst. prof. printmaking, Pratt Graphic Arts Ctr., 1963-; adj. asst. prof. printmaking, Pratt Inst., 1964-. Publications: co-illusr., "Spoon River Anthology," 1963; co-illusr., "Leaves of Grass," 1964; auth.,"Artist's Proof," 1964 & 1966; auth., "American Encyclopedia," 1971; co-auth., "The Complete Printmaker," 1972. **Sources:** WW73; Patricia Boyd Wilson, article, In: *Christian Sci. Monitor,* 1967; Faulkner & Ziegfield, *Art Today* (Holt, Rinehart & Winston, 1969); Pat Gilmour, *Modern Prints* (Studio Vista , London, 1970).

ROMANO, Emanuel Glicen
[Painter, illustrator, teacher, lecturer]
b.1897, Rome, Italy.
Emanuel Romano
Addresses: NYC. **Studied:** Switzerland, also with Enrico Glicenstein. **Member:** Artists League Am. **Exhibited:** WMAA; City Col, New York; S. Indp. A., 1929, 1938; Forth Worth Art Assn; PAFA, 1945; AIC, 1940; Greenville Mus Art, SC, 1962 (solo); Haifa Mus & Tel-Aviv Mus, Israel (solo). **Work:** Univ. Art Mus., Univ. Tex., Austin; FMA; MMAA; Detroit IA; New London Mus.; Mus. Ville Paris. Commissions: mural, Klondike Bldg., Welfare Island, NY; portraits in many pvt. collections. **Comments:** Publications: contribr., drawings, In: The Waste Land, The Hollow Men, Waiting for Godot, Beckett, Rhinoceros & Ionesco; plus many others. Teaching: lectr. mural painting in ancient & mod. times. Position: t., CCNY, 1944-45. **Sources:** WW73; WW47, puts birth at 1901.

ROMANO, E(spinoza) C(asada) *[Painter]* mid 20th c.
Addresses: NYC. **Exhibited:** S. Indp. A., 1925-26. **Sources:** Marlor, *Soc. Indp. Artists.*

ROMANO, Jaime (Luis) *[Painter]* b.1942, Santurce, PR.
Addresses: Hato Rey, PR. **Studied:** Univ. PR (B.A. humanities, 1966); Am. Univ. (M.A., 1969). **Exhibited:** Certamen Navidad Ateneo Puertorriqueño, San Juan, 1966-68 & 1971; David Lloyd Kreegar Award Exhib., Washington, 1969; Expos Panamericana Artes Gráficas, Cali, Colombia, 1970; Primera & Segunda Bienal Grabado Latinoamericano, San Juan, 1970 & 1972; Galeria Santiago, San Juan, PR, 1970s. Awards: first prize in painting, Soc. Amigos de Cristobal Ruiz, 1967; first prize in painting, David Lloyd Kreegar Award Exhib., 1968; first prize in painting, Certamen Ateneo Puertorriqueno, 1968. **Work:** Mus. Bellas Artes, Ponce, PR; Ateneo Puertorriqueño, San Juan, PR; Inst. Cult. Puertorriqueña, San Juan; Mus. Antropologia y Arte, Univ. PR, Rio Piedras; C. Law Watkins Mem. Collection, Am. Univ., Wash., DC. **Comments:** Preferred media: acrylics. Positions: v. pres., Fondo Becas Artes Plásticas, Inc., San Juan, 1970-. Teaching: instr. advan. drawing & painting, Univ. PR, Rio Piedras, 1969-71, acad. adv., 1970-71. Publications: auth., "Ernesto Alvarez," 1966; auth., "Art in Puerto Rico-Boom or Bust?", 1971; auth., "On Criticism, Critics & Criteria," 1972. **Sources:** WW73; Ernesto Alvarez, *Jaime Romano* (Artes Graficas, 1966); Antonio Molina, "Lo Ultimo de Romano," *El Mundo* (1968); "The Seven Minutes," *San Juan Star,* Oct. 15, 1972.

ROMANO, Nicholas *[Painter, sculptor, craftsperson]* b.1889, Montoro, Italy / d.1941.
Addresses: Phila., PA. **Studied:** A. Laessle. **Member:** DaVinci A. All. **Exhibited:** PAFA Ann., 1920-37 (7 times); AIC, 1924, 1928. **Work:** PAFA; Phila. A. Alliance; Graphic Sketch C., Phila.; Albright Gal.; Rochester Mem. Gal.; Bok Vocational Sch., Phila. **Comments:** Position: t., Graphic Sketch C. **Sources:** WW40; Falk, *Exh. Record Series.*

ROMANO, Salvatore Michael *[Painter, sculptor]* b.1925, Cliffside Park, NJ.
Addresses: NYC. **Studied:** ASL, with Jon Corbino; Acad. Grande Chaumière, Paris, France, with Edouard Georges & Ehrl Kerkam. **Exhibited:** Primary Structures, Jewish Mus., NYC, 1966; Cool Art Show, 1967 & Highlights of the Season, 1968-69, Aldrich Mus. Contemp. Art, Ridgefield, Conn., 1969; AM Sachs Gal., NYC, 1968 (solo); Max Hutchinson Gal., NYC, 1971(solo). **Comments:** Preferred media: acrylics, plaster, plastics, wood, metals, water. Teaching: adj. instr. sculpture, Cooper Union Sch. Arts & Archit., 1968-70; lectr. painting, sculpture & drawing, Herbert H. Lehman Col., City Univ. NY, 1969-. Publications: auth., article, In: Lehman Col. Art News Letter, 1971. **Sources:** WW73; Corinne Robins, "Floating Sculpture" (1965) & Grace Glueck, "New York Gallery Notes" (Sept. 10, 1971), *Art in Am.*; Carl Baldwin,"It Floats," *Art News* (Nov., 1971).

ROMANO, Umberto Roberto
[Painter, sculptor, etcher, teacher]
b.1906, Naples, Italy.
Umberto Romano 1962
Addresses: NYC; Gloucester, MA. **Studied:** NAD, 1921-26; Tiffany Foundation, summer 1925, fellowship, 1926; Am. Acad. Rome, 1926-27. **Member:** Century Assn. (exhib. committee, 1970-); Rockport AA; Nat. Mural Soc. (dir., 1962-); Provincetown AA; Gloucester SA; North Shore AA; Castle Hill Foundation (dir., 1950-58); Audubon Artists (pres., 1971-72). **Exhibited:** AIC, 1928, 1930 (prize); PAFA Ann., 1929-40, 1952, 1958; WMAA, 1932-57; Corcoran Gal biennials, 1928-61 (8 times); Salons of Am.; NAD, 1954, (Carnegie Award); Springfield AL, 1931 (prize)-32 (prize); CAFA, 1931 (prize); North Shore AA (prize); Tiffany Fnd. (medal); Springfield AC, 1930 (prize); Stockbridge, MA, 1932 (prize); CI, 1933-49; Worcester (MA) Art Mus., 1935 (solo); Galerie Andre Well, Paris, 1949 (solo); "Oriental Fragment," U.S. Govt. trav exh, Orient, 1950-52; "Fragment — Man Weeps," U.S. Govt. trav religious exh, to Italy, France, Spain & Germany, 1958-61; Century Assn., 1969 (gold med. of honor). Other awards: Pulitzer Prize, Columbia Univ., 1926. **Work:** NMAA; WMAA; Roosevelt Libr., Hyde Park, NY; FMA; WMA; CGA; AGAA; RISD; Smith Col.; Goodyear Coll.; Encyclopaedia Britannica; San Diego FAS; BMA; Smith Mus., Springfield, MA. Commissions: mural, "Three Centuries of New England History," USPO Springfield, Mass., 1938; portrait of Sara Delano Roosevelt for March-of-Dimes, Hyde Park Libr., 1942; mosaic mural, "After Chaos Came Order," Municipal Court House, NYC, 1961; "Pupil Learns from Past & Looks Toward The Future," P.S. 234, Brooklyn, 1964; "Mother and Child" (stained glass window), Allen Stevenson School, NYC, 1967. **Comments:** Preferred media: oils, acrylics, bronze, marble. Positions: first vice-pres., Int. Assn. Plastic Arts, 1965-; first vice-pres., NAD, 1965-; dir., Abbey Foundation, 1966-. Publications: contrib., *American Art Today,* Nat. Art Soc., 1939; illustrator, *Dante's The Divine Comedy,* 1946 & contrib., *Best of Art,* 1948, Double-Day; contrib., *Contemporary American Painting,* Univ. Illinois Press, 1949; contrib., *Expressionism in Art,* Liveright, 1958. Teaching: instr. in painting & sculpture, dir., Worcester Art Mus. School, 1933-40; Romano School Art, Gloucester, MA, 1933-60; Romano School Art, New York, 1950-72. **Sources:** WW73; Falk, *Exh. Record Series.*

ROMANOFFSKI, Dimitri *[Painter]* b.Russia / d.1971, NYC.
Addresses: NYC. **Studied:** ASL. **Exhibited:** PAFA Ann., 1912-13 (as Romanoffski), 1918 (as Romanovsky); S. Indp. A., 1917 (as Romanowsky). **Comments:** (His name has appeared as Romanoffski, Romanovsky, and Romanowsky). **Sources:** WW24; Falk, *Exh. Record Series.*

ROMANOVSKY, Dimitri See: **ROMANOFFSKI, Dimitri**

ROMANOWKSY, Dimitri See: **ROMANOFFSKI, Dimitri**

ROMANOWSKI, C. *[Painter]* early 20th c.
Addresses: NYC. **Exhibited:** S. Indp. A., 1917. **Sources:**

Marlor, *Soc. Indp. Artists.*

ROMANS, Bernard [*Engraver, mapmaker, botanist, and engineer*] *b.1720, Holland / d.1784.*
Comments: Educated in England and came to America in 1755 as a surveyor and botanist. Worked in Florida for some time and in 1775 published a work on the natural history of that region. When the Revolution broke out, he joined the colonists and was at the battle of Bunker Hill. In September 1775 he published (at Philadelphia) an engraving of the battle of Charlestown. He planned and partially built one of the forts at West Point and from 1776 to 1778 was captain of a Pennsylvania artillery company. It is believed that Romans was captured and taken back to England where he went back to his profession. In 1784, he disappeared on a voyage from England to the U.S.; it is said that he was murdered. **Sources:** G&W; Stauffer; *Portfolio* (Aug.-Sept. 1947), 11-13, and (Feb. 1954), 124.

ROMANS, Charles John [*Painter, teacher*] *b.1893, NYC / d.1973, Cape May, NJ.*
Addresses: Cape May, NJ. **Studied:** Buffalo State Teachers Col. (cert); NY Univ.; NAD, with Leon Kroll & Siguard Skou; also with George E. Browne, Provincetown, Mass. **Member:** Provincetown AA; Gotham Painters; Audubon A.; P & S S. of NJ; S.C. NJ Painters & Sculptors Soc (treas. & v. pres., 1944-45); All. A. Am. (secy., 1952-54); Nat. Assn. Painters Casein; Prof. Artists S. Jersey (pres., 1957-71); Atlantic City Art Ctr. Gal. (adv., 1964). **Exhibited:** S. Indp. A., 1934; All. A. Am. Ann,1937-1971(anonymous award); Audubon A., 1944; Montclair A. Mus., 1937-46, 1950; Jersey City Mus., 1944 (prize), 1945-46; Am. Fed. Traveling Ex., 1939; AWCS Ann., 1939; NAD Ann., 1941; Nat. Acad. Design Galleries; Riverside Mus. Spec. Exhib., 1952-54; Old Bergen Art Guild, Bayonne, NJ, 1970s Awards: Jersey City Mus. Award, Art Coun. NJ, 1950-51; Dr. M. Woodrow Award, Hudson Valley Art Assn., 1954. **Work:** Jersey City Pub. Mus., NJ; Union Mus., Albany, Ga.; La Salle Col. Union Permanent Coll., Phila., Pa.; Kosciuszko Found., NY. **Comments:** Preferred media: oils. Teaching: instr. fine arts, Dickinson High Sch., Jersey City, 1945-55; pvt. instr. art workshop, 1955-71; instr. art workshop, Seven Mile Beach Art League, Avalon, NJ, 1957-60. Married to artist Ethel Gilmore. **Sources:** WW73; WW47; Philbrook Smith, "The Romans' Concentrate Careers," *NJ Music & Arts* (Mar., 1969).

ROMANSKI, Henry J. [*Engraver, illustrator, designer*] *b.1861, Zytomir, Poland / d.1944, New Orleans, LA.*
Addresses: New Orleans, active c.1892-1942. **Member:** Artist's Assoc. of N.O., 1896; NOAA, 1905. **Exhibited:** Artist's Assoc. of N.O., 1897. **Comments:** Came to the U.S. c.1887 and worked in NYC at first. Went to New Orleans in c.1892 to find employment as a photo engraver. In 1895 he formed a company with Henry Grelle and in 1902 went into business on his own. **Sources:** *Encyclopaedia of New Orleans Artists*, 330.

ROMANSKY, Alvin S. [*Collector, patron*] *b.1907, Houston, TX.*
Addresses: Houston, TX. **Studied:** Univ. Penn.; Univ. Tex.; Univ. Houston; Univ. Calif., Davis (LLB). **Member:** Chambre Syndicate Estampe Dessin Tableaux, France. **Exhibited:** Dallas Mus. Fine Arts; Witte Mem. Mus., Tex. Gen. Exhib. & Nat. Photo Exhib., 1935-40, Houston Mus. Fine Art. Awards: three prizes, Houston Mus. Fine Arts. **Comments:** Positions: v. pres., Contemp. Arts Mus., 1947-52. Collections arranged: Rufino Tamayo Exhib. & Contemp. In Cotton, Contemp. Arts Mus.; Ashanti Goldwrights, Univ. Tex., 1971.Research: Ashanti art; gold weights. Art interests: donated collection of graphics to the University of Texas; donated Alvin Romansky Print Room to the University of Houston Museum of Fine Arts. Collection: French graphics, contemporary French art; Ashanti objects. **Sources:** WW73; *Tamayo Catalogue, Contemporary in Cotton;* plus others.

ROMBSKI, S. See: **REMBSKI, Stanislav**

ROME, Harold [*Collector, painter*] *b.1908, Hartford, CT.*
Addresses: NYC. **Studied:** Yale Univ. (B.A., 1929), Yale Law Sch., 1928-30, Yale Sch. Archit. (BFA, 1934). **Member:** Dramatists Guild. **Exhibited:** Salons of Am., 1932, 1936; solo show paintings & songs, Marble Arch Gal., NYC, 1964; solo show paintings, Bodley Gal., NYC, 1970. **Comments:** Positions: Composer & writer. Publications: Composer, "Fanny," 1954; "Destry Rides Again," 1959; "I Can Get it for You Wholesale," 1962; "Zulu and the Zayda," 1965; "Scarlett," (mus. adaptation of "Gone With the Wind"), Imperial Theatre, Tokyo, 1970. Collection: African sculpture; large collection of West African heddle-pulleys. **Sources:** WW73.

ROME, Jacob [*Artist*] *early 20th c.*
Addresses: Wash., DC, active 1922. **Sources:** McMahan, *Artists of Washington, DC.*

ROME, Richardson [*Block printer, designer, etcher, engraver, lithographer, lecturer*] *b.1902, Minneapolis, MN.*
Addresses: Estes Park, AC. **Studied:** E. Witter; S.C. Burton; Univ. Minn. **Member:** Phila. PC; Kansas City Woodcut S.; Northwest PM; Chicago Gal. A.; Am. S. Graphic A. **Work:** BM; MMA; Kansas City AI; Denver AM;Atkins Gal., W.R. Nelson Gal., Kansas City. **Comments:** Author: "High Country," (book of wood-cuts of the Colo. Rockies, Alden Galleries). **Sources:** WW40.

ROME, Samuel [*Graphic artist, painter, teacher*] *b.1914, NYC.*
Addresses: NYC. **Studied:** MMA Sch.; ASL; NAD; NYU. **Sources:** WW40.

ROME, T. Herzl [*Painter, sculptor, lecturer*] *b.1914, Worcester, MA.*
Addresses: Worcester, MA. **Exhibited:** WMA, 1938; GGE, 1930; Salon des Surindependants, Paris. **Sources:** WW40.

ROMEGAR [*Portrait and landscape painter*] *late 18th c.*
Addresses: Louisiana, active 1772. **Comments:** *Encyclopaedia of New Orleans Artists,* cites this to be the same artist as José Francisco Xavier De Salazar Y Mendoza. **Sources:** G&W; Thompson, *Louisiana Writers.*

ROMEIN, Peter De H. [*Portrait painter*] *mid 19th c.*
Comments: Painter of a portrait, dated 1844, of John Miller (privately owned, 1956). **Sources:** G&W; Information cited by G&W as being courtesy Howard S. Mott, NYC.

ROMELING, W. B. [*Painter*] *b.1909, Schenectady, NY.*
Addresses: Van Hornesville, NY. **Studied:** Pratt Inst., Brooklyn, NY; Syracuse Univ. Sch. Fine Arts; also with Ogden Pleissner. **Member:** Cooperstown Art Assn. (pres., 1970-72); Southern Vt. Artists. **Exhibited:** Central New York, Munson-Williams-Proctor Inst., Utica, NY, 1962; Invitational Watercolor Show, Sharon, Conn., 1967-68; Bennington Gallery, Vt, 1970-71(solo); Cooperstown Ann., NY, 1970-71; Muggleton Gallery, Auburn, NY, 1970-71(solo); Richard Comins, Bennington, VT, 1970s. Awards: purchase prize, Schenectady Mus., 1963; first prize, still life, 1966 & Godley Watercolor Award, 1970, Cooperstown Art Assn. **Work:** Schenectady Mus.; Cooperstown Art Assn. **Comments:** Preferred media: watercolors. Teaching: instr. art, Owen D. Young Sch., Van Hornesville, NY, 1943-69. **Sources:** WW73.

ROMER, Jessie [*Painter*] *mid 20th c.*
Addresses: Pleasantville, NY. **Exhibited:** PAFA Ann., 1940. **Sources:** Falk, *Exh. Record Series.*

ROMER, Paul [*Painter*] *b.1898, San Francisco, CA / d.1985, San Rafael, CA.*
Addresses: San Anselmo, CA. **Studied:** Calif. Sch. of FA, one year. **Member:** Marin Soc. of Artists (cofounder, 1927); Soc. of Western Artists. **Exhibited:** San Francisco AA annuals from early 1920s; Marin Soc. of Artists from 1927-80; GGE, 1939; Oakland Art Gal., 1932, 1939; Soc. of Western Artists, 1940s. **Comments:** Specialty: scenes of the Sierra Nevada and the Marin hills. **Sources:** Hughes, *Artists in California,* 478.

ROMERO, Andreis [*Painter*] *mid 20th c.*
Addresses: Melrose, PA. **Exhibited:** PAFA Ann., 1933. **Sources:**

Falk, *Exh. Record Series.*

ROMERO, Carlos Orozco *[Painter] mid 20th c.*
Exhibited: AIC, 1941-44. **Sources:** Falk, *AIC.*

ROMERO, Emilio *[Painter] early 20th c.*
Addresses: Guayama, Puerto Rico. **Member:** S.Indp.A.
Exhibited: S. Indp. A., 1921. **Sources:** WW21.

ROMNEY, Grace See: **BEALS, Grace R(omney)**

ROMNEY, Miles *[Sculptor] b.1806, Dalton, Lancashire
(England) / d.1877, St. George (Utah).*
Comments: One of the chief wood carvers employed in the building of the Mormon Temple at Nauvoo (Ill.) in the mid-1840's. He had joined the Mormon Church in England in 1837 and arrived in Nauvoo in 1841; moved to Utah in 1850. **Sources:** G&W; Arrington, "Nauvoo Temple."

ROMOSER, Ruth Amelia *[Painter, sculptor] b.1916,
Baltimore, MD.*
Addresses: Miami, FL. **Studied:** Baltimore Art Inst. (grad; sculpting courses with Xavier Corbera, Barcelona, Spain; Robert Motherwell Workshop; graphics with Joseph Ruffo. **Member:** Blue Dome Art Fel.; Fla. Artists Group; Lowe Mus.; Miami Art Ctr. **Exhibited:** Ringling Southeast Nat. Art Show, Sarasota, Fla., 1961-63; Nat. Drawing Exhib., Cheltenham, Pa., 1964; Four Arts Plaza Nat., Palm Beach, 1966; Hortt Mem. Regional, Fort Lauderdale Mus. Arts, 1966; Nat. Design Ctr., NYC, 1967 (solo); Bernard Davis, Miami, FL, 1970s. **Awards:** Eighth Ann. Hortt Mem. Award, Fort Lauderdale Mus. Arts, 1967; Design Derby Award, Designers-Decorators Guild, 1969; Artspo 1970, Coral Gables, 1970. **Work:** Miami MoMA; Lowe Mus., Univ. Miami, Fla.; Miami Herald; Nat. Cardiac Hosp., Miami; Int. Gal., Baltimore, Md. Commissions: two paintings for 12 productions, Actors Studio M., Coral Gables, Fla., 1963-64. **Comments:** Preferred media: oils, acrylics. Publications: ed., All Florida Artist in the House Mag., 1963; contribr., rev., In: *Art News Mag.,* 1967. **Sources:** WW73; Nellie Bower, "Arriving at a Style," *Miami Daily News,* 1965; Bernard Davis, Romoser foreword, catalogue (Miami Mus. Mod. Art, 1968); Doris Reno, "Lively Arts," *Miami Herald.*

RONALD, William *[Painter] b.1926, Stratford, Ontario.*
Addresses: Canada. **Studied:** Ont. Col. Art (hon. grad., 1951). **Exhibited:** Carnegie Int., 1958; Brussels World's Fair & traveling exhib., 1958; Sao Paulo Biennale, Mus. Arte Mod., 1959; WMAA annual, 1963; Corcoran Gal. biennial, 1963; Nat. Gal. Canada Biennial, 1957 (prize), 1968. Other awards: Hallmark Corp. Art Award for watercolor, 1952; natl. award, Can. sect., Int. Guggenheim Awards, 1956. **Work:** MoMA; Guggenheim Mus; WMAA; Nat. Gal. Can., Ottawa; Carnegie Inst. Commissions: acrylic mural, Nat. Art Cntr., Ottawa, 1970. **Comments:** Positions: host of TV show on arts, Can. Broadcasting Corp., Toronto, 1966-67. **Sources:** WW73; David Ralston & Hugo McPherson, "The Ronald Chapel in Toronto Harbour," *Canadian Art* (Apr., 1966); William Cameron, "Portrait of the Artist as a Violently Honest Man," *Macleans* mag. (Feb., 1971).

RONALDS, George L. *[Portrait painter] mid 19th c.*
Addresses: NYC, 1860. **Sources:** G&W; NYBD 1860.

RONALDSON, Douglass S. *[Engraver] b.c.1835, England.*
Addresses: Philadelphia (brought by his parents to Phila. 1840), active from 1858. **Sources:** G&W; 8 Census (1860), Pa. LIV, 166; Phila. CD 1858-60+.

RONAN, James P. *[Painter] mid 20th c.*
Exhibited: Salons of Am., 1934. **Sources:** Marlor, *Salons of Am.*

RONAY, Stephen Robert *[Painter, cartoonist, sculptor, illustrator, lecturer] b.1900, Arad, Romania.*
Addresses: Port Wash., NY; Roslyn, NY. **Studied:** Royal Acad. Des., Budapest; NAD. **Member:** Ar. Gld.; Ar. Un. **Exhibited:** Assn. Am. A.; Contemp. A. Gal.; Macbeth Gal.; CGA; AIC, 1937; CMA, 1938; MoMA, 1940; Parrish Art Mus., Southampton, NY, 1960-72; VMFA, 1968; plus solo shows, New York. **Awards:** The

Poet's Garden Award, 1969 & Garden & Beach Award, 1970, Parrish Art Mus. **Comments:** Preferred media: oils, graphics. **Sources:** WW73; WW47.

RONCHI, Nino *[Painter] mid 20th c.*
Addresses: NYC, 1925. **Exhibited:** S. Indp. A., 1925. **Sources:** Marlor, *Soc. Indp. Artists.*

RONCHI, Ottorino Donatello *[Caricaturist] b.1882,
Bologna, Italy / d.1944, San Francisco, CA.*
Addresses: San Francisco, CA. **Member:** Bohemian Cl.; San Fran. Art Commission. **Comments:** Position: prof. of language, UC Berkeley; editor, Italian newspaper, San Francisco. **Sources:** Hughes, *Artists in California,* 478.

RONDEAU, Zillah *d.1902, Chatawa, MS.*

RONDEL, Frederick (Jr.) *[Landscape painter] b.1855,
Malden, MA.*
Addresses: NYC. **Exhibited:** Brooklyn AA, 1870s; NAD, 1881-84. **Comments:** Son of Frederick, Sr. **Sources:** *Brooklyn AA.*

RONDEL, Frederick (Sr.) *[Landscape painter] b.1826, Paris,
France / d.1892, Philadelphia, PA.*
Addresses: Boston, 1855-57; So. Malden , MA, 1858; NYC, 1859-61; Europe, 1862-65; NYC, 1865-90; Phila., 1891-on. **Studied:** Paris, with marine and landscape painters Auguste Jungelet and Theodore Gudin. **Member:** A.N.A. (elected 1861). **Exhibited:** NAD, 1857-92; PAFA Ann., 1855-68, 1880-81; Brooklyn AA, 1881, 1891 (possibly also in the 1870s); Boston Athenaeum; AIC. **Work:** Society of Cal. Pioneers; Wheaton College, Norton, MA. **Comments:** Although he was an accomplished landscape painter in his own right, he is best remembered as Winslow Homer's only formal art teacher. Rondel immigrated to Boston c.1855, and Homer studied briefly with him c.1861 in NYC. In 1862, Rondel returned to Europe for the duration of the Civil War, returning to NYC in 1865 where he taught at the NAD. He painted extensively throughout New England, and in 1875 even visited San Francisco. **Sources:** G&W; Swan, BA; Cowdrey, NAD; Naylor, NAD; Rutledge, PA; Falk, PA, vol. 2; NYBD 1859. More recently, see Howat, *The Hudson River and Its Painters,* 137 (cat. no. 13); Hughes, *Artists in California.*; Campbell, *New Hampshire Scenery,* 135; Wright, *Artists in Virginia Before 1900.*

RONDEL, Louis *[Painter] late 19th c.*
Addresses: Poughkeepsie, NY, 1865-68; NYC, 1870. **Exhibited:** NAD, 1865-70. **Sources:** Naylor, *NAD.*

RONDELL, Lester *[Designer, painter, lecturer] b.1907, NYC.*
Addresses: NYC. **Studied:** N.Y. Sch. F. & App. A.; ASL, with Kimon Nicolaides. **Member:** A. Dir. Cl.; SI. **Exhibited:** PAFA Ann., 1940, 1949; Carnegie Inst., 1945; Sch. A. Lg., 1925 (med); U.S. Treasury Dept., 1943 (prize), 1944 (prize); Pepsi-Cola, 1946 (prize); Corcoran Gal biennial, 1949. **Comments:** Lectures: design & layout in advertising. **Sources:** WW59; WW47; Falk, *Exh. Record Series.*

RONDONI, Romolo *[Sculptor] early 20th c.*
Addresses: NYC. **Exhibited:** PAFA Ann., 1914. **Sources:** WW24; Falk, *Exh. Record Series.*

RONEY, Harold Arthur *[Painter, lecturer] b.1899, Sullivan,
IL / d.1986.*
Addresses: San Antonio, TX. **Studied:** Chicago Acad Art; AIC; also with Harry Leith-Ross, John Folinsbee & George A. Aldrich; de Young; Schuman. **Member:** SSAL; Tex. FAA; Palette C., San Antonio; AAPL. **Exhibited:** South Bend, Ind., 1923 (prize); SSAL, 1929-32, 1945; CAFA, 1937; Tex. FAA, 1929-33; San Antonio, 1944 (solo), 1945; NOAA, 1928-29, 1932; New Hope, Pa., 1935-36; Phila., (solo); Tex. Fed. WC, Lubbock, 1932; River Square Gal., San Antonio, Tex., 1971; Coppini Acad. Fine Arts, San Antonio, 1971. **Work:** Sullivan Pub. Libr., IL; Witte Mem. Mus.; Austin Pub. Libr., Tex.; South Bend Pub. Sch., Ind.; Southeast Tex. State Univ.; Austin AL. **Comments:** Preferred media: oils. Teaching: instr. oil landscape, Froman Sch. Art, 1958- **Sources:** WW73; WW47.

RONNE, Minna Clausen *[Painter] b.1868, Germany / d.1951, Berkeley, CA.*
Addresses: Berkeley, CA. **Exhibited:** Oakland A. Gal., 1928, 1929. **Sources:** Hughes, *Artists in California*, 479.

RONNEBECK, Arnold H *[Sculptor, lithographer, lecturer, writer, painter, teacher] b.1885, Nassau, Germany / d.1947, Denver, CO.*
Addresses: Wash., DC, active mid 1920s; Denver, CO, 1933. **Studied:** Paris, with Bourdelle, Maillol. **Member:** CAA. **Exhibited:** Soc. of Wash. Artists, 1924; Kansas City, Mo., 1928 (med); City C., Denver, 1928 (prize); Kansas City AI, 1929 (gold); Conner-Rosencrantz Gal., NYC, 1990s; WMAA, 1928-38. **Work:** NMAA; Cooper-Hewitt Mus.; Denver Nat. Bank, St. John's Cathedral, Hodges Mem., Church of the Ascension, all in Denver; Denver AM; WPA terra cotta relief, USPO, Longmont, Colo.; friezes of Indian Ceremonial Dances, La Fonda, Santa Fe. **Comments:** Best known for his energetic interpretations of NYC. Married to artist Louise Harrington Emerson. **Position:** t., Univ. Denver. **Sources:** WW47; McMahan, *Artists of Washington, DC;* Betsy Fahlman, exh. cat. (Conner-Rosencrantz Gal., NYC, 1990s).

RONNEBECK, Louise Emerson (Mrs. Arnold) See: **EMERSON, Louise Harrington (Mrs. Arnold Rönnebeck)**

RONSHEIN, John Noland *[Painter, designer] b.1920, Anderson, IN / d.1944, Italy (while in the Army Air forces).*
Studied: Corcoran A. Sch. **Comments:** Specialty: indst. design.

RONZONE, Benjamin A *[Painter, writer] b.1849 / d.1927, Brooklyn, NY.*
Comments: Author: "The Marquis of Murray Hill," many short stories.

ROOD, Henry, Jr. *[Painter, illustrator, teacher, lecturer] b.1902, Pleasantville, NY.*
Addresses: Greensboro, NC. **Studied:** ASL; N.Y. Univ., and with John Carlson, Frank DuMond. **Member:** North Carolina State A. Soc.; NAC. **Work:** North Carolina State Capitol Bldg., Governor's Mansion, State Welfare Bldg., State Col., all Raleigh; Wake Forest Col.; Univ. North Carolina; Pharmacy Bldg., Chapel Hill; Guilford Col.; High Point Col.; Woman's Col. of Univ. North Carolina; Greensboro Col.; Guilford County Courthouse; Mint Mus. A.; Davidson Col.; North Carolina State Hospital, Morganton; Medical Col. of Virginia, Richmond; South Carolina State Sch. for the Blind, Spartanburg; Dartmouth Col., Hanover, N.H. **Comments:** Illustrator: Forbes. **Sources:** WW59; WW47.

ROOD, John *[Sculptor, painter, writer, lecturer, educator] b.1902, Athens, OH / d.1974.*
John Rood (signature)
Addresses: Athens, OH; Minneapolis, MI; Washington, DC. **Studied:** Ohio Univ. **Member:** Minnesota AA; Soc. Minn. Sculptors; Columbus AL; AEA. (nat. pres., 1959-). **Exhibited:** nationally; Durand-Ruel Gal., 1944; Walker A. Ctr., 1945; PAFA Ann., 1952-64 (6 times); 17 solo exhs., New York; and in Milan and Rome, Italy, 1956; Mexico City, 1958. **Awards:** Minneapolis Inst. A.; Minnesota State Fair; WAC; SFMA. **Work:** Cranbrook Acad. A.; Ohio Univ.; St. Mark's Cathedral, Minneapolis; Our Lady of Grace Church, Edina, Minn.; Mt. Zion Lutheran Church, Minneapolis; Church of the Good Shepard, Athens, Ohio; Hamline Univ.; Wellesley Col.; Austin Jr. H.S. Austin, Minn.; Minneapolis Athletic Cl.; fountain & sc., Minneapolis Pub. Lib.; Minneapolis Inst. A.; WAC; CGA; Nat. Hdqtrs., AAUW, Wash., D.C.; AGAA. **Comments:** Position: t., Univ. Minn. (1944-46), Ohio Univ., from 1946. Author: "Wood Sculpture," 1940; "Sculpture in Wood," 1950; "Sculpture with a Torch," 1961. Chapter on Sculpture, "Book of Knowledge," 1952. **Sources:** WW66; WW47; Falk, *Exh. Record Series.*

ROOD, Roland *[Painter] 19th/20th c.; b.New York.*
Addresses: NYC. **Studied:** Académie Julian, Paris with Bouguereau and Ferrier, 1889, 1900. **Exhibited:** SNBA, 1894. **Sources:** WW19; Fink, *American Art at the Nineteenth-Century*

Paris Salons, 386.

ROOD, Stephen *[Engraver] b.c.1807, England.*
Addresses: NYC, by as early as 1846 (when his daughter was born), through at least 1850. **Sources:** G&W; 7 Census (1850), N.Y., LVII, 128.

ROODSSON, Nicholas *[Painter] mid 20th c.*
Exhibited: S. Indp. A., 1942. **Sources:** Marlor, *Soc. Indp. Artists.*

ROOK, Edward Francis *[Landscape, genre & flower painter] b.1870, NYC / d.1960, Old Lyme, CT.*
Addresses: Paris, France, 1896-97; Newport, RI, 1898-99; White Plains, NY, 1901-02; Old Lyme, CT, 1905-. **Studied:** Acad. Julian, Paris, with Jean Paul Laurens & Benjamin Constant, 1887-88, 1890-92. **Member:** ANA, 1908; NA, 1924; Lotos Club; Lyme AA. **Exhibited:** SNBA, 1895-97; PAFA Ann., 1896-19; AIC, 1897-1923 (1898 Temple gold med.); Boston AC, 1899-1907; Armory Show, 1913; Pan-Am. Expo, Buffalo, 1901(bronze med.); St. Louis Expo, 1904 (2 silver medals); Corcoran Gal. biennials, 1907-19 (5 times, incl. bronze medal, 1919); CI, 1910 (bronze med.); Buenos Aires Expo, 1910 (silver med.); Pan-Pacific Expo, San Fran., 1915 (gold med.); CGA, 1920 (bronze med. & prize); Lyme AA, 1929 (prize), 1938 (prize). **Work:** PAFA; PMA; CM; Florence Griswold Mus., Old Lyme; Boston AC; Portland Mus. Art; CGA; Lotos Cl. **Comments:** Rook was a wealthy member of the colony at Old Lyme about whom stories abound. A huge garage, which housed his three cars, was the focal point of his house, although he never learned to drive. He tormented rats by placing plate glass over his garbage pail. Not wanting to part with his paintings, he priced them high. He never had a solo show, nor was he connected to a commercial gallery. A Post-Impressionist, he painted some landscapes on Monhegan Island (ME) as well as in the West. **Sources:** WW59; WW47; P&H Samuels, 408; Curtis, Curtis, and Lieberman, 92, 186; *Connecticut and American Impressionism* 171-72 (w/repro.); Fink, *Am. Art at the 19th C. Paris Salons,* 386; Art in Conn.: The Impressionist Years; Falk, *Exh. Record Series.*

ROOK, Johann *[Painter] early 20th c.*
Exhibited: S. Indp. A., 1920. **Sources:** Marlor, *Soc. Indp. Artists.*

ROOKER, Samuel Saffel *[House, sign, and portrait painter] b.c.1800, Knoxville, TN / d.c.1875, Martinsville, IN.*
Addresses: Indianapolis, IN, 1821-after 1865; last years were spent in Mooresville and Martinsville, IN. **Comments:** Known to have painted a few portraits but none of his work has been located. **Sources:** G&W; Peat, *Pioneer Painters of Indiana*, 146-48, 237; Burnet, *Art and Artists of Indiana*, 58-59.

ROOKUS, Faith *[Painter] mid 20th c.*
Exhibited: P&S of Los Angeles, 1937. **Sources:** Hughes, *Artists in California*, 479.

ROOME, Sandford *[Painter] mid 20th c.*
Exhibited: Salons of Am., 1934. **Sources:** Marlor, *Salons of Am.*

ROOME, Tillie *[Artist] late 19th c.*
Addresses: Wash., DC, active 1889. **Sources:** McMahan, *Artists of Washington, DC.*

ROOMER, Mary *[Painter] mid 20th c.*
Exhibited: Salons of Am., 1934. **Sources:** Marlor, *Salons of Am.*

ROONEY, Helen *[Portrait painter, drawing specialist, teacher] b.1912.*
Addresses: Haddam, KS. **Studied:** R. Sandzen; R.J. Eastwood; K. Mattern; A. Bloch; Univ. Kans. **Member:** Am. Ar. Prof. Lg. **Exhibited:** Kans. State Fair, Hutchinson, 1939 (prizes); Kans. Free Fair, Topeka, 1939 (prize). **Work:** Kans. State Fed. Women's C. **Comments:** Position: t., Pub. Sch., Dobbs Ferry, NY. **Sources:** WW40.

ROONEY, Thomas E. *[Painter] mid 20th c.*
Exhibited: S. Indp. A., 1935. **Sources:** Marlor, *Soc. Indp. Artists.*

ROOP, J. L. *[Sculptor, illustrator] 20th c.*
Addresses: Louisville, KY. **Sources:** WW10.

ROOPE, Benjamin *[Sculptor] mid 20th c.*
Addresses: Chicago area. **Exhibited:** AIC,1947. **Sources:** Falk, *AIC.*

ROORBACH, A. S. *[Painter] late 19th c.*
Addresses: NYC, 1879-91. **Exhibited:** NAD, 1879-91. **Sources:** Naylor, *NAD.*

ROORBACH, Eloise J. (Mrs.) *[Listed as "artist"] early 20th c.*
Addresses: San Diego, CA, active 1913. **Exhibited:** Mark Hopkins Inst., 1905. **Sources:** Hughes, *Artists in California,* 479.

ROORBACH, G. Seldon *[Painter] late 19th c.*
Addresses: NYC, 1891. **Exhibited:** NAD, 1891. **Sources:** Naylor, *NAD.*

ROOS, Belle M. See: **ROSS, Isabel (Belle) M.**

ROOS, Bernard L. *[Illustrator] 20th c.*
Addresses: Chicago, IL. **Sources:** WW19.

ROOS, Gordon *[Painter] mid 20th c.*
Studied: ASL. **Exhibited:** S. Indp. A., 1928-32; Salons of Am., 1931. **Sources:** Falk, *Exhibition Record Series.*

ROOS, John Frederick Fitzgerald *[Amateur artist, traveler] early 19th c.*
Comments: Lithographs based on his sketches were used to illustrate his *Personal Narrative of Travels in the United States and Canada* (1827). **Sources:** G&W; Roos, *Personal Narrative,* copy in Library of Congress.

ROOS, Leonard Henrik *[Miniaturist and etcher] b.1787, Hjalleskate, Sweden / d.1827, Colombia.*
Addresses: Came from England (where he had arrived in 1824) to U.S., 1825. **Studied:** Sweden, Rome, and France, before 1824. **Exhibited:** PAFA (1825, posthumously in 1843). **Sources:** G&W; Thieme-Becker; Rutledge, PA.

ROOS, Peter *[Landscape painter, teacher] b.1850, Sweden. / d.1919.*
Addresses: Cambridge, MA. **Member:** Boston AC. **Exhibited:** Boston, 1874 (medal); Boston AC, 1882-98. **Sources:** WW31; *The Boston AC.*

ROOSEVELT, A(delheid) (Lange) (Mrs.) *[Painter] b.1878, St. Louis, MO / d.1962.*
Addresses: NYC. **Exhibited:** S. Indp. A., 1917-18. **Sources:** Marlor, *Soc. Indp. Artists.*

ROOSEVELT, Frances Webb *[Portrait painter] b.1920, Kansas City, MO / d.1998.*
Addresses: Oyster Bay, NY. **Studied:** Smith Col., 1939. **Comments:** Widow of Pres. Theodore Roosevelt's grandson, Quentin. She taught art at C.W. Post College, Brookville, NY, and during the 1940s was a courtroom sketch artist, covering the Alger Hiss spy trial. **Sources:** obit., *New York Times.*

ROOSEVELT, G(ladys) *[Painter] mid 20th c.*
Exhibited: Salons of Am., 1925. **Sources:** Marlor, *Salons of Am.*

ROOSEVELT, Samuel Montgomery *[Painter] b.1863, New York / d.1920, NYC.*
Addresses: NYC/Skaneateles, NY. **Studied:** ASL; Académie Julian, Paris with J.P. Laurens and Constant, 1887-88. **Member:** Port. P.; A. Fund. S.; Knickerbocker Cl, NYC. **Exhibited:** AIC, 1896; S.Indp. A., 1917. **Awards:** Chevalier Legion of Honor, 1904. **Sources:** WW19.

ROOSEVELT, V. S. (Miss) *[Painter] 20th c.*
Addresses: NYC. **Member:** Lg. AA. **Sources:** WW24.

ROOT, Alice *[Artist] late 19th c.*
Addresses: Active in Detroit, MI, 1879-87. **Sources:** Petteys, *Dictionary of Women Artists.*

ROOT, Edward W. (Mrs.) *[Collector] 20th c.*
Addresses: Clinton, NY. **Sources:** WW73.

ROOT, Elmira *[Painter] mid 19th c.*
Comments: Watercolor and pin-prick portrait, c.1840, found in Ashley (OH). **Sources:** G&W; Lipman and Winchester, 179; *Antiques* (Jan. 1946), 34, repro.

ROOT, Enoch *[Painter] late 19th c.*
Addresses: Chicago. **Exhibited:** AIC, 1891. **Sources:** Falk, *AIC.*

ROOT, Florence *[Artist] late 19th c.*
Addresses: Active in Honor, MI, 1899. **Sources:** Petteys, *Dictionary of Women Artists.*

ROOT, Franc See: **MCCREERY, Franc Root**

ROOT, J. Vaughan *[Painter] early 20th c.*
Exhibited: S. Indp. A., 1920. **Sources:** Marlor, *Soc. Indp. Artists.*

ROOT, Jennie *[Artist] early 20th c.*
Addresses: Active in Grand Rapids, MI, 1900-05. **Sources:** Petteys, *Dictionary of Women Artists.*

ROOT, Marcus A. *[Painter, daguerreotypist] b.1808, Granville, OH / d.1888, Philadelphia, PA.*
Studied: Thomas Sully, 1835 (painting); R. Cornelius, 1943 (daguerreotype process). **Exhibited:** London, 1851; NYC, 1853-54 (hon. men.). **Comments:** Active as a daguerreotypist in Mobile, AL (1844); New Orleans, LA (1845); bought J.E. Mayall's gallery in Philadelphia in 1846; NYC (1849-51, with his brother); then returned to Philadelphia. He is credited with coining the term "ambrotype" for glass plate positive photographs, in 1855. **Sources:** Newhall, *The Daguerreotype in America,* 152; Welling, 111.

ROOT, Nancy B. *[Painter] d.1972, NYC.*
Addresses: NYC. **Exhibited:** S. Indp. A., 1925. **Sources:** Marlor, *Soc. Indp. Artists.*

ROOT, Nellie *[Painter, teacher] early 20th c.*
Addresses: Active in Montpelier, IN, c.1921. **Studied:** Turman, State Normal School, Indiana. **Sources:** Petteys, *Dictionary of Women Artists.*

ROOT, Orville Hoyt *[Painter] 19th/20th c.*
Addresses: Paris, France. **Studied:** Académie Julian, Paris with J.P. Laurens and Benjamin-Constant, 1891-92. **Exhibited:** Paris Salon, 1896, 1898; AIC; PAFA Ann., 1914. **Sources:** WW17; Fink, *American Art at the Nineteenth-Century Paris Salons,* 386; Falk, *Exh. Record Series.*

ROOT, Robert Marshall *[Painter, etcher, decorator, craftsperson] b.1863, Shelbyville / d.c.1938.*
Addresses: Shelbyville, IL. **Studied:** St. Louis Sch. FA; Académie Julian, Paris with J.P. Laurens, Constant, and Lefebvre, 1890. **Member:** Brown County (Ind.) AA; Ind. A. Gal. Assn. **Exhibited:** Paris Salon, 1892; State Centenn., Springfield, Ind. 1918; AIC. **Work:** painting, Springfield; Lt. Gov. office, Atty. General office, Springfield; Masonic Temple and Country C., Decatur; Macon Court House, Vandalina Court House, Shelbyville Court House; State T. Col., Charleston, Ill. **Comments:** Fink gives birthplace as Vermont. **Sources:** WW38; Fink, *American Art at the Nineteenth-Century Paris Salons,* 386.

ROOT, Russell C., & Co. *[Lithographers and stationers] mid 19th c.*
Addresses: NYC, 1846. **Comments:** Russell C. Root was senior partner. **Sources:** G&W; NYBD and CD 1846.

ROPER, Margaret *[Portrait and landscape painter] late 19th c.*
Addresses: Norfolk, VA. **Exhibited:** Norfolk, VA, 1885-86. **Sources:** Wright, *Artists in Virginia Before 1900.*

ROPER, Matilda Secor (Mrs. George W.) *[Painter] b.1886, Morristown, NJ. / d.1958.*
Addresses: Norfolk, VA/Chairman, PA. **Studied:** NAD; E. Carlsen; O. Miller. **Member:** Norfolk SA; Norfolk Art Corner; Studio Guild. **Sources:** WW40.

ROPER, Murray J. *[Sculptor, painter] b.1910, David City, NE.*
Addresses: NYC; Yonkers, NY. **Studied:** Univ. Nebr.; PAFA; ASL; BAID. **Member:** Putnam County AA. **Exhibited:** PAFA Ann., 1938; Putnam County AA. **Work:** Nebr. State Mus., Lincoln. USPO, Harrison, NJ. WPA artist. **Sources:** WW40; Falk, *Exh. Record Series.*

ROPES, Andrew M. *[Painter] b.1830, Salem, MA / d.1913.*
Work: Peabody Mus., Salem (marine pen & ink). **Sources:** Brewington, 329.

ROPES, George *[Marine, landscape, carriage, and sign painter] b.1788, Salem, MA / d.1819, Salem, MA.*
Addresses: Worked in Salem his entire career. **Studied:** Michele Felice Corné, c.1802. **Work:** Peabody Mus., Salem. **Comments:** He was deaf from birth, and specialized in ship portraits as an artist. **Sources:** G&W; Belknap, *Artists and Craftsmen of Essex County,* 12; Robinson and Dow, *Sailing Ships of New England,* I, 63; Swan and Kerr, "Early Marine Painters of Salem"; *Antiques* (Jan. 1930), frontis.; *Panorama* (March 1946), 62. Note: G&W had listed a second George Ropes as active in Salem (Mass.), 1835-50, citing as reference Lipman and Winchester, 179; however G&W and Lipman (in letter to G&W) noted the possibility that both George Ropes.

ROPES, George *[Painter] late 19th c.*
Exhibited: NAD (1871: "Lake George"). **Sources:** G&W; Naylor, NAD.

ROPES, Joseph C. *[Landscape, miniature, and crayon artist and drawing teacher] b.1812, Salem, MA / d.1885, NYC.*
Addresses: Germantown, PA. **Studied:** did not seriously study painting until in his mid-thirties when he took lessons from John Rubens Smith and at the NAD. **Exhibited:** Hartford County Agricultural Society Fair (October 1851); NAD, 1848, 1869 (portraits); Brooklyn AA, 1871-79 (landscapes); PAFA Ann., 1876-80. **Work:** Wadsworth Atheneum, Hartford, CT. **Comments:** From 1851 to 1865 he had a studio in Hartford (CT). In 1865 he went abroad for eleven years; on his return he settled in Philadelphia where he taught drawing (among his students was Joseph Pennell). Ropes was the author of *Linear Perspective* (1850) and *Progressive Steps in Landscape Drawing* (1853). Best known paintings are four panels providing a panoramic view of Hartford (1855, now at Wadsworth Athen). **Sources:** G&W; French, *Art and Artists in Connecticut,* 79; Bolton, *Miniature Painters;* Cowdrey, NAD; Swan, BA; Hartford CD 1855; Tuckerman, *Book of the Artists;* Falk, *Exh. Record Series.* More recently, see Gerdts, *Art Across America,* vol. 1: 105-6, 266.

ROPES, Phebe See: **COLEMAN, Phebe Ropes (Mrs. Leslie)**

ROPP, Hubert *[Painter, educator, sculptor] b.1894, Pekin, IL.*
Addresses: Lake Bluff, IL. **Studied:** AIC, and in Vienna and Paris. **Member:** Chicago A. Cl.; Chicago Soc. A. **Exhibited:** AIC, 1933-39; CI; Boyer Gal., Phila.; Nat. Gal., Toronto; GGE, 1939; Chicago A. Cl. Awards: citation, AIGA. **Comments:** Positions: instr. a., Nat. Acad. A., Chicago, 1924-27, dean, 1927-31; instr., 1938-44, dean, 1944-, AIC. **Sources:** WW59; WW47.

ROPP, Roy M. *[Painter] b.1888, Butler County, KS / d.1974, Yucca Valley, CA.*
Addresses: Laguna Beach, CA. **Member:** AAPL; Laguna Beach AA; San Gabriel A. Gld.; Festival of Arts Assn., Laguna Beach, Cal; Los Angeles AA. **Work:** New Port Union H.S. **Comments:** Creator, dir., annual Festival of Arts, Laguna Beach, Cal. **Sources:** WW53; WW47. More recently, see Hughes, *Artists in California,* 479.

ROQUEN, August *[Lithographer] b.c.1825, France.*
Addresses: NYC in 1860. **Sources:** G&W; 8 Census (1860), N.Y., XLIII, 766.

RORIMER, James J. *[Museum director & curator, writer, lecturer] b.1905, Cleveland, OH / d.1968.*
Addresses: NYC. **Studied:** Harvard Univ. (B.A.); in Europe.

Member: AAMus.; AFA; F., Am. Geographical Soc.; AID (hon.); Archaeological Inst. Am.; Art & Antique Dealers Lg. (hon.); Assn. A. Mus. Dirs.; Cleveland Inst. A. (adviser); CAA; France-America Soc.; French Inst. in the U.S.; Intl. Inst. of Conservation; medieval Acad. Am. (councillor, 1955, exec. com., 1957-58); Mus. Council of New York City (chm. 1950-51); Nat. Council U.S. Art; Swedish Royal Acad. Let., Hist. & Antiquities (Foreign Corres. Memb.); Ex-officio Trustee. Mus. City of NY; NSS (hon.). **Exhibited:** Awards: Chevalier French Legion of Honor; Cross of the Commander of the Order of the Dannebrog, Denmark; Elsie de Wolfe Award, AID, 1960; Ohioana Career Medal, 1962; Sterling Silversmiths Gld. of America award for Cultural Leadership, 1962; St. Nicholas Soc. Medal of Merit, 1963; Greater New York Fund Award of Merit, 1963; Hon. D.F.A., NY Univ., 1964; Officer in the Order of Arts and Letters of the French Government, 1964; Bronze Medallion of the City of New York, 1965. **Comments:** Positions: asst., dept. dec. a., 1927-29, asst. cur., 1929-32, assoc. cur. 1932-34; cur., Dept. Medieval Art, 1934-55; dir., The Cloisters, 1949-; dir., MMA, 1955-. Monuments, Fine Arts & Archives Officer, Normandy, Paris, and Western Military Dist., World War II; ICOM Exec. Comm. (vice-pres. 1962-65); U.S. National Comm. for ICOM (vice-pres. 1954); member Committee 1964 WFNY; NY State Commissioner's Com. on Museum Resources; Adv. Council for Dept. A. Hist. & Archaeology, Columbia Univ.; Dumbarton Oaks Visiting Com.; Adv. Com., NY Univ. Inst. FA. Author: "The Cloisters--The Building and the Collection of Medieval Art," 1938; "Ultra Violet Rays and Their Use in the Examination of Works of Art," 1931; "Unicorn Tapestries," 1945; "Medieval Jewelry," 1944; "Survival, The Salvage and Protection of Art in War," 1950; "The Nine Heroes Tapestries at the Cloisters," 1953, and other books. Contributor to *Creative Art, Art Bulletin,* MMA Studies, and others. **Sources:** WW66; WW47.

RORIMER (OR RORHEIMER), Louis *[Sculptor, architect, craftsperson, lecturer, teacher] b.1872, Cleveland / d.1939.*
Addresses: Cleveland, OH. **Studied:** Académie Julian, Paris with Puech and Constant, 1893; LeBlanc in Paris; Widaman and Romeis in Munich. **Member:** Cleveland SA; SC; Arts in Trade C1.; Cleveland Arch. C1. **Sources:** WW31.

RORKE, Edward A. *[Landscape painter] b.1856 / d.1905, Brooklyn, NY.*
Addresses: Brooklyn, NY. **Exhibited:** Brooklyn AA, 1873-82, 1886; NAD, 1880-1894; PAFA Ann., 1888, 1895, 1899-1904. **Sources:** WW06; Falk, *Exh. Record Series.*

RORPHURO, Julius J. *[Painter] b.1861, Kuttelsheim, Alsace / d.1928, Fresno, CA.*
Addresses: San Francisco, CA, since late 1880s. **Studied:** French Academy of Arts; Mentado, MN; Lyons, IA. **Exhibited:** Mechanics Inst. Fair, San Francisco. **Work:** Oakland Mus.; Sierra Nevada Mus., Reno. **Comments:** Immigrated to America in 1874. As a young man he led the life of a cowboy for ten years. Specialty: Western scenes and landscapes. **Sources:** Hughes, *Artists in California,* 479.

ROSA, Guido *[Illustrator] b.1890, New Jersey.*
Addresses: Mt. Vernon, NY. **Studied:** E. Berta. **Member:** SC; Artists Gld.; AI Graphic Art; AFA. **Exhibited:** AI Graphic Art, 1920 (medal). **Sources:** WW32.

ROSA, J. (Miss) *[Sculptor, pastellist] late 19th c.*
Addresses: NYC, 1870; New Rochelle, NY, 1873. **Exhibited:** NAD, 1870, 1873. **Sources:** Naylor, NAD.

ROSA, Lawrence *[Illustrator, designer] b.1892, New Jersey.*
Addresses: Union City, NJ. **Comments:** Data for "Studied," "Member," and "Exhibited" are identical to those listed for Guido. **Sources:** WW29.

ROSADO, Lucy Alfonso Alfaro (Mrs.) *[Sculptor] b.1894, New Orleans, LA / d.1978, New Orleans.*
Addresses: New Orleans, active c.1908-1940s. **Comments:** She worked in the family waxworking business, in particular creating

costumes for the figures of black street vendors. She conceived the idea of making a washerwoman character in c.1940. Her son August Alfaro worked with her and carried on the family tradition. Daughter of Conception Vargas (see entry) and granddaughter of Francisco Vargas, Sr. (see entry). **Sources:** *Encyclopaedia of New Orleans Artists*, 331.

ROSALES, E. O. *[Sculptor] 20th c.*
Addresses: NYC. **Sources:** WW08.

ROSAMOND, Pier (Mrs William Morris) *[Painter]*
b.1916, Milton.
Addresses: Milton, MA. **Studied:** Child Walker Sch., Boston; E. O'Hara; L.B. Smith. **Member:** Boston AC; NAWPS. **Exhibited:** NAWPS; Am. WC Soc.; NYWCC, 1939. **Sources:** WW40.

ROSAS, J. A. G. *[Painter] mid 20th c.*
Exhibited: AIC, 1943. **Sources:** Falk, *AIC*.

ROSATI, James *[Sculptor, educator] b.1912, Washington, PA.*
Addresses: NYC, 1952-1968. **Exhibited:** WMAA Ann., 1952-68; Int. Coun. MoMA Exhib., France, Ger. & Scandinavia, 1965-66; Flint Inst., 1966; Colby Col., 1967; Mus. Contemp. Crafts Traveling Exhib., 1967-68; Marlborough Gallery, NYC,1970s Awards: Logan Medal & Prize, AIC, 1962; Carborundum Major Abrasive Mkt. Award, 1963; Guggenheim fel., 1964. **Work:** Yale Gal. Fine Arts; NY Univ.; WMAA; Geigy Chem. Corp., Ardsley, NY; Hopkins Art Ctr., Dartmouth Col.; pvt. colls. Commissions: sculpture, St John's Abbey, Collegeville, Md. **Comments:** Teaching: instr., Pratt Inst. & Cooper Union, NY; vis. critic sculpture, Hopkins Art Ctr., Dartmouth Col., spring 1963; adj. assoc. prof. sculpture, Yale Univ., 1964-. **Sources:** WW73; Michel Seuphor, *The Sculpture of this Century, Dictionary of Modern Sculpture* (A Zwemmer Ltd., London, 1959); Jean Selz, *Modern Sculpture* (Braziller, 1963); Herbert Read, *A Concise History of Modern Sculpture* (Praeger, 1964).

ROSATTI, Ector F *[Painter] 20th c.*
Addresses: Springfield, MA. **Sources:** WW17.

ROSE, Adelaide (Miss) E. *[Painter] late 19th c.*
Addresses: NY, 1864-74; Chardonne-sur-Vevey, Switzerland, 1910. **Exhibited:** NAD, 1864-74. **Sources:** WW10.

ROSE, Ailene *[Painter] mid 20th c.*
Addresses: Los Angeles, CA. **Exhibited:** LACMA, 1940. **Sources:** Hughes, *Artists in California*, 479.

ROSE, Arthur *[Painter, sculptor] b.1921, Charleston, SC.*
Addresses: Orangeburg, SC. **Studied:** Claflin Col. (B.A.); NY Univ. (M.A.); also with William Baziotes, Peter Busa, Hale Woodruff & James Podzez. **Member:** Nat. Conf. Artists (regional dir., 1958-62); SC Assn. Sch. Art; Smithsonian Assoc., Guild SC Artists. **Exhibited:** Cafe Tortilla, Bloomington, 1967; Stillman Col, Tuscaloosa, Ala., 1969; Columbia Mus. Art First Invitational, SC, 1969; Sandlapper Gal., Columbia, 1971; The Gal., Spartanburg, SC, 1972; Sandlapper Gal., Columbia, SC, 1970s. Awards: hon. men., Springs Cotton Mills, Lancaster, SC, 1961; best in show award, J.O. Endris & Son Jewelers, New Albany, Ind., 1967; second award, Nat. Conf. Artists, 1970. **Work:** SC State Art Coll.; Columbia Mus. Art; Citizens & Southern Nat. Bank, Columbia, SC; Ind. Univ., Bloomington, Ind.; Johnson Publ. Co., Inc., Chicago, Ill. **Comments:** Preferred media: oils, steel. Teaching: instr. sculpture & oil painting & hd. dept. art, Claflin Col., 1952-. **Sources:** WW73; Paul Lin, *Buried Sand Treasures* (Literary Star, 1960); Jack A Morris, *Contemporary Artists of SC* (privately pub., 1971); J. Edward Atkinson, *Black Dimensions in Contemporary American Art* (Carnation, 1971).

ROSE, Augustus Foster *[Jeweler, craftsperson, teacher]*
b.1873, Hebrown, Nova Scotia / d.1946, Providence, RI.
Addresses: Providence, RI/Oquossoc, ME. **Studied:** D. Ross; H.H. Clark; A. Fisher; C. Hanson; E. Schweitzer. **Member:** Boston SAC; Utopian C1., Providence; Providence AC; Soc. Medalists; Eastern AA; AFA. **Exhibited:** Salons of Am. **Comments:** Author: "Copper Work," "Art Metal Work," "The Metal Crafts," "Things In and About Metal." Co-Author:

"Jewelry Making and Design." Position: t., Providence Public Schools. **Sources:** WW40; Marlor, *Salons of Am.* (as A. Fraser Rose).

ROSE, Axel T. *[Painter] early 20th c.*
Addresses: NYC. **Exhibited:** S. Indp. A., 1920. **Comments:** Possibly Rose, A.T., ASL. **Sources:** Marlor, *Soc. Indp. Artists*.

ROSE, Barbara *[Art historian] b.1937, Wash. DC.*
Addresses: NYC. **Studied:** Columbia Univ. (M.A., Ph.D.). **Comments:** Publications: *American Art Since 1900* (Holt, Rinehart, 1964); *American Painting: Twentieth Century* (Skira & Rizzoli, 1986); *Robert Rauschenberg* (Avedon Edition, Vintage Books, 1987); and others. Positions: Contributing editor, *Art Int.*, 1963-65; *Art in Am.* & *Artforum*, 1965-72; *Journal of Art*, 1988-. **Sources:** Who's Who In American Art (1993-94).

ROSE, Bee (Beatrice Sandler) *[Painter] mid 20th c.*
Studied: ASL. **Exhibited:** S. Indp. A., 1937, 1940-41. **Sources:** Marlor, *Soc. Indp. Artists*.

ROSE, Bert Miles *[Painter] mid 20th c.*
Addresses: Santa Cruz, CA. **Member:** Santa Cruz Art League. **Exhibited:** Oakland A. Gal., 1928. **Sources:** Hughes, *Artists in California*, 479.

ROSE, Carl *[Illustrator] b.1903, NYC / d.1971, Rowayton, CT.*
Addresses: Rowayton, CT. **Studied:** ASL. **Member:** SI. **Exhibited:** Salons of Am.; S. Indp. A., 1925. **Sources:** WW59; WW47.

ROSE, D. F. *[Painter] early 20th c.*
Addresses: NYC. **Exhibited:** S. Indp. A., 1922. **Sources:** Marlor, *Soc. Indp. Artists*.

ROSE, Daniel *[Painter] b.1873, Wash., DC.*
Addresses: Anacostia, DC, active from 1896. **Member:** Wash. WCC. **Exhibited:** Wash. WCC, 1896, 1898-99; Soc. of Wash. Artists, 1898-1901. **Sources:** WW04; McMahan, *Artists of Washington, DC*.

ROSE, Dorothy *[Painter] b.1909, Brooklyn, NY.*
Addresses: Brooklyn, NY. **Studied:** Beaux Arts Inst. Design, 1933-35; New Sch. Soc. Res., 1949-50; ASL, 1951-55; with Robert Hale, John Carroll, Reginald Marsh, Morris Kantor. **Member:** AEA; Village Art Cntr. (mem. coun., 1959); ASL (life mem.). **Exhibited:** Panoras Gal., 1955-65 (5 solos); Silvermine Guild Ann., 1956; New York City Ctr., 1956-58; Village Art Cntr., 1959 (prize); Ringling Mus. 10th Ann., Sarasota, 1960; "15 Brooklyn Artists," Brooklyn Mus., 1963. **Work:** Staten Island Mus. Arts & Sci. **Comments:** Abstract figurative painter in oils, watercolors. Positions: juror, Janaf Art Exhib., fall 1968. **Sources:** WW73.

ROSE, Ed *[Painter] 20th c.*
Addresses: Dallas, TX. **Sources:** WW24.

ROSE, Elihu See: **ROSE & HOWE**

ROSE, Elizabeth Agnes *[Painter] early 20th c.*
Addresses: Paris, France, c.1909; Geneva, NY, c.1910-12. **Exhibited:** PAFA Ann., 1910. **Sources:** WW13; Falk, *Exh. Record Series*.

ROSE, Ethel Boardman (Mrs.) *[Painter, illustrator] b.1871, Rochester, NY / d.1946, Pasadena, CA.*
Addresses: Pasadena, CA. **Studied:** Vassar Col.; ASL; Académie Julian, Paris with Jean Paul Laurens; Girardot in Paris. **Member:** Calif. WC Soc.; Pasadena AA. **Exhibited:** Carmel A. & Cr. Cl., 1920; Calif. WC Soc., 1935 (prize); GGE, 1939; Ferargil Gals., NYC, 1938 (solo). **Comments:** She married Guy Rose (see entry) in 1895 and lived in France for several years. Contributed illustrations to *Vogue, Harpers Bazaar, L'Art et La Mode* (Paris), other magazines. **Sources:** WW53; WW47. More recently, see Hughes, *Artists in California*, 479; Petteys, *Dictionary of Women Artists*, reports that Brighton, NY may have been her birth place.

ROSE, George L. *[Painter] b.1861, Newport, RI.*
Addresses: Upper Montclair, NJ. **Studied:** J. La Farge. **Member:**

Mural P. **Sources:** WW33.

ROSE, George P. *[Engraver and jeweler] mid 19th c.*
Addresses: Elmira, NY, 1857. **Sources:** G&W; Elmira BD 1857.

ROSE, Gretchen *[Painter] mid 20th c.*
Addresses: NYC. **Exhibited:** S. Indp. A., 1926. **Sources:** Marlor, *Soc. Indp. Artists.*

ROSE, Guy *[Landscape painter, illustrator]* **Guy Rose**
b.1867, San Gabriel, CA / d.1925,
Pasadena, CA.
Addresses: NYC, 1896-98; Active in Giverny, France, 1900-14, Los Angeles, 1914-20; Pasadena, CA. **Studied:** San Francisco Art Sch., with E. Carlsen, Virgil Williams, 1885; Académie Julian, Paris with J.P. Laurens, Lefebvre, Constant, and Doucet, 1888-89. **Member:** Calif. AC; P&S of Los Angeles; Ten Painters of Los Angeles. **Exhibited:** Paris Salon, 1890-91, 1894 (prize); Boston AC, 1893, 1899; PAFA Ann., 1896-98, 1909-13; AIC, 1898, 1911; Atlanta Expo, 1895 (med.); Pan-Am. Expo, Buffalo, 1901 (med.); P.-P. Expo., San Fran., 1915 (med.); Panama-Calif. Expo, San Diego, 1915 (med.); Calif. AC, 1916, 1919 (prize); LACMA, 1916, 1918-19; landscape, Sacramento, 1920 (prize); Los Angeles AC, 1921 (prize); Stendahl A. Gal., 1926; NAD, 1896. **Work:** Bowers Mus., Santa Ana; Laguna AM; LACMA; Pasadena Art Inst.; San Diego MFA; CMA; San Diego FA Gal. **Comments:** Specialty: landscapes of California and France, coastal scenes, missions and figures. Son of a former senator and Southern California landowner, he spent many years in France, where he married Ethel B. Rose (see entry) in 1895. He knew Monet and the French Impressionists at Giverny. Lead poisoning interrupted his career in 1894 for five years, and ended it permanently in 1921. Position: teacher, PIA Sch., 1896-1900; director, Stickney School of Art, Pasadena, CA. Illustrator, *Harper's, Scribner's,* and *Century* magazines. **Sources:** WW25; Hughes, *Artists in California,* 479; P&H Samuels, 409; Fink, *American Art at the Nineteenth-Century Paris Salons,* 386; *300 Years of American Art,* 603; Falk, *Exh. Record Series.*

ROSE, Hanna Toby *[Art administrator] b.1909, NYC / d.1976.*
Addresses: NYC. **Studied:** Wellesley Col. (BA), with Alfred Barr, Jr. & grad study with Meyer Shapiro. **Member:** Int. Coun. Mus. (pres., Int. Educ. Comt., 1953,1962); Am. Assn. Mus.; Mus. Assn. Gt. Brit.; Nat. Comt. Art Educ. (coun. mem.); Int. Soc. Educ. Art. **Comments:** Positions: cur. educ., Brooklyn Mus., 1947-71, asst. dir. for educ., 1971-. Publications: co-auth., "Exploring New York," 1956; ed, "Museums and Teachers," 1956; ed., "Role of the Arts in Meeting Social and Educational Needs of Disadvantaged," 1967; auth., articles, In: UNESCO Occasional Papers, Sch. Arts & Mus. Research: art and disadvantaged children. **Sources:** WW73.

ROSE, Herman *[Painter, printmaker] b.1909, Brooklyn, NY.*
Addresses: NYC. **Studied:** NAD, 1927-29. **Exhibited:** MoMA, 1948 & 1952; WMAA, 1947-58; PAFA Ann., 1952; ACA Gal., 1955-56; Forum Gal., NY, 1962 (solo); Zabriskie Gal., NYC, 1970s. **Awards:** Yaddo Foundation fellowship, 1955; Longview Award, 1960 & 61; "NYC WPA Art" at Parsons School Design, 1977. **Work:** MoMA; WMAA; Univ. Texas; Univ. California; Smithsonian Inst. Print Coll.; priv. colls. **Comments:** WPA artist. Preferred media: graphics. Teaching: instr., Brooklyn Col., 1949-51; instr., New School Social Res., 1954-55; instr., Brooklyn Col., 1958-61; instr., Hofstra Col., 1959-60; instr., New School Social Res., 1963-; artist-in-residence, Univ. Virginia, 1966. **Sources:** WW73; *New York City WPA Art,* 74 (w/repros.); Falk, *Exh. Record Series.*

ROSE, Iver *[Painter, lithographer]* **Iver Rose**
b.1899, Chicago, IL / d.1972.
Addresses: NYC, 1923-29; Chcago, 1930-55; Springfield, MA/Rockport, MA, 1955-72. **Studied:** Hull House, Chicago; AIC; Cincinnati Acad. A., 1918-22. **Member:** Audubon A.; All. A. Am.; Am. A. Cong; Rockport AA. **Exhibited:** MMA; Carnegie Inst.; AIC; PAFA Ann., 1935-53 (10 times); Corcoran Gal biennials, 1943, 1953; Clearwater Mus. A.; BMA; Univ.

Nebraska; Springfield A. Mus.; CMA; AFA traveling exh.; Montclair A. Mus.; VMFA; DePauw Univ.; Nelson Gal. A.; Kansas City AI; Dayton AI; Joslyn A. Mus.; Univ. Illinois; NAD (purchase prize, 1959); Audubon A, 1950 (prize), 1953 (prize).; All. A. Am.; Milch Gal., 1949-52; MoMA traveling exh., 1954-55; solo; Kleeman Gal.; Schneider-Gabriel Gal.; Kraushaar Gal., 1938, 1940, 1942, 1945, 1947, 1949; Oehlschlaeger Gal., Chicago, 1953-76. Other awards: Rockport AA, 1944 (prize), 1955 (prize), 1961 (prize), 1963 (prize),1964 (gold medal). **Work:** Chicago Pub. Lib (Alice in Wonderland paintings, various branches); Munroe (NY) and Jefferson (NY) high schools; Walker A. Center; Cranbrook Acad. A.; AGAA; Univ. Georgia; Des Moines A. Center; Phila. A. All.; San Diego FA Gal.; Witte Mem. Mus.; Am. Acad. A. & Let.; Birmingham Mus. A.; Hassam Fund; Mus. of the New Britain Inst.; Parrish Mus., Southampton, LI; San Angelo A. Lg.; Encyclopaedia Britannica; NAD; Springfield (Mass.) Mus. A. **Comments:** Began as a commercial artist in NYC during the 1920s; moved to Chicago in 1930 and became a fine artist. His primary subjects were clowns, children, musicians, and old Jewish patriarchs. **Sources:** WW66; WW40; Falk, *Exh. Record Series.*

ROSE, Jack Manley *[Illustrator] 20th c.*
Comments: Position: affiliated with Doubleday Page & Co., Garden City, NY. **Sources:** WW15.

ROSE, John *[Painter] early 20th c.*
Exhibited: S. Indp. A., 1917-18. **Sources:** Marlor, *Soc. Indp. Artists.*

ROSE, John (Deacon) *[Amateur watercolorist and musician] early 19th c.*
Addresses: Dorchester, SC (some miles up the river from Charleston), early 19th century & possibly earlier. **Sources:** G&W; Rutledge, *Artists in the Life of Charleston,* 151.

ROSE, Julius *[Painter] late 19th c.*
Exhibited: NAD, 1882. **Sources:** Naylor, *NAD.*

ROSE, Leatrice *[Painter] mid 20th c.*
Addresses: NYC, 1950. **Exhibited:** WMAA, 1950; PAFA Ann., 1966. **Sources:** Falk, *Exh. Record Series.*

ROSE, Leize *[Painter, designer, decorator] 20th c.; b.Fortress Monroe, VA.*
Addresses: NYC/Purdy's, NY. **Member:** NAWA; Grand Central Art Gal. **Exhibited:** GGE, 1939; WFNY, 1939. **Work:** Photographic tapestries, Gen. Electric Co., Western Union Co., NY; mural Municipal Bldg., NY. **Comments:** (Mrs. Duncan M. Stewart). **Sources:** WW40.

ROSE, Minnie *[Artist] late 19th c.*
Addresses: Active in Grand Rapids, MI, 1891-94. **Sources:** Petteys, *Dictionary of Women Artists.*

ROSE, Peter Henry *[Art dealer] b.1935, NYC.*
Addresses: NYC. **Studied:** Hamilton Col. (B.A.); Univ. Pa. (M.A.); Columbia Univ.; Ecole Superieure, Univ. Paris. **Comments:** Positions: owner-dir., Peter Rose Gallery. Specialty of gallery: 20th-century contemporary American art. **Sources:** WW73.

ROSE, Richard Catan See: **CATAN-ROSE, (Richard)**

ROSE, Ronnie *[Sculptor] mid 20th c.*
Addresses: NYC. **Exhibited:** PAFA Ann., 1933. **Sources:** Falk, *Exh. Record Series.*

ROSE, Ruth Starr (Mrs. Wm. Searls Rose) *[Painter, lithographer, screenprinter, lecturer, teacher, designer, illustrator] b.1887, Eau Claire, WI / d.1965, Alexandria, VA.*
Addresses: Caldwell, NJ; Easton, MD; Alexandria, VA; Wash., DC. **Studied:** Vassar College (A.B.); ASL; H. Lever; V. Huntley; W. Palmer. **Member:** NY Soc. Women Artists; Phila. Pr. Cl.; Wash. WCC; Nat. Lg. Am. Pen Women; Washington Printmakers; Nat. Ser. Soc. **Exhibited:** Soc. Indep. Artists, 1925, 1930; Salons of Am, 1925, 1931 (as Ruth S. Rose); Lithographers, NJ State Exhib., 1934 (prize); NAWA, 1936 (prize), 1937 (prize),1944

(prize), 1945, 1949, 1950; WFNY, 1939; State of New Jersey, 1944 (prize); NAD, 1945-46; Nat. Color Pr. Soc., 1945-50; LOC, 1945-46, 1950; CI, 1950; Phila. Pr. Cl., 1944-45; Northwest Printmakers, 1949, 1950s (prize); Nat. Lg. Am. Pen Women, 1950s (prize); Washington Printmakers, 1951 (prize); Norfolk Mus. Arts & Sciences, 1950 (prize); CGA, 1951 (prize); CM, 1954; Farnsworth Mus. Art, Rockland, ME, 1954 (solo); Virginia Printmakers, 1957 (prize), 1960 (solo); Art Lg. of Northern Virginia, Wash. Area Printmakers, 1957 (prize); Art Fair, Alexandria & Wash., 1957 (prize); Religious Art Fair, 1958 (prize); Howard Univ., 1958 (solo); City Hall, Alexandria, VA, 1964 (solo); Nat. Serigraph Soc.; Wash. WCC; Rehoboth Art Lg. (solo).; George Wash. Univ. (solo); United Nations Club (solo). **Work:** LOC; MMA; Vassar College; PMA; Wells College; Williams College; Milliken College; Norfolk Mus. Art & Sciences, Univ. Virginia. **Comments:** Born Ruth Starr and later married to W.S. Rose, she was sometimes known as Starr Rose. Specialty: printmaking, primarily lithography and serigraphy. Lecturer to schools, and professional organizations. Instructor, serigraphy, YWCA, Wash., DC, 1959-65; Bolling AFB, Wash., DC, 1965. **Sources:** WW66; WW40, as (Ruth) Starr Rose; McMahan, *Artists of Washington, DC*.

ROSE, Seaver E.B. *[Painter] b.1887, New Orleans, LA / d.After 1925.*
Addresses: New Orleans, active 1906-23. **Sources:** *Encyclopaedia of New Orleans Artists,* 331.

ROSE, Starr See: **ROSE, Ruth Starr (Mrs. Wm. Searls Rose)**

ROSE, Thomas Albert *[Sculptor] b.1942, Wash., DC.*
Addresses: Minneapolis, MN. **Studied:** Univ. Wis.-Madison, 1960-62; Univ. Ill., Urbana, with Frank Gallo & Roger Majarowitz, 1962-65 (B.F.A., 1965); Univ. Calif., Berkeley, with Peter Voulkos, Harold Paris, William King & George Miyasaki, 1965-67 (M.A., 1967), study grant to Univ. Lund, 1967-68. **Exhibited:** Sculpture, Plastics West Coast, Hanson Gal., San Fran., 1967; First Int. Exhib. Erotic Art, Lund, Sweden, 1968; Realities Exhib., Contemp. Gal., Dallas, Tex, 1972; Graphic Form, Leger Galerie, Malmo, Sweden, 1972; Midwest Biennial, Joslyn Mus., Omaha, Nebr., 1972;Bolles Gal., San Fran., CA, 1970s. **Awards:** Nat Endownment Arts vis. artist grant & State Arts Comn. grant, N. Mex. State Univ., 1972-73; Kresge Found. grant, 1972-73. **Work:** Univ. N. Mex. Mus., Albuquerque; LOC; Metromedia Coll. Los Angeles, Calif., John Bolles, San Fran., Calif.; San Fran. Art Comm. **Comments:** Preferred media: plastics, polyester, fiber glass. Teaching: asst. to Richard O'Hanlon, sculpture class, UC Berkeley, 1966-67; asst. to Bertil Lundberg, lithography, ABF Sch., Malmo, Sweden, 1967-68; instr. sculpture, UC Berkeley, 1968-69; instr. sculpture & graphics, N. Mex. State Univ., 1969-72; instr. sculpture, Univ. Minn., Minneapolis, 1972-on. **Sources:** WW73.

ROSE, William F. *[Illustrator] b.1909, Pittsburgh, PA.*
Addresses: Oceanside, NY. **Studied:** Univ. Pittsburgh; Carnegie Inst. (B.A.). **Member:** SI. **Exhibited:** SI, 1945, 1946; PAFA Ann., 1966. **Comments:** Contributor to: *Collier's, Today's Woman, This Week* magazines. **Sources:** WW59; WW47; Falk, *Exh. Record Series*.

ROSE, William S., Sr. *[Portrait, landscape and marine painter] b.c.1846, Long Island, NY / d.1938, Forida.*
Addresses: England; Detroit, MI. **Studied:** Sir William Laighton. **Comments:** He was born while his English parents were on a mission for Queen Victoria; the family returned to England and he finally settled in the U.S. in 1883. In Detroit, he executed many portraits of prominent people. **Sources:** Gibson, *Artists of Early Michigan,* 206.

ROSE & HOWE *[Painters and sculptors] mid 19th c.*
Addresses: NYC. **Exhibited:** American Institute, 1846 (a bronze statuette). **Comments:** The partners were Elihu Rose and Joseph C. Howe. They were listed as painters in the directory but as they showed a bronze at the Am. Inst. in 1846, they were presumably sculptors as well. **Sources:** G&W; NYCD 1846-47; Am. Inst. Cat., 1846.

ROSEBERG, Carl Andersson *[Sculptor, art historian] b.1916, Vinton, IA.*
Addresses: Williamsburg, VA. **Studied:** Univ. Iowa (B.F.A., 1939, M.F.A., 1947); Cranbrook Acad. Arts, summers 1947 & 1948; Univ. Va., summer 1964; Univ. Mysore, summer 1965; Tyler Sch. Art, summer 1967. **Member:** Asian Soc.; Am. Assn. Mus.; Audubon Artists; Twentieth Century Gal. (bd. mem.); Tidewater Artists. **Exhibited:** PAFA Ann., 1953-54; 12 Va Sculptors, 1970, Norfolk Mus. Art & Sci.; Am. Art Today, New York World's Fair 1964; VA Sculptors Traveling Exhib., 1970-72; Tidewater Col. Faculty Exhib., Chrysler, Mus., 1972. **Awards:** Fulbright fel., India; award of honor, VA Chap. Am. Inst. Architects, 1968; Thomas Jefferson Award, Robert McConnell Found., 1971. **Work:** Springfield Art Mus., Mo.; Chrysler Mus., Norfolk, Va.; VMFA; Longwood Col., Va.; Univ. Iowa. **Commissions:** Bronze Hwy. Markers, Rockingham Co. Citizens Count., Va., 1955; William & Mary Medallion, Marshall-Wythe Sch. Law, 1967, Col. William & Mary Medallion, 1968 & Donald W. Davis Commemorative Plaque, Life Sci. Bldg., Col. William & Mary, 1970. **Comments:** Teaching: instr, Col. William & Mary, 1947-52, asst. prof. fine arts, 1952-75, assoc. prof., 1957-66, prof. & Heritage fel., 1966-. Research: art of India. Publications: illusr., "Little Red Riding Hood & Big Bad Wolf," 1953 & roll titles for "The Colonial Naturalist" (film), 1964. **Sources:** WW73; Falk, *Exh. Record Series*.

ROSEBURY, Fred *[Painter] mid 20th c.*
Exhibited: S. Indp. A., 1935. **Sources:** Marlor, *Soc. Indp. Artists*.

ROSEBURY, Theodore *[Painter] mid 20th c.*
Exhibited: Salons of Am., 1934; S. Indp. A., 1935. **Sources:** Falk, *Exhibition Record Series*.

ROSECRANS, Henry Wallace *[Sculptor] late 19th c.*
Addresses: Chicago. **Exhibited:** AIC, 1896. **Sources:** Falk, *AIC*.

ROSEKRANS, Ruth *[Painter] mid 20th c.*
Addresses: State College, PA. **Exhibited:** WMAA, 1952. **Sources:** Falk, *WMAA*.

ROSELAND, Harry (Herman) *[Painter] b.1866, Brooklyn, NY / d.1950, Brooklyn.*
HARRY ROSELAND.
Addresses: Brooklyn, NY. **Studied:** T. Eakins; C. Beckwith; J.B. Whittaker, in Brooklyn. **Member:** Brooklyn AC; SC, 1896; Brooklyn PS; Brooklyn SA. **Exhibited:** Brooklyn AC, 1888 (gold); Brooklyn AA, 1884-86, 1891; NAD, 1884-1900 (prize); PAFA Ann., 1888-1906 (4 times) & 1932; Boston, Mass., 1900 (med.), 1904 (gold); Charleston Expo., 1902 (med.); AAS, 1902 (med.), 1907 (gold); Boston AC, 1905-08; Corcoran Gal. annual, 1907; S. Indp. A., 1917-18, 1932; Brooklyn SA, 1930 (prize); SC; AIC; NY Acad. All. A.; Salons of Am. **Work:** Brooklyn Inst. A. & Sc., BM, Abraham Lincoln H.S., Plymouth Church, all in Brooklyn; Charleston A. Mus.; Huntington Lib., San Marino, Calif.; Huntington Art Mus.; Jackson Mus., Mich.; Heckscher Mus., Long Island, NY. **Comments:** Genre painter who most notably depicted scenes including post-Civil War African Americans. He stayed in NYC all his life, never traveling to Europe. Marlor gives birthdate as 1868. **Sources:** WW47; *300 Years of American Art,* 619; Falk, *Exh. Record Series*.

ROSELLINI, Lillian (Mrs. Carl) *[Painter] mid 20th c.*
Addresses: Tacoma, WA, 1957. **Studied:** self-taught. **Exhibited:** Western Wash. Fair, 1930s; Handforth Gal., Tacoma, 1955. **Sources:** Trip and Cook, *Washington State Art and Artists*.

ROSEMAN, Aaron Hillel *[Painter] mid 20th c.*
Addresses: NYC. **Exhibited:** AIC, !947. **Sources:** WW66.

ROSEMANN, Henry *[Painter] mid 20th c.*
Exhibited: Salons of Am., 1934. **Sources:** Marlor, *Salons of Am.*

ROSEN, Benjamin M. *[Painter] mid 20th c.*
Exhibited: Salons of Am., 1934, 1935. **Sources:** Marlor, *Salons*

of Am.

ROSEN, Charles *[Landscape painter, painter, illustrator] b.1878, Westmoreland County, PA / d.1950, Kingston, NY.* CHARLES ROSEN
Addresses: New Hope, PA; Woodstock, NY. **Studied:** NAD; New York Sch. Art, with Chase, DuMond, F.C. Jones; abroad. **Member:** ANA, 1912; NA, 1917; Am. Soc. PS & G; SC; NAC; Woodstock AA. **Exhibited:** PAFA Ann., 1904-21, 1926 (medal for best landscape), 1929-41; NAD, 1910 (prize), 1912 (prize), 1916 (gold, prize); SC, 1914 (prize); CI, 1914 (prize); Pan-Pacific Expo, San Francisco, 1915 (medal); Columbus, OH, 1924 (prize); Corcoran Gal biennials, 1907-43 (13 times); AIC; CAM; Herron AI; Columbus Art Lg., 1925 (prize); Salons of Am.; WMAA, 1932-68; Westmoreland County Mus. Art, Greensburg, PA, 1983 (retrospective & traveling exhib.); Allentown Mus., "The Penn. School of Landscape Painting," trav. exh. to CGA, Westmoreland Mus., Brandywine River Mus., 1984-85. **Work:** Minneapolis Inst. Art; Duluth FA Assn.; NOMA; Butler AI; CAM; Univ. Michigan; WMAA; PMA; TMA; Morris Mus.of Arts & Sciences, NJ; Columbus, OH; San Antonio, TX; Penn. State College; Dartmouth; murals, USPOs, Beacon (NY), Palm Beach (FL), Poughkeepsie (NY); Woodstock AA. **Comments:** Married Mildred Holden and became part of the Bucks County art colony and friends with William Langson (see entry) and Edward W. Redfield (see entry). He and some friends formed the New Hope Group, which Redfield did not join. In 1918, he went to Woodstock to teach landscape painting and settled in an enclave with his friends George Bellows (see entry) and Eugene Speicher (see entry). Possible birth date: 1875. Teaching: ASL Summer School, Woodstock, 1918-21; Woodstock School of Painting (with Henry L. McFee); Columbus (OH) Gallery of Fine Art; Witte Memorial Mus., Dallas, TX. **Sources:** WW47; *Woodstock's Art Heritage*, 125-27; Woodstock AA; Falk, *Exh. Record Series.*

ROSEN, Eduard (Mrs.) See: **MELTZER, Doris (Mrs. Edward Rosen)**

ROSEN, Elise See: **ELISE, (Elise Rosen)**

ROSEN, Ernest T. *[Painter] b.1877.*
Addresses: NYC. **Studied:** Académie Julian, Paris, 1893-95. **Exhibited:** SNBA, 1897, 1899; PAFA Ann., 1905, 1907; S. Indp. A., 1917, 1919. **Sources:** WW19; Fink, *American Art at the Nineteenth-Century Paris Salons*, 386; Falk, *Exh. Record Series.*

ROSEN, Esther Yovits *[Painter] b.1916, Schenectady, NY.*
Addresses: Teaneck, NJ. **Studied:** Samuel Brecher. **Member:** NAWA; Bergen County A. Gld. **Exhibited:** Audubon A., 1951; NAWA, 1948-51; Rutherford, NJ, 1952. Awards: prize, Bergen County A. Gld., 1956. **Work:** Collectors of Am. A. **Comments:** Positions: hd. a. dept., and Children and Adult Classes, Teaneck (NJ) Community Center, 1952-. **Sources:** WW59; WW47.

ROSEN, Gertrude E. *[Painter] mid 20th c.*
Addresses: NYC. **Studied:** ASL. **Exhibited:** S. Indp. A., 1934, 1938, 1940. **Sources:** Marlor, *Soc. Indp. Artists.*

ROSEN, Helena *[Painter] mid 20th c.*
Exhibited: S. Indp. A., 1937. **Sources:** Marlor, *Soc. Indp. Artists.*

ROSEN, Helene I. (S.) *[Painter] mid 20th c.*
Addresses: Brooklyn, NY. **Exhibited:** S. Indp. A., 1933-34. **Sources:** Marlor, *Soc. Indp. Artists.*

ROSEN, Hy(man) (Joseph) *[Cartoonist] b.1923, Albany, NY.*
Addresses: Albany, NY. **Studied:** AIC; ASL; State Univ. NY Albany; Stanford Univ., fellowship jour. **Member:** Assn. Am. Editorial Cartoonists (pres., 1972). **Exhibited:** Awards: top award, Freedom Foundation, Valley Forge, PA, 1950, 1955 & 1960; top award, Nat. Conference Christians & Jews, 1962. **Comments:** Preferred media: inks. Positions: editorial cartoonist, *Albany Times-Union*, 1945; editorial cartoonist, Hearst Newspapers. **Sources:** WW73.

ROSEN, Israel *[Collector, writer] b.1911, Baltimore, MD.*
Addresses: Baltimore, MD. **Studied:** Johns Hopkins Univ. (A.B.,

1931); Univ. Md. Sch. Med. (M.D., 1935). **Member:** BMA (accessions comt. contemp. art, 1961-67, com. spec. funds & develop., 1970-, bd. trustees, 1972-); Univ. Calif. Art Mus., Berkeley (nat. comt., 1970-). **Comments:** Collections: modern art, with special emphasis on abstract expressionism, including works by Pollock, de Kooning, Still, Kline, Rothko, Baziotes, Tobey, Rauschemberg, as well as works by twentieth century European artists such as Picasso, Mondrian, Kindinsky, Klee, Leger & Gris. Publications: auth., "Toward a Definition of Abstract Expressionism," *Baltimore Mus. News* (1959); auth., "Edward Joseph Gallagher III Mem. Collection," BMA, 1964 & MMA, 1965. **Sources:** WW73.

ROSEN, Paula *[Painter] mid 20th c.*
Addresses: NYC. **Exhibited:** Salons of Am., 1930; S. Indp. A., 1931, 1935-36, 1939-40. **Sources:** Falk, *Exhibition Record Series.*

ROSEN, Pauline *[Painter] mid 20th c.*
Addresses: Bronx, NY. **Studied:** ASL. **Exhibited:** S. Indp. A., 1928-29. **Sources:** Marlor, *Soc. Indp. Artists.*

ROSENBAUER, W(illiam) Wallace *[Educator, sculptor, mus, curator] b.1900, Chambersburg, PA.*
Addresses: Johnson County, KS; Danbury, CT. **Studied:** Wash. Univ., St. Louis, MO; Alexander Archipenko. **Member:** Kansas City SA.; AID. **Exhibited:** S. Indp. A., 1924; Kansas City AI, medals in 1925-26, 1927 (gold), 1929 & prizes in 1935-36, 1939-40; PAFA Ann., 1927-36 (4 times); CAM, 1929 (prize); AIC; WMAA,1936-48; WFNY 1939; New York City (solo); Stamford Mus. A. (solo); AAPL, 1954 (prize). **Work:** William Rockhill Gal.; Nelson Gal. A.; Springfield A. Mus.; St. Peter's Church, Kansas City; Tower of the Ascension, Kansas City; Cavalry Lutheran Church, Kansas City; war mem., Concordia, Kans.; Raytown Elem. Sch., Raytown, Mo. **Comments:** Positions: asst. dir. and cur. visual a., Stamford Mus. & Nature Center; instr. a. Appreciation & Drawing, Stamford Branch, Univ. Connecticut, as of 1959; l., instr., Parsons Sch. Des., NYC, 1950-53; dir. Kansas City AI, 1940-49. **Sources:** WW59; Falk, *Exh. Record Series.*

ROSENBAUM, Bertha *[Painter] mid 20th c.*
Addresses: Chicago area. **Exhibited:** AIC, 1947. **Sources:** Falk, *AIC.*

ROSENBAUM, Caroline *[Portrait painter] b.1896, Bonham, TX.*
Addresses: Orland, FL. **Studied:** AIC. **Member:** NAWPS; S. Indp. A.; AAPL. **Exhibited:** S. Indp. A., 1935. **Work:** Jewish Children's Home, New Orleans; Chicago Home of Jewish Orphans, Home for Aged Jews, Convalescent Home for Women and Children, all in Chicago; National Hebrew Orphan Home, NY; Hebrew Union Col., Cincinnati; Hospital for Crippled Children, Galveston, TX. **Sources:** WW40.

ROSENBAUM, David Howell, Jr. *[Painter, teacher] b.1908, Brigham City, UT.*
Addresses: Brigham City, UT/Ogden, UT in 1974. **Studied:** Utah State Agriculture College, with C. Fletcher, 1931; ASL, 1938; Am. Art Sch., NYC, with Sol Wilson, Moses Soyer, J. Liberté. **Member:** Utah State Inst. FA; Am. Artists Congress. **Exhibited:** Am. Art Sch., NY; S. Indp. A., 1941. **Work:** WPA Allocations, Utah. **Comments:** Position: teacher, Ogden Art Center, 1941. Painted in Guadalcanal as a Seabee in 1942. **Sources:** WW40; P&H Samuels, 409.

ROSENBAUM, Herzl *[Painter] mid 20th c.*
Addresses: NYC. **Exhibited:** S. Indp. A., 1936. **Sources:** Marlor, *Soc. Indp. Artists.*

ROSENBAUM, Leta Herzog *[Painter] b.1911, San Rafael, CA.*
Addresses: San Rafael, CA. **Studied:** Alice Chittenden; Calif. Sch. of FA, with George Post; with Percy Gray and Jack Wisby. **Exhibited:** Soc. for Sanity in Art, CPLH, 1940; SFMA, 1957. **Comments:** Specialty: watercolors, mosaics. **Sources:** Hughes, *Artists in California*, 480.

ROSENBERG, Anne *[Painter] mid 20th c.*
Exhibited: Salons of Am., 1930. **Sources:** Marlor, *Salons of Am.*

ROSENBERG, Ben See: **BENN, Ben**

ROSENBERG, Ceil *[Painter] mid 20th c.*
Addresses: Chicago area. **Exhibited:** AIC, 1934, 1936, 1938-40.
Sources: Falk, *AIC.*

ROSENBERG, Charles G. *[Landscape, portrait and figure painter] mid 19th c.*
Addresses: NYC, c. 1857-63; Philadelphia in 1866; NYC, 1867-72. **Exhibited:** NAD, 1858-72; PAFA, 1863-66; Brooklyn AA, 1868-69. **Work:** Museum of the City of New York ("Wall Street, Half Past 2 O'Clock, October 13, 1857," painted in collaboration with James H. Cafferty). **Sources:** G&W; Cowdrey, NAD; Rutledge, PA; NYBD 1859-60; *American Processional*, 245.

ROSENBERG, Emir *[Artist] early 20th c.*
Addresses: Wash., DC, active 1905. **Sources:** McMahan, *Artists of Washington, DC.*

ROSENBERG, Harold *[Critic, writer, poet, educator] b.1906, NYC / d.1978.*
Addresses: NYC. **Studied:** City Col. NY, 1923-24; Brooklyn Law Sch. (L.L.B.); St. Lawrence Univ., 1927; Lake Forest Col. (Litt.D., 1968); Md. Inst., Col. Art (D.F.A., 1970). **Member:** Int. Assn. Art Critics. **Comments:** Coined the phrase "action painting" to describe the gestural style and working method of Jackson Pollock and other Abstract Expressionists. Positions: art ed., *Am. Guide* series, 1938-40; founder and co-ed. (with Robert Motherwell), *Possibilities,* a review, 1947/48; art critic, *New Yorker,* 1967-; contribr., *Art News* Teaching: Regents lectr., Univ. Calif., 1962; lectr., Christian Gauss Sem., Princeton Univ., 1963; lectr., Baldwin Sem., Oberlin Col.; vis. prof., Univ. Southern Ill., 1966; prof. art & mem. social thought, Univ. Chicago, 1967-on. Awards: Frank Jewett Mather Award, Col. Art Assn., 1964; citation, UC Berkeley, 1970. Publications: auth, "The American Action Painters," *Art News* (December 1952): 22-23; auth., *The Tradition of the New* (McGraw, 1959 & 1965); auth., *The Anxious Object* (New Am. Libr., 1964 & 1969); auth., *Artworks and Packages* (Horizon, 1969); auth, *Act and the Actor* (World, 1971); auth., *The De-Definition of Art* (Horizon, 1972). **Sources:** WW73.

ROSENBERG, Harry *[Artist] early 20th c.*
Addresses: Wash., DC, active 1911. **Sources:** McMahan, *Artists of Washington, DC.*

ROSENBERG, Henry Mortikar *[Painter, teacher] b.1858, New Brunswick NJ. / d.1947, Citronelle, AL.*
Addresses: NYC; Citronelle, AL. **Studied:** F. Duveneck; Royal Acad., Munich; Florence; Venice. **Member:** SC; Nova Scotia SA. **Exhibited:** Boston AC, 1882, 1888, 1891, 1895-96, 1898; PAFA Ann., 1883-1900 (4 times);Paris Salon, 1885; Brooklyn AA, 1891; AIC; S. Indp. A., 1918; Salons of Am., 1933; 1887-96.
Comments: Position: dir., Nova Scotia College Art. **Sources:** WW40; Fink, *American Art at the Nineteenth-Century Paris Salons*, 386; Falk, *Exh. Record Series.*

ROSENBERG, Jack *[Artist] early 20th c.*
Addresses: Wash., DC, active 1905-20. **Sources:** McMahan, *Artists of Washington, DC.*

ROSENBERG, Jakob *[Writer, educator, museum curator] b.1893, Berlin, Germany / d.1980.*
Addresses: Arlington, MA. **Studied:** Univ. Bern; Univ. Zurich; Univ. Frankfurt-am-Main; Univ. Munich (Ph.D., 1922); Harvard Univ. (hon. M.A., 1942, hon. D.A., 1961). **Member:** Col. Art Assn. Am.; fel. Am. Acad. Arts & Sci.; hon. fel. Pierpont Morgan Libr. **Comments:** Positions: cur. prints, Fogg Mus. Art, Harvard Univ., 1939. Teaching: resident fel. & lectr., Harvard Univ., 1937-39, assoc. prof., 1940-47, prof. fine arts, 1948-64, emer. prof., 1964-; Robert Sterling Clark prof., Williams Col., 1964-65; sr. fel., Nat. Gal., Wash., DC, 1966-67. Publications: auth., "Great Draughtsmen from Pisanello to Picasso," Harvard Univ. Press, 1959; auth., "Zeichnungen Cranachs," 1960; auth., "Rembrandt,

Life and Work," Phaidon, 1964; auth.," On Quality in Art," Princeton Univ. Press, 1967; co-auth., "Dutch Art and Architecture," Penguin, 1972. **Sources:** WW73; WW47.

ROSENBERG, James N. *[Painter] b.1874,* Allegheny City, PA. 〽
Addresses: NYC. **Member:** NAC; Soc.Independent Artists; Wash. AC; AFA. **Exhibited:** Salons of Am.; S. Indp. A.,1919-21, 1923-25. **Sources:** WW33.

ROSENBERG, Julius *[Painter] mid 20th c.*
Exhibited: S. Indp. A., 1942. **Sources:** Marlor, *Soc. Indp. Artists.*

ROSENBERG, Louis Conrad *[Printmaker, illustrator, educator, architect] b.1890, Portland, OR / d.1983.*
Addresses: Lake Oswego, OR. **Studied:** MIT, 1912-14, traveling fel., 1920-22; Royal Col. Art, London, Eng., 1925-26; Am. Acad., Rome. **Member:** ANA, 1932; NA, 1936; Phila. SE; F., Royal Soc. P.E. & En., London; SAE; Chicago SE; Southern Pr.M.; Prairie Pr.M.; Audubon A.; Am. Veterans Soc. A.; Cleveland SE; Phila. SE; Am. Inst. Architects. **Exhibited:** Calif. Pr.M., 1924 (med.); Chicago SE, 1925 (med.), 1927 (med.); AIC, 1932 (prize); Brooklyn SE, 1926 (prize); SAE, 1932 (prize), 1933-37, 1938 (prize), 1939-41; Albany Pr. Cl.,1945-46 (prize); NAD, 1930-41, 1945-46; AIC, 1932; Albany Inst. Hist. & A., 1945; Wichita AA, 1946; Am.-British Goodwill Exh., London, 1945; Am. Inst. Architects, 1948 (fine arts gold medal). **Work:** Smithsonian Inst.; LOC; NYPL; Boston Pub. Lib.; BMFA; Albany Inst. Hist. & A.; British Mus., Victoria & Albert Mus., both in London; Univ. Nebr.; Honolulu Acad. A.; CMA; Mont. State Col.; Slater Mem. Mus., Norwich, Conn.; AGAA; Howard Univ.; Royal Ins. Co., NY; Cleveland Terminal Co.; Cincinnati Terminal Co.; Royal Acad. Arts, Stockholm; Fifty Prints of the Year, 1932, 1933, 1934, 1936. **Comments:** Author: *Davanzati Palace* (1922); illustrator, *Bridges of France* (1924); also, Middle East war projects of Johnson-Drake & Piper, 1943; contribr, print mags; plus others. Position: arch./des., Stanton & Johnston, Portland, 1934-. **Sources:** WW73; WW47.

ROSENBERG, Manuel *[Illustrator, cartoonist, writer, lecturer, teacher] b.1897, New Orleans.*
Addresses: Cincinnati, OH. **Studied:** Duveneck; Meakin; J. Maynard. **Member:** Commercial AC of Cincinnati; Western AA. **Comments:** Positions: art ed., *The Cincinnati Post;* chief a., The Scripps Howard League of Newspapers. Author: "Newspaper Art," "Practical Art," "Cartooning and Drawing," "The Art of Advertising" (with E. Walker Hartley, 1929). **Sources:** WW31.

ROSENBERG, Mordecai *[Painter] early 20th c.*
Addresses: Chicago, IL. **Exhibited:** AIC, 1909. **Sources:** WW10.

ROSENBERG, Nelson Chidecker *[Painter, teacher] b.1908, Baltimore.*
Addresses: Wash., DC. **Studied:** ASL; Pratt Inst.; Nat. Acad; D. Rivera. **Member:** Ar. Un., Wash., DC. **Exhibited:** Phillips Mem. Gal. (1939), Whyte Gal., Georgetown Gal., all in Wash., DC; BM. **Work:** Phillips Mem. Gal.; Allocations Gal., WPA, Wash. D.C.; murals, Roosevelt H.S., Wash. DC. **Sources:** WW40.

ROSENBERG, Pierce *[Collector] b.1908, Milwaukee, WI.*
Addresses: Milwaukee, WI. **Studied:** University of Michigan (A.B.). **Comments:** Collection: prints, paintings and sculpture. **Sources:** WW66.

ROSENBERG, Rosa *[Painter] 20th c.*
Addresses: Phila., PA. **Studied:** PAFA. **Sources:** WW24.

ROSENBERG, Samuel *[Portrait painter, painter, educator] b.1896, Philadelphia, PA / d.1972, Pittsburgh, PA.*
Addresses: Pittsburgh, PA. **Studied:** NAD; CI (B.A.); Collens; Sparks; Volk. **Member:** Assoc. A. Pittsburgh; Abstract Group; CAA; AAUP; A. Comm. City of Pittsburgh. **Exhibited:** Assoc. A. Pittsburgh, prizes in 1917, 1920-21, 1930, 1936, 1945, 1948; PAFA Ann., 1922, 1933-35, 1944-51; Pittsburgh SA, 1928 (prize)-29 (prize); WFNY, 1939; GGE, 1939; Butler AI, 1939 (prize), 1943 (prize), 1947 (prize); Carnegie Inst. (14 Internationals, 1920-

64, and 8 American, 1940-49, with prizes in 1945 and 1954); WMAA, 1934-48; John Herron AI; Univ. Illinois; AIC; Walker A. Center; Milwaukee AI; AGAA; Corcoran Gal biennials, 1932, 1947; Dayton AI; MoMA; LACMA; NAD; Univ. Nebraska; Nelson Gal. A., Kansas City; Riverside Mus., NY; Rochester Mem. A. Gal; Minneapolis Inst. A.; CAM; TMA; Springfield Mus. FA; VMFA; Columbia (SC) Mus. A.; solo: Bucknell Univ.; Univ. Tennessee; Butler AI; Cheltenham A. Center; BMFA Sch.; Pittsburgh Playhouse; Jewish Community Center, Cleveland; Indiana (Pa.) State T. Col., 1946 (prize); Pittsburgh A. & Crafts Center; Greensburg A. Cl., 1940; Assoc. Am. A., 1944, 1947; BMA, 1959; Westmoreland County Mus. A., 1960; Miami Univ., Oxford, Ohio, 1962; Pittsburgh Plan for Art, 1963; House Office Bldg., in office of Congressman Moorehead, 1963; Weirton Community Center, 1957; Hewlett Gal., Carnegie Inst., 1958, 1965. Other awards: Pepsi-Cola, 1947-48; Grensfelder Prize, 1953, 1955; "Man of the Year in Art," Pittsburgh Jr. Chamber Commerce and A. & Crafts Center, 1950; prize and silver med., Ligonier Valley A. Lg. **Work:** CI; Univ. Pittsburgh; Encyclopaedia Britannica; Butler AI; Somerset County Sch.; Pittsburgh Bd. Edu.; Slippery Rock (Pa.) State T. Col.; Pa. State Univ.; Pub. Sch., Court House, Chamber of Commerce, Pa. Col. for Women, all in Pittsburgh; Indiana State T. Col.; Wash. County Mus. FA; BMA; Westmoreland County Mus. A., Pa. **Comments:** He began his art career as a portrait painter, turning to views of the inner city and later experimenting with abstract expressionism. His scenes of the Depression era show a sense of social awareness and social criticism, which is continued in his works during the war years. Position: chairm., art dept., Pa. Col. for Women, Pittsburgh, 1937-45; prof., Carnegie Inst., Pittsburgh, 1944-64. **Sources:** WW66; WW40; Chew, ed., *Southwestern Pennsylvania Painters,* 109, 112-114; Falk, *Exh. Record Series.*

ROSENBERG, S(amuel) M(artin) *[Painter] b.1893, Wash., DC.*
Addresses: Springfield, MA/Congamond Lake, CT. **Studied:** H. Seldon. **Member:** Springfield A. Lg. **Exhibited:** Springfield A. Lg., 1927 (prize). **Sources:** WW40.

ROSENBERG, Yetta (Mrs. David V.) *[Ceramicist, teacher] b.1905, NYC.*
Addresses: Cleveland, OH. **Studied:** R. Aitken; W. Atchley; N.E. Dyer; Cleveland Sch. Art. **Member:** Am. Ceramic Soc. **Exhibited:** CMA, 1938 (prize). **Sources:** WW40.

ROSENBLATT, Adolph *[Painter, lithographer] b.1933, New Haven, CT.*
Addresses: NYC. **Studied:** Sch. Design, Yale Univ., with Albers, Brooks & Marca-Relli. **Exhibited:** Am. Fedn. Traveling Exhib., 1958; Boston Arts Festival 1961; Riverside Mus, NYC, 1962; Provincetown, Mass., 1963; Dorsky Gal., 1963, 1964 & 1972. **Work:** LOC. **Sources:** WW73.

ROSENBLATT, Alice *[Craftsman, painter, designer, teacher, lecturer] mid 20th c.; b.NYC.*
Addresses: Tuckahoe, NY. **Studied:** T. Col., Columbia Univ. (B.S.); Columbia Univ. (M.A.); Grand Central Sch. A., and with Henry B. Snell, George Bridgman; A. Woelfle; E. O'Hara; R. Brackman. **Member:** Eastern AA; Westchester A. & Crafts Gld.; Yonkers AA; Mt. Vernon AA (bd. dir.). **Exhibited:** S. Indp. A., 1932; PAFA; Barbizon Plaza, NY; Hudson River Mus., 1949; Westchester A. & Crafts Gld., 1948-55; Hudson Valley AA, 1951-52, 1955; Fla. Southern Col., 1952. Awards: prize, White Plains County Center, 1949 Yonkers AA; *Villager* cover contest, 1952. **Work:** mural, Jr. H.S. No. 55, NY; leather tooled and illuminated volumes, James Monroe H.S., Theodore Roosevelt H.S., NY. **Comments:** Positions: instr., a., Theodore Roosevelt H.S., NYC. **Sources:** WW59; WW47.

ROSENBLATT, Samuel *[Painter] mid 20th c.*
Exhibited: S. Indp. A., 1942. **Sources:** Marlor, *Soc. Indp. Artists.*

ROSENBLOOM, Charles J. *[Collector] 20th c.*
Addresses: Pittsburgh, PA. **Sources:** WW73.

ROSENBLUM, Gertrude *[Painter] 20th c.*
Exhibited: S. Indp. A., 1943. **Sources:** Marlor, *Soc. Indp. Artists.*

ROSENBLUM, Jay *[Painter] b.1933, NYC / d.1989.*
Addresses: NYC. **Studied:** Pratt Inst., with Richard Lindner; Bard Col. (B.A.), 1955), with Louis Schanker; Cranbrook Acad. Art (M.F.A., 1956), with Fred Mitchell. **Exhibited:** Festival of Two Worlds, Spoleto, Italy, 1956; Detroit Inst. Art, 1956; Highlights of 1970 Season, Aldrich Mus., 1970; solo shows, AM Sachs Gal., 1970 & Blue Parrot Gal., NYC, 1972; Recent Prints USA, New York Cult. Ctr., 1972. Awards: Carlos Lopez mem. prize in painting, Detroit Inst. Art, 1956; Painter of Yr., 1970, Larry Aldrich, 1970; City Walls Inc. grant, 1972. **Work:** Larry Aldrich Mus. Contemp. Art, Ridgefield, Conn.; MoMA Lending Serv., NYC; Albright-Knox Mus. Lending Serv., Buffalo, NY; 180 Beacon St. Collection, Cambridge, Mass. Commissions: Painting, comm by Larry Aldrich, Phoenix, Ariz., 1971. **Comments:** Preferred media: acrylics. Teaching: instr. painting, Dalton Sch., NY, 1963-; instr. painting, 92nd St YMHA, NYC, 1965-; adj. lectr. painting, Queensboro Community Col., 1969-; adj. lectr. painting, Lehman Col., 1971-on. **Sources:** WW73; Cindy Nemser, rev., In: *Arts Mag.* (Oct., 1970); Carter Ratcliff, rev., In: *Art Int.* (Feb., 1971); Ward Jackson, *Art now: New York* (May, 1971).

ROSENBLUM, Robert *[Art historian] b.1927, NYC.*
Addresses: NYC. **Studied:** Queens Col. (B.A.); Yale Univ. (M.A.); NY Univ. (Ph.D.). **Comments:** Teaching: instr. hist. art, Univ. Mich., 1955-56; assoc. prof. hist. art, Princeton Univ., 1956-66; prof. hist. art, NY Univ., 1967-. Areas of expertise: modern art, 1760 to the present. Publications: *Cubism and Twentieth Century Art,* 1960; *Transformations in Late Eighteenth Century Art,* 1967; *Ingres,* 1967; *Frank Stella,*1970; *Modern Painting and the Northern Romantic Tradition: Friedrich to Rothko,* 1975; "The Primal American Scene," *The Natural Paradise: Painting in America, 1800-1950* (New York, 1976); co-auth., *19th Century Art,* 1984. **Sources:** WW73.

ROSENBLUM, Sadie Skoletsky *[Painter, sculptor] b.1899, Odessa, Russia.*
Addresses: Miami Beach, FL. **Studied:** ASL; New Sch. Soc. Res.; also with Raphael Soyer, Kunioshr, Ben-Zion & Samuel Adler. **Exhibited:** MoMA; Corcoran Gal.; solo shows, Mus. Arts, Fort Lauderdale, Fla., 1962 & 1965, Lowe Art Mus., Univ. Miami, 1964 & Columbia Mus., SC, 1972. **Work:** PMA; Ohio Univ., Athens; El Paso Mus. Art, Tex.; Brandeis Univ. Mus., Waltham, Mass.; Lowe Art Mus., Univ. Miami, Coral Gables. **Comments:** Preferred media: oils. Positions: assoc. mem. adv. bd., Peabody Col. **Sources:** WW73.

ROSENBORG, Ralph M. *[Painter, teacher, lithographer] b.1913, NYC / d.1992.*
Addresses: NYC. **Studied:** School Art League, Am. Mus. Nat. Hist., 1929; Henriette Reiss in NYC, 1930-33. **Member:** "The Ten," 1936 (abstract painters); Am. Abstract Artists (founder); Southern PM Soc.; Scandinavian-Am. Artists; Fed. Modern Painters & Sculptors; Woodstock AA. **Exhibited:** Corcoran Gal. biennials, 1949, 1959; AIC; Salons of Am., and more than 300 group exhibitions, 1934-90; WMAA, 1946, 1956; 53 solo shows in New York & other U.S. cities in US, 1935-85, including Black Mountain Col., 1957; Univ. Notre Dame, 1967; ACA Gal., NYC; Am. Acad. Arts & Letters, 1960 (Purchase Award). **Work:** MoMA; Guggenheim Mus; PMG; MMA; CMA; Butler AI; New Britain Mus. Am. Art; Hirshhorn Mus.; Newark Mus.; Hudson River Mus.; Montclair AM; Wadsworth Atheneum; Princeton AM; St. Louis AM; Snite Mus., Notre Dame; Univ. Oregon Art Gal.; Johnson AM, Cornell; Gray AG, NYU; Rose AM, Brandeis; Univ. Maryland Art Gal.; Lowe AG, Syracuse; Univ. Georgia Art Mus.; Colby College. **Comments:** Abstract Expressionist. Teaching: WPA Mural & Easel Div.; Brooklyn Mus., 1936-38; Ox-Bow Summer School, Saugatuck, MI, 1949. **Sources:** WW73; WW40 (cites incorrect birth of 1910); complete exhib. record and biography in exhib. cat., Princeton Gal. FA (Princeton, NJ, 1988); *American Abstract Art,* 196; Woodstock AA.

ROSENDAHL, Gertrude *[Designer, craftsperson] 20th c.*
Addresses: Brockton, MA. **Studied:** BMFA Sch.; New Sch. Des; Boston Sch. Painting. **Member:** Boston SAC; Phila. ACG. **Sources:** WW40.

ROSENDALE, Harriet *[Painter] mid 20th c.; b.Buffalo, NY.*
Addresses: Sarasota, FL. **Studied:** New York Sch. Fine & Appl. Art; ASL, with Frank Vincent DuMond & Jon Corbino. **Member:** Nat. Assn. Women Artists; CAFA; Sarasota Art Assn.; Springfield Art League. **Exhibited:** Nat. Assn. Women Artists; New Eng. Regional New Canaan, Conn.; Springfield Art League, Mass.; CAFA; Sarasota Art Assn., Fla.; Munson Gallery, New Haven, CT, 1970s. **Awards:** New Eng. Regional, 1957 & Nat. Assn. Women Artists, 1959 & 1961. **Comments:** Preferred media: oils. Publications: works reproduced by Am. Artists Group, Bk. of Month Club, Cameo & E.E. Fairchild. **Sources:** WW73.

ROSENER, Hilda Frank *[Sculptor] 19th/20th c.*
Addresses: San Francisco, CA. **Studied:** San Jose Teacher's College; UC Berkeley. **Exhibited:** Mark Hopkins Inst., 1898. **Sources:** WW01; Hughes, *Artists in California,* 480.

ROSENFELD, Adelin C. *[Painter] mid 20th c.*
Addresses: NYC. **Exhibited:** PAFA Ann., 1942. **Sources:** Falk, *Exh. Record Series.*

ROSENFELD, Edward *[Painter] b.1906, Baltimore, MD.*
Addresses: Baltimore, MD. **Studied:** self-taught; Md. Inst. **Member:** Baltimore AA; Balt. A. Un.; Balt. A. Gld.; Wash. A. Gld.; AEA. **Exhibited:** PAFA Ann., 1933-35, 1941; AIC, 1938; Salons of Am.; BMA, 1939, 1945 (prize); Little Gal., Wash., DC, 1940; Corcoran Gal biennials, 1941, 1947; WFNY, 1939; GGE, 1939; Babcock Gal., NYC; Peale Mus., 1943 (prize); FMA,1943 (prize), 1945 (prize), 1947 (prize); Whyte Gal., 1945; CI, 1945; PMG, 1943 (solo); Boyer Gal., Phila. and NY. **Work:** PMG; BMA; San Diego FA Soc.; Am. Univ., Wash., DC; Washington County Mus. FA, Hagerstown, Md. **Sources:** WW59; WW47; Falk, *Exh. Record Series.*

ROSENFELD, Paul *[Critic, writer] b.1890, NYC / d.1946, NYC.*
Studied: Yale; Columbia. **Comments:** Author: "Port of New York," books on art. Editor. "Alfred Stieglitz: A Collective Portrait." Contributor: *Kenyon Review; Tomorrow; Commonweal,* other magazines.

ROSENFIELD, Hugo *[Painter] b.1885, Minneapolis / d.1932, NYC.*
Addresses: NYC. **Studied:** AIC; ASL; Paris. **Exhibited:** S. Indp. A., 1917. **Comments:** Brother of Lester. **Sources:** WW21.

ROSENFIELD, Lester *[Painter] b.1886, Minneapolis.*
Addresses: NYC. **Studied:** AIC; ASL; Royal Acad., Munich. **Exhibited:** Corcoran Gal biennial, 1912; AIC, 1912-13. **Comments:** Brother of Hugo. **Sources:** WW21; Falk, *Exhibition Records Series.*

ROSENFIELD, Milton *[Painter] mid 20th c.*
Exhibited: S. Indp. A., 1944. **Sources:** Marlor, *Soc. Indp. Artists.*

ROSENGREN, Herbert *[Painter, sculptor, etcher, illustrator, teacher & industrial designer] b.1908, Kewanee, IL / d.1971, Rockford, IL or Cedar Rapids, IA?.*
Addresses: Ottumwa and Cedar Rapids, IA; Woodcliff Lake, NJ. **Member:** Rockford AA; Iowa AC. **Exhibited:** AIC; Iowa State Fair, 1931 (prizes); Iowa AC, 1922, 1931 (prize); Iowa Federation Women's Clubs, 1932. **Work:** Mural, Roosevelt Jr. H.S., Rockford, IL. **Comments:** Industrial designer; according to Ness & Orwig, "first artist to work on machinery in the capital goods class." **Sources:** WW40; Ness & Orwig, *Iowa Artists of the First Hundred Years,* 179.

ROSENGREN, Imogene Easterly *[Painter] mid 20th c.*
Exhibited: AIC, 1935. **Sources:** Falk, *AIC.*

ROSENHAUSE, Beatrice C. *[Sculptor] mid 20th c.*
Addresses: Los Angeles, CA, 1920s, 1930s. **Exhibited:** Calif. AC, 1925. **Sources:** Hughes, *Artists in California,* 480.

ROSENHOUSE, Irwin Jacob *[Printmaker, illustrator] b.1924, Chicago, IL.*
Addresses: NYC. **Studied:** Cooper Union (cert., 1950). **Exhibited:** Am. Fedn. Arts; LOC; MoMA; PAFA; Boston Printmakers; Rosenhouse Gal., NYC. **Awards:** Award for graphics, Tiffany Found.; resident artist, Huntington Hartford Found., 1959 & 1961. **Work:** MMA; Cooper Union Mus.; NYPL Graphics Collection; Everhart Mus., Pa.; Brooklyn Col., NY. **Comments:** Preferred media: graphics. Positions: owner & operator, Rosenhouse Gal. NYC, 1963-71; free lance designer & illusr., 1972. Publications: illus., *What kind of feet does a bear have?* (Bobbs, 1963); illus., *Have you seen trees?*(Young-Scott, 1967). Teaching: instr. drawing, painting & graphics, MoMA, 1968-70; instr. graphics, Brooklyn Col., 1972. **Sources:** WW73.

ROSENKRANZ, Clarence C. *[Painter, teacher] b.1870, Hammondsport, NY.*
Addresses: NYC, 1899/St. Paul, MN. **Studied:** J.W. Stimson; W.M. Chase; W. Shirlaw. **Member:** Buffalo SA; Duluth AA; Minn. State AA. **Exhibited:** AIC, 1899; Buffalo FA Acad., 1909 (prize), 1911 (prize), 1912 (prize); Minn. Art Com., 1913 (prize). **Work:** Minn. Art Soc.; Hibbing, Minn. Pub. Lib.; Buhl, Minn. Pub. Lib. **Comments:** Position: t., Minn. Art Sch., St. Paul. **Sources:** WW40.

ROSENMEIER, Isador *[Painter] b.1896, Schweinfurth, Germany.*
Addresses: Chester, CT. **Studied:** Nurnberg A. Sch. (M.A.). **Member:** Silvermine Gld. A.; Essex AA; Springfield A. Lg. **Exhibited:** Silvermine Gld. A.; Essex AA; Springfield A. Lg.; New England Regional. **Award:** prize, New England Regional Exh., 1955. **Sources:** WW59.

ROSENMEYER, B(ernard) J(acob) ®
[Lithographer, illustrator, painter] b.1869, New York.
Addresses: NYC. **Studied:** ASL with H.S. Mowbray; Académie Julian, Paris with J.P. Laurens and Constant, 1891. **Member:** SI, 1902. **Exhibited:** AIC, 1898, 1908, 1912; NAD, 1897; PAFA Ann., 1900. **Work:** CI; NYPL; Butler AI; Poe Soc., Phila.; Mus. City of N.Y. **Sources:** WW40; Falk, *Exh. Record Series.*

ROSENQUIST, Fingal *[Sculptor] b.1901.*
Addresses: Huntingdon Valley, PA. **Exhibited:** PAFA, 1933; S. Indp. A., 1935; WFNY, 1939; AIC. **Sources:** WW40.

ROSENQUIST, James *[Painter] b.1933, Grand Forks, ND.*
Addresses: NYC. **Studied:** Minneapolis Sch. of Art, 1948; Univ. Minnesota, with Cameron Booth, 1952-54; ASL, 1955. **Exhibited:** Green Gal., NYC., solos, 1962, 1964; Sidney Janis Gal., NY, 1962, 1964; Pace Gal., Boston, 1962; DMFA, 1962; Dwan Gal., Los A., 1962; Wadsworth Atheneum, Hartford, 1962; Guggenheim Mus., 1963; AIC, 1963; WMAA, 1963-81; Albright-Knox Gal., Buffalo, 1963; Stockholm, 1964; NY World's Fair, 1964 (mural); Sonnabend Gal., Paris, 1964; WMAA, 1972 (solo). **Work:** Brandeis Univ.; priv. colls. **Comments:** One of the leading figures in Pop Art. From 1954 to 1960, Rosenquist worked as a billboard painter, the over-size, hyped up images of which became an integral part of his painting. His typical work juxtaposes fragments of unrelated objects creating a sense of dislocation or overlapping moments in time. This perceptual chaos has been likened to the effects of turning the dial of a television set. **Sources:** WW66; Baigell, *Dictionary;* Marcia Tucker, James Rosenquist (exh. cat., NYC: WMAA, 1972).

ROSENQUIST, Willard Virgil *[Painter, teacher] 20th c.; b.MT Vernon, WA.*
Addresses: Seattle, WA. **Studied:** Univ. of Wash.; Columbia Univ. **Comments:** Position: teacher, Seattle Pub. Schools. **Sources:** Trip and Cook, *Washington State Art and Artists.*

ROSENQUIT, Bernard *[Painter, printmaker] b.1923, Hotin, Roumania / d.1991.*
Addresses: NYC. **Studied:** Inst Art & Archeol., Paris; Fontainebleau Sch. Fine Arts, France; Brooklyn Mus. Sch. Fine Art, NY; Atelier 1917, NYC; ASL. **Member:** AEA; life mem.

ASL. **Exhibited:** Honolulu Acad. Fine Arts, Hawaii; BMFA; MoMA; Newark Mus. Art, NJ; seven solo shows, Roko Gal., NYC, 1951-71. Awards: Fulbright grant painting, Paris, 1958; Tiffany Found. grant printmaking, 1959. **Work:** MMA; Brooklyn Mus.; Victoria & Albert Mus., London, Eng.; Smithsonian Inst.; New York Pub. Libr. Print Coll. **Comments:** Preferred media: oils, gouache, wood. **Sources:** WW73.

ROSENSHINE, Annette (Miss) *[Sculptor] b.1880, San Francisco, Ca / d.1971, Oakland, CA.*
Addresses: NYC, 1925; San Francisco Bay area, CA. **Studied:** Mark Hopkins Inst.; Paris, France, with Matisse; psychology with Jung in Zürich. **Member:** San Francisco Soc. of Women Artists. **Exhibited:** S. Indp. A., 1925-27; Salons of Am., 1926; SFMA, 1935. **Work:** SFMA. **Sources:** Hughes, *Artists in California,* 480.

ROSENSON, Olga L(ea) *[Painter, etcher] b.1892, Brooklyn, NY / d.1959, Brooklyn, NY.*
Addresses: NYC. **Studied:** Packer Collegiate Inst.; ASL, with George Luks, Vincent DuMond, Joseph Pennell; BMSch. **Member:** NAWA; Brooklyn Soc. Artists; NAWPS. **Exhibited:** Salons of Am.; BM; NAD; Argent Gal.; Riverside Mus.; NAC; Brooklyn Lib.; traveling exhibs. U.S. and abroad. **Sources:** WW59; WW40; Marlor, *Salons of Am.*

ROSENSTEIN, A *[Sculptor] 20th c.*
Addresses: NYC. **Sources:** WW21.

ROSENSTEIN, Paul *[Sculptor] 19th/20th c.*
Addresses: San Francisco, CA, 1896-1900. **Exhibited:** Mechanics Inst., San Francisco, 1896. **Sources:** Hughes, *Artists in California,* 480.

ROSENTHAL, Abraham *[Painter] b.1886, Russia.*
Addresses: Rockport, MA/NYC. **Studied:** ASL; CUA Sch.; with Emile Gruppe. **Member:** Rockport AA. **Comments:** Specialty: seascapes. Work reproduced in *Christian Science Monitor,* 1950. Lectured with demonstrations. **Sources:** WW59; *Artists of the Rockport Art Association* (1956).

ROSENTHAL, Alan H. (Mrs.) *[Collector] d.1990.*
Addresses: NYC. **Comments:** Collection: ethnographica. **Sources:** WW73.

ROSENTHAL, Albert *[Painter, etcher, lithographer] b.1863, Phila., PA / d.1939, NYC.*
Addresses: Phila., New Hope, PA. **Studied:** his father, Max; PAFA; Académie Julian, Paris, 1890; Ecole des Beaux-Arts, Paris, with Gérôme; also in Munich. **Member:** SC; Phila. Alliance. **Exhibited:** PAFA Ann., 1887-1936; St. Louis Expo, 1904 (med.); Corcoran Gal biennials, 1907-28 (5 times); Pan.-Pac. Expo, San Fran., 1915 (med.); S. Indp. A., 1917; Salons of Am.; AIC. **Work:** BM; Butler AI; LACMA; Kansas City AI; Detroit AI; City Mus., St. Louis, Mus. FA, Dallas; Albright Art Gal.; Mus., Allentown, Pa.; H.S., New Hope, Pa.; RISD; Newport (R.I.) AA; Capitol, Supreme Court Bldg., both in Wash., DC; City Hall, Phila.; Capitol, Harrisburg, Pa. **Sources:** WW38; Falk, *Exh. Record Series.*

ROSENTHAL, Alice H. *[Painter] mid 20th c.*
Exhibited: S. Indp. A., 1937. **Sources:** Marlor, *Soc. Indp. Artists.*

ROSENTHAL, Alpha K. *[Painter] early 20th c.*
Addresses: Lawrence, LI, NY, 1922. **Exhibited:** S. Indp. A., 1922. **Sources:** Marlor, *Soc. Indp. Artists.*

ROSENTHAL, Bernard J. *[Sculptor] b.1914, Highland Park, IL.*
Addresses: Los Angeles, CA; NYC. **Studied:** Univ. Michigan (B.F.A., 1936); A. Archipenko; C. Milles; Cranbrook Acad. Art. **Exhibited:** AIC, 1939-42; MMA (AV), 1942; Oakland Art Gal., 1941; PAFA Ann., 1951, 1954 (prize), 1962, 1966; WMAA, 1953-73; Third Biennale, Sao Paulo, Brazil, 1955; Recent Sculpture USA, MoMA, 1959; Biennale, Middleheim Mus., Antwerp, Belgium, 1971; M. Knoedler, NYC, 1970s. Awards: honor award, Am. Inst. Architects, 1959; Ford Foundation Purchase Prize,

Krannert Art Mus., 1963; outstanding achievement award, Univ. Michigan, 1967. **Work:** MoMA; WMAA; Illinois State Mus.; Mus. Science & Industry, Strauss Mem. Center, both in Chicago; Middleheim Mus., Antwerp, Belgium; Israel Mus., Jerusalem; Albright-Knox Art Gallery, Buffalo. Commissions: USPO, Nokomis, IL; Cube, Alamo, New York, 1966; Large Cube, Univ. Michigan, Ann Arbor, 1968; bronze disk, Rondo, NYPL, 1969; Sun Disk, Financial Center Pacific, Honolulu, 1971; Pedestrian Plaza Sculpture, New York, 1972. **Comments:** Preferred media: metal. **Sources:** WW73; WW47; "Bernard Rosenthal," *Life* (1952); Gibson Danes, "Bernard Rosenthal," *Art Int.* (1968); Sam Hunter, *Rosenthal: Sculptures* (1968); Falk, *Exh. Record Series.*

ROSENTHAL, Charles *[Sculptor] mid 20th c.*
Exhibited: P&S of Los Angeles, 1938. **Sources:** Hughes, *Artists in California,* 480.

ROSENTHAL, Claire *[Painter] mid 20th c.*
Addresses: NYC. **Studied:** ASL. **Exhibited:** Salons of Am., 1934; S. Indp. A., 1934. **Sources:** Falk, *Exhibition Record Series.*

ROSENTHAL, David *[Painter, etcher, lecturer] b.1876, Cincinnati / d.1949.*
Addresses: Cincinnati, OH. **Studied:** Cincinnati Acad. A.; F. Duveneck; Meakin; Sharp; Nowotney; Azbe; G. Flad; Acad., Munich; Belle Arti, Rome. **Exhibited:** AIC; CM; Künstler Verein, Munich. **Sources:** WW47.

ROSENTHAL, Doris Patty (Mrs. Jack Charash)
[Painter, lithographer, designer, teacher] b.1889, Riverside, CA / d.1971, Oaxaca, Mexico.
Addresses: NYC; Oaxaca, Mexico. **Studied:** Teachers Col., Los Angeles, CA; Columbia Univ., 1912-13; ASL, 1918-19, with George Bellows, John Sloan; 1920-21 in Europe. **Member:** Am. Soc. PS & G; Am. Artists Congress. **Exhibited:** S. Indp. A., 1918, 1921-22, 1924-25, 1930-31, 1933, 1936, 1940-42; WMAA, 1925-46; Corcoran Gal biennials, 1930-53 (9 times); Salons of Am.; Northwest Printmakers (prize); Mus. Mod. Art, Paris, 1938; PAFA, 15 annuals, 1934-66; WMA; VMFA; RISD; Dallas MFA; GGE, 1939; AIC, 16 annuals, 1930-44; Latin America Traveling Exh.; MMA; Dayton AI; Collectors Gal., Chicago, 1961; St. Augustine AA, 1961; NAD, approx. 7 annuals, 1942-52 (Thomas B. Clark Prize),1965 (solo); Slater Mem. Mus. (solo); Midtown Gal., 1965 (solo). Awards: Guggenheim Fellowship, 1932, 1936; Am. Acad. Arts & Letters, grant, 1952. **Work:** MMA; AGAA; MoMA; Colorado Springs FA Center; Rochester Mem. Art Gal.; TMA; Univ. Arizona; LOC; San Diego FA Gal.; Davenport Mun. Art Gal.; Cranbrook Acad. Art; Encyclopaedia Britannica; "50 Prints of the Year", 1932. **Comments:** Specialty: Mexican Indians. Received a grant to paint in Mexico in 1931. Teaching: Teachers College and Monroe High School, both NYC; Columbia Univ. summer school. Contributed illustrations to *Life; The New Yorker; Art News,* other magazines. Author: *The Prim-Art Series.* Some previous sources had given her birthyear as 1895; more recent ones have corrected the date to 1889 (Falk, Marlor, White). **Sources:** WW66; WW47; Hughes, *Artists in California,* 480; P&H Samuels, 409; Falk, *Exh. Record Series.*

ROSENTHAL, Edward Toby See: **ROSENTHAL, Toby (Tobias) E. (Edward)**

ROSENTHAL, Gertrude *[Art historian, art administrator, writer] b.1903, Mayen, Germany / d.1989.*
Addresses: Baltimore, MD. **Studied:** Univ. Paris, 1925-26; Univ. Cologne & Univ. Bonn, Ph.D.(magna cum laude), 1932, with A.E. Brinckmann; (hon. L.HD.), Goucher Col., 1968; (hon. D.F.A.), Md. Inst. Baltimore Col. Art, 1968. **Member:** Am. Assn. Mus.; Col. Art Assn. Am.; MoMA; Walters Art Gal.; BMA. **Exhibited:** Awards: Nat. Found. Arts res. grant Am. & Ger. Romantic 19th-century painting, 1968; studies in hon. of G. Rosenthal, 1968 & 1972. **Comments:** Positions: res. asst., Courtauld Inst., Univ. London, 1939-40; art librn., Gourcher Col., Baltimore, 1940-45; from cu.r to chief cur., BMA, 1945-69, emer. chief cur., 1969-; ed. *Baltimore Mus. News,* 1959-63; consult., Western Col. Honolulu Acad. Arts, 1972-. Teaching: vis. prof., Johns Hopkins Univ.,

1948-50, vis. lectr., 1952-53. Collections arranged: Bacchiacca & His Friends, 1960, Four Paris Painters--Manet, Degas, Morisot & Mary Cassatt, 1962, Baltimore Mus. Art; Nineteen Hundred Fourteen, 1964, From El Greco To Pollock, Early & Late Works by Am. & Europ. Artists, 1968; Cone Collection, Mary Frick Jacobs Collection, Daingerfield Collection, & Wurtzburger Primitive Art Collection. Research: European and American art from the sixteenth century to 1965. Publications: auth., "French Sculpture in the Beginning of the 18th Century," 1933; articles on Gauguin, 1952, Matisse, 1956 & German Expressionism, 1957, *Baltimore Mus. News;* ed., Biennale Venezia 1960, Stati Uniti d'America, 1960; auth. & ed., "Four Paris Painters," 1962, "Nineteen Fourteen," 1964 & "From El Greco to Pollock, early and late works by European and American artists," 1968; auth. & ed., "Annual II, studies on Thomas Cole," BMA, 1968. **Sources:** WW73; WW47, puts date of birth at 1906.

ROSENTHAL, Jane P. *[Museum curator] 20th c.*
Addresses: Brooklyn, NY. **Comments:** Position: curator, Primitive Art, Brooklyn Museum of Art. **Sources:** WW66.

ROSENTHAL, Louis Chatel *[Sculptor] b.1888, Russia / d.1964, Baltimore, MD.*
Addresses: Baltimore, MD. **Studied:** Maryland Inst.; & with Ephraim Keyser. **Member:** NSS; Royal Soc. Min. P. S. & Gr., London; Charcoal Cl., Balt. **Exhibited:** CPLH, 1929; Phila. A. All., 1930; BMA, 1923; Royal Soc. Min. P. S. & Gr., London. **Sources:** WW53; WW47.

ROSENTHAL, Louis N. *[Lithographer and miniaturist] mid 19th c.; b.Turck, Russian Poland.*
Addresses: Came to U.S. c. 1850 and settled in Philadelphia; spent last years in Chicago. **Comments:** Sent at age 13 to a rabbinical school in Berlin. Active in Philadelphia, with his brother Max and later Morris and Simon (see entries on each), as a lithographer, printer, and publisher until about 1875. He was one of the pioneers in chromo-lithography in America, advertising his firm's services in that process and zincography by 1852. In later life he also painted some miniatures. His last years were spent in Chicago. **Sources:** G&W; Peters, *America on Stone;* Waite, "Beginnings of American Color Printing"; Phila. CD 1852-60+; 8 Census (1860), Pa., LII, 910. More recently, see Reps, 35, and cat. nos. 659 and 3487.

ROSENTHAL, Martin *[Painter] b.1899, Woburn, MA / d.1974.*
Addresses: NYC. **Studied:** ASL, with John Sloan, Robert Henri, George Luks, Boardman Robinson. **Exhibited:** BM; Springfield Mus. A.; S. Indp. A., 1938; Riverside Mus.; Contemporary A. Gal.; ACA Gal.; Morton Gal.; Montross Gal. (solo); Newark Mus.,1938. **Sources:** WW53; WW47.

ROSENTHAL, Max *[Lithographer, etcher, mezzotint engraver, and portrait painter] b.1833, Turck, Russian Poland / d.1918, Philadelphia, PA.*
Addresses: Emigrated to U.S. In 1849 or 1850, settled in Philadelphia. **Studied:** Lithography under Martin Thurwanger in Paris, c. 1846 (age 13); Carl Harmich, in Berlin; Schussele, in Phila. **Exhibited:** PAFA Ann., 1860, 1867, 1878, 1885-92; Paris Salon, 1891; St. Louis Expo, 1904 (med). **Work:** more than 500 portraits (prints) made with his son Albert, Smithsonian; CMA. He was also an artist who followed the Army of the Potomac, making sketches for the U.S. Military Commission. **Comments:** Active as a lithographer in Philadelphia until his retirement in 1884, working during much of that time with his older brothers Louis N., Morris, and Simon Rosenthal (see entries on each). After his retirement from business, Rosenthal devoted himself to teaching, mezzotint engraving, and oil painting. Best known for a series of over 500 portraits--etchings, lithographs, and mezzotints--executed in collaboration with his son Albert (see entry). **Sources:** G&W; Peters, *America on Stone;* Stauffer; Phila. CD 1852-60+; *Art Annual,* XV, obit.; *Artists Year Book;* Rutledge, PA; 8 Census (1860), Pa., LIX, 492. Bibliography: WW17; Fink, *American Art at the Nineteenth-Century Paris Salons,* 386; Falk,

Exh. Record Series.

ROSENTHAL, Maxine *[Painter] mid 20th c.*
Addresses: NYC, 1929. **Exhibited:** S. Indp. A., 1929; AIC, 1932; PAFA Ann., 1934. **Sources:** Falk, *Exh. Record Series.*

ROSENTHAL, Michael *[Painter] b.1888, Russia / d.1942, NYC.*
Addresses: Brooklyn, NY. **Studied:** R. Henri. **Member:** Indp. Art Soc. **Exhibited:** S. Indp. A., 1917-32, 1934; Montross Gal., NY, 1938. **Sources:** WW40.

ROSENTHAL, Mildred *[Painter, teacher, writer, lecturer] b.1890, Panama / d.1976, Mill Valley, CA.*
Addresses: San Francisco, CA. **Studied:** Cal. Sch. FA. **Member:** San F. AA; San F. Women A. **Exhibited:** Calif. State Fair, 1932; SFMA, 1935, 1939 (solo); San Fran. AA, 1936 (prize). **Sources:** WW53; WW47. More recently, see Hughes, *Artists in California,* 480.

ROSENTHAL, Morris *[Lithographer] mid 19th c.; b.Turck, Russian Poland.*
Addresses: Emigrated to U.S. in the late 1850's, settled in Philadelphia. **Studied:** apprenticed with a lithographer in London. **Comments:** Active with his brothers Louis, Max, and Simon (see entry) in Philadelphia for several years around 1860. Later abandoned lithography. **Sources:** G&W; Peters, *America on Stone.*

ROSENTHAL, Nan *[Writer, associate editor] b.1937, NYC.*
Addresses: NYC. **Studied:** Sarah Lawrence Col. (B.A.); Smith Col. **Comments:** Contributor articles to *Art in America, Show Magazine, N.Y. Herald Tribune, London Observer,* and others. Positions: assoc. ed., *Art in America,* 1964-; art ed., *Show Magazine,* Feb. 1962-Apr. 1964; reporter, *London Evening Standard,* Aug.-Dec., 1961; *NY Post,* Aug. 1960-61. **Sources:** WW66.

ROSENTHAL, Rena *[Decorator, designer] mid 20th c.*
Addresses: NYC. **Exhibited:** Mus. Mod. A., Wash., DC, 1939. **Comments:** Specialties: furniture, interior dec. **Sources:** WW40.

ROSENTHAL, R(udolph) (Mrs.) *[Painter] early 20th c.*
Addresses: NYC. **Exhibited:** S. Indp. A., 1918. **Sources:** Marlor, *Soc. Indp. Artists.*

ROSENTHAL, Seymour Joseph *[Painter] b.1914, NYC.*
Addresses: Flushing, NY. **Member:** AEA; Comt. Arts & Lit. & Lit. In Jewish Life, Jewish Fedn. Philanthropies. **Exhibited:** Civil Rights Art Show, Brooklyn Mus., 1962; solo shows, Herzl Inst., 1964, Suffolk Mus., 1968 & ACA Gal., NYC, 1969, 1970s; Major Drawings of 19th & 20th Century Exhib., 1964-65 & Art Dealers Choice Exhib., 1967, Gal. Mod. Art, NYC; Indianapolis Mus. Art, 1972; Associated American Artists, NYC, 1970s; ACA Gal., NYC, 1970s Awards: St. Gauden's Medal, Benjamin Franklin High Sch., 1939. **Work:** 39 lithographs, MMA Permanent Collection; Herron Mus. Art, Indianapolis, Ind.; Suffolk Mus., Stony Brook, NY; Technion Bldg., Haifa, Israel; Harry S. Truman Libr., Independence, Mo. Commissions: drawings of children, New York Bd. Educ., 1957; painting of Moses, Borough Pres., Queens, NY, 1962. **Comments:** Preferred media: watercolors, oils, tempera, lithography. Publications: illusr., *Parke Davis Med. J.,* 1956 & *Scope,* 1956; contribr., *Commonweal,* Vol. 1990, No. 1915. **Sources:** WW73; Jeanne Paris, "Artist has a great future," *Long Island Press* (1966); Edwin Newman, Today Show, NBC TV, 1970; Theo Metzger, "Directions," ABC TV, 1971.

ROSENTHAL, Simon *[Lithographer] mid 19th c.; b.Turck, Russian Poland.*
Addresses: Emigrated to U.S. in the late 1850's, settled in Philadelphia. **Studied:** apprenticed with a lithographer in London from the age of 13. **Comments:** Brother of Louis N., Max and Morris Rosenthal (see entries). Simon was for a number of years associated with his brothers in lithography at Philadelphia. Later gave up lithography. **Sources:** G&W; Peters, *America on Stone;* Phila. CD 1857-60+.

ROSENTHAL, Sophie *[Sculptor] 20th c.*
Addresses: NYC. **Sources:** WW15.

ROSENTHAL, Stephen *[Painter] b.1928, Richmond, VA.*
Addresses: NYC. **Studied:** ASL, with Edwin Dickinson; Tyler Sch. Fine Arts, Phila., Pa, with Boris Blai & BFA, 1960. **Exhibited:** Am. Acad. Arts & Lett., NYC, 1963; PAFA Ann., 1964; Amon Carter Mus., Fort Worth, Tex., 1964; Int. Watercolor Biennial, Brooklyn Mus., NY, 1965; Herron Inst., Indianapolis, Ind., 1967; 55 Mercer, NYC, 1970s. **Awards:** Mason Lord prize, BMA, 1967. **Work:** Arts Cl. Chicago, Ill.; Yale Univ. A. Gal., New Haven, Conn.; Art Fund, NY. **Comments:** Preferred media: tempera. **Positions:** bk. reviewer, *Arts Mag.*, New York, 1971-72. **Teaching:** Instr design, Cooper Union, New York, 1966-1967; lectr. painting, Univ. NC, Greensboro, 1971-72. **Sources:** WW73; Raymond Charmet, "Un jeune Americain," *Arts* (1966); Leach Levy, *The Drawn Line in Painting* (Parker St 470, 1971); Falk, *Exh. Record Series.*

ROSENTHAL, Toby (Tobias) E. (Edward) *[Portrait and historical genre painter] b.1848, New Haven, CT / d.1917, Munich, Germany.*
Addresses: San Francisco, CA; Munich, Germany. **Studied:** H. Bacon and F. Arriola, in San Fran., c.1864; Munich Acad., with Straehuber, C. Raupp, C. von Piloty, 1865. **Exhibited:** Mechanics Inst., San Francisco, 1864, 1885; NAD, 1875; San Francisco AA, 1875; galleries in San Francisco, 1875, 1878, 1884-85, 1895; Munich Expo (gold); Centennial Expo, Phila., 1876 (gold medal); Paris Salon, 1882, 1885; CPLH, 1939. **Awards:** Bavarian Order of St. Michael. **Work:** AIC; de Young Mus.; CPLH; Oakland Mus.; Mus., Leipzig, Germany; Univ. Illinois. **Comments:** Rosenthal was a popular American expatriate portrait painter in Europe. The son of a German immigrant from Strassburg, West Prussia, he was apparently born in Connecticut but grew up in San Francisco. In 1865, he went to Germany for further studies, married a German girl, and stayed for the rest of his life, returning to San Francisco for extended visits to exhibit and sell his works. In 1875, his most famous work, "Elaine" (inspired by a Tennyson poem) was exhibited in a San Francisco gallery, and was stolen, then recovered. **Sources:** WW17; Benezit; Thieme-Becker; Fink, *American Art at the Nineteenth-Century Paris Salons,* 386 (cites birthplace as San Francisco); Hughes, *Artists in California,* 480. According to Hughes, Rosenthal was born in Strassburg, West Prussia, and was brought to the U.S. by his family in 1853.

ROSENTHAL, William *[Sculptor] b.1882, Russia / d.1958, Bayville, LI, NY.*
Addresses: NYC. **Exhibited:** S. Indp. A., 1943-44. **Sources:** Marlor, *Soc. Indp. Artists.*

ROSENWALD, Barbara K *[Collector] b.1924, Norfolk, VA.*
Addresses: Bucks County, PA. **Studied:** BMFA; Fogg Mus., Harvard Univ.; Stella Elkins Tyler Sch. Fine Arts; also in Paris, France & Florence, Italy. **Comments:** Collection: modern Italian art, including works by Afro, Campigli, Moscha; French modern art, including works by Pignon and others. **Sources:** WW73.

ROSENWALD, Lessing Julius *[Collector, patron] b.1891, Chicago, IL / d.1979.*
Addresses: Jenkintown, PA. **Studied:** Cornell Univ.; Univ. Pa. (hon. D.H.L.); Lincoln Univ. (hon. D.H.L.); Jefferson Med. Col. (hon. L.L.D.). **Member:** Grolier Cl., NY; Benjamin Franklin fel. Royal Soc. Arts, Eng.; Print Coun. Am. **Exhibited:** Awards: Phila. Award, AEA, 1961; distinguished achievement award, Phila. A. All., 1963. **Comments:** Positions: hon. mem. bd. gov., Phila. Mus. Art; former trustee, Free Libr. Phila.; trustee, Rosenbach Found., Phila.; assoc., Blake Trust, London; trustee & benefactor, Nat. Gal. Art; benefactor, LOC; hon. mem., Inst. Advan. Study, PMA. Collection: prints, drawings, miniatures & rare illustrated books, including, *Fior di Virtu 1491* and *The Nineteenth Book.* **Sources:** WW73.

ROSENWALD, Robert *[Sculptor] mid 20th c.*
Addresses: NYC, 1954-58. **Exhibited:** WMAA, 1954-58. **Sources:** Falk, *WMAA.*

ROSENZWEIG, Irving *[Painter] b.1915.*
Addresses: Freeport, NY, 1967. **Exhibited:** WMAA, 1967. **Sources:** Falk, *WMAA.*

ROSENZWEIG, Lippa *[Sculptor] mid 20th c.*
Addresses: Phila., PA. **Exhibited:** PAFA Ann., 1926-27. **Sources:** Falk, *Exh. Record Series.*

ROSENZWEIG, Martin *[Painter] mid 20th c.*
Addresses: Chicago area. **Exhibited:** AIC, 1951. **Sources:** Falk, *AIC.*

ROSENZWEY, Paul *[Painter] late 19th c.*
Addresses: Phila., PA. **Exhibited:** PAFA Ann., 1877, 1881-90. **Sources:** WW17; Falk, *Exh. Record Series.*

ROSEVEAR, Kenneth *[Painter] mid 20th c.*
Exhibited: S. Indp. A., 1937. **Sources:** Marlor, *Soc. Indp. Artists.*

ROSEY, Alexander P. (Abraham Rosenstein) *[Sculptor] b.1890, Baltimore, MD.*
Addresses: NYC. **Studied:** NAD; BAID. **Exhibited:** NAD (med); BAID (med); PAFA; AV; CGA; BMA. **Sources:** WW53; WW47.

ROSHER, Frederick Woods *[Sculptor, painter] mid 20th c.*
Addresses: San Francisco, CA, 1926-35. **Exhibited:** Salons of Am.; SFMA, 1935. **Sources:** Hughes, *Artists in California,* 480.

ROSIENKIEWICZ, Martin *[Artist and teacher] mid 19th c.*
Addresses: Cincinnati, 1846-50. **Sources:** G&W; Cincinnati CD 1846-50.

ROSIER, George W. *[Painter] mid 20th c.*
Addresses: Chicago area. **Exhibited:** AIC, 1930-32, 1935, S. Indp. A., 1936. **Sources:** Falk, *AIC.*

ROSIN, Harry *[Sculptor, educator] b.1897, Phila., PA / d.1973.*
Addresses: Phila., PA; NYC; New Hope, PA. **Studied:** PMSchIA; PAFA; also study in Paris. **Member:** A.N.A. **Exhibited:** PAFA Ann., 1934, 1938-68 (gold 1939); World's Fair, Chicago, 1934; Tex. Centenn., 1936; GGE, 1939; WFNY, 1939; AIC, 1934-46; WMAA, 1938, 1942; CI; Mod. Am. A., Paris, 1932; Salon de L'Ouvre Unique, Paris, 1932; PAFA (solo); World's Fairs, San Francisco, Chicago, New York & Dallas. **Awards:** Widener Gold Medal; Am. Acad. Arts & Lett. grant; Bouregy Prize, Audubon Artists. **Work:** PAFA; PMA; Papete, Tahiti; mem., Fairmont Park, Phila.; L'Eglise de Julien, Trinidad Commissions: Connie Mack, Philadelphia Stadium; JB Kelly & Quaker & Puritan, Schuykill River, Philadelphia; Deerfield Boy, Mass; four large stone reliefs, Westchester, Pa. Ct. House. **Comments:** Preferred media: bronze. **Teaching:** sr. instr. sculpture, PAFA, 1939-. **Sources:** WW73; WW47; Falk, *Exh. Record Series.*

ROSIN, T(heodore) L(avelle) *[Painter, craftsperson] b.1886, Wilmington.*
Addresses: Wilmington, DE. **Studied:** T. Anschutz; PAFA. **Member:** Wilmington Soc. FA. **Sources:** WW25.

ROSKILL, Mark Wentworth *[Art historian, art critic] b.1933, London, England.*
Addresses: Amherst, MA. **Studied:** Trinity Col., Cambridge, Eng. (B.A., 1956; M.A., 1961); Harvard Univ. (M.A., 1957); Courtald Inst., Univ. London, 1957; Princeton Univ. (M.F.A. & Ph.D., 1961). **Member:** Col. Art Assn. Am. **Exhibited:** Awards: Am. Coun. Learned Socs. fel., 1965-66. **Comments:** Teaching: instr. & asst., Princeton Univ., 1959-61; from instr. to asst. prof., Harvard Univ., 1961-68; assoc. prof., Univ. Mass., Amherst, 1968- . Research: 19th- and 20th-century art; criticism; methodology of art history. Publications: auth., "English Painting from 1500 to 1865;" ed., "The Letters of Vincent Van Gogh," 1963; auth., "Dolece's Aretino and Venetian Art Theory of the Cinquecento," 1968; auth., "Van Gogh, Gauguin and the Impressionist Circle," 1970; contribr., "Atlantic Brief Lives," 1971. **Sources:** WW73.

ROSMER, Leo *[Painter] b.1905, Vienna, Austria.*
Addresses: NYC. **Studied:** Kunstgewerbe Sch., Vienna; Master Sch. Monumental Tech., Munich. **Exhibited:** Montross Gal., NY;

New Sch. Soc. Res.; Salons of Am.; watercolor, PAFA, 1938. **Sources:** WW40.

ROSNER, Bella *[Painter] mid 20th c.*
Addresses: Chicago area. **Exhibited:** AIC, 1942. **Sources:** Falk, *AIC.*

ROSNER, Charles *[Marine painter] b.1894, Germany / d.1975, Bellport, NY.*
Work: Mystic Seaport Mus. **Comments:** A sailor in his youth (1910-1915), he spent several years in Argentina, Chile, and Europe. He worked from photographs, and many of his works were later reproduced as chromolithograhs. **Sources:** Brewington, 331.

ROSOFSKY, Seymour *[Painter] b.1924, Chicago, IL.*
Addresses: Chicago, IL. **Studied:** AIC (B.F.A., 1949, M.F.A., 1950). **Member:** Alumni Assn. AIC. **Exhibited:** AIC; Mythology in our Time, Bologna, Italy, 1966; Fantasy & Figure, Am. Fedn. Arts Touring Exhib., 1968-69; Human Concern & Personal Torment, WMAA, 1969; Chemin de la Creation, France, 1970; Tamarind Touring Exhib., US &S. Am., 1970; Galerie du Dragon, Paris, France, 1970s; Graphics Gal;, San Francisco, CA, 1970s; plus many solo shows in US & Europe. Awards: Fulbright award, 1958-59; Guggenheim fel, 1962-63, 1963-64; Tamarind fel., 1968. **Work:** MoMA; AIC; LACMA; BM; Pasadena Mus. **Comments:** Preferred media: oils, watercolors, pastels. Teaching: prof. art, City Cols. Chicago, 1953-on. **Sources:** WW73.

ROSOL, John *[Cartoonist] b.1911, Phila.*
Addresses: Phila., PA. **Studied:** PMSchIA. **Comments:** Cartoonist: *Saturday Evening Post, Country Gentleman, Country Home, New York Journal.* **Sources:** WW40.

ROSRT, E. C. *[Painter] late 19th c.*
Exhibited: AIC, 1888. **Sources:** Falk, *AIC.*

ROSS, Adele *[Painter] early 20th c.*
Addresses: Chicago, IL. **Exhibited:** AIC, 1902. **Sources:** WW04.

ROSS, Alexander *[Painter, illustrator] b.1908, Dunfermline, Scotland / d.1990.*
Addresses: Ridgefield, CT. **Studied:** Carnegie Inst Technol, with R.Lepper; Boston Col. (hon. M.A.). **Member:** NAD; CAFA; AWS; Silvermine Guild Artists; Conn. Watercolor Soc.; SI. **Exhibited:** A. Dir. Cl., 1941, 1943, 1945-46; Contemporary Am. Illus., 1946; Los Angeles Co Fair, 1960 (First prize Popular Opinion Award); AWCS, Royal Soc Painters, London, 1966; New Canaan Ann., 1967 (Thomas Saxe Found Award); 200 Yrs. Watercolor, MMA ,1967; 18th Ann. New Eng. Exhib., Silvermine Guild, CT, 1968; Landscape One, De Cordova Mus., Lincoln, Mass., 1970; Spring Rebirth, S. New Eng. Invitational, Fairfield Univ., CT, 1970; NAD,1972 (Adolf & Cedar Obrig Award); Collectors Gal., Nashville, TN, 1970s; Joe Demers, Hilton Head Island, SC, 1970s. **Work:** New Britain Mus., CT; Waterbury Mus., CT; US Air Force Coll., Denver, Colo.; Am. Acad. Design, NYC; Mormon Church. Commissions: many portrait comns., by pvt. individuals & major Am. publ. **Comments:** Preferred media: watercolors, acrylics, oils. Positions: mem. art comt., Fairfield Univ., 1969-. Teaching: lectr. creative painting, Cath. Univ. Am., summer 1954. Publications: illus.: "With Rifle and Plow," 1938, "Council Fires," 1940; illusr., covers, *Good Housekeeping,* 1942-54, *Sat. Eve. Post,* 1943-50, *Cosmopolitan,* 1944-60, *Ladies Home J.,*1945-60 & *McCalls,* 1945-60; auth., "How I Use Watercolor," *Am. Artists,* 1962 & New Directions in Watercolor (film), Electrographic Corp., 1971. **Sources:** WW73; Robert Ulrich Godsoe, "Alex Ross: reluctant Prophet," *Esquire* (1948).

ROSS, Alvin *[Painter, educator] b.1920, Vineland, NJ / d.1975.*
Addresses: NYC. **Studied:** Tyler Sch. Fine Arts, Temple Univ. (B.F.A. & B.S.Ed., 1944); Barnes Found.; Acad. Belle Arti, Florence; also with Louis Bouche, Franklin Watkins, Earl Horter, Peggy Bacon, and Furman J. Finck. **Exhibited:** AIC, 1961; Am Acad Arts & Let., 1962; Butler Inst. Am. Art, 1970; Nat'l Arts Cl., 1970 (bronze medal for painting); NAD, 1972; NIAL, 1972.

Work: Minneapolis Inst. Arts; La Jolla Art Ctr.; New York Hilton Coll.; Univ. Nebr. **Comments:** Realist figurative painter in oils. Active in Provincetown, MA, 1950-75. Teaching: prof. hist. art & chmn. dept., Pratt Inst., 1952-on. **Sources:** WW73; Provincetown Painters, 268.

ROSS, Andrew *[Painter, photographer] b.c.1835, Bavaria, Germany / d.1896, New Orleans, LA.*
Sources: *Encyclopaedia of New Orleans Artists, 332.*

ROSS, Barbara Ellis (Mrs. Robert T.) *[Painter] b.1909, Deadwood, SD.*
Addresses: Lincoln, NE. **Studied:** Univ. Nebraska. **Member:** Art Assn. Rental Gal. **Exhibited:** IBM (med.); WFNY, 1939; SFMA, 1944; NAWA, 1945; Pasadena AI, 1946; CI; Lincoln, Nebr.; Omaha, Nebr.; Wichita, KS. **Sources:** WW59; WW47.

ROSS, C. B. *[Painter] mid 20th c.*
Exhibited: S. Indp. A., 1942. **Comments:** Possibly Ross, Constantino B. **Sources:** Marlor, *Soc. Indp. Artists.*

ROSS, C. Chandler *[Portrait painter] d.1952.*
Addresses: Ridgefield, CT. **Studied:** Académie Julian, Paris; Italy; Germany. **Work:** floral paintings reproduced and published by N.Y. Graphic Soc. **Comments:** Painted portraits of many prominent persons. **Sources:** WW47.

ROSS, Campbell *[Painter] early 20th c.*
Exhibited: WMAA, 1924. **Sources:** Falk, *WMAA.*

ROSS, Charles *[Sculptor] b.1937, Philadelphia, PA.*
Addresses: NYC. **Studied:** Univ. Calif. (A.B., 1960, M.A., 1962). **Exhibited:** Directions I: Options 1968, Milwaukee Art Ctr., 1968; Prospect '1968, Düsseldorf, 1968; Made of Plastic, Flint Inst., 1968; Univ. Pa., 1969; WMAA Sculpture Ann., 1969. Awards: James D. Phelan traveling scholar, Univ. Calif., 1962. **Work:** William Rockhill Nelson Gal. Art, Kansas City, Mo.; WMAA. **Comments:** Positions: co-dir. & collabr., Dancers Workshop Co., San Fran., 1964-66. Teaching: instr., Univ. Calif., 1962; instr., Cornell Univ., 1964; instr., Univ. Calif., 1965; artist-in-residence, Univ. Ky., 1965; instr., Sch. Visual Arts, New York, 1967; instr., Herbert Lehman Col., 1968. **Sources:** WW73; Tracy Atkinson, *Directions I; Options 1968* (Milwaukee Art Ctr., 1968).

ROSS, Charles *[Lithographer] b.c.1840, Pennsylvania.*
Addresses: Philadelphia in 1860. **Sources:** G&W; 8 Census (1860), Pa., LIV, 1051.

ROSS, Charles B. *[Landscape painter, portrait painter] b.1878, Chicago / d.1933, Port Washington, NY.*
Studied: ASL, 1896; Chase Sch.; AIC. **Comments:** Known as an editor and advisor to the commercial art world.

ROSS, Conrad Harold *[Printmaker, educator] b.1931, Chicago, IL.*
Addresses: Auburn, AL. **Studied:** Univ. Ill. (B.F.A., 1953); Univ. Chicago, 1954; Univ. Iowa (M.F.A., 1959). **Member:** Print Coun. Am.; Southern Graphic Arts Circle; Col. Art Assn. Am.; Phila. Print Cl.; Nat. Art Workers Community. **Exhibited:** The Artist Chooses Contemporary Art, Ackland Art Mus., Univ. NC, Chapel Hill, 1968; Drawing Nat., San Fran. Mus. Art, Calif., 1970; Second Ann. Exp. in Art & Technol Exhib., High Mus., Atlanta, Ga., 1970; The Henderson Series--Prints, Drawings Constructions, Birmingham-Southern Art Gal., Ala., 1971; Seventh Dulin Nat. Print & Drawing Competition, Knoxville, Tenn., 1971. Awards: Tiffany Found. grant printmaking, 1960; Auburn Univ. res grant-in-aid, 1965-67; purchase award, Prints & Drawings, Jacksonville, Fla, 1966. **Work:** LOC; Springfield Art Mus., Mo.; Norfolk Mus. Arts & Sci., Va.; Dallas Mus. Fine Arts, Tex.; Okla. Printmakers Soc., Oklahoma City. **Comments:** Preferred media: collage intaglio. Publications: contribr., *Artists' Proof*the annual of prints and printmaking, 1970. Teaching: instr. drawing, design, lettering & art appreciation, Louisiana Polytech Inst., 1961-63; asst. prof. drawing & printmaking, Auburn Univ., 1963-; vis. lectr. drawing & printmaking, Kans. Univ., 1968. **Sources:** WW73.

ROSS, Cornelia *[Painter] mid 20th c.*
Addresses: Pacific Palisades, CA. **Exhibited:** Artists Fiesta, Los Angeles, 1931. **Sources:** Hughes, *Artists in California*, 480.

ROSS, Dan C. *[Painter] 19th/20th c.*
Addresses: Spokane, WA. **Exhibited:** Seattle FA Soc., 1927; Spokane Soc. of Wash. Artists, 1928. **Sources:** Trip and Cook, *Washington State Art and Artists*.

ROSS, David P., Jr. *[Museum director, painter, sculptor] b.1908, St. Louis, MO.*
Addresses: Chicago, IL. **Studied:** AIC; Univ. Kansas; & with Bert Ray. **Exhibited:** St. Louis Pub. Lib., 1930; South Side Community A. Center, 1939, 1941; Barnett Aden Gal., 1940; AIC, 1941; Atlanta Univ., 1958. **Work:** Howard Univ.; Douglas Pub. Sch., Chicago. **Comments:** Lectures: "Influence of Contemporary Art." Position: exh. dir., South Side Community A. Center, 1939-42; dir., 1957-; South Side Community A. Center, Chicago, Ill.; instr. Int. Dec., Dunbar Vocational Sch., Chicago, 1951-52. **Sources:** WW59; WW47.

ROSS, Denman W(aldo) *[Painter, writer, lecturer, teacher] b.1853, Cincinnati, OH / d.1935, London, England.*
Addresses: Cambridge, MA. **Studied:** Académie Julian, Paris, 1876. **Member:** Copley S., 1892; Boston SAC; AFA; Boston S. Arch.; Arch. C.; F., Am. Acad. A. & Sc., 1885; India Soc., London. **Exhibited:** S. Indp. A., 1917. **Comments:** Position: L., Harvard, since 1899. Trustee: BMFA, to which he made gifts of more than 20,000 objects, including sculpture, painting, porcelains, ivories, and jewels. Founder: Ross Study Series at FMA, giving thousands of specimens that illustrated the history of design and technique. His collection of Peruvian textiles was given to the Peabody Mus. Nat. Hist., in Cambridge. Author: "A Theory of Pure Design" (1907), "On Drawing and Painting" (1912), "The Painter's Palette" (1919). **Sources:** WW31.

ROSS, Edward *[Painter] b.1926.*
Addresses: Roswell, GA, 1975. **Exhibited:** WMAA, 1975. **Sources:** Falk, *WMAA*.

ROSS, Elizabeth M. *[Painter] early 20th c.*
Exhibited: AIC, 1920. **Sources:** Falk, *AIC*.

ROSS, Ellen Marston *[Painter, teacher] mid 20th c.*
Addresses: Shippenburg, PA and Ogunquit, ME. **Studied:** Chas. H. Woodbury, Ogunquit Sch. **Comments:** Position: Listed 1930 and 1939 Woodbury Summer School brochure as "faculty;" hd., art dept., State Teachers' Col., Shippenburg, PA. Married to fellow Ogunquit faculty member, George K. Ross. **Sources:** *Charles Woodbury and His Students*.

ROSS, Eva M. *[Painter] mid 20th c.*
Addresses: NYC. **Exhibited:** PAFA Ann., 1964. **Sources:** WW15; Falk, *Exh. Record Series*.

ROSS, Frank *[Painter] mid 20th c.*
Addresses: Jackson Hts., NY. **Exhibited:** PAFA Ann., 1946. **Sources:** Falk, *Exh. Record Series*.

ROSS, Frederick Webb *[Painter] 20th c.*
Addresses: Indianapolis, IN. **Sources:** WW15.

ROSS, George Gates *[Portrait painter] b.1814, Springfield, NJ / d.1856, Newark, NJ.*
Addresses: Newark, NJ, active 1835-56. **Exhibited:** NAD (1839-43); Apollo Association. **Work:** Newark (NJ) Mus. **Comments:** Ross formed a partnership in Newark with the miniaturist John Alexander McDougall, offering patrons the chance to commission a large oil and a small watercolor portrait at the same time. He did not gain much popularity until about 1850, when his robust, unidealized portrait style brought him public attention. **Sources:** G&W; *Newarker* (April 1936), Newark *Daily Advertiser*, April 5, 1847, June 5, 1850, Dec. 3, 1852, Dec. 11, 1854, and obit., Aug. 18 and 19, 1856; Newark CD 1835-56; Cowdrey, NAD; Cowdrey, AA & AAU; *American Collector* (Jan. 1948), 6-7. More recently, see Gerdts, *Art Across America*, vol. 1: 231 (w/repro.).

ROSS, George K. *[Painter, teacher] b.1900 / d.1961.*
Addresses: Ogunquit, ME. **Studied:** Charles H. Woodbury, Ogunquit Sch. **Comments:** Positions: Woodbury School staff in 1934. (In 1939 Woodbury's Summer School became "Woodbury-Ross Summer School."); T., art education, New York Univ.; freelance commercial artist; contributor to professional magazines. Married to fellow Ogunquit teacher Ellen Marston Ross. **Sources:** *Charles Woodbury and His Students*.

ROSS, Gloria F. *[Designer] b.1923, NYC / d.1998, NYC.*
Studied: Mt. Holyoke College (B.A., 1943). **Work:** tapestrys of various artists' paintings in: MMA; BMFA; AIC; Denver AM; Textile Mus., Wash., DC. **Comments:** A tapestry maker who during the 1980s was the first to translate into wool famous paintings by Noland, Motherwell, Frankenthaler, Stella, Dubuffet, Nevelson, Youngerman, Bearden, and others. **Sources:** obit., *New York Times* (June 23, 1998).

ROSS, Gordon *[Illustrator] b.1873 / d.1946, NYC.*
Addresses: Montclair, NJ. **Sources:** WW21.

ROSS, Harry L. *[Painter] mid 20th c.*
Addresses: NYC?. **Exhibited:** PAFA Ann., 1919, 1933. **Sources:** Falk, *Exh. Record Series*.

ROSS, Henry C. *[Painter] mid 20th c.*
Addresses: Seattle, WA. **Studied:** Leon Derbyshire, Vanessa Helder, Paul Immel, Dorothy Rising. **Member:** Puget Sound Group of Northwest Painters, 1944. **Exhibited:** Vancouver, BC Art Mus.; Denver Art Mus.; SAM, 1945. **Sources:** Trip and Cook, *Washington State Art and Artists*.

ROSS, Henry W. *[Designer] late 19th c.*
Addresses: New Orleans, active 1885-88. **Sources:** *Encyclopaedia of New Orleans Artists*, 331.

ROSS, Herbert *[Painter] 20th c.*
Addresses: Pewee Valley, KY. **Sources:** WW25.

ROSS, Hilda Hatcher (Mrs. Homer) *[Painter] b.1885, Shenandoah, IA.*
Addresses: Shenandoah, IA. **Studied:** Gertrude Lloyd Mincer. **Exhibited:** Southwestern Iowa; Iowa Art Salon; Joslyn Mem., Omaha; Iowa Artists Exhibit, Mt. Vernon, 1938. **Sources:** Ness & Orwig, *Iowa Artists of the First Hundred Years*, 180.

ROSS, Isabel (Belle) M. *[Painter] late 20th c.; b.Buffalo, NY.*
Addresses: Buffalo, NY, 1890. **Studied:** ASL; Delecluse Acad., Paris; with Delance, Courtois, Rixens. **Exhibited:** Paris Salon, 1889, 1894, 1899; AIC; NAD, 1890; PAFA Ann., 1902-03. **Comments:** Also appears as Roos. **Sources:** WW24; Fink, *American Art at the Nineteenth-Century Paris Salons*, 386; Falk, *Exh. Record Series*.

ROSS, James *[Painter, architect] b.1871, Williamsburg, VA / d.1944, Yonkers, NY.*
Addresses: Yonkers, NY. **Studied:** Columbia Univ. Sch. Architecture. **Member:** Yonkers AA; Sketch Cl., NYC. **Exhibited:** Yonkers AA; S. Indp. A.; Westchester A. & Crafts Gld.; Matthew's Gal., Northvale, NJ, c.1985 (solo). **Work:** Hudson River Mus. **Comments:** An architect in the firm of Ross & McNeal (NYC), he was also an Impressionist painter in oils and watercolor. **Sources:** WW25.

ROSS, James Matthew *[Painter, educator] b.1931, Ann Arbor, MI.*
Addresses: Platteville, WI. **Studied:** Univ. Mich. (A.B.); Cranbrook Acad. Art (M.F.A.); Rockham Sch. Grad. Studies, Ann Arbor; Accad. Belle Arti, Rome. **Member:** Col. Art Assn. Am.; Wis. P&S Soc.; Am. Assn. Univ. Prof. **Exhibited:** Michigan Artists, 1951-60 & 1963; Detroit Inst. Art, 1959; PAFA Ann., 1960; Walker Art Ctr., 1959-60; Wis. Painters & Sculptors Ann., Milwaukee Art Ctr., 1963-65; Univ. Wis.-Whitewater, 1965. Awards: Fulbright grant painting to Italy, 1960 & 1961; prizes, Wis. Painters & Sculptors, 1963 & Mich. Fine Arts Exhib., 1964. **Work:** Butler Inst. Am. Art; Cranbrook Mus. Art; Detroit Inst. Art. **Comments:** Teaching: asst. prof. art, Univ. Wis.-Platteville,

1962-. **Sources:** WW73; Falk, *Exh. Record Series.*

ROSS, Jean G. *[Painter, instructor]* b.1925, Ridgewood, NJ. **Addresses:** Warren, NJ. **Studied:** Paterson State Teachers Col.; Park Col., MO. **Member:** AAPL; Somerset AA (vice-pres. activities). **Exhibited:** AAPL Grand Nat., NYC, 1969-72; Governor's Reception, Garden State AC, 1971 & 1972; Franklin Arts Council, Millstone, NJ, 1971 & 1972; AAUW, Bernardsville, NJ, 1971 & 1972; Suburban Artists Guild, Highland Park, NJ; The Carriage House, Mendham, NJ, 1970s. **Awards:** first prize for oils, 1971 & gold medal for oils, 1972, AAPL; first prize prof., Suburban Arts Council, 1971. **Comments:** Preferred media: oils. Teaching: instructor of oil painting, Ridgewood AA, NJ, 1961-66; instructor of oil painting, Somerset AA, Bernardsville, 1966-on. **Sources:** WW73.

ROSS, Jean I. *[Painter]* mid 20th c. **Addresses:** Lincoln Pk., MI. **Exhibited:** PAFA Ann., 1960. **Sources:** Falk, *Exh. Record Series.*

ROSS, John F. *[Painter]* mid 20th c. **Addresses:** Indianapolis, IN, 1954. **Exhibited:** PAFA Ann., 1954. **Sources:** Falk, *Exh. Record Series.*

ROSS, John T. *[Printmaker, educator]* b.1921, NYC. **Addresses:** Englewood, NJ. **Studied:** CUA Sch., graduated, 1948, with Morris Kantor & Will Barnet; New School Social Res., with Antonio Frasconi & Louis Schanker: Columbia Univ., 1953. **Member:** SAFA (pres., 1961-65; exec. council, 1965-); ANA; Boston Printmakers; Phila. Print Cl.; Am. Color Print Soc. **Exhibited:** Second Int. Color Print Exhib., Grenchen, Switz., 1961; Int. Biennale Gravure, Cracow, Poland, 1968; Prize-winning Am. Prints, Pratt Graphic Art Ctr., New York, 1968; Nat. Acad. Fine Arts, Amsterdam, Netherlands, 1968; Biennial Print Exhib., Calif. State Col., Long Beach, 1969; Assoc. Am. Artists, NYC, 1970s. **Awards:** Tiffany Foundation grant printmaking, 1954; Purchase Prize for 100 Prints of the Year, AAA Gal., 1963; citation for prof. achievement, CUA Sch., 1966. **Work:** Nat. Coll. Fine Arts, Wash., DC; Hirshhorn Coll.; MMA; LOC; Cincinnati AM. **Commissions:** ed. prints, Hilton Hotel, 1963, Assoc. Am. Artists, 1964, 1966 & 1972, Philadelphia Print Club, 1967, NY State Council Arts, 1967 & Int. Poetry Forum, 1968. **Comments:** Positions: dir., Art Center Northern NJ, 1966-67; pres., US Committee-Int. Assn. Art, 1967-69; chmn. advisory panel, CUA Sch., 1967-69. Publications: illustrator of many books; co-author, "The Complete Printmaker," Macmillan, 1972. Teaching: instructor, printmaking, New School Soc. Res., 1957-; instructor, printmaking, Pratt Graphic Center, 1963-; assoc. prof. art, Manhattanville College, 1964-; demonstrator & lecturer, U.S. Info. Agency Exhib., Romania & Yugoslavia, 1964-66. **Sources:** WW73; articles. *Am. Artist,* 1952; *Artists Proof,* 1964 & *Art in Am.,* 1965.

ROSS, Joseph B., Jr. *[Painter, educator]* b.1943, Wash., DC. **Studied:** Howard Univ. (B.A.); Univ. of Maryland. **Member:** Nat'l Conference of Artists; College AA; Wash., DC AA. **Exhibited:** Atlanta Univ., 1969; Black Printmaking Exh., 1969; Black Artists Exh., Chicago, 1970; WMAA, 1970-71; Univ. of Iowa, 1971-72; Ill. Bell Tel., traveling show, 1971-72; "Four Black Artists," Wash., DC, 1972. **Award:** Nat'l Soc. of Arts & Letters Grant, 1968-69. **Sources:** Cederholm, *Afro-American Artists.*

ROSS, Kenneth See: **ROSS, (Robert) Kenneth**

ROSS, L. Naramore *[Painter]* late 19th c. **Addresses:** NYC, 1883. **Exhibited:** NAD, 1883. **Sources:** Naylor, *NAD.*

ROSS, Leighton *[Painter]* b.1909, Gilroy, CA / d.1983, San Jose, CA. **Addresses:** San Jose, CA. **Studied:** Calif. Sch. of FA; Colorado Springs FA Center. **Member:** San Francisco AA. **Exhibited:** SFMA, 1935; San Francisco AA annuals, 1932-59; Oakland A. Gal., 1935. **Sources:** Hughes, *Artists in California,* 480.

ROSS, Louis *[Mural painter, painter, craftsperson, engraver]* b.1901, NYC / d.1963, NYC. **Addresses:** NYC. **Studied:** NAD; ASL, with Kenneth Hayes Miller, Boardman Robinson. **Member:** NSMP; Arch. Lg.; Soc. Designer-Craftsmen. **Exhibited:** Arch. Lg., 1941 (solo),1950; S. Indp. A., 1944; NSMP, 1956. **Work:** murals, Bellevue Hospital, NY; Manhattan Center; Am.-South African Steamship Lines; Pennsylvania Railroad; Moore-McCormack Lines; United States Lines; Panama Lines; Northwest Airlines; Fordham Univ. Lib.; Valley Hospital, Ridgewood, NJ; St. Luke's Episcopal Church, Evanston, IL; Stanvac Oil Co., NY; Nat. Lead Co., NY; Pfizer Intl., NY; Travelers Ins. Co., Hartford; Matson Lines; Chicago Western R.R.; Nestle Co., White Plains, NY; triptychs, Army & Navy Chapels; embellishments: Loyola Seminary; St. Anthony's Church, Boston; Temple Keneseth Israel, Allentown, Pa.; Central Synagogue, Rockville Centre; Temple Beth Sholom, Miami Beach; Temple Emanu-l, Lynbrook, LI; Temple Adas Israel, Passaic, NJ; mural panels, Northern Pacific Railroad; Canadian Pacific Railroad diners. **Comments:** Positions: treas., NSMP, NYC. **Sources:** WW59; WW47.

ROSS, Louise Pflasterer *[Sculptor]* b.1913, Cleveland. **Addresses:** Chicago, IL. **Studied:** Univ. Chicago. **Member:** United Am. Ar. **Exhibited:** United Am. Ar. Gal., Chicago. **Work:** Lowell Sch., Oak Park, Ill. **Sources:** WW40.

ROSS, M. (Miss) *[Painter]* mid 19th c. **Addresses:** Boston in 1836. **Exhibited:** Boston Athenaeum, 1836 ("Morning" and "Evening"). **Comments:** Address given as 16 Hancock Street, Boston. *Cf.* Miss -- Ross and E. Dalton. **Sources:** G&W; BA Cat., 1836; not listed in Boston CD 1835-37.

ROSS, Mabel *[Painter]* b.1906, Boston. **Addresses:** Springfield, MA. **Studied:** M. Huse. **Member:** Ar. Gld., Springfield; Springfield Art Lg. **Sources:** WW33.

ROSS, Marie Medora *[Craftsperson, painter, sketch artist]* b.c.1844, St. James Parish, LA / d.1920, New Orleans, LA. **Addresses:** New Orleans, active 1891-1906. **Studied:** Newcomb Col., 1885-87, 1889-93, 1895-97, 1901-1905. **Member:** Five or More Club, 1893. **Exhibited:** Tulane Hall, 1892-93; Artist's Assoc. of N.O., 1892, 1897. **Comments:** Member of the first Newcomb class of art pottery design. **Sources:** *Encyclopaedia of New Orleans Artists,* 332.

ROSS, Martha E. *[Painter]* late 19th c. **Exhibited:** AIC, 1899. **Sources:** Falk, *AIC.*

ROSS, Marvin Chauncey *[Museum curator, art historian]* b.1904, Moriches, NY. **Addresses:** Wash., DC. **Studied:** Harvard Univ. (A.B., A.M.); NY Univ.; Univ. Berlin; Centro de Estudios Historicos, Madrid, Spain. **Member:** Am. Assn. Mus.; Archaeol. Inst. Am.; Am. Ceramic Circle; English Ceramic Circle. **Comments:** Positions: cur. medieval art, Walters A. Gal., Baltimore, 1934-52; chief cur. art, LACMA, 1952-55; cur., Hillwood (art collection of Mrs Merriweather Post), Wash., DC, 1959-. Publications: ed., "The West of Alfred Miller," 1951 & 1967; ed., "George Catlin, Last Rambles with the Indians," 1959; auth., catalogue of the Byzantine antiquities in Dumbarton Oaks collection, 1962 & 1965; auth., "The art of Karl Faberge & His Contemporaries," 1965; auth., "Russian porcelains: Merriweather Post Collection," 1968. Collections arranged: Early Christian & Byzantine Art, Walters Art Gal., Baltimore, Md., 1947; Raoul Dufy, LACMA, 1953. **Sources:** WW73.

ROSS, Mary (Paxton) Herrick (Mrs.) *[Painter]* b.1856, San Fran., CA / d.1935, Piedmont, CA. **Addresses:** Oakland, CA. **Studied:** with her father; San Francisco School of Des. (first pupil). **Exhibited:** San Fran. Women's Dept., World's Columbian Expo., Chicago, 1893; Calif. Midwinter Int. Expo., 1894; Mark Hopkins Inst., 1897; Golden Gate Park Mus., 1916; San Fran. AA, 1917; San Fran. Art Inst., 1919; San Fran. Shriner's Convention, 1923. **Comments:** Specialty: floral still lifes. Her works are rare. **Sources:** WW17; Hughes, *Artists in*

California, 251.

ROSS, (Miss) *[Painter] early 19th c.*
Addresses: No address given during 1826 exhibition. **Exhibited:** PAFA, 1826 (a copy of Sir Joshua Reynolds' "Sleeping Girl"). **Comments:** *Cf.* Miss M. Ross and E. Dalton. **Sources:** G&W; PA Cat., 1826 (Her name does not appear in either of the indices of the catalogue, foreign or American artists); Rutledge/Falk, vol. 1, PA.

ROSS, (Mr. or Mrs.) *[Painter] mid 19th c.*
Addresses: NYC in 1835. **Exhibited:** NAD (1835: "View of Lanercost Priory, Cumberland, England"). **Comments:** Listed in the catalogue as Mrs. Ross and in the index as Mr. Ross; address given as 279 Pearl Street, NYC. **Sources:** G&W; Cowdrey, NAD; no Ross at this address in NYCD 1834-36.

ROSS, Pierre Sanford III *[Painter, lithographer] b.1907, Newark, NJ / d.1954, Rumsen, NJ?.*
Addresses: Rumson, NJ. **Member:** Am. Inst. Graphic Arts. **Exhibited:** WFNY, 1939; AFA Traveling Exh., 1940. **Work:** Fifty Prints of the Year, Newark Mus.; AGAA; SFMA; NYPL. **Comments:** Illustrator: *Fortune.* **Sources:** WW40.

ROSS, Raymond L. *[Painter] b.1880, Cattaraugus, NY.*
Addresses: Wash., DC. **Member:** Wash. WCC. **Exhibited:** Wash. WCC, 1913-44. **Sources:** WW40; McMahan, *Artists of Washington, DC.*

ROSS, Richard M. *[Painter] mid 20th c.*
Exhibited: AIC, 1938. **Sources:** Falk, *AIC.*

ROSS, Robert *[Portrait painter] b.c.1805 / d.1840, at sea.*
Addresses: New Orleans, 1830-40. **Studied:** Europe. **Comments:** Died of consumption while aboard a ship on route to New Orleans from Europe, where he had gone to study the fine arts. **Sources:** G&W; Delgado-WPA cites New Orleans CD 1830, 1832. More recently, see *Encyclopaedia of New Orleans Artists,* 332.

ROSS, (Robert) Kenneth *[Art administrator] b.1910, El Paso, TX.*
Addresses: Los Angeles, CA. **Studied:** Pasadena Jr. Col.; Chouinard Art Inst.; Art Ctr. Sch. Los Angeles; Nat. Acad., Florence, Italy; Acad. Grande Chaumière, Paris; Euton Rd. Drawing & Painting, London. **Member:** Jr. Arts Ctr. Los Angeles (bd. trustees); Munic. Art Patrons, Los Angeles. **Comments:** Positions: dir, Pasadena Art Inst., Calif.; dir., Mod. Inst. Art, Beverly Hills, Calif.; art critic, *Pasadena Star News;* art critic, *Los Angeles Daily News, Calif;* dir., Los Angeles Munic. Arts Dept., 1950-. Teaching: lectr. hist. art & art appreciation, Univ. Southern Calif. **Sources:** WW73.

ROSS, Rose Dane (Mrs. Louis) *[Painter] b.1872, Syracuse, NY / d.1951, Old Forge, NY.*
Addresses: NYC. **Exhibited:** S. Indp. A., 1927-28, 1936. **Sources:** Marlor, *Soc. Indp. Artists.*

ROSS, Sam H. *[Painter] mid 20th c.*
Exhibited: Salons of Am., 1934; S. Indp. A., 1934-35. **Sources:** Falk, *Exhibition Record Series.*

ROSS, Sanford *[Lithographer] mid 20th c.*
Addresses: NYC (1936); Rumson, NJ (1940-1941). **Exhibited:** WMAA, 1936, 1940-41. **Sources:** Falk, *WMAA.*

ROSS, Sue Robertson *[Painter] 20th c.*
Addresses: Fort Worth, TX. **Sources:** WW19.

ROSS, Thomas *[Painter] b.1829, Scotland / d.1896.*
Addresses: San Francisco, CA. **Exhibited:** Mechanics Inst. Fairs, 1870s-80s (prize 1886); San Francisco AA, 1872. **Work:** Calif. Hist. Soc.; Oakland Mus. **Comments:** He was in California by 1855. Position: Illust., *Morning Call* newspaper. **Sources:** Hughes, *Artists in California,* 481; Brewington, 331.

ROSS, Torey (Torex) *[Painter] b.1875, Gotthenburg, Sweden.*
Addresses: Chicago, IL. **Member:** Chicago SA. **Exhibited:** Salons of Am.; AIC; S. Indp. A., 1924. **Sources:** WW27.

ROSS, Walter (Mrs.) *[Collector, patron] 20th c.; b.NYC.*
Addresses: NYC. **Studied:** Columbia Univ. Extension; New York Univ. **Comments:** Collection: Late 19th and early 20th century art. **Sources:** WW66.

ROSS, Will Fallows *[Painter] mid 20th c.*
Addresses: Los Angeles, CA. **Exhibited:** Artists Fiesta, Los Angeles, 1931; Oakland Art Gal., 1936. **Sources:** Hughes, *Artists in California,* 481.

ROSS, William Allen *[Lithographer, engraver] b.1843, Glasgow, Scotland.*
Addresses: Detroit, MI. **Comments:** Came to Detroit, MI, in 1866. Position: staff, later vice-pres., dir., Calvert Lithographing & Engraving Co. **Sources:** Gibson, *Artists of Early Michigan,* 207.

ROSS, Y. *[Painter] early 20th c.*
Addresses: NYC. **Member:** S. Indp. A. **Exhibited:** S. Indp. A., 1921. **Sources:** WW25.

ROSSART, Michael *[Painter] early 20th c.*
Addresses: Los Angeles, CA, 1928-32. **Exhibited:** Calif. AC, 1928; Los Angeles County Fair, 1929. **Sources:** Hughes, *Artists in California,* 481.

ROSSE, Christ *[Engraver] b.c.1839, Germany.*
Addresses: Philadelphia in 1860. **Sources:** G&W; 8 Census (1860), Pa., LII, 911.

ROSSE, Hermann *[Painter, illustrator, architect, craftsperson, lecturer, teacher] b.1887, The Hague.*
Addresses: Pomona, NY/The Hague, Holland. **Studied:** Holland; Royal Col. Art, South Kensington, London; Stanford Univ. **Member:** Kunstring of The Hague. **Exhibited:** P.-P. Expo, San Fran., 1915 (med); AIC. **Work:** dome of the Peace Palace, The Hague; mural dec., Salt Lake City Orpheum Theatre; Netherland Pavilion, Brussels; Victoria & Albert Mus., London. **Comments:** Designer: scenery for plays and motion pictures, including "Emperor Jones." Illustrator: "Wonder Tales from Windmill Lands," by F.J. Olcott. Position: t., Delft Univ., Holland. **Sources:** WW40.

ROSSE, Leon *[Portrait painter] mid 19th c.; b.France.*
Addresses: From Paris, he was at Halifax (N.S.) in 1835 and at Philadelphia in 1842 (no address given in 1836). **Exhibited:** PAFA (1836); Artists' Fund Society, Phila. (1842). **Sources:** G&W; Piers, "Artists in Nova Scotia," 146; Rutledge, PA.

ROSSE, Marie *[Painter] mid 20th c.*
Exhibited: S. Indp. A., 1941. **Sources:** Marlor, *Soc. Indp. Artists.*

ROSSE, Maryvonne *[Sculptor] b.1917, Palo Alto, CA.*
Addresses: New City, NY. **Studied:** Acad. Fine Arts, The Hague, Netherlands (dipl.). **Member:** Nat. Sculpture Soc.; Pen & Brush Cl. (sculpture chmn., 1969-); Burr Artists (historian, 1968-); Catharine Lorillard Wolfe A. Cl. (bd. mem. & sculpture chmn., 1969-). **Exhibited:** Pulchri Studios, The Hague, 1936-47; New York World's Fair, 1939; Pen & Brush Cl, 1967-72; Catharine Lorillard Wolfe Art Cl, 1967-72; Nat. Sculpture Soc., 1971-72. **Awards:** hon. men., Catharine Lorillard Wolfe A. Cl., Nat. Acad., 1970; Pen & Brush Solo Exhib. Award, 1971; gold medal, Catharine Lorillard Wolfe A. Cl. Ann., 1972. **Work:** Mus Holland, Mich. Commissions: plaques, J. Bos, Netherlands, 1938; medals, Koninklyk Begeer, Netherlands, 1938; portraits, D. Tutein Noltenius, Netherlands, 1942; garden ornaments, Nederlanshe Olie Fabriek, Delft, Netherlands, 1946; commercial prototypes, DG Williams Inc., Brooklyn, 1948-66. **Comments:** Preferred media: clay, plaster, wood, bronze. Positions: sculpture, D.G. Williams, Brooklyn, NY, 1948-66; ed. news lett., Catharine Lorillard Wolfe A. Cl., 1968-72. Teaching: instr. sculpture, Rockland Found., Nyack, NY, 1947; instr. art, King Coit Theatre Sch. Children, NYC, 1947-48. Collections arranged: Catherine Lorillard Wolfe A. Cl., Nat. Acad. Gal.; NAC. **Sources:** WW73.

ROSSEAU, Percival L(eonard)
[Painter] b.1859, Point Coupeé Parish, LA / d.1937, North Carolina (summer home).

Rosseau 1928

Addresses: Old Lyme, CT. **Studied:** Académie Julian, Paris with Lefebvre and T. Robert-Fleury; also with H. Leon in Paris. **Member:** Lotus Club; Lyme AA; PAFA. **Exhibited:** Paris Salon, 1900 (prize), 1906 (med); Lyme AA, 1936 (prize). **Comments:** Famous for his portrayal of field and hunting dogs, Rosseau was an adventurer, who at times worked as a cowboy, cattle driver and commodities broker. In 1900, he won a prize at the Paris Salon for a nude, but became commercially successful in 1904 after he focused on animals. He returned permanently to the U.S. in 1915, working at Old Lyme and in North Carolina. **Sources:** WW38; *300 Years of American Art,* 540 (listed under Leonard Percival Rosseau).

ROSSER, Alvin Raymon *[Painter, teacher] b.1928, Port Clinton, OH.*
Addresses: Irvington, NJ. **Studied:** Ohio Univ. (B.F.A., M.F.A.); Hans Hofmann Sch. FA. **Member:** Bethlehem Palette Cl.; Lehigh Valley A. All. **Exhibited:** Ward Eggleston Gal., 1953-54; RoKo Gal., 1954-55; CMA, 1955; Lehigh Univ., 1956; NY City Center Gal., 1958-59; Ohio Univ., 1953 (solo). **Work:** Ohio Univ.; Chagrin Falls AA; Lehigh Univ. **Comments:** Positions: visual presentation a., Mutual Broadcasting System, 1954; teacher, Chagrin Falls, Ohio, Pub. Schs., 1955; instr., FA, Lehigh Univ., Bethlehem, Pa., 1955-57. **Sources:** WW59.

ROSSER, Barbara W. *[Painter] mid 20th c.*
Addresses: University, VA. **Exhibited:** S. Indp. A., 1927. **Sources:** Marlor, *Soc. Indp. Artists.*

ROSSET, Joseph *[Engraver] b.c.1832, Switzerland.*
Addresses: NYC in 1860. **Sources:** G&W; 8 Census (1860), N.Y., XLIII, 605; NYCD 1863.

ROSSETTE, John Baptiste See: **ROSSETTI, John Baptiste**

ROSSETTI, John Baptiste *[Portrait and miniature painter] b.Italy / d.1797, Charleston, SC.*
Addresses: NYC in 1794-95; Charleston, SC in 1797. **Comments:** He advertised in Charleston (SC) in January 1797 and his death there was announced on September 15 of the same year. **Sources:** G&W; NYCD 1794-95; Rutledge, *Artists in the Life of Charleston.*

ROSSETTO, Santina M. *[Painter] mid 20th c.*
Addresses: Oyster Bay, NY. **Exhibited:** WMAA, 1948. **Sources:** Falk, *WMAA.*

ROSSI, Barbara *[Painter, printmaker] b.1940, Chicago, IL.*
Addresses: Chicago, IL. **Studied:** AIC Sch. (M.F.A.). **Exhibited:** Spirit of the Comics, Inst. Contemp. Art, Univ. Pa., Phila., 1969, also circulating exhib. under auspices of Am. Fedn. Arts, 1970; Prints by Seven, WMAA, 1970; Chicago & Vicinity, AIC, 1971; Chicago Imagist Art, Mus. Contemp. Art, Chicago, 1972; Chicago Painters, Nat. Gal. Can., Ottawa, 1972; WMAA, 1975. **Awards:** Anna Louise Raymond traveling fel., AIC Sch., 1970. **Work:** AIC. **Comments:** Teaching: instr. intaglio processes, AIC Sch., 1971-. **Sources:** WW73; Franz Schulze, *Fantastic Images, Chicago Art Since 1945* (Follett, 1972).

ROSSI, Jean Baptiste *[Painter] mid 19th c.*
Addresses: New Orleans, 1859-68. **Comments:** Painted the frescoes on the ceiling of St. Alphonsus Church (1866), with Dominique Canova (see entry) and Perachi (see entry). He and Alexander Boulet (see entry) also painted frescoes in St. Louis Cathedral. **Sources:** G&W; Delgado-WPA cites CD 1859-60, 1865. More recently, see *Encyclopaedia of New Orleans Artists,* 332.

ROSSI, Joseph O. *[Painter, instructor] mid 20th c.; b.Peterson, NJ.*
Addresses: Clifton, NJ. **Studied:** Newark School Fine & Industrial Art; Columbia Univ.; also with John Grabach & Harvey

Dunn. **Member:** AWCS. (chmn. social affairs); NJ WC Soc. (vice-pres. & delegate-at-large); All. A. Am. (current work chmn.); Salmagundi Cl. (art chmn.); Audubon Artist Am. **Exhibited:** AWCS Ann.; All. A. Am. Ann.; Audubon Artists Ann.; NAD Ann.; Watercolor USA, MO. Awards: Salmagundi Oil Award, Herman Wick Mem., 1970; NJ Watercolor Award, hon. Peter H.B. Frelinghuysen, 1971; NJ Artist of Year Award, Am. Artist Prof. League. **Work:** Salmagundi Cl. Coll.; Norfolk (VA) Mus.; Bergen Mall Coll.; Newark Hospital Coll. **Comments:** Publications: author, "Watercolor Page," *Am. Artist,* 8/1972. Teaching: instructor of watercolor, oil & life drawing, Newark School Fine & Industrial Art; also private instructor & instructor for various art groups. **Sources:** WW73.

ROSSI, Locius *[Illustrator] 20th c.*
Comments: Position: affiliated with The Century Co., NYC. **Sources:** WW08.

ROSSI, Paul A. *[Painter, illustrator, sculptor, writer, museum director, western historian] b.1929, Denver, CO.*
Addresses: Tucson, AZ in 1974. **Studied:** Denver Univ., 1947-51. **Comments:** Served in the Air Force during the Korean War. Positions: acting curator, Colorado State Hist. Soc., until 1956; independent commercial artist, 1956; designer and illustrator, Martin Aircraft Co., Denver, 1959-61; museum director, Gilcrease Inst.; 1961-72. Editor, *The American Scene.* Co-author, "Art of the Old West." Contributed illustrations for *The Buffalo Soldier,* and saddle drawings for *The Vaquero* in *American Scene.* **Sources:** P&H Samuels, 409-10.

ROSSI, Tobias (Signor/Mr.) *[Portrait, historical, and landscape painter] mid 19th c.*
Addresses: Cincinnati, 1857-60. **Comments:** Listed as Signor Rossi in Cincinnati directories. **Sources:** G&W; Cincinnati CD 1857-59, BD 1859-60; Ohio BD 1859.

ROSSIGNOL, C. Jack *[Artist]*
Addresses: Wash., DC, active 1927-29. **Sources:** McMahan, *Artists of Washington, DC.*

ROSSIRE, Beatrice M. (Mrs.) *[Painter] 20th c.*
Addresses: NYC. **Member:** NAWPS. **Sources:** WW25.

ROSSITER, E. K. *[Painter] b.1854 / d.1941.*
Addresses: NYC. **Exhibited:** Boston AC, 1882, 1883, 1887. **Sources:** *The Boston AC.*

ROSSITER, George Ignatius *[Engraver] d.1920, Wash., DC.*
Addresses: Wash., DC, active 1901-20. **Sources:** McMahan, *Artists of Washington, DC.*

ROSSITER, Joseph Pynchon *[Profile painter] b.1789, Guilford, CT / d.1826, Detroit, MI (accidental drowning).*
Addresses: Salina, NY; Adams, MA, 1818; later to Detroit, MI. **Studied:** Yale College, 1810 (law degree). **Comments:** Practiced law briefly in Salina (NY) after graduating from Yale. **Sources:** G&W; Dexter, *Biographical Sketches of the Graduates of Yale College,* VI, 358-59; Carrick, *Shades of Our Ancestors,* 14; Carrick, "Profiles, Real and Spurious," five repros.

ROSSITER, Prudence Punderson See: **PUNDERSON, Prudence (Mrs. T. Rossiter)**

ROSSITER, Thomas Prichard *[Historical, religious, genre, and portrait painter] b.1818, New Haven, CT / d.1871, Cold Spring, NY.*
Addresses: New Haven, CT, until 1840; NYC, 1846-60; Cold Spring, NY, 1860-71. **Studied:** apprenticed to a Mr. Boyd, Winsted, CT; Nathaniel Jocelyn, New Haven; Europe, 1840-46. **Member:** ANA, 1840; NA, 1849. **Exhibited:** NAD, 1837-65; PAFA; in 1851 his religious pictures toured some American cities, including Detroit (Mechanics Inst.) and Milwaukee, WI; Paris Salon, 1855 (gold medal); Rochester Acad. of Arts, 1862; Brooklyn AA, 1863-73. **Work:** NGA; CGA; BMFA; MMA; Newark (NJ) Mus.; Shelburne (VT) Mus. **Comments:** In 1838, he opened a portrait studio in New Haven, and by 1839 he was painting in Troy, NY. In 1840, he traveled to Europe with Asher B.

Durand, John Kensett, and John W. Casilear; and in 1840 visited Rome with Thomas Cole, remaining there until 1846. Settling in NYC on his return, Rossiter shared a studio with Kensett and Louis Lang. Over the next seven years he relied on portraits for his income but also painted religious and historical works, including "The Return of the Dove to the Ark" and "Miriam, the Prophetess, exulting over Pharoah," both of which he sent on tour across the U.S. in 1851, and "Rebecca at the Wall" (1852, CGA). Rossiter went to Europe again in 1853, living in Paris until 1856. After returning to NYC, he devoted himself chiefly to historical and religious painting, also completing several genre pictures. In 1860 he built a home at Cold Spring, on the Hudson, where he lived until his death. **Sources:** G&W; DAB; Cowdrey, NAD; Cowdrey, AA & AAU; Rutledge, PA; Clement and Hutton; Tuckerman; CAB; P&H Samuels, 410; Muller, *Paintings and Drawings at the Shelburne Museum,* 120 (w/repro.); Fink, *American Art at the Nineteenth-Century Paris Salons,* 386; Baigell, *Dictionary*; Gerdts, *Art Across America,* vol. 1: 113, 197, and vol. 2: 237, 329.

ROSSKAM, Edwin B. *[Painter] early 20th c.*
Addresses: Phila., PA. **Exhibited:** PAFA Ann., 1925. **Sources:** WW25; Falk, *Exh. Record Series.*

ROSSMAN, Ruth *[Painter] mid 20th c.*
Addresses: Los Angeles, CA, 1960. **Exhibited:** PAFA Ann., 1960. **Sources:** Falk, *Exh. Record Series.*

ROSSOLL, Harry L. *[Cartoonist] b.1910, Norwalk, CT / d.1999, Atlanta, GA.*
Studied: Grand Central Art Sch., NYC, 1929. **Comments:** An illustrator for the U.S. Forest Service, he was one of he primary creators of "Smokey the Bear" (1944) which became thwe universal symbol of forest fire safety. **Sources:** *NY Times* obit, 5 Mar. 1999.

ROST, Christian *[Engraver] b.Germany / d.c.1907, Mount Vernon, NY.*
Addresses: Arrived U.S. by 1860, settling in NYC. **Studied:** Paris and London. **Comments:** About 1851 designed and engraved illustrations for a book on the Crystal Palace exhibition in London. Some time after his move to NYC he went to work for the American Bank Note Company. **Sources:** G&W; Stauffer (wrote in 1907 that Rost had died several years before at Mount Vernon (N.Y.); NYCD 1860+. Smith gives the date of birth as 1766, obviously an error.

ROST, Ernest C. *[Painter] b.1866.*
Addresses: NYC, act. 1883-94. **Exhibited:** NAD, 1884-87; PAFA Ann., 1887-88. **Sources:** Naylor, *NAD;* Falk, *Exh. Record Series.*

ROST, Miles Ernest *[Painter] b.1891, NYC / d.1961.*
Addresses: Wash., DC, active 1915-17; Carlsbad, CA. **Member:** Carlsbad-Oceanside A. Lg. (Chm. A. Com., 1955); Escondido A. Gld. (Hon.); Desert A. Center, Palm Springs. **Exhibited:** World's Fair, Chicago; and in Los Angeles, San Diego, La Jolla, Oceanside, Carlsbad, Palm Springs, and other local and regional galleries and museums. Illus., "My Attainment of the Pole"; "Candles of Christmas." Contributor illus. to scientific journals and desert magazines. Lectures: "Pen Etchings"; "American Food and Game Fish." **Work:** NMAH; in museums, libraries, schools and universities. **Sources:** WW59; McMahan, *Artists of Washington, DC.*

ROST, Tom *[Painter] 20th c.*
Addresses: Milwaukee, WI. **Work:** USPOs, Paoli, Ind., Elkhorn, Wis. WPA artist. **Sources:** WW40.

ROST, William C. F. *[Painter, teacher] 19th/20th c.*
Addresses: Baltimore, MD. **Studied:** Académie Julian, Paris, 1892. **Member:** Charcoal C. **Sources:** WW17.

ROSTAD, Eugenie *[Painter] mid 20th c.*
Exhibited: S. Indp. A., 1937. **Sources:** Marlor, *Soc. Indp. Artists.*

ROSTAD, Thorbjorg (Mrs. T.R. Freeland) *[Designer, painter, lecturer] mid 20th c.; b.Oslo, Norway.*
Addresses: Brooklyn, NY. **Studied:** in Norway; Maryland Inst., Grand Central A. Sch.; & with Eric Pape. **Member:** Norwegian A. & Crafts Cl., Brooklyn, N.Y. (Founder). **Exhibited:** BM; NAC; Vendome Gal.; Grand Central Gal.; S. Indp. A.; Women's Int. Exp., NY. **Work:** Norwegian Seamen's Center, Katonah, NY. **Comments:** Lectures: "History of Norwegian Peasant Design." **Sources:** WW53; WW47.

ROSTAING, A. *[Cameo portraitist] mid 19th c.; b.France.*
Addresses: Cincinnati, 1835-44. **Sources:** G&W; Cist, *Cincinnati in 1841,* 141; information provided G&W courtesy Edward H. Dwight, Cincinnati Art Museum (1957).

ROSTAN, L. *[Portrait painter] 19th c.*
Addresses: Boston, 1845. **Sources:** G&W; Boston BD 1845.

ROSTAND, Michel *[Painter] b.1895, Sadagor, Roumania.*
Addresses: Forest Hills, NY; Montreal, Canada. **Studied:** Univ. Vienna (LL.D.). **Member:** Assn. Fed. Art Libre, Paris. **Exhibited:** Mus. FA. Paris, 1948-49; Assn. Art Libre, Paris, 1948; Sweden, 1950; Mus. FA, Montreal, 1953; Ottawa, 1953; Museum of Granby, 1956; Quebec, 1957; Montreal, 1958. **Work:** Buckingham Palace, London; White House, Wash., DC; City of Granby, Canada. **Sources:** WW59.

ROSTER, D. *[Portrait painter] mid 19th c.*
Addresses: Illinois, 1853-55. **Work:** Chicago Historical Society: portraits of Mr. and Mrs. George Flower. **Sources:** G&W; *American Primitive Painting,* nos. 9 and 10; *Antiques* (Nov. 1950), 393.

ROSTER, Fred Howard *[Sculptor, educator] b.1944, Palo Alto, CA.*
Addresses: Honolulu, HI. **Studied:** Gavilan Col. (AA); San Jose State Col. (B.A. & M.A.); Univ. Hawaii (M.F.A.) & with Herbert H. Sanders. **Member:** Honolulu Acad Art. **Exhibited:** San Francisco Potters Assn. Ann., DeYoung Mus., 1968; Design Ten, Calif., 1968; Artists of Hawaii Ann., Honolulu Acad. Art, 1969-72; Hawaii Craftsmen's Ann., Honolulu, 1969-72; Contemp. Arts Ctr. Hawaii, 1972 (solo); Downtown Gal. Ltd., Honolulu, HI, 1970s. **Awards:** Elizabeth Moses Award, San Francisco Potter's Assn., 1968; sculptural grand award, Windward Artists Guild, 1971; res. grant, Univ. Hawaii, 1971. **Work:** Honolulu Acad Art, Hawaii; State Found Cult & Arts, Honolulu; Contemp Arts Ctr Hawaii; Hawaii State Dept Educ; Hawaii Loa Col, Kailua. Commissions: Ceramic sculptural pots, Flora Pacifica, Honolulu, 1970; stained glass mural, Vladimir Ossipoff Corp for Hilo, Hawaii, 1971. **Comments:** Teaching: instr. ceramics, San Jose State Col., 1968-69; asst. prof. sculpture, Univ. Hawaii, 1969-on. **Sources:** WW73.

ROSTI, Arpad *[Industrial designer, craftsperson] b.1909, Subotica, Yugoslavia.*
Addresses: New York 16, NY. **Studied:** German Tech. Inst., Prague (M.A. in Arch.). **Member:** IDI; Lg. New Hampshire A. & Crafts; NY Soc. Craftsmen. **Exhibited:** Syracuse Mus. FA, 1948-49, 1951; Nat. Craft Exh., Wichita, 1948-49, 1951; "Good Design in Your Business," Buffalo, 1947; MoMA, 1947; PAFA, 1947-49, 1951. **Work:** lamps, MoMA; Albright A. Gal.; Am. Mus., Newark. NJ; pottery, enamels, John Herron AI. **Sources:** WW53.

ROSTON, Arnold *[Painter, patron, writer, lecturer, designer] b.1913, Racine, WI.*
Addresses: NYC, Forest Hills, NY; Great Neck, NY. **Studied:** City Col. NY, 1935-37; NAD, 1937-39; New Sch. Social Res., 1939-40, with Alexey Brodovitch; R. Soyer. **Member:** Art Dirs Club (secy., 1971-73); Art Dirs. Scholar Fund (pres., 1962-); Assoc Coun. Arts; Sch. Art League of New York Bd. Educ. (trustee, 1969-). **Exhibited:** PAFA Ann., 1938; Nat. Exh. Adv. A., 1944 (prize); MoMA, 1940-1941(Hemispherical Poster Awards); WFNY, 1939; Contemporary A. Gal., 1936-40; Municipal A. Exh., NY 1937-38; Montclair A. Mus., 1937; Brooklyn Mus. Art Ann. Instructors Show; Cooper Union Art Sch. 90th Yr. Instructors Show, Cooper-Hewitt Mus., NY; Nat. Ann. Exhibs. Advert. & Ed. Art, New York, 1954 (Art Dirs. Gold Medal).

Awards: Yaddo Found. resident fel., 1938. **Work:** MMA; MoMA; NYPL Print Collection; Vatican Collection, Rome, Italy; Larry Aldrich Old Hundred Mus., Ridgefield CT. Commissions: copper mural wall, Great Publ. Works, Great Neck Pub. Libr., NY, 1971. **Comments:** Positions: visual info. specialist, US Off. Emergency Mgt., 1941-43; creative dir., RKO-MBS, 1944-58; art group head, Grey Advert. Agency, 1956-58; pres., Roston & Co, Great Neck, NY, 1959-; mem. art adv. bd., New York Community Col., 1972-. Teaching: instr. graphic design, Cooper Union, 1946-53; instr. graphic design, Brooklyn Mus. Art Sch., 1954-55; instr. graphic design, Pratt Inst., 1954-55. Art interests: works of master artists donated to WMAA, Hofstra University, Joseph and Emily Lowe Museum, National Portrait Gal. of the Smithsonian and others. Collection: master drawings, from Penni, Turner and Zuccaro to Ben Shahn, Warhol and Kuniyoshi; prints, from Pissarro, Matisse and Picasso to Castellon. **Sources:** WW73; Falk, *Exh. Record Series.*

ROSVALL, Arnold *[Painter, serigrapher] b.1916, San Francisco, CA.*
Addresses: San Francisco, CA. **Studied:** Calif. Sch. of FA., with Boynton and Stackpole; Calif. Col. of Arts and Crafts. **Member:** San Francisco Museum Soc. **Exhibited:** SFMA, 1935. **Sources:** Hughes, *Artists in California,* 481.

ROSZAK, Anton K. *[Sculptor] mid 20th c.*
Addresses: Chicago area. **Exhibited:** AIC, 1932. **Sources:** Falk, AIC.

ROSZAK, Theodore J. *[Sculptor, painter, designer, lithographer, teacher, craftsman] b.1907, Poland / d.1981, NYC?.*
Addresses: Chicago, IL (immigrated 1909); NYC, 1930-38; Chicago, 1938-40; NYC, 1940s-on. **Studied:** AIC, 1922-26, 1929 (awarded a traveling fellowship allowing him to go Europe); NAD, 1927, with C.W. Hawthorne; privately with Geo. Luks; Columbia Univ. (logic & philosophy); studied sculpture, learning tool making and design in NYC, 1932-. **Member:** Am. Art Congress; Drawing Soc. (adv. coun., 1972); Tiffany Found. (trustee, 1964-); Skowhegan Sch. Painting & Sculpture (mem. bd. gov., 1960-); NIAL (v. pres., 1970). **Exhibited:** AIC, 1929-31, 1933-34 (prize) 1938, 1941, 1947 (Logan Medal for sculpture), 1951 (Logan Medal) 1962 (Campagna Award); World's Fair, Poznan, Poland, 1930 (med.); WMAA, 1932-34 (prize), 1935-38, 1941-45, 1956 (retrospective); Minneapolis Inst. A., 1932-37; AGAA, 1932; CPLH, 1932; Honolulu Acad. A., 1933; PAFA Ann., 1936, 1949-54, 1956 (Widener Gold Medal), 1958, 1964-68; Columbus Gal., FA, 1937; Roerich Mus., 1934-35; A. Gld., 1936; (Futurama diorama, WFNY, 1939 (with Norman Bel Geddes); Julian Levey Gal., 1941; Robinson Gal., Chicago, 1932; Walker Art Ctr, 1956 (solo); Tate Gal., London, 1959; US Nat. Exhib., Moscow, USSR, 1959; Venice Biennale, 1960; Guggenheim Intl., NYC, 1964; WFNY, 1964 ("Flight"). **Work:** MoMA; WMAA; Univ. Ill.; Smith Col.; NMAA; Yale Univ. A Gal; PAFA. Commissions: Spire & Bell Tower, MIT, Cambridge, 1956; US Embassy Eagle, London, 1960; Invocation V, Maremont Bldg., Chicago, 1962; Sentinel, Pub. Health Lab., New York, 1968. **Comments:** Began as a painter and became interested in modern art, especially the ideas of the Bauhaus and Constructivists, while traveling abroad in 1929-30 (during which he lived mostly in Prague). Roszak took up sculpture seriously in the mid-1930s, making constructivist sculptures in brass, plastic, and wood. Around 1945, he began producing the welded medal sculptures for which he is best known. These works, freer and more expressive than his earlier work, have been compared with the gestural paintings of the Abstract Expressionist artists. Positions: taught design and composition at the WPA Design Laboratory, with Moholy-Nagy, in Chicago, 1938-40; Brewster Aircraft Corp, WWII (built aircraft and taught mechanics); teacher, S. Lawrence Col, 1940-56; Columbia Univ., 1970-72. **Sources:** WW73; Peter Selz, *Theodore Roszak* (MoMA, 1959); Michel Conil Lacolste, "Theodore Roszak," *Dict Mod Sculpture* (1960); H.H. Arnason, *Theodore Roszak* (exh. cat., Minneapolis: Walker Art Ctr, 1956); *American Abstract Art,* 196; Baigell,

Dictionary; Falk, *Exh. Record Series.*

ROTA, Alexander J. *[Painter] mid 20th c.*
Addresses: NYC. **Studied:** ASL. **Exhibited:** S. Indp. A., 1925-26. **Sources:** Marlor, *Soc. Indp. Artists.*

ROTAN, Walter *[Sculptor] b.1912, Baltimore, MD.*
Addresses: NYC. **Studied:** Md Inst; PAFA; also with Albert Laessle. **Member:** Fel., Nat. Sculpture Soc.; Audubon Artists; fel., PAFA. **Exhibited:** PAFA (Cresson traveling scholar, 1933); PAFA Ann., 1935-48, 1951; NAD, 1936 (prize) 1942 (prize), 1944 (prize), 1945 (prize); AIC, 1936, 1938; CAFA, 1938; PMA, 1940; CI, 1941; Chicago AC, 1943; MMA, 1943; WFNY, 1939; CM, 1938; WMAA, 1940; Audubon A., 1945; Phila. A. All., 1946; All. A. Am., 1956 (prize); Arch. Lg.; Springfield A. Lg.; NAC; New Haven PCC; Milch Gal; André Seligmann Gal.; Arden Gal.; Ferargil Gal. **Work:** PAFA; Brookgreen Gardens, SC. **Comments:** Position: t., Taft Sch. Watertown, Conn., 1938-. **Sources:** WW73; WW47; Falk, *Exh. Record Series.*

ROTCH, Anna Smith See: **STONE, Anna Smith R. (Mrs. Francis)**

ROTCH, Arthur *[Painter] b.1850, Boston, MA / d.1894.*
Studied: E. Vaudremer. **Exhibited:** Paris Salon, 1878, 1879; Boston AC, 1881-1893. **Comments:** Exhibited drawings at the Paris Salon. **Sources:** Fink, *American Art at the Nineteenth-Century Paris Salons,* 386; Schmidt Index.

ROTCH, Benjamin Smith *[Sketch artist] b.1817, Philadelphia, PA / d.1882, Milton, MA.*
Studied: Harvard Col., 1838. **Work:** Old Dartmouth Hist. Soc. **Comments:** Son of Anna Smith Rotch (see entry). Traveled extensively in Europe and active in Boston affairs. **Sources:** Blasdale, *Artists of New Bedford,* 157-58 (w/repro.).

ROTCH, Clara Morgan See: **FROTHINGHAM, Clara Morgan Rotch (Mrs.)**

ROTCH, Lisette DeWolfe *[Painter] d.1933.*
Addresses: Boston, MA. **Exhibited:** Boston AC, 1893, 1894, 1897. **Sources:** *The Boston AC.*

ROTCH, Lydia W. *[Artist] mid 20th c.*
Addresses: NYC, 1940-41; Middleboro, MA, 1942. **Exhibited:** PAFA Ann., 1940-42. **Sources:** Falk, *Exh. Record Series.*

ROTENBERG, Harold *[Painter, teacher, graphic artist] b.1905, Attleboro, MA.*
Addresses: Rockport, MA; Boston, MA; NYC. **Studied:** BMFA Sch.; Harvard Summer Sch.; Académie Julian and Acad. Grande Chaumière, Paris; Bezalel Art Sch., Jerusalem; Kunstgewerbe Acad., Vienna; Fogg Mus., Cambridge, Mass., also with Charles Hawthorne in Provincetown, MA. **Member:** AEA; Mus. Contemp. A., Boston; Boston AC; Cape Arm Soc. Mod. A.; East Gloucester Soc. A.; North Shore AA; Rockport AA; Soc Artistes Independents, Paris; Israel AA. **Exhibited:** North Shore AA (prize); PAFA Ann., 1930-31; PMA; CGA; BMFA; Grace Horne Gal.; Boston Pub. Lib.; Beth Israel Hospital; Boston AC; Hanover Inn, NH; Police Station, Rockport; Beaux-Arts Gal., Paris; San Diego FA Soc.; Cowie Gal., Los A.; Rockport AA, 1940-72; Safad, Israel, 1942-72; Vose Gal, Boston, 1952-62; Babcock Gal, NYC, 1955-60; Soc des Artistes Independents, Paris, 1962-72. **Work:** BMFA; San Diego FA Gal.; Knesset Israel. **Comments:** Positions: dir. art, Hecht House, Boston, 1930-52. Teaching: Sch. Practical Art, Boston, 1929-37; BMFA Sch., 1929-40. **Sources:** WW73; WW47; Falk, *Exh. Record Series.*

ROTERS, Carl G *[Painter] 20th c.*
Addresses: NYC. **Member:** GFLA. **Sources:** WW47.

ROTH, Barbara Quinn *[Mixed media artist] b.1938.*
Addresses: Altadena, CA, 1975. **Exhibited:** WMAA, 1975. **Sources:** Falk, *WMAA.*

ROTH, Ben *[Cartoonist] b.1909, Seletyn, Roumania / d.1960.*
Addresses: Scarsdale, NY. **Studied:** ASL, with Kimon Nicolaides, George Bridgman, William McNulty. **Member:** Nat.

Cartoonists Soc. Ed., "Best Cartoons From Abroad," 1955-58. **Exhibited:** Award: "Perfect Cup," Intl. Cartoon Exh., Bordighera, Italy, 1958. **Comments:** Position: cartoon editor, *Argosy Magazine,* 1948; owner, Ben Roth Cartoon Agency, syndicating in foreign countries the cartoons of 450 American cartoonists. Contributor of cartoons to *Saturday Evening Post; Colliers; Look; American; Ladies Home Journal; This Week; True,* and other national magazines. **Sources:** WW59.

ROTH, Ernest David *[Etcher, painter]* b.1879, Stuttgart, Germany / d.1964, Redding, CT.
Addresses: NYC. **Studied:** NAD; etching with James D. Smillie. **Member:** A.N.A; NA, 1928; NYWCS; AWCS; SC; Chicago SE; Cal. SE; NY SE; Wash. WC Cl.; Allied A.A.; Calif. Pr.M. **Exhibited:** Boston AC, 1900-03; PAFA Ann., 1900, 1905, 1910-25, 1931-33; PAFA, 1930 (gold); Corcoran Gal biennials, 1914, 1919; AIC, 1917 (prize); Phila. Pr. Cl., 1934 (prize); SC, prizes in 1911-12, 1915, 1917-18; Chicago SE, 1914 (prize), 1936 (prize); S. Indp. A., 1917-18; Calif. PM, 1922 (Prize); Salons of Am., 1934; SAE, 1935 (Prize); P.-P. Expo, 1915 (med); A. Fellowship, 1949 (med). **Work:** NYPL.; BMFA; LOC; AIC; Newark (NJ) Pub. Lib.; Minneapolis Inst. A.; Uffizi Gal., Florence, Italy; Silvermine Col. A., CT (his printing press). **Comments:** Marlor cites place of death as Cambridge, NY. **Sources:** WW53; WW47; Falk, *Exh. Record Series.*

ROTH, Ernest (Mrs) (Elizabeth Mackenzie) *[Painter]* 20th c.
Addresses: NYC. **Member:** NAWPS. **Sources:** WW25.

ROTH, Frank *[Painter]* b.1936, Boston, MA.
Addresses: NYC. **Studied:** CUA Sch., 1954; Hans Hofmann Sch. Fine Arts, 1955. **Exhibited:** WMAA, 1958; Corcoran Gal biennial, 1963; Midland Group, Nottingham, Eng., 1966; "Intl. Exhib. Young Artists," Tokyo, Japan, 1967 (prize); Ulster Mus., Belfast, Ireland; "Art in Embassies," 1969; Phila. A. All., 1969; TMA, 1969. Other awards: Ford Fndn. purchase award, 1962; Guggenheim fellow, 1964. **Work:** Albright-Knox Art Gal., Buffalo; WMAA; Santa Barbara Mus. Art; BMA; Walker Art Ctr., Minneapolis. **Comments:** Teaching: State Univ. Iowa, summer 1964; Sch. Visual Arts, NY, 1963-70s; Ford Found. artist-in-residence, Univ. RI, 1966; UC Berkeley, 1968; Univ. Calif., Irvine, 1971. **Sources:** WW73; William H. Gerdts, Jr., *Painting and Sculpture in New Jersey* (Van Nostrand-Reinhold, 1964).

ROTH, Frederick G(eorge) R(ichard) *[Sculptor]* b.1872, Brooklyn, NY / d.1944.
Addresses: W. Hoboken, NJ; NYC, White Plains, NY; Englewood, NJ, 1911-. **Studied:** Hellmer, in Vienna; Meyerheim, in Berlin. **Member:** ANA, 1906; NA, 1906; Arch Lg., 1902; NIAL; SAA, 1903; NSS, 1910; NAC; AM. Soc. PS & G. **Exhibited:** PAFA Ann., 1902-13, 1922-29, 1940; St. Louis Expo, 1904 (med); Boston AC, 1904; Buenos Aires Expo, 1910 (med); P.-P. Expo, San Fran., 1915 (gold); NAD, 1900, 1924 (prize); NAC, 1924 (prize), 1928 (prize), 1931 (med). **Work:** MMA; Detroit IA; Cincinnati AM; Children's Mus., Boston; San Fran. Mus.; Newark (NJ) Mus.; equestrians, Wash., NJ, Morristown, NJ; Baltimore mon., 18 animal tablets, mem. fountain, all in Central Park, NYC; 3 tablets, Prospect Park Zoo, Brooklyn; Bowdoin Col. **Comments:** Position: chief sculptor, Park Dept., NYC. **Sources:** WW40; Falk, *Exh. Record Series.*

ROTH, George J. *[Portrait painter]* mid 19th c.
Addresses: Buffalo, NY 1859-60. **Comments:** F.F. Sherman records a portrait painted by G.J. Roth, 1870, found at Schuylerville (NY). **Sources:** G&W; Buffalo BD 1859-60; Sherman, "Unrecorded Early American Portrait Painters" (1933), 31.

ROTH, George, Jr. *[Painter]* mid 20th c.
Addresses: Cincinnati, OH. **Exhibited:** Ohio State Fair, 1935; Cincinnati Mus., 1939. **Sources:** WW40.

ROTH, Harry *[Artist]* b.1903 / d.1976.
Member: Woodstock AA. **Sources:** Woodstock AA.

ROTH, Heinrich (Henry) *[Engraver]* b.c.1874.
Addresses: Detroit, MI. **Studied:** Detroit Mus. of Art School, with Joseph Gies and Gari Melchers. **Comments:** Position: staff, *Detroit Free Press.* Illustrator, national magazines like *Harper's Weekly, Collier's, Success, Pearson's* and *Metropolitan.* **Sources:** Gibson, *Artists of Early Michigan,* 207.

ROTH, Herbert *[Cartoonist, illustrator]* b.1953, Scarsdale, NY.
Addresses: Larchmont, NY. **Member:** SI, 1912. **Sources:** WW40.

ROTH, James Buford *[Art restorer, painter, teacher]* b.1910, California (Moniteau Co.), MO.
Addresses: Kansas City, MO. **Studied:** Kansas City AI, with Ernest Lawson & Ross Braught; Fogg Mus., Harvard Univ., Carnegie grantee. **Member:** Fel. Int. Inst. Conserv. Artistic Hist. Works; Int. Inst. Conserv., Am. Group (mem. coun.). **Exhibited:** Kansas City AI, 1932 (med), 1937 (prize); CAA, 1933 (prize). **Work:** Commissions: Rearidos, Grace & Holy Trinity Church, Kansas City, Mo, 1939 & Rockhurst Col. Chapel, Kansas City, 1940. **Comments:** Positions: art conservator & restorer, William Rockhill Nelson Gal. Art, 1933-; art conservator & restorer, Atkins Mus. Fine Arts, 1938-; also pvt. restorer. Publications: co-auth., "Separation of Two Layers of Chinese Wall Painting," 1952; auth., "Wax Relining," *Am. Assn. Mus. Bulletin;* "Notes on Transfer Technique," Expos Painting Conserv., 1962; "Conservation of Paintings," "Mus. Roundup" & "Unique painting technique of George Caleb Bingham," Int. Inst. Conserv., 1971. Teaching: lectr. painting tech., Kansas City Art Inst., 1940-49; lectr painting tech., Univ. Kans., 1950-; lectr. painting tech., Univ. Mo., 1950-; lect.r painting tech., Am. Assn. Mus. Workshops, 1970 & 1972. Research: Transfer techniques for paintings; in-painting restorations, using plastics as media. **Sources:** WW73.

ROTH, Julius J., Jr. *[Craftsperson, designer]* b.1897, NYC.
Addresses: NYC. **Comments:** Specialty: mirror furniture, mirror wall treatments, flat and structural glass treatments. **Sources:** WW40.

ROTH, Richard Lee *[Painter]* b.1946, Brooklyn, NY.
Addresses: NYC. **Studied:** RISD; Cooper Union (B.F.A.). **Exhibited:** Four Painters for Springs, Castelli Warehouse, NY, 1969; group show, Parker St. 470, Boston, Mass., 1969; 1969 Ann. Exhib. Contemp. Am. Painting, WMAA, 1970; O.K. Harris Gal., NYC, 1970 (solo), 1972 (solo). **Work:** Akron Art Inst., OH; Chase Manhattan Bank Coll., NYC. **Comments:** Teaching: adj. asst. prof., NY Univ, 1971-on. **Sources:** WW73.

ROTH, Robert *[Painter]* 20th c.
Addresses: NYC. **Member:** GFLA. **Sources:** WW27.

ROTH, Rubi *[Painter, instructor]* b.1905, NYC.
Addresses: Belle Harbor, NY. **Studied:** NY Univ.; Cooper Union; Columbia Univ. **Member:** AWCS; NAWA; Am. Artists Prof. League; AEA; Nat. Art League (bd. dirs., 1972). **Exhibited:** Am. Artists Prof. League, Lever House, NYC, 1971; AWCS, NAD, 1971; NAWA, NAD, & Lever House, NYC, 1972; Nat. Art League, Douglaston, NY, 1972. Awards: first prize, Am. Artists Prof. League, 1967; second prize, Flushing Merchants Assn., 1971; third prize, Nat. Art League, 1972. **Work:** Norfolk Mus., Va.; Seton Hall, NJ; Forbes Mus., NY; Long Beach Libr., NY; Beth El Day Sch., NY. Commissions: murals commissioned by Dr. George Novis, Manhasset, NY, 1970 & Louis Kerber, Belle Harbor, NY, 1971. **Comments:** Preferred media: watercolors, oils, collage. Positions: art judge, Police Athletic League, NYC, 1971. Publications: illusr., "Little Calypsos," 1970; contribr., "Arts & Crafts Activities Desk Book," Parker. Teaching: instr. art, Nat. Art League, 1957-, demonstrator, 1972. **Sources:** WW73.

ROTHAS, Jacob *[Teacher of architecture and drawing]* mid 19th c.

Addresses: New Orleans, 1835. **Studied:** Royal Academy of Art, Munich. **Sources:** G&W; Delgado-WPA cites *Bee,* Nov. 21, 1835. More recently, see *Encyclopaedia of New Orleans Artists,* 332, under Rothhaas.

ROTHBART, Albert *[Painter]* mid 20th c.
Addresses: NYC. **Studied:** ASL. **Exhibited:** S. Indp. A., 1929. **Sources:** Marlor, *Soc. Indp. Artists.*

ROTHBORT, Samuel *[Painter, sculptor, writer, lecturer]* b.1882, Wolkovisk, Russian Poland / d.1971, Brooklyn, NY.
Addresses: Brooklyn, NY (emigrated to NYC, 1904). **Studied:** self-taught. **Member:** Brooklyn Soc. of Artists; Soc. of Indp. Artists; Brooklyn WCC. **Exhibited:** SIA, 1917-40; Pratt Inst., 1919-22; Salons of Am., 1922-34; Brooklyn Mus., 1922-35; Anderson Gal., NYC, 1924-30; Nassau Cnty AL, 1932-33; NYC Municipal Art Salons of Am.; Comm'n, 1936-37; Brooklyn and Long Island Stamp Exh., 1932 (ribbon), 1933 (ribbon) for painting of postage stamps; Nat. Stamp Exh., Rockefeller Center, 1934 (prize); Charles Barzansky Gal., NY, 1940-44, 1961; VMFA, 1944; Heckscher Mus., 1963; Jewish Mus., NYC, 1984-85; Albuquerque Mus., 1986; H. Roman FA, NYC, 1980s; Giampetro Gal., NYC, 1997 (solo of self-portraits). **Work:** NMAA; Brooklyn Mus.; Heckscher Mus.; Mus of Stony Brook; Montclair AM; Sardoni AG; Rutgers Univ. AG. **Comments:** Best known for his scenes in and around NYC, he painted in a bold style marked by very heavy impasto. Although he exhibited frequently, he refused to sell his works, and in 1948 he opened his studio-home in Brooklyn as the "Rothbort Home Museum of Direct Art." He exhibited works in oil on canvas, carved wood, glass, and other materials, sometimes in collaboration with his brother, Lawrence. Author: "Out of Wood and Stone." Illus. lecture, "The Vanished Life of the Ghettos." **Sources:** WW59; WW47.

ROTHCHILD, Edward Sidney (Mrs.) *[Miniature portrait painter]* early 20th c.
Addresses: San Francisco, CA. **Exhibited:** San Francisco AA, 1903. **Sources:** Hughes, *Artists in California,* 481.

ROTHE, Mildred J. *[Painter]* mid 20th c.
Exhibited: Salons of Am., 1931, 1934. **Sources:** Marlor, *Salons of Am.* cites what is most likely the same artist listed in 1934 as "Miljean.".

ROTHENBERG, G. Gordon *[Painter]* mid 20th c.
Addresses: New Rochelle, NY. **Exhibited:** PAFA Ann., 1946-47. **Sources:** Falk, *Exh. Record Series.*

ROTHENBURGH, Otto H. *[Painter]* mid 20th c.
Addresses: NYC. **Studied:** ASL. **Exhibited:** S. Indp. A., 1931; PAFA Ann., 1935, 1938. **Sources:** Falk, *Exh. Record Series.*

ROTHENSTEIN, Albert *[Painter]* mid 20th c.
Exhibited: AIC, 1934. **Sources:** Falk, *AIC.*

ROTHER, Maria *[Painter]* mid 20th c.
Exhibited: WMAA, 1924-1928. **Sources:** Falk, *WMAA.*

ROTHERMEL, Peter Frederick *[Historical and portrait painter]* b.1817, Nescopeck, PA / d.1895, Linfield, PA.
Addresses: Primarily in Philadelphia. **Studied:** John Rubens Smith and Bass Otis, Phila.; PAFA. **Member:** NAD; Artists Fund Soc. (vice-pres., 1844), Phila.; Sketch Cl., Phila.; Graphics Cl., Phila.; PAFA (dir., 1847-55). **Exhibited:** NAD, 1863, 1880; Paris Salon, 1859; Brooklyn AA, 1872; PAFA Ann., 1876-81, 1888, 1905. **Work:** State Capitol Bldg., Harrisburg, PA ("Battle of Gettysburg"); Wm. Penn Memorial, Harrisburg, PA; PAFA; Patrick Henry Mem. Fndtn, Brookneal, VA. **Comments:** Early in career he was a portrait painter but in 1843 made his first success with a historical work, "De Soto Discovering the Mississippi." From 1847-55 he was Director of the PAFA and chairman of its education committee. In 1856 he went to Europe, painting historical themes in Rome for two years. In 1859, he returned to Philadelphia. After the Civil War he also painted grandiose religious themes and contemporary events, devoting almost five years to his most ambitious work, "The Battle of Gettysburg." In 1877, he moved to his home, "Grassmere," near

Linfield, PA. **Sources:** G&W; DAB; Cowdrey, NAD; Cowdrey, AA & AAU; Rutledge, PA; Tuckerman; Clement and Hutton; Swan, BA; Washington Art Assoc. Cat., 1857, 1859; 7 Census (1850), Pa., LIII, 264; 8 Census (1860), Pa., LV, 953; Sartain, *Reminiscences,* 185, 265; Fink, *American Art at the Nineteenth-Century Paris Salons,* 386; Falk, *Exh. Record Series.* More recently, see Baigell, *Dictionary.*

ROTHERMEL, Vera G. *[Designer, lithographer, painter]* b.1919, San Antonio, TX.
Addresses: San Antonio, TX. **Studied:** Witte Mem. Mus. Sch.; Univ. Mexico; San Antonio AI. **Member:** Texas FA Assn.; Mill Race A. **Exhibited:** LOC, 1945; CI, 1945; SFMA, 1946; Laguna Beach AA, 1946; SAM, 1946; Mint Mus. A., 1946; Wichita AA, 1946; Witte Mem. Mus., 1945-46; Dallas Mus. FA, 1945; Texas General Exh., 1945; Texas FA Assn., 1945. **Sources:** WW53; WW47.

ROTHERY, Albert *[Painter]* b.1851, Matteawan, NY.
Addresses: Omaha, NE. **Studied:** F. Rondel, A Chatain, in New York. **Member:** SWA. **Exhibited:** Western AA (gold, prize). **Sources:** WW15.

ROTHFARB, Edwin *[Sculptor]* b.1950.
Addresses: Boston, MA, 1975. **Exhibited:** WMAA, 1975. **Sources:** Falk, *WMAA.*

ROTHKO, Mark *[Painter, writer, lecturer]* b.1903, Dvinsk, Lithuania / d.1970, NYC (suicide).
Addresses: NYC. **Studied:** Yale Col.; ASL. **Member:** Fed. Mod. P. & S. **Work:** Art of this Century; WMAA. **Exhibited:** S. Indp. A., 1934; AIC, 1947, 1949; Salons of Am.; WMAA,1945-50; PAFA Ann., 1946; J.B. Neumann Gal., 1939 (solo); Art of this Century, 1945; Mortimer Brandt Gal., 1946; SFMA, 1946; Nat'l Gal. Art, 1998 (first major retrospective since 1978; traveled to WMAA and Paris MoMA, 1999). **Work:** Guggenhein Mus.; WMAA; MoMA; MMA; NMAA; National Gal., Wash., DC; Tate Gal., London; Vassar; Yale; Harvard Univ. Holyoke Center (murals). **Comments:** Born Marcus Rothkovich, he emigrated to Portland, Oregon, in 1913. He played a central role as a pioneer abstract expressionist of the post-war era, and was best known for his large, bold paintings (often featuring two or three stacked rectangles) from the 1950s. His work became darker and more meditative in the early 1960s and in that decade was commissioned to create 14 panels for a chapel in Houston, Texas (Inst. of Religion and Human Development, Texas Medical Ctr.). After his death, the Rothko Estate vs. Marlborough Gal. was one of the most highly publicized legal battles involving art in the 20th century (see entry for T. Stamos) Position: t., Calif. Sch. FA (summers), 1947-49. **Sources:** WW59; WW47; *300 Years of American Art,* 904; Baigell, *Dictionary;* Falk, *Exh. Record Series.* Rothko catalogue raisonné by David Anfam (New Haven: Yale Univ. Press & NGA, 1998).

ROTHKOWITZ, Marcus See: **ROTHKO, Mark**

ROTHLISBERGER, Jacob *[Painter]* 20th c.
Addresses: Muncie, IN. **Sources:** WW15.

ROTHMALER, Ernita *[Painter]* mid 20th c.
Addresses: Brooklyn, NY. **Exhibited:** PAFA Ann., 1946. **Sources:** Falk, *Exh. Record Series.*

ROTHMAN, Henry L. *[Painter, designer, etcher, lithographer]* b.1918, Philadelphia, PA.
Addresses: Philadelphia, PA. **Studied:** Barnes Fnd.; Graphic Sketch Cl., Phila.; PAFA; & with Henry McCarter, George Harding, James Chapin. **Member:** F., PAFA. **Exhibited:** PAFA Ann., 1938 (Cresson traveling scholarship), 1939; PAFA, 1941 (solo); Graphic Sketch Cl., 1933 (prize). **Work:** PAFA; mural, Pine Camp, NY. **Sources:** WW59; WW47; Falk, *Exh. Record Series.*

ROTHMAN, Joseph *[Painter]* b.1905, Brooklyn, NY.
Addresses: Brooklyn 5, NY. **Studied:** Corcoran Sch. A.; ASL; NY Univ., and with Fletcher Martin, Morris Davidson. **Member:** Albany A. Group; Berkshire AA. **Exhibited:** Albany Inst. Hist. &

Art, 1948-55; Munson-Williams-Proctor Inst., 1955,1957; Berkshire Mus. A., Pittsfield, Mass., 1954, 1956; Great Barrington, Mass., 1955-56; Cooperstown, NY, 1956; NY State Civil Service Employees Exh., Albany Inst. Hist. & A., 1951-52; Schenectady Mus. A., 1950-51, 1954-55; BM, 1958; Argent Gal., 1951; State T. Col., Albany, 1954, and others; solo: Albany Inst. Hist. & A., 1953, 1956; State T. Col., Albany, 1954; Brooklyn Arts Gal., 1958; L., State T. Col., and Milne H.S., Albany, NY, 1956. Awards: Mrs. Frederick Beinecke award, Great Barrington, Mass., 1955. **Sources:** WW59.

ROTHMAN, Sidney *[Art dealer, art critic] b.1918, USA.*
Addresses: Barnegat Light, NJ. **Studied:** Brooklyn Col.; Columbia Univ. (B.A., lang. & art hist.); New York Sch. Archit. Design. **Member:** Long Beach Found. Art & Science; AEA. **Comments:** Positions: art dealer, Philadelphia area, 1946-66, Barnegat Light, 1958-; assessor of paintings, Long Beach Found. Arts & Sci., 1971 & 72 season. Teaching: lectr. art, Women's Cl. Island, Beach Haven, NJ, 1967-68; lectr. art, Deborah Hosp., Browns Mills, NJ, 1969; lectr. art, Long Beach Found., Loveladies, NJ, 1971. Collections arranged: New Jersey Artists Show, 1968; South American Collection, 1969; Yugoslavian Printmakers, 1972; Collection of European Prints, Fordham Univ., 1972. Research: Spanish art of time of Velasquez thru Ribera. Publications: auth., articles, In: Beach Haven Times, 1967-71; contribr., "Arts of Asia," Hong Kong, 1971. **Sources:** WW73.

ROTHOLZ, Rina *[Printmaker] mid 20th c.; b.Israel.*
Addresses: Roslyn Heights, NY. **Studied:** Pratt Graphic Arts Ctr., NYC; Brooklyn Mus. Art Sch., NY. **Member:** Boston Printmakers; Nat. Assn. Women Artists; Prof. Artists Guild. **Exhibited:** Pucker/Safari Gal., Boston, Mass, 1972 (solo); group exhibs., De Cordova Mus., Lincoln, Mass, 1971; five exhibs., Audubon Artists, 1962-71; Boston Printmakers Ann. & Traveling Shows, 1967-72; New Direction in American Printmaking, 1968 & 1969. Awards: first prize of graphics, Port Washington Sixth Ann.; purchase prize, Nassau Community Second Graphic Exhib.; prize in graphics, Nat. Assn. Women Artists, 1972. **Work:** BMFA; Rose Art Mus., Brandeis Univ.; MoMA; Israel Mus., Jerusalem; Albright-Knox Mus., Buffalo, NY. Commissions: edition of 50 prints, 1969 & edition of 200 prints, Commentary Libr. Collection of Art Treasure; Blue Disc (greeting card design), UNICEF, 1972. **Comments:** Publications: auth., "Tuilegraphy, Artists Proof," Vol 7. Teaching: lectr. & demonstrations, Bd. Coop. Educ. Serv., Scholars in Residence Prog., Nassau Co., NY. Research: discovered process of 'Tuilegraphy,' which is the carving of vinyl asbestos tiles when they are still warm, then printing the tiles on intaglio plates to achieve a variety of textures, shapes, and high reliefs. **Sources:** WW73.

ROTHSCHILD, H. D. *[Painter] mid 20th c.*
Addresses: NYC, 1936-38. **Exhibited:** WMAA, 1936-38. **Sources:** Falk, *WMAA.*

ROTHSCHILD, Herbert M. *[Collector, patron] b.1891, NYC / d.1976.*
Addresses: Ossining, NY. **Comments:** Collection: 20th century European art. **Sources:** WW66.

ROTHSCHILD, Judith *[Painter] b.1921, NYC / d.1993, NYC.*
Addresses: NYC; Big Sur and Monterey, CA; Truro, MA; Woodstock, NY, 1959. **Studied:** Wellesley Col.; Ethical Culture Schools, with A. Brook; ASL, with R. Marsh, Maurice Stern, Hans Hofmann; Cranbrook Acad., with Zoltan; Atelier 17, with Hayter. **Member:** American Abstract Artists; Woodstock AA. **Exhibited:** AIC; PAFA Ann., 1947; Woodstock AA; Santa Barbara Mus. of Art, CA; CPLH; Albany Inst. of Art, 1966; PMA; Russia (solo); Jane Street Group and many other galleries in NYC; MMA, 1998 (retrospective). **Work:** Harvard Mus.; PMA; MMA. **Comments:** Abstract painter active in Provincetown, MA, 1949-70s. Preferred media: oil, gouache, collage. **Sources:** Provincetown Painters, 258; Woodstock AA; Falk, *Exh. Record Series.*

ROTHSCHILD, Lincoln *[Sculptor, writer, lecturer, teacher] b.1902, NYC / d.1983.*
Addresses: NYC; Dobbs Ferry, NY. **Studied:** Columbia Univ. (A.B., 1923, A.M., 1933); NY Univ. Inst. Fine Arts; ASL, with Kenneth Hayes Miller, Boardman Robinson & Allen Tucker. **Member:** Col. Art Assn. Am.; Am. Soc. Aesthetics; life mem. ASL (mem. bd. control, 1931); Am. Artists Cong. (treas. 1936-41). **Exhibited:** Salons of Am.; Village Art Ctr., 1949 (first prize for sculpture); WMAA, 1928-40; PAFA Ann., 1934. **Work:** Wood carving, Mother & Child, WMAA. **Comments:** Preferred media: wood. Positions: dir., New York Unit Index Am. Design, 1937-40; nat. exec. di.r, AEA, 1951-57; ed., Pragmatist In Art, 1964-78. Publications: auth., "Sculpture Through the Ages," 1942, "Style in Art," 1960; "Hugo Robus," 1960. Teaching: instr. art hist., Columbia Univ., 1925-35; asst. prof. art hist. & chmn. dept. art, Adelphi Col., 1946-50; lectr. art hist., City Col. New York, 1964-68. Contributor: *Journal of Philosophy,Parnassus, Saturday Review of Literature.* Research: interpretation of style; American art. **Sources:** WW73; WW47; Bibliography: *Archives of American Art Journal* vol.27, No. 2, 1987, p.36; Falk, *Exh. Record Series.*

ROTHSTEIN, Arthur *[Photographer, teacher] b.1915 / d.1985, New Rochelle, NY.*
Addresses: New Rochelle, NY. **Studied:** Columbia Univ. **Member:** Am. Soc. Mag. Photographers (founder). **Exhibited:** numerous gallery and museum solos nationwide. **Work:** LOC; IMP/GEH; MoMA; other major collections. **Comments:** One of the most important WPA photographers, during the Depression he was the first photographer hired by Roy Stryker for the Farm Security Administration. His best known image is "Dust Storm, Cimarron County, Oklahoma" (1936), which became the most widely published image in books and magazines of that era. Position: *Look* (staff, 1940; dir. photo., 1969); *Parade* mag (dir. photo., 1970s-on). **Sources:** Witkin & London, 225; PHF files.

ROTHSTEIN, Charlotte *[Painter, graphic artist, teacher] b.1912, Chicago.*
Addresses: Chicago, IL. **Studied:** AIC; Acad. FA, Chicago. T. Geller; R. Weisenborn; A. Refregier. **Member:** Chicago Soc. Ar; United Am. Ar., Chicago; Am. Ar. Cong. **Exhibited:** AIC; GGE, 1939; WFNY, 1939. **Work:** AIC. **Sources:** WW40.

ROTHSTEIN, Elizabeth L. *[Painter, teacher, designer, lecturer] b.1907, NYC.*
Addresses: Albany, NY. **Studied:** PAFA; ASL; Parsons Sch. Des.; NY Univ.; New Sch. for Social Research; F. Speight; G. Picken; E. Thurn; M. Davidson; H. Giles. BM Sch. A. **Member:** Albany A. Group. **Exhibited:** PAFA, 1929-32; AWCS, 1930-36; NAWA, 1934; A. of the Upper Hudson, 1943-52; Albany A. Group, 1946-1952; Munson-Williams-Proctor Inst., 1951; Albany Inst. Hist. & A., 1947 (solo), 1952 (solo). Awards: prizes, First Civil Service A. Exh. **Work:** pub. bldgs.; Public Service Comm., Albany, and in private colls. **Comments:** Specialties: adv. illus.; commercial poster design. **Sources:** WW59; WW47.

ROTHSTEIN, Irma *[Sculptor] mid 20th c.; b.Rostov, Russia.*
Addresses: New York 11, NY. **Studied:** Vienna, Austria, and with Anton Hanak. **Member:** NAWA; Springfield A. Lg.; Arch. Lg. **Exhibited:** MMA, 1942; Syracuse Mus. FA, 1948-52, 1954; PAFA Ann., 1954; solo: A. Gal., 1940, 1943; New Sch. for Social Research, 1942; Bonestell Gal., 1940, 1946; Galerie St. Etienne, 1954, 1956. Awards: prizes, Mint Mus. A., 1946; AAPL, 1946; New Jersey P. & S. Soc., 1948; Springfield A. Lg., 1951, 1958; NAWA, 1954. **Work:** Newark Mus. A.; Syracuse Mus. FA; G.W.V. Smith Mus., Springfield, Mass. **Sources:** WW59; Falk, *Exh. Record Series.*

ROTHSTEIN, Irving *[Painter] mid 20th c.*
Addresses: Brooklyn, NY. **Exhibited:** S. Indp. A., 1931. **Sources:** Marlor, *Soc. Indp. Artists.*

ROTHSTEIN, Theresa M. *[Painter] b.1893, Richmond, MN.*
Addresses: Vancouver, WA. **Studied:** C.L. Keller; Mus. Art Sch.,

Portland, OR; Conservatory Music & Art, St. Paul, MN. **Member:** AAPL; Oregon SA. **Exhibited:** Oregon SA, Portland, 1932 (prize), 1936 (prize), 1939 (prize); Salem, OR, 1935, 1936; AAPL, 1936. **Work:** Portland Women's Cl. **Sources:** WW40.

ROTHWEILER, Cora See: **REIBER, Cora Sarah (Mrs. Charles F. Rothweiler)**

ROTHWELL, Elizabeth L. *[Painter] mid 20th c.; b.California, PA.*
Addresses: Pittsburgh, PA. **Studied:** Chase; C. Beaux. **Member:** Pittsburgh AA. **Exhibited:** Pittsburgh AA, 1915 (prize), 1918 (prize), 1928 (prize). **Work:** Hundred Friends of Art, Pittsburgh. **Sources:** WW40.

ROTHWELL, J. *[Engraver] mid 19th c.*
Addresses: NYC in 1841. **Sources:** G&W; Stauffer.

ROTHWELL, Violet H(amilton) (Mrs.) *[Painter] b.1890, NYC.*
Addresses: NYC/Remsenburg, NY. **Studied:** C. Lumsdon; Acad. de Passy, Paris. **Sources:** WW31.

ROTIER, Peter *[Painter, designer, teacher] b.1887, Baldwin, WI / d.1964.*
Addresses: Milwaukee, WI. **Studied:** ASL of Milwaukee; Milwaukee State T. Col.; Milwaukee Normal A. Sch.; Chicago Acad. A.; ASL. NY; & with Henri, DuMond. **Member:** AWCS; Wis. P. & S. **Exhibited:** Milwaukee AI, 1930 (prize), 1932 (prize), 1934 (prize); Milwaukee Journal, 1939 (prize); Wis. State Fair, 1942 (medal); AWCS, annually; Kansas City AI; AIC. **Work:** Milwaukee AI; USPO, West Bend, Wis. WPA muralist. **Sources:** WW59; WW47, puts birth at 1888.

ROTTENBERG, Joseph *[Painter, teacher] b.1891, Russia / d.1966, Los Angeles, CA.*
Addresses: Los Angeles, CA. **Exhibited:** P&S of Los Angeles, 1937. **Sources:** Hughes, *Artists in California,* 481.

ROTTERDAM, Paul *[Painter] b.1939.*
Addresses: NYC, 1975. **Exhibited:** WMAA, 1975. **Sources:** Falk, *WMAA.*

ROTTMAN, Ad *[Engraver] mid 19th c.*
Comments: Engraver of a California scene, showing golddiggings on the Mokelumne River, c.1850. **Sources:** G&W; Dana, *United States Illustrated,* II, opp. 150.

ROUANEZ, P. P. *[Artist and teacher] early 19th c.*
Addresses: Philadelphia, 1807-19. **Sources:** G&W; Brown and Brown.

ROUARD, John *[Sculptor] mid 19th c.*
Addresses: San Francisco, 1856-58. **Sources:** G&W; San Francisco CD 1856, BD 1858.

ROUDEBUSH, Harriet Gene *[Etcher, painter] b.1908, Portland, OR.*
Addresses: Sacramento, CA; Pacific Grove, CA. **Studied:** Calif. Col. of FA, 1925; Calif. Sch. of FA, four years. **Exhibited:** San Francisco Soc. of Women Artists, 1931; Beaux Arts Gal., San Fran., 1930-33; Wordens Gal., San Fran., 1932-42; Trade Fair, Sausolito, 1952 (solo); San Francisco Art Fairs, 1957-69; Carmel Foundation, 1975 (solo); Monterey Library, 1975 (solo). **Work:** St. Mary's College, Moraga, CA. **Comments:** She produced etchings of the San Francisco Bay area as well as watercolors of the Monterey Peninsula. **Sources:** Hughes, *Artists in California,* 481.

ROUDEBUSH, John Heywood *[Sculptor] 20th c.; b.New York.*
Addresses: NYC. **Studied:** MacMonnies. **Exhibited:** Paris Salon, 1898 (prize); Paris Expo, 1900 (medal); Pan-Am. Expo, Buffalo, 1901 (medal). **Sources:** WW10; Fink, *American Art at the Nineteenth-Century Paris Salons,* 386.

ROUDENEZ, Ilario *[Etcher] late 19th c.; b.New Orleans, LA.*
Studied: L.-O. Merson. **Exhibited:** Paris Salon, 1892-94. **Sources:** Fink, *American Art at the Nineteenth-Century Paris Salons,* 387.

ROUDENKO, Etienne *[Painter] b.1897, Ekaterinoslav, Russia / d.1987, NYC.*
Addresses: NYC. **Studied:** Moscow Univ., 1916; Academy Belles Artes, Moscow; in Paris with Camille Boiry privately, and with Bonnât at École des Beaux-Arts, 1928; Gusmonde Roces in La Paz, Bolivia, 1932. **Exhibited:** Fontainebleau Gal., Butler Gal. and Thompson Gal. all in NYC. **Comments:** Shortly after the Bolshevik Revolution, he left Moscow for Greece and Constantinople, then France. In 1928 he married a French artist, Denise Bonhomme [1899-1989] and they settled in Ferrière-aux-âtangs. In 1929, after studying in Paris, they left for South America, living first in La Paz, Bolivia and then settling in Buenos Aires. In 1959, they emigrated to New York City where he continued as a painter but also worked as a picture framer. His works are remarkably consistent in style and similarity to to the drip-action paintings of Jackson Pollock. **Sources:** PHF files, estate collection.

ROUGERON, M(arcel) J(ules) *[Landscape painter] b.1875, Paris, France.*
Addresses: NYC. **Studied:** Académie Julian and Ecole des Beaux-Arts, Gérôme, Paris; J.G. Vibert; L. Van den Bergh. **Member:** NAC; Wash. AC; AFA; SC; Lotos Cl.; AAPL; Montreal AC; Paris AAA; Société des Artistes Français; Société Royale Artistes Belges. **Exhibited:** Paris Salon, 1902 (prize); P.-P. Expo, San Fran., 1915. **Awards:** Officer d'Académie, 1900; Officer of Public Instruction (France), 1910; Chevalier of the Order of Leopold (Belgium), 1931; Chevalier of the Legion of Honor, 1935. **Work:** BM; AIC; TMA; City Hall, NYC; Art Mus., Montreal; W.R. Nelson Gal. Art; NY Hist. Soc. **Comments:** Specialty: restoration of paintings. Son of J.J. Rougeron [1841-1880]. **Sources:** WW40.

ROUGET, Michael See: **ROUGUT, Michael**

ROUGUT, Michael *[Lithographer] b.c.1829, France.*
Addresses: Philadelphia in 1860. **Sources:** G&W; 8 Census (1860), Pa., LII, 42.

ROUILLÉ DE MARIGNY, Anne Marguerite-Henriette See: **HYDE DE NEUVILLE, Anne-Marguerite Henriette (Baroness)**

ROULAND, Orlando *[Portrait painter, teacher] b.1871, Pleasant Ridge, IL / d.1945, NYC.*
Addresses: NYC/Marblehead, MA. **Studied:** M. Thedy, in Germany; Académie Julian, Paris with J.P. Laurens and Constant, 1896; also in London, NYC, and Marblehead, MA. **Member:** ANA, 1936; SC, 1901; Paris AAA; Allied AA; AAPL; Lotos Club; North Shore AA; Springfield, AA; AFA. **Exhibited:** Corcoran Gal biennials, 1907, 1923; S. Indp. A., 1917; Duxbury AA, 1921 (prize); Salons of Am. **Work:** Yale; Trinity College, Cambridge Univ., England; Univ. Texas, State Capitol, both in Austin; Hist. Soc., St. Paul, MN; Wheaton College, Norton, MA; CI; Nat. Gal., Washington, DC; Engineers' Club; Soc. Mining Engineers, Columbia; Lotos Club; AAAL; City Club, Boston; Montclair (NJ) Mus. Art; Lexington (KY) Public Library; Amherst College; Art Club, Erie, PA; Rollins College, Winter Park, FL; Lafayette College, Easton, PA; AMNH. **Sources:** WW40; P&H Samuels, 410.

ROULEAU, Alice R. *[Painter] mid 20th c.*
Addresses: Oakland, CA. **Exhibited:** Oakland Art Gal., 1939. **Sources:** Hughes, *Artists in California,* 481.

ROULERY, Reuben See: **ROWLEY, Reuben**

ROULLIER, Albert Edward *[Dealer] b.1858, Paris, France / d.1920, Chicago.*
Exhibited: Awards: Officer of Public Instruction (France), in recognition of his efforts to promote friendship between the U.S. and France.

ROULLIER, Blanche *[Painter] 19th/20th c.; b.San Fran., CA, to Fr. parents.*
Addresses: Paris, France. **Studied:** Delance, in Paris. **Exhibited:** Paris Salon, 1889, 1890, 1893-97, 1899. **Sources:** WW06; Fink,

American Art at the Nineteenth-Century Paris Salons, 387.

ROULLIER, Christian Henry *[Portrait painter] late 19th c.; b.Lyon, France.*
Addresses: San Francisco, CA, active 1880s. **Studied:** Paris, with Leon Gerome. **Member:** Bohemian Club. **Exhibited:** Paris Salon, 1878; San Francisco AA, 1883; Mecahnics Inst., San Francisco, 1883. **Work:** Stanford Art Gallery; Bohemian Cl. **Sources:** Hughes, *Artists in California,* 481.

ROUND, Irene Leslie *[Painter, etcher, block printer] b.1903, Pueblo, Co.*
Addresses: St. Paul, MN. **Studied:** C. Winholz; L. Bobleter; C. Haupers; St. Paul Sch. Art, with C. Booth. **Member:** Southern PM Soc.; Club Montparnasse, St. Paul. **Work:** Art Cl., Birmingham, Ala. **Sources:** WW40.

ROUNDEY, Catherine Alice *[Painter] b.1857, San Francisco, CA / d.1923, San Francisco, CA.*
Addresses: San Francisco, CA. **Exhibited:** San Francisco AA, 1900, 1905, 1917. **Sources:** Hughes, *Artists in California,* 481.

ROUNDING, William *[Engraver] b.c.1822, England.*
Addresses: Philadelphia in 1850. **Sources:** G&W; 7 Census (1850), Pa., LII, 978.

ROUNDS, Edna Elizabeth *[Painter] mid 20th c.; b.Des Moines, IA.*
Addresses: Des Moines, IA. **Studied:** Wellesley College; Cumming School Art under Charles Atherton Cumming. **Exhibited:** Des Moines Women's Club; Iowa Art Salon, 1931 (prize); Iowa Art Guild, 1932. **Work:** In private collections. **Sources:** Ness & Orwig, *Iowa Artists of the First Hundred Years,* 180.

ROUNDS, George L. *[Painter] early 20th c.*
Addresses: Chicago. **Exhibited:** AIC, 1919, 1921. **Sources:** Falk, *AIC.*

ROUNDS, Glen H *[Painter, block printer, etcher, engraver, illustrator] b.1906, near Wall, SD.*
Addresses: Rapid City, SD. **Studied:** T.H. Benton; J. de Martelly. **Exhibited:** Kansas Artists Soc., Kansas City, 1934 (prize). **Work:** Jr. Col., Kansas City. **Comments:** Illustrator: *Vanity Fair.* **Sources:** WW40.

ROUNDTREE, Herman *[Illustrator] b.1878, Springfield, MO / d.1946.*
Addresses: South Kingston, RI. **Comments:** Illustrator: *The Sportsman, Field and Stream.* Specialty: animals in their native habitats.

ROUPEL, George *[Botanical draftsman and caricaturist] mid 18th c.*
Addresses: Charleston, SC, before 1776. **Comments:** Worked in the post office at Charleston (S.C.) before the Revolution. He illustrated some botanical papers which Alexander Garden sent to the Royal Society and at least one caricature which has been preserved. During or after the Revolution he went to England, leaving his wife and daughter in Charleston. John Singleton Copley painted his portrait and it was exhibited at the Royal Academy in 1780. **Sources:** G&W; Rutledge, *Artists in the Life of Charleston,* 118, 119, 173 (repro.).

ROURE, Emile A. *[Painter, illustrator] b.1880, San Francisco, CA.*
Addresses: Palm Springs, CA. **Studied:** Eugene Taniére. **Member:** P&S Los Angeles, 1938. **Sources:** Hughes, *Artists in California,* 481.

ROUS, Helen (Woods) *[Painter] mid 20th c.*
Studied: ASL. **Exhibited:** Salons of Am., 1935; S. Indp. A., 1937. **Sources:** Marlor, *Salons of Am.*

ROUSE, Charles Gaylor *[Painter, craftsperson] b.1875, NYC / d.1955, Huntington Beach, CA.*
Addresses: Riverside, CA. **Exhibited:** Riverside AA, Los Angeles City Hall, 1941. **Sources:** Hughes, *Artists in California,* 482.

ROUSE, Charles S. *[Landscape and portrait painter, engraver] late 19th c.*
Addresses: San Francisco, CA. **Exhibited:** Mechanics Inst., San Francisco, 1876. **Sources:** Hughes, *Artists in California,* 482.

ROUSE, Elizabeth *[Painter] early 20th c.*
Exhibited: Salons of Am., 1922. **Sources:** Marlor, *Salons of Am.*

ROUSE, G.
Work: NYHS owns two wax portraits of George Washington, signed by G. Rouse, 1797. **Comments:** Supposed modeler of wax portraits of George Washington, dated 1797. These are thought to be forgeries made in London about 1924. Groce & Wallace stated there was no reason to believe that there was ever an artist of this name. **Sources:** G&W; Wall, "Wax Portraiture," 22-24; Bolton, *American Wax Portraits,* 60. NYHS Catalogue (1974), cat. nos. 2194, 2195.

ROUSE, Mary Jane Dickard *[Educator] late 20th c.; b.Monroe, LA.*
Addresses: Bloomington, IN. **Studied:** Louisiana Polytech. Inst. (B.A.); Inst. Design, Chicago; La. State Univ. (M.A.); Stanford Univ. (Ph.D.). **Exhibited:** Awards: Danforth col. teacher fel., 1960-61; Stanford fel, 1961-62. **Comments:** Publications: auth., articles on res. & curric. & res. monogr. Teaching: instr., art dept., La Polytech Inst., 1956-60; from asst. prof. to assoc. prof. art educ., Ind. Univ., Bloomington, 1963-. Research: experimental aesthetics; evaluation; curriculum. **Sources:** WW73.

ROUSH, Louis L *[Illustrator] 19th/20th c.*
Addresses: NYC. **Sources:** WW01.

ROUSSE, Charles *[Painter] early 20th c.; b.Scotland.*
Addresses: Phila., PA. **Studied:** South Kensington Sch., London. **Exhibited:** AIC, 1902. **Sources:** WW04.

ROUSSEAU, Angeline Marie *[Painter, printer, teacher] b.1912, Detroit, MI.*
Addresses: Plymouth, Livonia, MI. **Studied:** Marygrove Col., Detroit (B.A.). **Member:** AAPL; Am. Fed. A. **Exhibited:** PAFA Ann., 1937; AFA traveling exh.; Detroit Inst. A., 1933; AIC, 1936; Phila. A. All., 1939. **Work:** Am. Lib. Color Slides. **Sources:** WW59; WW47; Falk, *Exh. Record Series.*

ROUSSEAU, Charles *[Sculptor, stonecutter] b.1823, Belgium / d.c.1900, Wash., DC.*
Addresses: Wash., DC, active 1858. **Work:** marble monument of Benjamin C. Greenup (1858), Glenwood Cemetery, Wash., DC. **Comments:** He operated his own marble yard in Wash., DC. **Sources:** McMahan, *Artists of Washington, DC.*

ROUSSEAU, Edme *[Miniature and portrait painter] mid 19th c.*
Addresses: NYC, 1826-30 and in 1843. **Exhibited:** NAD, 1843 (six portraits). **Sources:** G&W; NYCD 1826-30, 1843; Cowdrey, NAD.

ROUSSEAU, Helen Hoffman *[Painter] mid 20th c.*
Addresses: Long Beach, CA. **Exhibited:** Oakland Art Gal., 1932; Artists of Los Angeles, LACMA, 1942. **Sources:** Hughes, *Artists in California,* 482.

ROUSSEAU, Theodore *[Portrait painter] b.1812 / d.1867.*
Addresses: Boston in 1858-59; Charleston, SC in May 1859. **Exhibited:** Boston Athenaeum, 1868. **Sources:** G&W; Swan, BA; Boston CD 1858, BD 1859; Rutledge, *Artists in the Life of Charleston.*

ROUSSEAU, Theodore, Jr. *[Museum, curator] b.1912, Freeport, NY / d.1974.*
Addresses: NYC. **Studied:** Eton Col., Windsor, 1924-29; Sorbonne, 1933; Harvard Univ. (B.A., 1934, M.A., 1937). **Member:** Century Assn.; Grolier Cl. **Exhibited:** Awards: Legion of Hon., France; Order of Orange-Nassau; Comdr., Order of Alfonso X el Sabio, Spain, 1962. **Comments:** Positions: asst. cur.

paintings, Nat. Gal. Art, Wash., DC, 1940-41; assoc. cur. paintings, MMA, 1947, cur. Europ. paintings, 1948-67, chmm. dept. paintings, 1967-68, v.-dir. & cur. in chief, 1968-. Teaching: lectr. painting, univs. & mus. Collections arranged: Van Gogh Exhibition, MMA & AIC, 1949-50; Cezanne Exhibition, 1952, MMA & AIC; Vienna Art Treasures, 1950; Dutch Painting: The Golden Age, MMA, Toledo Mus Art & Art Gallery Toronto, 1954-1955. Publications: auth., "Paul Cezanne," 1953; auth., "Titian Abrams," 1955 & 1970; auth., "The Metropolitan Museum," 1957; contribr., *Art News, Rev Paris, Metrop Mus Art* & other museum bulletins. **Sources:** WW73.

ROUSSEAU-VERMETTE, Mariette *[Craftsman] b.1926, Trois Pistoles, PQ.*
Addresses: PQ, Canada. **Studied:** Ecole Beaux Arts, Quebec, 1948; Liebes Studio; Oakland Col. Arts & Crafts, Calif. **Member:** Conf. Arts; assoc. Can. Royal Acad.; Assn. Artistes Prof.; World Craft Coun.; Montreal Mus. Fine Art. **Exhibited:** 4 Biennales, Lausanne, Switz., 1962, 1965, 1969 & 1971; Quebec & Ont. Contemp. Painters Centennial Exhib., 1965; 300 Yrs. Art, Nat. Gal. Can., 1967; MoMA, 1969; Mus. Beaux Arts, Montreal, 1971; Marlborough-Godard Galleries, Montreal, PQ, 1970s Marlborough-Godard Galleries, Toronto, Ont., 1970s Awards: first prize, PQ Art Contest, 1957; Can. Art Coun. traveling bursary, 1967; Cult. Inst. Rome, Italy bursary, 1972-73. **Work:** Gal. Nat. Can., Ottawa; Mus. Quebec; many Can. embassies; Univ. Vancouver Arts Faculty Hall; Vancouver Art Gallery. Commissions: theater stage curtains, Govt. Nat. Art Ctr. Performing Art, 1965 & JF Kennedy Ctr., Wash., DC, 1971; tapestries, Macmillan Bloedel Hall, Vancouver, 1968, Hall of Justice Perce, 1968 & Hall of the Toronto Star, 1971-72. **Comments:** Preferred media: tapestry. Positions: dir., Can. Conf. Arts, 1958-. Teaching: prof tapestry, Ctr. Art Ste-Adele, PQ, 1952-56; prof. tapestry, Ctr. Art Laval, PQ, 1970-. Collection: Canadian paintings, sculptures and tapestries; graphic art; Polish tapestries, icons and paintings. **Sources:** WW73; "Le grande livre de la tapisserie," *Time* (1963); Guy Robert, "Symphonies en laines et couleurs," *Vie Arts* (1964); Eugene Cloutier, *Retrospective,* catalog (1972).

ROUSSEFF, Walter Vladmimir *[Painter, mural painter] b.1890, Silistria, Bulgaria.*
Addresses: Fish Creek, WI; Chicago, IL, 1932. **Studied:** AIC. **Exhibited:** AIC 1926 (prize), 1928 (prize), 1929 (med, prize), 1930 (prize); WMAA, 1932. **Work:** AIC; Municipal Art Lg.; Swift Sch., Chicago; murals, Nichols Sch., Evanston (Ill.), USPOs, Iron Mountain (Mich.), Salem (Ill.). WPA muralist. **Sources:** WW40.

ROUSSEL, Claude Patrice *[Sculptor, instructor] b.1930, Edmunston, NB.*
Addresses: St Anselme, NB, Canada. **Studied:** Ecole Beaux-Arts, Montreal, PQ, 1950-1956; Can. Coun. sr. traveling fel., Europe, 1961. **Member:** Can. Artist Representation (Moncton rep., 1972); Can. Sculptor Soc. **Exhibited:** Survey 1969, Montreal Mus. Fine Arts, 1969; NB Mus., 1970; Confedn. Art Gal., 1970; Air & Space Mus., Smithsonian Inst., 1971; Man & His World, Montreal, 1971. Awards: Allied Arts Medal, Royal Archit. Soc. Can., 1964; St. John City Hall Sculpture Competition, City of St. John, 1972. **Work:** Smithsonian Inst, Wash., DC; NB Mus., St. John; Confedn. Art Gal., Charlottetown, PEI; Univ. Moncton, NB; Mt. Allison Univ., Sackville, NB. Commissions: mural, Frederickton Airport, NB, 1964; mural, NB Centennial Bldg, 1966; monument, fishermen, Escuminac, NB, 1969; exterior sculpture & interior mural, Univ. Moncton Nursing Pavillion, 1971; archit. sculpture for City Hall, City of St John, 1972; plus 20 other archit. projs. **Comments:** Preferred media: wood, stone, steel, plastics. Positions: asst. curator, Beaverbrook Art Gal., Frederickton, 1959-61. Teaching: art instr., Edmunston Pub. Schs., 1956-59; art instr., Univ. Moncton, 1963-. **Sources:** WW73; "Painting a province," Nat. Film Bd., 1960; J. Villon, "L'art en acadie," *Rev. Liberté* (1970); E. Michel, *Reseau soleil* (C B C, 1971).

ROUSSEL, Marie (Mrs. de Calcinara) *[Landscape painter, editor] late 19th c.*
Addresses: New Orleans, active c.1894-95. **Comments:** Began a French language periodical "La Révue" which only lasted three months. Following her marriage she went to Galveston and then to Mexico. **Sources:** *Encyclopaedia of New Orleans Artists,* 333.

ROUSSEVE, Ferdinand Lucien *[Designer, educator, lecturer] b.1904, New Orleans, LA.*
Addresses: New Orleans, LA. **Studied:** MIT (B.S. in Arch.); Univ. Chicago (M.A.); Harvard Univ. **Member:** CAA; Mediaeval Acad. Am. **Comments:** Position: assoc. prof., Hd. FA Dept., Xavier Univ., New Orleans, La., 1934-. **Sources:** WW53; WW47.

ROUST, Eskesen See: ESKESEN-ROUST

ROUST, Helma (Mrs.) *[Painter] early 20th c.*
Addresses: NYC. **Member:** S. Indp. A. **Exhibited:** S. Indp. A., 1921. **Sources:** WW25.

ROUTHENSTEIN, Florence *[Painter] mid 20th c.*
Addresses: NYC. **Exhibited:** PAFA Ann., 1946, 1948. **Sources:** Falk, *Exh. Record Series.*

ROUX, Francis *[Lithographer] b.c.1830, France.*
Addresses: Philadelphia in 1860. **Sources:** G&W; 8 Census (1860), Pa., LVIII, 375 (living with his wife, an artificial flower maker, and two-year-old daughter, also born in France).

ROUYON, Adele *[Painter] b.1870, Brooklyn, NY.*
Addresses: NJ/ME. **Studied:** ASL, with J.C. Beckwith, 1888; Brooklyn At Sch., 1890; PIA Sch., 1897-1906. **Sources:** info. courtesy L. Nelson.

ROUZEÉ, William M. *[Painter, teacher] b.c.1850, Wash., DC.*
Addresses: Wash., DC. **Studied:** NYC. **Member:** Wash. AC. **Exhibited:** NAD, 1873-90; Brooklyn Art Assoc., 1878-79. **Comments:** In 1880 he founded the Rouzeé Art School in Wash., DC. **Sources:** McMahan, *Artists of Washington, DC.*

ROVE, M. Clarence Herbert *[Painter] late 19th c.; b.Philadelphia, PA.*
Studied: Bouguereau, Ferrier, Max Bohm. **Exhibited:** Paris Salon, 1899. **Comments:** Exhibited a drawing at the Paris Salon. **Sources:** Fink, *American Art at the Nineteenth-Century Paris Salons,* 387.

ROVELSTAD, Trygve A *[Sculptor, medalist, designer] b.1903, Elgin, IL / d.1990.*
Addresses: Elgin, IL. **Studied:** AIC; Univ. Wash.; also with Lorado Taft. **Member:** AAPL; Alumni Assn Sch. AIC. **Exhibited:** AIC; "A Thousand Years of Calligraphy & Illumination," Peabody Inst, Baltimore, 1959-60; Hudson Valley AA Ann, 1970, 1972; AAPL Grand Nat, 1971-72 (sculpture Award for Pioneer Father, 1971). **Work:** Designed & ed., Am. Roll Honor World War II, Am. Chapel St. Paul's Cathedral, London, England; portrait of Sen. William Barr, Capitol Bldg., Springfield, Ill.; dedication plaque of Gov. Stratton, Ill. State Off. Bldg. Commissions: Screaming Eagle Medal, 101st Airborne Div. Assn., 1969; Captive Nations Proclamation Medal, 1969; Chicago Coin Club 50th Anniversary Medal, 1969; Chicago Fire Centennial Medal, Chicago Hist. Soc., 1971; Martin Delaney Commemorative Medal, Am. Negro Commemorative Soc., 1972. **Comments:** Positions: sculptor, US War Dept, Shrivenham, Eng., 1945-46; designer-sculptor, various firms & studios; heraldic artist & medalist, Off. Qm., Wash., DC, auth & lithographer, Coast & Geodetic Surv., Map Div., Wash., DC, pres., Pioneer Mem. Found. Ill; gov., Assoc. Soc. Chicago; pres. & di.r, Pathfinder Inc., Elgin, Ill. **Sources:** WW73.

ROVER, Henry *[Artist and artists' supplier] mid 19th c.*
Addresses: NYC, 1848. **Sources:** G&W; NYBD and CD 1848.

ROVERSI, Luigi *[Writer] b.1860, Italy (came to U.S. c.1885) / d.1927, NYC.*
Studied: Royal Acad. FA, Bologna. **Comments:** Author: "Essays

on Italian Art," "State and Church in Italy," "Ricordi Canavesani." Correspondent: >*Corriere d'America.*

ROWAN, Dennis Michael *[Printmaker, educator]* b.1938, Milwaukee, WI.
Addresses: Champaign, IL. **Studied:** Univ. Wisc. (B.S., 1962); Univ. Ill. (M.F.A., 1964). **Member:** Boston Printmakers; Calif. Soc. Printmakers. **Exhibited:** Eight shows, Boston Printmakers Exhib., 1961-72; six shows, Northwest Printmakers Int. Exhib., Seattle, 1963-71; NAD 140th Ann., 1965; 22nd Int. Printmaking Biennale, Buenos Aires, Arg., 1970; 22nd Prints Nat., LOC, 1971. Awards: purchase award, Second Biennale Int. Gravure, Cracow, Poland, 1968; Yorkshire Arts Assn. Purchase Prize, Brit. Int. Print Biennale, 1970; Juror's prize, Graphik Biennale Wien, Europahaus, Vienna, Austria, 1972. **Work:** AIC; BMFA; SAM; Okla. Art Ctr., Oklahoma City; Honolulu Acad. Arts, Hawaii. **Comments:** Preferred media: intaglio. Publications: contribr., "Prize-Winning Graphics," Vol 3, 1965 & Vol 4, 1966. Teaching: prof. art, Univ. Ill., Urbana-Champaign, 1964-, assoc., Ctr. Advan. Study, 1971-. **Sources:** WW73.

ROWAN, Edward Beatty *[Painter, museum curator, sculptor, teacher, lecturer, critic]* b.1898, Chicago, IL / d.1946.
Addresses: Falls Church, VA. **Studied:** Miami Univ., Oxford, OH; Harvard Grad., Sch. of FA. **Member:** Iowa Artists Cl. **Exhibited:** Iowa Federation Women's Clubs, 1932; Iowa Artists Cl., 1933; Iowa Art Salon, 1933 (prize); Pennsylvania Acad. WC Exhibit, 1933; Gr. Wash. Indp. Exh., 1935; NGA; MOMA; South American Traveling Exh., U.S. State Dept.; Nat. Gal., Canada. Awards: Carnegie Grant, 1928-34. **Comments:** He was known for his small ceramic sculptures. Positions: dir., Little Gal., Cedar Rapids, Iowa, 1928-34; staff of Public Works of Art Project, Wash., DC, 1933; PBA Chief, 1930s-40s; head of fine arts section, U.S. Treausury Dep., until 1946. **Sources:** WW47; Ness & Orwig, *Iowa Artists of the First Hundred Years*, 180; McMahan, *Artists of Washington, DC.*

ROWAN, Frances Physioc *[Painter, printmaker]* mid 20th c.; b.Ossining, NY.
Addresses: Freeport, NY. **Studied:** Randolph-Macon Woman's Col., 1929-30; Cooper Union (cert., 1936); also graphics with Harry Sternberg & woodcuts with Carol Summers. **Member:** Prof Artists Guild; Silvermine Guild Artists. **Exhibited:** Brooklyn Mus 11th Nat. Print Show, 1958; Audubon Artists, 1958 & 1959; Am. Fedn. Arts Traveling Show, 1958-59; Knickerbocker Artists, 1961; Silvermine Guild Artists 6th Nat. Print Show, 1966. Awards: first prizes, Malverne Artist, 1952 & Hofstra Univ., 1957; Sam Flax Award, Knickerbocker Artists, 1961. **Work:** Randolph-Macon Woman's Col, Lynchburg, Va; Freeport High Sch., NY. **Comments:** Preferred media: graphics. Teaching: instr., drawing & painting, Country Art Gal. Westbury, NY, 1955-66; instr. drawing & painting, Five Towns Music & art Found., 1970-. **Sources:** WW73.

ROWAN, George Miles *[Painter]* 20th c.
Addresses: Silver Springs, MD. **Sources:** WW25.

ROWAN, Herman *[Painter, educator]* b.1923, NYC.
Addresses: Minneapolis, MN. **Studied:** Cooper Union; San Francisco State Col.; Kans. State Univ. (B.S.); State Univ. Iowa (M.A. & M.F.A.). **Exhibited:** Art USA, NY, 1960; San Francisco Mus. Nat. Ann., 1963; Southwest Ann., Houston Mus., 1963; Walker Art Ctr. Invitational, 1965; Box-Top Art, Tour NZ Galleries, 1971-72. Awards: Lyman Award, Albright Gal., 1959; purchase prize, San Diego Gal. Fine Arts, 1963; hon. men., Calif. Western Univ., 1963. **Work:** Walker Art Ctr., Minneapolis; Brooklyn Mus., NY; Univ. Notre Dame, South Bend, Ind.; Columbus Mus., Ohio; San Diego Gal. Fine Arts, Calif. **Comments:** Preferred media: oils. Teaching: prof. painting, Univ. Minn., Minneapolis, 1963-. **Sources:** WW73.

ROWAN, L. Gertrude *[Painter]* early 20th c.
Addresses: Phila., PA. **Exhibited:** PAFA Ann., 1927. **Sources:** Falk, *Exh. Record Series.*

ROWAND, William *[Portrait and miniature painter, teacher]* late 18th c.; b.Glasgow (Scotland).
Addresses: NYC, 1777. **Comments:** Advertised in NYC in December 1777. He also offered to teach drawing and had for sale a painting in oils. **Sources:** G&W; Kelby, *Notes on American Artists*, 14; Gottesman, *Arts and Crafts in New York*, II, no. 43.

ROWE, Baxter *[Painter]* mid 20th c.
Exhibited: S. Indp. A., 1937-38. **Sources:** Marlor, *Soc. Indp. Artists.*

ROWE, Carrie A. (W.?) *[Artist]* late 19th c.
Addresses: Active in Detroit, MI, 1889-97. **Comments:** Partner of Charles Robinson in the firm of C. Robinson & Co., 1889. **Sources:** Petteys, *Dictionary of Women Artists.*

ROWE, Clarence (Herbert) *[Illustrator in watercolor, etcher]* b.1878, Philadelphia, PA / d.1930, Cos Cob, CT.
Addresses: Phila., PA; Cos Cob, CT. **Studied:** PAFA; Académie Julian, Paris with Bouguereau and Ferrier, 1897; also with Max Bohm in France. **Member:** SC; SI; Calif. PM; GFLA; NAC. **Exhibited:** PAFA Ann., 1900, 1903; WMAA, 1920. **Sources:** WW29; P&H Samuels, 410; Falk, *Exh. Record Series.*

ROWE, Corinne (Mrs. Guy) *[Painter, cartoonist, illustrator]* b.1894, Marion, WI / d.1965.
Addresses: NYC. **Studied:** Detroit Sch. FA with Roman Kryzanowski, John P. Wicker, and Guy Rowe. **Member:** AEA. **Exhibited:** CGA, 1928; Detroit IA, 1926-42; Michigan Acad. Arts & Letters, 1930; NAWA, 1932, 1933; Detroit Art Market; Wadsworth Atheneum, 1932; WMAA, 1951; Riverside Mus., NYC, 1952; BMA, 1934 (solo). **Work:** LOC. **Comments:** Illustrator, "The Christmas Dates," 1945. Contributor of cartoons and illustrations to *Saturday Evening Post; Mademoiselle; Detroit Free Press.* **Sources:** WW59.

ROWE, Corrine (Mrs. Guy) See: **FINSTERWALD, Corrine (Mrs. Guy Rowe)**

ROWE, E. R. *[Artist]* mid 19th c.
Addresses: Benecia, CA in 1850. **Sources:** G&W; Peters, *California on Stone.*

ROWE, Frances Ely *[Painter, miniature painter]* mid 20th c.
Addresses: Maple Shade, NJ. **Exhibited:** PAFA, 1938; Wash. Soc. Min. PS & G. **Sources:** WW40.

ROWE, Guy (Giro) *[Painter, designer, illustrator, lecturer]* b.1894, Salt Lake City, UT Territory / d.1969, Huntington, Long Island, NY.
Addresses: Huntington Station, NY. **Studied:** Detroit Sch. FA; J.P. Wicker. **Member:** Royal Soc. A., London. **Exhibited:** Salons of Am.; S. Indp. A.; Detroit Inst. A.; Time magazine traveling exh., 1944-65; BMA; Assoc. Am. A.; Wayne Univ.; Georgetown A. Gal.; solo: NAC; Pasadena AI; BMA; Peoria Pub. Lib.; NY Pub. Lib.; Univ. Illinois; Allentown Mus. A.; Grand Forks (ND) Lib.; Southern Methodist Univ., Dallas; Univ. Texas; Houston Pub. Lib.; Marshall Fields, Chicago. Award: Christopher award, 1951. **Work:** LOC; General Foods; Eli Lilly Co.; Time, Inc.; Auto Owners Ins. Co.; Helen King Kendall Mem. Mus.; San Angelo (Tex.) A. Mus. **Comments:** I., *Time* magazine covers; I., "In Our Image." Lecture: Encaustic Printing and Painting. **Sources:** WW66; WW47.

ROWE, Helen Wright (Mrs. H. R.) *[Painter, designer, etcher, block printer]* b.1910, Pottsville, PA.
Addresses: Cuyahoga Falls, OH. **Studied:** Cleveland Sch. Art. **Member:** Ohio WCS; S. Indp. A. **Exhibited:** Akron Art Inst., 1929 (prize), 1930 (prize), 1931 (prize); S. Indp. A., 1936; AIC, 1936-38. **Comments:** Position: product designer, B. F. Goodrich Co., Akron, OH. **Sources:** WW40; Falk, *Exh. Record Series.*

ROWE, J. R. *[Painter]* mid 20th c.
Exhibited: Salons of Am., 1924. **Sources:** Marlor, *Salons of Am.*

ROWE, J. Staples *[Miniature painter, portrait painter]* b.1856 / d.1905.
Addresses: NYC. **Studied:** Boston. **Member:** Boston Art Cil;

Phila. Art Cl.; Orpheus Cl. **Exhibited:** Boston AC, 1901; PAFA Ann., 1903. **Work:** miniatures, Miss Helen Gould, President McKinley, J. Pierpont Morgan, other prominent persons. **Sources:** WW06; Falk, *Exh. Record Series.*

ROWE, L Earle *[Educator, museum curator] b.1882, Providence / d.1937.*
Addresses: Providence, RI. **Studied:** Brown; Am. Sch. Classical Studies, Athens, Greece, 1908-12. **Member:** Providence Art Cl.; Am. Fed. Arts; Eastern AA; Manual Training T.; Assoc. Mus. Dir. Member of the Harvard Egyptian expedition, Feb.-June, 1912. **Comments:** Positions: t., BMFA Sch., 1908-12, MIT; dir., RISD, 1912, became cur., 1928.

ROWE, L. K. *[Portrait painter] mid 19th c.*
Addresses: Salem, MA, 1860. **Sources:** G&W; Lipman and Winchester, 179.

ROWE, Lesbia Shaw *[Painter] mid 20th c.*
Addresses: Brooklyn, NY, 1944. **Exhibited:** S. Indp. A., 1944. **Sources:** Marlor, *Soc. Indp. Artists.*

ROWE, M. L. Arrington (Mrs.) *[Painter] d.1932, Canaan, CT.*
Member: Silvermine Gld. Artists; Pen & Brush Club; NAC. **Exhibited:** WMAA,1920, 1923.

ROWE, Mabel *[Painter] 20th c.*
Addresses: St. Joseph, MO. **Member:** St. Joseph Art Lg. **Sources:** WW25.

ROWE, Marion A. *[Painter] mid 20th c.*
Exhibited: S. Indp. A., 1940. **Sources:** Marlor, *Soc. Indp. Artists.*

ROWE, Minnie B. *[Painter] mid 20th c.*
Addresses: Chicago area. **Exhibited:** AIC, 1935. **Sources:** Falk, AIC.

ROWE, Nellie Mae *[Painter, sculptor] b.1900, near Atlanta, GA / d.1982, Vinings, GA.*
Addresses: Vinings, GA. **Exhibited:** Mus. Am. Folk Art, NYC, 1999 (retrospective). **Comments:** A self-taught African-American artist considered a folk artist, fine artist, and "Outsider" artist. She employed found objects in her figurative sculpture, and her paintings and drawings also showed images based on dreams and fantasy. From 1948-on she continued to compulsively pack the interior of her "Playhouse" home with eerie figures. **Sources:** Tessa DeCarlo, "An Artist Who Didn't Know She Was One," *NY Times,* Jan. 3, 1999, p.35.

ROWE, Reginald M. *[Painter, sculptor] b.1920, NYC.*
Addresses: San Antonio, TX. **Studied:** Princeton Univ. (B.A., 1944); ASLwith Louis Bosa, 1946-47; Inst. Allende, Univ. Guanajuato, 1958-59 (M.F.A., 1959). **Exhibited:** San Miguel Allende, Mexico, 1960 (prize); 18th Exhib. Southwest Prints & Drawings, Dallas Mus., 1969; Artists of the Southeast & Texas, NOMA, 1971; Witte Mus., San Antonio, 1968; solos, Wellons Gal., 1952, 1953 & 1956, Bianchini Gal., 1960 & Ruth White Gal., 1964 & 1970. **Work:** Marion Koogler McNay Mus., San Antonio, TX. **Commissions:** mural & outdoor sculpture, Hemisfair 1968, San Antonio, TX, 1968. **Comments:** Positions: chmn. exhibs., Witte Mus, 1965-67. Teaching: chmn. faculty painting, drawing & design, San Antonio Art Inst., 1964-. **Sources:** WW73; Ernest Hemingway, catalogue statement for first New York show, 1952; reviews, *Arts, Art News, Pictures on Exhibit, Times, Tribune & Art Int.,* 1952-70.

ROWE, William B. *[Painter, teacher, sculptor, lecturer, decorator, architect] b.1910, Chicago, IL / d.1955, Taos, NM.*
Addresses: Buffalo, NY. **Studied:** Cornell Univ., 1929-32; Buffalo AI; & with Edwin Dickinson; W.K. Stone; W. Erich. **Member:** Artists' Cooperative Group, Buffalo; Buffalo Dec. AG; Buffalo SA; Patteran Soc. (pres., 1937-39). **Exhibited:** Buffalo SA, 1935 (prize); Albright Art Gal., 1934-36, 1937 (prize), 1938-44; Arch. Comp., Seattle, WA, 1932 (prize); MMA, 1938; Riverside Mus., 1937, 1941; GGE, 1939; CGA, 1935; Great Lakes Traveling Exh., 1937; Baltimore WCC, 1938; Kansas City

AI, 1941; Rochester Mem. Art Gal., 1942; Syracuse Mus. FA, 1934; Albright Art Gal., 1934-44 (prize, 1937); Art Inst., Buffalo, 1951; Univ. Illinois, 1952. **Work:** Smithsonian Inst.; Rochester Mem. Art Gal.; murals, Bennett H.S. ; Marine Hospital, Buffalo, NY; Youngstown, NY. **Comments:** Moved to Buffalo in 1913. WPA artist. Position: instructor, pres., Buffalo AI, Buffalo, NY, 1941-45. **Sources:** WW53; WW47.

ROWE, Willie Lucille Reed (Miss) *[Etcher] b.1914, Goliad, TX.*
Addresses: Wash., DC. **Studied:** Newcomb Col., Tulane Univ.; Univ. Oklahoma; & with Hilton Leech, Max Pollak, & others. **Member:** New Orleans AA; SSAL; Louisiana SE; Southern Pr.M. **Exhibited:** New Orleans Fiesta, 1938-41 (prize, each yr.), 1943 (prize)-44 (prize), 1946 (prize); La. State Fair, 1939 (prize); La. A. Comm., 1940 (prize); A. Outdoor Fair, Wash., DC, 1946 (prize); NAD, 1943; LOC, 1943-45; CI, 1945; Northwest Pr.M., 1945; SSAL, 1940-46; NOAA, 1940-43, 1946; Caller-Times Exh., Corpus Christi, Tex., 1945-46. **Work:** Montgomery Mus. FA; Birmingham Pub. Lib.; Corpus Christi A. Fnd.; murals, Naval Officer Procurement Office, Radio Sch., Army Air Base, Int. House, all of New Orleans, La. **Sources:** WW53; WW47.

ROWELL, Fanny Taylor (Mrs. Horace C. Wait) *[Painter, teacher] b.1865, Princeton, NJ / d.1928.*
Addresses: NYC/Berryville, VA. **Studied:** J.B. Whittaker, in Brooklyn; Académie Julian, Paris with Bouguereau; Acad. Colarossi; LeBlanc in Paris; Trager in Sèvres. **Member:** NAC; NY Soc. Ceramics; NY Municipal AS; Arts Club, Jersey City; Bridgeport AC; Jersey Keramic Club; Wash. AC. **Exhibited:** Nat. Lg. Mineral Painters, 1898 (diamond medal); Boston AC, 1905, 1906. **Comments:** She taught arts and crafts to mountain children near her summer home in Tamassee, SC. **Sources:** WW27.

ROWELL, Louis *[Landscape painter] b.1873, New York / d.1928, Asheville, NC.*
Comments: Painted in the Tryon Hills, NC.

ROWELL, Samuel *[Portrait painter, miniaturist, and commercial artist] b.1815, Amesbury, MA / d.1890, Amesbury, MA.*
Addresses: Amesbury, MA (until at least 1843); Lawrence, MA (1848); Portsmouth, NH (c.1849). **Studied:** John Reubens Smith and Joseph Kyle in Phila., 1838-39. **Comments:** When he lost his first and second fingers on his right hand he became a master painter (not artist) at the Portsmouth Navy Yard (NH), 1861-70. A portrait miniature dated 1843 and marked "Amesbury" was sold at a J.D. Julia auction, Maine, Feb. 1998. **Sources:** G&W; Belknap, *Artists and Craftsmen of Essex County,* 12 (Records indicate he was living in Amesbury when he married in 1841.); Brewington, 333.

ROWELL, Samuel Torrigrossa *[Painter, cartoonist, teacher] b.1924, Kansas City, MO.*
Addresses: Melbourne, FL. **Studied:** Clemson Col.; Kansas City AI (B.A.); Skowhegan Sch. Painting. **Member:** Greenville (SC) A. Lg.; Mid-America AA; Melbourne (Fla.) AA; Fla. Fed. A. **Exhibited:** Missouri State Fair, 1949-50, 1952-54; Joslyn Mem. Mus., 1949; Springfield Mus. A., 1948; Nelson Gal. A., Kansas City, 1952; Melbourne AA, 1954-57; Vero Beach AA, 1955; Fla. Fed. A., 1957; solo: Bahama Beach Cl., 1955. **Awards:** prizes, Missouri State Fair, 1952 (3), 1954; Melbourne AA, 1954, 1957. **Work:** William Allen White Coll., Univ. Kansas; Melbourne Pub. Lib.; Westminster Col., Fulton, Mo.; People's Bank, Warrensburg, Mo.; priv. colls. **Comments:** Position: asst. prof., Kansas City AI. 1948; instr., Melbourne AA, Melbourne, Fla., 1957-58. Contributor cartoons to the *Star-Journal,* Warrensburg, Mo.; *The Daily Times,* Melbourne, Fla. **Sources:** WW59.

ROWEN, George Miles *[Painter] early 20th c.*
Addresses: Wash., DC, active 1917-24; Silver Springs, MD. **Member:** Soc. Wash. A., 1917-23. **Exhibited:** Soc. Wash. A, 1917, 1919. **Sources:** WW27; McMahan, *Artists of Washington, DC.*

ROWLAND, A. M. (Miss) *[Artist] early 20th c.*
Addresses: Active in Los Angeles, 1903-04. **Sources:** Petteys, *Dictionary of Women Artists.*

ROWLAND, Benjamin, Jr. *[Educator, writer, painter, lecturer] b.1904, Overbrook, PA / d.1972.*
Addresses: Cambridge, MA. **Studied:** Harvard Col. (B.S.); Harvard Univ. (Ph.D.). **Member:** Royal Soc. Arts, London; Am. Archaeological Assn.; Am. Oriental Soc.; Am. Inst. for Iranian A.Boston Mus. WC Painters; Chinese A. Soc. (ed.). **Exhibited:** WMAA, 1949-50; New Hampshire AA, 1951; PAFA, 1953; Boston A. Festival, 1954, 1956, 1957, 1961; solo: Doll & Richards, Boston, 1949, 1950, 1952, 1954, 1962; BMA, 1949; Detroit Inst. A., 1952; Cal. PLH, 1953. **Work:** BMFA; FMA; Detroit Inst. A.; CAM. **Comments:** Position: instr., 1930-35, asst. prof., 1935-40, assoc. prof., 1940-50, prof., 1950-, Fogg Art Museum, Harvard Univ., Cambridge Mass. Author: "Jaume Huguet," 1932; "Wall-Paintings of India, Central Asia and Ceylon," 1938; ed., translator: "The Wall-Paintings of Horyuji," 1944; author: "Harvard Outline and Reading Lists for Oriental Art," 1959; "Art and Architecture of India," 1953, 1959; "Art in East and West," 1955, paperback ed., 1964, Russian ed., 1958, Japanese ed., 1964; "The Classical Tradition in Western Art," 1963. Contributor to art publications. **Sources:** WW66; WW47.

ROWLAND, David Lincoln *[Industrial designer] b.1924, Los Angeles, CA.*
Addresses: New York 19, NY. **Studied:** Principia Col., Elsah, Ill. (B.S.); Cranbrook Acad. A. (M.F.A. in Indst. Des.), and with Moholy-Nagy at Mills Col. (summer sessions). **Exhibited:** Awards: prize, Illuminating Eng. Soc., 1951; chair des. award, Nat. Cotton Batting Inst., 1958; office des., for Nametra Travel Agcy., NYC. **Sources:** WW59.

ROWLAND, Earl *[Museum director, lecturer, educator, painter, blockprinter, drawing specialist] b.1890, Trinidad, CO / d.1963, Stockton, CA.*
Addresses: Stockton, CA. **Studied:** AIC; Sch. Illus., Los A., Cal. **Member:** AAPL; Calif. AC; Laguna Beach AA; Long Beach AA. **Exhibited:** Women's Cl., Phoenix, Ariz., 1923 (prize); Inglewood (Calif.) H.S., 1929 (prize); LOC. **Work:** Haggin Gallery; San Diego FA Soc.; Bd. Edu., Pub. Lib., Los A., Cal. **Comments:** Position: teacher,, Col. of the Pacific, Stockton, Univ. Redlands, Calif.; dir., Pioneer Mus. & Haggin A. Gal., Stockton, Cal., 1927-50s. Author: "The Instruction of Children in Museums." Lectures: "Rembrandt"; "The Paintings in the Huntington Galleries." **Sources:** WW59; WW47; Hughes, *Artists in California,* 482.

ROWLAND, Edward B. *[Painter] 20th c.; b.U.S.*
Addresses: Paris, France. **Studied:** Guillemet. **Sources:** WW13.

ROWLAND, Elden Hart *[Painter] b.1915, Cincinnati, OH / d.1982.*
Addresses: Sarasota, FL. **Studied:** Cincinnati Art Acad.; Cent. Acad. Commercial Art, Cincinnati; Jerry Farnsworth in Truro, MA; Robert Brackman in Provincetown and Conn.; San Antonio Art Inst. **Member:** AFA; Sarasota AA; Schenectady Art Mus.; Florida Artists Group; Cape Cod AA; Provincetown AA. **Exhibited:** Soc. Four Arts, Palm Beach, FL, 1960; Lowe Gal. Mem. Ann., 1962 (purchase prize); Spring Hill Col., 1963 (prize); Cooperstown Ann., 1971; Greater Schenectady Ann., NY, 1971; Berkshire Art Assn. Ann., 1971 (prize); Gail Hinchen Gal., Manchester, CT, 1970s. **Work:** Lowe Gal., Coral Gables, FL; New College, Sarasota, FL; Stetson Univ., Deland, FL; Spring Hill Col., Mobile, AL; Berkshire AA, Pittsfield, MA. Commission: murals for Monsanto Chemical, Springfield, 1955. **Comments:** Author: "Painters' Sutra," 1972. Teaching: Hilton Leech Art Sch., Sarasota. **Sources:** WW73; Crotty, 141.

ROWLAND, Henry *[Engraver] b.c.1839, New York.*
Addresses: NYC in 1860. **Comments:** *Cf.* Henry James Rowland of Philadelphia in 1887. **Sources:** G&W; 8 Census (1860), N.Y., XLVI, 820.

ROWLAND, Henry James *[Watercolorist] late 19th c.*
Addresses: Phila., PA. **Exhibited:** PAFA Ann., 1887 ("Yachts off Atlantic City"). **Comments:** *Cf.* Henry Rowland of New York in 1860. **Sources:** Falk, *Exh. Record Series.*

ROWLAND, Herron (Mrs.) *[Museum director] b.1891, Smith, AR.*
Addresses: Oxford, MS. **Studied:** Ward Seminary, Nashville, Tenn.; Deshler Inst., Tuscumbia, AL. **Comments:** Position: dir., Mary Buie Mus., Oxford, MS, 1939-1964. **Sources:** WW66.

ROWLAND, James S. *[Engraver] b.c.1823, Massachusetts.*
Addresses: Boston in 1850. **Comments:** His brother William was doorkeeper at the Boston Athenaeum. **Sources:** G&W; 7 Census (1850), Mass., XXV, 752; Boston CD 1850-52 (as plate printer).

ROWLAND, Orlando *[Painter] late 19th c.*
Addresses: NYC, 1898. **Exhibited:** NAD, 1898; PAFA Ann., 1905. **Sources:** Naylor, *NAD;* Falk, *Exh. Record Series.*

ROWLAND, Ruby *[Painter, teacher, illustrator] 20th c.; b.St. Mary's, KS.*
Addresses: Hollywood, CA. **Studied:** Kansas City AI. **Exhibited:** College AA (prize); Salons of Am. **Sources:** WW40.

ROWLAND, Stanley James *[Muralist] b.1891, Shelburne Falls, MA / d.1964, Greenwich, CT.*
Addresses: NYC. **Studied:** Brown Univ.; RISD; ASL. **Exhibited:** S. Indp. A., 1917. **Work:** murals at Yale Univ.; Williams College; Nantucket Hist. Assoc.; private residences. **Comments:** Position: cur. Arms & Armour, MMA. **Sources:** info. courtesy Nantucket Hist. Ass'n.

ROWLAND, W. E. *[Painter] 20th c.*
Addresses: Los Angeles, CA. **Sources:** WW29.

ROWLANDS, Tom *[Painter, designer] b.1926, Pleasant City, OH.*
Addresses: Yarmouth Port, MA. **Studied:** Parsons Sch. Design; ASL; Cooper Union; New Sch. Social Res.; Belle Arte, Florence, Italy. **Exhibited:** PAFA Ann., 1962; Carnegie Inst., Pittsburgh, Pa; Ward Nasse Gallery, NYC, 1970s. **Work:** Carnegie Mus., Pittsburgh, Pa.; Westmoreland Co. Mus. Art, Greensburg, Pa.; PAFA. **Comments:** Teaching: Artist-in-residence, Westmoreland Co. Mus. Art. **Sources:** WW73; Falk, *Exh. Record Series.*

ROWLEY, Blanche (Mrs. Edward R.) See: **HORNER, Blanche A.**

ROWLEY, (J.R.) Capel *[Painter] mid 20th c.*
Addresses: Bronx, NY. **Exhibited:** S. Indp. A., 1917-18, 1927, 1929, 1931. **Sources:** Marlor, *Soc. Indp. Artists.*

ROWLEY, Reuben *[Itinerant portrait and miniature painter] mid 19th c.*
Addresses: Chenango and Susquehanna Valley towns of New York State, mid-1820's; Albany, c. 1832;Boston, 1834-38. **Exhibited:** Boston Athenaeum, 1834-36. **Work:** Shelburne (VT) Mus. (attributed work, as of 1976). **Comments:** French identifled a Reuben Roulery as the instructor of Philip Hewins (see entry) in Albany in 1832. It seems extremely likely that was actually Reuben Rowley since there is no other evidence of a Reuben Roulery working in that area and it is known that Reuben Rowley was in Albany about 1832. **Sources:** G&W; Rathbone, "Itinerant Portraiture," 20; French, *Art and Artists in Connecticut,* 72 [as Reuben Roulery]; Boston CD 1834-38; Swan, BA; Lipman and Winchester, 179 [erroneously as of Amesbury, Mass.]; *Antiques* (Aug. 1925), 96, repro. More recently, see Muller, *Paintings and Drawings at the Shelburne Museum,* 120 (w/repro.).

ROWSE, J. B. *[Lithographer] mid 19th c.*
Addresses: Cincinnati, OH. **Comments:** Partner with John Sherer (see entry) in Sherer & Rowse, lithographers active in Cincinnati, 1847. **Sources:** G&W; Peters, *America on Stone.*

ROWSE, Samuel *[Lithographer] mid 19th c.*
Addresses: Cincinnati, 1845-48. **Sources:** G&W; Peters, *America on Stone.*

ROWSE, Samuel Worcester *[Crayon portraitist, engraver, and lithographer]* b.1822, Bath , ME / d.1901, Morristown, NJ. **Addresses:** Boston, MA, active c.1841-57; NYC, 1857-61; Boston, NYC, 1861-1881; NYC, 1880 and after. **Studied:** apprenticed to a wood engraver in Augusta, ME. **Exhibited:** Brooklyn AA, 1862, 1879; Boston AC, 1873, 1896; NAD, 1861. **Comments:** Rowse was brought up in Augusta, ME, and went to work in Boston, probably with the lithographic firm of Tappan & Bradford. He later became widely known as a crayon portraitist and had a studio in Boston for many years. He visited England in 1872, and in 1880 moved to NYC where he enjoyed considerable financial and popular success. His last years were spent in Morristown, NJ. **Sources:** G&W; DAB; *Art Annual*, IV, obit.; Boston BD 1844+; Cowdrey, NAD; NYCD 1858; Swan, BA; Peters, *America on Stone;* "Maine Artists." More recently, see Pierce & Slautterback, 180.

ROX, Henry *[Sculptor, educator, illustrator, commercial artist, designer, lecturer]* b.1899, Berlin, Germany. **Addresses:** South Hadley, MA. **Studied:** Univ. Berlin; Académie Julian, Paris; Kunstgewerbe Schule, Berlin. **Member:** NA; NSS; Springfield A. Lg. **Exhibited:** Springfield A. Lg., prizes in 1941, 1943, 1945, 1947, 1949, 1953, 1955; A. Headquarters Gal., NY, 1945 (solo); Springfield Mus. FA, 1945 (solo); NAD, 1944-45, 1952 (medal); Nat. Exh. Adv. A., NY, 1943; New Haven PCC, 1946; Concord State Lib., 1945 (solo); Kleeman Gal., 1946 (solo); deYoung Mem. Mus., 1947 (solo); WMA, 1948 (solo); Mt. Holyoke Col., 1940, 1947, 1959 (all solo); Wichita AA, 1949 (prize); PAFA Ann., 1949-54, 1958-60, 1966; Univ. New Hampshire, 1950 (solo); Dartmouth Col., 1950 (solo); Fitchburg A. Mus., 1953 (solo); WMAA, 1947-1956; PMA; NIAL; Syracuse Mus. FA, 1948 (prize), 1950 (prize); Yale Univ.; A. Dir. Cl.; AGAA; Wadsworth Atheneum; MMA; Smith Col.; Inst. Contemp. A., Boston; Boston A. Festival,1953 (prize); Univ. Wisconsin; Denver A. Mus.; Detroit Inst. A.; Oregon Ceramic Studio, Portland; Portland (Me.) A. Festival; Arch. Lg., 1949 (prize), 1954 (prize), 1955 (prize); Silvermine Gld. A., 1950(prize), 1952 (prize); A. Dir. Cl., NY, 1950 (prize); A. Dr. Cl., Chicago, 1957 (prize); Audubon A., 1951 (prize), 1954 (prize), 1956 (medal); and in Europe. Award: Guggenheim F., 1954. **Work:** Springfield Mus. FA; Mt. Holyoke Col.; Father Judge Mission Seminary, Monroe, Va.; LACMA; Smith Col.; Merchandise Mart, Chicago; AGAA; John Herron AI; Dartmouth Col.; Syracuse Mus. FA; Faenza, Italy; Wisteriahurst Mus., Holyoke, Mass. **Comments:** Positions: prof. a., Mount Holyoke Col., 1939-64; Mary Lyon Prof., 1963. instr. s., Worcester A. Mus., Worcester, Mass., 1946-52. Originator of "Photo-Sculpture" for advertising, children's books, and motion pictures. **Sources:** WW66; WW47; Falk, *Exh. Record Series.*

ROXBOROUGH, Alexander *[Engraver]* b.c.1806, Scotland. **Addresses:** Rhode Island in the early 1840's; Philadelphia, 1850-60. **Sources:** G&W; 7 Census (1850), Pa., LVI, 331 (age given as 44); 8 Census (1860), Pa., LX, 709 ((age given as 50). Two of his children were born in England and the last two were born in Rhode Island in the early 1840's.

ROXBOROUGH, William *[Engraver]* b.c.1829, England. **Addresses:** Philadelphia, active 1850-70s. **Comments:** Son of Alexander Roxborough (see entry). **Sources:** G&W; 7 Census (1850), Pa., LVI, 331; 8 Census (1860), Pa., LX, 701; Phila. CD 1871.

ROXBURY, Robert L. *[Designer, engraver, printer]* b.c.1840, Edinburgh, Scotland / d.1900, New Orleans, LA. **Addresses:** New Orleans, active 1882-84. **Sources:** *Encyclopaedia of New Orleans Artists*, 293.

ROXBURY, Theodore *[Painter]* mid 20th c. **Exhibited:** S. Indp. A., 1941. **Sources:** Marlor, *Soc. Indp. Artists.*

ROY *[Painter]* mid 20th c. **Addresses:** Hillcrest, DE. **Exhibited:** PAFA Ann., 1933 (still life). **Sources:** Falk, *Exh. Record Series.*

ROY, Pierre *[Painter, printmaker, illustrator]* b.1880, Nantes, France / d.1950, Milan, Italy. **Studied:** Académie Julian, Paris with J.P. Laurens; École des Arts Decoratifs with E. Grasset; École des Beaux-Arts. **Exhibited:** Brummer Gal., NYC, 1930, 1933 (solos); Carnegie Int'l, 1931, 1934, 1936-39, 1950; Wadsworth Atheneum, 1931 (surrealism exh.); Julien Levy Gal., NYC, 1932 (surrealism exh.); Expo. Universelle, Paris, 1937. **Comments:** A French artist who had a significant impact in bringing "Magic Realism" to America. Roy's style was one of meticulous realism, bordering on tromp l'oeil, but instilled with the spirit of Surrealism. Or, in Jeffrey Wechsler's words, "Magic realist painters try to convince us that ordinary things are strange, and these things are painted because they are possible." Roy's first exhibitions in NYC received praise, and throughout the 1930s he returned to the U.S. for his shows from New York to San Francisco. In 1936, he was selected as the juror from France for the Carnegie Int'l exhibition. He also painted in Hawaii. His popularity was further spread by his illustrations which appeared in *Vogue*. Among the Americans who were Magic Realists are Charles Rain, John Atherton, Jared French, Bernard Perlin, and O. Louis Guglielmi (see entries). **Sources:** Wechsler, 36; Benezit.

ROYAL, Bonny *[Painter]* early 20th c.; d.20. **Addresses:** Chicago. **Exhibited:** AIC, 1909. **Sources:** Falk, *AIC.*

ROYAL, Juan Cruz *[Painter]* mid 20th c. **Exhibited:** AIC, 1935. **Sources:** Falk, *AIC.*

ROYBAL, Alfonso See: AWA, Tsireh (Alfonso Roybal)

ROYBAL, Tonita Cruz *[Craftsperson]* 20th c. **Addresses:** Santa Fe, NM. **Exhibited:** the Exhibition of Inter-Tribal Arts. A full-blooded Tewa Indian, she was awarded many prizes for her pottery. **Sources:** WW40.

ROYCE, Elizabeth Randolph (Mrs Edward) *[Sculptor]* 20th c. **Addresses:** NYC/Ithaca, NY. **Member:** NAWPS. **Sources:** WW25.

ROYCE, Woodford *[Painter]* b.1902, Willimantic, CT. **Addresses:** Woodstock, NY. **Exhibited:** Nat. Acad., 1933; Salons of Am.; CAFA, 1938. **Sources:** WW40.

ROYER, Jacob S *[Painter, craftsperson]* b.1883, Waynesboro, PA. **Addresses:** Dayton, OH. **Studied:** Dayton AI; R. Oliver. **Member:** Dayton AG; AAPL. **Work:** Dayton AI. **Sources:** WW33.

ROYER, Samuel L. *[Artist]* early 20th c. **Addresses:** Wash., DC, active 1904-05. **Sources:** McMahan, *Artists of Washington, DC.*

ROYLA, Bonnie *[Painter]* 20th c. **Addresses:** Chicago, IL. **Sources:** WW10.

ROYS, Edna Blumve *[Painter, printmaker, sculptor]* b.1882, Pasadena, CA / d.1971, Pasadena, CA. **Addresses:** Pasadena, CA. **Studied:** USC, College of Fine Arts. **Exhibited:** PM of Los Angeles, 1916; Art Teacher's Assoc. of Southern California, 1924; First Pasadena Civic Art Exh. **Comments:** Position: t., USC, College of Fine Arts; t., Pasadena Jr. College. **Sources:** Hughes, *Artists in California*, 482.

ROYS, Mary G. *[Artist]* late 19th c. **Addresses:** Active in Grand Rapids, MI, 1897-98. **Sources:** Petteys, *Dictionary of Women Artists.*

ROYSHER, Hudson (Brisbine) *[Designer, art administrator, craftsman, teacher]* b.1911, Cleveland, OH. **Addresses:** Los Angeles, CA; Arcadia, CA. **Studied:** Cleveland Art Inst. (grad. dipl., 1934); Western Reserve Univ. (M.S., 1934); Univ. Southern Calif. (M.F.A., 1948). **Member:** Cleveland SA; CAA; Indust. Designers Soc. Am. (chmn. West Coast chap., 1946); Am. Assn. Univ. Prof. (chap. pres.); Southern Calif.

Designer Craftsmen (chap. pres., 1958-59); Am. Craftsman's Coun.; Assn. Calif. State Univ. Prof. (chap. pres., 1963-65 & 1971-72). **Exhibited:** Cleveland Mus. A., 1933 (prize), 1934 (prize), 1936 (prize), 1940 (spec award for continued excellence), 1941, 1946 (spec award for continued excellence); Boston Soc. A. & Crafts, 1940; St. Paul Gal. A., 1942 (solo); LACMA, 1941 (solo). US State Dept Traveling Exhib., 1950-1952; Eleven Southern Californians, De Young Mem Mus, San Francisco, Calif., 1952; Smithsonian Inst. Traveling Exhib., 1953-55; Designer Craftsmen of the West Traveling Exhib., 1957; Masters of Contemporary American Crafts Exhib., Brooklyn Mus.,1961. Award: outstanding prof award, 1966 & outstanding educator award, 1972, trustees of Calif. State Univ. & Cols. **Work:** Mace, Univ. Buffalo, NY; Mace, Univ. Southern Calif., Los Angeles; Mace, Syracuse Univ., NY; Mace, Calif. State Univ., Los Angeles; Mace, Bethune-Cookman Col., Daytona Beach, Fla. **Comments:** Preferred media: silver, gold, bronze. Positions: affiliated with Designers for Industry, Inc., Cleveland, Chicago, New York; t., Univ. Ill. (1937-39); asst. prof. indust. design, Univ. Southern Calif., 1939-42; head div. indust. design, Chouinard Art Inst., 1945-50; prof. art, Calif. State Univ., Los Angeles, 1950-70, chmn. dept. art, 1970-. **Sources:** WW73; "A Welded Steel Education," *Design Mag.* (London, 1951); H.E. Winter, "Three American Silversmiths," *Amerika* (May, 1953); "Churches & Temples," *Progressive Archit.*

ROZAIRE, Arthur D. *[Landscape painter] b.1879, Montreal, Canada / d.1922, Los Angeles, CA.*
Addresses: Los Angeles, CA. **Studied:** Canada. **Member:** Royal Canadian Academy; Calif. AC. **Exhibited:** Ranson Gal., Los Angeles, 1919; LACMA, 1921. **Work:** Laguna Beach Mus. of Art; LACMA. **Sources:** Hughes, *Artists in California*, 482.

ROZAK, Theodore J. *[Sculptor] b.1907, Inowroclaw, Poland / d.1981, NYC.*
Addresses: immigrated to NYC before 1928. **Sources:** info courtesy D.W. Johnson, *Dictionary of American Medalists* (pub. due 2000).

ROZAS, Linda de *[Painter] late 19th c.*
Addresses: Brooklyn, NY, 1898. **Exhibited:** NAD, 1898. **Sources:** Naylor, *NAD.*

ROZEN, Mel *[Painter] late 20th c.*
Addresses: Drexel Hill, PA. **Exhibited:** PAFA Ann., 1968. **Sources:** Falk, *Exh. Record Series.*

RUBEN, Edward *[Painter] b.1895, Boston, MA / d.1934, Saranac Lake, NY.*
Comments: Position: teacher, PIA Sch.

RUBEN, Marjorie *[Painter] mid 20th c.*
Addresses: Phila., PA. **Exhibited:** PAFA Ann., 1960. **Sources:** Falk, *Exh. Record Series.*

RUBEN, Richards *[Painter, educator] b.1925, Los Angeles, CA.*
Addresses: Los Angeles, CA-1958; NYC. **Studied:** Chouinard Art Inst. **Exhibited:** Corcoran Gal biennial, 1953; PAFA Ann., 1954, 1958; Pittsburgh Intl., CI, 1955; Sao Paulo 111rd Biennial, Brazil, 1955; 1st Paris Biennial, France, 1959; WMAA, 1963; Arte de America y Espana, Madrid, Spain, 1963; SFMA, 1953 (1st prize for oil), 1971. Other awards: Tiffany grant, 1954; Tamarind fellow, 1961. **Work:** Worcester Mus., Mass.; Brooklyn Mus.; LACMA; Corcoran Gal.; Pasadena AM. **Comments:** Teaching: Pomona Col., 1958-62; NY Univ., 1963-70s; Pratt Inst., 1967-71. **Sources:** WW73; Falk, *Exh. Record Series.*

RUBEN, Rita *[Sculptor] mid 20th c.*
Addresses: Phila., PA. **Exhibited:** PAFA Ann., 1951 (prize). **Sources:** Falk, *Exh. Record Series.*

RUBENACKER, George *[Artist] late 19th c.*
Addresses: Wash., DC, active 1892-96. **Sources:** McMahan, *Artists of Washington, DC.*

RUBENSTEIN, Leonard S. *[Designer, craftsperson, painter] b.1918, Rochester, NY.*
Addresses: Buffalo, NY. **Studied:** Alfred Univ. (B.F.A.); Cleveland Sch. A.; Univ. Rochester; & with C.K. Nelson, M.L. Fosdick. **Exhibited:** Syracuse MFA, 1941; AIGA, 1940; Finger Lakes Exh., 1940 (prize), 1941; Albright A. Gal., 1939-41. **Comments:** Position: art dir., Landsheft, Inc., Buffalo, NY, 1946-. Lectures: ceramics. **Sources:** WW53; WW47.

RUBENSTEIN, Lewis W. *[Painter, educator, lithpgrapher] b.1908, Buffalo, NY.* *Lewis R.*
Addresses: Poughkeepsie, NY; Buffalo, NY, 1941. **Studied:** Albright Gal. A. Sch.; Harvard, Traveling F., 1931-33; Paris, also with Leger & Ozenfant, Paris, frescoes with Rico Lebrun & lithography with Emil Ganso, Rome, plastic painting media with Jose Guttierez & sumi with Keigetsu, Tokyo. **Member:** Soc. Am. Graphic Artists. **Exhibited:** FMA, 1932, 1936, 1937; MoMA, 1934; AGAA, 1935; WMAA, 1938, 1941; Albany Inst. Hist. & A., 1936, 1945; 48 States Comp., 1939; AFA Traveling Exh., 1941; CGA, 1942, 1944; NAD, 1946,1952, 1956 & 1963; Albright A. Gal., 1941, 1946; Vassar Col., 1940, 1945; Wheaton Col., 1940; Wash. Pub. Lib., 1945; Wash. AC, 1945; Germanic Mus., Cambridge, Mass.; FMA; AGAA; Vassar; Albany Inst. Hist. & A.; murals, Johns Hopkins; USPOs, Wareham, Mass., Riverton, NJ; Germanic Mus.; Silvermine Guild Artists, 1959 (Fairfield Award); LOC, 1952-60; Soc. Am. Graphic Artists, NYC, 1952-72 (Am. Artists Group & Knobloch Prizes1953 & 1954); AWCS, 1955 & 1964; Three Arts, Poughkeepsie, NY, 1970s. Awards: Fulbright grant, Japan, 1957-58. **Work:** Ford Found., NYC; Am. Univ., Wash., DC; Vassar Col Art Gal., Poughkeepsie, NY; US Info Agency; Addison Gal. Am. Art. Commissions: frescoes, Busch-Reisinger Mus., Cambridge, Mass., 1937 & asst. to Orozco, MoMA, 1940; murals, Post Off., US Sect. Fine Arts, Wareham, Mass., 1940 & entrance, Jewish Ctr., Buffalo, 1950, four paintings, Marine Midland Nat. Bank, Poughkeepsie, 1965. **Comments:** Teaching: instr. fresco painting, BMFA Sch., 1937-38; prof. painting, Vassar Col., 1939-; instr. fresco painting, Univ. Buffalo, summer 1941. Publications: auth., "Fresco Painting Today," *Am. Scholar*, 1935; Time Painting by Lewis Rubenstein (film), 1956-1957 & Ceremony for a new planet (film), 1972, Vassar Col.; illusr., *For Serv J.*, 1958-66; co-auth., Psalm 104 (film), Weston Woods Studios, 1971. **Sources:** WW73; WW47; Guillermo Rivas, "Lewis Rubenstein," *Mex. Life* (Aug., 1951); Erica Beckh Rubenstein, "Lewis Rubenstein's Time Painting," *Vassar Alumnae Mag.* (May, 1957); Masao Ishizawa, "Rubenstein and his Sumi Painting," Hoshun, Japan, Feb. 25, 1959.

RUBIN, Bernard *[Painter] mid 20th c.*
Exhibited: Salons of Am., 1934. **Sources:** Marlor, *Salons of Am.*

RUBIN, Harry (Mr. & Mrs.) *[Collectors] 20th c.*
Addresses: NYC. **Sources:** WW73.

RUBIN, Hy *[Illustrator, cartoonist] b.1905 / d.1960.*
Addresses: NYC. **Exhibited:** Salons of Am. **Comments:** Contributor: illustrations, *Good Housekeeping*, 1939. **Sources:** WW40.

RUBIN, Irwin *[Painter, designer] b.1930, Brooklyn, NY.*
Addresses: Brooklyn, NY. **Studied:** Brooklyn Mus. Sch. Art; Cooper Union Art Sch.; Yale Univ. (B.F.A. & M.F.A.). **Exhibited:** Fla State Univ., 1960; BMA, 1960; Bertha Schaefer Gal., NY, 1960-63; Stable Gal., NY, 1964; Byron Gal., 1965. **Comments:** Positions: art dir., McGraw-Hill Bk. Co., NYC, 1958-63; art dir., Harcourt Brace Jovanovich, Inc., New York, 1971-. Teaching: instr. drawing & color design, Univ. Tex., 1955; asst. prof., Fla. State Univ., 1956-58; instr., Pratt Inst., Brooklyn, 1964-; asst. prof. archit., Cooper Union Art Sch., 1967-on. Publications: auth, "Permanency in Collage,"*Arts Mag.* (1957). **Sources:** WW73.

RUBIN, Joseph I. *[Painter] mid 20th c.*
Addresses: Los Angeles, CA, 1958; Monterey Pk., CA, 1962. **Exhibited:** PAFA Ann., 1958, 1962. **Sources:** Falk, *Exh. Record Series.*

RUBIN, Lawrence *[Art dealer, collector] b.1933, NYC.*
Addresses: NYC. **Studied:** Brown Univ.; Columbia Univ. (B.A.); Univ. Paris. **Comments:** Positions: owner & dir., Lawrence Rubin Gallery. Specialty of gallery: painters Stella, Motherwell, Poons, Louis, Bannard, Olitski, Holland, Sander and Dzubas; sculptors Caro, Arman and Scott. Collection: contemporary painting and sculpture. **Sources:** WW73.

RUBIN, William *[Art curator, art historian] b.1927, NYC.*
Addresses: NYC. **Studied:** Columbia Univ. (A.B., M.A. & Ph.D.); Univ. Paris. **Comments:** Teaching: prof. art hist., Sarah Lawrence Col., 1952-67; prof. art hist., NYC Univ., 1960-67; adj. prof., NY Univ. Inst. FA, 1968-. Positions: Am. art ed., *Art Int. Mag.,* 1959-64; chief cur. painting & sculpture, MoMA, 1968-. Publications: auth., *Modern Sacred Art and the Church of Assy.,* 1961; *Dada, Surrealism and their Heritage,* 1968 (exh. arranged); *Dada and Surrealist Art,* 1969, 1970; *Picasso in the Collection of the Mus. of Modern Art,* 1972 (exh. arranged). **Sources:** WW73.

RUBINA, (Mr./Signor) *[Painter, panoramist] mid 19th c.*
Exhibited: Artist of a panorama of the Hungarian War shown at Louisville (Ky.) in 1859. **Sources:** G&W; Louisville *Daily Democrat,* Feb. 25, 1859 (citation noted by G&W as being courtesy J.E. Arrington).

RUBINCAM, Barclay *[Painter] mid 20th c.*
Addresses: West Chester, PA. **Exhibited:** PAFA Ann., 1948-64 (6 times). **Sources:** Falk, *Exh. Record Series.*

RUBINGTON, Norman *[Painter, sculptor] mid 20th c.*
Addresses: Boston, MA. **Exhibited:** Corcoran Gal biennial, 1955. **Sources:** WW66.

RUBINS, David Kresz *[Sculptor, lithographer, teacher] b.1902, Minneapolis, MN / d.1985, NYC?.*
Addresses: Indianapolis, IN. **Studied:** Dartmouth Col.; BAID; Académie Julian, Paris, 1925; Ecole Beaux Arts; asst to James E. Fraser in Paris; Am. Acad. Rome, 1928. **Member:** Am. A. Cong. **Exhibited:** Arch. League New York, 1932 (prize)-33; NAD, 1933; Ind. Artists Ann., Indianapolis, 1936-70; PAFA Ann., 1941, 1954; Am. Sculpture Today, MMA, 1951. Awards: fel., Am. Acad. Rome, 1928; NIAL grant for sculpture, 1954. **Work:** Minneapolis Inst. A.; Indianapolis Mus. Art; John Herron AI; Ind. Univ.; Archives Bldg., Wash., DC; WPA sculpture, USPO, Court House, Indianapolis. Commissions: figure on steps, Arch. Bldg., Wash., DC, 1933 (WPA); work in Riley Hosp., Indianapolis, 1936-72; Lilly Monument, Crown Hill Cemetery, Indianapolis, 1961; Lincoln Monument, State Office Bldg. Plaza, Indianapolis, 1964. **Comments:** Teaching: from instr. to prof. sculpture & anatomy, Herron Sch. Art, Indianapolis, 1935-70s. Author: "The Human Figure — An Anatomy for Artists," (Viking Press, 1953). **Sources:** WW73; WW47; Falk, *Exh. Record Series.*

RUBINS, Harry Winfield *[Painter, etcher, decorator] b.1865, Buffalo, NY / d.1934.*
Addresses: Minneapolis, MN. **Studied:** AIC. **Member:** Chicago SE; Minneapolis SGA. **Exhibited:** AIC. **Work:** NYPL; Blake Sch. Lib., Minneapolis; St. Marks Church, Minneapolis; Nazareth Hall, St. Paul, Minn.; Northwestern Nat. Life Bldg., Minneapolis; Children's Hospital, Cincinnati. **Sources:** WW33.

RUBINS, Winfield See: **RUBINS, Harry Winfield**

RUBINSTEIN, M. Cady *[Artist] mid 20th c.*
Addresses: State College, PA. **Exhibited:** PAFA Ann., 1953. **Sources:** Falk, *Exh. Record Series.*

RUBIO, Arnaldo B. *[Painter, mural painter] b.1902, Mexico / d.1970, Los Angeles, CA.*
Addresses: Los Angeles, CA, 1917-1970. **Studied:** Academy of Fine Arts, Mexico City. **Exhibited:** P&S of Los Angeles, 1934. **Work:** San Bernardino Post Office. WPA artist. **Sources:** Hughes, *Artists in California,* 483.

RUBISOFF, Ben *[Painter] mid 20th c.*
Addresses: Chicago area. **Exhibited:** AIC, 1933. **Sources:** Falk, AIC.

RUBITSCHUNG, François H. *[Sculptor] b.1899, Germany.*
Addresses: NYC. **Studied:** BAID; Columbia Univ. **Member:** United Am. A.; Nat. AS, NYC. **Exhibited:** Springfield MFA, Mass.; New Sch. Soc. Res., NYC; S. Indp. A., 1932, 1934-36; WFNY, 1939; Columbia, 1936 (prize); PAFA Ann., 1946-47, 1951. **Work:** Astoria Pub. Sch., NY. **Sources:** WW40; Falk, *Exh. Record Series.*

RUBLE, Karl *[Painter] mid 20th c.*
Addresses: Chicago area. **Exhibited:** AIC, 1927. **Sources:** Falk, AIC.

RUBLER, Louis *[Listed as artist] b.c.1815, France.*
Addresses: NYC in 1850. **Sources:** G&W; 7 Census (1850), N.Y., XLIII, 285.

RUBY, Edna Browning *[Painter, designer, illuminator, lecturer] early 20th c.; b.Lafayette, IN.*
Addresses: Lafayette, IN. **Studied:** AIC; PMSchIA; PAFA; ASL. **Member:** fellow, Royal Acad., London; Nat. AAI; Int. Soc. Artists & Designers; Assoc. Des. of America & Europe; Art Dir. Cl.; Chicago AC Soc.; Indianapolis AA; Chicago Assn. Art & Indust.; Des. Assn., France; Indiana Fed. AC. **Exhibited:** Paris Expo, 1900; Buffalo Expo, 1900; Carnegie Inst., 1901; NYWCS, 1901-02; Pan-Pac. Expo, San Fran., 1915 (gold); Assoc. Designers, London, 1918 (gold); Krefeld, Germany, 1924 (medal); Hoosier Salon, 1927; Salon des Indépendants, Paris, 1928 (prize). **Work:** ecclesiastical art, windows, mosaics, decorations, textiles, furniture, mems. **Comments:** Designed book covers, textiles and furniture. Taught at John Herron Art School in Indianapolis. Lectures: Creative Design; Textile, Origin and Development; The Carnival Boats of Venice; The Marquis de LaFayette Ancestral Homes, in France, others. **Sources:** WW40.

RUCH, Edward A. *[Painter] b.1856.*
Addresses: Norristown, PA. **Exhibited:** PAFA Ann., 1883. **Sources:** Falk, *Exh. Record Series.*

RUCKDESCHEL, Charles (or J. Charles) *[General engraver] mid 19th c.*
Addresses: Philadelphia, 1858-60 and after. **Sources:** G&W; Phila. CD 1858, 1860+.

RUCKER *[Portrait painter] mid 19th c.*
Addresses: Richmond, VA in February 1846. **Sources:** G&W; *Richmond Portraits.*

RUCKER, Maud *[Painter] 20th c.*
Addresses: NYC. **Member:** Lg. AA. **Sources:** WW24.

RUCKLE, Thomas *[House and sign painter, amateur artist] b.1776 / d.1853.*
Addresses: Baltimore. **Comments:** In the early decades of the 19th century he painted a number of Baltimore views and scenes of the War of 1812 around Baltimore. He was the father of Thomas Coke Ruckle (see entry). **Sources:** G&W; Pleasants, *250 Years of Painting in Maryland,* 39.

RUCKLE, Thomas Coke *[Portrait, landscape, genre, and panorama painter] b.1811 / d.1891, Catonsville (MD).*
Addresses: Baltimore, active as early as 1833, spent most of life there. **Exhibited:** Md. Hist. Soc.; Apollo Association; Royal Academy, 1839-40; NAD, 1862-70. **Comments:** Son of Thomas Ruckle (see entry). Worked as a portrait artist in Richmond, VA, 1833, also painted landscapes of the mineral spas in Western Virginia. **Sources:** G&W; Pleasants, *250 Years of Painting in Maryland,* 39; Baltimore CD 1835-68; Cowdrey, AA & AAU; Rutledge, MHS; 7 Census (1850), Md., V, 674; Baltimore *Sun,* Sept. 27 and Oct. 14, 1858 (citations courtesy J.E. Arrington); Graves, *Dictionary;* Wright, *Artists in Virginia Before 1900.*

RUCKMAN, Grace Merrill (Mrs.) *[Painter] b.1873, Buchanan, MI.*
Addresses: Wash., DC, 1925-48; Chevy Chase, MD. **Studied:** Corcoran Sch. Art, with M. Leisenring; H. Breckenridge; L. Stevens. **Member:** Soc. Wash. Artists. **Exhibited:** Nat. Lg. Am. Pen Women, (prizes 1925, 1928, 1931, 1934); CGA, (prizes 1937,

1938); Soc. Wash. Artists, 1933-39; Burlington Hotel, 1939 (solo); Gr. Wash. Indep. Exh., 1935. **Sources:** WW40; McMahan, *Artists of Washington, DC.*

RUCKSTUHL, A. P. *[Painter] 20th c.*
Addresses: NYC. **Sources:** WW15.

RUCKSTULL, F(rederic) Wellington *[Sculptor, lecturer, writer] b.1853, Breitenbach, Alsace / d.1942.*
Addresses: NYC. **Studied:** Académie Julian, Paris with Boulanger and Lefebvre; Rollins Acad. with Mercié. **Member:** NSS, 1893; Arch. Lg., 1894; NIAL; NAC; Sect., Committee on Dewey Arch., 1898; Chief of Sculpture, St. Louis Expo., 1904. **Exhibited:** Paris Salon, 1888; Columbian Expo, Chicago, 1893 (med). **Work:** MMA; Harrisburg, PA; Columbia, SC; Baltimore; Little Rock, Ark.; Columbia, SC; LOC; Capitol, Wash., DC; Appellate Court, NYC; Salisbury, NC; Jamaica, NY; St. Louis; Petersburg, Va.; NY Customs House; mon., Battlefield of Long Island; Stafford Springs, Conn. **Comments:** Brought to U.S. in 1864, at age 11. Author: "Great Works of Art and What Makes Them Great.". **Sources:** WW40.

RUDA, Edwin *[Painter] b.1922, NYC.*
Addresses: NYC. **Studied:** Columbia Univ. (M.A., 1949); Sch. Painting & Sculpture, Mexico City, 1949-51; Univ. Ill.(M.F.A., 1956). **Exhibited:** Smithsonian Traveling Exhib., Latin Am., 1966; Systemic Painting, Guggenheim Mus., 1966; WMAA Painting Ann., 1969, 1973; Two Generations of Color Painting, Inst. Contemp. Art, Phila., 1970; Gal. A, Sydney, Australia, 1971. **Work:** State of NY Coll., Albany Mall; Indianapolis Mus. Art, Ind.; Dallas Mus. Fine Art, Tex.; Allentown Art Mus., Pa. **Comments:** Preferred media: mixed media. Positions: co-founder, Park Pl. Gal. Art Res. Publications: auth., "Park Place 1963-67: some informal notes in retrospect," *Art Mag,*1967; auth., "Jack Krueger: frontiers of zero," *Artforum,* April, 1968. Teaching: instr. painting, Univ. Tex., Austin, 1956-59; instr. painting, Sch. Visual Arts, New York, 1967-71. **Sources:** WW73; David Bourdon, "E=MC2 a go go" (Jan., 1966) & Carter Ratcliff, "Striped for Action" (Feb., 1972), *Artnews;* Dore Ashton, "New York Commentary," *Studio Int.* (Feb., 1970).

RUDD, Emma (Mrs.) *[Painter] 20th c.*
Addresses: Lyons, NY. **Member:** NAWPS. **Sources:** WW25.

RUDD, Nathaniel *[Wood engraver] mid 19th c.*
Addresses: Boston, 1857-60 and after. **Sources:** G&W; Boston CD 1857-60+.

RUDD, Tracy Porter *[Designer, craftsperson, illustrator] early 20th c.; b.Meran, Austria.*
Addresses: Boston, MA. **Studied:** Norwich A. Sch.; ASL; NAD. **Member:** Boston SAC. **Comments:** Position: des., draughtsman, Charles J. Connick Associates, Boston, MA. Specialty: stained glass. I.,"The Beggars Vision," 1921; "The Ring of Love," 1923. **Sources:** WW59; WW47.

RUDDER, Stephen Wm. C. D(ouglas) *[Painter, illustrator, etcher, block printer, writer, lecturer] b.1906, Salem / d.1932, Chicago, IL.*
Addresses: Salem, IN. **Studied:** AIC. **Member:** ASL of Chicago; Hoosier Salon; Ind. AA. **Sources:** WW32.

RUDDICK, Troy *[Painter] mid 20th c.*
Addresses: Flushing, NY. **Exhibited:** Kansas City AI, 1934, 1939; WFNY, 1939. **Sources:** WW40.

RUDDLEY, John *[Art administrator, painter] b.1912, NYC.*
Addresses: White Plains, NY. **Studied:** Cooper Union Sch. Art & Archit., with Tully Filmus, Ernest Fiene & Paul Feeley; Da Vinci Sch. Art, Columbia Univ. (B.S., hist. art); Columbia Univ. (M.A., art educ.). **Member:** Am. Soc. Aesthetics; A. Cl. Wash.; Inst. Study Art; Int. Soc. Educ. Art; Nat. Art Educ. Assn. **Exhibited:** Corcoran Gal., 1963; A Cl. Wash., 1963; Corcoran Sch. Art, 1963-64; Avant Gal., Alexandria, Va., 1964; Columbia Univ. Gal., NYC, 1965. **Work:** Corcoran Sch. Art, Wash., DC; A. Cl. Wash. **Comments:** Preferred media: acrylics, oils, watercolors. Positions: dean & hd., Corcoran Sch. Art, 1962-65; supvr. art,

Westchester Co., White Plains, NY 1965-; dir., Westchester Art Workshop, 1965-; trustee, Hammond Mus., North Salem, NY, 1969-; bd. govs., Cooper Union, New York, 1969-. Teaching: prof. design & painting, Corcoran Sch. Art, 1962-64; prof. hist. art, Lab. Inst. Design, NYC, 1964-69; prof. painting, Pace Col., Pleasantville, NY, 1970-71. Publications: auth., series of book reviews, *Nat. Art Educ. Assn. J.,* 1964-72. **Sources:** WW73.

RUDELL, Peter Edward *[Landscape painter] b.1854, Preston, Ontario / d.1899.*
Addresses: NYC. **Studied:** A.H. Wyant. **Exhibited:** Boston AC, 1881-83, 1898; PAFA Ann., 1881-82, 1888-92; Brooklyn AA, 1882-83, 1886,1891; AIC; Paris Salon, 1885; NAD, 1881-99; NYSF, St. Louis Expo, all in 1898. **Comments:** Exhibited works indicate he also painted in France. **Sources:** WW98; Falk, *Exh. Record Series.*

RUDERSDORF, Lillian C. *[Painter] mid 20th c.*
Addresses: Chicago, IL. **Studied:** AIC; Univ. Nebraska. **Exhibited:** AIC, 1934-39. **Sources:** WW40.

RUDERT, Anton *[Painter] b.1889 / d.1964, Bayside, NYC.*
Addresses: Newark, NJ. **Exhibited:** Salons of Am. **Sources:** WW13.

RUDGE, William Edwin *[Printer] b.1876, Brooklyn, NY / d.1931.*
Addresses: MT Vernon, NY. **Member:** AI Graphic A.; Grolier C.; Art in Trade C. **Exhibited:** AI Graphic A., (golds, medals); 2 Phila. exhs. (prizes); Institute Expo of Modern Decorative and Industrial Art at Paris, 1925. **Comments:** In April, 1931, he took over publication of the American Edition of the Studio of London under the name "Atelier.". **Sources:** WW25.

RUDIE, Michel *[Painter] early 20th c.*
Addresses: New Orleans, active 1908-1909. **Exhibited:** New Orleans, 1908. **Comments:** The police removed his painting from an exhibit in an art store because it depicted nudity. It was later found inoffensive by the city attorney and returned. **Sources:** *Encyclopaedia of New Orleans Artists,* 333.

RUDIGER, August E. *[Engraver and die sinker] b.c.1818, Germany.*
Addresses: NYC in 1850 and after. **Sources:** G&W; 7 Census (1850), N.Y., LI, 15; NYBD 1854, 1856.

RUDIN, Anna-Louise See: **FALK, Anna-Louise (Mrs. Harry R. Rudin)**

RUDIN, Paul *[Sculptor] b.1904 / d.1992, Patterson, NY.*
Addresses: Towners, NY. **Member:** NSS. **Exhibited:** Salons of Am.; S. Indp. A., 1932-33. **Work:** WPA sculpture, USPO, Dunn, NC. **Sources:** WW40.

RUDISILL, Margaret *[Painter] b.1857, Montgomery County, Indiana / d.1833, Indianapolis, IN.*
Studied: J. Cox (a pioneer Indiana artist); Académie Julian, Paris with T. Robert-Fleury and Bouguereau (3 years); Alfred Stevens in Paris. **Exhibited:** Paris Salon; Columbian Expo, Chicago, 1893; St. Louis Expo, 1904; Indiana State Fair.

RUDMORE, (Mrs.) *[Painter] 20th c.*
Addresses: Ft. Worth, TX. **Sources:** WW24.

RUDOLPH, Alfred *[Etcher, lithographer, craftsperson] b.1881, Alsace-Loraine. / d.1942.*
Addresses: Tucson, AZ; LA Jolla, CA. **Member:** San Diego AG. **Exhibited:** San Diego FA Gal., 1933 (prize), 1934 (prize); Calif.-Pacific Int'l Expo, San Diego, 1935; San Diego Art Guild, 1936. **Work:** LOC; Smithsonian; San Diego FA Gal. **Sources:** WW40; Hughes, *Artists in California,* 483.

RUDOLPH, C. Frederick (Mr. & Mrs.) *[Collectors] 20th c.*
Addresses: Williamstown, MA. **Sources:** WW73.

RUDOLPH, Ernest *[Listed as "artist"] b.c.1824, Massachusetts.*
Addresses: Baltimore in 1860. **Comments:** Amel Fagler (see

entry) was also at the same address. **Sources:** G&W; 8 Census (1860), Md., VII, 193.

RUDOLPH, Harold *[Portrait and landscape painter] b.c.1850 / d.c.1883.*
Addresses: New Orleans, active c.1873-84. **Exhibited:** Seebold's, N.O., 1873, 1883. **Comments:** He received critical acclaim by the N.O. newspapers for his portraits, but when his brother-in-law and partner Brutus Ducomman (see entry) committed suicide in 1877, he turned to painting landscapes. **Sources:** *Encyclopaedia of New Orleans Artists,* 333.

RUDOLPH, J. H. *[Painter] late 19th c.*
Addresses: NYC, 1879. **Exhibited:** NAD, 1879. **Sources:** Naylor, *NAD.*

RUDOLPH, Norman Guthrie *[Illlustrator, painter] b.1900, Phila., PA.*
Addresses: Jackson Heights, NY. **Studied:** Thernton Oakley, Fred Wagner, Daniel Garber, Pruett Carter. **Member:** AWCS; SI; Phila. Sketch Cl.; SC; A.Gld. **Exhibited:** AIC, 1936. **Sources:** WW53; WW47.

RUDOLPH, Paul *[Architect] b.1918, Elkton, KY / d.1997, NYC.*
Addresses: NYC. **Studied:** AL Polytech. Inst., 1940 (B.Arch.); Harvard, 1947 (M.Arch.). **Comments:** A modernist architect of the 1960s, his buildings were often executed in concrete and finished with a rough vertical texturing that was likened to corduroy, and later widely copied. While his buildings show the influence of Le Corbusier and German expressionist architects, their severe forms often attracted controversy. In 1969, student protesters set fire to his major work, Yale's Art & Architecture Building; it was later rebuilt. He was chairman of Yale's School of Architecture, 1957-65. **Sources:** obit., *New York Times* (Aug. 9, 1997, p. 50).

RUDOLPH, Pauline Dohn (Mrs. Franklin) *[Painter] 19th/20th c.; b.Chicago, IL.*
Addresses: Winnetka, IL/Chicago, IL, active 1888-1933. **Studied:** H.F. Spread & Robertson in Chicago; PAFA with Anschutz and Eakins; Académie Julian, Paris with Boulanger and Lefebvre; also with Charles Lasar and T. Couture in Paris. **Member:** Palette Cl.; Cosmopolitan Cl., Chicago; Chicago SA. **Exhibited:** Paris Salon, 1888; Chicago Art Acad., 1891-1901; NAD, 1892; Columbian Expo, Chicago, 1893; PAFA, 1894-1901; Boston AC, 1896, 1898, 1900; Chicago SA (prize); Carnegie Inst.; Cincinnati Spring Exhib.; Omaha (NE) Trans-Mississippi Expo, 1898. **Sources:** WW33; Fink, *American Art at the Nineteenth-Century Paris Salons,* 338; Petteys, *Dictionary of Women Artists.*

RUDQUIST, Jerry Jacob *[Painter, educator] b.1934, Fargo, ND.*
Addresses: Minneapolis, MN. **Studied:** Minneapolis Col. Art & Design (B.F.A., 1956); Cranbrook Acad. Art (M.F.A. 1958). **Exhibited:** Art Across America, Mead Nat. Painting Exhib., Columbus, OH, 1965; New Art From the Twin Cities, Chicago, 1970; Drei Amerikaner aus dem Mittleren Westen, Mannheimer Symposion der Künste, Ger., 1972; solo exhibs., Walker Art Ctr., Minneapolis, 1963 & Minneapolis Inst. Arts, 1964 & 1971; Suzanne Kohn Gal., Saint Paul, MN, 1970s. **Awards:** spec. donor & purchase award, Walker Art Ctr., 1962; purchase award, Minneapolis Inst. Arts, 1965; Mead Award for poster design, 1971. **Work:** Walker Art Ctr., Minneapolis, Minn.; Minneapolis Inst. Arts; Univ. Gal., Univ. Minn., Minneapolis; Saint Cloud State Col., Minn.; Anoka Ramsey State Jr. Col., Minn. **Comments:** Preferred media: oils. Teaching: prof. art, Macalester Col., 1958-; vis. lectr. & critic art, Boston Univ., summer 1969. Art interests: lithography. **Sources:** WW73; Dan Paris, "Rudquist" (film), produced by Minneapolis Ins Arts, Macalester Col. & Minn. State Arts Coun., 1971; Samuel Sachs II, *Jerry Rudquist: recent works* (Minneapolis Inst. Arts, 1971).

RUDULPH, Rella *[Painter] b.1906, Livingston, AL.*
Addresses: Birmingham, AL. **Studied:** A. Goldwaite; A.A. Andries; A. Brook. **Member:** Birmingham AC; Ala. AL; SSAL.

Exhibited: S. Indp. A., 1935; SSAL, Atlanta, 1937, Montgomery, Ala., 1938; Nat. Exh. Am. A., Rockefeller Center, NYC, 1938. **Work:** Montgomery MFA. **Sources:** WW40.

RUDY, Charles H. *[Sculptor, teacher] b.1904, York, PA / d.1986.*
Addresses: NYC, 1934-41; Ottsville, PA, 1942-on. **Studied:** PAFA,1927-28; C. Grafly; A. Laessle. **Member:** NAD; Nat. Sculpture Soc.; PAFA; S. Gld.; AFA. **Exhibited:** PAFA Ann., 1928-1962 (1947 John Howe Sculpture award); WMAA, 1936-53; CI, 1938; AIC, 1932,1939-52; Lincoln, Nebr., 1940; NAD, 1942; Trenton, N.J.; AFA Traveling Exh.; Am. Acad. A. & Let., 1944 (prize); WFNY, 1939; MMA, 1950; NAD, 1942, 1950-71. **Awards:** Guggenheim Found. fel., 1942; Am. Acad. Arts & Lett. Award, 1944. **Work:** PAFA; Brookgreen Gardens, Georgetown, SC; Michigan State Col; PMA; MMA; CI. Commissions: US Post Off., Bronx, NY, 1939; York, Pa. Pub. Schs.; US Govt. Bldg., 1939; five stone figures (with Roy Larson), Va. Polytech. Inst., Blacksburg, 1954; sculpture (with Willard Hahn), Lehigh Co. Ct. House, 1964; bronze gates (with Edward Green), William Penn Hist. Mus., Harrisburg, Pa., 1964. **Comments:** Preferred media: stone, bronze, wood, terra cotta. Positions: mem. Art Comn. Pa. 1949-72. Publications: auth., "Challenge to Form," *Mag. Art,* 140. Teaching: hd. dept. sculpture, Cooper Union, 1931-41; instr. sculpture, PAFA, 1950-52. **Sources:** WW73; WW47; "Scrap Sculpture Welding," *Life* (Dec. 20, 1943); Falk, *Exh. Record Series.*

RUDY, J. Horace *[Painter] early 20th c.*
Addresses: York, PA. **Studied:** PAFA. **Exhibited:** PAFA Ann., 1903. **Sources:** WW25; Falk, *Exh. Record Series.*

RUDY, James F. *[Painter] 20th c.*
Addresses: Los Angeles, CA. **Member:** Calif. AC. **Sources:** WW17.

RUDY, Mary Eleanor Robinson *[Painter] b.1861, Burlington, IA.*
Addresses: Chicago, IL. **Studied:** AIC; A.E. Brooks; Nyholm; G. Estebrook; Miss V. Philips. **Member:** Arché Club. **Exhibited:** AIC, 1913. **Sources:** WW25; Petteys, *Dictionary of Women Artists.*

RUEBSAM, Adolph C. *[Engraver]*
Addresses: Wash., DC, active 1892-1905. **Sources:** McMahan, *Artists of Washington, DC.*

RUEFF, Joseph A. *[Engraver] late 19th c.*
Comments: Engraver with the Bureau of Engraving and Printing from 1890-92. **Sources:** McMahan, *Artists of Washington, DC.*

RUEGG, Aimee Seyfort See: **SEYFORT, Aimee (Mrs. A. Seyfort Ruegg)**

RUEGG, Verena (Verna) *[Painter, etcher, lithographer, printmaker, craftsperson] b.1905, San Francisco, CA.*
Addresses: Hollywood, CA. **Studied:** Chouinard, Sch. A.; Otis AI. **Member:** Calif. AC. **Exhibited:** Corcoran Gal biennial, 1932; Calif. State Fair, 1932 (prize); Los Angeles Co. Fair, 1934 (prize), 1935 (prize), 1936 (prize). **Sources:** WW40.

RUELLAN, Andrée (Miss) *[Painter, lthographer, drawing artist] b.1905, NYC.* *Andrée Ruellan*
Addresses: Woodstock, NY; Shady, NY. **Studied:** ASL, scholar, 1920-22; Maurice Sterne Sch., Rome, Italy, scholar, 1922-23; Acad. Suédoise, Paris, France, with Per Krohg & Charles Dufresne. **Member:** Woodstock Artists A.; ASL; Phila. WC Cl.; AM. S. PS & G. **Exhibited:** S. Indp. A., 1925; AIC, 1937-38, 1940-41, 1943; CI, 1930, 1938, 1940, 1943-50; PAFA Ann., 1934-35, 1939-44, 1948-53, 1958; PAFA, 1945 (prize); Corcoran Gal biennials, 1939-53 (6 times); CM, 1937-38, 1940; VMFA, 1940, 1942, 1944, 1946; TMA, 1938, 1940, 1943; CAM, 1938-39, 1941, 1946; Phila. WC Cl., 1945 (Pennell Mem. Med.); Detroit Inst. A., 1943; GGE, 1939; WMAA, 1928-58; MMA (AV), 1943, 1950 (Am. Painting Today); Univ. Nebr., 1938-39, 1941; BM; Woodstock AA (prize); WMA, 1938 (prize); Grantees Exhib., Am.

Acad. Arts & Lett., 1945; Storm King Art Cntr., 1966 (retrospective); Kraushaar Gal., NYC, 1970s. Other awards: Am. Acad. Arts & Lett. grant arts, 1945; Guggenheim Fndn. fellow, 1950-51. **Work:** Oils, FMA; WR Nelson Gal.; MMA; PMG; Springfield Mus. FA; Zanesville AI; Encyc. Brit.; IBM Coll.; PMA; Univ. Nebr.; LOC; Columbia Mus Art, SC; drawings, WMAA. **Commissions:** murals, Post Off., Emporia, Va., 1940 & Lawrenceville, Ga., 1941; Newark Pub. Lib.; Broadmoor A. Acad. **Comments:** Preferred media: oils, gouache, graphics. Teaching: vis. artist, Pa. State Univ., summer 1957. **Sources:** WW73; WW47; Harry Salpeter, "About Andrée Ruellan," *Coronet* (Dec., 1938); Ernest Watson, "Andrée Ruellan," *Am. Artist* (Oct., 1943); Arthur Zaidenburg, *The Art of the Artist* (Crown, 1951); Falk, *Exh. Record Series.*

RUEN, Charles *[Lithographer] b.c.1823, Switzerland.*
Addresses: Philadelphia in 1860. **Sources:** G&W; 8 Census (1860), Pa., LII, 664. *Cf.* Charles Reen.

RUEPPEL, Merrill C. *[Art administrator] b.1925, Haddonfield, NJ.*
Addresses: Dallas, TX. **Studied:** Beloit Col. (B.A., 1949); Univ. Wis.-Madison, Ma., 1951 (Ph.D., 1955). **Comments:** Positions: res. asst., Minneapolis Inst. Arts, 1956-57, asst. to dir., 1957-59, ass. dir., 1959-61; asst. dir., City Art Mus., Saint Louis, 1961-64; dir., Dallas Mus. Fine Arts, 1964-. **Sources:** WW73; Assn. Art Mus. Dirs.; Am. Assn. Mus.; Archaeol. Inst. Am.

RUESCH, August *[Painter] mid 20th c.*
Exhibited: Salons of Am., 1934. **Sources:** Marlor, *Salons of Am.*

RUF, Donald Louis *[Painter] b.1906.*
Addresses: Chicago, IL. **Studied:** A.W. Dunbier; J. Norton; Oberteuffer; AIC. **Exhibited:** AIC, 1937, 1941. **Sources:** WW40.

RUFF, Alice (Isham)(Mrs.) *[Artist] early 20th c.*
Addresses: Wash., DC, active 1912-24. **Sources:** McMahan, *Artists of Washington, DC.*

RUFF, Cornelia W. (Mrs.Frederick H.) *[Painter] mid 20th c.*
Addresses: Seattle, WA, 1934. **Member:** Women Painters of Wash. **Exhibited:** Women Painters of Wash., 1934. **Sources:** Trip and Cook, *Washington State Art and Artists.*

RUFF, Margaret *[Painter, etcher] b.1847, Phila., PA / d.After 1897.*
Addresses: Philadelphia, PA, active until 1897. **Studied:** PAFA, with Eakins in the early 1880s; with Charles Müller, and in Paris. **Exhibited:** Paris Salon, 1878; PAFA Ann., 1879-87 (7 times); Cincinnati Industrial Expo., 1879; Boston AC, 1881, 1886; Southern Expo., 1886; AC of Phila.; NY Etching Cl. 1886; "Women Etchers of Am.," NYC, 1888; NAD, 1879-1884; BMFA; Phila. Soc. of Artists. **Comments:** Specialized in coastal scenes and still life. **Sources:** P. Peet, *Am. Women of the Etching Revival*, 63; Falk, *Exh. Record Series.*

RUFF, R. H. *[Artist] b.1821, Maryland.*
Addresses: Wash., DC, active 1860. **Sources:** McMahan, *Artists of Washington, DC.*

RUFFINI, Elise *[Educator, lecturer, painter, craftsperson, writer] b.1890, Austin, TX.*
Addresses: NYC. **Studied:** Teachers College, Columbia Univ. (B.S., M.A.); & abroad. **Member:** Eastern AA; Nat. Educ. Assn.; Nat. Congress Parent-Teachers Assn. (nat. chmn., 1946). **Comments:** Position: acting head, FA Dept., Teachers College, Columbia Univ., NYC, 1940-46. Co-Author, co-editor, "New Education Series," 1944. **Sources:** WW53; WW47.

RUFFNER, Kenneth *[Painter] mid 20th c.*
Addresses: Los Angeles, CA, 1930s. **Exhibited:** San Francisco AA, 1940; LACMA, 1940. **Comments:** Specialty: watercolors. **Sources:** Hughes, *Artists in California*, 483.

RUFFO, Joseph Martin *[Printmaker, designer] b.1941, Norwich, CT.*
Addresses: South Miami, FL. **Studied:** Pratt Inst.; Cranbrook

Acad. Art. **Exhibited:** 48th Ann. Print Exhib., Soc. Am. Graphic Artists, NYC, 1967; 12th Ann. Mid South Exhib., Memphis, 1967; 10th Dixie Ann., Montgomery Mus. Art, 1969; Nat. Print & Drawing Exhib., Miss. Art Assn., 1969; Miami Art Ctr. Mem. Exhib., 1971. **Awards:** Fulbright grant, Brazil, 1963; best in show, 12th Ann. Mid South Exhib., 1967; purchase prize, 10th Dixie Ann. Prints & Drawings, 1968. **Work:** Brooks Mem. Art Gal., Memphis, Tenn.; Ark Art Ctr., Little Rock; MoMA, Salvador, Brazil; Memphis Acad. Arts, Tenn.; Miss. Art Assn., Jackson. **Comments:** Teaching: instr. art, Memphis Acad. Arts, 1964-68; instr. art, Fla. Mem. Col., 1969-; asst. prof. art & chmn. dept., Barry Co., 1969-. Art interests: silkscreen & etching. **Sources:** WW73.

RUFFOLO, Gasper J. *[Painter] b.1908, Chicago, IL.*
Addresses: Chicago, IL. **Studied:** AIC, and with Wellington J. Reynolds, George Oberteuffer; C. Pacioni. **Member:** Assn. Chicago P. & S.; SC; Chicago Galleries Assn; All-Ill. SFA. **Exhibited:** AIC. **Awards:** prize, Chicago Galleries Assn. **Work:** portraits, State House, Lincoln, Neb.; Cotton Assn., Greenwood, Miss.; New Columbus Hospital. Many portraits of prominent persons. **Sources:** WW53; WW47.

RUFINIA, Sister *[Painter] mid 20th c.*
Addresses: Lafayette, IN. **Exhibited:** Hoosier Salon, 1933, 1935, 1937, 1938 (prize), 1940 (prize). **Sources:** WW40.

RUGAR, Jennie Shepard *[Painter, teacher] b.1857, Galesburg, IL / d.1939, Los Angeles, CA.*
Addresses: Los Angeles, CA. **Exhibited:** AIC, 1894-95; Artists Fiesta, Los Angeles, 1931. **Sources:** Hughes, *Artists in California*, 483.

RUGER, Albert *[Lithographic artist, landscape artist] b.1828, Prussia, Germany / d.1899.*
Addresses: Akron, OH, c. 1850-64; Battle Creek, MI, 1866; St Louis area, 1873-75; Akron, 1876 and after. **Comments:** Important lithographer who remained active in the profession for twenty-five years and produced over two- hundred and fifty lithographs, visiting twenty-four states East of the Rocky Mountains and three Canadian provinces in the Maritimes. His views are drawn from a sufficiently high perspective, displaying the street patterns fully as well as other elements of the places. He also prepared views of the South, not drawn by many other artists, as well as big cities like Chicago and Cleveland. He was also a teacher, training T.M. Fowler (see entry), Eli S. Glover (see entry), J.J.Stoner (see entry), C.N.Drie (see entry) and others.These started out as agents for Ruger, soon after working as artists themselves and establishing print companies like Fowler and Glover. **Sources:** Reps, 201-204 (pl.26,7,52,53).

RUGER, Julius *[Painter] b.1841, Oldenburg, Germany / d.1906.*
Addresses: Brooklyn, NY (immigrated as a boy). **Exhibited:** Brooklyn AA, 1869 (portrait). **Comments:** He served in the Civil War. **Sources:** WW01.

RUGER, Washington *[Portrait and landscape painter] mid 19th c.*
Addresses: Binghamton, NY, 1856-59. **Sources:** G&W; Binghamton CD 1857-59.

RUGER-DONOHO See: **DONOHO, (Gaines) Ruger**

RUGGIERO, (Prof.) *[Painter] mid 20th c.*
Addresses: Chicago, IL. **Exhibited:** S. Indp. A., 1926. **Sources:** Marlor, *Soc. Indp. Artists.*

RUGGLES, Carl *[Painter, teacher] b.1876, Marion, MA.*
Addresses: Coral Gables, FL/Arlington, VT. **Member:** S. Vt. Ar. **Exhibited:** S. Vt. Ar., 1939; Detroit AI, 1938-39. **Work:** WMAA; Addison Gal., Andover, Mass.; BM; Detroit AI. **Sources:** WW40.

RUGGLES, E., Jr. *[Engraver] mid 19th c.*
Comments: Engraver of one known New England bookplate, c.1790-1800. **Sources:** G&W; Stauffer.

RUGGLES, Edward *[Amateur landscape and marine painter]* d.c.1866.
Addresses: NYC. **Member:** NAD (hon. mem.); Century Assoc., 1848. **Exhibited:** showed several Italian and French views at the NAD and American Art-Union between 1851 and 1860. **Comments:** Prang lithographic company of Boston published nine of his NH views as "Ruggles' Gems. **Sources:** G&W; Cowdrey, NAD; Cowdrey, AA & AAU. More recently, see Campbell, *New Hampshire Scenery*, 135.

RUGGLES, Mary (Mrs.) *[Landscape painter]* mid 19th c.
Exhibited: NAD, 1859-60 (including "Roman Ruins"). **Comments:** Groce & Wallace speculated she might be the wife of Edward Ruggles (see entry). **Sources:** G&W; Cowdrey, NAD (address not given).

RUGGLES, Theo Alice See: **KITSON, Theo Alice Ruggles (Mrs. H.H.)**

RUGOLO, Joseph *[Painter]* mid 20th c.
Addresses: NYC. **Studied:** NAD; Beaux Arts Inst.; with William DeLeftwich Dodge. **Member:** Nat. Arts Cl. **Exhibited:** MoMA; ACA Gal., NY; Newark (NJ) Mus.; "NYC WPA Art" at Parsons School Design, 1977. **Work:** murals, City Hall, Buffalo, NY; Supreme Court Bldg., NYC; home of Arthur Brisbane, NY; Roosevelt H.S., NYC; solarium, Chronic Diseases Hospital, NYC; Smithsonian Inst.; Brooklyn Mus.; U.S.S. *Constellation;* many priv. colls. **Comments:** Positions: art curator/advisor, Triangle Communication Div., NYC, 1977. **Sources:** *New York City WPA Art*, 100.

RUHE, Miriam S. *[Painter]* 19th/20th c.; b.Allentown, PA.
Addresses: Phila., PA. **Studied:** E. Daingerfield; J. Sartain. **Exhibited:** Phila. A. Cl.; Soc. Wash. Artists; Trans-Mississippi Expo, Omaha. **Sources:** WW01; Petteys, *Dictionary of Women Artists.*

RUHL, James *[Lithographer]* d.1893, Wash., DC.
Addresses: Wash., DC, active 1865-93. **Comments:** He worked for the U.S. Coast Survey from 1865-93. **Sources:** McMahan, *Artists of Washington, DC.*

RUHL, John *[Sculptor]* b.1873, NYC.
Addresses: NYC. **Studied:** MMA Sch. with J.W. Stimson, F.E. Elwell. **Sources:** WW13.

RUHLAND, Edwin *[Painter]* b.1890, NYC / d.1922, Flushing, NY.
Studied: NAD. **Comments:** Specialty: decorative borders. Position: staff, *New York Review; Theatre Mag.*

RUHLAND, John *[Portrait and general painter]* mid 19th c.
Addresses: Buffalo, NY, 1850's. **Sources:** G&W; Buffalo CD and BD 1855-60.

RUHLIN, Helena C. *[Painter]* 20th c.
Addresses: Ft. Worth, TX. **Sources:** WW24.

RUHLMAN, Thoedor *[Painter]* early 20th c.
Addresses: NYC. **Exhibited:** S. Indp. A., 1921. **Sources:** Marlor, *Soc. Indp. Artists.*

RUHNKA, Roy *[Painter]* 20th c.
Addresses: Wynnewood, PA. **Member:** AWCS. **Sources:** WW47.

RUHTENBERG, Cornelis *[Painter]* b.1923, Riga, Latvia.
Addresses: Des Moines, IA. **Studied:** Hochschule für Bildende Künste, Berlin. **Exhibited:** Paintings: USA, 1950; MMA, 1956; MoMA, 1962; Corcoran Gal biennials, 1949-57 (3 times); PAFA Ann., 1953, 1960, 1966; AIC; NAD; Am. Acad. A. & Lets.; Denver A. Mus.; Colorado Springs FA Center; Des Moines A. Center and others. Awards: Childe Hassam purchase award, Am. Acad. A. & Lets., NY, 1956, 1965; prizes, Scranton, Pa., 1960, 1962; Des Moines A. Center, 1964. **Work:** Everhart Mus., Scranton; Denver A. Mus.; Colorado Springs FA Cente.; Des Moines A. Center; BMFA. **Sources:** WW66; Falk, *Exh. Record Series.*

RUIZ, Jose A. *[Sculptor]* mid 20th c.
Addresses: NYC, 1936. **Exhibited:** WMAA, 1936. **Sources:** Falk, *WMAA.*

RUIZ, Lola de *[Painter]* late 19th c.
Addresses: NYC, 1877, 1880; Paris, 1878. **Exhibited:** NAD, 1877-80. **Sources:** Naylor, *NAD.*

RULCOVIUS, John *[Painter]* early 20th c.
Addresses: NYC. **Exhibited:** S. Indp. A., 1928. **Sources:** Marlor, *Soc. Indp. Artists.*

RULE, Fay Shelley (Mrs.) *[Miniature painter]* b.1889, Chattanoga.
Addresses: Chattanooga, TN. **Studied:** L.F. Fuller; M. Welch; A. Beckington; F.V. DuMond. **Member:** Chattanooga AA. **Sources:** WW40.

RULE, Lewis B. *[Painter]* 20th c.
Addresses: Knoxville, TN. **Sources:** WW13.

RULLMAN, John W. *[Engraver]* early 20th c.
Addresses: Wash., DC, active 1901-05. **Sources:** McMahan, *Artists of Washington, DC.*

RUMBLE, Stephen (Mrs.) *[Amateur landscape painter]* mid 19th c.
Addresses: Natchez, MS. **Studied:** boarding school in New York. **Comments:** Filled her Natchez mansion ("Rosalie") in the 1850's with examples of her own work, which emulated the landscapes of the Hudson River School. **Sources:** G&W; Barker, *American Painting*, 525.

RUMBOLD, Hugo *[Painter]* mid 20th c.
Exhibited: AIC, 1934. **Sources:** Falk, *AIC.*

RUMBOLD-KOHN, Estelle (Mrs.) *[Sculptor]* mid 20th c.; b.St. Louis, MO.
Addresses: NYC. **Studied:** St. Louis School FA; Calif. School FA; ASL with Saint-Gaudens. **Exhibited:** AIC, 1925 (prize); PAFA Ann., 1925; Salons of Am.; Chicago Art Exhib., 1926 (prize); NSS. **Sources:** WW31; Petteys, *Dictionary of Women Artists;* Falk, *Exh. Record Series.*

RUMCHISKY, Blanche *[Miniature painter]* 20th c.
Addresses: Brooklyn, NY. **Sources:** WW25.

RUMFORD, Count See: **THOMPSON, Benjamin (Count Rumford)**

RUMLEY, Lucille *[Painter, teacher]* b.1901, Preble Co., OH.
Addresses: Hagerstown, IN. **Studied:** Hodgins; King; Wiggins. **Exhibited:** Richmond AA, 1932; CAFA, 1933. **Sources:** WW40.

RUMMEL, Gertrude See: **HURLBUT, Gertrude Rummel (Mrs.)**

RUMMELL, Alexander J. *[Painter]* b.1867, Dubuque, IA / d.1959.
Addresses: Glenbrook, CT. **Studied:** ASL; J.P. Laurens, at Académie Julian. **Member:** AAPL; SC; Silvermine GA. **Exhibited:** WFNY, 1939. **Work:** murals, St. John's Lodge, Norwalk, Conn.; 16 WPA murals, Norwalk H.S., 1937-41. **Sources:** WW47.

RUMMELL, John *[Painter, writer, lecturer, teacher]* b.1861, Springville, NY.
Addresses: Buffalo, NY. **Studied:** Lemuel.B.C. Josephs; John F. Carlson; F.V. Du Mond; G. Bridgman; Emerson College of Oratory, Boston, Ma. **Member:** Buffalo SA (treasurer and v. pres.); AAPL. **Exhibited:** Buffalo SA, 1917-19, 1921 (prizes), 1934 (prize); PAFA Ann., 1921; AIC. **Comments:** Teaching: English and French in Philadelphia and New York. Opened Buffalo School of Speech Arts in 1908. He considered painting an avocation until 1915. Then taught landscape painting. Author: "Aims and Ideals of Representative American Painters," 1901. **Sources:** WW40; Krane, *The Wayward Muse*, 195; Falk, *Exh. Record Series.*

RUMMELL, Richard *[Painter] b.1848 / d.1924.*
Addresses: Brooklyn, NY.

RUMMLER, Alexander Joseph *[Painter] b.1867, Dubuque, IA.*
Addresses: Norwalk, CT; Glenbrook, CT. **Studied:** Detroit, MI with Julius Melchers; ASL with W. Metcalf and Kenyon Cox; Académie Julian, Paris with J.P. Laurens, 1906. **Member:** AAPL; SC; Darien Group of Seven Arts. **Exhibited:** Salmagundi Cl.; Am. WC Soc.; Tennessee Expo; New Haven Paint & Clay Cl.; Buck Hill Falls, PA; WFNY 1939. **Work:** WPA murals, H.S., St. John's Lodge, Norwalk, CT. **Sources:** WW59; Ness & Orwig, *Iowa Artists of the First Hundred Years*, 180-81.

RUMPH, Alice E(dith) *[Etcher, teacher] b.1877, Rome, GA.*
Addresses: Birmingham, AL. **Studied:** Colarossi Acad., Paris, with McMonnies, Prinet; Chase; Hawthorne. **Member:** Chicago SE; SSAL. **Exhibited:** Salons of Am.; SSAL, 1939 (prize); WFNY 1939; AIC; Soc. Am. Etchers; AWCS. **Comments:** Position: teacher, Miss Beard's School, Orange, NJ. **Sources:** WW40; Petteys, *Dictionary of Women Artists*.

RUMPLER, William *[Portrait and landscape painter] b.1824, Frankfort, Germany.*
Addresses: New Orleans, active 1853-66. **Studied:** Jakob Becker. **Work:** Louisiana State Museum. **Sources:** G&W; New Orleans CD 1853, 1859; Thompson, *Louisiana Writers;* Delgado-WPA. See additional references in *Encyclopaedia of New Orleans Artists*.

RUMSEY, Adeline (M.) *[Painter] mid 20th c.*
Studied: ASL. **Exhibited:** S. Indp. A., 1937. **Sources:** Marlor, *Soc. Indp. Artists*.

RUMSEY, Charles Cary *[Sculptor] b.1879, Buffalo, NY / d.1922, Floral Park, NY.*
Addresses: NYC; Glen Head, LI, NY. **Studied:** BMFA Sch.; Acad. Julian, Paris, 1903; École des Beaux Arts, Paris. **Member:** Arch. Lg; New Soc. Artists; NSS; BAID; Soc. Animal P&S. **Exhibited:** AIC, 1912, 1916; Armory Show, 1913; PAFA Ann., 1914-15, 1921. **Comments:** He was known as a polo player, and principally created statues of race horses in bronze. He died in an automobile accident. **Sources:** WW21; Krane, *The Wayward Muse*, 45; Brown, *The Story of the Armory Show;* Falk, *Exh. Record Series*.

RUMSEY, David MacIver *[Sculptor, designer] b.1944, NYC.*
Addresses: Oxford, CT. **Studied:** Yale Univ. (B.A., 1966, B.F.A. & M.F.A., 1969). **Member:** Pulsa Group. **Exhibited:** Boston Pub Gardens, outdoor environments sponsored by Housing & Urban Develop., 1968; Spaces, MoMA, 1970; Work for New Spaces, Walker Art Mus., Minneapolis, Minn., 1971; Pulsa & Television Sensoriums, Automation House, 1971; PMA, 1971. **Comments:** Teaching: lectr. art, Yale Univ., 1968-72; vis. artist, Calif. Inst. Arts, 1970-73. Art interests: Environment art, using television, film, electronics, light and sound. **Sources:** WW73.

RUMSEY, Evelyn See: **CARY, Evelyn Rumsey (Mrs. Charles)**

RUMSEY, Evelyn See: **LORD, Evelyn Rumsey (Mrs.)**

RUMSEY, Hiram *[Listed as "artist"] b.c.1821, Virginia.*
Addresses: Philadelphia in 1850. **Sources:** G&W; 7 Census (1850), Pa., LI, 83.

RUMSEY, Sarah J. *[Artist] mid 19th c.*
Addresses: Active in Oregon 1865-75. **Comments:** First professional artist to advertise in Oregon. **Sources:** Trenton, ed. *Independent Spirits*, 107.

RUNDLE, Valiquette Morrsion *[Painter] b.1907, San Diego, CA.*
Addresses: Lincoln, NE. **Studied:** J. Norton; F.P. Glass; Heymann. **Member:** ASL, Chicago. **Sources:** WW33.

RUNDQUIST, Ethel Caroline *[Painter, illustrator, etcher] 20th c.; d.Minneapolis, MN.*
Addresses: Minneapolis, MN. **Studied:** AIC. **Sources:** WW17.

RUNGE, George *[Painter] mid 20th c.*
Addresses: Minneapolis, MN. **Exhibited:** Twin Cities Exh., Minneapolis Inst. A., 1936 (prize). **Sources:** WW40.

RUNGE, John *[Listed as "artist"] b.c.1821, Bremen, Germany.*
Addresses: NYC in 1860. **Sources:** G&W; 8 Census (1860), N.Y., LX, 1014.

RUNGIUS, Carl (Clemens Moritz) *[Painter, etcher, illustrator] b.1869, Berlin, Germany / d.1959, NYC.*
Addresses: NYC, 1906-34; Los Angeles, CA, 1930s; NYC. **Studied:** P. Meyerheim, Berlin Art School, School of Applied Arts, and Acad. FA, all in Berlin. **Member:** ANA, 1913; NA, 1920; SC; NAC; Century Assn. **Exhibited:** PAFA Ann., 1905-06, 1914-34; Corcoran Gal biennials, 1912-26 (5 times); Pan-Pac. Expo., 1915; S. Indp. A., 1917, 1924; SC, 1922 (Vezin prize); 1923 (Plimpton prize); NAD, 1898-20 (prize), 1921-25 (Ellen P. Speyer Memorial Award), 1926 (Carnegie Prize), 1927-29 (Saltus Prize), 1930-43; Calif. AC, 1938; GGE, 1939; AIC; CAM; CGA (prize); CI. **Work:** New York Zoological Soc.; Shelburne (VT) Mus.; Glenbow Foundation and Riveredge Foundation, Calgary; Harmsen Coll. **Comments:** Began painting in Germany in 1889. He came to NYC in 1894 and established his studio there. He also had a summer home and studio in Banff. His first sketching trip was to Wyoming and Yellowstone Park in 1895. Specialized in Western American big game painting. The Glenbow Fndn. has preserved his studio in the Rocky Mtns. as a museum. His works represent valuable records of the natural history of the region. **Sources:** WW59; WW47. More recently, see Hughes, *Artists in California*, 483; P&H Samuels, 411; Muller, *Paintings and Drawings at the Shelburne Museum*, 121-22 (w/repros.); *300 Years of American Art*, 628; Falk, *Exh. Record Series*.

RUNNELS, Frances Wright *[Painter] b.1914, San Francisco, CA / d.1971, Berkeley, CA.*
Addresses: Piedmont, CA. **Studied:** UC; Calif. Sch. of FA. **Member:** Soc. of Western Artists; Oakland AA; East Bay AA. **Exhibited:** Marin Jr. College, 1960; Alameda County Fair, 1968, 1969; Soc. of Western Artists, 1969. **Sources:** Hughes, *Artists in California*, 483.

RUNQUIST, Albert Clarece *[Painter] b.1894, Aberdeen, WA.*
Addresses: Portland, OR. **Studied:** Univ. Oregon (B.A.); Portland A. Mus. Sch.; ASL. **Member:** Oregon A. Gld. **Exhibited:** WFNY 1939; Am. A. Cong., 1939; SFMA, 1940; Portland A. Mus., 1932-33, 1935-36, 1938, 1942, 1944-45. **Work:** Univ. Oregon Lib.; mural, USPO, Sedro Wooley, Wash. **Sources:** WW53; WW47.

RUNQUIST, Arthur *[Painter, etcher, lithographer, teacher] b.1891, South Bend, WA.*
Addresses: Manzanita, OR; Nehalem, OR. **Studied:** Univ. Oregon (B.S.); ASL; Portland A. Mus. Sch. **Member:** Oregon A. Gld; Am. Ar. Cong. **Exhibited:** WFNY 1939; GGE 1939; Portland A. Mus., 1938(prize),1939; SAM. **Work:** Portland A. Mus.; murals, Univ. Oregon Lib.; H.S., Pendleton, Ore. **Sources:** WW59; WW47.

RUNYAN, M(anuel) G. *[Painter] mid 20th c.*
Addresses: Pensacola, FL, 1931. **Studied:** ASL. **Exhibited:** S. Indp. A., 1931. **Sources:** Marlor, *Soc. Indp. Artists*.

RUNYON, S. D. *[Illustrator] 20th c.*
Addresses: Millington, NJ. **Sources:** WW13.

RUOTOLO, Onorio *[Sculptor] b.1888, Cervinara, Italy / d.1966, NYC.*
Addresses: NYC, 1908. **Studied:** Royal Acad. FA, Naples, 1900-06; with V. Gemito. **Work:** Dante, 1921, NYU; Enrico Caruso, 1921, Metropolitan Opera House; Woodrow Wilson mem., 1929, Univ. Virginia. **Comments:** Was an artist and a social activist. Co-editor, *Il Fuoco* and founder, *Minosse*, both literary, art and political journals. As a sculptor, he is best known for his naturalistic

busts done during the 1910s and 1920s, although he also modeled realistic figures of ordinary people. **Sources:** *Fort,* The Figure in American Sculpture, 221 (w/repro.).

RUPALLEY, Jules *[Painter] mid 19th c.*
Addresses: Northern California, active until the late 1850s.
Work: Bancroft Lib., UC Berkeley. **Comments:** Specialty: watercolor sketches of the flora and fauna in the Sierra. **Sources:** Hughes, *Artists in California,* 484.

RUPEL-WALL, Gertrude *[Sculptor, craftsperson, writer, lecturer, teacher] 20th c.; b.Greenville, OH.*
Addresses: Berkeley, CA. **Member:** Am. Ceramic S.; San Fran. SWA; SFAA. **Comments:** Specialties: fountains; decorative tiles; pottery. **Sources:** WW31.

RUPERT, A. J. *[Painter] early 20th c.; d.Ft. Plain, NY.*
Addresses: Chicago, IL. **Studied:** RA, Munich. **Exhibited:** AIC, 1898, 1900, 1906, 1915, 1917, 1919. **Sources:** WW17.

RUPERTUS, William H. *[Fresco painter] early 20th c.*
Addresses: Wash., DC, active 1901-20. **Sources:** McMahan, *Artists of Washington, DC.*

RUPNOW, Norman *[Painter] mid 20th c.*
Addresses: Chicago area. **Exhibited:** AIC, 1950. **Sources:** Falk, *AIC.*

RUPP, Christian *[Engraver] mid 19th c.*
Addresses: NYC, 1850. **Comments:** Partner with Frederick Seiler in Seiler & Rupp, engravers and die sinkers, active 1850. **Sources:** G&W; NYCD 1850.

RUPP, Edward C. *[Lithographer] d.1914, Wash., DC.*
Addresses: Wash., DC, active 1877-1905. **Sources:** McMahan, *Artists of Washington, DC.*

RUPPERSBERG, Allen *[Mixed media artist, videographer] b.1944.*
Addresses: Los Angeles, CA, 1970; NYC, 197). **Exhibited:** WMAA, 1970, 1975. **Sources:** Falk, *WMAA.*

RUPPRECHT, Edgar A. *[Painter] mid 20th c.*
Addresses: Chicago, IL. **Exhibited:** AIC, 1916-48. **Sources:** WW21.

RUPPRECHT, George *[Illustrator, designer] b.1901, Brooklyn, NY.*
Addresses: NYC; Woodhaven, NY. **Studied:** PIASch. **Member:** SI; A. Gld. **Comments:** Position: art ed., Hearst Magazines. **Sources:** WW59; WW47.

RUPPRECHT, Richard E. *[Sculptor] late 19th c.*
Addresses: Wash., DC, active 1890. **Sources:** McMahan, *Artists of Washington, DC.*

RUPPRECHT, William *[Sculptor] late 19th c.*
Addresses: Wash., DC, active 1882-90. **Sources:** McMahan, *Artists of Washington, DC.*

RUSACK, Emmy *[Painter] 20th c.*
Addresses: Yonkers, NY. **Sources:** WW24.

RUSBATCH, Samuel *[Decorative, heraldic, and general painter] late 18th c.*
Addresses: Annapolis, MD. **Studied:** England with Robert Maberly, coach and herald painter. **Comments:** In January 1774, at Annapolis (Md.), advertised services as coach and herald painter, also offered decorative painting for interiors. He was described as working under the "direction" of Joseph Horatio Anderson, Annapolis architect. **Sources:** G&W; Prime, I, 293; Barker, *American Painting,* 178.

RUSCH, Mabel *[Painter] 19th/20th c.*
Addresses: NYC. **Exhibited:** PAFA Ann., 1899-1900. **Sources:** WW01; Falk, *Exh. Record Series.*

RUSCHA, Edward Joseph *[Painter, photographer, printmaker, author] b.1937, Omaha, NE.*
Studied: Chouinard Art Inst. **Exhibited:** WMAA, 1967, 1969, 1987; Drawings USA, Minn. Mus. Art, Saint Paul, 1971;

Continuing Surrealism, La Jolla Mus. Art, Calif., 1971; Top Boxed Art, Ill. State Univ., Normal, 1971; 11 Los Angeles Artists, Hayward Gal., London, 1971; Art Systems, Centro Arte Y Communication, Buenos Aires, Arg., 1971. **Work:** MoMA; LACMA; WMAA; Joseph Hirshhorn Coll., Wash., DC; Oakland Mus. Art, Calif. **Comments:** Associated with Pop Art and Conceptual Art. Publications: auth of over 15 books, including "On the Sunset Strip," 1966; "Thirty-four Parking Lots," 1967; "Royal Road Test," 1967; "Business Cards," 1968; "Nine Swimming Pools," 1968 (Heavy Indust. Publications) Teaching: lectr. painting, Univ. Calif., Los Angeles, 1969-70. **Sources:** WW73; Baigell, *Dictionary;* Linda Cathcart, *Edward Ruscha* (1976); Joyce Haber, article, In: *Los Angeles Times,* May 19, 1971; Rosalind Kraus, rev., In: *Artforum* (May, 1971).

RUSCICA, John *[Painter] mid 20th c.*
Addresses: NYC. **Exhibited:** S. Indp. A., 1924, 1928; Salons of Am., 1934. **Sources:** Falk, *Exhibition Record Series.*

RUSCO, Bessie A. *[Landscape painter] mid 20th c.*
Addresses: San Diego, CA, 1930s. **Exhibited:** Portland, OR, Art Mus., 1935. **Sources:** Hughes, *Artists in California,* 484.

RUSE, Margaret *[Painter] 20th c.*
Addresses: Monessen, PA. **Member:** Pittsburgh AA. **Sources:** WW21.

RUSH, Andrew *[Printmaker, painter] b.1931, MI.*
Addresses: Oracle, AZ. **Studied:** Univ. Ill. (B.F.A., hons., 1953); Univ. Iowa (M.F.A., 1958); Fulbright fel., Florence, Italy, 1958-59. **Exhibited:** USIS Traveling Exhib. to Europe & Latin Am., 1960-65; Graphic Art USA, Am. prints to Soviet Union, 1963; Brooklyn Mus. Biennial, 1964; 50 American Printmakers, Am. Pavilion, New York Worlds Fair, 1964-65; Intag. 1971, 30 Printmakers, San Fernando State Univ., 1971; Graphics Gal., Assoc. Am. A., NYC, 1970s Awards: Seattle Mus. Int. Printmakers, 1963 & purchase award, Brooklyn Mus. Biennial, 1964. **Work:** Uffizi Mus., Florence, Italy, Brooklyn Mus., NY; LOC; Dallas Mus., Tex.; SAM. Commissions: Law Prints (portfolio of three offset lithographs), Lawyers Publ. Co., 1968; mem. bd. ed. etching, Assn. Am. Artists, NYC, 1968; ed. etchings, Tucson Art Ctr., 1971. **Comments:** Teaching: assoc. prof. art, Univ. Ariz., 1959-69; vis. artist-in-residence, Ohio State Univ., 1970. **Sources:** WW73; "Andrew Rush," *Southwest Art Gallery Mag.* (Mar., 1972).

RUSH, Clara E. *[Painter] 20th c.*
Addresses: Seattle, WA. **Sources:** WW24.

RUSH, Frank P. *[Painter] 20th c.*
Addresses: Scottsdale, PA/Uniontown, PA. **Sources:** WW25.

RUSH, Ira G. *[Portrait painter] b.c.1822, Ohio.*
Addresses: New Orleans in 1850. **Sources:** G&W; 7 Census (1850), La., VI, 489.

RUSH, J. See: **RUSH, Ira G.**

RUSH, John *[Figurehead carver] b.1782, Philadelphia / d.1853, Philadelphia.*
Addresses: Philadelphia. **Comments:** Eldest son of William Rush (see entry), with whom he worked until the latter's death. John was active until his own death in 1853. **Sources:** G&W; Marceau, *William Rush,* genealogical table opp. 7; Pinckney, *American Figureheads and Their Carvers,* 58; 62-63, 199.

RUSH, (Miss) *[Teacher of drawing and painting on paper, velvet, satin, and ivory] early 19th c.*
Addresses: Charleston, SC in 1819. **Sources:** G&W; Rutledge, *Artists in the Life of Charleston.*

RUSH, Olive (Miss) *[Painter, illustrator, portraitist, muralist] b.1873, Fairmount, IN / d.1966, Santa Fe, NM.*
Addresses: Wilmington, DE, 1908, 1912; Germantown, PA, 1910; Boston, MA, 1913; NYC, 1917-18;Santa Fe, NM, 1920. **Studied:** Corcoran School Art; ASL with Twachtman, Mowbray; Howard Pyle School; Paris, with R. Miller. **Member:** NAWA. **Exhibited:** PAFA Ann., 1908-18 (6 times); Corcoran Gal. bienni-

als, 1912, 1923, 1935; AIC, 16 annuals, 1910-49; NAD, four annuals, 1911-16; CI; Mus. New Mexico; Soc. of Independent Artists, 1917, 1924, 1928-30; Richmond AA, 1919; Herron AI, 1919 (prize); Sesqui-Cent. Int. Expo, Phila., 1926; Hoosier Salon, 1931 (prize); Denver AA (prize), 1931; Nebraska AA (prize); Wilmington SFA (prize); MMA; BMFA; NAWA, annuals. **Work:** WMA; BM; PMG; John Herron AI; Mus. New Mexico; FA Center of Houston; Wilmington Soc. FA; Witte Mem. Mus.; Nebraska AA; murals, La Fonda Hotel & Pub. Lib., Santa Fe, NM; WPA murals, A&M College of New Mexico; WPA murals, USPO, Florence, CO and Pawhuska, OK. **Comments:** She made her first trip to Santa Fe in 1914 and became a permanent resident in c.1920. Rush painted in different styles during her career. She established a reputation as an illustrator and was a respected muralist. Illustrator: covers for *Ladies' Home Journal,* and illustrations for *Collier's; Scribner's,* other magazines. Specialties: women, children; frescos. **Sources:** WW59; WW47; Gerdts, *Art Across America,* vol. 2: 271-72; P&H Samuels, 411; Trenton, ed. *Independent Spirits,* 158; Falk, *Exh. Record Series.*

RUSH, Polly (Mrs. Jacob) See: **WRENCH, Polly (Mary)**

RUSH, Richard B. *[Sculptor] mid 20th c.*
Addresses: Chicago, IL. **Exhibited:** AIC, 1947-48; PAFA Ann., 1949. **Sources:** Falk, *Exh. Record Series.*

RUSH, Sylvia *[Painter] mid 20th c.*
Exhibited: Salons of Am., 1934. **Sources:** Marlor, *Salons of Am.*

RUSH, William *[Wood carver and sculptor] b.1756, Philadelphia, PA / d.1833, Phila.*
Addresses: Philadelphia, PA. **Studied:** apprenticed to the wood-carving shop of Edward Cutbush, c. 1771-c.1775. **Member:** Columbianum, Phila. (founder). **Exhibited:** PAFA Ann., 1811-32, 1906 ("Bust of William Rush"). **Work:** PAFA; PMA. **Comments:** Preeminent figurehead carver whose skill in that genre brought him fame and commissions for "pure" sculpture as well. The son of a ship carpenter, Rush set up his own shop in Philadelphia (about 1775) after serving with the Continental Army. His earliest figurehead commissions came from the U.S. Navy and from commercial shipbuilders. In 1808 he fulfilled the first of a number of non-maritime commission with his ideal figures of "Comedy" and "Tragedy" carved for the Chestnut Street Theater in Philadelphia. His best-known work, the "Water Nymph and Bittern" was commissioned in 1809 for placement in front of the Centre Square Water Works (Fairmount Park). Rush also carved a number of portrait busts, including his own and one of Lafayette (both at PAFA), as well as a life-size figure of George Washington (Independence National Park Collection). His last major works, "The Schuylkill River Chained" and "The Schuylkill River Freed" (both at PMA), were completed c.1828. Although he never worked in marble, he did work in plaster and terracotta. Rush was an active figure in promoting the arts in Philadelphia, helping to found the short-lived Columbianum and serving as a director of the Pennsylvania Academy. Among his pupils were his son, John Rush, and Daniel N. Train. **Sources:** G&W; Marceau, *William Rush,* catalogue raisonnée, illus.; DAB; Pinckney, *American Figureheads and Their Carvers,* 56-71; Rutledge, PA; Dunlap, *History;* Taft, *History of American Sculpture;* Falk, *Exh. Record Series.* More recently, see Craven, *Sculpture in America,* 20-26; Baigell, *Dictionary.*

RUSHBURY, Charles Henry *[Painter] mid 20th c.*
Exhibited: AIC, 1929, 1931, 1934, 1937. **Sources:** Falk, *AIC.*

RUSHMORE, Alice See: **WELLS, Alice Rushmore (Mrs. Henry C.)**

RUSHMORE, Delight *[Craftsperson] b.1912, Madison, NJ.*
Addresses: Madison, NJ. **Studied:** M. Robinson. **Member:** NYSC. **Comments:** Specialties: pottery, original glazes. **Sources:** WW40.

RUSHTON, Desmond V. *[Painter] b.1895, London, England.*
Addresses: Los Angeles, CA. **Studied:** W. Orphen; J. Ward; G.L. Brockhurst. **Member:** Indep. Artists of Los Angeles. **Exhibited:** Group of Independents of Los Angeles, 1923 (cofounder). **Sources:** WW25.

RUSK, Henry *[Etcher, painter, craftsperson] b.1902, Sacramento, CA / d.1979, San Fran., CA.*
Addresses: San Francisco, CA. **Studied:** Calif. Sch. of FA. **Exhibited:** San Francisco AA, 1920s; Bohemian Club, 1929. **Work:** de Young Mus. **Comments:** Position: art restorer, de Young Museum and CPLH, 34 years. **Sources:** Hughes, *Artists in California,* 484.

RUSK, Martha H. *[Painter] mid 20th c.*
Addresses: Urbana, IL. **Exhibited:** PAFA Ann., 1941. **Sources:** Falk, *Exh. Record Series.*

RUSK, Rogers D. *[Painter, teacher, writer,] b.1892.*
Addresses: South Hadley, MA/McConnelsville, OH. **Studied:** AIC; Cleveland Sch. Art; W. Adams. **Member:** Springfield AL; Holyoke AL; NYWCC. **Exhibited:** Springfield AL, 1935 (prize), 1936, 1937, 1939 (prize). **Comments:** Author: "Atoms, Mem., and Stars," 1937. Position: teacher, Mt. Holyoke College. **Sources:** WW40.

RUSK, William Sener *[Educator] b.1892, Baltimore, MD.*
Addresses: Aurora, NY. **Studied:** Princeton Univ. (A.B.); Johns Hopkins Univ. (A.M., Ph.D.); & abroad. **Member:** Am. Assn. Univ Prof.; CAA; Am. Soc. for Aesthetics; Am. Soc. Arch. Hist. **Comments:** Position: instr., prof., Wells Col., Aurora, NY. Author: "William Henry Rinehart, Sculptor," 1939. Contributor to *Thieme-Becker Allgemeines Künstlerlexikon; Dictionary of American Biography; Dictionary of the Arts;* etc. Articles on Art History, Architecture, Education, for journals & magazines. **Sources:** WW59; WW47.

RUSKE, Edna Edmondson *[Sand painter, teacher] b.1898, Milton, IA.*
Addresses: Active in Grand Lake, CO. **Studied:** AIC. **Sources:** Petteys, *Dictionary of Women Artists.*

RUSKIN, Lewis J. *[Collector, patron] b.1905, London, England / d.1981.*
Addresses: Paradise Valley, AZ. **Studied:** Arizona State Univ. (hon. L.L.D., 1968). **Exhibited:** Awards: hon. fellowship, Phoenix Art Mus. **Comments:** Positions: chmn., Arizona Commission Arts & Humanities, 1967-. Art interests: donated Renaissance and Baroque paintings to the Phoenix Art Museum and Renaissance, Baroque and Barbizon paintings and sculpture to Arizona State University Gallery. Collection: sixteenth, seventeenth and eighteenth century paintings. **Sources:** WW73.

RUSKIN, Mickey *[Collector] 20th c.*
Addresses: NYC. **Sources:** WW73.

RUSNAK, Julian David *[Sculptor] mid 20th c.*
Addresses: Chicago area. **Exhibited:** AIC, 1940. **Sources:** Falk, *AIC.*

RUSS, C. B. *[Painter] 19th/20th c.*
Exhibited: Boston AC, 1873. **Sources:** *The Boston AC.*

RUSS, Harry *[Painter] 19th/20th c.*
Addresses: Boston, MA. **Exhibited:** Boston AC, 1890-94. **Comments:** *Cf.* Horace Alexander Russ. **Sources:** *The Boston AC.*

RUSS, Horace A(lexander) *[Painter, teacher] b.1887, Logtown, MS.*
Addresses: Lake Shore, MS.; New Orleans , LA. **Studied:** Tulane Univ.; La. State Univ.; Columbia Univ.; PAFA. **Member:** SSAL; NOAA; NOAL; NOACC; La. State T. Assn., Pres. FA Dept. **Comments:** Position: instr., Nicholls H.S., New Orleans, La. **Sources:** WW53; WW47.

RUSS, John *[Engraver] b.c.1830, France.*
Addresses: Philadelphia in July 1860. **Comments:** Groce &

Wallace thought that this Russ might also be the John Russ who was listed as an engraver at NYC from 1856 to 1860. **Sources:** G&W; 8 Census (1860), Pa., LII, 94; NYBD 1856-60.

RUSSELL, Albert Cuyp *[Engraver and illustrator] b.1838, Boston, MA / d.1917, Roxbury, MA.*
Addresses: Active in Boston. **Studied:** apprenticed to Leopold Grozelier of Boston, 1860. **Comments:** Son of Moses B. and Clarissa Russell (see entries on each). Specialized in wood engravings. He engraved the illustrations used in the Century Dictionary. **Sources:** G&W; *Art Annual*, XV, obit.; 8 Census (1860), Mass., XXVIII, 103.

RUSSELL, Alfred *[Painter] mid 20th c.; b.St. Louis, MO.*
Addresses: NYC, 1949-54. **Member:** St. Louis AG. **Exhibited:** WMAA, 1949-1954; PAFA Ann., 1954. **Sources:** WW25; Falk, *Exh. Record Series.*

RUSSELL, Alice *[Artist] late 19th c.*
Addresses: Wash., DC, active 1885. **Sources:** McMahan, *Artists of Washington, DC.*

RUSSELL, Andrew Joseph *[Photographer, landscape painter] b.1830 / d.1902.*
Work: Boston Pub. Lib.; LOC; Mus N. Mex.; Natl. Archives; Oakland MA. **Comments:** A captain during Civil War, he is best known for documenting railroad construction and army fortifications, and later for his landscape views made for the expanding Union-Pacific RR, 1868-69. **Sources:** Witkin & London, 226; Welling.

RUSSELL, Benjamin *[Marine painter, engraver] b.1803, New Bedford, MA / d.1885, Warren, RI.*
Addresses: New Bedford, MA, active from 1841; Warren, RI, 1878-85. **Exhibited:** His panorama of a whaling voyage around the world was first exhibited in Boston in January 1849 and was subsequently shown in Cincinnati, Louisville, St. Louis, Baltimore, and NYC. **Work:** Old Dartmouth Hist. Soc. Whaling Museum; Francis Russell Hart Nautical Mus., MIT; Mariners Mus., Newport News, VA; Mystic Seaport Mus.; Peabody Mus., Salem, MA; Nantucket Hist. Ass'n. **Comments:** Best known for his accurate depictions of ships and scenes of the whaling industry. Between 1829-33 he owned shares in ten whaling vessels. From 1841-45 he was a cooper aboard the whaler "Kutusoff" which circumnavigated the world. In 1848 he produced his monumental oil painting, "Panorama of a Whaling Voyage Around the World" which was 8-1/2 x 1,300 feet long. Afterward, he produced lithographs, but since he appears to have had various jobs it was not until 1867 that he was listed in the city directory as an artist. Among his best known prints are "Sperm Whaling" (No. 1, 1859 and No.2, 1862), "Sperm Whaling with its Varieties" 1870, "Right Whaling in Behering Straits" 1871, and "Abandonment of the Whalers in the Arctic Ocean" 1871. He is also known to have worked with A. Van Beest and Robert S. Gifford, painting watercolor marines. **Sources:** G&W; NYBD 1854 [as engraver] Childs, "Thar She Blows"; information courtesy J.E. Arrington; Elton Hall, "Panoramic Views of Whaling by Benjamin Russel" (Old Dartmouth Hist. Soc., 1981); Brewington; Peters, *America on Stone.*

RUSSELL, Bruce Alexander *[Cartoonist] b.1903, Los Angeles, CA / d.1963.*
Addresses: Los Angeles, CA; Hermosa Beach, CA. **Studied:** UCLA; Fed. Sch. Cart.; & with C.L. Bartholomew, W.L. Evans. **Member:** President's People-to-People Com.; Nat. Cartoonists Soc.; Am. Assn. Editorial Cartoonists. **Exhibited:** Awards: Pulitzer prize, 1946; Freedom Fnd., 1950-58; Sigma Delta Chi, 1946-47, 1950- 51; Headliners cartoon award, 1948; U.C.L.A., 1951; U.S. Treasury Dept., 1958; Christopher Award, 1953. **Work:** FBI Coll.; Huntington Lib., San Marino, Cal.; Nat. Press Cl. **Comments:** Position: sports cart., *Los A. Evening Herald*, 1925-27; staff cart., 1927-34, ed. cart., 1934 *Los Angeles Times.* Created comic strip "Rollo Rollingstone," Assoc. Press Feature Service, 1931-33. **Sources:** WW59; WW47.

RUSSELL, C. D. *[Cartoonist, illustrator] mid 20th c.; b.Buffalo, NY.*
Addresses: NYC. **Studied:** AIC. **Member:** SI. **Comments:** In 1930, he created the internationally popular comic, "Pete the Tramp" (King Features Syndicate). **Sources:** WW59; WW47; *Famous Artists & Writers* (1949).

RUSSELL, Charles M(arion)
[Painter, sculptor, illustrator, writer] b.1864, Oak Hill, St. Louis, MO / d.1926, Great Falls, MT.
Addresses: Great Falls, MT/Lake McDonald, MT; began vacationing in Pasadena, CA in the 1920s. **Studied:** self-taught.
Exhibited: St. Louis Fair, 1904; PAFA Ann., 1905-06; NYC, 1911 (solo); AIC, 1912; CGA, 1925. **Work:** Amon Carter Mus. (large coll.), Ft. Worth, TX; Mus. New Mexico; Bancroft Library, UC Berkeley; Whitney Gal., Cody, WY; Nat. Cowboy Hall of Fame; Montana Hist. Soc., Helena; Montana State Capitol ("Lewis and Clark Meeting the Flathead Indians at Ross's Hole"); Trigg-Russell Gal., Great Falls; Gilcrease Inst.; major museums.
Comments: One of America's best-known and popular artists of Western subjects, he was an authentic cowboy, working as a wrangler, 1879-92, and living with the Blood Indians (of the Blackfoot nation) for 6 months in 1888. His first Western illus. for *Harper's* appeared in 1888, and his work (writings and illustrations) was soon also appearing in *McClure's* and *Leslie's.* In 1890 he published a portfolio of 12 paintings *Studies of Western Life.* Russell paintings tended to be action-filled adventure scenes, sometimes told with whimsy or humor, depicting cowboys or Indians and their animal quarries; rowdy cowboys in camp or out on the town; confrontations between cowboys and Indians; and gunfights between horse thieves and lawmen. Russell began bronze sculpting in 1904, although he had been modeling in clay and wax for years and using the figures as models for his paintings. He first visited NYC in 1903 and returned annually thereafter, holding his first NYC solo show in 1911; he visited Europe in 1914. Russell's work was extremely popular and often reproduced on calendars. A prolific artist he produced over 2,500 works (all media) in his lifetime. **Sources:** WW25; Baigell, *Dictionary;* Goetzman & Goetzman, 258-83; Frederic G. Renner, *Charles M. Russell* (New York, 1974); Harold McCracken, *The Charles M. Russell Book* (1957); P&H Samuels, 412; Eldredge, et al., *Art in New Mexico, 1900-1945,* 206; Falk, *Exh. Record Series.*

RUSSELL, Clara *[Landscape painter] mid 20th c.*
Exhibited: Kingsley AC, Sacramento, 1938, 1945. **Sources:** Hughes, *Artists in California,* 484.

RUSSELL, Clarissa (Mrs. Moses B.) See: **RUSSELL, Clarissa Peters (Mrs. Moses)**

RUSSELL, Clarissa Peters (Mrs. Moses) *[Miniaturist] b.1809, Andover, MA.*
Addresses: Boston, c.1842 to c.1854. **Exhibited:** Boston Athenaeum, 1842-44. **Comments:** Her husband, Moses B. Russell (see entry) was also a painter. Their son, Albert Cuyp Russell, was an engraver and illustrator (see entry). Hers was a straightforward realistic style combined with a liking for decorative fabric patterns. **Sources:** G&W; 7 Census (1850), Mass., XXV, 646; Swan, BA; Boston BD 1851-54; Jackson, *Ancestors in Silhouette,* 220. More recently, see Tufts, *American Women Artists,* cat. no. 30.

RUSSELL, David *[Engraver and plate printer] mid 19th c.*
Addresses: Boston, 1840's. **Sources:** G&W; Boston CD 1842-48.

RUSSELL, David McC. *[Engraver] d.1895, Wash., DC.*
Addresses: Wash., DC, active 1877-92. **Comments:** He may be the David Russell who was an engraver and plate printer in Boston from 1842-48. **Sources:** McMahan, *Artists of Washington, DC.*

RUSSELL, Dora Keen Butcher See: **BUTCHER, Dora Keen (Mrs. D.K.B Russell)**

RUSSELL, Doroth *[Painter] mid 20th c.*
Exhibited: Salons of Am., 1934. **Sources:** Marlor, *Salons of Am.*

RUSSELL, Edmund N. *[Marine painter] b.1852, West Tisbury, Martha's Vineyard, MA / d.1927, South Dartmouth, MA.*
Addresses: Active in Massachusetts, 1873-1927. **Studied:** NYC. **Exhibited:** NAD, 1882, 1884; E.B. Chase's Store, New Bedford, 1884; H.S. Hutchinson and Co., New Bedford; New Bedford A. Cl., 1907-08, 1917. **Work:** Kendall Whaling Mus., Sharon, MA; Peabody Mus., Salem, MA; Old Dartmouth Hist. Soc. **Comments:** Sailor aboard 3 whalers out of Edgartown in his youth. Entered the employ of William Maxfield, c.1873. By 1875 he had his own business as a flower painter, fresco painter, sign painter and grainer. He also worked for a time in the 1890s for Ullman Manufacturing Co., an art novelties firm. **Sources:** Blasdale, *Artists of New Bedford,* 161 (w/repros.); Brewington, 334, lists him as "Edward.".

RUSSELL, Edward John *[Marine painter, cartoonist, illustrator] b.1832, Isle of Wight, England / d.1906, Boston.*
Work: Mariner's Mus.; Mystic Seaport Mus.; Peabody Mus., Salem; Maine Maritime Mus.; Franklin Delano Roosevelt Mus. **Comments:** Came to Canada c.1852. Illustrator: *London Illus. News,* 1857-62, *Canadian Illus. News,* 1870; travel booklets for Boston and Providence steamship lines.

RUSSELL, Eva Webster (Mrs.) *[Painter] b.1956.*
Addresses: Chicago, IL. **Studied:** AIC, with Vanderpoel, Martha Baker. **Member:** Chicago Mun. AL. **Exhibited:** AIC, 1891-92, 1894, 1902-03. **Comments:** Position: teacher, McKinley H.S. **Sources:** WW10.

RUSSELL, Frank J(ohn) *[Painter, craftsperson, comm a] b.1921, Philadelphia, PA.*
Addresses: Syracuse, NY; Woodside, NY. **Studied:** ASL. **Member:** AEA; Spiral Group. **Exhibited:** BM; PMA, 1952, 1954; Univ. Illinois, 1953; PAFA Ann., 1954; Sunken Meadow A. Center, 1958; Great Neck, LI 1957; Artists Gal., NY, 1952, 1955; Contemp. A. Gal., 1946; Brown Univ., 1954; Dallas Collectors Cl.; Riverside Mus., 1956, 1958; Contemp. A. Collectors; Univ. Maine, 1957. **Comments:** Illus. for *Living for Young Home Makers; House & Gardens; Homes Guide; NY Times; NY Post; Herald-Tribune,* etc. **Sources:** WW59; WW24; Falk, *Exh. Record Series.*

RUSSELL, Frederick K. *[Painter] mid 20th c.*
Exhibited: AIC, 1941. **Sources:** Falk, *AIC.*

RUSSELL, G. D. *[Painter] 19th/20th c.*
Exhibited: Boston AC, 1873-1880. **Sources:** *The Boston AC.*

RUSSELL, (George) Gordon *[Painter] b.1932, Altoona, PA.*
Addresses: Altoona, Phila., PA. **Studied:** Penn. State Univ. with Hobson Pittman; PAFA with Walter Stuempfig; Barnes Found. **Member:** PAFA (fellow). **Exhibited:** PAFA Ann., 1953-54, 1964, 1966; Contemp. Paintings, Yale Univ. Art Gal., 1962; Durlacher Bros., New York, 1957-67 (6 solos); Forth Worth(TX) Art Center, 1962 (solo); Larcada Gal., New York, 1969 (solo), 1971 (solo). Awards: Lewis S. Ware Mem., 1953, J. Henry Schiedt Mem., 1954 & Toppan prize, 1954, PAFA. **Work:** PAFA; Fogg Art Mus.; Mus. FA Bowdoin Col., Brunswick, ME; Krannert Art Mus., Univ. Illinois, Urbana; NYC Hospital Coll. **Comments:** Preferred medium: oils. **Sources:** WW73; Falk, *Exh. Record Series.*

RUSSELL, Gertrude Barrer See: **BARRER, Gertrude (Russell)**

RUSSELL, Gordon See: **RUSSELL, (George) Gordon**

RUSSELL, Grace L. *[Painter] 20th c.; b.Caldwell, NJ.*
Addresses: Scarsdale, NY. **Studied:** Alethia Platt; Umberto Romano; Charles Gruppe; Parker Perkins. **Member:** Rockport AA; North Shore AA; Scarsdale AA; Studio Guild, NY; Yonkers AA; Gloucester SA; Barnard Club. **Exhibited:** North Shore AA; Yonkers AA; Rockport AA; All. Artists Am.; Scarsdale AA. **Sources:** WW53; WW47.

RUSSELL, Grace Mott *[Painter] mid 20th c.; b.Hampton, IA.*
Addresses: Hopkins, MN. **Studied:** Fitch & Charles Atherton

Cumming; Cornell Col.; AIC with John Vanderpoel; Frederick W. Freer; William Chase & Duveneck; ASL under Lowell Houser. **Exhibited:** Iowa Art Salon, 1931. **Sources:** Ness & Orwig, *Iowa Artists of the First Hundred Years,* 181.

RUSSELL, H. *[Miniaturist] mid 19th c.*
Addresses: Boston, c. 1860. **Sources:** G&W; Sherman, "Some Recently Discovered Early American Portrait Miniaturists," 294, 295 (repro.).

RUSSELL, H. B. *[Painter] 20th c.*
Addresses: Boston, MA. **Member:** Boston AC. **Sources:** WW31.

RUSSELL, Helen Crocker (Mrs. Henry P.) *[Collector, patron] b.1896, San Fran., CA / d.1966.*
Addresses: San Fran., CA. **Exhibited:** Awards: honorary LL.D., Mills College, Oakland, Cal., 1952. **Comments:** Positions: trustee, 1947-, chairman, Women's Board, 1935-49, SFMA; trustee, International Council, MoMA, 1954-; trustee, CPLH, 1963-; member, U.S. Advisory Committee on the Arts, 1960-61; trustee, AFA. Collection: French impressionist and modern art. **Sources:** WW66.

RUSSELL, Helen Diane *[Art historian] b.1936, Kansas City, MO.*
Addresses: Wash., DC. **Studied:** Vassar Col. (A.B.); Radcliffe Grad Sch.; Johns Hopkins Univ. (Ph.D.). **Member:** Col. Art Assn. Am. **Exhibited:** Awards: Woodrow Wilson Nat. fel., 1958-59. **Comments:** Positions: asst. to chief, Smithsonian Inst. Traveling Exhib. Serv., 1960-61; mus. cur., Nat. Gal. Art, Wash., DC, 1964-70, asst. cur. graphic, 1970-. Teaching: prof. lectr. 15th-17th cent. European painting & graphic arts, Am. Univ., Wash., DC, 1966-72. Collections arranged: Protest & Social Comment in Prints, 1970; Käthe Kollwitz, 1971; Rare Etchings by GB & GD Tiepolo, 1972. Research: Prints & drawings of the sixteenth through eighteenth centuries. Publications: auth., rev. of Louise Lucas, "Art Books a Basic Bibliography," 1968, Andre Mellerio, "Odilon Redon," 1969, *Museum News;* auth., "A Museum Worker Speaks, *Washington Print Club Newsletter,* 1972; auth., rev. Aldo Rizzi, "The Etchings of the Tiepolos," *Print Collectors Newsletter* (1972); auth., "Rare Etchings Giovanni Battista & Giovanni Domenico Tiepolo, 1972. **Sources:** WW73.

RUSSELL, Henry *[Painter] early 20th c.*
Exhibited: WMAA, 1920-26. **Sources:** Falk, *WMAA.*

RUSSELL, Hilda S. *[Artist] early 20th c.*
Addresses: Active in Los Angeles, c.1920. **Sources:** Petteys, *Dictionary of Women Artists.*

RUSSELL, Irone Hancock Russell (Mrs. B.J.) *[Sculptor] b.1867, Phila., PA / d.1946, Los Angeles, CA.*
Addresses: Wash., DC, 1876, active 1899; Kensington, MD, 1916. **Studied:** Wash., DC schools. **Exhibited:** Soc. of Wash. Artists, 1899; Wash. AC. **Work:** Life-size statue of Christ, St. Thomas' Episcopal Church, Wash., DC. **Comments:** A descendant of Henry Adams and John & Priscilla Alden, Russell is said to have invented the dress fastener, the army stretcher, and the ambulance. Her maiden name was Russell; she was married to Joe Sessions and then Benjamin Reeves Russell. In 1946 she died while visiting her daugher in Los Angeles, CA. **Sources:** McMahan, *Artists of Washington, DC.*

RUSSELL, James L. *[Painter] b.1872, New Albany.*
Addresses: New Albany, ID. **Member:** Louisville AL. **Sources:** WW25.

RUSSELL, James Spencer *[Painter] b.1915, Monticello, IN.*
Addresses: NYC. **Studied:** Univ. N. Mex. (B.F.A.), with Raymond Jonson; Yale Univ. (M.F.A.), with Donald Oenslager. **Exhibited:** Contempt. Wall Sculpture, Am. Fedn. Arts, 1964 & RI Sch. Design, Providence, 1965; Small Environments, Southern Ill. Univ., Carbondale, 1972. **Work:** Contemp. Am. Art, Am. Embassy, Beirut, Lebanon. **Sources:** WW73.

RUSSELL, Joseph Shoemaker *[Amateur watercolorist]*
b.1795, New Bedford, MA / d.1860, Philadelphia, PA.
Addresses: Active in New Bedford, MA area, 1814-18;
Philadelphia, 1818. **Work:** Old Dartmouth Hist. Soc. (27 water-
colors). **Comments:** Ran a lamp oil store in Philadelphia in 1818.
A number of his watercolors have been preserved, chiefly views
of buildings and interiors in Philadelphia and New Bedford.
Sources: G&W; Little, "Joseph Shoemaker Russell and His Water
Color Views," (seven repros.); Blasdale, *Artists of New Bedford*,
162 (w/repro.).

RUSSELL, L. C. See: **RUSSELL, Stephen S.C.**

RUSSELL, L. E. (Miss) *[Painter]* late 19th c.
Addresses: Boston. **Exhibited:** NAD, 1878. **Sources:** Naylor,
NAD.

RUSSELL, Leo *[Painter, teacher]* b.1917, Chicago, IL.
Addresses: NYC, 1929; Flemington, NJ, 1960; Philadelphia, in
1977. **Studied:** David Burluik. **Exhibited:** "NYC WPA Art" at
Parsons School Design, 1977. **Comments:** Received a stipend
from Mus. of Non-Objective Art as a teacher on WPA Art Project.
Much of his work was destroyed by fire in NY. He also provided
special effects for the "Captain Video" show; ran an art gallery,
printed graphic editions, worked as an art therapist and taught
methods at Trenton State College. **Sources:** *New York City WPA
Art*, 75 (w/repros.).

RUSSELL, Louise W. *[Painter]* late 19th c.
Addresses: Chicago. **Exhibited:** AIC, 1894. **Sources:** Falk, *AIC.*

RUSSELL, Lydia Smith *[Portrait painter]* early 19th c.
Addresses: Active in MA. **Comments:** Painter of a portrait of
Abigail (Smith) Adams, signed and dated 1804. **Sources:** G&W;
WPA (Mass.), *Portraits Found in Mass.*, no. 6.

RUSSELL, Marie *[Painter]* early 20th c.
Member: Detroit Soc. Women Painters & Sculptors (one of the
first members in 1910). **Sources:** Petteys, *Dictionary of Women
Artists.*

RUSSELL, Mark *[Painter, designer, illustrator, teacher, lectur-
er]* b.1880, Springfield, OH.
Addresses: Worthington, OH. **Member:** Ohio WCS; Columbus
AL. **Exhibited:** Columbus AL; Ohio WCS; Ohio State Fair.
Work: Last Judgment Window, Little Church Around the Corner,
NY; Le Veque Lincoln Tower Peace mural, Columbus, Ohio.
Comments: I., "Perennial Flowers"; "Plant Welfare;" *House
Beautiful;* Doubleday Doran, Garden Books. Position: t.,
Columbus Gal. FA, Ohio. **Sources:** WW59; WW47.

RUSSELL, Mary Burr *[Sculptor, woodblock printer]* b.1898 /
d.1977.
Studied: BMFA Sch., c.1916-23; in Florence, Italy for one year
(possibly in connection with the Child-Walker Sch., Cambridge,
MA); sculpture with Arnold Geissbuhler in Cambridge, early
1930s. **Comments:** During the late 1920s, she was active making
"white line" color woodblock prints and studying in
Provincetown, MA. **Sources:** info courtesy Steven Thomas,
Woodstock, VT (cat., 1991).

RUSSELL, Mary F. *[Painter]* d.c.1916.
Addresses: Boston, MA. **Exhibited:** Boston AC, 1877, 1888.
Sources: *The Boston AC.*

RUSSELL, Morgan *[Painter, sculptor]* b.1886, NYC / d.1953,
Ardmore, PA.
Studied: Paris & Italy, 1906; ASL with sculptor J.E. Fraser, 1906;
R. Henri, A. Dasburg, 1907; Paris (under Matisse?) 1908; E.
Tudor-Hart, 1911. **Exhibited:** Salon des Indépendants, Paris,
1913; in 1913, he & S. MacDonald-Wright mounted the first
major Synchromist exhs.: in June at Der Neue Kunstsalon,
Munich, and in October at Bernheim-Jeune Gal., Paris; Armory
Show, 1913; Carrol Gals., NYC, 1914; "Forum Exh. of Modern
Am. Painters," Anderson Gals., NYC, 1916; Oakland Art Gal.,
1927 (with S. MacDonald-Wright); LACMA, 1927, 1932 (with S.
MacDonald-Wright). **Work:** LACMA; WMAA; MoMA; NMAA;

San Diego Mus; Cornell Univ.; Munson-Williams-Proctor Inst.;
NY Univ. **Comments:** Important modernist who together with S.
MacDonald-Wright in Paris, 1913, invented "Synchromism," a
style in which form was generated by color. Russell was already
part of progressive art circles in Paris in 1909 when he met
Gertrude and Leo Stein, who introduced him to Matisse and
Picasso. Russell met MacDonald-Wright in 1911 and soon began
investigating color as a generator of form while studying with
Canadian color theorist Ernest Tudor-Hart. His first Synchromy
was a figurative work, "Synchromie en Vert" (1912-13, now lost),
the first abstract Synchromy dates from 1913 (his study for
Synchromy in Deep Blue-Violet," LACMA). Russell visited
America in 1916 but returned to Paris the next year and remained
there, producing non-objective works which the artist now called
"Eidos." In the years following, he also painted representational
works, including landscapes, nudes, and classical subjects. In
1931, Russell briefly joined the staff of the Chouinard School of
Art in Los Angeles but soon returned to Europe. After WWII he
settled in Ardmore, Pennsylvania. **Sources:** Baigell, *Dictionary;*
Gail Levin, *Synchromism and American Color Abstraction*
(WMAA, 1978); Abraham Davidson, *Early American Modernist
Painting, 1910-1935,* 128-32; Hughes, *Artists in California,* 484.

RUSSELL, Moses B. *[Portrait, miniature, and figure painter]*
b.c.1810, New Hampshire or Massachusetts / d.1884.
Addresses: Boston, 1834 to 1853; NYC, 1856-60; Philadelphia,
1860; Boston, thereafter. **Exhibited:** Boston Athenaeum;
American Institute, NYC. **Work:** Worcester (Mass.) Art Mus.;
Frick Art Ref. Lib., NYC (sketchbooks). **Comments:** Traveled to
Italy in 1853. His wife, Clarissa Russell (see entry), was also a
miniaturist; and their son, Albert Cuyp Russell (see entry),
became an engraver and illustrator. **Sources:** G&W; Swan, BA; 7
Census (1850), Mass., XXV, 646 (gives birthplace as New
Hampshire); 8 Census (1860), Pa., LIV, 266 (gives birthplace as
Massachusetts); Boston BD 1841-50; NYBD 1856-59; Am. Inst.
Cat., 1856; Bolton, *Miniature Painters;* Jackson, *Ancestors in
Silhouette,* 222; Lipman and Winchester [as N.B. Russell]. More
recently, see Strickler, *American Portrait Miniatures,* 102-03
(w/repro.).

RUSSELL, Norman E. *[Painter]* mid 20th c.
Addresses: Chicago. **Exhibited:** AIC, 1947. **Sources:** Falk, *AIC.*

RUSSELL, Shirley Marie (Ximena) Hopper *[Painter,
teacher, etcher, blockprinter, designer]* b.1886, Del Rey, CA /
d.1985, Honolulu, HI.
Addresses: Honolulu, HI. **Studied:** Stanford Univ. (A.B., 1907,
in art and modern languages); Calif. Sch. FA; Calif. Col. A. & Cr.;
Académie Julian, Paris, 1937-38; Andre Lhote in Paris after
WWII; Univ. Hawaii; also with Lionel Walden, Millard Sheets,
Hans Hofmann, Rico Le Brum, Serisawa, and Norman Ives.
Member: Assn. Honolulu Artists (secy., 1939-41); Honolulu SA;
Lg. Am. Pen Women; P.& S. League Honolulu; Honolulu Acad.
Art. **Exhibited:** Paris Salon, 1927; LACMA, 1937; Oakland Art
Gal., 1943-45; CPLH, 1946; Honolulu Exhib., annually, 1925-;
Honolulu Acad. Arts (solo), 1932 (prize), 1935 (prize), 1938
(prize), 1944 (prize), 1945 (prize); Matsonia Tour, 1963-65;
Mexico-Hawaiian Exchange Exhib., 1968; Downtown Gal.,
Honolulu, HI, 1970s. Awards: Grand Prize for Paukahana, 1933
& first prize for still life, 1946; Grand Prize for US Mail,
Territorial Fair, Honolulu, 1953. **Work:** Moana Hotel, Army
Hospital, Monanaloa Gardens, Acad. Art, Supreme Court, all of
Honolulu; Honolulu Acad. Art; State Found. Culture & Arts,
Capitol Bldg., Honolulu; Tennant Art Found. Gal.; Castel &
Cooke Art Coll.; Tokyo Nat. Mus. Art. Commissions: portraits,
Leslie B. Hicks, Hawaiian Elec. Co., Honolulu ; & Chief Justice
Perry & Kemp, Bar Assn. Honolulu. **Comments:** Russell first vis-
ited Hawaii in 1921. She taught for many years, including promi-
nent Hawaiian modernists, Keichi Kimura and Satoru Abe (see
entries). Preferred media: oils. Teaching: Calif. Schools, 1908-18;
Univ. Hawaii, summers 1930-39; McKinley H.S., Honolulu,
1923-46; Honolulu Acad. Art, 1954-55. **Sources:** WW73;
WW47; Meg Torbet & Kenneth Kimgrey, "Art in Hawaii,"

Design Quarterly (Walker Art Center, 1960); Forbes, *Encounters with Paradise*, 210, 245-46.

RUSSELL, Sigmond See: **ROESSLE, Sigmund G.**

RUSSELL, Stephen S.C. *[Wood engraver and designer]* b.c.1836, Maine.
Addresses: Boston, active from 1858. **Comments:** From 1859 through after 1860 he was in partnership with Stephen S.C. Russell (see entry) as Bricher & Russell (see entry). **Sources:** G&W; 8 Census (1860), Mass., XXVIII, 928; (living in home of his father, Edward T. Russell) Boston CD 1858-60+.

RUSSELL, Virginia Hansford *[Painter, sculptor, teacher]* b.1918, Richmond, VA.
Addresses: Richmond, VA. **Studied:** Univ. Richmond. **Exhibited:** Richmond Acad. A. & Sc.; Univ. Richmond. **Sources:** WW40.

RUSSELL, W. C. *[Miniaturist and portrait painter]* mid 19th c.
Addresses: NYC in 1837. **Exhibited:** NAD, 1837. **Sources:** G&W; Cowdrey, NAD; Bolton, *Miniature Painters.*

RUSSELL, Walter *[Painter, sculptor, illustrator, writer]* b.1871, Boston, MA / d.1963, Waynesboro, VA. **WALTER·RVSSELL·**
Addresses: NTC/Washington, CT. **Studied:** Boston, with A. Munsell, E Major; H. Pyle; Académie Julian, Paris with J.P. Laurens, 1890, 1906. **Member:** Member; Spanish Acad. A. & Letters; Soc. A. & Sc. **Exhibited:** Turin Expo, Italy, 1900; AIC, 1913; S. Indp. A., 1917. **Work:** Dallas Mus. FA; bust of T. Edison; Mark Twain Mon./ Mem., Hannibal, Mo.; Mark Twain Mem., Victoria Embankment Gardens, London; Goodyear Mem., Akron. **Comments:** Author/illustrator: "The Sea Children," "The Bending of the Twig," "The Age of Innocence," "The Universal One," "Salutation to the Day," "The New Electric Theory," "Rusell Genero-Radiative Concept." Position: art ed., *Collier's Weekly*, 1897; War Correspondent for *Colliers; Century.* **Sources:** WW40.

RUSSELL, William George *[Marine painter, landscape painter]* b.1860, Chatham, England.
Addresses: Atlantic City, NJ. **Studied:** self-taught. **Sources:** WW06.

RUSSELL, Winfred Jonathan *[Painter, illustrator]* mid 20th c.; b.Virginia.
Studied: BMFA Sch. **Exhibited:** S. Indp. A., 1925-26; Harmon Fnd., 1928, 1935; Independent Exhibit; New Art Circle; NY Pub. Lib.; Texas Centennial, 1936. **Work:** NYPL. **Comments:** Illus., national magazines and newspapers. **Sources:** Cederholm, *Afro-American Artists.*

RUSSERT, Otto Jerome *[Painter]* mid 20th c.
Addresses: Toms River, NJ. **Exhibited:** S. Indp. A., 1923-24, 1944. **Sources:** Marlor, *Soc. Indp. Artists.*

RUSSIN, H(erbert) B. *[Painter]* mid 20th c.
Addresses: NYC. **Exhibited:** S. Indp. A., 1925-26. **Sources:** Marlor, *Soc. Indp. Artists.*

RUSSIN, Robert I. *[Sculptor, educator, illustrator]* b.1914, NYC.
Addresses: NYC, 1942; Laramie, WY, 1948-76. **Studied:** CCNY (B.A., 1933, M.A., 1935); Beaux Arts Inst. Design, 1935; with Steinhof. **Member:** Nat. Sculpture Soc.; Sculptors Guild (exec. secy., 1946); Artists Lg. Am.; Am. Artists Congress; Audubon Artists; Am. Assoc. Univ. Prof.; Am. Inst. Arch. **Exhibited:** WFNY, 1939; GGE, 1939; WMAA, 1942-1956; MMA, 1943; AIC, 1942; Sculptors Guild, 1943-46; Arizona FA Fair, 1947, 1949; PAFA Ann., 1948, 1954, 1966; Wyoming State Fair, 1950; Assoc. Am. Artists ; Tucson Art Center, AZ, 1966 (solo); Colorado Springs Fine Arts Center, 1967 (solo); Palm Springs Desert Mus., 1970 (solo); Magnes Mus., Berkeley, CA, 1970 (solo); Heritage Gal., Los Angeles, CA, 1970s; Denver Art Mus.;

Joslyn Art Mus.; Nelson-Atkins Mus. Art; Kansas City Art Inst.; Nat. Acad. New Orleans Arts and Crafts; Fairmount Park, Phila., Phila. A. All.; Oakland Art Gal., Syracuse Mus. FA. **Awards:** Ford Foundation fellowship, 1953-54; Lincoln Sesquicentennial Medal, U.S. Congress, 1959; PAFA, 1966 (Charles G. B. Steele Sculpture Award). **Work:** Roosevelt Univ.; U.S. Navy (Abbott Laboratories Coll.); Hyde Park Mem.; Colorado Springs (CO) Fine Arts Center; Palm Springs (CA) Desert Mus.; Pomona Col., Claremont, CA; Gettysburg (PA) Mus.; Brookhaven Nat. Labs, NY. Commissions: two aluminum figures, Evanston Post Office, IL, 1939; Conshocken, PA; Lincoln Monument, State of Wyoming, Lincoln Highway, 1959; bronze group, Federal Bldg., Cheyenne, WY, 1966; fountain sculpture, City of Hope Nat. Medical Center, CA, 1967; carved wood reliefs, Federal Bldg., Denver, CO, 1968. **Comments:** Preferred media: marble, bronze. Teaching: instructor of sculpture, Cooper Union Art Inst., 1944-47; prof. sculpture, Univ. Wyoming, 1947-. Publications: contrib., "A New Sculptural Medium," *College Art Journal*, 1956, "The Lincoln Monument on the Lincoln Highway," *Lincoln Herald*, 1961 &" A University Bronze Foundry," *Am. Artists*, 1963. **Sources:** WW73; Rebecca Northern, "Robert Russin, Sculptor to Wyoming," *Western Farm Life* (Sept., 1950); O. A. Sealy, "Russin's metal magic" (Feb. 1956); F. K. Frame, "Russin's Lincoln" *Empire Magazine* (Feb. 1965); Tom Francis, "Robert Russin, Wyoming sculptor," *Am. Artist* (Jan. 1960). Bibliography: *American Scene Painting and Sculpture*, 62 (w/repro.); Falk, *Exh. Record Series.*

RUSSMAN, Arthur *[Painter]* mid 20th c.
Addresses: Chicago area. **Exhibited:** AIC, 1948. **Sources:** Falk, *AIC.*

RUSSMANN, Felix *[Painter, etcher, lithographer, teacher]* b.1888, NYC.
Addresses: Oak Park, IL. **Studied:** NAD; Royal Acad., Munich; & with Emil Carlsen. **Member:** Chicago SA; Chicago Galleries Assn.; Chicago No-Jury SA. **Exhibited:** NAD, 1918 (prize); Albrigh A. Gal.; Corcoran Gal biennial, 1919; AIC; CI; John Herron AI.; Chicago Gal., A., 1930 (prize). **Work:** Oberlin Col.; Univ. Kentucky. **Sources:** WW53.

RUSSO, Alexander Peter *[Painter, educator, illustrator, designer]* b.1922, Atlantic City, NJ.
Addresses: Atlantic City, NJ; NYC; Frederick, MD. **Studied:** Pratt Inst, 1940-42; Swarthmore Col., 1947; Bard Col., summer, 1947; Guggenheim fellow, 1948-50; Breevort-Eickenmeyer fellow, Columbia Univ., 1950-52 (B.F.A., 1952); Fulbright grant, Acad. Fine Arts, Rome, Italy, 1953-54; Univ. Buffalo, 1955. **Member:** Col. Art Assn.; Arts Club Wash. (chmn. exhibs., 1970-71); AEA; Soc. Wash. Artists; Edward McDowell Colony. **Exhibited:** Carnegie Nat., Pittsburgh, Pa., 1946; PAFA Ann., 1952; Int. Exhib., Bordighera, Italy, 1953 & 1954; Four Am. Artists Exhib., Biblioteca, Rome, Italy, 1954; Albright-Knox Gal. Regional, Buffalo, NY, 1956; Corcoran Gal biennials, 1947-63 (4 times); Corcoran Gal solo, 1946; Jackson, Miss., 1946; PMG, 1945; Norfolk Mus. A. & Sc., 1943; Whyte Gal., 1945 (solo); Swarthmore Col., 1946 (solo); Salon de la Marine, Paris, 1945; Frank Rehn Gal, NYC. **Work:** Albright-Knox Gallery, Buffalo; CGA; NMAA; Fed Ins Deposit Corp, Wash., DC; Acad Arts & Letters, NYC. Commissions: encaustic mural, "Telesio Interlandi," Capo San Andrea, Sicily, 1953; silk screen murals, Birge Co, Buffalo; 56 various design commissions, Doubleday Publ Co, Dutton Publ, Cohn Hall Marx, 1958-60; acrylic painting series, US Navy Dept, Wash., DC, 1964. **Comments:** Preferred media: acrylics, oils, plastics, metals. Positions: US Navy combat artist, US Navy Dept., Washington, 1942-46; acting art dir., Sewell, Thompson, Caire Advertising, New Orleans, La, 1948-49; free lance artist & designer, various agencies & orgns., New York; 1958-60; guest lectr. art, Roanoke & Hollins Cols., Univ. Southern Ill., Miss. Art Assn. Teaching: Corcoran Sch. Art, 1961-70, chmn. painting dept., 1966-69; chmn. art dept., Hood Col., 1970s. Research: Contemporary & Medieval Italian art. Publications: illusr., "To all Hands, an Amphibious Adventure," 1944 & "Many

a Watchful Night," 1945, McGraw; auth., "The Italian Experience," Inst. Int. Educ., 1953. **Sources:** WW73; Falk, *Exh. Record Series.*

RUSSO, Christopher, Jr. *[Engraver]* b.1893, New Orleans, LA / d.1936, New Orleans.
Addresses: New Orleans, active 1910-23. **Sources:** *Encyclopaedia of New Orleans Artists*, 334.

RUSSO, Michele *[Painter]* mid 20th c.
Exhibited: Corcoran Gal biennial, 1953. **Sources:** Falk, *Corcoran Gal.*

RUSSO, Sally Haley (Mrs.) See: **HALEY, Sally (Mrs. S.H. Russo)**

RUSSO, Sam (Alexander) *[Painter]* b.1922, Atlantic City, NJ.
Addresses: Frederick, MD. **Studied:** Pratt Inst. of Art and Des., Brooklyn, NY, 1940-42; Swarthmore Col., Pennsylvania, 1947; Bard Col., Annandale-on-Hudson, New York, summer 1947; Columbia Univ., NY (B.F.A., 1952); Academy of Fine Arts, Rome, 1952-54. **Exhibited:** Awards: Guggenheim Fellowship in 1948-50; Breevort-Eichenmeyer Fellowship, Columbia Univ.; Fulbright Fellowship, for painting and research in Rome, Italy, 1952-54. **Comments:** Moved to Buffalo in 1955. Teaching: Univ. of Buffalo, 1955-58. **Sources:** Krane, *The Wayward Muse*, 195.

RUST, David E. *[Art historian, collector]* mid 20th c.; b.Bloomington, IL.
Addresses: Wash., DC. **Studied:** NY Univ. Inst. Fine Arts (M.A., 1963). **Comments:** Positions: mus. cur., Nat. Gal. Art, Wash., DC, 1961-. Collections arranged: English Drawings & Watercolors, 1962; Old Master Drawing from Chatsworth, 1969; Nathan Cummings Collection, 1970. Collection: paintings & drawings, mostly European 16th-18th Century, some 19th Century; American 19th Century & some contemporary. Publications: auth., "Twentieth Century Paintings & Sculpture of the French School in the Chester Dale Collection," 1965; auth., " Eighteenth and nineteenth Century Paintings & Sculpture of the French School in the Chester Dale Collection," 1965; auth., "The Drawings of Vincenzo Tamagni da San Gimignano," Report & Studies Hist. Art, 1968. **Sources:** WW73.

RUST, Edwin C. *[Sculptor, art administrator]* b.1910, Hammonton, CA.
Addresses: Brooklyn, NY; Memphis, TN. **Studied:** Cornell Univ.; Yale Univ. (B.F.A.); also with Archipenko & Miles. **Member:** NSS. **Exhibited:** VMFA, 1938; MAA (AV),1942; WMAA, 1940; CI, 1940; PAFA, 1940; PMA, 1940 & 1949; MoMA, 1942; Brooks Mem. Mus., 1950 & 1952. **Work:** U.S. Court House, Wash., DC; College William and Mary; Univ. Tennessee, Knoxville; Univ. Mississippi; LeMoyne-Owen College, Memphis, TN; Memphis (TN) Acad. Arts. **Comments:** Positions: dir., Memphis Acad. Arts, 1949-. Teaching: assoc. prof. sculpture, College William & Mary, 1936-43, hd. fine arts dept., 1939-43. **Sources:** WW73; WW47.

RUST, Joseph S. *[Painter]* mid 20th c.
Addresses: NYC. **Studied:** ASL. **Exhibited:** S. Indp. A., 1919, 1922. **Sources:** Marlor, *Soc. Indp. Artists.*

RUST, Mildred Anderson (Mrs.) *[Artist]* mid 20th c.
Addresses: Wash., DC, active 1916-39. **Sources:** McMahan, *Artists of Washington, DC.*

RUST, Sam G. *[Painter]* mid 20th c.
Exhibited: S. Indp. A., 1937-38. **Sources:** Marlor, *Soc. Indp. Artists.*

RUSTAD, Roland E. *[Painter]* mid 20th c.
Exhibited: AIC, 1927-28. **Sources:** Falk, *AIC.*

RUTA, Peter Paul *[Painter, editor]* b.1918, Dresden, Germany.
Addresses: NYC. **Studied:** ASL New York, with Morris Kantor & Jean Charlot, 1938-42 & 1945-46; Acad. Fine Arts Venice, 1947-49, degree; Acad. Venice, with Guido Cadorin, 1948. **Exhibited:** Stonington Gal., Conn., 1960; Angeleski Gal., NYC,

1962; Hacker Gal., NYC, 1962; Surebaja Gal., NYC, 1967; Graham Gallery, NYC, 1972, all solos. **Awards:** first prize, Westchester Art Soc., 1965. **Work:** Uffizi Gal., Florence, Italy; Univ. Southern Ill. **Comments:** Preferred media: oils. Publications: ed., *Arts Mag.*, 1968-71; ed., Int. Art Exhibs., 1969. **Sources:** WW73.

RUTHERFORD, Alexander W. *[Genre, portrait, and still life painter]* b.1826, Vermont / d.1851, London, England.
Studied: Daniel Huntington, NYC, c. 1847; went to Europe in 1850 to continue his studies but died in London the following year (at age 26). **Exhibited:** NAD, 1849-50. **Comments:** Patronized by the American Art-Union in 1848 and after. **Sources:** G&W; *Panorama* (Jan. 1949), 56-57, back cover; Cowdrey, AA & AAU; Cowdrey, NAD; Tuckerman, *Book of the Artists; American Collector* (Dec. 1948), 17.

RUTHERFORD, Florence White *[Painter]* b.1867.
Addresses: NY. **Exhibited:** AIC, 1899-1900. **Sources:** Falk, AIC.

RUTHERFORD, J. C. *[Portrait painter]* mid 19th c.
Addresses: Active in Vermont. **Comments:** Painter of a portrait of John Calvin Bingham (1816-1870), owned in 1941 by a private collector in St. Johnsbury (Vt.). **Sources:** G&W; WPA (Mass.), *Portraits Found in Vermont.*

RUTHERFORD, John *[Portrait and miniature painter]* early 19th c.
Addresses: Cincinnati, OH, active1818/19. **Comments:** Promising painter who died young. **Sources:** G&W; Information cited by G&W as being courtesy Edward H. Dwight, Cincinnati Art Museum. More recently, see Hageman, 122.

RUTHLING, Ford *[Painter, designer]* b.1933, Santa Fe, NM.
Addresses: Santa Fe, NM. **Studied:** Randall Davey. **Exhibited:** Nelson Atkins Mus.; Mus. N. Mex.; Oklahoma City Mus. Fine Arts; Dallas Mus. Fine Art; Wichita Falls Mus. Fine Art. **Work:** Mus. N. Mex; Wichita Falls Fine Art Mus.; Univ. Utah Coll. C. **Comments:** Preferred media: oils. **Sources:** WW73.

RUTHRAUFF, Frederick Gray *[Painter, writer]* b.1878, Findlay, OH / d.1932.
Addresses: Berkeley, CA; Odgen, UT, since 1925. **Studied:** W.V. Cahill; W.H. Clapp; H. Morrisett, Paris. **Member:** Berkeley LFA; Calif. AC; Odgen Soc. of Artists. **Exhibited:** Public Works of Art Project, Southern Calif., 1924; San Francisco AA, 1925, 1927; Calif. AC, 1929. **Sources:** WW31; Hughes, *Artists in California*, 485.

RUTHRAUFF, Herbert Haulman *[Painter, lithographer teacher]* b.1894, Chambersburg, PA.
Addresses: Lansdale, PA. **Studied:** self-taught. **Member:** Lansdale A.Lg. **Exhibited:** New Hope, Pa.; Lansdale A. Lg. **Work:** Fleischer Mem., Phila., Pa.; Univ. Pennsylvania; Pa. Dept. Welfare; PMA; Phila. Sketch Cl.; mural, Kirkbride Sch., Phila. **Comments:** Position: t., Lansdale Sketch C. Affiliated with The Graphic Arts Corp. of Ohio, Toledo, OH. **Sources:** WW53; WW47.

RUTHVEN, Edwin C. *[Engraver]* mid 19th c.
Addresses: Active in Baltimore, 1856-57; at Philadelphia in 1860. **Comments:** In partnership with David Ring in engraving firm of Ruthven and Ring, Baltimore, active 1856-57. **Sources:** G&W; Baltimore CD 1856; BD 1857; Phila. CD 1860.

RUTILI, Renzo R. *[Designer]* b.1901.
Addresses: Grand Rapids, MI. **Studied:** CI. **Comments:** Specialty: furniture des. **Sources:** WW40.

RUTKA, Dorothy *[Etcher, portrait painter]* b.1907 / d.1985, Cleveland, OH.
Addresses: Cleveland Heights, OH. **Studied:** Cleveland Sch. A.; Huntington Polytech In. **Member:** Cleveland PM; Artists U. **Exhibited:** CMA, 1931, 1933 (prize), 1934-36. **Work:** Cleveland Bar Assn.; CMA.

RUTKOFF, Sylvia *[Artist] mid 20th c.*
Addresses: NYC. **Exhibited:** PAFA Ann., 1954. **Sources:** Falk, *Exh. Record Series.*

RUTKOWSKI, Rita *[Painter] mid 20th c.*
Exhibited: Corcoran Gal biennial, 1959. **Sources:** Falk, *Corcoran Gal.*

RUTLAND, Emily Edith *[Painter] b.1892, Lee Co, TX.*
Addresses: Robstown, TX; Kingsville, TX. **Studied:** X. Gonzales; C. Kay-Scott. **Member:** Texas Fine AA; Texas WCS; SSAL; South Texas Art Lg.; Print Guild; Art Foundation Corpus Christi. **Exhibited:** Int. Print Exhib., Austin 1943; WMAA, 1942; Texas General Exhib., 1943-45; Caller-Times Exhib., Corpus Christi, TX, 1944-45, Houston, 1937, 1939; Texas Women's Fed. Cl., Lubbock, 1931; SSAL, Nashville, 1935; Corpus Christi Nat., 1947; Texas Fine Arts Invitational, Austin, 1965; Corpus Christi Art Foundation, 1968; Texas Fine Arts Regional, Texas A&I Univ., 1971 & 1972. **Work:** Centennial Mus., Corpus Christi, TX; Corpus Christi Mus.; Dallas Mus.; Texas Tech. Univ. **Comments:** Preferred media: oils, acrylics. **Sources:** WW73; WW47; Petteys, *Dictionary of Women Artists,* cites alternate birth date of 1894.

RUTLEDGE, Ann *[Painter] b.1890, KS.*
Addresses: Long Beach, CA. **Studied:** V.H. Anderson; G.P.Ennis; C.W. Hawthorne. **Member:** Midwestern AA, Long Beach AA; Kansas AA. **Sources:** WW40.

RUTLEDGE, Bertha V. *[Painter] b.1890, KS.*
Addresses: Topeka, KS. **Studied:** Helen Anderson, Hawthorne, & G.P. Ennis. **Member:** Topeka Art Guild; Kansas AA. **Sources:** WW38; Petteys, *Dictionary of Women Artists.*

RUTLEDGE, James H. *[Painter] mid 20th c.*
Exhibited: Salons of Am., 1934. **Sources:** Marlor, *Salons of Am.*

RUTMAN, Herman S. *[Painter, sculptor, decorator, teacher] b.1889, Russia.*
Addresses: Philadelphia, PA. **Studied:** PMSchIA; PAFA; Temple Univ.; Barnes Fnd.; F.PAFA, 1936-46. **Exhibited:** NAD, 1940; Butler AI; Woodmere A. Gal.; YWHA, Phila., 1935 (prize). **Work:** City Hall, Phila., Pa. **Comments:** Originatior: "Fabri-Graph" des. for lithography. **Sources:** WW53; WW47.

RUTSCH, Alexander *[Painter, sculptor] mid 20th c.; b.Austria.*
Addresses: Pelham, NY. **Studied:** Acad. Fine Art, Belgrade, Yugoslavia; Vienna, Austria; govt. study grant, Paris, France. **Exhibited:** Foreign Artists in France (represented Austria), Petit Palais, Paris, 1962; International Sculptors, Mus. Rodin, Paris, 1962-63; solo show, Galerie Vendome, Brussels, Belgium, 1965; Int. Exhib., Grand Palais de Champs Elysses, Paris, 1966; Galerie St Louis, Morges, Switz., 1971. Awards: silver medal of arts, sci. & letters & bronze medal for art, City of Paris, 1958; first prize (three portraits of Picasso), Salon Artistique Int. de Sceaux, 1954. **Work:** Albertina Graphic A. Coll., Austria; Gal., Belvedere, Vienna; Munic. Mus., Vienna; Munic. Mus., Vienna; MoMA, Paris; Must Liege, Belgium. **Sources:** WW73; Jean Desville (producer), "The world of Rutsch" (film), 1964; Carlton Lake, *In Quest of Dali* (Putnams, 1969); Roger Seiler, "Inner eye of Alexander Rutsch" (film), produced by IBM, 1972.

RUTT, Anna Hong (Mrs. Norman E.) See: **HONG, Anna Emilie (Helga)**

RUTTER, George *[Heraldic and ornamental painter] late 18th c.*
Addresses: Philadelphia, active in the 1780's and 1790's. **Comments:** In 1796 he was associated with Jeremiah Paul, Matthew Pratt, and William Clarke in two firms: Pratt, Rutter & Co.; and Paul, Rutter & Clark (see entries each firm and artist). **Sources:** G&W; Scharf and Westcott, *History of Philadelphia,* II, 1040; Prime, I, 19, and II, 3-14; Dickson, "A Note on Jeremiah Paul," 393.

RUVOLO, Felix Emmanuele *[Painter, educator] b.1912, NYC.*
Addresses: Chicago, IL, 1940s; Berkeley, CA. **Studied:** AIC; Catania, Sicily; UCal Berkeley (M.F.A.). **Exhibited:** WMAA, 1944-52; VMFA, 1942, 1944 (prize), 1946; CI, 1941, 1943-45; PAFA Ann., 1942-52 (7 times); Corcoran Gal biennials, 1939-47 (4 times); AIC, 1938-45, 1942 (prize), 1947 (prize); SFMA, 1942 (prize), 1944, 1945 (prize), 1946, 1964 (award); Milwaukee AI, 1946 (med); San Fran, 1946 (med); Abstr & Surealist Art Am., Mus. Art, NYC, 1951; 60 Americans--1960, Walker Art Ctr., 1960; Invitational Am. Drawing, Moore Col. Art Gal., Phila., Pa, 1968; Drawings 1969, Ithaca Col. Art Gal., NY, 1969; Am. Drawing & Sculpture, 1948-69, Krannert Art Mus., 1971. Awards: Hall of Justice Competition Award, San Francisco Art Comm., 1967; grants, Univ. Calif. Inst. Creative Arts, 1964 & 1971. **Work:** Krannert Art Mus., Univ. Ill., Urbana; AIC; Walker Art Ctr., Minneapolis; Oakland Mus., Calif. Commissions: colored lithograph, Collectors Press, 1967. **Comments:** Teaching: AIC, 1944-48; UCal Berkeley, 1950-70s; Univ Southern Calif, summer 1963. **Sources:** WW73; WW47; K. Kuli, "Felix Ruvolo," *Mag Art* (1947) & "Painters Who Teach," *Pictorial Living* (1959); N. Pousette-Dart, *American Painting Today* (Hastings, 1957); Falk, *Exh. Record Series.*

RUWOLDT, Hans *[Painter] mid 20th c.*
Exhibited: AIC, 1936. **Sources:** Falk, *AIC.*

RUYL, Beatrice Baxter *[Painter] b.1875 / d.1942.*
Studied: Chas. H. Woodbury, Ogunquit Sch. **Exhibited:** "Charles H. Woodbury and His Students," Ogunquit Mus. of Amer. Art, 1998. **Comments:** Her daughter Ruth married Charles Woodbury's son David. **Sources:** *Charles Woodbury and His Students.*

RUYL, Louis H. *[Illustrator, etcher] b.1870, Brooklyn, NY.*
Addresses: NYC/Hingham, MA. **Member:** Artists GLd.; Stowaway C. **Comments:** Illustrator: "Cape Cod, Old and New," "Old Post Road, from Boston to Plymouth," "From Provincetown to Portsmonth." **Sources:** WW31.

RUYNES *[Engraver] 20th c.; b.NYC.*
Addresses: Paris, France. **Sources:** WW08.

RUZICKA, Antonin Joseph *[Painter, illustrator, craftsperson, teacher] b.1891, Racine, WI / d.1918, France (during WWI).*
Studied: AIC.

RUZICKA, Rudolph *[Painter, illustrator, printmaker, designer] b.1883, Kourim (Bohemia), Czechoslovakia / d.1978, Hanover, NH.*

·R·

Addresses: Dobbs Ferry, NY. **Studied:** AIC; NY Sch. A. **Member:** ANA; AIGA. **Exhibited:** AI Graphic A. (gold); Newark Pub. Lib., 1917 (solo of wood engravings). **Work:** AIC; CI; MMA; LOC; CMA; Brooklyn Mus. A. & Sc. **Comments:** Came to U. S. in 1894. Illustrator: Washington Irving's "Notes of Travel in Europe," Thoreau's "Walden," Oscar Wilde's "Happy Prince," Fables of La Fontaine. **Sources:** WW47; exh. pamphlet, Newark Pub. Lib. (1917).

RYAN, Angela (Mrs. William Fortune) *[Painter] mid 20th c.*
Addresses: Pullman, WA, 1936; St. Paul, MN. **Studied:** ASL; with E. Kinzinger, Munich. **Exhibited:** SAM, 1936; Tacoma Civic Art Assoc., 1937; St. Paul Sch. Art, 1940. **Comments:** Married to William F. Ryan (see entry). **Sources:** WW40; Trip and Cook, *Washington State Art and Artists.*

RYAN, Anne *[Printmaker, painterwriter, stage designer] b.1889, Hoboken, NJ / d.1954, Morristown, NJ.*

H Ryan

Addresses: NYC. **Studied:** Columbia Univ.; printmaking with Stanley W. Hayter. **Member:** Studio 17; Vanguard Print Group. **Exhibited:** MoMA; WMAA, 1951-54; Betty Parsons Gal., 1955 (memorial); Kraushaar Gal., NYC, 1957; Brooklyn Mus. & Marlborough Gal., 1974; Phila; Houston; Portland, OR; Mexico City; Paris. **Work:** MMA; MoMA; BM. **Comments:** Best known for abstract collages. **Sources:** WW53; WW47; Petteys,

Dictionary of Women Artists.

RYAN, Bonnie B. *[Painter] b.1903, San Diego, CA / d.1940, Los Angeles, CA.*
Addresses: Los Angeles, CA. **Studied:** Marlborough Col.; St. Mary's Col.; Otis Art Inst. **Member:** Women Painters of the West. **Sources:** Hughes, *Artists in California*, 485.

RYAN, Douglas *[Illustrator] 20th c.*
Addresses: NYC. **Sources:** WW21.

RYAN, Edward *[Illustrator] 20th c.*
Addresses: NYC. **Comments:** Related to Douglas Ryan.
Sources: WW21.

RYAN, Eric J., Jr. *[Artist] mid 20th c.*
Addresses: Phila., PA. **Exhibited:** PAFA Ann., 1953. **Sources:** Falk, *Exh. Record Series.*

RYAN, F. L. (Miss or Mrs.) *[Artist] early 20th c.*
Addresses: Active in Los Angeles, 1913-14. **Sources:** Petteys, *Dictionary of Women Artists.*

RYAN, H. Calvin *[Painter] 20th c.*
Addresses: Cleveland, OH. **Member:** Cleveland SA. **Sources:** WW27.

RYAN, James L. *[Lithographer's apprentice in 1860] b.c.1845, Massachusetts.*
Addresses: Boston, 1860. **Sources:** G&W; 8 Census (1860), Mass., XXVII, 254 (listed as being born of an Irish mother).

RYAN, John *[Engraver] b.c.1833, Pennsylvania.*
Addresses: Philadelphia in 1850. **Sources:** G&W; 7 Census (1850), Pa., L, 941 (born into Irish family, father was a tavern-keeper).

RYAN, Kathryn White (Mrs) *[Painter] mid 20th c.*
Addresses: NYC. **Exhibited:** Montross Gal., NY, 1937; NAC, 1935, 1939. **Sources:** WW40.

RYAN, Lewis Carleton *[Painter, printmaker] b.1894, Austin, TX / d.1982, Escondido, CA.*
Addresses: Escondido, CA. **Studied:** UCLA; Otis Art Inst. **Exhibited:** Calif. WC Soc., 1944. **Work:** Huntington Lib., San Marino, CA. **Comments:** Illustr., five books on Escondido history, written by his wife. His illustrations appeared in national magazines, and he was commercially successful with woodcuts and greeting cards. **Sources:** Hughes, *Artists in California*, 485.

RYAN, Mazie Therese *[Craftsperson, decorator] b.1880, New Orleans, LA / d.1946, Pass Christian, MS.*
Addresses: New Orleans, active 1900-14. **Studied:** Newcomb Col., 1896-1906; George W. Maynard; National School of Design, Columbia U., NYC. **Exhibited:** Louisiana Purchase Expo., 1904; Soc. of Keramic Arts, National Arts Club, NYC; NOAA, 1911. **Sources:** *Encyclopaedia of New Orleans Artists*, 334.

RYAN, McA. Donald (Lieut.) *[Painter] mid 20th c.*
Exhibited: S. Indp. A., 1942. **Sources:** Marlor, *Soc. Indp. Artists.*

RYAN, Michael D. *[Painter] late 19th c.*
Addresses: New Orleans, active 1885-88. **Sources:** *Encyclopaedia of New Orleans Artists*, 334.

RYAN, Sally (Miss) *[Sculptor, painter] b.1916, NYC / d.1968, London, England.*
Addresses: NYC; Redding, CT. **Studied:** H. Miller, Montreal; J. Camus, Paris. **Member:** NSS. **Exhibited:** Toronto A. Gal., 1933; Montreal A. Gal., 1933; Paris Salon, 1934, 1935; RA, London, 1935; Royal Scottish Acad., 1935, 1936; WMAA, 1938-42; WFNY, 1939; CM; AIC, Delgado Mus.; Hartford Atheneum; SFMA; PMA, 1940, 1950; Independents, NY; Cooling Gal., London, 1937 (solo); Marie Sterner Gal., 1937 (solo); Montreal AA, 1937 (solo), 1941 (solo); Wildenstein Gal., 1944 (solo); Am-British A. Center, 1950. **Work:** Tate Gal., London, Eng. **Sources:** WW59; WW47.

RYAN, Tom *[Painter, illustrator] b.1922, Springfield, IL.*
Addresses: Lubbock, TX in 1974. **Studied:** St. Louis School FA; Am. Acad. Art, Chicago with Sturba and Mosby, for three years; ASL with Frank Reilly and assistant to Dean Cornwell. **Member:** CAA. **Work:** Harmsen Coll.; Cowboy Hall Fame. **Comments:** Served in WWII. Contributed Western illustrations for book jackets; painted Western historical scenes, 1954-62, for a NYC gallery; and Western genre for calendars after 1964. **Sources:** P&H Samuels, 413.

RYAN, William Edmund (or Redmond) *[Amateur painter, illustrator, journalist] b.1823, England / d.c.1850, New Orleans, LA.*
Addresses: Active in California. **Comments:** Was working as a newspaper reporter in NYC by 1847, when he left for California with a group of volunteers for the Mexican War. The war was over by the time he arrived and he was discharged in Monterey in the fall of 1848. While unsuccessfully goldmining in the Stanislaus River area, he made sketches of the miners and mining towns he encountered. He then arrived in San Francisco and found work as a house and ship painter, all the while painting, sketching, and writing in his journal. Ill health forced him to leave California in late 1849 and he sent his sketches and journal back to relatives in London. His journal was published under his name as *Personal Adventures in Upper and Lower California, in 1848-49* (London, 1850), illustrated with 23 plates after his own sketches. Ryan never made in back to London, however; he died of Yellow Fever in New Orleans. **Sources:** G&W; CAB; NYCD 1847 [as artist]; Jackson, *Gold Rush Album;* Peters, *California on Stone.* More recently, see Hughes, *Artists in California.* There is some confusion over his birth/death dates. Hughes gives birth as 1823 and death as 1855 but states Ryan was 27 at time of his death; it is more likely that he died about 1850, soon after he left California.

RYAN, William Fortune *[Painter, teacher] mid 20th c.; b.Milwaukee, WI.*
Addresses: Pullman, WA, 1937; St. Paul, MN. **Studied:** C. Booth; M. Weber; E. Kinzinger, Munich. **Member:** Minn. AA. **Exhibited:** Minneapolis IA; Kansas City AI, 1939; St. Paul Sch. A., 1940; AIC, 1940; Minn. State Fair, 1927 (prize), 1934 (prize), 1938 (prize); Minneapolis AA, 1927 (prize), 1938 (prize); SAM, 1934 (prize), 1937. **Work:** SAM; Mem. U., Iowa; Iowa State Col., Ames, Iowa. **Comments:** Position: teacher, St. Paul Sch. A. **Sources:** WW40.

RYAN, William Lawrence *[Painter, etcher, lecturer] mid 20th c.; b.NYC.*
Addresses: Richmond Hill, NY. **Studied:** G.P. Ennis; O.H. Julius; L. DaVinci A. Sch.; NYU; CUA Sch. **Member:** AAPL; A. Edu. Soc., NYU. **Exhibited:** S. Indp. A., 1937. **Sources:** WW40.

RYBACK, Issahar *[Painter] mid 20th c.*
Exhibited: AIC, 1938. **Sources:** Falk, *AIC.*

RYBINGTON, Norman *[Painter] mid 20th c.*
Exhibited: PAFA Ann., 1952. **Sources:** Falk, *Exh. Record Series.*

RYBKA, Herbert *[Painter] mid 20th c.*
Addresses: Brooklyn, NY. **Exhibited:** S. Indp. A., 1931. **Sources:** Marlor, *Soc. Indp. Artists.*

RYCKE, Emma de *[Painter] late 19th c.*
Addresses: Brooklyn, NY, 1869. **Exhibited:** NAD, 1869. **Sources:** Naylor, *NAD.*

RYDEEN, Lloyd B. *[Painter] 20th c.*
Addresses: St. Paul, MN. **Sources:** WW24.

RYDELL, Amell Roi (Roy) *[Painter] b.1915, Minneapolis, MN.*
Addresses: Santa Cruz, CA. **Studied:** Minneapolis Art Inst.; Chouinard Art Sch.; USC; UC Berkeley; Ecole de la Grand Chaumière, Paris. **Exhibited:** All Calif. Exh., 1939; LACMA, 1943; Santa Barbara Mus., 1944 (solo); Santa Cruz County Fair, 1983; Stanford U., 1986 (solo), 1987 (solo); Santa Cruz Art League, 1988-89. **Sources:** Hughes, *Artists in California*, 485.

RYDEN, Henning *[Sculptor, designer, painter] b.1869, Ringamala, Sweden / d.1939, Columbus, OH.*

Addresses: immigrated 1891; Chicago, IL, 1899-1901; Montclair, NJ, 1914; NYC, 1916-; Columbus, OH. **Studied:** AIC; ASL; Berlin; London. **Member:** SC, 1908; Allied AA. **Exhibited:** PAFA Ann., 1899-1901, 1914-18; P.-P. Expo, San Fran., 1915; AIC; S. Indp. A., 1917. **Work:** Am. Numismatic S. **Comments:** Mistakenly entered in some catalogues as "Fleming Ryden." **Sources:** WW38; Falk, *Exh. Record Series.*

RYDER, Albert P(inkham) *[Painter]*
b.1847, New Bedford, MA / d.1917,
Elmhurst, Long Island, NY.

Ryder

Addresses: Active in New Bedford, 1847-70; NYC. **Studied:** W.E. Marshall, c.1867; NAD, 1870. **Member:** ANA, 1902; NA, 1906; SAA, 1878 (founder); NIAL. **Exhibited:** Brooklyn AA, 1873-74; NAD, 1873-88; PAFA Ann., 1879, 1894-95, 1902, 1907; Pan-Am. Expo, Buffalo, 1901 (medal); Corcoran Gal. annual, 1908; Armory Show, 1913; MMA, 1918 (mem. exh.); New Bedford Art Club, 1920; AIC; NMAA, 1989. **Work:** NMAA; AIC; NGA; BMFA; Detroit IA; BM; Phillips Coll., Wash., DC; MMA ("Toilers of the Sea"); Chrysler Mus., Norfolk, VA; Sheldon Mem. Art Gal, Univ. Nebraska; Nebraska AA; Vassar College Art Gal., Poughkeepsie, NY; David B. Findlay Art GAls., NYC; Minneapolis IA; St. Louis Art Mus.; Worcester Art Mus.; Butler IA; Smith College Mus. Art; Cleveland MA. Archival material: Special Coll., Morris Lib. The Univ. of Delaware holds the The Lloyd Goodrich-Albert Pinkham Ryder Archive, consisting of original letters by Ryder to his friends; manuscripts of Ryder's poems; personal reminiscences; pencil tracings and a sketchbook attributed to Ryder (from his 1882 trip to Europe); as well as other materials related to the artist, such as photographs and x-rays of Ryder's paintings, and several examples of forgeries. **Comments:** One of America's most important romantic painters. His subject matter included pastoral landscapes, marines, and literary and biblical themes, infused with a visionary, dreamlike quality. He visited Europe four times, the most significant trip being one made in 1882 that included travel through North Africa. After 1900, Ryder painted few original works but instead constantly reworked older ones, using materials and techniques that have caused some of his oils to darken and/or deteriorate. Despite his lack of production in these years, Ryder's fame began to grow in the decade before his death, and his work drew the interest of modernists such as Arthur B. Davies and Marsden Hartley. In 1913 the landmark Armory Show included ten of his paintings. About this time, forgeries of his work began appearing on the market, and after his death, as his popularity increased and the demand for his work grew, the number of forgeries multiplied. When the seriousness of the authentication problem became evident to art historian Lloyd Goodrich in the 1930s, he began an intense study of Ryder's working methods and, with the help of painting conservator Sheldon Keck, was later able to weed out many of the forgeries (see Homer and Goodrich). Of the 1,000 paintings attributed to Ryder over the years, only about 100 are genuine, and 20-30 more have been lost or destroyed. **Sources:** WW15; William I. Homer and Lloyd Goodrich, *Albert Pinkham Ryder, Painter of Dreams* (New York: Harry N. Abrams, 1989); Elizabeth Broun, *Albert Pinkham Ryder,* with catalogue by Eleanor L. Jones, Matthew J.W. Drutt, Sheri L. Bernstein and Elizabeth Broun (Washington, D.C.: Smithsonian Institution Press, 1989); Kendall Taylor, "Ryder Remembered" *Archives of Am. Art Journal* (vol.24, no.3, 1984); W.I. Homer, "The Ryder Cover-Up" *ArtNews* (Oct. 1989); *Selections from the Lloyd Goodrich-Albert Pinkham Ryder Archive* (exh. cat., Univ. of Delaware, 1989); Blasdale, *Artists of New Bedford*, 163-64 (w/repros.); Falk, *Exh. Record Series.*

RYDER, Chauncey F(oster) *[Painter,*
etcher, lithographer, illustrator] b.1868,
Danbury, CT / d.1949, Wilton, NH.

F. Ryder

Addresses: New Haven, CT; Chicago, IL; NYC/Wilton, NH. **Studied:** AIC, c.1891; Smiths Art Acad.; Académie Julian, Paris with J.P. Laurens, 1901; also with Raphael Collin in Paris; NYWCC; NAC; SAE; Calif. PM; Chicago SE; AFA. **Member:** ANA, 1915; NA, 1920; SC; NAC; Lotos Club; Allied Artists Am.;

AFA; AWC Soc.; Brooklyn Soc. of Artists; Chicago Soc Etchers; NYWCC. **Exhibited:** AIC; Paris Salon, 1903-06, 1907 (prize); PAFA Ann., 1906, 1910-38; Macbeth Gal., NYC, 1907; Corcoran Gal biennials, 1908-35 (9 times); Lyme AA, 1910-11; Pan-Pacific Expo, San Fran., 1915 (silver); Baltimore WCC, 1920 (prize); Central State Fair, Aurora, 1922 (prize); SC, 1926 (Show Prize); Brooklyn SE (prize); NAC, 1930 (medal, prize); AWCS, 1930 (prize); SAE, 1932 (prize); NAD, 1933 (Obrig Prize); Int. Expo, Paris, 1937 (gold); Soc. for Sanity Art, Chicago, 1939 (medal, prize); AWCS-NYWCC, 1939 (prizes). **Work:** AIC; PAFA; MMA; NOMA; Washington State AA; CGA; Hackley Art Gal., Muskegon, MI; Nat Exhib. Assn., Toronto; Denver AC; Engineer's Club, NYC; Société des Amis des Arts, Douai, France; CAM, St. Louis; Butler AI, Youngstown, Ohio; Minneapolis Inst. Art; NGA; Wilmington SFA; Randolph-Macon Women's College, Lynchburg, VA; Quinnipiac Club, New Haven, CT; Dayton Mus. Art; Macon (GA) AA; Rochester Mem. Art Gal.; Springfield (IL) AA; Brooks Mem. Art Gal., Memphis; NYPL; AIC; Dept. Prints and Drawings, British Mus., London.; Dept. Engraving, Victoria and Albert Mus., South Kensington; Graphic Art Dept., Smithsonian Inst.; Print Dept., BM; Indianapolis AA; John Herron AI; Hartford (CT) Atheneum; New Britain AI; Univ. Illinois, Urbana; Cabinet des Estampes, Bibliothèque Nationale, Paris; Newark Mus. Art; Syracuse MFA; New Haven PCC; Montclair (NJ) AA; Houston MFA; Joslyn Mem., Omaha; Springville (UT) H.S.; Print Dept., LOC; CMA. **Comments:** Ryder and his wife summered on Monhegan Island, ME from 1920-27; he also painted at the Old Lyme colony. Although best known for oils, he also painted with watercolors. Teaching: Smiths Art Acad., Chicago, 1890s. **Sources:** WW47; Curtis, Curtis, and Lieberman, 44, 186; *Connecticut and American Impressionism* 172 (w/repro.); *Art in Conn.: The Impressionist Years*; Falk, *Exh. Record Series.*

RYDER, Emily A. *[Landscape and portrait painter] late 19th c.*
Addresses: San Francisco, CA, 1879-85. **Exhibited:** San Francisco AA, 1880s. **Sources:** Hughes, *Artists in California,* 485.

RYDER, Eve *[Painter] b.1896, Lancaster, PA.*
Addresses: Nebraska from 1898. **Studied:** William A. Patty in Calif.; Augustus Dunbier & Lenore Benolken in Omaha. **Exhibited:** Six-States Exhib., Joslyn Art Mus., Omaha, NE, 1940; Grand Island, NE, annually; Lincoln & Kearney, NE. **Sources:** Petteys, *Dictionary of Women Artists.*

RYDER, Grace K. *[Painter] mid 20th c.*
Addresses: Roxbury, MA. **Exhibited:** PAFA Ann., 1935. **Sources:** Falk, *Exh. Record Series.*

RYDER, Henry Orne See: **RIDER, Henry Orne**

RYDER, J. F. *[Portrait painter] mid 19th c.*
Addresses: Cleveland, Ohio, in 1860. **Sources:** G&W; WPA (Mass.), *Portraits Found in Vt.*

RYDER, Jane G. *[Painter, sculptor, teacher] early 20th c.*
Addresses: North Cambridge, MA, 1909-13. **Sources:** WW13.

RYDER, John S. *[Painter] b.1850.*
Addresses: Boston, MA. **Exhibited:** PAFA Ann., 1885. **Sources:** Falk, *Exh. Record Series.*

RYDER, Mahler B. *[Painter, jazz musician] b.1937.*
Studied: Ohio State Univ., 1954-58; ASL, 1965-66; School of Visual Arts, NY, 1966-67. **Exhibited:** Satori Studio, NYC, 1965 (solo); Lever House, NYC, 1966-68; Minneapolis Inst. of Arts; Riverside Mus., NY, 1968; Pan Am Bldg., NYC, 1968; NYC Univ.; Ruder & Finn, 1969; High Mus. of Art, Atlanta, GA, 1969; Flint, MI, Inst. of Arts, 1969; Everson Mus. of Art, 1969; IBM Gallery, 1969; RISD, 1969; Memorial Art Gal., Rochester, 1969; SFMA, 1969; Contemporary Arts Mus., Houston, 1970; NJ State Mus.; Roberson Center for the Arts & Sciences, 1970; UC Santa Barbara, 1970 BMFA, 1970; WMAA, 1971; American Greetings Gallery, NY, 1968; ASL; 30 Contemporary Black Artists National Traveling Show. **Awards:** Ford Fnd. Grant, 1964-66. **Work:** Wisc.

State Univ.; Columbus Gallery of Fine Arts, Ohio; Chaim Gross Fnd.; priv. colls. **Sources:** Cederholm, *Afro-American Artists.*

RYDER, Marilla *[Sculptor] early 20th c.*
Addresses: Roxbury, MA. **Exhibited:** PAFA Ann., 1924.
Sources: WW25; Falk, *Exh. Record Series.*

RYDER, Mary Virginia See: **DOWNEY, Mary Virginia Ryder (Mrs.)**

RYDER, Platt Powell *[Genre and* **P.P. Ryder** *portrait painter] b.1821, Brooklyn, NY* **67** */ d.1896, Saratoga Springs, NY.*
Addresses: Brooklyn, NY, 1857-69; NYC studio, 1871-on.
Studied: as a youth in New Orleans; in Europe, 1854-57; in Paris with Bonnat, 1869-70; travel to Belgium, Holland, and London. **Member:** A.N.A., 1868; Brooklyn Academy of Design (founder); Century Assn. **Exhibited:** NAD, 1861-95; PAFA Ann., 1866, 1882, 1885; Paris Salon, 1870; Brooklyn AA, 1861-86. **Work:** MMA. **Sources:** G&W; CAB; Cowdrey, NAD; Naylor, NAD; Rutledge, PA; Boston *Transcript,* July 17, 1896; Fink, *American Art at the Nineteenth-Century Paris Salons,* 387; *300 Years of American Art,* vol. 1, 192; Falk, *Exh. Record Series.*

RYDER, W. F. (Mrs.) *[Miniature painter] late 19th c.*
Exhibited: Detroit WCS, c.1893. **Sources:** Petteys, *Dictionary of Women Artists.*

RYDER, Worth *[Landscape and portrait painter, etcher, lecturer] b.1884, Kirkwood, IL / d.1960, Berkeley, CA.*
Addresses: Berkeley, CA. **Studied:** Royal Acad., Bavarian State Acad., Hofmann Sch., all in Munich, Germany; Univ. California; ASL. **Member:** San F. AA; Univ. California A. Cl. & Faculty Cl; Pacific AA; Calif. Soc. of Mural Artists. **Exhibited:** P.-P. Expo, San Fran., 1915 (med) (gold); San Fran. AA, annually; SFMA, 1935 (hon. men.); GGE, 1939. **Work:** SFMA; Cal. Acad. Sc.; Piedmont (Cal.) H.S. **Comments:** Position: prof., UC Berkeley, 1926-55; prof. emeritus, 1955-. Contributor to *Art Education Today.* **Sources:** WW59; WW47. More recently, see Hughes, *Artists in California,* 485.

RYDINGSVÄRD, Ursula von *[Painter] b.1942, Germany.*
Sources: info. courtesy Peter C. Merrill.

RYER, Henry C. *[Artist] late 19th c.*
Addresses: Wash., DC, active 1877-82. **Sources:** McMahan, *Artists of Washington, DC.*

RYERSON, Edward Trowbridge *[Painter] mid 20th c.*
Addresses: Chicago area. **Exhibited:** AIC, 1936. **Sources:** Falk, AIC.

RYERSON, Luther L. *[Portrait painter] mid 19th c.*
Addresses: Roxbury, MA, 1860. **Comments:** Partner with George A. Leighton in Leighton & Ryerson, portrait painters, Roxbury (Mass.), 1860. **Sources:** G&W; Roxbury CD 1860; New England BD 1860.

RYERSON, Margery Austen *[Painter, etcher, teacher, writer, illustrator] b.1886, Morristown, NJ. / d.1989, Rye Brook, NY.*
Addresses: NYC. **Studied:** Vassar Col. (A.B.); ASL with Robert Henri; Charles W. Hawthorne in Provincetown, MA. **Member:** ANA; SAE; Wash. WCC; Calif. PM; Grand Central Art Gal.; Provincetown AA; Phila. SE; Southern PMS; Chicago SE; AWCS (life mem.); All. A. Am. (life mem.; vice-pres. 1952-53); NJ WC Soc.; NAC; Woodstock AA; Audubon Artists (corresp. secy., 1958-59); Soc. Am. Graphic Artists (recording secy.). **Exhibited:** PAFA Ann., 1918-35 (9 times); Corcoran Gal biennials, 1919, 1930; AIC; WMAA, 1938; NAD, 1959 (Maynard Prize); CAM; Phila. SE; Southern PM; Calif. PM; Phila. Pr. Cl.; All. Artists Am.; NAC, 1971 (silver medal); Montclair Art Mus. (prize); NJ WC Soc., Morristown, 1971; AWCS, 1962 (Hook Prize);1972; Audubon Artists, 1972; Grand Central Art Gals., NYC, 1970s. **Work:** oil portrait, Vassar College Gal., Poughkeepsie; CMA; Smithsonian; Roerich Mus., NYC; Frye Mus., Seattle, WA; etchings, MMA; oil portrait, Philbrook AC, Tulsa, OK; etching, Bibliothèque Nat., Paris, France. Commissions: many portraits.

Comments: Daughter of Mary Ryerson (see entry). Preferred media: watercolors, oils. Publications: editor, *The Art Spirit,* 1923; editor, *Hawthrone on Painting,* 1936; illustrator, *Winkie Boo,* 1948; contributor, *The Artist,* 1960; contributor, *Am. Artist.* **Sources:** WW73; WW47; E. Hobson," An Artist and a Child," *Foster's Daily Democrat,* Dover, NH, August 15, 1970; Doris di Savino, "Yesterday and Today", *Trends,* March 26, 1972; Woodstock AA; Falk, *Exh. Record Series.*

RYERSON, Martin Antoine *[Patron] b.1856, Grand Rapids, MI / d.1932.*
Addresses: Chicago/Lake Geneva, WI. **Member:** AIC, 1887 (pres., 1925-32). **Comments:** In his fifty years of collecting, he was among the first to envision the worth of the French Impressionists. The Ryerson Coll. now belongs to the AIC. In 1901 he presented the Institute with the 25,000-volume art library.

RYERSON, Mary McIlvaine *[Sculptor] b.Phila., PA / d.1936, NY.*
Addresses: NYC/Provincetown, MA. **Studied:** Saint-Gaudens, NAD; Solon Borglum; Fraser. **Exhibited:** NAD; PAFA Ann., 1917. **Comments:** Mother of Margery (see entry). **Sources:** WW33; Petteys, *Dictionary of Women Artists;* Falk, *Exh. Record Series.*

RYKER, Edward *[Engraver] b.c.1826, New Jersey.*
Addresses: NYC in 1850. **Sources:** G&W; 7 Census (1850), N.Y., XLV, 14.

RYLAND, Callie T. *[Portrait and still life painter] late 19th c.*
Addresses: Richmond, VA. **Member:** Art Club of Richmond, VA, 1895 (founding mem.). **Exhibited:** Art Club of Richmond, VA, 1896. **Sources:** Wright, *Artists in Virgina Before 1900.*

RYLAND, Columbus Jose *[Painter, architect] b.1892, San Jose, CA / d.1980, Walnut Creek, CA.*
Addresses: Walnut Creek, CA. **Studied:** Calif. Col. of A. and Cr.; University of Toulouse, France; with E. Charlton Fortune and Arthur Hill Gilbert. **Member:** Carmel AA. **Sources:** Hughes, *Artists in California,* 486.

RYLAND, Hildegard (Mrs. L.H.) See: **HAMILTON, Hildegard Hume**

RYLAND, Mark *[Engraver] b.c.1833, New Jersey.*
Addresses: NYC in 1860. **Sources:** G&W; 8 Census (1860), N.Y., LX, 655.

RYLAND, Robert Knight *[Mural* **R.K.RYLAND** *painter, illustrator] b.1873, Grenada, MS / d.1951, Wash., DC.*
Addresses: Brooklyn, NYC, NY/Russellville, KY. **Studied:** Bethel Col.; NAD; ASL; Am. Acad., Rome, schol., 1903-05. **Member:** ANA; SC; ASMP; All.A.Am.; Mural P.; Booklyn SA. **Exhibited:** S. Indp. A., 1917; NAD, 1924 (prize); Corcoran Gal biennials, 1926, 1937; CAM; AIC, 1926; PAFA Ann., 1927, 1935; BM; Brooklyn SA; SC. **Work:** Syracuse MFA; Washington Irving H.S., NY; Supreme Court, NY; Newark Mus. **Comments:** Illustrator: *Everybody's; Delineator; McCall's.* **Sources:** WW47; Falk, *Exh. Record Series.*

RYMAN, C. M. *[Miniature painter] 20th c.*
Addresses: Wilkes-Barre, PA. **Sources:** WW24.

RYMAN, Herbert D. *[Painter] mid 20th c.*
Addresses: Hollywood, CA, 1930s. **Exhibited:** P&S of Los Angeles, 1933. **Sources:** Hughes, *Artists in California,* 486.

RYMAN, Robert *[Painter] b.1930, Nashville, TN.*
Addresses: NYC. **Studied:** Tenn. Polytech. Inst., 1948-49; George Peabody Col., 1949-50. **Exhibited:** Guggenheim Mus, 1966 ("Systemic Painting,"), 1971 (Sixth Guggenheim Int.), 1972 (solo); "Anti-Illusion--Procedures, Materials," WMAA, 1969; Documenta, Kassel, Ger., 1972; John Weber Gal., NYC, 1970s. **Work:** MoMA; WMAA; Milwaukee Art Ctr., Wis.; Wadsworth Atheneum, Hartford, Conn.; Stedelijk Mus., Amsterdam, Netherlands. **Comments:** Abstract artist. Beginning c. 1964 he limited himself almost entirely to the use of white pigment and a

square format, seeking varying visual effects based on the method of paint application (varying the brush strokes), the type of paint (such as oil, baked enamel coatings, and printing inks), and the painting surface (including paper, canvas, fiberglass, steel, and linen). **Sources:** WW73; Baigell, *Dictionary;* Lucy R. Lippard, "The Silent in Art," *Art Am.* (Jan.-Feb., 1967); Carter Ratcliff, "New York Letter," *Art Int.* (Feb. 20, 1971 & May 20, 1971); D. Waldman, *Robert Ryman,* catalogue (Guggenheim Mus., 1972).

RYON, James P. *[Painter] 20th c.*
Addresses: NYC. **Sources:** WW21.

RYPSAM, Fred W. *[Painter, landscape painter] b.1880 / d.1969, Detroit, MI.*
Addresses: Detroit, MI. **Member:** Scarab Club, Detroit. **Exhibited:** locally. **Comments:** Retired from the automotive industry and devoted himself to painting snow scenes, marines and private yachts. Preferred media: oil, watercolor. **Sources:** Gibson, *Artists of Early Michigan,* 208.

RYPSAM, Russell *[Painter] 20th c.*
Addresses: NYC. **Member:** AWCS. **Sources:** WW47.

RYSHPAN, Daisy *[Painter] early 20th c.*
Addresses: NYC. **Exhibited:** S. Indp. A., 1925. **Sources:** Marlor, *Soc. Indp. Artists.*

RYTHER, Martha (Mignonne) *[Painter, teacher] b.1896, Boston, MA / d.1981, NYC.*
Addresses: NYC. **Studied:** BMFA Sch.; Maurice & Charles Prendergast, c.1906; Modern Art School, NYC; Acad. de la Grande Chaumière, École Moderne, both in Paris; also in Italy and Spain. **Member:** NYSWA. **Exhibited:** S. Indp. A., 1927-31, 1933, 1937; Salons of Am., 1925; Mary Mowbray Clark's Bookshop & Gal., c.1920; Argent Gal., (solo); Ferargil Gals., (solo); Am. British AC; Rockland Center for Arts, West Nyack, NY, 1891 (retrospective); Zabriskie Gal., 1978 (solo). **Comments:** (Mrs. Morris Kantor). Known under the names Ryther, Kantor, and Fulton. Painted scenes of Europe, Boston, and Cape Cod; and people and places in Rockland County, NY. Also did reverse paintings on glass. Ryther began art classes for children at the Rockland Center for the Arts in West Nyack, where she taught for 25 years. **Sources:** WW19; WW19 (as Ryther); WW40 (as Kantor); Falk, *Exh. Record Series;* Petteys, *Dictionary of Women Artists.*

RYTHER, Mary *[Artist] late 19th c.*
Addresses: Active in Three Oaks, MI. **Exhibited:** Michigan State Fair, 1882. **Sources:** Petteys, *Dictionary of Women Artists.*

Cover image, exhibition catalogue of
The Sketch Club, San Francisco, 1897.

S

SAA, Domingo *[Painter] mid 20th c.*
Addresses: Brooklyn, NY, 1930. **Exhibited:** S. Indp. A., 1930-32.
Sources: Marlor, *Soc. Indp. Artists.*

SAADIE See: **GRAHAM, Sadie**

SAALBURG, Allen Russell *[Painter, designer, comm a, illustrator, screenprinter] b.1899, Rochelle, IL.*
Addresses: Frenchtown, NJ; NYC, 1939-40. **Studied:** ASL, with John Sloan, Kenneth Hayes Miller, Mahonri Young. **Exhibited:** Bernheim Jeune, Paris (solo); Kraushaar Gal., NY (also solo); WMAA, 1924-40; AIC, 1939; murals, WFNY, 1939. **Work:** WMAA; PMA; murals, Pennsylvania Railroad; commissions for U.S. Steamship Lines; NY Park Dept.; stores, restaurants and private homes. **Sources:** WW59; WW40.

SAALBURG, Leslie *[Illustrator] b.1897 / d.1974.*
Studied: ASL (3 months). **Exhibited:** WMAA, 1924 (portrait).
Comments: Illus., *Esquire,* other national magazines and publications abroad. Specialty: drawing rooms, restaurant interiors, classic automobiles. **Sources:** W & R Reed, *The Illustrator in America,* 239.

SAAR, Betye *[Painter, collage artist, printmaker, designer] b.1926, Pasadena, CA.*
Addresses: Los Angeles, CA. **Studied:** UCLA (B.A., 1949); Univ. Southern Calif.; Long Beach State Col., 1956; San Fernando Valley State Col. **Exhibited:** Dickson Art Center, 1966;

BMFA, 1968; MoMA, 1968; High Mus., Atlanta; NJ State Mus., 1968; Contemporary Arts Mus., Houston, 1968; 25 Calif Women of Art, Lytton Ctr. Visual Art, Los Angeles, 1968; Oakland Mus., 1969; SFMA, 1969; Dimensions of Black, La Jolla Fine Arts Mus., Calif, 1970; Pasadena WC Soc., 1970 (Purchase award); Santa Barbara Mus. of Art, 1970; Sculpture Ann., 1970 & Contemporary Black Artists in America, 1971, WMAA, 1970; LOC; Black Artists Invitational, LACMA, 1972; Calif. State Col., Los Angeles, 1972 (purchase award for Small Images); Downy Mus. Art, 1972 (purchase award); LACMA, 1975 (solo). **Work:** Univ. Mass., Amherst; Wellington Evest Coll., Boston, Mass.; Golden State Mutual Life Ins. Coll., Los Angeles, Calif.; LACMA; Oakland Mus.; Home Savings & Loan Art Coll., Los Angeles. **Comments:** Saar began making assembled boxes in the late 1960s, creating a number in which she incorporated mystical and occult symbols and objects, drawn from African and Oceanic cultures. After the death of Martin Luther King in 1968, Saar produced a group of militant works in which she incorporated racial slurs and stereotypical images found in commercial products and white folklore. The most well-known of these was "The Liberation of Aunt Jemima" (1972, Univ. Art Mus., Berkeley, CA). Saar also created a series of boxes, nostalgic in nature, related to black culture. **Positions:** costume designer, Inner City Cult. Ctr., Los Angeles, 1968-71. **Teaching:** vis. artist, Calif. State Univ., Hayward, fall 1971; professor, Otis-Parsons Inst., Los Angeles, 1975-. **Publications:** auth., *Handbook* (1967). **Sources:** WW73; Rubinstein, *American Women Artists,* 418-20; "Black Talent Speaks," *Los Angeles Fine Arts/FM Mag.* (Jan., 1967); "Scatterly Talents," *Arts Mag.* (1968); Lewis & Waddy, "Black Artist on Art," *Contemp. Crafts* (1969); Cederholm, *Afro-American Artists.*

SAARI, Onni *[Abstract painter, illustrator] b.1920, Harrisville, NH / d.1992, upstate New York.*
Addresses: NYC, c.1945-91. **Studied:** Manchester (NH); BMFA Sch.; Paris. **Exhibited:** NYC galleries, 1940s-50s; Harrisville Designs, NH (memorial exh.). **Comments:** An abstract painter, he earned a living as a book and record jacket designer. Although he was a friend of many of the New York School abstract artists of the 1940s-50s, he became increasingly reclusive and refused to exhibit or sell his paintings. **Sources:** press release courtesy Edie Clark (1998).

SAARINEN, Eero (Mrs.) See: **SAARINEN, Lily (Lilian) Swann**

SAARINEN, Eliel *[Designer, architect] b.1873, Helsingfors, Finland.*
Addresses: Bloomfield Hills, MI. **Studied:** Inst. Polytech., Helsingfors. **Member:** White Rose Order of Finland; Finnish Acad. A.; Imperial Acad. A., Russia; Royal Acad., Stockholm; Detroit Chap. AIA; Mich. S. Arch; Jury of Arch. Comp., Olympiad, Paris, 1924, Los Angeles, 1932; Columbus Mem. Light-tower Comp., Santo Domingo. **Exhibited:** Arch. Lg., 1931 (gold); Nat. Comp., Smithsonian, 1939. **Work:** railway station, Keirkner Gal., associate on Nat. Mus., all in Helsingfors; town halls, in Lahti and Joensuu, Finland; Estobank, Reval, Estonia; Cranbrook Acad. A.; Cranbrook Sch. Boys, Kingswood Sch. for Girls, Bloomfield Hills, Mich. **Comments:** Position: pres., Cranbrook Acad. A. **Sources:** WW40.

SAARINEN, Lily (Lilian) Swann *[Sculptor] mid 20th c.*
Addresses: NYC; Cambridge, MA. **Studied:** Heinz Warneke, Albert Stewart, Brenda Flutnam, Maija Grotell. **Exhibited:** Soc. Indep. Artists, 1922; NAD, 1937; Huntington, 1937 (prize); NAWA, 1937 (prize), 1938, 1947 (prize); WFNY 1939; Midtown Gal., 1943 (solo); Wash., DC Art Fair, 1943 (prize); WMAA, 1945; PAFA Ann., 1945-47; Cranbrook Acad. A., 1946; MMA; BMA; AIC; Detroit IA (prize, 1954); Boston A. Festival, 1955; other museums and traveling exhs. **Work:** bas-reliefs, fountains, USPO, Carlisle, Ky.; Bloomfield, Ind.; Crow Island Sch., Winnetka, Ill.; Tofanetti Restaurant, Chicago; Jefferson Nat. Expansion Mem., St. Louis, Mo.; Detroit Federal Reserve Bank; J.L. Hudson's Northland Shopping Center; IBM Coll.; many com-

missions for private homes and gardens. **Comments:** Married to architect Eero Saarinen, she appears as Swann early in her career. Contributor to *Architectural Forum; Arts & Architecture; Interiors; Child Life,* and other leading magazines. Author:"Who Am I?" "Who Helps Who?", 1946. **Sources:** WW59; WW47; WW40 (as Swann); Falk, *Exh. Record Series.*

SAARINEN, Loja (Mrs. Eliel) *[Sculptor, designer] 20th c.; b.Helsingfors, Finland.*
Addresses: Bloomfield, MI. **Studied:** Helsingfors AI; Acad. Colarossi. **Member:** Decorators C., NYC; Detroit SAC; Helsingfors AS. **Work:** Cranbrook Acad. A.; Hudnut Salon, Yardley Shop, NYC; Chrysler Show Room, Detroit; Mendelssohn House, Bloomfield Hills, Mich. and Millbrook, NY. **Sources:** WW40.

SAATY, Wallace N. *[Painter] mid 20th c.*
Exhibited: Salons of Am., 1934. **Sources:** Marlor, *Salons of Am.*

SABA, Rintaro *[Painter] early 20th c.*
Addresses: Westfield, NJ. **Studied:** ASL. **Exhibited:** AIC, 1916; S. Indp. A., 1917. **Sources:** WW17.

SABATINI, Raphael *[Painter, educator, sculptor] b.1898, Phila., PA / d.1985.*
Addresses: Melrose Park, PA. **Studied:** PAFA, Cresson traveling scholarships; also with Arthur B. Carles, Fernand Leger, Antoine Bourdelle & Constantin Brancusi. **Member:** AEA; Phila. A. All. (v. pres., 1957-); PMA; fel., PAFA. **Exhibited:** PAFA Ann., 1916-24, (she was 1930-35, 1951-54, 1964); S. Indp. A., 1924, 1932; Sesquicentennial, Philadelphia, 1926; Golden Gate Expos, San Francisco. **Awards:** Limback Found. Award for distinguished teaching, 1962; Percy Owens Mem. Award for distinguished Pa. artist, 1963; 400th Anniversary of Michelangelo Award, Am. Inst. Ital. Cult., 1964. **Work:** PMA; PAFA; Allentown Mus.; Sturgis R. Ingersoll Coll., Pennlyn, Pa. Commissions: frieze for Fine Art Bldg, Sesquicentennial, Philadelphia, Pa., 1926; Mother Mary Drexel Chapel, Langhorn, Pa., 1929; NW Ayer Bldg., Philadelphia, 1928. **Comments:** Positions: comnr., Philadelphia Art Common, 1965-68; comnr., Fine Art Comn. Phila. Redevelop., 1971-72. Teaching: prof. painting & sculpture, Tyler Sch. Art, Temple Univ., 1936-66, emer. prof., 1966-. Publications: auth., "Sculpture Processes," Prothman Baldwin, 1957. **Sources:** WW73; WW40; Falk, *Exh. Record Series.*

SABATINO, John S. *[Architect, painter] b.1928, Phila., PA.*
Addresses: Lower Gwynedd, PA. **Studied:** Dominick DeSteffano, 1975-98. **Member:** AWCS; Phila. WCC; Phila. Sketch Cl.; Wynmoor Art Mus. **Exhibited:** Holy Family College, Phila., PA (solo); Phila. Sketch Cl.; Notre Dame Academy, Villanova, PA; other Phila. galleries since the 1980s. **Comments:** Spec. in water-colors.

SABBAGH, G. H. *[Painter] early 20th c.*
Exhibited: AIC, 1921. **Sources:** Falk, *AIC.*

SABER, Clifford *[Illustrator, writer, painter, lecturer] b.1914, Lawrence, MA.*
Addresses: NYC. **Member:** SI. **Exhibited:** AWCS; CGA, 1944 (solo); SI, 1943 (solo). **Comments:** Contributor to: national advertising magazine. **Sources:** WW53; WW47.

SABIN, M. Cordelia *[Artist] late 19th c.*
Addresses: Wash., DC, active 1877-82. **Sources:** McMahan, *Artists of Washington, DC.*

SABINE, Julia *[Art librarian] b.1905, Chicago, IL.*
Addresses: Utica, NY. **Studied:** Cornell Univ. (B.A.); Yale Univ.; Inst. Art & Archaeol., Paris; Univ. Chicago (Ph.D.). **Comments:** Positions: former supv. art & music librn., Newark Pub. Libr. Teaching: former vis. instr., Univ. Ky. & Rutgers Univ. **Sources:** WW73.

SABLE, Lawrence W. *[Painter] 20th c.*
Addresses: Baltimore, MD. **Sources:** WW17.

SABO, Betty *[Landscape painter] b.1928, Kansas City, MO.*
Addresses: Albuquerque, NM. **Studied:** Univ. New Mexico; Carl

Von Hassler. **Comments:** Known for snow scenes. **Sources:** P&S Samuels, 414.

SABO, Ladis W. *[Folk painter] b.1870, Budapest, Hungary / d.1953, NYC.*
Studied: self-taught. **Exhibited:** Gal. St. Etienne, NYC, 1946 (first solo), 1954 ("Natural Painters"); BMA, 1954; Smithsonian Inst., 1954 ("Naive Painters," traveled throughout Europe); R. York Gal., NYC, 1995 (solo). **Comments:** He emigrated to the U.S. in 1910, and traveled about the U.S., living in Chicago and Greenville, SC before finally settling in NYC in 1942. A tailor by trade, he began to paint at age 74, and his works were compared to those of Grandma Moses. **Sources:** exh. cat., R. York Gal. (NYC, 1995).

SABRE, Jan C. *[Sculptor, painter, printmaker] b.1906, Milwaukee, WI / d.1981, San Francisco, CA.*
Addresses: San Francisco, CA. **Studied:** self-taught; Calif. Sch. of FA, for a short time. **Member:** San Francisco AA. **Exhibited:** City of Paris, San Francisco; Gump's, San Francisco; San Francisco AA annuals, first prize 1944; SFMA, 1940s; de Young Mus., 1943. **Work:** SFMA; San Francisco City College; San Francisco Art Inst. WPA artist. **Sources:** Hughes, *Artists in California,* 487.

SABRE, Marjorie E. See: **EAKIN, Marjorie J.**

SAC, Ollet *[Painter, etcher, lithographer] b.1900, Albuquerque, NM.*
Addresses: New Orleans, LA. **Studied:** H.A. Nolan. **Member:** SSAL. **Sources:** WW33.

SACCARO, John *[Painter, lithographer, etcher] b.1913, San Francisco, CA / d.1981, San Fran.*
Addresses: San Francisco. **Studied:** Calif. Sch. FA with David Park, Elmer Bischoff. **Member:** San F. AA; Artists Council of San F. AA. **Exhibited:** Int'l WC Annual, AIC, 1939; SFMA, 1939 (solo), 1955; Portland (Oreg.) Mus. A., 1939; Cincinnati Mus., 1939; Corcoran Gal biennials, 1955-61 (4 times); Oakland Art Gal., 1954 (silver med.); Cal. Sch. FA, 1954 (prize); AFA, 1959; VMFA, 1958; West Coast Painters, 1959; Carnegie Inst., 1955; Sao Paulo, Brazil Biennial, 1955; Art:USA, 1958; Denver A. Mus., 1959-60; The Artist's Environment: West Coast Exh., 1962-63; numerous San F. AA annuals, 1939-60 (prize, 1954). **Work:** SFMA; M.H. de Young Mem. Mus. **Comments:** Work reproduced in *It Is* magazine, 1960. Visiting Lecturer, UCLA, 1963-64. **Sources:** WW66; WW40 (first named listed as "Giovanni"); Hughes, *Artists in California,* 487.

SACHAR, Edith *[Sculptor] mid 20th c.*
Exhibited: S. Indp. A., 1937-38. **Sources:** Marlor, *Soc. Indp. Artists.*

SACHEVERELL, John *[Engraver on gold, silver, brass, copper, and steel] mid 18th c.*
Addresses: Philadelphia, active 1732-33. **Sources:** G&W; Hamilton, *Early American Book Illustrators and Wood Engravers,* 48; Brown and Brown.

SACHS, A. M. *[Art dealer, collector] 20th c.; b.NYC.*
Addresses: NYC. **Studied:** Univ. Mich., Ann Arbor (B.A.). **Member:** Art Dealers Assn. Am. **Comments:** Positions: dir., AM Sachs Gallery. Collection: Altalio, Salemme, John Ferren Howard Mehring, Giorgio Cavollon, Warren Brandt, Peter Hutchinson and other contemporary American painters. Specialty of gallery: contemporary American painters. **Sources:** WW73.

SACHS, Bernard *[General and stencil engraver] mid 19th c.*
Addresses: Philadelphia, 1857 and after. **Sources:** G&W; Phila. CD 1857-60+.

SACHS, Carl I. *[Portrait painter, drawing specialist] b.1896.*
Addresses: Chicago, IL. **Exhibited:** AIC, 1930-34. **Work:** State Capitol, Springfield. **Sources:** WW40.

SACHS, Frederick *[Lithographer] b.c.1817, Germany.*
Addresses: Philadelphia in 1850. **Sources:** G&W; 7 Census (1850), Pa., L, 345; Phila. CD 1850 (his wife and three older chil-

dren were also born in Germany; the youngest child, aged 2, was born in Pennsylvania).

SACHS, Herman *[Mural painter] b.1889, Romania / d.1940, Hollywood, CA.*
Addresses: Chicago, IL; Dayton, OH; Los Angeles, CA. **Studied:** Europe. **Work:** Union Station, Los Angeles (murals). **Comments:** Immigrated to the U.S. as a child, but did his art studies in Europe. Founder: Munich School of Expressionists; Chicago Industrial Art School; Dayton Industrial School of Art. Position: dir., Dayton, OH, Art Mus.; dir., Creative Art Students League, Los Angeles. **Sources:** Hughes, *Artists in California,* 487.

SACHS, James H. *[Collector, patron] b.1907, NYC / d.1971.*
Addresses: Pound Ridge, NY. **Studied:** Harvard College (A.B.); Trinity College, Cambridge, England; Harvard Business School; French painting, prints and drawings under Paul J. Sachs. **Comments:** Collection: prints, drawings, paintings, association copies, first editions, manuscripts. **Sources:** WW66.

SACHS, Joseph *[Painter] b.1887, Shavil, Russia.*
Addresses: Phila., PA. **Studied:** PAFA; Anshutz; Chase; Kendall. **Member:** Phila. Sketch C.; Phila. Alliance. **Exhibited:.** **Sources:** WW24.

SACHS, Jules *[Painter] mid 19th c.; b.New York.*
Studied: Petit and Cogniet. **Exhibited:** Paris Salon 1869, 1870. **Sources:** Fink, *American Art at the Nineteenth-Century Paris Salons,* 387.

SACHS, Lambert *[Portrait and historical painter, teacher of drawing and painting] mid 19th c.*
Addresses: Philadelphia, 1850's. **Exhibited:** PAFA, 1854. **Sources:** G&W; Rutledge, PA; Phila. CD 1855, BD 1860; repro. Garbisch Collection, *Catalogue,* 105.

SACHS, Paul Joseph *[Educator, writer, lecturer, critic] b.1878, NYC / d.1965.*
Addresses: Cambridge, MA. **Studied:** Harvard Univ. (A.B.); (hon. degrees, LL.D.), Univ. Pittsburgh; (D.A.), Harvard Univ.; (D.A.), Colgate Univ.; Princeton Univ.; (D.H.L.), Yale Univ. **Member:** Archaeological Inst. Am.; AAMus.; Am. Philosophical Soc.; Century Assn.; Am. Assn. Mus. Dir.; AFA, Am. Acad. A. & Sc.; Am. Com. for Protection & Salvage of Artistic & Hist. Monuments in War Areas. **Comments:** Positions: assoc. dir., Emeritus, FMA, 1915-44; l., Wellesley Col., 1916-17; asst. prof. 1917-22, assoc. prof., 1922-27, prof., 1927-49, Harvard Univ., Cambridge, Mass.; Exchange prof. to France, 1932-33; administrative com., Dumbarton Oaks Research Lib.; trustee, BMFA; MoMA; Wellesley Col.; Smith Col., Radcliffe Col. Lectures: 18th century French Art. Author: "Focillon Memorial Volume of Gazette des Beaux-Arts"; co-author: "Drawings in the Fogg Museum," 1941; "Great Drawings," 1951; "Modern Prints and Drawings," 1954. **Sources:** WW59; WW47.

SACHS, Samuel II *[Art administrator, art historian] b.1935, NYC.*
Addresses: Minneapolis, MN. **Studied:** Harvard Univ. (A.B., cum laude); NY Univ. Inst. Fine Arts (A.M.) Awards: first prize, La. State Art Comn., 1954; first bd. dirs. prize, Beaumont Art Mus., 1965; Sears Judges Prize, Vincent Price Gal., 1966 & 1967. **Member:** AM Assn. Mus.; Am. Fedn. Arts (exhib. comt.), Col. Art Assn. Am. **Comments:** Positions: asst. prints & drawings, Minneapolis Inst. Arts, 1958-60, chief cur., 1964-; asst. dir., Univ. Mich. Mus. Art, 1962-64. Teaching: lectr. art hist., Univ. Mich., Ann Arbor, 1962-63; lectr. art hist., Minneapolis Inst. Arts, 1964-. Collections arranged: Chinese Art from the collection of His Majesty, The King of Sweden, 1967; The Past Rediscovered, XIX Century French Painting 1800-1900,1969. Research: fakes and forgeries; American 19th and 20th century painting. Publications: auth., "Reconstructing the whirlwind of 26th St.," *Art News* (Feb., 1963); auth., "Drawings and Watercolors of Thomas Moran," In: Thomas Moran (catalogue), Univ. Calif., Riverside, 1963; co-auth., "The Past Rediscovered: French painting 1800-1900" (catalogue), 1969; auth., "American Paintings at the Minneapolis

Institute of Arts," 1971; auth., "Art Forges Ahead," *Auction Mag.* Jan.,1972. **Sources:** WW73.

SACHSE, August *[Engraver] b.c.1810, Germany.*
Addresses: Baltimore, MD, in 1860. **Comments:** The name is spelled Sase in the Census. Living in 1860 with his wife Catherine and son August, born in Germany c.1839 and also listed as an engraver, and son Arthur, born in Maryland about 1854. He may have been a brother of the Baltimore lithographers, Edward and Theodore Sachse (see entries). **Sources:** G&W; 8 Census (1860), Md., VI, 35.

SACHSE, Edward *[Lithographer and painter] b.1804, Görlitz, near Breslau, Germany / d.1873.*
Addresses: Baltimore, MD. **Exhibited:** Maryland Historical Society. **Comments:** He operated a small printing and publishing establishment in Görlitz, but came to the U.S. in the late 1840's, accompanied by his family and his brother Theodore (see entry). They settled in Baltimore where the firm of Sachse & Company (see entry), lithographers, was active until the 1870's. About half of the firm's views were of Baltimore and Washington, DC, with Edward active until shortly before he died. In many of these views he collaborated with J.T. Palmatary but the exact nature of their business relationship is not clear. Reps speculates that Palmatary most likely did some of the field sketching while Sachse put the drawings on stone in Baltimore. **Sources:** G&W; Pleasants, *250 Years of painting in Maryland,* 51; Baltimore CD 1851-74; Peters, *America on Stone;* Stokes, *Historical Prints;* Rutledge, MHS. More recently see Reps, 204-206 (pl.88).

SACHSE, Emma F. *[Painter] 20th c.*
Addresses: Phila., PA. **Studied:** PAFA. **Sources:** WW25.

SACHSE, Janice R. *[Painter, printmaker] b.1908, New Orleans, LA.*
Addresses: Baton Rouge, LA. **Studied:** La State Univ., with Albrizio; Newcomb Col., Tulane Univ., with William Woodward. **Member:** La. Coun. Performing Arts; Am. Fedn. Art; La. Craft Coun.; La. WC Soc. **Exhibited:** Volksfest Exhib. New Orleans Galleries, Int. House, Berlin, Ger., 1968; Art On Paper, Witherspoon Gal., Univ. NC, 1968; 11th Midwest Biennial, Joslyn Art Mus., Omaha, Nebr., 1970; Sally Jackson Gal., Hong Kong, 1970; La State Univ. Union Art Gal., 1972; Downtown Gallery, New Orleans, LA, 1970s; Baton Rouge Art Gallery, Baton Rouge, LA, 1970s Awards: first prize, La. State Art Comn., 1954; first bd. dirs. prize, Beaumont Art Mus., 1965; Sears judges prize, Vincent Price Gal., 1966 & 1967. **Work:** Anglo Am. Mus., La. State Univ.; La. State Univ., Alexandria Libr. Collection; two prints, La. State Art Comn.; Arts & Sci. Mus., Baton Rouge, Pine Bluff Art Ctr., Ark. **Comments:** Preferred media: oils, watercolors, graphics. Publications: auth., "Janice R. Sachse 1960-70," Marco Publ., Hong Kong, 1970 & "Meet the Artist" series, La. State Univ., Alexandria, 1972. Collection: German Expressionists Nolde, Heckle, Davis, H. Moore, Burliuk, Rioux, Luks, Bellows & Tomayo. **Sources:** WW73.

SACHSE, John Henry David *[Miniaturist] mid 19th c.*
Addresses: Philadelphia, c.1830. **Sources:** G&W; Information cited by G&W as being courtesy Mrs. Joseph Carson (1957).

SACHSE, Theodore *[Lithographer] b.c.1815, Germany.*
Addresses: Baltimore, MD. **Comments:** Came to U.S. after 1847, settling in Baltimore, where he carried on a lithographic business (see Sachse & Company) with his older brother, Edward Sachse (see entry), until the 1870's. **Sources:** G&W; 8 Census (1860), Md., VI, 52; Pleasants, *250 Years of Painting in Maryland,* 51; Baltimore CD 1851-74 [under Sachse & Co.]. CD 1856 lists a Thomas Sachse, lithographer, probably an error for Theodore.

SACHSE, William *[Lithographer] mid 19th c.*
Addresses: Baltimore, MD, 1860. **Comments:** In 1860, he was a partner in Sachse & Company (see entry). **Sources:** G&W; Baltimore CD 1860.

SACHSE & COMPANY *[Lithographers] mid 19th c.*
Addresses: Baltimore (MD), 1851-1870 and after. **Comments:**

Founded by Edward c.1849, Theodore joined the company in the mid 1850's and, in 1860, William Sachse (see entries on each). They produced lithographies of city views as well as maps and drawings of steamboats and machinery, amongst others. In the 1880's, Adolph Sachse continued the company's tradition by drwaing and printing two lithographs of Washington, DC. **Sources:** G&W; Baltimore CD 1851-74; *Portfolio* (Dec. 1948), 93; Peters, *America on Stone*. More recently, see Reps, 204-206.

SACKER, Amy M. *[Designer, lecturer, teacher, illustrator] b.1876, Boston.*
Addresses: Boston, MA. **Studied:** DeCamp; J.L. Smith; C.H. Walker; Rome. **Member:** Boston SAC; Copley Soc.; AFA. **Exhibited:** Pan-Am. Expo, Buffalo, 1901 (medal); Boston SAC, 1930 (medal). **Comments:** Illustrator: children's books. Positions: director, Sacker Sch. of Design and Interior Dec., Boston; art director in motion pictures. **Sources:** WW40.

SACKET, Laura Frances *[Block printer] b.1907, Syracuse, NY.*
Addresses: Furlong, PA. **Studied:** PM Sch IA. **Member:** Phila. Print C.; Phila. Alliance. **Exhibited:** Phila. Print C., 1936. **Work:** Royal Mus. Art, Ontario, Canada. **Sources:** WW40.

SACKETT, Clara E(lisabeth) *[Portrait painter, miniaturist, teacher] 19th/20th c.; b.Westfield, NY.*
Addresses: Buffalo, NY, from 1897; NYC/Westfield, NY. **Studied:** ASL; Paris, with Aman-Jean; Acad. Delecluse & Colarossi, 1891-96. **Member:** Buffalo SA; Buffalo Gld. Artists (pres., 1912); Copley Soc.; Boston GA. **Exhibited:** PAFA Ann., 1904; Buffalo SA (prize); in NYC, Phila., Boston, and the West. **Work:** Buffalo Hist. Soc. **Sources:** WW40; Falk, *Exh. Record Series.*

SACKETT, Edith S. *[Painter] 19th/20th c.*
Addresses: Providence, RI. **Member:** NY Woman's Art Club, c.1900. **Exhibited:** NAD, 1883-90. **Sources:** WW01; Petteys, *Dictionary of Women Artists.*

SACKETT, Esther *[Primitive watercolor painter] mid 19th c.*
Addresses: New York State, active c.1840. **Comments:** Painter of a watercolor still life dated c.1840. **Sources:** G&W; Lipman and Winchester, 179.

SACKETT, Harry Ackley *[Artist] late 19th c.*
Addresses: Wash., DC, active 1890-92. **Sources:** McMahan, *Artists of Washington, DC.*

SACKETT, Richard R(oman) *[Drawing specialist, lecturer, painter, writer] b.1909, Bentonville, AR.*
Addresses: Minneapolis, MN. **Studied:** Fed. Sch., Milwaukee AI. **Exhibited:** Minn. State Fair, 1932 (prize). **Comments:** Auth., articles on Indian Lore, Minn. history. Position: asst. state dir., Hist. Records Survey. **Sources:** WW40.

SACKMAN, Louis *[Painter] mid 20th c.*
Addresses: NYC. **Studied:** Parsons. **Member:** Artists Union. **Exhibited:** "NYC WPA Art" at Parsons School Design, 1977. **Comments:** WPA artist. Positions: manager, Sentinel Books, after WWII for 28 years; editor, illustrator, market researcher, salesman, Arco Publ. Co., 2 years. Following retirement he devoted his time to painting. **Sources:** *New York City WPA Art*, 75 (w/repros.).

SACKRIDER, Jean A. *[Painter] early 20th c.*
Addresses: Active in Detroit. **Member:** Detroit Soc. Women P&S, 1905 (one of the first members). **Sources:** Petteys, *Dictionary of Women Artists.*

SACKS, Joseph *[Portrait and landscape painter] b.1887, Shavil, Russia. / d.1974, Philadelphia, PA.*
Addresses: Philadelphia, PA. **Studied:** PAFA with T. Anshutz; W.M. Chase; S. Kendall. **Member:** Phila. Alliance; N.A. **Exhibited:** PAFA Ann., 1911-32; PAFA, 1932 (prize); Corcoran Gal biennials, 1914-26 (4 times); Pan-Pac Expo, 1915; San Francisco AA annual, 1925; Calif. AC; LACMA; Calif. Artists at Southwest Mus., 1920s; NAD; AIC; St. Louis Art Mus. **Work:**

PAFA. **Sources:** WW40; McMahan lists a "Jos. Sacks" active in Wash., DC, in 1915; Hughes, *Artists in California*, 487; Falk, *Exh. Record Series.*

SACKS, Morton *[Painter] 20th c.*
Addresses: Boston, MA. **Sources:** WW66.

SACKS, Walter Thomas *[Landscape painter] b.1901, Phila., PA.*
Addresses: Caledonia, NY. **Member:** S. Sanity A.; Rationalists. **Exhibited:** Rochester AC, 1938 (prize), 1939 (prize). **Work:** Bevier Fnd.; Rochester Athenaeum; Mechanics Inst., Rochester, NY. **Sources:** WW40.

SACKSTEDER, Aloys *[Ceramist, educator, designer, sculptor] b.1911, Dayton, OH.*
Addresses: Sandusky, OH. **Studied:** Cleveland Sch. A.; Kent State Univ. (B.S. In Edu.); Ohio State Univ. (M.A.); Univ. So. California; Sophia Univ., Tokyo, Japan. **Member:** AL, Columbus, OH. **Exhibited:** Syracuse Mus. FA, 1936-41 (prize, 1937), 1947-48; Paris Salon, 1937; GGE, 1939; Columbus A. Lg., 1937-40; NAC, 1940; Phila. A. All., 1937, 1939; Ohio-Pennsylvania Exh., 1938. **Work:** Syracuse Mus. FA. **Comments:** Position: asst. prof. art, Indiana State T. Col., Terre Haute, Ind., 1938-48; U.S. Armed Forces Inst., Information and Edu., Tokyo, Japan, 1948-51. **Sources:** WW53; WW47.

SADAKATA, Kwaiseke S. *[Painter] mid 20th c.*
Addresses: NYC. **Exhibited:** S. Indp. A., 1924. **Sources:** Marlor, *Soc. Indp. Artists.*

SADD, Henry S. *[Mezzotint engraver] mid 19th c.; b.England.*
Addresses: Came to U.S. c. 1840; active in NYC until c. 1850, after which he went to Australia. **Exhibited:** London, 1832; NAD, 1840-49. **Sources:** G&W; Stauffer; Thieme-Becker; Graves, *Dictionary:* Cowdrey, NAD; NYCD 1843-49; *Portfolio* (Feb. 1954), 127.

SADEK, George *[Educator, art administrator] b.1928, Czechoslovakia.*
Addresses: NYC. **Studied:** Hunter Col.; City Univ. NY (B.A.); Indiana Univ. (M.F.A.). **Member:** Nat. Assn. Schools Art (bd. mem., 1968-71); Am. Inst. Graphic Arts (bd. mem., 1969-72); College Art Assn. (bd. mem., 1971-). **Exhibited:** Type Directors Cl. NY, 1969; Am. Inst. Graphic Arts, 1970; Typomondus, Frankfurt, Germany, 1971. **Work:** MoMA; LOC; Morgan Library. **Comments:** Positions: dean, School Art & Architecture, Cooper Union, 1968-. Teaching: from instructor to asst. prof., Design, Indiana Univ., 1960-66; prof., Graphic Design, Cooper Union, 1966-, chairman, Dept. Art, 1966-68. **Sources:** WW73; article in *Am. Inst. Graphic Arts Journal* (1968); article in *Print* (1970).

SADER, Lillian *[Painter] mid 20th c.*
Addresses: Chicago area. **Exhibited:** AIC, 1941. **Sources:** Falk, AIC.

SADLER, Rupert (or Rufus) *[Portrait painter and picture restorer] b.1816, Cork, Ireland.*
Addresses: Boston, active after 1848. **Sources:** G&W; 8 Census (1860), Mass., XXV, 294 [as Rufus Saddler]; New England BD 1849 and Boston BD 1852 [as R. Sadler]; Boston CD 1851 [as Rupert Sadler].

SADOW, Sue *[Painter] b.1896, Boston.*
Addresses: Active in Denver from 1972. **Studied:** Lyle Hatcher Bennett in Beverly Hill; Margaret Wise in Denver. **Exhibited:** Los Angeles. **Comments:** Began painting after WWII. **Sources:** Petteys, *Dictionary of Women Artists.*

SAECKER, Austin *[Painter] b.1896, Appleton / d.1974.*
Addresses: Appleton, WI. **Studied:** Wis. Sch. A.; A. Mueller; G. Moeller; F. Fursman; NAD; Paris; PAFA. **Member:** Wis. PS. **Exhibited:** Milwaukee AI, 1924 (med.); Business Men's AC; Wis. PS, 1926 (prize), 1927 (prize). **Comments:** He became a hermit. **Sources:** WW33.

SAEMONDSSON, Nina *[Sculptor] mid 20th c.; b.Iceland.*
Addresses: Hollywood, CA. **Exhibited:** S. exh., Oakland A. Gal.,

1938; WFNY, 1939. **Sources:** WW40.

SAENZ, Manuel *[Miniaturist] mid 19th c.*
Addresses: New Orleans in October 1842. **Comments:** Claimed a connection with the Madrid Academy of Painting and the Valladolid Society of Arts. **Sources:** G&W; Delgado-WPA cites *Courier*, Oct. 10, 1842.

SAFER, John *[Sculptor] b.1922, Wash., DC.*
Addresses: Bethesda, MD. **Exhibited:** solo shows, Pyramid Gallery, Wash., DC, 1970, Westmoreland Co. Mus., Greensburg, Pa., 1971, New York Cult. Ctr., 1971, US Embassy, London, Eng. & Montclair Mus. Art, NJ, 1972; Gimpel Weitzenhoffer Ltd., NYC, 1970s. **Work:** BMA; Corcoran Gal.; New York Cult. Ctr., NYC; PMA; SFMA. **Comments:** Preferred media: acrylics, brass. **Sources:** WW73; Gerald Nordland, "John Safer and the Light Fantastic," *Art Gallery Mag.* (Feb., 1972).

SAFFERSON, Matthew *[Sculptor] b.1909, London, England.*
Studied: Hebrew Educ. Alliance; Cooper Union; Leonardo Da Vinci Art School; apprenticed to Leo Friedlander SC. **Member:** Clay Club; Sculpture Center. **Exhibited:** "NYC WPA Art" at Parsons School Design, 1977. **Comments:** Came to the U.S. in 1923. Worked in porcelain ceramics with Von Tury. **Sources:** *New York City WPA Art,* 76 (w/repros.).

SAFFORD, Carleton Lewis *[Designer and teacher] b.1908, Bliss, NY.*
Addresses: Brooklyn, NY. **Studied:** Cornell Univ. (A.B.); A.M. Pratt Inst.; ASL; Robert Brackman. **Exhibited:** ASL; Pratt Inst. **Comments:** Positions: art supervisor, East Rockaway Public Schools, Long Island, NY; teacher, Crafts & Indus. Design, Univ. Iowa, 1938; designer, NY Dept. Store Market. **Sources:** Ness & Orwig, *Iowa Artists of the First Hundred Years,* 182.

SAFFORD, Charles Putnam *[Painter] b.1900, Logansport, IN. / d.1963, Mendocino, CA.*
Addresses: San Diego, CA. **Studied:** PIA School; with Roi Clarkson Colman; Hans Hofmann School, NYC. **Member:** Soc. of Original Desert Painters. **Sources:** WW40; Hughes, *Artists in California,* 487.

SAFFORD, Elizabeth *[Painter] mid 20th c.*
Exhibited: Salons of Am., 1934. **Sources:** Marlor, *Salons of Am.*

SAFFORD, Fanny *[Landscape painter] mid 18th c.*
Member: Penn. Academicians, 1863 (assoc. mem.). **Sources:** Petteys, *Dictionary of Women Artists.*

SAFFORD, Florence P. *[Painter] 19th/20th c.*
Addresses: Wash., DC, active 1895-1909. **Studied:** Wash., DC, with Helmick; Acad. Colarossi, Paris, with Colin and Courtois. **Sources:** McMahan, *Artists of Washington, DC.*

SAFFORD, Jeanne A. *[Painter] mid 20th c.*
Addresses: NYC. **Exhibited:** Salons of Am., 1929-30; S. Indp. A., 1929-30. **Sources:** Marlor, *Salons of Am.*

SAFFORD, Ruth Appleton Perkins (Mrs.) *[Painter, landscape painter] b.c.1897, Boston, MA / d.1979, Wash., DC.*
Addresses: Wash., DC, 1928. **Studied:** Mass. Col. A. (B.S.); also with Henry B. Snell; E.L. Major; J. De Camp; H. Breckenridge. **Member:** Gld. Boston Artists; Wash. AC; Copley Soc.; Boston AC; North Shore AA; NAWPS; AWCS; Washington WCC; Northern AA; Smithsonian Inst. (associate). **Exhibited:** Wash. WCC; NAWPS; Critics Choice, Cincinnati, New England Contemporary Art; AWCS; CGA; Wash. AC; NAD; Mellon Found Traveling Exhib., 3 years; Guild Boston Artists, Boston, MA, 1970s; Grand Central Gals., NYC, 1970s. **Work:** Farnsworth Mus., Rockland, ME; VMFA; Mint Mus., Charlotte, NC; Navy Hist. Mus., Wash., DC; Ball Mus., Muncie, IN. Commissions: portraits of interiors, VMFA, Nat. Cathedral, Mt. Vernon, Lee Mansion, Hyde Park & Gunstor Hall. **Comments:** Safford had over 100 solo exhibitions. Preferred medium: watercolors. Publications: auth., article, *Am. Artist.* Teaching: art instr., Medford (PA) public schools; Harvard Educ. School. **Sources:** WW73; WW47; various articles in newspapers; Petteys,

Dictionary of Women Artists; McMahan, *Artists of Washington, DC* states her birthdate as 1892.

SAFRANEK, Frank *[Artist] mid 20th c.*
Addresses: Cleveland, OH. **Exhibited:** PAFA Ann., 1960. **Sources:** Falk, *Exh. Record Series.*

SAGE, Cornelia Bentley *[Critic, museum director, painter, writer] b.1876, Buffalo, NY / d.1936, Santa Barbara, CA.*
Addresses: Hollywood, CA. **Studied:** Buffalo ASL; ASL with Twachtman, Beckwith, Wiles, Reid; École du Louvre, Paris, 1914. **Member:** Buffalo SA; Calif. AC; NYWCC; Los Angeles AA; Western Assoc. Mus. Dir.; Nat. Advisory Committee, Sesqui-Centenn. Expo, Phila., 1926. **Exhibited:** NYWCC; Société des Beaux-Arts, Paris, 1916 (bronze medal). Awards: NSS, 1916 (diploma); Decoration of L'Officier de l'Instruction Publique, Paris, 1917; Decoration Palme d'Acad., 1917; Cross of the Legion of Honor, 1921; Sorolla Medal, Hispanic Soc. of America, 1925. **Comments:** Married Major W.W. Quinton. Positions: dir., Albright Gal., 1910-24 & CPLH, 1924-30; art critic, magazines & newspapers. **Sources:** WW33; Hughes, *Artists in California,* 453.

SAGE, David W. *[Sculptor] 19th/20th c.*
Addresses: Wash., DC, active 1892-1902. **Sources:** McMahan, *Artists of Washington, DC.*

SAGE, Esther See: **BENBRIDGE, Hetty (aka Esther & Letticia) Sage (Mrs.Henry)**

SAGE, Hetty See: **BENBRIDGE, Hetty (aka Esther & Letticia) Sage (Mrs.Henry)**

SAGE, Jane White (Mrs. Cass Canfield) *[Sculptor] b.1897, Syracuse, NY / d.1984.*
Addresses: NYC/Bedford, NY. **Studied:** F. Grimes, Mahroni Young, A. Salemme; ASL; James Earle & Laura Gardin Fraser Studio; Borglum School; also with A. Bourdelle, Paris, France. **Exhibited:** Arch. Lg.; Weyhe Gal., NYC; Sculpture Pavilion, NYWF, 1939; British-Am. Art Gal., NY, 1955 (solo); Far Gal., New York, 1961 (solo) & 1965 (solo), 1970s; Country Art Gal., Locust Valley, 1971. **Work:** WMAA; Cornell Univ. MA. Commissions: XIX animals in lead for gate posts, Paul Mellon, Upperville, VA, 1940; animals in lead for gym entrance, Miss Porter's School, Farmington, CT, 1960; St. John Apostle in stone, Church of St. John of Lattington, Locust Valley, NY, 1963; herons in stone, Mem. Sanctuary, Fishers Island, 1969; Canadian geese in bronze for pool, Long Lake, MN, 1971. **Comments:** Preferred media: marble, stone, bronze, terra-cotta. Publications: "The Frog Prince," Harper & Row, 1970. **Sources:** WW40; WW73; Petteys, *Dictionary of Women Artists.*

SAGE, Jennie A. *[Miniature painter] b.1865, Hackensack, NJ.*
Addresses: Active in Hackensack, NJ, c.1913-19. **Sources:** WW19.

SAGE, Kay *[Painter, illustrator] b.1898, Albany, NY / d.1963, Woodbury, CT.* *Kay Sage '44*
Addresses: As a child, she lived mostly in Europe with her mother; Italy, 1919-35; Paris; Woodbury, CT, 1941-. **Studied:** mostly self-taught, took brief winter course at the Corcoran Art Sch., c.1915; informally with Onorato Carlandi. **Exhibited:** Milan, Italy, 1936 (solo); Salon des Surindépendents, Paris, 1938; Matisse Gal., 1940 (solo); SFMA, 1941 (solo); Julien Levy Gal., 1944 &1947 (solo); AIC, 1945 (prize), 1946-47, 1951; Corcoran Gal biennials, 1951-61 (5 times, incl. 4th prize, 1951); WMAA, 1946-62; CI, 1946-50; TMA, 1947-49; CPLH, 1949-50; Univ. Illinois, 1949, 1951; Herron AI, 1947- 48, 1951; LACMA, 1951; BM, 1951; Detroit IA, 1952; Viviano Gal., 1950, 1952, 1958 (solo shows); PAFA Ann., 1953; Wadsworth Atheneum, 1954 (with Yves Tanguy); Cornell Univ., 1977; Hirschl & Adler Gal., NYC, 1998 (surrealism exhib.). Awards: Connecticut Development Comm., 1951 (prize). **Work:** AIC; CPLH; WMAA; Wesleyan Univ., CT; MMA; MoMA; Walker Art Center. **Comments:** A surrealist active in Paris in the mid to late 1930s, she married Yves Tanguy in 1940 and moved with him to Woodbury, CT. Although

his career overshadowed her own, Sage continued to paint and exhibit in the 1940s and 1950s (Tanguy died in 1955). In 1958 she lost part of her vision after a double cataract operation; the following year she made an unsuccessful suicide attempt with barbiturates, and four years later she fatally shot herself with her husband's pearl-handled pistol. Author & illustrator: *Piove in Giardine* (1937); *Ale More I Wonder* (1957 verse); *Demain, Monsieur Silbe* (1957, French verse). **Sources:** WW59; Baigell, *Dictionary*; Rubinstein, *American Women Artists*, 290-92; Wechsler, 24; Regine T. Krieger, *Kay Sage* (exh. cat., Cornell Univ., 1977); Art in Conn.: Between World Wars; Falk, *Exh. Record Series*; death info courtesy Betty Krulick, Spanierman Gal., NYC.

SAGE, Letticia See: **BENBRIDGE, Hetty (aka Esther & Letticia) Sage (Mrs.Henry)**

SAGE, Olive K. *[Painter] 20th c.*
Addresses: Hartford, CT. **Member:** New Haven PCC. **Sources:** WW25.

SAGE & SONS *[Lithographers and music dealers] mid 19th c.*
Addresses: Buffalo, NY, 1856-60. **Comments:** The firm consisted of John Sage and his sons Henry H., John B., and William Sage. **Sources:** G&W; Peters, *America on Stone;* Buffalo BD 1856-60.

SAGER, Joseph *[Painter] mid 19th c.*
Addresses: Cincinnati, 1850. **Sources:** G&W; Cincinnati CD 1850 (courtesy Edward H. Dwight, Cincinnati Art Museum).

SAGLE, Lawrence William *[Painter] 20th c.*
Addresses: Baltimore, MD. **Sources:** WW25.

SAGUE, Julia *[Painter] early 20th c.*
Addresses: Poughkeepsie, NYC, 1905-09. **Sources:** WW10.

SAHAKIAN, Arthur *[Painter] mid 20th c.*
Exhibited: S. Indp. A., 1941-42. **Sources:** Marlor, *Soc. Indp. Artists*.

SAHLER, Helen (Gertrude) (Miss) *[Painter, sculptor, writer] b.1877, Carmel, NY / d.1950, NYC.*
Addresses: NYC. **Studied:** ASL; H. MacNeil; E. Yandell. **Member:** All. Artists Am.; CAFA; North Shore AA; NAWA; NY Mun. AS; Numismatic Soc.; AFA; NAC. **Exhibited:** PAFA Ann., 1913-28 (6 times) & 1937; NAD, from 1915, 1944, 1945 (Proctor award) & prior; S. Indp. A., 1917; WMAA, 1920-24; Arch. Lg., 1945; NAWA, 1945; All. Artists Am., 1945; AIC; CGA; Albright Art Gal.; CM; WFNY, 1939; Sesqui-Centenn. Expo, Phila. **Work:** Am. Numismatic Soc.; Macon Col. Lib.; College Physicians & Surgeons, NYC; church, Fall River, MA; Hackley Chapel, Tarrytown, NY; Scarborough, NY. **Comments:** Contributor: *The Outlook, International Book Review, American Review.* **Sources:** WW47; Falk, *Exh. Record Series.*

SAHLIN, Carl Folke *[Painter, illustrator] b.1885, Stockholm, Sweden.*
Addresses: Miami, FL. **Studied:** ASL. **Member:** NAC; AWCS; Miami A. Lg.; Blue Dome F.; CGA. **Exhibited:** AWCS, 1943-56; NAC; CGA; Blue Dome F.; Miami Art Lg., 1942-56; CGA (solo); NGA; Swedish Hist. Mus.; Lowe Gal.; Coral Gables, FL. **Awards:** Blue Dome Fellowship, 1950 (prize), 1951 (prize); Miami Art Lg., 1943; Florida WCS, 1943 (gold med.). **Work:** Swedish Hist. Mus., Stockholm; Musée Art Chinois, Montreal, Canada; Hickory (NC) Mus. Art. **Comments:** Illustrator, "This New World." Probably the same as "Fritzie Sahlins" who exhibited at Corcoran Gal biennial, 1957. **Sources:** WW59.

SAHRBECK, Everett William *[Painter] b.1910, East Orange, NJ.*
Addresses: South Harwich, MA. **Studied:** NY Univ. **Member:** AWCS; NJ WCS (pres.); Cape Cod AA (pres., 1971-72). **Exhibited:** AWCS, 1954-72; Montclair Art Mus. Statewide Ann., 1955-67; Royal Soc. Painters Watercolors, London, 1963; Landscape I, De Cordova Mus., 1970; Munson Gallery, Osterville, MA, 1970s. **Awards:** AWCS Ann. Prize; 1961; NJ WCS, 1970

(silver med.); Cape Cod AA, 1971 & 1972 (watercolor prize). **Work:** Montclair AM; Newark AM; Overlook Hospital, Summit, NJ; First Nat. Bank Boston. **Comments:** Preferred media: watercolors. Positions: art dir., Reach, McClinton & Co., 1934-68. **Sources:** WW73.

SAHULA-DYCKE, Ignatz *[Painter, illustrator, teacher] b.1900, Bohemia.*
Addresses: Dallas, TX. **Studied:** Chicago Acad. FA. **Member:** Chicago Art Directors Cl. **Exhibited:** AIC, 1926 (prize). **Comments:** Position: art dir., Tracy, Locke, Dawson, Dallas. Position: teacher, YMCA, Dallas. **Sources:** WW40.

SAID, Claus Milton *[Block printer, cartoonist, designer, illustrator, lecturer, teacher, writer] b.1902, Memphis, TN.*
Addresses: New Orleans, LA. **Studied:** C. Schroeder; P.B. Price; C. Ferring; F. Grant; C. Werntz; AIC; Chicago Acad. FA. **Member:** Tennessee SA (pres.); AAPL; SSAL; Artist Gld. Memphis; Mississippi AA. **Comments:** Creator: comics, "Inkid," "Buddy and Jazz.". **Sources:** WW40.

SAIDENBERG, Daniel *[Art dealer] b.1906, Winnipeg, Manitoba, Can.*
Addresses: NYC. **Studied:** Juilliard School Music. **Comments:** Positions: pres., Saidenberg Gallery. Specialty of gallery: 20th century European and American masters. **Sources:** WW73.

SAILORS, Robert D. *[Craftsperson, designer, printmaker, cartoonist, lecturer, teacher] b.1918, Grand Rapids, MI.*
Addresses: Cranbrook Acad. Art, Bloomfield Hills, MI. **Studied:** Olivet Col.; AIC; Cranbrook Acad. Art, 1944. **Exhibited:** La France Comp., Phila., 1945 (prize); Int. Textile Exhib., Greensboro, NC, 1945 (prize); MoMA, 1944-45; AIC, 1944; AFA Traveling Exhib., 1944; SFMA, 1945; MIT, 1946; Cornell Univ., 1945; Dallas Mus. FA, 1945; Detroit IA, 1946; Wichita AM, 1946; Royal MA, Toronto, 1945; CM, 1946; Dayton AI, 1946; Univ. Minnesota, 1944; Olivet College, 1944; Brooklyn College, 1944; Sioux City, Iowa, 1946. **Work:** textiles/rugs, Weatherspoon Art Gal. and Cranbrook Acad. Art. **Comments:** Position: teacher, Cranbrook Acad. Art, 1943-on. **Sources:** WW47.

SAILSBURY *[Painter] late 19th c.*
Exhibited: SNBA, 1890. **Sources:** Fink, *American Art at the Nineteenth-Century Paris Salons*, 387.

SAINT, Lawrence *[Painter, writer, lecturer, craftsperson, illustrator] b.1885, Sharpsburg, PA / d.1961.*
Addresses: Huntingdon Valley, PA. **Studied:** PAFA, and with William Chase, Cecelia Beaux; H.R. Poore; Kendall; J.H. Rudy. **Member:** Royal SA, London (fellow). **Exhibited:** PAFA Ann., 1922-23. **Awards:** Cresson traveling scholarship, PAFA, 1908. **Work:** stained glass drawings, Victoria & Albert Mus., London; CI; NYPL; Free Library, Phila.; glass formulas drawings, Corning Mus. of Glass; CM; MMA; stained glass windows, Washington (DC) Cathedral including North Trancept Rose; five windows, Bryn Athyn Cathedral, PA; St. Paul's Episcopal Church, Willimantic, CT; window, Riverside Cemetery, Norristown, PA; window, Episcopal Church Hillsboro, NC; maker of medieval type glass-ware, White House, Wash., DC; work reproduced in 3-reel educational motion picture by MMA; murals, Church of the Open Door, Phila., PA; Kemble Park Church, Phila., PA; Bob Jones Univ., Greenville, SC; Christ Church, Bethlehem, PA; Bethel Chapel, Huntingdon Valley, PA. **Comments:** Illustrator, "Lawrence Saint's Stained Glass Cree," "A Knight of the Cross," 1914; "Stained Glass of the Middle Ages in England and France," 1913 (reprinted, 4th ed.). Lectures on stained glass in museums, colleges and art societies. Contributor: trade publications; bulletins. **Sources:** WW59; WW47; Falk, *Exh. Record Series.*

SAINT, Louise *[Painter] 20th c.*
Addresses: Paris, France. **Sources:** WW25.

ST. ALARY, Charles E(mile) *[Portrait and landscape painter, pastellist] d.1865, Bordeaux, France.*
Addresses: Chicago, 1855-56; Detroit, MI, prior to 1855 and in 1860 and after. **Exhibited:** Illinois State Fair; Michigan State Fair,

1854, 1856, 1858. **Comments:** Groce & Wallace and Gibson cite his name as Charles Emile St. Alary; Gerdts gives his name as E. St. Alary and writes that he was a pastellist from Detroit, working in Chicago 1855-56. Position: teacher, Detroit high schools, 1860; associated with George Watson in St. Alary & Watson. He is said to have traveled all over the world. **Sources:** Groce & Wallace; Chicago *Daily Press,* Oct. 4 and 11, 1855; Gibson, *Artists of Early Michigan,* 208; Gerdts, *Art Across America,* vol. 2: 285.

ST. ALARY, E. See: **ST. ALARY, Charles E(mile)**

ST. AMAND, Joseph *[Painter] b.1925, NYC.*
Addresses: San Francisco, CA. **Studied:** UC Berkeley; Calif. Sch. Fine Art, San Francisco. **Exhibited:** SFMA 75th Ann., 1957; CPLH Winter Invitational, Calif., 1960-64; Carnegie Inst., Pittsburgh, Pa., 1964; Univ. Calif., Santa Cruz, 1969. **Work:** Cathedral Sch., Kristiansand, Norway. **Comments:** Preferred media: oils. **Sources:** WW73.

SAINT ARMAND, Dreux *[Scene painter] mid 19th c.*
Addresses: New Orleans, active 1838. **Comments:** Scene painter at a New Orleans theater in 1838. *Cf.* G. Armand. **Sources:** G&W; Delgado-WPA cites *Courier,* Sept. 14, 1838.

SAINT-AULAIRE, Felix Achille de Beaupil Marquis de
[Landscape painter and lithographer] b.1801, Verceil, France.
Addresses: Traveled to Louisiana, Kentucky, and Ohio, 1820-21. **Studied:** Jean-François Garneray and son in Paris. **Exhibited:** Salon, Paris, 1827 and 1838. **Comments:** French nobleman who visited the United States in 1820-21. He arrived in New Orleans Feb. 22, 1820, and while there sketched a number of street scenes. From there he went to Kentucky and Ohio, traveling as far West as Guyandotte on the Ohio River. He returned to France and in 1832 executed several lithographs of the American views. P. Langlumé (see entry) also lithographed several of Saint-Aulaire's New Orleans scenes. Also appears as Beaupil, or De Saint-Aulaire. **Sources:** G&W; *Portfolio* (June 1948), 220-21; Davidson, *Life in America,* I, 179. More recently, see *Encyclopaedia of New Orleans Artists.*

ST. CLAIR, Andrew *[Painter, decorator] late 19th c.*
Addresses: New Orleans, active 1884-86. **Sources:** *Encyclopaedia of New Orleans Artists,* 335.

SAINT CLAIR, Gordon *Gordon Saint Clair*
[Painter] b.1885. *1 9 1 5*
Addresses: Chicago, IL.
Member: Chicago SA. **Exhibited:** AIC, 1913-44; S. Indp. A., 1917, 1925; PAFA Ann., 1921. **Sources:** WW27; Falk, *Exh. Record Series.*

ST. CLAIR, Michael *[Art dealer, painter] b.1912, Bradford, PA / d.1999.*
Addresses: NYC. **Studied:** Kansas City Art Inst., Vanderslice scholar, with Thomas Hart Benton 1934-39; ASL with George Grosz; Colo. Springs Fine Arts Cntr., scholar, with Boardman Robinson and Y. Kuniyoshi. **Member:** Art Dealers Assn Am. **Exhibited:** Okla. Art Ctr., Oklahoma City, 1942 (solo). **Comments:** After his art studies, he taught at the WPA's Art Center School in Oklahoma City during the 1940s. Although he began as a painter, he became an art dealer in NYC, and from 1959-88 was the director of Babcock Galleries, NYC, the country's oldest commercial gallery devoted exclusively to American art. He was best known for having rediscovered and promoted Marsden Hartley (see entry), and mounted eleven exhibitions of the artist's works between 1959-80. He was also instrumental in building the reputations of Alfred Maurer, E. Ambrose Webster, and Childe Hassam. In 1998 he established the Babcock Galleries Endowed Fund for Art History at Penn State Univ. **Sources:** WW73; *NY Times* obit., 28 Feb. 1999.

SAINT CLAIR, Norman *[Landscape painter, architect]*
b.1863, England / d.1912, Pasadena, CA.
Addresses: Los Angeles, CA, since c.1897). **Studied:** self-taught. **Member:** Los Angeles Painters Cl.; Calif. AC. **Exhibited:** Mark Hopkins Inst., 1906; PAFA, 1910; AIC; Blanchard Gal., Calif.;

AC, 1912; LACMA, 1915 (memorial). **Work:** Laguna Beach Mus. **Comments:** Specialty: watercolor. Possibly the first painter in Laguna Beach, (1906). **Sources:** WW10; Hughes, *Artists in California,* 488.

ST. CLAIRE, Evangeline *[Painter] mid 20th c.*
Addresses: NYC. **Exhibited:** S. Indp. A., 1929-31. **Sources:** Marlor, *Soc. Indp. Artists.*

SAINT-GAUDENS, Annetta Johnson (Mrs. Louis)
[Sculptor, craftsperson] b.1869, Flint, OH / d.1943, Pomona, CA.
Addresses: Coconut Grove, FL/Cornish, NH; NYC/Windsor, VT. **Studied:** Columbus Art Sch.; ASL with Twachtman, Saint-Gaudens. **Member:** NAWPS; Columbus AL; NYSC; AAPL. **Exhibited:** NAWPS, 1913 (prize); PAFA Ann., 1914-30 (9 times); Pan-Calif. Expo, San Diego, 1915 (medal); Pan-Pacific Expo, San Francisco, 1915; S. Indp. A., 1917-21, 1924; AIC; City Art Mus., St. Louis; NSS. **Work:** Columbus Gal. FA; Carpenter Hall Gal., Dartmouth. **Comments:** Worked with her husband, Louis and her brother-in-law, Augustus. Position: associated with Orchard Pottery, Cornish and Pelican Pottery, Coconut Grove. **Sources:** WW40; WW01; Petteys, *Dictionary of Women Artists;* Falk, *Exh. Record Series.*

SAINT-GAUDENS, Augustus *[Sculptor]*
b.1848, Dublin, Ireland / d.1907, Cornish, NH.
Addresses: (brought to NYC when 6 months old) NYC/Windsor, VT/Cornish, NH. **Studied:** apprenticed to two NYC cameo-cutters, Avet (1861-64) and Jules Le Brethon (1864-67); studied at CUA School, NAD, beginning 1864-67; École des Beaux-Arts, Paris, with Jouffroy, 1867-70; in Florence and Rome, 1870-72, where he became interested in Renaissance Art. **Member:** SAA, founder, 1877; NA, 1889; Arch. Lg., 1902; Boston Soc. Arch.; Century; NIAL; Royal Acad., London; SBA; Institute de France; NSS. **Exhibited:** AIC; 1875-89; Centennial Exh., Phila., 1876; PAFA Ann., 1877-79, 1885, 1894-98, 1902-07; Paris Salon, 1880 (prize), 1894; World's Columbian Exposition, Chicago, 1896 (18-ft. "Diana," atop the McKim, Mead and White Agricultural Bldg.); SNBA, 1898, 1899; Paris Expo, 1900 (prize); Pan-Am. Expo, Buffalo, 1901 (medals); St. Louis Expo, 1904 (gold); SAA. **Work:** DIA; MMA; PMA (the "Diana," that stood atop the tower of the 1st Madison Square Garden); Saint-Gaudens Nat. Historic Site, Cornish, NH; Admiral Farragut statue in Central Park, NYC (his first public commission, 1881); equestrian statue of "General Sherman, preceded by Victory" Central Park, NYC, 1903; Shaw Mem. (a large bronze panel in high relief), Boston; Samuel Chapin, Puritan," Springfield, Mass., and Phila.; his strongest portrait statue, the standing "Lincoln," is located in Chicago's Lincoln Park (replica at Carnegie Inst. and a small one at the Newark Mus.). In Rock Creek Cemetery, Wash., DC, is one of his most impressive works, a bronze seated figure of a woman lost in thought. It is a memorial to Marian Hooper Adams and was commissioned by her husband, the historian Henry Adams, but bears no inscription. **Comments:** The leading sculptor of America's "Gilded Age," Saint-Gaudens brought the Beaux-Arts style to the U.S. and was responsible for creating the most vital and important commemorative sculptures and reliefs of his day. He also collaborated with other American painters and architects on a number of significant projects, including Trinity Church in Boston, the Boston Public Library, and the Vanderbilt Mansion and Villard House in NYC. He also executed many portrait busts, and low-relief portrait medallions and plaques; and the coinage of eagles and double eagles is from his designs. A vast amount of his work was left unfinished at his death, but a large part of it had been carried far enough to be completed by those who had been working with him. His "infinite power for taking pains" is well illustrated from the fact that it took him twelve years to complete the Shaw Mem. Many of the pedestals and architectural bases of his monuments were designed by Stanford White. Positions: sculpture consultant to Daniel Burnham for the World's Columbian Exposition in Chicago; he was one of the founders of the Society of American

Artists; co-founder of the American Academy in Rome in 1904. After his death, his studio and home in Cornish, NH, were declared a national historic site. **Sources:** WW04; Craven, *Sculpture in America*, 373-92; Baigell, *Dictionary*; Fink, *American Art at the Nineteenth-Century Paris Salons*, 387-88; Falk, *Exh. Record Series;* Detroit Inst. of Arts, *The Quest for Unity: American Art Between World's Fairs, 1879-1893*, 70-71, 162-67; Louise Hall Tharp, *Saint-Gaudens and the Gilded Era* (Boston and Toronto: Little, Brown and Co., 1969); John H. Dryfhout, *The Work of Augustus Saint-Gaudens* (Hanover, NH and London, 1982); Homer Saint-Gaudens, *Reminiscences of Augustus Saint-Gaudens* 2 vols. (New York, 1913).

SAINT-GAUDENS, Augusta Homer (Mrs. Augustus) *[Patron] d.1926, Cornish, NH.*
Comments: Died at her home "Aspet", Cornish, NH, July 7, 1926. She had maintained her husband's studio since his death, and had secured replicas in bronze and plaster of practically all of his work, which with Aspet, all of its furnishings and the studios formed the Augustus Saint-Gaudens Memorial, incorporated in 1919.

SAINT-GAUDENS, Carlot(t)a (Mrs. Homer) *[Miniature painter, illustrator] b.1884, Rochester, NY / d.1927, Pittsburgh, PA.*
Addresses: Pittsburgh, PA/Cornish, NH; Windsor, VT. **Studied:** PAFA; ASL, with Chase, Cox, Brush. **Member:** ASMP; Penn. SMP; NAC; Cornish (NH) Colony. **Exhibited:** AIC,1916. **Sources:** WW25.

SAINT-GAUDENS, Homer *[Museum director, educator, lecturer] b.1880, Roxbury, MA / d.1958.*
Addresses: Pittsburgh, PA. **Studied:** Harvard Univ. (A.B.); & abroad. **Member:** Am. Assn. Mus. Dir.; Cornish (NH) Colony. **Exhibited:** Awards: Order of the Crown of Italy, 1928; Chevalier Order of Leopold, 1929; Legion of Honor, 1933; Commander Hungarian Order of Merit, 1938; Hon. Foreign Corresponding Member of the Royal Acad., London. 1942. **Comments:** Position: asst. dir. fine arts, 1921, dir. fine arts, 1922-51, Carnegie Inst., Pittsburgh, PA. Author: "Reminiscences of Augustus Saint-Gaudens," 1909; "The American Artist and His Times," 1941. Contributor to: art & national magazines. Lectures: Contemporary Art. **Sources:** WW53; WW47.

SAINT-GAUDENS, Louis *[Sculptor] b.1854, NYC / d.1913.*
Addresses: Paris, France, 1899; Cornish, NH. **Studied:** with his brother, Augustus; École des Beaux-Arts, Paris. **Member:** NSS; Cornish (NH) Colony. **Exhibited:** PAFA Ann., 1899; Pan-Am. Expo, Buffalo, 1901 (medal); AIC. **Work:** "Lions," Boston Pub. Library; St. Louis Mus.; medal, MMA. **Comments:** Brother of Augustus Saint-Gaudens, married to Annetta. **Sources:** WW13; Falk, *Exh. Record Series.*

SAINT-GAUDENS, Paul *[Sculptor, craftsperson, writer, lecturer, teacher] b.1900, Flint, OH.*
Addresses: Cornish, NH; Windsor, VT. **Studied:** BMFA Sch.; British Acad., Rome; Julian Acad., Grande Chaumière, Paris, France; BAID, and with Alexander Archipenko, F. Applegate, O.L. Bachelder, C.A. Binns. **Member:** Cornish (NH) Colony; Boston SAC; New York Soc. Craftsmen; New Hampshire Lg. Artists & Craftsmen; Phila. SAC. **Exhibited:** nationally and internationally. **Work:** vases, St. Martin's Chapel, Denver; Newark Mus.; Denver AM. **Comments:** Lectures: Arts and Crafts. Contributor to *Craft Horizons*. Position: potter, Orchard Kilns, Cornish, NH. **Sources:** WW53; WW47.

ST. GAUDENS, Paul *[Sculptor, craftsman] b.1853, NYC / d.1913, Cornish, NH.*
Addresses: Windsor, VT. **Exhibited:** S. Indp. A., 1922, 1924, 1928. **Sources:** Marlor, *Soc. Indp. Artists.*

SAINT GES *[Artist and drawing master] early 19th c.*
Addresses: New Orleans, 1816. **Comments:** Came to New Orleans from France c.1816. **Sources:** G&W; Delgado-WPA cites *Ami des Lois*, June 7, 1816.

SAINTIN, Jules Émile *[Portrait, genre, historical and landscape painter] b.1829, Leme, Aisne, France / d.1894, Paris, France.*
Addresses: In NYC c.1853-66; returned to Paris permanently by 1865. **Studied:** Drolling, Le Boucher and Picot at École des Beaux Arts, 1845. **Member:** ANA,1859. **Exhibited:** NAD,1859-65; Brooklyn AA, 1861, 1877; PAFA,1867; Boston Athenaeum; Paris Salon,1848, 1866, 1870, 1886; Chevalier Legion Honor, 1877; Vienna, 1882. **Work:** BMFA. **Comments:** Specialized in Indian subjects although there is no record of his having visited the West. At the time of his death he was remembered in the U.S. chiefly for his "Pony Express" and a portrait of Stephen A. Douglas. **Sources:** G&W; N.Y. *Times*, July 16, 1894, obit.; NYBD 1856-60; Cowdrey, NAD; Naylor, NAD; Swan, BA. More recently, see Benezit; P&H Samuels, 414.

ST. JOHN *[Flower painter] mid 19th c.*
Addresses: NYC, active 1839. **Exhibited:** NAD, 1839. **Sources:** G&W; Cowdrey, NAD.

ST. JOHN, Bruce *[Art administrator, art historian] b.1916, Brooklyn, NY.*
Addresses: Stormville, NY. **Studied:** Middlebury Col. (A.B., 1938); Columbia Univ., 1940; NY Univ., 1946; Neth. Inst. Art Hist. Sem., 1964. **Comments:** Positions: dir., Mint Mus. Art, 1950-55; cur., Delaware Art Mus., 1955-57, dir., 1957-. Collections arranged: The Independents of 1910, 1960; The Life and Times of John Sloan, 1961; The Calder Family, 1961; Jerome Myers, 1966. Publications: ed., "John Sloan's New York Scene 1906-1913," Harper & Row, 1965; auth., "Jerome Myers" (catalogue), Del. Art Mus., 1966; auth., "John Sloan," Praeger, 1971; auth., "John Sloan in Philadelphia 1888-1904," *Am Art J.* (1971). **Sources:** WW73.

ST. JOHN, J. Allen *[Painter, illustrator] b.1872, Chicago.*
Addresses: Chicago, IL. **Studied:** ASL, with H.S. Mowbray, W.M. Chase, C. Beckwith, and F.V.DuMond; Académie Julian, Paris with J.P. Laurens. **Member:** Chicago PS; Cliff Dwellers; Chicago Gal. A. **Exhibited:** AIC, 1904-31; NAD, 1879, 1898; PAFA Ann., 1898, 1909, 1920. **Comments:** Teaching: AIC; Business Men's AC, Chicago. **Sources:** WW33; Falk, *Exh. Record Series.*

ST. JOHN, John *[Painter] mid 20th c.*
Exhibited: S. Indp. A., 1929-30. **Sources:** Marlor, *Soc. Indp. Artists.*

ST. JOHN, Lola Alberta *[Painter, craftsperson, designer] b.1879, Albany, IN.*
Addresses: Albany, IN. **Studied:** H.R. McGinnis; Herron AI; Cincinnati Art Acad, with Nowottny, Meakin; Indianapolis, with J.O. Adams, B. Steele. **Member:** Indiana Fed. AC; Muncie AA. **Exhibited:** Muncie AA (prize); Indiana State Fair, 1933 (prizes), 1934 (prizes), 1935 (prizes), 1937 (prizes). **Work:** Montpelier (IN) Lib.; Tipton AA. **Comments:** Specialty: china painting and design. **Sources:** WW40.

ST. JOHN, M. G. *[Painter] mid 20th c.*
Exhibited: S. Indp. A., 1941-42. **Comments:** Possibly St. Hohn, Miss Margaret G., b. 1876-d. 1965, NYC. **Sources:** Marlor, *Soc. Indp. Artists.*

ST. JOHN, S. H. (Mrs.) *[Artist] late 19th c.*
Addresses: Active in Los Angeles, 1890-91; Paris, 1892. **Sources:** Petteys, *Dictionary of Women Artists*, reports that this may be the same as Susan Hely St. John (see entry).

ST. JOHN, Susan Hely (Mrs.) *[Painter] b.1833, Boston, MA / d.1913.*
Addresses: Boston, MA,1913 and before. **Studied:** G.P.A. Healy, Chicago. **Exhibited:** NAD, 1883-87. **Sources:** G&W; *Art Annual*, XI, obit.

SAINT-LANNE, Louis *[Sculptor] b.1871, France.*
Addresses: NYC. **Work:** fountain of the seals/statue, NYC; equestrian statues, Charleston, Elkins, WV. **Sources:** WW40.

ST. LEGER, Isabella Henrietta *[Painter] d.1926, NYC.*
Addresses: NYC. **Studied:** ASL. **Exhibited:** Salons of Am.; AIC, 1916; S. Indp. A., 1918, 1924-26. **Sources:** WW21.

ST. LEGER EBERLE, Abastonia See: **EBERLE, Mary Abastenia St. Leger**

SAINT-LEONARD, George H. *[Painter] 19th/20th c.;*
b.Boston, MA.
Exhibited: Paris Salon, 1897. **Sources:** Fink, *American Art at the Nineteenth-Century Paris Salons*, 388.

SAINT MART, Lucienne de *[Painter, miniature painter]*
b.1863, Paris, France / d.1953, Laguna Beach, CA.
Addresses: France; Russia; NYC; New Orleans, LA; Laguna Beach, CA. **Studied:** sculpture in France; painting with Feyen-Perrin and Eugen Claude. **Exhibited:** Paris Salon; Laguna Beach AA; Laguna Festival of Arts. **Sources:** Hughes, *Artists in California*, 488.

SAINT-MÉMIN, Charles Balthazar Julien Fevret de
[Profilist, crayon and watercolor portraitist, landscape painter, and engraver] b.1770, Dijon, France / d.1852, Dijon.
Work: NYHS; Maryland Historical Society; Corcoran Gallery; Winterthur Mus.; Peabody Mus., Salem; MMA. **Comments:** With the outbreak of the French Revolution, he and his family emigrated to Switzerland and, in 1793, to the U.S., where they settled in NYC. Saint-Mémin had been an amateur landscape artist but in 1796 turned professional in order to assist his impoverished parents. His first productions were engraved views and maps but he soon took up the more lucrative profession of portraiture. With the aid of a physiognotrace (a machine invented in 1786 by Gilles-Louis Chrétien) he was able to create quick and accurate profiles, usually on pink or blue paper. His method was to draw the outline in pencil and then fill in details with black and white chalk. He also sold engraved versions in which the portrait image was reduced to a circular miniature size. Saint-Mémin moved from NYC to Burlington, NJ, in 1798 but spent much time in Philadelphia and traveling. Between 1804 and 1809 he journeyed to Niagara Falls; Baltimore; Annapolis; Wash., DC; Richmond; and Charleston. In Washington in 1804, he made early portraits of the Plains Indians. Returned to France in 1810 but was back in NYC in 1812, remaining there for two years and painting portraits and landscapes. In 1814 he returned permanently to Dijon where he served as director of the local museum until his death. Also appears as De Saint-Mémin. **Sources:** G&W; See biography of Saint-Mémin: Guignard, *Notice Historique sur la Vie. de Saint-Mémin* (1853), as well as numerous monographs and articles on various aspects of his work, chief among them being the following: Norfleet, *Saint-Mémin in Virginia*; Pleasants, *Saint-Mémin Water Color Miniatures*; Bolton, "Saint-Mémin's Crayon Portraits"; and Rice, "An Album of Saint-Mémin Portraits," with a useful bibliography. See also: DAB; *Richmond Portraits*; Stokes, *Iconography*. More recently, see Baigell and NYHS Catalogue (1974); P & H Samuels, 415.

SAINT PHALLE, Nikki de *[Sculptor, assemblage artist]*
b.1930, Paris, France.
Addresses: Grew up in U.S. but most of her career has been spent in Europe. **Exhibited:** The Art of Assemblage, MoMA, 1961; "Hon," a huge, hollow, reclining figure (in collab. with Jean Tinguely and Per Olof Ultvedt) shown as a temporary sculptural installation at Mod. Mus., Stockholm, Sweden, 1966; French Pavilion, Expo '67, Montreal; Pompidou Nat. Mus., Paris, 1980 (retrospective). **Comments:** Came to U.S. with her family in 1933. Moved to Paris about 1952 and became part of the avant-garde New Realist group. Her early work was inspired by dreams and often contained references to extreme violence. Around 1964, she began creating figural assemblages and huge, elaborately decorated sculptures of female goddesses. **Sources:** Rubinstein, *American Women Artists*, 358-59.

ST. PIERRE, A. Charles *[Painter] mid 20th c.*
Addresses: Duluth, MN. **Exhibited:** AIC, 1931, 1935. **Sources:** WW17.

SAINT REMY, De (Mme.) *[Portrait painter] mid 19th c.*
Addresses: NYC. **Exhibited:** NAD, 1844. **Sources:** G&W; Cowdrey, NAD.

ST. ROMAN, (Miss) *[Painter] mid 19th c.*
Addresses: New Orleans, active c.1868. **Exhibited:** Grand State Fair, 1868 (hon. men. for best miniature on ivory). **Sources:** *Encyclopaedia of New Orleans Artists*, 335.

SAINZ, Francisco *[Painter, designer] b.1923, Santander, Spain / d.1998, East Hampton, CT.*
Addresses: NYC. **Studied:** Acad. Fine Arts, Madrid; also with F. Sainz de la Maza, Barcelona. **Exhibited:** Knickerbocker Artists; FAR Gal.; Assoc Am Artists; Downtown Community Sch.; Dorsky Gal., NYC, 1960s (solos); M. Rank Gal., E. Hampton, NY, 1993 (solo). **Comments:** Figurative abstract painter of the New York School during the 1950s-60s. Designer/illustrator: *Antique French Paperweights*, 1955. Teaching: lecturer, wrought iron & Spanish art. **Sources:** WW73; obit., *New York Times* (Nov. 11, 1998).

SAISETT, Ernest Pierre De *[Painter] b.San Jose, CA / d.1899, San Jose.*
Studied: Académie Julian with Lefebvre, Bouguereau, and Constant.

SAISSEY, Mathilde *[Painter] mid 20th c.*
Exhibited: Salons of Am., 1934. **Sources:** Marlor, *Salons of Am.*

SAITO, Seiji *[Sculptor] b.1933, Japan.*
Addresses: Brooklyn, NY. **Studied:** Tokyo Univ. Art (B.F.A. & M.F.A.); Brooklyn Mus. Art School; also stone carving with Kametaro Akashi & Odilio Beggi. **Member:** NSS. **Exhibited:** Ann. Art Festival, Tochigi-Kaikan, Japan, 1958; solo shows, Samanthe Gal., NYC, 1968 & 1970; NSS Annuals, Lever House, NYC, 1970 & 1972. **Work:** NOMA; Methodist Hospital Brooklyn, NY. **Comments:** Preferred media: stone, bronze, wood. **Sources:** WW73.

SAKIDO, Yoshida *[Painter] early 20th c.*
Exhibited: Salons of Am., 1924. **Sources:** Marlor, *Salons of Am.*

SAKIER, George *[Designer, painter, writer] b.1898, NYC.*
Addresses: NYC. **Studied:** Columbia Univ.; PIA Sch. **Member:** Am. Soc. Indus. Des. (fellow). **Exhibited:** MMA; MoMA; Gld. Hall, East Hampton, NY; Phila. Artists All. (solo); PMA; WMA; GGE 1939; WFNY 1939; Paris Salon. **Comments:** Contributor to many technical and trade publications. Specialty: designer, Fostoria glassware. **Sources:** WW59; WW47, puts birth at 1897.

SAKLEM, Samuel Garabed *[Painter] b.1861, Syria / d.1943, Berkeley, CA.*
Addresses: Berkeley, CA. **Exhibited:** Oakland Art Gal., 1937. **Sources:** Hughes, *Artists in California*, 488.

SAKOAKA, Yasue *[Sculptor, instructor] b.1933, Himaji-City, Japan.*
Addresses: Lawrenceville, VA. **Studied:** Reed Col.; Portland Mus. Art Sch. (B.A.); Univ. Ore. (M.F.A.): Rinehart Inst. Sculpture, 1963-65; also with Fredrick Litman, Michel Russo, Manuel Izquierdo & Jan Zach. **Member:** Col. Art Assn. Am.; Nat. Art Educ. Assn.; Va. Art Educ. Assn. **Exhibited:** Northwest Inst. Sculpture Ann., 1962 & 1963; Rinehart Inst. Ann., Baltimore, 1964 & 1965; Int. Gallery Int. Exhib., Baltimore, 1965; Southern Assn. Sculptors, Inc. Ann. Traveling Exhib., 1970-71; Galerie Int. Exhib., NY, 1971; Shindler Gallery, Richmond, VA, 1970s Awards: Comn. awards, Jr. C. of C., Albany, Ore., 1960, Welsh Construct Co., 1963 & South Hill City Coun., 1970. **Work:** Parkside Gardens, Baltimore, Md.; Jasper Park, Ore.; Verlane, Lutherville, Md. Commissions: four concrete panels, Lake Co. Recreation Comn., Eugene, Ore., 1963; two totem sculptures, Welsh Construct. Co., Baltimore, 1965; play sculptures, Hollygrove Camp Broadmax, Va., 1970-71; play sculptures in

concrete, South Hill City Coun., Va., 1971. **Comments:** Preferred media: bronze, marble, steel. Positions: dir. arts & crafts prog., YW-YMHA Summer Camp, East Orange, NJ, 1972. Teaching: instr. sculpture, Md. Inst. Eve Sch., Baltimore, 1963-65; asst. prof. art, St. Paul's Col., Lawrenceville, Va., 1965-on. **Sources:** WW73.

SALA, Jeanne *[Painter, teacher] b.1899, Milan, Italy.*
Addresses: Wilmington, DE. **Studied:** Wilmington A. Center; Barnes Fnd.; PAFA;Europe; F. Bishop; N.C. Wyeth; E. O'Hara. **Member:** Nat. Lg. Am. Pen Women; Phila. A. All.; Pr. C., Phila.; Phila. Plastic Cl.; Rehoboth A. Lg.; Wilmington A. Center; Wilmington Studio Group. **Exhibited:** Wilmington A. Center, 1941-52; F., PAFA, 1943-46, 1952; Studio Group, 1940-52; Woodmere A. Gal., 1945.; Phila. Plastic Cl., 1946; Rehoboth A. Lg., 1944, 1951; NCFA, 1952. **Comments:** Position: instr., painting, privately. Lectures: Correlation of Art & Music. **Sources:** WW59; WW47.

SALAMON, Nicholas *[Painter] b.1894, Budapest, Hungary / d.1942, NYC.*
Addresses: Chicago area. **Exhibited:** AIC, 1923; WMAA, 1918, 1928; S. Indp. A., 1926. **Sources:** Falk, *Exhibition Record Series.*

SALAMONE, Gladys L. *[Painter] mid 20th c.; b.NYC.*
Addresses: Albuquerque, NM. **Member:** Am. Artists Prof. League, N. Mex. Art League; Nor Este Art Assn., Albuquerque. **Exhibited:** Sierra Art Soc., Truth Or Consequences, N. Mex., 1972 (first prize for oils); Fifth Ann. Nat., Fine Arts League Southern Colo., La Junta, 1972; N. Mex. 100 Invitational Nor Este Art Assn. Show, Albuquerque, 1972; N. Mex. Art League, 1972; Uncompahgre Art Guild Ann. Art Festival, Montrose, Colo., 1972 (second pl. & purchase prize in oils); Hotchkiss Fine Arts Show, 1972 (second prize in oils). **Work:** Albuquerque Nat. Bank Eastdale Off.; Sandia Officers' Club, Kirtland AFB; New Mex. Art League Old Town Gallery, Albuquerque. **Comments:** Preferred media: oils. **Sources:** WW73.

SALAZAR, Juan *[Painter, designer] b.1934, Mexico City, Mexico.*
Addresses: Mexico City, Mexico. **Studied:** Inst. Politecnico Nac.; Escuela Pintura y Escultura Inst. Nac Bellas Artes, with Carlos Orozco Romero. **Exhibited:** solo shows, Galeria Arte Mex., Mexico City, 1969, Agra Gal., Wash., DC & Mus. Nac. Arte Mod., Mexico City, 1972; Galeria de Arte Mexicano,1970s. **Work:** commissions: engravings, Carton y Papel, SA, Mexico City, 1971. **Comments:** Preferred media: oils. **Sources:** WW73; Enrique Gual, "Intereses varios," *Excelsior* (1969) & article, In: *Catalogo Expos* (1972); Ines Amor, article, In: *Catalogo Expos* (1972).

SALAZAR, Manuel *[Listed as "artist"] late 19th c.*
Addresses: New Orleans, active 1878-86. **Sources:** *Encyclopaedia of New Orleans Artists,* 335.

SALAZAR Y MAGANA, Francisca de (Mrs.) *[Portrait painter] b.1781, Mérida, Yucatan, Mexico.*
Addresses: New Orleans, active 1802. **Studied:** José De Salazar. **Member:. Comments:** She came to New Orleans with her father, José De Salazar (see entry) and other family members in 1782. She was commissioned in 1802 to make a copy of her father's portrait of Bishop Peñalver y Cardenas. Some sources say that she and/or her brother José may have assisted their father in his work. **Sources:** G&W; Van Ravenswaay, "The Forgotten Arts and Crafts of Colonial Louisiana," 195. More recently, see *Encyclopaedia of New Orleans Artists;* Gerdts, *Art Across America,* vol. 2, 92-93.

SALAZAR Y MENDOZA, José Francisco Xavier de *[Portrait painter] b.Mérida, Yucatan, Mexico / d.1802, New Orleans, LA.*
Addresses: Active in New Orleans, 1782 to 1802. **Work:** Louisiana State Mus. ("The Family of Dr. Montigut"). **Comments:** Arrived in New Orleans in 1782 as an accomplished artist and became the earliest professional portrait painter to work in that city, recording the likenesses of prominent people in the Spanish Colony. His works are the only known portraits surviving from the Spanish Occupation (1764-1803). Father of Francisca Salazar (see entry). Also appears as De Salazar. **Sources:** Groce & Wallace cited information courtesy the late William Sawitzky, who identified a number of paintings by this artist. More recently, see *Encyclopaedia of New Orleans Artists;* Gerdts, *Art Across America,* vol. 2, 92-93.

SALDIVAR, Jaime *[Painter] b.1923, Mexico.*
Addresses: Mexico DF, Mex. **Exhibited:** Mizrachi Gallery, 1965 & 1969, 1970s; Arte Naif Hispanamericano, Madrid, 1967; Naif Triennial, Bratislava, Czech, 1968; Retahlos de poetos, Castle of Chapultepec, 1971. **Work:** MoMA, Mexico City, Mex.; Pres House los Finos Mex. Commissions: Zocalo, Count Mariguy Hourlon; Villa, Pres Diaz Ordaz; Suave Patria, Pres Echeverria; Cathedral, Manuel Marron Collection. **Comments:** Publications: auth., "Naif Painters," 1970; auth., "400 Years of Plastic Arts in Mexico," 1971. Research: Art naif. **Sources:** WW73.

SALEMME, Antonio *[Sculptor, painter, graphic artist, teacher] b.1892, Gaeta, Italy. / d.1995, Easton, PA.*
Addresses: NYC. **Studied:** A. Zanelli, in Rome; Boston; Paris. **Member:** BAID; F., Guggenheim, 1932, 1936. **Exhibited:** PAFA Ann., 1921-24, 1945 (prize)-1953; S. Indp. A., 1924-25; AIC, 1930 (prize); WMAA, 1938-1941; MMA; Corcoran Gal biennials, 1947, 1955. **Work:** MMA; Newark Mus.; Syracuse MFA. **Sources:** WW47; Falk, *Exh. Record Series.*

SALEMME, Attilio *[Painter] b.1911, Boston, MA / d.1955.*
Addresses: NYC. **Exhibited:** WMAA, 1945-1953; PAFA Ann., 1951-54. **Work:** BM; MMA; MoMA; WMAA. **Comments:** Modern painter, whose work has been compared to that of Klee and De Chirico. He was married to Lucia Salemme (see entry), whom he met when working as a framemaker at the Guggenheim Mus. in NYC. **Sources:** *300 Years of American Art,* 943; Falk, *Exh. Record Series.*

SALEMME, Lucia (Autorino) *[Painter, educator] b.1919, NYC.*
Addresses: NYC. **Studied:** NAD, 1936; ASL, 1938. **Member:** AEA. **Exhibited:** Duveen-Graham Gal. (solo); Dorsky Gal. (solo); Grand Central Moderns (solo); William Zieler Gal. (solo); NYU Loeb Student Center (retrospective); Watercolors Selected By Sect., Fine Arts, Nat. Gallery Art, 1941; Trends Watercolors Today, Brooklyn Mus., 1943, 1945, 1957 & 1959; Am. Watercolor, AIC, 1944 & 1945; Sculpture & Watercolor Ann., 1949-51 & 1958 & Ann. Exhib. Contemporary Am. Painting, 1947-59, WMAA; "NYC WPA Art" at Parsons School Design, 1977. Awards: Guggenheim Foundation scholarship, 1942; MacDowell Colony fellowship, 1962. **Work:** WMAA; Nat. Gal. Art, Wash., DC; Italian Embassy, NYPL Print Collection. Commissions: mosaic mural, Mayer & Whittlesey, NY, 1958; many portraits, 1959-72; art restoration, ASL Painting Collection, NY, 1972. **Comments:** Preferred media: oils, watercolors, ink. Married to Attilio Salemme (see entry). Teaching: instructor, People's Art Center, MoMA, 1957-61; asst. prof. painting & drawing, NY Univ., 1959-; instructor painting & drawing, ASL, 1970-. Publications: author, "Color exercises for the painter," 1970; "Compositional projects for the painter," 1973, Watson-Guptill. **Sources:** WW73; *New York City WPA Art,* 76 (w/repros.).

SALEMME, Martha *[Painter] b.1912, Geneva, IL.*
Addresses: Easton, PA. **Studied:** Antonio Salemme. **Member:** Int. Platform Assn. **Exhibited:** Guild Hall, East Hampton, NY; Hudson River Mus.; Jersey City Mus.; Int. Platform Assn. Exhib., Wash. DC, 1969-71; Pietrantonio Gal., NY. **Work:** Collections: New York Hospital. **Sources:** WW73.

SALERNO, Charles R. *[Sculptor, educator] b.1916, NYC.*
Addresses: Staten Island, NY. **Studied:** ASL; Acad Grande Chaumière, Paris, Escuela Pintura Y Escultura, Mexico City; State

Univ. NY (teaching cert.); K. Nicolaides. **Member:** Audubon Artists (dir sculpture); NAD; Sculptors Guild (v. pres., 1965); NSS. **Exhibited:** PAFA Ann., 1942, 1950-66; WMAA, 1946-55; Newport AA, 1944; Clay C., NYC, 1946; NAC, 1944; Weyhe Gal., 1946 (solo), 1970s; CM, 1946; Fairmont Park Int., Philadelphia, 1949; Carvers, Modelers, Welders, MoMA, 1950; Am. Pavilion, Brussels Fair, Belg., 1958; Staten Island Mus., 1959 (purchase prize); WFNY, 1964; Audubon Artists Ann., 1971 (Margaret Hirsch-Levine Prize in Sculpture); NAD, 1972. Awards: Tiffany Found. fel. sculpture, 1948. **Work:** Mus. Art RI Sch. Design; Ariz. State Univ. Collection Am. Art; Atlanta Art Assn., Ga; Wadsworth Atheneum, Hartford, CT; Grand Rapids Art Mus., Mich. **Comments:** Preferred media: stone. Contributor: "G.I. Sketchbook." Teaching: asst. prof. sculpture, City Col. NY, 1964-. **Sources:** WW73; WW47; Frances Christoph, *Salerno sculpture* (Weyhe Gallery, 1965); Falk, *Exh. Record Series.*

SALERNO, Vincent *[Sculptor] b.1893, Sicily, Italy.*
Addresses: NYC. **Studied:** A.S. Calder; F.C. Jones; NAD BAID. **Exhibited:** Salons of Am; PAFA Ann., 1915-20, 1927. **Sources:** WW31; Falk, *Exh. Record Series.*

SALGANIK, Jassa Julius *[Portrait painter] b.1887, Kiev, Russia / d.1937.*
Addresses: NYC (came to U.S. in 1906). **Studied:** Kiev Conservatory; Md. Inst. Arts. **Work:** portraits, Pres. Taft, Charles Curtis, Cardinal Hayes, Cardinal Mundelein. **Sources:** WW.

SALIERES, Sylvain *[Teacher, sculptor] b.Auch Gers, France (came to NYC in 1902) / d.1920.*
Studied: Ecole des Beaux-Arts, Paris. **Exhibited:** Paris Salon, (med). **Award:** Grand Prix de Rome. **Work:** sculpture, Grand Central Station, NYC. **Comments:** Position: teacher, Carnegie Inst., 1916-20.

SALINAS, Baruj *[Painter] b.1935, Havana, Cuba.*
Addresses: Miami, FL. **Studied:** Kent State Univ. (B.Arch.). **Exhibited:** Exposicion 68 Año Olimpico, Mer Kup Gal., Mexico City, 1968; Watercolor USA, Springfield Mus., Mo., 1968 & 1970; Seventh Grand Prix Int. Peinture, Cannes, France, 1971; Fort Lauderdale Mus, 1969 (solo); Palacio Bellas Artes, Mex, 1971 (solo); Harmon Gallery, Naples, FL, 1970s. Awards: best transparent watercolor, Tex. WC Soc., 1964; best watercolor, Tenth Hortt Mem. Ann., 1968; Cintas Found. competition grant, 1970 & 1971. **Work:** Collections: Inst. Nac Artes, Mexico City, Mex.; Beit Uri Mus., Kineret, Israel; Inst. Int. Educ., NYC; Miami MoMA, Fla; Fort Lauderdale Mus. Arts, Fla. **Comments:** Preferred media acrylics. Publications: illusr., "Calendario del hombre Descalzo," 1970 & "Resumen AIP," 1971. **Sources:** WW73; Ràva Rémy, "Grand Prix Cote d' Azur: Baruj Salinas," *La Rev. Mod.* (1971); Wifredo Fernandez, *Baruj Salinas su mundo pictorico* (Ed. Punto Cardinal, 1971); Merle De Kuper, *Twenty-eight artists in Mexico* (Ed. Montauriol, 1972).

SALINAS, Porfirio *[Landscape and genre painter] b.1910, Bastrop, TX.*
Addresses: Probably in Austin, Texas in 1970. **Work:** priv. colls. **Comments:** When he was selling art supplies, he met Robert Wood and José Arpa who took him on field trips. Subjects: Southwest, bluebonnets, prickly cactus, rugged landscapes, village, bull fights. His paintings are untitled. **Sources:** WW66; P&H Samuels, 415.

SALING, Henry (Frederick) *[Painter] b.1901, Hartford.*
Addresses: Hartford, CT/Lyme, CT. **Studied:** P.E. Saling; M. Jacobs; J.G. McManus. **Member:** CAFA; Springfield AL. **Exhibited:** Springfield AL, 1932 (prize). **Sources:** WW40.

SALING, Paul E. *[Painter] b.1876, Germany / d.1936.*
Addresses: Hartford, CT/Lyme, CT. **Studied:** Germany; C.N.B. Flagg; A. Bunce; Conn. Lg. A. Student. **Member:** SC; CAFA; Conn. Lg. A. Students; Springfield AL; AFA. **Exhibited:** CAFA, 1915 (prize), 1934 (prize)-35 (prize); PAFA Ann., 1926; S. Indp. A., 1927. **Work:** Storrs Col., Storrs, Conn.; East Hartford Trust Co.; Odd Fellows Temple, Hartford; Elks' Temple, New London,

Conn. **Sources:** WW33; Falk, *Exh. Record Series.*

SALINGER, Flora *[Painter] 19th/20th c.*
Addresses: NYC. **Sources:** WW01.

SALISBURY, A(lta) West (Mrs. William) *[Painter, teacher] b.1879, Darnestown, MD / d.1933, New Rochelle, NY.*
Addresses: Wash., DC, until 1904; New Rochelle, NY, 1917. **Studied:** Corcoran Sch. Art; C. Yates and L. Dabo in NY; Fontainebleau Sch. FA; Dresden. **Member:** NAWPS; Brooklyn SA; Wolfe A. Club; New Rochelle AA (a founder); CAFA; Westchester ACG. **Exhibited:** Salons of Am.; Wash. WCC; Soc. Indep. Artists, 1917; New Rochelle AA (prize); Wolfe Club (prize); NAWPS, 1930 (medal). **Work:** Ebell Club, Los Angeles; Women's Club, New Rochelle. **Comments:** Most references state her birth as 1879, which is doubtful because she is listed as an artist in Wash., DC directories as early as 1891. **Sources:** WW31; McMahan, *Artists of Washington, DC.*

SALISBURY, C. B. *[Portrait painter] mid 19th c.*
Addresses: Albany, NY in 1852. **Sources:** G&W; Albany BD 1852.

SALISBURY, Cornelius *[Painter, teacher] b.1882, Richfield, UT / d.1970, Salt Lake City.*
Studied: J.F. Carlson, 1904; Univ. Utah, 1905; Brigham Young Univ., 1907-8, with Eastmond; ASL, 1908; PIA Sch. 1909-10; Corcoran Sch. Art, 1916-18; Broadmoor Art Acad., 1927. **Work:** Utah State and school collections. **Comments:** Specialty: views in Salt Lake City and ghost towns. He taught privately and at colleges and schools, 1907-43. Married to Rosine Howard Salisbury, also a painter (see entry). **Sources:** P&H Samuels, 415.

SALISBURY, Dorothy *[Painter] 20th c.*
Addresses: Maplewood, NJ. **Member:** AWCS. **Sources:** WW47.

SALISBURY, Eve *[Painter, decorator, teacher] b.1914.*
Addresses: NYC. **Studied:** Nat. Acad.; Grand Central Sch. A.; Roerich Acad. **Exhibited:** French Bldg., Rockefeller Center, NY, 1937; PAFA Ann., 1952, 1954. **Work:** USPO, Harrington, Del. **Comments:** Illustrator: Forum, 1935. WPA artist. **Sources:** WW40; Falk, *Exh. Record Series.*

SALISBURY, Helen Maynard *[Etcher] b.1890, New Jersey / d.1966, Santa Barbara, CA.*
Addresses: Santa Barbara, CA. **Exhibited:** Panama-Calif. Int'l Expo, San Diego, 1915. **Sources:** Hughes, *Artists in California, 488.*

SALISBURY, Laura Walker (Mrs. William L.) *[Miniature portrait painter] early 20th c.; b.Georgia.*
Addresses: Columbus, GA. **Studied:** W.M. Chase in NY. **Exhibited:** PAFA Ann., 1903. **Sources:** WW06; Falk, *Exh. Record Series.*

SALISBURY, Lee H(erbert) *[Painter, illustrator, etcher, writer, lecturer, teacher] b.1888, Verdon, SD.*
Addresses: Chicago, IL/Edgerton, WI. **Sources:** WW25.

SALISBURY, Paul *[Painter, illustrator] b.c.1903, Richfield, UT / d.1973, Provo, UT.*
Studied: his uncle Cornelius Salisbury (see entry). **Comments:** Work in *Western Horseman, Desert Magazine.* **Sources:** P&H Samuels, 415-16.

SALISBURY, Rosine Howard (Mrs. Cornelius) *[Painter, teacher] b.1887, New Brunswick, Canada / d.1975, Salt Lake City.*
Studied: Harwood and Richards, both in Utah; Univ. Utah, with Frazer and Evans, 1914; California, 1922 and 1928. **Work:** Utah schools. **Comments:** Teacher, Utah colleges and schools, 1922-44. Painted Utah landscapes and flowers, portraits and still-lifes. Her husband, Cornelius, was also an artist (see entry). **Sources:** P&H Samuels, 416.

SALISKE, Helen V. *[Painter] b.1909, New Britain, CT. / d.c.1989, Branford, CT.*
Addresses: Branford, CT. **Studied:** A.E. Jones; C.C. Vetter.

Member: Hartford Soc. Women P.; Assn. Conn. Ar. **Exhibited:** Hartford Soc. Women P., 1937, 1939; CAFA. **Comments:** Wife of the painter, James H.P. Conlon, she also painted local views but later turned toward abstract expressionism. **Sources:** WW40.

SALKO, Samuel *[Painter, decorator]* b.1888, Genichesk, Russia / d.1968, Phila., PA.
Addresses: Philadelphia, PA. **Studied:** Art Schs., Russia; PAFA (scholarship) with D. Garber, P. Hale, R. Vonnoh. **Member:** Providence WCC; Springfield A. Lg.; Irvington A. & Mus. Assn.; Jackson (MS) AA. **Exhibited:** AWCS, 1944-45; PAFA, 1935-36, 1941; PAFA Ann., 1951; Phila. Sketch C., 1934, 1952 (solo); Butler AI, 1943, 1945-46, 1947 (solo), 1952 (solo); PMA; Baltimore WCC, 1939; Mint Mus. A., 1943-46; Saranac A. Lg., 1943-44; State T. Col., Indiana, PA, 1944-46; Oakland A. Mus.; Oakland A. Gal., 1941-43, 1945; Jackson AA, 1942, 1944-46; Providence WCC, 1943-46; Providence AC, 1943; Newport AA, 1944-45; Ohio Univ., 1946; CAFA, 1946; NJ Soc. P. & S., 1945; Irvington A. & Mus. Assn., 1944-46; Montgomery (Ala.) WCC, 1944; Parkersburg FA Ctr., 1944-46; Corcoran Gal biennial, 1951; Phila. Free Lib.; Gilcrease Inst. Am. Hist. & A (prize); Jersey City Mus. A.; Hudson River Mus.; Sears Acad. FA, Elgin IL; Calif. WC Soc.; Crocker A. Gal., Sacramento; Portland (Me.) AA; Phila. A. All.; Woodmere A. Gal., 1945, 1946; Pacific Northwest Assn., 1946; Irvington (NJ) Pub. Lib., 1944 (solo); Cushing Mem., Newport, RI, 1945 (solo); Snellenburgs, Phila., 1952 (solo); Ardmore (Pa.) Women's Cl., 1953 (solo); Wanamakers, Phila., 1954 (solo); Gimbel, Phila., 1954 (solo); Temple Univ., Sullivan Lib., 1957 (solo); Germantown Saving Fund Soc., Phila., 1957 (solo). Other awards: PAFA fellow; Huckleberry A. Colony (prizes); fellow, MacDowell A. Colony. **Work:** U.S. War Dept.; Phila. Sketch Cl.; Jefferson Medical Col., Phila.; Univ. Penn. Sch. Medicine; Butler Inst. Am. A.; temples in Merion, PA and Boston. **Sources:** WW59; Falk, *Exh. Record Series.*

SALLA, Salvatore *[Portrait painter]* b.1903, Kosrowa, Persia.
Addresses: Oak Park, IL. **Studied:** L. De Mango, in Constantinople. **Exhibited:** AIC, 1929, 1933. **Sources:** WW40.

SALLEE, Charles L., Jr. *[Painter, graphic artist]* b.1913, Oberlin, OH.
Studied: Western Reserve Univ.; John Huntington Polytechnic Inst.; Cleveland Mus. School of Art. **Exhibited:** Howard Univ., 1937; International WC Show; Ann. May Show, Cleveland, 1937-39; American Negro Expo., Chicago, 1940; South Side Community Art Center, Chicago, 1941; Atlanta Univ., 1942. **Work:** Sunny Acres Hospital, Cleveland; US Nat'l Mus., Wash. WPA artist. **Comments:** Position: t., Playhouse Settlement; t., Kennard Junior High School, Cleveland. **Sources:** Cederholm, *Afro-American Artists.*

SALLEY, Eleanor King See: **KING, Eleanor (Eleanor King Salley Hookham)**

SALMI, Hazel Gowan *[Painter, craftsperson]* b.1893, Rockport, CA / d.1986, Richmond, CA.
Addresses: Richmond, CA. **Studied:** Calif. Sch. FA.; Calif. Col. A. & Crafts; Rudolph Schaefer Sch. Des.; Univ., California. **Member:** AFA; San Francisco Soc. of Women Artists; Western Assn. A. Mus. Dirs.; AA Mus.; Western Mus. Conference. **Comments:** Position: founder, Richmond A. Center, 1936; dir., 1936-60, Richmond, CA. **Sources:** WW59; Hughes, *Artists in California*, 488.

SALMIG, Paul E. *[Painter]* 20th c.
Addresses: Hartford, CT. **Sources:** WW19.

SALMOIRAGHI, Frank *[Photographer, instructor]* b.1942, Herrin, IL.
Addresses: Honolulu, HI. **Studied:** South. Ill. Univ. (B.S., 1965); Ohio Univ. (M.F.A., 1968). **Exhibited:** Young Photographers, Univ. N.Mex., 1968; Vision and Expression, George Eastman House, 1968-69; Serial and Modular Imagery, Purdue Univ., 1969; South. Ill. Univ., 1964 (solo); A Presence Beyond Reality, Honolulu Art Acad., 1971 (solo); The Foundry, Honolulu, HI,

1970s Awards: intramural res. grant, 1968-70 & honorarium to document vis. artists Tony Smith & Harold Tovish, 1969-70, Univ. Hawaii. **Work:** Int. Mus. Photog., George Eastman House; Nat. Mus. Can. **Comments:** Positions: free-lance photographer. Teaching: teaching asst. photog., Ohio Univ., 1966-68; instr. photog., Univ. Hawaii, 1968-71. Publications: illusr., "Popular Photog. Ann.;" illusr., "Young Photographers" (cat.), Univ. N. Mex., 1968; illusr., "Contemporary Photographers: Vision and Expression" (cat.), George Eastman House, 1968; illusr.," Nude in the Window," In: *Camera Mag.*, 1971. **Sources:** WW73.

SALMOIRAGHI, Lelio *[Painter]* mid 20th c.
Exhibited: Salons of Am., 1934. **Sources:** Marlor, *Salons of Am.*

SALMON, Daniel E. *[Illustrator]* 19th/20th c.
Addresses: Wash., DC, active 1878-1905. **Work:** pomological watercolors, U.S. Ntl. Arboretum. **Comments:** Illustrator for the U.S. Dep. of Agr. **Sources:** McMahan, *Artists of Washington, DC.*

SALMON, Larry *[Curator]* b.1945, Winfield, KS.
Addresses: Boston, MA. **Studied:** Univ. Kans. (B.A., 1967); Harvard Univ. (A.M., 1968). **Member:** Am. Assn. Mus.; Ctr. Int. Etude Textiles Anciens. **Comments:** Positions: curatorial asst., City Art Mus. St. Louis, Mo., summer 1968; asst. cur. textiles, BMFA, 1968-69, actg. cur. textiles, 1969-71, cur. textiles, 1971-on. **Sources:** WW73.

SALMON, Lionel E. *[Painter]* b.1885, London, England / d.1945, Tacoma, WA.
Addresses: Tacoma, WA, 1913-1945. **Studied:** Sir John Cass Inst., London, England; with his father, Ch. Wm. Salmon. **Exhibited:** Tacoma Art League, 1916, 1923. **Comments:** Left London in 1906 to travel the Western states until settling in Tacoma in 1913. Specialty: Western scenes, mainly Mt. Rainier. **Sources:** WW25; Trip and Cook, *Washington State Art and Artists.*

SALMON, Robert *[Marine and landscape painter]* b.1775, St. James, Whitehaven, England / d.c.1858.
Exhibited: PAFA, 1841, 1852, 1858 (in this year his "Gleaners in Brittany" was shown, listing his address as London, suggesting he was still alive). **Work:** NMAA; NGA; MMA; BMFA; CGA; Soc. for the Preservation of New England Antiquitites, Boston; Mariner's Mus., Newport News, VA; Shelburne (VT) Mus.; U.S. Naval Acad. Mus., Annapolis, MD; Mystic (CT) Seaport Mus. **Comments:** Active as a marine painter in England as early as 1800; he was at Liverpool from 1806 to 1812; at Greenock (Scotland) from 1812 to 1822; at Liverpool again from 1822-25, back to Greenock in 1825; and at London, Southampton, and North Shields in 1826. In 1828 he emigrated to America, first to New York, but soon settled in Boston where he thrived as the region's leading marine and ship painter until he returned to England in 1842. He died at an unknown date after that, sometime between 1844 and 1851 (see Brewington; Baigell; Wilmerding) but possibly even after 1858 (see Falk, PA, vol. 1, 193). Salmon had a significant impact on the develpment of marine painting in the U.S., influencing artists such as Fitz Hugh Lane, with whom he worked in the lithographic shop of William Pendleton (see entries on each). Salmon usually painted on small panels and it is estimated that he produced about 300 works while living in Boston. In 1839 he recorded his 1000th painting on a list begun in 1806. **Sources:** G&W; Childs, "Robert Salmon," with 15 repros.; Karolik Cat.; Boston CD 1831-40; Cowdrey, NAD; Swan, BA; Cowdrey, AA & AAU; Rutledge, PA, vol. 1; Falk, PA, vol. 2; Rutledge, MHS; Tolman, "Salmon's View of Boston." More recently see *300 Years of American Art*, vol. 1, 80; Brewington; Baigell, *Dictionary;* Wilmerding, *Robert Salmon: Painter of Ship and Shore*, (1971); Muller, *Paintings and Drawings at the Shelburne Museum*, 123 (w/repro.); also, the Boston Public Library owns Salmon's diary, dated 1828-41.

SALO, George K. *[Craftsman]* b.1915, Chicago, IL.
Addresses: Sutton, NH. **Studied:** AIC, with Elmer Forsberg; Whitney Sch. A., New Haven, Conn. **Exhibited:** BM, 1953;

Wichita AA, 1955; WMA, 1955; Huntington Gal., 1955; AFA traveling exh., 1950, 1953-55. Awards: des-craftsmen exh., 1953; Wichita, Kans., 1955. **Comments:** Positions: instr., Lg. of New Hampshire A. & Crafts; sample maker & des., Napier Silver Co., Meriden, Conn., 1946-48. **Sources:** WW59.

SALOMON, William *[Engraver, also printer and goldsmith]* *b.1822, New Orleans, LA / d.1881, New Orleans.*
Addresses: New Orleans, active 1841-59. **Comments:** He was ordered out of New Orleans when he refused to take the oath of allegiance to the U.S. after the city's occupation during the Civil War. Returned after the war and became a cotton weigher. **Sources:** G&W; 7 Census (1850), La., VI, 173; New Orleans CD 1841-42, 1846. More recently, see *Encyclopaedia of New Orleans Artists.*

SALOOMEY, Mabel Kaiser *[Designer, painter]* *b.1908, Bridgeport, CT.*
Addresses: Milford, CT. **Studied:** Yale. **Comments:** Specialty: screen and textile design. **Sources:** WW40.

SALSBURY, Edith Colgate *[Landscape painter, portrait painter]* *b.1907, Bedford, NY.*
Addresses: NYC. **Studied:** ASL; J. Lie; Ecole des Beaux-Arts, Fontainebleau Sch. FA. **Member:** NAWPS; NAC. **Sources:** WW40.

SALTER, Ann Elizabeth *[Painter]* *early 19th c.*
Addresses: Massachusetts, active c.1810. **Comments:** Maker of a memorial painting on velvet, Massachusetts, about 1810. **Sources:** G&W; Lipman and Winchester, 179.

SALTER, George *[Book designer, teacher]* *b.1897, Bremen, Germany / d.1967.*
Addresses: New York 3, NY. **Studied:** Municipal Sch. A. & Crafts, Berlin. **Member:** AIGA; Corres; Bund Deutscher Buchkünstler; Grolier Cl.; Soc. for Italic Handwriting, London. **Exhibited:** Fifty Books of the Year, 1937-64; Book Jacket Des. Gld., 1948-52. **Comments:** Position: instr., jacket des., Columbia Univ., 1936; book des., NY Univ., 1950-51; lettering, calligraphy, illus., CUASch., NYC, 1937-; art dir., Mercury Publications, 1939-58. Author: "Book Jacket in U.S.A.". **Sources:** WW66.

SALTER, John Randall *[Painter, sculptor]* *b.1898, Boston, MA / d.1978.*
Addresses: Flagstaff, AZ. **Studied:** AIC (B.F.A.); Univ. Iowa (M.A. & M.F.A.). **Exhibited:** AIC, 1932, 1939; Wichita Nat. Exhib., Kans., 1963; All. A. Painting Nat., NAD Galleries, 1968; Watercolor Biennial, Phoenix Art Mus., 1969; Collectors Choice, Northern Ariz. Univ., 1970; Exhib. Prints, Fedn. Rocky Mountain States, 1971; The Gallery, Rockford, IL, 1970s; Gallery 3, Phoenix, AZ, 1970s. **Work:** Northern Ariz. Univ., Flagstaff; Menninger Clin., Topeka, Kans.; var. Roman Cath. Churches; Univ. Iowa, Iowa City. Commissions: chapel (paintings, archit design, sculpture, tiles & stained glass), Church of the Epiphany, Flagstaff, 1963; woodblock wall mural, St. Pius Church, Flagstaff, 1969. **Comments:** Publications: auth., "A Comparison of Three Fertility Figures," Univ. Iowa Press, 1954. Teaching: assoc. prof. art, Northern Ariz. Univ., 1946-66. **Sources:** WW73; Bugatti, entry, In: *Encyclopaedia internazionale degli artisti* (1971).

SALTER, Nancy C. *[Painter]* *mid 20th c.*
Addresses: Clarkston, WA, 1948. **Exhibited:** Pacific Northwest Artists Annual Exh., Spokane, 1948. **Sources:** Trip and Cook, *Washington State Art and Artists.*

SALTER, Stefan *[Book designer, teacher]* *b.1907, Berlin, Germany.*
Addresses: Old Greenwich, CT. **Studied:** England & Germany. **Exhibited:** AIGA, 1945 (prize); "50 Books of the Year." **Comments:** Position: art dir., American Book-Stratford Press, 1937-43; H. Wolff Book Manufacturing Co., 1943-47; freelance, 1947-; dir., AIGA. Contributor to: *Book Binding & Book Production Magazine: Book Parade; Publisher's Weekly.* Conducted workshops in book design. **Sources:** WW66; WW47.

SALTMAN, Bertha *[Painter]* *mid 20th c.*
Exhibited: S. Indp. A., 1942. **Sources:** Marlor, *Soc. Indp. Artists.*

SALTMARCHE, Kenneth Charles *[Painter, art administrator]* *b.1920, Cardiff, Wales.*
Addresses: Windsor 15, Canada. **Studied:** Ont. Col. Art, Toronto, assoc., 1946; ASL, with Julian Levi. **Member:** Ont. Assn. Art Galleries (pres., 1968-69); Can. Art Mus. Dirs. Orgn. (secy., 1962-64); Can. Mus. Assn. **Work:** Art Gal. Hamilton, Ont.; London Art Mus., Ont.; Govt. Ont., Toronto. **Comments:** Positions: dir, Art Gallery Windsor, 1946-; art critic, Windsor Star, 1947-. Collections arranged: Some Canadians in Spain 1965; William G.R. Hind: Confederation Painter in Can., 1967; Things; Still Life Painting 17th to 20th Century, 1970. **Sources:** WW73.

SALTONSTALL, Elizabeth *[Painter, lithographer, teacher]* *b.1900, Chestnut Hill, MA / d.1990.*
Addresses: Chestnut Hill, MA. **Studied:** BMFA Sch. (dipl); also painting with Andre Lhote, Paris; lithography with Stow Wengenroth; Frank Swift Chase; P.L. Hale; H.H. Clark. **Member:** AEA; Audubon Artists; Springfield A. Lg.; NAWA; Pen & Brush Cl.; Boston Printmakers; Nantucket AA. **Exhibited:** LOC,1942, 1944-46 & 1949; NAD, 1944, 1946; NAWA, 1940-46; Jordan Marsh Gal.; Inst. Mod. A., Boston, 1943-45; Northwest Pr.M., 1945, 1946; BM, 1948; Carnegie Inst. Graphics Invitationals, 1946, 1947 & 1950; CI, 1951; Laguna Beach AA, 1945-46; Boston Printmakers, 1958, 1967 & 1969; Audubon Artists Ann., 1960, 1967 & 1969; Print Cl. Albany, 1971. **Work:** LOC;BMFA; Boston PL; Yale Univ. Art Gal.; Bixler Mus, Colby Col., Maine. **Comments:** Preferred media: oils. Teaching: instr. painting, Winsor Sch., Boston, 1923-28; instr. painting, Milton Acad., Mass., 1928-65. **Sources:** WW73; WW47.

SALTONSTALL, Nathaniel *[Collector]* *b.1903, Milton, MA.*
Addresses: Boston, MA. **Studied:** Harvard Univ.; MIT. **Comments:** Positions: AIA registered architect (partner), Massachusetts, New York and Virginia; hon. pres., Institute of Contemporary Art, Boston; trustee and advisory committee, Decorative Arts Exhibition Program, AFA; trustee and chairman, Visiting Committee, Textiles Department, BMFA; advisory council, Friends of Art, Colby College, Waterville, Me.; advisory board, Skowhegan School of Painting and Sculpture, Skowhegan, Me. Collection: American contemporary art. **Sources:** WW66.

SALTUS, J. Sanford *[Patron, painter]* *b.1853, New Haven, CT / d.1922, London.*
Addresses: NYC. **Member:** British Numismatic Soc. (pres.); Am. Numismatic Soc. (hon. pres.); Legion of Honor of France; SC. **Exhibited:** PAFA Ann., 1887-88. **Comments:** He annually gave the Saltus medal for merit at the National Academy of Design, and gave rare books on costume to the library of the Salmagundi Club. He donated $25,000 to the fund for the erection of the Joan of Arc statue on Riverside Drive, and presented a replica of it to the city of Blois, France. He also gave a life-size statue of Joan of Arc to the Cathedral of St. John the Divine for the French Chapel. **Sources:** WW21.

SALTUS, Medora *[Painter]* *late 19th c.*
Addresses: NYC, 1889-1893. **Exhibited:** PAFA Ann., 1887; NAD, 1889-93. **Sources:** Naylor, *NAD;* Falk, *Exh. Record Series.*

SALTZMAN, Mary P(eyton) E(skridge) *[Painter]* *b.1878, Ft. Leavenworth, KS.*
Addresses: Wash., DC, active mid 1930s; Hague, NY. **Member:** Wash. Art Lg.; Soc. Indep. Artists, Wash. **Exhibited:** S. Indp. A., 1932; Gr. Wash. Indep. Exhib., 1935. **Sources:** WW33; McMahan, *Artists of Washington, DC.*

SALTZMAN, William *[Painter, mural painter, teacher, designer]* *b.1916, Minneapolis, MN.*
Addresses: Minneapolis, MN; Rochester, MN, 1951. **Studied:** Univ. Minn. (B.S.), 1940. **Member:** United Am. Ar; Col. Art Assn. Am.; NSMP. **Exhibited:** Minneapolis Inst. A., 1936 (prize), 1937-41; Minn. State Fair, 1936, 1937 (prize), 1940 (prize), 1941; CPLH, 1946; St. Paul Gal. A., 1946; Minneapolis Women's C.;

Walker A. Ctr., 1941 (solo); St. Olaf Col., 1938 (solo); Univ. Minn., 1939 (solo); Abstract and Surrealist American Art, 58th Ann. Exhib. Am. Paintings & Sculpture, AIC, 1948; 13th Ann. Watercolor Exhib., San Francisco Art Assn, SFMA, 1949; Ann. Exhib. Contemp. Am. Painting, WMAA,1951-52; Corcoran Gal biennials, 1951, 1953; Pittsburgh Intl., CI,1952; PAFA Ann., 1953; 5th Midwest Biennial Exhib., Joslyn Art Mus., 1958; 48th Ann. Minn. State Fair, Saint Paul, 1958 (popular award); Second Ann. Exhib. Minn. Artists, Golden Rule, Minn.,1959 (popular award & president's medal for Illuminated Skyline in oil); Ball State 10th Ann. Show,1964 (award); Suzanne Kohn Gallery, Saint Paul MN, 1970s. **Work:** Mayo Clinic, Rochester, Minn.; Minneapolis Inst. Art; Walker Art Ctr., Minneapolis; Joslyn Mus, Omaha, Nebr. Commissions: exterior mural, glazed brick, YMCA-YWCA Bldg., Rochester, Minn., 1964; Univ. Minn.; paintings, Cummington Sch., MA; welded sculpture, Ten Commandments, Eternal Light & candelabra, B'nai Abraham Synagogue, St. Louis Park, Minneapolis, 1965; stained glass windows & meditation chapel, Univ. Minn. Hosps., Minneapolis, 1965. **Comments:** Positions: supvr. art, Fairmont Pub. Schs., Minn.; camouflage adv., US Engrs., 1942-46; mem. Gov. Comt., Minn.; State Art Soc., 1946-50; resident artist & dir., Rochester Art Ctr., 1948-64; juror, many exhibs., Iowa, Wis. & Minn., 1948-. Teaching: Univ. Minn. & asst. dir., Univ. Minn. Gal., Minneapolis, 1946-48; St. Olaf Col., 1951-54; Univ. Nebr., Lincoln Spring 1964; Macalester Col., 1966-70s. **Sources:** WW73; WW47; Falk, *Exh. Record Series.*

SALTZMANN, John C. See: **SALZMANN, Jean Christian**

SALVADOR, Richard *[Sculptor] mid 19th c.*
Addresses: New Orleans, active 1860-66. **Sources:** *Encyclopaedia of New Orleans Artists,* 336.

SALVATOR, John *[Painter] early 20th c.*
Addresses: NYC. **Exhibited:** S. Indp. A., 1920. **Sources:** Marlor, *Soc. Indp. Artists.*

SALVATORE, Victor D. *[Sculptor, painter, teacher] b.1884, Tivoli, Italy / d.1965.*
Addresses: NYC; Springfield Centre, NY. **Studied:** CUA Sch.; ASL; A. Phimister Proctor; Gutzon Borglum; Solon Borglum; Karl Bitter; Charles Niehaus. **Member:** ANA; NSS, 1913; Artists Aid Soc.; Arch. Lg.; Century Artists; All. Artists Am.; Cooperstown AA. **Exhibited:** St. Louis Expo, 1904 (med.); PAFA Ann., 1906, 1911-21, 1934, 1939, 1943; Armory Show, 1913; Pan-Pacific Expo, San Fran., 1915 (med.); NAD, 1919 (prize); AIC, 1919 (prize); Concord AA, 1920 (prize); MMA; NSS; Portland (OR) Mus. Art; MacDowell Club; Grand Central Art Gal.; WMAA, 1918-28. **Work:** MMA; BM; Portland (OR) Mus. Art; Cooperstown Baseball Mus.; NY Hist. Soc.; Cooperstown Hall of Fame. **Sources:** WW59; WW40, puts birth at 1885; Falk, *Exh. Record Series;* Brown, *The Story of the Armory Show.*

SALVIGNAC, Jean *[Portrait painter] mid 19th c.*
Addresses: New Orleans, 1830. **Sources:** G&W; Delgado-WPA cites New Orleans CD 1830.

SALVIOLI, Attilio *[Sculptor, decorator] 19th/20th c.*
Addresses: New Orleans, active 1900-1903. **Comments:** Learned his art in 1877 and established himself in N.O. in 1900. Preferred cemetery work. **Sources:** *Encyclopaedia of New Orleans Artists,* 337.

SALWAY, Cecile *[Painter] mid 20th c.*
Exhibited: AIC, 1942. **Sources:** Falk, *AIC.*

SALZ, Helen (Mrs. Ansley K.) *[Portrait painter] b.1883, San Francisco / d.1978, San Francisco.*
Addresses: San Francisco, CA. **Studied:** Calif. School FA, San Francisco, with G. Piazzoni; ASL, with Rockwell Kent and Robert Henri. **Member:** San Fran. AA; San Fran. Soc. Women Artists; AEA. **Exhibited:** Marie Sterner Gals., NYC, 1935 (solo); SFMA, 1935, 1939 (WC Ann.); GGE, 1939; Morton Gal., NY, 1939; CPLH, 1943; Rotunda Gal. of San Francisco, 1948, 1955; Carmel AA, 1949; Santa Barbara Mus., 1952; de Young Mus., 1959.

Work: SFMA; Santa Barbara Mus. **Comments:** Sister of G. Arnstein (see entry). Preferred medium: oil and watercolors; later, pastels. Founder: Presidio Hill School, San Francisco. **Sources:** WW40; Hughes, *Artists in California,* 488.

SALZ, Samuel *[Art dealer] 20th c.*
Addresses: NYC. **Sources:** WW66.

SALZBRENNER, Albert *[Painter] 20th c.*
Addresses: Salt Lake City, UT. **Sources:** WW15.

SALZMAN, Edward *[Painter] mid 20th c.*
Addresses: NYC. **Exhibited:** S. Indp. A., 1934, 1937. **Sources:** Marlor, *Soc. Indp. Artists.*

SALZMANN, Jean Christian *[Engraver] b.1758, Erfurt, Germany / d.1840, New Orleans, LA.*
Addresses: New Orleans, active 1827-40. **Comments:** His name also appears as John C. Salzmann (and Saltzmann). **Sources:** Groce & Wallace; *Encyclopaedia of New Orleans Artists,* 337.

SALZMANN, John C. See: **SALZMANN, Jean Christian**

SAMARAS, Lucas *[Sculptor, assemblage and multi-media artist, photographer] b.1936, Kastoria, Greece.*
Addresses: NYC. **Studied:** Rutgers Univ. (B.A., 1959) with Alan Kaprow; Columbia Univ., art history with Meyer Schapiro, 1959-62. **Exhibited:** Reuben Gal., NYC, 1959 (solo); Corcoran Gal biennial, 1963; WMAA, 1964-79; "Mirror Room," fabricated and shown at the Pace Gal., NYC, 1966; AIC, 1967; "The Obsessive Image," Inst. Comtemp. Art, London, 1968; "Dada, Surrealism and Their Heritage," MoMA, 1968; Documenta IV, Kassel, Ger., 1968; WMAA, 1972 (retrospective). **Work:** MoMA; WMAA; Albright-Knox Art Gal., Buffalo; LACMA; Walker Art Ctr., Minneapolis; Saint Louis AM. **Comments:** Took part in some of the first Happenings in 1959. Began making textured boxes in 1960, covering them with such things as pins and tacks; by the mid 1960s they were being constructed out of both banal and sometimes bizarre found objects. He made his first mirrored room in 1965. Samaras work has been intensely autobiographical; in 1963 he began using photographs of himself as part of his work. This continued through the 1970s. **Sources:** WW73; Baigell, *Dictionary* Kim Levin, *Lucas Samaras* (1975); Lawrence Alloway, *Samaras: Selected Works 1960-1966* (exh. cat., Pace Gallery, 1966); *Two Hundred Years of American Sculpture,* 307; Christopher Finch, *Pop Art: Object and Image* (Dutton, 1968); Max Kozloff, *Renderings* (Simon & Schuster, 1968).

SAMBROOK, Russell *[Illustrator] mid 20th c.*
Comments: From the 1920s-50s, he illustrated for *Sat. Eve. Post, People's Home Journal, The American Boy,* and other magazines. **Sources:** info. courtesy Illustration House (NYC, essay #11).

SAMBUGNAC, Alexander *[Sculptor, painter] b.1888.*
Addresses: NYC. **Studied:** F. von Stuck, in Munich; A. Bourdelle, in Paris. **Member:** NSS; Arch. Lg. **Exhibited:** Salons of Am.; WMAA, 1936. **Work:** USPOs, Mount Pleasant (Pa), Miami (Fla.), Rochester (Mich.); Courthouse, Miami; Mus. FA, Budapest; Cathedral, Vienna; Capitol, Havana. WPA artist. **Sources:** WW40.

SAMBURG, Grace B. *[Painter] mid 20th c.*
Exhibited: S. Indp. A., 1941. **Sources:** Marlor, *Soc. Indp. Artists.*

SAMERJAN, George E. *[Designer, painter, teacher, lecturer, sculptor, illustrator] b.1915, Boston, MA.*
Addresses: Hollywood, CA; Katonah, NY. **Studied:** Art Ctr. Col. (grad., 1938); Chouinard Art Inst., 1933; Otis Art Inst., 1940-41; also with Alexander Brook & Willard Nash; B. Miller; S. Reckless. **Member:** Calif. WCC; A. Dir. C., Los Angeles; Aquarelle P.; San Diego FA Soc; AWCS; Audubon Artists. **Exhibited:** AIGA, 1941 (prize); Los Angeles Adv. C., 1940 (prize); A. Fiesta, San Diego, 1938 (prize), 1939-42; Calif. WCC, 1938-42, 1943 (prize); Santa Cruz A. Lg., 1942 (prize); Oakland A. Gal., 1940 (med.); Laguna Beach AA, 1939 (prize); NAD, 1941; VMFA, 1940, 1942, 1943; PAFA, 1938-40, 1943; AWCS,

1941, 1942; Denver A. Mus., 1941-42; San Fran. AA, 1940-42; LACMA, 1939, 1941-42; New Haven PCC, 1941; Wash. WCC; CGA; Riverside Mus., 1938-39, 1941; Calif. State Fair, 1939-41; Santa Paula, Calif., 1942-45; Santa Barbara A. Mus.; Grand Central A. Gal.; SAM; Los Angeles AA; Calif. Inst. Tech.; Liège, Belgium; Paris, France. Awards: Am. Inst. Graphic Arts, Art Dirs. Club Phila. **Work:** San Diego Fine Arts Soc.; Fla. Southern Col.; Abbott Labs.; Ford Motor Co. Collection: Cole of California, Los Angeles. Commissions: WPA murals, US Post Off., Maywood, Calexico & Culver City, Calif.; murals, Lexington Hospital, Ky., Am. Red Cross & New York Hospital; design Arctic Commemorative Stamp, 1959, Adlai Stevenson Mem. Stamp, 1965 & Erie Canal Sesquicentennial Stamp, 1967, US Post Off. Dept.; SC Tricentennial, 1970. **Comments:** Positions: art dir., *Los Angeles Times,* 1946-; t., Occidental Col., Calif.; doc. artist, USAF in the Arctic & elsewhere; chmn., Soc. Illustrators Sem., 1962-63. Teaching: lect., Introduction to the Graphic Arts, New York Univ., adj. asst. prof., New York Univ. **Sources:** WW73; WW47.

SAMET *[Painter] mid 20th c.*
Addresses: Dannemora, NY. **Exhibited:** S. Indp. A., 1936. **Sources:** Marlor, *Soc. Indp. Artists.*

SAMIDE, Josephine *[Teacher and painter] b.1902, Denver, CO.*
Addresses: Des Moines, IA. **Studied:** Colorado State College of Educ., Greeley, CO; Estelle Struchfield. **Member:** Delta Phi Delta; Iowa Artists Cl. **Exhibited:** Iowa Artists Club, 1935 (prize); Iowa Artists Exhibit, Mt. Vernon, 1938; Fort Dodge Art Guild (prize). **Comments:** Position: art teacher, Des Moines Public Schools. **Sources:** Ness & Orwig, *Iowa Artists of the First Hundred Years,* 182.

SAMISH, Louis Robert *[Cartoonist, china painter] b.1879, San Francisco, CA / d.1963, San Fran.*
Addresses: San Francisco. **Studied:** with his father Robert L. Samish. **Exhibited:** PPE, 1915 (gold med. for china). **Comments:** Position: cart., U.S. Government war bonds. **Sources:** Hughes, *Artists in California,* 489.

SAMISH, Robert Louis *[China painter] b.1846, Austria / d.1926, San Francisco, CA.*
Addresses: Los Angeles, CA; San Francisco, CA. **Comments:** Father of Louis R. Samish (see entry). **Sources:** Hughes, *Artists in California,* 489.

SAMMANN, Detlef *[Landscape painter, mural painter] b.1857, Westerhever, Schleswig, Germany / d.1938, Dresden, Germany.*
Addresses: Pebble Beach, CA; Dresden, Germany, 1921-1938. **Studied:** with Wilhelm Ritter, Industrial Art School, Dresden; ASL. **Exhibited:** Calif. AC, 1911; Friday Morning Club, Los Angeles, 1914; AIC, 1914, 1918-19; Kanst Gallery, Los Angeles, 1916; S. Indp. A., 1917; Del Monte Art Gallery; San Francisco AA annuals; Golden Gate Park Memorial Mus., 1916; Panama-Calif. Int'l Expo, San Diego, 1916 (silver med.). **Comments:** Immigrated to the U.S. in1881 and worked in NYC as a mural painter and decorator. Moving to California in 1898, he painted many frescoes in the German rococo style in houses in San Diego, San Francisco and Pasadena. After retirement Sammann painted landscapes, coastal scenes and marines. **Sources:** WW17; Hughes, *Artists in California,* 489.

SAMMEL, Carrie E. See: **JONES, Carrie Sammel**

SAMMET, E. R. *[Painter] 20th c.*
Addresses: Columbus, OH. **Member:** Columbus PPC. **Sources:** WW25.

SAMMONS, Carl *[Painter] b.1886, Kearney, NE / d.1968, Oakland, CA.*
Addresses: Oakland, CA. **Studied:** Calif. Sch. of FA. **Exhibited:** Calif. Artists, Calif. Industries Expo, San Diego, 1926; GGE, 1940. **Comments:** Specialty: landscapes and coastal scenes in oil and pastel. **Sources:** Hughes, *Artists in California,* 489.

SAMMONS, Frederick Harrington Cruikshank *[Painter] b.1838, Bath, England / d.1917.*
Addresses: Chicago, IL. **Studied:** J. Gruder, in Dresden; J. Marshall, in Weimar. **Member:** Chicago SA. **Exhibited:** AIC, 1901-02. **Comments:** Official restorer of paintings for the Chicago AI. Godson of G. Cruikshank. **Sources:** WW17.

SAMOLAR, Esther R. *[Artist] mid 20th c.*
Addresses: Cleveland, OH. **Exhibited:** PAFA Ann., 1953. **Sources:** Falk, *Exh. Record Series.*

SAMOURI, Claude *[Engraver] mid 19th c.*
Addresses: New Orleans, 1850-51. **Sources:** G&W; Delgado-WPA cites New Orleans CD 1850-51.

SAMPLE, Paul Starrett
[Landscape and genre painter, teacher] b.1896, Louisville, KY / d.1974, Hanover, NH.

Paul Sample

Addresses: Pasadena, CA, 1931-34; Hanover, NH; Norwich, VT. **Studied:** Dartmouth, 1916-21 (less one year in the Navy); Otis AI; at age 30 with Jonas Lie; F. Tolles Chamberlain & Stanton MacDonald Wright. **Member:** AWCS; Calif. AC; ANA, 1937; NA, 1941; Calif. WCS. **Exhibited:** Corcoran Gal biennials, 1930-51 (9 times); AIC, 1930 (prize)-45; LACMA, 1930 (prize), 1936 (prize); Calif. AC, 1930 (prize), 1931 (prize); NAD, 1931 (prize), 1932 (gold), 1962 (1st Altman Prize); PAFA Ann., 1931-49, 1960 (1936 Temple Medal, 1941 prize); WMAA, 1936-44; Pasadena AI, 1932 (prize); Calif. State Fair, 1932 (prize); Santa Cruz Art Lg., 1933 (prize); CI, 1936 (hon. men.); Currier Gal. Art, Manchester, NH, 1948 (retrospective); Capricorn Gal., Bethesda, MD, 1970s; Eric Gal., NYC, 1970s. **Work:** BMFA; PAFA; MMA; AIC; BM; Springfield Mus. Art; Fnd. Western Artists, Los Angeles; White House, Wash., DC; Canajoharie (NY) Library; San Diego FA Soc.; AGAA; Butler AI; Joslyn Mem.; Brooks Mem. Art Gal.; RISD Mus.; Univ. Nebraska; Swarthmore College; Williams College; Univ. Minnesota; Univ. Southern Calif.; New Britain Mus. Art; Dartmouth. Commissions: murals, Nat. Life Ins. Co., Montpelier, VT; Brevoort Hotel, NYC; Appanaug Post Office, RI; Redondo Beach Post Office, CA; Massachusetts Mutual Ins. Co., Springfield. **Comments:** He turned to art while recuperating from tuberculosis in the Adirondacks. Went to California in 1926. Preferred media: oils, watercolors, acrylics. Positions: teacher, Univ. Southern Calif., 1926-; Dartmouth Col., 1938-62; war art correspondent, *Life Magazine,* 1942-45. **Sources:** WW73; WW47; P&H Samuels, 416; Falk, *Exh. Record Series.*

SAMPLINER, Paul H. (Mr. & Mrs.) *[Collectors] 20th c.*
Addresses: NYC. **Sources:** WW73.

SAMPSON, Alden *[Painter, writer] b.1853, Manchester, ME.*
Addresses: NYC. **Exhibited:** AIC, 1919. **Sources:** WW21.

SAMPSON, Andrea Sally (Mrs. F.W.) *[Painter, printmaker] b.1891, New Brighton, MN.*
Addresses: Everett, WA, 1962. **Studied:** C. Rice, A. Patterson, E. Ziegler, Leon March. **Member:** Women Painters of Wash., 1934. **Exhibited:** Women Painters of Wash., frequently, 1934-50s; Grant Galleries, NYC; Everett and Seattle, WA, 1938 (solos). **Comments:** Preferred media: oil, watercolor. **Sources:** Trip and Cook, *Washington State Art and Artists.*

SAMPSON, Atlanta Constance *[Abstract painter] b.1896.*
Addresses: NYC until c.1988; Toeterville, IA, thereafter. **Studied:** Univ. of Minn., 1918; with Hans Hoffmann in NYC, 1961. **Exhibited:** NAC, 1988 (first solo, at age 91). **Comments:** She taught art in Detroit public schools, then moved to NYC at age 65. **Sources:** articles in *New York Times* (Apr. 20, 1988), *Des Moines Register* (May, 3, 1988) and others courtesy Owen Ryan.

SAMPSON, Charles Clair *[Painter] b.1859, Marysville, CA / d.1927, San Francisco, CA.*
Addresses: San Francisco, CA. **Studied:** San Francisco, c.1880. **Comments:** He supported his wife and 7 children by painting

large nudes for local barrooms for 25 years. **Sources:** Hughes, *Artists in California*, 489.

SAMPSON, Cornelius Cogswell *[Painter, etcher, commercial artist] b.1907, Billings, MT / d.1978, Berkeley, CA.*
Addresses: San Francisco, CA. **Studied:** AIC, 1929-34.
Member: Industrial Designers of America. **Work:** Oakland Mus. WPA artist. **Comments:** He had a studio in San Francisco, and did watercolors and etchings in his leisure time. **Sources:** Hughes, *Artists in California*, 489.

SAMPSON, Elizabeth Marsh *[Painter] mid 20th c.; b.Clinton, MA.*
Addresses: Worcester, MA. **Studied:** O. Victor Humann, Herbert Barnett, A.T. Hibbard. **Member:** Worcester Guild of Artists and Craftsmen; Rockport AA. **Exhibited:** Worcester Guild of Artists and Craftsmen; Rockport AA; Worcester Art Mus. **Sources:** *Artists of the Rockport Art Association* (1946).

SAMPSON, Emma Steer Speed (Mrs. Henry A.) *[Painter] 19th/20th c.; b.Chatsworth, Crescent Hills, KY.*
Addresses: Louisville, KY. **Studied:** ASL; Acad. Julian, Paris with Lefebvre & Constant. **Member:** Louisville Art Lg., 1898. **Sources:** WW01; Petteys, *Dictionary of Women Artists.*

SAMPSON, Genevieve Fusch *[Painter] mid 20th c.*
Addresses: Chicago area. **Exhibited:** AIC, 1929. **Sources:** Falk, *AIC.*

SAMPSON, Helene *[Painter] b.1894, Superior, WI.*
Addresses: Active in New Orleans. **Studied:** B. Karfiol and G.E. Browne; Acad. Julian in Paris. **Exhibited:** Shreveport Art Club, 1938; SSAL, 1938; Argent Gals., NYC, 1939 (solo). **Sources:** Petteys, *Dictionary of Women Artists.*

SAMPSON, John *[Lithographer] b.c.1826, Maryland.*
Addresses: Baltimore in 1850. **Sources:** G&W; 7 Census (1850), Md., V, 66.

SAMPSON, John H. *[Designer, landscape painter] b.1896, Rush County, IN.*
Addresses: Chicago, IL. **Member:** Hoosier Salon. **Comments:** Designer: packages for merchandise and advertising. **Sources:** WW40.

SAMPSON, Margaret S. *[Painter] early 20th c.*
Addresses: NYC. **Studied:** ASL. **Exhibited:** S. Indp. A., 1924.
Sources: Marlor, *Soc. Indp. Artists.*

SAMSTAG, Gordon *[Painter, sculptor, illustrator, teacher] b.1906, NYC.*
Addresses: Bronxville, NY, 1940s-61; North Queensland, Australia, 1961-on. **Studied:** NAD; ASL; C.W. Hawthorne; Neillson; also in Paris. **Member:** ANA, 1939; CAFA; Allied AA; NAD; Contemp. Art Soc. (pres., 1968); Royal South Australian Soc. Art; Burnside Painting Group (pres., 1964). **Exhibited:** Corcoran Gal. biennials, 1928-43 (6 times); NAD, 1931 (prize), 1936 (prize) 1949 (Clarke Prize); Salons of Am., 1934; PAFA Ann., 1935-37 (prize 1936), 1950 (Lippincott Prize); AIC, 1936, 1938; All.A.Am., 1936 (prize); Pulitzer traveling scholarship, 1938; Palm Beach AL, 1935 (prize); CAFA, 1936 (prize); CI, 1959; Contemp. Art Soc. Interstate, Hobart Tas., Melbourne & Sydney, 1967-70; Woodville Critics Prize, 1968. **Work:** TMA; Santa Barbara Mus; Aldridge Collection, Australia. Commissions: WPA paintings USPO, Reidsville, NC & Scarsdale, NY; collage, Diamond Christensen, Adelaide. **Comments:** Teaching: NAD, 1940; dir., Am. Art Sch., NYC, 1951-61; South Australian Sch. Art, 1961-71. Publications: editor, *Bulletin Australian Soc. Educ. Through Art*, 1968; *Contemp. Art Soc. Quarterly*, 1969; *Collection*, Elliot Aldridge, 1970. **Sources:** WW73; WW47; Falk, *Exh. Record Series.*

SAMUEL, Hélène *[Painter] b.1894, Superior, WI.*
Addresses: New Orleans, LA. **Studied:** Académie Julian, Paris; B. Karfiol; G.E. Browne. **Member:** A.C.C., New Orleans; SSAL. **Exhibited:** Salons of Am.; S. Indp. A., 1932-34, 1937, 1940; Shreveport AC, 1938 (prize); SSAL, Montgomery, Ala., 1938;

Argent Gal., NY, 1939 (solo). **Work:** Seaton Gld., Minneapolis. **Sources:** WW40.

SAMUEL, William M. G.
[Painter] b.1815, Missouri / d.1902, San Antonio, TX.
Studied: self-taught. **Work:** Witte Museum (San Antonio) owns his four views of the main plaza of the city, dated 1849.
Comments: Specialties: painter of Texas town views and notables at mid-century. Came to Texas late 1830s; fought in the Indian Wars, worked for the San Antonio government; was also a sheriff. **Sources:** *Antiques* (June 1948), 457; Groce and Wallace; Lipman and Winchester, 179; P&H Samuels, 417.

SAMUELS, Albert *[Painter] late 19th c.*
Studied: Thomas LeClear, c.1860. **Comments:** Was active at the Buffalo Fine Arts Academy, c.1860s-1900. **Sources:** McMahan, *Artists of Washington, DC.* Bibliography: Krane, *The Wayward Muse*, 195.

SAMUELS, Dan *[Painter] mid 20th c.*
Addresses: Brooklyn, NY. **Exhibited:** PAFA Ann., 1952.
Sources: Falk, *Exh. Record Series.*

SAMUELS, George *[Painter] early 20th c.*
Exhibited: AIC, 1924. **Sources:** Falk, *AIC.*

SAMUELS, W. G. M. See: **SAMUEL, William M. G.**

SAMUELSON, Fred Binder *[Painter, educator] b.1925, Harvey, IL.*
Addresses: San Miguel de Allende, Mexico. **Studied:** AIC Sch. (B.F.A., 1951, M.F.A., 1953); Univ. Chicago, 1946-53.
Exhibited: 60th Ann. Exhib. Western Art, Denver Art Mus., 1954; 20th Ann. Tex. Painting & Sculpture Exhib., Dallas Mus. Fine Art, 1958; Southwest Am. Art Ann., Okla. Art Ctr., 1960; Segundo Festival Pictorico Acapulco, 1964; 53rd Tex. Fine Arts Assn. Ann., 1964; Four Winds Gal., Kalamazoo, MI, 1970s. **Work:** oil, Denver Art Mus., Colo.; watercolor, Witte Mus., San Antonio, Tex.; acrylics, Ohio Univ., Athens & Tex. Fine Arts Assn., Laguna Gloria Mus., Austin. Commissions: acrylic mural, Hemisfair 1968, San Antonio, 1968. **Comments:** Preferred media: acrylics. Teaching: instr. painting & drawing, Inst. Allende, San Miguel de Allende, Mex., 1955-63; chmn. faculty, San Antonio Art Inst., 1963-64; head grad. studies & painting, Inst. Allende, 1965-. **Sources:** WW73; Leonard Brooks, *Oil painting Traditional and New* (1959) & *Wash Drawings* (1961, Van Nostrand Reinhold); interview, *Time-Life* (1965).

SAMUELSON, Paul F. *[Painter] mid 20th c.*
Exhibited: AIC, 1949-50. **Sources:** Falk, *AIC.*

SAMYN *[Lithographer] mid 19th c.*
Work: Copy at Library of Congress. **Comments:** Lithographer of ten plates in John Delafield's *Inquiry into the Origins of the Antiquities of America* (N.Y., 1839). **Sources:** G&W.

SANBORN, C. T. See: **SANBORN, Caroline V. (Mrs. Nestor)**

SANBORN, Caroline V. (Mrs. Nestor) *[Painter, teacher] b.c.1843 / d.1943, Brooklyn, NY.*
Addresses: NYC, Brooklyn, NY. **Member:** S. Indp. A.
Exhibited: NAD, 1882; PAFA Ann., 1882-83; S. Indp. A., 1921-23. **Comments:** Taught art in her own studio and in private schools. Marlor & PAFA vol. II give date of death as 1934.
Sources: WW25 (listed as C.T. Sanborn); Naylor, NAD (listed as C.V. Sanborn); Marlor, *Soc. Indp. Artists;* Falk, *Exh. Record Series.*

SANBORN, Earl Edward *[Painter, teacher, designer] b.1890, Lyme, NH / d.1937.*
Addresses: Annisquam, Wellesley Hills, MA. **Studied:** BMFA Sch., with Burbank, Tarbell, Benson, Paxton. **Member:** Boston AC; Stained Glass Assn. of Am.; Rockport AA. **Exhibited:** S. Indp. A., 1917; PAFA Ann., 1918; Boston Tercentenary Exh., 1931 (gold). **Award:** BMFA traveling scholarship, 1914-16.
Work: stained glass, National Cathedral, Wash., DC; Trinity Col.,

Chapel, Hartford, CT; Boston Col. Library, Boston, MA; St. Margaret's Convent, Boston. **Sources:** WW33; Falk, *Exh. Record Series.*

SANBORN, Edward *[Illustrator] mid 20th c.*
Addresses: Burlington, VT. **Work:** Shelburne (VT) Mus. **Sources:** Muller, *Paintings and Drawings at the Shelburne Museum,* 123 (w/repros.).

SANBORN, Herbert James *[Lithographer, painter, mural painter, lecturer] b.1907, Worcester, MA.*
Addresses: Oglebay Park, WV; Alexandria, VA. **Studied:** NAD, Pulitzer traveling fellowship, 1929; Teachers College, Columbia Univ.; Univ. Chicago. **Member:** Wheeling (WV) A. Cl. (pres.); AA Mus.; Am. Assn. Adult Education; Wash. Chapter Am. Inst. Graphic Arts (pres., 1971); Print Cl. Phila.; Watercolor Soc. Wash.; Inter-Soc. Color Council. **Exhibited:** West Virginia Artists, Parkersburg, 1940 (prize); Arch. Lg., 1931; Davenport Mun. Art Gal., 1933; Joslyn Mem., 1934; Parkersburg FAC, 1940; Wickford (RI) AA, 1929; Third Ann. Virginia Printmakers, Univ. Virginia, 1962 (third prize); 10th Biennial Nat. Print Exhib., Print Club Albany, 1963; Jacksonville Council Arts Festival, 1964; Print Club Phila. Mem. Exhib., 1964; Hunterdon County Art Center, 1964 (purchase prize); Virginia Artists, VMFA, 1965; CGA Area Ann., 1965. **Work:** LOC; Nat. Collection Fine Arts, Smithsonian Inst.; Hunterdon County Art Center; murals, Children's Orthopedic Hospital, Univ. Iowa; Municipal A. Gal., Davenport, IA. **Comments:** Positions: dir., Davenport Municipal Art Gal., 1933-35; museum dir., Oglebay Inst., Wheeling WV, 1936-42; exhibs. officer, LOC, 1946-. Lectures: "Personality and Originality in Art." Publications: auth., "Hill Towns of Spain (lithographs)," 1930; auth., "Modern Art Influences on Printing Design," 1956. **Sources:** WW73; WW47; Eugene Ettenberg, "Modern Influences on Printing Design," *American Artist* (Sept., 1956); Ness & Orwig, *Iowa Artists of the First Hundred Years,* 182.

SANBORN, J. K. (Mrs.) *[Painter] mid 19th c.*
Addresses: Sandy Hill, NY, 1865. **Exhibited:** NAD, 1865. **Sources:** Naylor, *NAD.*

SANBORN, Julia Crawford *[Painter of harbor scenes] late 19th c.*
Addresses: Active in Ossineke, MI, 1890s. **Sources:** Petteys, *Dictionary of Women Artists.*

SANBORN, Percy A. *[Marine painter, teacher] b.1849, Waldo (near Belfast) ME / d.1929, Belfast, ME.*
Addresses: Belfast, ME. **Studied:** William Hall, a sign and house decorator. **Work:** Mystic Seaport Mus.; Penobscot (ME) Marine Mus.; Colby College AM; Ritz-Carlton Hotel, Boston; Maine Maritime Mus., Bath. **Comments:** A ship portrait painter most active in Belfast, ME from 1872-on. He also provided wood engraving Illustrations for the *Belfast Republican Journal,* and painted signs, stage backdrop curtains, ceiling frescoes, bean pots, dog portraits, and cat portraits. He was also an accomplished violinist and led an orchestra. He was killed by a car while crossing the street. **Sources:** A.J. Peluso, article in *M.A.D.* (Jan. 1986, p.18-D).

SANBURY, Charles M. H. *[Painter] late 19th c.*
Work: Peabody Mus., Salem, MA (marine watercolor). **Comments:** Active after 1863. **Sources:** Brewington, 341.

SANCAN, Justin *[Portrait painter] mid 19th c.*
Addresses: New Orleans, 1850-54. **Sources:** G&W; New Orleans CD 1854.

SANCHEZ, Carlos *[Painter] early 20th c.*
Exhibited: AIC, 1934, 1936. **Sources:** Falk, *AIC.*

SANCHEZ, Emil(io) *[Painter] b.1921, Nuevitas, Cuba.*
Addresses: NYC. **Studied:** ASL. **Exhibited:** Colteser Bienal, Medellin, Colombia; Bienal 1 & 2, San Juan, PR; PAFA Ann., 1966; Am. Color Print Ann. **Awards:** Eyre Medal, PAFA, 1969; David Kapan Purchase Award, Am. Color Print Soc., 1970. **Work:** MMA; MoMA; Brooklyn Mus.; PMA; Albright-Knox

Mus., Buffalo, NY. **Sources:** WW73; Falk, *Exh. Record Series.*

SÁNCHEZ Y TAPIA, Lino *[Survey artist, military draftsman] early 19th c.; b.Mexico.*
Work: Gilcrease Inst. **Comments:** Active 1927-28 in Texas as a member of boundary survey party from Mexico. The party depicted the area and its residents in word and watercolors. **Sources:** P&H Samuels, 417.

SAND, Albert *[Painter] mid 20th c.*
Addresses: Edgewater, NJ, 1930. **Exhibited:** S. Indp. A., 1930-31, 1934. **Sources:** Marlor, *Soc. Indp. Artists.*

SAND, Alice L. *[Painter] 20th c.*
Addresses: NYC. **Member:** Lg. AA. **Sources:** WW24.

SAND, Henry A. L. *[Painter] 20th c.*
Addresses: NYC. **Member:** Lg. AA. **Sources:** WW24.

SAND, John F. *[Portrait painter] mid 19th c.*
Addresses: NYC, 1840-43. **Exhibited:** NAD (1840-43); Apollo Association. **Comments:** Cf. John Sands. **Sources:** G&W; Cowdrey, NAD; Cowdrey, AA & AAU.

SAND, Max *[Landscape and genre painter] late 19th c.*
Addresses: NYC. **Exhibited:** Brooklyn AA, 1875-76, 1883-86. **Comments:** Exhibited works indicate he painted in the Catskill Mountains (NY), and in France and Switzerland. **Sources:** *Brooklyn AA.*

SANDBACK, Fred *[Sculptor] b.1943.*
Addresses: Brooklyn, NY, 1968. **Exhibited:** WMAA, 1968

SANDBERG, Charles M. *[Painter] mid 20th c.*
Addresses: Brooklyn, NY. **Exhibited:** S. Indp. A., 1932, 1934, 1938; Salons of Am., 1934. **Sources:** Falk, *Exhibition Record Series.*

SANDECKI, Albert Edward *[Painter, instructor] b.1935, Camden, NJ.*
Addresses: Haddonfield, NJ. **Studied:** PAFA, 1953-59. **Member:** fel., PAFA. **Exhibited:** Audubon Artists, 1957; PAFA Ann., 1957-60; NAD Ann., 1958; Wadsworth Atheneum Ann., 1960; Phila. WC Soc., 1960-67; James Graham & Sons, Inc, NYC, 1970s. **Work:** McNay Art Inst., Tex.; Lubbock Mus., Tex.; Corcoran Gal.; Albright-Knox Mus., Buffalo, NY. **Comments:** Preferred media: watercolors, oils. Teaching: instr. portraiture & still life, Sanski Art Ctr., 1959-. Art interests: conservator of paintings. **Sources:** WW73; Edith De Shazo, article, In: *Courier-Post;* John Cannady, article, In: *New York Times.*

SANDEFUR, John Courtney *[Etcher] b.1893, Alexandria, IA / d.1971, Pacific Grove, CA.*
Addresses: Chicago, IL; Los Angeles, CA; Pacific Grove, CA. **Studied:** Herron Art School, Indianapolis; AIC, with A.E. Philbrick. **Member:** Chicago SE; Ill. Acad. FA. **Exhibited:** Hoosier Salon, Chicago, 1928 (prize). **Work:** NMAA. **Comments:** Developed a popular series of greeting cards of the Monterey Peninsula. **Sources:** WW32; Hughes, *Artists in California,* 490.

SANDELIN, Gideon *[Painter] mid 20th c.*
Addresses: Chicago area. **Exhibited:** AIC, 1949, 1951. **Sources:** Falk, *AIC.*

SANDELIUS, Emmanuel *[Painter] b.Sweden / d.c.1845, possibly New Orleans, LA.*
Addresses: East Coast; Brazil; Mexico; Australia; California. **Work:** Soc. of Calif. Pioneers. **Comments:** He executed drawings and paintings of Southern California missions and towns in 1842. **Sources:** Hughes, *Artists in California,* 490.

SANDEN, Arthur G. *[Painter, printmaker, teacher, sculptor] b.1893, Colorado Springs, CO.*
Addresses: Bellingham, WA, 1941. **Studied:** Univ. of Wash.; Cornish Art Sch., Seattle; Univ. of Oregon. **Comments:** He drew pen and ink portraits of Mr. and Mrs. Herbert Hoover for the Republican Nat'l Campaign Committee, 1932. **Sources:** Trip and Cook, *Washington State Art and Artists.*

SANDER, A. H. (or Mrs.) *[Sculptor] b.1892.*
Addresses: Fort Worth, TX in 1948. **Work:** Dallas MFA.
Sources: P&H Samuels, 417.

SANDER, Betty S. *[Painter] mid 20th c.*
Addresses: Chicago area. **Exhibited:** AIC, 1950. **Sources:** Falk, *AIC.*

SANDER, David M. *[Painter] mid 20th c.*
Addresses: Chicago area. **Exhibited:** AIC, 1950. **Sources:** Falk, *AIC.*

SANDER, Ludwig (R.) *[Painter] b.1906, St. George, SI, NY / d.1975, NYC.*
Addresses: NYC. **Studied:** ASL. **Member:** Woodstock AA.
Exhibited: S. Indp. A.; PAFA Ann., 1954, 1966; Salons of Am.; Corcoran Gal biennial, 1967; Salon Realités Nouvelles, Paris, 1968; "Neue Kunst USA," MoMA-Munich, 1968; "Form of Color," TMA, 1970; "Plus By Minus - Today's Half Century," Albright-Knox Art Gal., Buffalo; "From Synchromism Forward," AFA traveling exh.; WMAA, 1973; Lawrence Rubin Gal, NYC, 1970s. Other awards: Nat. Council Arts Award, 1967; Guggenheim Fndn. fellowship, 1968; NIAL Art Award, 1971. **Work:** WMAA; Guggenheim Mus.; Corcoran Gal.; AIC; SFMA; Woodstock AA. **Comments:** Preferred media: oils, graphics.
Sources: WW73; Andrew Hudson, "Washington - an American Salon" (April, 1967) & Carter Ratcliff, "New York Letter" (April, 1972), *Art Int.;* Hilton Kramer, article, *NY Times,* Jan. 22, 1972; Woodstock AA; Falk, *Exh. Record Series.*

SANDER, Marie Rey *[Landscape painter] b.1857, San Francisco, CA / d.1945, Piedmont, CA.*
Addresses: Piedmont, CA. **Studied:** Wm. Keith. **Member:** San Fran. Sketch Club. **Exhibited:** San Fran. Sketch Club.
Comments: Daughter of Jacques J. Rey (see entry). **Sources:** Hughes, *Artists in California,* 490.

SANDERS, A. H. See: **SANDER, A. H. (or Mrs.)**

SANDERS, Adam A(chod) *[Sculptor, writer, teacher, painter] b.1889, Sweden.*
Addresses: NYC. **Studied:** CUASch.; BAID. **Member:** AFA; CCA; Brooklyn PSS; College AA. **Exhibited:** NSS; NAC; Salons of Am.; S. Indp. A. **Work:** Lincoln Mem. Coll., Wash., DC; Lib. of Friends of Music, NY; Col. of City NY; Brooklyn Col.; Tel-Aviv Mus., Israel; Am. Lib. Color Slides. **Comments:** Author: "The Theory of Altoform," 1945; "Cosmogony," 1950; "Man and Immortality," 1956. Des., Schubert medal.Conductor: Metropolitan Opera House, NY. **Sources:** WW59; WW47.

SANDERS, Andrew *[Engraver] b.c.1835, Canada.*
Addresses: NYC, 1860. **Sources:** G&W; 8 Census (1860), N.Y., XLII, 787.

SANDERS, Andrew Dominick *[Painter, instructor] b.1918, Erie, PA.*
Addresses: Sarasota, FL; Erie, PA. **Studied:** PMA Sch. (diploma, 1942). **Exhibited:** PAFA, 1941; Nat. Mus., Havana, Cuba, 1956; Sarasota Nat. Exhs. 1950-56; Mississippi Nat., 1952-55; Butler Inst. Am. Art, 1953-55; Int. Gulf-Carribbean, Mus. Fine Arts, Houston, TX, 1956; Southeastern Exh., 1951-53; Soc. Four Arts, 1952-54; Ringling Mus. Art, 1955; NOMA, 1954-55; NAD 146th Ann., NYC, 1971; Audubon Artists 30th Ann., NAD Galleries, 1972; Mainstreams '72 5th Ann., Marietta Col., OH, 1972; Butler Inst. Am. Art 38th Midyear Ann., Youngstown, OH, 1972. Awards: prizes, Sarasota AA, 1951-55; Maitland (FL) Research Studio, 1951; Milner award, 1951; first prize, All Florida Ann., 1953 & first prize paintings of circus, 1954, Ringling Mus. Art, Sarasota; hon. men., Mainstreams,1972, Marietta Col., 1972. **Comments:** Preferred media: oils. Teaching: instr. of drawing, painting & art history, Ringling School Art, Sarasota, FL, 1949-59; instr. of drawing & painting, Columbus Col. Art & Design, 1960-63; dir. of drawing & painting, Art School, Erie, 1964-. Lectures: Modern Art. **Sources:** WW73.

SANDERS, Bernard *[Etcher] b.1904, NYC.*
Addresses: NYC. **Studied:** W.A. Levy. **Exhibited:** Fifty Prints of

the Year, 1931, 1932. **Comments:** Illustrator: "Maggie." Position: in charge of research in the drawings of the mentally ill, Bellevue Hospital, NY. **Sources:** WW40.

SANDERS, Bertha Delina *[Painter] 19th/20th c.; b.Illinois.*
Addresses: NYC, from 1896. **Studied:** AIC; Cox & DuMond in New York; Merson, Collin, Julien Dupré, Aman-Jean, all in Paris. **Exhibited:** Paris Salon, 1896; AIC, 1892, 1901, 1905; PAFA Ann., 1896-97, 1903; MacDowell Club, NYC, 1914 (solo); S. Indp. A., 1917. **Sources:** WW15; Fink, *American Art at the Nineteenth-Century Paris Salons,* 388; Falk, *Exh. Record Series.*

SANDERS, F. *[Listed as "artist"] mid 19th c.*
Addresses: NYC, 1850. **Sources:** G&W; NYCD 1850.

SANDERS, H. M. *[Painter] 20th c.*
Addresses: Indianapolis, IN. **Sources:** WW25.

SANDERS, Helen Fitzgerald *[Illustrator] 20th c.*
Addresses: Butte, MT. **Sources:** WW13.

SANDERS, Herbert Harvey *[Craftsperson, designer, teacher] b.1909, New Waterford, OH.*
Addresses: Alliance, OH. **Studied:** A.E. Baggs. **Member:** Columbus AL; San Diego AGL; Central Calif. Cer. C. **Exhibited:** Columbus Gal. FA, 1933 (prize), 1934 (prize), 1937 (prize); Robineau Mem. Exh., Syracuse Mus. FA, 1934 (prize), 1939 (prize); GGE, 1939. **Work:** Mus. FA, Syracuse. **Comments:** Contributor: *Design.* Position: teacher, San Jose State Col. **Sources:** WW40.

SANDERS, Isaac *[Sculptor] 20th c.*
Addresses: Bronx, NY. **Sources:** WW19.

SANDERS, Joop A. *[Painter] b.1922, Amsterdam, Holland.*
Addresses: NYC. **Studied:** ASL, with George Grosz; also with De Kooning. **Exhibited:** Ninth St. Show, 1951; Stable Shows, 1952-55; Stedelijke Mus., 1960 (retrospective); Carnegie Int., 1960; PAFA Ann., 1966; Options, Mus. Contemporary Art, Chicago, 1968; New Bertha Schaefer Galleries, NYC, 1970s. Awards: Longview Foundation fellowship, 1960-61. **Work:** Stedelijke Mus., Amsterdam; Municipal Mus., The Hague; Belzalel Mus., Jerusalem; Dillard Univ. **Comments:** Preferred media: oils, acrylics, watercolors. Teaching: visiting lecturer, Carnegie Inst. Technology, spring 1965; prof., painting, State Univ. NY College New Paltz, 1966-, Research Foundation awards, 1971-72; visiting lecturer, Univ. Calif., Berkeley, spring 1968. **Sources:** WW73; Tom Hess, Forward to catalogue (Stedelijke Mus., 1960); Falk, *Exh. Record Series.*

SANDERS, S. Kent *[Painter] 20th c.*
Addresses: Paris, France. **Sources:** WW10.

SANDERS, Spencer E. *[Painter, etcher] mid 20th c.*
Addresses: Los Angeles, CA. **Exhibited:** Artists Fiesta, Los Angeles, 1931; Calif. WC Soc., 1931-32. **Comments:** Specialty: watercolors. **Sources:** Hughes, *Artists in California,* 490.

SANDERS, William Brownell *[Patron] b.1854, Cleveland / d.1929, Boston.*
Member: Am. Fed. Arts; John Herron Art and Polytechnic Trust (trustee); Horace Kelley Art Fnd.; CMA (first pres.).

SANDERS, William Carroll *[Portrait, figure, historical, and landscape painter] mid 19th c.*
Addresses: Active in Alabama and Mississippi through the 1870s, with several years spent in Italy. **Exhibited:** NAD, 1838, 1847; American Art-Union, 1845-49; PAFA, 1852. **Comments:** His name sometimes appears as Saunders. Although he gave no address when he first exhibited at the National Academy in 1838, he is known to have worked in Mobile (AL) off and on throughout the 1840's. He also visited Italy in this time period, giving his address as Florence in 1847, when he submitted a Roman subject painting to the National Academy. He was back in Mobile (AL) in 1847-48 (American Art-Union exh. records). From 1849-52 he was in Rome (Italy) where he held a consular position. When he returned to the U.S. he was active in Tuscaloosa (AL) and Florence (AL). In the 1870s he had a studio in Columbus (MS) on

the campus of the Columbus Female Institute, where his wife held a job. Sanders was known for his portraits of children but he also painted many historical works. *Cf.* Saunders (painter in Texas, 1843). **Sources:** G&W; Cowdrey, NAD; Cowdrey, AA & AAU; Rutledge, PA. More recently, see Gerdts, *Art Across America,* vol. 2, 82-83, 88.

SANDERS, Woodford J. *[Painter, sketch artist, photographer] b.1870, Richmond, VA or MS / d.1923, New Orleans, LA.*
Addresses: New Orleans, active 1881-1920. **Sources:** *Encyclopaedia of New Orleans Artists,* 337.

SANDERS & BROTHERS *[Varnishers and japanners] mid 19th c.*
Addresses: NYC. **Exhibited:** American Institute, 1844 (one painting). **Comments:** Firm consisted of James, Thomas W., and Walter Sanders. **Sources:** G&W; Am. Inst. Cat., 1844; NYCD 1845.

SANDERSON *mid 19th c.*
Comments: Painter or proprietor of a panorama of the Crimean War, shown in Baltimore in 1857 and Savannah (Ga.) in 1858. **Sources:** G&W; Baltimore *Sun,* Dec. 25, 1857, and Savannah *Republican,* April 8, 1858 (citations noted by G&W as being courtesy J.E. Arrington).

SANDERSON, Bill (William Seymour) *[Cartoonist] b.1913, Mound City.*
Addresses: Mound City, IL. **Studied:** Chicago Acad. Fa. **Comments:** Creator: comic strip "Pete Pentube," for RCA Radiotron Company. Cartoonist: *Collier's* "Hooey"; "Illinois Central". **Sources:** WW40.

SANDERSON, Charles Wesley *[Landscape painter in oils and watercolors] b.1838, Brandon, VT / d.1905, Boston, MA.*
Addresses: Boston, MA. **Studied:** J. Hope in Vermont; S.L. Gerry in Boston; Académie Julian, Paris with Boulanger, 1870-73; also with Oudinot in Paris; The Hague with Van Borselen and Mesdag. **Member:** Boston AC. **Exhibited:** Boston AC, 1876-1900; Brooklyn AA, 1879; AIC. **Comments:** He was a music teacher by profession. **Sources:** G&W; Clement and Hutton; *Art Annual,* V, obit. WW04, puts birth at 1835.

SANDERSON, George *[Engraver] b.c.1835, England.*
Addresses: Cincinnati, OH. **Comments:** Living with George Gibson (see entry) in Cincinnati in 1850. He was presumably Gibson's apprentice. **Sources:** G&W; 7 Census (1850), Ohio, XXII, 438.

SANDERSON, Henrietta *[Portrait painter] b.1909, Nashville, TN.*
Addresses: West Caldwell, NJ. **Studied:** G.E. Browne; M. Jacobs. **Member:** Allied AA; NAWPS. **Sources:** WW40.

SANDERSON, Henry *[Portrait, historical, landscape, and genre painter] b.1808, Philadelphia / d.1880, New Brunswick, NJ.*
Addresses: Settled in New Brunswick, NJ c.1830, remained there except for some time spent in London. **Studied:** London, 1841. **Exhibited:** NAD (1841-44, mostly genre paintings). **Work:** his copy of Leutze's "Washington Crossing the Delaware" and one of his sketch books are at Rutgers University. **Comments:** In 1868 he sold ten of his paintings at auction in New Brunswick. Sanderson was also active in local affairs, serving on the Board of Education and from 1853 to 1861 as postmaster of New Brunswick. **Sources:** G&W; Tombstone, First Baptist Cemetery, New Brunswick; New Brunswick *Weekly Advertiser,* Dec. 30, 1880, obit.; New Brunswick *Fredonian,* Dec. 24, 1868 (citations noted by G&W as being courtesy Donald A. Sinclair, Rutgers Univ. Library); Cowdrey, NAD.

SANDERSON, Raymond Phillips *[Sculptor] b.1908, Bowling Green, MO.*
Addresses: Scottsdale, AZ. **Studied:** AIC; Kansas City AI, and with Raoul Josset. **Exhibited:** WFNY, 1939; Denver A. Mus., 1939-42; Tempe (Ariz.) State T. Col., 1946 (solo); Ariz. PS, 1938. **Award:** City of Phoenix purchase prize, 1954. **Work:** miners

mon., Bisbee, Ariz.; carvings, U.S. Maritime Comm.; Hotel Westward Ho; Hotel Adams, Phoenix; Valley Nat. Banks in Winslow, Casa Grande, Chandler, Mesa and Phoenix, Ariz.; war mem., Univ. Arizona, Tucson; bust, Duncan (Ariz.) Chamber of Commerce; sc., Arizona State Col. Coll. of Am. Art., 1956-58; small sculpture for priv. colls. **Comments:** Position: instr., s., Arizona State Col., Tempe, Ariz., 1947-54. **Sources:** WW59; WW47.

SANDERSON, William *[Painter, illustrator, teacher, designer] b.1905, Latvia.*
Addresses: Denver, CO in 1969. **Studied:** Fach and Gewerbe Schule, Berlin; NAD, 1923-28; ASL. **Work:** Denver AM. **Comments:** Came to NYC in early 1920s. One of his favorite subjects was the working man. Positions: staff artist/advertising art director, *PM Newspaper,* NYC, 1938-42; teacher, Univ. Denver School Art, 1946. **Sources:** P&H Samuels, 417.

SANDERSON, William Seymour See: **SANDERSON, Bill (William Seymour)**

SANDFORD, Frank Leslie *[Painter, designer] b.1891, Oakland, CA / d.1977, Los Angeles, CA.*
Addresses: San Marino, CA. **Studied:** A. Center Sch., Los A., with AI King; J. Francis Smith A. Acad. **Member:** Cal. Color Soc.; Cal. A. Cl. (pres., 1956); P. & S. Cl. **Exhibited:** Cal. A. Cl., 1953 (med), 1955 (prize), 1958 (prize); P. & S. Cl., Los A., 1938, 1940 (prize), 1941 (prize), 1942. **Comments:** Position: hd. art dept., Martin Scenic Studios, 1920-26; scenic art dept., Lowe's Inc., (MGM) 1926-45, asst. hd. dept., 1934-42, hd., 1942-45. **Sources:** WW59.

SANDFORD, Joseph E. *[Painter] 20th c.*
Addresses: Brooklyn, NY. **Member:** GFLA. **Sources:** WW27.

SANDGREN, Ernest Nelson *[Painter, educator] b.1917, Dauphin, Man.*
Addresses: Corvallis, OR. **Studied:** Univ. Ore. (B.A. & M.F.A.); Univ. Michoacan, Mex.; Chicago Inst. Design. **Member:** Ore. Artists All.; Portland Art Mus. **Exhibited:** Denver Art Mus.; Santa Barbara Mus. Art; Brooklyn Mus., NY; also nat. tours; Am. Cult. Ctr., Paris, France; Turin & Bordighera, Italy & Johannesburg, S. Africa; 46 USA Printmakers, New Forms Gal., Athens, Greece, 1964. **Awards:** Northwest Painting Exhib., Spokane, Wash., 1957; de Young Mem Mus, 1958; Yaddo fel., 1961. **Work:** Portland Art Mus., Ore.; Am. Embassy Coll.; Victoria & Albert Mus., London. Commissions: murals in Eugene, Ore., State Univ. Libr., Corvallis & Portland, Ore. **Comments:** Positions: exped. artist, Am. Quintana Roo Mex. Exped., 1965 & 1966; exped. artist, CEDAM Exped. to Durango, Mex., 1970. Publications: co-auth., "A search for visual relationships" & "Northwest four and two" (color art films.) Teaching: instr. art, Univ. Oregon, 1947; prof. art, Oregon State Univ., 1948-; guest printmaker instr., Pa. State Univ., summer 1966; guest printmaker instr., Cent. Ore. Col., summers 1970-72. **Sources:** WW73.

SANDGROUND, Mark Bernard, Sr. *[Collector, patron] b.1932, Boston, MA.*
Addresses: Wash., DC. **Studied:** Univ. Mich. (B.A., 1952); Univ. Va. (L.L.B., 1955, J.D., 1971). **Member:** Friends of Corcoran Gal. (bd. dir., 1967-, pres., 1968-70); Pyramid Gal. (bd. dir., 1971-). **Exhibited:** Awards: La Chaine des Les Robsier Chevalier, 1971; Klip & Klop Gold Medal, 1972. **Comments:** Positions: pres., La Nicoise. Teaching: prof. humanities & cooking, Free Col. Belgravia, Lower Sch., 1965-66. Collections: Cuevas, Rico Lebrun, Lowell Nesbitt & Anne Truitt. Research: graphic works of Jose Louis Cuevas. Publications: auth., "Collected Letters from Unknown Artists, 1846-1871," privately pub., 1952; auth., "Erotica from the Falls Church Collection," 1972. **Sources:** WW73; D. Kane, *Killer Kock and the White Princess* (McGraw, 1972); "The Gypsie Princess" (film), 1972.

SANDHAM, (J.) Henry *[Historical, portrait, marine and landscape painter, illustrator] b.1842, Montreal, Quebec / d.1912, London, England.*

Addresses: Boston, MA, 1881-1901; London, 1901-1912.
Studied: O.R. Jacobi; J.A. Frazer. **Member:** RCA (charter mem., 1879); Copley Soc., 1899; Boston AC. **Exhibited:** Phila. Centennial Expo, 1876 (medal); London 1886 (medal); Boston, 1881 (medal); Boston AC, 1881-1901; NAD, 1881, 1894; PAFA Ann., 1881, 1890-98, 1901; Brooklyn AA, 1884; Royal Acad. London; Salon Paris; World's Columbian Expo, 1893; AIC. **Work:** Nat. Gal., Canada; Lexington Town Hall; Parliament Bldgs., Ottawa. **Comments:** Sandham worked at Notman's studio, retouching photographic portraits, and eventually became a partner. By 1870 he was known as a portrait and landscape painter. He toured England and France as well as the American West. Illustrator: "Picturesque Canada," 1882; "Century," 1883; "Art Amateur," 1885; "Lenore," by E.A. Poe, 1886; "Ramona," by H.H. Jackson, 1886. **Sources:** WW06; P&H Samuels, 417-18; Falk, *Exh. Record Series.*

SANDHAM, R. C. A. *[Illustrator] 19th c.*
Addresses: Boston, MA. **Comments:** Position: affiliated with Lamson, Wolffe & Co., Boston. **Sources:** WW98.

SANDLER, Beatrice See: **ROSE, Bee (Beatrice Sandler)**

SANDLER, Irving Harry *[Art critic, art historian] b.1925, NYC.*
Addresses: NYC. **Studied:** Temple Univ. (B.A., 1948); Univ. Pa. (M.A., 1950). **Member:** Int. Assn. Art Critics (pres., 1970-); Col. Art Assn. Am.; Inst. Study Art Educ. **Exhibited:** Awards: Tona Shepherd Fund grant travel in Ger. & Austria; Guggenheim Found. fel., 1965. **Comments:** Positions: art critic, *Art News,* 1956-62; art critic, *New York Post,* 1960-65; vis. critic, State Univ. NY, 1969-70; contrib. ed., *Art Am.,* 1972. Publications: contribr., "The New York School, Some Younger Artists," 1959; contribr., "Minimal Art: a Critical Anthology," 1968; auth., "The Triumph of American Painting, a History of Abstract Expressionism," 1970; ed., "Alex Katz," 1971; ed., "Art Criticism and Art Education," 1972. Teaching: instr. art hist., New York Univ., 1960-71; instr. art hist., State Univ. NY Col. Purchase, 1971-. Research: American art since 1930. **Sources:** WW73; Jay Jacobs, "Of Myths and Men," *Art Am.* (March-Apr., 1970); Rosalind Constable, "The Myth of the Myth-Makers," *Washington Post Bk. World* (Nov., 1970); "Gesture -Makers and Colour-Fieldsmen," *Times* Lit. Suppl. (June 1971).

SANDLER, Janice (Mrs. Harry Shapiro) *[Painter] b.1908, NYC.*
Addresses: NYC. **Studied:** ASL. **Exhibited:** S. Indp. A., 1934-35, 1937 (as Sandler); NAD, 1938 (as Sandler); Montross Gal., NY. **Work:** NYPL. **Sources:** Marlor, *Soc. Indp. Artists* (as Sandler); WW40 (as Shapiro).

SANDMEYER, Jacques *[Lithographer] mid 19th c.*
Addresses: NYC, 1857-59. **Sources:** G&W; NYBD 1857, 1859.

SANDOL, Maynard *[Painter] b.1930, Newark, NJ.*
Addresses: Chester, NJ. **Studied:** Newark State Col., 1952; Robert Motherwell. **Exhibited:** Corcoran Gal.; MoMA; Corcoran Gal biennial, 1961; NJ Pavilion, WFNY; Am. Greetings Gal., NYC; NJ State Mus., Trenton. **Work:** Newark Mus. Art; Wadsworth Atheneum, Hartford, Conn.; Princeton Univ; Finch Col. Mus., NYC; Hirshhorn Collection. **Sources:** WW73; William H Gerdts, Jr, *Paintings and Sculpture in New Jersey* (Van Nostrand, 1964).

SANDONA, Matteo *[Portrait painter] b.1883, Schio, Italy / d.1964, San Francisco, CA.*
Addresses: Hoboken, NJ; San Francisco, CA, 1901-64. **Studied:** Acad. FA, Verona, Italy with Nani, Bianchi; NAD. **Member:** San Fran. AA; Bohemian C., San Fran; AFA; Soc. Western A. **Exhibited:** Mark Hopkins Inst., 1901-05; San Francisco AA, 1906-25; PAFA Ann., 1918; PAFA, 1926; Bohemian Cl., 1922; Oakland Art Gal., 1916-26; PPE, 1915; Calif. State Fair, 1917 (med.), 1926; Chicago Gal. Assn., 1926 (prize); CPLH, 1926-36; Calif.-Pacific Int'l Expo, San Diego, 1935; Santa Cruz A. Lg., 1932 (prize); Lewis & Clark Expo, 1905 (med.); NAD;

Sesqui-Centenn. Expo, Phila., 1926; AIC, 1927; Bay Region A. Assn., 1939 (prize); Jury of Awards, P.-P. Expo. 1915; Soc. Western A., 1954 (prize). **Work:** NGA; CPLH; Mills Col.; Salt Lake City, H.S.; Springville (Utah) H.S.; Univ. California; Peninsula Hospital, San Mateo, Cal.; Women's City Cl., San F., Cal.; portraits of several governors; plaque, Veterans War Mem., San F.; Golden Gate Park Mem. Mus., San Fran.; Punahou Col., Honolulu; Calif. Capitol, Sacramento; San Fran. Opera House; Hahemann Hospital, San Fran.; Bohemian C., San Fran. **Comments:** He immigrated to the U.S. in 1894, but returned to Italy two years later to study art. In 1901 he cofounded the California Soc. of Artists as a reaction to the conservative attitudes of the San Francisco AA. **Sources:** WW59; WW47; Falk, *Exh. Record Series.* More recently, see Hughes, *Artists in California,* 490.

SANDOR, Alexander See: **KATZ, A(lexander) (Sándor) Raymond**

SANDOR, Gluck *[Artist] b.1899 / d.1978.*
Member: Woodstock AA. **Sources:** Woodstock AA.

SANDOR, Mathias
[Portrait painter, miniature painter, landscape painter, commercial artist] b.1857, Hungary / d.1920, NYC.

Mathias Sandor

Addresses: NYC. **Studied:** ASL, 1885-86; Académie Julian, with Flameng and Ferrier, 1889-90. **Member:** SC, 1898; A. Fund. S. **Exhibited:** PAFA Ann., 1910, 1913, 1917; Corcoran Gal biennial, 1914; AIC, 1916. **Work:** Harmsen collection. **Comments:** He came to the U.S. in 1881, and became well known for his Hopi Indian scenes at Taos. **Sources:** WW19; P&H Samuels, 418; Falk, *Exh. Record Series.*

SANDOW, Franz *[Sculptor, illustrator, designer] b.1910, Hawaii / d.1976, Berkeley, CA.*
Addresses: Berkeley, CA. **Studied:** Univ. Calif. **Member:** United Am. Ar.; Am. Ar. Cong.; Am. Ar. Prof. Lg. **Exhibited:** SFMA, late 1930s; Oakland A. Gal., 1930s; PAFA Ann., 1954. **Work:** relief, Labor Temple, Oakland; sculpture, Woodminster Amphitheater, Oakland. **Sources:** WW40; Hughes, *Artists in California,* 491; Falk, *Exh. Record Series.*

SANDRECZKI, Otto *[Painter] 20th c.*
Addresses: NYC. **Sources:** WW17.

SANDS, Alfred R. *[Portrait painter] mid 19th c.*
Addresses: NYC, 1844. **Sources:** G&W; NYBD 1844.

SANDS, Anna M. *[Painter] b.1860, Maryland / d.1927, probably Wash., DC.*
Addresses: Wash., DC. **Studied:** ASL of Wash., DC. **Member:** Wash. WCC; Soc. Wash. Artists, 1896-1927; Wash. AC; Wash. Soc. FA. **Exhibited:** Soc. Wash. Artists, 1896-1914; Cosmos Club, 1902. **Comments:** Specialty: pastel & watercolor. **Sources:** WW25; McMahan, *Artists of Washington, DC.*

SANDS, Ethel *[Painter] b.1873, Newport, RI / d.1962, London, England.*
Addresses: London, England, from 1900. **Studied:** Rolshoven; E. Carrière, in Paris; Sickert in England. **Exhibited:** SNBA, 1899; AIC; frequently in London; Paris from 1903; PAFA Ann., 1903. **Comments:** Impressionist painter of still lifes, figures, interiors, flowers. Was a naturalized English citizen. **Sources:** WW08; Fink, *American Art at the Nineteenth-Century Paris Salons,* 388; Petteys, *Dictionary of Women Artists;* Falk, *Exh. Record Series.*

SANDS, Gertrude Louis *[Painter, printmaker, designer] b.1899, Cawker City, KS.*
Addresses: Berkeley, CA. **Studied:** AIC; Calif. Sch. FA; with W. Gaw. **Member:** San Francisco AA. **Exhibited:** Oakland A. Gal., 1932, 1939; San Francisco AA, 1937; San Francisco Soc. of Women Artists, 1940; CPLH; SFMA. **Comments:** Specialty: still lifes. **Sources:** WW40; Hughes, *Artists in California,* 491.

SANDS, Jerry *[Painter] mid 20th c.*
Addresses: Seattle, WA, 1947. **Member:** Puget Sound Group of

Northwest Painters. **Exhibited:** SAM, 1947; Henry Gallery, 1951. **Sources:** Trip and Cook, *Washington State Art and Artists.*

SANDS, John *[Painter] mid 19th c.*
Addresses: NYC in 1844. **Exhibited:** American Institute, 1844 (oil painting). **Comments:** *Cf.* John F. Sand. **Sources:** G&W; Am. Inst. Cat., 1844.

SANDS, (Master) *[Painter] mid 19th c.*
Studied: J.H. Shegogue. **Exhibited:** Apollo Association (in 1839 he exhibited a copy of a genre painting by "Owen"). **Sources:** G&W; Cowdrey, AA & AAU.

SANDS, Richard *[Listed as "artist"] mid 19th c.*
Addresses: NYC, 1847-48. **Sources:** G&W; NYCD 1847-48.

SANDUSKY, William H. *[Survey and topographical drafts-man, mapmaker, printmaker] b.1813, probably Columbus, OH / d.1846, probably Galveston, TX.*
Addresses: Austin, TX in 1838; Galveston, TX 1841. **Work:** Austin Public Library, Texas. **Comments:** Drew views of Austin which he reproduced and colored. **Sources:** P&H Samuels, 418.

SANDY, Percy Tsisete *[Painter, illustrator, muralist] b.1918, Zuni Pueblo, NM.*
Addresses: Taos, NM in 1974. **Studied:** Zuni Public Day Sch.; Black Rock Sch.; Albuquerque (graduated in 1940); Santa Fe Indian Sch.; Sherman Inst., Riverside, CA. **Exhibited:** First Nat. Exh. Am. Indian Painters, Philbrook Art Center, 1946 (prize). **Work:** Gilcrease Inst.; Mus. Am. Indian; Mus. Northern Arizona; Mus. New Mexico; Oklahoma Univ. Mus. Art; Philbrook AC; SE Museum. **Comments:** Depicted the customs of the Zuni Indians. Contributed illustrations to "Sun Journey," by Clark, 1945. An injury in 1959 periodically prevented him from painting. **Sources:** WW47; P&H Samuels, 418-19.

SANDYS, Edwin *[Engraver] 19th c.*
Addresses: Baltimore, 1859-60. **Sources:** G&W; Baltimore BD 1859, CD 1860.

SANDZEN, Birger See: **SANDZEN, (Sven) Birger**

SANDZEN, Margaret *[Painter, lecturer, teacher] b.1909, Lindsborg, KS.*
Addresses: Lindsborg, KS. **Studied:** with her father, Birger Sandzen; Bethany Col. (A.B.); Columbia Univ. (M.A.); ASL with George Bridgman, Frank DuMond; with Edouard Lèon in Paris. **Member:** NAWA. **Exhibited:** Kansas State Fair, 1940 (prize); NAWA, 1941 (prizes); Stockholm, Sweden; Dallas, 1936; Kansas City AI, 1933, 1935, 1939. Awards: prizes, Rockefeller Fellowship, 1939-40, 1940-41. **Comments:** (Mrs. Charles Pelham Greenough, III). A back ailment forced her to give up painting in 1961. Position: art instructor, Bethany College, Lindsborg, KS, 1934-37, 1942-46; secy., Kansas State Fed. Art, 1956-58. Contributor: *Kansas* magazine. Lectures: Swedish arts & crafts; The Life and Art of Birger Sandzen; The Life and Art of Edvard Munch. **Sources:** WW59; WW47; PHF files (letters, 1986).

SANDZEN, (Sven) Birger *Birger Sandzen*
[Painter, graphic artist, educator, writer, illustrator, engraver, lithog-rapher] b.1871, Bildsberg, Sweden / d.1954, Lindsborg, KS.
Addresses: Lindsborg, KS. **Studied:** Stockholm Art Lg., with Zorn, Bergh, Erlandsson; in Paris, with Aman-Jean. **Member:** AWCS; SAGA; Calif. WC Soc.; Phila. WCC; Prairie Print Makers; Chicago SE. **Exhibited:** Kansas City Artists, 1917 (prize); S. Indp. A., 1917-18; PAFA Ann., 1918; Phila. WCC, 1922 (prize); Taos SA, 1922; AIC. Awards: Knight of the Swedish Royal Order of the North Star. **Work:** LOC; NYPL; Stockholm Art Mus.; Bibliothèque Nationale, Paris; AIC; BM; Yale Univ. Art Gal.; Mus. New Mexico, Santa Fe; British Mus., London, etc.; mural, USPO, Lindsborg, KS; Sandzén Mem. Gal., Lindsborg. **Comments:** Best known for landscapes of the Rocky Mountains, created in a bold Post-Impressionist style as block-prints, lithographs, and paintings. Position: WPA artist; teacher, Broadmoor, 1923-24; also taught in Denver and at Utah State College; hd. of art school, Bethany College, Lindsborg, KS.

Author, "With Brush & Pencil." **Sources:** WW53; WW47; P&H Samuels, 419; Falk, *Exh. Record Series.*

SANELL, Louis *[Painter] 20th c.*
Addresses: Kansas City, MO. **Sources:** WW21.

SANFORD *[Painter?] mid 19th c.*
Exhibited: NYC, 1853 (a panorama of the Mississippi River). **Sources:** G&W; NY *Herald,* Jan. 28, March 21, June I, 1853.

SANFORD, Edward Field, Jr. *[Sculptor, architectural sculp-tor] b.1887, NYC / d.1951, St. Augustine, FL.*
Addresses: NYC; Williamsburg, VA. **Studied:** ASL; NAD; Académie Julian, Paris, 1909; Royal Acad., Munich. **Exhibited:** PAFA Ann., 1913-18, 1929; AIC, 1916. **Work:** Core Mem., Norfolk, VA; Capitol, Sacramento, CA; finial figure/three colossal Gothic figures, Alabama Power Co. Bldg.; colossal figure, Yale Univ. Gymnasium; two colossal groups, Bronx County Court House, Francis P. Garvin Mausoleum (Woodlawn); animal frieze, NY State Roosevelt Mem. **Comments:** Position: dir., Dept. of Sculpture, Beaux-Arts Inst. Des., 1923-25. **Sources:** WW40; Falk, *Exh. Record Series.*

SANFORD, Elizabeth *[Painter] early 20th c.*
Addresses: New Haven, CT. **Exhibited:** S. Indp. A., 1919. **Sources:** Marlor, *Soc. Indp. Artists.*

SANFORD, Frank Leslie *[Painter, designer] b.1891, Oakland, CA / d.1963, Los Angeles, CA.*
Addresses: Los Angeles, CA. **Studied:** John F. Smith and F.T. Chamberlin. **Member:** P&S of Los Angeles. **Comments:** Position: Scenic artist, MGM Studios. **Sources:** Hughes, *Artists in California,* 491.

SANFORD, G. P. *[Landscape painter] mid 19th c.*
Addresses: NYC. **Exhibited:** NAD, 1842 (landscape). **Comments:** *Cf.* George T. Sanford. **Sources:** G&W; Cowdrey, NAD.

SANFORD, George T. *[Lithographer and artist] mid 19th c.*
Addresses: NYC, 1843-46. **Comments:** *Cf.* G.P. Sanford. **Sources:** G&W; NYCD 1843-44, 1846.

SANFORD, Isaac *[Engraver and occasional portrait and miniature painter] d.c.1842, Philadelphia.*
Addresses: Hartford, CT, active c. 1783-1822; later settled in Philadelphia. **Work:** family miniatures by him are in the Wadsworth Athenaeum; his papers are preserved in the Conn. Hist. Society. **Comments:** He was also an inventor and spent some years in England between 1799 and 1808 trying to sell his inventions. *Cf.* J. Sanford. **Sources:** G&W; Brainard, "Isaac Sanford"; Stauffer; Bolton, *Miniature Painters.*

SANFORD, Isobel Burgess *[Painter, designer, engraver, etch-er] b.1911, Edmonton, Alberta, Canada.*
Addresses: Burlingame, CA. **Studied:** Calif. Sch. FA; ASL, with Morris Kantor; Parsons Sch. Des. **Member:** San F. AA; Peninsula AA. **Exhibited:** NAD, 1946; LACMA, 1945; AV War Posters Exh., 1942; Oakland A. Gal., 1942-44; Gump's, San F., 1954; San F. AA, 1935-36, 1940-41, 1944, 1954-56, 1958. **Comments:** Des., Int. Des. Dept., Gump's, San Francisco, Cal., 1947-. **Sources:** WW59; WW47.

SANFORD, J. *[Profilist and silhouettist] early 19th c.*
Addresses: South Carolina, 1807. **Comments:** *Cf.* Isaac Sanford. **Sources:** G&W.

SANFORD, John Williams, Jr. *[Painter, graphic artist] b.1917, NYC.*
Addresses: Charlottesville, VA. **Studied:** ASL; Grand Central Sch. Art. **Exhibited:** Baylis Mus., Univ. Virginia; Soc. Wash. Artists, Corcoran Gal., 1940; S. Indp. A., 1942. **Sources:** WW40.

SANFORD, Josephine *[Painter] 19th/20th c.*
Exhibited: SNBA, 1899. **Sources:** Fink, *American Art at the Nineteenth-Century Paris Salons,* 388.

SANFORD, Lockwood *[Wood engraver] b.c.1817, Connecticut.*

Addresses: New Haven, active 1850 and after. **Sources:** G&W; 7 Census (1850), Conn., II; New England BD 1856, 1860; New Haven CD 1856-58; Hamilton, *Early American Book Illustrators and Wood Engravers,* 265, 329.

SANFORD, M. M. *[Folk "primitive" painter] mid 19th c.*
Comments: Known work: battle scene in oils, c. 1850. **Sources:** G&W; Lipman and Winchester, 179.

SANFORD, Marion *[Sculptor, illustrator] b.1904, Guelph, Ontario, Canada.*
Addresses: NYC, 1942-51; Lakeville, CT. **Studied:** PIASch; ASL; & with Brenda Putnam. **Member:** ANA; NSS; All. A. Am.; Arch.L.; AAPL; NAWA. **Exhibited:** NAWA, 1937 (prize); WFNY 1939; WMAA, 1940; PAFA Ann., 1942-51; NAD, 1938-46 (medal, 1943), 1947 (prize); All. A. Am., 1944, 1945 (med.); AAPL, 1945 (prize); PBC, 1946 (prize); Audubon A., 1945; Newport AA, 1940; Fairmount Park, Phila., 1949; Meriden, Conn., 1949 (prize); Springfield (Mass.) Mus. A., 1957 (prize). Awards: Guggenheim F., 1941-43. **Work:** PAFA; CGA; Brookgreen Gardens, S.C.; Warren (Pa.) Pub. Lib.; Haynes Coll., Boston; Norton Hall, Chautauqua, N.Y.; Warren General Hospital, Pa.; Cosmopolitan Cl., N.Y.; Trinity Mem. Church, Warren, Pa.; St. Mary's Chapel, Faribault, Minn.; mural, USPO, Winder, GA. **Comments:** Illustrator: "The Sculptor's Way," 1942. WPA artist. **Sources:** WW59; WW47, puts birth at 1902; Falk, *Exh. Record Series.*

SANFORD, Walter *[Painter] late 19th c.*
Addresses: NYC, 1879-1882, 1886; Antwerp, Belgium, 1887; Hartford, CT, 1888. **Exhibited:** NAD, 1879-1887; PAFA Ann., 1888. **Sources:** Naylor, *NAD;* Falk, *Exh. Record Series.*

SANFORD, Winona *[Landscape painter] b.1868, Marshall County, MS.*
Addresses: San Antonio, TX; San Francisco Bay area, active 1911-1950. **Exhibited:** Berkeley League of FA, 1924. **Sources:** Hughes, *Artists in California,* 491.

SANGER, Anthony *[Sculptor] b.c.1835, Württemberg.*
Addresses: Boston. **Comments:** Living in 1860 with Wendolin Sanger (see entry), presumably a younger brother. **Sources:** G&W; 8 Census (1860), Mass., XXVII, 365.

SANGER, Grace H.H. C(ochrane) *[Painter, illustrator] b.1881, Newark, NJ.*
Addresses: Ruxton, MD. **Studied:** H. Pyle; W.M. Chase; H. Breckenridge. **Member:** North Shore AA; Baltimore WCC; Baltimore Mun. Artists Soc.; Baltimore Friends Art. **Work:** McDonogh Sch., MD. **Comments:** Illustrator: "Eve Dorre." **Sources:** WW40.

SANGER, Henry L. *[Engraver] mid 19th c.*
Addresses: Boston, 1860. **Sources:** G&W; Boston CD 1860.

SANGER, Isaac Jacob ("Dick") *J. J. Sanger*
[Block printer, painter, designer, photographer] b.1899, Port Republic, VA / d.1986, Charlottesville, VA.
Addresses: NYC; Wash., DC, 1951-86; Bridgewater, VA, 1986. **Studied:** A.W. Dow; Columbia Univ. **Exhibited:** Phila. Print C., 1929 (prize), 1931 (prize); Fifty Prints of the Year, 1931; Fine Prints of the Year, 1936; WMAA, 1938, 1941. **Work:** NYPL; Newark Pub. Lib., San Diego FA Gal.; NMAH; NMAA. **Comments:** He served in the Army during WWII, and was a commercial artist for 25 years before moving to Wash., DC in 1951. From 1953 until the mid 1960s he was a graphic artist with the Dep. of Health, Education and Welfare. He died of injuries received in an accidental fall one month after moving to Bridgewater, VA, in June of 1986. **Sources:** WW40; McMahan, *Artists of Washington, DC.*

SANGER, Wendolin *[Sculptor] b.c.1838, Württemberg.*
Addresses: Boston. **Comments:** Living in 1860 with Anthony Sanger (see entry), presumably an older brother. **Sources:** G&W; 8 Census (1860), Mass., XXVII, 365.

SANGER, William *[Painter, graphic artist, etcher] b.1875, Brooklyn, NY.*
Addresses: NYC; Albany, NY. **Studied:** CUASch, B.S.; ASL; Artists & Artisans Inst., NY. **Exhibited:** Salons of Am.; S. Indp. A., 1917, 1920-22, 1930; PAFA Ann., 1934; Soc. Am. E., 1939; AIC. **Work:** Hispanic Mus.; WMAA; Newark Mus.; BM; VMFA; MMA; entire cycle of figures of the Gate of Glory, Santiago Cathedral, Spain; Avery Library, Columbia. **Comments:** Birth possibly 1888 in France. Marlor has birthplace as Berlin, Germany. **Sources:** WW59; WW47; Falk, *Exh. Record Series.*

SANGERNEBO, Alexander *[Sculptor] b.1856, Esthonia, Russia / d.1930.*
Addresses: Indianapolis, IN. **Member:** Ind. AC; Indianapolis Arch. C.; Indianapolis Athenaeum. **Work:** Indianapolis: Mural Temple; Lincoln Hotel; Union Station; Guarante Bldg.; Blind Institution; St. Joan of Arc Church; Ayres Bldg.; Ind. Nat. Guard Armory; Ind. Theatre; County Court House, Lebanon, Ind. **Sources:** WW29.

SANGERNEBO, Emma Eyles (Mrs. Alexander) *[Sculptor, painter] 20th c.; b.Pittsburgh, PA.*
Addresses: Indianapolis, IN. **Studied:** William Forsyth. **Member:** Indiana AC; Nat. Lg. Am. Pen Women; AAPL. **Work:** Garfield Park, Washington H.S., Elizabeth Hitt Mem., Woman's Dept. Club, all of Indianapolis; Union Bldg., Bloomington, IN. **Sources:** WW53; WW47.

SANGRÉE, Theodora (Mrs. Settele) *[Painter, lithographer] b.1901, Harrisburg, PA.*
Addresses: Chappaqua, NY. **Studied:** ASL with B. Robinson, K.H. Miller, T.H. Benton. **Exhibited:** WMAA, 1928; Salons of Am.; AIC; S. Indp. A., 1928, 1931; Corcoran Gal biennial, 1937. **Sources:** WW40; Falk, *Exhibition Records Series.*

SANGSTER *[Carver] b.1832.*
Comments: A Cleveland (Ohio) newspaper in July 1846 wrote of this 14-year-old as having whittled his way to fame at Buffalo (N.Y.) by his carving of the Lord's Supper. **Sources:** G&W; WPA (Ohio), *Annals of Cleveland.*

SANGSTER, Amos *[Painter, printmaker] b.1833, Kingston, Ont., Canada / d.1904, Buffalo, NY.*
Studied: self-taught in art. **Member:** Buffalo SA (charter mem. and first vice. pres.). **Comments:** Moved to Buffalo with family in 1844. Pos.: printing specialist in wood engraving, Courier Co. Began to paint seriously in 1858; began etching in 1885. Had a studio with A. W. Samuels. **Sources:** McMahan, *Artists of Washington, DC;* Krane, *The Wayward Muse,* 195.

SANGTELLER, Alexander See: **SENGTELLER, Alexander**

SANGUINETTI, Edward *[Painter] late 19th c.*
Addresses: NYC. **Exhibited:** NAD, 1878-82; Brooklyn AA, 1879-83; PAFA Ann., 1879; Boston AC, 1881. **Comments:** An artist-explorer, many of his subjects depict horses and riders, cavalry, and hunting. **Sources:** Naylor, *NAD;* Falk, *Exh. Record Series.*

SANGUINETTI, Eugene F. *[Art administrator, lecturer] b.1917, Yuma, AZ.*
Addresses: Salt Lake City, UT. **Studied:** Univ. Santa Clara (B.A.), 1939; Univ. Arizona, 1960-62. **Member:** Assn. Am. Mus.; Western Assn. Art Mus.; College Art Assn. Am.; Assn. Archit. Historians; AFA. **Comments:** Positions: dir., Tucson (AZ) Mus. & Art Center, 1964-67, Utah Mus. Fine Arts, Univ. Utah, Salt Lake City, 1967-; judge, five art shows, Colorado, Utah & Idaho, 1968-72. Teaching: lecturer. art history, Univ. Arizona, 1962-64; adjunct assoc. prof. art, Univ. Utah, 1967-. Collections arranged: Selected Drawings from the Collection of Edward Jacobson, 1970; Drawings by Living Americans, Objects from Buddhist Cultures & Etching Renaissance in France: 1850-80, 1971; Drawings by New York Artists, Prehistoric Utah Petroglyphs & Pictographs & Ron Resch and the Computer, 1972; plus 9 retrospectives & 11 solos, 1967-72. Publications: contributor,

"Alexander H. Wyant Retrospective" (1968); "John Marin Drawings Retrospective" (1969); "Etching Renaissance in France: 1850-1880" (1971); "Alex Katz Retrospective" (1971); "Drawings by New York Artists" (1972). **Sources:** WW73.

SANKEY, Celia (Mrs. Clifford H.) See: **JAMISON, Celia (Mrs. Clifford H. Sankey)**

SANKOWSKY, Itzhak [Painter, engraver, teacher] b.1908, Kishinew, Romania.
Addresses: Merion, PA. **Studied:** Univ. Pennsylvania (M.A.), and in Italy; A.B. Carles. **Member:** Phila. A. All.; AEA; Phila. WC Cl.; Phila. Pr. Cl. **Exhibited:** Y.M.H.A., Phila. 1939; Wash. WC Cl., 1941, 1950-52; AIC, 1941; PAFA, 1940,1951; PAFA Ann., 1954; Woodmere A. Gal., 1940-41, 1950, 1952; BM, 1954; SAGA, 1955; solo: Phila. A All., 1947, 1952, 1958; A. & Crafts Center, Pittsburgh; Lush Gal., Phila., Pa., 1953. Award: prize, YMHA, 1950. **Work:** PMA; Tel-Aviv Mus., Israel; medallions for stained glass windows, Har Zion Temple, Phila., Pa.; candelabra, Phila. Psychiatric Hospital; other work in priv. colls. **Comments:** Position: instr., PMASch. A., and Allens Lane A. Center. **Sources:** WW59; WW47; Falk, *Exh. Record Series.*

SANO, Kiokichi [Painter] mid 20th c.
Exhibited: S. Indp. A., 1941. **Sources:** Marlor, *Soc. Indp. Artists.*

SANON, John A. [Painter, teacher] b.1860, California / d.1929.
Addresses: Palo Alto, CA. **Member:** Bohemian C. **Comments:** Position: dean, San Fran. AI.

SANSAM, Edity See: **SANSUM, Edith M.**

SANSAY, Mme. See: **SARAZIN, L. (Mrs.)**

SANSEVERO, Frederick [Painter] mid 20th c.
Addresses: NYC. **Exhibited:** Salons of Am., 1932; S. Indp. A., 1932. **Sources:** Falk, *Exhibition Record Series.*

SANSOM, Joseph [Amateur landscape draftsman] mid 19th c.; b.Philadelphia?.
Addresses: Philadelphia. **Comments:** Noted in the early years of the 19th century as a traveler and author. In 1811 he contributed to *Port Folio* an account of Nantucket, illustrated by a view of Sherburne after his own sketch. **Sources:** G&W; *Panorama* (Feb. 1947), cover and p. 64; Stokes, *Historical Prints,* pl. 42a.

SANSONE, Leonard [Designer, cartoonist] b.1917, Norwood, MA. *Sgt. Sansone*
Addresses: Miami 43, FL. **Studied:** Mass Sch. A. **Member:** Nat. Cartoonist Soc.; A. Dir. Cl., Miami. **Exhibited:** MMA, 1950. Awards: A. Dir. Exh., Miami, 1953-57. **Comments:** Author: "The Wolf," 1945; i., "Semi-Private." 1943; "The Chain of Command," 1945; "Private Purkey's Private Peace," 1945; creator, "Willie," daily comic strip for United Features Syndicate, 1945-56. **Sources:** WW59.

SANSUM, Edith M. [Sketch artist, teacher, painter] b.1867, Evanston, Il / d.1934, New Orleans, LA.
Addresses: New Orleans, active 1884-1901. **Studied:** Zillah Rondeau, 1884; News Orleans AA, 1886, 1890. **Member:** News Orleans AA, 1890, 1896, 1893 (secretary); Black & White Club, 1890 (pres.). **Exhibited:** Zillah Rondeau's Studio, 1884; News Orleans AA (med.), 1886-87; 1890-94, 1901; Amateur Art League, 1891; Tulane U., 1892-93; Black & White Club (Pickney -Smith Medal). **Sources:** *Encyclopaedia of New Orleans Artists,* 337-338.

SANTA EULALIA, Alexis (Count [of]) [Sculptor] early 20th c.
Addresses: Ashbourne, PA. **Exhibited:** PAFA Ann., 1909, 1912. **Sources:** WW13; Falk, *Exh. Record Series.*

SANTEE, Ross [Illustrator, graphic artist, writer] b.1889, Thornburg, IA / d.1965, Globe, AZ.
Addresses: Phoenix, AZ, 1936-41. **Studied:** AIC, c.1900-04; again at AIC with G. Bellows, 1919; Ted De Grazia. **Exhibited:**

Arizona PS, 1938. **Work:** Read Mullan Gal. Western Art, Phoenix, AZ. **Comments:** Santee first studied to be a cartoonist. He was unsuccessful in NYC as a commercial artist. In 1915 he worked as a ranchhand and submitted sketches to St. Louis *Post Dispatch.* Following further study at the AIC with Bellows, he wrote and illustrated short stories and later Western books. Illustrator: "Powder River," 1938, "We Pointed Them North," 1939. Author/illustrator: "Men and Horses," 1926, "Cowboy," 1928. After he married he lived in Wilmington, DE and commuted to Arizona at roundup time. He was in Phoenix, 1936-41 working for the WPA. Frequent contributor to *Arizona Highways.* **Sources:** WW40; P&H Samuels, 421-22.

SANTELLA, Alexander See: **SENGTELLER, Alexander**

SANTELLO, Alexander See: **SENGTELLER, Alexander**

SANTERO, A. J. [Painter, sculptor] early 19th c.
Addresses: New Mexico. **Comments:** An anonymous *santero* or creator of religious images, active in the 1820s but not prolific. According to Eldredge,he was a technical innovator, whose style was characterized by spontaneity, color and distortion of figures and details. **Sources:** Eldredge, et al., *Art in New Mexico, 1900-1945,* 189.

SANTERO, Laguna [Painter] 18th/19th c.
Addresses: New Mexico. **Comments:** Active 1796-1808. Anonymous master of late-colonial religious paintings in many pueblo missions, including Laguna for which he is named. His simplified Baroque style influenced his assistants and the next generation of local religious artists. **Sources:** Eldredge, et al., *Art in New Mexico, 1900-1945,* 200.

SANTERO, Santo Niño [Painter, sculptor] mid 19th c.
Addresses: New Mexico. **Comments:** Anonymous *santero* or creator of religious images, named for his depictions of the Christ Child; active 1830-60. **Sources:** Eldredge, et al., *Art in New Mexico, 1900-1945,* 206-07.

SANTIAGO, Helene [Art dealer, collector] b.1910, Paris, France.
Addresses: San Juan, PR. **Studied:** Univ Vienna, 2 yrs.; Sorbonne, 1 yr. **Comments:** Positions: dir., Galeria Santiago. Collection: paintings and graphics of local contemporary artists. Specialty of gallery: Mainly abstract and avant-garde paintings and graphics of contemporary Puerto Rican artists. **Sources:** WW73.

SANTILLO, Lorenzo [Painter] mid 20th c.
Exhibited: S. Indp. A., 1935. **Sources:** Marlor, *Soc. Indp. Artists.*

SANTO, Pasquale (Patsy) [Painter] b.1893, Corsano, Italy.
Addresses: Bennington, VT. **Exhibited:** WMAA, 1940, 1944; CI, 1943-45; PAFA Ann., 1944; Corcoran Gal biennials, 1943, 1945; CAM, 1945; Stendahl Gal., Los A., Cal., 1941; AGAA, 1943; TMA, 1943; Marie Harriman Gal., 1940-42; Macbeth Gal., 1944; MoMA, 1936, 1939, 1943; Manchester, Vt., 1938-39; MMA, 1943; Albany Inst. Hist. & A., 1942, 1945; Pittsfield A. Lg., 1943; Williams Col., 1941; St. Etienne Gal., 1952; Berkshire Mus.,1954 (prize); Portsmouth AA,1954 (prize); European traveling exh., sponsored by Smithsonian Inst. & U.S. Info Agcy, 1954-55; Bennington Col., 1955; Tyringham (Mass.) Gal., 1955. **Work:** MoMA; Canajoharie Mus.; WMAA; Univ. Arizona; CI. **Sources:** WW59; WW47; Falk, *Exh. Record Series.*

SANTO NIÑO, Santero See: **SANTERO, Santo Niño**

SANTORE, Charles [Illustrator] b.1935, Phila., PA.
Addresses: Phila., PA. **Studied:** Phila. Col. Art, with Henry Pitz, Albert Gold. **Exhibited:** Art Dir. Club, Phila.(3 gold medals); Soc. of Publications Des. (award); SI (Hamilton King Award,1972); Tyler Sch.A./Temple Univ. (solo). **Work:** MoMA; Coll. of Free Lib., Phila., PA. **Comments:** Illus., advertising clients as well as *Time, Life, Newsweek* and other national magazines. **Sources:** W & R Reed, *The Illustrator in America,* 338.

SANTOYO, Matias [Painter] mid 20th c.
Addresses: NYC. **Exhibited:** S. Indp. A., 1927. **Sources:**

Marlor, *Soc. Indp. Artists.*

SANTRY, Daniel François [*Landscape painter*] *b.1858, Boston, MA / d.1915.*
Studied: Boulanger, Lefebvre. **Exhibited:** Paris Salon, 1886; Boston AC, 1889-91. **Sources:** Fink, *American Art at the Nineteenth-Century Paris Salons,* 388; *The Boston AC.*

SANXY, Eleanor E. [*Artist*] *early 20th c.*
Exhibited: WMAA, 1922. **Sources:** Falk, *WMAA.*

SAPHIER, Louis [*Painter*] *mid 20th c.*
Exhibited: S. Indp. A., 1930; Salons of Am., 1932, 1934. **Sources:** Falk, *Exhibition Record Series.*

SAPHIRE, Leonard [*Painter*] *mid 20th c.*
Exhibited: S. Indp. A., 1935. **Sources:** Marlor, *Soc. Indp. Artists.*

SAPIER, William [*Painter*] *early 20th c.*
Addresses: Chicago, IL. **Exhibited:** S. Indp. A., 1917. **Sources:** Marlor, *Soc. Indp. Artists.*

SAPP, Kitt George (Mr.) [*Painter*] *b.1887, Independence, MO.*
Addresses: Kansas City, MO. **Studied:** Kansas City AI; Univ. Kansas City; Colorado Springs FA Center. **Member:** AEA; Kansas City AI Alum. **Exhibited:** Sedalia State Fair, 1939 (prize); Springfield, Mo., 1940 (prize); Joslyn Mem.,1945(prize); Kansas City AI, 1938, 1939; Downtown Gal., 1951. **Work:** murals, Kansas City Stock Exchange. **Sources:** WW59; WW47.

SARANTOS, Bettie J. [*Painter, printmaker, interior designer*] *b.1934, Montgomery, PA.*
Addresses: Newport, RI. **Studied:** China (traveled with Dong Kingman, 1973); Workshops: Nathan Goldstein, Charles Movalli, Frank Webb, Charles Reid, Barbara Necchis, Betty Lou Schlem, Phyllis Case Bennett, Prof. I-Hsiung Ju. **Exhibited:** Arnold Art Gal., Newport, RI, many solo and group shows since 1973. **Comments:** Preferred media: oil, watercolor, mixed media. Specialist in Chinese brushpainting. Dealer: Roger King Fine Art Gallery, Newport, RI. **Sources:** info. courtesy of artist.

SARAZIN, L. (Mrs.) [*Drawing teacher, painter*] *early 19th c.*
Addresses: Hamilton Village, PA. **Exhibited:** Society of Artists & PAFA, Phila., joint exh., 1813; PAFA, 1822-27 (watercolors of fruits & flowers, crayon drawings). **Comments:** Groce & Wallace indicated that the Society of Artists Cat. of 1813 listed a Mme. Sansay of Hamilton (PA) as exhibiting artificial flowers in 1813. Given that Mrs. Sarazin is listed by Rutledge (PA) as also exhibiting with the Society of Artists in 1813 and that she, like Mme. Sansay, was from Hamilton Village, PA, it is very likely they are the same person and that the "Sansay" was a misspelling in the original catalog. Mrs. Sarazin seems to have specialized in crayon drawings and floral watercolors. **Sources:** G&W; Rutledge, PA; Society of Artists Cat., 1813.

SARDEAU, Helene [*Sculptor*] *b.1899, Antwerp, Belgium / d.1968.*
Addresses: Croton-on-Hudson, NY/Truro, MA. **Studied:** Barnard College, NYC; Cooper Union Art School; ASL, 1921-22; Am. Sch. Sculpture, NYC, 1924-25; self-study in Paris, 1926-29; Italy, 1931-32. **Member:** Sculptors Gld. **Exhibited:** Arden Gal., NYC, 1923 (solo), 1924 (solo, clay dolls); Salon d'Automne, Paris, 1928; Ehrich Gal., NYC, 1929; Ehrich Gal., 1930 (solo); Rome, Italy, 1932 (solo); Julian Levy Gal., 1934 (solo); Arch. Lg., 1934 (prize), 1941; WMAA, 1933-56; PMA, 1934; GGE, 1939; WFNY, 1939; MoMA, 1940; AFA, 1940; MMA, 1940, 1952; BM, 1940; CI, 1941; AIC, 1941; NAC (solo); Santa Barbara Mus. Art, 1943 (solo); PAFA Ann., 1944-64 (9 times); Assoc. Am. Artists, 1944 (solo); Carlen Gal., 1946 (solo). **Work:** terra cotta reliefs, Croton-on-Hudson H.S.; USPO, Greenfield, MA; USPO, Ossining, NY; limestone statue, Fairmount Park, Phila., PA; bronze relief, Nat. Lib., Rio de Janerio; bronze relief, Supreme Court, Mexico City; WMAA; PAFA; PMA; Tel Aviv Mus., Israel; MMA; Y.M.H.A. Bldg., NY; masks, Delphic Festival, Greece. **Comments:** From 1926-29, she had a studio in Paris. In 1931, she married George

Biddle (see entry) and had one joint exhibition with him in 1932 at the Italian Syndicate of Fine Arts in Italy. "Sardeau" was her pseudonym. **Sources:** WW66; WW47; Crotty, 95; Petteys, *Dictionary of Women Artists;* Falk, *Exh. Record Series.*

SARET, Alan Daniel [*Sculptor*] *b.1944.*
Addresses: NYC. **Exhibited:** WMAA, 1968, 1977, 1987. **Sources:** Falk, *WMAA.*

SARFF, Walter (Smith) [*Painter, designer, teacher, writer*] *b.1905, Perkin, IL.*
Addresses: NYC. **Studied:** Sch. Mod. Photog., NYC (grad., 1949); Sch. Portrait & Commercial Photog., New York; also with Alexey Brodovitch & Adolph Fassbender; Nat. Acad. Art, Chicago, traveling scholar, 1931 (grad.); Grand Cent. Sch. Art, NYC; ASL; Woodstock Sch. Painting, NY; also with Hubert Ropp, Chicago & Yasuo Kuniyoshi, New York. **Member:** Woodstock AA; Ulster County Ar. U.; Am. Soc. Mag. Photogr.; AEA; ASL; hon. mem. Hypo Club; MoMA. **Exhibited:** Woodstock AA, 1931 (prize), 1937 (prize); Nat. Acad. A., 1931 (traveling scholarship); S. Indp. A., 1936, 1940; Portland, Oreg., AM; 48 Sts. Comp., 1939; San Diego Expo, 1935; U.S.Nat. Mus., Wash., DC; CGA; Grand Central A. Gal.; WMA; Natural Hist. Bldg., Wash., DC; Denver A. Mus; Springfield Art Mus., Mass.; Worcester Art Mus., Mass.; Denver Art Mus., Colo.; SFMA; SAM. **Work:** collections of George Hillenbrand, M. Owen Page & Anna Carolan. **Comments:** Positions: dir., Sawkill Gallery, Woodstock; chmn. exec. bd., Woodstock Artists Assn., 1939 & juror; exec. secy., Ulster Co. Artists Union; pres., Sarff-Zumpano, Inc. Teaching: instr. & asst. registr., Nat. Acad. Art, Chicago, 1929-31; pvt. instr., 1931-42. Publications: contribr., *Am. Ann. Photog.,* cover, *Am. Photog., Art Photog., Cath. Digest & Charm.* **Sources:** WW73; WW47.

SARG, Mary [*Portrait painter, teacher, illustrator*] *b.1911, London.*
Addresses: New Hope, PA. **Studied:** W. Reiss; ASL; Phoenix Art Inst.; NY Sch. Applied Design for Women; J. Lie; G.W. Parker; Fontainebleau Sch. FA. **Member:** NAWPS. **Comments:** Illustrator: "Children's Corner," 1935, "Happy as Kings," 1936, "American Girl," 1935, "Today", 1935, 1936; Woman's Day, 1938, Junior Red Cross News, Mademoiselle, 1939. Position: teacher, Keramic Soc. & Des. Gld., NY. **Sources:** WW40.

SARG, Tony [*Designer, decorator, cartoonist, illustrator, sculptor, lecturer, writer*] *b.1880, Guatemala / d.1942, NYC.*
Addresses: NYC (1914-on)/Nantucket, MA. **Studied:** his father, an amateur watercolorist; his grandmother, Mary Ellen Best, also a watercolorist. **Member:** SC; SI. **Exhibited:** Easy St. Gal., Nantucket, 1924-on. **Work:** Nantucket Hist. Assn. **Comments:** He emigrated to London in 1905, illustrating children's books such as *Children For Ever* (1908) and *Molly's Book* (1908). In 1914, he moved to NYC, illustrating for *Collier's, Sat. Eve. Post, Cosmopolitan* and others. He also wrote and illustrated ten books, including *Book for Children, Alphabet, Marionette Book,* and *Trickbook.* He also illustrated *Speaking of Operations* and *Fiddle D.D.* He created his own marionettes and the motion picture shadowgraph productions. From 1922 until his death from appendicitis, he was an active member of the summer colony of artists on Nantucket. **Sources:** WW40; add'l info. courtesy Nantucket Hist. Ass'n.

SARGANT, Mary See: **FLORENCE, Mary Sargant**

SARGANT-FLORENCE, Mary See: **FLORENCE, Mary Sargant**

SARGEANT, Charles See: **BUCK, Claude**

SARGEANT, Clara McClean [*Painter*] *b.1889, Washington, IA.*
Addresses: Cleveland, OH. **Studied:** Cleveland Sch. Art; ASL; Corcoran Sch., Wash., DC. **Member:** Women's AC, Cleveland. **Exhibited:** Cleveland Mus. Art, 1922 (prize), 1924-28 (prizes).

Sources: WW29.

SARGEANT, Geneve Rixford (Mrs. Winthrop) *[Painter, lithographer, teacher]* b.1868, San Francisco, CA / d.1957, Santa Clara County, CA.
Addresses: Chicago, IL; San Fernando Valley, CA; Sausalito, CA, 1923; Paris (4 years); San Fran., CA. **Studied:** AIC; Calif. Sch. of Des. with Virgil Williams and Emil Carlsen; ASL with W.M. Chase; A. Lhote and O. Friesz in Paris. **Member:** NYSWA; San Francisco AA (dir., 1915-23); San Francisco Women Artists; Sketch Cl., San Francisco (co-founder). **Exhibited:** AIC, 1899-1903; San Fran. Sketch Cl., 1894-1914; Mark Hopkins Inst., 1896; Golden Gate Park Mus., 1915; Pan.-Pac. Expo, San Fran., 1915; San Francisco AA annuals from 1916; LACMA, 1919; Paris Salon, 1919; Corcoran Gal biennial, 1923; Beaux Arts Gal., San Fran., 1927; Calif. State Fair, 1930; S. Indp. A., 1931, 1934-35; Gump's, San Francisco, 1932; CPLH, 1933, 1934 (solo); Delphic Studio, NYC, 1932, 1936; Salons of Am., 1934; SFMA, 1935, 1939 (solo); Calif.-Pac. Expo, San Diego, 1935; GGE, 1939; San Francisco Women Artists (prize); PAFA, 1941; de Young Mus., 1948 (retrospective). **Work:** Mills College; de Young Mem. Mus.; Los Angeles AA; SFMA; Acad. Science & FA, Richmond, VA. **Sources:** WW53; WW47. More recently, see Hughes, *Artists in California,* 491.

SARGENT, Anita W. *[Painter]* b.1876, Phila., PA.
Addresses: Boston, MA/Bryn Mawr, PA. **Studied:** W. Sartain; E. Daingerfield; E. Tarbell; and in Paris. **Exhibited:** Boston AC, 1900; PAFA Ann., 1908. **Sources:** WW10; Falk, *Exh. Record Series.*

SARGENT, Charles *[Painter]* mid 20th c.
Addresses: Chicago area. **Exhibited:** AIC, 1937. **Sources:** Falk, AIC.

SARGENT, Christiana Keadie Swan (Mrs.) *[Landscape painter]* b.1777 / d.1867.
Exhibited: Boston Athenaeum, 1828, 1837. **Sources:** G&W; Swan, BA.

SARGENT, Henry *[Portrait, historical, religious, and genre painter]* b.1770, Gloucester, MA / d.1845, Boston.
Addresses: Boston, 1799-on. **Studied:** Benjamin West in London, 1793-c.1799; with Gilbert Stuart, 1806. **Member:** NAD, 1840 (hon. mem.); Artists' Assoc. Boston (first pres., 1845). **Work:** BMFA; Pilgrim Hall (Plymouth, MA). **Comments:** One of the earliest anecdotal genre painters in America. He spent his childhood in Gloucester and Boston, then trained with B. West in Boston. Upon his return, he took up a career as an Army colonel, politician and, in later years, as an inventor. He painted throughout his life, however, producing portraits and historical pieces, such as "The Landing of the Pilgrims" (1813, Pilgrim Hall), and is best known for his genre subjects, such as " The Tea Party" (c.1821, BMFA) and "The Dinner Party" (c.1821-25, BMFA). **Sources:** G&W; DAB; Julia Addison, "Henry Sargent, a Boston Painter," *Art in America* (October 1929); Dunlap, *History;* Dickson, *Observations on American Art by John Neal,* 7-8; Belknap, *Artists and Craftsmen of Essex County,* 12; Swan, BA; Flexner, *The Light of Distant Skies.* More recently, see Baigell, *Dictionary; 300 Years of American Art,* vol. 1, 77.

SARGENT, I. T. (Mrs.) See: **SARGENT, Christiana Keadie Swan (Mrs.)**

SARGENT, Irene *[Teacher, lecturer, critic, writer]* b.1932, Syracuse, NY.
Member: American Inst. Arch. & Allied Arts (the second woman to be elected an hon. mem. of the Inst.). **Comments:** Contributor: U.S., French, Italian publications. Positions: teacher, Syracuse Univ., for 36 years.

SARGENT, John Singer *[Painter, mural painter]* b.1856, Florence, Italy (of American parents) / d.1925, London, England.
Addresses: Paris, until 1886; London, 1886-on. **Studied:** Acad. FA, Florence, 1871-72; École des Beaux-Arts, Paris; privately with Léon Bonnat in Paris; privately with Carolus-Duran, in Paris, until 1879. (It is not generally recognized that Sargent studied at the Académie Julian; however, Fehrer notes that he is listed in their archives as a former student during 1875-76.). **Member:** ANA, 1891; NA, 1897; Mural P.; Port. P.; Copley S.; AIA; SAA; Paris SAP; Soc. Nat. des Beaux-Arts, Paris; Royal Acad., London (Assoc., 1894; R.A., 1897); Century Assn., NY; NIAL; Phila. WCC; Berlin Acad.; Inst. de France, 1905. **Exhibited:** Paris Salon, 1877-86 (prize, 1878, med. 1881), 1888; SNBA, 1890-92, 1894, 1896, 1898; New English Cl., London, 1887; Paris Expo, 1889 (prize); SAA; AIC, 1890-1939, 1922 (prize); Phila. AC, 1890 (med); PAFA, 1891-1910, 1914-26 (gold medal for best figure painting 1894, gold for best portrait in oil 1909); Columbian Expo, Chicago, 1893 (med); Pan-Am. Expo, Buffalo, 1901 (gold), 1903 (gold); Berlin, 1903 (gold), St. Louis Expo, 1904 (prize); Royal Soc. of Watercolor Ptrs., regularly from 1904; Liège Expo, 1905 (gold); Corcoran Gal biennials, 1907-23 (9 times, 44 paintings); Venice, 1907 (gold); Boston AC, 1909; NIAL, 1914 (gold); Royal Academy of Art, London, 1890s, 1926 (memorial); Copley Gal., Boston, 1917 (watercolors of Florida); MMA, 1926 (memorial); Detroit IA, 1979 (retrospective); Tate Gal., London, 1998 (retrospective of 150 paintings, traveled to BMFA, 1999). Other awards: Chevalier of the Legion of Honor, France, 1889; Order of Merit, Germany, 1909. **Work:** BMFA (oils and murals); Isabella Stewart Gardner Mus., Boston; MMA; NMAA; AIC; NGA; CGA; AIC; PAFA; PMA; High Mus. of Art, Atlanta; Brooklyn Mus.; Des Moines (IA) Art Ctr.; Boston Pub. Lib. murals (the task took from 1890-1925); Luxembourg Mus., Paris; Tate Gal., London; Uffizi Gal., Florence, Italy; Buffalo FA Acad.; Worcester (Mass.) A. Mus.; Indianapolis AA; Widener Lib., Harvard (murals); Colorado Springs Art Ctr.; NPG, London; Imperial War Mus., London (WWI pictures); Detroit IA; Nebraska AA; Nelson-Atkins MA, Kansas City; Clark AI, Williamstown, MA. **Comments:** Sargent was among the most important of America's expatriate artists, a master of the bravura brushstroke in oil and a master of watercolor as well. During the "Golden Age" of the late 19th and early 20th centuries, his portraiture, along with that of Whistler, was in greater demand by high society than that of any other American artist. His portraiture bears strong stylistic affinities with that of Boldini and Whistler; together they formed a triumvirate that was highly influential on an international scale. Although best known in his day for his portraits, Sargent spent long parts of each year traveling throughout the world and painting outdoors, sketching in Broadway, England; Venice; Nice; Spain; North Africa; and even in Florida (1917); In his late years especially, as Sargent tired of portraiture and even sought ways to avoid commissions, he focused on landscape, and it was in his watercolor landscapes that Sargent was most impressionistic. Sargent also produced a small number of lithographs. The most talented of Sargent's immediate followers were J. Sorolla y Bastida, Anders Zorn, John Lavery, Irving Wiles, and Albert Besnard. **Sources:** WW24; Denys Sutton, "The Yankee Brio of John Singer Sargent" *Portfolio* (Oct., 1979, p.46); Fink, *American Art at the Nineteenth-Century Paris Salons,* 388; biography by E. Kilmurray & R. Ordmond (Princeton Univ. Press, 1998); Carter Ratcliff, *John Singer Sargent,* NY: Abbeville Press, 1982 (incudes extensive bibliography); *Sargent at Broadway: The Impressionist Years* with essays by Stanley Olson, Warren Adelson, and Richard Ormond (NY: Coe Kerr Gallery, 1986); Fehrer, *The Julian Academy;* Donelson F. Hoopes, *Sargent Watercolors* (New York, 1970); Baigell, *Dictionary;* Susan Strickler, ed., *American Traditions in Watercolor,* cat. nos. 81-88; Falk, *Exh. Record Series.*

SARGENT, Margaret Holland *[Painter]* mid 20th c.
Addresses: Seattle, WA. **Studied:** UCLA, 1945-47; watercolor classes, Tokyo, Japan, 1956; oil painting with Herbert Abrams, New York, 1959-61 & Marcos Blahove, Fairfax, VA, 1969. **Exhibited:** Turkish Am. Assn., Ankara, 1963 (solo); Art Lg. Northern Virginia, 1968 (solo); Frye Art Mus., 1971 (solo); Coupeville (WA) Days, 1971; Bellevue(WA) Art Festival, 1972; Gordon Woodside Galleries, Seattle, 1972; Frye Art Mus., Seattle,

1972. Awards: blue ribbon for portrait of Lt. Gen. William F. Cassidy, Wash., DC; gold seal award, Montgomery Co. (MD) Ann. **Work:** commissions: portrait, Argentine Embassy, Ankara, Turkey. **Sources:** WW73.

SARGENT, Margarett W. *[Sculptor, painter] b.1892, Wellesley, MA / d.1978.*
Addresses: act. in Boston, MA, and Wellesley, MA; Stamford, CT. **Studied:** BMFA; Charles Woodbury at Ogunquit, ME, 1916; Gutzon Borglum, NYC; George Luks. **Member:** NAWPS. **Exhibited:** PAFA Ann., 1918-19; AIC; Kraushaar Gal, NYC, 1926-31 (solos); Corcoran Gal biennial, 1930; Doll & Richards, Boston , 1932 (solo); Davis Museum, Wellesley Col., 1996 (retrospective); Berry Hill Galleries, NYC, 1996 (retrospective); "Charles H. Woodbury and His Students," Ogunquit Mus. of Am. Art, 1998. **Comments:** Modernist artist who made portraits and figural works in a bold vivid style. She was friendly with many of the avant-garde artistic types of the 1920s and 1930s, including Alexander (Sandy) Calder, George Luks, Betty Parsons, Fanny Brice, Harpo Marx, and Jane Bowles. Sargent stopped painting about 1935. Family relationships, alcohol problems, and mental illness complicated a great portion of her later life. Assembled important collection of modern art. **Sources:** WW40; Petteys, *Dictionary of Women Artists;* Linda Nochlin, *Margarett Sargent* (exh. cat., NYC: Berry Hill Gal, 1996); Honor Moore, *The White Blackbird: A Life of the Painter Margarett Sargent by Her Granddaughter* (New York: Viking Press, 1996); *Charles Woodbury and His Students;* Falk, *Exh. Record Series.*

SARGENT, Marina L. *[Painter] late 19th c.*
Work: Peabody Mus., Salem, MA (sketchbook of the Far East, 1879). **Sources:** Brewington, 341.

SARGENT, Mary See: **FLORENCE, Mary Sargant**

SARGENT, Mary Forward (Mrs. William Dunlap)
[Etcher, craftsperson, sculptor, teacher, lecturer, illustrator] b.1875, Somerset, PA / d.1963, Newtown, CT.
Addresses: Westport, CT. **Studied:** Penn. College for Women; ASL; Teachers College, Columbia Univ.; Inst. d'Esthétique Contemp., Paris; Central Sch. Art, London & with William P. Robbins, Paul Burner, St. Gaudens, Wickey. **Member:** PBC; CAFA; NAWA; Silvermine Gld. Artists. **Exhibited:** Penn. College for Women, 1895 (gold); Morton Gal., 1939 (solo); CAFA, 1940-42, 1946; Silvermine Gld. Artists, 1940-43; Studio Gld., 1940; New England Print Assn., 1941; NAWA, 1942-43; SAE, 1942-44; NAD, 1943; LOC, 1944; Soc. Liberal Arts, Omaha, NE, 1944; PBC, 1944-46. **Work:** MMA; LOC; BM; Brooks Mem. Art Gal.; G.W.V. Smith Art Mus; Somerset (PA) PA. **Comments:** Illustrator: *House Beautiful.* Lectures: History & Appreciation of Etching. **Sources:** WW59; WW47.

SARGENT, Paul Turner *[Painter, mural painter] b.1880, Hutton, IL. / d.1946, Hutton, IL.*
Addresses: Charleston, IL/ Los Angeles, CA. **Studied:** John Harlow; Eastern Illinois State Normal School, with Anna Piper and Otis Caldwell; AIC, with C.F. Browne and J.H. Vanderpoel, 1906-12. **Member:** Brown County Art Gal. Assn.; Hoosier Salon. **Exhibited:** AIC, 1912-17; Charleston AA, 1913; Los Angeles Central Lib., 1940. **Work:** Eastern Illinois Univ.; Univ. Indiana, Bloomington; murals: Crippled Children's Home, Sherman Park Field House, John Smythe School, all Chicago. **Comments:** Position: teacher, Eastern Illinois State Teacher's College, 1938-42. **Sources:** WW40; Hughes, *Artists in California,* 491.

SARGENT, Richard *[Painter]* *DICK SARGENT* *b.1911, Moline, IL / d.1978.*
Addresses: Crestwood, NY. **Studied:** CGA; Phillips Mem. Gal.; with Ben Shahn. **Member:** SI. **Exhibited:** NYC; Wash., DC; San Francisco; and abroad. **Work:** USPO, Morrilton, AR. **Comments:** WPA artist. Illus., *The Saturday Evening Post, Fortune, Woman's Day* and other national magazines. He lived and painted in Spain for many years. **Sources:** WW40; W&R Reed, *The Illustrator in America,* 237.

SARGENT, Rosa *[Pioneer artist] b.1867, Clio, IA.*
Addresses: Corydon, IA; Washington State; Corydon. **Studied:** Mrs. Waymack, Allerton, IA, 1882; Prof. Scheiwie, Ottumwa, IA; Prof. Southwick, Des Moines. **Work:** Corydon Pub. Lib. (landscape in oil). **Comments:** Preferred media: oil, water colors, china decoration. **Sources:** Ness & Orwig, *Iowa Artists of the First Hundred Years,* 183.

SARGENT, Sidney Freeman *[Painter] mid 20th c.*
Addresses: Berkeley, CA, 1932. **Exhibited:** SFMA, 1935; San Francisco AA, 1938. **Sources:** Hughes, *Artists in California,* 491.

SARGENT, Walter *[Painter, etcher, writer] b.1868, Worcester, MA / d.1927.*
Addresses: Chicago, IL; North Scituate, RI. **Studied:** Colarossi Acad., Delecluse Acad., both in Paris; also with L'Hermitte and Delance in Paris. **Member:** Copley Soc., 1896; Paris AAA; Chicago PS. **Exhibited:** Boston AC, 1896, 1899, 1900; AIC, 1911-28 (prize); PAFA Ann., 1915; Corcoran Gal biennial, 1919. **Comments:** Author: "How Children Learn to Draw," "Art Education in the United States," "The Enjoyment and Use of Color." Positions: teacher, Univ. Chicago, Boston Pub. Sch., AIC; state supervisor of drawing for Massachusetts. **Sources:** WW25; Falk, *Exh. Record Series.*

SARIFF, Walter See: **SARFF, Walter (Smith)**

SARIS, Anthony *[Illustrator] b.1924, Joliet, IL.*
Addresses: NYC. **Studied:** Pratt AI; BM Sch.; New School for Social Research. **Exhibited:** NYC; Wash., DC; Art Directors Clubs; SI; American Inst. of Graphic Arts; Outdoor Advertising Show. **Comments:** Position: teacher, Pratt AI, 1956-on. Illustrator, national advertisers and major publications. **Sources:** W&R Reed, *The Illustrator in America,* 304.

SARISKY, Michael A(loysius) *[Painter] b.1906.*
Addresses: Cleveland, OH. **Studied:** H.G. Keller; H. Tonks; Slade Sch. **Member:** Cleveland SA. **Exhibited:** Ann. Exh. Work by Cleveland Artists and Craftsmen, CMA, 1931 (prize), 1932 (prize), 1933. Award: Prix de Rome, 1930, 1933. **Work:** USPO,. **Comments:** WPA artist. **Sources:** WW40.

SARKA, Charles Nicolas *[Mural painter, drawing specialist, decorator] b.1879, Chicago, IL / d.1960.* *SARKA*
Addresses: NYC/Canada Lake, NY.
Member: AWCS. **Exhibited:** Arch. Lg., 1913 (prize); PAFA Ann., 1913; St. Louis Pageant, 1914 (prize); Salons of Am.; AIC; S. Indp. A., 1925-26, 1928. **Work:** mural, U.S. Gov., Wash., DC; Vanderpoel AA, Chicago. **Comments:** He enjoyed travel, and went to many, often remote areas from the South Seas to North Africa, supporting himself with his drawing and painting. Thomas Hart(see entry) was one of his travel companions. Illus., newspapers in Chicago, San Francisco & NYC; *Judge, Cosmopolitan* and other magazines. **Sources:** WW40; Falk, *Exh. Record Series.*

SARKADI, Leo (Schuller) *[Painter, etcher, writer] b.1879, Budapest, Hungary / d.1947, NYC.*
Addresses: NYC. **Member:** S. Indp. A.; Am. Artists Congress; Artists Union. **Exhibited:** Salons of Am.; S. Indp. A., 1922, 1925-42; PAFA Ann., 1932, 1937; Corcoran Gal biennial, 1941. **Work:** Mount Morris Hospital; Folks Memorial Hospital, Oneonta; Brooklyn Technical H.S.; Summit Park Sanitorium, Pomona, NY; Board Educ., Newark; Edgar Allen Poe Sch., Theodore Roosevelt H.S., Pub. Sch. 90, Pub. Sch. 165, Riverside Hospital, all in NYC; Newark Airport, NJ. **Sources:** WW40; Falk, *Exh. Record Series.*

SARKIN, Jack *[Lithographer] mid 20th c.*
Addresses: Los Angeles, CA. **Exhibited:** GGE, 1939. **Sources:** Hughes, *Artists in California,* 491.

SARKIS, (Sarkis Sarkisian) *[Painter, drawing specialist, teacher] b.1909, Smyrna, Turkey / d.1977.*
Addresses: Detroit, MI. **Studied:** John P. Wicker Art Sch.; Art Sch. Soc. Art & Crafts with John Carroll. **Member:** Art Founder's Soc. & Friends Mod. Art, Detroit Inst. Arts; Scarab Cl. **Exhibited:**

AIC, 1931-43; S. Indp. A., 1931; PAFA Ann., 1934-36, 1947-51, 1958-60; Mich. Ar. Ann., 1937 (prize); Corcoran Gal biennials, 1935-55 (5 times); Art Founders Soc., 1938 (prize); Detroit Inst. A. (three Art Founder's Prizes); Am. Div. Golden Gate Expo, 1939; Univ. Mich., Ann Arbor (award); Butler Inst. Am. Art (award); MoMA; CI; Wayne State Univ; Henry Ford Community Col; Women's City Cl., Detroit; Detroit Artists Market and Arwin Gal., Detroit, 1970s. **Work:** murals, Julie Shop, Inc., Detroit; Fisher Bldg., Detroit; Detroit Inst. A.; Butler Inst. Am. Art. Commissions: mosaic tile, "Map of the World," Ford Admin. Bldg., Dearborn, Mich.; reredos & 16 other religious paintings, Church of Incarnation, Detroit, 1941; portrait of Gen. Calladay, Flint Armory, Mich. **Comments:** Preferred media: oils, mixed media. Teaching: Art Sch. Soc. Arts & Crafts, Detroit, 1933-66. **Sources:** WW73; WW40; Morley Driver, "Sarkis, the Grand old Man of Detroit's Art World," *Detroit Mag.* (Dec. 26, 1965); Joy Hakanson, "His Eyesight is Limited but not His Vision," *Sun. Mag., Detroit News,* Mar. 26, 1972; Falk, *Exh. Record Series.*

SARKISIAN, Paul *[Painter] b.1928.*
Addresses: San Francisco, CA. **Exhibited:** WMAA, 1969. **Sources:** Falk, *WMAA.*

SARKISIAN, Sarkis See: **SARKIS, (Sarkis Sarkisian)**

SARLIE, Jacques *[Collector] 20th c.*
Addresses: NYC. **Sources:** WW66.

SARNOFF, Arthur Saron *[Illustrator, commercial artist, painter] b.1912, Brooklyn, NY.*
Addresses: Glen Head, NY. **Studied:** Industrial School Art; Grand Central School Art; also with Harvey Dunne. **Member:** Soc. Illustrators; All. A. Am. **Exhibited:** Int. Art Galleries; Continental Art Galleries; Sports in Action, Grand Central Art Galleries, 1970s; Nat. Acad. Art; Allied Art Show; SI. Awards: Outdoor Poster award, 1957, Art Directors Club award. **Work:** Bass Mus.; Springfield Mus.; Parrish Mus.; Hartford Mus.; Grand Central Galleries & Nat. Art Mus. Sport, NYC. Commissions: fine art prints, Arthur Kaplan Co., Donald Art Co. & Cataldi Fine Prints. **Comments:** Preferred media: oils, acrylics. Publications: contributor, all leading magazines. Illustrator for national magazines and national advertisers. **Sources:** WW73; WW47.

SARNOFF, Lolo *[Sculptor, collector] b.1916, Frankfurt-am-Main, Germany.*
Addresses: Bethesda, MD. **Studied:** Reimann Art School, Berlin, Germany (grad., 1936). **Member:** AEA. **Exhibited:** Agra Gal., Wash., DC, 1968 (solo) & Corning Mus. Glass, 1970 (solo); Gal. Two, Woodstock, VT, 1969; Gal. Marc, Wash., DC, 1971; Art 1972, Int. Artmart, Basel, Switzerland, 1972; Gal. Liatowitsch, Basel, Switzerland, 1970s. **Work:** Nat. Acad. Sciences, Wash., DC; Kennedy Center, Wash., DC; Corning Glass Center, Corning, NY. Commissions: light sculptures, U.S. Embassy, New Delhi, 1970 & flame, Kennedy Center, 1971. **Comments:** Preferred media: fibers, acrylics. Collections: twentieth century drawings, paintings and sculptures; eighteenth century Fayence; eighteenth century porcelain. **Sources:** WW73.

SARNOFF, Robert W. *[Collector] b.1918, NYC.*
Addresses: NYC. **Comments:** Positions: trustee, John F. Kennedy Library Corp.; bd. of directors, Bus. Committee for Arts. Collection: contemporary art. **Sources:** WW73.

SARONY, Hector *[Lithographer, artist] mid 19th c.*
Addresses: NYC. **Exhibited:** American Institute, 1848 & 1849 (lithographs and a pencil drawing). **Comments:** He was listed at the same address as Napoleon Sarony (see entry). **Sources:** G&W; Am. Inst. Cat., 1848, 1849.

SARONY, Napoleon *[Lithographer, photographer, charcoal portraitist] b.1821, Quebec / d.1896, NYC.*
Addresses: NYC. **Studied:** studied drawing with a Mr. Robertson, probably Alexander. **Member:** American Photographic Society (founding mem.); Tile Cl.; Salmagundi Cl., 1871 (founding mem.). **Exhibited:** Centenn. Expo, Phila., 1876 (prize); PAFA

Ann., 1880 (crayon drawing); Boston AC, 1884-85, 1887, 1890-91; NAD, 1894. **Work:** represented at Princeton University by pastel portrait of Grover Cleveland. **Comments:** Came to NYC about 1836, eventually going to work as a lithographer for Henry R. Robinson and Nathaniel Currier. In 1846 he joined with Henry B. Major to form Sarony & Major, later expanded to Sarony, Major & Knapp (see entries). Sarony left the firm about 1867, visited Cuba for his health, and then went to Europe for six years, during which time he did some lithographic work in Germany, France, and England. After a brief visit to NYC he again went abroad and briefly operated a photographic studio in Birmingham, England, where he achieved a high reputation for artistic photography. Sarony returned to NYC in 1864 and opened a studio which became a great success, making him one of NYC's first fashionable photographers. He was an innovator, setting a new style for studio lighting, settings, and accessories, and even inventing a kind of "posing machine" which made it possible for a person to retain one pose, comfortably, over an extended period of time. He made portraits of thousands of celebrities, usually as cabinet cards. Sarony's studio was a melange of ancient artifacts, stuffed alligators, arms & armor, and countless curiosities. In *The Fortunes of Oliver Horn* (by F. Hopkinson Smith, 1902) Sarony is the character Julius Bianchi. After his death, the American Art Galleries sold his entire studio collection of art and artifacts for a total of only $1,025.75. An Egyptian mummy in case sold for only $14; a 40-inch gold leaf Burmese figure, only $15; and a 300-lb Japanese bronze bell, only $15. In later years he also did charcoal portraits, but at the auction even these generally sold for only $2-$15 each. **Sources:** G&W; Peters, *America on Stone;* Peters, *Currier & Ives,* I, 120-29; NYBD 1846 and after; Am. Inst. Cat., 1850; *Antiques* (Feb. 1927), 108-09; *NY Times* 1 Apr. 1896, 2:13; G&W cited some information as being courtesy Donald Egbert; Falk, *Exh. Record Series;* ; Witkin & London, 229; Welling, *Photography in America,* 171-72.

SARONY-LAMBERT, N. *[Painter] 20th c.*
Addresses: NYC. **Sources:** WW19.

SARONY & MAJOR *[Lithographers] mid 19th c.*
Addresses: NYC, 1846-67. **Work:** LOC (Div. of Prints & Photographs); NYPL (Stokes Collection); Peale Mus. (Baltimore, MD). **Comments:** The firm was established in 1846 by Napoleon Sarony and Henry B. Major (see entries), former employees of Nathaniel Currier (see entry). The firm printed numerous views of cities and towns by artists such as John Bachman, John William Hill, and Fitz Hugh Lane. In 1857 the firm became Sarony, Major & Knapp. **Sources:** G&W; Peters, *America on Stone;* Am. Inst. Cat., 1847-49. More recently, see Reps, 106 (repro.) and 118 (repro), cat nos. 1285, 1366, 2186, and many more catalogue entries listing locations of prints.

SARONY, MAJOR & KNAPP *[Lithographers] mid 19th c.*
Addresses: NYC, 1857-67. **Work:** LOC (Geography & Map Div.); Putnum Mus. (Davenport, Iowa); Picture Div., Public Archives of Canada (Ottawa). **Comments:** The firm was established when Joseph F. Knapp joined forces with Sarony & Major in 1857 (see entries). After Sarony's retirement from the company in 1867, the name was changed to Major & Knapp. **Sources:** G&W; Peters, *America on Stone.* More recently, see Reps, 37, and cat nos. 928, 1015, 1019, 3212, 3213.

SARRE, Carmen G. *[Portrait painter, lecturer, teacher, decorator] b.1895, Antwerp, OH.*
Addresses: New Orleans, LA. **Studied:** Agnes Scott Col.; Univ. Michigan (A.B.); NY School Design for Women; PM School Art; L. Makielski; E.H. Barnes; J.C. Chase; C. Link; B. Crawford; S.F. Kimball. **Member:** New Orleans AA; New Orleans Artists Gld.; SSAL. **Exhibited:** Wash. WCC, 1940-42; Chevy Chase Women's Club, 1944; New Orleans AA; New Orleans Artists Gld. **Comments:** Position: dir., Young People's Painting Class, NOMA; hd., School for Ecclesiastical Embroidery at Trinity Church, New Orleans, LA. Lectures: Decorative Art. **Sources:** WW59; WW47.

SARRE, Henry W. *[Painter, photographer] b.1829, Prussia, Germany / d.1872, New Orleans, LA.*
Addresses: New Orleans, active 1858-72. **Sources:** *Encyclopaedia of New Orleans Artists,* 338.

SARSONY, Robert *[Painter, printmaker] b.1938, Easton, PA.*
Addresses: Dover, NJ. **Exhibited:** All. A. Show, NYC, 1963-65; solo shows, Capricorn Galleries, Bethesda, MD, 1967-71; Mainstream 1971, Marietta (OH) College, 1971; Three Young Realists, ACA Galleries, New York, 1971; New Jersey Contemporary Masters, Heritage Arts, South Orange, 1971-72; Capricorn Galleries, Bethesda, MD, 1970s. **Work:** Butler IA; Georgia Mus. Art, Athens; Joslyn Art Mus., Omaha, NE; Sara Roby Foundation, NYC; Univ. Kansas Mus. Art, Lawrence.
Comments: Preferred media: oils, watercolors, graphics.
Sources: WW73; John S. Le Maire, "Robert Sarsony," *NJ Bus. Magazine* (1969); George Albert Perret, *Robert Sarsony--painter,* (Heritage Arts, 1971).

SARTAIN, Emily *[Painter, mezzotint engraver, teacher] b.1841, Phila., PA / d.1927.*
Addresses: Phila., PA. **Studied:** her father John Sartain; PAFA, with Schüssele, 1864-70; Luminais, in Paris. **Member:** Plastic Cl. (founder); New Century Cl., Phila. (founder); Lyceum Cl., London. **Exhibited:** Paris Salon, 1875, 1883; Centenn. Expo, 1876 (prize); PAFA Ann., 1876-79, 1881 (prize), 1883 (prize), 1884-85, 1889, 1905; Pan-Am. Expo. Buffalo, 1901 (prize); NAD, 1877-84. **Comments:** As a young woman studying in Paris, she was part of a circle of women artists that included Mary Cassatt. An important art educator considered a pioneer in the field, she served as principal of the Phila. Sch. Des. for Women (now called Moore College of Art) from 1886 until her retirement in 1920. Other positions: Jury of Selection and Hanging Com., PAFA, 1886 (she and Cecelia Beaux were the first women to serve); Jury of Award, Columbian Expo, Chicago, 1892. Delegate: U.S. Govt. to Int. Congress on Instruction in Drawing, Paris, 1900; Berne, Switzerland, 1904. Editor, *Our Continent* (illus. magazine published in Phila.), 1881-83. **Sources:** WW27; Rubinstein, *American Women Artists,* 74-75; Falk, *Exh. Record Series;* see also Sartain Family Papers, Archives of Am. Art, Smithsonian.

SARTAIN, Harriet *[Landscape painter, teacher] b.1873, Phila.*
Addresses: Phila., PA. **Studied:** Phila. School Design for Women; Teachers College, NY. **Member:** Phila. Art Teachers Assoc.; Eastern AA; Plastic Club; Phila. Art Alliance. **Exhibited:** PAFA Ann., 1901-03; Boston AC, 1907, 1908; AIC. **Comments:** Position: dean, Phila. School Design for Women. **Sources:** WW31; Falk, *Exh. Record Series.*

SARTAIN, Henry *[Engraver, architectural draftsman, portrait and religious painter] b.1833, Philadelphia / d.c.1895, Philadelphia.*
Addresses: Philadelphia. **Studied:** engraving with John Sartain; probably also studied painting and drawing at PAFA. **Exhibited:** PAFA , 1852-61. **Comments:** In 1866 he gave up engraving to take charge of the printing establishment which handled his father's (John Sartain) plates. **Sources:** G&W; Stauffer; Rutledge, PA; Paila. CD 1856+; 8 Census (1860), Pa., LIV, 260.

SARTAIN, John *[Engraver, portrait and miniature painter] b.1808, London / d.1897, Philadelphia.*
Addresses: Philadelphia, PA. **Studied:** apprenticed to a London engraver John Swain, 1823-30 (married his employer's daughter). **Member:** PAFA (dir. for 23 yrs); Artists Fund Soc. (dir.); Phila. Sch. Des. for Women (dir.). **Exhibited:** PAFA Ann., 1834-59, 1905; NAD, 1842-47. **Work:** PAFA. **Comments:** Emigrated to America in 1830 and settled in Philadelphia. A prolific engraver, he produced hundreds of illustrations for magazines, including his own *Sartain's Magazine of Literature and Art* (1849-52). He also helped to popularize mezzotints in the U.S. In the late 1850s he began making large engravings of important historical works by such artists as Benjamin West and Peter Rothermel. He also did

some portrait and miniature painting. Sartain was an active participant in the Philadelphia art community. He was a teacher and officer at the Philadelphia School of Design for Women and served as art director for the Centennial Exposition in 1876. He also exhibited works at several European expositions. Four of his eight children became engravers or painters: Samuel (1830-1906), Henry (1833-c. 1895), Emily (1841-1927), and William (1843-1924). John Sartain died shortly after finishing his autobiography, *Reminiscences of a Very Old Man* (published in 1899). **Sources:** G&W; WW97; DAB; Stauffer; Rutledge, PA; Falk, PA, vol. 2; Phila. CD 1831+; Cowdrey, NAD; Cowdrey, AA & AAU; 7 Census (1850), Pa., L, 251; 8 Census (1860), Pa., LIV, 260. More recently, see Baigell, *Dictionary.*

SARTAIN, Samuel *[Engraver, painter] b.1830, Philadelphia, PA / d.1906, Philadelphia, PA.*
Addresses: Philadelphia, PA. **Studied:** engraving with John Sartain; also studied painting at PAFA; France; Italy. **Member:** Artists Fund Soc., Phila; Photographic Soc., Phila.; Franklin Inst. **Exhibited:** PAFA Ann., 1849-66, 1905 (portraits & genre). **Comments:** Eldest son of John Sartain. Established his own engraving business in 1851. Later in his life he served as manager and treasurer of the Franklin Institute. **Sources:** G&W; DAB; Stauffer; Rutledge, PA; Phila. CD 1853+; 8 Census (1860), Pa., LIV, 260; WW06; Falk, *Exh. Record Series.*

SARTAIN, William *[Painter, teacher, writer] b.1843, Phildelphia, PA / d.1924.*
Addresses: Paris, 1869-75; Phildelphia, 1875-76; NYC, 1876-on. **Studied:** with his father, John Sartain; PAFA with Christian Schussele; privately with A. Yvon and L. Bonnât, in Paris, 1869; École des Beaux-Arts, Paris. **Member:** ANA, 1880; SAA, 1877 (a founder); New York Art Club (pres.). **Exhibited:** Brooklyn AA, 1876-84; PAFA Ann., 1876-91, 1900-12, 1921; PAFA, 1887 (prize); NAD, 1876-85, 1887-88, 1890-91, 1895-96, 1900; Boston AC, 1878-1900; Boston, 1881 (medal); Pan-Am. Expo, Buffalo, 1901 (medal); Charleston Expo, 1902 (medal); Corcoran Gal annuals/biennials, 1907-12 (4 times); Buenos Aires Expo, 1910 (medal); AIC; 1876-1900. **Work:** CGA; PAFA; PMA; NMAA; MMA; Brooklyn Mus.; Argentine Gov.; Luxembourg Gal., Paris; S.C. Art Assn.; Herron AI; Old Dartmouth Hist. Soc. **Comments:** Best known as a Tonalist whose favorite landscapes were the expansive tidal wetlands of Nonquitt, MA, where he summered, and along the Manasquan River, NJ, where he spent weekends. He was a close friend of Thomas Eakins, with whom he traveled to Paris to study. In 1870, he traveled to Spain with Eakins and H. Humphrey Moore; and he went to Algiers with Charles Sprague Pearce. From 1877-1924, he exhibited regularly at the National Academy. He was also a highly-respected teacher at PAFA and the ASL. Probably because he never received artistic sanction from his famous father, he destroyed much of his own early work; and, after his death in 1924, many of his later works were destroyed. **Sources:** WW24; Blasdale, *Artists of New Bedford,* 165 (w/repro.); *300 Years of American Art,* vol. 1, 399; Falk, *Exh. Record Series.*

SARTELLE, Mildred E. *[Sculptor] mid 20th c.*
Addresses: Germantown, PA, 1920; Wellesley, MA, c.1921-30. **Exhibited:** PAFA Ann., 1920-22, 1924. **Sources:** WW25; Petteys, *Dictionary of Women Artists;* Falk, *Exh. Record Series.*

SARTORI, Giovanni *[Sculptor] late 18th c.; b.Italy.*
Addresses: Active in Italy from c.1774-93; in Philadelphia c.1794. **Sources:** G&W; Thieme-Becker; Gardner, *Yankee Stonecutters.*

SARTZ, Eva *[Painter] mid 20th c.*
Exhibited: S. Indp. A., 1938. **Sources:** Marlor, *Soc. Indp. Artists.*

SASE See: **SACHSE, August**

SASLOW, Herbert *[Painter] b.1920, Waterbury, CT.*
Addresses: Westwood, NJ. **Studied:** NAD; ASL. **Member:** ASL. **Exhibited:** MMA, 1942; Univ. Illinois, 1955, 1957; WMAA, 1955; Univ. Nebraska, 1956; Mint Mus. Art; BM; PAFA Ann.,

1958; Corcoran Gal biennial, 1957; Babcock Gal., 1955, 1958 (both solo). **Awards:** Suydam medal, NAD, 1940; purchase award, Am. Acad. Arts & Letters, 1955. **Work:** Masillion Mus. Art; Newark Mus. Art; Crocker Art Gal., Sacramento, CA; Am. Acad. Arts & Letters; De Beers Diamond Collection. **Comments:** Illustrations in *Cosmopolitan; Redbook; Field & Stream; Good Housekeeping* magazines. **Sources:** WW66; Falk, *Exh. Record Series.*

SASSE, Fred A. *[Painter] 20th c.*
Addresses: St. Paul, MN. **Work:** United Engraving Co. **Sources:** WW24.

SASSMAN, John C. (or G.C.) *[Engraver and seal engraver] early 19th c.*
Addresses: New Orleans, 1807-22. **Comments:** Listed as G.C. Sassman in 1822 only. **Sources:** G&W; Delgado-WPA cites *Moniteur,* Oct. 17, 1807; New Orleans CD 1809; *Ami des Lois,* Aug. 26, 1813, and Nov. 10, 1817; *Gazette,* Oct. 15, 1822.

SATCHELL, James *[Engraver] b.c.1834.*
Addresses: NYC. **Comments:** Living with Thomas Neale (see entry) in 1850; presumably an apprentice. **Sources:** G&W; 7 Census (1850), N.Y., XLVIII, 285.

SATENSTEIN, Sylvia *[Painter] mid 20th c.*
Studied: ASL. **Exhibited:** S. Indp. A., 1931. **Sources:** Marlor, *Soc. Indp. Artists.*

SATER, Miles W. *[Painter] early 20th c.*
Addresses: Chicago, IL. **Member:** GFLA. **Exhibited:** AIC, 1915. **Sources:** WW27.

SATO, Tadashi *[Painter, sculptor] b.1923, Maui, HI.*
Addresses: Maui, HI. **Studied:** Honolulu School Art; Brooklyn Mus. Art School; New School Social Res., New York, with Davis, also with Ralston Crawford, Stuart Davis, John Ferren & Wilson Stamper. **Member:** Hui No Eau, Kahului, Maui (bd. of dirs., 1972); Lahaina (Maui) Art Soc.; Hawaii P&S Lg. **Exhibited:** 52 Young Painters of America, Guggenheim Mus., 1954; WMAA, 1958,1960-61; PAFA Ann., 1962, 1964; Pacific Heritage Exhibit, Los Angeles, 1963; Four Contemporary Painters, McRoberts & Tunnard Ltd., London, 1964; White House Festival of Arts, White House, Wash., DC, 1965; Am. Paintings in Berlin Art Festival, Germany, 1967; Willard Gal., NYC, 1970s. **Awards:** John Hay Whitney Foundation Opportunity fellowship, 1953; McInerny Foundation Honolulu Community fellowship, 1955; best painting in show, Honolulu Acad. Arts, 1957. **Work:** Guggenheim Mus.; WMAA; Honolulu (HI) Acad. Arts; Univ. Art Gal., Tucson, AZ. Commissions: oil mural, Maui War Mem. Gym., Wailuka, HI, 1962; concrete relief wall, State Library, Kahului, Maui, 1963; two oil murals, State Library, Aina Haina, Oahu, HI, 1965; mosaic floor design, Hawaii State Capitol Bldg., Honolulu, 1969; mosaic mural, West Maui Mem. Gym., Maui, 1972. **Comments:** Preferred media: oils. **Sources:** WW73; Falk, *Exh. Record Series.*

SATORSKY, Cyril *[Printmaker, illustrator] mid 20th c.; b.London, England.*
Addresses: Baltimore, MD. **Studied:** Leeds College Art, national diploma design; Royal College Art, Royal scholar, traveling scholar, research scholar, ARCA & first class hon. degree. **Member:** Phila. Print Cl. **Exhibited:** Philadelphia Print Cl. Ann.; Rental Gal., BMA, 1970; Sixth Dulin Nat. Print Show, Knoxville, TN, 1970; Ferdinand Roten, Baltimore, MD, 1970s. **Work:** Cincinnati AM; Wooster College; Essex Community College. **Comments:** Positions: advisor to univ. pub., Univ. Texas, Austin, 1962-65. Teaching: prof. illustration & printmaking, Maryland Inst. College Art, 1965-. Publications: author/illustrator, "A Pride of Rabbis," Aquarius, 1970; illustrator, "The Frenchman & the Seven Deadly Sins," Scribners, 1971; illustrator, "Sir Gawain & the Green Knight," Limited Ed. Club, 1972. **Sources:** WW73.

SATORU, Abe *[Sculptor] mid 20th c.*
Addresses: NYC. **Exhibited:** WMAA, 1960, 1964; PAFA Ann., 1960-66 (4 times). **Sources:** Falk, *Exh. Record Series.*

SATRE, August *[Painter] b.1876, Norway.*
Addresses: Middle Village, NY. **Member:** Providence WCC. **Sources:** WW29.

SATTERFIELD, Bob *[Painter] mid 20th c.*
Addresses: NYC. **Exhibited:** S. Indp. A., 1928. **Comments:** *Cf.* Robert Satterfield. **Sources:** Marlor, *Soc. Indp. Artists.*

SATTERFIELD, Robert W. *[Painter] 20th c.*
Addresses: Cleveland, OH, 1927. **Member:** Cleveland SA. **Comments:** Affiliated with Newspaper Enterprise Assn., Cleveland. *Cf.* Bob Satterfield. **Sources:** WW27.

SATTERLEE, Marion *[Illustrator] 19th c.*
Addresses: NYC. **Comments:** Position: affiliated with Scribner's Sons, NYC. **Sources:** WW98.

SATTERLEE, Walter *[Painter, etcher, illustrator] b.1844, Brooklyn, NY / d.1908.*
Addresses: NYC. **Studied:** NAD; Columbia, 1863; E. White, in NY; L. Bonnât, in Paris; Freeman, in Rome. **Member:** ANA; AWCS; Etching Club, NY; Artists Aid Soc.; Century Assn. **Exhibited:** Brooklyn AA, 1867-86; NAD, 1866-1908 (prize, 1886); AIC; Boston AC, 1881-82, 1884, 1888; PAFA Ann., 1885. **Comments:** He spent summers in East Hampton in the 1880s and exhibited scenes of the town. **Sources:** WW08; *East Hampton: The 19th Century Artists' Paradise; Falk,* Exh. Record Series.

SATTERTHWAIT, E. *[Sculptor] late 19th c.*
Addresses: Phila., PA. **Exhibited:** PAFA Ann., 1881 (plaques). **Sources:** Falk, *Exh. Record Series.*

SATTERTHWAITE, Linton *[Museum curator, educator] b.1897, Trenton, NJ.*
Addresses: Philadelphia 4, PA; Philadelphia 3, PA. **Studied:** Yale Univ.; Univ. Pennsylvania. **Comments:** Positions: curator, American Section, Univ. Pennsylvania Museum; prof., Anthropology, Univ. of Pennsylvania. **Sources:** WW66.

SATTERWHITE, Nell *[Painter] 20th c.*
Addresses: Nashville, TN. **Sources:** WW15.

SATTIG, Violet Miller *[Painter] d.1920.*
Addresses: East River, CT, from c.1913. **Member:** New Haven PCC. **Sources:** WW19.

SATTLER, Hubert *[Panorama and landscape painter] b.1817, Vienna / d.1904, Vienna.*
Studied: Vienna. **Comments:** He traveled widely in Europe, the Near East, North Africa, and North America, visiting NYC and Boston in 1850-51 with a collection of European and Asiatic views. **Sources:** G&W; Thieme-Becker; Cowdrey, NAD; N.Y. *Herald,* Dec. 11 and 12, 1850, and April 13, 1851, and Boston *Transcript,* July 7 and 12, Sept. 30, Nov. 11, and Dec. 29, 1851 (courtesy J. Earl Arrington).

SATURENSKY, Ruth *[Painter] b.1920, Denver, CO.*
Addresses: Los Angeles, CA. **Studied:** Colorado Woman's College; Otis Art Inst.; Jepson Art Inst.; Chouinard Art Inst. **Exhibited:** PAFA; Fine Arts Gal., San Diego; Long Beach Art Mus.; Jewish Community Center; Santa Barbara Mus. Art. **Awards:** LACMA, 1960 (prize), Westside Jewish Community Center, Los Angeles, 1963 (prize) & First Methodist Church, Santa Monica, 1963 (prize). **Comments:** Author/director, three theatre pieces (with Alex Haye's Los Angeles Summer Theatre Piece Lab), 1967. **Sources:** WW73.

SAUBERT-WETZEL, Patricia *[Painter] mid 20th c.*
Addresses: Chicago area. **Exhibited:** AIC, 1940, 1943. **Sources:** Falk, *AIC.*

SAUCIER, Charles Eberle *[Engraver, lithographer, draftsman] b.1872, New Orleans, LA / d.1922, New Orleans, LA.*
Addresses: New Orleans, active 1888-94. **Sources:** *Encyclopaedia of New Orleans Artists,* 338.

SAUCY, Claude Gerald *[Painter, educator] b.1929, Thayngen, Switzerland.*
Addresses: Kent, CT. **Studied:** Kunstgewerbeschule, Zurich:

Univ. Zurich. **Exhibited:** Invitational Artist, New Haven (CT) Art Festival, 1969 (hon. men.); Invitational Artists, Sharon (CT) Creative Arts Foundation (prize), 1970; Far Gal., NYC, 1970s. **Work:** MoMA; Wadsworth Atheneum, Hartford, CT. **Comments:** Preferred media: graphics. Teaching: chmn. dept. art & art history, Kent School, 1966-. **Sources:** WW73; H. Steiner, *Claude Saucy* (Schaffhauser-Nachrichten, Oct., 1965).

SAUER, Leroy D. *[Designer, commercial artist, craftsperson, lecturer] b.1894, Dayton, OH.*
Addresses: Dayton, OH. **Studied:** Cincinnati Acad. Art; Cleveland Sch. Art; Western Reserve Univ.; & with Henry Keller, Frank Wilcox, Ernest Peixotto, Hopkins, Meakin, Wessel, Orr, Lachman. **Member:** Dayton SE; Ohio Printmakers; Florida AA; Indiana Soc. Printmakers. **Exhibited:** Dayton SE, 1921-45; Ohio Printmakers, 1928-45; Florida AA, 1940 (prize); NAD, 1943-44; LOC, 1943 (prize); Tri-State Exh., 1944-45. **Work:** LOC; Dayton AI; Ohio Art and Artists; galleries in Canada. **Comments:** Lectures: Making of Prints, Demonstrations. Position: dir., L.D. Sauer Studios, Dayton. **Sources:** WW59; WW47.

SAUER, Margarita *[Painter] b.1925, NYC.*
Addresses: Washington 15, DC. **Studied:** Corcoran Sch. Art, and with Eliot O'Hara, Andrea Zerega, Peggy Bacon, Richard Lahey. **Member:** NAWA. **Exhibited:** United Nations Cl., 1948; Wash. WCC, 1949-50; Soc. Wash. Artists, 1948; CGA, 1949, 1951; Ward Eggleston Gal., 1952 (solo); Grand Central Gal., 1952; Florida Southern Col., 1952 (prize); Georgetown Gal., 1953 (solo); Venables Gal., 1955. Other awards: Zerega Group, 1948 (prize). **Sources:** WW59.

SAUER, Wanda *[Genre painter] early 20th c.*
Addresses: Active in Southern Calif., 1908. **Sources:** Petteys, *Dictionary of Women Artists.*

SAUERBREY, Adolph *[Sculptor, marble cutter, carver] b.c.1834, Bavaria, Germany / d.1909, New Orleans, LA.*
Addresses: New Orleans, active 1869-1907. **Comments:** Came to New Orleans c.1849. **Sources:** *Encyclopaedia of New Orleans Artists,* 338.

SAUERWEIN, Charles D. *[Portrait and genre painter] b.1839 / d.1918, Red Bank, NJ.*
Addresses: Baltimore, 1857-58 and 1870-80; Red Bank, NJ, 1880. **Studied:** Europe, 1860. **Exhibited:** NAD, 1882-1885. **Work:** Peabody Institute, Baltimore, MD; Shelburne (VT) Mus. **Comments:** He remained in Europe from 1860-70 and married there. Father of Frank (see entry). He was buried in Baltimore. **Sources:** G&W; Pleasants, *250 Years of Painting in Maryland,* 64; Muller, *Paintings and Drawings at the Shelburne Museum,* 123 (w/repro.).

SAUERWEIN, Frank (Peters) *FPSauerWein -*
[Painter] b.1871, Baltimore (or Yonkers or Cantonsville, NJ) / d.1910, Stamford, CT.
Addresses: Pasadena, CA/Taos, NM/ Chicago. **Studied:** his father, Charles; PAFA; AIC; PM School IA. **Member:** Denver AC, 1891-c.1904. **Exhibited:** AIC, 1897. **Work:** Mus. New Mexico; Southwest Mus.; Panhandle-Plains Hist. Soc.; LACMA. **Comments:** (Also appears as Paul Sauerwen) Moved to Denver in 1871 for health reasons and began to sketch Indians in the Rockies. By 1893 he was in Colorado Springs visiting the Ute reservation. He visited Taos in 1899, Santa Cruz and Santa Fe in 1900, Taos again in 1902 and 1903. He was also in California and in Taos a third time, 1906-08. To attempt a cure for his tuberculosis, he went to Connecticut, where he died. Specialties: Western scenes, Pueblo Indians. **Sources:** WW06; Hughes, *Artists in California,* 492; P&H Samuels, 420.

SAUERWEN, Paul See: **SAUERWEIN, Frank (Peters)**

SAUGSTAD, Eugenie de Land *[Painter, craftsperson, illustrator, teacher, muralist] b.1872, Wash., DC.*
Addresses: Wash., DC, active 1889-1940; Alexandria, VA, 1940. **Studied:** George Washington Univ.; Drexel Inst.; Corcoran Sch. Art, under E.F. Andrews; H. Pyle. **Member:** Wash. Soc. FA; Lg.

Am. Pen Women. **Exhibited:** Wash. WCC, 1889; Lg. Am. Pen Women; Gr. Wash. Indep. Exhib., 1935; Alexandria (VA) Pub. Lib. **Work:** murals, Eastern Star Temple, (ceiling) and Foundry Methodist Episcopal Church, both in Wash., DC; memorial window, Presbyterian Church, Laurel, MD; William & Mary College, Williamsburg; Custom House, Yorktown; Masonic Lodge, Alexandria; Lincoln Mus., Ford's Theater. **Comments:** She received national honors for her Liberty Bond posters in WWI and II. After moving to Alexandria, VA, in 1940, she had a studio in her home, Arcturus-on-the-Potomac, until at least 1947. Position: art teacher, McKinley H.S., Wash., DC, 1905-42. Appears as De Land. **Sources:** WW53; WW47; McMahan, *Artists of Washington, DC.*

SAUGSTAD, Olaf *[Craftsperson, teacher] b.Vernon County, WI / d.1950, Annapolis, MD.*
Addresses: Alexandria, VA. **Studied:** Univ. Minnesota; NY Inst. Art & Artisans; Columbia. **Member:** NY Gld. Arts & Crafts; Handicraft Gld., Wash., DC. **Work:** memorial tablet, Falls Church, VA; Friendship House, Wash., DC. **Comments:** Positions: teacher, McKinley H.S., Wash., DC, 1911-38 & Chevy Chase (MD) Women's Club. **Sources:** WW47.

SAUL, Charlotte R. *[Painter] mid 20th c.*
Exhibited: Salons of Am., 1930. **Sources:** Marlor, *Salons of Am.*

SAUL, Chief Terry *[Illustrator, commercial artist, educator, studio owner] b.1921, Sardis, OK / d.1976.*
Addresses: Bartlesville, OK. **Studied:** Jones Male Acad.; Bacone College, OK, 1940, with Woody Crumbo and Acee Blue Eagle; Univ. Oklahoma (B.F.A., 1948; M.F.A.,1949); ASL, 1951-52, with Baer. **Exhibited:** All-American Indian Days, Sheridan, WY, annually, (prizes, 1958, 1965, 1970); Am. Indian & Eskimo Art Exh. & State Pageant, Wash., DC; Am. Indian Expo, Anadarko, OK, annually (prize, 1963); Bismarck (ND) National Indian Art Show, 1963 (award); Denver Art Mus., CO (award); Am. Indian College Fnd., 1964; Five Civilized Tribes Mus., Muskogee, OK, solos, annually (prize, 1967; Indian Heritage Awards,1968, 1969, 1970, 1971); International Indian Art Show & Handicraft Trade Fair, Bismarck, ND, 1964 (prize); Gilcrease Inst., Tulsa, OK (purchase award, 1958); Heard Mus., Phoenix, AZ; Inter-Tribal Indian Ceremonials, Gallup, NM (prizes, 1957-64); "Scottsdale National Indian Art Exhib," Scottsdale, AZ, annually (prizes, 1963, 1968); Am. Indian Expo, Charlotte, NC, 1965 (prize); Laguna Gloria Art Mus., Austin, TX; Am. Indian Painting Comp., De Young Mus. & SFMA, annually; Mus. of New Mexico, Santa Fe (Glaman Award, 1961; School of Am. Research Award, 1962; Southwestern Assn. on Indian Affairs Award, 1963), also traveling show Fine Arts Gallery Tour of the U.S., 1956-64; Dept. of Interior, Wash., DC; U.S. Dept. of State, Wash., DC, 1963; Midwest Prof. Artists Benefit Art Show, Tulsa, OK; Contemporary Am. Indian Paintings, New Jersey State Mus., Trenton, 1959-60; Philbrook Mus. Art, Ann. Indian Art Exhib. & Am. Indian Paintings from the Permanent Collection, 1947-65 (prizes, 1948-65, 1969, 1970, 1971, 1973, 1974); Red Cloud Indian School, Pine Ridge, SD, annuals; Read Mullan Chevrolet Corporate Collection, Phoenix, AZ; Smithsonian Inst.; Native Am. Paintings, Joslyn Art Mus., 1979-80; Southern Plains Indian Mus., Anadorka, OK; Views and Visions: The Symbolic Imagery of the Native American Church, 1981; Shared Visions: Native Am. Painters & Sculptors in the 20th Century, Heard Mus., 1991-92; U.S. Univ. of Oklahoma, Norman, also solo; No Man's Land Hist. Mus., Panhandle State Univ. **Work:** Heard Mus., Phoenix, AZ; U.S. Dept. of the Interior; Mus. of New Mexico, Santa Fe; Panhandle State Univ., OK; Univ. Oklahoma, Norman; Philbrook Mus. Art, Tulsa; Chevrolet Corporate Collection, Phoenix, AZ; First National Bank, Dewey, OK; Fort Sill Indian Hospital, Lawton, OK; Masonic Temple, College H.S., Union National Bank, all Bartlesville, OK; Denmark, Austria, the Netherlands, Germany and Afghanistan. **Comments:** A member of the Choctaw/Chickasaw tribal nation, his native name was Tabaski (ember of fire or coal). He also went by Chief Terry Saul, or Chief T. Saul. Preferred media: oil on gesso, tempera, casein. First work

published by *Art Digest,* 1947. Owner of art studio, Bartlesville, 1950; artist for industrial companies, 1952-. Positions: director, art dept., Bacone College, Bacone, OK, 1970-75. **Sources:** info. courtesy of Donna Davies, Fred Jones Jr. Mus. Art, Univ. of Oklahoma; P&H Samuels, 421.

SAUL, J. H. Louis *[Etcher, engraver] d.1925.*
Addresses: Astoria, NY.

SAUL, Juliet *[Painter] mid 20th c.*
Exhibited: Salons of Am., 1930. **Sources:** Marlor, *Salons of Am.*

SAUL, Laurel *[Painter] mid 20th c.*
Addresses: Seattle, WA, 1947. **Exhibited:** SAM, 1947; Henry Gallery, 1951. **Sources:** Trip and Cook, *Washington State Art and Artists.*

SAUL, Maurice Bower *[Painter] b.1883, Phila.*
Addresses: Moylan, PA/Long Lake, NY. **Exhibited:** PAFA Ann., 1932-34, 1945. **Sources:** WW33; Falk, *Exh. Record Series.*

SAUL, Peter *[Painter] b.1934, San Francisco, CA.*
Addresses: Mill Valley, CA. **Studied:** Stanford Univ.; Calif. School Fine Arts 1950-52; Wash. Univ. (B.F.A., 1956), with Fred Conway. **Exhibited:** San Francisco Art Inst., Reed College & Calif. College Arts & Crafts, 1968 (solos); MoMA, New York, 1968; Univ. Oklahoma, 1968; Univ. Illinois, 1969; Mus. St. Etiènne, France, 1971 (solo); Allan Frumkin Gal., Chicago, IL, 1970s. Awards: New Talent Award, *Art in Am. Magazine,* 1962; William & Noma Copley Foundation grant, 1962. **Work:** AIC; Oberlin College; MoMA; Univ. Massachusetts. **Sources:** WW73.

SAUL, (Saul Kovner) *[Etcher, lithographer, painter] b.1904, Russia / d.1981, North Hollywood, CA?.*
Addresses: NYC; Burbank, CA. **Studied:** NAD; Ivan Olinsky; Charles Hawthorne; William Auerbach-Levy. **Member:** SAGA; AEA; Los Angeles AA. **Exhibited:** Salons of Am.; PAFA Ann., 1932 (gold)-1934, 1938; S. Indp. A., 1934; Morton Gal., 1943; Chabot Art Gal., Los Angeles, 1949 (solo); Bullocks, Pasadena, 1950 (solo); Glendale Pub. Lib., 1950 (solo). **Work:** MMA; Montpelier (VT) Mus. Art; LOC; Brooklyn College; State Teachers College, Indiana, PA; East New York H.S.; Princeton Univ. **Sources:** WW59; Falk, *Exh. Record Series.*

SAUL, Terry See: **SAUL, Chief Terry**

SAULNIER, Henry E. *[Engraver] mid 19th c.*
Addresses: Philadelphia, active c.1846-60. **Comments:** With Toppan, Carpenter & Company (see entry). **Sources:** G&W; Phila. CD 1846-60.

SAULNIER, James Philippe *[Portrait painter, designer, illustrator, commercial artist] b.1898, South Hamilton, MA.*
Addresses: Melrose, MA. **Studied:** Mass. Normal Art Sch., with Ernest Major, Richard Andrew, Wilbur Hamilton; Harvard Univ. **Member:** Gld. Boston Artists; North Shore AA. **Exhibited:** AIC, 1927; NYWCC, 1927-33; Gld. Boston Artists; North Shore AA; Grace Horne Gal., Boston WCC; Nashua (NH) Lib; East Gloucester AA; Jordan Marsh, 1942 & 1943 (gold medal); New England Contemp. Art Exh., 1942 (medal), 1943 (medal); AWCS. **Work:** TMA. **Sources:** WW59; WW47, puts birth at 1899.

SAULTER, Leon *[Sculptor] b.1908, Wilno, Poland / d.1986, Los Angeles, CA.*
Addresses: Los Angeles, CA. **Member:** Council All. Artists. **Exhibited:** LACMA, annually; Contemporary Art Gal.; UCLA; Occidental College; P&S of Los Angeles, 1936, 1940. **Work:** Horace Mann Jr. H.S.; Sierra Bonita H.S.; mem., Hollywood Cemetery. **Sources:** WW53; WW47. More recently, see Hughes, *Artists in California,* 492.

SAUMELL, Louis *[Artist] late 19th c.*
Addresses: Wash., DC, active 1892. **Comments:** May be the same as Louis G. Saumwell. **Sources:** McMahan, *Artists of Washington, DC.*

SAUMWELL, Louis G. *[Artist] late 19th c.*
Addresses: Wash., DC, active 1881. **Comments:** May be the

same as Louis Saumell. **Sources:** McMahan, *Artists of Washington, DC.*

SAUNDERS *[Painter] mid 19th c.*
Addresses: Active in Texas, 1843. **Comments:** Painter of a portrait of Florence and Elizabeth Crump of Waco (TX), 1843. *Cf.* William Carroll Sanders. **Sources:** G&W; WPA (Texas), Historical Records Survey.

SAUNDERS, Albert Frederic *[Designer, writer, lecturer] b.1877, Brooklyn, NY.*
Addresses: Sherrill, NY; Syracuse, NY. **Studied:** Adelphi College; PIA School. **Member:** Syracuse AA. **Exhibited:** Syracuse Mus. FA, 1939-42, 1945-46. **Comments:** Position: chief designer, George W. Shiebler Co., 1904-07; art director, Benedict Mfg. Co., East Syracuse, NY, 1907-50; Oneida, Ltd., 1950-; Iroquois China Co., Syracuse, NY, 1955-56; Stetson China Co., Lincoln, IL, 1958. Contributor: jewelers' pamphlets & magazines. Lectures: silverware design. **Sources:** WW59; WW47.

SAUNDERS, Aulus Ward *[Painter, educator] b.1904, Perry, MO / d.1991.*
Addresses: Oswego, NY. **Studied:** Westminster Col., MO (B.A.); Saint Louis School Fine Arts; Washington Univ. (M.A.); Univ. Iowa (Ph.D.); New York Univ.; also with Charles Cagle. **Exhibited:** Iowa Art Salon, 1934; Midwestern Ann. Art Exhib., Kansas City Art Inst., 1935 (prize); 30th & 31st Ann. Exhib. Paintings Am. Artists, Saint Louis City Art Mus., 1936 & 1937; 18th Ann. Exhib. Artists Cent. NY, Munson-Williams-Proctor Inst., Utica, NY, 1955; State Univ. NY College, Morrisville, 1967 (solo, watercolors). **Work:** mural H.S., University City, MO; State Univ. NY College, Oswego. **Comments:** Preferred media: watercolors, acrylics, oils. Teaching: prof., State Univ. NY College, Oswego, 1937-70; visiting prof., Southern Illinois Univ., Carbondale, summer 1949; visiting prof., Pennsylvania State Univ., University Park, summers 1950-52. Research: psychology of art, especially genesis and stability of art talent in children. Publications: author, "The Stability of Artistic Attitude," *Psychol. Monogr.,* 1936; author, "Feeling and Form," *School Arts,* 10/1970. **Sources:** WW73; WW47; Ness & Orwig, *Iowa Artists of the First Hundred Years,* 183-84.

SAUNDERS, Bernard *[Painter] mid 20th c.*
Exhibited: AIC, 1939. **Sources:** Falk, *AIC.*

SAUNDERS, Boyd See: **SAUNDERS, J. Boyd**

SAUNDERS, Clara R(ossman) *[Painter, teacher] b.1874, Hamilton or Cincinnati, OH / d.1951, Wash., DC.*
Addresses: Wash., DC, c.1900. **Studied:** Cincinnati Art Acad.; Corcoran Sch. Art; George Washington Univ.; Paris; W. Beck; C.W. Hawthorne; C. Guerin; E. Spiro; La Prade, Paris. **Member:** Wash. WCC; Soc. Wash. Artists; SSAL; NAWA; Wash. AC. **Exhibited:** NAWPS; Maryland Inst. (prizes); AIC; Wash. AC; Soc. Wash. Artists, 1930 (prize), 1934 (prize); SSAL, 1930 (prize), 1935 (prize); Gr. Wash. Indep. Exhib., 1935; Wash. WCC, annually, 1944 (prize); Women's Club, Wash., DC, 1930 (prize), 1942 (prize), 1946 (prize); PAFA; Inst. House, NY, 1930 (solo); Telfair Acad., 1945 (solo). **Comments:** Instructor: Abbott Sch. of Fine and Commercial Art; ASL of Wash., DC. **Sources:** WW47; McMahan, *Artists of Washington, DC.*

SAUNDERS, Elisabeth Moore Hallowell (Mrs. Charles F.) *[Illustrator, writer, craftsperson] 19th/20th c.; b.Alexandria, VA.*
Addresses: Phila., PA. **Studied:** H. Pyle; PM School IA. **Member:** Plastic Club. **Exhibited:** PAFA, 1892-93, 1895, 1899 (as Hallowell); AIC, 1902, 1904. **Sources:** WW10; Falk, *Exh. Record Series.*

SAUNDERS, George Lethbridge *[Miniaturist] b.1807, England / d.1863, Bristol, England.*
Exhibited: London, 1829-39, 1851,1853; Apollo Assoc., 1840; Artists' Fund Soc., 1840-41. **Work:** MHS. **Comments:** An English artist, not to be confused with George Sanders or Saunders (1774-1846). In 1840 he apparently came to the United

States. When he exhibited at the Artists' Fund Society in 1841 his address was given as London. Sully (see entry) met him in Philadelphia in 1843, shortly before Saunders again went to England. Saunders was at Richmond (VA) in May 1846 and at Columbia (SC) in 1848; he is known to have worked also in Baltimore, Charleston, and Savannah. After his return to London, where he exhibited again in 1851 and 1853, nothing further is known of him until his death at Bristol. **Sources:** G&W; DNB [under George Sanders]; Cowdrey, AA & AAU; Rutledge, PA; Graves, *Dictionary;* Rutledge, *Artists in the Life of Charleston,* 167; *Richmond Portraits,* 242. G&W pointed out that *Antiques* (Dec. 1930), 481-82, and Redgrave, in *Dictionary,* confused George Sanders and George L. Saunders.

SAUNDERS, Guy Howard *[Painter, designer] b.1901, Anita, IA.*
Addresses: Sarasota, FL. **Studied:** Chicago Acad. FA. **Member:** Florida Art Group; Sarasota AA; Manatee Art Lg.; Contemporary Artists Group, Pinellas, FL; Tampa Realistic Artists. **Exhibited:** Sarasota AA; Mint Mus. Art; Gertrude Herbert Mus., Augusta; St. Petersburg AA; Contemp. Gal., Pinellas, 1957 (prize); Pasadena AI; Tampa Realistic Gal.; Tampa AI; Hartman Art Gal., Sarasota. **Sources:** WW66.

SAUNDERS, Henry Dmochowski *[Sculptor] b.1810, Vilna, Lithuania / d.1863, Poland.*
Addresses: Philadelphia, PA, 1853-57; Washington, DC, 1857. **Studied:** Vilna; Paris, c.1846; London. **Exhibited:** PAFA, 1853-57; Wash. AA, 1857, 1860. **Work:** NPG; Capitol, Wash., DC (busts of Kosciuszko and Pulaski). Commissions: busts of George Washington, Thomas Jefferson, Benjamin Franklin, Sam Houston, John Calhoun, Henry Clay, and William Penn. **Comments:** His original name was Henry Dmochowski, the Saunders having been added after his coming to America. Educated in Vilna, then a part of Russian Poland, he fled to France after the unsuccessful Revolution of 1830 and lived for a time in London before coming to America. In 1857 he went to Washington. The sculptor soon after returned to Poland and died fighting for the liberation of his country. **Sources:** G&W; Fairman, *Art and Artists of the Capitol,* 161-62; Rutledge, PA; Phila. CD 1854-60; Washington CD 1860; Washington Art Assoc. Cat., 1857.

SAUNDERS, J. Boyd *[Printmaker, educator] b.1937, Memphis, TN.*
Addresses: Columbia, SC. **Studied:** Memphis State Univ. (B.S.); Univ. Miss. (M.F.A.); Bottega Arte Grafica, Florence, Italy. **Member:** Print Coun. Am.; Guild SC Artists (adv. bd., 1956); Columbia Art Assn.; Southeastern Graphics Soc. (pres.); Am. Assn. Univ. Prof. **Exhibited:** 6th Ann Mid-South Exhib Paintings, Prints & Drawings, Memphis, Tenn, 1961 (3rd prize);Soc. Washington Printmakers 24th Nat, Smithsonian Inst., Wash., DC, 1962; 1st Int. Printmaker's Exhib., Gallerie Bottega & Arte Grafica, Florence, 1967; 34th Graphic Arts & Drawing Nat., Wichita, Kans., 1969; 5th Dulin Print & Drawing Competition Nat., Knoxville, Tenn., 1970; 15th N. Dak. Print & Drawing Ann., Grand Forks, 1972 (purchase prize); Hubris Press, Columbia, SC, 1970s Other awards: grand prize, Guild Columbia Artists, 1971. **Work:** Denison Univ. Print Coll., Ohio; Columbia Mus. Art Print Coll., SC; SC State Coll., Columbia; Bottega Arte Grafica Coll.; Univ. Ariz. Print Coll., Tucson. Commissions: mixed media altar panel, Guess Chapel, Univ. Church, Oxford, Miss., 1962; mem. portrait comn., Tipoff Club, Columbia, SC, 1969; oil mural, Univ. House, Univ. SC, 1972. **Comments:** Preferred media: Graphics. Positions: staff artist, Dan Kilgo & Assocs., Tuscaloosa, Ala., 1959-60; designer-illusr., Chapparral Press, Kyle, Tex., 1963-65; art purchasing comt., SC Collection, Columbia, 1969-70; steering comt. mem., Fiesta '1972, Columbia, 1972. Teaching: instr. art, Univ. Miss., 1961-62; instr. art, Southwest Tex. State Col., 1962-65; asst. prof. art, Univ. SC, 1965-. Publications: illusr., "Bosque Territory; a History of an Agrarian Community," 1964; illusr.," Lyndon Baines Johnson; the Formative Years," 1965; auth, "A Summer's Printmaking in Florence," *Art Educ. J.,* 1968. **Sources:** WW73; Jack Morris, "Boyd Saunders, printmaker," *Contemp.*

Artists SC (1969); Harriet Door, "2 forceful exhibitions," *Charlotte Observer* (1972); Adger Brown, " Boyd Saunders/ Vital Forces," *State Rec.* (Columbia, 1972).

SAUNDERS, J. M. (Mrs.) *[Artist] late 19th c.*
Addresses: Active in Los Angeles, 1891-92. **Sources:** Petteys, *Dictionary of Women Artists.*

SAUNDERS, John Allen *[Cartoonist, writer, lecturer] b.1899, Lebanon, IN.*
Addresses: Toledo, OH. **Studied:** Wabash College (A.B., M.A.); Univ. Chicago; Chicago Acad. FA. **Member:** The Players, NY; Tile Club, Torch Club, Nat. Cartoonist Soc.; Newspaper Comics Council (chmn.). **Comments:** Position: continuity editor, Publishers Syndicate, 1940-; pres., Art Interests, Inc., an organization providing scholarships for talented young artists of the area. Author/illustrator: "Steve Roper"; "Mary Worth"; "Kerry Drake," widely syndicated comic strips. Author: "A Career for Your Child in the Comics" (pamphlet). Contributor to *Coronet, Colliers* and many popular fiction magazines. Lectures: Comics are Serious Business; The Philosophy of Humor. **Sources:** WW66.

SAUNDERS, Josephine See: **ECKERT, Josephine** **(Mrs. F. O. Saunders)**

SAUNDERS, Kendall *[Painter] b.1886, Templeton, MA.*
Addresses: Westport, CT. **Studied:** Académie Julian, Paris with J.P. Laurens, 1911. **Member:** SC; Paris AAA; Union Internationale des Beaux-Arts et des Lettres. **Exhibited:** AIC, 1913; PAFA Ann., 1918. **Sources:** WW25; Falk, *Exh. Record Series.*

SAUNDERS, L. Pearl *[Painter, lecturer, teacher] early 20th c.; b.Tennessee.*
Addresses: Jackson, TN. **Studied:** ASL; William Chase, Charles Hawthorne; André Lhote; Académie Julian, Paris. **Member:** Nashville Studio Club; SSAL (state chmn.); NAWA; AAPL; Lg. Am. Pen. Women; Tennessee SA; Nashville Mus. Art. **Exhibited:** war poster, New Orleans, 1916 (prize); S. Indp. A., 1917-19, 1923, 1925; Southeastern Fair Assn. (prize); Tenn. State Fair (prize); Italy (prize); Nashville Mus. Art, 1928 (prize); Paris Salon; SSAL; NAWA. **Work:** Nashville Mus. Art; Centennial Club, Nashville, TN; Woman's Club, Jackson, TN; St. Luke's Episcopal Church, Jackson, TN; Murfreesboro Women's Club; DAR, Wash., DC; Bank of Westminster, Paris. **Comments:** Position: dir., School Art & Applied Design (Nashville), Summer Sch. Art, Lake Junaluska (NC). Author: "Make Your Own Posters." **Sources:** WW53.

SAUNDERS, Maude *[Artist] late 19th c.*
Addresses: Active in Detroit, 1886-89. **Sources:** Petteys, *Dictionary of Women Artists.*

SAUNDERS, Raymond Jennings *[Painter, educator] b.1934, Pittsburgh, PA.*
Addresses: Oakland, CA. **Studied:** PAFA nat. scholastic scholar; Univ. Pa., nat. scholastic scholar; Carnegie Inst. Technol.(B.F.A.); Calif. Col. Arts & Crafts (M.F.A.). **Member:** Fel., Am. Acad. Rome. **Exhibited:** PAFA, 1955 (Thomas Eakins Prize), 1972; PAFA Ann., 1962-66; SFMA, 1961, 1971 (solo); Dintenfass Gal., NYC, 1962, 1964, 1966-67, 1969, 1970s; NIAL, 1963 (award); New School Art Gal., 1963-64, 1967; Am. Acad. Rome, 1964-66 (Prix de Rome); UCLA Traveling Exh., 1966-67; Dickson Art Center, 1966; PMA, 1968; St. Paul, MN, Art Center, 1968; MoMA, 1968, 1971; WMAA, 1969-73; Dartmouth Coll., 1969; Lehigh Univ., 1970; La Jolla Mus. of Art, 1970; James A. Porter Gal., 1970; Roberson Gal. for the Arts & Sciences, Binghampton, NY, 1970; CI, 1970; BMFA, 1970; Univ. of Iowa, 1971-72; Providence Mus. Art, 1972 (solo). **Work:** MoMA; WMAA, Andover Coll. Am. Art; PAFA; NIAL; Calif. Col. of Arts & Crafts; Allentown Art Mus., PA; Howard Univ.; Addison Gal. of American Art; Univ. of Texas; priv. colls. **Comments:** Positions: nat. consult. urban affairs, Volt Tech. Serv., NY, 1968-; art consult., Dept. Black Studies, Univ. Calif., Berkeley, 1969-; mem. Afro-Am. Acquisitions Comt., Univ. Art Mus., Berkeley, 1971-.

Publications: auth., "Black is a Color," privately publ., 1968. Teaching: prof. painting, Calif. State Univ., Hayward, 1968-; vis. critic, RI Sch. Design, 1968, vis. artist, 1972; vis. artist, Yale Univ., 1972. **Sources:** WW73; Bearden & McHolty, *The Painter's Mind* (Crown, 1969); Cederholm, *Afro-American Artists;* Falk, *Exh. Record Series.*

SAUNDERS, Sidney *[Painter] mid 20th c.*
Addresses: San Francisco, CA, 1928-40. **Exhibited:** Bohemian Cl., 1928; Soc. for Sanity in Art, 1940. **Sources:** Hughes, *Artists in California*, 492.

SAUNDERS, Sophia *[Miniaturist] mid 19th c.*
Addresses: NYC, 1851-52. **Sources:** G&W; NYBD 1851-52; Bolton, *Miniature Painters.*

SAUNDERS, Theodore (Raymond Vielant) *[Painter, craftsperson, designer] b.1908, Denver.*
Addresses: Chicago, IL. **Studied:** F.R. Cowles. **Member:** Chicago Assn. PS; Business Men's AC; South Side AA. **Exhibited:** AIC, 1929, 1933-39, 1949; PAFA Ann., 1938. **Comments:** Position: stage manager/designer, Little Ballet, Chicago. **Sources:** WW40; Falk, *Exh. Record Series.*

SAUNDERS, W. C. See: **SANDERS, William Carroll**

SAUNDERS, William *[Landscape painter] mid 19th c.*
Addresses: Philadelphia, 1863; Tarrytown, 1866. **Exhibited:** PAFA, 1863 (two views of "ancient" residences in Kent, England); NAD, 1866 ("Sunny Side"). **Comments:** Not to be confused with the William Carroll Sanders (sometimes spelled Saunders, see entry under Sanders) who was active about the same time but working primarily in the South. **Sources:** Falk, PA, vol. 2; Naylor, NAD.

SAUNDERS, William C. *[Artist] late 19th c.*
Addresses: Wash., DC, active 1882. **Comments:** *Cf.* William Saunders and William Carroll Sanders. **Sources:** McMahan, *Artists of Washington, DC.*

SAUNDERS, William Carroll See: **SANDERS, William Carroll**

SAUNDERS, William L(apham) *[Painter] mid 20th c.*
Addresses: Yonkers, NY. **Exhibited:** S. Indp. A., 1922, 1924, 1926-28, 1930-33; Salons of Am., 1927, 1931, 1932. **Sources:** Falk, *Exhibition Record Series.*

SAUNDERS, Xantippe *[Painter] 19th/20th c.*
Addresses: Louisville, KY. **Member:** Louisville AL. **Sources:** WW01.

SAUNDERSON, Laura Howland Dudley (Mrs. Henry H.) *[Museum curator, writer, lecturer] b.1872, Cambridge, MA.*
Addresses: Cambridge 40, MA. **Studied:** Radcliffe College (A.B., A.M.). **Member:** AA Mus. **Comments:** Position: Keeper of Prints, 1897-1939, Keeper of Prints Emerita, 1939-, Fogg MA, Harvard Univ., Cambridge, MA. Contributor to *Print Collectors Quarterly, Fogg MA Notes, Harvard Library Notes.* Lectures: History of Engraving. Arranged & catalogued collections of prints, History of Book Illustration, and many loan exhibitions of prints & early illustrated books, Fogg MA. **Sources:** WW59.

SAUNIER, Isabel *[Painter] mid 20th c.*
Exhibited: S. Indp. A., 1935. **Sources:** Marlor, *Soc. Indp. Artists.*

SAUNIER, Ysan *[Painter] mid 20th c.*
Exhibited: Salons of Am., 1934. **Sources:** Marlor, *Salons of Am.*

SAUPE, Max H. *[Painter] mid 20th c.*
Exhibited: S. Indp. A., 1937, 1940. **Sources:** Marlor, *Soc. Indp. Artists.*

SAUSSY, Hattie *[Painter, teacher] b.1890, Savannah, GA / d.1978, Savannah, GA.* *Hattie Soussy*
Addresses: Savannah. **Studied:** M. Baldwin Seminary, Staunton, VA, 1906-07; NY School FA, 1908-09; NAD, 1911-12; ASL, with E. Speicher; DuMond; E. O'Hara, Bridgman, both in 1912; Paris, with E.A. Taylor, 1913-14; Telfair Acad., Savannah, with A.W.

Blondheim, 1923; E.S. Shorter, F.S. Herring, in Brunsville, NC, 1950-51. **Member:** Georgia AA, 1932-34 (vice-pres.; pres.); Wolfe Art Club. **Exhibited:** Hist. Savannah Fnd., 1982 (retrospective); R.M. Hicklin Gal., Spartanburg, SC, 1983 (retrospective). **Comments:** Painted in oil and also some watercolor (portraits and landscapes) until shortly before her death. Teaching: Chatham Episopal Inst. (VA) and Savannah. **Sources:** WW25; exh. cat., R.M. Hicklin Gal. (Spartanburg, SC, 1983); Petteys, *Dictionary of Women Artists.*

SAUTER, Mary *[Painter] 20th c.*
Addresses: Bridgeport, CT. **Member:** ASMP. **Sources:** WW47.

SAUTER, Willard J. *[Educator, painter, designer, comm a, lecturer] b.1912, Buffalo, NY.*
Addresses: Utica, NY; Clinton, NY. **Studied:** Albright Art Gal. Sch. FA; Buffalo State Teachers College; International Sch. Art; M. Green; F.J. Bach; E. Zweybruck; Vienna. **Member:** Buffalo Soc. Art; Buffalo Art Council; Eastern AA; Syracuse AA; Utica Art Club; Munson-Williams-Proctor Inst. **Exhibited:** Albright Art Gal., 1940-45, (prize 1944),1946 (prize); Buffalo SA, 1933-39, 1940 (prize), 1941 (prize), 1942-43 (silver medal); 1944, 1945, 1946 (prize), 1947 (silver medal), 1952 (prize), 1956 (patrons prize & gold medal); Adams Gal., Buffalo (solo); Artists of Central NY; Munson-Williams-Proctor Inst., 1952 (Norman Hadley prize); Utica Art Cl. (prize).; Syracuse Artists; Artists of the Upper Hudson; Clinton Artists Exhib.; Old Forge Exhib.; New York State Fair; Utica, NY, 1962 (solo); Sherburne Art Soc., 1958 (prize); Mystic (CT) Outdoor Festival, 1960 (Galed Gesner award), 1960 (3 first prizes),1961 (first & second prizes). Other awards: Roy Mason F., 1948 (prize); NY State Dept. Commerce (special gold certificate). **Work:** Mohawk Valley Tech. Inst.; Munson-Williams-Proctor Inst.; YMCA, Buffalo; Gloria Dei Lutheran Church, Detroit; Zion Evangelical Church, Utica. **Comments:** Position: teacher, Buffalo Pub. Sch. (1933-43; 1946); senior instructor, Mohawk Valley Tech. Inst., Utica, NY; instructor, drawing, Kirkland AC, Clinton, NY, 1960-61. Lectures: "Color and You"; "Window Display from Idea to Sale"; "ChalkTalk." **Sources:** WW66; WW47.

SAUVE, Paul *[Engraver, lithographer] b.c.1849, Jefferson Parish, LA / d.1907.*
Addresses: New Orleans, active 1881-82. **Sources:** *Encyclopaedia of New Orleans Artists,* 339.

SAVAFE, Dorothy Lyman *[Painter] mid 20th c.*
Addresses: Baltimore, MD, 1925. **Studied:** PAFA. **Member:** PAFA (fellow). **Exhibited:** Salons of Am.; PAFA, 1925. **Comments:** *Cf.* Dorothy Savage Oudin. **Sources:** WW25; Petteys, *Dictionary of Women Artists.*

SAVAGE, A. J. *[Portrait painter] mid 19th c.*
Addresses: Probably in Ohio, active 1845. **Work:** Cincinnati Museum. **Sources:** G&W; *Antiques* (Jan. 1943), 37, repro.

SAVAGE, Augusta Christine (Mrs. James) *[Sculptor, educator, art center director] b.1900, Green Cove Springs, Florida / d.1962, Bronx, NY.*
Addresses: NYC. **Studied:** Tallahassee State Normal Sch.; Cooper Union with George Brewster, 1921-24; accepted but denied admittance, Fontainebleau Sch. FA; with H.A. McNeil; Grand Chaumière, Paris, 1934-35; Acad. FA, Rome; F. Benneteau, Paris. **Member:** NAWA (first African-Am. to be accepted); Woodstock AA. **Exhibited:** Sesqui-Centennial, Phila., 1926; Harmon Found., 1928, 1930-31; Salons of Am., 1932; Arch. Lg., 1934; NAWA, 1934; YWCA Harlem, 1934; Argent Gals., NYC, 1935, 1938; WFNY, 1939 ('The Harp'); Am. Negro Expo, Chicago, 1940; NY City Col., 1967; NYPL; Paris Salons; James A. Porter Gal., 1970; South Side Community AC, Chicago. Awards: Rosenwald Fellowships, 1929-31, 1930-32; CI Grant to open gallery in NYC. **Work:** Morgan State College; Nat. Archives; NYPL (135th St.); Howard Univ. Gal. of Art, Wash., DC. **Comments:** She left her family in Florida to pursue a career in art, becoming part of a circle of African American artists in Paris, which included Hale Woodruff, Claude McKay, Henry

Ossawa Tanner. Savage was primarily a portraitist, but little of her work survives. She was a prominent teacher and spokesperson for black cultural recoginition during the 1930s. Married John T. Moore, 1907, James Savage, and Robert Poston, 1923. Positions: founder/dir., Augusta Savage Art Studios, 1932; admin., WPA/FAP, 1936; founder, the Laboratory, 1936, later known as the Harlem Community Art Center, for which she became the director. **Sources:** WW40; Cederholm, *Afro-Am. Artists;* "African Am. Women Sculptors," *Am. Art Review* (Feb., 1998): 164-65; Fort, *The Figure in Am. Sculpture,* 221-22 (w/repro.), cites birthdate as 1892, as does Woodstock AA.

SAVAGE, Charles R. *[Photographer] b.1832, England (came to NYC in 1856) / d.1909.*
Addresses: Salt Lake City, UT (1860-on). **Comments:** A Western photographer, he is perhaps best remembered for his historic view of the joining of the Union Pacific and Central Pacific railroads at Promontory Point, Utah, in 1869. His firm, Savage & Ottinger, produced many views of the Rockies and Great Plains, often as stereoviews. **Sources:** Witkin & London, 230; Welling; Taft.

SAVAGE, Dorothy Lyman See: **SAVAFE, Dorothy Lyman**

SAVAGE, Edward *[Portrait and historical painter, engraver] b.1761, Princeton, MA / d.1817, Princeton, MA.*
Addresses: Boston, c.1785-89; NYC, 1789-91; Boston, 1794; Phila., 1795-1801; NYC, 1801-10; Boston. **Studied:** engraving in London, England, 1791-93 (he may also have studied with Benjamin West). **Exhibited:** Showed a panorama of London and Westminster in Phila. in 1795; his work was shown at his Columbian Gallery in its various locations (Phila., NYC, and Boston); Brooklyn AA, 1872; MMA, 1927 (Miniatures Painted in America); Worcester Art Mus., 1976. **Work:** NGA, Wash., DC ("The Washington Family," 1796); NPG, Wash., DC (engraving of "The Washington Family"); Worcester Art Mus. **Comments:** He was painting in Boston by c.1785, moving in 1789 to NYC, where he painted a portrait of President Washington which was commissioned by Harvard Univ. (in 1790, John Adams commissioned Savage to paint companion portraits of George and Martha Washington). After several years study in England (1791-93), he married in Boston in October 1794 and moved to Philadelphia in 1795. There he had an active business, painting, engraving and selling prints (assisted by David Edwin and John Wesley Jarvis); he also opened the Columbian Gallery (1796), where he showed ancient and modern paintings, as well as prints. Savage's major accomplishment in these years was his life-size portrait of the "Washington Family," which he showed at his gallery and later had engraved (with assistance by David Edwin) to much success. During the yellow fever epidemic of 1798 he moved to Burlington (N.J.) for a few months. From 1801 to 1810 Savage was in NYC where he reopened his Columbian Gallery, adding a natural history exhibit in 1802 (this section was later sold to a colleague who eventually sold it to P.T. Barnum). In 1811 or 1812 he once again moved his museum, this time to Boston where he remained until shortly before his death. **Sources:** G&W; Dresser, "Edward Savage"; DAB; Dickson, *John Wesley Jarvis,* 35-57; Morgan and Fielding, *Life Portraits of Washington,* 177-86; Stauffer. More recently, see Baigell, *Dictionary; 300 Years of American Art,* vol. 1: 68; Strickler, *American Portrait Miniatures,* 104-107.

SAVAGE, Eugene Francis *[Painter, teacher, sculptor] b.1883, Covington, IN.*
Addresses: Woodbury, CT; NYC. **Studied:** CGA; AIC; Am. Acad. in Rome; Reynolds; Henderson. **Member:** ANA, 1924; NA, 1926; NSMP; Century Assn.; Mural Artists Gld. **Exhibited:** Arch. Lg., 1921 (gold); AIC, 1922 (gold), 1924 (prize), 1925 (prize); NAD, 1922 (prize), 1924 (gold), 1961 (mural prize); Corcoran Gal biennials, 1923, 1926, 1928; PAFA Ann., 1924, 1926; Grand Central Gal., 1926 (prize),1929 (prize). Other awards: Fellowship, Am. Acad. in Rome, 1912-15. **Work:** AIC; CAM; LACMA; Providence Mus. Art; fountain, Grand Army Plaza, Brooklyn; Nebraska State Mus.; Herron AI; Oshkosh Pub. Mus.; murals, Yale Univ.; Columbia Univ.; USPO, Wash., DC;

Greenwich House, NYC; Friday Morning Club, Los Angeles; Purdue Univ., 1961; Penn. Treasury, Harrisburg; murals, WFNY 1939; Elks Nat. Mem., Chicago; Covington (IN) Court House; Texas State Centennial Mem., Dallas, 1936; mosaics, Tabernacle facade, Honolulu U.S. Military Mem., Epinal, France; Queens County Court House, 1960; work reproduced in Encyclopaedia Britannica. **Comments:** Author: report on art schools for Carnegie Corporation of NY. Position: appointed to Nat. Comm. FA, by Pres. Hoover, re-appointed by Pres. Roosevelt; William Leffingwell Prof. FA, Emeritus, Yale Univ. **Sources:** WW66; WW47; Falk, *Exh. Record Series.*

SAVAGE, Frances (Mrs. Curtis) *[Painter] mid 20th c.*
Exhibited: Salons of Am., 1934. **Sources:** Marlor, *Salons of Am.*

SAVAGE, James *[Sculptor] mid 20th c.*
Addresses: NYC. **Exhibited:** PAFA Ann., 1938. **Sources:** Falk, *Exh. Record Series.*

SAVAGE, Jessie See: **COLE, Jessie (Duncan) Savage (Mrs. Thomas L.)**

SAVAGE, Lilla D. (Mrs. Andrew B.) *[Painter, craftsperson, teacher] d.1909, Tacoma, WA.*
Addresses: Tacoma, WA, 1895-1909. **Member:** Tacoma Art League. **Exhibited:** Western Wash. Industrial Fair, 1891; Tacoma Art League, 1896. **Sources:** Trip and Cook, *Washington State Art and Artists.*

SAVAGE, M. F. *[Painter] mid 20th c.*
Addresses: NYC. **Exhibited:** S. Indp. A., 1929. **Sources:** Marlor, *Soc. Indp. Artists.*

SAVAGE, Marguerite Downing (Mrs.) *[Painter, illustrator] b.1879, Bay Ridge, NY.*
Addresses: Encino, CA; Worcester, MA; Prouts Neck, ME. **Studied:** in U.S. & Europe; ASL of Wash., DC, under E.C. Messer and E.L. Morse; R. Miller. **Member:** Worcester GAC. **Exhibited:** Cosmos Club, 1902; Soc. Wash. Artists; Wash. WCC; WMA, 1944; Boston (solo); Cleveland (solo). **Work:** Hobart College, Geneva, NY; Stanford Univ.; Union Seminary, NY; Worcester, MA, Polytechnic Inst.; Cornell Univ. **Comments:** Illustrator, *Harper's* magazine, 1902-11. **Sources:** WW53; WW47; McMahan, *Artists of Washington, DC* lists her birthdate as 1878.

SAVAGE, Thomas Michael *[Mural painter] b.1908, Fort Dodge, IA.*
Addresses: Fort Dodge, IA. **Studied:** Layton Art School and Univ. Iowa; Grant Wood. **Exhibited:** Iowa State Fair Salon, 1934 (first prize); Corcoran PWA show; All Iowa Exhibit, Carson Pirie Scott, 1937. **Work:** White House, Washington, DC; murals, USPOs, Jefferson, New Hampton, both in Iowa. **Comments:** WPA artist. **Sources:** WW40; Ness & Orwig, *Iowa Artists of the First Hundred Years,* 1885.

SAVAGE, Trudi See: **SAVAGE-JONES, Trudi (Gertrude) (Mrs. James)**

SAVAGE, Whitney Lee *[Painter, designer] b.1928, Charleston, WVA.*
Addresses: Piermont, NY. **Studied:** Univ. West Virginia; PIASch.; ASL; New Sch. Social Research. **Exhibited:** Silvermine Gld. Artists, 1957 (prize); Butler IA, 1956-57; Tri-State Annual, Athens, OH, 1949 (prize); Village AC, 1949-50 (prize), 1957; Armed Forces Painting, 1951(prize); RoKo Gal., NY, 1950-51; Chase Gal., NY, 1957 (solo); PAFA Ann., 1962, 1966. **Work:** Columbia (SC) Mus. FA; mural, Armed Forces Center, Mannheim, Germany. **Sources:** WW59; Falk, *Exh. Record Series.*

SAVAGE-JONES, James *[Sculptor, painter, craftsperson] b.1913, Kelty, Scotland.*
Addresses: Clearwater, FL. **Member:** Clay Club, NY; Sculpture Center, NY; Florida Fed. Art. **Exhibited:** PAFA, 1938; Arch. Lg., 1936; CAFA, 1937; BM, 1936; Clearwater Art Mus., 1947; Florida Gulf Coast AC, 1948-49; Florida Fed. Art, 1948-49; Gainesville Assn. FA, 1948; St. Petersburg A. Cl., 1950. **Work:**

Florida Gulf Coast AC; fountain, Clearwater, FL. **Sources:** WW59; WW47.

SAVAGE-JONES, Trudi (Gertrude) (Mrs. James) *[Portrait sculptor, teacher] b.1908, Roselle Park, NJ.* **Addresses:** Clearwater, FL. **Studied:** Grand Central Sch. Art; PAFA; Clay Club, NY. **Member:** Florida Fed. Art; Clay Club; Florida Gulf Coast Group; Clearwater AA. **Exhibited:** NAD; Montclair Mus. Art; Clearwater Art Mus.; Florida Fed. Art; Fla. Gulf Coast AC; Gainesville FAA; St. Petersburg Art Club. Awards: prize, PAFA, 1930. **Comments:** Teaching: Gulf Coast AC, 1956-57. Also appears as Gertrude Fish Jones and Trudi Savage. **Sources:** WW59; WW47.

SAVARY, Caroline A. *[Painter] b.1864.* **Addresses:** Boston, MA. **Exhibited:** Boston AC, 1894-96; AIC, 1897. **Sources:** Falk, *Exh. Record Series.*

SAVAS, Jo-Ann *[Painter, illustrator] b.1934, Opelika, AL.* **Addresses:** Huntsville, AL. **Studied:** Auburn Univ., Alpha Delta Pi scholar (B.S., art educ.). **Member:** Huntsville Art League & Mus. Assn. (first pres.); NAWA. **Exhibited:** Nat. Acad. Galleries, NYC; WFNY; Chateau de la Napole, Cannes, France; Southern Contemporaries Collection of Sears-Roebuck & Juried Int. Women's Show, 1966; Nat. Women's Watercolor Exhib., 1967 & 1968; plus 27 major solo shows & other group shows. **Comments:** Preferred media: watercolors. Positions: technical illustrator, Army Ballistic Missile Agency, Redstone Arsenal, AL, 1957-58. Teaching: private art instructor, Huntsville. **Sources:** WW73.

SAVELLI, Angelo *[Sculptor, printmaker] b.1911.* **Addresses:** Springtown, PA. **Exhibited:** WMAA, 1966; PAFA Ann., 1968. **Sources:** Falk, *Exh. Record Series.*

SAVELLI, Elena G. *[Painter] early 20th c.* **Addresses:** Phila., PA. **Exhibited:** PAFA Ann., 1924. **Sources:** WW25; Falk, *Exh. Record Series.*

SAVER, Gordon (Pfc.) *[Sculptor] mid 20th c.* **Addresses:** NYC. **Exhibited:** S. Indp. A., 1944. **Sources:** Marlor, *Soc. Indp. Artists.*

SAVER, John S. *[Engraver and lithographer] late 19th c.* **Addresses:** Cincinnati, 1860. **Comments:** Of Gregson & Saver, engravers and lithographers (see entry). **Sources:** G&W; Cincinnati BD 1860.

SAVERY, Halley (Brewster) See: **SAVERY, (Helen) Halley (Brewster)**

SAVERY, (Helen) Halley (Brewster) *[Art librarian] b.1894, Oakland, CA.* **Addresses:** Berkeley 8, CA. **Studied:** Univ. California; Univ. Washington (A.B.). **Comments:** Positions: curator, Henry Gal., Univ. Washington, Seattle, WA, 1927-47; librarian, Calif. Col. Arts & Crafts, Oakland, CA, 1951-on. Lectures: Asiatic and Modern Art. **Sources:** WW53.

SAVERYS, Albert *[Painter] mid 20th c.* **Exhibited:** AIC, 1931. **Sources:** Falk, *AIC.*

SAVIDGE, Elsie *[Painter] mid 20th c.* **Addresses:** Seattle, WA, 1939. **Exhibited:** SAM, 1937, 1939; Frederick & Nelson, Little Gal., 1943. **Sources:** Trip and Cook, *Washington State Art and Artists.*

SAVIER, Helen See: **DUMOND, Helen Savier (Mrs. Frank V.)**

SAVILLE, Bruce Wilder *[Sculptor] b.1893, Quincy, MA / d.1938.* **Addresses:** Boston, MA; Cleveland, OH, 1925; Santa Fe, NM. **Studied:** Massachusetts Sch. Art, with Dallin; Mr. & Mrs. Kitson. **Member:** Boston AC; NSS. **Exhibited:** PAFA Ann., 1916, 1925; AIC, 1922, 1924. **Work:** Civil War and WWI memorials, Quincy, MA; Vicksburg (MS) National Park; Collingwood Mem., Kansas City; Potter Mem., Annapolis; Quincy H.S.; mem. tablet to Unknown Dead of World War, Quincy; Canadian Infantryman, St.

John's; Victory figure, Chicopee, MA; Forrester Mem., Worcester, MA; mem. of the 3 wars, Palmyra, ME; mem. to 104th Infantry, 26th Div., Westfield, MA; World War Mem., Upton, MA; World War Mem., Ravenna, OH; Peace Mem., Civil War, State House grounds, Columbus; Mack Mem., Ohio State Univ.; three panels, Jeffrey Manufacturing Co. Office Bldg.; Ohio State World War Mem., Columbus; World War memorials at Glens Falls, NY; mem., Wollaston, MA; mem., Toledo; mem. group, White Chapel, Memorial Park, Detroit; Am. trophy, James Gordon Bennett Balloon Races; fountain group, White Chapel Memorial Park, Detroit; mem., Worcester, MA; mem., City Hospital, Boston; mem., Boston Airport; War memorial, National Cemetery, Santa Fe, NM. **Sources:** WW38; Falk, *Exh. Record Series.*

SAVIN, William H. *[Painter] mid 20th c.* **Addresses:** Chicago. **Exhibited:** AIC, 1922-23, 1926, 1935-36, 1943. **Sources:** Falk, *AIC.*

SAVIOUR, C.S.C., Sister Mary Devine See: **SISTER MARY OF DIVINE SAVIOUR, (C.S.C.)**

SAVITT, Sam *[Illustrator, writer] late 20th c.; b.Wilkes-Barre, PA.* **Addresses:** North Salem, NY in 1975. **Studied:** Pratt Inst., Brooklyn; ASL; NYU. **Comments:** Illustrator, national magazines; author/illustrator, "Around the World with Horses," "There Was a Horse," and "Rodeo." **Sources:** P&H Samuels, 421.

SAVITZ, Frieda *[Painter] b.1932, NYC / d.1985.* **Addresses:** New York, NY. **Studied:** Univ. Wisconsin; Columbia Univ.; NY Univ. (B.S., M.A.); CUA Sch. and with Hans Hofmann and abroad. **Exhibited:** Nat, Mus., Wash., DC; BM; Montclair Art Mus.; Newark Mus. Art; RoKo Gal.; G. Gal.; Louisiana State Capitol; Fleischman Gal.; NY City Center; Greenwich (CT) Theatre, 1957 (solo); Actor's Playhouse, NY, 1957; NY Univ., 1958. **Comments:** Position: instructor, Newark Mus., Bd. of Educ., Newark, NJ; Walt Whitman Sch. and Greenwich House, NYC. **Sources:** WW59.

SAVORY, Thomas C. *[Ornamental and fancy painter] mid 19th c.* **Addresses:** Boston, active 1837-52. **Comments:** In 1837 he was a partner with William Johns. Savory's painting of "The National Lancers on Boston Common, 1838," was exhibited in 1950 at the Corcoran Gallery. **Sources:** G&W; Boston CD 1837-52; *American Processional,* 242.

SAVOY, Chyrl Lenore *[Sculptor, educator] b.1944, New Orleans, LA.* **Addresses:** Mamou, LA. **Studied:** La. State Univ. (B.A., art); Acad. Fine Arts, Florence, with Gallo & Berti; Wayne State Univ.(M.F.A., sculpture). **Exhibited:** 58th Exhib. Mich. Artists, Detroit Inst. Arts Mus., 1971; 1971 Artist's Biennial Exhib. of Artists of Southwest & Tex., NOMA, 1971 (purchase award), 1972 (solo); 27th Ann. State Art Exhib. Prof. Artists, La. Art Comn. Galleries, Baton Rouge, 1971; 14th Ann. Delta Art Exhib., Ark. Art Ctr., Little Rock, 1971. **Work:** Our Lady Bayous Convent, Abbeville, La.; Herrod Jr. HS Libr., Abbeville; Mamou HS Libr., La. Commissions: renovation & redesigning of chapel, Dominican Rural Missionaries, Abbeville, 1972; sculpture, Our Lady Queen of All Saints, Ville Platte, La., 1972. **Comments:** Preferred media: woods, metals. Teaching: asst. sculpture, Wayne State Univ., summer 1970. **Sources:** WW73.

SAVOY, Louise *[Painter] late 19th c.; b.New York.* **Studied:** Santin Ciceri, Mme. M. Dumas. **Exhibited:** Paris Salon, 1890. **Sources:** Fink, *American Art at the Nineteenth-Century Paris Salons,* 338.

SAWE, Henry Leonard *[Painter] early 20th c.; b.Chicago.* **Addresses:** Paris, France. **Studied:** Merson; Simon; Cottet, in Paris. **Member:** Paris AAA. **Exhibited:** AIC, 1903-04; PAFA Ann., 1904-06. **Sources:** WW08; Falk, *Exh. Record Series.*

SAWIN, David *[Artist] mid 20th c.* **Addresses:** Cottage, NY. **Exhibited:** WMAA, 1955. **Sources:** Falk, *WMAA.*

SAWIN, Edward D. *[Engraver] b.c.1822, Rhode Island.*
Addresses: NYC, 1846-50. **Sources:** G&W; 7 Census (1850), N.Y., XLIV, 223; NYBD 1846.

SAWIN, J. W. *[Landscape painter] mid 19th c.*
Addresses: Springfield, MA, 1850. **Sources:** G&W; Lipman and Winchester, 179.

SAWIN, Wealthy O. *[Painter of still life in watercolors] early 19th c.*
Addresses: Massachusetts, c.1820. **Sources:** G&W; Lipman and Winchester, 179.

SAWITZKY, William *[Curator] b.1880, Riga, Latvia (came to U.S. in 1912) / d.1947.*
Addresses: Stamford, CT. **Studied:** Russia. **Comments:** An expert on early American paintings, he identified many works by Gilbert Stuart. Position: advisory curator, NY Hist. Soc.

SAWKINS, James Gay *[Portrait and genre painter] b.1806, Yeovil, Dorset, England / d.1875, Turnham Green, near London, England.*
Addresses: Came to Baltimore, c.1820; Boston; Cincinnati, OH, active 1830. **Exhibited:** National Academy and the Artists' Fund Society (1840). **Work:** Cincinnati Art Museum (portrait of Joseph Longworth). **Comments:** Sawkins was an itinerant artist, specializing in portrait miniatures. He was in Boston; traveled to Cincinnati, c.1830; and visited New Orleans in the winter of 1831 with Joseph H. Bush. He was in Mexico in 1830 and in Cuba by 1835, painting on commission. After a short visit to South America and experience in the Calif. mines, he went to Hawaii, 1850-52. Later he went to Australia and began a career in geology, which he pursued until 1870. **Sources:** G&W; Cowdrey, NAD; Rutledge, PA; Delgado-WPA cites *Bee*, Dec. 9, 1831. Hageman, 122; *Encyclopaedia of New Orleans Artists,* 339; Wright, *Artists in Virgina Before 1900; Forbes,* Encounters with Paradise, 141-46.

SAWRIE, Mary B. (Mrs.) *[Miniature painter] b.1879, Nashville.*
Addresses: Nashville, TN/Beersheeba, TN. **Studied:** AIC, with Vanderpoel; W.M. Chase; Arthur Dow; F.A. Parsons; Académie Julian, Paris. **Sources:** WW25.

SAWTELLE, Alice Elizabeth *[Painter, teacher] b.c.1875, Wash., DC / d.1956, Wash.*
Addresses: Wash., DC/Ogunquit, ME. **Studied:** Sch. Des. for Women; Drexel Inst.; Corcoran Sch. Art; C. Woodbury; Ingram Summer Sch., Cornwall, England. **Member:** Wash. WCC; Soc. Wash. Artists; Wash. AC; Wash. Soc. FA; Providence WCC; Ogunquit AA (a founding director). **Exhibited:** Wash. WCC; Soc. Wash. Artists, 1915-35; Providence WCC; CGA; Gr. Wash. Indep. Exhib., 1935; AIC; Maryland Inst.; S. Indp. A.; "Charles H. Woodbury and His Students," Ogunquit Mus. Am. Art, 1998. **Comments:** Teaching: instructor, Hill School of Art, Wash., DC.; instructor, watercolor class, Woodbury Summer School, Ogunquit, ME, 1919. **Sources:** WW40; McMahan, *Artists of Washington, DC; Charles Woodbury and His Students.*

SAWTELLE, Essie G. *[Artist] late 19th c.*
Addresses: Active in Los Angeles, 1888-91. **Sources:** Petteys, *Dictionary of Women Artists.*

SAWTELLE, Mary Berkeley (Mrs. Charles G.) *[Painter] b.1872, Wash., DC.*
Addresses: Wash., DC, 1912-17; Staunton, VA, 1917; 1917-33 in Ashville, NC, NYC, Millbrook & Cooperstown, NY. **Studied:** Delecluse Academy, Paris, under E. Scott; Colarossi Academy, Paris; Corcoran Sch. Art, under E.F. Andrews; I. Wiles, NY; C. Hawthorne, NY. **Member:** CGA, 1912; Wash. SA. **Exhibited:** Soc. Wash. Artists; Wash. WCC; SSAL; Corcoran Gal biennial, 1912; S. Indp. A., 1918. **Work:** NOMA. **Comments:** Teaching: art instructor, Wash., DC. **Sources:** WW33; McMahan, *Artists of Washington, DC.*

SAWYER, A. R. (Miss) *[Portrait painter (crayon artist)] late 19th c.*

Addresses: Boston, 1859-76. **Sources:** G&W; Boston BD 1859; Petteys, *Dictionary of Women Artists.*

SAWYER, Alan R *[Art consultant] b.1919, Wakefield, MA.*
Addresses: Wash., DC. **Studied:** Bates Col. (BS, 1941); BMFA Sch.; Boston Univ., 1947-48; Harvard Univ. (M.A., art hist.), 1949; Bates Col. (hon. D.F.A., 1969). **Member:** Archaeol. Inst. Am.; Soc. Am. Archaeol.; Inst. Andean Studies. **Comments:** Positions: cur. primitive art, Tex. Woman's Univ., 1949-52; asst. to cur. decorative arts, AIC, 1952-54, asst. cur. decorative arts in charge Early Americana & pre-Columbian art, 1954-56, assoc. cur. in charge primitive art, 1956-58, cur. primitive art, 1958-59; dir., Textile Mus., 1959-71; dir., Park Forest Art Ctr.; mem., Univ. Pa. Archeol. Expend to Bolivia, 1955; leader of Textile Mus. Archaeol. Exped. to Peru, 1960; leader, Brooklyn Mus. Study Tour to Peru, 1965; independent art consult, 1971-. Teaching: instr. art dept., Tex. Woman's Univ., 1949-52; group discussion leader, Looking at Modern Art, Ford Found., AIC, 1955-57; lectr., pub. lect. prog., Univ. Chicago-AIC , 1959; adj. prof. art & archaeol., Columbia Univ., 1968-69; lectr., Smithsonian Assocs., 1971-. Collections arranged: Designer-Craftsmen USA, 1954, Design in Scandinavia, 1956, coordr. of Midwest Designer-Craftsmen Exhib., 1957 & installation of all primitive art exhibs, 1952-59, AIC; installation of rug & textile exhibs, Textile Mus, 1959-71; cur., Master Craftsmen of Ancient Peru Exhib., Guggenheim Mus., 1965-69. Publications: auth., "Handbook of the Nathan Cummings Collection of Ancient Peruvian Art," 1954 & "Animal Sculpture in pre-Columbian Art," 1957, AIC; auth., "A Group of Early Nasca Sculptures in the Whyte Collection", *Archaeol Mag.* (1962); auth., "Ancient Peruvian Ceramics," MMA, 1966; auth., "Ancient Peruvian Art," 1968; plus numerous other articles & catalogs on Peruvian art. **Sources:** WW73.

SAWYER, Allan G. *[Painter] mid 20th c.*
Exhibited: Salons of Am., 1934. **Sources:** Marlor, *Salons of Am.*

SAWYER, Belinda A. *[Theorem painter] early 19th c.*
Comments: Active c.1820. **Sources:** G&W; *Antiques* (Feb. 1933), 61, repro.; Lipman and Winchester, 179.

SAWYER, Bill *[Painter] b.1936, Nashville, TN.*
Exhibited: Lyzon Gal., Nashville, 1959; Daniel Orr's, San Diego; The Little Gal., Memphis; Parthenon, Nashville, Durlacher Bros. Gal., NY, 1964, 1966. **Work:** Fine Arts Center, Cheekwood; Tennessee State Mus. **Comments:** Most paintings are microscopically exact renderings of old houses and figures. Sawyer gave up painting sometime before 1985. **Sources:** Kelly, "Landscape and Genre Painting in Tennessee, 1810-1985," 140-41 (w/repro.).

SAWYER, Charles Henry *[Photographer] b.1868 / d.1954.*
Addresses: Providence, RI, 1902; Norridgewock, ME, 1903; Farmington, ME, 1904-20; Concord, NH,1920-on. **Comments:** From 1903-70s, his Sawyer Picture Co. competed successfully (against Wallace Nutting and others) in the production of hand-colored pictorialist landscape photographs catering to the tourist trade. Around 1902-03, he worked for Nutting (see entry). Orginally located in Farmington, ME, the business later relocated to Concord, NH, to be closer to the White Mountains. While most of the firm's pictures center on New Hampshire scenes, it also produced scenes of the Monterey coast. **Sources:** auction review in *Maine Antique Digest* (Nov. 1996, p.16B); Ivankovitch, 209.

SAWYER, Charles Henry *[Museum director] b.1906, Andover, MA.*
Addresses: Ann Arbor, MI. **Studied:** Yale Univ. (AB); Harvard Law Sch. & Harvard Grad. Sch.; Amherst Col. (hon. L.H.D.); Univ. NH, (hon. D.F.A.); Clark Univ. (hon. L.H.D.). **Member:** Am. Assn. Mus.; Assn. Art Mus. Dirs.; Col. Art Assn. Am.; Am. Antiquarian Soc.; Am. Acad. Arts & Lett. **Comments:** Positions: dir., Addison Gal. Am. Art, Andover, Mass., 1930-40, mem. art comt., 1940-; dir., Worcester Mus. Art, Mass., 1940-47; mem. Mass. Art Comn., 1943-45; trustee, Corning Mus. Glass, 1950-; mem. Smithsonian Art Comn., 1954-; dir., Univ. Mich. Mus. Art, 1957-72. Teaching: prof. hist. art, Sch. Archit. & Design, Yale Univ., 1947-56; prof. mus. practice & hist. art, Univ. Mich., Ann

Arbor, 1957-on. Publications: auth., "Art Education in English Public Schools," 1937; auth., "Report of Committee on Visual Arts at Harvard," 1954-55; auth., "Integration in the Arts," 1957 & "The College Art Department and the Work of Art," 1965, *Col. Art J.;* contribr., var. art mags. **Sources:** WW73.

SAWYER, Clifton Howard
[Painter] b.1896, Massachusetts / d.1966, San Fernando, CA.
Addresses: Altadena, CA. **Exhibited:** Pasadena Soc. of Artists, 1934-37. **Sources:** Hughes, *Artists in California*, 492.

SAWYER, Conway *[Sculptor, teacher] b.1902, NYC.*
Addresses: Wilmington, DE. **Studied:** Archipenko. **Exhibited:** Wilmington Soc. FA; Weyhe Ga., N.Y.; Salons of Am.; WFNY, 1939. **Comments:** Position: t., Wilmington Acad. A. **Sources:** WW40.

SAWYER, Danton Winslow *[Painter, architect designer] b.1910, Clinton, MA.*
Addresses: South Hamilton, MA. **Studied:** Dartmouth Col. (A.B.); in France, and with Jose Clement Orozco, Bernard Karfiol. **Member:** Castle Hill A. Center, Ipswich, Mass. (Exec. Com.). **Exhibited:** WMA, 1938; CI, 1941; Inst. Mod. A., Boston; RISD; MMA; AGAA; Passedoit Gal., NY; Kreitzer Gal., Chicago; Silvermine Gld. A.; Marblehead AA; Topsfield (Mass.) Pub. Lib. **Work:** Wheaton Col.; Dartmouth Col. **Comments:** Lectures: Modern Painting. **Sources:** WW59; WW47.

SAWYER, E. T. (Mrs.) *[Still-life painter] late 19th c.*
Addresses: San Jose, CA. **Exhibited:** Calif. State Fair, 1881; Calif. Agricultural Soc., 1883. **Sources:** Hughes, *Artists of California*, 492.

SAWYER, Edith *[Miniature painter] mid 20th c.; b.South Coventry, CT.*
Addresses: NYC/Columbia, CT, c.1907-33. **Studied:** Adelphi Sch., ASL. **Member:** Penn. SMP; Brooklyn SMP; Brooklyn AG; New Haven PCC. **Exhibited:** AIC, 1916; PAFA, 1925. **Sources:** WW33.

SAWYER, Edmund Joseph *[Painter, illustrator, writer, lecturer, designer, craftsperson] b.1880, Detroit, MI.*
Addresses: Kirkland, WA. **Studied:** Holmes School I; Smiths A. Acad., Chicago. **Member:** Northwest Bird & Mammal Soc. (corresponding mem.); Agassiz Assn. (honorary). **Exhibited:** Cornell; Rockefeller Center; 48 States Comp., 1939. **Work:** New York State Mus.; Albright Art Gal.; Yellowstone Park Mus.; Bellingham (WA) Mus.; murals, USPO, Dennison, OH; WPA artist. **Comments:** Author/illustrator, "Land Birds of Northern New York," 1925; "Game Birds and Others of the Northwest," 1945; illustrator, "American Natural History"; & other bird books. Contributor to: Nature, Bird-Lore, Field & Stream, & other magazines. **Sources:** WW59; WW47.

SAWYER, Edmund O. *[Painter, newspaper artist] early 20th c.*
Addresses: Los Angeles, CA. **Studied:** Jean Mannheim. **Exhibited:** Press Artists Assoc. of Los Angeles, 1906. **Sources:** Hughes, *Artists in California*, 492.

SAWYER, Edward W(arren) *[Sculptor] b.1876, Chicago / d.1932, Clos Vert La Palasse, Toulon, France.*
Addresses: Folkestone, England; Paris, Toulon, France. **Studied:** AIC; Académie Julian, Paris with J.P. Laurens and Verlet, 1899; Frémiet, Injalbert, and Rodin, also in Paris. **Member:** NSS. **Exhibited:** St. Louis Expo, 1904 (medal); PAFA Ann., 1907-10, 1912; Intl. Expo, Ghent, 1913 (medal); Salon des Artistes Français, 1914 (prize); Pan-Pacific Expo, San Francisco, 1915; NYC, 1923; Am. Numismatic Soc., 1931 (prize). **Work:** Luxembourg, Paris; Am. Numismatic Soc., NY; U.S. Mint, Philadelphia; AIC; Massachusetts Hist. Soc.; Buffalo Bill Mus., Cody, WY. **Comments:** Specialty: medals. After 1900 he lived permanently in France, although he made two visits to the U.S. c.1912 and made a series of 40 bronze medals of various Indians tribes. **Sources:** WW24; P&H Samuels, 421; Falk, *Exh. Record*

Series.

SAWYER, Ellen M. *[Painter] early 20th c.*
Exhibited: Soc. Wash. Artists, 1909. **Sources:** McMahan, *Artists of Washington, DC.*

SAWYER, Esther (Hoyt) (Mrs. Ansley W.) *[Painter, graphic artist] mid 20th c.; b.Buffalo, NY.*
Addresses: Buffalo, NY. **Studied:** Albright A. Sch.; ASL, and with Charles Hawthorne, Edwin Dickinson, Nicholas Vastlieff. **Member:** The Patteran (bd. dir.); Nantucket AA; A. Collectors' A. Assn. (pres.). **Exhibited:** 45 Group, 1945; The Patteran, 1943, 1944; Riverside Mus., 1941, 1942; Albright A. Gal.; Garret C., Buffalo, 1945 (solo); Taylor Gal., Nantucket, Mass., 1945 (solo); Buffalo Mus. Science. **Sources:** WW59; WW47.

SAWYER, Grace M. *[Painter, craftsworker] early 20th c.*
Addresses: Great Hill Pond, NJ & Worcester, MA., c.1907-23. **Exhibited:** Worcester Art Mus., 1921. **Sources:** WW24; Petteys, *Dictionary of Women Artists.*

SAWYER, Helen Alton Farnsworth *[Painter, writer, lithographer, teacher] b.1900, Wash., DC.*
Addresses: North Truro, MA; Sarasota, FL. **Studied:** Masters Sch., Dobbs Ferry; NAD Sch., with Charles Hawthorne; Johansen; Sawyer. **Member:** ANA, 1937; Provincetown AA; Yonkers AA; Hudson Valley AA; NAC; Fla Artists Group (pres., 1953-1955); Audubon Artists; NAWA. **Exhibited:** PAFA Ann., 1923-25, 1932-36, 1940-51; Hudson Valley A. Inst., 1935 (prize), 1936 (prize); Fine Prints of the Year, 1937; AIC, from 1925, 1936 (prize); Carnegie Nat. & Int., Pittsburgh; Am. Painting Today, MMA; Century of Prog., Chicago, 1933-34; Corcoran Gal. biennials, 1937-47 (6 times); San Fran. World's Fair, 1939-40; NYWF, 1939; Ringling Mus. (Award for The Bareback Rider); AIC (first hon. mention for "Trees by the Turn"); Atlanta Mus. (first prize for landscape & still life); Frank Oehlschlaeger Gal., Sarasota, FL. **Work:** WMAA; PAFA; LOC; John Herron AI; Vanderpoel Coll.; TMA; Atlanta Mus.; Indianapolis Mus. Commissions: Paintings, Blue Ridge Spring, Chesapeake & Ohio RR, New York, First Nat. City Bank & Circus Parade, G. Lister Carlyle. **Comments:** Preferred media: oils, watercolors. The wife of Jerry Farnsworth, she was active in Provincetown in 1927, and 1954-72. Author: "Peter Sawyer Master Mariner," in *Cape Cod Compass;* "Paintings in Oils on Paper," in *Am. Artist; Living Among the Modern Primitives,* Scribner. **Sources:** WW73; papers in Archives and Archives of American Art; Falk, *Exh. Record Series.*

SAWYER, James J. *[Portrait and landscape painter] b.1813 / d.1888.*
Addresses: NYC, 1840-47; Putnam, CT, 1856. **Exhibited:** NAD and Am. Inst. **Sources:** G&W; Birth and death dates courtesy the late William Sawitzky; Cowdrey, NAD; NYCD 1840-47; NYBD 1846 [both as Sawyer and Sayer, at his business and home address respectively]; Am. Inst. Cat., 1842, 1845, 1846; New England BD 1856.

SAWYER, Kenneth B. *[Scholar, writer, critic] b.1923, San Fran., CA.*
Addresses: NYC. **Studied:** Reed College (B.A.); Johns Hopkins University (M.A.); Sorbonne, Paris. **Member:** Intl. Assn. of Art Critics. **Exhibited:** Awards: Frank Jewett Mather, Jr. Citation for Art Criticism, The College Art Assn., 1956. Specializing: contemporary American Painting and Sculpture, with particular emphasis on developments since World II. Author: "John Marin"; "Stamos"; numerous articles and essays. **Comments:** Field of research: the contemporary American art scene. **Sources:** WW66.

SAWYER, Lelia G. (Mrs. O. H.) *[Painter] early 20th c.*
Addresses: NYC. **Exhibited:** S. Indp. A., 1928; Fontainebleau Sch. FA, 1938 (prize); NAWPS, 1935-38; Studio Gld., N.Y., 1940. **Sources:** WW40.

SAWYER, Myra L. *[Painter] 20th c.*
Addresses: Salt Lake City, UT. **Sources:** WW15.

SAWYER, Natalie See: SAWYIER, Natalie

SAWYER, Philip *[Painter] early 20th c.*
Addresses: Washington, DC. **Studied:** ASL of Wash., DC.
Exhibited: Cosmos Club, 1902. **Sources:** McMahan, *Artists of Washington, DC.*

SAWYER, Phil(ip) (Ayer) *Phil Sawyer*
*[Painter, lithographer, decora-
tor, lecturer, etcher, teacher, craftsperson] b.1877, Chicago, IL /
d.1949, probably Clearwater, FL.*
Addresses: Tiskilwa, IL in 1934; Clearwater, FL. **Studied:** AIC,
with Vanderpoel; Purdue; Yale School FA; Ecole des Beaux-Arts,
with L. Bonnât. **Member:** Salon d'Automne, Paris; Artists' Union,
N.Y. **Exhibited:** AIC, 1926; S. Indp. A., 1934. **Work:**
Smithsonian Inst. (prints); LOC; NYPL; mural, Gary Sch.,
Chicago. **Comments:** Position: teacher, Clearwater Art Mus.,
1947. **Sources:** WW47; P&H Samuels, 421.

SAWYER, R. D. *[Painter] late 19th c.*
Addresses: NYC, 1888-1889. **Studied:** Académie Julian, Paris
with Boulanger and Lefedvre, 1883-85. **Exhibited:** Boston AC,
NAD, 1888-1889. **Comments:** .

SAWYER, Ralph Edmund *[Architect and painter] b.1873,
Boston, MA.*
Addresses: Des Moines, IA. **Studied:** Boston Art Club; MIT;
Ross Turner, D. A. Gregg, Edward Brown, E. B. Homer.
Member: Iowa Artists Club (treasurer, 1933-34). **Exhibited:**
Iowa Art Salon; Iowa Artists Club Ann. Exhibitions. **Work:** in
priv. colls. **Comments:** Positions: teacher of architecture,
Massachusetts Normal Art School; Des Moines, City Planning
Commission. **Sources:** Ness & Orwig, *Iowa Artists of the First
Hundred Years,* 184.

SAWYER, Roswell Douglas *[Painter] late 19th c.; b.New
York.*
Studied: Boulanger, Lefebvre. **Exhibited:** Paris Salon 1886,
1887. **Sources:** Fink, *American Art at the Nineteenth-Century
Paris Salons,* 388-89.

SAWYER, S. A. (Mrs.) *[Painter] late 19th c.*
Addresses: NYC, 1881,1882. **Exhibited:** NAD, 1880-82.
Sources: Naylor, *NAD.*

SAWYER, Thomas H. *[Portrait painter] b.c.1825,
Connecticut.*
Addresses: Boston, 1858-60. **Sources:** G&W; Boston BD 1858-
60; 8 Census (1860), Mass., XXVIII, 79.

SAWYER, Wallace B. *[Painter] b.1868, Galt, CA / d.1945, St.
Helena, CA.*
Addresses: near Sacramento, CA. **Exhibited:** Calif. State Fair,
1888; Salons of Am.; S. Indp. A., 1925-27; Crocker Art Gal., 1938
(solo); NAD, 1884. **Sources:** Hughes, *Artists in California,* 492.

SAWYER, Warren F. *[Painter] mid 20th c.*
Comments: A watercolor, "Hans Hoffmann at Work" 1941 was
sold at Bakker Auctions, Cambridge, MA, May, 1990.

SAWYER, Wells Moses *[Painter, Illustrator, decorator]
b.1863, near Keokuk, IA / d.1961, Sarasota, FL.*
Addresses: Wash., DC, 1890-1926; NYC; Spain; Mexico;
Sarasota, FL. **Studied:** John O. Anderson of the Duveneck Group;
AIC with John Vanderpoel; Howard Helmick; Corcoran School
Art; ASL of Wash., DC. **Member:** Wash. Soc. FA; Studio Guild;
Chicago Soc. Artists; Soc. Wash. Artists (hon.); Yonkers AA (hon.
pres.); AWCS; All. Artists Am.; AFA; SC (hon.); Sarasota AA;
Florida A. Group; Am. Ar. Prof. Lg.; Wash., DC ASL (pres.).
Exhibited: Wash. WCC; Cosmos Cl.; Soc. Wash. A., from 1892;
Chicago Worlds Fair, 1893; PAFA Ann., 1894; Fisher Galleries,
1898; Snedecor Gal., 1914; Babcock Gal., 1916-25; Ferargil Gal.,
1916, 1936 (solo); Majestic Gal., 1924; Studio Guild Gal., 1924;
Museo Nacional de Artes Moderno, Madrid, 1929; Yonkers Mus.
Science & Art, 1930; Corcoran Gal. biennials, 1937-43 (3 times);
other Corcoran Gal exh., 1931 (solo); Gibbs Art Gal., Charleston,
1931; AIC; NAD,1892; All. Artists Am.; AWCS, 1941-46;

Provincetown AA; Sarasota AA; West Coast Group, 1944-46;
Florida Fed. A. Traveling Exh., 1944; NGA 1931 (solo); Milch
Gal. (solo); Univ. Club Salon, Mexico City, 1941 (solo); Yonkers
AA; Nat. Gal. Mod. A., Madrid, Spain, 1928 (solo); Salon Belles
Artes, Amigos del Pais, Malaga, 1934 (solo); (old) U.S. Nat. Gal.
A., 1931 (solo); Southern Art Project, Univ. Georgia and other
universities, colleges and galleries in the State of Georgia (solo);
AFA traveling exh., 1939-41; Salon of the Univ. Cl., Mexico City
(paintings executed in Mexico, 1936-41); Ringling Mus. Art, 1950
(paintings executed in Spain); Sarasota AA, 1955 (paintings from
Spain, Mexico, Morocco, India and the U.S.). **Work:** NMAA;
State Cap., Sacramento, CA; CGA; Vanderpoel Collection;
NCFA; State Dept., Wash., DC; Mus. City of New York;
Benjamin West Soc.; Hudson River Mus.; Smithsonian; Yonkers
Mus. Science & Art, NY; LOC; Thos. J. Watson Coll.; IBM Coll.;
U.S. Dept. State. **Comments:** Illustrator with U.S. Geo. Survey
and Bur. of Am. Ethnology, 1891-97. He was an artist with the
Pepper-Hearst Expedition to the Florida Keys in 1896-97. From
1897-1906, with the U.S. Treasury Dep., he was in charge of
design and inspection of furnishing in Federal buildings.
Sources: WW59; WW47; Ness & Orwig, *Iowa Artists of the First
Hundred Years,* 184; McMahan, *Artists of Washington, DC* lists
his place of birth as Keokuk, KS; Falk, *Exh. Record Series.*

SAWYER, William *[Art dealer, collector] b.1920, Lindsay,
OK.*
Addresses: San Francisco, CA. **Comments:** Positions: director,
William Sawyer Gallery, San Francisco, CA. Collection:
Contemporary American and Mexican paintings, sculpture and
graphics. Specialty of gallery: contemporary American painting,
sculpture and graphics. **Sources:** WW73.

SAWYERS, Martha (Mrs. William *MARTHA
Reusswig) *[Illustrator, writer] b.1902,* SAWYERS
Cuero, TX.
Addresses: NYC. **Studied:** ASL. **Member:** SI. **Exhibited:** Marie
Sterner Gal., NYC (drawings of China and Indonesia).
Comments: Illus., *Collier's* magazine; she went to the China-
Burma-India area during WWII on behalf of the magazine, pro-
ducing numerous illustrated articles about her observations. *Life*
magazine published her pastel portraits of Asians in the British
Merchant Navy, and she illustrated books for Pearl S. Buck and
Mona Gardner. **Sources:** WW47.

SAWYIER, Natalie *[Painter] 19th/20th c.*
Addresses: NYC, 1890s; Woodstock, NY in 1917. **Studied:**
Elizabeth S. Hutchins; ASL, 1888-89 with James C. Beckwith.
Exhibited: Soc. Am. Artists, 1898. **Work:** Univ. Kentucky Art
Mus. **Comments:** Sister of Paul Sawyier (see entry). Taught
drawing in Frankfort, KY. Very few works by the artist have been
located but existing watercolors indicate some affinity between
her work and her brother's. (Also appears under Bentz and, proba-
bly misspelled, under Sawyer). **Sources:** WW01; Jones and
Weber, *The Kentucky Painter from the Frontier Era to the Great
War,* 41 (w/repro.).

SAWYIER, Paul *[Painter]* *PAUL SAWYIER*
*b.1865, Madison County, OH /
d.1917, Catskills, NY.*
Addresses: Frankfort, KY, c.1874-08; Jasmine County, KY, 1908-
13; NYC and Catskills, 1913-17. **Studied:** Cincinnati Art School,
1884 with Thomas S. Noble; ASL, 1889-90 with W.M. Chase;
Frank Duveneck, c.1891, in Cincinnati. **Work:** Univ. Kentucky
Art Mus., Lexington. **Comments:** Impressionist painter. Moved to
Frankfort, KY about 1870 where he was primarily a watercolorist
although he also worked in oil, charcoal and pastel. Later he
worked mostly in oil. He was one of the few proponents of
Impressionism in Kentucky around 1900. After 1908 he spent
about five years on a houseboat, and in 1913 moved to New
York, first in Brooklyn and then upstate. Sawyier sometimes
painted portraits out of economic necessity, but landscapes were
his specialty. **Sources:** WW17; Jones and Weber, *The Kentucky
Painter from the Frontier Era to the Great War,* 64-65 (w/repros.);
Gerdts, *Art Across America,* vol. 2: 168.

worked mostly in oil. He was one of the few proponents of Impressionism in Kentucky around 1900. After 1908 he spent about five years on a houseboat, and in 1913 moved to New York, first in Brooklyn and then upstate. Sawyier sometimes painted portraits out of economic necessity, but landscapes were his specialty. **Sources:** WW17; Jones and Weber, *The Kentucky Painter from the Frontier Era to the Great War,* 64-65 (w/repros.); Gerdts, *Art Across America,* vol. 2: 168.

SAX, Bernard *[Painter] mid 20th c.*
Exhibited: S. Indp. A., 1935. **Sources:** Marlor, *Soc. Indp. Artists.*

SAX, Carol M. *[Designer, teacher] 20th c.*
Addresses: Lexington, KY. **Member:** Charcoal C. **Comments:** Position: affiliated with Univ. Ky. **Sources:** WW27.

SAX, Sara *[Painter, decorator] b.1870, Cincinnati, OH / d.1949, Cincinnati.*
Comments: Worked with Rookwood Pottery, 1896-1931. Pieces decorated by Sax were presented to Charles A. Lindberg when he visited Cincinnati. **Sources:** Petteys, *Dictionary of Women Artists.*

SAXE, Carolyn N. *[Painter, teacher, lecturer, designer] b.1904, West Hurley, NY.*
Addresses: Lynbrook, NY; West Hurley, NY. **Studied:** Univ. Buffalo; Parsons Sch. Des.; T. Col., Columbia Univ. (B.S.); & with Charles J. Martin; B. Carter. **Member:** Woodstock AA; AEA; NAWA; Nassau County ATA. **Exhibited:** PAFA; Phila. A. All.; N.Y. WC Cl.; Argent Gal.; NAWA; AWS; Gloucester A. Festival, 1956. **Comments:** Position: supv., art, Pub. Sch., Lynbrook, NY, 1930-46. Lectures: Art and the Child. **Sources:** WW59; WW47.

SAXON, Charles David *[Cartoonist, illustrator] b.1920, NYC / d.1988.*
Addresses: New Canaan, CT. **Studied:** Columbia Univ. (B.A.); Hamilton Col. (L.H.D.). **Exhibited:** Awards: Gold medal, Art Dirs. Club New York, 1962; spec. award for TV cartoon, Venice Film Festival, 1965. **Work:** Brooklyn Mus., NY; LOC; Columbia Univ. **Comments:** Preferred media: pencil, ink. Publications: auth. & illusr., "Oh, happy, happy, happy," 1959-60; contribr., *New Yorker* anthologies; contribr., "Great Cartoons of the World," 1969-71. **Sources:** WW73; Jack Dillon, article, In: *Graphics* (1971).

SAXON, Lulu King (Mrs. Walter L.) *[Landscape painter, sketch artist, writer, poet, musician] b.1855, LA / d.1927, New Orleans, LA.*
Addresses: New Orleans, active 1884-1922. **Studied:** Andres Molinary, c.1884; Bror Anders Wikstrom; F. Arthur Callender; New Orleans AA, 1887, 1890, 1893. **Member:** New Orleans AA, 1897; NOAA, 1910. **Exhibited:** World's Indust. & Cotton Cent. Expo., 1884-85; New Orleans AA, 1887, 1888 (gold med.); 1889-97, 1899, 1901-02; Tulane Univ., 1892; NOAA, 1910, 1915; Arts & Crafts Club, 1922. **Comments:** Painted in oil and watercolor. **Sources:** WW15; *Encyclopaedia of New Orleans Artists,* 339.

SAXTON, E. Gerald *[Painter] mid 20th c.*
Exhibited: Oakland Art Gal., 1928. **Sources:** Hughes, *Artists of California,* 492.

SAXTON, Gerard *[Portrait and landscape painter] early 20th c.*
Addresses: NYC; New Orleans, active 1908-1909. **Exhibited:** Seebold's Gallery, N.O., 1908. **Comments:** Executed several commissions in New Orleans. **Sources:** *Encyclopaedia of New Orleans Artists,* 339.

SAXTON, John G(ordon) *[Landscape painter] b.1860, Troy, NY.*
Addresses: Seaford, LI, NY. **Studied:** Académie Julian, Paris with Lefebvre and T. Robert-Fleury; also with Merson in Paris. **Member:** Lotos Club. **Exhibited:** Paris Salon, 1895, 1897-98; PAFA Ann., 1899-1905; Paris Expo, 1900 (prize); Pan-Am. Expo, Buffalo, 1901 (prize); Boston AC, 1902-04; St. Louis Expo, 1904 (med.); Corcoran Gal. annual, 1907; AIC; S. Indp. A., 1917; NAD, 1900. **Sources:** WW33; Fink, *American Art at the Nineteenth-Century Paris Salons,* 389; Falk, *Exh. Record Series.*

SAXTON, Joseph *[Daguerreotypist] mid 19th c.*
Comments: On Oct. 16, 1839, this employee of the U.S. Mint in Philadelphia produced what is the earliest known daguerreotype, a view of the Philadelphia Arsenal from a window of the Mint. **Sources:** Welling, 11, 13.

SAY, Lucy Way Sista(i)re (Mrs. Thomas) *[Drawings and engravings of shells] b.1801, New London, CT / d.1886, Lexington, MA.*
Addresses: New Harmony, IN, 1833-41; NYC, Newburgh & West New Brighton, NY,1842 and after. **Member:** Academy of Natural Sciences of Phila., 1841(first female mem.). **Comments:** Married Thomas Say, the noted naturalist, in 1827, for whose *American Conchology* Lucy Say provided some of the illustrations. **Sources:** G&W; Weiss and Zeigler, *Thomas Say, Early American Naturalist,* Chap. XVI; Weiss and Zeigler, "Mrs. Thomas Say"; Peat, *Pioneer Painters of Indiana.*; Gerdts, *Art Across America,* vol. 2: 253-54.

SAYEN, Henry Lyman *[Painter, illustrator, mural painter] b.1875, Phila., PA / d.1918, Phila.* *Lyman Sayen.*
Addresses: Phila., PA. **Studied:** PAFA, 1899-c.1904, with Anshutz and Grafly; Paris, with Matisse, 1907-8. **Member:** Phila. Sketch C. **Exhibited:** PAFA Ann., 1903, 1905-06; Phila. Sketch C., 1914 (solo); Organizer: "Philadelphia's First Exhibition of Advanced Modern Art," with M.L. Schamberg, at McClees Galleries, 1916; S. Indp. A., 1918; NCFA, 1970. **Work:** NMAA (contains the largest coll. of his work); four lunettes, House Wing of the U.S. Capitol (Room H-143), 1904. **Comments:** Early American Modernist. Sayen worked as a scientist and electrical engineer before enrolling at PAFA, designing precision instruments and electrical circuitry, and in 1897 patented a self-regulating X-ray tube. While pursuing his art studies in Paris, he met Leo and Gertrude Stein in 1906 and became a member of Matisse's first art class in 1907-08. He painted Fauvist landscapes and cityscapes prior to and after his return to Philadelphia in 1914. Sayen altered his approach in 1916, borrowing organizational devices from Synthetic Cubism and Synchromism in creating vigorously patterned, collage-like compositions. Just before his death, he experimented with incorporating elements of American Indian art into his work. Designer: in collaboration with Carl Newman, designed four backdrops for the play "Saeculum," which opened at Philadelphia Academy of Music on Feb. 19, 1917. **Sources:** WW17; A. Davidson, *Early American Modernist Painting,* 232-37; Baigell, *Dictionary;* Adelyn D. Breeskin, *Henry Lyman Sayen* (exh. cat., NCFA, 1970); Falk, *Exh. Record Series.*

SAYER, Edmund S(ears) *[Marine painter, illustrator, craftsperson] b.1878, Meadville, PA / d.1962, San Diego, CA.*
Addresses: Wash., DC, active mid 1930s; San Diego, CA. **Member:** Spanish Village A. Assn.; Las Surenos A. Assn., San Diego. **Exhibited:** Soc. Indp. A.; ASL, Wash., DC; Golden Gate Expo., 1939. **Work:** LOC; NYPL; album of 10 historical ships, text, poems and illustrations: U.S. Naval Acad., Annapolis, Md.; Naval War College, Newport, RI; Naval Records, U.S. Navy Dept., Wash., DC and NY.Hist. Lib.; President's Study, White House; rotunda, Navy Dept., Wash., DC; Naval Training Station, San Diego; San Diego Am. Legion Post. **Comments:** He was either a career naval officer or an employee of the Navy Dep. in Wash., DC, NYC, and San Diego, CA, as his known works all relate to naval themes. **Sources:** WW40; Hughes, *Artists in California,* 492; McMahan, *Artists of Washington, DC.*

SAYER, Raphael *[Painter] mid 20th c.*
Exhibited: PAFA Ann., 1932. **Sources:** Falk, *Exh. Record Series.*

SAYER, Raymond S. *[Painter, illustrator, teacher] b.1840, New Hampshire.*
Addresses: Wash., DC, active 1880-1905. **Work:** Hist. Soc. of Wash., DC. **Comments:** Contributor: illustrations, J.W. Moore's *Picturesque Washington,* 1884. Instructor: art, George Wash. Univ./ Corcoran Scientific Sch. **Sources:** McMahan, *Artists of Washington, DC.*

SAYLE, Helen See: COURVOISIER, Helen Sayle

SAYLE, Mabelle *[Painter] early 20th c.*
Addresses: NYC. **Exhibited:** S. Indp. A., 1920. **Sources:** Marlor, *Soc. Indp. Artists.*

SAYLES, M. *[Painter] late 19th c.*
Addresses: NYC. **Exhibited:** NAD, 1897. **Sources:** WW01.

SAYLOR, James Conrad *[Painter, teacher] b.1903, West Collingswood, NJ.*
Addresses: Greenwich, CT. **Studied:** Pratt Inst.; ASL; Columbia Univ. **Member:** Member: SC; Greenwich Soc. A. **Exhibited:** NAD, 1925, 1927, 1928. **Awards:** Greenwich Soc. A., 1952. **Work:** Nat. Democratic Cl. **Comments:** Position: hd. art dept., Riverdale Country Sch., New York, 1931-44; Greenwich Country Day., 1944-52. **Sources:** WW53.

SAYPOL, Ronald D. (Mr. & Mrs.) *[Collectors] b.1929, NYC.*
Addresses: NYC. **Studied:** Dickinson Col. (B.A., 1951); Brooklyn Law Sch. (L.L.B., 1955). **Sources:** WW73.

SAYRE, Audrey Vale (Mrs. Edward A.) *[Painter] b.1889, East Liverpool, OH.*
Addresses: Des Moines, IA. **Studied:** Cumming School Art with Charles Atherton Cumming; Drake School FA. **Exhibited:** Iowa Art Salon (several first awards); Des Moines Women's Club. **Sources:** Ness & Orwig, *Iowa Artists of the First Hundred Years,* 185.

SAYRE, Eleanor Axson *[Curator] b.1916, Philadelphia, PA.*
Addresses: Boston, MA. **Studied:** Bryn Mawr Col. (A.B., 1938); Harvard Univ., 1938-40. **Comments:** Positions: asst. in exhibs., Yale Univ. Gal., 1940-41; gallery asst., Lyman Allyn Mus., New London, Conn., 1942; asst. dept. educ., RI Sch. Design Mus., 1942-45; from asst. cur. to cur. prints & drawings, BMFA, 1945-. Teaching: intermittent seminars in prints through Harvard Univ. & Radcliffe Col. for students of five colleges. Collections arranged: Rembrandt: Experimental Etcher, in collaboration with Morgan Library; Albrecht Dürer: Master Printmaker. Publications: auth., "A Christmas Book," 1966; co-auth., "Rembrandt: Experimental Etcher," 1969; auth., "Late Caprichos of Goya," 1971; co-auth., "Dürer: Master Printmaker," 1972. **Sources:** WW73.

SAYRE, Elizabeth Graves Evans (Mrs.) *[Painter, illustrator, craftsperson, teacher] b.1895, Fort Brady, MI. / d.1985, Wash., DC.*
Addresses: Wash., DC, 1915. **Studied:** Agnes Scott College, GA; R.S. Bredin; H.B. Snell; H. Giles. **Exhibited:** Wash. WCC; Gr. Wash. Indep. Exhib., 1935; Soc. Wash. Artists, 1937-39; NAWPS, 1936, 1937. **Comments:** Teaching: art instructor, Mt. Vernon Seminary, Wash., DC. **Sources:** WW40; WW27; McMahan, *Artists of Washington, DC* reports her birth in Sault Ste. Marie, MI, in 1896.

SAYRE, Fred Grayson *[Landscape painter, illustrator] b.1879, Medoc, MO / d.1938, Glendale, CA.*
Addresses: Glendale, CA, 1924-on. **Studied:** self-taught; with J. Laurie Wallace in Omaha, 2 months. **Member:** Palette & Chisel Club, Chicago, IL; P&S of Los Angeles (cofounder & pres., 1929). **Exhibited:** Bohemian Club, 1922; Glendale Chamber of Commerce, 1922 (solo); LACMA, 1922; Glendale Pub. Lib., 1962 (retrospective). **Work:** LACMA. **Comments:** Specialty: Arizona desert scenes before 1922. **Sources:** WW24; Hughes, *Artists in California,* 492.

SAZEGAR, Morteza *[Painter] b.1933, Teheran, Iran.*
Addresses: Cochranville, PA. **Studied:** Univ. Tex., El Paso (B.A., 1955, B.S., 1956); Baylor Univ. Col. Med., 1956-57; Cornell Univ., 1958-59. **Exhibited:** four solo shows, Poindexter Gal., New York, 1964-71, 1970s; AIC, 1965; Detroit Inst. Arts, Mich., 1965; WMAA Ann., 1969-70; Univ. Tex. Art Mus., Austin, 1972. **Work:** WMAA; SFMA; Riverside Mus., New York; Univ. Mass., Amherst; Int. Minerals & Chem. Corp., Chicago, Ill. **Comments:** Preferred media: acrylics. **Sources:** WW73.

SAZEWICH, Zygmund *[Sculptor] b.1899, Kovno, Russia / d.1968, San Francisco, CA.*

Addresses: San Francisco, CA. **Studied:** Univ. of Kazan; UC Berkeley; Calif. School of FA. **Member:** San Francisco AA. **Exhibited:** SFMA, 1941 (solo), 1953, 1955; Mills College, 1950 (solo), 1954 (solo); San Francisco AA annuals; GGE, 1939; Museu de Arte Moderna, Sao Paulo, Brazil, 1955; Oakland Mus., 1982. **Work:** USPOS: Kent, San Mateo, Roseville, CA; SFMA. **Comments:** Position: t., Calif. Sch. of FA, 1947-65; t., Mills College, Oakland, 1947-58. **Sources:** Hughes, *Artists in California,* 493.

SCACKI, Francisco *[Engraver] early 19th c.*
Comments: Engraver of one plate depicting the Battle of New Orleans, published in 1815. He is not known to have made any other engravings. **Sources:** G&W; Drepperd, "Three Battles of New Orleans."

SCAIFE, Emma J. (Miss) *[Painter] mid 19th c.*
Addresses: NYC, 1872-76. **Exhibited:** NAD, 1872-76. **Work:** Kennedy Gals., NYC ("Passaic River," dated 1868). **Sources:** Petteys, *Dictionary of Women Artists.*

SCALABRINI, Gaspari *[Painter] early 20th c.*
Addresses: Paris, France. **Exhibited:** S. Indp. A., 1926. **Sources:** Marlor, *Soc. Indp. Artists.*

SCALELLA, Jules A. *[Painter, designer, teacher] b.1895, Philadelphia, PA.*
Addresses: Elkins Park, Ardmore, PA. **Studied:** PM Sch. IA; Spring Garden Inst.; Phila. Graphic Sketch Club; A.J. Adolphe. **Member:** Phila. Sketch Club; Art Dir. Club, Phila.; DaVinci All.; Phila. Art All; Delaware Co. AA. **Exhibited:** PAFA Ann., 1926-27, 1930-32, 1939; PAFA, 1940, 1950; CAM, 1926, 1927; AIC, 1926; NAD, 1928; Phila. AC, 1927, 1928; S. Indp. A., 1930; Montclair Art Mus., 1931; Woodmere Art Gal., 1941-55; Delaware County AA, 1929-32; Graphic Sketch Club, Phila., 1929, 1931, 1932, 1944, 1945; DaVinci All., 1943 (medal); Snellenburg Exh., 1955 (medal). **Work:** Allentown (PA) Mus. **Sources:** WW59; WW47; Falk, *Exh. Record Series.*

SCAMMON, Charles Melville *[Painter] b.1825, Pittston, ME / d.1911, Oakland, CA.*
Addresses: Oakland, CA (1894-on). **Work:** Peabody Mus., Salem, MA (scrapbook); Kendall Whaling Mus., Sharon, MA. **Comments:** A captain of coastal vessels, he went to San Francisco in 1850 and became a captain of whaling ships. In 1865-66 he commanded an expedition to study the natural resources of Alaska and in 1869 began to publish works on whales and whaling. Auth.-illustr. *Marine Mammals of the Northwest Coast of North America and the American Whale Fishery* (1874). **Sources:** Brewington, 342.

SCAMMON, Lawrence N(orris) *[Etcher] b.1872, San Francisco, CA / d.1947, Oakland, CA.*
Addresses: Fruitvale, CA. **Studied:** Univ. Calif., Berkeley. **Member:** Calif. SE; San Fran. AA. **Exhibited:** Crocker Art Mus.; San Fran. AA, 1921; Calif. Artists Show at San Fran. Commercial Club, 1924; Calif. SE, Stanford Univ., 1928. **Work:** Soc. Calif. Pioneers; Crocker Mus., Sacramento. **Comments:** Position: teacher, Univ. Calif., Berkeley, c.1900; des., Roberts Manufacturing Company, San Fran.; teacher, art classes in his own studio. **Sources:** WW27; Hughes, *Artists of California,* 493.

SCANDBERGER, August *[Engraver] mid 19th c.; b.Württemberg, Germany.*
Addresses: Philadelphia, 1860. **Sources:** G&W; 8 Census (1860), Pa., LIV, 278.

SCANES, Ernest William *[Painter, designer, lithographer, illustrator] b.1909, Lorain, OH.*
Addresses: Grosse Pointe Farms, MI. **Studied:** Cranbrook Acad. Art; John P. Wicker. **Member:** Michigan WCS; Scarab Club, Detroit; Mich. Acad. Science, Arts & Letters; Detroit Mus. Art Founders Soc. **Exhibited:** Detroit Inst. Art, 1936 (prize), 1937 (prize), 1938-40, 1941 (prize), 1943-45, 1957 (prize); Milwaukee AI, 1944 (prize); 1945; WFNY, 1939 (prize); Great Lakes Exh., 1938; AIC, 1938, 1941; Albright Art Gal.; Butler AI, 1942;

Michigan Artists, 1949 (prize); Scarab Club (medal & prizes),1950, 1951, 1955, 1958. **Work:** Detroit Inst. Art; Milwaukee AI. **Comments:** Position: art dir., Dept. Public Relations, 1945-, art dir., *Engineering Journal,* 1953-, General Motors Corp., Detroit. **Sources:** WW59; WW47.

SCANGA, Italo *[Sculptor, educator] b.1932, Lago, Italy.* **Addresses:** Glenside, PA. **Studied:** Mich. State Univ. (B.A. & M.A.). **Exhibited:** PAFA Ann., 1962; WMAA,1970, 1983; MoMA, 1971; Mus. Contemp. Art, Chicago, 1971; CGA, 1971; Henri Gal., Wash., DC, 1970s. **Awards:** Best in show, 48th Ann. Wisc. P&S Show, 1962; Howard Found. grant, Brown Univ., 1970; Cassandra Found. grant, 1972. **Work:** MMA; Milwaukee (WI) AC; Univ. Wisc.-Madison; Mus. Art, RISD, Providence; PAFA. **Comments:** Teaching: RISD, 1964-68; Tyler Sch. Art, Phila., 1967-. **Sources:** WW73; article, *Arts Yearbook Contempt Sculpture* (1965); Meilach & Seiden, *Direct Metal Sculpture* (Crown, 1966); Willoughby Sharp, "Pythagoras & Christ," *Avalanche Magazine* (1971); Falk, *Exh. Record Series.*

SCANLAN, De Wolf *[Painter] late 19th c.* **Addresses:** NYC; Pittsburgh. **Exhibited:** AIC, 1888; PAFA Ann., 1888. **Sources:** Falk, *Exh. Record Series.*

SCANLON, Zaidee M. *[Painter] mid 20th c.* **Addresses:** Chicago area. **Exhibited:** AIC, 1927, 1935. **Sources:** Falk, *AIC.*

SCANTENA, Vincent See: **SCATENA, Vincent**

SCAPICCHI, Erminio *[Painter] mid 20th c.* **Addresses:** Chicago, IL. **Exhibited:** Artists Chicago Vicinity Ann. (1936), Int. WC Ann. (1938), P&S Ann. (1938), all at AIC. **Sources:** WW40.

SCARAVAGLIONE, Concetta Maria *[Sculptor, teacher] b.1900, NYC / d.1975, Bronx, NY.* **Addresses:** NYC. **Studied:** NAD with Frederick Roth, 1917-18; ASL with Boardman Robinson & John Sloan; Master Inst. with Robert Laurent. Awarded Prix de Rome to study at the Am. Acad. Rome, 1947-50. **Member:** NSS; Sculptors Gld.; An Am. group. Awards: Am. Arts & Letters grant, 1946. **Exhibited:** Salons of Am.; NAD; WMAA, 1926-58; PAFA Ann., 1934-66 (gold, 1934); Sculptors Gld, 1938 ("Girl with Gazelle," a critical and popular success); WFNY, 1939 ("Woman with Mountain Sheep" for the garden court of the Fed. Bldg.); VMFA, 1941 (first solo show); MoMA, 1959; BM; AIC; Kraushaar Gals., NYC, 1950-70s. **Work:** WMAA; MoMA; NMAA; Roerich Mus.; PAFA; Glasgow Mus. Commissions: "Railway Mail Carrier," Main Post Office, Wash., DC (1936) and "Agriculture," limestone bas-reliefs on the Fed. Trade Comn. bldg., Wash., DC (1937); wood relief,"Aborigines," Post Office, Drexel Hill, Pa, 1939; "Girl With Gazelle" (original shown at Sculptors Gld. 1938 exh.), several high schools, New York. **Comments:** From 1935-39 she received a number of important government commissions for the Treasury Dept. Section of Painting and Sculpture. Began working in welded metal with Theodore Roszack in 1946. As her career developed, her sculpture became more abstract. Scaravaglione also had a long teaching career: Educational Alliance, 1925-; NY Univ.; Sarah Lawrence College; Black Mountain College; Vassar College, 1952-67. Preferred media: wood, stone, bronze, copper, terra-cotta. **Sources:** WW73; WW47; Rubinstein, *American Women Artists,* 255-57 (w/repros.); Falk, *Exh. Record Series.*

SCARBOROUGH, Alonzo *[Illustrator] b.1878 / d.1943, NYC.*

SCARBOROUGH, John See: **SCARBOROUGH, William Harrison**

SCARBOROUGH, William Harrison *[Portrait & miniature painter] b.1812, Dover, TN / d.1871, Columbia, SC.* **Addresses:** Columbia, SC, 1843-71. **Studied:** Europe, 1857-58. **Work:** Columbia (SC) Mus. Art. **Comments:** Scarborough studied art and medicine in Cincinnati and worked for several years as a portraitist in Tennessee before moving to to South Carolina in 1830. After marrying into a prominent family in 1836, he settled in Darlington, SC, for a few years and then relocated permanently to Columbia, SC in 1843. There the artist gained considerable success as a painter of portraits and miniatures, painting the state's political leaders and the faculty of South Carolina College. He also worked in North Carolina and Georgia, and made frequent visits to NYC. Scarborough traveled to Europe (1857-58) and on his return tried to establish an art gallery in Columbia, but the destruction of the city during the Civil War brought an end to this endeavor. **Sources:** G&W; Hennig, *William Harrison Scarborough,* contains an account of the artist's life and a checklist of his work; F.F. Sherman in *Antiques* (Dec. 1933), pages 27-29, identified this artist as John Scarborough; but Sherman corrected this error in *Antiques* (Oct. 1934), page 149. More recently, see Gerdts, *Art Across America,* vol. 2: 61, 64, 138.

SCARBROUGH, Cleve Knox, Jr. *[Art administrator, art historian] b.1939, Florence, AL.* **Addresses:** Charlotte, NC. **Studied:** Florence State Univ. (B.S., 1962); Univ. Iowa (M.A., 1967). **Member:** College AA Am.; Am. Assn. Mus.; NC Mus. Council (bd. mem., 1970-72). **Comments:** Positions: dir., Mint Mus. Art, 1969-. Publications: ed. *North Carolinians Collect,* 1971 & *Graphics by Four Modern Swiss Sculptors,* 1972. Teaching: Univ. Iowa, 1964-67; Univ. Tenn., Knoxville, 1967-69. Collections arranged: "Graphics by Four Modern Swiss Sculptors," Mint Mus. Art, circulated by Smithsonian Traveling Service, 1972-. **Sources:** WW73.

SCARDIGLI, Remo *[Sculptor] mid 20th c.* **Addresses:** Carmel, CA. **Member:** Carmel AA. **Exhibited:** Stendahl Gal., Los Angeles, 1937. **Work:** New Monterey Lib.; Devendorf Plaza, Carmel; Harrison Mem. Lib., Carmel. **Sources:** Hughes, *Artists of California,* 493.

SCARDIGNO, Mary *[Painter] b.1910, San Francisco, CA / d.1973, Fribourg, Switzerland.* **Addresses:** San Francisco, CA; Sonora, CA; Fribourg, Switzerland, ca. 1965-1973. **Studied:** Calif. Sch. FA with Otis Oldfield. **Member:** Mother Lode AA. **Exhibited:** Mother Lode AA, 1950s (first prize). **Sources:** Hughes, *Artists of California,* 493.

SCARF, Constance Kramer *[Printmaker, painter] mid 20th c.; b.NYC.* **Addresses:** Brooklyn, NY. **Studied:** Brooklyn Mus. Art Sch. (grad.); Adja Jounkers; Abraham Rattner. **Member:** SAGA; Nat. Soc. Painters Casein & Acrylic (rec. secy., 1967-); Audubon Artists; NAWA (watercolor & print juries, 1960-); Wash. PM. **Exhibited:** LOC, 1954, 1955 & 1963; Long Island Artists Biennials, 1955 & Nat. Print Biennial, 1966, BM; Silvermine Guild, 1965; SAGA, 1965-71; Potsdam Nat. Print Show, 1966; Discovery Art Gals., Clifton, NJ & Etchings Int., NYC, 1970s. Awards: medals of honor, Audubon Artist, 1955 & NAWA, 1968; first prize for printmaking, Original Graphics & Brit. Printmakers, 1962. **Work:** BM; PMA; Norfolk (VA) Mus.; Furman Univ., Greenville, SC; Israel Mus., Jerusalem. Commissions: ed. prints, Contemp. AA, NY, 1956 & 1960 & Am. Assn. Contemp. Arts, 1968. **Comments:** Positions: chmn. traveling shows, Am. Soc. Contemp. Arts, 1955-57, mem. bd., 1962-; juror, All NJ State Show, 1971. **Sources:** WW73.

SCARLETT, Edith T. *[Painter] mid 20th c.* **Addresses:** Bryn Mawr, PA. **Exhibited:** PAFA Ann., 1944-45, 1949. **Sources:** Falk, *Exh. Record Series.*

SCARLETT, Rolph *[Painter, designer, printmaker] b.1889, Guelph, Ontario, Canada / d.1984, Woodstock, NY.* **Addresses:** NYC; Toledo, OH; California; Great Neck; Woodstock, 1953-on. **Studied:** Loretto Acad., Guelph, Ontario, 1907; Guggenheim Mus. (scholarship, 1938). **Member:** Woodstock AA. **Exhibited:** TMA, 1926 (1st prize); GGE, 1939; Guggenheim Mus.; Guelph, Ontario; Modern Age Gal., NYC, 1940, 1945; Gal. Réalités Nouvelles, Paris, 1940, 1946-49; Gal. Charpentier, Paris, 1940, 1947; Soc. Contemp. Art at AIC, 1948; MMA, 1950; Illinois State College, 1951; WMAA; 1951-52; Seligmann Gal., NYC, 1973 (solo); Jarvis Gal., Woodstock, NY, 1973 (solo); Univ. Guelph, Ontario, 1977; Zabriskie Gal., NYC, 1981; Carnegie Inst., 1983; Washburn Gal., NYC, 1982-83, 1988;

Assoc. Am. Artists, NYC, 1987 (solo); Struve Gal, Chicago, 1990 (solo). **Work:** Guggenheim Mus.; Woodstock AA; WMAA; MoMA; Brooklyn Mus.; Univ. Guelph, Ontario (50 paintings acquired , 1977). **Comments:** An important painter of geometric abstractions in the 1930s and 1940s, he came to NYC at the age of 18 but returned to Canada during the war years. He learned the jewelry trade at his father's urging. In 1918 he moved permanently to the U.S. , and returned to NYC in 1924, beginning his career as an abstract painter. In 1929, he went to Pasadena, CA and created stage designs for George Bernard Shaw's "Man and Superman." In 1936 he settled in NYC, creating modern furniture designs for Design Associate, and planning several,pavilions for the WFNY, 1939. In 1940 he designed stage sets for the Rockettes at Radio City Music Hall. Solomon Guggenheim and Hilla Rebay, who in 1939 were in the process of founding the Museum of Non-Objective Painting (later the Solomon R. Guggenheim Museum), took an interest in Scarlett's work and by 1940 he became the new museum's chief lecturer. After Guggenheim died in 1949, the museum changed direction toward a more balanced range of 20th century art, and the visibility of Scarlett's work lapsed. By 1953, when Scarlett had become nearly forgotten, the Guggenheim owned sixty of his paintings and monoprints. He continued to paint and make jewelry until his death, and showed his work in Woodstock exhibits. **Sources:** WW40; exh. cat., Struve Gal. (Chicago, 1990); *Woodstock's Art Heritage*, 128-129; *American Abstract Art*, 197; add'l info. courtesy of Jim Young, Woodstock; Woodstock AA.

SCARLETT, Samuel *[Landscape painter, picture restorer]* b.1775, Staffordshire.
Addresses: Philadelphia, 1860 and before. **Studied:** London, c.1795. **Exhibited:** PAFA; Boston Athenaeum. **Comments:** Scarlett practiced at Bath. He emigrated to America about1817. From 1829-46 he was curator or custodian of the PAFA. **Sources:** G&W; 8 Census (1860), Pa., L, 139; Dunlap, *History;* Phila. CD 1820-60; Rutledge, PA; Swan, BA.

SCARPITTA, G. Salvatore Cartiano *[Sculptor]* b.1887, Palermo, Italy / d.1948, Los Angeles, CA.
Addresses: NYC; Los Angeles, 1923-48. **Studied:** Inst. di Belli Arti, Palermo; Rome. **Member:** NSS; Sculptors Gld., Southern Calif.; NY Arch. Lg.; FA Soc., San Diego (hon.); Milwaukee Al (hon.); P&S Los Angeles. **Exhibited:** PAFA Ann., 1913-19; NAD, 1914 (prize); NY Arch. Lg., 1923 (prize); AIC, 1923 (prize); FA Gal., San Diego, 1926 (prize), 1933 (prize); Southern Calif. Chapt. AIA, 1931 (prize); Corcoran Gal. biennial, 1963. Other awards: decorated by Japanese and Cuban governments. **Work:** Church of St. John the Evangelist, Los Angeles; Church of the Sacred Blood, Los Angeles; Los Angeles Stock Exchange Bldg.; State Mutual Bldg. & Loan Assn., Los Angeles; County Gen. Hospital, Los Angeles; FA Gal., San Diego; Pal. Leg. Honor, San Fran.; Milwaukee AI; life size statue of Marlene Dietrich for Paramount picture, "Song of Songs"; portrait of Mussolini for New Forum, Rome. **Comments:** Settled in NYC in 1910 and permanently moved to Los Angeles in 1923. **Sources:** WW40; Hughes, *Artists of California*, 493; Falk, *Exh. Record Series.*

SCARPITTA, Nadja *[Sculptor, lecturer, writer, teacher, painter]* b.1900, Kovel, Poland.
Addresses: Hollywood 28, CA. **Studied:** ASL; Munich, Germany; Rome, Italy. **Comments:** Lectures for television and clubs. **Sources:** WW66.

SCARPITTA, Salvatore *[Sculptor]* b.1919, NYC.
Addresses: NYC. **Studied:** Italy, 1936-39. **Exhibited:** CGA, 1963; First Salon Int. Gals. Pilotes, Mus. Cantonal Beaux-Arts, Lausanne, Switz., 1963; Royaux Mus., Brussels, Belgium, 1964 (solo); Md. Inst., 1964; AIC, 1964; Univ. Illinois, 1965; Leo Castelli Gal., NYC, 1970s. **Work:** Stedelijk Mus., Amsterdam, Holland; Albright-Knox Art Gal., Buffalo, NY; Los Angeles Co Mus. Art; MoMA; Tel-Aviv Mus., Israel. **Comments:** Teaching: visiting critic, Md. Inst. College Art, 1966-. **Sources:** WW73; Harriet Janis & Rudi Blesh, *Collage, Personalities—Concepts—Techniques* (Chilton, 1962); Allen S. Weller, *The Joys and*

Sorrows of Recent American Art (Univ. Illinois, 1968); B.H. Friedman, "The Ivory Tower," *Art News* (April, 1969).

SCARR, Laura (Mrs.) *[Painter]* b.1871 / d.1936.
Addresses: Hasbrouck Heights, NJ. **Exhibited:** Montclair AM.

SCARROZZO, Joseph *[Painter]* b.1916, New Britain, CT.
Studied: Art Lg. of New Britain with Sanford Low, 1932; Vesper George Sch. Art, 1935-37. **Exhibited:** Conn. WCS, 1939, 1941 (prize); Wadsworth Atheneum, 1942 (prize); New Britain Mus. Am. Art, 1940 (solo); John Slade Ely House, New Haven, CT, 1989 (retrospective). **Comments:** In 1937, he went to NYC, painting murals for restaurant interiors. From 1939-41, he worked for the WPA, painting "The Life of Nathan Hale" murals for the Nathan Hale H.S. in New Britain. Although his vocation was as an engineer for Pratt-Whitney Aircraft (1940s-1977) he continued to paint New England landscapes. **Sources:** R. Smith, exh. cat. John Slade Ely House (New Haven, CT, 1989).

SCARTH, Lorraine Alice (Mrs. Virgil) *[Painter, designer]* b.1909, Dubuque, IA.
Addresses: Enid, OK. **Studied:** Univ. Iowa; AIC. **Member:** Wichita AA; Prairie PM. **Work:** mural, Mus., Univ. Iowa, Iowa City. **Sources:** WW40.

SCATENA, Hugo Francis *[Painter]* b.1893, California / d.1984, Placerville, CA.
Addresses: San Francisco, CA, active 1920-35. **Exhibited:** SFMA, 1935. **Sources:** Hughes, *Artists of California*, 493.

SCATENA, Vincent *[Painter]* mid 20th c.
Exhibited: S. Indp. A., 1938. **Sources:** Marlor, *Soc. Indp. Artists.*

SCATTERGOOD, David *[Wood engraver, bookseller]* mid 19th c.
Addresses: Philadelphia, 1848-60. **Comments:** During the 1850s he did engraving in association with Robert Telfer, Charles F. Noble, and Nicholas Sollin (see entries) **Sources:** G&W; Phila. BD 1848-60, CD 1849-59; Hamilton, *Early American Book Illustrators and Wood Engravers*, 230, 238, 387.

SCATTERGOOD, Mary P. *[Painter]* b.1864.
Addresses: Phila., PA. **Exhibited:** PAFA Ann., 1888. **Sources:** Falk, *Exh. Record Series.*

SCATTERGOOD-SOLLIN *[Wood engravers]* mid 19th c.
Addresses: Philadelphia, 1855. **Comments:** David Scattergood and Nicholas Sollin (see entries) **Sources:** G&W; Hamilton, *Early American Book Illustrators and Wood Engravers*, 238, 387; Phila. CD 1855.

SCATTERGOOD & NOBLE *[Wood engravers]* late 19th c.
Addresses: Philadelphia, 1859. **Comments:** Partners were David Scattergood and Charles F. Noble (see entries) **Sources:** G&W; Phila. CD 1859.

SCATTERGOOD & TELFER *[Wood engravers]* mid 19th c.
Addresses: Philadelphia, 1852-54. **Comments:** David Scattergood and Robert Telfer (see entries) **Sources:** G&W; Hamilton, *Early American Book Illustrators and Wood Engravers*, 230; Penna. BD 1854; Phila. CD 1852-54.

SCHAAF, Anton *[Sculptor, medalist]* b.1869, Milwaukee, WI / d.1943.
Addresses: Brooklyn, NY. **Studied:** W. Shirlaw; K. Cox; C. Beckwith; A. Saint-Gàudens; E.W. Dewing; CUA School; E. Ward, NAD. **Member:** NSS; Arch. Lg. **Work:** war memorials and statues at: Vicksburg Nat. Military Park; Glendale Mon., Ridgewood Mon., Brooklyn, NY; Shaw Mem., Woodlawn Cemetery, NY; Tompkins Ave. Church, Central Cong. Church all in Brooklyn; Erricson Mon., NYC; J. Temple Gwathmey, NY Cotton Exchange; Prudential Life Insurance Co., Newark, NJ; West Haven, CT; mem. ports., Todd Shipyards, NY; Central Cong. Church, Brooklyn; Cornell Univ. **Comments:** Do not confuse with an Austrian medalist [1845-1903] of the same name. **Sources:** WW40; add'l info courtesy D.W. Johnson, *Dictionary of American Medalists* (pub. due 2000).

SCHAAPHAUS, P. *[Painter] early 20th c.*
Addresses: NYC. **Studied:** ASL. **Exhibited:** S. Indp. A., 1929.
Sources: Marlor, *Soc. Indp. Artists.*

SCHAARE, Harry J. *[Illustrator, marine watercolorist]*
b.1922, Jamaica, LI, NY.
Addresses: Westbury, LI, NY. **Studied:** NYU School Arch., 1940;
Pratt Inst. with M. Herman, Ajoutian, Costello (graduated in
1947). **Member:** SI, 1960. **Work:** Air Force art coll.; War Mem.,
Indianapolis.; SI coll. **Comments:** Worked briefly as a commer-
cial artist and then established his own studio. Illustrated paper-
back covers including Westerns. Contrib. illustr. to *Saturday
Evening Post.* Painter of marine watercolors since 1971. **Sources:**
P&H Samuels, 421-22.

SCHAB, William H. *[Art dealer] mid 20th c.*
Addresses: NYC. **Sources:** WW66.

SCHABACKER, Betty B. *[Painter, lecturer] b.1925,*
Baltimore, MD.
Addresses: Erie, PA. **Studied:** Connecticut College Women;
Marian Carey AA, Newport, RI; Coronado (CA) Sch. Art with
Monty Lewis; Gerd & Irene Koch, Ojai, CA. **Member:** Calif.
Nat. WCS; Albright-Knox Mus. Rental Gal.; Los Angeles AA.
Exhibited: Mus. Art Mod., Paris, France, 1961-63; Butler Inst.
Am. Art Ann., 1964-69 (4 shows); Chautauqua Exh. Am. Art,
1966 & 1967 & Lake Erie College, 1971 (solo); Galerie 8, Erie,
PA & Gal. des Beaux Arts, Scranton, PA, 1970s. Awards:
Grumbacher Award, Providence Art Club, RI, 1959; Nancy
Hubbard Lance Award, Lake Erie College, 1971. **Work:** B.K.
Smith Gal., Lake Erie College, Painesville, OH; First Nat. Bank
Penn., Erie; Western Union, NYC; Erie AC. **Comments:**
Preferred media: watercolors, collage. **Sources:** WW73.

SCHABBEHAR, Ann (Brennan) *[Illustrator, commercial*
artist, teacher] b.1916, Dobbs Ferry, NY.
Addresses: Seneca Falls, NY. **Studied:** PIA School; Am. School
Design. **Comments:** Positions: instr., fashion illus., ASL; fashion
illus. for Saks Fifth Ave.; Bonwit Teller, NY; nat.l cosmetic ads;
Victrola Record album covers, etc. Contrib. illustr. to *Vogue,
House & Gardens, American Home, Good Housekeeping,
Seventeen, Madamoiselle,* and other leading magazines. **Sources:**
WW59.

SCHABELITZ, Charles F. *[Painter] late 19th c.*
Addresses: Stapleton, SI, NY. **Exhibited:** NAD, 1883. **Sources:**
Naylor, *NAD.*

SCHABELITZ, R(udolph) F(rederick) *[Illustrator] b.1884,*
Stapleton, SI, NY. / d.1959, NYC.
Addresses: NYC. **Studied:** C. Marr, Munich; ASL. **Member:** SI;
SC; Artists Guild. **Exhibited:** S. Indp. A., 1922. **Comments:**
Marlor gives year of birth as 1887. **Sources:** WW33; Marlor,
Soc. Indp. Artists.

SCHACHT, Louise *[Painter] mid 20th c.*
Addresses: NYC. **Exhibited:** Allied Artists Am., 1934; NAWPS,
1935-38. **Sources:** WW40.

SCHACHTER, Justine Ranson *[Painter, designer] b.1927,*
Brooklyn, NY.
Addresses: Levittown, NY. **Studied:** Tyler Sch. FA, Temple Univ.
(scholarship); Brooklyn Mus. Art Sch. with John Bindrum, Milton
Hebald & John Ferren; ASL with Will Barnet. **Member:** Am. Soc.
Contemp. Artists (chmn. admissions, 1968-71); NAWA; Artists
Equity Assn.; Int. Assn. Arts; Art Forms Creative Center (exec.
dir., 1971-). **Exhibited:** Ruth White Gal., 1961 (solo); NAWA
Traveling Graphics Show, U.S. & Europe, 1969-70; Am. Soc.
Contemp. Artists, New York, 1969-71. Awards: award for graph-
ics, Brooklyn Soc. Artists Ann., 1949; awards for mixed media,
Nassau Co. Office Cultural Development, 1970 & Am. Soc.
Contemp. Artists, 1971. **Work:** Bellmore Pub. Lib., NY; Island
Trees Pub. Lib., Levittown, NY; Wantagh H.S., NY.
Commissions: NY State Poster, NY State Parent-Teacher Assn.,
all NY public schools, 1970-71. **Comments:** Preferred media:
stone, graphics. Positions: dir. graphic arts, Audio-Visual Educ.

TV, Mineola Public Schools, 1964-65. Publications: illustr., *Long
Island Free Press,* 1970-71. Teaching: artist-in-residence,
Community Arts Program, Wantagh H.S., 1972. **Sources:**
WW73; Elyse Frommer, *Rock and Stone Craft* (Crown, 1972).

SCHADE, Harold *[Painter] mid 20th c.*
Addresses: Chicago area. **Exhibited:** AIC, 1940. **Sources:** Falk, *AIC.*

SCHADE, Robert *[Painter] early 20th c.*
Addresses: Milwaukee, WI. **Exhibited:** AIC, 1902. **Sources:**
Falk, *AIC.*

SCHAEFER, Anthony *[Engraver, die sinker] mid 19th c.*
Addresses: NYC, 1857-59. **Sources:** G&W; NYBD 1857-59.

SCHAEFER, Benton D. *[Sculptor] early 20th c.*
Addresses: Chicago area. **Exhibited:** AIC, 1930. **Sources:** Falk, *AIC.*

SCHAEFER, Bertha *[Art dealer] 20th c.*
Addresses: NYC. **Studied:** Mississippi State College for Women;
Parsons Sch.Design, New York & Paris. **Member:** AID; Arch. Lg.
NY; Dec. Club NY (pres., 1947-48, 1955-57); AFA; Art Dealer's
AA. **Exhibited:** Awards: Goods Design Award, MoMA, 1952;
Gold Medal, Dec. Club, 1959. **Comments:** Positions: dir., Bertha
Schaefer Gal. Contemp. Art, NYC, 1994-. Specialty of the gallery:
contemporary American and European painting and sculpture.
Sources: WW66.

SCHAEFER, Elizabeth F. *[Painter] early 20th c.*
Exhibited: S. Indp. A., 1927, 1930; Salons of Am., 1928.
Sources: Falk, *Exhibition Record Series.*

SCHAEFER, Hans *[Sculptor] b.1875, Sternberg,*
Czechoslovakia.
Addresses: NYC. **Studied:** Kunstgewerbeschule, Vienna, Austria.
Exhibited: AIC, 1924. **Sources:** WW33.

SCHAEFER, Henri-Bella (Mrs. De Vitis) *[Painter] mid*
20th c.; b.NYC.
Addresses: NYC. **Studied:** Columbia Univ. Extension; Art
Alliance Française, Acad. Lhote & Acad. Grande Chaumière,
Paris, France; Andre Lhote, Paris; William A. MacKay, 1935-38;
Fashion Inst. Technology, certificate, 1961. **Member:** NAWA (oil
jury, 1963-65); Artists Equity Assn. (exec. board, NY Chapt.,
1954-; dir., NY Chapt., 1956-57; nat. secy. & nat. exec. comt., nat.
dir., 1960-; chmn. grants & fellowships fine arts, 1963-); Nat.
Hist. Shrines Found. **Exhibited:** NAWA, 1948, 1950-51, 1960-69;
NAC, 1946-51; Art Gal., NY, 1941-42, 1948-50, 1953-58; Bar
Harbor, 1950, 1951; AEA, 1951; WMAA, 1951; Florida Southern
College, 1952; North Side Center for Child Development, NY,
1954-57; Butler IA, 1958; AFA, 1955, 1956; Salon d'Automne,
1938; Salon des Tulleries, Paris, 1939; Chateau de Napoule,
Cannes, 1965; Cognac Mus., 1965 & 1966; Int. Women's Salon,
Cannes, 1966; Spring Arts Festival Educ. & Cultural Trust Fund
of Elec. Indust., 1970 & 1971. Awards: Marcia Brady Tucker
Prize & Medal of Honor, NAWA, 1962. **Work:** Florida Southern
College; Butler IA; Norfolk (VA) Mus. Arts & Sciences; Virginia
Mus. Fine Art Arts, Richmond; Le Moyne College. **Sources:** WW73.

SCHAEFER, Howard *[Painter] mid 20th c.*
Addresses: Boston, MA. **Sources:** WW66.

SCHAEFER, Josephine Marie *[Painter, teacher] b.1910,*
Milwaukee, WI.
Addresses: Milwaukee, WI. **Studied:** Layton Sch. Art; AIC;
Europe; South America; Louis Ritman. **Member:** Chicago AC;
Wisc. P&S. **Exhibited:** AIC, 1935-37, 1939-41, 1943, 1944,
1946, 1949, 1950; Grand Rapids Art Gal., 1940; Wisc. P&S,
1936, 1939-41, 1944-46 (prize, 1945); Minneapolis IA, 1942;
Columbus Art Gal., 1942; Illinois State Mus., 1935-1937, 1940;
Rochester Mem. Art Gal., 1940, 1941; Kansas City AI, 1940;
WMA, 1945; AGAA, 1945; CMA, 1945; Gimbel Wisc. Exh.,
1949; Wisc. P&S, 1947, 1949, 1950, 1952; Springfield (MO) Art
Mus., 1945; Walker AC, 1945; Portland (OR) Art Mus., 1945;
Kalamazoo IA; Layton Art Gal. (solo); Milwaukee AI (solo), 1953
(group). **Comments:** Teaching: Layton Sch. Art, Milwaukee, WI.
Sources: WW66; WW47.

SCHAEFER, Martha W. (Mrs.) *[Painter] early 20th c.*
Addresses: Walnut Hills, Cincinnati, OH, c.1913. **Member:** Cincinnati Women AC. **Sources:** WW15.

SCHAEFER, Mathilde (Mrs. Mathilde Schaefer Davis) *[Sculptor, craftsperson] b.1909, NYC.*
Addresses: Scottsdale, AZ in 1962. **Studied:** Raoul Josset; Walter Emcke. **Exhibited:** AIC, 1938; WFNY, 1939; SFMA, 1938-40; Denver Art Mus., 1938-39; Santa Barbara Mus. Art, 1942 (solo); Mus. Northern Arizona, 1943; Univ. New Mexico, 1940; Dallas Mus. FA, 1947. **Work:** IBM; Mus. Northern Arizona; Katherine Legge Mem., Hinsdale, IL. **Comments:** Teaching: Desert Sch. Art, Scottsdale, AZ, 1950-57. **Sources:** WW59; WW47.

SCHAEFER, Rockwell B. *[Painter, lecturer, teacher, lithographer, writer] b.1907, NYC.*
Addresses: NYC. **Studied:** Columbia Univ.; ASL; BAID; Frank Mechau. **Member:** NAC; Artists & Writers; Am. Poetry Lg.; Town Hall Art Club; Nat. Soc. Painters in Casein; Springfield Art Lg.; Sarasota AA; Academic Artists; Audubon Artists; Am. Veterans Soc. Artists; SC; Westchester Arts & Crafts Gld.; Irvington Art & Mus. Assn.; Meriden Arts & Crafts; Alabama WCS; Wash. WCS; Conn. WCS. **Exhibited:** S. Indp. A., 1938-40, 1943; All. Artists Am., 1938, 1939, 1941, 1943; Audubon Artists, 1943-51; AWCS, 1942-45; Am. Veterans Soc. Artists, 1941-45; Vendome Gal., 1937, 1940 (prize), 1942; BM, 1941, 1945; Norwegian-Am. Relief Exh., 1940; Conn. WCS, 1949, 1951; NJ Painters Gld., 1948, 1951; Butler AI, 1950, 1951; Naval Personnel Exh., Wash., DC; Alabama WCS, 1952; *Life* magazine exh., 1949; exhibited in all membership exh., 1953-57; Hotel New Yorker, 1958; Critics' traveling exh., 1958. Awards: prizes, Penn. State Teachers College, 1950-52; New London Naval Base, 1948; Nat. Soc. Painters in Casein, 1953; AAPL, 1956; Westchester Art Gld., 1957. **Work:** Scranton Mus. Art; PMA; U.S. Navy Dept., Wash., DC. **Sources:** WW59; WW47, puts birth at 1901.

SCHAEFER, William G. *[Painter] early 20th c.*
Addresses: Wash., DC, active 1909-16; NYC, active 1917-26. **Member:** Wash. WCC; SC. **Exhibited:** Wash. WCC; SC; Wash. Arch. Club. **Sources:** WW24; McMahan, *Artists of Washington, DC.*

SCHAEFFER, Bertha M. *[Artist] late 19th c.*
Addresses: Wash., DC, active 1896. **Sources:** McMahan, *Artists of Washington, DC.*

SCHAEFFER, Edward *[Engraver] mid 19th c.*
Addresses: Wash., DC, active 1865. **Sources:** McMahan, *Artists of Washington, DC.*

SCHAEFFER, Hilda V. *[Artist] early 20th c.*
Addresses: Wash., DC, active 1923-28. **Sources:** McMahan, *Artists of Washington, DC.*

SCHAEFFER, John Simon *[Painter] 19th/20th c.*
Addresses: Brooklyn, NY, active from 1859 to 1901. **Exhibited:** NAD, 1859. **Sources:** G&W; Cowdrey, NAD; Brooklyn CD 1859-1901.

SCHAEFFER, Mead *[Illustrator]*
b.1898, Freedom Plains, NY / d.1980.
Addresses: NYC; Arlington, VT.
Studied: PIA Sch.; Dean Cornwell. **Member:** SI. **Exhibited:** Awards: PAFA, 1944 (gold medal); Am. Red Cross, 1944; SC. **Comments:** Contrib. illustr.: *Saturday Evening Post, Ladies Home Journal, Country Gentleman, Holiday, American, Cosmopolitan, Good Housekeeping, McCalls, Redbook, Harpers, Scribners, True,* and other magazines; illustr., 16 classics ("Moby Dick," "Typee," "Omoo," all by Herman Melville; "Les Miserables," by Victor Hugo; "Wings of the Morning," by Louis Tracy; "Sans Famille," by Hector Malot; "King Arthur and His Knights"; "Jim Davis," by John Masefield; "The Wreck of the Grosvenor," by W. Clark Russell). Permanent exh. in libraries and public bldgs. in the U.S. Artist & war correspondent for *Saturday Evening Post,* 1942-44. War paintings exhibited widely in U.S.

Mead Schaeffer—

Sources: WW59; WW47.

SCHAEFFER, Rudolph Frederick *[Designer, educator]*
b.1886, Clare, MI / d.1988, San Francisco, CA.
Addresses: San Fran. **Studied:** Thomas Normal Training Sch., Detroit (grad.); Ernest Batchelder; Ralph Johonnot; Douglas Donaldson; Paris; Munich; Vienna; the Orient; research indust. design & color for U.S. Dept. Educ., Munich, Germany, 1914. **Member:** SFAA; San Fran. Munic. Art Comn.; Am. Inst. Interior Designers; Nat. Soc. Interior Designers; Soc. Asian Art. **Exhibited:** GGE, 1940. **Comments:** Positions: art dir., Greek Theatre, Univ. Calif., Berkeley, 1923-24; founder & dir., Rudolph Schaeffer Scho. Design, San Fran., 1926-. Publications: auth., "Flower Arrangement Folio," 1935. Contrib.: *Homes of the West, Sunset, Better Homes & Gardens.* Teaching: Univ. Calif., Berkeley & Stanford Univ., 1916-24. Collection: Oriental art—Sung Dynasty ceramics and paintings. **Sources:** WW73; *Arts in American Life* (McGraw-Hill, 1933); WW47; Hughes, *Artists of California,* 493.

SCHAEFFER, Samuel B(ernard) *[Painter] early 20th c.*
Addresses: Brooklyn, NY. **Exhibited:** S. Indp. A., 1928, 1930. **Sources:** Marlor, *Soc. Indp. Artists.*

SCHAEFFER, William *[Painter] mid 19th c.*
Addresses: New Orleans, active 1869-70. **Sources:** *Encyclopaedia of New Orleans Artists,* 339.

SCHAEFFER, William C. *[Artist] late 19th c.*
Addresses: Wash., DC, active 1872. **Comments:** Probably the same artist listed as William Schaeffer, who was active in New Orleans from 1869-70. **Sources:** McMahan, *Artists of Washington, DC.*

SCHAEFFLER, Lizbeth (Elizabeth) *[Sculptor, ceramist]*
b.1907, Somerville, MA.
Addresses: New Rochelle, NY; Nantucket, MA. **Studied:** Pratt Inst.; NAD; ASL with Charles Keck, Mahonri Young & Adolph Weinman. **Member:** Clay Club; New Rochelle AA; NY Soc. Cer. Artists; Westchester Arts & Crafts Gld.; Nantucket AA. **Exhibited:** New Rochelle AA, 1946 (prize); NSS, 1936-38; Clay Club, NY; NY Soc. Cer. Artists; Silvermine Guild Artists Exh.; Westchester County Fair (first prize), White Plains; New Rochelle AA; Kenneth Taylor Gals., Nantucket. **Work:** Commissions: portrait relief mem. comn. by Mrs. Fred B. Smith for Church of Highlands, White Plains, NY, 1940; bronze medal, Dahlia Assn. Am., 1960; bronze portrait relief, mem. committee for William Gardner, Nantucket, MA, 1970. **Comments:** Preferred media: terra-cotta. Positions: exec. secy., Kenneth Taylor Gals., 1957-65. **Sources:** WW73; WW47.

SCHAERFF, Charles & J. W. *[Lithographers] mid 19th c.*
Addresses: St. Louis, 1854. **Comments:** They were operating under the name of Schaerff Brothers. **Sources:** G&W; St. Louis BD 1854.

SCHAETTLE, Louis *[Mural painter, decorator] b.Chicago / d.1917.*
Addresses: NYC. **Member:** Arch. Lg., 1911. **Work:** decorations at Georgian Court.; redecorated the yacht of the Prince of Wales, King Edward VII. **Sources:** WW15.

SCHAETZEL, May Conly *[Painter] b.1870, NYC / d.1952, Los Angeles, CA.*
Addresses: Los Angeles, CA; Paris, France, 1919-c.1934; NYC; Wash., DC; Los Angeles, CA. **Studied:** Académie Julian, Paris, 1919-28. **Exhibited:** Salon de la Soc. des Artistes Françaises, Paris; Salon des Indépendants; Salon d'Automne; Femmes Peintres et Sculpteurs; Bernheim-Jeune Gal.; Am. Women's Club; Am. Lib. Paris; Ilsley Gal.; Ebell Club; Palm Springs; Laguna Beach; Pasadena; Webb C. Ball Gals., Cleveland, OH, 1936; CGA, 1937; Reinhardt Gals., 1937 (solo); James O' Toole Gal., NYC, 1935 (solo), 1939 (solo), 1941 (solo); Biltmore Salon, Los Angeles, 1942. **Comments:** Specialty: floral still lifes and Paris scenes. **Sources:** Hughes, *Artists of California,* 493; Petteys, *Dictionary of Women Artists.*

SCHAFER, Alice Pauline *[Printmaker] b.1899, Albany, NY / d.1980, Albany?.*
Addresses: Albany. **Studied:** Albany Sch. FA (grad. cum laude). **Member:** Print Club Albany (pres., 1950); Southern Vermont Artists; SAGA; NAWA; SMPS&G Wash., DC. **Exhibited:** S. Indp. A., 1940; Albany Print Club, 1940-69; Cooperstown, NY, 1949-69; 3rd Nat.Buffalo (NY) PM, 1940; 123rd Ann., NAD, 1949; Royal Soc., Exchange, London, 1954; SAFA 1947-69 & SAGA 51st Ann., New York, 1971; NAWA, 1951-69 & NAWA 83rd Ann., 1972. Awards: Alice Standist Buell Mem. Award for The Music Shell, Pen & Brush Club, 1965; gold medal for Going to St. Ives, AAPL, 1966; John Taylor Mem. Prize for Some Journeys Begin, Print Club Albany, 1968; June 1 Gal., Bethlehem, CT, & Wash., DC, 1978, 1981. **Work:** MMA; Southern Vermont AC, Manchester, VT; NYPL; Hunt Bot Lib., Carnegie-Mellon Univ., Pittsburgh, PA; Butler IA. Commissions: etchings, facade, Nat. Commercial Bank & Trust, Albany, 1950 & Doll Lady, Print Club Albany, 1961. **Comments:** Preferred media: wood, linoleum. Positions: registrar, Albany Inst. Hist. & Art, 1952-64. Collection: contemporary printmakers. **Sources:** WW73; Petteys, *Dictionary of Women Artists*.

SCHAFER, Frances (Mrs. Henry Levy) *[Painter] b.1924, Vienna, Austria / d.1998, Portland, ME.*
Addresses: Monhegan Island, ME, 1947-90 (summers); Rockland, ME, 1985-90; Portland, ME, 1990. **Studied:** ASL, 1946-47; BM, 1947-49, with Tam, M. Beckman, Mike Loew; Murray Hantman, 1955, at Brooklyn Mus. Sch. **Exhibited:** Oswego Teachers College, 1966; Audubon WCS, NY, 1969; Gordon Gal., NYC, 1968. **Work:** Monhegan Island Mus. **Comments:** Fled Austria with her family in 1938 after Hitler's invasion. In NYC, she became part of the circle of Abstract Expressionists who gathered at the Cedar Bar. Shared a studio with Murray Hantman in lower Manhattan. Began summering on Monhegan Island in 1947, becoming part of that art colony. Married photographer Henry Levy in 1966 and thereafter devoted much time to helping preserve his vast photographic archive (Levy took the famous photo of Marilyn Monroe when her skirt blew up). Preferred media: oil, watercolor, sumi ink, pastels, charcoal. **Sources:** info courtesy John M. Day, Falmouth, ME.

SCHÄFER, Frederick Ferdinand *[Landscape painter, muralist] b.1839, Braunschweig, Germany / d.1927, Oakland, CA.*
Addresses: San Francisco, Oakland & Alameda, CA, after 1876; Oakland, CA, 1905-17. **Member:** SFAA, 1880s. **Exhibited:** SFAA, 1880; Mechanics Inst. Fair, 1879-80, 1882-84; Portland Mechanics Fair, 1885, 1886; Portland North Pacific Indus. Exh., 1890; Calif. State Fair, 1894. **Work:** Alameda (CA) Free Pub. Lib.; Art Gal., Greater Victoria (BC); British Columbia Archives; Calif. Hist. Soc.; San Fran.; Crocker AM, Sacramento, CA; Hoover Inst., Palo Alto, CA; Monterey (CA) Peninsula MA; Mus. Church Hist. & Art, Salt Lake City, UT; Monterey (CA) State Hist. Park; Seattle (WA) Art Mus.; Shasta (CA) State Hist. Park; Bancroft Lib., Univ. Calif., Berkeley; Oakland (CA) Mus.; LACMA; Sonoma County Mus., Santa Rosa, CA; Yosemite (CA) Nat. Park Mus.; murals, Masonic Lodge, Alameda, CA. **Comments:** Emigrated to U.S. at age 37. He spent summers on sketching trips through the Northwest, painting landscapes and Indian scenes. His later style was impressionistic. **Sources:** Hughes, *Artists of California*, 494; Campbell, *New Hampshire Scenery*, 136; P&H Samuels cite alternate birthdate of 1841, 422; addit. info. courtesy Jerome H. Saltzer, Cambridge, MA.

SCHAFER, George L(eslie) *[Painter, illustrator] b.1895, Wilmington, DE.*
Addresses: Wilmington, DE/Arden, DE. **Studied:** PAFA; Bellevue Art Training Center, Paris. **Member:** Wilmington SFA. **Work:** mural, Penn. Liquor Control Bldg., Phila. **Sources:** WW40.

SCHAFER, Henry K. *[Painter] mid 20th c.*
Addresses: Chicago area; Jackson, MI. **Exhibited:** AIC, 1941-44; PAFA Ann., 1942, 1947. **Sources:** Falk, *Exh. Record Series*.

SCHAFER, Irene S. (Mrs.) *[Lithographer, designer, drawing specialist] mid 20th c.; b.Boston, MA.*
Addresses: NYC. **Member:** NAAI. **Exhibited:** L.G. Hornby; J. Pennell. **Sources:** WW40.

SCHAFER, Marjorie *[Artist] mid 20th c.*
Addresses: NYC. **Exhibited:** PAFA Ann., 1942. **Sources:** Falk, *Exh. Record Series*.

SCHAFFER, L. Dorr *[Painter] 19th/20th c.*
Addresses: Phila., PA; Santa Barbara, CA. **Exhibited:** PAFA Ann., 1891 (landscapes in water color). **Sources:** WW17; Falk, *Exh. Record Series*.

SCHAFFER, Lisa *[Artist] mid 20th c.*
Exhibited: Salons of Am., 1934. **Sources:** Marlor, *Salons of Am.*

SCHAFFER, Myer *[Painter, graphic artist, teacher] b.1912, NYC.*
Addresses: Los Angeles, CA. **Studied:** Chouinard AI, Los Angeles with D.A. Siquerios. **Member:** Am. Artists Congress; Un. Fed. Artists. **Exhibited:** Los Angeles Mus. Hist., Science, & Art; Am. Artists Congress. **Work:** murals, Los Angeles Tubercular San.; McKinley Jr. H.S., Pasadena; Dept. Natural Resources, Carpenteria, CA. **Sources:** WW40.

SCHAFFER, Rose *[Painter, lecturer] b.Newark, NJ / d.1989.*
Addresses: East Orange, NJ. **Studied:** ASL, 1935-40, with George Bridgeman & Ivan Oninsky; Bernard Karfiol; Sol Wilson; Seong Moy; Antonio Frasconi. **Member:** NAWA (graphic jury); Nat. Fed. Arts; Summit AA; Artists Equity Assn.; Artists Equity Assn. NJ. **Exhibited:** NAD; BMFA; Delgado Mus., New Orleans; BM; Phila. Print Club. Awards: Awards, Terry Nat., Miami Beach, FL, 1955 & Seton Hall Univ., 1956; two purchase prizes, Art For Overlook, 1955-60. **Work:** Smithsonian Inst., Wash., DC; Norfolk (VA) Mus. Arts & Sciences; Springfield (MA) Mus. Art; Montclair (NJ) Mus.; State NJ Cultural Center. **Comments:** Preferred media: oils, casein, acrylics, wood. Teaching: lectures on modern art, Parent-Teacher Assn. **Sources:** WW73.

SCHAIBLE, Frederick Jacob *[Sculptor] b.1894, Germany / d.1955, Los Angeles, CA.*
Addresses: Los Angeles, CA, 1914-55. **Exhibited:** P&S Los Angeles, 1927. **Sources:** Hughes, *Artists of California*, 494.

SCHAINEN, Herman Jack *[Sculptor, designer] b.1934, NYC.*
Addresses: New York 17, NY; Mt. Freedom, NJ. **Studied:** Pratt Inst., Sch.f Arch. (B. Arch.). **Work:** co-designed & executed sculpture for lobby of Lorillard Bldg., NYC. **Sources:** WW59.

SCHALBACH, Carl *[Painter] mid 20th c.*
Exhibited: AIC, 1925-31. **Sources:** Falk, *AIC*.

SCHALDACH, William J(oseph) *[Etcher, painter, writer, illustrator] b.1896, Elkhart, IN.*
Addresses: West Hartford, CT; Sasabe, AZ; Tubac, AZ in 1964. **Studied:** ASL; Harry Wickey. **Member:** SAGA; SC; Indiana Soc PM; Inst. Interamericano (fellow); Am. Mus. Natural Hist. (life fellow). **Exhibited:** Salons of Am.; NAD, 1935-44; PAFA, 1941; SAGA, 1928-47; Chicago SE, 1929-30; SC; WFNY 1939; MMA (AV); Phila. Pr. Club, 1930-36; Indiana Soc. PM, 1938-46; Southern PM, 1939, 1940; Currier Gal. Art, 1939, 1940; John Herron AI, 1946, 1952; Dartmouth College, 1942, 1946. **Work:** SAGA; Vanderpoel Coll.; NYPL; MMA; Penn. State Univ.; Dartmouth College; LOC; SC. **Comments:** Wintered in Arizona until making it his permanent home in 1956. Specialty: writing and illustrating wildlife subjects in the Sonoran desert and in southern Arizona, Mexico and lower California. Auth.: "Carl Rungius, Big Game Painter," 1945; "Fish by Schaldach," 1937; "Currents and Eddies," 1944; Illustr.: "Coverts and Casts," 1943; "Upland Gunning," 1946. Contributor to: *Esquire, Natural History, Print Collectors Quarterly*, & other magazines. **Sources**

WW59; WW47; P&H Samuels, 422.

SCHALK, Edgar *[Painter] early 20th c.*
Addresses: Richmond, IN. **Sources:** WW06.

SCHALK, Louis *[Painter] 19th/20th c.*
Addresses: Boston, MA. **Exhibited:** Boston AC, 1895-97.
Sources: *The Boston AC.*

SCHALL, F(rederick) P(hilip) *[Painter, illustrator] b.1877,*
Chicago, IL.
Addresses: NYC. **Studied:** Académie Julian, Paris with J.P.
Laurens, 1900. **Member:** Kit Kat Club. **Exhibited:** S. Indp. A.,
1917. **Sources:** WW24.

SCHALLER, Edwin *[Painter] mid 20th c.*
Addresses: Los Angeles, CA. **Exhibited:** LACMA, 1940.
Sources: Hughes, *Artists of California,* 494.

SCHALLINGER, Max *[Painter, sculptor, craftsperson, edu-*
cator] b.1902, Ebensee, Austria / d.1955.
Addresses: Baltimore, MD; NYC. **Studied:** Acad. FA, Vienna;
Acad. FA, Munich; Bauhaus, Dessau. **Member:** Balt. Artists Gld.
Exhibited: Int. Craft Exh., Paris, 1926; Salzburg, Austria, 1930;
PMG, 1944 (solo); BMA, 1938 (solo), 1942 (solo),1945 (solo);
ACA Gal., 1947. **Work:** PMG; BMA; Am. Univ., Wash., DC.
Comments: Teaching: Hood College, Frederick, MD, 1940s.
Sources: WW53; WW47.

SCHAMBERG, Morton L(ivingston) *[Painter, photograph-*
er, sculptor] b.1881, Phila., PA / d.1918, Phila., PA.
Addresses: Phila., PA/Doylestown, PA. **Studied:** Univ. Penn.,
1903 (degree in arch.); PAFA with W.M. Chase, 1903-06 (visited
Europe many times). **Member:** Soc. Indep. Artists. **Exhibited:**
AIC, 1904, 1908-09; PAFA Ann., 1907-10; Armory Show, 1913;
Soc. Indep. Artists, 1917, 1920, 1936, 1941; Organizer:
"Philadelphia's First Exhibition of Advanced Modern Art," with
H.L. Sayen, at McClees Galleries, 1916; M. Diamond FA, NYC,
1980. **Work:** PMA; Yale Univ.; Columbus (OH) Gal. of Fine
Arts; Williams College Mus. Art, Williamstown, MA. **Comments:**
He and his classmate and friend Charles Sheeler (see entry) were
among Chase's favorite students until they both began exploring a
more formal structure and composition, which caused Chase never
to speak to either of his pupils again. Schamberg and Sheeler
became immersed in modern art while traveling through Europe
together in 1908/09. Returning to Philadelphia in 1910 they estab-
lished a joint studio in the city and bought a farmhouse in
Doylestown. Over the next several years, Schamberg collaborated
with Sheeler on commercial photography, explored Fauvism in his
painting, and, with his friend H.L. Sayen (see entry), experiment-
ed with Synchromism, painting a series of abstracted landscapes.
By 1916 Schamberg had become increasingly concerned with
simplifying form, and begun a series of paintings of machine
objects ("Still Life with Camera Flashlight," 1916; "Telephone,"
Columbus Gal. of Fine Arts, 1916), perhaps aware of Picabia's
machinist paintings. Schamberg had met Picabia and Marcel
Duchamp that same year and soon became a part of the Arensberg
circle in NYC, although he continued to live in Pennsylvania. In
c.1917 he created the first American Dada ready-made, an assem-
blage of plumbing pipes which he called "God" (PMA).
Schamberg died in the flu epidemic of 1918. **Sources:** WW17;
Baigell, *Dictionary;* A. Davidson, *Early American Modernist*
Painting, 96-99; Ben Wolf, *Morton Livingston Schamberg* (1963);
Pisano, *The Students of William M. Chase,* 38; Falk, *Exh. Record*
Series; Brown, *The Story of the Armory Show.*

SCHAMES, Samson *[Painter] mid 20th c.*
Addresses: NYC. **Exhibited:** PAFA Ann., 1953. **Sources:** Falk,
Exh. Record Series.

SCHANG, Frederick, Jr. *[Collector] b.1893, NYC.*
Addresses: Delray Beach, FL. **Studied:** Columbia Univ. (B.Lit.,
1915). **Exhibited:** Awards: Ritter of Danneborg, Govt. Denmark;
Order of Vasa, Govt. Sweden. **Comments:** Positions: pres.,
Columbia Artists Management, 1949-60. **Publications:** auth.,
"Visiting Cards of Celebrities," F. Hazen, Paris, 1971. Collection:

Works of Paul Klee; collection shown at Minn. Mus. Art, Soc.
Four Arts, Palm Beach & various colleges & museums. **Sources:**
WW73.

SCHANKER, Louis *[Abstract painter,*
printmaker, teacher, lecturer] b.1903,
NYC / d.1981, Stamford, CT. *Schanker*
Addresses: NYC; Stamford, CT. **Studied:** Cooper Union Art
Sch., 1919-23 (night classes); ASL; Educ. Alliance; Académie de
la Grand Chaumière, Paris, 1931-32. **Member:** Fed. Mod. P&S;
Am. Artists Congress; Am. Abstract Artists; Sculptors Guild; "The
Whitney Dissenters," 1938. **Exhibited:** with "The Ten Whitney
Dissenters" at Montross Gal., Passedoit Gal., Mercury Gal., all in
NYC & Galerie Bonaparte, Paris, 1938; Am. Abstract Artists
Group at the Squibb Bldg., NYC, 1937; WFNY, 1939 (mural,
Health Bldg.); VMFA; AIC; NAD; WMAA; BM, 1947 (prize);
Corcoran Gal. biennials, 1947, 1949; PAFA Ann., 1947, 1951,
1954; Willard Gal.; Kleemann Gal.; Detroit Inst. Art; PMG; PMA;
Phila. Pr. Club; Guggenheim Mus.; Univ. Illinois, 1958 (prize);
SFMA; SAGA; LOC; Victoria & Albert Mus., London; Martin
Diamond FA, NYC, 1981 (retrospective). Other awards: Yaddo
fellow, 1958. **Work:** Wittenborn & Co., NY, murals; Radio Statio
WNYC; Neponsit Beach Hospital, NY; MMA, CM; Munson-
Williams-Proctor Inst.; BM; Detroit AI; Univ. Michigan;
Wesleyan College; NYPL; PMG; MMA; WMAA; MoMA; PMA;
AIC. **Comments:** Auth.: *Line-Form-Color,* 1944 (portfolio with 5
color woodblock prints). Teaching: New School Social Res.,
1940-60; Univ. Colorado, 1953; Univ. Minnesota, 1959; Bard
College, 1949-64, prof. emeritus, 1964-on. **Sources:** WW73;
WW47; S.W. Hayter, *About Prints* (Oxford Univ. Press, 1962);
exh. cat., Martin Diamond FA, NYC, (1981); Diamond, *Thirty-*
Five American Modernists; American Abstract Art, 197; Falk,
Exh. Record Series.

SCHANTZ-HANSEN, Laurentza *[Educator, lecturer]*
b.1888, Neenah, WI.
Addresses: West Lafayette, IN. **Studied:** Univ. Chicago (Ph.B.);
Columbia Univ. (M.A.); Albert Heckman. **Member:** Mid-Western
College Art Conf.; Am. Assn. Univ. Prof.; AAUW. **Comments:**
Position: hd., Dept. Applied Design, Purdue Univ., West
Lafayette, IN, 1930-56; prof. emeritus, 1957-. Contrib.: *Better*
Homes in American Bulletin No. 6 & No. 7. Lectures: Am. con-
temporary artists. **Sources:** WW59.

SCHANZ, Elizabeth *[Painter] early 20th c.*
Addresses: Glen Ridge, NJ. **Sources:** WW25.

SCHANZENBACHER, Nellie *[Painter] mid 20th c.;*
b.Louisville, KY.
Addresses: Louisville, KY. **Studied:** ASL; William Chase; Robert
Henri; F. Luis Mora; E. Fitsch. **Member:** SSAL; Southern Indiana
& Kentucky Artists; Speed Mem. Mus. **Exhibited:** Speed Mem.
Mus., 1929 (prize); Kentucky Fed. Artists, 1940 (prize); Women's
Club, Louisville, 1943 (prize), 1945 (prize); *Journal & Louisville*
Times Exh., 1936 (prize). **Work:** State Lib., Frankfort, KY;
Louisville H.S.; St. Paul's Church, Louisville. **Sources:** WW53;
WW47.

SCHAPIRO, Cecil See: **SHAPIRO, Cecil**

SCHAPIRO, Charlotte *[Painter] mid 20th c.*
Addresses: NYC. **Exhibited:** S. Indp. A., 1944. **Sources:**
Marlor, *Soc. Indp. Artists.*

SCHAPIRO, Meyer *[Art historian, critic, educator] b.1904,*
Shavly, Russia / d.1996, NYC.
Addresses: NYC. **Studied:** Columbia Univ. (A.B.; M.A.; Ph.D.).
Comments: Important 20th-century art historian who applied
Marxist intellectual theory to an analysis of modern art. Teaching:
Columbia Univ., 1928-. Research: early Christian, medieval and
modern art. As a teacher, Schapiro had an impact on a generation
of art historians and artists. Among the artists who studied art his-
tory with him are George Segal, Robert Motherwell, Ad
Reinhardt, Allan Kaprow, Lucas Samaras, and Donald Judd.
Contributor of articles to *Journal of the Warburg and Courtauld*

Institutes; *The Journal of the History of Ideas;* and others. Author: *Van Gogh* (1950); *Cezanne* (1952); *Words and Pictures. On the Literal and the Symbolic in the Illustration of a Text* (Hague, 1973); *Modern Art 19th and 20th Centuries. Selected Papers* (New York, 1978); Schapiro's essay, "The Social Bases of Art" (1936) is reprinted in D. Shapiro, ed. *Social Realism—Art as a Weapon: Critical Studies in American Art* (New York, 1973). **Sources:** WW73; Kultermann, *The History of Art History,* 231-33.

SCHAPIRO, Miriam *[Painter, printmaker, author] b.1923, Toronto, Ontario.*
Addresses: NYC, 1950s; San Diego, 1960; Los Angeles, CA, 1973; NYC, 1975-. **Studied:** MoMA &Federal Art Project while in high school in NYC; Univ. Iowa (B.A., 1945; M.A., 1946; M.F.A., 1949). **Member:** Iowa Print Group; CAA (board); Woman's Caucus for Art (governing board);. **Exhibited:** Carnegie Int., 1958; WMAA,1958, 1966, 1971; Andre Emmerich Gal., New York, 1958-71 (7 solos); PAFA Ann., 1962, 1964; Toward A New Abstraction, Jewish Mus., 1963; Paul Brach & Miriam Schapiro— Double Retrospective, Newport Harbor Art Mus., 1969; ; Am. Women 20th Century, Lakeview (IL) Center Arts & Sciences, 1972; "Womanhouse,' with Judy Chicago and their students, Calif. Inst. Arts, Valencia, 1972; The College of Wooster (OH) Art Mus., 1980 (retrospective). Awards: Ford Found. Tamarind fellowship, 1964. **Work:** WMAA; MoMA; NY Univ. Permanent Coll.; Stanford Univ., Palo Alto, CA; St. Louis City Art Mus. **Comments:** Feminist artist/teacher/writer. Teaching: Univ. of San Diego, 1970; established, with Judy Chicago, the Feminist Art Program, Calif. Inst. Arts, Valencia, 1972-. Publications: auth., "The Education of Women as Artist, Project Womanhouse," *College Art Journal* (summer 1972); co-auth., *Womanhouse* (exh. catalogue, 1972). In 1975, with Lucy Lippard, she helped start Heresies, a collective of feminists (publishing a journal of same name) studying the relation between art and society. **Sources:** WW73; Rubinstein, *American Women Artists,* 403-07; Thalia Gouma-Peterson, *Miriam Schapiro; A Retrospective,* 1953-80 (exh. cat., Wooster, OH: The College of Wooster Art Mus., 1980); L. Campbell, "Miriam Schapiro Paints a Painting," *Art News* (May, 1967); Barbara Rose, "Abstract illusionism," *Artforum* (Oct., 1968); Hermine Freed, "Miriam Schapiro in her Studio in East Hampton" (video tape), August, 1972; Falk, *Exh. Record Series.*

SCHAR, A(xel) E(ugene) *[Painter, teacher] b.1887, Oslo, Norway.*
Addresses: Duluth, MN. **Studied:** Fritz Thaulow. **Member:** Duluth AA. **Sources:** WW33.

SCHARDT, Bernard P. *[Graphic artist] b.1904, Milwaukee, WI / d.1979, North Truro, MA.*
Addresses: NYC. **Exhibited:** Fed. Art Gal., 1937. **Sources:** WW47.

SCHARF, L. William *[Artist] mid 20th c.*
Addresses: Phila., PA. **Exhibited:** PAFA Ann., 1950. **Sources:** Falk, *Exh. Record Series.*

SCHARF, Ralph *[Painter] mid 20th c.*
Exhibited: Corcoran Gal. biennial, 1957. **Sources:** Falk, *Corcoran Gal.*

SCHARL, Josef *[Painter, etcher, illustrator] b.1896, Munich, Germany / d.1954.*
Addresses: New York 27, NY. **Studied:** Sch. Decorators, Acad. FA, Munich, Germany. **Member:** AEA; Bavarian Acad. FA; Fed. Mod. P&S. **Exhibited:** AIC, 1941, 1944; CAM, 1944, 1946; PAFA Ann., 1945-47; WMAA, 1945-46; VMFA, 1946; Nierendorf Gal., 1941 (solo), 1943-46; Pinacotheca, 1944; SFMA, 1944; Neumann Gal., 1949; Munich, Heidelberg, Cologne, 1950-51; BMFA Sch., 1952; Univ. Louisville, 1943; Nierendorf Gal., Hollywood, CA, 1944; Munson-Williams-Proctor Inst., 1944; de Young Mem. Mus., 1945; Denver Art Mus., 1945; Phila. Art All., 1946; Swarthmore College, 1946. Awards: Albrecht Dürer award, Nüremberg, 1929; Prix de Rome, 1930; Mond prize, Munich, 1931; Förderer prize, Essen, 1932. **Work:** State Gal., Mun. Gal.,

Munich; Albrecht Dürer Gal., Nüremberg; Acad. Tedesea, Rome; Rochester Mem. Art Gal. **Comments:** Illustr.: Grimm's "Fairy Tales," 1944; "Rock Crystal," 1945. **Sources:** WW53; Falk, *Exh. Record Series.*

SCHARLACK, Herman *[Landscape painter, etcher, lecturer, writer] b.1899, Newark, NJ.*
Addresses: NYC. **Studied:** H. Boss; A. Goldwaite; W. Von Schlegell. **Member:** Bronx AG; Yosian FA Club. **Sources:** WW40.

SCHARMAN, Leon *[Commercial artist, painter] b.1910, Oakland, CA.*
Addresses: Los Altos, CA; Palo Alto, CA. **Studied:** Stanford Univ.; Calif. Sch. FA. **Member:** Palo Alto AC. **Comments:** Position: artist, Schmidt Lithography Co., 1928-64. **Sources:** Hughes, *Artists of California,* 494.

SCHARPE, Christian *[Lithographer, engraver] b.1818, Bremen, Germnay / d.1872, New Orleans, LA.*
Addresses: New Orleans, active 1868-72. **Comments:** Commissioned with Gustave Koeckert to engrave an official map of the state of Louisiana. **Sources:** *Encyclopaedia of New Orleans Artists,* 340.

SCHARTE, C. Jerome *[Painter] early 20th c.*
Addresses: Chicago area. **Exhibited:** AIC, 1927. **Sources:** Falk, *AIC.*

SCHARY, Harry Alexander *[Painter, architect] b.1896, Chicago, IL / d.1947, Berkeley, CA.*
Addresses: Oakland, CA. **Member:** Calif. SE; Am. Inst. Arch. **Exhibited:** Oakland Art Lg., 1928; Oakland Art Gal., 1927, 1933, 1935, 1943; GGE, 1940. **Sources:** Hughes, *Artists of California,* 494.

SCHARY, Saul *[Painter, illustrator, designer, graphic artist] b.1904, Newark, NJ / d.1978.*
Addresses: NYC; New Milford, CT. **Studied:** ASL; PAFA; Paris. **Member:** AEA; PAFA (fellow); CAA; Royal Soc. Artists, London. **Exhibited:** WMAA, 1932-45; PAFA Ann., 1933-51 (6 times); AIC, 1942; CI, 1943-44; CPLH; Corcoran Gal. biennial, 1945; solos: Daniel, John Becker, Milch, Perls, Luyber & Salpeter gals., all in NYC; All. Artists Am. Gal., Los Angeles; Phila. Art All. **Work:** PAFA; CMA; Columbus (OH) Gal. FA. **Comments:** Illustr.: "Alice in Wonderland," 1930. **Sources:** WW59; WW47; Falk, *Exh. Record Series.*

SCHARY, Susan *[Painter] b.1936, Philadelphia, PA.*
Addresses: Los Angeles, CA. **Studied:** Tyler Sch., Temple Univ. (B.F.A. , honors); Vladamir Shatolov. **Member:** Artists Equity Assn. **Exhibited:** Florence Art Gal., Italy, 1965; 100 Distinguished Phila. Artists, 1967; Fleisher Art Mem. Faculty Show, 1967; Munic. Arts Festival, Los Angeles, 1970-71; Phila., 1964 (solo) & 1967 & Los Angeles, 1971-72 (solos). Awards: Gimble Awards, 1947-50; Fidelity Bank Ann., 1958 (hon. men.); Tyler Sch., 1958 (Dean's Prize). **Work:** City Hall, Temple Univ., Thomas Paine Center, Villanova Univ., all in Phila. **Comments:** Preferred media: oils. Teaching: Harcum Jr. College, Bryn Mawr, PA, 1960-62; Fleisher Art Mem., 1966-68. **Sources:** WW73.

SCHATIA, D. *[Sculptor] mid 20th c.*
Exhibited: S. Indp. A., 1943. **Sources:** Marlor, *Soc. Indp. Artists.*

SCHATT, Roy *[Painter, illustrator, cartoonist] b.1909, NYC.*
Addresses: Arlington, VA. **Studied:** ASL; Grand Central Sch.; Corcoran Gal. Sch. **Exhibited:** 48 Sts. Competition, 1939; PAFA Ann., 1940. **Comments:** Position: commercial artist, Warner Bros. Theatres, Wash., DC. **Sources:** WW40; Falk, *Exh. Record Series.*

SCHATTENSTEIN, Nikol *[Portrait painter] b.1877, Poniemon, Russia / d.1954, Port Chester, NY.*
Addresses: NYC. **Studied:** Vienna Akad. **Member:** All. Artists Am.; Künstlerhaus, Vienna; Knight Cross of the Francis Josef Order. **Exhibited:** Salons of Am.; S. Indp. A., 1925, 1932-34, 1937-41; MMA, 1942; AIC, 1943; Wildenstein Gal.; AFA, 1945-

6; Int. Expo, Vienna (gold); Nat. War Poster Comp., 1942 prize); Paris (prize); All. Artists Am., 1951 (prize); City of alzburg (prize); Prix de Rome. **Work:** Nat. Mus., Krakow, oland; Army Mus., Vienna; PMA; BMFA; Court of Appeals, Albany, NY; Supreme Court, Raleigh, NC; Court House, Winston-alem, NC; New York Univ. **Sources:** WW53; WW47.

CHATZ, Daniel Leon *[Portrait painter, mural painter]* b.1908, Milwaukee, WI.
Addresses: Chicago, IL. **Studied:** G. Moeller; R. von Newmann; Milwaukee AI; Layton Art Sch.; AIC; S. Ostrowsky, Paris. **Member:** Around the Palette. **Exhibited:** AIC, 1934-37. **Comments:** Position: Bureau of Design, Montgomery, Ward &Co., Chicago. **Sources:** WW40.

CHATZ, Otto *[Painter] mid 20th c.*
Exhibited: AIC, 1941. **Sources:** Falk, *AIC.*

CHATZ, Zahara *[Designer, painter, craftsperson] b.1916, Jerusalem, Israel.*
Addresses: New York 3, NY. **Studied:** École Nat. Supérieur des Artes Décoratifs; Académie de la Grande Chaumière, Paris, France. **Member:** Am. Abstract Artists; San Fran. AA. **Exhibited:** Am. Abstract Artists, 1951, 1952; Phillips Acad., 1949; Detroit A, 1949; Walker AC, 1948-49; Akron AI, 1947; San Fran. AA, 945-47; Mus. Non-Objective Painting, 1947-52; Columbus MFA, 951; Cooper Union, 1950; Yale Univ., 1950; Mus. New Mexico, 939 (solo); SFMA, 1944; Pinacotheca, 1947; Phila. Art All., 949; Bertha Schaefer Gal., 1951. **Awards:** prize, Bezalel Mus., erusalem, 1952. **Work:** Phillips Acad., Andover, MA; Munson-Williams-Proctor Inst.; Bezalel Mus.; mural, Warrick House, atlantic City, NJ. **Sources:** WW59.

CHATZLEIN, Charles *[Watercolorist, art collector, decorator] 19th/20th c.*
Addresses: Butte, MT. **Comments:** Active in Montana in 1890s; friend of Charles Russell at least 1899-1910. **Sources:** P&H amuels, 422-23.

CHAUER, Martha K. *[Teacher, painter, lecturer, writer] b.1889, Troy, OH.*
Addresses: Dayton, OH. **Studied:** PIA Sch.; Wittenberg Univ., springfield, OH (B.F.A.); Univ. Dayton (M.A.); R. Johonnot; M. angtry; O. Beck; A. Dow; C. Martin. **Member:** Ohio WCS; Dayton Soc. Painters; AAPL. **Exhibited:** Ohio WCS; Dayton AI, annually; Wittenberg Univ. (solo). **Work:** Dayton AI. **Comments:** eaching: Stivers H.S., Dayton, OH, 1912-56; Sat. Morning Sch. or Children, Dayton AI, 1926-57. **Sources:** WW59; WW47.

CHAUFFLER, Margaret Reynolds *[Painter, educator, craftsperson] b.1896, Cleveland, OH.*
Addresses: Oberlin, OH. **Studied:** Oberlin College (B.A.); Cleveland Sch. Art; Western Reserve Univ. (M.A.); Breckenridge; Forrest; Warshawsky. **Member:** AFA; AAUP; CAA. **Exhibited:** CMA, 1922, 1937, 1940; Allen Mem. Art Mus., Oberlin College, 925, 1931, 1934, 1937, 1943, 1945, 1947, 1949, 1951, 1955, 956, 1958; Wichita AA, 1952; Ogunquit AC, 1956-58. **Comments:** Teaching: Oberlin (OH) College, 1923-61. **Sources:** VW59; WW47.

CHAUS, Hermann *[Art dealer] b.1911.*
Addresses: NYC. **Comments:** In 1875, he succeeded to the busi-ness established by his uncle, William Schaus, and many impor-ant paintings were handled by the firm. **Sources:** Katlan, vol. I, 23.

CHAUS, William *[Art materials supplier, art dealer] d.c.1893.*
Addresses: NYC, 1847-91. **Comments:** In 1847, he was an agent of Goupil & Co., but in 1852 formed his own art supply business and gallery. He primarily sold paintings by the European masters. His art supplies were of high quality, imported from Paris and London, and the William Schaus stencil mark appears on the can-ases of American artists such as John W. Casilear, Th. Hicks, Geo. Inness, Seymour Guy, J.F. Kensett, and Charles Elliott. After 875, the firm was run by a number of successors until 1891.

Sources: Katlan, vol. I, 22.

SCHAUZ, Elzibeth *[Painter] early 20th c.*
Addresses: Caldwell, NJ. **Sources:** WW24.

SCHAWINSKY, Xanti *[Artist] mid 20th c.*
Addresses: NYC. **Exhibited:** WMAA, 1953. **Sources:** Falk, *WMAA.*

SCHECHERT, Dorothea (Mrs. Paul) *[Painter] b.1888, NYC.*
Addresses: Poulsbo, WA, 1941. **Studied:** Tillie Piper, Seattle. **Exhibited:** Kitsap County Fair, WA, 1928, 1929; SAM. **Sources:** Trip and Cook, *Washington State Art and Artists,* 1850-1950.

SCHECK, Helen Mildred *[Painter, craftsperson] b.1900, Los Angeles, CA.*
Addresses: Los Angeles. **Studied:** UCLA. **Member:** Pacific AA; Art Teacher's Assoc. Southern Calif. **Exhibited:** Los Angeles Pub. Lib., 1927; Hollywood Pub. Lib., 1927; LACMA, 1928. **Sources:** Hughes, *Artists of California,* 494.

SCHECKELL, T. O. *[Painter] early 20th c.*
Addresses: Salt Lake City, UT. **Sources:** WW15.

SCHEDLER, Joseph *[Lithographer] mid 19th c.*
Addresses: NYC, 1852-54. **Comments:** In 1854 with Theodore Liebler (see entry). **Sources:** G&W; NYBD 1852, CD 1854.

SCHEDLER & LIEBLER *[Lithographers] mid 19th c.*
Addresses: NYC, 1854. **Comments:** Partners were Joseph Schedler and Theodore A. Liebler (see entries) **Sources:** G&W; NYCD 1854.

SCHEEL, Emil G. *[Painter] early 20th c.*
Addresses: Rockaway Beach, NY. **Exhibited:** S. Indp. A., 1927-29. **Sources:** Marlor, *Soc. Indp. Artists.*

SCHEFFEL, Herbert H. *[Painter, commercial artist] b.1909, Clifton, NJ.*
Addresses: Clifton, NJ. **Studied:** Newark Sch. Fine & Indust. Art; New Sch. Social Research; Cape Sch. Painting; Wang Chl-Yuan; H. Hensche; B. Gussow; A. di Benedetto. **Member:** AWCS; Wash. WCC; New Jersey WCS; Audubon Artists; Boston Soc. Indep. Artists; Rockport AA. **Exhibited:** AAPL, 1936 (prize); New York, California, Massachusetts, New Jersey, Wash., DC; man solos. **Work:** Berkshire Mus.; Montclair Art Mus.; Carpenter Gal., Dartmouth College; Interstate Payment Corp. **Comments:** Positions: fes., Glen Rock Puppeteers (1937-38), Pepper Puppeteers, Clifton, NJ (1939). **Sources:** WW59; WW47.

SCHEFFIELD, Harold C. *[Painter] mid 20th c.*
Addresses: Chicago area. **Exhibited:** AIC, 1938. **Sources:** Falk, *AIC.*

SCHEFFLER, Carl *[Painter] early 20th c.*
Addresses: Chicago, IL. **Exhibited:** AIC, 1912. **Sources:** WW13.

SCHEFFLER, Rudolf *[Painter, craftsman, muralist] b.1884, Zwickau, Germany / d.1973, Valley Cottage, NY.*
Addresses: Brooklyn Heights/Old Lyme, CT (1924-42); Valley Cottage (Rockland Cnty), NY/ Old Lyme, CT (1942-73). **Studied:** Royal Acad., Dresden, with Otto Gussman; Carl Bantzer & Hermann Prel, 1902-12 (silver medal, 1912; Grand Prix de Rome, 1913); privately in Paris, 1908; travel to study in Florence & Venice, Italy, 1909; Holland, 1913. **Member:** "Rider on the Sea" group, Baltic coast, Germany, 1910-11; Brooklyn Soc. Mod. Artists; Mural Painters; NSMP. **Exhibited:** Salons of Am., 1924-36; PAFA Ann., 1925, 1929; "Paintings by Brooklyn and Long Island Artists," BM, 1930; S. Indp. A., 1931; Griswold Mus., Old Lyme, CT, 1989 (retrospective). **Work:** Griswold Mus., Old Lyme, CT; Springfield (IL) Hospital; murals and mosaics, State Office Bldg., Columbus, OH; mosaic, Cathedral of Saint Louis, MO; mosaic, Seminary of St. Francis, Milwaukee, WI; triptych for Bishop of Houston, TX; mosaic reredos for St. Augustine church in Minster, OH. Historical murals, Liederkranz Bldg.,

NYC; WPA mural, USPO, Maumee, OH; Windsor Castle, England; Lord Jenkins Castle, New South Wales; other mosaics and murals for churches in NY, CT, WA, MT, WI, IL, LA, CA, KY, OH, and throughout Germany and Europe. **Comments:** A member of the Old Lyme (CT) colony of artists, Scheffler was a post-impressionist whose paintings of the flowering gardens at his Lyme summer home remained private because did not exhibit after 1931. He also painted landscapes, figures, and still lifes, and spent many summers on Monhegan Island with his friend and fellow German immigrant, Emil Holzhauer. In Scheffler's student years at the Royal Academy of Art at Dresden, he formed a lasting friendship with Max Pechstein. In the early 1920s, Scheffler returned to teach at the Royal Academy, and was a highly sought-after portraitist in high society Dresden. In 1921, he bought a windmill in Weick, a village on the Baltic Sea near Denmark, and painted its interior in the ancient Nordic folk style, and carved its furniture — this windmill later became a national historic site. When Scheffler came to the U.S. in 1924, he was already recognized as a leading architectural artisan. He was the principal designer for the Puhl & Wagner Workshop of Berlin, and was especially known for his mosaics and stained glass. He lived in sculptor Robert Laurent's artists' building in Brooklyn Heights, and by the late 1920s was summering in Old Lyme. He produced a major mosaic for the Cathedral of Saint Louis (St. Louis, MO) and a magnificent mosaic dome for the Church of the Immaculate Conception in Waterbury, Conn. His most ambitious mural project was a large series for the State Office Bldg. in Columbus, Ohio. **Sources:** WW59; WW47; Peter Falk, *Rudolf Scheffler* (exh. cat., Sound View Press, for Florence Griswold Museum, 1989); Falk, *Exhibition Record Series;* Curtis, Curtis, and Lieberman, 152, 186; *Art in Conn.: Between World Wars.*

SCHEIBE, Fred Karl *[Painter, writer] b.1911, Kiel, Germany / d.1982.*
Addresses: Cape Canaveral, FL; Rogers, AK. **Studied:** Clark Univ. (B.A., 1938); Univ. Penn. (M.A., 1941); Univ. Cincinnati (Ph.D., 1954). **Member:** Cooperstown AA. **Exhibited:** Virginia Intermont AC, Bristol, 1962; Idioplasmic Precipitates, Die Galerie, Munich, Germany, 1971; solos: Stuttgart, Germany, 1963; Yager Mus., Hartwick College, 1970 & Exh. of Idioplasmic Precipitates, Two Rivers Gal., Robinson Center, NY, 1971; Golden Matador, Cocoa Beach, FL, 1970s. **Work:** "First Man on the Moon," Eisenhower Mus., Abilene, KS; "Galaxy," Nelson D. Rockefeller Coll., NYC; "Mexico, A Poem," Langenheim Mem. Lib., Greenville, PA; "Starry Night," Hartwick College Art Coll., Oneonta, NY. Commissions: "Industry is King" (mural), C of C, Abington, VA, 1963. **Comments:** Teaching: Sampson College, 1946-47; Western College for Women, 1947-51; Universidad Nacional de Mexico, 1952; Taft teaching fellowship, Univ. Cincinnati, 1952-54; Brooklyn College, 1955; Alderson-Broadus College, 1955-57; Thiel College, 1957-61; Emory & Henry College, 1961-64; Hartwick College, Oneonta, NY, 1964-71; Shelton College, Cape Canaveral, FL, 1971-74. Positions: cur., Stucki-Scheibe Mus. and Gal., Tallahassee, FL, 1978-80, Art School and Mus. Gallery, 1980-82; vice-pres., academic affairs, Freedom Univ., FL. Author of several books. Art interests: idioplasmic precipitates; developed secret enamel formula which produces vividly colored paintings. Married to Margaret E. Stucki (see entry). **Sources:** WW73; Frank Perretta, "Idioplasmic Precipitates," *Oneonta Star*, March 25, 1967; add'l info. courtesy of Peter Bissell, Cooperstown, NY.

SCHEIBE, Richard *[Painter] early 20th c.*
Exhibited: AIC, 1932, 1936. **Sources:** Falk, *AIC.*

SCHEIBE, Royal A. *[Sculptor] early 20th c.*
Addresses: Milwaukee, WI. **Exhibited:** AIC, 1922; PAFA Ann., 1928. **Sources:** WW24; Falk, *Exh. Record Series.*

SCHEIBLE, William F. *[Engraver, die sinker, stencil cutter, seal press & awning manufacturer] mid 19th c.*
Addresses: Philadelphia, 1855 and after. **Sources:** G&W; Phila. CD 1855-60+.

SCHEIBNER, Vira B. McIlrath (Mrs.) *[Landscape & figurative painter, teacher] b.1889?, Cleveland, OH / d.1956.*
Addresses: New Hope & Lambertville, PA, 1914-21; St. Augustine, FL, from 1921. **Studied:** Cleveland Sch. Art, 1913; PAFA, 1914-; Charles Rosen; Robert Spencer; John Carlson; E. Van Waeyenberge in England. **Member:** NAWA. **Exhibited:** NAWA, 1927 (prize), 1928-32; PAFA, 1925-32. **Comments:** Visited Woodstock, NY, while she was living in the New Hope area. After marrying Mr. Scheibner in 1921, she moved to Florida, where she continued to paint landscapes. **Sources:** WW53; WW47 cites 1889 birthdate; Roy Wood, Jr. cites 1881 birthdate.

SCHEIDACKER, Hanns T. *mid 20th c.*
Exhibited: Salons of Am., 1931; PAFA Ann., 1937. **Sources:** Marlor, *Salons of Am.,* in which his name appears as Hanns; PAFA, vol. III shows his name as Harris.

SCHEIDACKER, Harris See: **SCHEIDACKER, Hanns T.**

SCHEIDER, Charles Sumner *[Printmaker, architect] early 20th c.*
Comments: Brother of Arthur and William G.

SCHEIER, Edwin *[Ceramist, educator, sculptor, painter] b.1910, NYC.*
Addresses: Durham, NH. **Studied:** ASL; Columbia Univ. **Member:** Am. Ceramic Soc.; Am. Assn. Univ. Prof. **Exhibited:** WMA; BMA; CM; Syracuse Mus. FA, 1940 (prize), 1941 (prize); Phila. Art All.; RISD; Detroit Inst. Art (solo.); Toledo Mus. Art (solo.); Milwaukee AI (solo); Dartmouth College (solo).; Univ. Puerto Rico (solo); Univ. Minnesota (solo); Univ. New Hampshire (solo); Currier Gal. Art (solo); BM, 1953 (prize); Int. Exh. ceramics, Cannes, France, 1955 (medal); Mt. Holyoke College, 1964; Chatham College, 1963. **Work:** Walker AC: CM; AIC; MoMA; Syracuse Mus. FA; Phila. Art All.; Mus. RISD; Detroit Inst. Art; MMA; Exeter Acad.; Fitchburg Art Mus.; Currier Gal. Art; Stuttgart, Germany; Tokyo Mus., Japan; Royal Ontario Mus.; Int. Mus. of Ceramics, Florence, Italy; Rochester Mem. Art Gal.; Newark Mus.; VMFA; AGAA; Univ. Kansas; Univ. Nebraska; Univ. Minnesota; Univ. Illinois and Wisconsin. **Comments:** Teaching: Univ. New Hampshire, 1940-45. Position: hd., Cer. Section, Puerto Rico Development Co., 1945-46. **Sources:** WW66; WW47.

SCHEIER, Mary (Mrs. Edwin) *[Ceramist, designer, craftsperson, educator, painter] b.1910, Salem, VA.*
Addresses: Durham, NH. **Studied:** ASL; Parsons Sch. Des. **Exhibited:** Syracuse Mus. FA (several prizes), 1940 (prize), 1941 (prize); WMA; BMA; CM; Phila. Art All.; Rhode Island Mus. Art; Currier Gal. Art; VMFA; Detroit Inst. Art (solo); Toledo Mus. Art (solo); Milwaukee AI (solo); Dartmouth College (solo); Univ. Puerto Rico (solo); Univ. Minnesota (solo); Univ. New Hampshire (solo); Currier Gal. Art (solo); Mt. Holyoke College, 1964 (solo); Chatham College, 1963 (solo in collaboration with Edwin Scheier); Worcester (MA) Craft Center, 1964 (solo). **Work:** AIC; Syracuse Mus. FA; CM; MOMA; Univ. New Hampshire; Walker A. Center; Detroit Inst. A.; Rochester Mem. A. Gal., Newark Mus.; VMFA; Currier Gal. A.; Fitchburg A. Mus.; Tokyo Mus., Japan; Royal Ontario Mus.; Univ. Illinois; AGAA; Univ. Kansas, Nebraska, Minnesota, Wisconsin. **Comments:** Position: cer. des., Puerto Rico Dev. Co., San Juan, PR. Teaching: RISD. **Sources:** WW66; WW47.

SCHEIFER, H. *[Engraver, die sinker] mid 19th c.*
Addresses: NYC, 1851. **Comments:** This is either Henry Schiefer or Herman Schieffer (who may indeed have been one and the same). **Sources:** G&W; NYBD 1851.

SCHEIN, Eugenie *[Painter, instructor] b.1905, Austria.*
Addresses: NYC; Miami Beach, FL. **Studied:** C.J. Martin, Hunter College (B.A.); Columbia Univ. (M.A.); Martha Graham Sch. Dance; Nat. Univ. Mexico; ASL. **Member:** Lowe Art Mus.; Miami MOMA; Artists Equity Assn. (vice-pres., 1972-). **Exhibited:** AIC; Salons of Am.; S. Indp. A.; Int. Watercolors,

BM; Cincinnati Mus.; Riverside Mus., NYC; Soc. Four Arts, Palm Beach; Florida AA. **Work:** Carvell Mus., LA; Georgia Mus. Art, Athens; Lowe Art Mus., Coral Gables, FL; Miami (FL) MOMA. **Comments:** Preferred media: oils, acrylics, watercolors. **Sources:** WW73; WW40.

SCHEINMAN, Hortense W. *[Painter, sculptor, teacher]* *b.1901, Baltimore, MD.*
Addresses: Brooklyn, NY. **Studied:** Roben; Kaiser; Adams; Kroll. **Sources:** WW25.

SCHEIRER, George A. *[Miniature painter, hand bookbinder, craftsman, teacher] b.1895, Elmira, NY / d.1959, Wash., DC.*
Addresses: Bethesda 14, MD. **Studied:** Marian Lane in Wash., DC. **Member:** Wash. SMPS&G; Wash. AC. **Exhibited:** CGA, 1936 (solo); Wash. AC, 1946; Phila. Art All., 1937; Wash. Soc. Art & Crafts, 1929; Pub. Lib Wash., DC, 1934; SMPS&G, 1937-54; Gibbes Art Gal., 1954; Bethesda (MD) Pub. Lib., 1955; Smithsonian Inst., 1957, 1958. Award: prize, Smithsonian Inst., 1957. **Comments:** Specialty: hand bookbinding. Teaching: "Woodnook Bindery." Bethesda, MD, 1950-; ASL of Wash., DC. **Sources:** WW59; McMahan, *Artists of Washington, DC.*

SCHEIRER, Hortense W. *[Bookbinder, teacher] b.1895, Elmira, NY / d.1959.*
Addresses: Wash., DC. **Studied:** M. Lane. **Member:** Wash. AC; Wash. SMPS&G; Boston SAC. **Exhibited:** CGA, 1936; Wash. AC, 1946; Phila. Art All., 1937; Wash. SAC, 1929; Pub. Lib., Wash., DC, 1934; SMPS&G, 1937-39, 1940, 1944, 1946. **Comments:** Teaching: The Rabbit Hutch Bindery, Wash., DC, from 1935. **Sources:** WW47.

SCHEIWE, Johannes H. *[Painter] b.1849, Germany / d.1915, Los Angeles, CA.*
Addresses: Ottumwa, IA; Los Angeles, CA, 1913-15. **Work:** Ottumwa Pub. Lib.; Wapello County Mus. **Sources:** Hughes, *Artists of California,* 494.

SCHELER, Armin A. *[Sculptor, educator, designer] b.1901, Sonneberg, Germany.*
Addresses: New Rochelle, NY; Baton Rouge, LA. **Studied:** K. Killer, at Sch. Appl. Arts & Crafts, Munich; Acad. FA, Munich, with Kurz & Hahn. **Member:** NSS; Louisiana Teachers Assn.; New Orleans AA; Soc. Des. Craftsmen, NYC; New Rochelle AA. **Exhibited:** NAD; WMAA; Switzerland, 1923 (prize);Paris Expo, 1936 (med.), 1937; PAFA Ann., 1936, 1952-53, 1958, 1966; Delgado Mus. Art, 1939 (Nat. Sculpture Comp. prize), 1943-46; New Orleans SAC, 1946; WFNY, 1939; Switzerland, 1923 (prize); New Rochelle, 1938 (med.). **Work:** Govt. Office Bldg., New Orleans, LA; Govt. Printing office, Wash., DC; USPO, Evanston, IL; Mattawan, NJ. **Comments:** Lectures: "The Meaning & Study of Sculpture." Contrib.: *Magazine of Art.* WPA artist. **Sources:** WW53; WW47; Falk, *Exh. Record Series.*

SCHELL, Dorothy Root *[Painter] early 20th c.*
Addresses: Phila., PA, c.1917-25. **Member:** Plastic Club. **Sources:** WW25.

SCHELL, Francis H. *F̄ᴿᴬᴺᴷ H. Schell '62*
[Newspaper illustrator, lithographer] b.c.1832, Pennsylvania / d.1909, Germantown, PA.
Addresses: Philadelphia, PA, 1850; New Orleans, LA active, 1862-64; Germantown, PA. **Comments:** During the Civil War he was one of the staff artists for *Frank Leslie's Illustrated Newspaper* and after the war he was in charge of Leslie's art department. Later he formed a partnership with Thomas Hogan and for thirty years they worked together as illustrators. He was one of the illustrators for "Beyond the Mississippi." **Sources:** G&W; *Art Annual,* VIII, obit.; 7 Census (1850), Pa., XLIX, 423; Phila. CD 1856; Taft, *Artists and Illustrators of the Old West,* 296-97; *Portfolio* (Nov. 1944), cover. More recently, see *Encyclopaedia of New Orleans Artists,* 340; P&H Samuels, 423.

SCHELL, Frank Cresson *[Illustrator, writer] b.1857, Phila. / d.1942.*

Addresses: Phila., PA. **Studied:** T. Eakins; Anshutz. **Member:** Artists Aid Soc.; F. PAFA; Phila. Art All.; Phila. Sketch Club; Fairmount Park AA; Artists Fund Soc. **Exhibited:** PAFA Ann., 1895; AIC, 1896. **Work:** Mystic Seaport Mus.; Phila. Marine Mus.; Atwater Kent Mus.; Phila. **Comments:** Illustr.: *Harper's.* Position: art ed., *Leslie's, North American,* 1903-25. **Sources:** WW25; Falk, *Exh. Record Series.*

SCHELL, Frederick B. (or A.) *[Landscape & seascape painter] b.c.1838, Philadelphia, PA / d.1905, Chicago, IL.*
Addresses: Philadelphia, PA. **Exhibited:** NAD, 1880; PAFA Ann., 1880, 1883-85; Boston AC, 1888-89, 1892-93. **Comments:** The son of Charles Schell, bookkeeper. **Sources:** G&W; 8 Census (1860), Pa., LVIII, 349; Phila. CD 1871; Falk, *Exh. Record Series.*

SCHELL, Gus G. *[Scenic painter] early 20th c.*
Addresses: Columbus, OH. **Member:** Pen & Pencil Club, Columbus. **Sources:** WW25.

SCHELL, J. H. *[Combat artist] 19th c.*
Comments: Special artist for *Leslie's* during the Civil War. His views of troups operating along the James River at Westover were published in 1862. **Sources:** Wright, *Artists in Virginia Before 1900.*

SCHELL, John J. *[Lithographer] mid 19th c.*
Addresses: Philadelphia, 1856-59. **Comments:** With Jacobus & Schell (see entry). **Sources:** G&W; Phila. CD 1856-59.

SCHELL, Susan Gertrude *[Painter of landscape & genre, teacher] b.1891, Titusville, PA / d.1970.*
Addresses: Philadelphia, PA; Germantown, PA. **Studied:** State Teachers College, West Chester, PA; PAFA. **Member:** NAWA; Phila. Art All.; Mystic AA; The Ten; Germantown AL. **Exhibited:** NAWA, 1934 (prize), 1936 (prize), 1940 (prize); Moore College of Art & Design, Phila., 1998 (retrospective, "The Philadelphia Ten"); Woodmere Art Gal., Phila. 1962 (solo), 1972 (solo). **Work:** New Britain Mus.; State Teachers College, PA. **Comments:** Teaching: PM Sch. IA, Phila., 1925-56. **Sources:** WW59; WW47; Talbott and Sidney, *The Philadelphia Ten.*

SCHELLENBERG, Plum B. *[Marine painter] late 19th c.*
Addresses: Detroit, MI. **Exhibited:** Detroit Mus. Art, 1894. **Sources:** Gibson, *Artists of Early Michigan,* 209.

SCHELLENEN, C. *[Portrait artist] early 19th c.*
Comments: Drew a crayon portrait about 1840 of Mrs. Edward Mayer, owned in Ferrisburg (VT) in 1941. **Sources:** G&W; WPA (Mass.), *Portraits Found in Vermont.*

SCHELLENGER, E. M. *[Painter, miniaturist] 19th/20th c.*
Addresses: NYC, active 1897-1901. **Exhibited:** Boston AC, 1897-98; PAFA Ann., 1898. **Sources:** WW01; Falk, *Exh. Record Series.*

SCHELLER, Hilda M. *[Painter] b.1879.*
Work: Western Hist. Art Coll., Denver Pub. Lib. (landscape painting). **Sources:** Petteys, *Dictionary of Women Artists.*

SCHELLIN, Robert William *[Painter, educator, graphic artist, drawing specialist] b.1910, Akron, OH / d.1985, Milwaukee, WI.*
Addresses: Milwaukee, WI. **Studied:** Univ. Wisc.-Milwaukee (B.A., 1933); Hans Hofmann, New York, 1939-40; Univ. Wisc.-Madison (M.A., 1948); F. Taubes; G. Moeller. **Member:** Wisc. P&S; Wisc. Designer Craftsmen; Am. Craftsmen Council. **Exhibited:** AIC, 1933 (med.), 1944 AGAA, 1945; CMA, 1945; Walker AC, 1946; Milwaukee AI, 1933 (silver med.), 1936, 1939; Newark Mus., 1943; Portland Art Mus., 1946; Kalamazoo Inst. Art, 1946; Wisc. P&S, 1930-46; Madison Salon, 1936-37, 1944-45; Wisc. State Fair, 1943 (prize), 1944 (prize); Madison AA, 1945 (prize); U.S. Info Agency Am. Crafts Exh., Europe, 1961-62; Wisc. Craftsman, Smithsonian Inst., Wash., DC, 1962; Four Ceramists, Tweed Gal., Duluth, MN, 1963; Milwaukee AC, 1957 (Design Excellence Award), 1962 (first award for ceramics), 1964 (Commemorative Exh. Wisc. Art),1968 (Wisc. Art, 1850 To

Today). **Work:** Milwaukee (WI) Art Center; Whitefish Bay (WI) Pub. Sch.; Milwaukee State Teachers College; Madison AA; Univ. Wisc.-Milwaukee; Kenosha (WI) Pub. Mus. **Comments:** Preferred media: acrylics, clay. Positions: mem., Milwaukee Art Comn., 1962-70, chmn., 1968-70. Teaching: Milwaukee State College, 1945-51; Univ. Wisc. -Milwaukee, 1951-. **Sources:** WW73; WW47; add'l info. courtesy Anthony R. White, Burlingame, CA.

SCHEMPP, Theodore *[Painter] early 20th c.*
Addresses: Oberlin, OH. **Sources:** WW25.

SCHENCK, Albert F. *[Painter] early 20th c.*
Addresses: Phila., PA. **Sources:** WW06.

SCHENCK, Caroline C. *[Painter] 19th/20th c.*
Addresses: Phila., PA. **Exhibited:** PAFA Ann., 1887-88. **Sources:** WW13; Falk, *Exh. Record Series.*

SCHENCK, Edgar C. *[Museum director] b.1909, Hot Springs, NC.*
Addresses: Eastern Parkway (38); Brooklyn 1, NY. **Studied:** Princeton Univ (A.B.; M.F.A.). **Member:** AAMus.; CAA; AFA; Assn. Art Mus. Dir.; Mus. Council, NYC. **Comments:** Position: dir., Honolulu Acad. Art, 1934-47; dir., Smith College Mus., 1947-49; dir., Albright Art Gal., 1949-55; dir., Brooklyn Mus., 1955-. Auth.: "Expressionism in American Painting," 1952; "Painter's Painter," 1953; "What Is Painting?" 1953. Contrib. to *Am. Journal of Archaeology; Art Bulletin; College Art Journal; Bulletin of the Albright Art Gallery; Annual Bulletin, Honolulu Academy of Arts.* Lectures: Oriental, Polynesian, Western Painting, to museums, clubs and universities. Exhibitions arranged: Moore and Rodin, 1948; Pompaiana, 1949; Eugene Speicher, 1950. **Sources:** WW59.

SCHENCK, Edwin *[Painter] early 20th c.*
Addresses: Baltimore, MD. **Studied:** Académie Julian, Paris. **Member:** Charcoal Club. **Exhibited:** NAD, 1891-1896; PAFA Ann., 1892. **Sources:** WW21; Falk, *Exh. Record Series.*

SCHENCK, Franklin Lewis *[Painter] b.1885.*
Addresses: Northport, LI, NY. **Exhibited:** S. Indp. A., 1922. **Sources:** Marlor, *Soc. Indp. Artists.*

SCHENCK, James R. *[Engraver (?), copperplate printer] early 19th c.*
Addresses: Charleston, SC, 1819. **Sources:** G&W; Rutledge, *Artists in the Life of Charleston.*

SCHENCK, John H. *[Wood engraver] mid 19th c.*
Addresses: Boston, 1852-56. **Comments:** In 1853-54 Schenck was partner with Frederick J. Pilliner (see entry) in Schenck & Pilliner, engravers. **Sources:** G&W; Boston CD 1852-56.

SCHENCK, Marie Pfeifer (Mrs. Frank) *[Art director, sculptor] 20th c.; b.Columbus, OH.*
Addresses: Miami 38, FL. **Studied:** Cleveland Sch. Art; Columbus Sch. Art; Hugo Robus; John Hussey; Bruce Wilder Saville; Alys Roysher Young. **Member:** Am. Soc. for Aesthetics; Miami Art Lg. **Exhibited:** Columbus Art Lg.; Miami Art Lg.; Sarasota AA. Awards: Miami Woman's Club, 1957 (medal); City of Miami Beach, 1964 (citation, Hon. Citizen). **Comments:** Teaching: Columbus Art Sch.; Coburn Private School, Miami Beach; art dir., City of Miami Beach AC, 1942-64. **Sources:** WW66.

SCHENCK, Philip E. *[Artist] late 19th c.*
Addresses: Wash., DC, active 1896. **Sources:** McMahan, *Artists of Washington, DC.*

SCHENCK, Phoebe Josephine *[Painter] b.1883, Cleveland, OH.*
Addresses: NYC/Cos Cob, CT. **Studied:** Cleveland with Keller & Gottwald; DuMond, Henri & Chase in NYC. **Exhibited:** Salons of Am.; S. Indp. A., 1917-19, 1923. **Sources:** WW15.

SCHENCK, Robert C. *[Painter] early 20th c.*
Addresses: Chicago, IL. **Member:** Chicago NJSA. **Sources:** WW25.

SCHENCK & PILLINER *[Engravers] mid 19th c.*
Addresses: Boston, active 1853-54. **Comments:** Partners were John H. Schenck and Frederick J. Pilliner (see entries). **Sources:** G&W; Boston CD 1853-54.

SCHENEEBERGER, E. *[Miniature painter] early 20th c.*
Addresses: Chicago. **Exhibited:** AIC, 1910-11. **Sources:** Falk, *AIC.*

SCHENEEBERGER, J. *[Miniature painter] early 20th c.*
Addresses: Chicago. **Exhibited:** AIC, 1911. **Sources:** Falk, *AIC.*

SCHENK, A. *[Painter] mid 19th c.*
Exhibited: NAD, 1874. **Sources:** Naylor, *NAD.*

SCHEPP, Joseph J. *[Painter] mid 20th c.*
Addresses: NYC. **Exhibited:** S. Indp. A., 1944. **Sources:** Marlor, *Soc. Indp. Artists.*

SCHER, Edward *[Painter] b.1947.*
Addresses: NYC. **Exhibited:** WMAA, 1972. **Sources:** Falk, *WMAA.*

SCHERBAKOFF, Sergey John *[Painter] b.1894, Kokovka, Russia / d.1967.*
Addresses: San Francisco, CA. **Studied:** Kharkov Acad. FA (art & arch.). **Member:** Russian Art Soc.; San Fran. AA; Soc. Western Art. **Exhibited:** Ring Soc., Kharkov, 1912 (first solo); Calif. Soc. FA, 1927; Calif. State Fair, Sacramento, 1927; Santa Barbara Art Lg., 1928; Oakland Art Lg., 1928; LACMA, 1930; Berkeley Art Lg., 1930; CPLH, 1931; Stanford Art Gal., 1931; Gump's, San Fran., 1933; Courvoisier Gal., San Fran., 1934; Acad. Allied Arts, NYC, 1934; SFMA, 1935; GGE, 1939. **Work:** SFMA; Oakland Mus. **Comments:** During the Russian Revolution he lost most of his family and fled to Japan in 1919. There he sold many of his marine paintings to the imperial family, and was able to go to San Francisco in 1922. Specialty: watercolor landscapes of Yosemite, Russian River, Carmel and Marin County. **Sources:** Hughes, *Artists of California,* 494.

SCHERBONNIER, Henry *[Lithographer] b.c.1810, France.*
Addresses: Philadelphia. **Comments:** He and his wife were French, but their nine children, aged 19 to 2, were born in Philadelphia. **Sources:** G&W; 7 Census (1850), Pa., LI, 432.

SCHERER, Lester George *[Architect, painter, inventor] b.1898, Minnesota / d.1973, Los Angeles, CA.*
Addresses: Los Angeles, CA. **Member:** P&S Los Angeles. **Sources:** Hughes, *Artists of California,* 495.

SCHERMERHORN, B. B. (Mrs.) *[Artist] late 19th c.*
Addresses: Active in Hudson, MI, 1899. **Sources:** Petteys, *Dictionary of Women Artists.*

SCHERMERHORN, E. E. *[Painter] late 19th c.*
Addresses: NYC, 1871. **Exhibited:** NAD, 1871. **Sources:** Naylor, *NAD.*

SCHERMERHORN, Sophie E. *[Watercolorist] d.1914.*
Work: Western Hist. Coll., Denver Pub. Lib. (Colorado wild flowers, winter scenes). **Sources:** Petteys, *Dictionary of Women Artists.*

SCHERNBECK, John C. *[Painter, decorator] b.1854, New Orleans, LA / d.1909, New Orleans.*
Addresses: New Orleans, active 1881-1908. **Sources:** *Encyclopaedia of New Orleans Artists,* 340.

SCHERON, William *[Engraver] b.c.1827, Germany.*
Sources: G&W; 7 Census (1850), Pa., LII, 919.

SCHETKY, Caroline (Mrs. Sam. Richardson) *[Miniature, portrait, landscape & still life painter] b.1790, Edinburgh, Scotland / d.1852, Boston.*
Addresses: Philadelphia, c.1818-25; Boston 1825-52. **Exhibited:** PAFA, 1818-26 (miniatures and watercolor landscapes); Baltimore Mus., 1822 (she was invited to exhibit by Rubens Peale); Boston Athenaeum, 1827-41. **Comments:** Caroline Schetky was a daugh-

ter of the Scottish musician, Johann Georg Christoph Schetky, and a younger sister of artist, John Christian Schetky. By 1818, she was living in Philadelphia with another brother, the musician, George Schetky. The initial difficulties she experienced as a woman in gaining access to cultural circles in Philadelphia were described in a letter written to a friend in 1818 (Caroline Schetky to Ana Johnson, August 5, 1818, in Laurence Schetky, p. 200). Rubens Peale invited her to exhibit at his Baltimore Museum in 1822. Upon her marriage in 1825 to Samuel Richardson of Boston, she moved to that city. She was also an organist for the Brattle Street Church. **Sources:** G&W; Schetky, *The Schetky Family;* Vinton, *The Richardson Memorial,* 125-26; Phila. CD 1820-28; Rutledge, PA; Swan, BA; repro., *Analectic Magazine,* XIV (1819), frontis. More recently, see Miller, ed. *The Peale Family,* 230-31 which mentions Schetky's feeling of isolation in Philadelphia.

SCHETKY, John Christian *[Marine painter] b.1778, England / d.1874, England.*
Addresses: Portsmouth, England. **Exhibited:** PAFA, 1821. **Comments:** An elder brother of artist Caroline Schetky (who moved to Phila. c.1818), Groce & Wallace included him in their dictionary because he exhibited three works at PAFA in 1821; they did state, however, that it was probable he did not visit America himself. He was for many years professor of drawing at the Royal Naval College at Portsmouth (England) and also Marine Painter in Ordinary to George IV, William IV, and Victoria. **Sources:** G&W; Rutledge, PA; DNB.

SCHETTER, Charlotte O. *[Painter] early 20th c.*
Addresses: Orange, NJ. **Exhibited:** NAD, 1900. **Sources:** WW15.

SCHETTONE, Joseph *[Sculptor] mid 20th c.*
Addresses: Norristown, PA. **Exhibited:** PAFA Ann., 1966. **Sources:** Falk, *Exh. Record Series.*

SCHEU, Leonard *[Painter, lecturer, lithographer, illustrator] b.1904, San Francisco, CA.*
Addresses: Laguna Beach, CA. **Studied:** Calif Sch. FA, San Fran.; ASL, drawing with George Bridgeman. **Member:** Laguna Beach AA (mem. bd., 1956-; pres., 1956-57; exh. chmn., 1956-58); San Diego AA; Aquarelle Painters of Southern Calif.; San Diego AG; Calif. Nat. WCS; Nat. Soc. Painters Casein (bd. mem., 1956-59); Soc. Western Artists; New Jersey P&S. **Exhibited:** San Fran. AA, 1935; NYWCC, 1936; Laguna Beach AA, 1935-46; GGE, 1939; BM, 1941; Oakland Art Gal., 1938, 1945-46; Santa Cruz Art Lg., 1935, 1938; Found. Western Artists, 1936, 1938-39; Santa Fe New Mexico, 1937; San Diego FAS, 1938; Calif. State Fair, 1938, 1940-41; San Diego AG, 1938, 1939; Bowers Mem. Mus., 1939; Aquarelle Painters of Southern Calif., 1939; Santa Paula, CA, 1941-42; Calif. WCS, 1943; Riverside Mus., 1946; U.S. Naval Acad., Annapolis, MD, 1965; Butler Inst. Am. Art, Youngstown, OH, 1968; Holyoke (MA) Mus., 1969; Erie (PA) Pub. Mus., 1970; Anchorage (AK) FA Mus., 1971; William D. Gorman, Bayonne, NJ, 1970s. **Work:** Ford Motor Co. Coll., Dearborn (MI) Mus. **Commissions:** Calif. Motherlode & Jacksonville, OR, Ford Motor Co. **Comments:** Preferred media: watercolors, oils. Positions: juror, local & nat. exhs., 1953-. Publications: illustr., "Good Ghost Towns Never Die," *Lincoln Mercury Times,* 1954; illustr., "Saga of Cinnabar, New Almaden," 1954 & Gold Rush Town that Took its Time," 1961, *Ford Times.* Teaching: Whittier (CA) Sch. System, 1961-70; Banff Sch. FA, Univ. Alberta, 1962-65; Orange Coast College, 1962-67. **Sources:** WW73; M. Jackson, article, *Laguna Beach Post,* 1955.

SCHEUBER, Sylvia Fein See: **FEIN, Sylvia (Mrs. Sylvia Fein Scheuber)**

SCHEUCH, Harry William *[Painter, lithographer, designer, sculptor, teacher] b.1906, Elizabeth, NJ / d.1978, Pittsburgh, PA.*
Addresses: Edgewood, PA; Pittsburgh, PA. **Studied:** CI; Univ. Pittsburgh; A. Kostellow; G. Romagnoli. **Member:** Pittsburgh AA. **Exhibited:** Gulf Gals., 1934 (first solo); AIC, 1937-38; CI;

WMAA, 1947-49; Butler AI, 1942 (prize), 1943, 1955; Pepsi-Cola Exh., 1947 (medal), 1948 (medal); Pittsburgh AA, 1946 (prize), 1947 (prize),1948 (prize), 1951 (prize), 1952 (prize); Westmoreland County Mus., Greensburg, PA, 1962 (solo); Hist. Soc. Western Penn., 1981 (retrospective). **Work:** Butler AI; Prnn. State Univ; Pittsburgh Pub. Schs.; murals, City County Bldg., Pittsburgh; WPA mural, USPO, Scottdale, PA; 100 Friends of Pittsburgh Art; Labor Bldg., Wash., DC. **Comments:** Position: dir., Pittsburgh WPA, 1937-40; instr., Irene Kaufmann Settlement and privately. He regarded himself as a contemporary painter, depicting outdoor scenes and people in a realistic style. In the summer of 1953, he sold shares in paintings he was planning to make in Paris during a seven-week study period and returned with 50 canvases. **Sources:** WW59; WW47. More recently, see, Chew, ed., *Southwestern Pennsylvania Painters,* 114-17.

SCHEUER, Suzanne *[Painter, sculptor, mural painter] b.1898, San Jose, CA / d.1984, Santa Cruz, CA.*
Addresses: San Francisco; Santa Cruz. **Studied:** Calif. Sch. FA with Ray Boynton; Calif. College Arts & Crafts. **Exhibited:** San Fran. AA, 1925. **Work:** murals: Coit Tower, San Francisco; USPOs, Berkeley, CA; Caldwell, Eastland, both in Texas. **Comments:** WPA artist. Teaching: Los Banos & Salinas public schools; College of the Pacific, Stockton, CA, 10 years. **Sources:** WW40; Hughes, *Artists of California,* 495.

SCHEUERLE, Joseph *[Painter, illustrator, lithographer] b.1873, Vienna, Austria / d.1948, South Orange, NJ.*
Studied: Cincinnati AA. **Member:** Cincinnati AC. **Exhibited:**. **Work:** Boileau coll., Birmingham, MI. **Comments:** Came to Cincinnati in 1882. He was apprenticed to a lithographer and afterwards employed as a commercial artist. In 1896 he sketched Indians for posters. In 1900 he moved to Chicago, where he worked as an illustrator and produced Buffalo Bill posters. He made trips West, painting the Sioux Indian in 1909, the Crow and Blackfoot, 1910, the Cheyenne in 1911 and others. He was a friend of C.M. Russell, Gollings, and de Young. He moved back to Cincinnati during WWI and to NYC in 1923. **Sources:** WW04; P&H Samuels, 423.

SCHEUERMANN, Joseph *[Portrait painter] mid 19th c.*
Addresses: NYC, 1854-57. **Sources:** G&W; NYBD 1854, 1857.

SCHEUKER, Harry *[Sculptor] early 20th c.*
Addresses: Paris, France. **Sources:** WW13.

SCHEUREN, E. F. *[Painter] early 20th c.*
Addresses: Cleveland, OH. **Member:** Cleveland SA. **Sources:** WW27.

SCHEURTZEL, Anton *[Painter] early 20th c.*
Exhibited: AIC, 1930. **Sources:** Falk, *AIC.*

SCHEVER, Fannie *early 20th c.*
Exhibited: Salons of Am., 1934. **Sources:** Marlor, *Salons of Am.*

SCHEVILL, Margaret Erwin *[Painter, author, poet] b.1887, Jersey City, NJ / d.1962, Tucson, AZ.*
Addresses: Tucson, AZ; Berkeley, CA; Tucson, AZ. **Studied:** Wellesley College; William Gaw. **Work:** Wheelwright Mus., Santa Fe, NM; Univ. Arizona Mus., Tucson. **Comments:** Teaching: Tucson H.S. (English); Presidio Sch., San Fran. Auth.: *Canyon Gardens,* 1922 (poems); two books on Navajo myths, *Beautiful on the Earth,* and *The Pollen Path.* Specialty: Southwestern scenes, watercolors of the Navajos. **Sources:** Hughes, *Artists of California,* 495.

SCHEVILL, William V. *[Portrait painter] b.1864, Cincinnati, OH.*
Addresses: NYC; St. Louis, MO; Los Angeles, CA. **Studied:** Munich with Loefftz, Lindenschmitt, Gysis. **Member:** Century Assoc.; SC; St. Louis GA; AFA. **Exhibited:** St. Louis Expo, 1904 (bronze med.); PAFA Ann., 1907, 1922. **Work:** Cincinnati Mus.; portrait, Prince Henry of Prussia, Herron AI; Leipzig AM; portraits, Wash. Univ., St. Louis; War Dept., Wash., DC; St. Louis Art Mus. **Sources:** WW40; Falk, *Exh. Record Series.*

SCHEVLIN, Rubye Everts (Mrs. Joseph F.)
[Craftsperson, block printer, etcher, teacher] b.1892, Anthon, IA.
Addresses: Washington, DC. **Studied:** Iowa State Teachers College; Morningside College; Bess B. Morton; Chicago Acad. FA; George Scheirer; June Constable. **Exhibited:** Wash., DC. **Work:** YWCA. **Comments:** Teaching: YWCA, Wash., DC; St. Elizabeth's Hospital. **Sources:** WW40; Ness & Orwig, *Iowa Artists of the First Hundred Years*, 185; McMahan, *Artists of Washington, DC.*

SCHEWE, Theodore E. *[Painter] mid 20th c.*
Exhibited: S. Indp. A., 1938. **Sources:** Marlor, *Soc. Indp. Artists.*

SCHICK, Elma H. *[Painter] early 20th c.*
Addresses: Phila., PA. **Sources:** WW25.

SCHICK, Fred G(eorge) *[Painter, illustrator] b.1893, Buffalo, NY.*
Addresses: Buffalo, NY. **Studied:** Wilcox; M.B. Cox. **Member:** Buffalo AC. **Sources:** WW25.

SCHICK, Paul Raymond *[Painter, lecturer] b.1888, Bellaire, OH.*
Addresses: West Redding, CT. **Member:** SC. **Exhibited:** WFNY, 1939 (prize); GGE, 1939; SC, 1940-46; Soc. Four Arts; Norton Gal.; Newport AA; Guild Hall, East Hampton, NY, 1940 (prize); Ball State Teachers College. **Work:** Norton Gal., West Palm Beach, FL; murals, churches in Shreveport, LA; Bosier City, LA. **Comments:** Lectures: "The Importance of Art in the Post-War World." **Sources:** WW53; WW47.

SCHIEBALD, R(udolph) (M.) *[Painter] early 20th c.*
Addresses: NYC. **Exhibited:** S. Indp. A., 1929-32, 1937; Salons of Am., 1934. **Sources:** Falk, *Exhibition Record Series.*

SCHIEBLING, H. C. *early 20th c.*
Exhibited: Salons of Am., 1924. **Sources:** Marlor, *Salons of Am.*

SCHIEBOLD, Rudolph M. See: **SCHIEBALD, R(udolph) (M.)**

SCHIEFER, Henry *[Engraver] mid 19th c.*
Addresses: NYC, 1851. **Comments:** Probably the same as H. Scheifer and Herman Schieffer. **Sources:** G&W; NYCD 1851.

SCHIEFER, Johannus *[Painter] mid 20th c.*
Exhibited: PAFA Ann., 1945. **Sources:** Falk, *Exh. Record Series.*

SCHIEFFER, Herman *[Engraver] mid 19th c.*
Addresses: NYC, 1851. **Comments:** Probably the same as H. Scheifer and Henry Schieffer. **Sources:** G&W; NYCD 1851.

SCHIEFFER, Paul *[Lithographer] b.c.1818, Germany.*
Addresses: NYC, active c.1850. **Sources:** G&W; 7 Census (1850), N.Y., XLI, 495.

SCHIEL, Mary *[Artist] late 19th c.*
Addresses: Active in Saginaw, MI, 1897-99. **Sources:** Petteys, *Dictionary of Women Artists.*

SCHIENMAN, Esther *[Painter] mid 20th c.*
Addresses: Chicago area. **Exhibited:** AIC, 1941. **Sources:** Falk, AIC.

SCHIER, Helwig, Jr. *[Mural painter] 19th/20th c.*
Addresses: NYC. **Member:** Arch. Lg., 1898. **Sources:** WW10.

SCHIFF, Fredi *[Painter] b.1915, Cincinnati, OH.*
Addresses: Columbus, OH. **Studied:** Columbus Art Sch.; Gromaire, Paris; J. Smith. **Member:** Columbus AL; Ohio WCS; AAPL. **Exhibited:** Ohio WCS; Columbus AL, 1935 (prize), 1937 (prize), 1938 (prize). **Work:** Columbus Art Gal. **Sources:** WW40.

SCHIFF, Lonny *[Painter, printmaker] mid 20th c.*
Addresses: Framingham Centre, MA. **Studied:** Univ. Illinois (B.A., honors, 1953); Worcester Art Mus. Sch. (fine arts cert., 1964); etching study, Impressions Workshop, 1965. **Member:** NAWA; Cambridge AA (dir.); Copley Soc.; Sudbury AA; Int. Inst. for Conserv., London. **Exhibited:** Cape Cod AA, 1970-; Spectrum

Gal., 1972; Providence Art Club, 1971; Cambridge AA, 1972 (solo), Copley Soc., Boston, 1973 (solo) & Brandeis Univ., 1973(solo). Awards: first prize in graphics, & Larry Newman prize in oils, Cape Cod AA, 1971; Minna Pinter Prize in Graphics, Cambridge AA, 1971. **Work:** Commissions: complete restoration of 18 portraits for Framingham Hist. Soc., 1967; suite of 11 paintings, Radler Assoc., Wellesley, MA, 1968. **Comments:** Preferred media: oils, watercolors, graphics. Teaching: adult oil painting classes, Worcester Art Mus., 1963-67; Sudbury AA, 1968-69; Charles River AC, 1968. Research: lost old masters, conservation. **Sources:** WW73.

SCHIFF, Rose B. *[Painter] mid 20th c.*
Exhibited: S. Indp. A., 1943. **Sources:** Marlor, *Soc. Indp. Artists.*

SCHIFFER, Ethel Bennett (Mrs. W. B.) *[Painter] b.1879, Brooklyn, NY.*
Addresses: New Haven, CT. **Studied:** Yale Univ.; ASL. **Member:** New Haven PCC; NAWPS; New Haven Pen & Brush Club (pres.); Springfield AL; CAFA. **Exhibited:** S. Indp. A., 1917; CAFA, 1932; New Haven PCC, 1937 (prize). **Sources:** WW40.

SCHIFFER, William *[Painter] early 20th c.*
Addresses: NYC. **Exhibited:** S. Indp. A., 1929-30. **Sources:** Marlor, *Soc. Indp. Artists.*

SCHIFFMAN, Byron S(tanley) *[Painter] mid 20th c.*
Studied: ASL. **Exhibited:** S. Indp. A., 1941. **Sources:** Marlor, *Soc. Indp. Artists.*

SCHIFFMAN, Richard *[Painter] mid 20th c.*
Exhibited: S. Indp. A., 1937. **Sources:** Marlor, *Soc. Indp. Artists.*

SCHIFFMAN, Sterling *[Painter] mid 20th c.*
Exhibited: S. Indp. A., 1941. **Sources:** Marlor, *Soc. Indp. Artists.*

SCHIFRIN, Arnold *[Artist] mid 20th c.*
Addresses: Topanga, CA. **Exhibited:** PAFA Ann., 1960. **Sources:** Falk, *Exh. Record Series.*

SCHILCOCK, Charles *[Lithographer] b.c.1830, Ohio.*
Addresses: Philadelphia, 1860. **Comments:** He was in the same boarding house with Francis Devannie, sculptor (see entry), and Nicholas Ships and Adolphe Laborn, lithographers (see entries). **Sources:** G&W; 8 Census (1860), Pa., LII, 432.

SCHILDKNECHT, Edmund Gustav *[Painter, etcher, teacher] b.1899, Chicago, IL / d.1985, Eastport, ME?.*
Addresses: Indianapolis, IN; Eastport, ME. **Studied:** Wisconsin Sch. Art; PAFA with D. Garber; Acad. Julian, Paris; Acad. Grande Chaumière, Paris; Oberteuffer. **Member:** Indiana AC; Indiana PM. **Exhibited:** Salons of Am.; S. Indp. A., 1930; Corcoran Gal. biennial, 1930; AIC, 1928-29, 1931, 1934-36; PAFA, 1930, 1944; PAFA Ann., 1932, 1935; SAGA, 1937-38, 1943; CM, 1931-34; Hoosier Salon, 1943-44, 1946 (prize); Kansas City AI, 1935-36; John Herron AI, 1924-46, 1951-56 (prizes, 1932-33, 1939); Magnificent Mile, Chicago, 1955; Indiana Art Club, 1950-56 (prizes, 1952-55). **Work:** John Herron AI; Univ. Indiana; Arsenal Tech. H.S., Crispus Attucks H.S., Indianapolis; 600 paintings at Univ. Maine, Oronco. **Comments:** Teaching: Arsenal Technical H.S., Indianapolis, IN, 1924-57. **Sources:** WW59; WW47; Falk, *Exh. Record Series.*

SCHILDKNECHT, Ruth Stebbins (Mrs. Edmund G.)
[Painter, sculptor, teacher] 20th c.; b.Battle Creek, MI.
Addresses: Indianapolis, IN. **Studied:** AIC; Chicago Acad. FA; PAFA; A. Faggi. **Member:** Indiana PM. **Exhibited:** forty-fourth annual, NAWPS, 1935 (prize); Wichita AA, 1936 (prize). **Sources:** WW40.

SCHILL, Alice E. *[Painter] mid 20th c.*
Addresses: Richmond, IN. **Exhibited:** Hoosier Salon, 1934; Richmond AA, 1939. **Sources:** WW40.

SCHILLE, Alice *[Painter] b.1869, Columbus, OH / d.1955, Columbus.* *A. Schille.*
Addresses: Columbus. **Studied:** Columbus Art Sch., 1891-93;

ASL, 1897-99; NY Sch. Artwith W.M. Chase, K. Cox, 1897-99; Acad. Colarossi , Paris, 1903-04; privately in Paris with R.F.X. Prinet, J.R. Collin, G.C.E. Courtois & Wm.M. Chase. **Member:** AWCS; NAWA; NYWCC; Chicago WCC; Phila. WCC; Boston WCC; Soc. Western Artists. **Exhibited:** Louvre, Paris, 1900; AIC, 1904-28; Corcoran Ga.l biennials, 1907-12 (3 times); PAFA Ann., 1907-16, 1928; PAFA 1915 (Phila. WCC prize); Wash. WCC at CGA, 1908 (Corcoran Prize); NY Women's AC, 1908-09 (prizes); Jackson AA, 1910 (first solo); Cincinnati Art Mus., 1911 (solo), 1915 (solo); Soc. Western Artists, 1906-14 (prize, 1913); Ohio State Fair, 1914 (6 first prizes); Pan-Pacific Expo, San Fran., 1915 (gold for watercolor); Columbus AL, 1912 (solo), 1919 (1st prize), 1920 (Stevens prize); St. Louis AM, 1917 ("Six American Women"); Mus. New Mexico, 1920 (solo); Columbus Gal. FA, 1921 (solo), 1932 (solo), 1964 (solo); NAWA, 1929 (prize); Women's Int. Assn., Detroit, 1930 (prize); Phila. WCC, 1932 (first prize); El Paso Mus. Art, 1972 (retrospective); Vose Gal., Boston, 1982 (solo); High Mus. Art, Atlanta, 1986 ("Am. Post-Impressionism"); Nat. Mus. Women in Arts, 1987 (traveling survey); Keny & Johnson Gal., Columbus, 1987 (retrospective); Columbus Mus. Art, 1988 (traveled to Cheekwood FAC, Nashville); Canton AI and Hickory Mus. Art, 1989. **Work:** PAFA; Indianapolis MA; Phila. AC; Columbus MA; M.H. de Young Mus.; Colby College Mus. Art; Canton AI (OH); Capitol Univ. Columbus, OH; El Paso Mus. Art; High Mus. Art, Atlanta; McNay Art Mus., San Antonio; Ohio State Univ.; Univ. Club, Columbus. **Comments:** One of the leading women watercolor painters, she worked in the Post-Impressionist style. She traveled and painted landscapes from New England to Europe, North Africa, Corsica, the Middle East, England, Norway and Greece, to California and the Yucatan. She painted her first pointillist watercolor in 1909, and by 1913 she was the subject of a feature article in *Int. Studio.* She painted and exhibited in the Gloucester area during the summers of 1916-18 and began to employ Fauvist colors and expressive daubing. In 1922, she painted her first series of North African watercolors and would return there in 1929. From 1926-47 she spent many summers in the southwest and Mexico. In the 1930s-40s she traveled in Central America and New Mexico. Teaching: Columbus Art School, OH, 1902-48. **Sources:** WW53; WW47; Tufts, *American Women Artists,* cat. no. 69; exh. catalogues cited above from Vose Galleries (1982), High Mus. Art (1986), Keny & Johnson Gal, Columbus (1987), and Columbus MA (1988); Trenton, ed. *Independent Spirits,* 159; Falk, *Exh. Record Series.*

SCHILLER, Albert *[Artist] b.1899, Russia / d.1970, Brooklyn, NY.*
Addresses: Active in Brooklyn, NY, 1928-29. **Exhibited:** Salons of Am.; S. Indp. A., 1928-29, 1937. **Sources:** BAI, courtesy Dr. Clark S. Marlor.

SCHILLER, Beatrice *[Painter, graphic artist] 20th c.; b.Chicago, IL.*
Addresses: Chicago, IL. **Studied:** Inst. Design; Illinois Inst. Technology; AIC; Richard Florsheim; Jack Kearney; Herbert Davidson; Kwak Wai Lau; Stanley Mitruk. **Member:** Chicago Soc. Artists; Illinois Inst. Tech. (alumni); Munic. Art Lg. Chicago; AIC Art Rental & Sales Gal.; North Shore Art Lg. **Exhibited:** Nat. Exh Small Paintings, Purdue Univ., Lafayette, 1964; 17th Ann. Exh. Realistics Art, Mus. FA, Springfield, MA, 1966; AIC Art Rental & Sales Gal., IL, 1966-; Butler Inst. Am. Art, Youngstown, OH, 1967; New Horizons in Sculpture & Painting, Chicago, 1970. **Awards:** Reinhardt H. Jahn Purchase Prize, Sixth Union Lg. Art Show, 1965; Herbert C. Brook Purchase Prize, Seventh Union Lg. Art Show, 1967; hon. men., Munic. Art Lg. Chicago, 1971. **Comments:** Preferred media: watercolors, graphics, acrylics. **Sources:** WW73.

SCHILLER, Dorothy *[Painter] mid 20th c.*
Studied: ASL. **Exhibited:** S. Indp. A., 1922, 1924, 1926, 1943-44. **Sources:** Marlor, *Soc. Indp. Artists.*

SCHILLER, Gottfried *[Engraver] mid 19th c.*
Addresses: Newark, NJ in 1860. **Sources:** G&W; New Jersey BD 1860.

SCHILLING, Alexander See: **SHILLING, Alexander**

SCHILLING, Arthur O(scar) *[Painter, illustrator, drawing specialist, lecturer, writer] b.1882, Germany / d.1958, Rochester, NY.*
Addresses: Rochester, NY. **Studied:** Chicago; Buffalo; Rochester; Munich, Germany. **Member:** Buffalo AC. **Exhibited:** Salons of Am. **Comments:** Illustr.: "American Standard of Perfection on Poultry. Position: offical artist, Am. Poultry Assn. **Sources:** WW40.

SCHIMMEL, Norbert *[Collector] b.1904.*
Addresses: NYC. **Comments:** Positions: trustee, Am. Archaeology Inst.; mem. vis. comt., FA Dept., Harvard Univ. & Fogg Art Mus., mem. vis. comt., Egyptian, Near Eastern & Greek & Roman Art, MMA, New York. Publications: auth., Herberth Hoffmann. Collection: ancient art, especially Etruscan, Egyptian, Greek, Near Eastern and Iranian: works exhibited MMA, 1959 & Fogg Art Mus., 1964. **Sources:** WW73.

SCHIMMEL, William Berry *[Painter, lecturer, illustrator, writer, teacher] b.1906, Olean, NY / d.1989, Tucson, AZ.*
Addresses: Scottsdale, AZ; Paradise Valley, AZ (1976). **Studied:** Rutgers Univ.; Maryland Inst. Art, Baltimore; NAD; Gerry Peirce; Roy Mason. **Member:** AWCS; AAPL; Nat. Arts Club NY; Int. Inst. Arts & Letters. **Exhibited:** NAD (Ann. Watercolor Exh., three years); AWCS (eight years; Emily Goldsmith Award, 1970); Butler Inst. Am. Art, Youngstown, OH; Arizona State Fair (eight Valley Nat. Bank Purchase Awards); Buck Saunders Gal, Scottsdale, AZ (1970s). **Work:** Phoenix FA Mus.; Cincinnati Mus. FA; Univ. Mus., Univ. North Carolina; Phoenix Pub. Lib.; Nat. Casualty Life Ins. Bldg., Phoenix. **Comments:** Preferred media: watercolors, oils. Positions: art dir., Benton & Bowles, NYC, 1935-38. Auth.:"Watercolor, the Happy Medium," Macmillan, 1958. Teaching: Seattle (WA) AA; Fort Worth (TX) Pub. School System; School Mines, Brainerd, MN; Flagstaff (AZ) AA; Tucson (AZ) Watercolor Guild; Phoenix (AZ) Art Mus.; Gerry Peirce Watercolor Sch.; also private classes in Denver & Estes Park, CO, Jackson, WY, Prescott & Phoenix, AZ. **Sources:** WW73; P&H Samuels, 424; death date courtesy Wayne Kielsmeier, Tucson, AZ.

SCHIMONSKY, Stanislas *[Painter] mid 19th c.; b.Schleswig-Holstein, Germany.*
Addresses: Bellevue, NE, c.1852. **Comments:** A farmer, surveyor, and draftsman, he made watercolors of the area and painted some Indian scenes. His name appears as Schimonsky, Schmonsky, Shimonsky, and Tzschumonsky. **Sources:** G&W; WPA Guide, *Nebraska;* Turner, "Early Artists." More recently, see P&H Samuels, 424; Gerdts, *Art Across America,* vol. 3: 73.

SCHINASI, Leon *[Patron] b.1890 / d.1930.*
Addresses: NYC. **Studied:** Juan Iles Pins, France (while traveling). **Comments:** He was one of the foremost business magnates of America. His collection included "Madonna and Child," by Fillipo Lippi, purchased for $125,000. He also had a fine collection of rare tapestries.

SCHINDLER, Elsa *[Painter, illustrator, teacher] b.1880, Philadelphia.*
Addresses: Philadelphia, PA. **Studied:** W.L. Lathrop; E. Daingerfield; H.B. Snell; Phila. Sch. Design for Women (J. Sartain Fellowship). **Exhibited:** AIC, 1906. **Sources:** WW08.

SCHINDLING, Blume *[Painter] early 20th c.*
Addresses: Brooklyn, NY. **Exhibited:** S. Indp. A., 1932. **Sources:** Marlor, *Soc. Indp. Artists.*

SCHINNELLER, James Arthur *[Educator] b.1925, Pittsburgh, PA.*
Addresses: Madison, WI. **Studied:** Edinboro (PA) State Teachers College (B.S. in Art Educ.); Univ. Iowa (M.A. in Art Educ.; M.F.A.). **Member:** Wisc. Art Educ. Assn.; NAEA. **Comments:** Contrib. to *Journal of Education by Film and Radio.* Lectures: Why We Have Art in the Schools. Position: panel mem.r, NAEA, "Art and the Community," Cleveland, 1955. Teaching: art educ.,

Western Illinois State College, 1950-52; Univ. Iowa, 1952-54; Univ. Wisconsin, Madison, 1954-. **Sources:** WW59.

SCHINOTTI, C. A. *[Professor of painting] mid 19th c.*
Addresses: Baltimore, 1842. **Sources:** G&W; Lafferty.

SCHINOTTI, Edward *[Portrait & ornamental painter] mid 19th c.*
Addresses: New Orleans, 1835-46. **Sources:** G&W; New Orleans CD 1846. More recently, see *Encyclopaedia of New Orleans Artists,* 340.

SCHIOTT, Christian *[Painter] b.1882, Oslo, Norway / d.1960, Stamford, CT.*
Addresses: NYC. **Exhibited:** S. Indp. A., 1922-23. **Sources:** Marlor, *Soc. Indp. Artists.*

SCHIPFER, Frederick *[Lithographer] d.c.1894.*
Addresses: New Orleans, active 1884-90. **Sources:** *Encyclopaedia of New Orleans Artists,* 340.

SCHIPPER, Gerritt *[Miniaturist and crayon portraitist] b.1775, Amsterdam (Holland) / d.1830.*
Addresses: Charleston, SC, Boston, MA, 1803; Salem and Worcester, MA, 1804; Hartford, CT, 1805. **Studied:** Paris, 1790s. **Comments:** He came to America early in 1803; was married at Amsterdam (NY) in October 1806; and soon after went to England where he spent the rest of his life. **Sources:** G&W; Hyer, "Gerritt Schipper, Miniaturist and Crayon Portraitist"; repro., NYHS *Annual Report* for 1948, page 8.

SCHIRM, David *[Painter, teacher] b.1945, Pittsburgh, Pennsylvania.*
Addresses: Buffalo, NY. **Studied:** Carnegie Inst. Tech., Pittsburgh (B.F.A., 1967); Indiana Univ., Bloomington (M.F.A., 1972). **Comments:** Moved to Buffalo in 1985. Teaching: State Univ. of New York at Buffalo; Indiana Univ., 1970-72; Carnegie-Mellon Univ., Pittsburgh, PA, 1972-75; Univ. Cincinnati, OH, 1975; Univ. Calif., Los Angeles, 1977-80; Otis Art Inst., Parsons Sch. Design, Brooklyn, NY, 1981-84. **Sources:** Krane, *The Wayward Muse,* 195.

SCHIWETZ, Berthold *[Painter] mid 20th c.*
Addresses: Bloomfield Hills, MI. **Exhibited:** PAFA Ann., 1960. **Sources:** Falk, *Exh. Record Series.*

SCHIWETZ, Edward M. *[Designer, painter, lecturer] b.1898, Cuero, TX.*
Addresses: Houston, TX; living in College Station, TX in 1975. **Studied:** Texas A&M College (B.S. in Arch.); pupil of J. Kellogg; largely self-taught as a painter; ASL. **Member:** Calif. WCS; Texas WCS. **Exhibited:** Houston Artists, 1933 (prize); SSAL, 1936 (prize), 1938 (prize); New Orleans Art Soc., 1936 (prize); Philbrook AC(prize); Houston Mus. FA, 1938, 1939 AIC, 1931, 1943, 1945; AWCS, 1930, 1952, 1954 (prize); Phila. WCS, 1930; Grand Rapids Art Gal., 1940; Colorado Springs FA Center, 1947; Arch. Lg.; CPLH; LOC; Knoedler Gal.; Witte Mem. Mus (solo), 1944 (prize); Ft. Worth AA, 1948 (prize); Dallas Mus. FA (solo); Austin, TX (solo); Corpus Christi, Tex (solo); San Antonio Conservation Soc. (prize); Hughes Tool Co., 1950 (prize). **Work:** Dallas Mus. FA; Mus. FA Houston; Ft. Worth AA; indust. paintings for Standard Oil Co.; Union Oil Co.; Humble Oil & Refining Co.; Dow Chemical Co.; Monsanto Chemical Co. **Comments:** Position: art consult., McCann Erickson Co., Houston, TX. Contrib. illustr.: *Architectural Record, Architectural Forum, Pictorial Review,* and other leading magazines. Auth./illustr.: "Buck Schiwetz's Texas," 1960. Prints included in "Twelve from Texas." **Sources:** WW59; WW40; P&H Samuels, 424.

SCHLABACH, Barbara *[Painter] early 20th c.*
Addresses: Oklahoma City, OK. **Member:** Oklahoma AA. **Sources:** WW25.

SCHLADERMUNDT, Herman T. *[Mural painter, craftsperson] b.1863, Milwaukee, WI / d.1937, Kent, CT.*
Addresses: Bronxville, NY. **Studied:** Acad. Julian, Paris with Bouguereau and Ferrier, 1901; Acad. Delecluse, Paris. **Member:** Arch. Lg., 1893; Mural Painters; Century Assn. **Exhibited:** Arch. Lg, 1898 (prize); Columbian Expo, Chicago, 1893 (medal). **Work:** stained glass windows, Church, St. Augustine, FL; stained glass dome lights, Emigrants Bank, NYC; mosaic glass windows, House of Reps., Missouri Capitol, Jefferson City; USPO, Denver. **Sources:** WW33.

SCHLADITZ, Ernest *[Engraver] b.1862, Leipzig, Germany.*
Addresses: NYC. **Studied:** Europe. **Exhibited:** Boston; Philadelphia; Vienna; Columbian Expo, Chicago, 1893 (medal); Paris Expo, 1900 (medal); Pan-Am. Expo, Buffalo, 1901 (medal). **Comments:** Born of American parents. Specialty: wood engraving. **Sources:** WW13.

SCHLAFF, Herman (Dr.) *[Painter, sculptor] b.1884, Odessa, Russia.*
Addresses: Philadelphia, PA. **Studied:** School FA, Odessa. **Member:** AFA. **Exhibited:** S. Indp. A., 1927; PAFA Ann., 1929-36 (4 times). **Sources:** WW29; Falk, *Exh. Record Series.*

SCHLAFFER, Lisa *[Painter, drawing specialist] b.1907, Brooklyn, NY.*
Addresses: NYC. **Studied:** Pratt Inst.; Steris, in Paris. **Member:** NAWPS; S. Indp. A. **Exhibited:** Salons of Am.; S. Indp. A., 1932-35. **Sources:** WW40.

SCHLAG, Felix Oscar *[Sculptor] b.1891, Frankfurt, Germany / d.1974, Owosso, MI.*
Addresses: Owosso, MI. **Studied:** Kunstgewerbe Schule, Frankfurt; Acad. Art, Munich, Germany. **Exhibited:** AIC, 1939; Detroit, MI; NYC; abroad. **Work:** Champaign (IL) Jr. H.S.; Bloom Township H.S., Chicago Heights, IL; USPO, White Hall, IL; sculpture, Franklin & Roosevelt H.S., NYC; Frankfurt AM, War Mem., Amberg, Germany; fountain, Frankfurt, Germany. **Comments:** Came to the U.S. in 1924. Best known as the designer of the Jefferson nickel, U.S. Mint, Wash., DC, 1938. **Sources:** WW59; WW47.

SCHLAGER[S] *[Engraver of illustrations] mid 19th c.*
Comments: Engraved illustrations for *The Annals of San Francisco* (N.Y., 1855) and *Seven Years' Street Preaching in San Francisco* (New York, c. 1856). One cut is signed "Schlagers" and another "Genl. Schlager." **Sources:** G&W; Hamilton, *Early American Book Illustrators and Wood Engravers,* 238, 387.

SCHLAGETER, Ernest *early 20th c.*
Exhibited: Salons of Am., 1934. **Sources:** Marlor, *Salons of Am.*

SCHLAGETER, Robert William *[Art administrator] b.1925, Streator, IL.*
Addresses: Chapel Hill, NC. **Studied:** Univ. Illinois (B.A.; M.F.A.); Univ. Heidelberg (cert.); Univ. Chicago; Harvard Univ. **Comments:** Positions: dir., Mint Mus. Art, Charlotte, NC, 1958-66; assoc. dir., Downtown Gal., NYC, 1967; assoc. dir., Ackland Art Center, Univ. North Carolina, Chapel Hill, 1967-. Teaching: asst. prof. art history, Univ. Tennessee, Knoxville, 1952-1958. Collections arranged: Fifty Years of American Art (1900-1950), 1968; Age of Dunlap; Art of the Early Republic Exhibition. **Sources:** WW73.

SCHLAIKJER, Jes Wilhelm *[Painter, illustrator, teacher] b.1897, NYC / d.1982, Wash., DC.*
Addresses: South Dakota; Washington, DC. **Studied:** Ecole Beaux-Arts, France; AIC; Forsberg; Cornwell; Dunn; R. Henri. **Member:** ANA, 1932; NA, 1948; Artists Guild; Scandinavian-Am. Artists; Grand Central Art Gal.; Artists Fund Soc. **Exhibited:** AIC; Corcoran Gal. biennials, 1928-39 (5 times); SC; NAD (prizes 1926, 1928, 1932); PAFA Ann., 1930-36 (4 times). **Work:** NAD; U.S. War Dept.; U.S. Naval Acad.; Dept. State & Defense; Georgetown Univ.; Walter Reed Army Hospital; Am. Red Cross; U.S. Public Health Service. **Comments:** He was born aboard a ship enroute to NYC, and spent his early years on a ranch in South Dakota. After his studies, he came to Wash., DC during WWII, active first as an artist and then as an art consultant with the War Dept. Preferred media: oils. Positions: official artist, U.S. War Dept., Wash., DC, 1942-44, art consul., 1945-on; teacher,

Newark Sch. Fine & Indust. Art. **Sources:** WW73; WW47; Falk, *Exh. Record Series.*

SCHLAPP, Charles W. L. *[Painter, lithographer, teacher, drawing specialist] b.1895, Cincinnati, OH.*
Addresses: Rossmoyne, OH. **Studied:** Cincinnati Art Acad.; L.H. Meakin; J.R. Hopkins; H.H. Wessel; J.E. Weis. **Member:** Cincinnati AC (secy./treas., 1926-); Cincinnati Prof. Artists. **Exhibited:** Cincinnati AC; Cincinnati Prof. Artists; PAFA Ann., 1930; Butler AI, 1932; Ohio PM, 1938; CM, 1920-46;. **Work:** Knox Presbyterian Church, Medical College, Mabley & Carew Co., all of Cincinnati; Hayes Building Works, Du Quoin, IL; Hale Hospital, Wilmington, OH. **Comments:** Teaching: Cincinnati(OH) Art Acad., 1921-. **Sources:** WW59; WW47; Falk, *Exh. Record Series.*

SCHLATER, Katherine *[Painter, illustrator, lithographer, designer, lecturer] mid 20th c.; b.Philadelphia, PA.*
Addresses: Philadelphia, PA; Santa Fé, NM. **Studied:** PM Sch. IA; Hugh Breckenridge; Ralph M. Pearson; E. Horter. **Member:** Phila. Artists All.; Phila. Print Club; AAPL; Plastic Club. **Exhibited:** PAFA Ann., 1943-44; nat., several solo exhs. **Work:** fabric designs for Celanese Corp.; murals in private homes. **Sources:** WW59; WW47; Falk, *Exh. Record Series.*

SCHLAZER, Michael *[Painter, illustrator, teacher, lecturer] b.1910, Poland.*
Addresses: NYC; Miami, FL. **Studied:** AIC; Ostrowsky Educ. Alliance, NY. **Exhibited:** BM, 1939; S. Indp. A., 1941; MoMA; Non-Objective Painting, 1946-47; Contemp. Art Gal.; New Sch. Social Research; Exh. Am. Art, NY, 1938; Univ. Miami, 1955; FA Lg. of Carolinas; Int. Boat Show, 1957 (prize). **Work:** Board Educ., NY; Mus. Non-Objective Painting; Pub. School No. 94, NY; Ft. Hamilton H.S.; Jackson H.S., NY; Newark (NJ) Board Educ. **Comments:** Lectures: children's art. Illustr.: "Flying Health." **Sources:** WW59; WW47.

SCHLECHT, Charles *[Engraver] b.1843, Stuttgart, Germany.*
Studied: Charles Bush; Alfred Jones. **Comments:** Came to U.S. in 1852, and was an apprentice to the Am. Bank Note Co. in 1859. He worked off and on for the Bureau of Engraving and Printing in NYC and Wash., DC, 1886-97. Specialty: bank-note engraving. **Sources:** McMahan, *Artists of Washington, DC.*

SCHLECHT, Richard *[Painter, illustrator] b.1936, Dallas, TX.*
Addresses: Annapolis, MD. **Studied:** Univ. Denver (B.A.). **Exhibited:** 30th Ann. Midyear Show, Butler Inst. Am. Art, Youngstown, OH, 1965; NAD, 1967; NY Art Dir. Ann., 1968; Audubon Artists Ann., NY, 1968; Main-streams '1970, Marietta College, OH, 1970; Mickelson Gal., Wash., DC & Green Street Gal., Annapolis, MD, 1970s. Awards: third prize for oils, Am. Artists Lg. Wash., DC 26th Ann., 1963; Henry Ward Ranger Purchase Award, 1967. **Comments:** Preferred media: oils, acrylics, ink. **Sources:** WW73.

SCHLEDORN, Julius *[Painter] late 19th c.*
Addresses: Munich, 1879; NYC, 1890. **Exhibited:** NAD, 1879, 1890; Boston AC, 1887, 1890; PAFA Ann., 1890. **Sources:** Falk, *Exh. Record Series.*

SCHLEETER, Howard Behling *[Painter, craftsperson, educator, lecturer] b.1903, Buffalo, NY.*
Addresses: Albuquerque, NM in 1929; Santa Fe, NM in 1963. **Studied:** in Buffalo; briefly at Albright AS; largely self-taught. **Member:** Art Lg. New Mexico. **Exhibited:** AIC; Phila. Artists All., 1945 (solo); deYoung Mem. Mus., 1946; Kansas City AI, 1936-38; New Mexico Art Lg., 1939 (prize); New Mexico State Fair, 1939 (prize); Cedar City (NM), 1941-46; AIC, 1947; Mus. New Mexico, Santa Fe, 1951 (purchase prize), 1955 (purchase prize); Vienna, Austria, 1952; Guggenheim Mus., 1954; Karlsruhe

Mus., Germany, 1955; Stanford Univ., 1955 (solo); New Mexico Highlands Univ., 1957 (purchase prize); Colorado Springs FA Center, 1958; Swope Art Gal. **Work:** Encyclopaedia Britannica; Research Studio, Maitland, FL; Univ. New Mexico; Cedar City Inst. Religion; Art Lg. New Mexico; Mus. New Mexico, Santa Fe; murals, A&M College, New Mexico; Miners Hospital, Raton, NM. **Comments:** Western abstract painter. WPA artist, 1936-42. Teaching: Las Vegas Art Gal., 1938-39; Univ. New Mexico, 1950-51, 1954. **Sources:** WW59; WW47; P&H Samuels, 424.

SCHLEGEL, Fridolin *[Painter of portraits, still lifes, genre, and religious motifs] mid 19th c.*
Addresses: NYC, 1848; Newark, NJ, 1850; NYC, 1853-61. **Member:** ANA. **Exhibited:** NAD; Am. Art-Union; PAFA. **Work:** NYHS. **Sources:** G&W; Cowdrey, AA & AAU; Cowdrey, NAD; Rutledge, PA; New Jersey BD 1850; NYCD 1855-56, BD 1857-60.

SCHLEGELL, Gustav von *See:* **VON SCHLEGELL, William**

SCHLEGELL, William von *See:* **VON SCHLEGELL, William**

SCHLEICH, Charles F. *[Engraver] mid 19th c.*
Addresses: NYC, 1852-58. **Comments:** Of Wetzel & Schleich (see entry). **Sources:** G&W; NYBD 1852-58.

SCHLEIER, M. W. *[Painter] late 19th c.*
Addresses: Brooklyn, NY. **Exhibited:** AIC, 1894. **Sources:** Falk, *AIC.*

SCHLEIER, Thomas E. *[Artist] late 19th c.*
Addresses: Wash., DC, active 1890. **Sources:** McMahan, *Artists of Washington, DC.*

SCHLEIF, Oscar *[Painter] late 19th c.*
Addresses: Phila., PA. **Exhibited:** PAFA Ann., 1889. **Sources:** Falk, *Exh. Record Series.*

SCHLEIN, Charles *[Painter, etcher, sculptor] b.c.1900, Russia / d.1988, Los Angeles, CA.*
Addresses: NYC; Los Angeles, CA. **Studied:** L. Kroll. **Member:** Alliance. **Exhibited:** Corcoran Gal. biennials, 1930, 1935; Salons of Am.; Public Works of Art Project, Southern Calif., 1934 (scenes of NYC). **Sources:** WW33; Hughes, *Artists of California,* 495.

SCHLEMM, Betty Lou *[Painter] b.1934, Jersey City, NJ.*
Addresses: Rockport, MA. **Studied:** NY Phoenix Sch. Des. (scholarship); NAD (scholarship). **Member:** AWCS; Allied Artists Am. (secy., 1964-65); Rockport AA (bd. mem., 1970-); Boston Artists Guild; NJWCS. **Exhibited:** AWCS, 1964 (silver medal); Butler Inst. Am. Art; NAD; Allied Artists Am.; Audubon Artists; Hudson Valley AA, 1965 (gold medal). Awards: Robert Lehman Travel Grant, Washington Square Outdoor Art Exh., 1967. **Work:** USN; Grand Central Art Gals., New York; Andrew Mellon Coll. **Comments:** Preferred media: watercolors. In addition to Cape Ann and the North Shore area, painting locations included Monhegan Island (ME). Publications: auth., *Painting with Light* (Watson-Guptill); auth., "Watercolor Page," *Am. Artist,* 1964. **Sources:** WW73; Margaret Harold, *Prize Winning Art,* 1966; Margaret Harold, *Prize Winning Watercolors,* 1967; *100 Watercolor Techniques* (Watson-Guptill, 1969); Curtis, Curtis, and Lieberman, 37, 63, 186.

SCHLEMMER, F(erdinand) Louis *[Painter, teacher] b.1893, Crawfordsville.*
Addresses: Crawfordsville, IN/Provincetown, MA. **Studied:** Hawthorne; H.M. Walcott; AIC. **Member:** Indiana Art Soc.; Hoosier Salon. **Exhibited:** PAFA Ann., 1924, 1928; Indiana Artists, John Herron, 1927-31; Indiana State Fair, 1930 (prize); Richmond (IN) AA, 1929 (prize). **Work:** Miami Conservatory Art, FL; Wabash College, Crawfordsville, IN. **Sources:** WW40; Falk, *Exh. Record Series.*

SCHLEMMER, Oskar *[Painter] mid 20th c.*
Exhibited: AIC, 1941. **Sources:** Falk, *AIC.*

SCHLEMOWITZ, Abram *[Sculptor] b.1911, NYC.*
Addresses: NYC. **Studied:** Beaux-Arts Inst. Design, 1928-33; ASL, 1934; NAD,1935-39. **Member:** Sculptors Gld.; Am. Abstract Artists; New Sculpture Group. **Exhibited:** Woodstock AA; Riverside Mus.; RoKo, Collectors', Camino, Terrain, March, Brata & Stable Gals., NY; Howard Wise Gal., 1961-67 (solos); Collaboration: Artists and Arch., Mus. Contemp. Crafts, 1962; 12 New York Sculptors, Riverside Mus., 1962, Humanists of the 60s, New Sch. Social Res., 1963; Art In Embassies Traveling Exh., MoMA, circulated int., 1963-64;. **Awards:** Guggenheim fellowship, 1963. **Work:** Chrysler Mus., Provincetown, MA; Univ. Calif., Berkeley. **Comments:** Positions: organizing chmn., New Sculpture Group, 1957-58. Teaching: Contemp AC, YMHA, New York, 1936-39; Pratt Inst., 1962-63; Univ. Calif., Berkeley, 1963-64; Univ. Kentucky, 1965; Univ. Wisconsin, 1965-67; Kingsborough College, City Univ. NY, 1970-. Research: bronze casting. **Sources:** WW73.

SCHLERETH, Hans *[Portrait painter] b.1897, Bamberg, Bavaria.*
Addresses: Washington, DC, active 1925-41. **Studied:** C. von Marr; Munich Acad. FA. **Member:** Soc. Wash. Artists; Wash. AC. **Exhibited:** Univ. Munich, 1920 (medal); Soc. Wash. Artists, 1934 (first prize). **Work:** portraits, District Supreme Court, U.S. Labor Dept., Wash., DC; Harvard Law Sch.; Franklin & Marshall College, Lancaster, PA; Lafayette College, Easton, PA; Wittenberg College, Springfield, OH; portrait, State Capitol, Springfield, IL. **Comments:** Came to U.S. in 1920. In 1925 he painted Alexander Hecht's portrait, which has been exhibited on the ground floor of the Hecht Company Stores over the years. **Sources:** WW40; McMahan, *Artists of Washington, DC.*

SCHLESINGER, Louis *[Sculptor] b.1874, Fischern-Karlsbad, Bohemia.*
Addresses: NYC/Marlborough, NY. **Member:** Arch. Lg., 1913. **Sources:** WW27.

SCHLESSINGER, Alfred R. *[Illustrator] 19th/20th c.*
Addresses: NYC. **Sources:** WW01.

SCHLEY, Evander Duer (Van) *[Conceptual artist, photographer] b.1941, Montreal, PQ.*
Addresses: Topanga, CA. **Exhibited:** Place & Process, Edmonton, Alta, 1969; Architecture of Joy, Arch. Lg. NY, 1970; Software, Jewish Mus., New York, 1970; Information, MoMA, 1970; Encuentros de Espana, Pamplona, Spain, 1972. **Awards:** *Avalanche Magazine* art award, 1972. **Work:** Place and Process (film), in collections of Forth Worth AC, Miami-Dade College & Boston Mus. FA. **Comments:** Publications: author, *Signs,* 1972. Teaching: Univ. Calif., Santa Barbara, spring 1972. **Sources:** WW73; Billy Adler, "In the Midnight Hour" (videotape), 1969 & "Run" (videotape), GBF, Inc., 1972.

SCHLEY, George *[Artist] b.1795 / d.1846.*
Comments: He was said to have studied with a member of the Peale family. **Sources:** G&W; Lafferty.

SCHLEY, M(athilde) Georgina *[Painter, illustrator, teacher, writer] b.1864, Horicon, WI / d.1941.*
Addresses: Milwaukee, WI/Beaver Dam, WI. **Studied:** Richard Lorenz; Paris, 1899. **Member:** Salons of America; Chicago No-Jury Soc. of Artists; S. Indp. A.; Wisc. P&S. **Exhibited:** Salons of America; Chicago Artists; S. Indp. A., 1926-30, 1938; Chicago NJSA; Buffalo SIA, 1926; probably Phila. **Work:** Smithsonian; Newberry Lib., Chicago; NYPL; Harvard. **Comments:** From 1913-41, she was active in art and music circles and was a writer for the German-American press. Known as "Tante Tilde," she wrote in German, French, and English about nature as seen through the eyes of an American Impressionist. Marlor has birthdate of 1874. **Sources:** WW40; Marlor, *Salons of Am.;* PHF files courtesy Eugene Meier, Palatine, IL.

SCHLEY, Reeve III *[Painter] mid 20th c.*
Addresses: Whitehouse, NJ. **Exhibited:** PAFA Ann., 1966. **Sources:** Falk, *Exh. Record Series.*

SCHLICHER, Karl Theodore *[Painter, educator] b.1905, Terre Haute, IN / d.1989.*
Addresses: Nacogdoches, TX. **Studied:** Univ. Wisconsin (B.S. & M.S.); Colt School Art; AIC; Univ. Chicago; Ohio State Univ. (Ph.D.); Reynolds; Giesbert; Coats; Hopkins; Grimes. **Member:** College AA Am.; Texas FAA; Texas Art Educ. Assn. (pres., 1956-58); Royal Soc. Arts; Nat. Art Educ. Assn. **Exhibited:** Contemp. Art of the Southwest, 1956; Lufkin Art Lg.; Nacogdoches Fair; Stephen F. Austin State College Faculty Exhs. **Comments:** Positions: ed./publ., *Texas Trends in Art Educ.,* 1951-56. Publications: contrib. to *Texas Outlook, Western Arts Assn. Res. Bull & Texas Trends in Art Educ.* Teaching: Stephen F. Austin State Univ., 1948-70s. **Sources:** WW73.

SCHLICHTING, H. C. *[Painter] early 20th c.*
Addresses: Darien, CT. **Sources:** WW25.

SCHLICHTING, Max *[Painter] early 20th c.*
Exhibited: AIC, 1924. **Sources:** Falk, *AIC.*

SCHLICHTMANN, Margaret Sprado *[Painter] b.1898, Chicago, IL.*
Addresses: Alameda, CA. **Studied:** self-taught. **Member:** Bay Region AA. **Exhibited:** Calif. State Fairs & locally, 1920s-30s. **Comments:** Specialty: floral still lifes in watercolor. **Sources:** Hughes, *Artists of California,* 495.

SCHLICKUM, Charles, Sr. *[Painter] b.Prussia / d.1869.*
Addresses: Saginaw County, MI. **Exhibited:** Michigan State Fair, 1854-55. **Sources:** Gibson, *Artists of Early Michigan,* 209.

SCHLITZ, A. *[Painter] early 20th c.*
Addresses: Cincinnati, OH. **Exhibited:** PAFA Ann., 1929. **Sources:** Falk, *Exh. Record Series.*

SCHLOAT, G. Warren *[Painter] early 20th c.*
Addresses: Los Angeles, CA. **Exhibited:** Calif. AC, 1930. **Sources:** Hughes, *Artists of California,* 495.

SCHLOSBERG, Zeff *[Artist] early 20th c.*
Addresses: Wash., DC, active 1920. **Sources:** McMahan, *Artists of Washington, DC.*

SCHLOSS, Edith *[Painter, art critic] 20th c.*
Addresses: Rome, Italy. **Studied:** ASL. **Exhibited:** Assemblage, MoMA 1961; Women in Art, Stamford (CT) Mus., 1972; Il Segno, Rome, 1968 (solo), Am. Acad. Rome, 1971 (solo) & Green Mountain Gal., 1972 (solo). **Comments:** Preferred media: oils, watercolors. Positions: assoc. ed., *Art News,* 1955-61; art critic for Italy, *International Herald Tribune,* Paris, France, 1969-. Publications: auth., "The Unfinished Cathedral of Antonio Gaudi," *Art News,* 1958; auth., "Braibanti," *Village Voice,* New York, 1970; auth., "Art & Politics, One of Rome's Most Daring Exhibitions," 2/1971, auth., "Tiepolo a la Doge's Palace," 1910-71 & auth., "How to Catch the Moon," 1/1972, *International Herald Tribune.* Art interests: assemblage. **Sources:** WW73; Claudia Terenzi, "Poetic Imagination.".

SCHLUETER, Lydia Bicky *[Painter] b.1890, Seward, NE.*
Studied: H.H. Bagg. **Exhibited:** Alliance, NE; Nebraska State & County Fairs. **Sources:** Petteys, *Dictionary of Women Artists.*

SCHMALZ, Arthur E. *[Painter] mid 20th c.*
Addresses: Manchester, NH. **Work:** USPO, Eastman, GA. **Comments:** WPA artist. **Sources:** WW40.

SCHMALZ, Carl (Nelson, Jr.) *[Painter, educator] b.1926, Ann Arbor, MI.*
Addresses: Amherst, MA. **Studied:** Eliot O'Hara Watercolor School, summers 1943 & 1944; Harvard College (A.B., 1948); Harvard Univ. (M.A., 1949; Ph.D., 1958). **Member:** College AA Am.; Am. Archaeol. Inst.; Acad. Artists Assn. **Exhibited:** Colby College Invitational, ME, 1958; Portland Summer Art Festival, 1958 & 1959; AWCS, 1966, 1968 & 1970; Watercolor USA,

Springfield, MO, 1970; Wichita Centennial Nat. Art Exh., Kansas, 1970; Eric Schindler Gal., Richmond, VA, 1970s. Awards: first prize (watercolor), Cambridge AA Ann., 1947; first prize (traditional watercolor), Virginia Beach Boardwalk Show, 1965; Southern Missouri Trust Purchase Award, Watercolor USA, 1970. **Work:** Walker Art Mus., Brunswick, ME; Jones & Laughlin Steel Corp., Cleveland, OH; Diners Club Am.; Blue Cross-Blue Shield; Hampshire College. **Comments:** Preferred media: watercolors. Positions: vice-pres. & bd. dir., Portland (ME) Mus. Art, 1957-62; art consult., O'Hara Picture Trust, 1969-. Publications: contrib., *A Staining and Transparent Palette in Watercolor Portraiture,* Putnam, 1949; auth., "The Watercolor Page," 2/1972 & "Eliot O'Hara, Great Teacher of Watercolor," 3/1972, *Am. Artist Magazine.* Teaching: Bowdoin College, 1953-62; Amherst College, 1962-. **Sources:** WW73.

SCHMAND, J. Phillip *[Portrait painter] b.1871, Germania, PA / d.1942.*
Addresses: NYC/Lyme, CT. **Studied:** M. Cox; L. Hitchcock; H.S. Mowbray; Vonnoh; A.P. Lucas. **Member:** NAC; Wash. AC; SC; NAWPS; AAPL. **Work:** portraits of Blackstone, Pitt, Mansfield, John Marshall, at Lawyer's Club, NYC; Green Free Lib., Wellsboro, PA; Nat. Cash Register Co., Dayton; Rochester (NY) Consistory; Osage Inn, Essex, CT. **Sources:** WW40.

SCHMAUSS, Peter *[Painter, illustrator] early 20th c.*
Addresses: NYC. **Exhibited:** Boston AC, 1908; Corcoran Gal. biennials, 1914, 1916; PAFA Ann., 1917. **Sources:** WW17; Falk, *Exhibition Records Series.*

SCHMECKEBIER, Laurence E. *[Sculptor, educator] b.1906, Chicago Heights, IL.*
Addresses: Cleveland, OH; Lyme, NH. **Studied:** Univ. Wisconsin (B.A., 1927); Univ. Marburg, 1927-28; Sorbonne, 1928; Univ. Munich (Ph.D., 1930); M. Doerner; H. Hofmann. **Member:** College AA Am.; Minnesota Hist. Soc.; Minneapolis SFA. **Exhibited:** Cleveland Mus. Ann. May Show, 1949-54 (cert. merit, 1949-51); Rochester Mem. Mus. Finger Lakes Exh., 1955 (George L. Herdle Award)-1957; Regional Artists Exh., Everson Mus., Syracuse, 1956-57, 1959-60; Chautauqua AA Exh., 1956 (first prize for sculpture); Central NY Artists, 1956, 1958-59; Munson-Williams-Proctor Inst., Utica, NY, Corning Glass Center Ann. May Show, NY, 1970. **Work:** Syracuse (NY) Univ. Coll. **Comments:** Publications: auth., "Italian Renaissance Painting," 1938 & 1971; "Modern Mexican Art," 1939; "John Steuart Curry's Pageant of America," 1943; "Art in Red Wing," 1946; "Ivan Mestrovic, Sculptor and Patriot," 1959. Contrib.: art magazines & journals. Teaching: Univ. Wisconsin-Madison, 1931-38; Univ. Minnesota, Minneapolis, 1938-46; Cleveland (OH) Inst. Art, 1946-54; Syracuse Univ., 1954-70s. Research: Italian Renaissance painting; modern Mexican art; contemporary American art. **Sources:** WW73; WW47.

SCHMEDTGEN, William H(erman) *[Cartoonist, illustrator] b.1862, Chicago / d.1936.*
Addresses: Chicago, IL. **Studied:** AIC. **Exhibited:** AIC, 1891-1906. **Comments:** Specialty: outdoor sports. Position: staff, *Old Mail, The Record, The Record-Herald, The Daily News,* all in Chicago, since 1883. **Sources:** WW17.

SCHMEIDLER, Blanche J. *[Painter] b.1915, NYC.*
Addresses: Jackson Heights, NY. **Studied:** Hunter College; Columbia Univ. (B.A.); Samuel Brecher Art Sch.; ASL with Vytlacil; Seong Moy Graphics Workshop. **Member:** NY Soc. Women Artists (chmn. mem. comt., 1962-65; bd. dir., 1963-66); Am. Soc. Contemp. Artists (chmn. traveling exhs., 1963-66); NAWA; Silvermine Guild Artists; New Jersey P&S. **Exhibited:** NAD; Audubon Artists; Nat. Arts Club; WMAA; Silvermine Guild. Awards: prizes, NAWA, 1959 & Grumbacher prize, 1960, New Jersey P&S, 1961. **Work:** St. Vincent's College, Latrobe, PA; Seton Hall Univ., Newark, NJ; John Herron Art Mus., Indianapolis, IN. **Comments:** Teaching: lecturer, history & application of woodcut, NAD. **Sources:** WW73.

SCHMICH, Louis *[Engraver] late 19th c.*
Addresses: New Orleans, active 1885-87. **Sources:** *Encyclopaedia of New Orleans Artists,* 341.

SCHMID, Elsa *[Painter, craftsperson, sculptor] b.1897, Stuttgart, Germany / d.1970.*
Addresses: Rye, NY. **Studied:** ASL. **Exhibited:** MMA; MoMA; WMAA; S. Indp. A. **Work:** BMA; Newark Mus. Art; FMA; MoMA; mosaic fresco, Yale Univ. Chapel; mosaics, Church of St. Brigid, Peapack, NJ; mosaic floor, U.S. Cemetery, Carthage, Africa. **Comments:** Contrib.: articles, *Commonweal, Liturgical Arts, Art News.* Specialty; mosaics. **Sources:** WW59; WW47.

SCHMID, Frank *[Painter] b.1897.*
Exhibited: S. Indp. A., 1940-42. **Sources:** Marlor, *Soc. Indp. Artists.*

SCHMID, Richard Alan *[Painter] b.1934, Chicago, IL.*
Addresses: Sherman, CT. **Studied:** Am. Acad. Art, Chicago, 1952-55, with William Mosby. **Exhibited:** Invitational Drawing Exh., Otis Art Inst., Los Angeles, CA, 1966; 33rd Ann., Butler Inst. Am. Art, Youngstown, OH, 1968; 23rd Am. Drawing Biennial, Norfolk Mus. Arts & Sciences, 1969; 164th Ann., PAFA, 1969; AWCS Ann., NAD Gals., New York, 1970-71; Talisman Gal., Bartlesville, OK & Welna Gal., Chicago, IL, 1970s; plus many solo shows throughout USA, 1958-72. Awards: Jane Peterson Prize, Allied Artists Am., 1967; gold medal of honor, AWCS, 1971; AWCS Gold Medal of Honor for Marianne, Am. Artist, 1972. **Comments:** Preferred media: oils,watercolors, conté crayon, stone, wood. **Sources:** WW73.

SCHMID, Rupert *[Sculptor] b.1864, Munich, Germany / d.1932, Alameda, CA.*
Addresses: NYC, 1885; San Francisco, c.1890. **Studied:** Royal Academy, Munich. **Member:** San Fran. AA (bd. dir.). **Exhibited:** NAD, 1885; Mechanics Inst., San Fran., 1889-95; "California Venus," World's Columbian Expo, Chicago, 1893; "California Fountain," Calif. Midwinter Int. Expo, 1894; Pan-Pacific Expo, San Fran., 1915 (the large "Queen of the Pacific" and other works). **Work:** St. James Park, San Jose; Golden Gate Park; Oakland Mus.; Stanford Univ.; Alameda, Soldier's Monument. **Comments:** Immigrated to the U.S. in 1884. Schmid had a successful career in California, receiving many important commissions, including portrait busts for a number of leading San Franciscans and the sculptural decorations for the Speckrels and Chronicle buildings. He also gained fame for his female figure "California Venus," at the World's Columbian Expo. After the earthquake and fire of 1906, Schmid traveled and worked in Wash. (DC), Germany, Italy, and Mexico, returning to San Fran. in 1913. **Sources:** Hughes, *Artists in California.*

SCHMIDT, Agnes C. *[Artist] early 20th c.*
Addresses: Wash., DC, active 1912-39. **Exhibited:** Wash. WCC, 1915-16. **Sources:** McMahan, *Artists of Washington, DC.*

SCHMIDT, Albert Felix See: **SCHMITT, Albert F(elix)**

SCHMIDT, Albert Herman *[Painter] b.1885, Chicago, IL / d.1957, Chicago.*
Addresses: Chicago; Santa Fe, NM. **Studied:** AIC with C. F. Browne; Académie Julian, Paris, 1911; Henri Martin. **Member:** Santa Fe Artists Colony, after 1922. **Exhibited:** AIC, 1908-24; PAFA Ann., 1911; Vanderpoel AA, 1939; Mus. New Mexico, Santa Fe, 1940. **Work:** Field Mus., Chicago; Mus. New Mexico; Chicago Municipal Art Comn. **Sources:** WW40; P&H Samuels, 424-25; Falk, *Exh. Record Series.*

SCHMIDT, Al(win) (E.) *[Illustrator] b.1900, Des Peres, MO.*
Addresses: Upper Montclair, NJ; Bethel, CT in 1962. **Studied:** St. Louis Sch. FA; & with Fred Carpenter. **Member:** SI; Westport Artists. **Exhibited:** Am. Artists Exh., 1933-34; CAM, 1922; Mayfair Art Salon, St. Louis, 1933; St. Louis Artists Gld., 1933-34; CM, 1933; Terry AI, 1952; SI, 1944-45. **Comments:** Illustr. children's books as well as *Collier's, Redbook, Liberty,* and action Westerns. **Sources:** WW59; WW47; P&H Samuels, 425.

SCHMIDT, Antoine *[Painter] early 20th c.*
Addresses: Oakland, CA. **Studied:** San Fran. Inst. Art, 1909.
Exhibited: Calif. Hist. Soc, 1971; San Fran. AA; Calif. School
Des. **Work:** Oakland Mus. **Sources:** Hughes, *Artists of
California,* 496.

SCHMIDT, Arnold Alfred *[Painter, sculptor] b.1930,
Plainfield, NJ.*
Addresses: NYC. **Studied:** ASL , 1949-50; Cooper Union (cert.,
1956); Hunter College (B.A. & M.A., 1965);Hannes Beckman;
Neil Welliver; Tony Smith. **Exhibited:** The Responsive Eye,
1965, Optical Art, 1966 & Recent Acquisitions, 1966, MoMA; Op
Art and Others, Newark Mus., 1967; Form and Color, Stedelijk
Mus., 1967; Am. Paintings of the Nineteen Sixties, Currier Mus.
Art, 1972. **Work:** MoMA; Rose Art Inst., Brandeis Univ.; Newark
Mus.; Fairleigh Dickinson Univ.; Stedelijk Mus., Schiedam,
Netherlands. **Comments:** Preferred media: acrylics. **Sources:**
WW73; Alfred Barr, *What is Modern Art* (MoMA, 1967); Ray
Faulkner & Edwin Ilegfeld, *Art Today* (Holt-Reinhart & Winston,
1969).

SCHMIDT, August *[Sculptor] b.c.1809, Germany.*
Addresses: Philadelphia, 1850. **Sources:** G&W; 7 Census
(1850), Pa., LII, 893.

SCHMIDT, Carl *[Painter, mural painter] b.1885, Charles, MN
/ d.1969, San Bernardino, CA.*
Addresses: San Bernardino, CA, 1924-69. **Studied:** AIC.
Member: Laguna Beach AA; Los Angeles AA; San Bernardino
County AA. **Exhibited:** Stendahl Gal., Los Angeles (solo); San
Bernardino Cultural Center (solo); LACMA (solo). **Work:**
Laguna Beach Mus.; mural: Trinity Methodist Church, San
Bernardino. **Comments:** Specialty: Impressionist desert land-
scapes, Indians, still lifes, portraits, historic and religious genre.
Sources: WW40; Hughes, *Artists in California,* 496.

SCHMIDT, Carl *[Painter, etcher, lithographer] b.1909,
Cleveland, OH / d.1993, Cincinnati, OH?.*
Addresses: Cleveland, OH. **Studied:** John Huntington
Polytechnic Inst.; Cleveland Sch. Art. **Member:** Cleveland PM;
Cleveland AC. **Exhibited:** Phila. WCC, 1935; AIC, 1936; Denver
Art Mus., 1935, 1936; Ohio PM, 1932-36; CMA, 1932
(prize),1933-37. **Work:** CMA. **Sources:** WW53; WW47.

SCHMIDT, Carl Arthur *[Painter, illustrator, graphic artist]
b.1890, Berlin, Germany.*
Addresses: Chicago, IL. **Studied:** ASL; AIC; Berlin Acad.;
Munich Acad.; Acad. Julian, Paris. **Member:** AFA; AAPL; Soc.
Sanity in Art; All-Illinois SFA. **Exhibited:** All-Illinois SFA;
Palette, Chisel Acad. FA, Chicago; Garfield Park Mus., Chicago.
Sources: WW47.

SCHMIDT, Charles *[Cartoonist] b.1897,
Brooklyn, NY.*
Addresses: Winthrop, MA (1949).
Comments: Beginning in 1933, he drew the
comic strip "Sargeant Pat of Radio Patrol" (King Features
Syndicate). **Sources:** *Famous Artists & Writers* (1949).

SCHMIDT, Charles H. *[Painter] mid 19th c.*
Addresses: NYC, 1862. **Exhibited:** NAD, 1862. **Sources:**
Naylor, *NAD.*

SCHMIDT, Clarence *[Artist] b.1897 / d.1978.*
Member: Woodstock AA. **Sources:** Woodstock AA.

SCHMIDT, Curt *[Painter] early 20th c.*
Addresses: NYC. **Member:** S. Indp. A. **Exhibited:** S. Indp. A.,
1917, 1920-21. **Sources:** WW24.

SCHMIDT, Eberhard Winter *[Painter] b.1902,
Bremerhaven, Germany.*
Addresses: Brooklyn, NY. **Member:** Allied Artists Am.
Exhibited: Tricker Gal., NYC; Vendôme Gal., NYC; Salons of
Am.; S. Indp. A.; Allied Artists Am., 1939; PAFA Ann., 1940.
Sources: WW40; Falk, *Exh. Record Series.*

SCHMIDT, Elmer G. *[Painter] early 20th c.*
Addresses: Berkeley, CA, 1920s-30s. **Exhibited:** San Fran. AA,
1923-25; Calif. Indust. Expo, San Diego, 1926; Calif. State Fair,
1930; Oakland Art Gal., 1932. **Sources:** Hughes, *Artists of
California,* 496.

SCHMIDT, Eugene *[Lithographer, printer] mid 19th c.*
Addresses: New Orleans, active 1872-74. **Sources:**
Encyclopaedia of New Orleans Artists, 341.

SCHMIDT, Felix *[Illustrator] mid 20th c.*
Addresses: NYC; West Hempstead, NY. **Member:** SI. **Sources:**
WW53; WW19.

SCHMIDT, Felix G. *[Painter] early 20th c.*
Addresses: Evanston, IL. **Exhibited:** AIC, 1910, 1913, 1922.
Sources: WW19.

SCHMIDT, Fred A. *[Artist] early 20th c.*
Addresses: Wash., DC, active 1905-17. **Sources:** McMahan,
Artists of Washington, DC.

SCHMIDT, Frederick *[Lithographer] b.c.1826, Saxony
(Germany).*
Addresses: NYC, 1856-60 and after. **Comments:** His wife was a
native of Saxe-Cobourg (Germany); their two sons were born in
NYC about 1850 and 1854. **Sources:** G&W; 8 Census (1860),
N.Y., XLV, 62; NYCD 1856-63.

SCHMIDT, Frederick *[Lithographer & lithographic printer]
mid 19th c.*
Addresses: New Orleans, 1849-67. **Comments:** Listed in 1849 as
Frederick Smith, otherwise as Schmidt. **Sources:** G&W; New
Orleans CD 1849, 1852-55, 1860-61, 1865-67.

SCHMIDT, Frederick *[Sculptor] b.1807, Germany.*
Addresses: Richmond , VA, active 1838; Wash., DC, active 1850-
55. **Comments:** He changed his name from "Schmidt" to "Smith"
around 1850. **Sources:** G&W; Cf. Frederick Smith. *Richmond
Portraits,* 242; McMahan, *Artists of Washington, DC.*

SCHMIDT, Frederick *[Architect] late 19th c.*
Addresses: NYC, 1830s-70s. **Comments:** He was the delineator
of an 1834 view of the Park Hotel, lithographed and published by
George Endicott. **Sources:** G&W; NYCD 1837-70+; Stokes,
Iconography, Ill, 878.

SCHMIDT, Frederick Lee *[Painter, educator] b.1937, Hays,
KS.*
Addresses: Blacksburg, VA. **Studied:** Univ. Northern Colorado
(B.A.); Univ. Iowa with Stuart Edie (M.F.A.); Joe Patrick;
Howard Rogovin; James Lechay. **Member:** Nat. College AA.
Exhibited: Sioux City 32nd Ann., 1969; Des Moines (IA) State
Capitol, 1969; Benedicta AC 2nd Invitational Drawing Exh., Saint
Joseph, MO, 1971; 34th Semi-Ann. Southeastern Exh., Winston-
Salem, NC, 1972; group show, Asheville (NC) Art Gal., 1972;
Oliva Assoc., NYC, 1970s. **Awards:** Northwestern College sum-
mer grant, 1969; hon. men., North Carolina AA, 1971; Helene
Wurlitzer Found. grant, 1972. **Work:** Northwestern College,
Orange City, IA; Sioux City(IA) Art Center; Western Carolina
Univ., Cullowhee, NC; Univ. Iowa, Iowa City. **Comments:**
Preferred media: acrylics, oils. Teaching: Northwestern College,
1968-70; Western Carolina Univ., 1970-72; Virginia Polytech Inst.
& State Univ., 1972-. **Sources:** WW73.

SCHMIDT, Harvey *[Illustrator] b.1929, Dallas, TX.*
Studied: Univ. Texas. **Exhibited:** Numerous awards: SI, Art Dir.
Club annuals. **Comments:** Positions: des., NBC Television, NYC.
Illustr.: *Fortune , Sports Illustrated,* and others, also advertising.
Equally talented in art and music, he has also written musical
scores, incl. for *The Fantasticks,* most in collab. with lyricist Tom
Jones. **Sources:** W & R Reed, *The Illustrator in America,* 305.

SCHMIDT, Imanuel Albert *[Engraver, taxidermist] b.1838,
Hamburg, Germany / d.1892, New Orleans, LA.*
Addresses: New Orleans, active 1870-89. **Comments:** Listed as
manager of the American Bank Note Company, 1877-80.
Sources: *Encyclopaedia of New Orleans Artists,* 341.

SCHMIDT, Julius *[Sculptor] b.1923, Stamford, CT.*
Addresses: Kansas City, MO; Iowa City, LA. **Studied:** Oklahoma A&M College; Cranbrook Acad. Art (B.F.A., M.F.A.); Ossip Zadkine, Paris, France, 1953; Acad. Belle Arti, Florence, Italy. **Exhibited:** PAFA Ann., 1958, 1964; Sixteen Americans, MoMA, 1959; The Hirshhorn Coll., Guggenheim Mus., New York, 1962; Seventh Biennial, São Paulo, Brazil, 1963; Sculpture in the Open Air, Battersea Park, London, England, 1963; Biennial, Middleham, Belgium, 1971; WMAA; Marlborough Gals., NYC, 1970s. **Awards:** Guggenheim fellowship, 1964. **Work:** MoMA; AIC; Albright-Knox Art Gal., Buffalo, NY; Princeton (NJ) Mus. Art; WMAA, NY. **Comments:** Preferred media: bronze, iron. Teaching: Kansas City Art Inst., 1954-59; RISD, 1959-60; Univ. Calif., Berkeley, 1961-62; Cranbrook Acad. Art, 1962-72; Univ. Iowa, 1972-. **Sources:** WW73; *Sixteen Americans* (MoMA, New York, 1959); H. Read, *Concise History of Modern Sculpture* (Praeger, 1964); Redstone, *Art in Architecture* (McGraw, 1968); Falk, *Exh. Record Series.*

SCHMIDT, Karl *[Landscape painter] b.1890, Worcester, MA / d.1962, Santa Clara County, CA.*
Addresses: Boston/Worcester, MA, until c.1909; Santa Barbara, CA; Silvermine, CT, 1925; Ardmore, PA, 1936. **Studied:** self-taught. **Member:** SC; Phila. Art All. **Exhibited:** AIC, 1912-13; LACMA, 1917 (solo); PPE, 1915; PAFA Ann., 1917. **Sources:** WW40; Hughes, *Artists of California,* 496; Falk, *Exh. Record Series.*

SCHMIDT, Katharine M. *[Painter] early 20th c.*
Addresses: Phila., Pa. **Exhibited:** PAFA Ann., 1900-01, 1903. **Sources:** Falk, *Exh. Record Series.*

SCHMIDT, Katherine (Shubert) *[Painter] b.1898, Xenia, OH / d.1978, Sarasota, FL.*
Addresses: NYC; Little Compton, RI. **Studied:** ASL with F. Luis Mora, K.H. Miller, J. Sloan & G. Bridgman; travel studies in Europe, 1925-28. **Member:** Am. SPS&G; SIA; Woodstock AA. **Exhibited:** AIC; Salons of Am.; S. Indp. A., 1921-22, 1941; WMAA, 1923-67, 1982 (solo); Whitney Studio Club, 1923 (solo), 1925 (solo); MMA (solo); Newark Mus. (solo); Univ. Nebraska (solo); CI, 1940; Daniel Gal., NYC, 1927-31 (solos); PAFA Ann., 1932-49, 1964; Downtown Gal., NYC, 1934, 1936, 1939 (solos); Corcoran Gal. biennials, 1935-45 (4 times); Issacson Gal., 1961 (solo); Durlacher Gal., NYC; Zabriskie Gal., NYC, 1970s; Newark Mus.; Univ. Nebraska. **Work:** WMAA; MMA; MoMA; Newark Mus; Santa Barbara Mus. Art; Woodstock AA. **Comments:** Painted still lifes, figures, & landscapes. In 1931, she was listed as Mrs. Yasuo Kuniyoshi (married in 1919); and later as Mrs. Irving J. Shubert (married 1933). Preferred media: oils, pencils, conté. **Sources:** WW73; WW47; E. Halpert, *Director Downtown Gallery;* B. Burroughs, article, *Aris Magazine;* Woodstock AA; Petteys, *Dictionary of Women Artists;* Falk, *Exh. Record Series.*

SCHMIDT, Lillian Thomas *[Painter] early 20th c.*
Addresses: NYC. **Exhibited:** S. Indp. A., 1917. **Sources:** Marlor, *Soc. Indp. Artists.*

SCHMIDT, Marius *[Painter] early 20th c.*
Addresses: Oakland, CA, c.1909-17. **Exhibited:** San Fran. AA, 1917. **Comments:** Specialized in San Francisco Bay area scenes, coastals, and landscapes. **Sources:** Hughes, *Artists of California,* 496.

SCHMIDT, Max *[Lithographer] b.1850, Schönbaum, near Danzig, Germany / d.1936, San Francisco, CA.*
Addresses: San Francisco, CA. **Comments:** Position: lithographer, G.T. Brown & Co., Korbel Brothers. Founder, M. Schmidt & Co. **Sources:** Hughes, *Artists of California,* 496.

SCHMIDT, Minna Moscherosch *[Designer, educator, writer, lecturer] b.1866, Sindelfingen, Germany.*
Addresses: Chicago, IL. **Studied:** Kent College (LL.B.; LL.M.). **Member:** AIC; Illinois SFA; Chicago Hist. Soc.; Chicago Press Assn.; Nat. Press Assn.; Lg. Am. Pen Women. **Work:** figurines,

Trinity College, Wash., DC; Chicago Hist. Soc.; Holy Family Acad., Chicago; Historic Figurines, Centennial Mus., Springfield, IL. **Comments:** Teaching: Northwestern Univ.; historian, lecturer in Costumeology. Auth.: "400 Outstanding Women of the World." **Sources:** WW53; WW47.

SCHMIDT, Oscar F. *[Illustrator] b.1892 / d.1957.*
Addresses: NYC. **Studied:** Pratt Inst.; ASL, with Bridgman. **Member:** SI; SC. **Comments:** He went on an extended world tour after his discharge from WWI, and is said to have carved a tombstone for Paul Gauguin's grave. Illustr.: *Redbook, The Saturday Evening Post,* and others. Preferred medium: gouache. **Sources:** WW47; W & R Reed, *The Illustrator in America,* 192.

SCHMIDT, Otto *[Painter, illustrator, lecturer, teacher, writer] b.Philadelphia, PA / d.1940.*
Addresses: Philadelphia, PA/Lindenwood, NJ. **Studied:** PAFA with Anshutz, Thouron, Chase (also at Shinnecock Summer School); NAD with E. Carlsen, H. Ward. **Work:** mural, Northeast H.S., Philadelphia; PAFA Fellow Coll.; John H. Vanderpoel AA, Chicago. **Comments:** Illustr.: *Judge, Farm Journal, Saturday Evening Post;* "A Bid for Liberty," "Tales of Pioneer Pittsburgh," "The Fishing Creek Confederacy," "3 Hikes through Wissahickon," "Philadelphia Guide," "Pennsylvania," "Sea Transportation." **Sources:** WW40.

SCHMIDT, Peter *[Portrait painter, illustrator] b.1822, Baden, Germany / d.1867.*
Addresses: New Orleans, 1859-67. **Comments:** Also illustrated sheet music covers. **Sources:** G&W; Cline, "Art and Artists in New Orleans," 42; New Orleans CD 1859-67. More recently, see *Encyclopaedia of New Orleans Artists,* 341, Where his year of birth is given as 1829 and his death in 1866.

SCHMIDT, Peter Charles *[Engraver] b.1879, NYC / d.1948, New Orleans, LA.*
Addresses: New Orleans, active 1898-1948. **Comments:** Listed with Schmidt Brothers, 1919-49. Brother of William John Schmidt (see entry). **Sources:** *Encyclopaedia of New Orleans Artists,* 341.

SCHMIDT, Randall Bernard *[Sculptor, educator] b.1942, Fort Dodge, IA.*
Addresses: Tempe, AZ. **Studied:** Hamline Univ. (B.A.); Univ. New Mexico (M.A.). **Member:** Arizona Designer-Craftsmen; Nat. Council Educ. for Ceramic Arts. **Exhibited:** Nat. Crafts Invitational, Univ. New Mexico Art Mus., 1968; 25th Ceramics Nat., Everson Mus. Art, Syracuse, NY, 1968-70; Media 1968 & Media 1972, Civic Arts Gal., Walnut Creek, CA, 1968-72; Southwest Crafts, 1970, Am. Crafts Council, Los Angeles, CA, 1970; Crafts 1972, Richmond (CA) Art Center, 1972. **Awards:** best of show, First Ann. Invitational Art Exh., Phoenix Jewish Community Center, 1968; award, Media 1968, Civic Arts Gal., 1968; award, Four Corner Painting & Sculpture Biennial, Phoenix (AZ) Art Mus., 1971. **Work:** Univ. New Mexico Art Mus., Albuquerque; Univ. Art Coll., Arizona State Univ., Tempe; College Art Coll., Arizona Western College, Yuma; Univ. Art Coll., Pacific Lutheran Univ., Tacoma, WA; Yuma FAA. **Comments:** Preferred media: ceramics, vinyls. Publications: contrib., *Teaching Secondary School Art,P> W. Brown Co., 1971. Teaching: Arizona State Univ., 1968-; Pacific Lutheran Univ., summer 1971. Research: exploration of expanded vinyl as a sculptural material.* **Sources:** WW73.

SCHMIDT, Robert C. *[Painter] mid 20th c.*
Addresses: Chicago area; Milwaukee, WI. **Exhibited:** AIC, 1950; PAFA Ann., 1952; Corcoran Gal. biennial, 1957. **Sources:** Falk, *Exhibition Records Series.*

SCHMIDT, Solomon *[General & banknote engraver] b.1806, Baden (Germany).*
Addresses: New Orleans, c. 1840-c.1870. **Comments:** He became the local agent for Rawdon, Wright, Hatch & Edson and later for the American Bank Note Company. **Sources:** G&W; 7

Census (1850), La., V, 458-59 [under the name of Henry Schmidt, though Solomon seems intended]; 8 Census (1860), La., VI, 930 [as S. Schmidt]; New Orleans CD 1843-70. More recently, see *Encyclopaedia of New Orleans Artists,* 342.

SCHMIDT, Stephen *[Museum director] b.1925, NYC.*
Addresses: San Angelo, TX. **Studied:** Mohawk College, NY; Univ. New Mexico (B.A.). **Member:** Am. Assn. Mus.; Mountain-Plains Mus. Conf.; Am. Assn. State & Local History; Nat. Trust Hist. Preservation; Texas Hist. Found. **Comments:** Position: dir., Fort Concho Preservation & Mus. **Sources:** WW73.

SCHMIDT, Theodore B. W. *[Painter, printmaker] b.1869, Schleswig-Holstein, Germany.*
Addresses: Monroe, WA, 1941. **Studied:** Germany; AIC; St. Louis. **Sources:** WW21; Trip and Cook, *Washington State Art and Artists,* 1850-1950.

SCHMIDT, W. B. *[Painter] early 20th c.*
Addresses: Evanston, IL. **Exhibited:** AIC, 1918-19. **Sources:** WW19.

SCHMIDT, Walter *[Painter] mid 20th c.*
Exhibited: S. Indp. A., 1938. **Sources:** Marlor, *Soc. Indp. Artists.*

SCHMIDT, William John *[Engraver] b.1872, NYC / d.1931, New Orleans, LA.*
Addresses: New Orleans, active 1896-1931. **Comments:** Physician who stopped practicing medicine to become an engraver. Listed with Schmidt Brothers, partner and brother of Peter Charles Schmidt (see entry). **Sources:** *Encyclopaedia of New Orleans Artists,* 342.

SCHMIDTMAN, Mildred Florence (Mrs. Walter) *[Painter, etcher, teacher] b.1900, Chaonia, MO.*
Addresses: Seattle, WA. **Studied:** Univ. Wash.; Cornish Art Sch.; E. Ziegler; E. Forkner; leon March; F. Marshall; P. Immel; M. Merritt; Clifton holmes. **Member:** Women Painters of Wash. (pres.); Northwest WCS; SAM; PAM; Yakima Indian Nation (hon. mem.). **Exhibited:** Smithsonian Inst.; SAM, Henry Gal;, Frye Mus., all Seattle, from 1933. **Comments:** Specialty: Native American portraits. **Sources:** Trip and Cook, *Washington State Art and Artists,* 1850-1950.

SCHMIDTS, Clara *[Flower painter] late 19th c.*
Addresses: Detroit, MI. **Exhibited:** Detroit AA, 1875-76; Angell's Gal., Detroit, 1877. **Sources:** Gibson, *Artists of Early Michigan,* 209.

SCHMIERER, Martha *[Artist] early 20th c.*
Addresses: Active in Los Angeles, 1909. **Studied:** Los Angeles College FA. **Sources:** Petteys, *Dictionary of Women Artists.*

SCHMITT, Albert F(elix) *[Painter] b.1873, Boston, MA.*
Addresses: Boston, MA; Biarritz, France, 1940; NYC, 1947. **Studied:** Mass. Normal Art Sch.; Cowles Art Sch.; BMFA Sch.; abroad. **Member:** AWCS; Boston AC; Acad. d'Historie Int., Paris, Décoration Etoile d'Or et Cravate; Grand Chevalier of the Order of the Holy Sepulchre, 1934. **Exhibited:** PAFA Ann., 1903-17 (6 times); Boston AC, 1906; AIC, 1908; Corcoran Gal. biennials, 1907-14 (3 times); Salons of Am.; S. Indp. A., 1917, 1920, 1925-27. **Work:** CAM, St. Louis; Mus., RISD; BMFA; Musée du Ouvre, Paris; Musée de Pau, France; Musée de Lisbon, Portugal; Vatican, Rome. **Sources:** WW40; WW47 (as Albert Felix Schmidt); Falk, *Exhibition Records Series.*

SCHMITT, Carl *[Painter, writer, teacher] b.1889, Warren, OH.*
Addresses: Boston, MA, 1912; Norwalk, CT, 1920-30; New Canaan, Wilton, CT. **Studied:** NAD with Emil Carlsen; in Florence, Italy; Solon Borglum. **Member:** Silvermine Guild. **Exhibited:** AIC; CI; PAFA Ann., 1912, 1918-20, 1930; Corcoran Gal. biennials, 1912-28 (6 times). **Work:** Brady Mem. Chapel, Wernersville, PA; Oxford Univ., England; Pittsburgh Athletic Club; Mamaroneck (NY) Theater; Shelburne (VT) Mus. **Comments:** Painted still lifes as well religious subjects. Contrib. to national magazines. **Sources:** WW59; WW47; Muller,

Paintings and Drawings at the Shelburne Museum, 124 (w/repro.); *Art in Conn.: Between World Wars;* Falk, *Exh. Record Series.*

SCHMITT, Gertrude *[Painter, teacher] early 20th c.*
Addresses: Oakland, CA, 1920s-30s. **Exhibited:** Bay Region AA, 1936, 1937. **Sources:** Hughes, *Artists of California,* 496.

SCHMITT, Henry *[Sculptor] b.1860, Mainz, Germany / d.1921.*
Addresses: Buffalo, NY. **Studied:** Munich. **Member:** German Soc. Christian Arts, Munich; Buffalo SA. **Work:** Roman Catholic churches, Buffalo. **Comments:** Came to U.S. in 1884. Specialty: ecclesiastical subjects. **Sources:** WW10.

SCHMITT, Hermann Emil Christian *[Woodcarver] b.1872, Bad Ems, Germany / d.1928, Oakland, CA.*
Addresses: Philadelphia, PA; San Francisco. **Exhibited:** St. Louis World's Fair, 1904 (gold med.); PPE, 1915 (gold med.). **Work:** Pennsylvania State Capitol, Harrisburg; Oakland Mus. **Comments:** In 1892 he immigrated to Philadelphia and established a cuckoo clock factory there, but in 1903 he and his family settled in San Francisco. **Sources:** Hughes, *Artists of California,* 496.

SCHMITT, Hermann Joachim *[Woodcarver] b.1846, Muelben, Germany / d.1924, Oakland, CA.*
Addresses: Oakland, CA. **Comments:** After being woodcarver to Kaiser Wilhelm for 20 years, he and his family immigrated to the U.S. in 1892. He worked with his son, Hermann Schmitt (see entry) on several projects in California. **Sources:** Hughes, *Artists of California,* 496.

SCHMITT, Julius *[Lithographer] b.1821, Germany.*
Addresses: Baltimore, 1850. **Comments:** He was employed by and living with August Hoen (see entry) in 1850. **Sources:** G&W; 7 Census (1850), Md., V, 418.

SCHMITT, Paul Anton *[Mural painter, blockprinter, craftsperson, designer] b.1893, Philadelphia, PA / d.1983, San Leandro, CA.*
Addresses: Oakland, CA. **Studied:** San Francisco FA; Calif. Sch. Arts & Crafts. **Member:** Alameda AA; Soc. for Sanity in Art; Nat. WCS; Oakland AA; Bay Region AA; AAPL; Hayward AA; Berkeley Art Lg.; Soc. of Western Artists (cofounder). **Exhibited:** Oakland Art Gal., 1927, 1928, 1932, 1935 (prize), 1936; Berkeley Art Lg., 1928, 1930; Sacramento State Fair, 1931, 1938; Nat. WCS, Chicago, 1938 (prize); GGE, 1940; SFMA, 1940; Gump's, San Fran., 1944; CPLH, 1944; Alameda Free Lib., 1954 (solo); Hotel Alameda, 1956 (solo); San Leandro Festival, 1975. **Work:** St. Mary's College, Moraga; Nat. Maritime Mus., San Francisco; Oakland Mus.; St. Elizabeth Church, Oakland. **Comments:** Son of Hermann E. Schmitt (see entry), he began painting watercolors as a child. Later he also worked as a commercial artist for various publications and designed and built miniature yachts. **Sources:** WW40; Hughes, *Artists of California,* 496.

SCHMITT, Rene (Mr.) *[Painter] mid 20th c.*
Addresses: NYC. **Exhibited:** S. Indp. A., 1932-36, 1939-44; Salons of Am., 1934, 1936. **Sources:** Marlor, *Salons of Am.*

SCHMITT, Rose Elizabeth Bold *[Landscape painter] b.1892, Cold Spring, MN / d.1964, Oakland, CA.*
Addresses: Oakland, CA. **Member:** Alameda AA. **Comments:** She married Paul Schmitt (see entry) in 1914 and took up painting. Besides raising a large family, she often accompanied her husband on sketching trips. **Sources:** Hughes, *Artists of California,* 497.

SCHMITZ, Carl Ludwig *[Sculptor, teacher, lecturer] b.1900, Metz, France / d.1967, Nutley, NJ.*
Addresses: NYC. **Studied:** BAID; Maxim Dasio; Joseph Wackerle; State Sch. of App. Art; A. Hahn, State Acad. FA, Munich. **Member:** NA; NSS (Council, 1957-60); Arch. Lg.; Audubon Artists; All. Artists Am. **Exhibited:** PAFA Ann., 1934-54, 1958 (gold medal, 1940); Salons of Am., 1934; NAD, 1934-35, 1942-44, 1948-52, 1957-61 (Watrous gold medal & prize,

1959); NSS, 1934 (prize), 1939-41 (prize, 1940), 1943-44, 1946-60; WMAA, 1936-45, 1944; AIC, 1936-40; CGA, 1936, 1939; SFMA, 1935-36, 1941; S. Indp. A., 1940; AV, 1942 (prize); Arch. Lg., 1936, 1942, 1944, 1949-55; Paris France, 1937 (medal); Syracuse Mus. FA, 1938-41 (prize, 1939), 1946-58; Our Lady of Victory Comp., 1945 (prize); Meriden, CT, 1952 (prize); All. Artists Am., 1951(prize), 1956-60; WFNY, 1939; Audubon Artists, 1945, 1950-51, 1957-60. **Awards:** Guggenheim Fellowship, 1944; Am. Acad. Arts & Letters grant, 1947. **Work:** Syracuse Mus. FA; IBM; New York Munic. Coll.; Justice Bldg., USPO Dept. Bldg., Fed. Trade Comn. Bldg., all in Wash., DC; Fed. Bldg., Covington, KY; USPO, York, PA; designer, Delaware, Tercentenary half-dollar and medal for City Planning; Bar Assn. medal; Electrochemical Soc. medal; other work, Parkchester, NY; Michigan State College; Brooklyn Botanical Garden; Arch. L.; housing project, Metropolitan Life Ins. Co., the Bronx; reliefs, Loyola Seminary, Shrub Oak, NY; statues, Ciudad Trujillo, D.R.; House of Theology, Centerville, OH; reliefs, Pieta, Sorrowful Mother Shrine, Chicago, IL, bronze fountain, Culver Military Acad.; St. Leo Shrine, Chicago. **Comments:** Teaching: BAID, NYC; NAD, 1959-. Co-ed.: *National Sculpture Review,* 1959-. **Sources:** WW66; WW47; Falk, *Exh. Record Series.*

SCHMITZ, Elizabeth T(erris) *[Painter] early 20th c.; b.Philadelphia, PA.*
Addresses: Phila. **Studied:** PAFA. **Member:** Phila. Art All.; Phila. Art Week Assn. **Exhibited:** S. Indp. A., 1917. **Sources:** WW25.

SCHMITZ, M. S. *[Artist, drawing master] mid 19th c.*
Addresses: Philadelphia, 1856-60. **Comments:** This is probably Matthew Schmitz, music teacher at Philadelphia in the early fifties and after 1860. **Sources:** G&W; Phila. CD 1853-70; Phila. BD 1853 as M. Smitz, lithographer.

SCHMOHL, Fred C. *[Sculptor] b.1847, Württemburg, Germany / d.1922, Los Angeles, CA.*
Addresses: Los Angeles. **Exhibited:** World's Columbian Expo, Chicago, 1893; Seattle Expo., 1909; PPE, 1915; Pan-Calif. Expo, San Diego, 1915. **Work:** statuary, World's Fair, Chicago; also designed sculpture for expositions at Seattle, San Francisco and San Diego. **Sources:** Hughes, *Artists of California,* 497.

SCHMOHL, Henry R. *[Sculptor] b.1874, St. Joseph, MO / d.1941, Los Angeles, CA.*
Addresses: San Diego, CA. **Comments:** Son of Fred Schmohl (see entry). Position: sculptor, Paramount Studios. **Sources:** Hughes, *Artists of California,* 497.

SCHMOLZE, Hermann See: **SCHMOLZE, Karl Heinrich**

SCHMOLZE, Karl Heinrich *[Portrait, genre & historical painter, engraver, illustrator] b.1823, Zweibrücken (Germany) / d.1861.*
Addresses: Philadelphia, 1849 -1861. **Exhibited:** PAFA; Wash. AA. **Work:** PAFA (portrait of Washington). **Sources:** G&W; Thieme-Becker; Rutledge, PA; Washington AA Cat., 1859; WPA (Pa.), MS cat., of PA.

SCHMONSKY, Stanislas See: **SCHIMONSKY, Stanislas**

SCHMUCKER, Sam L. *[Painter] 19th/20th c.*
Addresses: Philadelphia, PA. **Exhibited:** PAFA Ann., 1900. **Sources:** WW01; Falk, *Exh. Record Series.*

SCHMUTZER, Ferd *[Etcher] early 20th c.*
Addresses: NYC. **Sources:** WW17.

SCHMUTZHART, Berthold Josef *[Sculptor, educator] b.1928, Salzburg, Austria.*
Addresses: Washington, DC. **Studied:** Acad. Applied Art, Vienna, Austria; masterclass for ceramics & sculpture with Robert Obsieger. **Member:** Am. Assn. Univ. Prof.; Guild Religious Archi.; Artist's Equity Assn. (first vice-pres., Wash., DC Chapt., 1971-). **Exhibited:** Southern Sculpture, Little Rock, AR, 1966 & Louisville, KY, 1968; Wash. Artists, Massilon Mus., OH, 1969;

Twenty Wash. Artists, Nat. Coll. FA, Wash., DC, 1970; Art Barn, US Dept. Interior, Wash., DC, 1971; Franz Bader Gal., Wash., DC, 1970s. **Awards:** First prize, Wash. Religious Arts Soc., 1960 & Southern Sculpture, 1966; first prize silver medal, Audubon Soc., 1971. **Work:** Fredericksburg (VA) Gal. Modern Art. Commissions: Christ (wood), 1962 & (bronze), 1964, St. James Church, Wash., DC; Bacchus fountain, Fredericksburg Gal., 1967; Christ (steel), 1968 & processional cross (bronze), 1971, St. Clements Church, Inkster, MI. **Comments:** Preferred media: wood, steel, bronze. Teaching: Corcoran Sch. Art, Wash., DC, 1963-; Montgomery College, Takoma Park, MD, 1971-. **Sources:** WW73; Office Economic Opportunity, "A Face for the Future" (film), Booker Assocs., Reston, VA, 1965; "Tools for Learning" (film), Kingsbury Center, Washington, DC, 1971.

SCHNABEL, Day N. *[Sculptor] b.1905, Vienna, Austria.*
Addresses: NYC. **Studied:** Acad. Art, Vienna; Paris with Malfray, Maillol & Zadkine. **Exhibited:** solo: Betty Parsons Gal., 1946, 1947, 1952, 1957; WMAA, 1946-66 ; and abroad. **Work:** WMAA; BM; Carnegie Inst.; WAC. **Sources:** WW59.

SCHNABEL, Edward *[Lithographer] b.c.1819, Germany.*
Addresses: Philadelphia, 1850. **Comments:** He was with Traubel, Schnabel & Finkeldey in 1850 (see entry). In 1857 he was associated with John F. Finkeldey (see entry) and William Demme (see entry), and thereafter with Finkeldey until after 1860. **Sources:** G&W; 7 Census (1850), Pa., L, 227; Peters, *America on Stone;* Phila. CD 1853-60+.

SCHNABEL, Herman *[Landscape painter] 19th/20th c.*
Addresses: San Francisco, CA. **Exhibited:** Mechanics Inst., 1889; San Fran. AA, 1890; Mark Hopkins Inst., 1900, 1903. **Work:** Camron-Stanford House, Oakland. **Sources:** Hughes, *Artists of California,* 497.

SCHNABEL & FINKELDEY *[Lithographers] mid 19th c.*
Addresses: Philadelphia, 1857-60 and after. **Comments:** The firm was established in 1857 as Schnabel, Finkeldey & Demme, but Demme withdrew the same year. The partners were Edward Schnabel, John Frederick Finkeldey, and William Demme (see entries). **Sources:** G&W; Phila. CD 1857-60+; see also Traubel, Schnabel & Finkeldey.

SCHNACKENBERG, Roy *[Painter, sculptor] b.1934, Chicago, IL.*
Addresses: Barrington, IL. **Exhibited:** Whitney Recent Acquisitions Show, 1967 & Whitney Ann., 1967-1969; New Am. Realists, Göteberg, Sweden, 1970; Beyond Illustration, The Art of Playboy (world tour), 1971-; Recent Acquisitions Show, AIC, 1971. **Awards:** Copley Found. Award, 1967. **Work:** WMAA; AIC. **Sources:** WW73.

SCHNAKENBERG, Henry Ernest *[Painter] b.1892, New Brighton, SI, NY / d.1970, Newtown, CT.*

H.E.Schnakenberg.

Addresses: NYC, 1923-41; Newtown, CT. **Studied:** Staten Island Acad.; K.H. Miller; Univ. Vermont (hon. D.F.A.). **Member:** NIAL. **Exhibited:** S. Indp. A., 1917, 1920-22, 1928, 1930-31, 1933-34, 1941; WMAA, 1921-57; PAFA Ann., 1923-52; AIC; Salons of Am.; Corcoran Gal. biennials, 1919-53 (14 times). **Work:** MMA; WMAA; BM; Montclair Art Mus.; PAFA; Savannah (GA) Gal.; AGAA; Springfield (MA) Mus.; Newark Mus.; New Britain Art Mus.; Wichita Art Gal.; Princeton Univ. Art Mus.; Wadsworth Atheneum; Fleming Mus., Montpelier, VT; Dartmouth College Gal.; Canajoharie (NY) Art Gal.; AIC; Univ. Nebraska; Minneapolis Inst. Art; Palace Legion Honor; Dallas Mus. FA; murals, USPO, Amsterdam, NY; Fort Lee, NJ; SFMA; Lawrence Mus., Williamstown, MA; Fleming Mus,, Burlington, VT. **Comments:** Contrib.: articles/criticism in *The Arts.* **Sources:** WW66; WW47; Falk, *Exh. Record Series.*

SCHNAPLE, Frederick *[Painter, designer] b.c.1872, Germany / d.1948, Detroit, MI.*
Addresses: Detroit. **Exhibited:** Detroit Inst. Arts; AIC. **Sources:**

Gibson, *Artists of Early Michigan,* 209.

SCHNARR, D. *[Portrait painter] mid 19th c.*
Sources: G&W; NYBD 1854; NYCD 1855-60.Daniel Schnarr, at the same address, is listed as a "hatter" in city directories from 1855 to 1860.

SCHNAUFFER, Gina *[Painter] early 20th c.*
Exhibited: AIC, 1932, 1936. **Sources:** Falk, *AIC.*

SCHNEBLE, Emil *[Engraver] early 20th c.*
Addresses: Wash., DC, active 1904-05. **Sources:** McMahan, *Artists of Washington, DC.*

SCHNEE, Bella Hermont *[Painter] early 20th c.*
Addresses: Chicago, IL, 1927. **Exhibited:** S. Indp. A., 1927-28. **Sources:** Marlor, *Soc. Indp. Artists.*

SCHNEEBAUM, Tobias *[Painter] b.1921, NYC.*
Addresses: NYC. **Studied:** WPA, 1935-36; City College NY (B.A., 1942); Brooklyn Mus. Art Sch. with R. Tamayo, 1946 & A. Osver, 1947. **Exhibited:** SI, Wash., DC, 1955; Univ. Nebraska, 1963; AIC, 1964; Univ. Colorado, 1965; Peridot-Washburn Gal., NYC, 1970s. **Awards:** Yaddo fellowship, 1953 & 1955; Fulbright fellowship, 1955 & 1956. **Work:** Mus. Estado, Guadalajara, Mexico; Mus. Nat., Cuzco, Peru. **Comments:** Preferred media: oils. Publications: illustr., *The Girl in the Abstract Bed,* 1954 & *Jungle Journey,* 1959. Teaching: Ajijic Sch. Art, Mexico, 1947-49. **Sources:** WW73.

SCHNEEBERGER, J. *[Painter] early 20th c.*
Addresses: Chicago, IL. **Sources:** WW13.

SCHNEIDAU, Maretta D. *[Landscape painter, still life painter] early 20th c.*
Addresses: New Orleans, active c.1901. **Exhibited:** Artist's Assoc. of N.O., 1901. **Sources:** *Encyclopaedia of New Orleans Artists,* 342.

SCHNEIDER, Arthur *[Sculptor] mid 20th c.*
Addresses: Detroit, MI. **Exhibited:** PAFA Ann., 1960, 1966. **Sources:** Falk, *Exh. Record Series.*

SCHNEIDER, Arthur E. *[Painter, etcher, illustrator] b.1866, Madison, WI / d.1942.*
Addresses: NYC, 1896; Boston, 1901-c.1904; NYC, 1905-c.1925; Tampa, FL. **Studied:** NYC; Europe. **Member:** AWCS; NYWCC. **Exhibited:** NAD, 1896; Boston AC, 1901-08; AIC, 1912; SC, 1906 (prize), 1907 (prize), 1912 (prize); AWCS, 1913 (prize); PAFA Ann., 1915. **Comments:** He may also have lived for a time in Cleveland. **Sources:** Falk, *Exh. Record Series;* WW25 (as Arthur Schneider, without the middle initial).

SCHNEIDER, Bernhard *[Painter] early 20th c.*
Addresses: Chicago area. **Exhibited:** AIC, 1902. **Sources:** Falk, *AIC.*

SCHNEIDER, Charles B. *[Engraver] b.1821, Pennsylvania.*
Addresses: Philadelphia from 1849. **Sources:** G&W; 8 Census (1860), Pa., LI, 654; Phila. BD 1849, CD 1854-60+.

SCHNEIDER, Clara M. *[Painter] early 20th c.*
Addresses: Memphis, TN. **Sources:** WW13.

SCHNEIDER, Edward Louis *[Painter, designer] b.c.1883, New Orleans, LA / d.1952, New Orleans.*
Addresses: New Orleans, active c.1895-1949. **Sources:** *Encyclopaedia of New Orleans Artists,* 343.

SCHNEIDER, Elsbeth *[Painter, etcher, engraver] b.1904, Chicago, IL / d.1963, San Diego County, CA.*
Addresses: Chico, CA. **Studied:** Univ. California (B.A.; M.A.). **Member:** Lg. Am. Pen Women; Calif. SE. **Exhibited:** SFMA, 1935; San Francisco AA, 1937; Oakland Art Gal., 1940, 1941, 1943-53; Laguna Beach AA, 1944; Calif. SE, 1945, 1946, 1949; Lg. Am. Pen Women, 1935 (prize), 1937 (prize); Santa Cruz Ann., 1934 (hon. men.), 1935 (hon. men.). **Comments:** Teaching: Chico (CA) State College, 1926-56. **Sources:** WW59; WW47.

SCHNEIDER, Ethel *early 20th c.*
Exhibited: Salons of Am., 1925. **Sources:** Marlor, *Salons of Am.*

SCHNEIDER, George W. *[Painter, teacher, illustrator] b.1876, Youngstown, OH.*
Addresses: Madison, WI. **Studied:** AIC; Académie Julian, Paris with J.P. Laurens, 1901. **Exhibited:** AIC, 1904; PAFA Ann., 1905. **Sources:** WW08; Falk, *Exh. Record Series.*

SCHNEIDER, Gertrude *[Painter] early 20th c.*
Addresses: Los Angeles, CA. **Exhibited:** Calif. WCS, 1930. **Sources:** Hughes, *Artists of California,* 497.

SCHNEIDER, Heinrich Rymer *[Painter, sculptor] b.1883.*
Addresses: Active Los Angeles, 1909-12, thereafter San Francisco. **Studied:** Brussels; Paris; Florence; Rome. **Member:** Royal Acad. Belgium. **Exhibited:** Award: Prix de Rome (age 19). **Work:** busts/lions, for Hershey Arms, Los Angeles.

SCHNEIDER, Isobel (Mrs. Otto H.) *[Painter] b.c.1875, NYC / d.1962, San Diego, CA.*
Addresses: Ocean Beach, CA, c.1924-. **Studied:** M.B. Cox; L. Hitchcock; ASL, Buffalo; ASL; Z. Shanfield, Paris. **Member:** Buffalo SA; San Diego Art Guild; Contemporary Artists of San Diego; Los Surenos Art Center, San Diego. **Exhibited:** Los Angeles County Fair, 1929; Calif.-Pacific Int. Expo, 1935; San Diego AG, 1936 (first prize). **Comments:** Born 1870 or 1880. Married to Otto Schneider (see entry). Position: county chairman, Fine Art, San Diego. **Sources:** WW40.

SCHNEIDER, Jo Anne *[Painter] b.1919, Lima, OH.*
Addresses: NYC. **Studied:** Sch. FA, Syracuse Univ. **Exhibited:** Corcoran Gal. biennial, 1957; WMAA; 50 Years Am. Art, AFA, 1964; Am. Acad. Arts & Letters, 1971 (Childe Hassam Fund exh.); Guild Hall, Southhampton, NY, 1967 (1st prize); NAWA, 1970 (Haldenstein Mem. Prize); Audubon Artists, 1972 (Grumbacher Mem. Award); plus nine solo exh. at galleries, 1954-72, incl. Frank Rehn Gal, NYC. **Work:** Butler Inst. Am. Art, Youngstown, OH; Syracuse Univ., NY; Allentown Mus., PA; St. Lawrence Univ., Canton, NY; Colby College, ME. **Comments:** Preferred media: oils. **Sources:** WW73; *Provincetown Painters,* 265.

SCHNEIDER, Leonie *[Painter] b.1883, Michigan / d.1973, Los Angeles, CA.*
Addresses: Los Angeles. **Exhibited:** Artists Fiesta, Los Angeles, 1931. **Sources:** Hughes, *Artists of California,* 497.

SCHNEIDER, Martha (Lemon) *[Artist, author]; b.Wash., DC.*
Studied: Miss Osborn's Acad.; Corcoran Sch. Art; ASL of Wash., DC. **Exhibited:** Wash., DC; Boston; NYC. **Sources:** McMahan, *Artists of Washington, DC.*

SCHNEIDER, Noel *[Sculptor] b.1920, NYC.*
Addresses: Brooklyn, NY. **Studied:** ASL with William Zorach; City Univ. NY. **Member:** Am. Vet. Soc. Artists. **Exhibited:** Bosshart Art Mus., NJ State College, 1962 (solo); Stamford (CT) Mus. Nat., 1968; solo slide show, City Univ. NY, 1968; Meet Sculptor Ser., Sculpture Center, New York, 1968; 28th Ann. Nat. Exh. Painters & Sculptors, Jersey City Mus., 1969. **Awards:** Ann. purchase prizes, Collectors Am. Art, 1962-64; first prize for sculpture, Am. Vet. Soc. Artists, 1968 & gold medal, 1970. **Work:** Bergen County YMHA, NJ. Commissions: Willner Memorial Bas Relief, Bergen County YMHA, 1964. **Comments:** Preferred media: wood, stone, steel. **Sources:** WW73.

SCHNEIDER, Otto Henry *[Landscape and figure painter, teacher] b.1865, Muscatine, IA / d.1950, San Diego, CA.*
Addresses: Ocean Beach, CA (from c.1924). **Studied:** AIC; ASL; Buffalo; ASL; Académie Julian, 1910-12. **Member:** San Diego AA, 1929 (cofounder); Contemp. Artists San Diego. **Exhibited:** Paris Salon, 1911; Buffalo SA, 1912 (prize), 1917 (prize), 1922 (prize); Southern Calif. Artists, 1931. **Work:** San Diego FA Gal. **Comments:** Teaching: Buffalo ASL, 1921-23; San Diego Acad. FA, 1925-50. **Sources:** WW40; Ness & Orwig, *Iowa Artists of the First Hundred Years,* 185; Hughes, *Artists of California,* 497.

SCHNEIDER, Otto J. *[Painter, illustrator, etcher]* b.1875, Atlanta, IL / d.1946.
Addresses: Chicago, IL. **Member:** Chicago SE.
Exhibited: AIC, 1903. **Work:** AIC; TMA;
NYPL; Vanderpoel AA; Cleveland MA. **Sources:** WW40.

SCHNEIDER, Rose *[Painter]* b.1895, La Grange, MO / d.1976, San Diego, CA.
Addresses: San Diego, CA. **Studied:** Maurice Braun; Charles Reiffel. **Member:** San Diego Art Guild. **Exhibited:** San Diego Art Guild, 1930s, 1940s; Calif.-Pacific Int. Expo, San Diego, 1935; GGE, 1939; Calif. State Fair, 1947 (hon. men.). **Sources:** Hughes, *Artists of California*, 497.

SCHNEIDER, Susan Hayward *[Painter]* b.1876, Pana, IL.
Addresses: Langhorne, PA. **Studied:** Smith College; PM Sch. IA; Fred Wagner Wayman Adams Rittenberg; Voss, in Munich.
Member: Phila. Art All.; AAPL; Plastic Club. **Exhibited:** Kaiser & Allman Gals., Phila., 1926; Phila. AC, 1936-1940; Indiana AC, 1936; PAFA, 1940; Reading Mus., 1940; New Century Club, Women's City Club, Plastic Club, all solos, all of Phila. **Work:** Langhorne (PA) Lib. **Sources:** WW53; WW47.

SCHNEIDER, Theophile *[Painter]* b.1872, Freiburg, Germany / d.c.1960.
Addresses: Boston, MA, 1913-19; Brooklyn, NYC, NY. **Studied:** Homer Boss; Hans Hofmann; Charles Hawthorne; George Noyes; Monks; Davol. **Member:** Boston AC; SC; Brooklyn SA.
Exhibited: PAFA Ann., 1913, 1919, 1924; S. Indp. A., 1917, 1920, 1922, 1925, 1928, 1930, 1936-37; Salons of Am.; BM; Boston AC, 1924 (prize); NYWCC. **Work:** BM; Master Inst., NY; Boston AC. **Comments:** Painting locations included Monhegan Island (ME). **Sources:** WW53; WW47; Curtis, Curtis, and Lieberman, 103, 186; Falk, *Exh. Record Series.*

SCHNEIDER, Ursula *[Sculptor]* b.1943.
Addresses: San Francisco, CA. **Exhibited:** WMAA, 1975.
Sources: Falk, *WMAA.*

SCHNEIDER, William G. *[Painter, illustrator]* b.1863, Monroe, WI / d.1912.
Addresses: NYC. **Studied:** Paris. **Member:** AWCS; SC, 1902; Players Club, NYC. **Exhibited:** Boston AC, 1898-1907; AIC.
Sources: WW13; *The Boston AC.*

SCHNEIDER, William N. *[Illustrator]* mid 20th c.
Addresses: NYC; Baltimore, MD. **Member:** SI. **Exhibited:** WMAA, 1949. **Sources:** WW53; WW47.

SCHNEIDERHAHN, Maximilian *[Sculptor]* b.Germany / d.1923.
Addresses: St. Louis, MO. **Studied:** Munich Acad. FA. **Work:** executed commissions for many Roman Catholic churches.
Comments: Came to St. Louis in 1870.

SCHNEIDERMAN, Dorothy *[Art dealer]* b.1919, NYC.
Addresses: Cold Spring Harbor, NY. **Comments:** Positions: dir., Harbor Gal., 1965-. Specialty of Gallery: contemporary American realists. **Sources:** WW73.

SCHNEIDERMAN, H(y) *[Painter]* mid 20th c.
Exhibited: S. Indp. A., 1938-43. **Sources:** Marlor, *Soc. Indp. Artists.*

SCHNEITTER, Stanley *[Painter]* mid 20th c.
Exhibited: Kingsley AC, Sacramento, 1932, 1936, 1943.
Sources: Hughes, *Artists of California*, 498.

SCHNELL, Jophn *[Painter]* b.1941.
Addresses: NYC. **Exhibited:** WMAA, 1975. **Sources:** Falk, *WMAA.*

SCHNELL, Madeleine *[Painter]* b.1830, Germany / d.1902.
Sources: info. courtesy Peter C. Merrill.

SCHNELL, Shirley (Mrs.) *[Painter]* mid 20th c.
Addresses: Minneapolis, MN. **Studied:** Minneapolis Sch. Art (B.F.A.); Yale Univ. (M.F.A.; 3 award scholarships). **Exhibited:** Walker Biennial, 1964; Minnesota State Fair, 1958; Fed. Reserve Bank of NY Comp. (first prize in oils). **Comments:** Teaching: Minneapolis Sch. Art. **Sources:** WW66.

SCHNELLE, William G. *[Painter, teacher]* b.1897, Brooklyn, NY.
Addresses: NYC/Rensselaerville, NY. **Studied:** PIA Sch.; ASL; W. Beck; H.B. Snell. **Member:** Soc. of the Five; NAC.
Exhibited: NAC, 1931. **Comments:** Teaching: Washington Irving Evening H.S., NYC. **Sources:** WW40.

SCHNICKE, Harry *[Illustrator, craftsperson]* b.1871, Cincinnati, OH.
Addresses: Cincinnati, OH. **Studied:** Cincinnati Art Acad. with Meakin, Sharp, Beck. **Sources:** WW10.

SCHNIDER, Elsa *[Painter]* early 20th c.
Addresses: Philadelphia, PA. **Sources:** WW04.

SCHNIER, Jacques *[Sculptor, teacher, writer]* b.1898, Romania / d.1988, Walnut Creek, CA.
Addresses: Lafayette, CA. **Studied:** Stanford Univ. (A.B., civil engineering); Univ. Calif. (M.A.); Calif. Sch. FA, San Francisco with Ralph Stackpole; Ray Boynton; Ruth Cravath. **Member:** Calif. Soc. Mural Painters; San Francisco AA; NSS. **Exhibited:** Beaux Arts Gal., San Francisco (solo); Northwestern Art Exh., Seattle, 1928 (prize);San Francisco AA, 1928 (first sculpture award); Braxton Gal., Hollywood, 1929; Courvoisier Gal., San Francisco, 1932; San Francisco, 1930 (prize); AIC, 1930, 1937; LACMA, 1934 (prize); Oakland Art Gal., 1936 (prize), 1948 (prize); GGE, 1939; Oakland Art Mus., 1948 (first sculpture prize & gold medal); Third Sculpture Int., Philadelphia Mus., 1949; solos: Sculpture, Stanford Univ. Mus., 1962; Sculpture, Santa Barbara Mus. Art, 1963; Bronze Sculpture, Ryder Gal., Univ. Calif., Berkeley, 1965; Transparency and Reflection, Judah Magnes Mus., Berkeley, 1971. Other awards: Inst. Creative Arts fellowship, Univ. Calif., 1963. **Work:** Oakland (CA) Art Mus.; playground fountain, San Francisco; memorial, Calif. Sch. FA; CPLH; Stanford Univ. Mus.; Santa Barbara Mus. Art; Honolulu Acad. Arts; Mills College Art Gal., Commonwealth Club, CA; Tel-Aviv Mus., Palestine; Calif. Hist. Soc.; Commissions: U.S. Half Dollar, commemorating San Francisco-Oakland Bay Bridge, 1936; architectural relief, Berkeley (CA) H.S., 1939; wood relief sculpture, State of Hawaii, Congress Club, Washington, DC, 1948; bronze wall sculpture, College Architecture Alumni, Univ. Calif., Berkeley, 1960; carved acrylic sculpture, Calif. College Arts & Crafts; Founders Centennial Award for Neil Armstrong, 1972. **Comments:** In the late 1920s he carved directly in marble and wood, completing a number of commissions for architectural sculpture. Schnier traveled around the world in 1932-33. He often used Asian women as models for his figures. After WWII he abandoned figures for abstract geometries and after the late 1960s incorporated industrial materials into his work. Positions: chmn. advisory board, Nat. Sculpture Center, Univ. Kansas, 1971-; mem. advisory board, Int. Sculpture Symposium, Eugene, OR, 1971-74; mem. advisory board, Section L, AAAS, 1972. Publications: auth., "The Tibetan Lamaist Ritual: Chöd," *Int. Journal Psychoanalysis,* Vol. 1937, No. 6; auth., "Reinforced Polyester Plastic and Acrylic Color for Sculpture," Proceedings Fifth Nat. Sculpture Conf., 1968; "Reflection and Transparency in Carved Acrylic Sculpture," Proceedings Sixth Nat. Sculpture Conf., 1970; auth., "The Cubic Element in my Sculpture," 1969; "Transparency and Reflection as Entities in Sculpture of Carved Acrylic Resin," 1972, Leonardo. Teaching: Calif. College Arts & Crafts, 1935-36; Univ. Calif., Berkeley, 1936-66. **Sources:** WW73; Fort, *The Figure in American Sculpture,* 222 (w/repro.).

SCHNIEWIND, Carl Oscar *[Museum curator, writer, lecturer]* b.1900, NYC / d.1957, Florence, Italy.
Addresses: Chicago, IL. **Studied:** Univ. Zurich (B.A.); Univ. Berne, Switzerland; Univ. Heidelberg, Germany. **Member:** AA Mus.; Grolier Publ. **Comments:** Co-author: "The First Century of Printmaking," 1941; "Posada, Printmaker to the Mexican People," 1944; "Drawings, Old and New." 1946. Contributor to art magazines. Lectures: 19th & 20th Century Prints. Position: librarian &

curator, Prints & Drawings, BM, Brooklyn, NY, 1935-40; cur., Prints & Drawings, AIC, Chicago, IL. **Sources:** WW53; WW47.

SCHNITTMAN, Sascha S. *[Sculptor, museum director]* *b.1913, NYC.*
Addresses: St. Louis, MO; San Jose, CA. **Studied:** Cooper Union Art School; NAD; BAID; École Beaux Artes, Paris, France; Olympio Brindisi; George Grey Barnard; Attilio Piccirilli; Charles Keck; Robert Aitken; Alexandre Sambougnac; Ceasare Stea; Gaetano Cecere. **Member:** Russian Sculpture Soc. (life fellow); Am. Acad. Sculptors; École Beaux Arts, Paris (hon. life mem.); Soc. Independent Artists; NSS; Am. Inst. Arch. Sculptors. **Exhibited:** Pan-Am. Arch. Soc., 1933 (prize); All. Artists Am., 1935, 1936; W.R. Nelson Gal., 1942; Soc. Indep. Artists; 1942 (prize), 1943-44; St. Louis AG, 1942; CAM, St. Louis, 1942 (prize); WMAA, 1943; Chicago AC, 1943; Kansas City AI, 1942 (prize); AIC, 1943 (prize); Indep. Artists, St. Louis, 1941-43; Jr. Lg. Missouri Exh., 1942 (prize). **Work:** Pan-Am Soc.; AMNH; Dayton Art Inst.; Kansas City Art Inst.; Moscow State Univ., Russia. **Commissions:** Am. Legion Mon., St. Louis, MO; aluminum figures for War Mem. Stadium, Little Rock, AR; Morgan Horse (life-size bronze), State Vermont, 1967; Martin Luther King, Jr. (heroic mem. portrait bust, four times life size), 1968; fountain figures, Henry Ford Centennial Lib., Dearborn, MI & Darsa Fountain, St. Louis, MO. **Comments:** Preferred media: marble, bronze. Positions: teacher, Univ. St. Louis; dir. & cur., Triton Mus. Art. Publications: auth./illustr., "Anatomy & Dissection for Artists," 1939; auth./illustr., "Plastic Histology," 1940; contrib. architecture magazines. **Sources:** WW73; "Sculptor Schnittmann gives Church Valuable Bronzes", *San Jose Mercury,* Dec. 16, 1971; Leonard Neft, "St. Joseph's Celebration," *The Mercury,* March 18, 1971; "Bust of Martin Luther King Unveiled at Grace Cathedral," *Voice of the People* (Feb. 26, 1972); WW47.

SCHNITZLER, Frederic *[Painter] late 19th c.*
Addresses: Phila., PA. **Exhibited:** PAFA Ann., 1884. **Sources:** Falk, *Exh. Record Series.*

SCHNITZLER, Max *[Painter] b.1903, Bukowsko, Poland.*
Addresses: NYC; Hopewell Junction, NY. **Studied:** in Paris with Leger, Ozenfant, L'Hote. **Exhibited:** WMAA; CM; Denver AM; SAM; SFMA; Albright Art Gal.; Columbia (solo); Zborowski Gal. (solo); Contemp. Art Gal. (solo); Pinacotheca (solo); Springfield Mus. Art; Wildenstein Gal.; Stable Gal.; Albany Inst. History & Art; Poindexter Gal., NY, 1957. **Work:** Collectors of Am. Art. **Sources:** WW59; WW47.

SCHNURR-COLFLESH, Elinore *[Painter] b.1932, Sandusky, OH.*
Addresses: NYC. **Studied:** Cleveland Inst. Art (B.F.A.). **Exhibited:** Recent Paintings USA: The Figure, MoMA, 1962; Butler IA, 1963; PAFA Ann., 1966; Caravan House Gal., New York, 1972 (solo) & Earl Hall, Columbia Univ., New York, 1972 (solo). **Sources:** WW73; Falk, *Exh. Record Series.*

SCHNYDER BROTHERS *[Painters] 19th/20th c.*
Addresses: New Orleans, active 1885-1901. **Comments:** Albert Schnyder and Joseph Schnyder, partners. **Sources:** *Encyclopaedia of New Orleans Artists,* 343.

SCHOBER, Frederick A. *[Lithographer, printer] b.1806, Germany / d.1869, Detroit, MI.*
Addresses: Detroit, MI, 1855-59. **Comments:** In partnership with Robert Burger, 1855-56, as Burger & Schober, lithographers. **Sources:** Gibson, *Artists of Early Michigan,* 210.

SCHOBER, Richard *[Painter] b.1866 / d.1896.*
Addresses: Chicago area. **Exhibited:** AIC, 1897. **Sources:** Falk, *AIC.*

SCHOBINGER, Gertrude *[Painter] mid 20th c.*
Addresses: Swarthmore, PA. **Exhibited:** PAFA Ann., 1945. **Sources:** Falk, *Exh. Record Series.*

SCHOCH, Pearl *[Painter] b.1894, NYC.*
Addresses: Brooklyn, NY. **Studied:** PIA Sch.; NYU; Columbia;

A. Fischer; M. Davidson; C.J. Martin. **Member:** AWCS; NAWA. **Exhibited:** AWCS, 1939-46; BM; NAWA; BM; Guild Hall, East Hampton, NY; traveling watercolor exh. in U.S. & Canada. **Sources:** WW47.

SCHOCK, William *[Etcher, decorator] b.1913, Porto Alegre, Brazil.*
Addresses: Kent, Cleveland, OH. **Studied:** K. Kubinyi; H. Keller; R. Stoll; F. Wilcox. **Exhibited:** CMA, 1936 (prizes), 1939 (prize); PAFA Ann., 1952-53. **Work:** CMA. **Sources:** WW40; Falk, *Exh. Record Series.*

SCHOEBEL, Joseph *[Lithographer, pressman, printer] b.1866, New Orleans, LA / d.1941, New Orleans.*
Addresses: New Orleans, active 1885-1939. **Sources:** *Encyclopaedia of New Orleans Artists,* 343.

SCHOEFFT, August *[Painter] mid 19th c.*
Addresses: NYC, 1864. **Exhibited:** NAD, 1864. **Sources:** Naylor, *NAD.*

SCHOELKOPF, Robert J., Jr. *[Art dealer] b.1927, NYC / d.1991.*
Addresses: NYC. **Studied:** Yale College (B.A.). **Member:** Art Dealers AA. **Comments:** Positions: dir. & owner, Robert Schoelkopf Gallery. Specialty of gallery: 19th & 20th c. Am. painting, sculpture and photography. **Sources:** WW73.

SCHOELLER, Ilse *[Painter] mid 20th c.*
Addresses: NYC. **Exhibited:** S. Indp. A., 1944. **Sources:** Marlor, *Soc. Indp. Artists.*

SCHOEN, Arthur Boyer (Mr. & Mrs.) *[Collectors] b.1923; 1915, Pittsburgh, PA; NYC.*
Addresses: NYC. **Studied:** Mr. Schoen, Princeton Univ. (B.A.); Mrs. Schoen, Columbia Univ.; Grand Central Sch. Art, NY. **Member:** Parrish Art Mus. (Mrs. Schoen, pres., 1970-); MMA; Mus. City of New York; Mrs. Schoen, York Club (pres.). **Exhibited:** Awards: Mrs. Schoen, six United Hospital Fund Awards, 1960-72. **Comments:** Collection: paintings, 18th c. Lowestoft (Chinese export); 10th & 12th Persian pottery; 18th c. English and Am. furniture. **Sources:** WW73.

SCHOEN, David (Dr.) *[Painter] early 20th c.*
Addresses: Baldwin, LI, NY. **Exhibited:** S. Indp. A., 1930-31. **Sources:** Marlor, *Soc. Indp. Artists.*

SCHOEN, Eugene *[Designer, architect, decorator] b.1880, NYC / d.1957.*
Addresses: NYC. **Studied:** Columbia Univ., B.S. (architecture); W.R. Ware. **Member:** Am. Inst. Dec.; Arch. Lg. **Exhibited:** Arch. Lg., 1931 (gold medal). **Work:** PMA; interior arch. des. for: Stewart and Co., Stern Bros., R.H. Macy and Co.; Savoy-Plaza Hotel; NYC; Kaufmans, Pittsburgh; Jordan Marsh Co., Boston; casino, Rye, NY; RKO Center Theatre; USSR Embassy, Washington, DC; Alfred Dunhill, London; Radio City, NYC; Boardwalk, Atlantic City, NJ; Hotels Concourse Plaza, New Yorker. **Comments:** Consultant and architect to New York State on Chicago World's Fair. Teaching: NYU. **Sources:** WW53; WW47.

SCHOEN, James D. *[Painter] early 20th c.*
Addresses: NYC. **Member:** S. Indp. A. **Exhibited:** S. Indp. A., 1918-21, 1925-26. **Sources:** WW25.

SCHOENBERG, Violet K. *[Painter] mid 20th c.*
Addresses: St. Charles, MO. **Exhibited:** S. Indp. A., 1936-44. **Sources:** Marlor, *Soc. Indp. Artists.*

SCHOENBORN, Annie M. *[Artist] 19th/20th c.*
Addresses: Wash., DC, active 1898; Cripple Creek, CO. **Exhibited:** Wash. WCC, 1898. **Comments:** Daughter of artist August Schoenborn. In 1898 she married Edward C. Fuelling of Cripple Creek, CO. **Sources:** McMahan, *Artists of Washington, DC.*

SCHOENBORN, August G. *[Architect, artist, draftsman] b.1827, Erfurt, Germany / d.1902, Wash., DC.*

Comments: Came to U.S. in 1849 and worked at the U.S. Capitol. Schoenborn was the designer of the dome of the Capitol, in addition to other buildings in Wash., DC. He was also a government map maker during the Civil War. During the building of the Capitol extension he was head draftsman, and worked there until his death in 1902. Father of artist Annie Schoenborn. **Sources:** McMahan, *Artists of Washington, DC.*

SCHOENBORN, Florene May (Mrs. Wolfgang) *[Collector, patron] b.1903, Denver, CO / d.1995.* **Addresses:** NYC. **Comments:** Heiress of the May Department store chain, from 1937-64, she formed an important art collection that included works by Picasso, Leger, Matisse, Bonnard, Gris, Brancusi, and other School of Paris masters. She bequeathed 18 works to the MMA and 14 to MoMA, valued at more than $150 million. **Sources:** WW66.

SCHOENE, Richard *early 20th c.* **Exhibited:** Salons of Am., 1934. **Sources:** Marlor, *Salons of Am.*

SCHOENER, Allon *[Art consultant] b.1926, Cleveland, OH.* **Addresses:** Grafton, VT. **Studied:** Yale Univ. (B.A., 1946; M.A., 1949); Courtauld Inst. Art, Univ. London, 1947-48. **Comments:** Positions: asst. dir., Jewish Mus., 1966-1967; visual arts program dir., NY State Council Arts, 1967-. Publications: ed., *Portal to America,* Holt, Rinehart & Winston, 1967; ed., *Harlem on My Mind,* Random, 1969. Collections arranged: Lower East Side: "Portal To American Life," 1966 & "Word From Jerusalem," 1972, Jewish Mus.; "Erie Canal; 1817-1967," NY State Council Arts, 1967; "Harlem On My Mind," MMA, 1969. **Sources:** WW73.

SCHOENER, Jacob B. *[Miniature & portrait painter] b.1805, Reading, PA / d.1846.* **Addresses:** Reading until c.1845; Boston, c.1845-46. **Studied:** PAFA. **Exhibited:** PAFA, 1826-28; BA, 1832. **Comments:** He learned miniature painting from Gennaro Persico. **Sources:** G&W; Montgomery, *Berks County,* 808; Rutledge, PA; Swan, BA.

SCHOENER, Jason *[Painter, educator] b.1919, Cleveland, Ohio.* **Addresses:** Oakland, CA. **Studied:** Cleveland Inst. Art; Western Reserve Univ. (B.S.); ASL; Columbia Univ. (M.A.). **Member:** San Fran. Art Inst.; College AA Am.; ASL; Am. Assn. Univ. Prof. **Exhibited:** SFMA painting ann., 1953-65; Corcoran Gal. biennial, 1957; Richmond (CA) Art Center, 1957 (prize); Calif. State Fair, 1958 (prize); Brooklyn Mus. Int. Watercolor Exh., 1959, 1961; Maine Art Gal., 1961 (prize); PAFA, Watercolor Ann., 1959-69; CPLH, Winter Invitationals, 1968, 1970; Landscape I & II, De Cordova Mus., 1970-71; Midtown Gal, NYC; Gumps Gal., San Fran. **Work:** CMA; WMAA; CPLH; Columbus Gal. FA; Munson-Wms.-Proctor Inst., Utica, NY. **Comments:** Preferred media: oils, watercolors, gouache. Teaching: Munson-Williams-Proctor Inst., 1949-53; Calif. College Arts & Crafts, Oakland, 1953-61, dir., public relations & special services, 1953-55, chmn. dept. fine arts, 1955-70, dir., evening college, 1955-69, dir., fine arts div., 1970s; visiting lecturer, Mills College, 1962; visiting prof., Athens Technological Inst., Greece, 1964-65. Publications: "Art Patronage in Greece," *Art Journal* (winter 1966-67). **Sources:** WW73.

SCHOENFELD, Flora See: **SCHOFIELD, Flora Itwin**

SCHOENFELD, Lucille *[Sculptor] early 20th c.* **Addresses:** San Francisco, CA, active 1919-23. **Exhibited:** San Francisco AA, 1918-20. **Sources:** WW21; Hughes, *Artists of California,* 498.

SCHOENINGER, Gretchen *[Sculptor] mid 20th c.* **Exhibited:** AIC, 1941. **Sources:** Falk, *AIC.*

SCHOENMAKERS, Pauline Aimee *[Painter] b.1867, San Francisco, CA / d.1946, San Fran.* **Addresses:** San Fran. **Studied:** Mark Hopkins Inst. with Virgil Williams, Aice Chittenden, Raymond Yelland, Arthur Mathews. **Member:** San Fran. AA. **Exhibited:** Calif.-Midwinter Int. Expo, 1894 (bronze med.). **Comments:** Specialty: still lifes and por-

traits. Her works are rare. **Sources:** Hughes, *Artists of California,* 498.

SCHOEPFLIN, Jane *early 20th c.* **Exhibited:** Salons of Am., 1934. **Sources:** Marlor, *Salons of Am.*

SCHOETTLER, Walter M. *[Painter] mid 20th c.* **Exhibited:** AIC, 1935. **Sources:** Falk, *AIC.*

SCHOFER, Carl T. *[Painter] early 20th c.* **Addresses:** Crafton, PA. **Member:** Pittsburgh AA. **Sources:** WW21.

SCHOFF, Stephen Alonzo *[Banknote and steel engraver] b.1818, Danville, VT / d.1904, Norfolk, CT.* **Addresses:** Boston, c.1842-69. **Studied:** Oliver Pelton, Boston engraver, 1834-37; Joseph Andrews, engraver, 1837 and after; Paris 1839/40-1842. **Member:** ANA, 1844-84. **Comments:** With Andrews he went abroad. After his return, he devoted himself mainly to banknote work, though he achieved a considerable reputation for his steel engravings and etchings of portraits, historical, and other paintings. He also made his home at various times in Washington, New York, Newtonville (MS), Brandon (VT), and finally in Norfolk (CT) **Sources:** G&W; DAB; Stauffer; Thieme-Becker; Boston BD 1850-60+; Cowdrey, AA & AAU; Cowdrey, NAD; Clark, *History of the NAD,* 269.

SCHOFIELD, Betty *[Painter] early 20th c.* **Addresses:** Beverly Hills, CA. **Exhibited:** Artists Fiesta, Los Angeles, CA, 1931. **Sources:** Hughes, *Artists of California,* 498.

SCHOFIELD, Claribald *[Painter] late 19th c.; b.Baltimore, MD.* **Studied:** Baschet; Schommer. **Exhibited:** Paris Salon, 1896 (drawing). **Sources:** Fink, *Am. Art at the 19th c. Paris Salons,* 389.

SCHOFIELD, Eliza H. *[Painter] late 19th c.* **Addresses:** Phila., PA. **Exhibited:** PAFA Ann., 1882-91 (6 times). **Sources:** Falk, *Exh. Record Series.*

SCHOFIELD, Flora Itwin *[Painter, sculptor, block printer, teacher] b.1873, Chicago, IL / d.1960, Chicago.* **Addresses:** Chicago. **Studied:** AIC; Paris with Friez, Gleizes, Lhote; Provincetown with C.W. Hawthorne, B.J.O. Nordfeldt, Wm. Zorach. **Member:** Chicago SA; Chicago AC; NYSWA; Cordon. **Exhibited:** Provincetown AA, 1916; PAFA Ann., 1918, 1920; Salon d'Automne & Salon de Indépendants, Paris, c.1925-35; Salons of Am.; S. Indp. A., 1917, 1919-21, 1926; AIC, 1897-1944 (prizes in 1929 & 1931); Women Painters of Am., Wichita Mus. Art, 1939 (prize); CI; Gal. Carmine, Paris (solo); Nat. Arts Club Gals., NYC, 1925; Marshall Field Gals., 1920s-40s (with "The Ten"); MoMA, "16 Cities". **Work:** Detroit IA. **Comments:** Teaching: AIC. **Sources:** WW47; WW53, which shows a birthdate of 1880; Falk, *Exh. Record Series.*

SCHOFIELD, Laura Gifford *[Portrait painter, teacher] b.1841, Fayette County, IN / d.1918, Rushville, IN.* **Studied:** mainly self-taught. **Sources:** Petteys, *Dictionary of Women Artists.*

SCHOFIELD, Louis Sartain *[Engraver] b.1868 / d.1936, Wash., DC.* **Comments:** Grandson of engraver John Sartain. He worked for the Bureau of Engraving and Printing in Wash., DC from 1888-1935, and was considered an expert line engraver and designer. **Sources:** McMahan, *Artists of Washington, DC.*

SCHOFIELD, Louise *[Landscape painter] d.1912, NYC.* **Sources:** Petteys, *Dictionary of Women Artists.*

SCHOFIELD, W(alter) Elmer *[Landscape painter] b.1869, Philadelphia, PA / d.1944, Cornwall, England.* **Addresses:** from 1902: winters in New Hope area & Phila., PA/summers in Cornwall, England. **Studied:** PAFA; Académie Julian, Paris with Bouguereau, Ferrier, Doucet, 1887-92; Ecole

des Beaux-Arts; also with Aman-Jean in Paris. **Member:** ANA, 1902; NA 1907; NIAL; SAA, 1904; Phila. AC; Century Assn.; NAC; SC; Royal Soc. British Artists; Chelsea Arts Club, London; St. Ives Art Cl., England; PAFA (fellow). **Exhibited:** PAFA Ann., frequently, 1891-1946 (medal 1903, gold 1914); Paris Salon, 1894; Phila. AC, 1898 (prize); SAA, 1900 (prize); Paris Expo, 1900 (prize); NAD, 1901 (prize), 1911 (gold), 1920 (prize); Pan-Am. Expo., Buffalo, 1901; CI, 1904 (medal); St. Louis Expo, 1904 (medal); Corcoran Gal. biennials, 1907-43 (17 times, incl. silver medal, 1926); NAC, 1913 (gold, prize); Pan.-Pacific Expo, San Francisco, 1915 (medal); AIC, 1921 (prize); Sesqui-Centennial Expo, 1926 (medal). **Work:** MMA; CGA; Cincinnati Mus.; CI; Albright Art Gal.; PAFA; Herron AI; Rochester, AIC; NAC; BM; Des Moines City Lib.; Harrison Gal., Los Angeles Mus.; Norfolk (VA) Mus. Art; Albright-Knox Art Gal., Buffalo, NY; Brandywine River Mus., PA; Delaware Art Mus.; Indianapolis Mus. Art; NMAA; Luxembourg, Paris; State Mus., Uruguay; Buenos Aires. **Comments:** New Hope (Bucks County) impressionist known for his snow scenes. He also lived in England part of each year, staying at Godolphin House in Breage, Cornwall, and painting the dramatic seaside cliffs around St. Ives. **Sources:** WW40; Danly, *Light, Air, and Color*, 72; *300 Years of American Art*, vol. 2: 610; Fink, *American Art at the Nineteenth-Century Paris Salons*, 389; Falk, *Exh. Record Series*.

SCHOFIELD, William B. See: **SCOFIELD, William B(acon)**

SCHOFLER, Raphael *[Painter] early 20th c.*
Addresses: Bronx, NY. **Sources:** WW15.

SCHOFT, Louis L. *early 20th c.*
Exhibited: Salons of Am., 1934. **Sources:** Marlor, *Salons of Am.*

SCHOLDER, Fritz *[Painter, printmaker] b.1937, Breckenridge, MN.*
Addresses: Galisteo, NM; Scottsdale, AZ in 1976. **Studied:** Univ. Kansas; Wisconsin State Univ.; Sacramento City College with Wayne Thiebaud; Sacramento State Univ. (B.A.); Univ. Arizona (M.F.A.). **Exhibited:** Winter Invitational, CPLH, San Francisco, 1961; Am. Indian Art, Edinburgh Art Festival & Berlin Festival, 1966; Indian Painting, Mus. Bellas Artes, Buenos Aires & Bib. Nac., Chile, 1967; Two Am. Painters, Nat. Coll. FA, Smithsonian Inst., 1972; Two Am. Painters, Madrid, Berlin, Bucharest, Belgrade, Ankara, Athens & London, 1972-73; Cordier & Ekstrom, NYC, 1970s. **Awards:** Southwest Indian Art Project scholarship, Rockefeller Found., 1961-62; purchase award, Ford Found., 1962; Opportunity fellowship, John Hay Whitney Found., 1962-63. **Work:** BM; Houston Mus. FA; Phoenix Art Mus.; San Diego Gal. FA; Dallas Mus. FA; Mus. New Mexico; Dartmouth Univ. **Comments:** Began painting in 1950, encouraged by Oscar Howe. Teaching: Univ. Arizona, 1964; Inst. Am. Indian Arts, after 1964; Dartmouth Univ., 1973. Concentrated on images of Indians in 1960s and completed an Indian portrait series while at Dartmouth. **Sources:** WW73; J.J. Brody, *Indian Painters and White Patrons* (Univ. New Mexico Press, 1971); Breeskin & Turk, *Scholder/Indians* (Northland Press, 1972); J. Mondale, *Art and Politics* (Lerner Publ., 1972); P&H Samuels, 425.

SCHOLDER, Laurence *[Printmaker, educator] b.1942, Brooklyn, NY.*
Addresses: Dallas, TX. **Studied:** Carnegie Inst. Tech. (B.F.A.); Univ. Iowa (M.A.). **Exhibited:** Am. Graphic Workshops, 1968, Cincinnati (OH) Art Mus., 1968, Multiples USA, Western Michigan Univ., Kalamazoo, 1970; Midwest Biennial, Joslyn Art Mus., Omaha, NE, 1970 & 1972; Seattle Print Int., SAM, 1971; LOC 22nd Print Nat., Wash., DC, 1971; Cordier & Ekstrom, NYC, 1970s. Awards: purchase award, Young PM, Herron Art Inst., 1967; purchase award, Print & Drawing Nat., Oklahoma AC, 1968; merit award, Southwest Graphics Invitational, San Antonio, 1972. **Work:** Fort Worth (TX) Art Center; Houston (TX) Mus. FA; Oklahoma AC, Oklahoma City; Arkansas AC, Little Rock; McNay Art Inst., San Antonio, TX. **Comments:** Preferred media: intaglio. Positions: artist's rep., bd. trustees, Dallas Mus.

FA, 1971-72. Teaching: South Methodist Univ., 1968-. **Sources:** WW73.

SCHOLL, Edward *[Illustrator, portrait painter, etcher] b.c.1884 / d.1946, NYC.*
Addresses: Los Angeles, CA, active 1920s-30s. **Studied:** NAD; J.W. Alexander; etching, J. Smillie. **Exhibited:** Calif. AC, 1920. **Comments:** Positions: staff, *New York World, Boston American, New York News.*

SCHOLL, Gustave *[Engraver] b.1819, Hamburg, Germany.*
Addresses: NYC, 1860. **Sources:** G&W; 8 Census (1860), N.Y., LI, 435.

SCHOLL, Harry Stewart *[Painter] early 20th c.*
Exhibited: AIC, 1929. **Sources:** Falk, *AIC.*

SCHOLL, R. *[Sketch artist] mid 19th c.*
Comments: Served as a lieutenant in the 9th Regiment of the Pennsylvania Volunteer Corps during the Civil War and drew several sketches of camp and battle scenes in Fairfax County, VA. **Sources:** Wright, *Artists in Virginia Before 1900.*

SCHOLTEN, Anita *early 20th c.*
Exhibited: Salons of Am., 1934. **Sources:** Marlor, *Salons of Am.*

SCHOLZ, Heinrich *[Sculptor] early 20th c.*
Addresses: NYC. **Exhibited:** S. Indp. A., 1924. **Sources:** Marlor, *Soc. Indp. Artists.*

SCHOLZ, Janos *[Collector, writer] b.1903, Sopron, Hungary.*
Addresses: NYC. **Studied:** Royal Hungarian College Agriculture (Dipl. Agr.; Dipl. Ing.); Royal Hungarian Conservatory Music (Dipl.). **Comments:** Publications: auth., articles & books on Italian drawings. Teaching: Columbia Univ., 1965; NY Univ. Research: Italian drawings. Collection: drawings by the Old Italian Masters porcelain; fayences; carpets. **Sources:** WW73.

SCHOLZ, Lee (Mrs.) See: **KINNEY, Belle (Mrs. Lee Scholz)**

SCHOLZ, Leopold F. *[Sculptor] b.1877 / d.1946.*
Addresses: Boiceville, NY. **Work:** USPOs, Angola (NY), Chattanooga (TN). **Comments:** WPA artist. **Sources:** WW40.

SCHOLZ, Virginia *[Painter] early 20th c.*
Addresses: Great Neck, LI, NY. **Exhibited:** S. Indp. A. 1934. **Sources:** Marlor, *Soc. Indp. Artists.*

SCHOMBERG, Bertram *[Painter, sculptor] early 20th c.*
Studied: ASL. **Exhibited:** Salons of Am., 1927-30; S. Indp. A., 1927-28. **Sources:** Falk, *Exhibition Record Series.*

SCHOMBURG, Alex *[Illustrator, painter] b.1905, Aguadilla, PR / d.1998, Beaverton, OR.*
Addresses: NYC (1912-45); New Canaan, CT (1945-54); Spokane, WA (1954-62); Newburg, OR (1962-98). **Studied:** with Fred Dahme. **Exhibited:** Portland AM, 1965; Smithonian Inst., early 1980s; Whitman College, 1991 (solo); many awards after 1975. **Comments:** Important illustrator and painter, who became best known for his airbrush work. Preferred media: oil, tempera, watercolor, pen & ink, air brush. Position: artist, Nat. Screen Service, NYC, 1928-44. Illustr. of books by Arthur C. Clarke; science fiction magazines, *Cosmos, Galaxy, Isaac Asimov's Science Fiction Magazine*, and many others; illustr. of comic books: *Captain America, Green Hornet Comics, Kid Komics*. Auth./illustr.: *Radio-Telefonia, Construccion y Manejo de Aparatos Simples de Reception*, by Alex Schomburg and Fernando Lafferiere. **Sources:** info. courtesy of Susan Schomburg, Los Angeles (granddaughter).

SCHON, (Carl) Sigurd *[Painter] b.1876, Kristiania, Norway.*
Addresses: NYC. **Exhibited:** AIC, 1919. **Sources:** WW17.

SCHON, Sigurd See: **SCHON, (Carl) Sigurd**

SCHONBAUER, Henry *[Sculptor] b.1895, Hungary.*
Addresses: NYC. **Studied:** Acad. FA, Munich; Acad. FA, Budapest. **Exhibited:** S. Indp. A., 1925, 1931, 1933-35, 1937, 1942, 1944; AIC, 1936; WMAA, 1936-49; PAFA Ann., 1938,

947-49, 1954. **Work:** CCNY. **Sources:** WW40; Falk, *Exh. Record Series.*

SCHONBERG, Charles L. *[Lithographer] mid 19th c.* **Addresses:** NYC, 1857-60. **Comments:** He worked with David L. Schonberg, 1857-60 (see entry). **Sources:** G&W; NYBD 1857, CD 1858-60.

SCHONBERG, David L. *[Lithographer] mid 19th c.* **Addresses:** NYC, 1857-60. **Comments:** He worked with Charles L. Schonberg (see entry). **Sources:** G&W; NYBD 1857, CD 1858-60.

SCHONBERG, James *[Listed as "artist"] b.1832, Hanover, Germany.* **Addresses:** Philadelphia, 1860. **Comments:** His wife was also from Hanover; a child was born in Philadelphia. **Sources:** G&W; Census (1860), Pa., LIV, 244.

SCHÖNBORN, Anton *Anton Schonborn del.* *[Topographical artist]* *b.Germany / d.1871, Omaha, NE.* **Work:** Amon Carter Mus. (11 watercolors). **Comments:** Artist on 1859 expedition to explore the upper Yellowstone River with Capt. Raynolds. A member of Dr. Hayden's survey of the Yellowstone basin in 1871. Schönborn committed suicide. **Sources:** P&H Samuels, 425-26.

SCHONHARDT, Henri *[Sculptor, painter, teacher] b.1877, Providence, RI.* **Addresses:** Providence, RI. **Studied:** Académie Julian, Paris with Peuch & Verlet, 1898; Ecole des Arts Decoratifs; Ecole des Beaux-Arts; Ernest Dubois. **Member:** AAPL. **Exhibited:** Paris Salon, 1908 (prize). **Work:** St. Stephen's Church, Providence; City Hall Park, Providence; RISD; Bristol, RI; Little Compton, RI; Quidnessett, RI; Rhode Island State House, Providence. **Sources:** WW40.

SCHONHORST, Ruth O'Day *[Painter] mid 20th c.* **Addresses:** Chicago area. **Exhibited:** AIC, 1950. **Sources:** Falk, AIC.

SCHONNAGEL, Albert *[Painter] 19th/20th c.* **Addresses:** NYC, 1898. **Exhibited:** NAD, 1898. **Sources:** WW01.

SCHONWALTER, Jean Frances *[Painter, instructor] 20th c.; b.Philadelphia, PA.* **Addresses:** South Orange, NJ. **Studied:** Moore College Art scholarship; B.F.A.); PAFA (graduate fellowship). **Member:** Artists Equity Assn. NJ; SAGA; New Jersey AA; NAWA. **Exhibited:** LOC; NJ State Mus. Exh.; Boston Mus. Exh.; Butler Inst. Art, Youngstown, OH; NAD; Schoneman Gals., NYC, 1970s. **Awards:** Pennypacker Prize for graphics, SAGA, 1966; purchase prize, NJ State Mus., 1967; first prize & medal of honor for graphic, NAWA, 1971. **Work:** PMA; NJ State Mus., Trenton; 3M; Slater Mus., Norwich, CT; NYPL. Commissions: two paintings of Temple B'Nai Jeshurun, NJ. **Comments:** Preferred media: oils, bronze. Teaching: Newark (NJ) Sch. Fine & Indust. Art, 1969-. **Sources:** WW73; Dona Meilach, *Direct Metal Sculpture* (Crown, 1958); E.F. Singer, "Meet the Artist—Jean Schonwalter," *Suburban Life* (1970).

SCHOOF, Milton George *[Painter] b.1913, Denver, IA.* **Addresses:** Waverly, IA. **Studied:** Univ. Iowa (B.A.); Harry Stinson; Catherine Macartney; Grant Wood; Herbert Sanborn; Homer Dill; Edith Bell; Aden Arnold. **Member:** Student Art Guild, Univ. Iowa (organizer & first pres.). **Work:** Children's Hospital, Iowa City, 1932-33. **Sources:** Ness & Orwig, *Iowa Artists of the First Hundred Years,* 185.

SCHOOK, Fred De Forrest *[Painter, teacher, illustrator] b.1872, MI / d.1942.* **Addresses:** Lombard, IL/Baileys Harbor, WI. **Studied:** AIC; Paris with Menard, Simon; H.O. Tanner, Etaples, France. **Member:** Chicago SA; Chicago WCC; Chicago AG; Chicago P&S; Cliff Dwellers. **Exhibited:** AIC, 1911-22. **Work:** Grand Rapids (MI) AM; Lombard (IL) Pub. Lib.; Sturgeon Bay (WI) Hospital. **Comments:** Teaching: AIC (30 years); summer schools in the Dunes (IN), Baileys Harbor (WI) Peninsula AA, Door County (WI). **Sources:** WW40.

SCHOOL, W. R. *[Artist] 19th/20th c.* **Addresses:** Wash., DC, active 1888-1900. **Work:** pomological watercolors, U.S. Nat. Arboretum. **Comments:** Illustr. with the U.S. Dept. of Agriculture. **Sources:** McMahan, *Artists of Washington, DC.*

SCHOOLCRAFT, C(ornelia) Cunningham (Mrs. James T.) *[Painter, illustrator, teacher, drawing specialist, block printer, lecturer] b.1903, Savannah, GA.* **Addresses:** Dover, NH. **Studied:** CUA Sch.; Grand Central Sch. Art; NAD; E. Roth; Berkshire Summer Sch. Art. **Member:** AAPL; New Hampshire AA; Nat. Lg. Am. Pen Women. **Exhibited:** Wash. WCC, 1934; Contemp. Am. Artists, 1942; Nat. Lg. Am. Pen Women, 1932-33; SSAL, 1931-34; Georgia AA, 1929-35; New Hampshire AA, 1940-42; solos: Georgia, Mississippi, Louisiana, Florida, 1927-42. **Work:** historical map of Georgia, The Golden Isles of Georgia; Univ. New Hampshire; Union College. **Comments:** Illustr.: "Thirteen Sonnets of Georgia," "Spaniard's Mark," "Death is a Little Man." Teaching: Univ. New Hampshire, Durham, 1945-46. **Sources:** WW47.

SCHOOLCRAFT, Freeman Lawrence *[Sculptor] mid 20th c.* **Addresses:** Chicago, IL. **Exhibited:** AIC, 1931-49, 1946-48 (5 prizes); WMAA, 1939. **Work:** USPO, Peoria, IL. **Comments:** WPA artist. **Sources:** WW40.

SCHOOLCRAFT, Henry Rowe *[Topographical artist, author] b.1793, Albany County, NY / d.1864, Washington, DC.* **Addresses:** Wash., DC. **Studied:** Union College; Middlebury College. **Comments:** Attended Union and Middlebury Colleges and was preparing to follow his father in the glass-making industry when he made his first visit to the frontier in 1818. In 1820 he accompanied Lewis Cass's expedition to the source of the Mississippi and became interested in the Indians of the region around Lake Superior, for whom he was appointed agent in 1822. On a second trip to the upper Mississippi, Schoolcraft discovered the headwaters of the river. From the 1830s Schoolcraft devoted himself to ethnological studies, the results of which were eventually embodied in his six-volume *Historical and Statistical Information Respecting the History, Condition, and Prospects of the Indian Tribes of the United States* (1851-57). He also recorded "The Myth of Hiawatha," popularized by Longfellow. **Sources:** G&W; DAB; *Encyclopedia Britannica* (11th ed.); examples of his work as an artist, in his *Scenes and Adventures in the Semi-Alpine Region of the Ozark Mountains of Missouri and Arkansas* (1853); P&H Samuels, 426; McMahan, *Artists of Washington, DC.*

SCHOOLER, Lee *[Collector] b.1923, Chicago, IL.* **Addresses:** Chicago, IL. **Studied:** Roosevelt Univ. (B.A., 1946). **Member:** AFA; MoMA; AIC. **Comments:** Collections: contemporary painting & sculpture; pre-Columbian sculpture. **Sources:** WW73.

SCHOOLEY, Elmer Wayne *[Painter, educator, lithographer] b.1916, Lawrence, KS.* **Addresses:** Silver City, NM;Montezuma, NM. **Studied:** Univ. Colorado (B.F.A., 1938); State Univ. Iowa (M.A., 1941). **Member:** Senior AG. **Exhibited:** Denver AM, 1939; Kansas City AI, 1940; Houston (TX) Southwestern Exh., 1962; Kansas City Mid-Am. Exh., 1964; Tucson (AZ) Festival Art Exh., 1964; Eight State Exh., Oklahoma City, 1968; Biennial Southwestern Exh., Santa Fe, 1972. **Awards:** purchase prizes, Ford Found., 1962 & Southwest Biennial, 1970 & 1972; hon. men., Kansas City Hallmark Purchase, 1964. **Work:** Paintings: MoMA, Hallmark Coll.; Kansas City, Mus. New Mexico, Santa Fe & Roswell Mus., NM; lithograph: MMA. Commissions: fresco (with Gussie Du Jardin), Las Vegas (NM) Hospital, 1950. **Comments:** Preferred media: oils, wood. Teaching: New Mexico Western Univ., 1946-47; New Mexico Highlands Univ., 1947-. **Sources:** WW73;

WW47.

SCHOOLFIELD, Garcie M. *[Painter, craftsperson, screen-printer]* b.1915, Knox, IN.
Addresses: San Antonio 9, TX. **Studied:** Ringling Sch. Art; AIC (B.A.E.); Univ. Chicago; Texas State College for Women. **Member:** Texas FAA; Texas WCS; San Antonio Art Lg.; Contemporary Weavers of Texas; San Antonio Craft Gld. **Exhibited:** Int. Textile Exh., 1947-48; Texas State Ceramic & Textile Exh., 1952; Texas Crafts, 1955; San Antonio Art Exh., 1953-55; Texas FAA, 1953-55; Contemp. Weavers, 1954-55. **Sources:** WW59.

SCHOONMAKER, Edward T. *[Painter]* late 19th c.
Addresses: NYC, 1878. **Exhibited:** NAD, 1878. **Sources:** Naylor, *NAD*.

SCHOONMAKER, Eugene Spalding *[Sculptor]* b.1898, NYC.
Addresses: NYC. **Studied:** L. Lentelli; H. McCarter; L. Lawrie; BAID. **Member:** Clay Club, NYC. **Exhibited:** WFNY, 1939. **Work:** sculpture, Lib., Univ. Cincinnati; Brookgreen Gardens, SC; memorial, Yale Univ. **Sources:** WW40.

SCHOONMAKER, Greta V. *[Sculptor]* early 20th c.
Addresses: NYC. **Sources:** WW17.

SCHOONMAKER, W(illiam) Powell *[Etcher, illustrator]* b.1891, NYC.
Addresses: Philadelphia, PA. **Studied:** G.B. Bridgman, ASL. **Member:** Phila. Sketch Club; Phila. Print Club; Art Dir. Club. **Comments:** Illustr.: *Country Gentleman, Ladies Home Journal.* **Sources:** WW40.

SCHOONOVER, Frank E(arle) *[Illustrator, painter, lecturer, teacher, writer,]* b.1877, Oxford, NJ / d.1972.
Addresses: Wilmington, DE/Bushkill, PA. **Studied:** Drexel Inst., 1896-97, with Howard Pyle. **Member:** SI, 1905; fellow, PAFA; Wilmington SFA. **Exhibited:** AIC, 1913; PAFA Ann., 1913. **Work:** Brown Vocational Sch., Wilmington; Wilmington SFA. **Comments:** Best known for his illustrations of Native Americans and mountain men of the West in *Scribner's, Harper's, Century, Colliers,* and *McClures.* Schoonover had a studio in Wilmington near Howard Pyle. He made his first trip to the Hudson Bay area in 1903 and was in Mississippi in 1911. In 1919, he painted WWI subjects for *Ladies' Home Journal* and from 1920-30 he illustrated a series of children's books. In 1930, he began to design stained-glass windows, spent time and painted in Bermuda in 1935; and in 1942, he started his own school. Throughout his career, he maintained chronological daybooks which identify 2,504 illustrations and landscapes. **Sources:** WW40; John R. Schoonover, *Frank E. Schoonover, Catalogue Raisonné* (Wilmington, DE: Schoonover Studios, 2001); Falk, *Exh. Record Series.*

SCHOONOVER, Margaret (Mrs.) See: **LEFRANC, Margaret (Mrs. Schoonover)**

SCHOPP, Conrad L. *[Painter]* mid 20th c.
Exhibited: S. Indp. A., 1938. **Sources:** Marlor, *Soc. Indp. Artists.*

SCHOPPE, Palmer *[Mural painter, painter, lithographer]* b.1912, Wood Cross, UT.
Addresses: Santa Monica, CA. **Studied:** UCLA; Yale Sch. FA; ASL. **Exhibited:** GGE, 1939; Calif. WCS, 1940-44; Toby Moss Gal., Los Angeles, 1985, 1987. **Comments:** Teaching: Chouinard Sch. Art, 1935-42; Art Center Sch., 1945-53; USC Film Dept., 1954-76. Position: staff, Walt Disney Studios. **Sources:** Hughes, *Artists of California,* 498.

SCHOR, Ilya *[Painter]* mid 20th c.
Addresses: NYC. **Exhibited:** PAFA Ann., 1949, 1952. **Sources:** Falk, *Exh. Record Series.*

SCHOR, Rhea Iress *[Painter, sculptor, writer]* b.1906, NYC.
Addresses: Maspeth 78, NY. **Studied:** Samuel Brecher Sch. Art.;

Lonzar Sch. Sculpture; Sculpture Center. **Member:** NAWA; Cosmopolitan Artists; Nat. Lg. Am. Pen Women; Sculpture Center; ASL. **Exhibited:** NAWA, 1946-47, 1951, 1953-54; Tomorrows Masterpieces Exh., 1944; MMA, 1938; AEA, 1948; Riverside Mus., 1952-1954; Contemp. Art Gal.; Barzansky Gal., 1956 (solo). Awards: prizes, Queens FA Soc., 1950, 1952; Huntington Hartford Fellowship, 1958. **Work:** Columbia Univ.; Barnard College; Dayton AI. **Comments:** Auth.: "To Understand," 1948; "Revelations to the Young Girl," 1954; "A String of Pearls," 1956. **Sources:** WW59.

SCHORER, R. Thomas *[Painter]* mid 20th c.
Addresses: Chicago area. **Exhibited:** AIC, 1951. **Sources:** Falk, *AIC.*

SCHORK, Joseph Carl *[Painter]* mid 20th c.
Addresses: New Haven, CT. **Exhibited:** New Haven PPC, 1933; WFNY, 1939. **Sources:** WW40.

SCHORR, Esther See: **BRANN, Esther (E. B. Schorr)**

SCHORR, Justin *[Painter, educator]* b.1928, NYC.
Addresses: NYC. **Studied:** City College NY (B.S.S., 1950); Columbia Univ. Teachers College (Ed.D., 1962). **Exhibited:** BM, 1958; NAD, 1959; PAFA, 1963; Butler Inst. Am. Art Youngstown, OH, 1964; West Broadway Gal., NYC, 1970s. **Work:** Butler Inst. Am. Art, Youngstown, OH; Waldemar Research Found.; Lock Haven State College, PA. **Comments:** Publications: auth., *Aspects of Art,* A.S. Barnes, 1967. Teaching: Columbia Univ. Teachers College, 1962-. **Sources:** WW73.

SCHOTT, Arthur *[Topographical artist, engineer, physician, teacher]* b.1813 / d.1875, Wash., DC.
Addresses: Wash., DC, 1858-75. **Comments:** He was with the U.S.-Mexico Boundary Survey expedition of 1849-55. Several engravings after his sketches appear in the *Report* of this survey. Schott was a professor of German and music. **Sources:** G&W; Taft, *Artists and Illustrators of the Old West,* 277; Emory, *Report on the U.S.-Mexican Boundary Survey;* Stokes, *Historical Prints;* P&H Samuels, 427; McMahan, *Artists of Washington, DC* states his birthdate as 1812.

SCHOTT, Joseph John *[Painter]* b.1922, Newark, NJ.
Addresses: Fanwood, NJ. **Member:** AAPL; Acad. Artists Assn.; Fed. AA NJ (charter mem.); Hudson Valley AA; Art Exhs. Council NJ. **Exhibited:** Contemp. NJ Art Exh., Bambergers, Newark, 1967; Contemp. Am. Realism Exh., Hammond Mus., North Salem, NY, 1968; Representational Works of Art Nat., Springfield Mus., MA, 1968 & 1969; NAD 144th Ann., NAD Gals., New York, 1969, AAPL Grand Nat., Lever House, New York 1969, 1970 & 1972. Awards: award for realistic painting, P&S Soc. Nat., Jersey City, NJ, 1967; award for traditional painting, AC of Oranges Statewide Exh., East Orange, NJ, 1967; best in show, Summit Art Center Statewide Exhib., NJ, 1972. **Work:** Fanwood Mem. Lib., NJ. **Comments:** Preferred media: oils. **Sources:** WW73; article, *Plainfield Courier News,* NJ, March 15, 1967; Michael Lenson, article, *Newark Sun News,* Dec. 20, 1970; Verdi Johnson, article, *Sun Star Ledger,* Newark, May 21, 1972.

SCHOU, Bertha *[Painter]* early 20th c.
Addresses: NY. **Exhibited:** AIC, 1922. **Sources:** Falk, *AIC.*

SCHOU, Sigurd See: **SKOU, Sigurd**

SCHOULER, Willard C. *[Painter]* b.1852, Arlington, MA.
Addresses: Boston, MA, 1891; Arlington, MA. **Studied:** H. Day; W. Rimmer. **Exhibited:** NAD, 1891; PAFA Ann., 1905, 1913, 1919-24; S. Indp. A., 1917. **Comments:** Specialty: Western and Arabian scenes. **Sources:** WW29; Falk, *Exh. Record Series.*

SCHOW, May *[Painter]* b.1895 / d.1976.
Addresses: Active in southeastern Texas, 1930s-50s. **Studied:** Columbia Univ.; Hans Hofmann; Millard Sheets; Fletcher Martin; Alexandre Hogue. **Comments:** Interpreted African Americans at work and play in rural Texas and also Hispanics. Teaching: Sam Houston State Teachers College, Hntsville, TX, 1938-62. **Sources:** Trenton, ed. *Independent Spirits,* 201.

SCHOYER, Raphael *[Copperplate printer, portrait engraver]* early 19th c.
Addresses: Baltimore, 1824; NYC, 1826. **Sources:** G&W; Stauffer.

SCHRACK, Joseph Earl *[Painter, teacher, designer, illustrator, lecturer]* b.1890, Pottstown, PA / d.1973.
Addresses: San Diego, CA. **Studied:** AIC; ASL with Frank Vincent Dumond, John Sloan & Robert Henri; John Herron AI; Hans Hofmann; George Innes, Jr. **Member:** Audubon Artists; Men's Art Inst., San Diego; La Jolla AC; San Diego FA Soc.; Alumni Assn. AIC. **Exhibited:** AIC, 1913 (Alumni Assn. prize); Salons of Am.; All. Artists Am., 1945; Audubon Artists, 1944-45; La Jolla AC (prize); San Diego FA Soc. (prize); Art Inst., San Diego (prize); Carlsbad AA, 1954 (prize). **Work:** Commissions: murals, First Fed. Savings Bank, San Diego & First Nat. Bank, El Cajon, CA; La Jolla AC; San Diego FA Soc.; Men's AI; Carlsbad AA.; Adm. Robert E. Coontz, USN (portrait), Pentagon, Wash., DC; Ike & Mamie Eisenhower (portrait), House Office Bldg., Wash., DC; Gunther Fur Co., NYC. **Comments:** Illustr.: *Century, Liberty, McCalls.* Founder/pres.: Acad. Creative Arts, Roerich Mus., 1930-35. Teaching: San Diego FA Gal.; Balboa Univ.; private classes. Two-year tour and art study in Europe, North Africa, 1956-58. Art interests: history & theory of classical & modern art. **Sources:** WW73; WW47.

SCHRADER, Doris *[Painter]* mid 20th c.
Exhibited: S. Indp. A., 1940, 1942. **Sources:** Marlor, *Soc. Indp. Artists.*

SCHRADER, Dorothy A. V. *[Painter]* early 20th c.; b.Chicago.
Addresses: Chicago, IL. **Studied:** AIC. **Member:** Soc. Independent Artists. **Exhibited:** AIC, 1922. **Sources:** WW25.

SCHRADER, Dwan Eloise *[Commercial artist]* b.1919, Des Moines, IA.
Addresses: Des Moines, IA. **Studied:** Cumming Sch. Art; Art Students Work Shop; Chouinard School Art; B.V. Setzer; Byron Ben Boyd; Lowell Houser; Alice McKee Cumming. **Exhibited:** Cumming Sch. Art; Younker's Foyer. Awarded two scholarships, Art Students Workshop & Cumming School Art. **Comments:** Position: artist, Younker Bros. Advert. Dept. **Sources:** Ness & Orwig, *Iowa Artists of the First Hundred Years,* 186.

SCHRADER, Gustave *[Painter]* b.1900, Elmhurst,NY / d.1985.
Addresses: Woodstock, NY. **Studied:** Woodstock Sch. Painting. **Member:** Woodstock AA. **Exhibited:** VMFA,1938; CGA; Albany Inst. History & Art; Woodstock AA; Key West Art & Historical Soc.; Key West Artists Group; Florida Southern College. **Sources:** WW59; WW47; Woodstock AA.

SCHRADER, Mildred (Rothe) *[Artist]* b.1903 / d.1983.
Member: Woodstock AA. **Sources:** Woodstock AA.

SCHRADER, Otto C. *[Painter]* 19th/20th c.
Addresses: San Francisco, CA, 1876; Alameda, CA, 1903-06. **Exhibited:** San Fran., 1895. **Sources:** Hughes, *Artists of California,* 498.

SCHRADER, Theodore *[Lithographer]* b.Prussia / d.1897, St. Louis, MO.
Addresses: St. Louis, MO, active before 1857-97. **Work:** St. Clair County Hist. Soc., Belleville, IL; Missouri State Mus., Jefferson City; Missouri Hist. Soc., St. Louis. **Comments:** After coming to St. Louis, MO, from Prussia, he went to work for brothers Edward and Charles Robyn (see entries). In 1857, he bought out their business and continued it until his death. He specialized in town and city views. **Sources:** G&W; St. Louis BD 1859.; Reps, 200, 201, cat. nos. 782, 894, 1988, 1996, 2000, 2076.

SCHRAEDER, Hannah Dick early 20th c.
Exhibited: Salons of Am., 1934. **Sources:** Marlor, *Salons of Am.*

SCHRAG, Karl *[Painter, engraver, illustrator, teacher]* *Karl Schrag*
b.1912, Karlsruhe, Germany.
Addresses: NYC. **Studied:** Ecole Beaux Arts, Geneva & Paris; Acad. Ranson, Paris; ASL with Lucien Simon, Roger Bissiere, Harry Sternberg & S.W. Hayter. **Member:** SAGA; Artists Equity Assn.; ASL; Art Lg. Am.; SAGA; Soc. Indep. Artists. **Exhibited:** AIC; WFNY, 1939; S. Indp. A., 1940-44; Contemp. Artists, 1940-43; SFMA, 1941-45; MMA (AV), 1942; WMAA, 1942-66; Phila. Art. All., 1942-44; Phila. Print Club, 1942, 1946; "100 Prints of the Year," "America at War," "50 American Prints" Traveling Exh.; Am.-British AC, 1943, CI, 1944-45; LOC, 1944-45; Kennedy Gal., 1944; Willard Gal., 1945; NYPL, 1945; U.S. Nat Mus., 1945 (solo); Kraushaar Gal., NYC, 1947-70 (several painting solos); Brooklyn Mus. Print Ann., 1947 & 1950 (purchase prizes); Corcoran Gal. biennial, 1953; "Modern Art in U.S.," Tate Gal., London & traveling exh. to Europe museums, 1956; PAFA Ann., 1962, 1964; AFA solo exh. paintings & prints, Brooklyn Mus. & tour, 1962; "Fourth Int. Exh. Contemp. Art," New Delhi, India, 1962 (best U.S. exhibitor); NMAA, 1972 (prints retrospective); Haslem Gal., Wash., DC, 1989 (solo). Other awards: Am. Acad Arts & Letters Grant, 1966. **Work:** NGA; MMA; MoMA; WMAA; AIC; LOC; U.S. Nat. Mus.; NYPL. **Comments:** Preferred media: oils, gouache, graphics. Publications: illustr., "The Suicide Club," 1941, Limited Editions; auth., "Some Thoughts on Art" *Cable,* 1958; auth., "Happiness and Torment of Printmaking," *Artist's Proof,* 1966; auth., "The Artist Alone versus the Artist in the Workshop," *New Univ. Thought,* autumn 1967. Teaching: dir. of etching, Atelier 1917, New York, 1950-51; printmaking, Brooklyn College, 1953-54; drawing & printmaking, Cooper Union, 1954-68. **Sources:** WW73; Falk, *Exh. Record Series.*

SCHRAGE, William Karl *[Artist, draftsman, designer]* b.1896, Baltimore, MD / d.1964, Wash., DC.
Studied: Maryland Inst. **Comments:** Positions: staff, lithographic company, Baltimore, MD; draftsman, U.S. Geological Survey, 1918; draftsman and designer, Coast and Geodetic Survey, 1934-35; Bureau of Engraving and Printing, 1936-61. **Sources:** McMahan, *Artists of Washington, DC.*

SCHRAM, A(braham) J(ohn) *[Painter]* b.1891, Grand Rapids, MI / d.1951, Wash., DC.
Addresses: Wash., DC, 1894; Philadelphia, PA; Upper Darby, PA. **Studied:** Georgetown Univ. (law degree, 1915); Corcoran Art Sch.; Art Sch., Chester Springs, PA; Charles Hawthorne; Lester Stevens. **Member:** Soc. Wash. Artists; Wash. Landscape Club. **Exhibited:** Corcoran Gal. biennial, 1930; Soc. Wash. Artists; Wash. Landscape Club; Maryland Inst.; Gr. Wash. Indep. Exh., 1935. **Comments:** He worked for the Justice Dep. from 1911-51. **Sources:** WW53; WW47; McMahan, *Artists of Washington, DC.*

SCHRAMM, George B. *[Painter]* early 20th c.
Addresses: Kew Gardens, LI, NY, 1934. **Exhibited:** S. Indp. A., 1934. **Sources:** Marlor, *Soc. Indp. Artists.*

SCHRAMM, James Siegmund *[Collector, patron]* b.1904, Burlington, IA.
Addresses: Burlington, IA. **Studied:** Coe College (hon. LL.D., 1954); Amherst College (hon. LH.D., 1961); Grinnell College (hon. D.F.A., 1972). **Member:** AFA (exec. comt., 1942-; pres., 1956-58); WMAA (Friends, 1968-); Guggenheim Mus. (Friends, 1969-). **Exhibited:** Awards: Distinguished Service Award, Univ. Iowa, 1971. **Comments:** Positions: pres. & trustee, Des Moines AC, 1942-; trustee, Chicago Mus. Contemporary Art, 1969-1970; hon. chmn., Amherst College AA, 1971-. Art interests: supporting art departments in colleges and universities; encouraging American contemporary artists. Collection: American painting and sculpture from the 1930s; some European, Japanese and American prints; African sculpture. **Sources:** WW73.

SCHRANK, Edith *[Painter]* mid 20th c.
Addresses: Chicago area. **Exhibited:** AIC, 1948. **Sources:** Falk, AIC.

SCHRECH, Horst See: **SCHRECK, Horst**

SCHRECK, Horst *[Painter] b.1885, Herisau, Switzerland.*
Addresses: El Paso, TX in 1935. **Studied:** BAID after WWI.
Comments: Schrech apprenticed as a photographer before emi-
grating to Canada in 1906, where he farmed. In 1916, he graduat-
ed in veterinary medicine. During WWI he produced recruiting
posters and illustrations. In Texas he painted animals, still lifes
and landscapes. **Sources:** P&H Samuels, 427.

SCHRECK, Michael Henry *[Painter, sculptor] 20th c.;*
b.Austria.
Addresses: Hollywood, FL. **Studied:** ASL; Tom Von Dreger,
Vienna & Colin Collahan, London. **Member:** Royal Soc. Arts,
London (life fellow); AFA; Smithsonian Inst. **Exhibited:** Mus.
FA, Montreal, 1953-56; Dom Gal., Montreal, 1954-56; Jersey City
Mus., NJ, 1959; Selected Artists Gal., New York, 1961 (solo);
Mus. Art Mod., Paris, 1964; Gloria Luria Gal., Miami, FL &
Dominion Gal., Montreal, PQ, 1970s. **Awards:** Grand Prix Int.,
Deauville, France, 1964; Prix Int. de Vichy, Mention Grand
Finale, 1964; Prix Rencontre Int., Chateau de Senou, France,
1965. **Work:** Heckscher Mus., NY; Miami (FL) MOMA; NY
Univ.; NY Univ. Medical Center; State Univ. NY Buffalo.
Commissions: Mexican mural, Thomaston, NY, 1969; sculpture
garden, R. Gimbel, New York. **Comments:** Preferred media: oils,
bronze. **Dealers: Sources:** WW73; P. Mornand, "Au Musée
d'Art Moderne," *La Révue Moderne* (1964); J.J. Leveque, "Le
Tour de Galeries," *Galerie Arts* (March, 1965); J. Paris, article,
Long Island Art Review (1966).

SCHRECKENGOST, Don *[Sculptor, painter, craftsperson,*
educator] b.1911, Sebring, OH.
Addresses: East Liverpool, OH. **Studied:** Cleveland Sch. Art;
Stockholm, Sweden; A. Blazys; N.G. Keller; Western Reserve
Univ.; Escuela de Bellas Artes, Mexico. **Member:** Am. Ceramic
Soc. (fellow); U.S. Potters Assn.; Ceramic Educ. Council (comt.
mem.); Inter-Soc. Color Council; Boston SAC; The Patteran;
Cleveland SA; Ceramic Gld., Cleveland. **Exhibited:** St. Louis
AM; CMA; Am. Ceramic Soc., 1946 (medal); Syracuse Mus. FA,
1941 (prize), 1954 (prize); Graphic Artists Exh., NY, 1940 (prize);
Albright Art Gal., 1938 (prize); Finger Lakes Exh., Rochester,
NY, 1940 (prize); SAGA, 1941 (prize); Alfred Univ., 1946
(bronze medal). **Work:** Rochester Mem. Art Gal.; IBM Coll.;
Univ. de Bellas Artes, San Miguel, Mexico. **Comments:** Position:
modeler, Gem Clay Forming Co., Sebring, OH, 1934-35; art dir.,
Salem China Co., Salem, OH, 1934-35; prof. indust. ceramic des.,
NY College Ceramics, Alfred Univ., 1935-45; adult classes, St.
Bonaventure College, 1943-44; art dir., Dubois Press, Rochester,
NY, 1942-43; art dir., Homer Laughlin China Co., Newell, WV;
des. consult., Tuvache Perfume Co., NY, 1942-45; des., sculptor,
Albert Victor Bleininger medal; planned and designed United
Potters Assn. Exh., Nat. Home Furnishings Show, NY, 1953.
Contrib.: *Am. Artist.* **Sources:** WW59; WW47.

SCHRECKENGOST, Viktor *[Sculptor, designer, craftsper-*
son, painter, educator] b.1906, Sebring, OH.
Addresses: Cleveland Heights, OH; Sebring, OH. **Studied:**
Cleveland Sch. Art with Julius Mihalik, 1924-29; Kunstgewerbe
Schule, Vienna; Michael Powolny, 1929. **Member:** Cleveland
Soc. Art; Am. Ceramic Soc.; Int. Inst. Arts & Letters (fellow);
Arch. Lg.; U.S. Potters Assn.; ADI; AWS; Am. Soc. Indust. Des.;
Ohio WCS. **Exhibited:** Syracuse Mus. FA, 1932-54 (prizes, 1933,
1938, 1947-48, 1950-51, 1954); PAFA Ann., 1932, 1934; AIC;
WFNY, 1939; Paris Salon, 1937; GGE, 1939; CMA, 1931 (first
prize), 1932 (prize), 1933, 1934 (prize), 1935, 1936-43
(prizes),1946-55 (prizes); Akron AI, 1931 (solo); WMAA, 1937;
CM, 1938, 1939, 1941; TMA, 1938, 1940; Phila., 1940 (award of
merit); Cranbrook Acad. Art, 1946; Alfred Univ., 1939 (medal);
many traveling exh., U.S. & abroad; nat. in leading museum and
galleries, 1931-52; Butler AI, 1949 (prize); IBM, 1954 (prize);
AWS, 1955 (prize); AIA, 1958 (gold medal). **Work:** MMA;
WMAA; Syracuse Mus. FA; Albright Art Gal.; CMA; Memphis
Mus. Art; IBM; cab design, White Motor Co., Cleveland; dinner-
ware design, Am. Limoges China Co., Sebring; bronze tablet,
Oberlin, OH; bronze tablet, Sebring Memorial, OH; Miami, FL,

1939. Brooks Mem. Art Gal.; Butler AI; Dartmouth College;
Slater Mem. Mus.; Cleveland Zoo; Lakewood (OH) H.S.;
Cleveland Airport; Texas Tech. College; Walker AC. **Comments:**
Instrumental in the evolution of ceramic sculpture from craft to
fine art. Contrib.: *Encyclopedia of the Arts*, 1945. Position: faculty
mem., Cleveland School Art, more than 50 years; art dir./des.,
Am. Limoges China Co., 1933-44; Salem China Co.,1936-46;
Sebring Pottery Co.; hd., dept. indust. des., Cleveland (OH) Inst.
Art; art dir. & des., Murray Ohio Mfg. Co., Nashville, TN; Salem
(OH) China Co.; consult., indust. des., Harris-Intertype Corp.,
Cleveland, Dayton, Westerly (RI); Holophane Co., Newark, OH.
Sources: WW59; WW47; Fort, *The Figure in American
Sculpture*, 223 (w/repro.); Falk, *Exh. Record Series.*

SCHREIBER, Anna Schilling *[Painter, craftsworker]*
b.1877, Columbus, OH.
Studied: Columbus Art Sch.; Miss Klippart & Mrs. Obetz.
Comments: Operated summer art school, Columbus. **Sources:**
Petteys, *Dictionary of Women Artists.*

SCHREIBER, B. Walters *[Artist] mid 20th c.*
Addresses: NYC, 1954. **Exhibited:** PAFA Ann., 1954 ("Leah").
Comments: Cf. Belle W. Schreiber of NYC. **Sources:** Falk, *Exh.
Record Series.*

SCHREIBER, Belle W. *[Artist] mid 20th c.*
Addresses: NYC, 1947. **Exhibited:** PAFA Ann., 1947 ("Boy").
Comments: Cf. B. Walters Schreiber of NYC. **Sources:** Falk,
Exh. Record Series.

SCHREIBER, Eileen Sher *[Painter, lecturer] 20th c.;*
b.Denver, CO.
Addresses: West Orange, NJ. **Studied:** Univ. Utah, 1942-45; NY
Univ. Ext., 1966-68; Tom Vincent ; Alan Goldstein. **Member:**
NAWA (watercolor jury, 1970-72); Artists Equity Assn.; Nat. P&S
Soc.; Hunterdon AA; Summit AA. **Exhibited:** Morristown Mus.
Arts & Sciences, 1965-72; NJ Mus., Trenton, 1969; AWCS Nat.;
NAD Gals., NYC, 1970; Audubon Artists, New York, 1970;
Pallazzo Vecchio, Florence, Italy, 1972; Betty Kardo, Highgate
Gal., Upper Montclair, NJ & Sidney Rothman, Barnegat Light,
NJ, 1970s. **Awards:** NJWCS Award, 1969; second watercolor,
NAWA, 1970; first in watercolor, collage, Hunterdon Mus. Art
Gal., 1971. **Work:** Morris Mus. Arts & Sciences, Morristown, NJ;
Seton Hall Univ., South Orange, NJ; Bloomfield College, NJ;
Morris Co. State College, Dover, NJ; also in collection of Sen
Harrison Williams, NJ. **Commissions:** painting on NJ beach area,
Broad Nat. Bank, Newark, 1970; Wolfgang Rapp Arch., Elkins
Park, PA, 1972. **Comments:** Preferred media: collage, acrylics,
watercolors. Teaching: lecturer. **Sources:** WW73; D. Bainbridge,
"Commentaries on Artists," *NJ Music & Arts Magazine* (April,
1968); M. Lenson, review, *Newark Evening News*, April, 1970.

SCHREIBER, George L. *[Painter, teacher] b.1862, NYC /*
d.1940, Santa Clara, CA.
Addresses: Santa Monica, CA. **Studied:** ASL with W. Sartain;
Ecole Des Beaux Arts, Paris, with Gerome, P.V. Galland.
Member: Calif. AC. **Exhibited:** Calif. WCS, 1942; AIC.
Sources: WW47; Hughes, *Artists of California*, 498.

SCHREIBER, Georges ("George")
[Painter, teacher, lithographer, writer]
b.1904, Brussels, Belgium / d.1977,
NYC.
Addresses: Came to NYC in 1928, remaining there except for
extended travel periods. **Studied:** Art Crafts School, Elberfeld,
Germany, 1920-22; Acad. Fine Arts, Düsseldorf & Berlin,
Germany, 1922; also in London, Florence & Paris, all 1923-28.
Exhibited: Salons of Am., 1932; CI, 1943-45; Corcoran Gal.
biennials, 1941-53 (5 times); PAFA Ann., 1933, 1939-42; AIC,
1932 (Int. Watercolor Exh., William Tuthill Prize); WMAA;
MMA (Artists For Victory); MoMA, 1939 (1st prize); Art Dir.
Club, 1943 (prizes); WFNY, 1939; Kennedy Gal., NYC, 1970
(solo of watercolors); "NYC WPA Art" at Parsons Sch. Design,
1977. **Work:** MMA; WMAA; BM; Swope Art Gal., Terre Haute;
Davenport Mun. Art Gal.; Mus. City of NY; Encyclopedia

ritannica Coll.; U.S. Navy Dept., series of marine & submarine aintings; TMA; Bibliothèque Nat., Paris; LOC. **Comments:** VPA artist who worked in a regionalist style in the 1930s-40s. old cartoons and drawing to the NY newspapers; was a war corsondent and poster designer in WWII. Schreiber visited each of ne 48 states during a two-year trip. Preferred media: oils, watercolors, graphics. Publications: auth./illustr., "Portraits and selfortraits" Houghton Mifflin, 1936 & "Books Library," 1969; illus-..: "Little Man, What Now?," by Hans Fallada, other children's ooks. Contrib.: national magazines. Auth./illustr.: "Bambino the own," Viking Press, 1957. Teaching: New School Social Res., 959-70s. **Sources:** WW73; WW47; P&H Samuels, 427; *New ork City WPA Art,* 77 (w/repros.); Todd Smith, *American Art om the Dicke Collection,* pp. 204, 210 (w/repros.); Falk, *Exh. ecord Series.*

CHREIBER, Isabel *[Painter, mural painter, illustrator, teacher] b.1902, Atchison, KS.* ddresses: Atchison, KS. **Studied:** Kansas Univ. (B.P.); J.R. razier; A. Bloch; R. Eastwood. **Member:** AAUW; Kansas State ed. Art; Prairie WC Painters. **Exhibited:** PAFA; Kansas City AI; oung Gal., Chicago. **Work:** Kansas State Col.; mural backrounds for bird exhibits in Dyche Mus., Lawrence, Kan.; murals, .tchison Pub. Sch.; Univ. Kansas. **Sources:** WW59; WW47.

CHREIBER, John *[Illustrator] b.1872 / d.1919.* ddresses: NYC. **Comments:** Position: staff, Butterick Pub. Co. chreiber died in 1919 of apoplexy.

CHREIBER, Martin *[Sculptor, painter] b.1923, Berlin, Germany.* ddresses: North Bellmore, NY. **Studied:** ASL; Brooklyn Mus. rt School; Ruben Tam. **Member:** Art Dir. Club, NY. **Exhibited:** rd Ann. Op Art Festival, E. Hampton Gal., NYC, 1966; Op Art nd It's Antecedents, AFA Traveling Exh., 1967; Silvermine Ann. shows); Gal. Mackay, Montreal, 1968; Spectrum Gal., New ork, 1971 (solo). **Awards:** first prize in acrylic, Silvermine, CT, 965. **Work:** Nassau Community College; Contemp. AC, incinnati, OH; Mary Washington College, VA; Corcoran Mus., Vashington, DC. **Comments:** Preferred media: acrylics, steel. ources: WW73.

CHREINER, George Albert *[Amateur painter, author, politician] b.1875, Roushasen, Germany.* ddresses: Wash., DC, from 1921. **Comments:** He painted in ratercolor as a hobby. **Sources:** McMahan, *Artists of Vashington, DC.*

CHREINER, Julia (Miss) See: **SCHREINER, Juliette (or Julia)(Miss)**

CHREINER, Juliette (or Julia)(Miss) *[Painter] late 19th c.; b.New York.* ddresses: Paris, 1893; NYC, 1895. **Studied:** Rolshoven. :xhibited: Paris Salon, 1893 (drawing); NAD, 1893, 1895. ources: Fink, *Am. Art at the 19th c. Paris Salons,* 389.

CHREINER, Martin *[Painter] early 20th c.* ddresses: Los Angeles, CA. **Exhibited:** Artists Fiesta, Los ngeles, 1931. **Sources:** Hughes, *Artists of California,* 498.

CHREINER, T. (Mrs.) *[Sketch artist] mid 19th c.* omments: Delineator of a view of the burning of the umberland Rail Road Bridge, Harrisburg (PA), December 4, 844. **Sources:** G&W; Peters, *America on Stone.*

CHRENK, John *[Engraver, lithographer] b.c.1836, Germany / d.1916, New Orleans, LA.* ddresses: New Orleans, active 1885-93. **Sources:** ncyclopaedia of New Orleans Artists, 343.

CHRENK, John, Jr. *[Engraver, lithographer] b.c.1866, New Orleans, LA / d.1951, New Orleans, LA.* ddresses: New Orleans, active 1894-97. **Comments:** Son of ohn Schrenk (see entry); he was also a music teacher. **Sources:** ncyclopaedia of New Orleans Artists, 344.

SCHREYER, Claudius *[Painter] b.1862, Philadelphia, PA.* **Addresses:** Philadelphia, PA. **Studied:** PAFA; Académie Julian, Paris with J.P. Laurens; also with Dagnan-Bouvert in Paris. **Exhibited:** AAS, 1902 (medal). **Sources:** WW10.

SCHREYER, Frank R. *[Painter] mid 20th c.* **Addresses:** NYC, 1935. **Exhibited:** S. Indp. A., 1935. **Sources:** Marlor, *Soc. Indp. Artists.*

SCHREYER, Greta L. *[Painter, lecturer] b.1923, Vienna, Austria.* **Addresses:** NYC. **Studied:** Acad. Arts, Vienna; Columbia Univ. with Seong Moy; ASL; Pratt Inst.; Moses Soyer; Fred Taubes. **Member:** AFA; Artist's Equity Assn. NY. **Exhibited:** New Sch. Soc. Res. AC, NY, 1960-68 (4 shows); Knickerbocker Artists, NY; St. Olaf College, Northfield, MN, 1966 (solo) & Panama (FL) AA, 1967 (solo); RoKo Gal., New York, 1972. **Awards:** Grumbacher Awards, 1956 & 1969. **Work:** Mus. Ha'aretz, Tel-Aviv, Israel; Jersey City (NJ) State College; New Sch. Social Res. AC, NYC; Pasadena (CA) Mus.; Mus. Art & Sciences, Norfolk, VA. **Comments:** Preferred media: oils, watercolors, lithography. Teaching: guest lecturer, Brandeis Univ., 1967-68; guest lecturer, Women Committee, Westbury Chapter, 1968-69; guest lecturer, MoMA, MMA, WMAA & Guggenheim Mus., New York, 1969-. **Sources:** WW73.

SCHREYER, William H. *[Painter] late 19th c.* **Addresses:** Phila., PA. **Exhibited:** PAFA Ann., 1879, 1887 (still life & landscapes). **Sources:** Falk, *Exh. Record Series.*

SCHREYVOGEL, Carl See: **SCHREYVOGEL, Charles (or Carl)**

SCHREYVOGEL, Charles (or Carl) *[Painter, illustrator, lithographer, sculptor] b.1861, NYC / d.1912, Hoboken, NJ.* *Chas Schreyvogel* **Addresses:** Hoboken, NJ, 1892, 1900; NYC, 1895, 1897. **Studied:** August Schwabe in Newark; Munich with C. Marr & Kirchbach, 1887-90. **Member:** ANA, 1901; SC, 1902. **Exhibited:** PAFA Ann., 1890; Boston AC, 1899; NAD, 1892-1900 (prize, 1900); Paris Expo, 1900 (med.); Pan-Am. Expo., Buffalo, 1901; St. Louis Expo, 1904 (med.). **Work:** MMA; LOC; C.R. Smith Coll.; Harmsen Coll.; Anschutz Coll.; Gilcrease Inst. **Comments:** As a youth he carved meerschaum and was apprenticed to a gold engraver. He became a die sinker and in 1877 a lithographer. By 1880 he was teaching drawing. He made his first visit West in 1893, sketching the Utes in Colorado and cowboys in Arizona. First prize for one of these paintings in the NAD exhibition of 1900 won him success and he returned West again in 1900 to sketch troopers and Indians in the Dakotas for a series on the Western Army. His output was limited to relatively few major works per year but reproductions were widely published. Schreyvogel died of blood poisoning. **Sources:** WW10; P&H Samuels, 429; Falk, *Exh. Record Series.*

SCHRIEBER, E. *[Painter] early 20th c.* **Addresses:** Toledo, OH. **Member:** Artklan. **Sources:** WW25.

SCHRIEFFER, Reuben P. *[Engraver, photographer, jeweler] b.1876, Louisiana / d.1944, New Orleans, LA.* **Addresses:** New Orleans, active 1894-1933. **Sources:** *Encyclopaedia of New Orleans Artists,* 344.

SCHROCK, Isabelle Counsil *[Painter, teacher] b.1903, Augusta, KS.* **Addresses:** California. **Studied:** Calif. College Arts & Crafts. **Member:** Oakland AA. **Exhibited:** Northern Calif. shows; Haggin Art Gal., Stockton (solo). **Comments:** Teaching: California public schools. **Sources:** Hughes, *Artists of California,* 498.

SCHRODER, Albert H. *[Painter, commercial artist] 20th c.; b.New Jersey.* **Addresses:** NYC. **Studied:** ASL. **Member:** Rockport AA. **Exhibited:** NJ State Exh., 1953 (award); Rockport AA, 1954 (hon. men.); First Prize R.C.A. Victor Album Design, 1951.

Sources: *Artists of the Rockport AA* (1956).

SCHRODER, Arnold *[Painter] early 20th c.*
Addresses: San Francisco, CA. **Sources:** WW17.

SCHRODER, Charles *[Painter] early 20th c.*
Addresses: Chicago, IL. **Exhibited:** AIC, 1912-13, 1923.
Sources: WW15.

SCHRODER, Heinrich *[Painter] early 20th c.*
Exhibited: AIC, 1930. **Sources:** Falk, *AIC*.

SCHROEDER, Charlotte D. (Mrs. H. W.) *[Painter]*
b.1893, Montclair, NJ.
Addresses: Montclair, NJ. **Studied:** Montclair Art Mus. Sch.;
Douglas Prizer Charles Chapman John R. Koopman. **Member:**
NAWA; West Essex AA. **Exhibited:** AWCS, 1940; Audubon
Artists, 1945; NAWA, 1942-46; Newark AC, 1946; NJWCS,
1940-42; Artists of Today, Newark, 1940; Montclair Art Mus.,
1933-41, 1943-45. **Sources:** WW53; WW47.

SCHROEDER, Cornelius *[Portrait and miniature painter]*
early 19th c.
Addresses: NYC, active 1811 and 1826; Alexandria, VA, 1816;
Richmond, VA, 1818. **Sources:** G&W; NYCD 1811-20 (McKay),
1826; *Richmond Portraits,* 243; McMahan, *Artists of Washington,
DC.*

SCHROEDER, David R. *[Engraver] mid 19th c.*
Addresses: New Orleans, 1853-54. **Sources:** G&W; New
Orleans CD 1853-54.

SCHROEDER, Eric *[Museum curator, writer, painter] b.1904,
Sale, Cheshire, England.*
Addresses: Cambridge, MA. **Studied:** Corpus Christi College;
Oxford Univ. (B.A.); Harvard Univ. **Member:** Today's Art Gal.,
Boston, 1945. **Comments:** Positions: Keeper of Islamic Art, Fogg
Art Mus., Harvard Univ, 1938-1970. Publications: auth., *Iranian
Book Painting,* 1940; co-auth., *Iranian & Islamic Art,* 1951; auth.,
Persian Miniatures in the Fogg Museum, 1942; auth.,
Muhammad's People, 1955; auth., *Visions of Element,* 1963; con-
trib., *Collier's Encyclopedia, Book of Knowledge, Survey Persian
Art, Ars Islamica.* **Sources:** WW73; WW47.

SCHROEDER, John *[Design artist] mid 19th c.*
Comments: He designed a view of Nauvoo (IL) and the Mormon
Temple on a map of Hancock County (IL), 1859. **Sources:**
G&W; Arrington, "Nauvoo Temple," Chapt. 8.

SCHROETER, W. *[Painter] late 19th c.*
Addresses: Chicago area. **Exhibited:** AIC, 1888. **Sources:** Falk,
AIC.

SCHROETTER, Hans V. *[Painter] early 20th c.*
Addresses: Chicago area. **Exhibited:** AIC, 1931. **Sources:** Falk,
AIC.

SCHROETTER, Mara Malliczky *[Painter] early 20th c.*
Exhibited: AIC, 1927. **Sources:** Falk, *AIC.*

SCHROFF, Alfred Hermann *[Painter, craftsperson, teacher]*
b.1863, Springfield, MA / d.1939.
Addresses: Carmel, CA. **Studied:** De Camp; Major; Chominski;
Cowles Art Sch. **Member:** Boston AC; Boston Arch. Club;
Laguna Beach AA; Pacific AA; Oakland AL; Soc. Oregon Artists;
Carmel AA; Copley Soc. **Exhibited:** Columbian Expo, Chicago,
1893 (medal); Boston AC, 1900-1906; Seattle, 1923 (prize); AIC,
1902-02; Springville, Utah, 1923 (prize); Diploma Beaux Arts,
Fountainebleau, 1924; World's Columbian, Kingston, Jamaica
(medal). **Comments:** Teaching: Univ. Oregon.; Summer Sch.,
Univ. Calif. **Sources:** WW38; *The Boston AC.*

SCHROM, Archie Mark *[Designer, graphic artist] b.1911,
Santa Cruz, CA.*
Addresses: Chicago, IL; Wilmette, IL. **Studied:** AIC. **Member:**
Chicago Assn. Commerce & Indust.; Soc. Photographic Illustr.;
Assn. Color Research; Gld. Freelance Artists; Art Directors Club,
Chicago; Soc. Typographic Artists. **Exhibited:** AIC, 1946; Art
Dir. Club, Chicago, 1942 (medal); Soc. Typographic Artists, 1944

(prize), 1946 (prize), 1952 (prize), 1954 (prize), 1957 (2 prizes).
Awards: Package Des. Council, 1953; Nat. Offset-Litho. Comp.,
1953; Curtis Paper Co., 1958 (certificate of merit). **Sources:**
WW59; WW47.

SCHROTH, Dorothy L. *[Painter, craftsperson] b.1906, San
Francisco, CA.*
Addresses: San Fran. **Studied:** M. Hartwell; R. Schaeffer; L.
Lebaudt. **Member:** San Fran. Soc. Women Artists. **Sources:**
WW33.

SCHROTH, Marcella *[Painter, teacher] b.1899, Cincinnati,
OH.*
Addresses: Cincinnati, OH. **Studied:** H. Allen; G.P. Ennis; F.
Hopkins. **Member:** Three Arts; Cincinnati Woman's AC.
Exhibited: Mid-Western Art Exh., Dayton, OH, 1934.
Comments: Teaching: Cincinnati (OH) H.S. **Sources:** WW40.

SCHROYER, Robert McClelland *[Designer, illustrator]*
b.1907, Oakland, CA.
Addresses: Miami, FL. **Studied:** Carnegie Inst.; Parsons Sch.
Design (scholarship, 1929); Acad. Grande Chaumière, Paris,
France. **Member:** Parsons Sch. Design Alumni; Am. Inst. Interior
Designers. **Exhibited:** Lowe Gallery, Miami, FL. Awards: House
& Garden scholarship, 1930; Upholstery Leather Group Assn.
Award; Advertising Art Award, Burdine Advertising Council, FL,
1959. **Comments:** Positions: des., *Delineator Magazine,* 1931-35;
free lance des. & illustr., all major magazines & advertising agen-
cies, 1935-. Teaching: asst instr.r, stage des., Parsons Sch. Design,
New York, 1929; instr., interior des., Paris, 1930-31. **Sources:**
WW73.

SCHRUP, John Edmund *[Painter, instructor] b.1937,
Madison, WI.*
Addresses: Dallas, TX. **Studied:** Univ. Wisconsin-Madison (B.S.;
M.S.; M.F.A.) with Robert Grilley, Alfred Sessler, Leo Steppat &
Dean Meeker. **Member:** Artists' Equity Assn. (pres., Dallas
Chapt., 1971-72). **Exhibited:** Wisc. P&S, Milwaukee, 1964;
Kansas Ann., Wichita, 1965-66; Wichita Art Mus., 1966 (solo);
Texas Ann., Dallas, 1967; Contemp. Gal., Dallas, 1969. **Work:**
Wichita Art Mus., Kansas; Univ. Wisconsin-Madison; Univ.
Wisconsin-La Crosse. **Comments:** Preferred media: oils.
Positions: Artists' Equity Alternate rep. to Dallas Mus. FA Bd.,
1971. Teaching: Univ. Wisconsin-Madison, 1962-64; Wichita
State Univ., 1965-1966; El Centro Community College, Dallas,
1970-. **Sources:** WW73.

SCHUBART, Pauline (Mrs.) *[Painter] mid 20th c.*
Addresses: NYC. **Exhibited:** S. Indp. A., 1943-44. **Sources:**
Marlor, *Soc. Indp. Artists.*

SCHUBBEL, Alfred R. *[Painter] early 20th c.*
Addresses: Williamstown, NJ. **Exhibited:** PAFA Ann., 1932.
Sources: Falk, *Exh. Record Series.*

SCHUBERT, Bess *[Artist] early 20th c.*
Addresses: Active in Los Angeles, 1900-10. **Sources:** Petteys,
Dictionary of Women Artists.

SCHUBERT, Eugene W. *early 20th c.*
Exhibited: S. Indp. A., 1917, 1922; Salons of Am., 1922, 1923.
Sources: Falk, *Exhibition Record Series.*

SCHUCHARD, Carl *[Topographical artist] b.1827, Hesse-
Cassel, Germany / d.1883, Mexico.*
Addresses: California, 1849; lived for a number of years in
Texas, then Mexico. **Comments:** Schuchard came to California as
a mining engineer.He later became a surveyor and draftsman, his
chief work in this line being the illustrations for Gray's survey of
a railway route along the 32d parallel. Schuchard provided 32
sketches for the Southern Pacific RR along a similar route c.1856,
but the originals were destroyed by a fire at the Smithsonian in
1864. **Sources:** G&W; Taft, *Artists and Illustrators of the Old
West,* 269; P&H Samuels, 428.

SCHUCHARD(T), F(erdinand), Jr. *[Genre painter] b.1855
/ d.After 1887.*

Addresses: NYC, 1878-87. **Exhibited:** NAD, 1876-87; Brooklyn AA, 1878-86; PAFA Ann., 1881; Boston AC, 1882-84. **Sources:** *Brooklyn AA; Falk, Exh. Record Series.*

SCHUCKER, Charles L. *[Painter] b.1908, Gap, PA / d.1997, Brooklyn, NY.*
Addresses: Brooklyn Heights, NY/Katonah, NY. **Studied:** Maryland Inst. Arts, 1934; traveling scholar, Europe, 1935. **Exhibited:** MoMA; CI; AIC; MMA; South Side Community AC, Chicago (solo); Roullier Gal., Chicago; Bertha Schaeffer Gal., 1946; Niveau Gal., 1946; Macbeth Gal., 1946; Amherst College; Walker AC, Minneapolis; Brooklyn Mus. (Audubon Prize); NAD, 1949 (Carnegie prize); PAFA Ann., 1951-53; Corcoran Gal. biennial, 1953; WMAA, 1971 (solo); Max Hutchinson Ga., NYC, 1970s; Katonah Village Lib., 1990s (retrospective). Other awards: Guggenheim Found. fellowship; Brooklyn Arts Council award. **Work:** WMAA; BM; Newark Mus. Assn.; Neuberger Coll.; New Britain Mus. Am. Art; Howard Wise Coll.; WPA mural, Baltimore City Coll. **Comments:** Positions: mem., Fed. Art Project, WPA, 1938-42; mem., bd. dir.s, Yaddo Found. Creative Arts. Teaching: art instructor, City College NY; NY Univ.; Pratt Inst., 1954-c.1984. **Sources:** WW73; WW47; obit. (1997); Falk, *Exh. Record Series.*

SCHUCKER, James W. *[Illustrator] b.1903, Mt. Carmel, IL.*
Addresses: Quakertown, PA. **Studied:** CI; AIC; Grand Central Art Sch. with Harvey Dunn. **Member:** SI; Phila. Art Alliance. **Exhibited:** AIC (hon. men.). **Comments:** Illustr.: *Redbook*, other magazines; national adv. campaigns. He was director of his own school in Quakertown, PA. **Sources:** WW47; W & R Reed, *The Illustrator in America*, 193.

SCHUCKMAN, George *[Lithographer] b.c.1836, Germany.*
Addresses: Pittsburgh, PA in 1850. **Comments:** Boarding together with his brother William (see entry). **Sources:** G&W; 7 Census (1850), Pa., III (part 2), 75.

SCHUCKMAN, William *[Lithographer] b.c.1824, Germany.*
Addresses: Pittsburgh, PA, 1850. **Comments:** Boarding together with his brother George (see entry).

SCHUELER, Dorner T. *[Painter, commercial artist] b.1904, Quincy, IL.*
Addresses: San Diego, CA. **Studied:** San Diego Acad. FA. **Member:** Marin Soc. Artists; Soc. Western Artists; Mother Lode AA; Stockton Art Lg.; West Coast WCS. (charter mem.). **Exhibited:** Artists of Southern Calif., San Diego FA Gal., 1927; de Young Mus.; Haggin Gal., Stockton; Otis Art Gal.; FA Gal., Springfield, MA. **Work:** Murphys Mus.; Santa Clara Coll. Mus.; Springfield (MA) Art Mus. **Comments:** Positions: comm. artist, San Diego; poster des., movie industry. Teaching: watercolor classes, Columbia College. **Sources:** Hughes, *Artists of California*, 499.

SCHUELER, Jon R. *[Abstract painter, lecturer] b.1916, Milwaukee, WI / d.1992, NYC.*
Addresses: Los Angeles (1944-47); San Fran. (1947-51); NYC (1951-57); Chester, CT (1967-70); Scotland (1970-75). **Studied:** Univ. Wisconsin (B.A., economics, 1938; M.A., English Lit., 1940); portraiture with David Lax, 1945; Calif. Sch FA, 1948-51, with David Park, Elmer Bischoff, Richard Diebenkorn, Hassel Smith, Clyfford Still, Clay Spohn. **Member:** College AA Am. **Exhibited:** Stable Gal., 1954 (1st NYC solo), 1961, 1963 (solos); Castelli Gal., NYC, 1957 (solo), 1959 (solo); WMAA, 1957-69 1975 (solo); Baltimore MA, 1961; Corcoran Gal. biennials, 1959, 1963; Walker AC, Minneapolis, MN; Maryland Inst., 1966, 1967 (solo) Univ. Illinois, 1968 (solo); Davison AC, Wesleyan Univ., 1970 (solo); Edinburgh College, Scotland 1973 (solo); Cleveland MA, 1975; Cornell Univ.; Univ. Edinburgh, Scotland, 1981 (solo); Perlow Gal, NYC, 1986-89, 1991 (solos); ACA Gal., NYC & Munich, 1995-96 (solos). **Work:** WMAA; NAD; Colby College MA; Glasgow AG, Scotland; Greenville (SC) County Mus. Art; Minneapolis IA; Neuberger Mus., Purchase, NY; Weisman Art Mus., Minneapolis; Union Carbide Corp. Coll. Commissions: lithographs, New York Hilton Hotel, 1962. **Comments:** Publications:

contrib., "Letter on the Sky," *It Is* magazine. Teaching: English Lit., Univ. San Fran., 1947; lecturer, painting, Yale Univ. Summer Sch. Art, 1960-62; head art dept., Univ. Illinois; Maryland Inst. **Sources:** WW73; John I.H. Baur, *Nature in Abstraction* (Macmillan, 1958); B.H. Friedman (ed.), *School of New York* (Grove Press, 1959); Lloyd Goodrich & John I.H. Baur, *American Art of Our Century* (WMAA, 1961). Bibliography: B.H. Friedman, exh. cat., ACA Gal. (NYC, 1996).

SCHUENEMANN, Mary B. *[Painter, teacher] b.1898, Philadelphia, PA.*
Addresses: Phila. **Studied:** Univ. Pennsylvania (B.S. in Educ.); PM Sch. IA; Tyler Sch. Art with John Lear; Earl Horter; Ernest Thurn. **Member:** Artists All., Plastic Club, WCC, Woodmere Gal., all of Phila.; Phila. Art Teachers Assn.; Eastern AA. **Exhibited:** PAFA, 1942-44; Phila. Art All., 1940, 1943, 1957 (solos); PMA; Plastic Club, 1945 (medal) 1946 (medal), 1952 (medal), 1953 (medal), 1954 (prize), 1955 (prize), 1960 (gold medal); Art Teachers Assn., 1950 (placque); Red Door Gal., Phila, 1959. **Work:** Phila. Pub. Sch. **Comments:** Teaching: Phila. (PA) pub. sch. **Sources:** WW59; WW47.

SCHUERCH, Robert *[Painter] mid 20th c.*
Exhibited: AIC, 1938. **Sources:** Falk, *AIC.*

SCHUETZE, Eva Watson See: **WATSON-SCHÜTZE, Eva**

SCHULEIN, Julius W. *[Painter, teacher] b.1881, Munich, Germany.*
Addresses: NYC. **Studied:** Munich, Germany; Paris, France. **Member:** Munich Acad. FA (hon.). **Exhibited:** WMAA, 1945; CI, 1945; Knoedler Gal., 1945 (solo) Salon d'Automne, Salon des Tuilleries, Paris; AIC; Univ. Illinois; Delius Gal. (solo); Schoneman Gal., 1955 (solo). **Sources:** WW59; WW47.

SCHULEIN, Suzanne See: **CARVALLO, Suzanne (Mrs. Julius W. Schulein)**

SCHULENBERG, Adele E. *[Sculptor, craftsperson] b.1883, St. Louis, MO / d.1971, Briarcliff Manor, NY.*
Addresses: St. Louis & Kirkwood, MO; Colchester, CT. **Studied:** G.J. Zolnay at St. Louis Sch. FA; Grafly in Phila.; Lewin Funcke, Berlin. **Member:** St. Louis AG. **Exhibited:** Alaska-Yukon-Pacific Expo, Seattle, 1909; NSS; PAFA Ann., 1911-28 (as Schulenberg), 1930 (as Gleeson); AIC, 1916. **Comments:** Sculpted reliefs, fountains, busts & sketches from Mexican life. Married Charles K. Gleeson, painter. White gives year of birth as 1878. **Sources:** WW40; Petteys, *Dictionary of Women Artists*; Falk, *Exh. Record Series.*

SCHULER, Anne *[Painter] early 20th c.*
Addresses: NYC. **Sources:** WW13.

SCHULER, Edward *[Portrait artist] late 19th c.*
Addresses: Alexandria, VA, 1880-81. **Sources:** McMahan, *Artists of Washington, DC.*

SCHULER, Eric *[Painter] early 20th c.*
Addresses: NYC. **Sources:** WW24.

SCHULER, H. J. *[Painter] early 20th c.*
Addresses: Toledo, OH. **Member:** Artklan. **Sources:** WW25.

SCHULER, Hans *[Sculptor, painter, teacher] b.1874, Alsace-Lorraine, Germany / d.1951.*
Addresses: Baltimore, MD. **Studied:** Académie Julian, Paris with Verlet, 1899; Rinehart Scholarship, Paris, 1905. **Member:** NSS, 1908; Charcoal Club. **Exhibited:** AIC; Paris Salon, 1901 (medal); St. Louis Expo, 1904 (medal); PAFA Ann., 1909-11; Arch. Lg., 1915 (prize). **Work:** Walters Gal., Baltimore; Johns Hopkins Monument, Baltimore; statue, Meridian Hill, Wash., DC; Martin Luther Mon., Marbury Mem., both in Baltimore. **Comments:** Immigrated in 1880. Position: dir., Maryland Inst. **Sources:** WW40; Falk, *Exh. Record Series.*

SCHULER, Lynnwood R. *[Artist] early 20th c.*
Addresses: Wash., DC, active 1920-28. **Comments:** Illustrator

with the Interior Dept. **Sources:** McMahan, *Artists of Washington, DC.*

SCHULGOLD, William R. *[Artist] mid 20th c.*
Addresses: NYC. **Exhibited:** PAFA Ann., 1936. **Sources:** Falk, *Exh. Record Series.*

SCHULHOF, Rudolph B. (Mr. & Mrs.) *[Collectors] mid 20th c.*
Addresses: Kings Point, NY. **Comments:** Collection: modern art since 1945. **Sources:** WW73.

SCHULHOFF, Marjory Collison (Mrs.) See: COLLISON, Marjory (Mrs. R. J. Nelms)

SCHULHOFF, William *[Painter] b.1898 / d.1943, Valhalla, NY.*
Addresses: NYC; Phila., PA. **Studied:** PAFA (Cresson Traveling Scholarship, 1924, 1925). **Exhibited:** NYC; Pittsburgh; Salons of Am.; PAFA Ann., 1929-31; Corcoran Gal. biennial, 1930; AIC. **Work:** PMG. **Sources:** WW25; Falk, *Exh. Record Series.*

SCHULL, Della F. *[Painter] early 20th c.*
Addresses: NYC. **Sources:** WW13.

SCHULLER, Grete (Margaret) *[Sculptor] late 20th c.; b.Vienna, Austria.*
Addresses: NYC. **Studied:** Vienna Lyzeum; Vienna Kunstakad.; ASL, sculpture with W. Zorach; Sculpture Center, New York. **Member:** NAWA; NSS (fellow); Allied Artists Am.; Audubon Artists. **Exhibited:** NAWA (prize); PAFA Ann., 1953-64 (5 times); NAD, 1961 (prize), 1964 (Ellen P. Speyer Prize; NSS; Sculpture Center, 1952-55, 1958 (solo); AFI Gal., 1963 (solo); Des Moines AC; Audubon Artists; Am. Acad. Arts & Letters, 1955; "150 Years of Sculpture," Old Westbury (NY) Garden Exh., 1960; All. Artists Am.; Knickerbocker Artists (Medal of Honor); Des Moines AC, 1952; Univ. Notre Dame, South Bend, IN, 1959; Detroit IA & PAFA, 1959-60; Gal. Madison/1990, NYC, 1970s. **Awards:** Arch. Lg. New York, 1954 (hon. men.); Pauline Law Prize, Allied Artists Am., 1972; Silvermine Gld. Artists (prize); NSS, 1963; New Jersey P&S, 1964; Art Lg. of Long Island, 1964. **Work:** Norfolk Mus. Arts & Sciences, VA; Mus. Natural Hist., New York; Mus. Science, Boston, MA. **Comments:** Preferred media: stone, wood. Publications: contrib., "The Form is in the Fieldstone," *Nat. Sculpture Review*, fall 1971. **Sources:** WW73; Falk, *Exh. Record Series.*

SCHULLER, Jack Valentine *[Designer, etcher, illustrator] b.1912, Springfield, MO.*
Addresses: Kansas City, MO. **Studied:** J.S. de Martelly. **Exhibited:** Rocky Mountain PM Exh., Denver Mus., 1934 (prize). **Work:** Denver Mus. **Sources:** WW40.

SCHULLER, John D. *[Seal engraver] mid 19th c.*
Addresses: NYC, 1860. **Sources:** G&W; NYBD 1860.

SCHULMAN, A(braham) G(ustav) *[Landscape painter, teacher] b.1881, Konigsberg, Germany / d.1935, Phoenix, AZ.*
Addresses: NYC. **Studied:** S.J. Woolf; NAD. **Member:** AAPL; Salons of America. **Exhibited:** Salons of Am.; S. Indp. A., 1917-18, 1920. **Comments:** Came to the U.S. as a boy. Positions: art editor, *Encyclopedia Americana;* teacher, CCNY. **Sources:** WW27.

SCHULMAN, Jacob *[Collector] b.1915, New York, NY.*
Addresses: Gloversville, NY. **Studied:** School Educ., NY Univ. (B.S.). **Comments:** Collection: contemporary painters and sculptors with emphasis on Jewish or Biblical themes, including works by Baskin, Bloom, Levine, Rattner, Shahn, Weber and Zorach. **Sources:** WW73.

SCHULMAN, Leon See: GASPARD, Leon

SCHULMAN, Z. *[Painter] mid 20th c.*
Exhibited: S. Indp. A., 1942. **Sources:** Marlor, *Soc. Indp. Artists.*

SCHULTE, Antoinette *[Painter] b.1897, NYC.*
Addresses: Paris, France; NYC. **Studied:** ASL with George Bridgman, Homer Boss; Fontainebleau Sch. FA, Paris; Lopez

Mezquita. **Member:** Audubon Artists. **Exhibited:** Salons of America, 1924, 1929, 1931-35; ; Marie Sterner Gal., 1936; Bignou Gal., 1942; Salon des Tuileries, Salon d'Automne, Paris; PAFA Ann., 1932-33, 1948, 1952; Corcoran Gal. biennial, 1932; Toronto, Canada; WMAA; Audubon Artists; NAD; Brussels, Belgium, 1955 (solo); Galerie Andre Weil, Paris, 1956 (solo); Galerie Charpentier, Paris, 1950 (solo). **Work:** Benjamin West Mus.; BM; CGA; CM; Newark Mus.; Montclair Art Mus.; MMA; French Govt. Coll.; Aix-en-Provence, France. **Sources:** WW59; WW47; Falk, *Exh. Record Series.*

SCHULTE, Arthur D. (Mr. & Mrs.) *[Collectors] b.1906, NYC.*
Addresses: NYC. **Studied:** Mr. Schulte, Yale Univ.; Mrs. Schulte, Hunter College, Columbia Univ. & NY Univ. **Comments:** Collections: French, Am., Italian and Greek paintings and sculpture. **Sources:** WW73.

SCHULTHEIS, Christian *[Engraver, die sinker] mid 19th c.*
Addresses: NYC, 1848-51. **Sources:** G&W; NYBD 1848, 1851.

SCHULTHEISS, Carl Max *[Etcher, engraver, illustrator, painter] b.1885, Nüremberg, Germany / d.1961, Kew Gardens, NY.*
Addresses: Kew Gardens, NY. **Studied:** Germany. **Member:** NA; SAGA (hon. pres.); Audubon Artists. **Exhibited:** CI, 1914, 1944, 1945; AIC, 1938; NAD, 1940-1946, 1947 (prize), 1952 (prize), 1955 (prize); CGA, 1946 (solo); Audubon Artists, 1946 (medal), 1952 (medal); SAGA, annually (prize, 1957); LOC, 1943 (prize), 1944 (prize), 1945 (prize); Wichita, KS, 1946 (prize); Laguna Beach AA, 1946 (prize). **Awards:** prizes, Talcott prize, 1940; John Taylor Arms prize, 1943, 1944; Nat. Inst. Arts & Letters grant, 1953; Phila., 1947 (medal). **Work:** LOC; NYPL. **Comments:** Contrib.: *Parnassus.* **Sources:** WW59; WW47.

SCHULTZ, Albert B. *[Illustrator] b.1868 / d.1913, NYC.*
Comments: Position: staff, *Puck,* over 20 years.

SCHULTZ, Arthur G. *[Engraver] b.c.1872, Louisville, KY / d.1943, New Orleans, LA.*
Addresses: New Orleans, active 1901-30. **Studied:** Europe. **Sources:** *Encyclopaedia of New Orleans Artists,* 344.

SCHULTZ, Carl *[Painter] late 19th c.*
Addresses: NYC, 1868. **Exhibited:** NAD, 1868. **Sources:** Naylor, *NAD.*

SCHULTZ, Florence *[Painter] early 20th c.*
Addresses: Chicago area. **Exhibited:** AIC, 1934. **Sources:** Falk, *AIC.*

SCHULTZ, Frederick *[Engraver] b.c.1823, Germany.*
Addresses: NYC, 1860. **Comments:** His wife was also a native of Germany, but their two children, ages 6 and 3, were born in NYC. **Sources:** G&W; 7 Census (1850), N.Y., XLI, 842.

SCHULTZ, George F. *[Landscape painter, marine painter] b.1869, Chicago, IL.*
Addresses: Chicago, IL. **Studied:** AIC. **Exhibited:** AIC, 1889-1925, 1918 (prize); PAFA Ann., 1894, 1916. **Work:** Union Lg. Club, Chicago; Cliff Dwellers, Chicago; Arche Club, Chicago; City of Chicago Coll.; Mt. St. Claire College, Clinton, IA; Muscatine, Iowa AA; Muskogee (OK) Pub. Lib. **Sources:** WW33; Falk, *Exh. Record Series.*

SCHULTZ, Harold A. *[Painter, educator] b.1907, Grafton, WI.*
Addresses: Urbana, IL. **Studied:** Layton Sch. Art; Northwestern Univ. (B.S. & M.A.); Sinclair; Quirt; Piccolli. **Member:** Illinois Art Educ. Assn.; Chicago SA; Nat. Art. Educ. Assn.; Western Art Assn.; Int. Soc. for Educ. through Art, UNESCO. **Exhibited:** AIC, 1928-42; Chicago SA, 1931, 1932 (prize), 1933, 1934, 1935 (medal), 1936-42; BM, 1931; Ferargil Gal., 1940. **Work:** reproduced in "Art of Today" by Jacobson (Chicago, 1933). **Comments:** Publications: co-auth., "Art in the Elementary School," 1948. Teaching: lecturer, American Art Today; head art

dept., Francis W. Parker School, Chicago, 1932-40; prof. art educ., Univ. Illinois, 1940-. **Sources:** WW73; WW47.

SCHULTZ, Harry *[Painter] b.1900, Sebastopol, Russia.*
Addresses: NYC. **Studied:** J. Sloan; K. Miller. **Member:** S. Indp. A.; Mus. Art Culture, Leningrad. **Exhibited:** Salons of Am.; S. Indp. A., 1920-22. 1925-26; 1928, 1930; PAFA Ann., 1932. **Sources:** WW31; Falk, *Exh. Record Series.*

SCHULTZ, Hart Merriam See: **LONE WOLF**

SCHULTZ, Isabelle See: **CHURCHMAN, Isabelle Schultz (Mrs. Edwin)**

SCHULTZ, John A. *[Painter] mid 20th c.*
Addresses: Lansdale, PA. **Exhibited:** PAFA Ann., 1949-51, 1954. **Sources:** Falk, *Exh. Record Series.*

SCHULTZ, L. L. (Barney) *[Designer, writer, painter] b.1903, Elgin, IL.*
Addresses: Bronxville, NY. **Studied:** AIC. **Member:** SI. **Comments:** Contributor to *Look* magazine. **Sources:** WW53; WW47.

SCHULTZ, Ralph T. *[Painter] early 20th c.*
Addresses: NYC. **Member:** SC. **Sources:** WW21.

SCHULTZ, Roger D. *[Painter, sculptor] b.1940, Troy, Ohio.*
Addresses: Santa Fe, NM. **Studied:** Univ. Cincinnati (B.S.). **Exhibited:** New Mexico Biennial,1967, 1969 & 1971 & Southwest Biennial, 1968 & 1972, FA Mus. New Mexico; Sesquicentennial FA Exh., Univ. Cincinnati, 1968; 11th & 12th Midwest Biennials, Joslyn Art Mus., Omaha, NE, 1970 & 1972; Mainstreams 1972, Marietta College, OH, 1972; Janus Gal., Santa Fe, NM, 1970s. **Awards:** Alfred Morang Comp. First Place Award, 1967; Univ. Cincinnati Purchase Award, 1968; major award & purchase award, FA Mus. New Mexico, 1971. **Work:** FA Mus. New Mexico, Santa Fe; FA Coll., Univ. Cincinnati, OH; First Nat. Bank Arizona, Phoenix; Westinghouse Corp., Norman, OK; Ansul Co., Marinette, WI. **Commissions:** sphere sculpture, Bank New Mexico, Albuquerque, 1969; sculpture, First Northern S&L Assn., Santa Fe, 1970; adobe residence, Dr. & Mrs. Robert M. Zone, Santa Fe, 1971; sculpture, Horizon Country Club, Belen, NM, 1972. **Comments:** Preferred media: acrylics, copper, bronze. **Sources:** WW73.

SCHULTZ, Suzette See: **KEAST, Susette Schultz (Mrs. W. R. Morton)**

SCHULTZ, Walter S. (Mrs.) *[Painter] early 20th c.*
Addresses: Hartford, CT. **Member:** Hartford AS. **Sources:** WW25.

SCHULTZ, William *[Portrait painter] mid 19th c.*
Addresses: Boston, 1856-57. **Sources:** G&W; New England BD 1856; Boston BD 1857.

SCHULTZ-CHURCHMAN, Isabelle (Mrs.) See: **CHURCHMAN, Isabelle Schultz (Mrs. Edwin)**

SCHULTZE, Carl Emil ("Bunny") *[Cartoonist, sculptor] b.1866, Lexington, KY.*
Addresses: NYC. **Studied:** Germany. **Comments:** Originator of the "Foxy Grandpa" series in *New York Herald* and the *American.* **Auth./illustr.:** *Bunny's Blue Book* and *The Nursery Prayer.* **Sources:** WW13.

SCHULTZE, Louis *[Painter] b.Germany / d.After 1895.*
Addresses: St. Louis, MO, from c. 1855 until at least 1895. **Studied:** Berlin, Germany, mid-1830s; Munich. **Member:** Art-Union Palett (vice-pres., 1895). **Exhibited:** NAD, 1867, 1871; "Historical Art Exh. of Works by St. Louis Artists of the Last 50 Years," sponsored by Art-Union Palette, St. Louis, 1895 (exhibited 39 oils and watercolors). **Work:** "Mother and Dead Christ," St. Joseph's Convent, St. Louis. **Comments:** It is not known when he came to the U.S., but he was in St. Louis by c.1855, working as as an assistant to Manuel Joachim de Franca. He was first listed in St. Louis directories as a portrait painter in 1859. Schultze painted portraits and religious, historical, and genre scenes, including a

work titled "And the Colored Troops Fought Nobly," shown at the NAD in 1867. In the 1860s, he also became known for his skill in watercolor and his landscapes in that medium. He specialized in views of Missouri and southern Illinois, but also exhibited scenes of Switzerland, the Tyrol, and the West. Nothing more is known of him after 1895, when a large selection of his works were shown at a special exhibition of St. Louis artists. **Sources:** Naylor, NAD; Gerdts, *Art Across America,* vol. 3: 44.

SCHULZ, Ada W. *[Painter] early 20th c.*
Addresses: Chicago, IL. **Exhibited:** PAFA Ann., 1919. **Sources:** Falk, *Exh. Record Series.*

SCHULZ, Adolph R. *[Painter] 19th/20th c.*
Addresses: Delevan, WI. **Studied:** Académie Julian, Paris, 1890-93. **Exhibited:** AIC, 1909. **Sources:** WW06.

SCHULZ, Amelia G. See: **SCHULZ, Emille (or Amelia G.)**

SCHULZ, Charles Monroe *[Cartoonist] b.1922, Minneapolis, MN.*
Addresses: Sebastopol, CA. **Studied:** Anderson College (hon. LH.D., 1963). **Comments:** The most widely syndicated cartoonist in history (over 2,300 newspapers and 1,400 books). Since 1950 he has been internationally known for his comic strip, "Peanuts." **Awards:** Outstanding Cartoonist of the Year, Nat. Cartoonists Soc., 1955; Outstanding Humorist of the Year, Yale Univ., 1957; Emmy Award for CBS cartoon special, 1966. **Positions:** cartoonist, *Saint Paul Pioneer Press & Saturday Evening Post,* 1948-49. **Auth./illustr.:** "Love is Walking Hand in Hand," 1965; "A Charlie Brown Christmas," 1965; "You Need Help, Charlie Brown," 1966; "Charlie Brown's All-Stars," 1966 & "You've Had It, Charlie Brown," 1969. **Sources:** WW73.

SCHULZ, Dote *[Painter] mid 20th c.*
Addresses: Chicago area. **Exhibited:** AIC, 1949-50. **Sources:** Falk, *AIC.*

SCHULZ, Emille (or Amelia G.) *[Artist] 19th/20th c.*
Addresses: Wash., DC, active 1898-1904. **Sources:** McMahan, *Artists of Washington, DC.*

SCHULZ, Frank *[Painter] mid 20th c.*
Exhibited: S. Indp. A., 1940-41. **Sources:** Marlor, *Soc. Indp. Artists.*

SCHULZ, Hart Merriam See: **LONE WOLF**

SCHULZE, Charles G. *[Engraver, stencil cutter] b.c.1844, Prussia / d.After 1921.*
Addresses: New Orleans, active 1866-85. **Studied:** with his father, Guben, Germany. **Comments:** Was in England before he came to the U.S. in 1862 and set up a business in St. Louis, MO. In 1865 he moved to New Orleans and went into business there. He engraved a silver medal to commemorate the World's Indust. and Cotton Cent. Expo., 1884. **Sources:** *Encyclopaedia of New Orleans Artists,* 344-345.

SCHULZE, Franze *[Educator, art critic] b.1927, Uniontown, PA.*
Addresses: Highland Park, IL. **Studied:** Northwestern Univ., 1943; Univ. Chicago (Ph.B.,1945); Sch. Art Inst. Chicago (B.F.A., 1949; M.F.A., 1950); Acad. FA, Munich. **Member:** College AA Am.; Arch. Am. Art; Am. Assn. Univ. Prof.; Louis Corinth Mem. Found. **Exhibited:** AIC, 1949, 1951 (prize); **Awards:** Ford Found. critic's fellowship, 1964; Harbison Award, Danforth Found., 1971; Graham Found. Advanced FA fellowship, 1971. **Comments:** Research: art and architecture in the Midwest, especially Chicago. **Positions:** art critic, *Chicago Daily News,* 1962-. **Teaching:** Purdue Univ, 1950-52; Lake Forrest College, 1952-. **Publications:** auth., *Art, Architecture and Civilization,* 1968; author, *Fantastic Images: Chicago Art since 1945,* 1972. **Sources:** WW73.

SCHULZE, Herbert (H. Z.) *[Painter] early 20th c.*
Addresses: NYC. **Exhibited:** S. Indp. A., 1917-18, 1920. **Sources:** Marlor, *Soc. Indp. Artists.*

SCHULZE, John H. *[Photographer, educator] b.1915, Scottsbluff, NE.*
Addresses: Iowa City, IA. **Studied:** Kansas State Teachers College (B.S.); Univ. Iowa (M.F.A.). **Member:** Soc. Photography Educ. (chmn., 1970); College AA Am.; Mid Am. College AA. **Exhibited:** Am. Photography: The Sixties, Sheldom Mem. Art Gal., NE, 1966; Photography in Fine Arts V, MMA, 1967; Photography USA, DeCordova Mus., 1968; Light Seven, Haydon Gal., MIT, 1968; Focus Gal., San Fran., 1968. **Work:** Nihon Univ., Tokyo; Haydon Gal., MIT; Univ. Alabama; Waterloo Munic. Gal.; Oakland Mus. Commissions: photography mural, Science Bldg., Univ. Northern Iowa, 1971. **Comments:** Publications: auth., "London Times" (education supplement), 1964; "Camera International," 1965;" Contemporary Photographer," 1967; contrib., *Aperture & Photography Ann.,* 1969. Teaching: Univ. Iowa, 1948-70a; artist-in-residence, Washburn Univ., 1972; artist-in-residence, Northwest Missouri State College, 1972. **Sources:** WW73; Kay Finch, "Elusive Shadow" (film), Univ. Iowa Camera, 1965.

SCHULZE, Paul *[Designer, instructor] b.1934, NYC.*
Addresses: Hartsdale, NY. **Studied:** Parsons Sch. Design (cert.); NY Univ. (B.S., indust. des., 1960). **Member:** Guild for Organic Environment: Nat. Alumni Council Parsons Sch. Design. **Exhibited:** Studies in Crystal 1966, Steuben Glass, New York, 1965; Islands in Crystal, Steuben Glass, New York, 1966. **Awards:** Student Comp. Award, Am. Soc. Indust. Designers, 1959. **Work:** Commissions: crystal cross, Steuben Glass, St Clement's Episcopal Church, New York. **Comments:** Preferred media: glass, mixed media. Positions: off. interior des., Bus. Equip. Sales Co., New York, 1960-61; des., Steuben Glass, 1961-69, asst. dir. des., 1969-1970, dir. des., 1970-. Publications: illustr., *Organics,* Steendrukkerij & Co, Holland, 1961; illustr., articles, *Indust. Design & Progressive Arch.* Teaching: Parsons Sch. Design, 1962-70. **Sources:** WW73.

SCHUMACHER, Herbert C(harles) *[Painter] early 20th c.*
Addresses: Brooklyn, NY. **Exhibited:** S. Indp. A., 1926. **Sources:** Marlor, *Soc. Indp. Artists.*

SCHUMACHER, William Emile *[Painter] b.1870, Boston, MA / d.1931.*
Addresses: Paris, France, 1901-12; NYC, 1915. **Studied:** Acad. Julian, Paris, 1890-96. **Member:** Woodstock AA. **Exhibited:** PAFA Ann., 1901-15 (6 times); AIC, 1912; Armory Show, 1913; S. Indp. A., 1917-20. **Sources:** WW17; Falk, *Exh. Record Series;* Woodstock AA; Brown, *The Story of the Armory Show.*

SCHUMAN, Robert Conrad *[Painter, instructor] b.1923, Baldwin, NY.*
Addresses: Lahaina, HI. **Studied:** NY Univ., 1948; Columbia Univ., 1948; Pratt Inst. Art Sch. (B.F.A., 1950); Univ. Hawaii (M.Ed., 1959); private study with Robert Brackman & Jean Charlot. **Member:** Nat. Art Educ. Assn.; Hawaii Educ. Assn.; Hawaii Arts Council; Hui Noeau (bd. dir.); Pacific AA. **Exhibited:** Easter Art Exh., Honolulu, 1963 & 1965; Lib. Hawaii, Honolulu, 1965; Hui Noeau, Maui, 1965 & 1968; Waldorf Astoria Art Gal., NY, 1966; Balik Art Show, Lahaina Art Gal., 1970. **Awards:** prizes, Hui Noeau, 1964; Maui County Fair, 1964. **Comments:** Positions: judge, Children's Art Show, Honolulu Acad. Art 1957; dir., State Art Week, 1959. Publications: contrib., articles to professional art journals. Teaching: Baldwin, NY, 1948-50; Nanakuli, Oahu, 1951, Eleele Kauai, 1951-57; Univ. Hawaii, 1958-64; Honolohua, Maui, 1965; Baldwin H.S., Maui, 1966-67; Lahainaluna H.S., 1968-. **Sources:** WW73.

SCHUMANN, Arno F. *[Painter] b.1891, Germany.*
Addresses: Phila., PA. **Studied:** PM Sch. IA. **Member:** Germantown AL. **Exhibited:** PAFA, 1939; AIC. **Sources:** WW40.

SCHUMANN, Marion *early 20th c.*
Exhibited: Salons of Am., 1934. **Sources:** Marlor, *Salons of Am.*

SCHUMANN, Paul R. *[Marine painter, landscape painter, teacher] b.1876, Reichersdorf, Germany.*
Addresses: Galveston, TX in 1881 & living there in 1941. **Studied:** Stockfeldt. **Member:** SSAL; Texas FAA; NOAA Galveston AL; Springfield (IL) AA. **Exhibited:** Dallas, 1924 (gold); Nashville, 1925 (prize); Salons of Am., 1925; Dallas Women's Forum, 1927 (prize); SSAL, 1929 (prize); West Texas Fair, San Angelo (prize); Waco Cotton Palace, Waco, TX (prizes); Midwestern Art Exh., Kansas City AI, 1935 (prize); NOAA, 1935 (prize). **Work:** Dallas Woman's Forum, Art Dept.; Sch. of Painting, Ft. Worth; Rosenberg Lib., Galveston; Springfield (IL) AA; Vanderpoel AA, Chicago. **Sources:** WW40; P&H Samuels, 429.

SCHUMANN, Walter *early 20th c.*
Exhibited: Salons of Am., 1934. **Sources:** Marlor, *Salons of Am.*

SCHUMM, Frederick *[Sculptor] mid 20th c.*
Addresses: NYC. **Exhibited:** PAFA Ann., 1966. **Sources:** Falk, *Exh. Record Series.*

SCHUMO, Mabel *[Painter] early 20th c.*
Addresses: Philadelphia, PA. **Sources:** WW19.

SCHUNKE, Adele R. *[Painter, teacher] b.1915, Seattle, WA.*
Addresses: Seattle, WA. **Studied:** Univ. Wash. **Exhibited:** SAM, 1939. **Sources:** Trip and Cook, *Washington State Art and Artists, 1850-1950.*

SCHUPAC, Marcia *early 20th c.*
Exhibited: Salons of Am., 1932. **Sources:** Marlor, *Salons of Am.*

SCHUPBACH, Hedwig Julia *[Painter] b.1889, Columbus, NE.*
Studied: Martha Turner; Floyde Blankenship. **Exhibited:** St. Louis World's Fair, 1904; Platte County (NE) Fair. **Sources:** Petteys, *Dictionary of Women Artists.*

SCHUPBACH, Mae Allyn *[Painter, block printer, drawing specialist, teacher] b.1895, Moberly, MO.*
Addresses: Tulsa, OK. **Studied:** J.F. Carlson; G. Wood; B. Sandzen; NY Sch. Fine & Applied Art. **Member:** Tulsa AA; Oklahoma AA; Prairie WCS; Painters & PMG, Tulsa; Arkansas WCS. **Exhibited:** Tulsa AA, 1934 (prize). **Comments:** Position: head, Mae Allyn Schupbach Sch. Art, Tulsa, OK. **Sources:** WW40.

SCHUREMAN, Alfred *[Engraver] b.1834, Ohio.*
Addresses: NYC, 1850. **Sources:** G&W; in. Cf. Alphonso B. Schureman.7 Census (1850), N.Y., XLIX, 235.

SCHUREMAN, Alphonso B. *[Engraver] mid 19th c.*
Addresses: NYC, 1850s. **Exhibited:** Am. Inst., 1849. **Comments:** From 1854-57 he was associated with Thomas Lippiatt. Cf. Alfred Schureman. **Sources:** G&W; NYCD 1854-60; Am. Inst. Cat., 1849.

SCHURMAN, C. *[Artist] mid 19th c.*
Addresses: Wash., DC, active 1850s-60s. **Comments:** Schurman was probably active with the engraving and printing firm of Selmar Siebert. **Sources:** McMahan, *Artists of Washington, DC.*

SCHUS, Adolph *[Cartoonist, illustrator] b.1908, NYC.*
Addresses: Harmon, NY. **Studied:** NY Sch. Fine & App. Art. **Member:** Am. Soc. Magazine Cartoonists. **Comments:** Contrib. to *Collier's* and various other magazines. Position: cartoon ed., *Pageant* magazine, 1945; art dir., *The Boulevardier,* Paris. **Sources:** WW59; WW47.

SCHUSSELE, Cecelia Muringer (Mrs. Christian) *[Painter] b.1841, Besancon, France, 1841 / d.1916.*
Addresses: Philadelphia, PA. **Exhibited:** PAFA Ann., 1878. **Comments:** Came to the U.S. at an early age. Specialty: flowers, still life. **Sources:** Falk, *Exh. Record Series.*

SCHUSSELE, Christian *[Historical, genre, portrait & landscape painter, lithographer & teacher] b.1824, Alsace / d.1879, Merchantville, NJ.* C.Schussele.
Addresses: Philadelphia, PA (immigrated 1848-on). **Studied:**

Strasbourg; Paris. **Member:** Artists' Fund Soc., Phila. (pres.). **Exhibited:** PAFA Ann., 1851-69, 1905; Brooklyn AA, 1872. **Work:** PAFA; NYHS; PMA; NPG; Gilcrease Inst. **Comments:** Best known as an academic history painter and teacher, Schussele was among the earliest artists to work as a chromolithographer for several years in Paris, before emigrating to Philadelphia in 1848. He soon married the daughter of Caspar Muringer (see entry). Despite his desire to paint full time, Schussele continued to support himself by chromolithographic work and designing for wood engravers. In 1854, the commercial success of one of his historical paintings (reproduced as an engraving by John Sartain) allowed him to dedicate himself to painting genre and historical works. From c.1863-on, Schussele was afflicted with a palsy that severely curtailed his production, but in 1868 he became professor of drawing and painting at PAFA, a position he held until his death. A highly respected teacher, he introduced important reforms into the academic program and did much to establish PAFA as an important teaching institution. He was succeeded at PAFA by his assistant (and former student), Thomas Eakins. According to Rutledge and the censuses, Schussele was born in 1824, although the DAB says 1826. **Sources:** G&W; DAB; Rutledge, PA; 7 Census (1850), Pa., LI, 924; 8 Census (1860), Pa., LV, 468; Sartain, *Reminiscences,* 249-51; Swan, BA; Thieme-Becker; *Connoisseur,* June 1947, 116; *American Collector,* July 1946, 13; *Portfolio,* Feb. 1952, 140; Baigell, *Dictionary; 300 Years of American Art,* vol. 1, 207; *In This Academy,* 62, 64, 69, 114; Falk, *Exh. Record Series.*

SCHUSTER, Arnauld *[Portrait painter] mid 19th c.*
Addresses: NYC, 1852. **Studied:** Munich Acad. **Sources:** G&W; NYBD 1852; Thieme-Becker.

SCHUSTER, Carl *[Writer] b.1904, Milwaukee, WI.*
Addresses: Woodstock, NY. **Studied:** Harvard College (A.B.); Harvard Univ. (A.M.); Vienna (Ph.D.). **Exhibited:** Awards: Harvard-Yenching Fellowship, 1929-32; Guggenheim Fellowship, 1937-39; Fulbright Fellowship, 1950-51; Bollingen, Fellowship, 1952-53. **Comments:** Contrib.r of articles on design-traditions among primitive peoples to *Anthropos, Far Eastern Quarterly, Communications of the Royal Tropical Institute (Amsterdam), Mankind (Sydney, Australia), Sudan Notes and Records (Khartum), Papers of 29th International Congress of Americanists, Anales del Museo de Historia Natural de Montevideo, Revista do Museu Paulista, Paul Rivet Memorial Volume, Artibus Asiae,* and other publications. **Sources:** WW66.

SCHUSTER, Donna N(orine)
[Painter, teacher] b.1883, Milwaukee, WI / d.1953, Los Angeles, CA. *Donna Schuster*
Addresses: Boston, MA; Los Angeles, CA. **Studied:** AIC; W.M. Chase; E. Tarbell; Stanton MacDonald-Wright; also in Europe. **Member:** Calif. AC; Laguna Beach AA; Soc. Indep. Artists; West Coast Arts; Calif. WCS (pres.); Women Painters of the West (cofounder). **Exhibited:** PAFA Ann., 1912-15; LACMA, 1914, 1917, 1920, 1927, 1929; NY Acad. FA; NYWCS; AWCS; S. Indp. A., 1917; AIC; Phoenix, AZ, 1918 (prize), 1919 (prize), 1920 (prize); Corcoran Gal. biennial, 1919; Calif. AC, 1921 (prize), 1931 (prize); Calif. WCS, 1926 (prize); Los Angeles County Fair, 1929 (prize), 1930 (prize); Orange County Fair, 1930 (prize); Art Teachers Assn., Los Angeles County, 1933 (prize); St. Paul Inst., 1915 (prize); Minnesota State Art Exh., 1913 (gold), 1914 (prize); Pan-Calif. Expo, San Diego, 1915 (medal); West Coast Arts, Inc., 1926 (prize), 1929 (prize); Riverside County Fair, 1930 (prize); Santa Cruz, 1931; GGE, 1939; San Fran. AA. **Work:** Downey Mus. Art; Laguna Muse.; LACMA; Oakland Mus.; Calif. WCS. **Comments:** Painted Calif. scenes, harbors, in oil & watercolor. Teaching: Otis AI, Los Angeles, from 1932; Los Angeles County AI, 1952. **Sources:** WW53; WW47; Falk, *Exh. Record Series.* More recently, see Hughes, *Artists of California,* 499; Trenton, ed. *Independent Spirits,* 72-73.

SCHUSTER, Eugene Ivan *[Art dealer, art historian] b.1936, St. Louis, MO.*
Addresses: Detroit, MI. **Studied:** Wayne State Univ. (B.A. &

M.A.); Univ. Michigan, Ann Arbor, 1959-62; Warburg Inst., Univ. London, Fulbright scholarship with E. H. Gombrich, 1962-65; Courtauld Inst., Univ. London & London School Economics, 1962-65. **Member:** Founders Soc., Detroit Inst. Arts; Detroit Art Dealers Assn.; Appraisers AA. **Exhibited:** Awards: Louis La Med. Prize for outstanding masters thesis on topic of Jewish cultural concern. **Comments:** Positions: dir., London Arts Gal. Publications: auth., *Les Peintres Maudits: A Study of the Cultural Relationship of the Jewish Artists of Paris,* 1960; auth., *Sir Charles Locke Eastlake,* Plymouth Art Mus., England. Teaching: Wayne State Univ., 1959-62; Eastern Michigan Univ., 1960; Rackham Extension, Univ. Michigan, 1961; Nat. Gal., London, 1962-65. Research: Quattrocento in Florence, especially formative changes caused by humanistic studies and leading to the Renaissance. Specialty of gallery: old and modern master graphics; western painting and sculpture from the 15th-20th c. **Sources:** WW73.

SCHUSTER, Sigismund *[Miniaturist, pastellist, lithographer, landscape painter, teacher] b.1807, Germany.*
Addresses: NYC, c.1851 was active there at least until 1860. **Exhibited:** Am. Inst., 1851; NAD, 1853-59. **Comments:** Auth.: *Practical Drawing Book* (1853). **Sources:** G&W; Thieme-Becker; Cowdrey, NAD; Am. Inst. Cat., 1851; NYCD 1851-60; Union Catalogue, LC.

SCHUSTER, Will *[Painter] early 20th c.*
Addresses: Santa Fe, NM. **Comments:** Affiliated with Santa Fe Mus. **Sources:** WW27.

SCHUSZLER, Alajos *[Painter] mid 20th c.*
Exhibited: S. Indp. A., 1936. **Sources:** Marlor, *Soc. Indp. Artists.*

SCHUTT, Ellen I. *[Artist] early 20th c.; b.Virginia.*
Addresses: Wash., DC, active 1904-14. **Work:** Watercolors, U.S. Nat. Arboretum; SI's Dept. of Botany. **Comments:** Illustrator with the U.S. Dept. of Agriculture. **Sources:** McMahan, *Artists of Washington, DC.*

SCHUTTER, Hubert *[Fresco, decorative & ornamental painter] b.1827, Prussia.*
Addresses: Wash., DC, active from 1859. **Member:** Wash. AC, 1876-77. **Comments:** He was in partnership with artist Joseph Rakemann in Wash., DC. **Sources:** McMahan, *Artists of Washington, DC.*

SCHUTZ, Ann (Mrs.) See: **FREILICH, Ann**

SCHUTZ, Anton (Joseph Friedrich) *[Etcher, writer] b.1894, Berndorf, Germany / d.1977, White Plains, NY.*
Addresses: Scarsdale, NY. **Studied:** Univ. Munich, 1912-19 (interrupted by WWI); Munich Acad. FA, 1919-23, with Groeber, P. von Halm; ASL, 1924-25, with Joseph Pennell. **Member:** SAGA; Chicago SE; Queens-Nassau Fair, Mineaola, 1932 (prize). **Exhibited:** Harbor Gal., NYC, 1985 (etchings of NYC), 1987 (etchings of home and abroad); in the US & abroad. **Work:** LOC; British Mus., London; Bibliothèque Nat., Paris, France; Uffizi, Florence, Italy; BM; NYPL; AIC; CMA; St. Louis Pub. Lib. **Comments:** A highly-decorated Lieutenant in the German Army during WWI, he resumed his studies in engineering and architecture after the war. By 1922, he was an established etcher of the German landscape; and in 1924 emigrated to the U.S. where he became best known for his architectural etchings of NYC. In 1925 he founded the New York Graphic Soc., and was its president until 1966 when the company was acquired by Time, Inc. He was also pres., Inter-Am Graphics, Ltd.; and publisher & co-editor, UNESCO World Art Series, 1954-60. Publications: auth., *New York in Etchings* (Bard Bros., NYC, 1939). His company, NYGS, was a major producer of reproduction prints, and his catalogues included *Fine Art Reproduction of Old and Modern Masters* (1941, 1961, 1965); *Handbook of Fine Art Color Reproductions* (1945); *Blue Book Color Reproductions* (1951); *Reproductions of American Paintings* (1961); and others. **Sources:** WW73; WW47.

SCHUTZ, J. *[Lithographic artist] mid 19th c.*
Comments: He was employed by Currier (see entry) about 1849-50, and did mostly lettering but also a few prints. **Sources:** G&W; *Portfolio* (April 1943), cover and p. 171; *American Collector* (Aug. 1945), 5.

SCHÜTZE, Eva Watson See: **WATSON-SCHÜTZE, Eva**

SCHÜTZE, G. *[Painter] late 19th c.*
Addresses: Monterey Co., CA, 1889. **Exhibited:** NAD, 1889.
Comments: Probably the husband of artist Lizzie Lawrence Schütze. **Sources:** Naylor, *NAD*.

SCHÜTZE, Lizzie Lawrence *[Painter] late 19th c.*
Addresses: Salinas, Monterey Co., CA, 1889. **Exhibited:** NAD, 1889. **Comments:** Probably the wife of artist G. Schütze.
Sources: Naylor, *NAD*.

SCHUTZE, Ruth G(oldsholl) (Mrs.) *[Painter] mid 20th c.*
Studied: ASL. **Exhibited:** S. Indp. A., 1941. **Sources:** Marlor, *Soc. Indp. Artists*.

SCHUTZENBERGER, Jacques *[Sculptor, painter] b.1898, Strasbourg, France / d.1940, Beverly Hills, CA.*
Addresses: Beverly Hills, CA. **Exhibited:** S. Indp. A., 1934; Calif. AC, 1935, 1936. **Sources:** Hughes, *Artists of California*, 500.

SCHUYLER, Montgomery *[Writer] b.1843, Ithaca, NY / d.1914.*
Addresses: Came to NYC in 1865; New Rochelle, NY. **Member:** NIAL; Century. **Comments:** Auth.:"Westward the Course of Empires," "Studies in American Architecture." Contrib.: *Architectural Record.* Positions: ed., *New York World*; staff, *New York Times,* 1883-1907.

SCHUYLER, Phillip Griffin *[Painter] b.1910, Marshfield, OR / d.1981, Newport Beach, CA.*
Addresses: Tacoma, WA. **Studied:** Oregon State Univ.; ASL.
Comments: Position: dir., several theaters in the Northwest before 1935; staff, *Boston Herald* and *Philadelphia Enquirer. Preferred medium:* oil. **Sources:** *Trip and Cook,* Washington State Art and Artists, 1850-1950.

SCHUYLER, Remington REMINGTON SCHUYLER
[Painter, illustrator, writer, lecturer] b.1884, Buffalo, NY / d.1955.
Addresses: NYC; Buckingham, PA. **Studied:** St. Louis Art Sch.; ASL with Bridgman, H. Pyle; Académie Julian, Paris with J.P. Laurens and E. Bashet; Acad. Colarossi, Paris. **Member:** SI.
Work: WPA murals: New Rochelle H.S., George Washington H.S., New Rochelle, NY; Darien H.S., CT; Clyde Steamship Co.; City of New Rochelle Coll. **Comments:** A specialist in Western and Indian subjects, he was possibly born in 1887. Auth./illustr.: *Art* (1944); *Sculpture* (1945); illustr., books for Boy Scouts of America. **Sources:** WW53; WW47; P&H Samuels, 429; *Community of Artists,* 76.

SCHUYLER, Sophie N. See: **DEY, Sophie N. Schuyler (Mrs. Henry)**

SCHWAB, Amanda *[Painter] mid 20th c.*
Exhibited: S. Indp. A., 1936-37. **Sources:** Marlor, *Soc. Indp. Artists.*

SCHWAB, Edith Fisher (Mrs. C.) *[Landscape painter] b.1862, Cincinnati, OH.*
Addresses: New Haven, CT. **Member:** New Haven PCC; Nat. Assn. Women P&S. **Exhibited:** New Haven PCC, 1900 (charter exh.); PAFA Ann., 1900; AIC, 1912, 1914; S. Indp. A., 1917.
Sources: WW24; Falk, *Exh. Record Series.*

SCHWAB, Eloisa (Mrs. A. H. Rodriguez) *[Painter] b.1894, Havana, Cuba.*
Addresses: NYC, Jackson Heights, NY; Fair Lawn, NJ. **Studied:** Acad. Julian, Paris, France; ASL with Bridgman & Miller.
Member: Burr Artists (corresp. secy., 1970-); Gotham Painters (corresp. secy., 1965-); AFA; Fair Lawn AA; ASL (life mem.);

Composers, Authors, Artists Am. (state pres., NJ Chapt.).
Exhibited: WMAA; S. Indp. A., 1918, 1920-23, 1925-29; Salons of Am.; PAFA Ann., 1923, 1938; Delphic Studios, NYC (solo); Crespi Gal., 1956 (solo); RoKo Gal., NYC (solo); Ahda Artzt Gal., 1965 (solo); Ridgewood (NJ) AA; Paterson (NJ) Pub. Lib.; Paterson Art League; Fair Lawn AA (first prize); Composers, Authors, Artists of Am.; Burr Artists. Other awards: State show, Paterson NJ (prize); Gotham Painters (prize). **Work:** Kate Duncan Smith DAR Sch. Grant, AL; Hickory (NC) Mus.; New Jersey Mus., Paterson; Arnot Art Mus., Elmira, NY; ASL. **Comments:** Preferred media: oils. **Sources:** WW73; WW33; Fehrer, The Julian Academy; Petteys, *Dictionary of Women Artists;* Falk, *Exh. Record Series.*

SCHWAB, Katherine (Katharine) Fisher *[Sculptor] b.1898.*
Addresses: NYC. **Studied:** Am. Sch. Sculpture; ASL. **Member:** New Haven PCC. **Exhibited:** New Haven PCC, from 1934 (prizes). **Sources:** WW40.

SCHWABACHER, Alfred *[Collector] b.1879, Felheim, Germany.*
Addresses: NYC. **Comments:** Collection: French impressionists.
Sources: WW73.

SCHWABACHER, Ethel K. *[Abstract painter, art critic] b.1903, NYC / d.1984.*
Addresses: NYC. **Studied:** Max Weber, 1928; in Europe, 1928-33; Arshile Gorky, 1935-36. **Exhibited:** WMAA, 1947-65; PAFA Ann., 1954; Corcoran Gal. biennial, 1959; Mexico City Biennale, 1960; Walker AC, 1960; CI, 1961; BM Watercolor Int., 1961-62; New York (several solos); traveling retrospective, Zimmerli AM, 1980s; Schlesinger-Boisanté Gal., NYC, 1980s (solo). **Work:** WMAA; Albright-Knox Gal., Buffalo; Rockefeller Univ., NYC; Syracuse (NY) Univ.; Wichita (KS) State Univ. **Comments:** Publications: auth., *Arshile Gorky,* (WMAA & Macmillan, 1957); "Arte Visivi," Rome, 1962. **Sources:** WW73; Falk, *Exh. Record Series.*

SCHWABE, (Henry) August *[Stained glass specialist] b.1842, Germany / d.1916.*
Addresses: Phila., PA; South Orange, NJ. **Studied:** NAD with W.M. Chase; Académie Julian, Paris, 1893; also in Stuttgart, Munich, and Cologne. **Exhibited:** PAFA Ann., 1884, 1887-88.
Work: designed windows for Chicago, Pittsburgh and Newark churches. **Comments:** Came to U.S. in 1871. **Sources:** Falk, *Exh. Record Series.*

SCHWACHA, George, Jr. *[Painter, teacher, lecturer] b.1908, Newark, NJ / d.1986.*
Addresses: Bloomfield, NJ. **Studied:** Arthur W. Woelfle; John Grabach; E. Dufner; A. Schweider. **Member:** AWCS; Audubon Artists; Phila. WCC; Calif. WCS; New Haven PCC; CAFA; NOAA; Springfield AL. **Exhibited:** State Art Exh., Montclair, NJ, 1935 (medal), 1937 (medal); Municipal Art Exh., Irvington, 1936 (prize); New Jersey Gal., 1937 (prize), 1939 (prize), 1940 (prize), 1942 (prize); Art Center of the Oranges, 1937; AAPL, 1939; New Haven PCC, 1939 (prize), 1944 (prize); Asbury Park SFA, 1940 (prize), 1942 (prize); Newark AC, 1942 (prize); Mint Mus. Art, 1943 (prize), 1946 (prize); Springfield AL, 1943 (prize); AWCS, 1944 (prize); Denver AM, 1944 (prize); Alabama WCS, 1944 (prize); New Jersey P&S, 1945 (prize); Allied Artists Am., 1945 (prize); Wash. WCC, 1946 (prize); CAFA, 1946 CM; CGA; Currier Gal. Art; Elgin Acad. Art; Delgado Mus. Art; NAD; NAC; Newark Mus.; PAFA; VMFA; AIC; Meriden Arts & Craft, 1952 (award) & Florida Southern College, 1952 (award); Audubon Artists, 1961(gold medal). **Work:** Albany Inst. History & Art; Mint Mus. Art; Elisabeth Ney Mus.; AWCS; New Haven PCC;Laguna Beach, CA; Montgomery FA; Newark Mus.; Women's Club, Perth Amboy, Bloomfield, NJ; Perth Amboy Pub. Lib. **Comments:** Publications: Margaret Harold (auth.), "Prize-Winning Paintings," Book IV. Contrib. articles, *Irvington Herald, Newark Evening News.* **Sources:** WW73; WW47.

SCHWADERER, Fritz [Painter] b.1901, Darmstadt, Germany.
Addresses: Los Angeles, CA. **Studied:** Art Sch. Prof. Bayer, Municipal Art Sch., Mainz, Acad. FA, Berlin, Germany, with Liebermann, Slevogt and Pechstein. **Member:** Rheinischer Künstlerbund (pres., 1946-49). **Exhibited:** United Nations Art Exh., 1960; Mus. FA of Houston, 1963; Los Angeles Mus. Art, 1963; Phoenix Art Mus., 1964; Palm Springs, 1964; Univ. of Judaism, Los Angeles, 1965; Ankrum Gal., Los Angeles (11 solos); Europe. **Work:** Museum of Mainz, Cologne and Munich; Univ. Judaism, Los Angeles; La Jolla A. Mus.; Colorado Springs FA Center; Palm Springs Mus. Murals: Mission Center, Marburg-Lahn. **Sources:** WW66.

SCHWAGER, John [Painter] early 20th c.
Addresses: Kansas City, MO. **Sources:** WW24.

SCHWALBACH, James Alfred [Painter, block printer, teacher] b.1912, South Germantown, WI.
Addresses: Milwaukee, WI. **Studied:** Univ. Wisconsin. **Member:** Wisc. P&S. **Comments:** Teaching: Washington H.S., Milwaukee, WI. **Sources:** WW40.

SCHWALBACH, Mary Jo [Painter, sculptor] b.1939, Milwaukee, WI.
Addresses: NYC. **Studied:** Pine Manor Jr. College (A.A.); Univ. Wisconsin (B.S.); NY Univ. Inst. FA; Sch. Visual Arts; Paris & Rome. **Exhibited:** Solos: Rhoda Sande Gal., New York, 1969; West Bend (WI) Mus. FA, 1969 & Dannenberg, New York, 1972; Bergstrom Mus., Neenah, WI, 1970 (retrospective); Beyond Realism, Upstairs Gal., East Hampton, NY, 1972. **Work:** Univ. Calif. Mus., Berkeley; Jazz Mus., NYC; Kellogg State Bank, Green Bay, WI; Am. City Bank, Menomonee Falls, WI; Kimberly State Bank, WI. Commissions: sculpture, 1st Fed. S&L, Menomonee Falls, 1969; three hockey sculptures, Phila. Flyers, The Spectrum, Phila., 1970; sculpture of Mario Andretti, *Clipper Magazine*, New York, 1972; sculpture, Computer TV Gulf & Western Bldg., New York, 1972; Am. Baseball Assn., 1972. **Comments:** Preferred media: mixed media. Positions: staff member, MoMA, 1962-67. Publications: illustr., *Down Beat*, 1965-72 & Prestige Record Jackets, 1966-69; illustr., art reproduced in *New Yorker,* 1970. Teaching: MoMA Sch., New York, 1965. **Sources:** WW73; S. Walton, "Mary Jo Schwalbach—Sports Artist," *Sporting News* (1971); article, *Clipper Magazine* (August, 1972); S. Fischler, "Mary Jo Schwalbach—Sports Action," *Sports Hockey* (1972).

SCHWALBE, Mary (Marie) [Artist] 19th/20th c.
Addresses: Active in Los Angeles, 1892-1903. **Sources:** Petteys, *Dictionary of Women Artists.*

SCHWALL, Kay Fuller (Mrs. E. E.) [Painter, teacher] b.1909, Dover, OH.
Addresses: New Concord, OH. **Studied:** Ohio Wesleyan Sch. FA; Ohio Wesleyan Univ. (A.B.); Ohio State Univ. (M.A.). **Member:** Ohio WCS. **Exhibited:** PAFA, 1941; TMA, 1942; Ohio WCS, 1943-46; Ohio Valley Exh., Athens, 1946; TMA, 1942; Canton AI, 1942 (prize); Massillon Mus. Art, 1945; Zanesville, OH, 1944, 1946. **Comments:** Teaching: Ohio Public Schools, 1936-42; Muskingum College, New Concord, OH, 1942-44. **Sources:** WW53; WW47.

SCHWAMM, Louise [Painter] b.1870, San Francisco, CA / d.1958, San Fran.
Addresses: San Fran. **Exhibited:** Mark Hopkins Inst., 1898. **Sources:** Hughes, *Artists of California,* 500.

SCHWAN, Phi[lip?] [Artist] b.c.1824, Germany.
Addresses: New Orleans, 1850. **Comments:** Boarding in with six other German artists; Merving, Rehn, and the four Heills (see entries). **Sources:** G&W; 7 Census (1850), La., V, 82.

SCHWANEKAMP, William J. [Painter, etcher, drawing specialist, designer] b.1893, Buffalo, NY / d.1970, Buffalo/Eggertsville, NY.
Addresses: Eggertsville/Cowlesville, NY. **Studied:** E. Fosbery;

W. Paxton; P. Hale; W. James, BMFA Sch. **Member:** AAPL; Buffalo SA (pres.); Artists Guild, Buffalo; Buffalo Print Club; Patteran Soc.; Northwest PM. **Exhibited:** Albright Art Gal., 1933, 1938 (prize); Western New York Ann., 1935 (prize). **Work:** Albright Art Gal., Buffalo. **Sources:** WW40.

SCHWANENFLUEGAL, Hugo Von [Painter] early 20th c.
Addresses: Lawrence, LI, NY, 1917. **Studied:** ASL. **Exhibited:** Salons of Am., 1928-32; 1934, 1935; S. Indp. A., 1917. **Sources:** Falk, *Exhibition Record Series.*

SCHWANINGER, William [Painter] mid 20th c.
Exhibited: S. Indp. A., 1938. **Sources:** Marlor, *Soc. Indp. Artists.*

SCHWANKOVSKY, Frederick John de St. Vrain [Painter, teacher, writer, lecturer, illustrator] b.1885, Detroit, MI / d.1974.
Addresses: Laguna Beach, CA; Meadow Lakes via Auberry, CA. **Studied:** Detroit Univ.; PAFA; ASL. **Member:** Laguna Beach AA (life); Am. Fed. Teachers; Calif. AC; Los Angeles AL; Calif. Art Teachers Assn.; Southwest AA (honorary pres.); Central Calif. AA; Soc. Western Artists (founding past pres.). **Exhibited:** GGE, 1939; Soc. Western Artists, 1955 (2 prizes); Laguna Beach AA, annually. **Work:** Mission Beach (CA) Art Gal.; Manual Arts H.S., Los Angeles. **Comments:** Contrib.: art reviews, newspapers. Positions: teacher, Manual Arts H.S., Los Angeles from 1919; dir., Festival of Arts, Laguna Beach, CA, 1946; teacher, Univ. Southern Calif.; Whittier Evening H.S., Los Angeles. **Sources:** WW59; WW47.

SCHWARCZ, Dorothea See: **GREENBAUM, Dorothea Schwarcz**

SCHWARCZ, June Therese [Craftsman] b.1918, Denver, CO.
Addresses: Sausalito, CA. **Studied:** Univ. Colorado, 1936-38; Univ. Chicago, 1938-39; Pratt Inst., 1939-41; Inst. Design, Chicago, with Moholy Nagy. **Member:** Am. Crafts Council; Soc. North-Am. Goldsmiths. **Exhibited:** New Talent USA, Art in Am., 1960; Mus. Contemp. Crafts, 1965 (solo); Objects USA, Johnson Wax Coll. & Exh., 1969; solos: Mus. Bellerive (Kunstgewerbermuseum), Zurich, Switzerland, 1971 & Schmuckmuseum, Pforzheim, Germany, 1972. **Awards:** Purchase award, Ceramic Nat., Everson Mus., Syracuse, 1960; First Calif. Craftsmen's Biennial, Oakland Mus., 1961; Goldsmith 1970, ex-Minnesota Mus. Art, 1970. **Work:** Kunstgewerbermuseum, Zurich, Switzerland; Johnson Wax Collection; Minnesota Mus. Art, St. Paul; Oakland Art Mus., CA. Commissions: Enameled bowl with technique demonstration bowls, Mus. Contemporary Crafts, 1958; three piece panel, Cent. Nat. Bank, Enid, OK, 1962. **Comments:** Preferred media: enamels. Publications: contrib., *Craftsmen's World,* 1959 & *Research in Crafts,* 1961, Am. Crafts Council Publ.; auth., "The Arts Turn to Plating," *Journal Electroplaters Soc.,* 11/1967. **Sources:** WW73; Uchida, "June Schwarcz" (Sept., 1959) & Ventura, "June Schwarcz: Electroforming" (Nov., 1965), *Craft Horizon*; Nordress, *Objects: USA* (Viking Press, 1970).

SCHWARM, Wesley A. [Painter, designer] b.1883, Lafayette, IN.
Addresses: Larchmont, NY. **Studied:** PIA Sch.; Robert Henri. **Exhibited:** Indiana Artists; MacDowell Club; NY Munic. Exh., 1938, 1939; Town Hall Club, NY; Westchester Artists; S. Indp. A., 1917, 1919, 1921. **Work:** Jefferson, Ford, & Washington Schools, Lafayette, IN. **Sources:** WW59; WW47.

SCHWARTZ, Alfred W. [Painter] early 20th c.
Addresses: NYC, Ulster Park, NY. **Exhibited:** PAFA Ann., 1906; S. Indp. A., 1929. **Sources:** WW06; Falk, *Exh. Record Series.*

SCHWARTZ, Alvin Howard [Painter, designer, teacher] b.1916, Baltimore, MD.
Addresses: Baltimore, MD; Pikesville, MD. **Studied:** NAD; Maryland Inst.; NYU. **Member:** Maryland Artists Un.; Maryland WCC; Balt. Artists Un.; Balt. Munic. AS. **Exhibited:** Awards: prizes, Maryland Artists Un., 1939-41,1948-50; BMA, 1939-

41;1952; Maryland Inst. (solo). **Work:** Work: BMA; City of Balt., Sch. Bd. Coll.; Sinai Hospital, Balt.; Jewish Educ. All., Balt.; murals, adv. des., Lord Balt. Hotel; Am. Oil Co., and numerous restaurants. **Comments:** Position: teacher, Night Sch., Maryland Inst.; des., illustr., Glen L. Martin Co., 1955-58; presentation des. & artist, Westinghouse Electric Corp., Electronics Div., Balt., MD, 1958-. **Sources:** WW59; WW47.

SCHWARTZ, Andrew T(homas) *[Mural painter] b.1867, Louisville, KY / d.1942, Louisville, KY.*
Addresses: NYC, Brooklyn, NY. **Studied:** Duveneck, Cincinnati; Cincinnati Art Acad.; Mowbray, ASL; Rome. **Member:** Louisville AA; AWCS; Circolo Artistica of Rome; Allied AA; SC; Fellow Am. Acad. Rome. **Exhibited:** AIC, 1905-09; PAFA Ann., 1909, 1911-12. Award: Lazarus scholarship to Italy, 1899-1902. **Work:** Dec.: Kansas City (MO) Life Insurance Co.; Baptist Church, S. Londonderry, VT; Cincinnati AM; Utica (NY) Pub. Lib.; murals, Atkins Mus. FA, Kansas City; murals, County Courthouse, NY. **Sources:** WW40; Falk, *Exh. Record Series.*

SCHWARTZ, Aubrey E. *[Printmaker, sculptor] b.1928, NYC.*
Addresses: Binghamton, NY. **Studied:** ASL; Brooklyn Mus. Art Sch. **Exhibited:** Young Am., WMAA, 1957; Print Council Am. Show, 1957; Grippi Gal., New York, 1958 (solo); Art USA, New York Coliseum, 1959; Contemp. Graphic Art, U.S. State Dept., 1959. Awards: Guggenheim Found. fellowship, creative printmaking, 1958-60; Tamarind fellowship, creative lithography, 1960; first prize for graphic art, Boston Arts Festival, 1960. **Work:** Nat. Gallery Art, Washington, DC; Brooklyn Mus. Art; Philadelphia Mus. Art; LOC; AIC. Commissions: editor, lithographs, "Predatory Birds," Gehenna Press, 1958, Midget & "Dwarf," Tamarind Workshop, 1960 & "Bestiary," Kanthos Press, 1961;. **Comments:** Editor: etchings, "Mothers & Children," New York, 1959 & "Wildflowers," New York, 1966. **Sources:** WW73; Carl Zigrosser (author), catalogue, Print Council Am., 1959; Allan Fern (author), catalogue, US State Dept., 1961; Harold Joachim (author), "A Bestiary," Kanthos Press, 1961.

SCHWARTZ, Barbara J. *[Art administrator] b.1947, Detroit, MI.*
Addresses: NYC. **Studied:** Univ. Wisconsin-Madison (B.S.). **Sources:** WW73.

SCHWARTZ, C. *[Stipple engraver] early 19th c.*
Addresses: Baltimore, c.1814. **Sources:** G&W; Stauffer.

SCHWARTZ, Carl E. *[Painter, instructor] b.1935, Detroit, MI.*
Addresses: Chicago, IL. **Studied:** AIC (B.F.A.). **Member:** Arts Club Am.; Artists Guild Chicago; Contemp. Art Mus. Chicago; North Shore Art Lg.; AIC. **Exhibited:** Ann. Exh. Michigan Artists, Detroit AI 1955, & 1969; Butler IA, 1963-65; Art Across Am., Columbus Gal. FA & 28 museums, 1965-67; Am. Painting Exh., Smithsonian Inst., Wash., DC & Tour, 1972; 18th Nat. Print Exh., BM, 1972-73. Awards: AIC, 1958 (Logan Medal & Award); Detroit AI, 1965 (Commonwealth Prize); Virginia Beach AA, 1969 (best of show). **Work:** AIC; LOC; Ball State Univ., Muncie, IN; Univ. Minnesota; Virginia Beach AA. **Comments:** Preferred media: acrylics. Publications: illustr., *Playboy*, 1965 & 1967; auth., article, *North Shore Art League News*, 1969. Teaching: North Shore Art Lg., 1958-; Suburban FAC, 1960-71. **Sources:** WW73; Allan Davidson, article, *Art League News* (1967); Thomas Carbol, *The Printmaker in Illinois* (Illinois Art Educ. Assn., 1972).

SCHWARTZ, Christian *[Engraver] mid 19th c.*
Addresses: Jersey City, 1859. **Comments:** He was working in NYC. **Sources:** G&W; NYCD and BD 1859.

SCHWARTZ, Cornelia B. *[Painter] b.1881 / d.1975.*
Studied: Master's School, Dobbs Ferry; Cooperstown, NY, with W.B. Romeling. **Comments:** Preferred medium: watercolor. **Sources:** *Rediscovery: A Tribute To Otsego County Women Artists,* exh. brochure (Hartwick Foreman Gallery, 1989), 13-14.

SCHWARTZ, Daniel *[Painter, illustrator] b.1929, NYC.*
Addresses: NYC. **Studied:** RISD (B.F.A.); ASL with Yasuo Kuniyoshi. **Exhibited:** Solos: Davis Gal., NYC, Cincinnati, OH, San Fran; SI, since 1961(8 gold medals), 1978 (Hamilton King Award); PAFA Ann., 1966. Other awards: TIffany Fellowship, 1956. **Comments:** Starting out as a painter, he did his first illustrations in 1958. Illustr.: *Sports Illustrated,* and other national magazines; adv., large corporate clients. **Sources:** W & R Reed, *The Illustrator in America,* 306; Falk, *Exh. Record Series.*

SCHWARTZ, Davis Francis *[Landscape painter, illustrator] b.1879, Paris, KY / d.1969, San Francisco, CA.*
Addresses: San Fran. **Studied:** AIC; Dayton, Cleveland, OH; Montreal, Canada, with Adam S. Scott. **Member:** Carmel AA; Oakland AA; Santa Cruz AA; Soc. Western Artists. **Work:** St. Mary's College, Moraga, CA; Officers Club, Treasure Island, San Fran. **Comments:** Position: art illustr., *Cleveland Plain Dealer, Los Angeles Times.* From 1915 on he devoted himself full time to fine art. Specialty: Northern California landscapes and missions. **Sources:** Hughes, *Artists of California,* 500.

SCHWARTZ, Elizabeth See: **SCHWARZ, Elizabeth (Mrs. Charles Neyland)**

SCHWARTZ, Elizabeth Brooks (Mrs. J. I. M.) *[Teacher, painter] b.1906, Emery, SD.*
Addresses: Sergeant Bluff, IA. **Studied:** Sioux City, IA; AIC; Detroit, MI; Carl Gustaf Nelson. **Exhibited:** Iowa Artists Exh. Mt. Vernon, 1938; ASL, Chicago (award). **Comments:** Teaching: Detroit Pub. Schools. **Sources:** Ness & Orwig, *Iowa Artists of the First Hundred Years,* 186.

SCHWARTZ, Ethel *[Painter] mid 20th c.*
Addresses: NYC. **Exhibited:** PAFA Ann., 1954. **Sources:** Falk, *Exh. Record Series.*

SCHWARTZ, Eugene M. *[Collector, patron] b.1927, Butte, MT.*
Addresses: NYC. **Studied:** New Sch. Social Res.; New York Univ.; Columbia Univ.; Univ. Washington. **Comments:** Positions: acquisitions comt., WMAA, 1967-68, 1968-69. Collections: contemp. Am.art since World War II, chiefly of the 1960s; parts of the collection shown as a group at Jewish Museum, Everson Mus. Art and the Albany Inst. History and Art. **Sources:** WW73.

SCHWARTZ, Felix Conrad *[Painter, educator, writer, lecturer] b.1906, NYC.*
Addresses: Macon, GA; Stillwater, OK. **Studied:** Corcoran Sch. Art; George Washington Univ. (B.A.; M.A.); Columbia Univ. (Ph.D.); Europe. **Member:** CAA; Western AA; Soc. Wash. Artists; Oklahoma AA: Enid (OK) Art Lg.; NAEA; AAUP; Southeastern AA; Midwestern AA; Eastern AA. **Exhibited:** CGA, 1927-35; PAFA, 1924-34; Carnegie Inst., 1930-34; Walker AC, 1934-39; Univ. Minnesota; Univ. Georgia; Phillips Univ.; Tricker Gal., NY, 1939 (solo); Soc. Wash. Artists; SSAL; Minnesota Artists; Virginia Artists; Enid Art Lg.; Oklahoma AA. Awards: Teaching Fellowship, George Washington Univ., 1926-27; Research Fellowship, Editorship, Columbia Univ., 1939-41. **Work:** George Washington Univ. **Comments:** Teaching: Mary Washington College, 1932-34; Phillips Univ., Enid, OK, 1944-48; Northwestern, LA, 1959-; Wesleyan College, Macon, GA, 1957-. Contrib.: educational & art magazines. **Sources:** WW59.

SCHWARTZ, Frank See: **SCHWARZ, Frank (or Franz) I.**

SCHWARTZ, Frederick *[Portrait painter] mid 19th c.*
Addresses: NYC, 1841. **Sources:** G&W; NYBD 1841.

SCHWARTZ, Henry *[Painter, instructor] b.1927, Winthrop, MA.*
Addresses: Boston, MA. **Studied:** Sch. Mus. FA, Boston (traveling fellowship & dipl., 1953); Akad. Bildendekunst, Salzburg, Austria (dipl.) with Oskar Kokoschka. **Exhibited:** Boston Arts Festivals, 1954-58; Boris Mirski Gal., 1956-68 (5 solos); Carnegie Int., 1961. **Work:** Mus. FA, Boston; Wheaton College, MA. **Comments:** Preferred medium: oils. Publications: illustr., film-

strip, United Churches of Christ, 1961; illustr., *Boston Magazine*, 1964-65. Teaching: Sch. Mus. FA, 1956-. **Sources:** WW73.

SCHWARTZ, Herman *[Painter] mid 20th c.*
Addresses: Philadelphia, PA. **Sources:** WW66.

SCHWARTZ, Ira W. *[Artist] mid 20th c.*
Addresses: Queens, NY. **Exhibited:** PAFA Ann., 1954. **Sources:** Falk, *Exh. Record Series.*

SCHWARTZ, J. Charles *[Painter] early 20th c.*
Addresses: Columbus, OH. **Member:** Columbus PPC. **Sources:** WW25.

SCHWARTZ, Lester O. *[Painter, teacher] mid 20th c.*
Addresses: Chicago, IL; Ripon, WI. **Member:** Ryerson Traveling Fellowship, AIC, 1937. **Exhibited:** AIC, 1936 (prize), 1947 (prize); WMAA, 1952; PAFA Ann., 1952. **Comments:** Teaching: AIC. **Sources:** WW40; Falk, *Exh. Record Series.*

SCHWARTZ, Manfred *[Painter, teacher, lecturer, writer] b.1909, Lodz, Poland / d.1970.*
Addresses: NYC. **Studied:** ASL; NAD. **Member:** Fed. Mod. P&S; Am. Artists Congress. **Exhibited:** S. Indp. A., 1931; PAFA Ann., 1940-42, 1951, 1968 (medal); WMAA, 1942-63; MMA, 1942; VMFA, 1942, 1946; AIC, 1942, 1944; CI, 1943-45; Corcoran Gal. biennials, 1943, 1957; BM, 1943, 1945, 1959 (solo), 1960 (solo); Wildenstein Gal.; Durand-Ruel Gal., 1947 (solo), 1949 (solo), 1950 (solo); WFNY, 1939; FAA, 1953 (solo), 1955 (solo), 1956-1958 (solo); Albert Landry Gal., NY 1962 (solo), 1963 (solo); 1942-55: Butler AI; BMA; CPLH; Inst. Contemp. Art, Boston; Nelson Gal. Art; Walker AC; Portland (OR). Mus. Art; CAM; MoMA; Denver Art Mus.; CM; High Mus. Art; Norton Gal. Art; Delgado Mus. Art. **Work:** Brooklyn College; Univ. Minnesota; Guggenheim Mus.; MoMA; NYPL; MMA; BM; WMAA; Newark Mus.; Rochester Mem. Art Gal.; PMA. **Comments:** Teaching: Brooklyn Mus. Art Sch., New York and New Sch. for Social Research, NY. Contrib. to *Etrêtat: An Artist's Theme and Development*, 1965 (Shorewood Publ.). **Sources:** WW66; WW47; Falk, *Exh. Record Series.*

SCHWARTZ, Marjorie Watson (Mrs. Merrill) *[Painter, craftsperson, teacher] b.1905, Trenton, TN.*
Addresses: Memphis, TN. **Studied:** State Teachers Col., Memphis, TN; Newcomb College, Tulane Univ. (B.Des.). **Member:** Memphis Gld. Handloom Weavers; AAPL. **Exhibited:** San Diego FA Soc., 1943; New Haven PCC, 1946; Mississippi AA, 1946; Virginia-Intermont Exh., 1946; Brooks Mem. Art Gal. (solo); Gld. Handloom Weavers, 1954, 1955; traveling exh., 1954. **Comments:** Teaching: Columbia (TN) Inst. **Sources:** WW59; WW47.

SCHWARTZ, Marvin D. *[Art historian] b.1926, NYC.*
Addresses: NYC. **Studied:** City College NY (B.S., 1946); Inst. FA, NY Univ., 1947, 1951; Univ. Delaware (M.A., 1954). **Member:** Soc. Arch. Hist.; College AA Am.; H.F. DuPont Winterthur Mus. (fellow). **Exhibited:** Awards: recipient stipend, Belgium-Am. Educ. Found. **Comments:** Positions: junior curator, Detroit IA, 1951-52; cur. of decorative arts & indust. design lab., Brooklyn Mus., 1954-68, ed. publ., 1959-60; ed., "New York News & Views," *Apollo Magazine*, 1957-60; advisor to FA Comt. of the White House & dept. design, Sears, Roebuck & Co., 1964-; lecturer & consultant, MMA, 1968-; trustee, Jerome Levy Found. Publications: auth., weekly antiques column, *New York Times*, 1966-; auth., "Collectors Guide to Antique American Ceramics"; auth., "Collectors Guide to Antique American Glass"; co-auth., "*New York Times* Book of Antiques," 1972; auth., articles on Am. furniture, Am. ceramics, calligraphy & enamels. Teaching: lecturer, City College NYk, 1948-51, 1956-64; State Univ. NY College Purchase, 1969-. **Sources:** WW73.

SCHWARTZ, Morris (Mrs.) *[Painter] early 20th c.; b.Bryan County, TX.*
Studied: College Indust. Arts, Denton, TX, 1918; Frank Klepper at McKinney, TX; Samuel E. & Sadie Gideon, Austin, TX. **Exhibited:** Texas State Fair; Cotton Palace, Waco; Century of Progress, Chicago; Texas FA Circuit Exh. **Sources:** Petteys, *Dictionary of Women Artists.*

SCHWARTZ, Nie *[Painter] early 20th c.*
Addresses: NYC. **Exhibited:** S. Indp. A., 1923. **Sources:** Marlor, *Soc. Indp. Artists.*

SCHWARTZ, Rudolph *[Sculptor] b.Austria / d.1912.*
Addresses: Indianapolis, IN. **Work:** carved figures at the base of the Indiana Soldiers' Mon.; statue of H.S. Pingree, Detroit. **Comments:** Came from Berlin to U.S. **Sources:** WW04.

SCHWARTZ, Rudolph *[Etcher] b.1899, Hungary.*
Addresses: Brooklyn, NY. **Studied:** W.A. Levy; A.J. Bogdanove. **Member:** GFLA. **Sources:** WW27.

SCHWARTZ, Sadie O. *[Painter] 19th/20th c.*
Addresses: Cincinnati, OH. **Exhibited:** Cincinnati Expo, 1898. **Sources:** WW04.

SCHWARTZ, Sol *[Painter, teacher, printmaker] b.1899, Newark, NJ / d.1960.*
Addresses: Brooklyn, NY. **Studied:** Pratt Inst., NYC; ASL, NYC; Raphael Soyer; Art Inst., Chester, PA; Sorbonne, Paris. **Exhibited:** S. Indp. A., 1931; City Hall, Los Angeles, 1963 ("People of Achievement" series). **Work:** portraits in public buildings: Supreme Court, Brooklyn, NY (Justice Mitchell May); NY Law Sch. (Judge Jacob Livingstone); Temple Emanuel, Brooklyn, NY (Mr. Benjamine Fine); BM. **Comments:** Subjects: portraits, figure studies, landscapes, abstracts, flowers, animals. His last project, "People of Achievement," consisted of 39 portraits of contemporary heroes, all chosen by Schwartz; among those honored were Albert Einstein, Eleanor Roosevelt, and Marian Anderson, all of whom Schwartz sketched from life. Other portraits included Franklin D. Roosevelt, Babe Ruth, Winston Churchill, Ghandi, Ernest Hemingwway, Helen Keller, and Frank Lloyd Wright. A devoted teacher, he taught art in NYC public schools for 37 years. **Sources:** info, including news clippings, courtesy Betty Schwartz estate, Lita Emanuel, trustee.

SCHWARTZ, Therese *[Painter, writer] mid 20th c.; b.NYC.*
Addresses: NYC. **Studied:** Corcoran Sch. Art, Wash., DC; Am. Univ.; Brooklyn (NY) Mus. Art Sch.,. **Member:** Women In Arts. **Exhibited:** Phillips Mem. Gal., 1954; Mus. Art Mod., Paris, 1956; Univ. NC, 1969; Stamford (CT) Mus., 1972; Suffolk Co. Mus., 1972; A.M. Sachs Gal., NYC, 1970s. Awards: second prize for oils, CGA Regional Show, 1952; New Talent USA Award, Art Am., 1962. **Work:** CGA; Howard Univ.; Fred C. Olsen Found.; Monroe Geller Found.; Barnet Aden Coll. Commissions: Traveling Watercolor Show, Howard Univ. under Congressional grant, southern univs. & mus., 1953-54. **Comments:** Positions: ed., *New York Element*, 1968-. Publications: auth., articles, *New York Element*, 1968-72; auth., *Plastic Sculpture and Collage*, Hearthside, 1969; auth., "The Political Scene," column in *Arts Magazine*, 1970-71; auth., *The Politicalization of the Avant-Garde* (ser.), *Art in Am.*, 11/1971, 3/1972 & 3/1973. Teaching: Great Neck Adult Program, 1967-70. **Sources:** WW73; S. Zimmerman, "The Unencumbered Icon" (Sept., 1966) & G. Brown, "Reviews" (Sept., 1969), *Arts Mag.*

SCHWARTZ, William Samuel *[Painter, lithographer, sculptor] b.1896, Smorgon, Russia / d.1977, Chicago, IL.* WILLIAM S. SCHWARTZ
Addresses: Chicago, IL. **Studied:** Vilna Art Sch., Russia (scholarship, 1908-1912); AIC; Auditorium Conserv. Music, Chicago, with Karl Stein, 1915-18; Francesco Daddi, 1918-19. **Member:** Phila. WCC. **Exhibited:** Detroit, 1925 (prize), 1926 (prize), 1936 (prize); PAFA Ann., 1927-31, 1942, 1958; AIC, 1927 (prize), 1928 (prize), 1930 (prize), 1936 (prize), 1945 (Mr. & Mrs. Jules F. Brower Prize), 1952 (Munic. Art Lg. Prize); Corcoran Gal. biennials, 1935-41 (3 times); Scarab Club, Detroit, 1936 (prize); Monticello College, Godfrey, IL, 1939 (prize); Oklahoma City, 1942 (prize); Corpus Christi, TX, 1945 (Art Found. Award); traveling exh., Hirschl & Adler Gal. (NYC) to Grand Rapids Art

Mus., Illinois State Mus., Illinois AG, 1984-86; WMAA. **Work:** AIC; Encyclopaedia Britannica Coll.; Detroit IA; LOC; Dept. Labor, Wash., DC; Phila. Art All.; Dallas Mus. FA; Madison AA; Monticello College; Oshkosh Pub. Lib.; Chicago Pub. Sch. Coll.; Univ. Illinois; Univ. Nebraska; Univ. Missouri; Univ. Wyoming; Univ. Minn.; Cincinnati Pub. Lib.; Biro-Bidjan Mus., Russia; Tel-Aviv Mus., Palestine; Chicago, Glencoe, Davenport Pub. Lib.; murals, USPOs, Fairfield, Eldorado, Pittsfield, all in Illinois; Cook County Nurses Home, Chicago; Univ. Wisc.; Munic. Gal., Davenport, IA; Barrington (IL) Pub. Lib., Illinois State Normal Univ. **Comments:** Came to U.S. in 1913. WPA artist. **Sources:** WW73; WW47; exh. cat., Hirschl & Adler Gal (NYC, 1984); Falk, *Exh. Record Series.*

SCHWARTZBURG, W. C. *[Sketch artist] 19th c.*
Addresses: Richmond, VA. **Comments:** Made a sketch of Libby Prison, Richmond, VA, later published by Patrick McHugh in 1864. **Sources:** Wright, *Artists in Virgina Before 1900.*

SCHWARTZBURGER, C. *[Engraver] b.1850, Leipzig, Germany.*
Addresses: Brooklyn, NY. **Studied:** Leipzig; Berlin. **Exhibited:** Pan-Am. Expo, Buffalo, 1901. **Comments:** Came to NYC in 1874. **Sources:** WW10.

SCHWARTZCHILD, Monroe M. *[Patron] d.1932, NYC.*
Comments: A major collector of the works and letters of George Cruikshank [1792-1878]. His collection ranked with those of Harvard and Princeton, and included many of the artist's illustrations for Dickens' works.

SCHWARTZE, Johan Georg *[Portrait & religious painter] b.c.1814 / d.1874.*
Addresses: Kensington, PA,1837; Philadelphia,1838; Düsseldorf, 1844-47; Amsterdam, 1847-58. **Exhibited:** PAFA, 1837-58. **Sources:** G&W; Rutledge, PA.

SCHWARTZKOPF, Earl C. *[Painter, illustrator, craftsperson] b.1888, Ohio.*
Addresses: Toledo, OH. **Member:** Toledo Tile Club. **Sources:** WW24.

SCHWARTZMAN, Broneta *[Painter] mid 20th c.*
Addresses: Brooklyn, NY. **Exhibited:** S. Indp. A., 1937, 1939-44. **Sources:** Marlor, *Soc. Indp. Artists.*

SCHWARZ, Amy *[Painter] early 20th c.*
Addresses: Phila., PA. **Member:** NAWPS. **Sources:** WW21.

SCHWARZ, Constance *[Painter] b.1914, NYC.*
Addresses: NYC. **Exhibited:** S. Indp. A., 1934-37, 1939-40. **Sources:** Marlor, *Soc. Indp. Artists.*

SCHWARZ, Elizabeth (Mrs. Charles Neyland) *[Painter] early 20th c.*
Addresses: Phila., PA., active 1915-21. **Member:** Women P&S; NYWCC; Plastic Club. **Exhibited:** AIC, 1913-17; Corcoran Gal. biennial, 1916. **Sources:** WW15; Petteys, *Dictionary of Women Artists.*

SCHWARZ, Felix Conrad *[Painter, educator, writer, illustrator] b.1906, NYC / d.1990.*
Addresses: Enid, OK; Saint Petersburg, FL. **Studied:** Corcoran Sch. Art; George Washington Univ.; Columbia Univ.; England; France; Belgium; Italy; Holland; Switz. **Member:** CAA; Western AA; Soc. Wash. Artists; Oklahoma AA; Enid AL; Teaching Fellowship, George Washington Univ., 1926-27; Research Fellowship, Editorship, Columbia, 1939-41. **Exhibited:** CGA, 1927-35; PAFA, 1924-34; CI, 1930-34; Walker AC, 1934-39; Univ. Minn.; Univ. Georgia, 1934-39; Phillips Univ.; Tricker Gal., NY, 1939 (solo); Soc. Wash. Artists; SSAL; Minn. Artists; Virginia Artists; Enid AL; Oklahoma AA; Wisc. State Univ., 1965 (solo) Birmingham Mus. Art, 1968 (solo), Montgomery Mus. FA, 1968 (solo), Spring Hill College, Mobile, 1969 (solo) & Thor Gal., Louisville, KY, 1969 (solo). **Work:** George Washington Univ.; Wash. (D.C.) Jr. H.S. **Comments:** Contrib.: educ. and art magazines. Teaching: Phillips Univ., Enid., OK, from 1944; State

Univs. of Virginia, NC, Minn. & Wisc. over a period of 40 years. Ed.:*Advanced Sch Digest.* **Sources:** WW73; WW47; review articles, *La Révue Moderne, Art News, New York Times, New York Herald Tribune.*

SCHWARZ, Frank (Henry) *[Painter, drawing specialist, craftsperson, designer, lecturer, teacher, illustrator] b.1894, NYC / d.1951, Mt. Vernon, NY.*
Addresses: NYC, Croton, NY. **Studied:** AIC; NAD; C. Hawthorne; H.M. Walcott. **Member:** ANA; NAD; NSMP; Royal SA, London, England; Arch. Lg. **Exhibited:** S. Indp. A., 1917; NAD, 1925-46; AIC; CI; SC (prize); Tiffany Fnd., 1927 (med); PAFA Ann., 1930-31, 1935. Awards: Prix de Rome, 1921. Guggenheim F., 1926; F., Royal SA, London, 1940. **Work:** BM; Univ. Nebraska; Oregon State Capitol; Family Relations Court, Phila.; churches: Montreal, Seattle; stone floor des., mon., Harrodsburg, KY. **Sources:** WW47; Falk, *Exh. Record Series.*

SCHWARZ, Frank (or Franz) I. *[Artist] 19th/20th c.*
Addresses: Wash., DC, active 1894-1901. **Comments:** *Cf.* Franz J. Schwarz. **Sources:** McMahan, *Artists of Washington, DC.*

SCHWARZ, Franz J. *[Ceramicist, miniature painter, teacher] b.1845, Offenburg, Germany / d.1930, Wash., DC.*
Studied: Inst. Ceramic Art, Nüremburg, Bavaria. **Comments:** For three years he resided at the Castle of King Ludwig II of Bavaria, painting typical scenes from the Wagnerian operas on several sets of porcelains. He privately taught many of the royalty of Europe. In 1890 he immigrated to the U.S. and maintained studios in Wash., D.C. and Chicago. *Cf.* Frank or Franz I. Schwarz.

SCHWARZ, Heinrich *[Museum curator, educator, writer] b.1894, Prague, Czech. / d.1974.*
Addresses: Providence, RI, 1943-53; Middletown, CT, 1954-74. **Studied:** Univ. Vienna (Ph.D.); Wesleyan Univ. (M.A.). **Member:** CAA; AFA; Drawing Soc. (nat. comt.); Print Council Am. (bd. dirs.); Master Drawings (ed. adv. bd.); Print Council Am. (bd. dirs.). **Exhibited:** AIC, 1930. Awards: Austrian Cross of Honor for Science & Art, First Class, 1964. **Comments:** Positions: asst., Albertina Mus., Vienna, 1921-23; cur., Austrian State Gal., Vienna, 1923-38; res. asst., Albright-Knox Art Gal., 1941-42; cur. paintings, drawings & prints, Mus. Art, RISD, 1943-53; cur. collections, Davison AC, Wesleyan Univ., 1954-72. Teaching: Wellesley College, 1952; Mt. Holyoke College, 1954; Wesleyan Univ., 1954-52; Yale Univ., 1958; Columbia Univ., 1966-67, 1967-68. Publications: auth., "Amicis" (yearbook of Austrian State Gal.), 1927; co-auth.," D.O. Hill, Master of Photography," 1931; auth., "Carl Schindler" (monograph), 1931; auth., "Salzburg und das Salzkammergut," 1936 & 1958; contrib., scientific articles to European & Am. magazines. **Sources:** WW73; WW47; WW53.

SCHWARZ, Joseph *[Painter] mid 20th c.*
Addresses: Athens, GA. **Exhibited:** WMAA, 1958. **Sources:** Falk, *WMAA.*

SCHWARZ, Myrtle Cooper (Mrs.) See: **COOPER, Myrtle**

SCHWARZ, S. L. *[Painter] early 20th c.*
Addresses: NYC. **Sources:** WW13.

SCHWARZ, William Tefft *[Painter, illustrator, teacher] b.1888, Syracuse, NY.*
Addresses: Arlington, VT. **Studied:** Syracuse Univ.; C. Hawthorne; France; Spain. **Work:** Onondaga County Savings Bank, Syracuse; State House, Montpelier, VT; Shriner's Hospital, Phila.; hotels in Atlantic City, Phila., Utica, NY, Syracuse, Oswego, NY; Fulton Nat. Bank, Lancaster, PA; Auditorium, Valley Forge, PA; mural for Girl Scout Hdqtrs.; Episcopal Acad., Overbrook, PA; restaurant, Phila.; Apollo Theatre, Atlantic City; Bennington Hist. Mus., VT; Engineer's Club, NYC; Petroleum Bldg., WFNY, 1939; Conastoga Inn, Bryn Mawr, PA; State House, Montpelier, VT; Masonic Temple, Phila., PA, and Arlington, VT. **Comments:** Illustr.: *Saturday Evening Post.* Position: hd., art unit, Hist. of Surgery, WWI. **Sources:** WW59;

WW47.

SCHWARZBURG, Nathaniel (Nat) *[Painter, lecturer, teacher, graphic artist]* b.1896, NYC.
Addresses: Long Island City , NY. **Studied:** College City of NY; ASL with George Bridgman, Sigurd Skou. **Member:** Art Lg. Am.; Am. Artists Congress. **Exhibited:** Salons of Am.; Midtown Gal., 1934; Contemp. Artists, 1937; ACA Gal., 1941, 1946; Am. Artists Congress, 1938, 1941; Vanderbilt Gal., 1944; Riverside Mus., 1945. **Comments:** Teaching: Seward Park H.S., NY; Bryant Adult Center. **Sources:** WW59; WW47.

SCHWARZENBACH, Peter A. *[Illustrator, craftsperson, teacher]* b.1872, NYC.
Addresses: NYC. **Studied:** NAD; ASL. **Comments:** Specialty: decorative illustr. **Sources:** WW17.

SCHWARZENBERGER, Fannie *[Painter]* late 19th c.
Addresses: Phila., PA. **Exhibited:** PAFA Ann., 1889. **Sources:** Falk, *Exh. Record Series.*

SCHWARZOTT, Maximilian M. *[Sculptor]* early 20th c.
Addresses: NYC, 1883; Boston, MA; Lew Beach, NY. **Member:** NSS, 1898. **Exhibited:** PAFA Ann., 1878, 1913; NAD, 1883; St. Louis Expo, 1904. **Sources:** WW17; Falk, *Exh. Record Series.*

SCHWEBEL, Celia (Mrs. Albert Gerson) *[Painter]* b.1903, NYC.
Addresses: Yorktown Heights, NY. **Studied:** ASL, with Kenneth Hayes Miller. **Member:** NAWA; ASL; AEA. **Exhibited:** Salons of Am.; CAA; Whitney Club; Marie Harriman Gal.; NAWA; Woodstock Gal.; Roerich Mus., 1956; Dartmouth College, 1957; Bernheim Gal., Paris, France, 1958; Assoc. Am. Artists (solo); Theodore Kohn & Sons Gal.; The Hotchkiss Sch., 1949; NY State Mus., 1950; Hudson River Mus., 1951; Nat. Audubon Soc., 1951; Hunter College, 1951; Roerich Mus., 1952, 1954; NYPL, 1952 (2 traveling exh.); Berkshire Mus., 1954; Caravan Gal., 1954. **Sources:** WW59; WW47.

SCHWEBEL, Lewis *[Portrait painter]* b.c.1802, France.
Addresses: Cincinnati, OH, 1850. **Comments:** Lived with his wife, a Frenchwoman, and six children born in Germany before 1846. One son, Lewis Schwebel, Jr., was also a portrait painter (see entry). **Sources:** G&W; 7 Census (1850), Ohio, XXII, 143.

SCHWEBEL, Lewis, Jr. *[Portrait painter]* b.c.1833, Germany.
Addresses: Cincinnati, OH, 1850. **Comments:** His father, Lewis Schwebel was also a portrait painter(see entry). **Sources:** G&W; 7 Census (1850), Ohio, XXII, 143.

SCHWECKLER, Jean *[Painter]* mid 20th c.
Exhibited: S. Indp. A., 1940-41. **Sources:** Marlor, *Soc. Indp. Artists.*

SCHWEDELER, William *[Painter]* b.1942.
Addresses: Phila., PA; NYC. **Exhibited:** PAFA Ann., 1968; WMAA, 1969, 1972-73. **Sources:** Falk, *Exh. Record Series.*

SCHWEICKARDT, A. *[Sculptor]* early 20th c.
Addresses: NYC. Affiliated with Gorham Co., NYC. **Sources:** WW13.

SCHWEIG, Aimee Gladstone (Mrs. Martin) *[Painter, teacher]* b.1897, St. Louis, MO.
Addresses: St. Louis, MO. **Studied:** St. Louis Sch. FA, Washington Univ.; Charles Hawthorne; Henry Hensche. **Member:** NAWA; St. Louis Artists Gld.; Shikari; Soc. Independent Artists; Provincetown AA; AEA; Artists Gld., 1942, 1946, 1955. **Exhibited:** MMA (AV), 1942; CAM, 1945 (prize); Chicago; Davenport, IA; Corcoran Gal. biennial, 1947; Denver Art Mus.; Kansas City AI; Springfield, MO; Springfield, IL; Mid-Am. Artists; Renaissance Soc., Univ. Chicago; Colorado Springs FAC; NAWA; St. Louis Artists Gld. **Work:** Hamilton & Pershing Pub. Sch., St. Louis; CAM. **Comments:** Positions: co-dir., Ste. Genevieve Summer Sch Art; head, painting dept., Upper School of Mary Inst., Clayton, MO. **Sources:** WW59; WW47.

SCHWEIG, Martyl Suzanne See: **MARTYL, (Suzanne Schweig Langsdorf)**

SCHWEIGARDT, Frederick William *[Sculptor]* b.1885, Lorch, Germany / d.1948, Albany, NY.
Addresses: San Francisco, CA. **Studied:** Stuttgart Acad.; Munich Acad.; with Rodin, Paris. **Member:** San Diego FAS; Los Angeles AA.; Soc. for Sanity in Art. **Exhibited:** Pal. Leg. Honor, 1939, 1945; Paris Expo, 1913 (prize); Calif.-Pacific Intl. Expo, San Diego, 1935 (gold), 1936 (gold). **Work:** fountains, Hall Edu., Balboa Park, San Diegop; Univ. Southern Calif.; Deutches M., Munich; NY Mus. Science & Indust., Rockefeller Center. **Comments:** Immigrated to America in 1930 and settled in San Francisco in 1931. **Sources:** WW40; Hughes, *Artists of California,* 500.

SCHWEINSBURG, Roland Arthur *[Mural painter, illustrator, lecturer]* b.1898, Ellwood, City, PA.
Addresses: Youngstown, OH. **Studied:** H. Keller; P. Travis; F. Wilcox; O. Ege; G. Shaw; M. Evans; H.T. Bailey. **Member:** Mahoning Soc. Painters; Youngstown WCS; Buckeye AC. **Exhibited:** CMA, 1925 (prize). **Work:** murals, Children's Room, McMillan Pub. Lib., Youngstown; WPA murals, USPOs, East Liverpool (OH), Alexandria (IN), Eaton (OH); Struthers (OH) H.S.; Carnegie Lib., E. Liverpool, OH. **Comments:** Illustr.: "The Roaring Loom," by E.H. Miller, 1935. **Sources:** WW40.

SCHWEITZER, Aurelia *[Painter]* mid 20th c.
Exhibited: S. Indp. A., 1941. **Sources:** Marlor, *Soc. Indp. Artists.*

SCHWEITZER, Gertrude *[Painter, sculptor]* b.1911, NYC.
Addresses: Hillside, NJ; Palm Beach, FL. **Studied:** Pratt Inst.; NAD; Académie Julian, Paris. **Member:** NAD; AWCS; Phila. WCC; Wash. WCC; NJWCS; Palm Beach AA; Audubon Artists; AAPL; AWCS. **Exhibited:** NAWA, 1933 (prize); PAFA Ann., 1933, 1937; PAFA, 1936 (prize); AC of the Oranges, 1935 (prize); AIC, 1935-38; Phila. WCC, 1936 (prize); Corcoran Gal. biennials, 1937, 1939; AAPL, 1934 (med.); AWCS, 1933 (med.); Montclair Art Mus. (med.), 1935, 1952 (first prize as best woman painter NJ State Exh.); Soc. Four Arts Awards, 1948 & 1959 (watercolor prizes), 1950 & 1951 (oil prizes); Gal. Charpentier, Paris, 1948 (solo), 1954 (solo),1961 (solo); Norton Art Gal., 1946 (prize), 1947 (solo), 1966 (solo); Hanover Gal., London, 1953 (solo); Phila. Art All., 1969 (solo); Hokin Gal., Palm Beach, FL, 1971 (solo). **Work:** MMA; AIC; TMA; BM; WMAA; Canajoharie Art Gal.; Hackley Art Gal.; Mus. of Alibi, France; Davenport Munic. Art Gal; Montclair (NJ) Art Mus. **Comments:** Positions: chmn. arts & skill corps., Am. Red Cross, 1942-45. **Sources:** WW73; WW47; René Barotte, *G. Schweitzer, Peintures et Dessins* (Ed. Chène, Paris, 1965); Falk, *Exh. Record Series.*

SCHWEITZER, J. Otto See: **SCHWEIZER, J(akob) Otto**

SCHWEITZER, M. R. *[Art dealer, collector]* b.1911.
Addresses: NYC. **Member:** Am. Soc. Appraisers (charter mem.). **Comments:** Positions: owner, M.R. Schweitzer Gals. Research: Am. painting by little-known masters, 1830-1930. Specialty of gallery: Am. painting, 1830-1930; European painting, 17th-19th c. Collection: Am. and English 19th c.; Spanish and Italian 17th c. **Sources:** WW73.

SCHWEITZER, Mac *[Painter]* b.1924, Cleveland, OH / d.1963, Tucson, AZ.
Addresses: Tucson, AZ (1946-on). **Studied:** Cleveland Sch. Art. **Comments:** Painter of Arizona landscapes, particularly scenes of cowboy life and horses. She painted in oil using a palette knife. Also known as Mary Alice Cox. **Sources:** info courtesy Wayne Kielsmeier, Tucson, AZ.

SCHWEITZER, Moy J. *[Miniature & landscape painter]* b.1872, England.
Addresses: Ampere, NJ. **Studied:** ASL. **Member:** NSC; Gld. Book Workers. **Exhibited:** NJ State Annual Exh., Montclair AM, 1935. **Sources:** WW13.

SCHWEIZER, J(akob) Otto *[Sculptor] b.1863, Zurich, Switzerland / d.1955, Philadelphia, PA.*
Addresses: Phila. **Studied:** Art Sch., Switzerland; Royal Acad., Dresden, with J. Schilling; Florence, Italy. **Member:** NSS. **Exhibited:** PAFA Ann., 1908-17, 1923-31. **Work:** statues, mem., busts, figures, monuments: City Hall, Phila., Pittsburgh, PA; State Mem., Gettysburg; State Mem., Carlisle, PA; Union League, Phila.; Milwaukee, WI; Utica, NY; Valley Forge, PA; Germantown, PA; Capitol Bldg., Harrisburg, PA; Marietta, GA; Little Rock, AR; Fairmount Park, Phila.; Old Custom House, Phila.; Vista, CA; Mexican War & WWI medals for Pennsylvania; Am. Numismatic Soc. **Comments:** Immigrated 1894. **Sources:** WW53; WW47; Falk, *Exh. Record Series.*

SCHWENTKER, Hazel F. *[Painter] b.1894, Panama, NE.*
Addresses: Rapid City, SD, from 1952. **Studied:** Peru, NE; Scottsdale, AZ. **Exhibited:** Black Hills State College, Spearfish, SD; Rapid City Civic Art Gal.; South Dakota Sch. Mines & Tech.; South Dakota State Fairs, Huron. **Sources:** Petteys, *Dictionary of Women Artists.*

SCHWERTFEGER, Ellen Newman *[Painter, writer, lecturer, teacher] b.1918, Galveston, TX.*
Addresses: Galveston, TX. **Studied:** Univ. Texas; AIC; Incarnate Word College, San Antonio, TX (B.A.). **Member:** Galveston Art Lg.; Texas State Teachers Assn. **Exhibited:** AIC, 1937 (prize); Mus. FA Houston, 1938-39; Texas Educator's Exh., Dallas, 1937-38; Galveston Art Lg., 1934-46. **Comments:** Teaching: Galveston (TX) Pub. Sch. Auth./ed.: "Hold a Candle to the Sun," 1938; "Galveston Community Book," 1945. Lectures: modern art history. **Sources:** WW53; WW47.

SCHWIEDER, Arthur I. *[Painter, teacher, illustrator] b.1884, Bolivar, MO / d.1965, NYC.*
Addresses: NYC. **Studied:** Drury College, Springfield, MO; AIC. **Member:** AEA. **Exhibited:** AIC, 1909; Salons of Am.; S. Indp. A., 1930-32, 1934; Rehn Gal., 1955; CI, 1945, 1948; PAFA Ann., 1945. **Comments:** Position: illustr., Doubleday, Doran, and Co.;dir., instr., Schwieder Art Classes, NYC. **Sources:** WW59; WW47; Falk, *Exh. Record Series.*

SCHWIEGER, Christopher Robert *[Printmaker, educator] b.1936, Scottsbluff, NE.*
Addresses: Minot, ND. **Studied:** Nebraska West College (A.A.); Chadron State College (B.F.A.); Univ. North Colorado (M.A.); Univ Denver. **Member:** Nat. Art Educ. Assn.; Manisphere Group Artists. **Exhibited:** Manisphere 99 and 100 Int. Exh., Winnipeg, Canada, 1970-71; 12th & 14th Print & Drawing Nat., Oklahoma AC, 1970 & 1972; 42nd Int. Northwest PM Exh., SAM, 1971; 12th Midwest Biennial, Joslyn Art Mus., Omaha, NE, 1972; Ohio State Univ., 1972 (solo). **Awards:** Miss. AA Purchase Awards, 1969-71; West New Mexico Univ. Purchase Awards, 1971; jury commendations, Northwest PM, SAM, 1971. **Work:** Ohio State Univ., Columbus, Univ. Northern Colorado; West New Mexico Univ., Silver City; South Dakota Mem. AC, Brookings; Miss. AA Gals., Jackson. Commissions: gilded gold & mixed media on glass mural, Univ. Northern Colorado Student Center, Greeley, 1966. **Comments:** Preferred medium: graphics. Publications: contrib., *College Educ. Rec.*, 6/1969. Teaching: Minot State College, 1967-. **Sources:** WW73.

SCHWIERING, Conrad *[Landscape painter, author] b.1916, Boulder, CO / d.1986.*
Addresses: Settled in Jackson Hole, WY after WWII & living there in 1976. **Studied:** Univ. Wyoming (arts minor); Robert A. Grahame & Raphael Lillywhite; ASL with Charles S. Chapman. **Member:** Nat. Acad. Western Art. **Sources:** P&H Samuels, 429.

SCHWILL, William V. *[Portrait painter] b.1864, Cincinnati.*
Addresses: NYC; Munich, Bavaria, 1889. **Studied:** Europe. **Member:** SC, 1904. **Exhibited:** NAD, 1889; St. Louis Expo, 1904 (med.). **Sources:** WW06.

SCHWINDT, Robert See: **GSCHWINDT, Robert**

SCHWINN, Barbara E. *[Illustrator, portrait painter, teacher, writer, lecturer] b.1907, Glen Ridge, NJ.*
Addresses: NYC; Marbella, Spain. **Studied:** Parsons Sch. Design; Grand Central Art Sch.; ASL with Frank DuMond, Luigi Lucioni & others; Grande Chaumière & Acad. Julian, Paris, France. **Member:** SI. **Exhibited:** SI (2 solo exhs.); Barry Stephens Gal. (solo); NAD, 1955; Royal Acad., England, 1956. **Awards:** prizes, Gld. Hall, East Hampton, NY; Art Dir. Club; Illustration House, NYC, 1991 (retrospective). **Comments:** A "Romance Illustrator" most active from the early 1940s to the mid 1960s. Positions: instr., Parsons Sch. Des., NYC, 1952-54; advisory council, Art Instruction Schools, 1956-70; founder/chmn. art committee, UNICEF, 1950-61. Lectures: illustr. & portrait painting. Auth.: *The Technique of Barbara Schwinn & Fashion Illustration, Past and Present*, Art Instr. Schs., 1968. Contr.: *Ladies Homes Journal; Good Housekeeping; Colliers; Cosmopolitan; McCalls; Sat. Eve. Post;* and French, British, Belgian, Danish, and Swedish magazines. **Sources:** WW66; WW47; WW73; exh. flyer, Illustration House, NYC (1991)

SCHWITTER, Fridolin *[Engraver] mid 19th c.*
Addresses: NYC, 1857-60. **Comments:** In 1859 of Schwitter Brothers (see entry). **Sources:** G&W; NYCD 1857, 1860; NYBD 1859.

SCHWITTER, George *[Engraver] mid 19th c.*
Addresses: NYC, 1859-60. **Comments:** In 1859 of Schwitter Brothers (see entry). **Sources:** G&W; NYBD 1859; NYCD 1860.

SCHWITTER, Joseph *[Engraver] mid 19th c.*
Addresses: NYC, 1859-60. **Comments:** In 1859 of Schwitter Brothers (see entry). **Sources:** G&W; NYBD 1859; NYCD 1860.

SCHWITTER BROTHERS *[Engravers] mid 19th c.*
Addresses: NYC, 1859. **Comments:** Fridolin, George, and Joseph Schwitter (see entries). **Sources:** G&W; NYBD 1859.

SCHWOB, Andre *[Painter] early 20th c.*
Addresses: NYC. **Exhibited:** S. Indp. A., 1930. **Sources:** Marlor, *Soc. Indp. Artists.*

SCHWODE, Andrea *[Portrait painter] b.c.1825, Bavaria (Germany).*
Addresses: New Orleans, 1860. **Sources:** G&W; 8 Census (1860), La., VI, 761.

SCHWORM, Melvina Calvert See: **CALVERT, Melvina (Melvina Calvert Schworm)**

SCHYE, Mildred Ruth *[Painter, illustrator] b.1901, Chicago, IL.*
Addresses: St. Paul, MN. **Studied:** C. Booth; D. Albinson; C. Winholtz; H. Hofmann. **Member:** Minneapolis AI. **Exhibited:** Minn. State Fair; Portland (OR) Art Mus. **Sources:** WW40.

SCHYLHOFF, William *[Painter] early 20th c.*
Exhibited: Dudensing Gal., NYC, 1920s; Corcoran Gal. biennial, 1928. **Sources:** Falk, *Corcoran Gal.*

SCIARRINO, Cartaino *[Sculptor] early 20th c.*
Addresses: NYC. **Sources:** WW13.

SCIARRONE, Lawrence *[Painter] mid 20th c.*
Exhibited: S. Indp. A., 1939-41. **Sources:** Marlor, *Soc. Indp. Artists.*

SCIASCIA, Luigi (Louis) *b.1899, Brazil.*
Studied: ASL. **Exhibited:** Salons of Am., 1934; S. Indp. A., 1935-38. **Sources:** Falk, *Exhibition Record Series.*

SCIBETTA, Angelo Charles *[Painter, illustrator, decorator] b.1904, Italy.*
Addresses: Buffalo, NY/Lancaster, PA. **Studied:** ASL; CUA Sch.; NAD; BAID. **Member:** Tiffany Fnd.; ASL. **Exhibited:** Albright Gal., Buffalo. **Work:** murals, H.S., Hamburg, NY; Buffalo Hist. Soc.; painting. YMCA, Buffalo. **Sources:** WW40.

SCIOCCHETTI, Luigi *[Painter, mural painter, sculptor]* *b.1878, Ascoli, Piceno, Italy / d.1961, San Francisco, CA.*
Addresses: San Fran. **Work:** St. Leo's Church, Oakalnd; Church of the Immaculate Conception, San Fran.; Santa Rita Church, Fairfax. **Comments:** Ordained as a priest by the Pope, he was allowed to study art at the Vatican Gallery. He retired from the church about 1930. Specialty: religious art. **Sources:** Hughes, *Artists of California,* 500.

SCIPP, Anna M(argaret) *[Painter] early 20th c.*
Addresses: NYC. **Exhibited:** S. Indp. A., 1923, 1926. **Sources:** Marlor, *Soc. Indp. Artists.*

SCOFIELD, Dorothy P. *[Portrait painter] mid 20th c.*
Exhibited: Kingsley Art Club, Sacramento, 1937. **Sources:** Hughes, *Artists of California,* 501.

SCOFIELD, Edna See: **HALSETH, Edna M. Scofield (Mrs. Odd S.)**

SCOFIELD, Mildred Bruce *[Painter] b.1889, Davis Creek, Modoc County, CA / d.1983, Laguna Beach, CA.*
Addresses: San Francisco, CA; Los Angeles, CA. **Studied:** William Hubacek; Peter Blos; Robert Rishell; Leon Franks; Marquis Reitzel. **Exhibited:** Poor Richards Gal., San Mateo, 1952 (solo); The Uplands, Hillsborough, 1955 (solo); Soc. Western Artists, de Young Mus., 1954, 1955, 1960; Ebell Club, Los Angeles, 1958; Calif. AC, Los Angeles, 1958-60; Friday Morning Club, 1959-60; Laguna Beach AA, 1961-62; Laguna Hills Art Guild, 1971 (solo); Laguna Fed. S&L, 1982 (solo); Gallery 170, Los Angeles, 1986 (solo), 1988 (solo). **Comments:** Specialty: realistic pastels and oils. **Sources:** Hughes, *Artists of California,* 501.

SCOFIELD, William B(acon) *[Writer, sculptor] b.1864, Hartford, CT. / d.1930.*
Addresses: Worcester, MA. **Studied:** G. Borglum. **Member:** AFA. **Work:** WMA. **Comments:** Author: "Verses," "Poems of the War," "A Forgotten Idyl," "Sketches in Verse and Clay." Position: city ed., *Worcester Evening Gazette.* **Sources:** WW29.

SCOLAMIERO, Peter *[Painter, sculptor, illustrator, teacher] b.1916, Newark, NJ.*
Addresses: New York 9, NY. **Studied:** Newark Sch. Fine & Indust. Art; Louis Schanker. **Exhibited:** AFA traveling exh., 1950; Exchange Exh. to Germany, 1952; Phila. Pr. Club, 1950, 1951; BM, 1950-1952; Hacker Gal., 1951; Peridot Gal., 1950; Univ. Arkansas, 1950; Rabin & Krueger Gal., Newark, 1951 (solo); Newark Mus., 1952; MMA, 1952; 3-man exh., Morris Plains, NJ, 1953. **Awards:** BM, 1950. **Work:** BM; Newark Pub. Lib.; murals, Camp Kilmer, NJ. **Sources:** WW59.

SCOLES, John *[Engraver] 18th/19th c.*
Addresses: NYC, 1793-1844. **Comments:** He is best known for his views of NYC buildings and his landscape prints. **Sources:** G&W; NYCD 1794-1820 (McKay), 1821-44 (after 1844 as "late engraver"); Stokes, *Iconography;* Weitenkampf, "Early American Landscape Prints"; *Portfolio* (Jan. 1943), 102.

SCOLLAY, Catherine (Miss) *[Landscape & figure painter, lithographer] b.1783 / d.1863.*
Addresses: Boston, MA. **Exhibited:** Boston Athenaeum, 1827-48. **Work:** Boston Pub. Lib. **Comments:** In addition to her painting, she drew on stone a series of six views of Trenton Falls which were printed by the Pendleton shop (see John and William Pendleton) and published as an album. **Sources:** G&W; Swan, BA; Ramsay, "The American Scene in Lithograph, The Album," 181. More recently, see Pierce and Slautterback, 6; Campbell, *New Hampshire Scenery,* 136.

SCOMA, Mario *[Sculptor] early 20th c.*
Addresses: Brooklyn, NY. **Exhibited:** PAFA Ann., 1914-15; S. Indp. A., 1935. **Sources:** WW15; Falk, *Exh. Record Series.*

SCONHOFT, Earnford Steen *[Painter] b.1907, Brooklyn, NY / d.1937, San Pedro, CA.*
Addresses: San Pedro, CA. **Studied:** NYC, Pratt Inst., Cooper Union, ASL, with Robert Henri; Otis Art Inst. with Vysekal; MacDonald-Wright. **Exhibited:** San Pedro Pub. Lib., 1927; Indep. Los Angeles, 1934. **Sources:** Hughes, *Artists of California,* 501.

SCORESBY, Thomas *[Painter] mid 19th c.; b.England.*
Addresses: Centreville, Sullivan Cnty, NY (c.1854). **Work:** Kendall Whaling Mus., Sharon, MA (marine watercolor). **Comments:** He was oficer aboard the ship *Fame.* **Sources:** Brewington, 348.

SCOT *[Artist, possibly an amateur] early 19th c.*
Addresses: Boston. **Comments:** In 1803 he painted a copy of the State House portrait of the Rev. John Wheelwright (1594-1679). **Sources:** G&W; Weis, *Checklist of the Portraits. in the American Antiquarian Society,* 116.

SCOT, Robert *[Engraver, watchmaker] late 18th c.; b.England.*
Addresses: Philadelphia, from 1781. **Comments:** He described himself as "late engraver to the State of Virginia." He did general engraving for a number of years, but in 1793 began his long connection with the U.S. Mint at Philadelphia where he held the position of die-sinker at least until 1820. **Sources:** G&W; Prime, I, 27, and II, 73; Phila. CD 1796-1820; Stauffer; Dunlap, *History.*

SCOTT, A. (Mrs.) *[Painter on velvet] mid 19th c.*
Exhibited: Mechanics Inst., RIchmond, VA, 1854. **Sources:** Petteys, *Dictionary of Women Artists.*

SCOTT, Alice *[Painter]; b.San Francisco, CA.*
Studied: William Keith. **Member:** Spinner's Club (co-founder, 1897). **Sources:** Hughes, *Artists of California,* 501.

SCOTT, Ann *[Artist] mid 20th c.*
Addresses: St. Louis, MO. **Exhibited:** PAFA Ann., 1950, 1953. **Sources:** Falk, *Exh. Record Series.*

SCOTT, Anna Page *[Painter, craftsperson, writer, teacher, lecturer] b.1863, Dubuque, IA / d.1925, Dubuque.*
Addresses: Dubuque; NYC; Rochester, NY. **Studied:** Anshutz; A. Dow; AIC; PAFA; Colarossi Acad.; Holland. **Member:** Rochester Art Lg. **Exhibited:** AIC, 1904; Rochester AC, 1911-12; Dubuque AA, 1912 (solo). **Work:** Carnegie Stout Pub. Lib., Dubuque, IA; Rochester Mem. Art Gal. **Comments:** Specialty: mural painting. She believed in art as a necessity of life, not a luxury. Auth.: "Art in its Relation to Industry," c.1900. Illustr.: *Century Publishing Co.,* NYC. Teaching: Mechanics Inst., Rochester, NY, 1897-1913. **Sources:** WW24; Ness & Orwig, *Iowa Artists of the First Hundred Years,* 186; add'l info. courtesy of Edward P. Bentley, Lansing, MI.

SCOTT, Arden *[Sculptor] b.1938.*
Addresses: NYC. **Exhibited:** WMAA, 1973. **Sources:** Falk, *WMAA.*

SCOTT, Benton F. *[Painter, teacher] b.1907, Los Angeles, CA / d.1983, Orange County, CA.*
Addresses: North Hollywood, CA. **Studied:** in Europe; Will Foster. **Member:** Calif. Art Club; P&S Los Angeles; Soc. for Sanity in Art; Soc. Western Artists. **Exhibited:** CPLH, 1946; Santa Barbara Mus. Art, 1944; LACMA, 1939-45, 1943 (prize), 1944-47; Calif. AC, 1946 (prize), 1950 (prize); Calif. State Fair, 1941 (prize), 1947, 1950; CPLH, 1946; CI, 1949; NAD, 1949; Paris, France, 1949, 1950; deYoung Mem. Mus., 1951, 1953; Awards: prizes, Pepsi-Cola, 1949; Soc. Western Artists, 1951, 1953. **Comments:** Teaching: FA, Los Angeles County AI, 1952-55. Illustr.: "With a Feather on My Nose." **Sources:** WW59; WW47.

SCOTT, Bertha *[Portrait painter, writer, lecturer] b.1884, Frankfort, KY / d.1965.*
Addresses: Frankfort, KY. **Studied:** Wellesley College; Anson Kent Cross; Andrene Kauffman; Gerrit A. Beneker. **Member:** Louisville AC; Louisville AA; SSAL. **Work:** Kentucky Capitol and in historical shrines and public schools. **Sources:** WW59; WW47.

SCOTT, Bessie A. *[Artist] late 19th c.*
Addresses: Wash., DC, active 1897. **Sources:** McMahan, *Artists*

of Washington, DC.

SCOTT, C. Kay *early 20th c.*
Exhibited: Salons of Am., 1924, 1925. **Sources:** Marlor, *Salons of Am.*

SCOTT, Caree Dawson *early 20th c.*
Exhibited: Salons of Am., 1925, 1926. **Sources:** Marlor, *Salons of Am.*

SCOTT, Carlotta Buttoraz *[Painter] b.1894, Rome, NY / d.1972, near Santa Cruz, CA.*
Addresses: Calexico, CA; Yardley, PA; Santa Cruz, CA. **Studied:** ASL with Kenneth Hays Miller; College of FA, Univ. So. Calif., 1916-17; Calif. Sch. FA., 1920s; Académie Colarossi, Paris. **Exhibited:** Pan-Pacific Expo, San Fran.o, 1915; Santa Cruz Art Lg.; Santa Cruz County Fairs; Contemp. Club of Trenton, 1945 (solo); AAPL, 1945 (prize). **Work:** Barbara Worth Hotel, El Centro, CA. **Comments:** (Mrs. Robert J. Cole) Painted Calif. desert scenes, old missions, & portraits. Also known as (Mrs.) Robert J. Cole. **Sources:** Hughes, *Artists of California,* 501; Petteys, *Dictionary of Women Artists,* cites birth date of 1886.

SCOTT, Carrie D. *[Artist] early 20th c.*
Addresses: Wash., DC, active 1919-23. **Sources:** McMahan, *Artists of Washington, DC.*

SCOTT, Catherine *[Painter, drawing specialist, lecturer] b.1900, Ottawa, KS.*
Addresses: Ottawa, KS. **Studied:** AIC. **Member:** AFA. **Exhibited:** Kansas City AI; Joslyn Mem. **Sources:** WW59; WW47.

SCOTT, Charles T(homas) *[Painter, sculptor, craftsperson, teacher] b.1876, Chester Co., PA.*
Addresses: Churchville, PA. **Studied:** PM Sch. IA. **Member:** Eastern Art Teachers Assn. **Exhibited:** AIC, 1902. **Comments:** Teaching: PM Sch. IA. **Sources:** WW21.

SCOTT, Charlotte Harrington *[Painter, teacher, lecturer, decorator, block printer, craftsperson] b.1905, Holyoke, MA.*
Addresses: Worcester, MA. **Studied:** WMA Sch.; École des Beaux-Arts, Fontainebleau, France; Copley Art Sch., Boston; Clark Univ., Worcester, MA (B.S. in Educ.); Hans Hofmann. **Member:** Worcester Gld. Artists & Craftsman (pres.); Scituate AA. **Exhibited:** PAFA, 1931; WMA. **Work:** Princeton; Worcester City Hospital; Sherborne Reformatory, Framingham, MA. **Comments:** Teaching: South H.S. & Worcester (MA) Jr. College. **Sources:** WW53; WW47.

SCOTT, C(harlotte) T. (Mrs. Hugh B.) *[Painter] b.1891, East Liverpool, OH.*
Addresses: Wheeling, WV. **Studied:** Virginia B. Evans. **Member:** AAPL; Wheeling AC; Grand Central Art Gal. **Exhibited:** WFNY, 1939; Parkersburg (WV) FAC, 1941; Clarkesburg, WV, 1943; Intermont College, 1946, 1950; Oglebay Mus., 1946,1948, 1950 (prize), 1951, 1956-58; Terry AI, 1952; Ogunquit AC, 1952, 1954-58. **Work:** Oglebay Mansion Mus. **Sources:** WW59; WW47.

SCOTT, Clyde Eugene *[Painter, designer, teacher, illustrator] b.1884, Bedford, IA / d.1959.*
Addresses: West Los Angeles, CA. **Studied:** Boston Art Sch.; Richard Andrews; Edward Kingsbury; E. Felton Brown. **Member:** Calif. Art Club; P&S Los Angeles; Laguna Beach AA; Santa Monica AA; Soc. Am. Illustr.; Soc. Motion Picture Artists & Illustr.; Artists of Southwest. **Exhibited:** Pan-Pacific Expo, 1915 (med.); GGE 1939; Calif. Art Club, 1940 (prize); LACMA; Haggin Mem. Gal.; Stanford Univ.; Pomona Col.; Santa Cruz Art Lg.; Oakland Art Gal., 1928, 1939; San Gabriel Art Gal.; Los Angeles Pub. Lib.; Santa Monica Pub. Lib.; CPLH, 1945; Glendale AA; San Juan Capistrano; Los Angeles Co. Fair, Pomona; Acad. West. Painters, Los Angeles; Sacramento State Fair, 1931 (prize); Holly Riviera Club, 1936 (prize); Gardena (CA) H.S., 1939 (prize); Laguna Beach AA, 1939 (prize), 1956 (prize); P&S Los Angeles, 1942 (prize), 1945 (prize),1948-52 (prizes) ; Ebell Salon, 1944 (prize), 1958 (prize);

Chaffey Jr. College, 1944 (prize); Clearwater H.S., 1945 (prize); Santa Monica AA, 1945 (prize); Univ. So. Calif.; de Young Mem. Mus.; Artists of Southwest; Soc. Western Artists; Westwood AA; Arizona State Fair; Cedar City, UT. Awards: prizes, Santa Monica, 1957; Santa Paula, 1956; Greek Theatre, Los Angeles. **Work:** Haggin Mem. Gal., Stockton, CA; Chaffey Jr. College; Santa Monica Munic. Coll.; Clearwater H.S., Gardena H.S., CA. **Comments:** Position: artist, special visual effects, 1933-50, 20th Century Fox Film Corp., Beverly Hills, CA. **Sources:** WW59; WW47.

SCOTT, Colin (Alexander) *[Painter, teacher] b.1861, Ottawa, Canada. / d.1925.*
Addresses: South Hadley, MA/Provincetown, MA. **Member:** Providence AA. **Exhibited:** Boston AC, 1895, 1906-07; AIC, 1897. **Sources:** WW25; *The Boston AC.*

SCOTT, David W. *[Painter] mid 20th c.*
Addresses: NYC. **Exhibited:** NYWCC, 1937; AWCS, 1938; Phila. WCS, 1938; AWCS-NYWCC, 1939. **Sources:** WW40.

SCOTT, David Winfield *[Art administrator, painter] b.1916, Fall River, MA.*
Addresses: Washington, DC. **Studied:** ASL; Harvard College (A.B.); Claremont Grad. Sch. (M.A. & M.F.A.); Univ. Calif., Berkeley (Ph.D.). **Member:** Calif. WCS (pres., 1952). **Exhibited:** Laguna Beach AA, 1935, 1939; NYWCS, 1938; Calif. WS, 1939-54; LACMA, 1949, 1950; MM, 1953. **Comments:** Positions: from lecturer art to prof., Scripps College, 1946-63; dir., Nat. Coll. FA, Wash., DC, 1964-69; consult., Nat. Gal. Art, Wash., DC 1969-. Specialty: watercolors. **Sources:** WW73; Hughes, *Artists of California,* 502.

SCOTT, Dorothy Carnine (Mrs. Ewing C.) *[Painter, print-maker, lecturer] b.1903, Hannaford, ND.*
Addresses: Syracuse, NY. **Studied:** Colorado College (A.B.); Univ. Chicago (M.A.); Colorado Springs FA Center; Syracuse Univ. (B.S.); Robinson; Snell; Lockwood; Montague Charman. **Member:** Lynchburg AC; Syracuse PM; Syracuse AA; SSAL; Colorado Springs FA Center. **Exhibited:** Colorado Springs FA Center, 1934; Corcoran Gal. biennial, 1937; Wichita, KS, 1939; Lynchburg AC, 1932-46; Virginia Art Exh., 1939 (prize); Lynchburg Civic AL, 1933-40, 1937 (prize); VMFA, 1932-45; Richmond Acad. Arts & Sciences, 1938-40; Wash. WCC, 1934; SSAL, 1936-39; Sweetbriar College, 1938 (solo), 1944 (solo); Lynchburg Art Gal., 1938 (solo); VMFA, 1932-45 (solo,1944); Virginia-Intermont College, 1944-46; Munson-Williams-Proctor Inst., 1949; Sweet Briar College, 1938, 1944 (solos); Syracuse AA, 1946-55; Lynchburg Art Gal., 1938 (solo); Rio de Janeiro, 1942; VMFA, 1944; Syracuse Mus. FA, 1954-55; Syracuse PM, 1958 (Print of the Year). **Work:** Sweet Briar College; Beth-el Hospital, Colorado Springs, CO; VMFA; John Wyatt Jr. Sch., Lynchburg, VA. **Sources:** WW59; WW47.

SCOTT, Edith A(lice) *[Portrait painter, teacher] b.1877, Malden, MA / d.1978, Norwood, MA.*
Addresses: Medford, Boston, MA. **Studied:** BMFA Sch. with Tarbell, Benson, Hale. **Member:** Copley Soc. **Exhibited:** PAFA Ann., 1913, 1918; Vose Gals., Boston, MA, 1915, 1917; S. Indp. A., 1917. **Work:** Nat. Portrait Gal. (Amelia Earhart). **Comments:** Painted at Fenway Studios, Boston, 1906-11. **Sources:** WW25; Vose Galleries, *Mary Bradish Titcomb and Her Contemporaries,* 50; Falk, *Exh. Record Series.*

SCOTT, Edith May Romig *[Painter] b.1885, Lockport, NY / d.1979, Demorest, GA.*
Addresses: Clarement, CA; Demorest, GA. **Studied:** RISD, 1916. **Exhibited:** Laguna Beach AA, 1935-40; Calif. WCS, 1944. **Comments:** Specialty: watercolors. **Sources:** Hughes, *Artists of California,* 502.

SCOTT, Eduardo T. *[Illustrator, painter] b.1897, San Francisco, CA / d.1925, San Francisco.*
Addresses: San Francisco. **Exhibited:** San Fran. AA, 1919-20. **Comments:** Scott commited suicide. **Sources:** Hughes, *Artists of*

California, 502.

SCOTT, Edward *[Lithographer] mid 19th c.*
Addresses: New Orleans, 1854. **Sources:** G&W; New Orleans CD 1854.

SCOTT, Edward J. *[Painter] late 19th c.*
Addresses: San Francisco, CA, active 1890s. **Work:** Fort Mason Officer's Club. **Comments:** Specialty: portraits and cityscapes. **Sources:** Hughes, *Artists of California,* 502.

SCOTT, Elisabeth P. *[Painter] late 19th c.; b.New York.*
Exhibited: SNBA, 1890 (drawing). **Sources:** Fink, *American Art at the Nineteenth-Century Paris Salons,* 389.

SCOTT, E(mily) M(aria Spafard) (Mrs.) *[Painter] b.1832, Springwater, NY / d.1915, NYC.*
Addresses: NYC, 1881-94. **Studied:** NAD; ASL; Collin, Paris. **Member:** NYWCC (charter mem.); NYWAC; AWCS; PBC; NAC; Nat. Assoc. Women P&S (early pres.). **Exhibited:** NAD, 1880-94; Boston AC, 1889-1907; AIC, 1889-1915; Atlanta Expo, 1895 (medal); Trans-Mississippi Expo, Omaha, 1898; Pan-Am. Expo, Buffalo, 1901; NYWAC, 1902 (prize); Corcoran Gal. annual, 1907. **Work:** MMA; Brooklyn Inst. Mus. **Comments:** Specialty: flower painting. **Sources:** WW13.

SCOTT, Emily (Miss) *[Painter] late 19th c.*
Addresses: NYC, 1872. **Exhibited:** NAD, 1872. **Sources:** Naylor, *NAD.*

SCOTT, Eric G(lidden) *[Painter, etcher, teacher] b.1893, Bega, Australia.*
Addresses: Paris, France. **Studied:** Académie Julian, Paris with H. Royer and J. Pagès; J. Asthon. **Member:** Chicago SE; Australian Painter-Etchers; Calif. SE. **Exhibited:** AIC. **Sources:** WW33.

SCOTT, Esther E. (Mrs. Myrgle) *[Painter, printmaker] b.1906, Yakima, WA.*
Addresses: Toppendish, WA. **Studied:** Martha B. Nevitt. **Exhibited:** Whitman College, WA, 1938; E. Wash. Fair, 1938. **Sources:** Trip and Cook, *Washington State Art and Artists, 1850-1950.*

SCOTT, Frank Campbell *[Painter] early 20th c.*
Addresses: NYC. **Exhibited:** S. Indp. A., 1923, 1926. **Sources:** Marlor, *Soc. Indp. Artists.*

SCOTT, Frank Edwin *[Painter] b.1862, Buffalo, NY / d.1929.* EDWIN SCOTT
Addresses: NYC, 1886; Paris, France (since 1895). **Studied:** Cabanel at Ecole des Beaux-Arts. **Member:** Knight, Legion of Honor, Paris. **Exhibited:** NAD, 1886; Paris Salon, 1888-89, 1891-94, 1896-97, 1899; PAFA Ann., 1892-93, 1896-97; Antwerp Expo, 1894 (med.);AIC. **Comments:** Specialty: Paris street scenes. **Sources:** WW25; Fink, *American Art at the Nineteenth-Century Paris Salons,* 389; Falk, *Exh. Record Series.*

SCOTT, Frederick S. *[Painter] early 20th c.*
Addresses: Los Angeles, CA. **Exhibited:** Artists Fiesta, Los Angeles, 1931. **Sources:** Hughes, *Artists of California,* 502.

SCOTT, Georges *[Painter] early 20th c.*
Exhibited: AIC, 1930. **Sources:** Falk, *AIC.*

SCOTT, Georgiana (or Georginia) Helen *[Miniature painter] b.c.1851, London, England / d.1947.*
Addresses: NYC, 1878, 1895; New Rochelle, NY. **Studied:** with her father, William W. Scott. **Exhibited:** NAD, 1878, 1895. **Comments:** Came to U.S., 1865.

SCOTT, Geraldine Armstrong *[Painter, lecturer, teacher] b.1900, Elkhart, IN.*
Addresses: Kokomo, IN. **Studied:** Northwestern Univ.; NY Sch. Fine & Applied Art; Parsons Sch. Des., NY and Paris; Indiana Univ. Center, Kokomo; E.R. Sitzman. **Member:** Kokomo AA (dir.); Indiana AC; Three Arts Club; Indiana AL. **Exhibited:** Hoosier Salon; Indiana Art Club; South Bend, 1928 (prize); S.

Indp. A., 1928; Northern Indiana AL (prize). **Work:** Butler Univ.; Carnegie Lib., Kokomo; Carnegie Lib., Tipton, IN; Indiana Fed. Club.; Northwestern Univ.; Noblesville (IN) H.S. **Comments:** Teaching: Indiana Univ. Kokomo AC, 1945-57. **Sources:** WW59; WW47.

SCOTT, Harold Winfield *[Illustrator] b.1898, Danbury, CT.*
Addresses: Croton Falls, NY in 1975. **Studied:** PIA Sch., 1923, with Max Hermann. **Comments:** Grew up in Montana and moved to Brooklyn after his father died. His arm was shattered in military service. Illustr.: cowboys for Western magazines of 1930s-40s. **Sources:** P&H Samuels, 430.

SCOTT, Henry (Edwards), Jr. *[Painter, educator] b.1900, Cambridge, Mass.*
Addresses: West Tisbury, MA. **Studied:** Harvard Univ. (Sachs fellowship, 1925; Bacon art scholarship, 1926-1928; B.A. & M.A.); ASL; Edward Forbes in Italy; George Bridgman in New York. **Member:** College AA Am.; Am. Assn. Univ. Prof. **Exhibited:** Rochester AA, 1928 (prize); Amherst College, Springfield, MA, 1942; Boston & Cambridge, MA, 1947; Martha's Vineyard, 1947-63 (four shows); Kansas City, MO, 1950-69. **Work:** Fogg Art Mus., Cambridge; Univ. Kansas Medical Center; Univ. Kansas Law Sch.; Amherst College; Regency House, Kansas City. Commissions: originated & directed stage production of Giotto's Frescoes of the Nativity, Pittsburgh, PA, 1932-33; Amherst College, periodically since 1935; stage designs for Amherst Masquers, 1935-36 & Univ. Kansas City Playhouse, 1949-50. **Comments:** Preferred media: watercolors, oils. Positions: asst. to dir., Mem. Art Gal., Univ. Rochester, 1928-29; cur. art, Amherst College, 1938-43; mem., Munic. Art Comn., Kansas City, MO, 1954-69. Publications: auth., "Historical Outline of the Fine Arts," 1936. Teaching: Harvard Univ. & Radcliffe College, 1923-26; Univ. Rochester, 1928-29; Univ. Pittsburgh, 1929-34; Amherst College, 1935-43; Univ. Missouri-Kansas City, 1947-70s. Collections arranged: eight exhs. yearly, Univ. Kansas, Kansas City, 1948-65. **Sources:** WW73.

SCOTT, Henry (Harry) Elliot *[Painter, printmaker] b.1909, Grants Pass, OR.*
Addresses: San Francisco & Los Angeles, CA. **Studied:** Harvard Univ.; Univ. Munich; Univ. Oregon; Mills College, Oakland, CA; AC Sch., Los Angeles. **Exhibited:** Reed College, 1936; Portland, OR, Chamber of Commerce, 1936; Oakland Art Gal., 1937; Paul Elder Gal., San Fran., 1938. **Sources:** Hughes, *Artists of California,* 502.

SCOTT, Howard *[Illustrator] b.1902 / d.1983.* HOWARD SCOTT
Addresses: NYC. **Member:** SI. **Sources:** WW53; WW47.

SCOTT, James *[Painter, graphic artist] b.1889, Racine, WI.*
Addresses: Milton, NY. **Studied:** ASL; Acad. Julian, Paris, 1898; Acad. Colarossi; Acad. Grande Chaumière. **Member:** SC; APPL. **Exhibited:** Pan-Pacific Expo, San Fran., 1915; AIC; PAFA Ann., 1927. **Work:** Am. Expeditionary Forces Univ., France. **Sources:** WW40; Falk, *Exh. Record Series.*

SCOTT, James B. *[Lithographer] mid 19th c.*
Addresses: Buffalo, NY, 1856. **Comments:** Of Jamison & Scott (see entry), lithographers of Buffalo (NY). **Sources:** G&W; Buffalo CD 1856.

SCOTT, James P(owell) *[Painter, educator, lithographer illustrator, teacher] b.1909, Lexington, KY / d.c.1984.*
Addresses: Tucson, AZ (1974). **Studied:** AIC; Anisfeld; Ritman; Chapin; Oberteuffer. **Member:** Tucson Palette & Brush Club; Am. Assn. Univ. Prof; Arizona Soc. P&S. **Exhibited:** AIC, 1930,1931; NAD, 1946; Chicago Munic. Art Lg., 1930 (prize); Tucson FAA, 1936-55 (prizes, 1938, 1951); Oakland Art Mus., 1953; Arizona State Fair, 1953 (prize) Awards: prizes, Chicago Munic. Art Lg., 1930. **Work:** Little Rock (AR) Art Mus. **Comments:** Illustr.: "Dusty Desert Tales," 1941. Teaching: Univ. Arizona, Tucson. **Sources:** WW59; WW47; P&H Samuels, 430.

SCOTT, Jane Elizabeth *[Painter] b.1915, Marion, IA.*

Addresses: Marion, IA. **Studied:** Edwin Bruns; Carl Flick. **Exhibited:** Little Art Gal., Cedar Rapids; library, Marion, IA; Iowa Art Salon, 1935. **Sources:** Ness & Orwig, *Iowa Artists of the First Hundred Years,* 186.

SCOTT, Janet Laura *[Painter] early 20th c.*
Addresses: Chicago, IL. **Exhibited:** AIC, 1926. **Sources:** WW19.

SCOTT, Jeannette *[Painter, teacher] b.1864, Kincardine, Ontario, Canada / d.1937, Skaneateles, NY.*
Addresses: Phila., PA; Skaneateles, NY; NYC, 1895. **Studied:** PAFA; Phila. Sch. Des. for Women; Paris. **Member:** AFA. **Exhibited:** PAFA Ann., 1887-88, 1904; Boston AC, 1890; SNBA, 1894; NAD, 1895. **Work:** Syracuse Mus. FA. **Comments:** Impressionist painter in oil, watercolor, charcoal (portraits). Teaching: Syracuse Univ., 1895-27. Supported opportunity for women in her art dept. and founded the first faculty in the fine arts. Lost her sight in 1932 due to cataracts. **Sources:** WW33; Fink, *American Art at the Nineteenth-Century Paris Salons,* 389; Petteys, *Dictionary of Women Artists;* Falk, *Exh. Record Series.*

SCOTT, Jessie *[Landscape painter, watercolorist, muralist] b.1912, Portis, KS.*
Addresses: Haxtun, CO in 1975. **Studied:** Univ. Colorado; Famous Artists Sch. Painting, 1953; William Sanderson, Univ. Denver. **Comments:** Subjects: prairie windmills, portraits, pueblos. **Sources:** P&H Samuels, 430.

SCOTT, Joanne S. *[Painter] b.1928, Brockton, MA.*
Addresses: Monhegan Island, ME (summers). **Studied:** BMFA Sch.; RISD; Maryland College Inst. Art. **Exhibited:** CGA (prize); Baltimore Mus. Art. **Comments:** Longtime summer resident of Monhegan Island in Maine. Teacher of watercolor painting. **Sources:** Curtis, Curtis, and Lieberman, 125, 186.

SCOTT, John *[Illustrator] b.1907, Camden, NJ / d.1987.*
Addresses: NYC; Ridgefield, CT, 1975. **Studied:** Philadelphia, 1923. **Member:** SI. **Work:** murals for Mormon Temple, Wash., DC, Salt Lake City & Independence, MO; commissioned by Garcia Corp. **Comments:** Concentrated on drawings and paintings for pulp magazines before WWII; a staff artist for *Yank* magazine; after the war *This Week, Woman's Day, Chatelaine,* and *Toronto Star;* by the 1960s for *True, Sports Afield.* Specialty: hunting and fishing subjects. **Sources:** WW47; P&H Samuels, 430; The Cœur d'Alene Art Auction, July 25, 1998.

SCOTT, John G(reen) *[Illustrator] b.1887, Buck Mountain, PA.*
Addresses: Tamaque, PA. **Studied:** PM Sch. IA. **Sources:** WW25.

SCOTT, John Tarrell *[Painter, graphic artist] b.1940, New Orleans, LA.*
Studied: Xavier Univ. (B.F.A.; Michigan State Univ. (fellowship); M.F.A.). **Exhibited:** Univ. Iowa; Xavier Univ., 1959; Orleans Gal., 1966; Hibernia Nat. Bank, 1966; Louisiana State Univ., 1966 (prize); Florida A&M Univ., 1968; Our Lady of Holy Cross College, 1969; Experience Gal., 1971; Laemmle FA Theatres, 1971; Kalamazoo Inst. Art, 1971; Fisk Univ., 1971. **Work:** All Girls Acad., Minneapolis, MN; Louisiana State Univ.; Fisk Univ.; Florida A&M Univ.; Sisters of the Blessed Sacrament, VA; St. Joseph School, IL; Methodist Church, AL; Naples County Civic Center, FL; Xavier Univ. Student Center, New Orleans; Methodist Church, MN; The Maji Shop, New Orleans; St. Phillips' Church, New Orleans; St. Angela Merici Church, LA; Johnson Pub. Co., Chicago. **Comments:** Teaching: Xavier Univ., LA. **Sources:** Cederholm, *Afro-American Artists.*

SCOTT, John White Allen *[Portrait, landscape & marine painter, lithographer, engraver] b.1815, Roxbury, MA / d.1907, Cambridge, MA.*
Addresses: Cambridge, MA; Boston, MA. **Studied:** William S. Pendleton, Boston. **Member:** Boston AC. **Exhibited:** Boston Athenaeum; Boston AC. **Work:** Mass., State House, Boston. **Comments:** He served his apprenticeship under the Boston lithographer William S. Pendleton at the same time as Nathaniel Currier (see entry), and spent his entire career in and around Boston. In the mid-1840s he was in partnership with Fitz Hugh Lane. At his death, he was the oldest member of Boston AC. **Sources:** G&W; *Art Annual,* VI, obit.; Peters, *America on Stone;* Boston CD 1844-57; Swan, BA; 7 Census (1850), Mass., XXIII, 727; Campbell, *New Hampshire Scenery,* 136-137.

SCOTT, Jonathan *[Painter] b.1914, Bath, England.*
Addresses: Taos, NM. **Studied:** Heatherly Sch., London; Mauritz Heymann Sch., Munich; The Accad., Florence. **Member:** Calif. Nat. WCS (pres., 1960); Taos AA (art comt. & mem. bd., 1972). **Exhibited:** New English Art Club, London, 1938; Butler Inst. Am. Art, Youngstown, OH, 1954; Los Angeles Mus.; Frye Mus., Seattle; McNay Mus., San Antonio, TX, 1962; Gallery A, Taos, NM, 1970s. Awards: awards, Pasadena Soc. Artists, 1942-61, Calif. WCS, 1955 & Laguna Beach AA, 1961. **Work:** Pasadena (CA) Art Mus.; Santa Fe, NM; Lindsay AAf; San Marino (CA) H.S.; G.G. de Silva Coll., Los Angeles. Commissions: paintings, USN Art Program, 1963-64; also portrait comns. **Comments:** Teaching: Univ. Southern Calif., 1946; Pasadena Art Mus., 1947-48; Riverside AA, 1962-63. **Sources:** WW73.

SCOTT, Joseph T. *[Engraver] late 18th c.*
Addresses: Philadelphia, 1793-96. **Comments:** He was chiefly a designer and engraver of maps. **Sources:** G&W; Stauffer; Brown and Brown.

SCOTT, Josephine B. *[Painter] late 19th c.*
Addresses: Active in Perrysburg, OH. **Exhibited:** Columbian Expo, Chicago, 1893. **Sources:** Petteys, *Dictionary of Women Artists.*

SCOTT, Joy (Mrs. Tom) See: **PRIDE, Joy (Mrs. Tom Scott)**

SCOTT, Julia H. *[Artist] late 19th c.*
Addresses: Wash., DC, active 1885-92. **Sources:** McMahan, *Artists of Washington, DC.*

SCOTT, Julian *[Painter, illustrator] b.1846, Johnson, VT / d.1901, Plainfield, NJ.*
Addresses: Plainfield, NJ, 1867, 1876-98; NYC, 1870-75. **Studied:** NAD, 1963-64; Leutze, 1864-68; Paris, 1866. **Member:** ANA, 1870 or 1871; Artists Fund Soc. **Exhibited:** NAD, 1870-98; Brooklyn AA, 1881; Boston AC, 1888, 1894. **Work:** Univ. Pennsylvania; Div. of Ethnology, Smithsonian; Vermont State House; Union League Club, NYC. **Comments:** When the Civil War broke out he enlisted in The Vermont Regiment as a musician; later he was appointed to the staff of Gen. "Baldy" Smith. He was the first man to receive the Medal of Honor for bravery on the battlefield. In 1864, he opened a studio in NYC, selling Civil War and historical genre paintings. He sketched the death of Maj. General John Sedgewick in Spotsylvania County, VA, and his oil painting, "Retreat up the Shenandoah" (1872) was probably based on sketches he made during the Civil War. He was appointed as artist-correspondent for "Report on Indians Taxed and Indians Not Taxed" in 1890, working with Kiowa, Comanche, Wichita, and other Oklahoma Indians; the Pueblos of New Mexico and Arizona; and the Navahos. His 11 aquatints illustrated "The Song of the Ancient People." **Sources:** WW01; P&H Samuels, 431; Wright, *Artists in Virgina Before 1900;.*

SCOTT, K. *[Painter] mid 20th c.*
Addresses: NYC. **Exhibited:** S. Indp. A., 1944. **Comments:** Possibly Kathryn Scott, ASL. **Sources:** Marlor, *Soc. Indp. Artists.*

SCOTT, Katherine H. *[Portrait painter, designer, teacher, writer] b.1871, Burlington, IA.*
Addresses: West Chester, PA. **Studied:** AIC with John Vanderpoel, William M. Chase, Frank Duveneck; Snow-Froelich Sch. Indust. Art. **Member:** Chester County AA; ASL, Chicago; AIC Alumni. **Exhibited:** AIC; Artist Guild; Marshall Field

Galleries; Portland Mus., OR; Fresno, CA; Honolulu; New York; Wichita, KS; Mason City, IA; S. Indp. A.; Burlington Tri-State Fair; Mississippi State Fair; Chester County AA. **Work:** portraits, Des Moines Country Court House, Pub. Lib. and Merchants Nat. Bank, Burlington; Parson College, Fairfield, IA; J.H. Vanderpoel AA, Chicago. **Comments:** Teaching: State Teachers College, West Chester, PA. Contrib.: illustrated articles, *Industrial Art, Everyday Art, Art Activities.* **Sources:** WW40; Ness & Orwig, *Iowa Artists of the First Hundred Years,* 187.

SCOTT, Kenneth *[Painter] mid 20th c.*
Addresses: NYC. **Exhibited:** AIC, 1947. **Sources:** Falk, *AIC.*

SCOTT, L. *[Painter] late 19th c.*
Addresses: NYC, 1885. **Exhibited:** NAD, 1885. **Sources:** Naylor, *NAD.*

SCOTT, Leslie G(rant) (Mrs.) *[Painter] early 20th c.*
Addresses: NYC. **Exhibited:** Salons of Am., 1923, 1924, 1934; S. Indp. A., 1923-25, 1927, 1932, 1934. **Sources:** Falk, *Exhibition Record Series.*

SCOTT, Lucy *[Artist] late 19th c.*
Addresses: Wash., DC, active 1882. **Sources:** McMahan, *Artists of Washington, DC.*

SCOTT, Madeline *[Painter] early 20th c.*
Addresses: Knoxville, TN. **Sources:** WW13.

SCOTT, Marie Theodora *[Painter, photographer, teacher] b.1903, Los Angeles, CA / d.1976, Laguna Niguel, CA.*
Addresses: Los Angeles, CA; Laguna Niguel, CA. **Studied:** UCLA; with André L'Hote in Paris; Columbia Univ. **Exhibited:** Calif. State Fairs; Calif. WCS, 1930-38; Artists Fiesta, Los Angeles, 1931; Ebell Club, Los Angeles, 1934 (first prize); GGE, 1939. **Work:** Santa Cruz Hist. Mus.; Laguna Mus.; LACMA. **Comments:** Teaching: Alexander Hamilton H.S., Los Angeles; head of art dept., Valley College. **Sources:** Hughes, *Artists of California,* 502.

SCOTT, Mary *[Painter] b.1858.*
Addresses: Birmingham, PA. **Exhibited:** PAFA Ann., 1888. **Sources:** Falk, *Exh. Record Series.*

SCOTT, Mona Dugas *[Painter] early 20th c.; b.Augusta, GA.*
Addresses: NYC. **Studied:** L.F. Jones. **Member:** NAWPS. **Sources:** WW31.

SCOTT, Nellie E. Burrell *[Painter] b.1856, Sacramento, CA / d.1913, San Francisco, CA.*
Addresses: San Fran. **Studied:** San Fran. Sch. Des.; Partington Art Sch., San Fran. **Exhibited:** San Fran. AA, 1883; Mechanics Inst., 1893; Calif. State Fair, 1899. **Sources:** Hughes, *Artists of California,* 502.

SCOTT, Paul M. *[Painter, illustrator, teacher] b.1910, Puyallup, WA / d.1982, Gloucester, MA.*
Addresses: Puyallup, WA; Rockport, MA. **Studied:** Armstrong Sch. Art, Tacoma; Derbyshire Sch. Art, Seattle. **Exhibited:** Tacoma Art Lg., 1940. **Sources:** Trip and Cook, *Washington State Art and Artists, 1850-1950.*

SCOTT, Powell *[Painter] early 20th c.*
Exhibited: AIC, 1932. **Sources:** Falk, *AIC.*

SCOTT, Quiller F., Jr. *[Painter] mid 20th c.*
Studied: ASL. **Exhibited:** S. Indp. A., 1942. **Sources:** Marlor, *Soc. Indp. Artists.*

SCOTT, Quincy *[Cartoonist] b.1882, Columbus, OH.*
Addresses: Portland, OR/Bainbridge Island, WA. **Studied:** Cox; Bridges; Morgan; ASL; W.Q. Scott; Ohio State Univ. **Work:** Huntington Lib., San Marino, CA; Columbus (OH) Gal. FA. **Comments:** Auth./Illustra.: "Night Riders of Cave Knob," 1911. Illustr.: "Northwest Nature Trails," 1933. Position: ed. cart., *The Oregonian,* Portland. **Sources:** WW40.

SCOTT, R(alph) *[Painter, drawing specialist, teacher] b.1896, Elliston, Newfoundland.*
Addresses: Providence, RI/Rockport, MA. **Studied:** J. DeCamp;

E.L. Major; A.T. Hibbard; Mass. Sch. Art; Rockport Summer Sch. Drawing & Painting; Darlington Tech. College, Eng. **Member:** Providence AC; Providence WCC; Rockport. **Work:** Plantation Club, Providence. **Comments:** Teaching: Providence Pub. Sch. **Sources:** WW40.

SCOTT, Retta E. *[Painter] b.1916, Omak, WA.*
Addresses: Los Angeles, CA. **Studied:** Cornish Art Sch.; Music & Art Found., Seattle; Chouinard Art Inst. **Exhibited:** Northwest Artists, 1939; SAM, 1937, 1939; Sunset Club, Seattle, 1939 (solo). **Comments:** Position: layout sketch artist, Walt Disney Productions. **Sources:** Trip and Cook, *Washington State Art and Artists, 1850-1950.*

SCOTT, Robert See: **SCOT, Robert**

SCOTT, Robert Gillam *[Educator, painter] b.1907, St. Johns, MI.*
Addresses: New Orleans, LA. **Studied:** Harvard Univ. (A.B.); Yale Univ. (M.F.A.). **Member:** SSAL; Am. Assn. Univ. Prof. **Exhibited:** Texas General Exh., 1943-45; SSAL, 1945-46; Detroit Inst. Art, 1945; Pepsi-Cola, 1946. **Comments:** Teaching: Sophie Newcomb College, Tulane Univ., New Orleans. **Sources:** WW53; WW47.

SCOTT, Samuel *[Painter] b.1940.*
Addresses: Santa Fe, NM. **Exhibited:** WMAA, 1975. **Sources:** Falk, *WMAA.*

SCOTT, Stella Bradford (Mrs. Roger M.) *[Painter, lithographer] b.1920, Providence, RI.*
Addresses: Worcester 9, MA. **Studied:** RISD (B.F.A.); Colorado Springs FA Center. **Member:** Providence Art Club. **Exhibited:** NAD, 1942; LOC, 1942, 1946; Rhode Island Art Club, 1941 (prize), 1942, 1946; Contemp. Art, 1941, 1946; Providence Art Club, 1947-51, 1953, 1954; WMA, 1949, 1951, 1952, 1953; Lowell Art Gal., Worcester, MA, 1950; Providence Art Club, 1946 (solo); Corycia Gal., Hancock, NH, 1948. **Sources:** WW59.

SCOTT, Thomas S. *[Artist] mid 19th c.*
Addresses: Philadelphia, c.1852. **Comments:** He was working for the lithographer P.S. Duval (see entry). **Sources:** G&W; Peters, *America on Stone.*

SCOTT, Townsend *[Painter] early 20th c.*
Addresses: Baltimore, MD. **Sources:** WW24.

SCOTT, W. Stafford *[Painter] b.1859.*
Addresses: Phila., PA. **Exhibited:** PAFA Ann., 1883. **Sources:** Falk, *Exh. Record Series.*

SCOTT, Walt *[Painter] early 20th c.*
Addresses: Cleveland, OH. **Sources:** WW25.

SCOTT, William Edouard *[Painter, illustrator, decorator] b.1884, Indianapolis, IN.*
Addresses: Chicago, IL/Indianapolis, IN. **Studied:** AIC with J. Vanderpoel; Acad. Julian, Paris, 1913; Acad. Colarossi Acad.; H.O. Tanner in Paris. **Member:** Chicago Art Lg.; Hoosier Salon; AIC, Alumni Assn. **Exhibited:** Royal Acad., London, 1912; Indiana State Fair, 1914; Paris Salons; Cincinnati Mus.; San Diego Mus.; LACMA; Port-au-Prince, 1931 (solo); Johannesburg, Africa; Harmon Found., 1927 (gold med.),1928, 1931, 1933, traveling exh., 1934-35; AIC, 1932; Smithsonian Inst., 1933; New Jersey State Mus., 1935; Findlay Gals.s, Chicago, 1935; Texas Centennial, 1936; Am. Negro Expo, Chicago, 1940; South Side Community AC, Chicago, 1941, 1945; Howard Univ., 1945; James A. Porter Gal., 1970; Chicago Art Lg. (prizes). **Awards:** Legion of Honor, Govt. of Haiti; Frederick Manus Brand Prize (twice); Rosenwald Fellow, 1931; Jesse Binga Prize, 1931; James McVeagh Prize, 1931. **Work:** murals: Evanston, IL; Herron Al, Indianapolis; Ft. Wayne (IN) Court House; Lafayette (IN) Court House; Springfield (IL) State House; schools, Inst. West Virginia, Charleston; First Presbyterian Church, Chicago; Chicago Defender Newspaper Lobby; Binga State Bank, Chicago; Anthony Hotel, Ft. Wayne; Edwardsville (IL) Nat. Bank; South Park Methodist Episcopal Church, Chicago; Paris Salon; RA, London;

First Nat. Bank and H.S., Michigan City, IN; Peoples Finance Corp. Bank, St. Louis; Tuley Park, Davis Sq., Standford Park Field House, all in Chicago; murals, John Shoop School, Betsy Ross Jr. H.S., Chicago; Argentine Gov.; Port-Au-Prince, Haiti; Century of Progress Expo, Chicago; Cook County Juvenile Court, Chicago; YMCA, Indianapolis: 135th St. Branch, NYPL; 135th St. Branch, YMCA, NYC; Munic. Tuberculosis Sanitarium, Chicago; City Hospital, Indianapolis; murals, Pilgrim Baptist Church, Bethesda Baptist Church, Metropolitan Community Center, Chicago. **Sources:** WW40; Gerdts, *Art Across America*, vol. 2: 271; Cederholm, *Afro-American Artists.*

SCOTT, William J. *[Painter] b.1870 / d.1940.*
Addresses: Hackettstown, NJ (1925); Westport, CT. **Member:** SC. **Exhibited:** AIC, 1928-29. **Comments:** Evidentally a wealthy man, he spent his summers on painting trips, sometimes with his friend, Thomas Hart Benton. **Sources:** WW25; *Community of Artists,* 76.

SCOTT, William M. *[Engraver] b.1821, Pennsylvania.*
Addresses: Wash., DC, active 1860. **Sources:** McMahan, *Artists of Washington, DC.*

SCOTT, William Wallace *[Portrait, miniature, and landscape painter] b.1819, Roxbury, MA / d.1905, Cambridge, MA.*
Addresses: NYC (40 years); New Rochelle, NY. **Member:** NAD; Royal Acad., London; AWCS. **Exhibited:** Royal Acad., London, 1841-59; NAD, 1866-78; Brooklyn AA, 1868-77, 1884; Boston AC, 1889; AIC. **Comments:** The Royal Academy listed him as a painter of portrait miniatures, but his exhibited works in the U.S. also include landscapes, and even a tiger hunt in India. **Sources:** Cowdrey, NAD. WW04 cites a birth date of 1822.

SCOTT, Winfield Lionel *[Painter, craftsperson, poet] b.c.1839, New York.*
Addresses: Detroit, MI, 1885-1900 and after. **Exhibited:** Detroit Mus. Art, 1886. **Sources:** Gibson, *Artists of Early Michigan,* 210.

SCOTT-HURST, Clara See: **HURST, Clara Scott (Mrs.)**

SCOTTEN, Bessie Marjorie *[Painter] late 19th c.*
Addresses: Active in Detroit, MI. **Studied:** Maud Mathewson. **Exhibited:** Mathewson Sch. Art, Detroit, 1894. **Sources:** Petteys, *Dictionary of Women Artists.*

SCOTTEN, S. C. *[Patron] b.1851, Burlington, IA / d.1920.*
Addresses: Chicago, IL. **Comments:** He owned what at the time was said to be the fifth largest art collection in America.

SCOVEL, Florence See: **SHINN, Florence ("Flossie") Scovel (Mrs. Everett)**

SCOVEL, Mary C. *[Painter, teacher] b.1869 / d.1941.*
Addresses: Carmel, CA. **Member:** Western AA (pres.). **Comments:** Positions: hd., teacher training dept., AIC, until 1933.

SCOVILLE, Martha J. See: **MOSER, Martha Scoville (Mrs. James Henry)**

SCOVILLE, V(irginia) Busenbenz See: **BUSENBENZ-SCOVILLE, V(irginia)**

SCRANTON, Lydia M. *[Artist] 19th/20th c.*
Addresses: Active in Detroit, MI, 1898-1900. **Sources:** Petteys, *Dictionary of Women Artists.*

SCRATCH, Patty Switzer See: **SWITZER, Patty**

SCRIBNER, Elizabeth *[Painter] b.1874, Middleton, NY.*
Addresses: Pittsfield, MA. **Studied:** W. Chase; Beckwith; Fabier; Gautier Sch. **Member:** NAC; CLW Art Club. **Exhibited:** Salons of Am. **Comments:** (Mrs. Sidney Jones). **Sources:** WW40.

SCRIVER, Robert Macfie (Bob) *[Sculptor] b.1914, Browning, MT / d.1999.*
Addresses: Browning, MT. **Studied:** Vandercook Sch. Music (M.A., 1951). **Member:** Salmagundi Club; NSS; Cowboy Artists Am. **Exhibited:** Soc. Animal Artists, NYC, 1961; Audubon Artists, New York, 1964; NAD, New York, 1964; Acad. Artists, Springfield, MA, 1964; Int. Art Guild, Palais de la Scala, Monte

Carlo, Monaco, 1967. Awards: gold medals, 1969, 1970 & 1971 & silver medal, 1972, Cowboy Hall of Fame. **Work:** Glenbow Found., Calgary, Alberta; Whitney Gal. Western Art, Cody, WY; Montana Hist. Soc., Helena; Cowboy Hall Fame, Oklahoma City, OK; Panhandle Plains Mus., Canyon, TX. Commissions: over life-size statue of bison, Great Falls H.S., Montana, 1967; Bill Linderman (heroic statue), Rodeo Cowboy Assn. for Cowboy Hall of Fame, Oklahoma City, 1968; Rustler (statue), C.M. Russell H.S., Great Falls, 1968. **Comments:** Although trained as a musician, Scriver became a taxidermist. He established the Mus. of Montana Wildlife in 1956 (Scriver Museum) which included his sculpture, dioramas, and taxidermy. The museum was destroyed by fire in 1975. In 1962, he had his work cast in bronze for exhibit and in 1967 he began sculpting full-time. Preferred media: clay, bronze. **Sources:** WW73; article, *Am. Artist Magazine* (1963); article, *La Révue Mod.* (1964); article, *Montana Historical Society;* P&H Samuels, 431-32.

SCRUGGS-CARRUTH, Margaret Ann (Mrs.) *[Etcher, teacher, illustrator, writer, lecturer, craftsperson, block printer, designer, drawing specialist] b.1892, Dallas, TX.*
Addresses: Dallas, TX; Indian River, MI. **Studied:** Bryn Mawr College; Southern Methodist Univ. (B.A.; MA.); Frank Reaugh; Ralph Pearson. **Member:** Texas FAA; Dallas AA; SSAL; AFA; AAPL; Soc. Medalists; Southern PM; Dallas Pr. Soc.; Prairie PM; Calif. PM; Highland Park AA; Woodcut Soc.; Nat. Lg. Am. Pen. Women; Reaugh AC. **Exhibited:** S. Indp. A., 1930; Ogunquit, ME, 1931; Dallas All. Artists, 1932 (prize); Texas Centenn. Expo, Dallas, 1936; WFNY, 1939; Garden Center Flower Exh., Dallas, 1951-55 (awards), 1958 (designed their bookplate). **Work:** Elisabet Ney Mus.; CGA; Am. Embassy, Bucharest, Roumania; Nat. Soc. DAR; Texas Fed. Garden Clubs. **Comments:** Heraldic artist, handmade lineage books, Coats of Arms, Lineage Trees, etc. Lectures: etching. Illustr./co-auth.: "The Rainbow-Hued Trail;" "Gardening in the South and West" (new ed., 1959); "French Period;" "Victorian Period;" Flower Arrangements." Contrib.: *House & Gardens, Better Homes & Gardens, National Horticulture Magazine,* and others. **Sources:** WW59; WW47.

SCRUGGS-SPENCER, Mary See: **SPENCER, Mary (Mary Scruggs-Spencer)**

SCRYMSER, Christabel *[Miniature painter] b.1885, Brooklyn, NY.*
Addresses: Rockville Center, NY. **Studied:** Whittaker; Twachtman; Metcalf; Beck; Fisher; CUA Sch.; PIA Sch. **Member:** Brooklyn SMP; NAWPS; Penn. SMP. **Sources:** WW33.

SCUDDER, A. M. (Mrs.) *[Painter] mid 19th c.*
Comments: Painted in 1845 "A Vision of the Northeast Corner of Beaver and Broad Streets [in NYC] in the 1600s." **Sources:** G&W; *Antiques* (May 1934), 188, repro.

SCUDDER, Alice Raymond (Mrs. R. Coates) *[Landscape painter, craftsperson] b.1879, New Orleans, LA / d.1957.*
Addresses: New Orleans, active 1904-16; Pasadena, CA, c.1925. **Studied:** Newcomb Art Sch., NY Sch. Applied Design; Chase; Mora. **Member:** NOAA, 1904-05, 1907, 1911, 1913; Art Exh. Club, 1901; AFA. **Exhibited:** NOAA, 1904-05, 1907, 1911, 1913, 1915-16; Mary L.S. Neill Watercolor Comp. (hon. men.). **Comments:** Also known as Alice Raymond Scudder Coates. **Sources:** WW33; *Encyclopaedia of New Orleans Artists,* 345.

SCUDDER, Antoinette L. Quimby *[Painter, writer] b.1888, Newark, NJ / d.1958, Newark.*
Addresses: Newark/Provincetown, MA. **Studied:** Hawthorne; ASL. **Member:** NAWPS. **Exhibited:** Salons of Am., 1925, 1928, 1929; S. Indp. A., 1925-26. **Comments:** Marlor lists birth date as 1886. **Sources:** WW25; Marlor, *Salons of Am.*

SCUDDER, Emily *[Artist] 19th/20th c.*
Addresses: Wash., DC, active 1896-1901. **Sources:** McMahan, *Artists of Washington, DC.*

SCUDDER, Hilda *[Sculptor] early 20th c.*
Addresses: Boston, MA. **Exhibited:** PAFA Ann., 1932. **Sources:** Falk, *Exh. Record Series.*

SCUDDER, J. M. (Miss) *[Flower painter] late 19th c.*
Addresses: Boston, MA. **Exhibited:** Boston AC, 1878-92. **Sources:** *The Boston AC.*

SCUDDER, James Long *[Still life, portrait, landscape, genre, and animal painter] b.1836, East Neck, LI, NY / d.1881, Huntington , LI, NY.*
Addresses: Active in Huntington, LI, NY, entire career. **Exhibited:** NAD, 1859-77; Brooklyn AA, 1876-77. **Work:** Huntington Hist. Soc. **Comments:** Originally a house and sign painter. Produced paintings of the Long Island landscape and a variety of other subjects. Visited Florida in 1875. Scudder's interest in natural history and science is reflected in the attention to detail found in his paintings. He was married to Lydia E. Kelcey and had two sons, one of whom, Thomas Lessing Scudder (see entry), became an artist and lived in Santa Anna (CA). **Sources:** G&W; Mrs. Martha K. Hall, "James Long Scudder, Artist," *The Long Island Forum,* XVIII, March 1955, 43-44, 56; Cowdrey, NAD; Pisano, *The Long Island Landscape,* n.p.

SCUDDER, Janet (Netta Deweze Frazee Scudder)
[Sculptor, painter, writer] b.1869, Terre Haute, IN / d.1940, Rockport, MA.
Addresses: Chicago, 1891-93; Paris, 1894-96; NYC, 1896-?; Paris, c.1897-1939; NYC/Rockport, MA, 1939-40. **Studied:** Rebisso at Cincinnati Art Acad.; Taft in Chicago (assisting him with sculptures for the World's Columbian Expo.); F. MacMonnies in Paris, 1893. **Member:** NAD; ANA; NSS, 1904; NAWA; NAC; AFA; Chevalier de la Legion d'Honneur, 1925. **Exhibited:** World's Columbian Expo, Chicago 1893 (medal); Sun Dial Comp., NYC, 1898 (prize); PAFA Ann., 1903-30 (9 times); St. Louis Expo, 1904 (medal); Paris Salon, 1899,1911 (prize); AIC, 1922 (prize); Pan-Pacific Expo, San Francisco, 1915 (medal); Int. Expo, Paris, 1937 (medal); Ferargil Gal., 1926 (solo); Macbeth Gal., 1933 (solo). Additional awards: Olympiad Medal, Amsterdam, 1928. **Work:** Brooklyn Mus.; fountains: MMA, AIC, Peabody Inst., Baltimore, BM; Richmond (IN) public school; Indianapolis AA; LOC; MMA; Musée du Luxembourg, Paris; Indiana Centenn.; Minneapolis Inst.; RISD; Phillips AM, Bartlesville, OK; St. Bethesda on the Sea, Palm Beach, FL; National Suffrage Fountain, "Femina Victrix," Wash., DC.; seal, Assn. of the Bar, City of NYC. **Comments:** (Born Netta Dewee Frazee Scudder) Best known for her garden sculptures and fountains, frequently of children, as well as portrait medallions and heads, in terra cotta, bronze and marble. "Frog Mountain" is one of her best-known works. She studied and lived in Paris for altogether forty-five years and was active in relief work during World War I in France, receiving a Chevalier of the Legion of Honor in 1925. She was the first American woman to have her portrait medallions acquired by the Musée du Luxembourg, Paris. Autobiography: *Modeling My Life.* **Sources:** WW40; Pisano, *One Hundred Years.the National Association of Women Artists,* 81; Petteys, *Dictionary of Women Artists;* Falk, *Exh. Record Series;* Tufts, *American Women Artists,* cat. no. 117; Rubinstein, *American Women Artists,* 94-97; Mary Smart, *A Flight with Fame* (Sound View Press, Madison, CT, 1997), includes references to Scudder's years as MacMonnies' assistant. (Note: Scudder was vague about her date of birth, which was previously believed to be 1875; however the Indiana State Lib. supplied a date of 1869 from Vigo County birth records).

SCUDDER, Martha See: TWACHTMAN, Martha ("Mattie") Scudder (Mrs. John H.)

SCUDDER, Netta See: SCUDDER, Janet (Netta Deweze Frazee Scudder)

SCUDDER, Raymond *[Painter] early 20th c.*
Addresses: New Orleans, IN. **Sources:** WW15.

SCUDDER, Thomas Lessing *[Painter] b.1866, NYC / d.1954, Santa Ana, CA.*
Addresses: Santa Ana, CA, since 1894. **Comments:** Son of James Long Scudder (see entry). **Sources:** Hughes, *Artists of California,* 503.

SCUDDER, Winthrop Saltonstall *[Art editor] b.1846 / d.1929.*
Addresses: NYC. **Studied:** Harvard. **Comments:** Position: art. ed., Houghton Mifflin Co., for 40 years.

SCULL, Nina Woloshukova *[Painter, lecturer, teacher, designer, decorator] b.1902, St. Petersburg, Russia.*
Addresses: Philadelphia, PA; Cape May, NJ. **Studied:** ASL; Corcoran Sch. Art; Columbia Univ.; Wayman Adams; George Elmer Browne. **Member:** PAFA (fellow); New Jersey P&S; Phila. Plastic Club; Da Vinci Art All.; AFA; All. Artists Am.; Provincetown AA; Phila. Art All.; Somerset AA; New Jersey A&P; Nat. Soc. Mod. Art; Pittsburgh AA. **Exhibited:** NAD, 1939-44; CI, 1936-1946; AFA traveling exh., 1939; Ogunquit AC, 1940; PAFA, 1942-45; MMA (AV), 1942; Montclair Art Mus., 1942; Provincetown AA, 1940-44; Phila. Sketch Club, 1945; MMA; Da Vinci All., 1943-1945; Haverford College, 1942; Norfolk Mus. Arts & Sciences, 1930, 1939; Penn. State Teachers College, 1938-39; Pittsburgh AA, 1939; 100 Club, Phila., 1955 (solo); Newman Gal., Phila., 1939; All. Artists Johnstown; Glassboro (NJ) State Teachers College; Brooks Mem. Mus.; Phila. Art All. **Work:** 100 Friends of Art, Pittsburgh; Imperial Gal., Phila.; Pittsburgh Pub. Schs.; Am. Legion, Somerset, PA. **Comments:** Position: owner, dir., instr., Inperial Art Sch., Philadelphia, PA. Contrib.: newspapers & magazines. **Sources:** WW59; WW47.

SCULL, Robert C. *[Collector] mid 20th c.*
Addresses: NYC. **Sources:** WW73.

SCULLY, Margaret See: ZIMMELE, Margaret Scully (Mrs. Harry B. Zimmele)

SCULLY, (Mary) Morrow Murtland (Mrs. Henry R.)
[Painter] b.1853 / d.1932, Pittsburgh, PA.
Addresses: Pittsburgh, PA. **Studied:** Pittsburgh Sch. Design for Women. **Member:** Pittsburgh AA. **Exhibited:** Phila. Soc. Artists; PAFA Ann., 1880; S. Indp. A., 1925-26, 1929; Salons of Am., 1927. **Sources:** WW25; Falk, *Exh. Record Series.*

SCULLY, Vincent *[Art historian, educator] b.1920, New Haven, CT.*
Addresses: New Haven, CT. **Studied:** Yale Univ. (B.A., 1940; M.A., 1947; Ph.D., 1949). **Member:** College AA Am.; Soc. Arch. Hist.; Am. Inst. Archeology; Conn. Acad. Arts & Sciences. **Exhibited:** Awards: Fulbright grant to Italy, 1951-52; Billings Mem. fellowship, Greece, 1955; Howard Found. fellowship, Sicily, 1956 & Bollingen fellowship to Greece & Turkey, 1957-58. **Comments:** Publications: auth., "Modern Architecture," *Great Ages of World Architecture Series,* Braziller, 1961; auth., *The Earth, the Temple and the Gods,* Yale Univ. Press 1962 & Praeger, 1969; "Louis I. Kahn," *Makers of Contemporary Architecture Series,* Braziller, 1962; auth., *American Architecture and Urbanism,* Praeger, 1969, auth., "Pueblo Architecture of the Southwest: A Photographic Essay," *Amon Carter Museum of Western Art Series,* Univ. Texas Press, 1971. Teaching: Yale Univ., 1947-70s. **Sources:** WW73.

SCURIS, Stephanie *[Sculptor, educator] b.1931, Lacedaemonos, Greece.*
Addresses: Baltimore, MD. **Studied:** Sch. Art & Arch., Yale Univ. (B.F.A. & M.F.A.) with Josef Albers. **Exhibited:** New Haven Art Festival, 1958-59; Art: USA, traveling exh., 1958 & 1960; MoMA, 1962; WMAA, 1964. Awards: Winterwitz Award, prize for outstanding work & alumni award, Yale Univ.; Peabody Award, 1961-62; Rinehart fellowship, 1961-64. **Work:** Jewish Community Center & West View Center, Balt., MD. Commissions: sculpture, Bankers Trust Co., NYC; lobby sculpture, Cinema I & II, New York. **Comments:** Teaching: Maryland

Inst. Art, 1961-. **Sources:** WW73.

SCUTERI, Ilario *[Painter] early 20th c.*
Addresses: Hollywood, CA, 1924. **Studied:** ASL. **Exhibited:** S. Indp. A., 1924. **Sources:** Marlor, *Soc. Indp. Artists.*

SCUTT, Winifred *[Painter, lecturer, writer] b.1890, Long Island, NY.*
Addresses: Taos & Santa Fe, NM; Santa Barbara, CA; Colorado Springs, CO. **Studied:** ASL; Wayman Adams; George Bridgman; Wood Woolsey. **Member:** PBC. **Exhibited:** S. Indp. A., 1923; Studio Club, NY, 1937 (solo)(prize); P&S of Southwest, 1943; Tucson, AZ 1938; Woman's Club, El Paso, TX, 1937; PBC, 1944; Mus. New Mexico, 1942 (solo); Joseph Sartor Gal., Dallas, 1943 (solo); Salon of Seven Artists, Jackson Heights, NY, 1937 (solo); Chappell House, Denver,1942 (solo). **Work:** many portraits of prominent persons. **Comments:** Painted scenes from the life of Junipero Serra and children. Author/illustrator: "The Children's Master," 1925. **Sources:** WW53; WW47.

SEABORNE, William *[Sculptor] b.1849 / d.1917.*
Addresses: NYC.

SEABOURN, Bert Dail *[Painter, illustrator] b.1931, Iraan, TX.*
Addresses: Oklahoma City, OK. **Studied:** Oklahoma City Univ. (certificate in art); Famous Artists Schools, Westport, CT (certificate in art); Oklahoma Central State Univ. **Member:** Artists of Oklahoma, Inc. (pres., 1969); Art Directors Cl. Oklahoma City (pres., 1970); Oklahoma Art Guild (pres., 1970); Oklahoma Mus. Art; Oklahoma City Advertisers Club. **Exhibited:** Kansas Printmakers Nat., Wichita, 1961; Contemporary Am. Art Ann., Oklahoma City, 1964; Int. Petroleum Art Exhib., Tulsa, OK, 1966; Center Arts of Indian Am., Wash., DC, 1968; Eight State Painting & Sculpture Ann., Oklahoma City, 1971. Awards: purchase award, Oklahoma AC, 1969; first place, Heard Mus., 1969; second place, Five Civilized Tribes Mus., 1971. **Work:** Oklahoma Art Center, Oklahoma City; Five Civilized Tribes Mus., Muskogee, OK; Heard Mus., Phoenix, AZ; Indian Arts & Crafts Board, Wash., DC; Pacific Northwest Indian Center, Gonzaga Univ., Spokane, WA. **Comments:** Preferred media: oils, watercolors. Positions: artist & jJournalist, USN, 1951-55; art director & artist, Oklahoma Gas & Electric Co., Oklahoma City, 1955-. Publications: author/illustrator, "Indian Gallery," 1972. **Sources:** WW73.

SEABRING, Andrew T. *[Engraver] mid 19th c.*
Addresses: NYC, 1857. **Sources:** G&W; NYBD 1857.

SEABROOK, Georgette *[Painter] b.1916, NYC.*
Studied: CUA Sch. **Exhibited:** American Negro Expo, Chicago, 1940; Atlanta Univ.; YMCA Art Group, 1933; Harlem Art Workshop, 1933; NJ State Mus., Trenton, 1935; Harmon Fnd., 1936; Wanamaker Art Gal., 1938; Augusta Savage Studios, 1939; LOC, 1940. **Work:** NYPL. **Sources:** Cederholm, *Afro-American Artists.*

SEABURY, Charles F. *[Portrait painter] b.1815, Newport/Tiverton, RI.*
Addresses: In New Bedford, MA, 1839-41. **Comments:** Listed as portrait painter in *New Bedford City Directory* and advertised in *New-Bedford Mercury*, 1839. **Sources:** Blasdale, *Artists of New Bedford*, 165.

SEABURY, David *[Painter] mid 20th c.*
Addresses: NYC. **Exhibited:** S. Indp. A., 1924. **Comments:** Possibly Seabury, Dr. David, b. 1886, Boston, MA-d. 1960, Tucson, AZ. **Sources:** Marlor, *Soc. Indp. Artists.*

SEABURY, Roxoli (Merriam) (Mrs.) *[Painter, craftsperson, teacher] b.1874, Massachusetts / d.1960, Laguna Beach, CA.*
Addresses: Colorado Springs, CO; Laguna Beach, CA. **Studied:** D.W. Ross; R. Reid; Knirr, Munich; BMFA Sch.; AIC; PIA Sch. **Member:** Laguna Beach AA. **Exhibited:** S. Indp. A., 1923. **Comments:** Position: affiliated with Broadmoor Art Acad. **Sources:** WW25; Hughes, *Artists in California*, 503.

SEACORD, Alice N(icholson) (Mrs. Jay G.) *[Painter] b.1888, Milwaukee, WI.*
Addresses: Milwaukee, WI; Chicago, IL. **Studied:** Chicago Acad. FA; Syracuse Univ. College FA; Milwaukee AL; Van Amburg Studio, Chicago. **Member:** All-IIlinois SFA; Milwaukee AA. **Exhibited:** S. Indp. A., 1931; Salons of Am., 1934. **Sources:** WW40.

SEAFORD, John A. *[Painter] 19th/20th c.*
Addresses: Spiceland, IN. **Exhibited:** Boston AC, 1881. **Sources:** WW06; *The Boston AC.*

SEAGER *[Portrait artist, working in bronze] early 19th c.*
Addresses: New Bedford & Salem, MA, 1834. **Comments:** In 1840 one Scager of London (and lately of the United States) advertised in Halifax (NS) that he painted portraits and miniatures and executed portraits in bronze; this was probably the same artist. **Sources:** G&W; Belknap, *Artists and Craftsmen of Essex County*, 22; Piers, "Artists in Nova Scotia," 146-47.

SEAGER, Catharine *[Artist] 19th/20th c.*
Addresses: Wash., DC, active 1901. **Sources:** McMahan, *Artists of Washington, DC.*

SEAGER, Charles See: **BEAGER, Charles**

SEAGER, Edward *[Portrait and landscape painter] b.c.1809, Maidstone, Kent, England / d.1886, Wash., DC.*
Addresses: Boston, 1840's; Baltimore, MD, 1871. **Exhibited:** Boston Atheneum, 1847-48. **Comments:** Came to Canada c.1832, and traveled and sketched in Panama and Cuba in the 1830s. He was living in Boston in 1838. In 1844 he became drawing master at the English High School, where the sculptor John Rogers was one of his pupils (see entry). He became the first professor of drawing and drafting at the U.S. Naval Academy, Annapolis, 1850-c.1867. He sketched on trips along the East coast, including NH, and traveled to Western Virginia. **Sources:** G&W; Swan, BA; Boston CD 1845-50; *Catalogue of the Past and Present Members of the English High School of Boston*, [3]. More recently, see Campbell, *New Hampshire Scenery*, 137-38; Wright, *Artists in Virginia Before 1900*.

SEAGER, (Miss) *[Portrait and miniature painter] mid 19th c.*
Addresses: NYC, 1833-36; Utica, NY,1839-40. **Exhibited:** NAD, 1833-40. **Comments:** Her address in New York City and Utica was the same in both places as that of Mrs. Sarah Seager, probably her mother. **Sources:** G&W; Cowdrey, NAD; Dunlap, *History.*

SEAGER, Sarah (Mrs.) *[Miniature and portrait painter] mid 19th c.*
Addresses: NYC, 1833-36; Utica, 1839-40. **Exhibited:** NAD. **Comments:** This may be the Mrs. Seager of London who exhibited at the Royal Academy in 1827. Miss -- Seager, presumably her daughter, lived with her in NYC and Utica. **Sources:** G&W; NYCD 1833-36; Cowdrey, NAD; Utica CD 1839; Graves, *Dictionary.*

SEAGER, William S. See: **SEGAR, William S.**

SEALEY, Alfred *[Line engraver] b.c.1815, New York State / d.c.1868.*
Addresses: NYC, active 1838-68. **Comments:** About 1858-60 he was with the firm of Sealey & Smith, for which his brother Benjamin T. Sealey was an agent. After1860 Alfred worked for the American Bank Note Company. Stauffer reported that Sealey was said to have died in Canada c.1862, but he was listed in NYC directories until 1868. **Sources:** G&W; 8 Census (1860), N.Y., LXI, 771; NYCD 1838-68; Cowdrey, NAD; Stauffer; Rice, "Life of Nathaniel Jocelyn."

SEALEY & SMITH *[Engravers] mid 19th c.*
Addresses: NYC, 1858-60. **Comments:** Alfred Sealey and Charles H. Smith, engravers, and Benjamin T. Sealey, agent. **Sources:** G&W; NYBD and CD 1858; Stauffer.

SEALY, Alfred See: **SEALEY, Alfred**

SEAMAN, Charles *[Portrait and miniature painter]* d.Before 1870, Maysville, KY.
Addresses: NYC, c.1831-33; Albany, 1834-35; Chambersburg, PA; Maysville, KY, 1839-. **Comments:** Handicapped from birth, he is said to have worked with his toes as well as with his hands. **Sources:** G&W; Information cited by Groce & Wallace as being courtesy Georgia M. Palmer, West Chester (PA), great-great-granddaughter of the artist; NYCD 1831-33; Albany CD 1834-35; Bolton, *Miniature Painters.*

SEAMAN, Drake F. *[Painter]* 20th c.
Addresses: Williams, AZ. **Studied:** Kachina Art School, 1959-63, with Jay Datus; also murals with Ray Strong, 1970. **Exhibited:** Palace Arts & Sciences, San Francisco, 1970; Santa Barbara Mus. Art, 1970; O'Brien's Art Emporium, Scottsdale, AZ, 1970-71; Troys Cowboy Art Gal., Scottsdale, 1971-72; Jamison Gal., Tucson, AZ, 1972; Dan May, Tempe, AZ, 1970s. **Work:** commissions: landscape mural, Seventh Day Adventist Church, Santa Barbara, CA. **Comments:** Preferred media: oils. Teaching: landscape instructor, Brooks FAC, Santa Barbara, 1969-70. **Sources:** WW73; Bob Austin, *Reflections on Oil* (Austin Gallery, 1970).

SEAMAN, Emery *[Portrait painter]* mid 19th c.
Addresses: Boston, c.1849-53; NYC, 1857-59. **Sources:** G&W; Boston BD 1849, 1853; NYBD 1857-59.

SEAMAN, Henry *[Listed as "artist"]* b.c.1824, NYC.
Addresses: NYC, active 1860. **Comments:** A native of NYC, living there in 1860 with his wife and two children, also born in New York. **Sources:** G&W; 8 Census (1860), N.Y., LXII, 213.

SEAMAN, Mary *[Painter]* mid 20th c.
Addresses: Brooklyn, NY, 1924. **Studied:** ASL. **Exhibited:** S. Indp. A., 1924; AIC, 1934. **Sources:** Falk, *AIC.*

SEAMANS, F. M. *[Painter]* 20th c.
Addresses: Cleveland, OH. **Sources:** WW08.

SEARCY, Elisabeth *[Painter, etcher, teacher, writer, lecturer]* mid 20th c.; b.Memphis, TN.
Addresses: Memphis, TN. **Member:** SSAL; Wash. AC; CAA. **Exhibited:** Arch. Lg.; NOMA; Brooks Mem. Art Gal.; Sulgrave Club, Wash., DC, 1941 (solo). **Work:** MMA; Mus. City of NY; LOC; Helena (AR) Mus. Art; PC; Brooks Mem. Art Gal. **Comments:** Lectures: History and Romance of Etching. **Sources:** WW59; WW47.

SEARL, Helen See: **SEARLE, Helen R. (or L.)**

SEARL, Leon A. *[Cartoonist]* b.1882 / d.1919.
Addresses: Flushing, NY. **Comments:** Contributor of cartoons for the movies. Position: art editor, *Rocky Mountain News, Denver; Evening World; Evening Telegram, NYC.*

SEARLE, Alice T. *[Miniature painter]* b.1869, Troy, NY.
Addresses: NYC. **Studied:** ASL; Colarossi Acad.; Mme. Debillemont-Chardon, Paris. **Member:** Brooklyn AG. **Exhibited:** St. Louis Expo, 1904 (bronze medal); AIC. **Sources:** WW25.

SEARLE, Cyril *[Music teacher and amateur artist]* early 19th c.
Comments: Made a view of Augusta (ME) in 1823. **Sources:** G&W; North, *History of Augusta,* frontis. and 445.

SEARLE, George *[Heraldic painter]* b.c.1751 / d.1796.
Addresses: Newburyport, MA. **Comments:** He was a nephew of John Gore and cousin of Samuel Gore and probably worked with Edward Bass, who succeeded to Searle's business. **Sources:** G&W; Bowditch, "Early Water-Color Paintings of New England Coats of Arms," 185-87, figs. 7 and 8.

SEARLE, Helen R. (or L.) *[Still-life painter]* b.1830, Burlington, VT / d.1884, Jacksonville, IL.
Addresses: Rochester, NY, c.1843-66; Batavia, NY, 1867; Écouen, France, 1881; Jacksonville, IL, 1884. **Studied:** still-life painting with Johann W. Preyer in Düsseldorf, late 1860s. **Exhibited:** Babies Hospital Relief Bazaar, 1863; NAD, 1866-83; Paris Salon, 1879. **Work:** Nat. Mus. Am. Art, Smithsonian.

Comments: Her still life compositions often include fruit on marble ledges, with silver, porcelain, and glassware. Searle also created portraits, landscapes, and animal paintings. She traveled extensively, and was in Düsseldorf and Wash., DC in 1872. She married painter James W. Pattison in 1876, and they lived for six years in a small artists' colony in France. Teaching: Bryan Female Seminary, Batavia, NY, before 1870. **Sources:** G&W; Ulp, "Art and Artists in Rochester;" Naylor, NAD; *For Beauty and for Truth,* 82 (w/repro.); Petteys, *Dictionary of Women Artists;* Tufts, *American Women Artists,* cat. no. 89.

SEARLE, John *[Watercolor artist]* early 19th c.
Addresses: NYC, active 1822. **Comments:** He painted a view of the interior of the Park Theatre in NYC during a performance in November 1822, with portraits of noted citizens. This may have been the John Searle listed as a wine merchant in NYC directories for 1822 and 1823. **Sources:** G&W; Stokes, *Iconography,* III, 576; NYCD 1822-23.

SEARLE, Mary *[Painter]* b.1858, Osborn, IL.
Addresses: Alva, OK. **Studied:** PAFA; ASL; Acad. Colarossi; Thomas Eakins, Kenyon Cox. **Exhibited:** PAFA; AIC; Iowa Art Salon, 1928 (prize), 1929 (prize), 1931 (prize), 1934 (prize). **Comments:** Lived in Iowa 1899-1938. **Sources:** Ness & Orwig, *Iowa Artists of the First Hundred Years,* 187.

SEARLE, Ronald *[Illustrator, cartoonist, designer]* mid 20th c.; b.Cambridge, England.
Work: Shelburne (VT) Mus. **Comments:** Illustrator of over 40 books including "By Rocking Chair Across America," "From Frozen North to Filthy Lucre," "Searle's Cats," "The Square Egg," "The Great Fur Opera," "Annals of the Hudson's Bay Company," and "The Addict". Searle designed sets for films and contributed illustrations to American, French and German magazines. He also produced a cartoon entitled "John Gilpin". **Sources:** Muller, *Paintings and Drawings at the Shelburne Museum,* 124 (w/repro.).

SEARLES, Charles Robert *[Painter, educator]* b.1937, Phila., PA.
Addresses: Phila., PA. **Studied:** Fleisher Art Mem., Phila.; PAFA (Cresson traveling scholar, 1971 & Ware traveling awards, 1973). **Member:** Phila. North Arts Council. **Exhibited:** Afro American Artist 1900-69, Phila. Civic Center, 1969; New Black Artist, BM, 1969; Univ. Florida, 1970; PMA, 1970; State Armory, Wilmington, DE, 1971; Contemporary Black Artist in America, WMAA, 1971; All Phases Due II, Studio Mus., New York, 1971; Bryn Mawr College, Phila., 1972 (solo). Awards: Drake Press Award, 1970; Quaker Storage Co. Prize, 1973. **Work:** PAFA. Commissions: mural, Ife Afro-Am. Mus., Philadelphia, 1973. **Comments:** Preferred media: acrylics, watercolors. Positions: bd. mem., Philadelphia Northern Arts Council, 1971-; mem. exhibition committee, Peale Galleries, PAFA, 1972. Teaching: lecturer drawing, PMA, summer 1970; art instructor, Model Cities Cultural Arts, 1970-. **Sources:** WW73; Cederholm, *Afro-American Artists.*

SEARLES, Stephen *[Sculptor, instructor, painter]* b.1914, Leonia, NJ.
Addresses: Leonia, NJ; Boston, MA. **Studied:** ASL, with George Bridgman, Frank V. DuMond & Reginald Marsh; Grand Central School Art, NYC, with Georg Lober; A. Lee; W. Hancock, also with Gelin, Fontainebleau, France; NAD. **Member:** AFA; Copley Soc.; New England SS; NSS; AAPL; Rockport AA; Am. Vet. Soc. Artists. **Exhibited:** CGA, 1943; Grand Central Art Gal., 1937, 1938; Montclair AM, 1938-52; Guild Hall, East Hampton, 1939 (prize); Ogunquit AC, 1938 (prize); CPLH, 1945; All. Artists Am.; Copley Soc., Boston; Sculpture Exhibs., Grassy Gal., Biarritz, France, 1946; Palace of Fontainebleau, France, 1949; Salmagundi Cl., New York, 1952 (best sculpture awards); Rockport AA, 1968 (award); Springfield (MA) Mus. Art, 1965 & 1969 (Soc. Acad. Artists Award); Guild of Boston Artists, MA, 1972; East Rockport AA, 1972. **Work:** Commissions: Biarritz, France; Army Medical Mus., Wash., DC; Our Lady of Good Voyage statue, Church of

Our Lady of Good Voyage, Gloucester, MA; Thar She Blows whaler & other sculptures made of Gloucester fishermen; sculpture for African Hall, Am. Mus. Natural History, New York; plus many portrait busts in bronze of well-known people. **Comments:** Preferred media: bronze, stone. Positions: medical illustrator, Army Med. Mus., Wash., DC, 1942-43; art dir., Ninth Service Command, 1944-45. Teaching: instructor of drawing & sculpture, Biarritz Am. Univ., 1945-46; instructor life drawing & sculpture, Newark School Fine & Industrial Art, 1950-53; instructor life drawing, Vesper George School Art, Boston, 1962-. **Sources:** WW73; WW47.

SEARLES, Victor A. *[Illustrator] 19th/20th c.*
Addresses: Boston. **Sources:** WW01.

SEARS, Benjamin Willard *[Painter] b.1846, Guilford, CT / d.1905, Pacific Grove, CA.*
Addresses: Sonora, CA; San Francisco, CA. **Member:** San Francisco AA; Olympic Club. **Exhibited:** Newhall & Co., San Francisco, 1877 (solo); San Francisco , 1882; Mark Hopkins Inst., 1903; Soc. of Calif. Pioneers, 1965. **Work:** Oakland Mus.; Calif. Hist. Soc.; Soc. of Calif. Pioneers; Calif. State Lib.; Tuolumne County Hist. Soc. **Comments:** Working as a photographer at first, he switched to oil painting in the early 1870s. His paintings appear on canvases as well as tins, wood panels, etc. Position: sketch artist, U.S. Signal Coast Survey. Specialty: nocturnes, inshore marine views, landscapes of the Sierra Nevada, Yosemite and Tuolumne County. **Sources:** Hughes, *Artists in California*, 503.

SEARS, Caroline Page *[Painter] 19th/20th c.*
Addresses: Danvers, MA. **Exhibited:** Boston AC, 1905. **Sources:** WW06; *The Boston AC.*

SEARS, Charles Payne *[Landscape painter] b.1864, NYC / d.1908, Atlantic Highlands, NJ.*
Addresses: NYC, 1880s; Atlantic Highlands, NJ. **Exhibited:** NAD, 1880-86; PAFA Ann., 1882-83, 1887-88; Brooklyn AA, 1886 (Adirondacks scene). **Sources:** Falk, *Exh. Record Series.*

SEARS, Ed *[Wood engraver] late 19th c.*
Comments: His work appeared in books published in NYC between 1859-79. **Sources:** G&W; Hamilton, *Early American Book Illustrators and Wood Engravers*, 248, 337, 475.

SEARS, Elinor Lathrop *[Pastelist, miniature painter, painter, sculptor, drawing specialist, etcher, teacher] b.1902, Hartford, CT.*
Addresses: West Hartford/Old Lyme, CT, 1925; Lyme, CT. **Studied:** P. Hale, R.F. Logan, Mora, Miller, Calder, A. Jones. **Member:** AWCS; CAFA; Lyme AA; Hartford AS. **Work:** Lyman Allyn Mus.; New London Hist. Soc. **Comments:** Born Elinor Louise Adams, she painted under the name Sears. In later years she specialized in pastel portraits of children. Publications: Elinor Sears, *Pastel Painting Step by Step* (Watson-Guptill). **Sources:** WW47; WW25 (as Elinor Louise Lathrop); add'l info. courtesy Jinna Anderson, Guilford, CT.

SEARS, Helen W. *[Painter] b.1865.*
Addresses: Phila., PA. **Exhibited:** PAFA Ann., 1885-99 (4 times). **Sources:** Falk, *Exh. Record Series.*

SEARS, John *[Illustrator] 20th c.*
Addresses: Rochester, NY. **Comments:** Affiliated with *Rochester Times.* **Sources:** WW15.

SEARS, Mary Crease *[Designer, bookbinder] b.Boston / d.1938.*
Addresses: Boston, MA. **Studied:** BMFA School; J. Domont, in Paris; R. Cervi. **Member:** Copley Soc.; Boston SAC. **Exhibited:** St. Louis Expo, 1905 (gold); Boston SAC (medal); Tercentenary FA Exh., Boston, 1930 (medal). **Work:** books bound: St. Clement's Church, Phila.; Grace Church, Colorado Springs; Gardner Mus., Boston; Harvard; Cathedral of St. John the Divine; Riverside Church, NYC; St. Martin's Church, Providence. **Sources:** WW38.

SEARS, Mary E. *[Artist] mid 20th c.*
Addresses: Boston, MA. **Exhibited:** PAFA Ann., 1940-41. **Sources:** Falk, *Exh. Record Series.*

SEARS, Marylee *[Painter] mid 20th c.*
Addresses: San Francisco, CA, 1932. **Exhibited:** Oakland Art Gal., 1933. **Sources:** Hughes, *Artists in California*, 503.

SEARS, Olga Itasca *[Painter] b.1906, Framingham, MA / d.1990, Boston, MA.*
Addresses: Boston, MA/Rockport, MA. **Studied:** New England School Design; Margaret J. Patterson (Monhegan, ME); Chas. H. Woodbury, Ogunquit School; George Demetrios, Gloucester. **Member:** Rockport AA. **Exhibited:** Gloucester Art Festival, 1953; Boston Soc. Indep. Artists, 1954; Boston Art Festival, 1954; DeCordova Mus., 1954; Portland Mus. Art,1954; Boston WCS,1958; Rockport AA, frequently; Cambridge AA, 1962; BMFA, 1968; Butler IA, 1977. **Comments:** A dedicated, demanding, and revered teacher, she taught at several schools, including Saint-Mary's-In-The-Mountains School, Littleton, NH; Museum School, Boston; Vesper George Sch., Boston, 1949-; at Monhegan, with Margaret Patterson; and the Boston Center for Adult Education, 1950-. In an effort to support her painting, she held over one hundred jobs (teaching and non-teaching) in her lifetime. **Sources:** *Charles Woodbury and His Students; Olga Sears, An Artist Remembered* (Cambridge, Mass: James Bakker Antiques, Inc., 1992); add'l info. courtesy of Selma Koss Holz, Waban, MA.

SEARS, Philip Shelton *[Sculptor] b.1867, Boston, MA / d.1953.*
Addresses: Brookline, MA. **Studied:** Harvard Law School; BMFA Sch.; & with Daniel Chester French. **Member:** NSS; Guild Boston Artists; North Shore AA; Copley Soc., Boston. **Exhibited:** PAFA Ann., 1926-31. **Work:** busts, memorials, statues: State House, Boston, MA; County Court House, NY; Harvard Varsity Club, Cambridge, MA; Am. Indian Mus., Harvard, MA; BMFA; Harvard Medical Sch., Cambridge, MA; White House, Wash., DC; Royal Acad. Art, London; parks in Manchester, MA, San Francisco, CA, and Philadelphia, PA. **Comments:** Practiced law in Boston from 1892-98; began working as a sculptor in 1919. **Sources:** WW53; WW47; P&H Samuels, 432; Falk, *Exh. Record Series.*

SEARS, Sarah C(hoate) (Mrs. J. Montgomery) *[Painter] b.1858, Cambridge, MA / d.1935, West Goldsboro, ME.* S.C.S.
Addresses: Boston, MA. **Studied:** R. Turner; J. De Camp; D.M. Bunker; E.C. Tarbell. **Member:** NYWCC; Copley Soc., 1891; NAC; Phila. WCC; Boston WCC; Boston SAC. **Exhibited:** Brooklyn AA, 1885; Boston AC, 1885-96; PAFA Ann., 1892-99, 1902-03; AWCS, 1893 (prize); Columbian Expo, Chicago, 1893 (medal); Paris Expo, 1900 (prize); Pan-Am. Expo, Buffalo, 1901 (medal); Charleston Expo, 1902 (medal); St. Louis Expo, 1904 (medal); AIC; S. Indp. A., 1917. **Comments:** Some of her works relate to Bermuda. **Sources:** WW33; Falk, *Exh. Record Series.*

SEARS, Taber *[Painter, muralist] b.1870, Boston, MA / d.1950.* ⏁
Addresses: Paris, France; NYC. **Studied:** BMFA Sch.; NAD with Edgar M. Ward; Académie Julian, Paris with Jean Paul Laurens and Benjamin Constant, 1895-96; also with Merson. **Member:** SC; AWCS; All. Artists Am.; AAPL; NYWCC; Arch. Lg. 1899; Mural Painters; NY Mun. AS; Century Assn.; Artists Fellowship. **Exhibited:** Paris Salon, 1897, 1898; PAFA Ann., 1898-1901; NYWCC (prize); St. Louis Expo, 1904 (medal); AIC, 1911-28; AWCS, 1926 (prize); Kaja Veilleux Gal., Newcastle, ME, 1998 (solo). **Work:** Rollins College, Winter Park, FL; New York City Hall; churches in Brooklyn & Los Angeles; Chapel of the Intercession, St. Thomas' Church, St. James' Church, First Presbyterian Church, all in NYC; Trinity Church, Buffalo, NY; Choir School, NYC. **Comments:** Best known as a watercolor painter, he traveled extensively, painting in Europe and Bermuda. **Sources:** WW53; WW47; Fink, *American Art at the Nineteenth-*

Century Paris Salons, 389; Falk, *Exh. Record Series.*

SEATON, Charles H. *[Painter] b.1865, Monson, MA / d.1926.* **Addresses:** Glencarlyn, VA; Wash., DC, active 1915-26. **Studied:** self-taught. **Member:** Soc. Wash. Artists; Wash. Landscape Club. **Exhibited:** Soc. Wash. Artists, 1911-25. **Comments:** Employed by the U.S. Dept. of Agriculture. **Sources:** WW27; McMahan, *Artists of Washington, DC.*

SEATON, Walter Wallace *[Illustrator] b.1895, San Francisco, CA / d.1957.* **Addresses:** Woodstock, NY. **Studied:** Calif. Inst. Design, San Francisco; Univ. California; ASL. **Member:** SI; Woodstock AA. **Work:** Woodstock AA. **Comments:** Illustrator, *Cosmopolitan, Saturday Evening Post, Ladies Home Journal, Collier's* magazines. **Sources:** WW59; WW47; Woodstock AA.

SEAVER, Elizabeth *[Sculptor, teacher] b.1899, Michigan / d.1970, Crystal, MI.* **Addresses:** Cleveland, OH. **Exhibited:** Cleveland Mus. Art, 1934 (prize), 1936 (prize), 1939 (prize). **Comments:** Position: teacher, Cleveland Mus. Art. **Sources:** WW40.

SEAVER, Esther Isabel (Mrs. R.H. Burno) *[Educator] b.1903, Beloit, WI / d.1965.* **Addresses:** Chicago 13, IL. **Studied:** Beloit College (A.B.); Radcliffe College (A.M., Ph.D.); & with A.K. Porter & Paul Sachs. **Member:** AFA; CAA; Am. Assn. Univ. Prof.; Am. Inst. Archaeology. **Comments:** Position: hd., art dept., 1930-46, prof. art, 1935-46, Wheaton (IL) College; educ. dir., Wadsworth Atheneum, Hartford, CT, 1946-50; dir., Dayton (OH) AI, 1950-56. Editor: "Patron and Artist: Pre-Renaissance and Modern," symposium, 1936. Lectures: Scandinavian art; modern painting. Wrote museum catalogues: "Thomas Cole (1801-48): One Hundred Years Later," Wadsworth Atheneum and WMAA, 1948; "The Life of Christ," Wadsworth Atheneum, 1948; "City by the River and the Sea: Five Centuries of Skylines," Dayton AI, 1951; "Flight, Fantasy, Faith and Fact," Dayton AI, 1953. Contributor to art publications. **Sources:** WW59.

SEAVER, Hugh D. *[Painter] b.1896, Cleveland, OH / d.1959, Grayling, MI.* **Addresses:** Cleveland, OH. **Member:** Cleveland SA. **Sources:** WW27.

SEAVER, James T. *[Sketch artist] 19th c.* **Work:** Peabody Mus., Salem, MA (pencil drawing). **Comments:** Active in Mobile, AL, during the Civil War. **Sources:** Brewington, 349.

SEAVEY, George W. *[Painter] b.1841 / d.1913.* **Addresses:** Boston, MA, 1883-84. **Exhibited:** Boston AC, 1873-79; NAD, 1883, 1884. **Sources:** WW15; *The Boston AC.*

SEAVEY, Julian Ruggles *[Painter, illustrator, teacher] b.1857, Canada (or Boston, MA) / d.1940, Hamilton, Ontario, Canada.* **Addresses:** Hamilton, 1884; London, Ontario, 1884; Hamilton, 1908. **Studied:** Paris, Rome and Germany. **Comments:** Early works were mainly trompe l'œil and landscapes; later historical and book illustrations and flower studies. Seavey traveled in the Am. Northwest. Positions: art director, Hellmuth Ladies College, London, Ontario, 1884; Alma College, St. Thomas; art education, Hamilton, 1908. **Sources:** P&H Samuels, 432.

SEAVEY, Lafayette W. *[Painter] late 19th c.* **Addresses:** NYC, active, 1885-89. **Exhibited:** Boston AC, 1886-87. **Sources:** *The Boston AC.*

SEAVEY, Lilla B. *[Painter] late 19th c.* **Addresses:** Denver, CO, 1898. **Exhibited:** NAD, 1898; Trans-Mississippi Expo, Omaha, 1898. **Sources:** WW98.

SEAVEY, Thomas *[Figurehead carver] mid 19th c.; b.Bangor, ME.* **Addresses:** Bangor, ME. **Comments:** By 1843 he was working in partnership with his son, William L. Seavey (see entry). **Sources:** G&W; Harris, "American Ship Figureheads," 11; Pinckney,

American Figureheads and Their Carvers, 142, 200.

SEAVEY, William L. *[Figurehead carver] mid 19th c.* **Addresses:** Bangor, ME. **Comments:** He was working with his father, Thomas Seavey (see entry), in 1843. **Sources:** G&W; Pinckney, *American Figureheads and Their Carvers,* 200.

SEAWELL, H(enry) W(ashington) *[Painter, illustrator, teacher] b.1865, San Francisco, CA / d.1945, San Fran.* **Addresses:** San Francisco. **Studied:** San Francisco Sch. of Des.; Paris, with Laurens, Constant. **Member:** Paris AA; Bohemian Club, San Francisco AA; Pacific AA; Soc. for Sanity in Art. **Exhibited:** Paris Salon, 1895; Mark Hopkins Inst., 1906; PPE, 1915; San Francisco AA, 1916; Bohemian Club, 1922, 1935, 1939; CPLH, 1945. **Comments:** Position: art instructor, UC, 1906-16; teacher, Lowell High School, San Francisco. **Sources:** WW33; Hughes, *Artists in California,* 503; Fink, *American Art at the Nineteenth-Century Paris Salons,* 389.

SEAWRIGHT, James *[Sculptor] b.1936, Jackson, MS.* **Addresses:** NYC. **Studied:** ASL, with José De Creeft, 1961-62. **Exhibited:** WMAA, 1966. **Work:** MMA. **Comments:** Creator of electronic sculpture. Positions: stage technician, with choreographer Alwin Nickolais, 1962-63; technician, Columbia-Princeton Electronic Music Ctr., 1963-. **Sources:** Baigell, *Dictionary;* Falk, *WMAA.*

SEBALD, Hobarth *[Engraver] b.1826, Germany.* **Addresses:** Philadelphia in 1860 and after. **Comments:** His wife and two children were all born in Pennsylvania. *Cf.* Hugo Sebald. **Sources:** G&W; 8 Census (1860), Pa., LVI, 10.

SEBALD, Hugo *[Wood engraver and designer] late 19th c.* **Addresses:** Philadelphia, 1855-71. **Comments:** *Cf.* Hobarth Sebald. **Sources:** G&W; Phila. CD 1855-71.

SEBERHAGEN, Ralph H. *[Painter] mid 20th c.* **Addresses:** NYC. **Exhibited:** PAFA, 1934, 1935, 1938; AWCS-NYWCC, 1939. **Sources:** WW40.

SEBOLD, Howard R. *[Painter] mid 20th c.* **Addresses:** Bronxville, NY. **Exhibited:** AWCS, 1936, 1937; NYWCC, 1936, 1937; AWCS-NYWCC, 1939. **Sources:** WW40.

SEBREE, Charles *[Painter, illustrator] b.1914, Madisonville, KY.* **Studied:** AIC. **Exhibited:** AIC, 1935-42; Internat'l WC Soc., 1935; Katharine Kuh Gal., Chicago, 1936; Federal Art Project Gal., Chicago, 1937; Breckenridge Gal., 1938; Grace Horne Gal., Boston, 1939; American Negro Expo., Chicago, 1940; Howard Univ., 1941; Inst. of Modern Art, Boston, 1943; Roko Gal., 1949; South Side Community Art Center, Chicago, 1941, 1945; NY City Col., 1967; James A. Porter Gal., 1970. **Work:** Renaissance Soc. Col.; Univ. of Chicago; Thornton Wilder Col.; McBride Col., Chiacago; Nat'l Archives; NYPL; Atlanta Univ.; priv. colls. WPA artist. **Sources:** Cederholm, *Afro-American Artists.*

SEBRING, F. W. (Mrs.) *[Pastelist] late 19th c.* **Addresses:** Active in Saginaw, MI. **Exhibited:** Michigan State Fair, 1875. **Sources:** Petteys, *Dictionary of Women Artists.*

SEBRING, Frank A. *[Craftsperson] b.1936.* **Addresses:** Sebring, OH. **Comments:** One of the founders (1887) of the nationality known Potteries of Sebring, Ohio.

SEBRING, William E. *[Painter] mid 20th c.* **Addresses:** NYC. **Exhibited:** WMAA, 1958. **Sources:** Falk, *WMAA.*

SEBRON, Hyppolite Victor Valentin *[Diorama and landscape painter] b.1801, Caudebec, France / d.1879, Paris.* **Addresses:** New Orleans,1851-52; NYC, 1854. **Studied:** Louis Jacques Mandé Daguerre; Léon Cogniet. **Exhibited:** Paris Salon, 1831-78; Royal Bazaar, London, 1833; Commercial Reading Room, 1847; Faivre's music store, 1852; World's Expo., Paris, 1855; NAD, 1854. **Comments:** Despite having only one arm, he enjoyed a long and successful career. Sebron was noted for exterior and interior views taken from his travels through Europe

(1831-48), Europe and Asia (1867-77) and the U.S. He spent the years 1849 to 1855 in the United States, principally as a painter of dioramas. **Sources:** G&W; Thieme-Becker; Delgado-WPA cites *Courier,* May 12, 1852, and *Bee,* May 11, 1852; NYBD 1854; Cowdrey, NAD. More recently, *Encyclopaedia of New Orleans Artists,* 346.

SECARNS, Robert *[Illustrator] 19th c.*
Addresses: Brooklyn, NY. **Comments:** Affiliated with *Brooklyn Life.* **Sources:** WW98.

SECKAR, Alvena Vajda (Mrs. Alvena Bunin) *[Painter, writer, designer, illustrator, lecturer] b.1916, McMechen, WV.*
Addresses: NYC; Pompton Lakes, NJ. **Studied:** PMSchIA; NY Univ. (B.A., M.A.), and with Walter Emerson Baum, Sol Wilson, Phil Reisman. **Member:** CAA; F., Princeton, 1938; F., Inst. A. & Archeology, Paris, 1939; Nat. Lg. Am. Pen Women. **Exhibited:** Allentown, Pa., 1938 & 1950 (solo); Univ. Pa., 1935-37; Cohn Gal., 1944 (solo); Webster Lib., 1945 (solo); Parkersburg, W.Va., 1946; Miss. AA, 1946; Mint Mus. A., 1946; Pittsburgh A. Cl., 1947 (solo); Irvington A. Mus., 1949; Phila. Y.M.H.A., 1950; Barzansky Gal., 1952 (solo); Montclair A. Mus., 1955, 1957 (prize); Hackensack A. Cl.; Newark A. Cl. Award: Herald Tribune Book Festival. **Comments:** Author: "Zuska of the Burning Hills"; "Trapped in the Old Mine," 1953; "Misko of the Moving Hills," 1956. Contributor: *L'udovy Dennik,* (Slovanik newspaper) Pittsburgh. Position: cur. textiles, CUA Sch., 1941-42; des., Saks Fifth Ave., NYC 1946. **Sources:** WW59; WW47.

SECKBACH, Amalie *[Painter] b.1870 / d.1944.*
Exhibited: AIC, 1936. **Sources:** Falk, *AIC.*

SECKEL, Joshua C. *[Painter of small portraits and miniatures] mid 19th c.*
Addresses: Philadelphia; 1838-50. **Sources:** G&W; Gillingham, "Notes on Philadelphia Profilists," 516; Phila. BD 1850.

SECKEL, Paul Bernhard *[Painter, graphic artist] b.1918, Osnabrück, Germany.*
Addresses: New Rochelle, NY. **Studied:** London Cent. Sch. A. & Cr.; Univ. Buffalo (B.F.A.); Yale Univ. (M.F.A.). **Member:** Westchester Art Assn. **Exhibited:** Recent Drawings, USA, MoMA, 1956; Drawings by Invitation, Flint Inst. Art, 1957; Exhib. of Paintings Eligible for Purchase, Am. Acad. Arts & Lett., 1963; plus various Audubon Artists Ann.; Alessandro Oliva, NYC, 1970s. Awards: Emily Lowe Award, 1963. **Comments:** Preferred media: acrylics, oils. Publications: auth., "How to Make Original Color Lithographs--a Manual for Professional Artists," 1970. **Sources:** WW73.

SECKLER, Dorothy Gees *[Art critic, lecturer] b.1910, Baltimore, MD.*
Addresses: Bronxville, NY. **Studied:** Teachers Col, Columbia Univ. (B.S. art educ.); Md. Inst. Art, traveling scholar, 1931; New York Univ.; also in Europe. **Exhibited:** Awards: Am. Fedn. Arts Award for art criticism, 1954. **Work:** MoMA. **Comments:** Positions: assoc. ed., *Art News & Art News Ann.,* 1950-55; gallery ed., Art in Am., 1955-61; spec. contribr. fine arts, MD *Med. News Mag.,* 1957-61. Teaching: lect., Modern Art, MoMA, 1945-49; part-time instr., NYU, 1947-52; lect. & instr., City Col., NY, 1957-60, Pratt Inst., 1960-61. Publications: co-auth., "The Questioning Public," MoMA, 1949; co-auth., "Modern Art Section," in: *Famous Artist's Course,* 1953; co-auth., *Figure Drawing Comes to Life,* 1957; contr., *Encylcl. World Art,* 1959; contr., numerous articles to *Art News;* reviews on exh. and monographs. **Sources:** WW73.

SECOR, David Pell *[Artist, critic, and collector] b.1824, Brooklyn, NY / d.1909, Bridgeport, CT.*
Sources: G&W; *Art Annual,* VII, obit. He gave Stanford Univ. the Hervey Herborium Collection and the Bridgeport Scientific Society a collection of Indian relics.

SECORD, M(atilda) *[Painter] early 20th c.*
Addresses: NYC. **Exhibited:** S. Indp. A., 1917. **Comments:** Also appears as McCord. **Sources:** Marlor, *Soc. Indp. Artists.*

SECUNDA, Arthur See: **SECUNDA, (Holland) Arthur**

SECUNDA, (Holland) Arthur *[Painter, sculptor] b.1927, Jersey City, NJ.*
Addresses: NYC. **Studied:** NY Univ.; ASL; Acad. de la Grande Chaumière; Acad. Julian; with Zadkine & Lhote, Paris, France, 1948-50; Inst. Meschini, Rome; also study in Mex. **Exhibited:** solo shows, La Jolla Art Mus., Calif, 1966; Gal. Richard Foncke, Gent, Belg., 1968, Fleischer-Anhalt Gal., Los Angeles, Calif, 1968, Konstsalongen Kavaletten, Uppsala, Sweden, 1971, Galerie Leger, Malmo, Sweden plus many others. Awards: Tamarind fel., Calif., 1970 & Mex., 1972. **Work:** Smithsonian Inst.; Nat. Collection Fine Arts, Wash., DC; MoMA; AIC; Brooklyn Mus, NY; plus many others in USA, Sweden, Belg. & Switz. **Comments:** Dealer: San Francisco, CA. **Sources:** WW73.

SEDERS, Francine Lavinal *[Art dealer] b.1932, Paris, France.*
Addresses: Seattle, WA. **Studied:** Univ. Paris Law Sch.; Univ. Wash. (M.C.S.). **Comments:** Positions: mgr., Otto Seligman Gal., Seattle, Wash., 1965-66, mgr-owner, 1966-70; mgr.-owner, Francine Seders Gal., Seattle, 1970-. Specialty of gallery: contemporary paintings, sculpture and graphics. **Sources:** WW73.

SEDGEWICK, Anne Douglas *[Painter] late 19th c.*
Exhibited: SNBA, 1896. **Sources:** Fink, *American Art at the Nineteenth-Century Paris Salons,* 389.

SEDGEWICK, J(ane) M(inot) *[Painter] 19th/20th c.*
Addresses: Stockbridge, MA, active 1889-1906. **Exhibited:** Boston AC, 1889-1902; AIC, 1889. **Sources:** WW06; Falk, *Exh. Record Series.*

SEDGEWICK, Martha Moran *[Portrait painter, teacher] d.1942.*
Addresses: Richmond, VA. **Work:** Valentine Mus., Richmond, VA (portrait of her father, Gen. John R. Sedgewick). **Comments:** Position: teacher, Woman's College, Richmond, 1895-96. **Sources:** Wright, *Artists in Virginia Before 1900.*

SEDGWICK, Frances See: **SEDGWICK, Francis Minturn**

SEDGWICK, Francis Minturn *[Collector, sculptor] b.1904, NYC / d.1967, Santa Barbara, CA.*
Addresses: Los Olivos, CA. **Studied:** Harvard University; Trinity College, Cambridge University; NYC with DeWitt Lochman; sculpture with Herman MacNeil. **Work:** Triton Mus., Santa Clara, CA; Laurel Hill "Pioneer Monument", Colma, CA; American Field Service Monument, Darenth, England; equestrian statue, Earl Wilson Showgrounds, Santa Barbara; Robert Frost Plaque, San Francisco; Cabrillo Senior High School, Lompoc, CA; "Pan", Dumbarton Oaks, Wash., DC. **Comments:** Positions: vice-pres., Santa Barbara Museum of Art; vice-chairman, Art Affiliates, University of California, Santa Barbara. Collection: 15th, 16th and 17th century Italian, German, Flemish, Dutch paintings; collection was donated to the University of California, Santa Barbara. **Sources:** WW66; Hughes, *Artists in California,* 503; P&H Samuels report that Sedgwick was living in Santa Ynez Valley, CA in 1968, 432.

SEDGWICK, J. *[Artist] early 20th c.*
Addresses: Wash., DC, active 1916. **Work:** watercolors, U.S. Ntl. Arboretum; Dept. Fruit Lab., Beltsville, MD. **Comments:** Illustrator with the U.S. Dept. of Agr. **Sources:** McMahan, *Artists of Washington, DC.*

SEDGWICK, Jane Minot See: **SEDGEWICK, J(ane) M(inot)**

SEDGWICK, John Popham, Jr. *[Scholar, writer, educator] b.1925, Cambridge, MA.*
Addresses: Greensboro, NC. **Studied:** Williams College (A.B.); Harvard Univ. (M.A., Ph.D.). **Exhibited:** Awards: Fulbright Fellowship, Paris, 1951-52; Ford Foundation Teaching Internship, Columbia Univ., 1953-54. **Comments:** Positions: teacher, Columbia Univ. & Hunter College, NY; art prof., University of

North Carolina, Greensboro, NC, 1962-. Author: "Art Appreciation", 1959; "Structure and Evolution of the Major Cultures", 1962; "An Illustrated History of Art" (with E. M. Upjohn), 1963. Contributor: articles to *Art News, Encyclopedia Americana,* and others. **Sources:** WW66.

SEDGWICK, Susan Anne Livingston Ridley (Mrs. Thomas) *[Painter] b.1789 / d.1867.*
Addresses: Albany, NY c.1808 -21; Stockbridge, MA. **Work:** Mass. Hist. Soc. **Comments:** She painted a miniature of a liberated slave in 1811. She was also the author of a number of books for children and young people. **Sources:** G&W; WPA (Mass.), *Portraits Found in Mass.,* no. 1446; DAB, under Theodore Sedgwick.

SEDLIN, Jacob See: **SELDIN, Jacob**

SEDSWICK, M. E. *[Painter] mid 20th c.*
Addresses: Chicago area. **Exhibited:** AIC, 1945. **Sources:** Falk, *AIC.*

SEDULA, Sonia *[Painter] mid 20th c.*
Addresses: NYC. **Exhibited:** PAFA Ann., 1953. **Sources:** Falk, *Exh. Record Series.*

SEE, Ella E. *[Painter, teacher] early 20th c.*
Addresses: Rochester, NY, c.1907. **Member:** Rochester AC. **Sources:** WW21.

SEE, Imogene *[Painter] b.1848, Ossining, NY / d.1940, Ocean Grove, NJ.*
Addresses: Active in Nebraska, 1885; Port Chester, NY. **Comments:** Painted prairie dwellings in the West. **Sources:** Petteys, *Dictionary of Women Artists.*

SEE, Salvator *[Artist] b.c.1822, England.*
Addresses: NYC, 1850. **Comments:** Of his children, John (4) was born in Maryland, Steven (2) in England, and Rosina (9 months) in New York. **Sources:** G&W; 7 Census (1850), N.Y., LI, 54.

SEEBERGER, Pauline Bridge (Mrs. Roy Vernon Sowers) *[Painter, block printer, engraver] b.1897, Chicago.*
Addresses: San Francisco. **Studied:** École Français; J. Despujols, Rome; G. Rose in California; Sch. Decorative Design, Boston. **Comments:** Also known as Pauline Sowers Gibberd. **Sources:** WW40; Petteys, *Dictionary of Women Artists.*

SEEBOLD, Frederic William Emile (W.E.) *[Art dealer, engraver, printer] b.1833, Lachem, Hannover, Germany / d.1921, New Orleans, LA.*
Addresses: New Orleans, active c.1865-1920. **Member:** founding member of: Southern Art Union, Artist's Assoc. of N.O, NOAA. **Comments:** Came to U.S. as a young man. He fought for the Confederacy during the Civil War. For over half a century he was a prominent dealer in New Orleans, and in his galleries were held exhibitions of work by all the local artists and by many visiting artists of note. He was the first print dealer to introduce the photogravure process. Father of Herman Boehm De Bachelle Seebold and Marie Madeleine Seebold Molinary (see entries). **Sources:** *Encyclopaedia of New Orleans Artists,* 346.

SEEBOLD, Herman Boehm De Bachelle *[Sketch artist, painter, primarily a physician] b.1875, New Orleans, LA / d.1950, New Orleans.*
Addresses: New Orleans, active 1906-1907. **Comments:** Drew illustrations for an issue of the "Illustrated Sunday Magazine" of the "Daily Picayune." He created watercolor and pencil illustrations of French Quarter buildings and courtyards for his articles in the New Orleans American, 1915 and was the author of "Old Louisiana Plantation Homes and Family Trees." Son of F. W. Seebold (see entry), brother of Marie Madeleine Seebold Molinary (see entry). **Sources:** *Encyclopaedia of New Orleans Artists,* 346.

SEEBOLD, Marie M. See: **MOLINARY, Marie Madeleine Seebold (Mrs. Andrés)**

SEEBOLD, W. E. See: **SEEBOLD, Frederic William Emile (W.E.)**

SEEDS, Elise See: **ELISE, (Elise Cavanna Seeds Armitage)**

SEEGER, Stanley, Jr. *[Collector] 20th c.*
Addresses: Frenchtown, NJ. **Sources:** WW66.

SEEGERT, Helen M. *[Sculptor] b.1907 / d.1975.*
Addresses: Santa Barbara, CA. **Exhibited:** Calif.-Pacific Int'l Expo, San Diego, 1935; GGE, 1939. **Work:** Lompoc National Park; Lompoc Veteran's Building. WPA artist. **Sources:** Hughes, *Artists in California,* 504.

SEEGMILLER, Janette *[Artist] late 19th c.*
Addresses: Active in Grand Rapids, MI, 1885. **Sources:** Petteys, *Dictionary of Women Artists.*

SEEGMULLER, Wilhelmina *[Educator, writer] b.1856, Fairview, Ontario / d.1913, Indianapolis, IN.*
Addresses: Indianapolis, IN. **Studied:** PIA School, 1894-95; Brooklyn, NY; Toronto, Ontario. **Comments:** Author: "The Applied Arts Drawing Books," "Little Rhymes for Little Readers." Positions: art teacher, Grand Rapids, MI; Allegheny, PA; art director, Indianapolis Public Schools, 1895-1913.

SEELEY, George H. *[Painter] early 20th c.*
Addresses: Stockbridge, MA, 1917. **Exhibited:** S. Indp. A., 1917. **Sources:** Marlor, *Soc. Indp. Artists.*

SEELEY, Sue *[Painter] early 20th c.*
Addresses: Chicago. **Exhibited:** AIC, 1923. **Sources:** Falk, *AIC.*

SEELIG, Grace B. *[Painter] mid 20th c.*
Exhibited: AIC, 1937. **Sources:** Falk, *AIC.*

SEELY, Florence *[Painter] 19th/20th c.*
Addresses: NYC, 1884-90. **Exhibited:** NAD, 1884-90; Brooklyn AA, 1886, 1891; AIC, 1889; PAFA Ann., 1892. **Sources:** WW01; Falk, *Exh. Record Series.*

SEELY, W(alter) Fredrick *[Painter, lecturer] b.1886, Monkton, Canada / d.1959, Los Angeles, CA.*
Addresses: Los Angeles, CA. **Studied:** Otis Art Inst., and with J.W. Smith; C.T. Wilson. **Member:** P&S of Los Angeles; Cal. A. Cl. (pres. 1957-58); A. of the Southwest; Soc. of Western Artists. **Exhibited:** nationally. CPLH, Soc. for Sanity in Art, 1945; LACMA, 1942 (med.); and numerous prizes. **Work:** ports, in private colls. **Sources:** WW59; WW33. More recently, see Hughes, *Artists in California,* 504.

SEEMAN, James *[Painter, designer, screenprinter] b.1914, Austria.*
Addresses: Richmond Hill 19, NY; Great Neck, NY. **Studied:** Pratt Inst. A.; and in Vienna. **Member:** NSMP; IDI; AID; Arch. Lg.; Nat. Soc. Int. Des.; Am. Des. Inst. **Award:** Allenan award, 1954. **Work:** murals, Eden Roc Hotel, Miami Beach; Bulova Watch Co.; Belmont Plaza Hotel, NY; Progressive Cl., Atlanta; The Texas Co.; Metropolitan Indst. Bank; sc., Americana Hotel, Miami Beach. **Comments:** Position: pres., Seeman Studios, Murals, Inc., Richmond Hill, NY, and James Seeman Designs, NYC; pres., Murals, Inc., and Art for Architecture, NYC. **Sources:** WW59.

SEEMAN, Lolita *[Painter] b.1903, Minnesota.*
Exhibited: S. Indp. A., 1936. **Sources:** Marlor, *Soc. Indp. Artists.*

SEEMAN, Mary (Mrs. Erwin W.) See: **HUNTOON, Mary (Mrs. Willis C. McEntarfer)**

SEERY, John *[Painter] 20th c.*
Addresses: NYC. **Exhibited:** Andre Emmerich Gal., 1970 & 1972; Spoleto Art Festival, Italy; 2 Generations of Lola Field Painting, Univ. Pa.; 10 Americans, Australia; solo shows, New York & Chicago. **Work:** AIC; WMAA; BMFA; Cincinnati Mus. Contemp. Art; RI Sch. Design Mus. **Sources:** WW73; Sdzeleahl, "From Creative Plumbing to Lyrical Abstraction," *New York Times,* 1970; Marandel, "La Nouvelle Peinture Abstraction

Americaine," *Opus* (1971); Ratcliff, "Painterly vs. Painted," *Art News J.* (1972).

SEETH, Frederick *[Marine painter] b.1845 / d.1929.*
Sources: Sotheby's Arcade auc. cat., 30 Mar. 1999, lot 46.

SEEVER, Robert *[Sketch artist] 19th c.*
Addresses: Delaware, OH. **Comments:** He did pencil sketches of James Kilbourne and others. **Sources:** Hageman, 122.

SEEWALD, Margaret *[Etcher, muralist, wood carver] b.1899, Amarillo.*
Addresses: Amarillo, TX. **Studied:** AIC with Allen Philbrick. **Member:** SSAL; Texas FAA; Amarillo AA. **Exhibited:** Chicago Soc. Etchers, 1933; University Oklahoma; Fifty Best Prints, NYC. **Sources:** WW40; Petteys, *Dictionary of Women Artists.*

SEFARBI, Harry *[Painter] mid 20th c.*
Addresses: Phila., PA. **Exhibited:** PAFA Ann., 1960, 1962. **Sources:** Falk, *Exh. Record Series.*

SEFF, Manuel (Mr. & Mrs.) *[Collectors] 20th c.*
Addresses: NYC. **Sources:** WW73.

SEFFEL, E. A. , Jr. *[Trompe l'œil painter] late 19th c.*
Addresses: California, 1895. **Sources:** P&H Samuels, 432.

SEFTON, William P. *[Engraver] early 20th c.*
Addresses: Wash., DC, active 1901-20. **Sources:** McMahan, *Artists of Washington, DC.*

SEGAL, Bernard *[Artist] mid 20th c.*
Addresses: Phila., PA. **Exhibited:** PAFA Ann., 1949, 1958. **Sources:** Falk, *Exh. Record Series.*

SEGAL, Dorothy (Mrs.) *[Painter, designer, teacher] b.1900, Godlevo, Russia.*
Addresses: Hartford, CT. **Studied:** BMFA Sch.; Boston Univ. **Member:** CAFA. **Exhibited:** PAFA Ann., 1932; Cooper prize, Connecticut, 1932; Corcoran Gal biennial, 1935; Mun. A. Com., NYC; Jerome Stavola Gal., Hartford, CT, 1933; S. Indp. A., 1942; Stuart A. Gal., Boston, 1945. **Comments:** Teaching: Randall Sch., Hartford, Conn., 1944-on. **Sources:** WW53; WW47; Falk, *Exh. Record Series.*

SEGAL, Evelyn Buff *[Painter] mid 20th c.*
Exhibited: Corcoran Gal biennial, 1959. **Sources:** Falk, *Corcoran Gal.*

SEGAL, George *[Sculptor, painter] b.1924, NYC.*
Addresses: North Brunswick, NJ. **Studied:** Cooper Union, 1941; Pratt Inst., 1947; NY Univ., (B.S., art educ., 1950); Rutgers Univ. (M.F.A., 1963). **Exhibited:** Hansa Gallery, solo shows, 1956 (figure paintings), 1957-59; WMAA biennials, 1959-72; Sidney Janis Gal., NYC, many solo shows since 1965; AIC, 1966 (1st prize); Mus Contemp Art, Chicago, 1968 (solo); Vancouver Art Gal., BC, 1969; Haywood Gal., London, 1969; Gal. Speyer, Paris, 1969; Walker Art Cntr., Minneapolis, 1978 (retrospective); Jewish Mus., NYC, 1998 (retrospective). **Awards:** Walter K. Gutman Fndtn. Award, 1962. **Work:** MoMA; WMAA; Hirshhorn Mus.; MoMA Stockholm, Sweden; Art Gal. Ont., Toronto; Nat. Gal. Can., Ottawa; AIC; many outdoor sites. **Comments:** Pop Art sculptor of the 1960s best known for his life-size white plaster figures, created by wrapping his models in plaster-soaked gauze. His works from the 1970s-80s continued this technique but incorporated the figures with mixed media, and placed them in "inhabited" settings. Teaching: NJ High Schs., 1957-63. **Sources:** WW73; William Seitz, *George Segal* (New York, 1972); Craven, *Sculpture in America*, 659-60; Baigell, *Dictionary;* Christopher Finch, *Pop Art: Object and Image* (Dutton, 1968); Gregory Battcock (ed), *Minimal Art: A Critical Anthology* (Dutton, 1968).

SEGAL, Jacques H. *[Painter, architect, designer, drawing specialist] b.1905.*
Addresses: Phila., PA. **Studied:** Percy Ash; Pa. State Col. **Member:** Fed. A. Workers; Phila. City Planning Commission. Cover design, Penn State Players. **Sources:** WW40.

SEGAL, Ruth *[Painter] 20th c.*
Addresses: MT Vernon, NY. **Member:** AWCS. **Sources:** WW47.

SEGAL, William C. *[Painter] mid 20th c.*
Exhibited: Salons of Am., 1935. **Sources:** Marlor, *Salons of Am.*

SEGALL, Julius G. *[Painter] b.1860, Nankei, Prussia / d.1925.*
Addresses: Milwaukee, WI. **Studied:** Munich; Karlsruhe. **Exhibited:** AIC; Acad. FA, Venice, 1887 (prize). **Comments:** Also a poet. **Sources:** WW10.

SEGAR, Elzie Crisler *[Cartoonist] b.1894, Illinois / d.1938, Orange, CA.*
Addresses: California. **Comments:** In 1919, he created the popular comic character "Popeye" for his strip, "Thimble Theater, Starring Popeye" which later became *Popeye, the Sailor Man.* After Segar's death, "Popeye" was drawn by Bill Zaboly (see entry). **Sources:** Hughes, *Artists in California*, 504; *Famous Artists & Writers* (1949).

SEGAR, William S. *[Portrait, landscape, sign, and ornamental painter] b.1823, New York / d.1887, Covington, IN.*
Addresses: Syracuse, c.1852; Indiana, c.1878-87. **Comments:** He began his career as a windowshade painter at Utica (NY) about 1844, in association with J. Wesley Segar, his father or brother. William moved to Syracuse about 1852 and by the sixties was advertising as a copier of photographs, crayon portraitist, landscape, sign, and ornamental painter. Possibly related to Mrs. Sarah Seager (see entry). **Sources:** G&W; Peat, *Pioneer Painters of Indiana*, 129, 238; Utica CD 1844-51; Syracuse CD 1853-78.

SEGEDIN, Leopold B. *[Painter] mid 20th c.*
Addresses: Chicago area. **Exhibited:** AIC, 1950-51 (prize). **Sources:** Falk, *AIC.*

SEGEL, David *[Painter] mid 20th c.*
Addresses: Chicago, IL. **Exhibited:** WMAA, 1952; PAFA Ann., 1952. **Sources:** Falk, *Exh. Record Series.*

SEGEL, (Jacob) Yonny *[Craftsman, teacher, designer, sculptor] b.1912, NYC.*
Addresses: New York 9, NY. **Studied:** Edu. All. A.Sch.; BAID; City Col. of NY (M.S. in Edu.); NY.Univ., Post-Grad. in Edu. **Exhibited:** S. Indp. A., 1933, 1942; MMA, 1942; Univ. Nebraska, 1944; New Sch. for Social Research, 1940; AFA traveling exh., 1953-56; Am. Mus. Natural Hist., 1950; American House, 1952; Florence (S.C.) Mus., 1955; St. Paul A. Gal., 1952; Brussels World's Fair, 1958 (jewelry). **Comments:** Position: instr., New School for Social Research, NYC. **Sources:** WW59.

SEGEL, Yonny See: **SEGEL, (Jacob) Yonny**

SEGER, Edward *[Painter] b.1809, Maidstone, Kent, England / d.1886, Washington, DC.*
Addresses: Boston, by 1838. **Exhibited:** Boston Athenaeum, Boston, 1847, 1848; U.S. Naval Acad., Annapolis, MD, 1986. **Work:** U.S. Naval Acad., Mus., Annapolis, MD; Old Dartmouth Hist. Soc. **Comments:** Was living in Canada by 1832. From the mid-1830s he was traveling in the U.S. His travels may be traced through his artistic work. He was in Central America, the Virgin Islands and Cuba during the late 1830s. Positions: drawing teacher, English H.S., Boston, six years; prof. drawing and drafting, mathematics, Naval Acad., Annapolis, MD, 1850-71. **Sources:** Blasdale, *Artists of New Bedford*, 166-67 (w/repros.).

SEGERSTEN, Alice H. *[Sculptor] mid 20th c.*
Exhibited: S. Indp. A., 1937. **Sources:** Marlor, *Soc. Indp. Artists.*

SEGESMAN, John F. *[Painter, illustrator] b.1899, Spokane, WA.*
Addresses: Seattle, WA. **Studied:** Univ. of Wash.; Cornish Art Sch.; American Academy of Art, Chicago. **Member:** Puget Sound Group of Northwest Painters. **Exhibited:** Frye Mus., Seattle; SAM, 1946. **Sources:** Trip and Cook, *Washington State Art and Artists.*

SEGHERS, Dominique Edouard *[Painter, draftsperson, architect] b.1848, New Orleans, LA / d.1911, New Orleans.*
Addresses: New Orleans, active 1874-86. **Comments:** Painted watercolors of New Orleans buildings used for real estate transactions. **Sources:** *Encyclopaedia of New Orleans Artists,* 348.

SEGLOVE, Ilene *[Video artist] b.1950.*
Addresses: Los Angeles, CA. **Exhibited:** WMAA, 1975, 1977. **Sources:** Falk, *WMAA.*

SEGURA, Juan Jose *[Painter] b.1901, Guadalajara, Mexico.*
Addresses: NYC. **Exhibited:** Salons of Am., 1926, 1927; S. Indp. A., 1827-28. **Sources:** Falk, *Exhibition Record Series.*

SEGUSO, Armand *[Illustrator] 20th c.*
Addresses: Tuckahoe, NY. **Member:** SI. **Sources:** WW47.

SEGY, Ladislas *[Art dealer, collector, designer, painter, lecturer] b.1904, Budapest, Hungary / d.1988.*
Addresses: NYC. **Studied:** College de France; Cent. State Univ. (hon. D.Litt., 1953). **Member:** A. Lg. Am. **Exhibited:** S. Indp. A., 1942; Wildenstein Gal., 1943; Pepsi-Cola, 1945; Finley Gal., 1937; Newhouse Gal., 1938; Decorator's C., 1938; Acad. All. A., 1939; Seligmann Gal., 1942-43; Gal. Mod. A., 1942; Am.-British A. Ctr., 1942-43 (solo), 1944; A. Assn., 1942; Niveau Gal., 1943; Marquie Gal., 1943, 1944 (solo); Peikin Gal., 1944; NYPL, 1944; A. Lg. Am., 1944; A. Hdqtrs., NYC, 1944 (solo); Raymond Gal., 1941 (solo); Acquavella Gal., 1941. **Work:** PMG; BM; NYPL. **Comments:** Positions: dir. & owner, Segy Gallery. Teaching: lectr., African Sculpture & Its Background & African Sculpture & Mod. Art, throughout US. Collections arranged: Circulating Exhib. African Sculpture, throughout US, 1949-. Research: African art. Specialty of gallery: African sculpture. Collection: African art: French and American modern painting and sculpture; Peruvian textiles; Mexican Mascala sculptures; pre-historic axes. Publications: auth., "Geometric Art and Aspects of Reality," fall 1957 & "The Phenomenological Approach to the Perception of Artworks," summer 1965, *Cent. Rev. Arts & Sci.;* auth., ...The Ashanti Akua'Ba Statues a Archetype," and "The Egyptian Ankh," Anthropos, 1963; auth., "The Yoruba Ibeji Statue," Acta Tropica, Vol 1927, No 2; auth., "The Mossi Doll, an Archetypal Fertility Figure," Tribus, 1973. **Sources:** WW73; WW47.

SEHESTED, Ada T. Gerfers *[Painter] b.1894, Texas / d.1979, San Francisco.*
Addresses: Larkspur, CA. **Exhibited:** Soc. for Sanity in Art, CPLH. **Comments:** Also appears as Gerfers-Sehested. **Sources:** Hughes, *Artists in California,* 504.

SEHLMEYER, Caroline *[Painter] b.1906, NYC.*
Addresses: Bronx, NY. **Exhibited:** PAFA Ann., 1938; S. Indp. A., 1940. **Sources:** Falk, *Exh. Record Series.*

SEHON, Adeliza Drake *[Decorator, painter] d.1902.*
Addresses: Cincinnati, OH. **Comments:** Worked at Rookwood Pottery, CIncinnati, 1896-1902. **Sources:** Petteys, *Dictionary of Women Artists.*

SEIBEL, Fred(erick) O(tto) FRED O. SEIBEL
[Cartoonist] b.1886, Durhamville, NY / d.1968.
Addresses: Richmond, VA. **Studied:** ASL. **Member:** Richmond Acad. A. **Exhibited:** VMFA, 1944 (solo exh. of 200 cartoon originals). **Work:** Huntington Lib., San Marino, Cal.; Alderman Lib., Univ. Virginia. **Comments:** Position: cart., Richmond (Va.) *Times-Dispatch.* **Sources:** WW59; WW47.

SEIBERLING, Dorothy Buckler Lethbridge *[Writer, art editor] b.1922, Akron, OH.*
Addresses: NYC. **Studied:** Vassar Col. (A.B., 1943). **Exhibited:** Awards: Penney-Missouri Mag. Award for *Life Mag.* series on "The Woman Problem," 1972. **Comments:** Positions: mem. staff, *Life Mag.,* 1943-49, co-ed. art dept., 1950-54, art ed., 1954-, ser. ed., 1965-. **Sources:** WW73.

SEIBERLING, Gertrude Penfield (Mrs. Frank A.)
[Painter] b.1866 / d.1946.

Addresses: Akron, OH. **Exhibited:** Ohio State Fair, 1935; NAWPS, 1935-38. **Sources:** WW40.

SEIBERT, Edward *[Sculptor] mid 19th c.*
Addresses: NYC, 1856. **Sources:** G&W; NYCD 1856.

SEIBERT, Henry *[Lithographer] mid 19th c.*
Addresses: NYC, active 1852-60. **Comments:** Partner in Robertson & Seibert, 1847-57; and Robertson, Seibert & Shearman, 1859-60 (see entries). **Sources:** G&W; NYCD 1852-58; NYBD 1854-60.

SEIBERT, Jacob *[Lithographer] mid 19th c.*
Addresses: NYC, active1859-60. **Comments:** Of Seibert & Wetzler (see entry). **Sources:** G&W; NYBD 1859; NYCD 1860.

SEIBERT, John O. *[Painter] early 20th c.*
Addresses: Wash., DC, active 1901-22. **Member:** Wash. AC. **Exhibited:** Soc. Wash. A. **Sources:** McMahan, *Artists of Washington DC,.*

SEIBERT & WETZLER *[Lithographers] mid 19th c.*
Addresses: NYC, 1859-60. **Comments:** Jacob Seibert and Ernest Wetzler(see entries). **Sources:** G&W; NYCD 1859-60.

SEIBOLD, Maximilian *[Painter] early 20th c.*
Addresses: Rochester, NY. **Exhibited:** PAFA Ann., 1913; Salons of Am. **Sources:** WW15; Falk, *Exh. Record Series.*

SEIDE, Charles *[Painter, educator] b.1915, Brooklyn, NY / d.1980.*
Addresses: NYC. **Studied:** NAD, 1932-1937, with Leon Kroll. **Member:** Am. Assn. Univ. Prof. **Exhibited:** Paintings of Yr., Pepsi-Cola Co, 1946 & 1948; NAD, 1951 & 1957; PAFA Ann., 1952; Art USA, 1958. Awards: Prize for painting, 1946 & Regional fel., 1948, Pepsi-Cola Co.; graphics prize, Brooklyn Soc. Artists, 1957. **Work:** Fogg Mus. Art, Cambridge, Mass. **Comments:** Preferred media: oils, acrylics. Positions: nat. dir., AEA, 1953-54; v. pres., Brooklyn Soc. Artists, 1953-55. Publications: contribr., "Encaustic, Materials and Methods," 1949; contribr., "Diameter," 1951; illusr., Brooklyn Heights Press, 1953. Teaching: instr. painting & mat. tech., Brooklyn Mus. Art Sch., 1946-62; assoc. prof. art, Cooper Union, 1950-, dir., Eve. Sch., 1966-68, hd. dept. art, 1968-70, hd. dept. painting, 1970-71; instr. painting, Silvermine Col. Art, 1966-67. **Sources:** WW73; Dorothy Seckler, "Changing Means to New Ends," *Art News* (1952); Vincent Longo, "Studio Talk," *Arts Mag.* (May 1956); Falk, *Exh. Record Series.*

SEIDEL, Charles Frederick *[Amateur artist, pastor and school principal] mid 19th c.; b.Moravia.*
Addresses: Salem, NC, 1806-09; Nazareth, PA,1809-17; Bethlehem(PA), 1817-61. **Comments:** Seidel was a Moravian minister who came to America in 1806 and served as pastor at Salem (N.C.) from 1806-09, as pastor and school principal at Nazareth (Pa.), 1809-17, and pastor and school principal at Bethlehem (Pa.) from 1817 to 1861. He sketched the first house in Bethlehem (Pa.) shortly before its destruction in 1823. **Sources:** G&W; Levering, *History of Bethlehem.*

SEIDEL, Emory P. *[Sculptor, lecturer] b.1881, Baltimore, MD.*
Addresses: River Forest, Chicago, IL. **Studied:** E Keyser; W.J. Reynolds. **Member:** Palette and Chisel Acad. FA; Assn. of Chicago PS; Cliff Dwellers; Austin, Oak Park and River Forest AL; Chicago Gal. Assn. **Exhibited:** AIC, 1913-41; PAFA Ann., 1915, 1919-20, 1927-29; Chicago Assn. PS, 1937 (prize). **Work:** fountain, Freeport (Ill.); mem., Chicago; bridge, Aurora (Ill.). **Sources:** WW40; Falk, *Exh. Record Series.*

SEIDEL, Frederick *[Landscape painter] mid 19th c.*
Addresses: NYC, active 1858-59. **Sources:** G&W; NYBD 1858-59.

SEIDEL, Jochen *[Painter] b.1924, Bitterfield, Germany / d.1971, Provincetown, MA.*
Comments: Grafitti artist active in Provincetown, MA, 1964-71. **Sources:** Provincetown Painters, 269.

SEIDEL, William A. *[Painter] early 20th c.*
Addresses: San Diego, CA. **Exhibited:** San Diego FA Gallery, 1927. **Sources:** Hughes, *Artists in California,* 504.

SEIDENBERG, Janet *[Miniature painter] early 20th c.*
Addresses: Brooklyn, NY. **Exhibited:** AIC, 1912. **Sources:** WW15.

SEIDENBERG, Roderick *[Painter] early 20th c.*
Addresses: NYC. **Exhibited:** WMAA, 1920-27. **Sources:** WW24.

SEIDENECK, Catherine Comstock (Mrs.) *[Painter, craftsperson, teacher] b.1885, Evanston, IL / d.1967, Carmel, CA.*
Addresses: Carmel, CA. **Studied:** Roycroft Shop of Elbert Hubbard, East Aurora, NY; AIC; UC; Calif. College of Arts & Crafts. **Member:** Soc. of Western Artists; Carmel AA (cofounder); Nat. Soc. of Craftsmen. **Exhibited:** Washington State Fair, 1912 (gold medal); PPE, 1915 (gold medal); Santa Cruz Annuals (hon. men.); Stanford Art Gal.; Carmel A. & Cr. Cl., 1920; Monterey Peninsula Mus. of Art, 1966 (together with her husband). **Work:** City of Monterey Collection. **Comments:** (Catherine Comstock) Married to George Seideneck (see entry) in 1920. Specialty: leather sculpture, watercolors and pastels. Teacher, Calif. College Arts & Crafts. **Sources:** Hughes, *Artists in California,* 504.

SEIDENECK, George J(oseph) *[Painter] b.1885, Chicago, IL / d.1972, Carmel, CA.*
Addresses: Chicago, IL; Carmel, CA. **Studied:** Smith Art Academy, Chicago, IL; AIC; Royal Academy, Munich, with W. Thor, Carl von Marr. **Member:** Chicago AC; Chicago AG; Chicago SA; Chicago Palette and Chisel C.; Carmel AA (cofounder 1927). **Exhibited:** AIC; Calif. State Fairs; Santa Cruz Art Annuals; Soc. of Western Artists, de Young Mus., 1949 (Klumpke Award). **Work:** portrait, Fed. Bldg., Chicago; Carmel AA. **Comments:** Position: teacher, Academy of FA, Academy of Design, both Chicago, IL. He and his wife Catherine Comstock (see entry) spent two and a half years in Europe. **Sources:** WW21; Hughes, *Artists in California,* 504.

SEIDENZAHL, Edward G. *[Painter] mid 20th c.*
Addresses: Chicago area. **Exhibited:** AIC, 1951. **Sources:** Falk, *AIC.*

SEIDLER, Doris *[Painter, printmaker] b.1912, London, Eng / d.c.1989, Great Neck, NY.*
Addresses: Great Neck, NY. **Studied:** Alteier 1917, NYC, with Stanley William Hayter. **Member:** Soc. Am. Graphic Artists (rec. secy., 1964-71); Soc. Can. Painter-Printmakers; Print Cl. Phila. **Exhibited:** Brooklyn Mus. Bi-Ann.; Vancouver; Int. Print Exhib.; First Hawaii Nat. Print Exhib., Honolulu Acad. Arts; PAFA; Soc. Am. Graphic Artists, Kennedy Gal., 1971; Roko Gallery, NYC, 1970s Awards: awards, Print Club Philadelphia, 1967; purchase award, Brooklyn Mus., 1968; medal of creative graphics, Audubon Artists, 1972. **Work:** LOC; Smithsonian Inst.; PMA; Brooklyn Mus.; SAM. **Comments:** Publications: auth., articles, In: *Artist Proof.* **Sources:** WW73.

SEIELSTAD, Benjamin Goodwin *[Illustrator, painter] b.1886, Lake Wilson, MN.*
Addresses: Inglewood, CA. **Studied:** ASL; & with Jean Mannheim, Richard Miller. **Member:** SI. **Work:** many portraits of servicemen, South Pacific area & U.S. **Comments:** Contributor to: *Popular Science, Life, Fortune, Outdoor Life* & other magazines. **Sources:** WW53; WW47.

SEIFERHELD, Helene (Mrs.) *[Art dealer] 20th c.*
Addresses: NYC. **Sources:** WW66.

SEIFERT, F. *[Portrait painter] mid 19th c.*
Addresses: Mobile, AL, 1859. **Sources:** G&W; WPA (Ala.), Hist. Records Survey cites Mobile *Daily Register,* Feb. 4, 1859.

SEIFERT, Henry *[Lithographer] b.1824, Saxony, Germany / d.1911, Milwaukee, WI.*
Addresses: Milwaukee, WI, c.1852-1911. **Work:** Milwaukee County Hist. Soc.; Milwaukee Pub. Lib.; LOC; Boston Pub. Lib. **Comments:** He came to America in 1852 as a trained lithographer and became a leading lithographer in Milwaukee. Over the years he was associated with Louis Lipman, Louis Kurz, Henry Gugler and James Lawton. He was a co-founder of the Milwaukee Lithographing and Engraving Co. in 1871, from which he retired in 1898. **Sources:** G&W; Kent, "Early Commercial Lithography in Wisconsin," 249; Thomas Beckman, *Milwaukee Illustrated* (exh. cat., Milwaukee Art Mus., 1978).

SEIFFERT, F. *[Painter] mid 19th c.*
Addresses: NYC, 1864. **Exhibited:** NAD, 1864. **Sources:** Naylor, *NAD.*

SEIGAL, Eva F. *[Painter] mid 20th c.*
Addresses: Brooklyn, NY, 1929. **Exhibited:** S. Indp. A., 1929. **Sources:** Marlor, *Soc. Indp. Artists.*

SEIGFRED, F. G. *[Painter] mid 19th c.*
Addresses: NYC. **Exhibited:** NAD, 1862-65. **Sources:** Naylor, *NAD.*

SEIGLE, Ralph Cornell *[Painter, graphic artist, lecturer, designer, teacher] b.1912, Jeffersonville, IN.*
Addresses: San Francisco, CA. **Studied:** Chouinard AI; & with Millard Sheets, Phil Dike, Donald Graham, & others. **Member:** Calif. AC. **Exhibited:** GGE, 1939; Oakland A. Gal., 1942; LOC, 1946; SFMA (solo); Tucson AA (solo); SAM; Santa Cruz AL; South American traveling exh.; de Young Mem. Mus. (solo); Gumps, San Fran. (solo); Tucson AA. **Comments:** Lectures: Contemporary Art. **Sources:** WW53; WW47.

SEILE, Simeon B. *[Engraver] mid 19th c.*
Addresses: NYC, 1856. **Comments:** *Cf.* Simon Benno Seile. **Sources:** G&W; NYCD 1856.

SEILE, Simon Benno *[Engraver, jeweler] b.c.1840, Austria.*
Addresses: New Orleans, active 1868-84. **Comments:** *Cf.* Simeon B. Seile. **Sources:** *Encyclopaedia of New Orleans Artists,* 348.

SEILER, Frederick *[Engraver and die sinker] mid 19th c.*
Addresses: NYC, 1850-54. **Comments:** Of Seiler & Rupp in 1850 (see entry). **Sources:** G&W; NYCD 1850, 1853-54; NYBD 1850, 1851, 1854.

SEILER & RUPP *[Engravers and die sinkers] mid 19th c.*
Addresses: NYC, 1850. **Comments:** Frederick Seiler and Christian Rupp (see entries). **Sources:** G&W; NYBD and NYCD 1850.

SEINDENBERG, (Jacob) Jean *[Sculptor, educator] b.1930, NYC.*
Addresses: Tallahassee, FL. **Studied:** Brooklyn Mus. Sch.; MoMA Sch.; Syracuse Univ. **Member:** Col. Art Assn. Am. **Exhibited:** Exhib. of Nine, La. State Univ. Centennial Yr., Baton Rouge, 1959; Photogr. Choice, Univ. Ind., Bloomington, 1959; Recent Painting USA, The Figure, MoMA, 1962; Art in Embassies Prog., US Dept. State, 1966; Volksfest 1968, West Berlin, Ger., 1968; Bienville Gal., New Orleans, LA, 1970s; plus solo exhibs., La., Ark., Vt. & New York. Awards: Awards, New Orleans Art Assn. Ann., Delgado Mus., 1951, 1953 & 1958 & La. State Art Comn. Ann., 1951 & 1954; Louis Comfort Tiffany Found. fel. painting, 1960. **Work:** Ark. Art Ctr., Little Rock; Ball State Univ. Art Gal., Muncie Ind. Commissions: welded steel figure, Oil & Gas Bldg., New Orleans, La., 1960; bronzes, Children on Glide, Simon-Diaz Pediat. Clinic, New Orleans, 1962; five life-size figures, Corpus, St. Joseph, Mary, St. Rita & Sacred Heart, Stations, St. Rita Cascia Church, Hanrahan, La., 1964 & St. Richard, St. Richard's Cath. Church, Jackson, Miss., 1966; La-Gettysburg design, La. Gettysburg Monument Comn., 1968. **Comments:** Preferred media: bronze, lead, mixed media, wood. Teaching: instr. photog., Tulane Univ. La., 1957-65; asst. prof. sculpture, Fla. State Univ., 1972-. **Sources:** WW73.

SEINDENBERG, Jean See: **SEINDENBERG, (Jacob) Jean**

SEIPP, Alice *[Illustrator, commercial artist, writer, painter, designer] b.1889, NYC.*
Addresses: NYC. **Studied:** CUA School; ASL; D. Volk; B.W. Clinedinst; O. Linde; J. Peterson. **Member:** PBC; AWCS; NAWA; NYWCC. **Exhibited:** NAWA; AWCS; PAFA; NAC; CGA; Palm Beach AC, 1934; Balt. WCC. **Comments:** Author/illustrator: textbooks, on costume design, for Woman's Inst. Domestic Arts & Sciences, 1940. **Sources:** WW59; WW47.

SEIPP, Anna Margaret *[Painter] mid 20th c.*
Addresses: NYC. **Studied:** ASL. **Exhibited:** Salons of Am., 1925, 1927, 1928, 1931, 1932; S. Indp. A., 1925. **Sources:** Falk, *Exhibition Record Series.*

SEISS, Covington Few *[Painter] late 19th c.*
Addresses: Phila., PA. **Exhibited:** PAFA Ann., 1881, 1887. **Sources:** Falk, *Exh. Record Series.*

SEISSER, Martin B. *[Painter] b.1845, Pittsburgh, PA.*
Addresses: Pittsburgh, PA. **Studied:** Carl Otto, Munich; Royal Acad. of Bavaria, 1869-71. **Comments:** After study in Munich, Seisser returned in 1871 to Pittsburgh, where he painted portraits and one painting entitled "The Crusaders" which was stolen from an auction sale in Philadelphia in 1878. **Sources:** Clement and Hutton, 248.

SEITHER, Anne Barber (Mrs.) *[Painter] early 20th c.; b.Phila.*
Addresses: Phila., PA, 1904-15. **Studied:** PAFA; Phila. School Des. Women, with E. Daingerfield; Colarossi Acad., Paris. **Exhibited:** PAFA Ann., 1904, 1910-11. **Sources:** WW15; Falk, *Exh. Record Series.*

SEITZ, Charles B. *[Wood and ivory turner] b.c.1832, Germany.*
Addresses: Detroit, MI, 1864-1900 and after. **Comments:** Associated with Bernard Hellenberg in Charles B. Seitz & Co. 1865-66. **Sources:** Gibson, *Artists of Early Michigan,* 210.

SEITZ, Helen A. *[Teacher and designer] b.1902, Monona, IA.*
Addresses: Cresco, IA. **Exhibited:** Iowa Art Salon, 1936 (prize). **Comments:** Position: teacher, Cresco, IA. **Sources:** Ness & Orwig, *Iowa Artists of the First Hundred Years,* 187.

SEITZ, Herman *[Painter] mid 20th c.*
Exhibited: Salons of Am., 1934, 1936. **Sources:** Marlor, *Salons of Am.*

SEITZ, Jacob *[Lithographer] late 19th c.*
Addresses: New Orleans, active 1889-91. **Sources:** *Encyclopaedia of New Orleans Artists,* 348.

SEITZ, John *[Engraver] b.c.1808, Germany.*
Addresses: Philadelphia, 1850. **Comments:** Seitz, his wife, and their daughter were all born in Germany. **Sources:** G&W; 7 Census (1850), Pa., LII, 100.

SEITZ, William Chapin *[Educator, art historian] b.1914, Buffalo, NY / d.1974.*
Addresses: Charlottesville, VA. **Studied:** Albright Art Sch., Buffalo, 1932-33; Art Inst. Buffalo, 1933-35; Univ. Buffalo (B.F.A., 1946); study in Europe, 1949; Princeton Univ., jr. fel., 1950-51, Procter fel., 1951-52 (M.F.A.), AM Coun. Learned Socs. fel., 1952-53, Ph.D., 1955); Fulbright grant to France, 1956-57. **Member:** Col. Art Assn. Am. (bd. mem., 1972); Am. Assn. Mus. Dirs.; Am. Assn. Univ. Prof.; Eng. Speaking Union; Nat. Found. on Arts (bd. mem., 1972). **Exhibited:** solos, Arista Gal., NYC, 1938, Princeton Univ. Art Mus., 1949 & 1950 & Willard Gal., New York, 1949, 1950 & 1953; WMAA. **Comments:** Positions: New York City Fed. Art Proj., 1935-38; chief drafts-man, Hewitt Rubber Co, Buffalo, 1941-43, proj. engr., 1943-45; cur., Dept Painting & Sculpture Exhibs., MoMA, 1960-65; dir., Rose Art Mus. & Poses Inst. FA, Brandeis Univ., 1965. Teaching: instr. painting & drawing, Buffalo AI, 1941; Univ. Buffalo, 1946-49; lect. & critic, Princeton Univ., 1952-55, asst. prof., 1955-56; Brandeis Univ., 1965; Univ. VA, 1971-. Curated: Claude Monet: Seasons and Moments, 1960, The Art of Assemblage, 1961,

Arshile Gorky & Mark Tobey, 1962, Hans Hofmann, 1963, Art Israel, 1964, The Responsive Eye, 1964, all at MoMA; Louise Nevelson, Adolph Gottlieb, James Rosati & others, Rose AM, 1965-71; US Exhib. at 9th annual Biennial Sao Paulo, Brazil, 1967; 7th Biennial of Canadian Painting, Nat. Gallery Can., Ottawa, 1968. Publications: auth., *Assemblage & Collage* (Encycl. Americana, 1968); *Kinetic Art, The Peter Stuyvesant Collection* (Abrams, Amsterdam, 1969); *Sculpture, Quality: Its Image in the Arts* (Atheneum, 1969); *Manet & Turner* (Atlantic Mo Press, 1971); *George Segal* (Abrams, 1972). **Sources:** WW73.

SEKANINA, Jaroslav *[Painter] early 20th c.*
Addresses: Chicago, IL. **Exhibited:** AIC, 1909. **Sources:** WW13.

SEKIDO, Yoshida *[Painter, etcher] b.1894, Tokyo, Japan / d.c.1965.*
Addresses: San Francisco, CA. **Studied:** T. Seiho; Ontario College of Art; ASL, with G.B. Bridgman. **Member:** San Fran. AA. **Exhibited:** Vancouver, Canada, 1921 (prize); S. Indp. A., 1925; NAD, 1928; NY WC Soc., 1920s; Woman's Club Art Gal., Watsonville, 1931; Portland, Or, Art Mus., 1932; CPLH, 1932; SFMA, 1935; Calif. State Fair, 1936; GGE, 1939; Santa Cruz AL, 1936 (prize). **Work:** CPLH; SFMA; Mus. A., Murray Warner Mem. Coll. of Oriental Art, Univ. Oreg., Eugene; Southwest Mus., Los Angeles; Art Mus., Toronto, Canada. WPA artist. **Comments:** Immigrated to Cananda in 1921 and was in NYC by 1922. Specialty: watercolors on silk of birds, trees and flowers. **Sources:** WW40; Hughes, *Artists in California,* 505.

SEKULA, Sonia *[Painter] b.1918, Lucerne, Switzerland.*
Addresses: St. Moritz, Switzerland; NYC. **Studied:** ASL, and with Morris Kantor, Kurt Roesch; also study In Italy. **Exhibited:** BM; PAFA Ann., 1946; Santa Barbara Mus. A.; Nebraska AA, 1949; WMAA, 1950, 1956; Mus. New Mexico, 1951; Univ. Illinois, 1952; Paris, France, 1948; Sao Paolo, Brazil, 1948; solo: Berry Parsons Gal.,1948, 1949, 1951, 1952. **Work:** SFMA; BM, and in priv. coll. **Sources:** WW59; Falk, *Exh. Record Series.*

SEL, B. *[Theatrical scene painter and drawing master] early 19th c.*
Addresses: New Orleans in 1813-14 and 1817. **Comments:** Possibly the same as Jean Baptiste Sel. **Sources:** G&W; Delgado-WPA cites *Moniteur,* July 29, 1813, *Ami des Lois,* Oct. 22, 1814, and *La. Courier,* Feb. 10, 1817.

SEL, Jean Baptiste *[Portrait & miniature painter, teacher] b.Santo Domingo / d.1832, New Orleans, LA.*
Addresses: New Orleans, 1822-32. **Comments:** Born c.1780-90. Came to New Orleans c.1800 and visited Alabama in 1825. Possibly the same as B. Sel. **Sources:** G&W; Delgado-WPA cites *La. Courier,* Jan. 28, 1832, obit.; New Orleans CD 1822-24, 1827, 1830; WPA (Ala.), Hist. Records Survey; Cline, "Art and Artists in New Orleans." More recently, see *Encyclopaedia of New Orleans Artists,* 348.

SEL, John B. See: **SEL, Jean Baptiste**

SELBY, F. *[Sketch artist] mid 19th c.*
Addresses: California, 1852. **Comments:** Drew a pen and col-ored crayon sketch of Fort Crook, Shasta County (Cal.) in 1852. The artist was a member of Co. C, California Volunteer Cavalry. **Sources:** G&W; *Childs Gallery Bulletin* (Feb. 1952), back.

SELBY, Joe *[Ship painter] b.1893, Mobile, AL / d.1960, Miami, FL.*
Addresses: Overtown, Miami, FL. **Studied:** self-taught. **Work:** Mystic Seaport Mus. **Comments:** An African-American painter of ships and yachts that docked at the Miami city pier between 1921-1959. In 1905, as a 12-year-old deck hand, he lost a leg in an accident aboard ship. During the 1930s, he crewed again aboard a steamer out of Mobile, AL. But he was primarily a marine artist who, by 1921, concentrated on painting yacht portraits in Miami. **Sources:** article, A.J. Peluso, in *Maine Antique Digest* (n.d., c.1990).

SELBY, Lila *[Painter] mid 20th c.*
Exhibited: S. Indp. A., 1942. **Sources:** Marlor, *Soc. Indp. Artists.*

SELDEN, Dixie *[Portrait, genre, and landscape painter; illustrator] b.1871, Cincinnati, OH / d.1935, Cincinnati.*
Addresses: Cincinnati. **Studied:** 1884-90 at Cincinnati Mus. Assoc. Art School with Duveneck (1890 & 1903); Cincinnati Art Acad.; a summer class with W.M. Chase in Venice, Italy, c.1910; in Great Britain with H.B. Snell, c.1914. **Member:** Cincinnati Women's AC (pres.); NAWPS; Cincinnati MacDonald Club; NAC; Chicago Gal. Assn.; SSAL; Louisville AA. **Exhibited:** Cincinnati AM, annuals (frequently), three person show (with Annie Sykes and Emma Mendenhall), 1910; Cincinnati Woman's AC; Corcoran Gal biennials, 1914-23 (3 times); PAFA Ann., 1915-16, 1919-23, 1927-30; AIC; NAWPS, 1929 (prize). **Work:** Cincinnati Art Mus.; Univ. Kentucky Art Mus., Lexington; Cincinnati Public Schools Collection, Cincinnati Mus. Center (these works were originally in the Kirby, Bond Hill, and Hughes High Schools, Cincinnati). **Comments:** Most of her career took place in Cincinnati, where she was a highly regarded member of the art community. She spent her childhood and later years in Covington, KY. Selden painted along the New England coast during summers and traveled frequently, usually with fellow painter Emma Mendenhall, recording scenes of Mexico, Normandy, Brittany, Spain, and Italy. **Sources:** WW33; Jones and Weber, *The Kentucky Painter from the Frontier Era to the Great War,* 65-66 (w/repros.); Barbara Kuntz, "Cincinnati School House Treasures," *American Art Review,* vol. 10, no. 2 (April, 1998): 124-131; *Cincinnati Painters of the Golden Age,* 98-100 (w/illus.); Falk, *Exh. Record Series.*

SELDEN, Henry Bill *[Painter, etcher, teacher] b.1886, Erie, PA / d.1934, New London, CT?.*
Addresses: Greenwich, New London, CT. **Studied:** ASL; PAFA; C. Woodbury, Ogunquit Sch., 1910; B. Harrison, Kenyon Cox; George Bridgman; Howard Pyle. **Member:** AWCS; NYWCC; Allied AA; A. Fund S.; CAFA; NAC; St. Botolph; SC; Lyme AA. **Exhibited:** PAFA Ann., 1910-11, 1917; CAFA, 1929 (prize), 1931 (prize); AWCS; SC, St. Botolph Cl.; "Charles H. Woodbury and His Students," Ogunquit Mus. of Amer. Art, 1998. **Work:** Conn. Col. **Comments:** Position: t., Conn. Col., New London, Ct.; founded art department. Dir., Lyman Allen Mus., New London, CT. Painted impressionist landscapes with members of Old Lyme Art Colony. **Sources:** WW33; *Charles Woodbury and His Students;* Falk, *Exh. Record Series.*

SELDEN, Jacob See: **SELDIN, Jacob**

SELDEN, Julia See: **SPENCER, Julia Selden (Mrs. R. P.)**

SELDIN, Jacob *[Painter] mid 20th c.*
Addresses: Brooklyn, NY. **Exhibited:** Salons of Am., 1924; S. Indp. A., 1924-30, 1932-33, 1935, 1937. **Sources:** Falk, *Exhibition Record Series.*

SELDIN, Jules B. *[Painter, sculptor] mid 20th c.*
Addresses: NYC. **Exhibited:** S. Indp. A., 1934. **Sources:** Marlor, *Soc. Indp. Artists.*

SELDIS, Henry J. *[Art critic, educator] b.1923, Berlin, Germany / d.1978.*
Addresses: Los Angeles, CA. **Studied:** NY Univ. (B.A.); Columbia Univ.; New School Social Res.; also criticism with Donald Bear, Santa Barbara. **Member:** College Art Assn. Am; AFA; Am. Soc. Aesthetics & Criticism; Venice Committee (exec. vice chmn. Los Angeles Chapter, 1970-); Committee Rescue Italian Art (exec. chmn. Southern Calif. Chapter, 1966-67). **Exhibited:** Awards: Frank Jewett Mather Award, College Art Assn. Am., 1953; Taft & Rita Schreiber Found. research grant, 1970. **Comments:** Positions: art critic, *Santa Barbara News-Press,* 1950-58; editor & senior art critic, *Los Angeles Times,* 1958-; art consultant, Century City, 1967-68; dir. traveling exhibitions, Municipal Art Galleries, Los Angeles. Publications: co-author, "Sculpture of Jack Zajack," 1961; author, "Rico Lebrun"

(monograph) & "Henry Moore an American"; contribrutor, *Art Int. & Art Am.* Teaching: art lecturer, Univ. Calif., Santa Barbara, 1955-58; art lecturer, Univ. Calif., Los Angeles, 1967-69; also, pub. lecturer. Collections arranged: The Image Retained, 1962 & Pacific Heritage, 1964, Municipal Art Galleries, Los Angeles, Rico Lebrun Retrospective, LACMA, 1968; Henry Moore Exhib., 1973. **Sources:** WW73.

SELDON, Isabel Virginia Hall *[Painter, teacher] b.1898, Wash., DC / d.1985, Wash., DC.*
Addresses: Wash., DC. **Studied:** Univ. Chicago (B.A.); Columbia Univ. (M.A.). **Comments:** Instructor: Wash., DC public schools, until 1960 (more than 44 years). **Sources:** McMahan, *Artists of Washington, DC.*

SELDON, Reeda (Mrs. Emrys Wynn Jones) *[Portrait painter, block printer] b.1905, NYC.*
Addresses: Norwalk, CT. **Studied:** E. Stange; NAD; BAID. **Member:** NAWPS. **Sources:** WW40.

SELETZ, Emil *[Sculptor] b.1909, Chicago, IL.*
Addresses: Beverly Hills, CA; Los Angeles 27, CA. **Studied:** Univ. Chicago (B.S.); Temple Medical Sch., Phila., Pa. (M.D.); studied sculpt., with Jo Davidson and George Grey Barnard. **Member:** Cal. P. & S. Cl.; A. of the Southwest; Cal. A. Cl.; F. Am. Col. of Surgeons. **Exhibited:** Greek Theatre, Los A.; LACMA; CPLH. Awards: prizes, Cal. P. & S., 1950, 1952; A. of the Southwest, 1951, 1953, 1955. **Work:** specializes in sc. port. busts of prominent doctors: Johns Hopkins Hospital; Cedars of Lebanon Hospital; Los Angeles General Hospital; Univ. California, San F.; Inst. Neurosurgery, Panama. Many bronze busts in priv. colls. **Comments:** Position: bd. dir., A. of the Southwest and Authors Cl., 1955; asst. prof., Neurosurgery, Univ. Southern California, School of Medicine, 1950-. Lectures: What is Art?; A Doctor Looks at Sculpture. **Sources:** WW59.

SELEY, Jason *[Sculptor] b.1919, Newark, NJ / d.1983.*
Addresses: Ithaca, NY. **Studied:** Cornell Univ. (A.B., 1940); ASL, with Ossip Zadkine; Ecole Nat. Superieur des Beaux Arts, Atelier Gaumond. **Member:** Col. Art Assn. Am. **Exhibited:** The Art of Assemblage, 1961 & Americans 1963, 1963, MoMA; Festival of Two Worlds, Spoleto, Italy, 1962; Sculpture in the Open Air, Battersea Park, London, Eng., 1963; Documenta III, Kassel, Ger., 1964; WMAA. Awards: Maintenance & travel grant for Haiti, US State Dept & US Off. Educ., 1947-49; Fulbright scholar for France, Inst Int Educ, 1949-50; artist-in-residence for Berlin, Deutscher Akademischer Austauschdienst, 1970-71. **Work:** MoMA; WMAA; Nat. Gal., Ottawa, Can.; NJ State Mus., Trenton; Univ. Mus., Univ. Calif., Berkeley. **Commissions:** Taliesmen (bronze abstract), Casper Col., Wyo, 1969-70. **Sources:** WW73; William Seitz, *The art assemblage* (1961) & Dorothy Miller, *American 1963* (1963, MOMA, New York); Herbert Read, *A concise history of modern sculpture* (Praeger, 1965).

SELF, Albert E. *[Painter] mid 20th c.*
Addresses: Jackson Heights, LI, NY. **Exhibited:** S. Indp. A., 1929. **Sources:** Marlor, *Soc. Indp. Artists.*

SELF, Berte *[Painter] mid 20th c.*
Addresses: NYC. **Exhibited:** S. Indp. A., 1926. **Sources:** Marlor, *Soc. Indp. Artists.*

SELFRIDGE, Reynolds L. *[Painter, writer, lecturer, teacher] b.1898, Jasonville, IN.*
Addresses: Indianapolis, IN. **Studied:** Hawthorne; Forsyth. **Exhibited:** John Herron AI, Indianapolis, 1926 (prize), 1928-29 (prize), 1930 (prize); Richmond, Ind., 1929 (prize). **Sources:** WW40.

SELIG, Manfred (Mr. & Mrs.) *[Collectors, patrons] 20th c.*
Addresses: Seattle, WA. **Comments:** Collection: old and modern paintings; graphic art. **Sources:** WW73.

SELIG, Martin *[Collector] 20th c.*
Addresses: Seattle, WA. **Sources:** WW73.

SELIGER, Charles *[Painter, designer]* b.1926, NYC.
Addresses: Mount Vernon, NY. **Exhibited:** Abstract & Surrealist American Art, 1947 & 65th Am. Exhib., 1962; AIC; Abstract Art in America, MoMA, 1951; PAFA Ann., 1962; Art of Organic Forms, Smithsonian Inst.,1968; Miniaturen '70 Int., Galerie 66 H.G. Krupp, Hofheim, Germany, 1970; Willard Gal., NYC, 1970s; WMAA. **Work:** MoMA; WMAA; SAM; Addison Mus. Art, Andover, MA; Munson-Williams-Proctor Inst., Utica, NY. **Comments:** Positions: vice-pres. design, Pictorial Products Inc, Mount Vernon, 1960-. Teaching: painting instructor, Mount Vernon AC, NY, 1950-53. **Sources:** WW73; Falk, *Exh. Record Series.*

SELIGMAN, Alfred L. *[Sculptor, patron]* b.1864, NYC / d.1912.
Addresses: NYC. **Studied:** P. Nocquet. **Comments:** He befriended many struggling artists, particularly the sculptor Paul Nocquet; he was also the cellist and the moving spirit and financial backer of the Young Men's Symphony Orchestra, and owned a very valuable collection of stringed instruments. **Sources:** WW10.

SELIGMAN, Emma (Mrs.) *[Still life painter]* mid 19th c.
Addresses: Active in Phila.; Tarrytown, Westchester Co., 1870; Irvington, NY, 1877. **Exhibited:** PAFA, 1863-67; NAD, 1870, 1877. **Sources:** Petteys, *Dictionary of Women Artists.*

SELIGMANN, Arnold *[Art dealer]* b.1870, France / d.1932.
Addresses: Paris. **Comments:** The brothers Arnold, Jacques, and Simon Seligmann ran a gallery founded in Paris in 1879. Around 1900, Arnold emigrated to NYC and founded Arnold Seligmann, Rey and Co. He was one of the earliest dealers to recognize the importance of American museums and to foster their growth. Uncle of Georges Seligmann.

SELIGMANN, Georges E. *[Art dealer]* b.1893, Paris, France / d.1995, NYC.
Comments: In 1940, on the even of WWII, he left his Paris gallery to join the business of his uncle, Jacques Seligmann, in NYC. Their clients included J.P. Morgan, Geo, Blumenthal, Wm. Randolph Hearst, and Sir Wm. Burrell. From 1946-70, he ran his own gallery in NYC. **Sources:** obit., *New York Times* (June 8, 1995).

SELIGMANN, Kurt *[Painter, educator, writer, lecturer]* b.1900, Basel, Switzerland / d.1961, Middletown, NY.
Addresses: NYC. **Studied:** Ecole des Beaux-Arts; Geneva, Switzerland; Italy and France; E. Buchner; E. Amman; Lhote. **Exhibited:** WMAA; GGE, 1939; AIC, 1943-49; CI, 1946; Canadian Nat. Exh., 1939; WFNY, 1939; PAFA Ann., 1944-54; Corcoran Gal biennials, 1947-57 (5 times); solos in galleries in Paris, London, Milan, Rome, Tokyo, Mexico City, Hollywood, Minneapolis, NYC, and Chicago. **Work:** Albright A. Gal.; Smith Col.; Univ. Illinois; MMA; MModA; WMAA; NY Pub. Lib.; BM; AIC; PAFA; Coll. des Musees Nationaux de France; Kunstkredit, Basel, Switzerland; Coll. de la Manufacture d'Aubusson, France; Palacio Bellas Artes, Mexico City; Bibliotheque Nationale, Paris; Mus. Mod. A., Lodz, Poland. **Comments:** Illustrator: *Vagabondages Heraldiques,* 1934; *Hommes et Metiers,* 1935; *Oedipus,* 1944, and others; *The History of Magic,* (various editions, 1948-58). Author: *A History of Western Magic,* 1946. Stage des. for modern and ballet dancers. **Sources:** WW59; WW47; Falk, *Exh. Record Series.*

SELIGSBERG, Rosa D. *[Painter]* mid 20th c.
Exhibited: S. Indp. A., 1939. **Sources:** Marlor, *Soc. Indp. Artists.*

SELINGER, Armand *[Painter]* b.1918, Riverside, CA.
Addresses: Carlsbad, CA. **Studied:** San Diego State Col. (B.A. M.A.); Claremont Grad. Sch. **Member:** Laguna Beach AA; Carlsbad AA. **Exhibited:** Laguna Beach, La Jolla A. Center and Carlsbad Gal., annually. **Work:** murals, Oceanside Lodge of Elks Cl.; Acapulco Gardens; Royal Palms Inn. **Comments:** Position: hd., art dept., Oceanside-Carlsbad Col., 1945-50; prin., Occanside-Carlsbad H.S. as of 1959. **Sources:** WW59.

SELINGER, Emily Harris McGary (Mrs. Jean P.) *[Painter, writer]* b.1848, Wilmington, NC / d.1927.
Addresses: Boston, MA, c.1904-10. **Studied:** Cooper Inst., NYC; with A. Rocchi, Florence; M. Roosenboom, Holland. **Exhibited:** Boston AC, 1885-1905; Mass. Charitable Mechanics Assoc., Boston (silver medals). **Comments:** Specialty: flowers. Lived and traveled extensively in Europe, as a correspondent for *Boston Evening Transcript.* **Sources:** WW10.

SELINGER, Jean (or John) Paul *[Painter]* b.1850 / d.1909.
Addresses: Boston, MA, 1880. **Studied:** Munich Acad.; W. Lieble; Lowell Inst., Boston. **Member:** Boston AC. **Exhibited:** Munich Expo (prize); Mass. Charitable Mechanics Assn., Boston (medal); NAD, 1880; PAFA Ann., 1885, 1890; Boston AC, 1888-1908; Paint & Clay Club, Boston, 1889; Osborne Exhibition, NY, 1905 (prize). **Comments:** Specialty: figures, also NH landscapes. **Sources:** WW08; Campbell, *New Hampshire Scenery,* 138; Falk, *Exh. Record Series.*

SELINGER, John Paul See: **SELINGER, Jean (or John) Paul**

SELLA, Alvin Conrad *[Painter, educator]* b.1919, Union City, NJ.
Addresses: University, AL. **Studied:** Yale Univ. Sch. Art; ASL with Brackman & Bridgman; Columbia Univ. with Machau; Col. Fine Arts, Syracuse Univ.; Univ. NM; also in Mexico. **Member:** ASL; Am. Assn. Univ. Prof.; Col. Art Assn. Am.; fellow, Int. Inst. Arts & Lett. **Exhibited:** Corcoran Gal biennials, 1957, 1961; AFA traveling exhib., 1961-62; Centenary Col., NJ (solo); Lauren Rogers Mus. Art, Laurel, Miss. (solo); Munic. A.Gal., Jackson, MS (solo); 54th Ann. Miss. Juried Exhib. (1st prize); 7th Juried Mobile Art Exhib., 1972 (3rd prize); 32nd Ann. WC Exhib., Birmingham Mus. Art, 1969 (solo), 1972 (1st & 2nd prize). **Work:** Bristol Iron & Steel Co; Collectors of Am. Art; Sullins Col. **Comments:** Teaching: hd. dept. art, Sullins Col., 1948-61; Univ. Ala., 1961-70s; vis. prof., Miss. Art Colony, spring workshops, 1962-64; vis. prof., Shreveport Art Colony, 1964-68; artists-in-residence, Summer Sch. Arts, Univ. SC, 1968. **Sources:** WW73.

SELLE, (Mr.) See: **SEL, Jean Baptiste**

SELLECK, Margaret *[Painter, illustrator, lecturer, teacher]* b.1892, Salt Lake City, UT / d.c.1960.
Addresses: Des Plaines, IL; Wilmette, IL; Wisconsin. **Studied:** AIC; Univ. Wisconsin; Western Univ.; with Dudley Crafts Watson, Rudolph Weisenborn, Oskar Gross; J. Hobby; Allen Philbrick. **Member:** AEA; Nat. Lg. Am. Pen Women; Northwest Art Lg.; All-Illinois Soc. FA. **Exhibited:** Central States Fair, Aurora, IL, 1931; All-Illinois Soc. FA, 1934 (medal); Illinois Fed. Women's Club, Chicago, 1935 (prize); PAFA, 1941; CM, 1936; Allerton Gal., Chicago, 1935 (solo); Stevens Hotel, Chicago (solo); Layton Gal. Art, Milwaukee, 1936 (solo); Wisconsin Union, Univ. Wisconsin, 1936 (solo); Beloit College, 1936 (solo); Oshkosh Art Mus. (solo); Contemporary Art Gal., Evanston, IL (solo). **Comments:** Illustrator: school textbooks. Lectures: "Historic Wisconsin"; "Drama of Chicago"; "Old Northwest Territory," etc. **Sources:** WW59; WW47; Petteys, *Dictionary of Women Artists.*

SELLECK, R(h)oda *[Painter, craftsworker, teacher];* b.Michigan.
Addresses: Michigan; Indiana. **Studied:** Denman Ross, Harvard Univ. **Sources:** Petteys, *Dictionary of Women Artists.*

SELLERS, Anna B. *[Painter]* b.1824, Phila. / d.1905, Chattanooga, TN.
Addresses: Upper Darby, PA. **Studied:** PAFA, with Eakins; Rome. **Exhibited:** PAFA Ann., 1866, 1877-78. **Comments:** Specialist in still lifes and landscapes (oils and watercolors). Granddaughter of Charles Willson Peale; daughter of Sophonisba Anguisciola Peale Sellers and Charles Coleman Sellers. **Sources:** Petteys, *Dictionary of Women Artists;* Miller, ed. *The Peale Family,* 39, 171-72; Falk, *Exh. Record Series.*

SELLERS, Charles Coleman *[Art historian] b.1903, Overbrook, PA.*
Addresses: Carlisle, PA. **Studied:** Haverford Col (B.A., 1925); Harvard Univ., 1926. **Comments:** Teaching: instr. Am. art, Dickinson Col., 1950-56; librn., Waldron Phoenix Belknap Jr., Res. Libr. Am. Painting, 1956-59. Awards: Bancroft Prize, Columbia Univ., 1970. Publications: auth., "Charles Willson Peale," 1947 & rev. ed., 1969; auth., "Portraits and Miniatures by CW Peale," 1952; ed., "American Colonial Painting," 1959; auth., "Benjamin Franklin in portraiture," 1962; auth., "Charles Willson Peale with Patron and Populance," 1969. **Sources:** WW73.

SELLERS, George Escol *[Amateur artist] b.1808 / d.1899.*
Addresses: Illinois, c.1854; Pennsylvania, after 1854.
Comments: Grandson of Charles Willson Peale. Escol Sellers helped in his grandfather's museum as a boy, but did not become a professional artist. He was an inventor of note and established a manufacturing community in Hardin County (Ill.) about 1854, calling it Seller's Landing. The venture was not very successful and Sellers spent his latter years in Pennsylvania. **Sources:** G&W; Sellers, "Sellers Papers in the Peale-Sellers Collection," repro. of sketch on the Ohio River *c.* 1854; Sellers, *Charles Willson Peale,* II, 354, 420.

SELLERS, George W. *[Artist] early 20th c.*
Addresses: Wash., DC, active 1911-20. **Sources:** McMahan, *Artists of Washington, DC.*

SELLERS, Mary (or Minnie) *[Painter, graphic artist, teacher] b.1869, Pittsburgh, PA.*
Addresses: Pittsburgh. **Studied:** A. Robinson; A. Hennicott, Holland. **Member:** Pittsburgh AA; Nat. Assoc. Women P&S. **Exhibited:** S. Indp. A., 1917, 1921, 1924; Salons of Am., 1925; AIC. **Sources:** WW40.

SELLERS, William Freeman *[Sculptor, lecturer] b.1929, Bay City, MI.*
Addresses: Salt Point, NY. **Studied:** Univ. Mich. (B.Arch., 1954, M.F.A., 1962). **Exhibited:** WMAA, 1966, 1968; Plus by Minus: Today's Half-Century, Albright-Knox Art Gal., Buffalo, NY, 1968; American Sculpture of the Sixties, Grand Rapids Art Mus., Mich., 1969; Painting and Sculpture Today, Indianapolis Mus. Art, Ind., 1970; Max Hutchinson Gallery, NYC, 1970s. Awards: Jurors' show award, Mem. Art Gallery, 1966. **Work:** Suspension, Six Cubes & Converging Cubes, Mem. Art Gallery, Rochester, NY. Commissions: Four Squares (painted steel), Stud. Assn., NY State Univ. Col. Cortland, 1969. **Comments:** Preferred media: metals, wood, plastics. Teaching: instr. design, Rochester Inst. Technol., 1962-1965; asst. prof. sculpture, Univ. Rochester, 1966-70; lectr. sculpture, ceramics, drawing & design, Lehman Col., 1970-. **Sources:** WW73.

SELLEW, K. W. *[Painter] late 19th c.*
Addresses: NYC, 1891. **Exhibited:** NAD, 1891. **Sources:** Naylor, *NAD.*

SELLICK, Rhoda See: SELLECK, R(h)oda

SELLORS, Evaline C. *[Sculptor] mid 20th c.*
Addresses: Chester Springs, PA. **Exhibited:** PAFA Ann., 1931-32. **Sources:** Falk, *Exh. Record Series.*

SELLS, C. H. *[Painter] late 19th c.*
Comments: Possibly Cato (Hedden) Sells born in Vinton, IA, c.1864, a lawyer who moved to Cleburne, TX in 1907 and was Commissioner of Indian Affairs, 1913-21. His paintings are of Southwest Indians. **Sources:** Peggy and Harold Samuels, 433.

SELLSTEDT, Lars Gustaf *[Portrait, landscape, and marine painter] b.1819, Sundsvall, Sweden / d.1911, Buffalo, NY.*
Addresses: Buffalo, NY, 1845-1911. **Studied:** self-taught. **Member:** ANA, 1871; N.A., 1874. **Exhibited:** NAD, 1851-99. **Work:** Albright A. Gal., Buffalo; portraits of Presidents Millard Fillmore and Grover Cleveland, and several mayors of Buffalo; founder of Buffalo FA Acad. **Comments:** He went to sea at the age of 11 and worked as a merchant seaman until 1845 when he settled at Buffalo and began a new career as a portrait painter. Except for several visits to Europe he spent the rest of his life in Buffalo where he was active in organizing the Buffalo Fine Arts Academy (1862), of which he was pres., 1876-77. His autobiography was published in 1904, his *Art in Buffalo* in 1911, and his *Life and Works of William John Wilgus* in 1912. **Sources:** G&W; WW10; Sprague, "Lars Gustaf Sellstedt"; DAB; Sellstedt, *From Forecastle to Academy;* Cowdrey, NAD; Rutledge, PA; Krane, *The Wayward Muse,* 195.

SELMER-LARSEN, Johan *[Sculptor] b.1876, Sarpsborg, Norway / d.1969, Marblehead, MA.*
Addresses: Marblehead, MA. **Member:** Marblehead AA (founder). **Exhibited:** Marblehead AA, 1997 (retrospective of early member's works). **Work:** bas-relief medallions: Marblehead High Sch., entrance to Sumner Tunnel, Boston; sculpture: Trustees of the Reservations, Massachusetts; St. Cecilia's Church, Boston (crucifix); MIT (bronze busts); Public Garden, Boston. His eagles form the flagpole base at the Cloisters, NYC. **Comments:** Created bronzes and plaster statuary for Boston-area public buildings and private gardens, working from 1912-c.1950 for the landscape architectural firm of Frederick Law Olmsted of Brookline, MA. He also carved in wood. In addition, he was a boat designer and was one of the originators of model boat racing on Redd's Pond in Marblehead; he also invented the sloped-stern design used in Ameria Cup vessels and built a series of wooden boats. He taught sculpture at the Worcester MA, and later at MIT (until 1946). **Sources:** PHF files, courtesy Ann Whittier.

SELONKE, Irene A. *[Painter] b.1910, Chicago, IL / d.1981.*
Addresses: Leawood, KS. **Studied:** AIC; Kansas City Art Inst.; also with Joseph Fleck, Taos, NM & Olga Dormandi, Paris, France. **Member:** Nat League Am Pen Women (state art chmn., 1971-1972). **Exhibited:** Coun. Am. Artists, Lever House, NYC, 1964; Nat. League Am. Pen. Women Biennial State Show, Saint Louis, Mo., 1965; Nat. League Am. Pen. Women Regional State Show, Kansas City, 1965; Greater Kansas City Art Assn. Exhibs., 1966; Nat. League Am. Pen. Women Nat. Exhib., Salt Palace, Salt Lake City, Utah, 1969; Ken Gilbert 83rd & Summerset, Prairie Village, KS, 1970s. Awards: four awards, Nat. League Am. Pen. Women, 1962-69; five awards, Greater Kansas City Art Assn., 1962-68; Pikes Peak Nat. Award, 1972. **Work:** Ralph Foster Mus., Point Lookout, Mo.; Gill Studios, Olatha, Kans.; Johnson Co. Nat. Bank, Prairie Village, Kans.; Three-Thirty-Three Myer Bldg., Kansas City, Mo.; Golden Ox, Wash., DC. Commissions: Tron furs, Sylvan Tron, Kansas City, 1960; hist. mural & many portraits, Mr. & Mrs. Dave Lorenz, Platt Woods, Mo., 1966. **Comments:** Preferred media: watercolors, oils. Positions: illusr., *Mod. Handcraft Mag.,* Kansas City, 1959-61. Publications: contri-br., *Workbasket Mag. & Workbench Mag.,* 1959-61. **Sources:** WW73.

SELOVER, Zabeth *[Painter] early 20th c.*
Addresses: Chicago. **Exhibited:** AIC, 1909. **Sources:** Falk, *AIC.*

SELTZER, Isadore *[Illustrator] b.1930, St. Louis, MO.*
Addresses: Los Angeles, CA; NYC. **Studied:** Chouinard AI; Art Center School, Los Angeles. **Comments:** Positions: staff, Push Pin Studios, NYC, 1960-on. Teaching: Syracuse Univ.; Parsons Sch. Des., NYC. Illus., *The Saturday Evening Post,* and other national magazines, national advertising campaigns and movie posters. **Sources:** W & R Reed, *The Illustrator in America,* 338.

SELTZER, Olaf Carl *[Painter, illustrator, miniature painter] b.1877, Copenhagen, Denmark / d.1957, Great Falls, MT.*
Addresses: Came to Great Falls, MT, age 14.
Studied: Danish Art School and Polytechnic Inst., Copenhagen, c.1889. **Work:** Gilcrease Inst.; Amon Carter Mus.; Harmsen, Eiteljorg-Stenzel collections; Masonic Library, Helena, MT. **Comments:** Born 1877 or 1881. Began to paint in oil at age 20 and was painting fulltime at age 44 when he was laid off by the railroad. He was a friend and stylistic follower of C.M. Russell,

completing some of his commissions in 1926 in NYC. He produced over 2,500 paintings, but by the 1930s his vision weakened due to focusing on a commission of 100 Western miniatures. **Sources:** P&H Samuels, 433.

SELVAGE, Helen A. Coe *[Miniature painter] 20th c.*
Addresses: Newark, NJ. **Sources:** WW17.

SELVIG, Forrest Hall *[Art historian, writer] b.1924, Tacoma, WA.*
Addresses: Roxbury, CT. **Studied:** Harvard Col. (AB, 1949); Univ. Calif., Berkeley, 1953-56. **Member:** Am. Assn. Mus. **Comments:** Positions: asst. dir., Minneapolis Art Inst., Minn., 1961-63; asst. dir., Gal. Mod. Art, NYC, 1963-65; dir., Akron Art Inst., OH, 1966-68; ed., New York Graphic Soc., Greenwich, Conn., 1968-71. **Publications:** auth., "The Nabis and their Circle," 1962; auth., "American collections," 1963; auth., "Charles Demuth," 1968; auth., "Review of the Whitney Sculpture Annual," 1969; ed., "19th Century Landscape Painting," 1971. Collections arranged: selections From Richard Brown Baker Collection, 1960; The Nabis, 1961; Pavel Tchelitchew, 1964; Jean Helion, 1965; Charles Demuth, 1968; plus others. Research: Late 19th century French painting, especially the Nabis and the Symbolists. **Sources:** WW73.

SELWIN *[Assistant scene painter] mid 19th c.*
Addresses: Boston, 1856. **Comments:** Worked at the Boston Theatre in April 1856. **Sources:** G&W; Boston *Evening Transcript*, April 14, 1856 (courtesy J.E. Arrington).

SELZ, Peter H. *[Art historian, art museum director] b.1919, Munich, Germany.*
Addresses: Berkeley, CA. **Studied:** Univ. Chicago, fel., 1946-49 (M.A. & Ph.D.); Univ. Paris, Fulbright award, 1949-50, Calif. Col. Arts & Crafts (hon. D.F.A., 1967). **Member:** Col. Art Assn. Am. (dir., 1959-68); Soc. Archit. Historians. **Exhibited:** Awards: Belg.-Am. Educ. Found. fel., 1953; Order of Merit, Fed. Repub. of Ger., 1963; sr. fel., Nat. Endowment Humanities, 1972. **Comments:** Positions: hd., Art Educ. Prog., Inst. Design, Ill. Inst. Technol., 1953-54; chmn. dept. art & dir. art gallery, Pomona Col., 1955-58; cur. painting & sculpture exhibs., MoMA, 1958-65; dir., Univ. Art Mus., UC Berkeley, 1965-; ed., *Art America*; mem. consult comt., *Art Quarterly*. **Publications:** auth., *Alberto Giacometti*, 1965; *Directions in Kinetic Sculpture*, 1966; *Funk*, 1967; *Harold Paris: The California Years* (UC Art Mus., 1972); *Ferdinand Hodler*, 1972; *Two Decades of American Painting: 1920-1940* (exh. cat., Dusseldorf, Zurich & Brussels, 1979). Contr., *Art Bull.*, *Art News*, *Art J.*, *Arts*, *Arts & Arch.*, *Sch. Arts*, *Penrose Ann.*, *Encycl. Britannica*. **Sources:** WW73.

SEMANS, James Hustead *[Patron] b.1910, Uniontown, PA.*
Addresses: Durham, NC. **Studied:** Princeton Univ. (A.B.); Johns Hopkins Univ. (M.D.). **Comments:** Positions: chmn., bd. trustees, NC Sch. Arts, 1964-; bd. mem., Mary Duke Biddle Found. **Sources:** WW73.

SEMMEL, Joan *[Painter] b.1932, NYC.*
Addresses: Spain, 1963-70; NYC, 1970-on. **Studied:** Cooper Union; ASL; Pratt Inst. (BFA, 1963). **Exhibited:** Madrid, 1965, 1966; Uruguay; Buenos Aires; NYC, c. 1973 (rented gallery at 141 Prince Street and staged her own show because no New York gallery would take her erotic paintings); many shows in 1980s and 1990s. **Work:** Newport Beach Mus.; Chrysler Mus., Norfolk, VA; Mus. Contemp. Art, Houston; Aldrich Mus., Ridgefield, CT. **Comments:** Painter of large photo-realist works with erotic themes. **Sources:** Rubinstein, *American Women Artists*, 390-91.

SEMMES, A. Gertrude O. See: **ORRICK-SEMMES, Gertrude**

SEMMES, Thomas Jenkins *[Designer] b.1824, Georgetown, Wash., DC / d.1899, New Orleans, LA.*
Addresses: New Orleans, active 1862. **Comments:** Attorney who moved to New Orleans in 1850 and was elected LA Attorney General. He designed the Great Seal of the Confederate States of America. **Sources:** *Encyclopaedia of New Orleans Artists*, 349.

SEMON, John *[Painter, teacher] b.1917.*
Addresses: Cleveland. **Member:** Cleveland SA. **Work:** CMA. **Comments:** Marsden Hartley studied with him in the 1890s. **Sources:** WW17; Gerdts, *Art Across America*, vol. 1: 27.

SEMON, Walter F. *[Painter] early 20th c.*
Addresses: NYC. **Exhibited:** S. Indp. A., 1917. **Sources:** Marlor, *Soc. Indp. Artists*.

SEMONOFF, Sadie (Mrs. Leon) *[Painter] mid 20th c.*
Addresses: Providence, RI. **Exhibited:** S. Indp. A., 1934-35. **Sources:** Marlor, *Soc. Indp. Artists*.

SEMPLE, J. *[Marine painter] late 19th c.*
Work: Peabody Mus., Salem, MA; Camden Pub. Lib. (ME). **Comments:** Active in Belfast and Derry, ME, 1861-75. **Sources:** Brewington, 350.

SEMSER, Charles *[Painter] mid 20th c.*
Addresses: Phila., PA. **Exhibited:** PAFA Ann., 1948-49. **Sources:** Falk, *Exh. Record Series*.

SENAT, Prosper Louis *[Painter] b.1852, Germantown, PA / d.1925, Germantown, PA.*
Addresses: Philadelphia, PA, 1878 to 1890s; Pasadena, CA, 1905-10; Annisquam, MA. **Studied:** Ecole des Beaux-Arts in Paris; E.L. Hampton, London; South Kensington Sch., London; Gérome. **Member:** SC; ACP; Phila. Soc. Artists; A. Fund S. **Exhibited:** NAD, 1877-88; PAFA Ann., 1877-80, 1883, 1887, 1895; Brussels Expo., 1880; Boston AC, 1883-1905; Naples Nat. Expo., 1889; Vienna National Exh., 1893; Columbian Expo., Chicago, 1893 (med); Atlanta Expo., 1895 (med); AIC. **Work:** Delaware Art Mus.; Joslyn Art Mus. **Comments:** (His last name also appears as Senet and Serrat) Exhibited works indicate he painted frequently in Maine, at Mount Desert and at Grand Manan (New Brunswick). From 1895-1925, he was regularly painting in Bermuda. **Sources:** WW21; Hughes, *Artists in California*, 505; Falk, *Exh. Record Series*.

SENATOR, Bernard *[Painter] mid 20th c.*
Exhibited: Salons of Am., 1934. **Sources:** Marlor, *Salons of Am.*

SENCE, Leonard *[Sculptor] mid 19th c.*
Addresses: NYC, 1848-52. **Comments:** He worked in plaster and marble. He was working with Victor Flagella (see entry), from 1848 to 1850. His widow was listed in 1856. **Sources:** G&W; Am. Inst. Cat., 1848-49; NYBD 1849-50; NYCD 1851-52, 1856.

SENCE, Leonard *[Engraver] mid 19th c.*
Addresses: NYC, 1856-59, home in Hoboken, NJ. **Sources:** G&W; NYCD 1856-59.

SENCE & FLAGELLA *[Sculptors] mid 19th c.*
Addresses: NYC, 1848-50. **Exhibited:** Am. Inst. (1848 and 1849). **Comments:** Leonard Sence and Victor Flagella (see entries). They exhibited plaster statuary at the American Institute winning a diploma in 1848. **Sources:** G&W; Am. Inst. Cat. and *Proceedings*, 1848, 1849; NYBD 1849-50.

SENDAK, Maurice *[Illustrator] b.1928, Brooklyn, NY.*
Addresses: NYC. **Studied:** ASL, with John Groth. **Exhibited:** Awards: Doctor of Humanities, Boston Univ.; Hans Christian Anderson Award; Caldecott Award, and others. **Comments:** Widely successful and important children's book illustrator, whose *Where the Wild Things Are*, (Harper& Row, 1962, and after) went on to become a modern classic, after evoking much criticism at first for its depictions of horrifying beasts. Other books include *In the Night Kitchen, The Juniper Tree,* and *Tales from Grimm*. He also designed sets for opera and ballett productions, and created an animated TV musical together with songwriter Carole King. **Teaching:** Parsons Sch. Des., NYC.

SENDORF, Reinhardt *[Engraver] b.c.1831, Germany.*
Addresses: Philadelphia, 1860. **Sources:** G&W; 8 Census (1860), Pa., LVI, 861.

SENECAL, Ralph L. *[Painter, illustrator] b.1883, Bolton, Canada.*

Addresses: Palmer, MA. **Studied:** NAD. **Member:** Springfield AC; Conn. SA; Springfield AL; CAFA. **Sources:** WW33.

SENEFELDER LITHOGRAPHIC COMPANY
[Lithographers] mid 19th c.
Addresses: Boston. **Comments:** Named after the European discoverer of the art of lithography, the firm was founded in 1828 by a splinter group from Pendleton's Lithography. Thomas Edwards and Moses Swett were the original leaders. Other principals joining the firm were William B. Annin, George G. Smith, Hazen Morse, and John Chorley. By 1830 the firm's imprint was Annin & Smith. Senefelder Lith. Co. In 1831 Senefelder's was bought by William S. Pendleton. (See entries on each individual and firm). **Sources:** G&W; Boston CD 1830 (adv.); Whitmore, "Abel Bowen." More recently, see Pierce and Slautterback, 150-51, with repros., which recounts the firm's history and their output.

SENET, Prosper Louis See: **SENAT, Prosper Louis**

SENGSTACK, Charles Philip *[Amateur artist, house and sign painter] b.1798, Buckeystown, MD / d.1873, Wash., DC.*
Addresses: Wash., DC. **Comments:** In 1848 he was appointed to a government post by President Polk. He painted primarily portraits, as an avocation. **Sources:** McMahan, *Artists of Washington, DC.*

SENGTELLER, Alexander *[Engraver] b.c.1813, France.*
Addresses: Wash., DC, 1858-71. **Comments:** Worked with the U.S. Coast and Geodetic Survey. Last name also appears as Sangteller and Santella. **Sources:** G&W; Washington CD 1858-71; 8 Census (1860), D.C., II, 132.

SENICH, Michael *[Cartoonist] mid 20th c.*
Addresses: U.S. Coast Guard. **Exhibited:** S. Indp. A., 1942. **Sources:** Marlor, *Soc. Indp. Artists.*

SENIOR, C. F. *[Primitive genre painter] late 18th c.*
Addresses: Reading, PA, 1780. **Comments:** Primitive genre painting in oils. **Sources:** G&W; Lipman and Winchester, 179.

SENIOR, Dorothy Elizabeth *[Painter] late 20th c.; b.Willimantic, CT.*
Addresses: Lincoln, RI. **Studied:** Converse Art Sch. of Norwich Free Acad., Conn.; Chestnut Hill Art Sch.; with Walter Olin Green; also with Herman Itchkawich, RI & Helen Van Wyk, Mass. **Member:** NAC; Nat. Soc. Painters In Casein & Acrylic; Pen & Brush; Am. Artists Prof. League; Acad. Artists Assn. **Exhibited:** Rockport Art Assn., Mass., 1969; Acad. Artists Assn., Mus. Fine Arts, Springfield, Mass., 1969; NAC, 1971; Nat. Soc. Painters in Casein & Acrylic, NYC, 1971; Pen & Brush, NYC, 1972. Awards: Award for Kim and Kris (oil portrait), Slater Mus., Pawtucket, RI, 1965; award for Woodland (oil), S. Co. Art Assn., RI, 1966; award for Gloucester Sea (oil), NAC, 1967. **Work:** Admiral Inn, Cumberland, RI. **Comments:** Preferred media: oils & pastels. **Sources:** WW73.

SENN, Emil *[Painter] mid 20th c.*
Addresses: NYC. **Studied:** ASL. **Member:** Bronx AG. **Exhibited:** S. Indp. A., 1920, 1930. **Sources:** WW25.

SENN, John *[Fresco painter] b.c.1825, Switzerland / d.1883, New Orleans, LA.*
Addresses: New Orleans, active 1870-72. **Sources:** *Encyclopaedia of New Orleans Artists*, 349.

SENNETT, John T. *[Portrait painter] mid 19th c.*
Addresses: Elmira, NY, 1859. **Sources:** G&W; N.Y. State BD 1859.

SENNHAUSER, John *[Abstract painter, designer] b.1907, Rorschach, Switzerland / d.1978.*
Addresses: NYC (immigrated 1928). **Studied:** Royale Acad., Venice, Italy, 1926-27; Cooper Union Art Sch., NYC, 1930-33; Florence Royale Acad. Fine Art, Italy, 1936. **Member:** Am. Abstr. Artists (1945; secy.-treas., 1950-52); Fedn. Mod. Painters & Sculptors (pres., 1966-68); Int'l Inst. Arts & Letters, Zurich. **Exhibited:** Contemporary Arts Gal., NYC, 1939 (solo); NAD, 1935; PAFA Ann., 1936, 1952; Albright AG, Buffalo, 1940;

Guggenheim Mus., 1942-44 (annuals); Brooklyn Mus "Watercolors Int'l" 1943, 1949, 1951-53; AIC, 1947; WMAA, 1948-1951 (purchase award, 1951), 1953, 1955-56; Walker Art Ctr., Minneapolis, 1953; Philbrook Art Ctr., 1951 (prize); Artists' Gal., NYC, 1947, 1950, 1952 (solos); Corcoran Gal. biennial, 1953; Brown Univ., 1954 (solo); Black Mntn. Col. (NC), 1954 (solo); Zabriskie Gal., NYC, 1956-59 (solos); Mark Rothko Foundation grants, 1971-72; AFA traveling exh. "Geometric Abstractions of the 1930s" 1972-71; Martin Diamond FA, NYC, 1980 (solo), 1982, 1984; Struve Gal., Chicago, 1988 (retrospective); Urdang FA, Boston, 1990. **Work:** NMAA; AIC; WMAA; CI; Dallas MFA; Houston MFA; MMA; Univ. Georgia Mus.; Guggenheim Mus.; Philbrook Art Ctr, Tulsa, Okla; Munson-Williams-Proctor Inst, Utica, NY; Birla Acad. Art & Cult., Calcutta, India; Tel-Aviv Mus.; Wichita State Univ. Commissions: murals, Salomon Bros., New York, 1970; Price-Waterhouse, Wash., DC, 1971; Boston Harbor, Clark, Dodge & Co., Boston, 1972. **Comments:** A geometric abstractionist of the 1930s-40s, he was an important member of the Am. Abstract Artists group in NYC. Positions: asst. to cur., Mus. Non-Objective Painting, New York, 1943-45; designer, R. Guetler Studio, NYC, 1945-47; art dir., C.R. Gracie & Sons, NYC, 1957-72. Teaching: instr. life drawing & painting, Leonardo Da Vinci Art Sch., 1936-39; dir., Contemp. Art Sch., 1939-42. **Sources:** WW73; Saul Dworkin, *Collage Film* (1970); *American Abstract Art*, 197; Diamond, *Thirty-Five American Modernists* p.18; Falk, *Exh. Record Series.*

SENSEMAN, Raphael *[Painter] b.1870, Camden, NJ / d.1965, Camden.*
Studied: Germany. **Comments:** Nephew of 19th cent. NY and Phila. artist William Lippencott. Senseman visited Wash., DC frequently to see his son and also to paint and sell his watercolors in the area. Active for over 70 years, he supported his large family solely on the sale of his paintings. **Sources:** McMahan, *Artists of Washington, DC.*

SENSENEY, George Eyster *[Etcher, block printer, painter] b.1874, Wheeling, WV / d.1943.*
Addresses: Wash., DC, active mid 1890s-1904; Holyoke, MA; Ipswich, MA. **Studied:** Corcoran A. Sch., with H. Helmick; Académie Julian, Paris with J.P. Laurens and Constant, 1899. **Member:** Soc. of Wash. Artists; SC. **Exhibited:** Soc. of Wash. Artists; PAFA Ann., 1911; P.-P. Expo., San Fran., 1915 (silver med.); Wash. WCC; AIC. **Work:** LOC; NMAA; South Kensington Mus., London. **Comments:** Specialty: designs for industrial art. **Sources:** WW40; McMahan, *Artists of Washington, DC,* which gives his death date as 1941; Falk, *Exh. Record Series.*

SENTENNE, Samuel H. *[Engraver] late 19th c.*
Addresses: Wash., DC, active 1877. **Sources:** McMahan, *Artists of Washington, DC.*

SENTER, Elva Harriet *[Painter] b.1892, Callao, MO / d.1973, Palo Alto, CA.*
Addresses: Columbia, CA; Palo Alto, CA, 1958-73. **Member:** Palo Alto AC. **Comments:** Specialty: watercolors. **Sources:** Hughes, *Artists in California,* 505.

SENTERI, Florio *[Painter] 20th c.*
Addresses: Brooklyn, NY. **Member:** S. Indp. A. **Sources:** WW21.

SENTOVIC, John M. *[Illustrator, commercial artist] b.1924, Lead, SD.*
Addresses: San Diego 5, CA. **Studied:** La Jolla Sch. A. & Crafts; Los A. A. Center Sch. **Member:** Tech. Publishing Soc. **Exhibited:** Awards: prizes, Tech. Pub. Soc. Exh. (3). **Work:** Book illustrations; silk screen brochures. Cart., Illus., Copley Press. **Comments:** Position: special asst. to Dr. Krafft Ehrike. Convair Astronautics, Space Illustrations. Contributor to *Life Magazine; Missile & Rockets* Magazine. **Sources:** WW59.

SENYARD, George *[Painter] b.1924, Olmstead Falls, OH.*
Comments: He toured the country with Lincoln, sketching him in the debates with Stephen A. Douglas over the slavery issue.

SEPESHY, Zoltan L. *[Painter, educator]* b.1898, Kassa, Hungary.

Zoltan Sepeshy

Addresses: Bloomfield Hills, MI; Detroit, Birmingham, MI. **Studied:** Acad Fine Art & Art Teachers, Budapest, Hungary (M.F.A.); also in Vienna, Paris, Germany & Italy. **Member:** NA, 1945; NIAL; NSMP; AAPL; Scarab C., Detroit. **Exhibited:** Detroit Inst. A., prizes in 1925, 1930, 1936, 1938, 1940, 1945, 1953, 1955; PAFA Ann., 1927-32, 1940-44, 1947-54, 1958-60; PAFA, 1936-45, 1946 (med); The Patteran, 1939 (prize); IBM, 1940 (prize); Pepsi-Cola Comp., 1945 (prize); Am. Acad. A. & Let., 1946 (prize); CGA, 1936-46; AIC, 1932-49; WMAA, 1936-52; TMA, 1936-46; CI, 1938-46, 1947 (first prize); WFNY, 1939; NAD, 1952 (med), 1964 (Morse Medal); CI Int., Brooklyn Int., NY, Chicago Int.; Corcoran Gal biennials, 1939-55 (9 times); Cranbrook Acad Art (retrospective); Syracuse Univ, NY (catalogued LOC), 1965; Midtown Gal, NYC, 1970s. Other awards: NAAL & NIAL grant, 1946; Tupperware fellow, 1957. **Work:** Sheldon Swope A. Gal.; Tupperware Mus., Orlando, Fla.; Albright A. Gal.; Swope A. Gal.; Wichita A. Mus.; San Diego FA Soc.; CAM; Butler AI; Milwaukee AI; Lincoln Mus. A.; Nelson Gal. A.; Univ. Michigan; PAFA; Akron AI; Dallas MFA; Davenport Mun. A. Gal.; Walker A. Center; Howard Univ.; High Mus. A.; Grand Rapids A. Gal.; Flint Inst. A.; Univ. Arizona; Encyclopaedia Britannica Coll.; IBM Coll.; Cranbrook Acad. A. Mus.; McGregor Pub. Lib., Highland Park, Mich.; U.S. State Dept.; Tel-Aviv Mus., Israel; Santa Barbara Mus. A.; Telfair Acad.; VMFA; MMA; AIC; Detroit IA; TMA; City Art Mus, St Louis, Mo; Commissions: Secco murals, City of Dearborn, Mich, 1928, Fordson H.S., Dearborn, Mich.; General Motors Bldg., Detroit; WPA mural, USPO, Lincoln Park, Mich., US Govt, Nashville, Ill, 1940, Mich Eng Soc, Rackham Bldg, Detroit, 1945 & Fed Bank & Loan Co, Kalamazoo, Mich, 1950. **Comments:** Preferred media: tempera, graphics. Positions: from dir. to pres., Cranbrook Acad. Art, 1947-66. Author: manual on tempera painting, Crowell Collier; articles in *Fine Arts; Art Digest; Col. Art Journal.* Teaching: Sch. Social Arts & Crafts, Detroit, 1926-28; resident artist, Cranbrook Acad. Art, Bloomfield Hills, Mich, 1931-67. **Sources:** WW73; H. Salpeter, "At Home in Two Worlds," *Esquire* (NYC, 1942); "Sepeshy Tempera Painting," *Am. Artist* (1944); Falk, *Exh. Record Series.*

SEPP, George (T.) *[Painter] mid 20th c.*
Exhibited: Salons of Am., 1934; S. Indp. A., 1940-41, 1943. **Sources:** Falk, *Exhibition Record Series.*

SERA, J. *[Painter of theatrical scenery, transparencies, landscapes, and fancy paintings, teacher of drawing] early 19th c.*
Addresses: Charleston, SC, active from 1824 -37. **Sources:** G&W; Rutledge, *Artists in the Life of Charleston.*

SERAILIAN, Mihran Kevork *[Landscape and portrait painter]* b.1867, Turkey / d.1957, San Francisco, CA.
Addresses: San Francisco, CA. **Exhibited:** City of Paris, San Francisco, 1924; Hotel Huntington, Pasadena, 1926. **Sources:** Hughes, *Artists in California,* 505.

SERBAROLI, Hector *[Portrait and mural painter, teacher]* b.1886, Rome, Italy / d.1951, Los Angeles, CA.
Addresses: Los Angeles, CA. **Studied:** Inst. San Michele, Rome; Acad. San Luca; C. Maccari, Lorretto, both in Italy. **Member:** San Fran. AA; Acad. West P.; PS C., Los Angeles; Circolo Artistico, Rome. **Exhibited:** P.-P. Expo, San Fran., 1915; Family Club, San Francisco, 1922 (solo); PS C., 1938 (prize); West P. Ann., Los Angeles Mus. Hist., Sc. & A. **Work:** LACMA; St. Raphael's Church, San Rafael, CA. **Comments:** Positions: teacher, Mount Tamalpais Military Academy; sketch artist., motion picture studios. **Sources:** WW40; Hughes, *Artists in California,* 505.

SEREDY, Kate *[Illustrator] mid 20th c.; b.Budapest, Hungary.*
Addresses: Montgomery, NY. **Studied:** Budapest Acad. Arts (grad., 1920). **Exhibited:** Awards: John Newberry Medal, Am. Libr. Assn., 1937. **Work:** May Massee Mem., William White

Libr., Emporia State Col. **Comments:** Preferred media: pencil, crayon. Publications: auth. & illusr., "The Good Master," 1935; "The White Stag," 1937; "The Singing Tree," 1938; "Tree for Peter," 1940; "The Chestry Oak," 1948, Viking Press. **Sources:** WW73; articles, in: *Horn Bk., Publ. Weekly & Elementary English.*

SERENO, Nunzio *[Painter] mid 20th c.*
Exhibited: S. Indp. A., 1935. **Sources:** Marlor, *Soc. Indp. Artists.*

SERET, Henri *[Painter] mid 20th c.*
Addresses: MIlltown, NJ. **Exhibited:** S. Indp. A., 1934. **Sources:** Marlor, *Soc. Indp. Artists.*

SERGEANT, Edgar *[Painter] b.1878, NYC.*
Addresses: Nutley, NJ. **Studied:** Columbia Univ.; ASL; Grand Central A. Sch.; & with Frank DuMond, Gifford Beal; G.P. Ennis. **Member:** SC; AFA. **Exhibited:** NAD (prize); All. A. Am. (prize); Montclair A. Mus. (prize); Newark Mus. **Sources:** WW59; WW47.

SERGEANT, Tacie N. *[Painter] mid 20th c.*
Addresses: Nutley, NJ. **Exhibited:** N.J. State Exh., Montclair Mus., 1935 (med.). **Sources:** WW40.

SERGER, Frederick B. *[Painter]* b.1889, Ivancice, Czechoslovakia / d.1965.
Addresses: NYC/Woodstock, NY. **Studied:** Acad. Art, Munich, Germany, and in Paris and Vienna. **Member:** CAFA; Woodstock AA; AEA; Artists Lg. Am. **Exhibited:** Bernheim Jeune Gal., Paris (solo); CI, 1945; NAD, 1944; Santa Barbara Mus. Art, 1944; La Tausca Pearls Comp., 1946; PAFA Ann., 1947, 1954, 1960-62; Corcoran Gal biennials, 1947, 1949; Springfield AA; Hartford, CT; CAFA; Salon d'Automne, Paris; Salon des Tuilleries, Paris; de Young Mus. Art, San Francisco (solo); New Mexico Mus. Art (solo); Lilienfield Gal., NYC, 1947 (solo); NOMA, 1948 (prize); Norton Gal. Art, 1950 (prize); Santa Barbara Mus. Art; G.W.V. Smith Mus. Art, 1950 (prize); Mint Mus. Art; Sweat Art Mus., Portland, ME; Woodstock AA; Butler AI; TMA; Univ. Illinois; Springfield (MO) Mus. Art (solo); Butler Inst. Am. Art (solo); Mint Mus. Art; Jersey City Mus.; Rudolph Gal., Woodstock, NY. **Work:** Mus. City of Paris; Art Collectors & Art Assn., Buffalo, NY; Butler AI; SFMA. **Comments:** Abstract painter of figures, landscapes, and still life. **Sources:** WW66; WW66; exhib. cat., Lilienfield Gal., NYC (1947); Woodstock AA cites birthdate of 1879; Falk, *Exh. Record Series.*

SERGER, Helen *[Art dealer]* b.1901, Skoczow, Poland / d.1989.
Addresses: NYC. **Member:** Art Dealers Assn Am. **Comments:** Specialty of gallery: paintings, drawing and graphics by German and Austrian Expressionists; 20th century masters. **Sources:** WW73.

SERISAWA, Ikuo *[Art dealer] mid 20th c.*
Addresses: Los Angeles, CA. **Studied:** AIC, 1943-47. **Comments:** Positions: owner & dir., Serisawa Gallery. Specialty of gallery: contemporary paintings and graphics; also antique Oriental prints and modern Oriental graphics. **Sources:** WW73.

SERISAWA, Sueo *[Painter, mural painter, printmaker, teacher]* b.1910, Yokohama, Japan.
Addresses: Seattle; Long Beach, CA, 1921; NYC; Los Angeles, CA. **Studied:** With Yoichi Serisawa (father) & George Baker; Otis AI, 1932-33; AIC; in NY with Yasuo Kuniyoshi. **Member:** Foundation of Western Art; Calif. WC. Soc. (pres.); Laguna Beach AA. **Exhibited:** Oakland Art Gal., 1939; Foundation Western Art, 1940 (prize); Calif. State Fair, 1940 (prize); Los Angeles Mus. Hist., Science & Art, 1941 (solo); PAFA Ann., 1947 (Carol H. Beck Gold Medal), 1949, 1951; Corcoran Gal biennials, 1947, 1949, 1961; CPLH, 1948; Dayton, OH, Inst. of Art; Dalzell Hatfield Gal, Los Angeles; Scripps College, Claremont; Pasadena Mus.; MMA, 1950 (purchase award); AIC; LACMA, 1941, 1950 (purchase prize), 1956 (purchase prize), 1957 (purchase prize); San Diego FA Soc.; Denver Art Mus.; SFMA; CI, 1952; Tokyo Int., Japan, 1952; Sao Paulo Biennale, Brazil, 1955;

WMAA,1958, 1960; Pacific Heritage, U.S. State Dept., Berlin, Germany, 1965; Occidental College, Laguna Beach (retrospective); Serisawa Gal, Los Angeles, 1970s. **Work:** MMA; LACMA; Santa Barbara Mus. Art; Pasadena AM; San Diego MA; Smithsonian Inst. **Comments:** Came to Seattle in 1918. His family moved East during WWII to avoid the California internment camps, but he returned to Southern Calif. in 1947. Preferred media: oils. Teaching: Kann Inst. Art, 1948-51; Scripps College, 1949-50; Claremont Grad. School; U.S.C. Summer School, Idyllwild; Laguna Beach School of Art. **Sources:** WW73; WW47; Arthur Millier, "Inner Development of Artists," *Am. Artist* (1950); Ed Biberman, "20 artists" (film), Los Angeles Mus. & Univ. Calif., Los Angeles, 1970; Joe Mugnaini, *Oil painting techniques and materials* (1969) & *Logics of drawing* (1973, Reinholt); "Modernism in California Printmaking," (Nov. 1998, Annex Gal., Santa Rosa, CA); Falk, *Exh. Record Series.*

SERL, John *[Painter] b.1894 / d.1993, Lake Elsinore, CA.*
Addresses: Lake Elsinore, CA. **Studied:** self-taught. **Exhibited:** Cavin-Morris Gal., NYC; Jamison-Thomas Gal., Portland, OR (both 1990s). **Work:** NMAA; Laguna Beach AM; Mus. Am. Folk Art. **Comments:** An "Outsider" artist who began painting in 1949, he was a prolific painter.

SERMAN, Ada (Mrs. Maxwell) See: **MORENSKI, Ada David**

SERNEAUX-GREGORI, Charlot *[Artist] b.1899 / d.1979.*
Member: Woodstock AA. **Sources:** Woodstock AA.

SERPELL, Susan Watkins See: **WATKINS, Susan**

SERRA, Daniel See: **SERRA BADUE, Daniel**

SERRA, Richard *[Sculptor] b.1939, San Francisco, CA.*
Addresses: NYC. **Studied:** UC Berkeley; UC Santa Barbara (B.A.); Yale Univ., with Josef Albers (B.A. & M.F.A.). **Exhibited:** Galleria La Lalita, Rome, 1966 (showed his Animal Habitats); Noah Goldowsky Gal., NYC, 1968 (rubber and neon pieces); Stedelijk Mus., Amsterdam, Holland, 1969; Kunsthalle, Bern, Switz., 1969; Guggenheim Mus., 1969;"Anti-Illusion" show, WMAA, 1969; Larry Aldrich Mus. Contemp. Art, Ridgefield, Conn., 1969; WMAA biennials , 1968-81. **Work:** WMAA. **Comments:** As a college student, Serra worked in steel plants. A Fulbright fellowship in 1964 allowed him to go to Italy where he became involved in the *arte povera* movement. In his work of 1969-70, gravity became the central focus of his work, especially in his Prop series, in which huge lead sheets of steel were leaned against each other, supported only by the thrust and counterthrust of their own weights. His typical works of the 1970s and 1980s were site-specific outdoor pieces consisting of massive steel units configured so as to make powerful, three-dimensional designs out of the space being used and create a presence that impacts the viewer's physical and psychological environment. In March 1989 his "Tilted Arc" was removed by a government agency from the Federal Plaza in NYC because of protests from workers in the building. A huge controversy ensued, widely discussed in the press and eventually tried in the U.S. District Court, which ruled in favor of the sculpture's removal. **Sources:** WW73; Baigell, *Dictionary; Two Hundred Years of American Sculpture,* 309; excerpts from a Yale lecture by Richard Serra regarding the "Tilted Arc" controversy were reprinted in Charles Harrison and Paul Wood, eds. *Art in Theory, 1900-1990: An Anthology of Changing Ideas* (Cambridge, MA: Blackwell, 1992), pp.1124-27.

SERRA, Rudy *[Sculptor] b.1948.*
Addresses: San Francisco, CA. **Exhibited:** WMAA, 1975. **Sources:** Falk, *WMAA.*

SERRA BADUE, Daniel *[Painter, educator, writer, graphic artist] b.1914, Santiago de Cuba.*
Addresses: Havana, Cuba, until 1962; Jersey City, NJ. **Studied:** Escuela Munic Bellas Artes, Santiago de Cuba, 1924-26; Studio of Jose Simont & ASL, 1927-28; with Monturiol, Barcelona, 1929, Hernandez Giro, Santiago de Cuba, 1930-31, Borrell-Nicolau & Luis Muntane, Escuela Bellas Artes, Barcelona, 1932-

36; ASL, NAD & Columbia Univ., 1938-40; Escuela Nac Bellas Artes, Havana, 1943; Pratt Inst. Graphic Art Ctr., NYC, 1964; Art Critics Workshop, Am. Fedn. Arts, 1967. **Exhibited:** John Wanamaker Comp., 1928 (prize); AIC, 1938; All. AA, 1938; WFNY, 1939; CI, 1941; Acad. All. A., 1939; Spain; Cuba; GGE, 1939; Univ. Michigan, 1939; WMAA, 1940; CAM, 1941; TMA, 1941; PAFA Ann., 1941(prize); CI, 1941; Univ. Tampa, 1951(prize); Havana, Cuba, 1954 (gold med.); Potentials Gal., Cal., 1964 (winner print contest); Int. Exhib. Graphics, Univ. Conn. Mus. Art, Storrs, 1971; Am. Soc. Contemp. Artists Ann., New York, 1971 & 1972; Pintura Cubana, Miami Art Ctr., Fla., 1972; solo shows, John Wanamaker's Fine Arts Gal., Phila., Saint Peter's Col., Jersey City, Columbia Mus. Art, SC & Cisneros Gal., New York, 1972. Awards: John Simon Guggenheim Mem. Found. fel., 1938 & 1939; Oscar B. Cintas Found. fel., 1963 & 1964. **Comments:** Positions: asst. dir. cult., Ministry Educ., Havana, 1959-1960. Teaching: prof. drawing, Prov. Sch. Plastic Arts, Santiago de Cuba, 1943-1945; prof. artistic anatomy & perspective, Sch. Plastic Arts, Santiago de Cuba, 1945-1960; instr. art, Univ. Oriente, Cuba, summers, 1948 & 1950; prof. design, Sch. Journalism, Santiago de Cuba, 1954-59; prof. still life painting, Nat. Sch. Fine Arts, Havana, 1960-62; lectr. painting, Columbia Univ., 1962-63; instr. drawing & painting, Brooklyn Mus. Art Sch., 1962-; instr. art, Saint Joseph's Col. Women, New York, summers 1964-65; asst. prof. art hist., Saint Peter's Col., 1967-70, chmn. dept., 1967-, assoc. prof., 1970-. Publications: auth., weekly articles, in: *Diario de la Marina,* Havana, March, 1946 to June, 1947 & *Diario de Cuba,* Santiago de Cuba, Dec., 1957 to Dec., 1958; auth., *The Plastics Arts in Santiago de Cuba* (XVI to XIX centuries). **Sources:** WW73; WW47; Rene Buch, "Simbolos Silenciosos: la Pintura de Serra Badue," *Vision* (New York, Nov., 1961); Florencio Garcia Cisneros, *40 Latin American Painters in New York* (Rema Press, Miami, 1964); Cindy Hughes, "Geometry, People Mixed in Palette," *New York World-Telegram,* Feb., 1964; Falk, *Exh. Record Series.*

SERRANO, Hugo *[Painter] mid 20th c.*
Exhibited: Salons of Am., 1934. **Sources:** Marlor, *Salons of Am.*

SERRAO, Luella Varney (Mrs.) *[Sculptor] b.1865, Angola, NY / d.After 1935.*
Addresses: Cleveland, OH. **Studied:** Cleveland Art School. **Exhibited:** AIC, 1916-20; PAFA Ann., 1920. **Work:** Roman Catholic Cathedral, Odessa, Russia; Capitol, MN; Seaton Hall, Newark, NJ; Cleveland Pub. Libr.; Catholic Cathedral, Cleveland. **Comments:** Sculpted portrait statues and busts in marble, including those of Mark Twain, Susan B. Anthony, Mary Baker Eddy, and others. **Sources:** WW25; Petteys, *Dictionary of Women Artists;* Falk, *Exh. Record Series.*

SERRAT, Prosper Louis See: **SENAT, Prosper Louis**

SERRE, Florence J. *[Painter] mid 20th c.*
Exhibited: S. Indp. A., 1941. **Sources:** Marlor, *Soc. Indp. Artists.*

SERRELL, Henry R. *[Lithographer] b.1817, England.*
Addresses: NYC, 1848-54. **Exhibited:** Am.Inst., 1848. **Comments:** Until 1852 of Serrell & Perkins (see entry). He came to New York before 1838. **Sources:** G&W; NYBD 1848-52; NYCD 1848-54; Am. Inst. Cat., 1848; Peters, *America on Stone;* 7 Census (1850), N.Y., LIV, 583.

SERRELL, Jeanne M. *[Painter] mid 20th c.*
Exhibited: Salons of Am., 1934. **Sources:** Marlor, *Salons of Am.*

SERRELL, Ottilie *[Painter] 20th c.*
Addresses: Montvale, NJ. **Sources:** WW24.

SERRELL & PERKINS *[Lithographers] mid 19th c.*
Addresses: NYC, 1848-52. **Comments:** Henry R. Serrell and S. Lee Perkins (see entries) **Sources:** G&W; NYBD 1848-52; Peters, *America on Stone.*

SERSAM, Alfred A. *[Painter] mid 20th c.*
Addresses: NYC. **Exhibited:** S. Indp. A., 1933. **Sources:** Marlor, *Soc. Indp. Artists.*

SERSEN, Fred M. *[Painter] b.1890, Czechoslovakia / d.1962, Los Angeles, CA.*
Addresses: Los Angeles, CA. **Studied:** Portland, OR. **Member:** Calif. WC Soc.; Academy of Western Painters, Los Angeles; P&S of Los Angeles. **Exhibited:** GGE, 1940; P&S of Los Angeles, 1942 (second prize). **Comments:** Position: hd. of special effects dep., 20th Century Fox Studios (winner of two Academy Awards). Specialty: desert, coastal and city scenes in oil and watercolor. **Sources:** Hughes, *Artists in California,* 506.

SERTH, Arthur (Arthur M. Sertich-Serth) *[Painter, craftsperson] b.1898, Croatia, Yugoslavia.*
Addresses: Highland Park, MI; Royal Oak, MI. **Studied:** Univ. Michigan; in Europe, & with John P. Wicker, William Pascoe, & others. **Member:** Scarab Cl., Detroit. **Exhibited:** Detroit Inst. A., 1922-25, 1926 (prize), 1927-46; Mich. State Fair, 1927 (prize), 1928 (prize), 1931 (prize), 1939 (prize); Scarab C.; numerous solo and group exh. in Detroit; WFNY, 1939; Chicago World's Fair; Saugatuck, Mich., 1957 (solo); Mus. Sc. & Indst., Chicago, 1957; Brussels World's Fair, 1958. **Work:** murals in many churches in Detroit, Mich.; Chicago, Ill.; & abroad; Mus. Sc. & Indst., Chicago; dioramas, General Motors Parade of Progress; background for stage, General Motors Motorama; transportation murals (2) and diorama, General Motors; mural, Croatian Home Bldg., Detroit, Mich. **Comments:** Position: ed., asst. supv., Aeronautical Charts, Army Map Service, 1942-45; artist, H.B. Stubbs Co., 1947-56. **Sources:** WW59; WW47.

SERVEN, Lydia Maria *[Painter, teacher] b.1898, Wash., DC.*
Addresses: Wash., DC, active 1920s; Warrenton, VA. **Studied:** ASL. **Exhibited:** Wash. WCC; S. Indp. A. **Comments:** Instructor: Abbott School of Fine & Commercial Art. **Sources:** WW25; McMahan, *Artists of Washington, DC.*

SERVER, J(ohn) William *[Painter, teacher] b.1882, Philadelphia, PA.*
Addresses: Philadelphia/Paris. **Studied:** Deigendesch; W.M. Chase; Acad. Colarossi, Paris. **Member:** Phila. ASL; T Square C., Phila. **Exhibited:** Corcoran Gal annual/biennial, 1907, 1916; PAFA Ann., 1910. **Sources:** WW25; Falk, *Exh. Record Series.*

SERWAZI, Albert B. *[Painter, designer, illustrator] b.1905, Philadelphia, PA.*
Addresses: Philadelphia; Newtown Square, PA. **Studied:** PMSch. Indst. A.; PAFA. **Member:** PAFA; A. Dir. Cl. **Exhibited:** PAFA Ann.,1934-54, 1964 (prize 1941); Da Vinci All.(med); Warwick Gal., Phila., 1938 (gold); Sketch C., Phila (medals), 1938; MMA, 1943; GGE, 1939; A. Dir. Cl., Phila., 1948 (prize); Butler AI; NAD; AIC; CI; CAM; TMA; Corcoran Gal biennials, 1939-47 (5 times, incl. 4th hon men, 1939); VMFA; Contemp. A. Gal.; Phila. A. All., 1957 (solo) and prior; Phila. A. Cl. Award of Merit, Magazine Advertising Art, NYC, 1950. **Work:** PAFA; Friend's Central Sch.; WMAA; LACMA; Allentown A. Mus. **Comments:** Position: art dir., Lewis & Gilman, 1943-48; chief art dir., Neal D. Ivey Co., 1949-51, Philadelphia; adv. dept., Dupont Co., 1951-52; art dir., McKee & Albright, Philadelphia., 1952-53; Ladies Home Journal, 1953-on. **Sources:** WW59; WW40; Falk, *Exh. Record Series.*

SERZ, John *[Engraver] b.c.1810, Bavaria, Germany.*
Addresses: NYC, 1849-50; Philadelphia thereafter. **Comments:** He apparently left Germany about 1848. In Philadelphia he did banknote, portrait, landscape, and historical engraving. **Sources:** G&W; 8 Census (1860), Pa., LVI, 881; NYCD 1849-50; Phila. CD 1851-60+.

SESSFORD, Rosalie M. *[Artist] 19th/20th c.*
Addresses: Wash., DC, active 1901. **Sources:** McMahan, *Artists of Washington, DC.*

SESSIONS, Annamay Orton (Mrs. Frank M.) *[Painter, craftsperson] b.1855, Rome, NY / d.1947.*
Addresses: Chicago. **Comments:** She designed and painted the chinaware for President Taft. Mother of James.

SESSIONS, James Milton *[Marine painter, illustrator] b.1882, Rome, NY / d.1962.*

SESSIONS (handwritten)

Addresses: Chicago. **Studied:** AIC, 1903-06. **Exhibited:** MMA; AIC; CMA; Milwaukee AM; Campanile Gal., Chicago, 1982. **Work:** Chicago Tribune Collection; J.P. Speed Mus.; Great Lakes Naval Training Inst.; NY Graphic Soc., "American Masters Collection"; Borg-Warner Collection, Chicago. **Comments:** He was a master watercolorist, with a style similar to that of John Whorf, Ogden Pleissner, A. Lassell Ripley, and Sears Gallagher. However, his bouts with alcohol and his self-imposed high standards for finished works led him to destroy many of his watercolors. His love of the sea began as a wheelsman aboard Great Lakes ships from 1906-14. He joined the Illinois Naval Reserve during World War I, and later became a commercial illustrator, primarily with Vogue-Wright Studios in Chicago. In 1933 he began to focus on watercolor. During World War II he was a "brush reporter" of the Pacific Theatre. He also made a 60-painting documentary of jeeps in World War II action for Willys Overland Co. His World War II scenes were the subject of a book, and were exhibited at the MMA. Later, he produced calendars for Brown & Bigelow Co., St. Paul, and many of his hunting and marine watercolors were reproduced by the NY Graphic Society. Sessions traveled extensively around the U.S., painting in Cape Ann (MA), Nova Scotia, the Caribbean, and the Southwest. Signature note: His signature style, with the two flourishing "S's" was consistent. **Sources:** Falk, *James Sessions* (unpub. ms).

SESSLER, Alfred A. *[Painter, educator, graphic artist, lecturer] b.1909, Milwaukee, WI / d.1963, Madison, WI.*
Addresses: Madison, WI. **Studied:** Layton Sch. A. (B.S. in A. Edu.); Univ. Wisconsin (M.S.). **Member:** Milwaukee PM; Wis. Ar. Fed.; Wis. P & S.; Madison AA. **Exhibited:** Univ. Wisconsin, prizes in 1934-35, 1943-44, 1946, 1950-51, 1953; Milwaukee AI, prizes in 1935, 1937-38, 1942, 1945-46, 1950-52, 1955; Wis. State Fair, 1938 (prize)-39, 1940-44 (prizes), 1946-55 (prizes); Madison A. Exh., prizes in 1946, 1948-49, 1953; Nat. Exh. Am. A., NY, 1936; Corcoran Gal biennials, 1937, 1939; AIC, 1936, 1938; Albright A. Gal., 1938; Am. FA Soc. Gal., 1938; WFNY, 1939; AFA traveling exh., 1940; CI, 1941; Inst. Mod. A., Boston, 1941; VMFA, 1942; Wis. P. & S., 1933-46, 1947, 1950-52, 1955; Wis. Salon A., 1935-47, 1949, 1951-53, 1955; Univ. Wisconsin, 1936, 1941, 1945 (solo); Layton A. Gal., 1940, 1944 (solo); Kansas City AI, 1939; Wustum Mus. FA, 1942; Milwaukee State T. Col., 1944 (solo); Madison A. Exh., 1946; Milwaukee Pr. M. Ann., prizes in 1937, 1951-52, 1955; 48 States Comp., 1939; Walker A. Center, 1947, 1949, 1951, 1954; PAFA Ann., 1949-50, 1954; LOC, 1949 (prize), 1951 (prize), 1952, 1954, 1955 (prize); SAGA, 1950, 1952-55 (prize); MMA, 1950; New Britain Mus., 1952-53; SFMA, 1952; Univ. So. Cal., 1953; Springfield, Ill., 1953; Univ. Illinois, 1953; Soc. Wash. Pr. M., 1953; Wichita AA, 1953 (prize); Gimbel, 1949-53 (prizes); BM, 1955; Denver A. Mus., 1954-55. **Work:** Milwaukee AI; Univ. Wisconsin; WPA murals, USPO, Lowell, Mich.; Moriss, Minn.; work also in colls. of Gimbels, Milwaukee; LOC; Lawrence Col., Appleton, Wis.; Beloit Col.; Wichita AA. **Comments:** Editor: "The Wisconsin Artist." Teaching: Milwaukee State T. Col., 1945; Milwaukee AI, 1945-46; Univ. Wis., 1944-50s. **Sources:** WW59; WW47; Falk, *Exh. Record Series.*

SESSLER, Stanley Sascha *[Painter, etcher, lecturer, teacher, designer] b.1903, St. Petersburg, Russia.*
Addresses: South Bend, IN; Siloam Springs, AR. **Studied:** Mass. Col. Art (dipl. fine arts, 1927 & dipl. art educ., 1928), with Major, Hamilton & Andrews; Courtauld Inst. Art, London; in Europe, 1955. **Member:** Hoosier Salon; Ind. AC; A. of Northern Ind.; AAPL; fel., Royal Soc. Arts, London, Eng.; fel., Int. Inst. Arts & Lett.; Midwestern Col. Art Conf.; Acad. Art Assn., Springfield, MA. **Exhibited:** Hoosier Salon, 1929-37, 1938 (PC Reilly first prize for painting), 1939-42; South Bend, Ind., 1942 (prize), Ind. AC, 1939-42; Northern Ind. A., 1929-46, 1955 (first prize for painting), 1966 (outstanding work in show); Ogunquit A. Center, 1937-38; Palm Beach A. Center, 1937-38; Hoosier Show,

Chicago, Ill & Indianapolis, Ind.; Springfield Mus. Art, Mass.; Ill. State Fair Exhib., Springfield; Nat. Exhib. Realistic Art, Springfield, Mass.;Heritage Art Galleries, Chicago, IL, 1970s. **Work:** Univ. Notre Dame, Ind.; Philbrook Art Ctr., Tulsa, Okla.; Columbus Mus. Arts & Crafts, Ga.; Univ. of the South, Sewanee, Tenn.; Beverly Art Gal., Chicago, Ill. Commissions: hist. map & landscapes, Buchanan Pub. Libr., Mich.; altar piece, Ascencion, St. Mary's Church, Floyd's Knobs, Ind.; Early Hist. South Bend, Robertson's Dept Store. **Comments:** Preferred media: oils. Teaching: instr. drawing, Vesper George Sch. Art, Boston, Mass., 1927-28; from instr. art to emer. prof., Univ. Notre Dame, 1928-70, hd. dept., 1937-60. **Sources:** WW73; WW47, which puts date of birth at 1905.

SETON, Ernest Thompson *[Illustrator, lecturer, painter, sculptor, teacher, writer] b.1860, South Shields, England / d.1946, near Santa Fe.*
Addresses: Santa Fe, NM. **Studied:** Toronto Collegiate Inst.; Royal Acad., London; Paris, 1890-96; Académie Julian, Paris with Bouguereau and Ferrier, 1891-92; also with Gérôme and Mosler in Paris. **Member:** NIAL. **Exhibited:** John Burroughs and Daniel G. Elliott medals, 1928. **Work:** Mus. New Mexico. **Comments:** Seton immigrated to Canada as a boy (c.1866), and studied in Toronto, London, and Paris before settling in the U.S. He became best known for depicting animals, and was head of the Boy Scout movement in America until 1915. He was also chief of Woodcraft League of America; President, Seton Inst., Santa Fe, NM; College Indian Wisdom, Santa Fe (founder). Author/illustrator: *Art Anatomy of Animals; Wild Animals I Have Known; The Biography of a Grizzly; Animal Heroes; The Book of Woodcraft; Lives of Game Animals; Gospel of the Redman* and *Great Historic Animals.* **Sources:** WW40; P&H Samuels, 433.

SETTANNI, Luigi *[Painter, illustrator] b.1908, Torremaggiore, Italy.*
Addresses: Phila., PA. **Studied:** Oakley; Dull. **Exhibited:** PAFA Ann., 1933-34, 1942. **Sources:** WW38; Falk, *Exh. Record Series.*

SETTELE, Theodora See: **SANGRÉE, Theodora (Mrs. Settele)**

SETTERBERG, Carl Georg *[Painter, illustrator] b.1897, Las Animas, CO.*
Addresses: NYC. **Studied:** AIC; Am. Acad. Fine Arts. **Member:** SI; NAD; AWCS; Audubon Artists; Salmagundi Cl.; Soc. Illusr. (v. pres.). **Exhibited:** AWCS, 1942-72 (Watercolor USA Award, 1967 & William Church Osborne Award, 1969); All. A. Am., 1948-71; NAD, 1948-71 (1958, Ranger Fund Award); Royal Acad., 1960; Western Art Assn., Phoenix Art Mus., 1971. **Work:** McChord AFB, Wash., DC; Air Force Acad., Colorado Springs, Colo.; Columbus Mus., Ga.; De Beers Collection; Soc. Illusr. Commissions: 14 doc. paintings, USAF; portraits, Air Force Acad. **Comments:** Preferred media: oils, watercolors. Positions: illusr., *McCalls, Colliers, Womans Home Companion, Am., Rd. Bk.* & others. Publications: auth., "Treatise," *Am Artist,* 1961. **Sources:** WW73; WW47; Norman Kent, *Watercolor techniques* (Watson-Guptill, 1968); Ralph Fabri, *American Watercolor Society* (1969).

SETTLE, Paul (Mrs.) See: **BROAS, Mary Adele**

SETTLEMYRE, Julius Lee, Jr. *[Painter, lecturer, teacher, mus dir] b.1916, Hickory, NC.*
Addresses: Kings Mountain, NC; Rock Hill, SC; McConnells, SC. **Studied:** George Washington Univ.; Corcoran Sch. A.; in Paris; & with Richard Lahey, Catherine Critcher. **Member:** Gaston A. Lg.; AA Mus.; Southeastern Assn. Mus. **Exhibited:** Nat. Mus., Wash., DC, 1939; Sorbonne Sch. FA, Paris, 1940; CGA, 1937, 1939; Mint Mus. A., 1940, 1943, 1946; Chapel Hill, NC, 1943; MMA, 1942. Award: D.A.R., 1955. **Work:** mural, Shakespeare Auditorium, Shelby, NC; Snyder Mem., Charlotte, NC; Winnesboro Mem. Bldg., Montreat, NC; Court House, Shelby, NC; Univ. North Carolina; ports., Baptist Hospital, Columbia, SC; Court House, York, SC; Medical Col., Charleston, SC. **Comments:** Position: dir., Children's Nature Mus., Rock Hill,

SC. Lectures: Early American Art; Natural History; Indians of the Region; Non-objective and Abstract Art. **Sources:** WW59; WW47.

SETTY See: **CITTI, Louis**

SETZER, Bernice Voshel (Mrs.) *[Painter, designer, teacher, lecturer] mid 20th c.; b.Kentucky.*
Addresses: Des Moines, IA. **Studied:** John Herron Art Inst.; Indianapolis Normal School; Butler Col.; Applied Arts Summer School, Chicago; Calif. Col. Arts & Crafts; Chouinard School Art; International School Art; Joseph Binder; Marya Werten; Norman Edwards; William Allen; Xanier Martinez; Frederick Meyer; Pedro de Lemos. **Exhibited:** Nelson Gallery, Kansas City; Des Moines; Chouinard A. Sch. Gal. **Comments:** Positions: art teacher, Indianapolis, IN; teacher & assistant dir. art, San Antonio, TX; art prof., Kent State Teachers Col.; assistant dir., art education, Des Moines Public Schools. **Sources:** Ness & Orwig, *Iowa Artists of the First Hundred Years,* 187-88.

SEULITRINIC, Francesca *[Painter] mid 20th c.*
Studied: ASL. **Exhibited:** Salons of Am., 1925; S. Indp. A., 1926. **Sources:** Falk, *Exhibition Record Series.*

SEVATOS, Fanny Bunand See: **BUNAND-SEVATOS, Fanny**

SEVER, Alfredo *[Painter] mid 20th c.*
Addresses: NYC. **Exhibited:** S. Indp. A., 1919-20, 1924. **Sources:** Marlor, *Soc. Indp. Artists.*

SEVERANCE, Benjamin J. *[General and fancy painter] early 19th c.*
Addresses: Northfield, MA, 1823. **Work:** Shelburne (VT) Mus. **Comments:** His fancy work included Masonic painting, carriages, signs, portraits, overmantels, and landscapes. **Sources:** G&W; Dods, "Connecticut Valley Painters," 207; Lipman and Winchester, 179; Muller, *Paintings and Drawings at the Shelburne Museum,* 125 (w/repro.).

SEVERANCE, Clare M. (Mrs.) *[Craftsman, lithographer] b.1887, West Bend, WI / d.1955.*
Addresses: Madison, WI. **Studied:** Univ. Wisconsin; William H. Varnum; Ralph M. Pearson. **Member:** Wisc. Designer-Craftsmen; Boston Soc. Arts & Crafts; Madison AA; Minnesota S. Group. **Exhibited:** Milwaukee , 1928 (prize) 1930 (prize) 1939 (prize); Madison AA, 1944 (prize), 1947 (prize), 1952 (prize); Milwaukee AI, 1946 (prize), 1947 (prize); Nat. All. Art & Indus. 1933; Phila. Art All., 1937, 1944; Minnesota S. Group, 1946; Wisconsin Salon Art, 1940-41, 1942-43; Milwaukee Printmakers, 1940, 1942, 1944, 1946, 1949; Milwaukee Designer-Craftsmen, 1928, 1930, 1939, 1944, 1946; Phila. Print Club, 1948. **Sources:** WW47; WW53.

SEVERANCE, John L. *[Patron] b.1863, Cleveland / d.1936, Cleveland Heights, OH.*
Comments: President of Cleveland Mus. A., 1926-36. He donated his great collection of arms and armor in 1917; also he gave Severance Hall, the home of the Cleveland Symphony Orchestra.

SEVERANCE, Julia Gridley *[Sculptor, etcher] b.1877, Oberlin, OH / d.1972, San Diego, CA.*
Addresses: Oberlin, OH; San Diego, CA. **Studied:** AIC; Cleveland School Art; ASL; Oberlin College. **Member:** AAPL; San Diego Art Gld.; Cleveland Women's AC. **Exhibited:** AIC, 1916-24. **Work:** Oberlin College; LOC; St. Mary's School, Knoxville, IL; Allen Mem. Mus., Oberlin, OH; San Diego FA Gal. **Sources:** WW59; WW47.

SEVERIN, A. A. *[Painter] 20th c.*
Addresses: Chicago, IL. **Member:** GFLA. **Sources:** WW27.

SEVERIN, Charles See: **SEVERYN, Charles**

SEVERINO, D(ominick) Alexander *[Educator, art administrator] b.1914, Boston, MA.*
Addresses: Worthington, OH. **Studied:** Mass. Sch. Art (B.S.); Boston Univ. (Ed.M.); Harvard Univ. (Ed.D.). **Member:** Col. Art

Assn. Am.; Nat. Art Educ. Assn.; Am. Fedn. Art; Assn. Sch. Adminr.; Nat. Educ. Assn. **Comments:** Positions: asst. dean art & design, RI Sch. Design, 1947-48; chmn. dept. art, Bradford Durfee Tech. Inst., 1948-52; dir. fine & appl. art, Ohio State Univ., 1955-57, assoc. dean Col. Educ., 1957-. Teaching: instr. art, RI Col. Educ., 1939-43; prof. art, Univ. Wis., 1952-55. **Sources:** WW73.

SEVERY, Albert William *[Painter] b.1906, Oakland, CA / d.1976, Berkeley, CA.*
Addresses: Oakland, CA. **Studied:** Calif. Col. of Arts & Crafts. **Exhibited:** Oakland Art Gal., 1937. **Comments:** Position: editor, *Honululu Star Bulletin;* cartographer, Rand McNally Publishers. Specialty: oil paintings of landscapes, still lifes and seascapes. **Sources:** Hughes, *Artists in California,* 506.

SEVERYN, Charles *[Lithographer] b.1820, Poland.*
Addresses: NYC, 1845-1860's. **Comments:** He was born between 1808 and 1820. He was occasionally employed by Currier & Ives (see entry), and he was also a partner of Eliphalet Brown (c.1851-53) and of George W. Hatch (1853-54), but for the most part Severyn worked on his own. **Sources:** G&W; 7 Census (1850), N.Y., LVI, 1 [aged 30]; 8 Census (1860), N.Y., LVI, 14 [aged 52]; Peters, *Currier & Ives,* I, 119; Peters, *America on Stone.*

SEVIN, Clifford L. *[Engraver] b.c.1892, LA.*
Addresses: New Orleans, active 1907-17. **Sources:** *Encyclopaedia of New Orleans Artists,* 349.

SEVIN, Whitney *[Educator, painter, sculptor] b.1931, Birmingham, MI.*
Addresses: Franklin, IN; Hampton, VA. **Studied:** Kalamazoo Col.; Cranbrook Acad. A. (B.F.A., M.F.A.). **Member:** AEA; CAA. **Exhibited:** Butler Inst. Am. A., 1957-58, 1960, 1964; Ball State T. Col., 1957-59, 1962; Provincetown A. Festival, 1958; Columbia Mus. A., 1957; Exh. Momentum, Chicago, 1952-53; Michigan A., 1953-57; Michiana Regional, 1957, 1964; Ind. State Fair, 1960-61; Louisville A. Center, 1961, 1964; Religious A. Festival, Duluth, 1964; Duluth A. Center, 1964; PAFA Ann., 1966. Solo: Hampton Inst. Mus., 1964; Va., State Col, Norfolk, 1964; Basil Gal., Duluth, 1964. Included in "Prize Winning Paintings," 1960. Awards: prizes, Kalamazoo AA, 1952; Army Photographic Comp., 1956; South Bend AA, 1957 (purchase); Art for Religion, Indianapolis, 1958; Eli Lilly European travel grant, 1959; Indiana A., 1960, 1964; Indiana State Fair, 1960, 1961; Louisville A. Center, 1961 (2). **Work:** Cranbrook Acad. A.; South Bend AA; Cranbrook Sch. Galleries. **Comments:** Position: prof., Art Dept., Franklin College, Franklin, Ind.; prof., chm. Art Dept., Hampton Institute, Hampton, Va., 1964-. **Sources:** WW66; Falk, *Exh. Record Series.*

SEWALL, Alice Archer See: **JAMES, Alice Archer Sewall (Mrs. John H.)**

SEWALL, Annie L. *[Artist] mid 20th c.*
Addresses: Wash., DC, active 1912-35. **Exhibited:** Greater Wash. Indep. Exhib., 1935. **Sources:** McMahan, *Artists of Washington, DC.*

SEWALL, Blanche Harding (Mrs. Cleveland) *[Painter] b.1889, Ft. Worth, TX.*
Addresses: Houston, TX. **Studied:** J.C. Tidden; F. Wagner. **Member:** SSAL. **Sources:** WW33.

SEWALL, Edward *[Painter] 20th c.*
Exhibited: AIC, 1934, 1941. **Sources:** Falk, *AIC.*

SEWALL, Howard S. *[Painter, graphic artist, teacher] b.1899, Minneapolis.*
Addresses: Portland, OR. **Studied:** Wash. Sch. A. (founder). **Member:** Am. Ar. Cong. **Exhibited:** Portland AM. **Work:** murals, Timberline Lodge, Mt. Hood, Ore.; H.S. Oregon City. **Comments:** Position: t., Salem A. Center. **Sources:** WW40.

SEWARD, Coy Avon *[Etcher, blockprinter, lithographer, writer, painter] b.1884, Chase, KS / d.1939.*

Addresses: Wichita, KS, 1908-39. **Studied:** Washburn College, Topeka, with A.T. Reid, Geo. M. Stone; Bethany College, Lindsborg, with B. Sandzén. **Member:** Wichita AA; Wichita AG; Calif. PM; Chicago SE; Prairie PM. **Exhibited:** Kansas City AI, 1924 (prize); PAFA, 1925; Mid-West Artists, 1927 (medal), 1928, (gold); Delta Phi Delta Graphic Arts, 1936 (prize). **Work:** Kans. Masonic Grand Lodge; Sedgwick Co. Historical Society; Los Angeles Mus. Hist. & A.; Springfield (MA) Public Library; Smoky Valley AC, Lindsborg, KS; H.S. Art Club; Twentieth Century Club; Univ. Wichita AA; Calif. State Library; Kansas Fed. Women's Club; Univ. Kans.; N.Mex. Fed. Women's C.; AIC; Vanderpoel Memorial H.S., Chicago; Mulvane Art Mus., Topeka, KS; Tulsa University; Univ. Oklahoma; Belhaven College, Jackson, MS; Lawrence College, Appleton, WI; CMA; Smithsonian; LOC; RISD; Bibliothèque Nationale, Paris; Honolulu Acad. Art. **Comments:** Author: "Metal Plate Lithography for Artists." Contributor: articles in "Prints" and "The Palette." Position: printer, Western Lithograph Co., Wichita, 1923-39. **Sources:** WW38; P&H Samuels, 433-34.

SEWARD, James *[Engraver] b.c.1832, NYC.*
Addresses: NYC, 1858 and after. **Sources:** G&W; 8 Census (1860), N.Y., XLVI, 906; NYBD 1858.

SEWARD, William E. *[Ship carver] mid 19th c.*
Addresses: Baltimore. **Comments:** Partner with James Thompson Randolph (see entry) in firm of Randolph & Seward, ship carvers, active in Baltimore 1853-60. **Sources:** G&W; Pinckney, *American Figureheads,* 121, 199; Baltimore CD 1853-60.

SEWELL, Alice *[Painter, sculptor, lecturer, teacher] mid 20th c.; b.Hillsboro, OR.*
Addresses: Portland, OR. **Studied:** DuMond; A. Fairbanks; Voisin; E. Steinhof. **Member:** Oreg. SA. **Exhibited:** Oreg. SA Annual Exh., 1932 (prize), 1938 (prize); Carnegie F., Univ. Oregon, 1933. **Work:** sculpture, Sha Kung Sch., China; Pacific Univ., Forest Grove, Oreg.; mural Hillsboro H.S., Hillsboro. **Comments:** Position: t., Brandon Sch. Expression, Portland. **Sources:** WW40.

SEWELL, Amanda Brewster *[Painter] b.1859, North Elba, Essex County, NY / d.1926.*
Addresses: Oyster Bay, NYC, NY. **Studied:** Cooper Union with Douglas Volk and R. Swain Gifford; ASL with W.M. Chase & William Sartain; Académie Julian, Paris with Robert-Fleury, William Bourguereau; privately with Carolus-Duran. **Member:** ANA, 1903; NAWA; Cosmopolitan Club; Women's AC. **Exhibited:** Brooklyn AA, 1882; Paris Salon, 1886-88, 1889; AIC; NAD, 1881-84, 1888 (Dodge Prize), 1903 (Clarke Prize); PAFA Ann., 1888 (under Brewster); 1889-1905; Columbian Expo., Chicago, 1893 (med.); Boston AC, 1896, 1898, 1904; Pan-Am. Expo., Buffalo, 1901 (med.); Charleston Expo., 1902 (med.); St. Louis Expo., 1904 (med.); Am. Art Assoc. 1891 (solo); Corcoran Gal annual, 1907. **Comments:** Specialized in Arcadian landscapes as well as portraiture. Born Lydia Amanda Brewster, she married Robert V. Sewell, and is usually known as Amanda Brewster Sewell. **Sources:** WW27; Pisano, *One Hundred Years.the National Association of Women Artists,* 81; Fink, *American Art at the Nineteenth-Century Paris Salons,* 324; Falk, *Exh. Record Series.*

SEWELL, Amos *[Illustrator] b.1901, San Francisco, CA / d.1983.*
Addresses: NYC; Westport, CT. **Studied:** Calif. Sch. FA; ASL and Grand Central Sch. Art with Guy Pene du Bois, Harvey Dunn, Julian Levy. **Member:** SI; Guild Freelance Artists; Westport Artists. **Exhibited:** Annual exh. American Illustration; SC; Art Dir. Club, annually; Cambridge (MA) Sch. Design. **Work:** SI. **Comments:** Illustrations and covers for national magazines including *Country Gentleman, Saturday Evening Post* and text-books. **Sources:** WW66; WW47; P&H Samuels, 434.

SEWELL, Annie See: **SEWALL, Annie L.**

SEWELL, Brice H. *[Sculptor] mid 20th c.*
Addresses: Albuquerque, NM. **Exhibited:** PAFA Ann., 1931.
Sources: Falk, *Exh. Record Series.*

SEWELL, Edith G. *[Painter] 19th/20th c.*
Addresses: NYC, c.1898-1900. **Exhibited:** Soc. Am. Artists,
1898. **Sources:** WW01; Petteys, *Dictionary of Women Artists.*

SEWELL, H. *[Artist and lithographer] early 19th c.*
Addresses: Ridgewood, NJ. **Exhibited:** PAFA Ann., 1921.
Comments: He was working for Henry and William J.
Hanington, the dioramists, in NYC in the mid-thirties. **Sources:**
G&W; Peters, *America on Stone*; Fred J. Peters, *Clipper Ship
Prints*; N.Y. *Herald*, Dec. 7 and 22, 1836, and Boston *Transcript*,
Sept. 10, 1838 (courtesy J.E. Arrington); Falk, *Exh. Record Series.*

SEWELL, Harriet *[Genre painter, watercolorist] early 19th c.*
Comments: Genre painting in watercolors, c.1810. **Sources:**
G&W; Lipman and Winchester, 179.

SEWELL, Helen Moore *[Illustrator, writer, painter] b.1896,
Mare Island, CA / d.1957.*
Addresses: NYC. **Studied:** Frederick Baker, Otto Beck, Max
Herrmann, Hawthorne, & Archipenko; Packer Inst.; PIA School;
Charlot. **Comments:** Author/illustrator: "Jimmy and Jemima,"
1940; "Birthdays for Robin," 1944. Illustrator: "Poems by Emily
Dickinson," "Jane Eyre," "A First Bible." **Sources:** WW53;
WW47.

SEWELL, Jack Vincent *[Museum curator] b.1923,
Dearborn, MO.*
Addresses: Chicago, IL. **Studied:** Saint Joseph Jr. Col., Mo.,
1941-43; City Col. NY, 1943-44; Univ. Chicago (M.F.A., 1950);
Harvard Univ., 1951-53. **Member:** Far Eastern Ceramic Group;
Japan-Am Soc Chicago (dir., v.pres.); The Cliff Dwellers; Arts Cl.
Chicago. **Comments:** Positions: mem. staff, Oriental dept., AIC,
1950-56, assoc. cur. Oriental art, 1956-58, cur., 1958-. Teaching:
lect., Indian and Far Eastern Art, The Arts of China, Strength in
Delicacy--A Study of Archaic Chinese Bronzes & Sculpture of
Gandhara. Collections arranged: Complete reinstallation of
Oriental Collections, AIC, 1958. Publications: contribr., Archaeol.
& Chicago Art Inst. Quart. **Sources:** WW73.

SEWELL, Joseph *[Painter] late 19th c.*
Addresses: NYC, 1886. **Exhibited:** NAD, 1886. **Sources:**
Naylor, *NAD.*

SEWELL, Lydia Amanda Brewster See: **SEWELL,
Amanda Brewster**

SEWELL, M. M. *[Painter] 19th/20th c.*
Addresses: Active in Brooklyn, NY, c.1898-1900. **Studied:** F.D.
Henwood. **Exhibited:** Boston AC, 1898. **Sources:** WW01; *The
Boston AC.*

SEWELL, Marion Brown *[Painter] mid 20th c.*
Exhibited: S. Indp. A., 1937. **Sources:** Marlor, *Soc. Indp. Artists.*

SEWELL, Robert V(an) V(orst) *R.V.V.S.*
*[Mural painter] b.1860, NYC /
d.1924, Florence, Italy.*
Addresses: Paris, 1885; NYC, 1888-90; Tangier, Morocco, 1895,
1899; Oyster Bay, NY. **Studied:** Académie Julian, Paris with
Lefebvre and Boulanger, 1883-87. **Member:** ANA, 1901; NY
Arch. Lg., 1899; Mural P.; Century Assn.; Union Lg. C.; Lotos C.
Exhibited: Paris Salon, 1885, 1887-88; Boston AC, 1887-1901;
PAFA Ann., 1888-1905 (7 times); NAD, 1885-99 (prize, 1889);
Boston, 1891 (med); Pan-Am. Expo., Buffalo, 1901 (med); St.
Louis Expo., 1904 (med); AIC. **Work:** Georgian Court,
Lakewood, NJ; St. Regis Hotel, NY; Sweat Mem., Portland,
Maine. **Comments:** He was much in demand as a mural painter at
the turn of the century, receiving many commissions from
libraries and banks. He also painted landscapes, including some
on Monhegan Island (Me.). **Sources:** WW24; Curtis, Curtis, and
Lieberman, 33, 186; Fink, *American Art at the Nineteenth-
Century Paris Salons*, 389; Falk, *Exh. Record Series.*

SEWELL, W. *[Sculptor] mid 20th c.*
Exhibited: S. Indp. A., 1940. **Sources:** Marlor, *Soc. Indp. Artists.*

SEWELL, William J. *[Sculptor] 20th c.*
Exhibited: S. Indp. A., 1938, 1941-42. **Sources:** Marlor, *Soc.
Indp. Artists.*

SEWERYN, Leonard *[Painter] mid 20th c.*
Exhibited: Salons of Am., 1934. **Sources:** Marlor, *Salons of Am.*

SEXAUER, Donald Richard *[Printmaker, educator] mid
20th c.; b.Erie, PA.*
Addresses: Greenville, NC. **Studied:** Col. William & Marry;
Edinboro State Col. (B.S.); Kent State Univ. (M.A.). **Member:**
Soc. Am. Graphic Artists; Acad. Artists Assn. **Exhibited:** Soc.
Am. Graphic Artists, 1964-72; New Talent In Printmaking, New
York, 1966; 140th Ann., NAD, 1966; San Diego Print Invitational,
Calif., 1971; 16th Hunterdon Nat., Clinton, NJ, 1972; Garden
Gallery, Raleigh, NC, 1970s. Awards: print prize, 140th Ann.,
NAD, 1966; purchase award, Piedmont Print Ann., Mint Mus.,
1971; purchase award, Bradley Print Show, Peoria. **Work:** Butler
Inst. Am. Art; NYPL; Boston Pub. Libr.; Mint Mus. Art,
Charlotte, NC; Montgomery Mus. Fine Arts, Ala. Commissions:
print eds., Woman, Assoc. Am. Artists, 1966 & To Fly, To Fly, Int.
Graphic Arts Soc., 1966; Vietnam Fragments (folio), Off, Chief
Mil. Hist., Wash., DC, 1971. **Comments:** Preferred media:
intaglio. Publications: illusr., "Red Clay Reader Number 5,"
Southern Lit. Rev., 1968. Teaching: prof. printmaking, Sch. Art, E.
Carolina Univ., 1960-on. **Sources:** WW73.

SEXTON, Duard Warren *[Commercial artist and designer]
b.1904, Scranton, IA.*
Addresses: Des Moines, IA. **Studied:** Cumming School Art;
Drake Univ. **Exhibited:** Iowa Art Salon, 1935-36; Joslyn Mem.;
Five State Exhibit, Omaha, 1935 (first honors). **Comments:**
Positions: Register and Tribune Co.; Warns Art Service; Glendale
Mem. Co. Illustrator, "American Humor." **Sources:** Ness &
Orwig, *Iowa Artists of the First Hundred Years,* 188.

SEXTON, Emily S(tryker) *[Painter] b.1880, Long Branch,
NJ / d.1948.*
Addresses: Long Branch, NJ/Woodstock, NY. **Studied:** NJ State
Normal School; ASL; M. Field; C. Rosen; H. Giles; NY School
Fine & Applied Art; Woodstock School Mod. Art. **Member:**
AAPL; Asbury Park FA Soc. **Exhibited:** Traphagen School, 1925
(prize), 1926 (prize); PAFA Ann., 1936, 1939, 1946; Corcoran Gal
biennial, 1937; NAD, 1936, 1939; Asbury Park FAA; Allenhurst
AC; Montclair AM, 1939-46. **Sources:** WW47; Falk, *Exh.
Record Series.*

SEXTON, Frederick Lester *SEXTON*
*[Landscape painter, teacher, lecturer]
b.1889, Cheshire, CT / d.1975.*
Addresses: Lyme, CT, 1936-on; New Haven, CT. **Studied:** Yale
School FA with Sergeant Kendall, Edwin Taylor, A.V. Tack
(Winchester Traveling Fellow, 1915; B.F.A., 1917). **Member:** SC,
1929; Lyme AA, 1936-72; New Haven Paint & Clay Club, 1922-
on; Meriden Arts & Crafts Club; CAFA. **Exhibited:** Univ.
Connecticut, 1929 (solo); Yale Sch. FA, 1930 (solo); New Haven
PCC, 1922-49 (prizes in 1923, 1927, 1940, 1943), 1975 (memori-
al solo); Meriden Arts & Crafts Assn., 1941 (portrait prize);
CAFA, 1927 (prize), 1938 (prize), 1944 (Carney Prize); NAD,
1929, 1934, 1941; SC, 1929-75; Lyme AA, 1939-72, 1975
(memorial solo); Hartford Salmagundians; Munson Gal., New
Haven, 1930s-40s (4 solos); Newton Gal., NYC, 1936, 1940
(solos); Lyman Allyn Mus.; Bridgeport AA; Corcoran Gal bienni-
al, 1949; East Hampton (LI) AA; St. Johns by the Sea, 1967
(prize); Conn. Gal., Marlborough, 1987 (retrospective). **Work:**
New Haven PCC; Yale-New Haven Hospital, Hopkins School;
New Haven City Hall; St. Margaret's School, Waterbury; Univ.
Connecticut, Storrs; St. John's Mem. Chapel, Waterbury, CT;
LACMA. **Comments:** Most of his landscapes were painted in the
region between New Haven and Old Lyme, CT. He was active
with the Old Lyme colony of artists beginning in the late 1920s-
early 1930s, and painted in a bold but realist Post-Impressionist

style, often employing a palette knife. As a baby, he was severely burned in a fire, and, although his right hand was permanently closed, this did not affect his ability to paint throughout his life — or to build his own 28-ft sailing yacht, in 1955. After studying at Yale, he served in WWI as an ambulance driver; upon his return in 1919, painting became his profession. He also taught widely at schools in the New Haven area. **Sources:** WW59; WW47; Art in Conn.: Between World Wars; Helen Fusscas, exh. cat. (Conn. Gal., Marlborough, 1987).

SEXTON, Henry *[Painter] mid 20th c.*
Addresses: NYC. **Exhibited:** PAFA Ann., 1946. **Sources:** Falk, *Exh. Record Series.*

SEXTON, Lee W. *[Painter] mid 20th c.*
Studied: ASL. **Exhibited:** S. Indp. A., 1941. **Sources:** Marlor, *Soc. Indp. Artists.*

SEXTON, Leo Lloyd, Jr. *[Painter, sculptor] b.1912, Hilo, HI / d.1990.*
Addresses: Honolulu, HI. **Studied:** Punahou School; BMFA Sch., 1931, Cummings travel scholarship; Slade Sch., Univ. London; in Europe. **Member:** Hawaii Painters & Sculptors League (pres., 1960). **Exhibited:** Boston A. Cl., 1933; Vose Gal., Boston, 1933; Gumps, San Francisco, 1933; Bournemouth Mus., England, 1936; Royal Acad., London, 1936 & 1939; Oakland (CA) Mus.,1940; Honolulu Acad. Arts, 1933 (first solo), 1955-56; Grossman-Moody Gal., Honolulu, 1957 (solo); Hilton Hawaiian Village Hotel Gal., 1961 (solo). **Awards:** Univ. London (first prize, life drawing). **Work:** Honolulu Acad. Arts. **Comments:** Preferred media: oils. Sexton painted landscapes and flowers. **Sources:** WW73; WW40; Forbes, *Encounters with Paradise,* 213, 265.

SEXTON, Samuel H. *[Portrait and landscape painter] mid 19th c.*
Addresses: Schenectady, NY, 1839-60. **Exhibited:** NAD; American Art-Union. **Sources:** G&W; Cowdrey, NAD; Cowdrey, AA & AAU; Schenectady CD 1857, 1860; N.Y. State BD 1859; Stauffer, no. 2557; represented in New York State Museum. Mrs. Margaret F. Eden of Los Angeles, CA, owns a portrait signed and dated, "S.H. Sexton, Schenectady, March 1839" (letter, NYHS, April 8, 1956).

SEXTON, William *[Sculptor] b.c.1824, Ireland.*
Addresses: NYC, 1860. **Sources:** G&W; 8 Census (1860), N.Y., LVII, 768.

SEYBOLD, Henry *[Lithographer] b.c.1832, Frankfort, Germany.*
Addresses: NYC, 1860. **Comments:** His wife was Irish and their children were all born in New York. **Sources:** G&W; 8 Census (1860), N.Y., XLIII, 631.

SEYDEL, Victor L. A. *[Painter] early 20th c.*
Addresses: NYC/Terrace Park, OH. **Member:** Cincinnati AC; SC. **Exhibited:** AIC, 1918. **Sources:** WW25.

SEYFERT, Theodore H. *[Painter] 20th c.*
Addresses: Phila. **Sources:** WW04.

SEYFFERT, Helen F. (Mrs. Leopold G.) *[Painter] early 20th c.*
Addresses: Phila., PA, c.1915-25. **Studied:** PAFA. **Member:** PAFA (fellow). **Exhibited:** Corcoran Gal biennials, 1914, 1916; PAFA Ann., 1917-19; AIC, 1923. **Comments:** Affiliated with AIC. **Sources:** WW25; Petteys, *Dictionary of Women Artists;* Falk, *Exh. Record Series.*

SEYFFERT, Leopold *Leopold Seyffert 1936* **(Gould)** *[Painter] b.1887, California, MO / d.1956, Bound Brook, NJ.*
Addresses: Phila., PA; NYC; Easton, CT. **Studied:** PAFA with W.M. Chase. **Member:** Phila. Sketch Club; ANA, 1916; NA, 1925; Portrait Painters; AFA; Cliff Dwellers; Phila. AC; SC. **Exhibited:** PAFA Ann., 1911-52 (gold 1918 & 1921, prize 1926 & 1929); Corcoran Gal biennials, 1912-43 (15 times); Phila. AC, 1913 (gold); Pan-Pacific Expo, San Francisco 1915 (prize);

Chicago, 1923 (Logan prize); Mun. Art Lg., Chicago (medal); Sesqui-Centennial Expo, Phila., 1926 (medal); NAD, 1916-18 (prize), 1921 (prize, each yr.), 1923 (gold), 1924 (gold); AIC, 1924 (prize); CI, 1930 (prize); Salons of Am., 1934. **Work:** AIC; PAFA; Detroit IA; Rochester Mem. Art Gal.; Carnegie Inst.; CGA; LACMA; BM; Nelson Gal. Art; NY Hist. Soc.; Wilmington (DE) Hist. Soc.; MMA; memorial, St. Louis, MO. **Sources:** WW53; WW47; Falk, *Exh. Record Series.*

SEYFFERT, Richard L. *[Painter] b.1915, Philadelphia, PA.*
Addresses: New York 3, NY; New Canaan, CT. **Studied:** NAD; in Switzerland, and with Leon Kroll, Gifford Beal. **Member:** All. Artists Am.; Nat. Soc. Painters in Casein; NAC; AAPL; Knickerbocker Artists. **Exhibited:** NAD, 1936; AIC, 1942, 1943; NAC, 1959; AAPL, 1958 (prize). **Sources:** WW59.

SEYFORT, Aimee (Mrs. A. Seyfort Ruegg) *[Painter, teacher] b.1905, London, England.*
Addresses: Binghamton, NY. **Studied:** Paris. **Exhibited:** BM, 1926 (solo); Roerich Mus., 1930 (solo); Weyhe Gal., 1939 (solo), 1941 (solo); Am.-British AC, 1942 (solo); Mus. New Mexico, Santa Fe, 1945 (solo); New Mexico Art Lg., 1946 (solo); Amsterdam (solo); Paris (solo). **Sources:** WW53; WW47.

SEYFRIED, John Louis *[Sculptor] b.1930, St Louis, MO.*
Addresses: Memphis, TN. **Studied:** Washington Univ. (B.F.A., 1958); Syracuse Univ.; Cranbrook Acad. Art (M.F.A., 1962). **Exhibited:** Michigan Show, Detroit, 1961-62; Missouri Show, St Louis, 1962-64; Drawings Int., Detroit, 1964; Mid-South Show, Memphis, TN, 1966, 1968, 1970 & 1972; New Media Sculpture Show, Atlanta, GA, 1969; New Bertha Schaefer Gal., NYC, 1970s. **Work:** Albright Mus.; Charleston Art Gal.; Tennessee Arts Commission. Commissions: heroic fountain group, Chase Park Plaza, St. Louis, MO, 1963-64; divider screen, IE Milestone, St. Louis, 1964; wall mural, Fred Seidel, NYC, 1966; five welded reliefs, Self Mem. Hospital, Greenville, SC, 1967; heroic mem. & wall relief, Prof. Photo Am., Des Plaines, IL, 1968-69. **Comments:** Positions: exec. dir., People's AC, 1962-63. Teaching: instr. of sculpture & ceramics, Webster Col., St. Louis, 1962-63; asst. prof. art, Merimec Community Col., Kirkwood, MO, 1963-64; assoc. prof. of sculpture, Memphis (TN) Acad. Arts, 1965-. **Sources:** WW73.

SEYFRIED, Joseph A. *[Artist] mid 20th c.*
Addresses: NYC. **Exhibited:** S. Indp. A., 1922, 1926, 1931, 1943-44; Salons of Am., 1934. **Sources:** Falk, *Exhibition Record Series.*

SEYLER, David Warren *[Craftsperson, designer, painter, lecturer] b.1917, Dayton, KY.*
Addresses: Erlanger, KY; Lincoln, NE. **Studied:** Art Acad. Cincinnati, diploma; AIC; Univ. Chicago (B.F.A.); Univ. Wisconsin (M.F.A.); W. Hentschel; F. Chapin; E. Zettler. **Member:** Mod. Art Soc.; Nebraska AA; Crafters Club, Cincinnati; College Art Assn. Am.; Int. Soc. Arts & Letters (fellow). **Exhibited:** Syracuse Mus. FA, 1938 (prize)-41; AIC, 1938 (prize), 1939, 1944 (solo); Univ. Chicago, 1938 ("Big 10 Exhib."), 1939; Phila. Art All., 1939; WFNY, 1939; Loring Andrew Gal., Cincinnati, 1943 (solo); CM, 1939-46; PAFA Ann., 1951; Sheldon Gal. & Lakewood Arts Studio, Lincoln, NE, 1970s. **Awards:** Drakenfeld first prize, Nat. Ceramic Exhib.; Woods Foundation travel grant, Italy, 1959-60; Univ. Nebraska Foundation grant, England, 1971-72. **Work:** Syracuse Univ., NY; Univ. Chicago, IL; Cincinnati AM; Sheldon Art Gal., Lincoln, NE. Commissions: mural, U.S. Navy Govt. Lakes Training Station, 433; stained glass & altar, Holy Trinity Episcopal Church, Lincoln, 1962-72; mural, KOLN-TV, Lincoln, 1968-69. **Comments:** Preferred media: stone, ceramics, bronze. Teaching: sculptor/designer, Rookwood Pottery, Cincinnati, 1936-39; art dir., Kenton Hills Porcelains, Inc., Erlanger, KY, 1940-; prof. sculpture, drawing & design, Univ. Nebraska, Lincoln, 1948-. Collection: prints & paintings. Art interests: prints-paintings as gifts to local museum. **Sources:** WW73; WW47; Warren E. Cox, *Pottery & Porcelain* & Herbert Peck, *The Book of Rookwood Pottery* (Crown); Falk, *Exh. Record Series.*

SEYLER, Julius *[Painter] b.1873 / d.1949.*
Addresses: St. Paul. **Exhibited:** Armory Show, 1913. **Sources:** WW15; Brown, *The Story of the Armory Show.*

SEYMOUR, Cella B(urnham) *[Portrait painter, illustrator, etcher] b.1872, Buffalo, NY / d.1958.*
Addresses: NYC/Oakland, CA. **Studied:** ASL; Pratt Inst.; with Wm. Chase; Paris; Holland. **Member:** Carmel AA. **Exhibited:** San Francisco AA, 1916-25; East Bay Artists, Oakland Art Gal., 1917; Berkeley Lg. FA, 1924; Santa Cruz Art Lg., 1929; GGE, 1939. **Comments:** Illustrator: "Mexican Types." Specialty: portraits in pastel and red chalk. **Sources:** WW15; Hughes, *Artists in California,* 506. He states her year of birth as 1869.

SEYMOUR, Charles *[Artist] mid 19th c.*
Addresses: Wash., DC, active 1865. **Sources:** McMahan, *Artists of Washington, DC.*

SEYMOUR, Charles, Jr. *[Art historian, curator] b.1912, New Haven, CT / d.1977.*
Addresses: New Haven, CT. **Studied:** Yale Univ. (Sterling fellowship, 1935-37; B.A.; Ph.D.); Univ. Paris; Cambridge Univ. **Member:** Renaissance Soc. Am.; College Art Assn. Am. **Exhibited:** Awards: Guggenheim Foundation fellowship, 1954-55. **Comments:** Positions: curator of sculpture & asst. chief curator, Nat. Gallery Art, 1939-49; curator of Renaissance art, Yale Univ. Art Gallery, 1949-. Publications: author, "Notre Dame of Noyon," 1939 & 1970; author, "Masterpieces of Sculpture in The National Gallery of Art," 1949; author, "Tradition and Experiment in Modern Sculpture," 1949; author, "Sculpture in Italy 1400-1500," *Pelican History of Art,* 1966; author, "Sculpture of Verrocchio," 1971. Teaching: prof. art history, Yale Univ., 1949-; visiting Mellon Professor of art history, Univ. Pittsburgh, 1965. Research: Medieval and Renaissance art, especially architecture, sculpture and painting. **Sources:** WW73.

SEYMOUR, Helen W(ells) *[Painter] early 20th c.*
Exhibited: S. Indp. A., 1918. **Sources:** Marlor, *Soc. Indp. Artists.*

SEYMOUR, Henry T. *[Painter] 20th c.*
Addresses: South Orange, NJ. **Sources:** WW06.

SEYMOUR, Isabelle D. *[Painter] 20th c.*
Addresses: Baltimore. **Sources:** WW25.

SEYMOUR, J. O. *[Engravers, die sinkers, lithographers, and stationers] mid 19th c.*
Addresses: NYC, 1856-59. **Comments:** Of Latimer Brothers & Seymour (see entry). **Sources:** G&W; NYBD 1856-59; NYCD 1856-59.

SEYMOUR, John B. *[Wood engraver] mid 19th c.*
Addresses: NYC, 1852; Cincinnati, 1853-55. **Sources:** G&W; NYCD 1852; Cincinnati BD and CD 1853, 1855.

SEYMOUR, John F. *[Engraver and printer] mid 19th c.*
Addresses: NYC, 1850s. **Sources:** G&W; NYCD 1856 [as printer]; 1857 [as engraver]; 1858 [as printer].

SEYMOUR, Joseph H. *[Engraver] 18th/19th c.*
Addresses: Worcester, MA, c.1791-95; Philadelphia, c.1796-1822. **Comments:** He was employed by Isaiah Thomas (see entry) at Worcester (MA) between 1791-95. Joseph H. and Samuel Seymour probably were related, since both had the same address in 1819-20. **Sources:** G&W; Stauffer; Fielding, *Supplement to Stauffer;* Phila. CD 1803-20.

SEYMOUR, Louise *[Painter] mid 20th c.*
Addresses: Chicago area. **Exhibited:** AIC, 1940. **Sources:** Falk, *AIC.*

SEYMOUR, May Davenport *[Museum curator] b.1883, Boston, MA.*
Addresses: New York 28, NY. **Member:** AAMus.; Actors' Fund of Am.; Episcopal Actors Gld. **Comments:** Position: curator, Theatre and Music College of the Museum of the City of New York, 1926-; where she arranged all exhibitions held in Theatre Gallery of the Museum of the City of New York, including, Alfred Lunt's Toy Theatres; Gertrude Lawrence and Ruth Draper Memorials; James and Eugene O'Neill; The Pageant of the Opera; The Art of the Negro in Dance, Music and Drama, and others. Her name also appears as Eckert (married to William Stanley Eckert). **Sources:** WW59.

SEYMOUR, M(unsey) *[Landscape painter] b.1832, Calcutta, India / d.1912, Barton, VT.*
Addresses: NYC, 1883-84. **Exhibited:** Brooklyn AA, 1882-84; NAD, 1883-84. **Sources:** *Brooklyn AA.*

SEYMOUR, Ralph Fletcher *[Etcher, designer, illustrator, writer, painter, teacher] b.1876, Milan, IL / d.1966, Batavia, IL.*
Addresses: Chicago, IL. **Studied:** Cincinnati Acad. Art; Nowottny; Meakin and in Paris, France; Knox College, Galesburg, IL (hon. D.F.A.). **Member:** AIGA; Chicago SE; Cliff Dwellers; NAC; Caxton Club; Cliff Dwellers; Chicago Hist. Soc. **Exhibited:** Hoosier Salon (prizes); Chicago SE, 1934 (prize); Phila. Pr. Club, 1936 (prize). **Work:** AIC; Sorbonne, Paris; AFA; Knox College; Newberry Lib., Chicago; NGA; Bibliothèque Nationale, Paris; series of murals, LaSalle Hotel, Chicago; mural, Custer Hotel, Galesburg, IL; painting of Lincoln-Douglas Debate for Knox College, Galesburg, IL. **Comments:** Illustrator & designer of bookplates. Author/illustrator: "Across the Gul," "Some Went This Way," "Our Midwest." Positions: teacher, AIC, 1909-18; supervisor of publications, Knox College, Galesburg, 1936-37. **Sources:** WW59; WW47.

SEYMOUR, Ralph Russell *[Painter] 20th c.*
Addresses: Hartford, CT. **Member:** CAFA. **Sources:** WW25.

SEYMOUR, Ruth *[Painter] mid 20th c.*
Addresses: NYC. **Exhibited:** S. Indp. A., 1924-25, 1928. **Sources:** Marlor, *Soc. Indp. Artists.*

SEYMOUR, Samuel *[Engraver, landscape and portrait painter] b.c.1775, England (probably) / d.c.1832.*
Addresses: Philadelphia, 1796-1823; NYC in 1823. **Exhibited:** WMA; CI, 1939. **Work:** Beinecke Library, Yale Univ.; New York Pub. Libr. **Comments:** In 1819-20 and 1823 he served as draftsman with S.H. Long's exploring expeditions, first to the Rocky Mountains and second to the upper reaches of the Mississippi, the published accounts of which are illustrated with Seymour's drawings. While he was absent in the West, Samuel was listed in the Philadelphia directories at the same address as Joseph H. Seymour, presumably a close relative. **Sources:** G&W; Stauffer; Fielding, *Supplement to Stauffer;* Phila. CD 1808-20; Butts, *Art in Wisconsin,* 24; James, *Account of an Expedition from Pittsburgh to the Rocky Mountains;* Keating, *Narrative of an Expedition to the Source of St. Peter's River;* Rutledge, PA; Stokes, *Iconography,* I, 468-69; Taft, *Artists and Illustrators of the Old West,* 379; McDermott, "Samuel Seymour: Pioneer Artist of the Plains and the Rockies," 16 plates; Campbell, *New Hampshire Scenery,* 138; P&H Samuels, 434.

SEYMOUR, Truman (General) *[Painter] b.1824 / d.1891.*
Addresses: Portland, ME, 1872. **Studied:** U.S.M.A., West Point, NY, with R.W. Weir. **Exhibited:** NAD, 1872; U.S.M.A., West Point, NY, 1974 (retrospective); Everhart Mus., 1986; Richardson-Clarke Gal, Boston, MA, 1999. **Comments:** Beginning in 1850, he taught at West Point, then married R.W. Weir's daughter. He served in the U.S. Army from 1842-76 years, during which time he fought in the Mexican War and Civil War, and attained the rank of brevet major general. After his retirement in 1876, he and his wife traveled extensively through Europe, and eventually settled in Florence, Italy. Like his expatriate friend, Henry R. Newman (also living in Florence) Seymour painted largely in watercolors **Sources:** info courtesy Richardson-Clarke Gal, Boston, MA.

SEYMS, Katherine *[Painter] 20th c.*
Addresses: Hartford, CT. **Member:** CAFA. **Sources:** WW25.

SEYPPEL, Ferdinand *[Wood engraver] mid 19th c.*
Addresses: Cincinnati, 1853-56. **Sources:** G&W; Ohio BD 1853; Cincinnati CD 1856.

SGOUROS, Thomas *[Illustrator, painter, teacher] b.1927.*
Studied: RISD, BFA, 1950. **Member:** Boston Soc. WC.Painters; American WC Soc. **Exhibited:** SI and Art Dir. Club Shows in NYC, Boston, Providence, Denver (many medals and awards); several solo shows. **Work:** Cleveland Mus. FA; Jacksonville Mus.FA; RISD. **Comments:** After finishing school, he worked as a free-lance illustrator for several years, working for *Time, Life,* and other national magazines, for advertising accounts and major publishers. From 1962-on, he was associated with the Illustration Dept. at RISD in several capacities. **Sources:** W & R Reed, *The Illustrator in America,* 340.

SHACKELFORD, Katharine Buzzell *[Painter, teacher] mid 20th c.; b.Fort Benton, MT.*
Addresses: La Cañada, CA. **Studied:** Montana State Col.; Univ. California (B.E.); with Nicolai Fechin. **Member:** Glendale AA; Women Painters of the West; Los Angeles Mus. Assn. Town & Country FA; Los Angeles AA. **Exhibited:** Northern Montana Fair, 1942 (prize); Glendale AA, 1932 (prize), 1943 (prize),1953-55 (prizes); Women Painters of the West, 1954 (prize); Los Angeles AA; Glendale City Hall; Los Angeles City Hall; Madonna Festival; Pasadena AI; Sao Paulo, Brazil; Colombo, Ceylon; Singapore; Great Falls (MT) Public Library. **Comments:** Lectures: approach to portraiture; art and religion; faces and places around the world. **Sources:** WW66; WW47.

SHACKELFORD, L. T. (Pvt.) *[Painter] mid 20th c.*
Addresses: Fort Monmouth. **Exhibited:** S. Indp. A., 1942.
Sources: Marlor, *Soc. Indp. Artists.*

SHACKELFORD, Shelby *[Printmaker, illustrator, painter, writer, teacher, etcher] b.1899, Halifax, VA / d.1987.*
Addresses: Baltimore, MD. **Studied:** Maryland Inst.; R. Moffett; in Paris, with Marguerite & William Zorach, Othon Friesz & Fernand Leger. **Member:** Artists Union; Baltimore AG; S. Indp. A.; Provincetown AA; Am. Artists Congress; NYSWA. **Exhibited:** S. Indp. A., 1925; Graphic Exhib., NYC, 1936; BMA, 1944-46, 1959 (first prize for painting); Eastern Art Assn. (prize for drawing); Eastern Show Regional, 1968; Notre Dame Col., 1972; Jewish Community Center, Baltimore, 1972; WMAA; many Maryland regional shows. **Work:** BMA; NYPL; Morgan State Col.; Western Maryland Col., Westminster. **Comments:** (Her married name was Cox) Modernist painter. Preferred media: casein. Teaching: hd. dept. art, St. Timothy's School, Stevenson, MD, 1944-62; BMA, 1946, 1950-65. Author/illus.: *Now for Creatures,* 1934; *Electric Eel Calling,* 1940. Illustrator: *Time, Space and Atoms,* 1932. **Sources:** WW73; WW47; 50 Prints of the Year, 1930-32; add'l info. courtesy Arthur J. Phelan.

SHACKLEFORD, W. S. *[Portrait painter] mid 19th c.*
Addresses: Greencastle & Bloomington, IN, active from the 1830's-60's. **Sources:** G&W; Peat, *Pioneer Painters of Indiana.*

SHACKLETON, Charles *[Painter] b.c.1856, Mineral Point, WI / d.1920, New Canaan, CT (on the golf links).*
Addresses: Cleveland, OH/Silvermine, Norwalk, CT. **Studied:** Cleveland Sch. Art, with F.C. Gottwald; Italy. **Member:** Cleveland SA; Cleveland EC; Cleveland AA; SC, 1904; NAC; Soc. Independent Artists; Wash. AC; Chicago AC; Conn. S&P; Silvermine Group; New Canaan Soc.; Provincetown AA. **Exhibited:** PAFA Ann., 1909; S. Indp. A., 1917. **Work:** CMA. **Sources:** WW19; Falk, *Exh. Record Series.*

SHACKNOVE, Reta *[Painter, sculptor] mid 20th c.; b.Hamilton, Ontario.*
Addresses: NYC. **Studied:** Hunter College (B.A.); New York Univ. (M.A.); with Leo Manso, Hans Hofmann, Genichiro Inokuma & Gregorio Prestopino. **Exhibited:** Thirteenth Ann. New England Exhib., Silvermine Guild Artists, CT, 1962; New Finds, Joan Avnet Gal., Great Neck, Long Island, 1965; St. Scholastica Educ. Center, Fort Smith, AR, 1972; Rangely Col., CO, 1972; Univ. Missouri-Columbia, 1972 (solo). Awards: Golden Jubilee Award for best designed windows, Fifth Ave. Assn., New York, 1950. **Work:** Chrysler Mus., Norfolk, VA; Newark (NJ) Art Mus.; Syracuse (NY) Univ., NY; North Carolina Mus. Art, Raleigh;

St.Lawrence Univ. Commissions: interior fixtures for store (with Ferris Shacknove), Raymond Loewy, NYC, 1948; interior props design collection of lamps & bowls (with Ferris Shacknove), Gottschalk Sales Co., New York, 1950-60; sculptures in wire, papier mache & plaster (with Ferris Shacknove), Bergdorf Goodman, Bonwit Teller, Lord & Taylor, Tiffany & Kislav, New York, 1950; theatrical props (with Ferris Shacknove) for "The King & I," New York; Posters (collages), Filium, Inc., Buenos Aires, Argentina, 1972. **Comments:** Preferred media: mixed media, collage. Positions: secy., New York chapter, Indust. Designers Inst., 1955; co-founder, secy. & treasurer, Communicating Arts Foundation, New York, 1970; board overseers & co-chmn. commission fine arts, Fairleigh Dickinson Univ., 1972; trustee, Inst. Advanced Study Theatre Arts, 1972. Publications: co-author, "No Art: An American Psycho-Social Phenomenon," Leonardo, 1971. Teaching: instr. design & art history, Samuel J. Tilden H.S., New York, 1938-43; chmn. art seminars, Fairleigh Dickinson Univ., 1969-71; lecturer art, Am. Soc. Appraisers, 1970. **Sources:** WW73; "Structural Modern," *Design Magazine,* 1952.

SHADBOLT, Jack Leonard *[Painter, teacher, writer] b.1909, Shoeburyness, Essex, England.*
Addresses: Vancouver, BC in 1976. **Studied:** Varley, 1934; Euston Rd. Group, London, England, in 1936 with Victor Pasmore & William Coldstream; André Lhote, Paris, France; ASL, 1947. **Exhibited:** Canada Traveling Exhibs.; Sao Paulo, Brazil; Caracas, Venezuela; Carnegie Inst.; Seattle World's Fair, 1962. **Work:** Art Gal. Toronto, Ontario; Nat. Gal. Canada; Montreal Mus. Fine Arts; SAM; Vancouver Art Gal. Commissions: murals, Hart House, Toronto, Edmonton Int. Airport & Charlottetown Mem. Center. **Comments:** Publications: author, articles on contemporary art problems in Canada. Teaching: head drawing & painting section, Vancouver School Art. In 1956-57 he painted in France. **Sources:** WW73; P&H Samuels, 435.

SHADE, William Auguste *[Painter] b.1848, New York / d.1890, Switzerland.* **W.A.S.**
Addresses: Rome, 1887. **Studied:** Düsseldorf, with W. Sohn; London and Rome, 1883-88. **Exhibited:** NAD, 1887. **Sources:** Naylor, *NAD;* Bénézit.

SHADEK, J. E. *[Sketch artist] 19th c.*
Comments: He drew over 100 sketches of battle scenes while serving as a corporal in Company A of the 8th Connecticut Volunteers in the Civil War. **Sources:** Wright, *Artists in Virgina Before 1900.*

SHADIONS, Alma J. *[Painter] mid 20th c.*
Addresses: Union City, NJ. **Exhibited:** S. Indp. A., 1934-35. **Sources:** Marlor, *Soc. Indp. Artists.*

SHADRACH, Jean H. *[Painter, art dealer] 20th c.; b.La Junta, CO.*
Addresses: Anchorage, AK. **Studied:** Univ. New Mexico; Sumié, Okinawa; Constatine & Roman Chatov Studio, Atlanta, GA; Alaska Methodist Univ. & Anchorage Community College. **Member:** Alaska Artist Guild (pres., 1970-71). **Exhibited:** Central Georgia Juried Exhib., 1967; All Alaska Juried Art Exhib., Anchorage, 1968-72; Northwestern WC Soc. Ann., Seattle, WA, 1970; Design I, Anchorage, 1971; Artists of Alaska, traveling show in US, 1971-73; Artique, Anchorage, AK, 1970s. Awards: best of show, Elmendorf AFB, 1969; drawing award, All Alaska Juried Art Exhib., 1970; Governor's Award, Alaska, 1970. **Work:** Anchorage Fine Arts Mus.; Pfeils Prof. Travel Service, Anchorage; also in collection of Sen. Ted Stevens, Washington, DC. **Comments:** Preferred media: acrylics. Positions: co-owner, Artique, Ltd., Fine Art Gallery, Anchorage, 1971-. Publications: author, "Okinawa, Sketchbook,"1962. Specialty of gallery: Alaskan artists work. **Sources:** WW73.

SHAEFER, William G. *[Painter] 20th c.*
Addresses: New Rochelle, NY. **Member:** New Rochelle AA. **Sources:** WW24.

SHAFER, Burr *[Cartoonist, lecturer, writer, historian]* *b.1899, Fostoria, OH / d.1965.*
Addresses: Santa Ana, CA. **Studied:** Occidental College. **Comments:** Author/illustrator of cartoon books: "Through History with J. Wesley Smith," 1951 (cartoon character feature "Through History with J. Wesley Smith" appeared weekly in *Saturday Review* since 1945); "Through More History with J. Wesley Smith," 1953; "Louder and Funnier," 1954. Contributor cartoons to *Saturday Review, Saturday Evening Post, Christian Science Monitor, New York Times,* and other major magazines. Lectures: "Through History with J. Wesley Smith," for Columbia Lecture Bureau, NY. **Sources:** WW59.

SHAFER, Claude *[Cartoonist]* *b.1878, Little Hocking, OH.*
Addresses: Cincinnati, OH. **Work:** Princeton Univ. Lib.; Ohio State Univ. Lib.; Hist. Soc. of Cincinnati; Huntington Lib., San Marino, CA. **Comments:** Position: editorial cartoonist, Cincinnati *Times-Star.* **Sources:** WW53; WW47.

SHAFER, Ella M. (Mrs. Simon) *[Fruit and floral painter]* *19th/20th c.*
Addresses: Detroit, MI, c.1885; Earlville, OH, 1898. **Exhibited:** Detroit galleries, 1885-97, with her husband. **Comments:** Married to Simon P. Shafer (see entry). **Sources:** Gibson, *Artists of Early Michigan,* 211.

SHAFER, Grace Hoover *[Painter]* *b.1872, Gilroy, CA / d.1963, Los Altos, CA.*
Addresses: Los Altos, CA. **Exhibited:** Palo Alto Art Club, 1923. **Sources:** Hughes, *Artists in California,* 507.

SHAFER, L. A. *[Painter, etcher, illustrator]* *b.1866, Geneseo, IL / d.1940.*
Addresses: New Rochelle, NY. **Member:** SI 1911; New Rochelle AA. **Exhibited:** AIC, 1897, 1905. **Comments:** Illustrator: "The Shock of Battle," by Vaux; "The Road to Glory," by Powell; "Heading North," by Barbour; posters of the Great War; cover designs, *American Legion Monthly, The Literary Digest.* **Sources:** WW40.

SHAFER, Marguerite (Phillips) Neuhauser *[Painter, teacher]* *b.1888, North Arlington, VA / d.1976, Wash., DC.*
Addresses: Wash., DC/Gloucester, MA. **Studied:** Corcoran Art Sch., with Bertha Perrie; George Noyes. **Member:** Wash. AC; Soc. of Wash. Artists. **Exhibited:** Soc. of Wash. Artists; Maryland Inst.; Greater Wash. Indep. Exhib., 1935; Wash. AC, 1954 (solo). **Comments:** Instructor: Abbott School of Fine & Commercial Art. **Sources:** McMahan, *Artists of Washington, DC.*

SHAFER, Samuel C. *[Portrait painter]* *early 19th c.*
Addresses: Ohio, c.1810. **Comments:** Pen-and-ink group portrait. **Sources:** G&W; Lipman and Winchester, 179; *Antiques* (Jan. 1946), 35.

SHAFER, Simon P. *[Still life and figure painter]* *19th/20th c.*
Addresses: Detroit, MI, c.1885; Earlville, OH, 1898. **Exhibited:** Detroit galleries, 1885-97, with his wife. **Comments:** Married to Ella M. Shafer (see entry). **Sources:** Gibson, *Artists of Early Michigan,* 211.

SHAFFER, Carl *[Painter, graphic artist, designer, illustrator, lecturer]* *b.1904, Everett, PA / d.1993, Philadelphia, PA?.*
Addresses: Philadelphia, PA. **Studied:** AIC; PAFA; with Arthur Carles. **Member:** Phila. Print Club. **Exhibited:** FMA, 1930, 1931; PAFA, 1924-28; AIC, 1937; Boyer Gal., Ragen Gal., Art All., Print Club, Sketch Club, Graphic Sketch Club, all of Phila. **Work:** MMA. **Comments:** Illustrator: "Southwest Passage," 1943; "What is Music?" 1944; Junior Science Series 1944. Lectures: modern art. **Sources:** WW53; WW47.

SHAFFER, Elizabeth Dodds (Mrs. Verl R.) *[Painter]* *b.1913, Cairo, IL.*
Addresses: New Castle, IN. **Studied:** Butler Univ. (A.B.); with Wayman Adams, Jerry Farnsworth. **Member:** Indiana Art Club. **Exhibited:** Hoosier Salon, prizes, 1951, 1955, 1956, 1960; Indiana Art Club, prizes, 1953-55, 1957, 1960; John Herron AI; Indiana State Fair, prizes, 1949, 1952, 1954, 1957, 1959 (2

prizes); Old Northwest Territory Exhib., Springfield; Nat. Exhib. Am. Artists, NYC; Michiana Regional, 1956 (prize). **Sources:** WW66.

SHAFFER, Henry *[Portrait sketch artist]* *early 19th c.*
Comments: Delineator of a portrait of the Rev. Alfred Brunson, missionary to the Sioux Indians, engraved in 1837 by J.W. Paradise. **Sources:** G&W; Stauffer, no. 2390.

SHAFFER, John *[Engraver]* *b.c.1825, Pennsylvania.*
Addresses: Philadelphia, 1860. **Sources:** G&W; 8 Census (1860), Pa., LVI, 747.

SHAFFER, Lucy K. *[Painter, teacher]* *b.1885, Cincinnati, OH.*
Addresses: Cincinnati, OH. **Studied:** Cincinnati Art Acad.; NY School Fine & Applied; O'Hara Watercolor School. **Member:** Womens AC, Cincinnati. **Exhibited:** Womens AC. **Sources:** WW40.

SHAFFER, Myer *[Painter]* *mid 20th c.*
Addresses: Los Angeles, CA, active 1930s. **Exhibited:** P&S of Los Angeles, 1935. **Work:** Mt. Sinai Home for Invalids, Los Angeles; City of Hope, Los Angeles. **Sources:** Hughes, *Artists in California,* 507.

SHAFFER, Owen Vernon *[Museum director, educator, painter]* *b.1928, Princeton, IL.*
Addresses: Beloit, WI. **Studied:** Beloit College (B.A.); Michigan State Univ. (M.A.). **Member:** AFA; AAMus.; Midwest Mus. Conference; CAA. **Work:** City of Beloit. **Comments:** Position: director, Wright Art Center, Beloit College, Beloit, WI; where he arranged, designed and installed over 30 exhibitions. Designed and constructed exhibition of American Indian objects for the USIS for Overseas Exhibitions. **Sources:** WW59.

SHAFFRAN, Jascha *[Portrait painter, miniature painter, drawing artist, teacher]* *b.1891, Irkutsk, Russia / d.1955.*
Addresses: Memphis, TN; Olive Branch, MS. **Studied:** NAD; ASL; with Charles C. Curran, Leon Kroll, Ivan Olinsky. **Member:** AAPL. **Exhibited:** NAD; Brooks Mem. Art Gal.; Acad. All. Artists. **Work:** Univ. Tennessee Medical School; Tennessee State Capitol; Southwestern Univ. **Comments:** Position: teacher, School FA, Memphis. **Sources:** WW53; WW 47.

SHAFRON, Maria (Mrs. Harold M.) See: **NORONHA DE, Maria (Mrs. Harold M. Shafron)**

SHAFROTH, Janet Durrie *[Painter]* *mid 20th c.*
Exhibited: AIC, 1937. **Sources:** Falk, *AIC.*

SHAFTBERG, Lewis See: **SHAFTEBERG, Lewis**

SHAFTEBERG, Lewis *[Miniaturist]* *late 18th c.*
Addresses: Baltimore, MD, active, 1783; Richmond, VA, active 1789. **Sources:** G&W; Prime, I, 8; Bolton, *Miniature Painters;* Wright, *Artists in Virginia Before 1900.*

SHAFTENBERG, Lewis See: **SHAFTEBERG, Lewis**

SHAGARN, Robert (Mrs.) See: **NOEL, Helen Jeanette (Mrs. Robert M. Shagarn)**

SHAHN, Ben *[Painter, graphic artist, photographer]* *b.1898, Kovno (now Kaunas), Lithuania / d.1969, NYC.*
Addresses: Came to U.S. in 1906; Brooklyn, NY/ active in Provincetown, MA, 1925-35. **Studied:** apprenticed as lithographer, 1903-17; NAD, 1919-22; NYU; CCNY; Acad. de la Grande Chaumière, Paris, 1925, 1927. **Exhibited:** Salons of Am., 1930, 1932-33; WMAA Birnnial, 1932-67; AIC; PAFA Ann., 1940-64 (gold medal 1956); Corcoran Gal biennials, 1941-63 (8 times, incl. 4th prize, 1961); MoMA, 1947 (retrospective); Fogg MA, 1956 (retrospective); Sao Paulo Biennial, 1954 (prize); Venice Biennial, 1954; Stedelijk Mus., Amsterdam, 1961 (retrospective); New Jersey State Mus., Trenton, 1969 (retrospective); Ishibashi Mem. Hall, Kurume, Japsn, 1970 (retrospective); New Haven (CT) Jewish Community Center; Downtown Gal., NY; "NYC WPA Art" at Parsons School Design, 1977; Jewish Mus., 1998

(retrospective). **Work:** Newark Mus.; WMAA; BMFA; MoMA; Albright-Knox Art Gal., Buffalo; AIC; BMA; Brooklyn Mus.; CI; DIA; MMA; PAFA; Phillips Coll.; St. Louis AM; VMFA. WPA murals: Central Park Casino, 1934; Roosevelt Community Ctr., Hightstown, NJ; Bronx Central Annex Post Office; Jamaica (NY) Post Office; Health & Educ. Bldg., Wash., DC; Riker's Island Penitentiary, NY, 1935 (mural was never completed); Mural mosaic, New Jersey State Mus., Trenton, 1960s; 3,000 photos at Fogg MA, Harvard Univ; other photos at IMP, LOC, & RISD; the SLT (Stephen Lee Taller) Ben Shahn archive is at Fine Arts Lib., Harvard Univ. **Comments:** In the 1930s and early 1940s he was an enormously popular artist with both critics and the public, praised for his imagery which appealed to America's social consciousness. His earliest work in this vein was concerned with highly controversial political and social issues, such as the case of Sacco and Vanzetti, two Italian immigrants who were convicted of a murder many argued they did not commit. Shahn created a cycle of 23 paintings (1931-32) related to the trial, bitterly satirizing the antileftist hysteria surrounding the charges and the underlying social prejudice. In his later 1930s he created murals for the WPA and in his work moved awary from direct political criticisms toward an expression of more universal social and humanitarian concerns. Shahn was also a photographer who, from 1935-38, worked for the WPA Farm Sec. Admin., often shooting NY street scenes. During the 1940s, he made posters for the Office of War Information and served as director of the Graphic Arts Section of the Congress of Industrial Organization (1945-46). In the post-war years he provided an alternative to the abstraction of the emerging New York School, but his work ultimately became politically pigeon-holed as Leftist, and aesthetically criticized by Clement Greenberg (see entry) as having "a poverty of culture and resources." Shahn's work became more personal in his later years, and at times almost completely abstract. Designer: sets for ballets and plays, including e.e. cummings' play, "Images," and Jerome Robbins' "Events," in Spoleto, Italy; mural mosaics for synagogues, private homes. Author: *The Shape of Content* (1957). **Sources:** WW40; M. Kimmelman, "Trying to Separate Ben Shahn's Art From His Politics," *New York Times* (Nov. 13, 1998) p.E35; Susan Chevlowe, *Common Man, Mythic Vision* (Princeton Univ. Press, 1998); John Morse, ed., *Ben Shahn* (New York: Praeger, 1972); Frances K. Pohl, *Ben Shahn: New Deal Artist in a Cold War Climate, 1947-54* (Austin, TX: University of Texas Press, 1989); Baigell, *Dictionary; New York City WPA Art,* 77 (w/repro.); Witkin & London, 232; Falk, *Exh. Record Series.*

SHAHN, Judith *[Artist] mid 20th c.*
Addresses: NYC. **Exhibited:** PAFA Ann., 1962. **Sources:** Falk, *Exh. Record Series.*

SHAINBLUM, Eli *[Painter] mid 20th c.*
Addresses: S. Ozone Park, NY. **Exhibited:** S. Indp. A., 1932-33. **Sources:** Marlor, *Soc. Indp. Artists.*

SHAINESS, Clara *[Sculptor, painter, designer, craftsperson] b.1898, Manchester, England.*
Addresses: NYC. **Studied:** A. Goodelman. **Member:** NAWA; NYWSA; NY Soc. Ceramic Artists. **Exhibited:** Argent Gal.; Contemporary Artists; ACA Gal.; J.B. Neumann Gal.; Bonestell Gal.; Norlyst Gal.; NAD; Audubon Artists; WFNY, 1939. **Sources:** WW47.

SHAKESPEARE, (Mrs.) *[Painter, craftsperson] late 19th c.*
Addresses: New Orleans, active 1884-85. **Exhibited:** Woman's Dept., World's Indust. & Cotton Centenn. Expo, 1884-85. **Sources:** *Encyclopaedia of New Orleans Artists,* 349.

SHAKMAN, Aline *[Painter] mid 20th c.*
Addresses: NYC. **Studied:** ASL. **Exhibited:** S. Indp. A., 1920, 1922. **Sources:** Marlor, *Soc. Indp. Artists.*

SHALER, Clarence Addison *[Sculptor] b.1860, Mackford Prairie, WI / d.1941, Pasadena, CA.*
Addresses: Pasadena, CA. **Studied:** Ripon College (M.A.). **Work:** Ripon College. **Comments:** Successful businessman and inventor, who pursued his art full time after retirement, 1928.

Sources: Hughes, *Artists in California,* 507.

SHALER, Frederick *[Painter, illustrator] b.1880, Findlay, OH / d.1916, Taorima, Italy.*
Addresses: NYC. **Studied:** with Chase; DuMond. **Exhibited:** Boston AC, 1908; Salons of Am., 1924. **Sources:** WW13; Falk, *Exh. Record Series.*

SHALIST, Belle *[Painter] mid 20th c.*
Addresses: Bronx, NY. **Exhibited:** S. Indp. A., 1940, 1944. **Sources:** Marlor, *Soc. Indp. Artists.*

SHALKOP, Rodert L. *[Museum director] b.1922, Milford, CT.*
Addresses: Scranton 10, PA. **Studied:** Maryville (TN) College; Univ. Chicago (M.A.); Sorbonne, Univ. Paris. **Member:** AAMus.; Am. Anthropological Assn.; Royal Anthropological Inst. of Great Britain & Ireland; Soc. for Am. Archaeology. **Comments:** Positions: director, Rahr Civic Center, Manitowoc, WI, 1953-56; director, Everhart Mus., Scranton, PA, as of 1959. Arranged exhibs.; among others, The George May Collection (1957), Collectors' Choice, Regional Art Exhibition (1958). **Sources:** WW59.

SHALLENBERGER, Martin C. *[Painter, lecturer] b.1912, San Francisco, CA.*
Addresses: Harrods Creek, KY; Eferding, Upper Austria. **Studied:** Corcoran Sch. Art; ASL; NAD; U.S. Naval Acad. (B.S.); Univ. Vienna (M.A.). **Member:** AWS; NSMP. **Exhibited:** Joslyn Mem. Mus.; Louisville, KY; Ferargil Gal.; Minneapolis, MN; in France & Germany; Vienna, 1937 (solo); Budapest, 1936; Greenwich, CT, 1939; Hanley Gal., Minneapolis, 1938; Joslyn Mem. Mus., 1939; Louisville AC, 1940; Louisville River Road Gal., 1942; Galerie Jeanne Castel, Paris, 1946; Ferargil Gal., 1946; CPLH, 1947; San Diego FA Soc., 1948; Ruth Dicken Gal., Chicago, 1952; Louisville AC, 1953. **Work:** murals, Supermarket, Stewart's Dry Goods Store, Commonwealth Bldg., Southside Baptist Church, all Louisville. **Sources:** WW59; WW47.

SHALLUS, Francis *[Engraver] b.1774, Philadelphia / d.1821, Philadelphia.*
Addresses: Philadelphia, 1797-1821. **Comments:** He was the son of a Revolutionary officer. Though active as an engraver, Shallus was better known as the author of *The Chronological Tables for Every Day in the Year,* published in 1817. He also operated a circulating library and was active in politics and militia affairs. **Sources:** G&W; Stauffer.

SHAMBAUGH, Bertha M. Horack (Mrs. B.) *[Painter, photographer] b.1871 / d.1953.*
Addresses: Active in Iowa City, IA. **Comments:** Preferred media: watercolor, oil, pen & ink sketches. Known for paintings of historical landmarks. **Sources:** Petteys, *Dictionary of Women Artists.*

SHAMPANIER, A(braham) *[Painter] mid 20th c.*
Addresses: Paterson, NJ. **Studied:** ASL. **Exhibited:** S. Indp. A., 1917, 1920, 1922; WMAA, 1924-28; Salons of Am., 1929, 1931. **Sources:** Falk, *Exhibition Record Series.*

SHANAHAN, Ray P. *[Illustrator, cartoonist] b.1892 / d.1935, Boston, MA.*
Comments: A newspaper artist widely known in Boston and New York.

SHANANQUET, Ida W. *[Sculptor] b.1878, Massachusetts / d.1956, San Diego, CA.*
Addresses: San Diego, CA. **Exhibited:** San Diego Art Guild, 1937. **Sources:** Hughes, *Artists in California,* 507.

SHAND, Helen *[Painter] 20th c.*
Addresses: Naberth, PA. **Studied:** PAFA. **Sources:** WW25.

SHANDANK, William *[Fresco painter] b.c.1846, Louisiana.*
Addresses: New Orleans, active c.1875-80. **Sources:** *Encyclopaedia of New Orleans Artists,* 349.

SHANDS, Anne T. *[Painter] 19th/20th c.; b.St. Louis.*
Addresses: St. Louis, MO. **Studied:** St. Louis Sch. FA. **Member:**

St. Louis AG; St. Louis Assn. P&S. **Exhibited:** St. Louis Expo, 1898. **Sources:** WW01.

SHANE, Annie Cornelia See: **SHAW, Annie Cornelia**

SHANE, Fred(erick) E(manuel) *[Painter, educator, lithographer, drawing specialist] b.1906, Kansas City, MO.*
Addresses: Columbia, MO; Beverly Hills, CA, 1972-on. **Studied:** Kansas City Art Inst., 1923-24; also with Randall Davey, Santa Fe, NM, 1924; Broadmoor Art Acad., summers 1925-26.
Exhibited: S. Indp. A., 1924, 1927, 1929-30; Salons of Am., 1928-29; AIC, 1940; Corcoran Gal biennial, 1939; CI; WFNY, 1939-40 & 1964-65; PAFA Ann., 1940-41; WMAA, 1940-41; Pepsi-Cola, 1945; Denver AM; CAM, 1942 (prize)-43 (prize); Springfield Mus. Art (prize); Assn. Am. Artists; LACMA, 1945; Mid-Western Exhib., Kansas City, 1927 (medal), 1936 (prize), 1937 (prize); St. Louis, 1929 (prize); Kansas City AI, 1939 (prize); Davenport (IA) Mus. Art, 1950 (second painting prize); Columbia Art League, 1960 (popular painting prize); Williams & McCormick, Kansas City, MO, c.1986 (solo of drawings); Nelson-Atkins MA, 1988 (traveling exhib. to FA Mus. of the South, Jimmy Carter Lib., Springfield AM). Other awards: Byler Award for achievement in art & teaching, 1971. **Work:** St. Louis AM; Nelson-Atkins Mus.; Denver AM; Springfield MA; Fine Arts Mus. of the South, Mobile, AL; Univ. of Missouri; Missouri Hist. Soc.; Nat.l Mus. Art, Tel-Aviv, Israel; IBM Corp Collection; Wolfsonian Foundation, Miami. Commissions: paintings of Army Medicine, War Dept., Abbott Collection, Wash., DC; Portrait of James M. Wood, Stephens College; mural, USPO, Eldon, MO; General Hospital, Board of Educ., Kansas City; Scruggs-Vandervoort-Barney Collection, Univ. Missouri; Jefferson City Jr. College; mural, Independence, MO. **Comments:** Regionalist painter in oils and casein; active in Santa Fe, 1927-28. After spending 1928 painting in Paris, he opened a studio in NYC; and in 1932 returned to Kansas City where he became a close friend of Thomas Hart Benton. From 1932-71 he taught at the Univ. of Missouri (chmn. dept., 1958-67). During WWII, he was an artist correspondent with the Army Medical Corps. Publications: author, "Fred Shane Drawings" (Univ. Missouri Press, 1964). **Sources:** WW73; WW47; Henry Adams, exh. cat. (Nelson-Atkins MA, 1988);Falk, *Exh. Record Series.*

SHANE, George Walker *[Art critic, painter] b.1906, Eldon, IA.*
Addresses: Des Moines, IA. **Studied:** Univ. Kentucky; AIC; with Louis Bouche. **Exhibited:** Des Moines AC, 1952 (purchase award); Iowa Art Educators Assn. (purchase award). **Work:** Joslyn Art Mus.; Davenport Municipal Mus.; Des Moines AC; Mulvane AC. **Comments:** Positions: pres., Des Moines Art Forum, 1952-53; art critic, *Des Moines Register*, 1938-. Research on Impressionism in Paris, 1958, under grant from Guivi Malville (art patron). **Sources:** WW66.

SHANE, Mildred Dora *[Painter, teacher] b.1898, Kansas City.*
Addresses: Kansas City, MO. **Studied:** Wilimovsky; Frazier; Hawthorne. **Sources:** WW25.

SHANE, Rose M. *[Painter] 19th/20th c.*
Addresses: Nunda, NJ. **Exhibited:** AWCS, 1898. **Sources:** WW01.

SHANE, S(amuel) L(ewis) *[Painter] b.1900, Russia.*
Addresses: NYC. **Exhibited:** S. Indp. A., 1928, 1930-31. **Sources:** Marlor, *Soc. Indp. Artists.*

SHANES, Harry B. *[Painter, craftsperson] b.1902, Philadelphia, PA.*
Addresses: Salisbury, VT. **Studied:** PAFA; Temple Univ.; Univ. Pennsylvania. **Member:** Southern Vermont AA. **Exhibited:** PAFA. **Sources:** WW59.

SHANES, Helen Berry (Mrs.) See: **BERRY, Helen Murrin (Mrs H. Berry Shanes)**

SHANFIELD, Zelda *[Miniature painter] early 20th c.*
Addresses: Paris, France, c.1913. **Sources:** WW13.

SHANK, Maurita *[Painter, printmaker, teacher] b.1916, Tacoma, WA.*
Addresses: Tacoma, WA. **Studied:** Univ. Washington; Univ. Puget Sound. **Exhibited:** SAM, 1937; Tacoma Art Lg., 1940. **Sources:** Trip and Cook, *Washington State Art and Artists.*

SHANK, Rosella *[Still-life painter] late 19th c.*
Addresses: Active in New York, 1885. **Sources:** Petteys, *Dictionary of Women Artists.*

SHANKEL, Tamuz F. *[Painter] b.1892, Virginia / d.1969, Contra Costa County, CA.*
Addresses: San Francisco, CA. **Studied:** self-taught. **Exhibited:** Lady Fair Expo, San Francisco, 1963. **Comments:** Painted florals and landscapes in a primitive style. **Sources:** Hughes, *Artists in California,* 507.

SHANKLIN, Ettie (Mrs. O. G.) *[Painter] b.1862, Charleston, IL / d.1942, Tacoma, WA.*
Addresses: Tacoma, WA. **Studied:** Conservatory of Art, Osagemission, KS; with E. Forkner. **Member:** Painters of the Pacific Northwest. **Exhibited:** SAM, 1937-39. **Sources:** Trip and Cook, *Washington State Art and Artists.*

SHANKS *[Political cartoonist] early 19th c.*
Addresses: NYC, 1838. **Sources:** G&W; Peters, *America on Stone.*

SHANKS, Bruce McKinley *[Editorial cartoonist] b.1908, Buffalo, NY.*
Addresses: Buffalo, NY. **Exhibited:** Awards: Pulitzer Prize, 1958; Grand Award, Nat. Safety Council, 1961; Cartoon Citation, All-Am. Conference Combat Communism, Wash., DC, 1964. **Work:** Dept. Justice, Wash., DC; Supreme Court Office, Wash., DC. **Comments:** Positions: editorial cartoonist, *Buffalo Evening News,* 1973. Publications: author, cartoons, *New York Times, Newsweek, US News & World Report, Time* & others. **Sources:** WW73.

SHANKS, Maria Gore *[Illustrator, writer] b.1875, Albany, NY / d.1950, Princes Bay, SI, NY.*
Studied: ASL. **Exhibited:** S. Indp. A., 1917. **Comments:** Illustrator for *New York Tribune* for eight years. Her pseudonym was Maria Gore. **Sources:** Petteys, *Dictionary of Women Artists.*

SHANNON, Aileen Phillips (Mrs. Edmund G.) *[Painter] b.1888, Gillsburg, MS.*
Addresses: Las Cruces, NM. **Studied:** PAFA; Chicago Acad. FA; M. Pemberton Ginther, William M. Chase, Wayman Adams; Tudor Hart; Académie Julian, Paris; Art Instruction, Inc., Minneapolis. **Member:** NAWA; SSAL; AAPL; Mississippi AA; San Francisco AA; PAFA (fellow). **Exhibited:** NOAA, 1915; Soc. Wash. Artists, 1936; NAWA, 1942; SSAL; Parkersburg FAC; Virginia-Intermont College, Santa Fe, NM; Fed. Sch., NM, 1933 (prize), 1939 (prize); Women Painters Am., Wichita, KS, 1938; Rockefeller Center, NYC, 1938; CGA; Grand Central Art Gal.; PAFA; Mississippi AA; NOMA; El Paso, TX; DMFA; Santa Fe, NM (solo); Albuquerque, NM; Jackson, MS (solo); Alamogordo, Tularosa, & Hobbs, NM (all solo). **Work:** Mississippi AA; Rock Springs (WY) AA; New Mexico State College; Brannigan Mem. Lib., Las Cruces, NM; 20th Century Club, Clayton, NM. **Sources:** WW59; WW47. More recently, see *Encyclopaedia of New Orleans Artists,* 349.

SHANNON, Charles Eugene *[Painter] b.1914, Montgomery, AL / d.1996.*
Addresses: Montgomery, AL. **Studied:** Emory Univ., Atlanta, GA (2 yrs); Cleveland School Art, 1932-36 (traveling fellowshp., 1936). **Exhibited:** CMA, 1935-36 (prize); GGE 1939 (prize); AIC, 1939; CAM, 1939; Clearwater Exit., 1939; CI, 1939; WMAA, 1939-40; Montgomery Mus. FA, 1937 (solo), 1984; Cleveland Sch. A., 1938 (solo); Jacques Seligmann Gal., NYC, 1938 (1st solo); Ala-Arts, 1980 (retrospective). Awards: Gund Rosenwald Fellowship, 1938-39, 1939-40. **Work:** mural, Ft. Belvoir, VA. **Comments:** Beginning in 1935, he painted rhythmical, elongated figures in local Montgomery scenes. With several friends, he formed an art center/gallery called the "New South" at

which he presented his discovery exhibition of the works of Bill Traylor (see entry), and dedicated the rest of his life to preserving and documenting the works of this African-American "outsider" artist. Position: artist in residence, West Georgia College, Carollton, GA, 1941-42; artist correspondent, U.S. Army, 1943; art information & educ., U.S. Army, 1944-45. **Sources:** WW53; WW47; Sotheby's Arcade auc. cat., 30 Mar. 1999, lot 377.

SHANNON, (David) Patric *[Art administrator] b.1920, Durant, OK.*
Addresses: Santa Fe, NM. **Studied:** Stanford Univ. (honors program, A.B.); Univ. Calif. (M.A.); study with Hans Hofmann; Univ. Calif, 1963-64. **Member:** College Art Assn. Am.; Am. Assn. Mus.; Western Assn. Art Mus.; AFA (Oklahoma State advisor, 1970). **Exhibited:** LACMA, 1948; WMAA, 1950; Oakland Mus. Art Ann., 1950; SFMA, 1950; Texas Ann., Dallas MFA, 1957. **Awards:** Humanities award for art, Stanford Univ., 1929; visual arts adv., Oklahoma Arts & Humanities Council, 1965-72. **Comments:** Positions: editorial asst. to director, Oakland Art Mus., 1950-51; color consultant, W&J Sloane's, San Francisco, 1951-53; staff designer, Cleveland Playhouse, 1953-54; drama instructor, C.K. McClatchey H.S., Sacramento, CA, 1955-56; dir., Oklahoma AC, 1965-72; dir., Contemporary Art Gal., Inc., Santa Fe, 1972-. Teaching: lecturer on design, San Jose State College, 1964; dir. of theatre arts, El Camino College, 1956-57; chmn. art dept., Austin College, 1957-61. Collections arranged: Washington Gallery Modern Art Collection; Winston and Ada Eason Monuments of American Master Prints; Trebor Collection of Mexican Artists' Works; Dorothy Doughty Porcelain Bird Collection; Jerome Westheimer Collection of Contemporary Paintings. Specialty of gallery: non-provincial contemporary paintings and architectural sculpture by nationally known, Santa Fe area-related American painters and sculptors; monumental work for public buildings, corporations, architects, decorators and collectors. Publications: editor, *Weiner Sculpture Collection,* Times-Journal Publ., 1965; editor, *Les Fauves,* Norman Transcript Press, 1967; editor, *Invitational, Past Jurors,* Norman Transcript Press, 1969; author, "The Role of the Trustee in the 70's" (book review), *Museum News* (June, 1972). **Sources:** WW73.

SHANNON, Howard J(ohnson) *[Illustrator, writer, painter] b.1876, Jamaica, NY.*
Addresses: Jamaica, NY. **Studied:** PIA School; & with Herbert Adams, Frank DuMond. **Exhibited:** BM, 1935; PIA School; Queensboro Public Library, Jamaica, Far Rockaway, NY. **Work:** Queensboro Public Library, Jamaica Branch. **Comments:** Author/illustrator: "The Book of the Seashore," 1935; nature & natural science articles for *Journal of Am. Mus. Natural Hist., Scientific Monthly, Nature, Harpers, American Forests.* **Sources:** WW59; WW47.

SHANNON, Ida May Garmeyer *[Painter] b.1880, Three Rivers, MI / d.1962, Eugene, OR.*
Addresses: Seattle, WA; Vashon Island, WA. **Comments:** Specialty: paintings on elk and deer hides. She painted life size portraits of Native Americans and was also known as a "lightning artist," painting in minutes as people looked on and selling the works while they were still wet. **Sources:** Trip and Cook, *Washington State Art and Artists.*

SHANNON, James J(ebusa) (Sir) *[Portrait painter] b.1862, Auburn, NY / d.1923, London.*
Addresses: London, England. **Studied:** South Kensington School. **Member:** ANA, 1908; New English AC; Soc. Portrait Painters; ARA, 1897; RA, 1909. **Exhibited:** Royal Academy, London, 1881-1904; Paris Expo, 1889 (gold), 1900 (medal); PAFA Ann., 1895 (prize), 1898, 1901, 1907; AIC, 1899, 1906; Berlin (medal); Vienna (medal); Munich (medal); CI, 1897 (medal); SNBA, 1895; Pan-Am. Expo, Buffalo, 1901 (gold); St. Louis Expo, 1904 (gold); Int. Expo, Venice, 1906 (gold); Corcoran Gal annuals/biennial, 1907-08, 1910; Barcelona, 1911 (medal, prize); Brooklyn AA, 1912. **Work:** CGA; CI; MMA; Tate Gal., London. **Comments:** Shannon settled in England in 1878, at age 16, and became one the leading expatriate portrait painters of the "Belle Époque." He

was made a Knight in 1922, just a year before his death. **Sources:** WW19; Fink, *American Art at the Nineteenth-Century Paris Salons,* 389; Falk, *Exh. Record Series.*

SHANNON, Joseph *[Painter] mid 20th c.; b.Lares, Puerto Rico.*
Addresses: Vienna, VA. **Studied:** Corcoran School Art, Wash., DC, 1954; Temple School Art, Tucson, AZ, 1955; Smithsonian Inst., with Peter Paul DeAnna, 1958. **Exhibited:** Studio Gallery, Tucson, 1956 (prize) & 1957 (solos); Tucson FAC, 1962; Corcoran Gal., 1969 (solo), Poindexter Gallery & Henri Gallery, Wash., DC, 1971 (solo); Poindexter Gal., NYC, 1970s. **Comments:** Preferred media: acrylics, crayon. **Sources:** WW73.

SHANNON, Martha A. *[Painter, lecturer] b.1842, Boston, MA.*
Addresses: Roxbury, MA. **Studied:** CUA School; Lambinet in Paris. **Member:** BAC, 1874; Copley Soc., 1896. **Exhibited:** Poland Springs Art Gal., 1898. **Comments:** Lectured on English and Am. art. **Sources:** WW06; Petteys, *Dictionary of Women Artists.*

SHANNON, Patric See: **SHANNON, (David) Patric**

SHANNON, W. *[Sculptor] mid 19th c.*
Addresses: San Francisco, 1858. **Sources:** G&W; San Francisco BD 1858.

SHANNON, William (Mrs.) See: **LENNEY, Annie (Mrs. William Shannon)**

SHANSKY, Aaron Lionel *[Painter] b.1911, Bluffton, IN.*
Addresses: Des Moines, IA. **Studied:** Milwaukee State Teachers College (B.E.); Gustave Moeller, Robert Von Neumann. **Member:** Wisconsin Artists Fed.; Milwaukee Printmakers; Wisconsin Soc. Applied Art. **Exhibited:** Wisonsin P&S; Jewish Center Art Exhibit; Wisconsin Art Salon; Wisconsin Artists Calendar. **Comments:** Position: director, Mus. Extension Project, WPA, Des Moines, IA. **Sources:** Ness & Orwig, *Iowa Artists of the First Hundred Years,* 188.

SHANTON, George Thomas *[Painter, stage designer] b.1918, NYC.*
Addresses: New Hampshire, 1970s-on. **Studied:** Yale Drama School; theatre scene painting with Woodman Thompson. **Exhibited:** Gold St. Gal., Lakeport, NH, 1997 (solo). **Awards:** NH Arts Council, 1982 (grant); Kimball-Jenkins Fndtn, Concord, 1985 (artist in residence fellowship). **Comments:** From the early 1940s to the early 1980s, he painted stage sets for theatre and ballet productions throughout the U.S. His easel paintings often feature trains passing through rocky terrain. **Sources:** press release, Gold St. Gal. (Lakeport, NH, July, 1997).

SHAO, Fang Sheng *[Painter, craftsperson, designer, teacher, lecturer] b.1918, Tientsin, China.*
Addresses: Williamstown, WV. **Studied:** in China with old master of Peking; Frank Lloyd Wright Fnd. at Taliesen East & West (Fellowship); Florida Southern College. **Member:** Nat. Soc. Arts & Letters; Chautauqua AA. **Exhibited:** Gallery at Taliesin, Spring Green, WI (solo); AIC; AFA traveling exhib.; Norfolk Mus. Arts & Sciences; J.B. Speed Mus. Art; San Jose, CA; South Bend, IN; New Haven, CT; Bowling Green, OH; Manchester, NH; Saratoga Springs, NY; Rollins College, Winter Park, FL; Florida Southern College; Tampa AI; Winter Haven AA; Chautauqua, NY, 1964 (prize); Swaney Gal., New Cumberland, WV, 1962 (prize); Oglebay Inst.; MMA; Zanesville AI; Bethany College, WA, 1963 (prize); Marietta Art Lg., 1962 (prize). **Work:** Norfolk Mus. Arts & Sciences; Zanesville AI. Commissioned by the Chinese Government to make paintings of the frescoes in the Cave of the Thousand Buddhas, a IV Century Buddhist cliff sanctuary, in the Gobi Desert. These paintings were on a loan exhibition to the MMA, and were exhibited in solo shows at the AIC; and the Zanesville (OH) Art Institute (1964). **Comments:** Positions: instructor, Florida Southern College, Lakeland, FL; Chatauqua Summer School, NY. **Sources:** WW66.

SHAPINSKY, Harold *[Painter] mid 20th c.*
Addresses: NYC. **Studied:** Subjects of the Artist Sch. with Rothko and Motherwell, 1948. **Exhibited:** Kootz Gal., NYC, 1950; Mayor Gal., London, c.1985 (solo); NAC, 1992 (retrospective). **Work:** Tate Gal., London; NGA, Wash., DC. **Comments:** Among the second generation of Abstract Expressionists, he painted in obscurity until his work was discovered in the mid 1980s.

SHAPIRO, Babe *[Painter] b.1937, Irvington, NJ.*
Addresses: NYC. **Studied:** State Teachers College, Newark, NJ (B.S.); Hunter College (M.A.), with Robert Motherwell. **Exhibited:** AFA, 1960; Biennial Exhib. Contemporary Am. Painting, Univ. Illinois, 1963; New York World's Fair, 1965; Cincinnati AM, 1966; Indianapolis Mus. Art, 1970; A.M. Sachs Gal., NYC & Gertrude Kasle Gal., Detroit, MI, 1970s. Awards: Newark Mus. Triennial Purchase Prize Award, 1958 & 1961; first prize in painting, Monmouth College, NJ, 1963; Ford Foundation Artist-in-Residence, Quincy (IL) Art Club, 1966. **Work:** Kresge AC, Michigan State Univ., East Lansing; Newark Mus.; Andrew Dickson White Mus., Cornell Univ., Ithaca, NY; Albright-Knox Art Gallery, Buffalo, NY; Cooper-Hewitt Mus, Smithsonian Inst., NYC. **Comments:** Preferred media: acrylics. Teaching: painting instructor, Maryland Inst. College Art, Baltimore, 1964-. **Sources:** WW73.

SHAPIRO, Cecil *[Painter, teacher, craftsperson] mid 20th c.; b.NYC.*
Addresses: New York 24, NY. **Studied:** Hunter College (A.B.); Teachers College, Columbia Univ. (A.M.); ASL; Alfred Univ. **Member:** Phila. WCC; AEA; NAWA; NY Soc. Ceramic Artists. **Exhibited:** NY Soc. Ceramic Artists, 1923-30; AWCS, 1936, 1939; Morton Gal., 1936-41; Phila. WCC, 1939-46; All. Artists Am., 1938-46; S. Indp. A., 1942; AEA, 1951; All. Artists Am.; Phila. Art All., 1952-55; NAWA, 1954, 1955; AFA traveling exhib., 1939-40; Art: USA, 1958. **Comments:** (Name appears as Schapiro and Shapiro) Position: NY Board Educ., 1940; fine arts instructor, New York City schools. *Cf.* Celia C. Shapiro. **Sources:** WW59 (spelled as Shapiro); WW47 (spelled as Schapiro).

SHAPIRO, C(elia) C. *[Painter] mid 20th c.*
Addresses: Brooklyn, NY. **Exhibited:** Salons of Am., 1927-29; S. Indp. A., 1927-29. **Comments:** *Cf.* Cecil Shapiro. **Sources:** Falk, *Exhibition Record Series.*

SHAPIRO, Daisy Viertel *[Collector, patron] b.1892, NYC.*
Addresses: NYC. **Studied:** painting with Louise Pollet & Alex Redein. **Member:** Art Collectors Club Am.; Friends of WMAA & MoMA; Guggenheim Mus., Arch. Am. Art. **Comments:** Art interests: donations of many works of art to museums and colleges including Dartmouth College. Collection: contemporary American painting and sculpture. **Sources:** WW73.

SHAPIRO, Daniel *[Painter, graphic artist, educator, designer, illustrator] b.1920, NYC.*
Addresses: NYC; Bennington, VT. **Studied:** CUA School; Columbia Univ.; L. Katz; M. Kantor. **Member:** AEA. **Exhibited:** CUA School, 1940 (prize), 1941 (prize); Oakland Art Gal., 1944; LOC, 1945, 1946; Mun. Art Gal., Jackson, MS, 1945-46; SAM, 1946; Brooklyn Soc. Art, 1942; "Art of the GI," Tribune AC, 1946; Peter Cooper Gal., 1952 (solo). **Work:** CUA School; Howard Univ.; mural, Westover (MA) Service Club. **Comments:** Positions: graphic designer, record albums and magazine covers, including *Fortune.* Position: art faculty, Bennington College, Bennington, VT, 1947-. **Sources:** WW59; WW47.

SHAPIRO, David *[Painter, educator] b.1944, NYC.*
Addresses: NYC. **Studied:** Skowhegan School, ME, 1965; Pratt Inst. (B.F.A., 1966); Indiana Univ., Bloomington (M.F.A., 1968). **Exhibited:** Gertrude Kasle Gal., Detroit, Mich., 1970; Beaux Arts, Columbus Gal. Fine Art, OH, 1971; Pointdexter Gal., NYC, 1971 (solo); Owen Gal., Denver, CO, 1972 (solo); Color Forum, Univ. Texas Art Mus., Austin, 1972. Awards: Milton Avery Memorial scholar, Mr. & Mrs. Roy Neuberger, 1965. **Work:** Indiana Univ. Art Mus., Bloomington; Westinghouse Corp., Pittsburgh. **Comments:** Teaching: art history, John Herron Art

School, Indianapolis, 1966-67; drawing, Pratt Inst., 1969-71; Drake Univ., 1970; Univ. Bridgeport, fall 1971. **Sources:** WW73.

SHAPIRO, David *[Painter] mid 20th c.*
Addresses: NYC. **Exhibited:** WMAA, 1951; Corcoran Gal biennial, 1959. **Sources:** Falk, *Exhibition Records Series.*

SHAPIRO, Frank D. *[Painter, craftsperson, teacher] b.1914, NYC.*
Addresses: Parkchester, NY; Fresh Meadows, NY. **Studied:** NAD; CCNY (M.A.). **Exhibited:** CGA, 1939; Syracuse MFA, 1941; Detroit IA. **Work:** WPA mural, USPO, Washington, N.S. **Comments:** Position: chmn., art dept., Fashion Inst. Tech., NYC. **Sources:** WW59; WW47.

SHAPIRO, Helen V. *[Painter] mid 20th c.*
Exhibited: S. Indp. A., 1938. **Sources:** Marlor, *Soc. Indp. Artists.*

SHAPIRO, Hilda *[Painter] mid 20th c.*
Exhibited: Corcoran Gal biennial, 1963. **Sources:** Falk, *Corcoran Gal.*

SHAPIRO, Irving *[Painter, instructor] b.1927, Chicago, IL.*
Addresses: Glenview, IL. **Studied:** AIC; Chicago Acad. Fine Art; Am. Acad. Art, Chicago. **Member:** AWCS; Artists Guild Chicago. **Exhibited:** AWCS Ann., NAD Gal., 1958 (Ranger Award)-1962; Union League Cl., Chicago, 1955 (first watercolor award), 1957 (first watercolor award) & 1959; Butler IA, 1962; AIC Sales & Rental Galleries, 1966-68; Blair Galleries, Santa Fe, NM, 1970s. Other awards: Illinois State Mus. Purchase Award, 1966-67. **Work:** Univ. Vermont; Columbus (GA) Mus. Art; Lakeview Mus. Art, Peoria, IL; Illinois State Mus., Springfield; Macon (GA) Mus. Art. **Comments:** Preferred media: watercolors. Publications: author/illustrator, article *Am. Artist Magazine,* 1959; contributor, "100 Watercolor Techniques" (1970), "Acrylic Watercolor," (1971) & "Palette Talks" (1972). Teaching: instructor of watercolors, Am. Acad. Art, 1945-; director, 1971-. **Sources:** WW73.

SHAPIRO, Janice See: **SANDLER, Janice (Mrs. Harry Shapiro)**

SHAPIRO, Joel (Elias) *[Sculptor] b.1941, NYC.*
Addresses: NYC. **Studied:** New York Univ. (B.A. & M.A.). **Exhibited:** Anti-illusion: Procedure/Material, 1969 & Sculpture Ann., 1970, WMAA; Hanging/Leaning, Emily Lowe Gallery, Hofstra Univ., NY, 1970; Paula Cooper Gal., NYC, 1970 & 1972 (solos); Works on Paper, Soc. Contemporary Art 31st Ann., AIC, 1971; Kid's Stuff?, Albright-Knox Gallery, Buffalo, NY, 1971. **Work:** Fogg Art Mus.; Univ. Massachusetts; WMAA; Lannan Found., FL; Weatherspoon Art Gallery, Univ. North Carolina. **Comments:** Preferred media: mixed media. **Sources:** WW73; Marcia Tucker & James Monte, *Anti-illusion: Procedure/Material* (WMAA, 1969); Robert Pincus-Witten, "New York," *Artforum* (May, 1970); Denise Wolmer, "In the Galleries," *Arts Magazine* (March, 1972).

SHAPIRO, Lili *[Ceramicist, craftsperson, teacher] b.1896, Boston.*
Addresses: Boston, MA. **Studied:** E. Brown; B.K. Brink; L. Beckerman; F. Allen. **Member:** Boston SAC (master craftsman). **Exhibited:** Int. Expo, Paris, 1937; Boston, 1937 (prize). **Comments:** Position: teacher, Paul Revere Pottery. **Sources:** WW40.

SHAPIRO, Maurice L. *[Painter] mid 20th c.*
Addresses: Hillside, NJ. **Exhibited:** S. Indp. A., 1932. **Sources:** Marlor, *Soc. Indp. Artists.*

SHAPIRO, Seymour *[Painter, teacher] b.1927, Irvington, NJ.*
Addresses: Rutherford, NJ. **Studied:** Newark School FA; New Jersey State Teachers College (B.S. in Educ.); Hunter College. **Exhibited:** Newark Mus., 1958 (prize), 1961 (prize); Stable Gal., NY, 1959; AFA traveling exhib., 1960; American Gal., NY, 1962; Stryke Gal., NY, 1962; Provincetown Art Festival, 1958; Newark Arts Festival, 1958 (prize); PAFA Ann., 1962; Univ. Illinois, 1963; Monmouth (NJ) Festival, 1963 (prize). **Work:** Cornell Univ.; Newark Mus. (3); Albright-Knox A. Gal.; Union Carbide Co.

Comments: Position: teacher, Maryland Inst. Art, Baltimore, MD. **Sources:** WW66; Falk, *Exh. Record Series.*

SHAPLEIGH, Frank Henry *F. H. Shapleigh.*
[Landscape painter] b.1842,
Boston, MA / d.1906, Jackson, NH.
Addresses: Boston, MA, 1866-70; Jackson, NH (winters in St. Augustine, FL after 1886). **Studied:** Lowell Inst. Drawing School, Boston; E. Lambinet, in Paris, 1866-69. **Member:** Boston AC, 1876. **Exhibited:** Boston Athenaeum, 1864 (first landscape exhibited); NAD, 1866, 1869, 1870; Boston NAD, 1866-70; AC, 1874-84. **Work:** Farnsworth AM, Rockland, ME; Hood MA, Dartmouth College, NH; New Britain Mus. Am. Art; Portland MA; Univ. of NH; NH Historical Society. **Comments:** One of the best known artists of New Hampshire's White Mountains, he had a summer studio there throughout the last quarter of the 19th century, located in the Crawford House, an upscale hotel in Mount Washington Valley that attracted the tourists who were his clientele. Shapleigh had served in the Civil War from 1863 and then established a portrait studio in Boston. After studying in Paris, he shared a studio in Boston with John Appleton Brown, and in 1870 made a trip west to Yosemite. Beginning in 1886, he also kept a studio in St. Augustine, FL. He appears to have stopped painting c.1897. He generally indicated the place and date on each of his paintings. **Sources:** WW06; Campbell, *New Hampshire Scenery*, 138-143; P&H Samuels, 435; *300 Years of American Art*, vol. 1, 325.

SHAPLEY, Fern Rusk *[Museum curator, writer] b.1890, Mahomet, IL.*
Addresses: Wash., DC. **Studied:** Univ. Missouri (A.B.; A.M.; Ph.D.; A.Ed.; fellowship, 1915-16); Bryn Mawr College (fellowship). **Exhibited:** Other awards: European fellowship, 1915. **Comments:** Positions: asst. art & archaeology, Univ. Missouri, 1916-17, asst. professor art, 1925; research asst., Nat. Gallery Art, 1943-47, curator paintings, 1947-56, asst. chief curator, 1956-60, curator research, Samuel H. Kress Foundation, 1960-. Publications: author, "George Caleb Bingham, The Missouri Artist," 1917; author, "European Paintings from the Gulbenkian Collection," 1950; author, "Paintings from the Samuel H. Kress Collection: Italian schools, XIII-XV Century," 1966; author, "Paintings from the Samuel H. Kress Collection: Italian Schools, XV-XVI Century," 1968; co-author, "Comparisons in Art," 1957; contributor, articles *Gazette Beaux Arts, Art Quarterly, Art in America, Am. Journal Archaeology.* **Sources:** WW73.

SHAPLEY, John *[Art historian] b.1890, Missouri / d.1969.*
Addresses: Wash., DC. **Studied:** Univ. Missouri (A.B.); Princeton Univ. (M.A.); Univ. Vienna (Ph.D.). **Exhibited:** Awards: Carnegie Corp. Medal; decoration, Shah of Iran, 1960. **Comments:** Teaching: art professor, NY Univ., 1924-29; art professor, Univ. Chicago, 1929-39; art professor, Catholic Univ. Am., 1952-60; art professor, Univ. Baghdad, 1960-63; art professor, Howard Univ., 1963-70. Publications: illustrator, "Editorial Board: Survey of Persian Art," 1933-; co-author, "Comparisons in Art," Praeger, 1957; author, many articles & reviews; contributor, various serials, *Art Bulletin, Archeology* & others. **Sources:** WW73.

SHAPPIRO, Samuel D. *[Engraver] late 19th c.*
Addresses: Wash., DC, active 1892. **Sources:** McMahan, *Artists of Washington, DC.*

SHAPSHAK, Rene *[Sculptor] b.Paris, France / d.1985.*
Addresses: NYC. **Studied:** École Beaux Arts, Paris; École Beaux Arts, Bruxelles; Art School, London, England. **Member:** Arch. League; AFA, French Art Theatre; Am. Int. Inst.; Syndicate African Artists. **Exhibited:** UN, 1955 (solo); Palais Beaux Arts, Paris, 1955; WMAA, 1956; Mus. Art Mod., Paris, 1971-72. **Work:** Philathea College MoMA, London, Ontario; Butler IA; Munic. Mus., Paris; Cecil Rhodes Mus., Bishop-Stortford, England; Pinakotheki, Athens, Greece. Commissions: marble bas-relief, 1942 & granite bas-relief, 1942, New General Post Office, Capetown, South Africa; metal sculptures, South African Broadcasting Corp., 1950 & munition factory, Pretoria, 1954; fountain, City of New York, 1972. **Comments:** Positions: director,

Rene Shapshak MoMA, London, Ontario, Canada. **Sources:** WW73.

SHARADIN, Henry William *[Painter, craftsperson, illustrator, lecturer, teacher] b.1872, Kutztown, PA / d.1966.*
Addresses: Kutztown, PA. **Studied:** PM School IA; Académie Julian, Paris; Tudor-Hart; Bompianni and Nardi in Rome. **Member:** NAC; Lehigh Art All., Allentown, PA. **Exhibited:** PM School IA (prize); NAC; Soc. Keramic Artists; Lehigh Art All.; Reading Mus. Art; & in Paris. **Work:** Reading Mus. Art; mural, State Teachers College, Kutztown, PA; numerous churches in Pennsylvania. **Comments:** Following his studies in Paris and Rome, Sharadin opened a studio in Reading, PA in 1895. Positions: director, Keystone State Normal School, 1902; director, art dept., 1907-16, 1926-39, Kutztown State Teachers College, Kutztown, PA. Today there is a gallery named for him at Kutztown State Univ., honoring his years of instruction there. He is known for landscapes and religious murals executed for local churches. **Sources:** WW53; WW47; Malmberg, *Artists of Berks County,* 27.

SHARADY, H. M. *[Painter] 19th/20th c.*
Addresses: NYC. **Sources:** WW01.

SHARE, Henry Pruett *[Illustrator, etcher, engraver] b.1853, Los Angeles, CA / d.1905.*
Addresses: NYC, 1878-80; Phalanx, Red Bank, NJ, 1885; Flatbush, NY. **Exhibited:** NAD, 1878-85; PAFA Ann., 1880-81. **Comments:** Cousin of M.J. Burns. Position: art editor, *The New York World.* **Sources:** Falk, *Exh. Record Series.*

SHARER, William E. *[Painter] late 20th c.; b.New Mexico.*
Addresses: Santa Fe, NM in 1975. **Studied:** Am. Acad. Art, Chicago; William H. Mosby and Joseph Vanderbrouck. **Member:** Nat. Acad. Western Art. **Exhibited:** Stacey Scholarship Award, 1971, & others. **Comments:** Following his studies he was in Colorado, Taos, and finally Santa Fe where he built a studio. **Sources:** P&H Samuels, 436.

SHARKEY, Donna L. *[Artist] mid 20th c.*
Addresses: Ypsilanti, MI. **Exhibited:** PAFA Ann., 1960. **Sources:** Falk, *Exh. Record Series.*

SHARMAN, Florence M. *[Sculptor] b.1876, Bloomington, IL.*
Addresses: St. Louis, MO. **Studied:** St., Louis School FA, with R.P. Bringhurst. **Member:** St. Louis AG. **Sources:** WW06.

SHARMAN, John *[Painter, teacher] b.1879 / d.1971.*
Addresses: Boston, 1912; Oxford, NH, 1913; Winchester, MA, 1921; Belmont, MA, c.1926-on. **Studied:** Chas. H. Woodbury, Ogunquit School. **Member:** Phila. AC; Boston GA; CAFA. **Exhibited:** Corcoran Gal biennials, 1912-39 (10 times); PAFA Ann., 1913-18, 1921-24, 1927-28; CAFA, 1922 (prize); AIC, 1915-29. **Comments:** Teaching: Mass. School Art; BMFA Sch, 1932, 1935; listed in Woodbury Summer School (Ogunquit, ME) brochure as faculty, 1930. **Sources:** WW40; *Charles Woodbury and His Students;* Falk, *Exh. Record Series.*

SHAROFF, Yetta *[Painter] early 20th c.*
Addresses: NYC. **Exhibited:** Salons of Am., 1926; S. Indp. A., 1927. **Sources:** Falk, *Exhibition Record Series.*

SHARON, Mary Bruce *[Painter] b.c.1877 / d.1961.*
Addresses: Kentucky. **Exhibited:** Wellons Gal., NYC, 1952; MMA, 1955. **Comments:** Began painting when she was over 70 years old. **Sources:** Petteys, *Dictionary of Women Artists.*

SHARP, Bennis (Mrs. Frank W. Hart) *[Painter, craftsperson] b.1884, New Orleans, LA / d.1979, New Orleans.*
Addresses: New Orleans, active 1913-26. **Studied:** Newcomb College, 1902-07; PAFA. **Member:** NOAA. **Exhibited:** NOAA, 1913; Arts & Crafts Club, 1926. **Sources:** WW15; *Encyclopaedia of New Orleans Artists,* 349.

SHARP, Bernardine See: **CUSTER, Bernadine (Mrs. Arthur E. Sharp)**

SHARP, Chalkey Melvin *[Engraver, painter, etcher, cartoonist]* *b.1881, Phila., PA.*
Addresses: Wash., DC, active early 1900s. **Studied:** PAFA.
Member: Steel & Copper Plate Engravers' Soc. (pres.). **Work:** 9 engravings, NMAH. **Comments:** Positions: engraver of U.S. notes, bonds, securities and other artwork, Bureau of Engraving & Printing, 1905; specialist in graphic productions, U.S. Chamber of Commerce. **Sources:** McMahan, *Artists of Washington, DC.*

SHARP, Cornelia Weems *[Painter]* *b.1867.*
Addresses: NYC. **Exhibited:** NAD, 1887; PAFA Ann., 1887, 1890. **Sources:** Falk, *Exh. Record Series.*

SHARP, Edwin V. *[Lithographer]* *mid 19th c.*
Comments: He was possibly from Georgia. His drawing of the Macon Volunteers appeared in the *U.S. Military Magazine* in 1842 and sometime in the 1850's. F. Heppenheimer lithographed Sharp's view of Stone Mountain in Georgia. **Sources:** G&W; Todd, "Huddy & Duval Prints"; Peters, *America on Stone; Portfolio* (Nov. 1945), 54.

SHARP, Eliza Mary *[Artist]* *b.1829, England.*
Addresses: Dorchester, MA, 1848. **Exhibited:** Boston Athenaeum, 1848. **Comments:** She was the daughter of William and Emma Sharp, with whom she was living in Dorchester (MA). **Sources:** G&W; *Vital Records of Dorchester,* 68; Swan, BA.

SHARP, George Henry *[Lithographer]* *b.1834, England.*
Addresses: Boston, c.1857-62. **Comments:** Son of William and Emma Sharp. **Sources:** G&W; *Vital Records of Dorchester,* 68; 8 Census (1860), Mass., XXIX, 583; Boston CD 1857-62.

SHARP, Harold *[Illustrator]* *b.1919, NYC.*
Addresses: NYC. **Studied:** NAD, 1937-41; Columbia Univ. (B.A.); Hunter College, M.A. (Ashton Award). **Comments:** Preferred media: watercolors, ink. Publications: illustrator, L.W. Frolich Agency, *New York Times,* Gray Agency, *Journal Am. Medical Assn. & Physician Publ.* **Sources:** WW73.

SHARP, Hill *[Painter, lithographer, teacher]* *b.1907, Pendleton County, KY.*
Addresses: Muncie, IN. **Studied:** Ball State Teachers College; John Herron AI; Académie Julian, Paris; George Luks, George Pearse Ennis, Wayman Adams. **Member:** AEA; Indiana Art Club; Indiana Printmakers. **Exhibited:** VMFA, 1939; All. Artists Am., 1939; Phila. Print Club, 1939; Southern Printmakers, 1940 (prize); Hoosier Salon, 1928-46 (prizes, 1928, 1929,1934, 1936, 1938, 1939, 1941, 1943) ; Indiana Artists, 1929-46 (prize 1939); Indiana Art Club, 1940-46 (prizes 1942 & 1946); Indiana Printmakers, 1945, 1946 (prize); Muncie AA, 1928 (prize), 1929 (prize),1932 (European scholarship); *Indianapolis Star,* 1936 (prize). **Work:** Am. Church in Paris; Univ. Wisconsin; Univ. Club, Madison, WI; Court House Baraboo, WI; Indiana Univ.; Ft. Wayne Art Mus.; Ball State Teachers College. **Sources:** WW59; WW47.

SHARP, I. T. *[Painter]* *mid 20th c.*
Addresses: Dormont, PA. **Exhibited:** PAFA Ann., 1932. **Sources:** Falk, *Exh. Record Series.*

SHARP, James *[Artist]* *early 19th c.*
Addresses: Boston. **Exhibited:** Boston Athenaeum, 1831("Simple Cottage Scene"). **Work:** Shelburne (VT) Mus. **Comments:** This artist could be James Clement Sharp (see entry), although that James Sharp would have been only 13 years of age at the time of this exhibition (1831). **Sources:** G&W; BA Cat., 1831; Muller, *Paintings and Drawings at the Shelburne Museum,* 125 (w/repro.).

SHARP, James Clement *[Lithographer, natural science teacher]* *b.1818, Dorchester, MA / d.1897.*
Addresses: Boston, MA. **Work:** Boston Athenaeum. **Comments:** James C. was the son of Edward and Mary Sharp and elder brother of William Comely Sharp (see entry). He worked as a lithographer in the early 1840's when he was a partner with his distant relative William Sharp (see entry) in the firm of W. & J.C. Sharp (from c.1841-42). The firm produced sheet music covers and at least one portrait. From 1844 until 1845, James C. Sharp shared

an address with his brother William Comely Sharp, and in mid-1844 sold William C. his lithographic stones, paper, and stock. James apparently gave up lithography in 1845. His name is absent from the Boston directories until 1866; from then until the 1880's he is listed as a teacher of natural sciences. **Sources:** G&W; *Dorchester Births,* 308; Boston CD 1842-97; Boston BD 1842-45; date of death in Boston CD 1897; Peters, *America on Stone.* More recently, see Pierce & Slautterback, 151-152.

SHARP, John *[Painter]* *mid 20th c.*
Exhibited: Salons of Am., 1934. **Comments:** *Cf.* Sharp, John Oliver Robert. **Sources:** Marlor, *Salons of Am.*

SHARP, John Oliver Robert *[Painter and ceramics worker]* *b.1911, Galesburg, IL.*
Addresses: NYC; Lumberville, PA. **Studied:** Davenport Municipal Art School; State Univ. Iowa; ASL; National Acad. Design; Greenwich Pottery School; Du Bois, Bridgeman, Von Schleggal. **Exhibited:** Iowa Art Salon; Little Gallery, Cedar Rapids; PAFA Ann., 1940, 1947, 1951-53; Corcoran Gal biennials, 1949-53 (3 times); Detroit Mus.; Radio City, NY; NYC Galleries; Municipal Art Mus. Galleries; Studio Guild Galleries, NY. **Work:** Walter P. Chrysler, Jr. Collection, NY; USPO, Bloomfield, IA. **Comments:** WPA artist. **Sources:** WW40; Ness & Orwig, *Iowa Artists of the First Hundred Years,* 188; Falk, *Exh. Record Series.*

SHARP, Joseph H(enry) *[Painter, illustrator, teacher]* *b.1859, Bridgeport, OH / d.1953, Pasadena, CA.*

J.H.SHARP. 1913

Addresses: Cincinnati, OH; Taos, NM, 1912-/Pasadena, CA (1947). **Studied:** McMicken Sch. Design, 1873; Cincinnati Art Acad.; C. Verlat, in Antwerp, 1881; von Marr at Munich Acad., 1886; Duveneck, in Spain and Italy; Académie Julian, Paris with J.P. Laurens and Constant, 1895-96. **Member:** Taos SA (charter mem. since 1915); Cincinnati AC; Calif. AC; SC; Calif. PM; AFA; Soc. of Western Artists. **Exhibited:** PAFA Ann., 1891, 1900-01; Paris Salon, 1896; NAD, 1897-98; Dept. Ethnology, Pan-Am. Expo, Buffalo, 1901 (medal); Cincinnati AC, 1901 (prize); Corcoran Gal biennials, 1907, 1928; Pan-Calif. Expo, San Diego, 1915 (gold), 1916 (gold); Calif. Art Exh., Pasadena AI, 1930 (prize); AIC; Taos SA, 1915-on; Cincinnati Art Mus., 1915-c. 1930 (solo exhibitions held every Christmas for fifteen years), also showed at annuals. **Work:** Museum of New Mexico, Santa Fe; Gilcrease Mus., Tulsa; Univ. Calif. (Anthropology Dept., nearly 100 portraits of Indians); NMAA; Stark Museum of Art, Orange, TX; Butler Mus.; Houston MFA; Phillips Mus., Bartlesville, OK; Amon Carter Mus.; Wyoming State Gal.; Herron AI; Cincinnati Art Mus.; Academy of Natural Sciences, Phila.; Houston MFA. **Comments:** One of the founders of the Taos Society of Artists, he specialized in American Indian subjects and was an accomplished illustrator. Sharp began his study of art at the age of 14, when he left public school after an accident caused a hearing loss. He made a sketching trip out West to Santa Fe and California in 1883, and first visited Taos, NM, in 1893, producing sketches and commentary for *Harper's Weekly.* In 1901 Sharp was commissioned by the Crow Agency (of the U.S. government) to build a studio near the Custer battlefield in Montana and make a visual record of the Indians who had fought against Custer; over the next several years he completed over 200 Indian portaits (painted from life) and photographed an additional 400 more. He regularly visited Taos every summer from about 1900, and for many years split his time between his summers there (he established a permanent residence in Taos in 1912)., his teaching at the Cincinnati Art Academy, and painting on the plains. Sharp's romanticized depictions of Pueblo Indians engaged in traditional activities such as grinding corn or gathering for a ceremonial dance reflected his concern (and those of other Taos artists) that the traditions of Indian culture were disappearing and should therefore be preserved pictorially. Sharp visited Hawaii several times in the 1930s, painting seascapes and still lifes. He also visited the Orient. Teaching: Cincinnati Art Academy, 1892-1902. **Sources:** WW47; P&H Samuels, 436; Sotheby's, "The American

West: the John F. Eulich Collection," May 20, 1998; *Cincinnati Painters of the Golden Age*, 100-02 (w/illus.); Eldredge, et al., *Art in New Mexico, 1900-1945*, 207; Forbes, *Encounters with Paradise*, 251; Fink, *American Art at the Nineteenth-Century Paris Salons*, 389; *300 Years of American Art*, 545; Schimmel, *Stark Museum of Art*, 84--87; Suzan Campbell, "Taos Artists & Their Patrons," *American Art Review* (June, 1999): pp.112-27; Falk, *Exh. Record Series*.

SHARP, L. R. *[Painter, illustrator]* b.1865, Boston, MA. **Addresses:** NYC. **Studied:** W. Shirlaw; W. Sartain; E. Speicher. **Exhibited:** AIC, 1896-1905. **Work:** G.H. Buck Collection Am. watercolors. **Sources:** WW13.

SHARP, Louis Hovey *[Landscape painter]* b.1875, Glencoe, IL / d.1946, Pasadena, CA. **Addresses:** Oak Park, IL; Pasadena, CA/ Taos, NM. **Studied:** AIC; with C.E. Boutwood; W.M. Chase; F. Duveneck. **Member:** Calif. AC; Calif. WC Soc.; P&S of Los Angeles. **Exhibited:** AIC, 1904; Panama-Calif. Expo, San Diego, 1915 (silver & bronze medals); Kanst Gallery, Los Angeles, 1917; Biltmore Salon, Los Angeles, 1925; Taos & Pasadena, 1914-29. **Work:** Santa Fe RR Collection. **Comments:** Sharp sketched on the Hopi Reservation in Arizona. He settled in Pasadena in 1914 and also kept a studio in Taos; he moved to the Austrian Tyrol after 1929. **Sources:** WW08; Hughes, *Artists in California*, 507-508; P&H Samuels, 436.

SHARP, Lucile (Mrs. W. A.) *[Painter]* 20th c.; b.Mississippi. **Addresses:** Jackson, MS. **Studied:** Dixie Artists Colony, with Marie Hull, Karl Wolfe, William Hollingsworth. **Exhibited:** Delgado Mus. Art; Mint Mus. Art; Corpus Christi, TX; SSAL. **Sources:** WW53.

SHARP, Marion Leale (Mrs. James R.) *[Painter]* mid 20th c.; b.NYC. **Addresses:** Pelham, NY. **Studied:** ASL, 1909; also with Lucia Fairchild Fuller. **Member:** Nat. Lg. Am. Pen Women; Balt. WCC; MMA. **Exhibited:** PAFA; Penn. SMP; BMA; Nat. Lg. Am. Pen Women, 1938 (first prize for oil portrait), 1946; Smithsonian Inst., 1946 (first prize for portrait miniatures, Nat. League Am. Pen Women Exhib.); Nat. Collection Fine Arts, 1952 (first prize); BM; LACMA; All. A. Am.; New York SMP. **Sources:** WW73; WW47.

SHARP, Minnie Lee *[Painter]* mid 20th c. **Addresses:** Houston, TX. **Exhibited:** SSAL, San Antonio, 1939; Houston MFA, 1939. **Sources:** WW40.

SHARP, (Mr.) *[Portrait painter]* early 19th c. **Addresses:** New Orleans, 1838. **Sources:** G&W; Delgado-WPA cites *Commercial Bulletin*, May 12, 1838.

SHARP, Philip Thomas *[Lithographer and photographer]* b.1831, England. **Addresses:** Boston, active until 1862. **Comments:** He was the son of William and Emma Sharp. Brought to Boston at the age of nine, he grew up there and began working as a lithographer with his father, who took him into partnership in 1852 (Sharp & Son). Philip later turned to photography. **Sources:** G&W; *Vital Records of Dorchester*, 68; 8 Census (1860), Mass., XXIX, 583; Boston CD 1852-62; Peters, *America on Stone* [erroneously as Philip P.].

SHARP, Theodora *[Miniature painter]* 20th c. **Addresses:** St. Davids, PA. **Sources:** WW19.

SHARP, Virginia S. *[Painter]* late 19th c. **Addresses:** Phila., PA. **Exhibited:** PAFA Ann., 1891. **Sources:** Falk, *Exh. Record Series*.

SHARP, William *[Painter, etcher, lithographer, illustrator]* b.1900, Lemberg, Austria (now L'vov, Ukraine) / d.1961, NYC. **Addresses:** Forest Hills, NY. **Studied:** Acad. FA & Indus., Lemberg; Acad. FA, Crakow, and in Germany. **Member:** SAGA. **Exhibited:** LOC (prize); WMAA; MMA; CI; SAGA (prize); Weyhe Gal., NYC; Graham Gal., NYC; Mary Ryan Gal., NYC. **Work:** LOC; CI; NYPL; MMA. **Comments:** During the late

1920s, he worked as a magazine and newspaper artist in Berlin, Germany. His political cartoons were bitterly critical of Hitler and the rising Nazi movement. Even though he signed his work in pseudonyms he was forced to flee Germany in 1933 and arrived in NYC in 1934. He continued his political cartoons as a staff artist for *Esquire* and also contributed to *Life, Collier's* and *Coronet* magazines and the *New York Post*. He also illustrated books for a number of publishers. **Sources:** WW59; obit, *New York Times*, Apr. 2, 1961, p.76; PHF files; WW47.

SHARP, William *[Pioneer color lithographer, portrait and landscape painter, drawing teacher]* b.1803, Ramsey, near Peterborough (England) / d.1875. **Addresses:** Boston, 1839 and after. **Member:** Soc. of British Artists. **Exhibited:** Royal Academy, 1819-29; Suffolk Street Artists Soc.; Boston Athenaeum, 1839-72. **Work:** Boston Athenaeum. **Comments:** Arrived in Boston in 1839, coming from London where he had worked as a lithographer for Charles Hullmandel (He had also worked in Paris for Lemercier.) Sharp brought to Boston his skill as a draftsman, especially in portraiture, and also his experience in color lithography, with which he had begun to experiment as early as 1835. In 1840, Sharp, with his partner Francis Michelin, used tint stones to produce one of the earliest tinted lithographs in Boston ("Freeman's Quick Step," a sheet music cover, now at the Boston Atheneum). In that same year he produced the first color lithograph printed in Boston (and most likely, in the U.S.) in his portrait of Francis William Pitt Greenwood of King's Chapel (Boston Ath.). By the late 1840s, he was producing full-color lithography (chromlithography) and gained particular notice for his illustrations of fruit and flowers in *Fruits of America*, 1847-52. Between 1840 and 1862 Sharp had various partners, including Francis Michelin, Ephraim W. Bouvé, James C. Sharp, and his own son Philip T. Sharp. Another son, George Henry Sharp, also was a lithographer. William Sharp is to be distinguished from William Comely Sharp, also a lithographer in Boston at that time. **Sources:** G&W; 8 Census (1860), Mass., XXIX, 583 [aged 58]; Karolik Cat., 474-76 [erroneously as William C. Sharp]; Graves, *Dictionary;* Waite, "Beginnings of American Color Printing," 13, 18; *Portfolio* (Aug. 1946), 10-13; Swan, BA; Boston CD 1840-62; Peters, *America on Stone; Vital Records of Dorchester*, 67-68 [children of William and Emma Sharp]. More recently, see Pierce & Slautterback, 9-11, 152-54.

SHARP, Will(iam) Alexander **WASharp**
[Painter, stained-glass designer, printmaker] b.1864, Taunton, England / d.1944, Alhambra, CA. **Addresses:** Wash'., DC, active 1905-10; Los Angeles, CA, from 1907. **Studied:** Chicago Acad. FA. **Member:** Wash. WCC & Soc. Wash. Artists, until 1907; Calif. AC; Painters & Sculptors of Los Angeles. **Exhibited:** LACMA, 1924 (solo); AIC. **Work:** Nat. Air & Space Mus.; NMAA. **Comments:** Positions: teacher, Stetson Univ., Deland, FL (1890-1900s), Occidental College. **Sources:** WW21; Hughes, *Artists in California*, 508; McMahan, *Artists of Washington, DC.*

SHARP, William Comely *[Lithographer]* b.1822, Dorchester, MA / d.1897. **Addresses:** active c.1844 into the 1880's in Boston/Dorchester, MA. **Comments:** Not to be confused with William Sharp (born c.1802), also a Boston lithographer. William Comeley Sharp was the son of Edward and Mary and younger brother of James C. Sharp. He and his brother shared the same business address in 1844-45, although they were not listed as partners. From 1846-49 he was partnered with Joshua H. Peirce in the firm of Sharp, Peirce & Company. After that Sharp retained the same address, continuing his lithography and printing practice. His main line of work seems to have been maps but he also printed sheet music covers, bookplates, views, circulars, and business cards and seals. Sharp had other ventures as well: in 1879 he patented a window shade roller and in the last ten years of his life he worked in real estate. **Sources:** G&W; *Dorchester Births*, 316; Boston CD 1844-98; death date in Boston CD 1898; Peters, *America on*

Stone. More recently, see Pierce & Slautterback, 151-152.

SHARP & SON *[Chromolithographers] mid 19th c.*
Addresses: Boston, 1852-53. **Comments:** William Sharp and Philip T. Sharp (see entries). **Sources:** G&W; Boston CD 1852, BD 1853; Peters, *America on Stone;* Pierce & Slautterback, 152-54.

SHARP, MICHELIN & COMPANY *[Lithographers] mid 19th c.*
Addresses: Boston, 1840-41. **Comments:** William Sharp and Francis Michelin (see entries). **Sources:** G&W; Boston BD 1841; Peters, *America on Stone;* Pierce & Slautterback, 152-54.

SHARP, PEIRCE & CO. *[Lithographers] mid 19th c.*
Addresses: Boston, 1846-49. **Comments:** The firm was established by William C. Sharp, Joshua H. Peirce , and H. Clapp (see entries). Clapp dropped out about 1848 and in its last year the firm was called simply Sharp & Peirce. **Sources:** G&W; Peters, *America on Stone;* Boston CD 1847-48, BD 1848-49; Pierce & Slautterback, 152.

SHARP, W. & J. C. *[Lithographers] mid 19th c.*
Addresses: Boston, 1842. **Comments:** Active briefly in 1842, the partners were William and James C. Sharp. **Sources:** G&W; Boston BD 1842, CD 1842-43; Pierce & Slautterback, 152-54.

SHARP, WILLIAM, & COMPANY *[Lithographers] mid 19th c.*
Addresses: Boston, 1845-47. **Comments:** Working in association with Charles Bradlee & Company, music publishers. **Sources:** G&W; Boston CD 1845-46, BD 1846-47.

SHARPE, Anna *[Painter] 19th c.*
Addresses: Phila., PA. **Exhibited:** PAFA Ann., 1881-82. **Sources:** Falk, *Exh. Record Series.*

SHARPE, Charles W. *[Engraver and artist] d.c.1875.*
Addresses: Newark, NJ, active from 1845-75. **Comments:** His widow is listed in 1876. This may be the C.W. Sharpe mentioned by Stauffer as being at Philadelphia in 1850. Another Charles W. Sharpe, of London, exhibited four engravings at the Royal Academy between 1858 and 1883. **Sources:** G&W; Newark CD 1845-76; Stauffer; Graves, *Dictionary.*

SHARPE, Cornelius N. *[Ship carver] d.1828.*
Addresses: NYC, c.1810-28. **Comments:** Of Sharpe & Ellis (see entry) 1810-12 and of Dodge & Sharpe(see entry)1814-28. **Sources:** G&W; Pinckney, 92, 200; NYCD 1814-30.

SHARPE, Frank *[Painter, printmaker] b.1942, Columbia, SC.*
Studied: Pratt Inst.; Benedict College, Columbia, SC. **Member:** AFA. **Exhibited:** WMAA, 1971; Smith-Mason Gal., 1971; American-German Artist, Hanau, Germany, 1966-67; Wilson Col., PA, 1968; Brooklyn Pub. Libr., 1969; BM, 1970; Prints & Graphics, Phila., 1970; American Federation of Artists, 1971-72; Lincoln Penison Univ., 1971; Cinque Gal., NYC, 1971 (solo), 1972; Little Carnegie Theatre, NYC, 1971 (solo). **Awards:** Contemporary Black Artists. **Work:** Bibliothèque Nationale, Paris, France; Print Shop; Amsterdam, Holland; Far Gallery, NYC. **Comments:** Position: artist & lecturer, Bronx College, NYC. **Sources:** Cederholm, *Afro-American Artists.*

SHARPE, H. Percy *[Painter] 20th c.*
Addresses: Seattle, WA. **Sources:** WW21.

SHARPE, Jim *[Illustrator, painter] b.1936, Vernon, TX.*
Addresses: Detroit, MI; NYC, 1968-on. **Studied:** Texas Tech., Lubbock; Art Center School, Los Angeles (grad. 1964). **Comments:** Worked as a free-lance illus. from 1968-on, for major book publishers, advertising accounts and national magazines. Between 1970 and 1979 he did over two dozen covers for *TV Guide,* 2 for *Newsweek* and others. He received commissions from The Franklin Library for limited edition titles, and painted for the National Parks Association. He worked for ABC and NBC Television, and designed stamps for the U.S. Postal Service. **Sources:** W&R Reed, *The Illustrator in America,* 342.

SHARPE, Julia Graydon *[Portrait painter, landscape painter, writer] b.Indianapolis / d.c.1938.*
Addresses: Indianapolis, IN, c.1905-/Harbor Springs, MI. **Studied:** ASL; W.M. Chase at Indiana School Art; J.O. Adams; W. Forsyth; H.S. Mowbray; Saint-Gaudens. **Member:** Indiana SA. **Work:** Indianapolis Univ. Club; Herron AI; MacDonald Club, NYC; Richmond (IN) AC; mem., Second Presbyterian Church, D.A.R. House, both in Indianapolis. **Comments:** Painter of portraits and landscapes, bookplate designer, and a writer of short stories. **Sources:** WW38.

SHARPE, Matthew E. *[Painter, teacher] b.1902, Philadelphia, PA.*
Addresses: Conshohocken, PA. **Studied:** PM School IA; PAFA; & with Arthur B. Carles; Barnes Fnd., Merion, PA; Paris; Madrid. **Exhibited:** WMAA, 1938; PMA, 1936-38; PAFA Ann., 1945; Graphic Sketch Cl., Phila.; Cheltenham Art Gal. **Work:** PMA; Allentown Art Mus. **Comments:** Positions: teacher, Temple Univ., Miquon School, Stella Elkins Tyler School FA, Phila. **Sources:** WW53; WW47; Falk, *Exh. Record Series.*

SHARPE & ELLIS *[Ship carvers] early 19th c.*
Addresses: NYC, 1810-12. **Comments:** Cornelius N. Sharpe and John Ellis (see entries). **Sources:** G&W; Pinckney, 200; NYCD 1810-12.

SHARPLES, Ellen Wallace *[Pastel and watercolor portraitist] b.1769, probably Birmingham, England / d.1849.*
Addresses: Philadelphia; c.1793-97; NYC, 1797-1801; England, 1801-09; NYC, 1809-11; Bristol, c.1811-49. **Studied:** drawing with James Sharples at Bath. **Exhibited:** Royal Acad., London, 1807. **Work:** Ellen Sharples' diary is in the County Central Reference Lib., Deanery Rd., Bristol, England; City of Bristol Museum and Art Gallery; Bristol Fine Arts Academy (later called the Royal West of England Academy); NYHS; Mt. Vernon (stitchery portrait of George Washington). **Comments:** A member of a wealthy English Quaker family, she married her teacher James Sharples (see entry/she was his third wife, the first two having died) about 1787 after which she worked closely with him, often making copies of his popular cabinet sized pastel portraits and also executing her own portraits. The Sharples came to America in 1793, traveling as itinerant artists through New England towns with their children before settling in Philadelphia, where Ellen herself was soon swamped with commissions. Among her subjects were George Washington, Martha Washington, Alexander Hamilton, and Lafayette. In about 1797 the family moved to NYC, remaining there until 1801 when they returned to England. They came back to America in 1801 but returned permanently to England after James's death in February 1811. Ellen Shaples also worked in watercolor and was an expert fancy needleworker. The Sharples had two children, James, Jr., and Rolinda, both of whom became professional artists. Mrs. Sharples survived all of her children and left a substantial estate to the Bristol Fine Arts Academy, which she had founded several years earlier with a gift of 2,000 pounds. **Sources:** G&W; Knox, *The Sharples;* Graves, *Royal Academy of Arts;* Bolton, *Crayon Draftsmen.* More recently see Rubinstein *American Women Artists* 40-41; NYHS Catalogue (1974), cat. nos. 79, 153, 154.

SHARPLES, Felix Thomas *[Pastel portraitist] b.c.1786 / d.After 1824.*
Addresses: Phila., 1793-97; NYC, 1797-1801; England; NY, Virginia, & North Carolina, 1806 until at least 1824. **Studied:** James Sharples. **Work:** NYHS. **Comments:** He was the son of James Sharples (see entry) and his second wife. Felix came to America with the rest of the Sharples (including his father's third wife Ellen--see entry) in 1793, and like them returned to England in 1801. He began assisting his father and stepmother with the pastel business at a young age, and began his independent career in 1806 when he came to America for the second time, along with his half-brother, James Sharples, Jr. (see entry). Felix worked briefly in NYC but several years later began working in the South. His father and other family members had come back to America in 1809, but after his father's death in 1811 they returned to

England. Felix, however, remained in America. **Sources:** G&W; Knox, *The Sharples; Richmond Portraits*, 231; Bolton, *Miniature Painters*. More recently, see NYHS Catalogue (1974), cat. no. 838.

SHARPLES, Helen Brinton *[Painter] early 20th c.* **Addresses:** West Chester, PA. **Exhibited:** PAFA Ann., 1913. **Sources:** WW15; Falk, *Exh. Record Series*.

SHARPLES, James *[Pastel and oil portraitist, inventor] b.c.1751, Lancashire, England / d.1811, NYC.* *JSharples 1788* **Addresses:** Philadelphia, c.1793-1797; NYC, 1797-1801; Bath (England), 1801-09; NYC 1809-11. **Studied:** with Romney (according to Bolton). **Exhibited:** Royal Acad., 1779, 1782, 1783, 1785; Brooklyn AA, 1866, 1875 (portrait heads). **Work:** Shelburne (VT) Mus.; NYHS. **Comments:** Sharples was an accomplished pastel portraitist who worked in Bath (1781), Bristol (1783 and 1785), Liverpool and London before coming to America in 1793 with his third wife, Ellen Wallace (see Ellen Wallace Sharples), their two children, James, Jr., and Rolinda, as well as a son, Felix, from Sharples' second marriage. On arriving in America, the Sharples traveled through New England selling relatively inexpensive pastel portraits before settling in Philadelphia. In that city James Sharples, with the help of his wife, made cabinet-sized pastel portraits, many of them in profile, of the city's leading citizens, including one of George Washington (c.1796-97). Four years later the family moved to NYC, where they were equally successful. It is believed that James also traveled through the South with his son, Felix. In 1801 the family returned to England and settled in Bath. In 1806 the two sons returned to America as professional artists, followed by the rest of the family in 1809. After his death in 1811 all of the family except Felix returned to England. **Sources:** G&W; Knox, *The Sharples;* Bolton, "James Sharples"; N.Y. *Public Advertiser,* Feb. 28, 1811, obit.; Graves, *Royal Academy of Arts;* DAB; Morgan and Fielding, *Life Portraits of Washington;* DNB; Muller, *Paintings and Drawings at the Shelburne Museum,* 125 (w/repro.); the NYHS Catalogue (1974), contains many catalogue entries.

SHARPLES, James, Jr. *[Pastel portraits, still life, watercolors] b.c.1788, probably in Liverpool, England / d.1839.* **Addresses:** NYC, 1806-11; Bristol, England 1811-39. **Studied:** trained by his father James Sharples in England. **Exhibited:** Royal Acad., London, 1815, 1817, 1821, 1823. **Work:** City of Bristol Museum and Art Gallery; Bristol Fine Arts Academy (later called the Royal West of England Academy). **Comments:** Son of James and Ellen Wallace Sharples, he grew up in England and America (see entries for his parents). He began his professional career in England at the age of 15. Came back to America in 1806 with his half-brother Felix Sharples; they were joined by the rest of family in 1809. After his father's death in 1811, James went back to England with his mother and sister (Rolinda Sharples, see entry) and they settled together in Bristol. **Sources:** G&W; Knox, *The Sharples;* Graves, *Royal Academy of Arts* (as G. Sharples); Bolton, "James Sharples."

SHARPLES, Rolinda *[Portrait, genre, and historical painter in oils and watercolors, pastelist, and watercolorist] b.c.1793, probably Bath, England / d.1838, Bristol, England.* **Addresses:** Philadelphia, 1793-1797; NYC, 1797-1801; England, 1801-09; NYC, 1809-11; Bristol 1811-38. **Studied:** Ellen Wallace Sharples (her mother). **Member:** Society of British Artists (1827; hon. mem.). **Exhibited:** Royal Academy, London, 1820, 1822, 1824. **Work:** Bristol Fine Arts Academy (later called the Royal West of England Academy); City of Bristol Museum and Art Gallery. **Comments:** The daughter of James (see entry) and Ellen Wallace Sharples (see entry). She was already painting when her family made its second trip to America in 1809; and after they returned to England in 1811 she devoted herself entirely to art. She received strong encouragement from her mother who took her to art galleries and gave her art lessons. Rolinda Sharples specialized in genre and historical subjects and was awarded an honorary

membership in the Soc. of British Artists in 1827. She died of breast cancer in 1838. **Sources:** G&W; Knox, *The Sharples;* Bolton, "James Sharples;" Graves, *Royal Academy of Arts.* More recently see Rubinstein *American Women Artists* 40-41.

SHARPLESS, Ada May *[Sculptor] b.1904, Hilo, HI.* **Addresses:** Los Angeles, CA. **Studied:** A. Bourdelle. **Member:** Calif. AC; Société des Artistes Indépendants, Paris; Los Angeles AA. **Exhibited:** Calif. AC, 1929 (prize), 1930 (prize)-32; Ebell Salon, 1933 (prize), 1934 (prize); Los Angeles County Fair, 1931-33 (prize, each yr.); San Diego SFA, 1934 (prize); Riviera Gal., Hollywood, 1936 (prize). **Work:** Historical Mus., Santa Ana, CA; New General Hospital, mon., Echo Park, both in Los Angeles; reliefs, Sierra Vista School, sculpture, Malibar School, Los Angeles; Los Angeles Mus. History, Science & Art. **Sources:** WW40.

SHARPLESS, Amy C. *[Painter] early 20th c.* **Addresses:** Haverford, PA. **Sources:** WW13.

SHARPLESS, Ida J. Seal (Mrs. Wallace) *[Painter] 20th c.* **Addresses:** Unionville, PA. **Studied:** PAFA. **Sources:** WW25.

SHARPSTEIN, W. C. (Mrs.) *[Painter] 19th/20th c.* **Addresses:** Tacoma, WA, 1891-96. **Member:** Tacoma Art Lg., 1892. **Exhibited:** Western Wash. Indus. Expo, 1891. **Sources:** Trip and Cook, *Washington State Art and Artists.*

SHARRARD, Alice B. *[Painter, craftsperson] 19th/20th c.; b.Louisville, KY.* **Addresses:** Louisville, KY. **Studied:** Harvey Joiner; Cincinnati Art Acad.; E. Biederman in Freiburg, Germany. **Member:** Louisville Art Lg. **Exhibited:** Louisville Art Lg., 1898. **Sources:** WW04.

SHARRER, Honoré Desmond (Mrs. Perez Zagorin) *[Painter] b.1920.* **Addresses:** New Haven, CT; Millbrook, NY; Coronado, CA; Baltimore, MD; Rochester, NY. **Studied:** Yale Univ., c. 1938 (one year); Calif. Sch. of Fine Arts. **Exhibited:** GGE, 1939, 1940; San Diego Art Guild, 1941; 48 Sts. Comp., 1939; PAFA Ann., 1952; Knoedler's Gal., 1951 ("A Tribute to the Working People"); Corcoran Gal biennials, 1957, 1965; WMAA biennials, 1958, 1961, 1963, 1965. **Work:** MOMA; USPO, Worcester, Mass. **Comments:** In the early 1940s when Sharrer was painting public murals depicting working class people, her work came to the attention of Lincoln Kirsten, who bought one of her studies for MOMA. Shortly thereafter, Sharrer began making small paintings in the meticulous manner of the Flemish and early Renaissance masters, in particular emulating Hieronymous Bosch. Her major project was a polyptych made up of five panels, entitled "A Tribute to the Working People" (1951, Sara Roby Foundation, NYC), which took over four years to complete and brought her a great deal of attention Sharrer retreated from the art world for several years, emerging in 1969 to begin showing large satirical works. **Sources:** WW66; WW40; Rubinstein, *American Women Artists,* 302-03; Falk, *Exh. Record Series.*

SHARRER-POLAND, Madeleine *[Painter] b.1898 / d.1988.* **Addresses:** Guilford, CT. **Studied:** Geo. Luks; C.W. Hawthorne; Acad. Colarossi & Acad. de la Grand Chaumière, Paris. **Member:** New Haven PCC, 1958. **Exhibited:** NAD; New Orleans MA; New Britain Mus. Am. Art; Wadsworth Atheneum; Springfield MFA; San Diego FA Gal (solo); Silvermine Gld. (solo); Conn. WC Soc. (prize); Guilford (CT) Art Lg. (prize); New Haven PCC (prize). **Work:** Brown Univ.; Brandeis Univ. (portraits). **Comments:** Position: occupational therapy, Yale Univ. Human Relations Dept., 1960s-70s; Creative Arts Workshop, New Haven; privately in Guilford, CT. **Sources:** PHF files, courtesy New Haven PCC.

SHARRON, John *[Engraver] b.c.1823, Bavaria.* **Addresses:** Philadelphia, 1860. **Sources:** G&W; 8 Census (1860), Pa., LIV, 795.

SHARROW, Sheba Grossman *[Painter] mid 20th c.*
Addresses: Chicago area. **Exhibited:** AIC, 1922-23, 1949 (as Sheba Grossman). **Comments:** (Sheba or Sheila Grossman). **Sources:** Falk, *AIC.*

SHATALOW, Vladimir Mihailovich *[Painter] b.1917, Belgorod, Russia.*
Addresses: Philadelphia, PA. **Studied:** Inst. Art, Kharkov, 1934-36 & Inst. Art, Kiev, USSR, 1938-41 with Prof. Sharonow and Showkunenko. **Member:** AA Augsburg (Germany); All. AA; AEA; Audubon Artists; Philadelphia WCC; PAFA. **Exhibited:** Butler IA, 1968; Watercolor Show, PAFA, 1969; AWCS Ann., NYC, 1970; Wichita (KS) Centennial WC Competition, 1971; Watercolor USA Nat., Springfield, MO, 1972. Awards: gold medal hon for oil painting, All. AA, 1965; gold medal for watercolor, NAC, 1968; grand award plaque for watercolor, Wichita Centennial, 1971. **Work:** Kiev AI; Hist. Mus., Dniepropetrovsk, Russia; Ministry of Edu., Czechoslovakia. **Comments:** Preferred media: oils, tempera, acrylics. **Sources:** WW73.

SHATTUCK, Aaron Draper *A.D.Shattuck*
[Landscape, portrait, and animal painter, inventor] b.1832, Francestown, NH / d.1928, Granby, CT.
Addresses: NYC, 1861-84; Granby, CT, after 1884-1928. **Studied:** Alexander Ransom in Boston, 1851; NAD, 1852. **Member:** ANA, 1856; NA, 1861. **Exhibited:** NAD, 1855-60, 1861-84; Boston Athenaeum; PAFA, 1856-57, 1863, 1865, 1868; Washington Art Assoc., 1857; Brooklyn AA, 1859-76; New Britain (CT) Mus. of Amer. Art, 1970. **Work:** Albright-Knox Art Gal.; Vassar College; New Britain (CT) Mus. of Amer. Art. **Comments:** A second generation Hudson River School painter, specializing in scenes of the White Mountains. During the 1860s-70s, his intimate, small landscapes were very popular. In 1860 he married the sister of Samuel Colman (see entry), landscape painter. Shattuck painted during the summers in upstate New York and in New England, often in the White Mountains, NH; and was one of the first artists to paint on Monhegan Island. Many of his paintings are intimate barnyard scenes with cattle and sheep on his farm in Granby. He was also the inventor of a popular stretcher-frame which he patented in 1883, with improvements patented in 1885 and 1887. Unfortunately, a serious illness forced him to stop painting around 1885. In addition to his inventions, he turned to making violins. At the time of his death, he was the oldest member of NAD. **Sources:** G&W; WW27; DAB; French, *Art and Artists in Connecticut,* 144; Tuckerman, *Book of the Artists,* 560-61; Cowdrey, NAD; Naylor, NAD; Swan, BA; Rutledge, MHS; Rutledge, PA; Washington Art Assoc. Cat., 1857; Baigell, *Dictionary;* Campbell, *New Hampshire Scenery,* 144-148; Metropolitan Mus. of Art, *American Paradise;* Curtis, Curtis, and Lieberman, 25, 84-85 (repros.), 131, 186; Charles B. Ferguson, *Aaron Draper Shattuck, N.A.* (exh. cat., New Britain Mus., 1970); Art in Conn.: Early Days to the Gilded Age.

SHATTUCK, Cynara *[Painter] mid 20th c.*
Addresses: Chicago area. **Exhibited:** AIC, 1922-23. **Sources:** Falk, *AIC.*

SHATTUCK, J. L. *[Lithographer] mid 19th c.*
Addresses: NYC, 1853. **Comments:** Of Michelin & Shattuck (see entry); his home was in Brooklyn. **Sources:** G&W; NYCD 1853.

SHATTUCK, William Ross *[Painter] b.1895, Enderlin, ND / d.1962, Los Angeles, CA.*
Addresses: NYC; Laguna Beach, CA. **Studied:** Chicago Acad. FA; PAFA. **Exhibited:** CPLH, 1948; AIC. **Comments:** Position: art director, Metro-Goldwyn-Mayer, 1930s; instructor, Chouinard Art School. **Sources:** Hughes, *Artists in California,* 508.

SHAUGHNESSEY, Stephen J. *[Landscape and genre painter] mid 19th c.*
Addresses: NYC, 1861-82. **Exhibited:** Brooklyn AA, 1863-82; NAD, 1861-82; PAFA Ann., 1881-82. **Sources:** Naylor, NAD; *Brooklyn AA;* Falk, *Exh. Record Series.*

SHAVE, Rose M. *[Painter, teacher] b.1848, Nunda, NY.*
Addresses: Nunda, NY. **Studied:** L.M. Wiles; I.R. Wiles; R.H. Nicholls, NYC; Académie Julian, with Robert-Fleury, Académie Julian, Paris with Bouguereau and T. Robert-Fleury. **Comments:** Teaching: summer sketching classes in Nunda, NY. **Sources:** WW10.

SHAVER, A. G. *[Monochromatic artist] mid 19th c.*
Addresses: Hartford, CT, 1858-59. **Exhibited:** Am. Inst., 1856. **Sources:** G&W; Am. Inst. Cat., 1856 [nos. 537-39, as A.G. Sharer; no. 2035, as A.G. Shaw; no. 2079, as A.G. Shaver]; Hartford CD 1858-59.

SHAVER, J(ames) R(obert) *J.R.SHAVER*
[Painter, illustrator, cartoonist] b.1867, Reeds Creek, AR / d.1949.
Addresses: NYC. **Studied:** St. Louis Sch. FA; Drexel Inst.; F.O. Sylvester; P. Cornoyer; B.W. Clinedinst. **Member:** SC. **Comments:** Author/illustrator: "Little Shavers" (drawings of children). Position: contributor to *Life* for 28 years. Specialty: humorous drawings of children in pen and ink. **Sources:** WW47.

SHAVER, Kathryn E. *[Painter] mid 20th c.*
Addresses: New Brighton, SI, NY. **Exhibited:** S. Indp. A., 1929. **Sources:** Marlor, *Soc. Indp. Artists.*

SHAVER, Samuel M. *[Itinerant portrait, miniature, and landscape painter] b.1816, Kingsport, TN / d.1878, Jerseyville, IL.*
Addresses: Rogersville, TN, 1845 -52; eastern Tennessee area until c.1868; Jerseyville, IL, c.1868-78. **Work:** Tennessee State Mus. **Comments:** Shaver's first painting dates from 1845. In that same year he was married at Rogersville (TN) to the daughter of Congressman Samuel Powel (1776-1841). He remained in Rogersville until 1852, painting portraits there and in Eastern Tennessee, while also teaching drawing and painting at the Odd Fellows' Female Institute (1851). His travels are unknown from 1852 until the death of his wife in January 1856, when he returned to Rogersville. The artist moved to Knoxville in 1859 and during the 1860s painted portraits throughout Eastern Tennessee, including Russellville (1863). Moved to Jerseyville, IL, in 1868. **Sources:** G&W; Price, *Samuel Shaver: Portrait Painter,* two repros., and checklist; Kelly, *Landscape and Genre Painting in Tennessee, 1810-1985,* 40-41 (w/illus.); Gerdts, *Art Across America,* vol. 2: 138 (w/repro.).

SHAVER, Vincent Payson *[Portrait & miniature painter] mid 19th c.*
Addresses: Rochester, NY, 1833-c.38; Albany, NY, 1840-on. **Exhibited:** NAD, 1837, 1840. **Comments:** One of the early portraitists to work in Rochester, NY. **Sources:** G&W; Cowdrey, NAD; Gerdts, *Art Across America,* vol. 1: 194-95.

SHAW *[Teacher of flower and ornamental painting] early 19th c.*
Addresses: New Orleans, 1832. **Comments:** He was said to be from Boston. **Sources:** G&W; Delgado-WPA cites *Courier,* March 24, 1832.

SHAW, Alan W. *[Painter, graphic artist, writer] b.1894, NYC.*
Addresses: Miami, FL. **Member:** AAPL. **Exhibited:** St. Petersburg AC, 1936 (prize); Nat. Exhib. Am. Artists, NY, 1937; VMFA, 1937; Audubon Artists, 1945; Fed. Art Project (FL) traveling exhib., 1939 (solo); Contemporary Artists, 1943-44 (solo); Morton Gal., 1941 (solo). **Comments:** Position: dir., St. Petersburg AC. **Sources:** WW53; WW47.

SHAW, Alice Harmon (Mrs. Donald B. Kirkpatrick) *[Painter, etcher] b.1913, Portland, ME.*
Addresses: Cape Elizabeth, ME; South Portland, ME. **Studied:** School Fine & Applied Art, Portland, ME; Alexander Bower. **Member:** NAWA; Portland SA; Portland WCC; Maine WCS. **Exhibited:** Farnsworth Gal., Rockland, ME; LACMA, 1937; San Diego FA Soc., 1941; Denver Art Mus., 1941; AWCS, 1939, 1941; NAWA, 1939, 1941-44; Portland SA, 1934-55; Currier Gal. Art, 1939, 1942; Portland WCC, 1942-49; Hayloft AC, Portland, 1935-49; Brick Store Mus., Kennebunk, ME, 1941, 1942, 1946-

58; Laing Gal., Portland, ME, 1955, 1958 (solo); Maine WCS, 1949-58. **Work:** Farnsworth Mus., Rockland, ME. **Sources:** WW59; WW47.

SHAW, Annie Cornelia *[Painter and art teacher] b.1852, West Troy, NY / d.1887, Chicago, IL.*
Addresses: Chicago, IL, 1878-83; Evanston, IL, 1884. **Studied:** Henry C.Ford, Chicago (1868-72); probably learned to etch from John Vanderpoel in 1880 at the Chicago Academy of Design, where she was a teacher. **Member:** Chicago Academy of Design (1873, associate; 1876 first woman full mem.; the Acad. later became the Chicago Art Institute). **Exhibited:** Illinois State Fair, 1864 (silver medal for a pencil drawing); Centennial Exhib., Phila., 1876 ("Illinois Prairie"); MMA; BMFA; NAD, 1878-84; Bohemian A. Cl. in Chicago; SC; AWCS; SAA; Providence A. Cl.; Chicago Inter-State Industrial, 1876, 1881-83; PAFA Ann., 1880-88 (6 times); Boston AC, 1881,1908; Mass. Charitable Mechanic Assoc, 1881,1884; New England Manufacturers' & Mechanics' Inst., 1883, 1884; Cincinnati Industrial Expo, 1883; AIC 1887 (memorial exhibit & sale of 270 paintings); "Woman Etchers of America," Boston & NYC, 1888-89; AIC lent one of her paintings to the 1901 Pan-American Expo in Buffalo.
Comments: She grew up in Chicago and won her first award for a pencil drawing at age twelve. After studying for four years she opened her first studio in Chicago at age 22, in 1874. Shaw painted from nature and during the summers she traveled to various parts of the country to paint on location. She also became a well-known art teacher at the Chicago Acad. of Design. She later opened studios in NY (1881-84) and Boston (1884-85) and her work was bought by leading collectors of the time. A solo exhibition and sale held at the Art Institute of Chicago after her death included 241 oil paintings and 50 watercolors; of which very few can be found today. None of her etchings are presently located.
Sources: Rubinstein *American Woman Artists* 63; P. Peet, *Am. Women of the Etching Revival*, 63; Falk, *Exh. Record Series.*

SHAW, Charles G(reen) *[Painter, writer, illustrator, designer] b.1892, NYC / d.1974, NYC.*
Addresses: NYC. **Studied:** Yale Univ. (Ph.B., 1914); Columbia Univ., 1915; ASL; with Thomas Hart Benton & George Luks. **Member:** Am. Abstract Artists; Fellow Int. Inst. Arts & Letters; Nantucket AA (executive committee). **Exhibited:** Salons of Am.; Valentine Gal., NYC, 1934 (first solo), 1938 (solo); S. Indp. A., 1935; Chicago AC, 1938; SFMA, 1938; SAM, 1938; Am. Abstract Artists, 1937-46; AIC, 1943; CI, 1945; WMAA, 1945-63; Fed. Mod. P.S., 1942-46; Inst. Mod. Art, Boston, 1945; Gal. Living Art, NY, 1938; Art of Tomorrow Mus., 1940; Passedoit Gal., 1945; Galerie Pierre, Paris, 1936; Mayor Gal., London, 1936; Berkshire Mus., 1940; 8 x 8 Exh., PMA, 1945; Walker Art Center, Minneapolis; Hemisfair, San Antonio; AFA traveling exhib. to Europe & Japan; Century Assn. (first prize for painting); Nantucket Art Assn., 1958 (prize), 1960 (first prize); Corcoran Gal biennial, 1961; PAFA Ann., 1966; Bertha Schaefer Gal., NYC, 1973; R. York Gal., NYC, 1987 (1930s abstractions).
Work: PMA; BMA; Detroit Inst. Art, MI; MoMA; MMA; Guggenheim Mus. **Comments:** Publications: author, "New York Oddly Enough" (1938); "The Giant of Central Park" (1940); "Moment of the Now" (1969); also, articles and covers for *Vanity Fair, The Smart Set,* and *The New Yorker.* Illustrator: "The Milk that Jack Drank" (1944); "Black and White" (1944); "It Looked Like Spilt Milk" (1945); poster for Shel-Mex Ltd.
Sources: WW73; WW47; exh. cat., R. York Gal. (NYC, 1987); *American Abstract Art,* 198; Falk, *Exh. Record Series.*

SHAW, David *[Painter] mid 20th c.*
Addresses: NYC. **Exhibited:** NYWCC, 1937; Phila. WCC, 1938; AWCS-NYWCC, 1939. **Sources:** WW40.

SHAW, Donald Edward *[Painter, sculptor] b.1934, Boston, MA.*
Addresses: Houston, TX. **Studied:** BMFA School. **Exhibited:** Nova Gal., Boston, 1956-58 (solos); Inst. Aragon, Guadalahara, Mexico & Univ. Guadalahara, 1968; David Gal., Houston, 1972;

Gal. Modern Art, Taos, NM, 1971. **Comments:** Preferred media: mixed media. Publications: contributor, logo, Agencia Noticias Mexico, 1969 & cover illustrator, *Southwest Art Gallery Magazine,* 1972. **Sources:** WW73; Ann Holmes, "Fantastic artists," *Southwest Art Gallery Magazine* (Feb., 1972).

SHAW, Edwin Coupland *[Philanthropist] b.1863, Buffalo, NY / d.1941, Akron, OH.*
Studied: Yale Univ.; Univ. Akron (hon. L.L.D., 1933).
Comments: An executive with the B.F. Goodrich Co., he was a humanitarian who amassed a large collection of American paintings and prints. He was a president of the Akron Art Institute, and left one million dollars to the Akron Community Trusts. **Sources:** Karl Grismer, *Akron and Summit County*; Akron Pub. Lib. local history files.

SHAW, Elsa Vick (Mrs. Glenn M.) *[Painter, craftsperson, designer] b.1891, Cleveland, OH / d.1974, Sun City, AZ.*
Addresses: Lakewood, OH; Chagrin Falls, OH. **Studied:** Cleveland School Art; & with Henry Keller, Charles Hawthorne.
Member: Cleveland Women's AC; CMA. **Exhibited:** CMA, 1923 (prize), 1927 (prize), 1929 (prize), 1931 (prize), 1932 (prize), 1934 (prize), 1937 (prize), 1944 (prize), 1945 (prize), 1955 (prize); Ohio WCS; CMA, 1923-33 (prizes); Ten-Thirty Gals., Cleveland; Mid-Western Exhib., Dayton, 1934 (prize); Dayton AI, 1934 (prize); Ohio WCS. **Work:** murals, Severance Hall, Cleveland, OH; S.S. President Polk. **Sources:** WW59; WW47.

SHAW, Esmond *[Educator, scholar, writer] b.1902, Saba, Dutch West Indies.*
Addresses: NYC. **Studied:** King's College School, Windsor, Nova Scotia; McGill Univ., Montreal; ASL; NY Univ. **Member:** AIA (NY Chapt.) Committee Memberships: Education, 1950-51; LeBrun Scholarship, 1952-53; Brunner Scholarship, 1952-53; Education & Scholarships, 1958-59; James Stewardson Traveling Scholarship, 1959-; Civic Design, 1954-55; chmn., Advisory Comm. of the Education Committee, 1961-. **Exhibited:** Awards: Governor General's Medal, Canada, 1920; Arnold W. Brunner Fellowship, New York Chapter, AIA, 1951; Fellow, AIA, Wash., DC, 1964. **Comments:** Positions: supervisor, park designer, Robert Moses, commissioner, NY, 1934-35; drafting, designer, Ralph S. Gerganoff, Ypsilanti, MI, 1945; prof. architecture & asst. dean, Cooper Union Art School, NY, 1935-56; prof. & head dept., asst. dean, architecture, 1956-63; dean & head dept., architecture, The Cooper Union School of Art & Architecture, NYC, 1963-. Collection: American first editions: Faulkner, Williams, etc. Field of research: Medieval architecture. Works published: "Christ's Church in the Town of Rye, 1695-1945" (1945) *The Rye Chronicle*; "Art Education Today," (1949) *The Art Education Bulletin*; "Country House in Town," (1951) *McCalls Magazine*; "Planning and Community Appearance" (1958), Fagin & Weinberg, Editors, Joint Committee of AIA; "Peter Cooper and the Wrought Iron Beam" (1959) CUAS No. 7 a publication of The Cooper Union School of Art & Architecture. **Sources:** WW66.

SHAW, Frederic A. *[Sculptor] late 19th c.; b.Boston.*
Studied: Acad. Julian. **Exhibited:** Paris Salon, 1889, 1891; SNBA, 1893. **Sources:** Fink, *American Art at the Nineteenth-Century Paris Salons,* 389.

SHAW, George Eleanor (Miss) *[Block printer, designer, teacher] b.1890, Woburn, MA.*
Addresses: Medford, MA. **Studied:** E. Watson; J. DeCamp; C. Dallin; Munsell; Mass. School Art; Harvard, Carnegie Grant, 1936. **Comments:** Position: teacher, Medford (MA) high school. **Sources:** WW40.

SHAW, (George) Kendall *[Painter, educator] b.1924, New Orleans, LA.*
Addresses: Brooklyn, NY. **Studied:** Georgia Inst. Technology, 1944-46; Tulane Univ. (B.S., 1949); Louisiana State Univ., 1950; New School Social Res., 1950-52; Brooklyn Mus. Art Sch., 1953; Tulane Univ. (M.F.A., 1959); also with Edward Corbett, Ralston Crawford, Stuart Davis, O. Louis Guglielmi, George Rickey & Mark Rothko. **Member:** College Art Assn. Am. **Exhibited:** Tibor

de Nagy Gal., NYC, 1964-68 (4 solos); Contemporary Painting, Mus. Contemporary Art, Nagaoka, 1965; Modular Painting, Albright-Knox Art Gal., 1970; Sets for The First Reader by Gertrude Stein, MoMA & MMA, 1970-71; John Bernard Myers Gal., NYC, 1972 (solo). **Work:** Albright-Knox Art Gal., Buffalo, NY; Mus. Contemporary Art, Nagaoka, Japan; NY Univ.; Tulane Univ., New Orleans. **Comments:** Preferred media: acrylics. Teaching: painting instructor, Parsons School Design, 1966-; painting instructor, Brooklyn Mus. Art School, 1969-, chmn. painting dept., 1972-. **Sources:** WW73.

SHAW, George R. *[Painter] b.1849 / d.1937.*
Addresses: Boston, MA. **Exhibited:** Boston AC, 1885, 1887. **Sources:** *The Boston AC.*

SHAW, George S. *[Painter] late 19th c.*
Addresses: Phila., PA. **Exhibited:** PAFA Ann., 1879 (portrait in crayon). **Sources:** Falk, *Exh. Record Series.*

SHAW, Glenn Moore *[Painter, designer, teacher, educator] b.1891, Olmsted Falls, OH.*
Addresses: Lakewood, OH; Chagrin Falls, OH. **Studied:** Cleveland Inst. Art; & with Henry Keller, Charles Hawthorne. **Member:** Cleveland SA (pres., 1937-39); Ohio WC Soc. (pres., 1939-40); FA Commission, Cleveland City Planning Comm. **Exhibited:** CMA, 1921-54 (prizes,1926, 1928, 1952); Ohio WC Soc., 1928-52; CMA traveling exhib. **Work:** CMA; murals, Central Nat. Bank, Cleveland, Ohio; Lincoln Nat. Bank, Ft. Wayne, IN; Old Nat. Bank, Lima, OH; Fed. Reserve Bank, Pittsburgh, PA; Statler Hotels, Cleveland, OH, Buffalo, NY; Lakewood (OH) H.S.; Case Inst. Tech. Observatory; Shaker Savings Assn.; Rocky River war mem.; S.S. America; USPO, Canton, Warren & Perrysburg, OH; Wells College, Aurora, NY. **Comments:** WPA artist. Teaching: instructor, Cleveland (OH) Inst. Art (retired 1957). **Sources:** WW59; WW47.

SHAW, H. J. *[Painter] 20th c.*
Addresses: Columbus, OH. **Member:** Pen & Pencil Club, Columbus. **Sources:** WW15.

SHAW, H(arriett) M(cCreary) (Mrs. T.) *[Portrait, land-scape and miniature painter, writer, teacher] b.1865, Fayetteville, AR / d.1934.*
Addresses: Setalle, WA. **Studied:** Univ. Arkansas; Univ. Art School, Denver; with M. Heurman in Chicago; S. Richards, in Munich; C.P. Adams, in Denver; G. Platt at AIC. **Member:** AFA; Seattle FAS. **Exhibited:** St. Louis Expo, 1904 (gold medal); Seattle Expo (gold & silver medals); Guggenheim Fellowship. **Work:** William Woods College. **Comments:** Teaching: instructor, Denver School FA; Seattle YWCA. Author: "Outlines of American Painting." **Sources:** WW38.

SHAW, Harry Hutchison *[Painter, illus-trator, lecturer, teacher, block printer, draw-ing specialist] b.1897, Savannah, OH.* H.H. Shaw
Addresses: Phila., PA, 1926; Lafayette, LA; Sarasota, FL. **Studied:** Univ. Michigan; Cleveland Schiik Art; PAFA; Russ Moffet School, Provincetown; Ohio State Univ. (B.F.A. & M.A.); Nat. Univ. Mexico; Stanford Univ.; G. Harding; J.R. Hopkins; Chester Springs (PA) Summer School. **Member:** Columbus AL; Cent. Stud. E. Scambi Int., Rome; Longboat Key AA. **Exhibited:** Phila. WCC, 1925; PAFA Ann., 1926; Phila. AC, 1926; Soc. Independent Artists, 1927; Butler AI; Columbus Gal. FA; CM; Massillon Mus; Inst. Mexican-Am. Cultural Relations, Mexico City, 1964-68; Inst. Cultural Relations, Guadalajara, Mexico, 1968; Mus. Art, Columbia, SC, 1970. Award: fellowship, Research Studio, Maitland, FL, 1939. **Work:** Smithsonian Inst.; Mod. Mus Art, Mexico City; Lord Neuffield Foundation, London, England; U.S. Embassy, Mexico City; Ford Motor Co., Dearborn, MI. Commissions: Akron YWCA, 1929; Women's League Chapel, Univ. Michigan, Ann Arbor, 1930; Lafayette (LA) Pub. Libr. **Comments:** Preferred media: oils, acrylics, watercolors. Illustrator: "Quest," 1934 (a book of block prints). Positions: head dept. art, Marietta College, 1936; director Summer School, Ohio School Painting, 1936-38. Teaching: instructor, Miami Univ.,

1925-26; instructor of painting, Art Mus. School, Clearwater, FL, 1941-42; assoc. professor of art, Univ. Southwestern Louisiana, 1942-59. **Sources:** WW73; WW47; Conroy Maddox, article *Arts Review,* London 1962; Falk, *Exh. Record Series.*

SHAW, Horatio W. *[Landscape and animal painter, farmer] b.1847, Adrian, MI / d.1918, Cadmus, MI.*
Addresses: Adrian, MI. **Studied:** PAFA, with Thomas Eakins, two years. **Exhibited:** PAFA Ann., 1887; Detroit, 1940 (retrospec-tive). **Work:** Detroit Inst. of Arts; Adrian College, Adrian, MI. **Sources:** Gibson, *Artists of Early Michigan,* 211; Falk, *Exh. Record Series.*

SHAW, J. *[Portrait painter] mid 19th c.*
Addresses: Cincinnati, 1853. **Comments:** His address was the same as that of Dr. John Logan in the city directory for that year. **Sources:** G&W; Ohio BD 1853; Cincinnati CD 1853.

SHAW, Jack *[Painter, author] b.1898, Kansas.*
Addresses: Kirkland, WA. **Studied:** AIC; with Mark Tobey; mostly self-taught. **Exhibited:** SAM, 1936; Western Wash. Fair, 1940. **Work:** WPA artist. **Sources:** Trip and Cook, *Washington State Art and Artists.*

SHAW, James *[Engraver] b.c.1830, England / d.Before 1871, Pennsylvania.*
Addresses: Philadelphia, 1860. **Comments:** His wife Sarah was also English, but their two-month-old son James was born in Pennsylvania. **Sources:** G&W; 8 Census (1860), Pa., LXII, 597; Phila. CD 1871 (wife Sarah is listed as a widow).

SHAW, Joseph *[Listed as "artist"] early 19th c.*
Addresses: Philadelphia, 1819-24. **Comments:** He was probably Joshua Shaw. **Sources:** G&W; Phila. CD 1819-20, 1823-24.

SHAW, Josephine Hartwell *[Jeweler, craftsperson] 20th c.*
Member: Boston Soc. of Arts and Crafts. **Comments:** Arts and Craft jeweler. **Sources:** Rubinstein, *American Women Sculptors,* 208.

SHAW, Joshua *[Landscape painter, inventor] b.c.1777, Bellingborough, England / d.1860, Burlington, NJ.* *J. Shaw.*
Addresses: Philadelphia, 1817-c.1843; Bordentown, NJ, c.1843. **Studied:** sign-painter in Manchester, England. **Member:** Artists' Fund Soc., Phila. (founder); Artists & Amateur Assn, Phila. (founder); NAD (hon. mem.). **Exhibited:** Royal Academy, London, 1799-14; PAFA, 1818-32, 47-62; Artists' Fund Soc., Phila 1835-45; NAD, 1828-52; Brooklyn AA, 1872; also, in Boston and Baltimore;. **Work:** MMA; BMFA; Victoria and Albert Museum, London. **Comments:** Landscape painter and one of the first artists to record topographical views of American scenery for reproduction and widespread distribution as engravings. Shaw was an established painter of portraits, flowers, still life, landscapes, and cattle scenes before coming to America in 1817 and settling in Philadelphia. In 1819-20, Shaw traveled along the eastern seaboard and through the South, making sketches and taking sub-scriptions for his series, *Picturesque Views of American Scenery,* which were engraved by John Hill (see entry) and published in Philadelphia in 1819-20. Shaw was active in the Philadelphia art community, helping to found several organizations. He continued to exhibit until 1853 when he was stricken with paralysis. Shaw was also an inventor, and between 1817-43 he patented numerous improvements for firearms which later brought him financial awards from the American and Russian governments. Author: *A New and Original Drawing Book* (1816); *Picturesque Views of American Scenery* (2d ed., 1820, at NYHS); *United States Directory for the Use of Travelers and Merchants* (1822). **Sources::** Groce & Wallace; Cummings, *Historic Annals,* 288-89; *Documents, Official and Unofficial, Relating to the Claim of Joshua Shaw, the Inventor of the Percussion Caps and Locks for Small Arms* (Wash., DC, 1847); Dunlap, *History;* Dunlap, *Diary;* Graves, *Dictionary;* Rutledge, PA; Rutledge, MHS; Cowdrey, NAD; Cowdrey, AA & AAU; Swan, BA; Dickson, *John Wesley Jarvis;* Karolik Cat., repro.; Sartain, *Reminiscences;* Phila. CD

1819-24 [as Joseph Shaw], 1825-42; Stokes, *Iconography;* Flexner, *The Light of Distant Skies.* More recently, see Baigell, *Dictionary; 300 Years of American Art,* vol. 1, 83; P & H Samuels, 437; Gerdts, *Art Across America,* vol. 2: 64.

SHAW, Kendall See: **SHAW, (George) Kendall**

SHAW, Kenneth A. (Mrs.) *[Artist] mid 20th c.*
Addresses: Wash., DC, active 1924. **Sources:** McMahan, *Artists of Washington, DC.*

SHAW, Lois Hogue (Mrs. Elmer E.) *[Painter] b.1897, Merkel, TX.*
Addresses: Sweetwater, TX. **Studied:** AIC; Baylor College; ASL; with John Sloan & others. **Exhibited:** group & solo exhibitions regularly. Awards: Texas FAA (several); West Texas AA; Ft. Worth. **Work:** murals, Sweetwater H.S. **Comments:** Position: art instructor, McMurry College, Abilene; Baylor College, Belton, TX & in public schools. **Sources:** WW59.

SHAW, M. I. See: **SHAW, M. J. (or M.I.)**

SHAW, M. J. (or M.I.) *[Painter] late 19th c.*
Addresses: NYC, 1882. **Exhibited:** NAD, 1882; PAFA Ann., 1882. **Sources:** Falk, *Exh. Record Series.*

SHAW, Margaret (Mrs. Harry Hutchison) See: **ALLEN, Margo (Margaret) Newton (Mrs. H. Hutchison Shaw)**

SHAW, Paula *[Painter] mid 20th c.*
Exhibited: S. Indp. A., 1935. **Sources:** Marlor, *Soc. Indp. Artists.*

SHAW, Richard Blake *[Sculptor] b.1941, Hollywood, CA.*
Addresses: Stinson Beach, CA. **Studied:** Orange Coast Col., 1961-63; San Francisco Art Inst. (B.F.A., 1965); Alfred Univ., 1965; Univ. Calif., Davis (M.A., 1968). **Member:** Order Golden Brush. **Exhibited:** Dilexi Gal., San Francisco, Calif., 1968 (solo); Objects USA, Johnson's Wax Collection, 1969; WMAA, 1970; Contemporary American Ceramic, MoMA, Kyoto & Tokyo, Japan, 1971-72; International Ceramics, 1972, Victoria & Albert Mus., London, England, 1972; Ruth Braunstein, San Francisco, CA, 1970s. Awards: Agnus Brandenstein fellowship, 1964-65; Nat. Endowment Arts, 1970-71. **Work:** Oakland (CA) Mus.; Objects USA, Johnson's Wax Collections; U.S. Info Agency, traveling exhibs. **Comments:** Preferred media: ceramics, wood, mixed media. Teaching: chmn. ceramics dept., San Francisco Art Inst., 1965; member faculty, Univ. Wisconsin-Madison, summer 1971. **Sources:** WW73; articles, *Arts Int.,* May-June, 1966; "Objects USA," Viking Press, 1969 & *Arts Canada,* summer 1971.

SHAW, Robert *[Painter, etcher, pyroengraver, illustrator] b.1859, Wilmington, DE / d.1912, Wilmington.*
Addresses: Wilmington, DE. **Studied:** with Homer A. Herr, also possibly with Henry Price. **Member:** Phila. Sketch Club; Phila. SE (only out-of-town member). **Exhibited:** PAFA Ann., 1887-88, 1890; Columbian Expo, Chicago, 1893; American WC Soc, 1896-1901; AIC. **Work:** series of plates, New York Hist. Soc.; LOC; Delaware Hist. Soc.; PMA; Delaware Art Mus.; Pennsylvania Hist. Soc. **Comments:** Impaired through a childhood disease, he lived most of his life on the family farm, taking trips around the Delaware valley, visiting Britain in 1885-86, Southern Calif. c.1893, Britain and France in 1897-98, the Hudson River Valley in 1902 and the Delaware Water Gap in 1911. Specialty: hist. subjects; arch. views and landscapes. Drew and engraved a view of the Wren Building of the College of William and Mary. His *American Memorial Etchings* set (1904-10), published in New York received wide-spread distribution and is mentioned in Frank Weitenkamp's *American Graphic Art,* 1912. Most of his surviving paintings are bucolic watercolors. He was a contemporary of Wilmington artists Howard Pyle and J.D. Chalfant (see entries on both). **Sources:** Wright, *Artists in Virgina Before 1900;* Falk, *Exh. Record Series;* add'l info. courtesy of Thomas Beckman, Hist. Soc. of Delaware; Beckman is also the author of "The Etchings of Robert Shaw," *Delaware History,* vol. 24, no. 2 (Fall-Winter, 1990): 75-108.

SHAW, Robert M. *[Landscape painter, craftsperson] b.1915, Marion.*
Addresses: Marion, IN. **Studied:** H. Davisson; C. Bohm; G. Cleveland. **Member:** Brown County Art Gal. Assn. **Exhibited:** Hoosier Salon, 1937 (prize). **Comments:** Position: manager, Pioneer Gal., Marion, IN. **Sources:** WW40.

SHAW, Russell H. *[Painter] 20th c.*
Addresses: Providence, RI. **Member:** Providence. **Sources:** WW25.

SHAW, S. L. *[Portrait painter] mid 19th c.*
Addresses: Akron, OH, active 1843. **Comments:** Advertised in the *American Democrat.* **Sources:** Hageman, 122.

SHAW, S. Van D. (Mrs.) See: **SHAW, Sarah Isabella Field (Mrs.)**

SHAW, Samuel S. (Mrs.) *[Illustrator] 19th c.*
Addresses: Cooperstown, NY. **Comments:** The wife of the publisher of the *Freeman's Journal,* she illustrated stories by James Fenimore Cooper. **Sources:** *Rediscovery: A Tribute To Otsego County Women Artists,* exh. brochure (Hartwick Foreman Gallery, 1989), 9.

SHAW, Samuel T. *[Patron] b.1861 / d.1945.*
Addresses: NYC. **Comments:** Shaw awarded annual prize at NAD and SC; purchased work by American artists.

SHAW, Sarah H. *[Painter] mid 20th c.; b.Glenshaw, PA.*
Addresses: Glenshaw, PA. **Studied:** Wells Col.; Carnegie Library Sch. (grad.); Univ. of Pittsburgh; CI, with George Sotter; PAFA; with George Oberteuffer, Raymond Simboli, Frank Rines; ASL. **Member:** Pittsburgh AA; Rockport AA. **Exhibited:** Studio Club, NYC; Assoc. Artists, Pittsburgh; Salons of Am.; S. Indp. A., 1925; PAFA Ann., 1927. **Sources:** WW25; *Artists of the Rockport Art Association* (1956); Falk, *Exh. Record Series.*

SHAW, Sarah Isabella Field (Mrs.) *[Painter] early 20th c.; b.Phila. or New York.*
Addresses: Chicago, 1889-1911; Phila., c.1911-1917. **Studied:** Whistler; AIC. **Member:** Chicago SA. **Exhibited:** AIC, 1889-1910; AWCS, 1899; PAFA Ann., 1905, 1910. **Comments:** Specialized in watercolors of France, Spain, Germany, Holland, Venice. In 1907 she was painting at Étaples, France, with Minerva Chapman. Also known as Sarah Van Doren Shaw and as Mrs. S. Van D. Shaw. **Sources:** WW10; WW17; Falk, *Exh. Record Series.*

SHAW, Sarah Van Doren See: **SHAW, Sarah Isabella Field (Mrs.)**

SHAW, Seth Louis *[Photographer, painter] b.1816, Windsor, VT / d.1872, Ferndale, CA.*
Addresses: San Francisco, CA; Ferndale, CA. **Work:** Bancroft Lib., UC Berkeley. **Comments:** He and his brother Stephen Shaw (see entry) went to San Francisco with the Gold Rush in 1849, where Seth opened a daguerreotype gallery. **Sources:** Hughes, *Artists in California,* 508.

SHAW, Stephen William *[Portrait painter, teacher] b.1817, Windsor, VT / d.1900, San Francisco, CA.*
Addresses: San Francisco, CA, c.1849-1900. **Studied:** self-taught. **Member:** Mechanics Inst.; San Francisco AA. **Exhibited:** J.B.Steel's Store, 1848; Hewlett's Exchange, 1849, all in New Orleans; Calif. Art Union, 1865; Newhall & Co., San Francisco, 1874. **Work:** Crocker Mus., Sacramento; Humboldt County Hist. Soc.; Calif. Hist. Soc. **Comments:** Position: director and teacher, Boston Atheneum before 1849. He painted scenes of Mexico during the U.S. occupation in 1847, went to California in 1849 via New Orleans and Panama, and had a successful career as a portrait painter in San Francisco. From 1850 he was artist to the Masons of California and he is said to have painted over 200 portraits of Masonic officers, as well as of many Western notables. He also took part in the expedition which discovered Humboldt Bay in New Guinea. **Sources:** G&W; *Art Annual,* III (1900), 60; *Antiques* (July 1946), 59; Delgado-WPA cites New Orleans

Picayune, Jan. 10, 1849; San Francisco CD 1856+. More recently, see WW98; *Encyclopaedia of New Orleans Artists,* 350; P&H Samuels, 437.

SHAW, Susan M. *[Painter] mid 19th c.*
Addresses: Active 1852. **Work:** still-life painting on velvet, 1952, formerly in Isabel Wilde Collection, Cambridge, MA. **Sources:** Petteys, *Dictionary of Women Artists.*

SHAW, Sydney Dale *[Landscape painter, craftsperson] b.1879, Walkley, England / d.1946.*
Addresses: NYC, Mamaroneck, NY; Pasadena, CA (summers of 1914-19). **Studied:** ASL; Acad. Colarossi, École des Beaux-Arts, both in in Paris. **Member:** Calif. AC; AWCS; SC. **Exhibited:** Boston AC, 1907; PAFA Ann., 1912, 1915-16; AIC; Armory Show, 1913; Corcoran Gal biennials, 1914, 1916; Pan-Calif. Expo, San Diego, 1915 (medal); Los Angeles, 1916; AWCS, NYC, 1917 (prize); S. Indp. A., 1917; SC, 1929 (prize). **Work:** Colby College Art Mus. **Comments:** An Impressionist watercolorist, he came to NYC in 1892. **Sources:** WW40; P&H Samuels, 437; Falk, *Exh. Record Series.*

SHAW, Sylvia See: **JUDSON, Sylvia Shaw**

SHAW, Thomas B. *[Craftsperson, designer] b.1914.*
Addresses: Berkeley, CA. **Comments:** Designer of modern accessories, Amberg Hirth Studios, San Francisco. **Sources:** WW40.

SHAW, Thomas Mott *[Painter] 20th c.*
Addresses: Concord, MA. **Member:** Concord AA. **Sources:** WW25.

SHAW, Vinnorma *[Painter] 20th c.*
Addresses: Indianapolis, IN. **Sources:** WW17.

SHAW, Wilfred B. *[Painter, etcher, illustrator, writer, historian] b.1881, Adrian, MI.*
Addresses: Ann Arbor, MI. **Studied:** Univ. Michigan (A.B.); Frank Holme Sch. Illus., Chicago. **Member:** Ann Arbor AA. **Exhibited:** Detroit; NYC; Ann Arbor; Toronto; Chicago; Wash., DC; Hackley Art Gal. (solo). **Comments:** Author/illustrator: "Short History of Univ. Michigan," 1937. Illustrator, *Michigan Alumni Quarterly Review;* "Ballads and Songs of Southern Michigan"; "Fortress Islands of the Pacific"; "Short Account of the Copts," and others. Contributor: *International Studio, Craftsman, Scribner's,* & other magazines. **Sources:** WW59; WW47.

SHAW, William R. *[Sketch artist, sign painter] b.1860, New Orleans, LA / d.1950, New Orleans.*
Addresses: New Orleans, active 1886-98. **Studied:** Tulane Univ., 1886. **Comments:** Drew pencil and ink sketches of New Orleans, Louisiana and Mississippi. **Sources:** *Encyclopaedia of New Orleans Artists,* 350.

SHAW, William V. *[Portrait painter] b.1842 / d.1909.*
Addresses: Jamaica, NY.

SHAWHAN, Ada Romer *[Portrait & still life painter] b.1865, San Francisco, CA / d.1947, Oakland, CA.*
Addresses: Oakland, CA. **Exhibited:** Mechanics' Inst., 1897; Mark Hopkins Inst., 1904. **Work:** Bohemian Club. **Sources:** Hughes, *Artists in California,* 509.

SHAWLEE, Walter James *[Painter] b.1911, Havre, MT / d.1978, Los Angeles, CA.*
Addresses: Los Angeles, CA. **Exhibited:** Southern Calif. Art, San Diego FA Gal., 1934; San Diego Art Guild, 1936. **Sources:** Hughes, *Artists in California,* 509.

SHAY, Joseph A. *[Painter] mid 20th c.*
Addresses: NYC. **Studied:** ASL. **Exhibited:** S. Indp. A., 1933. **Comments:** Poassibly Shay, Joseph A., b. 1875, Syracuse, NY-d.1951, Fresh Meadows, LI, NY. **Sources:** Marlor, *Soc. Indp. Artists.*

SHAYN, John *[Painter, designer] b.1901, Ukraine.*
Addresses: NYC. **Studied:** Massachusetts Normal Art School,

1917-18; Boston Univ., 1919-21; Mus. Fine Arts School, Boston, 1922-23; ASL, 1924. **Member:** AEA; Inst. Graphic Arts; AS. **Exhibited:** PAFA Ann., 1952; Miami, Chicago, Boston, & Great Neck, NY; NYC (solos). Awards: New York Bldg. Congress, 1927 (first prize); Eastern Fine Paper Grand Nat. Award, 1966 (second prize). **Work:** Union of Am. Hebrew Congregations; Berg Foundation; Frank Lloyd Wright Foundation, WI. **Comments:** Publications: author, "True Craftsmanship as Applied to Design"; illustrator, "Art and the Bible." Teaching: radio & television lectures on Bible art & symbolism. Art interest: inventor, wax color tempera medium. **Sources:** WW73; Falk, *Exh. Record Series.*

SHAYS, William P. See: **SHEYS, William P.**

SHEA, Aileen Ortlip (Mrs. Alton J.) *[Painter, teacher] b.1911, Philadelphia, PA.*
Addresses: Houghton, NY; Wellsville, NY. **Studied:** NAD; Sorbonne, Paris, France; G. Beal; L. Kroll; A. Covey; C.S. Chapman. **Member:** NAC. **Exhibited:** Rochester-Finger Lakes Exhib., 1946; David A. Howe Mem. Lib., Wellsville, NY, 1955. Awards: Pulitzer traveling scholarship, 1935. **Comments:** Position: teacher, Houghton College; art instructor, Public Schools, Wellsville, NY. **Sources:** WW59; WW47.

SHEA, Alice *[Painter] late 19th c.*
Addresses: NYC, 1886-90. **Exhibited:** NAD, 1886-90; PAFA Ann., 1890. **Sources:** Falk, *Exh. Record Series.*

SHEA, Annie K. *[Artist] early 20th c.*
Addresses: Wash., DC, active 1918-23. **Sources:** McMahan, *Artists of Washington, DC.*

SHEA, Beverly *[Art dealer] b.1938, Albany, CA.*
Addresses: Canyon, CA. **Comments:** Positions: owner, Beverly Shea Gallery. Specialty of gallery: contemporary oils. **Sources:** WW73.

SHEA, Daniel *[Carver] d.1917, Wash., DC.*
Addresses: Wash., DC, active 1877-92. **Sources:** McMahan, *Artists of Washington, DC.*

SHEA, Dorothy *[Painter] b.1924, Connecticut / d.1963, Buffalo, NY.*
Addresses: Buffalo, NY. **Studied:** Pratt Inst. of Art & Design, Brooklyn, NY 1947-50; Albright Art School, Buffalo, 1950-51; Univ. of Buffalo (B.Ed., 1951). **Member:** Patteran Soc. (pres., 1960-61). **Comments:** Moved to Buffalo in 1950. Teaching: Albright Art School, 1954-58; Canisius College, 1962-63; State Univ. of New York at Buffalo, 1958-63. **Sources:** Krane, *The Wayward Muse,* 196.

SHEA, Eileen A. *[Artist] early 20th c.*
Addresses: Wash., DC, active 1918. **Comments:** In 1918 she resided at the same address as Elizabeth K. Shea. **Sources:** McMahan, *Artists of Washington, DC.*

SHEA, Elizabeth K. *[Artist] early 20th c.*
Addresses: Wash., DC, active 1918-20. **Comments:** In 1918 she resided at the same address as Eileen A. Shea. **Sources:** McMahan, *Artists of Washington, DC.*

SHEA, Frank P. *[Painter] b.1885, Middlebury, VT / d.1977, Fairhaven, MA.*
Studied: Middlebury College; Columbia Univ. (M.A.); New College, Oxford Univ. England. **Member:** Boston Art Soc.; New Bedford Soc. Independent Artists (pres.). **Work:** Mt. Pleasant Street School, New Bedford. **Comments:** Positions: principal, John H. Clifford School, 1914; head, Mt. Pleasant Street School, 1923; principal, H.M. Knowlton School, 1930; trustee, New Bedford Free Public Library; pres., School Principals' Assoc. **Sources:** Blasdale, *Artists of New Bedford,* 167 (w/repro.).

SHEA, John *[Lithographer] b.1840, Ireland.*
Addresses: NYC, 1860. **Sources:** G&W; 8 Census (1860), N.Y., XLIII, 24.

SHEAD, Ralph *[Painter] 20th c.*
Addresses: Jenks, OK. **Sources:** WW17.

SHEAD, Ray S. *[Painter, sculptor] b.1938, Cartersville, GA.*
Addresses: LaGrange, GA. **Studied:** Atlanta Art Inst. (B.F.A., 1960); Art Center College Design (B.P.A., 1963); also with John Rodgers & Loser Fiedelson, Los Angeles. **Member:** College Art Assn. Am. **Exhibited:** Southeastern Ann., Atlanta, 1960; Dixie Ann., Montgomery, AL, 1960; 6th Ann. Callaway Gardens Exhib., GA, 1969; 49th Shreveport (LA) Art Exhib., 1970; Georgia Artists Exhib. I & II, Atlanta, 1971-72; Beverly Singlee, LaGrange, GA, 1970s. **Awards:** Second Dixie Ann. Award, 1960; Southern Contemporary Award, 1969; Sixth Ann. Columbus Exhib. Award, 1970. **Work:** Columbus (GA) Mus.; Montgomery (AL) Mus.; Opelika Art League, AL; Atlanta High Mus., GA; Southwest Georgia Art Mus, Albany. **Commissions:** painting, Chrysler Corp., Atlanta, 1960; sculpture, Dibco-Wayne Corp, Atlanta, 1968; painting, Callaway Gardens, GA, 1970. **Comments:** Preferred media: acrylics, epoxy. Positions: art dir., Compton Advertising, NYC, 1963-67. Teaching: assoc. prof. art & hd. dept., LaGrange College, 1968-. **Sources:** WW73.

SHEAFER, Frances B(urwell) (Mrs. Samuel Waxman)
[Painter, lecturer, craftsworker, teacher] b.Pennsylvania / d.1938.
Addresses: Cambridge, MA/Greenbush, MA. **Studied:** PAFA; Phila. School Design for Women; W. Sartain. **Member:** Plastic Club (life mem.); Scituate AA; AFA; Copley Soc. **Exhibited:** St. Louis Expo, 1904 (medal); Horticultural Soc. Mass., 1931 (silver medals). **Comments:** Specialty: botanical watercolors. **Sources:** WW40.

SHEAFER, (Francis) W. *[Painter] mid 20th c.*
Addresses: NYC. **Exhibited:** S. Indp. A., 1924-28. **Sources:** Marlor, *Soc. Indp. Artists.*

SHEAFER, Frank W. *[Painter] b.1867, Pottsville, PA.*
Addresses: Phila., PA. **Studied:** PAFA. **Exhibited:** PAFA Ann., 1895, 1903, 1915; Boston AC, 1908; AIC; S. Indp. A., 1917. **Sources:** WW24; Falk, *Exh. Record Series.*

SHEAHAN, D. B. *[Sculptor] late 19th c.*
Addresses: NYC, 1876-81. **Exhibited:** NAD, 1876-81. **Sources:** WW10.

SHEAHAN, Joseph Gary *[Painter] 20th c.*
Addresses: Chicago, IL. **Member:** Chicago NJSA. **Sources:** WW25.

SHEAHEN, D. B. See: **SHEAHAN, D. B.**

SHEAKS, Barclay *[Painter, educator] 20th c.; b.East Chicago, IN.*
Addresses: Newport News, VA. **Studied:** Virginia Commonwealth Univ. (B.F.A.); College William & Mary (teaching certificate). **Member:** Tidewater AA; Salmagundi Cl. **Exhibited:** Nat. Drawing Biennial (drawing selected for Smithsonian Inst. Nat. Traveling Exhib.), Norfolk (VA) Mus., 1965; Butler IA Mid-Year Show Am. Painting, 1965, 1966 & 1967; 99 Exhibition, AWCS, NAD, 1966; Juried Art Exhib., Corcoran Gal., 1967; Ten Top Realists SE, Gal. Contemporary Art, Winston-Salem, NC, 1969-70; Chester Smith, Seaside Art Gal., Nags Head, NC, 1970s. **Work:** VMFA, Richmond; Butler IA; Columbia (SC) Mus. Fine Arts; Mobile (AL) Mus.; Mariners Mus., Newport News, VA. **Commissions:** relief sculpture, Riverside Hospital, Newport News, 1963; portrait of U.S.S. America, USN, 1964; portrait of U.S.S. Enterprise, commissioned by officer of ship, 1965; portrait of U.S.S. John F. Kennedy, City of Newport News, 1969; painting series, executive suite, Tenneco Corp., Newport News Shipyard, 1972. **Comments:** Preferred media: acrylics, polymers. Positions: art consultant, Hunt Mfg. Co. Phila., 1965; lecturer, Virginia Mus., Richmond, 1970; artist-in-residence, Richmond Humanities Center, 1971. Teaching: head art dept., Newport News Public Schools, 1949-69; assoc. professor art, Virginia Wesleyan College, 1969-. Publications: author, "Painting with Acrylics from Start to Finish," Davis Mass, 1972.

Sources: WW73; Russel Woody, chapter, *Painting in Synthetic Media & Complete guide to Polymer Painting* (Van Nostrand-Reinhold); chapter, *Prize Winning Paintings* (1966).

SHEAN, Charles M. *[Mural painter] b.Brooklyn, NY / d.1925, Brooklyn, NY.*
Addresses: NYC. **Studied:** ASL; Cabenel, in Paris. **Member:** Mural Painters; Arch. Lg., 1887; SC; Lg. Am. Artists. **Exhibited:** St. Louis Expo, 1904 (medal); Salons of Am., 1922, 1927; S. Indp. A., 1922-23, 1927. **Work:** Manhattan Hotel; Old Hotel Plaza; NYC; stained glass window, St. John's Church, Larchmont; portrait of Lincoln, Capitol, Carson City, NV. **Sources:** WW24.

SHEAR, Fera Webber *[Painter, lecturer] b.1893, Eustace, FL / d.1974, Berkeley, CA.*
Addresses: Berkeley, CA. **Studied:** Cornell Univ. (B.E.); NYU; Calif. College Arts & Crafts; Calif. Sch. FA. **Member:** Women Painters of the West; Bay Region AA; Soc. for Sanity in Art; Calif. AC; Bay Region AA; Soc. Western Artists; All Arts Club, Berkeley. **Exhibited:** Gardena High School, 1933 (purchase prize); Springville, UT, 1935-42, 1946; Oakland Art Mus., 1934 (prize)-1940, 1948; Gump's, San Francisco, 1934; Mission Inn, Riverside, CA, 1933-35; All Arts Club, Berkeley, 1934-40, 1951, 1954; CPLH, 1939, 1940, 1942, 1945, 1947; Berkeley Woman's City Club, 1934 (solo); Calif. State Fair, 1933-38 (prizes,1934, 1936, 1937); Bay Region AA, 1935-38; Soc. Western Artists, 1939-42, 1945; Soc. for Sanity in Art, 1939-42, 1945; GGE, 1939 (prize). **Comments:** Many lectures on historic homes and buildings of California, accompanied by exhibition, to women's clubs, art groups and civic organizations. **Sources:** WW59; WW47.

SHEARER, Catherine *[Artist] 19th/20th c.*
Addresses: Active in Detroit, 1899-1900. **Comments:** May be the same as Chrissie Shearer. **Sources:** Petteys, *Dictionary of Women Artists.*

SHEARER, Chrissie *[Artist] late 19th c.*
Addresses: Active in Jackson, MI, 1897. **Comments:** May be the same as Catherine Shearer. **Sources:** Petteys, *Dictionary of Women Artists.*

SHEARER, Christopher High *C H Shearer 1911*
[Landscape painter] b.1840, Reading, PA / d.1926, Reading, PA.
Addresses: Reading, PA/Düsseldorf, Germany, 1879/Paris, France, 1880; Phila., PA, 1881-95/Tuckerton, PA, 1891. **Studied:** F.D. Devlan and J.H. Raser; Düsseldorf Sch. of Art, Germany; Munich; Paris. **Exhibited:** Brooklyn AA, 1874, 1882; Boston AC, 1877; PAFA Ann., 1878-85, 1891, 1895; NAD, 1881; Mass. Charitable Mech. Assoc., Boston. **Comments:** Known primarily for his large landscapes, he also painted still lifes, self-portraits, watercolors, and did engravings. Shearer attended local public schools whenever possible while working on the family farm full time. At the age of eighteen he began to study art under F.D. Devlan and J.H. Raser. By twenty-seven years of age, Shearer was a recognized artist in America. He opened a studio in Reading, Pa. in 1883 and taught art there, encouraging the growth of an art colony in Berks County. He was also instrumental in the founding of the Reading Public Museum and Art Gallery with Dr. Levi Mengel. Christopher Shearer's brother Edmund was also an artist, as were Christopher Shearer's sons, Victor and Arthur. **Sources:** G&W; *Art Annual,* XXIII, obit.; Falk, *Exh. Record Series.* More recently, see Campbell, *New Hampshire Scenery,* 148-149; Malmberg, *Artists of Berks County,* 28.

SHEARER, E. L. *[Painter] late 19th c.*
Addresses: Tuckerton, PA, 1891. **Exhibited:** PAFA Ann., 1891. **Sources:** Falk, *Exh. Record Series.*

SHEARER, Ethel *[Painter] mid 20th c.*
Addresses: Corte Madera, CA. **Exhibited:** SFMA, 1935; Oakland Art Gallery, 1936. **Sources:** Hughes, *Artists in California,* 509.

SHEARER, Inez Rogers *[Painter] mid 20th c.; b.Chaumont, NY.*
Studied: Mt. Holyoke College; Univ. of Chicago; Buffalo, NY,

Art Inst.; Cape Ann Art Sch., Rockport, MA. **Member:** Patteran Soc.; Rockport AA. **Exhibited:** Albright Art Gallery; Art Inst. of Buffalo, NY. **Comments:** Specialty: Mexican pictures. **Sources:** *Artists of the Rockport Art Association* (1946).

SHEARER, Victor *[Painter] b.1872, Reading, PA / d.1951, Reading, PA.*
Addresses: Reading, PA. **Comments:** Began his career in his own business of basketmaking at age twenty-six. He soon pursued a career in art, as did his father, Christopher. Known for his "generic" scenes, Shearer produced similar landscape paintings, selling them for a few dollars apiece on the streets of Reading, PA. **Sources:** Malmberg, *Artists of Berks County,* 32.

SHEARMAN, James A. *[Lithographer] mid 19th c.*
Addresses: NYC (active 1851-88). **Exhibited:** Brooklyn AA, 1879. **Work:** FDR Lib., Hyde Park, NY; Mystic Seaport Mus. **Comments:** Of Robertson, Seibert & Shearman (see entry), NYC, 1859-61. He later headed the firm of Shearman & Hart (see entry). **Sources:** G&W; Peters, *America on Stone;* NYBD 1859-60; Brewington, 352.

SHEARN, Clarence, Jr. *[Painter] mid 20th c.*
Addresses: NYC. **Studied:** ASL. **Exhibited:** Salons of Am., 1933; S. Indp. A., 1933, 1937. **Sources:** Falk, *Exhibition Record Series.*

SHEARN, Edith G. *[Painter] 20th c.*
Addresses: NYC. **Sources:** WW04.

SHEBL, Joseph J. *[Sculptor] b.1913, Crete, NE.*
Addresses: Salinas, CA in 1968. **Comments:** Traditional Western sculptor of historical subjects, animals. Also a medical doctor and radiologist. **Sources:** P&H Samuels, 437.

SHEBLE, Horace *[Etcher, painter] b.1869.*
Addresses: Phila., PA. **Studied:** self-taught. **Comments:** Specialty: stipple etching. **Sources:** WW40.

SHECKELS, Glenn *[Painter, commercial artist] b.Puget Sound area, WA / d.1939, Seattle, WA.*
Addresses: Seattle, WA. **Studied:** Leon Derbyshire, Oliver Fiedeman. **Member:** Puget Sound Group of Northwest Painters. **Exhibited:** SAM, 1938, 1929, 1937. **Comments:** Position: art director, Western Engraving and Colortype, Seattle. **Sources:** Trip and Cook, *Washington State Art and Artists.*

SHECKER, Herman *[Lithographer] mid 19th c.*
Addresses: Reading, PA, about 1860. **Comments:** He was a butterfly collector and made drawings on stone to illustrate his own publications. **Sources:** G&W; Peters, *America on Stone.*

SHECTER, Pearl S. *[Painter, instructor] b.1910, NYC.*
Addresses: NYC. **Studied:** Hunter College (B.F.A.); Columbia Univ. (M.F.A.); Hans Hofmann School Painting; Archipenko School Art, New York; New Bauhaus School Design, with Moholy-Nagy; Acad. Grande Chaumière, Paris. **Member:** Exp., Art & Technology; Int. Assn. Art Bulletin UNESCO; Group 8 Artists New York (pres., 1972). **Exhibited:** Walker AC, 1963; Carnegie Endowment Center, New York, 1963; Lehigh Univ., Allentown, PA, 1967; Manuf. Hanover Trust Bank, 1970 & 1971; Union Carbide Gal., New York, 1972; Surgil Associates, NYC, 1970s. **Awards:** Carnegie Founation grant, 1950; gold medal Patronato Scholastico Arti, Italy, 1963; certificate of merit, Int. Biog., England, 1970. **Work:** NY Univ.; John F. Kennedy Library; Miami (OH) Univ.; Int. Relations Foundation, New York. **Comments:** Positions: art dir., Elisabeth Irwin H.S., 1972. **Publications:** contributor, articles *Art News, Art Digest & Art Now,* 1963-70. **Teaching:** lecturer studio courses, NY Univ., 1958-69; instructor studio courses, Newton-Harvard Creative AC, 1963. **Sources:** WW73; entry, *Encyclopedia Internacionale Degli Artisti* (1971); "Artists New York" (tape), Voice of Am., 1972.

SHED, Charles Dyer *[Painter] b.1818, Massachusetts / d.1893, Alameda, CA.*
Addresses: Alameda, CA. **Member:** Calif. Art Union, 1865; San Francisco AA. **Exhibited:** Mechanics' Inst., 1858; Mechanics'

Inst. Fair, 1860; San Francisco AA, 1883. **Work:** Oakland Mus. **Sources:** Hughes, *Artists in California,* 509.

SHEDWICK, John *[Engraver] b.c.1816, England.*
Addresses: West Philadelphia, 1850. **Comments:** His wife and four children (10 to 2 years) were also born in England. His real property was valued at $11,000. In 1852 Shedwick was listed as a pattern cutter. **Sources:** G&W; 7 Census (1850), Pa., LV, 1154; Phila. CD 1852.

SHEDY, Roy T. *[Portrait painter] b.1931, Ft. Smith, AR.*

SHEEHE, Lillian Carolyn *[Painter, instructor] b.1915, Conemaugh, PA.*
Addresses: Johnstown, PA. **Studied:** Indiana (PA) Univ. (B.S., art); ceramics & sculpturing with Sheldone Grumbling, majolica with Hugh Geise & painting & sculpturing with George Ream. **Member:** All. Artists (member board, many years; pres., 1970-72); Pittsylvania Ceramic Guild; Area Arts Council; Arts Assocs.; Cultural Affairs Committee (coordinator, spec. events publ.). **Exhibited:** All Allied Artists Juried Shows, 1936-; Pittsylvania Ceramic Guild All-Penn. competition, 1964-71; Three Rivers Arts Festival, 1965 & 1966; Allied Artists Graphic Arts Show, 1970; Johnstown C of C, 1972 (solo). **Awards:** purchase award, U.S. Bank Show, 1961; Allied Artists Best of Show, U.S. Bank Show, 1970; Phoebe Jerema Award, Pittsylvania Ceramic Guild, 1971. **Work:** U.S. Bank Gal.; Art Assocs. Gal.; Court of Gabrielle (serigraph), David Glosser Library; Trees at Christmastime in California (serigraph), Flood Mus.; 130 glass-fired paintings & sagged bottle collection, C of C, Johnstown, PA. **Commissions:** golf mural, Journal Cover, Johnstown, PA, 1944; designed & printed Christmas cards, Penn. Rehab. Center & Bur Voc. Rehab., 1959-71; emblem design, Lee Hospital Rehab. Medical Dept., 1966; landscape mosaic, Mrs. Lyn Hoffman, 1970; art calendar, All. A. Am., 1971. **Comments:** Preferred media: fired glass, oils, copper enameling. Positions: designer & coordinator, Around About Now in Johnstown, 1971-72. **Teaching:** art supervisor, East Conemaugh Schools, 1936-42; instructor of art & world history, Westmont H.S., 1944-45 & 1953-54; instructor of art & art supervisor, Ferndale-Dale Grade & H.S., 1955-59; instructor arts & crafts, Penn. Voc. Rehab. Center, 1959-72. Research: experimented 20 years on applications for fired glass. **Sources:** WW73; "Art Exhibit" (two TV shows on glass work), George Mengelson, producer, 1969. Publications: author/illustrator, Allied Artists Fall Show Catalog (plus cover design), 1958; author, "Useless to Useful," *Leather Craftsman Magazine,* 1961; author/illustrator, "Antiquity in a Day," *Ceramics Arts & Crafts,* 1964; author/illustrator, textbook on photo--tinting--color--oils, Bur Voc. Rehab., 1965.

SHEEHY, Cornelius A. *[Artist] early 20th c.*
Addresses: Wash., DC, active 1913. **Sources:** McMahan, *Artists of Washington, DC.*

SHEELER, Charles *[Painter, photographer] b.1883, Philadelphia, PA / d.1965, Dobbs Ferry, NY.*
Addresses: Doylestown, PA, 1910-18; Greenwich Village, NYC, 1919-; S. Salem, NY; Ridgefield, CT; Irvington, NY. **Studied:** PM School IA, 1900-03; PAFA with W.M. Chase, 1903-06 (and two summer classes with Chase in Europe, 1906-08). **Exhibited:** PAFA Ann., 1907-10, 1930-31, 1939-58; AIC, 1907 -49 (prize, 1945); Armory Show, 1913; Marius De Zaya's Gal., 1917 (photographs); Forum Exh., NYC, 1917; Soc. Indep. Artists, 1917; Salons of Am., 1923; Corcoran Gal. biennials, 1932-57 (11 times); FMA, 1934 (solo); MoMA, 1939; AGAA, 1947; Currier Gal. Am. Art, 1948; Walker AC, 1952; traveling exhib. in 1954-55 to: UCLA, PAFA, Ft. Worth AM, de Young MA; San Diego MA; Munson-Williams-Proctor Inst.; Downtown Gal., 1958; WMAA. **Awards:** Harris prize, 1945 (prize); Hallmark Award, 1957. **Work:** MOMA; Cleveland Mus.; PMA; PAFA; WMAA; BMFA; NMAA; FMA; Columbus Gal. FA; WMAA; WMA; Springfield MA; AIC; Newark Mus.; Santa Barbara MA; Univ. Nebraska; Detroit AI; Yale Univ. AG; CPLH; PMG; CMA; Regis Coll., Minneapolis;

Munson-Williams-Proctor Inst., Utica, NY; CGA. **Comments:** Leading Precisionist painter and photographer. After studying for several years with Chase, Sheeler became interested in modern art during a visit to Europe (1908-10) with Morton Schamberg. Returning to America, Sheeler took up photography and began supporting himself as a commercial photographer in 1912. For the next several years he took pictures of rural farmhouses (around Doylestown) in a sharp-focus style that reveals his taste for simple and austere forms. Throughout his career, the composition of his paintings and his photographs reflected similar aesthetic concerns. In 1917 he began making paintings of barns, leaving out the surrounding outdoor setting and paring down the image to its most basic shapes and lines, in an effort to "reduce natural forms to the borderline of abstraction" (quoted in Davidson, 187); he also made a number of abstracted still lifes, using as his subject matter the Shaker antiques he had begun collecting. In the 1920s he was hired by Ford Motor Company to photograph the River Rouge plant near Detroit. From the 32 prints made, a number of Precisionist paintings resulted, including "Classic Landscape" and "American Landscape" (both MOMA). These photographs and paintings helped to make Sheeler's reputation, and in the 1930s he further explored industrial subjects and also painted a series of paintings of older America, and a number of sparse domestic interiors, absent of human beings. In the 1940s Sheeler experimented with multiple images, both in his photography and in his painting. Positions: contrib., fashion and portrait photos to *Vogue* and *Vanity Fair,* 1920s; contrib., photos for N.W. Ayer advertising agency, Phila.; collaborated with Paul Strand on "Manhatta," a six-minute film, in 1921; photographer-in-residence, MMA, 1942-45 (Sheeler photographed works in the collection); artist-in-residence, Phillips Acad., Andover, MA, 1946; Currier Gal. Art, Manchester, NH, 1948. **Sources:** WW59; WW47; Witkin & London, 232; A. Davidson, *Early American Modernist Painting,* 186-93; Martin L. Friedman, *Charles Sheeler* (New York, 1975); Carol Troyan and Erica E. Hirshler, *Charles Sheeler, Paintings and Drawings* (Boston, 1987); Falk, *Exh. Record Series;* Baigell, *Dictionary;* Brown, *The Story of the Armory Show.*

SHEEN, Ann Evelyn (Mrs. D. Carney) *[Painter, craftsperson] early 20th c.*
Addresses: New Orleans, active c.1911-14. **Studied:** Newcomb College, 1911; ASL; John Carlson. **Exhibited:** Newcomb College, 1911; NOAA, 1914 (silver medal). **Sources:** *Encyclopaedia of New Orleans Artists,* 350.

SHEERER, Mary Given *[Craftsperson, painter, teacher] b.1865, Covington, KY / d.1954.*
Addresses: New Orleans, active 1894-1931; Cincinnati, OH/Ogunquit, ME. **Studied:** Cincinnati Art Acad.; PAFA; ASL; D. Ross; A.W. Dow; F. Duveneck; H. Breckenridge; Anna M. Riis; Kenyon Cox; Henry S. Mowbray. **Member:** NOAA; Cincinnati Women's AC; Cincinnati Crafters Club (pres.); Cincinnati Mus. Assn.; Am. Ceramic Soc. (fellow & delegate to Int. Expo Modern Dec. & Indus. Art, Paris, 1925); Hoover Comm. **Exhibited:** New Orleans AA, 1894, 1897, 1899, 1905, 1915-18; Louisiana Purchase Expo; Pan -Pacific Expo, San Francisco, 1915. **Comments:** Hired in 1894 from the Cincinnati School of Art to organize the Newcomb College pottery department. Contributor: articles, *Journal of Am. Ceramic Society.* Position: teacher, assistant professor, professor, asst. director, 1894-1931, Newcomb College, New Orleans. Upon her retirement she returned to Cincinnati. **Sources:** WW40; *Encyclopaedia of New Orleans Artists,* 350-51.

SHEETS, Cree *[Painter] 20th c.*
Addresses: Columbus, OH. **Member:** Columbus PPC. **Sources:** WW25.

SHEETS, John *[Listed as "artist"] b.c.1812, Prussia, Germany.*
Addresses: Philadelphia,1860. **Comments:** His wife and two older children (ages 10 and 6) were born in Prussia, while a third child (3) was born in New York. **Sources:** G&W; 8 Census (1860), Pa., LIV, 373.

SHEETS, Millard Owen *[Designer, painter, etcher, illustrator, mural painter] b.1907, Pomona, CA / d.1989, Gualala, CA.*
Addresses: Claremont, CA; Los Angeles, Gualala, CA. **Studied:** Chouinard Art Inst.,1925-29, with Chamberlin and Hinkle; with Theodore Modra; Otis Art Inst. (M.F.A., 1963); Univ. Notre Dame (honorary L.L.D., 1964). **Member:** Laguna Beach AA; NA, 1947; Calif. AC; Calif. WCS; AWCS; Soc. Motion Picture Art Directors; Bohemian Club. **Exhibited:** Los Angeles County Fair, 1918 (prize), 1928, (prize), 1930 (prize); Calif. WCS, 1927 (prize); Arizona State Fair, 1928-30 (prize); San Antonio, 1929 (prize); PAFA Ann., 1929-40 (4 times); Dalzell Hatfield Gal., Los Angeles, 1929 (first solo); LACMA, 1930, 1932 (prize), 1945 (prize); Calif. State Fair, 1930 (prize), 1932 (prize), 1933 (prize), 1938 (prize); Santa Cruz AL, 1931 (prize), 1932 (prize); Oakland Art Gal., 1932; P&S C., 1932 (prize); Corcoran Gal biennials, 1932-49 (6 times); Foundation of Western Art, 1936; AIC, 1938 (prize); WFNY, 1939; GGE, 1939; WMAA, 1939; Pasadena Art Inst., 1950 (solo); MM, 1960; Denver Art Mus.; Faulkner Mem. Gal.; Currier Gal. Art; BMFA; VMFA; CI; CAM; Albright Art Gal.; Kansas City AI; Nebraska AA; Delgado Mus. Art (solo); Brooks Mem. Art Gal.; Springfield Art Mus.; Rochester Mem. Art Gal.; High Mus. Art; Honolulu Acad. Art; Milch Gal.; Univ. Nebraska; Sao Paulo, Brazil. **Work:** MMA; MoMA; AIC; CI; LACMA; Scripps College; The White House, Wash., DC; San Diego Mus.; SFMA; Los Angeles Pub. Lib; BM; CMA; Smithsonian Inst.; SAM; de young Mus.; NMAA; High Mus., Atlanta; Wood Art Gal., Montpellier, VT; Hackley Art Center, Muskegon, MI. Commissions: Libr. tower granite mosaic, Univ. Notre Dame, South Bend, IN; mosaic dome & chapel, Nat Shrine, Wash., DC; mosaic facade, Detroit Pub. Libr.; mural, Rainbow Tower, Hilton Hotel, Honolulu, HI; two large murals, Los Angeles City Hall, East Los Angeles, CA; numerous banks, savings & loans, and murals in California & Texas. **Comments:** He chose as the main subject of his paintings the West coast urban poor. Positions: artist, *Life* magazine, Burma-India front, 1943-44; U.S. State Dept. Specialist Progam to Turkey & Russia, 1960-61; trustee, Scripps College, 1966-70; trustee, Calif. Inst. Arts, 1968-. Teaching: Chouinard Art Inst., 1928-35; prof. art, Scripps College, 1931-, head dept. art, 1932-55; director, Otis Art Inst., 1955-62. **Sources:** WW73; WW47; Falk, *Exh. Record Series.* More recently, see Hughes, *Artists in California,* 509.

SHEETS, Nan Jane (Mrs. Fred C.) *[Art administrator, painter (landscapes), printmaker] b.1889, Albany, IL / d.1976.*
Addresses: Oklahoma City, OK in 1976. **Studied:** Valparaiso Univ.; Univ. Utah; Broadmoor Art Acad.; also with John F. Carlson, Robert Reid, Everett A. Thayer, N. Knopf, K.E. Cherry, L Warner, Birger Sandzen & Hugh H. Breckenridge. **Member:** Oklahoma AA; Oklahoma City AL; MacDonald Club; North Shore AA; NAWPS; SSAL; AFA; Nat. League Am. Pen Women; Oklahoma Hall of Fame. **Exhibited:** Midwestern Artists Traveling Show, AFA, 1923; Broadmoor Art Acad., 1923 (Birger Sandzen Prize for best landscape),1924 (prize); Midwestern Art Exhib., 1924 (purchase prize); Kansas City AI, 1924 (prize); SSAL, 1929 (prize); Artists US, Brooklyn Mus., 1928; Witte Mem. Mus., 1929 (Mrs. Adolph Wagner Prize); Woman's Int. Exhib., Detroit, MI, 1929; WFNY, 1939 & 1940; Coronado Cuarto Centennial Expos, Albuquerque, NM, 1940. **Work:** Kansas City AI; Springfield (IL) Mus. Art; Springfield (MO) AA; Oklahoma AC, Oklahoma City; Univ. Oklahoma AM, Norman; Philbrook AC & Mus., Tulsa, OK; Cowboy Hall of Fame & Western Heritage Center, Oklahoma City; Vanderpoel Collection; Dallas MFA. **Comments:** Preferred media: oils. Positions: art critic, *Daily Oklahoman;* auth., "Nan Sheets By-Line," weekly column in *Sun Oklahoman,* 1934-62; dir., Oklahoma-WPA & supervisor, State of Oklahoma Art Project, 1935-42; dir., Oklahoma Art Center, 1935-65. Collections arranged: many exhibitions, Oklahoma Art Center, 1935-65. **Sources:** WW73; WW47; Leila Macklun, article, *Am. Magazine of Art* (August, 1927); Victor Harlow, article, *Harlows Weekly* March 2, 1931; Marilyn Hoffman, article, *Christian Science Monitor,* Feb. 3, 1948; P&H Samuels, 438; Trenton, ed. *Independent Spirits,* 246, 262-63.

SHEETS, Willie A. *[Painter] 20th c.*
Addresses: Ft. Worth, TX. **Comments:** Affiliated with Texas Women's College, Ft. Worth. **Sources:** WW24.

SHEETZ, Ruth *[Painter] mid 20th c.*
Exhibited: AIC, 1946. **Sources:** Falk, *AIC.*

SHEFFER, Glen C. *[Painter, illustrator] b.1881, Angola, IN / d.1948.*
Addresses: Chicago, IL. **Studied:** Denison Univ.; AIC; Am. Acad. Art, Chicago; H. Larvin, in Vienna; W.D. Goldbeck, in Chicago. **Member:** Palette & Chisel Club, Chicago; Scarab Club, Detroit; Cameo Salon, Chicago. **Exhibited:** Detroit Inst. Art; AIC; Ainslie Gal.; Chicago Gal. Assn.; numerous solo exhibits; Palette and Chisel Club, Chicago, 1946 (medal). **Work:** Senn H.S., Chicago. **Sources:** WW47.

SHEFFERS, Peter Winthrop *[Painter, lecturer, graphic artist, teacher] b.1893, San Antonio, TX / d.1949.*
Addresses: Portland, OR. **Studied:** RA, Berlin, Germany; A. Lecomte, in Paris; A. Jarosy, in London. **Member:** AAPL; Oregon SA; Carmel AA; All-Ill. SFA; AFA. **Exhibited:** All-Illinois SFA; Drake Hotel, Chicago (solo). **Work:** Belle Keith Art Gal., Rockford, IL; Peoria (IL) Public Library. **Sources:** WW47.

SHEFFIELD, Clinton Anson *[Educator, commercial artist] b.1880, Story City, IA.*
Addresses: Story City, IA; Dickinson, ND. **Studied:** Charles A. Cumming; Ed Brewer; A. Idse. **Exhibited:** Iowa Art Salon. **Comments:** Positions: art instructor, Government Schools; art dept. director. **Sources:** WW59; Ness & Orwig, *Iowa Artists of the First Hundred Years,* 189.

SHEFFIELD, Gloria Angela *[Sculptor, painter, craftsperson, teacher, block printer, lecturer] b.1879, Charlotte, MI.*
Addresses: Toledo, OH. **Studied:** Olivet College; AIC; School Universal Crafts; School of TMA; with Lorado Taft, John Vanderpoel, William M. Chase, Daniel C. French, S.L. Wise & C.J. Mulligan. **Exhibited:** TMA, 1936 (prize). **Work:** Toledo Zoological Soc. **Comments:** Lectures: contemporary sculptors. **Sources:** WW53; WW47.

SHEFFIELD, Harold *[Painter] mid 20th c.*
Addresses: Atlanta, GA. **Exhibited:** PAFA Ann., 1932. **Sources:** Falk, *Exh. Record Series.*

SHEFFIELD, Isaac *[Portrait and miniature painter] b.1798, Guilford, CT / d.1845, New London, CT.*
Addresses: Stonington, CT; New London, CT, c.1833-45. **Work:** NGA; Lyman-Allyn Mus., New London, CT; Mus. of Amer. Folk Art, NYC; Shelburne (VT) Mus. **Comments:** During his short careeer, his specialty appears to have been portraits of sea captains and their families. Only 7 of his works have been documented, painted from 1833-40. He lived and worked in the Connecticut towns and cities of Guilford, New Haven, Stonington, and finally, New London. **Sources:** G&W; French, *Art and Artists in Conn.,* 60; Sherman, "Unrecorded Early American Portrait Painters" (Dec. 1933); *Art in America* (April 1936), 81, repro.; Muller, *Paintings and Drawings at the Shelburne Museum,* 126, repro.; *300 Years of American Art,* vol. 1, 120.

SHEFLAN, Lili *[Painter] mid 20th c.*
Exhibited: S. Indp. A., 1940. **Sources:** Marlor, *Soc. Indp. Artists.*

SHEGOGUE, Alfred M. *[Painter] mid 19th c.*
Exhibited: NAD, 1858 (a fruit piece). **Comments:** He was listed at the same address as James H. Shegogue (see entry), probably his father. **Sources:** G&W; Cowdrey, NAD.

SHEGOGUE, James Hamilton *[Portrait, genre, historical, and landscape painter] b.1806, Charleston, SC / d.1872, Warrenville, CT.*
Addresses: NYC, from c.1833-61; Warrenville, CT, from 1862. **Member:** ANA, 1841; NA,1843 (corresponding secretary for a time). **Exhibited:** American Academy (1833); NAD (frequently, 1834-61). **Work:** NYHS; Brooklyn Museum. **Comments:** Began his professional career in NYC about 1833 and, except for several

trips to Europe, he worked in NYC until he moved to Warrenville (CT) in 1862. **Sources:** G&W; French, *Art and Artists in Conn.,* 71; CAB and Fielding [erroneously as James Henry Shegogue]; Cowdrey, AA & AAU; Cowdrey, NAD; NYCD 1834+; 7 Census (1850), N.Y., LII, 323; Thieme-Becker. see also NYHS Catalogue (1974), 65, 1001, 1154.

SHEILDS, Thomas W. See: **SHIELDS, Thomas W.**

SHEKA, Oska *[Painter] mid 20th c.*
Exhibited: S. Indp. A., 1934. **Sources:** Marlor, *Soc. Indp. Artists.*

SHELBY, Lila (Welker) *[Painter] mid 20th c.*
Exhibited: S. Indp. A., 1940-41. **Sources:** Marlor, *Soc. Indp. Artists.*

SHELDAHL, Merrenda Airetta *[Designer, teacher] b.1913, Sheldahl, IA.*
Addresses: Des Moines, IA. **Studied:** Cumming School Art with Charles Atherton Cumming & Alice McKee Cumming; with Marie Wiley Giles. **Exhibited:** Muncipal Art Fair, 1935; Des Moines Women's Club, 1937, 1938; Grace Line Exhibition, Rockefeller Center, 1936. **Comments:** Figure drawing in "Bridgman's Book of 100 Figure Drawings." Position: design instructor, Cumming School Art. **Sources:** Ness & Orwig, *Iowa Artists of the First Hundred Years,* 189.

SHELDEN, C. G. *[Painter] 20th c.*
Addresses: Everitt, WA. **Sources:** WW24.

SHELDEN, M. A. (Miss or Mrs.) *[Artist] late 19th c.*
Exhibited: Columbian Expo, Chicago, 1893 (book covers). **Sources:** Petteys, *Dictionary of Women Artists.*

SHELDEN, Roy See: **SHELDON, Roy**

SHELDON, Charles Mills *[Illustrator] b.1866, Lawrenceburg, IN / d.1928, England.*
Addresses: Des Moines, IA; London, England. **Studied:** W.M. Chase in NYC; Académie Julian with Constant and Lefebvre, 1890-91. **Member:** Chelsea Art Club. **Comments:** Sheldon went to London to illustrate for *Pall Mall* and *Black and White.* He married in London and spent the rest of his life there. He covered world events — including the Spanish Am. War, South African War, and WWI — as an illustrator for British magazines and Assoc. Press. **Sources:** WW13; Ness & Orwig, *Iowa Artists of the First Hundred Years,* 189.

SHELDON, Ella E. *[Painter] late 19th c.*
Addresses: Phila., PA. **Exhibited:** PAFA Ann., 1882, 1884. **Sources:** Falk, *Exh. Record Series.*

SHELDON, George William *[Writer] b.1843, Summerville, SC / d.1914, Summit, NJ.*
Studied: Princeton Univ., 1863. **Comments:** Author: *American Painters; Hours with Arts and Artists; Artistic Homes; Artistic Country Seats; Recent Ideals of American Art; Ideals of Life in France.* Positions: teacher, Union Theological Seminary; art editor, *New York Evening Post;* literary advisor, D. Appleton & Co., London, 1892-1900. **Sources:** WW15.

SHELDON, Joshua *[Landscape painter] mid 19th c.*
Addresses: Newburyport, MA, 1849; Salem, MA, 1857. **Sources:** G&W; Belknap, *Artists and Craftsmen of Essex County,* 13.

SHELDON, Lucy *[Amateur painter] b.1788, Litchfield, CT / d.1889, Litchfield.*
Comments: She married Theron Beach in 1832. As a pupil at Miss Peirce's School in Litchfield about 1802-03, she painted several genre pictures which have been preserved and reproduced. **Sources:** G&W; Vanderpoel, *Chronicles of a Pioneer School,* 43-66.

SHELDON, Marshall H. *[Painter] 20th c.*
Addresses: Pawntucket, RI. **Member:** Providence, WCC. **Sources:** WW25.

SHELDON, Mary A. *[Painter, teacher] b.1859 / d.1912.*
Studied: E. Graffet, in Paris; L.F. Day, in London. **Comments:**

Positions: teacher, Normal College, CUA School, Barnard School. **Sources:** WW13.

SHELDON, Nellie [Painter] early 20th c.
Addresses: Active in Los Angeles, 1903-08; Marshalltown, IA, after 1908. **Studied:** AIC with Millet. **Comments:** Married G. W. Lawrence in 1908 and moved to Iowa. Painted flowers, female heads & scenes of Chinatown in oil and watercolor. **Sources:** Petteys, *Dictionary of Women Artists.*

SHELDON, Olga N. [Patron, collector] b.1897, Lexington, NE.
Addresses: Lexington, NE. **Exhibited:** Awards: Distinguished Nebraskan Award, Nebraska Soc. Wash., DC, 1971. **Comments:** Collection: works of Robert Henri, American art; works on loan or donated to Sheldon Memorial Art Gallery, University of Nebraska, Lincoln; Philip Johnson Building donated by family. **Sources:** WW73.

SHELDON, R. V. A. [Painter] mid 20th c.
Addresses: Paris, France. **Member:** Paris AA. **Exhibited:** Salons of Am., 1925. **Sources:** WW25.

SHELDON, Roy [Sculptor] mid 20th c.
Addresses: NYC. **Exhibited:** AIC, 1924, 1929; PAFA Ann., 1930. **Sources:** Falk, *AIC,* which lists his name as Sheldon, and PAFA, Vol. III, in which his name appears as Shelden.

SHELDON, Rufus [Painter] b.1917.
Addresses: Pittsfield, MA. **Member:** SC, 1897. **Sources:** WW15.

SHELDON, Walter G. [Painter] 20th c.
Addresses: Providence, RI. **Member:** Providence AC. **Sources:** WW25.

SHELESNYAK, Ida [Painter] mid 20th c.
Exhibited: Salons of Am., 1933. **Sources:** Marlor, *Salons of Am.*

SHELL, Irving W. (Mr. & Mrs.) [Collectors] 20th c.
Addresses: Chicago, IL. **Comments:** Collections arranged: works by Emilio Greco, Reg Butler, Julio Le Parc, Yuichi Inoue, Zuebel Kachadoorian, Siqueiros and Morio Hoshi. **Sources:** WW73.

SHELLARD, C. (Mrs.) [Painter] early 20th c.
Exhibited: S. Indp. A., 1917. **Sources:** Marlor, *Soc. Indp. Artists.*

SHELLBASE, George [Painter] mid 20th c.
Exhibited: Salons of Am., 1934. **Sources:** Marlor, *Salons of Am.*

SHELLEY, Fay [Painter] 20th c.
Addresses: Nashville, TN. **Sources:** WW15.

SHELLHASE See: **SHELLBASE, George**

SHELTON, Alphonse Joseph [Painter] b.1905, Liverpool, England.
Addresses: Southport, ME; Wiscasset, ME. **Studied:** BMFA School; L.P. Thompson; P. Hale; L. Stevens. **Member:** Gld. Boston Artists; Grand Central Art Gal. **Exhibited:** Salons of Am., 1934; S. Sanity in Art, 1941 (medal). **Work:** Farnsworth MA, Rockland, ME; Bowdoin College; Sheldon Swope AM, Terre Haute, IN. **Comments:** Position: chmn., Maine Art Commission. **Sources:** WW59; WW47.

SHELTON, Frederick Davis [Painter, illustrator] b.1910, Columbia, CT / d.1943, Atlanta, GA.
Studied: High Mus. Art School; Corcoran Art School; Paris. **Comments:** Position: staff, *Atlanta Journal.*

SHELTON, George F. [Painter] 19th/20th c.
Addresses: NYC, 1877-88. **Member:** AWCS. **Exhibited:** Brooklyn AA, 1875-85; NAD, 1877-88; PAFA Ann., 1882; Boston AC, 1884; AIC. **Sources:** WW25; Falk, *Exh. Record Series.*

SHELTON, Michael [Painter] late 20th c.
Exhibited: Phila. Civic Center Mus.; State Armory, Wilmington, DE, 1971; Lee Cultural Center, Phila. **Sources:** Cederholm, *Afro-American Artists.*

SHELTON, P. (Miss) [Painter] late 19th c.
Addresses: Ohio, 1876. **Exhibited:** NAD, 1876. **Sources:** Naylor, *NAD.*

SHELTON, Paul P. [Artist] early 20th c.
Addresses: Wash., DC, active 1915. **Sources:** McMahan, *Artists of Washington, DC.*

SHELTON, William Henry [Painter, illustrator, writer] b.1840, Allen's Hill, NY / d.1912, Morristown, NY. *W.H.Shelton*
Addresses: NYC, 1882-92. **Studied:** ASL. **Member:** SC. **Exhibited:** Brooklyn AA, 1879-85; Boston AC, 1881, 1887, 1889; PAFA Ann., 1881, 1883; AIC; NYC, 1882-95. **Comments:** Illustrator: *Harpers, Leslies, Century, New York Ledger.* Author: "History of the Salmagundi Club," 1926. Position: curator, Jumel Mansion, NYC (Washington's Hdqtrs.), 1908-16. One of the founders and librarian of the Salmagundi Club, he (with Sandord Saltus) formed its famous collection. During the summers of 1881-82, he painted in East Hampton, Long Island. **Sources:** G&W; *Art Annual X,* obit. WW21, cites incorrect death date of 1932; *East Hampton: The 19th Century Artists' Paradise;* Falk, *Exh. Record Series.*

SHENESHON, Clare [Painter, illustrator, teacher] b.1895, Minneapolis.
Addresses: Minneapolis, MN. **Studied:** G. Luks; B. Robinson. **Sources:** WW25.

SHENFELDER, Mary L. (Mrs. Harry) [Painter, teacher] b.1853, Reading, PA.
Addresses: Reading, PA, c.1886-1912. **Studied:** J. Heyl Raser; School of Art, Phila., with Professor Moran. **Exhibited:** Art expos in Phila. & Reading, PA, c.1900. **Comments:** After her studies, Shenfelder returned to Reading, PA, where she opened a studio and offered art classes. Her specialties were landscapes and still lifes. Her family was known for its pottery. **Sources:** Malmberg, *Artists of Berks County,* 34; Petteys, *Dictionary of Women Artists.*

SHENG, Shao Fang [Painter, instructor] b.1918, Tietsin, China.
Addresses: Williamstown, WV. **Studied:** Painting with Old Master of Peking; Taliesin East & West, archit. with Frank Lloyd Wright; Florida Southern College; Marietta College. **Member:** Int. Platform Assn.; Nat. Soc. Arts & Letters; Ohio Arts & Crafts Guild; West Virginia Artists & Craftsmen Guild; Allied Artists West Virginia. **Exhibited:** Taliensen East & West, 1948-49; Florida Southern College, Lakeland, 1950; AIC, 1950 (solo); AFA Traveling Exhib., 1951; Contemporary Art Gal., Palm Beach, 1968-69. Awards: first prizes, for Yin-Yang, The Creative & Receptive, Appalachian Corridors, 1968, Dream of Rockhound (oil), Chatauqua Art Gal., 1969 & Facet 3D (sculpture), All. A. West Virginia, 1971. **Work:** Norfolk Mus. Arts & Sciences; Zanesville (OH) Art Inst. Commissions: paintings & frescoes, Chinese Govt., 1945; paintings, Frank Lloyd Wright, 1948-49; mural & five paintings, Herbert Randall, 1959; paintings, Noah Ganz, 1968 & Charleston Nat. Bank, 1971. **Comments:** Preferred media: acrylics, watercolors, silver, copper. Positions: res. painter, Acad. Sinic, Manking, China, 1942-44 Teaching: painting instructor, Florida Southern College, 1948-49; instructor of painting & Chinese language, Chatauqua Inst., 1955-; instructor of painting & Chinese language, 1971-72. **Sources:** WW73.

SHENTON, Edward [Illustrator, teacher, writer] b.1895, Pottstown, PA / d.1977. *Edward Shenton*
Addresses: West Chester, PA. **Studied:** PM School IA; PAFA. T. Oakley; H. McCarter; G. Harding. **Exhibited:** PAFA, 1922 (prize); PAFA Ann., 1956. **Comments:** Illustrator: *Scribner's, Collier's, Cosmopolitan, Saturday Evening Post;* "The Yearling," pub. Scribners, 1937, "Northern Lights," pub. Viking, 1939, "Face of a Nation," pub. Scribners, 1939. Position: teacher, PM School IA. **Sources:** WW40; Falk, *Exh. Record Series.*

SHEPARD, Agatha M. *[Painter] early 20th c.*
Addresses: NYC. **Exhibited:** S. Indp. A., 1917. **Sources:** Marlor, *Soc. Indp. Artists.*

SHEPARD, Anna B. *[Painter] mid 20th c.*
Addresses: Woodhaven, LI, NY. **Exhibited:** S. Indp. A., 1927, 1929; Salons of Am., 1934. **Sources:** Falk, *Exhibition Record Series.*

SHEPARD, Augustus D., Jr. *[Mural painter] late 19th c.*
Addresses: NYC. **Member:** Arch. Lg., 1894. **Sources:** WW10.

SHEPARD, C. E. *[Painter] 20th c.*
Addresses: Kansas City, MO. **Sources:** WW17.

SHEPARD, Clare (Shisler) See: **SHISLER, Clare Shepard**

SHEPARD, Daniel M. *[Portrait and fresco painter] mid 19th c.*
Addresses: Salem, MA, 1850. **Sources:** G&W; Belknap, *Artists and Craftsmen of Essex County,* 13.

SHEPARD, Effie *[Painter] 20th c.*
Addresses: New Orleans, LA. **Sources:** WW15.

SHEPARD, Elsie *[Painter] 20th c.*
Addresses: NYC. **Sources:** WW24.

SHEPARD, Erin E.(Effie) *[Craftsperson, teacher] d.1917, New Orleans, LA.*
Addresses: New Orleans, active 1900-14. **Studied:** Newcomb Col., 1900-09. **Member:** NOAA, 1905. **Exhibited:** NOAA, 1910-11; 1914; Newcomb Art Alumn. Christmas Show, 1910, 1913. **Award:** Mary L. S. Neill medal for watercolor, 1905. **Comments:** Teaching: professor, Tulane Univ., 1912; teacher, Newcomb College, 1914. **Sources:** *Encyclopaedia of New Orleans Artists,* 351.

SHEPARD, Gilbert C. *[Painter] b.1884, NYC.*
Addresses: Ozone Park 16, NY. **Studied:** NAD. **Member:** Art Lg. of Long Island (pres., 1958); St. Luke's Art Gld. **Exhibited:** Queens Art Festival, 1950-57; Art Lg. of Long Island, 1948-58 (prizes: 1948, 1952, 1955-1957); Washington Square, NY, 1949-52; Flushing, LI, 1949-51; St. Luke's Art Gld., 1953-58 (prizes: 1952, 1956, 1957, 1958); NY State Fair, 1940 (prize), 1942 (prize), 1946, 1956 (prize); NYC Golden Jubilee, 1948; group shows, 1953, 1955. **Work:** Art Lg. of Long Island. **Sources:** WW59.

SHEPARD, Isabel Benson *[Painter, printmaker, craftsperson] b.1908, Spokane, WA.*
Addresses: Riverside, CA/Seattle, WA. **Studied:** Univ. Wash.; Art Center, Riverside, CA. **Member:** Riverside AG. **Exhibited:** Northwest PM, SAM, 1937-38; Riverside AG, 1939; GGE, 1939; SAM, 1939. **Sources:** WW40.

SHEPARD, Jane Reynolds *[Painter] b.1912, E. Orange, NJ.*
Addresses: Saratoga Springs, NY. **Exhibited:** S. Indp. A., 1933. **Sources:** Marlor, *Soc. Indp. Artists.*

SHEPARD, Mary N. *[Painter] 20th c.*
Addresses: NYC. **Sources:** WW15.

SHEPARD, Ralph *[Painter] 20th c.*
Addresses: Hartford, CT. **Sources:** WW13.

SHEPARDSON, Ira A. *[Painter] late 19th c.*
Addresses: NYC, 1873. **Exhibited:** NAD, 1873. **Sources:** Naylor, *NAD.*

SHEPHARD, Clarence *[Painter, architect] b.1869, Cortland, NY.*
Addresses: Kansas City, MO/Fryeburg, Maine/Bemis Point, NY. **Studied:** Keith; Griffin. **Member:** Kansas City SA; Mid-Western Artists; AIA; Arch. Lg. **Sources:** WW33.

SHEPHARD, Elizabeth Hammond *[Painter] 20th c.*
Addresses: Milwaukee, WI. **Sources:** WW24.

SHEPHARD, Minnie *[Painter] early 20th c.*
Addresses: San Francisco, CA. **Sources:** WW19; AA, 1918.

SHEPHEART, Frederick *[Listed as artist] b.c.1813, Germany.*
Addresses: Philadelphia, 1850. **Comments:** He and his wife and their children (ages 9 to 3) were all born in Germany. **Sources:** G&W; 7 Census (1850), Pa., LI, 47.

SHEPHERD, Charles *[Painter] b.1844, Yorkshire, England / d.1924.*
Addresses: Brooklyn, NY. **Comments:** Came to Brooklyn, NY, in 1869.

SHEPHERD, Chester George *[Painter, illustrator] b.1894, Lathrop, MI.*
Addresses: Chicago, IL. **Studied:** AIC. **Member:** Palette & Chisel Club; Assn. Art & Indust. **Sources:** WW29.

SHEPHERD, Clinton J. See: **SHEPHERD, J. Clinton**

SHEPHERD, Dorothy G. (Mrs. Ernst Payer) *[Museum curator] b.1916, Wellend, Ontario.*
Addresses: Cleveland, OH. **Studied:** Univ. Michigan (A.B. & M.A.); Inst. Fine Arts, NY Univ. **Member:** College Art Assn. Am.; Archaeology Soc. Am.; Am. Res. Center in Egypt; Centre Int. Études Textiles Anciens, Middle East Inst.; Am. Soc. Aesthetics. **Comments:** Positions: monuments off., Monuments & Fine Arts Section, SHAEF, Berlin, 1945-47; curator, Textiles & Near Eastern Art, Cleveland MA, 1954-. Publications: contributor to "Arts Orientalis" & *Cleveland Mus. Art Bulletin.* Teaching: lecturer, Islamic art & architecture, art & architecture of Spain, Islamic & medieval textiles & art of the ancient Near East; adjunct professor history of art, Case-Western Reserve Univ., 1973. **Sources:** WW73.

SHEPHERD, Fitch *[Engraver] b.c.1805, NYC.*
Addresses: NYC, 1850. **Sources:** G&W; 7 Census (1850), N.Y., LII, 406.

SHEPHERD, G. S. *[Listed as "artist"] mid 19th c.*
Exhibited: NAD, 1847. **Comments:** Exhibited "View at Hempstead" [Long Island?]. *Cf.* N.G. Shepherd. **Sources:** G&W; Cowdrey, NAD.

SHEPHERD, George *[Painter] 20th c.*
Addresses: Chicago. **Member:** GFLA. **Comments:** Affiliated with Burleigh Withers Co., Chicago. **Sources:** WW27.

SHEPHERD, George B. *[Painter] b.1891 / d.1939.*
Addresses: NYC. **Exhibited:** S. Indp. A., 1917; WMAA, 1923. **Sources:** WW17.

SHEPHERD, George M. *[Engraver on copper and steel] b.c.1823, England.*
Addresses: NYC by 1846-54; Philadelphia, 1854-57; NYC, 1857 until after 1860. **Sources:** G&W; 7 Census (1850), N.Y., XLIII, 398; NYCD 1846-53, 1857-60+; Phila. CD 1854-57.

SHEPHERD, Harris B. *[Painter] mid 20th c.*
Addresses: Cazenovia, NY. **Exhibited:** S. Indp. A., 1924; Salons of Am., 1925. **Sources:** Falk, *Exhibition Record Series.*

SHEPHERD, J. Clinton *[Sculptor, painter, lecturer, teacher, illustrator] b.1888, Des Moines, IA / d.1975.*

J. CLINTON SHEPHERD

Addresses: NYC/Westport , CT, 1920s; Palm Beach, FL, 1962. **Studied:** Univ. Missouri; Kansas City School FA; AIC; BAID; & with Walter Ufer, Harvey Dunn. **Member:** Palm Beach Art League; Soc. Four Artists; NSS; WWI Pilots Assn. **Exhibited:** NSS, 1923; PAFA Ann., 1923-24, 1929-30; Salons of Am., 1929; NAD; Norton Gal.; Silvermine Guild Artists. **Awards:** prize, Miami Art League, 1940; Palm Beach Art League, 1941. **Work:** John Herron AI; WWI memorial, Westport, CT. **Comments:** Specialty: traditional Western life and animals. Positions: dir., Norton School Art, Palm Beach, FL, 1941-46; art dean, Barry Col., Miami. During the 1920s, he was a successful magazine illustrator in NYC. Lectures: history of art; art appreciation.

Sources: WW59; WW47; P&H Samuels, 439; Ness & Orwig, *Iowa Artists of the First Hundred Years,* 189; *Community of Artists,* 76; Falk, *Exh. Record Series.*

SHEPHERD, J. F. *[Painter] mid 20th c.*
Addresses: Los Angeles, CA. **Exhibited:** Artists Fiesta, Los Angeles, 1931. **Sources:** Hughes, *Artists in California,* 510.

SHEPHERD, Mary E. (Miss) *[Portrait painter] 19th/20th c.*
Addresses: Pierce County, WA; Seattle, WA. **Exhibited:** Alaska Yukon Pacific Expo, 1909; Tacoma Art League, 1914. **Sources:** Trip and Cook, *Washington State Art and Artists.*

SHEPHERD, N. G. *[Landscape painter] mid 19th c.*
Addresses: NYC, 1856. **Exhibited:** NAD, 1856. **Comments:** *Cf.* G.S. Shepherd. **Sources:** G&W; Cowdrey, NAD.

SHEPHERD, Nellie *[Painter] b.1877, Kansas / d.1920.*
Addresses: Oklahoma. **Studied:** Cincinnati Art Acad.; Paris with Henry Martin. **Exhibited:** Paris Salon, 1910. **Comments:** Impressionist painter who spent time in the Southwest painting the Pima poeple before returning to teach at Univ. Oklahoma. **Sources:** Trenton, ed. *Independent Spirits,* 244-46.

SHEPHERD, Nina *[Painter, etcher, teacher] mid 20th c.; b.Des Moines, IA.*
Addresses: Springfield, MO. **Studied:** ASL; Am. Acad. Art, Chicago; Colorado Springs FA Center; Hayley Lever, Robert Weissman, Carl Hockner, Oskar Gross, Adrian Dornbush. **Member:** SSAL; Ozarks AA. **Exhibited:** Midwestern Exhibit, Kansas City; Southern States Art League; Springfield Art Mus.; St. Louis AL, Thumb-box Show, 1930-32 (prizes); Boston, 1938 (prize); Ozarks Empire Dist. Fair, 1939 (prize). **Work:** Old Court House, St. Louis. **Comments:** Position: head, art dept., Board Educ., Springfield, MO. **Sources:** WW40; Ness & Orwig, *Iowa Artists of the First Hundred Years,* 189-90.

SHEPHERD, Thomas S. *[Miniaturist, portrait painter and draftsman] mid 19th c.*
Addresses: NYC, active in the 1840's. **Exhibited:** Am. Inst., 1847 (specimen of print coloring). **Sources:** G&W; NYCD 1843-47; Am. Inst. Cat., 1847; Bolton, *Miniature Painters.*

SHEPLER, Dwight (Clark) *[Painter, writer, teacher, illustrator, graphic artist] b.1905, Everett, MA.*
Addresses: Chestnut Hill, MA; Weston, MA. **Studied:** BMFA Sch., 1928-29; Williams College (B.A., 1928); also with Leslie P. Thompson, Philip Hale & Harry Sutton, Jr. **Member:** St. Botolph Club (vice-pres., 1964-); Boston WCS (chmn. exhibs.); Guild Boston Artists (pres., 1969-); Am. Artists Group; AAPL; Weston AA; Concord AA. **Exhibited:** PAFA, 1936 (watercolor ann.); AIC, 1940; CGA, 1943; CI, 1944; BMFA, 1943, 1951-68; Minneapolis IA, 1943; NGA, 1943-45; Salon de la Marine, Paris, 1945; MMA, 1945; Montclair AM, 1941 (solo); Philbrook AC, 1942; Boston (solo); NYC (solo); Chicago (solo); American Watercolors, NAD, 1943 & 1945; Boston WCS; Navy Paintings Invitational, Nat. Gal. Art, Wash., DC, 1956; Guild Boston Artists, 1970 (solo). **Work:** BMFA; Williams Col.; Borough Mus., Dartmouth, England; portraits, Harvard Univ. Grad. Schools & Library; U.S. Navy Collection. **Commissions:** habitat group, Boston Mus. Science; mural decorations, Schußverein Ski Club, Glen, NH, 1939-40; mural decorations, U.S. Naval Acad., Annapolis, MD, 1945-47; mural decorations, Williams College, 1946-52, Hubbard Mem. (sculpture), Arctic Inst. North Am., Ellesmore Island, Arctic, 1952. **Comments:** Preferred media: watercolors, oils. Positions: official U.S. Navy combat artist, 1942-46. Publications: illustrations & articles, *Boston Sunday Herald;* covers, *Sportsman, Time,* 1936; contributor of illustrations, "Many a Watchful Night" (1944),"The Navy at War" (1943); contributor, "History of US Naval Operations in World War II," 1948; contributor, "Life's Picture History of World War II," 1948; contributor, "Am. Heritage," to 1970; author, "Dwight Shepler: An Artist's Horizons," Barre Publ. **Sources:** WW73; WW47.

SHEPLEY, Annie Barrows *[Painter] 19th/20th c.*
Addresses: NYC, 1888-93, 1895-99; Winchester, MA, 1894; Worcester, MA, c.1899-1907. **Studied:** H.S. Mowbray, in NYC; Académie Julian, Paris with Lefebvre and Constant; also with L. Simon in Paris. **Member:** NYWCC; NAC. **Exhibited:** Boston AC, 1888-98; NAD, 1888-99; PAFA Ann., 1893-1901; AIC, 1894-1900; NYWCC; PAFA; Phila. Art Club; Trans-Mississippi Expo, Omaha; NYC Gals., 1905 (solos). **Comments:** Painted portraits, figures in landscapes. **Sources:** WW08; Petteys, *Dictionary of Women Artists;* Falk, *Exh. Record Series.*

SHEPPARD, Carl Dunkle *[Art historian] b.1916, Wash., DC.*
Addresses: Minneapolis, MN. **Studied:** Amherst College (B.A.); Harvard Univ. (M.A., 1942; Ph.D., 1947). **Member:** College Art Assn. Am. (mem. bd. dirs., 1970-); Soc. Archit. Historians; Int. Center Medieval Art (advisory bd.); Medieval Acad.; Int. Congress Art Historians. **Exhibited:** Awards: Del Amo Found grant, Spain, 1957; Fulbright lectureship, Istanbul, 1962-63; McMillan travel grant, Italy, 1968. **Comments:** Teaching: instructor, Univ. Michigan, Ann Arbor, 1946-49; from asst. professor to professor, UCLA, 1950-64; professor art history & chmn. dept., Univ. Minnesota, Minneapolis, 1964-. Publications: author, introduction & chapters 7, 8 & 11, "Looking at Modern Painting," Norton, 1962; author, "Subtleties of Lombard Marble Sculpture of the VII th and VIII th centuries," *Gazette Beaux Arts,* 1964; author, "Carbon 14 Dating and Santa Sophia," *Dumbarton Oaks Papers* (Istanbul, 1965); author, "Byzantine Carved Marble Slabs," *Art Bulletin* March, 1969); author, "The Bronze Doors of Augsburg Cathedral," *Festschrift* (1972). **Sources:** WW73.

SHEPPARD, Edward or Edwin W. *[Painter of birds] mid 19th c.*
Addresses: Philadelphia, active 1858-59; Washington, active 1860. **Exhibited:** Washington AA, 1859. **Sources:** G&W; Rutledge, PA; Washington Art Association Cat., 1859.

SHEPPARD, Ella W. See: **GALLAGHER, Ella Sheppard (Mrs. William)**

SHEPPARD, Frances (Fannie) M. *[Painter] late 19th c.*
Addresses: Phila., PA. **Exhibited:** PAFA Ann., 1883, 1885. **Sources:** Falk, *Exh. Record Series.*

SHEPPARD, George W. *[Portrait painter, commercial artist] b.1914, Los Angeles, CA / d.1986, Ross, CA.*
Addresses: Ross, CA. **Studied:** AIC; Art Center School, Los Angeles. **Exhibited:** Pasadena Art Inst., 1928. **Work:** Bohemian Club; Medical Center & Hoover Inst., Stanford Univ.; Marshall Hale Hospital; Golden Gate Univ.; UC Santa Cruz. **Sources:** Hughes, *Artists in California,* 510.

SHEPPARD, J. Warren *[Painter, illustrator] b.1882, Brooklyn, NY.*
Addresses: Brooklyn, NY/Lincoln Park, NJ. **Studied:** his father Warren. **Comments:** Illustrator: *Brooklyn Eagle, New York Herald Tribune, New York Sun,D. Appleton, Century, Scribner's.* **Sources:** WW40.

SHEPPARD, John Craig *[Painter, educator] b.1913, Lawton, OK / d.1978.*
Addresses: Reno, NV. **Studied:** Univ. Oklahoma (B.F.A. [painting], 1937; B.F.A. [sculpture], 1938); also in Norway, France & Mexico. **Member:** Am. Assn. Univ. Prof.; Pacific AA (regional rep., 1950-); Western Assn. Mus. Dirs. (regional dir., 1948-65); Nevada State Arts Council (chmn., 1962); Nevada Art Gallery (board dirs., 1950-62). **Exhibited:** Mus. Art, Bergen, Norway, 1956; De Young Mus. Art, San Francisco, 1958; Salon Art Libre & Mus. Beaux Arts, Paris, 1962; Brooklyn Mus., 1963; Watercolor USA, Springfield Art Mus., 1968. Awards: bronze medal, Denver Art Mus., 1941; silver medal, Kansas City Midwest Ann., 1944; purchase prize, Mus. Art Mod., Paris, 1962. **Work:** Mus. Art Mod., Paris; Brooklyn Mus., NY; El Paso Mus. Art; Gilcrease Mus. Art, Tulsa, OK; Mus. Great Plains, Lawton. **Commissions:** murals, Bus. Admin. Bldg., Univ. Oklahoma, Norman, 1941, Student Union Bldg., Montana State Univ.,

Bozeman, 1942, Will Rogers Theater, Tulsa, 1946; Arthur Orvis Portrait, Univ. Nevada, Reno, 1968. **Comments:** Preferred media: watercolors, oils. Positions: dir. of product illustration, Douglas Aircraft Co., Tulsa, 1942-46. Publications: illustrator, "Horses of the Conquest" (1949) & "Life and Death of an Oilman" (1951), Univ. Oklahoma Press; co-author/illustrator, "Landmarks on the Emigrant Trail," University of Nevada Press, 1971. Teaching: instructor of sculpture & painting, Montana State Univ., 1940-42; chmn. dept. art, Univ. Nevada, Reno, 1947-71; guest lecturer Indian art, Univ. Oslo, 1955-56. **Sources:** WW73; Green Peyton, *America's Heartland: The Southwest* (Univ. Oklahoma Press, 1948); Per Rom, *Kunsten Idag* (W. Nygaard, Oslo, 1959); Robert Laxalt, "Nevada" (Coward, 1970).

SHEPPARD, Joseph Sherly *[Painter, sculptor]* b.1930, Owings Mills, MD.
Addresses: Baltimore, MD. **Studied:** Maryland Inst. Art, certificate fine art; also with Jacques Maroger. **Member:** All. A. Am. **Exhibited:** Allied Artists Nat., 1956 & 1959; Realists, Laguna Beach, 1964; Regional, Butler Ins. Am. Art Nat., 1967, 1972 (solo); BMA Art Regional, 1971; Westmoreland Co. Mus, Greenburg, PA, 1972; Grand Central Galleries, NYC & IFA Gal., Wash., DC, 1970s. Awards: Emily Lowe Prize, Allied Artists, 1956; Guggenheim Foundation fellowship, 1957-58; purchase prize, Butler IA, 1967. **Work:** BMA; Butler IA; Davenport (IA) Munic. Art Gal.; Univ. Arizona Mus.; Norfolk (VA) Mus. Arts & Science. Commissions: portrait of Pres. Hawkins, Towson State College, MD, 1967; Discovery of Scurvy, Public Health Hospital, Baltimore, 1968; Battle of Ft. McHenry, Equitable Trust Co., Baltimore, 1969; Christ Crowned With Thorns, Lutheran High School, Baltimore (MD) Co., 1970; seven historical murals, Baltimore Police Dept., 1970-71. **Comments:** Preferred media: oils. Teaching: instructor of oil painting, Dickinson College, 1955-57 & Maryland Inst. Art, 1963-. **Sources:** WW73.

SHEPPARD, Margaret Elizabeth *[Painter]* b.1915, Boston, MA.
Addresses: Laguna Beach, CA. **Studied:** Massachusetts; with Eliot O'Hara. **Member:** Los Angeles AA; Laguna Beach AA; Calif. WC Soc.; AWCS. **Comments:** Position: teacher, Eliot O'Hara art school, 3 years; teacher, watercolor workshops in Southern Calif. Preferred medium: watercolor, oil, acrylic. **Sources:** Hughes, *Artists in California*, 510.

SHEPPARD, Mary *[Painter, teacher]* b.1889.
Addresses: Buckshutem, NJ. **Studied:** State Normal School, Trenton, NJ; Columbia Univ. **Exhibited:** 25 solos in Delaware, New Jersey & New York. **Comments:** An art teacher in Atlantic City and Delaware; and co-founder of Kinaloha Co-op, an art school at Cragsmoor, NY, in 1944. Sheppard traveled extensively. **Sources:** Petteys, *Dictionary of Women Artists*.

SHEPPARD, Richard H. *[Portrait miniature, sign, and ornamental painter]* mid 19th c.
Addresses: Baltimore, active 1840s-50s. **Work:** Maryland Hist. Soc. **Sources:** G&W; Lafferty; Pleasants, *250 Years of Painting in Md.*, 55; Brewington, 352.

SHEPPARD, Warren *[Painter,* WARREN SHEPPARD *illustrator, writer]* b.1858, Greenwich, NJ / d.1937, Greenwich.
Addresses: NYC, 1880-81; Bay Ridge Park, LI, 1894; Lincoln Park, NJ; Brooklyn, NY; Isle of Shoals, NH. **Studied:** CUA School; briefly with Hertzberg and M.F.H. de Haas; apparently studied in Paris and Venice, 1888-93. **Exhibited:** Brooklyn AA, 1874-81; NAD, 1880-99; PAFA Ann., 1884; St. Louis Expo, 1904; Denver Expo, 1884 (gold). **Work:** Albright Art Gal.; TMA; Springfield (MA) Public Library; AGAA; India House, NYC; Mystic Seaport Mus.; Peabody Mus., Salem, MA. **Comments:** As a marine painter, he was accutely aware of details because he was also designer and navigator of racing yachts. He sailed widely along the New England coast, painting scenes from New Jersey to Maine. He won the famous New York-to-Bermuda race, and published the authoritative *Practical Navigation*. He was also known

for his paintings of canal scenes in Venice. **Sources:** WW33; Brewington, 352; *300 Years of American Art,* vol. 1, 507; Falk, *Exh. Record Series*.

SHEPPARD, William H. C. *[Painter, illustrator, writer, lithographer]* b.1871, Philadelphia, PA.
Addresses: Philadelphia, PA. **Studied:** PAFA (Cresson traveling scholarship, 1895); Spring Garde Inst.; Académie Julian, Paris with Bouguereau, 1895; École des Beaux-Arts with Gérome. **Member:** AAPL. **Exhibited:** PAFA Ann., 1890-92, 1896-1902, 1930-34; Paris Salon, 1899; Salons of Am., 1934; AAPL, 1939-40; Currier Gal. Art; Cape May, NJ, 1946-51 (prize, 1950); Terry AI, 1951. **Comments:** Author/illustrator: "Rambler Club Series" (15 books). Author: "Don Hale" stories (4 books). **Sources:** WW53; WW47; Fink, *American Art at the Nineteenth-Century Paris Salons*, 390; Falk, *Exh. Record Series*.

SHEPPARD, William Ludlow See: **SHEPPARD, William Ludwell**

SHEPPARD, William Ludwell *[Watercolorist, illustrator, and sculptor, teacher, painter]* b.1833, Richmond, VA / d.1912, Richmond.

W. L. Sheppard '86

Addresses: Richmond, VA, 1868. **Studied:** NYC and Paris, before 1860; Paul Soyer, in London and Paris, 1877-78. **Member:** Richmond AC (founding mem.). **Exhibited:** NAD, 1868; Richmond AC, 1896, 1897. **Work:** Soldiers' and Sailors' Monument, statue of Gen. A.P. Hill, Howitzer Mem. Hall, watercolors of Civil War, Confederate Museum; Virginia Hist. Soc., all in Richmond. **Comments:** First gained attention through tobacco labels he had designed. Enlisted as an officer in the Richmond Howitzers and made sketches of military life. His drawings of Southern genre and Virginia landscapes appeared in *Harper's, Leslie's* and others, 1867-90. He redrew illustrations originally done by J. Wells Champney in 1873, and while in London also copied a series of portraits of Englishmen involved in Virginia history. Illustrator, "Dombey and Son," by Dickens, 1873, "Picturesque America," 1872. **Sources:** G&W; *Art Annual,* X, obit.; Barker, *American Painting,* 553; Hamilton, *Early American Book Illustrators and Wood Engravers,* 455-57; P&H Samuels, 439; Wright, *Artists in Virgina Before 1900.* G&W gives middle name as Ludlow.

SHEPPERD, Harris B. See: **SHEPHERD, Harris B.**

SHERA, R. E. (Miss) *[Painter, teacher]* 19th/20th c.
Addresses: Tacoma, WA. **Member:** Tacoma Art League, 1892. **Exhibited:** Western Wash. Industrial Expo, 1891; Tacoma Pub. Lib., 1891. **Sources:** Trip and Cook, *Washington State Art and Artists*.

SHERBELL, Rhoda *[Sculptor, collector]* mid 20th c.; b.Brooklyn, NY.
Addresses: Brooklyn, Westbury, NY. **Studied:** ASL, with William Zorach; Brooklyn Mus. Art School, with Hugo Robies; also study in Italy & France. **Member:** All. A. Am.; Audubon Artists; New York Soc. Women Artists; Catharine Lorillard Wolfe AC. **Exhibited:** PAFA Ann., 1960, 1964 (prize), 1966; Detroit IA, 1960; Am. Acad. Arts & Letters, 1960; Brooklyn Mus. Art Award Winners, 1965; NAD & Heckscher Mus. Show, 1967; Retrospective Sculpture & Drawing Show, Huntington Hartford Gal., New York, 1970; Frank Rehn, Inc., NYC, 1970s. Awards: Am. Acad. Arts & Letters & NIAL grant, 1960; Ford Foundation Purchase Award, 1965; Tiffany Foundation grant, 1966. **Work:** The Dancers, Oklahoma Mus. Art, Oklahoma City; The Flying Acrobats, Colby College Art Mus., Waterville, ME. Commissions: Marguerite & William Zorach Bronze, Nat. Arts Collection, Smithsonian Inst., 1964; Casey Stengel, Country Art Gallery Long Island, Baseball Hall of Fame, Cooperstown, NY; Yogi Berra, commissioned by Percy Uris. **Comments:** Preferred media: bronze. Collection: contemporary American realistic work, including M. Soyer, W. Zorach, Marguerite Zorach, Mervin Honig, Harry Sternberg, John Koch Agostine H. Jackson. **Sources:** WW73; *The Artist and the Sportsman* (Nat. Art Mus. Sport,

1968); Alfredo Valente, *Rhoda Sherbell Sculpture* (New York Cultural Center & Fairleigh Dickinson, 1970); Falk, *Exh. Record Series.*

SHERER, John *[Lithographer and publisher]* mid 19th c.
Addresses: Cincinnati, 1847-59. **Comments:** In 1847 he was of Sherer & Rowse(see entry); in1859 he was listed as a Masonic publisher. **Sources:** G&W; Peters, *America on Stone;* Cincinnati BD 1850, CD 1851, 1856-59.

SHERER, Mary Richards *[Painter]* b.1884, Minnesota / d.1970, Newport Beach, CA.
Addresses: Laguna Beach/Desert Hot Springs, CA. **Studied:** Univ. of Minnesota; Chicago Academy of FA; with G. Brandriff, Ruth Peabody, F. Taubes. **Member:** Laguna Beach AA. **Exhibited:** Laguna Beach Festival of Arts; Desert Hot Springs. **Sources:** Hughes, *Artists in California,* 510.

SHERER, Renslow Parker *[Painter, sculptor]* b.1888, Chicago, IL.
Addresses: Chicago; Highland Park, IL. **Studied:** Univ. Chicago; R. Ingerle; G.H. Brandriff. **Exhibited:** AIC, 1937, 1939, 1940, 1944; Milwaukee AI. **Sources:** WW53; WW47.

SHERER & ROWSE *[Lithographers]* mid 19th c.
Addresses: Cincinnati, 1847. **Comments:** John Sherer and J.B. Rowse (see entries). **Sources:** G&W; Peters, *America on Stone.*

SHERIDAN, Blanche *[Artist]* early 20th c.
Addresses: Wash., DC, active 1918. **Sources:** McMahan, *Artists of Washington, DC.*

SHERIDAN, Clare *[Sculptor]* 20th c.
Addresses: NYC. **Sources:** WW25.

SHERIDAN, Frank J., Jr. *[Illustrator, writer]* 20th c.; b.Dubuque, IA.
Addresses: NYC/Sands Point, NY. **Member:** SI; Philadelphia Sketch Club; MMA. **Sources:** WW40; Ness & Orwig, *Iowa Artists of the First Hundred Years,* 190.

SHERIDAN, John E. *[Illustrator, painter]* *Sheridan*
b.1880, Tomah, WI / d.1948.
Addresses: NYC. **Studied:** Georgetown Univ., 1895-1900. **Member:** SI, 1912. **Comments:** During his study at Georgetown Univ., he produced several lithographic announcements of the university's athletic events, which were later reproduced as posters. He then moved to NYC, illustrating for national magazines, including *Saturday Evening Post* and *Collier's.* **Sources:** WW53; WW47; McMahan, *Artists of Washington, DC.*

SHERIDAN, Joseph Marsh *[Painter, etcher, illustrator, sculptor, lithographer, mural painter]* b.1897, Quincy, IL / d.1971, Fresno, CA.
Addresses: New Wilmington, PA. **Studied:** Beloit College (B.A.); ASL; AIC; Univ. California (M.A.); Norton; Hofmann; Archipenko; E.D. Kinzinger. **Member:** San Fran. AA; San Diego Art Gld.; Artists Congress; Art Center, San Fran. **Exhibited:** Minneapolis IA, 1929 (prize), 1930, 1931 (prize); European & Am. Abstractionists Exh., 1933; Oakland Art Gal., 1932-45; SFMA, 1932-45; AIC, 1931, 1933; many solos in U.S. **Work:** SFMA; Berkeley (CA) Pub. Lib.; Oakland Pub. Lib.; Univ. California; Beloit College; Univ. Minnesota; A.F. of L. Bldg., San Francisco; Univ. Arizona; Mills College; Westminster College, PA; Oakland (CA) H.S.; Piedmont (CA) H.S. **Illustr.:** *Expressionism in Art,* 1934. **Teaching:** Univ. Minnesota, 1928-30; Univ. Arizona, 1944-45; Westminster College, New Wilmington, PA, 1945-46. WPA printmaker in California, 1930s. **Sources:** WW59; WW47; exh. cat., Annex Gal. (Santa Rosa, CA, n.d., c.1988).

SHERIDAN, Marion B. *[Artist]* late 19th c.
Addresses: Wash., DC, active 1884. **Comments:** She had a studio in the Corcoran Building in 1884. **Sources:** McMahan, *Artists of Washington, DC.*

SHERIDAN, Mark *[Designer, painter]* b.1884, Atlanta, GA.
Addresses: Ridgeland, SC. **Studied:** Georgia Sch. Tech.; PM Sch

IA; PAFA. **Member:** NAC; Georgia AA; Savannah AC. **Exhibited:** NAC, 1940, 1945; Georgia AA; Savannah AC; mural, Atlanta (GA) Theatre.; DeSoto Beach Club, Savannah. **Work:** Telfair Acad. Arts & Sciences, Savannah, GA. **Sources:** WW59; WW47.

SHERIDAN, Max *[Illustrator]* 20th c.
Addresses: NYC. **Member:** SI. **Sources:** WW47.

SHERIFF, Daisy *[Painter]* 20th c.
Addresses: Pittsburgh, PA. **Member:** Pittsburgh AA. **Sources:** WW25.

SHERINYAN, Elizabeth *[Craftsperson, painter, sculptor, lecturer, teacher, writer]* b.1877, Harpoot, Armenia / d.1947.
Addresses: Worcester, MA. **Studied:** R. Martin; Marot; Hale; H.D. Murphy; Major; Greenwood; Cornoyer; WMA Sch.; Mass. Normal Art Sch.; Europe; Asia; Africa. **Member:** CAFA. **Work:** Monastery of S. Lazzari, Venice, Italy. **Comments:** Position: teacher, Public School, Worcester, MA. **Sources:** WW40.

SHERKER, Leon *[Painter]* mid 20th c.
Addresses: NYC. **Exhibited:** S. Indp. A., 1928, 1934-35. **Sources:** Marlor, *Soc. Indp. Artists.*

SHERLOCK *[Listed as" artist"]* early 19th c.
Addresses: New Orleans, 1823. **Sources:** G&W; Delgado-WPA cites CD 1823.

SHERLOCK, M. *[Painter]* mid 20th c.
Exhibited: Salons of Am., 1934. **Sources:** Marlor, *Salons of Am.*

SHERMAN, Albert *[Printmaker]* mid 20th c.
Exhibited: AIC, 1949. **Sources:** Falk, *AIC.*

SHERMAN, Alfred *[Painter]* mid 20th c.
Studied: ASL. **Exhibited:** S. Indp. A., 1941. **Sources:** Marlor, *Soc. Indp. Artists.*

SHERMAN, Beatrix *[Painter]* early 20th c.
Addresses: Chicago, IL. **Exhibited:** AIC, 1914. **Sources:** WW15.

SHERMAN, C. H. *[Painter]* 20th c.
Addresses: NYC. **Member:** SC. **Sources:** WW25.

SHERMAN, Charlotte See: **SHERMAN, Z. Charlotte**

SHERMAN, Clifford C. *[Cartoonist]* b.1878 / d.1920, Springfield, IL.

SHERMAN, Dorothy Frances *[Painter]* b.1914, Des Moines, IA / d.1938.
Studied: Pupil of Jean Dayton West & Bernice Setzer. **Member:** Iowa Artists Club, 1934. **Exhibited:** Iowa City (award); Younker Tea Room (solo); Des Moines Library. **Sources:** Ness & Orwig, *Iowa Artists of the First Hundred Years,* 190.

SHERMAN, Edith Freeman (Mrs.) *[Sculptor, writer, craftsperson, teacher]* b.1876, Chicago.
Addresses: Brookfield, Chicago, IL. **Studied:** L. Taft, at AIC. **Exhibited:** AIC, 1901, 1903, 1907-08; PAFA, 1902. **Comments:** Also appears as Edith Emogene Freeman. **Sources:** WW15; Falk, *Exh. Record Series.*

SHERMAN, Edwin Allen *[Amateur artist]* b.1829, North Bridgewater, MA / d.1914, Oakland, CA.
Addresses: Sonoma, CA, c.1850-54; Massachusetts, 1854; Calif., 1854-1914. **Comments:** Enlisting in the U.S. Army in 1845, he served in Mexico during the Mexican War and then joined the Gold Rush to California, arriving in May 1849. Soon after he made a sketch of Sutter's Fort. After a year in the gold fields, he settled down in Sonoma and in 1852 became city clerk. A retrospective drawing of the raising of the American flag in Sonoma in 1846 dates from this period. **Sources:** G&W; Van Nostrand and Coulter, *California Pictorial,* 60-61.

SHERMAN, Effim H. *[Painter, graphic artist, teacher, illustrator, lithographer]* b.1889, Romania / d.1964, NYC?.
Addresses: NYC. **Studied:** CUA School; NAD, and with Emil Carlsen, Douglas Volk, G. deForest Brush. **Member:** SAGA;

Wash. WCC; CAFA. **Exhibited:** Salons of Am.; S. Indp. A., 1927-28; Nat. Exh. Am. Artists, NYC, 1936, 1938; NAD, 1938-46; PAFA, 1937-38, 1950; AIC, 1938-39; LACMA, 1938; WFNY, 1939; SFMA, 1942, 1944-46, 1953; SAM, 1937-46; SAGA, 1937-46 (prize 1943), 1948-57; Phila. Pr. Club, 1950, 1952, 1954; Albany Inst. Hist. & Art, 1943-45, 1957; CGA, 1938-40; Portland Soc. Art, 1952; CAFA, 1948-58; Smithsonian Inst., 1952, 1956-58; Audubun Artists, 1948-52, 1954 (prize), 1957; Chicago Soc. Etchers, 1952-56; Newport AA, 1948-58; LOC, 1948-51; CI, 1948, 1950 (prize); Laguna Beach AA; Albany Soc. Etchers; Buffalo Pr. Club; MMA, 1952, 1955; Portland Mus. Art, 1953-55; Albany Pr. Club, 1955, 1957 (prize); Southern PM; Venice, Italy; Wash. WCC, 1954-55. **Work:** MMA; BM; PMA; AGAA; CI; Penn. State Univ.; and in many New York high schools. **Comments:** White gives year of birth as 1885. **Sources:** WW59; WW47.

SHERMAN, Elizabeth Evelyn *[Printmaker, painter] b.1896, Chicago, IL / d.1986, La Jolla, CA.*
Addresses: Coronado/La Jolla, CA, c.1932. **Studied:** Paris; NYC; Santa Fe. **Exhibited:** San Diego FA Gallery, 1927; Pasadena Art Inst., 1928; Calif.-Pacific Int. Expo, San Diego, 1935; SFMA, 1935; San Diego Art Guild, 1936-41; GGE, 1939. **Comments:** She went on painting trips to North Africa and Spain. Specialty: portraits and still lifes. **Sources:** Hughes, *Artists in California*, 510-11.

SHERMAN, Ella Bennett (Mrs. John) *[Painter] early 20th c.; b.NYC.*
Addresses: Wash., DC; Rochester, NY, mid to late 1920s. **Studied:** ASL, NYC & Wash., DC; D. Volk; W.M. Chase; Henri. **Member:** Wash. AC; Wash. WCC; Soc. Wash. Artists. **Exhibited:** Soc. Wash. Artists; Wash. WCC; Los Angeles, CA; NYWCC. **Sources:** WW25; McMahan, *Artists of Washington, DC.*

SHERMAN, Emily Elnora *[Art teacher] b.1887, Martinez, CA / d.1964, Alameda County, CA.*
Addresses: Alameda County, CA. **Studied:** Calif. College of Arts & Crafts; ASL. **Exhibited:** San Francisco AA, 1923; Oakland Art Gal., 1945. **Sources:** Hughes, *Artists in California*, 511.

SHERMAN, F. Taylor (Florence Taylor Kushner) *[Painter, lecturer] b.1911, Boston, MA.*
Addresses: Coconut Grove, FL; Miami, FL. **Studied:** BMFA School; & with Philip Hale, Florence Spaulding, Bernard Keyes. **Member:** Miami Art Lg.; Blue Dome F.; Florida Fed. Art (dir.); Copley Soc., Boston. **Exhibited:** Sarasota, FL, 1936-37; Blue Dome Fellowship, 1941, 1945; Miami Beach Art Gal., 1941; Miami AL, 1940-41 (prize), 1942 (prize), 1944 (prize); Florida Fed. Art, 1937 (prize)-38, 1940-46; Univ. Nebraska, 1938; AAPL, 1941 (prize), 1943 (prize)-44 (prize). **Comments:** Lectures: early history of portrait painting. **Sources:** WW59; WW47.

SHERMAN, Frederic Fairchild *[Writer, publisher, patron] b.1874, Peekskill, NY / d.1940.*
Addresses: Westport, CT. **Comments:** Began his career as a publisher of monographs on American artists. In 1913, he became publisher and editor of the periodical *Art in America.* He wrote extensively for the journal throughout his life and was one of the first scholars to research and write about Albert Pinkham Ryder, in 1920.

SHERMAN, Gail See: **CORBETT, Gail Sherman (Mrs. Harvey Wiley)**

SHERMAN, George E. *[Engraver] b.c.1810, Connecticut.*
Addresses: NYC, active from c.1840-60. **Comments:** From 1840-53 he was in partnership with John Calvin Smith (see entry). In 1850 Charles Smith and family were living in the same house with the Shermans. **Sources:** G&W; 7 Census (1850), N.Y., XLII, 160; 8 Census (1860), N.Y., XLIII, 623; NYCD 1840-58.

SHERMAN, Henry K. *[Landscape painter] b.1870 / d.1946.*
Addresses: Butler, PA. **Studied:** C. Walter. **Member:** Pittsburgh AA; Butler County AA. **Exhibited:** Pittsburgh AA, 1936 (prize);

Butler County AA, 1936 (prize), 1937 (prize). **Work:** 100 Friends of Art, Pittsburgh. **Sources:** WW40.

SHERMAN, Heyman (Hyman, Herman) *[Painter] early 20th c.*
Addresses: NYC. **Member:** S. Indp. A. **Exhibited:** S. Indp. A., 1918-22, 1926. **Sources:** WW25.

SHERMAN, Hoyt Leon *[Painter, designer, etcher, lithographer, lecturer, teacher] b.1903, Lafayette, AL.*
Addresses: Columbus, OH. **Studied:** J.R. Hopkins; C. Rosen; Ohio State Univ. **Exhibited:** Columbus AL, 1937 (prize). **Comments:** Position: teacher, Ohio State Univ. Roy Lichenstein was one of his students (1940s). **Sources:** WW40.

SHERMAN, Irving Josef *[Illustrator, painter] b.1917, NYC.*
Addresses: NYC/Plainfield, NJ. **Studied:** Pratt Inst., Brooklyn. **Exhibited:** Brooklyn WCC; FA Gal., NYC; Am. WCS-NYWCC, 1939. **Comments:** Illustrator: *Mademoiselle, Pictorial Review.* **Sources:** WW40.

SHERMAN, James Russell *[Painter, lithographer, illustrator,] mid 20th c.; b.Maxwell, IA.*
Addresses: NYC; Lamar, CO. **Studied:** Kansas City AI; ASL. **Exhibited:** WFNY, 1939; LOC, 1943, 1945-46; AIC, 1939-40; PAFA, 1942; CI, 1943; Denver AM, 1940, 1942; Philbrook AC, 1945 (solo); 8th St. Gal., 1938 (solo); Weyhe Gal., NYC. **Work:** Philbrook AC; Logan Co. (CO) Art Mus.; murals, U.S.P.O., Loveland, CO; U.S. Army. **Comments:** Position: art editor, *Nat. Ice Skating Guide,* 1943, 1944, 1946-52. Illustrator: "So You Think It's New," 1939; "City Government," 1941. Contributor to national magazines & newspapers. WPA artist. **Sources:** WW59; WW47.

SHERMAN, Jessie (Gordan) *[Painter, designer] mid 20th c.; b.Lenox, MA.*
Addresses: Boston, MA. **Studied:** Vesper George, William B. Hazelton, Umberto Romano; New Sch. Design; H.E. Smith; P.M.M. Jones. **Member:** NAWA; Boston Soc. Indep. Artists (pres.); Boston SAC; Fitzwilliam (NH) Art Center. **Exhibited:** Inst. Mod. Art, Boston, 1941, 1944; NAWA, 1945; Jordan Marsh Gal., annually; Boston Soc. Indep. Artists, annually. **Comments:** Position: dir., Boston Soc. Indep. Artists. **Sources:** WW59; WW47.

SHERMAN, John *[Painter, designer, teacher] b.1896, Brooklyn, NY.*
Addresses: Omaha, NE. **Studied:** CI; ASL; Maryland Inst.; J. Carlson. **Member:** Omaha AG. **Exhibited:** Joslyn Mem. (solo). **Work:** Joslyn Mem.; Univ. Nebraska; Bethesda Chapel, Moorhead, IA. **Sources:** WW40.

SHERMAN, John H. *[Artist] b.c.1835, Massachusetts.*
Addresses: Philadelphia, 1860. **Sources:** G&W; 8 Census (1860), Pa., LV, 271.

SHERMAN, John K(urtz) *[Critic] b.1898, Sioux City, IA / d.1969.*
Addresses: Minneapolis, MN. **Studied:** Univ. Minnesota. **Comments:** Positions: art editor & critic of art, music & drama, *Minneapolis Star & Tribune.* Author: "Music and Maestros: The Story of the Minneapolis Symphony Orchestra"; "Music and Theatre in Minnesota History"; "Sunday Best: Collected Essays". **Sources:** WW66; WW47.

SHERMAN, Julia Munson (Mrs. Frederic F.) *[Craftsperson] b.1875, Jersey City.*
Addresses: Westport, CT. **Studied:** L.C. Tiffany. **Member:** Boston SAC. **Work:** Walters Art Gal., Baltimore. **Comments:** Specialty: enamels; jewelry. **Sources:** WW40.

SHERMAN, L. Gordanier (Mrs.) *[Painter] late 19th c.*
Addresses: Chicago. **Exhibited:** AIC, 1891-92. **Sources:** Falk, *AIC.*

SHERMAN, Lenore (Walton) *[Painter, lecturer] b.1920, NYC.*
Addresses: San Diego, CA in 1976. **Studied:** Leon Franks,

Hayward Veal, Orrin A. White & Sergei Bongart, watercolor with James Couper Wright, portrait with Eignar Hansen. **Member:** San Diego Art Inst. **Exhibited:** San Diego Art Inst. 18th Ann., 1971; Mission Valley (CA) Expos Art, 1967; Rancho Calif. Invitational, 1970-71; Southern Calif. Expos, Del Mar, CA, 1970-72; Calif. Federated Women's Clubs Fine Arts Festival, 1971; Challis Galleries, Laguna Beach, CA, 1970s. Awards: first award for oils, San Diego Landmarks Theme, Southern Calif. Expos, 1970; first award for Calif. landmarks & second award for still life, Calif. Fed. Clubs Fine Arts Festival, 1971; purchase award, San Diego Art Inst. 18th Ann., 1971. **Work:** San Diego Law Library; Chateaubriand Restaurant, San Diego; various banks. **Comments:** Worked as a ventriloquist and comedienne. Began painting c.1950. Preferred media: oils, watercolors, acrylics. Teaching: instructor of oil painting, Del Gardens AA, San Diego, spring 1972; instructor of oil painting, Foothills AA La Mesa, CA, summer 1972; also private seminars. **Sources:** WW73; Ed Ainsworth, *The Cowboy in Art* (World Publ., 1968); articles, *San Diego Union*, 1960-72.

SHERMAN, Leslie *[Painter] mid 20th c.*
Addresses: San Francisco/North Hollywood, CA. **Studied:** Chouinard Art School. **Exhibited:** P&S of Los Angeles, 1937; Calif. WC Soc., 1939; GGE, 1939; San Francisco AA, 1940. **Sources:** Hughes, *Artists in California*, 511.

SHERMAN, Lucy McFarland *[Amateur watercolorist] b.1838 / d.1878.*
Studied: theorem painting. **Comments:** She married John Dempster Sherman in 1857. She was the mother of Frank Dempster Sherman, born at Peekskill (NY) in 1860 and professor in the Columbia University School of Architecture from 1886 until his death in 1916. **Sources:** G&W; Sherman, *Sherman Genealogy*, 15-16; Lipman and Winchester, 180.

SHERMAN, Martha E. Coleman *[Painter] b.1875, Henderson, KY.*
Addresses: Chicago, IL. **Studied:** AIC. **Exhibited:** AIC, 1902. **Sources:** WW04.

SHERMAN, Martha L. (Mrs. George) *[Printmaker, sculptor] b.1909, Roseberry, ID.*
Addresses: Mt. Vernon, WA. **Studied:** Univ. Washington; Archipenko; Louise Williams. **Exhibited:** Northwest PM, 1932, 1934. **Sources:** Trip and Cook, *Washington State Art and Artists*.

SHERMAN, Mary Read *[Painter] late 20th c.*
Addresses: NYC. **Exhibited:** AIC, 1895. **Sources:** Falk, *AIC*.

SHERMAN, P. A. (Mrs.) *[Painter] mid 19th c.*
Addresses: NYC, 1864, 1867. **Exhibited:** NAD, 1860 (fruit and flower pieces), 1864, 1867. **Sources:** G&W; Cowdrey, NAD.

SHERMAN, Sarai *[Painter, designer] 20th c.; b.Philadelphia, PA.*
Addresses: Phila., PA; NYC. **Studied:** Temple Univ. Tyler School Art (B.F.A., B.S., educ.); Barnes Foundation; Univ. Iowa (M.F.A). **Exhibited:** PAFA Ann., 1947-48, 1952-53, 1962-64; WMAA, 1949-64; Recent Painting USA: The Figure, MoMA, int. tour, 1962-63; Premio Marzotto, Milan, Paris, Hamburg, London & Belgrade, 1967-68; Childe Hassam Acquisition Fund, 1970; Venice Biennial, Int. Graphics: USA, Italy, 1972; Forum Gallery, NYC, 1970s. Awards: Fulbright scholarship, 1952-54; award for painting, NIAL, 1964; European Community Prize, Premio Marzotto, 1967. **Work:** WMAA; MoMA; Hirshhorn Collection, SI, Washington, DC; Uffizi Gallery Print Collection, Florence, Italy; Tel Aviv Mus., Israel. **Comments:** Preferred media: oils, graphics. **Sources:** WW73; Bryant & Venturoli, "Painting of Sarai Sherman," monograph (Galleria Penelope, Rome, 1963); Pastorino, "Pittura Come Vita," Documenta Film, Rome, 1968; Bernari, *Folk Rock, Blues, Flower Children* (Ed Grafica Romero, 1969); Falk, *Exh. Record Series*.

SHERMAN, Stowell B(radford) *[Painter, etcher] b.1886, Providence.*
Addresses: Providence, RI/Rockport, MA. **Studied:** RISD.

Member: Providence AC; Providence WCC. **Sources:** WW33.

SHERMAN, T. (Mrs.) *[Painter] late 19th c.*
Addresses: NYC, 1867. **Exhibited:** NAD, 1867. **Sources:** Naylor, *NAD*.

SHERMAN, T. P. *[Artist] early 20th c.*
Addresses: Wash., DC, active 1907. **Sources:** McMahan, *Artists of Washington, DC*.

SHERMAN, William A. *[Painter] late 19th c.*
Addresses: NYC, 1878. **Exhibited:** NAD, 1866, 1878. **Sources:** Naylor, *NAD*.

SHERMAN, Winnie Borne *[Painter, lecturer] b.1902, NYC.*
Addresses: Westbury, NY. **Studied:** Teachers College, Columbia Univ., with Haney & Grace Cornell; Cooper Union Art School, with Perard & Traphagen (B.F.A., 1923); NAD, with Ivan Olinsky & Hawthorn; ASL, with Bridgman, Dumond, Lever & Pennell; also with Dean Cornwell. **Member:** Catharine Lorillard Wolfe Art Club (pres., 1968-71); Nat. Soc. Arts & Letters (corresponding secy., 1962-64; NY art chmn., 1962-66; first vice-pres. & pres., 1968-70, Empire State Chapter; nat. art chmn., 1966-68); Nat. League Am. Pen Women (art chmn., 1966-68; first vice-pres.,1968-72; Royal Soc. Arts, London (hon. fellow); AAPL. **Exhibited:** Sols, Westchester Co. Center, White Plains, NY, New Rochelle (NY) Public Library, Burr Gallery, New York, Archit. League, New York & New School, New York. Awards: award for watercolor,*Am. Artist Magazine*, 1953; first prize for graphics, Westchester Arts & Crafts Guild, 1954; award for watercolor, Nat. Arts Club, 1961. **Work:** Seton Hall Univ. Library, NJ; Thomas Watson Private Collection, IBM, New York; Houston (TX) Mus.; Oklahoma AI, Tulsa; Grumbacher Artists' Palette Collection, New York. **Comments:** Preferred media: watercolors. Positions: hospitality chmn. & exhib. committee, Westchester Arts & Crafts Guild, 1953-57; chmn. art section, Women's Club, New Rochelle, 1955-58; social chmn. & exhib. committee, Nat. Arts Club,1958-62; juror for various exhibs. Teaching: instructor of fine arts, New York City high schools, 1925-35; instructor of private classes, 1935-; art director, Beaupré School Mus. & Art, 1946-48; instructor of fine arts, Hunter College H.S. Art & Design, 1957-65; instructor of art, City College New York, 1960-64; instructor of art, Inst. Retired Prof., New School Social Res., 1966-69. **Sources:** WW73.

SHERMAN, Z. C. P. See: **SHERMAN, Z. Charlotte**

SHERMAN, Z. Charlotte *[Painter] b.1924, Los Angeles, CA.*
Addresses: Pacific Palisades, CA. **Studied:** UCLA; Otis Art Inst.(now Los Angeles Art Inst.) (three scholarship awards); Kann Art Inst., UCLA (graduate course with Rico Lebrun); with Keith Finch. **Member:** Calif. WCS; Nat. WCS (signature mem.); Women Painters of the West. **Exhibited:** Walker AC, 1958; LACMA, 1956, 1958; Pasadena AM,1959; CPLH, 1961; Butler AI, 1961; Scripps College Art Gal., 1964; Univ. of Calif., Berkeley, Art Gal., Student Union, 1965 (solo); Richmond (CA) Art Mus, 1965; PAFA, 1965; Laguna Art Mus., 1966 (solo); Denver Mus. Art,1967 (invitational); Sylvan Simone Gal., Los Angeles, 1956 (solo); Parsons Gal., Los Angeles, 1957, 1958, 1959 (solo); Heritage Gal. 1962-97 (solo & group exhibitions); Gal. Eight, NYC, 1965 (solo); Gal. 21, Marina Del Ray, CA, 1971 (solo). **Work:** Municipal Art Gal., Los Angeles; Palm Springs (CA) Mus.; Laguna (CA) Mus. Art; Glass Container Corp of Am.; Winthrop Rockefeller Foundation, AR; F. Fuller Foundation, Los Angeles. **Comments:** Abstract painter. Painted in Japan, Hong Kong, Thailand, Cambodia, Java, Greece, Israel, Mexico, Central America, and India. Preferred media: oils, watercolors, pen and ink and charcoal, printmaking (lithography and etching). Teaching: Los Angeles City Cultural Arts Dept, 1965-79. **Sources:** info. courtesy of Z. Charlotte Sherman, Pacific Palisades, CA.

SHERMAN & SMITH *[Engravers] mid 19th c.*
Addresses: NYC, 1840-53. **Comments:** George E. Sherman and John Calvin Smith (see entries). **Sources:** G&W; NYCD 1840-

53.

SHERMUND, Barbara *[Cartoonist, illustrator, etcher, painter] mid 20th c.; b.San Francisco, CA.*
Addresses: NYC; Seabright, NJ. **Studied:** Calif. School FA; ASL. **Member:** SI; Nat. Cartoonists Soc. **Exhibited:** San Francisco AA, 1923, 1924; Salons of Am., 1934; de Young Mus., 1943; Int. Cartoon Exhib., Belgium, 1964; San Diego Exposition, 1964. **Work:** Soc. of Calif. Pioneers. **Comments:** Contributor to *Esquire, New Yorker,* and others. **Sources:** WW66; WW47; Hughes, *Artists in California,* 511.

SHERRARD, (Mrs.) *[Painter] mid 19th c.*
Addresses: Richmond, VA. **Exhibited:** Fair of the Mechanics Inst., Richmond, VA, 1855 (prize). **Sources:** Wright, *Artists in Virginia Before 1900.*

SHERRATT, Margaret J. *[Artist, china painter] 19th/20th c.*
Addresses: Wash., DC, active 1890s-1930. **Comments:** She and her husband, Samuel, ran their own business, Sherratts' China Art Store, which she took over after her husband's death in 1903. **Sources:** McMahan, *Artists of Washington, DC.*

SHERRATT, Samuel *[Artist, china decorator] d.1903, Wash., DC.*
Addresses: Wash., DC, active 1889. **Comments:** He had his own store, Sherratts' China Art Store in Wash., DC. After his death, his wife, Margaret J., and his nephew, T.J. Baines, took over the business. **Sources:** McMahan, *Artists of Washington, DC.*

SHERRER, Sabrina Doney *[Artist] b.1857, Kewaskum, WI / d.1930, Huron, SD.*
Addresses: Huron, SD, 1883-. **Studied:** self-taught. **Sources:** Petteys, *Dictionary of Women Artists.*

SHERRIFF, George R. *[Landscape painter] b.1864, Jersey City Heights, NJ / d.1934, Pasadena, CA.*
Addresses: Pasadena, CA. **Exhibited:** P&S of Los Angeles, 1926; Calif. State Fairs; Ebell Club. **Work:** Gardena H.S. **Sources:** Hughes, *Artists in California,* 511.

SHERRIFF, Roy Burton *[Painter] b.1892, NYC / d.1953, Los Angeles, CA (suicide).*
Addresses: Los Angeles, CA. **Member:** P&S of Los Angeles. **Comments:** Son of George Sherriff (see entry). **Sources:** Hughes, *Artists in California,* 511.

SHERRILL, Charles H. *[Patron, writer, lecturer] b.1867 / d.1936, Paris.*
Comments: Wrote and lectured about stained glass. In 1923, as a member of the council of NYU, he reorganized the art department, inactive since 1872; it is now known as the School of Architecture and Allied Arts.

SHERRILL, Edgar B. *[Printer] 20th c.*
Addresses: Boston, MA. **Member:** Boston SAC; Soc. Printers, Boston. **Exhibited:** AI Graphic Arts. **Work:** "Printing for Commerce." **Comments:** Position: owner, Sherrill Press, Boston. **Sources:** WW32.

SHERRY, Dorothy *[Painter] mid 20th c.*
Exhibited: Corcoran Gal biennial, 1947. **Sources:** Falk, *Corcoran Gal.*

SHERRY, William Grant *[Painter, sculptor] b.1914, Amagansett, NY.*
Addresses: Mill Valley, CA. **Studied:** Acad. Julian, Paris, with Pierre Jerome; Heatherly Sch. Art, London, with Ian McNab. **Exhibited:** De Young Mus, San Francisco, CA; Colby College, ME; Ringling Mus., Sarasota, FL, 1949; Boston Arts Festival, 1956; Art USA, Madison Square Garden, New York, 1958; Center Street Gal, Winter Park, FL; ADI Gal, San Francisco, CA, 1970s. **Awards:** Laguna Beach Festival Arts, Natl. Painting Contest, 1951; Steiger purchase prize, Springfield (MA) MFA, 1957. **Work:** Farnsworth Mus., Rockland, ME; Mod. Mus. Art, Fort Lauderdale, FL; Am. Embassy, Pakistan; Parliament Bldg., Canada; Springfield (MA) Mus. Fine Art. **Comments:** Preferred media: oils, wax. Teaching: chief instructor & art dir, Florida Gulf

Coast AC, Beleair, FL, 1957-64; instructor, Hamilton AFB, Ignacio, CA, 1965-67. **Sources:** WW73.

SHERWIN, John H. *[Lithographer and painter] b.1834, Bellows Falls, VT.*
Addresses: NYC, c.1851. **Studied:** Morawski, NYC, c.1851 (lithography). **Exhibited:** PAFA, 1860. **Comments:** He studied first for the ministry but in 1851-52 he took up lithography. During the next ten years he worked in Philadelphia for the Rosenthals, then in NYC and Boston. After an unsuccessful painting venture in Boston, according to Peters, Sherwin retrieved his fortunes by marrying a rich widow. **Sources:** G&W; Peters, *America on Stone;* Rutledge, PA; *Antiques* (Feb. 1926), 83.

SHERWIN, Margaret *[Painter] mid 20th c.*
Exhibited: Salons of Am., 1930. **Sources:** Marlor, *Salons of Am.*

SHERWIN, Thomas *[Engraver] mid 19th c.*
Addresses: Wilmington, DE, 1857-59. **Sources:** G&W; Wilmington BD 1857; Delaware BD 1859.

SHERWOOD, A. *[Sculptor, printmaker] b.1923, Birmingham, AL.*
Addresses: Hialeah, FL. **Studied:** Univ. Florida; Hampton Inst.; Wesley College; Delaware State College; Univ. Philippines. **Exhibited:** Norfolk (VA) Mus., 1966 & 1967; VMFA, Richmond,1967; Audubon Soc., Wash., DC, 1969; Rehoboth (DE) Art Lg., 1970; Royal Art Gal., Manila, Philippines, 1972. **Awards:** award for "Owl Furry" (sculpture), Atlantic City Nat. Art Show, 1969; award for "Roadrunner" (sculpture), Acad. Arts, 1969; award for "Vulture" (sculpture), Rehoboth Art Lg., 1970. **Work:** Lilliputian Fnd., Wash., DC; Acad. Art, Easton, MD; U.S. Navy; U.S. Air Force. Commissions: oil paintings for Phillips Elem. School, Hampton,VA, 1966. **Comments:** Positions: TV art illustrator, Univ. Florida Agric. Educ. Dept., 1958-60; art illustrator, special services, Pope A.F.B., 1961-63; art illustrator, Mag O'Club, Langley A.F.B., 1963-65. Illustrator: *Elavet News,* Gainesville, FL, 1958-60; various bulletins, Gainesville, FL, 1958-60; *Agric. News,* Univ. Florida, 1959. Teaching: art instructor, Pope A.F.B., NC, 1961-63; art instructor, Alexander Graham Bell Jr. H.S., Fayetteville, NC, 1962-63. Collections: Pre-Columbia pottery; Central America Stone ware; celadon; Sung, Ming & Ching porcelain; brass from Asia. **Sources:** WW73; Joe Aaron, "Air Force Wife Successfully Combines," *Daily Press,* Virginia, 1967; Murray Bond, "Artist Finds Found Objects, *Airlifter,* 1968; S. Stern Berger, "Art Is Where She Finds It," *Evening Journal,* Delaware, 1970.

SHERWOOD, A. *[Portrait painter] b.c.1823, New York.*
Addresses: Cincinnati, 1850. **Sources:** G&W; 7 Census (1850), Ohio, XX, 257.

SHERWOOD, Anna K. K. (Mrs.) *[Portrait painter, musician] d.1931, NYC.*
Addresses: Brooklyn, NY. **Studied:** G. Luks. **Exhibited:** S. Indp. A., 1918-19, 1922. **Comments:** Also studied music with Edward MacDowell.

SHERWOOD, Berta *[Painter] mid 20th c.*
Addresses: Chicago area. **Exhibited:** AIC, 1940. **Sources:** Falk, AIC.

SHERWOOD, Bette (Wilson) *[Painter, sculptor] mid 20th c.; b.Sheffield, AL.*
Addresses: Houston, TX. **Studied:** AIC; Corcoran School Art; Mississippi State College Women; Inst. Allende, San Miguel Allende; also with Henri Gadbois. **Member:** Int. Platform Assn.; Nat. League Am. Pen Women (pres., Houston Branch, 1968-70; founder Member Branch, 1970); Int. Poetry Soc.; Southwestern Watercolor Soc.; River Oaks Ladies Reading Club. **Exhibited:** Nat. League of Am Pen Women, Houston, 1968 (best of show & hon. mention) & 1969; Southwestern Watercolor Soc., 1969; Art League of Houston, 1969; Galerie Int., NYC, 1971; Med. Soc. Art Show, Houston Oaks Hotel, 1971. **Work:** Lions Camp, Kerrville, TX; Tennessee Valley Art Mus.; River Oaks Bank & Trust Co. Commissions: portrait of daughter, Mrs. Eugenie Feffer, Haifa,

Israel, 1970; children's portraits, Jame T. Fox, Bellaire, TX, 1971; portrait of Mrs. E. E. Hunter, Morristown, NJ, 1971; portraits, commissioned by Jimmy Lyon, Houston, TX, 1971. **Comments:** Preferred media: oils. **Sources:** WW73.

SHERWOOD, Eveline Maria *[Painter] b.1872, England / d.1942, Oakland, CA.*
Addresses: Oakland, CA. **Exhibited:** San Francisco AA, 1886. **Sources:** Hughes, *Artists in California*, 511.

SHERWOOD, Franklin Paul *[Painter] b.1864, California / d.1952, La Jolla, CA.*
Addresses: La Jolla, CA. **Studied:** East Coast; Europe. **Exhibited:** LACMA, 1923 (solo). **Comments:** A mining engineer, he took up painting late in life. **Sources:** Hughes, *Artists in California*, 511.

SHERWOOD, H. A. *[Painter] 20th c.*
Addresses: Hartford, CT. **Member:** CAFA. **Sources:** WW25.

SHERWOOD, Henry *[Painter] early 19th c.*
Studied: J.I. [J.] Holland. **Exhibited:** American Academy, 1818 (landscape drawing). **Sources:** G&W; Cowdrey, AA & AAU.

SHERWOOD, Henry J. *[Listed as "artist"] b.c.1795, New York.*
Addresses: NYC in 1850. **Sources:** G&W; 7 Census (1850), N.Y., XLVIII, 269. NYCD 1850 lists only Henry J. Sherwood, hardware. *Cf.* Henry Sherwood.

SHERWOOD, J. P. *[Portrait and historical painter] early 19th c.*
Work: NYHS (four portraits, probably painted in the mid-1830's; they represent Rev. & Mrs. Adiel Sherwood and Col. & Mrs. T.A. Sherwood). **Comments:** The NYHS also owns a portrait of J.J.P. Sherwood by John Vanderlyn (see entry). Jr. Vanderlyn and Sherwood advertised together in Charleston (SC) in 1836. **Sources:** G&W; NYHS artist file; Rutledge, *Artists in the Life of Charleston*.

SHERWOOD, Jennie Emmaline *[Sculptor] late 19th c.*
Addresses: Chicago. **Exhibited:** AIC, 1896. **Sources:** Falk, *AIC.*

SHERWOOD, Lionel Claude *[Painter, teacher] b.1873, California / d.1961, Pasadena, CA.*
Addresses: San Diego, CA; Pasadena, CA. **Exhibited:** San Diego FA Gal., 1927. **Comments:** Position: teacher, public schools for 39 years. **Sources:** Hughes, *Artists in California*, 511.

SHERWOOD, Mary Clare (Miss)s *[Painter, teacher] b.1868, Lyons, NY / d.1943, Vicksburg, MS.*
Addresses: Vicksburg, MS/Lyons, NY. **Studied:** ASL, with Weir, Chase, Cox, W. Long, A. Archipenko; Berlin, with C. Fehr, C. Hermanns; F.E. Scott, in Paris. **Member:** NAWA; Mississippi AA; SSAL. **Exhibited:** Louvre, Paris; SSAL; S. Indp. A.; Mississippi AA, 1931(gold), 1934 (gold), 1938 (prize); Art Exhib., Women's Fed. Club, MS, 1933 (prize); NAWA. **Comments:** Painted mainly landscapes in oil & watercolor. Position: teacher, All Saints College, Vicksburg, MS, 1920-43. **Sources:** WW40.

SHERWOOD, Newton *[Sculptor, painter] mid 20th c.*
Addresses: NYC. **Exhibited:** S. Indp. A., 1931. **Sources:** Marlor, *Soc. Indp. Artists.*

SHERWOOD, Rosina Emmet (Mrs. Arthur M.) *[Painter] b.After 1854, NYC / d.1948, NYC.*
Addresses: NYC, 1889-94; New Rochelle, NY; Stockbridge, MA. **Studied:** Wm. M. Chase; Académie Julian, Paris with T. Robert-Fleury, 1884-85. **Member:** SAA, 1886; ANA, 1906; NYWCC; AWCS. **Exhibited:** AIC; NAD, 1881-94; PAFA Ann., 1882-83, 1895-1900; Boston AC, 1886-87, 1892, 1894, 1896; Paris Expo, 1889 (medal); Columbian Expo, 1893 (medal); AWCS, 1898; MacBeth Gal., NYC, 1900 (solo); Pan-Am. Expo, Buffalo, 1901 (bronze medals); St. Louis Expo, 1904 (silver medal); S. Indp. A., 1917; Doll & Richards, Boston, 1920 (solo), 1924 (solo). **Comments:** She came from a family of women artists that included her sisters Lydia Emmet and Jane Emmet De Glehn, as well as

their cousin Ellen Emmet Rand. Rosina was one of the earliest students of Wm. M. Chase. After joining the design firm *Associated Artists,* and a subsequent trip to Paris, Sherwood supported herself by working as an illustrator for major periodicals. After 1900 she mainly painted portraits in watercolor and paste. She married Arthur Sherwood in 1887 and had five children. Robert Emmet Sherwood, her son, was a Pulitzer prize winning playwright. In 1922 she took a trip around the world with her brother and daughter, painting many watercolors along the way. **Sources:** WW47; Martha J. Hoppin, *The Emmets: A Family of Women Painters* (The Berkshire Museum, Pittsfield, Mass., 1982); Pisano, *One Hundred Years.the National Association of Women Artists*, 81; Tufts, *American Women Artists*, cat. no. 70; Petteys, *Dictionary of Women Artists;* Falk, *Exh. Record Series.*

SHERWOOD, Ruth (Mrs. Albin Polasek) *[Sculptor, teacher] b.1889, Chicago, IL / d.1953.*
Addresses: Chicago; Winter Park, FL; Chautauqua, NY. **Studied:** Univ. Chicago (B.S.); AIC; with Albin Polasek. **Member:** Chicago PS; Chicago Gal. Assn. **Exhibited:** Chicago AC; PAFA Ann., 1924-25; NSS; Century of Progress, Chicago, 1933-34; SFMA; Wash., DC; Chicago Women's Aid (prize); Chicago Gal. Assn., 1928 (prize), 1930 (prize); AIC, 1913-33 (prizes 1921, 1922, 1929, 1930); Municipal Art Lg., 1936 (prize); Assn. Chicago P&S, 1939 (prize). Other awards: Lathrop Foreign Fellowship, 1921; Adams Foreign Fellowship, 1921. **Work:** River Forest (IL) Women's Club; Portland Cement Assn.; Law Sch., Univ. Wisconsin; Univ. Chicago; Lake Shore Bank medal for architecture; Sch. Religion; Lyons, NY; Chautauqua, NY; Kenilworth, IL; Johns Hopkins Univ. **Comments:** Teacher, AIC. Author: "Albin Polasek, Carving His Own Destiny." **Sources:** WW53; WW47; Falk, *Exh. Record Series.*

SHERWOOD, Sherry (Mr.) *[Designer, painter, sculptor, craftsperson] b.1902, New Orleans, LA / d.1958.*
Addresses: Chicago, IL; NYC. **Studied:** Maryland Inst.; AIC; Chicago Acad. FA; J. McBurney; L. Taft. **Exhibited:** Century of Progress, Chicago, 1933, 1934; Atlantic City Auditorium; San Diego Expo; Texas Centenn.; GGE, 1939. **Work:** WPA mural design, Chicago. **Comments:** Designer: scenery for NY theatrical productions. **Sources:** WW53; WW47.

SHERWOOD, Walter J. *[Writer, painter] b.1865, Wauscon, OH.*
Addresses: Wilmette, IL. **Studied:** AIC. **Exhibited:** AIC, 1940; Mun. Art Exhib., Chicago; Ravinia (IL) Gal. **Work:** Illinois Athletic Club, Chicago. **Comments:** Contributor: *Magazine of Art, Athena* magazine, & others. Author/editor: "Weekly News Letter," 1923-40. Position: manager, printing & publications, AIC, Chicago, IL, 1911-45. **Sources:** WW53; WW47.

SHERWOOD, William (Anderson) *[Etcher, painter] b.1875, Baltimore, MD / d.1951, Bruges, Belgium.*
Addresses: Bruges, Belgium. **Member:** Société Royale des Beaux-Arts Belge; Société Royale des Aqua-Fortists de Belgique; Chicago SE; Calif. PM; AFA; Chevalier de l'Ordre de la Couronne (Belgique). **Work:** Etchings owned by Elisabeth, Dowager Queen of Belgium; etchings in Royal Lib., Brussels, Musée Plantin-Moretus, Antwerp, LOC, NGA; Cleveland Pub. Lib.; Detroit Pub. Lib.; Worcester Free Lib.; AIC; Calif. State Lib.; City Lib., Sacrament, CA; paintings, Musée Royal de L'Armée, Brussels. **Sources:** WW40.

SHESTACK, Alan *[Museum director, art historian] b.1938, NYC.*
Addresses: New Haven, CT. **Studied:** Wesleyan Univ. (B.A.); Harvard Univ. (M.A.). **Member:** College AA; Print Council Am.; Assn. Mus. Dir.; Am. Assn. Mus. **Comments:** Positions: curator, Lessing J. Rosenwald Collection, Nat. Gallery Art, 1965-67; curator prints & drawings, Yale Univ. Art Gallery, 1967-71 & director, 1971-. Publications: author, "Master E.S." (1967), Fifteenth Century Engravings of Northern Europe" (1967), The Complete Engravings of Martin Schongauer" (1969), "Master L. Cz. and Master W.B." (1972) & author, articles, *Art News, Burlington*

Magazine, Master Drawings &*Art News, Art Quarterly.*
Collections arranged: Fifteenth Century Engravings of Northern
Europe, catalog & exhib., Nat. Gallery Art, Washington, DC,
1967; Master E.S. (catalog & exhib.), Philadelphia Mus. Art,
1967; The Danube School (catalog & exhib.), Yale Uni. Art
Gallery, 1968. Research: specialist in fifteenth century German art
and history of printmaking. **Sources:** WW73.

SHEUE *[Miniaturist and landscape painter] mid 19th c.;*
b.Prussia, Germany.
Addresses: St. Louis, before 1860. **Comments:** He is said to have
been the tutor of a Count Feltenstine in Germany. Sheue taught
German and painted miniatures at Pittsburgh and later painted
miniatures, portraits, and landscapes in St. Louis. **Sources:**
G&W; Breckenridge, *Recollections of Persons and Places in the
West*, 96-97, 233.

SHEVEHON, Clare *[Painter] 20th c.*
Addresses: Minneapolis, MN. **Sources:** WW25.

SHEVELSON, Annette See: **TROXEL, Annette
Shevelson**

SHEWCRAFT, Richard Turner *[Portrait, landscape and
still life painter] b.c.1869, Windsor, Ontario.*
Addresses: Detroit, MI. **Studied:** Detroit Mus. of Art School,
1885. **Exhibited:** locally in Detroit. **Comments:** Of English,
Native American and African American ancestry, his family
moved to Detroit, when he was young. **Sources:** Gibson, *Artists
of Early Michigan*, 211.

SHEWSBURY, Henrietta C. *[Painter] 20th c.*
Addresses: Darby, PA. **Sources:** WW04.

SHEYS, William P. *[Portrait and miniature painter] early
19th c.*
Addresses: NYC, 1813 & 1820. **Studied:** John Wesley Jarvis.
Comments: Dunlap states that he sank to "vicious courses" and
died a common sailor in a foreign land. **Sources:** G&W; NYCD
1813, 1820; Dickson, *John Wesley Jarvis;* Dunlap, *History.*

SHIBLEY, Gertrude *[Painter] b.1916, Brooklyn, NY.*
Addresses: NYC. **Studied:** Brooklyn College (B.A.); with
Francis Criss, 1942; Pratt Inst.; Am. Artists School; New School;
Hans Hofmann School Fine Arts, 1952-53; graduate work, CCNY.
Member: Guild Hall; Spiral Group (secretary). **Exhibited:**
WFNY 1939-40; NAWA; Village Art Center, 1949 (solo)(prize);
NAD Gallery, 1951-52; Springfield Mus. Art; Riverside Mus.,
1952, 1954, 1956, 1958, 1960; honorable mention, Terry Art
Award, Miami, FL, 1952; Prizewinners Village Art Center,
WMAA, 1954; Panoras Gal., 1954, 1958 (solo); Copain Gal.,
1953 (solo); Art USA, New York, 1958; Phoenix Gal., 1965,
1967, 1969, 1972, 1975 (all solo); Southampton College
Invitational, 1971; Phila. Mus. Art, 1974; Maison pour Tous,
Annemasse, France, 1976; La Culture de Cluses, France, 1976;
"NYC WPA Art" at Parsons School Design, 1977. **Work:** Wichita
State Univ. Mus. Collection. **Comments:** Preferred media: oils.
Positions: ceramist, Design Technics, 1944-48. Teaching: painting
instructor, WPA Art Project, 1938-40; painting instructor,
Community Center of East Side, 1938-42; painting instructor,
Halloran Hospital, Staten Island, 1942-44; painting instructor,
Ruth Ettinger School, New York, 1955-56; instructor, Beach
Brook School, 1955-56. **Sources:** WW73; WW59; *New York City
WPA Art*, 78 (w/repros.).

SHIDELER, Paul *[Painter, etcher] b.1888, Indianapolis.*
Addresses: Indianapolis, IN. **Studied:** Forsyth; Coats. **Sources:**
WW33.

SHIELDS *[Engraver] b.c.1815, Pennsylvania.*
Addresses: Boston in 1850. **Sources:** G&W; 7 Census (1850),
Mass., XXIV, 354.

SHIELDS, Alan J. *[Designer, painter] b.1944, Lost Springs,
KS.*
Addresses: Shelter Island, NY. **Studied:** Kansas State Univ.
Exhibited: Paula Cooper, NYC, 1970s; WMAA. **Work:** MoMA;

WMAA; Guggenheim Mus.; Akron (OH) Art Inst.; Fort Worth
(TX) Art Center. **Sources:** WW73.

SHIELDS, Albert Beckwith *[Painter] b.1863, Cape Breton,
Nova Scotia / d.1930.*
Addresses: Boston, MA, until 1909; San Diego, CA, 1909-30.
Studied: Worcester Academy; Boston Univ.; L. Kromberg; later
attended the Episcopal Theological Seminary and became a minis-
ter. **Member:** Copley Soc.; Boston AC, 1912 (absentee);
Langham Studios, London. **Work:** Calif. State Lib. **Comments:**
Episcopal minister who supported himself as a portrait painter
while studying theology at Harvard, Oxford, and the Univ. of
London. He was Rector of the Church of the Redeemer in South
Boston for 15 years. **Sources:** WW10; WW10 (as Beckwith A.
Shields); Hughes, *Artists in California*, 90 (as Albert Beckwith
Campbell-Shields); *Boston Art Club*, 451, (as A. B. Shields).

SHIELDS, Beckwith A. See: **SHIELDS, Albert Beckwith**

SHIELDS, Blanche Cumming *[Painter] mid 20th c.*
Addresses: Neenah, WI. **Exhibited:** AIC, 1914, 1916, 1918,
1923. **Sources:** WW17.

SHIELDS, C. Marguerite *[Painter, sculptor] mid 20th c.*
Addresses: NYC. **Exhibited:** S. Indp. A., 1927. **Sources:**
Marlor, *Soc. Indp. Artists.*

SHIELDS, Charles *[Engraver and decorative painter and
printer] mid 19th c.*
Addresses: NYC, 1840-60. **Sources:** G&W; NYCD 1840-60.

SHIELDS, Emma Barbee *[Portrait painter] d.1912, NYC.*
Addresses: Active in Texas; New York from 1893.

SHIELDS, Francis (Frank) Bernard *[Lithographer, screen-
printer, painter, illustrator] b.1908, NYC.*
Addresses: Freeport, NY. **Studied:** Columbia Univ.; NAD; ASL,
with Olinsky, Hawthorne, Nicolaides; D. Wortman. **Member:**
Freeport Art Gld. **Exhibited:** MMA (AV), 1943; LOC, 1941;
Univ. Kansas, 1939; Garden City, NY, 1943; Freeport Mem. Lib.,
1939 (solo), 1941-45; Weyhe Gal., WPA Gal., both in NY;
Stamford Mus. Art; CI; CM; Nassau Art Lg., 1949 (prize). **Work:**
MMA; LOC; BM; Univ. Kansas; New York public school.
Comments: Illustrator: "A Collection of Animal Story
Masterpieces," 1939; "Parade of Fairy Tales," 1945, and other
books. Contributor to *Natural History, Boy's Life* magazines. WPA
printmaker in NYC, 1930s. **Sources:** WW53; WW47; exh. cat.,
Annex Gal. (Santa Rosa, CA, n.d., c.1988).

SHIELDS, Irion *[Painter] b.1895, Texas / d.1983, Sacramento,
CA.*
Addresses: San Diego, CA; Sacramento, CA. **Member:** Kingsley
AC. **Exhibited:** Crocker A. Gal. **Comments:** Position: sign
painter, McClellan Air Force Base, 40 years. **Sources:** Hughes,
Artists in California, 511.

SHIELDS, J. W. (Mrs.) *[Painter] mid 19th c.*
Exhibited: Fair of the Mechanics Inst., Richmond, VA, 1854
(prize). **Sources:** Wright, *Artists in Virginia Before 1900.*

SHIELDS, Jennie C. *[Artist] late 19th c.*
Addresses: Wash., DC, active 1892-93. **Sources:** McMahan,
Artists of Washington, DC.

SHIELDS, Mattie E. Pursell (Mrs. James) *[Craftsperson]
d.1921, New Orleans, LA.*
Addresses: New Orleans, active c.1888. **Exhibited:** Tulane
Decorative Art League for Women, 1888. **Sources:**
Encyclopaedia of New Orleans Artists, 351.

SHIELDS, Phyllis *[Painter] b.1909, Los Angeles, CA.*
Studied: Otis Art Inst. **Exhibited:** Zeitlin's, Los Angeles, 1929;
Hatfield's, Los Angeles, 1932; P&S of Los Angeles, 1934; Calif.-
Pacific Int. Expo, San Diego, 1935. **Sources:** Hughes, *Artists in
California*, 511.

SHIELDS, Thomas H. *[Wood and copperplate engraver]
b.c.1818, NYC / d.1875, New Orleans, LA.*
Addresses: New Orleans, 1836-56. **Comments:** Advertised a

general practice for engraving and printing and executed masthead designs for several N.O. newspapers. In 1842 of Shields & Collins (see entry). He was also active in politics. **Sources:** G&W; Delgado-WPA cites *Picayune*, Jan. 9, 1836, and New Orleans CD 1841-42, 1844, 1849-56. More recently, see *Encyclopaedia of New Orleans Artists*, 353.

SHIELDS, Thomas W. *[Painter]* THOS·W·SHIELDS·
 b.1849, St. Johns, New Brunswick /
 d.1920, Brooklyn, NY.
Addresses: Brooklyn, NY; Paris, 1881; NYC, 1882-88; Brooklyn, NY, 1890, 1900. **Studied:** NAD with Wilmarth; Acad. Julian, Paris with J. Lefebvre; also in Paris with Gérôme and Carolus-Duran, c.1880. **Exhibited:** Brooklyn AA, 1877, 1882-83; NAD 1877-1900; PAFA Ann., 1882. **Work:** Brooklyn Mus. Art. **Sources:** WW01; Falk, *Exh. Record Series.*

SHIELDS, William See: **SHIELS, William**

SHIELDS & COLLINS *[Copperplate engravers] mid 19th c.*
Addresses: New Orleans, 1842. **Comments:** Partners were Thomas H. Shields and Charles Collins (see entries). **Sources:** G&W; New Orleans CD 1842.

SHIELDS & HAMMOND *[Engravers, printers] mid 19th c.*
Addresses: New Orleans, active 1845. **Comments:** Partners were Thomas H. Shields and John T. Hammond (see entries). **Sources:** *Encyclopaedia of New Orleans Artists*, 352.

SHIELS, William *[Portrait painter] early 19th c.*
Addresses: NYC in 1817-18; Charleston, SC, 1820-22. **Exhibited:** American Acad., 1817-18; South Carolina Acad. Fine Arts, 1820-22. **Comments:** In 1821 he was a director of the South Carolina Academy of Fine Arts. Possibly the William Shiels (1785-1857) who was a member of the Royal Scottish Academy and exhibited domestic pictures at the Royal Academy in London between 1808-52. **Sources:** G&W; Cowdrey, AA & AAU; Rutledge, *Artists in the Life of Charleston;* Swan, BA; Graves, *Dictionary;* Dunlap, *Diary,* 527.

SHIER, Leonora *[Painter] mid 20th c.*
Exhibited: Salons of Am., 1930. **Sources:** Marlor, *Salons of Am.*

SHIERER, Mary G. *[Painter] 20th c.*
Addresses: New Orleans, LA. **Comments:** Position: affiliated with Newcomb Art School. **Sources:** WW15.

SHIFF, E. Madeline (Mrs. Arnold Wiltz) *[Painter, craftsperson, miniature painter] b.1885, Denver, CO / d.1966.*
Addresses: Woodstock, Bearsville, NY. **Studied:** Adelphi College (B.A.); ASL; with J.B. Whittaker, DuMond, W.M. Chase, H.E. Field. **Member:** Woodstock AA; Salons of Am.; Brooklyn SMP. **Exhibited:** AIC; Salons of Am.; PAFA Ann., 1933; Rudolph Gal., Woodstock; Coral Gables, FL. **Awards:** Charlotte R. Smith Mem. award, Baltimore, MD, 1923. **Work:** WMAA; Woodstock AA. **Sources:** WW59; WW47; Woodstock AA; Falk, *Exh. Record Series.*

SHIGEMATSU, I *[Painter] early 20th c.*
Addresses: NYC. **Exhibited:** S. Indp. A., 1917-18. **Sources:** Marlor, *Soc. Indp. Artists.*

SHIGG, William *[Wood engraver] b.c.1831, England.*
Addresses: NYC, 1850. **Sources:** G&W; 7 Census (1850), N.Y., XLIX, 720.

SHIKLER, Aaron *[Painter] b.1922, Brooklyn, NY.*
Addresses: NYC. **Studied:** Tyler School Fine Arts, Temple Univ. (B.F.A.; B.S. Educ.; M.F.A.); Barnes Foundation; Hans Hofmann School. **Member:** NAD; Century Assn. **Exhibited:** New Britain (CT) Mus. Art, 1964; Gallery Mod. Art, New York, 1965; NAD, 1965; Brooklyn Mus., 1971; CPLH, 1971; Davis Galleries, NYC, 1970s. **Awards:** Ranger Award, 1959; Proctor Prize, NAD, 1959 & 1960; Thomas B. Clarke Prize, 1961. **Work:** MMA; Mint Mus. Art, Charlotte, NC; Parrish Mus. Art, Southampton, NY; NAD; Montclair (NJ) Art Mus. **Commissions:** portraits of Pres. & Mrs. John F. Kennedy for White House. **Comments:** Publications: contributor, two chapters, "Pastel Painting, 1968. **Sources:** WW73;

Shikler & Levine (Brooklyn Mus., April, 1971); articles, *Am. Artist* (Sept. 71) & *Current Biography* (Dec., 1971).

SHILL, F. Hutton *[Painter] b.1872, Omaha, NE.*
Addresses: Camden, Port Norris, NJ; St. Ives, Cornwall, England, 1908-10; Silvan Springs, Petro, AR. **Studied:** PAFA with T. Anshutz, W.M. Chase, and C. Beaux (Cresson traveling scholarships, 1904, 1907). **Member:** Phila. Sketch Club. **Exhibited:** PAFA Ann., 1903, 1905-09, 1911; Corcoran Gal biennial, 1910. **Sources:** WW19; Falk, *Exh. Record Series.*

SHILLARD, Georgine Wetherell (Mrs. C. Shillard Smith) *[Landscape painter, teacher] b.1874, Philadelphia, PA / d.1955.*
Addresses: Phila., PA; Edgewater Park, NJ; Belleair, FL. **Studied:** PAFA; with Robert Henri, Whistler, Simon, Collet, in Paris, France. **Member:** Phila. Plastic Club; AFA; Florida Fed. Art; NIAL; NAWA. **Exhibited:** PAFA Ann., 1913, 1918; Phila. Plastic Club (prize); Clearwater Art Mus (prize); S. Indp. A. **Comments:** Position: teacher/pres., Clearwater (FL) Art Mus.; founder & chmn. of Board of Governors, Gulf Coast Art Center, Belleair, FL. **Sources:** WW53; WW47; Falk, *Exh. Record Series.*

SHILLING, Alexander *[Landscape painter, etcher, teacher] b.1860, Chicago, IL / d.1937.*
Addresses: NYC, since 1885. **Studied:** G.S. Collis; H.A. Elkins, 1878. **Member:** AWCS; NY Etching Club; SC; Century Assn.; Chicago AL (founder). **Exhibited:** NAD, 1886-95; Boston AC, 1886-99; AIC, 1889-1911; Paris Salon, 1889, 1892; Phila. AC, 1901 (gold); PAFA Ann., 1903; St. Louis Expo., 1904 (medal); SC, 1913 (prize). **Work:** MMA; Print Coll., NYPL. **Comments:** An important but lesser-known Tonalist landscape painter. During the early 1880s, he and John Vanderpoel organized outdoor painting classes, going first to the Muskoka Lakes in Ontario, and later to the Juniata and Lebanon Valley in PA. By December, 1885 he had established his studio in NYC. WW25 lists his address as Leonia, NJ and spells his name as "Schilling;" however, he had already changed the Germanic spelling of his name with the advent of WWI. **Sources:** WW33; Alec J. Hammerslough, *The Story of Alexander Shilling* (Paisley Press, 1937); Fink, *American Art at the Nineteenth-Century Paris Salons,* 389; Falk, *Exh. Record Series.*

SHIMADA, Kainan T. *[Etcher] 20th c.*
Addresses: Los Angeles, CA. **Sources:** WW24.

SHIMIN, Symeon *[Painter, illustrator] b.1902, Astrakhan, Russia.*
Addresses: NYC. **Studied:** CUA Sch., and with George Luks. **Member:** Art Lg. Am.; AEA. **Exhibited:** 48 Sts. Competition, 1939; WMAA, 1940-41, 1959; CGA, 1940; AIC, 1940; Nat. Mus., Ottawa, Canada, 1940; U.S. Exhib., Guatemala, 1941; BM, 1943; NGA, 1943; Provincetown Art Festival (purchase prize). **Work:** murals, Dept. Justice, Wash. DC; USPO, Tonawanda, NY; Chrysler Art Mus. **Comments:** WPA artist. Illus. for children's books. **Sources:** WW53; WW47; WW59 (first name appears as Semyon; in all other references it is Symeon).

SHIMIZU, Kioshi (Kumioshi) *[Landscape painter] early 20th c.*
Exhibited: Salons of Am., 1926. **Sources:** Marlor, *Salons of Am.*

SHIMIZU, Kiyoshi *[Painter] mid 20th c.*
Exhibited: Salons of Am., 1925-29, 1931; S. Indp. A., 1925-28, 1931. **Sources:** Marlor, *Salons of Am.*

SHIMIZU, Toshi *[Painter] b.1887, Tochigi-Ken, Japan / d.1945, Japan.*
Addresses: NYC. **Member:** Soc. Indep. Artists. **Exhibited:** S. Indp. A., 1919, 1921-24; Salons of Am., 1922; AIC. **Sources:** Falk, *Exhibition Record Series.*

SHIMODA, Osamu *[Sculptor, painter] b.1924, Manchuria.*
Addresses: NYC. **Studied:** St. Paul Univ., Tokyo; Acad. Grande Chaumière, Paris. **Member:** Sculptors Guild. **Exhibited:** Granite Gal., New York, 1966; Nat. MoMA Ann., Tokyo, 1967; Suzanne Kohen Gal., Minneapolis, 1970; Bertha Schaefer Gal., 1970;

Sculptors Guild, 1971 & 1972. **Work:** St. Paul Univ., Tokyo; Syracuse Mus.; Nat. MOMA, Tokyo. Commissions: murals, Hawaii Chamber of Commerce & Industm, 1959. **Comments:** Preferred media: iron. **Sources:** WW73.

SHIMON, Paul *[Painter, illustrator] mid 20th c.; b.NYC.* **Addresses:** NYC. **Studied:** ASL; also with Jean Liberté. **Member:** AEA. **Exhibited:** Audubon Artists, 1954; Macdowell Alumni Show, 1971; Skylight Gallery, NYC, 1970s. Awards: Emily Lowe Watercolor Award, 1953; Macdowell Colony fellowship, 1960. **Work:** Butler IA, Youngstown, Ohio; four U.S. Info Agency Embassy bldgs., Africa. **Comments:** Preferred media: gouache, tempera, oils. Publications: illustrator, "The Alluring Avocado," 1966. **Sources:** WW73.

SHIMONSKY See: **SCHIMONSKY, Stanislas**

SHIMOTORI, Show *[Painter] early 20th c.* **Addresses:** NYC. **Exhibited:** AIC, 1918. **Sources:** WW19.

SHINDELMAN, H. M. *[Painter] mid 20th c.* **Addresses:** NYC. **Exhibited:** S. Indp. A., 1932. **Sources:** Marlor, *Soc. Indp. Artists.*

SHINDER, Antonion Zeno See: **SHINDLER, Antonion Zeno**

SHINDLEMAN, H. E. *[Painter] mid 20th c.* **Exhibited:** Salons of Am., 1934. **Sources:** Marlor, *Salons of Am.*

SHINDLER, Antonion Zeno *[Painter of pastel portraits and landscapes; teacher; photographer] b.c.1813, Germany / d.1899, Wash., DC.*
Studied: Paris, France. **Exhibited:** PAFA, 1852-63 (pastel portraits and scenes of Paris and London, as well as Pennsylvania, New Hampshire and Virginia.). **Work:** NMAA; BMFA; Atwater Kent Mus.; Denver (CO) Public Library. **Comments:** Around 1845, Shindler joined the party of ethnologist William Blackmore on an expedition to the Indian country in the U.S., where he painted Indian life. In the 1850s he settled in Phila., where he taught drawing and was a portrait draftsman. He moved to Wash., DC, around 1858, where he photographed Indians visiting the city and copied pictures and drawings from Army officers and Indian agents. He was in Chicago, when most of his possessions were destroyed by the fire of 1871. He was back in Phila. during the 1870s, and in Wash., DC in 1876, where he spent most of the rest of his life working as an artist at the Smithsonian Inst. Stokes credits to him a view of Reading (PA) of about 1834. **Sources:** G&W; Rutledge, PA; Phila. CD 1853-60+; *Panorama* (Aug. 1946), 10; Stokes, *Historical Prints;* 7 Census (1850), Pa., LIII, 217. More recently, see Campbell, *New Hampshire Scenery,* 149; McMahan, *Artists of Washington DC,*.

SHINDLER, Evelyn Kroll *[Painter] mid 20th c.; b.Boston, MA.* **Addresses:** Boston, MA; Rockport, MA. **Studied:** Mass. School of Art; BMFA; with A. Hibbard, Robert Brackman. **Member:** Boston AC; Rockport AA; Cape Cod AA; AEA; Grand Central Art Gallery, NYC. **Exhibited:** Speed Memorial Mus., Louisville, KY; Rockport AA, 1950 (prizes). **Sources:** *Artists of the Rockport Art Association* (1946,1956).

SHINDLER, William H. *[Illustrator] 19th/20th c.* **Addresses:** NYC. **Sources:** WW01.

SHINER, Nate *[Painter, educator] b.1944, Vallejo, CA.* **Addresses:** Sacramento, CA. **Studied:** Napa College, A.A.; Sacramento State College (B.A. & M.A.). **Exhibited:** San Francisco Art Inst. Centennial, SFMA, 1971; Contemporary Painting in America, WMAA, 1972; Sacramento Sampler, Oakland (CA) Art Mus., 1972; Invitational (traveling exhib.), Sao Paulo, Buenos Aires, Brazilia Porto Alegre, E.B. Crocker Art Gal., CA, 1972; Candy Store Art Gal., Folsom, CA, 1970s. **Comments:** Preferred media: acrylics. Teaching: drawing instructor, Sacramento State College, 1970-71; instructor of drawing & painting, Sacramento City College, 1971-on. **Sources:** WW73.

SHINN, Alice R. *[Painter, teacher] early 20th c.* **Addresses:** Active in Colorado Springs, CO, 1900-13; NYC, after 1913. **Studied:** with Chase; PAFA. **Exhibited:** Colorado College, 1900; S. Indp. A., 1917, 1935. **Sources:** Petteys, *Dictionary of Women Artists.*

SHINN, Elizabeth Stanley See: **HASELTINE, Elizabeth Stanley Shinn (Mrs.)**

SHINN, Everett *[Painter, illustrator, muralsit, designer, writer, decorator] b.1876, Woodstown, NJ / d.1953.* *EVERETT SHINN* **Addresses:** NYC (1897-on)/Westport, CT (1920s-30s). **Studied:** PAFA, 1893-97; Spring Garden Inst., Phila; Paris; London. **Member:** Cornish (NH) Colony; The Eight; ANA, 1935; NA, 1943. **Exhibited:** PAFA Ann., 1899-1908, 1944; Boston AC, 1901-07; Corcoran Gal biennials, 1907-49 (6 times); MacBeth Gal., 1908 (as a member of the Eight);The Exh. of Indep. Artists, NYC, 1910; Charleston Expo (medal); AIC, 1939 (medal); WMAA, 1945; "The Ashcan Artists and Their New York," NMAA, 1995. **Work:** AIC; WMAA; BM; Detroit Inst. Art; PMG; MMA; BMFA; Albright-Knox AG, Buffalo, NY; New Britain (CT) Mus. Art; Phillips Gal., Wash. DC; mural on industrial themes, Council Chamber, City Hall, Trenton, NJ; interior, Belasco Theatre, NYC. **Comments:** Shinn met Robert Henri and other future members of "The Eight" (or the "Ashcan School") while working as a reporter-artist for the *Philadelphia Press* Although he did paint some urban slum Ashcan subjects, he was far more interested in theatrical subjects and in these images celebrates the excitement of the spectacle. About 1899 he began a series of murals and designs for private houses and in 1907 painted eighteen panels for the Stuyvesant Theater. Shinn's involvement with in the theater was extensive, and from 1917-23, he worked as art director for Metro-Goldwyn-Mayer and other studios. He was also an impresario who wrote, produced, and created scene designs for plays held at his own 55-seat theatre in his NYC home. Although he met little success as a playwright, his best known play was "More Sinned Against than Usual." Shinn continued his illustration work throughout his career, illustrating 28 books as well as 94 stories in *Harper's, Delineator, McClure's,* and other magazines. A brash and often flamboyant character, he went through a series of marriages and divorces. **Sources:** WW53; WW47; *Community of Artists,* 59; *300 Years of American Art,* 729; Baigell, *Dictionary;* Sylvia Yount, "Consuming Drama: Everett Shinn and the Spectacular City," *American Art* (Fall 1992); William Innes Homer, *Robert Henri & His Circle* (1969); Bennard B. Perlman, *The Immortal Eight: American Painting from Eakins to the Armory Show, 1870-1913* (New York, 1962); Mecklenburg, Zurier, and Snyder, *Metropolitan Lives: the Ashcan Artists and their New York;* Falk, *Exh. Record Series.*

SHINN, Florence ("Flossie") Scovel (Mrs. Everett) *Florence Scovel Shinn* *[Illustrator, writer] b.1869, Camden, NJ / d.1940.* **Addresses:** NYC. **Studied:** PAFA. **Exhibited:** PAFA Ann., 1901, 1903; AIC, 1906. **Work:** LOC. **Comments:** During her marriage to Everett Shinn (his mercurial temper resulted in four divorces), she illustrated *Lovey Mary, Mrs. Wiggs of the Cabbage Patch,* and *Coniston.* After her divorce in the early 1920s she never returned to illustration, but wrote several popular books: *The Game of Life and How to Play It* (1925), *Your Word is Your Wand* (1928), and *The Secret Door to Success* (1940). **Sources:** WW21; Falk, *Exh. Record Series.*

SHINN, John M. *[Painter] mid 20th c.* **Addresses:** Mt. Vernon, NY. **Exhibited:** S. Indp. A., 1928, 1932-33. **Sources:** Marlor, *Soc. Indp. Artists.*

SHIPLEY, Annie Barrows See: **SHEPLEY, Annie Barrows**

SHIPLEY, George Alfred *[Painter, illustrator] b.1872.* **Addresses:** NYC, Flatbush, NY. **Studied:** ASL. **Exhibited:** PAFA

Ann., 1901. **Sources:** WW08; Falk, *Exh. Record Series.*

SHIPLEY, Henry H. *[Engraver] b.c.1830, New York.*
Addresses: Cincinnati, active 1850 to after 1860. **Comments:** He was associated with his brother William Shipley and in 1853 with George K. Stillman (see entries). **Sources:** G&W; 8 Census (1860), Ohio, XXV, 244; Cincinnati BD 1850--56, CD 1853-59.

SHIPLEY, James R. *[Educator, designer] b.1910, Marion, OH / d.1990.*
Addresses: Champaign, IL. **Studied:** Cleveland Inst. Art (diploma, 1935), with Viktor Schreckengost; Western Reserve Univ. (B.S., 1936); Univ. Southern Calif.; Inst. Design, Chicago; Univ. Illinois (A.M., 1948). **Member:** Nat. Assn. Schools Art (vice-pres., 1960-61; pres, 1961-63); Midwest College AA (vice-pres., 1960-61; pres., 1961-62; chmn. accreditation committee, 1963-70); Indust. Designers Soc. Am. (educ. committee, 1965-70); Advisory Panel Visual Arts, Illinois Arts Council. **Exhibited:** May Show, Cleveland Mus. Art, 1935; Michigan Artists Ann., Detroit IA, 1937. Awards: Univ. Illinois Research Board grant, visual pollution, 1970-72. **Comments:** Positions: commercial artist, J.H. Maish Advertising Agency, Marion, OH, 1929-31; designer, Gen. Motors Corp., Detroit, 1936-38; free lance designer & art director, various Midwestern firms, 1944-. Publications: author, "Programs in Art in the State Universities," *Print,* 1-2/1960; author, "Interior Design," Small Homes Council, revised edition, 1969; co-author, "The New Artist," *Contemporary American Painting and Sculpture 1969,* Univ. Illinois Press, 1969; contributor, "Graduate Education in the Humanities and the Arts," State Illinois Board Higher Educ., 1970. Teaching: art professor & head dept. art & design, Univ. Illinois, Champaign, 1939-; instructor of product design, Inst. Design, Chicago, summer 1948; acad. director design, Advanced Studies for Designers, Inst. Contemporary Art, Boston, MA, summer 1958. **Sources:** WW73.

SHIPLEY, William *[Engraver] mid 19th c.*
Addresses: Cincinnati, 1853-60. **Comments:** Associated with his brother Henry (see entry). **Sources:** G&W; Cincinnati CD 1853-60.

SHIPLEY & STILLMAN *[Wood engravers] mid 19th c.*
Addresses: Cincinnati, 1853. **Comments:** Henry H. and William Shipley and George K. Stillman. **Sources:** G&W; Ohio BD 1853; Cincinnati CD 1853.

SHIPMAN, Mary P. *[Painter, teacher] d.1932, Wash., DC.*
Addresses: Wash., DC, active 1905-32. **Member:** Wash. AC; Wash. Soc. FA. **Sources:** McMahan, *Artists of Washington DC,.*

SHIPPEN, Zoe (Mrs. Eugene Jewett) *[Painter] b.1902.*
Addresses: Hartford, CT. **Studied:** L.P. Thompson; P. Hale; BMFA Sch.; W. Hazelton; J.P. Wicker; Sch. FA, Detroit. **Comments:** Specialty: red chalk and oil portraits. **Sources:** WW31.

SHIPPER, Nicholas L. *[Engraver] mid 19th c.*
Addresses: NYC, 1848-58. **Sources:** G&W; NYBD 1848-58.

SHIPS, Nicholas *[Lithographer] b.1830, Pennsylvania.*
Addresses: Philadelphia, 1860. **Comments:** He was boarding in Philadelphia in the same house as Francis Devannie, sculptor, Charles Schilcocks and Adolphe Laborn, lithographers (see entries). **Sources:** G&W; 8 Census (1860), Pa., LII, 432.

SHIRAS, George E. *[Painter] early 20th c.*
Addresses: Los Gatos, CA. **Member:** Cleveland SA. **Exhibited:** S. Indp. A., 1917. **Sources:** WW27.

SHIRAS, O. C. *[Painter] 20th c.*
Addresses: Cleveland OH/ Chicago IL. **Member:** Cleveland SA. **Sources:** WW27.

SHIRE, Mildred *[Painter] b.1907, NYC.*
Addresses: NYC. **Studied:** Nat. Acad.; ASL. **Member:** MacDowell College; Silvermine Artists Gld.; Am. Artists Congress. **Exhibited:** Salons of Am., 1934, 1936; Am. Artists Congress, 1938-39; Am. FA Soc., 1938; Currier Gal., Manchester, NH. **Sources:** WW40.

SHIREFFE, Mattie *[Artist] late 19th c.*
Addresses: Active in Chesaning, MI, 1899. **Sources:** Petteys, *Dictionary of Women Artists.*

SHIRK, Jeannette C(ampbell) *[Illustrator, writer] b.1898, Middletown, PA.*
Addresses: Glenshaw, PA. **Studied:** E.F. Savage; C.J. Taylor; G. Sotter; College FA, CI. **Member:** Pittsburgh AA. **Exhibited:** Pittsburgh AA, 1927 (prize). **Comments:** Author: "Bela the Juggler," 1936 Illustrator: "The Concert"; Millie Ruth Turner's books of nature verses. **Sources:** WW40.

SHIRLAW, Walter *[Genre, mural, and portrait painter, illustrator, teacher, and banknote engraver] b.1838, Paisley, Scotland / d.1909, Madrid, Spain.*
Addresses: Grew up in Hoboken, NJ; NYC; Chicago; 1865-70; Munich, 1870-77; NYC, 1877-on. **Studied:** apprenticed in the early 1850s to a banknote engraver; Munich, Germany,1870-77, painting and drawing with Raab, Wagner, Ramberg, Lindenschmidt. **Member:** NA, 1888; SAA (founder/first pres., 1875); SC, 1879; Century Assn.; AWCS; Mural Painters; Artists Aid Soc.; AIC (founder), 1868. **Exhibited:** Royal Acad., Munich (medal); PAFA Ann., 1861-1905 (12 times); Centennial Expo, Phila., 1876 (medal); NAD, 1861-99, 1903-10 (prize, 1895); Boston AC, 1876-1906; Brooklyn AA, 1877-80, 1885, 1892, 1912; NY Etching Club, 1883; AIC, 1888-1908; Paris Expo, 1889 (prize); Worlds Columbian Expo., 1893 (also decorated one of the domes of the Liberal Art sBldg.); Pan-Am. Expo, Buffalo, 1901 (medal); St. Louis Expo, 1904 (medal); Corcoran Gal annuals, 1907-08; after his death, memorial exhibitions were held in Chicago, New York, Buffalo, St. Louis, and Washington, DC. **Work:** BMFA; NMAA; LOC (ceiling); MMA; AIC; St. Louis AM, Albright-Knox AG, Buffalo; Indianapolis MA. **Comments:** Began as a banknote engraver and after several years took up painting, although he continued to support himself through his engraving. From 1865 to 1870, he worked for the Western Bank Note and Engraving Company of Chicago, during which time he was also active in the founding of the Art Institute of Chicago. In 1869, he sketched in the Rockies for six months, going abroad the following year to study art. Around 1877, he returned to NYC, where he painted figural groups, primarily rural scenes and landscapes with animals, and also exelled as a muralist. In addition he worked as a magazine illustrator (for *Century* and *Harper's Monthly*), designed of stained glass windows, and was an influential teacher at the ASL. In 1889 he was among the five artists sent to take the census of American Indians on the Crow and Cheyenne reservations; his text along with color reproductions of his paintings was included in the report *Indians Taxed* (1890). **Sources:** G&W; WW08; DAB; Dreier, "Walter Shirlaw," with 5 repros.; *N.Y. Times,* Dec. 30, 1909; *Art Annual,* VIII, obit.; Baigell, *Dictionary;* P & H Samuels, 440; *American Painter-Etcher Movement* 46; Falk, *Exh. Record Series.*

SHIRLEY, Alfaretta Donkersloat *[Craftsman, sculptor, teacher] b.1891, New Jersey.*
Addresses: Short Hills, NJ. **Studied:** NY School Fine & Applied Art; Parsons School Design; Columbia Univ. (B.S., M.A.); Alfred Univ., with Charles F. Binns. **Member:** CAA; NY Ceramic Soc.; Nat. Assn. Art Educ.; AAUW; Artist-Craftsmen of NY; Millburn-Short Hills AC; Nat. Educ. Assn.; New Jersey Educ. Assn.; Newark AC. **Exhibited:** Syracuse Mus. FA; Arch. Lg.; Montclair Art Mus.; Newark Mus.; NY Ceramic Soc. traveling exhib.; Rutgers Univ.; Millburn-Short Hills AC. **Comments:** Position: ceramics instructor, Newark School Fine & Indust. Art, 1921-34; instructor of art & art history, Barringer H.S., Newark, NJ, 1935-56; Parsonage Hills Studio, 1956-. **Sources:** WW59; WW47.

SHIRLEY, Cephas P. *[Teacher] early 20th c.*
Comments: Position: director, Newark Sch. Fine & Indust. Arts, 1910-19. **Sources:** exh. cat.; *80th Anniv., Newark Sch. Fine & Indust. Art* (1963).

SHIRLEY, Gerald N. *[Painter] mid 20th c.*
Addresses: Cedar Falls, IA. **Exhibited:** PAFA Ann., 1960.
Sources: Falk, *Exh. Record Series.*

SHIRMER, George P. *[Painter] mid 20th c.*
Exhibited: Salons of Am., 1934. **Sources:** Marlor, *Salons of Am.*

SHIRVINGTON, J. *[Miniature portraits in water colors] mid*
19th c.
Addresses: Charlottesville, VA, c.1840. **Sources:** G&W; Lipman and Winchester, 180.

SHISLER, Clare Shepard *[Miniature painter] b.1884,*
Seattle, WA (?) / d.1985, Reno, NV.
Addresses: Seattle, WA; Pasadena, CA; San Anselmo, CA.
Studied: C. Vanatta; L. Pettingill; PAFA. **Member:** Calif. SMP; Penn. SMP; West Coast Arts, Inc. **Exhibited:** Washington State Arts & Crafts, Seattle, 1908; Yukon-Pacific Expo, 1909 (medal); Pan-Pac. Expo, San Francisco, 1915 (medal); Seattle FAS, 1913 (prize); West Coast Arts, Inc., 1923 (prize); Calif. SMP, 1929 (prize); GGE, 1939; SAM; AIC. **Sources:** WW29; WW15.

SHIVA, R(amon) *[Painter, lecturer] b.1893, Santander, Spain.*
Addresses: Santa Fe, NM. **Studied:** AIC. **Exhibited:** AIC, 1921 (prize), 1923 (prize). **Comments:** Manufacturer: Shiva Artist Oil Colors. **Sources:** WW40.

SHIVELY, Douglas *[Landscape painter] b.1896, Santa Paula,*
CA.
Addresses: Santa Paula, CA. **Studied:** Occidental College, Los Angeles; Univ. California (B.A.). **Member:** Calif. AC; Buenaventura AA; Santa Paula AA. **Exhibited:** Eisteddfod, Oxnard, CA, 1930-32 (prize); Santa Cruz AL, 1935 (prize); Calif. AC (solo); Ojai Art Center, 1954 (solo). **Work:** Santa Paula City Hall and various county hospitals and libraries. **Comments:** A bank president, rancher and artist. He took many sketching trips in Southern California with other artists like John Cotton (see entry), George Demont (see entry) and others. He also took painting trips to Asia and Europe. **Sources:** WW53; WW47. More recently, see Hughes, *Artists in California,* 512.

SHIVELY, Hazel Z. *[Painter, teacher] early 20th c.*
Addresses: Los Angeles, 1921-30. **Comments:** Teaching: Southwest College Music & Art, Los Angeles. **Sources:** Petteys, *Dictionary of Women Artists.*

SHIVELY, Paul *[Painter] mid 20th c.*
Addresses: NYC. **Member:** AWCS. **Exhibited:** AIC, 1931, 1934. **Sources:** WW59; WW47.

SHIYUMEN, Ota *[Painter] mid 20th c.*
Exhibited: AIC, 1931. **Sources:** Falk, *AIC.*

SHKURKIN, Vladimir Pavlovich *[Landscape painter, mural*
painter] b.1900, Northern China / d.1985, Vallejo, CA.
Addresses: Seattle, WA; San Francisco, CA; Vallejo, CA.
Studied: School of Fine Art, Kiev, 1917-22. **Member:** Soc. of Western Artists; Artist League of Vallejo; Diablo AA; Oakland AA; El Cerrito AA; Sonoma Art Center. **Work:** murals: Mare Island Officers Club; Vallejo City Hall; Vallejo Maritime Mus.; St. John's Church, Berkeley; Russian Orthodox Church, Bryte, CA; Vallejo Home State Park. **Comments:** He immigrated to America in 1925. Position: artist, Mare Island Naval Shipyard. **Sources:** Hughes, *Artists in California,* 512.

SHNYDORE, Ignatius *[Painter in all its branches] late 18th*
c.
Addresses: NYC, active 1788-94. **Comments:** In June 1788 Shnydore advertised in NYC that he had resigned as scene painter to the Old American Company of Comedians, desired to become a citizen, and offered his services in every variety of painting, gilding, and glazing. **Sources:** G&W; Gottesman, *Arts and Crafts in New York,* II, no. 1150; NYCD 1790-94 (Mc-Kay).

SHOBAH WOONHON See: **TOLEDO, José Rey**

SHOBER, Charles *[Lithographer] late 19th c.*
Addresses: Philadelphia, 1856-57; Chicago, active c.1858-83.

Comments: In 1857-58 his partner was Charles Reen (see entry); after 1860 he and one Carqueville formed the Chicago Lithographic Company which flourished until it was burned out in 1883. **Sources:** G&W; Phila. CD 1856-57; Chicago CD 1858-59; Peters, *America on Stone;* Arrington, "Nauvoo Temple," Chap. 8.

SHOBERT, Alonzo *[Lithographer] mid 19th c.*
Comments: Lithographer of an illlustration in *The Horticulturalist,* V (1855), probably at Philadelphia. **Sources:** G&W; Peters, *America on Stone.*

SHOCKLEIDGE, R. *[Portrait painter] mid 19th c.*
Addresses: Connecticut, active 1856. **Sources:** G&W; Information from signed and dated portrait, courtesy Thomas D. Williams, Litchfield (CT).

SHOCKLEY, May Bradford *[Painter] b.1879, Moberly, MO*
/ d.1977, Palo Alto, CA.
Addresses: Nevada, Palo Alto, CA. **Studied:** Stanford Univ., with Bolton Brown; Paris, with Richard Miller. **Member:** Palo Alto AC (charter member). **Exhibited:** S. Indp. A., 1924-25. **Comments:** Position: U.S. Deputy Mineral Surveyor, NV (first woman in that post). Specialty: landscapes of the Santa Clara Valley. **Sources:** Hughes, *Artists in California,* 512.

SHOEFT, Mary Fraser Wesse *[Painter] early 20th c.*
Exhibited: Salons of Am., 1923. **Sources:** Marlor, *Salons of Am.*

SHOEMAKER, Andrew *[Engraver] b.c.1828, Bavaria,*
Germany.
Addresses: Philadelphia in 1860. **Comments:** He, his wife, and one child aged 9 were born in Bavaria; two younger children were born in Pennsylvania. **Sources:** G&W; 8 Census (1860), Pa., LV, 477.

SHOEMAKER, Ann Green (Mrs.) *[Painter] 20th c.*
Addresses: Doylestown, PA. **Studied:** PAFA. **Sources:** WW25.

SHOEMAKER, Edna See: **COOKE, Edna Shoemaker**
(Mrs.)

SHOEMAKER, Gottlieb *[Lithographer] b.c.1820, Germany.*
Addresses: Philadelphia, active 1850. **Comments:** Lived with his German wife and three children (under 7 years) born in Pennsylvania. **Sources:** G&W; 7 Census (1850), Pa., XLIX, 1073; Phila. CD 1850-52.

SHOEMAKER, John W. *[Painter] mid 20th c.*
Exhibited: S. Indp. A., 1936. **Sources:** Marlor, *Soc. Indp. Artists.*

SHOEMAKER, Mary A. *[Painter] late 19th c.*
Addresses: NYC. **Exhibited:** PAFA Ann., 1884. **Sources:** Falk, *Exh. Record Series.*

SHOEMAKER, Peter *[Painter, educator] b.1920, Newport,*
RI.
Addresses: Berkeley, CA. **Studied:** Calif. School Fine Arts, San Francisco with Clyfford Still, Caly Spohn & Elmer Bischoff, 1947-50; UC Berkeley (B.A., 1951). **Member:** San Francisco Art Inst. **Exhibited:** III Biennial, Sao Paulo, Brazil, 1955; Corcoran Gal biennial, 1957; Pacemakers, Contemporary Arts Mus., Houston, 1957; Carnegie Intl, 1958; "Painters Behind Painters," CPLH, 1967; John Bolles Gal, San Francisco, 1970s. **Work:** CPLH; Richmond(CA) Art Center; Oakland (CA) Mus. **Comments:** Teaching: Calif. College Arts & Crafts, Oakland, 1960-. **Sources:** WW73; Mary Fuller, "Was There a San Francisco School?," *Artforum* (January, 1971).

SHOEMAKER, Vaughn
Richard *[Editorial cartoon-*
ist, painter, teacher] b.1902,
Chicago, IL.
Addresses: Carmel, CA. **Studied:** Chicago Acad. Fine Arts.
Member: Palette & Chisel (hon. mem.); Ridge AA, Chicago (hon. mem.). **Exhibited:** O'Brien Galleries, Chicago, 1935 & 1936; Marshall Field Galleries, Chicago, 1938, 1946. **Awards:** Pulitzer Prizes, Columbia Univ, 1938 &1947; Headliners Award, Atlantic City, 1943; National Safety Council Award, 1945. **Work:**

Huntington Library, San Marino, CA; Syracuse (NY) Univ.; Del Mesa Carmel, CA. **Comments:** Positions: cartoonist, *Chicago Daily News*, 1922-25; chief editorial cartoonist, 1925-52; editorial cartoonist, *New York Herald Tribune*, 1956-61; chief editorial cartoonist,*Chicago Am.-Chicago Today*, 1961-. Publications: author, '38 AD, '39 AD, '40 AD, 1941-42 AD & 1943-44 AD. Teaching: instructor, editorial cartooning, Chicago Acad. Fine Arts, 1927-42; instructor, editorial cartooning, Studio School Art, Chicago, 1943-45. **Sources:** WW73; WW47; Gerald W. Johnson, *The Lines are Drawn* (Lippincott, 1958).

SHOEMAKER, W. I. *[Painter] late 19th c.*
Addresses: Phila., PA. **Exhibited:** PAFA Ann., 1881. **Sources:** Falk, *Exh. Record Series*.

SHOENFELT, Joseph Franklin *[Painter, craftsperson, educator, writer, teacher] b.1918, Everett, PA / d.1968.*
Addresses: Oswego, NY. **Studied:** State College, Indiana, PA (B.S., art educ.); Teachers College, Columbia Univ. (M.A.); grad. study, Syracuse Univ., and School for Am. Craftsmen, Rochester, NY; Univ. Guanajuato, Mexico (M.F.A.). **Member:** AFA; NAEA; CAA; Am. Craftsmen's Council; World Crafts Council; York State Craftsmen; Syracuse Univ. Art Faculty. **Exhibited:** Harrisburg AA, 1941; All. Artists Johnstown; Finger Lakes Exhib., 1953, 1962-64; NY State Fair, 1953, 1954, 1960; NY State Craftsman, 1960-65; San Miguel de Allende, Mexico, 1958; Erie, PA, 1963; Oswego AC, 1964. **Work:** mural, State College, Indiana, PA; metal sc., Lydia Penfield Library, Oswego, NY. **Comments:** Position: assoc. professor of art, State Univ. of New York, Oswego, NY; guest instructor, San Miguel de Allende, 1958; board dirs., York State Craftsmen; pres., Oswego Art Gld.; consultant, NY State Council on the Arts. Author: "Designing and Making Hand-Wrought Jewelry," 1960, paperback edition, 1963. **Sources:** WW66; WW47.

SHOESMITH, Mark *[Sculptor] b.1912, Payette, ID.*
Addresses: Alamogordo, NM. **Studied:** Univ. Oregon (B.A.) and grad. study in sculpture with Oliver Barrett; Master Inst. of United Artists, with Louis Slobodkin; Teachers College, Columbia Univ. (M.A.), and with Maldarelli, Archipenko. **Exhibited:** Nat. Exhib., NY, 1938; Arch. Lg., 1941; Mus. New Mexico, Santa Fe, 1954, 1955. **Work:** Hyde Park Mus.; busts, plaques, statues, Oregon State School for the Blind; Ripley Odditorium; Albertina Kerr Nursery Home, Portland, OR; Presidential Palace, Buenos Aires, Argentina; Royal Canadian Golf Assn., Toronto. **Comments:** Position: art teacher, NY Inst. for the Blind, 1938-44; manager, dept. for blind, Goodwill Industries, Dayton, OH, 1944-48; manager, New Mexico Industries for the Blind, div. New Mexico School for Visually Handicapped, 1948-. **Sources:** WW59.

SHOKLER, Harry *[Painter, serigrapher, lecturer, writer, educator] b.1896, Cincinnati, OH / d.1978, Hanover, NH.*
Addresses: NYC, Brooklyn, NY; Londonderry, VT. **Studied:** Cincinnati Art Acad.; PAFA, summer; New York School Fine & Applied Arts; Acad.Colarossi, Paris; H. Wessel; D. Garber; H. Giles. **Member:** Nat. Ser. Soc.; Am. Color Pr. Soc.; Artists Lg. Am; Southern Vermont Artists (art committee & trustee, 1971); Miller Art Center; Chaffee Art Mus.; Chester Art Guild; West River Artists. **Exhibited:** S. Indp. A., 1926; Paris Salon, 1928; PAFA Ann., 1930, 1936; NAD, 1943-46; LOC, 1944, 1945; SFMA, 1945; Northwest Printmakers, 1944-45; Southern Vermont Artists; Dayton Art Inst.; Chaffee Art Mus., 1969 (Award for Pigeon Cove); Albany Print Biennial (award for Tunisian Coffee House); Miller Art Center (award for West River in March); "NYC WPA Art" at Parsons School Design, 1977; Grand Central Art Galleries, NYC, 1970s. **Work:** MMA; PMA; CI; Syracuse (NY) Mus.; Newark Mus.; Munson-Williams-Proctor Inst.; Cincinnati Public Library; Princeton Print Club; LOC. **Comments:** WPA artist. Preferred media: oils. Publications: author,"Artists Manual for Silk Screen Printmaking," 1946. Teaching: teacher, BM School, Brooklyn; lecturer, serigraphy, Princeton Univ.; Columbia Univ. , 1941-45; instructor of oil painting, Southern Vermont Artists. **Sources:** WW73; WW47; *New York City WPA Art*, 78 (w/repros.); Falk, *Exh. Record Series*.

SHOKLER, Morris *[Painter] 20th c.*
Addresses: Cincinnati, OH. **Sources:** WW24.

SHOLL, Anna McClure *[Painter, writer] b.c.1868, Philadelphia, PA / d.1956, NYC.*
Addresses: NYC. **Studied:** mainly self-taught; Cornell Univ. **Member:** NAC. **Exhibited:** NAC, annually; Staten Island Inst. Art & Sciences; New York (solo). **Comments:** Author/editor: "Blue Blood and Red" (1915), "Fairy Tales of Weir" (1918), "Ancient Journey." Co-editor: Success Library series. Contributor: national magazines. **Sources:** WW53; WW47.

SHOLL, Elizabeth L. *[Artist] mid 20th c.*
Addresses: Wash., DC, active 1922-28. **Sources:** McMahan, *Artists of Washington DC*.

SHONBORN, Lewis J. *[Painter] late 19th c.; b.Nemora, IA.*
Addresses: Paris, France. **Studied:** Bonnât and Crauk, in Paris. **Exhibited:** Paris Salon, 1877, 1879-81, 1883, 1885-87, 1890, 1894, 1899. **Sources:** WW08; Fink, *American Art at the Nineteenth-Century Paris Salons*, 390.

SHONNARD, Eugenie Frederica *[Painter, sculptor, craftsman] b.1886, Yonkers, NY / d.1978, Santa Fe, NM.*
Addresses: NYC; Santa Fe, NM in 1927. **Studied:** New York School Applied Design for Women, with Alphonse Mucha; ASL, with James Earl Fraiser; also with Auguste Rodin & Emile Bourdelle, Paris, France. **Member:** Taos AA; Fellow, NSS; Salon d'Automne, Salon Nationale des Beaux-Arts, Paris. **Exhibited:** PAFA Ann., 1916-17, 1920, 1936; Paris, France, 1926 (solo); Mus. New Mexico, 1927, 1937, 1954 (retrospective); AIC; MoMA, 1933; Salons of Am., 1934; WFNY 1939; WMAA,1940-41; BM; New Mexico State Fair, 1940 (grand prize),1941 (first prize); New Mexico Artists, 1956-58; Arch. League; School Am. Res. & Mus. New Mexico, 1954 (hon. fellowship in fine arts). **Work:** Brittany Peasant (bronze head), MMA; IBM Coll.; Mus. Guethary, France; Luxembourg Mus., Paris; Jardin des Plantes, Paris; CMA; Colorado Springs (CO) Fine Arts Center; Tingley Hospital for Crippled Children, Hot Springs, NM; Mus. New Mexico, Santa Fe. Commissions: decorative wooden panels for U.S. Treasury Dept., Waco, TX; decoration in terra-cotta for Ruth Hanna Memorial Wing, Presbyterian Hospital, Albuquerque, NM; chapel in wood, Mrs. Frederick M.P. Taylor, Black Forest, CO; Miguel Chavez (portrait bust in bronze), St. Michael's Col., Santa Fe, NM; Chief Justice Charles Rufus Brice (portrait plaque in bronze), Supreme Court Building, Santa Fe; Sandia Sch., Albuquerque, NM; statue, St. Francis, Denver, CO; St. Andrews Episcopal Church, Las Cruces, NM; Brookgreen Gardens, SC; Catholic Seminary, Santa Fe. **Comments:** Worked in a variety of materials, modeled and carved. Specialties: Pueblo Indians, designs and carves furniture, doors, bird cages executed in iron. Also appears as Mrs. Gordon Ludlam. **Sources:** WW73; WW47; P&H Samuels, 440; Fort, *The Figure in American Sculpture*, 223-24 (w/repro.); Falk, *Exh. Record Series*.

SHONTZ, Janet *[Painter] 20th c.*
Addresses: Erdenheim, PA. **Sources:** WW19.

SHOOK, Anna Nott *[Painter] mid 20th c.*
Addresses: NYC. **Exhibited:** S. Indp. A., 1930. **Sources:** Marlor, *Soc. Indp. Artists*.

SHOOK, Georg E. *[Painter] b.1932, Charleston, MS.*
Addresses: Memphis, TN. **Studied:** Orange Vocational College, Orlando, FL; Univ. Florida; Ringling Inst. Art, Sarasota, FL. **Member:** Art Dirs. Club Memphis (pres., 1970-72); Memphis WCS (co-founder & director, 1969-); Tennessee WCS (pres., 1971-72); Artist's Registry, Brooks Mem. Art Gal. **Exhibited:** 9th-11th Tennessee All-State Artists Ann., Nashville, 1969-71; 14th-16th Mid-South Ann., Brooks Art Gallery, Memphis, 1969-71; Watercolor USA, Springfield Art Mus., 1971 & 1972; 7th Cent South Ann., Parthenon Galleries, Nashville, 1972; 105th AWCS Ann., NYC, 1972. Awards: Ellen J. Martin Purchase Award, 1971 & purchase award, 1972, Watercolor USA, Springfield; Southern Postcard Co. Watercolor Award, Central South Exhib., Nashville,

1972; Little Art Shop Award, Tennessee WCS First Ann., 1972. **Work:** Ellen J. Martin Collection, Springfield, MO; City of Springfield Collection & Watercolor USA Collection, Springfield Art Mus.; Artist's Registry, Brooks Mem. Art Gallery, Memphis, TN. **Comments:** Preferred media: watercolors. Positions: art director, Memphis Publ. Co., 1961-. **Sources:** WW73.

SHOOK, Janet (Mrs. Phil) *[Painter, teacher, craftsperson] b.1912, Austin, TX.*
Addresses: San Antonio, TX. **Studied:** Incarnate Word College, and with Hugo Pohl, Dan Lutz, Alice Naylor. **Member:** Texas WCS. **Exhibited:** Audubon Artists; Texas General, 1946-48, 1950; Texas WCS, 1952, 1954; San Antonio Art Lg.; San Angelo Mus. Art; Frost Bros., San Antonio, 1955 (solo); Witte Mus. Art; La Villeta, San Antonio; Elisabet Ney Mus. Founder, Julian Onderdonk Mem. Fund (purchase prize fund for Texas artists). Awards: prizes, Texas FA Festival, Austin, 1953; Texas WCS, 1954; San Angelo Mus. Art, 1954. **Sources:** WW59.

SHOOKS, Andrew J. *[Painter] b.1848, Baltimore, MD / d.1912, Fairhaven, MA.*
Addresses: Active in Fairhaven, MA area, 1868-1912.
Comments: Enlisted in the navy at age 12. Served throughout the Civil War, until 1865. Was employed in various capacities but also considered himself an artist by profession. **Sources:** Blasdale, *Artists of New Bedford,* 168.

SHOPE, Henry B(rengle) *[Etcher, architect] b.1862, Baltimore, MD / d.1929, Bellevue, France.*
Addresses: Paris, France. **Studied:** ASL; Preissig; W.R. Ware; R.M. Hunt; Satterlee. **Member:** Arch. Lg.; Chicago SE; Brooklyn SE; Calif. PM. **Exhibited:** S. Indp. A., 1917. **Work:** etchings, NYPL; U.S. National Mus. **Sources:** WW27.

SHOPE, Irvin ("Shorty") *[Painter, illustrator, muralist] b.1900, Boulder, MT / d.1977.*
Addresses: Helena, MT, in 1976. **Studied:** degree in art & history, 1933; Grand Central School Art, with H. Dunn, 1935. **Member:** CAA, 1965-. **Exhibited:** locally, 1925-26. **Work:** USPO, Webster, SD; murals in banks and public buildings. **Comments:** Knew Paxson while in high school. Began easel painting–on Paxson's easel–parttime in 1942 and full time in 1946. Specialty: cowboy artist. WPA artist. Friend of C.M. Russell and Will James. **Sources:** WW40; P&H Samuels, 441.

SHOPEN, Kenneth *[Painter, educator] b.1902, Elgin, IL / d.1967, Norwich, VT.*
Addresses: Chicago, IL; Norwich, VT. **Studied:** Univ. Illinois (B.A.); AIC. **Member:** CAA. **Exhibited:** Corcoran Gal biennials, 1941-47 (3 times); PAFA; AIC; CI; VMFA. **Work:** Norton Gal. Art; Dartmouth College; Toledo Mus. Art; Chicago Public Library. **Comments:** Teaching: AIC, 1932-45; Chicago Latin School, 1940; Biarritz Am. Univ., France, 1945-46; Univ. Illinois, Chicago Circle, 1946-65. Art critic, *Chicago Daily News,* 1953-56. **Sources:** WW66; WW47.

SHORB, D. L. (Mrs.) *[Painter] late 19th c.*
Addresses: Active in Denver, CO, c.1881-82. **Sources:** Petteys, *Dictionary of Women Artists.*

SHORE, Clover Virginia *[Painter, educator] b.1906, Durango, TX.*
Addresses: Fort Worth, TX. **Studied:** Abilene Christian College (B.A.)O; George Peabody College (M.A.); Texas Woman's Univ.; Univ. Colorado, Boulder; also with Clyfford Still, Mark Rothko, Jacob G. Smith & Frederic Taubes. **Member:** Texas State Teachers Assn. (life mem.); Fort Worth AC; Texas Fine AA. **Exhibited:** Butler AI, 1956; Texas Fine Arts, Austin; Birmingham (AL) Mus. Fine Arts, 1960-62; Nat. Watercolor Show, Jackson (MS) Mus. Art, 1961; Local Artists, Fort Worth AC, 1964; Cross Galleries, Fort Worth, TX, 1970s. Awards: first place in graphics, West Texas Mus., Abilene, 1951; Texas Fine Arts citation awards, 1956 & 1964; Blanche McVeigh Print Award, 1964. **Work:** Science Bldg., Texas Christian Univ.; Central Mus., Utrecht, Netherlands; Fort Worth (TX) Osteopathic Hospital; Abilene

Christian College, Fort Worth Campus. **Comments:** Preferred media: oils, watercolors, graphics. Teaching: asst. professor art, Texas Christian Univ., 1946-48; lecturer, Univ. Texas, Arlington, 1957-58 & 1960-63; chmn. art dept., Abilene Christian College, Fort Worth Campus, 1968-on. **Sources:** WW73.

SHORE, Helen (or Helene) M. *[Painter] mid 20th c.*
Addresses: Elmhurst, LI, NY, 1930. **Exhibited:** S. Indp. A., 1930 (as Helen M. Shore), 1936 (as Helene Shore). **Sources:** Marlor, *Soc. Indp. Artists.*

SHORE, Henrietta Mary *[Painter, muralist, lithographer] b.1880, Toronto, Ontario / d.1963, San Jose, CA.*
Addresses: Los Angeles, from 1913; NYC, 1920-21; Los Angeles, CA, 1927-c.36; Carmel, CA, 1927-on. **Studied:** NY School Art, with Robert Henri, William Chase; ASL, with Kenneth Hayes Miller; Heatherly Art Sch., London, England (before 1913); Canada. **Member:** S. Indp. A.; Painters & Sculptors of Los Angeles (founder); Carmel AA; Los Angeles Modern Art Soc. (a founder); NY Soc. of Women Artists (founding mem.); Calif. WC Soc. **Exhibited:** Pan-Pacific Expo, 1914 (medal); 1915 (medal); LACMA, 1914, 1917, 1918 (joint exh. with Helena Dunlap), 1927; Pan-Amer. Expo., San Diego, 1915 (silver med.); San Francisco AA, 1916-19, 1931 (prize); S. Indp. A., 1917, 1919-25; San Diego FA Gallery, 1920s (solo); PAFA Ann., 1921; AIC, 1921; Kraushaar Gal., 1921 (solo); Salons of Am., 1922, 1925; Erhich Gal., 1923; WMA, 1923 (retrospective); San Francisco Soc. Women Artists, 1928 (prize); de Young Mem. Mus., 1933 (solo); Passedoit Gal., 1939 (solo); GGE, 1939; CAM; AIC; WMAA; Arch. Lg.; Minnesota State Fair; CPLH, 1928, 1931; Carmel Art Assoc., c. 1964 (posthumous exh.); London (solo); Paris (solo); Liverpool (solo); Ottowa Gallery, Canada; Monterey Peninsula Mus. of Art, 1986 (retrospective); Laguna Mus., 1987 (retrospective). **Work:** LOC; San Diego FA Soc.; Dallas Mus. FA; Univ. Wash.; Nat. Gal., Ottawa; WPA murals, USPOs, Santa Cruz, CA (1936-37), and Monterey, CA (1936-37); Custom House, Monterey. **Comments:** Precisionist-realist painter. At the beginning of her career, while in London, she became a friend of John Singer Sargent (see entry), whose influence can be seen in her early work. After moving from Los Angeles to NYC in1920 Shore gained recognition for her semi-abstract precisionist works, and along with Marguerite Zorach founded the avant-garde NY Soc. of Women Artists. Shore later visited Mexico where she painted portraits of Diego Rivera and Jean Charlot. In 1927 she moved back to Los Angeles where her paintings depicting large, close-up views of sea shells drew the attention of Edward Weston who was thus inspired to begin his well-known series of photographs of the same subject. **Sources:** WW53; WW47; Merle Armitage, Edward Weston, and Reginald Poland, *Henrietta Shore* (E. Wehye, 1933); Rubinstein, *American Women Artists,* 262-63; Jean Charlot, *Art from the Mayans to Walt Disney,* (1939; devotes a chapter to Shore); Hughes, *Artists in California,* 513; Trenton, ed. *Independent Spirits,* 75; Falk, *Exh. Record Series;.*

SHORE, Lilli Ann Killen *[Craftsman, educator] b.1924, Detroit, MI.*
Addresses: New York 25, NY. **Comments:** Position: head art dept., Henry Street Settlement, NYC. **Sources:** WW59.

SHORE, Mary *[Painter] b.1912, Philadelphia, PA.*
Addresses: Gloucester, MA. **Studied:** Cooper Union Art School, scholarship; AIC. **Member:** AEA (pres. Northeast Chapter). **Exhibited:** oils, Boris Mirski Gallery, Boston, 1964 (solo); constructions, masks, assemblage & collage, Philadelphia A. All., 1965 (solo); oils & watercolors, Hilliard Gal., Martha's Vineyard, MA, 1971; Fitchburg Art Mus., 1965 (solo); Pingree School Gal., Hamilton, MA, 1972 (solo). Awards: Blanche E. Colman Art Foundation Award, 1966. **Work:** Addison Gallery Am. Art, Andover, MA; Fitchburg (MA) Art Mus.; BMA. **Sources:** WW73.

SHORE, Richard Paul *[Sculptor] b.1943, Jersey City, NJ.*
Addresses: Tenafly, NJ. **Studied:** Marietta College (B.A., 1966); New School Soc. Res., NYC, 1966-67. **Member:** Mod. Arts

Guild; Painters & Sculptors Soc. NJ. **Exhibited:** Sculpture in the Park, Van Saun Park, Paramus, NJ, 1971; Audubon Artists Nat., NAD Galleries, 1971; Bergen Community Mus. Art, Paramus, 1972; Jersey City Mus., 1972; invited exhib., Greenwich, Conn, 1972. **Awards:** Saks Westchester Art Soc., 1971 (prize); Ellen A. Ross Mem. Prize, 1971 & Painters & Sculptors Soc. Prize, 1972, Jersey City Mus. Nat. Exhib.; Alonzo Gal., NYC & Kornbluth Gal., Fair Lawn, NJ, 1970s. **Work:** Storm King Art Center Mus. Art (on loan), Mountainville, NY; Aldrich Mus. Contemporary Art (on loan), Ridgefield, CT. **Comments:** Teaching: guest lecturer aesthetics, Caldwell College, 1970-71; faculty member, Art Center Northern NJ, 1972-. **Sources:** WW73.

SHORE, Robert *[Illustrator, painter] b.1924, NYC.*
Studied: Cranbrook Academy, Detroit; ASL; Fulbright Fellowship in painting, 1952. **Exhibited:** Detroit Inst. of FA; Smithsonian Inst.; National Gallery, Wash., DC; National Academy; Cornell Univ.; SI, 1967 (gold medal). **Comments:** Positions: teacher, Henry Street Settlement, Cooper Union, School of Visual Arts, NYC. Illustrator: *Esquire, Seventeen, The Reporter, Woman's Day,* and many other magazines; also book publishers and advertisers. **Sources:** W & R Reed, *The Illustrator in America,* 305.

SHORE, Robert (Mrs.) *[Artist] late 19th c.*
Exhibited: Michigan AA, 1879. **Sources:** Petteys, *Dictionary of Women Artists.*

SHORES, Franklin See: **SHORES, (James) Franklin**

SHORES, (James) Franklin *[Painter] b.1942, Hampton, VA.*
Addresses: Phila. **Studied:** PAFA (awards: Cresson European traveling scholarship & Eakins Figure Painting Prize, 1964). **Exhibited:** PAFA, 1967 & 1969; Phila. WCC Exhibs., 1968-72. **Work:** PAFA, Philadelphia. **Comments:** Preferred media: watercolors, oils. **Sources:** WW73.

SHOREY, George H. *[Painter, etcher, teacher] b.1870, Hoosick Falls, NY / d.1944, Schenectady, NY.*
Addresses: NYC, 1897; Grantwood, NJ; Burnt Hills, NY. **Studied:** W. Shirlaw; ASL. **Exhibited:** AIC, 1896; NAD, 1897; S. Indp. A., 1924. **Work:** soldiers bronze memorial tablet, Trinity Episcopal Church, Grantwood; Print Collection, LOC. **Comments:** Illustrator: *Cathedral of St. John the Divine, New York Parks, Old Kingston,* and other books. Position: teacher, Browning School, NY. **Sources:** WW40.

SHOREY, Mary F. Jones (Mrs. George H.) *[Sculptor, teacher] b.c.1865 / d.1944, Schenectady, NY.*

SHOREY, Maude Kennish *[Painter, teacher] b.1882, Rutland, ND.*
Addresses: Puyallup, WA. **Studied:** Central Wash. College, Ellensburg; art lessons in Bellingham; Federal Art Sch., Minneapolis. **Exhibited:** Western Wash. Fair, 1929 (prize); Wash. Hist. Soc., 1958 (solo). **Comments:** Position: teacher, public schools, 17 years. Her mother Lizzie N. Shorey also painted. **Sources:** Trip and Cook, *Washington State Art and Artists.*

SHORT, Jessie Francis See: **JACKSON, Jessie Glen Francis Short**

SHORT, Vernan W. *[Painter] mid 20th c.*
Exhibited: Salons of Am., 1928. **Sources:** Marlor, *Salons of Am.*

SHORTER, Edward S(wift) *[Painter, collector, teacher, lecturer, designer] b.1902, Columbus, GA.*
Addresses: Macon, GA; Columbus, GA. **Studied:** Mercer Univ. (A.B. & L.L.D.); Corcoran School Art; Fontainebleu, Paris, with Andre Lhote, E. Renard, Wayman Adams, Hugh Breckenridge, W.L. Stevens; BMFA Sch. **Member:** North Shore AA; Soc. Wash. Artists; Wash. Landscape Club; SSAL; S. Indp. A.; Wash. AC; Atlanta AA; Chicago AL; Macon AA; Georgia AA (pres. 1955-57); Am. Assn. Mus.; Artists Equity Assn.; AAPL; SC; Soc. Washington Artists. **Exhibited:** Southern Artists Exhib., Nashville, TN, 1926 (prize); S. Indp. A., 1927-28; Georgia Artists Exhib., 1928 (prize) 1932 (prize), 1934 (prize), 1937 (prize); SSAL, 1934 (prize); Chattahoochee Valley Fair, 1938 (prize);

PAFA; CGA; SSAL; Soc. Washington Artists; Southeastern Art Ann. **Awards:** Gari Melcher Award, Artists Fellowship; Algenon Sydney Sullivan Award, Mercer Univ. **Work:** CGA; Episcopal H.S., Alexandria, VA; MFA, Montgomery, AL; Atlanta AA; Ft. Hays, KS; Wesleyan College, Macon, GA; Mercer Univ., Macon, GA. **Commissions:** portraits, Mercer Univ., Macon AA, Baylor Univ., TX; paintings, Housing Authority Columbus, Tift College & St. Francis Hospital. **Comments:** Preferred media: oils. Positions: acting director, Columbus Mus. Arts & Crafts (1953-55), director (1955-68), emer. director (1968-). Collections arranged: Am. Traditionalists of Twentieth Century; spec. exhib. Old Master Drawings & Graphics; Contemporary Exhib. Georgia Artists. Collection: American paintings, European porcelains, Oriental ivories, and rugs. **Sources:** WW73; WW40, puts birth at 1900.

SHORTREED, Letitia Quinn *[Painter] b.1906, Cleveland, OH / d.1940, Los Angeles, CA.*
Addresses: Los Angeles, CA. **Exhibited:** P&S of Los Angeles, 1937. **Sources:** Hughes, *Artists in California,* 513.

SHORTWELL, Frederic Valpey *[Painter, illustrator, etcher, lecturer, teacher] b.1907, Detroit / d.1929.*
Addresses: Detroit, MI/Bay View, MI. **Studied:** Berninghaus; Carpenter; Pennell; Dodge; Bridgman; Sepeschy. **Member:** Detroit SE; Scarab Club. **Work:** murals, Library Fordson (MI) School; General Motors Bldg., Detroit. **Comments:** Established the Frederick Valpey Shotwell Memorial Fund, set up to render aid in emergency to young artists of Detroit. **Sources:** WW31.

SHOSHANA *[Painter] mid 20th c.*
Addresses: Chicago area. **Exhibited:** AIC, 1946-51 (prizes, 1948, 1950). **Sources:** Falk, *AIC.*

SHOSTAK, Edwin Bennett *[Sculptor] b.1941, NYC.*
Addresses: NYC. **Studied:** Ohio Univ.; Cooper Union. **Exhibited:** Walter Chrysler Art Mus., Provincetown, MA, 1963; Bykert Gal., New York, 1968; WMAA, 1969-73; Fischbach Gal., New York, 1971 (solo); Critic's Choice, Sculpture Center, New York, 1972. **Work:** Philip Johnson Collection, New Canaan, CT. **Comments:** Preferred media: wood. **Sources:** WW73; Bob Hughes, "In Search of the New, Pursuit of the Old," *Time Magazine* (Jan., 1971); Garrit Hery, "New York Letter," *Art Int.* (October, 1971); Denise Green, "New York Reviews," *Arts Magazine* (Nov., 1971).

SHOTWELL, H. C. *[Wood engraver] mid 19th c.*
Addresses: Cincinnati, 1853. **Sources:** G&W; Stauffer.

SHOTWELL, Helen Harvey *[Painter, photographer] b.1908, NYC.*
Addresses: NYC; Woodstock, NY. **Studied:** painting with Henry Lee McFee, Edwin Scott & Paul Pusinas; photography with Flora Pitt Conrey. **Member:** NAWA; Woodstock AA; Int. Inst. Arts & Letters (fellow); Jackson Heights Art Club; Fitchburg AM; Royal Photographic Soc., London. **Exhibited:** PAFA annuals, 1935-36; Corcoran Gal biennial, 1937; Argent Gal., 1946 (solo); Fitchburg AC; Carolina AA, 1946 (solo); Woodstock, NY; Dayton AI; Montclair AM; High Mus Art; CI; photographs shown in intl. salons in New Zealand, Iceland, India, Spain, South America & US. **Work:** IBM Collection; Fitchburg Art Mus; Columbia Univ.; Albert Schweitzer Foundation; China Inst. New York. **Sources:** WW73; WW47; Falk, *Exh. Record Series.*

SHOTWELL, Margaret *[Painter] b.1873, NYC / d.1965.*
Addresses: Paris, France. **Studied:** E. Scott. **Member:** Woodstock AA. **Work:** Woodstock AA. **Sources:** WW15; addit. info. courtesy Woodstock AA.

SHOUDY, Theodore *[Painter, teacher] b.1881, Brooklyn, NY.*
Addresses: Wells, NY; Mt. Vernon, NY. **Studied:** Adelphi College; ASL, and with William Chase, Jane Peterson. **Member:** Academic Artists, Springfield; SC; New Orleans AA; AEA; Mt. Vernon AA; Hudson Valley AA; AAPL; Yonkers AA. **Exhibited:** SC, 1933-50, 1956-58; All. Artists Am., 1952; Hudson Valley AA, 1946-58; Barbizon Gal., 1957 (solo); Bronxville, 1958 (solo).

Awards: prizes, Mt. Vernon AA, 1947; Westchester Women's Club, 1948; Hudson Valley AA, 1953, 1956; Yonkers AA, 1958. **Work:** Mt. Vernon Art Center; Vanolyn Gal., Fleetwood, NY; Hall of Art; Little Studio, NY. **Sources:** WW59.

SHOULBERG, Harry *[Painter, serigrapher, teacher] b.1903, Philadelphia, PA.* *Shoulberg*
Addresses: NYC. **Studied:** CCNY; Am. Artists School; J. Reed; S. Wilson; C. Holty; H. Glintenkamp and Harriton. **Member:** Nat. Ser. Soc.; Artists Lg. Am.; United Am. Artists; Audubon Artists; Am. Soc. Contemporary Artists; NJ Soc. P&S; AEA. **Exhibited:** Bronx House, NY, 1942 (prize); Corcoran Gal biennials, 1941; CI, 1945; LOC, 1945-46, 1947 (Print Exhib); San Francisco AA, 1946; SAM, 1944-46; NAD, 1946; Modern Age Gal., 1945 (solo); Francis Webb Gal. (solo); Nat. Ser. Soc. (solo); Teachers Center (solo); Denver Univ. (solo); Salpeter Gal. (solo); Hudson Guild (solo); High Point Gal. (solo); Harbour Gal. (solo); Print & Watercolor Exhib., PAFA, Philadelphia, 1946; Audubon Artists 28th Ann., New York, 1970; NAD 146th Ann. , 1971; "NYC WPA Art" at Parsons School Design, 1977; Harbor Gal., Cold Spring Harbor, NY, 1970s. Awards: Tanner Prize, Phila.; Guild Hall, East Hampton (first prize); Parrish Mus., South Hampton (second prize); Jane Peterson Prize; Emily Lowe Award, 1956; Kapp Award, Silvermine Guild, 1957; M.J. Kaplan Mem. Award, Am. Soc. Contemporary Artists, 1966. **Work:** MMA; Norfolk (VA) Mus. Arts & Sciences; Denver AM; SFMA; BMA; Ain Herod Mus.; Brooks Mem. Gal.; Carnegie Inst.; New York State Univ.; Univ. Wisconsin; Ball State Teachers College; St. Lawrence Univ.; Albrecht Gal.; George Walter Vincent Smith Mus.; Univ. Oregon, Univ. Arizona; New Jersey State College; Butler AI; Wichita State Univ. **Comments:** He was among the early group of WPA artists working in the screenprint medium, and later turned to oils. **Sources:** WW73; WW47; H. Shokler, *Artists Manual for Silk Screen Printmaking* (1946); A. Reese, *American Prize Prints of the 20th Century* (1949, Am. Artists Group); Margaret Harold, *Prize Winning Art Book 7* (1966); *New York City WPA Art,* 79 (w/repros.).

SHOUMATOFF, Elizabeth Avinoff (Mrs.) *[Painter] b.1888, Kharkov, Russia / d.1980, Glen Cove, NY.*
Studied: St. Petersburg, Kiev, and Moscow. **Work:** Shelburne (VT) Mus. **Comments:** Came to the U.S. in 1917, where she painted over 3,000 portraits; she was painting a watercolor of FDR in Georgia when he suffered a stroke in 1945. **Sources:** Muller, *Paintings and Drawings at the Shelburne Museum,* 126 (w/repro.).

SHOURDS, George Washington *[Engraver] b.1833, Pennsylvania.*
Addresses: Philadelphia, 1850. **Comments:** In 1855 he contributed one engraving to *The Annals of San Francisco* (N.Y., 1855). **Sources:** G&W; 7 Census (1850), Pa., LV, 5; Phila. CD 1854-60+; Hamilton, *Early American Book Illustrators and Wood Engravers,* 331.

SHOURDS, John *[Lithographer] mid 19th c.; b.Pennsylvania.*
Addresses: Philadelphia, 1860. **Comments:** He lived with his father, William H. Shourds, Constable. **Sources:** G&W; 8 Census (1860), Pa., LIV, 927; Phila. CD 1861.

SHOUSE, Helen Bigoney (Mrs.) *[Craftsman, painter, designer, educator] b.1911, Rockville Centre, NY.*
Addresses: Appomatox, VA. **Studied:** PIA School; New York Univ. (B.S. educ.); Teachers College, Columbia Univ. (M.A.). **Member:** NY Soc. Craftsmen. **Exhibited:** NY Soc. Craftsmen, 1946. **Comments:** Position: asst. professor, industrial art, Richmond Professional Inst., College William & Mary, Richmond, VA, 1945-47. Lectures on design and color, flower arrangement, to women's clubs and garden clubs. **Sources:** WW59; WW47.

SHOVEN, Hazel Brayton *[Painter] b.1884, Jackson, MI / d.1969, San Diego, CA.*
Addresses: San Diego, CA. **Studied:** A.W. Burnham, Johanson; AIC; Chicago Acad. FA; and with Schneider. **Member:** San Diego AG; Los Surenos AC; La Jolla AG; Laguna Beach AA. **Exhibited:** Calif. State Fair, 1930; Orange County Fair, Santa Ana, Calif., 1930 (prize); Los Angeles County Fair, 1931 (prize); Calif.-Pacific Int. Expo, San Diego, 1935. **Sources:** WW40; Hughes, *Artists in California,* 513.

SHOVER, Edna Mann *[Painter, designer, illustrator, writer, teacher] b.1885, Indianapolis, IN.*
Addresses: Indianapolis, IN. **Studied:** PM School IA; PAFA with Faber& Deigendesch; T. Scott; P. Muhr; J.F. Copeland. **Member:** Indianapolis AA.; Indiana AC; AFA. **Exhibited:** PM School IA Alumni Assn. (gold). **Comments:** Principal, Art School, Herron Art Inst., Indianapolis. Author/illustrator: "Art in Costume Design." **Sources:** WW59; WW47.

SHOVER, Lucy M. *[Painter] 20th c.*
Addresses: Indianapolis, IN. **Sources:** WW17.

SHOW, John D. *[Artist]*
Addresses: Wash., DC, 1895-98. **Sources:** McMahan, *Artists of Washington DC,.*

SHOW, S. Van D. (Mrs.) *[Painter] 20th c.*
Addresses: Chicago, IL. **Member:** Chicago WCC. **Sources:** WW17.

SHOWE, Lou Ellen (Mrs.) See: **CHATTIN, Lou-Ellen**

SHOWELL, Kenneth L *[Painter] b.1939, Huron, SD.*
Addresses: NYC. **Studied:** Kansas City Art Inst. (B.F.A., 1963); Indiana Univ. (M.F.A., 1965). **Exhibited:** WMAA Ann., 1967-69; Highlights of the 1969-70 Art Season, Aldrich Mus., Ridgefield, CT; Lyrical Abstraction, WMAA, 1971; Spray, Santa Barbara MA, 1971; Painting & Sculpture Today 1972, Indianapolis MA, 1972. **Work:** AIC; WMAA; Michener Collection, Univ. Texas, Austin; Akron (OH) Mus. **Comments:** Preferred media: acrylics. **Sources:** WW73; R. Pincus-Witten, "New York" (review), *Artforum* (Jan., 1970); C. Ratcliff, "The New Informalists," *Art News* (February, 1970).

SHPRITZER, Philip *[Painter] mid 20th c.*
Exhibited: S. Indp. A., 1941. **Sources:** Marlor, *Soc. Indp. Artists.*

SHRADER, Alfred *[Lithographer] b.c.1823, Darmstadt, Germany.*
Addresses: Philadelphia in 1860. **Comments:** Lived with his wife and son, aged 2, the latter born in Pennsylvania. **Sources:** G&W; 8 Census (1860), Pa., LII, 256.

SHRADER, E(dwin) Roscoe *[Painter, illustrator, teacher] b.1879, Quincy, IL / d.1960, La Cañada, CA.* *RS₉*
Addresses: Claymont, DE; New Hope, PA; La Cañada, CA. **Studied:** AIC, 1902-04; with Howard Pyle, 1904 (scholarship), Wilmington. **Member:** Calif. AC; Wilmington Soc. FA; Los Angeles Friends of Art; Southwestern Archaeological Fed. **Exhibited:** PAFA Ann., 1913, 1916; Calif. AC, 1930 (prize). **Work:** LACMA; Hollywood H.S. **Comments:** Active in Wilmington, DE, 1904-14; New Hope, PA colony 1914-17. Illustrator for magazines and books. Moved to California where he was known as a painter and also director of Otis AI. Shrader was also a cellist. Position: teacher, Otis AI, 1917-48. Specialty: historical Indian subjects, people and their activities. **Sources:** WW40; Hughes, *Artists in California,* 513; P&H Samuels, 441; Falk, *Exh. Record Series.*

SHRADY, Frederick Charles *[Sculptor, medalist] b.1907, Eastview, NY / d.1990, Easton, CT.*
Sources: info courtesy D.W. Johnson, *Dictionary of American Medalists* (pub. due 2000).

SHRADY, Henry M(erwin) *[Sculptor] b.1871, NYC / d.1922, NYC.*
Addresses: NYC; Elmsford, NY. **Studied:** Columbia (law); self-taught in art. **Member:** ANA, 1909; NSS, 1902; Arch. League, 1902; NIAL. **Exhibited:** NAD (painting); Pan-Am. Expo, Buffalo, 1901; PAFA Ann., 1902, 1909. **Work:** monument, Detroit; Charlottesville, VA; Duluth, MN; Holland Soc.; equestri-

an statue of Washington, Williamsburg Bridge, Brooklyn; sculpted massive Grant Memorial in Washington, DC (approx. 252 ft. base), from 1902-22; Cowboy Hall of Fame. **Comments:** Began painting at 29. The sculptor, Karl Bittner, encouraged Shrady and in 1901 he was commissioned to sculpt the statue of Washington for the Williamsburg Bridge. He spent the last 20 years of his life modeling the Grant Memorial. **Sources:** WW21; P&H Samuels, 441-42; Falk, *Exh. Record Series.*

SHRADY, William *[Painter] mid 19th c.*
Exhibited: NAD, 1866. **Sources:** Naylor, *NAD.*

SHRAMM (OR SCHRAMM), Paul H. *[Sculptor, painter, illustrator, craftsperson, teacher] b.1867, Heidenheim, Germany.*
Addresses: Buffalo, NY. **Studied:** Claudinso; Schrandolph; J. Grunenwald, in Stuttgart; MacNeil, at Pratt Inst.; Arangi. **Member:** NY Soc. Ceramics; Progredi AC. **Exhibited:** Salons of Am., 1925. **Comments:** Specialty: jewelry. Active in NYC, 1906. **Sources:** WW21.

SHRANK, William *[Listed as artist] b.1807, Germany.*
Addresses: Philadelphia, 1850. **Comments:** He was an inmate of the Philadelphia Alms House. **Sources:** G&W; 7 Census (1850), Pa., LVI, 122.

SHREEVE, John *[Portrait painter] b.1823, Pennsylvania.*
Addresses: Philadelphia, 1845-1870 and after. **Comments:** He may have been the John Shreeves of 80 Green St., Philadelphia, who executed two silhouettes reproduced in *Antiques* in September 1922. These silhouettes are assigned the date *c.* 1810, but as John Shreeves, the portrait painter, was living on Green St. between 1850-54, it is possible that he was the artist and that the silhouettes have been wrongly dated. **Sources:** G&W; 8 Census (1860), Pa., LIV, 981; Phila. CD 1845-54, 1859-70+; *Antiques* (Sept. 1922), 131.

SHREEVES, John See: SHREEVE, John

SHREVE, Catherine Shock *[Painter, printmaker] mid 20th c.*
Addresses: Glendale, CA. **Exhibited:** P&S of Los Angeles, 1927, 1934; Calif. WCS, 1927, 1930; Artists Fiesta, Los Angeles, 1931. **Comments:** Position: teacher, George Washington High School, Pasadena. **Sources:** Hughes, *Artists in California,* 513.

SHREWSBURY, Henrietta C. *[Painter] early 20th c.*
Addresses: Darby, PA. **Exhibited:** PAFA Ann., 1901. **Sources:** Falk, *Exh. Record Series.*

SHRIEVE, Sara *[Painter] late 19th c.*
Addresses: NYC. **Exhibited:** PAFA Ann., 1885. **Sources:** Falk, *Exh. Record Series.*

SHROCK, John Granville *[Painter, lithographer, designer, teacher] b.1910, Nappanee, IN / d.1976, Greenbrae, CA.*
Addresses: San Francisco, CA, 1930s. **Studied:** Albion College (A.B., M.A.); ASL; Univ. California; & with Kimon Nicolaides, Waylande Gregory. **Member:** San Francisco AA. **Exhibited:** Detroit IA, 1933, 1941; SFMA, 1937-39, 1941, 1946; San Francisco AA, 1938; CPLH, 1946; Olivet, MI, 1941; Jackson, MS, 1940. **Work:** Albion (MI) College. **Comments:** Position: teacher, UC, San Francisco; art instructor, 1932-34, head art dept., 1939-42, Albion (MI) College; resident artist & art instructor, Washington State College, 1936-37; U.S. Army, 1942-45. **Sources:** WW53; WW47. More recently, see Hughes, *Artists in California,* 513.

SHROPSHIRE, George E. *[Painter] 20th c.*
Addresses: NYC. **Member:** GFLA. **Sources:** WW27.

SHRYOCK, Burnett Henry, Sr. *[Painter, educator, designer, graphic artist, craftsperson, lithographer] b.1904, Carbondale, IL / d.1971, Carbondale.*
Addresses: Carbondale, IL. **Studied:** Univ. Illinois (A.B.); Am. Acad. Art, Chicago; AIC; Teachers College, Columbia Univ. (M.A.); E.V. Poole, AIC; Y. Kuniyoshi; E. Thurn. **Member:** Soc. Arts & Sciences, NY; NEA; NAEA; AAUP. **Exhibited:** S. Indp. A., 1941; CAM, 1943 (prize)-1945; Alabama WC Exhib., 1944

(prize); La Tausca Pearls Competition, 1946 (prize); AIC, 1936, 1938, 1944, 1946; Denver Art Mus., 1944, 1945; Kansas City AI, 1945; W.R. Nelson Gal., 1946 (solo); Jackson, MS, 1944 (solo); New Orleans Art & Crafts, 1948 (solo). **Work:** CAM; Southern Illinois Univ. **Comments:** Position: asst. professor art (1935-42), chmn. art dept. (1942-44), Southern Illinois Univ.; assoc. prof. art, chmn. art dept., 1944-, Univ. Kansas City, MO; chmn. & art professor (1950-), dean, school fine art & art professor (1955-), Southern Illinois Univ. **Sources:** WW66; WW47.

SHRYOCK, John Carter *[Graphic artist, writer] 20th c.*
Addresses: Pittsburgh, PA. **Member:** Pittsburgh AA. **Sources:** WW25.

SHRYOCK, Lucy W. *[Painter] 20th c.*
Addresses: Pittsburgh, PA. **Member:** Pittsburg AA. **Sources:** WW25.

SHUBERT, Alexandre de *[Painter] early 20th c.*
Addresses: NYC. **Exhibited:** S. Indp. A., 1923-24. **Sources:** Marlor, *Soc. Indp. Artists.*

SHUBERT, Irving (Mrs.) See: SCHMIDT, Katherine (Shubert)

SHUCK, Charles F. *[Painter] late 19th c.*
Addresses: Sandusky, OH. **Exhibited:** NAD, 1889. **Sources:** Naylor, *NAD.*

SHUCK, Kenneth Menaugh *[Art administrator, painter] b.1921, Harrodsburg, KY.*
Addresses: Springfield, MO. **Studied:** Ohio State Univ. (B.S., art educ. & M.A., art history); Univ. Chile, Inst. Int. Educ. scholarship, 1950. **Member:** Midwest Mus. Conference (pres., 1963); Missouri State Council Arts (chmn. visual arts, 1966-68); Am. Assn. Mus.; AFA. **Exhibited:** Denver Art Mus. Ann.; Watercolor USA & 10 State Regional, Springfield, MO. **Comments:** Preferred media: watercolors, acrylics. Positions: director, Springfield (MO) Art Mus., 1951-. Collections arranged: 10 State Regional Exhib., 1951-72; Watercolor USA, 1961-72. **Sources:** WW73.

SHUDEMAN, C. *[Sculptor] mid 20th c.*
Addresses: Chicago area. **Exhibited:** AIC, 1929-31. **Sources:** Falk, *AIC.*

SHUFF, Lily (Lillian Shir) *[Painter, engraver] b.1906, NYC.*
Addresses: NYC. **Studied:** Hunter College (B.A.); Columbia Univ.; Brooklyn Acad. Fine Art; ASL, with Morris Kantor; also with Adja Junkers & Jerry Farnsworth; J. Corbino. **Member:** NAWA (chmn. member jury, 1956-58 & 1964-66; board directors, 1958-67); Art Lg. Am.; Brooklyn SA; Nat. Soc. Painters Casein (recording secretary, 1957-64); New York Soc. Women Artists (board governors, 1956-71); Audubon Artists (graphics director, 1970-72); NJ Painters & Sculptors (admission jury, 1971). **Exhibited:** NAD; Riverside Mus.; NAC; Argent Gal.; S. Indp. A.; Hofstra College FA Gal.; traveling exhibits, Phila., Kansas City, San Francisco, Los Angeles; Ten Years of American Prints 1947-56, Brooklyn Mus., NY, 1956; Munic. Mus. Art, Uneo Park, Tokyo, Japan, 1960; Mus. Nac. Bellas Artes, Buenos Aires, Argentina, 1963; Royal Scottish Acad., Edinburgh, Scotland, 1963; Int. Cultural Center, New Delhi, India, 1966; East Side Gallery, NYC, 1970s. **Awards:** gold medal of honor of watercolor, NJ Mus., 1956 & 1962; Windsor & Newton Prize for oil, Am. Soc. Contemporary Artists, 1966, 1968 & 1970; Elizabeth Rungius Fulda Prize for oil, NAWA, 1969 & 1970. **Work:** MMA; LOC; Yale Univ. Art Gallery, New Haven, CT; Butler IA; Bezalel Nat. Mus., Jerusalem, Israel; plus 32 other museum collections. **Comments:** Preferred media: oils, watercolors. Publications: contributor, "Art Collector's Almanac," 1965; contributor, "Prize Winning Paintings," 1967; contributor, "Today's Art," 1970; contributor, "How to Paint a Prize Winner," 1970. Art interests: slides of paintings circulated in universities & colleges in USA by Gas Mus. Fine Art, Athens. **Sources:** WW73; article, *Think* (1959); *Alfred Khouri Collection* (Norfolk Mus., 1963); WW47.

SHUFFLER, Dale *[Painter] mid 20th c.*
Addresses: Phila., PA. **Exhibited:** PAFA Ann., 1968. **Sources:** Falk, *Exh. Record Series.*

SHUGG, Richard *[Wood engraver] mid 19th c.*
Addresses: NYC, 1858-60. **Comments:** In 1858 he was with McLees & Shugg (see entries). **Sources:** G&W; NYBD 1858, 1860.

SHUI, Walter Wong *[Painter] mid 20th c.*
Addresses: NYC. **Exhibited:** Corcoran Gal biennial, 1947; PAFA Ann., 1948. **Sources:** Falk, *Exh. Record Series.*

SHUKOTOFF, Alice Zelma *[Painter, designer, teacher] b.1911, Brooklyn, NY.*
Addresses: NYC. **Studied:** NYU; CCNY; NY School Fine & Applied Art. **Sources:** WW40.

SHUL, Philip *[Painter] mid 20th c.*
Exhibited: S. Indp. A., 1938. **Sources:** Marlor, *Soc. Indp. Artists.*

SHULER, Clyde *[Designer, educator] b.1892, Pottstown, PA.*
Addresses: Philadelphia, PA; Media, PA. **Studied:** PM School Art; BAID, and with Paul Phillipi Cret. **Member:** Phila. AA; IDI (fellow); Phila. Sketch Club. **Exhibited:** Arch. & Indust. Design, Phila. Sketch Club; PM School Art; Phila. Art All. **Work:** arch. design, offices, homes, stores, etc. **Comments:** Positions: tnt. designer, John Wanamaker (1914-15), Price & McLanahan (1915-18), McLanahan & Bencker, 1918-21; designer-in-chief, Ralph Bencker, 1921-29; Clyde Shuler Assoc., 1929-; William Heyl Thompson, 1953. Lectures: industrial design. **Sources:** WW59.

SHULER, Robert G. *[Printmaker] mid 20th c.*
Addresses: Chicago area. **Exhibited:** AIC, 1951. **Sources:** Falk, AIC.

SHULGOLD, William (Robert) *[Painter, etcher, teacher] mid 20th c.; b.Russia.*
Addresses: Pittsburgh, PA, 1929-35; NYC, c.1936-on. **Studied:** Sparks; Sotter; Levy; C.W. Hawthorne. **Member:** Pittsburgh AA; Tiffany Fnd. **Exhibited:** Corcoran Gal biennials, 1926-39 (5 times); PAFA Ann., 1929, 1935, 1941; AIC, 1931. **Work:** "One Hundred Friends of Art" gave his "Sketching" and "Self Portrait" to Pittsburgh Public Schools. **Sources:** WW40; Falk, *Exh. Record Series.*

SHULKIN, Anatol *[Painter, graphic artist, lecturer, teacher] b.1899, Russia / d.1961.*
Addresses: NYC. **Studied:** NAD,with L. Kroll; ASL; Columbia Univ.; BAID; and with Charles Curran, George Bellows, and others. **Member:** NSMP; AEA; Am. Artists Congress. **Exhibited:** NAD, 1921 (Chaloner scholarship); PAFA Ann., 1932-34, 1940-42; 48 Sts. Competition, 1939; Corcoran Gal biennials, 1930-43 (5 times); CM; CAM; Rhode Island Mus. Art; CI; Am. Artists Congress; Soc. Indep. Artists; Pepsi-Cola, 1942; VMFA; WMAA; MMA; AIC. **Awards:** mural competition, Section FA, Wash., DC, 1935, 1937-38, 1940. **Work:** MMA; WMAA; murals, Barbizon-Plaza Hotel, NYC; WPA murals, USPO, Canajoharie, NY. **Comments:** Teaching: CUA School, NY, 1932-36; Newark School Fine & Indust. Art, Newark, NJ, 1944-45. **Sources:** WW59; WW47, puts birth at 1901 but Falk, *Corcoran Gal* cites 1899.

SHULL, Della F. (Mrs. K. M. Thompson) *[Painter] early 20th c.; b.Albia, IA.*
Addresses: NYC. **Studied:** Robert Henri; William Chase. **Member:** NAWPS. **Exhibited:** PAFA Ann., 1910, 1923, 1933; AIC, 1911, 1915; S. Indp. A., 1917, 1920-21. **Comments:** Married Kennedy M. Thompson in NY. Active c.1920-30. **Sources:** WW27; Ness & Orwig, *Iowa Artists of the First Hundred Years,* 190-91; Falk, *Exh. Record Series.*

SHULL, J(ames) Marion *[Painter, illustrator, designer, writer] b.1872, North Hampton, OH / d.1948, Chevy Chase, MD.*
Addresses: Wash., DC, from 1906; Chevy Chase, MD. **Studied:** Valparaiso Univ.; Antioch College; ASL. **Member:** Wash. AC.

Exhibited: CGA; PMG. **Work:** U.S. Dept. Agriculture, Bureau of Plant Industry; Mycology Lab., Beltsville, MD; U.S. Nat. Arboretum. **Comments:** Author/illustrator: "Rainbow Fragments: A Garden Book of the Iris," 1931. Contributor: *Country Life; Ladies' Home Journal; Garden.* Position: artist with U.S. Dept. of Agric. **Sources:** WW47; McMahan, *Artists of Washington DC.*

SHULL, Louis D. *[Landscape painter] late 19th c.*
Addresses: San Francisco, CA. **Exhibited:** San Francisco AA, 1874. **Sources:** Hughes, *Artists in California,* 513.

SHULMAN, Joseph L. *[Collector] 20th c.*
Addresses: Bloomfield, CT. **Comments:** Collection: includes works by Modigliani, Picasso, Gris, Valaden, Marini, Metzinger, Laurencin, Pascin, Renior, Guttuso, Le Corbusier, Bauschant, Matisse, Lipchitz, Fresnay, Hofmann, Gates, Du Fresne, Liberte, Kermelouk, Mirko, Marino, Botkin, Vespianna and Epstein. **Sources:** WW73.

SHULMAN, Leon *[Art curator, instructor] b.1936, Worcester, MA.*
Addresses: Worcester, MA. **Studied:** Worcester Art Mus. School (certificate); San Francisco Art Inst. (M.F.A.). **Comments:** Positions: assoc. curator contemporary art, Worcester Art Mus. Publications: author, "Light and Motion" (catalog) (1967), The Direct Image (cat) (1969) & "Marisol" (cat) (1971). Teaching: instructor of art history & painting, School of Worcester Art Mus. Collections arranged: Light and Motion; The Direct Image in Contemporary Painting; Marisol. **Sources:** WW73.

SHULMAN, Morris M. *[Painter, teacher] b.1912, Savannah, GA / d.1978.*
Addresses: NYC. **Studied:** NAD, 1931-34; ASL, 1946-47; Siqueros Fresco Workshop, NYC, 1935-36; Hans Hofmann School Art, NYC, 1948-49; New School Soc. Research, 1949-50. **Exhibited:** "New York Realists," five-man shows, ACA Gal., NYC, 1938, 1939, 1941; WFNY, 1939; "Directions in American Painting," Carnegie Inst., 1941; AIC, 1941; "An American Group," Assoc. Am. Artists Gals, NYC, 1941; Contemporary Am. Painting, VMFA, 1942; Exhib. of Contemporary Art, MMA, 1942; Annual Watercolor and Print Exhibs., PAFA Ann., 1947-49, 1954; Artists Gal., NY, 1948 (solo); Audubon Art. Nat. Acad. Gals., NYC, 1948, 1950; "Am. Artists for Israel," Jewish Mus., 1950; Watercolor Exhibs., BM, 1950-61 (first watercolor prize, 1950); Frank K. M. Rehn Gal., NYC, 1951-54 (solos); Carnegie Inst. Int., 1952; Duveen-Graham Gal., NYC, 1956 (solo); Springfield Mus., 1957 (purchase prize); Nat. Soc. Painters in Casein, 1958 (hon. men.), 1960 (Gramercy Prize); "Experiences in Art," Hirschl & Adler, NYC, 1959; Staten Island Mus., 1962 (hon. men.); Maine Coast Artists, Rockport, ME, 1963 (solo); "New Images Exhib.," Richard Feigan Gal., NYC, 1964; "Painting in Maine," Colby College, 1964; Westbeth Gal., NY, 1973 (solo); Erpf Catskill Cultural Center, Arkville, NY, 1975 (solo); "NYC WPA Art" at Parsons School Design, 1977. **Work:** NMAA; MMA; Carnegie Inst.; BM; Jewish Mus., NYC; Springfield (MA) Mus.; Rose Art Mus., Brandeis Univ., Waltham, MA; Bates College, Lewiston, ME; Edwin Ulrich Mus. Art, Wichita, KS; St. Mary's (MD) College; Vassar College Collection; Stamford (CT) Mus.; Bezalel Mus., Tel Aviv. **Comments:** WPA artist: fresco asst., Bellevue Hosp., NYC, 1936-37. Teaching positions: Brooklyn Mus. School, 1950-59; School Visual Art, NYC, 1961-78; teacher, Phila. College of Art, 1960-76; Skowhegan Art School, ME, 1965-66; New School for Soc. Research, NYC, 1975-76; CUA School, 1977. **Sources:** WW40; *New York City WPA Art,* 79; Falk, *Exh. Record Series;* add'l info. courtesy John Day, Falmouth, ME.

SHULTZ, Charles *[Lithographer] b.1841, Württemberg, Germany.*
Addresses: Philadelphia, 1860. **Comments:** He was living with his parents. **Sources:** G&W; 8 Census (1860), Pa. LVIII, 396.

SHULTZ, George F. *[Painter] early 20th c.*
Addresses: Chicago area. **Exhibited:** AIC, 1902, 1909. **Sources:**

Falk, *AIC.*

SHULTZ, George Leonard *[Portrait painter, lecturer]*
b.1895, St. Louis, MO.
Addresses: Tulsa, OK. **Studied:** St. Louis Sch. FA; in France; &
with Robert Bringhurst, Richard Miller. **Member:** St. Louis Art
Gld.; Am. Artists All.; Soc. Indep. Artists. **Exhibited:** St. Louis
Art Gld.; Soc. Indep. Artists; Am. Artists All.; CAM; Joslyn Art
Mus.; Philbrook Art Center. **Work:** many portraits for private col-
lections & business firms including, Am. Legion Headquarters,
Indianapolis; City Hall, St. Louis; Nat. Real Estate Exchange,
Chicago. **Comments:** Lectures to service clubs and church
groups. **Sources:** WW59; WW47.

SHULTZ, Ralph T. *[Painter, illustrator]* 19th/20th c.
Addresses: Tacoma, WA, 1897; NYC. **Member:** SC. **Exhibited:**
ASL; Ferry Mus., 1899. **Sources:** WW25; Trip and Cook,
Washington State Art and Artists.

SHULZ, Ada Walter (Mrs. Adolph) *[Painter]* b.1870, Terre
Haute, IN / d.1928, near Nashville, IN.
Addresses: Nashville, IN, summers from 1908, permanently from
1917. **Studied:** AIC, with Vanderpoel and Oliver Pennet Grover;
Vitti Acad., Paris; Munich. **Member:** Chicago Cordon Club;
Indiana AC; Chicago Gal. Art; Brown County Gal. Assn.
(founder). **Exhibited:** AIC, 1917 (Municipal Purchase Prize),
1918 (hon. men.); Hoosier Salon, 1925 (prize), 1926 (prize), 1928
(prize); Chicago Galleries Assoc; H. Leiber Co., Indianapolis;
Milwaukee Art Soc. Gallery, Dec., 1914 (with husband Adolph
and son Walter); Indiana State Museum, Indianapolis, 1998 (first
retrospective). **Work:** Milwaukee AI; Municipal Art Lg., Chicago
Collection; Brown County Public Library ("Mother and Two
Children Outdoors"). **Comments:** Specialty: impressionistic por-
trayals of mothers and children in outdoor settings. Married to
Adolph Shulz (see entry) in 1894, the two artists established a
joint studio in Munich in April, 1895. Returned to Delavan, WI, in
September of that year. In 1908, she and her husband began
spending their summers painting in Nashville (Brown County),
IN, soon drawing other artists to the region and helping to estab-
lish the Brown County art colony. She also contributed magazine
covers for *The Advance* (May, 1914), *Woman's Home Companion*
(Jan, 1920), and *Literary Digest* (December, 1924). The Shulzes
divorced in 1926. Their son Walter (see entry) had just embarked
on his art career before his early death in 1918. **Sources:** WW27;
Gerdts, *Art Across America,* vol. 2: 273-74 (with repro.); Rachel
Berenson Perry, "The Paintings of Ada Walter Shulz," *American
Art Review* vol. 10, no.1 (February, 1998): 94-101.

SHULZ, Adolph Robert *[Painter, teacher]* b.1869, Delavan,
WI / d.1963.
Addresses: Nashville, IN, summers from 1908, permanently from
1917. **Studied:** AIC; ASL; Académie Julian, Paris with J.P.
Laurens, Lefebvre, and Constant; Munich. **Member:** Chicago
Palette and Chisel Club; Brown County Galleries Assn.; Chicago
Galleries Assn.; Sarasota AA; Florida Fed. Art. **Exhibited:** AIC,
1900 (prize), 1904 (prize), 1908 (prize); Milwaukee AI, 1918
(med); Brown County Galleries Assn., 1937 (prize); Hoosier
Salon, 1936 (prize); Chicago Galleries Assoc; H. Leiber Co.,
Indianapolis; Milwaukee Art Soc. Gallery, Dec., 1914 (with wife
Ada and son Walter). **Work:** Indianapolis Mus. Art ("The Turkey
Roost," 1918). **Comments:** Shulz painted impressionist and tonal
scenes. Married in 1894 to Ada Walter Shulz (see entry), also a
painter, they were among the original settlers of the Brown
County (IN) art colony. The couple divorced in 1926; their son
Walter (see entry) had only just begun his art career before his
early death in 1918. **Sources:** WW59; WW47; Gerdts, *Art Across
America,* vol. 2: 273 (with repro.).

SHULZ, Alberta Rehm (Mrs. A.) *[Painter]* b.1892,
Indianapolis, IN / d.1980.
Addresses: Nashville, IN. **Studied:** Butler Univ.; Univ. Texas;
Indiana Univ.; Herron AI; Ringling School Art; & with Adolph
Shulz, C. Curry Bohm, A. Pillars, L.O. Griffith, Will Vawter.
Member: Brown County Galleries Assn.; Hoosier Salon; Sarasota

AA (hon.); Florida Federation of Arts. **Exhibited:** Hoosier Salon;
Brown County Galleries Assn.; Swope Art Gal.; & other exhibs.
in Indiana & Florida. **Comments:** Married to A. Shulz (see entry)
in 1926, they were members of the Brown County art colony.
Sources: WW59; WW47; *Art by American Women:.the Collection
of L.and A. Sellars,* 105.

SHULZ, Walter *[Painter]* b.1895, Munich, Germany / d.1918.
Addresses: Nashville, IN. **Studied:** AIC, 1914. **Exhibited:**
Milwaukee Art Soc. Gallery, Dec., 1914 (with parents Adolph and
Ada). **Comments:** The son of Adolph and Ada Shulz (see entries).
He enrolled at the AIC in 1914 and exhibited with his parents in
December of that year. Walter enlisted in the army in the spring of
1917, and contracted and died from diptheria in Germany after the
armistice. **Sources:** Rachel Berenson Perry, "The Paintings of
Ada Walter Shulz," *American Art Review* vol. 10, no.1 (February,
1998): 94-101.

SHULZE, Eliza *[Illustrator]* b.1847 / d.c.1920, Reading, PA.
Comments: Co-illustrator (with Virginia Jones and Josephine
Klippart), "Nest and Eggs pf Birds of Ohio," 1886. **Sources:**
Petteys, *Dictionary of Women Artists.*

SHUMAKER, Philip G. *[Painter]* b.1921, Beaver, PA /
d.1967.
Studied: Grand Central Art School; ASL with Frank Vincent
Dumond. **Comments:** Shumaker was an admirer of Frederick
Waugh. He believed the horizon played a major part in establish-
ing the mood of a picture.Painting locations include Monhegan
Island (ME). Publication: author, "Painting the Sea" (Sterling
Publishing Co., 1966.). **Sources:** Curtis, Curtis, and Lieberman,
117, 186.

SHUMAN, Anna M. *[Painter, teacher]* b.1890, Pittsburgh /
d.1919.
Addresses: Pittsburgh, PA/Provincetown, MA. **Studied:**
Hawthorne & Dow. **Member:** Pittsburgh AA. **Sources:** WW19.

SHUMAN, Ray *[Illustrator, painter]* mid 20th c.
Addresses: Los Angeles, CA. **Exhibited:** Artists Fiesta, Los
Angeles, 1931. **Comments:** Position: staff, Los Angeles
Examiner. **Sources:** Hughes, *Artists in California,* 513.

SHUMAN, Septimus T. *[Portrait painter]* late 19th c.
Addresses: Alexandria, VA, active 1880-81; Wash., DC, 1885-87;
Richmond, VA, 1892. **Sources:** McMahan, *Artists of Washington
DC,.*

SHUMATE, Ella A. *[Painter]* mid 20th c.
Addresses: Lebanon, IN/Kansas City, MO. **Studied:** E. Webster;
Lhote, in Paris; Newland, Landsend, in England. **Member:**
NAWPS; Hoosier Salon; Kansas City SA; Indiana Artists Club.
Exhibited: S. Indp. A., 1928. **Sources:** WW40.

SHUMATE, Frances Louise *[Illustrator, commercial artist]*
b.1889, Macomb, IL.
Studied: Am. Acad. Art, Chicago. **Exhibited:** Midwestern Artists,
Kansas City AI, 1930-32; Nebraska Artists AI, Omaha, 1930.
Sources: Petteys, *Dictionary of Women Artists.*

SHUMATE, Jessamine W. *[Painter, screenprinter]* mid 20th
c.; b.Martinsville, VA.
Addresses: Martinsville, VA. **Studied:** Univ. North Carolina
Woman's College; Univ. Virginia; ASL. **Member:** AFA; VMFA;
Roanoke AA; Lynchburg AA. **Exhibited:** Norfolk Mus. Art;
Roanoke AA; Lynchburg AA; VMFA; Springfield Mus. Art, 1957.
Awards: prizes, VMFA; Assn. Univ. Women, Roanoke, VA, 1956;
Virginia Highlands Festival, 1956. **Work:** VMFA; Univ. North
Carolina Woman's College. **Sources:** WW59.

SHUMWAY, Henry Colton *[Miniaturist and portrait painter]*
b.1807, Middletown, CT / d.1884, NYC.
Addresses: NYC, 1828-84. **Studied:** School of the National
Academy, 1828-30. **Member:** NA, 1832. **Exhibited:** NAD, 1861.
Comments: After two years of study at the National Academy, he
established himself as a miniature painter in NYC. He spent time
in New Orleans in 1859-60. He was highly successful until the

advent of the photograph and devoted himself chiefly to coloring photographs after 1860. Shumway was for over fifty years prominent in the 7th New York Regiment of the State Militia. **Sources:** G&W; Bolton, *Miniature Painters;* Clement and Hutton; French, *Art and Artists in Connecticut,* 73-74; Cowdrey, NAD; Cow-drey, AA & AAU; NYCD 1834-60+; 8 Census (1860), N.Y., LVII, 365; Swan, BA; Rutledge, PA; *Encyclopaedia of New Orleans Artists,* 352.

SHUNN, Carrie P. *[Painter] mid 20th c.*
Exhibited: Salons of Am., 1934. **Sources:** Marlor, *Salons of Am.*

SHUNNEY, Andrew *[Painter] b.1921, Attleboro, MA.*
Addresses: Nantucket, MA. **Studied:** RISD; ASL; also with Diego Rivera, Mexico. **Exhibited:** Hammer Galleries, NYC, 1970s. **Work:** Art in Embassies Program, State Dept., Wash., DC; Kenneth Taylor Gallery, Nantucket, MA; Buehrle Collection, Zurich, Switzerland; Salon Automne, Paris, France; Countess Guy de Toulouse-Lautrec Collection. **Comments:** Preferred media: acrylics, gouache. **Sources:** WW73.

SHUPP, Alice Connel *[Artist] b.1896, Las Vegas, NM.*
Addresses: Living in Las Vegas, NM, 1947. **Sources:** Petteys, *Dictionary of Women Artists.*

SHURE, Guinnette *[Painter] mid 20th c.*
Exhibited: S. Indp. A., 1939. **Sources:** Marlor, *Soc. Indp. Artists.*

SHURTLEFF, Dorothy H. *[Painter] mid 20th c.; b.Concord, NH.*
Studied: Manchester Inst. of Arts & Sciences; BMFA School; Paris, France; with Prescott M.M. Jones; Romano School of Art. **Member:** Inst. Modern Art; Eastern AA. **Sources:** *Artists of the Rockport Art Association* (1946).

SHURTLEFF, Elizabeth *[Painter] b.1890, Concord, NH.*
Addresses: NYC. **Studied:** BMFA Sch. **Exhibited:** Doll & Richards, Boston, 1925 (solo). **Sources:** WW15; Petteys, *Dictionary of Women Artists.*

SHURTLEFF, Paul *[Painter] 20th c.*
Addresses: NYC, 1915. **Sources:** WW15.

SHURTLEFF, Roswell Morse *[Landscape and animal painter, illustrator, lithographer] b.1838, Rindge, NH / d.1915, NYC.*
Addresses: Buffalo, NY, 1858-59; Boston, 1860; NYC, 1860-61; Hartford, CT, 1869-75; NYC, 1875-1915. **Studied:** Dartmouth College (attended but did not graduate), prior to 1857; Lowell Inst., Boston, 1858-59; NAD, 1860. **Member:** ANA, 1880; NA, 1890; AWCS; SC, 1888; Artists Fund Soc.; Lotos Club. **Exhibited:** NAD, 1872-1900; Brooklyn AA, 1874-86; Boston AC, 1877-1908; PAFA Ann., 1881, 1888; AIC, 1888-1914; Pan-Am. Expo, Buffalo, 1902 (medal); St. Louis Expo, 1904 (medal); AWCS, 1910 (prize); Corcoran Gal biennials, 1907-12 (4 times). **Work:** Adirondack Museum; CGA; NGA; MMA. **Comments:** Shurtleff was an architect's assistant in Manchester (NH) in 1857; worked for lithographer in Buffalo (NY) in 1858-59 and next moved to Boston where he drew for the engraver John Andrew. In 1860-61 he worked in NYC as a magazine illustrator, then volunteered for service in 1861, was wounded in July and spent eight months in a Southern prison, after which he returned to NYC and his work as a magazine illustrator. Married in 1867 and settled in Hartford, CT, but began spending his summers in the Adirondacks, at Keene Valley, NY. It was here that Shurtleff devoted himself to oil painting and took up the subject for which he became best known — forest interiors. He and John Lee Fitch were responsible for drawing a large other artists to the Keene Valley region, including Winslow Homer, Alexander Wyant, James David Smillie, and Julian Alden Weir (who built a studio on the lot next to Shurtleff). Contributed two Western illustrations for *Beyond the Mississippi.* **Sources:** G&W; DAB; CAB; French, *Art and Artists in Connecticut,* 146; *Art Annual,* XII. WW13; Falk, *Exh. Record Series.* More recently, see Gerdts, *Art Across America,* vol. 1: 182-83; *Keene Valley: The Landscape and its Artists;* P&H Samuels, 442; Art in Conn.: Early Days to the Gilded Age.

SHURTLIFF, Wilford Haskill *[Painter, graphic artist, craftsperson, teacher] b.1886, Ogden, UT.*
Addresses: Salt Lake City, UT. **Studied:** Univ. Chicago; AIC; Univ. Utah. **Comments:** WPA artist. Position: teacher, Utah State Art Center. **Sources:** WW40.

SHUSAKU See: **ARAKAWA, (Shusaku)**

SHUSTER, Arnauld See: **SCHUSTER, Arnauld**

SHUSTER, Sigismund See: **SCHUSTER, Sigismund**

SHUSTER, Valentine Francis *[Sculptor] b.1901, Russia / d.1958, San Francisco, CA.*
Addresses: San Francisco, CA. **Member:** Soc. for Sanity in Art. **Comments:** WPA artist. **Sources:** Hughes, *Artists in California,* 514.

SHUSTER, Will(iam) Howard ("Will") *[Painter, graphic artist, sculptor, educator, illustrator] b.1893, Philadelphia, PA / d.1969, Albuquerque, NM.*
Addresses: Santa Fe, NM. **Studied:** Drexel Inst. (electrical engineering); Philadelphia, with J.W. Server; Santa Fe, with J. Sloan, 1920. **Member:** Santa Fe P&S; Los Cinco Pintores; AAPL; Soc. Independent Artists. **Exhibited:** S. Indp. A., 1921-23, 1925-28, 1940-42; Sesqui-Centennial Expo, Phila., 1926; WFNY 1939; GGE, 1939; Mus. New Mexico, Santa Fe, 1946 (solo); numerous traveling exhib.; Santa Fe Fiesta; Santa Fe Rodeo Assn.; New Mexico State Fair (prize); Grand Junction, CO (prize). **Work:** Mus. New Mexico, Santa Fe; Newark Art Mus.; BM; NYPL.; sculpture, Spanish Am. Normal Sch., El Rio, NM; Carlsbad Caverns Nat. Park. **Comments:** Injured during WWI; returned to study art, but was advised to go West for his health. He followed Sloan to New Mexico in 1920. One of Los Cinco Pintores. He explored Carlsbad Caverns in 1924. Primarily a realist. Illustrator: "My Life on the Frontier," by Gov. M.A. Otero. **Sources:** WW59; WW47; P&H Samuels, 442; Eldredge, et al., *Art in New Mexico, 1900-1945,* 207.

SHUTE, Augustus B. *[Painter] 19th/20th c.*
Addresses: Brookline, MA, active 1881-1910. **Member:** Boston AC. **Exhibited:** Boston AC, 1881, 1882. **Sources:** WW10; *The Boston AC.*

SHUTE, Ben E. *[Painter, instructor, museum director, lecturer] b.1905, Altoona, WI / d.1986.*
Addresses: Atlanta, GA. **Studied:** AIC; Chicago Acad. Fine Arts; H.A. Oberteuffer; G. Oberteuffer; A. Philbrick; C. Werntz. **Member:** SSAL; Georgia AA (bd. mem.); Atlanta Art Gld; Nat. Soc. Painters in Casein. **Exhibited:** Pasadena AI, 1946; Ass. Am. Artists, 1945; AIC, 1929; CPLH, 1945; Caller-Times Exhib., Corpus Christi, TX, 1945; Georgia AA; SSAL, 1930-38, 1939 (prize), 1940-46; Corcoran Gal biennial, 1939; Butler IA; Telfair Acad. Art; BM; Atlanta WCC, 1960 (prize); Mead Paper Co. Award, 1961 (prize); Southeastern Ann., 1961 (prize). **Work:** High Mus. Art, Atlanta, GA; Columbus (GA) Mus. Arts & Crafts; Georgia Inst. Technology, Atlanta; Emory Univ., Atlanta; Mus. Art, Columbia, SC. **Comments:** Positions: chmn., Southeastern Ann. Exhib., 16 years. Teaching: lectures on contemporary Am. painting; instructor, Atlanta Art Inst., 1928-43, head fine arts dept., 1943-70. **Sources:** WW73; WW47.

SHUTE, Nell Choate *[Painter] b.1900, Athens, GA.*
Addresses: Atlanta, GA. **Studied:** Hollins College; Atlanta AI; Parsons School Fine & Applied Art; and Fontainebleau, France. **Member:** Georgia AA; NAWA. **Exhibited:** NAWA; Southeastern AA, 1945-1955, 1958; Assn. Georgia A.; AFA traveling exh. 1956; High Mus. Art (prizes); Atlanta Paper Co. Exhib., 1958. **Sources:** WW59.

SHUTE, Roberta *[Painter] mid 20th c.*
Addresses: Wash., DC. **Exhibited:** PAFA Ann., 1954. **Sources:** Falk, *Exh. Record Series.*

SHUTE, Ruth Whittier (Mrs. Samuel) *[Portrait painter] b.1803, Dover, NH / d.1882, Kentucky.*

Addresses: Weare, NH, 1834-36; Concord, NH, 1836-. **Studied:** self-taught. **Work:** Rockefeller Folk AC, Williamsburg, VA; Clayville Mus., Pleasant Plains, IL; Old Sturbridge Village, MA; Shelburne (VT) Mus.; Fruitlands Mus. **Comments:** Ruth and her husband Samuel traveled as a husband-wife team through New England and upper NY state, painting primitive portraits of 19th century small-town Americans. Their works appear to be painted primarily in watercolor, with pencil and gouache, although they also produced some oils and pastels. From 1827 (when they were married) until 1839, Ruth alone painted at least thirty works. After Samuel died in 1836, Ruth continued to paint, but in 1840 and she married Mr. Alpha Tarbell and moved to Kentucky. **Sources:** G&W; WPA (Mass.), *Portraits Found in Vt.;* WPA (Mass.), *Portraits Found in N.H.* More recently see Ch. Rubinstein, *American Women Artists,* 35-36; *300 Years of American Art,* Vol.1, 129.

SHUTE, Samuel A. *[Portrait painter] b.1803, Byfield, MA / d.1836, Champlain, NY.*
Studied: self-taught. **Work:** Rockefeller Folk AC, Williamsburg, VA; Clayville Mus., Pleasant Plains, IL; Old Sturbridge Village, MA; Shelburne (VT) Mus.; Fruitlands Mus. **Comments:** He teamed with his wife, Ruth (see entry), in painting primitive portraits. Initially, Ruth drew the face and hands, and he did the painting. He was also a doctor, but his brief painting career seems to have spanned only from 1827-33. **Sources:** *300 Years of American Art,* vol. 1, 129.

SHUTTLEWORTH, Claire *[Painter, teacher] b.1868, Buffalo, NY / d.1930, Buffalo.*
Addresses: Buffalo, NY/Chippawa, Ontario. **Studied:** Buffalo ASL with Bridgman; Acad. Vitti, Paris, with Luc-Olivier Merson, Raphael Collin, Paul Leroy; landscape painting in France and Italy with Frank Vincent DuMond. **Member:** Buffalo SA; NAWA; Rockport AA; Buffalo GAA (pres.), 1926-27); AFA; Buffalo ASL 1892-1900. **Exhibited:** Paris Salon, 1896-99; AIC, 1897-1908; PAFA Ann., 1900-04, 1916, 1924; Buffalo SA, 1910 (prize), 1929 (prize); S. Indp. A., 1917, 1921, 1924-25; Springville (Utah) H.S A. Assn., 1927 (prize). **Work:** Arnot Art Gal., Elmira, NY; Buffalo Hist. Soc. **Comments:** Executed over 100 paintings of Niagara Falls and the Niagara gorge. She traveled widely, including to Bermuda. **Sources:** WW29; Krane, *The Wayward Muse,* 196; Fink, *American Art at the Nineteenth-Century Paris Salons,* 390; Falk, *Exh. Record Series.*

SHWAYDER, Reva C. *[Artist] mid 20th c.*
Addresses: Detroit, MI. **Exhibited:** PAFA Ann., 1960. **Sources:** Falk, *Exh. Record Series.*

SHYROCK, John C(arter, Jr.) *[Painter] mid 20th c.*
Exhibited: Salons of Am., 1934. **Sources:** Marlor, *Salons of Am.*

SIBBEL, Joseph *[Sculptor] b.Germany / d.1907, NYC.*
Work: large statue of St. Patrick and subordinate statues, St. Patrick's Cathedral; death mask of Archbishop Corrigan.

SIBBEL, Susanna *[Folk painter] early 19th c.*
Addresses: Active in Pennsylvania, 1808. **Sources:** Petteys, *Dictionary of Women Artists.*

SIBEL, Lawrence *[Artist]*
Addresses: Wash., DC, active 1905-35. **Exhibited:** Gr. Wash. Indep. Exhib., 1935. **Sources:** McMahan, *Artists of Washington DC,.*

SIBELL, Muriel Vincent (Mrs. Wolle) See: **WOLLE, Muriel (Vincent) Sibell**

SIBERZ, Mayi *[Painter] b.1915, Mitchell, SD.*
Addresses: Des Moines, IA. **Studied:** Drake Univ.; Florence Sprague, Oma Strain, Edyth Goldmann. **Member:** Delta Phi Delta Art Fraternity. **Exhibited:** Joslyn Mem., 1934, 1935; Drake Univ.; Des Moines Public Library. **Comments:** Positions: art editor, Drake Univ. , 1936. **Sources:** Ness & Orwig, *Iowa Artists of the First Hundred Years,* 191.

SIBLEY, Charles Kenneth *[Painter, educator] b.1921, Huntington, WV.*
Addresses: Cape Charles, VA. **Studied:** Ohio State Univ. (B.S.); AIC; Columbia Univ. (M.A.); State Univ. Iowa (M.F.A.). **Exhibited:** Corcoran Gal biennials, 1951, 1953; Carnegie Intl, 1957; WMAA , 1952, 1957-59; PAFA Ann., 1953; Nat. Soc. Arts & Letters, 1959; NAD, 1961 (Stern Medal); "50 Artists/50 States," AFA, 1968; Norfolk Mus. 1971 (1st prize). Other awards: Louis Comfort Tiffany grant, 1955; Irene Leache Mem. prize. **Work:** MMA; North Carolina Mus., Raleigh; Virginia Mus., Richmond; Rochester Mem. Mus., NY; Harvard Univ., Cambridge, MA. Commissions: panels, U.S.S. Kennedy, 1971 & *Seventeen Magazine,* 1972; Virginia landscape (oil), Gov. Mansion, Richmond, 1972. **Comments:** Preferred media: oils, acrylics, watercolors. Teaching: Duke Univ., 1950-51; Old Dom Univ., 1955-, chmn. dept., 1955-70. **Sources:** WW73; Falk, *Exh. Record Series.*

SIBLEY, Ferol *[Painter] 19th/20th c.*
Addresses: Columbus, OH. **Exhibited:** S. Indp. A., 1917-21, 1937. **Sources:** WW01.

SIBLEY, Gladys M. (Mrs. John) *[Painter] b.Darby, MT / d.1964, Seattle, WA.*
Addresses: Portland, OR; Seattle, WA. **Exhibited:** SAM; Frye Mus. **Sources:** Trip and Cook, *Washington State Art and Artists, 1850-1950.*

SIBLEY, Marguerite (Mrs. Will Lang) *[Sculptor] 20th c.; b.Butler, IN.*
Addresses: Rockford, IL. **Studied:** Minneapolis Sch. Art; Acad. de la Grande Chaumière, Paris; Rockford Col.; with Marques Reitzel, Stephen Beams. **Member:** Rockford AA; Winnebago County Hist. Soc. **Exhibited:** CGA, 1938-39, 1941-44, 1946; Burpee Art Gal., 1931, 1933-36, 1938, 1941(solo)-46, 1951 (solo); Beloit Col., 1940; Rockford Col., 1934, 1940; Belle Keith Gal., Rockford, 1932, 1940; Smithsonian Inst., 1947-51; Rockford AA, 1952-58; Rockford Woman's Cl., 1958. **Work:** Burpee Art Gal., Rockford, IL; Chicago Temple, Chicago, IL; Emanuel Episcopal Church, Rockford, IL. **Sources:** WW59; WW47.

SIBLEY, Mary Elizabeth *[Painter] 19th/20th c.*
Addresses: Chicago, IL. **Exhibited:** AIC, 1900. **Sources:** WW01.

SIBOLT, S. H. (Mrs.) See: **LIBOLT, S. H. (Mrs.)**

SIBONI, Emma Benedikta *[Painter, miniature painter] b.1877, Sorö, Denmark.*
Addresses: Illinois; California; Washington, DC, 1917-40. **Studied:** AIC; W.M. Chase; F. Duveneck; Royal Art Acad., Copenhagen; Académie Julian, Paris with Laforge; also in Berlin and Munich. **Member:** AFA; Calif. SMP; Calif. AC. **Exhibited:** AIC; PPE, 1915; Wash. WCC, 1917, 1937; LACMA, 1921 (first prize), 1928 (first prize); Riverside, 1926 (third prize); Long Beach Expo, 1928 (gold medal); Pomona, CA, 1929 (first prize); Soc. Wash. Artists 1939; Wash. SMPS & G, 1937, 1939. **Work:** Huntington Art Gal., Los Angeles. **Comments:** Born of Italian parents, she came to the U.S. around 1894. **Sources:** WW40; Hughes, *Artists in California,* 514. Bibliography: McMahan, *Artists of Washington DC,.*

SIBURNEY, Alex *[Sculptor] b.1942.*
Addresses: NYC. **Exhibited:** WMAA, 1973. **Sources:** Falk, *WMAA.*

SICARD, Louis Gabriel *[Painter, lecturer] 20th c.; b.New Orleans, LA.*
Addresses: Amarillo, TX. **Studied:** Tulane Univ., with Elswoodward; also with Luis Granier, understudy of Sorola & Chas Wellington Boyle. **Member:** AAPL; Coppini Acad. Fine Arts; Men's Art Guild (founder, 1968); Men's Prof. Art League (founder, 1972); Artists & Craftsmen Assn.; Royal Soc. Art (fellow). **Exhibited:** Coun Am Artist Socs Nat, 1964 & 1965 & Am Artists Prof League Grand Nat, 1972, Lever House, NYC; Witte Mus., San Antonio, TX, 1965; Coppini Acad. Fine Arts, 1972-.

Work: Commissions: Chamber of Commerce, New Orleans, 1928; Southwestern Elec. Power Co., Shreveport, LA, 1956; B&B Systems Adv. Co., Shreveport, 1958; Selber Bros., 1960; two portraits, Louisiana State Exhib. Mus., Shreveport, 1967. **Comments:** Preferred media: oils. Positions: organizer, Louisiana Artists Inc., Shreveport, 1955; emer. director, Shreveport Art Club, 1960. **Sources:** WW73.

SICARD, Montgomery *[Marine painter] b.1836, NYC / d.1900, possibly Utica, NY.*
Work: Mariners Mus., Newport News, VA. **Comments:** A career Navy officer (1851-98), he served in the Mediterranean and China, was in New Orleans in 1860, and in 1870 was shipwrecked on Ocean Island in the Pacific. **Sources:** Brewington, 353.

SICHEL, Harold M. *[Illustrator, painter, designer] b.1881, Benicia, CA / d.1948, Oakland, CA.*
Addresses: NYC, 1921; Oakland, CA, 1940. **Studied:** with A.F. Mathews, Calif. Sch. Des. **Member:** SC. **Exhibited:** SC, 1926. **Comments:** Illustrator: *The Good Wolf*, F.H. Burnett, 1908; *Shoe and Stocking Stories*, E. Mardaunt, 1915; *The Truce of God*, M.R. Rinehart, 1920; *Wonder Tales from Goblin Hills*, F.J. Olcott, 1930; *The Story of Cotton*, D. Searborough, 1933. Appears to have split time between NYC and Oakland, CA. **Sources:** WW40; WW21; Hughes, *Artists in California.*

SICHI, Andrew T. *[Sculptor]*
Addresses: Wash., DC. active 1913-27. **Work:** Glenwood Cemetery. **Comments:** He made the marble monument (1913) dedicated to Teresina Vasco (Marion Kahlert?), a young girl who was the first known victim of an automobile accident in the U.S., in Glenwood Cemetery. Unfortunately, it was vandalized in the 1980s. Sichi also contributed to the sculptural decoration on the Ntl. Cathedral in the 1920s. **Sources:** McMahan, *Artists of Washington DC,.*

SICKELS, Noel Douglas See: **SICKLES, Noel Douglas**

SICKLER, Edward E. *[Painter] 19th/20th c.*
Exhibited: AIC, 1899. **Sources:** Falk, *AIC.*

SICKLES, Noel Douglas
[Illustrator, cartoonist] b.1910, Chillicothe, OH / d.1982.
Addresses: New Canaan, CT, 1966. **Comments:** Began as a newspaper artist; he developed the syndicated comic strip, "Scorchy Smith." Illustrated military instruction manuals in WWII. After the war he worked in advertising and as an illustrator of fiction, specializing in historical subjects including Westerns. **Sources:** WW40; WW40 (as Sickels); P&H Samuels, 443 (as Sickles).

SICKLICK, Isabelle *[Painter] 20th c.*
Addresses: NYC. **Exhibited:** S. Indp. A., 1942-44. **Sources:** Marlor, *Soc. Indp. Artists.*

SICKMAN, Jessalee Bane *[Painter, instructor] b.1905, Denver, CO.*
Addresses: Washington, DC. **Studied:** Univ. Colorado; Goucher College; Corcoran School Art; also with Richard Lahey & Eugen Weisz. **Member:** Artists Equity Assn.; Soc. Washington Artists. **Exhibited:** Public LIbrary, Wash., DC, 1942 (solo watercolor show); Corcoran Gal biennials, 1947-57 (5 times); Colony Club, Wash., DC, 1958 & 1962; Soc. Wash. Artists exh, Smithsonian Inst., 1968; Wash. Arts Club. Awards: Landscape Award, Corcoran School Art, 1937; Alice Barney Mem. Portrait Award, 1938. **Work:** CGA. Commissions: portrait commissioned by Mr. Pach, Cleveland, OH, 1951; "Pigeons," commissioned by Mrs. Bruton, Alexandria, VA, 1955; figure study commissioned by Mrs. Woods, San Diego, CA, 1971. **Comments:** Preferred media: oils. Illustrator: *Forum* magazine. Teaching: instructor of still life, Warrentown Country School, VA, 1940; instructor of life portrait, Corcoran School Art, 1940-63; instructor of portrait & still life, Sickman Studios, Washington, DC, 1964-70s. **Sources:** WW73; WW47.

SICKMAN, Laurence Chalfont Stevens *[Art administrator, art historian] b.1906, Denver, CO.*
Addresses: Kansas City, MO. **Studied:** Harvard Univ. (A.B. (cum laude), 1930; Harvard-Yenching fel China Peking, 1930-35; resident fellowship, Fogg Art Mus., 1937-39); Rochurst College, 1972 (hon. D.F.A.). **Member:** Assn. Art Mus. Dirs. (pres., 1964); Am. Assn. Mus. (council member, 1963-69); College Art Assn. Am. (board directors, 1963-68); Chinese Art Soc. Am. (board gov., 1948-; editor, Arch., 1948-66); Am. Council Learned Socs. (committee Far Eastern Studies, 1948-53). **Exhibited:** Awards: Knight Order of the Pole Star, HM King of Sweden, 1968. **Comments:** Positions: curator, Oriental art, Nelson Gallery Art, Kansas City, MO, 1935-45, vice-director, 1946-53 & director, 1953-. Publications: editor, *The University Prints, Oriental Art, Series O, Early Chinese Art*, 1938; co-author, *The Art and Architecture of China*, Pelican History of Art, 1956; editor & contributor, *Chinese Calligraphy and Painting in the Collection of John M. Crawford, Jr.,* 1962. Teaching: lectures on art history, Univ. Kansas, 1970- & Univ. Missouri- Kansas City, 1970-. Research: Far Eastern art, especially Chinese paintings and sculpture. **Sources:** WW73.

SICURO, Ida *[Painter] b.1886, Italy.*
Addresses: Active in Brooklyn, NY for 46 years. **Studied:** Self-taught. **Exhibited:** NYC. **Sources:** Petteys, *Dictionary of Women Artists.*

SIDEBOTHAM, Mary H. (M.) (Mrs.) *[Miniature painter] 20th c.*
Addresses: NYC; Mascoma, NH. **Exhibited:** S. Indp. A., 1917, 1920; Salons of Am., 1934. **Sources:** WW13.

SIDEBOTTOM, Josh *[Painter] 20th c.*
Addresses: Brooklyn, NY. **Exhibited:** S. Indp. A., 1924. **Sources:** Marlor, *Soc. Indp. Artists.*

SIDENBERG, Robert (Corp.) *[Painter] 20th c.*
Addresses: Fort Jackson. **Exhibited:** S. Indp. A., 1942. **Sources:** Marlor, *Soc. Indp. Artists.*

SIDER, Aida *[Painter] 20th c.*
Exhibited: S. Indp. A., 1940. **Sources:** Marlor, *Soc. Indp. Artists.*

SIDER, Deno *[Painter, sculptor] b.1926, Norwich, CT.*
Addresses: Encino, CA. **Studied:** Norwich Acad., diploma; also with Leon Franks. **Member:** San Fernando Valley Art Club (life member); Calif. Art Club; Valley Artist Guild; Burbank AA. **Exhibited:** Int. Madonna Festival, Los Angeles, 1958-61 & 1963-64; Calif. State Show, Sacramento, 1962 & 1966; Los Angeles Co. Art Show, Los Angeles, 1966; Hollywood Bowl Art Festival, Los Angeles, 1968-69; Gallery Tour, distributed by Ira Roberts. Awards: Mattatuck Mus. Purchase Award, 1964; Madonna Festival Award, Methodist Church, Los Angeles, 1964; Hollywood Bowl Best of Show, 1968 & 1969. **Work:** Mattatuck (CT) Mus. Commissions: map of U.S. & decor, Aldo, Hollywood, 1956; side panels & fish murals (mixed media), Aquarium, Tarzana, 1966. **Comments:** Preferred media: oils, clay, ink, charcoal. Positions: partner, Leedes Art Gallery, 1964-71, owner, 1971-. Publications: illustrator, *Epicurean Magazine*, 1969-70; illustrator/editor, *Prospector News*, 1971-. Teaching: art instructor & oils & owner, Sider Art School, Hollywood, 1954-64; instructor of art & oils, Leedes Art School, Encino, CA, 1964-. Collections: Leon Franks; Egyptian 18th Dynasty art; G McGregor; T'sung Dynasty scrolls. **Sources:** WW73.

SIDERIS, Alexander (Aristide) D. *[Painter, designer] b.1898, Skopelos, Greece / d.1978.*
Addresses: NYC. **Studied:** ASL with George Bridgman; Académie Julian, Paris; Pierre Laurence. **Member:** AAPL (vice-pres. NY Chapter, 1956-58). **Exhibited:** Salons of Am.; S. Indp. A., 1924, 1927, 1937-38, 1940, 1942; Oakland A. Gal.; Argent Gal., 1935 (solo); NAD, 1938; WFNY, 1939; Allied Artists Am, 1940-44, 1957; Am Artists Prof League, 1953 (prize); Barbizon Gallery, 1954; Nat Arts Club, 1955, 1961 (award); Knickerbocker Artists, 1959-1961, 1964 (gold medal), 1970 (hon. mention for

oil); Vendome Gal.; Hellenic Am Union Gallery, Athens, Greece, 1968 (solo). **Work:** Amarillo (TX) Mus.; Wesleyan College, Macon, GA; Greek Church, Phila.; murals, Church of the Annunciation, Pensacola, FL; Byzantine mural, Greek Cathedral, NYC. **Sources:** WW73; WW47, puts birth at 1895.

SIDES, Dorothy Smith *[Miniature painter, wood carver] 20th c.*
Addresses: Riverside, CA. **Exhibited:** Calif. Soc. of Min. Painters, 1932. **Sources:** Hughes, *Artists of California*, 514.

SIDLE, John W., Jr. *[Painter] 20th c.*
Addresses: Phila., PA. **Sources:** WW19.

SIDLE, Peggy *[Sculptor] 20th c.*
Addresses: Chicago area. **Exhibited:** AIC, 1933. **Sources:** Falk, AIC.

SIEBENHUENER, John *[Painter] 20th c.*
Exhibited: S. Indp. A., 1941. **Sources:** Marlor, *Soc. Indp. Artists.*

SIEBENTHAL, Myrtle Madden *[Painter]*
Addresses: Wash., DC, 1904-33. **Exhibited:** Soc. Wash. Artists; Soc. Independent Artists; PAFA Ann., 1933. **Work:** NMAA. **Sources:** McMahan, *Artists of Washington DC;* Falk, *Exh. Record Series.*

SIEBER, Edward George *[Landscape painter] b.1862, Brooklyn, NY.*
Addresses: Brooklyn, NY, 1886, 1894; NYC, 1897-98. **Studied:** NAD; Académie Julian, Paris with Flameng and Ferrier, 1888-90. **Member:** New York Mun. Art Soc.; SC, 1899; Brooklyn AC. **Exhibited:** NAD, 1886-98; Brooklyn AC, 1887 (gold medal); Charleston Expo, 1902 (medal). **Comments:** Specialty: paintings of cattle. **Sources:** WW08.

SIEBER, Roy *[Educator, museum curator] b.1923, Shawano, WI.*
Addresses: Bloomington, IN. **Studied:** New School Social Res., B.A., 1949; Univ. Iowa (M.A., 1951; Ph.D., 1957). **Member:** Royal Anthrop Inst.; African Studies Assn. (chmn. arts & humanities committee, 1963); College Art Assn. Am.; Am. Assn. Univ. Prof.; Midwest Art Assn. (secretary, 1963). **Exhibited:** Awards: African-Am. Univ. grant, 1964; Indiana Univ. Int. Studies grant, 1964, 1967; Nat. Endowment for Humanities sr, 1970-71. **Comments:** Positions: member for area fellowship programs, Africa Screening Committee, 1959-63; curator of primitive art, Indiana Univ. FA Mus., 1962-; member primitive art advisory committee, MMA; member joint committee Africa, Am. Council Learned Socs.-Social Sciences Res. Council, 1962-70; trustee, Mus. African Art. Teaching: lecturer, African art to colleges, Peace Corps, and others; instructor, later asst. professor, Univ. of Iowa, 1950-62; staff, Indiana Univ., 1962-64, prof. art history, 1964-, chmn. fine arts dept., 1967-70; visiting prof., Univ. of Ghana, 1964, 1967; visiting prof., Univ. Ife, Nigeria, 1971. Publications: author, *Sculpture of Northern Nigeria*, Mus. Primitive Art, NY, 1961; co-author, *Sculpture of Black Africa*, LACMA,1968; author, *African Textiles and Decorative Arts*, MoMA, 1972. **Sources:** WW73.

SIEBERLING, Gertrude Penfield *[Painter] b.c.1866 / d.1946, Akron, OH.*
Exhibited: Ohio State Fair, 1935; Nat. Assoc. Women P&S, 1935-38. **Sources:** Petteys, *Dictionary of Women Artists.*

SIEBERN, E. *[Painter] 20th c.*
Addresses: NYC. **Sources:** WW25.

SIEBERN, Emil *[Sculptor] b.1888, NYC / d.1942.*
Addresses: NYC. **Studied:** CUA School; ASL; NAD; Italy; France; Greece. **Exhibited:** PAFA Ann., 1916-28 (5 times). **Work:** sculpture, Hqtrs. Bldg., Bank of Montreal, Ottawa, Canada; stainless steel figures, Astoria Park, NY; statues, William and Mary College, Williamsburg, VA; sculpture, Central Park Zoo, NYC; Prospect Park Zoo, Brooklyn; portrait, Hall of Patriots, CCNY. **Sources:** WW40; Falk, *Exh. Record Series.*

SIEBERNS, Caroline Lenore (Mrs. Gerold R. Bradbury) *[Painter, designer] b.1911, Spring Valley, WI.*
Addresses: San Diego, CA. **Studied:** Minneapolis Sch. Art; Columbia Univ.; & with B.J.O. Nordfeldt, Dong Kingman, & others. **Member:** La Jolla AC; San Diego Artists Gld.; Spanish Village AC (secretary, 1952-54). **Exhibited:** San Francisco AA, 1940; AWCS, 1941; Minneapolis IA, 1935-37; San Diego Artists Gld., 1940-42, 1945, 1946, 1953; Spanish Village AC, 1954-58 (prize); Denver Art Mus., 1945; San Diego FAS, 1940 (prize), 1941 (prize). **Work:** Acad. of the Holy Angels, Minneapolis, MN; mural, Hotel Bella Vista, Cuernavaca, Mexico; mural dec., Pres. Aleman's Rancho Florido. **Sources:** WW59; WW47.

SIEBERT, A. C. *[Painter] 20th c.*
Addresses: St. Louis, MO. **Sources:** WW25.

SIEBERT, Albert *[Artist, photographer]*
Addresses: Wash., DC, 1872-77. **Comments:** Known under "Reichman and Siebert" in 1877. **Sources:** McMahan, *Artists of Washington DC,.*

SIEBERT, Edward S(elmar) *[Portrait painter, etcher, teacher] b.1856, Washington, DC / d.1944, Rochester, NY.*
Addresses: Wash., DC, 1876-80, 1895-1911; New York, 1884-95; Rochester, NY, 1932. **Studied:** with Albert A. Baur, Wiemar Art Acad., Germany, 1873-76; Munich Royal Acad. with Carl Hoff and Ferdinand Keller, 1880-83; Wilhelm von Diez in Munich, 1892. **Exhibited:** Soc. Wash. Artists, from 1891; Corcoran Gal. (prize for a "black &white"); Wash. WCC; NAD, 1890; Brooklyn AA, 1884; Rochester, NY (prize). **Work:** State of Georgia (portrait of Thomas Watson); CGA; NMAA; George Wash. Univ.; ceiling of LOC, Wash., DC. **Comments:** Son of engraver Selmar Seibert. He painted portraits of Andrew Carnegie, Thomas Watson (candidate for pres. in the Populist Party), and the last portrait of Thundercloud, the famous Blackfoot Indian Chief whose profile appears on the 5-cent buffalo coin. Instructor: drawing and painting, ASL of Wash., DC. Contributor: illustrations, (1876-77), *Erinnerungsblüten von Anno Dazumal.* **Sources:** WW29; obit., *Rochester Democrat* (n.d.); McMahan, *Artists of Washington DC,.*

SIEBERT, Erhart *[Sculptor] 20th c.*
Exhibited: WMAA, 1920. **Sources:** Falk, *WMAA.*

SIEBERT, Marie H. *[Artist]*
Addresses: Wash., DC, active 1917. **Sources:** McMahan, *Artists of Washington DC.*

SIEBERT, Selmar *[Copper engraver, photographer] b.1808, Lehnin, Prussia.*
Addresses: Washington, DC, c.1840-77. **Member:** Wash. Art Assoc. **Comments:** Father of artist Edward S. Siebert. He was trained in Germany and worked there until his emigration to America between 1840 and 1843, when he settled in Wash., DC. There he opened his own engraving and printing establishment. Much of his work was for the Fed. Govt., including the steel engravings which illustrated the *Reports of Explorations and Surveys to Ascertain the Most Practicable and Economic Route to the Pacific Ocean*, 1855-61. **Sources:** G&W; Thieme-Becker; Washington CD 1858-60; 8 Census (1860), D.C., II, 539; McMahan, *Artists of Washington DC.*

SIEBERT (OR SIEBERN), Annie Ware Sabine *[Miniature painter] b.1864, Cambridge, MA / d.1947.*
Addresses: Columbus, OH. **Studied:** With Edward Barnard, Boston; Hawthorne, Provincetown; J. R. Hopkins, Ohio State Univ. **Exhibited:** AIC, 1916-17; Am. SMP, NYC & Phila.; Columbus. **Comments:** (Note: Street address is the same as that for E. Siebern.) **Sources:** WW21; Petteys, *Dictionary of Women Artists.*

SIEBOLD, Chester N. *[Painter] 20th c.*
Addresses: Cleveland, OH. **Member:** Cleveland SA. **Comments:** Affiliated with Nat. Lamp Works, Cleveland. **Sources:** WW27.

SIEDENBURG, Annie *[Flower & fruit painter] late 19th c.*
Exhibited: Detroit, 1890. **Sources:** Petteys, *Dictionary of Women*

Artists.

SIEDLECKI, Frederick *[Painter] 20th c.*
Studied: ASL. **Exhibited:** S. Indp. A., 1919. **Sources:** Marlor, *Soc. Indp. Artists.*

SIEDMAN, Paul L. *[Painter] b.1904, NYC.*
Exhibited: S. Indp. A., 1936. **Sources:** Marlor, *Soc. Indp. Artists.*

SIEDSCHLAG, Lydia *[Educator, designer] b.1891, Flint, MI.*
Addresses: Kalamazoo, MI. **Studied:** AIC, B.A.E.; Teachers College, Columbia Univ., A.M.; Mills College; with Archipenko. **Member:** Michigan Acad. Arts, Sciences & Letters. **Work:** designed furniture & decorated residence halls & bldgs., Western Michigan Univ. **Comments:** Position: head art dept., Western Michigan Univ., Kalamazoo, MI, 1942-; art consultant, Univ. Bldg. Project. **Sources:** WW66.

SIEFERT, Grace Christine Rosaaen *[Painter] b.1889, Fisher, MN / d.1978, Stockton, CA.*
Addresses: Oakland, CA; Stockton, CA. **Exhibited:** Bay Region AA, 1940. **Sources:** Hughes, *Artists of California,* 514.

SIEG, Nelle C. *[Painter] 20th c.; b.Indianapolis, IN.*
Addresses: Rockport, MA. **Studied:** Sanderson School; with Mae Bennett-Brown, A. Hibbard, George Dinckel. **Member:** Rockport AA; North Shore AA; Marblehead AA; Copley Soc., Boston. **Sources:** *Artists of the Rockport Art Association* (1946, 1956).

SIEGEL, Adrian *[Photographer, painter] b.1898, NYC / d.1978.*
Addresses: Philadelphia, PA. **Member:** Phila. Art Alliance; AEA; fellow Royal Soc. Art, England; Philadelphia Print Club; PAFA;Woodstock AA; AAPL. **Exhibited:** PAFA Ann., 1934-52 (10 times); PAFA, 1941-45; Corcoran Gal biennial, 1939; AV, 1944; Friends Exhib., Phila., 1940-45; Phila. Art Alliance, 1943 (solo); "Three Photographers," PMA; trav exhibs., "Musicians at Work" & "People & Art," PMA; "Six Photographers," MoMA, 1949; Art Dir. Club, New York, 1949 (gold medal); Pepsi Cola Show, MMA; Artist Equity Exhib., Civic Center, Philadelphia, 1972. **Work:** PMA; MoMA. **Comments:** Positions: official photographer, Philadelphia Orchestra, 1937. Publications: author, *Concerto for Camera,* Philadelphia Orchestra Assn. **Sources:** WW73; "Orchestra Man Looks at the World's Great Musicians," *Life* (1943); Charles D. Sigsbee, "Idol Moments in the Orchestra," *Sun Magazine* (1952); "A Lens Among the Strings," *High Fidelity Magazine* (1955); WW47; Woodstock AA; Falk, *Exh. Record Series.*

SIEGEL, Alan *[Painter] b.1938.*
Addresses: NYC. **Exhibited:** WMAA, 1969, 1973. **Sources:** Falk, *WMAA.*

SIEGEL, Dink See: **SIEGEL, (Leo) Dink**

SIEGEL, Ethel *[Sculptor] mid 20th c.*
Addresses: Chicago area. **Exhibited:** AIC, 1946. **Sources:** Falk, AIC.

SIEGEL, Irene *[Painter] 20th c.; b.Chicago, IL.*
Addresses: Chicago, IL. **Studied:** Northwestern Univ., B.S.; Univ. Chicago; Illinois Inst. Technology; Inst. Design (Moholy-Nagy scholarship; 1954, M.S.). **Exhibited:** Drawing Soc. Show, Mus. Fine Arts, Houston, TX, 1965; Form & Fantasy, AFA, 1969; Tamarind Prints, MoMA, 1969; Soc. Contemporary Art, AIC, 1971; Relativerend Realisme, Van Abbemuseum, Eindhoven, Holland, 1972. Awards: Mr. & Mrs. Frank Logan Prize 1966; Tamarind fellowship, Ford Foundation, 1967. **Work:** AIC; MoMA; Los Angeles Co. Mus; World Bank, Washington, DC; Pasadena (CA) Mus. **Sources:** WW73; Williams S. Lieberman, *Homage to Lithography* (MoMA, 1969); Garo Antreasian, *The Tamarind Book of Lithography* (Abrams, 1971); Franz Schulze, *Fantastic Images* (Follett, 1972).

SIEGEL, Jerome (Mr. & Mrs.) *[Collectors] 20th c.*
Addresses: NYC. **Sources:** WW66.

SIEGEL, (Leo) Dink *[Illustrator, cartoonist] b.1910, Birmingham, AL.*
Addresses: NYC. **Studied:** NAD; ASL; Am. School Art; with Robert Brackman. **Member:** Soc. Illustrators. **Comments:** Preferred media: watercolors, inks, oils, gouache. Publications: illustrator, *Redbook Cosmopolitan, Saturday Evening Post, Good Housekeeping, New Yorker & Playboy.* **Sources:** WW73.

SIEGEL, Solomon (Sol) *[Sculptor] 20th c.*
Exhibited: S. Indp. A., 1940-41. **Sources:** Marlor, *Soc. Indp. Artists.*

SIEGEL, Zachary Leonard *[Painter] 20th c.*
Studied: ASL. **Exhibited:** S. Indp. A., 1939. **Sources:** Marlor, *Soc. Indp. Artists.*

SIEGER, Nicholas F. *[Painter] b.1910, Mineral Point, WI.*
Addresses: Racine, WI. **Studied:** Sister M. Sylvia, Racine; B.V. Shamberk. **Exhibited:** CGA, 1939. **Work:** St. John, Nep. Ch., Racine. **Sources:** WW40.

SIEGFRIED, Edwin C. *[Painter] b.1889, Alameda, CA / d.1955, Oakland, CA.*
Addresses: Alameda, CA. **Studied:** self-taught. **Exhibited:** GGE, 1939; Alameda Hist. Mus., 1983 (retrospective). **Comments:** Member of a pioneer California family, he was a painter as well as a musician. WPA artist. Preferred media: pastel. **Sources:** Hughes, *Artists in California,* 514.

SIEGLER *[Painter or proprietor of a panorama of a voyage] mid 19th c.*
Exhibited: Louisville, KY, 1850 (panorama of a voyage from New York to California via Cape Horn). **Sources:** G&W; Louisville *Morning Courier,* June 5, 1850 (citation courtesy J.E. Arrington).

SIEGLER, Maurice *[Painter, teacher] b.1896, NYC.*
Addresses: Atlanta, GA/NYC. **Studied:** ASL; PAFA; Fontainebleau School FA. **Member:** SSAL; Georgia AA; Tiffany Fnd. (fellow). **Exhibited:** SSAL, 1938; San Antonio, Texas, 1939; WFNY, 1939. **Work:** Richmond Acad. A.rt & Sciences; Library, State Capitol, Atlanta, GA. **Comments:** Position: teacher, Georgia School Technology, Atlanta. **Sources:** WW40.

SIEGLIN, Helen *[Painter] 20th c.*
Exhibited: S. Indp. A., 1940. **Sources:** Marlor, *Soc. Indp. Artists.*

SIEGNARS [?], Charles *[Listed as "artist"] b.1820, Ohio.*
Addresses: Cincinnati, 1850. **Comments:** Not found in the Cincinnati Directory, though there is a Mrs. Mary Signar in the 1853 directory. **Sources:** G&W; 7 Census (1850), Ohio, XX, 731; Cincinnati CD 1850, 1853.

SIEGRIEST, Louis B(assi) *[Painter, illustrator, designer] b.1899, Oakland, CA.*
Addresses: Oakland, San Francisco, CA. **Studied:** Calif. College Arts & Crafts, with Perham Nahl; Calif. Sch. FA with F. van Sloan and Glenn Wessels. **Exhibited:** Soc. of Six, Oakland Art Gallery 1923-28; GGE, 1939 (posters); Gump's, San Francisco, 1931 (solo), 1933 (solo), 1946 (solo); Crocker Art Gal, Sacramento, 1946 (solo); Calif. State Fairs, 1950s; Corcoran Gal biennial, 1951; MM, 1952; de Young Mus., 1952 (solo); Oakland Mus., 1954 (solo), 1960 (solo), 1972 (solo), 1979 (solo), 1981; PAFA Ann., 1958; UC Berkeley, 1963 (solo); San Francisco AC, 1964 (solo); San Francisco AI, 1965 (solo); WMAA, 1973; Triangle Gallery, San Francisco, 1969-85 (solos); Charles Campbell Gal., San Francisco, 1980 (solo). **Work:** Oakland Mus.; Stanford Mus.; SFMA; Univ. Nevada. **Comments:** As a young man, c.1917 he became a member of the Society of Six, an important group of avant-garde painters, including Selden Gile (see entry), Maurice Logan (see entry), B. von Eichman (see entry) and others. Position: art director, C.R. Stuart, Inc.; teacher, ASL of San Francisco, 1948-51. He worked as a commercial artist until c.1945, when he devoted all his time to painting. **Sources:** WW40; Hughes, *Artists of California,* 514; Falk, *Exh. Record Series.*

SIEGRIEST, Louis L. ("Lundy") *[Painter, instructor]* b.1925, Oakland, CA / d.1985, Oakland, CA.
Addresses: Oakland, CA. **Studied:** Calif. College Arts & Crafts, Oakland, certificate. **Exhibited:** PAFA Ann., 1950-51, 1954; 3rd Biennale Sao Paulo, Brazil, 1955; Carnegie Inst. Int., Pittsburgh, 1955; Young Am. Under 1935, 1958 & Contemporary Am. Painting, 1960, WMAA; 17 Am. Painters, Brussels World's Fair, 1958; Bolles Gal., San Francisco, CA, 1970s. **Awards:** Albert M. Bender grant, 1952; purchase awards, CPLH, 1952 & Santa Barbara Mus., 1955. **Work:** WMAA; Denver Art Mus.; LOC; Santa Barbara Mus.; Oakland Mus. **Comments:** Preferred media: oils, mixed media. Teaching: painting instructor, Acad. Art, San Francisco, CA, 1951-64; painting instructor, Jr. Center Art, Oakland, 1953-71; painting instructor, Civic Arts, Walnut Creek, CA, 1964. **Sources:** WW73; "New talent, Art USA," *Art Am.* (1957); *Contemporary American Painting* (Univ. Illinois Press, 1963); Falk, *Exh. Record Series.*

SIEGRIST, Emil *[Painter]* early 20th c.
Exhibited: Salons of Am., 1924. **Sources:** Marlor, *Salons of Am.*

SIELKE, Leo, Jr. *[Painter]* b.1880 / d.1930, NYC.
Member: S. Indp. A. **Exhibited:** S. Indp. A., 1919, 1920.
Comments: Specialty: magazine cover designs, including portraits and landscapes.

SIEMER, Christian *[Painter, mural apinter]* b.1874, New Zealand / d.1940, Los Angeles, CA.
Addresses: Los Angeles, CA. **Member:** Painters & Sculptors of Los Angeles. **Exhibited:** Century of Progress Fair; GGE, 1939; Calif. State Fairs; Del Mar Fairgrounds, 1940. **Work:** Commission: series of mural-size canvases of Los Angeles, Chamber of Commerce. **Sources:** Hughes, *Artists of California,* 514.

SIEMINSKI, F. R. *[Painter]* 20th c.
Exhibited: S. Indp. A., 1942. **Sources:** Marlor, *Soc. Indp. Artists.*

SIEMS, Alice Lettig (Mrs. H. B.) *[Sculptor, portrait painter]* b.1897, Iowa City, IA.
Addresses: Chicago, IL/Pass-a-Grille, FL. **Studied:** Univ. Wisconsin; C.A. Cumming; AIC under Lorado Taft & Alban Polasek; Univ. Iowa. **Member:** Assn. Chicago PS; AIC; Chicago Gal. Assn. **Exhibited:** NAD; PAFA Ann., 1925; Cordon Galleries, 1931-35 (solos); AIC; Chicago Galleries, 193-034 (solos, prizes); Cordon Galleries, 1931-35; Tudor Galleries, 1934 (solo); Northwestern Univ., 1934 (solo); Davenport (IA) Municipal Art Gal., 1930 (solo), 1931 (prize); Chicago Gal. Assn., 1931 (prize), 1932 (prize). **Work:** Univ. Chicago; Univ. Iowa; Univ. South Dakota. **Sources:** WW40; Ness & Orwig, *Iowa Artists of the First Hundred Years,* 191-92; Falk, *Exh. Record Series.*

SIEMSEN, Frederick *[Painter]* 20th c.
Addresses: NYC. **Member:** GFLA. **Sources:** WW27.

SIERON, Maurice *[Painter]* 20th c.
Addresses: NYC. **Exhibited:** S. Indp. A., 1929. **Sources:** Marlor, *Soc. Indp. Artists.*

SIETZ, Lewis *[Listed as "artist"]* b.c.1827, Württemberg, Germany.
Addresses: NYC, 1860. **Comments:** His wife was from Baden and they had a son, 11 months old, born in NYC. **Sources:** G&W; 8 Census (1860), N.Y., LIV, 926; NYCD 1863.

SIEVAN, Maurice *[Painter, teacher]* b.1898, Ukraine, Russia / d.1981.
Addresses: NYC; Flushing, NY. **Studied:** NAD, with Leon Kroll & Charles Hawthorne; ASL; also with Andre L'Hote, Paris, France. **Member:** Woodstock AA; Fed. Modern Painters & Sculptors (all committees); College Art Assn. Am.; Artists Equity Assn. **Exhibited:** Salon d'Automne, Paris France, 1931; BM Int. Watercolor Exhibs., 1941 & 1953; Artists For Victory, MMA (AV), 1942; Painting USA, CI, 1943, 1944 & 1945; Corcoran Gal biennial, 1945; PAFA Ann., 1944, 1946, 1949; AIC, 1941; VMFA, 1944; WMAA, 1943; NAD, 1926, 1938, 1942-45; AWCS, 1941; Minnesota State Fair, 1943; de Young Mem. Mus., 1943; G.W.

Smith Art Mus., 1944; Tomorrow's Masterpieces Traveling Exhib., 1943-44; Wadsworth Atheneum, 1944; Inst. Modern Art, Boston, 1945; Bucknell Univ., 1940; Riverside Mus., 1943; Wildenstein Gal., 1942-46; Midtown Gal., 1933-34; Contemporary Artists, 1939 (solo), 1941 (prize), 1944; ACA Gal., 1938, 1946; Gal. Mod. Art, 1944; Babcock Gal., 1943, 1944; Mortimer Brandt Gal., 1945 (solo); Summit (NJ) AA, 1945 (solo); MoMA, Romantic Painting Am., 1943, Recent Drawings, 1956 & New Acquisitions 1964-65; "NYC WPA Art" at Parsons School Design, 1977. **Awards:** Newhouse Mem. Award, Audubon Artists, 1946; first prize, Queens Botanical Gardens, 1949; Invitation Award Res. Studios, Maitland, FL, 1953. **Work:** MMA; BM; BMA; Butler Inst. Am. Art, Youngstown, OH; Walter Chrysler Mus., Provincetown, MA; Woodstock AA. **Comments:** WPA artist. Preferred media: oils, watercolors, pastels. Teaching: Summit AA, 1940-50; Queens College, Flushing, NY, 1946-68. **Sources:** WW73; Elizabeth McCausland, *Work for artists* (Am. Artists Group, 1947); Lawrence Campbell, "Maurice Sievan," *Art News* (May, 1955); Ivan Karp, *Seven paintings by Sievan* (Barone Gallery, Jan., 1960); WW47; *New York City WPA Art,* 80 (w/repros.); Woodstock AA; Falk, *Exh. Record Series.*

SIEVENTHAL, M. M. *[Painter]* early 20th c.
Exhibited: Salons of Am., 1929. **Sources:** Marlor, *Salons of Am.*

SIEVERS, Frederick William *[Sculptor, craftsperson]* b.1872, Fort Wayne, IN / d.1966, Richmond, VA.
Addresses: Richmond, VA, 1892-98; Europe, 1898; NYC, 1905-10; Richmond, 1911 and after. **Studied:** Royal Acad. FA, Rome, Italy; Académie Julian, Paris, 1902. **Member:** VMFA. **Exhibited:** NSS; VMFA. **Awards:** prizes, Royal Acad. FA, Rome. **Work:** monuments, mem., statues; Abingdon, VA; Gettysburg, PA; Richmond, VA; Vicksburg, MS; State Capitol, VA; Hall of Fame, NY; Leesburg, VA; Elmira, NY; State Capitol, Nashville, TN. **Sources:** WW59; WW47. More recently, see Wright, *Artists in Virgina Before 1900.*

SIEVERS, Lucille Scott (Mrs.) *[Painter]* 20th c.
Addresses: Delaware, OH. **Member:** S. Indp. A. **Exhibited:** S. Indp. A., 1921. **Sources:** WW25.

SIEVERT, Emilie I. *[Painter]* 20th c.
Addresses: Chicago, IL. **Exhibited:** AIC, 1905. **Sources:** WW06.

SIGALL, Josef *[Portrait painter]* b.1891, Poland / d.1953, La Jolla, CA.
Addresses: Saratoga, CA; La Jolla, CA. **Studied:** Royal Art Academy, Vienna, Austria, 1909-15 (gold medalist). **Work:** Montgomery Theatre, San Jose Municipal Auditorium; Univ. of Santa Clara. **Comments:** Painter of royalty in Europe, he immigrated to the U.S. in 1922, where he painted important political figures such as Presidents Coolidge, Hoover, Roosevelt, their families and cabinets. **Sources:** Hughes, *Artists in California,* 515.

SIGEL, Barry Chaim *[Painter]* b.1943, Baltimore, MD.
Addresses: New York, NY. **Studied:** Maryland Inst. Art; Acad. Art, New Haven; with Mrs. Rosenfield, North Truro, MA; also with A. G. Giovanni, Giorzinko, Sicily. **Member:** Charcoal Club Baltimore. **Exhibited:** Baltimore Mus. Art, 1965 & 1966; Datza Mabot Gallery, Pecarino, Sicily, 1967; Grand Prix de Still Life, Ostend, Belgium, 1968; Greenwich Village Outdoor Show, 1969; Green Mountain Art Gallery, New York, 1971. **Awards:** Louis Waitsman prize, Baltimore AA, 1966; Chalk Championship New York, 1971. **Work:** Union Plumbers Am. Hall, Pasadena; Harvey House Rest, Baltimore; Grand Canyon Hist. Mus., AZ; Royal Mus, Bombay, India. Commissions: portraiture & bust, Richard Lyttle, New Haven, CT, 1968; mural, Pierre's Beauty Salon, NYC, 1969; watercolor, Mr. & Mrs. Dilly McKenzie, Cape Cod, MA, 1969; outdoor sign, Right-on Church of Good Vibes, Mesa, WY, 1970; collage (with Ann Kutti), Layed Back'n Mello Rest Home, San Francisco, 1972. **Comments:** Preferred media: oils, watercolors, feathers. Teaching: critic painting, Scungia Acad., Sicily, 1969. **Sources:** WW73; N.P. Clark, article, *Baltimore News Post,* 1966; Tworkov, "You Call These Paintings?," *NH Hist. Magazine*

(1968).

SIGEL, Emil *[Engraver and die sinker] mid 19th c.*
Addresses: NYC, 1856-58. **Sources:** G&W; NYBD 1856, 1858.

SIGER, Clyde *[Painter] 20th c.*
Exhibited: AIC, 1938. **Sources:** Falk, *AIC.*

SIGFRID, Mabs (Miss) *[Painter] early 20th c.*
Addresses: Floral Park, NY. **Exhibited:** Salons of Am., 1926; S. Indp. A., 1926-27. **Sources:** Marlor, *Salons of Am.*

SIGFUS, S. I. See: **SIGRUS, S. L. (or S. I. Sigfus)**

SIGGONS, Louis K. *[Engraver]*
Addresses: Wash., DC, active 1904-20. **Sources:** McMahan, *Artists of Washington DC,.*

SIGISMUND, Violet Mattersdorfer *[Painter, printmaker] 20th c.; b.NYC.*
Addresses: NYC. **Studied:** ASL; also with Sidney Laufman & George Grosz. **Member:** Knickerbocker Artists; NAWA; Provincetown AA; Artists Equity Assn. NY (exec. board, 1960-73; chmn. membership, 1960-73). **Exhibited:** PAFA Ann., 1942; PAFA, 1947; Audubon Artists, New York, 1947, 1948 & 1961; Butler IA, 1962; NAD, 1962 & 1964; NAWA, Int Festival Cannes, France, 1965; group print shows, Albany Inst. Arts, 1971, Cayuga Mus, 1973 & Washington Co. Mus., MD, 1971-73; Clinton Seeley, Rye Beach, NH & Paul Kessler, Provincetown, MA, 1970s. Awards: silver medal, Knickerbocker Artists, 1952; Friend's Award, Silvermine Guild, 1960; Sargent Prize, NAWA, 1963. **Comments:** Preferred media: oils, watercolors, woodblock. **Sources:** WW73; Falk, *Exh. Record Series.*

SIGLIN, Jennie *[Painter, teacher] b.1849, England.*
Addresses: Active in Marathon, IA. **Studied:** Self-taught with a few lessons from Paul Wendt. **Comments:** Emigrated in 1854. **Sources:** Petteys, *Dictionary of Women Artists.*

SIGMUND, Jay G. *[Sculptor and wood carver] b.1887, Rock Falls, IL.*
Addresses: Waubeek, IA. **Studied:** Self-taught. **Exhibited:** All Iowa Exhibit, Carson Pirie Scott, 1937. **Work:** Grace Church, Cedar Rapids, IA. **Comments:** Author: *Frescoes, Pinions, Land O'Marge Folk, Drowsy Ones, Altar Panels,* and books of short stories. **Sources:** Ness & Orwig, *Iowa Artists of the First Hundred Years,* 192.

SIGMUND, Louise Bernardine (Mrs. Jay) *[Wood carver] b.1887, Rock Falls, IL.*
Addresses: Active in Waubeek, IA. **Exhibited:** Iowa Fairs (prizes). **Work:** hospitals and churches, Cedar Rapids & Dubuque, IA. **Comments:** Married Jay Sigmund (see entry). **Sources:** Petteys, *Dictionary of Women Artists.*

SIGRUS, S. L. (or S. I. Sigfus) *[Painter] 20th c.*
Addresses: Chicago, 1930-32. **Exhibited:** AIC, 1931; PAFA Ann., 1930 ,1932. **Sources:** Falk, *Exh. Record Series* (appears as S.L. Sigrus in PAFA exh. records and S.I. Sigfus in AIC exh. records).

SIGSBEE, Mary Ellen See: **FISCHER, Mary Ellen Sigsbee (Mrs. Anton O.)**

SIGSTEDT, Thorsten *[Woodcarver] b.1884, Stockholm, Sweden.*
Addresses: Bryn Athyn, PA. **Member:** Phila. Alliance. **Work:** Royal Barge, King of Sweden; restoration of antique masterpieces, Swedish Acad. Antiquities; gothic carvings, Baltimore Protestant Cathedral; St. Michael Chapel, Torresdale, PA; Catholic Church, Saratoga Springs, NY; St. Andrews School, Middletown, DE; panel, Am-Swedish Hist. M., Phila. **Comments:** Specialty: figure work. **Sources:** WW40.

SIGSTEDT, Val *[Artist] 20th c.*
Addresses: Bryn Athyn, PA. **Exhibited:** PAFA Ann., 1960. **Sources:** Falk, *Exh. Record Series.*

SIHVONEN, Oli *[Painter] b.1921, Brooklyn, NY.*
Addresses: Taos, NM, (1956-70s); NYC (1970s-on). **Studied:**

ASL with Corbino; Black Mountain College, NC, with Josef Albers & Buckminster Fuller. **Exhibited:** Galeria Escondida, Taos, 1956-63; Geometric Abstraction in America, 1962 & Whitney Ann., 1963, 1965 & 1967, WMAA; The Responsive Eye, MoMA, 1965; 30th Biennial Am. Painting, CGA, 1967; plus X Minus Today Half Century, Albright-Knox, Buffalo, NY, 1968. Awards: Nat. Council Arts Award, 1967; purchase award, Corcoran Biennial, 1967. **Work:** MOMA, New York, NY; Whitney Mus Am Art, New York; Corcoran Gallery Art, Washington, DC; Dallas Mus Fine Arts, Tex; Art Inst Chicago, Ill. Commissions: Lobby wall painting, State Agency Bldg., S. Mall, Albany, NY, 1968; painting, Northwestern Univ., Evanton, IL, 1969. **Comments:** Abstract color field painter employing circular shapes and bright colors. **Sources:** WW73; WW47; article, "La Galeria Escondida" in *Artforum* (n.d.).

SILBER, Esther See: **REED, Esther Silber**

SILBER, Zavel See: **ZAVEL, (Zavel Silber)**

SILBERFELD, Sylvette *[Painter] early 20th c.*
Exhibited: Salons of Am., 1931. **Sources:** Marlor, *Salons of Am.*

SILBERGER, Manuel Grosz *[Painter] b.1898, near Ksa, Hungary (now Czechoslovakia) / d.1968, Cleveland, OH.*
Addresses: Cleveland, OH. **Exhibited:** Int. Lithographer, Engraver Ann., AIC, 1937, 1938, 1939; 48 States Competition, 1939. **Comments:** Came to U.S. in 1921. **Sources:** WW40.

SILBERMAN, Charles *[Painter] 20th c.*
Addresses: NYC. **Exhibited:** S. Indp. A., 1943-44. **Sources:** Marlor, *Soc. Indp. Artists.*

SILBERMAN, Sarah G(ettleman) *[Sculptor] b.1909, Odessa, Russia.*
Addresses: Atlantic City, NJ; Phila., PA. **Studied:** A. Laessle; W. Hancock; PAFA, 1931 (Cresson Traveling Scholarship). **Exhibited:** PAFA Ann., 1933. **Sources:** WW40; Falk, *Exh. Record Series.*

SILBERSTEIN, Muriel Rosoff *[Instructor, painter] mid 20th c.; b.Brooklyn, NY.*
Addresses: Staten Island, NY. **Studied:** Carnegie Inst. Technology, B.F.A.; Phila. Mus. Art, with Hobson Pitman; Inst. Modern Art, with Victor D'Amico, Donald Stacy & Jane Bland. **Member:** New York Art Commission (commissioner, 1970-); MMA (trustee, 1971-); Staten Island Council Arts; New York Cultural Council (visual arts committee, 1972); Heritage House (director). **Exhibited:** Jewish Community Center Group Show, 1971-72; Panoras Gallery, NYC, 1972 (solo). Awards: Woman of Achievement, Staten Island Advan., 1967; achievement award, Lambda Kappa Mu Sorority. **Work:** Commissions: program drawings, Philadelphia Symphony Orchestra Children's Concerts, 1949; murals & other projects, Mt. Sinai Hospital & Philadelphia' Psychiatric Hospital. **Comments:** Preferred media: assemblage, collage. Positions: assoc. director & scene designer, Pittsburgh Playhouse, 1944-46; interior display designer, various Pittsburgh dept. stores, 1946-47; art educ. consultant, Staten Island Mental Health Schools, Head Start, Staten Island Community Co. Publications: contributor, *Art Caravan.* Teaching: art instructor, Inst. Modern Art, MoMA, 1963; guest lecturer and art educator at various colleges and community groups, NYC, 1967; instructor, Int. Playgroups Art Workshops, NYC, 1970; instructor, Staten Island Community College, 1970-; instructor, parent-child classes, MMA. **Sources:** WW73.

SILBERT, Ben *[Portrait painter, etcher] b.1893, Gorki, Russia.*
Addresses: NYC. **Studied:** AIC. **Exhibited:** AIC. **Work:** AIC; Baltimore Mus. Art;BM; Milwaukee AI; etchings, Honolulu Acad. Art; Los Angeles Mus. of History, Science & Art; Mus. of Cahors, French Nat. Collection. **Comments:** Contributor of articles & illustrations to French, German, & American press. **Sources:** WW40.

SILEIKA, Jonas *[Painter, teacher] b.1883, Lithuania.*
Addresses: Lekeciaia, Lithuania. **Studied:** AIC; Munich RA. **Member:** AFA; AS of Lithuania. **Exhibited:** AIC, 1920 (prize).

Work: Gal. of Ciur Lionis, Kauna, Lithuania. **Sources:** WW29.

SILEIKIS, Michael Justin *[Painter, writer, lecturer] b.1893, Lithuania.*
Addresses: Chicago, IL. **Studied:** AIC; & with Leopold Seyffert, Leon Kroll. **Member:** Hoosier Salon; All-Illinois Soc. FA.
Exhibited: AIC (prize 1925); Hoosier Salon; All-Illinois Soc. FA.
Comments: Position: art critic, *Lithuanian Daily News,* Chicago, IL. **Sources:** WW53; WW47.

SILER, Elmer Wayne *[Painter, graphic artist, art historian] b.1910, Brute, NE.*
Addresses: Bloomington, IL. **Studied:** Art history with Dimitri Tselos, Lorenz Eitner, H. Harvard Arnason; art with Kyle Morris, Malcolm H. Myers, Walter Quirt, Syd Fossum; and in France and Ireland; Univ. Illinois, A.B.; Univ. Minnesota, M.A. **Member:** Des Moines AC. **Exhibited:** WAC; Minneapolis Inst. Art; St. Paul School Art Gal.; Univ. Minnesota. Awards: prize, Des Moines AC. **Sources:** WW59.

SILIGATO, Carlo *[Painter] 20th c.*
Addresses: Wash., DC. **Sources:** WW17.

SILINS, Janis *[Painter, educator] b.1896, Riga, Latvia.*
Addresses: Roselle, NJ. **Studied:** Univ. Moscow; Riga Univ., M.A. & Ph.D.; Univ. Stockholm; Univ. Marburg; Art School Ilya Mashkov, Moscow; Art School Kazan. **Member:** Latvian Artists Group New York; Sarasota AA; Orlando AA (board member, 1962); Assn. Artists, Sadarbs, Riga (secretary, 1924-38); Am. Assn. Univ. Prof. **Exhibited:** Nat. Art Exhib., Riga, 1928; Exhib. Artists In Exile, Stuttgart, Germany, 1948; Ringling Mus. Art, Sarasota, 1963; Latvian Exhib. Arts & Crafts, Boston, 1964; Latvian Artist Group NYC, 1967. Awards: Order of Three Stars, Govt. Latvia, 1936; Kriskian Baron Award, Riga Univ., 1937. **Work:** Univ. Art Collection, Riga; Art Mus. Jelgava, Latvia.
Comments: Preferred media: oils, watercolors. Positions: director, art museum, Riga Univ., 1941-44; art consultant, Norfolk Mus., 1955-; executive director, Morse Gallery Art, 1956-60. Publications: author, *Rudolph Perle,* 1928; author, *Michelangelo,* 1931; author, *Karlis Zale, His Monumental Sculpture,* 1938 & 1943; author, *Laudolf Liberts, Painter and Stage Designer,* 1942; author, *Janis Gailis, A Latvian Landscape Painter,* 1948. Teaching: art history instructor, Riga Univ. & Latvian Acad. Art, 1931-44; art history instructor, Univ. Würzburg, 1946-51; art history instructor, Rollins College, 1956-63. Collections arranged: Hugh Gowan Miller Collection Paintings, Norfolk (VA) Mus., 1955; Arts of Norway, Morse Art Gallery, Winter Park, FL & tour, 1958. **Sources:** WW73; J. Kadilis, *Janis Silins,* Cels, 1946; L. Liberts, *Janis Silins,* 1946; A. Annus, *Seeking for Beauty and Truth,* 1966, Laiks.

SILK, George *[Photographer] b.1916, New Zealand.*
Addresses: New York, NY; Westport, CT. **Exhibited:** Awards: gold medal, Art Dirs. Club, NY, 1961; Photographer of the Year award, 1960, 1962, 1963, 1964 (sponsored by the Univ. Missouri and Nat. Press Photographers Assn.); prints accepted for "Photography in the Fine Art," exhib. **Sources:** WW66.

SILKE, Lucy S. *[Painter, craftsperson, teacher] 20th c.; b.Yonkers, NY.*
Addresses: Chicago. **Studied:** AIC; A.W. Dow, in NYC.
Exhibited: AIC, 1906-07. **Sources:** WW08.

SILKOTCH, Mary Ellen *[Painter, teacher] b.1911, NYC.*
Addresses: Piscataway, NJ. **Studied:** Van Emburgh School Art; also with Jonas Lie, Sigismund Ivanowski & Dudley Gloyne, summers. **Member:** NAWA; Plainfield AA (pres., 1952-60); AAPL (pres., NJ Chapter, 1969-); NJ Adult Educ. Assn.; Westfield AA; Millburn-Short Hills AA. **Exhibited:** Allied Artists Am., 1943, 1944; Audubon Artists, 1945; NAWA, 1944-46; Plainfield AA, 1936-38, 1942-46, 1944 (prize); Morton Gal., 1946; NJ Gal., 1939; Newark Mus., 1942; Montclair Art Mus., 1942, 1944-46; East Orange, NJ (prize); AAPL (prize); Atlantic City AC; Irvington Mus. & AA. **Comments:** Positions: vice-pres., Academic Artist, 1967-; vice-pres. Trailside Mus. Arts Center NJ.

Teaching: art instructor, Van Emburght School, Plainfield, 1944-64; art instructor, Adult Educ., Dunellen, NJ, 1948-57; art instructor, Bound Brook Adult Educ., 1950-57; art instructor, North Plainfield, 1951-54. **Sources:** WW73; WW47.

SILKS, Donald Kirk *[Painter, teacher] b.1912, Kansas City, MO.*
Addresses: NYC; Glen Cove, NY. **Studied:** Univ. Kansas, B.A., B.F.A.; Univ. North Carolina. **Member:** CAA. **Exhibited:** Kansas City AI, 1939-41; 48 States Comp., 1939; Village Art Center, NY. **Work:** St. Joseph (MO) Jr. College; Topeka Art Center; Friends of Art Soc., St. Joseph; mural, USPO, Augusta, KS. **Comments:** Positions: instructor, St. Joseph (MO) Jr. College, 1938-41; Univ. Kansas, 1941-42; Ferree School Art, Raleigh, NC, 1950-51. **Sources:** WW53; WW47.

SILL, Ebenezer Enoch *[Listed as "artist"] b.1822, Moreau, NY.*
Addresses: NYC, 1854. **Comments:** He was married to Beatris Weatherspoon when living in New York. **Sources:** G&W; *Genealogy of the Descendants of John Sill,* 38.

SILL, Howard *[Painter] 20th c.*
Addresses: Baltimore, MD. **Sources:** WW25.

SILL, Joseph *[Portrait painter] b.1801, Carlisle, England / d.1854, Philadelphia.*
Exhibited: Artists' Fund Society, 1837 (copy of a portrait by Thomas Sully). **Sources:** G&W; information courtesy Mrs. Harold M. Sill, Phila.; Rutledge, PA.

SILLCOX, Luise M. *[Painter] 20th c.*
Addresses: NYC. **Member:** GFLA. **Sources:** WW27.

SILLIERE, Paul *[Still life & landscape painter] 20th c.*
Exhibited: Salons of Am., 1922, 1923. **Sources:** Marlor, *Salons of Am.*

SILLMAN, J. H. *[Painter] 20th c.*
Exhibited: S. Indp. A., 1939. **Comments:** Possibly Sillman, Dr. John H., b. 1899, London, England-d. 1967, Summit, NJ. **Sources:** Marlor, *Soc. Indp. Artists.*

SILLS, Thomas Albert *[Painter] b.1914, Castalia, NC.*
Addresses: NYC. **Studied:** Self-taught. **Exhibited:** Betty Parsons Gallery, NYC, 1955, 1957, 1959, 1961 (solo); Paul Kantor Gallery, Los Angeles, 1962; Bodley Gallery, NYC, 1964, 1967, 1969, 1972; Stable Gallery, NYC, 1955; New School for Social Research, NY, 1956; Camino Gallery, 1956; WMAA, 1959-72; Fairleigh-Dickinson Univ., 1964; Creighton Univ., Omaha, NE, 1967; Wilson Col, Chambersberg, Pa, 1968; Minneapolis Inst. of Art, 1968; Mt. Holyoke College, 1969; Ruder & Finn Fine Arts, NYC, 1969; Student Center Art Gallery, Brooklyn College, NY, 1969; New Am. Painting & Sculpture, The First Generation, MoMA, 1969; Afro-Am. Artists Exhib., Mus. Phila. Civic Center, 1969; Mt. Holyoke College, South Hadley, MA, 1969; BMFA, 1970; State Armory, Wilmington, DE, 1971. Awards: William & Norma Copley Foundation Award, 1957. **Work:** Bodley Gallery, Fordham Univ., Finch College Museum, WMAA, MMA, MoMA, Chase Manhattan Collection, all NYC; Sheldon Mem Gallery, Lincoln, NE; Williams College Mus., Williamstown, MA; Phoenix (AZ) Art Mus.; Norfolk (VA) Mus. of Arts & Sciences; LACMA; Univ. of Illinois; Rockefeller Univ., NY; Hofstra Univ., NY; SFMA; Ciba-Geigy Co.; Johnson Pub. Co. **Sources:** WW73; Cederholm, *Afro-American Artists.*

SILSBEE, Bertha Woolman *[Sculptor] b.1875, Ohio / d.1964, San Diego, CA.*
Addresses: San Diego, CA. **Exhibited:** Artists Fiesta, Los Angeles, 1931; Calif.-Pacific Int. Expo, San Diego, 1935. **Sources:** Hughes, *Artists in California,* 515.

SILSBEE, Martha (Miss) *[Painter] b.1858, Salem, MA / d.c.1928, Dublin, NH.*
Addresses: Boston, MA; Dublin, NH. **Studied:** BMFA School.
Member: Boston WCC. **Exhibited:** Boston AC, 1885-1906; PAFA Ann., 1895, 1902; AIC; S. Indp. A., 1918; Doll &

Richards, 1927 (solo). **Comments:** Preferred medium: watercolor. She painted at Fenwick Studios, 1912-18. **Sources:** WW27; Campbell, *New Hampshire Scenery*, 149; Vose Galleries, *Mary Bradish Titcomb and Her Contemporaries*, 51; Falk, *Exh. Record Series.*

SILSBURY, George M. *[Listed as "artist"] b.c.1816, Maine.*
Addresses: Portland, 1850. **Sources:** G&W; 7 Census (1850), Me., IV, 432.

SILSBY, Clifford *[Painter, etcher] b.1896, New Haven, CT / d.1986, Los Angeles, CA.*
Addresses: Sherman Oaks, CA; Los Angeles, CA (1984); Nice, France. **Studied:** Académie Julian, Paris with Laurens, Dechenaud, Royer and Jules Pages; École des Beaux-Arts, Paris; also with Lucien Simon and J. Francis Smith. **Member:** Soc. Motion Picture A&I. **Exhibited:** Paris Salon, 1923; Calif. Printmakers, 1929, 1930, 1936; GGE, 1939; LACMA, 1936 (solo), 1940-1945; Los Angeles P&S, 1929, 1935-37, 1943; Oakland Art Gal., 1935, 1944; San Diego FA Soc., 1940; Santa Cruz Art Lg., 1936; Santa Paula, CA, 1941-43; Maxwell Galleries, San Francisco, 1954-62. **Work:** LACMA; Victoria & Albert Mus., London; Evansville (IN) Mus. of Art. **Comments:** Positions: special effects artist, motion pictures, Hollywood & New York, 1918-62. Adopted son of Wilson Silsby (see entry). **Sources:** WW59; WW47.

SILSBY, Murray Wilcox *[Painter] b.1910, Sokane, WA.*
Addresses: Los Angeles, CA. **Studied:** William Woods College, Fulton, MO; Chouinard School of Art. **Work:** Evansville, IN, Mus.; Waterbury, CT, Mus. **Comments:** Married to Clifford Silsby (see entry). Specialty: reverse glass painting. **Sources:** Hughes, *Artists in California*, 515.

SILSBY, Wilson Eugene *[Etcher, lithographer, painter, writer, teacher] b.1883, Chicago, IL / d.1952, Los Angeles, CA.*
Addresses: Los Angeles, CA. **Studied:** with W. Chase, A. Thayer, F. Holmes. **Exhibited:** Salon d'Automne, 1922; Société des Artistes Français, Paris, 1923; Ebell Salon, Los Angeles, 1934; PAFA, 1935; GGE, 1939; Columbus Gal. FA, 1939 (solo); Gumps, San Fran., 1926 (solo). **Work:** MMA; LOC; Rockefeller Fnd., Paris; AIC; PAFA; BMFA; NYPL; PMA; CAM; Currier Gal. Art; Crocker Art Gal.; W.R. Nelson Gal.; CM.; CMA; Oakland Art Gal.; Mus. New Mexico; Toledo Mus. Art; SAM; Denver AM; Springfield (MA) MFA; Ft. Worth Mus. Art; Brooklyn Pub. Lib.; de Young Mem. Mus., San Francisco; NJ State Mus., Trenton; SFMA. **Comments:** Author/illustrator: *Etching Methods and Materials,* 1943. The inventor of "no ground" etching plate; a designer of stage sets and art director for various motion picture companies. **Sources:** WW47.

SILTON, Charlotte (Silverman) *[Painter] 20th c.*
Studied: ASL. **Exhibited:** S. Indp. A., 1941, 1943. **Sources:** Marlor, *Soc. Indp. Artists.*

SILVA, Francis A(ugustus) *[Marine painter] b.1835, NYC / d.1886.* FRANCIS A. SILVA.
Addresses: NYC, 1868-86. **Studied:** apparently self-taught. **Member:** AWCS, 1872. **Exhibited:** American Institute, 1848-50 (exhibited pen drawings, along with other child artists N.P. Beers and Henry Hays, Jr.); NAD, 1868-86; Brooklyn AA, 1869-85; Boston AC, 1883. **Work:** NGA; Peabody Mus., Salem; Brooklyn Mus;. **Comments:** A Luminist of the second generation of the Hudson River School, he was known for his brilliant sunsets and intensified atmospheric effects. He became known for his paintings of marine scenes all along the coastline from Chesapeake Bay to at least as far north as Cape Ann, MA. He took up painting as his career after serving as a Captain during the Civil War. **Sources:** G&W; Am. Inst. cat., 1848-50; *Panorama* (Aug. 1948), 9; *Portfolio* (May 1955), 216, repro.

SILVA, Freeman *[Painter] 20th c.*
Addresses: Oakland, CA. **Exhibited:** San Francisco AA, 1939; Oakland Art Gallery, 1939. **Comments:** Specialty: watercolors.

Sources: Hughes, *Artists in California*, 515.

SILVA, Roberto *[Painter, designer, commercial artist] 20th c.*
Addresses: Los Angeles, CA, active 1932-40. **Exhibited:** Artists Fiesta, Los Angeles, 1931. **Sources:** Hughes, *Artists of California*, 515.

SILVA, Rufino *[Painter] mid 20th c.*
Exhibited: AIC, 1941-42, 1946-47. **Sources:** Falk, *AIC.*

SILVA, William Posey
[Landscape painter] b.1859, Savannah, GA / d.1948, Carmel, CA. WILLIAM P SILVA
Addresses: Chattanooga, TN, c.1887; Washington, DC, 1910-14; Charleston; New Orleans; Carmel, CA. **Studied:** Chatham Acad., Savannah; Académie Julian, Paris with J.P. Laurens and Royer, 1907; C. Ryder in Etaples, France; A.W. Dow in NYC. **Member:** AAPL; AFA; SC; Soc. Wash. Artists; Mississippi AA; Calif. AC; Chattanooga AA; Paris AA; SSAL; NOAA; Carmel AA.
Exhibited: Corcoran Gal biennial, 1910; AIC; Salon d'Automne, 1908; Peabody Inst.; Delgado Mus. Art; Appalachian Expo, Knoxville, TN, 1910 (silver medal); Veerhoff Gal., Washington, DC, 1911; PAFA Ann., 1912-13; Pan-Calif. Expo, San Diego, 1915 (medal), 1916 (medal); Mississippi AA, 1916 (gold); S. Indp. A., 1917; Salon Artistes Français, Paris, 1922 (honorable mention); SSAL, 1928 (prize), 1927 (prize), 1930 (prize), 1932-37; AFA Traveling Exh., 1929-28 (solo); Carmel AA, 1946 (solo); Georgia-Alabama Exh., Nashville, 1926 (prize); Mississippi State Fair, 1926 (prize); Springville, UT, 1927 (prize); 1929 (prize); San Antonio, 1928 (prize); Santa Cruz AL, 1930, 1931 (prize); Reaugh AC, 1932 (prize); NOAA, 1926 (prize); 1932 (prize); Mississippi AA, 1932 (prize); Calif. State Fair, 1920 (prize), 1921 (prize), 1924 (prize), 1935 (prize). **Work:** Blandon Mem. Art Gal., Ft. Dodge, IA; LOC; MMA; Gibbes Art Gal., Charleston; Ft. Worth AA; Delgado Mus. Art; Palo Alto Public Library; Janesville (WI) AI; Mississipi Art Gal., Jackson; Milwaukee AI; Kansas State Teachers College, Emporia; French Govt. Collection; Columbia (SC) College; Springville, UT; Harrison Library, Carmel, CA; MFA, Houston; Los Angeles Mus. Art; many high schools; Carnegie Public Library, Chattanooga; 19th Century Club; Huntington Club, Savannah; Centennial Club, Nashville; Nashville AA; Cary AC, Jackson, MS; Tennessee Pen Women's Club; Women's Club, Ft. Worth; White Library, Marquette, MI; Public Library, Birmingham; Art Appreciation Club, Meridian, MS; Boise (ID) AA; Mus. Art, Montgomery, AL; Library, Edgefield, SC; Women's Club, Santa Monica; Tennessee FAC, Cheekwood; Brooks Mem. Art Gall., Memphis; Tennessee State Mus. **Comments:** He started his profession in art in his 40s, after giving up business pursuits, and painted in an Impressionist style. **Sources:** WW47; McMahan, *Artists of Washington DC;* Kelly, *Landscape and Genre Painting in Tennessee*, 1810-1985, 102-103 (w/repro.); Falk, *Exh. Record Series.*

SILVAN, Rita *[Painter, teacher, lecturer] b.1928, Minneapolis, MN.*
Addresses: Dumont, NJ. **Studied:** Univ. Minnesota, B.A.; NY Univ. Grad. School, and with Paul Burlin, Ralston Crawford, Cameron Booth. **Member:** AEA. **Exhibited:** NY City Center, 1958; Newark Mus., 1958; Minneapolis IA, 1950; Minnesota State Fair, 1948-50; Harriet Hanley Gal., Minneapolis, 1951 (solo). **Awards:** Minnesota State Fair, 1948, 1949 (3). **Comments:** Position: art instructor, Art Center, Englewood, NJ; Y.W.C.A., Ridgewood, NJ; research asst., photography dept., MoMA, 1953. **Sources:** WW59.

SILVEIRA, Belle See: **GORSKI, Belle Silveira (Mrs. W. O.)**

SILVEIRA, Joseph N. *[Listed as "artist"] mid 19th c.*
Addresses: Philadelphia, 1856. **Sources:** G&W; Phila. BD 1856.

SILVER, Alice L. *[Painter] 20th c.*
Addresses: Worcester, MA. **Sources:** WW24.

SILVER, David *[Painter] 20th c.*
Exhibited: S. Indp. A., 1936. **Sources:** Marlor, *Soc. Indp. Artists.*

SILVER, Herbert F. *[Painter] 20th c.*
Exhibited: Salons of Am., 1934. **Sources:** Marlor, *Salons of Am.*

SILVER, Michael *[Illustrator] 20th c.*
Addresses: NYC. **Member:** SI. **Sources:** WW53; WW47.

SILVER, Rose *[Painter, illustrator] b.1902, NYC.*
Addresses: Seattle, WA. **Studied:** Univ. Wash.; with R. Schaeffer.
Member: Univ. Wash. AC. **Comments:** Illustrator: cover, *Judge*, 1922 (prize); also *New Yorker* magazine. **Sources:** WW33.

SILVERBERG, E. Myer *[Portrait painter] b.1876, Russia.*
Addresses: NYC. **Studied:** Royal Acad., Munich. **Member:** Pittsburgh AA. **Work:** High schools and other public institutions in Pittsburgh. **Sources:** WW21.

SILVERCRUYS, Suzanne (Mrs Edward Ford Stevenson) *[Sculptor, lecturer, painter, writer] b.1898, Maeseyck, Belgium / d.1973.*
Addresses: East Norwalk, CT; Tucson, AZ. **Studied:** Les Filles de la Croix, Liege; Newham College, Cambridge Univ.; Georgetown Visitation Convent, Washington, DC; Yale Univ. School Fine Arts, B.F.A., 1928; study in Paris & Belgium; Temple Univ., hon L.H.D., 1942; Mt. Allison Univ., L.LD. **Member:** NAWPS; PCC. **Exhibited:** CGA; Nat. Inst. Archit. Educ.; Salon de Printemps, 1931; BAID, 1927 (prize) **Awards:** first prize, Rome Alumni Competition, 1927; Chevalier de L'Ordre de Leopold; Officer de L'Ordre de la Couronne, Belgium. **Work:** Busts, plaques & mem., Louvain Library; McGill Univ., Canada; Yale Univ. School Medicine; Reconstruct. Hospital, NY; MoMA; First Lutheran Church, New Haven, CT; Duell Award for NY Press Photographer Assn.; Rumford (RI) mem.; Gov. House, Ottawa, Canada; MMA. **Commissions:** Amelia Earhart Trophy, Zonta Club; bust of Cardinal Cushing, Stonehill College, Northeaston, MA; statue of Padre Kino of Ariz for Statuary Hall, Rotunda, U.S. Capitol, Washington, DC; Hon. Joseph W. Martin, Rotunda of old House of Rep., Washington, DC; war mem., Shawinigan Falls, Canada. **Comments:** Position: radio artist, NBC-TV. **Teaching:** lectures on process of sculpture making. **Publications:** author, *Suzanne of Belgium;* author, *A Primer of Sculpture*, 1942. Also appears as Suzanne Farnum. **Sources:** WW73; WW47.

SILVERMAN, Adolph *[Painter] 20th c.*
Addresses: Brooklyn, NY. **Member:** S. Indp. A. **Exhibited:** WMAA, 1920-25; S. Indp. A., 1920-21, 1927. **Sources:** WW24.

SILVERMAN, Alen *[Painter] 20th c.*
Addresses: Brooklyn, NY, 1934. **Exhibited:** S. Indp. A., 1934.
Sources: Marlor, *Soc. Indp. Artists.*

SILVERMAN, Anne *[Painter] 20th c.*
Addresses: Brooklyn, NY. **Exhibited:** S. Indp. A., 1927, 1934.
Sources: Marlor, *Soc. Indp. Artists.*

SILVERMAN, Burton Philip *[Painter, illustrator] b.1928, Brooklyn, NY.*
Addresses: NYC. **Studied:** Pratt Inst.; ASL, 1946-49, with Louis Bouché and Reginald Marsh; Columbia Univ., B.A., 1949.
Member: NA. **Exhibited:** PAFA Ann., 1949; Seven Shows, Butler IA, 1954-70; NAD, 1964-71 (Henry W Ranger Purchase Prize, 1965 & Benjamin Altman Figure Prize, 1969); San Diego Arts Festival, 1966; Childe Hassam Exhib., NIAL,1967; FAR Gallery, NYC, 1970s; Kenmore Galleries, Philadelphia, PA, 1970s. **Awards:** Dillard Collection Purchase Prize, Art on Paper, Univ. North Carolina, 1966. **Work:** BM; PMA; Anchorage Mus. Art; New Britain (CT) Mus. Am. Art; Parish Mus. Art, Southhampton, NY. **Comments:** Preferred media: oils, watercolors, pastels. Illustrator: *Sports Illustrated,* first in 1959, and other national magazines. **Publications:** co-author, "A New Look at the Eight," *Art News*, 2/1958; author, *Homage to Thomas Eakins,* 1967 & *Art for Pablo Picasso's Sake*, 1968, Book World. **Teaching:** instructor of drawing & painting, School Visual Arts, New York, 1964-67. **Sources:** WW73; Fredrick Whitaker, *Four Realists,* (Oct., 1964) & Elizabeth Case, *Burton Silverman*

Captures the Moment, (June, 1971), *Am. Artist Magazine*; Joseph Singer, *Pastel Portraits* (Watson-Guptill); Falk, *Exh. Record Series.*

SILVERMAN, Elijah *[Painter] 20th c.*
Exhibited: Salons of Am., 1934. **Sources:** Marlor, *Salons of Am.*

SILVERMAN, Mel(vin Frank) *[Painter, graphic artist, illustrator, writer] b.1931, Denver, CO / d.1966.*
Addresses: NYC. **Studied:** AIC, B.F.A., B.A.E. **Member:** SAGA. **Exhibited:** Art: USA, 1958, 1959; AFA, 1959-60; Phila. Pr. Club, 1958, 1959; BM, 1959; Univ. Oklahoma, 1959; Denver Mus. Art, 1954-55; Artists Gal., NY, 1956 (solo), 1963 (solo); Salpeter Gal., NY, solos: 1957, 1958, 1961, 1964; Assoc. Am. Artists, 1959 (solo); Ein Harod, Israel, 1960 (solo); Zanesville Mus. Art, 1960 (solo); Northwest Printmakers, 1962-65; Boston Printmakers, 1964, 1965; Oklahoma Printmakers, 1963-65; Wichita Print Exhib., 1965; SAGA, 1962-65; PAFA, 1965; Univ. Illinois, 1965; Butler IA, 1960 (solo), 1965; U.S. Nat. Mus., 1964; Univ. Ohio, 1963; BM, 1963, 1964; Silvermine Gld. Artists, 1963, 1964; US-Russia Exchange Exhib. **Work:** Butler IA; Univ. Minnesota; Public Library, Wash., DC; Denver Public Schools Collection; USIA; Univ. California; Univ. Maine; PMA; Free Library, Philadelphia; Allentown (PA) Mus.; Univ. Indiana.
Comments: Author/illustrator: children's books, such as *Ciri-Biri-Bin* (1957), *Good for Nothing Burro* (1958), *Hymie's Fiddle* (1959). Illustrator: *Two Uncles of Pablo* (1958), *Roderick* (1960), *My First Geography of the Panama Canal* (1959), *Songs Along the Way* (1960), *Apprentice to Liberty* (1959), *Who Made America Great* (1962), *Portals to the Past* (1963), *Awani* (1964), *Tuchin's Mayan Treasure* (1963), *Fire in the Sky* (1964). Position: instructor of graphics, Ein Harod, Israel; display designer, New York City, 1956-60. **Sources:** WW66.

SILVERMAN, Miles (Mittenthal) *[Painter, graphic artist, illustrator, educator, etcher, lithographer] b.1910, Flint, MI.*
Addresses: Toledo, OH; Washington, DC. **Studied:** Univ. Notre Dame; Univ. Michigan; Univ. Toledo; AIC; Toledo Mus. Art.
Member: Ohio WCS; Calif. WCS; AEA; Palette Club, Toledo; Toledo Fed. Art Soc. (pres., 1951-52). **Exhibited:** S. Indp. A., 1942; Calif. WCS, 1938; Ohio WCS, 1937-45; Butler AI, 1936-46, 1948 (prize); TMA, 1934-43, (prize 1941), 1944-48 (prizes), 1950 (prize), 1952 (prize); Ohio Valley Exhib., 1948, 1949; Commerce Nat. Bank, Toledo, 1950; Illinois State Fair; Montgomery County (Ill.), 1949, 1950; Wash. WC Soc., 1949, 1952, 1953; Wash. Area Artists, CGA, 1954. **Awards:** prize, Toledo Fed. Art Soc., 1950. **Work:** Geneva College, Beaver Falls, PA; Jewish Fed. Bldg., Toledo; Toledo Mus. Art. **Comments:** Position: instructor, Toledo Public Schools, 1947-52; Toledo Mus. Art, 1948-52; supervisor, publ. prod., Erco Div., ACF Industries, Riverdale, MD; art director, Interstate Electronic Corp., Wash., DC, 1958-. Illustrator: "Jerry Goes to Camp." **Sources:** WW59; WW47.

SILVERMAN, Ronald H. *[Educator] 20th c.*
Addresses: Los Angeles, CA. **Studied:** Univ. Calif., Los Angeles, B.A., 1952; Los Angeles State College, M.A., 1955; Stanford Univ., Ed.D., 1962. **Comments:** Teaching: art professor, Los Angeles State Univ., 1955-. **Sources:** WW73.

SILVERS, Herbert Ferber *[Painter, sculptor] b.1906, NYC.*
Addresses: NYC. **Exhibited:** PAFA Ann., 1931, 1934; Corcoran Gal biennial, 1932. **Sources:** WW33; Falk, *Exh. Record Series.*

SILVERSTEIN, Shel *[Cartoonist, playwright] b.1932, Chicago, IL / d.1999, Key West, FL.*
Addresses: NYC/Key West, FL. **Comments:** During the 1950s, he began as a cartoonist for *Playboy.* From 1963 through the 1980s, his books on poetry for children sold more than 14 million copies. He was also a songwriter; in 1969 he wrote "A Boy Named Sue" for Johnny Cash. **Sources:** obit., *NY Times* (11 May 1999).

SILVETTE, Brooks Johnson (Mrs. Herbert) *[Painter, teacher] b.1906, Willoughby Beach, VA.*

Addresses: University, VA. Studied: P. Bornet. Comments: Affiliated with Univ. Virginia. Sources: WW33.

SILVETTE, David [Painter] b.1909.
Addresses: Richmond, VA. Studied: E.M. Silvette; Cecilia Beaux; Charles Hawthorne. Exhibited: PAFA Ann., 1932-33; Corcoran Gal biennials, 1932 (bronze medal), 1937. Work: Virginia State Capitol; Richmond Acad. FA; CGA; WPA mural, USPO, New Bern, NC. Sources: WW40; Falk, *Exh. Record Series*.

SILVETTE, Ellis M. [Painter, sculptor] b.1876.
Addresses: Richmond, VA. Work: portraits, Confederate Mus., Richmond; Stevens Inst. Tech., VA; Univ. Virginia; State Chamber of Commerce, NYC. Sources: WW40.

SILVETTE, Marcia [Painter] 20th c.
Addresses: Richmond, VA. Exhibited: NA, 1933-34; Corcoran Gal biennials, 1935-39 (3 times). Sources: WW40; Falk, *Exhibition Records Series*.

SILVIS, Caroline [Painter] 20th c.
Addresses: Rosemont, PA. Sources: WW13.

SILVIS, Margaret Ward [Painter] b.1875, East Downingtown.
Addresses: Downingtown & Phila., PA. Studied: Dainerfield; Chase. Exhibited: PAFA Ann., 1901, 1903; AIC, 1914, 1916. Sources: WW17; Falk, *Exh. Record Series*.

SILVIUS, Paul T. [Painter] b.1899, Hampton, IA / d.1970, Orange County, CA.
Addresses: Los Angeles, CA. Member: Painters & Sculptors of Los Angeles; Laguna Beach AA. Sources: WW33; Hughes, *Artists of California*, 516.

SILZ, Arthur [Painter, teacher, lecturer, illustrator, designer] b.1901, Berlin, Germany.
Addresses: NYC. Studied: Berlin Acad., M.A.; ASL. Member: AEA. Exhibited: VMFA, 1940, 1942, BM, 1941; MMA, 1942; Pepsi-Cola, 1946; Dallas MFA, Montclair Art Mus.; Brooks Mem. Art Gal.; Riverside Mus., NAD; PAFA, 1946; Walker Art Center, 1947; Syracuse MFA, 1947; Hudson Walker Gal., 1938 (solo); Wakefield Gal., 1943 (solo); Worth Ave. Gal., Palm Reach, FL, 1945 (solo); Artists Gal., NY (solo). Comments: Positions: instructor, City College of NY Ext. Div.; Art Workshop, NYC. Illustrator: *Airplanes and How They Fly*, 1943. Sources: WW53; WW47.

SIMA, Esther See: COHEN, Esther Sima

SIMBOLI, Raymond [Painter] b.1894, Pescina, Italy / d.1964, Neenah, WI.
Addresses: Pittsburgh, PA. Studied: CI, with Arthur Watson Sparks. Member: Pittsburgh AA. Exhibited: Westmoreland County Mus. of Art, 1965 (retrospective). Award: "Artist of the Year," 1955, Arts & Crafts Center, Pittsburgh. Comments: A number of summers were spent traveling and painting in the Western states and in Mexico; on these trips he almost exclusively used watercolor, developing some of the subjects into oil paintings later. Positions: instructor & assist. professor, CI, 1920-62; he also taught at Pittsburgh Art Inst., Seton Hill College, Westmoreland County Museum, at art clubs in Pittsburgh, Beaver and Greensburg, as well as privately in his home. Sources: WW25; Chew, ed., *Southwestern Pennsylvania Painters*, 118-121.

SIME, John [Art administrator] b.1925, Milford Haven, Wales.
Addresses: Toronto 179, Ontario. Studied: Trinity College, Cambridge Univ., M.A. Exhibited: Awards: Canadian Council travel grants, 1968 & 1972. Comments: Positions: director, Artist's Workshop, Holkley Valley School, New School Art, 1962-70; exec. director, Three Schools Art, Toronto, Ontario, 1970-; director, Mus. Contemporary Art, Toronto. Sources: WW73; Vera Frenkel, "The New School of Art: Insight-Explosions," *Arts Canada* (October, 1968).

SIMEON, Nicholas (A.) [Painter] b.1867, Zurich, Switzerland.

Addresses: NYC. Studied: ASL; Germany; Switzerland. Member: S. Indp. A.; Whitney Studio Club. Exhibited: S. Indp. A., 1917, 1925; AIC, 1931. Sources: WW24.

SIMES, Mary Jane [Miniaturist] b.1807, Baltimore / d.1872.
Studied: With Sarah Peale. Exhibited: Philadelphia & Baltimore, 1825-35. Comments: She was a granddaughter of James Peale (see entry). She was the protégée of her aunts, Sarah and Anna (see entries). Her miniatures are said to be similar to Anna Peale's, but slightly more primitive and harsher in color. She later married Dr. John Floyd Yeates, ceased painting and had four children. Sources: G&W; Sellers, *Charles Willson Peale*, II, 423; Rutledge, PA; Rutledge, MHS; Lafferty. More recently Rubinstein *American Women Artists*, , 49-50.

SIMITIERE, Pierre Eugene du See: DU SIMITIERE, Pierre Eugene

SIMKHOVITCH, Simkha See: SIMKOVITCH (SIMKHOVITCH), Simkha (Mr.)

SIMKHOVITCH (SIMKOVITCH), Helena [Sculptor] 20th c.; b.New York, NY.
Addresses: New York 11, NY. Studied: in Paris, France. Member: Fed. Mod. P&S; Sculpture Gld. (exec. board, 1958); AEA (director at large & chmn, Int. Cultural Relations Committee, 1954-58; nat. secretary, 1957, 1958). Exhibited: S. Indp. A., 1941; WMAA, 1953-57; PAFA Ann., 1953-54; AFA traveling exhib., 1952; MoMA traveling exhib., 1955, 1956; Fed. Mod. P&S, 1947, 1952-56; Sculpture Gld., 1952-58; Petit Palais, Paris, 1950; Musee d'Anvers, Belgium, 1950. Awards: Palmes Academiques: Officier de l'Instruction Publique, Paris, 1955. Work: WMAA; Wadsworth Atheneum. Comments: Position: U.S. delegate, Int. Assn. of Plastic Arts, Venice, 1954, Dubrovnik, 1957; member, U.S. Nat. Comm. for UNESCO, 1958. Founder, "New York Six" (Paris) and "Sculpture in a Garden" (biennial exhib., NY, 1954, 1956, 1958). Lectures: "American Sculpture," auspices U.S. Dept. of State, in Europe. Sources: WW59; Falk, *Exh. Record Series*.

SIMKINS, Martha (Mattie) [Portrait, still life, landscape and flower painter, teacher] b.1866, Monticello, FL / d.1969, North Hollywood, CA (at age 103).
Addresses: NYC, 1892-1906; Dallas, TX/Woodstock, NY, 1915-24; NYC/Woodstock, 1924-34; Dallas, 1934-68. Studied: ASL, with W.M. Chase (1892, 1906), Cecilia Beaux (1906), Kenyon Cox, H.S. Mobray; Europe with John Singer Sargent and C. Beaux, from 1906; ASL, with Henry Snell, Emil Carlsen. Member: L. Wolfe Club; Pen & Brush Club; ASL (life member); Woodstock AC; NAWA. Exhibited: L. Wolfe Club (frequently, prizes); S. Indp. A., 1917; Corcoran Gal biennial, 1923; Art Mus., Houston, TX, 1926 (solo); Southern State Art League, Charleston, SC, 1927; Paris Salon, 1927; Dallas Womens Club; Oakcliffe Soc. of FA, 1928; NAD; Buffalo MFA; Baltimore Gal; MacBeth Gal, NYC; Ainslee Gal, NYC; many more locally in TX. Work: Gibbs Gallery, Charleston, SC. Comments: Traveled to Europe in 1906 and remained there until about 1915 (visiting there once again in 1927). On her return to the U.S. in 1915, she established a winter studio in Dallas, TX, and a summer one in Woodstock. She still spent time in NYC , eventually spending more of her time there from 1924-34, but returning once again to Dallas in 1934. She apparently moved back and forth between NYC and Dallas fairly easily because ASL records show her enrolled there in 1914, 1915-16, 1921, 1922, 1928-29, 1940, and summer of 1961. Simkins was best known for her portraits but also gained recognition for her still life and floral pictures. Teaching: North TX Normal School, Denton, TX, 1901-06; Crozier Technical School, Dallas, TX, c.1950; she also taught privately. Sources: WW15 (as Martha Simpkins); WW33 (as Martha Simkins); add'l info., including letters and clippings, courtesy of Robert A. Horn, NYC, and Roger E. Saunders, Maryland; Trenton, ed. *Independent Spirits*, 186.

SIMKINS, Mattie See: SIMKINS, Martha (Mattie)

SIMKOVITCH, Helena See: SIMKHOVITCH (SIMKOVITCH), Helena

SIMKOVITCH (SIMKHOVITCH), Simkha (Mr.)
[Painter, teacher] b.1893, Kiev, Ukraine / d.1949, Milford, CT.
Addresses: NYC, 1924-31; Greenwich, CT, early 1930s. **Studied:** Odessa Art School, c.1908-13; Royal Acad., St. Petersburg, Russia, c.1913-18. **Exhibited:** First Soviet Govt. exh, 1918 (prize); Salons of Am., 1925; Sterner Gal., NYC, 1927, 1929, 1931 (all solos); Hackett Gal., NYC, 1933 (solo); Midtown Gal., NYC, 1941-45 (all solos); Milch Gal, 1933-41, 1946-49; Mattatuck Mus., Waterbury, CT; New Britain Mus.; Wildenstein Gal., NYC; Wadsworth Atheneum, 1947; WMA, 1933 (prize); Addison Gal., Andover, MA, 1941; CI, 1933-45; NAD, 1926, 1942, 1946, 1948; Cincinnati AM, 1930-47; AIC, 1932-45; AID, 1932 (medal, prize); PAFA Ann., 1933-38, 1941, 1944; Whitney Mus.; Toledo AM, 1933-47; Virginia AM; Worcester Biennial, 1933-47; Corcoran Gal biennials, 1932-47 (8 times); WYNY, 1939; Brooklyn Mus. (many watercolor exhib.); Dallas MFA; MMA, 1940, 1942; Cranbrook Acad., 1940. **Work:** WWMA; Mus. of the Winter Palace, Petrograd; Mus. Art, Petrograd; Krakow Mus., Poland; New Britain (CT) Mus.; Worcester(MA) AM; WPA murals: USPO, Beaufort, NC, USPO and Court House, Jackson, MI. **Comments:** Came to the U.S. in 1924. Painted the New England landscape and people. Teacher, All Arts Studio, Greenwich, CT. **Sources:** WW40; exhib. cat., J. Marqusee Fine Arts, NYC (1987); Art in Conn.: Between World Wars; Falk, *Exh. Record Series.*

SIMMANG, Charles *[Craftsperson, engraver] b.1874, Lee County, TX.*
Addresses: San Antonio, TX. **Studied:** C. Stubenrauch. **Member:** San Antonio AL; AFA. **Work:** Witte Mem. Mus., San Antonio. **Comments:** Specialty: steel relief engraving. **Sources:** WW40.

SIMMONE, T. See: SIMONNE, T.

SIMMONS, Abraham *[Engraver] early 19th c.*
Addresses: NYC, 1814-15. **Sources:** G&W; NYCD 1814-15.

SIMMONS, Cordray *[Painter, graphic artist, teacher] b.1888, Jersey City, NJ / d.1970, Lancaster, PA.*
Addresses: Jersey City, NJ; NYC; Batavia, IL; NYC; Lancaster, PA. **Studied:** W.M. Chase; F.L. Mora; R. Henri; Geo. Bellows; K.H. Miller; H.D. Webster; ASL; also in England, France, Germany. **Member:** Allied Artists of America; Audubon Artists; AEA. **Exhibited:** Macy Gal., NYC, 1925, 1928, 1929; Whitney Studio Club, NYC, 1925,1928; National Academy, NYC, 1925, 1945-68 (Audubon Artists Assoc.); P&S Gal., NYC, 1925; Feragil Gal., NYC, 1927 (first solo); Utica Art Soc., 1927 (solo); Weyhe Gal., NYC, 1928; Kennedy & Co., NYC, 1928-29; BM, 1930-31; AFA traveling exh., 1931; Morton Gal., NYC, 1931 (solo), 1932; Grant Gal., NYC, 1934 (solo); Salons of Am., 1933; Corcoran Gal biennial, 1935; PAFA Ann., 1935; PAFA, 1940, 1946; MMA, 1935, 1938 (first synthetic resin painting exhibited), 1942 (AV); AIC, 1935, 1942; Rouillier Art Galleries, Chicago, IL, 1935; Univ. Indiana, 1940; Indiana Mus. for Modern Art, 1940; WMAA, 1944, 1951 (AEA); Walker Art Center, Minneapolis, MN, 1947; Geneva, IL, 1955; Batavia (IL) Public Library; Marshall Field & Co., Chicago, IL, 1975; Barclay Bank Int. Ltd., Chicago, 1975; Flint (MI) Inst. of Arts, 1978; Longwood College, Farmville, VA, 1980 (retrospective with Lou Osborne). **Work:** MMA. **Comments:** Married to painter Lou Osborne (see entry) in 1929. Together they successfully developed a method of painting with synthetic resin, which allowed them to work on each element of a painting in separate stages, integrating the final composition through a final coat of binder. They never capitalized on their invention, though Cordray corresponded and shared their discovery with a chemist of the Mellon Inst. at the Univ. of Pittsburgh. Resins were readily available and their use in painting eventually resulted in the medium of acrylic paint. Positions: teacher, Evening Technical High School, Jersey City; owner, art supply store, Greenwich Village, NYC; technical artist, MMA, c.1930-on; guest inst., Aurora Art League, IL, 1954. **Sources:** WW59;

WW47; Pamela Elizabeth Mayo, *Cordray Simmons & Lou Osborne* (Farmville, VA: Bedford Gallery, Longwood Fine Arts Center, 1980); Falk, *Exh. Record Series;* add'l info. courtesy of Joel L. Fletcher, Fredericksburg, VA.

SIMMONS, Dorothy *[Painter] 20th c.*
Addresses: NYC. **Exhibited:** S. Indp. A., 1928, 1931. **Sources:** Marlor, *Soc. Indp. Artists.*

SIMMONS, Edward Emerson
[Mural painter, painter] b.1852, Concord, MA / d.1931, Baltimore, MD.

Edward Simmons

Addresses: San Francisco, CA (c.1874-77); Boston (1878); Europe (1879-91); NYC (1891-on). **Studied:** Harvard Univ., 1874; Boston Mus. School and Wm. Rimmer in Boston, 1878; Académie Julian, Paris with Boulanger and Lefebvre, 1879-81. **Member:** Ten Am. Painters; NIAL; Harvard Art Club. **Exhibited:** Paris Salon, 1881-89; NAD, 1884-85, 1889; Boston AC, 1885; Paris Expo, 1889 (med); PAFA annuals, 1890-1903 (10 times, incl. Temple silver medal, 1890); World's Columbian Expo, Chicago, 1893 (mural); Pan-Am. Expo, Buffalo, 1901 (gold); Arch. Lg., 1912 (prize); Corcoran Gal biennials, 1919, 1930; AIC. **Work:** Murals: Mass. State House, Boston; LOC; Criminal Court, NYC; Minn. State Capitol, St. Paul; Capitol Bldg., Pierre, SD; Court House, Mercer, PA; Astor Gallery, Astoria, NY; Court House, Des Moines, Iowa; Appellate Court, NYC; Memorial Hall, Harvard College. **Comments:** He was the most unheralded member of the "Ten American Painters" group, most likely because he was dedicated to mural rather than easel painting. As a young man, he explored California and was even a writer for the San Francisco *Chronicle,* 1875-77. However, after deciding to become a painter he studied in Boston, and then embarked for thirteen years in Europe where he painted many fine landscapes and genre scenes at the artists colonies in Concarneau, Brittany, France, and at St. Ives on England's Cornish coast. He also made a trip to Spain. He was the nephew of Ralph Waldo Emerson. **Sources:** WW29; Hughes, *Artists of California,* 516; Fink, *American Art at the Nineteenth-Century Paris Salons,* 390; Falk, *Exh. Record Series.*

SIMMONS, F. Ronald *[Painter] 20th c.*
Addresses: Providence, RI. **Member:** Providence WCC. **Sources:** WW24.

SIMMONS, Franklin *[Sculptor] b.1839, Lisbon, ME / d.1913, Rome, Italy.*
Addresses: Maine, 1839-1865; Washington, DC, 1860-67; Italy, 1867-1913. **Studied:** With John Adams Jackson in Boston. **Exhibited:** Awards: Knighted by King Humber of Italy; the first American artist to receive the Cross of Caxilere. **Work:** Portland (ME) Society of Art (the Franklin Simmons Memorial), Naval Monument in front of the Capitol building, Wash., DC. **Comments:** Grew up in Bath (ME), taking up modeling while working in a mill at Lewiston (ME). Although he opened a studio in Lewiston, he traveled frequently, executing portrait busts in Waterville, Brunswick, and Portland before 1860. Simmons moved to Washington, DC, during the Civil War, and there made busts of a number of leading national figures. In 1867 he went to Italy, settling in Rome, where, except for several visits to America, he remained for the rest of his life. While there he completed a statue of Roger Williams (Providence, RI), as well as portrait busts, ideal figures, and Civil War monuments. Simmons left his estate to the Portland (ME) Society of Art. **Sources:** G&W; WW13; DAB; Fairman, *Art and Artists of the Capitol;* Clement and Hutton; New England BD 1860 [at Lewiston, Me.]; Craven, *Sculpture in America.*

SIMMONS, F(reeman) W(illis) *[Painter] b.Fredonia, PA / d.1926.*
Addresses: Cleveland, OH; Paris, France. **Studied:** Académie Julian, Paris with Boulanger, Lefebvre, Constant, 1886-92; also with Mosler and W.M. Chase. **Member:** Paris AAA; Cleveland SA. **Exhibited:** Paris Salon, 1887, 1893; PAFA Ann., 1894, 1903,

1912-13. **Work:** portrait, CMA. **Comments:** Fink Gives birthplace as Cleveland, Ohio. **Sources:** WW25; Fink, *American Art at the Nineteenth-Century Paris Salons,* 390; Falk, *Exh. Record Series.*

SIMMONS, George Harmon *[Painter, illustrator, designer]* *b.1870, Phila.*
Addresses: Rochester, NY. **Studied:** ASL; F.J. Boston, C. Hawthorne. **Member:** Rochester AC. **Sources:** WW10.

SIMMONS, Henry Eyland (England) *[Painter] 20th c.*
Exhibited: Salons of Am., 1927, 1932, 1934. **Sources:** Marlor, *Salons of Am.*

SIMMONS, James *[Painter] 20th c.*
Exhibited: Salons of Am., 1934. **Sources:** Marlor, *Salons of Am.*

SIMMONS, John W. *[Painter, photographer] b.1950.*
Studied: Fisk Univ. **Exhibited:** Nat. Students Union Assn.; Fisk Univ., 1969-71; Tennessee State Mus., 1972 (solo). **Awards:** Sengstacke Publication Award, Chicago, IL, 1971. **Sources:** Cederholm, *Afro-American Artists.*

SIMMONS, Kate Cameron *[Painter] 20th c.*
Addresses: Brooklyn, NY, 1913. **Comments:** *Cf.* Kate Cameron, active 1864-77. **Sources:** WW13.

SIMMONS, Marion L(ouise) *[Painter] b.1908, Rumson, NJ.*
Addresses: Rumson, NJ; Jamaica, B.W.I. **Studied:** H.B. Snell; G.P. Ennis. **Member:** NAC; AWS. **Sources:** WW53; WW40, which puts date of birth at 1903.

SIMMONS, Nell *[Painter] 20th c.*
Addresses: San Francisco, CA. **Exhibited:** Calif. Statewide, Santa Cruz, 1929; Oakland Art Gallery, 1932. **Sources:** Hughes, *Artists in California,* 516.

SIMMONS, (P.) Marcius *[Painter] b.1867 / d.1909.*
Addresses: NYC. **Exhibited:** Boston AC, 1909. **Sources:** *The Boston AC.*

SIMMONS, S. *[Banner painter] mid 19th c.*
Addresses: Charleston, SC, 1860. **Sources:** G&W; Rutledge, *Artists in the Life of Charleston.*

SIMMONS, Teresa See: **CERUTTI-SIMMONS, Teresa (Mrs. William)**

SIMMONS, Vesta Schallenberger *[Painter] late 19th c.*
Studied: with V. Williams. **Exhibited:** Paris Salon, 1884-87, 1889. **Sources:** Fink, *American Art at the Nineteenth-Century Paris Salons,* 390.

SIMMONS, Will (Mrs.) See: **CERUTTI-SIMMONS, Teresa (Mrs. William)**

SIMMONS, William *[Etcher, painter, teacher] b.1884, Elche, Spain / d.1949, Baltimore, MD.*
Addresses: Baltimore, MD. **Studied:** Académie Julian, Paris with Lefebvre, 1912; also with A. Harrison and E. Simmons. **Member:** SAE; Chicago SE; Calif. PM; Prairie PM. **Exhibited:** AIC, 1913-17; S. Indp. A., 1917-20, 1925; WMAA, 1922-28; Salons of Am., 1925; U.S. Nat. Mus., Wash., DC, 1939. **Work:** NYPL; Smithsonian; LOC; Bibliothèque Nationale, Paris; Pub. Lib., Liverpool, England. **Comments:** Specialty: natural history. **Sources:** WW47; Falk, *Exh. Record Series.*

SIMMS, Carroll Harris *[Painter, sculptor, educator, jeweler] b.1924, Bald Knob, AK.*
Studied: Hampton Inst., 1944-45; Univ. of Toledo, 1945-47; TMA School, 1945-48; Cranbrook Academy of Art, MI, BA, 1950, MFA, 1961; Wayne Univ., Detroit, 1949-50; Univ. of London, 1954-56; Royal College of Art, London, 1955; Central School of Arts & Crafts, London, 1954-55; The British Mus., 1955-56; Swedish Inst., Stockholm, 1964; Singer Bronze Art Foundry, London, 1955-56; Univ. of Ibadan, Nigeria, 1968-69. **Member:** American Soc. of African Culture; Slade Soc., London; Texas Assn. of College Teachers; Texas Commission on the Arts & Humanities. **Exhibited:** TMA, 1948, 1949 &1950 (1st prizes, sculpture), 1951 (solo); Syracuse Mus., 1949; Wichita Mus., 1949;

Detroit Art Inst., 1949-50; Atlanta Univ., 1950-52; Houston Mus. of FA, 1950, 1952-54; State Capitol Bldg., Austin, TX, 1951; Boston Contemporary Mus., 1952; Cranbrook Mus., 1952-53 (purchase award); Dallas Mus., 1951(1st prize), 1952-53 (prize, jewelry); Whitty Memorial Mus., 1953; Contemporary Arts Mus., Houston, 1953; Royal Soc. of British Artists, 1955; Slade Soc., London, 1955; International Inst. of Education, 1957; American Inst. of Des. & American Inst. of Decorators Ann., 1957-60; Wellington Art Galleries, NYC, 1958; Ford Fnd. Invitational, Fort Worth, 1958, 1959; Invitational, The Town Gallery, Toledo, OH, 1959; Phillip Johnson & Lipchitz Shrine, New Harmony, IN, 1960; Beaumont Mus., 1960; American Soc. of African Culture, Univ. of Penn., 1960; Houston Baptist College, 1965; Am. Inst. of Arch. at Rice Univ., 1965-67; Denver Mus., 1967. **Awards:** Fulbright Fellow, 1954-56; Southern Fellowship Fund Grant, 1968-69. **Work:** Eliza Jones Home, Houston; Phillip Johnson & Lipchitz Shrine, IN; Longshoreman's Temple, Houston; Boynton Methodist Church, Houston; George Wash. Carver High School, Houston; TX Southern Univ.; St. Oswald's Church, Coventry, England; Texas Capitol State Room; Univ. of Houston. **Comments:** Position: teacher, Texas Southern Univ., Houston. **Sources:** Cederholm, *Afro-American Artists.*

SIMMS, Frank (Mrs.) *[Painter]*
Addresses: New Orleans, active c.1891-1901. **Member:** Arts Exhib. Club, 1901. **Exhibited:** Artist's Assoc. of N.O., 1891. **Sources:** *Encyclopaedia of New Orleans Artists,* 353.

SIMMS, Samuel See: **SIMS, Samuel**

SIMMS, Theodore Freeland *[Industrial designer, graphic artist, painter, craftsperson, blockprinter] b.1912, Arvada, CO.*
Addresses: Seattle, WA. **Studied:** Univ. Southern California, B.Arch.; Chappell House, Denver, CO; with Dan Lutz; Clayton Baldwin, M. Elrod; A. Montgomery; A. Jones; H. Harvey; M. Gniesen; G. Lukens. **Member:** Southern Calif. WCS; Scarab Club. **Exhibited:** Denver Art Mus., 1934, 1937; Chappell House, Denver, 1934 (solo); Southern Calif. WCS, 1939. **Work:** Central City Opera House Assn., Denver, CO. **Comments:** Lectures: architecture. Position: teacher, Univ. Southern Calif. **Sources:** WW59; WW47.

SIMON, Allen *[Painter] mid 20th c.*
Addresses: NYC. **Exhibited:** "NYC WPA Art" at Parsons School Design, 1977. **Comments:** WPA artist. **Sources:** *New York City WPA Art,* 80 (w/repros.).

SIMON, Arline *[Painter] b.1927, Yonkers, NY.*
Studied: Cooper Union, B.F.A. **Exhibited:** Solo shows: Upstream Gallery, Hastings-on-Hudson, New York and 101 Wooster Gallery, NYC. Group shows: NAWA and Galleria Principal, Altos do Chovan, Dominican Republic. **Comments:** Painting locations include Monhegan Island (ME). **Sources:** Curtis, Curtis, and Lieberman, 56, 186.

SIMON, August *[Listed as "artist"] b.c.1825, Wittenberg or Württemberg.*
Addresses: NYC, 1860. **Comments:** Listed in 1860 as living with his wife, a native of Württemberg. **Sources:** G&W; 8 Census (1860), N.Y., XLV, 513.

SIMON, Augustus D. See: **SYMON, Augustus D.**

SIMON, Benedict *[Lithographer, publisher] b.1824, Baden, Germany / d.1878, New Orleans, LA.*
Addresses: New Orleans,1850-78. **Comments:** He arrived in New Orleans in 1849 and became one of the city's earliest and finest color lithographers of local views. Between 1855-60 he was with Pessou & Simon (see entry) and in 1860 two younger lithographers from Baden, August Bercoli and Henry Flicon, were living with Simon and his wife (see entries). Around 1869-78 he published lithographs of scenes by Marie Adrien Persac (see entry) and E. Vidal (see entry). **Sources:** G&W; 8 Census (1860), La., VIII, 14; 7 Census (1850), La., V, 84; New Orleans CD 1853-60. More recently, see *Encyclopaedia of New Orleans Artists.* 353.

SIMON, Bernard *[Sculptor, instructor]* b.1896, Russia / d.1980.
Addresses: NYC. **Studied:** Educ. Alliance & Art Workshop, New York. **Member:** Silvermine Guild Arts; Brooklyn Soc. Artists; Knickerbocker Artists; Provincetown AA; Cape Cod AA. **Exhibited:** Audubon Artists; Silvermine Guild Art; Boston Arts Festival; Provincetown Group; Hyannis AA. Awards: prizes, Knickerbocker Artists, Audubon Artists & NJ Soc. P&S. **Work:** Slater Mem Mus, Norwich, CT; Norfolk (VA) Mus. Arts & Sciences. **Comments:** Teaching: instructor, MoMA, New School of Social Research & Bayonne Art Center. **Sources:** WW73.

SIMON, Dionis (Dennis) *[Lithographer]* b.1830, Baden, Germany / d.1876, New Orleans.
Addresses: New Orleans, active 1857-76. **Comments:** In 1860 he and his family resided with his partner Jean Tolti (see entry); in 1866-72 he was in partnership with Jules Manouvrier (see entry), and in 1874 with Henry Klung (see entry). **Sources:** G&W; 8 Census (1860), La., VIII, 15; *Creole*, March 26, 1857 (courtesy Delgado-WPA); New Orleans CD 1858-70. More recently, see *Encyclopaedia of New Orleans Artists.* 353.

SIMON, Ellen R. *[Designer, painter]* b.1916, Toronto, Ontario.
Addresses: NYC. **Studied:** Ontario College Art; ASL; New School Social Res.; also with Joep Nicolas & Yvonne Williams. **Exhibited:** Nat. Gallery Canada; Phila. Mus. Art; Smithsonian Inst.; Carnegie Library, Pittsburgh, PA; Mus. Contemporary Crafts, New York. **Work:** Albertina Collection, Vienna; NYPL; Brooklyn Mus., NY; Nat. Gallery Canada; Art Gallery Ontario. Commissions: stained glass windows in many churches & synagogues in Canada; Sidney Hillman Mem. Windows, Hastings-on-Hudson, NY; Church of St. Michael & All Angels, Toronto, 1960-67; windows for Holy Family Narthex, Princetone Univ. Chapel, 1966; Adlai Stevenson Mem Window. **Comments:** Publications: author/illustrator, *The Critter Book*, 1940; illustrator, *Inga of Porcupine Mine* (1942), *Americans All* (1944) & *Music in Early Childhood* (1952). Teaching: instructor in stained glass, Riverside Church Arts & Crafts Progam, NY, 1965-. **Sources:** WW73.

SIMON, Eugene *[Sketch artist, painter, photographer]* b.c.1850, New Orleans, LA / d.1914, New Orleans, LA.
Addresses: New Orleans, active 1879-89. **Comments:** Had his own studio from 1879-89. **Sources:** *Encyclopaedia of New Orleans Artists,* 353.

SIMON, Eugene J. *[Painter]* b.1889, Hungary.
Addresses: NYC/Woodstock, NY. **Studied:** ASL; K.H. Miller. **Member:** Soc. Indep. Artists; Woodstock AA; Bronx AG. **Exhibited:** S. Indp. A., 1919; AIC, 1921. **Sources:** WW29.

SIMON, George Gardner See: **SYMONS, (George) Gardner**

SIMON, Grant Miles *[Architect, painter, lithographer, lecturer, illustrator]* b.1887, Philadelphia, PA / d.1967, Philadelphia, PA.
Addresses: Philadelphia, PA. **Studied:** PM School IA; Univ. Pennsylvania, B.S., M.S.; PAFA; École des Beaux-Arts, Paris; Bernier. **Member:** Fellow, AIA; AWCS; Nat. Inst. Arch. Educ. (hon.); BAID. **Exhibited:** AIC, 1930; AWCS, 1943-55; NAD, 1945, 1946; LOC, 1941-43; Ferargil Gal., 1938. Awards: Cope prize, 1907; Stewardson scholarship, 1910; Brooke prize, 1911. **Work:** Easton (PA) Court House; PAFA; BM; Atwater Kent Mus., Phila.; Penn Hist. Soc.; LOC. **Comments:** Contributor to: *Historic Philadelphia* and *Architectural Record.* Co-author: *Historic Germantown,* 1955. Author: *The Beginnings of Philadelphia,* 1957. Lectures: theory of design. Positions: teacher and critic for the T-Square Atelier of the Univ. of Penn.; advisory arch. for the Independence Nat. Hist. Park. Among his Philadelphia building projects was the Univ. Club (Univ. of Penn.); First Unitarian Church; Fidelity Phila. Trust Company. Worked in Bermuda in 1939. **Sources:** WW59; WW47; obit, *Phila. Inquirer,* May 5, 1967.

SIMON, Gustave *[Engraver, lithographer]* b.c.1860, New Orleans, LA / d.1934, New Orleans, LA.
Addresses: New Orleans, active 1877-83. **Sources:** *Encyclopaedia of New Orleans Artists,* 353.

SIMON, Henry *[Painter]* 20th c.
Addresses: Chicago area. **Exhibited:** AIC, 1940, 1944-45. **Sources:** Falk, *AIC.*

SIMON, Hermann *[Painter]* b.1846 / d.c.1897.
Hermann Simon
NY. 1896
Addresses: Phila., PA; NYC. **Exhibited:** PAFA Ann., 1876-87; Boston AC, 1892-96; AIC, 1897; NAD, 1897. **Sources:** Falk, *Exh. Record Series.*

SIMON, Howard *[Illustrator, painter, etcher, wood engraver]* b.c.1903, NYC / d.1979, White Plains, NY.
Addresses: Stanfordville, NY. **Studied:** NAD; Académie Julian, Paris. **Member:** AIGA; Calif. SE. **Exhibited:** 50 Prints of Year; 50 Books of Year; Victoria & Albert Mus., London; Int. Printmakers, Los Angeles; Oakland Art League, 1928; Smithsonian Inst. (solo); Art Center, New York (solo). **Work:** MMA; BMA; NYPL Print Collection; Mills College Print Collection, CA; Brooks Mem., Memphis; Univ. Oregon Library; CPLH; Gramercy Park Hotel, NYC. **Comments:** Preferred media: watercolors, oils, wood. Publications: illustrator, many books, including *History of California Pathfinders, Ballads of Villon, Robin of the Mountains, Lost Corner* by C.M. Simon, *Back Yonder,* 1926-; author,*500 Hundred Years of Art in Illustration*; *Cabin on a Ridge,* Follett, 1969. Teaching: adjunct asst. professor of painting & drawing, New York Univ. School Visual Arts, 1945-65. **Sources:** WW73; WW47. More recently, see Hughes, *Artists in California,* 516.

SIMON, Ida J. *[Sculptor]* 20th c.
Addresses: Chicago area. **Exhibited:** AIC, 1937. **Sources:** Falk, *AIC.*

SIMON, Jeanne *[Painter]* 20th c.
Exhibited: AIC, 1923. **Sources:** Falk, *AIC.*

SIMON, Jewel W. *[Painter, sculptor, printmaker]* b.1911, Houston, TX.
Studied: Atlanta Univ., BFA; Atlanta School of Art, BFA (1st African-American graduate); Colorado Univ., with Hale Woodruff, Alice Dunbar, Lois Hellman. **Member:** Nat. Conference of Artists; Atlanta Artists Club. **Exhibited:** Houston, TX, 1934-39; Atlanta Univ., 1943-1949 (prize), 1950-1953 (prize), 1954 (hon. mention), 1955 (prize)-1957 (hon. mention), 1958-62 (prize),1963-64 (hon. mention), 1966, 1967 (hon. mention), 1968 (prize), 1973; Wayne State Univ., Detroit, 1952; Tuskegee Arts Festival, 1953-54; West Hunter Library, 1953 (solo); Houston Fine Arts Mus., 1957; Art USA, NYC, 1958; Howard Univ., 1960; Adair's Art Gallery, W. Peachtree, 1963 (solo); Xavier Univ., 1963; High Mus., Atlanta, 1964-67, 1971; NYWF, 1965; Los Feliz Jewish Comm. Center, 1965; UCLA, 1966-67; Oakland Mus., 1966-67; Dickson Art Center, 1966; Emory Univ. Art Show, 1967; Experiment in Friendship, Moscow, 1966-67; Emory Univ., 1967; West VA. State Col., 1968; Augusta Richmond Lib., 1969; Stillman Col., Tuscaloosa, AL, 1970; Jackson, MS, State Col.; CI, 1971; GA Inst. of Techn.; Atlanta Artists Club, 1971. **Work:** Atlanta Univ.; Clark College; Nat. Archives; CI; Chicago Univ.; Univ. of Maryland; Univ. of South AL. **Sources:** Cederholm, *Afro-American Artists.*

SIMON, Leo (Mr. & Mrs.) *[Collectors]* 20th c.
Addresses: NYC. **Sources:** WW66.

SIMON, Marie Ethalind *[Painter]* 20th c.
Addresses: Phila., PA. **Studied:** PAFA. **Sources:** WW25.

SIMON, Mildred See: **RACKLEY, Mildred (Mrs. Mildred Rackley Simon)**

SIMON, Natalie *[Lithographer]* mid 20th c.
Comments: WPA printmaker in California, 1930s. **Sources:** exh. cat., Annex Gal. (Santa Rosa, CA, n.d., c.1988).

SIMON, Norton [Collector] b.1907, Portland, OR.
Addresses: Fullerton, CA. **Comments:** Positions: board member, museum assocs., Los Angeles Co. Mus Art; pres. & trustee, Hunt Foods & Industries Mus. Art. Collection: paintings. **Sources:** WW73.

SIMON, Paul [Painter] 20th c.
Addresses: Chicago area. **Exhibited:** AIC, 1930. **Sources:** Falk, AIC.

SIMON, Sidney [Educator, art historian] b.1922, Pittsburgh, PA.
Addresses: Minneapolis, MN. **Studied:** Carnegie Inst. (B.F.A.); Harvard Univ. (Ph.D.). **Member:** College Art Assn. Am. **Exhibited:** Awards: Fulbright research fellowship, 1959. **Comments:** Not to be confused with the Sidney Simon born in 1917, also in Pittsburgh. Positions: senior curator, Walker AC, 1953-59; director, Univ. Minnesota Art Gallery, 1959-67. Teaching: assoc. professor art, Univ. Minnesota, 1959-67, professor of art history, 1968-. Collections arranged: collaborated on Gerhard Marcks, Sculptor, 1953, Reality and Fantasy 1900-54, Expressionism 1900-55, Sculpture of Theodore Roszak, 1956, Paintings by Stuart Davis, 1957, The 18th Century: One Hundred Drawings by One Hundred Artists, 1961, The 19th Century: 125 Master Drawings, 1962 & 20th Century Master Drawings, 1963. **Sources:** WW73.

SIMON, Sidney [Sculptor, painter, teacher] b.1917, Pittsburgh, PA / d.1997, NYC.
Addresses: NYC. **Studied:** Carnegie Inst.; PAFA (Cresson fellowship, 1940; Edwin Austin Abbey fellowship, 1940-41, B.F.A.) with George Harding; Univ. Penn. (B.A.); Barnes Foundation. **Member:** Pittsburgh AA; Abbey F., 1940; Artists Equity Assn. New York; Century Assn.; Arch. Lg.; Skowhegan School P&S; Provincetown AA. **Exhibited:** NGA; MMA, 1945; Pittsburgh AA, 1936-41, 1945; PAFA, 1946 (solo); YMHA, Pittsburgh, 1946; Corcoran Gal biennials, 1947, 1961; other Corcoran Gal exh, 1941 (prize), 1945 (prize); PAFA Ann., 1948-53, 1960-64; Am. Painting, MMA, 1950; Nine WMAA Ann, 1950-1962; MoMA Assemblage Exhib., 1962; "L'Aquarelle Comtemporaine aux États Unis," State Dept., 1963; Graham Gallery, NYC, 1970s. **Work:** MMA; Arch.-Hist. Div., U.S. War Dept., Washington, DC; Am. Embassy, Paris, France; Cornell Univ. Medical Center, Kramer College, Ithaca, NY. Commissions: Crucifix & St. John, Our Lady of Angels, Glenmont, NY; bronze grill, State Univ. NY Downstate Medical Center, entrance hall; wall design, Walt Whitman H.S., Yonkers, NY; The Circus (mobile), Woodland House, Hartford, CT; entrance sculpture, 747 Bldg., New York, 1972. **Comments:** Positions: artist-in-residence, Am. Acad Rome, Italy, 1969-70; Sarah Lawrence College, 1971-72. Teaching: New School Social Res.; founding director, Skowhegan School Painting & Sculpture, ME, 1945-58; Brooklyn Mus. School; Salzburg Sem. Am. Studies, 1971. **Sources:** WW73; Robert Rice, Sidney Simon (Motel on Mountain 1960); Richard McLanathan, Sidney Simon (Grippi Gal, 1964); Barbara Kafka, Craft Horizons (1967); WW47; Falk, Exh. Record Series.

SIMON, Suzanne [Painter] 20th c.
Addresses: Chicago area. **Exhibited:** AIC, 1946-47. **Sources:** Falk, AIC.

SIMON, Walter Augustus [Painter, educator] b.1913, NYC.
Exhibited: Atlanta Univ., 1951 (prize). **Work:** National Archives. **Comments:** Position: teacher, Paterson (NY) State College. **Sources:** Cederholm, Afro-American Artists.

SIMON-SIEMIATKOWSHI, C(hester) [Painter] 20th c.
Exhibited: S. Indp. A., 1940-41. **Sources:** Marlor, Soc. Indp. Artists.

SIMOND, Louis [Amateur painter] b.1767, France / d.1831, Geneva, Switzerland.
Addresses: NYC, 1792-1815. **Member:** NYHS, 1812. **Comments:** Simond was a merchant and auctioneer, and designed the vignette of Hudson's Half Moon which was later engraved for the Society's membership diploma by A.B. Durand. His drawing of "Moses Rescued by Pharaoh's Daughter" was engraved by Leney and Peter Maverick in 1816. Simond was the author of three travel books on England, Switzerland, and Italy, published between 1815 and 1828. He was also known as a distinguished amateur painter and art critic. **Sources:** G&W; Biographie Universelle, Supplement (1849); NYCD 1793-1814; Vail, Knickerbocker Birthday, 62-64, including repro. of a water color portrait of Simond by the Baroness Hyde De Neuville, owned by NYHS; Stephens, The Mavericks, 110.

SIMONDS, Charles [Sculptor] b.1945.
Addresses: NYC. **Exhibited:** WMAA, 1975, 1977. **Sources:** Falk, WMAA.

SIMONDS, E(dith) V(ernon) M. (Mrs. F.M.) [Painter] 20th c.
Studied: ASL. **Exhibited:** S. Indp. A., 1917-18, 1930-31; Salons of Am., 1930, 1931. **Sources:** Falk, Exhibition Record Series.

SIMONDS, George W. [Lithographic engraver] b.1838, New York.
Addresses: Boston, 1860. **Comments:** He was boarding at the same house as Willard C. Vanderlip. **Sources:** G&W; 8 Census (1860), Mass., XXVII, 890.

SIMONE, Edgardo G. F. [Sculptor, designer, teacher, writer, lecturer] b.1890, Brindisi, Italy.
Addresses: Chicago, IL. **Studied:** Dorsi; Gemito; Inst. of Classics, Lecce, École des Beaux Arts, all in Rome. **Exhibited:** AIC, 1937-39. **Work:** mon., Czar Alexander II, St. Petersburg, 1912 (award); Ipiranca mon., St. Paulo, Brazil, 1919 (award); war mon.: Ferrara, Monopoli; Brindisi; Sarno; Verona; Pianura; Avezzano; Majori; St. Bartolomeoin Bosco, Cerreto; Sannita; Marrara; St. Marzano sui Sarno; Minore; St. Pietro a Majella; Viggiano; St. Vito dei Normanni, Italy; Tampa, FL; religious mon.: Naples; Ravenna; Monopoli; St. Frances of Assisi, Sarno; Nocera Superiore; Benevento; Cathedral, Verona; mausoleum, Brindisi, Gattino maus, Torino; Naples; Caracas, Venezuela; Ferrera, Italy and St. Paulo, Brazil; busts: Queen Margherita of Italy; Senator Claude Kitchen, U.S. Capitol, Wash.; many notables. **Comments:** Lectures: Horticultural Bldg., Century of Progress, 1931. **Sources:** WW40.

SIMONE, P. Marcius [Painter] 19th/20th c.
Addresses: NYC. **Comments:** Represented by S.P. Avery, Jr. **Sources:** WW01.

SIMONET, Sebastian B. [Illustrator, painter, designer, teacher, lecturer, writer] b.1898, Stillwater, MN / d.1948, San Diego, CA.
Addresses: Stillwater, MN; San Francisco, CA, 1920-40s; San Diego, CA. **Studied:** Minneapolis Sch. Art; ASL; NAD; Henri; B. Robinson. **Exhibited:** Minnesota State Fair, 1921 (prize), 1928 (prize); NY State Fair, 1922 (prize); San Francisco AA, 1925. **Work:** Stillwater (MN) H.S. **Comments:** Positions: illustrator, U.S. Govt. publications; scientific illustrator, Univ. Calif., Div. War Research, U.S. Navy Radio & Sound Lab., San Diego, CA, from 1944. **Sources:** WW47; Hughes, Artists in California, 516.

SIMONI, Antonio [Listed as "artist"] b.c.1831, Italy.
Addresses: Boston, 1860. **Comments:** Louis Bernett boarded with him (see entry). **Sources:** G&W; 8 Census (1860), Mass., XXV. 32.

SIMONI, John Peter [Painter, educator] b.1911, Denver, CO.
Addresses: Wichita, KS. **Studied:** Colorado State College Educ., B.A. & M.A.; Nat. Univ. Mexico; Kansas City AI, with Thomas Hart Benton; Colorado Univ., with Max Beckmann; Ohio State Univ., Ph.D.; MIT; also in Trentino, Italy. **Member:** Am. Soc. Aesthetics; College Art Assn. Am.; Kansas Fed. Art; Southwestern College Art Conference (pres., 1962-64); Int. Inst. Arts & Letters (fellow). **Exhibited:** Mulvane Mus. Art; Wichita Art Mus.; Colorado State Univ.; Birger Sandzen Mem. Gallery, Lindsborg, KS; Univ. Wichita. Awards: Trentino Prize, Italy, 1928; Carter Prize, Denver, 1931; Knight Off., Order of Merit, Rep. Italy,

1966. **Work:** Colorado Friends of Art Collection. Commissions: reliefs, sculpture, murals, Southwest-Citizens Fed. Savings & Loan Assn., Wichita, Kansas State Bank, Newton, Fine AC Theatre, Univ. Wichita, East Heights Methodist Church & Citizens Nat. Bank, Emporia, KS. **Comments:** Positions: gallery director, Baker Univ., 1937-55; director, Univ. Galleries, Univ. Wichita, 1957-63; color consultant, Western Lithograph Co., Wichita, KS & Houston, TX, 1961-63; co-director, Univ. Gallery, Wichita State Univ., 1964-67; designer, John Coultis Interiors, 1964-. Publications: contributor, book reviews, *College Art Journal*; art critic, weekly art column for *Wichita Eagle* & monthly art column, *The Baldwin Ledger*, 1965-. Teaching: lectures on art education today, Italian Renaissance, art in religion & others; head dept. art, Baker Univ., 1937-55; professor art, Univ. Wichita, 1955-57 & chmn. dept. art, 1957-63; professor art, Wichita State Univ., 1964-. Collections arranged: organized Elsie Allen Art Gallery & assembled the Allen Collection of paintings, Baker Univ.; arranged & catalogued the Bloomfield Collection of paintings, Univ. Wichita, 1956. **Sources:** WW73.

SIMONIN, D. *[Miniaturist] mid 19th c.*
Addresses: New Orleans, before 1860. **Sources:** G&W; Carolina Art Assoc. Cat., 1935.

SIMONNE, T. *[Engraver] early 19th c.*
Addresses: NYC, 1814-16. **Comments:** He did work for the publishers Longworth and T.C. Fay. Possibly the same as Thomas Simonne, teacher of French (1819) and Theodore Simonne, teacher of languages (1822-23). **Sources:** G&W; Stauffer [as T. Simonne]; NYCD 1815-20 [engraving by Simonne of Stollenwerck's Mechanical Panorama]; NYCD 1819, 1822-23.

SIMONS, Amory C(offin) *[Sculptor] b.1869, Charleston, SC / d.1959, Santa Barbara, CA.*
Addresses: Phila., PA; Paris, France; Santa Barbara, CA. **Studied:** PAFA; Académie Julian, Paris with Puech; also with Dampt and Rodin in Paris. **Member:** AFA; Paris; Paris AA; NSS. **Exhibited:** PAFA Ann., 1894-24 (10 times); Paris Salon, 1897-99; Paris Expo, 1900; Pan-Am. Expo, Buffalo, 1901; St. Louis Expo, 1904 (medal); Paris Salon, 1906; Pan-Pacific Expo, San Francisco, 1915; AIC, 1916; NAD, 1922 (prize); CPLH, 1929. **Work:** bronzes, High Mus. Art; BMA; Brookgreen Gardens, SC; Charleston Mus.; Crag Mus., Cody, WY, MMA; Santa Barbara Mus. Art; Santa Barbara Public Library; Mus. Natural Hist., NY. **Comments:** Specialty: animal sculpture. Teaching: Santa Barbara School of Arts. **Sources:** WW53; WW47; Fink, *American Art at the Nineteenth-Century Paris Salons*, 390; Falk, *Exh. Record Series*.

SIMONS, Charles *[Copperplate, die, and seal engraver] early 19th c.*
Addresses: Charleston, SC, 1820-35. **Sources:** G&W; Rutledge, *Artists in the Life of Charleston*.

SIMONS, Elvera Hustead (Mrs. James) (El Vere)
[Ceramist, cartoonist, decorator, designer, teacher, writer] 20th c.; b.Omaha, NE.
Addresses: San Fran. **Studied:** AIC; Los Angeles AI; Federal School Minneapolis; Mills College; Univ. California; Calif. School FA. **Member:** Assn. San Fran. Potters (treas.). **Exhibited:** Calif. School FA, 1945, 1946; Mills College, 1944. **Comments:** Also worked under names of Elvera Hustead and El Vere. Author: *Colorology*, 1929. Contributor: caricatures & magazine articles for trade magazines. **Sources:** WW47; WW40 (as Hustead); WW53.

SIMONS, Francis X. *[Wood engraver] mid 19th c.*
Addresses: Philadelphia, 1855. **Sources:** G&W; Phila. CD 1855.

SIMONS, George *[Painter of western scenes, portrait painter] b.1834, Streeter, IL / d.1917, Long Beach, CA.*
Addresses: Council Bluffs, IA, 1890's; moved to California, c.1900. **Work:** Council Bluffs Public Library. **Comments:** Specialty: Western subjects; best known for "Kit Carson's Shot." He was one of the earliest artists to visit the territory of

Nebraska (1854) and an early settler of Council Bluffs (Iowa). **Sources:** G&W; *Art Annual*, XII, obit.; WPA Guide, *Nebraska*; Council Bluffs CD 1889, 1894; Peggy and Harold Samuels, 443.

SIMONS, Henry *[Sculptor] late 19th c.; b.Philadelphia, PA.*
Studied: with Chapu, Millet, Gauthier. **Exhibited:** Paris Salon, 1894. **Sources:** Fink, *American Art at the Nineteenth-Century Paris Salons*, 390.

SIMONS, James E. (Mrs.) See: **SIMONS, Elvera Hustead (Mrs. James) (El Vere)**

SIMONS, John P. *[Lithographer] b.c.1834, New York.*
Addresses: NYC in 1850. **Sources:** G&W; 7 Census (1850), N.Y., LIII, 275.

SIMONS, Joseph *[Heraldic engraver on stone, steel, silver, and other metals] mid 18th c.; b.Berlin (Germany).*
Addresses: NYC, active 1763. **Sources:** G&W; Gottesman, *Arts and Crafts in New York*, I, 13-14; Stephens, *The Mavericks*, 16.

SIMONS, Lavinia Dorothy See: **WRIGHT, Lavinia Dorothy Simons (Mrs. Charles Cushing)**

SIMONS, Marcius *[Painter] 19th/20th c.; b.New York.*
Addresses: Paris. **Studied:** J.-G. Vibert. **Exhibited:** Paris Salon, 1882; Corcoran Gal annual, 1908. **Comments:** *Cf.* Marcius-Simons. **Sources:** Falk, *Corcoran Gal (where first name is "Marcus;"* Fink, *American Art at the Nineteenth-Century Paris Salons*, 390.

SIMONS, Marcius See: **MARCIUS-SIMONS, Pinckney (Pincus)**

SIMONS, Milton E. *[Portrait painter] early 19th c.*
Addresses: NYC, 1835-37. **Exhibited:** NA. **Sources:** G&W; NYCD 1835; Cowdrey, NAD.

SIMONS, Miriam S. *[Artist]*
Addresses: Wash., DC, active 1922. **Sources:** McMahan, *Artists of Washington DC,*.

SIMONS, Rudolph *[Engraver]*
Addresses: New Orleans, active 1875-78. **Sources:** *Encyclopaedia of New Orleans Artists*, 353.

SIMONS, (the Misses) *[Teachers of drawing and painting, music, French, and other accomplishments] early 19th c.*
Addresses: Charleston, SC, 1820. **Comments:** In 1822 only one Miss Simons advertised. They may have been related to Charles Simons, the Charleston engraver. **Sources:** G&W; Rutledge, *Artists in the Life of Charleston*.

SIMONSON, Lee *[Designer, painter, writer, lecturer] b.1888, NYC / d.1967, NYC.*
Addresses: NYC. **Studied:** Harvard Univ., B.A. **Exhibited:** S. Indp. A., 1917; Int. Exhib. Theatre Art, MoMA, 1933; WFNY 1939; WMA, 1940; MMA, 1945; FMA, 1950. **Work:** NYPL; settings for numerous stage productions including "Heartbreak House," "Back to Methusaleh," "Amphtrion 38," Wagner's "Ring of the Nibelungen." Collection of costume designs & photographs of state settings at Stanford Univ. Lib. **Comments:** Position: consultant, costume exhib., MMA, 1944, 1945; consultant, theatre, Univ. Wisconsin, Univ. Indiana, Hunter College. Author: *The Stage is Set*, 1932; *Part of a Lifetime*, 1943; *The Art of Scenic Designs*, 1950, & others. Contributor to: architectural, art & theatre magazines. Lectures: History of Stage Settings; History of Costume. Contributor to Encyclopaedia Britannica, "Modern Theatre Design." **Sources:** WW66; WW47.

SIMONSON, Marion *[Painter] b.1913, New York, NY.*
Addresses: Lively, VA. **Studied:** Phoenix AI; ASL; Grand Central Art School; Farnsworth School Art, and with Jay Connaway. **Member:** ASL; NAWA; Rappahannock Art Lg. **Exhibited:** Hudson Valley AA, 1953, 1954; Westchester Arts & Crafts Gld., 1942, 1947, 1952, 1953; NAWA, 1953, 1954; Portraits, Inc., 1952-55. Awards: medal, NAD, 1941, 1942; Hudson Valley AA, prize, 1954. **Work:** Am. Univ., Cairo, Egypt; Domestic Relations Court, Birmingham, AL; Hunter College H.S.;

Denville Mem. Lib., Denville, NJ; Baptist Foreign Mission Bd., Richmond, VA. **Sources:** WW59.

SIMONT, Joseph *[Illustrator] 20th c.*
Addresses: NYC. **Member:** SI; Artists' Guild. **Comments:** Illustrator: *Colliers, American.* **Sources:** WW40.

SIMONT, Marc *[Illustrator] b.1915, Paris, France.*
Addresses: West Cornwall, CT. **Studied:** Acad. Ranson; NAD; also with Andre L'Hote. **Member:** Authors League. **Exhibited:** Awards: Caldecott Medal, Am. Library Assn., 1957. **Comments:** Publications: illustrator, *The Happy Day* (1949), *The Thirteen Clocks* (1951) *&A Tree is Nice* (1957); author/illustrator, *The Lovely Summer* (1952), *A Child's Eye View of the World* (1972). **Sources:** WW73; Elizabeth Lansing, biographical paper, *Caldecott Medal Books* (Horn Book, 1957).

SIMONTON, Emily M. *[Artist] 19th/20th c.*
Addresses: Active in Detroit, MI, 1895-1901. **Sources:** Petteys, *Dictionary of Women Artists.*

SIMPER, Frederick *[Painter] b.1914, Mishawaka, IN.*
Addresses: West Bloomfield, MI. **Member:** Michigan WCS. **Exhibited:** Detroit IA, 1938-68; AIC, 1948; Watercolor USA, Springfield, MO, 1965; Butler IA; PAFA; AIC; Arwin Galleries, Detroit, MI, 1970s. Awards: Detroit IA Founders Soc. Award, 1942; Baltimore Sun Award for black & white drawing, 1945; Michigan WCS Award, 1972. **Work:** Detroit IA; South Bend (IN) Art Mus.; U.S. Embassies Collection. **Comments:** Preferred media: watercolors. Positions: art director, D'Arcy, MacManus Int., 1949-. Teaching: watercolor instructor, Soc. Arts & Crafts, Detroit, 1948-51; watercolor instructor, Bloomfield AA, Birmingham, MI, 1968-70. **Sources:** WW73.

SIMPKINS, Henry John *[Painter, illustrator] b.1906, Winnipeg, Manitoba.*
Addresses: Dorval, PQ. **Studied:** Winnipeg School Art, with Frans Johnson; also with Lemoine Fitzgerald & Jessie Dow. **Member:** Royal Canadian Acad. Arts (assoc. member); Montreal Arts Club. **Exhibited:** Can Nat Gallery Travelling Exhib, 1937; Royal Can Acad Art, 1958; solo shows, Klinkhoff Gallery, Montreal, 1969 & Wallack Gallery, Ottawa, 1970 & 1972. Awards: First Prize for watercolor, Jessie Dow, 1932 & 1934. **Work:** Commissions: mural (oil), Trans Canada Telephone Co., Expos 1967. **Comments:** Preferred media: watercolors. Positions: illustrator, Brigden's Ltd., Winnipeg, 1925-28; illustrator, Rice Studio, NYC, 1928-29; illustrator, Rapid Grip & Battens, Montreal, 1930-58. **Sources:** WW73.

SIMPKINS, Martha See: **SIMKINS, Martha (Mattie)**

SIMPLOT, Alexander *[Painter] b.1837, Dubuque, IA / d.1914, Dubuque, IA.*
Studied: Rock River Seminary; Union College. **Work:** Tennessee State Mus. **Comments:** As an artist for *Harper's Weekly* he was with Gen. Fremont's army in Missouri in 1861 and later with Grant and other leaders during the Civil War. He returned to Iowa in 1863, married, and went into business. He later opened an engraving and patent office and in 1899 published a weekly series, "Story of the War" Pen and Pencil Reminiscenes," in the *Dubuque Sunday Times.* Kelly, "Landscape and Genre Painting in Tennessee, 1810-1985," 52-53 (w/repro.).

SIMPS, James C. See: **SIMPSON, James C.**

SIMPSON, Alice Mary *[Painter] b.1870, Newark, NJ / d.1934, NYC.*
Addresses: NYC/Gloucester, MA. **Studied:** ASL with Cox, Chase, Mowbray. **Member:** Arch. Lg. (asst. secretary). **Exhibited:** S. Indp. A., 1917, 1925-26; Salons of Am., 1925-27. **Comments:** In 1934, she was awarded the President's Medal, in recognition of her "forty years of unsparing devotion" to the Arch. Lg. **Sources:** WW33.

SIMPSON, Anna (Sophie) Frances (Fannie) Connor *[Craftsperson] b.1880, New Orleans, LA / d.1930, New Orleans, LA.*
Addresses: New Orleans, active 1897-1930. **Studied:** Newcomb College, 1902-08. **Exhibited:** NOAA, 1910-11, 1913, 1916-18; Newcomb, 1911, 1913; Panama-Pacific Expo, San Francisco, 1915; SSAL, TX, 1929 (silver medal); MFA, Houston, TX, 1930 (solo retrospective). **Comments:** Primarily known for her art pottery designs, she was also skilled in printmaking and needlework. **Sources:** *Encyclopaedia of New Orleans Artists,* 353-54.

SIMPSON, Bernard *[Painter] b.1918, Cairo, IL.*
Addresses: Chicago, IL. **Studied:** AIC; H. Wallace. **Exhibited:** AIC, 1940 (prize). **Sources:** WW40.

SIMPSON, C. Helen See: **WHITTEMORE, Helen Simpson (Mrs. William J.)**

SIMPSON, Clara (Mrs.) See: **DAVIDSON, Clara D. (Mrs. Chax. Simpson)**

SIMPSON, David *[Painter, educator] b.1928, Pasadena, CA.*
Addresses: Richmond, CA. **Studied:** Calif. School Fine Arts, with Clifford Still & others, B.F.A., 1956; San Francisco State College, M.A., 1958. **Exhibited:** Carnegie Int., Pittsburgh, PA, 1961 & 1964; Americans 1963, MoMA, 1963; Post Painterly Abstraction, Los Angeles, 1966; PAFA Ann., 1968; Hank Baum Gallery, San Francisco, 1970s. **Work:** San Francisco MA; Oakland AM; MoMA: Phila. MA; Baltimore MA. **Comments:** Preferred media: acrylics. Teaching: art professor, Univ. Calif., Berkeley, 1965-. **Sources:** WW73; Falk, *Exh. Record Series.*

SIMPSON, E. V. *[Painter] 20th c.*
Addresses: Salt Lake City, UT. **Sources:** WW15.

SIMPSON, Edna Heustis (Mrs.) *[Miniature painter] b.1882, Troy, NY / d.1964, NYC.*
Addresses: NYC. **Studied:** Emma Willard Art Sch.; Cornell Univ.; ASL. **Member:** Penn. SMP. **Exhibited:** Penn. SMP, 1906-26; Pan-Pac. Expo., 1915; Chicago World's Fair, 1933; ASMP. **Work:** portrait commissions. **Comments:** Later married Radcliffe Swinnerton. **Sources:** WW47.

SIMPSON, Frances *[Painter] 20th c.*
Addresses: New Orleans, LA. **Sources:** WW15.

SIMPSON, Herbert *[Painter] 20th c.*
Addresses: NYC. **Sources:** WW25.

SIMPSON, Herbert William *[Designer] b.1904, Evansville, IN.*
Addresses: Evansville 14, IN. **Member:** Soc. Typographic Artists, Chicago; Cliff Dwellers; Soc. for Italic Handwriting, England. **Comments:** Awards: "Best of Industry" Design awards, Direct Mall Adv. Assn., 1947-1950; certificate, AIGA, 1952, 1953. **Sources:** WW59.

SIMPSON, Hugh (J.) *[Painter] 20th c.*
Addresses: Phila., PA. **Exhibited:** S. Indp. A., 1924-28. **Sources:** Marlor, *Soc. Indp. Artists.*

SIMPSON, I. See: **SIMPSON, J. J.**

SIMPSON, J. J. *[Engraver] b.1829, Pennsylvania.*
Addresses: Philadelphia in 1850. **Comments:** Possibly John G. Simpson. **Sources:** G&W; 7 Census (1850), Pa., L, 672.

SIMPSON, James Alexander *[Portrait painter, teacher] b.1805, Washington, DC / d.1880, Baltimore.*
Addresses: Georgetown (Wash., DC), 1850-64; Baltimore, 1865-80. **Exhibited:** Washington Metropolitan Mechanics Inst., 1853. **Work:** Nat. Trust for Hist. Preservation (Decatur House); Syracuse Univ.; Maryland Hist. Soc.; Georgetown Univ. (includes early views of the University's grounds). **Comments:** Part-time teacher of drawing and painting at Georgetown College, 1830-65. Sitters included William Henry Harrison (1840) and Com. Stephen Decatur. **Sources:** G&W; Washington and Georgetown CD 1853-64; Baltimore CD and Lafferty, 1865-80; 7 Census (1850), D.C., II, 460 [as J. Simpson]; 8 Census (1860), D.C., I, 46 [as J.R. Simpson]. More recently, see McMahan, *Artists of Washington,* 199.

SIMPSON, James C. *[Engraver and die sinker, designer, and landscape painter in watercolors] mid 19th c.*
Addresses: NYC, 1847-49; Philadelphia1851-67. **Exhibited:** NA, 1848; PAFA, 1856. **Sources:** G&W; NYCD 1847-49; NYBD 1849 [as James C. Simps]; Cowdrey, NAD; Phila. CD 1851-67; Rutledge, PA.

SIMPSON, Jean L. *[Artist] early 20th c.*
Addresses: Wash., DC, 1905. **Sources:** McMahan, *Artists of Washington DC,*.

SIMPSON, John *[Listed as "artist"] mid 19th c.*
Addresses: NYC, 1850. **Sources:** G&W; NYCD 1850.

SIMPSON, John G. *[Engraver] mid 19th c.*
Addresses: Philadelphia, 1858-63. **Comments:** Possibly the same as J.J. Simpson. **Sources:** G&W; Phila. CD 1858, 1860, 1863.

SIMPSON, Joseph *[Lapidary and seal engraver] b.c.1794, Hungary.*
Addresses: Baltimore, active 1842-56. **Sources:** G&W; Baltimore BD 1842, 1844, 1848, CD 1850, 1856; 7 Census (1850), Md., V, 168.

SIMPSON, Joseph *[Engraver and stencil cutter] mid 19th c.*
Addresses: NYC, 1843-60 and after. **Sources:** G&W; NYCD 1843-60+.

SIMPSON, Kenn *[Painter, educator]*
Studied: Howard Univ., AB; Catholic Univ., MFA; DC Teachers College; American Univ.; NY Univ.; with Jack Perlmutter. **Member:** DC AA; Nat. Conference of Artists; CGA; Neighborhood Arts Council. **Exhibited:** State Armory, Wilmington, DE, 1971; Smith-Mason Gallery, 1971; Soc. of Wash. Artists; Hampton Inst.; Howard Univ.; Catholic Univ.; DCAA, Anacostia Neighborhood Mus.-Smith. Inst.; Lycoming Col.; Cosmos Club; Mus. of Natural Hist., Smithonian; Ontario Gallery; Margaret Dickey Gallery (solo); DC Teachers College; Shaw Univ.; Alabama State; National College of FA, DC; CI, 1971-72 (Max Roach Award); NJ State Mus.; Univ. of Pittsburgh; Bowie State College (solo); DC Central Library. **Work:** Shaw Univ.; Alabama State Art Inst.; DC Juvenile Court; Anacostia Neighborhood Mus.-Smithonian Inst. **Sources:** Cederholm, *Afro-American Artists.*

SIMPSON, Lee *[Painter] b.1923, Cisco, TX.*
Addresses: Taos, NM. **Studied:** Columbia Univ., with Arnold Leondar; also with Louise Nevelson & Elaine DeKooning, New York, NY. **Member:** Taos AA. **Exhibited:** Spec Group Show, Panhandle-Plains Hist Mus, Canyon, Tex, 1969; Ninth & Tenth Ann Awards Show, Taos Art Asn, 1971 & 1972; Southwest Fine Arts Biennial, Mus N Mex, Santa Fe, 1972; solo show, W Tex State Univ, Canyon, 1968. Awards: Juror's citation State Citation Show, Texas Fine AA, 1968 (prize) & 1969 (prize); Ninth Ann. Awards Show, Taos AA, 1972 (first award); Gallery A, Taos, NM, 1970s. **Work:** Couse Mus., Taos, NM; Johnson-Everheart Collection, Miami Beach, FL; State Nat. Bank, El Paso, TX; Whirlpool Corp., Benton Harbor, MI; U.N. Plaza, New York. Commissions: mural, Perryton Natm Bank, TX, 1969. **Comments:** Preferred media: oils. Positions: owner & instructor of oil painting, Simpson Gallery & Studio, Amarillo, 1962-70. Teaching: guest lecturer on oil painting, West Texas State Univ., 1969; guest instructor of oil painting, Amarillo Jr. College, 1969-70. **Sources:** WW73.

SIMPSON, Lillian B. *[Painter] 20th c.*
Addresses: Kansas City, MO. **Sources:** WW17.

SIMPSON, Margaret See: **SPICER-SIMSON, Margaret Schmidt (Mrs. Theodore)**

SIMPSON, Marian Hahn (Mrs. Lesley Byrd) *[Painter, mural painter] b.1899, Kansas City, MO / d.1978, Berkeley, CA.*
Addresses: Berkeley, CA. **Studied:** with H. G. Keller. **Member:** Club Beaux Arts, San Francisco. **Exhibited:** Cleveland Artists, 1923 (prize), 1924 (prize); San Francisco, 1927; Berkeley Lg. of

FA, 1924; San Francisco AA, 1925, 1927, 1930 (prize); Oakland Art Gallery, 1928; Salons of Am., 1930; SFMA, 1935; GGE, 1939. **Work:** Cleveland; Mills College Gal., Oakland, CA; YWCA, San Francisco; mosaic, Alameda County Courthouse, Oakland, CA. **Sources:** WW40.

SIMPSON, Marie *[Painter] late 19th c.*
Studied: Benjamin-Constant. **Exhibited:** Paris Salon, 1888. **Comments:** *Cf.* Marie A. Simpson. **Sources:** Fink, *American Art at the Nineteenth-Century Paris Salons,* 390.

SIMPSON, Marie A. *[Artist]*
Addresses: Wash., DC, active 1905. **Sources:** McMahan, *Artists of Washington DC,*.

SIMPSON, Marilyn Jean *[Painter, instructor] b.1929, Birmingham, AL.*
Addresses: Fort Walton Beach, FL. **Studied:** Univ. Alabama; ASL; Inst. Allende, San Miguel Allende, Mexico; Madison (CT) Art School; also with Robert Brackman; Am. Univ. Avignon, France. **Member:** Pensacola AC; Prof. Artist Guild NW Florida (secretary, 1970); Arts & Design Soc. (vice-pres., 1963). **Exhibited:** Smithsonian Inst., Washington, DC; Paula Insel Gallery, NYC; Birmingham (AL) Mus.; Mobile(AL) Art Gallery; Florida Fed. Art, De Bary, FL. Awards: best in show (oil), Beaux Arts, 1962; first in portraits (pastels), Arts & Design Show, FL, 1963; first in portraits (pastels), Florida Second Ann. Art Exhib., 1970; VZTop Gallery, Pensacola, FL, 1970s. **Work:** Govt. Bldg., Tallahassee, FL; VZTop Gallery, Pensacola, FL; Shelby Studio, Göppingen, Germany. **Comments:** Preferred media: pastels, oils. Teaching: art instructor, private school, Fort Walton Beach, FL, 1969-. **Sources:** WW73.

SIMPSON, Marshall S. *[Painter, educator, lecturer, designer] b.1900, Jersey City, NJ / d.1958, Middletown, NJ.*
Addresses: Middletown, NJ. **Studied:** MIT; ASL, and with John Sloan, Maurice Sterne, G. Pene du Bois. **Member:** New Jersey AA; Artists of Today, Newark. **Exhibited:** Newark Mus.; Princeton Univ.; Montclair A. Mus.; Bonestell Gal.; in collaboration with Roslynn Middleman; WMAA; MoMA; Rose Fried Gal; Salons of Am. **Work:** PMA; Univ. Penn.; NJ State Mus., Trenton. **Comments:** Position: student advisor, Newark School Fine & Indust. Art, Newark, NJ. Lectures on survey of art history; drawings of children, etc. **Sources:** WW53; WW47.

SIMPSON, Martha Hoit *[Painter] b.1877, Chicago, IL / d.1955, Los Angeles, CA.*
Addresses: Hollywood, CA. **Studied:** AIC with R. Davey; Paris, with Lhote, M. Blanchard; ASL. **Member:** NAWA. **Exhibited:** S. Indp. A., 1922, 1933-36; Salons of Am., 1933; GGE, 1939; AIC, 1936, 1941-42; WMAA, 1936. **Sources:** WW40.

SIMPSON, Mary E. *[Painter] b.1872, Englewood, IL.*
Addresses: Minneapolis, MN. **Studied:** Minneapolis School FA, with R. Koehler. **Member:** Minnesota Soc. Arts & Crafts. **Sources:** WW17.

SIMPSON, Maxwell Stewart *[Maxwell Stewart Simpson]*
[Painter, sculptor, etcher, lithographer, illustrator, teacher] b.1896, Elizabeth, NJ / d.1984, Scotch Plains/Elizabeth, NJ.
Addresses: Elizabeth, Plainfield, Scotch Plains, NJ. **Studied:** NAD, 1914 & 1918; ASL, summer 1916 with Cheffetz; etching with Auerbach Levy, 1917; in London and Oxford, England; Paris, France & Italy, 1923, 1924 & 1929. **Member:** Assoc. Artists NJ; Mod. Artists, NJ; Audubon Artists. **Exhibited:** PAFA Ann., 1920, 1922, 1953; Soc. Nat. Beaux Arts, Paris Salon, 1924; S. Indp. A., 1927-28; Salons of Am., 1928, 1933, 1934; 10th Int. Water Exhib., AIC, 1930; Surv. Am. Art, BMA, 1934; WFNY, 1939; Homage To Isadora Duncan, San Francisco World's Fair, 1939; NAD, 1945, 1948-49, 1953 (prize); Los Angeles Mus. Art, 1945; CI, 1941, 1943; NGA, 1940; Corcoran Gal biennial, 1939; WFNY 1939; WMAA, 1934; GGE, 1939; Summit (NJ) AA, 1942; Montclair Art Mus., 1943 (prize),1944; Riverside Mus.,1944; Artists of Today, Newark, 1946; Newark Mus., 1943,

1952; NAC, 1951 (medal), 1957 (award); MMA (AV), 1942; Pepsi-Cola, 1947; Terry AI, 1952 (prize, honorable mention for "Old Woman"); Art Center of the Oranges, 1955, 1958 (awards); Plainfield AA, 1956 (award); Albright Art Gal.; Rochester Mem. Art Gal.; BMFA; Nat. Univ. Mexico; Dudensing Gal., 1930 (solo), 1932 (solo); Artists Gal., 1941 (solo). Emily Lowe Competition Award for Spring Landscape; 1958; NJ Artist of Year Award, 1959; Grand Central Gal, NYC, 1970s. **Work:** NGA (etching); NYPL; Briarcliff Sch.; Newark Public Library; Public Library, Elizabeth, NJ; Newark Mus.; Shelburne (VT) Art Mus. Commissions: murals, Stage House Inn, commissioned by Mrs William G. Mennen, Jr., Scotch Plains, NJ, 1960; Savings Bank Cent NJ, 1971; portraits, Mrs. William Casford, Chatham, NJ, 1969, Mr Charles Hoffman, Elizabeth, NJ, 1971 & Mrs. Ian Prior, West Caldwell, NJ, 1972. **Comments:** Preferred media: oils, watercolors. Illustrator, "Aucassin and Nicolete," (*50 Books of the Year,* 1936). Author: "The relationship of modern art to modern industry," *Dun's Review,* 4/1938. Teaching: Elizabeth Art Club Studio, 1925-28; Newark Sch. Fine & Industrial Arts, 1936-46; Simpson Studio, Elizabeth, 1936-46. **Sources:** WW73; WW47; Frederic Whitaker, "The Paintings of Maxwell Stewart Simpson," *Am Artist* (May, 1963); Muller, *Paintings and Drawings at the Shelburne Museum,* 127; Falk, *Exh. Record Series.*

SIMPSON, Merton D *[Painter, art dealer] b.1928, Charleston, SC.*
Addresses: NYC. **Studied:** NY Univ.; Cooper Union Art School, with Robert Motherwell & Baziotes; also with William Halsey. **Member:** Spiral. **Exhibited:** Chatham College, PA; Dickinson College, NY; Contemporary Arts Gallery, NYC; Barone Gallery, NYC; Guggenheim Mus., New York; MMA; BM; Bertha Schaefer Gallery, NYC; Nat. Gallery, Paris; Red Cross Exchange Exhib., Tokyo & Paris, 1950; Atlanta Univ., 1950, 1951 & 1956; Intercultural Club, 1951; Oakland Art Mus., 1952; Nat. Mus. Japan; NY City College, 1967; Univ. of Michigan; Fisk Univ., 1969; Barnet Aden Gallery, Wash., DC; Afro-American Exhib., NYC; Alfredo Valente Gallery, 1964; Gibbes Art Gallery. **Work:** James J. Sweeney Collection, Guggenheim Mus.; Howard Univ., Washington, DC; Scott Field Mus., Chicago; Atlanta Univ.; Gibbs Art Gallery; Univ. Massachusetts; Fisk Univ.; Columbia (SC) Mus. of Art. **Comments:** Specialty of gallery: primitive art, especially African. **Sources:** WW73; Cederholm, *Afro-American Artists.*

SIMPSON, Nancy Griswold (Mrs. J. H.) *[Portrait painter] b.1902, Toronto, Canada.*
Addresses: Seattle, WA. **Studied:** ASL. **Member:** Women Painters of Wash. **Exhibited:** Seattle FAS, 1920-24; SAM, 1937; Peninsula Artists, Monterey, CA. **Sources:** Trip and Cook, *Washington State Art and Artists, 1850-1950.*

SIMPSON, Samuel *[Painter, writer, lecturer, teacher] b.1868, Centerville, MI.*
Addresses: Tolland, CT. **Studied:** ASL. **Member:** CAFA. **Sources:** WW25.

SIMPSON, Solomon L. *[Amateur artist] mid 19th c.*
Exhibited: American Inst., 1845-48 (drawings, including one of the steamship *Great Britain,*). **Comments:** He was probably the son of Lissack H. Simpson, distiller and importer, and he himself had gone into the import trade by 1853. **Sources:** G&W; Am. Inst. Cat., 1845, 1848; NYCD 1845, 1853.

SIMPSON, Wallace *[Painter, illustrator] b.1880, Moweaqua, IL.*
Addresses: Fort Worth, TX (1935). **Studied:** With Frank Reaugh. **Comments:** Cowboy artist who depicted ranch life, particularly longhorns, painted horses and cowboys at work. Illustrator in Oklahoma City, El Paso and for *Dallas News, Fort Worth Star-Telegram.* **Sources:** P&H Samuels, 443.

SIMPSON, William *[Painter, illustrator] b.1823, Glasgow, Scotland / d.1899, London, England.*
Addresses: San Francisco, CA; London. **Member:** Royal Inst., 1874. **Work:** Bancroft Library, UC Berkeley; Peabody Mus.,

Harvard Univ.; Victoria & Albert Mus.; Capetown, Edinburgh, Glasgow, Nice museums. **Comments:** Apprenticed to Glasgow lithographers at age 14 and was a lithographer in London in 1851. Was in India, 1856-63. From 1865-85 he was Special Artist for *Illustrated London News,* traveling extensively including a world trip in 1872. In 1873 he accompanied A. Bierstadt (see entry) to Yosemite. **Sources:** Hughes, *Artists in California,* 517; P&H Samuels, 443-44.

SIMPSON, William E. (Mrs.) *[Sketch artist] 19th/20th c.*
Addresses: Tacoma, WA, 1892. **Member:** Tacoma Art League, 1891, 1892. **Exhibited:** Western Wash. Industrial Expo, 1891. **Sources:** Trip and Cook, *Washington State Art and Artists, 1850-1950.*

SIMPSON, William H. *[Painter] b.1818, Buffalo, NY / d.1872, Boston, MA.*
Addresses: Boston, MA, 1856-72; Wash., DC, 1867. **Exhibited:** Howard Univ., 1945, 1967; Downtown Gallery, 1942. **Work:** Howard Univ.; Nat. Archives; Masonic Lodge, Boston. **Comments:** Black portrait painter who was born and brought up in Buffalo, NY. He served his apprenticeship there and in Boston under Matthew Wilson from 1854-56, and worked in Boston until his death. **Sources:** G&W; Brown, *The Rising Sun,* 478-81; Porter, *Modern Negro Art,* 51-52; Porter, *Versatile Interests of the Early Negro Artist,* 2 repros.; Boston CD 1858-65; McMahan, *Artists of Washington DC,* Cederholm, *Afro-American Artists.*

SIMPSON, William Kelly *[Art historian, educator] b.1928, New York, NY.*
Addresses: Katonah, NY. **Studied:** Yale Univ. (B.A., 1947; M.A., 1948; Ph.D., 1954); École Practique Hautes Études, Paris, France. **Member:** Archaeology Inst. Am.; Am. Oriental Soc.; Am. Rest Center in Egypt; Egypt Exploration Soc.; Soc. Française Egyptologie. **Exhibited:** Awards: Guggenheim Foundation fellowship, 1965. **Comments:** Positions: curator of Egyptian Art, Mus. Fine Arts, Boston, 1970-. Publications: author, *Papyrus Reisner I-Records of a Building Project,* 1963; author, *Papyrus Reisner II-Accounts of the Dockyard Workshop,* 1965; author, *Papyrus Reisner III-Records of a Building Project in the Early Twelfth Dynasty,* 1969; co-author, *The Ancient Near East: A History,* 1971; co-author, *The Literature of Ancient Egypt,* 1972. Teaching: professor Egyptology, Yale Univ., 1956-; visiting prof essor of Egyptology, Univ. Penn. Collections arranged: The Pennsylvania-Yale Expedition to Nubia, Peabody Mus., Yale Univ., New Haven, CT, 1963; Recent Accessions in Egyptian and Ancient Near Eastern Art & The Horace L. Mayer Collection, 1972, Mus. Fine Arts, Boston, MA; also MMA & Univ. Penn. Mus, Phila. Research: art, history, and literature of ancient Egypt. **Sources:** WW73.

SIMPSON, William Marks *[Sculptor, teacher] b.1903, Norfolk, VA.*
Addresses: Baltimore, MD. **Studied:** J.M. Miller, H. Schuler; H. Adams; Rhinehart School of Sculpture, Maryland Inst.; Am. Acad., Rome. **Member:** Norfolk SA; Baltimore Mus.; Soc. Med. **Exhibited:** Norfolk SA, 1920 (prize), 1921 (prize), 1923 (prize), 1914 (prize); Am. Acad. Rome Comp., 1920; PAFA Ann., 1928; Maryland Inst., 1934 (medal). **Work:** Virginia Miltary Inst., Lexington; Villa Aurelia, Rome, Italy. **Comments:** Position: director, Rinehart Sch. of Sculpture, Maryland Inst. **Sources:** WW40; Falk, *Exh. Record Series.*

SIMPSON, William R. *[Portrait painter] b.c.1826, St. Louis.*
Addresses: NYC, 1850; St. Louis, MO, c.1851-54. **Studied:** probably under Daniel Huntington (NYC). **Exhibited:** NA, 1849 (portrait of Daniel Huntington). **Comments:** In1854 he was living in the home of Robert Simpson, treasurer of the Boatmen's Saving Institution. **Sources:** G&W; Cowdrey, NAD; NYCD 1850 [as William H. Simpson]; St. Louis CD 1851-54; FARL question file lists a portrait owned by a private collector in 1938; 7 Census (1850), N.Y., LVI, 435.

SIMPSON, William Skinner *[Landscape painter] b.1795, London, England / d.1865, Petersburg, VA.*

Addresses: Petersburg, VA. **Work:** Assoc. for the Preservation of Virginia Antiquities. **Comments:** Followed his future wife from England to Virginia in 1819. Working as an insurance agent, he made many sketches and watercolors of several counties in Virginia. **Sources:** Wright, *Artists in Virgina Before 1900.*

SIMPSON, William Skinner, Jr. *[Landscape painter]*
b.1823, Petersburg, VA / d.1895, Petersburg, VA.
Addresses: Petersburg, VA. **Comments:** Son of William S. Simpson (see entry), he worked as an insurance agent and notary, producing landscape sketches and watercolor drawings. Wright, *Artists in Virgina Before 1900.*

SIMPSON-MIDDLEMAN, Roslynn (Roslynn Middleman) *[Painter, teacher]* b.1929, Philadelphia, PA.
Addresses: Plainfield, NJ. **Studied:** New Jersey College for Women; Newark Sch. Fine & Indust. Art; W. Benda; R. Naklan; B. Gussow. **Exhibited:** Corcoran Gal. biennials, 1955, 1957; WMAA, 1951, 1955; Newark Mus. Art, 1952, 1954-55; Univ. Nebraska, 1956; BMFA, 1955; Mem. Union Gal., Madison, WI; St. Paul Gal. Art; DMFA, 1956; TMA, 1956; Boeing Aircraft, Seattle, 1957; Nat. Aeronautical Inst., 1958; Schenectady Mus. Art, 1956; Rose Fried Gal., 1951 (solo); John Heller Gal., 1955, 1957. **Work:** WMAA; Newark Mus. Art; MMA. **Sources:** WW59.

SIMS, Agnes C. *[Painter, sculptor]* b.1910, Rosemont, PA.
Addresses: Santa Fe, NM. **Studied:** Philadelphia School Design for Women; PAFA. **Member:** Hon. assoc. Archaeology, School Am. Res.; Artists Equity Assn. **Exhibited:** AIC; Palace Legion Honor, 1946; Mus. N.Mex., 1945 (solo); Santa Barbara Mus. A., 1946 (solo); SFMA, 1946 (solo); Colorado Springs Fine Arts Ctr; Walker Art Center, Minneapolis, MN; exhib. of wall hangings based on Southwest Indian Petroglyphs for U.S. Info Service at U.S. Embassy, London, England, 1964. **Awards:** Am. Philos. Soc. grant for research & recording Southwest Indian Petroglyphs, 1949; Neosho grant, 1952; Ingram Merrill Foundation grant, 1960. **Work:** Mus. New Mexico; Colorado Springs FAC; Denver Art Mus.; Taylor Mus., Colorado Springs, CO. **Commissions:** mural, New Mexico Petroglyphs, Mutual Bldg. & Loan, 1970. **Comments:** Publications: author/illustrator,*San Cristobal Petroglyphs,* 1950. Collections arranged: exhib. of reproductions of Southwest Indian petroglyphs, Brooklyn Mus., 1953 & Musée L'Homme, Paris, 1954. **Sources:** WW73; WW47.

SIMS, Charles *[Painter]* 20th c.
Exhibited: AIC, 1926. **Sources:** Falk, *AIC.*

SIMS, Florence See: **REID, Florence Sims (Mrs. R. S.)**

SIMS, Joseph Patterson *[Lithographer, designer, illustrator, architect]* b.1890, Philadelphia, PA.
Addresses: Philadelphia, PA. **Studied:** Univ. Pennsylvania, B.S. in Arch. **Member:** AIA; Phila. Print Club. **Exhibited:** Southern PM, 1942 (prize). **Work:** State House, Phila., Pa.; LOC; public libraries in several cities. **Comments:** Co-author (with C. Willing): "Old Philadelphia Colonial Details," 1914. Specialty: dec., historical, and animal maps. **Sources:** WW53; WW47.

SIMS, (Miss) See: **SIMES, Mary Jane**

SIMS, Ralph W. *[Sculptor]* 20th c.
Addresses: Delphi, IN; Chicago. **Member:** Indiana SS.
Exhibited: AIC, 1913, 1915, 1923. **Sources:** WW25.

SIMS, Samuel *[Plaster modeler]* mid 19th c.
Addresses: NYC, 1844-46. **Exhibited:** Am. Inst., 1844 (unidentified plaster bust), 1845-46 (plaster medallion of Andrew Jackson). **Comments:** The address given for him is that of Hannah, widow of Palin Sims, carpenter. **Sources:** G&W; Am. Inst. Cat., 1844-46; NYCD 1838, 1845.

SIMS, Townsel D. *[Artist]*
Addresses: Wash., DC, active 1902-04. **Sources:** McMahan, *Artists of Washington DC,.*

SIMSON, Bevlyn A. *[Painter, printmaker]* b.1917, Columbus, OH.

Addresses: Columbus, OH. **Studied:** Ohio State Univ., B.A. & M.F.A.; also with David Black, Sidney Chafetz, Charles Czuri, Robert Gatrell, E.H. Hebner, Robert King, Rose Lazar & Stanley Twardoweicz. **Member:** Int. Platform Assn.; AFA; Bexley Area Art Guild; Columbus Art League (secretary-treasurer). **Exhibited:** Salon 1969 Soc. L'École Français Salles d'Exposition La Ville Paris, 1969; J.B. Speed Mus., Louisville, KY, 1970 (solo) & 1972 (solo); Huntington Gallery, Columbus, 1970 (solo); Bodley Gallery, NYC, 1971 (solo); Print & Drawing Nat., Western Illinois Univ., Macomb, 1972; Palais Beaux-Arts, Rome, Italy, 1972; Bodley Gallery, NYC & Gilman Galleries, Chicago, IL, 1970s. **Awards:** Columbus Gallery Fine Arts Painting Award, 1969 & 1971; awards, Eighth Grand Prix Int., La Cote d'Azur, Cannes, France, 1972; six awards, 23rd Grand Prix Int., Deauville, France, 1972. **Work:** Pres. Richard M. Nixon Collection, Washington, DC; Columbus Gallery Fine Arts, Ohio; Kresge Collection, Detroit, MI; Ohio State Univ. Library, Rare Books & Manuscript Collection, Columbus. **Commissions:** tree panel acrylic paintings, First Investment Co., Columbus, & Raymond Lappin, former pres., Fed. Nat. Mortgage Assn., Washington, DC, 1970; paintings, Ohio State Nisonger Center Mental Retardation. **Comments:** Publications: author, *Prints and Poetry,* 1969. **Sources:** WW73; "Salles d'Exposition de la Ville de Paris," *La Rev. Mod.* (Paris, Jan., 1970); L. Soretsky, *Hard-Edge Geometrics* (City-Eastern Cepcor, Inc., New York, Feb., 1971); Artirnomis reviews, *Art Magazine & Art Digest, Inc.* (New York, Feb., 1971).

SIMSON, R. *[Engraver]* 17th c.
Comments: Engraver of a map of the Raritan River of New Jersey in 1683, said to be the earliest known American engraving on copper. **Sources:** G&W; Weiss, *The Number of Persons and Firms.,* 4.

SINAIKO, (Avrom) Arlie *[Sculptor, collector]* b.1902, Kapule, Russia.
Addresses: NYC. **Studied:** Univ. Wisconsin, B.S.; Northwestern Univ., M.D.; AIC; Sculpture Center, New York; ASL; Atelier, with Archipenko, Lassaw & Harkavy. **Member:** Am. Soc. Contemporary Artists (exec. committee, 1967); Artist Equity Assn.; Audubon Artists (exec. committee, 1972); Provincetown AA. **Exhibited:** Detroit IA; Riverside Mus., NY, Art USA 1959; PAFA Ann., 1960; Provincetown AA; Bodley Gallery, NYC, 1970s. **Awards:** purchase prize, PAFA, 1961; hon. mention for sculpture, Audubon Artists, 1968; Kellner Award for sculpture, Am. Soc. Contemporary Artists, 1971. **Work:** Lincoln Center Performing Arts, NYC; PAFA; Walker AC, Minneapolis, MN; Isaac Delgado Mus., New Orleans, LA; Santa Barbara AM. **Comments:** Preferred media: wood, bronze. Positions: chmn. art commission, Int. Synagogue, NY. Collection: Renoir sculpture; Klee drawing; also works of Derain, Dufy, Fujita & many contemporary artists & many lithographs & etchings of Picasso, Braque, Matisse, Rouault & Miro; early American primitive painters. **Sources:** WW73; Falk, *Exh. Record Series.*

SINATRA, Frank *[Singer, painter]* b.1916 / d.1998.
Comments: Yes, the famous crooner was also a prolific painter. From the mid 1950s-1995, he painted at his compound in Palm Springs, CA. His style was primarily that of geometric abstraction, and his favorite color was orange. **Sources:** *Arch. Digest* (Dec. 1998, p.177).

SINCLAIR, Archie *[Painter, craftsperson]* b.1895, Pitlochry, Scotland.
Addresses: Portland, OR. **Studied:** J.H. Dixon; C.L. Keller. **Member:** Soc. Indep. Artists; Chicago NJSA; Salons of America. **Exhibited:** Salons of Am., 1925, 1934; S. Indp. A., 1924-25. **Work:** Normal School, North Adams, MA; church dec. and stained glass windows. **Sources:** WW33.

SINCLAIR, Audrey *[Painter, teacher]* b.1910, Australia.
Addresses: Bridgeport, CT. **Studied:** St. Joseph Convent, Tech. School, Perth, Australia; Yale. **Member:** AAPL. **Exhibited:** Bridgeport (CT) Public Library; Reads Hall, Bridgeport.

Sources: WW40.

SINCLAIR, Bernice *[Painter, teacher] b.1888, Knox, IN.*
Addresses: Ft. Wayne, IN. **Studied:** O. Stark; W. Forsyth.
Comments: Position: teacher, North Side H.S., Ft. Wayne, IN.
Sources: WW40.

SINCLAIR, Ellen Chisholm *[Painter, graphic artist] b.1907, Philadelphia, PA.*
Addresses: Indianapolis, Lake James, IN; Toledo, Sylvania, OH.
Studied: PAFA (Cresson traveling scholarship, 1930-31); Barnes
Fnd.; Acad. Colarossi, Paris. **Member:** Indiana Artists Club;
AEA. **Exhibited:** PAFA, 1932 (prize), 1953; PAFA Ann., 1934-
36, 1939; AIC, 1937; Indianapolis AA, 1938 (prize); DMFA,
1953; Corcoran Gal. biennial, 1937; VMFA, 1937, Nat. Ser. Soc.,
1955; Buyer Gal., Phila., 1936 (solo); TMA, 1940 (solo), 1953
(prize),1954 (solo); Town Gal., Toledo, 1953 (solo); Downtown
Exhib., Toledo, 1955 (prize); Carriage House Studios, Phila., 1956
(solo). **Work:** PAFA; Toledo Fed. Art Coll.; Lambert Coll.
Sources: WW59; WW40; Falk, *Exh. Record Series.*

SINCLAIR, Eva *[Painter] 20th c.*
Addresses: Atlanta, IN. **Sources:** WW24.

SINCLAIR, Gerrit Van W. *[Painter, teacher] b.1890, Grand Haven, MI / d.1955.*
Addresses: Chicago, IL; Milwaukee, WI. **Studied:** AIC; & with
Vanderpoel, Walcott, Norton. **Member:** Wisc. P&S; Wisc. Fed.
Artists; Wisc. PM. **Exhibited:** PAFA Ann., 1920, 1924-25, 1931-
32, 1949, Salon d'Automne, Paris, 1929; Salon Printemps, Paris,
1930; Corcoran Gal biennials, 1923, 1928, 1930; Carnegie Inst.,
1924-26; AIC, 1917, 1921, 1924, 1930, 1931, 1942; WFNY 1939;
NAD, 1926; NYWCC, 1926; BM, 1930; WMAA, 1933;
Milwaukee AI, 1929-1945 (medals, 1921-28). Awards: Wisconsin
State, 1943 (prize). **Work:** Layton Art Gal.; Milwaukee AI; mural,
Wausau (WI) Fed. Bldg.; St. James Church, County Court House,
Milwaukee; Sherman Park, Chicago, schools; Walworth,
Shorewood, Port Wash., WI. **Comments:** Teaching: Layton
School Art, Milwaukee, WI, 1921-50s. **Sources:** WW53; WW47;
Falk, *Exh. Record Series.*

SINCLAIR, Irving *[Portrait painter] b.1895, British Columbia / d.1969, San Francisco, CA.*
Addresses: San Francisco, CA. **Studied:** with Wayman Adams in
NYC. **Comments:** Well known for portraits of Hollywood stars
and other famous Americans. **Sources:** Hughes, *Artists
inCalifornia,* 517.

SINCLAIR, Isabella *[Painter] late 19th c.*
Addresses: Makaweli, Kauai/Niihau. **Comments:** Painted water-
colors of Hawaiian flora, which were later published as
"Indigenous Flowers of the Hawaiian Island" (London, 1885).
Sources: Forbes, *Encounters with Paradise,* 96.

SINCLAIR, L. [?] *[Lithographer] b.1831, Pennsylvania.*
Addresses: Washington, 1850. **Sources:** G&W; 7 Census (1850),
D.C., I, 304.

SINCLAIR, Marjorie *[Sculptor] 20th c.; b.U.S.*
Addresses: Paris, France. **Studied:** Bourdelle, Paris. **Sources:**
WW15.

SINCLAIR, Peter *[Painter] mid 19th c.*
Exhibited: Davenport, IA, 1860 (panorama of the effects of
intemperance). **Sources:** G&W; Schick, *The Early Theater of
Eastern Iowa,* 301 (citation courtesy J.E. Arrington).

SINCLAIR, Thomas S. *[Lithographer] b.c.1805, Orkney Islands / d.1881, Philadelphia.*
Addresses: Phila., c.1830; several years in NYC in 1830s.
Studied: learned lithography in Edinburgh and other European
cities. **Comments:** Came to the U.S. c.1830 and settled in Phila.
From about 1850 he was assisted by his sons William and
Thomas, Jr. His firm of Thomas Sinclair & Son was established in
1870 and continued until 1889. His lithographs appeared in vari-
ous publications, including *The North American Sylva*
(Philadelphia, 1846). **Sources:** G&W; Peters, *America on Stone;*

7 Census (1850), Pa., LV, 679 Phila. CD 1839-60+; Waite,
"Beginnings of American Color Printing," 18; Am. Inst. Cat.,
1849. McClinton, "American Flower Lithographs," 362.

SINCLAIR, Thomas, Jr. *[Listed as "artist"] b.c.1832, Pennsylvania.*
Comments: He was a son of Thomas Sinclair, the Philadelphia
lithographer (see entry), with whom he lived in 1850. **Sources:**
G&W; 7 Census (1850), Pa., LV, 679.

SINCLAIR, William *[Lithographer] b.c.1827, Scotland.*
Addresses: NYC and Philadelphia, 1850-c.1881. **Comments:** He
was the eldest son of Thomas Sinclair (see entry). William was
brought to America as a child and grew up in NYC and
Philadelphia. He was listed as a lithographer as early as 1850 and
seems to have worked for his father until the latter's death in
1881. William carried on the business until 1889 and then sold
out. **Sources:** G&W; 7 Census (1850), Pa., LV, 579; 8 Census
(1860), Pa., XLIX, 198 Phila. CD 1855-60+; Peters, *America on
Stone.*

SINDBERG, Lawrence Hansen *[Painter, designer] b.1902, Fredericia, Denmark.*
Addresses: Bozeman, MT. **Studied:** Art Acad., Denmark; AIC; &
with William Schwartz, Anthony Angarola. **Exhibited:** AIC,
1929-32. **Work:** U.S. Govt. **Comments:** Contributor: articles,
Chicago Daily News, Fredericia Soc. Democrat. Designer of
medals & silverware. **Sources:** WW53; WW47.

SINDELAER, Charles *[Painter, etcher] b.1885, Cleveland, OH / d.1947, Los Angeles, CA.*
Addresses: Los Angeles, CA. **Member:** Painters & Sculptors of
Los Angeles. **Sources:** Hughes, *Artists of California,* 517.

SINDELAR, Charles J. *[Painter] 20th c.*
Addresses: NYC. **Sources:** WW25.

SINDELAR, Ed *[Graphic artist] 20th c.*
Exhibited: S. Indp. A., 1937. **Sources:** Marlor, *Soc. Indp. Artists.*

SINDELAR, Thomas A. *[Illustrator] b.1867.*
Addresses: NYC. **Studied:** C. Hecker; A.M. Mucha. **Member:**
SC, 1898; Lotos Club; Artists Fund Soc. **Sources:** WW21.

SINDLER, Allan P. & Lenore B. (Mr. & Mrs.) *[Collectors] b.1928, NYC.*
Addresses: Ithaca, NY. **Studied:** Harvard University, B.A., M.A.,
Ph.D. **Comments:** Position: professor of government, Cornell
University. Collection: contemporary graphics, drawings, small
sculpture. **Sources:** WW66.

SINE, David William *[Sculptor, painter] b.1921, Verde Valley, AZ.*
Addresses: Sells, AZ. **Exhibited:** Scottsdale (AZ) Nat. Indian
Arts Council Inc., 1965-72 (hon. mention for Skywalkers of
Apache Pass). **Work:** Commissions: murals, Last Supper, Rev.
Camillas, Pisinimo, Papago Reservation, AZ, 1968 & Station of
the Cross, Rev. Joseph Bauer, Topawa, Papago Reservation, AZ,
1969. **Sources:** WW73.

SINEL, Joseph C. *[Painter, designer, commercial artist] b.1890, New Zealand / d.1975, Oakland, CA.*
Addresses: NYC; San Francisco, CA. **Studied:** self-taught.
Member: GFLA. **Exhibited:** Calif. College Arts & Crafts, 1970
(retrospective). **Comments:** Immigrated to the U.S. in 1917 and
for a while lived among the Native Americans of the Southwest
and Montana. **Sources:** WW27; Hughes, *Artists in California,*
517.

SINGER, Burr (Mrs. B. Lee Friedman) *[Painter, lithogra-pher] b.1912, Saint Louis, MO.*
Addresses: Los Angeles. **Studied:** St. Louis School FA; AIC;
ASL; also with Walter Ufer. **Member:** Calif. WCS (vice-pres.,
1958); Artists Equity Assn.; Los Angeles AA; Council Allied
Artists; Am. Artists Congress. **Exhibited:** Kansas City AI, 1938,
1939; WFNY, 1939; GGE, 1939; Los Angeles Mus. Art, 1940-45;
Calif. WCS, 1940-45, 1953-58, 1968, & traveling exhib.; AV,
1943; Fnd. Western Art, 1943-45; Denver Art Mus., 1943-46;

Pepsi-Cola, 1944; Audubon Artists, 1945; CAM, St. Louis; Frye Mus Art, Seattle, 1960 & 1962; Art of Los Angeles & Vicinity, 1961 & 1969; Kramer Gallery, Los Angeles, 1963; Watercolor: USA, Springfield, MO, 1964; Los Angeles Co. Fair, 1951 (award),1953 (award); Marineland Exhib. 1955 (prize). **Work:** Warren Flynn School, Clayton, MO; LOC; Beverly-Fairfax Jewish Community Center, Los Angeles; Child Guidance Clinic, Los Angeles. **Sources:** WW73; WW47.

SINGER, Clyde J. *[Painter, mural painter, etcher, teacher] b.1908, Malvern, OH.*
Addresses: Youngstown, OH. **Studied:** Columbus (OH) Art School; ASL, with Kenneth Hayes Miller; John Stuart Curry; A. Brook; Bridgman; Lahey; Olinsky; DuMond; Thomas Hart Benton. **Member:** Columbus AL. **Exhibited:** PAFA Ann., 1935-41, 1949-50; CM, 1935-38; NAD, 1936, 1938 (First Hallgarten prize); Texas Centenn., 1936; CI, 1936-39; WMAA, 1936, 1940, 1941 (Painting & Sculpture Biennial); Corcoran Gal biennials, 1937, 1939; GGE, 1939; WFNY, 1939; VMFA, 1940, 1942; Pepsi-Cola, 1945; Butler AI, 1937-46, 1938 (prize), 1942 (prize); Columbus AL, 1936, 1937 (prize), 1938 (prize), 1939, 1941, 1946; AIC, 1935 (Norman Wait Harris silver medal), 1936-38; Portland AM, 1939 (prize); Columbus Gal. FA, 1946 (prize); Denver AM, 1935; AV, Rockefeller Center, New York, 1945; Ohio State Fair Fine Art Exhib., 1968 (first prize). **Work:** PAFA; Vanderpoel Collection; Columbus Gallery Fine Arts; Thomas Gilcrease Inst. History & Art, Tulsa, OK; Wadsworth Atheneum; Butler AI; Massillon Mus. Art; Canton (OH) Art Inst. Commissions: mural, *Skaters,* Post Office, New Concord, OH, 1940. **Comments:** Preferred media: oils. Positions: art critic, *Vindicator,* Youngstown, 1940-; asst. director, Butler Inst. Am. Art, 1940-. **Sources:** WW73; Roger Bonham, "Clyde Singer; Ohio Painter," *Am. Artist* (Feb., 1969); Paul Chew, *Singer Retrospective 1932-72* (Westmoreland Co. Mus. Art, March, 1972); WW47; Falk, *Exh. Record Series.*

SINGER, Esau H. *[Painter] 20th c.*
Exhibited: S. Indp. A., 1941. **Sources:** Marlor, *Soc. Indp. Artists.*

SINGER, Esther Forman *[Painter, art critic] 20th c.; b.NYC.*
Addresses: South Orange, NJ. **Studied:** ASL, 1940-41; Temple Univ., 1941-44; New York Univ., 1947-49; New York School Social Res., 1968-70. **Member:** Artist's Equity Assn. New York; Artist's Equity Assn.; NJ Art Exhibs. Council; P&S Soc NJ; Miniature Artists Assn. NJ. **Exhibited:** New York World's Fair, 1965; Kenosha (WI) Pub. Mus., 1970; Centenary College, Hackettstown, 1970 (solo); Bloomfield College, NJ, 1971 (solo); Ohio Univ., St. Clairsville, OH, 1972; Gallery 9, Chatham, NJ & Gallery 1952, South Orange, NJ, 1970s. Awards: Nat. Design Centerr Award for Contemporary Art, 1966; first prize for oils, Roseland Festival Art, 1966, 1967 & 1968; first prize for oils, Summit Art Center-Collage, 1968. **Work:** Newark (NJ) Mus.; NJ State Mus., Trenton; Finch Mus. Contemporary Art, New York; Hudson River Mus., Yonkers, NY; Seton Hall Univ. Collection, South Orange, NJ. **Comments:** Preferred media: oils, mixed media. Positions: guest panelist, "Art Forms," WOR TV, 1967-68; editor, *Jewish Standard Newspaper* (1970-71); *Jersey Journal Newspaper* (1970-72) & *Suburban Life Magazine NJ*(1970-); judge, Menlo Park Outdoor-Indoor Art Show, 1971; advisor, Art Exhibs. Council, NJ, 1971-72; judge, Art Exhibs. Council Art Show, 1972; art editor, *Newark News Newspaper,* 1972-. Publications: contributor, *Am. Artist Magazine,* 4/1972. Teaching: instructor childrens' exp. art, South Orange Community Center, 1968-69; lecturer on contemporary art, Deborah Hospital, 1968-
Sources: WW73; Smith, feature story & cover photo, *NJ Music & Art Magazine* (Nov.,1965); Nancy Kallis, review, *Art Review Magazine* (April, 1966); Carlette Winslow, article, *NJ Suburban Life Magazine* (March, 1970).

SINGER, George Frederic *[Painter, comm a] b.1927, Evansville, IN.*
Addresses: Evansville 14, IN. **Studied:** AIC; John Herron AI, B.F.A.; Indiana Univ., and with Jack Tworkov, Harry Engle. **Exhibited:** Audubon Artists, 1950; Indiana Artists, 1951, 1957;

Butler AI, 1950; Tri-State Exhib., 1949 (prize), 1950-54 (prize), 1955-57; Kentucky-So. Indiana Exhib., 1950, 1953, 1954 (prize). **Work:** Evansville Pub. Mus.; Kentucky Wesleyan College. **Comments:** Position: staff artist, Evansville Printing Corp., 1947-50 (summers); designer, Swanson-Nunn Signs, 1953-54; art instructor, Columbus (IN) Jr. H.S., 1956-. **Sources:** WW59.

SINGER, John *[Listed as "artist"] b.c.1820, Germany.*
Addresses: NYC. **Comments:** Living in 1850 at the same house as lithographer Henry Konger (see entry). **Sources:** G&W; 7 Census (1850), N.Y., XLVIII, 130; NYCD 1850.

SINGER, Malvin *[Illustrator] b.1911, NYC.*
Addresses: NYC; Brooklyn, NY. **Studied:** Brooklyn College; Grand Central Art School; NAD. **Comments:** Illustrator: *Redbook, Cosmopolitan, McCall's, Liberty* magazines. **Sources:** WW53; WW47.

SINGER, Robert Lee *[Painter, decorator] b.1865, New Orleans, LA / d.1907, New Orleans, LA.*
Addresses: New Orleans, active 1880-1907. **Sources:** *Encyclopaedia of New Orleans Artists,* 354.

SINGER, Theodore *[Painter] b.1929.*
Addresses: Athens, OH. **Exhibited:** WMAA, 1969. **Sources:** Falk, *WMAA.*

SINGER, William Earl *[Painter, sculptor, lecturer] b.1910, Chicago, IL.*
Addresses: Los Angeles, CA. **Studied:** Univ. Chicago; AIC; Andre L'Hote, Paris, France; also with Charles Wilimovsky & John Norton. **Member:** Am. Artists Congress; United Am. Artists; Int. Inst. Art & Letters (fellow); Calif. WCS; Chicago Sculptors Assn.; Beaux-Arts Soc. Paris, France. **Exhibited:** AIC, 1932-41; WFNY, 1939; GGE, 1939; Great Lakes Traveling Exhib., 1939; Denver AM, 1938 (prize), 1939; Albright Art Gal., 1939; Toronto AM, 1938-39; AIC, 1940 (solo); Art Fair, Chicago, 1933 (prize), 1932 (prize), 1940 (prize); Beaux-Arts Soc., Paris, 1934; Havana, 1946 (prize); Haarlem Mus., Netherlands. Awards: Medal of Honor of France, 1968; decorated by Andre Malraux, Palais Royale, Paris; Citizen Honoraire, France, 1968; Chevalier de l'Ordre des Arts et des Lettres, 1969; also honored by Italy & Netherlands. **Work:** Grand Rapids Art Gallery; Illinois State Mus.; Univ. Minnesota; AIC; LOC; Univ. Illinois; U.S. Govt.; Libertyville (IL) Court House; Biro-Bidjan Mus., Russia; Osaka Mus., Japan; Mound City Pub. Lib.; Serge Collection, Brussels; French Consulate, Chicago; St. Paul's College, Winnipeg, Canada; Board of Educ., Chicago; Scopus College, Melbourne, Australia; Presidential Palace, Colombia; Israeli Govt.; Am Embassy, Paris, France; Commissions: Thomas Mann Mem., Zurich, Switzerland; Gertrude Lawrence Mem., London, England; Am. Embassy, London; Oscar Hammerstein Mem., New York; bronze monument of Vincent Van Gogh for the City of Arles, France, 1968.
Comments: Positions: color consultant, Chicago World's Fair & Brussels Int. Publications: author/illustrator, *Paintings of Israel;* contributor to *New Horizons in American Art,* MoMA & *American Art Today,* Nat. A.S. Teaching: lecturer, contemporary painting & Old Masters. **Sources:** WW73; Andre Blum, *William Earl Singer* (Musée Louvre, Paris, 1951); Maximilian Gauthier, *An American in Paris* (1962); Alex Drier, "The World of William Earl Singer," documentary (1968); WW47 puts birth at 1909.

SINGER, William H., Jr. ~~W.H.SINGER~~ ~~- 1923 -~~
[Painter] b.1868, Pittsburgh, PA / d.1943, Olden, Norway.
Addresses: Edgeworth, PA; Olden, Nordfjord, Norway (since 1914). **Studied:** Martin Borgord in Pittsburgh; Académie Julian, Paris with J.P. Laurens, 1901. **Member:** ANA, 1917; NA, 1931; Pittsburgh AS; AFA; Allied AA; St. Lucas SA. **Exhibited:** CI, 1900; Boston AC, 1901; PAFA Ann., 1906-37 (13 times); Wash. County MFA (Md.), 1981 (retrospective); Pan-Pacific, Expo, San Fran., 1915 (medal); AIC, 1916. Awards: Royal Order of St. Olaf, 1929. **Work:** AIC; PAFA; NOMA; Stedelijk, Amsterdam; Royal Mus., Antwerp; Musée du Luxembourg, Paris; CI; Milwaukee AI; Carnegie Pub. Lib., Ft. Worth; Delgado Mus.; Pinacothek Mus.,

Munich; MMA; BM; Brooks Mem. Art Gal., Memphis; City Mus. of the Hague, Holland; large collection at Wash. County Mus. FA, Hagerstown, MD; Curtis Inst., Phila.; Walker Gal. Art, Brunswick, ME; Sweat Mem. AM, Portland, ME; Florence Griswold Mus., Old Lyme, CT; Nat. Gal., Oslo, Norway; Mus. des Beaux-Arts, Brussels, Belgium; Mus. des Beaux-Arts, Cairo; PIA School; MFA, Ghent, Belgium; Norwegian Legation, Wash., DC; Van Abbe Mus., Einhoven, Holland. **Comments:** An American Impressionist, he spent most his life in Europe, particularly Norway. He was a member of a wealthy steelmaking family in Pittsburgh and worked in the family business for 11 years. He painted and sketched in his free time. Encouraged by his success and his teacher Borgord, he went to Monhegan, ME, c.1900 to paint. A year later he and his wife, accompanied by Borgord, sailed for Paris. For several years they lived at the Dutch artists' community of Laren, settling permanently in Norway several years later. In 1930, he established the Washington County Museum of Fine Arts, Hagerstown, MD. In the 1970s, his estate collection in Holland was purchased by Szymanski Gal., Beverly Hills, CA. **Sources:** WW40; exh. cat., Wash. Cnty MA; *300 Years of American Art,* 617; Falk, *Exh. Record Series.*

SINGER, Win(n)aretta Eugénie *[Painter] b.1865, Yonkers, NY.*
Addresses: Paris, France, c.1897-1905. **Studied:** Eugene Le Roux, Barrias, Mathey, in Paris. **Exhibited:** Paris Salon, 1882, 1885-87, 1889, 1890; Soc. Nat. Beaux-Arts, 1893-96, 1898. **Sources:** WW06; Fink, *American Art at the Nineteenth-Century Paris Salons,* 390-91.

SINGERMAN, Gertrude Sterne *[Painter] 20th c.*
Addresses: Seattle, WA; NYC, c.1917-27. **Exhibited:** Seattle FFA, 1922 (hon. mention). **Sources:** WW27.

SING HOO, (Sing Hoo Yuen) *[Sculptor, painter] b.1908, Canton, China.*
Addresses: Toronto, Ontario. **Studied:** Toronto College Art; Ontario College Art, assoc., with A. Barnes & Emmanual Hahn; Slade School, Univ. London, with Turner. **Exhibited:** Ontario Soc. Artists, 1932-68; Canadian Nat. Exhib., 1932-68; Royal Canadian Acad. Art, 1936-72; Sculptor's Soc. Canada, 1940-67. **Work:** London Mus., England; Nat. Gallery Ottawa, Ontario; Royal Ontario Mus., Toronto. **Commissions:** Sun Dial & bronze figures of daughter & gardener, parks, Toronto. **Comments:** Preferred media: bronze, marble, wood, clay, wax. Positions: asst. paleontology dept., Royal Ontario Mus., 1934-40. Teaching: lectures on Oriental & Western art, Chinese School, 1936-40. **Sources:** WW73.

SINGLE, J. F. *[Engraver] mid 19th c.*
Addresses: Painesville (Ohio), 1853. **Sources:** G&W; Ohio BD 1853.

SINGLETARY, Robert Eugene *[Graphic artist] b.1945, Bloomington, IL.*
Addresses: Alexandria, VA. **Studied:** Illinois State Univ. with Walter Bock & Harold Boyd; Corcoran Gallery Art, Washington, DC. **Exhibited:** Fourth Biennial of Drawing USA, St. Paul, MN, 1969; Nat. Drawing Exhib., San Francisco Mus., 1970; Drawing Soc. 70 Nat. Exhib., Corcoran Gallery Art, 1970; Fendrick Gallery, Washington, DC, 1972 (solo). Awards: purchase award, Phila. Mus. Art, 1970. **Work:** Phila. Mus. Art; State Dept., Washington, DC. **Comments:** Preferred media: graphite lead. **Sources:** WW73; AFA, Drawing Society's 1970 National Exhibition, 1970; Cornelia Noland, "The Singletary Style," *Washingtonian* (Aug., 1971); Joanna Eagle, "Washington, DC," *Art Gallery Magazine* (April,1972).

SINGLETON, Alexander (E.) *[Painter] 20th c.*
Addresses: NYC. **Studied:** ASL. **Exhibited:** Salons of Am., 1927; S. Indp. A., 1927-28, 1930; PAFA Ann., 1930. **Sources:** Falk, *Exhibition Record Series.*

SINGLETON, Esther *[Writer] b.Baltimore / d.1930, Stonington, CT.*

Addresses: NYC. **Member:** Royal Society Arts, England; Colonial Dames of America. **Comments:** Author: fifty books (five dealing with antiques, thirteen on art). Position: editor,*The Antiquarian,* since 1923.

SINGLETON, (Mr.) *[Painter of miniatures and perspective views of gentlemen's estates] late 18th c.*
Addresses: Charleston, SC, active 1784. **Sources:** G&W; Prime, I, 8; Rutledge, *Artists in the Life of Charleston.*

SINGLETON, Robert Ellison *[Painter, printmaker] b.1937, Jacksonville, NC.*
Addresses: Altamonte Springs, FL. **Studied:** College William & Mary; Richmond Prof. Inst.; also with Teresa Pollock. **Exhibited:** Solos: Mus. Arts & Sciiences, Daytona Beach, FL, 1968, Coconut Grove Playhouse Gallery, Miami, FL, 1969, Ludwig Katzenstein Gallery, Baltimore, MD, 1970 & Loch Haven AC, Orlando, 1970; Piedmont Graphics Competition, Mint Mus. Art, Charlotte, 1971 & 1972; Gallery International, Winter Park, FL, 1970s. Awards: first place, Int. Winter Park Sidewalk Art Festival, 1967-69 MacDowell Colony grant, 1970-72. **Work:** Mint Mus. Art, Charlotte, NC; Loch Haven ArC, Orlando, FL; Florida Gas, Orlando; Twentieth Century Gallery, Williamsburg, VA; Archit. Designers Inc. Dallas, TX. Commissions: murals & paintings, Sentinel Star Co., Orlando, 1968 & 1971; paintings, Loger Properties, San Antonio, Jacksonville & Orlando, 1969 & 1971; paintings, George Barley Inc., 1970-72; painting, Tupperware Int., Orlando, 1972; paintings, Bank East Orange, Orlando, 1972. **Comments:** Positions: curator exhibits, Jamestown Festival Park, VA, 1962-63. Teaching: painting instructor, Loch Haven AC, Orlando, 1968-; lectures & seminar critiques throughout southeastern states, 1968- **Sources:** WW73; articles, *Orlando Sentinel,* 1968-72; filmed documentary, WFIA TV, Tampa, 1971; series of interviews (video-tape), WMFE TV, Orlando, 1972-73.

SINGTEBLOR, Alexander See: SENGTELLER, Alexander

SINN, Fanny P. *[Painter] 19th c.*
Addresses: Phila., PA. **Exhibited:** PAFA Ann., 1879, 1882-85, 1890. **Sources:** Falk, *Exh. Record Series.*

SINNARD, Elaine (Janice) *[Painter, sculptor] b.1926, Fort Collins, CO.*
Addresses: Westtown, NY. **Studied:** ASL New York, 1948-49, with Reginald Marsh; New York Univ., 1951, with Samuel Adler; also with Robert D. Kaufmann, 1951; Sculpture Center, 1955, with Dorothea Denslow; Acad. Grande Chaumière, Paris, France, 1956; also with Betty Dodson, 1960. **Exhibited:** City Center Gallery, New York, 1954; Riverside Mus. Eighth Ann., New York, 1955; First Ann. Metrop. Young Artists, Nat. Arts Club, New York, 1958; Ward Eggleston Galleries, New York, 1959 (solo) & Fairleigh Dickinson Univ, NJ, 1960 (solo); Lord & Taylor Art Gallery, NYC, & Zantman Galleries Ltd., Carmel-by-the-Sea, CA, 1970s. **Work:** Commissions: five wall hangings (with Mrs Louise Darlington, Marlin Studios), Scandinavian Airline, New York, 1961; three oil paintings, Basker Bldg. Corp. 5660, Miami Beach, FL, 1970. **Comments:** Preferred media: oils. **Sources:** WW73; article, *Art News* (1954); James E Duffy, article, *World Telegram,* 1959; Fran Hepperle, article, *Times Herald Record,* 1972.

SINNETT, Francis *[Listed as "artist"] mid 19th c.*
Addresses: Elmira, NY, 1857. **Sources:** G&W; Elmira BD 1857.

SINNETTE, Margaret *[Painter] 20th c.*
Addresses: West Cornwall, CT. **Sources:** WW10.

SINNICKSON, Mary H. *[Painter] early 20th c.; b.Philadelphia, PA.*
Addresses: Phila., PA; Camden, NJ. **Studied:** PAFA; Académie Julian, Paris. **Member:** Plastic Club; Baltimore WCC. **Exhibited:** PAFA Ann., 1879, 1884-92. **Sources:** WW13; Falk, *Exh. Record Series.*

SINNOCK, J(ohn) R(ay) *[Sculptor, painter, med, teacher] b.1888, Raton, NM / d.1947, Staten Island, NY.*
Addresses: Phila., PA. **Studied:** PM School IA. **Member:** Phila.

Sketch Club; Phila. Alliance; NSS; AFA. **Exhibited:** PAFA Ann., 1930-45. **Work:** Luxembourg Mus., Paris; Nat. Mus., Wash., DC; Am. Numismatic Soc. M., NY. **Comments:** Position: chief engraver/medalist, U.S. Mint, Phila. **Sources:** WW40; Falk, *Exh. Record Series.*

SINNOTT, Richard J. *[Painter] 20th c.*
Addresses: Chicago area. **Exhibited:** AIC, 1935, 1938. **Sources:** Falk, *AIC.*

SINNOTT, Robert *[Painter] 20th c.*
Addresses: Chicago area. **Exhibited:** AIC, 1935-36, 1943-44. **Sources:** Falk, *AIC.*

SINSABAUGH, Art (Arthur R.) *[Photographer, educator] b.1924, Irvington, NJ / d.1983.*
Addresses: Champaign, IL. **Studied:** Illinois Inst. Technology Inst. Design, B.S., with Moholy-Nagy & Harry Callahan, M.S., with Aaron Siskind. **Member:** Soc. Photography Educ. (founding member); Soc. of Topographic Artists; AAUP. **Exhibited:** WAC, 1949; Chicago AC, 1952; MoMA, 1950, 1958, 1963 (The Photographer and the American Landscape); George Eastman House, Rochester, NY, 1957; Abstract Photography, AFA, New York, 1955; AFA traveling exhib., 1957, 1958; Momentum Exhib. Chicago, 1948, 1950, 1952-54, 1956; AIC, 1963 (solo); Gallery 500d, Chicago, 1965 (solo); Photography USA, De Cordova Mus., Lincoln, MA, 1968. **Awards:** Arts in Am. Magazine Award, New Talent, USA Award Show, 1962; Guggenheim fellowship, 1969; assoc., Univ. Illinois Center Advanced Studies, Champaign, 1972. **Work:** MoMA; AIC; George Eastman House, Rochester, NY; Exchange Nat. Bank, Chicago; Smithsonian Inst., Washington, DC. **Commissions:** The Quality of Life (mural), Chicago City Planning Commission, First City Plan of Chicago, 1961-63; Midwest landscape photograph mural, Univ. Illinois Medical Center, Chicago, 1965. **Comments:** Publications: co-author, "6 Mid-Am. Charts/11 Midwest Photographs," 1964; contributor, portfolio of works, *Tri Quarterly,* winter 1965; contributor, portfolio of works & cover, *New Letter,* spring, 1972; contributor, *Chicago Art Directors Bulletin; Photography* (London); *Architectural Review; Western AA Bulletin.* Lectures: "The Approach to Photography as a Creative Medium." Teaching: photography instructor, Illinois Inst. Technology Inst. Design, 1949-58; professor off art & head dept. photography & cinematography, Univ. Illinois, Champaign, 1958-. **Sources:** WW73; Gene Thornton, "Two Tales of One City," *New York Times,* March 22, 1970; *Great Print Makers of Today* (Life Library of Photography, 1970); Allen Porter, "Sinsabaugh," *Camera* (Switzerland, June, 1972); WW59.

SINTENIS, René´e *[Painter] 20th c.*
Exhibited: AIC, 1932. **Sources:** Falk, *AIC.*

SINTON, Nell (Walter) *[Painter, instructor] b.1910, San Francisco, CA.*
Addresses: San Francisco, CA. **Studied:** San Francisco Art Inst., with Maurice Sterne; Inst. Creative & Artistic Development. **Member:** San Francisco Art Inst. (trustee, 1966-). **Exhibited:** San Francisco Mus. Art, 1957, 1963 & 1970; Standford Research Inst., Palo Alto, CA, 1958; Staempfli Gallery, New York, 1960; Am. Acad Arts & Letters, New York, 1967; Univ. Calif., Berkeley, 1972; Quay Gallery, San Francisco, CA, 1970s. **Awards:** San Francisco Art Inst. Award, De Young Mus., 1956; Oakland Mus. Art Awards, 1958 & 1961. **Work:** San Francisco Mus. Art; Oakland Mus. Art; Chase Manhattan Bank, NYC; Lytton Trust Co., San Jose, CA. **Comments:** Preferred media: acrylics. Positions: artist member, San Francisco Art Commission, City & Co., 1958-63. Publications: author, reviews, *Clear Creek Magazine,* 1970 & 1971. Teaching: drawing instructor, San Francisco Art Inst., 1970-71. **Sources:** WW73; M. Tapié, *Morphologie Autre* (1960); F. Martin, "Review San Francisco," *Art Int.* (1963) & *Artforum* (1963 & 1967).

SINTZENICH, Eugene *[Landscape and portrait painter, teacher] b.1792 / d.c.1852.*
Addresses: England, 1833; Rochester, NY, 1839-44; Albany &

NYC, 1844-48; Rochester,1851 and after. **Exhibited:** London (1833; views of Niagara Falls, Upper Canada, and New York State); Am. Inst. (1849). **Work:** Rochester Hist. Soc., NY. **Comments:** In the 1830s, Sintzenich resided in London for several years, showing views of Niagara Falls (which he had visited in 1831) and New York State. He then returned to America and was living in Rochester as early as 1839. There he painted portraits and more Niagara views, several of which were commissioned by Abelard Reynolds to hang on the walls of Reynold's Arcade Hall. While living outside of Rochester for several years in the 1840s, Sintzenich painted a view of NYC after the great fire of December 1845. In 1851 he was once again in Rochester, listed as a professor of drawing. It is believed he died about 1852. In 1857 a Mrs. Esther Sintzenich was listed in the Rochester directory, along with Eugene M. Sintzenich, daguerreotypist. **Sources:** G&W; London *Times,* Jan. 7 and March 26, 1833; Ulp, "Art and Artists in Rochester," 32; Rochester CD 1841, 1851, 1857; Albany CD 1844, 1845, 1848; NYBD 1846; Am. Inst. Cat., 1849; Peters, *America on Stone;* Smith, "New York's Fire of 1845 in Lithography," 120; *Portfolio* (Jan. 1942), 5; NYHS *Quarterly Bulletin* (Jan. 1945), 29. More recently, see Gerdts, *Art Across America,* vol. 1: 196.

SINZ, Walter A. *[Sculptor, medalist, teacher, lecturer] b.1881, Cleveland, OH / d.1966.*
Addresses: Cleveland, OH; University Heights, OH. **Studied:** Cleveland Sch. Art; H.N. Matzen; Académie Julian, Paris with Paul Landowski. **Member:** Cleveland SA; NSS. **Exhibited:** CMA, annually, prizes in 1922-23, 1933-34, 1938, 1941, 1943, 1948-50; PAFA Ann., 1925-34 (4 times); WMAA, 1941; Jewish Mus., NY, 1953; Ohio State Fair, 1953; Syracuse Mus. FA, 1954; Butler AI, 1954; Cleveland Soc. Art, 1958 (solo). **Work:** CMA; Nat. Air Race trophies; Cleveland 125th Anniversary Med.; YMCA Fountain, Cleveland; Cleveland Flower Show Med.; sculpture group, St. Luke's Hospital, Cleveland; Mt. Union College, Alliance, OH; Baptist Church, Shaker Heights, OH; Statler Hotel, Cleveland; medal for Metallurgical Soc., Detroit; medal for Case Inst. Tech., 1953, portrait busts of prominent persons. **Comments:** Contributor to *Ceramic Monthly; Arts* magazines. Teaching: Cleveland Sch. Art, Ohio, 1912-50s. **Sources:** WW59; WW47; Falk, *Exh. Record Series.*

SIPE, Edward H. *[Engraver] b.1835, Wash., DC.*
Addresses: Wash., DC, active 1860-92. **Comments:** Position: staff of U.S. Coast Survey. **Sources:** McMahan, *Artists of Washington DC,.*

SIPIORA, Leonard Paul *[Museum director, writer] b.1934, Lawrence, MA.*
Addresses: El Paso, TX. **Studied:** Vanderbilt Univ.; Univ. Michigan, Ann Arbor (A.B. (cum laude), 1955; M.A., 1956). **Member:** Kappa Pi; Am. Assn. Mus.; AFA; Am. Platform Assn.; Nat. Soc. Arts & Letters (first vice- pres., El Chapter). **Work:** American paintings and graphics. **Comments:** Positions: co-founder & pres., El Paso Arts Council, 1969-70, director, 1971-; board member, Texas Mus. Conference; membership chmn., Mountain-Plains Mus. Conference. Publications: author, "The Universality of Tom Lea" (catalog), 1971; author, "A Community Oriented Art Museum," *Southwest Gallery Art Magazine,* 1971; contributor, foreword to "Biography of John Enneking," 1972. Collections arranged: Ann. Nat. Sun Carnival Exhib.; Biennial, Int. Designer Craftsmen; W.S. Horton Retrospective, 1970; Tom Lea Retrospective, 1971; Walter Griffin Retrospective, 1971. Collection: American paintings and graphics. **Sources:** WW73.

SIPLE, Ella Simons (Mrs. Walter H.) *[Writer, lecturer, mus curator, educator, craftsperson] b.1889, Virden, IL.*
Addresses: Cambridge, MA. **Studied:** Wellesley College, B.A.; & in Europe. **Member:** CAA; AA Mus. **Comments:** Contributor: *Burlington* magazine, news of *Art in America, WMA Bulletins,* with articles on art, with special emphasis on tapestries. Lectures: appreciation of the arts & art history. Positions: head educ. dept., 1918-23, curator, decorative arts, 1923-29, WMA; lecturer, CM, 1935-39; special editor for tapestries, historical fabrics & cos-

tumes, "Webster's New International Dictionary," 1927-31; lecturer, Mass. Dept. Educ., Div. Univ. Ext., 1921-29, 1951-55. **Sources:** WW59; WW47.

SIPLE, Jessie *[Artist] late 19th c.*
Addresses: Active in Otsego, MI, 1897-99. **Sources:** Petteys, *Dictionary of Women Artists.*

SIPOE, Jessie See: **SIPLE, Jessie**

SIPORIN, Jennie *[Painter] 20th c.*
Addresses: Chicago area. **Exhibited:** AIC, 1941-51. **Sources:** Falk, *AIC.*

SIPORIN, Mitchell *[Painter, educator, illustrator] b.1910, NYC / d.1976, Newton, MA.*
Addresses: Wash. DC.; Newton, MA. **Studied:** Crane College, Chicago, IL; AIC; Todros Geller. **Member:** Am. Artists Congress; United Am. Artists; Woodstock AA. **Exhibited:** AIC, 1933 ("Century of Progess" Expo), 1938-39, 1941 (Florsheim prize), 1944-50; MoMA, 1936, 1941-42; PAFA Ann., 1939-44, 1946 (Pennell medal), 1947-53, 1962; WFNY, 1939; San Francisco World's Fair, 1940; Downtown Gal., NYC, 1940 (first solo), 1942 (solo) 1946 (solo); Springfield MFA, 1943; Corcoran Gal biennials, 1941-53 (5 times); WMAA, 1943-50; Carnegie Inst., 1940-60; MoMA-Paris, 1946; Univ. Iowa Annual, 1947 (1st prize); Phila. Art Alliance, 1949 (solo); Inst. Contemp. Art, Boston, 1949; Babcock Gal., NYC, 1990 (retrospective). Other awards: Guggenheim Foundation fellowships, 1945-46; Prix de Rome for painting, Am. Acad. Rome, 1950; Fulbright fellow, Italy, 1966-67. **Work:** WMAA; MoMA; MMA; AIC; NMAA; PMA; St. Louis AM; Smith College MA; Wichita MA; Smith College; Univ. New Mexico; Encyclopedia Britannica Collection; Univ. Georgia; Fogg AM, Harvard; Addison Gal.; Alabama Polytech.; BPL; Cranbrook Acad.; Butler IA; Hirschhorn Mus.; Newark Mus.; NYPL; Brandeis Univ.; Univ. Arizona; Georgia MA; Krannert AM, Univ. Illinois; Univ. Iowa; Shledon Mem. Gal, Univ. Nebraska; Univ. New Mexico AM; Wichita AM. Commissions: frescoes, USPO Decatur, IL, 1937; USPO Saint Louis, 1939; murals, H.S., Chicago Heights, IL; Lane Tech. H.S., Chicago; Woodstock AA. **Comments:** Preferred media: oils, watercolors. Illustrator: *Esquire, Ringmaster, New Masses.* Teaching: Brandeis Univ., 1951- **Sources:** WW73; WW47; S. Cheney, *Expressionism in Art* (Liveright, 1934); H. Cahill, *New Horizon in American Art* (MoMA, 1939); *Americans 1942* (MoMA, 1942); Falk, *Exh. Record Series.*

SIPORIN, Sussanna *[Painter] 20th c.*
Addresses: Chicago area. **Exhibited:** AIC, 1941. **Sources:** Falk, *AIC.*

SIPPEL, Carl *[Painter, illustrator] 20th c.*
Addresses: Phila., PA. **Exhibited:** PAFA Ann., 1903. **Sources:** WW04; Falk, *Exh. Record Series.*

SIQUEIROS, David Alfaro *[Painter] b.1896, Santa Rosalia, Mexico / d.1974.*
Addresses: Mexico City, Mexico. **Studied:** Acad. San Carlos. **Member:** Nat. Acad. Arts (pres.); Acad. Artes Florencia; Acad. Artes Berlin; Acad. Artes Moscow. **Exhibited:** AIC, 1940-44; 25th Bienal International Arte Venecia, 1950; Mus. Nat. Art Mod., Paris, 1952; Los Angeles Co. Mus. Art, 1963; Siqueiros, Exposición Retrospectiva: 1907-67, Nat. Univ. Mex., 1967; Expos Retrospective Mus. Cent. Art, Tokyo, Japan, 1972. Awards: Premio Int. Venecia, Mus. Art Mod., Sào Paulo, 1950; Premio Nac. Art, Gobierno Mex., 1967; Premio Lenin de la Paz, USSR-Gobierno, 1967. **Work:** Mus. Arte Mod., Mexico City; MoMA; Phila. Mus. Art. Commissions: La América Tropical, Mural Block Painters, Los Angeles, 1932; Retrato de la Burguesia, Sindicato Mex. Electricistas, Mexico City, 1939; Por Una Seguridad Social Para Todos los Mexicanos, Inst. Mex. Seguro Socialm, Mexico City, 1951-54; Del Porfirismo a la Revolucion, Mus. Nac. Hist., Mexico City, 1957-66; La Marcha de la Humanidad, Manuel Suárex, Mexico City, 1966-71. **Comments:** Publications: author, "Como Se Pinta un Mural," 1951; author, "El

Nuevo Realismo Mexicano, Integración Plástica," 1966; author," A un Joven Pintor Mexicano," 1967; co-author, "Un Mexicano y Su Obra," 1969. Teaching: instructor, Chouinard School Art, Los Angeles, 1932; professor, Escuela Pintura San Miguel Allende, 1948-49; instructor murals, Escuela Taller Siqueiros, Cuernavaca, 1966-71. **Sources:** WW73; *La Pintura Mural de la Revolucion Mexicana* (Fondo Ed Plastica Mexicana, 1960); De Micheli, *D Alfaro Siqueiros* (Fratelli Fabbri Ed., 1968); "Muros de Fuego" (film), Mentor Films, 1967-70.

SIRENA, (Contessa Antonia Mastrocristino Fanara) *[Painter, collector] 20th c.; b.White Plains, NY.*
Addresses: East Meadow, NY. **Member:** Accad oli Paestum Accad dei 500; Accad Tiberina; Int. Committee Culture, Rome; MMA. **Exhibited:** Solos: Van Diemen-Lilienfield Galleries, New York, 1966, Gallerie Andre Weil, Paris, 1968, Mike Douglas TV Show Exhib., 1968, Palazzo delle Esposizioni, Comune di Roma, Rome, 1969 & State Gallery in Teatro Massimo, Palermo, Sicily, 1970. Awards: Gold Cup (First Int. Prize), Quadriennale of Europe, 1967; Dame of Grand Cross Award, Order of St. Constantine, 1968; gold medal of Pres. of Senate, Mayor of Rome, 1972. **Work:** MOMA, Rome, Italy; Mus Castello Sforzesco, Milano, Italy; Mus. Campidoglio, Rome; Regione Fruili Venezia Giulia, Regione Siciliana; Regione Sarda. Commissions: paintings for Federico Fellini, Frankie Laine, Gina Lollobrigida, Vittorio de Sica, The Vatican & Pope Paul XI. **Comments:** Positions: art gallery director, Sirena Art Galleries, Long Island, NY, 1963-. Teaching: lecturer on art, colleges & organizations, internationally, 1970-. Art interests: art exhibitions and awards for talented artists, national and international. Collections: paintings of new artists, contemporary art and old masters, antique furniture, clocks, candelabras and other art. **Sources:** WW73; Aurelio Prete, *Sirena* (ERS, Rome, 1966); Guilio Bolaffi, *Bolaffi on Modern Art* (Torino, Italy, 1970 & 1972); Giovanni Quattrucci, *Sirena* (Europe Ed., 1972).

SIRUGO, Salvatore *[Painter] 20th c.; b.Pozzallo, Italy.*
Addresses: NYC. **Studied:** ASL, 1948-49; Brooklyn Mus. Art School, NY, 1950-51. **Member:** ASL New York (life member, board control, 1961); Artists' Club. **Exhibited:** WMAA, 1952; PAFA Ann., 1953; Art USA: 1958, New York, 1958; Provincetown (MA) Arts Festival, 1958; solos: Camino Gallery, 1959, Tanager Gallery, 1961, K. Gallery, 1963 & Great Jones Gallery, 1966. Awards: Emily Lowe Award, Joe & Emily Lowe, 1951; Woodstock Foundation Award, Woodstock AA, 1952; Longview Foundation Award, 1962. **Work:** Pace Col, New York; Southern Ill Univ, Carbondale; Dillard Univ, New Orleans, LA; Ciba-Geigy Corp., Harrison, NY. **Comments:** Preferred media: acrylics, casein. **Sources:** WW73; Natalie Edgar, "The Private Worlds of Sal Sirugo," *Art News* (Nov., 1966); F. W. McDarrah, *The Artist's World in Pictures* (Dutton, 1961); Falk, *Exh. Record Series.*

SISCO, Curtis F., Jr. *[Painter]; b.Manhasset, NY.*
Studied: ASL. **Exhibited:** S. Indp. A., 1933-35; Salons of Am., 1934-36. **Sources:** Marlor, *Salons of Am.*

SISKIND, Aaron *[Photographer] b.1903, NYC / d.1991.*
Addresses: Providence, RI. **Studied:** CCNY, 1926. **Member:** Photo Lg., 1930. **Exhibited:** Photo Lg., NYC, 1941; MoMA, 1941, 1965; Egan Gal., NYC, 1947 (solo); AIC, 1965; Denver AM, 1965; IMP, 1965 (retrospective); Santa Barbara AM, 1965; Brown Univ., 1975. **Work:** MoMA; IMP; Siskin archive at Ctr. Creative Ph., Tucson. **Comments:** Best known for his abstract photographic images of walls, signs, and graffiti (beginning 1943), which are closely related in spirit to the work of F. Kline and other abstract expressionists exploring shapes. Teaching positions: Black Mountain Col. (1951); Chicago Inst. Des. (1951-70); RISD (1971-76). Publications: *Places* (1976). **Sources:** Witkin & London, 235; Baigell, *Dictionary.*

SISLEY, Raymond See: **STOOPS, Herbert Morton**

SISSMAN, Anna F. *[Painter] 20th c.*
Addresses: Hillside, NJ. **Exhibited:** S. Indp. A., 1934. **Sources:**

Marlor, *Soc. Indp. Artists.*

SISSON, Edward R. (Dr.) *[Amateur painter] b.1828, Westport, MA / d.1919, New Bedford, MA.*
Addresses: Worked in New Bedford, 1846-1919. **Exhibited:** New Bedford Art Club, 1909; Thumb Box Exhib., 1910. **Work:** Old Dartmouth Hist. Soc. **Comments:** Had careers as a sailor and a doctor by age 26. Was a well-known bicyclist and one of the first members of the New Bedford Art Club. **Sources:** Blasdale, *Artists of New Bedford,* 169-70 (w/repro.).

SISSON, Frederick Rhodes *[Painter, critic, teacher] b.1893, Providence, RI / d.1962, Falmouth, MA.*
Addresses: Providence, RI; Falmouth, MA (1952-on). **Studied:** RISD; BMFA School; Acad. de la Grande Chaumière, Paris; with Abbott Thayer in NH, 1920-21. **Member:** Providence Art Club; Contemporary Artists, Providence. **Exhibited:** AIC, 1924, 1926; S. Indp. A., 1924, 1927; Corcoran Gal biennial, 1928; MMA (AV); PAFA Ann., 1930; L.D.M. Sweat Mem. Mus., 1946; Brown Univ. Contemporary Artists, Providence, 1946; RISD, 1946; Rhode Island State College, 1946; Attleboro (MA) Mus., 1946; Texas A&M College, 1954; Univ. Houston, 1954; New Hampshire AA (solo); Providence Art Club, 1935 (solo), 1951 (solo), 1955; Van Dieman-Lillenfeld Gal., 1952 (solo); Cape Cod AA, 1952 (solo); Grace Horne Gal., Boston. **Work:** RISD; Brown Univ.; L.D.M. Sweat Mem. Mus.; mural, Houston, TX. **Comments:** Positions: teacher, RISD, 1924-52; critic, *Providence Journal,* 1932-50. **Sources:** WW59; WW47; exh. cat., Art & Antique Gal., (Worcester, MA, 1982); Falk, *Exh. Record Series.*

SISSON, Hattie A. *[Metal worker, jeweler, painter] b.1865, New Bedford, MA / d.1941, New Bedford, MA (suicide).*
Addresses: Active in New Bedford, 1889-1941. **Comments:** Positions: assistant instructor, metal work and jewelry, Swain Free School Design. **Sources:** Blasdale, *Artists of New Bedford,* 170.

SISSON, Laurence Philip *[Painter] b.1928, Boston, MA.*
Addresses: Boothbay Harbor, ME. **Studied:** WMA School; Yale Summer School. **Member:** AWS; Boston WC Soc.; New Jersey P&S Soc. **Exhibited:** Illinois Festival, 1951; Corcoran Gal biennial, 1953; NAD, 1951, 1953, 1954; All. Artists Am., 1955; AFA traveling exhib.; Clark Univ., Worcester, MA (solo); CM; Bradford Jr. College; Portland (ME) Mus. Art. **Awards:** prizes, Fitchburg Mus. Art, 1948; Yale Summer School, 1949; Hallmark award, 1949; All. A. Am., 1955; Boston Outdoor Show, 1950; Boston Art Festival, 1956; Portland Art Festival (purchase), 1957; bronze medal, New Jersey P&S, 1951. **Work:** BMFA; Berkshire Mus. Art; Bowdoin College; Hickory Mus. Art; Columbia (NC) Mus. Art; New Britain Mus. **Comments:** Position: artist in residence, Publick House, Sturbridge, MA, 1950; guest instructor, CM, 1953; director, Portland School Fine & Applied Art, 1955. Contributor: cover to *Fortune* magazine, 1951. **Sources:** WW59.

SISSON, Nellie Stowell *[Landscape and still life painter] 19th/20th c.; b.Illinois.*
Addresses: Missoula, MT; Bremerton, WA, 1941. **Studied:** AIC; with Frank Peyraud, Carl Erneke. **Exhibited:** Wash. State Arts & Crafts, 1909; Artists Prof. League, Portland. **Sources:** WW19; Trip and Cook, *Washington State Art and Artists,* 1850-1950.

SISSONS, Lynn E *[Painter] 20th c.; b.Portage La Prairie, Manitoba.*
Addresses: Manitoba, Canada. **Studied:** Winnipeg School Art, 1920; Univ. Manitoba School Art. **Member:** Manitoba Soc. Artist (all offices, 1929-68); Winnipeg Sketch Club (all offices, 1920-72); Poetry Soc. Winnipeg (board member & treasurer, 1960-70); Manitoba Theatre Soc. (working member, 1923-40). **Exhibited:** Winnipeg Sketch Club Ann., 1921-; Manitoba Soc. Artists in Winnipeg & traveling Shows, 1929-; 50th Anniversary Winnipeg Art Gallery, 1963 (solo); One Hundred & Fifty Years of Art in Manitoba, Legis Bldg., 1970; Simpson Co-Toronto Art Gallery. **Awards:** George Wilson first prize for best sketch in Manitoba, 1927; first prize & hon. mention, Manitoba Soc. Artists Ann., 1967; prize for best painting for sch., Investors Group. **Work:** Winnipeg Art Gallery; Canadian Dent. Soc., Toronto, Ontario;

Manitoba Hist. Soc.; Medicine Hat Alta Gallery; Manitoba Schools Library Art. Commissions: reproductions of old forts of Winnipeg, Hist. Mus. **Comments:** Preferred media: watercolors. Publications: many articles written & published in *Free Press & Winnipeg Tribune.* **Sources:** WW73.

SISTER CAMILLE OSTENDORF *[Painter, designer, graphic artist, craftsperson, teacher] b.1901, Vincennes, IN.*
Addresses: Indianapolis, IN/St. Marys-of-the-Wood, IN, 1947; Chicago, IL, 1959. **Studied:** St. Mary-of-the-Woods College (B.A.); Northwestern Univ. (M.A.); Corcoran School Art; AIC; Chicago Am. Acad. Art; Oskar Gross; Gordon Mess. **Member:** Indianapolis AA; Hoosier Salon; Indiana AC. **Exhibited:** Hoosier Salon, 1935, 1940; John Herron AI, 1934, 1935, 1942; Indiana A. Cl., 1935-39; First Archdiocesan Religious Art Exhib., Wash., DC, 1958. **Comments:** Position: teacher, Ladywood School, Indianapolis, as of 1947; art instructor, Providence H.S., Chicago, IL, 1959. **Sources:** WW38 (as Sister Camille); WW40 (as Sister Camille); WW47 (as Ostendorf, Sister Camille); WW59 (as Ostendorf, Sister Camille).

SISTER CORITA (I. H. M.) KENT *[Serigrapher, designer, educator] b.1918, Fort Dodge, IA / d.1986, Boston, MA.*
Addresses: Los Angeles, CA, c.1945 through at least 1973; Boston, MA, in 1982. **Studied:** Immaculate Heart College (B.A.); Univ. Southern Calif. (M.A.); Chouinard Art Inst. **Exhibited:** "The Beatitude Wall" for the Vatican Pavilion, New York World's Fair, 1964-65; IBM Bldg., 1966; Morris Ga., 1967 (in 1967 alone she had over 150 shows in U.S. mus., gals. & univs.); Sala Gaspar Gal., Spain. **Work:** AIC; MMA; LOC; NGA; Victoria & Albert Mus., London. **Comments:** (Born Frances Kent, known as Sister Corita Kent) A Roman Catholic nun for over thirty years (1936-68), she gained recognition during the sixties as a Pop artist. Incorporating bright primary colors and slogans from the mass media in her silk screen prints, she used her work to convey strong social and religious messages. As a teacher and the head of the art department at Immaculate Heart College, Los Angeles (she began teaching there in 1945), she stressed the importance of finding art in ordinary objects and everyday life. Her classes grew in popularity during the 1960s and were viewed as "happenings," drawing ordinary students and professional artists alike. The enormous pressures of such attention (she also received personal commissions to design wrapping paper, advertisements, books, and record jackets) apparently brought her to a decision to return to private life in 1968. She continued to work after leaving the convent, completing such diverse projects as a mural for the autopsy room at U.C.L.A. and designing rainbow patterns for the sides of business machines (Digital Equipment Corp., 1978). Her most famous and controversial outdoor work is her monumental rainbow brushstrokes on a huge gas storage tank on the Boston harborfront, painted during the Vietnam War. Detractors claimed that one of the brushstroke flourishes formed the face of Ho Chi Min, and political controversy ensued. Publications: author/illustrator, *Footnotes and Headlines: A Play-Pray Book* (1967); *Sister Corita* (1968); co-author, *City, Uncity* (Doubleday, 1969); author/illustrator, *Damn Everything But the Circus* (Holt, Rinehart & Winston, 1970); co-author & illustrator, *To Believe in Things* (Harper & Row 1971). **Sources:** WW73; WW66 (as Sister Mary Corita); Rubinstein, *American Women Artists,* 345-47.

SISTER ESTHER NEWPORT *[Educator, painter, lecturer, writer, illustrator, sculptor] b.1901, Clinton, IN.*
Addresses: St. Mary-of-the-Woods, IN. **Studied:** AIC (B.A.Educ.); St. Mary-of-the-Woods College (A.B.); Syracuse Univ. (M.F.A.); William Forsyth; Oskar Gross; Frances Foy; St. Mary's College, Notre Dame (LL.D., 1956). **Member:** Indiana Artists Club. **Exhibited:** MMA (illuminated manuscript), 1944; Lakeside Press Gal., (book illus.), 1933; Hoosier Salon, 1933, 1937 (prize), 1939 (prize), 1940, 1942 (prize); John Herron AI, 1938; Int. Expo of Sacred Art, Rome, 1950; Contemporary Religious Art, Tulsa, OK, 1949. **Comments:** Illustrator: *A Bible History,* 1933 (Macdonald and Jackson). Positions: head art dept., St. Mary-of-the-Woods, 1937-64; founder, Catholic AA, 1936;

director, 1936-40, board of advisors, 1940-58; assembled U.S. Section of Int. Expo Sacred Art, Rome, 1950; chmn., U.S. Committee for the Holy Year Exhibit, 1949-51; staff member, Catholic Univ., 1952-57; art director, Workshop, Catholic Univ., 1954, 1958, 1959; art consultant, 1956, & Nat. Liturgical Week, 1957; Collecting Committee for Children's Art Exhib. for Vatican Pavillion, Brussels World Fair, 1958; founder/general chmn., Conference of Catholic Art Educators, 1958, and permanent exec. secretary, 1960-63; director, art section of Nat. Catholic Charities Jubilee Program, 1958-60; art supervisor, Sisters of Providence, and Board of Education, 1962; director, Summer Inst. of Art Education, Chicago, 1965; speaker and consultant on Elem. Art Educ. at NCEA convention, NYC, 1965. Contributor: *Liturgical Arts, Journal of Arts & Letters, St. Paul, Catholic Art Quarterly, Church Property Administration, The Catholic Educator;New Catholic Encyclopaedia*'s "Art Education" (1965). Founder/editor, *Catholic Art Quarterly,* 1937-40; editor, *Creative Art,* 1955; *Catholic Art Education, New Trends,* 1959; *Reevaluating Art in Education,* 1960. Author: course of study for Jr. H.S., Diocese of Indianapolis, 1936; art section of "Report of Everett Curriculum Workshop," 1956; *Art Teaching Plans* (3 books), 1960; *Art Appreciation and Creative Work,* 1961; 90 picture studies for Barton Cotton's Picture Series; Junior Art Hist. section of CAA Course of Study for Art in Elementary Grades; Art Section of "Self Evaluative Criteria for Elem. Schools" (Catholic Educ. Assn.), 1965. Lectures: modern, creative, plastic art and art educ. **Sources:** WW38; WW66; WW73.

SISTER HELENE *[Craftsman, sculptor, painter, graphic artist, writer] 20th c.; b.Alameda, CA.*
Addresses: Adrian, MI. **Studied:** St. Joseph College; AIC; Siena Heights College (A.B.); Claremont Grad. Art Seminar; Cranbrook Acad. Art (M.F.A.), and abroad. **Member:** Mich. Acad. Sc.; AAPL; Catholic AA; Stained Glass Assn. Am.; Assn. Am. College (art committee, 1945-52). **Exhibited:** Inst. Modern Art, Boston, 1994; Detroit Inst. Art, 1939, 1942, 1945; Catholic AA, 1938-42. **Work:** Inst. Modern Art, Boston, 1944; Detroit Inst. Art, 1939, 1942, 1945; Catholic AA, 1938-42; Cranbrook Mus.; Des Moines AC; Springfield Mus. Art; Saginaw Mus. Art; Sioux City AC. **Comments:** Both nun and ecclesiastic artist, she specialized in stained glass but also created bronze doors, figures, and murals for churches, as well as the Christian Culture medal. Contributor to *Stained Glass Quarterly, Catholic Art Quarterly; American Apostolate,* research film strip for metal designers; educ. film strips. Position: director, Studio Angelico, Adrian, MI, 1935-; faculty visitor, 1952-. **Sources:** WW59.

SISTER JANE CATHERINE LAUER *[Painter, etcher, teacher] mid 20th c.*
Addresses: Toledo, OH. **Studied:** F. Allen; D. Rosenthal; S.B. Tannahill; C. Martin; J.E. Dean. **Member:** Ohio WCS; S. Toledo Women A. **Exhibited:** Toledo Fed. A. Soc., 1931, 1934, 1935. **Comments:** Position: teacher, Mary Manse Col.; Ursuline Convent, Toledo. **Sources:** WW40.

SISTER JEANNETTE BLAIR *[Educator] 20th c.*
Addresses: Wash., DC. **Studied:** Notre Dame Univ.; Western Reserve Univ.; Columbia Univ.; Ursuline Col.; Cleveland Sch. A. **Comments:** Position: asst., prof., dir. a. dept., Catholic Univ., Wash., DC. Contributor to: liturgical magazines. **Sources:** WW53; WW47.

SISTER MARIE-TERESA MACKEY *[Painter, teacher] b.1877, Stillwater, MN.*
Addresses: St. Paul, MN. **Studied:** NY Sch. A.; ASL; PAFA; Henri; Florence; Munich. **Member:** St. Paul AS. **Exhibited:** St. Paul Inst., 1916 (prize), 1918 (med.); Minn. State Art, 1919 (prize); Minn AA, 1920 (med.); Minn. State Fair, 1922 (prize); Minn. State Art S., 1923 (prize); S. Indp. A., 1925. **Sources:** WW33.

SISTER MARY ALBERTINE *[Landscape and figure painter] b.1851, Pittsburgh, PA / d.1917, St. Louis, MO.*
Addresses: Terre Haute, IN; Indianapolis, IN. **Studied:** AIC;

Cincinnati AA; with Bierstadt, Eakins, Chase; Royal Academy, Munich. **Comments:** Positions: teacher, Catholic girls' school, Terre Haute, 1870-78; teacher, St. John's Academy, Indianapolis, 1883-87. **Sources:** Petteys, *Dictionary of Women Artists.*

SISTER MARY CORITA See: **SISTER CORITA (I. H. M.) KENT**

SISTER MARY DAVIDICA *[Painter] 20th c.*
Addresses: Manitowoc, WI. **Member:** Lg. AA. **Sources:** WW24.

SISTER MARY FRANCIS IRVIN *[Painter, educator, engraver] b.1914, Canton, OH.*
Addresses: Greensburg, PA. **Studied:** Seton Hill College; Carnegie-Mellon Univ. (B.F.A.); AIC; Cranbrook Acad. Art (M.F.A.). **Member:** Penn. Art Educ. Assn.; Pittsburgh AA; Greensburgh AC; CAA; Catholic AA. **Exhibited:** Pittsburgh AA, 1943-46, 1945 (prize); LOC, 1944; CI, 1944; Greensburg Art Cl., 1944-64 (four awards); Religious Art Center Am., 1960; Westmoreland County Mus. Art, 1964; Pittsburgh Nat. Bank, 1964. **Work:** CI; St. Charles Borromeo Church, Twin Rocks, PA; Peabody, Central Catholic & Elizabeth Seton High Schools, Pittsburgh, PA. **Comments:** Positions: mem. of bd., Religious Art Center Am. Teaching: prof. art & dir. development, Seton Hill College, 1965-72. **Sources:** WW73.

SISTER MARY IRENA UPTEGROVE *[Educator, designer, painter, illustrator, sculptor] b.1898, Melrose, MN.*
Addresses: St. Joseph, MN; St. Paul 2, MN. **Studied:** Univ. Minnesota; College of St. Benedict, B.A.; Univ. Michigan, M.A.; Minneapolis Inst. Art; AIC. **Member:** Western AA; Catholic AA; CAA. **Exhibited:** Catholic AA; Univ. Minnesota; Xavier Univ., 1957; Nat. Liturgical Congress, 1958; traveling exhib., 1956-58. **Work:** Archbishop Murray Mem. H.S., St. Paul, MN (2 murals); College of St. Benedict, St. Joseph, MN; Mercy Hospital, Battle Creek, MI; St. Paul's Priory. **Comments:** Position: art professor, College of St. Benedict, St. Joseph, MN, until 1948; instructor, art history, Mount St. Scholastica, Atchison, KS; art supervisor, Visitation H.S., and Our Lady of Peace H.S., St. Paul, 1955; Faculty, St. Paul's Priory, St. Paul, MN, 1956-. Illustrator: "The Man Who Made the Secret Doors," 1946. **Sources:** WW59; WW47.

SISTER MARY LAUREEN *[Painter, designer, lecturer, teacher] b.1893, Ft. Wayne, IN.*
Addresses: Holy Cross, IN. **Studied:** Univ. Chicago, AIC; Univ. Calif.; Notre Dame Univ. **Member:** Hoosier Salon. **Exhibited:** Hoosier Salon, 1937 (prize). **Comments:** Teaching: St. Mary's College. **Sources:** WW38; WW40.

SISTER MARY NORBERT *[Painter and teacher] b.1885, Veseleyville, ND.*
Addresses: Cedar Rapids, IA. **Studied:** Leon Zeman & Edwin Bruns; Univ. Iowa (B.A., 1933, M.S., 1936). **Exhibited:** Iowa Art Salon, 1931-; Czechoslovakian Art Exhib., Cedar Rapids; Little Gallery; Milwaukee, WI; Terre Haute, IN; Marshalltown, IA; Iowa Federation of Women's Clubs, Cedar Rapids; Killian Co., Cedar Rapids; Catholic Col. Art Assoc. Exhib. (hon. men.). **Work:** Mount Mercy, Cedar Rapids. **Comments:** Teaching: art teacher, Cedar Rapids Mount Mercy Jr. College. Also known as Sister Mary Norbert Karnik. **Sources:** Ness & Orwig, *Iowa Artists of the First Hundred Years,* 119.

SISTER MARY OF DIVINE SAVIOUR, (C.S.C.) *[Painter, teacher, designer, craftsperson, graphic artist] b.1899, Manchester, NH.*
Addresses: Manchester, NH. **Studied:** Univ. New Hampshire; Sch. Practical Art, Boston; Beaux-Arts, Montreal, Quebec, Canada; Manchester Inst. Art & Science; Philip Hicken; R. Coleman; Charles Maillard; A. Schmaltz; John Chandler; John Hatch. **Member:** New Hampshire AA. **Exhibited:** Ogunquit AC; Dartmouth College; Jordan Marsh, Boston; Manchester Women's Club, 1942 (solo); Currier Gal. Art. Awards: Currier Gal. Art, 1955; prizes, Manchester Inst. Art & Sciences, 1942, 1945; Am.

Soc. for Control of Cancer, 1942; Manchester Art Festival, 1958. **Work:** Design & decoration of churches, Troy, Walpole, West Swanzy, Salmon Falls, Charlestown, all in NH; des., Doucet Mon., Nashua, NH; religious paintings, des. liturgical altars & cemetery memorials. **Comments:** Teaching: Holy Cross Art School, Manchester, NH. **Sources:** WW59; WW47.

SISTER MARY STANISIA *[Painter, teacher] b.1888, Chicago, IL.*
Addresses: Chicago, IL. **Studied:** AIC; Univ. Chicago; Ralph Clarkson; Charles Hawthorne. **Member:** AIC; Univ. Chicago; R. Clarkson; C. Hawthorne; von Zukotynski. Renaissance Soc., Univ. Chicago; All-Illinois SFA; South Side AA; Soc. for Sanity in Art; Ridge AA. **Exhibited:** Eucharistic Congress, Chicago, 1925; Warsaw World's Fair, 1932 (silver medal); Davis Gals., Evanston, IL, 1935; Century of Progress Expo, Chicago. **Work:** St. George H.S., Evanston, IL; murals, Cathedral, St. Paul, MN; Adrian College, MI; Mount Mary College, Milwaukee, WI; St.Joseph's Hospital, St. Margaret's Church, Holy Cross Church, all of Chicago. **Comments:** Positions: dir., FA Guild, Chicago; head, art dept., Acad. of Our Lady, Chicago, IL. **Sources:** WW53; WW47.

SISTER M. IMMACULATA *[Painter] 20th c.*
Addresses: Notre Dame, IN. **Work:** St. Mary's College. **Sources:** WW15.

SISTER M. THARSILLA *[Educator, painter] b.1912, Westphalia, TX.*
Addresses: San Antonio, TX. **Studied:** Our Lady of the Lake College (B.A.); Columbia Univ. (M.A.); AIC; NY Univ.; Texas Univ.; Constantine Pougialis; Robert Lifendahl; Buckley MacGurrin. **Member:** CAA; Western AA; Texas Art Educ. Assn.; Nat. Art Educ. Assn.; Texas WCS. **Exhibited:** Witte Mem. Mus., 1943-44, 1950; Texas General, 1945-46; Texas WCS, 1950; San Antonio Press Club, 1963. **Comments:** Teaching: Our Lady of the Lake College, San Antonio, TX. **Sources:** WW66; WW47.

SISTER REGINA BERNARD *[Teacher] b.1879 / d.1947, Jersey City.*
Comments: Position: art teacher, St. Aloysius Acad.

SISTER THOMASITA, (Mary Thomasita Fessler) *[Sculptor, educator] b.1912, Milwaukee, WI.*
Addresses: Milwaukee, WI. **Studied:** St. Mary's Acad.; Univ. Wisconsin-Milwaukee (B.E.); AIC (B.F.A. & M.F.A.). **Member:** Liturgical Arts Assn.; College Art Assn. Am.; Nat. Art Educ. Assn.; Int. Soc. for Educ. through Art; Wisc. Art Educ. Assn. **Exhibited:** NYC, Wash., DC, Dayton, OH, Seattle, Chicago. Awards: Friends of Art Award, 1964; Quota Club Women of Achievement Award, 1964; Theta Sigma Phi Award to Do'ers of the 1970s, 1970. **Work:** Commissions: two wood mosaic murals, Marquette Univ. Mem. Library; mahogany carved sanctuary crucifix, outdoor stone sculpture, rectory crucifix & wood mosaic stations of the cross for the Sisters' Chapel, St. Cyprian's Church, River Grove, IL; stained glass windows, St. Xavier's Hospital, Dubuque, IA. **Comments:** Positions: mem., Am. Delegation to First Int. Congress Catholic Artists, Rome, 1950; Milwaukee Art Center Exhib. Committee, 1950-; bd. mem., Milwaukee Children's Arts Program, 1952-; U.S. rep., Fourth Int. Assembly Int. Soc. Educ. through Art, Montreal, PQ, 1963; Gov. Council on Arts, 1963-; advisory bd., *Arts & Activities* magazine; advisory bd., Wisc. Montessori Soc., 1963-. Teaching: St. Anthony's High School, Sterling, CO; St. Mary's Aca., Milwaukee; chmn. art dept., Cardinal Stritch Col., 1947-; also summer sessions at Catholic Univ., Univ. Notre Dame, St. Martin's Col., Maryhurst Col., Holy Name Col. & Marquette Univ.; also worldwide lectures on liturgical art. Publications: author, articles, *New World, Everyday Art, Catholic Trends in Art Educ., Salesianum & School Arts.* **Sources:** WW73; articles, *Liturgical Arts, Journal Arts & Letters, Catholic Art Quarterly.*

SISTI, Anthony J. *[Collector, painter, drawing specialist, educator] b.1901, Greenwich Village, NY / d.1983, Buffalo, NY.*
Addresses: Buffalo, NY. **Studied:** Albright Art School, Buffalo, with Urquhart Wilcox; Royal Acad., Florence, Italy, 1925-31; doc-

tor's degree, with Felice Carena; anatomy at St. Mary's Hospital, Florence, Italy, under Chirugi; Acad Julian, Paris, France; Royal Acad., Munich. **Member:** Buffalo SA; G. Allied Arts, Buffalo; The Patteran Soc. (pres., 1957); Basalica Club. **Exhibited:** Albright Art Gal, 1930, 1932 (prize); Salons of Am., 1934; Buffalo SA, 1934 (prize), 1947 (prize); PAFA Ann., 1934; Western NY Artists, 1936 (prize), 1938 (prize), 1947 (prize); MoMA; Mus. of City of New York; Riverside Mus., New York; CPLH; Howard Univ., Washington, DC; Albright-Knox Art Gallery. Awards: Patteran Soc., 1943 (prize). **Work:** Mussolini Gal., Rome; Buffalo City Hospital; mural, Univ. Buffalo; Albright A. Gal., Buffalo.Commissions: Portrait, Hon Frank A Sedita, mayor of Buffalo, Fedn Ital Socs of Buffalo, 1970. **Comments:** Worked for the WPA mural project, completing several murals in western New York. Chose boxing subjects for many of his works; he had firsthand experience in the sport as he was Bantam Weight Champion for New York State. Positions: teacher, Buffalo AI in painting and anatomy, 1932-38; teacher, School of Applied Design for Women, NYC; chmn., First Allentown Exhib., 1956; chmn., Civic Art Festival, Buffalo, 1965. Collection: Old masters, impressionists, modern art. **Sources:** WW73; WW40; Falk, *Exh. Record Series;* addl. info. courtesy Martin-Zambito Fine Art, Seattle, WA.

SIST. MARY FLEURETTE BLAMEUSER, (BVM Order) *[Painter, instructor] 20th c.; b.Skokie, IL.*
Addresses: Wichita, KS. **Studied:** AIC; Univ. Colo.; Columbia Univ.; Clarke Col., BA; State Univ. Iowa, MA; Georgio Cini Found. fel., Venice, Italy, 1965; watercolor with Noel Quinn & Edgar Whitney. **Member:** Wichita Art Assn.; Wichita Art Mus. Mem.; Kans. Watercolor Soc. (bd. mem.-publicity, 1970-1972). **Exhibited:** Cath. Art Assn. Traveling Show, 1940; Contemporary, State Univ. Iowa, Iowa City, 1948; Wichita Women Artists, 1957; Kans. Watercolor Soc. Exhib., Wichita, 1970 & 1971; Kans. Cult. Arts Comn. Traveling Show, 1972; Wichita Art Mus., Wichita, KS, 1970s. Awards: watercolor award, Wichita Women Artists, 1957. **Work:** Wichita Art Assn., Kans. Commissions: mosaic mural, 1961 & bronze tabernacle, 1963, Sisters of Charity, BVM, Wichita. **Comments:** Preferred media: watercolors, oils, lithography. Positions: chmn. art educ. Archdiocese Los Angeles, 1946-1956; mem., Diocesan Liturgical Art Comn., Wichita, 1964-; active comt., Scholastic Art Awards, Kans. Regional, 1969-. Teaching: Instr. sec. art, Holy Angels Acad. Milwaukee, Wis., 1933-1945; instr. sec. art, Bishop Conaty Mem. High Sch., Los Angeles, Calif., 1945-1956; instr. art educ. & painting, Clarke Col., Dubuque, Iowa, 1951 & 1958; instr. sec. art, Mt. Carmel Acad., Wichita, 1956-. **Sources:** WW73; SM Cathlin, "The Story of a Mosaic," *Vista,* Sisters of Charity, BVM, 1963; John Simoni, "Nun Exhibits Sensitivity," *Wichita Eagle & Beacon,* May 9, 1965; Connie Close, "Nun Finishing Mosaic Mural," *Wichita Eagle,* 1965.

SITE, Clara B. *[Artist]*
Addresses: Wash., DC, 1900-31. **Sources:** McMahan, *Artists of Washington DC,.*

SITER, Eliza Clayton *[Painter] 20th c.; b.Phila., PA.*
Addresses: Phila., PA. **Studied:** Eakins & Chase in Phila.; Lasar in Paris. **Member:** Phila. Plastic Club; PAFA. **Exhibited:** PAFA Ann., 1881-90 (4 times). **Sources:** WW10; Falk, *Exh. Record Series.*

SITES, George *[Painter] 20th c.*
Addresses: Brockton, MA. **Sources:** WW17.

SITGREAVES, W. K. *[Sketch artist] early 19th c.*
Exhibited: PAFA, 1813 (sepia drawing, from nature, of a view on the Delaware River). **Sources:** G&W; Rutledge, PA.

SITNEY, Clara *[Painter] 20th c.*
Addresses: NYC. **Exhibited:** S. Indp. A., 1942, 1944. **Sources:** Marlor, *Soc. Indp. Artists.*

SITTERLE, Harold F. *[Painter] d.1944.*
Addresses: Chicago area. **Exhibited:** AIC, 1943. **Sources:** Falk,

AIC.

SIT(T)IG, Augusta *[Painter] 20th c.*
Addresses: Brooklyn, NY, active 1909-40. **Exhibited:** Brooklyn Mus., 1934; NAWPS, 1935-38. **Sources:** WW40.

SITTON, John Melza *[Painter, graphic artist, designer, writer, lecturer, educator] b.1907, Forsyth, GA.*
Addresses: Long Island City, NY. **Studied:** Yale Univ., B.F.A.; ASL; NAD; Am. Acad. in Rome; & with Eugene Savage, Ivan Olinsky, & others. **Member:** All. Artists Am.; NSMP; NY Mun. Art Soc.; Audubon Artists; Century Assn.; SC; Nat. Indst. Adv. Assn.; Grand Central AG; Ridgewood AA; Charcoal Club, Baltimore, MD. **Exhibited:** NAD, 1932; WMAA, 1937; AIC,m 1942; Pepsi-Cola, 1943; SSAL, 1943-46; All. Artists Am., 1944; Audubon Artists, 1945; Mint MA, 1943; Dayton AI, 1946; Century Assn., 1945; SC, 1943; Laguna Beach AA, 1943; High MA, 1942 (solo), 1946 (medal); Dayton AI, 1933; Grand Central Art Gal., 1945, 1946; Telfair Acad., 1943; Clearwater AM, 1943; Cornell, 1944; Watson Pub. Co., 1955-. **Awards:** Prix de Rome, 1929. **Work:** Yale Univ. Art Gal.; AGAA; Mint MA; IBM Collection; Bendix Radio Collection; Texas Tech College, Lubbock, TX; Fed. Reserve Bank, Atlanta, GA; Riverside Mem. Chapel, NY; USPO, Clifton, NJ. **Comments:** Position: teacher, New York Sch. Applied Design for Women (1940), Cornell (1941-44). **Sources:** WW59; WW47.

SITZ, Clara B. *[Artist] early 20th c.*
Addresses: Active in Washington, DC, 1900-31. **Sources:** Petteys, *Dictionary of Women Artists.*

SITZMAN, Edward R. *[Painter, lecturer, teacher] b.1874, Cincinnati, OH.*
Addresses: Indianaplis, IN. **Studied:** Duveneck; H. Farney, Cincinnati Art Acad.; London; Munich. **Member:** Indiana AC; Indianapolis AA; Chicago Gal. Assn. **Work:** Cincinnati AM; Indiana public libraries & schools. **Sources:** WW40.

SIVARD, Robert Paul *[Painter, art administrator] b.1914, New York, NY / d.1990, Washington, DC.*
Addresses: Washington, DC. **Studied:** Pratt Inst.; NAD; Académie Julian, Paris. **Member:** Am. Inst. Graphic Arts. **Exhibited:** MoMA, Paris, 1954; Carnegie Invitational, 1957; Gallerie Charpentier, 1959; Philadelphia Mus., 1960; PAFA Ann., 1964; Dallas Mus., 1965; Midtown Gallery, NYC, 1970s. **Awards:** 11th Ann. Corcoran Mus. Award, 1957; Thomas B. Clarke Award for painting, NAD, 1958; Art Directors Club, 1958 (gold medal). **Work:** NJ State Mus. Art; Library Congress. Commissions: murals (with Frank Schwartz), Oregon State Capitol, 1939 & Treasure Island San Francisco, City of San Francisco, 1940; commemorative postage stamp, The American Woman, 1960. **Comments:** Preferred media: casein. Positions: director visual & art services, U.S. Embassy. Paris, 1950-55; chief, Exhib. Div., U.S. Information Agency, 1958-65, agency art dir., 1966-. Collections arranged: U.S. Nat. Exhib. Moscow, 1959; Official U.S. Exhib., São Paulo Bienales, 1959, 1961, 1963 & 1965 & Venice Bienales, 1962 & 1964. **Sources:** WW73; "Sivard," *Time* (1955); *Un American à Paris, Illu.* (France, 1955);"Sivard, Shopping With" *Horizon* (1959); Falk, *Exh. Record Series.*

SIVRAJ, J. *[Painter] early 19th c.*
Exhibited: Society of Artists, 1814 ("Musidora"). **Comments:** This was in all probability the well-known New York artist and wit, John Wesley Jarvis. **Sources:** G&W; Rutledge, PA.

SIVYER, Henrietta R. *[Educator] 20th c.*
Addresses: Knoxville 16, TN. **Comments:** Position: head of art dept. **Sources:** WW59.

SIZER, Theodore *[Painter, craftsperson, designer, educator] b.1892, New York, NY.*
Addresses: Bethany, CT. **Studied:** Harvard Univ., B.S.; & with Denman W. Ross. **Exhibited:** Awards: Yale Univ., 1931 (M.A., hon. degree); Order of the Crown of Italy, 1945; Guggenheim Fellowship, 1947. **Comments:** Position: assoc. prof., art history, 1927-31; prof., 1931-57; art gallery director, to 1947; prof. emeritus, 1957-; all at Yale Univ., New Haven, CT. Contributor to various art and history periodicals & to the Dictionary of American Biography. Author: "Works of Col. John Trumbull, Artist of the American Revolution," 1950; "The Autobiography of Col. John Trumbull," 1953 (ed).; "The Recollections of John Ferguson Weir," 1957 (ed.). **Sources:** WW66.

SKALING, Audrey *[Painter] mid 20th c.*
Addresses: NYC. **Exhibited:** AIC, 1947. **Sources:** Falk, *AIC.*

SKEAPING, John *[Painter] mid 20th c.*
Exhibited: AIC, 1937, 1939. **Sources:** Falk, *AIC.*

SKEELE, Anna Katharine *[Painter, teacher, mural painter] b.1896, Wellington, OH / d.1963, Pasadena, CA.*
Addresses: Pasadena, CA. **Studied:** ASL; Acad. FA, Florence, Italy; Andre Lhote in Paris, France; Armin Hansen, Monterey. **Member:** Laguna Beach AA; Calif. WCS; Council Allied Artists, Los Angeles. **Exhibited:** San Fran. AA, 1924; Dudensing Gal., NYC, 1930; Little Studio Gal., Monrovia, 1930; San Diego FAS, 1930 (prize), 1933 (prize), 1938 (prize); Sacramento State Fair, 1930 (prize); Pomona County Fair, 1930 (prize), 1932 (prize), 1934; Los Angeles PS, 1931 (prize); LACMA, 1931 (prize); SFMA, 1935; Oakland Art Gal., 1939; GGE, 1939; CPLH, 1946; Doheny Lib., Univ. Southern Calif.; Madonna Festival, Los Angeles, 1952 (prize). **Work:** San Diego FAS; Laguna Beach Mus.; LACMA; murals, Torrance and Hawthorne (CA) H.S. **Comments:** Painted Indian subjects and murals. Position: teacher, Monrovia H.S.; co-owner (with her husband, Frode Dann) & teacher, Pasadena Sch. FA, 1952-59; instructor, drawing & painting, Pasadena School FA, Pasadena, CA. Also known as Katharine Skeele Dann. **Sources:** WW59; WW47. More recently, see Hughes, *Artists in California,* 518; P&H Samuels, 444.

SKEELE, Harriet See: **SKEELE, Harriet (Hannah) Brown**

SKEELE, Harriet (Hannah) Brown *[Painter] b.1829, Kennebunkport, ME / d.1901, Portland, ME.*
Addresses: St. Louis, MO; Portland, ME, 1871. **Studied:** self-taught. **Exhibited:** St. Louis Agric. & Mech. Assoc., 1858; Western Acad. Art, St. Louis, 1860-; Mississippi Valley Sanitary Fair, 1864; St. Louis Fair, 1869-70; in Portland, ME. **Comments:** Still life specialist, frequently painting animals and views of the outdoors. Also painted portraits. **Sources:** *For Beauty and for Truth,* 86 (w/repro.).

SKEGGS, David Potter *[Designer, painter] b.1924, Youngstown, OH / d.1973, Bath or Poland, OH.*
Addresses: Bath, OH. **Studied:** Denison Univ (A.B.); Iowa State Univ. (M.A.); Hans Hofmann. **Member:** Ohio Designer-Craftsmen; Am. Crafts Council; Artists Equity Assn. **Exhibited:** Canton Art Inst.; AIC; Syracuse MFA; LOC; Wadsworth Atheneum. **Work:** Akron AI; Butler AI, Youngstown, OH; Joslyn MA; Sloux City AC; U.S. Embassies, abroad. **Comments:** Positions: dir., Sioux City AC, 1954-57; des., Garth Andrew Co., Bath, OH, 1957-65; des., Skeggs Design Studio, 1960-; des., Far Corners, Inc., 1965-. Teaching: Youngstown College, 1948-50s. **Sources:** WW73.

SKELLY, Gladys Gertrude *[Craftsman] b.1901, Mexico, MO.*
Addresses: St. Louis, MO. **Studied:** R. Barry; St. Louis Sch. FA. **Member:** Artist-Craftsmen of NY; Boston Soc. Arts & Crafts; St. Louis AG; Shikari; St. Louis Soc. Indep. Artists. **Exhibited:** Sedalia, MO, 1932-33 (prizes); St. Louis, 1934 (prize); Paris Expo, 1937; SAM, 1941; deYoung Mem. Mus., 1941; Philbrook AC, 1941; CAM, 1940-43, 1950, 1951; MFA of Houston, 1941; Davenport Art Gal., 1941; Allen Mus., Oberlin, OH, 1942; Oshkosh MA, 1942; Brooks Mem. Art Gal., 1942; Am. House, 1952; Phila. Artists All., 1950; Wichita, KS, 1950, 1952; Mid-Am. Artists, 1952; St. Louis Women Artists, 1952; Delgado MA, 1953; Brentano, NY, 1958. **Sources:** WW59; WW47.

SKELLY, Jerry *[Illustrator] mid 20th c.*
Addresses: NYC. **Member:** SI. **Sources:** WW47.

SKELTON, Helen *[Painter] mid 20th c.*
Exhibited: S. Indp. A., 1938, 1940-42. **Sources:** Marlor, *Soc. Indp. Artists.*

SKELTON, Leslie J(ames)
[Landscape painter, illustrator]
b.1848, Montreal, Canada / d.1929,
Colorado Springs, CO.
Addresses: Colorado Springs, CO (since 1890s). **Studied:** Iwill, Paris, c.1885. **Member:** Broadmoor Art Acad.; Colorado Springs AS. **Exhibited:** Paris, London, NYC & Montreal, beginning in 1901; S. Indp. A., 1917. **Work:** Nat. Art Gal., Canada, Ottawa; Perkins Art Gal., Colorado College; Montreal AA. **Comments:** Popular Colorado painter whose landscapes were reproduced as postcards (about 5 million sold). Arranged the 1900 art exhibition at the opening of the Colorado College gallery. **Sources:** WW27; P&H Samuels, 444.

SKELTON, Phillis Hepler *[Painter, teacher] b.1898, Pittsburgh, PA.*
Addresses: Claremont, CA. **Studied:** Univ. Southern Calif. (B.A., cum laude); Scripps College (M.A.) with Eliot O'Hara, Dong Kingman, Phil Dike, Millard Sheets & David Scott. **Member:** Calif. Nat. WCS; Laguna Art Gal. **Exhibited:** Calif. Nat. WCS (prize); Pasadena Art Gal.; Scripps College, Claremont, CA; Laguna Art Gal. (prize); AWCS. Awards: Pasadena AM. **Work:** Pasadena (CA) Mus. Art; Bowdoin College, Brunswick, ME. **Comments:** Preferred media: watercolors. Teaching: instructor, Calif., 1920-23; private instructor, 1950-; art instructor, Scripps College, Claremont, 1959-67; head dept. art, Mayfield Sr. H.S., Pasadena, 1960-68. **Sources:** WW73.

SKELTON, Ralph Fisher *[Painter, etcher] b.1899, Port Byron, IL.*
Addresses: Chicago, IL/London, England. **Studied:** H. Tonks; W.W. Russell; Sir W. Orpen. **Exhibited:** AIC, 1929-30. **Sources:** WW29.

SKELTON, Red *[Painter, comedian] b.c.1913 / d.c.1997.*
Comments: A famous comedian of the 1950s-60s, he was known for his portraits of clowns. Color lithograph editions were also produced after the originals, and it was estimated that Skelton earned $2.5 million a year from his clown themes. **Sources:** undated clipping c.1997 citing the theft of $100,000-worth of Skelton paintings stolen from a La Quinta, Calif., home.

SKELTON, Robert Munshower *[Painter, sculptor, teacher] mid 20th c.; b.Wellsboro, PA.*
Addresses: Forest Ave., Greensboro, NC. **Studied:** State Teachers College, PA; Columbia; A. Archipenko. **Member:** Southeatern AA. **Exhibited:** Person Hall Art Gal., Chapel Hill, NC; VMFA. **Comments:** Teaching: Women's College, Univ. North Carolina. **Sources:** WW40.

SKELTON, Tommi *[Painter] mid 20th c.*
Exhibited: S. Indp. A., 1940. **Sources:** Marlor, *Soc. Indp. Artists.*

SKELTON, Verna (M.) *[Painter] mid 20th c.*
Exhibited: S. Indp. A., 1935-36, 1938. **Sources:** Marlor, *Soc. Indp. Artists.*

SKEMP, Olive Hess (Mrs.) *[Painter] early 20th c.*
Addresses: Scottsdale, PA. **Member:** S. Indp. A. **Exhibited:** S. Indp. A., 1921. **Sources:** WW25.

SKEMP, Robert Oliver *[Painter]*
b.1910, Scotdale, PA / d.1984.
Addresses: Westport, CT. **Studied:** ASL with Thomas Hart Benton, George Bridgman, Frank Dumond, Robert Laurent, 1928-29; Grand Central Sch. Art; in France & Spain; aGeorge Luks; Ch. Baskerville; J.C. Chase. **Member:** Am. Soc. Marine Artists (fellow, 1979). **Exhibited:** Art Dir. Club of Chicago, 1951-52 (gold medals), 1953 (prizes); "Art: USA," NYC, 1964; Portraits, Inc., NYC; Grand Central AG, NYC. **Work:** Rayburn Bldg., Wash., DC; U.S. Coast Guard, Wash., DC; R.J. Reynolds Tobacco Co., Winston-Salem, NC; Ackland Gal., Univ. North Carolina;

Springfield (IL) Art Mus. Commissions: "Man's Search For Happiness," Church of L.D.S. bldg., WFNY, 1964; portraits, Chief Judge Paul V. Rao, Fed. Court, NYC, 1967; Mr. Haakon Romnes, NYC, 1969; Dean Douglas Brown, Princeton Univ., 1969; Mrs. Roger Blough, Pittsburgh, 1970. **Comments:** Son of Olive Hess Skemp. **Sources:** WW73; Howard Munce, "Portrait Painting," *Northlight Magazine* (winter, 1970); add'l info courtesy Mrs. R.O. Skemp, 1994.

SKERRETT, R. *[Marine painter] b.Warrenton, VA / d.c.1949.*
Work: Mariners Mus., Newport News, VA. **Comments:** From 1889-1902 he was a draftsman for Bureau C&R and later the Electric Boat Co. **Sources:** Brewington, 356.

SKEWIS, Dorothy D. *[Lithographer, engraver, calligrapher] b.1900, Inwood, IA.*
Addresses: Storm Lake, IA. **Studied:** AIC; Arts & Crafts, Detroit, MI; Cranbrook, Detroit; Ernst F. Detterer, Jean Eschman, Bennett. **Member:** Soc. Typographic Artists; Women Painters, Detroit. **Exhibited:** Detroit, MI, 1935-37; Women Painters of Detroit, 1936-37; Wichita, KS; Am. Assoc. Univ. Women Ann. Show, Storm Lake; Tri-State Exhibition, Omaha; Iowa Art Salon, 1938 (first award). **Comments:** Teaching: Cass Technical H.S., Detroit, MI. **Sources:** Ness & Orwig, *Iowa Artists of the First Hundred Years,* 192-93.

SKIDMORE, Lewis Palmer *[Painter, restorer, educator, illustrator, lecturer, museum director] b.1877, Bridgeport, CT / d.1955.*
Addresses: NYC; Atlanta, GA. **Studied:** Yale Univ. with J.H. Niemeyer (B.F.A.); Académie Julian, Paris with J.P. Laurens and Bouguereau, 1901; Ecole des Beaux-Arts with Bonnât. **Member:** Atlanta AA; SSAL; AAPL; Georgia AA; Brooklyn SA; Brooklyn WCC; New Haven PCC; Studio Club, Atlanta; AAA, Paris. **Exhibited:** NAD, 1907, 1910, 1917; PAFA Ann., 1910; Georgia AA, 1931, 1933. **Comments:** Position: dir., High Mus Art, from 1929. **Sources:** WW53; WW47; Falk, *Exh. Record Series.*

SKIDMORE, Thornton D. *[Illustrator, cartoonist] b.1884, Brooklyn, NY.*
Addresses: Jackson Heights, NY; Falls Church, VA. **Studied:** Eric Pape Sch. Art; Howard Pyle. **Member:** SI; Artists Gld. **Comments:** Illustr.: *Cosmopolitan, Collier's, American, Woman's Home Companion* magazines; U.S. Naval Ordinance publications. Position: in charge of technical illustrations, McLaughlin Research Corp. for U.S. Navy, Washington, DC. **Sources:** WW53; WW47.

SKILES, Charles *[Cartoonist] b.1911, Pekin, IN / d.1969.*
Addresses: Daytona Beach, FL. **Comments:** Contributor: *McCalls, Good Housekeeping, Ladies Home Journal, Christian Science Monitor, Wall Street Journal. American Legion*; King Features Syndicate; drew "Josephine" panel for General Features Corp. **Sources:** WW66.

SKILLIN, John *[Ship & house ornamental carver] b.1746, Boston / d.1800, Boston.*
Addresses: Boston, 1767-1800. **Work:** Peabody Mus., Salem; Yale Univ. Art Gal. **Comments:** He was a son of Simeon Skillin, Sr. (see entry). Worked in his father's shop in 1777-78. Although none of his figurehead carvings survive, he is believed to have been the brother to carve the figurehead for the Continental frigate, *Confederacy,* in 1778 (a drawing for the figurehead is in the Admiralty records in London). From about 1780 he was in partnership with his brother, Simeon Skillin, Jr. At William Rush's (see entry) recommendation, John received the commission to carve the figurehead "Hercules" for the frigate " *Constitution,* in 1797 (the carving was destroyed in the Battle of Tripoli). The Skillins also produced garden figures, carved capitals and other ornament for architecture (public and private), and ornamental carvings for furniture. In the latter category is a carving of three figures, representing "Liberty," for a chest of drawers (Yale Univ., Garvan Collection). The Skillin shop also produced four larger free-standing wooden figures (a Hermit, Shepherdess, a figure representing Plenty, and a Gardener) for Elias Hasket Derby's gar-

den at his farm in Danvers, MA. (Only "Plenty" survives and is now at the Peabody Mus.) Other attributed works of note include the large Corinthian capitals for Bulfinch's State House in Boston. **Sources:** G&W; Thwing, "The Four Carving Skillins," 326-28; Swan, "A Revised Estimate of McIntire," 340-43; Swan, "Boston's Carvers and Joiners, Part I," 199-200; Pinckney, *American Figureheads and Their Carvers,* 45-55; Craven, *Sculpture in America,* 12-16, 19.

SKILLIN, Samuel *[Ship carver]* b.Boston / d.1816, Boston. **Addresses:** Boston, active c.1790-1816. **Comments:** He was a son of Simeon Skillin, Sr.(see entry). **Sources:** G&W; Thwing, "The Four Carving Skillins," 326-28; Pinckney, *American Figureheads and Their Carvers,* 45-55; Craven, *Sculpture in America,* 10.

SKILLIN, Simeon *[Ship carver]* 18th/19th c. **Addresses:** NYC, active 1799-1822. **Comments:** From 1806-11 he was in partnership with Jeremiah Dodge (see entry) as Skillin & Dodge. After 1822 he was a dealer in crockery and earthenware. His relationship, if any, to the Boston Skillins is not known. **Sources:** G&W; NYCD 1799-1830.

SKILLIN, Simeon III *[Ship carver]* b.1766 / d.1830. **Addresses:** Boston; Charlestown, MA, 1829. **Comments:** The relationship with the Boston Skillins (see entries for Simeon, Sr.; Simeon, Jr.; John; and Samuel) is unclear. Groce & Wallace and others had speculated that he might be the son of Samuel Skillin. **Sources:** G&W; Swan, "Boston's Carvers and Joiners, Part II," 285; Thwing, "The Four Carving Skillins," 326-28.

SKILLIN, Simeon, Jr. *[Ship & house ornamental carver]* b.1756, Boston / d.1806. **Addresses:** Boston, active 1776-1806. **Comments:** He was a son of Simeon Skillin, Sr. (see entry) and worked in his father's shop in 1777-78 and with his brother John after the death of their father (see John Skillin's entry for further discussion of works attributed to their shop). **Sources:** G&W; Swan, "A Revised Estimate of McIntire"; Thwing, "The Four Carving Skillins"; Pinckney, *American Figureheads and Their Carvers;* Lipman, *American Folk Art,* repro. 180; Craven, *Sculpture in America,* 12-16, 19.

SKILLIN, Simeon, Sr. *[Ship & house ornamental carver]* b.1716 / d.1778, Boston. **Addresses:** Boston, active 1738-78. **Comments:** Operated a carpentry and carving shop from c.1740 until his death. Records indicate the shop provided ordinary carpentry services, as well as ornate decorative work for furniture makers, carved shop signs, and carved figureheads for ships. Simeon, Sr. is recorded as carving a bust of Lord Chatham, or William Pitt, for a monument in Dedham, MA, that was placed in 1767 and destroyed by British troops two years later. In 1777 he was commissioned to carve the 6-foot 9-inch figurehead "Minerva" for the brig *Hazard,* one of the first armed ships of the Revolution. He was the father of Simeon (Jr.), John, and Samuel Skillin (see entries), all of whom worked with him in the shop. Some scholars had attributed the well-known "Little Admiral" (Old State House, Boston) to Simeon, Sr.; but others have pointed to the lack of documentary evidence to support this (see Craven, p. 11-12, for discussion). **Sources:** G&W; Swan, "Simeon Skillin, Senior, the First American Sculptor"; Thwing, "The Four Carving Skillins"; Swan, "Boston's Carvers and Joiners, Part I"; Pinckney, *American Figureheads and Their Carvers,* 45-55; Craven, *Sculpture in America,* 10-12.

SKILLIN & DODGE *[Ship carvers]* early 19th c. **Addresses:** NYC, active 1806-11. **Comments:** Partners were Jeremiah Dodge and Simeon Skillin of NYC (see entries) **Sources:** G&W; NYCD 1810; Pinckney, *American Figureheads and Their Carvers,* 200.

SKILLMAN, John B. *[Painter]* early 20th c. **Exhibited:** Salons of Am., 1934. **Sources:** Marlor, *Salons of Am.*

SKILTON, John Davis, Jr. *[Writer, museum curator, painter]* b.1909, Cheshire, CT. **Addresses:** Fairfield, CT. **Studied:** Yale Univ (A.B.; A.M.); Univ. Paris; New York Univ. **Member:** Cercle de l'Union Interalliée, Paris, France. **Exhibited:** WFNY, 1939. Awards: La Medaille de la Reconnaissance Française; Rockefeller Fellowship, 1935-36; Legion d'Honneur, 1957; Order of Merit First Class, German Govt., 1958. **Work:** AIC; NGA. **Comments:** Author: "Défense de l'Art Européen," 1948; "Würzburg," 1945; "Aus dem Tagebuch eines Amerikanischen Kunstschutzoffiziers," 1952. Positions: research asst., Am. Nat. Com. Engraving, 1940; curator, Marcella Sembrich Mem., Lake George, 1941; senior mus. aide, NGA, 1942-43; asst. to dir., Detroit IA, 1946-47; Parke-Bernet Gal., NY, 1949-53; monuments spec. officer, World War II; dir., Collectors of American Art, Inc. **Sources:** WW66; WW47.

SKINAS, John Constantine *[Painter]* b.1924, Passaic, NJ / d.1966. **Addresses:** Jersey City, NJ. **Studied:** Newark Sch. Fine & Indust. Art; ASL. **Member:** ASL. **Exhibited:** Solomon Guggenheim Mus., 1954; Midwestern Art Conf., 1954; DMFA, 1955; Guggenheim Mus. traveling exh., 1955-56; Athens. Greece, 1955: Village AC, 1954; Jersey City Mus., 1961; Northwest PM, SAM and Portland (OR) Mus. Art, 1963. Awards: prizes, Village AC, 1954; Guggenheim Mus., 1954; Midwestern Art Conf., Bloomington, IN, 1954. **Sources:** WW66.

SKINNER, Charles Everett *[Painter]* early 20th c. **Addresses:** Minneapolis, MN. **Sources:** WW19.

SKINNER, C(harlotte) B. (Mrs. William Lyle) *[Painter, etcher]* b.1879, San Francisco, CA / d.1963, Morro Bay, CA. **Addresses:** Morro Bay, CA. **Studied:** Calif. Sch. FA; Mark Hopkins Inst. Art; A.F. Mathews; G. Piazzoni. **Member:** Las Amigas del Morro; San Francisco Soc. Women Artists; Los Angeles AA. **Exhibited:** Santa Cruz Statewide, 1928; Oakland Art Gallery, 1928; San Francisco AA, 1930; Calif. State Fair, 1930; San Luis Obispo County Exhibit, 1956. **Work:** Calif. State Library; painting, government collection in Oregon. **Sources:** WW40; Hughes, *Artists of California,* 518; P&H Samuels, 444.

SKINNER, Clara (Clara Skinner Guy) *[Painter, printmaker, illustrator]* b.1902, Chicago, IL / d.1976, Camden, ME. **Addresses:** Conn./NYC, 1942-45; Vermont, 1945-46; Jacksonville, IL, 1946-54; Conn., 1946-; Camden, ME, 1970-on. **Studied:** Univ. Southern Calif.; ASL; Hans Hofmann. **Exhibited:** "50 Best American Prints Traveling Exh.," AFA, 1935; Mod. Mus., Moscow, Russia, 1940; "Responsive Eye," MoMA, 1966; Castallone Gallery, 1958 (solo), 1966 (solo) ("Optical Paintings."). **Work:** MMA Print Coll., NYC; SFMA; Cleveland MA; Detroit MA; St. Louis Mus. FA. **Comments:** Known for her wood engravings, Skinner was an illustrator of numerous children's books. Traveled to Moscow and Kiev, 1938. Teaching: assoc. prof. art, MacMurray College, Illinois, 1946-54; public high school, East Hampton, CT, 1954-69. She and husband James Guy (see entry) ran a summer painting school for several years (1940s and 50s) from their home in East Hampton, CT. During the 1960s she painted in an Op Art style. From 1970, she lived in Camden, ME, and Hyannis, MA. **Sources:** WW73; add'l info. courtesy Peggy MacAuslan (sister of James Guy) and and Nancy Syme (daughter of the artist).

SKINNER, Dewitt A. *[Painter]* b.1880, Gates NYC. **Addresses:** Rochester, NY. **Studied:** A.L. Mervis. **Sources:** WW21.

SKINNER, Edwin F. *[Painter]* late 19th c. **Addresses:** Chicago, IL, 1882. **Exhibited:** NAD, 1882. **Sources:** Naylor, *NAD.*

SKINNER, Elsa Kells *[Painter, illustrator]* 20th c.; b.Syracuse, NY. **Addresses:** Albuquerque, NM. **Studied:** Syracuse Univ. (B.F.A.); Univ. New Mexico with Randall Davey & Kenneth Adams; Rex Brant; Milford Zornes; Robert E. Wood Jr.; Bud Biggs; George

Post. **Member:** Southwestern WCS (mem. chmn., New Mexico Chapt., 1971-72). **Exhibited:** Nat. Assn. Am. Penwomen Nat., Smithsonian Inst., Wash., DC, 1960; Mus. New Mexico Biennial, Santa Fe, 1963; Southwestern Regional, Oklahoma City, 1964; Reno (NV) Regional, 1965; El Paso (TX) Sun Carnival Nat., 1967; Wagon Trails Gal., Albuquerque, NM, 1970s. Awards: "The Humming-bird," first prize watercolor, 1962 & "Gold and Brown," first prize mixed & "The Creatures," first prize acrylic 1967, New Mexico State Fair; "Old Mine at Golden," first purchase award, City of Albuquerque, 1968. **Work:** Old Mine at Golden, Albuquerque (NM) City Hall; Seminole Child, Bernalillo Co. Health Bldg, Albuquerque; Out Cerrillos Way, New Mexico Bank & Trust Co., Hobbs. Commissions: oil portrait of Oñate, New Mexico Hist. Soc., New Mexico State Univ., Las Cruces. **Comments:** Preferred media: watercolors. Positions: painter & designer, Charles Hall, NYC, 1932-33; free lance bookjacket designer, Thomas Nelson & Sons, 1934-35; designer, Decorative Utilities Corp, Newark, NJ, 1934-40; free lance illustrator & designer, Berland Printing Co., New York, 1935-39. **Sources:** WW73.

SKINNER, Frances Johnson *[Painter, teacher] b.1902, Dallas, TX / d.1983.*
Addresses: Houston, TX. **Studied:** BMFA Sch.; Chouinard AI; & with Everett Spruce. **Member:** Texas FAA; SSAL; NAWA. **Exhibited:** PAFA Ann., 1938; Nat. Exhib. Am. Art, NY, 1938; Kansas City AI; Texas Centenn.; SFMA; Dallas MFA, 1940 (prize), 1941 (prize); Houston MFA, 1943 (prize); Texas General, 1947 (prize); Texas FAA, 1943 (prize), 1948 (prize); NAWA, 1945 (prize), 1949 (prize); Texas State Fair, 1931 (prize), 1932 (prize), 1933 (prize); Denver AM; New Zealand-Wesleyan College Exchange Exh.; NAD; Argent Gal., NY; Sartor Gal., Dallas (solo); Dallas Little Theatre (solo); Junior League, Houston (solo). **Work:** Dallas MFA; Dallas Pub. Sch. Collection; Mus. FA of Houston; Texas FAA. **Comments:** Teaching: Mus. FA of Houston, TX. **Sources:** WW59; WW47; Trenton, ed. *Independent Spirits*, 205-06; Falk, *Exh. Record Series.*

SKINNER, Frank W. *[Painter] b.1878, Janesville, IA.*
Addresses: Minneapolis, MN/Beaver Bay, MN. **Studied:** Cumming School Art. **Exhibited:** solo shows in Midwest. **Comments:** Painted scenes of the Superior National Forest and North Shore of Lake Superior. **Sources:** Ness & Orwig, *Iowa Artists of the First Hundred Years,* 193.

SKINNER, George H. *[Painter] b.1829, London, England / d.1896, New Orleans, LA.*
Addresses: New Orleans, active 1860-94. **Sources:** *Encyclopaedia of New Orleans Artists,* 354.

SKINNER, Goodwin Y. *[Artist] early 20th c.*
Addresses: Wash., DC, active 1906-15. **Sources:** McMahan, *Artists of Washington DC,.*

SKINNER, Jessie R. *[Painter] b.1863 / d.1946.*
Addresses: Madison, WI. **Studied:** Univ. Wisconsin, Madison. **Comments:** Mother of Rachel Skinner (see entry). **Sources:** WW24; Petteys, *Dictionary of Women Artists.*

SKINNER, John M. R. See: **SKINNER, John R. M.**

SKINNER, John R. M. *[Portrait & landscape painter] mid 19th c.*
Addresses: Norwich, CT, 1844; NYC, 1846. **Exhibited:** NA, 1844, 1846. **Sources:** G&W; Cowdrey, NAD.

SKINNER, L. B. *[Painter] early 20th c.*
Addresses: Dunedin, FL. **Sources:** WW24.

SKINNER, L. R. (Mrs.) *[Artist] late 19th c.*
Addresses: Active in Los Angeles, 1883-97. **Sources:** Petteys, *Dictionary of Women Artists.*

SKINNER, M. K. *[Sculptor] late 19th c.*
Addresses: NYC. **Exhibited:** PAFA Ann., 1881 (relief). **Sources:** Falk, *Exh. Record Series.*

SKINNER, Mary Colle *[Painter] early 20th c.*
Addresses: NYC. **Sources:** WW17.

SKINNER, Mary Dart *[Painter] b.1859, San Luis Obispo Co., CA.*
Addresses: Active in San Jose, CA, 1974. **Sources:** Petteys, *Dictionary of Women Artists.*

SKINNER, Orin Ensign *[Designer, craftsperson, writer, lecturer] b.1892, Sweden Valley, PA.*
Addresses: Newtonville, MA. **Studied:** Rochester Atheneum Art School, NY (grad., 1915) with Herman J Butler; F. von der Lancken; also research in France & England, 1923-25. **Member:** Boston Arch. Club; Boston SAC; Int. Inst. Arts & Letters (fellow); Stained Glass Assn. Am. (pres., 1948-49; fellow). **Exhibited:** Awards: Master craftsman, Boston Soc. Arts & Crafts, 1940. **Work:** Commissions: stained glass windows, Princeton Univ. Chapel, 1930, St. John the Divine Cathedral, NYC, 1932, Heinz Mem. Chapel, Univ. Pittsburgh, 1938, St. Patrick's Cathedral, New York, 1956 & Grace Cathedral, San Francisco, 1966. **Comments:** Preferred media: stained glass. Positions: designer, Charles A. Baker, Rochester, 1912-16; designer, R. Toland Wright, Cleveland, OH, 1917-19; manager, treasurer & pres., Charles J. Connick Assocs., 1920-; editor, *Stained Glass,* 1930-48. Publications: contributor, *Am. Architect,* 1927, *Liturgical Arts,* 1937, *Am. Fabricks,* 1950 & *Holy Cross Magazine,* 1967. Research: Restoration of Great Western Rose Window of Rheims Cathedral. **Sources:** WW73; WW47.

SKINNER, Rachel L. *[Painter, teacher] b.1893 / d.1981.*
Addresses: Milwaukee, WI. **Studied:** Univ. Wisconsin, Madison. **Comments:** Teaching: Riverside H.S., Milwaukee. Daughter of Jesse R. Skinner (see entry). **Sources:** WW24; Petteys, *Dictionary of Women Artists.*

SKINNER, Thomas C. *[Painter, lithographer, illustrator] b.1888, Kuttawa, KY / d.1955.*
Addresses: Newport News, VA. **Studied:** NAD; ASL; George Bridgman; Robert Henri; George Luks. **Work:** murals, Mariners' Mus., Newport News, VA; U.S. Naval Officer's Club, Guantamano, Cuba; lithographs: LOC; Peabody Mus.; U.S. Naval Acad., Annapolis, MD; MIT; India House, NY; VMFA; Marine Mus., City of NY; U.S. Merchant Marine Acad., Kings Point, NY; murals on many steamships & U.S. Naval craft. **Sources:** WW53; WW47.

SKINNER, Thomas G. *[Painter] early 20th c.*
Addresses: NYC. **Exhibited:** S. Indp. A., 1917. **Comments:** Cf. Skinner, Thomas C., b. 1888, Kuttawa, KY-d. 1955. **Sources:** Marlor, *Soc. Indp. Artists.*

SKINNER, Varley *[Painter] early 20th c.*
Addresses: Brooklyn, NY, 1934. **Exhibited:** S. Indp. A., 1934. **Sources:** Marlor, *Soc. Indp. Artists.*

SKINNER, William *[Listed as "artist"] mid 19th c.*
Addresses: Albany, NY. **Exhibited:** American Inst., 1850 ("The Last Chance"). **Sources:** G&W; Am. Inst. Cat., 1850.

SKINNER, William Lyle *[Sculptor] b.1878, Rothville, CA / d.1952, Morro Bay, CA.*
Addresses: San Francisco, CA; Morro Bay, CA. **Studied:** Arthur Putnam. **Exhibited:** Oakland Art Gal., 1928. **Comments:** He was a mining engineer by profession, but started a three-year apprenticeship with A. Putnam (see entry) in 1901. Married to Charlotte Butler Skinner (see entry) in 1905. **Sources:** Hughes, *Artists in California,* 518.

SKIPWORTH *[Painter of gouache portraits] early 19th c.*
Comments: Gouache portraits, dated 1804, of Ebenezer Storr, Treasurer of Harvard College, and Mrs. Storr. **Sources:** G&W; information courtesy Israel Sack, NYC.

SKIRVING, John *[Panoramist, marine painter, architectural designer in watercolor] mid 19th c.*
Addresses: Phila., 1838-41; Boston, 1849; Wash., DC 1853; Phila., 1858; Germantown, 1861-65. **Exhibited:** Artists' Fund

Soc., Phila., & PAFA, 1838-65; Boston, 1849 ("Skirving's Moving Panorama: Col. Frémont's Western Expedition, Pictorialized," his panorama of Frémont's overland journey to California, painted from sketches by Frémont and others). **Sources:** G&W; Rutledge, PA; Boston *Evening Transcript*, Sept. 26, and Oct. 4, 1849 (citation courtesy J.E. Arrington). More recently, see P&H Samuels, *Illustrated Biographical Encyclopedia of Artists of the American West.*

SKLAR, Dorothy (Mrs. Phillips) *[Painter, teacher] mid 20th c.; b.NYC.*
Addresses: Los Angeles, CA. **Studied:** Univ. Calif., Los Angeles (B.E.); Chouinard Art Center Sch., Los Angeles; also with S. MacDonald Wright & Millard Sheets. **Member:** NAWA; NOAA; Springfield (MA) AL; Calif. Nat. WCS (treasurer, 1961; vice-pres., 1962); Southern Calif. Chapt. AEA (treasurer, 1951); Nat. Soc. Painters Casein; Laguna Beach AA. **Exhibited:** CPLH, 1945; Alabama WCS, 1944-45; Wawassee Art Mus., 1944-45; Newport, RI, 1945; NOMA, 1944-46; Gloucester, MA, 1944-46; NAWA, 1946; Portland (ME) AL, 1944-46; Santa Cruz Art League, 1944-46; Jackson (MS) AA, 1944-46; Denver Art Mus,. 1945; Oakland Art Gal., 1945; Laguna Beach AA, 1944-46, 1960 (award in oil); Santa Cruz AL, 1944, 1946; Santa Paula (CA) Chamber of Commerce, 1945; Springfield (MA) AL, 1945-46; PAFA, 1953, 1957; PAFA Ann., 1954; LACMA, 1955; Butler IA, 1963-68; Frye Mus, Seattle, WA, 1966 (Child Hassan Award); Calif. State Fair, Sacramento, 1966; Kramer Art Gal., Los Angeles, CA, 1970s. Other awards: Ida M. Holiday Mem. Award, NAWA, 1960. **Work:** Los Angeles Munic. Art Comn., Los Angeles City Hall; Baptist Univ., Shawnee, OK; Westside Jewish Community Center, Los Angeles. **Comments:** Preferred media: watercolors, acrylics. Teaching: Santa Monica City Schools, 1943. **Sources:** WW73; WW47; Falk, *Exh. Record Series.*

SKLAR, George *[Animal painter, educator, lecturer, designer, sculptor, teacher] b.1905, Philadelphia, PA / d.1968.*
Addresses: Drexel Hill, PA. **Studied:** PIA School; BAID; Yale Sch. FA (B.F.A.; M.F.A.; fellowship, 1933); Académie Julian, Paris with Landowski. **Member:** Acad. of Natural Sciences, Phila.; Phila. Zoological Soc.; Phila. Pr. Club; Phila. WCC; FIAL. **Exhibited:** Ecole des Beaux-Arts, Paris, 1932 (prize); PAFA Ann., 1940; Phila. A. All.; PMA; Woodmere A. Gal.; Rochester Mem. A. Gal.; Lafayette AA (Ind.); Butler AI; Stephens Col., Columbia, Mo.; Weyhe Gal.; Moore Inst. A. & Sc. (solo); Am. Mus. Nat. Hist. (solo); Phila. Pub. Lib.; Univ. Pa. Sch. FA; Fellowship House, Univ. Pa.; Phila. Plastic Cl.; Audubon A.; Laurel Gal., N.Y.; Florence (S.C.) Mus. A.; Canton AI; Phila. WC Cl.; PMA. Awards: European scholarship, Phila., 1927; Tiffany Found. Fellowship, 1929. **Work:** PMA; drawings for Phila. Zoo; Am. Mathematical Soc. **Comments:** Teaching: PM School IA, 1927-29; Yale School FA, 1935-37; New Jersey College, Rutgers Univ., 1937-41; Parsons School Design, 1945-50; Moore IA, Phila., 1945-60s; lecturer on fine arts; gave classes in painting, Lansdale, PA, & zoo drawing, at Phila. Zoo. **Sources:** WW66; WW47; *Intl. Directory of Arts,* Berlin; included in "Drawings of the Masters" series; Falk, *Exh. Record Series.*

SKLAR-WEINSTEIN, Arlene (Joyce) *[Painter, printmaker] b.1931, Detroit, MI.*
Addresses: Hastings-on-Hudson, NY. **Studied:** Parsons School Design; MoMA (scholarship); Bernard Pfreim; Albright Art School; New York Univ. with Hale Woodruff (B.A., 1952; M.S., art educ., 1955); Pratt Graphics Center with Andrew Stasik. **Member:** Yonkers AA, Hudson River Mus. (pres., 1970-72); Women in Art (rotating leadership, 1972); NAWA. **Exhibited:** Regional Juried Graphics, Albright-Knox Gallery, Buffalo, NY, 1952; The Visionaires, East Hampton Galleries, New York, 1968; Juried Regional, Yonkers AA, Hudson River Mus., 1970 & 1971; Juried Nat., NAWA, Lever House, New York, 1972; Evolutions, Hudson River Mus., 1971 (solo); West Broadway Gallery, 1972 (solo). Awards: Geigy award for painting, Ciba-Geigy Corp, 1969; first prize, Regional Juried at Hudson River Mus., Yonkers AA, 1971; award at print competition, Gestetner Corp., 1971.

Work: MoMA; NYPL Permanent Print Collection; Grace Gallery, NYC Community College, Brooklyn; Hudson River Mus. Permanent Collection, Yonkers, NY; Manufacturers Hanover Trust Co., Mount Vernon, NY. **Comments:** Preferred media: acrylics. Positions: visual arts coordinator, Council Arts Westchester, White Plains, NY, 1969-70. Teaching: chmn. dept art for jr. h.s., Plainedge Schools, Farmingdale, NY, 1953-56; instructor of art & director art school, YM-YWHA, Inwood-Wa Washington Heights, NY, 1956-58; coordinator-instructor art workshops, H. Hastings Creative Arts Council, NY, 1962-68. **Sources:** WW73; Masters & Houston, *Psychedelic Art* (Grove, 1968); H. H. Arnason, *History of Modern Art* (Abrams, 1969); Barry N. Schwartz, introduction to catalogue (Hudson River Mus., 1971).

SKODIK, Antonin C. *[Craftsperson, sculptor] b.1870, Modra, Moravia.*
Addresses: NYC. **Studied:** ASL with Cox, Mowbray, Blum, Barnard, Bitter, Miss Lawrence. **Member:** NSS. **Exhibited:** PAFA Ann., 1899. **Comments:** Came to U.S. in 1892. **Sources:** WW10; Falk, *Exh. Record Series.*

SKOGGARD, Arvid *[Painter] b.1886, Norrland, Sweden.*
Addresses: Floral Park, LI, NY. **Exhibited:** S. Indp. A., 1930, 1944. **Sources:** Marlor, *Soc. Indp. Artists.*

SKOLFIELD, Raymond White *[Painter, lithographer] b.1909, Portland, ME.*
Addresses: Brooklyn, NY/Portland, ME. **Studied:** P. Hale; G. Demetrios; M. Young; G. Picken; G. Pene Du Bois. **Member:** ASL. **Exhibited:** PAFA Ann., 1932, 1937; Corcoran Gal. biennial, 1932; Salons of Am., 1934; WMAA, 1936, 1938. **Sources:** WW40; Falk, *Exh. Record Series.*

SKOLLE, John *[Painter, teacher, illustrator, lecturer] b.1903, Plauen, Germany.*
Addresses: Santa Fe, NM. **Studied:** Acad. FA, Leipzig, Germany. **Exhibited:** MoMA, 1942; CPLH, 1946 (medal); Bonestell Gal. (solo); Mus. New Mexico (solo); Univ. New Mexico (solo); Denver Art Mus., 1930 (prize); Colorado Springs FAC; CI; Bonestell Gal. (solo); Mus. New Mexico, Santa Fe; Univ. New Mexico; SAM; Santa Barbara Art Mus. **Work:** Denver Art Mus.; DMFA; Roswell Mus. Art. **Comments:** Illustrator: *Holiday Magazine;* "Maya," 1958. Contributor: articles to *Hudson Review, Southwest Review, Landscape* magazines. Author: *Azalal,* 1956. Teaching: Brownmoor School for Girls, Phoenix, AZ, 1945-51. **Sources:** WW59; WW47.

SKONVERE, Harold *[Painter] early 20th c.*
Addresses: Astoria, NY. **Member:** Soc. Independent Artists. **Sources:** WW25.

SKOOG, Helen Knudsen *[Painter] b.1889, Illinois / d.1972, La Jolla, CA.*
Addresses: Southern California, late 1930s-72. **Exhibited:** Scandinavian-Am. Art Soc. West, Los Angeles, 1939. **Sources:** Hughes, *Artists in California,* 518.

SKOOG, Karl F(rederick) *[Painter, sculptor] b.1878, Sweden / d.1933.*
Addresses: Boston, MA. **Studied:** B.L. Pratt. **Member:** CAFA; Boston SS; Boston AC. **Exhibited:** Rochester, NY, 1908 (prize); SAA, 1912, 1918 (prize) 1920; CAFA, 1915, 1918, 1930 (prize); Swedish-Am. Artists, 1912, 1918 (prize) 1920, 1921 (prize); PAFA Ann., 1916-24, 1929; S. Indp. A., 1918-20, 1922-23; Salons of Am., 1923; AIC, 1919-23. **Work:** bust, K. of P. Bldg., Brockton, MA; tablet, Home for the Aged Swedish People, West Newton; mon., Forest Dale Cemetery; Elks Bldg., Malden, MA; medallion, R.W. Emerson, Mus. Numismatic Soc., NYC; mon., Cambridge, MA, mon., Cromwell, CT; hospital, Boston; mem., Cromwell Gardens, Cromwell, CT; Masonic Temple, Goshen, IN; John Morton Mem. Mus., Phila.; Vanderpoel Collection, Chicago. **Sources:** WW33; Falk, *Exh. Record Series.*

SKOORA, Pinhos *[Painter] early 20th c.*
Addresses: NYC. **Exhibited:** S. Indp. A., 1927. **Sources:** Marlor, *Soc. Indp. Artists.*

SKOORKA, Paul *[Painter] mid 20th c.*
Addresses: NYC. **Studied:** Cooper Union; Educ. Alliance.
Exhibited: "Artists Against Fascism and War," Artist Int. Assoc.,
London, England, 1935; Municipal Art Gal., ACA Gal.; "Buy
American Art," Park Vendone Gal.; WFNY, 1939-40; Pepsi Cola
Exhib., 1946; "NYC WPA Art" at Parsons School Design, 1977.
Work: Ain Harod, Israel; Mus. Holocaust, Jerusalem.
Comments: WPA artist, 1936-40. Directed art activities in
District 65 for the Union, 1954-70. **Sources:** *New York City WPA
Art,* 81 (w/repros.).

SKOP, Michael *[Sculptor, educator] b.1932, Lakewood, Ohio.*
Addresses: Durham, CT. **Studied:** Syracuse Univ. with Ivan
Mestrovic (B.F.A.); Univ. Notre Dame (M.F.A.); Danish Royal
Art Acad. with Mogens Boggild; Univ. Perugia, Italy; Am.
Scandinavian grant to Denmark, 1959; Fulbright grant to
Florence, Italy, 1960. **Member:** Nat. Art Educ. Assn. **Exhibited:**
Syracuse(NY) Art Mus., 1953; Danish Royal Art Acad., 1959;
Cincinnati Art Mus., Art Acad. Faculty, 1963-66; Brecksville
(OH) Art Gal., 1963-72; Smith Art Mus., Springfield, MA, 1968
(solo). **Work:** Danish Royal Art Acad., Copenhagen; Univ.
Massachusetts, Amherst, Jewish Community Center, Cincinnati,
OH. Commissions: crucifix, St. Josapth Ukranian Church,
Cleveland, OH, 1959; Walter Draper Mem., Queen City Club,
Cincinnati, 1963; religious compositions, Christ Church,
Cincinnati, 1965; mem., Op. Engineers, New Haven, CT, 1972.
Comments: Preferred media: bronze, polyester, wood, stone.
Positions: asst. to Ivan Mestrovic, Syracuse Univ., 1953-55; grad-
uate asst. curator, Univ. Notre Dame, 1958-59; consult., Trait
Texas Indust., Cleveland, 1970-. Teaching: Cincinnati Art Acad.,
1963-67; Southern Conn. State College, 1967- **Sources:** WW73;
Michael Skop Sculptor (Arte Armonia, Florence, Italy, 1960);
Arthur Darrach, "Michael Skop," *Cincinnati Enquirer,* (1963);
Donald Reichert, *Michael Skop,* Smith Mus. Catalog (MA, 1968).

SKOU, Bertha Gladys *[Painter] early 20th c.*
Exhibited: AIC, 1924. **Sources:** Falk, *AIC.*

SKOU, Sigurd *[Painter, teacher] b.Norway / d.1929, American
Hospital, Paris.*
Addresses: NYC/Concarneau, France. **Studied:** Zorn in
Stockholm; Krogh in Paris. **Member:** All. Artists Am.; NYWCC;
AWCS; Aquarellists; CAFA; SC; Palette & Chisel; Paris AAA;
Boston AC; NAC; Grand Central Art Gal. (founder). **Exhibited:**
S. Indp. A., 1917-18; AIC, 1919-30; Norske Club, Chicago, 1922
(prize), 1923 (prize), 1926 (prize); Salons of Am., 1922-24; PAFA
Ann., 1922, 1924; Corcoran Gal. biennials, 1923, 1926; Norse
Centenn., St. Paul, MN, 1924 (gold); WMAA, 1926; SC, 1926
(prize), 1929 (prize); All. Artists Am., 1926 (gold); Baltimore
WCS, 1927 (prize), 1928 (prize). **Sources:** WW27; Falk, *Exh.
Record Series.*

SKOUGER, Martha Gilbert See: **SKOUGOR, Martha
Gilbert**

SKOUGOR, Martha Gilbert *[Painter] b.1885, Brooklyn, NY.*
Addresses: Brooklyn, NY/Neshantic, NJ. **Studied:** F.V. Du
Mond. **Member:** NAWPS; ASL. **Exhibited:** Argent Gals., NYC
(solo). **Sources:** WW33.

SKOUVERE, Harold *[Painter] early 20th c.*
Addresses: Astoria, LI, NY. **Exhibited:** S. Indp. A., 1921.
Sources: Marlor, *Soc. Indp. Artists.*

SKRAINKA, Blanche *[Painter] early 20th c.*
Addresses: St. Louis, MO. **Sources:** WW25.

SKUPAS, Anthony J. See: **COOPER, Anthony J.**

SLACK, Abraham (or Abram) *[Engraver, die sinker, and
printer] b.1811, Pennsylvania.*
Addresses: Philadelphia, active from mid-1850's. **Comments:** He
was the father of Robert M. and William Slack (see entries).
Sources: G&W; 8 Census (1860), Pa., XLIX, 283; Phila. CD
1855-60+.

SLACK, Dee *[Painter] b.1946, Salisbury, MD.*
Addresses: New York, NY. **Studied:** Maryland Inst. College Art,
B.F.A. **Exhibited:** Women Artists in Revolution, Soho, New York,
1969; Painterly Realism, traveling show, AFA, 1970-72; Multi-
Media '1971 & Drawing Each Other, 1971, Brooklyn Mus., NY;
Green Mountain Gallery, New York, 1972 (solo). **Work:**
Commissions: portrait of Robert Gordon, commissioned by Mr. &
Mrs. Gordon, Scranton, PA, 1972; painting of Bob Keitel, com-
missioned by Robert S. Keitel, NYC, 1972; tropical seascape,
commissioned by Mr. & Mrs.A. Kaupinis, Houston, TX.
Comments: Preferred media: oils. **Sources:** WW73.

SLACK, Emma Patton *[Painter] 20th c.*
Addresses: Minneapolis, MN. **Sources:** WW15.

SLACK, Erle E. *[Cartoonist, illustrator] b.1892, Nashville, TN.*
Addresses: Tulsa, OK. **Studied:** with Carey Orr, Sykes,
McCrutcheon. **Member:** Nat. Cartoonist Soc.; Int. Typographical
Un. **Exhibited:** Awards: Freedom Fnd. medal, Valley Forge, PA.
Work: Archives of the State of Oklahoma; LC; Univ. Oklahoma;
designed and created the Seal of Tulsa. Drawings of Will Rogers
in Claremore Roundup Club Bldg., Claremore, OK. Many draw-
ings of prominent persons. **Comments:** Position: cartoonist,
World-Tribune, Tulsa, OK. **Sources:** WW59.

SLACK, Ira Samuel *[Painter] b.1890, Vermont / d.1956, Los
Angeles, CA.*
Addresses: Los Angeles, CA. **Member:** P&S of Los Angeles.
Exhibited: GGE, 1940. **Sources:** Hughes, *Artists in California,*
519.

SLACK, Robert M. *[Engraver] b.c.1842, Pennsylvania.*
Addresses: Philadelphia, 1860. **Comments:** He was a son of
Abraham Slack (see entry), with whom he was living. **Sources:**
G&W; 8 Census (1860), Pa., XLIX, 283.

SLACK, William J. *[Lithographic printer] b.c.1844,
Pennsylvania.*
Addresses: Philadelphia, 1860. **Comments:** He was living with
his father, Abraham Slack (see entry). **Sources:** G&W; 8 Census
(1860), Pa., XLIX, 283.

SLADE, Alison L. (Miss.) *[Painter] late 19th c.*
Addresses: NYC, 1871. **Exhibited:** NAD, 1871. **Sources:**
Naylor, *NAD.*

SLADE, C(aleb) Arnold *[Painter] b.1882, Acushet, MA /
d.1961, Truro, MA.*
Addresses: Truro, MA. **Studied:** Brown Univ.; ASL; F.V. Du
Mond; Académie Julian, Paris with J.P. Laurens, Schommer, and
Bachet, 1907. **Member:** Phila. AC; Paris AA; Allied Artists of
London; Grand Rapids AC; Springfield (IL) AC; New Bedford
AA; Phila. Sketch Club. **Exhibited:** Salon des Artistes Français,
Paris, 1913; Grand Rapids, MI, c.1920; Vose Gall., Boston, 1923;
Swain Free School Design, c.1920; New Bedford Art Club, 1913-
19. **Work:** Springfield AC; Phila. AC; Attleboro (MA) Public
Collection; Usabella Stewart Gardner Mus., Boston; New Beford
(MA) Free Public Library; Milwaukee AI; Bethany Church,
Phila.; Fitzgerald Gall., Brookline, MA; Paramont Theatre, NYC;
John Wanamaker and Elkins Collection, Phila. **Comments:**
Traveled in Europe after completing his studies. At the beginning
of WWI he was in a studio in France. He joined the U.S. Army
and was in the camouflage unit. After the war he returned to Tunis
to do a series which was published in *Scribners,* 1921. He became
proficient in portraiture as well as landscapes and biblical scenes.
Sources: WW40; Blasdale, *Artists of New Bedford,* 170-71
(w/repro.).

SLADE, Cora L. (Mrs. Abbott E.) *[Painter] d.1937.*
Addresses: Fall River, MA. **Studied:** R.S. Dunning. **Member:**
Provdence AC; Newport AA; Fall River AC. **Exhibited:** S. Indp.
A., 1918. **Sources:** WW33.

SLADE, Emily *[Sculptor, painter] 19th/20th c.; b.Phila., PA.*
Addresses: NYC, active 1887-1904. **Studied:** with Carroll
Beckwith, A. Stevens. **Member:** NYWAC; Cornish (NH) Colony.

Exhibited: Paris Salon 1887; NAD, 1889-93; Woman's Art Clubu, NYC, 1890; Boston AC, 1890, 1892, 1895; PAFA Ann., 1891-92, 1895-8; NAWA; NYWCC, 1898. **Sources:** WW04; Fink, *American Art at the Nineteenth-Century Paris Salons,* 391; Petteys, *Dictionary of Women Artists;* Falk, *Exh. Record Series.*

SLADE, Helen (Miss) *[Painter] late 19th c.*
Addresses: NYC, 1870-72. **Sources:** Naylor, *NAD.*

SLADE, Margaret Louise *[Painter, graphic artist] b.1949, Newark, NJ.*
Studied: Newark School Fine & Indust. Arts. **Exhibited:** Rutgers Univ., 1968; Blazor Art Festival, Newark, 1969 (prize); Newark School Fine a& Indust. Arts, 1969, 1970 (prize),1971 (prize); Wash. Park Outdoor Exhib., Newark, 1969; Seton Hall Univ., 1969; Midblock Art Gallery, 1970; Carson Art Gallery, 1971, all East Orange, NJ; Newark Pub. Lib., 1971; Newark Mus., 1971; Harris Gallery, 1971 (solo). **Work:** Spelman College, Atlanta; Elias Boudinot School, Elizabeth, NJ. **Comments:** Position: graphic designer, Essex County College. **Sources:** Cederholm, *Afro-American Artists.*

SLADE, Roy *[Painter, educator] b.1933, Cardiff, Wales.*
Addresses: Washington, DC. **Studied:** Cardiff College Art, N.D.D., 1954; Univ. Wales, A.T.D., 1954. **Exhibited:** Contemporary Painting, Nat. Mus. Wales, 1953-60; Art in Alliance, Washington, DC, 1968; Jefferson Pl Gallery, Washington, DC, 1968, 1970 & 1972 (solos); Washington Art, State Univ. NY College, Potsdam & State Univ. NY, Albany, 1971; Nat. Print Club, Nat. Collection Fine Art, Washington, DC, 1972; Nesta Dorrance, Washington, DC, 1970s. **Awards:** Fulbright-Hays scholarship, 1967. **Work:** Arts Council Great Britain; Contemporary Art Soc.; Nuffield Foundation; Westinghouse Corp.; Brit Overseas Airways Corp. **Comments:** Preferred media: acrylics. Positions: visiting, Boston School of Mus. Fine Art, 1970-; member, DC Commission Arts, 1972-; lecturer, numerous universities & schools. Publications: author, "Up the American Vanishing Point," 11/1968 & "Report from Washington," 1/1972, *Studio Int.*; author, "A New Cultural Centre", *Yorkshire Post,* 2/1969; author," Artist in America," *Contemporary Review,* 5/1969. Teaching: senior lecturer postgrad. studies, Leeds College Art, England, 1964-69; professor of painting, Corcoran Scool Art, Washington, DC, 1967-68; dean 1970-. **Sources:** WW73.

SLADE, S. V. *[Engraver] mid 19th c.*
Comments: His work appeared in *Our World: or, The Slaveholder's Daughter* (N.Y., 1855). **Sources:** G&W; Hamilton, *Early American Book Illustrators and Wood Engravers,* 437.

SLAFTER, Alonzo *[Portrait and still life painter] b.1801, Norwich, VT / d.1864, Bradford, VT.*
Addresses: Bradford, VT. **Studied:** Abigail Henderson in Newbury (VT). **Comments:** The son of Edmund Farwell and Clarissa (Tolman) Slafter. He studied law but turned artist and poet and lived alone on a farm at Bradford (VT) until his death, February 8, 1864. Some of his paintings are privately owned in Vermont and New Hampshire. **Sources:** G&W; Information courtesy Mrs. Katharine McCook Knox, who cites Rev. Edmund Farwell Slafter, *Slafter Memorial. of John Slafter, with a Genealogical Account of His Descendants, Including Eight Generations* (Boston, 1869), 49; see also 7 Census (1850), Vt., VII, 353; WPA (Mass.), *Portraits Found in N.H.,* 22.

SLAFTER, Theodore Shorey *[Painter] b.1890.*
Addresses: Boston/Dedham, MA, active 1888-1925. **Member:** Boston AC; Copley Soc. **Exhibited:** Boston AC, 1888-1901; AIC. **Sources:** WW25; *The Boston AC.*

SLAGBOOM, Teco *[Illustrator, painter] b.Indonesia / d.1988.*
Addresses: Monhegan Island, ME. **Comments:** Spent many summers on Monhegan Island (ME). Illustrator: Robert Murphy, author, *The Pond, and The Falcon;* Robert Murphy , author, *Peregrine Falcon.* Slagboom signed his work, Teco. **Sources:** Curtis, Curtis, and Lieberman, 74, 186.

SLAGER, Walter Dean *[Paintera] b.1886 / d.1952, Mexico City, Mexico.*
Exhibited: S. Indp. A., 1923. **Sources:** Marlor, *Soc. Indp. Artists.*

SLANEY, John *[Historical and portrait engraver] mid 19th c.*
Addresses: Philadelphia, 1846-48. **Sources:** G&W; Phila. BD 1846, 1848.

SLANY, Paul P. *[Sculptor] 20th c.*
Addresses: Altadena, CA. **Exhibited:** Artists Fiesta Los Angeles, 1931. **Sources:** Hughes, *Artists in California,* 519.

SLAPPEY, Katherine *[Painter] mid 20th c.*
Exhibited: Corcoran Gal biennials, 1951. **Sources:** Falk, *Corcoran Gal.*

SLATE, Joseph Frank *[Painter, writer] b.1928, Holiday's Cove, WV.*
Addresses: Gambier, OH. **Studied:** Univ. Washington, B.A., 1951; printmaking, Tokyo, Japan, 1957; Yale Univ. School Art & Arch., Alumni fellowship & B.F.A., 1960, with Josef Albers, Gabor Peterdi, Neil Welliver, Bernard Chaet & William Bailey; Dante Aligheri Inst., Florence, Italy, 1971. **Member:** Mid-Ohio Colleges AA (pres., 1964-65); College Art Assn. Am.; Mid-Am. College AA. **Exhibited:** 12th Nat. Print Show, Brooklyn Mus., 1960; Pioneer Gallery, Cooperstown, NY, 1961; Artist-in-Residence Exhib., Milton College, Univ. Wisconsin, 1963; Kenyon College, 1971 (solo); Accent House, Mount Vernon, OH, 1970s. Awards: Ohio Expos, 1962 (hon. mention). **Work:** Drawing, Yale Univ. **Comments:** Positions: consultant, Studies on Aesthetics & Perception, Yale Univ. Dept. Psychoogyl, 1960-65; member exec. committee, Kress Foundation Consortium Art History, 1965-69. Publications: author, "Those Old Italians" 1962 & "Respect," 1964, *New Yorker;* author, "This Heavy Folk Thing," *Kenyon Review,* 1969; author, "So Hard to Look at," *Contempora,* 1970; contributor, "The Art of Drawing," 1972. Teaching: professor of art & chmn. dept., Kenyon College, 1962-, chmn. fine arts div., 1967-69. Research: perception. **Sources:** WW73.

SLATER *[Miniature painter] early 19th c.*
Exhibited: Boston Athenaeum, 1830 (miniature portrait of a lady). **Comments:** Swan suggests that this might be Josiah or J. W. Slater, a British miniaturist of this period. *Cf.* also S.M. Slater. **Sources:** G&W; Swan, BA.

SLATER *[Sketch artist]*
Comments: Delineator of a portrait of the Rev. Legh Richmond engraved for the American Sunday School Union at Philadelphia by James B. Longacre. **Sources:** G&W; Stauffer, no. 2079.

SLATER, Edwin C. *[Painter, writer] b.1884, NJ.*
Addresses: Greenwich, CT. **Studied:** PAFA with W.M. Chase, C. Beaux, T.P. Anshutz, H. Breckenridge; B. Harrison; C. Grafly; H.D. Murphy; H.R. Poore; G. Bridgman. **Member:** SC; Copley Soc. **Comments:** Author: "The Future of Picture Framing in America" in *Arts and Decoration* (Aug., 1916, p.450). **Sources:** WW40; add'l info. courtesy Eli Wilner Co., NYC.

SLATER, Ella M. (Mrs.) *[Painter]*
Addresses: Wash., DC, 1926. **Exhibited:** Soc. Wash. Artists, 1926; Soc. Indp. A., 1927. **Sources:** McMahan, *Artists of Washington DC,.*

SLATER, S. M. *[Painter of a miniature] early 19th c.*
Comments: Painter of a miniature of a lady, signed and dated January 27, 1823, No. 3 State Street, New York. The name does not appear in the NYC directories, although John Slater, Jr., merchant, was at 8 State Street in 1823. **Sources:** G&W; *Antiques* (Aug. 1925), 99; NYCD 1823.

SLATER, Van *[Printmaker] b.1937, Arkansas.*
Studied: Los Angeles City College; Univ. Calif., Los Angeles. **Exhibited:** Prints, Traveling Inv., 1965-67; Soviet Union Exhib. of American Negro Artists, 1966-67; Univ. of Calif., 1966-67; Watts Festival, 1970; Compton College, 1970; Emerald Gallery; Diplomat Hotel, Hollywood, FL, 1970; Brand Library, Glendale, CA; Los Feliz Jewish Comm. Center; Dickson Art Center, 1966.

Sources: Cederholm, *Afro-American Artists.*

SLATKIN, Charles E. *[Art dealer] b.1908 / d.1977.*
Addresses: NYC. **Sources:** WW66.

SLATTERY *[Painter] mid 19th c.; b.New Orleans.*
Comments: A young "genius at painting" of New Orleans for whose benefit a fund for European study was sought in March 1851. **Sources:** G&W; Delgado-WPA cites *Orleanian,* March 12, 1851.

SLATTERY, Michael *[Engraver and die sinker] mid 19th c.*
Addresses: NYC, 1852. **Sources:** G&W; NYBD 1852.

SLAUGHTER, Hazel Burnham (Mrs.) *[Painter, designer]*
b.1888, Hartford, CT / d.1979, Stamford, CT.
Addresses: NYC. **Studied:** Hartford, CT; with Marshal Fry, NYC; Int. Silk Show traveling scholarship, 1923, to Egypt to study art from the tomb of Tutankhamen; ASL. **Exhibited:** Salons of Am., 1932; S. Indp. A., 1937; ASL; Feigl Gal., NYC, 1946 (solo), 1948 (solo). **Sources:** Marlor, *Salons of Am.;* Petteys, *Dictionary of Women Artists.*

SLAUGHTER, Julia Cornelia Widgery *[Painter] b.1850, Devonshire, England / d.1905, West Cardiff, Wales.*
Addresses: NYC, 1876; Tacoma, WA, 1891-1904. **Studied:** with her father W. Widgery; Europe. **Member:** Tacoma Art League (co-founder, 1891). **Exhibited:** Soc. British Artists; NAD, 1876-86; Am. AA; regional shows in the state of Wash. **Comments:** Member of a family of artists, she married Samuel Slaughter, a Tacoma land developer and community leader in 1889. She was the Wash. State commissioner for the Chicago Columbian Expo, 1892, and led a group of women painters to Dawson, AK in 1898, to sketch scenes of the gold rush. Though influential in her time, few records of her work are attainable. **Sources:** Trip and Cook, *Washington State Art and Artists.*

SLAUGHTER, Lurline Eddy *[Painter] b.1919, Heidelberg, MS / d.1991.*
Addresses: Silver City, MS. **Studied:** Mississippi State College Women, Columbus, grad.; Mississippi Art Colony Workshops, with Alvin Sella, Fred Mitchell, Ida Kohlmeyer, Howard Goodson, Frank Engel, Andrew Bucci, Alex Russo & Bob Gelinas; also with Marie Hull & Malcolm Norwood. **Member:** Mississippi Art Colony, (board of directors, 1965-); Mississippi AA (state advisory committee, 1967-); Tennessee Art Lg.; Gulf S. Arts Council, McComb & Greenville, MS (gallery artist); McCartys Galleries, Merigold, MS & Monteagle, TN (gallery artist). **Exhibited:** Six Nat. Oil Painting Exhibs., Jackson, MS, 1960-69; Hunter Gallery Ann., Chattanooga, TN, 1965; Cent. S. Ann., Parthenon Mus., Nashville, TN, 1966; Masur Mus. Ann., Monroe, LA, 1966; Fine Arts Registry, Brooks Mem. Mus, Memphis, TN, 1970; plus solo shows, NY, Mississippi, Tennessee & Arkansas. **Awards:** Outstanding Artist Award, Fine Arts Registry, 1966; best in show awards, Southern Contemporary Art Festival, Greenville, MS, 1966 & Holiday Arts Festival, McComb, MS, 1967. **Work:** Pine Bluff (AR) Arts Center; Mississippi State College Women; Univ. of the South, Sewanee, TN; Mississippi State Univ., Starkville. **Comments:** Preferred media: acrylics, oils. **Sources:** WW73.

SLAUGHTER, M. W. (Pvc.) *[Cartoonist] 20th c.*
Addresses: Fort Dix. **Exhibited:** S. Indp. A., 1942. **Sources:** Marlor, *Soc. Indp. Artists.*

SLAUGHTER, Robert K. *[Listed as "artist"] b.c.1826, England.*
Addresses: NYC, 1850. **Sources:** G&W; 7 Census (1850), N.Y., XLVIII, 71.

SLAVIN, Arlene *[Painter] b.1942.*
Addresses: NYC. **Exhibited:** WMAA, 1973. **Sources:** Falk, *WMAA.*

SLAVIN, John Daniel *[Painter, teacher] b.1907, Washington, DC.*
Addresses: Washington, DC. **Studied:** George Washington Univ.;

Corcoran Sch. Art; ASL; Tarbell; B. Baker; R.S. Meryman; E. Weisz; M. Leisenring. **Exhibited:** Studio Gld., 1940; Blackston College for Girls; Norfolk Mus. Art; CGA, 1938; U.S. Nat. Mus.; PAFA; CMA; Virginia Lg. FA (prize); U.S. Nat. Mus., Wash., DC, 1940 (solo); Anderson Gal., Richmond, 1933 (prize); Smithsonian Inst. (prize). **Work:** State Capitol, Richmond, VA; Acad. Science & FA, Richmond, VA; many portraits; Norfolk Mus. Arts & Sciences; Medical College,VA; Hotel J.Marshall, Richmond; Chesapeake & Ohio R.R. Com. Cincinnati, OH; Parish Church, Williamsburg, VA. **Comments:** Illustrator: articles by T.B. Campbell. **Sources:** WW53; WW47.

SLAYBACK, Minnette See: **CARPER, Minnette Slayback**

SLAYMAKER, Elizabeth *[Painter, illustrator, teacher] early 20th c.; b.Atlanta, GA.*
Addresses: Norfolk, VA. **Studied:** Académie Julian and Vitti Acad., Paris. **Exhibited:** AIC, 1902. **Sources:** WW08.

SLAYTON, Ronald Alfred *[Painter, illustrator, teacher] b.1910, Barre, VT.*
Addresses: Burlington/Weston, VT. **Studied:** PIA School; Univ. Vermont. **Member:** Southern & Northern Vermont Artists; Burlington Community Art Council. **Exhibited:** Southern & Northern Vermont Artists; WFNY, 1939. **Comments:** Position: teacher, Burlington (VT) Community AC. **Sources:** WW40.

SLEE, W. F. *[Painter] 19th/20th c.*
Addresses: Dorchester, MA. **Exhibited:** Boston AC, 1907. **Sources:** WW08; *The Boston AC.*

SLEEPER, Charles Frederick *[Architect] late 19th c.*
Addresses: Boston, 1851-70. **Exhibited:** Boston Atheneum, 1856 (architectural drawing). **Sources:** G&W; Swan, BA.

SLEEPER, John See: **STEEPER, John**

SLEETH, Lola McDonald Miller (Mrs. Francis V.)
[Painter, sculptor, teacher] b.1864, Croton, IA / d.1951, Laguna Beach, CA.
Addresses: Virginia; Washington, DC, active 1910; California, c.1933. **Studied:** Whistler; MacMonnies; Emil Carlson; Douglas Tilden. **Member:** Wash. AC; Wash. WCC; Soc. Wash. Artists; San Francisco AA; Laguna Beach AA. **Exhibited:** Soc. Wash. Artists, 1910; Corcoran Art Gal.; Maryland Inst. **Work:** portrait busts, CGA; Mem. Continental Hall; D.A.R. Constitution Hall; Cathedral Foundation; all in Washington, DC. **Comments:** Instructor: Nat. Cathedral School, Wash., DC, for over 30 yrs. Her portrait bust of Martha Washington is in the Museum at Valley Forge, and was used on the one cent postage stamp. **Sources:** WW33; Ness & Orwig, *Iowa Artists of the First Hundred Years,* 193; McMahan, *Artists of Washington DC;* Petteys, *Dictionary of Women Artists,* cites alternate birth dates of 1860, 1864, 1866.

SLEETH, R. L. *[Painter]*
Addresses: Pittsburgh, PA. **Sources:** WW21.

SLEIGH, Gordon *[Painter] 20th c.*
Addresses: Media, Philipsburg, PA. **Exhibited:** PAFA Ann., 1960, 1962, 1966. **Sources:** Falk, *Exh. Record Series.*

SLES, Steven Lawrence *[Painter] b.1940, Jersey City, NJ.*
Addresses: Valencia, Spain. **Studied:** Inst. Allende, Mexico; Bard College; Univ. Madrid; Swarthmore College; ASL; also with Hans Hoffman & Sol Wilson. **Member:** Fellow, Royal Soc. Arts; Int. Arts Guild (hon. vice-pres., Span. Committee, 1970); Free Painters & Sculptors, London; Arte Actual, Valencia; Vereinigung Mund und Fussmalenden Künstler in Aller Welt (dipl. member). **Exhibited:** FAR Gallery, New York, NY; Provincetown (MA) Art Assn.; Jersey City Mus.; Petchburi Gallery, Bangkok, Thailand; Galeria Toison, Madrid, Spain. **Awards:** purchase prize, Pearson Gallery, Swarthmore College, 1962; Charles T. Bainbridge Award, Jersey City, 1970; first & second prizes, Kenny Inst. Int. Mus. Art Show, 1971. **Work:** Swarthmore College; Vereinigung Mund und Fussmalenden Künstler Gallery, Florence, Italy; Vereinigung

Mund und Fussmalenden Künstler in Aller Welt Gallery, Munich, Germany & Liechtenstein. **Comments:** Preferred media: oils, ink, glass. Positions: director, personal art staff, Valencia, Spain, 1966-; director, Galerie Privée, Valencia, Spain, 1970-. Publications: author, "Ahora que te has ido, Poesía Española," Madrid, 1970; author, "Amor, río que estas dormido, Poesía de Venezuela," Caracas, 1970; author, "Mujer en la oscuridad del día," Azor, Barcelona, Spain, 1970; author, "Three poetries, Arbol de fuego," Caracas, 1970; author, "El guerrero y la guerra de la vida," Mensaje, Lérida, Spain, 1970. **Sources:** WW73; articles in: *Elizabeth Daily Journal,* April-Sept., 1964); Agramunt, article in *Avanzada* (Madrid, Sept., 1970); "Sheer determination" (film), Vereinigung der Mund und Fussmalenden Künstler in Aller Welt Gallery, 64-71.

SLESSINGER, Mary *[Miniature portrait painter] 20th c.*
Addresses: San Francisco, CA. **Exhibited:** San Francisco AA, 1903. **Sources:** Hughes, *Artists of California,* 519.

SLETTEHAUGH, Thomas Chester *[Painter, educator] b.1925, Minneapolis, MN.*
Addresses: Minneapolis, MN. **Studied:** Univ. Minnesota (B.S., 1949; M.Ed., 1950) with Walter Quint, Malcolm Myers & John Rood; Penn. State Univ., D.Ed., 1956, with Vicktor Lowenfeld; special study at Williams College, Univ. South Carolina, Univ. Georgia & Syracuse Univ. **Member:** Int. Soc. Educ. in Art; Int. Soc. Aesthetics; Int. Soc. Art Hist.; Int. Soc. Empirical Aesthetics; Int. Council Educ. for Teaching. **Exhibited:** Baltimore Mus. Art Regional, 1968; Corcoran Gallery Art Regional, Washington, DC, 1969; Carnegie Mus. Regional, Pittsburgh, PA, 1970; Outer Space Concepts, Kuntsforum Gallery, Germany, 1971 (solo); Grape Leaf--Variations, Bucharest Univ., 1972 (solo). Awards: Intercultural Art of Hungary & America Award, Off. Int. Progams, Univ. Minnesota, 1971; psychoaesthetic development award, College Educ., Univ. Minnesota, 1971. **Work:** Bucharest Univ., Romania; Cultural Center, Budapest, Hungary; Cortland Gallery, State Univ. NY, Cortland. Commissions: Symbol of excellence, commissioned by admin., Mississippi State College Women, 1970; Mississippi State College Women Crest for Apollo 1914, commissioned by Alumni Assn., 1971. **Comments:** Preferred media: mixed media. Positions: curator of art, Frostburg State College, 1962-68; council member, Maryland Arts Council, 1966-68; gallery director, Mississippi State College Women, 1968-70; council member, Mississippi Council Arts, 1968-70; council member, Minnesota Art Educators, 1971-72. Publications: author, "Psychoaesthetic, The Tactile Modalities and Creative Thinking," 1970; author, "The Creative Use of Tactile Modalities & Creative Thinking," 1970; author, "Art Education as a Means to International Understanding," 1972; author, "Non Visual Motivations for Art Expressions," 1972; author, "Perceptual Understanding Based on Tactile Art Experience," 1972. Teaching: professor of art, Frostburg State College, 1962-68; professor fine arts, Mississippi State College Women, 1968-70; assoc. prof essor grad. studies art educ., Univ. Minnesota. **Sources:** WW73.

SLEVIN, Mary C. *[Painter] 20th c.*
Exhibited: S. Indp. A., 1938-39. **Sources:** Marlor, *Soc. Indp. Artists.*

SLICK, James Nelson *[Painter, sculptor] b.1901, Salt Lake City, Utah / d.1979.*
Addresses: Costa Mesa, CA. **Studied:** Cornell Univ.; also with William McDermot. **Exhibited:** Awards: Blue Grass Fair, 1964 (first prize). **Work:** Permanent Collections of Los Angeles Turf Club, Arcadia, CA, Bay Meadows Race Track, Golden Gate Fields, Keeneland Race Course & Hialeah Race Track; two in Hall of Fame & other in museums proper, Thoroughbred Nat. Mus. Racing, Saratoga, NY. Commissions: Adios (life-size bronze), Meadows Race Track, Pittsburgh, PA, 1968; plus over 300 private commissions. **Comments:** Preferred media: oils. Teaching: instructor of horse portraiture, Studio Club, Lexington, KY, 1965-66. **Sources:** WW73; Kent Cockran, articles, *Racing Form;* articles, *Calif. Thoroughbred & Thoroughbred Rec.*

SLICK, Margery Singley *[Painter] 20th c.*
Addresses: Chicago, IL. **Member:** Chicago NJSA. **Sources:** WW25.

SLIFKA, Joseph (Mr. & Mrs.) *[Collectors] 20th c.*
Addresses: NYC. **Sources:** WW73.

SLINGERLAND, Harold B. *[Portrait painter] b.1898, Saratoga Springs, NY / d.1985, Sarasota, FL.*
Addresses: Sarasota, FL (1940s-on). **Studied:** Edward Byck in Albany, NY; Harvard Univ. **Exhibited:** Audubon Artists; Ringling AM, Sarasota; Ogunquit Art Cntr; Quincy AC, Ill.; Montgomery AM, Ala.; Dartmouth College; NAD; Norton Gal, Palm Beach. **Sources:** PHF files (press release, Doyle Antiques, Hudson, NY, Apr., 1999).

SLINGLANDT, Jacob *[Music engraver] b.c.1813, New Jersey.*
Addresses: New York State, c.1842; Louisville, KY, c.1845-70. **Comments:** His sons, Edgar and Benjamin F., worked with him after 1860 (see entries). **Sources:** G&W; 7 Census (1850), Ky., XI, 387 1/2; Louisville CD 1852-70.

SLINGSBY, Della *[Painter] b.1879, Humboldt County, CA / d.1971, Ferndale, CA.*
Addresses: Humboldt County, CA. **Studied:** with Charles T. Wilson. **Comments:** Specialty: oils of redwood trees. **Sources:** Hughes, *Artists inCalifornia,* 519.

SLINKARD, Rex *[Painter, teacher] b.1887, Bickwell, IN / d.1918, NYC.*
Addresses: Los Angeles, CA. **Studied:** with R.Henri; USC; ASL of Los Angeles. **Exhibited:** memorials: LACMA, 1919, 1929; Knoedler Gallery, NYC, 1920; Taos Building, Los Angeles, 1923; Long Beach Mus., 1964; Stanford Art Gallery, 1975. **Comments:** Position: teacher, ASL of Los Angeles, 1910-13. **Sources:** Hughes, *Artists in California,* 519.

SLIVE, Seymour *[Educator, writer] b.1920, Chicago, IL.*
Addresses: Cambridge, MA. **Studied:** Univ. Chicago (A.B., 1943; Ph.D., 1952); Harvard Univ., hon. M.A., 1958. **Member:** Am. Acad. Arts & Sciences (fellow); Karel van Mander Soc. (hon. member); College Art Assn. Am. (dir., 1958-62, 1965-69); Renaissance Soc. **Exhibited:** Awards: Fulbright fellowship to the Netherlands, 1951-52; Guggenheim fellowship, 1956-57; Fulbright research scholarship, Univ. Utrecht, 1959-60. **Comments:** Positions: member of editorial staff, *Art Quarterly,* 1963. Publications: author, catalogue of Frans Hals Exhibition held in Haarlem, 1962; author, "Frans Hals, Das Festmahl der St. Georgs-Schutzengild 1616," 1962; author, "Rembrandt Drawings," 1965; co-author, "Dutch Painting: 1600-1800," 1966; author, "Frans Hals," 2 vols., 1970. Teaching: instructor of fine arts, Oberline College, 1950-51; asst. professor & chmn. art dept., Pomona College, 1952-54; asst. professor of fine arts, Harvard Univ., 1954-57, assoc. professor, 1957-61, profesor of fine arts, 1961-, chmn. dept. fine arts, 1967-70; exchange professor, Univ. Leningrad, 1961; Ryerson lecturer, Yale Univ., 1962; Slade professor, Oxford Univ., 1973. **Sources:** WW73.

SLIVKA, David *[Sculptor] b.1913, Chicago, IL.*
Addresses: NYC. **Studied:** Calif. School Fine Arts. **Exhibited:** GGE, 1939; Hirshhorn Collection Mod. Sculpture, 1962-63; Univ. Texas Mus., 1966; Brandeis Univ. Creative Arts Award Winners, Aldrich Mus. Contemporary Art, CT, 1966; Southern Illinois Univ., Carbondale, 1968 (solo); Selections from Chase Manhattan Bank Collection, 1971; Helen Gee, NYC, 1970s. Awards: Brandeis Univ. Creative Arts Award For Am. Sculpture, 1962. **Work:** stone relief, pub. sch., San Francisco; USPO, Berkeley, CA; Univ. Texas Mus., Austin; Walker AC, Minneapolis; Univ. Calif., Berkeley; Brooklyn Mus., NY; Stuttgart Mus., Germany. **Comments:** WPA artist. Preferred media: bronze, wood, marble. 1965. Teaching: professor sculpture, Univ. Mass., Amherst, 1964-67; artist-in-residence, Southern Illinois Univ., Carbondale, 1967-68; Queens College, NY, 1971-73. **Sources:** WW73; Harvey Arnason, *Modern Sculpture from the Joseph Hirshhorn*

Collection (Guggenheim Mus., 1962); Georgine Oeri, *The Sculpture of David Slivka* (Quadrum, 1963); Harold Rosenberg, *The Anxious Object,* Illus.; WW40.

SLIVKA, Rose *[Art editor]* 20th c.
Addresses: NYC. **Comments:** Positions: editor-in-chief & writer, *Craft Horizons.* **Sources:** WW73.

SLOAN, Bessie Imogene Boyle *[Painter]* b.1866, California / d.1956, Alameda, CA.
Addresses: Alameda, CA. **Exhibited:** Oakland Art Gallery, 1937. **Sources:** Hughes, *Artists in California,* 519.

SLOAN, Blanding *[Painter, sculptor, etcher, lithographer, block printer, illustrator, teacher]* b.1886, Corsicana, TX / d.1975, Hayward, CA.
Addresses: Cos Cob, CT. **Studied:** B. Nordfeldt. **Member:** Chicago SE. **Work:** BM; Calif. Palace of the Legion of Honor. **Comments:** Illustrator: "Way Down South," C. Muse. **Sources:** WW40; add'l info. courtesy Anthony R. White, Burlingame, CA.

SLOAN, Edna (Mrs.) *[Painter]* 19th/20th c.
Addresses: Salt Lake City, UT. **Member:** Soc. Utah Artisits. **Comments:** Secretary, Utah Art Inst., 1903. **Sources:** WW01; Petteys, *Dictionary of Women Artists.*

SLOAN, Eunice *[Fashion illustrator]* 20th c.
Addresses: New York 16, NY. **Member:** SI. **Sources:** WW53.

SLOAN, Harold Olcott *[Painter]* 20th c.
Addresses: Larchmont, NY. **Exhibited:** S. Indp. A., 1932. **Sources:** Marlor, *Soc. Indp. Artists.*

SLOAN, Helen Farr See: **FARR, Helen (Helen Farr Sloan)**

SLOAN, Hugh J., Jr. *[Painter, teacher]* b.1931 / d.1985.
Addresses: East Weymouth, MA. **Studied:** New England School Art, 1951; BMFA School (1959, graphic arts); Tufts Univ. (B.S. Art Educ., 1959); Bridgewater State College (M.Educ., 1961). **Member:** Weymouth AA. **Exhibited:** Regis College, Weston, MA, 1978 (solo); Tufts Univ., 1980 (solo). **Comments:** Position: art teacher at Mass. public schools, 1959-66; director of art educ., Kingston, MA, 1966-72; art Educ. coordinator for Weymouth Public Schools, 1972-on. Author of many essays on art education.

SLOAN, J. Seymour (Mr. & Mrs.) *[Collectors, patrons]* 20th c.
Addresses: NYC. **Comments:** Collection: primarily American art, but also includes works by Europeans such as Moore, Jongkind, Gromaire, Fraser and Matisse. **Sources:** WW73.

SLOAN, J(ames) Blanding *[Painter , etcher, illustrator, craftsperson, woodcarver, teacher]* b.1886, Corsicana, TX / d.1975, Hayward, CA.
Addresses: Corsicana, TX; Chicago, IL; NYC; San Francisco, CA; Los Angeles, CA. **Studied:** Chicago Acad. FA; B.J.O. Nordfeldt; G. Senseney. **Member:** Chicago SE. **Exhibited:** Berkeley League of FA, 1924; AIC. **Work:** Brooklyn Mus.; Mus. of NM; CPLH; de Young Mus. **Comments:** Designer of stage sets in NYC as well as Hollywood, he also had a puppet theatre in San Francisco. He was put in charge of the WPA Federal Theater in Los Angeles in 1934. **Sources:** WW33; Hughes, *Artists in California,* 519.

SLOAN, John *[Painter, etcher,* ~~John Sloan~~ *illustrator, teacher, writer, lithographer]* b.1871, Lock Haven, PA / d.1951, Hanover, NH.
Addresses: Phila., PA; NYC/Santa Fe, NM. **Studied:** PAFA with Anshutz, 1892. **Member:** S. Indp. A. (pres., 1918-51); AIAL; Taos SA. **Exhibited:** AIC, 1900-46; PAFA Ann., 1901-51 (gold for best portrait, 1931); Corcoran Gal. biennials, 1907-51 (17 times); Macbeth Gal., 1908; Armory Show, 1913; S. Indp. A., 1917-44 (annually); WMAA, 1918-50; SAE, 1940 (prize); Pan-Pacific Expo., San Fran., 1915 (medal); Sesqui-Centenn. Expo, Phila., 1926 (gold); Taos SA, from 1922; WFNY 1939; Delaware Art Mus.; "The Ashcan Artists and their New York," NMAA, 1995. **Work:** Delaware Art Mus. (major collection); NYPL; Newark Pub. Lib.; CM; CI; MMA; BM; Mus. New Mexico; PMG; CGA; Pennsylvania State College; Barnes Found.; Newark Mus.; Detroit Inst. Art; LACMA; San Diego FAS; AIC; WMAA; BMFA; AGAA; Wichita Mus. Art; PAFA; PMA; TMA; WPA murals, USPO, Bronxville, NY; Mint Mus., Charlotte; Parrish AM, Southhampton; Bowdoin Col. Mus. FA; Gilcrease Inst. **Comments:** One of the "black gang" in Phila. with Henri, Luks, Shinn and Glackens (all of whom were working as artist-reporters). By 1904 all five were in NYC and by 1908 they formed "The Eight" later known as the "Ashcan School." Sloan painted his first urban scenes in 1897, basing the scene on his own observations of the city streets, a method he practiced and advocated throughout his career. He joined the Socialist party in 1909 and contributed drawings to several Socialist papers thereafter, including the Masses for which he was editor 1912-16. Sloan lightened his palette about 1909 and also began to paint more landscapes and interiors. He visited Santa Fe, NM, in 1919 and bought an adobe house there in 1920. He spent most summers thereafter in Santa Fe, painting landscapes in his studio because the New Mexico light affected his nearsightedness. Married artist Helen Farr (Sloan) in 1944. Note: at the 1924 Soc. of Indep. Artists' exhibition, Sloan showed two works under his own name and one work under the name of Josh Nolan (an anagram for John Sloan). Positions: artist/reporter, *Inquirer,* 1892; *Philadelphia Press,* 1895-1903; made drawings for Socialist news organs, the *Call* and *Coming Nation;* ed., the *Masses* 1912-16; teacher, ASL, 1914-26, 1935-37; pres., ASL. Illustrator: etchings and drawings for novels of Paul de Kock, 1902-05; and for Gaboriau; *Of Human Bondage,* Ltd. Ed., 1938. Auth.: *Gist of Art,* 1939 (autobiographical). **Sources:** WW47; Rowland Elzea and Elizabeth Hawkes, *John Sloan: Spectator of Life* (Wilmington: Delaware Art Mus., 1988); David W. Scott, *John Sloan* (New York, 1975); Mecklenburg, Zurier, and Snyder, *Metropolitan Lives: the Ashcan Artists and their New York;* William Innes Homer, *Robert Henri & His Circle* (1969); Bennard B. Perlman, *The Immortal Eight: American Painting from Eakins to the Armory Show, 1870-1913* (New York, 1962); Baigell, *Dictionary;* P&H Samuels, 446; Eldredge, et al., *Art in New Mexico, 1900-45,* 207-08; Falk, *Exh. Record Series.*

SLOAN, Junius R. *[Landscape and* ~~Junius R. Sloan 1892~~ *portrait painter]* b.1827, Kingsville, OH / d.1900, Redlands, CA.
Addresses: Erie, PA, 1858-1863; Chicago, 1863-67; NYC, 1867-73; Chicago, 1873 and after. **Studied:** Moses Billings was his mentor in Erie, Pa., 1848. **Exhibited:** Art Emporium Exhib., Chicago, 1864; NAD, 1871; Brooklyn AA, 1871-72, 1884; AIC, 1892, 1895. **Work:** Chicago Hist. Soc.; Minn. Hist. Soc.; Sloan Collection, Valparaiso Univ. Mus. of Art. **Comments:** He began as an itinerant portrait painter at Ashtabula (OH) and Erie (PA) in 1848, and during the next several years worked in Ohio, Pennsylvania, upstate New York, and Vermont, spending winters in Erie and Cincinnati. He painted in Princeton (IL) from 1855-57 and in NYC during the winter of 1857-58. After his marriage in 1858, he settled in Erie, remaining there, except for summer visits to NYC and the Catskills, until 1863. He worked in Chicago from 1863 to 1867, establishing himself as a landscape painter and opening a studio in Appleton's Building. From 1867-73 he lived and painted in NYC and the Hudson Valley. After 1873 he returned to Chicago, but made frequent trips to the East and through the Midwest. **Sources:** G&W; Webster, "Junius R. Sloan," 15 repros.; Sweet, *Hudson River School;* NYBD 1858. More recently, see Gerdts, *Art Across America,* vol. 1: 300 and vol. 2: 176 (repro.), 290, 322.

SLOAN, Louis B. *[Painter]* 20th c.
Addresses: Phila., PA. **Exhibited:** PAFA Ann., 1960-62 (medal for best landscape), 1964, 1968. **Sources:** Falk, *Exh. Record Series.*

SLOAN, Marianna *[Painter, mural painter]* b.1875, Lock Haven, PA / d.1954.

Addresses: Philadelphia, PA. **Studied:** Phila. School Design for Women, with Henri, late 1890s; E. Daingerfield, Phila. **Exhibited:** PAFA, 1898-1905, 1913-15 (landscapes and seascapes); AIC, 1902-09; Royal Acad. & British Inst., London, 1905; St. Louis Expo, 1904 (med); Boston AC, 1905-08; Soc.Indep. Artists, 1917. **Work:** PAFA; murals, Church of Annunciation, Phila.; St. Thomas Church, White Marsh, Pa.; St. John Baptist Church, Germantown, Pa.; St. Louis C. **Comments:** Younger sister of John Sloan. Not to be confused with Marian Parkhurst Sloane. Preferred media: oil, watercolor, pastel. She painted urban, coastal, and marine scenes as well as landscapes. **Sources:** WW53; WW47; Rubinstein, *American Women Artists,* 168-69; *The Pennsylvania Academy and Its Women, 1850-1920* (exh. cat., Phila: Pennsylvania Academy of the Fine Arts, 1974), no. 43; Danly, *Light, Air, and Color,* 74; *Art by American Women:.the Collection of L.and A. Sellars,* 95; Falk, *Exh. Record Series.*

SLOAN, Robert Smullyan *[Painter, private art dealer]* b.1915, NYC.
Addresses: Mamaroneck, NY. **Studied:** City College NY (A.B., 1936); Inst. Fine Arts, NYU, 1937-39. **Member:** Appraisers Assn. Am.; Mamaroneck Artists Guild (pres., 1954). **Exhibited:** Nat. Soldier Art Show, 1945 (watercolor div. award); NGA, 1945; ASL, 1945; West Point; CI, 1948; Corcoran Gal biennial, 1949; "Portraits of Year," Portraits, Inc., 1949; Am. Watercolor Soc. Exhib., NAD, 1956. Awards: citation for distinguished service, U.S. Treasury, 1943. **Work:** IBM Collection; Bradford Jr. College, Haverhill, MA; White Art Mus., Ithaca, NY. Commissions: many covers & special features, *Time, Coronet & Colliers,* 1941-50; posters, Russian War Relief, 1943 & Doing All You Can, Brother, U.S. Treasury, 1943. **Comments:** Preferred media: oils. Specialty of gallery: American and European painting, incl. Hudson River School. Publications: illustrator, *Army Educ. Program* & other mags. **Sources:** WW73; George Wiswell, "Discovery of a Copley Portrait," *Am. Heritage Magazine* (1960); WW47.

SLOAN, Samuel *[Architect]* b.1815 / d.1884.
Addresses: Philadelphia. **Exhibited:** PAFA, 1852 (architectural drawings). **Sources:** G&W; Rutledge, PA.

SLOANE, A. B. *[Listed as "artist"]* b.c.1810, South Carolina.
Addresses: Charleston, 1850. **Sources:** G&W; 7 Census (1850), S.C., II, 330.

SLOANE, Anna Bogenholm *[Artist]* early 20th c.
Addresses: Active in Washington, DC, 1907-17. **Sources:** Petteys, *Dictionary of Women Artists.*

SLOANE, Cyril *[Painter]* 20th c.
Addresses: Westport, CT. **Exhibited:** Soc. Indep. Artists, 1938, 1941-42. **Sources:** Marlor, *Soc. Indp. Artists.*

SLOANE, E. K. *[Museum director]* 20th c.
Addresses: Norfolk, VA. **Sources:** WW59.

SLOANE, Eric *[Illustrator, writer, landscape painter, designer]* b.1910, NYC / d.1985. *Eric Sloane*
Addresses: Taos, NM 1925 and 1960; Cornwall Bridge, CT in 1976. **Studied:** ASL; Sch. Fine Arts, Yale Univ., 1939; New York Sch. Fine & Applied Art, 1935. **Member:** NA, 1968; SC; Lotos Club. **Exhibited:** S. Indp. A., 1941. Awards: gold medal, Hudson Valley AA, 1964; Freedom Found Award, 1965. **Work:** Gilcrease Mus., Tulsa; Shelburne (VT) Mus; Sloane-Stanley Mus., Kent, CT. Commissions: designed & executed Willett's Mem., Am. Mus. Natural History; murals, International Silver Co., Meriden, CT, Morton Salt Co., Chicago & Wings Club, Biltmore Hotel, all NYC. **Comments:** Born Everard Jean Hinrichs, he came from a non-artistic family, but decided early on to pursue a career in art. In 1925 he took a road trip, painting signs, trucks and store windows along the way, spending time in the Pennsylvania Amish country, the French Quarter in New Orleans, and Taos, NM. Around 1930 he changed his name to Sloane. His interest in mete-

orology led to his "cloudscape" paintings, studies at MIT and several books on weather. Muller reports that Sloane was the first weatherman on television. Publications: auth., "Skies and the Artist," 1951; "Return to Taos," 1960; "Museum of Early American Tools," 1964; "Reverence for Wood," 1965; "Remember America," 1971. His autobiography is "Eighty: An American Souvenir." Donor, Eric Sloane Mus. Early Am. Tools, Kent, CT. **Sources:** WW73; P&H Samuels, 445; Muller, *Paintings and Drawings at the Shelburne Museum,* 127 (w/repro.); *300 Years of American Art,* 940.

SLOANE, Eunice *[Illustrator]* 20th c.
Addresses: NYC. **Member:** SI. **Sources:** WW47.

SLOANE, George *[Painter]* b.1864 / d.1942.
Addresses: Boston, MA. **Member:** Providence AC. **Exhibited:** Boston AC, 1893-99; AIC; PAFA Ann., 1893, 1898. **Sources:** WW25; Falk, *Exh. Record Series.*

SLOANE, Joseph Curtis *[Art historian, educator]* b.1909, Pottstown, PA.
Addresses: Chapel Hill, NC. **Studied:** Princeton Univ. (A.B., 1931; M.F.A., 1934; Hodder fellowship, 1948; Ph.D., 1949). **Member:** College Art Assn. Am. (pres.); North Carolina State Arts Council; Am. Soc. Aesthetics; Am. Council Arts Educ. (pres.). **Exhibited:** Awards: Fulbright senior research grant, 1952; alumni distinguished prof., Univ. North Carolina, 1963-. **Comments:** Publications: author, "French Painting Between the Past and the Present," Princeton Univ. Press, 1951; author, "Paul Marc Joseph Chenavard," Univ. North CaArolina Press, 1962; author, articles, *Art Bulletin, Art Quarterly, Gazette Beaux-Arts, Art Journal.* Teaching: instructor of art hist., Princeton Univ., 1935-37; asst. professor art hist. & chmn. dept. art, Rutgers Univ., 1937-38; from assoc. professor art hist. to professor & chmn. dept. art, Bryn Mawr College, 1938-58; pro essor art hist. & chmn. dept. art, Univ. North Carolina, Chapel Hill, 1958-; director, William Hayes Ackland AC. Research: nineteenth and twentieth century art, especially painting. **Sources:** WW73.

SLOANE, Marian Parkhurst Webber Waitt (Mrs. George) *[Landscape painter, art critic]* b.1876, Salem, MA / d.c.1954, Gloucester, MA.
Addresses: Boston, MA. **Studied:** BMFA Sch.; T. Juglaris, Gallison, and L. Kronberg in Boston. **Member:** Gld. Boston Artists; All. Artists Am.; North Shore AA; Rockport AA; NAWPS; CAFA; Grand Central Gal. Assn.; Copley Soc., 1904. **Exhibited:** Corcoran Gal biennials, 1926-37 (6 times); PAFA Ann., 1918 (as Waitt), 1928-34; NAD, 1939; BMFA; Montclair Art Mus.; Currier Gal. Art. Award: medal, prize, Jordan Marsh, Boston, 1948. **Work:** Montclair Art Mus. **Comments:** Not to be confused with Marianna Sloan. Position: art critic, *Boston Journal.* **Sources:** WW53; WW47; WW25 (as Marian Parkhurst Waitt); Vose Galleries, *Mary Bradish Titcomb and Her Contemporaries,* 51; Falk, *Exh. Record Series.*

SLOANE, Mary (Humphreys) *[Painter]* b.1912, NYC.
Addresses: Bernardston, MA. **Studied:** Wells College, A.B., 1931; Columbia Univ.; also with George Picken. **Member:** Artists Equity Assn.; NAWA; Cape Cod AA; Provincetown AA; Springfield Art League. **Exhibited:** Minot State Teachers College, ND, 1962; New Mexico Highlands Univ., 1962; Unitarian Soc., Amherst, MA, 1968; Int. Group, Roland Gibson Art Foundation, 1968; St. Paul's School, Concord, NH, 1969. Awards: medal of honor, NAWA, 1957; Silvermine Guild Art, 1957; silver medal, Springfield Art League, 1959. **Comments:** Positions: Mass. State Art Chmn.; Am. Assn. Univ. Women Art Leader, Nine-State Northeast Conference, 1960. Publications: author, "Strong Cables Rising," 1942. Teaching: lectures on art to colleges & library associations. **Sources:** WW73.

SLOANE, Patricia Hermine *[Painter]* b.1934, NYC.
Addresses: NYC. **Studied:** Dayton Art Inst., 1947-49, scholarship, 1949; RISD, scholarship, 1953-54, B.F.A., 1955; Ohio Univ. Grad. College, scholarship, 1955-956; Na.t Acad. Design, 1956-58; Hunter College, M.A., 1968; also with Hans Hofmann; New

York Univ., Ph.D., 1972. **Member:** College Art Assn. Am.; Am. Soc. Aesthetics. **Exhibited:** Riverdale YMHA, 1964; Emanu-el Midtown YMHA, 1964; Chelsea Exhib., St. Peter's Episcopal Church, 1964; Grand Central Moderns, 1968 (solo); Fordham Univ.; Univ. Rhode Island, 1968. **Work:** MoMA Lending Collection, New York; Andrew Dickson White Mus., Cornell Univ.; Univ. Notre Dame, IN Commissions: book jacket design & book design for New York City publ. **Comments:** Publications: contributor, drawings, *Village Voice*; contributor, critical articles, *East* (newspaper of the arts). Teaching: instructor, introduction to fine arts, Ohio Univ., 1956; instructor of arts & crafts, Jewish Community Center, Providence, RI; instructor, Scarsdale Studio Workshop, 1965-; instructor, Univ. Rhode Island, Community College of City Univ. New York, Trenton Jr. College & others; gallery lecturer, WMAA; asst. professor, City Univ. New York. **Sources:** WW73.

SLOAT, Florence M. *[Painter] 20th c.*
Exhibited: Salons of Am., 1935. **Sources:** Marlor, *Salons of Am.*

SLOBE, Laura *[Painter] b.1909, Pittsburgh, PA.*
Addresses: Chicago, IL. **Studied:** AIC. **Exhibited:** AIC, 1932 (prize), 1933 (prize), 1934 (prize). **Sources:** WW40.

SLOBE, Thelma *[Painter] 20th c.; b.NYC.*
Addresses: Chicago, IL; NYC, Rochester, NY. **Exhibited:** AIC, 1940 (prize), 1943-45, 1946 (prize) (solo); Am.-British AC, 1942; MMA, 1942; PAFA Ann., 1942, 1946, 1950; VMFA, 1946; Rundel Gal., Rochester, NY, 1944 (solo); AIC, 1940 (prize), 1943-46 (solo, prize). **Sources:** WW53; WW47; Falk, *Exh. Record Series.*

SLOBODKIN, Louis *[Sculptor, illustrator, writer, lecturer, teacher] b.1903, Albany, NY / d.1975, Miami Beach, FL.*
Addresses: NYC; Bay Harbor Island, FL. **Studied:** BAID, 1918-23. **Member:** An Am. Group; Sculptors Gld.; AIGA; Albany Art Group; Rockport Art Group; NSS; Am. Artists Congress; Municipal AS. **Exhibited:** Salons of Am., 1935; WMAA, 1935-49; WFNY, 1939; AIC, 1939-43; MMA, 1942; Sculptors Gld. Traveling Exhib.; An Am. Group, 1939-46; PAFA Ann., 1942-45; AIGA, 50 Best Books Exhib., Am. Inst. Graphic Art, 1944; MMA Illus. Exhib., 1944; AV Goodwill Tour, Europe; AFA Traveling Exhib., 20 Best Children's Books, 1944. **Awards:** Caldecott Medal, 1943. **Work:** mem. tower, Phila. Commissions: U.S. Post Office, Washington, DC; statue of Lincoln, Symbol of Unity, for Fed. Bldg. garden; Young Abe Lincoln (bronze statue), Interior Bldg., Washington, DC; two panels, Madison Square Post Office, New York; Tropical Postman (aluminum). **Comments:** Author: "Magic Michael," 1944; "Clear the Track," 1945. Illustrator: "Rufus M," 1943; "Many Moons," 1943; "Tom Sawyer," 1946; "Robin Hood," 1946. Author/illustrator: "Read About the Postman," 1966; "Read About the Fireman," 1967; "Read About the Busman," 1957; "Round Trip Spaceship," 1968; "Wilbur the Warrior," 1971. Contributor: *Magazine of Art* & *Horn Book.* Teaching: lecturer, contemporary sculpture & designing & illustrating children's books; head sculpture dept., Master Inst., New York, 1934-37; head sculpture div., New York City Art Project, 1941-42. **Sources:** WW73; WW47; Falk, *Exh. Record Series.*

SLOBODKIN, Simon Harris *[Designer] b.1891, Boston, MA / d.1956.*
Addresses: NYC. **Studied:** Harvard Univ. **Exhibited:** MMA, 1934, 1940; WMA, 1933; Richmond Acad. A. & Sc., 1934; Indst. A. Exp., N.Y., 1934; Paris Int. Expo, 1937; MoMA, 1935. **Sources:** WW53; WW47.

SLOBODKINA, Esphyr *[Abstract painter, illustrator, writer, designer, craftsperson, sculptor] b.1908, Tcheliabinsk, Russia.*
Addresses: NYC; Great Neck, NY. **Studied:** NAD; & abroad. **Member:** Am. Abstract Art (1930s-60s); Fed. Mod. P&S; Artists Union, 1930s. **Exhibited:** WMAA, 1950-58; ; John Heller Gal.; CGA; Phila. MA ("Eight by Eight" exhib.), 1945. **Work:** WMAA. **Comments:** She married the abstract painter, Ilya Bolotowsky, in

1933. She was also a textile designer, and in 1936 worked on WPA projects. She also created abstract collage. Author/illustrator: "Caps for Sale"; "Sleepy ABC"; "The Wonderful Feast"; "Little Dog Lost," "The Little Fireman," "Hiding Places" & other books. **Sources:** WW59; WW47 (she gave an incorrect birth date of 1914); *American Abstract Art,* 178.

SLOCOMB, Cora Anne (Mrs. Samuel) *[Sculptor, painter] b.c.1810, New Orleans,LA / d.1884.*
Addresses: New Orleans, active ca.1868. **Studied:** Mme. Louis Grec-Durussel. **Exhibited:** Grand State Fair, 1868 (hon. mention); Paris Salon, 1881. **Sources:** *Encyclopaedia of New Orleans Artists,* 354; Fink, *American Art at the Nineteenth-Century Paris Salons,* 391.

SLOCOMB, Edwin Pliny *[Portrait and landscape painter and miniaturist] b.1823, Sutton, MA / d.1865, Morrisania, NY.*
Addresses: Active in Worcester, MA; Charleston, SC; Baltimore, MD; Wilmington, DE; and in and around NYC. **Comments:** He was married in Wilmington in 1859. A vegetarian and an opponent of vaccination, he died of small pox. **Sources:** G&W; Slocum, *History of the Slocums, Slocumbs and Slocombs of America,* I, 537.

SLOCUM, Annette M. (Mrs.) *[Sculptor] 20th c.*
Addresses: Phila., PA. **Exhibited:** PAFA Ann., 1913-14. **Sources:** WW24; Falk, *Exh. Record Series.*

SLOCUM, Samuel Gifford *[Architect, sculptor] b.1854, Leroy, NY.*
Addresses: Phila., PA; NYC/Saratoga Springs, NY. **Studied:** Cornell Univ. **Member:** SC; AIA 1887. **Exhibited:** PAFA Ann., 1889 (medalion & drawing). **Sources:** WW08; Falk, *Exh. Record Series.*

SLOCUM, Serena L. *[Painter] 20th c.*
Addresses: Pennsylvania. **Exhibited:** PAFA Ann., 1951. **Sources:** Falk, *Exh. Record Series.*

SLOCUM, Victor V. *[Sculptor] 20th c.*
Addresses: Phila., PA. **Exhibited:** PAFA Ann., 1924. **Sources:** Falk, *Exh. Record Series.*

SLOHOTKIN, Louis *[Sculptor] 20th c.*
Addresses: NYC. **Sources:** WW25.

SLOMAN, Joseph *[Painter, craftsperson, designer, illustrator] b.1883, Philadelphia, PA.*
Addresses: Union City, NJ. **Studied:** Drexel Inst.; & with Howard Pyle, William Chase; B.W. Clinedinst; C. Grayson. **Exhibited:** Phila. AC; AWCS; S. Indp. A.; PAFA; NAD; Ft. Worth, TX; Marshall Field, Chicago (solo). **Awards:** prizes, Drexel Inst.; Wanamaker prize, 1904. **Work:** Bordentown (NJ) Hist. Soc. Mus.; mem., Snyder H.S., Jersey City, NJ; mural, Gorham Silver Co., NY; stained glass, Union City Pub. Lib. & churches in Boston, New York, Athens, GA, Hoboken, NJ. **Comments:** Illustrator: "In Many Lands" (1923), "A Declaration of Dependence," "Alias Kitty Kasey". **Sources:** WW53; WW47.

SLOMIS, S. *[Painter] 20th c.*
Exhibited: Salons of Am., 1934. **Sources:** Marlor, *Salons of Am.*

SLONIMSKY, Nicolas (Mrs.) See: **ADLOW, Dorothy (Mrs. Nicolas Slonimsky)**

SLONIN, Malvina C. *[Painter] 20th c.*
Addresses: Brooklyn, NY. **Exhibited:** S. Indp. A., 1933-34. **Sources:** Marlor, *Soc. Indp. Artists.*

SLOOP, Jacob H. *[Landscape painter] mid 19th c.*
Addresses: Cincinnati, 1850-51. **Sources:** G&W; Cist, *Cincinnati in 1851.*

SLOPER, Norma (Wright) *[Painter] b.1892, New Haven, CT.*
Addresses: New Britain, CT. **Studied:** A.E. Jones; L. Simon; R. Ménard, Paris. **Member:** Soc. Conn. Painters; CAFA. **Exhibited:** S. Indp. A., 1920; CAFA, 1922 (prize). **Sources:** WW33.

SLOSHBERG, Leah Phyfer *[Art administrator] b.1937, New Albany, MS.*
Addresses: Trenton, NJ. **Studied:** Mississippi State College Women, B.F.A.; Tulane Univ. , M.A. **Member:** Am. Assn. Mus. **Comments:** Positions: curator of arts, asst. director, 1969-71 & director, 1971-, NJ State Mus., Trenton. Collections arranged: Burgoyne Diller Retrospective, 1966; Focus on Light, 1967; Ben Shahn Retrospective, 1969. **Sources:** WW73.

SLOTNICK, Mack W. *[Portrait painter, drawing specialist, teacher] b.1899, Russia.*
Addresses: Plainfield, NY. **Studied:** CUA School; Arts & Crafts Guild; NAD. **Member:** Plainfield AA; Montclair AA; Orange AA. **Sources:** WW47.

SLOTNICK, Mortimer H. *[Painter] b.1920, New York, NY.*
Addresses: New Rochelle, NY. **Studied:** City College New York; Columbia Univ. **Member:** Allied Artists Am.; AAPL; Am. Vet. Soc. Artists; Westchester AA; New Rochelle AA. **Exhibited:** WMAA; Riverside Mus.; Hudson River Mus.; NYPL; NAD. **Comments:** Teaching: professor of art & art educ., City College New York; supervisor of arts & humanities, City School District, New Rochelle, NY; lecturer art educ., College New Rochelle. **Sources:** WW73.

SLOWNE, Anna Bogenholm *[Artist]*
Addresses: Wash., DC, active 1901-17. **Sources:** McMahan, *Artists of Washington DC,*.

SLUIZER, Kurt *[Painter] b.1911, Holland / d.1988, Zena, NY.*
Addresses: Amsterdam, Holland; Woodstock, NY. **Studied:** Federal Academy of Art, Amsterdam, 1930-36 (honors & prizes). **Member:** Woodstock Artists AA. **Exhibited:** Academy of Art, Amsterdam (2 solos); The Hague (solo); Berkshire Art Festival, Pittsfield, MA, 1946 (prize); Rensselaer Art Community Federal Center, Troy, NY, 1979 (1st prize, landscape); Mid-Hudson Art Center, Poughkeepsie, 1979; Woodstock Soc. of Art; galleries in NYC and upstate NY. Awards: Kuniyoshi Fund Award, 1980. **Work:** Woodstock AA. **Comments:** He escaped to the U.S. from the Nazi invasion in 1939 and settled in Woodstock a few years later. His paintings range from impressionist landscapes to circus scenes and studies of geese and horses. **Sources:** info. courtesy of Peter Bissell, Cooperstown, NY; Woodstock AA.

SLUSSER, Jean Paul *[Museum director, painter, writer, educator, lecturer] b.1886, Wauseon, OH / d.1978.*
Addresses: Ann Arbor, MI. **Studied:** Univ. Michigan (A.B., A.M.); Univ. Munich; BMFA Sch.; ASL, and with Hofmann, McFee, Shahn, J.F. Carlson. **Member:** Am. Assn. Univ. Prof.; CAA; AAMus.; Woodstock AA. **Exhibited:** Corcoran Gal biennial, 1935; AIC; WMAA; BM; WFNY, 1939; S. Indp. A., 1921-22, 1924, 1926-27; Detroit IA, 1926-52, prizes: 1924, 1928, 1931, 1937, 1945; Ann Arbor AA, 1926-52; Detroit MA, 1931 (prize); Detroit SA, 1937 (prize). Michigan WCS, 1946-52 (prize 1951); Old Northwest Territory Exhib., 1951 (prize), 1952. Awards: Michigan Acad. Science, Arts & Letters, 1960 (prize). **Work:** IBM; Detroit IA; Ann Arbor AA; Univ. Michigan; Illinois State Mus.; WPA murals, USPO, Blissfield, MI; Detroit SAC. **Comments:** Author: "Bernard Karfiol," Am. Artists Series, 1931. Positions: Univ. Michigan Mus. Art (Ann Arbor) acting chmn., 1926-54, prof., 1945-56, director, 1947-56. **Sources:** WW66; WW47; Woodstock AA.

SLUTZ, Helen Beatrice *[Miniature painter] b.1886, Cleveland, OH.*
Addresses: Chicago, IL; Los Angeles, CA, c.1923; Dallas, TX; Evanston, IL. **Studied:** Cleveland School Art. **Member:** Calif. SMP (1920s); Artland Club of Los Angeles; AFA; Hollywood AA; Klepper Art Club, Dallas. **Exhibited:** Theobald Gal., Chicago; Women's City Club, Kansas City; Dallas Women's Expo; AIC. **Sources:** WW40; Hughes, *Artists in California,* 519.

SLUTZKER, Paula *[Painter] 20th c.*
Exhibited: S. Indp. A., 1938, 1943. **Sources:** Marlor, *Soc. Indp. Artists.*

SLUYTERS, Jan *[Painter] 20th c.*
Exhibited: AIC, 1929. **Sources:** Falk, *AIC.*

SLY, Franklin *[Painter] 20th c.*
Addresses: Seattle, WA. **Sources:** WW24.

SLY, Vera Elizabeth Youngberg *[Painter, craftsperson, ceramacist] b.1941, Middletown, NY.*
Addresses: New Hampton, NY. **Studied:** Univ. of Tennessee; Gould Studio, Washingtonville, NY; Orange County CC; Middletown, NY. **Member:** National Inst. Poetry, MD. **Exhibited:** Orange County Fair (prize). **Comments:** Realist painter who specialized in Hudson River scenes. Author of articles on life along the Hudson River. **Sources:** info. courtesy Vera Sly, New Hampton, NY.

SMALL, Alice Jean *[Painter, printmaker, teacher, illustrator] 20th c.*
Addresses: Tacoma, WA. **Studied:** Univ. of Wash. **Member:** Northwest Printmakers; Northwest WC Soc. **Exhibited:** SAM; Wash. State Hist. Soc., 1950; Univ. of Puget Sound (solo). **Comments:** Position: teacher, Tacoma Pub. Schools; art faculty, Univ. of Wash.; hd. of art dept., Univ. of Florida. Illustrator of children's books. **Sources:** Trip and Cook, *Washington State Art and Artists.*

SMALL, Amy Gans *[Sculptor, instructor] b.1910, NYC / d.1997, Woodstock, NY.*
Addresses: Woodstock, NY, 1928. **Studied:** Hartford Art School, 8 yrs; ASL, with Zorach; New School Social Res., with Seymour Lipton; Nat. Park College, Forest Glen, MD; Sculpture Center, New York; Cent. Cult., Inst. Nat. Bellas Artes, Mexico City, Mexico, 1971-72; also with Lothar J. Kestenbaum. **Member:** Woodstock AA (board member, three times); Artists Equity Assn. NY (board member twice). **Exhibited:** Woodstock Presentation Show, NY, 1950; Woodstock AA, 25 yrs; Krasner Gal., New York, 1958 (solo), 1959 (solo); Selected Artist Gal., NY, 1961 (solo), 1968 (solo); Easthampton Guild Shows, 1961, 1967-68; Lewis Gallery, Woodstock, NY & Herbert H. Kende, NYC, 1970s. Awards: Best in show, Westchester Arts & Crafts Guild Show; Presentation Show Award, Woodstock AA, 1948. **Work:** Woodstock AA; Selected Artists Gallery, New York. Commissions: head of Ann Buckman (clay & cast stone), Dr. Moses Buckman, Westchester, NY, 1950; stone figures for sculpture Evan Frankel, Easthampton, NY, 1961. **Comments:** Married to John Small, brother of Hannah Small Ludins. Preferred media: wood, stone, metal. Teaching: instructor, sculpture, Lighthouse School for the Blind, New York, 1960-61; head sculpture section, Woodstock School Art, 1969-71; head private school, Easthampton & Woodstock, 1969-72; instructor, sculpture, Univ. Poughkeepsie, 1970-71. **Sources:** WW73; Zaidenberg, *Anyone Can Sculpt* (Harper & Row, 1952); Howard DeVree & Stuart Preston, articles, *New York Times,* 1961; Zaidenberg, *New & Classic Sculpture Methods* (World Publishing, 1972); add'l info. courtesy Woodstock AA.

SMALL, Angela Francis *[Painter] b.1881, Wash., DC / d.1966, Warrenton, VA.*
Addresses: Wash., DC; Warrenton, VA, c.1950. **Studied:** Corcoran Sch. Art; Royal Acad. Art, London. **Member:** Wash. AC; Gr. Wash. Indep. Exhib., 1935. **Sources:** McMahan, *Artists of Washington DC,*.

SMALL, Arthur Andrew (Captain) *[Painter] b.1885, Brockton, MA / d.1958, Brighton, MA.*
Exhibited: New Bedford Soc. Independent Artists Exhib., Swain Free School Design, 1931-32. **Work:** Old Dartmouth Hist. Soc. **Comments:** Sea captain, who painted marine scenes. Many of his paintings were destroyed during the hurricane of 1938, when he was manning the light at Palmer's Island Lighthouse. **Sources:** Blasdale, *Artists of New Bedford,* 172 (w/repro.).

SMALL, Elizabeth *[Painter, printmaker] 20th c.*
Addresses: San Francisco, CA. **Exhibited:** San Francisco AA, 1935, 1938. **Sources:** Hughes, *Artists in California,* 519.

SMALL, Eugene Walter *[Painter] b.1871, NYC / d.1934, NYC.*
Addresses: NYC. **Studied:** CCNY; NYU Law School.
Exhibited: S. Indp. A., 1932-34; Salons of Am. (solo); Independent Artists, Rockefeller Center (solo). **Comments:** He had been a lawyer & began painting c.1929.

SMALL, F(lorence) W(ilson) *[Illustrator] 20th c.*
Addresses: Brooklyn, NY. **Comments:** She died at age 96, but birth and death dates are unknown. **Sources:** WW21.

SMALL, Frank O. *[Illustrator, painter] b.1860, Boston, MA / d.1928.*
Addresses: Boston, MA. **Studied:** Académie Julian, Paris with Bouguereau and T. Robert-Fleury, 1885-87. **Exhibited:** Paris Salon, 1887-88; PAFA Ann., 1890, 1906; Boston AC, 1906. **Comments:** Some of his works relate to Bermuda. **Sources:** WW17; Fink, *American Art at the Nineteenth-Century Paris Salons,* 391; Falk, *Exh. Record Series.*

SMALL, George G. *[Portrait and landscape painter] b.1818.*
Addresses: Boston, 1850; Charlestown (Boston), 1860. **Sources:** G&W; 7 Census (1850), Mass., XXIV, 38; New England BD 1860.

SMALL, Hannah (Hannah Ludins) *[Sculptor] b.c.1903, NYC / d.1992, Woodstock, NY.*
Addresses: Woodstock, NY, 1923. **Studied:** Sch. Applied Design for Women, NYC; ASL with A. Stirling Calder, Boardman Robinson. **Member:** Woodstock AA. **Exhibited:** Fairmount Park, Phila., PA; AIC, 1940 (prize); WMAA, 1942-51; Woodstock AA; Rudolph Gal., Woodstock; Passedoit Gal., 1942 (solo), 1950 (solo); PAFA Ann., 1945, 1947, 1954; Des Moines AC, 1951. **Work:** Woodstock AA; Univ. Nebraska; Santa Fe Pub. Lib. **Comments:** Direct carver in a variety of materials. Favorite subjects: female figure often with children; animals. WPA artist. Granddaughter of Moses J. Ezekiel; cousin of Alfred Stieglitz (see entries); wife of Eugene Ludins, painter. **Sources:** WW59 & PAFA, Vol. III, give birth date as 1908; Fort, *The Figure in American Sculpture,* 224 (w/repro.), cites birth date as 1903 and death date as 1992; Woodstock AA gives 1903 as birth date and 1992 as death date.

SMALL, Hazel *[Painter, teacher] 20th c.*
Addresses: Denver, CO, c.1915-21. **Member:** Denver Artists Club. **Sources:** WW21.

SMALL, Isabel C. *[Painter] 19th c.*
Addresses: York, PA. **Exhibited:** PAFA Ann., 1890. **Sources:** Falk, *Exh. Record Series.*

SMALL, May See: **MOTT-SMITH, May Bird (Mrs.)**

SMALL, Nea Hazeltine (Mrs.) *[Painter] late 19th c.*
Addresses: Active in Oregon in 1886. **Sources:** Petteys, *Dictionary of Women Artists.*

SMALL, Suzanne *[Painter, teacher] b.1856, Kankakee, IL / d.1931, Kankakee, IL.*
Addresses: Kankakee. **Studied:** In Paris with Calain and Monet; in Spain, 1908-1909. **Sources:** Petteys, *Dictionary of Women Artists.*

SMALLEY, Janet Livingston *[Illustrator, writer, commercial artist] b.1893, Philadelphia, PA / d.1964.*
Addresses: Swarthmore, PA; Yeadon, PA. **Studied:** PAFA with Henry McCarter; Cresson traveling scholarship, PAFA, 1915; PAFA (fellowship). **Comments:** Illustrator: "Silver Yankee," 1953; "House Next Door," 1954; "Farm Girl," 1955; "Let's Play a Story," 1957; "Gift from the Mikado," 1958. Contributor to *Jack and Jill, Children's Hour* magazines. **Sources:** WW59; WW47.

SMALLEY, Katherine *[Landscape painter] b.c.1865, Waverly, IA.*
Addresses: Settled in Colorado Springs, 1889; living in Colorado City, 1924. **Studied:** AIC with Charles Corwin, 1884-85. **Exhibited:** AIC, 1892; Colorado College, 1892. **Comments:** Active 1890-. Smalley assisted with the painting of "Battle of Gettysburg," a cyclorama. She moved to Denver in 1888 to paint oil and pastel portraits. In Colorado Springs she specialized in watercolor landscapes. **Sources:** P&H Samuels, 446.

SMALLEY, Marian Frances Hastings *[Painter, decorator] b.1866, New Orleans, LA / d.1957, Hollywood.*
Addresses: Cincinnati, 1899-1902; NYC, 1903. **Comments:** Worked at Rookwood Pottery in Cincinnati; married Francis W. Vreeland (see entry) and moved to NYC, where she worked for Nat. Arts Club. **Sources:** Petteys, *Dictionary of Women Artists.*

SMALLWOOD, Virgina L. *[Painter]*
Addresses: San Francisco, Ca, 1890s; Oakland, CA, 1911. **Exhibited:** Mechanics' Inst. Fair, 1899; San Francisco AA 1900. **Sources:** Hughes, *Artists in California,* 520.

SMALLWOOD, William *[Listed as "artist"] late 19th c.*
Addresses: Indianapolis, 1860. **Sources:** G&W; Indianapolis BD 1860.

SMART, Anna *[Painter] b.1847, Baltimore, MD / d.1914, NYC.*
Studied: with Bouguereau, Ferrier. **Exhibited:** Paris Salon, 1891. **Sources:** Petteys, *Dictionary of Women Artists;* Fink, *American Art at the Nineteenth-Century Paris Salons,* 391.

SMART, Edmund Hodgson *[Portrait painter] b.1873, Ainwick, England / d.1942.*
Addresses: Los Angeles, CA (since 1925). **Studied:** Antwerp Acad.; Sir. H. von Herkomer; Académie Julian, Paris. **Exhibited:** Royal Academy, London; Paris Salon. **Work:** NMAA. **Comments:** Came to U.S. in 1916. **Sources:** Hughes, *Artists of California,* 520.

SMART, Emma *[Painter] b.1862, Buffalo, NY / d.1924.*
Addresses: Active in Utah. **Studied:** in New York. **Sources:** Petteys, *Dictionary of Women Artists.*

SMART, John *[Engraver] b.1810, New York.*
Addresses: NYC, 1860. **Comments:** He owned property valued at $6,100. His son Robert, 18, was an apprentice engraver. **Sources:** G&W; 8 Census (1860), N.Y., LXII, 672.

SMART, Mary-Leigh (Mrs. J. Scott) *[Collector, patron, writer] b.1917, Springfield, IL.*
Addresses: Ogunquit, ME. **Studied:** Oxford Univ., diploma, extra mural delegacy, 1935; Wellesley College, B.A., 1937; Columbia Univ., M.A., 1939; also with Bernard Karfiol, 1938-39. **Member:** Barn Gallery Assocs. (founding secretary & program dir., 1958-69; pres., 1969-70; hon. director, 1970-); Inst. Contemporary Art, Boston (corporator, 1965-); DeCordova Mus. (acquisitions committee, 1966-); Strawbery Banke (overseer, 1971-); AFA. **Comments:** Art interests: contemporary art and organizations promoting it; publisher of two works of conceptual art by Christopher C. Cook. Collection: twentieth century New England painting and sculpture; American, European and Asian contemporary graphics. Publications: editor/author, *Hamilton Easter Field Art Foundation Collection* (catalogue, 1966); editor,*Art: Ogunquit, A National Exhibition of Artists Who Have Worked in Ogunquit* (catalogue, 1967); author, *Barn Gallery Assocs. in Action* (1969); "The Barn Gallery" (1970). **Sources:** WW73.

SMAUL, Fay B. *[Painter] 20th c.*
Addresses: Phila., PA. **Exhibited:** PAFA Ann., 1958. **Sources:** Falk, *Exh. Record Series.*

SMEDLEY, Victor J. *[Painter] late 19th c.*
Studied: with Lefebvre. **Exhibited:** Paris Salon, 1889; AIC, 1891-92. **Sources:** Fink, *American Art at the Nineteenth-Century Paris Salons,* 391.

SMEDLEY, Will Larrymore *[Painter, craftsperson, graphic artist, designer, sculptor, architect, illustrator, writer, lecturer] b.1871, Sandyville, OH / d.c.1958, Chatauqua, NY.*
Addresses: Chautauqua-on-the-Lake, NY. **Studied:** Case Sch. Applied Science. **Member:** Soc. A&I; Cleveland Soc. Artists; Nat. Craftsmen. **Exhibited:** NAD; AMPS; PAFA; AWS; S. Indp. A.; Albright Art Gal.; AIC; NYC; Phila.; Cleveland; Chicago.

Sources: WW53; WW47.

SMEDLEY, William T(homas)
[Painter, illustrator] b.1858, West Bradford, Chester, PA / d.1920, Bronxville, NY.

Addresses: NYC, 1881-98; Bronxville, NY. **Studied:** PAFA; Acad. Julian, Paris, with J.P. Laurens. **Member:** ANA, 1897; NA, 1905; SAS, 1882; AWCS; Mural Painters; NIAL; SI, 1901; Portrait Painters; Artists Aid Soc.; Century Assn. **Exhibited:** PAFA Ann., 1881, 1898-1908, 1917; NAD, 1881, 1883, 1894-98, 1903-19 (medals in 1906, 1907, and 1916); Brooklyn AA, 1882-83; Paris Salon, 1888; AIC, 1888-1917; AWCS, 1890 (prize); Boston AC, 1886, 1898; Paris Expo, 1900 (medal); Pan-Am. Expo, Buffalo, 1901 (medal); Corcoran Gal annuals/biennial, 1907-08, 1912. **Work:** NGA; Library of Congress (drawings); MMA. **Comments:** Smedley was best known as an illustrator of New York's beautiful women and the upper class. He began as an engraver in Philadelphia, studied painting at PAFA, and then worked in NYC for a magazine before studying in Paris. When he returned, he became an important illustrator of social life for magazines, first using pen and ink and then opaque watercolor. A book of his drawings was published in 1899. In 1882 he traveled in the Canadian West, making illustrations for *Picturesque Canada*. He also sketched and traveled in the US before making a trip around the world in 1890. **Sources:** WW19; P&H Samuels, 446; Falk, *Exh. Record Series.*

SMEE, Esther *[Painter] 20th c.*
Addresses: Long Beach, CA. **Member:** Laguna Beach AA. **Exhibited:** Calif. Art Club, 1937-38. **Sources:** Hughes, *Artists in California*, 520.

SMEHYL, Charles *[Painter] mid 20th c.*
Exhibited: Corcoran Gal biennials, 1941. **Sources:** Falk, *Corcoran Gal.*

SMELEFF, Gertrude H(eilprin) *[Painter] 20th c.*
Exhibited: Salons of Am., 1923. **Sources:** Marlor, *Salons of Am.*

SMELTZER, Sterling *[Painter] 20th c.*
Addresses: Charleston, WV. **Work:** WPA mural, Willoughby, OH. **Sources:** WW40.

SMERALDI, John D. *[Mural painter, furniture designer] b.1868, Palermo, Sicily / d.1947, Queens, NY.*
Addresses: Los Angeles, CA. **Work:** hotels & private residences. **Comments:** Came to U.S., 1889. **Sources:** Hughes, *Artists in California*, 520.

SMERTZ, Robert *[Painter] 20th c.*
Addresses: Pittsburgh, PA. **Member:** Pittsburgh AA. **Sources:** WW25.

SMET, Pierre-John de (Father) See: **DE SMET, Father Pierre-Jean (Blackrobe)**

SMIBERT, John *[Portrait painter] b.1688, Edinburgh (Scotland) / d.1751, Boston, MA.*
Addresses: Newport, RI; Boston, from May, 1729. **Studied:** apprenticed to a house painter in Edinburgh, 1702-09; Godfrey Kneller's Great Queen Street Academy, London, c. 1714. **Exhibited:** Brooklyn AA, 1872 ("Dean Berkeley and His Family" Yale Univ.). **Work:** Smibert 's Notebook, an account book recording details of his career from 1709 to 1747 (including his activities during his trip to Italy and a list of his portrait commisssions), is located at the Public Record Office in Boston; his paintings are in collections at Yale Univ. Art Gallery; National Gallery of Ireland; MMA; Rhode Island Hist. Soc.; Winterthur Mus. (Winterthur, DE); Fogg Mus. at Harvard (Smibert's copy of Van Dyck's Cardinal Guido Bentivoglo, donated by Trumbull in 1791). **Comments:** Went to London, c.1709, where for the next four years he worked as a coach painter and copyist before entering Kneller's drawing academy. He returned to Edinburgh in 1717 and painted portraits until sometime in 1719, when he departed for Italy. Smibert spent three important years in Italy, studying the great paintings and making copies after old masters. From 1723-

28 he worked in London. In the latter year he was asked to join his friend Dean George Berkeley, and several others, on a journey to Bermuda, where Berkeley hoped to establish a college. Before they departed, John Wainwright, an admirer of Berkeley, commissioned Smibert to paint a large commemorative portrait of the group. Setting sail in 1728, they arrived in Virginia and then went on to Newport (RI), where they had to wait for additional funds from the English Parliament (funding was ultimately rejected). In the meantime, Smibert left Berkeley's party and went to Boston, where he spent the rest of his life. A notebook entry from November of 1730 confirms that Smibert was still finishing the portrait of the Berkeley entourage. When finished, the "Bermuda Group" (Yale Univ. Art Gallery; a smaller, earlier, version is at National Gallery of Ireland), became the largest painting in the colonies (69.5 in. x 93 in.). It also helped firmly establish Smibert's reputation and served as a source of inspiration for artists who followed. For various reasons, Wainwright never claimed the painting and it remained in Smibert's studio until well after the artist's death. Thus it was seen by everyone who visited the studio, which also showcased his copies after old masters, his large print collection, antique casts, and additionally served as a painting supply shop. This collection was an important learning tool for young American artists who had not gone to Europe. As for his own work, Smibert was received with great enthusiasm in Boston and the colonies. His academic training and his knowledge of the newest fashions in portraiture placed him in great demand. Between 1729-46, when he retired because of vision problems, he created about 250 paintings. Smibert's son Nathaniel Smibert was also an artist (see entry). **Sources:** G&W; Henry Wilder Foote, *John Smibert, Painter* (1950). More recently, see Saunders and Miles, 113-125; Craven, *Colonial American Portraiture* 160-177.

SMIBERT, Nathaniel *[Portrait painter] b.1735, Boston / d.1756, Boston.*
Addresses: Boston, 1735-56. **Comments:** Nathaniel, son of John Smibert, painted portraits in Boston between 1750-56. **Sources:** G&W; Foote, *John Smibert, Painter*, 257-74, with catalogue of his work; Burroughs, "Paintings by Nathaniel Smibert."

SMILEY, Helen A. *[Craftsman, teacher, writer, block printer, designer] b.1900, Philadelphia, PA.*
Addresses: Philadelphia, PA. **Studied:** Temple Univ., B.S.; Columbia Univ., M.A.; PMSchIA. **Member:** Phila. Art All.; Penn. Soc. Craftsmen. **Exhibited:** Phila. Art All., 1941 (prize), 1942-43, 1953. **Comments:** Specialty: jewelry, textile designer, pottery. **Sources:** WW59; WW47, puts date of birth at 1896.

SMILEY, M. F. *[Painter] late 19th c.*
Addresses: Scarsdale, NY, 1882. **Exhibited:** NAD, 1882. **Sources:** Naylor, *NAD.*

SMILEY, Ralph Jack *[Painter, instructor] b.1916, NYC.*
Addresses: Hollywood, CA. **Studied:** ASL; NAD; also with George B. Bridgman, Frank Vincent DuMond, Charles S. Chapman, Jules Gotlieb & Sidney E. Dickerson. **Member:** ASL; Calif. Art Club; Los Angeles AA; Painters & Sculptors Club Los Angeles; Am. Inst. Fine Arts. **Exhibited:** Greek Theatre, Los Angeles, 1956; Calif. Art Club, 1957 (first prize for portrait); Painters & Sculptors Club, Los Angeles, 1958 (first prize); Ebell Club, 1959; Friday Morning Club, 1960 (first prize). **Work:** Commissions: portraits & still lifes. **Comments:** Preferred media: oils. Teaching: instructor, anatomy & drawing & lecturer, painting, Hollywood Art Center School, 1959-70s. **Sources:** WW73.

SMILEY, Wilford *[Painter] late 19th c.*
Exhibited: NAD, 1873. **Sources:** Naylor, *NAD.*

SMILLIE, George F(rederick Cumming) *[Engraver] b.1854, NYC / d.1924.*
Addresses: Wash., DC, 1894. **Studied:** NAD; his uncle, James D. Smillie in Am. Bank Note Co. **Member:** Cosmos Club; Wash. Soc. FA; AFA; NMAH. **Work:** the so-called "picture notes" ($2 and $5 silver certificates of 1895); back of $100 Fed. Reserve notes; large portraits of presidents Grant, McKinley, Roosevelt Taft and Wilson. **Comments:** Position: engraver, American and

Canadian banknote companies, before 1894; principal engraver, U.S. Bureau Engraving, 1894-22 (promoted to superintendent of the picture engraving dep. in 1901); American Bank Note Co., after 1922. **Sources:** WW29; McMahan, *Artists of Washington DC,*

SMILLIE, George Henry *Geo. H. Smillie. '74.*
[Landscape painter] b.1840, NYC / d.1921, Bronxville, NY.
Addresses: NYC, 1862-1900. **Studied:** engraving with his father, James Smillie, NYC; painting with James MacDougal Hart, NYC. **Member:** ANA, 1864; NA (elected 1882; recording secretary, 1892-1902); AWCS. **Exhibited:** Philadelphia Centennial, 1876; Boston Athenaeum, 1868; Boston AC, 1880-1908; AWCS, 1882; SC, 1883; NY Etching Cl., 1884; NAD, 1862-1900; Brooklyn AA, 1863-85; AIC, 1888-1917; Corcoran Gal annual, 1908; S. Indp. A., 1917; PAFA; Parrish AM, 1984 ("Painter-Etchers" exhib.). **Work:** Oakland Mus. Art; CGA; MMA; Union League Club of Philadelphia; NAD; RISD; Parrish AM. **Comments:** The son of James Smillie (see entry), he spent his professional life in NYC, although he made painting trips which took him to all parts of the country, including the Adirondack Mountains in northern New York, the White Mountains of New Hampshire (1870s-80s), and the Rockies and Yosemite in 1871. In 1881, he married Nellie Sheldon Jacobs, a pupil of James D. Smillie, his brother, with whom they subsequently shared a studio in NYC. **Sources:** G&W; DAB; CAB; *Art Annual*, XVIII; Rutledge, PA; Naylor, NAD> More recently, see Campbell, *New Hampshire Scenery,* 149; Hughes, *Artists of California, 520;* P & H Samuels, 447; *Keene Valley: The Landscape and Its Artists; American Painter-Etcher Movement 47.*

SMILLIE, Helen (Nellie) *N.S.J. Smillie*
Sheldon Jacobs [Painter] b.1854, NYC / d.1926, NYC.
Addresses: Bronxville, NY. **Studied:** NAD; Cooper Union, NYC; privately with J.O. Eaton & James D. Smillie. **Member:** AWCS. **Exhibited:** NAD, 1875-81 (as Jacobs), 1882-97 (as Smillie); Brooklyn AA, 1876-81 (as Jacobs) 1882-85 (as Smillie); AIC, 1889,1891; NAD; Brooklyn AA; PAFA, 1877, 1880 (as Jacobs). **Comments:** Painted genre scenes in oil & watercolor. Better known as Nellie, she appeared under the last name of Jacobs until 1881, after which she appeared as Smillie (married to painter George Henry Smillie). **Sources:** WW25; Petteys, *Dictionary of Women Artists; Naylor, NAD.Brooklyn Art Ass'n; Falk, Exh. Record Series.*

SMILLIE, James [Engraver] b.1807, Edinburgh, Scotland / d.1885, Poughkeepsie, NY.
Addresses: Quebec1821-27; Britain, 1927-1828; NYC, active 1829 and after; Poughkeepsie, NY, 1881. **Member:** NAD, 1851. **Exhibited:** NAD, 1832-60, 1868-81; Brooklyn AA, 1869, 1877. **Comments:** He was apprenticed to an engraver and after his family moved to Quebec in 1821 he worked with his father, a jeweler, and brother, William C. Smillie, an engraver. During most of his career his chief income came from banknote engraving, though he was widely known for his fine steel engravings of landscapes and figure pieces by well-known artists, especially Cole's "Voyage of Life" series. Three of his sons, James David, George Henry, and William Main, were also noted artists (see entries). **Sources:** G&W; DAB; Cowdrey, NAD; NYCD 1834-60+; Stokes, *Iconography,* pl. 136; Stauffer; Cowdrey, AA & AAU.

SMILLIE, James David *Smillie*
[Landscape painter, engraver, etcher, and lithographer] b.1833, NYC / d.1909, NYC.
Addresses: NYC, 1864-98.
Studied: Univ. of City of New York; steel engraving with his father James; NAD. **Member:** ANA, 1868; NA, 1876; AWCS (founder, 1867; pres. 1873-79); Century; NY Etching Club (founder, 1877; sec./treasurer, 1877-79; pres., 1880-81; catalogue committee, 1891-93). **Exhibited:** PAFA Ann., 1857, 1867-69, 1885; Brooklyn AA, 1863-85; NAD, 1853, 1864-1905; Centennial

Expo, Phila., 1876; Boston AC, 1881-98; AIC, 1889-1911; Corcoran Gal annual, 1907; Jill Newhouse, NYC, 1981 (solo of drawings); Parrish AM, 1984 ("Painter-Etchers" exhib.). **Work:** BMFA; CGA; Amon Carter Mus.; Oakland MA; NYPL; NAD; Montclair AM. **Comments:** He learned engraving from his father, James Smillie (see entry), with whom he collaborated until about 1864. They specialized in bank-note vignettes, but also made engravings for the *Mexican Boundary Survey Report* (1857). He also wrote articles on etching for magazines. From 1865 on, after a two-year trip to Europe, he devoted himself to landscape painting, particularly mountain scenes; he also worked in etching, drypoint, aquatint, and lithography. He traveled widely in through the Sierra and Rocky Mountains (1871), as well as the Catskills and the Adirondacks. His illustrations from these trips appeared in *Picturesque America* (1872). He married in 1881, and had two sons. He was in France in 1884. By the mid-1880s he was spending a good deal of time making prints, mostly of landscapes, cityscapes and figure and portraits studies. From 1888-96 he produced a set of flower still-life prints, many in drypoint. Teacher, NAD, 1868; 1894-1903. **Sources:** G&W; WW08; DAB; *Art Annual,* VII, obit.; Cowdrey, NAD; Swan, BA; Rutledge, PA; *Antiques* (June 1948), 457, repro; Falk, *Exh. Record Series.* More recently, see Hughes, *Artists of California, 520;* P & H Samuels, 447; exh. cat., Jill Newhouse, (NYC, 1981); *American Painter-Etcher Movement 47; For Beauty and for Truth,* 87 (w/repro.).

SMILLIE, M. F. See: **SMILEY, M. F.**

SMILLIE, Nellie S. See: **SMILLIE, Helen (Nellie) Sheldon Jacobs**

SMILLIE, William Cumming [Engraver] b.1813, Edinburgh (Scotland) / d.After 1899.
Addresses: Quebec, Canada, arrived there 1821 with his father; NYC, 1830 and after. **Studied:** engraving, in Quebec, after 1821. **Comments:** A brother of James Smillie (see entry). Joined his brother in NYC in 1830 and spent the rest of his professional life there as a banknote engraver. He was still living in 1899. **Sources:** G&W; Stauffer; NYCD 1832-58+; 7 Census (1850), N.Y., LIII, 252.

SMIRKE [Engraver] mid 19th c.
Comments: His work appeared in Hinton's *History and Topography of the United States* (Boston, 1857). **Sources:** G&W; Hinton, *op. cit.*

SMIT, Derk [Decorator, lecturer] b.1889, Netherlands.
Addresses: Chicago, IL. **Studied:** AIC; J. Allworthy; C. Buck. **Member:** All Illinois SFA; Beverly Sketch Club; South Side AA; Ridge AA, Chicago. **Exhibited:** Navy Pier, Chicago, 1939; Palmer House, Auditorium Hotel, Chicago. **Comments:** Position: pres., D. Smit Interior Dec. Co., Chicago, IL. **Sources:** WW40.

SMITH [Portrait painter] b.1747, New York / d.1834.
Addresses: Italy, 1764 and after. **Comments:** Artist known through writings of William Dunlap. Dunlap, in his diary entry of June 2, 1834, describes a discussion between Samuel F.B. Morse and James Fenimore Cooper about an old American artist who was then residing in Florence. Morse and Cooper believed him to have been born c.1747 in New York or on Long Island and to have relocated to Italy permanently in 1764. He was not successful as as an artist and was thought to have become a picture dealer. In his *History* Dunlap expanded and changed this account of Smith, indicating that he was the uncle of Col. William [Stephens] Smith, son-in-law of John Adams, and changing his year of birth to 1718, on the basis of somebody's assertion that Smith was 116 years old in 1834. **Sources:** G&W; Dunlap, *Diary,* III, 790; Dunlap, *History,* I, 145.

SMITH, A. B. [Painter] 19th c.
Exhibited: AIC, 1894. **Sources:** Falk, *AIC.*

SMITH, A. C. [Miniaturist and portrait painter] 19th c.
Addresses: Baltimore,1831-37; Philadelphia,1844; Clark County, KY, 1852-56. **Exhibited:** Artists' Fund Society, 1844. **Comments:** He also advertised at Charleston in January1834. **Sources:**

G&W; Baltimore CD 1831, 1837; Lafferty; Rutledge, *Artists in the Life of Charleston;* Rutledge, PA; Phila. CD 1844.

SMITH, A. Knight *[Miniature painter] 20th c.*
Addresses: Phila., PA. **Sources:** WW24.

SMITH, A. (Miss) *[Listed as "artist"] early 19th c.*
Addresses: Baltimore. **Exhibited:** Boston Athenaeum, 1829.
Sources: G&W; Swan, BA.

SMITH, A. Reginald *[Painter] 20th c.*
Exhibited: AIC, 1929. **Sources:** Falk, *AIC.*

SMITH, Adelaide *[Painter, composer, philanthropist] d.1907, Pittsburgh, PA.*
Addresses: Pittsburgh, PA. **Studied:** ASL; Académie Julian, Paris with T. Robert-Fleury. **Exhibited:** Pittsburgh Exhib. (prize); New Orleans Exhib. (prize).

SMITH, Adolphus *[Listed as "artist"] b.c.1828, New York.*
Comments: He was a son of William D. Smith, engraver (see entry). **Sources:** G&W; 7 Census (1850), N.Y., XLIII, 529.

SMITH, Albert *[Itinerant portrait painter] early 19th c.*
Addresses: Morristown, NJ, active c.1804. **Sources:** G&W; N.Y. *Sunday Mirror,* Jan. 2, 1949, "Magazine Section," p. 18.

SMITH, Albert *[Engraver] b.1832, Pennsylvania.*
Addresses: Philadelphia, 1850. **Comments:** Listed as living with his family. **Sources:** G&W; 7 Census (1850), Pa., LIII, 553.

SMITH, Albert Alexander *[Painter, etcher, teacher, graphic artist] b.1896, NYC / d.1940.*
Addresses: France (WWI, c.1918-19); NYC; Spain, Belgium & Paris, c.1920-26; NYC; Paris, c.1934-40. **Studied:** Ethical Culture Art School (scholarship), 1911; NAD, 1915-18, 1919-20; Acad. de Beaux Arts, Paris, 1920; Royal Acad., Belgium and privately with a Belgian etcher in Liège, 1923-24. **Member:** NA. **Exhibited:** NAD, 1917 & 1919 (Sydham Medal), 1919 (Chaloner Prize), 1920; Tanner Art Lg., Wash., DC, 1922 (gold medal for etching); S. Indp. A., 1922; NYPL, 1928 (solo); AIC, 1927; Ethical Culture Art School, 1928; Smith. Inst., 1929; Harmon Fnd., 1928-31 (bronze medal, 1929),1933, 1935-36, traveling exhib., 1935-36; Tanner Lg. Exhib., Wash., DC, 1931 (gold); BMFA, 1932; NJ State Mus., 1935; Veterans Exhib., Paris, 1932; New Jersey State Mus., 1935; AAPL, Paris, 1935-38; Texas Centennial, 1936; Paris, 1938; BM, 1939; American Negro Expo, Chicago, 1940; South Side Community Art Center, Chicago, 1945. **Work:** Harmon Fnd.; NYPL; National Archives; Fisk Univ., Nashville, TN; Hampton (VA) Univ. Mus.; Mus. of the Nat. Center of Afro-Am. Artists, Boston; Schomburg Center, NYC. **Comments:** Author: "On Negro Exhibitions" (letter to the editor), *New York Amsterdam News* Jan. 4, 1928. **Sources:** WW33; Cederholm, *Afro-American Artists;* Richard J. Powell, *Black Art and Culture in the 20th Century* (London: Thames and Hudson, 1997), 55-56; add'l info. courtesy Jacqueline Francis, New Haven, CT, who also cites news clippings from L.S. Alexander Gumby Papers, Amistad Research Center, New Orleans; as well as archival material available at the Schomburg Center for Research in Black Culture (letters in Arthur S. Schomburg Papers).

SMITH, Albert Delmont *[Portrait painter, museum director] b.1886, NYC / d.1962.*
Addresses: NYC; Huntington, NY. **Studied:** ASL; Frank DuMond; W.M. Chase. **Member:** All. Artists Am.; Chelsea AC, London; SC; Century. **Exhibited:** AIC, 1911; PAFA Ann., 1921, 1925; Corcoran Gal biennials, 1921, 1923; All. Artists Am., 1940 (medal), 1946 (medal). **Work:** TMA; CAM; Detroit IA; Gallop AC; East Hampton, NY; NY Hist. Soc. **Comments:** Author: pamphlets, "Shepard'Alonzo Mount," 1945; "Robert Feke," 1946. Position: art director, Heckscher Art Mus., Huntington, NY. **Sources:** WW59; WW47; Falk, *Exh. Record Series.*

SMITH, Albert E. *[Painter, illustrator] b.1862, Waterbury, CT. / d.1940.*
Addresses: Cos Cob, CT. **Studied:** Yale.
Member: SC. **Sources:** WW29.

SMITH, Albert Felix *[Painter] 20th c.*
Exhibited: Salons of Am., 1923. **Sources:** Marlor, *Salons of Am.*

SMITH, Albert L. *[Painter] late 19th c.*
Studied: Benjamin-Constant; Lefebvre. **Exhibited:** Paris Salon,1890. **Sources:** Fink, *American Art at the Nineteenth-Century Paris Salons,* 391.

SMITH, Alberta Uhle *[Portrait and miniature painter] b.1894, Phila., PA / d.1983, Wash., DC.*
Addresses: Wash., DC, from 1915. **Studied:** PAFA. **Work:** NGA; Mt. Vernon; Colonial Williamsburg. **Comments:** Wife of artist Cyril J. Smith. **Sources:** McMahan, *Artists of Washington DC,.*

SMITH, Alexis *[Artist] b.1949.*
Addresses: Venice, CA. **Exhibited:** WMAA, 1975, 1979, 1981. **Sources:** Falk, *WMAA.*

SMITH, Alfred *[Painter] late 19th c.*
Addresses: NYC, 1874. **Exhibited:** NAD, 1874. **Sources:** Naylor, *NAD.*

SMITH, Alfred Aloysius ("Trader Horn") *[Painter] b.c.1854 / d.1927.*
Comments: His autobiography, *Trader Horn,* edited by E. Lewis, 1928, reveals that he taught painting to wealthy young women around Texas. **Sources:** P&H Samuels, 448.

SMITH, Alfred E(verett) *[Painter] b.1863, Lynn, MA / d.1955.*
Addresses: Boston, MA; Nashua, NH. **Studied:** BMFA Sch., with Crowninshield, Grundmann, Vonnoh; Académie Julian, Paris with Boulanger, Lefebvre, Constant, and Doucet, 1889. **Member:** North Shore AA; Gloucester SA. **Exhibited:** CI; Corcoran Gal biennial, 1919; AIC; Boston AC, 1891-1906; PAFA Ann., 1892-95, 1903-07, 1919, 1930;Gloucester SA; Rockport AA. **Work:** Harvard Dental Sch.; Wheaton College; Phillips Exeter Acad., Exeter, NH; State Capitol, Concord, NH; State Capitol, Augusta, ME; State Lib., Concord, NH; Univ. New Hampshire; St. Paul's Sch., Concord, NH; Bowdoin College, ME. **Sources:** WW53; WW47; Falk, *Exh. Record Series.*

SMITH, Alfred H. *[Painter]*
Addresses: Wash., DC, active 1904-10. **Exhibited:** Wash. WCC, 1904, 1908. **Sources:** WW13; McMahan, *Artists of Washington DC,.*

SMITH, Alfred J. *[Painter, muralist] late 20th c.; b.Boston, MA.*
Studied: Boston Univ., 1966. **Exhibited:** Brandeis Univ., 1969; BMFA, 1970; Studio Mus., Harlem, 1969-70. **Sources:** Cederholm, *Afro-American Artists.*

SMITH, Alice Flint *[Painter] 20th c.*
Addresses: NYC. **Exhibited:** S. Indp. A., 1917. **Sources:** Marlor, *Soc. Indp. Artists.*

SMITH, Alice J. *[Painter] 19th/20th c.*
Addresses: NYC, active 1898-1900. **Exhibited:** Boston AC, 1898-99; AWCS. **Sources:** WW01; *The Boston AC.*

SMITH, Alice P. *[Painter] 19th c.*
Addresses: Phila., PA. **Exhibited:** PAFA Ann., 1881. **Sources:** Falk, *Exh. Record Series.*

SMITH, Alice R(avenel) Huger *[Painter, illustrator, printmaker, writer] b.1876, Charleston / d.c.1958.*
Addresses: Charleston, SC. **Member:** SSAL; Carolina AA; AFA; NAWPS; NAC. **Exhibited:** widely in the South; Baltimore ARt Mus.; Traveling exhib. AFA; Phila. Art All.; Knoedler GAls., NYC; Michigan and Rhode Island; Houston MFA; AIC, 1913, 1919, 1928; WMAA, 1936. Award: Mt. Holyoke College, South Hadley, MA, 1937 (hon. degree). **Work:** Delgado AM, New Orleans; Carolina AA; Brooklyn Inst. Arts & Sciences; Albany Inst. History and Art. **Comments:** Author/illustrator, co-author (with her father): "The Dwelling Houses of Charleston;" "The Life of Charles Fraser;" "Twenty Drawings of the Pringle House;" "A Carolina Rice Plantation of the Fifties." **Sources:** WW40;

Petteys, *Dictionary of Women Artists.*

SMITH, Allen, Jr. *[Portrait and genre painter]* b.1810, Rhode Island / d.1890, Cleveland, OH.
Addresses: NYC, after 1830-42; Detroit, MI, 1837; Cleveland, OH, 1842-90. **Studied:** NA. **Member:** ANA, 1833. **Work:** House of Representatives, Lansing, MI (portrait of Michigan's first governor); Cleveland Museum of Art ("View of the River at Painesville"); Western Reserve University, Cleveland (Portraits of prominent citizens). **Comments:** He exhibited regularly in NYC until 1842 when he moved to Cleveland (OH). He is credited with designing the first flag for the State of Michigan in 1837. Hageman states that he was born in Massachussetts. **Sources:** G&W; Mallett; Cowdrey, NAD; Cowdrey, AA & AAU; Clark, *History of the NAD;* WPA (Ohio), *Annals of Cleveland;* 7 Census (1850), Ohio, XI, 249; Cleveland BD 1857; Ohio BD 1859. Hageman, 122; Gibson, *Artists of Early Michigan,* 214.

SMITH, Alvin *[Painter, educator]* b.1933, Gary, IN.
Addresses: NYC. **Studied:** State Univ. Iowa, B.A., 1955; Kansas City Art Inst., 1957; Univ. Illinois, A.M., 1960; Teachers College, Columbia Univ., Heft Scholarship, 1967-69. **Member:** Brooklyn Mus. (advisory committee, Community Gallery, 1969-); Inst. Soc. Educ. Through Art; Nat. Art Educ. Assn. **Exhibited:** TM, 1961, 1962; Dayton Art Inst. & Mus., 1961-66, 1972 (4 purchase awards); Atlanta Univ., 1962-67 (4 purchase awards); Cont. Arts Gallery, NYC, 1962; NY Univ., 1963; The Dulin Gallery, Knoxville, TN, 1964; Purdue Univ., Lafayette, IN, 1964; Ruth Sherman Gallery, NYC, 1964; National Academy Galleries, NYC, 1965; Columbia Univ. Teachers College, 1966-67; Childe Hassam Exhib., Am. Acad. Arts & Letters, 1968; Living Arts Center, Dayton, OH, 1969; Brooklyn College, 1969; Mt. Holyoke College, MA, 1969 (solo, purchase award); Allusions, Community Gallery, Brooklyn Mus., 1970; Gallery Mus., Saratoga, NY, 1970; Eight Afro-Am. Artists, Rath Mus., Geneva, Switzerland, 1971; Irish Exhib. Living Art, Dublin, Ireland, 1972; Young American Artists, Gentofte Kunstvenner, Copenhagen, Denmark, 1972. Awards: purchase award, Columbia Univ.; Dow Award, 1967; 1 Council Foundation, NY State Council Arts, 1972. **Work:** Atlanta Univ.; Dayton (OH) Mus.; Teachers College, Columbia Univ.; Kerlan Collection, Univ. Minnesota; Mt. Holyoke College; Gary (IN) Public Library; Tougaloo College, MS. **Comments:** Preferred media: mixed media. Positions: art correspondent, *Art Int.,* 1972. Publications: illustrator, "Shadow of a Bull," 65 illusr, cover, *Art Int.,* summer 1971. Teaching: lecturer art educ., Queens College (NY), 1967-. Research: fine art by Afro-Americans: 1945-70. **Sources:** WW73; Peter Schjedahl, "A Triumph Rather Than a Threat," *New York Times* (April 27, 1969); Barbara Rose, article, *Art in Am.* (Sept. 10, 1970); Jean-Luc Daval, article, *Art Int.* (October 20, 1971); Cederholm, *Afro-American Artists.*

SMITH, Alvin J. See: SMITH, Allen, Jr.

SMITH, Amanda Banks *[Painter]* b.1846 / d.1824, Greenwich, CT.

SMITH, Ambrose A. *[Painter]* late 19th c.
Addresses: Boston, MA, active 1884-88. **Exhibited:** Boston AC, 1884-90; NAD, 1885. **Sources:** *The Boston AC.*

SMITH, André See: SMITH, J(ules) André

SMITH, Anita M(iller) *[Painter, craftsperson]* b.1893, Torresdale, PA.
Addresses: New Hope, PA; NYC, Lake Hill and Woodstock, NY. **Studied:** J. Carlson; ASL. **Member:** NAWPS; Alliance; Woodstock AA. **Exhibited:** AIC, 1917, 1920; PAFA Ann., 1919-20, 1923. **Work:** PAFA. **Sources:** WW40; Falk, *Exh. Record Series;* addit. info. courtesy Woodstock AA.

SMITH, Anna P. *[Artist]* late 19th c.
Addresses: Active in Muskegon, MI, 1877-93, 1899. **Sources:** Petteys, *Dictionary of Women Artists.*

SMITH, Anne Fry (Mrs. E. Lovett) *[Painter]* b.1890, Phila., PA.

Addresses: Oreland, Glenside, PA. **Studied:** F. Wagner; Chester Springs Summer School PAFA. **Member:** Phila. Alliance; Plastic Club. **Exhibited:** PAFA Ann., 1920; Penn. State College. **Sources:** WW40; Falk, *Exh. Record Series.*

SMITH, Annie *[Painter]* 20th c.
Addresses: Chicakasha, OK. **Sources:** WW17.

SMITH, Annie (Anna) E(dwards) *[Painter]* early 20th c.
Addresses: Coalburgh, WV, 1899. **Exhibited:** PAFA Ann., 1899; Wash. WCC, 1912. **Work:** Private collections in WV and NC (watercolors dated 1893 and c.1912). **Sources:** McMahan, *Artists of Washington DC;* Falk, *Exh. Record Series.*

SMITH, Annie H. Raeburn (Mrs.) *[Miniature painter]* 20th c.
Addresses: Phila., PA. **Sources:** WW08.

SMITH, Anthony *[Painter]* 20th c.
Exhibited: S. Indp. A., 1935 ("The Red Room"). **Comments:** *Cf.* Tony Smith. **Sources:** Marlor, *Soc. Indp. Artists.*

SMITH, Archibald Carey *[Marine painter and yacht designer]* b.1837, NYC / d.1911, Bayonne, NJ.
Addresses: NYC, active until c.1877. **Studied:** Mauritz F.H. De Haas (marine painting). **Exhibited:** NAD, 1865-81; PAFA, 1866-69; Brooklyn AA, 1865-77. **Comments:** Son of Joseph B. Smith, also a ship portrait painter. Archibald Smith studied ship building and practiced the shipwright's trade in NYC until the mid-1860s. From about 1867 to 1877 he concentrated mainly on marine painting. After 1877 he did little painting, instead devoting himself to the designing of yachts and other craft. He was J.G. Tyler's teacher. **Sources:** G&W; DAB; Swan, BA; Rutledge, PA; Clement and Hutton; *Art Annual,* X, obit.

SMITH, Arthur B. *[Painter]* 20th c.
Addresses: Cleveland, OH. **Member:** Cleveland SA. **Sources:** WW25.

SMITH, Arthur Hall *[Painter]* b.1929, Norfolk, VA.
Addresses: Washington, DC. **Studied:** Illinois Wesleyan Univ., B.F.A., 1951; École Beaux-Arts (Atelier Souverbie), Paris, Fulbright fellowship, 1951; Atelier 1917, Paris, 1952, with S. W. Hayter; grad. study, Univ. Washington, 1955; also with Mark Tobey, Seattle, WA, 1955-57. **Exhibited:** Seventh Ann. Virginia-North Carolina Painting, Norfolk Mus. Arts, 1949; Virginia Artists Ann., Virginia Mus. Fine Arts, Richmond, 1951; Washington Artists Series, Corcoran Gallery Art, 1961 (solo); Huit Americains de Paris, Center Cultural Am., Paris, France, 1964; The American Artist and Water Reclamation, Nat. Gallery Art, Washington, DC, 1972; Franz Bader Gallery, Washington, DC, 1970s. Awards: Merwin Medal for painting, Bloomington AA, 1948; painting prize, 15th Area Exhib., Corcoran Gallery Art, 1962. **Work:** Chrysler Mus., Norfolk; Corcoran Gallery Art, Washington, DC; Phillips Collection, Washington, DC; Baltimore Mus. Art; Seattle Art Mus. Commissions: centennial murals, Mem. Center, Illinois Wesleyan Univ., Bloomington, IL, 1950; Mammals in World Art, Mammal Hall, U.S. Mus. Natural Hist., Smithsonian Inst., Washington, DC, 1958; Truckee Storage Triptych, Bur Water Reclamation, U.S. Dept. Interior, Washington, DC, 1972. **Comments:** Preferred media: oils, acrylics, ink. **Sources:** WW73.

SMITH, Arthur P. *[Painter]* late 19th c.
Studied: Boulanger; Lefebvre. **Exhibited:** Paris Salon, 1887. **Sources:** Fink, *American Art at the Nineteenth-Century Paris Salons,* 391.

SMITH, Artine See: SMITH, (Robin) Artine

SMITH, B. H. *[Painter]* mid 19th c.
Exhibited: Fair of the Mechanics Inst., Richmond, 1855 (first prize). **Sources:** Wright, *Artists in Virgina Before 1900.*

SMITH, Barbara Baldwin See: BALDWIN, Barbara (Miss Barbara Baldwin Smith)

SMITH, Beatrice May *[Painter] b.1915, New Albin, IA.*
Addresses: Burlington, IA. **Studied:** Cornell College, 1936, A.B.; Nama Lathe. **Member:** Iowa Artists Club, 1934. **Exhibited:** Des Moines; Grinnell; Great Hall, Iowa State College; Iowa City; Cornell College; Iowa Artists Exhibits, Burlington; Iowa Artists Club, 1934; Iowa Artists Exhibit, Mt. Vernon, 1938. **Sources:** Ness & Orwig, *Iowa Artists of the First Hundred Years,* 193.

SMITH, Belle *[Artist]*
Addresses: Active in Washington, DC, 1871-72. **Work:** Private collection in Santa Ana, CA (2 portraits, dated 1884). **Comments:** *Cf.* Belle Patterson Smith, active 1909-35. **Sources:** McMahan, *Artists of Washington DC.*

SMITH, Belle Patterson (Mrs. Myron) *[Painter]*
Addresses: Wash., DC, 1909-35. **Member:** Wash. WCC. **Exhibited:** Soc. Wash. Artists, 1909-26; Wash. WCC, 1911-26; Gr. Wash. Indep. Exhib., 1935. **Comments:** *Cf.* Belle Smith, active 1870s. **Sources:** WW29; McMahan, *Artists of Washington DC.*

SMITH, Benjamin F. *[Lithographer] b.1830, South Freedom, ME / d.1927, Maine.*
Comments: From 1848-57 he and his brothers, George Warren, Francis, and David Clifford Smith, were in the print publishing business in Boston and NYC. Benjamin did some of the art work, though most of it was done by John W. Hill, Fanny Palmer, and Charles Parsons (see entries). Both George and Francis had served as agents for E. Whitefield (see entry), so their involvement was more on the production and distribution side of the business. Benjamin, who also worked for Whitefield, worked more as an apprentice and assistant and Whitefield and Smith published together from 1848-52. Upon some disagreement relations were broken and the Smith Brothers went their own way. Some scholars believe that the breakup was over competition (see Reps). In 1858 Francis went to Omaha (NE) where he established a bank and Benjamin joined him in 1860. They also bought a mine and became very wealthy. In the 1880's he and his brothers retired to Maine and when Benjamin died, he was supposedly the richest man in Maine. **Sources:** G&W; *Portfolio* (Jan. 1954), 99-102; Stokes, *Historical Prints;* Stokes, *Iconography,* pl. 145. More recently, see Reps, 206-208.

SMITH, Benjamin H. *[Artist]*
Addresses: Wash., DC, active 1901. **Sources:** McMahan, *Artists of Washington DC,.*

SMITH, B(ernice) C. *[Painter] 20th c.*
Exhibited: Salons of Am., 1934. **Sources:** Marlor, *Salons of Am.*

SMITH, Berta A. *[Artist] late 19th c.*
Addresses: Active in Jackson, MI, 1895-99. **Sources:** Petteys, *Dictionary of Women Artists.*

SMITH, Bertha *[Painter] 20th c.*
Addresses: Bladensburg, OH. **Member:** Cincinnati Women's AC. **Sources:** WW15.

SMITH, Bertram (Mrs) *[Collector, patron] 20th c.; b.Dallas, TX.*
Addresses: NYC. **Studied:** New York Inst. Fine Arts. **Comments:** Positions: patron, trustee, member of painting & sculpture acquisitions committee & secretary of int. council, MoMA. Collections: Post-Impressionist, School of Paris paintings, drawings and sculpture. **Sources:** WW73.

SMITH, Beryl Kirk *[Painter, teacher] b.1888, Texas / d.1975, Ventura County, CA.*
Addresses: Los Angeles, CA. **Exhibited:** San Diego FA Gallery, 1927; Calif. WCC, LACMA, 1927. **Comments:** Position: teacher, UCLA, 1928. **Sources:** Hughes, *Artists in California,* 520.

SMITH, Bissell Phelps *[Painter, teacher, graphic artist, illustrator, writer, lecturer] b.1892, Westbrook, CT.*
Addresses: Wethersfield 9, CT. **Studied:** Syracuse Univ.; Yale Univ. School FA, and with Arthur J. E. Powell, Glenn Newall, Harry Waltman, Stanley Woodward, Emile Gruppe. **Member:**

Academic Artists Assn.; AFA; Am. Artists Group; AAPL; Artists & Writers of Conn.; Berkshire AA; CAFA; Dutchess County AA; Classic AA; North Shore AA; Hudson Valley AA; Kent AA; Meriden Art & Crafts Assn.; New Britain Art Lg.; SC; South Windsor Art Lg.; Torrington Artists; Lyme AA; Rockport AA; Berkshire Mus.; Wadsworth Atheneum. **Exhibited:** Kent AA, 1939-62; Ogunquit AC; CAFA, 1942-62; Meriden Arts & Crafts, 1956-62; Terry AI, 1952; Cape Ann Art Festival, 1956-58; Artists & Writers of Conn., 1955, 1956; Washington AA, 1954-62; Torrington AA, 1955-62; Pawling Mission, 1938, 1939; Albany Inst. Hist. & Art, 1956; Berkshire AA, 1955-62; Rockport AA, 1954, 1962; Welles-Turner Memorial; Wethersfield Lib. (solo); West Hartford Art Lg. **Awards:** prizes, Artists & Writers of Conn., 1954; Washington AA, 1955; Grumbacher Award of Merit, 1959; South Glastonbury AA, 1955-59; Berlin Fair, 1960; Cherry Hill Art Festival, 1961. **Work:** oils: Roosevelt Memorial Lib.; Welles-Turner Memorial; Wethersfield and Wallingford (Conn.) Libs.; Syracuse Univ.; Choate School; Loomis School. **Comments:** Author/art editor, *Veeder's Digest,* monthly industrial magazine, Veeder-Root, Inc., 1948-58. Conducted oil painting demonstrations and lectures. **Sources:** WW66.

SMITH, Blanche E. *[Artist, teacher] late 19th c.*
Addresses: Active in Grand Rapids, MI, 1899. **Sources:** Petteys, *Dictionary of Women Artists.*

SMITH, Bloomfield *[Engraver] mid 19th c.*
Addresses: NYC, 1856. **Sources:** G&W; NYBD 1856.

SMITH, Brantley *[Painter] 20th c.*
Addresses: Nashville, TN. **Sources:** WW25.

SMITH, C. B. *[Painter] 19th c.*
Addresses: Boston, MA, 1885. **Exhibited:** NAD, 1885. **Sources:** Naylor, *NAD.*

SMITH, C. G. *[Artist]*
Addresses: Wash., DC, active 1920. **Sources:** McMahan, *Artists of Washington DC,.*

SMITH, C. J. *[Illustrator] b.c.1898 / d.c.1947.*
Addresses: Philadelphia, PA. **Sources:** WW25.

SMITH, C. M. *[Painter] late 19th c.*
Exhibited: NAD, 1873. **Comments:** Possibly artist Calvin Rae Smith. **Sources:** Naylor, *NAD.*

SMITH, C. R. *[Collector] 20th c.*
Addresses: New York, NY. **Sources:** WW73.

SMITH, C. W. (Mrs.) *[Painter] 20th c.*
Addresses: Glendale, CA. **Sources:** WW21.

SMITH, Calvin Rae *[Painter]* *C. Rae-Smith.*
b.1850, NYC / d.1918, Brooklyn.
Addresses: Brooklyn, NY, 1877, 1879; NYC, 1880-89. **Studied:** NAD; Carolus-Duran, École des Beaux-Arts, Paris. **Member:** SC, 1886. **Exhibited:** Brooklyn AA, 1873-86; NAD, 1877-89; Paris Salon, 1878; Boston AC, 1881; PAFA Ann., 1881. **Comments:** Position: teacher, CCNY. **Sources:** WW17; Fink, *American Art at the Nineteenth-Century Paris Salons,* 391; Falk, *Exh. Record Series.*

SMITH, Carl F. See: **SMITH, F(rederick) Carl**

SMITH, Carl M. *[Painter] 20th c.*
Exhibited: S. Indp. A., 1941. **Sources:** Marlor, *Soc. Indp. Artists.*

SMITH, Carl R. *[Sculptor] b.1931.*
Studied: self-taught. **Exhibited:** Studio Mus., Harlem, 1969; Phila. Civic Center; Halfway Art Gallery; Pittsburgh Plan for Art. **Sources:** Cederholm, *Afro-American Artists.*

SMITH, Carl Rohl (or Roehl) See: **ROHL-SMITH, Carl**

SMITH, Carrie M. *[Artist] d.1901, Wash., DC.*
Addresses: Wash., DC, 1886-99. **Work:** CGA (oil copy of Charlotte Cordey imprisoned). **Sources:** McMahan, *Artists of Washington DC,.*

SMITH, Catherine N. *[Fancy wax worker] b.c.1785, Philadelphia.*
Addresses: Philadelphia, 1860. **Sources:** G&W; 8 Census (1860), Pa., LVIII, 226.

SMITH, Cecelia (Frederick) *[Painter, illustrator, teacher] b.1900, Atlanta, GA.*
Addresses: East Orange, NJ/Boothbay, Harbor, ME. **Studied:** I.W. Stroud. **Sources:** WW25.

SMITH, Cecil A. *[Painter, illustrator, sculptor, teacher] b.1910, Salt Lake City, UT / d.1984.*
Addresses: Somers, MT in 1976. **Studied:** BYU; Univ. Utah; NYC, with John Carroll, Max Weber, Kuniyoshi. **Exhibited:** Represented in a government collection which toured Europe, 1935. **Comments:** Illustrator: *Sunset Magazine.* Cowboy artist who found his subjects on his 89,000 acre ranch. Began painting fulltime in 1960. **Sources:** P&H Samuels, 448.

SMITH, Cecilia J. (Miss) *[Painter] 19th c.*
Exhibited: PAFA Ann., 1876. **Comments:** Cf. Mrs. Cecilia Thibault Smith of Philadelphia. **Sources:** Falk, *Exh. Record Series.*

SMITH, Cecilia Thibault (Mrs.) *[Painter] 19th c.*
Addresses: Phila., PA. **Exhibited:** PAFA Ann., 1877-78. **Comments:** Cf. Miss Cecilia J. Smith. **Sources:** Falk, *Exh. Record Series.*

SMITH, Channing *[Landscape and portrait painter, printmaker] b.1906, St. Louis, MO / d.1984, Tucson, AZ.*
Studied: Corcoran Sch. Art, Wash., DC; St. Louis Sch. FA; privately in Paris; Univ. Arizona, 1954 (drama). **Member:** Kent AA; CAFA; Sourthern Arizona Watercolor Group. **Comments:** He also worked in xylography (etchings from woodblocks) and did stage design. Teaching: Kent School, CT. **Sources:** info courtesy Wayne Kielsmeier, Tucson, AZ.

SMITH, Charles *[Engraver] b.c.1817, Connecticut.*
Addresses: NYC, 1850. **Comments:** With his wife and two children, living with George Sherman (see entry). Smith's children, aged 7 years and 5 months respectively, were born in Connecticut. **Sources:** G&W; 7 Census (1850), N.Y., XLII, 160.

SMITH, Charles *[Engraver] b.c.1831, New York.*
Addresses: NYC, 1860. **Comments:** He was living in NYC with his wife Emeline and four children, all born in New York. **Sources:** G&W; 8 Census (1860), N.Y., LIV, 655.

SMITH, Charles A. *[Artist] 20th c.*
Addresses: Wash., DC, active 1920-39. **Comments:** Cf. Charles Albert Smith. **Sources:** McMahan, *Artists of Washington DC,* lists Washington Business Dir., 1928-38, Wash. City Dir., 1920.

SMITH, Charles Albert *[Engraver] b.1890, Springlake, FL / d.1959, Wash., DC.*
Comments: After serving in WWI, he worked for the Bureau of Engraving and Printing, from 1919-25. He then worked in NYC and Phila. until 1934 as an engraver, joining again the staff of the Bureau. **Sources:** McMahan, *Artists of Washington DC,.*

SMITH, Charles Augustus *[Painter] mid 20th c.*
Addresses: NYC. **Exhibited:** Corcoran Gal biennial, 1947; WMAA, 1947-49. **Sources:** Falk, *Exhibition Records Series.*

SMITH, Charles C. *[Engraver] mid 19th c.*
Addresses: NYC, 1836-59. **Comments:** He was listed as a geographer in 1854-55 and publisher in 1856-57. **Sources:** G&W; NYCD 1836-59.

SMITH, Charles H. *[Engraver] 19th c.*
Addresses: NYC, active 1844-60. **Comments:** In 1858-60 he was with Sealey & Smith (see entry). His home was in Brooklyn and Bedford, Long Island. **Sources:** G&W; NYBD and CD 1844-60.

SMITH, Charles L. *[Painter, panoramist] b.c.1812, New York State.*
Addresses: New Orleans, active c.1830-57. **Comments:** Was in NYC 1840-41 and then New Orleans, painting in the theater. He painted panoramas of "Texas and California," the "Creation," and "Perry's Expedition to Japan." In 1850 three of his sons, James (19), William (16), and Charles (13), were also listed as artists in the census. **Sources:** G&W; 7 Census (1850), La., IV (1), 423; Delgado-WPA cites *Bee,* May 1, 1852, and June 5, 1857, and *Crescent,* June 5, 1857; Arrington cites *Picayune,* April 29, 1852, and June 4, 1857. More recently, see *Encyclopaedia of New Orleans Artists,* 355; P&H Samuels, 448.

SMITH, Charles L. A. *[Painter] b.1871, Auburn, MI / d.1937, Los Angeles, CA.*
Addresses: Los Angeles, CA. **Studied:** self-taught. **Member:** Boston AC; Calif. AC; Calif. WCC; Chicago SA; Soc. Western Artists. **Exhibited:** AIC, 1902-16; PPE, 1915; PAFA Ann., 1917; Calif. Liberty Fair, 1918; Ebell Club, Los Angeles, 1921; Calif. State Fair, 1930. **Work:** Laguna Beach Mus.; Univ. of Maine Art Gallery; Lawrence (MA) Art Mus.; Gardena H.S. **Sources:** WW33; Hughes, *Artists in California,* 520; Falk, *Exh. Record Series.*

SMITH, Charles Moore *[Painter] 20th c.*
Addresses: Mt. Vernon, NY. **Member:** SC. **Sources:** WW21.

SMITH, Charles Timothy *[Painter] b.1897, Pittsburgh.*
Addresses: Pittsburgh, PA. **Member:** Pittsburgh AA. **Exhibited:** Corcoran Gal biennial, 1935. **Sources:** WW40.

SMITH, Charles W. *[Music engraver] b.c.1822, Massachusetts.*
Addresses: Boston, active 1850-53. **Sources:** G&W; 7 Census (1850), Mass., XXIV; Boston CD 1850-53.

SMITH, Charles W. *[Engraver, blockprinter] mid 19th c.*
Addresses: NYC, 1857-58. **Exhibited:** WMAA, 1936, 1938. **Comments:** Of Bourke & Smith (see entry), his home was in Brooklyn. **Sources:** G&W; NYCD 1857-58.

SMITH, Charles (William) *[Painter, educator, graphic artist, engraver, block printer] b.1893, Lofton, VA / d.1987, Lynchberg, VA?.*
Addresses: Charlottesville, VA. **Studied:** Corcoran School Art, Washington, DC; Yale Univ., certificate in art. **Member:** AIGA. **Exhibited:** Willard Gal., NYC (solo); AIC (solo); BMFA (solo); VMFA (solo; MOMA (solo); Graphic Arts Leaders Exhib., 1926; Ferargil Gal.; S. Indp. A., 1929; Phila. Art All.; Detroit Inst. Art; Montclair Art Mus.; Univ. of Kansas, Chicago, Virginia; Newcomb College; Yale Univ.; Bennington College; Hollins College; High Mus. Art; SFMA. **Work:** FMA; MoMA; WMAA; AIC; SAM; PMG; SGA; CMA; VMFA; Hollins Collge; Portland (OR) Art Mus.; Valentine Mus.; Mus. Non-Objective Painting; Yale; NYPL; Newark Mus.; 50 Prints of the Year, 1934; Springfield (MA) Pub. Lib.; William and Mary College, VA; Detroit Inst. Art; Springfield (MA) Mus.; BMA; Newcomb College; Rosenwald Collection, MoMA; Rosenwald Collection, Nat. Mus., Washington, DC; Guggenheim Mus., New York; SAM. Commissions: mosaics for public schools & banks. **Comments:** Preferred media: oils, acrylics. Publications: author, "Linoleum Block Printing," 1925; author, "Old Virginia in Block Prints," 1929; author, "Old Charleston," 1933; "The University of Virginia" (32 woodcuts), 1937; "Abstractions by Charles Smith," 1939; author, "Experiments in Relief Print Making," 1954; author, "My Zoological Garden" (portfolio block paintings), 1956. Teaching: instructor of graphic art & painting, Bennington (VT) College, 1938-46; professor of painting, Univ. Virginia, 1946-63, chmn. dept. art, 1947-63. **Sources:** WW73; Schniewind, *Abstractions, Charles Smith," Johnson, 1939;* O'Neal, Prints & Paintings, 1958; *Charles Smith,* Univ. Virginia Press.

SMITH, Clark Ashton *[Painter] 20th c.*
Addresses: Auburn, CA. **Exhibited:** S. Indp. A., 1928. **Sources:** Marlor, *Soc. Indp. Artists.*

SMITH, Clayton B. *[Painter, craftsperson, lecturer, teacher] b.1899, New Bedford, MA.*
Addresses: Eden Park, RI. **Member:** Providence AC; Rhode

Island Assn. Teachers of Drawing & Manual Arts. **Sources:** WW31.

SMITH, Clement H. *[Etcher] b.1883, Eldorado, IA / d.1937, Laguna Beach, CA.*
Addresses: Laguna Beach, CA. **Exhibited:** San Francisco AA, 1917; Calif. Soc. of Etchers, 1917, 1918; PM of Los Angeles at LACMA, 1920. **Sources:** Hughes, *Artists of California,* 520.

SMITH, Clemie C. *[Painter, craftsperson, teacher, writer] 20th c.; b.Tiskilwa, IL.*
Addresses: Omaha, NE. **Studied:** Mrs. Chambers, S.K. Tracy & Augustus Dunbier in Nebraska; Univ. Nebraska; Omaha AI; Boston, Providence, & Chicago. **Exhibited:** Signey (NE) County Fair, 1923. **Comments:** Painted landscapes and china, from c.1916. **Sources:** WW33; Petteys, *Dictionary of Women Artists.*

SMITH, Cora *[Painter, etcher] 20th c.*
Addresses: Ocean Beach, CA. **Exhibited:** San Diego FA Gallery, 1927; Calif.-Pacific Int. Expo, San Diego, 1935; GGE, 1939. **Sources:** Hughes, *Artists of California,* 520.

SMITH, Corinne L(awrence) *[Painter] 20th c.*
Addresses: Phila., PA. **Exhibited:** S. Indp. A., 1928-29. **Sources:** Marlor, *Soc. Indp. Artists.*

SMITH, Creagh (Mrs.) *[Portrait and religious painter] late 19th c.*
Addresses: Philadelphia, active 1860 and after. **Exhibited:** PAFA, 1860-62. **Comments:** Probably the wife or mother of Creigh Smith, Jr., jeweler. **Sources:** G&W; Rutledge, PA; Phila. CD 1860.

SMITH, Curtis Wager *[Painter, illustrator] 20th c.*
Addresses: Philadelphia, PA. **Sources:** WW04.

SMITH, Cyril J. *[Artist, appraiser] b.1888, San Francisco, CA / d.1957, Wash., DC.*
Addresses: Wash., DC. **Studied:** Santa Clara Univ.; PAFA. **Comments:** Husband of artist Alberta Smith. Worked in Wash., DC, for the U.S. District Court. He also operated an antique shop in Wash., DC. **Sources:** McMahan, *Artists of Washington DC.*

SMITH, D. Averill *[Painter] 20th c.*
Addresses: NYC. **Exhibited:** S. Indp. A., 1933-34; Salons of Am., 1934. **Sources:** Falk, *Exhibition Record Series.*

SMITH, D. R. *[Listed as "artist"] mid 19th c.*
Addresses: Pittsburgh, PA, active 1855. **Comments:** He established the Pittsburgh (Pa.) Academy for Instruction in Drawing and Painting in 1855. *Cf.* Robert Smith. **Sources:** G&W; Fleming, *History of Pittsburgh,* III, 626; McMahan, *Artists of Washington, DC* states that a D.R. Smith exhibited a work with the Soc. Wash. Artists, 1914.

SMITH, Dan *[Illustrator, painter, etcher] b.1865, Ivigut, Greenland (came to NYC as a boy) / d.1934.*
Addresses: NYC. **Studied:** Public AI, Copenhagen, 1879; PAFA. **Member:** SI, 1912.
Comments: Position: staff artist for *Leslie's,* 1890-97; Hearst newspapers, after 1897; many covers for Sunday New York *World* magazine section. Made trips to the West c.1891, and illustrated various western subjects thereafter. He was artist-correspondent during Spanish Am. War. **Sources:** P&H Samuels, 449.

SMITH, Dan Evans *[Typographic designer, lecturer, teacher, writer] b.1905, Aurora, IL.*
Addresses: Chicago, IL. **Studied:** Un. Typothetae of Am. Sch. Printing; Univ. Wisconsin; Am. Acad. Art, with Frank Young. **Member:** Soc. Typographic Artists; Art Dir. Club; Artists Gld., Chicago; Dayton AC. **Exhibited:** Art Dir. Club, NY, 1942-43, 1945 (medal); Direct Mail Assn. Am., 1938-45; Soc. Typographic Artists, 1939-46 (medals); Artists Gld., Chicago, 1943-46; Art Dir. Club, Chicago, 1939-46 (medals, 1942-46). **Awards:** Mark Twain Soc. **Work:** Univ. Illinois Lib.; Chicago Pub. Lib.; Univ. Chicago; & many college libraries. **Comments:** Author/illustrator/editor:

"Graphic Arts A B C"; "Square Serif," 1945. Contributor to trade magazines. Lectures: printing & graphic arts. Position: instrauctor, Art Center, Chicago, IL. **Sources:** WW53; WW47.

SMITH, Dan J. *[Painter] 20th c.*
Addresses: Columbus, OH. **Member:** Columbus PPC. **Sources:** WW25.

SMITH, Daniel *[Engraver] b.c.1825, England.*
Addresses: NYC, 1860. **Comments:** His wife and eldest child were born in Ireland; five younger children, ages 13 to 3, were born in New York. **Sources:** G&W; 8 Census (1860), N.Y. XLII, 975.

SMITH, Daniel T. *[Wood engraver] mid 19th c.*
Addresses: NYC, active1846-50; Boston, active1852-60 and after. **Exhibited:** American Inst., 1846-47. **Comments:** In Boston he was associated with Baker & Smith, 1852-54; Smith & Pierson, 1855-56; Smith & Hill, 1858; and Smith & Damoreau, 1860. **Sources:** G&W; NYCD 1847-50; Am. Inst. Cat., 1846-47; Boston CD 1852-60+; Hamilton, *Early American Book Illustrators and Wood Engravers,* 134.

SMITH, Daniel W. *[Listed as "artist"] late 19th c.*
Addresses: New Bedford, MA, 1897. **Sources:** Blasdale, *Artists of New Bedford,* 173.

SMITH, Daniel W. *[Engraver and copperplate printer] early 19th c.*
Addresses: Charleston, SC, 1816-18. **Sources:** G&W; Rutledge, *Artists in the Life of Charleston.*

SMITH, David *[Portrait painter] d.1841.*
Addresses: New Orleans. **Comments:** He was convicted of petty larceny and died in jail in 1841. **Sources:** G&W; Delgado-WPA cites *Picayune,* March 4, 1841.

SMITH, David *[Lithographer] mid 19th c.*
Addresses: Philadelphia, 1858-59. **Sources:** G&W; Phila. CD 1858-59.

SMITH, David *[Sculptor, engraver] b.1906, Decatur, IN / d.1965, Albany, NY.*
Addresses: NYC and Brooklyn, NY, 1926-40; Bolton Landing, NY, 1940-on. **Studied:** Univ. Ohio; George Washington Univ.; ASL, with R. Lahey, J. Sloan, J. Matulka, 1926-32. **Member:** Am. Abstract Artists; United Am. Artists; Am. Artists Congress. **Exhibited:** Marian Willard's East River Gal., NYC, 1938 (solo of his drawings and welded sculpture); BM; S. Indp. A.; Denver AM; WFNY, 1939; WMAA biennials, 1941-64; Buchholz Gal., 1946 (retrospective); Willard Gal., 1946; PAFA Ann., 1947, 1952-56; AIC, 1947; Walker Art Center, 1950; SFMA, 1954; MoMA, 1957 (retrospective); Venice Biennale, 1958 (solo show organized by MOMA); commissioned by Gian-Carlo Menotti and Italian Gov't to produce 26 sculptures fo exh. in Spoleto, Italy, 1962. **Awards:** Guggenheim Fellowship, 1950-51, 1951-52. **Work:** Detroit Inst. Art; WMAA; MoMA; CAM; Hirshhorn Mus.; BMFA; Dallas MA; Walker Art Center; Univ. Michigan; Indiana Univ.; AIC; Univ. Minnesota; Brandeis Univ.; CM; Carnegie Collection, Pittsburgh; Munson-Williams-Proctor Inst. **Comments:** One of the major 20th-century sculptors and the leading sculptor associated with Abstract Expressionism. Known for his welding of abstract forms in series such as "Medals of Dishonor" (1937-40); "Agricola" (begun 1951); "Tank Totem" (begun 1953); "Zig" (begun 1960); "Voltri-Bolton" (begun 1962); and "Cubi" (begun 1963). His style grew out of European abstraction and Surrealism, but by the 1940s he had developed a personal symbolism, and after 1950 he focused more on formal concerns in the creation of his monumental pieces. Smith first learned medal handling techiques while working at the Studebaker automobile plant in South Bend, IN (1925). He made his first welded sculptures in the early 1930s and soon after established a sculpture studio in the Brooklyn Terminal Iron Works. During the 1940s and 1950s he had at least 35 solo shows in the U.S. and Europe, and participated in many group exhibitions. While still at the height of his career he was fatally injured in an accident, purportedly while dri-

ving drunk. He was married to artist Dorothy Dehner from 1927 to c.1951. Positions: visiting prof., Sarah Lawrence College; Univ. Arkansas; Univ. Indiana; Univ. Mississippi, etc.; Delegate to Int. Congress Plastic Arts, Venice, 1954; appointed by Pres. Lyndon Johnson to the National Council on the Arts, February, 1965. **Sources:** WW59; *Two Hundred Years of American Sculpture,* 310-11; Rosalind E. Krauss, *Terminal Iron Works: The Sculpture of David Smith* (Cambridge, MA: MIT Press, 1971); Garnett McCoy, ed. *David Smith* (Praeger Publishers, 1973); Baigell, *Dictionary;* Falk, *Exh. Record Series;* death info courtesy Betty Krulick, Spanierman Gal., NYC.

SMITH, David H. *[Amateur artist] b.1844, Nauvoo, IL / d.1904, Elgin, IL.*
Addresses: Nauvoo, IL, active 1853-c.1863. **Comments:** He was the posthumous son of the Mormon leader Joseph Smith. As early as 1853 he made some drawings of the ruins of Nauvoo which have been preserved and reproduced, and in 1863 he painted an idealized picture of the same subject. He later became a leader of the Reorganized Church in Utah and a well-known hymn writer. **Sources:** G&W; Arrington, "Nauvoo Temple," Chap. 8.

SMITH, David Loeffler *[Painter, educator, writer] b.1928, New York, NY.*
Addresses: New Bedford, MA. **Studied:** Bard College, B.A.; Cranbrook Acad. Art, M.F.A.; also with Hans Hofmann & Raphael Soyer. **Member:** AAUP; Pittsburgh AA. **Exhibited:** Carnegie Inst., 1960 & 1961 (Henry Posner Prize); Seligman Gallery, NYC; Boston; First Street Gallery, New York, 1972 (solo). **Comments:** Preferred media: oils. Positions: asst. professor of art, acting chmn. art dept., Chatham College, Pittsburgh, PA; dean & director, professor of art, Swain School of Design, New Bedford, MA. Series of lectures on American Art, European Art for educational television programs. Author: articles, *American Artist,* 1959-62; *Carnegie Magazine,* 1960; *American Journal,* 1963; *Quarterly Journal of the Old Dartmouth Historical Society,* 1965; *Antiques Magazine* (Nov., 1967); *Arts Magazine* (March, 1968); *Art & Artists* (Jan., 1970 and May, 1971). **Sources:** WW73; WW66.

SMITH, David (Mrs.) See: **DEHNER, Dorothy**

SMITH, David V. *[Miniaturist] early 19th c.*
Addresses: Philadelphia, 1832; Baltimore, 1833. **Exhibited:** PAFA, 1832 (two miniatures after British artists). **Sources:** G&W; Rutledge, PA; Lafferty.

SMITH, De Cost *[Painter, illustrator, writer] b.1864, Skaneateles, NY / d.1939, Amenia, NY.* DE COST SMITH / 1898
Addresses: Paris, 1887; NYC, 1888-1901; Amenia, NY. **Studied:** McMullin School, NYC; ASL; Académie Julian, Paris with Boulanger and Lefebvre, 1878-82. **Member:** American Ethnological Soc.; SC, 1891. **Exhibited:** Paris Salon, 1886; NAD, 1887-1900; PAFA Ann., 1887-92, 1901; Boston AC, 1905, 1908; AIC. **Work:** AMNH; Mus. Am. Indian. **Comments:** Raised near the Onondaga Indian Reservation in New York State, he took his first of many trips West in 1884 to the Dakota Territory. Co-author/illustrator (with E.W. Deming): "Sketching Among the Sioux," 1893; "Sketching Among the Crow Indians," 1894 (both articles for *Outing Magazine*); author: "With Gun and Palette Among the Red Skins," 1895 (illus. by Remington). He also worked as an illustrator for national magazines such as *Century.* His autobiography was entitled *Indian Experiences* (1943). **Sources:** WW31; P&H Samuels, 449; Fink, *American Art at the Nineteenth-Century Paris Salons,* 391; *300 Years of American Art,* 581; Falk, *Exh. Record Series.*

SMITH, Dolph *[Painter, educator] b.1933, Memphis, TN.*
Addresses: Memphis, TN. **Studied:** Memphis State Univ.; Memphis Acad. Arts, B.F.A., 1960. **Exhibited:** Watercolor USA, Springfield, MO, 1965; AWCS, NYC, 1966; Invitational (one of four mid-south artists chosen to celebrate Memphis sesquicentennial with an exhib.), Brooks Mem. Art Gallery, 1969; Brooks Mem. Art Gallery, 1965 (solo) & Charles Bowers Mem. Mus.,

Santa Ana, CA, 1967 (solo); Memphis (TN) Academy of Arts, 1970s. Awards: first prize for watercolor, Mid-South Exhib., Brooks Mem. Art Gallery, 1964. **Work:** Arkansas State Univ., Jonesboro; Brooks Mem. Art Gallery, Memphis, TN; Southwestern at Memphis; Tennessee Arts Commission, Nashville; North Carolina Nat. Bank, Charlotte. Commissions: paintings for various locations nationwide, Holiday Inns Am., 1965-72; painting for Tennessee Exec. Mansion Christmas Card, Gov. & Mrs. Winfield Dunn, 1971; painting for Sen. Albert Gore, Democratic Party, Shelby Co., TN, 1971. **Comments:** Preferred media: watercolors. Positions: art director, Ward Archer Assoc., Memphis, 1964-67. Publications: illustrator, *Delta Review Magazine,* 10/1967, 1911-12/1969 & fall 1970; illustrator, *Mid-South Magazine,* 12/1971. Teaching: asst. professor painting & drawing, Memphis Acad. Arts, 1964-; visiting instructor painting, Southwestern College, 1966-68. **Sources:** WW73; Jo Potter, "The Real World of Dolph Smith," produced on WKNO-TV, 1965; Margaret Harold (compiler), *Prize-Winning Watercolors* (1965); William Thomas, "Dolph Smith's Mid-South," *Mid-South Magazine* (Feb. 9, 1969).

SMITH, Don R. *[Painter, mural painter] 20th c.; b.Cambridge, MA.*
Studied: with Stanton MacDonald-Wright, Morgan Russel, L. Feitelson; Otis Art Inst.; ASL of Los Angeles. **Exhibited:** Painters & Sculptors of Los Angeles. **Work:** murals: Los Angeles Public Library; El Rodeo Jr. High School; Banning High School; Gardena H.S. **Sources:** Hughes, *Artists in California,* 520.

SMITH, Donald E. *[Painter] mid 20th c.*
Exhibited: Corcoran Gal biennial, 1957. **Sources:** Falk, *Corcoran Gal.*

SMITH, Dora F. *[Artist] late 19th c.*
Addresses: Active in Washington, DC, 1888-92. **Comments:** **Sources:** Petteys, *Dictionary of Women Artists.*

SMITH, Dorman H(enry) *[Painter, cartoonist, illustrator] b.1892, Steubenville, Ohio / d.1956.*
Addresses: San Anselmo, CA, 1940; San Rafael, CA, 1953. **Studied:** self-taught. **Member:** Cleveland Soc. Art; Marin County Soc. Art; Bohemian Club, San Francisco; Nat. Headliners Club. **Exhibited:** CMA; Marin Soc. Art; Bohemian Club, 1935, 1939. Awards: medals, Sigma Delta Chi for editorial cartoonists; Nat. Headliners Club; Freedom Fnd. **Work:** CMA; Bohemian Club; Huntington Lib., San Marino, CA; Penn. Hist. Soc. **Comments:** Contributor: editorial cartoons to *Colliers.* Position: cartoonist, *San Francisco Examiner* and affiliates. Author: "101 Cartoons," (compilation of work) 1936; "Cartooning, A Course of Study," 1938. **Sources:** WW53; WW40.

SMITH, Dorothy Alden *[Book designer, illustrator] b.1918, Atlantic City, NJ.*
Addresses: Wayne, PA. **Studied:** NY School Fine & Applied Art; School Professional Artists, NY. **Member:** Phila. Art All.; PAFA; MoMA; PMA; Phila. Booksellers Assn.; Women in Graphic Arts. **Exhibited:** 50 Best Books of the Year, 1945 (prize), 1946 (prize); Phila. Book Exhib., 1946-55 (prizes, Book Show Chmn., 1953), 1962-64; Art Dir. Club, Phila., 1948-55, silver medal, 1957. **Comments:** Positions: asst. adv. director, Theodore Pressers Co., Phila., 1940-41; art director, designer, The Westminster Press, Phila., 1944-; juror, Phila. Book Exhib., 1956; curator & board of directors, King of Prussia Hist. Soc., 1958-. Lectures: "Illustrating Books", Moore College of Art, Phila., 1965. **Sources:** WW66; WW47.

SMITH, Dorothy Dehner See: **DEHNER, Dorothy**

SMITH, Dorothy Hope *[Illustrator] b.1895 / d.1955.*
Addresses: Westport, CT (1923-on). **Studied:** AIC. **Comments:** A specialist in painting children, she was the creator of the Gerber Baby which appears on the labels of the company's baby foods. She also illustrated books for Putnam's in NYC and ads for Lux and Ivory Snow before working for Gerber's. She was married to the cartoonist, Perry Barlow (see entry). **Sources:** *Community of*

Artists, 68.

SMITH, Dorothy Oldach [Teacher, painter, writer, lecturer] b.1906, Philadelphia, PA.
Addresses: Linden, NJ. **Studied:** Univ. Pennsylvania, B.S.; Moore Inst., Phila.; NY Univ., M.A.; & with Yarnall Abbott, Stanley Woodward. **Member:** AAPL; Eastern AA; New Jersey Art Educ. Assn.; Nat. Educ. Assn. **Exhibited:** Assoc. Am. Artists, NY; Linden (NJ) Nat. Art Week Exhib. **Comments:** Position: head art dept., Linden H.S., Linden, NJ, in 1959. Author: "Monographs on Contemporary Artists." Lectures: Masterpieces of Art (Renaissance to Early 20th Century). **Sources:** WW59.

SMITH, Duncan [Painter, teacher] b.1877, Charlottesville, VA / d.1934, Charlottesville, VA.
Addresses: NYC. **Studied:** ASL, 1896; Am. Acad., Rome; Cox; Twachtman; DeCamp; Brush; Blum. **Member:** Arch. Lg.; Fifteen Gal. **Exhibited:** S. Indp. A., 1917; WMAA, 1918-23; Fifteen Gal. **Work:** murals, NYC, other cities; Univ. of Virginia; Virginia State Lib. **Comments:** Position: teacher, ASL. **Sources:** WW33; Wright, Artists in Virginia Before 1900.

SMITH, E. Bert [Cartoonist] 20th c.
Addresses: Denver, CO. **Member:** Denver AC. **Comments:** Position: staff, Rocky Mountain News, Denver. **Sources:** WW06.

SMITH, E. Boyd See: **SMITH, E(lmer) Boyd**

SMITH, E. Galusha (Mrs. William H.) [Painter, teacher] b.1849, Morris, IL.
Addresses: Peoria, IL. **Studied:** Chataine; M. Pullman; F.C. Peyraud. **Member:** Peoria AL; Peoria AA. **Exhibited:** Fine Arts Dept., National Implement Assn., 1920 (prize). **Work:** Shirley-Savoy Hotel, Denver. **Sources:** WW24.

SMITH, E. L. See: **SMITH, Esther L.**

SMITH, E. V. (Mrs.) [Painter (also made crayon drawings)] 19th c.
Addresses: Richmond, VA. **Exhibited:** Fair of the Mechanics Inst., Richmond, VA, 1854 (prize), 1855 (prize). **Sources:** Wright, Artists in Virginia Before 1900.

SMITH, E. Zabriskie Banta See: **BANTA, E. Zabriskie (Mrs. Oliver Smith)**

SMITH, E(arl) Baldwin [Educator, writer, lecturer] b.1888, Topsham, ME.
Addresses: Princeton, NJ. **Studied:** PIA School; Bowdoin College, A.B., L.H.D.; Princeton Univ., A.M., Ph.D. **Member:** CAA; Archaeological Inst. Am.; Iranian Inst. **Comments:** Author/editor: "Early Christian Iconography," 1918. Contributor to art magazines & bulletins. Position: professor of art & archaeology, 1916-, chmn., dept., 1945-, Princeton Univ., Princeton, N.J. **Sources:** WW53; WW47.

SMITH, Edith M. [Painter] 20th c.
Addresses: Chicago, IL. **Exhibited:** WMAA, 1954. **Sources:** Falk, WMAA.

SMITH, Edith Paul (Mrs. Charles) [Sculptor, painter] b.1876, New Orleans, LA.
Addresses: New Orleans, active 1896-1903. **Studied:** Achille Prelli. **Sources:** Encyclopaedia of New Orleans Artists, 356.

SMITH, Edith T. [Painter] 20th c.
Addresses: Wethersfield, CT. **Exhibited:** Springfield AL, 1936. **Sources:** WW40.

SMITH, Edmund Revel [Landscape painter] b.1829 / d.1911.
Addresses: Skaneateles, NY, 1859. **Exhibited:** NAD, 1859 (scene in the vicinity of Düsseldorf, Germany). **Sources:** G&W; Cowdrey, NAD.

SMITH, Edna Kenderdine [Portrait painter] b.1879, Rockford, IL.
Studied: Académie Julian, Paris. **Exhibited:** Paris Salon, 1900. **Comments:** Director/founder, Birmingham (AL) School Art. **Sources:** Petteys, Dictionary of Women Artists.

SMITH, Edna M(ay) (Mrs. Charles J.) [Painter] 20th c.
Exhibited: S. Indp. A., 1941. **Sources:** Marlor, Soc. Indp. Artists.

SMITH, Edna Wybrant [Painter] 20th c.
Addresses: Phila., PA. **Sources:** WW08.

SMITH, Edward [Portrait, genre, and still life painter] mid 19th c.
Addresses: Philadelphia, active 1832-44. **Exhibited:** PAFA, 1832, 1834, 1844. **Sources:** G&W; Rutledge, PA.

SMITH, (Edward) Gregory [Painter] b.1880, Grand Rapids, MI / d.1961, Boiling Springs, PA.
Addresses: Old Lyme, CT, 1910-61. **Studied:** AIC, 2 years. **Member:** Lyme AA (pres., 1934-58); CAFA, 1938 (prize); Allied AA; New Soc. Am. Artists. **Exhibited:** AIC, 1915, 1921; PAFA Ann., 1915, 1919-21; Corcoran Gal biennial, 1916; S. Indp. A., 1917; Lyme AA, (prizes) 1922 (W.S. Eaton Purchase Prize), 1927 (Woodhull Adams Mem. Prize), 1931 (Goodman Prize), 1936 (Goodman Prize); Lyme Hist. Soc., 1977 (retrospective). **Work:** Grand Rapids (MI) Art Gal.; Hackley Art Gal., Muskegon, MI. **Comments:** An active member of the colony at Old Lyme from 1910. Most of his work was destroyed in a 1925 fire. (He was also a charter member of the Old Lyme Volunteer Fire Dept. started in 1923). He called himself Gregory, although he signed some paintings with his full name. **Sources:** WW40; Connecticut and American Impressionism 173 (w/repro.); Art in Conn.: The Impressionist Years; Falk, Exh. Record Series.

SMITH, E(dward) Herndon [Painter, sculptor] b.1891, Mobile, AL.
Addresses: Mobile, AL. **Studied:** Weir; Tack; Yale. **Member:** Brooklyn Soc. Modern Art. **Exhibited:** S. Indp. A., 1920, 1924; Salons of Am., 1934. **Sources:** WW33.

SMITH, Edward R. [Librarian, painter, sculptor] b.1854, Beyrout, Syria / d.1921, Stamford, CT.
Addresses: NYC. **Studied:** W. Rimmer; R. Duveneck. **Member:** Arch. Lg., 1910; NY Municipal AS; Archaeological Inst. Am.; Am. Numismatic Soc.; Am. Lib. Assn. **Exhibited:** Boston AC, 1881. **Comments:** Position: librarian, Avery Library, Columbia Univ. **Sources:** WW19; The Boston AC.

SMITH, Edward R(evel?) [Painter] b.1829 / d.1911.
Addresses: NYC, 1895-96. **Exhibited:** NAD, 1895-96. **Sources:** Naylor, NAD.

SMITH, Edwin A. (Mrs.) [Genre and still life painter] 19th c.
Exhibited: Fair of the Mechanics Inst., Richmond, 1856. **Sources:** Wright, Artists in Virginia Before 1900.

SMITH, Edwin B. [Portrait and historical painter] mid 19th c.
Addresses: Cincinnati, active1811-c.1825; Troy, OH, active1832; New Orleans, active1841. **Sources:** G&W; Cist, Cincinnati in 1841, 139; Knittle, Early Ohio Taverns; Clark, Ohio Art and Artists, 73, 491. Hageman, 122.

SMITH, Edwin James [Painter] b.1899, Omaha.
Addresses: Omaha, NE. **Studied:** P. Dickinson. **Sources:** WW40.

SMITH, Eileen A. [Painter] b.1899, Hastings, NE.
Addresses: Delaware, OH. **Member:** Alliance. **Exhibited:** S. Indp. A., 1921. **Sources:** WW25.

SMITH, Elisabeth Hall [Painter] 19th/20th c.
Addresses: Active in Boston, c.1900. **Sources:** Petteys, Dictionary of Women Artists.

SMITH, Eliza Lloyd [Painter] b.1872, Urbana, OH.
Addresses: Wash., DC/Bluemont, VA, active 1908-31. **Studied:** CGA School. **Member:** Wash. WCC. **Exhibited:** Wash. WCC, 1908-23. **Sources:** WW31; McMahan, Artists of Washington, DC.

SMITH, Elizabeth [Painter] 20th c.
Addresses: Baltimore, MD. **Member:** Baltimore WCC. **Sources:**

WW29.

SMITH, Elizabeth See: **INGHAM-SMITH, Elizabeth (Mrs. Francis Smith)**

SMITH, Elizabeth Easby See: **EASBY-SMITH, Elizabeth H.**

SMITH, Elizabeth Hay *[Still life painter]* 20th c.
Addresses: San Francisco, CA. **Exhibited:** Oakland Art Gallery, 1929; San Francisco Soc. of Women Artists, 1931. **Sources:** Hughes, *Artists of California,* 521.

SMITH, Elizabeth W. *[Painter]* late 19th c.
Exhibited: Soc. Wash. Artists, 1879. **Sources:** McMahan, *Artists of Washington, DC.*

SMITH, Ella B. *[Painter]* 20th c.
Addresses: Boston, MA. **Member:** Chicago NJSA. **Exhibited:** Doll & Richards, Boston, 1908, 1923, 1937; PAFA Ann., 1915; S. Indp. A., 1917-26, 1930-31; Salons of Am., 1930. **Sources:** WW25; Falk, *Exh. Record Series.*

SMITH, Ella Tanner *[Painter]* b.1877, Sutter Creek, CA / d.1918, Berkeley, CA.
Addresses: Berkeley, CA. **Studied:** Crocker Art School, Sacramento; Mark Hopkins Inst.; with R. Max Meyers. **Comments:** Specialty: portraits, landscapes and scenes of the San Francisco Bay area. Her works are rare. **Sources:** Hughes, *Artists of California,* 521.

SMITH, Elma (Mrs.) *[Painter]* 20th c.
Addresses: East Cleveland, OH. **Member:** Cleveland Women's AC. **Sources:** WW25.

SMITH, E(lmer) Boyd — E. BOYD SMITH —
[Painter, illustrator, writer]
b.1860, St. John, New Brunswick, Canada / d.1943, Wilton, CT.
Addresses: Boston, MA, 1880s & 1890s; Wilton, CT (early 1900s-on). **Studied:** Académie Julian, Paris with Boulanger and Lefebvre, 1881-84; also with H. Lefort. **Member:** Boston AC. **Exhibited:** Boston AC, 1885-86, 1896-98;PAFA Ann., 1885, 1898; Paris Salon, 1891 (etchings), 1892-94; Soc. Nat. Beaux-Arts, 1897, 1899. **Comments:** After spending the 1880s-90s in France (living in Paris and Auvers), he traveled through the West sketching and briefly lived in Kansas City where he was the first director, Kansas City AA and School of Design. By the early 1900s he settled in Connecticut. Author/illustrator: "The Story of Noah's Ark," "The Chicken World," "Pocahontas and Captain John Smith," "The Story of Our Country." **Sources:** WW33; P&H Samuels, 449-50; Fink, *American Art at the Nineteenth-Century Paris Salons,* erroneously lists him as E. Smith Boyd (323) and correctly as E. Boyd Smith (391); Falk, *Exh. Record Series.*

SMITH, E(mil)P. *[Lithographer]* b.c.1822, Germany.
Addresses: NYC, 1860; Wash., DC, 1872-77. **Comments:** His wife and two older children (16 and 7) were born in Germany; two younger children (4 and 2) were born in New York. **Sources:** G&W; 8 Census (1860), N.Y., XLII, 692. More recently, see McMahan, *Artists of Washington, DC.*

SMITH, Emily Guthrie (Mrs. Tolbert C.) *[Painter, instructor]* b.1909, Fort Worth, TX / d.1987.
Addresses: Fort Worth, TX. **Studied:** Texas Woman's Univ.; ASL; Univ. Oklahoma; also with Mitchell Jamieson, R. Brackman & Frederic Taubes. **Member:** SSAL; Texas FAA; Fort Worth Art Center Mus.; Dallas Mus. Fine Arts. **Exhibited:** VMFA, 1946; Oakland Art Gal., 1945; AWCS, 1946; Caller-Times Exhib., Corpus Christi, TX, 1945; SSAL, 1941-46; Texas General Exhib., 1942-46; Texas FAA, 1943-46; Ft. Worth AA, 1940-45; Texas Pavilion, Hemisfair, San Antonio, 1968; Am. Watercolor Soc., NYC; Virginia Biennial, Richmond Mus. Fine Arts; Fort Worth Art Center Mus. (solo retrospective); Carlin Galleries, Fort Worth, TX, 1970s. **Awards:** Texas Ann. Award, Dallas Mus. Fine Arts, 1963; top award, Tarrant Co. Ann., Fort Worth Art Center Mus., 1965; first award, Longview Invitational, Jr. Service League,

1968. **Work:** Fort Worth Art Center Mus.; Dallas Mus. Fine Arts; West Texas Mus. Fine Arts, Lubbock; Lone Star Gas Co. Collection, State of Texas; Univ. Texas, Arlington. **Commissions:** portraits, commissioned by Mary Martin, 1946 & Major Carswell, Carswell AFB, Fort Worth, 1957; murals, Western Hills Hotel, Fort Worth, 1951, Fort Worth Savings & Loan, 1954 & mosaic, All Saints Hospital, Fort Worth, 1956. **Comments:** Preferred media: pastels, oils. Teaching: instructor of portrait painting, mosaics & drawing, Fort Worth Art Center Mus., 1955-70; instructor, Taos, NM & Las Vegas, Texas, summers 1960-69. Collections: contemporary painting. **Sources:** WW73; WW47.

SMITH, Emma *[Artist]* early 20th c.
Addresses: Active in Detroit, 1900-06. **Sources:** Petteys, *Dictionary of Women Artists.*

SMITH, Emma J. McGrew (Mrs.) *[Painter]* b.1848, Covington, KY / d.1947, Washington, DC.
Addresses: Wash., DC, from 1865. **Studied:** ASL, Wash., DC; Courtois in Paris, France. **Member:** Wash. WCC (founding member, 1896); Washington AC (founding member, 1916). **Exhibited:** Wash. WCC, until c.1927; Soc. Wash. Artists; CGA. **Sources:** WW31; McMahan, *Artists of Washington, DC,* 200.

SMITH, Emma J.B. *[Painter, teacher]* b.c.1846 / d.1889, New Orleans, LA.
Exhibited: World's Indust. & Cotton Cent. Expo, 1884-85. **Comments:** Advertised drawing classes and and portraits in oil, pastel, crayon and in china painting. **Sources:** *Encyclopaedia of New Orleans Artists,* 356.

SMITH, Erik Johan *[Painter]* 20th c.
Exhibited: AIC, 1923. **Sources:** Falk, *AIC.*

SMITH, Ernest Browning *[Landscape painter]* b.1866, Brimfield, MA / d.1951, Los Angeles, CA.
Addresses: Los Angeles, CA. **Studied:** self-taught; Europe. **Member:** Calif. AC; Laguna Beach AA. **Exhibited:** Calif. AC, 1914-29; San Francisco AA, 1916; Sacramento State Fair, 1925 (prize); Pomona County Fair,1925, 1928, 1930 (prize); LACMA, 1932 (solo). **Work:** LACMA; SFMA. **Comments:** Played French horn in Los Angeles Symphony Orchestra, 1897-1911. **Sources:** WW53; WW47; Hughes, *Artists in California,* 521.

SMITH, Erwin E. *[Sculptor, photographer]* b.1888, Honey Grove, TX / d.1947, Bermuda Ranch, near Bonham, TX.
Studied: Lorado Taft, Chicago; Bela Pratt, Boston. **Comments:** Illustrator: "Life on the Texas Range," J.E. Haley, 1952; cowboy and pioneer scenes in many of George Patullo's Western stories. **Sources:** P&H Samuels, 450.

SMITH, Esther L. *[Portrait painter]* mid 19th c.
Addresses: Active in Greenfield, MA & Hartford, CT, c.1870. **Exhibited:** NAD, 1897 (as E. L. Smith). **Comments:** Her sister, Sara J. Smith, was also an artist (see entry). **Sources:** Petteys, *Dictionary of Women Artists;* Naylor, *NAD.*

SMITH, Esther Morton *[Painter]* b.1865.
Addresses: Phila., PA, 1889-94. **Exhibited:** PAFA Ann., 1889, 1891, 1894 (still life & landscape). **Sources:** Falk, *Exh. Record Series.*

SMITH, Ethel Amelia *[Painter]* 20th c.
Addresses: Woodbury, NJ. **Studied:** PAFA. **Sources:** WW25.

SMITH, Ethel M. *[Painter]* 20th c.
Addresses: Worcester, MA. **Sources:** WW25.

SMITH, Eugene See: **SMITH, W. Eugene**

SMITH, Eugene A. *[Museum director]* 20th c.
Addresses: Roswell, NM. **Sources:** WW66.

SMITH, Eunice See: **HATFIELD, Eunice Camille (Mrs. John Smith)**

SMITH, Eva Augusta Ford (Mrs. A. O.) *[Painter, illustrator, teacher]* 19th/20th c.; b.Northfield, VT.
Addresses: NYC. **Studied:** With H. M. Walcot and Frank Vincent DuMond, NYC; Clyde Cook in Munich. **Exhibited:** Portland

(OR) Art Mus., 1900 (prize). **Comments:** Married John P. Cline in 1874 and A. O. Smith in 1909. **Sources:** Petteys, *Dictionary of Women Artists.*

SMITH, Eva F. *[Painter]*
Addresses: NYC. **Exhibited:** AWCS, 1898. **Sources:** WW01.

SMITH, F. Rollin *[Painter] late 19th c.*
Addresses: NYC, 1886, 1889. **Exhibited:** NAD, 1886, 1889.
Sources: Naylor, *NAD.*

SMITH, F. S. *[Painter] late 19th c.*
Addresses: NYC, 1884-1895. **Exhibited:** NAD, 1884-95.
Sources: Naylor, *NAD.*

SMITH, F. Stanley *[Painter] 20th c.*
Addresses: North Shirley, MA. **Member:** Phila. WCC. **Sources:** WW31.

SMITH, Florence *[Landscape painter] 19th/20th c.*
Exhibited: Norfolk, VA, 1886. **Sources:** Wright, *Artists in Virgina Before 1900.*

SMITH, Florence Sprague (Mrs. Jefferson R.) *[Sculptor]*
b.1888, Paullina, IA.
Addresses: St. Louis, MO; Des Moines, IA. **Studied:** C. Mulligan; Alban Polasek, AIC; ceramics at Lewis Inst. Chicago. **Member:** Indep. Artists. St. Louis; Iowa AC; Des Moines FAA; College AA. **Exhibited:** AIC, 1930; Am. Ann., 1931; NAD, 1931; Iowa Fed. Women's Clubs Exh., 1932; Iowa Artists Club, 1932 (prize). **Work:** portrait bust, Drake Univ. Chapel; Des Moines Water Works; Des Moines Pub. Lib. **Comments:** Teaching: Drake Univ., 1920-34; Stone City Art Colony, summers 1932-33. **Sources:** WW33; Ness & Orwig,, *Iowa Artists of the First Hundred Years,* 196.

SMITH, Frances S. (Mrs. George De Forest) *[Painter] 20th c.*
Addresses: NYC. **Member:** NY Women's Art Club. **Sources:** WW04.

SMITH, F(rancis) Berkeley *[Illustrator, architect, writer]*
b.1868, Astoria, NY / d.1931.
Addresses: Paris, France. **Studied:** Columbia. **Comments:** Author/illustrator: "The Real Latin Quarter," "Budapest, the City of the Magyars"; mag. articles; short stories. Son of F. Hopkinson. Position: practicing architect until 1896. **Sources:** WW33.

SMITH, F(rancis) Drexel *[Painter] b.1874, Chicago, IL / d.1956, Colorado Springs, CO.*
Addresses: Colorado Springs, CO. **Studied:** AIC; Broadmoor Art Acad.; & with John Vanderpoel, John Carlson, Everett Warner, 1894. **Member:** Denver AA; Mississippi AA; Chicago Galleries Assn.; New Orleans AA; Dubuque AA; Broadmoor Art Acad. (trustee, 1919; pres.); Colorado Springs FA Center (trustee). **Exhibited:** S. Indp. A., 1922; Salons of Am., 1922-23; CI, 1924, 1929-30; NAD, 1922; PAFA Ann., 1924, 1932; AIC, 1931; Oakland Art Gal.; Portland (OR) Art Mus.; New Haven, CT; Buffalo, NY; Palm Beach, FL; Kansas City AI, 1924 (prize); SAM, 1929 (prize); New Orleans AA, 1940 (prize); Seattle FA Soc., 1923; Buffalo SA, 1925 (prize); Denver AM, 1927 (prize), 1928 (prize), 1936 (prize); Colorado Springs, 1929 (prize), 1930 (prize), 1932 (prize); Mississippi AA, 1932 (medal); Corcoran Gal biennial, 1947; Colorado State Fair, 1949 (prize). **Work:** Kansas City AI; Denver AM; Vanderpoel Collection; Colorado Springs FA Center; Dubuque AA; Municipal AC & Belhaven College, Jackson, MS; Mus. FA, Montgomery, AL; Grinnell College; Mississippi State College for Women. **Sources:** WW53; WW47; P&H Samuels, 450; Falk, *Exh. Record Series.*

SMITH, F(rancis) Hopkinson
[Landscape painter, lllustrator, writer, lecturer] b.1838, Baltimore, MD / d.1915, NYC.
— *F.Hopkinson Smith ~'80*
Addresses: NYC, 1880. **Studied:** self-taught. **Member:** AWCS (treasurer, 1873-78); Phila. AC; NIAL; SI, 1906; Cincinnati AC; Century Assn.; Tile Club. **Exhibited:** NAD, 1868, 1880; Brooklyn

AA, 1875-84, 1891; PAFA Ann., 1879-80, 1892, 1900; Boston AC, 1880-1905; AIC, 1889-1908; Pan-Am. Expo, Buffalo, 1901 (medal); Charleston Expo, 1902 (medal); Phila. AC, 1902 (gold); AAS, 1902 (gold). **Awards:** Commander Order of the Mejidieh, 1898; Order of Osmanieh, 1900. **Work:** CGA; Albright Art Gal., Buffalo. **Comments:** After the Civil War he worked as a naval engineer with fellow artist J. Symington. They built the foundation for the Statue of Liberty and many breakwaters. By the 1880s, he had given up engineering in order to paint (a hobby until then), travel, write, and lecture. Noted especially for his watercolors and charcoal drawings, many of which appeared in his books of travel. He, Arthur Quartly and Charles Stanley Reinhart were part of an artists' colony that developed at Cold Spring Harbor, New York. Author: "Col. Carter of Cartersville," "Fortunes of Oliver Horn," "American Illustrators," 1894. **Sources:** G&W; DAB; CAB; *Art Annual,* XI1; "The Tile Club at Play," *Scribner's Monthly,* February, 1879; "The Tile Club Ashore," *Century Magazine,* February, 1882; Falk, *Exh. Record Series.* More recently, see Gerdts, *Art Across America,* vol. 1: 148; Pisano, *The Long Island Landscape, 1865-1914,* introduction; Campbell, *New Hampshire Scenery,* 150-151.

SMITH, Frank Anthony *[Painter] b.1939, Salt Lake City, Utah.*
Addresses: Salt Lake City, UT. **Studied:** Univ. Utah (B.F.A., 1962; M.F.A., 1964). **Exhibited:** Drawings USA, 1963; three-man shows, Mickelson Gallery, Washington, DC, 1965; Artists West of the Mississippi, 1967; 73rd Western Ann., Denver, CO, 1972; Realist Painting 12 Viewpoints, 1972; Max Hutchinson Gallery, NYC, 1970s. **Awards:** San Francisco Art Dirs. Gold Medal, 1964; purchase award, Third Intermt. Biennial, 1968. **Work:** Univ. Utah Mus. Fine Art; Utah State Univ.; Salt Lake Art Center; Max Hutchinson Gallery, NYC. **Commissions:** Buffalo dance piece 1966 & Diamond dance piece (with Linda C. Smith), 1971, Repertory Dance Theatre; Stimuli sensory environment for children, Salt Lake Art Center, 1970; mural, Univ. Utah Biology Bldg., 1972. **Comments:** Preferred media: acrylics. Teaching: asst. professor of painting & drawing, Univ. Utah, 1968-. **Sources:** WW73.

SMITH, Frank Eugene See: **EUGENE, Frank**

SMITH, Frank H. See: **SMITH, F(rancis) Hopkinson**

SMITH, Frank Hill *[Decorator, painter] b.1841, Boston, MA / d.1904.*
Addresses: Boston, MA. **Studied:** architecture, with Hammatt Billings; Bonnât, Atelier Suisse, Paris; Italy. **Exhibited:** Paris Salon, 1870; Boston AC, 1877. **Work:** decorated the Windsor Hotel and the Opera House, Holyoke, MA, as well as public and private bldgs. in Boston and Cambridge. **Comments:** Spent many years abroad, in Belgium, Holland, Italy, and France. In the 1870s he began concentrating on decoration. Positions: jury of fine arts, Centenn. Expo, Phila, 1876; director, School of the Museum of the Fine Arts, Boston. **Sources:** Clement and Hutton; Fink, *American Art at the Nineteenth-Century Paris Salons,* 391; *The Boston AC.*

SMITH, Frank Vining
[Marine painter, writer, illustrator, cartoonist] b.1879, Whitman, MA / d.1967, Hingham, MA.
— *FRANK VINING SMITH*
Addresses: Boston, Hingham, MA. **Studied:** BMFA School; & with Frank Benson, Philip L. Hale, and Edmund Tarbell; Central Ontario Sch. Design, Toronto; ASL. **Exhibited:** PAFA Ann., 1918; AIC, 1923; Doll & Richards Gal., Boston, 1930, 1934; Swain Free School Design, 1931; Bose Gal., Boston, 1938; Jordan Marsh, Boston, 1939 (gold medal), 1942 (gold medal), 1945 (gold medal), 1946 (gold medal); Schwartz Gal., New York; Barbizon Plaza, NY; Anderson Gal., Chicago; Findlay Gal., Chicago; Gump Gal., San Francisco; John Hanna Gal., Detroit; J. J. Gillespie Gal., Pittsburgh; Heritage Plantation, Sandwich, MA, 1975. **Work:** Kendall Whaling Mus.; Mariners Mus.; Mystic Seaport Mus.; Old Dartmouth Hist. Soc.; yacht clubs: Grosse Pointe, MI, New Bedford, MA, Hingham, Marblehead, both in MA; Dartmouth

Inst., New Bedford; murals for steamship companies; Heritage Plantation, Sandwich, MA; Seamen's Bank for Savings, NY. **Comments:** Smith was fascinated with the sea and sea-going vessels. Contributor: *Yachting, Field & Stream, Outdoors* magazines. Illustrator: *McClure's, Boston Journal, Boston Herald.* In the camouflage dept. in 1918 and 1919. He spent time painting in Bermuda. **Sources:** WW59; WW47; Blasdale, *Artists of New Bedford,* 173-74 (w/repro.); Falk, *Exh. Record Series.*

SMITH, Frederic Augustus *[Medal designer] d.1852, Washington, DC.*
Comments: Designer of the reverse of the medal struck in honor of General Zachary Taylor's victory at Buena Vista in 1847. Smith was a graduate of West Point in 1833; he was promoted to captain in 1838. **Sources:** G&W; Loubat, *Medallic History of the U.S.,* pl. 64.

SMITH, Frederic Marlett Bell See: **BELL-SMITH, Frederic Marlett**

SMITH, Frederick See: **SCHMIDT, Frederick**

SMITH, Frederick B. *[Engraver and die sinker] mid 19th c.*
Addresses: NYC, 1835-60 and after. **Comments:** From 1835-47 he was of Bale & Smith (se entry);1850-59 of Smith & Hartmann (see entry). **Sources:** G&W; NYCD 1835-60+.

SMITH, F(rederick) Carl *[Portrait painter] b.1868, Cincinnati, OH / d.1955, Pasadena, CA.*
Addresses: Washington, DC, c.1900; NYC, 1900; Pasadena, CA, c.1917 and after. **Studied:** Cincinnati Art Acad.; Académie Julian, Paris with Bouguereau, Ferrier, Constant. **Member:** Calif. AC; Soc. of Washington Artists; Washington WC Club; Paris American AA; Laguna Beach AA; Pasadena SA. **Exhibited:** Paris Salon, 1897, 1899; NAD, 1900; Soc. of Washington Artists; Washington WCC; AAS, 1902; LACMA; Corcoran Gal annual, 1908; S. Indp. A., 1917; Southwest Mus., Los Angeles, 1921 (prize). **Work:** Pub. Lib., Minneapolis, MN; Continental Hall, Wash., DC; Allegheny (PA) Observatory; State Capitol, Denver; State Capitol, Columbus, OH. **Comments:** Studied and painted in Paris for 7 years, marrying Isabel E. Smith (see entry) in 1895 in London and returning to the U.S. c.1900. **Sources:** WW53; WW47; Marlor, *Soc. Indp. Artists,* listed as F(rithjof) Carl Smith; McMahan, *Artists of Washington, DC,* 200; Fink, *American Art at the Nineteenth-Century Paris Salons,* 391 (as Carl F. Smith).

SMITH, Frederick W. *[Painter] b.1885, Malden, MA.*
Addresses: Kennebunkport, ME. **Studied:** E. O'Hara. **Member:** North Shore AA; Goose Rocks Beach AA. **Sources:** WW40.

SMITH, Frithjof See: **SMITH, F(rederick) Carl**

SMITH, G. G. *[Listed as "artist"] mid 19th c.*
Addresses: NYC, active 1833. **Exhibited:** NA, 1833 (scene from Cooper's *The Water Witch*). **Comments:** *Cf.* George Girdler Smith. **Sources:** G&W; Cowdrey, NAD.

SMITH, G. Ralph *[Painte] 20th c.*
Addresses: Phila., PA. **Exhibited:** PAFA Ann., 1953. **Sources:** Falk, *Exh. Record Series.*

SMITH, Gary M. *[Art dealer] b.1944, Vinita, OK.*
Addresses: NYC. **Studied:** Kansas City Art Inst.; Cooper Union. **Comments:** Specialty of gallery: contemporary American painting and pre-Columbian artifacts. **Sources:** WW73.

SMITH, Gean *[Painter, illustrator] b.1851, New York State / d.1928, Galveston, TX.*
Addresses: NYC, 1892, 1896; Galveston (since 1923). **Exhibited:** AIC, 1892, 1897; NAD, 1892, 1897. **Comments:** His art training consisted of one lesson taken at the age of sixteen, costing one dollar. He maintained a studio in NYC (after moving from Chicago in 1885). His paintings comprise a pictorial record of the champion racing horses of America. He also painted dogs and western animals. **Sources:** P&H Samuels, 450.

SMITH, George *[Engraver] late 18th c.; b.London.*
Addresses: NYC, 1778. **Sources:** G&W; Kelby, *Notes on*

American Artists.

SMITH, George *[Engraver] b.1822, England.*
Addresses: Frankford (Philadelphia), 1850. **Sources:** G&W; 7 Census (1850), Pa., LVI, 329.

SMITH, George *[Painter, sculptor] b.1941, Buffalo, NY.*
Studied: North Carolina A&T; Florida A&M; San Francisco AI; Hunter College. **Exhibited:** Oakland Mus., 1968; Newark Mus., 1971; Reese Palley Gallery, NYC, 1970; Hunter College, 1970. **Work:** priv. colls. **Sources:** Cederholm, *Afro-American Artists.*

SMITH, George Ann *[Painter] b.1921, VA.*
Addresses: Wash., DC. **Studied:** Corcoran Gal. School, Wash., DC. **Exhibited:** Smithsonian, 1937; Wash. WCC, 1939. **Sources:** WW40.

SMITH, George D. (W.) *[Painter] 20th c.*
Addresses: Hamilton, MA. **Exhibited:** S. Indp. A., 1925-26. **Sources:** Marlor, *Soc. Indp. Artists.*

SMITH, George F. *[Designer] mid 19th c.*
Addresses: Philadelphia, 1851-52. **Sources:** G&W; Phila. CD 1851-52.

SMITH, George Girdler *[Portrait and banknote engraver, lithographer] b.1795, Danvers, MA / d.1878, Boston.*
Comments: He was probably a pupil of Abel Bowen (see entry), for whom he was working as early as 1815. From about 1820-33 he was in partnership with William B. Annin (see entry) and in 1830 he was a member of the Senefelder Lithographic Company. He later worked with Terry, Pelton & Co. and with Charles A. Knight and George H. Tappan (see entries). **Sources:** G&W; *Danvers Vital Records;* death date in Boston CD 1879; 7 Census (1850), Mass., XXV, 154; 8 Census (1860), Mass., XXVIII, 229; Stauffer; Belknap, *Artists and Craftsmen of Essex County,* 5; Boston CD 1820-79; Whitmore, "Abel Bowen," 41. Some of his watercolor drawings and mss. are in J.R. Smith's "Old Boston" (1857) at the Boston Public Library.

SMITH, George Melville *[Painter] 20th c.*
Addresses: Chicago, IL. **Exhibited:** S. Indp. A., 1917, 1927-30; AIC, 1933, 1937-38; 48 Sts. Competition, 1939. **Work:** WPA murals, USPOs, Elmhurst (IL), Park Ridge (IL), Crown Point (IN). **Sources:** WW40.

SMITH, George N. *[Painter] 20th c.*
Addresses: Oakland, CA. **Sources:** WW19.

SMITH, George Robert, Jr. *[Painter] b.1889, NYC.*
Addresses: Bronx, NY. **Studied:** ASL; West End School Art; G.E. Browne. **Member:** Provincetown AA; Cyasan Artists; Bronx AG. **Exhibited:** Salons of Am., 1922; S. Indp. A., 1927. **Sources:** WW31.

SMITH, George W *[Sculptor, educator] b.1941, Buffalo, NY.*
Addresses: Cheektawaga, NY. **Studied:** San Francisco Art Inst., B.F.A.; Hunter College; City Univ. New York, M.A., with Tony Smith. **Exhibited:** Reese Palley Gallery, New York, 1970 (solo); Contemporary Am. Black Artists, Hudson River Mus., Yonkers, NY, 1970; WMAA, 1970-71; Black Artists-Two Generations, Newark Mus., 1971; Everson Mus. Art, Syracuse, 1972 (solo); Reese Palley Gallery, NYC, 1970s. **Awards:** John Simon Guggenheim Mem. Foundation fellowship in sculpture, 1971-72. **Work:** Newark (NJ) Mus.; Everson Mus. Art, Syracuse, NY; collection of Reese Palley, NYC. **Commissions:** 22nd and theme sculpture, City & Co. Art Commission, San Francisco, 1968; sculptures, San Jose Dr., Nat Assn. Advan Colored People, in connection with Olympics in Mexico, 1968. **Comments:** Preferred media: steel, bronze. Teaching: asst. professor sculpture, State Univ. NY Buffalo, 1972-. **Sources:** WW73; S.S. Lewis, "Black Artists on Art, Vol. II," Contemporary Crafts, Inc., CA, 1971.

SMITH, George Walter Vincent *[Patron] b.1923.*
Comments: Position: donor/director, Springfield (MA) Art Mus., 1985.

SMITH, George W(ashington) *[Landscape painter, architect]* b.1879, East Liberty, PA / d.1930, Montecito, CA.
Addresses: Wash., DC.; Santa Barbara, CA (since 1917).
Studied: Harvard, 1894-96 (arch.); École des Beaux-Arts, Paris, 1912-14; Rome. **Member:** Paris AAA; NAC; Calif. AC; AIA.
Exhibited: AIC, 1915, 1917; Pan-Pac Expo, 1915; Soc. Wash. Artists, 1916; Corcoran Gal biennial, 1916; PAFA Ann., 1916, 1918; Soc. of Independent Artists, 1917. **Work:** USPOs, Berkeley and Watsonville, CA; Alamo School, San Francisco. **Sources:** WW29; Hughes, *Artists in California*, 522; McMahan, *Artists of Washington, DC.;* Falk, *Exh. Record Series.*

SMITH, Georgine (Mrs. C.) See: **SHILLARD, Georgine Wetherell (Mrs. C. Shillard Smith)**

SMITH, Gertrude Binney *[Landscape painter, marine painter]* b.c.1873 / d.1932, Beverly, MA.
Addresses: Amesbury, MA. **Exhibited:** Northshore AA, East Gloucester. **Comments:** With several of her paintings under her arm, she was en route to an exhibition of the North Shore AA at East Gloucester, when she discovered she had taken the wrong train. With the train well underway, she is believed to have jumped off, and was instantly killed.

SMITH, Gertrude Roberts (Mrs. Frederich) *[Painter, teacher, craftsperson]* b.1869, Cambridge, MA / d.1962.
Addresses: New Orleans, active 1887-1934. **Studied:** Mass. Normal Art School; Chase School; Colarossi Acad., Paris.
Member: SSAL; Boston ACS; NOAA; NOACC; Needle & Bobbin Club; Soc. of Western Artists. **Exhibited:** Tulane Decorative Art League For Women, 1888; Art League of N.O., 1889; Artist's Assoc. of N.O., 1889-92, 1894, 1897, 1899, 1901-02; Tulane Univ., 1890, 1892-93; NOAA (gold), 1905, 1907, 1910-11, 1913-15, 1917-18; Delgado AM, 1921 (purchase prize); Pan.-Pacific Expo, San Francisco, 1915. Award: Louisiana Purchase Expo., 1904. **Work:** Newcomb College. **Comments:** Painted landscapes and travel scenes in oil and watercolor. Position: teacher, Newcomb College, 1887-89, assist. prof., 1889-1906, professor, 1907-34. **Sources:** WW40; *Encyclopaedia of New Orleans Artists*, 357.

SMITH, Gladys K. *[Painter, block printer, drawing specialist, sculptor, teacher]* b.1888, Phila.
Addresses: Phila, PA/Avalon, NJ. **Studied:** Phila. Sch. Design; PAFA. **Member:** Plastic Club; Eastern AA. **Work:** Star Garden Rec. Center, Phila. **Comments:** Position: teacher, Shaw Jr. H.S., West Phila. **Sources:** WW40.

SMITH, Gladys Nelson *[Portrait still life, landscape and figure painter]* b.1890, Chelsea, KS / d.1980, Kensington, MD.
Addresses: Wash., DC, 1924 and after. **Studied:** Univ. of Kansas School FA; AIC; CGA; Soc. Wash. Artists. **Exhibited:** Soc. Wash. Artists, 1929 (medal), 1936 (prize) 1939 (prize); Greater Wash. Independent Exhib., 1935; Corcoran Gal biennial, 1937; Landscape Club of Wash., 1939; Veerhoff Gallery, 1979 (solo); Corcoran Gal, 1984-85 (solo). **Sources:** WW40; McMahan, *Artists of Washington, DC.*

SMITH, Glendower E. *[Painter]*
Addresses: New Orleans, active 1890-95. **Sources:** *Encyclopaedia of New Orleans Artists*, 357.

SMITH, Glyndon *[Painter]* b.1898, Midway, UT.
Addresses: Eureka, CA. **Member:** Humboldt AC. **Sources:** Hughes, *Artists of California*, 522.

SMITH, Gord *[Sculptor, painter]* b.1937, Montreal, PQ.
Addresses: Victoria, BC. **Studied:** Sir George Williams Univ.
Member: Assoc. Royal Canadian Acad. Art; Quebec Sculptor's Assn. **Exhibited:** Waddington Galleries, Montreal, 1959-69 (6 shows); Three Canadian Exhibition, Art Gallery Toronto, 1961-62; Montreal Mus. Fine Art, 1962; Canadian Outdoor Sculpture Competition, Nat. Gallery Canada, 1961-64; Isaacs Gallery, Toronto, 1963; Waddington Galleries, Montreal, PQ, 1970s.
Awards: first prize, Nat. Federation Canadian Univ., 1957; first prize, Beth Tzedec Art Exhib., Toronto, 1968; Nat. Design

Council Chairman Award, 1970. **Work:** NGC; Montreal Mus. Fine Art; Mus. Art Contemporaine Montreal; Sir George Williams Univ.; McGill Univ. Commissions: bronze relief, Waterloo Trust Co., Kitchener, 1963; steel screen, Canadian Pavilion, Expo 1967; stainless steel relief, Int. Nickel Co. Can., Toronto, 1967; bronze sculpture, Canadian Embassy, Bonn, Germany, 1968; stainless steel split circle, Confederation Center, PEI, 1972. **Comments:** Contributor: *The Canadian Architect*, 1962; *Canadian Art Magazine*, 1964; *École Montreal*, 1964; *Symp. Quebec*, 1965. Co-author: *Gord Smith, sculptor* (monograph), Quebec Sculptor's Assn., 1972. Teaching: assoc. professor sculpture, Univ. Victoria, 1972-. **Sources:** WW73; Gordon Burwash, "Focus" (film), Nat. Film Board Canada, 1963; Anita Aarons, article, *Royal Arch. Inst. Can. Allied Arts Catalogue* (1966).

SMITH, Gordon *[Painter, educator]* b.1919, Brighton, England.
Addresses: West Vancouver, BC. **Studied:** Winnipeg School Art; Vancouver School Art; Calif. School Fine Arts; Harvard Univ. Summer School. **Member:** British Columbia Soc. Art; Canadian Soc. Painter-Etchers & Engravers; Royal Canadian Acad. Arts (assoc.); Canadian Group Painters. **Exhibited:** São Paulo, Brazil, 1961; Canadian Exhib., Warsaw, Poland, 1962; Canadian Biennial, 1963; Seattle World's Fair, WA, 1963; New Design Gallery, Vancouver, BC, 1964. **Awards:** Canadian Biennial, 1956; Canadian Council senior fellow for study abroad, 1960-61. **Work:** Nat Gallery Can; Art Gallery Toronto; Art Gallery Winnipeg; London Mus Art, Ont; Hart House Univ. Toronto; plus others. **Comments:** Teaching: assoc. professor art, Univ. British Columbia. **Sources:** WW73.

SMITH, Gordon Mackintosh *[Museum director]* b.1906, Reading, PA / d.1979.
Addresses: Buffalo, NY. **Studied:** Williams College, B.A., 1929; Graduate School Arts & Sciences, Harvard Univ., 1929-31; in Europe, 1931-32; honorary Litt.D., D'Youville College, 1963.
Member: Benjamin Franklin fellow, Royal Soc. Arts, London; Am. Fedn. Arts; Assn. Arts Mus. Directors; College Art Assn. Am.; Intermuseum Conservation Assn. **Comments:** Positions: curator, Berks County Hist. Soc., 1935-36; asst. regional director., New England Fed. Art Project, WPA, 1936-41; chief, Plans & Intelligence Unit, Engr. Bd., Fort Belvoir, VA, 1942-44; project specialist, Off. Strategic Serv., Washington, DC, 1944-46; director, Currier Gallery Art, 1946-55; director, Albright-Knox Art Gallery, Buffalo, NY, 1955-. **Sources:** WW73.

SMITH, Grace P. *[Painter, illustrator]* 20th c.; b.Schenectady, NY.
Addresses: NYC. **Member:** AG. **Sources:** WW31.

SMITH, Grances A. *[Engraver]* late 19th c.
Comments: Engraved designs by Cornelia S. Post, "Daughers of America," Hanaford, 1883. **Sources:** Petteys, *Dictionary of Women Artists*.

SMITH, Gregory See: **SMITH, (Edward) Gregory**

SMITH, Gretta *[Art librarian]* b.1888, Gilman, IA.
Addresses: Baltimore, MD. **Studied:** Grinnell College, B.A.; Drexel Inst. Lib. School; Lib. School of NYPL; Yale Univ.
Member: Am. Lib. Assn.; Special Lib. Assn. **Exhibited:** Awards: Carnegie Fellowship, Yale Univ., 1931-32. **Comments:** Position: librarian, FA Dept., Univ. Pittsburgh, 1930-31; director of exhibits, 1932-34, head fine art dept., 1935-, Enoch Pratt Free Lib., Baltimore, MD. Editor: series of 46 art book lists issued by Enoch Pratt Free Lib., 1935-40. **Sources:** WW53.

SMITH, Guy *[Illustrator]* 20th c.
Addresses: Yonkers, NY. **Sources:** WW19.

SMITH, H. Armour *[Museum director]* 20th c.
Addresses: Yonkers 3, NY. **Member:** Yonkers AA (pres.).
Comments: Position: director, Hudson River Mus., Yonkers, NY, 1953. **Sources:** WW53.

SMITH, H. E. *[Painter, illustrator]* 20th c.
Addresses: Paris, France. **Comments:** Position: staff, *Harper's*.

Sources: WW13.

SMITH, H. Majesty (Miss) *[Painter] 20th c.*
Addresses: Silsvermine, CT. **Exhibited:** Salons of Am., 1929; S. Indp. A., 1929. **Sources:** Marlor, *Salons of Am.*

SMITH, H. Nevill *[Painter] 20th c.*
Addresses: Los Angeles, CA. **Exhibited:** Artists Fiesta, Los Angeles, 1931. **Sources:** Hughes, *Artists of California, 522.*

SMITH, H. Robert (Reverend Dr.) *[Painter, rector] 20th c.*
Addresses: Gloucester, MA. **Studied:** self-taught. **Member:** North Shore AA; Rockport AA. **Exhibited:** North Shore AA, 1950 (prize); Rockport AA, 1954 (prize). **Sources:** *Artists of the Rockport Art Association* (1956).

SMITH, Harriet E. *[Decorator] 20th c.*
Addresses: Montpelier, VT. **Studied:** Yale; Metropolitan Art School. **Member:** Boston SAC. **Comments:** Specialty: decoration of trays, chairs, chests, antiques only. **Sources:** WW40.

SMITH, Harriet F(rances) *[Painter, illustrator, teacher] b.1873, Worcester, MA / d.1935.*
Addresses: Allston, MA. **Studied:** Mass. Normal Art Sch.; Denman Ross; E.W.D. Hamilton; H.B. Snell; C.H. Woodbury, Ogunquit Sch.; Philip L. Hale. **Member:** Copley Soc.; EAA; AAA; NYWCC; AFA; Boston AC. **Exhibited:** S. Indp. A., 1917; NAD; AIC. **Comments:** Position: teacher & art supervisor, Boston Public Schools. **Sources:** WW31; *Charles Woodbury and His Students.*

SMITH, Harry K(nox)
[Painter, craftsperson, graphic artist, designer] b.1879, Philadelphia, PA.
Addresses: NYC; Phila., PA. **Studied:** T. Anshutz, PAFA. **Exhibited:** Boston AC, 1903-07; S. Indp. A., 1917; PAFA Ann., 1903, 1950. **Work:** stained glass windows in many public buildings and churches; paintings in private collections. **Comments:** Boston AC Exhibition Record gives date of death as 1951 & Marlor as 1957 (NYC). **Sources:** WW59; WW47; *The Boston AC;* Marlor, *Soc. Indp. Artists;* PAFA, Vol. III.

SMITH, Hassel Wendell, Jr. *[Painter, teacher, lithographer] b.1915, Sturgis, MI.*
Addresses: San Francisco, CA; Los Angeles, CA. **Studied:** Northwestern Univ. (B.S.); Calif. School Fine Arts with Maurice Sterne; Abraham Rosenberg fellowship, 1941-42. **Member:** San Francisco AA; Art Gld. **Exhibited:** San Francisco AA, 1938-46 (prize, 1942); GGE, 1939; SFMA, 1941, 1975; CPLH, 1953; Pasadena Art Mus., 1961 (retrospective); Corcoran Gal biennial, 1961; "Painters of the Southwest" traveling exhib., 1962; John Moore's Ann. Invitational, Liverpool, England, 1963; San Francisco State College, 1964 (retrospective); San Francisco Art Inst., 1966; LACMA, 1968; Santa Barbara Mus. Art, 1969 (solo); Oakland Mus., 1973. **Work:** Tate Gallery, London; Albright-Knox Art Gallery, Buffalo; CGA; WMAA; San Francisco MA; Pasadena Art Mus.; Oakland Mus. **Comments:** Teaching: Calif. School Fine Arts, 1945-48; San Francisco State College, 1946-47; Univ. Oregon, 1948-49; Calif. School Fine Arts, 1949-52; Presidio Hill Elem. School, San Francisco, 1952-55; Univ. Calif., Berkeley, 1963-65. **Sources:** WW73; WW47. More recently, see Hughes, *Artists in California, 522.*

SMITH, Helen Henrietta *[Painter, commercial artist, educator] late 20th c.; b.Boston, MA.*
Studied: Mass. Inst. of Art. **Exhibited:** Harmon Fnd., 1928, 1933. **Sources:** Cederholm, *Afro-American Artists.*

SMITH, Helen Hunter *[Painter] 20th c.*
Exhibited: S. Indp. A., 1942, 1944. **Sources:** Marlor, *Soc. Indp. Artists.*

SMITH, Helen Leona *[Painter, craftsperson, decorator] b.1894, Frederick, MD.*
Addresses: Frederick, MD. **Studied:** Maryland Inst. Art & Design, C.Y. Turner. **Member:** Frederick Art Club. **Exhibited:** Frederick County Art Exhib. **Work:** murals in Court House and Masonic Temple, Frederick, MD; Unionville Church, Burkettsville, MD; Methodist Church, Libertytown, MD; church in Mt. Carmel, MD; portraits, Univ. Virginia Masonic Temple, Frederick and Balt., MD; Hood College; Maryland State School for the Deaf; Frederick Mem. Hospital; Univ. Maryland; First Baptist Church, Frederick, MD. **Sources:** WW59; WW47.

SMITH, Helen M. *[Illustrator, painter] b.1917, Canton, Ohio.*
Addresses: St. Louis, MO. **Studied:** Univ. Melbourne, Australia, 1942-43; Washington Univ. (B.F.A., 1953; M.A., 1958); Art Instruction, Inc., certificate; St. Louis Univ. **Member:** St. Louis Artists Guild; Archaeology Soc. Am.; Oriental Archaeology Soc.; Int. Inst. Arts & Letters (fellow); Illinois Art Educ. Assn. **Exhibited:** St. Louis Artists Guild; Ann. Missouri Exhib.; Liturgical Art, Seattle; Catholic Art Exhib., CA; Springfield (MO) Art Mus. **Awards:** Ruth Kelso Renfrow Art Club Award, 1955; first, second & third prizes, Soc. Technical Writers & Publ. Exhib. **Comments:** Positions: medical illustrator, St.Louis Univ. Medical Center, 1961-65; director medical illustration, dept. ophthalmology, Washington Univ., 1964-68; consultany, Am. College Radiology, 1964-. Publications: illustrator, "Aghios Kosmos," 1959; illustrator of many medical journals & books. Teaching: art isntructor, Villa Duchesne, St. Louis, 1953-56; instructor of art & head art dept., Maryville College, 1958-60, asst. professor of art & archaeology & director of art dept., 1960-61, asst. professor & director of art & archaeology depts., 1961-68; lecturer, Harvard Univ. & Oriental Inst. Archaeology, Yale Univ., 1960; asst. professor art history & director instruction graphics, Southern Illinois Univ., 1968. **Sources:** WW73.

SMITH, Helen Shelton *[Painter] 19th/20th c.*
Addresses: NYC, active 1895-1901. **Exhibited:** NAD, 1898; NYWCC; Phila. Art Club; Boston AC, 1895-99; PAFA Ann., 1900; AIC. **Sources:** WW01; Falk, *Exh. Record Series.*

SMITH, Helen Stafford *[Painter] b.1871, St. Charles, IL.*
Addresses: Laguna Beach, CA. **Studied:** with Anna Hills, George Brandriff, Millard Sheets. **Exhibited:** Southern Calif.; GGE, 1939. **Work:** Springville (UT) Mus. **Sources:** Hughes, *Artists in California, 522.*

SMITH, Helena Wood *[Painter] 19th/20th c.*
Addresses: Oakland, CA; Brooklyn, NY; Bangor, ME; Carmel, CA. **Exhibited:** Boston AC, 1893, 1900; PAFA Ann., 1896-97; San Francisco IA, 1910. **Comments:** Active 1893-1904. **Sources:** WW04; Hughes, *Artists in California, 522;* Falk, *Exh. Record Series.*

SMITH, Helene F. *[Sculptor] 20th c.*
Addresses: NYC. **Exhibited:** PAFA Ann., 1913. **Sources:** WW15; Falk, *Exh. Record Series.*

SMITH, Henry *[Engraver] b.c.1832, Pennsylvania.*
Addresses: Philadelphia, 1860. **Comments:** Lived with his wife Anna and sons Frederick and William. **Sources:** G&W; 8 Census (1860), Pa., LVIII, 464.

SMITH, Henry Atterbury *[Painter] 20th c.*
Addresses: NYC. **Exhibited:** Soc. Indep. Artists, 1917, 1920, 1926, 1941. **Sources:** WW10.

SMITH, Henry B. *[Sketch artist] b.1856 / d.1906.*
Work: College of William and Mary (pencil sketch of Bruton Parish Church, Williamsburg, c. 1880). **Sources:** Wright, *Artists in Virginia Before 1900.*

SMITH, Henry Few See: **FEWSMITH, Henry**

SMITH, Henry Holmes *[Photographer, educator] b.1909, Bloomington, IL / d.1986.*
Addresses: Bloomington, IN. **Studied:** Illinois State Univ.; Art Inst. Chicago; Ohio State Univ.; New Bauhaus (Chicago School Design); Indiana Univ.; also with L. Moholy-Nagy, Gyorgy Kepes, Hin Bredendieck, Alexander Archipenko. **Member:** Soc. Photography Educ. (founding member; vice-chmn., 1963-67; member board dirs., 1963-). **Exhibited:** S. Indp. A., 1929;

Abstract Photography, MoMA, 1951, 1960; Photography at Mid-Century, 1959, Twentieth Century Photographers,1966 Eastman House, Rochester; Photographers Choice, Indiana Univ. Art Gallery, Bloomington, 1959; The Gallery, Bloomington, IN, 1970s. **Work:** MoMA; Eastman House, Rochester, NY; Mus. Fine Arts, St. Petersburg, FL; Univ. Nebraska Mus. Art, Lincoln; AIC Museum. **Comments:** Publications: author, "Image, Obscurity & Interpretation," 1957 & "Museum Taste and the Taste of our Time," 1962, *Aperture Quarterly*; author, "Photographs of Van Deren Coke," *Photography* (London), 1963; author, "New Figures in a Classic Tradition," *Aaron Siskind Photographer,* 1965 & "Photography in Our Time, *Photographers on Photography,* 1966. Teaching: photography instructor, New Bauhuas, Chicago, 1937-38; photography prof., dept. art, Indiana Univ., Bloomington, 1947-. Research: aesthetics of photography. **Sources:** WW73.

SMITH, Henry Pember HENRY·P·SMITH
[Landscape painter] b.1854, Waterford, CT / d.1907.
Addresses: NYC (1877-c.1901); Asbury Park, NJ (c.1901-on). **Studied:** apparently self-taught. **Member:** AWCS; Artists Fund Soc. **Exhibited:** NAD, 1877-96, 1899, 1901, 1906; Brooklyn AA, 1878-85, 1892; Boston AC, 1880-90; PAFA Ann., 1881, 1888; AIC. **Comments:** Best known for his tightly-rendered pastoral landscapes of New England, often featuring a country cottage by a stream or pond. However, he also he painted shoreline scenes from New Jersey to Newport (RI) to Cape Ann (MA) to Maine. He traveled widely, also painting along the England's Cornish coast, Brittany and Normandy, and Venice during the 1880s. **Sources:** WW06; Falk, *Exh. Record Series.*

SMITH, Henry S. *[Engraver] mid 19th c.*
Addresses: NYC, 1850-52. **Sources:** G&W; NYBD 1850-52.

SMITH, Henry T. *[Illustrator] b.1866, Stoke-on-Trent, England / d.1947.*
Addresses: Upper Montclair, NJ. **Comments:** Came to the U.S. as a child. Positions: staff, *The Evening World,* NYC; director, art dept., 1901-31.

SMITH, Henry W. *[Engraver] b.c.1823, New York.*
Addresses: Boston, 1851. **Comments:** Probably the Henry Smith, engraver, listed in the 1850 Boston census. **Sources:** G&W; Boston CD 1851; 7 Census (1850), Mass., XXV, 616.

SMITH, Herndon *[Painter] 20th c.*
Exhibited: WMAA, 1924-25, 1927. **Sources:** Falk, *WMAA.*

SMITH, H(ezekiah) Wright *[Engraver in line and stipple] b.1828, Edinburgh (Scotland).*
Addresses: NYC,1870-77; Philadelphia,1877-79. **Studied:** Thomas Doney, NYC (engraving); Joseph Andrews, Boston (1850). **Exhibited:** PAFA Ann., 1879. **Comments:** He was brought to America at the age of 5 and grew up in NYC. After April 1879 he suddenly gave up his business, sold his belongings, and disappeared. **Sources:** G&W; Stauffer; Boston CD 1860; Falk, *Exh. Record Series.*

SMITH, Holmes *[Painter, teacher, writer, lecturer] b.1863, Keighley, England / d.c.1938.*
Addresses: St. Louis, MO/Magog, Quebec, Canada. **Member:** St. Louis AG; 2x4 S.; Archaeological Inst. Am.; St. Louis Chapt. AIA. **Exhibited:** AIC, 1891-92, 1896; PAFA Ann., 1893. **Sources:** WW33; Falk, *Exh. Record Series.*

SMITH, Hope *[Landscape painter] b.1879, Providence, RI.*
Addresses: Providence, RI. **Studied:** Woodbury; Chase; RISD; Paris; Wm. M. Chase. **Member:** Providence AC; South County AA (RI). **Exhibited:** S. Indp. A., 1917; PAFA Ann., 1929; Providence AC; South County AA (RI); "Charles H. Woodbury and His Students," Ogunquit Mus. Am. Art, 1998. **Work:** RISD. **Sources:** WW40; *Charles Woodbury and His Students;* Falk, *Exh. Record Series.*

SMITH, Houghton Cranford *[Landscape painter] b.1887, Arlington, NJ / d.1983, NYC.*

Addresses: NYC. **Studied:** Tom Hunt, Nantucket School of Design, summer, 1907; G. Bridgman, ASL, 1907-09; Pratt Inst. High School; ASL, 1907-09; C.W. Hawthorne in Provincetown, MA, summers, 1908-09; Ambrose Webster in Provincetown, 1908; Acad. de la Grande Chaumière, Paris, 1913; Académie Julian, Paris with J.P. Laurens, 1913; André Lohte, Paris, 1929; Amédée Ozenfant, Paris, 1930. **Member:** Provincetown AA (founding member); Beachcombers Club, Provincetown. **Exhibited:** Provincetown AA , 1914; Passedoit Gal., NYC, 1940s; Corcoran Gal biennial, 1945; Richard York Gallery, 1996, 1998 (solos). **Comments:** Smith worked as commercial artist for Calkins & Holdins in 1911. He traveled frequently throughout his long career, painting in Provincetown, summers 1908-16, and opening an art supply store there in 1909. Spent winter in Bermuda, 1911-12 and returned again in 1929. Also traveled and painted in Jamaica and Cuba (1912) and South America (1912, remained there for four years). Lived in NYC 1916-20, moving to Lawrence, KS, in 1921 to take a professorship at Univ. of Kansas. Next several summers spent in Colorado; Taos, NM; Nantucket, RI; and Gloucester, MA. Left Kansas in 1925, staying briefly in NYC before going to Europe in 1926, visiting Spain and living in France through 1928, returning there again (after stay in New York and visits to Bermuda and Spain) from 1929-33. Prior to 1930, he painted in an impressionist manner, but after studying with Ozenfant in Paris (1930) his style changed to reflect that of the Purists. When he returned to NYC in the 1930s, he lived above the New School for Social Research in a building his parents had donated as the basis of the school. Just before WWII, Smith established his own school at the New School. Author: *The Provincetown I Remember* (1963, priv. pub. in 1991). **Sources:** WW25; exh cats., Richard York Gal. (NYC, 1996 and 1998).

SMITH, Howard *b.1928, Moorestown, NJ.*
Studied: PAFA. **Exhibited:** Amos Anderson Mus., Helsinki, Finland. **Work:** Turku Mus., Finland; MoMA. **Sources:** Cederholm, *Afro-American Artists.*

SMITH, Howard E(verett) HOWARD E. SMITH
[Landscape and portrait painter, lithographer, illustrator] b.1885, West Windham, NH / d.1970, Carmel, CA.
Addresses: Carmel, CA; West Chester, PA; NYC. **Studied:** ASL with George Bridgman; BMFA Sch. with E.C. Tarbell; Howard Pyle; also in France, Spain and Italy. **Member:** ANA, 1921; Gld. Boston Artists; North Shore AA; Carmel AA (dir.); AAPL; AWCS; Rockport AA; BMFA; Chester County AA. **Exhibited:** Corcoran Gal biennials, 1914-37 (4 times); Santa Cruz AL (prize); Oakland Art Gal.; Boston AC, 1907; PAFA Ann., 1912-36 (11 times); Pan-Pacific Expo, 1915 (medal); NAD,1908 (prize), 1917 (prize), 1920 (gold medal), 1921 (medal), 1930 (prize), 1931 (prize); AIC, 1923 (prize); Sacramento State Fair, 1942 (prize); Wilmington SFA (prize); AAPL (prize), 1945 (prize); CPLH, 1945; LOC; Chester County AA; Woodmere Art Gal.; Carmel AA; Soc. Western Artists; Sacramento State Exhib. **Awards:** prizes, Wanamaker prize, Phila., 1909. **Work:** PAFA; North Adams (MA) Public Library; Rand Sch., NY; Portia Law Sch., Latin Sch., both in Boston; de Cordova & Dana Mus.; Univ. Nebraska; Brown Univ.; State House, Boston; State House, Sacramento, CA; U.S. Treasury Dept.; Crocker Art Gal.; Diocesan House, San Francisco. **Comments:** Illustrator: *Children's Longfellow, The Beginning of the American People,* as well as national magazines. WW47. More recently, see Hughes, *Artists of California,* 521; Falk, *Exh. Record Series.* **Sources:** WW59.

SMITH, Howard Ross *[Museum curator] b.1910, Los Angeles, CA.*
Addresses: San Francisco, CA. **Studied:** Univ. Calif., M.A.; Calif. College Arts & Crafts; also with Eugen Neuhaus. **Comments:** Positions: curator, CPLH, 1951-55, asst. director, 1955-70, assoc. director, 1970-. Teaching: head dept. art, Univ. Maine, 1942-49. **Sources:** WW73.

SMITH, Hugh Knight *[Painter, commercial artist] 20th c.; b.Hanson, MA.*

Addresses: Boston, MA. Studied: Mass. Sch. of Art; BMFA Sch. Member: Cambridge AA; Rockport AA. Exhibited: Newspaper AA, 1948 (prize). Work: Bedford Hospital (murals). Comments: Position: staff, *Boston Herald*. Sources: *Artists of the Rockport Art Association* (1956).

SMITH, Hughie Lee See: **LEE-SMITH, Hughie**

SMITH, I. B. See: **SMITH, Joseph B.**

SMITH, Ira *[Painter] 20th c.*
Addresses: NYC. Member: AWCS. Sources: WW47.

SMITH, Ira J. *[Painter] 20th c.*
Addresses: Pittsburgh, PA. Member: Pittsburgh AA. Sources: WW25.

SMITH, Irwin Elwood *[Painter] b.1893, Labette, KS.*
Addresses: Topeka, KS; Leesburg, FL. Studied: Chicago Acad. FA; Washbum Univ.; G.M. Stone; C. Werntz; F.R. Southard; D.H. Overmeyer. Member: Kansas Fed. Art; Florida Fed. Art; Leesburg AA (treas.); Topeka Art Gld.; Prairie WCA. Exhibited: Kansas City AI; Joslyn Mem.; Topeka AG; Prairie WC Exh.; Kansas Fair, 1934 (prize), 1936 (prize); Kansas Art Exhib., Topeka, 1945 (prize). Kansas State College; Eustis (FL) AA; Leesburg AA; Ocala AA; Bushnell (FL) Women's Club (solo); Wildwood (FL) Women's Club, (solo). Work: Kansas Fed. Women's Club; Highland Park Jr. H.S., Boswell Jr. H.S., Crane Jr. H.S., Topeka, KS; Stephenson School, Winfield, KS; Nat. Hdqtrs. Gal., Nat. Assn. Ret. Civil Employees, Wash., DC. Sources: WW59; WW47.

SMITH, Isabel E. (Mrs. F. Carl) *[Miniature painter, teacher] b.1843, Smith's Landing, OH / d.1938, Pasadena, CA.*
Addresses: Cincinnati, OH; NYC; Wash., DC, c.1900-18; Pasadena, CA, 1918-38. Studied: Germany (2years); Paris (3 years), with L'Hermite, Delance, Callot; Dresden. Member: Paris Woman's AC; Nat. League of American Pen. Women; Pasadena FAC. Exhibited: Soc. Nat. Beaux-Arts, 1897-99; Soc. Wash. Artists, 1901; Nat. Lg. Am. Pen Women. Comments: Married to Frederick Carl Smith (see entry) in 1895. Her sitters included royalty and heads of state. Author of articles on art in magazines and newspapers. She also taught art in Chautauqua, NY for four years. Sources: WW40; Hughes, *Artists in California*, 522; McMahan, *Artists of Washington, DC;* Fink, *American Art at the Nineteenth-Century Paris Salons*, 391.

SMITH, Ishmael *[Painter, sculptor, illustrator] b.1886, Barcelona, Spain.*
Addresses: NYC. Member: SC; Am. Soc. Bookplate Collectors & Designers; MoMA; Soc. Indep. Artists. Exhibited: S. Indp. A., 1919-24, 1934-37; PAFA Ann., 1921-25; Salons of Am., 1934; AIC. Work: monu., Catalonia; port., Institute des Estudies Catalans; port., Mus. Barcelona, Spain; British Mus., London; Hispanic Mus., NYC; Cleveland Mus.; Carmelite Fathers, Wash., DC. Sources: WW40; Falk, *Exh. Record Series*.

SMITH, J. *[Sculptor] 20th c.*
Addresses: NYC. Sources: WW19.

SMITH, J. Benedict *[Painter] 20th c.*
Addresses: Roxbury, CT. Exhibited: PAFA Ann., 1932. Sources: Falk, *Exh. Record Series*.

SMITH, J. E. (Miss) *[Artist] 19th/20th c.*
Addresses: Active in Los Angeles, c.1898-1910. Comments: Sources: Petteys, *Dictionary of Women Artists*.

SMITH, J. F. *[Painter] 20th c.*
Addresses: Toledo, OH. Member: Artklan. Sources: WW25.

SMITH, J. H. (Mr.) *[Painter] 20th c.*
Exhibited: S. Indp. A., 1918. Sources: Marlor, *Soc. Indp. Artists*.

SMITH, J. Harrison *[Painter] 20th c.*
Addresses: Detroit, MI, 1927. Exhibited: S. Indp. A., 1927. Sources: Marlor, *Soc. Indp. Artists*.

SMITH, J. Howard *[Painter] 20th c.*
Addresses: Chicago, IL. Exhibited: AIC, 1908. Sources:

WW10.

SMITH, J. (Mrs.) *[Painter] mid 19th c.*
Exhibited: Maryland Historical Society, 1850 ("The Belle of Philadelphia"). Sources: G&W; Rutledge, MHS.

SMITH, J. R., Jr. See: **SMITH, John Rowson**

SMITH, Jack W(ilkinson) *JACK WILKINSON SMITH.*
[Painter] b.1873, Paterson, NJ / d.1949, Monterey Park, CA.
Addresses: Alhambra, CA, c.1906. Studied: Cincinnati Art Acad. with Duveneck; AIC. Member: Calif. AC; Calif. WC Soc.; Allied AA; SC; Laguna Beach AA; Ten Painters of Los Angeles. Exhibited: San Diego Expo, 1915 (medal), 1916 (medal); Sacramento Expo, 1917 (medal), 1918 (medal), 1919 (gold); Los Angeles Liberty Expo, 1918 (prize); Calif. AC, 1919 (prize); Phoenix (AZ) Expo, 1919 (prize), 1920 (prize); AIC, 1922; Painters of the West, 1924 (gold), 1929 (gold), 1929 (prize); GGE, 1939; Stendahl Galleries, Biltmore Salon, both in Los Angeles. Work: Phoenix Municipal Collection; Laguna Beach MA, CA; Springville MA, Utah. Comments: Smith was a primary force in the establishing of the Biltmore Salon. Position: commercial artist, Lexington, KY; staff, *Cincinnati Enquirer*. Specialty: Sierra landscapes, missions and marines. Sources: WW40; Hughes, *Artists in California*, 522; P & H Samuels, 451.

SMITH, Jacob Getlar *[Painter, drawing specialist, teacher] b.1898, NYC / d.1958, Bronx, NY.*
Addresses: NYC. Studied: NAD. Member: NYWCC; NSMP; An Am. Group; AWCS. Exhibited: CI; VMFA; WMAA; S. Indp. A., 1924; Corcoran Gal biennials, 1926-43 (6 times); AIC, 1926 (prize), 1930 (prize); PAFA Ann., 1927-43 (9 times). Awards: Guggenheim Fellowship, 1929. Work: WMAA; Butler AI; Corpus Christi Mem. Art Gal.; U.S. Dept. Labor, Wash., DC; Missouri State Teachers College; murals, USPO, Nyack, NY; Salisbury, MD. Comments: Author: "Water-color Demonstrated," 1945; "Watercolor for Beginners," 1951. Contributor: *American Artist* magazine. Sources: WW53; WW47; Falk, *Exh. Record Series*.

SMITH, Jacob, Jr. *[Wood engraver] mid 19th c.*
Addresses: NYC, 1854. Sources: G&W; NYBD 1854.

SMITH, James Calvert *[Illustrator] 20th c.*
Addresses: NYC. Member: SI; Artists Guild; SC. Sources: WW31.

SMITH, James E. *[Engraver] b.c.1828, Ohio.*
Addresses: Cincinnati in 1850- c.1853; Louisville, KY, 1859. Comments: His father, Thomas Smith, was a collector; his brother Stephen, a lawyer; and George W., a manufacturer of white lead. Sources: G&W; 7 Census (1850), Ohio, XXI, 952; Cincinnati BD, 1850-53; Louisville CD 1859.

SMITH, James P. *[Miniature and portrait painter, drawing teacher] b.c.1803 / d.1888.*
Addresses: Philadelphia, active 1824 until at least 1850. Exhibited: PAFA, 1824-50 (miniatures). Work: NYHS. Sources: G&W; Smith; Rutledge, PA; Phila. CD 1829-60+; *Art in America* (April 1923), 160, repro. [gave dates as 1808-1888]. More recently, see NYHS Catalogue (1974), cat. no. 387.

SMITH, James Robert *[Marine painter, illustrator] b.1898, Portland, ME.*
Addresses: Portland, ME. Studied: as a boy, with Walter Griffin and Alexander Bower. Member: AAPL. Work: U.S. Naval Acad.; Bates College; Martime Acad., Bath, ME; Fogg Mus., Harvard Univ. Comments: During the 1920s he began a career in illustration for the railroads. From 1927-32, he produced illustrations for Dr. Morris H. Turk's books and lectures. His series of large oils for Henry F. Merrill's *The Life of Christ* were exhibited 1932-36. Thereafter, he returned to painting ships, especially historical clipper ships. He also wrote several books, including *Pallette Chemistry* (1933) and *Prismatic Refraction* (1934). In 1972, he shot and killed his 23-year-old grand-niece; and in 1974, jealousy over a woman caused him to shoot and kill his son-in-

law who was recovering in an Ocala, FL hospital. **Sources:** PHF files courtesy M. Joachim.

SMITH, Jane M. *[Painter] 20th c.*
Addresses: Havertown, PA. **Exhibited:** PAFA Ann., 1949. **Sources:** Falk, *Exh. Record Series.*

SMITH, Janette *[Painter] 20th c.*
Addresses: Indianapolis, IN. **Exhibited:** PAFA Ann., 1951. **Sources:** Falk, *Exh. Record Series.*

SMITH, Jaquelin Taliaferro *[Craftsperson, teacher] b.1908, Wash., DC.*
Addresses: Arlington, VA. **Studied:** Maryland Inst. **Member:** Arts Club Wash. **Sources:** WW40.

SMITH, Jean Eleanor Mackay See: **BOWMAN, Jean Eleanor**

SMITH, Jerome Howard *[Illustrator, cartoonist, painter] b.1861 or 1860, Pleasant Valley, IL / d.1941, Vancouver, British Columbia.*
Studied: Chicago, c.1884; Paris, 1890-92. **Comments:** Cartoonist: Chicago *Rambler*; *Judge*, NYC, 1887. Sent to the Northwest as a correspondent for *Leslie's*. He worked throughout the West as a miner, cowboy, driver and settled in British Columbia where he painted Western scenes for reproudction as lithographs. **Sources:** P&H Samuels, 451.

SMITH, Jerome Irving *[Museum curator, librarian] b.1910, New York, NY.*
Addresses: Grosse Point, MI. **Studied:** Columbia Univ., B.A., 1932. **Member:** Am. Assn. Mus. (nat. chmn. registr. sect., 1958); Spec. Lib. Assn. (nat. chmn. museum librarians, 1938, vice-chmn. museums, humanities & picture librarians section, 1972); Am. Library Assn.; Detroit Book Club; Founders Soc., Detroit Inst. Arts. **Comments:** Positions: librarian, curator, fire-fighting collection & manuscripts & director of publicity, Mus. of City of New York, 1933-50; director, Mus. History & Industry, Seattle, 1951-52; registrar, Henry Ford Mus. & Greenfield Village, 1953-56, librarian, 1966-69, chief librarian, 1969-. Publications: contributor, *Country Life, Antiques, Art In Am., The Connoisseur, Avocations* & other magazines & newspapers. **Sources:** WW73.

SMITH, Jesse D. (Mrs.) *[Painter] late 19th c.*
Exhibited: NAD, 1873. **Sources:** Naylor, *NAD.*

SMITH, Jessie *[Painter] b.1910, St. Louis, MO.*
Exhibited: Russell Woods Show, 1964; Scarab Club; Detroit Inst. of Art; Grosse Point Memorial Church; Wayne State Univ., 1969; Harlem Art Gallery Square; St. Clair (MI) Art Show, 1972; Detroit Artists Mart, 1972. **Work:** Mount Carmel Mercy Hospital; Vernon Chapel, AME Church. **Sources:** Cederholm, *Afro-American Artists.*

SMITH, Jessie Sherwood *[Craftsperson, teacher] b.1885, Vesper, WI.*
Addresses: Hollywood, CA. **Studied:** AIC; Calif. College Arts & Crafts; Columbia; RISD; G. Lukins; E. Mayer; A.W. Dow; H.S. Dixon; A.F. Rose. **Member:** Art Teachers of Southern Calif.; Pacific AA. **Exhibited:** PAFA; AFA Exhib., Paris Salon, 1937; GGE, 1939; Los Angeles County Fair, 1936 (prize). **Comments:** Specialties: jewelry; silver; coppersmithing. Positions: teacher, Los Angeles City H.S. (from 1923), Univ. Calif., 1945-46. **Sources:** WW47.

SMITH, Jessie Wellborn (Mrs. Lewis) *[Painter, writer]; b.Indianola, NE.*
Addresses: Des Moines, IA. **Studied:** Orleans College, NE; Charles Cumming; Cumming School Art. **Comments:** Published in magazines where poems illustrated were the chief interest; her book plates and painted coats of arms are in several libraries. Registered and accredited Heraldist. **Sources:** Ness & Orwig, *Iowa Artists of the First Hundred Years*, 193-94.

SMITH, Jessie Willcox *[Painter, illustrator] b.1863, Phila., PA / d.1935, Phila.* 𝕵𝕰𝕾𝕾𝕴𝕰 𝖂𝕴𝕷𝕷𝕮𝕺𝖃 𝕾𝕸𝕴𝕿𝕳
Addresses: Phila., PA. **Studied:** Phila. School Design for Women; PAFA, briefly with Eakins, 1885; Drexel Inst., with H. Pyle, 1894. **Member:** Plastic Club; Phila. WCC; SI 1904; NYWCC; Phila. Alliance; AFA. **Exhibited:** PAFA Ann., 1888, 1898-1903 (prize), 1905-06, 1918-20; PAFA, for nearly 50 years, including 1936 (memorial exhib.); Plastic Club; Charleston Expo, 1902 (medal); Univ. Pittsburgh, 1902; AIC, 1903-22; St. Louis Expo, 1904; Soc. Illustrators, NYC, 1907; Rome Expo, 1911; Phila. WCC, 1911 (prize); Newport AA, 1912 (innaugural); Copley Gal., Boston, 1913 (solo), 1916 (solo); Pan-Pacific Expo, San Francisco, 1915 (medal). **Work:** Brandywine River Mus., Chadds Ford, PA. **Comments:** She met and befriended Violet Oakley and Elizabeth Shippen Green while studying with Pyle. The three artists formed a close association, sharing a Chestnut Street studio in Phila. before moving, in 1902, to a remodeled country inn which they called the "The Red Rose." They then moved to nearby Chestnut Hill, living and working in the home and carriage house-studio they named "Cogslea." After Green married in 1911, Smith moved to a new home which she called "Cogshill." Illustrator: *Child's Garden of Verses*, by R.L. Stevenson; *Water Babies*, by C. Kingsley; cover designer, *Good Housekeeping* and many other magazines. Specialty: children. **Sources:** WW33; Rubinstein, *American Women Artists*, 161-62; Brandywine River Mus., *Catalogue of the Collection* 113-15; S. Michael Schnessel, *Jessie Willcox Smith* (New York: Thomas Y. Crowell, 1976); Falk, *Exh. Record Series.*

SMITH, John *[Listed as "image-maker"] late 18th c.*
Addresses: NYC, 1792. **Sources:** G&W; NYCD 1792 (McKay).

SMITH, John *[Listed as "artist"] 18th/19th c.*
Addresses: Phila., 1798-1804. **Sources:** G&W; Brown and Brown.

SMITH, John *[Sculptor] b.c.1805, Ireland.*
Addresses: NYC, 1850. **Comments:** His wife was also Irish, but their six children, ages 19 to 2, were born in New York. John Smith, stonecutter, appears in the 1863 directory. **Sources:** G&W; 7 Census (1850), N.Y., LVI, 386; NYCD 1863.

SMITH, John A. See: **SMITH, John Rubens**

SMITH, John B. *[Lithographer] b.c.1835, Pennsylvania.*
Addresses: Philadelphia, 1860. **Sources:** G&W; 8 Census (1860), Pa., LII, 648.

SMITH, J(ohn) B(ertie) *[Educator, painter] b.1908, Lamesa, TX.*
Addresses: Laramie, WY, 1947; Waco, TX, 1973. **Studied:** Baylor Univ., A.B., 1929; Univ. Chicago, A.M.; Columbia Univ., Ed.D., 1946; J. Bakos; P. Mangravite. **Member:** Am. Assn. Univ. Prof.; CAA; Southeastern AA (pres., 1949-50); Midwestern College Art Conference (pres., 1954-55); Texas FAA (pres., 1958-59); Texas Art Educ. Assn. (pres., 1969-71). **Exhibited:** Denver AM, 1938-45; Artists West of Mississippi, Colorado Springs FAC, 1945; SSAL, 1944-45; Southeastern Art Ann., Atlanta, GA, 1947;Mobile (AL) AC, 1948 (solo); Texas WCS, San Antonio, 1955. **Work:** Denver AM ("Arroyo Hondo," watercolor); Univ. Wyoming; Athens (TX) Pub. Lib. **Comments:** Preferred media: watercolors. Teaching: chmn. dept. art, Adams State College, 1931-39; chmn. dept. art, Univ. Wyoming, 1939-45; chmn. dept. art, Univ. Alabama, 1945-49; dean, Kansas City Art Inst., 1949-54; chmn. dept. art, Hardin-Simmons Univ., 1954-60; chmn. dept. art, Baylor Univ., 1960-. Contributor: *Design, School Review.* **Sources:** WW73; WW47.

SMITH, John Calvin *[Engraver] mid 19th c.*
Addresses: NYC, 1835-53. **Comments:** Of Sherman & Smith (see entry). **Sources:** G&W; NYCD 1835-53.

SMITH, John Calvin (Mrs.) *[Painter on velvet] mid 19th c.*
Exhibited: American Institute, 1842 (framed painting on velvet). **Comments:** Her husband was an engraver (see entry). **Sources:** G&W; Am. Inst. Cat., 1842, as Mrs. J.C. Smith; her address was the same as that of John Calvin Smith in the NYCD 1842.

SMITH, John Christopher *[Painter] b.1891, Ireland / d.1943, Los Angeles, CA.*
Addresses: NYC; Chicaco, IL; Los Angeles, CA. **Studied:** with Robert Henri in NYC. **Exhibited:** Wilshire Galleries, Los Angeles; Pasadena Art Inst. **Work:** Laguna Beach Mus. **Comments:** Came to the U.S. c.1903. He was a friend of Franz Bischoff (see entry), with whom he sketched and exhibited. **Sources:** Hughes, *Artists in California,* 523.

SMITH, John E. *[Painter] 20th c.*
Addresses: St. Paul, MN. **Sources:** WW17.

SMITH, John F. *[Engraver] b.c.1833, Massachusetts.*
Addresses: Boston, 1850. **Sources:** G&W; 7 Census (1850), Mass., XXVI, 130.

SMITH, J(ohn) Francis *[Painter, teacher, illustrator] 20th c.; b.Chicago, IL.*
Addresses: Los Angeles, CA. **Studied:** Académie Julian, Paris with Boulanger, Lefebvre, and Constant, 1885-90; also with Gregori in Paris. **Member:** Paris AAA; Chicago SA; Calif. AA. **Exhibited:** Paris Salon, 1891. **Comments:** Teaching: Chicago AA; Calif. Inst. Art, Los Angeles; Smith Art School, Los Angeles; he also claims to have taught at the Académie Julian, but is not listed by Fehrer. **Sources:** WW40; Fink, *American Art at the Nineteenth-Century Paris Salons,* 391.

SMITH, John Henry *[Sculptor] b.1879.*
Studied: Self-taught. **Exhibited:** S. Indp. A., NY, 1938-41; Barzensky Galleries. **Work:** National Archives. **Sources:** Cederholm, *Afro-American Artists.*

SMITH, John L. *[Profilist and miniaturist] early 19th c.*
Addresses: Charleston,1816-19. **Sources:** G&W; Rutledge, *Artists in the Life of Charleston;* Charleston CD 1819.

SMITH, John Lockhart *[Portrait painter] mid 19th c.*
Addresses: St. Louis, 1852-53. **Sources:** G&W; St. Louis CD 1852-53.

SMITH, John Rowson *[Scenic and panoramic artist, landscape painter] b.1810, Boston / d.1864, Philadelphia.*
Addresses: Philadelphia, 1830-31; frequent travel thereafter; Carlstadt, NJ, 1848-. **Studied:** John Rubens Smith, in Brooklyn and Philadelphia, before 1830. **Exhibited:** PAFA, 1830-31. **Work:** Shelburne (VT) Mus. **Comments:** He was the son of John Rubens Smith (see entry) and was sometimes called J.R. Smith, Jr. He showed several views at PAFA and became a scene painter after 1832, working in Philadelphia, New Orleans, St. Louis, and other cities. Smith took up panorama painting at the end of the 1830s and in 1844 he completed a panorama, four miles long, depicting the Mississippi, sending it on a successful tour of the U.S. and Europe. After the European tour was completed in 1848, he moved to a farm at Carlstadt (NJ). He continued to paint scenery for theaters in NYC and other cities, especially in the South. **Sources:** G&W; DAB; Rutledge, PA; McDermott, "Newsreel--Old Style." More recently, see *Encyclopaedia of New Orleans Artists,* 357-58; Campbell, *New Hampshire Scenery,* 151; Muller, *Paintings and Drawings at the Shelburne Museum,* 128 (w/repro.).

SMITH, John Rubens *[Portrait, miniature, and topographical painter; engraver and lithographer; drawing teacher] b.1775, London / d.1849, NYC.*
Addresses: Came to U.S. (Boston) by 1809; Brooklyn, NY, c.1814 and after; Phila., 1830's; NYC, 1840's. **Studied:** with his father, John Raphael Smith, in England. **Exhibited:** Royal Academy, London, 1796-1811(portraits); NAD, 1844-46; PAFA and Artists Fund Soc., 1824-41. **Comments:** Grandson of landscape painter Thomas Smith of Derby, and son of John Raphael Smith, mezzotint engraver. After moving to Boston in 1809, he established himself in Brooklyn (NY), opening a drawing academy about 1814; among his pupils were Eliab Metcalf, Anthony Derose, Thomas Seir Cummings, and Frederick S. Agate (see entries). He ran a similar school during the 1830s in Philadelphia, where Emanuel Leutze (see entry) and James De Veaux were his

students. Smith also wrote several instruction books on drawing. His son, John Rowson Smith (see entry), was also an artist. **Sources:** G&W; DAB; Graves, *Dictionary;* NYCD 1814-26, 1846-47; Phila. CD 1834, 1841-43; Cowdrey, AA & AAU; Cowdrey, NAD; Rutledge, PA; Swan, BA; E.S. Smith, "John Rubens Smith," 9 repros.; Stauffer; Peters, *America on Stone;* Rutledge, *Artists in the Life of Charleston;* info from BAI, courtesy Dr. Clark S. Marlor.

SMITH, John, Jr. *[Lithographer] b.c.1832, New York.*
Addresses: NYC, 1850. **Sources:** G&W; 7 Census (1850), N.Y., LV, 274.

SMITH, Joline Butler *[Landscape painter] 19th/20th c.*
Addresses: New Haven, CT, 1887; Madison, CT. **Studied:** Académie Julian, Paris, 1887. **Member:** CAFA; New Haven PCC. **Exhibited:** NAD, 1887; New Haven PCC, 1900 (charter exhib.). **Work:** Kerwin Gal., Burlingame, CA, 1979 (portrait). **Sources:** WW25; Petteys, *Dictionary of Women Artists.*

SMITH, Joseph A(nthony) *[Painter, illustrator] b.1936, Bellefonte, PA.*
Addresses: Staten Island, NY. **Studied:** Penn. State Univ. (undergrad., 1955, 1956 & 1957; grad., 1960, with Hobson Pittman); Pratt Inst., B.F.A. **Member:** Philadelphia WCC; AFA. **Exhibited:** PAFA, 1961, 1967 & 1969; Fourth Collectors Choice Exhib., City Mus. Saint Louis, 1962; Staten Island Inst Arts & Science, 1966 (solo); Nat.Acad. Arts & Letters, NYC, 1968; Am. Drawings: The Last Decade, Katonah Gallery, NY, 1971. Awards: Mary S. Litt Award for watercolor, 100th Ann. AWCS, 1967; hon. mention, PAFA Bi-Ann. Exhib. Watercolors, Prints & Drawings, 1967; first prize juror's choice, Third Ann. Arts Festival, Penn. State Univ., University Park, 1971. **Work:** PAFA; Bloomsburg (PA) State College. **Comments:** Positions: design consultant, Brooks Bros., 1970-; exhib. designer & consultant, Staten Island Inst. Arts & Sciences, 1970-; member board dirs., Staten Island Council Arts, 1971-. Publications: contributor & illustrator, *Pangolin,* 1969; illusrtrator, *Nat. Parks Magazine,* 1970-71; illustrator, "Sierra Club Survival Songbook," 1971; illustrator, "David Johnson Passed Through Here," 1971; illustrator, *Harper's Magazine,* 1972. Teaching: asst. professor fine art, Pratt Inst., 1961-; asst. professor fine art, Penn. State Univ., University Park, summers 1969-. **Sources:** WW73.

SMITH, Joseph B. *[Marine and townscape painter] b.1798, NYC / d.1876, Camden, NJ.*
Addresses: NYC and Brooklyn, 1798-1876. **Exhibited:** Brooklyn AA, 1862 ("Steamboat Pacific"). **Comments:** Known for his view of John Street Methodist Church, NYC, painted in 1824 and published as a lithographic print in 1844 and 1868. He also made views of other churches and a view of the Sing Sing Camp Meeting (1838). Smith is also known for his paintings of ships and marine scenes, made in partnership with his son, William S. Smith. Another son, Archibald Cary Smith, was also a marine painter. Groce & Wallace speculated that P.C. Smith (see entry) was probably Joseph's brother. **Sources:** G&W; Howell, "Joseph B. Smith, Painter"; Stokes, *Iconography,* I, 344; NYCD 1824-28; Brooklyn CD 1852-61; *Portfolio* (June 1952), 232-33, and (July 1943), 262; Dunshee, *As You Pass By,* plate V; info. from BAI, courtesy Dr. Clark S. Marlor.

SMITH, Joseph Lindon *[Painter, sculptor, decorator, craftsperson, lecturer] b.1863, Pawtucket, RI / d.1950.*
Addresses: Boston, MA; Dublin, NH. **Studied:** BMFA Sch., with Crowninshiled, Grundmann; Académie Julian, Paris with Boulanger and Lefebvre. **Member:** Mural Painters; Boston SAC; Copley Soc., 1882; Century Assn.; AFA. **Exhibited:** PAFA Ann., 1885-87, 1892, 1901; Boston AC, 1886-1892; AIC, 1902; Phila. WCC, 1905 (prize). **Work:** murals, Boston Pub. Lib.; Horticultural Hall, Phila.; paintings, CGA; Smithsonian Inst.; AIC; BMFA; Gardner Mus., Boston; RISD; Dartmouth College; FMA; Harvard; Musée Guimet, Paris; Louvre Sch., Paris; studies from sculpture in: Italy, Egypt, Turkey, Mexico, Guatemala, Java, India, China, Sudan, Cambodia, Siam, Greece, Hondura, Yucatan,

Japan, for museums. **Comments:** Lectures on Persia; Egypt. **Position:** hon. curator, Egyptian Dept., BMFA; Harvard-Boston Mus. Exp., Pyramids, Egypt. **Sources:** WW40; Falk, *Exh. Record Series.*

SMITH, Josephine *[Painter]* 20th c.
Addresses: Madison, WI. **Sources:** WW25.

SMITH, Josiah Howard See: **SMITH, Jerome Howard**

SMITH, Judson De Jonge *[Painter, teacher, mural painter]* b.1880, Grand Haven, MI / d.1962, Woodstock, NY.
Addresses: Michigan; Woodstock, NY. **Studied:** Detroit Art Acad. with Joseph Gies and John Wicker; ASL; John La Farge, John Twachtman; Kenyon Cox. **Member:** Audubon Artists; Woodstock AA; Am. Soc. PS&G; NMSMP. **Exhibited:** Salons of Am.; S. Indp. A., 1921-26; Corcoran Gal biennials, 1935-39 (3 times); WMAA; CI, 1931 (hon. mention); AIC, 1932 (prize),1933 (prize); VMFA, 1944 (prize); Audubon Artists; Detroit IA, 1926 (gold) (prize); Asbury Park SFA, 1939 (gold); PAFA Ann., 1940-47 (3 times); Woodstock AA, 1949 (solo), 1953-54 (retrospective); Phila. Art All., 1950 (solo); Durand Ruel Gal., 1948 (solo); Hacker Gal., 1950 (solo); Stephens Col., Columbia, MO, 1951 (solo); New York State Univ., New Paltz, NY. **Work:** Detroit Free Press; Detroit IA; WMAA; Clinton Hotel, NYC; WPA murals, USPOs, Albion, NY, Kutztown, PA; Woodstock AA. **Comments:** Position: art prof., Univ. Texas, Austin, TX, 1945; dir., Woodstock Sch. Painting, Woodstock, NY. **Sources:** WW59; WW47; Woodstock AA; Falk, *Exh. Record Series.*

SMITH, J(ules) André *[Painter, etcher, teacher, writer, sculptor, architect, illustrator]* b.1880, Hong Kong / d.1959, Maitland, FL.
Addresses: Maitland, FL/Stony Creek, CT.
Studied: Cornell Univ. (B.S. in Arch., 1902; M.S. In Arch., 1904). **Member:** SAE. **Exhibited:** Pan-Pacific Expo, San Francisco, 1915 (gold for etching); AIC, 1915; Cornell Univ. Mus. Art, 1968 (retrospective); Falk Gal., Madison, CT, 1998. **Work:** LOC; MMA; BMFA; BMA; Honolulu Acad. Art; New Britain Museum of Am Art; A.D. White MA, Cornell Univ.; large collection at Maitland Art Center. **Comments:** Within a few years of earning degrees in architecture, André Smith he gave up the practice to pursue painting and etching in France. When World War I broke out, he was the first of eight official artists selected by the army to record battle scenes at the front. Immediately after the war, his drawings were published as a book, *In France with the American Expeditionary Forces* (NY: A. Hahlo Pub, 1919). Upon his return to America, he settled in Stony Creek, Conn. Smith returned to France — particularly the southern region — every year through 1934. He became highly regarded as a master etcher, and his name was often associated with those of his contemporaries — Joseph Pennell, Muirhead Bone, and Edmund Blampied — whose works also reflected the influence of Whistler. However, as early as 1912 Smith also made many bold modernist works — and this dual artistic pursuit continued throughout his life. Despite a war injury that led to the amputation of his leg, he continued his painting excursions in France. In 1936, he found a patroness in Mary Curtis Bok Zimbalist, heir to the Curtis Publishing fortune. She also commissioned him to design and build a major art studio and complex in Maitland, Florida that he called the Research Studio Art Center. Today, the buildings that comprise this artists' colony rank as one of the nation's most important examples of "fantastic architecture," inspired by the ancient native cultures of Central America. Now called the Maitland Art Center, the complex houses the bulk of André Smith's art collection, including the works of many of the artists he attracted to take sabbaticals there. From 1936-59, fifty or more artists were attracted to Smith's retreat. Among them were Milton Avery, Charles Prendergast, Ralston Crawford, David Burliuk, Arnold Blanch, Doris Lee, George Marinko, and many others. During the late 1930s, Smith was a pioneer in surrealism, and published *Art and the Sunconscious* (Maitland, FL: Research Studio, 1937). **Sources:** WW47; WW59; *Fine Prints of the Year,* 1931.

SMITH, Julia Russell See: **WOOD, Julia Smith (Mrs. Richmond)**

SMITH, Justin V. *[Art administrator, collector]* b.1903, Minneapolis, MN.
Addresses: Minneapolis, MN. **Studied:** Princeton Univ., A.B., 1925. **Comments:** Positions: pres., T. B. Walker Foundation, Minneapolis; member board directors, Walker Art Center, Minneapolis. Collection: painting and sculpture of the twentieth century. **Sources:** WW73.

SMITH, K. H. *[Painter]* late 19th c.
Addresses: NYC, 1886. **Exhibited:** NAD, 1886. **Sources:** Naylor, *NAD.*

SMITH, Katharine Conley *[Painter, printmaker]* b.1895, MT Vernon, WA.
Addresses: MT Vernon, WA, 1941. **Studied:** Chicago School Applied Art; mostly self-taught. **Exhibited:** Mt. Vernon, 1939. **Comments:** Preferred medium: watercolor. Illustrator: *Dog of the Pioneer Trail,* by Delia M. Stephenson, 1937. **Sources:** Trip and Cook, *Washington State Art and Artists,* 1850-1950.

SMITH, Katharine Cox *[Painter, teacher]* b.1896, Rome, GA / d.1980, Chevy Chase, MD.
Addresses: Wash., DC. **Studied:** Parsons Sch. FA.; Peabody College for Teachers; Univ. of Chicago; American Univ., Wash., DC. **Exhibited:** High Mus. of Art, Atlanta, GA; art galleries in Wash., DC and Alabama. **Comments:** Position: teacher, Georgia and Alabama. **Sources:** McMahan, *Artists of Washington, DC.*

SMITH, Katharine English *[Painter]* b.1899, Wichita.
Addresses: Wichita, KS. **Studied:** E.M. Church; B. Sandzen; C. Hawthorne; R. Reid; G.B. Bridgman; ASL. **Member:** Wichita AA; Smoky Hill AC. **Exhibited:** S. Indp. A., 1925. **Sources:** WW29.

SMITH, Katherine Adams *[Painter]* 19th/20th c.
Addresses: Paris, France. **Exhibited:** Soc. Nat. Beaux-Arts, 1898. **Sources:** WW01; Fink, *American Art at the Nineteenth-Century Paris Salons,* 391-92.

SMITH, Kenyon Alwyn *[Painter]* 20th c.
Addresses: Phila., PA. **Exhibited:** S. Indp. A., 1927. **Sources:** Marlor, *Soc. Indp. Artists.*

SMITH, Kimber *[Painter]* 20th c.
Addresses: NYC. **Exhibited:** WMAA, 1959. **Sources:** Falk, *WMAA.*

SMITH, Kit Bellinger *[Painter, designer]* 20th c.
Addresses: Rochester, NY. **Sources:** WW10.

SMITH, Langdon *[Painter, illustrator, commercial artist]* b.1870, Massachusetts / d.1959, Forest City, CA.
Addresses: NYC; Forest City, CA. **Studied:** Los Angeles School of Art and Des. **Comments:** Position: illustrator, *New York Herald;* working partner, stage coach line ; illustrator, *West Coast Magazine* and books, 1907-12. Specialty: scenes of the last of the Old West, mining scenes and early California. **Sources:** Hughes, *Artists in California,* 523.

SMITH, Lawrence Beall *[Painter, illustrator, lithographer, comm a]* b.1902, Washington, DC.
Addresses: Boston, MA; Cross River, NY. **Studied:** Univ. Chicago; AIC, and with Thurn, Hopkinsoza, Zimmerman. **Exhibited:** AIC, 1940 (prize), 1941-62; PAFA Ann., 1940-44. **Work:** John Herron AI; Harvard Univ.; AGAA; Swope Art Gal.; Univ. Minnesota; Mus. City of NY; Brandeis Univ.; MIT; Philbrook Art Center; Washington County Mus. Art; Reading Mus. Art; Honolulu Acad. FA; Fitchburg Art Center. **Comments:** Position: teacher, Pub. Sch., Boston. Illustrator: "Robin Hood"; "Mad Anthony Wayne"; "The Black Arrow"; "Caine Mutiny." **Sources:** WW59; WW47; Falk, *Exh. Record Series.*

SMITH, Lawrence M. C. *[Collector, patron]* b.1902, Philadelphia, PA / d.1975.
Addresses: Philadelphia, PA. **Studied:** Univ. Pennsylvania (A.B.,

1923; LL.B., 1928); Magdalen College, Oxford Univ. (B.A., 1925; M.A., 1946). **Member:** Benjamin Franklin fellow, Royal Soc. Arts; Art Collectors Club; AFA (pres., 1948-52; trustee, 1973-). **Comments:** Positions: trustee, Philadelphia Mus. Art; chmn. board, Civic Center Mus, 1957-60. Collection: paintings and graphic art. **Sources:** WW73.

SMITH, Leon Polk *[Painter, sculptor, lecturer, teacher]* *b.1906, Chickasha, OK / d.1996.*
Addresses: NYC; Shoreham, NY. **Studied:** Central State College (B.A., 1934); Columbia Univ. (M.A., 1938). **Member:** Nat. Educ. Assn. **Exhibited:** BM, 1942-44, 1995 (retrospective); AIC, 1943, 1947; WMAA; SFMA, 1944; Telfair Acad. Art, 1941; MMA, 1943; NY, 1941 (solo), 1943 (solo), 1946 (solo), 1960 ("Construction Geometry In Painting"); Mus. Bellas Artes, 1962 (solo); Corcoran Gal biennials, 1963, 1965; Galeria Müller, Stuttgart, Germany, 1964 (solo); "New Shapes of Color," Stedelijk Mus., Amsterdam, Holland, 1966; San Francisco Mus. & Rose Mus., 1968 (retrospective). Other awards: grants, Longview Fndn., 1956, Nat. Council Arts, 1967; Tamarind, 1968; Guggenheim fellow, 1944. **Work:** Guggenheim Mus; MMA; MoMA; Mus. Bellas Artes, Caracas; Cleveland Mus.; Indiana Mus. Mod. Art; Univ. Arizona; Univ. Georgia. **Comments:** Known for his geometric abstractions, he influenced painters Ellsworth Kelley, Jack Youngerman, and Al Held. Teaching: lecturer, Brandeis Univ., 1968; artist-in-residence, Univ. Calif., Davis, 1972. **Sources:** WW73; WW47.

SMITH, Lester P. *[Painter]* *20th c.*
Addresses: NYC. **Exhibited:** S. Indp. A., 1944. **Sources:** Marlor, *Soc. Indp. Artists.*

SMITH, Letta Crapo *[Genre and floral painter]* *b.1862, Flint, MI / d.1921, Boston, MA.*
Addresses: Detroit, MI; NYC, 1892. **Studied:** W.M. Chase in NYC; Académie Julian, Paris with Bouguereau and T. Robert-Fleury; J. Rolshoven, in Paris; G. Hitchcock; traveled to Brittany, Holland, Sicily, Japan & England. **Member:** Detroit Soc. Women Artists & Sculptors (third pres.). **Exhibited:** Paris Salon, 1890-91, 1893-94; NAD, , 1892; PAFA Ann., 1895-1909 (5 times); AIC, 1896-1912; St. Louis Expo, 1904 (bronze medal); Detroit Soc. Women Artists & Sculptors. **Sources:** WW19; Fink, *American Art at the Nineteenth-Century Paris Salons,* 333; Falk, *Exh. Record Series.*

SMITH, Leverett L. *[Painter]* *20th c.*
Addresses: Wheaton, IL. **Exhibited:** AIC, 1907-08. **Sources:** WW10.

SMITH, Leyland C(roft) *[Painter, illustrator, teacher]* *b.1910, Opelika.*
Addresses: Opelika, AL. **Studied:** F.W. Applebee; R.H. Staples; S.W.J. VanSheck. **Exhibited:** Montgomery Mus. FA, 1932. **Work:** Ct. House, Opelika; Alabama Polytechnic Inst., Auburn. **Sources:** WW40.

SMITH, Lilian Wilhelm See: **SMITH, Lil(l)ian Wilhelm (Mrs.)**

SMITH, Lillian B. *[Painter]* *19th/20th c.*
Addresses: Denver, CO. **Sources:** WW01.

SMITH, Lil(l)ian Wilhelm (Mrs.) *[Illustrator, painter, teacher, designer]* *b.1882 / d.1971.*
Addresses: Arizona, 1913. **Studied:** NAD; ASL. **Work:** Arizona Mus., Phoenix. **Comments:** Best known for her watercolors, she also designed porcelain for Goldwater's Store in Phoenix, and painted landscapes and occasional portraits of Native Americans. She had come to Arizona with her cousin, Zane Grey, to illustrate his book, "The Rainbow Trail." She was the wife of a prominent Indian guide and a volunteer art supervisor for Navajo and Hopi children at Tuba City. **Sources:** P&H Samuels, 452; Trenton, ed. *Independent Spirits,* 131-42.

SMITH, Linus Burr *[Painter, architect, designer, lecturer, teacher]* *b.1899, Minneapolis, KS.*
Addresses: Lincoln, NB. **Studied:** Kansas State College; Harvard Univ. **Member:** AIA (pres.); Nebraska AA. **Comments:** Position: teacher, Univ. Nebraska. **Sources:** WW40.

SMITH, Lochlan See: **SMITH, Thomas Lochlan**

SMITH, Louis (Mrs.) *[Collector]* *20th c.*
Addresses: NYC. **Comments:** Collection: ethnographia. **Sources:** WW73.

SMITH, Louise J(ordan) *[Portrait and landscape painter, teacher]* *b.1868, Warrenton, VA / d.1928, Lynchburg, VA.*
Addresses: Lynchburg, VA/Flint Hill, VA. **Studied:** ASAL with J.H. Twachtman and J.A. Weir; Académie Julian, Paris with Lefebvre and T. Robert Fleury. **Member:** Virginia Art Teachers' Assn.; Wolfe AC. **Comments:** Smith started a permanent art collection for Randolph-Macon Women's College and bequeathed the college her estate and funds for future acquisitions. Position: teacher & head art dept., Randolph-Macon Women's College, Lynchburg. Marlor gives date of birth as 1873. **Sources:** WW27; Wright, *Artists in Virgina Before 1900;.*

SMITH, Lucian E. *[Illustrator, architect]* *20th c.*
Addresses: NYC. **Sources:** WW17.

SMITH, Lura Gertrude (Mrs. Aubrey) *[Painter, teacher]* *b.1875, Sandborn, IN.*
Addresses: Phoenix, AZ. **Studied:** Calif. School Arts & Crafts; with Ralph Johonnot, Monterey, CA; with Michael Jacobs, Metro. Art School, NYC; trips to London, France, Belgium, Berlin, Italy, and North Africa. **Member:** Phoenix FAA (charter member). **Comments:** **Sources:** Petteys, *Dictionary of Women Artists.*

SMITH, Lydia Dunham *[Painter]* *20th c.*
Addresses: Chicago, IL. **Exhibited:** AIC, 1907. **Sources:** WW10.

SMITH, Lyman *[Painter]* *20th c.*
Addresses: Sheridan, WY. **Studied:** Colorado Springs FAC; AIC. **Member:** Colorado Springs FAC; Art Forum, Sheridan. **Exhibited:** Colorado Springs FAC, 1935-37. **Sources:** WW40.

SMITH, M. A. *[Painter]* *late 19th c.*
Addresses: NYC, 1890. **Exhibited:** NAD, 1890. **Sources:** Naylor, *NAD.*

SMITH, M. E. *[Painter]* *20th c.*
Addresses: Portland, OR. **Exhibited:** 48 States Competition, 1939. **Sources:** WW40.

SMITH, M. Lavinia Olin (Mrs. C. E.) *[Painter]* *b.1878, Platte Co., NE.*
Studied: With Mrs. E. Laughlin; Minneaplis School Art. **Exhibited:** Joslyn Art Mus., 1931; Kansas City AI, 1932; Chicago. **Comments:** **Sources:** Petteys, *Dictionary of Women Artists.*

SMITH, Mabel Beatrice *[Miniature painter]* *20th c.; b.Phila.*
Addresses: NYC, active 1900-19. **Studied:** Phila. School Design for Women; ASL with Alice Beckington & Mabel Welch; Am. School Min. Painting, NYC. **Exhibited:** AIC, 1916, 1919. **Sources:** Falk, *AIC;* Petteys, *Dictionary of Women Artists.*

SMITH, Mabel Fairfax See: **KARL, Mabel Fairfax Smith (Mrs.)**

SMITH, Marcella (Claudia Heber) *[Painter, teacher]* *b.1887, Molesey, Surrey, England.*
Addresses: Wash., DC/St.Ives, Cornwall and London, England. **Studied:** Delecluse in Paris; F. Milner at Royal British Acad., London; Corcoran Sch. Art; Phila. Sch. Des. **Member:** Soc. Wash. Artists; Royal Inst. Painters in WC. **Exhibited:** Soc. Wash. Artists, 1917 and after; Royal Inst. Painters in WC. **Comments:** Appears to have divided her time between the U.S. and Europe. Author: *Flower Painting in Watercolor,* 1955. **Sources:** WW33; McMahan, *Artists of Washington, DC.*

SMITH, Margaret L. *[Block printer]* *b.1910, Guanapinto, Mexico.*
Addresses: Pasadena, CA. **Member:** Northwest PM. **Sources:** WW32.

SMITH, Margaret Pumpelly *[Painter] b.1891, Holmesburg, PA.*
Addresses: Newport, RI, 1921. **Exhibited:** S. Indp. A., 1921.
Sources: Marlor, *Soc. Indp. Artists.*

SMITH, Margery Hoffman *[Designer, craftsperson, painter, lecturer] b.1888, Portland, OR.*
Addresses: San Francisco, CA. **Studied:** Bryn Mawr College, A.B.; Portland (OR) Art Mus. Sch.; ASL; F.H. Wentz; K.H. Miller; A.B. Dow; H. Rosse. **Member:** San Francisco Soc. Women Artists; Portland AA; Portland ACS. **Exhibited:** San Francisco Soc. Women Artists. **Comments:** Position: art director, WPA, Oregon; board member, SFMA; Portland (OR) Art Mus. Lectures: practical aspects of design. Contributor: *Design* magazine. **Sources:** WW53; WW47.

SMITH, Marguerite Mason See: **MASON SMITH, Marguerite Lacamus (Mrs.)**

SMITH, Marie *[Painter] 20th c.*
Addresses: NYC. **Member:** Bronx AG. **Exhibited:** S. Indp. A., 1922. **Sources:** WW27.

SMITH, Marie Vaughan *[Educator, painter, craftsperson, lecturer, writer] b.1892, Tacoma, WA / d.1977.*
Addresses: South Pasadena, CA. **Studied:** Calif. College Arts & Crafts; Portland (OR) Mus. Art Sch.; Univ. Chicago; Univ. Oregon, B.S.; UCLA; Chouinard AI, and with Millard Sheets, Walter Sargent, Joseph Binder. **Member:** Pacific AA; Women Painters of the West; Pasadena Soc. Artists; Calif. WCS; Southern Calif. Art Teachers Assn. **Exhibited:** Los Angeles Mus. Art; Hollywood, CA; Pasadena AI; Washington State Fair; Calif. State Fair; Southern Calif. Art Teachers Assn.; Calif. WCS. **Awards:** prizes, Women Painters of the West, 1946, 1950. **Comments:** Positions: art director, Alhambra, CA (20 years); art supervisor, Vancouver, WA (8 years); Duluth, MN; Dodge City, KS. Editor: *Women Painters of the West News,* 1948-51. **Sources:** WW59; Hughes, *Artists in California,* 523.

SMITH, Mariette Riggs *[Sculptor, painter] b.1852, Peoria, IL / d.1890.*
Addresses: Colorado; NY. **Studied:** Henry Kirk Brown in Newburgh, NY; Kenyon Cox, Beckwith, & Augustus St. Gaudens in NYC. **Sources:** Petteys, *Dictionary of Women Artists.*

SMITH, Marion Canfield *[Painter, teacher] b.1873 / d.1970.*
Addresses: Nebraska. **Studied:** Nebraska, Minnesota, Illinois, PAFA. **Comments:** Impressionist landscape painter. Founder of the art dept., Kearney State College, Nebraska. **Sources:** Trenton, ed. *Independent Spirits,* 249.

SMITH, Marion Patience (Mrs. Seneca) *[Painter] b.1883, Belmond, IA.*
Addresses: Fort Dodge, IA. **Studied:** Clarion, IA; Nina Courson. **Exhibited:** Iowa Artists Club, 1935; Iowa Artists Exhibit, Mt. Vernon, 1938. **Sources:** Ness & Orwig, *Iowa Artists of the First Hundred Years,* 194.

SMITH, Marius *[Painter] b.1868, Copenhagen, Denmark / d.1938, Laguna Beach, CA.*
Addresses: Laguna Beach, CA. **Studied:** Copenhagen. **Comments:** Specialty: florals and Calif. landmarks. **Sources:** Hughes, *Artists in California,* 523.

SMITH, Marjorie Elizabeth Wellborn *[Artist and photographer]; b.Tabor, IA.*
Addresses: Des Moines, IA. **Studied:** Drake Univ.; Univ. Pittsburgh; Layton School Art; Cumming Art School; Brooklyn Acad. Arts & Sciences; Charles Atherton Cumming; Adolf Fassbender. **Member:** National Arts Club, NY; Royal Photographic Soc. Great Britain; Iowa Press & Authors Club; Pictorial Forum, NY. **Exhibited:** Brooklyn Mus.; Brooklyn Acad. Arts & Sciences (solo); National Arts Club, NY; Indianapolis Art Inst.; Iowa State Fair (first prize). **Comments:** Made over 2,000 photographs of blacks which appeared in many periodicals. **Sources:** Ness & Orwig, *Iowa Artists of the First Hundred Years,* 194.

SMITH, Marjorie Harvey (Mrs. Ernest G.) *[Painter] b.1886, Wilkes-Barre, PA.*
Addresses: Wilkes-Barre, PA. **Exhibited:** S. Indp. A., 1934. **Sources:** Marlor, *Soc. Indp. Artists.*

SMITH, Marrow Stuart (Mrs.) *[Painter, teacher, lecturer, writer] b.1889, Staunton, VA.*
Addresses: Norfolk, VA/London Bridge, VA. **Studied:** A. Dow; J. Carlson; G. Cox; G. Cootes; R.S. Bredin. **Member:** Norfolk Art Corner; Eastern AA; VMFA. **Exhibited:** Norfolk SA, 1927-38 (prizes); S. Indp. A., 1930; Salons of Am., 1932. **Comments:** Position: art director, Norfolk Public School. **Sources:** WW40.

SMITH, Marshall D. *[Painter] 20th c.*
Addresses: Chicago, IL. **Exhibited:** AIC, 1933-39. **Comments:** WPA artist. **Sources:** WW40.

SMITH, Marshall Joseph, Jr. *[Painter, draftsman] b.1854, Norfolk, VA / d.1923, Covington, LA.*
Addresses: New Orleans, active 1870-1906. **Studied:** Adolphe J. Jacquet, c.1866; at college in Virginia, 1867-69; Richard Clague, c.1870-73; Theodore S. Moise, 1874; J.O. de Montalent, Academia dei Medici, Rome, 1874; Prof. Rensur, Royal Bavarian Academy of Fine Arts, Munich, Germany, 1876. **Member:** Southern Art Union (charter member). **Exhibited:** Seebold's, 1874; Southern Art Union, 1881; Artist's Assoc. of N.O., 1889-90; Tulane Univ., 1893; G. Moses Gallery, 1902. **Comments:** Was brought to New Orleans as a child and later became the favorite pupil of Richard Clague (see entry). After extensive studies in Europe, he returned to the U.S. – first Atlanta and then New Orleans. He later became an insurance agent, but never gave up painting and had a studio in the city through 1906. His subject were coastal landscapes and moss-laden trees, but he also designed many carnival tableaux for the Carnival Krewe of Proteus (founder, 1882). He taught at St. Mary's Dominican College, c.1900-06 and moved to Covington in 1906. **Sources:** *Encyclopaedia of New Orleans Artists,* 358.

SMITH, Marvin Pentz *[Painter] b.1910, Nicholasville, Kentucky.*
Studied: ASL; with Augusta Savage; Fernand Leger, Paris; Universities Nice, France. **Member:** Negro Artists Guild, NYC. **Exhibited:** Harlem Community Art Center, 1938; American Negro Expo., Chicago, 1940 (3rd prize); Lexington Colored Fair; Augusta Savage Studios, 1939. **Sources:** Cederholm, *Afro-American Artists.*

SMITH, Mary A. *[Portrait painter] mid 19th c.*
Addresses: Rome, NY, 1859; Utica, NY, 1860. **Sources:** G&W; Rome CD 1859, BD 1860.

SMITH, Mary D. *[Artist] b.1877 / d.1967.*
Member: Woodstock AA. **Sources:** Woodstock AA.

SMITH, Mary (Miss) *[Animal, landscape, and flower painter] b.1842, Rockhill (near Philadelphia, PA) / d.1878, Jenkintown, PA.*

Mary Smith

Addresses: Jenkintown, PA, 1868. **Exhibited:** PAFA Ann., 1859-69, 1876-79, 1905 (deceased); NAD, 1868; Centennial Exhib., Phila., 1876. **Work:** PAFA. **Comments:** Specialized in barnyard scenes. She was the daughter of Russell and Mary Priscilla Wilson Smith (see entries). In order to help promote the careers of women artists, she designated that a portion of her painting sales go toward creating an annual award for women; the result was the Mary Smith prize, established at her death and awarded each year until 1969 to the best work by a woman in the annual student exhibition at the Pennsylvania Academy. **Sources:** G&W; DAB, under Russell Smith; *A Brief Sketch of the Life of Mary Smith, the Painter;* Rutledge, PA; Falk, *Exh. Record Series.* More recently, see *300 Years of American Art,* vol. 1: 322.

SMITH, Mary Priscilla Wilson (Mrs.) *[Flower and landscape painter] d.1874.*
Addresses: Phila. & Jenkintown, PA. **Exhibited:** PAFA, 1840, 1860-69; Apollo Assoc. **Comments:** Married artist Russell Smith

in 1838. She had been a teacher of Latin and French. After their marriage the Smiths lived for a time in Philadelphia, later moving to Jenkintown. At least one of her flower drawings was reproduced in *The Florist and Horticultural Journal,* which was published for several years in Philadelphia, beginning in 1853. She was the mother of Mary and Xanthus R. Smith, also artists (see entries). **Sources:** G&W; DAB [under Russell Smith]; Rutledge, PA [under Mary Wilson and Mrs. William T. Russell Smith]; Cowdrey, AA & AAU; McClinton, "American Flower Lithographs," 362; more recently, see Petteys, *Dictionary of Women Artists;* Gerdts and Burke, *American Still-Life Painting,* 241-42, note 13.

SMITH, Mary S. *[Artist] early 20th c.*
Addresses: Active in Washington, DC, 1902. **Sources:** Petteys, *Dictionary of Women Artists.*

SMITH, Maryan *[Primitive watercolorist] mid 19th c.*
Addresses: Active in Pennsylvania, 1854. **Sources:** Petteys, *Dictionary of Women Artists.*

SMITH, Mason (Mrs.) *[Painter] 19th/20th c.*
Addresses: New Orleans, LA. **Sources:** WW01.

SMITH, May Electa Ferris *[Etcher] b.1871.*
Addresses: Philadelphia, PA. **Studied:** etching with her father Stephen J. Ferris; Antique Class at PAFA 1888-1889. **Exhibited:** PAFA, 1888; "Women Etchers of America," Union League Club, 1888 (as May Electa Ferris); Worlds Columbian Exposition, 1893. **Comments:** Active 1880s-90s, May Electa Ferris was the daughter of Stephen J. Ferris, one of the first artists in America to take up etching. She married Noah B. Smith in the 1890s. Her brother Jean Leon Gerome Ferris was also an artist. Her mother was Elizabeth Moran, the sister of artists Thomas, Peter, John and Edward. **Sources:** P. Peet, *Am. Women of the Etching Revival,* 64; Petteys, *Dictionary of Women Artists;* Falk, *Exh. Record Series.*

SMITH, May Mott See: **MOTT-SMITH, May Bird (Mrs.)**

SMITH, Mercedes Monez *[Painter] b.1917.*
Addresses: Oakland, CA. **Studied:** Calif. Coll. of Arts and Crafts, with Martinez, Wessels, Miljarak. **Member:** San Francisco Women Artists; Oakland AA; Marin Soc. of Artists. **Exhibited:** Alameda County Fair, 1964 (first prize); Labaudt Gallery, 1968 (solo); San Francisco Women Artists, 1968 (second prize); SFMA, 1970 (solo). **Comments:** Position: teacher, San Leandro School District, 23 years. **Sources:** Hughes, *Artists of California,* 523.

SMITH, (Messrs.) *[Artists]*
Exhibited: PAFA, 1850 ("Picture of Philadelphia."). **Sources:** G&W; Rutledge, PA.

SMITH, Mildred R. See: **MARTIN, Mildred Smith**

SMITH, Minna Walker (Mrs.) *[Painter] b.1883, New Haven, CT.*
Addresses: New Haven, CT. **Studied:** Yale Sch. FA. **Member:** AWS; Conn. WCS; Academic AA; Meriden Arts & Crafts; New Haven PCC; NYWCC. **Exhibited:** Ogunquit AC, 1932 (prize); New Haven PCC, 1933 (prize). **Work:** Wesleyan College; Art Mus., Macon, GA; New Haven PCC. **Sources:** WW59; WW47.

SMITH, Miriam *[Painter] 20th c.*
Addresses: La Jolla, CA, 1930s. **Exhibited:** San Diego Art Guild, 1936-41. **Sources:** Hughes, *Artists in California,* 523.

SMITH, Miriam Tindall *[Painter, craftsperson, sculptor] 20th c.; b.Norwood, PA.*
Addresses: Charlotte, NC; Philadelphia, PA. **Studied:** PM School IA; & with Arthur Carles. **Member:** Phila. Art All. **Exhibited:** S. Indp. A., 1930; PAFA Ann., 1930, 1938; PM School IA, 1933 (medal); AIC, 1934-36; William Rockhill Nelson Gal., 1936; Minneapolis IA, 1936; Dayton AI, 1936; PMA, 1935; WFNY, 1939; Phila. Sketch Club, 1940 (medal); Woodmere Art Gal., 1941; Phila. Art All.; Frankford Hist. Soc.; Warwick Gal., 1937 (solo); Blood Gal., 1955 (solo); Allentown Art Mus., 1955 (solo).

Work: murals, Lutheran Church, Norwood, PA; NY Central & Santa Fe railways; Children's Ward, Univ. Pennsylvania Hospital; Baptist Church, Shelby, NC; CGA; Phila. Mus.; Reading Mus. **Sources:** WW59; WW47; Falk, *Exh. Record Series.*

SMITH, Moishe *[Printmaker] b.1929, Chicago, IL / d.1993, Logan, UT.*
Studied: Carnegie Inst.; New School Social Research (B.A., 1950); Univ. Iowa, with Lasansky, (M.F.A., 1953); Skowhegan School Painting & Sculpture; Acad. Florence with Giorgio Morandi, 1959-61. **Member:** SAGA. **Exhibited:** Sao Paulo Int, Brazil, 1955; Print Coun Am Traveling Exhib, 1959, 1962; Int Prints, Cincinnati Mus, Ohio, 1962; Salon de Mai, Paris, 1965; Libr Cong, 1969, 1971. Awards: Four Seasons res grant, Southern IL Univ, 1957; Fulbright fel, 1959-61; Guggenheim Found fellowship, 1967; Utah Gov. Award in the Arts, 1993. **Work:** MMA; NGA; BM; AIC; MoMA; BMFA; Mus. Boymans, Beuningen, Rotterdam; Kestner Mus., Hannover; Gal. Uffizi, Florence. **Comments:** Teaching: printmaking, Univ. Wisconsin, 1966-67; Ohio State Univ., spring 1971; Univ. Iowa, autumn 1971; Univ. Wisconsin-Parkside, 1972-. **Sources:** WW73; obit., *Journal of the Print World* (winter, 1994, p.3).

SMITH, Molly Higgins (Mrs.) See: **HIGGINS, Mollie (Mrs. Smith)**

SMITH, Moore *[Painter] 20th c.*
Addresses: Stamford, CT, 1890; Mt. Vernon, NY. **Exhibited:** NAD, 1890. **Sources:** WW13; Naylor, *NAD.*

— MOORE — SMITH — 1908

SMITH, Morris *[Miniature painter] mid 19th c.*
Addresses: Active in New Bedford, 1840-45. **Comments:** Advertised in local papers and was listed in the *New Bedford City Directory.* **Sources:** Blasdale, *Artists of New Bedford,* 175.

SMITH, Mortimer L. *[Landscape painter, architect] b.1840, Jamestown, NY / d.1896, Detroit, MI.*
Addresses: Detroit, MI, 1882. **Studied:** Oberlin and Sandusky, OH. **Exhibited:** Detroit Inst. of Arts; Michigan State Fair, 1868, 1878-79; NAD, 1882; local galleries, Detroit, MI. **Work:** priv. collections. **Sources:** Gibson, *Artists of Early Michigan,* 215.

SMITH, (Mr.) *[Miniaturist land drawing teacher] early 19th c.*
Addresses: Charleston, SC, 1816. **Comments:** In 1817 Mr. and Mrs. Smith advertised as teachers of drawing and French. This was probably John L. Smith. **Sources:** G&W; Rutledge, *Artists in the Life of Charleston.*

SMITH, Murray Clinton See: **CLINTON-SMITH, Murray**

SMITH, Myron Davis (Mrs.) *[Painter] early 20th c.*
Addresses: Active in Washington, DC, c.1913. **Sources:** Petteys, *Dictionary of Women Artists.*

SMITH, Myrtis *[Painter, teacher] b.1887, Kosciucsko, MS.*
Addresses: Memphis, TN. **Studied:** Mississippi State College for Women; AIC; NY School Fine & Applied Art; Tulane; G. Bellows; R. Reid. **Member:** Palette & Brush Club, Memphis; SSAL; Western AA. **Comments:** Position: teacher, Snowden Jr. H.S., Memphis, TN. **Sources:** WW40.

SMITH, Myrtle Holm (Mrs. Clifford P.) *[Painter, drawing specialist] b.1875, Toledo, OH.*
Addresses: Brookline, MA. **Studied:** Grinnell College; & with Wilber Reaser, George Noyes, Charles Woodbury. **Member:** North Shore AA; Mablehead AA. **Exhibited:** North Shore AA; Grace Horne Gal.; Dayton AI traveling exhib.; Boston AC. **Sources:** WW53; WW47.

SMITH, Nancy *[Painter] 19th c.*
Comments: Painted Hiawatha for Louis Prang & Co. **Sources:** Petteys, *Dictionary of Women Artists.*

SMITH, Natasha *[Painter] 20th c.*
Addresses: Berkeley, CA. **Exhibited:** Oakland Art Gallery, 1937. **Sources:** Hughes, *Artists of California,* 524.

SMITH, Nathaniel Cannon *[Painter, architect] b.1866, New Bedford, MA / d.1943, New Bedford, MA.*
Addresses: Active in New Bedford, 1893-1940. **Studied:** Wood engraving with E. G. Dobbins; École des Beaux-Arts, Paris and with Henri Duray, Aaument, Girault (all architects). **Exhibited:** New Bedford Art Club, 1908-13, 1916-17; Thumb Box Exhib., 1910-11; Swain Free School Design, 1929, 1931. **Work:** New Bedford Free Public Library; Brockton Public Library; Fall River YMCA; Clarence A. Cook School; New Bedford Yacht Club. **Comments:** Formed a partnership with Myron P. Howland, called Smith and Howland, which lasted until 1921. Also painted in oils and sketched in pencil, favoring landscape and marine scenes. **Sources:** Blasdale, *Artists of New Bedford*, 175-76 (w/repros.).

SMITH, Nino See: **MACKNIGHT, Nino (Mrs. Wilbur Jordan Smith)**

SMITH, Norbert B. *[Painter] 20th c.*
Addresses: Chicago area. **Exhibited:** AIC, 1951. **Sources:** Falk, AIC.

SMITH, Norwood B. *[Painter] 20th c.*
Addresses: San Francisco Bay area, early 1920s. **Exhibited:** Palo Alto AC, 1923. **Sources:** Hughes, *Artists of California*, 524.

SMITH, Oliver *[Painter] b.1896, Lynn, MA.*
Addresses: Ozona, FL. **Studied:** RISD; also with Charles Hawthorn, Provincetown, MA. **Member:** SC; Rockport AA; St. Petersburg AC; Clearwater AA; Gulf Coast AC. **Exhibited:** NAD; AWCS; Audubon Artists; Philadelphia WCC; Smithsonian Inst., Washington, DC; CGA; Rockport AA. Awards: Gulf Coast AC, Rockport AA & St.Petersburg AC. **Work:** Univ. Florida, Gainesville; Remington Rand Corp. Commissions: stained glass, Princeton Univ. Chapel, Temple Emanu-El, New York, Wittenberg Univ., Springfield, OH, Mellon Cathedral, Pittsburg, PA & Nazareth Hospital Chapel, Phila. **Comments:** Married to artist E. Zabriskie Banta. Preferred medium: watercolor. Research: stained glass windows; glass blowing by hand. **Sources:** WW73.

SMITH, Oliver (Mrs.) See: **BANTA, E. Zabriskie (Mrs. Oliver Smith)**

SMITH, Oliver Phelps *[Painter, craftsperson, decorator, designer] b.1867, Hartford, CT / d.1953.*
Addresses: Brooklyn, NY; Haddam, CT. **Studied:** NAD; CUA School. **Member:** AWCS; NYWCC. **Exhibited:** PAFA Ann., 1895-98; Boston AC, 1896, 1899 ; AIC. **Work:** stained windows: Temple Beth-El, Detroit, Mich.; Dix Mem. Chapel, Old Trinity Church, NY; Mem. Chapel, Wesleyan Univ., Middleton, CT; heraldic windows: A.E.F. Mem. Chapel, Meuse-Argonne Cemetery, Romagne, France; glass mosaic ceiling, Woolworth Bldg., NY. **Sources:** WW53; WW47; Falk, *Exh. Record Series*.

SMITH, Owen E. *[Painter] 20th c.*
Addresses: Hartford, CT. **Member:** CAFA. **Sources:** WW25.

SMITH, P. C. *[Sketch artist] early 19th c.*
Addresses: NYC, active 1824. **Comments:** He drew a view of the John Street Methodist Church, NYC, with Joseph B. Smith (see entry) in 1824 (later published as a lithographic print) This was probably the Peter C. Smith listed as a printer and book seller at the same address as Joseph B. Smith in 1828. They were likely brothers. **Sources:** G&W; Stokes, *Iconography*, I, 344; NYCD 1824, 1828.

SMITH, Pamela Colman *[Illustrator, painter, lithographer, theater stage and costume designer] b.c.1877 / d.c.1950.*
Addresses: NYC, 1893-99; London, from 1899; also lived in Jamaica. **Studied:** PIA School, 1893-97; A.W. Dow. **Exhibited:** first non-photographic artist to be exhibited at Stieglitz' Little Galleries of the Photo-Secession, 1907-09 (solo shows); MacBeth Gallery, NYC; Delaware Art Mus., 1975 (retrospective). **Work:** Stieglitz Collection, Yale Univ. **Comments:** After settling in London in 1899, she befriended artists of the Irish Renaissance. A mystic and believer in the occult, she produced watercolors of fantasy subjects drawn from her subconscious.

Published and edited "The Grean Sheaf," London, 1903-04, with poems by W.B Yeats and others; designed the "Rider deck" of Tarot cards, 1909. **Sources:** WW01; Rubinstein, *American Women Artists,* 180; Petteys, *Dictionary of Women Artists.*

SMITH, Patrick Knox *[Commercial artist] b.1907, Edinburgh, Scotland.*
Addresses: Minneapolis, MN. **Studied:** Federal School, Inc. **Exhibited:** Minnesota State Fair, 1931 (prize); North Montana Fair, 1932 (prize). **Comments:** Position: staff artist, Bureau of Engraving, Federal Schools. **Sources:** WW40.

SMITH, Paul *[Designer, illustrator, writer] b.1907, Worthington, MN.*
Addresses: NYC; Fair Haven, NJ. **Studied:** Univ. Minnesota. **Member:** SI; Art Dir. Club. **Exhibited:** Art Dir. Club, NYC, 1934 -35 (medals), 1942 (medal), 1945 (medal), 1948 (medal); 1952 (medal); Art Dir. Club, Chicago, 1930-33 (medals), 1935 (medal),1945 (medal), 1947-48 (medals) ; Adv. Art Exhib., 1942 (medal); MoMA, 1952. **Comments:** Position: pres., Calkins & Holden, NYC, 1957-. Editor, *Creativity,* 1958. **Sources:** WW59; WW47.

SMITH, Paul H. *[Graphic artist, architect] b.1894, Brooklyn, NY.*
Addresses: Fox Lake, IL. **Studied:** PIASch. **Member:** Chicago SE; Prairie PM. **Work:** Smithsonian; Holabird and Root, Arch., Chicago. **Sources:** WW40.

SMITH, Paul J. *[Museum director] b.1931.*
Addresses: NYC. **Studied:** Art Inst. Buffalo; School for Am. Craftsmen. **Member:** Int. Council Mus.; Mus. Council New York; NY State Assn. Mus. **Comments:** Positions: vice-pres., Louis Comfort Tiffany Foundation; board member, NY State Craftsmen & Artist-Craftsmen of New York; board member, Elder Craftsmen Shop New York; board member, Haystack Mountain School Crafts; director, Mus. Contemporary Crafts, New York, in 1973. Collections arranged: Made with Paper; Plastic as Plastic; Object in the Open Air; Fantasy Furniture; Amusements Is; Objects: USA. **Sources:** WW73.

SMITH, Paul Kauvar *[Painter] b.1893, Cape Girardeau, MO.*
Addresses: Moved to Colorado in 1921; living in Denver, CO in 1973. **Studied:** St. Louis Sch. FA and Washington Univ.; Denver Art Acad.; F.G. Carpenter; J.E. Thompson. **Member:** AAPL; Gilpin County AA; Denver Art Guild; Denver Art Mus. **Exhibited:** CPLH, 1946; Springville, UT, 1946 Heyburn, Idaho, 1940-42, 1946; Kansas City AI, 1938-39, 1942; Joslyn Mus., 1939, 1943-45; Denver AG, 1934 (prize), 1935-45, 1969 (prize); WFNY, 1939; Denver Art Mus., 1923-56, 1962-64; 15 Colorado Artists, 1949-65; Denver Metrop. Exhibs, 1950-64; Mulvane Art Center, Topeka, 1956 & 1964; Lever House, NYC, 1964; Central City, 1964 (award); Canon City, CO, 1969 (award). **Work:** Heyburn (ID) Public School; Denver AM. **Comments:** Specialty: mining towns. **Sources:** WW47; P&H Samuels, 452.

SMITH, Paul Roland *[Painter, educator] b.1916, Colony, KS.*
Addresses: Saint Paul, MN. **Studied:** Pittsburg State College, B.S.; Univ. Iowa, M.F.A. **Member:** Artists Equity Assn. (pres., 1964-67); Midwest College AA (program dir., 1969); College Art Assn. Am.; Walker AC; Minnesota State Arts Con. (chmn. visual arts, 1971-). **Exhibited:** Awards: First awards, Des Moines Art Ctr, 1957, Minn Centennial State Fair, 1958 & Sioux City AC, 1959. **Work:** Des Moines AC, Iowa; Wright Mus., Beloit, WI; Univ. Iowa, Iowa City; Sioux City AC, Iowa; St. Cloud Mus., St. Cloud (MN) State College. **Comments:** Preferred media: oils, ink, watercolors. Positions: director, Int. Exhib., Kappa Pi, 1965-, member board dirs., Minnesota Mus. Art, 1971-. Teaching: professor of painting & drawing, Univ. Northern Iowa, 1951-65; professor, painting & drawing & chmn. dept. art, Hamline Univ., 1965-70s. Publications: author, "Adult Nursery Rhymes," Waverly Publ. Co., 1972. **Sources:** WW73.

SMITH, Paul Williamson *[Painter, craftsperson, teacher]*
b.1886, Philadelphia, PA.
Addresses: St. Davids, PA. **Studied:** PM School IA; PAFA; &
with William Chase, Cecilia Beaux. **Member:** Phila. Art All.
Exhibited: Woodmere A. Gal.; Phila. A. All.; Warwick Gal.,
Phila.; PAFA. Awards: F., PAFA; Cresson traveling scholarship,
PAFA, 1908. **Sources:** WW53; WW47.

SMITH, Pauline Crumb (Mrs. Robt. Aura) *[Painter]*
d.1959, Westport, CT.
Exhibited: S. Indp. A., 1939-40. **Sources:** Marlor, *Soc. Indp.
Artists.*

SMITH, R. K. *[Engraver] early 19th c.*
Comments: Engraved a stipple portrait of the Rev. John Flavel
used as frontispiece to a book by Flavel published at Richmond
(VA) in 1824. **Sources:** G&W; Stauffer.

SMITH, R. P. *[Lithographer] mid 19th c.*
Addresses: Philadelphia, 1858-60 and after. **Comments:** Partner
in the firm of F. Bourquin & Company. He could be Robert
Pearsall Smith, map publisher, although the addresses listed in the
Phila. City Directory for each are different. **Sources:** G&W;
Phila. CD 1858-60+.

SMITH, Rachel *[Painter] 20th c.*
Exhibited: Salons of Am., 1924. **Sources:** Marlor, *Salons of Am.*

SMITH, Rae *[Engraver] mid 19th c.*
Addresses: NYC, 1859. **Sources:** G&W; NYBD 1859.

SMITH, Ralph Alexander *[Writer, educator] b.1929, Ellwood
City, PA.*
Addresses: Urbana, IL. **Studied:** Columbia Univ.(A.B.; Teachers
College, M.A. & Ed.D.). **Member:** Am. Soc. Aesthetics; Philos.
Educ. Soc.; Nat. Art Educ. Assn.; Inst. Study Art In Educ.; World
Future Soc. **Comments:** Teaching: instructor of art history & art
educ., Kent State Univ., 1959-61; asst. professor art history & art
educ. & chmn. dept. art, Wisconsin State Univ.-Oshkosh, 1961-
63; asst. professor art history & art educ., State Univ. NY College
New Paltz, 1963-64; asst. professor aesthetics educ., Univ.
Illinois, Urbana, 1964-67, assoc. professor, 1967-71, professor,
1971-. Research: theoretical foundations of aesthetic and human-
istic education. Publications: editor, "Aesthetics and Criticism in
Art education," Rand, 1966; author, "Aesthetic Education: A Role
for the Humanities Program," *Teachers College Rec.,* 1/1968; edi-
tor, "Aesthetic Concepts and Education," 1970 & "Aesthetics and
Problems of Education," 1971, Univ. Illinois Press; author,
"Aesthetic Foundations," *The Teacher's Handbook,* Scott F., 1970.
Sources: WW73.

SMITH, Ray Twitchell *[Drawing specialist] 20th c.*
Addresses: Charleston, SC. **Sources:** WW24.

SMITH, Ray Winfield *[Collector, art historian] b.1897,
Marlboro, NH.*
Addresses: Dublin, NH. **Comments:** Positions: editorial consul-
tant, *Journal Glass Studies*; chmn., Int. Committee Ancient Glass.
Publications: author, "Glass from the Ancient World," 1957; many
radio & TV interviews; TV program, "Nefertiti & the Computer,"
BBC, 3/20/1971. Collection: ancient glass; medieval furniture,
rugs and paintings. Research: technological research with
Brookhaven National Laboratory on ancient glass. **Sources:**
WW73.

SMITH, Richard *[Artist] b.1931.*
Addresses: NYC. **Exhibited:** WMAA, 1967. **Sources:** Falk,
WMAA.

SMITH, Richard Somers *[Amateur artist] d.1877.*
Exhibited: PAFA, 1849 ("Mathematical Abstraction"), 1853
("Peveril of the Peak"). Exhibited as Lt. R.S. Smith of West
Point. **Comments:** A graduate of West Point in 1829. **Sources:**
G&W; Rutledge, PA; Heitman, *Historical Register.*

SMITH, Robert *[Painter] early 19th c.*
Addresses: active in Pittsburgh, PA, 1826, 1839. **Comments:** At
Pittsburgh, in September 1826, he gave a lecture and exhibited

transparencies of Columbus, Washington, Jefferson, Madison, and
Monroe. In 1839 he is said to have "photographed in oil" two
Pittsburgh scenes. *Cf.* Russell Smith and D.R. Smith. **Sources:**
G&W; Anderson, "Intellectual Life of Pittsburgh: Painting," 290.

SMITH, Robert Alan *[Painter, instructor] 20th c.;
b.Pasadena, CA.*
Addresses: Ojai, CA. **Studied:** Chouinard Art Inst., Los Angeles,
1946, 1953; Inst. Allende, San Miguel de Allende, Mexico, 1948;
painting with David Alfaro Siqueiros, Mexico. **Member:** Western
Serigraph Inst. **Exhibited:** Ann. Print Exhib., LOC, 1959 & 1960
(purchase award); 50 Am. Printmakers, De Cordova Mus., 1961;
Santa Barbara Mus. Art, 1964; Am. Art Today, New York Word's
Fair, 1965; White House, Washington, DC, 1967. Other awards:
purchase awards, Pasadena Art Mus., 1962; James D. Phelan
Award for Calif. Painters, 1961. **Work:** LOC; Nat. Collection,
Smithsonian Inst., Washington, DC; MMA; Phila. Mus.; Pasadena
Art Mus. **Comments:** Preferred media: oils. Teaching: painting
instructor, Calif. Inst. Arts, Los Angeles, 1965; instructor, Ventura
College, 1965-. Art interests: paintings of the Holy Spirit.
Publications: contributor, *Western Serigraph Inst. Bulletin,* 1961
& *Ventura Fine Arts Magazine,* 1962; illustrator, "Long Ago Elf,"
1968 & "Crocodiles Have Big Teeth All Day," 1970, Follett.
Sources: WW73; Langsner, "Art News from Los Angeles," *Art
News Magazine,* 2/1959 & 2/1960 & "Los Angeles Letter," *Art
Int.,* 3/1962; Seldis, "Art," *Los Angeles Times,* 10/1961.

SMITH, Robert B. *[Portrait painter] mid 19th c.*
Addresses: Rochester, NY, 1840's. **Sources:** G&W; Rochester
CD 1844; Ulp, "Art and Artists in Rochester," 32.

SMITH, Robert C *[Educator] b.1912, Cranford, NJ / d.1975.*
Addresses: Glenmore, PA. **Studied:** Harvard Univ. (A.B., 1933;
A.M., 1934; Sachs fellowship, 1934-35; Ph.D., 1936). **Member:**
Hispanic Soc. (corresponding member); Acad. Am. Franciscan
Hist. (corresponding member); Nat. Acad.Fine Arts, Portugal (cor-
responding member). **Exhibited:** Awards: Guggenheim fellow-
ship, 1946-47; Gulbenkian fellowship, 1962-. **Comments:**
Positions: asst. director, Hispanic Foundation, LOC, 1939-45;
research assoc., Winterthur Mus., 1959-. Publications: author,
"Guide to the Art of Latin America," Govt. Printing Office, 1948
& Arno, 1971; author, "Cadeirais de Portugal," *Horizonte,* Lisbon,
1968; author, "The Art of Portugal," Weidenfeld & Nicolson,
London, 1968; author, "S Oporto," 1968; author, "Art of Portugal;
Fifteen Hundred to Eighteen Hundred," Hawthorn, 1968.
Teaching: assoc. fine arts, Univ. Illinois, 1937-39; assoc. professor
of art history, Sweet Briar College, 1945-46; assoc. professor of
art history, Univ. Penn., 1948-56, professor, 1956-. Research:
Luso-Brazilian art; art of the United States. **Sources:** WW73.

SMITH, R(obert) Harmer *[Painter, etcher, designer, archi-
tect] b.1906, Jersey City, NJ.*
Addresses: Jersey City, NJ; Madison, NJ. **Studied:** School Fine
& Applied Art, Pratt Inst., certificate in arch.; School Fine Arts,
Yale Univ., B.F.A.; ASL. **Member:** Jersey City Mus. Assn. (gov.);
Hudson Artists (hon. member); NJWCS; SC. **Exhibited:** AWCS;
Arch. League; Jersey City Mus. Assn.; Madison (NJ) Public
Library. Awards: Trustees' Prize for Upstream, Jersey City Mus.
Assn., 1953; Jersey Journal Medal for Snug Berth, 1961; Patrons'
Prize for From The Bridge, Hudson Artists, 1967. **Work:** USN
Art Collection, Washington, DC; Jersey City Public Library; Old
Bergen Church, Jersey City. **Comments:** Preferred media: water-
colors. Publications: author/illustrator, "Pencil Sketches by R.
Harmer Smith," *Pencil Points,* 7/1931; contributor, reproductions,
Pencil Points & Am. Artist, 1930-1940. **Sources:** WW73; Fred H.
Scherff, "R. Harmer Smith," *Pencil Points* (Oct., 1937); WW47.

SMITH, Robert M. *[Painter] 20th c.*
Addresses: Columbus, OH. **Sources:** WW25.

SMITH, (Robin) Artine *[Painter, commercial artist, designer]
b.1903, Warren, AR.*
Addresses: Dallas, TX. **Studied:** AIC; Northwestern Univ.; in
Vienna, Austria, and with Hubert Ropp, Eliot O'Hara. **Member:**
Dallas AA; Texas FAA; NAWA; Texas WCS. **Exhibited:** SSAL,

1944-45; Reaugh Club, 1943-45; Klepper Club, 1943-45; AWCS, 1945, 1948, 1952; NAWA, 1945-46, 1948; All. Artists, Dallas, 1943-44 (prizes), 1945-46, 1948 (prize), 1949-50, 1952, 1953 (prize); Texas General Exhib., 1943-46, 1948-49; Texas FAA, 1945 (prize), 1946, 1948-49, 1951; Texas Artists Group, from 1945; AIC, 1949 (as Artine Smith); Terry AI, 1952; Texas WC Soc., 1950-51 (prizes), 1952, 1957; Dallas MFA, 1953 (prize); Dallas County Exhib., 1955 (prize); Austin, TX, 1948 (solo); San Antonio, TX, 1951; Dallas, TX, 1951. **Work:** Dallas MFA. **Comments:** Has appeared as Robin Artine, Robin Artine Smith, and Artine Smith. **Sources:** WW59; WW47.

SMITH, Rosamond L. See: **BOUVÉ, Rosamond Lombard Smith (Mrs.)**

SMITH, Roswell T. [Portrait painter] mid 19th c.
Addresses: Nashua, NH. **Comments:** Physically challenged from childhood, he became an itinerant painter as a young man and in the late 1850's was painting in Nashua and Hollis (NH) and in Massachusetts. After his marriage he settled in Nashua where he ran a book store for many years. He was also an inventor. **Sources:** G&W; Sears, *Some American Primitives,* 91-109.

SMITH, Rufus Way [Painter] 19th c.
Addresses: Cleveland, OH. **Exhibited:** PAFA Ann., 1890-91. **Sources:** Falk, *Exh. Record Series.*

SMITH, Russell [Scenic and panoramic artist, portrait and landscape painter] b.1812, Glasgow, Scotland / d.1896, Glenside, PA (near Philadelphia).

Russell Smith, 1865.

Addresses: Pittsburgh, PA, 1822-35; Philadelphia, PA, and area, from 1835. **Studied:** James Reid Lambdin, Pittsburgh, PA, c.1828-30. **Member:** PAFA (board); Artists Fund Soc., 1836. **Exhibited:** PAFA Ann., 1834, 1847-89; Artists Fund Soc., 1835-45; Boston Athenaeum, 1842, 1852; Apollo Assn., Phila., 1838-40; Am. Artists Union, 1838-48; Centennial Exhib., Phila., 1876; AIC, 1945; Baltimore MA, 1945; Univ. Pittsburgh, 1948; Vose Gal., Boston, 1977 (solo), 1979 (with son Xanthus Smith). **Work:** Westmoreland County Mus. of Art, Greensburg, PA; CI; Hist. Soc. of Western Pennsylvania, Pittsburgh; Historical Soc. Pennsylvania, Philadelphia. **Comments:** Baptized William Thompson Russell Smith (and known professionally as William Russell Smith and Russell Smith), he emigrated with his parents to western Pennsylvania in 1819, settling with them in Pittsburgh about 1822. When his teacher James Reid Lambdin traveled south in 1830, Smith ran Lambdin's Pittsburgh Museum and Gallery of the Fine Arts. In 1832 he established himself as a portraitist, but turned to scenic and panorama painting in 1833 and began to record the local landscape. When his theater company moved to Philadelphia and Washington, DC in 1835, Smith went with them, settling in Philadelphia and later moving to nearby Jenkintown and Glenside, PA. He continued to work for the theatre, designing scenery and painting drop curtains for the Chestnut and Walnut Street Theaters and for the Academy of Music, while also gaining recognition for his landscapes and becoming Philadelphia's leading landscape painter. In 1850 he made a panorama based on William McIlvaine's (see entry) sketches of scenes in California and Mexico; it was shown in Philadelphia and Baltimore. In 1851-52 he visited Europe to paint a panorama of the Holy Land. He also designed scenery and sets for theaters in Baltimore, Washington, DC, and Boston. In addition, Smith worked as a scientific draftsman for geological surveys in Pennsylvania and Virginia. His wife, Mary Priscilla Wilson Smith, and both his children, Mary and Xanthus R. Smith, were also painters (see entries on each). *Cf.* Robert Smith, who exhibited transparancies in Pittsburgh in 1826. **Sources:** G&W; DAB; Rutledge, PA, vo. 1 (as William Thompson Russell Smith); Clement and Hutton (as William Russell Smith); Falk, PA, vol. 2; Cowdrey, AA & AAU; Sweet, *Hudson River School;* obits., N.Y. *Herald* and Boston *Transcript,* Nov. 9, 1896. More recently, see Gerdts, *Art Across America,* vol. 1: 285; *300 Years of American Art,* vol. 1: 154; Campbell, *New Hampshire Scenery,* 152-154; P & H Samuels, 452; *Russell Smith and Xanthus Smith: Pennsylvania Landscapes,*

1834-1892 (exh. cat., Vose Gal., Boston, 1979); Judith Hansen O'Toole and Carla S. Herling, "Treasures from the Westmoreland Museum," *American Art Review* (February 1999), 138.

SMITH, Russell Train [Educator, designer, lecturer, painter, architect] b.1905, Concord, MA.
Addresses: Boston, MA; Brookline, MA. **Studied:** Harvard Univ., A.B., M.Arch. **Member:** Wash. WCC. **Exhibited:** Fitzwilliam Art Center, NH, 1939 (prize). **Comments:** Position: head art dept., Univ. North Carolina, 1936-40; head, BMFA School, Boston, MA, 1940-60s; art professor, Tufts College, Medford, MA, 1943-60s. Lectures: design & art history. **Sources:** WW59.

SMITH, Ruth See: **REININGHAUS, Ruth (Ruth Reininghaus Smith)**

SMITH, S. A. See: **SMITH, Serena A.**

SMITH, S. (Miss) [Artist] late 19th c.
Addresses: Active in Los Angeles, 1886-88. **Sources:** Petteys, *Dictionary of Women Artists.*

SMITH, Sam [Painter, educator] b.1918, Thorndale, TX.
Addresses: Albuquerque, NM. **Studied:** Randall Davey, Jack Levine, Ben Turner & Carl von Hassler. **Member:** New Mexico Art League (life member); Artists Equity Assn. (pres.). **Exhibited:** Corcoran Gallery, 1948 (solo); Santa Fe (NM) MFA, 1949; Botts Mus. Art, Albuquerque, NM, 1964; Panhandle-Plains Hist. Mus, Canyon, TX, 1964; Roswell (NM) Mus. Art, 1965; M. James Hall Gal., Ruidoso, NM, 1970s. Awards: Questa (NM) purchase prize, 1962 & first prize for watercolor, 1962, New Mexico State Fair; first prize for watercolor, Ouray (CO) Alpine Show, 1964. **Work:** War Dept. Hist. Properties Section; Santa Fe Mus.; Univ. New Mexico; New Mexico State Fair Collection; Panhandle Mus. Fine Art. Commissions: mural, Camp Barkley, Texas, War Dept., 1942; paintings, Infantry Weapons, Camp Barkley, 1942. **Comments:** Preferred media: watercolors, oils. Teaching: Univ. New Mexico, 1956-70s. **Sources:** WW73; Robert Ruark, *Sam Smith, Artist* (Assoc. Press, 1948).

SMITH, Samuel [Artist and drawing master] b.c.1786, England.
Addresses: Baltimore, 1824-51. **Comments:** His wife and a daughter born about 1825 were also born in England. Three younger children, born between 1826-29 were born in Maryland. **Sources:** G&W; Lafferty; 7 Census (1850), Md., V, 835.

SMITH, Samuel P. [Miniature painter] b.c.1804, Philadelphia.
Addresses: Philadelphia, 1850. **Comments:** Had a wife and seven children. **Sources:** G&W; 7 Census (1850), Pa., L, 284.

SMITH, Samuel, Jr. [Miniaturist] d.1812, Charleston, SC.
Addresses: Charleston, SC, active 1801. **Studied:** London. **Sources:** G&W; Rutledge, *Artists in the Life of Charleston.*

SMITH, Sarah [Painter] mid 20th c.
Addresses: Ft. Worth, TX. **Exhibited:** SSAL, Montgomery, AL, 1938; San Antonio, TX, 1939. **Sources:** WW40.

SMITH, Sarah E. [Artist] mid 19th c.
Exhibited: Michigan State Fair, 1851 (India ink drawing). **Comments:** Cf. Sarah E. Smith who exhibited in Boston. **Sources:** Petteys, *Dictionary of Women Artists.*

SMITH, Sarah E. (Miss) [Painter] late 19th c.
Exhibited: Boston AC, 1877-81 (landscapes, Massachusetts and North Carolina). **Comments:** Active 1851-79. *Cf.* Sarah E. Smith of Michigan. **Sources:** *The Boston AC.*

SMITH, Sara(h) J. (Miss) [Painter, teacher] 20th c.
Addresses: Greenfield, MA, 1870-72; Hartford, CT, c.1913-15. **Exhibited:** NAD, 1872 ("Mountain Laurel"). **Comments:** Sister of Esther L. Smith (see entry). Taught drawing in Greenfield, Mass., 1870s. **Sources:** WW15; Petteys, *Dictionary of Women Artists.*

SMITH, Sarah K(atherine) [Painter, etcher, illustrator, teacher, lecturer] 20th c.; b.Rio Vista, CA.

Addresses: Wheaton, IL. **Studied:** Wheaton College; AIC; BMFA School; & with Howard Pyle; William Chase; Vanderpoel; Benson; Freer. **Member:** NAWA; Wilmington Soc. FA; SSAL; Gulf Coast AA; NOAA. **Exhibited:** AIC; SSAL; Mississippi AA, 1939 (gold medal); Gulf Coast AA (prize); NYWCC; AWCS; Watercolor Exhib., Boston; Plastic Club, Phila. **Work:** Ruston (LA) Library. **Comments:** Contributor: national magazines. Position: teacher, Wheaton (IL) College Acad.; head art dept., Gulf Park (MS) College, 1940. Lectures: "American Furniture in the South." **Sources:** WW53; WW47.

SMITH, Sarah R. *[Painter] early 20th c.*
Addresses: NYC. **Member:** NAWPS. **Sources:** WW21.

SMITH, Serena A. *[Painter] late 19th c.*
Exhibited: NAD, 1868-73. **Sources:** Naylor, *NAD* (lists as S.A. Smith and Serena A. Smith).

SMITH, Sherman *[Painter] early 20th c.*
Addresses: Pittsburgh, PA. **Member:** Pittsburgh AA. **Sources:** WW25.

SMITH, Shirlann *[Painter] 20th c.; b.Wichita, KS.*
Addresses: NYC. **Studied:** Kansas State Univ. (B.F.A.); Provincetown (MA) Workshop Art School; ASL. **Exhibited:** Young Provincetown Painters, Chrysler Mus., Provincetown, MA, 1964; New England Exhib., Silvermine, CT, 1967; American Painting 1970, Virginia Mus., Richmond, 1970; Lyrical Abstraction, Aldrich Mus. Contemporary Art, Ridgefield, CT, 1970; Recent Acquisitions & Lyrical Abstraction, WMAA, 1971; 55 Mercer Gallery, NNYC, 1970s. Awards: Grumbacher Artists Material Co. award for mixed media, New England Exhib., Silvermine, 1967. **Work:** WMAA; Univ. Calif., Berkeley, Art Mus.; Wichita (KS) State Univ. Art Mus.; Aldrich Mus Contemporary Art, Ridgefield, CT; Phoenix (AZ) Art Mus. **Sources:** WW73; Gordon Brown, review, *Arts Magazine* (summer, 1970); Dorothy Grafley, "Lyrical Abstraction," *Art in Focus* (October, 1970).

SMITH, Sibley *[Painter] b.1908, NYC.*
Addresses: Wakefield, RI. **Studied:** Harvard Univ.; Yale Univ. School Arch. **Exhibited:** FAP, Wash., DC, 1942; Inst. Mod. Art, Boston, 1945; Providence Mus. Art, 1943-46; Tilden-Thurber Gal., Providence, 1942; Willard Gal., NY, 1945, 1948, 1950 (solo), 1955; Pinacotheca; Soc. Four Arts, Palm Beach, FL; Boston AC; Margaret Brown Gal., 1949-50; WMAA, 1948-51; U.S. State Dept. traveling exhib,. Europe, 1954; BM, 1955; Pioneer Valley AA, 1953 (award); Mystic AA, 1957 (award); South County (RI) AA, 1957 (award); Essex AA, 1958 (award). **Work:** Providence (RI) Mus. Art; Rochester Mem. Art Gal. **Sources:** WW59; WW47.

SMITH, Sidney *[Cartoonist] b.1877, Bloomington, IL / d.1935, Harvard, IL (auto collision).*
Comments: Best known as the creator of the comic strip "The Gumps," published in Europe, Hawaii, Canada, Australia, and the U.S. He had produced "Old Doc Yak" and at least three other series of cartoon characters before "The Gumps" in 1917. In 1922, Smith signed a $1,000,000 contract for "The Gumps" to extend over a ten-year period — the largest figure ever guaranteed a similar feature at that time.

SMITH, Sidney Lawton *[Painter, engraver, craftsperson] b.1845 / d.c.1906.*
Addresses: Boston, MA. **Member:** Boston SAC. **Exhibited:** Boston AC, 1884; PAFA Ann., 1898. **Sources:** WW10; Falk, *Exh. Record Series.*

SMITH, Sidney Paul *[Landscape painter] b.1904, Salt Lake City.*
Addresses: Living in Denver, CO after 1965. **Studied:** Lawrence Squires; A.B. Wright; NAD with Kroll, 1932-34. **Comments:** Specialty: watercolor. **Sources:** P&H Samuels, 452.

SMITH, Stowell Le Cain (Mrs.) See: **FISHER, Stowell Le Cain (Mrs. Stowell Le Cain Smith)**

SMITH, Susan *[Artist] b.1934.*
Addresses: NYC. **Exhibited:** WMAA, 1973. **Sources:** Falk, *WMAA.*

SMITH, Susan E. *[Painter] 19th/20th c.*
Addresses: Cambridge, MA, active 1892-1908. **Member:** Copley Soc., 1892. **Exhibited:** Boston AC, 1878, 1898; PAFA Ann., 1899. **Comments:** Not to be confused with Susanne F. Smith (see entry). **Sources:** WW10; Falk, *Exh. Record Series.*

SMITH, Susanne F. *[Painter] 19th/20th c.*
Addresses: Boston, MA, active 1898-1913. **Exhibited:** Boston AC, 1898. **Comments:** There was also a Susan E. Smith (see entry) who exhibited at the Boston AC in 1898; however she listed a different residence than Susanne F. Smith. **Sources:** WW98; Falk, *Boston AC.*

SMITH, Suzanne Mullett (Mrs.) See: **MULLETT, Suzanne (Mrs. Suzanne Mullett Smith)**

SMITH, Sydney *[Painter] early 20th c.*
Addresses: Buffalo, NY. **Sources:** WW17.

SMITH, T. J. *[Wood engraver] mid 19th c.*
Addresses: NYC, active 1847. **Exhibited:** American Institute, 1847 (wood engraving). **Comments:** He may have been an apprentice of Butler & Roberts (see entry). **Sources:** G&W; Am. Inst. Cat., 1847; NYBD 1846.

SMITH, T. M. (Master) *[Sketch artist] early 19th c.*
Exhibited: PAFA, 1827 &1829 (india ink and chalk drawings, including a copy after one of the Peale family). **Sources:** G&W; Rutledge, PA.

SMITH, Thomas *[Engraver] mid 19th c.*
Addresses: Lowell, MA,1834-35. **Sources:** G&W; Belknap, *Artists and Craftsmen of Essex County,* 5.

SMITH, Thomas A. *[Listed as "artist"] b.1836, Dartmouth, MA / d.1896, New Bedford, MA.*
Addresses: Active in New Bedford area, 1876-95. **Work:** Old Dartmouth Hist. Soc. **Sources:** Blasdale, *Artists of New Bedford,* 177 (w/repro.).

SMITH, Thomas A. (or H.) *[Painter, panoramist] 19th c.*
Comments: Painter of a panorama entitled "California on Canvas," based on drawings by Thomas A. Ayres. Cf. Thomas H. Smith. **Sources:** G&W; Van Nostrand and Coulter, *California Pictorial,* 136 [as Thomas A.]; San Francisco *Daily Alta California,* Aug. 11 and 14, 1854, and N.Y. *Herald,* Feb. 5, 1856 [as Thomas H.].

SMITH, Thomas (Captain) *[Portrait painter] mid 17th c.*
Addresses: Boston, MA, from 1650. **Work:** Worcester Art Museum. **Comments:** Projected to be the artist of a group of portraits from the last quarter of the 17th century, some signed simply with the monogram TS. Among the works are a self-portrait (dated c.1680-90) and a portrait of his daughter (both at the Worcester Art Museum). The attribution for the group of portraits is based partly on a record of payment of four guineas made by Harvard College in June 1680 to a "Major Thomas Smith" for "drawing Dr. Ames's effigies," and on the knowledge that a Captain Thomas Smith came to Boston from Bermuda in 1650. The self-portrait includes a ship in the background, a reference, it can be assumed, to Smith's mariner background. **Sources:** G&W; The self-portrait is discussed in Louisa Dresser's *XVIIth Century Painting in New England.* See also Jonathan Fairbanks, et al. *New England Begins* 3 volumes (Boston: Museum of Fine Arts, 1982), vol. 3 :474; Craven, *Colonial American Portraiture,* 65, 67, 68, 72, 116; Baigell, *Dictionary.*

SMITH, Thomas G. *[Engraver, photographer, printer] b.1875, Louisiana.*
Sources: *Encyclopaedia of New Orleans Artists,* 359.

SMITH, Thomas H. See: **SMITH, Thomas A. (or H.)**

SMITH, T(homas) Henry *[Portrait, figure, and flower painter] mid 19th c.*
Addresses: NYC (1840s); Philadelphia, PA (1860s); Boston, MA, 1876. **Exhibited:** NAD, 1843-47, 1874; American Art-Union, 1843-49; Brooklyn AA, 1864; PAFA Ann., 1876-77. **Comments:** Possibly the painter of the panorama "California on Canvas" mentioned above under Thomas A. Smith (see entry). **Sources:** G&W; Cowdrey, NAD; Cowdrey, AA & AAU; NYCD 1847; Falk, *Exh. Record Series.*

SMITH, Thomas Herbert *[Painter] b.1877, NYC.*
Addresses: Wilton, CT. **Studied:** G. Bellows; ASL. **Member:** NAC; Brooklyn SA; Silvermine GA; SC; New Rochelle AA; Group of Wilton Artists. **Exhibited:** Bridgeport AL (prize);S. Indp. A., 1917-20, 1922, 1925-29; Salons of Am.1922, 1925,-31, 1934. **Work:** Wilton (CT) Town Hall. **Sources:** WW40.

SMITH, Thomas Lochlan *[Landscape painter] b.1835, Glasgow, Scotland / d.1884, NYC.*
Addresses: Albany, NY,1859; NYC, 1862-84. **Studied:** George H. Boughton, Albany , NY. **Member:** ANA, 1869. **Exhibited:** Brooklyn AA, 1864-83; Boston AC, 1873-82; NAD, 1863-84; PAFA; Centennial Exhib., Phila., 1876. **Comments:** Smith immigrated to the U.S. at an early age. He specialized in winter scenes. **Sources:** G&W; Clement and Hutton (as T.L. Smith); CAB; Cowdrey, NAD; Swan, BA; Rutledge, PA; Albany CD 1859-60.

SMITH, Thomas William *[Landscape painter] b.1807, Fairfax County, VA / d.1869, Lynchburg, VA.*
Comments: Painted in watercolor around Lynchburg, VA, c.1866. **Sources:** Wright, *Artists in Virgina Before 1900.*

SMITH, Tony *[Sculptor, painter, architect] b.1912, South Orange, NJ / d.1980.*
Addresses: Orange, NJ. **Studied:** ASL, 1934-35, with Geo. Grosz and V. Vytlacil; New Bauhaus, Chicago, 1937-38, with Moholy-Nagy (architecture); apprentice to Frank Lloyd Wright, 1938-40. **Exhibited:** Wadsworth Atheneum, Hartford, Conn, 1964, 1967; Jewish Mus, NYC, 1966; WMAA, !966, 1970, 1973; Philadelphia Inst Contemp Art, 1967; World's Fair, Osaka, 1970; Knoedler Gal., NYC, 1970s; MoMA, 1998 (retrospective). **Work:** Princeton Univ. **Comments:** Minimalist sculptor. Smith worked as an architect from 1938 to c.1963 and although he painted and sculpted in these years and was a member of the avant-garde, he did not show his work until the 1960s. In 1961, he began the first of a series of complex, sometimes monumental, geometric sculptures that would earn him recognition as an important minimalist sculptor of the 1960s-70s. Teaching: NYU, 1946-50; Cooper Union, 1950s; Pratt Inst; Bennington College; Hunter College, 1962-. *Cf.* Anthony Smith. **Sources:** WW73; Samuel Wagstaff, Jr., "Talking with Tony Smith," *Artforum* vol. 5 (Dec. 1966): pp.14-19; Baigell, *Dictionary; Two Hundred Years of American Sculpture,* 311; Eleanor Greene, *Tony Smith: Painting and Sculpture* (exh. cat., Univ. of Maryland, 1974).

SMITH, Tryphena Goldsbury (Mrs.) *[Amateur painter of watercolors and mural frescoes] b.1801 / d.1836.*
Comments: She was the wife of the Rev. Preserved Smith of Warwick (MA). **Sources:** G&W; Dods, "Connecticut Valley Painters," 209.

SMITH, Twigg *[Painter] b.1882, Nelson, New Zealand.*
Addresses: Honolulu, Hawaii. **Studied:** AIC; H.M. Walcott. **Member:** Hawaiian SA; Chicago ASL. **Exhibited:** AIC, 1917; PAFA Ann., 1918. **Sources:** WW25; Falk, *Exh. Record Series.*

SMITH, Vernon B. *[Painter, sculptor, craftsperson, teacher] b.1894, Cortland, NY / d.1969.*

VERNON Smith

Addresses: Orleans, MA. **Studied:** NY Sch. Fine & Applied Arts; in Paris, 1918; C.W. Hawthorne in Provincetown; with Howard Giles, R. Sloan Bredin. **Member:** Cape Cod AA (founder, pres.); Provincetown AA; Eastern AA; Mass. Art Educ. Assn. **Exhibited:** Walker Gal., Boston, 1934 (solo); Inst. Mod. Art, Boston, 1939; Kraushaar Gal, NYC, 1944-65, 1947 (solo); Virginia MFA, 1946;

PAFA Ann., 1946; Montclair AM, 1952; Addison Gal. Am. Art, 1959; Cape Cod AA, 1959 (solo); Henderson Gal., Carmel, CA, 1960-66, 1960 (solo); Symphony Hall, Boston, 1961 (solo); DeCordova Mus., Lincoln, MA, 1977; Orleans AG (MA), 1978 (solo); Anchorage Mus. Art, 1987 (WPA exh.); Provincetown AA, 1938-61, 1997 (retrospective). **Work:** BMFA; MoMA; Springfield MFA; New Britain Mus.; Dartmouth College Mus.; Anchorage Mus.; Cape Cod MFA; Provincetown AA; Toledo MA. **Comments:** Abstract figurative painter and bas-relief wood carver. In 1937, he was painting in Alaska for the WPA. From 1946-on, his hand-carved abstract bas-relief panels became his principal mode of expression. Teacher: Orleans (MA) public schools; WPA (regional dir., 1934-37). **Sources:** WW59; WW47; exh. cat., Provincetown AA, 1997; Falk, *Exh. Record Series.*

SMITH, Vincent DaCosta *[Painter, printmaker] b.1929, Brooklyn, NY.*
Studied: ASL; BM School; Pratt Inst.; Skowhegan (ME) Art School; with Robert Blackburn, Roberto Lamonico, Krista Reddy, Robert Cale. **Exhibited:** ACA Gallery, NYC, 1955; Roko Gallery, NYC, 1955; BM, 1955; National Arts Club, NYC, 1966; Contemporary Arts Gallery, NYC,1966; NAD, 1967; Barnard College, 1968; Skowhegan Ann., 1968-69; Studio Mus., Harlem, 1969 (solo); Fisk Univ., 1970 (solo); Univ. of Iowa; NIAL, 1968 (prize); Wilson College, PA, 1968; Nassau Community College; C.W. Post College, 1969; Long Island Univ., 1968; Lever House Gallery, 1969; NY Comm. College, 1969; Brooklyn College, 1969; Univ. of Hartford, CT, 1970; Muhlenberg College, PA, 1970; College of Mount St. Vincent, Riverdale, NY, 1970; Illinois Bell Telephone, 1971-72; Finch College, 1971; BMFA, 1970; Hall of Springs Mus., 1970; Hudson River Mus., Yonkers, NY, 1970-71; Newark Mus., 1971; Illinois State Univ., 1971; Seton Hall Univ., 1971; Smith-Mason Gallery, Wash., DC, 1971; NJ State Mus., Trenton, 1972; International Artists for Angela Davis, 1972; Whitney Mus. Art Resources Center, 1971 (solo), WMAA, 1971; Spelman College, 1971; Metropolitan Applied Research Center, Inc., 1972. Awards: Whitney Fellowship, 1959. **Work:** Westinghouse Co.; Chase Manhattan Bank, NYC; Newark Mus.; Fisk Univ.; Spelman Univ.; Malcolm X Univ.; IBM; Larcada Gallery, NYC. **Sources:** Cederholm, *Afro-American Artists.*

SMITH, Violet Thompson (Mrs.) *[Miniature painter] b.1882, Annapolis, MD.*
Addresses: West Haddonfield, NJ. **Studied:** Archambault. **Member:** Alliance. **Exhibited:** PAFA, 1925. **Sources:** WW33.

SMITH, Virginia Jeffrey *[Painter, teacher] 20th c.; b.Rochester, NY.*
Addresses: Rochester, NY/Gloucester, MA. **Studied:** Tryon; Breckenridge. **Member:** North Shore AA; Rochester AC. **Sources:** WW40.

SMITH, Von See: **VON SMITH, Augustus A.**

SMITH, W. *[Painter] early 19th c.*
Exhibited: NYC, 1810 ("Spanish Armada" and "Fire of London"). **Sources:** G&W; New York *Evening Post,* Jan. 3, 1810 (citation courtesy J.E. Arrington).

SMITH, W. Eugene *[Photographer] b.1918, Wichita, KS / d.1978, Tucson, AZ.*
Exhibited: MoMA; IMP: Univ. Oregon. **Work:** Smith Archive at Center Creative Photography, Tucson, AZ; other major collections. **Comments:** An important and influential photojournalist from 1936-on, he is best known for his moving photo-essays for *Life* such as "Spanish Village," "Country Doctor," "A Man of Mercy," and "Minamata." **Sources:** Witkin & London, 238.

SMITH, W. Harry *[Mural painter, etcher, designer] b.1875, Devon, England / d.1951.*
Addresses: Cambridge, MA. **Member:** Copley Soc., Boston; Boston SAC; Boston SWC Painters; Chicago SE. **Exhibited:** Chicago SE, 1925, 1946 (prize). **Work:** BMFA; FMA; MIT; NGA; AIC; Whistler House, Lowell, MA. **Sources:** WW47.

SMITH, W. Linford *[Painter]* *b.1869, Pittsburgh, PA.*
Addresses: Pittsburgh, PA/Miami, FL. **Studied:** C. Walters.
Member: Pittsburgh AA. **Sources:** WW25.

SMITH, W. Singerly *[Painter]* *20th c.*
Addresses: Charlotte, NC. **Exhibited:** S. Indp. A., 1930.
Sources: Marlor, *Soc. Indp. Artists.*

SMITH, Wallace Herndon *[Painter]* *b.1901, St. Louis, MO /*
d.1953.
Addresses: Clayton, MO; NYC. **Studied:** Princeton Univ. (A.B.);
Charousset; C.W. Hawthorne. **Member:** AIA. **Exhibited:** Artists
Guild; Salons of Am., 1924, 1934; St. Louis, MO, 1929 (prize);
AIC, 1932; PAFA Ann., 1934, 1938; Corcoran Gal biennials,
1939, 1941. **Work:** CAM. **Sources:** WW53; WW47; Falk, *Exh.
Record Series.*

SMITH, Walt Allen *[Sculptor, designer, lecturer, teacher]*
b.1910, Wellington, KS / d.1971.
Addresses: Los Angeles 26, CA. **Studied:** Los Angeles County
AI. **Member:** Calif. Art Club; FIAL; Otis AI Alumni Assn. (pres.,
1952-62). **Exhibited:** Nat. Orange Show, 1948, 1950, 1959 (gold
medal; prize); Calif. Int., 1950, 1956; Calif. Centennial, 1949;
Palm Springs, 1955-56; Greek Theatre, Los Angeles, 1949-50;
Los Angeles Art Festival, 1949-64; Bowers Mem. Mus., 1956-59;
Wilshire Ebell, 1957; Cunningham Mem. Gal., Bakersfield, 1957;
LACMA, 1957-59; Descanso Gardens, 1957-65; Duncan Vail
Gal., 1956-65; Palos Verdes Lib., 1956-57; Florentine Gal.,
Pacific Palisades, 1956-58; Whittier Gal., 1956-57; Pacific Coast
Club, Long Beach, 1958-59; Madonna Festival, 195-57, 1959-60
(prize), 1961 (prize)-1965; Calif. Art Club, 1955 (gold medal),
1956, 1958 (prize), 1959 (prize); Glendale Lib., 1957; Van De
Kamp Wilshire Gal., 1960-61; Wilshire Federal, 1960-61; Kagel
Canyon, 1960-61; Pasadena Art Fair, 1960 (prize); Santa Barbara
Art Festival, 1960-61; Am. Artists Acad., 1961; Los Angeles
County Arboretum, 1959-64; John Wesley Branch General
Hospital, 1960; Smithsonian Inst., 1963; Vault Gal., Los Gatos,
Cal., 1965; Guardian Bank, Hollywood, 1964 (solo); Tanar Gal.,
Hollywood, 1963 (2-man); Hollywood, 1965 (with K. Tanahashi).
Work: Cole Co.; Electronic Eng. of California; memorial for the
Hungarian Revolution of 1957 commissioned by Baron &
Baroness Von Braun de Bellatini, 1957. **Comments:** Lectures
with demonstrations on sculpture and jewelry design. Judge, Calif.
State Fair, 1962 & 1964. **Sources:** WW66.

SMITH, Walter Granville See: **GRANVILLE-SMITH,**
W(alter)

SMITH, Walter W(ashington) *[Painter, designer]* *b.c.1892,*
Clearfield, PA / d.1950, Germantown, PA.
Addresses: Greencastle, PA; Phila. & Germantown, PA, c.1914-
50 (returned to Greencastle, PA, part of 1920s). **Studied:**
Carnegie Inst., 1905; & with C. J. Taylor. **Member:** Germantown
AL. **Exhibited:** Indep. Artist's Exhib., NYC; Le Salon de
Indépendents de New York, in Paris, France, 1923 (hon. mention
for "Creek Bridge"); Paris, France, 1923; CGA, 1928; City Art
Mus., St. Louis, 1929 ("Snowing"); Newman Gals., Phila.;
Germantown AL (prizes); Buffalo Fine Arts Acad. annual,
Albright Art Gal., Buffalo, NY, 1929; Atlanta Univ. (prize for
"April Blizzard"); 84th Annual Exhib. of Small Oil Paintings by
Phila. Artists, 1948; Harmon Foundation, 1950; Durham, NC.
Work: Allison-Antrim Museum, Greencastle, PA (15 paintings);
Clark Atlanta Univ., Atlanta, GA. **Comments:** Specialized in
snow scenes that reflect his close observation of nature. His
"Snowing" (Allison-Antrim Mus.) took years to finish because
Smith, having started the work during one particular winter storm,
had to wait several years for the same type storm to appear again.
Positions: designer of rings, pins, for George Frye & Co., Phila.,
c.1914-; owner/operator of a shop in Wildwood, NJ, selling his
hand-painted ties, handkerchiefs, and leather covers for telephone
books during the summer months, c.1914-1920s; scene painter for
the Standard Theater, Phila., after 1929; owner of sign and poster
store, Ludlow St., Phila.; director, Display Sign Shop, Food Fair,
Phila., 1947-50. Marlor gives year of birth as 1884. **Sources:**

WW53; WW47; Marlor, *Soc. Indp. Artists;* information courtesy
Bonnie Shockey, Allison-Antrim Museum.

SMITH, Wayne C. *[Painter]* *20th c.*
Studied: ASL. **Exhibited:** S. Indp. A., 1941. **Sources:** Marlor,
Soc. Indp. Artists.

SMITH, Wilbur Jordan (Mrs.) See: **MACKNIGHT,**
Nino (Mrs. Wilbur Jordan Smith)

SMITH, William *[Engraver]* *mid 19th c.*
Addresses: Philadelphia, 1858-60. **Sources:** G&W; Phila. BD
1858, 1860.

SMITH, William *[Engraver]* *b.1811, England.*
Addresses: Washington, DC, c.1835-60 and after. **Comments:**
His wife and children were born in Washington. **Sources:** G&W;
7 Census (1850), D.C., I, 204; 8 Census (1860), D.C., II, 741;
Washington CD 1843-64.

SMITH, William *[Sculptor]* *19th c.*
Comments: Modeler of a wax portrait of John Paul Jones; pre-
sumed to be American. **Sources:** G&W; E.S. Bolton, *American
Wax Portraits,* 61.

SMITH, William Arthur *[Painter, printmaker, illustrator,*
writer] *b.1918, Toledo, OH.*
Addresses: NYC; living in Pineville, PA in 1976. **Studied:**
Keane's Art School, Toledo; ASL; Grand Central Art School, New
York; École Beaux Arts, Paris; Acad. Grande Chaumière, Paris;
Univ. Toledo, M.A. **Member:** NA, 1952 (council member &
recording secretary, 1954-55); SI; AWCS (pres., 1956-57, hon-
orary pres., 1957-); Int. AA (executive committee, 1963-69; vice
pres., 1966-69; pres. US Committtee, 1970-); Audubon Artists;
NA Western Art; Philadelphia WCC. **Exhibited:** AWCS, 1942-44,
1946, 1956 (grand prize & gold medal), 1965 (grand prize & gold
medal); Art Directors Club, 1943; SI, 1944, 1946 (solo); MMA,
1943, 1966-67 (200 Years Watercolor Painting Am.);
Contemporary Am. Illus., 1946; Ohio State Exhib., 1933; Calif.
WCS, 1946; Phila. WCC, 1946; Toledo Mus. Art, 1943 (solo);
NAD, 1949 (award), 1951 (award, prize for oil painting, Adolf &
Clara Obrig); PAFA Ann., 1952, 1954; Contemporary Arts US,
Los Angeles, 1956; 27 solo exhibitions, major cities in Europe,
Asia, & US. **Work:** MMA; Los Angeles County Mus., CA;
Chrysler Corp., war paintings collection; LOC; NAD.
Commissions: mural of history Maryland, State of Maryland,
Maryland House, Aberdeen, 1968. **Comments:** Preferred media:
oils, watercolors. Illustrator: "The Chinese Children Next Door,"
1942; "The Water-Buffalo Children," 1943. Author/illustrator, "Art
Behind the Iron Curtain," 2/1960 & "The Changing Art of the
Orient," 8/1965, *Harpers Bazaar;* author, "Ben Shahn," *Ben
Shahn, Osaka Shiritsu Bijutsukan-Mainichi Shimbun,* Japan, 1970.
Lecturer: various universities & art schools in Europe, Asia & US.
Sources: WW73; WW47; P&H Samuels, 452; Falk, *Exh. Record
Series.*

SMITH, William Brooke *[Painter]* *20th c.*
Addresses: Phila., PA. **Sources:** WW06.

SMITH, William C. *[Engraver]* *mid 19th c.*
Addresses: NYC, 1852. **Sources:** G&W; NYCD 1852.

SMITH, William D. *[Engraver]* *b.c.1800, New York.*
Addresses: NYC, active1822-60 and after. **Comments:** During
part of this time he lived in Newark (N.J.). His son Adolphus was
listed as an artist in the 1850 census (see entry). **Sources:** G&W;
7 Census (1850), N.Y., XLIII, 529; Stauffer; *Portfolio* (May 1946),
198.

SMITH, William E. *[Landscape painter]* *mid 19th c.*
Addresses: Philadelphia. **Exhibited:** Artists' Fund Soc., Phila.,
1840-41. **Comments:** His subjects included English, Dutch, and
Greek views. **Sources:** G&W; Rutledge, PA.

SMITH, William E. *[Graphic artist, painter]* *b.1913,*
Chattanooga, TN.
Studied: Cleveland School of Art; Huntington AI, Cleveland;
with Richard R. Beatty; Chouinard AI. **Member:** Art West

Associated, Los Angeles; Karamu Artists. **Exhibited:** Cleveland May Show, 1935-39; Dayton AI, 1939; CAFA, 1938; American Negro Expo, Chicago, 1940; Assoc. Am. Artists Gallery, 1942; Cleveland Mus. Art (merit award), 1935-41; LOC, 1943; Atlanta Univ., 1942, 1969; NAD, 1966-68; Oakland Mus., 1968; Denver Art Mus.; Frye Mus., Seattle; Val-Verde, CA, Art & Hobby Show (prize); Benedict Art Gallery, Chicago (solo); Lyman Brothers Gallery, Indianapolis (solo); Florenz Gallery, Los Angeles (solo). **Work:** LOC; Cleveland Mus. of Art; Howard Univ.; Golden State Ins. Co., Los Angeles; Oakland Mus. **Sources:** Cederholm, *Afro-American Artists.*

SMITH, William Good [*Portrait and miniature painter*] 19th c.
Addresses: NYC, 1842-44. **Exhibited:** American Institute, 1842 (india ink drawing). **Sources:** G&W; Am. Inst. Cat., 1842; NYBD 1844; Bolton, *Miniature Painters.*

SMITH, William H. [*Painter*] 20th c.
Addresses: Hartford, CT. **Member:** CAFA. **Sources:** WW25.

SMITH, William Harold [*Painter, designer, educator, lecturer*] b.1900, Casteltown, ND / d.1951, Norman, Ok?.
Addresses: Norman, OK. **Studied:** AIC; Univ. Washington (B.A. in Educ., M.F.A.). **Member:** Am. Assn. Univ. Prof. **Exhibited:** Chicago, New York, Seattle, Kansas City, Tulsa, Oklahoma City. **Work:** Univ. Washington; Northwest Printmakers; Oklahoma City Public School. **Comments:** Lectures: "Art in Industry."Position: teacher, Univ. Oklahoma, from 1936. **Sources:** WW53; WW47.

SMITH, William L. [*Painter*] early 20th c.
Exhibited: Harmon Fnd., 1928. **Sources:** Cederholm, *Afro-American Artists.*

SMITH, William Mason (Mrs.) See: **MASON SMITH, Marguerite Lacamus (Mrs.)**

SMITH, William O. [*Engraver*] mid 19th c.
Addresses: NYC, 1846. **Sources:** G&W; NYCD 1846.

SMITH, William R. [*Still life and figure painter*] mid 19th c.
Addresses: NYC, active 1836-38. **Exhibited:** NAD, 1836; Apollo Association, 1838. **Sources:** G&W; Cowdrey, NAD; Cowdrey, AA & AAU; NYCD 1838.

SMITH, William R. [*Engraver*] mid 19th c.
Addresses: NYC, 1852-60. **Sources:** G&W; NYBD 1852-58, CD 1854-60.

SMITH, William Russell See: **SMITH, Russell**

SMITH, William S. [*Marine painter*] b.1821.
Addresses: Brooklyn, NY, 1853-60. **Exhibited:** NAD, 1860.
Comments: Son and partner of Joseph B. Smith (see entry). The Smiths painted marine scenes and ship portraits. **Sources:** G&W; Howell, "Joseph B Smith, Painter"; Brooklyn CD 1853-60; Cowdrey, NAD.

SMITH, William W. [*Painter, graphic artist*] mid 20th c.
Exhibited: Atlanta Univ., 1944. **Sources:** Cederholm, *Afro-American Artists.*

SMITH, Win(n)ifred [*Artist*] late 19th c.
Addresses: Active in Saginaw, MI, 1897-99. **Sources:** Petteys, *Dictionary of Women Artists.*

SMITH, Wuanita [*Painter, block printer, etcher, graphic artist, writer, illustrator*] b.1866, Philadelphia, PA / d.1959, Philadelphia, PA.
Addresses: Philadelphia, PA. **Studied:** Phila. Sch. Des. for Women; PAFA; ASL; H. Pyle; H. Breckenridge; R. Pearson; Paris. **Member:** Am. Color Pr. Soc. (founder, treas., 1940-51); Phila. Pr. Club; PAFA (fellow); Phila. Plastic Club (hon.); Woodmere Art Gal.; New Haven PCC; Bridgeport AA; NAC. **Exhibited:** Irvinton (NJ) AA (prize); Wilmington AA, 1934 (prize), 1952; Phila. PC, 1929 (prize), 1933 (prize); Mississippi AA (medal); New Haven PCC, 1936; PAFA Ann., 1943; Bryn Mawr AC, 1949 (color woodblock prints); Woodmere Art Gal., 1954. **Work:** PAFA; LOC; Phila. Plastic Club; Phila. Sch. Des.

for Women; PMA; Oklahoma AC; Scranton Mus. Art & Science. **Comments:** Widely known for her etchings, block prints, and illustrations. Illustrator: "The Four Courner Series," "The Admiral's Granddaughter," "Grimms's Fairy Tales," "Gulliver's Travels," "Washington Square Classics," "Virginia Books". **Sources:** WW59; WW47; Petteys, *Dictionary of Women Artists;* Falk, *Exh. Record Series.*

SMITH, Xanthus Russell [*Marine, landscape, portrait, and historical painter; photographer; writer*] b.1839, Philadelphia, PA / d.1929, Edgehill or Weldon, PA.
Addresses: Philadelphia, PA; Casco Bay, ME. **Studied:** With his father; medicine, Univ. Pennsylvania, 1856-58; PAFA; Royal Acad., London. **Exhibited:** PAFA Ann., 1856-87; Vose Gal., Boston, 1979 (with his father Russell Smith). **Work:** PAFA; Mariner's Mus.; BMFA; Delaware Hist. Soc.; Colby College; Union League Club, Phila. (The Battle of the "Monitor" and the "Merrimac"); Tennessee State Mus. **Comments:** Son of artists Russell and Mary Priscilla (Wilson) Smith (see entries). During the Civil War he served in the Navy and later painted, on a large scale, the important naval engagements of the war. After the war he focused on marines and landscapes, including a 30-foot-long canvas of a beach scene at Cape May, NJ, painted for the Pennsylvania Railroad Co. In his later years he turned to portraits and also became interested in photography. For many years he had a summer home at Casco Bay (ME); his winters were spent at Edgehill, near Philadelphia. Illustrator: *Battles & Leaders of the Civil War* (1884). **Sources:** G&W; DAB; Rutledge, PA; Washington Art Assoc. Cat., 1859; *Antiques* (Nov. 1951), 39; *American Collector* (Oct. 1945), 11; WW10; Falk, *Exh. Record Series; 300 Years of American Art,* vol. 1: 303; *Russell Smith and Xanthus Smith: Pennsylvania Landscapes, 1834-1892* (exh. cat., Vose Gal., Boston, 1979); Peggy and Harold Samuels, 453; Kelly, "Landscape and Genre Painting in Tennessee, 1810-1985," 64-65 (w/repro.).

SMITH, Yeamans [*Sculptor, sign painter*] early 19th c.
Addresses: Richmond, VA, 1804-05. **Sources:** Wright, *Artists in Virginia Before 1900.*

SMITH, Zenobia [*Painter*] late 20th c.
Exhibited: Smith-Mason Gallery, Wash., DC, 1971. **Work:** Johnson Pub. Co. **Sources:** Cederholm, *Afro-American Artists.*

SMITH-LEWIS, John See: **LEWIS, John J. Smith**

SMITH & DAMOREAU [*Wood engravers and designers*] mid 19th c.
Addresses: Boston, 1860. **Comments:** The partners were Daniel T. Smith and probably Charles F. Damoreau (see entries). **Sources:** G&W; Boston Almanac 1860.

SMITH & HARTMANN [*Die sinkers*]
Addresses: NYC, 1850-59. **Comments:** Frederick B. Smith and Herman Hartmann (see entries) **Sources:** G&W; NYCD and BD 1850-59.

SMITH & HILL [*Engravers*]
Addresses: Boston, 1858. **Comments:** Daniel T. Smith and George W. Hill (see entries). **Sources:** G&W; Boston BD 1858.

SMITH & KNIGHT AND SMITH, KNIGHT & TAPPAN [*Engravers*] mid 19th c.
Addresses: Boston, 1857-60. **Comments:** From 1857 -59 the partners were George G. Smith, Charles A. Knight, and George H. Tappan (see entries); in1860 Tappan was no longer with the firm. **Sources:** G&W; Boston CD 1857-60.

SMITH & PIERSON [*Engravers*]
Addresses: Boston, 1855-56. **Comments:** Daniel T. Smith and Paul R.B. Pierson (see entries). **Sources:** G&W; Boston CD 1855, BD 1855-56.

SMITH & PLUMER [*Engravers*] mid 19th c.
Addresses: Boston, 1855-56. **Comments:** Plumer was probably Jacob P. Plumer; Smith could be Henry W., George G., or Daniel

T. **Sources:** G&W; Boston CD 1855, BD 1855-56.

SMITHBURN, Florence Bartley *[Painter, etcher, drawing specialist, teacher]* b.1904, New Augusta, IN / d.1988, New York, NY/ New Augusta, IN?.
Addresses: NYC/Augusta, IN. **Studied:** W. Forsyth; J. Herron Art School; R. Lahey; H. Sternberg; G.P. Ennis. **Member:** Hoosier Salon; Indiana AA; NAWPS; ASL. **Exhibited:** Indiana State Fair, 1929 (prize), 1930-34 (prize); Hoosier Salon, Chicago, 1929 (prize); Indiana Artists' Exhib., 1931; Salons of Am., 1934. **Sources:** WW40.

SMITHE, Helen Leigh *[Painter]* 20th c.
Exhibited: S. Indp. A., 1935. **Sources:** Marlor, *Soc. Indp. Artists*.

SMITHER, James *[Engraver and seal cutter]* d.1797, Philadelphia.
Addresses: Philadelphia,1768-78; Philadelphia, 1786-97. **Comments:** He was accused of treason in 1778 and left with the British troops for NYC. By 1786 he had returned to Philadelphia. **Sources:** G&W; Prime, I, 28, II, 73; Gottesman, II, no. 107; Weiss, "The Growth of the Graphic Arts in Phila.," 78.

SMITHER, James, Jr. *[Engraver]* 18th/19th c.
Addresses: Philadelphia, 1794-1824. **Comments:** Son of James Smither (see entry). **Sources:** G&W; Brown and Brown; Phila. CD 1823-24 [as James Smithers].

SMITHERS, Herbert H. *[Painter]* 20th c.
Addresses: Buffalo, NY. **Member:** Chicago NJSA. **Sources:** WW25.

SMITHSON, George E. *[Painter]* b.1906, Arizona / d.1952, Oakland, CA.
Addresses: Oakland, CA. **Studied:** Calif. College of Arts and Crafts. **Exhibited:** Oakland Art Gallery, 1930s. **Sources:** Hughes, *Artists of California*, 524.

SMITHSON, Robert I. *[Sculptor, writer, lecturer]* b.1938, Passaic, NJ / d.1973.
Studied: ASL. **Exhibited:** Artists Gal., NYC, 1958 (solo, paintings); WMAA, 1966-73; "Primary Structures," Jewish Mus., NYC, 196 (showed steel sculpture); Albright-Knox Gallery, Buffalo, 1968; Tate Gallery, London, 1968; Haags Gemeentemuseum, The Hague, 1968; "The Art of the Real, USA, 1948-68", MoMA, 1968; Cornell Univ., 1969; Stedeli Mus, Amsterdam, Holland, 1969. **Awards:** Art Inst Chicago Award, 1972. **Work:** WMAA; MoMA; Milwaukee AC; Neue Galerie, Aachen, Germany. Projects: "Spiral Jetty," Great Salt Lake, UT, 1969-70; "Broken Circle and Spiral Hill", Emmen, Holland. **Comments:** A pioneering "Earth Work" artist, he died in a plane crash while surveying his "Amarillo Ramp" in Texas. He began his series of Sites and Non-Sites in 1968, expressing his ideas in a statement: "Instead of putting a work of art on some land, some land is put into the work of art." (quoted in *Two Hundred Years.*). Smithson wrote a number of articles on entropy as it applied to sculpture and earthworks, and also wrote more generally on his art theories. Positions: consultant, Tibbetts, Abbott, McCarthy & Stratton, Architects & Engineers, 1966-67. Teaching: lecturer, at Columbia Univ., Yale Univ., & New York Univ. Publications: "Incidents of Mirror Travel in the Yucatan," *Artforum*, 1969; *The Spiral Jetty, Art of the Environment* (1972); see also Nancy Holt, ed. *The Writings of Robert Smithson* (New York, 1979). **Sources:** WW73; *Two Hundred Years of American Sculpture*, 312; Baigell, *Dictionary*; Robert Hobbs, *Robert Smithson: Sculptor* (1981); Douglas MacAgy, *Plus by Minus: Today's Half-Century*, Albright-Knox Gallery, 1968; C. Goossen, *The Art of the Real, USA, 1948-68 (MoMA, 1968)*.

SMITHSON, Willie (Mrs.) *[Painter]*
Addresses: New Orleans, active c.1894. **Exhibited:** New Orleans AA, 1894. **Sources:** *Encyclopaedia of New Orleans Artists*, 359.

SMITHWICK, John G. *[Engraver]* b.1844.
Addresses: NYC. **Exhibited:** PAFA Ann., 1883. **Comments:** Engraver for Harper & Bros., NYC. **Sources:** Falk, *Exh. Record Series*.

SMITTEN, Eda St. John *[Landscape painter]* b.1856, Grass Valley, CA / d.1914, Berkeley, CA.
Addresses: Grass Valley, CA; Berkeley, CA. **Studied:** with L. P. Latimer and William Herbert Burgess in San Francisco. **Member:** San Francisco AA; Sequoia Club. **Exhibited:** Mechanics' Inst., 1871 (silver medal), 1896; San Francisco AA, 1903; Oakland Art Fund, 1905. **Sources:** Hughes, *Artists in California*, 524.

SMITZ, M. See: **SCHMITZ, M. S.**

SMOCK, Sue M. *[Sculptor]* late 20th c.
Exhibited: James A. Porter Gallery, 1970. **Sources:** Cederholm, *Afro-American Artists*.

SMOKY, Lois *[Painter]* b.1907, near Anadarko, OK.
Addresses: Living in Virden, OK in1967. **Studied:** Univ. of Okhahoma, with Edith Mahier, 1927. **Member:** Susie Peters' Fine Arts Club (1926), Anardko, Ok. **Exhibited:** First Intl. Art Exposition, Prague, Czech., 1928. **Work:** Mus. Am. Indian; McNay AI, San Antonio; Gilcrease Inst. **Comments:** One of the "Five Kiowas" (the others were Spencer Asah, Jack Hokeah, Steven Mopope, and Monroe Tsatoke), a group of Native American artists who were brought to the Univ. of Oklahoma by Oscar B. Jacobson (see entry) in 1926 (Smoky came in 1927, however) and provided with studio space and materials; they subsequently attracted international interest at the Prague Expo., 1928. P&H Samuels report that Smoky "had to overcome the Plains Indian custom that women not paint in a representational style" and that that "pressure caused her to drop out" of the Five Kiowas. She stopped painting by the end of the 1920s, but her work is shown in two publications "Kiowa Indian Art," 1929, "Am. Indian Painters," 1950, both by Oscar B. Jacobson. Additional **Sources:** Schimmel, *Stark Museum of Art*, 132-35; P&H Samuels, 11 (under entry for S. Asah), 453.

SMOLEN, Francis (Frank) *[Painter, illustrator, designer, sculptor, craftsperson, teacher]* b.1900, Manor, PA.
Addresses: Sharon, PA. **Studied:** Fed. School, PA; CI; & with Bicknell, Readio, Ashe. **Member:** Sharon AA (vice-pres.); Friends of Art, Youngstown, OH. **Exhibited:** Devoe & Raynolds Exhib., 1940; Pittsburgh AA, 1928, 1931-34; Butler AI, 1935 -36, 1938, 1941, 1943; Sharon AA, 1933-42 (prizes 1935, 1939, 1943), 1945; Albright Art Gal., 1949; Alliance College, Cambridge Springs, PA1951; Watercolor traveling exhib., 1952. **Work:** Buhl Girls Club, Sharon, PA; Somerset (PA) H.S. **Sources:** WW59; WW47.

SMOLIN, Nat (C.) *[Sculptor, painter, lecturer, teacher, writer]* b.1890, NYC / d.1950.
Addresses: NYC. **Studied:** ASL; CCNY; J. Sloan; A. Bourdelle; C. Guerin. **Member:** AAPL. **Exhibited:** Am. Veterans SA; S. Indp. A., 1940; Salon des Tuileries, annually; Salon d'Automne, annually; Colson & Leger, Paris. **Work:** Musée du Jeu de Paume, Musée de la Rochelle, France; BM; Sterling Mem. Lib., Yale; mon., Yale. **Comments:** Contributor: *Revue de la Pensée Française*. **Sources:** WW47.

SMONGESKI, Joseph L. *[Book designer, painter, lithographer, screenprinter, teacher]* b.1914, Two Rivers, WI.
Addresses: Quincy, MA; Boston, MA; Wollaston, MA. **Studied:** Univ. Chicago; Univ. Wisconsin; AIC, and with Louis Ritman. **Member:** Book Builders Club, Boston. **Exhibited:** AIC, 1939; Madison Salon, 1938-40; Contemporary Art Gal., 1942; Chappellier Gal., 1953; Elmira (NY) Art Gal., 1945 (solo); Tardif Gal., Belmont, MA, 1949 (solo); Cornell College, 1950 (solo); Publick House, Sturbridge, MA, 1951 (solo); BMFA, 1950 (solo); Milton, MA, 1953 (solo); Quincy, MA, 1953 (solo), 1956 (solo). **Comments:** Position: painting instructor, Adult Classes, Milton H.S. Designed & illustrated "Cocina Criolla," a Spanish cookbook. **Sources:** WW59; WW47.

SMOOT, Margaret *[Sculptor]* b.1907, Lakeport, CA.
Addresses: Chester Springs, PA; Maitland, FL. **Studied:** C. Grafly; PAFA 1930, 1931 (Cresson Traveling Scholarship); A. Laessle. **Exhibited:** PAFA Ann., 1931-33. **Sources:** WW33; Falk,

Exh. Record Series.

SMUL, Ethel Lubell (Mrs.) *[Painter, instructor, lithographer] b.c.1897, NYC / d.1978, NYC.*
Addresses: NYC. **Studied:** ASL; Maxwell School Teachers; Hunter College, B.A. & M.A.; Pratt Graphic AC; also with John Sloan, Boardman Robinson, Brackman, Olinsky, Barnet & Bob Blackburn; Robinson; von Schlegell. **Member:** Am. Soc. Contemporary Artists (treasurer, 1959-70s; director); New York Soc. Women Artists (director); NAWA; NY Teachers Gld.; Soc.Indep. Artists. **Exhibited:** S. Indp. A., 1929-42; Salons of Am., 1934-35; NAD, 1936,1956-57 & 1964; LOC, 1946; Argent Gal., 1934-46; FA Gal., NY; Everhardt Mus.; CI, 1949; Cincinnati Art Mus ,1953 (Second Int. Biennial Contemp Color Lithography); Riverside Mus., 1949, 1953-54,1956 & 1958; Traveling Shows, 1953-54 & 1958. **Work:** Cincinnati Art Mus.; Riverside Mus. **Comments:** Preferred media: oils, watercolors, graphics. Teaching: teacher, NY Public Schools, from 1922; instructor of fine arts & crafts & engraving, NY, 1936-59. Marlor gives year of birth as1891. **Sources:** WW73; WW47; Marlor, *Soc. Indp. Artists.*

SMULL, William Lubell *[Painter] b.1921, NYC.*
Exhibited: S. Indp. A., 1940. **Sources:** Marlor, *Soc. Indp. Artists.*

SMULLYAN, Robert See: **SLOAN, Robert Smullyan**

SMULLYAN, Rosina (Mrs. Isidore) *[Painter] b.1875 / d.1961, NYC.*
Addresses: NYC. **Exhibited:** S. Indp. A., 1944. **Sources:** Marlor, *Soc. Indp. Artists.*

SMUTNY, Joseph S. *[Portrait painter] b.1855, Bohemia (came to NYC ca. 1888) / d.1903.*
Studied: Vienna.

SMYSER, C. Bruce *[Artist] 20th c.*
Addresses: Detroit, MI. **Exhibited:** PAFA Ann., 1960. **Sources:** Falk, *Exh. Record Series.*

SMYTH, Craig Hugh *[Art administrator, art historian] b.1915, NYC.*
Addresses: NYC. **Member:** College Art Assn. Am. (director, 1953-57; secretary, 1956); Comite Int. Hist. Art (alternate U.S. member, 1970-); U.S. Nat. Committee Hist. Art; MMA (hon. trustee, 1968-); Vis. Committee, Dept. Art & Archaeoogy, Princeton Univ. **Comments:** Positions: research asst. & senior mus. aide, Nat. Gallery Art, Washington, DC, 1941-42. Teaching: lecturer, Frick Collection, New York, 1946-50; from asst. professor to professor, Inst. Fine Arts, New York Univ., 1950-, acting director & acting head dept. fine arts, 1951-53; director & head grad. dept. fine arts, 1953-. Research: sixteenth century Italian painting and drawing; sixteenth century Italian architecture. Publications: author, "The Early Works of Bronzino," *Art Bulletin,* 1949; author, "Mannerism and Maniera" 1963; author, "The Sunken Courts of the Villa Giula and the Villa Imperiale," *Essays in Memory of Karl Lehmann,* 1963; co-author, "Michelangelo and St Peter's--I: The Attic as Originally Built on the South Hemicycle," *Burlington Magazine,* 1969; author, "Bronzino as Draughtsman," 1971. **Sources:** WW73.

SMYTH, Edmund R. *[Designer, painter, writer, illustrator] b.1902, Toronto, Canada.*
Addresses: Burbank, CA. **Studied:** AIC; Chicago Acad. FA; Grande Chaumière, Paris, France; Rome, Italy; Munich, Germany. **Member:** Tech. Illus. Management Assn. (treas., 1958). **Exhibited:** Charney Gal., 1934; Allerton Gal., 1935; Davis Gal., 1935-36, all in Chicago; All-Illinois Soc. FA, 1936; Chicago Jubilee Exhib., 1937. **Comments:** Contributor: *Saturday Evening Post.* **Sources:** WW59; WW47.

SMYTH, Grace Allan, Jr. *[Sculptor] b.1907, Blacksburg, VA.*
Addresses: Salem, VA. **Studied:** A. Laessle, at PAFA. **Exhibited:** PAFA Ann., 1935. **Sources:** WW47; Falk, *Exh. Record Series.*

SMYTH, Hawthorne L(ewis) *[Painter] 20th c.*
Addresses: Mt. Vernon, NY, 1926. **Exhibited:** Salons of Am.,

1926; S. Indp. A., 1926-27. **Sources:** Falk, *Exhibition Record Series.*

SMYTH, Nora See: **SWEENEY, Nora (Mrs. Samuel Gordon Smyth)**

SMYTH, S(amuel) Gordon *[Etcher, block printer, illustrator, painter, teacher] b.1891, Holmesburg, Phila.*
Addresses: Upper Darby, PA. **Member:** Art Teachers Assn. of Phila.; Phila. SE. **Exhibited:** Calif. Printmakers, 1936. **Work:** Franklin Inst., Phila. **Comments:** Position: teacher, Overbrook H.S., Phila. **Sources:** WW47.

SMYTH, William *[British naval officer and topographical artist] b.1800, England / d.1877, Tunbridge Wells, England.*
Work: Bancroft Lib., UC Berkeley; Peabody Mus., Harvard Univ.; Greenwich, England, Mus. **Comments:** He accompanied Captain Frederick Beechey's expedition to explore the Bering Strait in 1825. The expedition wintered in San Francisco and Monterey Bays in 1826 and 1827 and Smyth painted at least eight California scenes. He later retired with the rank of Rear Admiral. **Sources:** G&W; Van Nostrand and Coulter, *California Pictorial,* 22-27; Peters, *California on Stone;* Hughes, *Artists in California,* 524.

SMYTHE, David Richard *[Sculptor] b.1943, Washington, DC.*
Addresses: NYC. **Studied:** Corcoran School Art, Washington, DC, 1962-64; AIC (B.F.A., 1967; M.F.A., 1969). **Exhibited:** Allan Franklin Gallery, Chicago & New York, 1968 & 1970; Contemporary Am. Painting & Sculpture, Univ. Illinois, Urbana, 1969; Inst. Contemporary Art, Univ. Penn., 1970; WMAA, 1972; Ronald Feldman Fine Arts, Inc., New York, 1972. **Awards:** George D. Brown traveling fellowship, AIC, 1969 & Richard Rice Jenkins Award, 1970; Tamarind Inst. fellowship, Albuquerque, NM, 1972. **Work:** WMAA; also in collections of James Speyers, AIC, Whitney Halsted, Chicago & Ronald Feldman, New York. **Commissions:** relief painting, Blue Cross-Blue Shield, C. F. Murphy Arch., Chicago, 1969. **Sources:** WW73.

SMYTHE, Eugene Leslie *[Landscape painter] b.1857, NYC / d.1932, Townshend, VT.*
Addresses: Providence, RI. **Member:** Providence, AC. **Exhibited:** Brooklyn AA, 1883; Boston AC, 1884-88. **Comments:** Position: staff, Tilden-Thurber Co., Providence. **Sources:** WW24.

SMYTHE, Lionel Percy *[Painter] 20th c.*
Addresses: Pas-de-Calais, France. **Sources:** WW10.

SMYTHE, M. B. (Mrs.) *[Listed as "artist"]*
Addresses: New Orleans, active c.1883-87. **Studied:** Henriette Winant, 1883; Artist's Assoc. of N.O., 1886-87. **Exhibited:** Southern Art Union, 1883 (first prize); Artist's Assoc. of N.O., 1886-87. **Sources:** *Encyclopaedia of New Orleans Artists,* 359.

SMYTHE, Margarita Pumpelly (Mrs. Henry L.) *[Painter] b.1873, Newburgh, NY.*
Addresses: Watertown, MS. **Studied:** Abbott H. Thayer. **Member:** Newport AA. **Exhibited:** AIC, 1901. **Comments:** Married Harvard professor, Smythe, in England in 1894. **Sources:** WW25; Petteys, *Dictionary of Women Artists.*

SMYTHE, Robert L. *[Sculptor] b.c.1820, Ireland.*
Addresses: NYC, 1850. **Sources:** G&W; 7 Census (1850), N.Y., LI, 575.

SMYTHE, Willard Grayson *[Painter, designer, educator, writer, illustrator] b.1906, Bellefontaine, OH / d.1995.*
Addresses: Chicago, IL. **Studied:** AIC. **Member:** 27 Chicago Des.; AAUP; FIAL. **Exhibited:** AIC, 1934-46, 1947 ("Abstract & Surrealist Art"), 1949, 1955; Nat. Advertising Art & Illus. Exhib., 1940; AIGA, 1935, 1937 (award of excellence), 1938, 1952 (award of excellence); Great Lakes Exhib., 1939; Northern Mississippi Valley Artists, 1943; Soc Typographic Artists, 1929-44 (prize, 1931); Art Dir. Club, Chicago, 1936-44, 1948; Art Dir. Club, NY, 1938; Toledo, OH, 1948; Palmer House Gal., 1949-50,

1953; Magnificent Mile Exhib., Chicago 1951, 1952; Chicago Pub. Lib., 1954; Chicago & Vicinity Exhib., 1959. **Awards:** certif. award, Chicago and Midwest Book Clinic, 1950-51, 1954-55; "Finest Printed Product Award", Graphic Arts Council, Chicago, 1964; "Designer of the Month", Inland Printer-American Lithographer, 1964. **Work:** mem. plaque, Santa Fe Railroad; advertising des., Abbott Laboratories, Monsanto Chemical Co., Searle Laboratories, & others. **Comments:** Geometric abstract painter. Contributor: printing, art, design & color magazines. Positions: professor, advertising design, AIC, Chicago, 1928-60; art editor, *Printing Art Quarterly*, 1938-41; art editor, Quarrie Corp., *World Book Encyclopedia*, 1943-46; exec. art director, Consolidated Book Publishers, Chicago, 1946-; member, Gilbert Letterhead Award panel, Gilbert Paper Co., Menasha, WI; jury member for Golden Reel Film Festival, Film Council of Am., 1958. **Sources:** WW66; WW47; *American Abstract Art,* 199.

SNAËR, Jonathan *[Lithographer] b.c.1830, Louisiana.* **Addresses:** New Orleans, 1850. **Comments:** His father, Francis Snaër, was from the West Indies. **Sources:** G&W; 7 Census (1850), La., V, 409.

SNAER, Seymour *[Painter, photographer] mid 20th c.* **Addresses:** San Francisco, CA, 1930s-40s. **Member:** San Francisco AA. **Exhibited:** Oakland Art Gal., 1934; San Francisco AA, 1939. **Sources:** WW40.

SNAITH, William T. *[Painter] mid 20th c.* **Addresses:** NYC. **Exhibited:** WMAA, 1949, 1950; PAFA Ann., 1951. **Sources:** Falk, *Exh. Record Series.*

SNAPP, Frank *[Illustrator] early 20th c.* **Addresses:** NYC. **Member:** SI, 1910. **Exhibited:** AIC, 1922. **Sources:** WW24.

FRANK SNAPP 1911

SNARR, Mildred Ann *[Painter] early 20th c.* **Addresses:** Cincinnati, OH. **Sources:** WW25.

SNAVELY, Dick *[Painter] mid 20th c.* **Addresses:** South Pasadena, CA. **Exhibited:** All Calif. Exh., 1939; GGE, 1939. **Sources:** Hughes, *Artists of California,* 524.

SNEAD, Louise W(illis) (Mrs. Harry V.) *[Miniature painter, designer, craftsperson, writer, lecturer] mid 20th c.; b.Charleston, SC.* **Addresses:** Norton; CT. **Studied:** Chase; ASL with Theodora Thayer; Palestine; Egypt. **Exhibited:** Charleston Expo, 1902 (prize); Seal for a South Carolina city, 1915 (prize); Mineola, LI, 1911 (prize), 1912 (prize). **Work:** Mem. Lib., Shreveport (LA); D.A.R. Bldg., Charleston, SC. **Comments:** Author/illustrator: "History of Stamford, Connecticut"; "Silver and Gold," for Stamford Trust Co. Author/producer: Oriental plays and pageants, designing the stage settings and costumes under the name of "Gulnare el Nahdir." **Sources:** WW40.

SNEDECOR, Charles E. *[Art dealer] b.1875 / d.1917.* **Addresses:** Sea Cliff, NY. **Comments:** Head of the well-known art firm of Snedecor and Company, established by John Snedecor in NYC, 1852.

SNEDEKER, Virginia (Mrs. William L. Taylor) *[Painter, craftsperson, illustrator, graphic artist] b.1909, Brooklyn, NY.* **Addresses:** Woodside, NY. **Studied:** NAD; ASL; BAID; Kenneth Hayes Miller; Kimon Nicolaides. **Member:** NY Soc. Women Artists. **Exhibited:** Salons of Am., 1934; Albright Gal., Buffalo; Contemporary Art Gal., NY. **Awards:** Tiffany Found. Fellowship, 1931-32. **Work:** Mus. City of NY; mural, USPO, Audubon, IA. **Comments:** Contrib.: *New Yorker, Woman's Home Companion* magazines. **Sources:** WW53; WW47.

SNEDEN, Eleanor Antoinette (Mrs.) *[Sculptor] b.1876, NYC.* **Addresses:** Avon-by-the-Sea, NJ. **Studied:** Genevieve Granger, Paris. **Exhibited:** PAFA Ann., 1907. **Comments:** Specialty: portrait medallions. **Sources:** WW13; Falk, *Exh. Record Series.*

SNEDEN, Robert K. *[Topographical engineer, sketch artist] mid 19th c.* **Comments:** Sketched numerous scenes of the Civil War in Virginia, while serving in the 40th New York Regiment, 1862-65. Some were published as wood engravings in *Battles and Leaders,* (New York, Century Co., 1888). **Sources:** Wright, *Artists in Virgina Before 1900.*

SNEED, Patricia M. *[Art dealer, collector] b.1922, Spencer, IA.* **Addresses:** Rockford, IL. **Studied:** Drake Univ., 1940-42; Univ. Cincinnati, 1945-46. **Member:** AFA. **Comments:** Positions: pres. & board trustees, Burpee Art Mus.; owner & director, Sneed Gallery, 1935, 1958-; member of art advisory panel, State of Illinois, 1966-. Publications: author, "Show Me a Picture" (children's art appreciation program). Collections arranged: Fifty Artists for Fifty States (nat. art exhibit), 1965-; Art in Other Media, 1970. Specialty of gallery: contemporary American art. Collection: contemporary American art. **Sources:** WW73.

SNELGROVE, Isabel *[Painter] b.1887 / d.1980.* **Addresses:** North Dakota. **Comments:** Preferred medium: oil. Teaching: Univ. North Dakota. **Sources:** P&M Kovinick, *Encyclopedia;* add'l info. courtesy of Stephanie A. Strass, Reston, VA.

SNELGROVE, Walter H. *[Painter] b.1924, Seattle, WA.* **Addresses:** Berkeley, CA. **Studied:** Univ. Washington; Calif. School FA with Hassel Smith, Antonio Sotamayor & James Weeks; Univ. Calif, Berkeley (B.A. & M.A.) with James McCray & M. O'Hagan. **Member:** San Francisco AA. **Exhibited:** CI; AIC; Albright-Knox Art Gallery, Buffalo, NY; Virginia MFA, Richmond; Foothill College, 1967 (retrospective). **Awards:** prizes, Oakland Mus., 1962; San Francisco Mus. Art, 1963; Kelham Mem. Awards, CPLH. **Work:** WMAA; Oakland (CA) Mus.; Colorado Springs FAC; CPLH; Stanford Univ. **Comments:** Teaching: Univ. Calif., 1951-53. **Sources:** WW73.

SNELL, Ann Loomis *[Painter] b.1911, Minneapolis, MN / d.1976, NYC.* **Addresses:** NYC. **Exhibited:** S. Indp. A., 1932. **Sources:** Marlor, *Soc. Indp. Artists.*

SNELL, Carroll C(lifford) *[Designer, illustrator, lecturer] b.1893, Medina, NY.* **Addresses:** NYC. **Comments:** Illustr. for leading publishers; posters, displays, des., for Theatre Guild, R. H. Macy & Co., Lord & Taylor, etc. Lectures: chromatics. Originator of Snell System of Color Harmony. Listed as retired in 1959. **Sources:** WW59; WW47.

SNELL, Florence Francis (Mrs. Henry B.) *[Painter] b.1850, London / d.1946.* **Addresses:** NYC, 1896-97; New Hope, PA. **Studied:** ASL. **Member:** NYWCC; AWCS; NAWPS; NAC. **Exhibited:** Brooklyn AA, 1877, 1882-86 (as Francis), 1912 (as Snell); NAD, 1879-88 (as Francis), 1896, 1897, 1906-22; Boston AC, 1887 (as Francis), 1890-1909 (as Snell); AIC, 1895-1916 (as Snell); PAFA Ann., 1888 (as Francis), 1890, 1898-1906, 1912-22 (as Snell); Corcoran Gal. biennials, 1908-19 (3 times); NAWPS, 1913 (prize), 1915 (prize); NAC (prize). **Comments:** Born Florence Francis, she married Henry Bayley Snell (see entry) in 1888. After her marriage her name sometimes appeared as Florence Frances (sic) Snell. **Sources:** WW40; *Brooklyn Art Ass'n;* Falk, *Exh. Record Series.*

SNELL, George *[Etcher] b.1820, Boston, MA / d.1893.* **Addresses:** Boston, MA. **Exhibited:** Paris Salon, 1867; Boston AC, 1873-84. **Sources:** Fink, *American Art at the Nineteenth-Century Paris Salons,* 392; *The Boston AC.*

SNELL, Henry B(ayley) *[Painter, teacher] b.1858, Richmond, England / d.1943.* **Addresses:** NYC; New Hope, PA. **Studied:** ASL. **Member:** ANA, 1902; NA, 1906; NYWCC; AWCS; SAA, 1905; SC, 1903; Lotos Club; Fellowship PAFA,

Henry B. Snell.

1916; NAC; Allied AA. **Exhibited:** Boston AC, 1887-1909; PAFA Ann., 1890-1938; AIC, 1894-1926; AC Phila. 1896 (gold), 1916 (prize); NAD, 1896-98, 1903-34; Nashville Expo, 1897 (prize); Paris Expo, 1900; Pan-Am. Expo, Buffalo, 1901 (medal); St. Louis Expo, 1904 (medal); Worcester Mus., 1905 (prize); NYWCC, 1905 (prize); Corcoran Gal. biennials, 1907-37 (12 times); Pan-Pacific Expo, San Francisco, 1915 (medal; gold); SC, 1918 (prize). **Work:** PAFA; Albright Art Gal., Buffalo; Worcester Mus.; Herron AI, Indianapolis; MMA. **Comments:** He came to NYC at age 17 and supported himself by working for an engineering firm and a lithography studio while studying art. Snell married Florence Francis (see entry) in 1888 and began painting in New Hope in 1900 (moving there permanently about 1926). Affiliated with the New Hope Impressionist School, his paintings are done from nature, but forgo the emphasis on depicting seasonal and atmospheric conditions. He painted on many trips to Europe and India, and is especially noted for his coastal scenes of Cornwall, England. He also painted harbor scenes of Gloucester, MA, and Boothbay Harbor, ME. He was a prominent teacher of art. Teaching: NYC; Wash., DC; Phila. School of Des. for Women, 1899-1943; asst. director, FA, U.S. Comm., Paris Expo, 1900. **Sources:** WW40; *300 Years of American Art,* 527; Falk, *Exh. Record Series.*

SNELL, Lulu M. *[Painter] early 20th c.*
Addresses: Toledo, OH. **Member:** Chicago NJSA. **Sources:** WW25.

SNELL, Perez *[Lithographer] b.c.1795.*
Addresses: New Orleans, 1835-52. **Comments:** He was a partner in P. Snell & Becker (1841); Snell & Fishbourne (1842-44); and Manouvrier & Snell (1846, 1850-52). **Sources:** G&W; Delgado-WPA cites New Orleans CD 1837, 1841-44, 1846, 1851-52. More recently, see *Encyclopaedia of New Orleans Artists.*

SNELL, William R. *[Engraver] b.c.1837, Pennsylvania.*
Addresses: Philadelphia, 1860. **Comments:** He was the son of Lewis Snell, weigher. **Sources:** G&W; 8 Census (1860), Pa., LVI, 78.

SNELL, Zulma M. *[Painter] early 20th c.; b.Franklin, OH.*
Addresses: Toledo, OH. **Studied:** Cincinnati Art Acad.; AIC. **Member:** Athena Soc., Toledo. **Sources:** WW17.

SNELL & BECKER *[Lithographers] mid 19th c.*
Addresses: New Orleans, 1841. **Comments:** Partners were Perez Snell and George J. Becker (see entries). **Sources:** G&W; Delgado-WPA cites New Orleans CD 1841. Note: G&W had listed as Snell & Baker but the *Encyclopaedia of New Orleans Artists* corrected the "Baker to "Becker".

SNELL & FISHBOURNE *[Lithographers, engravers] mid 19th c.*
Addresses: New Orleans, 1842-44. **Comments:** Partners were Perez Snell and R.W. Fishbourne. **Sources:** G&W; Delgado-WPA cites New Orleans CD 1842-44; *Encyclopaedia of New Orleans Artists.*

SNELLGROVE, Charles *[Painter] 19th/20th c.*
Addresses: San Francisco, CA, c.1890s-1917. **Exhibited:** Mechanics' Inst., 1896. **Sources:** Hughes, *Artists in California,* 524.

SNELSON, Kenneth D. *[Sculptor] b.1927, Pendleton, OR.*
Addresses: NYC. **Exhibited:** WMAA, 1966-73; Sculpture of the Sixties, LACMA, 1967; Five Monumental Sculptures, Kröller Müller Mus., 1969; Int. Sculpture Symposium, Osaka, Japan, 1969; Kunsthalle Düsseldorf, Germany, 1970; Snelson Sculpture Exh., Hannover Kunstverein, Hannover, Germany, 1971. **Work:** WMAA; MoMA; Milwaukee AC; Kröller Müller Mus., Otterloo, Holland; Staedelijk Mus., Amsterdam, Holland. **Commissions:** Tower of Light Pavillion, NY World's Fair, 1964; Japan Iron & Steel Fed., Expo-1970, Osaka, Japan, 1970. **Comments:** Preferred media: steel. Publications: author, "A Design for the Atom," *Industrial Design,* 2/1963; author, "Continuous Tension, Discontinuous Compression Structures," 1965 &" A Model for

Atomic Forms," 1966, U.S. Patent Off. **Sources:** WW73.

SNEPP, Hazel *[Painter] early 20th c.*
Addresses: Indianapolis, IN. **Sources:** WW17.

SNIDER, Ann Louise *[Painter] early 20th c.*
Addresses: Santa Barbara, CA, 1930s. **Exhibited:** Federal Art Project, Southern Calif., 1936; GGE, 1939; Oakland Art Gallery, 1939. **Sources:** Hughes, *Artists of California,* 524.

SNIDER, George *[Lithographer] b.c.1830, France.*
Addresses: Philadelphia, 1850. **Comments:** His parents, Michael and Sarah Snider, were French; of their four children only the youngest, aged 11, was born in the United States. The Sniders lived with the family of John Henry Camp. **Sources:** G&W; 7 Census (1850), Pa., XLIX, 257.

SNIDER, Jenny *[Painter] b.1940.*
Addresses: NYC. **Exhibited:** WMAA, 1944. **Sources:** Falk, *WMAA.*

SNIDER, Lillian Bohl (Mrs. W. A.) *[Painter, teacher, lecturer] b.1893, Kansas City, KS / d.c.1955.*
Addresses: Albany, MO. **Studied:** Chicago Acad. FA; Kansas State Teachers College (B.S.); Teachers College, Columbia Univ.; AIC; F.A. Parsons in Paris; C. Martin; E. Bisttram. **Member:** Nat. Educ. Assn.; Western AA; Kansas State AA; St. Joseph AA. **Exhibited:** Kansas City AI, 1937 (prize), 1938-40; Joslyn Mem., 1941, 1942; William R. Nelson Gal.; St. Joseph (MO) AA (solo). **Work:** William Rockhill Nelson Gal.; Joslyn Mem. **Sources:** WW53; WW47.

SNIDER, Marguerite *[Painter] early 20th c.*
Addresses: Tacoma, WA. **Member:** Tacoma FAA. **Sources:** WW25.

SNIDOW, Gordon *[Painter, commercial artist, lithographer, sculptor] b.1936, Paris, MO.*
Addresses: Raised in Texas & Oklahoma; Albuquerque, NM, 1959; living in Belen, NM in 1976. **Studied:** Art Center School, Los Angeles, 1955. **Member:** CAA. **Exhibited:** prize-winning works by 1963. **Work:** Montana Hist. Soc.; Nat. Cowboy Hall Fame; P.T. Cattle Co. **Comments:** Specialty: modern cowboy. **Sources:** P&H Samuels, 454.

SNIFF, John E. *[Painter] early 20th c.*
Addresses: Columbus, OH. **Member:** Columbus PPC. **Sources:** WW25.

SNIFFEN, Florence H. *[Painter] early 20th c.*
Addresses: Woodhaven, LI, NY. **Exhibited:** Salons of Am., 1932, 1934; S. Indp. A., 1932. **Sources:** Marlor, *Soc. Indp. Artists.*

SNODGRASS, Davis J. *[Painter] early 20th c.*
Addresses: Columbus, OH. **Member:** Columbus PPC. **Sources:** WW25.

SNODGRASS, Jeanne Owens *[Art administrator, lecturer] b.1927, Muskogee, OK.*
Addresses: Muskogee, OK. **Studied:** Art Instr., Inc.; Norhteastern State College; Oklahoma Univ. **Member:** Oklahoma Mus. Assn. (secretary); Ethno-Hist. Assn.; Tulsa Hist. Soc. **Exhibited:** Awards: outstanding contribution to Indian art, U.S. Dept. Interior, 1967. **Comments:** Positions: asst. to director & curator Am. Indian Art, Philbrook AC, 1955-68; admin. asst. to pres., Educ. Dimensions, Inc., 1969-71; assoc., Am. Indian Affairs & member Arts & Crafts Advisory Committee; consult., Gilcrease Mus.; juror, many nat. & regional Indian Art Exhs. Publications: auth., "American Indian Paintings," 1964; ed., "American Indian Basketry," 1964; auth., "American Indian Painters: A Biographical Directory," Heye Found., 1968. Teaching: lecturer, American Indian Painting: Its History and Its Artists. Collections arranged: 214 exhs. of Indian art & artifacts, Philbrook AC, 1955-68; Am. Indian Artists Nat. Competition Ann., Philbrook AC, 1955-68. **Sources:** WW73.

SNOOK, Eugene W. *[Engraver] late 19th c.*
Addresses: Wash., DC, active 1890-92. **Sources:** McMahan,

Artists of Washington, DC.

SNOW, Andrew C. *[Landscape painter]* 19th/20th c. **Addresses:** Alameda, CA, 1896-1900. **Exhibited:** Mechanics' Inst., 1896. **Sources:** Hughes, *Artists of California*, 524.

SNOW, Charles H. *[Landscape & marine painter, etcher]* b.1864 / d.1945. **Addresses:** Marblehead, MA. **Member:** Marblehead AA (founder, 1920s). **Comments:** Best known for his scenes depicting Cape Ann and Gloucester, MA. Father of Louise Snow. **Sources:** WW25; exh. cat., LeBlanc FA, Manchester, NH (1990).

SNOW, Daniel W. *[Listed as "artist"]* late 19th c. **Addresses:** Active in New Bedford, MA area, 1892-98. **Comments:** Worked for Ullman Manufacturing Co., 1892; listed as an artist in *New Bedford City Directory,* for three years. **Sources:** Blasdale, *Artists of New Bedford*, 177.

SNOW, E. E. *[Painter]* early 20th c. **Addresses:** Salt Lake City, UT. **Sources:** WW15.

SNOW, Eben H. *[Illustrator]* b.1870 / d.1945. **Addresses:** Boston, MA. **Comments:** Position: staff, *Boston Globe* for 50 years.

SNOW, Edith Huntington *[Hand weaver, teacher]* mid 20th c.; b.Lawrence, KS. **Addresses:** NYC. **Studied:** Columbia; Univ. Kansas, Stanford; Mary Kissel; Vanner, Stockholm. **Member:** NYSC; Boston SAC; Needle & Bobbin Club; PBC. **Sources:** WW40.

SNOW, Edward Taylor *[Landscape painter, illustrator]* b.1844, Phila. / d.1913. E.T.SNOW **Addresses:** Phila., PA. **Studied:** PAFA; Schussele; France; Holland; Germany. **Member:** AC Phila. **Exhibited:** PAFA Ann., 1883-84, 1899-1904; Boston AC, 1901, 1906; AAS, 1902 (gold); AIC. **Comments:** Art commissioner at the Tennessee Centennial and Omaha Expositions. **Sources:** WW13; Falk, *Exh. Record Series*.

SNOW, Jenny Emily *[Amateur painter of landscapes & biblical scenes in oils]* mid 19th c. **Addresses:** Hinsdale, MA, c.1845. **Studied:** self-taught. **Work:** A.A. Rockefeller Folk AC. **Comments:** She painted her version of *Belshazzar's Feast* at age fifteen. **Sources:** G&W; Lipman and Winchester, 180; Dewhurst, MacDowell, and MacDowell, 171.

SNOW, Laura E. *[Painter]* early 20th c. **Addresses:** Phila., PA. **Studied:** her father, Edward Taylor Snow. **Member:** Plastic Club. **Exhibited:** Am. Art Soc., 1902 (gold medal); Charleston Expo, 1902 (bronze medal); PAFA Ann., 1903; AIC. **Sources:** WW10; Falk, *Exh. Record Series*.

SNOW, Louise *[Painter, etcher]* b.1890 / d.1982. **Addresses:** Marblehead, MA. **Comments:** Daughter of Charles H. Snow.

SNOW, Margaret Clark *[Lithographer of city views]* early 19th c. **Addresses:** Boston, active 1827-31. **Comments:** She drew on stone for Annin & Smith (see entry), Smith-Senefelder's (see entry) and Pendleton's (see entry). In 1828 she started giving private drawing and painting lessons and opened her own drawing academy. In 1831 she married William S. Pendleton (see entry) with whom she had four children. **Sources:** Pierce & Slautterback, 180.

SNOW, Mary Ruth Ballard (Mrs. Philip J. Corr) *[Painter]* b.1908, Logan, Utah. **Addresses:** Washington, DC. **Studied:** Univ. Utah (B.A.); Corcoran Sch. Art; ASL; Otis AI; Grand Central Sch. Art; also in Paris & Berlin. **Member:** Soc. Wash. Artists (pres., 1951-53; bd. mem., 1958-59; community liaison, 1961-62); Wash. Art Club; NAWA; Wash. Artists Gld. (pres. 1958-59; bd. mem., 1960-61); Wash. WCC. **Exhibited:** Corcoran Gal. biennials, 1941, 1943; Wash. Art Club, 1945 (solo), 1952 (prize); VMFA; Whyte Gal., 1951; MMA; Wash. WCC; PC; Soc. Wash. Artists, 1952 (prize), 1960; Georgetown Gal.; Wash. Artists Gld., 1960 & prior; American Univ., Wash., DC; Norfolk Mus. Art & Science; NCFA; Los Angeles Mus. Art; NAD; NAWA; Art Mart, Georgetown, DC, 1961; Rockville Art Gal., 1961; Religious Art Exh., Wash., DC, 1964, 1965; Creative Art Gal., NY; Nat. Acad. Arts & Letters; Pan-Am. Union; Univs. of Maryland & Utah; Germany. Chequire House, Alexandria, 1950 (solo); Silver Springs (MD), Art Center, 1950 (solo); Alexandria Pub. Lib., 1945, 1950 (solos); Nat. Cathedral School; Colony Gal., Wash., DC (solo); Rotary Clubwomen, Mayflower, Hotel, Wash., DC (solo); Wash. Gal. Mod. Art, 1965 (solo); Panoras Gal., NY, 1965 (solo). **Work:** Utah Pub. Sch. Coll. **Comments:** Positions: advisor, Board Educ., Arlington County, 1951-52. **Sources:** WW66; WW47 (listed as Mrs. Ralph D. Snow).

SNOW, Michael *[Painter, film maker]* b.1929, Toronto, Ontario. **Addresses:** NYC. **Studied:** Ontario College Art, Toronto. **Exhibited:** Gallery Mod. Art & WMAA; CI; MoMA; represented Canada, Venice Bienale, Italy,1970; Bykert Gallery, NYC & Isaacs Gallery, Toronto, Ontario, 1970s. **Awards:** Grand Prize, Fourth Int. Experimental Film Festival, Brussels, Belgium, 1968; Guggenheim fellowship, 1972. **Work:** MoMA; Art Gallery Toronto; Montreal MFA; Nat. Gallery Canada; Anthology Film Arch., New York. **Sources:** WW73.

SNOW, Robert K. *[Marine painter]* d.1936. **Addresses:** Santa Barbara, CA. **Comments:** He died en route to Bar Harbor, ME, for an exhibition of his paintings. Specialty: seascapes.

SNOW, V. Douglas *[Artist]* mid 20th c. **Addresses:** Los Angeles area?. **Exhibited:** PAFA Ann., 1954. **Sources:** Falk, *Exh. Record Series*.

SNOW-DAVIS, Jessie See: **DAVIS, Jessie (Freemont) (Snow)**

SNOWDEN, A. D. *[Painter]* late 19th c. **Addresses:** NYC, 1868. **Exhibited:** NAD, 1868. **Sources:** Naylor, *NAD*.

SNOWDEN, Chester Dixon *[Painter, illustrator, teacher, writer]* b.1900, Elgin, TX. **Addresses:** Houston, TX. **Studied:** Univ. Texas; CUA Sch.; ASL; Boardman Robinson; Walter J. Duncan; Harry Sternberg; Grand Central Art Sch.; Richard Art Sch., Los Angeles. **Member:** SSAL. **Exhibited:** Mus. FA Houston, 1935-37, 1938 (prize), 1939 (prize), 1940-45, 1946 (prize), 1954 (prize), 1955 (prize); Corcoran Gal. biennial, 1941; Southwest Texas Exh., 1946, and prior; Texas General; Laguna Gloria Mus., Austin, TX; Elisabet Ney Mus., Austin; Junior Lg., Houston, 1952 (solo). **Awards:** prizes, Art Lg. of Houston, 1953, 1955; Beaumont Mus. Art, 1958. **Comments:** Illustrator: "Shafts of Gold," 1938; "Children of Hawaii," 1939; "Ape of Heaven"; "Half Dark Moon"; "Wildwood Friends," and other books. Author: "Pioneer Texas" (a play). **Sources:** WW59; WW47.

SNOWDEN, Elsie Brooke *[Painter]* b.1887, Ashton, MD. **Addresses:** Norristown, PA; Wash., DC/Ashton, MD. **Studied:** Corcoran Sch. Art; PAFA (Cresson traveling scholarship, 1914). **Exhibited:** PAFA Ann., 1912; Soc. of Wash. Artists & Wash. WCC, 1910-33; Corcoran Gal biennials, 1923, 1926; Soc. of Independent Artists, 1924-27. **Comments:** Specialty: figure. **Sources:** WW33; McMahan, *Artists of Washington, DC; Falk, Exh. Record Series*.

SNOWDEN, George Holburn *[Sculptor, teacher, lecturer]* b.1901, Yonkers, NY / d.1990, Los Angeles, CA. **Addresses:** NYC; Los Angeles, CA. **Studied:** Yale School FA (B.F.A.); A.A. Weinman; Grande Chaumière, Paris; Am. School, Athens. **Member:** ANA, 1937; NA, 1941; Arch. Lg.; NSS (fellow); Am. Acad. in Rome; Yale Club; Books & Authors Assn.; P&S Assn. **Exhibited:** New Haven PCC, 1926 (prize); BAID, 1926 (prize), 1935 (prize); PAFA Ann., 1932, 1942; WFNY, 1939;

NAD (medal); AIC; Grand Central Art Gal.; Madonna Festival. Awards: Prix de Rome, 1927; FA Fed., NY (prize); S. Indp. A., 1941. **Work:** panels, figures, monuments, memorials, Springfield Mus. Art; Saratoga Springs, NY; Armonk, NY; Yale Mem., Pershing Hall, Paris; Bronx County Courthouse, NY; State Capitol Grounds, Hartford, CT; USPO, Washington, DC; ecclesiastical work: Church of Our Lady of Refuge, Tong Beach; Mt. Carmel Chapel, Los Angeles; Sacred Heart H.S., Loretto H.S., Los Angeles; St. Timothy's Church, West Los Angeles; St. Therese Church, Alhambra, Cal.; St. Francis Church, Catalina, CA; Father Juniper Serra statue, San Francisco; St. Sebastian Church, Santa Paula, CA. **Comments:** Teaching: Yale School FA. **Sources:** WW59; WW47, puts birth at 1902; Falk, *Exh. Record Series.*

SNOWDEN, William Etsel, Jr. *[Designer, illustrator, graphic artist, writer]* b.1904, Elberton, GA.
Addresses: Atlanta, GA. **Studied:** Georgia Sch. Tech.; Maryland Inst.; Fed. Sch., Inc., Minneapolis. **Member:** SSAL; Soc. Mem. Des. & Draftsmen; Direct Mail Advertising Assn.; Augusta AC; Assn. Georgia Artists; Atlanta Club of Printing House Craftsmen; AIGA. **Exhibited:** Augusta AC, 1936 (prize),1937, 1938; Atlanta AA; Printing House Craftsmen, 1945 (prize); Maryland Inst.; Georgia AA, 1934-36, 1938; AIGA, 1945. Awards: Direct Mail Assoc., 1940. **Work:** historical maps & brochures; Elbert County (GA) War Mem., Aiken, SC; Augusta, GA; Atlanta, GA. **Comments:** Position: pres., Snowden & Steward Advertising, Atlanta, GA. Contrib. to trade publications. **Sources:** WW59; WW47.

SNOWE, William St. Francis *[Painter]* late 19th c.
Exhibited: Salons of Am., 1923. **Comments:** Active 1870-74, painting White Mountain (NH) scenes. This is possibly the Francis Snowe who exhibited at the Boston AC in 1877. **Sources:** Campbell, *New Hampshire Scenery*, 154; *The Boston AC.*

SNYDER, Alba K. *[Painter]* early 20th c.
Addresses: Brooklyn, NY. **Exhibited:** S. Indp. A., 1933-34. **Sources:** Marlor, *Soc. Indp. Artists.*

SNYDER, Annie F. *[Painter]* early 20th c.
Addresses: Rochester, NY, c.1915. **Member:** Rochester AC. **Sources:** WW21.

SNYDER, Bladen Tasker *[Painter]* b.1864, Wash., DC / d.1923, Wash., DC.
Addresses: Wash., DC. **Studied:** Wash., DC; Paris, Académie Julian, with Lefebre, Boulanger. **Exhibited:** Paris Salon, 1893 (hon. mention); Soc. of Wash. Artists, 1890. **Work:** NMAH. **Comments:** He studied, traveled and painted around Europe and North Africa, returning to Wash., DC by 1887. Specialty: landscapes and city scenes. **Sources:** McMahan, *Artists of Washington, DC;* Fink, *American Art at the Nineteenth-Century Paris Salons,* 392.

SNYDER, C. B. B. *[Painter]* late 20th c.
Addresses: Brooklyn, NY, 1884. **Exhibited:** NAD, 1884. **Sources:** WW04.

SNYDER, C. F. *[Painter]* early 20th c.
Addresses: Paris, France. **Member:** Paris AAA. **Sources:** WW25.

SNYDER, Clarence W. *[Painter]* b.1873, Phila., PA / d.1948, Phila., PA.
Addresses: Phila., PA. **Member:** PAFA; Drexel Inst.; Phila. AC. **Exhibited:** PAFA Ann., 1923-25, 1936; S. Indp. A., 1927, 1930. **Sources:** WW33; Falk, *Exh. Record Series.*

SNYDER, Clifford *[Painter]* early 20th c.
Addresses: NYC. **Sources:** WW10.

SNYDER, Corydon Granger *[Illustrator, commercial artist, painter, teacher, writer, lecturer, sculptor]* b.1879, Atchison, KS.
Addresses: Chicago, IL. **Studied:** AIC; Minneapolis Inst. Art; Toronto AI. **Member:** Chicago No-Jury Soc. Art. **Exhibited:** S. Indp. A., 1926; Palette & Chisel Acad., 1931 (solo); Chicago No-

Jury Soc. Art, 1946; Illinois State Fair, 1955; Central YMCA Art Club, Chicago. **Work:** Historical Soc., St. Paul, MN. **Comments:** Author/illustrator: "Fashion Illustration," 1916; "Pen and Ink Technique," 1920; "Art and Human Genetics", 1952. Position: instructor, Fed. Schs., Minneapolis, 1916-18; Meyer Both Comm. Art Sch., 1920-30; Krompier Sch. Des., Chicago, 1940-43; advertising illustrator, Meyer Both Co., Chicago, IL. **Sources:** WW59; WW47.

SNYDER, Earl *[Painter]* mid 20th c.
Exhibited: S. Indp. A., 1941. **Sources:** Marlor, *Soc. Indp. Artists.*

SNYDER, George *[Lithographer]* b.c.1802, Germany.
Addresses: NYC, 1850. **Sources:** G&W; 7 Census (1850), N.Y., XLIX, 935.

SNYDER, George *[Lithographer]* b.c.1820, New York.
Addresses: NYC, 1845-72. **Comments:** Of Snyder & Black; and Snyder, Black & Sturn (see entry). In 1860 he owned property to the value of $10,000. **Sources:** G&W; NYCD 1845-72; 8 Census (1860), N.Y., XLV, 868.

SNYDER, Henry H(ale) *[Painter]* early 20th c.
Addresses: Rockford, IL. **Exhibited:** Salons of Am., 1923, 1925; S. Indp. A.,1923-24, 1926-28, 1934. **Sources:** Marlor, *Salons of Am.*

SNYDER, Henry M. *[Wood engraver & designer]* late 19th c.
Addresses: Philadelphia, 1852-71. **Comments:** In 1853 and after he was with Van Ingen & Snyder (see entry). **Sources:** G&W; Phila. CD 1852-71; Hamilton, *Early American Book Illustrators and Wood Engravers,* 432, 456, 483.

SNYDER, Henry W. *[Stipple engraver]* 18th/19th c.
Addresses: NYC,1797-1805; Albany, NY,1813-15. **Comments:** His work also appeared in books published in Boston between 1807-16. From about 1822-32 he was Chamberlain or Treasurer of the City of Albany and he also designed the Albany Alms House. **Sources:** G&W; Stauffer; Albany CD 1813-15, 1822, 1826, 1828, 1831, 1832; Munsell, *Annals of Albany; Antiques* (Feb. 1935), 51, repro.

SNYDER, James Wilbert (WILB) *[Painter, writer]* mid 20th c.; b.Phila., PA.
Addresses: Sanibel, FL. **Studied:** Univ. Penn. School FA (B.F.A.); New York Univ. (M.A.; Ph.D.); Cambridge Univ., Am. Univ, Beirut; Elliot O'Hara. **Member:** Sanibel-Captiva Art League (bd. mem.); Art Council Southwest Florida; Soc. North Am. Artists. **Exhibited:** Philadelphia, Cape Cod, NJ & Southwest Florida. Awards: various blue ribbons & hon. mentions in shows & exhs. **Comments:** Preferred media: watercolors. Teaching: Social Science, Univ. Penn., New York Univ. & Athens College, Greece. **Sources:** WW73.

SNYDER, Jerome *[Painter, designer, illustrator, teacher]* b.1916, NYC.
Addresses: NYC. **Member:** Art Lg. Am. **Exhibited:** Biarritz, France, 1946 (solo); ACA Gal., 1943, 1945; 48 States Comp., 1939; Art Dir. Club, 1949-55 (prizes, 1954, 1955); Danish Des. Circle; AIGA, 1953 (prize), 1954 (prize); MMA; ATC; MoMA. **Work:** Container Corp.; murals, USPO, Fenton, Mich.; Social Security Bldg., Wash., DC. **Comments:** Illustrator: "Portfolio #2," Black Sun Press, Paris. WPA artist. Position: art director, *Sports Illustrated.* Contributor to *Charm, Mademoiselle, Harper's Bazaar, Graphis,* and other publications. **Sources:** WW59; WW47.

SNYDER, Joan *[Painter]* b.1940, New Brunswick, NJ.
Addresses: NYC. **Studied:** Rutgers Univ. (M.F.A.). **Exhibited:** Rutgers Univ. Lib., 1971-74 (these exhibitions of all women's art were organized by Snyder because the all-male faculty would not show the work in the Univ. Gallery); Paley & Lowe Inc., New York, 1971 (solo); Parker 470, Boston, MA, 1971 (solo); WMAA biennials, 1972-73, 1981; Grids, Inst. Contemp. Art, Phila., 1972; Am. Woman Artist Show, Kunsthaus, Hamburg, Germany, 1972. **Work:** MMA; MOMA; Allan Mus., Oberlin (OH) College. **Comments:** Painterly abstractionist who has incorporated sym-

bolic imagery into her work, including such items as fabric, cheesecloth, valentines, and paper maché. During the 1970s her work responded to Feminist and personal issues. Teaching: State Univ. NY Stony Brook, 1968-70. **Sources:** WW73; Rubinstein, *American Women Artists,* 414-16; Marcia Tucker, "The Anatomy of a Stroke; Recent Paintings by Joan Snyder," *Artforum* (May 19,1971); Lizzie Bordon, "New York," *Artforum* (Jan. 1972); Kenneth Bake, article in *Christian Science Monitor,* (April 20, 1972).

SNYDER, M. Elizabeth *[Miniature painter] 19th/20th c.*
Exhibited: Wash. WCC, 1903. **Sources:** McMahan, *Artists of Washington, DC.*

SNYDER, Philip *[Painter] mid 19th c.*
Addresses: Schoharie, NY, c.1830. **Sources:** G&W described as a primitive painter in oils; Lipman and Winchester, 180.

SNYDER, Robert *[Engraver] b.c.1815, Pennsylvania.*
Addresses: Philadelphia, 1860. **Comments:** His widow, Jane Snyder, was listed in 1871. **Sources:** G&W; 8 Census (1860), Pa., LVIII, 316; Phila. CD 1871.

SNYDER, Seymour *[Illustrator, instructor, designer] b.1897, Newark, NJ.*
Addresses: NYC. **Studied:** PAFA; Grand Central School Art; ASL; Newark (NJ) School Art; Fawcett School Indust. Art. **Member:** ASL (life mem.); AAPL; Artists Equity Assn. **Exhibited:** Lynn Kottler Gallery, 1968; AAPL, 1969; SC, 1969 (watercolor prize); Nat. Arts Club, New York, 1970. **Work:** Commissions: advertising & promotional work for various national companies. **Comments:** Preferred media: oils, watercolors, gouache. Publications: illustrator, *McCalls, House & Gardens, Better Homes & Gardens, Successful Farming & American Home*; illustrator of various calendars. Teaching: High School Art & Design & New York Adult Educ. Program, 1962-69; Pels School Art, New York, 1970-. **Sources:** WW73; WW47.

SNYDER, T. *[Painter] mid 20th c.*
Addresses: NYC. **Exhibited:** WMAA, 1951. **Sources:** Falk, *WMAA.*

SNYDER, W. P. *[Sketch artist, painter] late 19th c.*
Addresses: NYC. **Exhibited:** Boston AC, 1884. **Comments:** His drawing of Natural Bridge, VA, was published as a wood engraving in *Harper's Weekly,* 1888. **Sources:** Wright, *Artists in Virginia Before 1900; The Boston AC.*

SNYDER, Warren A. *[Painter] mid 20th c.*
Addresses: Allentown, PA. **Exhibited:** PAFA Ann., 1942. **Sources:** Falk, *Exh. Record Series.*

SNYDER, William Henry *[Landscape painter] b.1829, Brooklyn, NY / d.1910, Brooklyn.* *W.H.Snyder.*
Addresses: Brooklyn, 1866-1900. **Studied:** NYC & Paris. **Member:** Brooklyn Art Club, 1910. **Exhibited:** Brooklyn AA, 1863-86, 1891; NAD, 1866-1900, 1903; PAFA Ann., 1882-83. **Comments:** Teaching: Brooklyn Art Sch. (manager). **Sources:** G&W; *Art Annual,* IX, obit; WW01; Falk, *Exh. Record Series.*

SNYDER, William McKendree *W. M. Snyder.*
[Landscape painter] b.1848, Liberty, IN / d.1930.
Addresses: Madison, IN. **Studied:** John Insco Williams, Cincinnati, 1869; W.M. Hunt, Boston; A. Bierstadt, Geo. Inness, & A.H. Wyant in NYC, 1872-75. **Work:** mostly in private collections. **Comments:** At age 12, he was a drummer boy in the Union Army. His earliest painting is dated 1865, and his last 1927. He was painting in Brown County, 1870-72, one of the first to paint there, while he was living in Columbus, IN; then traveled East for private instruction. After marrying in 1875, he settled permanently in Madison where he specialized in dense forest interiors, especially beech trees, painted in great detail. He painted his eastern landscapes, 1872-90. For a short time he was in the photographic business with his brother in Columbus, IN. He was known only locally for his portraiture, but he painted more than 700 land-

scapes of southern Indiana, southern Ohio, and northern Kentucky. Signature note: Usually consistent signature style, but beginning in the 1890s seemed to fluctuate bewteen using "M" or "McK" in the middle. He frequently signed in orange, but also signed in black or red. **Sources:** Gerdts, *Art Across America,* vol. 2: 275 (with repro.); R. Traut, unpub. ms (1988).

SNYDER & BLACK *[Lithographers] mid 19th c.*
Addresses: NYC, 1850-53. **Comments:** Partners were George Snyder and James Black (see entries). **Sources:** G&W; NYCD 1850-53.

SNYDER, BLACK & STURN *[Lithographers] mid 19th c.*
Addresses: NYC, 1854-72. **Comments:** Partners were George Snyder, James Black, and Hermann Sturn (see entries). **Sources:** G&W; NYCD 1854-72.

SOARE, William F. *[Painter] mid 20th c.*
Addresses: NYC. **Exhibited:** PAFA Ann., 1930. **Sources:** Falk, *Exh. Record Series.*

SOBEL, Janet *[Painter] mid 20th c.*
Addresses: Brooklyn, NY. **Exhibited:** AIC, 1947. **Sources:** Falk, AIC.

SOBEL, Jehudith *[Painter] mid 20th c.*
Addresses: NYC. **Exhibited:** PAFA Ann., 1962. **Sources:** Falk, *Exh. Record Series.*

SOBERS, Rex Warren *[Sculptor] b.1910, Bridgman, MI.*
Addresses: Chicago, IL. **Studied:** Avard Fairbanks. **Exhibited:** AIC, 1936. **Comments:** Specialty: industrial and ceramic design. **Sources:** WW40.

SOBIESKE, Thaddeus *[Crayon artist] early 19th c.*
Addresses: Richmond, VA, 1814. **Sources:** G&W; *Richmond Portraits,* 243.

SOBLE, John (Jack) Jacob *[Painter, teacher] b.1893, Russia.*
Addresses: Stroudsburg, PA; Bushkill, PA; NYC. **Studied:** NAD; C.C. Curran; L. Kroll; I. Olinsky; F.C. Jones. **Member:** AEA; Lehigh Art All.; All. Artists Am. (pres., 1957-58). **Exhibited:** S. Indp. A., 1920, 1934; Salons of Am., 1934-36; Ogunquit Art Center, 1935 (prize); NAD, 1925, 1929, 1932, 1936, 1938; PAFA Ann., 1936-37; TMA, 1936-37; GGE, 1939; AIC, 1936; CI, 1941; Corcoran Gal biennial, 1937; VMFA, 1938; Pepsi-Cola, 1945; Audubon Artists, 1950; Terry AI, 1952; All. Artists Am., 1951, 1957 (prize); Ain-Harod Mus., Israel. **Awards:** Academic AA, Springfield, MA, 1958 (prize). **Work:** TMA. **Comments:** Position: teacher, State Teachers College, East Stroudsburg, PA; art director, Tamiment (PA) Art Gal. **Sources:** WW59; WW47; Falk, *Exh. Record Series.*

SOBOL, Janet *[Painter] mid 20th c.*
Exhibited: PAFA Ann., 1945. **Sources:** Falk, *Exh. Record Series.*

SOBY, James Thrall *[Writer, critic] b.1906, Hartford, CT / d.1979.*
Addresses: New Canaan, CT. **Studied:** Williams College, 1924-26 (hon. L.H.D., 1962). **Exhibited:** Awards: Star of Solidarity, Italian Govt. **Comments:** Positions: asst director, MoMA, 1943, director painting & sculpture, 1943-45, trustee, 1943, hon. chmn., committee on mus. collections, member exec. & program committee, vice pres., 1961-; art critic, *Sat. Rev. Lit.,* 1946-57; ed., *Magazine of Art,* 1950-51, chmn., ed. board, 1951-52. Publications: author, *Modern Art and the New Past,* 1957; *Juan Gris,* 1958; *Joan Miro,* 1959; *Ben Shawn: Paintings,* 1963; *Margritte,* 1965. Contributor of articles and criticism in leading art publications. **Sources:** WW73.

SOCHA, John Martin *[Painter, teacher] b.1913, St. Paul, MN.*
Addresses: Minneapolis, MN. **Studied:** Minneapolis Sch. Art; Univ. Minnesota; & with Glenn Mitchell, Robert Brackman; Diego Rivera, in Mexico. **Member:** Minnesota AA; Minnesota Art Union; Montparnasse Club, St. Paul; Minnesota Educ. Assn.; Minneapolis Soc. FA; Walker Art Center; Western AA. **Exhibited:**

Minnesota State Fair, 1938-40 (prize), 1941 (prize), 1942; Minneapolis Women's Club, 1938-42 (prize); Minneapolis IA, 1938-41, 1942 (prize), 1943-46; AIC, 1941-42; MMA, 1941-42; WMAA, 1942; NGA, 1940, 1942; Guatemala City, 1940; Mexico City, 1942; Walker Art Center, 1938, 1940, 1949 (prize); Davenport Municipal Art Gal., 1941; St Paul Art Gal., 1938-42; Denver Art Mus.; Univ. Wisconsin; Fed. Courts Bldg (solo), Hamline Univ. (solo), St. Catherine's Col. (solo), Public Library (solo), St. Paul Park H.S (solo), all in St. Paul; Guy Mayer Gal., NY (solo); Mankato State College, 1957 (solo). **Work:** Univ. Nebraska; Minneapolis IA; Minneapolis Woman's Club; Walker Art Center; Dayton College; Univ. Minnesota; Am. Red Cross, Wash., DC; murals, Winona (MN) State Teachers College; Univ. Minnesota; Fed. Reserve Bank, Minneapolis; St. Luke's Cathedral, St. Paul, MN; New Ulm H.S.; St. James Episcopal Church, Minneapolis Chapel, Ft. Snelling, MN. **Comments:** Position: instructor, Marshall H.S., Minneapolis, MN, 1951-. **Sources:** WW59; WW47.

SOCHOR, Bozena (Miss) *[Painter] b.1901, Sonov, Czechoslovakia.*
Addresses: Uniontown, PA. **Studied:** Pennsylvania State College; CI. **Member:** Uniontown (PA) AC; Assoc. Artists Pittsburgh; All. Artists Johnstown. **Exhibited:** CI, 1945; Butler AI, 1944; Parkersburg FAC, 1943-46; Ohio Univ., 1945; Uniontown (PA) AC, 1941-58; Uniontown (PA) Pub. Lib., 1952 (solo); All. Artists Johnstown, 1948-58. **Sources:** WW59; WW47.

SOCKETT, C. E. *[Painter] late 19th c.*
Exhibited: SNBA, 1895. **Sources:** Fink, *American Art at the Nineteenth-Century Paris Salons,* 392.

SODERBERG, George E *[Etcher] 20th c.*
Addresses: Chicago, IL. **Member:** Chicago SE. **Sources:** WW27.

SODERBERG, Gunnar *[Painter] mid 20th c.*
Exhibited: AIC, 1930-31. **Sources:** Falk, *AIC.*

SODERBERG, Yngve Edward *[Painter, etcher, teacher, writer, designer, lithographer] b.1896, Chicago, IL / d.1971.*
Addresses: Mystic, CT. **Studied:** AIC; ASL. **Member:** Mystic AA; SAGA; Chicago SE. **Exhibited:** AIC, 1934, 1937; Chicago SE, 1936 (prize); Kennedy Gal., NY; SAGA, 1945 (prize); Grand Central Art Gal., 1949 (solo), 1954 (solo); Am-Swedish Mus., Phila., 1954 (solo); Lyman Allyn Mus. 1955 (solo); Mystic, CT, 1959-60 (prizes); Meriden, CT, 1961 (prizes). **Work:** Mystic Seaport Mus.; AIC; LOC; Smithsonian Inst.; Lyman Allyn Mus.; murals of training ship "Eagle", U.S. Coast Guard Academy, New London, CT, 1962; USPO, Morrisville, PA. **Comments:** WPA artist. Position: art instructor, New London (CT) H.S. Author: *Drawing Boats and Ships* (1958). **Sources:** WW66; WW47; Brewington, 360.

SODERLIND, Nona Bymark *[Sculptor] b.1900, St. Paul, MN.*
Addresses: Minneapolis, MN/Marine on Saint Croix, MN. **Studied:** Minneapolis Sch. Art; C. Milles; Cranbrook Acad. Art. **Member:** Minnesota Artists Union. **Exhibited:** Minnesota State Fair, 1928 (prize), 1931 (prize); Minneapolis IA, 1928 (prize), 1930 (prize), 1931 (prize),. **Work:** relief, Farmer-Labor party; portrait, Am. Inst. Swedish Arts, Minneapolis. **Sources:** WW40.

SODERQUIST, Anna *[Painter] early 20th c.*
Addresses: Saratoga Springs, NY, 1922. **Exhibited:** S. Indp. A., 1922. **Sources:** Marlor, *Soc. Indp. Artists.*

SODERQUIST, Carl *[Painter] early 20th c.*
Addresses: Saratoga Springs, NY. **Exhibited:** S. Indp. A., 1920. **Sources:** Marlor, *Soc. Indp. Artists.*

SODERSTON, Herman *[Painter] b.1862, Sweden / d.1926.*
Addresses: New Haven, CT. **Studied:** Royal Acad. FA, Stockholm; PCC; CAFA. **Exhibited:** S. Indp. A., 1917. **Work:** Memorial Hall, Hartford; Sheffield Scientific Hall, New Haven, CT. **Sources:** WW25; Marlor, *Soc. Indp. Artists* (as Herman Sodersten), probably a misspelling.

SODERSTON, Leon (Harold) *[Painter] mid 20th c.*
Studied: ASL. **Exhibited:** S. Indp. A., 1941. **Sources:** Marlor, *Soc. Indp. Artists.*

SOELLNER, Oscar Daniel *[Painter, designer, educator] b.1890, Chicago, IL / d.1952.*
Addresses: Chicago, IL; Oak Park, IL; Grand Detour, IL. **Studied:** AIC. **Member:** Chicago Galleries Assn.; Assn. Chicago P&S; Palette & Chisel Acad. FA; Austin, Oak Park and River Forest AL; AFA; AAPL; All-Illinois SA.; Chicago Galleries Association; Illinois Academy of FA; Maywood AC. **Exhibited:** Palette & Chisel Acad., Chicago, 1930 (prize); All-Illinois Soc. FA, 1932 (gold); Springville, UT, 1932 (prize); NAD; CI; AIC, 1923-49; John Herron AI; Nebraska AA; Kansas City AI; Salt Lake City, Utah; Des Moines FAA; Illinois State Mus.; Mayo Gallery, Richmond, VA, 1994 (retrospective). **Work:** mem., monument, Oglesby, IL; Pub. Sch., Oak Park and River Forest. **Comments:** Son of a German immigrant woodcarver, he showed an early interest in art, and became an important member of the Grand Detour art colony. His poetic landscapes distinguish him as an important American regionalist. **Sources:** WW53; WW47; addit. info. courtesy of Joel L. Fletcher, Fletcher Copenhaver Fine Art, Fredericksburg, VA.

SOFFA, Orville H. *[Painter] mid 20th c.*
Addresses: Chicago area. **Exhibited:** AIC, 1951. **Sources:** Falk, *AIC.*

SOFFER, Sasson *[Sculptor] b.1925, Baghdad, Iraq.*
Addresses: NYC. **Studied:** Brooklyn College, 1950-54, with Mark Rothko. **Exhibited:** WMAA, 1961, 1966; CI; Yale Univ. Art Gallery; Harvard Univ.; BMFA. **Awards:** Ford Foundation Purchase Award, WMAA, 1962; Ford Foundation artist-in-residence, Portland Mus., 1966. **Work:** WMAA; Indianapolis Mus. Fine Art; Albright-Knox Gallery, Buffalo, NY; Rockefeller Inst., New York; Butler IA, Youngstown, OH. **Comments:** Preferred media: glass. **Sources:** WW73.

SOFO, Arturo *[Sculptor] b.1899, NYC / d.1990, NYC.*
Exhibited: WMAA, 1920-28; Salons of Am., 1934. **Sources:** Falk, *Exhibition Record Series.*

SOGIOKA, Gene *[Painter] mid 20th c.*
Addresses: Los Angeles, CA, 1930s. **Studied:** Chouinard Art Sch. **Exhibited:** Calif. WC Soc., 1937. **Sources:** Hughes, *Artists in California,* 524.

SOGLOW, Otto *[Cartoonist] b.1900, NYC / d.1975, NYC.*

O. SOGLOW

Addresses: NYC. **Studied:** ASL, 1919-25, with John Sloan. **Member:** SI; Nat. Cartoonists Soc. **Exhibited:** S. Indp. A., 1924-32; Salons of Am., 1925; WMAA, 1926-27. **Awards:** Reuben Award as outstanding cartoonist of the year, Nat. Cartoonist Soc., 1967. **Work:** Baltimore Mus. **Comments:** Best known for his cartoon, "Little King" which first appeared in *New Yorker* in 1931. In 1925-26 he was a cartoonist for *New York World* and in 1933 was hired by King Features Syndicate. Author & illustrator: *Pretty Pictures, Everything's Rosey,* and *Wasn't the Depression Terrible.* Also, contributor to *Colliers, Life* and other magazines. **Sources:** WW73; WW47; *Famous Artists & Writers* (1949).

SOHIER, Alice Ruggles *[Painter] b.1880, Quincy, MA.*
Addresses: Boston, MA, 1914; Concord, MA, 1920s. **Studied:** Buffalo; BMFA Sch. with Tarbell; in Europe (under Paige traveling scholarship). **Member:** Boston GA; Concord AA. **Exhibited:** Corcoran Gal biennials, 1914-28 (4 times); Pan-Pacific Expo, San Francisco, 1915 (medal); PAFA Ann., 1915-16; AIC; Boston GA, 1916 (solo), 1922 (solo), 1925 (solo). **Work:** State House, Boston; Episcopal Theological Sch., Cambridge; State Savings, Albany, NY; Metropolitan Opera House, NYC. **Sources:** WW40; Falk, *Exh. Record Series.*

SOHN, Frank *[Designer, craftsperson, painter, graphic artist, lecturer] b.1888, Columbus, IN.*
Addresses: Toledo, OH. **Studied:** Univ. Illinois; AIC; A. Gunther; I. Manoir; A. Angarola; F. Grant. **Member:** Brown County Art

Gal. Assn.; Toledo AC; Hoosier Salon. **Exhibited:** WMAA, 1933; MMA; AIC; Hoosier Salon; TMA, 1946 (prize). **Work:** glass murals, Toledo Pub. Lib.; numerous restaurants in Chicago & Detroit. **Comments:** Specialty: design products, bldgs., interiors, involving opaque structural glass and metal. Position: manager, Arch. Service Dept., Libbey Owens Ford Glass Co., Toledo, OH, 1935-. **Sources:** WW53; WW47.

SOHNER, Theodore *[Painter, lecturer, teacher] b.1906, St. Paul, MN.*
Addresses: Minneapolis, MN. **Studied:** St. Paul Sch. Art; Minneapolis Sch. Art, and with Andre Lhote, in Paris; A. Angarola; C. Booth; Michele Garinei in Florence, Italy. **Member:** Minnesota AA. **Exhibited:** Minneapolis IA, 1942, 1943-45 (prizes), 1949-51 (prize); Minnesota State Fair, 1932 (prize), 1933 (prize), 1942, 1944 (prize), 1946 (prize); Minneapolis Women's Club, 1943, 1944, 1946-49 (prizes), 1950-52; Minnesota Centennial, 1949-50; Swedish IA, 1952; Joslyn Art Mus., 1952; Minnesota Artists, St. Paul, 1958. **Work:** Minnesota State Capitol; St. Olaf College; Minneapolis IA; Univ. Minnesota; Univ. Illinois; South Dakota State Capitol; Kenyon College; House of Temple, Wash., DC; St. Mary's Hall; St. James Military Sch.; Breck Sch.; mural, Scottish Rite Temple, Minneapolis. **Comments:** Position: teacher, Minneapolis Sch. Art, 1945-46. **Sources:** WW59; WW47.

SOHON, Gustavus
[Topographical and portrait draftsman, photographer] b.1825, Tilsit, East Prussia, Germany / d.1903, Wash., DC.
Addresses: Brooklyn in 1842; Wash., DC, 1862-63; San Francisco, 1863-65; Wash., DC, 1866-on. **Work:** NMAA; National Archive's Ctr. for Cartographic & Architectural Archives; Washington State Hist. Soc.; Georgetown Univ. **Comments:** Sohon worked as a bookbinder and woodcarver in Brooklyn before enlisting in the U.S. Army in July 1852. Over the next five years he served as artist on several military exploring expeditions to the West. He made sketches that were later lithographed for Major Isaac Stevens' report on the exploration of the Northern railway route from the Mississippi River to Puget Sound, and also made drawings of Stevens' negotiations with the Indian tribes of the Columbia Valley and Montana. Sohon also drew portaits of the Flathead Chiefs and Christian Iroquois in 1854. From 1858-62 he worked as civilian guide and interpreter for Lieutenant John Mullan on a military road-building expedition over the Rockies. In 1862 Sohon went to Washington, DC, with Mullan, assisting him on the completion of the official report (Pacific Railroad and Mullan Road Exp. Reports), which included 10 lithographs made from Sohon's drawings. Sohon operated a photographic and Ambiotype studio in San Francisco from 1863-65, but then returned to Washington, where for the remainder of his life he ran a shoe business. **Sources:** G&W; Ewers, "Gustavus Sohon's Portraits of Flathead and Pend D'Oreille Indians, 1854;" Draper, "John Mix Stanley;" Taft, *Artists and Illustrators of the Old West,* 276. More recently, see Dawdy, vol. 1, 218; P & H Samuels, 454-55; McMahan, *Artists of Washington, DC.*

SOKOLE, Miron *[Painter, educator, lithographer] b.1901, Odessa, Russia / d.1985.*
Addresses: New Canaan, CT, 1977; NYC. **Studied:** Cooper Union (certificate); NAD with Ivan Olinsky. **Member:** Woodstock AA; Exp. Art & Technology; Am. Artists Congress; Artists Equity Assn. (nat. director, 1952). **Exhibited:** Salons of Am., 1927, 1928, 1934; NAD (medal); AIC, 1931-44 ; WMAA, 1936-53 & 1954 (Watercolors Show); PAFA Ann., 1936, 1940-42, 1954; BM, 1939, 1943; Dallas Mus. FA; Detroit Inst. Art; CPLH; Rochester Mem. Art Gal.; Dayton AI; Milwaukee AI; Lehigh Univ.; Columbia; Albany Inst. Hist. & Art; Minneapolis Inst. Art; CM; Albright Art Gal.; CGE, 1939; WFNY, 1939; Springfield Mus. Art; BMA; Corcoran Gal biennials, 1935-45 (4 times); Columbus Gal. FA; CI, 1943-46; VMFA, 1944; Pepsi-Cola, 1944, 1945; MMA, 1942, 1944, 1945; Walker Art Center, 1944; G.R.D. Gal., 1930 (solo); Cheshire Gal., 1932 (solo); Midtown Gal., 1934

(solo), 1935 (solo), 1937 (solo), 1939 (solo), 1944 (solo); Oklahoma City, 1938 (solo); Int. Expos. Mus. Art Mod., Paris, 1946; Audubon Artists, New York, 1964; 21st Ann., Norfolk (VA) Mus., 1965; "NYC WPA Art" at Parsons School Design, 1977; Jarvis Gal, Woodstock, NY, 1970s. **Work:** Butler Inst. Am. Art, Youngstown, OH; Mus. Tel Aviv, Israel; Univ. Minnesota, Minneapolis; IBM Collection; Upjohn Collection. **Comments:** Preferred media: oils, acrylics. Positions: free lance stage designer, 1935-38; WPA artist; stage & industrial designer, 1942-46. Teaching: Am. Artists School, NYC, 1938-41; Kansas City Art Inst., MO, 1947-51; professor of art, Fashion Inst. Technology, New York, 1962-70s. **Sources:** WW73; WW47; Salpeter, "Miron Sokole," *Esquire* (Sept., 1945); A. Guskin, *Painting in USA* (1954); Martha Cheney, *Modern Art in America* (Tudor); *New York City WPA Art,* 81 (w/repros.); Woodstock AA; Falk, *Exh. Record Series.*

SOKOLKSY, Sulamith *[Painter] b.1889, NYC.*
Addresses: NYC. **Studied:** CUA School; NAD. **Exhibited:** Salons of Am., 1927, 1929, 1930, 1934; S. Indp. A., 1927-28, 1930, 1932-33. **Sources:** WW21.

SOKOLOFSKY, Stephen G. *[Painter, teacher] 20th c.*
Addresses: Phila., PA. **Studied:** PAFA. **Sources:** WW25.

SOKOLOVE, Stanley N. *[Painter] mid 20th c.*
Addresses: Phila., PA. **Exhibited:** PAFA Ann., 1930. **Sources:** Falk, *Exh. Record Series.*

SOLARI, Joseph *[Painter] 20th c.*
Addresses: Kirkwood, MO. **Member:** St. Louis AG. **Sources:** WW27.

SOLARI, Mary *[Painter, writer] b.1849 / d.1929, Memphis.*
Studied: Academy in Florence, Italy (first woman admitted).

SOLBERT, R. G. *[Painter] mid 20th c.*
Exhibited: Corcoran Gal biennials, 1957. **Sources:** Falk, *Corcoran Gal.*

SOLDWEDEL, Frederic *[Painter, architect] b.1886, NYC.*
Addresses: Living in NYC in 1941. **Studied:** England; Italy; Greece; France. **Exhibited:** AIC, 1930. **Comments:** Watercolor painter specializing in marine scenes. **Sources:** WW40; P&H Samuels, 455.

SOLERI, Paolo *[Architect-environmental planner, sculptor] b.1919, Torino, Italy.*
Addresses: Scottsdale, AZ. **Studied:** Polytech Torino, Frank Lloyd Wright fel. **Exhibited:** CGA, 1970; WMAA, 1970; Mus. Contemporary Art, Chicago, 1970; Nat. Conference Center, Ottawa, Canada, 1971; Univ. Art Mus., Berkeley, CA, 1971. Awards: Graham Foundation, 1962; Guggenheim Foundation, 1954 & 1967. **Work:** MoMA. Commissions: II Donnone (sculpture), Phoenix (AZ) Civic Center, 1972. **Comments:** Publications: author, "Arcology: The City in the Image of Man," 1969 &" The Sketchbooks of Paolo Soleri," 1971, MIT Press; author, "The Bridge Between Matter & Spirit is Matter Becoming Spirit," Doubleday, 1973. **Sources:** WW73.

SOLES, William *[Sculptor, engraver, craftsperson, teacher] b.1914, NYC / d.1967, Easthampton, LI, NY.*
Addresses: Long Island, NY. **Studied:** ASL and with Alfeo Faggi. **Member:** Woodstock AA; Guild Hall, East Hampton. **Exhibited:** MMA; Weyhe Gal., NY; Kennedy Galleries, NY; PMA; LOC; Sigma Gal., and Guild Hall, Southampton; Southampton Gal., New York and Southampton; Parrish Art Mus. Regularly, Woodstock, NY. Awards: St. Gaudens Medal; Keith Mem. Award, Woodstock. **Work:** NYPL (print); LOC; ceramic murals in private homes. **Sources:** WW66; Woodstock AA.

SOLEY, Walter H. *[Painter] late 19th c.*
Addresses: Malden, MA. **Exhibited:** Boston AC, 1893-94. **Sources:** *The Boston AC.*

SOLIAN-SCHMITT, C. F. *[Painter] mid 20th c.*
Addresses: NYC. **Exhibited:** PAFA Ann., 1916. **Sources:** Falk, *Exh. Record Series.*

SOLIGNY, E. J. *[Sculptor] late 19th c.*
Addresses: Brooklyn, NY, 1878. **Exhibited:** NAD, 1878.
Sources: Naylor, *NAD*.

SOLINGER, David M *[Collector, patron] mid 20th c.*
Addresses: NYC. **Member:** AFA (board of trustees, 1954);
WMAA (pres., board of trustees, 1966-). **Comments:** Collection:
twentieth century paintings and sculpture. **Sources:** WW73.

SOLITARIO, Joseph *[Painter] mid 20th c.*
Exhibited: Corcoran Gal biennials, 1951. **Sources:** Falk,
Corcoran Gal.

SOLLENTO, Michael *[Painter] mid 20th c.*
Addresses: NYC. **Studied:** ASL. **Exhibited:** S. Indp. A., 1924,
1930; Salons of Am., 1928. **Sources:** Falk, *Exhibition Record
Series.*

SOLLOM, Vincent P. *[Painter] 20th c.*
Addresses: Pittsburgh, PA. **Member:** Pittsburgh AA. **Comments:**
Affiliated with Carnegie Inst., Pittsburgh. **Sources:** WW25.

SOLLOTT, Lillian *[Portrait painter, illustrator, lecturer] 20th
c.; b.Phila.*
Addresses: Phila., PA. **Studied:** PAFA; Phila. Sch. Des. Women;
Barnes Found.; R.S. Bredin; G. Harding; H. Snell; H. McCarter.
Sources: WW40.

SOLMAN, Joseph *[Painter, printmaker, instructor] b.1909,
Vitebsk, Russia.*
Addresses: NYC. **Studied:** NAD, 1926-29; ASL, 1929-30;
Columbia. **Member:** The Ten, NY; Fed. Modern Painters &
Sculptors (pres., 1965-67, vice-pres., 1967-). **Exhibited:** The Ten,
1938; Int. WC Ann., AIC, 1939; WFNY, 1939; Neumann-Willard
Gal., NY, 1940; Bonestell Gal., NYC, 1940s; PAFA Ann., 1944,
1951-53, 1960; Corcoran Gal biennials, 1947-57 (4 times); PMG,
1949 (retrospective); WMAA, 1950-55; Int. Assn. Plastic Arts
European traveling exh Am. Art, 1956; Second Expos
Contemporary Art, Inst. Brasil-Estados Unidos, Rio de Janeiro,
1960; NIAL, 1961 (prize); NAD, 1969 (Isaac N. Maynard Prize
for Portrait), 1971(Saltus Gold medal for Merit); ACA Galleries,
NYC; "NYC WPA Art" at Parsons School Design, 1977. **Work:**
WMAA; Phillips Gallery, Wash., DC; Fogg Mus., Cambridge,
MA; Butler Inst. Am. Art; LACMA. **Comments:** Preferred media:
oils, gouache, silkscreen, monotype. Positions: editor & co-editor,
Art Front magazine, 1937-39. Teaching: MoMA, 1952-54; New
School Social Res., 1964-66; City College New York, 1967-70s.
Sources: WW73; D. Seckler, "Solman Paints a Picture," *Art News*
(summer, 1951); S. Burrey, "Joseph Solman: The Growth of
Conviction, *Arts* (Oct, 1955); *Monotypes by Joseph Solman* (Da
Capo Press, 1977); autobiography, *Joseph Solman* (Crown, 1966);
New York City WPA Art, 82 (w/repros.); Falk, *Exh. Record Series.*

SOLMANS, Alden *[Painter] b.1835 / d.1930, South Norwalk,
CT.*
Comments: He was a well-known banker who at the age of 80
took up the study of art and exhibited with much success towards
the end of his life.

SOLOMAN, Gertrude *[Painter] mid 20th c.*
Addresses: Oakland, CA, 1910-33. **Exhibited:** Oakland Art
Gallery, 1933. **Sources:** Hughes, *Artists in California*, 525.

SOLOMON, Alan R. *[Scholar, writer] 20th c.*
Addresses: NYC. **Studied:** Harvard College (A.B.); Harvard
University Graduate School (M.A., Ph.D.) Museum training with
Paul Sachs and Jakob Rosenberg. **Comments:** Positions: director,
White Museum Art, Cornell University (initiated the Museum),
1953-61; director, The Jewish Museum, NY, 1962-64 (reorganized
Museum and instituted new program in contemporary art); assoc.
professor, history of art, Cornell Univ. to 1962; U.S.
Commissioner, XXXII Venice Biennale, 1964; visiting prof.,
Cornell College of Arch., New York program, 1963-. Author:
"Robert Rauschenberg"; "Jasper Johns"; numerous articles and
catalog texts on New American Art. **Sources:** WW66.

SOLOMON, Daniel *[Painter] b.1945, Topeka, KS.*
Addresses: Toronto, Ontario. **Studied:** Univ. Oregon (B.Sc.).
Exhibited: Canadian Artists, Art Gallery Ontario, 1968; Survey
1969, Montreal Mus. Fine Arts, 1969; Isaac Gallery, 1970 (solo)
& 1971 (solo). **Awards:** Canadian Council Bursary for Painting,
1970 & 1972. **Work:** Commissions: outdoor mural, Benson &
Hedges Tobacco Co., 1971. **Comments:** Preferred media: acrylic.
Teaching: painting instructor, Ontario College Art, Toronto, 1970-.
Sources: WW73; L. Lippard, review (Feb., 1969) & M.
Greenwood, review (August & Sept., 1971), *Arts Magazine;* also
review, *Arts Magazine* (June, 1970).

SOLOMON, Florine Mott *[Painter] mid 20th c.*
Exhibited: S. Indp. A., 1935. **Sources:** Marlor, *Soc. Indp. Artists.*

SOLOMON, Harry See: **SOLON, Harry**

SOLOMON, Hyde *[Painter] b.1911, NYC / d.1982.*
Addresses: NYC. **Studied:** ASL; Pratt Inst.; Columbia Univ.
Exhibited: S. Indp. A., 1941; "Talent 1950," Kootz Gal, NYC;
CI, 1957-59; Corcoran Gal biennials, 1957, 1959; "60 Am.
Painters," Walker AC, Minneapolis, 1960; "Nature In
Abstraction," WMAA, 1960; PAFA Ann., 1962; Poindexter Gal,
NYC, 1970s. Other awards: Mus. Purchase Award, Gloria
Vanderbilt, 1957; Childe Hassam Fund Purchase Award, Acad.
Arts & Letters, 1970. **Work:** WMAA; Wadsworth Atheneum,
Hartford, CT; Munson-Williams-Proctor Inst., Utica, NY; Art
Mus. Princeton Univ., NJ; Univ. Calif. Mus., Berkeley.
Comments: Abstract painter who retained a strong sense of the
structure of nature and used luminous color to produce one of his
favorite subjects, enormous skies. He frequently spent his sum-
mers on Monhegan Island (ME). Positions: artist-in-residence,
Princeton Univ., 1959-62. **Sources:** WW73; Thomas B. Hess,
"U.S. Painting: Some Recent Directions," *Art News Ann.* (1956);
Martica Sawin, "Profile of Hyde Solomon," *Arts Magazine*
(November, 1958). Bibliography: Curtis, Curtis, and Lieberman,
129, 186; Falk, *Exh. Record Series.*

SOLOMON, J. *[Portrait painter] mid 19th c.*
Addresses: Charleston, SC, 1845. **Sources:** G&W; Sherman,
"Unrecorded Early American Painters" (Oct. 1934), 149.

SOLOMON, Mary C. *[Painter] 20th c.*
Addresses: Brooklyn, NY. **Sources:** WW19.

SOLOMON, Mary Elizabeth *[Painter] mid 20th c.*
Studied: ASL. **Exhibited:** S. Indp. A., 1935. **Sources:** Marlor,
Soc. Indp. Artists.

SOLOMON, Maude Beatrice (Mrs. Joseph) *[Painter,
sculptor] 20th c.; b.Seattle, WA.*
Addresses: NYC. **Studied:** PAFA; J.L. Tadd; H. Breckenridge.
Comments: Illustrator: "Aristocrats of the North." **Sources:**
WW33.

SOLOMON, Mitzi *[Sculptor, designer, teacher, lecturer]
b.1918, NYC.*
Addresses: NYC. **Studied:** Columbia; ASL; O. Maldarelli; A.
Goldthwaite. **Member:** S.Gld.; NAWA; NY Soc. Women Artists;
Audubon Artists; Springfield Art Lg. **Exhibited:** Smith Art Gal.,
Springfield, MA, 1940 (prize), 1943 (prize), 1945 (prize); S. Indp.
A., 1941-42, 1944; Irvington (NJ) Pub. Lib., 1944 (prize);
WMAA, 1945-49; AIC, 1942; CM, 1939, 1941; MMA (AV),
1942; Denver Art Mus., 1942-44; Mint Mus. Art, 1945, 1946;
NAWA, 1943-46; CAFA, 1940; North Carolina Artists, 1943-44;
Newport AA, 1944-45; Springfield Art Lg., 1941-44, 1946; PAFA
Ann., 1947-49 (prize 1947, gold medal 1949); Syracuse Mus. FA
(solo); Phila. Art All. (solo); de Young Mem. Mus. (solo);
Milwaukee AI (solo); Brooks Mem. Art Gal. (solo). **Sources:**
WW47; Falk, *Exh. Record Series.*

SOLOMON, Richard *[Collector] b.1934, Boston, MA.*
Addresses: Boston, MA. **Studied:** Harvard University; Harvard
Graduate School of Business Administration. **Comments:**
Positions: trustee, Institute of Contemporary Art, Boston.
Collection: contemporary paintings, drawings, sculpture, includ-
ing works by Vasarely, Warhol, Oldenburg, Nevelson,

Rauschenberg, Cesar, Poliakoff, Sonderborg, Trova, Hajdu, Kelly, Higgins, Callary, and others. **Sources:** WW66.

SOLOMON, Sidney L. (Mr. & Mrs.) *[Collectors] early 20th c.; b.Salem, MA (and Boston).*
Addresses: NYC. **Studied:** Mr. Solomon, Harvard College (B.A.), Harvard Bus. School (M.B.A.); Mrs. Solomon, Radcliffe College (A.B.) & Simmons College (B.S.). **Comments:** Born 1902 and 1909. Collections: sculpture of the twentieth century to contemporary, including Giacometti, Lipchitz, Marini, Nevelson, Dubuffet, Arp, Chadwick, Calder, Schmidt, Doris Cassar & Trova; painting collection includes Sargent, Vuillard, Tomayo, Leger, Giacometti, Monet and Matta; drawings of Maillol, Archipenko, Degas, Lachaise & many others; watercolors of Nolde & Marini; also a collection of Pop Art. **Sources:** WW73.

SOLOMON, Syd *[Painter, instructor] b.1917, Uniontown, PA.*
Addresses: Sarasota, FL. **Studied:** AIC, 1934; École Beaux-Arts, Paris, France, 1945. **Member:** AEA; Allied Arts Council. **Exhibited:** WMAA, 1945; nat. & int. exhibs including Univ. Illinois, New England Ann., Silvermine Guild Art, Painting of the Year Inst. Chicago, Guild Hall, East Hampton, NY; Saidenberg Gal., NYC, 1970s. **Awards:** first prize, Ringling Mus. Art, 1962; Silvermind Guild, 1962; Ford Foundation Purchase Prize, 1965. **Work:** NOMA; Butler IA; Birmingham (AL) Mus. Art; WMAA & Solomon R. Guggenheim Mus., NYC. **Comments:** Positions: camouflage designer, Engineers Board, Wash., DC, 1942. Teaching: director, painting classes, Ringling Mus. Art, 1952-; faculty director, Famous Artists School, 1953-; visiting professor art, New College, Sarasota, FL,1966-68. **Sources:** WW73.

SOLOMONS, Aline E. *[Painter] b.1860, NYC / d.1942, Wash., DC.*
Addresses: Wash., DC, 1880-1935. **Studied:** Washington ASL. **Member:** Soc. Wash. Artists; Arts Club of Wash. (charter mem.); American Federation of Arts; Wash. Soc. of FA. **Exhibited:** Transmississippi Expo, Omaha, 1898; Washington ASL at the Cosmos Club, 1902; Soc. Wash. Artists annuals; Corcoran Gal annuals/biennials, 1908, 1912; Wash. WCC. **Sources:** WW25; McMahan, *Artists of Washington, DC.*

SOLON, C. *[Sketch artist] mid 19th c.*
Comments: Delineator of a view of the Great Falls of the Missouri, lithographed by J.T. Bowen of Philadelphia in the mid-1850's. The artist was probably Gustavus Sohon whose view of these falls was lithographed by Sarony, Major & Knapp and published in Vol. XII, Part I, of the War Department's *Reports of Explorations and Surveys.* (1860). **Sources:** G&W; Peters, *America on Stone.*

SOLON, Camille Antoine *[Painter, mural painter, ceramic artists] b.1878, Stoke-on-Trent, England / d.1960, San Rafael, CA.*
Addresses: Mill Valley, CA. **Studied:** with his father; Slade School and Univ. College, London. **Comments:** Immigrated to the U.S. in 1914. Position: designer & art director, W. R. Hearst, San Simeon. **Sources:** Hughes, *Artists in California, 525.*

SOLON, Harry *[Portrait painter] b.1873, San Francisco, CA / d.1958, NYC.*
Addresses: NYC. **Studied:** Calif. School Design, San Fran.; AIC; Académie Julian, Paris with Royer, 1911. **Member:** SC; AFA. **Exhibited:** AIC, 1908-15; S. Indp. A., 1917. **Work:** Capitol Bldg., Des Moines; Morningside Univ., Sioux City; portrait, Gen. Jose F. Uriburu, President of Argentina; portrait, Hon. Edwin Morgan, U.S. Ambassador to Rio de Janeiro; portrait Hon. Leland Harrison, U.S. Minister to Uruguay. **Sources:** WW33; WW24 (listed as Harry Solomon); Hughes, *Artists in California, 525.*

SOLON, Leon Victor *[Painter, designer, book illustrator, writer, lecturer, craftsperson, architect] b.1872, Stoke-on-Trent, England.*
Addresses: Lakeland, FL. **Studied:** Royal College Art, London, England. **Member:** Hellenic Soc., London; Art Workers Gld., London; Royal Soc. British Artists; Arch. Lg.; NSS; NSMP.

Exhibited: AIA, 1928 (gold), 1931 (gold); Arch. Lg., 1932 (gold), 1936 (medal); Am. Cer. Soc., 1935 (gold). **Awards:** Int. medal, Spain; Sill medal, Paris, France. **Work:** Barcelona Mus.; Victoria & Albert Mus., London; polychromatic decorations, Fairmount Park Mus., Phila.; Rockefeller Center, NY. **Comments:** Contributor to *Architectural Record.* Author: "Architectural and Sculptural Polychromy". **Sources:** WW53; WW47.

SOLOTARNOFF, Moisha M *[Painter] mid 20th c.*
Studied: ASL. **Exhibited:** Salons of Am., 1925, 1928; AIC, 1942. **Sources:** Marlor, *Salons of Am.*

SOLOTAROFF, Morris M(oi) *[Painter] mid 20th c.*
Studied: ASL. **Exhibited:** S. Indp. A., 1928. **Sources:** Marlor, *Soc. Indp. Artists.*

SOLOWAY, Reta *[Painter, lecturer] b.1911, Wash., DC.*
Addresses: Elmont, NY. **Studied:** Corcoran School Art, 1922-27; Parsons, 1928-30; Phoenix School Design, 1928-30; PMA Sch., 1931-35; Philadelphia Graphic Sketch, 1935-36; Nat. Acad. School, 1969; New School, 1971; also with Umberto Romano, Thornton Oakley, Henry Pitz, S.G. Schell, Joseph Stefanelli & Eric Isenburger. **Member:** Allied Artists Am. (advisor, 1969-72; asst. corresponding secretary, 1971-73); Nat. Art League (Bulletin editor, 1970-71); Catharine Lorillard Wolfe Art Club; Am. Artists Prof. League; Malverne Artists LI (pres., 1970-71; advisor, 1970-). **Exhibited:** Nat. Art League, 1965-72; Malverne Artists LI, 1965-72; Knickerbocker Artists, 1969; All. A. Am., 1969-72; Catharine Lorillard Wolfe Art Cl.,1972; The Art Mart, Woodmere, NY, 1970s. **Awards:** best in show, Gregory Mus. Inc., 1971; first in oil, Long Beach Open Spring Exhib., 1971; first in oil, Malverne Artists 28th Open Exhib., 1972. **Work:** Gregory Mus., Hicksville, LI. Commissions: portraits, Major Gen. Arthur Gaines, Denver, CO, 1970 & Dean Emer., Charles Smythe, Pennington Prep. School, 1971. **Comments:** Preferred media: oils. Publications: contributor, "Portrait in Occupational Therapy," 1946 & "Portrait of the World," 1965. Teaching: instructor of painting, Re-Art Studio, Elmont, NY, 1966-; demonstrator, Nat. Arts Club, Malverne Library, 1970-; IPA Nat. Convention, Washington, DC, 1972. **Sources:** WW73.

SOLOWEY, Ben *[Painter, sculptor] b.1900, Warsaw, Poland / d.1978.*
Addresses: Bedminster, Phila., PA; NYC, 1935; Bucks County, PA, 1942. **Studied:** Graphic Sketch Club, Philadelphia, PA; PAFA. **Member:** AEA; Allentown Art Mus; AWCS; fellowship PAFA; Phila. WCC; Woodmere Art Gallery. **Exhibited:** NAD; PAFA Ann., 1922, 1927-28, 1935; PAFA,1932, 1936, 1938, 1954 (gold medal); Salons of Am., 1934; AIC,1936, 1937, 1939; AWCS, 1934, 1936; Wilmington (DE) Soc. Fine Arts; Woodmere Art Gal., Philadelphia, 1970 (sculpture award); Phila. WCC (medal); Allentown (PA) Art Mus. Drawing Award, 1971. **Work:** Portraits in Phila. General Hospital, Kensington Hospital, Phila. Board Education & Pennsylvania School Soc. Works, University Pennsylvania, all in Phila. **Comments:** Painted portraits of many theatrical personalities, but his favorite subject was his wife, Rae. Teaching: drawing instructor, New Hope (PA) FA Workshop; Phila. Mus. College Art, 1957-59; PAFA. **Sources:** WW73; WW47; Erika J. Smith, "The Visual Heritage of Bucks County," *American Art Review,* December, 1998; Falk, *Exh. Record Series.*

SOLTMANN, H. *[Painter] late 19th c.*
Addresses: NYC, 1869. **Exhibited:** NAD, 1869. **Sources:** Naylor, *NAD.*

SOLWAY, Carl E. *[Art dealer] b.1935, Chicago, IL.*
Addresses: Cincinnati, OH. **Member:** Art Dealers Assn Am. **Comments:** Positions: director, Carl Solway Gallery. Specialty of gallery: twentieth century American and European painting, sculpture and graphics; urban environment and wall projects; Eye Editions, publisher of graphic works by John Cage, Richard Hamilton and Nancy Graves. **Sources:** WW73.

SOMERBY, Frederic Thomas *[Portrait and fancy painter] b.1814, Newburyport, MA / d.After 1870.*

Addresses: Boston, c.1834-70. **Comments:** He is said to have painted a a "deception" (probably a trompe l'œil) in oils on wood as early as 1832. The Somerby family also included Horatio G. and Lorenzo. Frederic was listed as a portrait painter in 1838-39, an artist 1841-44, and a fancy painter from 1845-70 after which his name disappears from the directories. **Sources:** G&W; *Vital Records of Newburyport;* Lipman and Winchester, 180; Boston CD 1838-70.

SOMERBY, Horatio Gates *[Fancy painter]* b.1805, Newburyport, MA.
Addresses: Boston, 1834 -1840's. **Comments:** He was an older brother of Frederic T. and Lorenzo Somerby (see entries). **Sources:** G&W; *Vital Records of Newburyport;* Boston CD 1834+.

SOMERBY, Lorenzo *[Portrait and banner painter]* b.1816, Newburyport, MA / d.1883, Boston.
Addresses: Boston, 1838-83. **Comments:** He was the younger brother of Frederic T. and Horatio G. Somerby (see entries). The Somerby family moved to Boston about 1834. In his early days he did some portraits and from about 1870 he was known as a banner painter. **Sources:** G&W; Sears, *Some American Primitives,* (repro.), 109-10; *Vital Records of Newburyport;* Boston CD 1838-1883 [date of death in 1883 CD].

SOMEREST, Frances M(ack) *[Painter]* mid 20th c.
Addresses: Active in NYC, c.1921-23. **Member:** S. Indp. A. **Exhibited:** S. Indp. A., 1920-23. **Sources:** WW25.

SOMERS, Helene *[Painter]* mid 20th c.
Exhibited: Salons of Am., 1928. **Sources:** Marlor, *Salons of Am.*

SOMERSET, Frances M(ack) *[Painter]* d.c.1924.
Exhibited: Salons of Am., 1922, 1923. **Sources:** Marlor, *Salons of Am.*

SOMERVELL, Marbury W. *[Etcher]* b.1873, Wash., DC / d.1939, Paris, France.
Addresses: Seattle, WA; Los Angeles, CA, 1925. **Studied:** Cornell Univ.; Academy of FA, Florence, Italy. **Member:** Calif. SE. **Exhibited:** Los Angeles Public Lib. **Comments:** Position: arch., NYC, Vancouver, Seattle; pres., Somervell & Putnam, arch. **Sources:** WW17; Hughes, *Artists in California,* 525.

SOMERVILLE, Howard *[Illustrator]* 19th c.
Addresses: Brooklyn, NY. **Comments:** Affiliated with Brooklyn *Life.* **Sources:** WW98.

SOMERVILLE, M. *[Miniature and watercolor painter]* mid 19th c.
Addresses: NYC, active 1841. **Exhibited:** Apollo Assoc., 1841 (miniature of Lord Byron and watercolors entitled "Adoration" and "Parthenon."). **Sources:** G&W; Cowdrey, AA & AAU.

SOMERVILLE, Matt See: **MORGAN, Matthew Somerville**

SOMKIN, Ida *[Painter]* mid 20th c.
Addresses: NYC. **Studied:** Newark School Industrial Art, 1923-26; abstract painting with Morris Kantor at ASL. **Exhibited:** Newark Art Mus.; Nat. Art Gal., Wash., DC; Allan Stone Gal., 1977; "NYC WPA Art" at Parsons School Design, 1977. **Comments:** After her studies, Somkin worked in advertising, scenic art, murals and portraits. She also worked on the WPA Mural Project, 1935-37, as well as the Easel Project. **Sources:** *New York City WPA Art,* 82 (w/repros.).

SOMMARIJA, Marie *[Painter]* mid 20th c.
Exhibited: Salons of Am., 1934. **Sources:** Marlor, *Salons of Am.*

SOMMER, A. Evelyn *[Painter, graphic artist, teacher, designer, writer, lecturer]* mid 20th c.; b.Jersey City, NJ.
Addresses: Baltimore, MD. **Studied:** Maryland Inst.; Johns Hopkins Univ. (B.S.); Teachers College, Columbia Univ. (M.A.); Woodstock, NY; Provincetown, MA, and with Albert Heckman, Emil Ganso. **Member:** AAPL; Am. Artists Congress; AEA; Nat. Art Educ. Assn.; Eastern AA; CAA; Nat. Educ. Assn. **Exhibited:** BMA annually; Chesapeake Club, Balt., MD; Maryland Inst., 1939. **Comments:** Positions: instructor, Maryland Inst. Day School, 1927-29; Balt. Pub. Sch., 1931-; Eastern H.S., 1932-46; instructor, painting, in art curriculum under Carnegie Grant, Eastern H.S., Baltimore, MD. **Sources:** WW59; WW47.

SOMMER, Charles A. *[Painter]* late 19th c.
Addresses: NYC, 1863-71. **Exhibited:** NAD, 1863-71. **Sources:** Naylor, *NAD.*

SOMMER, Edwin G. *[Painter, illustrator, designer, craftsperson]* b.1899, Roseville, NJ.
Addresses: Macedonia, OH. **Studied:** W. Sommer. **Exhibited:** CMA, 1923 (prizes), 1924 (prize). **Work:** CMA; Cleveland Pub. Sch. **Sources:** WW40.

SOMMER, Emmy (Mrs.) *[Craftsperson, painter, teacher]* b.1878, Copenhagen, Denmark.
Addresses: Woodside Park, MD. **Studied:** Royal Danish Art Acad., Copenhagen; Manufacture Nationale des Gobelin, Paris. **Member:** Wash. Handicraft Guild; Wash. Soc.Arts & Crafts. **Exhibited:** tapestries, Italy, France, Germany, England. **Work:** supervised restoration of 16th-century tapestries, Corcoran Gal. **Sources:** WW40; McMahan, *Artists of Washington, DC.*

SOMMER, Frederick *[Photographer]* b.1905, Angri, Italy / d.1999.
Addresses: Tucson, AZ (1985). **Studied:** Cornell, 1927 (landscape architecture). **Exhibited:** Santa Barbara MA, 1946; Chicago Inst. Des., 1957; Pasadena AM; Phila. College Art. **Work:** AIC; FMA; IMP; MoMA, Univ. New Mexico; Center Creative Photography, Tucson. **Comments:** Surrealist, sometimes nightmarish, photographer of assemblages and collages, beginning 1935. **Sources:** Witkin & London, 239; Trenton, ed. *Independent Spirits,* 148.

SOMMER, Julius G. *[Painter, illustrator]* early 20th c.
Addresses: NYC. **Studied:** ASL. **Member:** AI Graphic Artists. **Exhibited:** S. Indp. A., 1917. **Comments:** Position: affiliated with *To-day's* magazine. **Sources:** WW25.

SOMMER, Lillian M. *[Painter]* early 20th c.
Addresses: NYC. **Exhibited:** S. Indp. A., 1917. **Sources:** Marlor, *Soc. Indp. Artists.*

SOMMER, Otto *[Landscape painter]* mid 19th c.
Addresses: Active in 1860s in NJ and NY; 1870s in Europe. **Exhibited:** NAD, 1862-66. **Work:** Los Angeles Athletic Club (as Otto Sommer); U.S. Capitol (as Sommers); New Jersey Hist. Soc. (as Otto Sommer); Harmsen collection (as A. Sommers, active 1850s if the same artist). **Comments:** Samuels report that it is unclear whether Otto Sommer, Otto Sommers, and A. Sommers are one and the same artist. Paintings include "Westward Ho!," and New England and European landscapes. **Sources:** P&H Samuels, 455.

SOMMER, Verna Lee *[Painter]* 20th c.
Addresses: NYC. **Member:** Lg. AA. **Sources:** WW24.

SOMMER, William *[Painter, decorator]* b.1867, Detroit, MI / d.1949, Cleveland, OH.
Addresses: Macedonia, OH. **Studied:** Acad. Art, Munich, Germany; with J. Melchers; L. Schmidt; J. Herterich in Munich. **Member:** Cleveland SA; Ko-Koon AC. **Exhibited:** Great Art Loan, 1883; AIC, 1931(prize); Great Lakes Exhibit, Detroit, MI 1939; CMA, 1924 (prize), 1927 (prize), 1929 (prize), 1932 (prize), 1935 (prize), 1939 (prize), 1941 (prize), 1942 (prize), 1943 (prize), 1945 (prize); MoMA, 1933; WMAA, 1933-34, 1937; AFA Traveling Exhib. 1933-34; CMA, 1922-46; Tate Mus., London, 1946; Butler AI; Akron AI; 1930 Gal., Cleveland, 1944-46. **Work:** CMA; AIC; Akron AI; Univ. Minnesota; Oberlin Mus.; BM; City of Cleveland Collection; murals, Cleveland Pub. Lib.; USPO, Geneva, Ohio.WPA artist. **Sources:** WW53; WW47.

SOMMERBURG, Miriam *[Painter, sculptor]* b.1910, Hamburg, Germany / d.1980.

Addresses: NYC. **Studied:** sculpture with Richard Luksch, Ger & design with Friedrich Adler, Germany. **Member:** Audubon Artists (sculpture jury, 1968); Am. Assn. Contemp. Artists; NAWA (sculpture jury, 1962-65; graphics jury, 1966-69); Print Council Am.; AFA. **Exhibited:** PAFA Ann., 1954, 1966; Exhibs, Edinburgh, Scotland, 1963, Birmingham, Eng., 1964, Mus. Cognac, Cannes, France, 1965-1966; New Delhi, Bombay & Calcutta, India, 1965-66 & Palazzo Vecchio, Florence & Pompeiian Pavilo, Naples, Italy, 1972. Awards: First, second & third prizes for sculpture & graphics, Village AC, 1946-60; Member's Award For Sculpture, NAWA, 1961; Medal For Creative Sculpture, Audubon Artists, 1966. **Work:** MMA; Butler IA, Youngstown, OH; Springfield (MO) Mus.; Norfolk (VA) Mus. **Comments:** Preferred media: wood, stone, stained glass. Positions: life fellow, Intercontinental Biog. Assn., England, 1972. **Sources:** WW73; Joseph L. Young, *Mosaics, Principles & Practice* (Van Nostrand Reinhold, 1963); Carlo E. Bugatti, *Enciclopedia Internazionale Degli Artisti* (1971); Falk, *Exh. Record Series.*

SOMMERFELD, William F. *[Painter] mid 20th c.*
Addresses: NYC. **Exhibited:** PAFA Ann., 1941, 1946. **Sources:** Falk, *Exh. Record Series.*

SOMMERS, A. See: **SOMMER, Otto**

SOMMERS, Alice (Mrs.) See: **DECKER, Alice**

SOMMERS, Caroline A. *[Painter] mid 20th c.*
Exhibited: S. Indp. A., 1938, 1940. **Sources:** Marlor, *Soc. Indp. Artists.*

SOMMERS, Otto See: **SOMMER, Otto**

SON, Sara F. *[Painter] late 19th c.*
Addresses: Utica, NY, 1899. **Exhibited:** NAD, 1899. **Comments:** Naylor, *NAD.*

SONDAG, Alphonse Emile *[Painter, mural painter, sculptor] b.1874, Paris, France / d.1971, Santa Rosa, CA.*
Addresses: San Francisco, CA; Honululu, HI; Fruitvale, CA; Santa Rosa, CA. **Studied:** École des Beaux-Arts, Paris, three years; Spain, one year; Mark Hopkins Inst., San Francisco. **Exhibited:** CPLH; Oakland Art Gallery; GGE, 1939; Sonoma County Lib., Santa Rosa, 1976 (memorial). **Work:** Soc. of Calif. Pioneers; Oakland Mus.; San Rafael, CA, Mission; Mendocino County Mus.; Calif. State Lib.; Sonora Chamber of Commerce; Eureka, Ukiah, San Rafael courthouses, CA. **Comments:** He grew up in San Francisco, but returned to Europe at age 17 to study art. After serving in WWI he was an active member of the San Francisco art community. Although best known for his California missions, adobes and scenes of historical spots, Sondag's work also includes scenes of Honululu and Europe. **Sources:** Hughes, *Artists in California, 525.*

SONDAG, Lauretta *[Painter, teacher] b.1900, Covington, KY / d.1930, Philadelphia, PA.*
Addresses: Seattle, WA. **Studied:** AIC; ASL; with John Horton, John Carroll. Tiffany Foundation Scholarship. **Member:** ASL. **Exhibited:** Side Galleries, Philadelphia; Anderson Galleries, NYC; AIC; CGA; SAM, memorial exhib.; Frederick & Nelson, Little Gallery, 1939. **Comments:** Position: teacher, Seattle Pub. Sch.; teacher, AIC. **Sources:** Trip and Cook, *Washington State Art and Artists.*

SONDERMANN, Mary Albertine (Sister) See: **SISTER MARY ALBERTINE**

SONDHEIMER, Rosalee (Mrs. Bertrand W. Cohn) *[Sculptor] b.1910.*
Addresses: NYC; Memphis, TN. **Studied:** G. Lober; Grand Central Sch. Art; École d'Art; A. Archipenko. **Member:** NAWPS; Tennessee SA; Southern AA. **Exhibited:** PAFA Ann., 1933-34; Salons of Am., 1934; AIC; S. Indp. A., 1935. **Comments:** Also known as Rosalee Cohn. **Sources:** WW40; Falk, *Exh. Record Series.*

SONDIN, Julian *[Printmaker] mid 20th c.*
Addresses: Chicago area. **Exhibited:** AIC, 1947, 1951. **Sources:** Falk, *AIC.*

SONED, Warren *[Painter, sculptor, designer, teacher, etcher, lecturer] b.1911, Berlin, Germany / d.1966, Miami, FL.*
Addresses: Brooklyn, NY; Miami Beach, FL. **Studied:** FA Acad., Düsseldorf, Germany; École des Beaux-Arts, Grande Chaumière, Paris, France; Univ. Miami (B.A.). **Member:** Mural Artists Gld., Soc. Indep. Artists; "Lead & Ink" (hon.), Nat. Journalistic Fraternity, Univ. Miami; Florida Art Teachers Assn.; United Scenic Artists (hon. mem.); Miami Art Lg. (hon. mem.); F.I.A.L. **Exhibited:** Soc. Indep. Artists; Army Art Exhib., 1945 (prize); Lowe Gal., Univ. Miami, 1949-195?; Art Dir. Club, Miami, 1953 (prize and silver medal). Award: Best Trade Magazine adv., 1953. **Work:** designed covers of Univ. Miami Yearbook, 1949-51 (won All-Am. Intercollegiate award for Des.); bas-reliefs, Broad Causeway, Bay Harbor, FL; murals, USPO, Hapeville, GA; NY Telephone Bldg.; Pildes Optical Co., NY; Barbizon School Fashion Modeling, NY; Walter Reed Hospital, Wash., DC; Tides Hotel, Miami Beach; Biscayne Osteopathic Hospital, Miami; North Miami Beach Clinic; Bible Baptist Church, North Miami; Bayfront Clinic, Miami; Veteran's Admin., NY; bas relief mural, Mem. Hall, Temple Beth El, Hollywood, FL; glass murals, interiors, exteriors, sculptures, etc. in many clubs, restaurants, homes, offices and public bldgs., in U.S. and abroad. Exteriors: Hebrew Acad., Miami Beach; interiors & murals; Palm Springs (FL) Lanes; offices for Air France, Miami and Caribbean. **Comments:** Positions: founder/director, Art Unlimited Art Sch., 1952-; instructor, Art Dept., Univ. Miami; instructor, art consultant, Dade County Schools, 1957-58. Designer of shows for Jewish Folk Art Theatre. WPA artist. **Sources:** WW66; WW47.

SONENBERG, Jack *[Painter] b.1925, Toronto, Ontario.*
Addresses: NYC. **Studied:** Ontario College Art, Toronto; NY Univ.; Wash. Univ. (B.F.A.). **Exhibited:** PAFA Ann., 1957; Contemp. Am. Painting & Sculpture, Krannert Art Mus., 1963; Art in Process, Finch College Mus., New York, 1965; Fourth Int. Japan Cultural Forum, Tokyo, 1967; WMAA Painting Ann., 1967; Brooke Alexander, NYC, 1970s. Awards: first prize for painting, 13th New England Ann., 1962; premio, Fourth Am. Print Biennial, Chile, 1970. **Work:** Guggenheim Mus.; WMAA; MMA; Nat. Gal. Can, Ottawa. Commissions: steel wall construction, Ciba-Geigy Corp., Ardsley, NY, 1971. **Comments:** Positions: Ford Foundation & AFA artists-in-residence grant, Hampton Inst., 1966. Teaching: instructor, painting & printmaking, School Visual Arts, New York, 1964-; instructor, painting & printmaking, Pratt Inst., 1968-. **Sources:** WW73; Falk, *Exh. Record Series.*

SONFIST, Alan *[Painter] b.1946, NYC.*
Addresses: NYC. **Studied:** Western Illinois Univ.; Pratt Inst.; Hunter College (M.A.). **Exhibited:** Reese Palley, New York, 1970 (solo); Boston Elements Show, Mus. Fine Arts, 1971; Stedijk Mus., Holland, 1971; Harcus Karkow, Boston, 1971. **Comments:** Teaching: professor, Montclair State College, 1970-71. **Sources:** WW73; Gracie Gliuck, "Nature Artists," *New York Times,* November, 1970; Cindy Nemser, "Sonfist-Phenomenist," *Art in Am.* (March, 1971); Benthall, "Sonfist & Haague," *Studio In* (June, 1971).

SON LINDING, Herman M. See: **LINDING, Herman M(agnuson)**

SONMAN, Carl *[Painter] mid 20th c.*
Exhibited: Salons of Am. 1927, 1934; S. Indp. A., 1927, 1928, 1930-31. **Sources:** Falk, *Exhibition Record Series.*

SONN, Albert H. *[Painter, illustrator] b.1867, Newark / d.1936, NYC.*
Addresses: Newark, NJ. **Studied:** NAD; CUA School. **Member:** SC, 1900; AWCS; Artists Fund Soc.; NYWCC; AFA; AAPL. **Exhibited:** AIC, 1909-10, 1915, 1918. **Comments:** Author: "Early American Wrought Iron." Position: head artist, Am. Lithograph Co. **Sources:** WW33.

SONNECK, S. *[Painter] early 20th c.*
Addresses: NYC. **Member:** S. Indp. A. **Exhibited:** S. Indp. A., 1921. **Sources:** WW21.

SONNENBERG, Benjamin (Mr. & Mrs.) *[Collectors] 20th c.*
Addresses: NYC. **Comments:** Collection: ancient art, ethnographica. **Sources:** WW73.

SONNENBURG, Jack *[Artist] b.1925.*
Addresses: NYC. **Exhibited:** WMAA, 1967, 1973. **Sources:** Falk, *WMAA*.

SONNENSCHEIN, Edward *[Patron] b.1881 / d.1935, Chicago.*
Comments: His famous collection of Chinese jade assembled during his travels made him recognized as one of the foremost authorities on his subject. Pieces from his collection were constantly on loan in museums and exhibitions.

SONNESCHEIN, Hugo, Jr *[Patron, art historian] b.1917, Chicago, IL.*
Addresses: Chicago, IL. **Studied:** Swarthmore College; Lake Forest College (B.A.); Univ. Virginia (L.L.B. & J.D.); John Marshall Law School, Chicago (L.L.M.). **Member:** AIC (life mem.); MoMA; Soc. Contemporary Art. **Comments:** Positions: editor, *Chicago Bar Rec.,* 1950-66; trustee, Lake Forest College, 1969-. Research: prints and drawings; legal art. Art interests: donor, Sonnenschein Collection to Lake Forest College & Lake Forest Acad. **Sources:** WW73.

SONNICHSEN, Yngvar *[Landscape, portrait and mural painter, etcher, designer, teacher] b.c.1873, Christiania (now Oslo), Norway / d.1938, Seattle, WA.*
Addresses: Seattle, WA, 1908-38. **Studied:** Polytech. Inst., Norway, 1894; Royal Acad., Antwerp and Brussels; Académie Julian, with Bouguereau, Constant, 1895-99. **Member:** SAM; Puget Sound Group of NW Painters. **Exhibited:** Norway, 1900-04; Int. Exhib., St. John, NB, Canada, 1906 (prize); Alaska Yukon Pacific Expo, 1909; Northwest Artists Annual Exhib., Seattle, 1920 (prize); S. Indp. A., 1931. **Work:** dec., Norway Hall, Seattle; Mun. Galleries, Christiania, Arendal, Laurvik, all in Norway; Freemasons' Lodge, St. John, NB; Vanderpoel AA, Chicago; Norwegian Club, Brooklyn, NY; Norwegian-Am. Hist. Mus., Decorah, IA; Tower Hotel, Bellingham; County Hospital, Seattle; Monroe Soldiers' Home, Orting; Seaman's Mission, Seattle. **Comments:** Contributor: articles on fine arts, *Western Viking* (Tacoma), *Washington Post* (Seattle). Specialty: landscapes of southeast Alaska. **Sources:** WW38; P&H Samuels, 455.

SONNIER, Keith *[Video artist] b.1941.*
Addresses: NYC. **Exhibited:** WMAA, 1970, 1973, 1977. **Sources:** Falk, *WMAA*.

SONNTAG, William Louis Jr. *[Sketch artist, painter] b.1869, NYC / d.1898.*
Addresses: NYC, 1888-90; New Orleans, active 1894. **Member:** AWCS. **Exhibited:** NAD, 1888-90; Boston AC, 1891, 1892, 1895; AWCS, 1898; AIC. **Comments:** Son of William Louis Sonntag, Sr. **Sources:** WW98; *Encyclopaedia of New Orleans Artists,* 360; Falk, *Exh. Record Series.*

SONNTAG, William Louis
[Landscape painter] b.1822, East Liberty, Pittsburgh, PA / d.1900, NYC.

W·L·Sonntag

Addresses: Cincinnati, c.1842-55; Italy, 1855-56; NYC, 1857-1900. **Studied:** believed to have been a pupil of G. Frankenstein at the Cincinnati Acad. FA, early 1840s; visited Europe in 1853 and Florence, Italy, 1855-56. **Member:** ANA, 1860; NA (1861-); AWCS; Artists Fund Soc.; Am. Art Union. **Exhibited:** PAFA Ann., 1853-69, 1876-80, 1887-89; NAD, 1861-1900; Brooklyn AA, 1862-86, 1891; Phila. AC; AWCS; AIC; Boston AC; Omaha Expo, 1898. **Work:** NMAA; CGA; Peabody Institute; Berkshire Mus.; Brooklyn Mus; Chrysler Mus., Norfolk, VA (Massanutten Mountain on the Shenandoah River); Fogg Mus.; Harvard Univ.; Vassar College Art Gallery; Cincinnati AM. **Comments:** One of the central figures of the Hudson River School. His early landscapes were made on painting excursions from Cincinnati into the Ohio River Valley, Kentucky, and West Virginia (1856 and 1859). He also collaborated with John C. Wolfe on a large panorama of Milton's *Paradise Lost* and *Paradise Regained.* After his return from Europe in 1857 he settled in NYC, exhibited extensively, and became known for his romantic American and Italian landscapes. His painting "The Blue Ridge from Near Luray" was engraved by R. Hinshelwood and published in the *Ladies Repository,* 1869. He was the father of William Louis Sonntag, Jr. (see entry). **Sources:** G&W; WW98; *Art Annual,* II, obit.; CAB; Clement and Hutton; Cist, *Cincinnati in 1851;* Ohio BD 1853; Cowdrey, NAD; Cowdrey, AA & AAU; Rutledge, PA; Rutledge, MHS; Swan, BA; N.Y. *Herald,* May 5, 1851; Clark, *Ohio Art and Artists,* 78, repro.; *Art in America* (Oct. 1951), 104, repro.; *Encyclopaedia of New Orleans Artists,* 360; Campbell, *New Hampshire Scenery,* 154-157; *300 Years of American Art,* vol. 1, 195; *Cincinnati Painters of the Golden Age,* 103-104 (w/illus.); Wright, *Artists in Virgina Before 1900;* Falk, *Exh. Record Series.*

SONREL, Antoine *[Engraver, lithographer and photographer] d.1879, Woburn, MA.*
Addresses: Woburn, MA, 1853-56. **Comments:** In 1833 Sonrel joined the naturalist's Louis Agassiz artistic and scientific colony in Neufchatel, Switzerland as part of the team of artists who illustrated Agassiz's findings. He was producing exquisite and highly detailed lithographs. In 1848 he followed Agassiz to Cambridge, opening his own firm in 1850. He also made drawings of insects which were engraved for *A Treatise on Some of the Insects Injurious to Vegetation* (Boston, 1862). In the 1860's he gave up lithography in order to become a photographer. **Sources:** G&W; Mass. BD 1853; New England BD 1856; Hamilton, *Early American Book Illustrators and Wood Engravers,* 401. More recently, see Pierce & Slautterback, 180-81.

SONTAG, William Louis See: **SONNTAG, William Louis**

SOOK, Robert J. *[Sculptor] early 20th c.*
Addresses: Phila., PA. **Exhibited:** PAFA Ann., 1917. **Sources:** WW17; Falk, *Exh. Record Series.*

SOOP, Charles William *[Painter] mid 20th c.*
Addresses: Georgetown, MD. **Exhibited:** S. Indp. A., 1926-27, 1936-39, 1944. **Sources:** Marlor, *Soc. Indp. Artists.*

SOOTS, C. *[Painter] mid 20th c.*
Addresses: Astoria, LI, NY. **Exhibited:** S. Indp. A., 1934. **Sources:** Marlor, *Soc. Indp. Artists.*

SOOY, Louise Pin(c)kney *[Painter, decorator, lecturer, writer, teacher] b.1889, Blairstown, IA / d.1965, Torrance, CA.*
Addresses: Los Angeles, CA. **Studied:** Minneapolis School FA; Teachers College, Columbia Univ.; Arthur W. Dow. **Member:** Univ. California AA; California ATA; California WCS; Pacific AA; P&S of Los Angeles; The Seven, 1929 (a founder). **Exhibited:** Oakland, CA, 1929; Los Angeles, San Francisco; Minneapolis; Honolulu. **Work:** Oakland Mus. **Comments:** Position: chairman of art dept., UCLA; chairman of art dept., Univ. Hawaii; instructor, Teachers College, NY. Editor: "Art and Education." Lectures: "Interior Decoration"; "Costumes." Author: "Plan Your Own Home," 1940. Co-author: "Early California Costumes," 1932. **Sources:** WW40; Ness & Orwig, *Iowa Artists of the First Hundred Years,* 194; Hughes, *Artists in California,* 525; Petteys, *Dictionary of Women Artists,* cites alternate birth date of 1885.

SOPER, James See: **GARDNER-SOPER, James H(amlin)**

SOPER, Richard F. *[Stipple engraver] b.c.1810, England / d.c.1862.*
Addresses: NYC, 1831 and after. **Comments:** He was working for NYC publishers as early as 1831, according to Stauffer, and later worked mainly for J.C. Buttre. His widow, Isabella Soper, was listed in the 1863 directory. **Sources:** G&W; 8 Census

(1860), N.Y., XLIII, 625; Stauffer; NYCD 1863.

SOPHER, Aaron *[Illustrator, cartoonist, painter, educator]*
b.1905, Baltimore, MD / d.1972, *Aaron Sopher*
Baltimore, MD. *59*
Addresses: Baltimore, MD.
Studied: Baltimore Polytechnic Inst.; Maryland Inst; Alon
Bement. **Member:** Baltimore Art Union; Baltimore Art Gld.; Am.
Artists Congress; AEA. **Exhibited:** BMA,1934 (prize), 1940-46
(prizes, 1943 & 1946), 1991 (solo); Print Club, 1936 (prize);
Phillips Mem. Gallery Studio House, Wash., DC, 1937 (solo show
of drawings); AIC, 1938, 1940, 1942; Brooklyn M, 1941;
WMAA, 1942; LOC, 1943, 1945; CI, 1943; Albany Inst. Hist. &
Art, 1943, 1945 ; NAD, 1945-46; CGA 1953 (prize); Butler IA,
1960-61; Peale Mus., 1964 (prize). Awards: prizes, *Balt. Evening
Sun,* 1931, 1933, 1943, 1945. **Work:** WMAA; PMG; BM;
Dumbarton Oaks Collection; BMA; Edward Bruce Mem.
Collection; Cone Collection, Balt.; Nelson Gutman Collection,
Balt.; AGAA; Walters Art Gal., Baltimore. **Comments:** Like
Norman Rockwell, Sopher was an illustrator of the American
Scene, but with a more critical eye. With a mixture of biting
satire, compassion, humor, and subtle observation, Sopher chroni-
cled the human condition for five decades through his drawings,
expressing his concerns for the poor, weak, and defeated, as well
as his enjoyment of everyday characters and encounters.
Illustrator: *Rivers of the Eastern Shore* (1944); portfolio 45 draw-
ings, *Maryland Institutions," (1949);* Princess Mary of Maryland
(1956); *People, People* (poems, 1956). Included in *6 Maryland
Artists* (1955). Contributor: *Baltimore Sun, Harpers, Johns
Hopkins* magazine, *New Yorker, Wall Street Journal,* & other pub-
lications. **Sources:** WW66; WW47; Forbes Watson, *Aaron Sopher*
(1940); Wilbur H. Hunter, Jr., *Aaron Sopher* (1960); Peter
Hastings Falk, *Aaron Sopher, Satirist of the American Condition*
(Madison, CT: Sound View Press, 1991).

SOPHER, Bernhard D. *[Sculptor]* b.1879, Safed, Syria /
d.1949.
Addresses: Hollywood, CA. **Studied:** Royal Acad., Berlin &
Royal Acad., Weimar, Germany, with P. Breuer, A. Brutt.
Exhibited: Acad. Award, Berlin, 1905 (prize); San Diego FA Soc.,
1937 (prize); GGE, 1939; SFMA, 1940, 1945 (prize); PAFA Ann.,
1943; Joslyn Mem., 1943; CAM, 1943; Mus. FA of Houston,
1943; LACMA, 1937; de Young Mem. Mus., 1944. **Work:** Mills
College, Oakland, CA; many German museums. **Comments:**
Articles: German and California newspapers. **Sources:** WW47;
Hughes, *Artists in California,* 525; Falk, *Exh. Record Series.*

SOPHIR, J. (Mrs.) See: **YOUNG, Dorothy O. (Mrs. Jack
J. Sophir)**

SORAVIA, Irene Bianucce (Mrs.) See: **BIANUCCI,
Irene (Mrs. I. Bianucci Soravia)**

SORBY, J. Richard *[Painter, educator]* b.1911, Duluth, MN.
Addresses: Denver, CO; Glen Haven, CO. **Studied:** Univ.
Minnesota; Univ. Northern Colorado (A.B., 1937; M.A., 1951);
AIC; Univ. Americas; Univ. Calif., Los Angeles, with John
Ferren; Univ. Colorado with Jimmy Ernst. **Member:** East Bay AA
(vice-pres., 1967-68); Group 21 (vice-pres., 1972). **Exhibited:**
NGA, 1941; Joslyn Mem., 1941-43, 1945, 1956 (first award &
purchase for Crown of Light, 4th Biennial 10 State Exhib.);
PAFA, 1941; Kansas City AI, 1941. Denver Art Mus. Ann.
Western Artists, 1940-59; Nat. Watercolor Competition, Nat.
Gallery Art, Washington, DC, 1941; First & Second Ann. Rocky
Mountain Nat. Invitational, Utah State Univ., 1957 & 1958;
Northern Calif. Artists Ann., Crocker Art Gallery, Sacramento,
1961-68; First Nat. Exhib. Polymer Paintings, Eastern Michigan
Univ., 1967; Univ. Santa Clara Sullivan-Hickson Fund, 1966 (first
prize for Passing Shadows); 27th Ann., Cedar City, Utah,
1967(first award & purchase for Mountain Steam); Copenhagen
Galleri, Solvang, CA, 1970s. **Work:** Williams Rockhill Nelson
Gallery, Kansas City, MO; Denver (CO) Art Mu.; Joslyn Mem.
Mus. Art, Omaha, NE; Brigham Young Univ.; Rural
Electrification Admin., Washington, DC. Commissions:

Spaulding Mem., Papantla (pyroxylin), Univ. Northern Colorado,
Greeley, 1958. **Comments:** Preferred media: acrylics, watercol-
ors, mixed media. Publications: illustrator, *Lincoln-Mercury
Times,* 1954, *Ford Times,* 1956 & *Empire Magazine, Denver Post,*
1958. Teaching: art instructor, Univ. Nebraska, Lincoln, 1940-42;
assoc. professor painting, School Art, Univ. Denver, 1947-59; pro-
fessor painting & design, Calif. State Univ., San Jose, 1959-72,
emer. professor, 1972-. **Sources:** WW73; WW47; Arneil, "The
Work of Richard Sorby," *Empire Magazine, Denver Post,*
November, 1958; M.L. Stribling, *Painting in Found Materials*
(1971).

SOREL, Edward *[Illustrator, satirist]* b.1929, NYC.
Addresses: NYC. **Studied:** Cooper Union. **Member:** Push Pin
Studio (founding member, 1953). **Comments:** Illustrator:*Esquire*
magazine, in the feature "The Spokesman," and in *Atlantic* for the
features "Unfamiliar Quotations" and "First Encounters," in col-
lab. with his wife. He also did illustrations for *Harper's, Time,
Village Voice,* and *Ramparts.* Auth/illustrator: *How to be
President; Moon Missing; Making the World Safe for Hypocrisy
and Superpen.* Positions: contrib. editor, *New York* magazine.
Sources: W&R Reed, *The Illustrator in America,* 341.

SOREN, John Johnston *[Landscape and marine painter]*
d.1889, Boston.
Addresses: Boston. **Exhibited:** BA, 1831, 1846; Apollo Assoc.,
1841. **Comments:** From about 1826-47 he was teller of the
Washington Bank and from 1848-75 cashier of the Boylston
Bank. **Sources:** G&W; Swan, BA; Cowdrey, AA & AAU;
Boston CD 1826-89.

SORENGER, Ralph C. *[Painter]* early 20th c.
Addresses: Los Angeles, CA. **Studied:** with Jean Mannheim.
Exhibited: Press AA, Los Angeles, 1906. **Sources:** Hughes,
Artists in California, 526.

SORENSEN, Carl Sofus Wilhelm *[Sculptor, painter]*
b.1864, Denmark.
Addresses: Chicago, IL. **Studied:** Acad. FA, Copenhagen; P.S.
Kroyer, Copenhagen. **Exhibited:** AIC, 1896-1913. **Sources:**
WW15.

SORENSEN, Clara Barth Leonard See: **DIEMAN, Clare
Leonard (Mrs. Charles)**

SORENSEN, John Hjelmhof *[Cartoonist]* b.1923,
Copenhagen, Denmark / d.1969.
Addresses: Little Rock, AR. **Studied:** Copenhagen, Denmark.
Member: Nat. Cartoonists Soc. **Exhibited:** Awards: prize,
Arkansas Mus. FA, 1955; Outdoor Advertising Assn. of Am.,
1956, 1957, 1958, 1959, 1963 Dallas-Ft. Worth Art Dirs. Club,
1959. **Comments:** Positions: pres., Sorensen & Associates, Inc.,
Little Rock, AR. Contributor to *Saturday Evening Post, True,
American Weekly, King Features Syndicate, Esquire,
Cosmopolitan, Saturday Review,* and other national magazines.
Cartoons published in Denmark, England, France, Italy,
Switzerland, etc. **Sources:** WW66.

SORENSEN, Katherine *[Painter]* mid 20th c.
Addresses: Whittier, CA, 1930-32. **Exhibited:** Calif. WCS, 1930.
Sources: Hughes, *Artists in California,* 526.

SORENSEN, Olga *[Painter]* mid 20th c.
Addresses: NYC. **Exhibited:** Min. PSG Soc., Wash.,DC, 1935;
Am. Soc. Min. P., 1935; WFNY, 1939. **Sources:** WW40.

SORENSEN, Rex *[Painter, sculptor]* mid 20th c.
Addresses: Los Angeles, CA. **Exhibited:** Scandinavian-American
Art Soc. of the West, 1939; LACMA, 1940. **Work:** Virgil Jr. High
School, Los Angeles, CA. **Sources:** Hughes, *Artists in California,*
526.

SORENSEN-DIEMAN, Clara See: **DIEMAN, Clare
Leonard (Mrs. Charles)**

SORENSON, Poul Boye *[Painter]* mid 20th c.
Addresses: NYC. **Exhibited:** S. Indp. A., 1923. **Sources:**
Marlor, *Soc. Indp. Artists.*

SORGMAN, Mayo *[Teacher, painter, designer, lecturer]* *b.1912, Brockton, MA.*
Addresses: Stamford, CT. **Studied:** Mass. Sch. Art (B.S.); NY Univ. (M.A.); Parsons School Des.; Taos Valley Art Sch.; Kansas City AI. **Member:** Silvermine Gld. Artists; CT WC Soc.; Rockport AA; Eastern AA; Nat. Educ. Assn.; Conn. Teachers Assn. **Exhibited:** Audubon Artists; CAM, 1944; Nelson Gal. Art, 1944; Conn. WCS, 1941-45, 1956, 1958; Rockport AA, 1942, 1955 (solo); Springfield Art Lg., 1941; NGA; Grand Central Art Gal., 1949; Wadsworth Atheneum; Dartmouth College; Riverside Mus.; New Britain Art Mus.; Silvermine Gld. Artists, 1955 (solo)(award), 1956 (Emily Lowe award); AWCS, 1958; Cape Ann Mod. Art, 1957; Audubon Artists; Eleanor Smith Gal., St. Louis (solo); Stamford Mus. (solo). **Comments:** Position: head, art dept., Stamford, CT H.S.; chmn., Cultural Commission, Cape Ann Soc. Mod. Art; director, Conn. AA. **Sources:** WW59; . WW47.

SORIA, Martin Sebastian *[Educator, writer, lecturer, mus consultant]* *b.1911, Berlin, Germany / d.1961.*
Addresses: East Lansing, MI. **Studied:** Univ. Madrid (BA.); Univ. Zurich; Harvard Univ. (M.A., Ph.D.), with Chandler Post, J. Rosenberg, B. Rowland. **Member:** CAA; Renaissance Soc. Am.; Am. Soc. for Aesthetics. **Exhibited:** Awards: Rich scholarship, Harvard Univ., 1940; Bacon Traveling Fellowship, Harvard Univ., 1941; Latin American Travel Grant, Am. Council Learned Soc., 1942; Bollingen Fellowship, 1950, 1955, 1956; Guggenheim Fellowship, 1950; Am. Philosophical Soc. grant, 1951, 1955. **Comments:** Position: instr., Princeton Univ., 1944-46; Mich. State Univ., art dept., 1948-; visiting prof., Columbia Univ., summer, 1951. Author: "The Paintings of Zurbaran," 1953, 2nd ed., 1954; "Agustin Esteve y Goya," 1957; "La pintura del siglo XVI en Sudamerica," 1956; "The Arts and Architecture of Spain, Portugal and their Dominions 1500-1800" (with G. Kubler), 1959; numerous articles in *Art Bulletin, Art Quarterly, Art in America, Gazette des Beaux Arts, Burlington Magazine,* and others. Lectures on Spanish and Latin American Art, especially painting from Greco to Goya; Baroque Art. Graphic art consultant to American and European museums and to the Int. Council Mus. for Conservation of Art Objects. **Sources:** WW59.

SORIA, Paola (Paola Soria Sereni) *[Painter]* *b.1908, Rome, Italy.*
Addresses: NYC. **Studied:** Acad Belle Arti, with Umberto Coromaldi & Carlo Siviero; also with Antonio Fabres & Giacomo Balla; ASL, with Robert Brackman; NAD, with Louis Bosa. **Exhibited:** Fifty American Artists, 1961, 1963 & 1965; AAPL Grand Nat., 1963; NAC; Salmagundi Club; Burr AA, 1970. Awards: Palais des Beaux Arts, 67th Salon, 1951; Prix de Paris, 1964 & 1967. **Work:** Landscape, Norfolk (VA) Mus.; Brandeis Univ. Library, Boston, MA. Commissions: Mr. Lee M. Freidman (portrait), Jewish Hist. Soc. **Comments:** Preferred media: oils. **Sources:** WW73.

SORIANO, Esteban *[Painter, craftsperson, designer, cartoonist, comm a, illustrator]* *b.1900, San Juan, Puerto Rico.*
Addresses: New York 11, NY; Long Island City 4, NY. **Exhibited:** BMA, 1945; CM, 1946; Mus. Natural Hist. (Animals in Art). **Comments:** Illustrator: "Three Times I Bow," 1942; "Illiterary Digest"; "Almanac for New Yorkers," 1937, 1938, 1939. Contributor of cartoons to *New York Tribune, New York World, New York Times, New York Herald-Tribune, Saturday Review, Colliers, Saturday Evening Post, Panama American,* etc. **Sources:** WW59.

SORIANO, Juan *[Painter]* *mid 20th c.*
Exhibited: AIC, 1941-44. **Sources:** Falk, *AIC.*

SORINE, S(avely) *[Painter]* *b.1884, Russia.*
Addresses: NYC/Paris, France. **Studied:** St. Petersburg AFA. **Work:** H.R.H. The Duke of York; Luxembour Museum, Paris. **Sources:** WW27.

SORKIN, Leon *[Painter, teacher]* *b.1914, Phila.*
Addresses: Minneapolis, MN. **Studied:** Minneapolis Inst. Art; R.

Brackman. **Exhibited:** Minnesota State Fair, 1943; Minneapolis IA, 1943-45; St. Paul Art Gal., 1945; Minneapolis Women's Club, 1945. **Work:** Minneapolis IA. **Comments:** Position: teacher, Walker Art Center School, Minneapolis. **Sources:** WW47.

SORKNER, E. *[Painter]* *20th c.*
Addresses: Seattle, WA. **Member:** Seattle FAS. **Sources:** WW15.

SOROE, Charles F. *[Lithographer, printer, pressman]* *b.c.1874, New Orleans, LA / d.1910, New Orleans, LA.*
Addresses: New Orleans, active 1887-1905. **Sources:** *Encyclopaedia of New Orleans Artists,* 360.

SOROE, John F. *[Lithographer, printer]* *early 20th c.*
Addresses: New Orleans, active 1904-24. **Sources:** *Encyclopaedia of New Orleans Artists,* 360.

SOROE, Theodore *[Lithographer, pressman]* *b.1878, New Orleans, LA / d.1909, New Orleans, LA.*
Addresses: New Orleans, active 1899-1905. **Sources:** *Encyclopaedia of New Orleans Artists,* 360.

SORTER, Minnie L. *[Painter]* *20th c.*
Addresses: Minneapolis, MN. **Sources:** WW17.

SORVER, G. P. *[Painter]* *early 20th c.*
Addresses: Phila., PA. **Exhibited:** PAFA Ann., 1904. **Sources:** WW06; Falk, *Exh. Record Series.*

SORVER, J. D. *[Painter]* *late 19th c.*
Addresses: Phila., PA. **Exhibited:** PAFA Ann., 1888. **Sources:** Falk, *Exh. Record Series.*

SORVINO, Gennaro *[Painter]* *mid 20th c.*
Addresses: Brooklyn, NY. **Exhibited:** PAFA Ann., 1925. **Sources:** WW25; Falk, *Exh. Record Series.*

SOSA, Vivencio *[Engraver, painter, photographer]* *b.1876, U.S. A.*
Addresses: New Orleans, active 1910-22. **Sources:** *Encyclopaedia of New Orleans Artists,* 360.

SOSIN, Dorothy Sharpe *[Painter]* *b.1910, Illinois / d.1970, Los Angeles, CA.*
Addresses: Los Angeles, CA. **Exhibited:** Artists Fiesta, Los Angeles, CA, 1931. **Sources:** Hughes, *Artists in California,* 526.

SOSKICE, Roussana (Mrs. Victor) *[Painter]* *early 20th c.*
Addresses: NYC. **Exhibited:** S. Indp. A., 1918-19. **Sources:** Marlor, *Soc. Indp. Artists.*

SOSKIN, Abraham *[Painter]* *mid 20th c.*
Exhibited: S. Indp. A., 1938. **Sources:** Marlor, *Soc. Indp. Artists.*

SOTER, John *[Painter]* *20th c.*
Addresses: Seattle, WA. **Sources:** WW24.

SOTOMAYOR, Antonio *[Painter, mural painter, illustrator, sculptor, caricaturist]* *b.1902, Bolivia, South America / d.1985, San Francisco, CA.*
Addresses: San Francisco, CA. **Studied:** School FA, La Paz, with Adolf Lambert; Mark Hopkins Art Inst. **Member:** San Francisco AA; The Family; Bohemian Club. **Exhibited:** SFMA, 1935; GGE, 1939; San Francisco Art Festival, 1959 (prize). Award of Honor, San Francisco Art Commission, 1978. **Work:** SFMA; Mills College; Pasadena Mus. of Modern Art; San Diego Mus.; Newark Mus.; IBM; Museo de la Plata, Argentina; Hillside Methodist Church, San Mateo; St. Augustine's Roman Catholic Church, Pleasanton, CA; murals, Sonoma Mission Inn, CA; Sharon Bldg., San Francisco; Happy Valley Room, Palace Hotel, San Francisco. **Comments:** Position: instructor, Mills College, Oakland, CA, 1942-43; Calif. School of FA, 1940-50. Illustrator: "Guatemalan Tales," "Man in Nature," "Cartilla Mejicana," "Quetzal Quest" "San Francisco Chronicle." **Sources:** WW40; Hughes, *Artists in California,* 526.

SOTTA, L. (or Mr.) *[Portrait painter and copyist] early 19th c.; b.France.*
Addresses: New Orleans, active 1840, 1842. **Exhibited:** Salon, Paris, 1833, 1838. **Work:** Musée de Versailles. **Comments:** There are some questions relating to this artist's name and gender. Seebold had listed the artist as L. Lotta. The more recent *Encyclopaedia of New Orleans Artists* (1988), however, states that Lotta was a misinterpretation of the name Sotta and identified the artist as simply Mr. Sotta. The slightly earlier *Painting in the South* exhibition catalogue (1983) identified the artist not as Mr. Sotta but as L. Sotta and also described the person as the "only female French portrait painter" working in New Orleans in the early nineteenth century. Benezit also lists L. Sotta, identifying the artist as a French woman and listing the Musée de Versailles as the holder of her "Portrait de Vieilleville." According to New Orleans directories, Sotta occupied space on Chartres St. in 1840 and on St. Louis St. in 1942. **Sources:** G&W; New Orleans CD 1842; Seebold, *Old Louisiana Plantation Homes and Family Trees,* I, 23 (listed as L. Lotta). More recently see *Painting in the South, 1564-1980,* compiled by David S. Bundy (exh. cat., Virginia Mus., Richmond, 1983), 233; *Encyclopaedia of New Orleans Artists;* Bénézit.

SOTTEK, Frank *[Painter, illustrator, etcher, craftsperson]* b.1874, Toledo, OH / d.c.1938.
Addresses: Detroit, MI. **Member:** Toledo Indep. Artists. **Exhibited:** Toledo Fed. Art Societies, 1924 (prize); S. Indp. A., 1930. **Sources:** WW38.

SOTTER, Alice Bennett (Mrs. George W.) *[Craftsman, painter, designer]* b.1883, Pittsburgh, PA / d.c.1967.
Addresses: Holicong, PA. **Studied:** Pittsburgh Sch. Des. for Women; CI. **Member:** Phillips Mill Assn.; Woodmere Art Gal. **Exhibited:** Pittsburgh and Phila., PA; Phillips Mill, New Hope, PA, 1957. **Work:** stained glass windows, Father Coakley Mem. Chapel, Sacred Heart Church, Pittsburgh, PA. **Comments:** Collaborated with husband, George W. Sotter (see entry), in stained glass and decorative work. **Sources:** WW59; WW47.

SOTTER, Elizabeth *[Painter] 20th c.*
Addresses: Pittsburgh, PA. **Member:** Pittsburgh AA. **Sources:** WW21.

SOTTER, George William *[Craftsman, painter]* b.1879, Pittsburg, PA / d.c.1954, Holicong, PA.
Addresses: Holicong, PA. **Studied:** PAFA; & with Henry Keller; William Chase; Anshutz, Redfield, Lathrop. **Member:** Liturgical Art Soc.; Pittsburgh AA; Stained Glass AA; Alliance Phillips Mill Assn.; CAFA. **Exhibited:** PAFA Ann., 1903-25, 1931, 1937; Corcoran Gal biennials, 1912-23 (4 times); San Francisco, 1915 (medal); Pittsburgh AA, 1917 (prize); Pittsburgh Art Soc., 1920 (prize); CAFA, 1921 (prize), 1923 (prize); CI, 1903-25; AIC; Venice, Italy; Toledo, Ohio (solo); Rochester, NY (solo); Pittsburgh, Reading. PA (solo); Bianco Gal., Buckingham, PA, 1993 (retrospective). **Work:** NJ State Mus., Trenton; Reading MA; State College, PA; stained glass: churches in NYC, Pittsburgh (PA), St. Louis (MO), St. Paul (MN), Wheeling (WV), Salt Lake City (UT), Harrisburg (PA), Scranton (PA), Cleveland (OH), Union City (NJ), Doylestown (PA), Cincinnati (OH), Los Angeles (CA), Phila. (PA). **Comments:** He created stained glass windows for many churches, cathedrals and monasteries in his own studio, where he employed approximately 10 craftsmen. He was also noted for his night snow scenes of Buck County, as well as seascapes of Rockport, MA. He married Alice E. Bennett in 1907, and they both studied and painted in Europe on an extended honeymoon trip. Positions: teacher, Carnegie Inst. of Technology; teacher, Phila. School Des. **Sources:** WW53; WW47; *300 Years of American Art,* 757; catalogue raisonné by Bianco Gal. (Buckingham, PA, c.1997); Falk, *Exh. Record Series.*

SOTTOSANTI, Angelo Anthony *[Painter]* b.1917, Williamsport, PA.
Addresses: San Francisco, CA. **Studied:** Beaux Arts Inst., ASL, Da Vinci School, all NYC. **Exhibited:** GGE, 1939; MoMA, 1938; Paul Elder's Gallery, San Francisco, 1940 (solo); CPLH, 1943 (solo); Crocker Mus., Sacramento, 1948 (solo); Maxwell Galleries, 1956 (solo); SFMA, 1958; Calif. State Fair, 1960; San Francisco Art Festival, 1976; Am. Savings & Loan, San Francisco, 1984 (solo); Roos Atkins Gallery, San Francisco, 1929 (solo). **Work:** San Francisco General Hospital. **Comments:** He assisted Diego Rivera (see entry) on murals for the GGE. **Sources:** Hughes, *Artists in California,* 526.

SOUBY, Edward J. *[Sketch artist, photographer]* b.1844, Louisiana / d.1907, New Orleans, LA.
Addresses: New Orleans, active 1880-84. **Sources:** *Encyclopaedia of New Orleans Artists,* 361.

SOUCHON, Marion *[Painter]* b.1870, New Orleans, LA.
Addresses: New Orleans, LA. **Member:** SSAL; New Orleans AA; Mississippi AA. **Exhibited:** Corcoran Gal biennial, 1945; CI, 1941; SSAL; New Orleans AA; Mississippi AA. **Sources:** WW53; WW47.

SOUDEIKINE, Sergei Yurievich *[Designer, painter, illustrator, cartoonist, decorator]* b.1886, near Smolensk, Russia / d.1946, Nyack, NY.
Addresses: NYC/Woodstock, NY. **Studied:** Moscow PS School, Imperial Acad., St. Petersburg, Russia; Grand Chaumière, Paris. **Member:** Salon D'Automne; Diaghilev's World of Art; Russian Artists. **Exhibited:** Reinhardt Gal., NY; AIC, 1929-30. **Work:** Luxembourg Mus., Paris; Mus. Leningrad; MoMA; Mordsoff Gal., Girshman Gal., both in Moscow. **Comments:** Positions: set designer, "Porgy and Bess" (Theater Gld.), "Chauve Souris"; art director, Radio City Music Hall. **Sources:** WW40.

SOUDEN, James G *[Educator, painter]* b.1917, Chicago, IL.
Addresses: Los Angeles, CA. **Studied:** AIC; Univ. Arizona (B.F.A. & M.A.); Inst. Design, Illinois Inst. Technology (M.S., art educ.). **Comments:** Teaching: assoc. professor art, Univ. Arizona, 1949-62, acting head art dept., 1962; professor art & dean college, Otis Art Inst., 1962-. **Sources:** WW73.

SOUDER, Bert(ha) Klandrud *[Painter, teacher] mid 20th c.; b.La Crosse, WI.*
Addresses: Mountainside, NJ. **Studied:** La Crosse State College and with Frank LaVanco, Gerald Foster, Joachim Loeber, Maxwell Simpson. **Member:** Westfield AA (pres.); AAPL; AM. Veterans Soc. Artosts; Hunterdon County AC; Plainfield AA. **Exhibited:** NAD, 1956; Silvermine Gld. Artists, 1957; Art: USA, 1958; Springfield Mus. Art, 1957, 1958; Montclair Art Mus., 1955, 1957-58; Newark Mus., 1955, 1958; Hunterdon County AC, 1954-58; AC of the Oranges, 1956-58; Am. Veterans Soc. Artists, 1956-57 (prize), 1961 (bronze medal); Knickerbocker Artists; AAPL; Rahway AC, 1954 (prize); Jersey City Mus.; Westfield AA, 1955 (prize), 1959 (2 prizes), 1964 (prize); Wickersham Gal., NY; Robbins Gal., East Orange, NJ. Other awards: St. John's Exhib., Elizabeth, NJ, 1958; AAPL, 1958, 1959; Patrons Award, South Orange, Art Gal., 1958, 1964; Finalist, Benedictine Award, 1963. **Sources:** WW66.

SOUDER, George B. *[Sketch artist] mid 19th c.*
Comments: Made an on-the-spot drawing of the burning of the U.S. Steam Frigate "Missouri" at Gibraltar on August 26, 1843. It is not known whether Souder was a member of the crew or even an American. **Sources:** G&W; *Military Affairs,* XI (1947), 166, repro.

SOUDER, Mary Rinard *[Painter] 20th c.*
Addresses: San Francisco, CA. **Sources:** WW15.

SOUDIEKIN, C. *[Painter] mid 20th c.*
Addresses: NYC. **Exhibited:** S. Indp. A., 1924. **Sources:** Marlor, *Soc. Indp. Artists.*

SOUFERT *[Cameo portraitist] mid 19th c.*
Addresses: New Orleans, active 1849. **Comments:** Executed a Cameo portrait of General Taylor. Cf. Seifert. **Sources:** G&W; Delgado-WPA cites *Picayune,* Jan. 24, 1849.

SOULE, Charles, Jr. *[Portrait painter]* mid 19th c.
Addresses: Dayton (Ohio), 1859. **Comments:** He was the son of Charles Soule, Sr. **Sources:** G&W; Ohio BD 1859; Clark, *Ohio Art and Artists,* 111.

SOULE, Charles, Sr. *[Portrait and job painter]* b.1809, Freeport, ME / d.1869, Dayton, OH.
Addresses: Cincinnati, 1849-51. **Work:** Dayton Art Inst. (portrait of Benjamin Wickes Mead, 1830; self-portrait). **Comments:** He was brought to Dayton (OH) at the age of two and began painting signs, carriages, etc., there and at Greenfield (OH) in his teens. Orphaned at the age of ten, he went to live with his aunt Eleanor and uncle Joseph Thoits Moore (see entry). At age sixteen he moved to Dayton with Samuel Dolly to work in his carriage works, and Dolly is said to have encouraged him to paint portraits. In 1827 he went into business for himself and married Elizabeth Mead in 1830. He continued as ornamental and portrait painter and had a shop selling painting and framing supplies. He eventually turned to portraits and painted in several Ohio cities in the mid-thirties and later. He subsequently spent several years in NYC, but in 1856 returned to Ohio. He had two daughters and a son who were artists: Clara, Octavia, and Charles Soule, Jr.(see entries). **Sources:** G&W; Clark, *Ohio Art and Artists,* 110-11; Cincinnati CD 1849-5l; Cist, *Cincinnati in 1859; The Museum* (July 1949), 9; Knittle, *Early Ohio Taverns.* Hageman, 92-94.

SOULE, Claire F. *[Painter]* 20th c.
Addresses: South Freeport, ME. **Sources:** WW24.

SOULE, Clara *[Portrait painter]* mid 19th c.
Addresses: Dayton (Ohio), 1859. **Comments:** She was a daughter of Charles Soule, Sr., sister of painters Octavia Soule and Charles Soule, Jr. (see entries); she later married a man named Medlar. **Sources:** G&W; Ohio BD 1859; Clark, *Ohio Art and Artists,* 111.

SOULE, Lucia A. *[Designer]* b.1877, St. Albans, VT.
Addresses: Brookline, MA. **Studied:** Miss Sacker's School of Decorative Design, Boston. **Member:** Boston SAC (Master Craftsman). **Sources:** WW40.

SOULE, Octavia *[Painter in watercolors and on porcelain]* mid 19th c.
Comments: Daughter of Charles Soule, Sr. and sister of painters Clara and Charles Soule, Jr. She later became Mrs. Gottschall. **Sources:** G&W; Clark, *Ohio Art and Artists,* 111.

SOULE, Ruth Brooks (Mrs.) *[Miniature painter]* 20th c.
Addresses: Brooklyn, NY. **Sources:** WW13.

SOULEN, Harvey H. *[Painter]* 20th c.
Addresses: Minneapolis, MN. **Sources:** WW17.

SOULEN, Henry James *[Illustrator]* b.1888, Milwaukee / d.1965. *H. J. Soulen*
Addresses: Phoenixville, PA/Oceanville, ME. **Studied:** ASL, Milwaukee; AIC; H. Pyle. **Comments:** Illustrator: *Saturday Evening Post, Ladies' Home Journal, Country Gentleman.* **Sources:** WW40.

SOULIE, George S. *[Sculptor, painter, commercial artist, decorator]* b.1844, Paris, France / d.c.1910.
Addresses: New Orleans, active c.1872-1910. **Studied:** with his father, in Paris. **Work:** side altars, St.Louis Cathedral, 1873. **Comments:** Immigrated to New Orleans c.1872 from Paris. Received commissions in and around New Orleans and did the decorative figures for the 1873 parade of the carnival organization Comus. His son Henry A. Soulie succeeded him in his practice. **Sources:** *Encyclopaedia of New Orleans Artists,* 361.

SOULNIER, James P. *[Painter]* mid 20th c.
Exhibited: AIC, 1929-30. **Sources:** Falk, *AIC.*

SOUSZ, Merlin *[Painter]* mid 20th c.
Addresses: Clemens, MI. **Exhibited:** PAFA Ann., 1960. **Sources:** Falk, *Exh. Record Series.*

SOUTER, Mary L. *[Painter]* 19th/20th c.
Addresses: Wash., DC. **Comments:** *Cf.* Mary Langhorne Souther. **Sources:** WW13.

SOUTHALL, Joseph *[Painter]* 20th c.
Addresses:. **Exhibited:** AIC. **Sources:** Falk, *AIC.*

SOUTHARD, Frank R. *[Painter]* 20th c.
Addresses: Brooklyn, NY. **Sources:** WW15.

SOUTHER, Francis *[Painter]* mid 20th c.
Exhibited: S. Indp. A., 1941. **Sources:** Marlor, *Soc. Indp. Artists.*

SOUTHER, John K(erfoot) *[Painter]* b.1870, Erie, PA / d.1909, Wash., DC.
Addresses: Wash., DC, 1890s-1909. **Member:** Cosmos Club, 1900-09; Wash. Arts & Crafts Club. **Exhibited:** Corcoran Gal annual, 1908; Soc. Wash. Artists, 1909; PAFA Ann., 1909. **Comments:** Married to Mary Souther (see entry). After his untimely death in 1909 a memorial exhibition and sale of paintings donated by local artists was held in Washington. **Sources:** WW10; McMahan, *Artists of Washington, DC;* Falk, *Exh. Record Series.*

SOUTHER, Lyna Chase (Mrs. Latham T.) *[Painter, sculptor, writer]* b.1880, St. Louis.
Addresses: Springfield, IL. **Studied:** E. Wuerpel; B. Lovatt-Lorski; Klasstorner. **Member:** Springfield AA; Illinois Acad. FA. **Sources:** WW33.

SOUTHER, Mary Langhorne Tayloe *[Painter]* d.1945, Wilmington, DE.
Addresses: Wash., DC, active 1897-1920. **Exhibited:** Wash. WCC, 1897, 1908, 1910. **Comments:** Married to John K. Souther (see entry). **Sources:** WW13; McMahan, *Artists of Washington, DC.*

SOUTHERLAND, Genevieve (Mrs. Robert H.) *[Painter, teacher]* b.1895, East Liberty, PA.
Addresses: Mobile, AL. **Studied:** ASL. **Member:** SSAL; Alabama Art Lg.; Mobile AA; Alabama WCS; Birmgham AC. **Exhibited:** Alabama WCS, 1942-46 (1944, medal; 1946, prize); Mary Buie Mus., Oxford, MS; Tampa AI; Loren Rogers Mus., Laurel, MS; Mississippi AA; Mobile MA; Studio Gld., NY, 1944, 1946; SSAL, 1945; Alabama Art Lg., 1942-45 (prize), 1945-46. **Work:** Montgomery Mus. FA. **Sources:** WW53; WW47.

SOUTHGATE, John Frederick *[Copperplate engraver]* b.1831, Leicester, MA / d.1858, Worcester, MA.
Addresses: Worcester, MA, active 1851-58. **Comments:** His father, John P. Southgate, moved to Worcester about 1834 and John F. was active as an engraver there. **Sources:** G&W; Crane, *Historic Homes and Institutions. of Worcester County,* I, 256; Worcester CD 1851-58; Mass. BD 1853; New England BD 1856.

SOUTHGATE, William *[Portrait and heraldic painter]* b.1782 / d.1811.
Addresses: Leicester, MA. **Comments:** He is said to have received instruction from Ralph Earl (see entry), to whom he was remotely related, and from Gilbert Stuart (see entry). **Sources:** G&W; Crane, *Historic Homes and Institutions. of Worcester County,* I, 255; Bowditch, "Early Water-Color Paintings of New England Coats of Arms," 198.

SOUTHWARD, George *[Portrait and miniature painter]* b.1803, Salem, MA / d.1876, Salem, MA.
Addresses: Salem, MA. **Studied:** J.A. Ames in Boston; Thomas Sully in Phila. **Work:** American Antiquarian Society. **Sources:** G&W; Belknap, *Artists and Craftsmen of Essex County,* 13; Salem BD 1851, 1853, 1855, 1857, 1859, 1861; Bolton, *Miniature Painters;* Brewington, 362.

SOUTHWELL, Owen J. T. *[Painter]* early 20th c.
Addresses: Urbana, IL. **Exhibited:** AIC, 1918. **Comments:** Affiliated with Univ. Illinois, Urbana. **Sources:** WW19.

SOUTHWICK, Albert A. *Albert A. Southwick*
[Painter] early 20th c.

Addresses: NYC. **Studied:** Académie Julian, Paris, 1897.
Member: SC. **Sources:** WW21.

SOUTHWICK, Elsie Whitmore *[Miniature painter] early*
20th c.; b.Providence, RI.
Addresses: NYC/Paris, France. **Studied:** Prinet, Dauchez, Mme.
Chennevieres, all in Paris. **Exhibited:** AIC, 1908. **Work:** Herron
AI, Indianapolis. **Sources:** WW15.

SOUTHWICK, Hammersley W. *[Mural painter, miniature*
painter, cartoonist, decorator, illustrator, teacher] b.1894.
Addresses: NYC. **Work:** over 6,000 drawings and color plates
for Webster's New International Dictionary; magazine covers,
"Home Decorations," "Yacht Decorations"; groups, models, back-
grounds; Coral Reef Group, Rotifer Group, American Mus.
Natural History, NY Comics/Cartoons/Drawings: "New York
Morning World and Evening World." **Comments:** Position: staff
artist, Am. Mus. Natural History, NY. **Sources:** WW40.

SOUTHWICK, Jeanie Lea *[Painter, craftworker, writer]*
b.1853, Worcester, MA.
Addresses: Worcester, MA. **Studied:** ASL; BMFA Sch.; Ross
Sterling Turner; Wm. Merritt Chase; Woodbury; Carmine in Paris.
Member: Boston AC; Worcester Art Mus. **Exhibited:** PAFA
Ann., 1887, 1895-1900; Boston AC, 1892-98; Coronation
Ceremonies, Kyoto, Japan, 1915 (prize); NYWCC. **Comments:**
Position: lecturer and author on the arts of Japan and Java.
Sources: WW40; *Charles Woodbury and His Students;* Falk, *Exh.*
Record Series.

SOUTHWICK, Katherine See: **KEELER, Katherine**
Southwick (Mrs. R. Burton Keeler)

SOUTHWICK, Lawrence Abbold *[Painter] late 19th c.*
Studied: Bouguereau, Ferrier. **Exhibited:** Paris Salon, 1893,
1894. **Sources:** Fink, *American Art at the Nineteenth-Century*
Paris Salons, 392.

SOUTHWICK, Lawrence Abbold (Mrs.) *[Painter] late*
19th c.; b.Buffalo, NY.
Studied: with Bouguereau. **Exhibited:** Paris Salon, 1899.
Sources: Fink, *American Art at the Nineteenth-Century Paris*
Salons, 392.

SOUTHWORTH, Albert Sands *[Daguerreotypist, teacher]*
b.1811, West Fairlee, VT / d.1894, Charlestown, MA.
Addresses: Boston, MA, 1841-on. **Studied:** S.F.B. Morse in
NYC, 1840 (daguerreotype process). **Work:** It is unusual that the
Southworth & Hawes studio collection of 1,500 portraits have sur-
vived; they were bequeathed in the 1930s to the BMFA, MMA,
and Int. Mus. Photography. **Comments:** An important early
daguerreotypist, he formed a partnership with Josiah Johnson
Hawes. From 1843-61, the firm of Southworth & Hawes pho-
tographed all the major literary, political, and artistic notables of
New England. **Sources:** Welling, 209; Newhall, *The*
Daguerreotype in America, 153.

SOUTHWORTH, Ella *[Primitive painter] b.1872, Westbrook,*
CT.
Exhibited: Unknown Am. Painters exhib. **Comments:** Began
painting at age 55. **Sources:** Petteys, *Dictionary of Women*
Artists.

SOUTHWORTH, Fannie B. *[Painter] b.1853 / d.After 1934.*
Exhibited: Boston AC, 1890. **Sources:** *The Boston AC.*

SOUTHWORTH, F(red) W. *[Painter, illustrator] b.1860,*
Ontario, Canada / d.1946.
Addresses: Tacoma, WA. **Studied:** Ontario Sch. of Art; self-
taught. **Member:** Tacoma FAA; North West AA; Chicago Brush
and Palette Club. **Exhibited:** Western Wash. Industrial Expo,
1892; PPE, 1915; Frye Mus., 1916; SAM; Wash. State Hist. Soc.
Work: Ferry Mus., Tacoma; Scottish Rite Cathedral, Tacoma;
YMCA/YWCA, Tacoma; Masonic and Shrine Temples, Tacoma;
Women's Club, Tacoma; Tacoma Pub. Sch.; Joselyn Memorial,
Omaha, NE; Iowa Memorial Union, Univ. Iowa. **Comments:**
Practicing physician who was a prolific painter in his spare time.

Illustrator: *The Mountain,* by Bernice Newell. **Sources:** WW40;
Trip and Cook, *Washington State Art and Artists.*

SOUTHWORTH, Helen McCorkle (Mrs.) *[Painter]*
b.1898, Detroit, MI.
Addresses: Philadelphia, PA. **Studied:** with Justin Pardi, Guy
Wiggins. **Member:** AAPL; Woodmere Art Gal.; AEA; NAWA;
Germantown Art Lg.; Bryn Mawr AC; Phila. Art All.; Phila.
Plastic Club. **Exhibited:** Scranton Art Lg., 1939; Phila. Plastic
Club, 1944-46, 1949 (medal), 1951 (medal), 1953 (prize), 1955
(medal), 1957 (medal), 1958; Woodmere Art Gal., 1942-46, 1948-
52, 1958; Phila. Art All., 1944; Phila. Sketch Club, 1940, 1944,
1945; DaVinci All., 1940, 1943, 1944, 1949-52, 1958; Ogunquit
AC, 1946, 1949, 1950, 1952; Bryn Mawr AC, 1946 (solo); Florida
Southern College, 1952 (prize); Women's City Club, Phila., 1947
(solo); Temple Univ., 1949; Vernon House, Phila., 1954 (solo);
PMA; AAPL. **Work:** Allentown (PA) Mus. Art; Woodmere Art
Gal. **Sources:** WW59; WW47.

SOUTHWORTH, Katherine *[Painter] mid 20th c.*
Exhibited: S. Indp. A., 1944. **Sources:** Marlor, *Soc. Indp. Artists.*

SOUTHWORTH, Nathaniel *[Miniaturist] b.1806, Scituate,*
MA / d.1858, Dorchester, MA.
Addresses: Boston, active1836-48. **Exhibited:** BA; PAFA.
Comments: He went to Europe, and on his return worked chiefly
in NYC and Philadelphia. **Sources:** G&W; CAB; *Scituate Vital*
Records; Swan, BA; Boston BD 1842-50; Rutledge, PA; Bolton,
Miniature Painters.

SOUTHWORTH, Philip M. *[Painter] mid 20th c.*
Addresses: NYC. **Exhibited:** S. Indp. A., 1943-44.

SOUTHWORTH, William, Jr. *[Painter] 19th/20th c.*
Addresses: NYC, 1890. **Exhibited:** NAD, 1890; PAFA Ann.,
1889. **Sources:** Falk, *Exh. Record Series.*

SOUTO, Arturo *[Painter] mid 20th c.*
Exhibited: AIC, 1941-42, 1944. **Sources:** Falk, *AIC.*

SOUVARINE, Joshua S. *[Painter] b.1874, Naples.*
Addresses: Chicago, IL. **Exhibited:** AIC, 1906. **Sources:**
WW08.

SOVEREIGN, Helen See: **BURKHART, Helen**
Sovereign (Mrs. Bruce)

SOVERNS, Louise See: **BRANN, Louise**

SOVETSKI, Bunni *[Sculptor] mid 20th c.*
Addresses: Chicago area. **Exhibited:** AIC, 1951. **Sources:** Falk,
AIC.

SOWER, Caroline A. *[Painter] late 19th c.*
Addresses: Phila., PA, 1885-87; Camden, NJ, 1889. **Exhibited:**
PAFA Ann., 1885, 1887, 1889. **Sources:** Falk, *Exh. Record*
Series.

SOWERBUTTS, Laura G. *[Artist] early 20th c.*
Addresses: Active in Washington, DC, 1917. **Sources:** Petteys,
Dictionary of Women Artists.

SOWERS, Miriam R *[Painter, art dealer] b.1922, Bluffton,*
OH.
Addresses: Albuquerque, NM. **Studied:** Miami Univ.; AIC; Univ.
New Mexico. **Exhibited:** Dayton AI; Butler IA; Akron AI; Ann.
Bible Soc. Gallery, New York (solo); TMA (prizes). **Awards:**
Ouray (CO) Nat. (prize); New Mexico State Fair (prize). **Work:**
Texas A&I Univ.; Houston Baptist College; Lovelace Clinic,
Albuquerque; Int. Arch., London, England; New York World's
Fair. Commissions: many commissioned portraits; stained glass
mural. **Comments:** Preferred media: oils. Positions: owner,
Symbol Gallery Art, 1961-. Specialty of gallery: symbolic por-
traits and figurative landscapes, oils on gold leaf. **Sources:**
WW73; Walter Trimble, "Insight," *Encanto Magazine;* articles,
Albuquerque Tribune, Albuquerque Clubwoman Magazine &
Albuquerque Journal.

SOWERS, Pauline (Mrs. Roy Vernon) See:
SEEBERGER, Pauline Bridge (Mrs. Roy Vernon

Sowers)

SOWINSKI, Jan *[Sculptor, painter]* *b.1885, Opatow, Poland.*
Addresses: Long Island City, NY. **Studied:** BAID; & in Poland.
Member: Modelers & Sculptors of Am. & Canada. **Exhibited:**
BAID (prize). **Work:** theatre & church interiors; murals, St.
Stephen's Church, Paterson, NJ; Trinity Church, Utica, NY; &
others; many medallions, medals, and trophies. **Sources:** WW59;
WW47.

SOWINSKI, S(tanislaus) J(oseph) *[Painter, illustrator, lecturer]* *b.1927, Milwaukee, WI.*
Addresses: Honolulu 18, Hawaii. **Studied:** San Diego Sch. Arts
& Crafts (certificate); San Diego State College (B.A.), and with
Ben Messick, E.A. Boerner, Everett Jackson, Ruth Ball. **Member:**
Laguna Beach AA; La Jolla AA; La Mesa AA. **Exhibited:** Laguna
Beach Art Gal., 1958, 1959 (solo); Calif. State Fair, 1956; La
Mesa AA, 1959 (solo); Artists of Hawaii, 1960, 1961; Laguna Art
Festival, 1960. **Awards:** prizes, So. Calif. Expo., 1953; Calif.
Fiesta, 1955, 1956, 1959; Carlsbad-Oceanside Art Lg., 1954;
Milwaukee, WI, 1945. **Work:** U.S. Navy Dept., Wash., DC.
Comments: Positions: commanding officer, USS Abnaki, 1960-.
Contributed illustrations to *Ford Times, Milwaukee Journal, San
Diego Tribune, Navy Times, All Hands,* and others. Lectures:
water color techniques; Suiboku techniques; oriental art.
Sources: WW66.

SOYER, Bela See: **SOYER, Isaac**

SOYER, Isaac *[Painter,
instructor, lithographer]*
*b.1902, Tombrov, Russia /
d.1981, NYC.*
Addresses: NYC. **Studied:** Cooper Union; BAID; Educ. Alliance
Art Sch., NYC; NAD; also in Paris, France & Madrid, Spain.
Member: Am. Artists Congress. **Exhibited:** Salons of Am., 1926
(as Bela Soyer-see comments), 1931; Western NY Exhib., 1944
(first prize); Albright Art Gal., 1944 (prize); Audubon Artists,
1945 (first prize for landscape); WMAA; Corcoran Gal biennials,
1937-45 (4 times); AIC; Milwaukee AI; GGE, 1939; CM; VMFA;
Akron AI; CPLH; Soc. Four Arts, Palm Beach, FL; Walker Art
Center; MoMA; PAFA; WFNY; "NYC WPA Art" at Parsons
School Design, 1977. **Work:** "Employment Agency," WMAA;
"Portrait of My Father," Brooklyn Mus.; "Rebecca," Albright-
Knox Mus., Buffalo, NY; "The Art Beauty Shoppe," DMFA;
"Cafeteria," Brooks Mem. Gallery, Memphis, TN. **Comments:**
WPA artist. Worked at Bell Aircraft Corp. in Buffalo, NY, during
WWII. Brother of Raphael (see entry) and Moses (see entry).
Clark Marlor, in *Salons of Am.,* noted that, in 1982, Raphael Soyer
told him that for a short time Issac had adopted his mother's first
name, Bela, as his first name. Teaching: Albright Art Sch.,
Buffalo, NY, 1941-44; instructor, Buffalo Art Inst. and Niagara
Falls Art Sch., 1940s; instructor, painting & drawing, Educ.
Alliance Art School, New York, 1950-; instructor, painting &
drawing, New School Social Res., 1968-; instructor, painting &
drawing, ASL, New York, 1969. **Sources:** WW73; John H.
Bauer, *Revolution & Tradition in American Art* (1951); L.
Goodrich & J. Bauer, *American Art of Our Century* (1961);
Edmund Feldman, *Varieties of Visual Experience* (Abrams,
1972); *New York City WPA Art*, 83 (w/repros.); Krane, *The
Wayward Muse*, 196; Marlor, *Salons of Am.*

SOYER, Moses *[Painter, drawing specialist, teacher, lithographer] b.1899,
Borisglebsk, Tombrov, Russia / d.1974,
Hampton Bays, NY.*
Addresses: NYC/Hampton Bays, NY. **Studied:** CUA School;
NAD, with George Maynard; BAID; Educ. Alliance Art School;
Ferrer School All., 1916-20; also with Robert Henri & George
Bellows. **Member:** NAD; Artists Equity; Audubon Artists; An
Am. Group; Am. Soc. Painters, Gravers & Sculptors; Nat. Inst.
Arts & Letters. **Exhibited:** Salons of Am., 1923, 1930; WMAA,
1925-63; J. B. Neumann Gal., NYC, 1929; AIC, 1932-46;
Corcoran Gal biennials, 1935-53 (7 times); Kleeman Gal., NYC,

1936 (solo); Boyer Gal., NYC, 1936 (solo), 1937 (solo); PAFA
Ann., 1938-52, 1958, 1964-66; Little Gal., Washington, DC, 1939
(solo), 1940 (solo); Macbeth Gal., NYC, 1940 (solo), 1941 (solo),
1942 (solo); A.C.A. Gal., NYC, 1944-74, 1977 (numerous solos);
SC Award, 1964; Audubon Artists, 1966 (Award of Merit);
Reading Mus., Reading, PA, 1968 (solo); Albrecht Gallery Mus.,
St. Joseph, MO, 1970 (solo); Loch Haven Art Center, Orlando,
FL, 1972 (solo); St. Lawrence Univ., Canton, NY, 1972 (solo);
Syracuse Univ., NY, Joslyn Mus. of Art, Omaha, NE,
Weatherspoon Art Gal. , Univ. of North Carolina, Guild Hall of
East Hampton, NY, Arkansas Art Center, Little Rock, AR,
Birmingham Mus. of Art, AL, Canton Art Inst., OH, all 1972-73
(solos); Springfield (OH) Art Center, 1982 (solo); Daytona Beach
Mus. of Arts & Sciences, FL, Polk Mus., Lakeland, FL, 1996-97
(solos); LOC & Phillips Collection, Washington, DC; TMA;
Newark (NJ) Mus.; Butler Inst. Am. Art, Youngstown, OH; NAD;
"NYC WPA Art" at Parsons School Design, 1977. Other awards:
Childe Hassam Fund of the Am. Acad. of Arts & Letters, 1964;
Thomas B. Clarke Award, 1964; Henry W. Ranger Purchase
Award, 1965; Frank C. Kirk Mem. Award, 1966; Samuel Finley
Breese Morse Medal, 1967; Andrew Carnegie Prize. **Work:**
MMA; MoMA; WMAA; BM; Newark Mus.; Jewish Mus., NYC;
PMA; AIC; LACMA; NMAA; NPG, Wash., DC; Hirshhorn Mus.;
CGA; CI; Montclair Mus.; Walker Art Center; CAM; NOMA;
Ringling Mus.; CM; Speed Mus., Louisville; Birmingham (AL)
Mus.; Wadsworth Atheneum; Daytona Beach Mus. of Arts &
Sciences; Butler IA; Parrish Art Mus., Southhampton, NY;
Phoenix Art Mus.; Neuberger Mus., NY; Swope Art Gal.; PMG;
TMA; Detroit Inst. Arts, MI; Everson Mus. Art, Syracuse, NY;
prints, LOC. Commissions, WPA murals: Greenpoint Hospital and
other hospitals & children's libraries, NYC (10 murals); USPO,
Kingsessing Station, Phila., PA (with his brother Raphael).
Comments: Twin of Raphael (see entry) and brother of Isaac (see
entry), he came to NYC in 1912. Like his brothers, Moses' early
works were strongly influenced by the experience of the Great
Depression, and he wrote essays defending social realism and
attacking regionalism. After completing murals for the WPA
Project, however, he focused his attention on sensitive portrayals
of the human figure. His favored subject in the 1940s was
dancers, and he painted numerous portraits. Teaching: instructor,
Educational Alliance School of Art; instructor, Contemporary
School Art, New York; instructor, New School Social Res.;
instructor, Educ. Alliance Art School. Publications: author,
Painting the Human Figure, Watson-Guptill (1964); co-author,
with Peter Robinson *Oil Painting in Progress* (NYC, 1972).
Illustrator: *Palestine Dances,* by C. Chochem and M. Roth (NYC,
1941); *First Book of Ballet,* by Noel Streitfeld (NYC, 1953);
Vovick, by Charles Paver. **Sources:** WW73; WW47; Bernard
Smith, *Moses Soyer,* monograph (ACA Gallery, 1944); Charlotte
Willard, *Moses Soyer* (World Publ., 1962); Baigell, *Dictionary;*
Falk, *Exh. Record Series; American Scene Painting and Sculpture,*
63 (w/repro.); *New York City WPA Art,* 100 (repros.); addit. info.
courtesy of David Soyer (son), NYC and Joel L. Fletcher,
Fredericksburg, VA.

SOYER, Raphael *[Painter, lithographer,
teacher] b.1899, Borisogliebsk, Russia /
d.1987, NYC.*
Addresses: NYC. **Studied:** Cooper Union Art School, 1914-17;
NAD, 1918-22; ASL, 1920-21, 1923, 1926, with G. P. du Bois.
Member: NAD; Am. Acad. Arts & Letters; Am. Soc. PS&G; Am.
Artists Congress; An Am. Group; NIAL; AE. **Exhibited:** S. Indp.
A., 1922, 1925, 1940-41; Salons of America, NYC, 1924-25,
1930; WMAA, 1927-73; Daniel Gal., NYC, 1929 (first solo);
L'Elan Gal., NYC, 1932; CPLH; AIC annuals, 1932 (prize), 1940
(prize), 1941 (prize); Curt Valentine Gal., NYC, 1933-35, 1937-
38; PAFA Ann., 1933,1934 (gold), 1938-66 (gold 1943, prize
1946); Macbeth Gal., NYC, 1935; Corcoran Gal biennials, 1935-
63 (12 times, incl. bronze med, 1943); VMFA, 1938; Frank Rehn
Gal., NYC, 1939; Assoc. Am. Artists, NYC, 1940-41, 1948, 1953,
1958; BM, 1941; Weyhe Gal., NYC, 1944; CI, 1944; PMG, 1944;
Dallas Mus. FA, 1945; MoMA, 1946; Phila. Art Alliance, 1949

(solo); NAD, 1951, 1952, 1980; Krasner Gal., NYC, 1957; ACA Gal., NYC, 1960; Alfredo Valente Gal., NYC, 1961; Bernard Crystal Gal., NYC, 1962; Forum Gal., NYC, 1964, 1966, 1967, 1972, 1977; Am. Foundation Arts, 1967; Georgia Mus. Art, 1968; Forum Gal, NYC, 1970s; Margo Feiden Gal., NYC, 1972; New Jersey State Mus., 1979; Gal. Albert Loeb, Paris, France, 1980; Akademie Der Kunst, Berlin, 1980. **Work:** MMA; WMAA; MoMA; Addison Mus. Art, Andover, MA; PMA; PMG; BMA; NYPL; AGAA; Columbus Gal. FA; CGA; Buffalo AA; BM; WPA mural (with his brother Raphael), U.S.P.O., Kingsessing Station, Phila., PA. **Comments:** American Scene artist. Twin of Moses (see entry) and brother of Isaac (see entry), he came to NYC in 1912 and became most noted for his empathetic portrayal of urban life and Depression subjects. He also made portraits of artist-friends, dancers, and bohemians. During the 1930s, Soyer made many lithographs of Depression scenes. Teaching: ASL; Am. Art School; New School Social Res. **Publications:** author/illustrator, *A Painter's Pilgrimage* (1962); *Homage to Thomas Eakins* (1966); *Self Revealment: A Memoir* 1969; *Diary of an Artist* (1977). Editor, *Reality*, 1953-55. **Sources:** WW73; Baigell, *Dictionary*; Lloyd Goodrich *Raphael Soyer* (Praeger, 1967); Sylvan Cole *50 Years of Printmaking* (Da Capo, 1967); Joseph K. Foster *Watercolors & Drawings* (Crown, 1969); autobiographical article, *Art & Antiques* (Jan., 1988, p.69); *American Scene Painting and Sculpture*, 63 (w/repros.); Falk, *Exh. Record Series.*

SOZIO, Armando *[Painter, teacher, engraver] b.1897, Salerno, Italy / d.1966.*
Addresses: South Orange, NJ. **Studied:** Faucett School Fine & Industrial Arts; NAD; New York Univ. **Member:** New Jersey Retired Educators Assn.: Assoc. Artists of New Jersey; AAPL; Hunterdon County Art Center; All. Artists Am.; New Jersey WC Soc.; Art Center of the Oranges; South Orange Art Gal.; Maplewood Art Gal. **Exhibited:** All. Artists Am., 1946, 1953, 1955; NAC, 1954-55; AWCS, 1955; Montclair Art Mus., 1949, 1950, 1952, 1955; Tinton Falls, NJ, AAPL, 1955; Newark, NJ, 1937; Washington, NJ, 1949; NAD, 1960; Trenton State Mus.; Newark Mus.; CAFA; Academic AA. **Awards:** NAD, 1918-21 (prizes & silver medal),1917 (bronze medal), 1922 (prize), 1957 (prize); All. Artists Am., 1955 (gold medal), 1957 (prize); Art Center of the Oranges, 1955 (prize), 1956 (prize); Washington, NJ, 1949; New Jersey Soc. P&S, 1958; Seton Hall Univ., 1956, 1958 (prize and silver medal); AAPL, 1957, 1961; New Jersey WCS, 1958; Hunterdon County Art Center. **Work:** Thomas Jefferson H.S., Elizabeth, NJ; Am. Bank Note Co., NY; Pompton Lakes School; Telephone Bldg., Union, NJ; YM-YWHA, Newark, and many private collections. **Comments:** Positions: instructor, Newark Sch. Fine & Industrial Arts, Newark, NJ, as of 1966. **Sources:** WW66.

SPAAR, William, Jr. *[Illustrator, cartoonist, painter, writer] b.1896, Arlington, NJ.*
Addresses: East Orange, NJ. **Studied:** Fawcett School Art, Newark; New York Univ. **Comments:** Cartoonist: *King Features Syndicate, Saturday Evening Post, Collier's, Liberty.* **Sources:** WW40.

SPACKMAN, Cyril (Saunders) *[Miniature painter, painter, sculptor, etcher, engraver, lithographer, lecturer, teacher, writer] b.1887, Cleveland, OH / d.1963, Croyden, England?.*
Addresses: Surrey, England. **Studied:** H.G. Keller in Cleveland; Kings College Architectural Studio, London. **Member:** Royal Soc. British Artists; Royal SMPS&G; Royal Soc. Antiquaries of Ireland; F.S. Antiquaries of Scotland; Royal Soc. Art (fellow); Licentiate Royal Inst. British Arch.; Croydon Arts Club; Southeastern Soc. Arch.; AFA; SAGA; Cleveland SA; Chicago SE. **Exhibited:** Assn. Arch. & Surveyors (medal); AIC. **Work:** CMA; AIC; Print Room, British Mus.; City of Hull Coll.; 13th-c. church, Grosmont, Monmouthshire; Crucifix in stone, Sanctuary, William Lillico Mem. Church of All Saints, Selhurst, Surrey.

Comments: Designer: med. of Masonic Million Mem. Position: art ed. *The Parthenon.* **Sources:** WW40.

SPACKMAN, Emily S. *[Sculptor] early 20th c.*
Addresses: NYC. **Exhibited:** PAFA Ann., 1922. **Sources:** WW24; Falk, *Exh. Record Series.*

SPADE, Frank *[Painter] early 20th c.*
Addresses: Avon-by-the-Sea, NJ. **Exhibited:** S. Indp. A., 1930. **Sources:** Marlor, *Soc. Indp. Artists.*

SPADER, W(illiam) E(dgar) *[Painter, craftsperson, illustrator] b.1875, Brooklyn, NY / d.c.1954.*
Addresses: Jamaica, NY. **Studied:** H. Siddons Mowbray, Joseph H. Boston; ASL. **Member:** Brooklyn PS; AWCS. **Exhibited:** S. Indp. A., 1917-19; AWCS, 1921-23, 1925-27, 1929, 1932, 1937-42, 1946; NAD; AIC. **Work:** Fort Worth (TX) Mus. Art. **Comments:** Marlor gives a birthdate of 1892. **Sources:** WW53; WW47; Marlor, *Soc. Indp. Artists.*

SPAET, Mollie *[Painter] early 20th c.*
Addresses: NYC. **Studied:** ASL. **Exhibited:** S. Indp. A., 1926. **Sources:** Marlor, *Soc. Indp. Artists.*

SPAETH, Carola (Mrs.) *[Portrait painter] b.1883, Phila.*
Addresses: Princeton, NJ. **Studied:** PAFA; Graphic Sketch Club, Phila. **Member:** Phila. Art All. **Comments:** Specialty: children. **Sources:** WW33.

SPAETH, Eloise O'Mara *[Collector, patron, writer] b.1904, Decatur, IL / d.1998, East Hampton, NY.*
Addresses: NYC. **Studied:** Millikin Univ. **Member:** Am. Assn. Mus.; College AA Am.; Art Collectors Club. **Comments:** Positions: trustee, Dayton Art Inst., 1938-44, director, Modern Gallery, 1940-44; trustee, AFA, 1945-, chmn. extension service, 1947-59; trustee, Guild Hall Mus., 1950-, chmn. acquisitions committee, 1962-; trustee & vice-pres., Arch. Am. Art, 1959; chmn., East Div. Arch., 1959; director, Friends of WMAA; member, Smithsonian Inst. Fine Art Commission. **Publications:** author, *American Art Museums and Galleries,* (1960s); *Collecting Art* (1968). Collection: American and European art between WWI-WWII. **Sources:** WW73; obit., *New York Times* (Nov. 5, 1998).

SPAETH, Janet D. *[Sculptor] early 20th c.*
Addresses: Princeton, NJ. **Exhibited:** PAFA Ann., 1932; Salons of Am., 1934. **Sources:** Falk, *Exh. Record Series.*

SPAETH, Marie Haughton (Mrs. J. Duncan) *[Portrait painter] b.1883, Hanover, NH / d.1937, Sarasota, FL.*
Addresses: Chesham & Hanover, NH/Princeton, NJ. **Studied:** PAFA; Penn. School Design; Spain; France; Italy. **Member:** NAWPS; Wolfe AC; AFA. **Exhibited:** PAFA Ann., 1898, 1914, 1920; Pan-Pacific Expo, San Fran., 1915; SIA, 1918-30; Corcoran Gal. biennial, 1923; Salons of Am.; NAD, 1924; Babcock Gal., NYC, 1929 (solo); Wolfe AC, 1932 (prize); BM; Mus., Princeton Univ. **Work:** PAFA; Princeton Univ.; Proctor Found., Princeton, NJ; Grace Erdman Mem. Hall, Occidental College, CA. **Comments:** Cf. Marie L. Haughton. **Sources:** WW33; Falk, *Exh. Record Series.*

SPAFARD, Myra B. *[Painter, teacher] 19th/20th c.; b.Manchester, MI.*
Addresses: NYC; Denver, CO; Detroit, MI/Manchester, MI; active 1898-1903. **Studied:** ASL; Teacher's College; Mrs. E.M. Scott, NY. **Member:** NAWPS. **Exhibited:** NAD, 1869, 1888; PAFA Ann., 1896-1903; NYWCC, 1898; Boston AC, 1899, 1902, 1903; AIC. **Sources:** WW31; Falk, *Exhibition Record Series.*

SPAFARD, Octavia Maverick See: **MAVERICK, Octavia**

SPAFFORD, Elizabeth H. *[Teacher of landscape drawing] mid 19th c.*
Addresses: Albany, 1835. **Comments:** Teaching: landscape drawing, Albany Female Acad. **Sources:** G&W; Albany CD 1835.

SPAFORD, O. (Mrs.) See: **SPAFARD, Myra B.**

SPAGNA, Vincent *[Painter] b.1898, Sicily, Italy.*
Addresses: NYC. **Studied:** Conn. ASL, Hartford, CT. **Exhibited:**

Salons of Am., 1926, 1928, 1931, 1932; S. Indp. A., 1930, 1937-38, 1941-42, 1944; PAFA Ann., 1943, 1950; Pepsi-Cola, 1944 (prize); La Tausca Pearls Comp. (prize); Corcoran Gal. biennials, 1939-45 (4 times); MMA, CI; Midtown Gal., NY, 1939; WMAA, 1946. **Work:** AGAA; Pepsi-Cola Coll.; IBM Coll. **Sources:** WW59; WW47; Falk, *Exh. Record Series.*

SPAGNOLO, Kathleen Mary *[Printmaker, illustrator]*
 b.1919, London, England.
Addresses: Alexandria, VA. **Studied:** Bromley Art School; Royal scholarship & Princess of Wales scholarship to Royal College Art, London, 1939-42; School Design with E. W. Tristram; Am. Univ. with Robert Gates & Krishna Reddy. **Member:** Wash. PM; Wash. WCC; Wash. Print Club; Artist's Equity Assn. **Exhibited:** CGA, 1962; Phila. Print Club, 1963; Silvermine Guild Artists, 1963; Wash. PM, 1969-72; Hensley Gal., Alexandria, VA. **Work:** Dept. Int., Wash., DC; Univ. Virginia, Charlottesville, George Washington Univ., Wash., DC; LOC. Commissions: Rendering (bench), Index Am. Design, Nat. Gallery Art, Wash., DC, 1969. **Comments:** Preferred media: graphics. **Sources:** WW73.

SPAGOT, Eva *[Landscape & still life painter]* late 19th c.
Addresses: Norfolk, VA. **Exhibited:** Norfolk, VA, 1886.
Sources: Wright, *Artists in Virginia Before 1900.*

SPAHN, Dorothy Rose (Mrs. Charles J.) *[Painter]* *b.1908, Dubuque, IA.*
Addresses: Dubuque, IA. **Studied:** Carleton College; Stone City Art Colony; Grant Wood, Adrian Dornbush Alfred Hyslop. **Exhibited:** Dubuque Artists Exhs., 1932 (prizes); Iowa Fed. Women's Clubs Exh., 1932. **Sources:** Ness & Orwig, *Iowa Artists of the First Hundred Years,* 195.

SPAHR, John early 20th c.
Studied: ASL. **Exhibited:** S. Indp. A., 1925-35; Salons of Am., 1934. **Sources:** Falk, *Exhibition Record Series.*

SPAHR, Margaret *[Painter]* mid 20th c.
Exhibited: S. Indp. A., 1940. **Sources:** Marlor, *Soc. Indp. Artists.*

SPAHR, May G. *[Painter]* early 20th c.
Addresses: NYC. **Exhibited:** S. Indp. A., 1926-31, 1934-35.

SPAINHOUR, Mrs. See: **SPENCER, Selina**

SPALDING, Elisabeth (or Elizabeth) *[Landscape and floral painter]* *b.c.1870, Erie, PA / d.1954, Denver, CO.*
Addresses: Denver, CO, from 1874 (with periods of study in NYC & Phila.). **Studied:** ASL; Rhoda Holmes Nicholls; PAFA; J. Alden Weir & Twachtman at Cooper Union; Charles Woodbury. **Member:** Wash. WCC; NYWCC; Am. Artists Club, Denver (charter mem.); Denver Art Mus. (charter mem.). **Exhibited:** Am. Artists Club, Denver; Erie Art Club, 1900 (prize); S. Indp. A., 1917; AIC, 1921 (prize); Colorado State Fair, 1930 (prize); Wash. WCC, 1931 (prize); Corcoran Gal. Art, 1931; Stockholm, 1932 (solo); NYWCC; Salon de la Soc. Nat. des Beaux-Arts, 1928; Paris, 1932 (solo);WFNY, 1939. **Work:** Erie (PA) Art Club; Denver Art Mus.; Children's Hospital, YWCA, Morey Jr. H.S., Girls Indust. School, St. Luke's Hospital, Denver; Denver Pub. Lib. **Comments:** Prolific watercolor painter of floral and landscape subjects. **Sources:** WW40; P&H Samuels, 456 (birth date possibly 1868); Gerdts, *Art Across America,* vol. 3: 120.

SPALDING, Eliza Hart (Mrs. H. H.) *[Amateur watercolorist]* *b.1807, Berlin, CT / d.1851, Brownsville, OR.*
Addresses: Oregon, 1836-51. **Work:** Oregon Hist. Soc.
Comments: Eliza Hart spent her childhood in Berlin (CT) and in Oneida County (NY). In 1833 she married the Rev. Henry Harmon Spalding of Bath (NY) and three years later they went to the Oregon Territory as missionaries of the Presbyterian Church. As part of her instruction to the native tribes, she painted "The Protestant Ladder" (1844, Oregon Hist. Soc.). **Sources:** G&W; Rasmussen, "Art and Artists in Oregon;" Spaulding, *The Spalding Memorial,* 455; Warren, *Memoirs of the West, The Spaldings* (cited by Rasmussen); This may be the E. Spalding, watercolor landscapist, listed in Lipman and Winchester, 180; Gerdts, *Art Across America,* vol. 3:183.

SPALDING, Geraldine Wyman *[Painter]* 20th c.;
 b.Evanston, IL.
Studied: AIC; School Applied Des. for Women, NYC; Grand Central Art School; ASL; Edmund Greacen; Robert Brackman; Jerry Farnsworth. **Member:** Rockport AA. **Exhibited:** NYC Galleries; Stockbridge AA; Pittsfield Mus. **Sources:** *Artists of the Rockport AA* (1946, 1956).

SPALDING, Grace *[Painter]* early 20th c.
Addresses: NYC. **Exhibited:** PAFA Ann., 1924. **Sources:** Falk, *Exh. Record Series.*

SPALDING, James McKee *[Painter]* *b.1880, Hawaii / d.1954, Pasadena, CA.*
Addresses: Pasadena, CA. **Exhibited:** P&S Los Angeles, 1934-37. **Comments:** He shared a studio with David Tauszky (see entry) and often painted with Nicolai Fechin (see entry). He did not depend on his art work for income. **Sources:** Hughes, *Artists in California,* 526.

SPALDING, Melvin Pratt *[Painter]* early 20th c.
Addresses: NYC. **Exhibited:** AIC, 1916. **Sources:** WW17.

SPALDING, Philip E. *[Museum official]* *b.1889, Minneapolis, MN.*
Addresses: Honolulu, HI. **Studied:** Stanford Univ. **Exhibited:** Awards: LL.D., Univ. Hawaii, 1961. **Comments:** Positions: trustee & officer, Honolulu Acad. Arts, 1994-. **Sources:** WW66.

SPALLER, Gertrude S. *[Painter]* early 20th c.
Addresses: Chicago, IL. **Member:** Chicago SA. **Exhibited:** AIC, 1911-20. **Sources:** WW25.

SPALTEHOLZ, Charlotte *[Painter]; b.Germany.*
Sources: info. courtesy Peter C. Merrill.

SPALTHOFF, Antonia *[Sculptor]* late 19th c.
Addresses: Active in Saginaw, MI, 1895-99. **Sources:** Petteys, *Dictionary of Women Artists.*

SPAMPINATO, Clemente *[Sculptor]* *b.1912, Italy.*
Addresses: NYC in 1946; living in Sea Cliff, NY in 1982.
Studied: Acad. FA, Rome, Italy; French Acad. Nude, Rome; School of Governatorate, Rome; Royal School of the Medal, Rome. **Member:** NSS (fellow); Circolo Artistico Int.; Int. Fine Arts Council; Int. Am. Inst. **Exhibited:** Nat. Comp. Sport Figure, Rome, 1939 (first prize); Nat. Comp. Ski Trophy Olympic Games, Rome, 1940 (first prize); Sport Sculpture Int., Rome, 1940-1948; Allied Artists Am., 1946-51; AAPL, New York, 1951; Grand Central Palace, NY, 1952; Int. Triennial, Naples, Italy, 1952; Rome, 1953; U.S. Naval Acad. Comp. for monument,1956 (award); NSS, New York, 1952-72; NAD, 1964-72; Nat. Art Mus. Sport, NYC, 1968; Munic. Art Lg., Chicago, IL, 1970 (gold medal, grand award); Campanile Gal., Chicago, 1982 (solo). **Work:** Nat. Mus. Sport, New Madison Square Garden, NYC; Rockwell Gal. Western Art, Corning, NY; Isaac Delgado Mus. Art, New Orleans, LA; Notre Dame Univ., IN; Oklahoma Art Center, Oklahoma City. Commissions: soccer trophy, int. competition, Italian Govt., 1940; Navy Goat (bronze statue), comt. class 1915, U.S. Naval Acad., Annapolis, MD 1957; several architectural reliefs, Bd. Educ. & Dept. Public Works, New York, 1957-72; three different bronze statues of Columbus, Huntington, NY, 1964, Mineola, NY, 1965 & Bridgeport, CT, 1971; two lime-stone bas reliefs, Brooklyn Heights Branch Lib., NY, 1960. **Comments:** Preferred media: bronze, marble. Specialties: sports; Western subjects. **Sources:** WW73; Samuels, 456.

SPANDORF, Lily Gabriella *[Painter]* 20th c.
Addresses: Washington, DC. **Studied:** Acad. FA Vienna (grad.). **Member:** Wash. Press Club; Artist's Equity Assn.; Wash. WCC. **Exhibited:** Wash. WCC Nat., 1961-67; Am. Drawing Ann. & Smithsonian Travel Exh., Norfolk (VA) Mus., 1963; Metrop. Art Exh., Smithsonian Inst., 1963-66; Agra Gal., 1965-67 (solo), 1970 (solo) & 1972 (solo); Bodley Gal., New York (solo). **Work:** Smithsonian Inst., Washington, DC; LOC; Washington Co. MFA, Hagerstown, MD; Munic. Mus., Rome, Italy; The White House, Washington, DC. Commissions: paintings, presented as gifts of

State to HRH Princess Margaret, pres. of Korea, Chung Hee Park & former pres. of Iceland, Asgeir Asgeirsson by President Lyndon B. Johnson; designed U.S. postage stamp for Christmas, 1963, Post Office Dept. **Comments:** Preferred media: gouache, watercolors, mixed media. **Sources:** WW73.

SPANDORFER, Merle S. *[Artist] mid 20th c.*
Addresses: Cheltenham, PA. **Exhibited:** PAFA Ann., 1966. **Sources:** Falk, *Exh. Record Series.*

SPANFELLER, James J. *[Illustrator, teacher] b.1930, Phila., PA.*
Addresses: NYC. **Studied:** Phila. College Art; PAFA. **Member:** SI. **Exhibited:** Awards: Artists Guild "Artist of the Year,"1964; *Herald-Tribune* Children's Book Award, 1965; gold and silver medals, Soc. of Publication Designers. **Comments:** Illustrator of major book publishers and national magazines. Teaching: Parsons Sch.Des. **Sources:** W & R Reed, *The Illustrator in America,* 341.

SPANG, Frederick A. *[Painter] b.1834, Norristown, PA / d.1891, Reading, PA.*
Addresses: Reading , PA; San Francisco, CA, late 1860s-early 70s. **Studied:** J.R. Lambdin in Philadelphia. **Comments:** Spang started out as a machinist but struck out to pursue his childhood love of art. His art studies with Lambdin were interrupted by his enlistment in the 15th Penn. Volunteer Cavalry for three years. After the war, he resumed his artistic career in Reading, PA, where he opened a studio and instructed several young followers such as E.E. Hafer and Fannie Diehl. An accomplished portrait painter, Spang was also known for his fine still lifes, landscapes and paintings of animals and birds. **Sources:** Hughes, *Artists in California,* 526; Malmberg, *Artists of Berks County,* 35.

SPANG, O. S. *[Portrait painter] mid 19th c.*
Addresses: Philadelphia, 1860. **Work:** Tennessee State Mus. **Sources:** G&W; Penna. BD 1860; Kelly, "Landscape and Genre Painting in Tennessee, 1810-1985," 69 (w/repro.).

SPANG, Tillie Neville (Mrs C. S. Prizer) *[Painter] d.1939, Long Island, NY.*
Addresses: Phila., Reading, PA; Westport, CT & NYC, c.1913-25; Long Island, NY. **Studied:** portraiture at PAFA in 1890; Atelier Julian; Académie Colarassi, Bouguereau; Gerendin; Duran. **Member:** PAFA (fellow). **Exhibited:** PAFA Ann., 1895 (as Spang), 1912 (as Prizer); Salons of Am., 1930; WMAA, 1926-28. **Comments:** Tillie Spang was the eldest daughter of artist Frederick Spang. Following her studies in Paris she opened a studio in Philadelphia, then moved to Reading, PA, where she tried to establish an art organization such as she had seen in Paris. Mrs. C.S. Prizer (as she became known following her marriage in 1898) painted until her death on Long Island. **Sources:** Falk, *Exh. Record Series.*

SPANG, William *[Painter] late 19th c.*
Addresses: Phila., PA. **Exhibited:** PAFA Ann., 1877-87. **Sources:** Falk, *Exh. Record Series.*

SPANGENBERG, Ferdinand T. *[Portrait painter] b.c.1820, Prussia, Germany.*
Addresses: NYC, active 1850s; Richmond, VA, active 1859; NYC, active 1860; Germany, 1866. **Comments:** In 1860 he resided in NYC with his wife and three children (ages 2 to 6 years, born in New York) and owned realty valued at $6,000. By 1866 he had returned to Germany. **Sources:** G&W; 8 Census (1860), N.Y., L, 290; NYBD 1860; *Richmond Portraits.*

SPANGENBERG, George *[Landscape painter] b.1907, Buffalo, NY / d.1964.*
Addresses: Buffalo, NY; Southern California, 1930s. **Studied:** Charles Burchfield; John Carlson; Buffalo Sch. FA. **Member:** Niagara Art Guild. **Comments:** Specialty: portraits and still lifes, landscape around San Diego. It is said that he often traded his works for food and art supplies. In 1964 a fire destroyed his studio and most of his work perished, except for that done in Calif. **Sources:** Hughes, *Artists in California,* 527.

SPANGLER, C. D. *[Painter] late 19th c.*
Addresses: Hagerstown, MD, 1884. **Exhibited:** NAD, 1883-84. **Sources:** Naylor, *NAD.*

SPANUTH, Lillian See: **LINDING, Lillian (Mrs. H. M.)**

SPARACINO, Justin V. *[Painter] early 20th c.*
Exhibited: Salons of Am., 1922. **Sources:** Marlor, *Salons of Am.*

SPARHAWK-JONES, Elizabeth *[Painter] b.1885, Baltimore, MD / d.1951, Phila., PA.* *Elizabeth Sparhawk-Jones.*
Addresses: Phila., PA. **Studied:** PAFA with Chase. **Exhibited:** PAFA Ann., 1908-19, 1926-29, 1936-43, 1966 (prize 1908, 1912); CI, 1909 (prize); Corcoran Gal. biennials, 1910-57 (5 times); Soc. Indep. Artists, 1917; AIC, 1926 (prize); Rehn Gal., NYC, 1937 (solo), 1942 (solo); WMAA. **Work:** AIC; PAFA. **Comments:** Also appears as Jones. **Sources:** WW40; Falk, *Exh. Record Series.*

SPARK, Victor David *[Art dealer] b.1898, Brooklyn, NY / d.1991.*
Addresses: NYC. **Studied:** NY Univ. (B.S., 1921). **Comments:** Positions: dir., Victor D. Spark Art Gal. Specialty of gallery: Am. and foreign paintings, drawings and other works of art; appraisals of fine art. **Sources:** WW73.

SPARKS, Arthur Watson *[Landscape & genre painter, teacher, architect] b.1870, Washington, DC / d.1919, Philadelphia, PA.* *A.W Sparks*
Addresses: Washington, DC; Paris, France/Europe, 10 years; Pittsburgh, PA. **Studied:** Howard Helmick; Académie Julian, Paris with J.P. Laurens, Bouguereau, and Ferrier, 1901-03; École des Beaux-Arts, Paris; also in Paris with Cormon, Thaulow, Mucha, and Courtois. **Member:** Pittsburgh AA. **Exhibited:** Wash. WCC, 1898; PAFA Ann., 1908-19 (7 times); Soc. Wash. Artists, 1908, 1910-15; CI, 1912, 1914; NAD; AIC; Corcoran Gal. biennial, 1912; Pittsburgh AA, 1913 (prize); PPE, 1915 (medal); Westmoreland County (PA) Mus. Art, 1963 (retrospective). **Comments:** Known as an experimenter early on, his style developed in the direction of Impressionism. Designer, U.S. Pavillion, Paris Expo, 1900. Teaching: CI, c.1910-19. **Sources:** WW19; Chew, ed., *Southwestern Pennsylvania Painters,* 127-128; McMahan, *Artists of Washington, DC;* Falk, *Exh. Record Series.*

SPARKS, Charlotte *[Painter] mid 20th c.*
Exhibited: S. Indp. A., 1937. **Sources:** Marlor, *Soc. Indp. Artists.*

SPARKS, Edward *[Engraver] b.c.1831, Ireland.*
Addresses: NYC, 1850. **Sources:** G&W; 7 Census (1850), N.Y., XLI, 379.

SPARKS, Gar *[Painter] mid 20th c.*
Addresses: Orange, NJ. **Exhibited:** AIC, 1947. **Sources:** Falk, AIC.

SPARKS, George S. *[Painter] early 20th c.*
Addresses: NYC. **Sources:** WW15.

SPARKS, H. L. *[Illustrator] early 20th c.*
Addresses: NYC. **Studied:** SI. **Sources:** WW31.

SPARKS, Jeff *[Painter] early 20th c.*
Exhibited: S. Indp. A., 1936. **Sources:** Marlor, *Soc. Indp. Artists.*

SPARKS, Joseph *[Painter, lithographer, lecturer, sculptor, designer] b.1896, Jersey City, NJ / d.1975, Detroit, MI.*
Addresses: Detroit, MI. **Studied:** Percy Ives; Paul Honore; Leon Kroll; AIC; Leger & Ozenfant, in Paris. **Member:** Scarab Club, Detroit; Michigan Acad. Science, Arts & Letters. **Exhibited:** Detroit IA, annually; LOC, 1945; Ferargil Gal.; J.L. Hudson Co.; Gordon Beer Gal., Detroit; Univ. Michigan; CAA traveling exh., 1932; Mexico City, 1932; Rochester Mem. Art Gal., 1935; Detroit Art Market, 1937. **Work:** St. Michael's Church, Detroit; Detroit IA; Detroit Hist. Lib.; LOC; murals, Winterhalter Sch., Detroit; Ft. Wayne; Maple Sch. Lib., Dearborn, MI. **Comments:** Illustr.:

"Letters to a Pagan"; "The Pine Tree of Michigan." Auth./ed./illustr.: portfolios of prints & designs. **Sources:** WW59; WW47.

SPARKS, Lillian B. *[Artist] early 20th c.*
Addresses: Active in Washington, DC, 1914-17. **Sources:** Petteys, *Dictionary of Women Artists.*

SPARKS, M. A. (Mrs.) *[Artist] early 20th c.*
Addresses: Active in Los Angeles, 1911-16. **Sources:** Petteys, *Dictionary of Women Artists.*

SPARKS, Mollie *[Painter, educator] early 20th c.*
Studied: AIC. **Comments:** Teaching: Valparaiso Univ., early 1900s. **Sources:** Petteys, *Dictionary of Women Artists.*

SPARKS, Richard *[Illustrator, painter] b.1944.*
Addresses: NYC. **Studied:** Texas A&M Univ. (arch.); Art Center Sch., Los Angeles, with Harry Carmean, D. Puttman, J. Henninger. **Exhibited:** Awards: SI (gold medal, award of excellence); Am. Inst. Graphics Arts. **Work:** Nat. Portrait Gal., Wash., DC (portrait of Mstislav Rostropovich); Franklin D. Roosevelt Lib.; Acad. Art College, San Fran. **Comments:** He spent three years as a free-lance illustrator in Amsterdam, Holland, together with his wife. Illustr.: *Time* magazine (including covers), *Fortune, Esquire* and other publications. Designer of stamp of George Mason, author of the Bill of Rights, for the U.S. Postal Service. **Sources:** W & R Reed, *The Illustrator in America,* 342.

SPARKS, Will *[Painter, etcher, writer, teacher, lecturer, muralist] b.1862, St. Louis, MO / d.1937, San Francisco, CA.*
Addresses: San Francisco, CA (since 1891). **Studied:** St. Louis Sch. FA; Acad. Colarossi, with Gérôme, Harpignies; Acad. Julian, Paris with Bouguereau. **Member:** Bohemian Club, San Francisco; AFA; San Francisco AA; Sequoia Club; Calif. SE. **Exhibited:** St. Louis Expo, 1886; San Francisco AA annuals from 1894; Gump's, San Francisco; Hotel Del Monte, Monterey, 1907-25; Calif. State Fair, 1929. **Work:** Huntington Lib., San Marino, CA; Crocker Mus., Sacramento; murals & oils, Bohemian Club; Plaza Hotel, San Francisco; de Young Mem. Mus.; CPLH; FA Gal., San Diego; TMA; Minneapolis Inst. Art; City Art Mus., St. Louis; Bordeaux Municipal Mus., France; Honolulu Art Mus. **Comments:** Despite selling his first painting at age 12, he first pursued a career in medicine before turning to a career in art. While studying in Paris he worked as an anatomical illustrator for Louis Pasteur. For three years, he was on the illustration staffs of newspapers in California, then taught anatomy at Univ. Calif. Medical School, 1904-08. He became one of the leading tonalist landscape painters in the San Francisco Bay area, nationally known for his paintings of the California missions and his nocturnal adobe scenes. **Sources:** WW40; Hughes, *Artists of California,* 527; P&H Samuels report that Sparks was living in San Francisco in 1941, and also refer to William F. Sparks, 456.

SPARKS, William F. See: **SPARKS, Will**

SPARKS, William F. *[Listed as "artist"] late 19th c.*
Comments: Worked for *Leslie's Weekly,* 1881. Compare with Will Sparks. **Sources:** P&H Samuels, 456.

SPARLING, John Edmond (Jack) *[Illustrator, cartoonist, painter, sculptor] b.1916, Winnipeg, Canada.*
Addresses: Freeport, NY. **Studied:** Arts & Crafts Club, New Orleans, LA; Corcoran Sch. Art. **Member:** SI; Cartoonists Soc., NY. **Exhibited:** Awards: Treasury Dept. Citations, 1944, 1945. **Work:** Hyde Park Coll. **Comments:** Position: ed. cartoonist, *New Orleans Item-Tribune,* 1935-37; *Washington Herald,* 1937-39. Created, wrote & produced "Hap Hopper, Washington Correspondent," United Features Syndicate, 1939-43; "Claire Voyant," *Chicago Sun* & PM newspaper Syndicate, 1943-46. **Sources:** WW59; WW47.

SPARROW, Henrietta M. *[Artist] late 19th c.*
Addresses: Active in Detroit, MI, 1891-94. **Studied:** Maud

Mathewson. **Exhibited:** annual spring exh., Mathewson's Studio, 1891. **Sources:** Petteys, *Dictionary of Women Artists.*

SPARROW, Jack *[Painter] b.1893, Edinburgh, Scotland / d.1961, NYC.*
Addresses: NYC. **Studied:** ASL; Robert Henri; John Sloan; George Bellows. **Exhibited:** AIC; Arch. Lg.; BM; Salons of Am.; Salon d'Automne, Paris, France; S. Indp. A. **Work:** murals for mining companies: Trebor Co., Mariposa, CA; H. C. Dudley, Ontario, Canada; Duluth, MN; & in Mexico. **Sources:** WW53; WW47.

SPARROW, Louise Winslow Kidder (Mme. Paul E. H. Gripon) *[Sculptor, writer] b.1884, Malden, MA / d.1979, Wash., DC.*
Addresses: Washington, DC, from c.1909; Garonne, France, 1940s. **Studied:** Europe; Bela Pratt;, Frederick W. Allen; Eric Pape; H. Coleman; Bush-Brown; U. Dunbar. **Member:** Soc. Wash. Artists; AAPL; Scarsdale AA; Royal Soc. Artists (fellow). **Exhibited:** Soc. Wash. Artists, 1930 (medal); Diplome d'Honneur, Coloniale Int., Paris, 1931 (prize); CGA; NGA; Wash. AC, 1930-31(solo); George Washington Univ. (solo); Newport AA; Greenwich AA. **Work:** U.S. Naval Observatory, Wash., DC; Smithsonian Inst.; U.S. Nat. Mus.; George Washington Univ.; Cornell Univ.; Howard Univ.; Univ. Alabama; Montgomery MFA; U.S. Military Acad., West Point, NY; U.S. Naval Acad., Annapolis, MD; State Capitol, Helena, MT; South Church, Portsmouth, NH; Boston Author's Club; U.S. Senate; Wash., DC; Medical Soc., Denver, CO; Bar Assn., Wash.,DC; U.S. Merchant Marine Acad., Kings Point, NY; NY State Maritime Acad., Ft. Schuyler, NY; Vassar College; Wayne Univ. **Comments:** Author: *The Last Cruise of the U.S.S. 'Tacoma' and 'Tankas'; Lyrics and Translations* (translation from Nico D. Horigoutchi). **Sources:** WW53; WW47. More recently, see, McMahan, *Artists of Washington, DC.*

SPARROW, Thomas *[Engraver on wood and copper] b.c.1746, Annapolis, MD.*
Addresses: Philadelphia,1759-64; Annapolis, 1764 -84. **Studied:** Philadelphia (silversmithing). **Comments:** He worked as a goldsmith, silversmith, engraver, and jeweler. His engravings include title pages and tail pieces for books, bookplates, paper money, and newspaper advertisements. **Sources:** G&W; Arthur, "Thomas Sparrow, an Early Maryland Engraver"; Hamilton, *Early American Book Illustrators and Wood Engravers,* 49; Stauffer.

SPATES, John *[Listed as "artist"] b.c.1824, Virginia.*
Addresses: Baltimore,1860. **Comments:** His wife and children (12 and 9) were also born in Virginia. George Cross and family lived with the Spates family. **Sources:** G&W; 8 Census (1860), Md., VII, 189.

SPAULDING, Alice See: **HEMENWAY, Alice Spaulding (Mrs.)**

SPAULDING, Cora Alice Timmons *[Painter] b.1876, Missouri / d.1964, Long Beach, CA.*
Addresses: Long Beach, CA. **Member:** Los Angeles Art Lg. (pres.). **Exhibited:** Artists Fiesta, Los Angeles, 1931; Los Angeles Art Lg., Los Angeles City Hall, 1941. **Sources:** Hughes, *Artists in California,* 527.

SPAULDING, Elisabeth See: **SPALDING, Elisabeth (or Elizabeth)**

SPAULDING, Fanny Foster *[Painter] b.1863, Kansas / d.1954, Sacramento, CA.*
Addresses: Sacramento, CA. **Exhibited:** Calif. State Fair, 1881; Calif. Agricultural Soc., 1883. **Comments:** Specialty: still lifes, landscapes, china decoration. **Sources:** Hughes, *Artists in California,* 527.

SPAULDING, Florence Louise *[Painter, illustrator, teacher] b.1899.*
Addresses: Brookline, MA. **Studied:** Boston MFA School. **Member:** Copley Soc.; Union des Femmes P&S, Paris. **Comments:** Specialty: medical illustrations. **Sources:** WW40.

SPAULDING, Grace See: **JOHN, Grace Spaulding (Mrs.)**

SPAULDING, Henry P(lympton) *[Painter] b.1868, Cambridge, MA / d.1938, Boston, MA.*
Addresses: Brookline, MA. **Studied:** R. Turner; Blummers. **Member:** Copley Soc.; AFA. **Exhibited:** Boston AC, 1897-1900; AIC; PAFA Ann., 1901. **Sources:** WW33; Hughes, *Artists in California,* 527; Falk, *Exh. Record Series.*

SPAULDING, Warren (Dan) *[Painter, educator, lithographer, illustrator] b.1916, Boston, MA.*
Addresses: Lincolnville, ME; South Thomaston, ME; New Haven, CT, 1951; St. Louis, MO, 1954. **Studied:** Mass. School Art (cert. in painting, 1937); School FA, Yale Univ. (Alice K. English fellowship foreign travel & study; 1949; B.F.A. & M.F.A.). **Member:** Maine Art Gallery. **Exhibited:** FAP, 1940 (prize); CGA, 1940; Portland (ME) SA, 1940; Asbury Park SFA, 1940; Cincinnati AM Art Ann., 1940; Am. Watercolors, NGA, 1940, 1941; traveling exh. 1941-42; Mint Mus. Art, 1946; LOC, 1946; Exhib. Current Am. Prints, CI, 1947; St. Louis Artists Guild, 1951 (first prize for oil & sculpture exh.); PAFA Ann., 1951, 1954; Midwest Biennial, Joslyn Art Mus., 1956 & 1958 (purchase prize); Main Street Gallery, Rockland, ME, 1970s. Awards: Nat. Watercolor Comp. Purchase Award, U.S. Section FA, 1940. **Work:** Univ. Maine, Orono; Joslyn Art Mus., Omaha; U.S. Section FA, Marine Hospital, Carville, LA; Branford College, Yale Univ., New Haven, CT; St. Louis (MO) Artists Guild. **Comments:** Preferred media: watercolors, acrylics, oils, pencil, ink. Illustrator: children's stories; "World Horizons"; "Open Road for Boys"; magazines, 1938-39. Teaching: School FA, Yale Univ., 1949-50; Taft School, Watertown, CT, 1950-51; School FA, Wash. Univ., 1951-61. **Sources:** WW73; WW47; Falk, *Exh. Record Series.*

SPAVENTA, George *[Sculptor] b.1918, NYC / d.1978.*
Addresses: NYC. **Studied:** Leonardo da Vinci Art School; Beaux Art Inst. Design; Grande Chaumière, Paris. **Exhibited:** Carnegie Inst., 1949-50; WMAA, 1962, 1966; MoMA, travelling exhib., U.S., 1964-65, Paris & other European cities, 1965-66; Poindexter Gallery, NYC, 1970s. **Work:** Univ. Calif., Berkeley; MIT, Cambridge. **Comments:** Teaching: New York Studio School, 1964-70s; Skowhegan School Painting & Sculpture, 1968; Maryland Inst. Art, 1969. **Sources:** WW73.

SPEAKMAN, Anna W(eatherby Parry) (Mrs. T. Henry) *[Illustrator] b.Springfield, IL / d.1937.*
Addresses: Phila., c.1915-25; Stamford, CT. **Studied:** PAFA. **Member:** Plastic Club; NAWPS; Phila. Alliance. **Exhibited:** S. Indp. A., 1917, 1925; PAFA Ann., 1920, 1922, 1925; Corcoran Ga. biennials, 1921, 1923. **Sources:** WW33; Falk, *Exh. Record Series.*

SPEAKMAN, Esther (Miss) *[Portrait painter, copyist] mid 19th c.*
Addresses: Philadelphia. **Exhibited:** Artists Fund Soc., 1843; PAFA , 1843, 1850. **Comments:** Daughter of John Speakman, treasurer of Acad. Nat. Sciences, Phila. **Sources:** G&W; Rutledge, PA; Thieme-Becker.

SPEAKMAN, Russel (Lindsay) (Mrs. Harold) *[Painter] 20th c.; b.Topeka, KS.*
Addresses: Redding Ridge, CT. **Studied:** F.V. DuMond; J. James; AIC; Fontainebleau Sch. FA. **Member:** Mural Painters. **Exhibited:** S. Indp. A., 1931; Fontainebleau Sch. FA, ann. exh., 1932 (prize); Corcoran Gal. biennial, 1932; Salons of Am., 1934. **Work:** Children's Ward, Eye Inst., Columbia-Presbyterian Hospital, NYC (fairy story panels). **Sources:** WW40.

SPEAR, Annie Austin *[Artist] late 19th c.*
Addresses: Active in Washington, DC, 1896-99. **Sources:** Petteys, *Dictionary of Women Artists.*

SPEAR, Arthur P(rince) *arthur Spear* [handwritten signature]
[Painter] b.1879, Washington, DC / d.1959,
Waban, MA.
Addresses: Paris, France, 1906-07; Boston, MA; Waban, MA. **Studied:** George Washington Univ.; ASL of Wash.; Académie Julian, Paris with J.P. Laurens, 1902-07. **Member:** ANA, 1920; Boston AG; St. Botolph's Club; Allied AA. **Exhibited:** Cosmos Club, Wash., 1902; Soc. Wash. Artists, 1900, 1904; PAFA Ann., 1906-34; Boston AC, 1908; Pan-Am. Expo, 1915 (medal); NAD, 1921 (Altman Prize), 1922 (prize); AIC; Corcoran Gal. biennials, 1908-37 (10 times). **Comments:** He painted at Fenway Studios, Boston, 1912-35. **Sources:** WW59; WW47; McMahan, *Artists of Washington, DC;* Vose Galleries, *Mary Bradish Titcomb and Her Contemporaries,* 52; Falk, *Exh. Record Series.*

SPEAR, Emma Annie *[Artist] early 20th c.*
Addresses: Active in Washington, DC, 1913-25. **Sources:** Petteys, *Dictionary of Women Artists.*

SPEAR, H. H. *[Painter] late 19th c.*
Addresses: NYC, 1885. **Exhibited:** NAD, 1885. **Sources:** Naylor, *NAD.*

SPEAR, Joseph *[Engraver] b.c.1829, New Jersey.*
Addresses: NYC, 1860. **Sources:** G&W; 8 Census (1860), N.Y., LVIII, 51.

SPEAR, Lloyd *[Educator] mid 20th c.*
Addresses: Lindsborg, KS. **Comments:** Position: dean, College of Fine Arts. **Sources:** WW59.

SPEAR, M. *[Painter] early 20th c.*
Exhibited: Salons of Am., 1934. **Sources:** Marlor, *Salons of Am.*

SPEAR, Thomas Truman *[Portrait, miniature & historical painter] b.1803, Massachusetts / d.c.1882.*
Exhibited: Boston Atheaneum, 1838-56. **Comments:** He worked in Boston principally, though he made frequent visits to Charleston (SC) between 1833-51. He made copies of Stuart's Washington and Allston's "Belshazzar's Feast." **Sources:** G&W; Swan, BA; 7 Census (1850), Mass., XXV, 597 [aged 50]; Rutledge, *Artists in the Life of Charleston;* Boston BD 1841-60+; Campbell, *New Hampshire Scenery,* 157.

SPEAR, William F. *[Engraver] b.c.1842, Nova Scotia.*
Addresses: Boston, 1860. **Comments:** His father, Robert Spear, was a tailor. **Sources:** G&W; 8 Census (1860), Mass., XXVIII, 537.

SPEARE, Caroline (M.) (Miss) *[Painter] early 20th c.*
Addresses: Woodstock, NY. **Studied:** ASL. **Member:** Chicago NJSA. **Exhibited:** S. Indp. A., 1917-18, 1920, 1925-26, 1930; Salons of Am., 1925. **Sources:** WW25; Marlor, *Salons of Am.*

SPEARING, Thomas P. *[Wood engraver, print colorer, print seller] mid 19th c.*
Addresses: NYC, 1840s. **Exhibited:** Am. Inst., 1844. **Comments:** He was a partner of Henry A. Havell with whom he exhibited samples of print coloring at the American Institute in 1844. Spearing was listed as a wood engraver only in 1841. **Sources:** G&W; NYBD 1841; NYCD 1844-45; Am. Inst. Cat., 1844.

SPEARS, Ethel *[Painter, lithographer, screenprinter, illustrator, teacher, craftsperson] b.1903, Chicago, IL / d.1974.*
Addresses: Chicago, IL; Navasota, TX, 1961. **Studied:** AIC; Alexander Archipenko in Woodstock, NY; ASL; J. Norton; H. Rosse. **Member:** NSMP; Chicago SA; Art Center, Chicago. **Exhibited:** S. Indp. A., 1927, 1931; AIC, 1946 (prize),1951, & prior; Rogers Park Women's Club, Chicago (prize); Chicago SA; San Diego FA Soc., 1944; La Jolla AC, 1944; New Trier H.S., Winnetka, IL, 1945; Chicago College Club, 1946; Oak Park Women's Club, Chicago Women's Club, 1945; 750 Gal., 1952; Palmer House, Chicago, 1952; Demonstrations of silk screen printing. **Work:** AIC; community houses, Chicago; Lowell School Oak Park; Oakton School, Evanston, IL; Crippled Children's Ward, IL; Research Hospital; USPO, Hartford, WI; Pub. Lib., Rochelle, IL. **Comments:** In her watercolors Spears depicted everyday rural life in Texas. Position: WPA artist; instr.,

drawing, design, silk screen printing, enameling, AIC, Chicago, IL, 1944-52. **Sources:** WW59; WW47; Trenton, ed. *Independent Spirits*, 195, cites birth date of 1902.

SPEARS, Helen M. *[Painter] early 20th c.*
Addresses: NYC. **Exhibited:** S. Indp. A., 1920. **Sources:** Marlor, *Soc. Indp. Artists.*

SPECK, Walter Edward *[Craftsperson, lithographer, painter, teacher] b.1895, Detroit, MI.*
Addresses: Detroit, MI. **Studied:** J.P. Wicker; Freisz, in Paris. **Member:** Scarab Club. **Exhibited:** Salons of Am., 1924; S. Indp. A., 1925; Scarab Club, Detroit, 1931 (prize). **Work:** Pottery, Fisher Theatre, Detroit; water-color, Detroit IA; State of Michigan. **Comments:** Position: dir., Detroit Sch. Art. **Sources:** WW40.

SPECTOR, George *[Painter] early 20th c.*
Exhibited: Salons of Am., 1926, 1927. **Sources:** Marlor, *Salons of Am.*

SPECTORSKY, I. *[Painter] early 20th c.*
Addresses: NYC. **Exhibited:** S. Indp. A., 1930. **Sources:** Marlor, *Soc. Indp. Artists.*

SPEED, Emma See: **SAMPSON, Emma Steer Speed (Mrs. Henry A.)**

SPEED, Rosalie *[Painter, designer, commercial artist] b.1908, Dallas, TX.*
Addresses: Dallas, TX. **Studied:** Aunspaugh Art Sch., Dallas, TX; Southern Methodist Univ.; Texas State College for Women, Denton. **Member:** Texas FAA; SSAL; Dallas AL; Frank Reaugh AC, Dallas. **Exhibited:** Dallas MFA, 1935 (prize), 1940 (prize), 1943 (prize); Texas Centenn., 1936; SSAL, 1936; Art of the Americas, 1937; San Francisco, 1938; Kansas City AI, 1938; Texas FAA, 1943-46; Dallas All. Artists, 1935, 1940, 1943, 1946, 1949, 1950. **Work:** Dallas MFA. **Sources:** WW59; WW47, which puts birth at 1907.

SPEED, Thelma Gladys *[Painter, designer] b.1914, Bronx, NY.*
Addresses: Lynbrook, NY. **Studied:** Pratt Inst., Brooklyn. **Member:** Nassau Art Lg., Hempstead, NY. **Exhibited:** Mineola (NY) Co. Fair; WC Exh., Noank, CT; WFNY, 1939. **Work:** St. Andrews Textile Co., NY. **Sources:** WW40.

SPEED, U. Grant *[Sculptor] b.c.1935, San Angelo, TX.*
Addresses: Living in Pleasant Grove, UT in 1976. **Studied:** Utah State Univ. (animal husbandry); self taught as an artist. **Work:** Nat. Cowboy Hall Fame, Oklahoma City, OK; Rodeo Cowboys Assn. **Comments:** Was a rodeo rider and school teacher; began sculpting fulltime in 1970. **Sources:** P&H Samuels, 457.

SPEER, Anniola *[Painter] early 20th c.*
Addresses: Ft. Worth, TX. **Sources:** WW24.

SPEER, Will W. *[Painter] early 20th c.*
Addresses: Pittsburgh, PA. **Member:** Pittsburgh AA. **Sources:** WW25.

SPEERS, Nellie Dodd *[Painter] early 20th c.*
Exhibited: Salons of Am., 1932, 1934. **Sources:** Marlor, *Salons of Am.*

SPEICHER, Eugene E(dward) *[Painter] b.1883, Buffalo, NY / d.1962, Woodstock, NY.* *Eugene Speicher*
Addresses: NYC/Woodstock, NY. **Studied:** Albright Art Gal. Sch.; ASL; abroad; Chase, DuMond, Henri at New York Sch. Art; Robert Henri again at the Henri Sch. **Member:** ANA, 1912; NA, 1925; Port. Painters; NAC; Boston AC; NIAL; Contemporary; ASPS&G; Woodstock AA. **Exhibited:** NAD, 1910-1948 (medals, 1911, 1914, 1915, 1947); Brooklyn AA, 1912; PAFA Ann., 1912-13, 1918-21, 1929-56 (gold, 1920 & 1938; prize, 1945); SC, 1913 (prize); Pan-Pacific Expo, 1915 (medal); S. Indp. A., 1920, 1926, 1936; WMAA, 1925-49; VMFA, 1938 (prize); CI, 1922 (medal);

AIC, 1926 (gold); Corcoran Gal biennials, 1912-57 (18 times, incl. silver medal, 1928; gold medal, 1935); Int. Expo, Paris, 1937 (medal). **Work:** Woodstock AA; Albright Art Gal., CMA; CGA; Detroit IA; MMA; MoMA; WMAA; PMG; FMA; CI; TMA; Art Lg., Galveston, TX; Decatur (IL) Mus.; Minneapolis Mus.; Brooklyn Mus.; Worcester AM; MFA, Des Moines, IA; BMFA; W.R. Nelson MA, Kansas City; Los Angeles Mus. Hist., Science & Art; Munson-Williams-Proctor Inst.; Newark MA; Delgado MA, and in private collections. **Comments:** Speicher supported himself with portrait commissions early in his career, but changed over to non-commissioned portraits in the mid 1910s. He also painted small informal landscapes, still lifes and nudes. In 1936, *Esquire* called him "America's most important living painter." **Sources:** WW59; WW47; *Woodstock's Art Heritage*, 132-133; Woodstock AA; Falk, *Exh. Record Series.*

SPEIDEN, Marion (Miss) *[Painter] 19th/20th c.*
Addresses: Louisville, KY. **Member:** Louisville Art Lg. **Sources:** WW01.

SPEIGHT, Francis *[Painter, educator] b.1896, Windsor, NC / d.1989.* *Francis Speight 1938*
Addresses: Phila., PA, until 1943; Doylestown, PA, 1944-61; Greenville, NC, from 1961. **Studied:** Wake Forest College (D.H.L.); Corcoran Gal; PAFA; College of the Holy Cross (D.F.A., 1964). **Member:** NA, 1940; ANA, 1937; NIAL; North Carolina Art Soc. (advisory board). **Exhibited:** PAFA Ann., 1926-66 (prize 1940); PAFA, 1926 (gold), 1930 (prize), 1961 (Percy Owens Award); Soc. Wash. Artists, 1929 (prize); NAD, 1930 (prize); AIC, 1930 (prize); Corcoran Gal. biennials, 1928-57 (11 times, incl. bronze medal, 1937); CAFA, 1932 (prize); Sketch Club, Phila. 1938 (prize); North Carolina Mus. Art, Raleigh, 1961 (retrospective); Penn. Nat. Exh., Ligonier Valley, 1961 (prize); WMAA. Other awards: Gold Medal For Achievement In Art, State of NC, 1964. **Work:** MMA; BMFA; Toronto Gal. Art; PAFA; Norton Gal. Art; Montpelier Mus. Art; Encyclopaedia Britannica Coll.; WPA mural, USPO, Gastonia, NC; MoMA; Rochester Mem. Gal.; Butler IA. **Comments:** Teaching: PAFA, 1926-61; Eastern Carolina Univ., 1961-70s. **Sources:** WW73; WW47; Falk, *Exh. Record Series.*

SPEIGHT, Sarah B. See: **BLAKESLEE, Sarah Jane (Mrs. Francis Speight)**

SPEIR, Andrew H. *[Painter] early 20th c.*
Addresses: Baltimore, MD. **Sources:** WW25.

SPEIR, Esther B. *[Painter] early 20th c.*
Addresses: Active in Washington, DC, 1914-15. **Sources:** Petteys, *Dictionary of Women Artists.*

SPELCE, Fannie Lou *[Folk painter] b.1908, Dyer, AK.*
Addresses: Austin, TX, 1966. **Studied:** Laguna Gloria Art Mus., 1966. **Comments:** She documented in detailed paintings her early years of growing up on a farm in the Ozark Mountains. **Sources:** Dewhurst, MacDowell, and MacDowell, 171.

SPELLMAN, Coreen Mary *[Lithographer, painter, designer, illustrator, teacher, lecturer] b.1909, Forney, TX / d.1978, Denton, TX.*
Addresses: Denton, TX. **Studied:** Texas State College for Women (B.S.); Columbia Univ. (M.A.); ASL; Univ. Iowa (M.F.A.); Provincetown, MA, summers; K.H. Miller; C. Locke; V. Vytlacil; W. Schumacker; E. O'Hara. **Member:** SSAL; Denton AL; Printmakers Guild; Nat. Women's Teachers Assn. **Exhibited:** 50 Prints of the Year, 1932; Provincetown Gal., 1933; SSAL, 1932, 1936, 1937, 1944 (prize); Am. Artists Congress, 1936; Texas Centennial, 1936; Nat. Exh. Am. Art, NY, 1937; WFNY, 1939; Phila. Art All., 1939; Am. Artists Congress, 1938; Texas State Fair, 1938, 1939; Kansas City AI, 1936, 1937, 1942; West Texas Art Exh., 1940 (prize), 1942 (prize), 1945 (prize) 1946 (prize); Univ. Iowa, 1942 (prize); Texas Pr. Exh., 1941,1942 (prize), 1943 (prize), 1944, 1945 (prize); WMAA, 1941; SAE, 1943; AFA Traveling Exh., 1944-45; Assn. Am. Artists, 1946; *Caller-Times*

Exh., Corpus Christi, TX, 1944-45; Denver Art Mus., 1944-46, 1953; Printmakers Guild, 1940-55; Texas General Exh., 1940-50 (prize 1943); Texas FAA, 1932, 1933, 1940, 1943 (prize), 1944-45 (prize), 1946-50; DMFA, 1951 (prize). **Work:** "Fifty Prints of the Year," 1932; Texas State College for Women; CI. **Comments:** Focused on industrial and man-made features of contemporary landscape. Illustr.: "Dona Perfecta," 1940; "El Mundo Espanol," 1942; "A Wedding in the Chapel"; & others. Designer, brick mural, Texas State College for Women, 1955; pictorial map of campus, 1947. Represented in "Prize Prints of 20th Century"; "12 From Texas," 1951. Teaching: Texas State Teachers College, Denton, TX. **Sources:** WW59; WW47, which puts birth at 1905; Steward, *Lone Star Regionalism,* 122; Trenton, ed. *Independent Spirits,* 184, 199.

SPELMAN, Jill Sullivan *[Painter] b.1937, Chicago, IL.*
Addresses: NYC. **Studied:** Hilton Leech Art School, Sarasota, FL, 1955-57; Paul Ninas, New Orleans, 1956-58. **Member:** Nat. Soc. Painters in Casein & Acrylic (corresp. secy., 1971). **Exhibited:** Sarasota AA, 1958; Watercolor USA, Springfield (MO) Art Mus., 1967; Mainstreams '70, Marietta (OH) College, 1970; The Landscape of the Mind, Phoenix Gal., NYC, 1971; Salon 1972, Ward Nasse Gal., New York, 1972. **Awards:** Sarasota AA First Prize, Art Students Exh., 1957; Hamel Prize, Sarasota AA Ann., 1958; Grumbacher Oil Prize, Knickerbocker Artists Ann., 1970. **Work:** Univ. Mass., Amherst. **Comments:** Preferred media: acrylics. Positions: pres., Phoenix Coop Gal., 1972-. Teaching: lecturer, Ringling Mus. Art, Sarasota, 1958-60. **Sources:** WW73.

SPELMAN, John Adams *[Painter] b.1880, Owatonna, MN.*
Addresses: Grand Marais, MN; Oak Park, IL. **Member:** Chicago P&S; Palette & Chisel Acad. FA; Oak Park & River Forest Art Lg.; Chicago Gal. Art. **Exhibited:** PAFA Ann., 1924; AIC, 1926 (prize); Chicago Gal. Art, 1927 (prize), 1928 (prize), 1929 (prize); Chicago P&S (gold); Oak Park AL, 1930 (gold); Palette & Chisel Acad. FA, 1933 (gold). **Work:** Springfield AA; Chicago Athletic Club; Univ. Nebraska; State Mus., Springfield, IL. **Sources:** WW40; Falk, *Exh. Record Series.*

SPENCE, Andrew *[Painter] mid 20th c.*
Addresses: Los Angeles, CA. **Exhibited:** WMAA, 1975, 1989. **Sources:** Falk, *WMAA.*

SPENCE, J. *[Painter] late 19th c.*
Addresses: NYC, 1888-95. **Exhibited:** NAD, 1888-95. **Sources:** Naylor, *NAD.*

SPENCELEY, J. Winfred *[Etcher, illustrator] 19th/20th c.*
Addresses: Boston, MA. **Member:** Boston SAC. **Sources:** WW01.

SPENCER, Ann Hunt *[Painter, teacher] b.1914, Toronto, Ontario.*
Addresses: NYC; Housatonic, MA. **Studied:** NAD; Sarah Lawrence College; Jerry Farnsworth. **Member:** Nat. AC. **Exhibited:** NAC, 1937 (prize); Kohn Gal., NY, 1938 (solo); NAD, 1939-40; Corcoran Gal. biennial, 1939; Berkshire Mus. Other awards: traveling scholarship, Kosciuszko Found., 1937. **Work:** portraits (12) lobby, No. 2 Fifth Ave., NY; WPA mural, Southington, CT; Univ. Plastic Corp., NY. **Comments:** (Mrs. Ann Spencer Pratt). **Sources:** WW59; WW47.

SPENCER, Asa *[Banknote engraver] b.c.1805, Pennsylvania.*
Addresses: Philadelphia, active c.1825-50. **Studied:** probably learned engraving from Gideon Fairman or John Draper, Phila. **Comments:** He worked for the following firms: Fairman, Draper, Underwood & Co. (1825-27); probably Draper, Underwood & Co. (1827-31); Draper, Underwood, Bald & Spencer (1833); Underwood, Bald & Spencer (1835); Underwood, Bald, Spencer & Hufty (1837-43); Danforth, Bald, Spencer & Hufty (1843); and Spencer, Hufty & Danforth (1844-47). Spencer was listed in the 1850 Census, but his name does not appear in Philadelphia directories after 1849. **Sources:** G&W; 7 Census (1850), Pa., LI, 925; Phila. CD 1825-49; Toppan, *100 Years of Bank Note Engraving,*

8-11.

SPENCER, Asa, Jr. *[Banknote engraver] mid 19th c.*
Addresses: Philadelphia, active from 1841-44. **Comments:** He was employed by Underwood, Bald, Spencer & Hufty and Spencer, Hufty & Danforth (see entries), in both of which firms his father was a partner. **Sources:** G&W; Phila. CD 1841-44.

SPENCER, Asah See: **ASAH, Spencer**

SPENCER, Benjamin R. *[Listed as "artist"] mid 19th c.*
Addresses: NYC, 1850s. **Sources:** G&W; NYCD 1850-57.

SPENCER, Bertha Augusta *[Craftsman, etcher, educator, writer, lecturer] 20th c.; b.Paxton, IL.*
Addresses: Pittsburgh, KS; Carthage, MO. **Studied:** Stout Inst., Menomonie, WI; Handicraft Gld., Minneapolis, MN; Kansas State Teachers College (B.S.); Columbia Univ. (A.M.); Martin; L. Taft; J. Shapley; Europe. **Member:** Nat. Soc. Des. Club; Nat. Educ. Assn.; Nat. Art Educ. Assn.; Western AA; Kansas Fed. Art; Kansas State Art Teachers Assn. (hon. life mem.); Ozark Art Gld.; Kappa Pi (nat. secy.-treas., 1946). **Exhibited:** ceramics & metalcraft in many cities. **Awards:** Nat. Block Print prize, Minneapolis, MN. **Comments:** Teaching: Kansas State Teachers College, Pittsburg, 1921-50s. **Sources:** WW59; WW47.

SPENCER, Claire *[Painter] early 20th c.*
Exhibited: Salons of Am., 1930. **Sources:** Marlor, *Salons of Am.*

SPENCER, Clara Barton *[Painter, designer, craftsperson] mid 20th c.; b.Wash., DC.*
Addresses: NYC. **Studied:** Nat. Acad., Chicago; Am. Acad., Chicago. **Exhibited:** Delphic Studio, NY (solo); NY Municipal Gal. (solo). **Sources:** WW40.

SPENCER, Edna Isbester *[Sculptor, painter, teacher, commercial artist] b.1883, St. John, NB, Canada.*
Addresses: Boston, MA, 1920; Miami, FL. **Studied:** BMFA Sch.; ASL; Bela Pratt; Robert Aitken. **Member:** Miami Art Lg. **Exhibited:** PAFA Ann., 1920; Concord AA (prize); Miami Art Lg., 1940 (prize); Paris Salon, 1926 (prize); Medallic Art Co., 1952. **Work:** numerous portrait busts. **Sources:** WW59; WW47; Falk, *Exh. Record Series.*

SPENCER, Eleanor Patterson *[Writer, art historian] mid 20th c.; b.Northampton, MA.*
Addresses: Paris, France. **Studied:** Smith College (B.A. & M.A.); Radcliffe College (Ph.D.); Goucher College (1967, hon. L.H.D.). **Member:** College AA Am. **Exhibited:** Awards: Sachs fellowship, Harvard Univ., 1928; Fulbright fellowship, 1962. **Comments:** Positions: trustee, Walters Art Gal., Baltimore, 1962; trustee, Baltimore Mus. Art, 1962; trustee, Peale Mus., Baltimore, 1962. Publications: author, articles, *Scriptorium,* 1963, 1965 & 1969; author, articles, *Burlington Magazine,* 1965 & 1966. Teaching: Goucher College, 1930-962. Research: illuminated manuscripts of the 15th c. in France. **Sources:** WW73.

SPENCER, Elizabeth C. *[Painter] early 20th c.*
Addresses: Baltimore, MD/Westchester, NY. **Member:** NAWPS. **Exhibited:** Corcoran Gal. biennials, 1916, 1923; AIC, 1917, 1919; PAFA Ann., 1918, 1920. **Sources:** WW25; Falk, *Exh. Record Series.*

SPENCER, Frank B. *[Painter] early 20th c.*
Addresses: Rochester, NY. **Sources:** WW08.

SPENCER, Frann *[Painter] mid 20th c.*
Addresses: Berkeley, CA. **Exhibited:** WMAA, 1951. **Sources:** Falk, *WMAA.*

SPENCER, Frederick R. *[Portrait & genre painter] b.1806, Lennox, NY / d.1875, Wampoville, NY.*
Addresses: NYC, c.1831-57. **Studied:** self-taught. **Member:** Am. Acad. (1833-35; board directors); ANA (1837-46); NA (1849-50; corresp. secy.). **Exhibited:** NAD. **Comments:** In 1858 he retired to Canistota in upstate New York. **Sources:** G&W; Dunlap, *History,* II, 436; CAB; Cowdrey, NAD; Cowdrey, AA & AAU; NYCD 1831-56; NYBD 1841-57; Swan, BA; Stauffer, nos. 605,

2397; Clement and Hutton.

SPENCER, G. P. *[Engraver or sculptor] mid 19th c.*
Addresses: St. Johnsbury, VT, 1849. **Sources:** G&W; New England BD 1849.

SPENCER, Guy Raymond *[Cartoonist] b.1878, Jasper County, MO.*
Addresses: Omaha, NE. **Comments:** Positions: staff, *Omaha World-Herald* (since 1899), *Lincoln Commoner* (1902-10). **Sources:** WW21.

SPENCER, Henry Cecil *[Educator, painter, illustrator, writer] b.1903, Magnum, OK.*
Addresses: Chicago, IL. **Studied:** Baylor Univ. (A.B.); Texas Agricultural & Mechanical College (B.S. in Arch.; M.S.); Ernest Blumenschein; ASL with Romanovsky. **Member:** Soc. for the Promotion of Engineering Educ.; Am. Inst. Draftsmen; SSAL. **Work:** Baylor Univ., Waco, TX. **Comments:** Teaching: Texas A&M College, College Station, TX, 1930-40; Illinois Inst. Tech., Chicago, 1941-. Auth.: "Technical Drawing," 1940; "The Blueprint Language," 1946. Contrib.: *Journal of Engineering Drawing.* **Sources:** WW59; WW47.

SPENCER, Howard Bonnell *[Painter, teacher, illustrator] b.1871, Plainfeld, NJ / d.1967, NYC.*
Addresses: NYC; West Chester, PA. **Studied:** ASL; Frank DuMond; George Elmer Browne; Albert Lucas; Walt Kuhn. **Member:** All. Artists Am. (pres., 1946-48); SC, 1924 (director, 1948-51); Barnard Club; Studio Gld.; Lime Rock AA; Yonkers AA; Ogunquit AC; Art Fellowship, Inc.; Provincetown AA; AAPL (director); Hudson Valley AA; Nat. Soc. Painters in Casein (vice-pres.); Nat. Pastel Soc.; FA Fed. **Exhibited:** MMA (AV); NAD; All. Artists Am., 1949 (prize), 1951 (prize); Ogunquit AC; Provincetown AA; Town Hall, NY; S. Indp. A.; NAC; Buck Hills Falls, PA; AAPL, 1951-53 (prizes). **Work:** Wesleyan College, Macon, GA; Oregon State AAPL Chapter; City Hall, NY. **Sources:** WW59; WW47.

SPENCER, Hugh *[Illustrator, photographer, lithpgrapher, writer] b.1887, Saint Cloud, MN / d.1975.*
Addresses: Chester, CT; Sacramento, CA. **Studied:** Chicago School Applied & Normal Art; ASL; NY Evening School Indust. Art; Charles Chapman; Arthur Covey; H. Dunn. **Member:** Photographers AA; Soc. Conn. Craftsmen; Meriden Arts & Crafts; Conn. Bot. Soc. (pres., 1963-64); Sierra Camera Club; Capital Wood Carvers Assn.; Phila. ACG. **Exhibited:** Weinstock's Photo Exh. & Comp., Sacramento, CA, 1962 (hon. men.); Capital Wood Carvers Assn. Show, 1972. **Comments:** Positions: illustr., nature & science readers & textbooks. Auth.: "Nature"; "American Forests and Forest Life"; "Bird Lore"; "American Photography." Illustr. of books on biology and natural science. **Sources:** WW73; WW47.

SPENCER, Inez Ludlow *[Painter] late 19th c.*
Addresses: NYC, 1883. **Exhibited:** NAD, 1883. **Sources:** Naylor, *NAD.*

SPENCER, Irvin B. *[Painter] early 20th c.*
Addresses: Columbus, OH. **Member:** Columbus PPC. **Sources:** WW25.

SPENCER, J. C. *[Portrait painter] mid 19th c.*
Addresses: Phelps, NY, 1859. **Sources:** G&W; N.Y. State BD 1859.

J.C. Spencer 1902

SPENCER, J. S. See: **SPENCER, Julia Selden (Mrs. R. P.)**

SPENCER, Jean *[Painter, designer, teacher, writer] b.1904, Oak Park, IL.*
Addresses: Oak Park, IL; NYC; New Rochelle, NY. **Studied:** Wellesley College; AIC; Grand Central School Art; A. Woelfle; W. Adams; Traphagen School Fashion, NY. **Member:** Pen & Brush Club; Studio Gld., NY; NAWA (chmn. jury & jury of awards; chmn. entertainment; mem. advisory bd.); Audubon

Artists; Portraits, Inc.; Grand Central Art Gal.; Martha's Vineyard AA; All. Artists Am. (treas.); Audubon Artists (chmn., public relations). **Exhibited:** Grand Central School Art (medal); All. Artists Am.; All-Illinois Soc. Painters; NAC; Pen & Brush Club (prizes); Audubon Artists (purchase prize); Manor House, NY, 1938 (solo); Studio Gld., NY, 1938 (solo); NAWPS, 1938-38; NAWA (prizes); B.T. Batsford, Ltd., NY (solo); Marshall Field & Co., Chicago (solo); Wilton, CT (solo).; Creative Art Gal., Charlottesville, VA (solo).; Martha's Vineyard AA (solo); IFA Gal., Wash., DC (solo). **Work:** portraits, public buildings, Charlottesville, VA; Sioux Falls, SD; Trenton, NJ; Court House, High Point, NC; NYPL; Osteopathic Clinic, NY; House Office Bldg., Wash., DC; Florida Southern College; Arizona Mus., Dragoon, AZ. **Comments:** Author: "Fine and Industrial Arts." **Sources:** WW66; WW47.

SPENCER, Jeannette Dyer *[Mural painter, craftsperson] b.1892, Cleveland, OH / d.1986, San Francisco, CA.*
Addresses: San Francisco, CA. **Studied:** Western Reserve Univ., Cleveland, OH; Univ. Calif., Berkeley (1915, arch.; M.A., 1920); École du Louvre, Paris (stained glass studies). **Work:** Congregational Church, Oakland, CA (stained glass); Ahwanee Hotel, Yosemite; First Church of Christ Science, San Francisco (murals). **Comments:** Position: interior des., Yosemite National Park. **Sources:** Hughes, *Artists in California,* 528.

SPENCER, Jim-Edd *[Block printer, illustrator, painter] b.1905, Kansas City.*
Addresses: Independence, MO. **Studied:** Kansas City AI; Univ. Missouri; B. Sandzen; J.S. Ankeney. **Member:** Kansas City Soc. Artists. **Sources:** WW40.

SPENCER, Job (Joseph) B. *[Fruit & flower, animal & landscape painter] b.1829, Salisbury, CT / d.1899, probably Grand Rapids, MI.*
Addresses: NYC; Scranton, PA, active 1870's; Grand Rapids, MI. **Exhibited:** NAD, 1858 (landscape). **Comments:** Trained as a house painter, he later studied for several years in NYC. *Cf.* Joseph Spencer of Perth Amboy, NJ. **Sources:** G&W; French, *Art and Artists in Connecticut,* 141; Cowdrey, NAD; Fielding [as Joseph B.]; Gibson, *Artists of Early Michigan,* 217.

SPENCER, John R. *[Art historian, art administrator] b.1923, Moline, IL.*
Addresses: Washington, DC. **Studied:** Grinnell College (B.A., 1947; hon. D.F.A., 1972); Yale Univ. (M.A., 1951; Ph.D., 1953); also with Charles Seymour, Jr. **Member:** College Art Assn. Am. (secretary, 1967; vice-pres., 1971); Am. Assn. Mus.; Assn. Art Mus. Dir.; Instituto per la Storia dell'arte Lombarda; AFA. **Comments:** Positions: museum director, Oberlin College, 1962-72. Teaching: instructor/asst. prof. art, Yale Univ., 1952-58; assoc. prof. art & acting chmn. dept., Univ. Florida, 1958-62; prof. art history, Oberlin College, 1962-. Publications: author, "L.B. Alberti, On Painting," 1955 & 1967; author, "Filarete's Treatise on Architecture," 1965. Research: fifteenth century Italian art, with emphasis on painting & theoretical writings. **Sources:** WW73.

SPENCER, Joseph *[Painter] mid 19th c.*
Addresses: Perth Amboy, NJ, 1863. **Exhibited:** NAD, 1863-64 (figural works). **Comments:** *Cf.* Job B. Spencer. **Sources:** Naylor, *NAD.*

SPENCER, Joseph *[Painter] mid 20th c.*
Addresses: Detroit, MI. **Exhibited:** Ann., PAFA, 1939; San Francisco AA, 1939. **Sources:** WW40.

SPENCER, Joseph B. See: **SPENCER, Job (Joseph) B.**

SPENCER, Julia Selden (Mrs. R. P.) *[Painter] mid 20th c.; b.Connecticut.*
Addresses: Deep River, CT, until 1925; Miami, FL. **Studied:** ASL with Seyffert; NY School Fine & Applied Art with Walter & Bredin; Breckenridge in East Gloucester. **Member:** North Shore AA; Miami Beach AL. **Exhibited:** S. Indp. A., 1918, 1921 (as J.S. Spencer). **Sources:** WW27; Marlor, *Soc. Indp. Artists.*

SPENCER, Leontine (Gridelly) (Mrs. S. Reid) *[Painter, teacher]* b.1882, NYC / d.1964, NYC.
Addresses: Brooklyn, NY. **Studied:** Hunter College; ASL; Teachers College, Columbia Univ.; Grand Central School Art; Frank DuMond; George Pearse Ennis; Arthur Woelfle. **Member:** ASL; AWCS; Wolfe Art Club; AAPL. **Exhibited:** S. Indp. A., 1931; AWCS, 1932, 1934; All. Artists Am., 1933, 1934, 1936-37, 1940-42; Salons of Am., 1934; NAD, 1934; Rockefeller Center, NY, 1934; South Brooklyn Board Trade, 1939; BM, 1939-40, 1943; Brooklyn P&S, 1934, 1936; NAC, 1954-57; 8th St. Gal., 1954; Butler Gal., 1954-57; Wolfe Art Club, 1956-58; AAPL, 1956-57; Crespi Gal., 1956. **Comments:** Teaching: Thomas Jefferson H.S., Brooklyn. **Sources:** WW59.

SPENCER, Lily Martin *[Portrait, still-life and genre painter]* b.1822, Exeter, England / d.1902, Crum's Elbow, NY.
Addresses: Marietta, OH,1833-41; Cincinnati, 1841-47; NYC, 1847. **Studied:** C. Sullivan & S. Bosworth, Marietta, OH, before 1841; NAD, 1847. **Member:** NA (hon. mem., 1850). **Exhibited:** Marietta, OH, 1841; Cincinnati Soc. for the Promotion of Useful Knowledge; Cincinnati Young Men's Mercantile Lib.; Cincinnati Western Art Union; NAD, 1848-58; Brooklyn AA, 1865-78; Phila. Centenn. Expo, 1876 (gold); Am. Art Union, NYC; Nat. Mus. Am. Art, 1973 (retrospective). **Work:** NMAA; BM; Newark Mus. (purchase 1944; "The war spirit at home. Celebrating the victory at Vicksburg, 1866"). **Comments:** A popular painter of sentimental domestic genre scenes, often including children or dogs. Angelique Marie Martin was born in England where her French parents had a school. The family emigrated to America in 1830, with the idea of forming a utopian colony. Lily (or Lilli) was educated at home and was a prodigy who began painting in her teens. An exhibition of her work in 1841 brought her to the attention of wealthy Cincinnati patron N. Longworth who offered to send her to Europe for further study. The artist turned this down however, instead spending the next several years in Cincinnati, where she worked with John Insco Williams. After her marriage to Benjamin Rush Spencer in 1844, the artist continued to search for exhibition opportunities and in 1847 achieved some financial success through the sale of her work by the Western Art-Union in Cincinnati. In 1848 she and her family moved to New York with the hope of finding a larger audience for her work. There, for many years, she enjoyed great popularity as a genre painter of home life while her husband supported her talent by handling many of the domestic chores as well as the business side of her work. She gave birth to 13 children, and the 7 who survived were often subjects in her genre scenes. She continued to paint up to the time of her death, producing at least 500 works, many of which were reproduced as very popular engravings and lithographs. **Sources:** G&W; Reiter, "Lily Martin Spencer;" Cowdrey, "Lilly Martin Spencer;" Cowdrey, NAD; Newark CD 1858; Essex, Hudson, and Union Counties BD 1859; Clark, *Ohio Art and Artists*, 106; Swan, BA; *Art Digest* (Jan. 15, 1945), 30; the N.A.D.'s *Century and a Half of Am. Art* fails to list her as an honorary member, and Clark's *History of the N.A.D.* is the only primary source to do so. More recently, see Rubinstein *American Women Artists*, 50-53; Tufts, *American Women Artists*, cat. nos. 36-37, 87-88; *300 Years of American Art*, vol. 1, 196.

SPENCER, Lyman Potter *[Amateur artist]* b.1840, Geneva, OH.
Addresses: Washington, DC, 1878; Newark , NJ, 1889.
Comments: He was a son of Platt R. Spencer, originator of the "Spencerian System" of penmanship, and a brother-in-law of the artist Junius R. Sloan. He was studying art as early as 1854. During the Civil War he served with the army and the family has preserved his illustrated letters and sketchbooks of that period. He was later a publisher and a noted penman. **Sources:** G&W; Webster, "Junius R. Sloan," 116, 145; Williams, *History of Ashtabula County, Ohio*, 110; Spencer, *Spencer Family History and Genealogy*.

SPENCER, Margaret Fulton (Mrs. Robert) *[Painter, architect]* b.1882, Philadelphia, PA.

Margaret.F. Spencer

Addresses: New Hope, PA; Tucson, AZ. **Studied:** Bryn Mawr College; MIT; NY School Design; ASL; in Paris, France; with Birge Harrison & H. Walker; with her husband, R. Spencer. **Member:** AIA; AAPL; Union des Femmes P&S, Paris. **Exhibited:** PAFA Ann., 1916-22, 1926-32; Corcoran Gal. biennials, 1916-30 (5 times); Paris Salons: Rome, Italy; AIC; PMA; Carnegie Inst.; BMA; Memphis Acad. Art; Santa Barbara Mus. Art; Tucson FAA, 1956-58; Rosequist Gal., regularly. **Work:** Simpson College, Phila. **Comments:** Painted flowers & portraits. **Sources:** WW59; WW47; Falk, *Exh. Record Series.*

SPENCER, Margaret K. *[Painter]* 19th/20th c.
Addresses: South Orange, NJ, 1900. **Exhibited:** NAD, 1900. **Sources:** WW01; Naylor, *NAD.*

SPENCER, Marion Dickinson (Mrs. Ivar D.) *[Painter, educator]* b.1909, Grand Rapids, MI.
Addresses: Kalamazoo 73, MI. **Studied:** Western Michigan Univ. (B.A.); Colorado State College (M.A.). **Member:** Michigan Acad. Art, Science & Letters; Am. Assn. Univ. Women; Michigan Art Educ. Assn.; Nat. Educ. Assn. **Exhibited:** Kalamazoo IA, 1937 (prize); Grand Rapids Art Gal., 1942 (prize); Barnsdall AC, Los Angeles, 1948; Kalamazoo Clothesline Exh., 1953. **Comments:** Teaching: Kalamazoo Pub. School, 1932-44; Kalamazoo IA, 1944-47; Chouinard AI, Los Angeles, 1947; Mod. IA, Beverly Hills, CA, 1948; Western Michigan College, 1950; Kalamazoo City School, 1952-; Vicksburg Elem. School, 1954-57;Kalamazoo (MI) Region Secondary Schools, College Agreement Assn., 1954; East Campus Branch, Audio-Visual Center, Western Mich. Univ., 1957-. **Sources:** WW59.

SPENCER, Mary *[Painter, sculptor]* b.1912, Grinnell, IA.
Addresses: Grinnell, IA. **Studied:** AIC, 1933; ASL with Alexander Brook & George Bridgeman; Europe. **Exhibited:** Iowa Artists Club, 1934 (prize), 1935 (prize); Grinnell College, 1934 (Steiner prize); AIC, 1936. **Sources:** Ness & Orwig, *Iowa Artists of the First Hundred Years,* 196.

SPENCER, Mary *[Watercolor painter, teacher]* mid 20th c.; b.Fitchburg, MA.
Addresses: Brooklyn, NY. **Studied:** H. Adams; H.B. Snell; A. Dow; R. Miller; Pratt Inst. **Member:** NAWPS. **Exhibited:** NAWPS, 1936-38. **Sources:** WW40.

SPENCER, Mary A. *[Painter]* b.1835, Springfield, OH / d.1923.
Addresses: Cincinnati, OH, from 1858; NYC, 1883. **Studied:** C.T. Webber in Springfield & in Cincinnati. **Member:** Cincinnati Women's AC (founder; first pres., 1892-98). **Exhibited:** Cincinnati; Boston AC, 1882; NAD, 1883; World Columbian Expo, Chicago, 1893; Trans-Mississippi Expo, Omaha, 1898; Pan-Pacific Expo, San Francisco, 1915. **Work:** Cincinnati Art Mus. **Comments:** Positions: teacher of oil painting, Springfield Female Seminary, until 1860; portrait colorist, Hoag and Quick, Cincinnati. Specialized in still life subjects, some of which were reproduced as chromolithographs. Also produced miniatures and portraits. **Sources:** WW23; G&W; *Cincinnati Painters of the Golden Age*, 104 (w/illus.); Gerdts, *Art Across America*, vol. 2: 195-196; *For Beauty and for Truth*, 88 (w/repro.); *The Boston AC.*

SPENCER, Mary Jones *[Painter, designer, lecturer, teacher]* b.1900, Terre Haute, IN.
Addresses: Riverside, IL; Santa Fe, NM. **Studied:** Indiana State Teachers College; AIC; Chicago Acad. FA. **Member:** Hoosier Salon; All-Illinois SFA; Indiana Art Club; Chicago SA; NAWPS; Art All. New Mexico; Chicago P&S; Chicago Soc. Art. **Exhibited:** NAWA, 1937, 1938; CAFA, 1939; Hoosier Salon, 1934-39, 1940 (prize); AIC, 1936, 1939; South Carolina AA, 1943, 1944; Art Gal., Santa Fe; Springfield, IL; State Mus., Santa Fe. **Work:** Mason City (IA) Pub. Lib.; Pub. Sch., Chicago, IL. **Comments:** Position: teacher, Chicago Acad. FA; artist & lectur-

er, Navajo Ceremonial Art Mus.; display designer, Palace of the Governor's Mus., Santa Fe. Lectures on color. **Sources:** WW59; WW47.

SPENCER, Mary (Mary Scruggs-Spencer) *[Painter, instructor] b.1909, Ancon, Panama.*
Addresses: Longview, TX. **Studied:** Univ. Alabama; Southern Methodist Univ. with DeForrest Judd. **Member:** Texas FAA; East Texas FAA (bd. mem., 1970-71); Texas WCS (mem.-at-large, 1972; dir.-at-large, 1972-73); Gregg Art Guild; Tyler Art Lg. **Exhibited:** Butler Mus. FA Nat. Exh., Youngstown, OH, 1964; Artists of the Gulf States, Delgado Mus., New Orleans, LA, 1964; Sun Carnival Nat. Exh., El Paso (TX) Mus. FA, 1965-67; Parthenon, Nashville, TN, 1965 (solo); Beaumont (TX) Mus., 1970; Frederick-Nila, Longview, TX, 1970s. Awards: Texas FAA, 1963 (hon. mention); Elizabet Ney Mus., 1964 (Grumbacher Award); Beaumont Mus., 1967 (Fred Miller Award). **Work:** Commissions: romantic garden scene, Riff's Bridal Salon, Longview, TX, 1957. **Comments:** Preferred media: oils. Teaching: night dept., Kilgore Jr. College, TX, 1966-72; St. Mary's, Longview, TX, 1972; Longview Mus. & AC; private workshops. Collection: contemporary regional artists. **Sources:** WW73; Ashford, "Arts," *San Antonio Express,* January 13, 1963; Stevens, "Aux États Unis," *La Révue Mod.* (February, 1965); Hieronymus, "Art & Theatre," *Nashville Tennessean,* March 14, 1965 & April 18, 1965.

SPENCER, Meade A(hley) *[Architect, block printer, designer, drawing specialist, etcher, illustrator, painter] b.1896, Sandusky, OH.*
Addresses: Cleveland Heights, OH. **Studied:** W. Felton Brown; MIT. **Member:** Cleveland PM; Cleveland Print Club. **Exhibited:** Exh. Cleveland Arts & Craftsmen, Cleveland Mus., 1929 (prize), 1934 (prize). **Work:** Cleveland Print Club. **Sources:** WW40.

SPENCER, Niles *[Painter] b.1893, Pawtucket, RI / d.1952, Dingman's Ferry, PA.*
Addresses: NYC/Provincetown, MA. **Studied:** Woodbury lectures, RISD, 1913; Chas.H. Woodbury, Ogunquit School, 1913; Hamilton Easter Field School, Ogunquit, 1915; ASL with Geo. Bellows and R. Henri, 1916; in France and Italy, 1921-22. **Member:** An Am. Group; Woodstock AA. **Exhibited:** S. Indp. A., 1922; Salons of Am., 1922, 1932, 1936; WMAA,1922-50, 1965-66 (retrospective); CI, Pittsburgh, 1930 (prize); Corcoran Gal. biennials, 1932-51 (7 times); PAFA Ann., 1933-51; MoMA; AIC; Detroit IA; Univ. Kentucky (retrospective); Munson-Williams-Proctor Inst. (retrospective); Portland (ME) Mus. Art (retrospective); Allentown AM (retrospective); Currier Gal. Art (retrospective); RISD; Ogunquit Mus. Am. Art. **Work:** Albright Art Gal.; PMG; WMAA; MoMA; MMA; Field Fnd.; Ann Arbor AA; Wichita MA; Providence MA; Columbus Gal. FA; Columbus (OH) MFA; Northern Trust Co., Chicago; WPA mural, USPO, Aliquippa, PA. **Comments:** For most of his career, Spencer worked in a precisionist style, choosing interiors, still lifes, urban views, and farm scenes as his subject matter during the 1920s, and concentrating on industrial themes in the 1930s. Spencer's work became more abstract during the 1940s and he gradually eliminated almost all spatial references. Painted also in Bermuda (1927, 1928, 1931). **Sources:** WW47; Baigell, *Dictionary; Charles Woodbury and His Students;* Falk, *Exh. Record Series;* add'l info. courtesy Woodstock AA.

SPENCER, R. P. (Mrs.) *[Painter] early 20th c.*
Addresses: NYC. **Exhibited:** S. Indp. A., 1917. **Sources:** Marlor, *Soc. Indp. Artists.*

SPENCER, Raymond M. *[Painter] early 20th c.*
Addresses: Columbus, OH. **Member:** Columbus PPC. **Sources:** WW25.

SPENCER, Robert *[Landscape painter] b.1879, Harvard, NE / d.1931, New Hope, PA (suicide).* *Robert Spencer*
Addresses: Point Pleasant, New Hope, Bucks County, PA. **Studied:** NAD (1899-1901) with Francis C. Jones, G. Maynard,

R. Blum; NY Sch. Des (1903-05); W.M. Chase; F.V. DuMond; R. Henri; D. Garber. **Member:** ANA, 1914; NA, 1920; SC; NAC; Century Assn. **Exhibited:** PAFA Ann., 1910-32 (medal, 1914); Corcoran Gal, biennials, 1910-30 (10 times); NAD, 1913 (prize), 1914 (gold), 1920 (prize), 1921 (prize), 1928 (gold); Phila AC, 1913 (prize), 1923 (prize), 1928 (gold); Boston AC, 1915 (medal); Pan-Pacific Expo, San Francisco, 1915 (gold); AIC, 1919 (medal); CI, 1920 (prize), 1926 (prize); SC, 1921 (prize); Wilmington SFA, 1921 (prize); Sesqui-Centenn. Expo, Phila., 1926 (gold). **Work:** MMA; Boston AC; Detroit IA; AIC; National AC; CGA; Pittsburgh Athletic Assn.; Brooks Memorial Art Gal., Memphis, TN; NAD; Union Lg. Club, Chicago; Phila. AC; CI; Brooklyn Mus.; Newark Mus. Assn.; Albright Art Gal., Buffalo; Soc. FA, Wilmington, DE; PMG. **Comments:** A New Hope (Bucks County) impressionist, he favored painting the local architecture in its settings, rather than the rural landscape. His depictions of the living and working conditions of local mill workers combine a social subject matter with the technical advances of the New Hope Impressionists. He traveled to France, Italy and Spain in 1925 and France again in 1927. In his later works he turned to religious themes. **Sources:** WW29; *300 Years of American Art,* 754-755; Falk, *Exh. Record Series.*

SPENCER, Selina *[Portrait painter] mid 19th c.*
Addresses: Statesville, NC, 1847-60. **Comments:** She married a Mr. Spainhour. **Sources:** G&W.

SPENCER, W. Clyde *[Cartoonist] b.1874, Peoria, IL / d.1915.*
Addresses: NYC. **Comments:** Cartoonist: *Denver Republican,* 1895-1909; NYC papers, 1909-15.

SPENCER, W. H. *[Engraver] early 19th c.*
Addresses: NYC, 1825. **Sources:** G&W; Dunlap, *History* (1918); Fielding.

SPENCER, William *[Engraver] b.c.1834, England.*
Addresses: NYC, 1860. **Comments:** Lived with his English wife and three children (3 years to 2 months old) born in New York. **Sources:** G&W; 8 Census (1860), N.Y., L, 771.

SPENCER, HUFTY & DANFORTH See: **DANFORTH, SPENCER & HUFTY**

SPENNER, E. E. *[Painter] early 20th c.*
Addresses: Indianapolis, IN. **Sources:** WW25.

SPENS, Nathaniel *[Primitive painter, sculptor, decorator] b.1838, Edinburgh, Scotland / d.1916, Mountainville, UT.*
Addresses: American Fork, UT, c.1865; Mountainville, UT, 1890. **Work:** Latter Day Saints temples. **Comments:** Came to U.S. in 1862. **Sources:** P&H Samuels, 457.

SPERAKIS, Nicholas George *[Painter, printmaker] b.1943, NYC.*
Addresses: NYC. **Studied:** Pratt Inst. (scholarship, fall 1960); NAD Sch. FA, New York (scholarship), painting with Louis Boucie, 1960-61; ASL (scholarship), 1961-63, painting with Joseph Hirsch, Charles Alsom, Edwin Dickenson, Will Barnet & Harry Sternberg & graphics with Harry Sternberg; Pratt Graphic AC, scholarship, printmaking with Sid Hammer, Clair Romano & Ed Casserella. **Member:** FAFA; Artists Equity Assn.; Rhino Horn Org. Humanist Art. **Exhibited:** Three Brooklyn Mus. Biennials, 1964, 1966 & 1970; 100 Prints From Pratt Graphic AC, Jewish Mus., New York, summer 1964; New Acquisitions, Chrysler Mus., Provincetown, MA, 1964-65; New Acquisitions, Norfolk Mus. Arts & Sciences, 1965; Paul Kessler Gallery, Provincetown, MA, 1970s. Awards: purchase prize, Mercyhurst College Paint Ann., 1964; Lawrence & Hinda Rosenthal fellowship, Am. Acad. Arts & Letters & NIAL, 1969; J.S. Guggenheim Mem. Found. fellowship graphics, 1970. **Work:** BM Print Coll.; PMA Print Coll.; Chrysler Mus. Permanent Coll., Provincetown, MA; Norfolk (VA) Mus. Arts & Sciences; 42nd St. Pub. Lib., NYC. Commissions: portraits, Johnethan Charnolble, Coll. of Carla Rueban, Mari Galleries, Larchmont, NY, 1966, Dr. John Courins, Maplewood, NJ, Marvin Bolozky, New York, 1967, Chaim Gross, New York,

1969 & George Viener, Redding, PA, 1971. **Comments:**
Teaching: Art School Educ. Alliance, 1968-69; 92nd St. YMHA,
New York, 1970-71; Brooklyn Mus. Art School, 1971-72.
Sources: WW73; Robert Henkes, *The Crucifixion as Depicted by
Contemporary Artists* (Nazarine College, 1972); Barry Shwarts,
20th Century Humanist Art (Praeger, 1973); Una Johnson,
American Printmaking (Brooklyn Mus.).

SPERANDIO, Alois *[Painter] mid 20th c.*
Exhibited: Salons of Am., 1934, 1936; S. Indp. A., 1938-39,
1941. **Sources:** Marlor, *Salons of Am.*

SPERLING, George J. *[Painter] early 20th c.*
Addresses: Pittsburgh, PA. **Member:** Pittsburgh AA. **Sources:**
WW21.

SPERO, M. J. *[Illustrator, painter] early 20th c.*
Addresses: NYC. **Exhibited:** Corcoran Gal. biennial, 1914; S.
Indp. A., 1917. **Sources:** WW24; Falk, *Exhibition Records
Series.*

SPERO, Nancy *[Painter, collage artist] b.1926, Cleveland,
OH.*
Addresses: NYC. **Studied:** AIC (BFA, 1949); Atelier Andre
L'Hote; Ecole des Beaux Arts, 1949-50. **Work:** MOMA; PMA;
Mus. des Beaux Arts, Montreal; Australian Natl. Gal. **Comments:**
Feminist artist. In 1971 Spero created a mural, "Tortures of
Women," in which she incorporated newsclippings, other verbal
documentation, and images. In 1969, with Juliette Gordon and
other women artists, she formed W.A.R. (Women Artists in
Revolution) to pressure museums and commercial galleries into
showing the work of women. **Sources:** Rubinstein, *American
Women Artists,* 375, 377.

SPERONI, John L. *[Engraver] mid 19th c.*
Addresses: NYC, 1860-62. **Comments:** Of Griffin & Speroni
(see entry). **Sources:** G&W; NYCD 1860-62.

SPERRY, Edward Peck *[Painter] early 20th c.*
Addresses: NYC. **Member:** Mural Painters; Arch. Lg. **Sources:**
WW13.

SPERRY, Keith (Mrs. Thomas K. Givens) *[Designer, dec-
orator] b.1888, Louisville, KY.*
Addresses: Louisville, KY. **Member:** Louisville AC. **Comments:**
Owner of Sideway Shop, designers and makers of furniture and
ironwork. (Appears also as Keith Sperry Givens.). **Sources:**
WW40.

SPERRY, Theodore S. *[Landscape painter] b.1822,
Bozrahville, CT / d.1878, Hartford, CT.*
Comments: He studied medicine in Boston and was for a time a
practicing physician. About 1844 he began to paint and later in
life he gave himself almost entirely to painting. He made his
home in Hartford and was noted especially for his Connecticut
Valley scenes. Dr. Spencer died of a fall in Allyn Hall, Hartford,
where he was painting scenery. **Sources:** G&W; French, *Art and
Artists in Connecticut,* 111.

SPEYER, A. James *[Art administrator, painter] 20th c.;
b.Pittsburgh, PA.*
Addresses: Chicago, IL. **Studied:** CI (B.S.); Chelsea
Polytechnique, London, England; Sorbonne; Illinois Inst. Tech.
(M.A.) with Mies van der Rohe. **Exhibited:** Pittsburgh AA, 1936
(prize). **Comments:** Positions: private architect, 1946-57; Chicago
corresp., *Art News Magazine*, 1955-57; cur. contemp. art, AIC,
1961-. Teaching: Illinois Inst. Tech., 1946-61; Nat. Univ. Athens,
1957-60; Ford Found. seminar, AIC. Collections arranged: Am.
Bi-Ann., 20th C. Sculpture Exh., 1967 & Mies van der Rohe
Retrospective, 1968, AIC. **Sources:** WW73; WW40.

SPICER, Catherine *[Painter] b.1893, Washington / d.1929,
Los Angeles, CA.*
Addresses: Los Angeles, CA. **Studied:** Otis Art Inst. **Exhibited:**
Calif. WCS, 1928; Los Angeles Mus., 1929 (mem. exh.).
Sources: Hughes, *Artists of California,* 528.

SPICER, Clayton V. (Lieut.) *[Painter] early 20th c.*
Addresses: NYC. **Exhibited:** S. Indp. A., 1917. **Sources:**
Marlor, *Soc. Indp. Artists.*

SPICER, Etta M. *[Artist] late 19th c.*
Addresses: Active in Battle Creek, MI, 1887. **Sources:** Petteys,
Dictionary of Women Artists.

SPICER-SIMSON, Margaret Schmidt (Mrs. Theodore)
[Miniature painter] b.1874, Wash., DC.
Addresses: Cannondale, MA. **Studied:** Kraus in Berlin; Bouter
de Monvel & Carrière in Paris. **Exhibited:** Paris Salon, 1899;
Expo Universelle, 1900; Royal Acad., London, 1900-01. **Sources:**
WW17; WW01; Fink, *American Art at the Nineteenth-Century
Paris Salons,* 392.

SPICER-SIMSON, Theodore
*[Sculptor] b.1871, Havre, France /
d.1959, Miami.* T·S-S
Addresses: Flushing, NY; Miami, FL. **Studied:** England;
Germany; Académie Julian & École des Beaux-Arts, Paris.
Member: Soc. Nationale des Beaux Arts, 1928; Century Assn.;
NSS, 1911; ANA; NSS (fellow); Numismatic Mus. (fellow).
Exhibited: PAFA Ann., 1910-11; Brussels Expo, 1911 (prize); Int.
Exh., Belgium, 1913 (medal); Ghent Expo, 1915 (prize); Pan-
Pacific Expo, San Francisco, 1915 (medal); NSS, 1955 (medal);
NY Numismatic Soc., 1956 (medal). **Work:** MMA; Victoria &
Albert Mus.; Nat. Portrait Gal., London; Numismatic Mus., NY;
AIC; Detroit IA; Minneapolis Mus. Art; City Mus. Art, St. Louis;
Pub. Lib., Paris. Designed medals of award for Nat. Acad. Sc.;
Guggenheim Aeronautical; Electrical Research, Princeton Univ.
Numerous busts and statues in England, France, Holland,
Belgium, Germany, Austria, Czechoslovakian Mus., India and
U.S. **Comments:** Lectures: portraits and medals. **Sources:**
WW59; WW40; Falk, *Exh. Record Series.*

SPICKLER, C. A. *[Painter] early 20th c.*
Addresses: Yardley, PA. **Exhibited:** PAFA Ann., 1931. **Sources:**
Falk, *Exh. Record Series.*

SPICUZZA, Francesco J. F SPICUZZA
*[Painter] b.1883, Sicily, Italy /
d.1962, Milwaukee, WI.*
Addresses: Milwaukee, WI. **Member:** NYWCC; Wisc. P&S;
Soc. Arts & Science, NY. **Exhibited:** St. Paul Inst., 1915 (medal),
1916 (prize); 1917 (medal); S. Indp. A., 1917; Wisc. P&S, 1919
(prize); Milwaukee AI, 1922 (gold), (prize), 1930 (prize); 1932
(prize); AIC. **Work:** St. Paul IA; Milwaukee AI. **Comments:**
Teaching: Milwaukee AI. **Sources:** WW40.

SPIDELL, Enid Jean *[Painter, educator] b.1905, Hampton,
NB.*
Addresses: New Rochelle, NY. **Studied:** NY School Fine &
Applied Art; Parsons School Design; New York Univ. (B.S., art
educ.); Teachers College, Columbia Univ. (M.A.); private study
with George Pearse Ennis; ASL; Syracuse Univ. Extension, Taxco,
Mexico. **Member:** AWCS; Int. Soc. Color Council; Springfield
AA; New Rochelle AA (dir., 1956-59; pres., 1959-63; dir., 1963-);
Wolfe AC; Studio Gld. **Exhibited:** AV-Am. Art Group Design
Comp., 1943 (prize); Wolfe AC, 1937 (prize); PAFA; AWCS,
1937-45; Ogunquit AC, 1945; New Rochelle AA, 1940-45; New
Rochelle Pub. Lib., 1956 (solo),1964 (solo); Bronxville Pub. Lib.,
1964 (solo); New Rochelle, 1968 (solo). **Work:** Eastport (ME)
Pub. Lib. **Comments:** Teaching: Pratt Inst. **Sources:** WW73;
WW47.

SPIEDEN, William L. *[Painter, architect, photographer]
19th/20th c.*
Addresses: Wash., DC, active 1877-1905. **Exhibited:** Soc. Wash.
Artists, 1892. **Sources:** McMahan, *Artists of Washington, DC.*

SPIEGEL, Doris *[Etcher, engraver, illustrator, writer] b.1907,
NYC.*
Addresses: NYC; Englewood, NJ. **Studied:** C. Balmer in NY; P.
Chentoff in Paris. **Exhibited:** NAD, 1939; AIC, 1935; SAE, 1936;
LOC, 1945. **Awards:** Guggenheim Fellowship, 1930. **Comments:**

Auth./illustr.: "Danny and Company 92," 1945; & other books. Contrib. illustr. to *New Yorker, Forum,* & other magazines. **Sources:** WW59; WW47.

SPIEGEL, Dorothy A. *[Painter] b.1904, Shelbyville, IN.*
Addresses: Indianapolis, IN. **Studied:** Indiana Univ.; John Herron AI (B.A.E.); Butler Univ.; Eliot O'Hara; Emil Bisttram; P. Hadley. **Member:** Indianapolis AA; Art Club. **Exhibited:** Hoosier Salon, 1936 (prize); Indiana State Fair, 1941 (prize); Goose Rocks Beach, ME, 1938 (medal); Indiana Fed. AC Traveling Exh.; Indiana Art Club, 1937 (prize), 1938 (prize). **Work:** West Lafayette (IN) H.S. **Sources:** WW59.

SPIEGEL, Louis *[Painter, sculptor] b.1901, London, England / d.1975, Cincinnati, OH.*
Addresses: Cincinnati, OH. **Studied:** Cincinnati Art Acad.; Frank Duveneck; Cornelia Cassidy Davis. **Comments:** Came to the U.S. c.1904. Portraits of clowns were his specialty; he once said:"I don't just paint the clown, I paint the soul." He also painted harbor, scenes, still lifes and other subjects. **Sources:** info. courtesy of Patricia Weiner, Cincinnati, OH.

SPIEGEL, Sam *[Collector] b.1904, Austria.*
Addresses: NYC. **Studied:** Univ. Vienna. **Member:** Art Collectors Club. **Comments:** Collections: modern impressionist art. **Sources:** WW73.

SPIEGLE, Charles *[Wood engraver] b.c.1831, Pennsylvania.*
Addresses: Philadelphia, c.1850-57; Brooklyn, NY, c.1863-83; Passaic, NJ, 1885. **Comments:** He was working in Philadelphia as early as 1850 and from 1855-57 headed the firm of Spiegle & Johnson there. Sometime between 1857-63 he settled in Brooklyn (NY, working in NYC for the next 20 years. Two other members of the family, Frederick M. and Charles, Jr. (see entries), also were working as engravers or designers in NYC. **Sources:** G&W; 7 Census (1850), Pa., XLIX, 827; Phila. CD 1854-57; Brooklyn CD 1863, 1866, 1867; NYCD 1868-85; *Art Annual,* V, obit.; Smith; Hamilton, *Early American Book Illustrators and Wood Engravers,* 223, 238.

SPIEGLE, Charles, Jr. *[Painter, etcher] d.1905.*
Addresses: Passaic, NJ. **Comments:** Specialty: watercolors. Spiegle was killed in 1905 as he stepped off a train near his home in Passaic.

SPIEGLE, Frederick M. *[Painter, etcher] b.1863, NYC / d.1942, NYC.*
Addresses: NYC. **Studied:** Paris. **Exhibited:** NY Etching Club, 1886; S. Indp. A., 1918; Salons of Am., 1934; "Painter-Etchers," Parrish AM, 1984. **Comments:** An enigmatic figure, his etchings were published by C. Klackner in NYC, 1885, featuring animals and sentimental genre scenes. **Sources:** *American Painter-Etcher Movement* 48.

SPIEGLE & JOHNSON *[Wood engravers] mid 19th c.*
Addresses: Philadelphia, 1855-57. **Comments:** Charles Spiegle and Charles E. Johnson (see entries). **Sources:** G&W; Phila. CD 1855-57; Hamilton, *Early American Book Illustrators and Wood Engravers,* 180, 354.

SPIELBERGER, Morris *[Painter] early 20th c.*
Addresses: Chicago, IL. **Member:** Chicago SA. **Exhibited:** AIC, 1910, 1915-16. **Sources:** WW17.

SPIELER, George *[Miniaturist] mid 19th c.*
Addresses: Philadelphia, 1839-40. **Sources:** G&W; Phila. CD 1839-40.

SPIELER, William F. *[Portrait painter, photographer] mid 19th c.*
Addresses: Philadelphia, 1844-60 and after. **Sources:** G&W; Phila. CD 1844-60+.

SPIELMANN, Lucretia *[Painter] early 20th c.*
Addresses: Paris, France. **Sources:** WW10.

SPIERER, William McK. *[Designer, teacher, painter, lecturer, illustrator] b.1913, NYC.*
Addresses: NYC; Manhasset, NY. **Studied:** ASL; NAD; Syracuse Univ. (B.F.A.); DuMond; Boss; Bridgman. **Member:** AWCS; Art Dir. Club; NAC; Nat. Soc. Art Dir. **Exhibited:** Editors & Publishers & Printers Assn., 1939 (prize), 1940 (prize); AWCS, 1929, 1946; NAD, 1931; PAFA, 1939. Awards: several for advertising designs. **Comments:** Camouflage expert, U.S. Army, WWII. Position: art director, sales promotions manager, Ethyl Corp., NYC. Lectures on advertising art. **Sources:** WW59; WW47.

SPIERS, Harry *[Painter] b.1869, Selsea, Sussex, England.*
Addresses: Dedham, MA. **Studied:** Académie Julian, Paris, 1892. **Member:** Boston SWCP. **Exhibited:** AIC, 1917. **Work:** BMFA; Historical Soc., Framingham, MA; Ontario Government Gallery, Toronto. **Sources:** WW40.

SPIERS, Richard N. *[Stained glass, designer] b.1873, London / d.1936.*
Addresses: Brooklyn, NY. **Work:** stained glass windows, Riverside Church & St. Bartholomew's Church, both in NYC. **Comments:** Came to U.S. in 1886.

SPIGOLI, Virgilo *[Sculptor] early 20th c.*
Addresses: Chicago. **Exhibited:** AIC, 1921. **Sources:** Falk, *AIC.*

SPILLER, Maud See: **HOLT, Maud Spiller (Mrs. Winfield Scott)**

SPILMAN, Lucretia *[Portrait painter] late 19th c.*
Addresses: Fauquier County, VA. **Work:** Fauquier County Courthouse. **Sources:** Wright, *Artists in Virginia Before 1900.*

SPINDLER, Bernard *[Lithographer of topographical views] b.1826, Germany / d.1865, West Roxbury, MA.*
Addresses: Boston, active c.1853-mid 60s. **Comments:** He appears first in BD in 1853 as a stone cutter and a year later as lithographer. He drew at least one Boston view on stone for Tappan and Bradford (see entry). He died of consumption at the age of 39. **Sources:** Pierce & Slautterback, 181.

SPINDLER, John *[Teacher of drawing, crayon drawing & oil painting] early 19th c.*
Addresses: Richmond, VA, 1805. **Sources:** G&W; *Richmond Portraits,* 243.

SPINDLER, Louis *[Painter, teacher] b.c.1920, Vienna, Austria / d.1986.* *L. Spindler 75*
Studied: Rutgers Univ. (1941, B.A.; 1942, M.A.); NJ State Teachers College, 1949 (B.S., 1958-59); École des Beaux-Arts and privately with André Marchand, Paris, 1944-46 (while with the U.S. Army Intelligence); ASL with Will Barnet, H. Sternberg, Vytlacil, and Tschakbasov, 1946-48; Columbia Teachers College, 1950-51; Hunter College with R. Motherwell, 1955-56. **Exhibited:** Durand-Ruel Gal., Paris, 1945; ACA Gal., NYC, 1949; various galleries in the NY-NJ area, 1950s-60s; Montclair AM; Bodley Gal., NYC, 1970s. **Work:** Montclair AM; Newark Mus. **Comments:** Teaching: extensively in NJ schools and colleges 1941-on. **Sources:** PHF files.

SPINETTA, Fred *[Painter] early 20th c.*
Addresses: NYC. **Member:** S. Indp. A. **Exhibited:** S. Indp. A., 1921. **Sources:** WW21.

SPINGARN, Amy E. (Mrs. Joel E.) *[Painter, lithographer] b.1883, NYC / d.1980, NYC.*
Addresses: NYC/Amenia, NY. **Studied:** K.H. Miller & Hans Hofmann. **Member:** Soc. Independent Artists. **Exhibited:** S. Indp. A., 1918-22, 1924-26, 1929-38, 1944; Salons of Am., 1922-24, 1926, 1927; Soc. Indep. Artists, 1930, 1931; YMCA, NYC, 1933 (solo); Passedoit Gal., NYC, 1938 (solo). **Comments:** Known for portraits of prominent blacks in art, literature and music. **Sources:** WW29; Marlor, *Salons of Am.*; Petteys, *Dictionary of Women Artists.*

SPINGARN, Honor *[Painter] b.1910, NYC.*
Exhibited: Salons of Am., 1926, 1927. **Sources:** Marlor, *Salons of Am.*

SPINGARN, Laurette *[Painter] b.1905, Jersey City, NJ.*
Exhibited: Salons of Am., 1923, 1936. **Sources:** Marlor, *Salons of Am.*

SPINGARN, Mary *[Painter] mid 20th c.*
Exhibited: S. Indp. A., 1935. **Sources:** Marlor, *Soc. Indp. Artists.*

SPINGLER, Oakley Austin *[Painter] b.1908, Newport, RI.*
Addresses: Providence, RI/Provincetown, MA. **Studied:** RISD; Provincetown Summer School. **Member:** Provincetown AC; Newport AA. **Exhibited:** Provincetown AC; Newport AA; WFNY, 1939. **Work:** Newport Fire Dept.; Rhode Island State College; Ft. Adams, Newport. **Sources:** WW40.

SPINNER, Louis P. *[Painter] b.c.1851, Pennsylvania.*
Addresses: Wash., DC, active 1880-1914, still a resident in 1924. **Exhibited:** Carnegie-Mellon Univ., 1984. **Work:** U.S. Army's Portrait Gallery. **Sources:** McMahan, *Artists of Washington, DC.*

SPINNING, Alfred A. *[Landscape painter] mid 19th c.*
Addresses: Cincinnati, active 1849-59. **Comments:** He lived with Jonathan Spinning, bricklayer, probably his father. *Cf.* C.S. Spinning. **Sources:** G&W; Cincinnati CD 1849, 1853, 1857, 1859.

SPINNING, C. S. *[Landscape painter] mid 19th c.*
Addresses: Cincinnati, 1847-51. **Comments:** *Cf.* Alfred A. Spinning. **Sources:** G&W; Cist, *Cincinnati in 1851.*

SPINNING, Hester Johnson *[Painter, writer, poet] b.1848, Niagara Falls, Ontario / d.1915, Detroit, MI.*
Addresses: Active in Detroit, late 1800s. **Comments:** Painted flowers, animals, landscapes & portraits. **Sources:** Petteys, *Dictionary of Women Artists.*

SPIRO, Eugene *[Painter, etcher, lithographer, teacher, illustrator] b.1874, Breslau, Germany.*
Addresses: New York 23, NY. **Studied:** Art Acad., Breslau, Munich, Germany; Franz von Stuck. **Member:** SC. **Exhibited:** MoMA, 1942; St. Etienne Gal., NY, solos: 1943, 1945, 1947, 1949-50, 1952, 1954. **Awards:** Officer d'Acad. des Beaux-Arts Francaise, Paris; Herman Wick Mem. award, SC, 1958. **Work:** Archdiocese, Detroit, MI; Mus. City of New York; German Embassy, Wash., DC; CI; Musée du Jeu de Paume, Paris; & in numerous museums in Germany. **Comments:** Illustrator: "In Konzert," 1922 (lithographs of famous musicians); "Antique Frescoes," 1922. **Sources:** WW59; WW47.

SPITLER, Johannes *[Decorator] b.1774, Shenandoah County, VA / d.1837, Fairfield County, OH.*
Addresses: Shenandoah County, late 1700s, early 1800s; Ohio, c.1805. **Work:** Abby Aldrich Rockefeller Folk Art Coll., Williamsburg, VA. **Comments:** Specialty: furniture design; geometrical patterns, compass work, motifs of plants and animals. **Sources:** Wright, *Artists in Virginia Before 1900.*

SPITTALL, John *[Wood and metal engraver] b.1811, England / d.1886, Philadelphia, PA.*
Addresses: Philadelphia,1837-60 and after. **Work:** Lib. Company of Phila. **Comments:** First worked in Philadelphia as a wood engraver of illustrations for books, broadsides, also druggist's labels. Later he also made brass dies for small advertising logotypes for business cards, envelopes, billheads and ads, now called cameo stamps.He had customers as far away as Virginia. Beckman cites a birth date of 1806. **Sources:** G&W; 7 Census (1850), Pa., LIV, 1005; Phila. CD 1837-60+; Thomas Beckman, "The Philadelphia Cameo Stamp Trade," *Nineteenth Century* (Fall 1998).

SPITZ, Barbara S *[Printmaker] b.1926, Chicago, IL.*
Addresses: Highland Park, IL. **Studied:** AIC; RISD; Brown Univ. (A.B.); Leon Golub; Franz Schulze; Letterio Calapai. **Member:** Artist Equity Assn.; Chicago Soc. Artists; Arts Club Chicago; Boston PM; Renaissance Soc., Univ. Chicago. **Exhibited:** AIC 71st Ann., 1968; The Print Club, Phila., 1969 & 1972; SAGA 51st Ann., Kennedy Gals., NYC, 1971; Benjamin Gals., Chicago, 1971 (solo); Boston PM 23rd & 24th Ann., De Cordova & Rose Art Mus., 1971 & 1972; Benjamin Gals., Chicago, IL, 1970s. **Awards:** Munic. Art Lg. Prize, Art Inst. 71st Ann., 1968; purchase awards, Boston Printmakers 23rd & 24th Ann., De Cordova Mus., 1971 & 1972; purchase award, Oklahoma AC 14th Ann., 1972. **Work:** AIC; De Cordova Mus., Lincoln, MA; Oklahoma AC, Oklahoma City; First Nat. Bank Boston, MA. **Comments:** Preferred media: intaglio. **Sources:** WW73; T&B Carbol (ed), article, *The Printmaker in Illinois* (Illinois Art Educ. Assn., 1972).

SPITZER, Frances R. *[Collector] b.1918, NYC.*
Addresses: NYC. **Studied:** Syracuse Univ. (B.S.). **Comments:** Collection: French impressionists; contemporary American art. **Sources:** WW73.

SPITZER, Francis A. E. *[Painter] mid 20th c.*
Exhibited: S. Indp. A., 1937. **Sources:** Marlor, *Soc. Indp. Artists.*

SPITZGLASS, Vicci *[Painter] b.1901, Brooklyn.*
Addresses: Chicago, IL. **Studied:** R. Weisenborn. **Member:** United Am. Artists. **Exhibited:** Artists Union Gal., Chicago; Chicago NJSA. **Sources:** WW40.

SPITZMILLER, Walt *[Illustrator] b.1944, St. Louis, MO.*
Addresses: St. Louis, MO; Connecticut. **Studied:** Wash. Univ., St. Louis (B.F.A., 1969). **Exhibited:** SI; Art Dir. Clubs (awards). **Work:** Rodeo Mus., Colorado Springs, CO. **Comments:** Teaching: St. Louis Junior College; Wash. Univ. Illustr.: *Sports Illustrated, Golf, Outdoor Life,* and others. Specialty: Western (rodeo) and other sports subjects. **Sources:** W & R Reed, *The Illustrator in America,* 343.

SPIVACK, Sydney Shepherd *[Scholar] 20th c.*
Addresses: Far Hills, NJ. **Studied:** Columbia University (A.M.; Ph.D.). **Member:** Am. Sociological Assn. (fellow); Soc. Applied Anthropology (fellow). **Comments:** Field of research: sociology of art. **Sources:** WW66.

SPIVAK, H. David *[Painter, illustrator] b.1893, Phila. / d.c.1938.*
Addresses: Denver, CO. **Studied:** Norton; Johansen; Henri. **Member:** Denver AG; Denver Art Mus. **Exhibited:** S. Indp. A., 1917; Colorado State Fair, 1921 (prize), 1929 (prize). **Work:** B.M.H. Synagogue, Denver. **Sources:** WW33.

SPIVAK, Max *[Painter, craftsperson, designer, teacher, lecturer] b.1906, Bregnun, Poland.*
Addresses: NYC. **Studied:** CUA School; Grand Central Art School; CCNY; ASL; Grande Chaumière, Paris. **Member:** Soc. Des.-Craftsmen; NSMP, 1969-70 (pres.); Arch. Lg., 1966-68 (vice-pres.); Am. Abstract Artists. **Exhibited:** AIC; Newark Mus.; Denver Art Mus.; BMA; ACA Gal.; Contemp. Art Gal.; WFNY 1939; GGE, 1939; Valentine Gal., 1939; MoMA, 1936, 1950; Bonestell Gal., 1945 (solo); Grace Borgenicht Gal.; Fishkill Art Gal.; Pratt Inst.; Mortimer Levitt Gal., 1948-50 (solo): WMAA, 1947-49; Arch. Lg., 1956 (silver medal; 1965 (hono. men.); "NYC WPA Art" at Parsons School Design, 1977. **Work:** BMA; Newark Mus.; H.S., Ft. Hamilton, NY; Astoria (NY) Pub. Lib.; mosaic murals, SS "Constitution"; SS "Independence"; Statler Hotel, Los Angeles; Spuyten Duyvil Lib.; Calderone Theatre, Hempstead; Gen. Wingate H.S., Brooklyn; Cerebral Palsy School, NY; Warner-Lambert Pharmaceutical Co., Morris Plains, NJ; Johnson & Johnson, New Brunswick, NJ; Jr. H.S. 189, Queens, NY; Textile Center, NYC; Chas. Pfizer & Co. Research Center, Groton, CT. **Comments:** Teaching: Bard College, Annandale-on-Hudson, NY, 1959-62; The New School Reserach, 1960-62; Pratt Inst., Brooklyn, NY, 1960-70. Lectures: art & architecture, Architectural Sch., Columbia Univ., Cooper Union, Pratt Inst. **Sources:** WW66; WW47; *New York City WPA Art,* 83 (w/repros.).

SPIZZIRRI, Luigi *[Painter, teacher] b.1894, Spezzano, Grand Prov. of Cosenza, Italy.*
Addresses: Phila., PA/Summerdale Park, Camden, NJ. **Studied:** PAFA with E. Carlsen; R. Vonnoh; J. Pearson; D. Garber; P. Hale; W.M. Chase. **Exhibited:** AIC, 1917, 1928, 1930; Corcoran Gal. biennials, 1923, 1926; PAFA Ann., 1923-24. **Sources:** WW33; Falk, *Exh. Record Series.*

SPOERL, Christian George *[Painter] early 20th c.*
Addresses: Phila., PA. **Sources:** WW13.

SPOFFARD, E. W. *[Painter] early 20th c.*
Addresses: NYC. **Member:** GFLA. **Sources:** WW27.

SPOFFORD, E. (Miss) *[Painter] late 19th c.*
Addresses: New Orleans, active c.1884-85. **Exhibited:** World's Indust. & Cotton Cent. Expo, 1884-85. **Comments:** Probably daughter of Mrs. O. M. Spofford, also a painter who exhibited at the same expo. **Sources:** *Encyclopaedia of New Orleans Artists,* 363.

SPOHN, Clay (Edgar) *[Painter, lithographer, illustrator, mural painter] b.1898, San Francisco, CA / d.1977, New York, NY.*
Addresses: San Francisco, CA (1958-68); Taos, NM (1951-57, 1969-on). **Studied:** Mark Hopkins Inst. Art, San Francisco; Berkeley School Arts & Crafts; Univ. California; ASL with Miller, B. Robinson, Luks, DuBois; Acad. Moderne, Paris, France. **Member:** San Francisco AA; Taos AA. **Exhibited:** San Francisco AA, 1929, 1939 (prize), 1945 (prize); Albert Bender Grant, San Francisco, 1944-45 (prize); CPLH, 1938, 1939, 1945,1946; SFMA, 1938, 1939, 1942 (solo), 1946; Am. Abstract Artists, 1949; Colorado Springs FAC, 1951; Denver Art Mus., 1952; Galeria Escondida, Taos, 1950s; Taos AA; Blue Door and Ruins Gal., Taos; Intermountain region traveling exh.; Los Alamos Gal.; Univ. Illinois, 1953; Rotunda Gal., San Francisco, 1946 (solo); Taos, NM, 1952 (solo). **Work:** Castro Valley (CA) Community Center; USPO, Montebello, CA; Los Gatos (CA) Union H.S.; Fire Dept., Carmel, CA. **Comments:** Teaching: Calif. School FA, San Francisco, CA, 1945-50; Mount Holyoke College, South Hadley, MA, 1957-58. WPA printmaker in California, 1930s. **Sources:** WW59; exh. cat., Annex Gal. (Santa Rosa, CA, n.d., c.1988); WW47; article, "La Galeria Escondida" in *Artforum* (n.d.).

SPOHN, George *[Lithographer] b.c.1823, France.*
Addresses: Philadelphia, 1850. **Comments:** His wife was German, but their children (7 to 2 years) were born in Pennsylvania. **Sources:** G&W; 7 Census (1850), Pa., XLIX, 14; Phila. CD 1850.

SPOLANDER, Fridolf N. *[Painter] early 20th c.*
Addresses: Chicago. **Exhibited:** AIC, 1918-35. **Sources:** Falk, AIC.

SPOLAR, Steve *[Painter] early 20th c.*
Exhibited: Salons of Am., 1925. **Sources:** Marlor, *Salons of Am.*

SPONENBURGH, Mark *[Art historian, sculptor] b.1916, Cadillac, MI.*
Addresses: Corvallis, OR. **Studied:** Cranbrook Acad. Art (scholarship, 1940); Wayne Univ.; École Beaux-Arts, Paris, France; Univ. London; Univ. Cairo. **Member:** College AA Am.; Northwest Inst. Sculpture; Am. Assn. Mus. **Exhibited:** PAFA Ann., 1948; Durand-Ruel & Paris Salon France; Inst. Fine Arts Cairo; Nat. Gallery, Pakistan; 25 solos, sculpture. **Awards:** Tiffany Found. fellowship. 1941; Fulbright Found. fellowship, 1951-53; purchase prizes, Detroit AI & Portland Art Mus. **Work:** Detroit IA; Portland Art Mus.; Univ. Oregon; MOMA, Egypt; Pakistan Arts. **Comments:** Publications: contrib., *Arts Quarterly, Journal Inst. Egypte, Review Caire, Near Eastern Bulletin & Journal Near Eastern Studies,* plus others. Teaching: Univ. Oregon, 1946-56; Royal College Arts, 1956-57; Nat. College Arts, Pakistan, 1958-61; Oregon State Univ., 1961-. Collections arranged: Sculpture Pacific Northwest, Univ. Oregon, 1955; 2000 Years Horse & Rider In Arts of Pakistan, 1959 & Folk Arts of Swat, 1961, Nat. College Arts, Pakistan; CRIA, Corvallis Arts Council, 1967-. **Sources:** WW73; Falk, *Exh. Record Series.*

SPONG, W. B. *[Painter] early 20th c.*
Addresses: Amityville, NY. **Exhibited:** AIC, 1907-08. **Sources:** WW08.

SPONGBERG, Grace *[Painter, photographer, craftsperson, graphic artist] b.1906, Chicago, IL.*
Addresses: Chicago, IL. **Studied:** AIC; A. Krehbiel; F. Poole; F.

Fursman; L. Ritman; E. Zoir. **Member:** Chicago Soc. Art; Swedish Artists, Chicago. **Exhibited:** PAFA; AIC; Joslyn Art Mus.; Chicago Soc. Art; Riverside Mus.; Swedish-Am. Exh., Chicago, 1936 (prize); CM. **Work:** Horace Mann School, Chicago; Bennett School, Chicago; Byford School, Chicago; Mus. Vaxco, Sweden. **Comments:** Preferred media: watercolors. **Sources:** WW73; WW47.

SPONSLER, Edwin E. *[Painter] mid 20th c.*
Addresses: Mechanicsburg, PA. **Exhibited:** PAFA Ann., 1951-52, 1954; WMAA, 1953-56. **Sources:** Falk, *Exh. Record Series.*

SPOODLYKS, Max *[Cartoonist, designer of sheet music] mid 19th c.*
Addresses: NYC, active c.1843. **Comments:** His sheet music covers were published in NYC about 1843. **Sources:** G&W; *American Collector* (Aug. 1947), 13, repros.; represented by cover of "Knickerbocker Quadrille" in Bella C. Landauer Collection, NYHS.

SPOONER, Alice M. *[Artist] late 19th c.*
Addresses: Active in Greenville, MI, 1891-97. **Comments:** Sister of Fannie Spooner (see entry). **Sources:** Petteys, *Dictionary of Women Artists.*

SPOONER, Charles H. *[Landscape painter] b.1836, Philadelphia, PA / d.1901, Phila.*
Addresses: Germantown, PA, 1864-65; Phila. **Member:** Artists' Fund Soc.; Phila. Sketch Club; Phila. AC; Phila. Soc. Artists. **Exhibited:** PAFA Ann., 1863-67 (views in Pennsylvania and Nicaragua), 1876-90 (landscapes). **Sources:** G&W; *Art Annual,* IV, obit.; WW01; Falk, *Exh. Record Series.*

SPOONER, Fannie H. *[Artist] late 19th c.*
Addresses: Active in Greenville, MI, 1891-97. **Comments:** Sister of Alice Spooner (see entry). **Sources:** Petteys, *Dictionary of Women Artists.*

SPOONER, Jane E. (Mrs. Shearjashub) *[Painter] mid 19th c.*
Addresses: NYC, 1840s-50s. **Exhibited:** Am. Inst., 1845 (two oil paintings and one "Shell Church"). **Comments:** Born Jane E. Foot, she first married Allen Darrow and later Shearjashub Spooner (see entry). **Sources:** G&W; Am. Inst. Cat., 1845; DAB [under Shearjashub Spooner].

SPOONER, Shearjashub *[Writer, art historian, possibly engraver] b.1809, Orwell, VT / d.1859, Plainfield, NJ.*
Addresses: NYC. **Comments:** After studying medicine in Montreal, Spooner began studying dentistry in NYC in 1833. He had a successful dental practice in NYC but gave it up sometime before 1842 in order to focus his attention on the promotion of art in Ameria. Spooner's first endeavor was the republication of of Boydell's *Shakespeare Gallery* from the original plates. Groce & Wallace speculated that this might explain why he was listed in the 1850 business directory as an engraver. In 1850 Spooner published his three-volume *Anecdotes of Painters, Engravers, Sculptors and Architects* and in 1853 published his *Biographical and Critical Dictionary of Painters, Engravers, Sculptors and Architects.* His wife, Jane Spooner, was an artist. **Sources:** G&W; DAB; NYBD 1850.

SPOOR, Ruth *[Painter, designer, teacher] 20th c.; b.Bismarck, ND.*
Addresses: Boston, MA; Rockport, MA. **Studied:** Radcliffe College, M.A.; Harvard; with Eugene Weiss, A. Hibbard; CGA; Europe. **Comments:** Positions: stage designer, Middlebury College, Harvard Summer School, Boston Univ.; dramatic director, South End House, Norfolk House; instructor, Lasell Junior College and Garland School, Boston; secretary, Hibbard School of Painting, Rockport, MA. **Sources:** *Artists of the Rockport Art Association* (1946,1956).

SPORN, Irving *[Collector, patron] b.1917, New York, NY.*
Addresses: Portland, ME. **Studied:** New York Univ. (B.S.); Columbia Univ. (M.Sc.; Ph.D.; LL.D.). **Member:** Maine Hist. Soc.; Portland Hist. Soc. **Comments:** Collection: Pre-Columbian

art; medieval manuscripts; Incunabula; Orientalia; Oceanic art. **Sources:** WW66.

SPOTH-BENSON, Eda *[Painter, sculptor]* *b.1898, Brooklyn, NY.*
Addresses: West Cornwall, CT. **Studied:** Dabo; Eggleston. **Member:** Lime Rock (CT) Artists; Brooklyn SA; Palm Beach Al. **Exhibited:** Lime Rock AA, 1929 (prize); Florida Fed. Art, Miami Beach, 1930-31 (prize). **Sources:** WW33.

SPRADLING, Frank *[Illustrator]* *b.1885 / d.1972.*
Addresses: Interlaken, NJ. **Sources:** WW21.

SPRAGUE, Amelia *[Painter, teacher]* *early 20th c.*
Addresses: Buffalo, NY. **Sources:** WW21.

SPRAGUE, Amelia Browne *[Painter, decorator]* *b.1870, Cincinnati / d.1951, Lawrence, KS.*
Studied: Cincinnati Art Acad.; Pratt Inst. **Exhibited:** AIC, 1902; Cincinnati exh. marking 50th Ann. of Rookwood, 1930. **Comments:** Position: decorator, Rookwood Pottery, Cincinnati, 1887-1903. **Sources:** WW04.

SPRAGUE, Curtiss *[Painter]* *early 20th c.*
Addresses: Nutley, NJ. **Member:** GFLA. **Sources:** WW27.

SPRAGUE, Elizabeth *[Painter]* *early 20th c.*
Addresses: Wichita, KS. **Comments:** At Fairmount College in Wichita, c.1915. **Sources:** WW15.

SPRAGUE, Elmer E. *[Painter]* *early 20th c.*
Addresses: Columbus, OH. **Member:** Columbus PPC. **Sources:** WW25.

SPRAGUE, Florence See: **SMITH, Florence Sprague (Mrs. Jefferson R.)**

SPRAGUE, Florence M. *[Artist]* *late 19th c.*
Addresses: Active in Washington, DC, 1897-99. **Sources:** Petteys, *Dictionary of Women Artists.*

SPRAGUE, Harold Conger *[Painter, teacher]* *b.1903, Ridgefield Park, NJ.*
Addresses: Fanwood, NJ. **Studied:** ASL; John F. Carlson; John J. Newman. **Member:** SC; AAPL; Westfield AA (vice-pres.); Plainfield AA. **Exhibited:** Spring Lake, NJ; Westfield AA; Plainfield AA, 1945 (prize); Raritan Valley Club; Morton Gal., NY. **Sources:** WW53; WW47.

SPRAGUE, Howard Freeman *[Marine painter, illustrator]* *b.1871, Huron, OH / d.1899, Buffalo, NY.*
Addresses: Cleveland, OH; Detroit, MI, 1895. **Studied:** some training in art school. **Work:** Mariners Mus., Newport News, VA; Dossin Great Lakes Mus., Detroit. **Comments:** Naval artist during Spanish-American War. Died of tuberculosis. Illustr.: *Harper's Weekly.* **Sources:** Gibson, *Artists of Early Michigan,* 219. Bibliography: WW1899.

SPRAGUE, Isaac *[Landscape painter]* *b.1811, Hingham, MA / d.1895, Grantville, MA.*
Addresses: Cambridge, MA,1846-c.1855; Grantville, (Needham), c.1855-95. **Work:** Boston Athenaeum. **Comments:** In 1843 he served as artist-assistant to John James Audubon on an ornithological expedition up the Missouri River. Sprague contributed several landscapes for Oakes' *Scenery of the White Mountains* (1848). **Sources:** G&W; Sprague, *Sprague Families in America,* 307; Audubon, *Audubon and His Journals;* Oakes, *Scenery of the White Mountains; Cambridge* CD 1848-63. More recently, see Campbell, *New Hampshire Scenery,* 157-158; P&H Samuels, 457.

SPRAGUE, Julia Frances *[Artist]* *b.1826, Huron, OH / d.1886, Tacoma, WA.*
Addresses: Active in Tacoma, WA. **Sources:** Petteys, *Dictionary of Women Artists.*

SPRAGUE, M. U. (Mrs.) *[Artist]* *late 19th c.*
Addresses: Active in Wayland, Allegan Co., MI, 1887-93. **Sources:** Petteys, *Dictionary of Women Artists.*

SPRAGUE, Mark Anderson *[Painter, educator]* *b.1920, Champaign, IL.*
Addresses: Champaign, IL. **Studied:** Univ. Illinois (B.F.A., 1946; M.F.A., 1949). **Exhibited:** AFA traveling exh., 1949; AIC ann., 1951; Western Art Ann., Denver, CO, 1951-52; Corcoran Gal. biennials, 1951, 1953; NAD ann., 1958-62. **Work:** Illinois State Univ. Mus., Bloomington. Commissions: painting for "Great Ideas of Western Man," Container Corp. Am., Chicago. **Comments:** Preferred media: oils, polymers, collage. Teaching: Univ. Illinois, Champaign, 1946-70s. **Sources:** WW73.

SPRAGUE, Martin *[Portrait painter, engraver]*
Addresses: Boston. **Comments:** Reputed to have worked in Boston during the Colonial period. **Sources:** G&W; Bayley, *Little Known Early American Portrait Painters,* No. 3.

SPRAGUE, Nancy Kunzman *[Sculptor]* *b.1940, NYC.*
Addresses: Iowa City, IA. **Studied:** RISD; Univ. Penn. (B.F.A.); Tyler Sch. Art, Temple Univ.; Univ. Kansas; Univ. Iowa (M.A. & M.F.A.). **Member:** College AA Am. **Exhibited:** Ruth White Gal., New York, 1969 (solo); Young Sculptors Comp., Sculptors Guild, New York, 1969; 16th Ann. Drawing & Small Sculpture, Ball State Univ., 1970; Mid-South Art Exh., Brooks Mem. Art Gallery, Memphis, 1971; 24th Ann. Iowa Artists Exh., Des Moines AC, 1972. **Work:** Tennessee Sculpture '1971, Tennessee Arts Comn., Fairleigh Dickinson Univ. Commissions: bronze sculpture, Friends of Elvis Presley, 1971. **Sources:** WW73.

SPRAGUE, Reynold (Marjorie Reynolds) *[Sculptor, graphic artist, teacher]* *b.1914, White Plains, NY.*
Addresses: Sarasota, FL. **Studied:** Ringling School Art, Sarasota. **Member:** Sarasota AA; Florida Fed. Art; SSAL. **Exhibited:** Denver AA, 1938; Ringling Art Mus., 1939; SSAL, San Antonio, 1939. **Comments:** Teaching: Sherman Reynolds Studios, Sarasota. **Sources:** WW40.

SPRAGUE, Robert Burkitt *[Painter, designer, teacher, comm a, writer, lecturer, critic]* *b.1904, Dayton, OH.*
Addresses: Dayton, OH; St. Petersburg, FL. **Studied:** Antioch College, B.A.; Dayton AI; Roerich Mus., NY; Taos School Art, and with Guy Wiggins, Emil Bisttram, Cart Holly. **Member:** Florida Art Group; Florida Fed. Art; St. Petersburg Art Lg. **Exhibited:** CM; PAFA Ann., 1935; Riverside Mus.; AIC; CAFA; Denver Art Mus. (solo); Nelson Gal. Art (solo); Oklahoma City AC (solo); Mus. New Mexico, Santa Fe; Ferargil Gal.; Hoosier Salon; Southeastern Ann., 1956; Delgado Mus. Art, 1958; CAA; Soc. Four Arts, 1956; Ringling Mus. Art; High Mus.; Atlanta; Grand Central Art Gal.; Florida Fed. Art traveling exhibs.; Florida Art Group; Dayton AI (solo); Richmond AA (solo); Tampa AI (solo); Stetson Univ. (solo); Winter Haven, FL (solo). Awards: prizes, Dayton, OH, 1934 (prize); Florida State Fair, 1952 (prize), 1953 (prize); Florida Gulf Coast Group (prize); citation of merit, Florida Southern College, 1952; Clearwater, FL, 1953 (prize). **Work:** Coshocton (OH) Pub. Lib.; Dept. Justice Bldg., Wash., DC; Clearwater Art Group; murals, Jackson School, Dayton; Courthouse, Roswell, NM; Trailside Mus., Cincinnati. **Comments:** Position: dir., Roswell (NM) Mus. Art, 1935-36; dir., Sprague Art School, St. Petersburg, FL. Contrib. to *St. Petersburg Times.* **Sources:** WW59; WW40; Falk, *Exh. Record Series.*

SPRAGUE, Rose M. *[Painter]* *early 20th c.*
Addresses: NYC. **Exhibited:** S. Indp. A., 1917. **Sources:** Marlor, *Soc. Indp. Artists.*

SPRAGUE-SMITH, Isabelle Dwight (Mrs. Charles) *[Painter, designer, lecturer, teacher]* *b.1861, Clinton, NY / d.1950, Winter Park, FL.*
Addresses: Winter Park, FL, 1947. **Studied:** Dwight School Art; ASL; Paris. **Member:** Florida Hist. Soc.; Audubon Soc.; All. Artists Florida. **Comments:** Positions: art instructor & principal at Veltin School for Girls, NYC, 1900-25; director, MacDowell Assn., Peterborough, NH; founder of Bach Festival, Winter Park, FL. **Sources:** WW47; Petteys, *Dictionary of Women Artists* (cites obit., *New York Times,* Dec. 29, 1950, p. 20).

SPRANG, William *[Painter] late 19th c.*
Exhibited: PAFA Ann., 1877 (black panel). **Sources:** Falk, *Exh. Record Series.*

SPRATLEY, Henry *[Lithographer] mid 19th c.*
Addresses: NYC, 1850. **Sources:** G&W; NYBD 1850.

SPRATLING, William *[Craftsman, designer] b.1901 / d.1967, Taxco, Mexico.*
Comments: One of the most influential silver jewelry designers of the 20th century. In 1929, he was an architecture professor at Tulane Univ. when he decided to write a book about Mexico. He settled in Taxco, but his 1931 experiment of making silver articles in Taxco soon grew into an industry. By 1940, he had created a colony of more than 300 silversmiths who executed the "Spratling design" which combined pre-Columbian motifs with modernist design. **Sources:** autobiography: *File on Spratling;* article by Leah Gordon in *Antiques & Arts Weekly* (July 31, 1998, p.92).

SPRATT, Alberti (A. S. Lamb) *[Painter, lithographer, illustrator] b.1893, Gilroy, CA / d.1950, Monterey, CA.*
Addresses: Monterey, CA. **Studied:** Calif. School Design; College of Pacific, Stockton. **Member:** Carmel AA; Oakland AA. **Exhibited:** Carmel AA. **Work:** murals, Orinda (CA) Country Club. **Comments:** Specialty: horticultural illustr. WPA printmaker in California, 1930s. **Sources:** WW40; exh. cat., Annex Gal. (Santa Rosa, CA, n.d., c.1988).

SPRAY, Robert *[Painter, sculptor, printmaker] b.1910, Spokane, WA.*
Addresses: Oakland, CA; Tucson, AZ. **Studied:** Calif. College Arts & Crafts (scholarship). **Exhibited:** Oakland Art Gallery, 1936, 1937; Arizona State Fairs; Tucson FAA, 1951 (first prize). **Sources:** Hughes, *Artists in California,* 528.

SPRAYREGEN, Morris *[Collector] mid 20th c.*
Addresses: NYC. **Comments:** Collection: primarily French impressionist and post-impressionist art. **Sources:** WW73.

SPREAD, Anne *[Painter] early 20th c.; b.Chicago.*
Addresses: Chicago, IL. **Studied:** AIC; Académie Julian, Paris with Bouguereau and Ferrier. **Member:** ASL, Chicago. **Exhibited:** AIC, 1906. **Sources:** WW08.

SPREAD, Henry Fenton (or N. F.) *[Portrait, landscape, and figural painter] b.1844, Kinsdale, Ireland / d.After 1875.*
Addresses: NYC (1870); Chicago, IL (1870-on). **Studied:** South Kensington, England; watercolors with Riviere and Warren; with Slingeneyer in Brussels, 1863. **Member:** Chicago Acad. Design. **Exhibited:** Chicago Ind. Expo, 1875 (NH scene); NAD, 1880-82; AIC; PAFA Ann., 1888. **Comments:** Before coming to the U.S. in 1870, he painted in Melbourne, Australia, and took sketching tours in New Zealand and Tasmania. **Sources:** Clement and Hutton; Campbell, *New Hampshire Scenery,* 158-159; Falk, *Exh. Record Series.*

SPREEN, Fred A. *[Painter] early 20th c.*
Addresses: Pittsburgh, PA. **Member:** Pittsburgh AA. **Sources:** WW25.

SPRENKLE, Arthur George *[Painter, etcher, teacher] b.1881, Hanover, PA / d.1940, Los Angeles, CA.*
Addresses: Los Angeles, CA. **Studied:** PM School IA. **Member:** Acad. Western Painters, Los Angeles; Los Angeles AA; Calif. WCS; Calif. AC; P&S Los Angeles. **Exhibited:** Calif. WCS, 1935, 1936; Calif. AC, 1936, 1937 (prize), 1938; Acad. Western Painters, 1936-38; GGE, 1939. **Comments:** Positions: teacher, Chouinard AI; affiliated with W&J Sloane, Bevery Hills, CA. **Sources:** WW40; Hughes, *Artists in California,* 528.

SPRETER, Roy Frederic *[Illustrator, painter, designer] b.1899, Chicago, IL.* *Spreter*
Addresses: NYC. **Studied:** AIC; with J. Chenoweth, Ph. Lyford, L. Seyffert. **Member:** SI; Art Dir. Club. **Comments:** Illustrator of national advertising campaigns & women's monthly magazines. **Sources:** WW53; WW47.

SPRIGGS, Edward S. *[Museum director] mid 20th c.*
Addresses: NYC. **Comments:** Positions: dir., Studio Mus. Harlem. **Sources:** WW73.

SPRINCHORN, Carl *[Painter] b.1887, Broby, Sweden / d.1971, Albany, NY.* *Carl Sprinchorn*
Addresses: NYC, Mt. Vernon, NY; Selkirk, NY. **Studied:** Robert Henri at NY Sch. Art & Henri Sch. **Member:** Brooklyn Soc. Modern Art; Soc. Indep. Artists; Salons of America; AEA. **Exhibited:** PAFA ann., 1910, 1925; Armory Show, NYC, 1913; S. Indp. A., 1917-18, 1920, 1922-24, 1928; Salons of Am., 1922, 1923, 1927, 1934; Corcoran Gal. biennials, 1943, 1951; AIC, 1932, 1943; WMAA, 1936, 1938; Walker AC, 1943; Toledo Mus. Art, 1943; CM, 1932; WMA (solo); Chicao AC (solo); Am.-Swedish Hist. Mus., Phila, 1942 (solo); Summit (NJ) AA, 1935 (solo); George Hellman Gal.; Knoedler Gal.; Marie Sterner Gal.; Frank Rehn Gal.; Ainslie's Gal.; Macbeth Gal.; Delaware AC, Wilmington, 1960 (50th Anniversary Exh., Independent Artists); Colby College, 1964 ("Maine Artists" exh.); T. Veilleux Gal, Farmington, ME, 1994 (solo). **Work:** PMG; PMA; BM; Dayton AI; Mus. City of NY; RISD; Macbeth Gal., NYC; PC; FMA; MMA; High Mus. Art; Univ. Maine; New Britain Mus.; Providence Mus. Art; Am-Swedish Hist. Soc., Phila., PA. **Comments:** He came to NYC at age 16 and became a long-time student of Robert Henri. Sprinchorn traveled and painted in Europe in 1914, joining a small Swedish-American settlement in Maine during the 1920s. Contrib.: *Dial.* **Sources:** WW66; WW47; *300 Years of American Art,* 819; Falk, *Exh. Record Series.*

SPRING, E. W. *[Painter] early 20th c.*
Addresses: Toledo, OH. **Member:** Artklan. **Sources:** WW25.

SPRING, Edward Adolphus *[Sculptor and modeler, teacher, lecturer] b.1837, NYC.*
Addresses: Eagleswood, Perth Amboy, NJ. **Studied:** H.K. Brown, 1852; J.Q.A. Ward, 1861-62; W. Rimmer, 1864-65; England; France. **Exhibited:** NAD, 1873-86; Wash., DC, 1876 (exhibited over 200 objects in clay, which then went to the Nat. Mus. of Educ.); PAFA Ann., 1880. **Comments:** Spring opened a studio in Eagleswood (NJ) in 1862, sharing a studio with William Page. In 1868 he turned his attention to work in terra-cotta, establishing the Eagleswood Art Pottery Company in 1877. He was also a popular lecturer and teacher. **Sources:** G&W; Clement and Hutton; Thieme-Becker; Falk, *Exh. Record Series.*

SPRING, John *[Miniaturist] late 18th c.*
Addresses: Charleston, SC, c.1796. **Sources:** G&W; Sherman, "Some Recently Discovered Early American Portrait Miniaturists."

SPRING, M. L. (Miss) *[Painter] late 19th c.*
Addresses: Pittsburgh, PA. **Exhibited:** PAFA Ann., 1878. **Sources:** Falk, *Exh. Record Series.*

SPRINGARN See: **SPINGARN, Amy E. (Mrs. Joel E.)**

SPRINGER, Carl *[Painter] b.1874, Fultonham, OH / d.1935, Delaware, OH.*
Addresses: Columbus, OH; Brevort, MI. **Member:** ASL; Columbus Pen & Pencil Club; Columbus AL; SC. **Exhibited:** SC, Detroit, 1913 (prize), 1916 (prize); PAFA Ann., 1914; Corcoran Gal. biennials, 1916, 1919; Ohio State Expo, 1920 (prize); Columbus Art Lg., 1920 (prize); 1924 (prize); 1926 (prize). **Work:** Gal. FA, Columbus. **Comments:** Specialty: snow scenes. **Sources:** WW33; Falk, *Exh. Record Series.*

SPRINGER, Charles H(enry) *[Painter, craftsperson, teacher, sculptor, illustrator, designer] b.1857, Providence / d.1920.*
Addresses: Providence, RI. **Studied:** ASL; H. Breul in Providence; F.W. Freer in NY. **Member:** Providence AC; RISD. **Exhibited:** PAFA Ann., 1888, 1890. **Comments:** Specialties: wood carving furniture design. **Sources:** WW19; Falk, *Exh. Record Series.*

SPRINGER, Eva *[Painter, graphic artist]* *b.1882, Cimarron, NM / d.1962.*
Addresses: Wash., DC, c.1913-after 1935/NYC; Phila., 1940; Santa Fe, NM, 1947. **Studied:** Highlands Univ., Las Vegas, NM (B.A.); Columbia Univ.; ASL with W.H. Foote and K.H. Miller; Académie Julian, Paris with Mme. Laforge; Acad. Grande Chaumière, Acad. Delecluse, and Sultan Acad., all in Paris. **Member:** Brooklyn SMP; Penn. SMP; ASL; Wash. SMP; Wash. WCC; NAWA; PBC; NAC. **Exhibited:** Acad. Julian, Paris (medal, prize); Grand Central Art Gal.; NCFA; Wash. WCC, c.1913-25; Penn. SMP; S. Indp. A., 1917-18; PAFA Ann., 1918; ASMP; Soc. Wash. Artists, 1919-32; Wash. SMPS&G; Mus. New Mexico, Santa Fe, 1953, 1955 (solo); NAC; BM; NAD; CGA; AIC; State Fair, Albuquerque, 1955, 1956, 1958; & in Paris, London, Rome, Florence. **Work:** Mus. New Mexico, Santa Fe; Penn. SMP; PMA. **Sources:** WW59; WW47; Falk, *Exh. Record Series.* More recently, see, McMahan, *Artists of Washington, DC.*

SPRINGER, Ferdinand *[Painter] mid 20th c.*
Exhibited: AIC, 1937. **Sources:** Falk, *AIC.*

SPRINGER, Frederick M. *[Painter] b.1908, Bellevue, OH.*
Addresses: Cincinnati, OH. **Studied:** Cincinnati Art Acad. **Exhibited:** AIC; Columbus AL, 1935 (prize), 1936 (prize). **Work:** Columbus Gal. FA. **Comments:** Illustr.: "Patterns of Wolfpen," 1935. **Sources:** WW40.

SPRINGFIELD, Adam *[Painter] late 19th c.*
Addresses: NYC, 1873. **Exhibited:** NAD, 1873. **Sources:** Naylor, *NAD.*

SPRINGWEILER, Erwin Frederick *[Sculptor, craftsperson] b.1896, Pforzheim, Germany / d.1968.*
Addresses: Carinthia Heights, Bronx, Wyandanch, NY. **Studied:** Art Craft School, Pforzheim; BAID; Acad. FA, Munich; asst. to Paul Manship, Herbert Hazeltine. **Member:** NSS; ANA; Int. Inst. Art & Letters; CAFA; McDowell Colony; Soc. Animal Artists. **Exhibited:** NSS, 1937 (prize); NAD, 1937, 1938 (prize, 1939-46; 1949 (prize), 1959 (Speyer Prize); NAD, 1937-46; PAFA Ann., 1938-50; WFNY, 1939; Arch. Lg., 1949 (prize); NAC, 1956 (medal of honor); AIC; Academic AA, 1959 (Sculpture House award); Locust Valley, LI, 1959 (sculpture prize), 1960 (sculpture prize); 150 Years of American Sculpture Exh., Old Westbury, NY, 1960. **Work:** Congressional gold medals of George M. Cohan and General W. L. Mitchell; statues, Washington Zoo and Detroit, MI; Brookgreen Gardens; reliefs, Washington Zoo, USPO, Chester, PA, Highland Park, Detroit, Manchester, GA. Metalwork: Williamsburg Savings Bank Bldg., Brooklyn; Pub. Lib., Jamaica, N.Y. WPA artist. Other works at Norton Mus., Shreveport, LA; Syracuse Univ. **Comments:** Contributor of articles to *National Sculpture Review.* **Sources:** WW66; WW47; Falk, *Exh. Record Series.*

SPROUL, John *[Architect] late 18th c.*
Addresses: Philadelphia. **Exhibited:** Columbianum, 1795. **Sources:** G&W; Columbianum Cat.

SPROULE, Robert Auchmuty *[Sketch artist, print maker] b.1799, Ireland / d.1845.*
Addresses: Montreal, c.1826 and after. **Comments:** Advertised in 1829 in Montreal views of the city, which were to be engraved and printed, sold by subscription. These engravings were reissued as lithographs in 1871 by A. Bourne (see entry). He also published other views by Sproule, in the early 1830's. **Sources:** Reps, 208.

SPROULL, M. Magdalen *[Painter] b.1870, Rochester, NY.*
Addresses: Freeport, NY. **Studied:** ASL with F.V. DuMond; Académie Julian, Paris with Flameng and Ferrier; also with Collin in Paris. **Sources:** WW13.

SPROUR, John See: **SPRUOR, John**

SPROUT, Christopher *[Sculptor] b.1945.*
Addresses: Jamaica Plain, MA. **Exhibited:** WMAA, 1973. **Sources:** Falk, *WMAA.*

SPROUT, Donald A. *[Painter] early 20th c.*
Addresses: Phila., PA. **Studied:** PAFA. **Sources:** WW25.

SPRUANCE, Benton (Murdoch) *[Lithographer, painter, educator] b.1904, Philadelphia, PA / d.1967, Phila.*
Addresses: Germantown, PA; Phila. **Studied:** Univ. Penn. School FA; PAFA with D. Garber (Cresson traveling scholarship); G. Harding; R. Nuse; A. Lhote in Paris. **Member:** NA; SAGA; Phila. Pr. Club; Phila. Art All.; Am. Artists Congress. **Exhibited:** many nat. print exhs., 1929-65; Phila. Pr. Club,1929 (prize), 1932 (prize), 1929 (prize), 1941, 1953, 1956; WC Ann., 1937 (prize); WMAA, 1933-45; AIC, 1937-38, 1941; PAFA Ann., 1939-53 (gold medal 1946); Corcoran Gal. biennial, 1941; Laguna Beach AA, 1943, 1944; Audubon Artists, 1947; LOC, 1948; Boston Printmakers, 1949; Phila. Art All., 1951; NAD, 1953, 1957, 1959; Am. Color Pr. Soc., 1954, 1960, 1961; SAGA, 1955, 1962; Calif. Etchers, 1959; Bay PM, 1959; Joslyn Mus. Art , 1954 (retrospective); Mt. Holyoke, 1954 (retrospective); Swarthmore, 1954 (retrospective); Woodmere Art Gal., Phila., 1960; Phila. Sketch Club, 1965 (Medal for Distinguished Service to Art); Phila. Art All., 1965 (Medal of Achievement). Solos in numerous colleges, universities, galleries & museums nationally, 1954-65. Other awards & medals: Pennell medal, 1937; Eyre medal, 1939; Beck medal, 1946; Guggenheim Fellowship, 1950, 1963; hon. D.F.A., Phila. College of Art, 1962; PAFA Fellowship, 1964. **Work:** MoMA; WMAA; CI; LOC; NGA; PMA; SAM; PAFA; NYPL; AGA. Murals, Municipal Court Bldg., Phila.; Philadelphia House of Detention Chapel. **Comments:** Positions: professor of fine art & chmn., Dept. of FA, Beaver College, Glenside, PA, 1932-60s; director, Graphic Art, Philadelphia College of Art; member, Philadelphia Art Commission. **Sources:** WW66; WW40; Falk, *Exh. Record Series.*

SPRUANCE, Helen *[Landscape painter] b.c.1887 / d.After 1980.*
Addresses: Active in Jamison, Bucks Co., PA. **Studied:** with Roy Nuss, PAFA. **Exhibited:** Walton Center of George School, Newtown, PA; Friends Central School& Overbrook School, Newton; Rodman House Gal., Bucks Co. Council Arts, 1979. **Comments:** Began painting at age 63. **Sources:** Petteys, *Dictionary of Women Artists.*

SPRUCE, Everett Franklin *[Painter, printmaker, teacher] b.1908, Conway, Faulkner County, AR.*
Addresses: Living in Austin, TX in 1976. **Studied:** private study with Olin H. Travis & Thomas M. Stell; Dallas AI, 1925-29. **Member:** Texas FAA; Lone Star PM; Dallas Artists League. **Exhibited:** Nine Young Dallas Artists Exh., 1932; Dallas Mus. FA, 1932 (solo), 1933 (solo), 1934, 1935 (Sanger Brothers Purchase Prize), 1938 (Kiest Prize), 1939, 1940 (Dealey Prize); Texas State Fair Exh., 1933; First Nat. Exh. Am. Art, Rockefeller Center, 1936; Texas Centennial, 1936; Lawrence Art Gal., 1936; WMAA, 1936-59; Delphic Studios, NY, 1937; AIC, 1937, 1939-45; Hudson D. Walker Gal., 1938; Texas FAA, 1939-42 (prize), 1940-45; Corcoran Gal. biennials, 1939-53 (7 times, incl. 4th prize, 1949); SFMA, 1940 (prize); MoMA, 1942; PAFA Ann., 1944-49, 1952 (prize, 1947); WMA, 1945 (prize); Pepsi-Cola, 1946 (prize); Critics Choice, CM, 1944; Joseph Sartor Gal., 1934 (solo); Texas General Exh., 1939-45; Texas Centennial, Dallas, 1936; La Tausca Pearls Exh., 1947; Hudson Walker Gal., 1939 (solo); Leavitt Gal., 1945 (solo); Witte Mem. Mus., 1943 (solo); CI; Brussels, Belgium & Bordighera, Italy; Ford Found.(retrospective), circulated nationally by AFA; Pan-Am Union, Wash., DC. **Work:** U.S. Dept. State, Wash., DC; Mus. FA, Houston; Dallas Mus. FA; PMG; Witte Mem. Mus. Art; MoMA; North Texas State Teachers College, Denton; CPLH; Mus. Fine Arts Rio de Janeiro, Brazil; Nelson Gallery, Kansas City, MO; PAFA; Meadows Mus., SMU, Dallas, TX. **Comments:** A regionalist painter of landscapes and animals, he was raised on an apple and peach farm in the Ozark Mountains. Member of "Dallas Nine." Positions: gallery asst., Dallas Mus. FA, 1931-34, registrar, 1935, asst. dir., 1935-40. Teaching: Dallas Mus. School, 1936-40; Univ.

Texas, Austin, 1940-70s. **Sources:** WW73; WW47, which puts birth at 1907; Stewart, *Lone Star Regionalism*, 187-88 (w/repros.), which puts birth at 1908; John I. H. Baur, *Revolution and Tradition in Modern American Art* (Harvard Univ. Press, 1959); John Leeper, *Everett Spruce* (Am. Federation Arts, 1959); portfolio of paintings, Vol. I in *Blaffer Series* (Univ. Texas Press); Falk, *Exh. Record Series.*

SPRUEHLER, Ernest R. *[Painter] mid 20th c.*
Addresses: Chicago area. **Exhibited:** AIC, 1946. **Sources:** Falk, AIC.

SPRUNCK, Marian L. *[Painter] early 20th c.*
Addresses: Los Angeles, CA, 1920s-30s. **Exhibited:** Calif. AC, 1922; P&S Los Angeles, 1921-31; Modern Art Workers, 1926; LACMA, 1927; Calif. WCS, 1930, 1932; AIC. **Sources:** WW24; Hughes, *Artists in California*, 529.

SPRUNCK, Paul B. *[Painter] early 20th c.*
Exhibited: Salons of Am., 1924; S. Indp. A., 1924. **Sources:** Falk, *Exhibition Record Series.*

SPRUNGER, Arthur L. *[Painter, engraver, craftsperson, teacher, designer] b.1897, Berne, IN.*
Addresses: Goshen, IN. **Studied:** Goshen College (B.A.); John Herron AI; AIC; W. Forsyth. **Member:** Hoosier Salon; Northern Indiana Art Lg.; AAPL; Indiana PM; Elkhart County Art Lg. **Exhibited:** Hoosier Salon, 1928-30, 1931 (prize), 1934,1936, 1937-40, 1943; Artists Lg. Northern Indiana, 1920 (prize); Friends of Art, South Bend, 1929 (prize), 1932 (prize), 1933 (prize), 1934 (prize), 1937 (prize); 1939 (prize), Indiana State Fair,1928-34, 1936-37, 1939 (prize); Elkhart County Art Lg., 1939 (prize); PAFA; Albright Art Gal.; SAM; Phila. WCC; Indiana PM; Indiana Arts & Craftsmen; Indianapolis AA. **Comments:** Teaching: Goshen (IN) College, 1926-. **Sources:** WW53; WW47.

SPRUNGER, Elmer *[Painter] b.c.1915, probably Bigfork, MT.*
Addresses: Living in Bigfork, MT in 1969. **Studied:** Elizabeth Lochrie. **Comments:** Specialty: wildlife. **Sources:** P&H Samuels, 458.

SPRUNK, Robert Godfrey *[Painter, illustrator] b.1862, Kröxen, Germany / d.1912, Ridgefield, N.J.*
Addresses: Detroit, MI (immigrated 1868); Brooklyn, 1890; Ridgefield, NJ, 1895-1909. **Studied:** PAFA with Eakins; Jakobides, in Munich; Académie Julian, Paris with Bouguereau and T. Robert-Fleury. **Member:** Paris Salon, 1889; PAFA. **Exhibited:** Michigan State Fair, 1880; AIC; PAFA Ann., 1884-1905 (7 times); NAD, 1890-98. **Sources:** WW10; Gibson, *Artists of Early Michigan*, 219; Falk, *Exh. Record Series.*

SPRUOR, John *[Lithographer] mid 19th c.*
Addresses: New Orleans, active 1856-66. **Sources:** G&W; New Orleans 1859-66. More recently, see *Encyclopaedia of New Orleans Artists*, 363.

SPRUYT, Lee E *[Painter] b.1931, Lisbon, Port.*
Addresses: NYC. **Studied:** apprentice (at 1914) to Pachita Crespi; Pratt Inst. Night School; ASL; RISD; Carnegie Inst. Tech., scholarship to Atheneum School, Finland, 3 years; study with Robert Rabinowitz & Samuel Rosenberg. **Member:** Artists Equity Assn. New York. **Exhibited:** Lord & Taylor, 1964, 1965-73 (5 solos); Artists Equity Assn. Gallery, New York; Arch. League New York, 1970 & 1972; Portrait of the Old Met. Mus. Performing Arts, Lincoln Center, 1972-73; 48 drawings & gouache, New York City. **Comments:** Preferred media: oil & gouache, encaustic. Teaching: Carnegie-Mellon Univ.; Boys Club Rhode Island. **Sources:** WW73; 10 drawings, *Show Magazine*, 2/1970, 3/1970; articles, *New York Times*, 10/1972 & *Metropolitan Opera Program*, 11/1972.

SPRY, Charles V. *[Painter, designer] b.1914 / d.1942, Pittsburgh, PA.*
Studied: CI. **Member:** Pittsburgh Arts Comm.

SPURGEON, Joseph E. *[Designer, lecturer] b.1903.*
Addresses: Chicago, IL. **Studied:** Cincinnati Art Acad. **Member:**

Hoosier Salon. **Exhibited:** All-Am. Packaging Comp., 1935; Hoosier Salon, 1936 (prize); WC, 1939 (prize); Am. Management Assn. 1939 (prize); All. Am. Packaging Comp., 1939 (medal). **Comments:** Specialty: package and product design. **Sources:** WW40.

SPURGEON, Sarah (Edna M.) *[Painter, educator] b.1903, Harlan, IA / d.1985.*
Addresses: Ellensburg, WA. **Studied:** Univ. Iowa, 1922-28 (B.A. & M.A.); Harvard Univ.; Grand Central School Art; also with Grant Wood, Paul Sachs; C. Macartney; George Oberteuffer. **Member:** Nat. Educ. Assn.; Am. Assn. Univ. Prof.; Iowa AG; Wash. Educ. Assn.; Women Painters Wash. **Exhibited:** Des Moines Publ. Lib.; Corcoran Gal.; Kansas City Art Inst.; Kansas City AI; Joslyn Mus; Des Moines Art Salon; Calif. SE; Univ. Iowa, 1931 (prize); Iowa Art Salon, 1930 (prize), 1931 (prize), 1935 (prize). SAM; Gumps, San Francisco, CA; Awards: Carnegie fellowship, 1929-30. **Work:** Iowa Mem. Union, Iowa City; SAM; Ginkgo Mus., Vantage, WA; Henry Gal., Univ. Wash., Seattle. Commissions: mural, Univ. Experimental School, Iowa City. **Comments:** Publications: contrib. to *Design & Childhood Education Magazine.* Teaching: Buena Vista College, Storm Lake, IA; Central Washington State College, 1939-42, 1944-71, emeritus, 1971-. **Sources:** WW73; WW47; Ness & Orwig, *Iowa Artists of the First Hundred Years*, 197.

SPYBUCK, Ernest *[Painter, farmer, historical informant] b.1883, Near Tecumseh, Potawatomi-Shawnee Res. / d.1949, west of Shawnee, OK.*
Addresses: West of Shawnee, OK. **Studied:** Shawnee (OK) Boarding School; Sacred Heart Mission, South-Central Oklahoma. **Exhibited:** American Indian Expo. and Congress, Tulsa, OK, 1937; Heard Mus., Phoenix, AZ; Oklahoma Hist. Soc. Mus., Oklahoma City; Nat. Mus. Am. Indian, Smithsonian Inst., Wash., DC; Oklahoma Mus. Art, Oklahoma City; "Shared Visions: Native Am. P&S in the 20th Century," Heard Mus., 1991-92. **Work:** Creek Indian Council House and Mus., Okmulgee, OK; Gilcrease Inst., Tulsa, OK; Heard Mus., Phoenix, AZ; Oklahoma Hist. Soc. Mus., Oklahoma City; Nat. Mus. Am. Indian, Smithsonian Inst.; Oklahoma Mus. Art; Okla. Science & Art Found., Inc.; Gerrer Coll., Oklahoma City. **Comments:** A member of the Shawnee tribal nation, his native name was Mahthela. Preferred media: oil, watercolor, pencil, pen & ink. **Sources:** info. courtesy of Donna Davies, Fred Jones Jr. Mus. Art, Univ. of Oklahoma.

SQUAREY, Gerry *[Painter, teacher, lecturer] 20th c.; b.Sydney, Canada.*
Addresses: Falmouth, MA; NYC. **Studied:** Mass. College Art, B.S. in Educ.; Hyannis Teachers College, M.E.; Boston Univ.; Connecticut Univ.; Hillyer Col. (Prof. Certif.). **Member:** NAWA; Hartford Soc. Women Painters; Conn. WC Soc.; Cape Cod AA (exec. vice-pres., 1960-64; director, 1964-); Falmouth Art Gld.; Provincetown AA; Conn. AA; Eastern AA; Conn. Educ. Assn. **Exhibited:** NAD; Argent Gal.; Wadsworth Atheneum; Springfield Mus. FA; Yale Univ.; Lyman Allyn Mus. Art; Farnsworth Mus.; Slater Mus. Art; New Britain Mus. Art; Portland Mus. Art; Silvermine Gld. Artists; Cape Cod AA; Provincetown AA; Boston Art Festival, 1957; New Britain Teachers College, 1958; Central College of Conn.; Falmouth Art Gld.; Cape Cod AA, 1959 (solo). Awards: prizes, Hartford Soc. Women Painters, 1950, 1953, 1954; Conn. WC Soc., 1953, purchase, 1958; NAWA, 1953; Cape Cod AA, 1955, 1960; Falmouth Art Gld., 1959, 1960, 1964; NY Comm. on Art, for New York Hospitals, purchase, 1964. **Comments:** Positions: chmn., art dept., Hartford Public H.S., 1949-61; painting instructor, Central College of Conn., 1959-61. **Sources:** WW66.

SQUIBB, E. R. *[Painter] 20th c.*
Addresses: Bernardsville, NJ. **Exhibited:** S. Indp. A., 1920. **Sources:** Marlor, *Soc. Indp. Artists.*

SQUIER, Benjamin T. *[Painter] 20th c.*
Exhibited: Salons of Am., 1928. **Sources:** Marlor, *Salons of Am.*

SQUIER, Donald Gordon *[Painter, commercial artist, illustrator]* b.1895, Amherst, MA.
Addresses: Exeter, NH. **Studied:** BMFA School; in France, Germany, Italy; & with Tarbell, Hale. **Member:** Copley Soc. **Exhibited:** NAD; Corcoran Gal biennial, 1928; PAFA; S. Indp. A., 1922; Whistler House, Lowell, MA; Boston AC, 1935 (solo); Copley Soc., Boston, 1934 (solo) 1953 (solo); No.10 Gal., 1936 (solo). **Work:** many portraits of prominent persons. **Sources:** WW59; WW47.

SQUIER, Frank *[Painter]* 19th/20th c.
Addresses: Brooklyn, NY. **Member:** B&W Club; SC 1893; NAC. **Sources:** WW01.

SQUIER, Jack Leslie *[Sculptor, educator]* b.1927.
Addresses: Ithaca, NY. **Studied:** Indiana Univ., B.S., 1950; Cornell Univ., M.F.A., 1952. **Member:** Inst Assn. Art (dept. vice-pres., 1972-); Sculptors Guild. **Exhibited:** Carnegie Int., Pittsburgh; Brussels World's Fair; Recent Sculpture USA, MoMA; 30 Americans Under 35, 1957; WMAA; PAFA Ann., 1964. **Work:** MoMA; WMAA; Everson Mus, Syracuse, NY; Johnson Mus., Cornell Univ.; Stanford Univ. Mus. Commissions: disc (fiber glass & aluminum leaf sculpture), Ithaca College, 1968. **Comments:** Preferred media: resin, fiber glass, bronze. Teaching: professor, sculpture, Cornell Univ., 1958-. **Sources:** WW73; William Lipke, *Disc, by Jack Squier* (Cornell Univ., 1968); Falk, *Exh. Record Series.*

SQUIER, (Miss) *[Portrait and landscape painter, teacher]* late 19th c.
Addresses: Norfolk, VA. **Exhibited:** Norfolk, VA, 1885. **Sources:** Wright, *Artists in Virginia Before 1900.*

SQUIERS, David Ellicott *[Painter, etcher, educator, teacher, lecturer]* b.1918, Dowagiac, MI.
Addresses: Oxford, OH. **Studied:** Western Michigan College; Kalamazoo College, A.B.; Harvard Univ., A.M.; & with Alan Burroughs, Henry Rosenberg, Arthur Pope. **Member:** Am. Archaeological Soc.; AFA. **Exhibited:** Kalamazoo Inst. Art, 1938 (prize); Cincinnati, OH. **Work:** mural, Kalamazoo College. **Comments:** Lectures: "The Northern Baroque Painters." Position: teacher, Western College, Oxford, OH, from 1944. **Sources:** WW53; WW47.

SQUIRE, Allan Taft *[Designer, painter, writer, lecturer, teacher]* b.1904, New Haven, CT / d.c.1950.
Addresses: Wash., DC. **Studied:** Taft School, Watertown, CT; Yale Univ.; Am. School Classical Studies, Athens, Greece. **Member:** AIA. **Exhibited:** PMG, 1939. **Comments:** Positions: architecect, FHA, until 1942; City Planning Commissioner, Naval Govt., Guam, from 1945. **Sources:** WW47.

SQUIRE, Dorothea (Mrs. Dorothea Squire Cram)
[Painter, educator, illustrator, teacher] b.1901, Vaughan, NC.
Addresses: Richmond, VA. **Studied:** Richmond Sch. Art, College William & Mary, B.F.A., M.F.A.; Columbia Univ.; École des Beaux-Arts, France. **Member:** CAA; Southeastern AA; Nat. Vocational Assn. **Exhibited:** BAID, 1928; Fed. Art traveling exhib., 1940; CGA, 1942; PAFA, 1943; Richmond Acad. Arts & Sciences, 1941 (prize), 1942 (prize), VMFA, 1941 (prize); IBM, 1941 (prize); Butler AI; Wash. WCC, 1942 (prize); Arts & Sciences, 1941, 1942; BMA, 1944 (prize), 1945 (prize). **Work:** IBM Collection; frescoes, College William & Mary. **Sources:** WW53; WW47.

SQUIRE, Eunice Pritchett (Mrs. John W.) See:
PRITCHETT, Eunice Clay (Mrs. John W. Squire)

SQUIRE, Maude H(unt) *[Painter, block printer, drawing specialist, illustrator]* b.1873, Cincinnati, OH / d.c.1955, Vence, France.
Addresses: NYC, 1902; Vence, France. **Studied:** Cincinnati Art Acad. **Member:** Société du Salon d'Automne, Paris. **Exhibited:** PAFA Ann., 1902; Pan-Pacific Expo, San Francisco, 1915; Provincetown AA, 1917-20; S. Indp. A., 1917; AIC; Salon d'Automne, Paris, 1923, 1925. **Work:** Herron AI, Indianapolis;

South Kensington Mus., London; CGA. **Comments:** Close friend and companion of Ethel Mars (see entry). Illustrator: *Child's Garden of Verse,* R. Stevenson; *Greek Heroes,* Kingsley; *Adventures of Ulysses,* Kingsley; *When I was Little,* E. Kelley; *Hindu Tales,* T.P. Williston, 1917. **Sources:** WW40; Falk, *Exh. Record Series.*

SQUIRES, C. Clyde *[Illustrator]* b.1883, Salt Lake City / d.1970, Great Neck, NY.
Addresses: NYC/Little Neck, NY. **Studied:** NY School Art, 1901 with Henri, K. H. Miller, Du Mond, Mora, Pyle. **Member:** Artists Guild; SI, 1912. **Comments:** Apprenticed to Salt Lake City engraver. Worked as a commercial artist while studying at NY School of Art. Illustrator: *Life,* 1906; later for *Woman's Home Companion, Western Romances,* and other Western magazines. Cousin of Lawrence (see entry). **Sources:** WW33; P&H Samuels, 458.

SQUIRES, Gerald Leopold *[Painter, educator]* b.1937, Nfld.
Addresses: Ferryland, Nfld, Can. **Studied:** Danforth Tech, Toronto; Ontario College Art, Toronto. **Member:** Great Northern AUK Workshop; Oshawa Art Gallery (founding member). **Exhibited:** Ontario Soc. Artist, 1965; Western Ontario Ann., 1966; Montreal Mus. Fine Arts, 1967; Painters in Nfld., 1968-71. Awards: first & second prize, Great Northern AUK Workshop Conceptual Partic Painting & Sculpture, Nfld. Arts & Letters Competition, 1972; Ron Mason, Nfld, Canada & George Ruckus, Picture Loan Gallery, Toronto, Ontario, 1970s. **Work:** Vincent Price Collection; Montreal Mus. Fine Arts; Mem. Univ. Nfld; Univ. Toronto; Saidye & Samuel Bronfman Collection, Montreal. **Comments:** Preferred media: acrylics, clay. Teaching: art instructor, Mem. Univ. Nfld., 1970-, extension artist-in-residence, 1972. **Sources:** WW73; Kat Kritzweiser, "From a Modern Squires an Old Monk's Dream," *Globe & Mail* (Toronto); Nat. CBC show.

SQUIRES, Harry See: **SQUIRES, Henry**

SQUIRES, Henry *[Primitive landscape painter]* b.1850, Putney, Surrey, England / d.1928, Salt Lake City, UT.
Addresses: Salt Lake City, UT. **Studied:** Univ. Deseret, c.1870; self taught as a painter. **Work:** Utah State Capitol. **Comments:** Came to Salt Lake City in 1853 with his parents. Visited Mexican, European and Eastern art galleries, 1908-09 with his nephew, Lawrence (see entry). **Sources:** P&H Samuels, 459.

SQUIRES, Lawrence *[Painter, etcher]* b.1887, Salt Lake City, UT / d.1928, Salt Lake City, UT.
Addresses: Salt Lake City; near Tucson, AZ, 1924-25. **Studied:** Mahonri Young, 1905; in Europe, 1907-10; ASL, with K.H. Miller, G. Bridgman, 1912-14. **Exhibited:** S. Indp. A., 1917. **Work:** South Cache H.S.; memorial collection, Hyrum, UT; Denver Art Mus.; Utah State Capitol collection; eight Utah high schools. **Comments:** Went to Europe as a Mormon missionary and continued as an art student. Worked as a furniture decorator until WWI, in the course of which his lungs were damaged by poison gas. Specialty: decorative furniture, Utah landscapes, Arizona scenes. **Sources:** WW27; P&H Samuels, 459.

SQUIRES, Norma-Jean *[Sculptor, painter]* 20th c.; b.Toronto, Ontario.
Addresses: Los Angeles, CA. **Studied:** ASL; Cooper Univ., certificate, 1961; also special studies with James Rosati, sculptor. **Exhibited:** Hudson River Mus., Yonkers, NY, 1966 (solo) & East Hampton Gal., New York, 1969 (solo); Affect-Effect, La Jolla (CA) Mus. Art, 1969; Recent Trends in American Art, Westmoreland Co. Mus. Art, Greensburg, PA, 1969; Sculptured Light, Suffolk Co. Mus., Long Island, NY, 1970; Orlando Gallery, Encino, CA, 1970s. Awards: Sarah Cooper Hewitt Award for the Advancement of Science & Art, Cooper Union, 1961. **Work:** Sterling Forest Gardens, Long Island, NY; Galeria Vandres, Madrid, Spain. **Comments:** Preferred media: wood, aluminum, mirrors, motors. Teaching: sculpture instructor, Lucinda Art School, Tenafly, NJ, 1967-69. **Sources:** WW73; Shirley Fischler, newspaper profile, *Toronto Daily Star,* 4/1968; Burton Wasserman, "Modern Painting--The Movements, The Artists, Their Work,"

Davis Publ., 1970.

SQUIRES, S. A. *[Painter] mid 19th c.*
Addresses: NYC, active 1847. **Exhibited:** Am. Inst., 1847
(steamer *Cornelius Vanderbilt*). **Sources:** G&W; Am. Inst. Cat.,
1847.

SQUIRES, Warren L. *[Painter] b.1886, Fostoria, CA /
d.1938, Riverside, CA.*
Addresses: Idaho; California. **Member:** P&S of Los Angeles;
Laguna Beach AA. **Work:** Riverside Public Lib. **Sources:**
Hughes, *Artists in California,* 529.

SROUFE, Susan *[Landscape painter] 19th/20th c.*
Addresses: San Francisco, CA. **Studied:** San Fran.; Munich;
Paris. **Exhibited:** Paris Salon (hon. mention); Calif. State Fair,
1880; San Fran. AA, 1885; Calif. State Bldg., World's Columbian
Expo, Chicago, 1893; Calif. Midwinter Expo, 1894; Mark
Hopkins Inst., 1898; Mechanics' Inst. Fair, 1899. **Comments:**
Also appears as Loosley. **Sources:** Hughes, *Artists of California,*
529.

STAATS, Florence *[Painter, educator] b.1940, Newark, NJ.*
Studied: Parsons School Des.; NY Univ. (B.S.); Pratt Inst.
(M.F.A.). **Member:** College AA Am.; Am. Craftsmen Council;
Nat. AA Am. **Exhibited:** Jersey City Pub. Lib., 1968; Montclair
Mus. Ann., 1960-61; Newark Mus., 1960, 1969, also Black
Motion Art Exh. Touring Show, 1969-70; P&S Soc. of NYC,
1961; NJ Lg. Contemp. Artists, 1961; Ahda Artzt Gallery, NY,
1961; Drawing USA, St. Paul, MN, 1963; Kaymar Gallery, NYC
& Cape Cod; Treasure Gallery Ann., Bellville, NJ, 1966; Nutley
Mus., 1967-68; Temple Menorah Ann., 1967-68; Sterington House
Artist of the Month, Montclair, NJ, 1968 (solo); Midblock Art
Gallery, East Orange, NJ, 1968; Newark Pub. Lib., 1958; Angry
Arts Program Cover Des. Contest, 1968; New Brunswick
Community Center, 1968 (award); NJ State Council on the Arts,
1969-70; Art Center of the Oranges, 1970; Mid-Hudson Art Show,
New Paltz, NY, 1970 (award); Pratt Graduate Gallery, 1970;
Stuart Art Gallery, Princeton, NJ, 1971; NJ State Mus., 1972.
Work: Newark Mus. **Sources:** Cederholm, *Afro-American
Artists.*

STAATS, Teresa Simpson (Mrs.) *[Painter, craftsworker, lec-
turer, teacher] b.1896, Opelika, AL.*
Addresses: Bordentown, NJ. **Studied:** Columbia Univ. (B.S.;
M.A.); AIC; Univ. Chicago. **Exhibited:** Nat. Fed. Women's Club,
1934 (award); Harmon Found., 1933,1938; Atlanta Univ., 1942-
44; Trenton State Fair, 1934; Bowie State Normal Sch,, 1935; NJ
State Mus., Trenton, 1935; Harmon Found., traveling exh.;
Pyramid Club, Phila., PA; Artists of Today Gal., Newark, NJ.
Work: portrait, Carver Center, Trenton, NJ. **Comments:**
Teaching: Manual Training School, Bordentown, NJ, 1920-.
Sources: WW53; WW47; Cederholm, *Afro-American Artists.*
Cederholm cites a birth date of 1894.

STABER, Karl *[Painter, technical illustrator] b.1909, Vienna,
Austria / d.1986.*
Addresses: Grew up in Vienna, Austria; came to U.S. with family
in 1928 & settled in Delray, MI. **Studied:** apprenticed as drafts-
man and textile designer at Cosmanos, Vienna, Austria, until
1928. **Member:** Downriver Arts Guild (exh. dir. &
lecturer/demonstrator); Scarab Club. **Exhibited:** Ann Arbor (MI)
Art Fairs; Wyandotte (MI) Art Fairs; Flint (MI) Inst. Arts; Left
Bank Gal., Flint, MI (solo shows); Rackham Bldg., Ann Arbor;
The Little Gal., Birmingham (MI); Sheldon Ross Gal.,
Birmingham (MI); Southfield Cultural Center (MI); Ford Motor
Co., annual employee shows, 1955-1970s (frequent prize winner).
Work: Library, Cranbrook Acad. Art; U.S. Steel, Pittsburgh, PA;
City Nat. Bank, Detroit; Univ. Wisconsin; Trenton (MI) City Hall.
Comments: Abstract Expressionist painter. For many years he
worked for Ford Motor Co. (Detroit, MI), translating blueprints
into three-dimensional drawings. Outside of work, he devoted
himself to painting and was a participant in many local
(Michigan) art organizations and exhibitions. Author: *Art,* mid-
1960s. **Sources:** PHF files; info. courtesy Mark Doren, Gallerie

454, Grosse Pointe Park, MI.

STACEY, Anna Lee Day (Mrs. John F.) *[Painter] b.1865,
Glasgow, MO / d.1943, Pasadena, CA.*
Addresses: Paris, France; Chicago, IL; Pasadena, CA. **Studied:**
AIC with Ochtoman; Académie Delecluse; Italy, Belgium, &
Spain. **Member:** Chicago PS; Chicago WCC. **Exhibited:** AIC,
1895-1933 (solos & prizes); PAFA Ann., 1908-15, 1920-25;
Chicago SA, 1912 (prize); PPE, 1915; Calif. AC, 1938; GGE,
1939; Soc. for Sanity in Art, CPLH, 1940; Corcoran Gal. biennial,
1910; Chicago Gal. Assn., 1927 (solo). **Work:** Chicago Woman's
Club; Kenwood Club, Chicago; Union Lg. Club, Chicago;
Chicago Artists. Commission purchase, 1914, 1924. **Comments:**
Painter of landscapes, portraits, figures. **Sources:** WW40;
Hughes, *Artists in California,* 529; Falk, *Exh. Record Series.*

STACEY, Dorothy Howe-Layman *[Painter, designer, writer,
commercial artist] b.1904, Des Moines, IA.*
Addresses: Des Moines, IA. **Studied:** St. Joseph Acad.; Des
Moines Univ. (B.A.); Cumming Sch. Art with C.A. Cumming,
A.M. Cumming, Lynn Stacey. **Member:** Iowa Art Gld.; Int.
Platform Soc.; Composers, Authors & Artists Am. (nat. exec. sec-
retary); Soc. Sanity in Art. **Exhibited:** Grand Central Art Gal.,
1935; Univ. Idaho, 1936; Denver AM, 1936; College AC, Santa
Maria, CA, 1936; Gill Gallery, Portland, OR, 1936; Iowa AG,
1928-59; Iowa Art Salon, 1928-31 (golds), 1932-40; Univ. Iowa,
1926-59; Little Gal., Cedar Rapids, IA; Rockford AA; Buena
Vista College; Cornell College, 1937; Blandon Mem. Gal., Ft.
Dodge, IA, 1932; Des Moines Women's Club, 1930 (prize); Iowa
State College, 1950-59; Sioux City AC, 1951, 1952, 1955, 1959;
Des Moines AC, 1948-59; CMA, 1957. Awards: prizes, Des
Moines Lib. scholarship, 1925. **Work:** Inst. Contemp. Art Lib.,
London, England. **Comments:** Positions: manager, assoc. design-
er, Lynn Stacy Co., Des Moines, IA, 1951-; assist. art dir.,
Freeman Decorating, Des Moines, IA. **Sources:** WW66; WW47.
More recently, see Ness & Orwig, *Iowa Artists of the First
Hundred Years,* 197.

STACEY, Dorothy Layman See: **STACEY, Dorothy
Howe-Layman**

STACEY, J. George *[Painter] b.1863, Fayette, NY.*
Addresses: Geneva, NY/Provincetown, MA. **Studied:** ASL; C.W.
Hawthorne; S.R. Knox. **Member:** Rochester AC; AAPL;
Provincetown AA. **Exhibited:** S. Indp. A., 1926; Rochester, NY,
1927 (prize), 1928 (prize). **Sources:** WW33.

STACEY, John Franklin *[Painter,* JOHN F. STACEY.
teacher] b.1859, Biddeford, ME.
Addresses: Chicago, IL; Pasadena, CA. **Studied:** Mass. Normal
School, Boston; Acad. Julian, Paris with Boulanger & Lefebvre,
1883-85. **Member:** Chicago P&S; Pasadena SA. **Exhibited:**
PAFA Ann., 1899, 1909, 1916, 1924; St. Louis Expo, 1904
(medal); Field Exh., 1907 (prize); Buenos Aires, 1910 (medal);
Corcoran Gal. biennial, 1910; AIC, 1911 (prize), 1924 (medal),
1928 (prize); Chicago Gal. Assn., 1931 (prize); Chicago P&S,
1937 (prize); Pasadena Art Exh., 1938 (prize). **Work:** MFA,
Santiago, Chile; Union Lg. Club, Chicago; Herron AI; Chicago
Art Commission, 1922. **Comments:** Married to Anna Lee Stacey.
Sources: WW40; Falk, *Exh. Record Series.*

STACEY, Lynn (Nelson) *[Painter, designer, illustrator, com-
mercial artist] b.1903, Washington, DC.*
Addresses: Des Moines, IA. **Studied:** Univ. Iowa (B.A.);
Cumming School Art; NAD with Frances Jones, Raymond
Neilson. **Member:** Des Moines Press & Radio Club; AFA; Art
Dir. & Artists AA; AAPL; Iowa Art Gld.; Composers, Authors &
Artists Am. (nat. pres., 1951-54; dir., 1954-57); Soc. Sanity in Art;
Am. Advertisers & Illus.; F.I.A.L. **Exhibited:** Iowa Art Salon,
1927-40 (medals, 1927-28, 1930-31); Des Moines Women's Club,
1928 (prize), 1929 (medal), 1934 (medal), 1955 (prize), 1956
(prize), 1958 (prize); NAD, 1931; NJ School Indust. Art, 1936;
Michigan State College, 1936; CGA, 1934; Duluth AC, 1936;
Illinois State Teachers College, 1936; Univ. North Dakota, 1936;
Iowa Art Gld., 1928-55; Iowa State College, 1948-55; Sioux City

AC, 1951, 1955; Des Moines AC, 1948-55; CMA, 1957 (2 prizes). Award: Composers, Authors & Artists of Am., Cleveland (prize). **Work:** Univ. Iowa; CGA; Nat. Bank, Dallas, TX; Iowa State College; Inst. Contemporary Art Lib., London, England. Des Moines Women's Club; Iowa City.; pub. bldgs., Wash., DC; design for 50th Anniversary of Mutual of Omaha. **Comments:** Positions: art director, Freeman Decorating Co., 1927-55; 1st vice-pres., Freeman Contractors, 1940-; partner, Freeman-Stacey, Des Moines, Iowa, 1941-51; owner, Lynn Stacey Co., Des Moines, Iowa, 1951-. Contributed illustrations & covers to *Wallace Farmer, Iowa Homestead*; designs for Sheaffer Pen Co.; N.W.Bell Telephone Co.; General Motors; Ford Motor Co., and others. Related to Dorothy L. **Sources:** WW66; WW47.

STACHELBERG, Charles G. (Mrs.) *[Collector, patron]* mid 20th c.; b.NYC.
Addresses: NYC. **Studied:** Columbia Univ. Extension; New York Univ. **Comments:** Collection: late 19th-20th c. art. **Sources:** WW73.

STACK, Charles J. *[Painter]* early 20th c.
Addresses: Pittsburgh, PA. **Member:** Pittsburgh AA. **Sources:** WW21.

STACKEL, Alie (Ann Liebman) *[Sculptor, painter, teacher]* b.1909, New York, NY.
Addresses: Brooklyn 12, NY. **Member:** Brooklyn Soc. Art. **Exhibited:** NAD; NY Univ.; with Prof. Feldman & with Joseph Boston, Carnegie Hall Studios; BM, 1946, 1947; Riverside Mus., 1950, 1952, 1957; NSS, 1951; New Sch. for Social Research, 1940; Rockefeller Center, 1940; Hofstra College, 1946; Abraham & Straus, Brooklyn, 1949, 1951, 1953; Medallic Art Exh., 1949-50; Hotel New Yorker, 1956; NAC, 1958. Award: Sculpture House. **Work:** Educ. Art School, Port Hope, Ontario, Canada. **Comments:** Teaching: New York Lg. of Girls Clubs, 1950. **Sources:** WW59.

STACKER, Antoine *[Lithographer]* b.1814, Germany.
Addresses: Boston, 1850. **Comments:** His wife was also German, but their children, ages 4 years to 6 months, were born in Massachusetts. **Sources:** G&W; 7 Census (1850), Mass., XXV, 772.

STACKPOLE, Adele Barnes (Mrs. Ralph W.)
[Printmaker, sculptor, painter, designer] b.1885, Sacramento, CA / d.1979, Oakland, CA.
Addresses: Oakland, CA. **Studied:** Calif. College Arts & Crafts with Xavier Martinez; arch., Univ. Calif. **Exhibited:** Calif. College Arts & Crafts, Hotel Oakland, 1924. **Work:** Presidio Open Air School, San Francisco; Watsonville, CA; Kauai, HI. **Comments:** Married to Ralph Stackpole (see entry) from 1912-20s. **Sources:** Hughes, *Artists in California*, 529.

STACKPOLE, Alice *[Painter]* b.c.1867 / d.1949.
Addresses: Boston, MA. **Member:** Copley Soc., 1893. **Exhibited:** Boston AC, 1892-1904; PAFA Ann., 1893-95, 1901. **Sources:** WW06; Falk, *Exh. Record Series.*

STACKPOLE, Frank C. *[Painter]* early 20th c.
Addresses: Pelham, NY. **Exhibited:** S. Indp. A., 1934. **Sources:** Marlor, *Soc. Indp. Artists.*

STACKPOLE, Patrick M. *[Engraver]* mid 19th c.
Addresses: NYC, 1852-54. **Sources:** G&W; NYBD 1852, 1854.

STACKPOLE, Ralph W. *[Sculptor, painter, etcher, teacher]* b.1885, Williams, OR / d.1973, Chauriat, France.
Addresses: San Francisco, CA, until 1949; Chauriat, France. **Studied:** Mark Hopkins Inst. with Arthur Mathews; R. Putnam; G. Piazonni; École des Beaux-Arts, Paris; NYC with Robert Henri. **Member:** Calif. SE (co-founder, 1913); San Francisco Sketch Club; San Francisco AA. **Exhibited:** Paris Salons, 1907, 1921, 1923; Pan-Pacific Expo, San Francisco, 1915 (hon. men.); Calif. Liberty Fair, 1918 (first prize); San Francisco AA, 1906-18 (gold med.), 1919-20, (gold) 1930 (prize), 1935 (prize); S. Indp. A., 1925; Gump's, San Francisco, 1926, 1948; MoMA, 1933; Calif.-Pacific Int. Expo, San Diego, 1935; SFMA, 1935; sculp-

ture, GGE, 1939. Awards: Whitney prize, NYC, 1911. **Work:** Plaza Park, Sacramento; Univ. Calif.; Stanford Univ.; City Hall Stock Exchange, both in San Francisco; murals, Coit Tower, George Washington H.S., both in San Francisco; Sacramento Jr. College; WPA mural, Dept. Interior, Wash., DC. **Comments:** Internationally known for his sculpture, he was an influential teacher as well as a known oil painter, who was responsible for bringing Diego Rivera (see entry) to San Francisco in 1930. Married to Adele Barnes Stackpole (see entry) from 1912-1920s. Teaching: Calif. Sch. FA, 1918-41; Mills College, Oakland, 1936-38. WPA artist. **Sources:** WW40; Hughes, *Artists in California*, 529.

STACKPOLE, Robert *[Painter]* early 20th c.
Exhibited: Salons of Am., 1930. **Sources:** Marlor, *Salons of Am.*

STACKS, Leon *[Painter, art restorer]* b.1928, Charlotte, NC / d.1991.
Addresses: Blowing Rock, NC. **Studied:** W. Lester Stevens, 1943-45 & William J. Potter, 1946. **Member:** Am. Art Soc.; North Carolina AA (dir., 1970-72); Salmagundi Club; Winston-Salem AA; Nat. Arts Club. **Exhibited:** Rockport(MA) AA Member Exh., 1944-46; Piedmont Exh., Mint Mus., Charlotte, 1950; North Carolina AA Ann., 1969-72; Nat. Soc. Painters In Casein & Acrylic Open Exh., New York, 1972; Wash. SMP, 1972; Am. Art Soc., Newport, VA & Shepherd-Lambeth Co., Winston-Salem, NC, 1970s. **Work:** USN Coll., Mariner's Mus. Norfolk, VA; North Carolina Nat. Bank, Charlotte; Greenville (NC) Art Center; Goldsboro(NC) Art Center; State Univ. NY, Albany. Commissions: restoration commissions, private & corporate collections, govt. bldgs. & universities including Davidson College, Wofford College, Univ. South Carolina, Wake Forest Univ., Univ. North Carolina, Clemson College& Winthrop College, 1945-. **Comments:** Preferred media: oils, acrylics. Positions: director & charter member, Rockport Summer Group, 1945-; board member, North Carolina Arts Council, 1972-75. Collections arranged: asst., Elliot Daingerfield Retrospective, Mint Mus., Charlotte & North Carolina State Mus., Raleigh, 1971; also contributor to catalog. **Sources:** WW73.

STACY, Mary Burr (Miss) *[Still life painter]* 19th/20th c.
Addresses: Tacoma, WA, 1891. **Member:** Tacoma Art League, 1892. **Exhibited:** Western Wash. Industrial Expo, 1891. **Sources:** Trip and Cook, *Washington State Art and Artists, 1850-1950.*

STACY, William Corning *[Painter]* b.1836, Burlington, VT / d.1919, Burlington.
Addresses: Burlington. **Studied:** Providence, RI. **Work:** Shelburne (VT) Museum ("The Steamboat Elfreida on Lake Champlain"). **Comments:** Painter of the Vermont State coat-of-arms which hung over the Speaker's chair in the House of Representatives for many years. Stacy commited suicide. **Sources:** Muller, *Paintings and Drawings at the Shelburne Museum*, 128.

STADEKER, Claire Leo *[Painter]* b.1886, NYC / d.1911.
Exhibited: AIC, 1910.

STADELMAN, Henryette Leech *[Painter, teacher]* b.1891, Brownsville, PA.
Addresses: Wilmington, DE. **Studied:** PAFA with H. Breckenridge, Hawthorne, Pyle. **Member:** Plastic Club; Wilmington SFA; AFA. **Exhibited:** PAFA Ann., 1924, 1928-29; AIC, 1926. **Sources:** WW29; Falk, *Exh. Record Series.*

STADLER, Al *[Painter]* b.1914, NYC.
Addresses: Wash., DC. **Studied:** Corcoran Sch. Art; N. Crandell. **Member:** DC Art Union.; United Am. Artists. **Exhibited:** New Sch. Social Research, NY, 1937; PMG, 1939; The Bookshop, Wash., DC, 1939; Allocations Gal., Wash., DC, 1938-40. **Sources:** WW40.

STADLER, Albert *[Painter]* b.1923, NYC.
Addresses: NYC. **Studied:** Univ. Penn.; Univ. Florida. **Exhibited:** WMAA; CGA; Dayton AI; LACMA; Walker AC; Art Gal. Toronto; Fishbach Gallery, NYC. **Comments:** Preferred

media: acrylics. Art interests: color, in all its changing hues, chroma's & lights. **Sources:** WW73.

STADTFELD See: **STATFELD, Moritz**

STAEHLE, Albert *[Illustrator, designer]* b.1899, Munich, Germany.
Addresses: NYC; Mt. Pocono, PA. **Studied:** ASL; Charles Hawthorne; Wicker School FA, Detroit; in Germany. **Member:** SI. **Exhibited:** Outdoor Advertising Exh., Chicago, 1937-42, 1946; Art Dir. Club, NY, 1943 (prize); Art Dir. Club, Phila., 1942 (prize). Award: Kerwin Fulton medal, 1938-40. **Comments:** He worked for *Saturday Evening Post* and was one of the creators of "Smokey the Bear" (1944). He also producd the "Butch" covers for *American Weekly* magazine, and designed "Butch" ceramics for Goebel Co., creators of Hummel figurines. **Sources:** WW59; WW47.

STAEHLE, Albert (Sr.) *[Painter]* late 19th c.
Addresses: Munich, Germany. **Exhibited:** PAFA Ann., 1890. **Sources:** Falk, *Exh. Record Series.*

STAEL *[Portrait painter]* mid 18th c.
Addresses: NYC, 1764. **Sources:** G&W; Groce, *William Samuel Johnson,* 196. Cf. -- Steele.

STAEMPFLI, George W. *[Art dealer, painter]* b.1910, Bern, Switzerland / d.1999, Annapolis, MD.
Addresses: NYC. **Studied:** Univ. Erlangen (Ph.D., 1935). **Exhibited:** M. Knoedler & Co., NYC, 1941 (solo) & 1947 (solo), and in Europe. **Comments:** Positions: cur., Houston MFA, 1954-56; coordinator of fine arts, Am. Pavilion, Brussels Expo, 1957-58; pres., Staempfli Gallery, 1959-92. Specialty of gallery: contemporary European and American painting and sculpture, including the works of Americans Joan Brown, David Park, and George Rickey. **Sources:** WW73; obit., *NY Times* (29 Mar. 1999).

STAFF, Jessie A. *[Sculptor]* early 20th c.
Addresses: NYC. **Sources:** WW15.

STAFFORD, B. E. D. *[Painter]* early 20th c.
Addresses: Pittsburgh, PA. **Member:** Pittsburgh AA. **Sources:** WW21.

STAFFORD, Clara B. *[Craftsperson, teacher]* b.1868, Manchester, VT.
Addresses: Manchester, VT. **Studied:** Columbia Univ. **Member:** Shuttlecraft Guild; Weavers Guild, Boston. **Sources:** WW40.

STAFFORD, Dorothea Taber (Mrs.) *[Painter]* early 20th c.
Addresses: Stowe. VT, 1928. **Exhibited:** WMAA, 1925, 1927; S. Indp. A., 1928; Salons of Am., 1929; AIC. **Sources:** Marlor, *Salons of Am.*

STAFFORD, Helen T. *[Painter]* 19th/20th c.
Addresses: Wash., DC, active 1892-93. **Exhibited:** Soc. Wash. Artists, 1892. **Sources:** McMahan, *Artists of Washington, DC.*

STAFFORD, John M. *[Wood engraver]* mid 19th c.
Addresses: NYC, 1847-48. **Studied:.** **Exhibited:** Am. Inst., 1847 ("Specimen American Scenery"). **Sources:** G&W; Am. Inst. Cat., 1847; NYBD 1848.

STAFFORD, Katherine June *[Sculptor]* b.1890, Spokane, WA / d.1971, El Cajon, CA.
Addresses: San Diego, CA; El Cajon, CA. **Member:** San Diego Art Guild. **Exhibited:** Calif.-Pacific Int. Expo, San Diego, 1935. **Sources:** Hughes, *Artists in California,* 530.

STAFFORD, Lulu C. *[Artist]* late 19th c.
Addresses: Active in Detroit, MI. **Sources:** Petteys, *Dictionary of Women Artists.*

STAFFORD, Marjorie See: **PINKHAM, Marjorie Stafford**

STAFFORD, Mary (Mrs. John R. Frazier) *[Portrait painter]* b.1895, Chicago.
Addresses: Providence, RI/Provincetown, MA. **Studied:** AIC; Acad. Grande Chaumière; C.W. Hawthorne. **Member:** Providence

AC. **Exhibited:** Corcoran Gal. biennial, 1923; NAD, 1925; AIC, 1925 (prize), 1927 (prize); PAFA Ann., 1925, 1929. **Sources:** WW40; Falk, *Exh. Record Series.*

STAFFORD, Nellie T. *[Painter]* late 19th c.
Addresses: Active in Washington, DC, 1892-93. **Exhibited:** Soc. Wash. Artists. **Sources:** Petteys, *Dictionary of Women Artists.*

STAFFORD, P. S(cott) *[Painter]* early 20th c.; b.Brooklyn, NY.
Addresses: NYC. **Studied:** R. Henri. **Member:** PPC, Columbus, OH. **Exhibited:** PAFA Ann., 1910. **Sources:** WW24; Falk, *Exh. Record Series.*

STAGER, Emil *[Engraver]* b.1838, France.
Addresses: Philadelphia, 1860. **Sources:** G&W; 8 Census (1860), Pa., LX, 709.

STAGG, Clarence Alfred *[Painter]* b.1902, Nashville, TN.
Addresses: Nashville, TN. **Studied:** C.W. Hawthorne. **Member:** SSAL; Nashville Studio Club. **Exhibited:** Nashville, 1927 (prize), 1928 (prize); PAFA Ann., 1929; S. Indp. A., 1932; Salons of Am., 1934; SSAL, 1935. **Sources:** WW40; Falk, *Exh. Record Series.*

STAGG, Jessie (Jessica) A. (Mrs. J. H.) *[Craftsman, sculptor]* b.1891, Burnage, England / d.1958.
Addresses: Woodstock, NY. **Studied:** ASL; British Acad.; Rome, Italy & England. **Member:** NY Soc. Ceramic Artists; Soc. Des.-Craftsmen; NY Soc. Craftsmen; NSS; NAWPS (pres.); AFA; Woodstock AA. **Exhibited:** Salons of Am., 1923; PAFA Ann., 1928, 1931-32. **Sources:** WW53; WW47; Woodstock AA; Falk, *Exh. Record Series.*

STAGI, Pietro *[Sculptor]* b.18, Italy.
Addresses: Carrara and Leghorn, 1783-93; Philadelphia, 1795-99. **Sources:** G&W; Gardner, *Yankee Stonecutters,* 59; Thieme-Becker.

STAGPOLE, Ralph See: **STACKPOLE, Ralph W.**

STAHL, Ben(jamin) (Albert) *[Painter, illustrator]* b.1910, Chicago, IL. *Stahl*
Addresses: Weston, CT (1940s-50s); Sarasota, FL (1960s-on). **Studied:** AIC. **Member:** SI; Westport Artists (co-founder); Sarasota AA (vice-pres., 1953); AAPL; Int. Platform Assn. **Exhibited:** AIC, 1931-36; Chicago GFLA, 1937; Chicago Fed. Advertising Club, 1939, 1941; Art Dir. Club, Chicago, 1943, 1944, 1949 (prize); NAD, 1949 (Saltus gold medal); Art Dir. Club, NY, 1952 (prize); Audubon Artists; Bridgeport Univ., 1969; Fort Lauderdale, FL, 1970. **Work:** (Illustr.) Hall of Fame; New Britain Mus. Am. Art; Albion College; Adelphi College; Duke Univ. Commissions: 14 stations of cross for Catholic Bible & Catholic Press, Chicago, 1955. **Comments:** Illustrator: *American Artist, Magazine World; Saturday Evening Post,* other nat. magazines; plus anniversary edition of *Gone With the Wind.* Auth./illustr.: *Blackbeard's Ghost,* 1965; *The Secret of Red Skull,* 1971. Teaching: Chicago Acad FA; Mem founding faculty, Famous Artists Schools, Westport, CT, 1949. Other positions: board member advisory, Am. Art Found., founder & vice-pres., Mus. of the Cross, Sarasota, FL, 1965-. **Sources:** WW73; *Community of Artists,* 110.

STAHL, Benjamin F. *[Illustrator]* b.1932, Chicago, IL.
Addresses: Chicago, IL. **Exhibited:** Awards: Am. Inst. Graphic Arts Awards, 1977, 1979; Outstanding Science Books for Children, 1976. **Comments:** He did not sign many of his works, or he used a pseudonym, in order not to trade on his father's name. Illustr. for major book publishers. Specialty: children, teenagers. Teaching: Famous Artists' School and Bridgeport (CT) Univ.; Ringling School Art, Sarasota, FL. **Sources:** W & R Reed, *The Illustrator in America,* 346.

STAHL, Edith Osborne *[Painter]* b.1883, California / d.1960, Pomoma, CA.
Addresses: Pomona, CA. **Member:** Palos Verdes AA. **Exhibited:** P&S Los Angeles, 1928; Calif. AC, 1929. **Sources:** Hughes, *Artists in California,* 530.

STAHL, Everett *[Painter] early 20th c.*
Addresses: Phila., PA. **Exhibited:** PAFA Ann., 1932. **Sources:**
Falk, *Exh. Record Series.*

STAHL, Harve O. *[Painter] mid 20th c.*
Exhibited: S. Indp. A., 1941. **Sources:** Marlor, *Soc. Indp. Artists.*

STAHL, Louise Zimmerman (Mrs. Charles H.) *[Painter,
teacher, illustrator, lecturer] b.1920, Philadelphia, PA.*
Addresses: Phila. **Studied:** Moore Inst. Art (B.F.A.); PM School
Art; PAFA with Millard Sheets, Henry Pitz, Daniel Garber.
Exhibited: PAFA, 1943; Moore Inst. Art, 1946-58; Phila. Art All.
Comments: Contributor of illustrations to *Saturday Evening Post.*
Lectures: History of Color Theory; How and Why We See Color,
etc. Designer of currency for foreign governments, E.A. Wright
Co. **Sources:** WW59.

STAHL, Marie Louise *[Painter, block printer, drawing spe-
cialist, teacher] mid 20th c.; b.Cincinnati, OH.*
Addresses: Middletown, OH. **Studied:** Cincinnati Art Acad.;
ASL; William Chase; Charles Hawthorne; at Taos, NM, with Leon
Gaspard; E.A. Webster; M. Sterne. **Member:** Provincetown AA.;
Cincinnati Women's AC. **Exhibited:** CM; Dayton AI; Columbus
AC; Albright Art Gal.; Provincetown AA; New Orleans, LA; New
York, NY; S. Indp. A. **Work:** Univ. Ohio, Athens, OH; Christ
Hospital, Cincinnati, OH; H.S., Country Club, both in Athens,
OH. **Comments:** Teaching: Univ. Ohio, Athens, OH, 25 years.
Sources: WW53; WW47.

STAHLEY, Joseph *[Painter, illustrator, teacher, art editor]
b.c.1900, Rochester, NY.*
Addresses: NYC (1948); probably living in California in 1968.
Studied: AIC, c.1915; Harvey Dunn; Dean Cornwell; Nicolai
Fechin. **Comments:** Specialty: Western subjects. Positions: art
editor, Houghton-Mifflin, NYC; art teacher, Rochester Inst. Tech.;
set illustrator for movie companies. **Sources:** P&H Samuels, 459.

STAHMER, Arnold J., Jr. *[Painter, commercial artist]
b.1915, Chicago, IL.*
Addresses: Seattle, WA. **Member:** Puget Sound Group of NW
Painters. **Exhibited:** SAM, 1936. **Comments:** Positions: commer-
cial artist, Stahmer & Son; draftsperson, Todd Pacific Shipyard,
1942; artist, Ballard News Pub. Co., 1951. **Sources:** Trip and
Cook, *Washington State Art and Artists, 1850-1950.*

STAHMER, Arnold J., Sr. See: **STAHUNN, (Mr.)**

STAHNKE, Gustave F. *[Painter] early 20th c.*
Addresses: Chicago. **Exhibited:** AIC, 1923. **Sources:** Falk, *AIC.*

STAHR, Fred C. *[Mural painter] b.1878 / d.1946.*
Addresses: Stapleton, NY. **Studied:** Am. Acad. Rome; Lazarus
scholarship, 1911-14. **Member:** Mural Painters. **Sources:**
WW25.

STAHR, Paul C. *[Illustrator] b.1883, NYC.*
Addresses: NYC/Long Beach, NY in 1941. **Studied:** John Ward;
NAD. **Member:** SI. **Comments:** Illustrator: *Life, Collier's,
American, Harper's Bazaar, Woman's Home Companion* and pulp
Westerns; "The Hornet," "The Mask," "The Seer." Specialty:
flourescent painting. **Sources:** WW40; P&H Samuels, 459-60.

STAHUNN, (Mr.) *[Painter, commercial artist] 19th/20th c.;
b.Chicago, IL.*
Addresses: Tacoma, WA. **Member:** Tacoma FAA; Puget Sound
Group of NW Painters, 1928. **Exhibited:** Tacoma FAA, 1922,
1923; SAM, 1936. **Comments:** Positions: commercial artist,
Stahmer & Son; staff, Tacoma Engineering Co., 1925. **Sources:**
WW25; Trip and Cook, *Washington State Art and Artists, 1850-
1950.*

STAIGER, Monsieur *[Architect, teacher of architecture &
drawing] mid 19th c.*
Addresses: Charleston, SC, 1843. **Sources:** G&W; Rutledge,
Artists in the Life of Charleston.

STAIGG, Richard Morell *[Portrait, miniature, genre, and
landscape painter] b.1817, Leeds (England) / d.1881, Newport,*
RI.
Addresses: Newport, RI, c.1831; Boston, active c.1841;
Baltimore, 1845; NYC ,1850s. **Studied:** Jane Stuart; Washington
Allston (1830s). **Member:** ANA, 1856; NA, 1861. **Exhibited:**
Boston in 1841; Brooklyn AA, 1861-62, 1872; Royal Acad.,
London, 1847, 1864; Paris Salon, 1868; Boston AC, 1874-81;
NAD, 1861-82; PAFA Ann., 1877. **Comments:** In 1831 his family
came to America. He gave up miniature painting about 1862 to
devote himself to oil and crayon portraits; in later life he also
painted landscapes and genre. Made several trips to Europe: Paris,
1867-69; Europe, 1872-74. **Sources:** G&W; Decatur, "Richard
Morell Staigg," 6 repros.; CAB; Clement and Hutton; Tuckerman;
Swan, BA; Cowdrey, NAD; Baltimore CD 1845; Boston BD
1849-53, 1858, 1860; NYBD 1858-60; Newport CD 1863, BD
1858; Fink, *American Art at the Nineteenth-Century Paris Salons,*
392; Falk, *Exh. Record Series.*

STAIR, Ida M. (Mrs.) *[Painter, illustrator, sculptor, teacher]
b.1857, Logansport, ID / d.1908, Denver, CO.*
Addresses: Denver, CO. **Studied:** P. Powers; AIC, with Taft,
Chase. **Member:** Denver AC. **Exhibited:** Columbian Expo,
Chicago, 1893; Omaha Expo, 1898 (medal). **Work:** statues, parks,
Denver. **Comments:** Teaching: Women's Club, Denver. **Sources:**
WW08.

STAIR, Jean (Mrs. B.W.) *[Painter] mid 20th c.*
Exhibited: S. Indp. A., 1937. **Sources:** Marlor, *Soc. Indp. Artists.*

STALDES, Mary *[Painter] early 20th c.*
Exhibited: S. Indp. A., 1934. **Sources:** Marlor, *Soc. Indp. Artists.*

STALEY, Allen *[Art historian] b.1935, St. Louis, MO.*
Addresses: NYC. **Studied:** Princeton Univ. (B.A., 1957); Yale
Univ. (M.A., 1960; Ph.D., 1965). **Comments:** Research: English
painting; Benjamin West. Positions: asst. curator, PMA, 1965-68.
Publications: co-author, "Victorian Artists in England" (cata-
logue), 1965; co-author, "Romantic Art in Britain" (catalogue),
1968; ed., "From Realism to Aymbolism: Whistler and his World"
(catalogue), 1971. Teaching: lecturer, Frick Coll., NYC, 1962-65;
assoc. prof., Columbia Univ., 1969-. **Sources:** WW73.

STALEY, C(larence) W. *[Painter] b.1892, Sandborn, IN.*
Addresses: Martinsville, IN. **Studied:** J.O. Adams. **Exhibited:** S.
Indp. A., 1939. **Sources:** WW17.

STALEY, Earle *[Painter] b.1938.*
Addresses: Houston, TX. **Exhibited:** WMAA, 1975. **Sources:**
Falk, *WMAA.*

STALEY, May Evans *[Painter] early 20th c.*
Addresses: Wash., DC, active 1926-35. **Exhibited:** Soc. Wash.
Artists; Wash. AC. **Sources:** McMahan, *Artists of Washington,
DC.*

STALEY, Willie Anna *[Painter, teacher] b.c.1865, Sedalia,
MO.*
Addresses: Idaho. **Sources:** Petteys, *Dictionary of Women
Artists.*

STALKER, E. *[Engraver] early 19th c.*
Addresses: Philadelphia, 1815. **Sources:** G&W; Stauffer; Brown
and Brown.

STALLINGS, Charles W. *[Painter, printmaker, sculptor, edu-
cator] b.1919, Gary, Indiana.*
Exhibited: Atlanta Univ., 1951 (prize). **Work:** Morgan State
College, Baltimore, MD. **Comments:** Teaching: Morgan State
College, Baltimore, MD. **Sources:** Cederholm, *Afro-American
Artists.*

STALLKNECHT, Alice *[Portrait & mural painter] b.1880,
NYC / d.1973.*
Addresses: Chatham, MA. **Studied:** Dan Beard, NYC.
Exhibited: Ferargil Gal., NYC, 1931 (solo); Bostin Inst.
Contemp. Art, 1950; Rockland (ME) Mus., 1952 (solo); de Young
Mem. Mus., 1958 (solo); traveling exh. to Mus. FA Houston, Los
Angeles, & Nat. Portrait Gal., Washington, DC, 1977. **Work:**
Chatham Hist. Soc. (3 large murals painted in the 1930s-40s).

Sources: Petteys, *Dictionary of Women Artists.*

STALLMAN, Emma S. *[Craftsman, teacher] b.1888, Chestnut Hill, Philadelphia, PA / d.1959.*
Addresses: Norristown, PA. **Studied:** Moore Inst. Arts & Sciences; RISD. **Member:** Phila. Plastic Club; Phila. Plastic Club; Penn. Gld. Craftsmen. **Exhibited:** Phila. Art All.; Pennn. Gld. Craftsmen; Phila. Plastic Club; Moore Inst. Arts & Sciences; Maryland Inst.; Hershey Park (PA) Mus., 1951. **Work:** Mus. Northern Arizona, Flagstaff, AZ. **Comments:** Teaching: Phila. Sch. Occupational Therapy. **Sources:** WW59; WW47.

STALOFF, Edward *[Painter, illustrator, etcher] b.1893, Jersey City, NJ.*
Addresses: Mt. Vernon, NY. **Studied:** Wickey; ASL. **Exhibited:** Salons of Am., 1934; S. Indp. A., 1935; WFNY, 1939. **Work:** Fifty Prints of the Year; Am. Graphic Art Section, Paris Int. Expo, 1937. **Sources:** WW40.

STAMATO, Frank *[Painter, sculptor] b.1897, Phila.*
Addresses: Phila., PA. **Studied:** PAFA; C. Grafly; A. Laessle; Lhote; awarded 2 Cresson Traveling Scholarships from PAFA. **Member:** Phila. Art Alliance; Da Vinci AA; Graphic Sketch Club. **Exhibited:** PAFA Ann., 1920-26, 1935. **Work:** Reading AM; Graphic Sketch Club; PAFA; Bd. Educ. Bldg., Phila., Allentown (PA) Mus.; SFA, Wilmington, DE. **Sources:** WW40; Falk, *Exh. Record Series.*

STAMATS, Peter Owen *[Collector, patron] b.1929, Cedar Rapids, Iowa.*
Addresses: Cedar Rapids, IA. **Studied:** Dartmouth College (B.A., 1951). **Member:** AFA; Cedar Rapids AA (dir., 1958-; pres, 1959-60). **Comments:** Positions: mem., Iowa State Arts Council, 1966-70. Art interests: support of Cedar Rapids AC. Collection: 15th-19th c. prints. **Sources:** WW73.

STAMATY, Stanley *[Cartoonist, illustrator] b.1916, Dayton, OH / d.1979.*
Addresses: Elberon, NJ. **Studied:** Cincinnati Art Acad. **Member:** Nat. Cartoonists Soc.; Magazine Cartoonists Guild (chmn. mem. comt.); Art Dir. Club NJ. **Exhibited:** De Young Mus. Cartoon Exh., 1943; Metrop. Mus. Art Cartoon Exh. **Work:** Commissions: poster for Fire Prevention Week, Am. Ins. Assn. **Comments:** Preferred media: ink, watercolors, acrylics. Positions: mem., advisory board, Guild Creative Art, 1965-. Publications: auth., "Fun Can Be Work," *Writer's Digest,* 1949; illustr., McGraw, Am. Book Co., *Am. Journal Nursing & Dynamic Maturity.* **Sources:** WW73.

STAMBAUGH, Dean *[Painter, teacher] b.1911, Galeton, PA.*
Addresses: Washington, DC. **Studied:** Edinboro (PA) State Teachers College (B.S. in Art Educ.); Penn. State College (M. in Educ.); Hobson Pittman. **Exhibited:** NAD, 1935; PAFA Ann., 1941, 1944, 1948, 1960; CI, 1941; S. Indp. A., 1941; Corcoran Gal biennials, 1943-51 (4 times); Butler AI, 1945, & prior; BMA. **Work:** Penn. State Univ. **Comments:** Teaching: St. Albans School for Boys, Wash., DC. **Sources:** WW59; WW47; Falk, *Exh. Record Series.*

STAMM, Florence W. *[Painter] mid 20th c.*
Exhibited: S. Indp. A., 1940. **Sources:** Marlor, *Soc. Indp. Artists.*

STAMM, John Davies *[Collector] b.1914, Milwaukee, WI.*
Addresses: NYC. **Studied:** New York Univ. (B.S.). **Comments:** Collection: modern American paintings; lithographs by Lautrec, as well as books, catalogues, magazines and papers pertaining to him. Publications: auth., exhibition catalogue of Lautrec posters & lithographs, Milwaukee Art Inst., 1965; auth., introduction to Philip Evergood Exhibition (catalogue). **Sources:** WW73.

STAMOS, Theodoros (S.) *[Painter, educator] b.1922, NYC / d.1997, Yiannia, Greece.*
Addresses: East Marion, NY. **Studied:** Am. Artists School with S. Kennedy. **Member:** Art Lg. Am.; MMA (life fellow). **Exhibited:** Wakefield Gal., 1943 (solo); Mortimer Brandt Gal., 1944, 1946; CI, 1945; WMAA, 1945-67; PAFA Ann., 1946-53, 1962-66; VMFA, 1946; AIC, 1947, 1949; Corcoran Gal. biennials, 1947-67

(9 times); Documenta, Kassel, Germany; "New Am. Painting," Paris, Zurich, New York, London, Madrid; "Abstract Expressionists & Imagists," Guggenheim Mus., NYC; Dada, Surrealism & Their Inheritors, MoMA; Marlborough Gal., NYC, 1970s. Other awards: Brandeis Univ. Creative Arts Award; Tiffany Found. fellowship; Nat. Arts grant. **Work:** MoMA; MMA; WMAA; AIC; BMA; CGA; Hirshhorn Mus.; Phillips Coll.; SFMA; Walker Art Center, MN; Detroit IA; Addison Gal., Andover, MA; Albright-Knox Gal., Buffalo; Univ. Calif. Mus., Berkeley; NJ State Mus, Trenton. Commissions: oil mural, S.S. *Argentina,* 1946 & tapestry, New York, 1971, Moore McCormack Lines. **Comments:** An early Abstract Expressionist, of whom the legendary art critic, Clement Greenberg, said "I scorched his show and I was wrong. You keep on learning." Later, Stamos scorched his own reputation during a famous 1972-75 court case involving his role as an executor of the estate of his painter-friend, Mark Rothko. The trial concluded in 1975 with a $9.2 million judgement against Stamos and the Marlborough Gallery in New York. Teaching: ASL; Columbia Univ; Brandeis Univ. Publications: illustr., *Sorrows of Cold Stone* (Dodd). **Sources:** WW73; K. Sawyer *Stamos* (Mus. Poche, Paris, 1960); Ralph Pomeroy, *Theodoros Stamos* (Abrams, 1973); obit., *Art & Auction* 1997; Baigell, *Dictionary;* Falk, *Exh. Record Series.*

STAMOULES, Emma *[Painter] mid 20th c.*
Addresses: Jamaica, LI, NY, 1939. **Exhibited:** S. Indp. A., 1939-44. **Sources:** Marlor, *Soc. Indp. Artists.*

STAMOULES, Hilda (Hulda) C. *[Painter] mid 20th c.*
Exhibited: Salons of Am., 1934, 1935; S. Indp. A., 1934-35, 1939-41, 1944. **Sources:** Falk, *Exhibition Record Series.*

STAMPER, Mabelle Richardson (Mrs. W. Y.) *[Painter] mid 20th c.*
Addresses: Mt. Adams, OH. **Exhibited:** Cincinnati AM, 1937, 1939; AIC, 1937. **Sources:** WW40.

STAMPER, Willson Young *[Painter, educator] b.1912, NYC / d.1988.*
Addresses: Mt. Adams, OH; Kailua, HI. **Studied:** ASL with Kimon Nocolaides & Rico Lebrun, 1932-36; Cincinnati Art Acad., 1938-39; schools, USN. **Member:** P&S Hawaii. **Exhibited:** GGE, 1939; CAM, 1937, 1939, 1941(Expressionism, El Greco to Picasso), 1942 (first prize, Artists Greater Cincinnati); Invitational, Albright-Knox Art Gal., Buffalo, NY, 1951; CI, 1962; Honolulu Acad. Art.19th Ann., 1948 (Grand Prize),1966 (purchase award); Downtown Gal., Honolulu, HI, 1970s. **Work:** MoMA; Cincinnati AM; Marion Hendrie Coll., Cincinnati; Honolulu Acad. Art; State Found. Culture & Art, State Capitol, Honolulu. Commissions: murals & ceramic tile, State Hawaii Int. Airport Bldg., 1972. **Comments:** Preferred media: Oils. Teaching: Cincinnati Art Acad., 1937-43; Honolulu Acad. Art, 1945-62. Publications: co-auth., *Stamper, Abels, Richardson,* 1939; contrib., "The Development of Eugene," *Am. Psychology,* 1940. **Sources:** WW73; WW40; "Wilson Stamper," *La Révue Moderne* (Paris, 1949); Madge Tennent, *Miracle in Art* (Paradise Pac., 1958); "Art in Hawaii," *House Beautiful* (1958).

STAMPFER, Winfield N. *[Painter] mid 20th c.*
Addresses: Chicago area. **Exhibited:** AIC, 1944-47. **Sources:** Falk, *AIC.*

STAMPFLE, Felice *[Art curator, writer] b.1912, Kansas City, MO.*
Addresses: NYC. **Studied:** Wash Univ. (A.B. & A.M.); Radcliffe College. **Comments:** Research: drawings, especially 18th c. Italian. Positions: curator of drawings & prints, Pierpont Morgan Lib., 1945-; ed., "Master Drawings," 1963-. Publications: auth., articles, reviews & exh. catalogues. **Sources:** WW73.

STAMUS, Aristides P. *[Artist] mid 20th c.*
Addresses: Media, PA. **Exhibited:** PAFA Ann., 1953-54. **Sources:** Falk, *Exh. Record Series.*

STAN, (Dr.) *[Painter] early 20th c.*
Exhibited: Salons of Am., 1924-29. **Sources:** Marlor, *Salons of*

Am.

STANCLIFF, John Wells *[Marine painter] b.1814, Chatham, CT / d.1891.*
Addresses: Hartford, CT. **Studied:** oil painting with Alexander H. Emmons and Jared B. Flagg; watercolor painting with Benjamin H. Coe. **Member:** Connecticut Sch. Design (pres., 1878). **Exhibited:** NAD, 1880. **Comments:** Originally trained as a carriage painter and copperplate engraver, Stancliff became a marine painter at age 55. He had had a photography business in Hartford and was managed a telegraph office. Only a few of his marine paintings are known. **Sources:** G&W; French, *Art and Artists in Connecticut,* 84-85; Art in Conn.: Early Days to the Gilded Age.

STANCZAK, Julian *[Painter, educator] b.1928, Borownica, Poland.*
Addresses: Seven Hills, OH. **Studied:** Uganda, Africa & London, England; Cleveland Inst. Art (B.F.A., 1954); Yale Univ. (M.F.A., 1956) with Albers & Marca-Relli. **Member:** Am. Abstract Artists; Am. Int. Platform Assn. **Exhibited:** PAFA Ann., 1966; Kent State Univ. & Dartmouth College, 1968 (solos); Albright-Knox Art Gallery, 1968; Univ. Illinois, 1939; Herron Mus. Art, Indianapolis, IN, 1969; WMAA; Martha Jackson Gallery, NYC, 1973. **Awards:** Cleveland Fine Arts Award, 1970; Outstanding Educ. Am., 1970; Ohio Arts Council Award, 1972. **Work:** Dayton AI; Albright-Knox Art Gallery, Buffalo, NY; Larry Aldrich Mus., Ridgefield, CT; Des Moines AC; LOC. **Comments:** Pioneer in optical art. Teaching: Art Acad. Cincinnati, 1957-64,; Cleveland Inst. Art, 1964-; Dartmouth College, 1968. **Sources:** WW73; George Rickey, *Constructivism: Origins and Evolution* (Braziller, 1967); Udo Kultermann, *Neue Formen des Bildes* (Verlag Ernst Wasmuth, Tübingen, 1969); Kenneth F. Bates, *Basic Design* (World Publ., 1970); Falk, *Exh. Record Series.*

STAND, (Dr.) See: **STAN, (Dr.)**

STANDAERT, Jerry *[Painter] mid 20th c.*
Addresses: Kent, WA, 1947. **Exhibited:** SAM, 1947; Henry Gallery, 1951. **Comments:** Preferred medium: watercolor. **Sources:** Trip and Cook, *Washington State Art and Artists, 1850-1950.*

STANDEN, Edith Appleton *[Art historian] b.1905, Halifax, NS.*
Addresses: NYC. **Studied:** Oxford Univ. (B.A.). **Member:** CAA. **Comments:** Research: European post-medieval tapestries. Positions: art secretary, Joseph Widener Collection, Elkins Park, PA, 1929-42; assoc. cur., MMA, 1949-70, cur. consult., 1970-. Publications: auth., articles, *Metrop. Mus. Bulletin, Metrop. Mus. Journal & Art Bulletin,* 1951-72; co-auth., "Art Treasures of the Metropolitan," 1952 & "Decorative Art from the Samuel H. Kress Collection," 1964. **Sources:** WW73.

STANDINGBEAR, George Eugene *[Painter, technical editor, illustrator, fencing & art instructor] b.1929, Pawhuska, OK / d.1974.*
Studied: Univ. Tulsa (B.A., 1952); graduate work. **Exhibited:** Philbrook Mus. Art, Tulsa, OK, Indian Art Ann.; Univ. Tulsa; Benedictine Heights College, Tulsa (solo); Tulsa FA Festival, 1964 (Grand Award). **Work:** murals, Catholic Info Center, Tulsa, OK; Tulsa Charity Horse Show, 1964 (posters & brochure). **Comments:** A member of the Osage/Sioux tribal nation, his Osage name was Zshinga Heka (Little Chief), and his Sioux name was Mahtohn Ahzshe (Standing Bear). **Sources:** info. courtesy of Donna Davies, Fred Jones Jr. Mus. Art, Univ. of Oklahoma.

STANDING SOLDIER, Andrew *[Painter] b.1917, Hisle, SD.*
Addresses: Wanblee, SD. **Exhibited:** CGA, 1939; Pine Ridge, SC, 1931 (prize); CGE, 1939 (prize). **Work:** WPA murals, USPO, Blackfoot, ID. **Comments:** Illustr.: "There Still Are Buffalos," "Pine Ridge Porcupine," 1943 & other books. **Sources:** WW47.

STANDISH, Albert H. (Mrs.) *[Artist] late 19th c.*
Addresses: Active in Grand Rapids, MI, 1881. **Sources:** Petteys, *Dictionary of Women Artists.*

STANDISH, Frank B. *[Landscape painter] b.1860, England / d.1944, Berkeley, CA.*
Addresses: San Francisco, CA. **Work:** San Jose Hist. Mus.; Oakland Mus. **Sources:** Hughes, *Artists in California,* 530.

STANDISH, H. P. See: **STANDISH, Henry**

STANDISH, Henry *[Lithographer] b.c.1831, England.*
Addresses: NYC, 1860. **Comments:** Groce & Wallace noted that the 1860 Census (8 Census, 1860, N.Y., LVI, 601, and LVII, 589) listed Henry Standish, 29, a native of England, as a lithographer, and H.P. Standish, 28, a native of England, as a lithographer. These could be the same man. **Sources:** G&W.

STANDISH, Irene Swift *[Painter] early 20th c.*
Exhibited: Salons of Am., 1929-30. **Sources:** Marlor, *Salons of Am.*

STANFIELD, F. W. *[Painter] mid 19th c.*
Addresses: NYC, active 1843. **Exhibited:** Am. Inst., 1842 (oil painting). **Comments:** In 1843 he was connected with Stanfield & Cooper (see entry), transparency painters. **Sources:** G&W; Am. Inst. Cat., 1842; NYCD 1843.

STANFIELD, Marion Baar (Mrs.) See: **BAAR, Marion (Mrs. Stanfield)**

STANFIELD, Mary *[Painter, sculptor] mid 20th c.*
Addresses: Los Angeles, CA, 1930s. **Exhibited:** P&S Los Angeles, 1936-38; GGE, 1939. **Sources:** Hughes, *Artists in California,* 530.

STANFIELD & COOPER *[Transparency painters] mid 19th c.*
Addresses: NYC, 1843. **Comments:** F.W. Stanfield and B.S. Cooper (see entries). **Sources:** G&W; NYCD 1843.

STANFORD, Daisy *[Painter] early 20th c.*
Exhibited: Salons of Am., 1934. **Sources:** Marlor, *Salons of Am.*

STANFORD, Eva Wyckoff *[Painter] early 20th c.*
Addresses: Rahway, NJ, 1927. **Exhibited:** Salons of Am., 1927; S. Indp. A., 1927. **Sources:** Falk, *Exhibition Record Series.*

STANFORD, Lurie E. *[Listed as "artist"] 19th/20th c.*
Addresses: Wash., DC, active 1897-1916. **Sources:** McMahan, *Artists of Washington, DC.*

STANG, Henry J. *[Painter, decorator] early 20th c.*
Addresses: New Orleans, active 1908-09. **Sources:** *Encyclopaedia of New Orleans Artists,* 363.

STANGE, Emile *[Painter, teacher] b.1863, Jersey City, NJ / d.1943.*
Addresses: W. Hoboken, NJ, 1895; North Hackensack, NJ, 1917. **Member:** Allied AA; AAPL; SPNY. **Exhibited:** PAFA Ann., 1895; AIC, 1896, 1899; S. Indp. A., 1917-18. **Sources:** WW40; Falk, *Exh. Record Series.*

STANGER, Gerda *[Art librarian] b.1915, Ann Arbor, MI.*
Addresses: Toledo, OH. **Studied:** Univ. Michigan (A.B.); Univ. Freiburg. **Comments:** Position: librarian, Toledo (OH) Mus. Art, 1939-. **Sources:** WW53.

STANGL, J. M. *[Ceramicist] b.1888, Bavaria.*
Addresses: Flemington, NJ. **Exhibited:** Pan-Pacific Expo, San Francisco, 1915 (medal); Sesqui-Centenn. Expo, Phila., 1926 (gold). **Comments:** Position: dir., Fulper Pottery Co. **Sources:** WW40.

STANGLAND, Jessie See: **GRANGE, Jessie Cary Stangland**

STANGLE, Jack Warren *[Painter] b.1928, Tacoma, WA.*
Addresses: Seattle, WA. **Studied:** mostly self-taught; Cornish Art School. **Exhibited:** SAM, 1949; other shows in the Northwest (awards). **Comments:** Lived and painted in Spain, 1956-58, and several years in Japan after 1963. **Sources:** Trip and Cook, *Washington State Art and Artists, 1850-1950.*

STANISIA, Mary (Sister) See: **SISTER MARY STANISIA**

STAN(ISZEWSKI), Walt(er) (P.) *[Illustrator, designer, cartoonist, painter, lecturer, teacher] b.1917, Wilmington, DE.* **Addresses:** Wilmington, DE. **Studied:** PM School IA (B.A.); Robert Riggs. **Member:** Am. Art Assn.; Phila. Graphic Sketch Club; Advertising Assn.; Phila. WCC. **Exhibited:** PAFA, 1939, 1958; Pepsi-Cola, 1944; Delaware AC, 1941 (prize), 1942, 1944, 1945; Phila. Art All., 1958; PM School IA (prize). **Work:** mural, New Castle Army Air Base, DE; Du Pont Co.; Children's ward, Delaware Hospital, Wilmington. **Comments:** Illustrator for manufacturers appearing in national magazines. Lectures: production illustrations. **Sources:** WW59; WW47.

STANKIEWICZ, Richard Peter *[Sculptor, assemblage artist, educator] b.1922, Philadelphia, PA / d.1983.* **Addresses:** Huntington, MA, 1970s. **Studied:** Hans Hofmann, 1945-49; Fernand Leger, 1950; Ossip Zadkine, 1950-51. **Exhibited:** PAFA Ann., 1954, 1966; Venice Biennale, 1958; Pittsburgh Int., Carnegie Inst., 1958-61; Bienal, São Paulo, 1961; Four Americans, Mod. Mus, Stockholm, 1962; Nat. Gallery Victoria, Melbourne; WMAA; Zabriskie Gallery, NYC, 1970s. **Awards:** Brandeis Univ. & Nat. Council Arts. **Work:** WMAA; MOMA, MOMA, Stockholm; Guggenheim Mus., New York; Albright-Knox Mus., Buffalo. **Comments:** After studying in Europe in the early 1950s, Stankiewicz returned to America and began creating junk assemblages out of scrap metal and discarded mechanical and household objects. Teaching: State Univ. NY Albany, 1967-; Amherst College, 1970-71. **Sources:** WW73; Baigell, *Dictionary;* Falk, *Exh. Record Series.*

STANLAWS, Penrhyn (Penrhyn Stanley Adamson) *[Painter, illustrator, etcher, writer] b.1877, Dundee, Scotland / d.1957, Los Angeles, CA.* **Addresses:** NYC/Greenwich, CT. **Studied:** Académie Julian, Paris with J.P. Laurens and Benjamin-Constant. **Exhibited:** AIC, 1912; S. Indp. A., 1917; PAFA Ann., 1930. **Work:** Heckscher Park Art Mus., Huntingon, NY. **Comments:** Author of plays: "The End of the Hunting," "Instinct"; and movies: "The Little Minister," & others. **Sources:** WW40; Falk, *Exh. Record Series.*

STANLEY See: **TWARDOWICZ, Stanley John (Jan)**

STANLEY, Abram Ross *[Portrait painter] b.1816, New York State / d.1880.* **Addresses:** Shullsburg (WI), 1846 and after. **Studied:** received instruction from an Italian artist, c.1830. **Work:** NGA (Garbisch Coll.). **Comments:** In 1856 he painted a portrait of a resident of Shullsburg (WI) where Stanley had been postmaster for ten years. **Sources:** G&W; Butts, *Art in Wisconsin,* 97; repro., Garbisch Collection, Catalogue, 90.

STANLEY, Anna H. *[Painter] late 19th c.; b.Ohio.* **Addresses:** San Antonio, TX, 1890; NYC, 1894. **Studied:** Boulanger, Lefebvre, Rixens, Courtois. **Exhibited:** Paris Salon, 1888, 1889; NAD, 1890, 1894; Boston AC, 1894. **Sources:** Fink, *American Art at the Nineteenth-Century Paris Salons,* 392; *The Boston AC.*

STANLEY, Beatrice *[Sculptor] mid 20th c.* **Addresses:** Los Angeles, CA, 1930s. **Member:** San Francisco AA. **Exhibited:** GGE, 1939; Los Angeles County Fair, Pomona, 1941. **Sources:** Hughes, *Artists of California,* 530.

STANLEY, Blanche H(untington) *[Painter] early 20th c.; b.Pennsylvania.* **Addresses:** Chester, PA, active 1907-09; Wash., DC, 1928-35; Gloucester, MA, 1939 and after. **Studied:** CGA; PAFA; Paris, France. **Exhibited:** PAFA Ann., 1907; Soc. Wash. Artists; Wah. AC; Maryland Inst.; Greater Wash. Indep. Exhib., 1935. **Sources:** WW25; McMahan, *Artists of Washington, DC;* Falk, *Exh. Record Series.*

STANLEY, Bob *[Painter] b.1932, Yonkers, NY.* **Addresses:** NYC. **Studied:** Ogelthorpe Univ. (B.A.); Columbia Univ.; ASL; Brooklyn Mus. Art School (Max Beckman painting scholarship, 1955-56). **Exhibited:** WMAA Painting Ann., 1967, 1969 & 1972; Documenta 4, Kassel, Germany, 1968; Obsessive Image, Inst. Contemporary Arts, London, England, 1968; 29th Ann., AIC, 1969; Monumental Art, Contemp. AC, Cincinnati, OH, 1971; Paul Bianchini, NYC, 1970s. **Awards:** Cassandra Found. Award, 1969. **Work:** WMAA; Milwaukee AC; Wash. Univ. Mus., St. Louis; Fogg Art Mus., Cambridge, MA; MMA. **Comments:** Preferred media: acrylics. **Sources:** WW73; Christgau, "Big Paintings," *Cheetah Magazine* (1968); Honnef, *Mythen des Alltags-transzendiert* (Gegenverkehr Aachen, 1969); Gassiot-Talabot , "Robert Stanley," *Opus Int.* (December, 1971-January, 1972).

STANLEY, Caroline A. *[Listed as "artist"] d.1919, Wash., DC.* **Addresses:** Wash., DC, active, 1905-13. **Sources:** McMahan, *Artists of Washington, DC.*

STANLEY, Charles St. George *[Illustrator, landscape painter, writer] late 19th c.; b.probably England.* **Addresses:** Active in Colorado, c.1870. **Studied:** Royal Acad., London. **Comments:** Correspondent for *Leslie's* and *Harper's,* during General Crook's battles with the Sioux. Had studios in Leadville (1880) and Georgetown (1878). **Sources:** P&H Samuels, 460.

STANLEY, Frederic *[Painter, illustrator] early 20th c.* **Addresses:** New Rochelle, NY. **Sources:** WW21.

STANLEY, George M. *[Sculptor, teacher] b.1903, Acadia Parish, LA / d.1973, Los Angeles, CA.* **Addresses:** Los Angeles. **Studied:** Otis AI, Los Angeles, 1923-26. **Member:** Am. Artists Congress. **Exhibited:** LACMA, 1927 (solo), 1932; CPLH, 1929; P&S Los Angeles, 1925-38; Southern Calif. Artists, 1934 (prize); GGE, 1939. **Work:** Griffith Park Planetarium, Los Angeles; bas-reliefs, Bullocks Wilshire, Telephone Bldg., Los Angeles; granite figures, Hollywood Bowl; Scripps Col., Claremont; Pasadena Jr. College; movie industry's Oscar award. WPA artist. **Comments:** Teaching: Otis AI. **Sources:** WW40; Hughes, *Artists in California,* 531.

STANLEY, Harvey *[Stonecutter] b.1811, Vermont.* **Addresses:** Nauvoo, IL, 1840 and after. **Comments:** One of the stonecutters employed on the sun-face capitals of the Mormon Temple at Nauvoo (IL) in the mid-1840s. He did not join the trek to Utah in 1848, but spent the rest of his life in Missouri and Iowa. **Sources:** G&W; Arrington, "Nauvoo Temple."

STANLEY, Jane Caroline Mahon *[Painter] b.1863, Detroit, MI / d.1940, Ann Arbor, MI.* **Addresses:** Ann Arbor/Charlevoix, MI. **Studied:** Charles Sanderson; L.K. Harlow; H.H. Hallett; S.P.R. Triscott; L. Richmond, London. **Member:** Detroit Soc. Women P&S (charter mem.); Detroit WCS; Detroit AC; Ann Arbor AA; NAWA. **Exhibited:** CGA; Detroit IA; Detroit Soc. Women P&S; John Hanna Gals., Detroit; NAD; PAFA; Memorial Hall, Ann Arbor, MI. **Comments:** Daughter-in-law of John Mix Stanley (see entry) and mother of Alice Stanley Acheson (see entry). **Sources:** WW40; Gibson, *Artists of Early Michigan,* 221; Petteys, *Dictionary of Women Artists.*

STANLEY, John Mix *[Portrait & landscape painter, photographer] b.1814, Canandaigua, NY / d.1872, Detroit, MI.* **Studied:** apprenticed to coachmaker, Canandaigua, NY,1828; James Bowman, Detroit, c.1836. **Exhibited:** PAFA, 1858 (self-portrait); Cincinnati (North Am. Indian Gallery), 1845; Apollo Rooms, Louisville, KY , 1846; "The Trial of Red Jacket", 1868 (toured Detroit, Buffalo, NYC, Chicago, and other cities, 1868-71, earning him $8000 in admission fees). **Work:** Detroit IA; Univ. Michigan Mus. Art; Buffalo & Erie County Hist. Soc.; NMAA; MMA; Smithsonian Inst.; Amon Carter Mus.; Stark Mus. of Art,

Orange, TX; Honolulu Mus. **Comments:** Renowned for his paintings of Indian life in the West. He was working as a sign painter in Detroit by 1834 but after receiving encouragement from James Bowman (see entry) he took up portrait painting. In 1837 Mix and Bowman went to Chicago, where they briefly established a joint studio. When that business failed, he traveled briefly to Galena (IL) in 1838 and then to Fort Shelling (MN) in 1839, where he began painting western scenes, including Indian portraits. He returned East in 1840 and spent the next two years painting portraits in Troy (NY), Philadelphia, and Baltimore. When he went West again in 1842, he turned his focus to the western subjects that would occupy him for the rest of his career. Stanley established a base at Ft. Gibson (then Arkansas Territory, now Oklahoma) in 1842, and from there traveled to various Indian peace councils, documenting events by recording group and individual portraits. Among these were the Tehuacana Creek Council in Texas (March 1843), the Council at Tahlequah, OK (May 1843, resulting in the multifigured "International Indian Council," NMAA), and the peace council at Cache Creek, OK (Nov./Dec., 1843). He kept his base at Fort Gibson until the spring of 1845 when he took his series of 85 Western scenes to Cincinnati and St. Louis, exhibiting them as "Stanley and Dickerman's North American Indian Gallery." He next went to Santa Fe, NM, and from there joined Kearny's military expedition to California. During 1847-48 he worked in California and Oregon, afterward sailing for Hawaii where he remained until 1850, executing some of the finest portraits done in Hawaii at that time. Upon his return to the U.S. in 1850, he settled in Washington, DC and traveled with his "Indian Gallery" to several Eastern cities before depositing the collection at the Smithsonian Inst. (1852) in hopes that it would be purchased by the Federal Government. This did not happen, but he remained in Washington for the next decade except for a surveying trip to the Pacific Northwest in 1853, during which he made daguerreotypes of Indians living in the Columbia River area and field sketches that he later used in preparing a huge panorama of 42 western scenes (the panorama is now lost). Stanley returned to Detroit in 1863 where he painted several major historical Indian canvases, including "The Trial of Red Jacket" (1868, Buffalo Hist. Soc.), his most famous work. During these years he also painted panoramic landscapes, as well as more intimate rural and urban genre scenes. His collection of Indian paintings (152 pictures) was almost totally destroyed in the Smithsonian fire of 1865. Other Indian paintings by Stanley were destroyed by fire at P.T. Barnum's American Museum in NY. **Sources:** G&W; Taft, *Artists and Illustrators of the Old West;* Kinietz, *John Mix Stanley and His Indian Paintings;* Draper, "John Mix Stanley, Pioneer Painter"; Pipes, "John Mix Stanley"; Bushnell, "John Mix Stanley"; DAB; Rutledge, PA; 8 Census (1860), D.C., I, 743; Washington Art Assoc. Cat., 1857, 1859; Stanley, "Portraits of North American Indians." More recently, see Baigell, *Dictionary;* P & H Samuels, 460-61; Gerdts, *Art Across America,* vol. 2: 113, 127, 163, 231-32, 234-35, 238, 239, 240, 247, 281-82, 285; Campbell, *New Hampshire Scenery,* 159; Forbes, *Encounters with Paradise,* 91-92; *300 Years of American Art,* 161; Newhall, *The Daguerreotype in America,* 154.

STANLEY, L. C. (Mrs.) *[Artist] late 19th c.*
Addresses: Active in Los Angeles, 1895-96. **Sources:** Petteys, *Dictionary of Women Artists.*

STANLEY, Lee *[Cartoonist] b.1885, Topeka, KS.*
Comments: In 1902, he as Cleveland's first daily sports cartoonist. In 1920, he created "Old Home Town" (King Features Syndicate). **Sources:** *Famous Artists & Writers* (1949).

STANLEY, Robert *b.c.1932, Yonkers, NY / d.c.1997, NYC.*
Studied: Columbia Univ.; Oglethorpe College, Atlanta (B.A., 1953); High Mus. Art. **Exhibited:** WMAA; P. Bianchini Gal., NYC, 1965 (first solo); M. Algus Gal., NYC, 1997 (solo). **Work:** MoMA; MMA; WMAA; Fort Worth MoMA; Corcoran Gal.; Milwaukee AM. **Comments:** Pop artist and brother-in-law of Roy Lichtenstein, in the early 1960s he used newspaper and magazine photographs as the basis for his imagery on canvas; by the late

1960s he was taking his own photos. Teaching: Sch. Visual Arts, NYC (16 years).

STANLEY, Rosamond *[Painter] mid 20th c.*
Addresses: Berkeley, CA. **Exhibited:** Bay Region AA, 1935; San Francisco AA, 1935; AIC. **Work:** SFMA. **Sources:** Hughes, *Artists of California,* 531.

STANLEY, Wallace P. See: **CADY, Henry Newell**

STANLEY-BROWN, Rudolph *[Etcher, painter, architect] b.1889, Mendon, OH / d.1944, Wash., DC.*
Addresses: Cleveland Heights, OH; Wash., DC, c.1935. **Studied:** Columbia Sch. Arch.; École des Beaux Arts, Paris. **Member:** IAI; Soc. Beaux Arts Arch.; Cleveland PM; Cleveland Print Club; Cosmos Club, Wash., DC (1938-44). **Exhibited:** Wash. WCC, 1924, 1926, 1927; Greater Wash. Indep. Exh., 1935. **Work:** CMA; Yale Art Mus. **Comments:** Grandson of President James A. Garfield. **Sources:** WW32; McMahan, *Artists of Washington, DC.*

STANNARD, E. (Jr.) *[Painter] mid 19th c.*
Addresses: Westbrook, CT, 1855. **Work:** Mariners Mus., Newport News, VA (marine watercolor). **Sources:** Brewington, 365.

STANNARD, Eva (Mrs.) *[Painter] early 20th c.; b.Syracuse, NY.*
Addresses: NYC. **Studied:** PIA School; Buffalo FA Acad., W.A. Graves. **Sources:** WW25.

STANNARD, Jean *[Painter] mid 20th c.*
Exhibited: S. Indp. A., 1936. **Sources:** Marlor, *Soc. Indp. Artists.*

STANSBURY, Arthur J. *[Painter, printmaker, illustrator] b.1781, NYC / d.1865.*
Addresses: NYC, 1781; Wash., DC, 1823-until at least 1848. **Work:** Nat. Portrait Gal. (lithographic death bed portrait of John Quincy Adams). **Comments:** Artist of several NYC views in the 1820s and a flower print in *The Grammar of Botany;* illustrator of children's books. Stansbury was a native of New York, where he was licensed as a preacher in 1810. He was best known for his "Plan of the Floor of the House of Representatives Showing the Seat of Each Member" (1823). **Sources:** G&W; Peters, *America on Stone;* Stokes, *Iconography,* VI, pl. 96-a; *Antiques* (June 1946), 361; McMahan, *Artists of Washington, DC.*

STANSFIELD, F. W. See: **STANFIELD, F. W.**

STANSFIELD, John Heber *[Landscape & portrait painter] b.1878, Mt. Pleasant, UT / d.1953, Mt. Pleasant.*
Addresses: Mt. Pleasant. **Studied:** self-taught, but influenced by meeting T. Moran in Calif. and encouraged by Harwood and Culmer. **Work:** Springville AG, Utah. **Comments:** Teaching: Snow College, UT, for thirteen years. Stansfield traveled and painted during summer vacations. **Sources:** P&H Samuels, 461.

STANSON, George C(urtin) See: **STOJANA, Gjura**

STANTEN, Ernest A. See: **STANTON, Eric**

STANTON, Annette O. *[Painter] late 19th c.*
Addresses: NYC, 1886. **Exhibited:** NAD, 1886. **Sources:** Naylor, *NAD.*

STANTON, Charles *[Painter] mid 19th c.*
Addresses: Stonington, CT, 1853. **Comments:** Painter of a group portrait. **Sources:** G&W; FARL question file.

STANTON, Elizabeth Cady (Mrs. William Harold Blake) *[Painter, lecturer, teacher] b.1894, NYC.*
Addresses: NYC; North Falmouth, MA; Nyack, NY. **Studied:** ASL; Tiffany Fnd.; with Cecilia Beaux, F. Luis Mora, G. Bridgman, A. Sterner. **Member:** NAWA (pres., 1928-30); Tiffany Fnd.; Women's Faculty Club, Columbia Univ. **Exhibited:** S. Indp. A., 1918; NAD; PAFA Ann., 1928; Columbia Univ., 1954 (medal); NAWA, 1957 (medal); AWCS; Tiffany Fnd.; Newport AA; Woodstock, NY; Westport, CT; Women's Faculty Club; & in London, England. **Comments:** Position: teacher, Horace Mann-Lincoln School, NYC, from 1946. **Sources:** WW59; WW47;

Falk, *Exh. Record Series.*

STANTON, Eric *[Illustrator] b.1927 / d.1999, Clinton, CT.*
Addresses: NYC (until 1978); Clinton, CT (1978-on).
Comments: A WWII pinup illustrator in the U.S. Navy whose best-known character was "Bettie Page." He was also a cartoonist for the *NY Daily News* and the *Brooklyn Mirror.* He later turned to overtly erotic illustration, particularly of sexual fetishes, found in *Eric Stanton: Dominant Wives and Other Stories* (Taschen, Germany). His birth name was actually "Ernest A. Stanten."
Sources: obit., *Antiques & Arts Weekly* 2 Apr. 1999.

STANTON, Gideon Townsend *[Painter] b.1885, Morris, MN / d.1964, New Orleans, LA.*
Addresses: New Orleans, LA; Bay St. Louis, MS. **Studied:** Rugby Acad., New Orleans; Balt. Charcoal Club, & with S. Edwin Whiteman. **Member:** New Orleans Arts & Crafts Club; NOAL; NOAA; SSAL; St. Augustine AA; AFA; MMA.
Exhibited: Soc. Indep. Artists, Balt.; New Orleans Arts & Crafts Club; NOAA, 1911 (prize), 1912 (medal), 1925 (prize), 1932 (medal); S. Indp. A., 1918-19, 1927; NOAL, 1925 (prize), 1932 (prize), 1937 (prize); 1947 (prize); Atlanta, GA; Ogunquit AC.
Work: Louisiana State Univ. **Comments:** Came to New Orleans c.1888 and worked primarily as a stock broker. He was active in several art groups and held varying positions. He was the Louisiana State Director for the WPA Federal Art Project (1935-38). **Sources:** WW59; WW47. More recently, see *Encyclopaedia of New Orleans Artists,* 364.

STANTON, Grace Harper (Mrs.) *[Miniature painter] b.1872, NYC.*
Addresses: NYC, Garrison, NY. **Studied:** ASL; W. Whittemore in NYC; Académie Julian, Paris with Bouguereau and Ferrier; miniatures with Mme. Debillemont-Chardon in Paris. **Exhibited:** AIC, 1902; PAFA Ann., 1902. **Sources:** WW08; Falk, *Exh. Record Series.*

STANTON, John (Aloysius) *[Painter, mural painter, etcher] b.1857, Grass Valley, CA / d.1929, Palo Alto, CA.*
Addresses: San Francisco, CA. **Studied:** San Francisco School of Des.; with Laurens and De Chavannes in Paris. **Member:** Bohemian Club; San Francisco AA. **Exhibited:** Calif. State Fair, 1896 (gold med); Mark Hopkins Inst., 1897-98; Mechanics' Inst., 1896; San Francisco AA 1896-1916; Paris, Munich, NYC. **Work:** St. Ignatius Church, Palo Alto (murals); Bohemian Club; de Young Mus. **Comments:** Position: San Francisco School of Des., 26 years. **Sources:** WW17; Hughes, *Artists of California,* 531.

STANTON, Louise Parsons *[Painter] 20th c.*
Addresses: Chicago, IL. **Exhibited:** AIC, 1935, 1939. **Sources:** WW40.

STANTON, Lucy May *[Portrait painter, miniaturist, teacher] b.1875, Atlanta, GA / d.1931, Athens, GA.*
Addresses: Atlanta, GA, 1899-1901; NYC, 1902; Athens, GA, 1902-31 with time in Boston, MA, and summers, Maine. **Studied:** Mme. Seago, New Orleans (at age seven); Southern Female Sem., La Grange, GA; Southern Baptist College for Women, grad., 1895; École de la Grande Chaumière, Colarossi Acad., L. Simon, E. Blanche, La Gandara, A. Koopman, Virginia Reynolds, Whistler, anatomy at the Sorbonne, all in Paris, 1896-99.
Member: Penn. SMP; Am. SMP; NAWA, 1915; Wash. WCC; Guild Boston Artists; Copley Soc.; Concord AA. **Exhibited:** PAFA Ann., 1899, 1903, 1910; PAFA, 1917 (medal); Penn. SMP, 1899-1931; Amer. SMP, 1902; Paris Salon;, 1906; Royal SMP, London, 1914; Pan-Pacific Expo, 1915; Doll and Richards, 1919 (solo); NAD, five annuals, 1912-17; AIC, 7 annuals, 1913-20; Concord AA, 1923 (medal), NAWA, 1925; Grand Central Art Gallery, NYC, and Boston Guild of Artists, 1931-32 (memorials).
Work: Capitol, Wash., DC ("Howell Cobb," former Speaker of the House). Miniatures: NPG, Wash., DC; Concord AA; Mus. of Amer. China Trade, Milton, MA. ("Linton Ingraham, Ex Slave"); Lincoln Mem. Mus., Milton, MA; PMA (self-portrait).
Comments: Her portrait miniature subjects were taken from her Southern heritage and include images of African Americans, mountain people, and frontiersmen, as well as straightforward portraits. About 1906, she developed a technique for miniature painting she termed puddling, which involved loose washes of watercolor, different from the traditional stippling technique. She occasionally taught at the University of Georgia in Athens.
Sources: WW29; Tufts, *American Women Artists, 1830-1930,* cat. no. 34; Petteys, *Dictionary of Women Artists;* Gerdts, *Art Across America,* vol. 2: 71 (repro.); *Art by American Women:.the Collection of L.and A. Sellars,* 114; Falk, *Exh. Record Series.*

STANTON, M. A. (Miss) *[Painter] late 19th c.*
Exhibited: NAD, 1868. **Sources:** Naylor, *NAD.*

STANTON, Martha Zelt *[Printmaker, instructor] b.1930, Washington, PA.*
Addresses: Rosemont, PA. **Studied:** Conn Col; Pa Acad Fine Arts; New Sch Social Res, with Antonio Frasconi; Mus Arte Mod, Brazil, with John Friedlaender; Univ. New Mexico, with Gar Antreasian; Temple Univ., B.A. **Member:** Print Club; PAFA (fellow). **Exhibited:** Salao Arte Mod, Rio de Janeiro, Brazil, 1961; Int Bienale, Sao Paulo, Brazil, 1961; Pa Acad Fine Arts Nat Ann, 1961-1970; Var Print Club Nat Exhibs, Philadelphia, 1961-; Cheltenham AC Print Nat., PA, 1971. Awards: Cresson traveling award, 1954 & Scheidt Mem. traveling award, PAFA; Print Club fellowship, 1965. **Work:** Philadelphia Free Library. **Comments:** Positions: director, graphic workshop prof. artists, PAFA, 1963-65; demonstrating artist-printmaker, Prints-in-Progress, Philadelphia, 1963-71; secretary, Exp. in Art & Technology, Inc., Philadelphia, 1968. Teaching: instructor of silk screen, PAFA, 1968-; instructor of print-making, Philadelphia Mus. Art, 1968-; instructor of silk screen, Philadelphia College Art, 1969-.
Sources: WW73.

STANTON, Phineas, Jr. See: STAUNTON, Phineas

STANTON, Samuel Ward *S.W.STANTON*
[Marine painter] b.1870, Newburgh, NY / d.1912, (on the Titanic).
Addresses: NYC. **Studied:** ASL, with Twachtman, Geo. Bridgman, F.V. DuMond; Académie Julian, Paris with Lefebvre, 1912. **Exhibited:** Columbian Expo, Chicago, 1893. **Work:** Shelburne (VT) Mus. **Comments:** An authority on the rendering of vessels of different types and periods; made murals for many steamers; assisted F.D. Millet in his decorations for the Baltimore custom house. He had been to Spain to make studies for an Alhambra series of panels to decorate the S.S. Washington Irving of the Hudson River Day Line. Position: publ., "American Steam Vessels," 1895, *Nautical Magazine.* **Sources:** Muller, *Paintings and Drawings at the Shelburne Museum,* 129 (w/repro.).

STANTON & CO., G. E. *[Painter] mid 19th c.*
Addresses: Sing Sing, NY. **Exhibited:** Am. Inst., 1849 (two oil paintings). **Sources:** G&W; Am. Inst. Cat., 1849.

STANWOOD, A. (Franklin) *[Landscape and marine painter] b.1852, Portland, ME / d.1888, Gorham, ME.*
Addresses: Portland, ME. **Studied:** self-taught. **Comments:** Born in the Portland Alms House he was adopted by Capt. Gideon Stanwood. A sailor by profession, he painted ship portraits as well as landscapes in a linear, primitive style. He was in Montevideo, Uruguay, 1875; and in Mexico. **Sources:** G&W; Lipman and Winchester, 180. More recently, see Campbell, *New Hampshire Scenery,* 159; Brewington, 365.

STANWOOD, Gertrude See: STRUVEN, Gertrude Stanwood (Mrs.)

STANWYCK, Gary *[Painter] 20th c.*
Addresses: Woodside, L.I., NY. **Exhibited:** Salons of Am., 1934; S. Indp. A., 1933-35. **Sources:** Falk, *Exhibition Record Series.*

STAPELFELDT, Karsten *[Painter] 20th c.*
Exhibited: Salons of Am., 1936; S. Indp. A., 1936-37. **Sources:** Marlor, *Salons of Am.*

STAPLES, Clayton Henri *[Painter, lecturer, educator] b.1892, Osceola, WI.*

Addresses: Wichita, KS; Gloucester, MA; LA Vein, CO. **Studied:** AIC, and abroad. **Member:** AWCS; SC. **Work:** public schools in Winfield, KS & Peoria, IL; Bloomington (IL) AA. **Comments:** Position: art director, Univ. Wichita, KA; director, Cuchara Summer School Art, La Veta, CO. **Sources:** WW59; WW47.

STAPLES, Edna Fisher Stout (Mrs. Arthur C.)
[Landscape painter, sculptor, teacher] b.1871, Phila.
Addresses: Phila., PA. **Studied:** Phila. School Des. with E. Daingerfield, H.B. Snell, M. Sloan. **Exhibited:** Wanamaker Comp., 1904 (prize). **Comments:** Specialty: watercolor. **Sources:** WW10.

STAPLES, Frank A. *[Craftsperson, teacher, lecturer] d.1900.*
Addresses: Concord, NH/Biddeford, ME. **Studied:** Mass. School Art. **Member:** Lg. New Hampshire Arts & Crafts. **Comments:** Position: teacher, National Recreation Assn., NYC. **Sources:** WW40.

STAPLES, Roy Harvard *[Painter, teacher] b.1905, Lynn, MA / d.1958.*
Addresses: Auburn, AL. **Studied:** J. Sharman; C. Martin; E. O'Hara; Mass. School Art; Alabama Polytechnic Inst., Auburn. **Member:** Alabama Al; SSAL. **Exhibited:** Alabama AL, Montgomery, 1934. **Work:** murals, Alabama Polytechnic Inst.; paintings, Montgomery MFA; Univ. Florida. **Comments:** Position: teacher, Alabama Polytechnic Inst. **Sources:** WW40.

STAPLES, Vera C. M. *[Landscape painter] b.1883, England / d.1954, Los Angeles, CA.*
Addresses: Los Angeles, CA. **Member:** Long Beach AA; Los Angeles Art League (pres., 1941). **Exhibited:** Los Angeles Art League, Los Angeles City Hall, 1941. **Sources:** Hughes, *Artists in California*, 531.

STAPLETON, Joseph F. *[Painter] 20th c.*
Addresses: Brooklyn, NY. **Exhibited:** PAFA Ann., 1954. **Sources:** Falk, *Exh. Record Series.*

STAPLEY, M. *[Painter] b.1872.*
Addresses: NYC. **Exhibited:** AIC, 1902. **Sources:** WW04.

STAPP, Philip *[Painter] 20th c.*
Addresses: NYC. **Exhibited:** WMAA, 1947. **Sources:** Falk, *WMAA.*

STAPP, Ray Veryl *[Educator, painter] b.1913, Norton, KS.*
Addresses: Charleston, IL. **Studied:** Bethany College, Lindsborg, KS, B.F.A., with Birger Sandzen; Kansas City AI, life with Thomas Hart Benton; ASL, with Dumond, Reilly & Trafton; Teachers College, Columbia Univ., B.A., with Ziegfield; Penn. State Univ., Ed.D., with Lowenfeld. **Member:** Nat Art Educ. Assn.; Western Arts; Illinois Art Educ. Assn. (council member, 1969-70). **Exhibited:** Nat. Craft & Ceramics Show, Wichita AA, 1957; Erie (PA) AA, 1960; 18th An. Area Show, Peoria, IL, 1969. **Work:** Painting, Lowenfeld Mem Collection, Penn. State Univ. **Comments:** Preferred media: oils. Positions: engraver & lithographer, Hallmark Card Co., 1937-39; advertising artist, Armstrong Cork Co., 1948-49; product illus., Boeing Airplane Co, 1956-57. Publications: author, "You Can Mix Your Own Glazes," 1958 & "Planning An Art Lesson," 1967, *Arts & Activities.* Teaching: instructor & asst. professor design & art educ., Bethany College, 1949-56; asst. professor & assoc. professor art, Edinboro State College, 1957-64; assoc. professor & professor design & art educ., Eastern Illinois Univ., 1964-. Research: relationships of measures of creativity, general intelligence and memory; extension of research used as criteria for evaluating children in grades 4-8. **Sources:** WW73.

STAPPLES, E. S. (Mrs.) *[Painter] 19th/20th c.*
Addresses: Wausau, WI. **Exhibited:** Cincinnati Spring Exhib., 1898. **Sources:** WW01.

STAPRANS, Raimonds *[Painter, sculptor] b.1926, Riga, Latvia.*
Addresses: San Francisco, CA. **Studied:** School Art, Esslinger, Stuttgart, 1946; Univ. Wash. (B.A., 1952); Univ. Calif., M.A.

(1955); also with Archipenko. **Exhibited:** Portland (OR) Art Mus., 1956-57; Oakland Art Mus., 1957; CPLH, Winter Invitational, 1957, 1959-60; Litton Indust., 1962; Am. Acad. Arts & Letters, NYC, 1970; Maxwell Gal., San Francisco, 1998 (solo). **Work:** CPLH; Oakland (CA) Mus.; Santa Barbara (CA) Mus.; LACMA; Phoenix Art Mus. **Comments:** His scenes of the Bay Area balance broad fields of vivid color with a strong architectonic structure. **Sources:** WW73; "California Canvas" (film), KRON, San Francisco, 1966; "Artists Eye" (film), Motion Media, 1967.

STARBIRD, Kenneth *[Sculptor] 20th c.*
Addresses: La Jolla, CA?. **Exhibited:** PAFA Ann., 1964 (prize). **Sources:** Falk, *Exh. Record Series.*

STARBIRD, Mary Ann (Miss) *[Listed as "artist"] b.c.1830, Maine.*
Addresses: NYC, 1860. **Exhibited:** NAD, 1863. **Comments:** She was living with her father, Solomon P. Starbird, "gentleman." In 1863 she was listed as Anne Starbird, artist. **Sources:** G&W; 8 Census (1860), N.Y., LIV, 598; NYCD 1863.

STARBUCK, Ellen *[Painter] 19th c.; b.Brooklyn, NY.*
Addresses: NYC, active 1888-1913. **Studied:** Dagnan; Courtois; Collin; Nozal. **Exhibited:** Paris Salon, 1888, 1889; SNBA, 1890, 1896; Boston AC, 1896, 1901, 1902; NAD, 1900. **Sources:** WW10; Fink, *American Art at the Nineteenth-Century Paris Salons,* 392; *The Boston AC.*

STARIN, Arthur N(ewman) *[Painter, illustrator] 20th c.; b.Falls Church, VA.*
Addresses: Duluth, MN; Talbot County, MD. **Studied:** PIA School; ASL; George Washington Univ., & with C.C. Rosencranz, Eliot O'Hara. **Member:** Acad. Art, Easton, MD; Baltimore WCS; Royal Soc. Arts, London (fellow); New Jersey Soc. Arch.; Rehoboth Art Lg. **Exhibited:** All. Artists Am., 1933-52; Florida Southern College, 1952; traveling exhib., Casein Paintings, 1952; AIC; Ferargil Gal.; Vendome Gal.; Wash. WCC; CGA; Newark Mus.; Newark Art Club; New Jersey Gal., Newark; Paper Mill Playhouse; Art Center of the Oranges, 1952; Easton (MD) Art Festival, 1957, 1958; Morris County AA, 1948-55; Ford Motor Co. Bldg., NY Worlds Fair, 1964; Wash., DC, 1964; Maryland Inst., 1962-64; Easton Acad. Art; Rehoboth Beach, MD, 1963. **Work:** Florida Southern College. **Comments:** Contributor to architectural magazines. Illus. for *Ford Times,* 1959-. **Sources:** WW66; WW15.

STARK, Forrest F. *[Portrait painter, sculptor, teacher] b.1903, Milwaukee, WI.*
Addresses: Ft. Wayne, IN. **Studied:** Milwaukee State Teachers College; Mills College; PAFA; & with Leon Kroll, Charles Grafly, George Harding; A. Laessle; G. Oberteuffer; B.Robinson; PAFA, 1927 (Cresson Traveling Scholarship). **Member:** Indiana AC. **Exhibited:** PAFA Ann., 1941; Indiana Artists, annually; Ft. Wayne Art Mus., annually; Hoosier Salon, 1932 (prize), 1952 (prize); Milwaukee AI, 1933 (prize); John Herron AI, 1932 (prize). **Awards:** Thieme award, Ft. Wayne Art School, 1954, 1957. **Work:** Ft. Wayne Art Mus.; John Herron AI; relief, Forsyth Mem., Indianapolis. **Comments:** Position: art instructor, Ft. Wayne (IN) Art School & Mus. **Sources:** WW59; WW47; Falk, *Exh. Record Series.*

STARK, George King *[Educator, sculptor] b.1923, Schenectady, NY.*
Addresses: Oswego, NY. **Studied:** State Univ NY Col Buffalo, BS(art educ); teachers col, Columbia Univ, MA; State Univ NY Buffalo, Ed.D.; also with Dorothy Denslow. **Exhibited:** 17th & 19th Ceramic Nat., 1952 & 1956 & Ceramic Int. Exhib., 1958, Syracuse Mus. Fine Arts; Western NY Ann., Albright-Knox Gallery, Buffalo, 1957 & 1960; Lowe Art Mus., 1967 (solo). **Awards:** shared first prize for ceramic sculpture, 19th Ceramic Nat., 1956; Am. Inst. Architects Sculpture Award, Albright-Knox Gal., 1957 & 1960. **Work:** IBM Collection; Lowe Art Mus., Univ. Miami, FL; Am. Art Clay Co.; State Univ. NY College Buffalo; State Univ. NY College Oswego. **Commissions:** sculptured light

fixtures, Savoy Hilton Hotel, New York, 1959; Space Modulator, Sheraton-Palace Hotel, San Francisco,1960; divider screen, Park-Sheraton Hotel, New York, 1960; wall relief sculpture, Prudential Steamship Lines, New York, 1961; sculptured fountain, commissioned by Robert E. Maytag, Newton, IA, 1971. **Comments:** Preferred media: brass. Publications: author, "Silent Images," 11/1963 & "Mass Communication and Faculty/Student Dialogue," 4/1969, *Art Education Journal*; author, "On Sculpture," *School Arts*, 3/1964; author, "A Games Theory in Education," *School & Soc.,* fall, 1967; author, "Think Stream," *S&W*, fall, 1969-winter, 1970. Teaching: professor of art, State Univ. NY College Oswego, 1964-. Research: analysis of artist-teacher's statements on their creativity. **Sources:** WW73.

STARK, Jack Gage *[Painter]* *Jack G. Stark*
b.1882, Jackson County, MO /
d.1950, Santa Barbara, CA.
Addresses: Silver City, NM; Santa Barbara, CA. **Studied:** Paris, with J.E. Blanche, V.H. Millet, 1900. **Member:** Calif. AC. **Exhibited:** Paris, 1905; New Mexico, 1909-15; Los Angeles; Calif.-Pacific Int. Expo, San Diego, 1935; GGE, 1939; AIC. **Work:** Santa Barbara Mus. Art; San Diego Mus.; AIC. **Sources:** WW47; Hughes, *Artists in California,* 531.

STARK, John (J.) *[Painter]* 20th c.
Studied: ASL. **Exhibited:** S. Indp. A., 1932-33; Salons of Am., 1934. **Sources:** Marlor, *Salons of Am.*

STARK, Margaret *[Painter]* b.1915, Indianapolis, IN.
Addresses: NYC. **Studied:** Indiana Univ.; Oberlin College; ASL; H. Hofmann. **Exhibited:** AIC; CI, 1944-46; Springfield (MA) Mus. FA, 1944; WMAA, 1944-45; Herron AI, 1944, 1945; Montclair AM, 1944; MoMA, 1944; Mod. Art Festival, Boston, 1945; Zanesville AI, 1945; 1030 Gal., Cleveland, 1945; BM, 1945; Philbrook AC, 1945; PAFA Ann., 1946-47; Univ. Iowa, 1946; Perls Gal., 1944 (solo); Passedoit Gal., 1946 (solo). **Sources:** WW47; Falk, *Exh. Record Series.*

STARK, Melville F. *[Painter, educator]* b.1903, Honesdale, PA.
Addresses: Zionsville, PA. **Studied:** East Stroudsburg State College; Univ. Penn., Mus. College Fine Arts, Philadelphia; Syracuse Univ., with Cullan Yates & W. E. Baum; also in England & France. **Member:** Lehigh Art All.; Mus. Fine Arts, Springfield; Rockport AA; North Shore AA; Sarasota AA; Knickerbocker Art Club. **Exhibited:** PAFA; NAD; Phila. Sketch Club; Woodmere Art Gal.; Phila. Art All.; Reading Art Mus.; Scranton Art Mus.; Lehigh Univ.; Univ. Penn.; Allentown Art Mus; AWCS; Nat. Soc. Painters Casein (First Myers mem. Award); Mus. Fine Arts, Springfield, MA (hon. mention); Phila. WCC; Brandenton, FL (first prize for landscape, Manatee Art League); Mus. Fine Arts, Springfield. **Work:** Several U.S. Embassies; Lehigh Co. Court House, Allentown, PA; Allentown City Hall; Reading (PA) Art Mus. **Comments:** Preferred media: oils, watercolors, pastels, acrylics. Positions: director, Allentown Art Mus., 1954-60. Teaching: head dept. painting, Baum Art School, Allentown Art Mus., 1931-62, director of school, 1956-62; head dept. painting, Cedar Crest College, 1940-55; head, dept. art history, Muhlenberg College, 1955-60. **Sources:** WW73; WW47, which puts birth at 1904.

STARK, Otto *[Painter, illustrator, craftsperson]* b.1859, Indianapolis, *Otto Stark*
IN / d.1926, Indianapolis, IN.
Addresses: NYC, 1883, 1888; Paris, 1886; Indianapolis, IN, 1895. **Studied:** School of Design, Univ. Cincinnati, 1877; ASL with W. M. Chase, Carroll Beckwith, Walter Shirlaw, and Thomas Dewing, 1882-83; Académie Julian, Paris with Lefebvre and Boulanger, 1884-87; also with Cormon in Paris. **Member:** Indianapolis AA (honorary member, 1898); Int. SAL; Hoosier Salon (founder); Indiana AC (pres., 1901); Portfolio Club (president, 1901); Soc. Western Artists, 1897 (treasurer, 1907). **Exhibited:** Tenth Ann. Exhibition School Design, Cincinnati, 1878-79; NAD, 1883-95; Brooklyn AA, 1883, 1886; PAFA Ann., 1889, 1895, 1909; Indianapolis Art Assoc. Ann.,

1889; Am. WC Soc., 1882; Paris Salon, 1886, 1887; Denison Hotel, Indianapolis, 1894; AIC, 1894-1901; Five Hoosier Painters, Chicago, 1894; First Ann., Soc. Western Artists, 1896; Trans-Mississippi and International Expo, Omaha, NE, 1898; Louisiana Purchase Expo, St. Louis, 1904; H. Lieber Co. Galleries, Indianapolis, 1906; Richmond Art Assoc. Ann. Exhibition, 1907 (honorable mention); Richmond Art Assoc. Ann. Exhibition, 1908 (Foulke prize); International Exhibition, Buenos Aires and Santiago, 1910; Palmer House, Lake Maxinkuckee, 1913; Herron AI, 1915 (prize); Panama-Pacific Expo, San Francisco, 1915; J. I. Holcomb award, 1915; Hoosier Salon, 1925 (prize), 1926 (prize). **Work:** Indianapolis Art Assoc.; Herron AI, Indianapolis; Cincinnati AM; mural project, City Hospital, Indianapolis; murals, Public Schools #60, #54 ("The Family," 1895), Indianapolis; Indiana State House; Univ. Kansas; Art Assoc. Richmond ("Autumn Scene"). **Comments:** Son of Old World craftsmen, he was first apprenticed as a carver and cabinetmaker and then, in 1875 in Cincinnati, as a lithographer. He moved to NYC in 1879 and studied at the Art Students League, working on landscapes, portraits and figures under W.M. Chase. In 1885 Stark went to Académie Julian in Paris, and there married Marie Nitschelm, whom he met while boarding at the home of novelist Anatole France. They returned to NY in 1888, where he took a position as a commercial artist and did additional illustration work for journals such as *Scribner's Monthly* and *Harper's Weekly*. Following the untimely death of his wife in 1891, Stark moved with his young family back to the Midwest. He opened a studio in Indianapolis and taught classes. He displayed his work along with that of T. C. Steele, William Forsyth, R. B. Gruelle and J. Ottis Adams in 1894, which marked the beginning of professional and personal relationships among the artists. Stark's choice of subject matter was consistent with the Impressionistic emphasis upon simple scenes, relaxed and informal settings, which he chose from everyday life in and around Indianapolis. As an educator, Stark introduced innovative exercises in pen, charcoal and brush and according to Gerdts was "probably the most outstanding teacher among this generation." Following his retirement from teaching, he spent some time in Leland, Michigan and New Smyrna, Florida with J. Ottis Adams, vacationing and painting. Author, "The Evolution of Impressionism", *Modern Art*, 1895. Supervisor of Art, Manual Training H.S., Indianapolis, 1899-1919; art faculty, John Herron Art Inst., 1905-19. **Sources:** WW25; Newton and Gerdts, 11-52; Gerdts, *Art Across America*, vol. 2, 253-79 (with repro.); Newton and Gerdts, 35-53,153 (with repro.); Falk, *Exh. Record Series.*

STARK, Ronald C. *[Photographer, lecturer]* b.1944, Sidney, NY.
Addresses: McLean, VA. **Studied:** Univ. Denver; NY State Univ., B.A. **Exhibited:** Baltimore Mus. Art, 1970; MIT Gallery, Boston, 1971; Studio Gallery, Washington, DC & Graphiks Biennale, Vienna, Austria, 1972 (solos); CGA, 1972; Neikrug Gallery, NYC, 1970s. **Work:** Baltimore Mus Art, Md; Smithsonian Inst, Washington, DC. Commissions: Walt Disney Movie Stills, commissioned by M. Goldfarb, Denver, CO, 1965; photo exhib., commissioned by L. Hager, Woodland Mus., Cooperstown, NY, 1967 & 1968; photo exhib., NY State Univ., 1968. **Comments:** Teaching: student lecturer, Univ Denver, 1962-64; student lecturer, photography, film & TV, State Univ. NY, 1966-68; faculty member, Smithsonian Inst., 1969-. **Sources:** WW73.

STARK, Sallie See: CROCKER, Sallie Stark

STARKENBORGH, Jacobus Nicolaus Baron Tjarda van *[Landscape and marine painter]* b.1822, Wehl, Groningen, Holland / d.1895, Wiesbaden, Germany.
Addresses: Philadelphia, 1850-52; Germany, 1855; Düsseldorf, 1858-61. **Exhibited:** PAFA, 1850-62 (coastal scenes and views of Europe, Pennsylvania & New Jersey). **Sources:** G&W; Thieme-Becker; Rutledge, PA; Phila. CD 1852 [a William T. van Starkenborgh was also listed, perhaps his brother].

STARKENBORGH, William T. van *[Landscape, marine, and animal painter]* mid 19th c.

Addresses: The Hague, 1850; Philadelphia, 1852-57; Holland, 1859. **Exhibited:** PAFA (he exhibited as W.T., W.F., or W.S. van Starkenborgh from 1850-62, showing Dutch meadows and many landscapes with cattle); Washington Art Association, 1857-59. **Comments:** Probably a brother of Jacobus Nicolaus Tjarda van Starkenborgh. **Sources:** G&W; Rutledge, PA; Phila. CD 1852-57 [as Starkenborgh, Van Starkenburgh, or Van Starkbougher]; Washington Art Assoc. Cat., 1857, 1859.

STARKEY [Portrait painter and silhouettist] mid 19th c.
Addresses: Charleston, SC,1834. **Sources:** G&W.

STARKEY, George [Sculptor] 19th c.
Addresses: Scranton, PA, 1879-81. **Exhibited:** PAFA Ann., 1879, 1881. **Sources:** Falk, Exh. Record Series.

STARKEY, James [Listed as "artist"] b.c.1839, Pennsylvania.
Addresses: Philadelphia, 1860. **Comments:** His father, Nathan Starkey, was a well-to-do manufacturer of medicine chests.
Sources: G&W; 8 Census (1860), Pa., LIV, 266.

STARKEY, Jo Anita (Josie A.) Bennett (Mrs. Lee D.)
[Painter, craftsworker, designer] b.1895, Gresham, NE / d.1962, Los Angeles, CA.
Addresses: Living in Los Angeles, CA in 1962. **Studied:** with Loren Barton, Orrin White, Marion K. Wachtel. **Member:** Women Painters of the West. **Exhibited:** Hollywood Women's Club; Pasadena Public Library; Laguna Beach AA; Santa Monica Women's Club; Los Angeles Mem. Library ; Hollywood, CA, 1948 (prize); Ebell Club, 1949 (prize), 1950 (prize);Pasadena AI, 1950 (prize); Bowers Mus. Art; Santa Ana, CA; Greek Theatre, Los Angeles, 1950 (prize); Pasadena AI. **Sources:** WW59; P&H Samuels, 461.

STARKEY, Josie A. See: **STARKEY, Jo Anita (Josie A.) Bennett (Mrs. Lee D.)**

STARKS, Chloe Lesley [Painter] b.1866, Ohio / d.1952, Palo Alto, CA.
Addresses: Palo Alto, CA, 1915-52. **Studied:** Stanford Univ.; Corcoran Sch. Art; Colarossi Acad. **Exhibited:** San Francisco AA, 1917. **Sources:** WW15; Hughes, Artists in California, 532.

STARKS, Elliott Roland [Art administrator, educator] b.1922, Madison, WI.
Addresses: Madison, WI. **Studied:** Univ. Wisc.-Madison (B.S., 1943; M.S., 1946). **Member:** Madison AA; Elvehjem AC; Wisc. Arts Council; Int. Assn. College Unions. **Comments:** Publications: author, "Arts and Crafts in the College Union," 1962. Teaching: art instructor, Amphitheater School, Tucson, AX, 1946-47; art instructor, Thomas School, Tucson, 1948-50; asst. professor, social educ. & director, Wisc. Union, Univ. Wisc.-Madison, 1951-. Collections arranged: Wisconsin Union Collection Original Art, 1951-; Frank Lloyd Wright, 1955; Alexander Calder Exhib., 1956; Leo Steppat mem. Sculpture Exhib., 1967. **Sources:** WW73.

STARKWEATHER, J. M. (Miss) [Landscape painter] mid 19th c.
Addresses: Chicago, c.1855. **Exhibited:** Illinois State Fair, 1855. **Sources:** G&W; Chicago Daily Press, Oct. 15, 1855.

STARKWEATHER, Louise See: **BROWNING, Louise**

STARKWEATHER, R. E. [Painter] 20th c.
Exhibited: P&S of Los Angeles, 1920. **Sources:** Hughes, Artists in California, 532.

STARKWEATHER, William Edward Bloomfield
[Painter, writer, lecturer, teacher] b.1876, Belfast, Ireland / d.1969, New Haven, CT.
Addresses: NYC, Brooklyn, NY. **Studied:** ASL with J.H. Twachtman, 1897-99; Académie Colarossi, Paris, 1899-1901; with Sorolla, in Madrid, Spain, 1904-06; independently in Italy, 1906-09. **Member:** All. Artists Am.; AWCS; Hispanic Soc. Am.; Phila. WCC; New Haven PCC; SC; NYWCC. **Exhibited:** PAFA Ann., 1909-10, 1918, 1935; PAFA, 1925 (gold), 1929 (prize); Soc. des Artistes Français, 1912-26; Albright-Knox AG, Buffalo, 1914-

15, 1917; MacDowell Club, NYC, 1917; SIA, 1917-1920; NYWCC, 1919; Ainslee Gal., NYC, 1923; Folsom Gal., NY, 1914 (first solo), 1916 (solo); NYPL, 1923 (solo); Fifteen Gal., NYC, 1937-38, 1940 (solos); NAD; All. Artists Am., 1926-46; AWCS, 1915-46; WC Exhib., NYC, 1925 (prize); Baltimore, 1926 (prize); New Haven PCC, 1924; Kansas City AI, 1929 (solo); Brooklyn Mus., 1923, 1934-35; CGA, 1925; AIC, 1911-44; Mystic (CT) Soc. Art, 1926; Phila. Art Alliance, 1930; Brooklyn SA, 1933-34, 1936, 1943; Newport AA, 1934; Mus. City of NY, 1937; Mus. Art, New Market, VA, (installed, 1948-76); MMA, 1962 (AWCS Centennial exhib.); Showcase Gal., NYC, 1962 (solo); Hunter College AG, 1988; Hickory MA and St. John's MA, 1989. **Work:** MMA; BM; San Diego FA Soc.; Univ. Pennsylvania; Randolph-Macon College for Women; Instituto de Valencia de Don Juan, Madrid, Spain; Hickory Mus. Art; murals, Endless Caverns, New Market, VA (also 55 watercolors and oils). **Comments:** Born William Edward Bloomfield, his mother brought him to the U.S. in 1884 but she died soon thereafter, and he was adopted by the Starkweathers of Winchester, CT, who gave him their name. After studies in Europe, he worked for the Hispanic Society and organized Sorolla's 1909 and 1911 exhibitions in the U.S. From 1910-16 he was curator of the Hispanic Society. From 1918-46 he taught art in NY schools; his last position was at Hunter College, from 1936-46. He traveled extensively, painting in oils, but after 1921 he worked primarily in watercolor. Author: Drawings and Paintings by Francisco Goya in the Collection of Hispanic Society of America. Contributor to: Mentor magazine; article on Goya in New Century Cyclopaedia of Names (1955). He also wrote about John S. Sargent, Alma-Tadema, van Dyck, and da Vinci. Lectures: Spanish Painting. Note: the artist had long believed that he was born in Edinburgh, Scotland in 1879 but later found evidence that he was actually born in Belfast, Ireland, in 1876 (see Myers, 1989). **Sources:** WW59; Anthony Panzera and Tracy Myers, exh. cat., The Travel Pictures (Hunter College AG, 1988); Tracy Myers, exh. cat., Vantage Points (Hickory MA, 1989); WW47; Falk, Exh. Record Series.

STARLING, S. S. (Mrs.) [Painter, teacher] mid 19th c.
Addresses: Active in Indianapolis, 1863-72. **Sources:** Petteys, Dictionary of Women Artists.

STARR [Painter] mid 19th c.
Addresses: Boston, active1847. **Exhibited:** Boston, 1847 ("diaphanous paintings"). **Sources:** G&W; Boston Evening Transcript, Feb. 11, 1847 (citation courtesy J.E. Arrington).

STARR, Edgar Gerry [Painter] b.1908, Imperial, CA / d.1971, Puerto Vallarta, Mexico.
Addresses: Los Angeles, CA; Puerto Vallarta, Mexico, 1954-1971. **Studied:** Calif. College of Arts & Crafts; PAFA; with Lawrence Murphy and Millard Sheets, Chouinard Art School. **Member:** Calif. WC Soc. **Comments:** Position: artist, Walt Disney Studios, 1930s. **Sources:** Hughes, Artists inf California, 532.

STARR, Eliza Allen [Art teacher and painter, lecturer, writer, illustrator] b.1824, Deerfield, MA / d.1901, Durand, IL.
Addresses: Boston, until 1854; Chicago, 1856 and after; South Bend, IN; 1871 and after; Durand, IL, 1901. **Studied:** Caroline Negus (Mrs. Richard Hildreth; before 1854). **Exhibited:** Boston Athenaeum, 1855. **Comments:** Miss Starr practiced in Boston for several years, but left in 1854 to teach art in private schools in Philadelphia and Brooklyn and in a private family at Natchez (MS). Between 1856-76 she was well known as a teacher and as a lecturer on art. After the loss of her studio in the great fire of 1871, she left Chicago to organize an art department at St. Mary's Academy in South Bend (IN). She later gained a national reputation as a lecturer on art and writer-illustrator of Catholic devotional books. **Sources:** G&W; DAB; Swan, BA.

STARR, Ethel Thayer See: **THAYER, Polly (Ethel) (Mrs. Donald C. Starr)**

STARR, Ida M. H. (Mrs. Wm. J.) [Painter, writer] b.1859, Cincinnati, OH / d.1938, Easton, MD.

Addresses: Easton, MD. **Studied:** Myra Edgerly; L. Adams; H. Schultze. **Member:** Soc. Indep. Artists of NYC, Chicago, Buffalo. **Exhibited:** S. Indp. A., 1924-35; Salons of Am., 1925. **Sources:** WW29.

STARR, Ivy Edmondson *[Portrait painter] b.1909, Cleveland, OH.*
Addresses: NYC/Cleveland, OH. **Studied:** H. Keller; L. Lucioni. **Member:** Cleveland PM; ASL. **Sources:** WW40.

STARR, Judson L. *[Painter, etcher, illustrator, printmaker] b.1890, Los Gatos, CA / d.1960, San Francisco, CA.*
Addresses: San Francisco, CA. **Exhibited:** San Francisco AA, 1923, 1924; City of Paris Gallery, San Francisco, 1924; Calif. SE, 1928; GGE, 1940. **Sources:** Hughes, *Artists of California,* 532.

STARR, Katharine Payne (Mrs. Frederick H.) *[Miniature painter, lithographer] b.1869, Kansas City, MO / d.1943, Hollywood, CA.*
Addresses: Hollywood, CA. **Studied:** with J. Telfer & E.S. Bush. **Member:** Calif. SMP. **Exhibited:** Calif. SMP, Los Angeles Mus. Art, 1937 (hon. mention).

STARR, Katherine E. *[Painter] 20th c.*
Exhibited: Salons of Am., 1925, 1926, 1931. **Sources:** Marlor, *Salons of Am.*

STARR, Lorraine Webster (Mrs. William) *[Painter, illustrator, lecturer, teacher, miniature painter] b.1887, Old Holderness, NH.*
Addresses: Bozman, MD; Talbot County, MD. **Studied:** Vassar College, B.A.; BMFA School; ASL; Am. School Min. Painters, & with Mabel Welch, Elsie Dodge Pattee, William Paxton, Philip Hale, Lewis Pilcher. **Member:** Penn. SMP; Balt. WCC. **Exhibited:** PAFA; ASMP; Wash. WCC; Balt. WCC; S. Indp. A.; BMA; CI; Detroit IA; CAM; Calif. SMP; NCFA. **Work:** PMA. **Comments:** Lectures: history of architecture, painting & sculpture. **Sources:** WW59; WW47.

STARR, Louis *[Painter] 20th c.*
Addresses: Dinard, France. **Sources:** WW25.

STARR, Louisa *[Painter] late 19th c.*
Exhibited: NAD, 1866. **Sources:** Naylor, *NAD.*

STARR, Mary H. *[Portrait painter] 19th c.*
Addresses: Boston, MA, active 1875-84. **Exhibited:** Boston AC, 1875, 1880-81, 1884, 1886. **Sources:** *The Boston AC.*

STARR, Maxwell B. (M.H.) *[Painter, sculptor, teacher] b.1901, Odessa, Russia / d.1966, NYC.*
Addresses: NYC. **Studied:** NAD; BAID; NYU; K. Cox; C.W. Hawthorne; I.G. Olinsky. **Member:** Arch. Lg.; NSMP; All. Artists Am.; Am. Artists Congress; Mural AG; Tiffany Art Gld.; Rockport AA; Audubon Artists; AEA; North Shore AA. **Exhibited:** NAD, 1919 (prize), 1920 (medal),1921 (prize), 1922 (prize), 1923 (medal), 1924 (prize), 1926-32; BAID, 1922-24 (medal); PAFA Ann., 1927-29, 1934, 1941; Corcoran Gal biennial, 1930; All. Artists Am., 1941-45; AIC, 1925; Salons of Am., 1925, 1931-34; WMAA, 1926-39; MoMA, 1939; BMFA, 1934; WFNY, 1939; Int. Mural Comp., 1925 (prize); BAID, 1922-24 (medal); Hartwell Gal., Los Angeles, 1947 (solo); Bodley Gal., NY, 1959 (solo), 1961 (solo); Collectors' Gal., Wash., DC (solo) Other awards: Tiffany Fnd. Fellowship, 1923-24; Chaloner prize, 1922-24. **Work:** Am. Mus. Numismatics; murals, U.S. Customs Office, NY; Brooklyn Tech. H.S.; USPO, Siler City, NC; Rockdale, TX. **Comments:** Position: teacher, Boys' Club, NYC, 1940; founder/director, Maxwell Starr School Art, NYC and East Gloucester, MA. **Sources:** WW66; WW47; Falk, *Exh. Record Series.*

STARR, N. B. *[Portrait painter] mid 19th c.*
Addresses: Cincinnati, 1841. **Sources:** G&W; information courtesy Edward H. Dwight, Cincinnati Art Museum.

STARR, Polly Thayer See: **THAYER, Polly (Ethel) (Mrs. Donald C. Starr)**

STARR, Rose See: **ROSE, Ruth Starr (Mrs. Wm. Searls Rose)**

STARR, Sidney *[Mural painter] b.1857, Kingston-on-Hull, Yorkshire, England / d.1925.*
Addresses: NYC/Lawrence, NY. **Studied:** Poynter; Legros. **Member:** Universal Expo, Paris, 1889 (bronze). **Work:** murals, Grace Chapel, NYC; LOC. **Sources:** WW24.

STARR, Walter D. *[Painter] 20th c.*
Addresses: Princeton, NJ. **Exhibited:** S. Indp. A. 1918. **Sources:** Marlor, *Soc. Indp. Artists.*

STARR, William *[Engraver] b.c.1825, New York.*
Addresses: NYC, 1850. **Sources:** G&W; 7 Census (1850), N.Y., XLI, 494.

STARRETT, Jim *[Painter] b.1937.*
Addresses: NYC. **Exhibited:** WMAA, 1972-73. **Sources:** Falk, *WMAA.*

STARRETT, Virginia Frances *[Painter, illustrator] b.1901 / d.1931, Pasadena, CA.*
Member: Pasadena AI. **Comments:** Illustrator: excelled in imaginative illustrations, four books, edited by Hildegarde Hawthorne; "The Arabian Nights."

STARRETT, William K. *[Painter] 20th c.*
Addresses: Forest Hills, NY. **Member:** GFLA. **Sources:** WW27.

STARRS, Mildred *[Painter, instructor] 20th c.; b.Brooklyn, NY.*
Addresses: Douglaston, NY. **Studied:** Maxwell Training School Teachers; Pratt Inst.; New York Univ., certificate, with J. Haney. **Member:** AAPL (treasurer, 1967-); Nat. Art League (vice-pres., 1962-); Catharine Lorillard Wolfe Art Club (member board directors, 1971-); Hudson Valley AA; Acad. AA. **Exhibited:** Barbizon Gal., New York, 1965-67 (solos) & George Washington Univ., 1966 (solo); Acad. Artists Assn., Springfield (MA) Mus., 1965-72; Nat. Gallery, Catherine Lorillard Wolfe Art Club, 1967; Allied Artists Am., Nat. Gallery, New York, 1971. **Awards:** first prize, St. Luke Art Guild, 1963 & 1964; best in show, Catharine Lorillard Wolfe Art Club, 1967; spec. award, Nat. Art League, 1970. **Work:** Meadowbrook Hospital, LI; John F. Kennedy Bldg. Art Gallery; George Washington Univ. Law School, Washington, DC; Nat. Gallery Sports, NYC. Commissions: Toni, Lauri, Dr. & Mrs. Alfred Lapin, NY; Terri, Mr. & Mrs. Richard Wheeler, NY; Jennifer, Mr. & Mrs. Victor Borod, Miami, FL; Summer & Winter (two), Mr. & Mrs. Michael McCormack, NY; Hollywood, Mrs. Frederick Paulsen, NY. **Comments:** Preferred media: watercolors. Teaching: art instructor, Board Educ., New York, 1927-61 & chmn. art, 1946-61. **Sources:** WW73.

STARUP, Edward *[Listed as "artist"] b.c.1829, Norway.*
Addresses: Boston, 1860. **Sources:** G&W; 8 Census (1860), Mass., XXVI, 400.

STASACK, Edward Armen *[Painter, printmaker] b.1929, Chicago, IL.*
Addresses: Honolulu, HI. **Studied:** Univ. Illinois, B.F.A. & M.F.A. **Member:** SAGA; Honolulu Printmakers (pres., 1959-61); Hawaii P&S; Boston Printmakers. **Exhibited:** Japan Print Biennial, Tokyo, 1962; CI, 1965; Downtown Gal., New York, NY, 1965 (solo); PAFA Ann., 1966; Krakow Print Biennial, Poland, 1970; Buenos Aires Print Biennial, Argentina, 1970. **Awards:** Tiffany Foundation fellowship, 1958; Rockefeller Foundation fellowship, 1959; MacDowall Colony Foundation fellowship, 1971. **Work:** LOC; Honolulu Acad. Arts; Phila. Mus. Art; Boston Public Library; Achenbach Foundation Collection, San Francisco; CPLH. Commissions: precast concrete murals, City of Honolulu, Fort St. Mall, 1968, Chart House Restaurant, Honolulu, 1969 & Honolulu Community College, 1972. **Comments:** Positions: member advisory committee, Contemporary AC Hawaii, 1969-; board member, Artist-In-Residence Program, State of Hawaii, 1970-; member advisory committee, Hawaii 200th Congress U.S. & Hawaii Bicentennial Celebrations, 1971-. Publications: author, "Hawaiian Petroglyphs," *Malamalama Magazine,* 1967; author, reviews,

Honolulu Star-Bulletin, 1968; co-author, "Hawaiian Petroglyphs," Bishop Mus., 1970. Teaching: art professor & chmn. dept., Univ. Hawaii, 1969-. **Sources:** WW73; George Tahara, "Drawing--Painting--Stasack" (film), 1967; Falk, *Exh. Record Series.*

STASCHEN, Shirley *[Painter, lithographer] b.1914, Oakland, CA.*
Addresses: Woodacre, CA. **Studied:** self-taught; for a short time at the Calif. College Arts & Crafts and Calif. School of FA. **Member:** Artists & Writers Union. **Exhibited:** GGE, 1939. **Work:** SFMA. **Comments:** Part of a group of twenty artists who produced lithographs for the "Chronicle Contemporary Graphics" project of 1940. **Sources:** exh. cat., Annex Gal. (Santa Rosa, CA, n.d., c.1988); Hughes, *Artists in California,* 532.

STASIK, Andrew J. *[Painter, educator, art dealer] b.1932, New Brunswick, NJ.*
Addresses: NYC. **Studied:** New York Univ.; Columbia Univ., B.F.A., 1954; Univ. Iowa; Ohio Univ., M.F.A., 1956. **Exhibited:** Int. Biennale Graphics, Krakow, Poland, 1966, 1968, 1970 & 1972; Int. Expos Original Drawings, Rijeka, Yugoslavia, 1968; Prints/Multiples, Univ. Washington, 1970; Fourth Am. Biennale Santiago, Chile, 1970; plus many other group & solo shows in Austria, Norway, Yugoslavia, Porto Alegre, Romania, PR, Poland, Canada, Sweden New York, Japan. Awards: purchase award, Ikla Art Center, 12th Ann. Nat. Exhib. Prints & Drawings, 1970; purchase prize, Multiples Exhib., Western Michigan Univ., 1970; President's award in graphics, Audubon Artists Ann., 1970. **Work:** Mus. Fine Arts, Budapest, Hungary; Nat Mus, Krakow, Poland; MMA; Nat. Collection Fine Arts, Washington, DC; Cleveland Mus. Fine Art. **Comments:** Positions: visiting critic printmaking, Yale Univ.; editor, *Print/Printmaking Review;* director, Pratt Graphics Center; private print dealer. Publications: author/illustrator, "Prints and Poems" (folio), 1963; editor, "Printmaking in Eastern Europe," Abrams, 1971. Teaching: asst. professor printmaking, Pratt Inst. **Sources:** WW73.

STATE, Charles *[Illustrator] 19th/20th c.; b.Montreal, Quebec.*
Addresses: NYC. **Studied:** J.H. Walker, in Montreal. **Member:** Soc. Am. Wood Engravers. **Comments:** Contributor: illus. to *Century.* **Sources:** WW01.

STATES, Mignon Trickey (Mrs.) *[Watercolorist, china painter] b.1883, New Orleans.*
Studied: Univ. Nebraska; Univ. Wyoming. **Exhibited:** Wyoming State Fair; Laramie, Lander & Saratoga, WY. **Sources:** Petteys, *Dictionary of Women Artists.*

STATFELD, Moritz *[Listed as "artist'] b.c.1830, Germany.*
Addresses: NYC, 1860. **Comments:** He had property valued at $3,000 in 1860. In 1863 he was listed as a photographer. **Sources:** G&W; 8 Census (1860), N.Y., LIII, 973; NYCD 1863.

STATMAN, Jan B. *[Painter] 20th c.; b.NYC.*
Addresses: Longview, TX. **Studied:** Hunter College, with William Baziotes, Bernard Klonis & Richard Lippold, A.B.; also with Saul Berliner. **Member:** Texas FAA; East Texas FAA. **Exhibited:** Jr. Service League Ann., Longview, 1965-72; 1st Ann. Small Paintings Exhib., New Mexico Art League, Albuquerque, 1971; 13th Ann. Nat. Sun Carnival Art Exhib., El Paso (TX) Mus. Art, 1971; 32nd Am. Nat. Exhib., Cedar City Art Committee, Utah, 1972; Ann. 9-State Exhib., Barnwell AC, Shreveport, LA, 1970. Awards: circuit merit, Laguna Gloria Mus., Texas Fine Arts Spring Exhib., 1963; merit award & jury mention, New Mexico Art League West & Southwest Exhib., 1970; Longview Bank & Trust Co. Award, East Texas FAA, 1970; L & L Gallery, Longview, TX, 1970s. **Work:** MOMA Alto Aragon, Huesca, Spain; Civic Mus. Contemporary Art, Sasso Ferrato, Italy; Longview (TX) Bank & Trust Co.; Temple Emanu-El, Longview. **Comments:** Preferred media: oils, acrylics, watercolors. Publications: author, "Art Notes" (weekly column), *Longview News,* 1965-70; author, "Artist's World" (weekly column), *Women's World Weekly,* 1970-. Teaching: art consultant, Longview Independent School District, 1960-64; instructor of painting, Red Barn Arts Crafts Center, Longview, 1969-71; instructor of paint-

ing, Longview Mus. & Arts Center, 1972-. **Sources:** WW73.

STATSINGER, Evelyn *[Painter] 20th c.*
Addresses: Chicago area. **Exhibited:** AIC, 1951 (prize); WMAA. **Sources:** Falk, *AIC.*

STATTLER, George *[Ship carver] late 18th c.*
Addresses: Charleston, SC, c.1798. **Comments:** In 1798 he carved a figurehead of General Charles C. Pinckney. **Sources:** G&W; Pinckney, *American Figureheads and Their Carvers,* 82, 201.

STAUBEL, William *[Painter] 20th c.*
Addresses: Rutherford, NJ. **Member:** Soc. Independent Artists. **Sources:** WW25.

STAUCH, Alfred *[Sculptor] b.c.1836, Saxe-Coburg (Germany).*
Addresses: Philadelphia, active1860; Europe, 1866; Philadelphia, 1868 and after. **Exhibited:** PAFA, 1860-69. **Comments:** He probably was a younger brother of Edward Stauch (see entry), with whom he was living in 1860. **Sources:** G&W; Rutledge, PA; 8 Census (1860), Pa., LV, 613.

STAUCH, Edward *[Sculptor] b.c.l830, Saxe-Coburg (Germany).*
Addresses: Philadelphia, active late1850's-60's. **Exhibited:** PAFA. **Comments:** Alfred Stauch (see entry), presumably his brother, was at the same address in 1860. **Sources:** G&W; 8 Census (1860), Pa., LV, 613; Rutledge, PA; Phila. CD 1854-60+.

STAUFER, Jack *[Painter] 20th c.*
Exhibited: S. Indp. A., 1937. **Sources:** Marlor, *Soc. Indp. Artists.*

STAUFFER, David McNeely *[Sketch artist] b.1845 / d.1913.*
Studied: Franklin & Marshall College. **Comments:** A sailor aboard the USS Alexandria in the Mississippi delta area during the Civil War. His 58-page sketchbook entitled "Louisiana Sketches" (1864) was sold at auction by Phillips, Jan. 21, 1999. **Sources:** press release, Phillips, NYC.

STAUFFER, Edna Pennypacker (Miss) *[Painter, lithographer, educator, lecturer, illustrator, graphic artist] b.1887, Chester County, PA / d.1956, Ashfield, MA.*
Addresses: NYC. **Studied:** Wells College, Aurora, NY; Teachers College, Columbia Univ.; PAFA; ASL; Chase; Pennell; McCarter; T. Anschutz; H. Breckenridge; Academie Moderne, Andre L'Hote, Paris, France. **Member:** NAWA; Pen & Brush Club; SAGA; Audubon Artists. **Exhibited:** WMAA, 1922-28; Salons of Am., 1934; Middlefield (MA) Fair, 1944 (prize), 1945 (prize); NAWA, 1946, 1947 (prize), 1951; Albany Inst. Hist. & Art, 1946; Pen &Brush Club, 1945 (prize), 1950 (prize); Phila. Art All., 1946; Paris Salon, 1948 (prize); PAFA; Audubon Artists,1950, 1952; SAGA, 1950, 1952; LOC, 1950, 1952; Buffalo, NY, 1951. **Work:** Whitney Club; MMA. **Comments:** Position: art professor, Hunter College, NYC, to 1951. **Sources:** WW53; WW47; Petteys, *Dictionary of Women Artists,* gives death place as NYC.

STAUFFER, Ethel *[Painter, teacher] d.1987.*
Studied: PAFA; Columbia Univ. **Member:** New Haven PCC, 1934 (pres., 1945-49 & 1960-62; hon. life member, 1966). **Exhibited:** New Haven PCC, 1930-64. **Comments:** A painter of portraits and still life for four decades, she was an important member of the New Haven PCC, where she taught classes for the New Haven Brush & Palette Club. **Sources:** PHF files, courtesy New Haven PCC.

STAUFFER, Jacob *[Listed as "artist", general storekeeper, job printer, pharmacist, lawyer, botanist, and photographer] b.1808 / d.1880.*
Addresses: Richland (now Mount Joy) PA, 1839-58; Lancaster, PA, 1858 and after. **Comments:** His son Jacob McNeely Stauffer (see entry), author of *American Engravers upon Copper and Steel,* was born in 1845 in Richland. In Lancaster (PA) Jacob became librarian of the Lancaster Athenaeum. **Sources:** G&W; Kieffer, "David McNeely Stauffer."

STAUFFER, Joseph K. (R.) *[Painter] 20th c.*
Addresses: Riverdale, NY, 1928. **Exhibited:** S. Indp. A., 1928.
Comments: Possibly Stauffer, Joseph R., b. 1898, Scottsdale, PA-d. 1960, Stamford, CT. **Sources:** Marlor, *Soc. Indp. Artists.*

STAUFFER, W. C. (Mrs) *[Painter]*
Addresses: New Orleans, active c.1881-87. **Member:** Southern Art Union, 1881. **Exhibited:** Artist's Assoc. of N.O., 1887.
Sources: *Encyclopaedia of New Orleans Artists,* 364.

STAUGHTON, Anna Claypoole Peale See: **PEALE, Anna Claypoole**

STAUNTON, P. P. *[Painter] late 19th c.*
Addresses: LeRoy, NY, 1878. **Exhibited:** NAD, 1878. **Sources:** Naylor, *NAD.*

STAUNTON, Phineas *[Painter, teacher] b.1817, Middlebury (later called Wyoming), NY / d.1867, Quito (Ecuador).*
Addresses: Itinerant in early years; Ingham Univ. campus (Staunton Cottage), LeRoy, NY, 1847-67. **Studied:** informal study by observing Grove S. Gilbert in LeRoy and Rochester, NY, 1835-37; PAFA, 1838-39; Buffalo, NY, 1840. **Exhibited:** NAD, 1841, 1845, 1859, 1860; Apollo Assoc., 1841; Norman's Bookstore, New Orleans, 1847; Wash. AA, 1859; Buffalo Fine Arts Acad., 1864; Brooklyn AA, 1865; Boston AC, 1875; "Early American Portraits," Stonington (CT) Village Improvement Soc., 1925; "Ingham Centennial," Woodward Mem. Lib., LeRoy, NY, 1935; "Exhib. of American Portraits found in Oberlin and Vicinity," Allen Memorial AM, Oberlin (OH) College, 1935. **Work:** LeRoy (NY) Hist. Soc.; Brooklyn (NY) Borough Hall; Economy Village, Ambridge, PA; Middlebury (NY) Hist. Soc.; Mystic (CT) Seaport Mus.; Patterson Lib., Westfield, NY; Presbyterian Chuch USA, 24 Lombard St., Phila; Stonington (CT) Hist. Soc.; Univ. of Conn., Storrs; Frank Stevenson Archives, Old Saybrook, CT. **Comments:** Painter of portraits (full-size and miniatures) and religious subjects. The son of General Phineas Stanton, he grew up on the family farm in Middlebury, NY. (In 1853 he changed his name from Stanton to Staunton). Phineas worked in the South, 1836-37. After studying in Phila., he opened a studio in Buffalo in 1840 and that same year painted along the Hudson, from Albany to NYC. In 1841 he opened studio in the Granite Building, NYC. He painted in Savannah, GA, 1842; and in Charleston, SC in the summer of 1844. In the fall of 1844 he was back in LeRoy, NY and had studio in NYC, 1845; he painted at Stonington, CT in 1846. In 1847 he visited New Orleans and was married that same year in LeRoy, NY, to Emily Ingham who, along with her sister Marietta, founded Ingham Collegiate Institute (later Ingham University) in LeRoy, the first all-female college in the United States. While on his honeymoon in Europe (June-Dec., 1847), visiting England, Paris, and Florence, Staunton copied seven old master paintings. Upon their return, he and his wife took up residence in a cottage on the campus of Ingham Univ., but Staunton continued to take painting trips, visiting New Orleans again in 1853; Stonington, CT in 1853 and 1854; and Bridgeport, CT in 1855. He occupied a space in the Studio Building at Tenth St. in NYC, during the winters of 1859-61. During the Civil War, he served as a colonel; his diary (unlocated) describing his war experiences was used in the writing of the *History of the One Hundredth Regiment of New York State Volunteers,* by George Stowits, 1870. In 1867 Staunton joined an expedition, sponsored by Williams College and the Smithsonian Institution, which traveled through South America in search of art and scientific artifacts for each institution's museum collections. He became ill during that trip and died in Quito, Ecaudor, in September of 1867. To date (1998), fifty-eight works have been located (Staunton often did not sign his works). Positions: teacher of modern languages, prof. of drawing, painting, & art of design, as well as head of art dept., Ingham Univ., Leroy, NY, 1847-67; vice-chancellor & acting chancellor of Ingham Univ.,1856-67.
Sources: G&W; Stanton, *A Record. of Thomas Stanton, of Connecticut, and His Descendants,* 521-22; Cowdrey, AA & AAU; Cowdrey, NAD; NYCD 1841, 1845; Rutledge, *Artists in the Life of Charleston;* Delgado-WPA cites *Bee,* April 16, 1847, and *Picayune,* April 4, 1847, and Jan. 26, 1853. More recently, see

Encyclopaedia of New Orleans Artists, 364; BAI, courtesy Dr. Clark S. Marlor; add'l info., including chronology, exhib. records, list of extant works and public collections where Staunton is represented, courtesy of Annette B. Peck, Winnetka, IL.

STAVE, George *[Painter] 20th c.*
Exhibited: AIC, 1945. **Sources:** Falk, *AIC.*

STAVENITZ, Alexander Raoul *[Etcher, lithographer, designer, teacher, painter, lecturer] b.1901, Kiev, Russia / d.1960, South Norwalk, CT.*
Addresses: NYC; South Norwalk, CT. **Studied:** St. Louis Sch. FA, Washington Univ., B. Arch.; ASL. **Member:** Am. Artists Congress; Rudolph Assoc., NYC, 1946-. **Exhibited:** Awards: Guggenheim Fellowship, 1931; numerous awards in "Fifty Prints of the Year," "Fine Prints of the Year." **Work:** NYPL; WMAA; Wesleyan College; Mus. Modern Western Art, Moscow.
Comments: Positions: instructor, Indust. Des., Pratt Inst., Brooklyn, NY, 1945-47; instructor, arch. design, Inst. Des. & Construction, Brooklyn, NY, 1947-; assoc. professor of art, City College of NY, 1950; instructor, People's Art Center, MoMA, 1954-; Commission on Art Educ., MoMA. Lectures: design and the arts. **Sources:** WW59; WW47.

STEA, Cesare *[Sculptor, painter, teacher] b.1893, Bari, Italy / d.1960, Chatham, NJ.*
Addresses: Long Island City, NY; Chatham, NJ. **Studied:** NAD; CUA School; BAID; Grande Chaumière, Paris, with Anton Bourdelle, & with Hermon MacNeil, Sterling Calder; Italian-Am. AA; Victor Salvatore; Carle Heber; Anton Bourdelle. **Member:** NSS; Sculptors Gld.; Am. Veterans Art Soc. **Exhibited:** AIC, 1916; Salons of Am., 1922, 1925, 1931, 1934; S. Indp. A., 1923; PAFA Ann., 1924, 1944, 1948-50; CPLH; Hispanic Mus.; WFNY 1939; BM, 1941; MMA, 1942, 1951; WMAA, 1923-28, 1943; NAD, 1926 (prize); Montclair AM, 1933 (prize); Pan-Pacific Expo, San Francisco, 1915 (medal); Nat. Defense Soc. (prize); Am. Veterans Art Soc., 1952 (prize). **Work:** WMAA; Brooklyn College; Evander Childs H.S., NY; Queensbridge Housing Project; Bowery Bay Disposal Bldg., NY; U.S. Military Acad., West Point, NY; U.S.P.O., Necomerstown, OH; Wyomissing, PA; Bowery Bay Water Treatment Plant, NYC. **Comments:** Figure sculptor, active in NYC, 1920s-30s. WPA artist. **Sources:** WW59; WW47; Fort, *The Figure in American Sculpture,* 225 (w/repro.); Falk, *Exh. Record Series.*

STEADMAN, L. Alice Tuttle (Mrs. Harold) *[Sculptor, painter, teacher] b.1907, Stokes County, NC.*
Addresses: Charlotte 7, NC. **Studied:** Meredith College, Raleigh; PAFA; and with Hugh Breckenridge, Oberteuffer, Eliot O'Hara, Naum Los. **Member:** AAUW; Gld. Charlotte Artists. **Exhibited:** Statesville (NC) Mus., 1965 (solo). Awards: Margaret Graham silver cup, 1935; Raleigh Studio Club gold medal, 1936; Ethel Parker silver cup, 1937; Blowing Rock, NC, 1957, 1958; Mint. Mus. Art, 1958. **Work:** portrait sculpture in private collections; statues, Police Club; Boy Scout "Camp Steere." **Comments:** Position: art instructor, Mint Mus. School Art, Charlotte, NC, 1936-; Queens College, 1953-54. **Sources:** WW66.

STEADMAN, Marcia Hunt (Mrs.) *[Painter] 20th c.*
Addresses: Chattanooga, TN, c.1915-21. **Member:** Cincinnati Women's AC. **Sources:** WW21.

STEADMAN, Royal C. *[Painter, illustrator, commercial artist] 19th/20th c.; b.New England.*
Addresses: Wash., DC, c.1900. **Exhibited:** Greater Washington Independent Exhib., 1935. **Work:** U.S.National Arboretum; Mycological Laboratory, Beltsville, MD; Carnegie-Mellon Univ., Pittsburth, PA. **Comments:** Position: chief scientific illus., U.S. Department of Agriculture. **Sources:** McMahan, *Artists of Washington, DC.*

STEADMAN, William Earl *[Museum director] b.1921, Pigeon, MI.*
Addresses: Tucson, AZ. **Studied:** With Josef Albers & Willem De Kooning; Michigan State Univ., B.S., 1942; Univ. Arizona,

B.F.A. (art history), 1946; Yale Univ. (B.F.A. , arch. & design, 1950; M.F.A.,arch. & design, 1951). **Comments:** Positions: asst. director & head mus. art school, New Mexico Mus., Roswell, 1951-52; asst. director & head mus. art school, Canton (OH) Art Inst., 1952-53; curator fine arts, U.S. Military Acad., West Point, NY, 1953-58; director, Mus. Fine Arts, Little Rock, AR, 1958-59; director, Univ. Arizona Mus. Art, 1961. Publications: editor, "Charles Burchfield, His Golden Year" (catalogue), 1965; author/editor, "Homage to Seurat" (catalogue), 1968; editor, "East Side, West Side" (catalogue), 1969; editor, "Cornelius Theodorus Marie Van Dongen" (catalogue, 1971; author/editor, "Childe Hassam" (catalogue), 1972. Collections arranged: Charles Burchfield, His Golden Year, 1965-66; Homage to Seurat, 1968-69; East Side, West Side (Reginald Marsh Retrospective), 1969; Van Dongen Retrospective (1st in America), 1971; Childe Hassam Retrospective, 1972. **Sources:** WW73.

STEAG, Jacob *[Engraver] b.c.1834, Pennsylvania.*
Addresses: Philadelphia, 1860. **Sources:** G&W; 8 Census (1860), Pa., LX, 49.

STEARNS, Frederic Wainwright *[Etcher, illustrator, block printer] b.1903, Pittsburgh, PA.*
Addresses: Horseneck, MA. **Studied:** Saint-Gaudens; C. Grapin. **Member:** AIA; Phila. Chapter, BAID; Phila. PC; T- Square Cub. **Work:** Fifty Prints of the Year, 1932; Penn. Athletic Club, Phila. **Sources:** WW40.

STEARNS, G. Douglas *[Painter] late 19th c.*
Addresses: Brooklyn, NY, 1891. **Exhibited:** NAD, 1891. **Comments:** Naylor, *NAD.*

STEARNS, G. Douglas (Mrs.) *[Painter] 19th/20th c.*
Addresses: Brooklyn, NY. **Member:** B&W Club. **Sources:** WW01.

STEARNS, Helen *[Painter]*
Addresses: Des Moines, IA. **Studied:** State Univ. Iowa, B.A.; Charles Atherton Cumming. **Member:** Iowa Art Guild, 1936. **Exhibited:** Iowa Art Salon; Joslyn Mem.; Des Moines Women's Club Ann. Art Exhibition. **Sources:** Ness & Orwig, *Iowa Artists of the First Hundred Years,* 198.

STEARNS, J. F. (Mrs.) *[Painter] 19th c.*
Addresses: NYC, 1877. **Exhibited:** NAD, 1877. **Sources:** Naylor, *NAD.*

STEARNS, John Barker *[Educator] b.1894, Norway, ME.*
Addresses: Hanover, NH. **Studied:** Dartmouth College, A.B.; Princeton Univ., M.A., Ph.D. **Member:** Am. Philological Assn.; Archaeological Inst. Am.; Am. Classical Lg.; Classical Assn. of New England. **Comments:** Positions: instructor, Hist. Ancient Art, Classical Civilization, Alfred Univ., 1920-21, Princeton Univ., 1922-24, Yale Univ., 1925-28; prof., 1928-, chmn., art dept., 1954-, Dartmouth College, Hanover, NH; prof. emeritus, 1961. Author: "Studies of the Dream as a Technical Device," 1927; "The Assyrian Reliefs at Dartmouth," 1953; "Byzantine Coins in the Dartmouth Collection," 1954. Contributor to *Classical Weekly, Classical Philology, Classical Journal.* **Sources:** WW66.

STEARNS, Junius Brutus *[Portrait, genre, and historical painter] b.1810, Arlington , VT / d.1885, Brooklyn, NY.*

Stearns 1851

Addresses: NYC; Brooklyn, NY. **Studied:** NAD, c.1838; Paris and London, 1849. **Member:** ANA, 1848; NA, 1849 (recording secretary, 1851-55). **Exhibited:** NAD,1838-84; Apollo Association, 1838; Brooklyn AA, 1862-81. **Work:** Brooklyn Mus; VMFA; Butler Inst. Am. Art; New York City Hall; Toledo Mus. Art. **Comments:** Though he painted mainly portraits, Stearns was also known for his historical subjects, especially a series on George Washington. Many of his historical paintings included Native Americans. **Sources:** G&W; CAB; Cowdrey, NAD; Cowdrey, AA & AAU; Clark, *History of the NAD,* 271; Swan, BA; NYCD 1838+; Rutledge, PA; several repros. listed in *Art Index;* P & H Samuels report alternate birthplace of Burlington, VT, 461-62; *300 Years of American Art,* vol. 1, 148.

STEARNS, Martha G. (Mrs. Foster) *[Craftsperson, lecturer] 20th c.; b.Amherst, MA.*
Addresses: Hancock, NH. **Member:** NY Needle & Bobbin Club; Boston SAC (master craftsman); New Hampshire Lg. Arts & Crafts (council). **Sources:** WW40.

STEARNS, Mary Ann H. *[Painter] early 19th c.*
Addresses: Billerica, MA, 1827. **Comments:** Painted a watercolor still life. **Sources:** G&W; Lipman and Winchester, 180.

STEARNS, Neilson (Mrs. Traphagen Stearns) *[Sculptor] 20th c.*
Addresses: Brooklyn, NY. **Member:** NAWPS. **Sources:** WW25.

STEARNS, Nellie George (Mrs. George F.) *[Painter, art teacher] b.1855, Warner, NH.*
Addresses: Boston, 1882. **Studied:** Boston MFA School with Emilio Longino. **Exhibited:** New Orleans Expo, 1884; Columbian Expo, Chicago, 1893; various New England cities. **Sources:** Petteys, *Dictionary of Women Artists.*

STEARNS, Robert L. *[Illustrator] b.c.1871 / d.1939.*
Addresses: NYC. **Studied:** NYC; Paris, France. **Comments:** Illustrator: *Life, Judge.* He was also a businessman and hotel owner. **Sources:** WW01; Gibson, *Artists of Early Michigan,* 221.

STEARNS, Thomas (Robert) *[Sculptor, craftsperson] b.1936, Oklahoma City, OK.*
Addresses: NYC. **Studied:** Memphis Acad. Art; Cranbrook Acad. Art; Acad. FA, Venice, Italy. **Exhibited:** Venice Bienal (Glass-Italian Section), 1962; Brussels Int., 1961; Seattle World's Fair, 1962; Mus. Contemporary Crafts, NY; Czechoslovakia and Italy, 1964; Parke Bernet Gal., NY; Willard Gal., NY, 1964; PAFA Ann., 1966. Guest Designer, Venini (Glass), Venice, Italy, 1960-62. Awards: Italian Government award, 1960; Fulbright travel grant, 1960; Guggenheim Fellowship, 1965; NIAL Grant, 1965. **Work:** Cranbrook Mus. Art. **Sources:** WW66; Falk, *Exh. Record Series.*

STEARNS, William *[Painter] early 19th c.*
Addresses: Massachusetts or Maine, c.1825. **Comments:** Painter of a still life on velvet. **Sources:** G&W; Lipman and Winchester, 180.

STEARUS, D. *[Painter] 20th c.*
Exhibited: S. Indp. A., 1942. **Sources:** Marlor, *Soc. Indp. Artists.*

STEBBING, John Noel, Jr. *[Painter, graphic artist, sculptor] b.1906, Baltimore, MD.*
Addresses: Wash., DC. **Studied:** Maryland Inst.; Corcoran School Art; H. Podolsky. **Member:** Soc. Wash. Etchers. **Exhibited:** CGA; U.S. Maritime Comm. **Sources:** WW40.

STEBBINS, Carlos *[Portrait painter] mid 19th c.*
Addresses: Western New York, 1830's. **Work:** Museum in Letchworth State Park, Portage (NY), portrait of Mary Jemison. **Sources:** G&W; Merrill, *The White Woman and Her Valley* (Rochester, 1955), 134, repro, opp. 22.

STEBBINS, Emily S. (Mrs.) *[Painter] 19th c.*
Addresses: Rochester, NY, 1868. **Studied:**. **Exhibited:** NAD, 1868 ("Skating on the Genesee River at Rochester, NY"). **Comments:** Not to be confused with the sculptor Emma Stebbins. **Sources:** Naylor, *NAD.*

STEBBINS, Emma *[Sculptor, portrait painter, watercolorist, crayon and pastel artist] b.1815, NYC / d.1882, NYC.*
Addresses: Rome, 1857-70. **Studied:** Paul Akers. **Member:** ANA. **Exhibited:** PAFA, 1845, 1847; NAD, 1855. **Work:** "The Angel of the Waters" (The Bethesda Fountain), Central Park, NYC; "Columbus," Brooklyn Civic Ctr. (orig. in Central Park, NYC); "Horace Mann," Mass. State House, boston. **Comments:** Stebbins concentrated on drawings in black and white and oil paintings until she was in her forties, occasionally exhibiting her work at PAFA and the NAD. She became interested in sculpture during a visit to Rome in 1857 and from then on devoted herself to that medium. Stebbins remained in Rome until 1870 and became part of a group of women that included Charlotte Cushman, her constant companion, as well as George Sand and

others. Back in America, she and Cushman took up residence in Newport, RI and she also worked in NYC. Stebbins' work included portrait busts, monuments, and ideal figures. Author: *Charlotte Cushman: Her Letters and Memories of Her Life* (1878).
Sources: G&W; CAB; Clement and Hutton; Taft, *History of American Sculpture,* 211; Rutledge, PA; Cowdrey, NAD; Gardner, *Yankee Stonecutters;* Tuckerman, *Book of the Artists,* 602-03. More recently see Rubinstein, *American Women Artists* 85-86; Gerdts, *White Marmorean Flock;* Baigell, *Dictionary.*

STEBBINS, Mary Emma See: **FLOOD, Mary Emma (Mrs. T. E. Stebbins)**

STEBBINS, Roland Stewart *[Painter, educator, lecturer]* *b.1883, Boston, MA / d.1974.*
Addresses: Madison, WI. **Studied:** Royal Art Acad., Munich, Germany; Grande Chaumière, Paris; PAFA; & with Charles Chapman, Hugh Breckenridge, Charles Hawthorne, Joseph de Camp; Dow; ASL; Columbia; Mass. School Art. **Member:** Boston AC; Copley Soc., Boston; North Shore AA, Madison AA; AFA; Wisc. P&S;Wisc. Art Fed. **Exhibited:** NAD, 1945; North Shore Gal., Gloucester, MA, annually; Boston AC; Copley Soc.; Madison AA, 1932 (prize), 1942 (prize), 1944 (prize), 1945 (prize), 1946; Madison Salon, 1944-46; Milwaukee P&S, 1945, 1946; Grace Horne Gal., 1928 (solo); Paris, France, 1928 (solo); Wisc. State Fair, 1944 (prize); Miami, FL; Boca Raton, FL, 1954, 1955. **Work:** Univ. Wisconsin; City Lib., Madison, WI; murals, Medical School, Madison, WI; Med. Mem. Room, Memorial Union; Wisc. State Hospital; Madison Club; portraits, Medical School, Law School, Pine Bluff Observatory, all in Madison, WI. **Comments:** Position: art prof., emeritus, Univ. Wisconsin, Madison, WI. Illustrator for*Christian Endeavor World.* Lectures: techniques of painting. **Sources:** WW59; WW47.

STEBBINS, Theodore Ellis, Jr. *[Art historian, art administrator]* *b.1938, New York, NY.*
Addresses: New Haven, CT. **Studied:** Yale Univ., B.A., 1960; Harvard Univ. Law School, J.D., 1964; Harvard Univ., Ph.D., 1971. **Member:** College Art Assn. Am.; AFA. **Comments:** Positions: curator, Yale Univ. Art Gallery, 1968-77; curator, Am. painting, MFA Boston,from 1977. Publications: author, "Richardson and Trinity Church," *Journal Soc. Archit. Historians,* 1968; "Thomas Cole at Crawford Notch," Nat. Gallery Art, 1968; "Martin Johnson Heade," WMAA, 1969 &"American Landscape: Some New Acquisitions at Yale," *Yale Univ. Art Gallery Bulletin,* (autumn 1971); coauthored, *A New World: Masterpieces of American Painting, 1760-1910* (MFA Boston, 1983); *Life and Works of Martin Johnson Heade* (Yale Univ., 1975); *The Lure of Italy: American Artists and the Italian Experience, 1760-1914* (1992). Teaching: Yale Univ., 1969-77; Boston Univ., 1982-. Areas of expertise: American landscape painting of the nineteenth century; history of American drawings and watercolors. Collection: nineteenth and twentieth century American art.
Sources: WW73; *Who's Who In American Art* (1993-94).

STECCATI, Hugo *[Painter, photographer]* *b.1916, Oakland, CA.*
Addresses: Oakland, CA. **Studied:** Calif. College of Arts & Crafts, 1938. **Exhibited:** San Francisco AA, 1940. **Comments:** Position: teacher, high schools in Antioch and Berkeley. Married to Alva Tofanelli (see entry). **Sources:** Hughes, *Artists in California,* 532.

STECHER, William F. *[Painter, illustrator, graphic artist, designer, teacher]* *b.1864, Boston, MA.*
Addresses: Dorchester, East Milton, MA. **Studied:** Julian Acad., Paris; & with Edward Knobel, William Bougereau; Acad. Colarossi, Paris; Acad. Dusseldorf, Germany; Académie Julian, Paris with Bouguereau, T. Robert-Fleury, and Ferrier, 1890-91. **Member:** Soc. WC Painters, Boston. **Exhibited:** Boston AC, 1893-1903; PAFA Ann., 1896-98; Phila.; Chicago; St. Louis; Wash, DC; AIC. **Work:** BMFA. **Comments:** Illustrator of books for children, and contributor to*Youth's Companion.* Teaching: Scott Carbee Sch. Art, Boston, 1940. **Sources:** WW53; WW47;

Falk, *Exh. Record Series.*

STECHOW, Wolfgang *[Art historian, educator]* *b.1896, Kiel, Germany / d.1975.*
Addresses: Oberlin, OH. **Studied:** Univ. Freiburg, 1914; Univ. Berlin, 1920; Univ. Göttingen, Ph.D., 1921; Univ. Michigan, hon. L.H.D., 1966; Oberlin College, hon. D.F.A., 1967. **Member:** College Art Assn. Am. (vice-pres., 1945-46); Nat. Committee Hist, Art; Am. Soc. Aesthetics; Archaeology Inst. Am. **Comments:** Positions: consultant comt., *Art Quarterly & Calif. Studies in the History of Art;* editor, *Art Bulletin,* 1950-52. Publications: author, "Apollo und Daphne" (1932 & 1965), "Salomon van Ruysdael" (1938), "Dutch Landscape Painting of the 17th Century" (1966 & 1968), "Rubens and the Classical Tradition" (1967) & "Bruegel" (1969). Teaching: from instructor of art history to asst. professor, Univ. Göttingen, 1926-36; from asst. professor art history to assoc. professor, Univ. Wisconsin, 1936-40; professor of art history, Oberlin College, 1940-63; visiting prof., Univ. Michigan, Williams College, Smith College, Vassar College, Yale Univ., Cleveland Mus., Nat. Gallery & others, 1963-72. Research: fifteenth to seventeenth century northern painting; iconography. **Sources:** WW73; WW47.

STECK, Alden L. *[Painter, teacher]* *b.1904, Calumet, MI.*
Addresses: Calumet, MI; Laurium, MI. **Exhibited:** Grand Rapids Art Gal., 1942; AIC, 1938; CM; Kansas City AI, 1938, 1939; SFMA, 1938, 1940; Oakland Art Gal., 1938, 1941, 1944; AWCS, 1944; Acad. All. Artists, 1940; NAD, 1944; Mississippi AA, 1943; Springfield Art Mus., 1945; Detroit IA, 1941, 1945; Soumi College, 1956 (prize), 1957. **Sources:** WW59; WW47.

STECKEL, Edwin M. *[Museum director]* *20th c.*
Addresses: Wheeling, WV. **Sources:** WW59.

STECKLER, Jeanet See: **DRESKIN, Jeanet Steckler**

STECZYNSKI, John Myron *[Sculptor, educator]* *b.1936, Chicago, IL.*
Addresses: Lincoln, MA. **Studied:** AIC; Craft Center, Worcester, MA; Univ. Notre Dame, B.F.A.; Yale Univ., Woodrow Wilson fellowship, 1958, M.F.A.; Acad. Fine Arts, Polish Govt. grant, 1960, Warsaw; also with Umberto Romano. **Exhibited:** Warsaw, Poland & Worcester Art Mus., 1961 (solos); Craftsmen of the Northeastern States, Worcester, MA, 1963; Craftsmen of the Eastern States, circulated by Smithsonian Inst., 1963-64; Christocentric Arts Festival, Univ. Illinois, 1964; Prints for Collectors, Worcester Craft Center, 1964. **Awards:** Univ. Illinois, 1953; Polish Arts Club Chicago Prize, 1959; Chopin Fine Arts Club Award, Butler IA, 1961. **Work:** Commissions: wood relief panels, Ursuline Provincialate, Kirkwood, MO; wood sculpture, Moreau Sem., Notre Dame, IN; banners, Little Flower Church, South Bend, IN; St. Mark's Episcopal Church, Worcester, MA. **Comments:** Teaching: lecturer, modern liturgical art, Polish folk art & Byzantine art to clubs & univ. groups; professor of art, Worcester Art Mus. School; instructor of art history, Boston Mus. Fine Arts School, 1961-63; ass.t professor & chmn. dept. art, Newton College of the Sacred Heart, in 1973. **Sources:** WW73.

STEDMAN, Esther *[Painter]* *20th c.*
Addresses: Santa Barbara, CA. **Exhibited:** AIC, 1919. **Sources:** WW19.

STEDMAN, F. Marsha Hunt See: **HUNT, F. Marcia**

STEDMAN, Jeannette *[Portrait painter]* *b.1880 / d.1924, Chicago, IL.*
Addresses: Chicago. **Studied:** Paris.

STEDMAN, Margaret Weir *[Miniature painter, teacher]* *b.1882.*
Addresses: Haddonfield, NJ/Ocean City, NJ. **Studied:** PIA School; NYU; A.M. Arcambault; L. Spizziri. **Member:** Penn. SMP. **Sources:** WW40.

STEDMAN, Myrtle Kelly (Mrs. Wilfred H.) *[Painter]* *b.1908, Charleston, IL.*
Addresses: Santa Fe, NM. **Studied:** F. Browne; W. Stedman.

Member: Houston Art Gal.; Texas FAA. **Exhibited:** Houston MFA, 1933. **Sources:** WW40.

STEDMAN, Wilfred Henry *[Painter, sculptor, designer, illustrator, architect, block printer, teacher] b.1892, Liverpool, England / d.1950.*
Addresses: Santa Fe, NM. **Studied:** Minneapolis IA; SAL; Broadmoor Art Acad.; France; G. Goetch; L.M. Phoenix; H. Dunn; L. Mora; F.V. Du Mond; J.F. Carlson; B. Sandzen; R. Reid; C.S. Chapman. **Member:** Houston Art Gal.; Texas FAA. **Exhibited:** Glockner Sanatarium, Colorado Springs, CO; Church of Christ, Houston, TX; James M. Lykes Shipping Co., Rice Inst., both in Houston; Catholic Tubercular Hospital, Colorado Springs; NY Engineering Soc. **Comments:** Author/illustrator: "Santa Fe-Style Homes," 1936. Position: art editor, "New Mexico Plan Book," 1939; *New Mexico* magazine. **Sources:** WW47.

STEED, Robert *[Painter, teacher, designer] b.1903, Elizabeth, NJ.*
Addresses: New York 3, NY. **Studied:** NAD, with Hawthorne, Olinsky, Curran; ASL; Cape Cod School Art; Buffalo State Teachers College; NY Univ., M.A. in Art Educ. **Exhibited:** PAFA Ann., 1946; Barone Gal., 1954, 1957; Buck Hill Falls, PA, 1957; auspices of U.N. Ambassador of India, 1958 (solo). Award: NY State Exhib., 1931. **Work:** Fiske Univ. **Comments:** Position: art instructor, NY Board Educ.; Columbia Univ. research in contemporary India projects (in India, 1949-51, in New York, 1952-54); book & magazine designer, 1926-32. **Sources:** WW59; Falk, *Exh. Record Series.*

STEEG, Esther *[Painter] 20th c.*
Addresses: Elizabeth, NJ, 1934. **Exhibited:** S. Indp. A., 1934-35. **Sources:** Marlor, *Soc. Indp. Artists.*

STEEGMULLER, Beatrice (Stein) (Mrs. Francis) *[Painter] 20th c.*
Exhibited: S. Indp. A., 1936. **Sources:** Marlor, *Soc. Indp. Artists.*

STEEL, Alfred B. *[Engraver] b.c.1828, Pennsylvania.*
Addresses: Philadelphia, 1860. **Comments:** He lived with his father, the engraver James W. Steel (see entry). **Sources:** G&W; 8 Census (1860), Pa., LI, 620.

STEEL, Gordon *[Painter] mid 20th c.*
Exhibited: Corcoran Gal biennials, 1955. **Sources:** Falk, *Corcoran Gal.*

STEEL, James W. *[Engraver, landscape and portrait painter] b.1799, Philadelphia, PA / d.1879, Philadelphia, PA.*
Addresses: Philadelphia, PA, 1799-1879. **Comments:** He was a pupil of Benjamin Tanner and George Murray and worked for a time for Tanner, Vallance, Kearney & Co (see entry). He did much portrait, historical, and landscape engraving, but later became a banknote engraver. Alfred B. Steel, engraver (see entry), was his son. **Sources:** G&W; Stauffer; Phila. CD 1825-60; 8 Census (1860), Pa., LI, 620; Penna. Acad. Cat., 1832; *Antiques* (Aug. 1928), 131, repro.; NYHS *Quarterly Bulletin* (OCt. 1944), 121, repro.; Dunlap, *History,* II, 379; Wright, *Artists in Virgina Before 1900.*

STEEL, John *[Lithographer] b.c.1825, Germany.*
Addresses: NYC, 1850-60. **Sources:** G&W; NYBD 1851-52, 1854, and NYCD 1851-52, 1858-60, as John Steel; NYBD 1856-59 and NYCD 1856-57, as John Steels; 7 Census (1850), N.Y., XLII, 348, as John Steel.

STEEL, Ryhs See: **CAPARN, Rhys (Rhys Caparn Steel)**

STEEL, Sophie B. *[Painter] 20th c.*
Addresses: Mt. Airy, PA. **Sources:** WW06.

STEEL, T. Sedgwick See: **STEELE, Thomas Sedgwick**

STEEL & CO. *[Lithographers, printers]*
Addresses: New Orleans, active 1870-71. **Comments:** Partners were Thomas Steel and William Weed. **Sources:** *Encyclopaedia of New Orleans Artists,* 364.

STEELE, A. (Mrs.) *[Miniaturist] mid 19th c.*
Addresses: New Orleans, active 1845; NYC, active 1848. **Exhibited:** NAD, 1848. **Comments:** Possibly the same as Mrs. Daniel Steele. **Sources:** G&W; Cowdrey, NAD. More recently, see *Encyclopaedia of New Orleans Artists,* 364.

STEELE, Albert W(ilbur) *[Cartoonist] b.1862, Malden, IL.*
Addresses: Denver, CO. **Comments:** Position: staff, *Denver Post,* since 1897. **Sources:** WW13.

STEELE, Brandt Theodore *[Designer, craftsperson, architect, lecturer] b.1870, Battle Creek, MI.*
Addresses: Indianapolis, IN. **Studied:** T.C. Steele; Aman-Jean, in Paris; Munich. **Member:** Indiana Artists Club; Indianapolis AA; Indianapolis Arch. Assn.; Indianapolis Camera Club. **Sources:** WW40.

STEELE, C. B. (Mrs.) *[Artist] early 20th c.*
Addresses: Active in Los Angeles, 1911-18. **Sources:** Petteys, *Dictionary of Women Artists.*

STEELE, Clarence H. *[Painter] 20th c.*
Addresses: Seattle, WA, 1949. **Member:** Puget Sound Group of Northwest Painters. **Exhibited:** SAM, 1949; Henry Gallery, 1950, 1951. **Sources:** Trip and Cook, *Washington State Art and Artists, 1850-1950.*

STEELE, Daniel *[Portrait painter] b.1801, Auburn, NY / d.1839.*
Addresses: Rochester, NY, 1834. **Comments:** He began his career about 1830, probably at Cincinnati. Possibly the husband of Mrs. Daniel Steele (see entry). **Sources:** G&W; Cist, *Cincinnati in 1841,* 140; Rochester CD1834; Ulp, "Art and Artists in Rochester," 30. More recently, see *Encyclopaedia of New Orleans Artists,* 364.

STEELE, Daniel (Mrs.) *[Miniaturist and portrait painter] mid 19th c.*
Addresses: Charleston, SC, active1841; Richmond, VA, active1842; NYC, 1843; Syracuse, NY;1844. **Exhibited:** NAD, 1843, 1844. **Comments:** She may have been the wife of Daniel Steele (see entry), and the same as Mrs. A. Steele, who exhibited at the National Academy in 1848 as of NYC. **Sources:** G&W; Rutledge, *Artists in the Life of Charleston; Richmond Portraits;* Cowdrey, NAD; *Encyclopaedia of New Orleans Artists,* 364.

STEELE, Delton Wilbur *[Painter, sculptor, designer] b.1894, Ohio / d.1979, Los Angeles, CA.*
Addresses: Los Angeles, CA. **Exhibited:** San Diego FA Gallery, 1927. **Sources:** Hughes, *Artists of California,* 532.

STEELE, Frederic Dorr *[Illustrator, etcher] b.1873, Marquette, MI / d.1944, NYC.*
Addresses: NYC. **Studied:** NAD; ASL. **Member:** SI, 1902. **Exhibited:** Boston AC, 1896; St. Louis Expo, 1904 (medal); Salons of Am., 1934. **Work:** LOC. **Comments:** Illustrator: "The Return of Sherlock Holmes," and other tales by Doyle, books by R.H. Davis, Mark Twain, Myra Kelly, Gouverneur Morris, Mary Roberts Rinehart, Kipling, Conrad, Bennett, Tarkington. **Sources:** WW40; *The Boston AC.*

STEELE, Gile McLaury *[Painter] b.1908, Ohio / d.1952, Los Angeles, CA.*
Addresses: Los Angeles, CA. **Exhibited:** Los Angeles County Fair, 1929; P&S of Los Angeles, 1934; Public Works of Art Project, 1934. **Comments:** Position: costume designer, movie industry. **Sources:** Hughes, *Artists of California,* 532.

STEELE, Helen McKay (Mrs. Brandt) *[Painter, illustrator, craftsperson] 20th c.; b.Indianapolis.*
Addresses: Boston, MA. **Studied:** T.C. Steele & W. Forsyth; AIC. **Member:** Indianapolis AA. **Comments:** Painted portrait sketches and designed stained glass. Her husband was also a painter (see entry). **Sources:** WW17.

STEELE, Ivy (Newman) *[Sculptor, educator, lithographer] b.1908, Saint Louis, MO.*

Addresses: Chicago, IL. **Studied:** Wash. Univ. Art School; AIC; Wellesley College, B.A.; also with Cosmo Campoli, Chicago. **Member:** Arts Club Chicago; Renaissance Soc. Univ. Chicago; Artists Equity Assn. (vice-pres., secretary, director, member various committees); Chicago Soc. Artists (secretary, director, first vice-pres.); College Art Assn. Am. **Exhibited:** 4th Ann. Watercolors, Drawings & Prints, Oakland (CA) Art Gallery, 1936; 1st Nat. Exhib. Lithography, Oklahoma AC, Oklahoma City, 1939; Sculpture By Chicago Artists, AIC, 1940; Am. Inst. Architects, Chicago Chapter, 1959 (solo); Sculpture Show, Ruth White Gallery, 1964-65; Berenice Green, Chicago, IL, 1970s. **Work:** Wellesley Art Mus., MA. Commissions: epoxy exterior relief, Covenant Methodist Church, Evanston, IL, 1968; Flight (bronze sculpture), Highland Park (IL) Hospital,1970; relief sculpture (polyester resin), Ravinia Nursery School, Highland Park, 1971. **Comments:** Preferred media: bronze, wood, resins. Teaching: art instructor, Francis W. Parker School, Chicago, 1941-45; art instructor, Hull House Art School, 1945-54; art instructor, Psychometry & Psychiatry Research Inst. Chicago, 1960-71. **Sources:** WW73; "Ivy Steele," *La Révue Moderne* (1938); article, *Inland Architect* (1959); WW40.

STEELE, Juliette *[Painter, lithographer, designer, teacher]* b.1909, Union City, NJ.
Addresses: San Francisco, CA. **Studied:** Calif. Sch. FA. **Member:** San Francisco Artists Gld.; San Francisco Women Artists. **Exhibited:** CPLH, 1946; San Francisco AA, 1944-46; Oakland Art Gal., 1944; Laguna Beach AA, 1944; San Francisco Women Artists, 1945. **Sources:** WW53; WW47.

STEELE, Margaret See: **NEUSACHER, Margaret (Mrs.)**

STEELE, Marian Williams (Mrs. Chauncey D., Jr.) *[Painter]* b.1916, Trenton, NJ.
Addresses: Cambridge, MA; Gloucester, MA. **Studied:** PAFA; Trenton Sch. Indust. Art; Barnes Fnd. **Member:** Guild Boston Artists; Academic Artists; Cambridge AA; AAPL; Calif. AA; Laguna Beach AA; Rockport AA; North Shore AA. **Exhibited:** Los Angeles Mus. Art, 1944; PAFA, 1933-37 (prizes), 1939, 1943; AAPL, 1938-41; Rockport AA, 1942, 1952-55; Newark Mus., 1938; Long Beach AA, 1944 (prize); Santa Paula, CA, 1944 (prize); Laguna Beach AA, 1933 (prize), 1934 (prize), 1935; Jordan-Marsh, Boston, 1942, 1946, 1953-55; AAPL, 1938 (prize), 1939 (prize); Gld. Boston Artists, 1953-55 (solo); North Shore AA, 1953-55 (prizes); Academic Artists, 1954-56; Cambridge AA, 1953-56; Busch-Reisinger Mus., Harvard Univ., 1958. Awards: Cresson traveling scholarship, PAFA, 1936. **Work:** portrait, New Jersey State Hospital; Leahy Clinic, Boston; Boston Skating Club. **Sources:** WW59.

STEELE, (Mr.) *[Portrait painter]* late 18th c.
Comments: C.W. Peale met him in Philadelphia in 1762 or 1763. He is said to have been of a good Maryland family and to have studied in Italy, but Peale thought him a poor artist and slightly mad. **Sources:** G&W; Sellers, *Charles Willson Peale,* 50-52. Cf. - - Stael.

STEELE, Sandra (Mrs. George Steele) *[Painter, illustrator]* b.1938, Las Vegas, NV.
Addresses: Van Nuys, CA in 1968. **Studied:** Pierce Jr. College; Famous Artists School. **Member:** CAA (assoc. member). **Comments:** Animation artist at Walt Disney Studio. **Sources:** P&H Samuels, 462.

STEELE, Susan F. *[Painter]* b.1835, Massachusetts.
Addresses: Washington, DC, from 1872. **Exhibited:** Soc. of Wash. Artists, 1899-1900 (miniature portrait). **Sources:** McMahan, *Artists of Washington, DC;* Petteys, *Dictionary of Women Artists,* cites birth date of 1834.

STEELE, T(heodore) C(lement) *T C STEELE*
[Portrait painter, landscape painter]
b.1847, near Gosport, Owen County,
IN / d.1926, Brown County, Indiana.
Addresses: Waveland, IN; Indianapolis, IN; Bloomington, IN. **Studied:** Waveland Collegiate Inst., 1859-68; with J. Tingley of Asbury College, 1863; Chicago and Cincinnati; Royal Acad., Munich with Benczur, 1880; and in Schleissheim with Currier and landscape with Loefftz, 1881; honorary M.A., Wabash College; honorary LL.D., Indiana Univ. **Member:** Portfolio Club, 1890 (charter member); ANA, 1913; Boston AC; Indianapolis AA; Ind. AC; member of jury for Paris Expo, 1900, St. Louis Expo, 1904, and Panama-Pacific Expo, 1915; Soc. Western Artists (president, 1898). **Exhibited:** Russellville Fair, 1861 (prize); County Fair, Terre Haute, 1863 (prize); Royal Acad., Munich. 1884 (silver medal); Art Exhibit of Hoosier Colony in Munich, 1885; Boston AC, 1886-1890; PAFA Ann., 1888, 1900, 1906; NAD, 1888-95; World's Columbian Expo, Chicago, 1893; Denison Hotel, Indianapolis, 1894; Five Hoosier Painters, Chicago, 1894; Indiana State Fairs; Soc. of Am. Artists, 1886; Paris Expo, 1900 (honorable mention); Louisiana Purchase Expo, St. Louis, 1904; Richmond Art Assoc., 1906 (Mary T. R. Foulke award); annually, Soc. Western Artists, Chicago, 1909 (Fine Arts Building Award); International Exhibition FA, Buenos Aires and Santiago, 1910; Panama-Pacific Expo. San Francisco, 1915; Hoosier Salon, Marshall Field Galleries, Chicago, 1926 (Rector Prize); AIC. **Work:** Mural project, Indianapolis City Hospital; Indianapolis Mus. Art ("Pleasant Run"); Cincinnati Mus.; Herron AI, Indianapolis; St. Louis Mus.; Richmond AA; Univ. Missouri; Christian College, Columbia, MO; Indiana Univ.; Richmond (IN) Gal.; Boston AC; many clubs & universities. **Comments:** Steele grew up in Waveland, IN where he first began to develop his artistic talents. He studied briefly in Chicago and Cincinnati and was a professional portraitist for three years in Battle Creek, MI before moving to Indianapolis. There he became the most important art figure in 1870s and the best-known Hoosier artist of the late 19th-early 20th centuries. He organized the short-lived Indianapolis Art Assoc., along with John Love and several others, in1877. In 1878 he went to Munich to study at the Royal Academy. He returned to Indianapolis in 1885 and opened a studio. He was one of those known as the "Five Hoosier Painters" (along with Adams, Forsyth, Gruelle, and Stark). In 1889 he opened an art school--one of his students was Booth Tarkington. Forsyth joined him there in 1891 when the school was incorporated by the Art Assoc. as the Indiana School of Art, which operated for six years. By the 1890s Steele had adopted a style that was a modified version of Impressionism. After 1898 Steele spent summers painting at a home he owned with J. Ottis Adams in Brookville. After the death of his wife, Libbie, he made trips to Oregon and California. In 1907 he remarried and moved to Brown County which became a major summer art colony in the Midwest. Positions: instructor, drawing and painting, Waveland Collegiate Inst., 1865-68; honorary professor of art, Univ. Indiana, 1918-26. **Sources:** WW25; Gerdts, *Art Across America,* vol. 2: 261, 268-73 (with repro.); Newton and Gerdts, 154; Falk, *Exh. Record Series.*

STEELE, Thomas Sedgwick *[Painter, illustrator]* b.1845, Hartford, CT / d.1903, Swampscott, MA.
Addresses: Hartford, CT, *T, S, Steele-'91,* 1895; later in Boston, MA. **Studied:** P. Marcius-Simons, in Paris. **Member:** SC, 1894; Boston AC. **Exhibited:** Brooklyn AA, 1875, 1891; NAD, 1877, 1895; Boston AC,1890-99. **Comments:** A specialtist in painitng fish, game, and flowers, he was also an author/illustrator of travel books. **Sources:** WW01.

STEELE, Viola *[Miniature painter]* 20th c.
Addresses: NYC. **Exhibited:** AIC, 1912-13. **Sources:** WW15.

STEELE, Willard Karl *[Painter, educator] b.1910, Willard, OH.*
Addresses: Wheaton, IL; Jackson, MI. **Studied:** John Herron Art Sch., Indianapolis, IN. **Member:** Indiana Artists Club. **Exhibited:** Hoosier Salon, 1930-35, 1936-39 (prizes), 1937-46; Indiana Artists Club, 1936 (prize), 1938, 1941, 1942; Indiana Artists (prize). **Work:** Northwestern Univ. **Comments:** Position: artist in residence & lecturer, Wheaton (IL) College, 1946-. **Sources:** WW53; WW47.

STEELE, William Porter *[Painter of portraits, animals, and scenes from shakespeare's plays] b.1817, Harmony Hall, Lancaster County, PA, / d.1864, NYC.*
Addresses: NYC, 1864 and before. **Comments:** He graduated from Rutgers College in New Jersey and studied law at Lancaster (PA). **Sources:** G&W; Lancaster County Historical Society, *Papers,* XVI (1912), 278.

STEELE, Z. de L. (Mrs.) See: **STEELE, Zulma (Mrs. Neilson T. Parker)**

STEELE, Zulma (Mrs. Neilson T. Parker) *ZULMA STEELE*
[Painter, potter, printmaker, craftsperson, furniture maker, book designer] b.1881, Appleton, WI / d.1979, Westchester, NY.
Addresses: Woodstock, NY, 1902-67; Rutland, VT, 1891; Brooklyn, NY. **Studied:** AIC; PIA School, late 1890s; BMFA School; ASL with B. Harrison; A. Lhote. **Member:** NAWPS; Woodstock AA; Gld. Craftsmen. **Exhibited:** Boston AC, 1894, 1896, 1899; NAD, 1891; AIC; S. Indp. A.; PAFA; BMFA; Baltimore MA; CI; Ohio Univ.; Indiana State Univ.; Paradox Gal., Woodstock, NY, 1980s (solo); Assoc. Am. Artists, NYC, 1988 (solo, monotypes). **Work:** Woodstock AA. **Comments:** She was among the first artists to live and work in the utopian colony, Byrdcliffe, founded in 1902 near Woodstock. With Edna Walker she designed "mission oak" furniture on which she painted landscapes and leaf designs, c.1902-09. She also made pottery called "Zedware," and designed books. She painted rural Catskill scenes in an Impressionist manner. She married a farmer, Nelson Parker, in 1926. After he died in 1928, she traveled extensively in Europe. **Sources:** WW33; exh. flyer, Paradox Gal., Woodstock, NY (1980s); Woodstock AA.

STEELMAN, Larry *[Painter] b.1919, Ely, NV / d.1986, Larkspur, CA.*
Addresses: Marin County, CA. **Member:** Soc. of Western Artists. **Exhibited:** GGE, 1939. **Sources:** Hughes, *Artists of California,* 532.

STEELS, John See: **STEEL, John**

STEENE, William *[Portrait painter, sculptor] b.1888, Syracuse, NY / d.1965.*
Addresses: Ocean Springs, MS. **Studied:** ASL with R. Henri, H.B. Jones, and K. Cox; NAD; Académie Julian, Fontainebleau Sch. Art, Acad. Colarossi, and École des Beaux-Arts, all Paris. **Member:** Mural Painters; NSMP; AFA; Grand Central Art Gal.; CAFA; SSAL; Artists Fund of Am.; Lotos Club; Salmagundi Club. **Exhibited:** Arch. Lg.; NAD; Macbeth Gal.; Milch Gal.; Grand Central Art Gal.; Allied Artists Am.; CAFA; BM; Southern State AA; PAFA; Lyme AA; BAID (medal); Mississippi AA (medal). **Work:** City Hall, Galveston; Court House, Tulsa; Talequah, OK; Washington County (AR) Court House;Presbyterian Church, New Rochelle, NY; Univ. Alabama; Gov. Mansion, Hist. Soc., both in Jackson, MS; Georgia Military Acad., Atlanta; Masonic Hall, Greenville, MS; Macon, GA; Mississippi AA, Asheville, N.C; Winthrop College, Rock Hill, SC; Central H.S., Charlotte, NC; Milledgeville, GG; Tift College, Forsyth, GA; A&M College, Starkville, MS; M.S.C.W., Columbus, MS; mural, H.S., Tulsa; Medical Center, NYC; NYU; Columbia; Duke Univ.; AIC; Supreme Courts, Georgia, North Carolina; Hercules Powder Co., Wilmington, DE; murals, Hist. Soc., Raleigh, NC; Martha Washington Jr. College, Washington, DC. **Sources:** WW59; WW40.

STEENKS, Gerard L. *[Still life painter] 19th/20th c.*
Addresses: Brooklyn, NY (act. 1890-1901). **Exhibited:** NAD, 1890-92; Brooklyn AA, 1891; Boston AC, 1891; AIC; PAFA Ann., 1895. **Sources:** WW01; Falk, *Exh. Record Series.*

STEENROD, Margaret See: **FETZER, Margaret Steenrod**

STEEPER, John *[Engraver] mid 18th c.*
Addresses: Philadelphia, active 1755-62. **Comments:** In 1755 he collaborated with Henry Dawkins on an engraving entitled "Southeast Prospect of the Pennsylvania Hospital." **Sources:** G&W; Stauffer; Prime, I, 27 [erroneously as Sleeper]; *Penna. Gazette,* March 25, 1762; Hamilton, *Early American Book Illustrators and Wood Engravers,* 48.

STEER, Emma See: **SAMPSON, Emma Steer Speed (Mrs. Henry A.)**

STEER, Philip Wilson *[Painter] b.1860 / d.1942.*
Exhibited: Armory Show, 1913; AIC, 1935. **Sources:** Falk, *AIC;* Brown, *The Story of the Armory Show.*

STEERE, Arnold *[Portrait painter] b.1792, Smithfield, now Woonsocket, RI / d.1832.*
Addresses: Woonsocket and Philadelphia, active 1815-32. **Exhibited:** Am. Acad., 1928; NAD, 1828. **Sources:** G&W; Sears, *Some American Primitives,* 290, as Steere; Cowdrey, NAD, as Steers; Cowdrey, AA & AAU, as F. Steere.

STEERE, Lora (Dora) Woodhead *[Sculptor] b.1888, Los Angeles, CA / d.1984, Riverside County, CA.*
Addresses: Hollywood, San Jacinto, CA. **Studied:** Univ. Southern California; BMFA School, with Bela Pratt; Stanford Univ., A.B.; George Washington Univ., M.A.; Calif. School FA; Art Schule Reiman in Berlin, and with A. Torff; & with Ralph Stackpole; Lentelli, Florence Wyle, in Toronto. **Member:** San Diego Art Guild; Calif. AC; Southern Calif. Sculptors Guild; Artland Club, Los Angeles. **Exhibited:** AIC; PAFA Ann., 1922; SFMA; LACMA; San Francisco AA, 1924; S. Indp. A., 1928-29; Mission Gal., Riverside, CA, 1933 (solo);. **Work:** Los Angeles Mus. Art; Univ. Southern California; Lincoln Mem. Univ., Cumberland Gap, TN; Jordan H.S., Los Angeles; Forest Lawn, Los Angeles; Albert Wilson Hall, Los Angeles; Stanford Univ.; Pearl Keller Sch. Dramatic Arts, Glendale, CA. Scientific drawings for Smithsonian Inst.; porcelain port. of children; port. busts, Idyllwild School Music & Art. **Comments:** Position: ceramics instructor, Los Angeles (CA) High Schools; Idyllwild (CA) School Music & Art. **Sources:** WW59; WW47; Falk, *Exh. Record Series.* More recently, see Hughes, *Artists in California,* 533.

STEERE, William T. *[Sketch artist] mid 19th c.*
Work: Shelburne (VT) Mus. ("The Narrows, Lake George"). **Comments:** Active c.1860. **Sources:** Muller, *Paintings and Drawings at the Shelburne Museum,* 129 (w/repro.).

STEERS, Arnold See: **STEERE, Arnold**

STEERS, L. May *[Artist] late 19th c.*
Addresses: Active in Wayne, MI, 1885. **Sources:** Petteys, *Dictionary of Women Artists.*

STEES, Sevilla L. *[Painter] 20th c.; b.Phila., PA.*
Addresses: Phila., PA. **Studied:** PAFA; Women's School Des. **Member:** Phila. Plastic Club. **Exhibited:** PAFA, 1925; Soc. Indep. Artists, 1927; Salons of Am., 1934, 1935. **Sources:** WW33.

STEESE, Edward *[Painter] 20th c.*
Exhibited: Salons of Am., 1923. **Sources:** Marlor, *Salons of Am.*

STEESE, Maud Heaton *[Painter] 20th c.*
Exhibited: Salons of Am., 1923, 1924. **Sources:** Marlor, *Salons of Am.*

STEFAN, Ross *[Painter] b.1934, Milwaukee, WI.*
Addresses: Living in Tucson, AZ in 1976. **Work:** Gilcrease Inst.; The Arizona Bank. **Comments:** Began painting fulltime at age 21,

with a studio and gallery in Tubac, AZ. Specialty: Southwestern deserts and mountains, portraits. **Sources:** P&H Samuels, 462.

STEFANELLI, Joseph J. *[Painter] b.1921, Philadelphia, PA.*
Addresses: New York, NY. **Studied:** Philadelphia Mus. College Art, 1938-40; PAFA, 1940-41; New School Social Res., New York, NY, 1949-50; ASL, 1950-51; Hans Hofmann School Painting, New York, 1951-52. **Exhibited:** Corcoran Gal biennial, 1959; Carnegie Intl; WMAA,1957-61; AIC; Westbeth Gals., 1971 (solo); New School Social Res., 1972 (solo). Other awards: Fulbright Award for Rome, 1958-59; Am. Res. Center Egypt fellowship, 1966-67; NY State Council Arts Award, 1971. **Work:** WMAAt; Walker Art Center; Norfolk Art Mus.; Baltimore Mus.; New York Univ. **Comments:** Teaching: Univ. Calif., Berkeley, summers 1960 & 1963; visiting critic, Cornell Univ.; artist-in-residence, Princeton Univ., 1963-66; Spear Research Fund Award, Rome, summer 1965; visiting critic, Univ. Arkansas; Columbia Univ., 1966-; New School Social Res., 1966-70s. **Sources:** WW73.

STEFANOTTY, Robert Alan *[Art dealer] b.1947, Arlington, NJ.*
Addresses: NYC. **Studied:** Bowland College, Univ. Lancaster, England, A.B. (honors), aesthetics with Prof. Sibley; Bryn Mawr Grad. School. **Comments:** Positions: manager, Felix Landau Gallery, Los Angeles, 1970-71; asst. director, La Boette, New York, 1971-72; director, Gimpel & Weitzenhoffer, Ltd., 1972-. **Sources:** WW73.

STEFFAN, Edward *[Apprentice lithographer] b.c.1842, Pennsylvania.*
Addresses: Philadelphia, active 1860-71. **Comments:** He was listed in 1871 as a lithographer. **Sources:** G&W; 8 Census (1860), Pa., LX, 342; Phila. CD 1871.

STEFFAN, Eugene *[Engraver] b.c.1839, Switzerland.*
Addresses: NYC, active 1860. **Sources:** G&W; 8 Census (1860), N.Y., XLIII, 90.

STEFFEN, Bernard Joseph *[Painter, lithographer] b.1907, Neodesha, KS / d.1980, Flushing, or Woodstock, NY?.*
Addresses: NYC. **Studied:** S. Macdonald-Wright; E. Lawson; B. Robinson; T.H. Benton. **Member:** Am. Artists Congress; Woodstock AA. **Exhibited:** Mid-Western Exhib., Kansas City AI, 1930-31 (medals); WMAA, 1940-42; AIC. **Work:** WPA mural, USPO, Neodesha, KS; Woodstock AA. **Sources:** WW40; Woodstock AA.

STEFFEN, Randy *[Illustrator, painter, sculptor, writer-historian] b.c.1915, Maverick County, TX.*
Addresses: Living in Dublin, TX in 1974. **Studied:** US Naval Acad., Annapolis. **Comments:** Of Sioux descent, Steffen lived with the Sioux before working in Hollywood as a stuntman. Specialty: horses and riders, including the American military; Native Americans. **Sources:** P&H Samuels, 462-63.

STEG, J. L. *[Printmaker] 20th c.; b.Alexandria, VA.*
Addresses: New Orleans, LA. **Studied:** Rochester Inst. Technology, 3 year certificate; State Univ. Iowa, B.F.A. & M.F.A. **Member:** Am. Color Print Soc. **Exhibited:** Eighth Int. Print & Drawing Exhib., Lugano, Switzerland, 1964; Eight Am. Intaglio Printmakers, Germany, 1965; Graphic Arts USA to Russia, 1966; Prints of Two Worlds, Rome & Philadelphia, 1966; Big Prints USA, State Univ. NY College New Paltz, 1968; Assoc. Am. Artists, NYC, 1970s. Awards: Charles Lea Prize, Philadelphia Print Club, 1950-64; purchase prize, Eighth Int. Print & Drawing Exhib., Lugano, 1964; purchase prizes, State Univ. NY College Potsdam Print Exhib., 1964-68. **Work:** LOC; Smithsonian Nat. Collection, Washington, DC; Brooklyn Mus., NY; MoMA; Fogg Mus., Cambridge, MA. Commissions: edition of 50 prints, Assoc. Am. Artists, 1966. **Comments:** Publications: author, article, *Artists Proof,* 1966. Teaching: instructor of drawing & painting, Cornell Univ., 1949-51; professor of drawing & printing, Tulane Univ., 1951-. **Sources:** WW73.

STEGAGNINI, Louis *[Ornamental sculptor or marble mason] mid 19th c.*
Addresses: Philadelphia, 1823-40. **Sources:** G&W; Phila. CD 1823-40, as Stegagnini; Scharf and Westcott, *History of Philadelphia,* as Stegnani.

STEGALL, Irma Matthews (Mrs. Charles W.) *[Painter, lecturer] b.1888, Llano, TX.*
Addresses: Montgomery, AL. **Studied:** North Texas State Teachers College; Dallas AI; & with Martha Elliott, Olin Travis. **Member:** Alabama Art Lg.; AAPL; Texas FAA; Alabama WCS; SSAL; AAUW. **Exhibited:** Texas FAA; SSAL; Alabama Art Lg., 1932 (prize), 1947 (prize); Alabama WCS; Birmingham AL; Women's Club, Montgomery (solo); Montgomery MFA (solo); Carnegie Lib., Montgomery (solo). **Comments:** Positions: art director, Am. Assn. Univ. Women, Montgomery Branch, 1944-45, 1945-46; Woman's Club, 1944-45, 1945-59; board member, Montgomery MFA, 1945-46, 1954-56. Contributor to *Montgomery Advertiser,* on current art exhibits. **Sources:** WW59; WW47.

STEGALL, James Park *[Painter, instructor] b.1942, Wichita Falls, TX.*
Addresses: Fort Worth, TX. **Studied:** PAFA; restoration of painting with Marilyn Roswell Weidner; also with Walter Stuempfif & Ben Kamihira, Spain. **Exhibited:** NAD, 1956-64; PAFA Ann., 1963-65 (Cresson Mem. Award, 1964); Pittsburgh Nat., 1965 (first purchase award); Tarrant Co. Ann., Fort Worth, TX, 1968 (first prize); Carlin Galleries, Fort Worth, TX, 1970s. **Comments:** Preferred media: oils. Teaching: art instructor, Fort Worth AC Mus., 1968-. **Sources:** WW73.

STEGE, Wallace T. *[Sculptor, painter] 20th c.*
Addresses: Racine, WI. **Exhibited:** Milwaukee AI, 1936 (sculpture prize); AIC, 1939. **Sources:** WW40.

STEGEMAN, Charles *[Painter, educator] b.1924, Ede, Netherlands.*
Addresses: Gladwyne, PA. **Studied:** Acad. Beeldende Kunst, The Hague; Acad. Royale Beaux Arts, Brussels; Inst. Nat. Superieur Beaux-Arts, Antwerp. **Exhibited:** Western Art Circuit, Western Canada, 1952-53; Toronto Art Gallery, 1961; Winnipeg Biann, 1961; Montreal MFA, 1962; Chicago Centennial Exhib., 1963; Harold Patton, Detroit, MI, 1970s. **Work:** Nat. Gallery Canada; Ontario Art Gallery; Vancouver Art Gallery; Art Gallery Greater Victoria; Univ. BC. **Comments:** Preferred media: oils, acrylics. Teaching: assoc. professor of painting, AIC, 1962-69; assoc. professor of painting & chmn. dept., Haverford College, 1969-. **Sources:** WW73.

STEGNANI, Louis See: **STEGAGNINI, Louis**

STEGNER, Nicholas *[Painter, craftsperson] b.1882, Honesdale, PA.*
Addresses: Honesdale, PA; NYC. **Member:** AAPL. **Exhibited:** S. Indp. A., 1922-26; Salons of Am., 1931; Studio Gld., 1939; Hallmark Exhib., 1949, 1952; Hawley Lake, PA, 1958. **Work:** "The White Deer Inn," Hawley, PA. **Comments:** Decorator of china, glass, and furniture. **Sources:** WW59; WW47.

STEGNER, Sophie Hartman *[Printmaker, painter] b.1883, NYC / d.1973, Santa Barbara, CA.*
Addresses: San Francisco, CA; Santa Barbara, CA. **Exhibited:** San Francisco AA, 1935. **Sources:** Hughes, *Artists of California,* 533.

STEHL, Edward Richard *[Mural painter] b.1844 / d.1919, Sea Cliff, NY.*

STEHLIN, Caroline *[Painter] 20th c.*
Addresses: NYC. **Exhibited:** PAFA Ann., 1904-11; AIC, 1908-10. **Sources:** WW13; Falk, *Exh. Record Series.*

STEIB, Josef *[Painter] 20th c.*
Exhibited: AIC, 1932. **Sources:** Falk, *AIC.*

STEICHEN, Edward (Eduard) (Jean) STEICHEN *[Photographer, painter, curator] b.1879,* MDCCCCX *Luxembourg / d.1973, W. Redding, Connecticut.*
Addresses: Hancock, MI (immigrated 1881); NYC/Voulangis, France 1906-23; NYC/Crecy-en-Brie, France. **Studied:** Milwaukee ASL, 1898; Académie Julian, Paris with J.P. Laurens, 1900-01. **Member:** Linked Ring, 1901; Photo-Secession, 1902 (co-founder); Salon d'Automne, Paris. **Exhibited:** Boston AC, 1905, 1906; Photo-Secession, 1906, 1908, 1909; "Younger American Painters," 291 Gal., NYC, 1910; PAFA Ann., 1906-07, 1920; AIC, 1910; Corcoran Gal biennial, 1910; S. Indp. A., 1917; Salon d'Automne, 1922; Salons of Am., 1930; Photo. Soc. of Germany, 1960 (prize); Royal Photo. Soc., London, 1961 (prize); MoMA, 1932, 1961; Heckscher Mus., 1985; Luxembourg Mus., 1988. Other awards: Pres. Medal Freedom, 1963. **Work:** MoMA (largest collection, as well as the Steichen Archive); IMP; AIC; LOC; MMA; NOMA; Royal Photo. Soc.; other major collections; paintings at: MMA; TMA; murals, Luxembourg Mus.
Comments: From 1896-1910s, he was both a painter and a pictorialist photographer who became, along with Alfred Stieglitz, one of the founders the Photo-Secession. In 1905 he and Stieglitz established the "Little Galleries of the Photo-Secession" (later referred to as "291"). He also designed the covers for the Photo-Secession's *Camera Work.* During WWI, he changed the spelling of his first name from "Eduard," and was chief photographer for the Air Force. In 1922, he renounced painting and burned many of his canvases. From 1923-38, he did fashion photography and celebrity portraiture for *Vogue* and *Vanity Fair.* During WWII, he was director of all combat photography for the Navy. From 1947-62 he was photography curator at MoMA, and organized the landmark exhibition "Family of Man," which was seen in 69 countries from 1952-55. Signature note: His pictorialist photos and landscape paintings (1890s-1910s) are usually signed in a consistent style of capital letters with dates in Roman numerals. Author: *A Life in Photography* (New York: Doubleday, 1963). **Sources:** WW29; Witkin & London, 241; William I. Homer, *Alfred Stieglitz and the Photo-Secession* (Boston, Little, Brown, and Co.. 1983); Anne Cohen De Pietro, *The Paintings of Eduard Steichen* (Huntington, NY: Heckscher Mus., 1985); Mary Anne Goley, From Tonalism to Modernism: The Paintings of Eduard J. Steichen (exh. cat., Luxembourg Gallery, 1988); Pisano, *The Long Island Landscape,* n.p.; Baigell, *Dictionary;* Falk, *Exh. Record Series.*

STEIDER, Doris (Mrs. C. B. McCampbell) *[Painter] b.1924, Decatur, IL.*
Addresses: Albuquerque, NM in 1976. **Studied:** Purdue Univ., B.S. (applied design), 1945; Univ. New Mexico, M.A. (fine art), 1965. **Member:** Nat. League Am. Pen Women (national art board); Artists Equity Assn.; New Mexico Arts & Crafts Fair (board member, six years); Albuquerque Fine Arts Advisory Board. **Exhibited:** Smithsonian Inst.; Army Traveling Print Shows, 1963 & 1964; Albuquerque Invitational, 1964, Annual Traveling Shows, 1966- & Southwest Biennials, Mus. New Mexico; Witte Mus. Western Art Show, San Antonio, TX; El Paso Sun Carnival, TX;Brandywine Galleries, Albuquerque, NM & Baker Collector Gallery, Lubbock, TX, 1970s. Awards: popular awards, 1963-65, first prize prints & drawings, 1964, first prize acrylics & second prize oils, 1967 & 1969, purchase prizes 1970 & 1971, New Mexico State Fair; special award for traditional oils, Nat. League Am. Pen Women Shows, Tulsa, 1965; second prize, 14th Annual. **Work:** Commissions: Christmas card design for Int. Cardiovascular Foundation, 1960; Christmas card for New Mexico Crippled Children's Soc., 1964; cover brochure for Nat. Council Teachers Math, 1969; Christmas card for Delta Gamma Sorority, 1970; murals; St Joseph's Hospital, Albuquerque; plus others. **Comments:** Preferred media: egg tempera. Publications: illustrator, check series for Citizen's Bank, Albuquerque; paintings reproduced for cards, nat. distribution, Saga Printers. **Sources:** WW73; article & illustrations in *Trailer Life* (June,1969); article & cover in *Pen Woman Magazine* (March, 1969 & June, 1972); P&H Samuels, 463.

STEIG, Joseph *[Painter] 20th c.*
Addresses: NYC. **Exhibited:** Downtown Gal., NYC, 1937; Mus. Mod. Art, Wash., DC, 1938; AIC, 1937, 1939; WMAA, 1938. **Sources:** WW40.

STEIG, Mimi *[Painter] 20th c.*
Addresses: NYC. **Exhibited:** S. Indp. A., 1934. **Sources:** Marlor, *Soc. Indp. Artists.*

STEIG, William *[Cartoonist, painter,* W.Steig *sculptor] b.1907, NYC.*
Addresses: NYC. **Studied:** City College New York, 1923-25; NAD, 1925-29. **Exhibited:** AWCS, 1933, 1936; AIC, 1936; Downtown Gallery, New York, 1939 (sculpture solo); Smith College, 1940 (drawings & sculpture); PAFA Ann., 1944-46; WMAA, 1945-46. Awards: Caldecott Medal, 1970. **Work:** Wood sculpture, Rhode Island Mus. Art & Smith College; paintings, Brooklyn Mus. **Comments:** Preferred media: wood. Illustrator: cartoons, *New Yorker* and other leading magazines; "About People," pub. Random House, 1939. Other publications: author/illustrator, "Sylvester and the Magic Pebble" (1969), "The Bad Island" (1969), "An Eye for Elephants" (1970), "Amos & Boris" (1971) & "Male/Female" (1971). **Sources:** WW73; WW40; Falk, *Exh. Record Series.*

STEIGER, Harwood *[Painter, block printer, lecturer, teacher] b.1900, Macedon, NY.*
Addresses: NYC/Edgartown, MA. **Studied:** D. Garber, PAFA; H. Breckenridge. **Exhibited:** Mem. Art Gal., Rochester, 1928, 1929 (prize) 1930 (prize), 1931 (prize); AIC; WMAA. **Work:** Mem. Art Gal., Rochester, NY; WMAA; WPA mural, USPO, Fort Payne, AL. **Comments:** Position: teacher, Stieger Paint Group, Edgartown, MA. **Sources:** WW40.

STEIGERWALD, Thomas *[Painter] b.1945.*
Addresses: Phila., PA. **Exhibited:** WMAA, 1969. **Sources:** Falk, *WMAA.*

STEIGLITZ, Alfred See: **STIEGLITZ, Alfred**

STEIGNER, Adelaide *[Painter] 20th c.*
Addresses: Newark, NJ. **Sources:** WW19.

STEIN, A. *[Landscape painter] mid 19th c.*
Addresses: Munich, 1850; Philadelphia, 1855. **Exhibited:** PAFA, 1850 (copy after Murillo); PAFA, 1855. **Sources:** G&W; Rutledge, PA.

STEIN, Aaron *[Lithographer] b.1835 / d.1900.*
Exhibited: Calif. State Bldg., World's Columbian Expo, Chicago, 1893; GGE, 1940. **Work:** Oakland Mus.; Soc. of Calif. Pioneers. **Comments:** His view of *California and Oregon State Company* was reproduced by Britton & Rey, lithographers. **Sources:** Hughes, *Artists of California,* 533.

STEIN, Annie *[Painter] b.1879, NYC.*
Addresses: NYC. **Studied:** ASL, with George Bridgman, Richard Lahey, Alexander Brook; Thurn School, Gloucester, MA. **Member:** NAWA; Bronx Art Lg. **Exhibited:** Morton Gal., NYC, 1937 (solo); Pub. Lib., NYC, 1938; Studio Guild, 1938; Cornell Univ.; Yonkers, Mus.; ASL, 1939. **Work:** WPA mural, Marine Hospital, Carville, LA; FAP, Wash., DC. **Sources:** WW53; WW47; Petteys, *Dictionary of Women Artists,* cites birth date of 1889.

STEIN, B(eatrice) *[Painter] 20th c.; b.NYC.*
Addresses: NYC. **Studied:** with Walter Pach, Jacques Villon. **Exhibited:** S. Indp. A., 1929, 1932-35; 1937-38, 1941, 1943-44; Vendome Gal., 1940; Theodore Kohn Gal., 1941; Mus. New Mexico, Santa Fe,1941; Milwaukee AI, 1945. **Comments:** <I>Cf. Steegmuller, Beatrice Stein. **Sources:** WW53; WW47.

STEIN, Charles *[Portrait painter] mid 19th c.*
Addresses: NYC, 1854-57. **Sources:** G&W; NYBD 1854-57.

STEIN, David *[Painter] b.1887 / d.1959, Waterbury, CT.*
Exhibited: S. Indp. A., 1942. **Sources:** Marlor, *Soc. Indp. Artists.*

STEIN, Evaleen [Painter, designer, illustrator, author]; b.Lafayette, IN.
Addresses: Active in Lafayette, IN, early 20th c. **Sources:** Petteys, Dictionary of Women Artists.

STEIN, Frances [Artist] b.1903 / d.1986.
Member: Woodstock AA. **Sources:** Woodstock AA.

STEIN, Gertrude [Patron, writer] b.1874, Allegheny, PA / d.1946, Neuilly (Paris).
Studied: Johns Hopkins Univ. (medicine). **Comments:** From 1893-97 was a student at Radcliffe College, where she was a pupil of William James & experimented with spontaneous automatic writing. Studied medicine for 4 years at Johns Hopkins Univ., spent a year in London, and in 1903 settled in Paris. Possessing an independent income, she became a patron of Picasso, Matisse, Braque, and other moderns, introducing them to the French and American public. Her first book was titled "Three Lives," 1909.

STEIN, Harve [Painter, educator, illustrator, graphic artist, lecturer] b.1904, Chicago, IL.
Addresses: Mystic, CT; Noank, CT. **Studied:** AIC, 1922-26; Académie Julian, Paris, 1927; ASL, 1930-33; also with Harvey Dunn. **Member:** Soc Illustrators (hon. life member); AWCS; Audubon Artists; Artists Fellow; Appraisers Assn. Am.; Mystic AA; Providence AC. **Exhibited:** AIC, 1937; WFNY, 1939; AWCS, 1934-44; Mystic AA, 1934-45; PAFA, 1934-40; South Country AA; Springfield AL; Providence Watercolor Club, 1956 (award); New Haven Paint & Clay Club, 1957 (award); Providence Art Club, 1963 (award). **Work:** U.S. State Dept.; Univ. Minnesota; Brown Univ.; Public Archives, Toronto, Montclair (NJ) Art Mus. **Comments:** Preferred media: watercolors. Positions: director, Stone Ledge Studio Art Galleries, Noank, CT, 1963-. Publications: illustrator of many books; contributor to many magzines; author, "The Illustrator Explains," Am. Artist, 1958. Teaching: Connecticut College, 1946-47 & 1951; New London ASL, 1948-59; Mitchell College, summers, 1955-56; emer. prof., RISD. **Sources:** WW73.

STEIN, Helen C. [Painter] b.1896, NYC / d.1964, Gloucester, MA.
Addresses: E. Gloucester, MA. **Exhibited:** S. Indp. A., 1930. **Sources:** Marlor, Soc. Indp. Artists.

STEIN, Irene [Painter, printmaker, stained glass artisan, sculptor] b.1895, Denver, CO.
Studied: AIC; Univ. Colorado. **Exhibited:** traveling exhibs. at Dallas Mus., Hastings (NE) College, Minneapolis & San Francisco; Int. House, Denver, 1960 (solo); Neusteters. Gal., 1969 (solo). **Sources:** Petteys, Dictionary of Women Artists.

STEIN, Jacob [Engraver] b.1811, Bavaria (Germany).
Addresses: NYC, 1860. **Comments:** Jacob Stein, machinist, was listed in 1863. **Sources:** G&W; 8 Census (1860), N.Y., XLVIII, 914; NYCD 1863.

STEIN, Janet A. [Portrait painter] 20th c.
Addresses: NYC. **Studied:** ASL; Woodstock Sch. Art. **Member:** ASL. **Exhibited:** S. Indp. A., 1932; Salons of Am., 1934, 1936; Corcoran Gal biennial, 1935. **Sources:** WW40.

STEIN, John [Portrait painter] b.c.1794, possibly Washington, VA.
Addresses: Steubenville, OH, c.1820; Natchez, MS, 1822; Hillsboro, OH, 1826; Steubenville in 1827. **Work:** Western Reserve Hist. Soc., Cleveland, OH (portraits of Mr. and Mrs. Bezaleel Wells, 1827). **Comments:** An itinerant painter, he was the first teacher of Thomas Cole, c.1820 in Steubenville. He also taught James Reid Lambdin about the same time. Stein was in Mississippi in 1822 where he met John James Audubon and gave the naturalist some lessons in oil painting. He is believed to have been a native of Washington (VA), born between 1790-98 and to have died at a young age while on board a ship to Europe. **Sources:** G&W; Dunlap, History, II, 260. More recently, see Hageman, 95; Gerdts, Art Across America, vol. 1: 285 and vol. 2: 88, 207.

STEIN, Lewis [Painter] b.1946.
Addresses: NYC. **Exhibited:** WMAA, 1969. **Sources:** Falk, WMAA.

STEIN, Maurice Jay [Painter, designer] b.1898, New York, NY.
Addresses: New York, NY. **Studied:** Cooper Union; Pratt Inst., City College New York; Acad. Venice; Columbia Univ. **Member:** Kappi Pi (hon. member); Royal Soc. Arts (fellow); Nat. Soc. Arts & Letters (treasurer, 1966); Catholic Fine Arts Soc. (hon. member). **Exhibited:** United Irish Charities, New York, 1962; Nat. Soc. Arts & Letters, 1963; Farnsworth Mus., Rockland, 1963 & 1964; Nat. Soc. Arts & Award Show, New York, 1967; 20 Selected Professionals, March of Dimes, 1968. Awards: Grumbacher award of merit, 1961; first prize gold medal, United Irish Co. Charities, Hunter College 30th Art Exhib., 1962; gold medal for year, Catholic Fine Arts Soc., 1970. **Work:** Seaman & Int. Inst. Gallery, New York; Univ. Maine, Orono; St. Peters Episcopal Church, Rockland, ME; Yeshiva Univ., New York; College John Hamilton Gillespie Mus., Sarasota, FLa. Commissions: portraits, Dr. Jonas E. Salk, Virus Research, Univ. Pittsburgh, 1959, Capt. Eddie Rickenbacker, USA, 1960 & Lt. Gen. August Shomburg, USA, 1961; Christ, St. Peters Episcopal Church, 1968; Profet Micah, Temple Judea, Manhasset, NY, 1970. **Comments:** Positions: designer of jewelry for various manufacturers, 1920-50; chmn., Palette Scholarship Award Comnittee, 1967. Teaching: instructor in oil painting, Treasure Art Guild, Paramus, NJ, 1962-65; instructor in oil painting, Synagogue Golden Age Group, 1964-67. Art interests: founded Palette Scholarship Award for honor art h.s. students in 1967. **Sources:** WW73.

STEIN, Modest [Painter] b.1871 / d.1958, Flushing, NY.
Addresses: NYC. **Member:** GFLA. **Exhibited:** S. Indp. A., 1917. **Sources:** WW27.

STEIN, Ralph [Cartoonist, illustratir, writer] b.1912, NYC / d.1997, Old Saybrook, CT.
Addresses: Westbrook, CT. **Comments:** During the 1930s, he was an illustrator for the World Telegram; during WWI he was a staff cartoon editor for Yank and his humorous views of Army life were compiled as the book, What Am I Laughing At? After WWII, he drew and wrote the famous Popeye comic strip for five years. Later, he wrote The Pinup from 1852 to Now. **Sources:** obit., New York Times.

STEIN, Roger Breed [Art historian] b.1932, Orange, NJ.
Studied: Harvard Univ., AB, 1954, AM, 1958, PhD, 1960. **Comments:** Publications: John Ruskin and American Aesthetic Thought, 1840-1900 (1960); Seascape and the American Imagination (Whitney Mus Am Art, 1975); Copley's Watson and the Shark and Aesthetics in the 1770's (SUNY, 1976); "Charles Willson Peale's Expressive Design, Prospects (No 6,1981). Teaching: SUNY, Binghamton, 1970-86; Univ. VA, 1986-98. **Sources:** Who's Who In American Art (1993-94).

STEIN, Ronald Jay [Sculptor] b.1930, NYC.
Addresses: NYC. **Studied:** Cooper Union, certificate in fine art, with Will Barnet; Yale Univ., B.F.A., with Joseph Albers; Rutgers Univ., M.F.A. **Exhibited:** CI, 1957; Inst. Contemporary Art, Boston, 1958; AIC Intl., 1960; Corcoran Gal biennial, 1961; Marlborough Gal., London, England, 1967 (solo); "Art in the Mirror," MoMA, 1970; Marlborough Gal, NYC, 1970s. **Work:** CI; Guggenheim Mus., New York; Tennessee FAC, Nashville; Wadsworth Atheneum, Hartford, CT; Loch Haven (FL) Art Center. Commissions: mosaic murals (with Lee Krasner Pollock) Uris Bros., New York, 1958. **Comments:** Preferred media: plastic. **Sources:** WW73.

STEIN, Ruth Phillips [Painter] 20th c.
Addresses: Chicago area. **Exhibited:** AIC, 1924. **Sources:** Falk, AIC.

STEIN, Walter [Painter, sculptor] b.1924, New York, NY.
Addresses: New York, NY. **Studied:** ASL; Cooper Union; NY

Univ.; New School Social Res.; Acad. Belle Arti, Florence. **Exhibited:** PAFA Ann., 1952; Corcoran Gal biennial, 1953; WMAA, 1955, 1960. **Work:** Phillips Collection, Washington, DC; Indianapolis Mus. Art; Fogg Art Mus., Cambridge, Mass; MoMA, New York; MMA. **Comments:** Preferred media: oils, watercolors, aluminum, plastic. Editor/illustrator: "Common Botany," 1953; "Tichborne's Elegy," 1968; illustrator, "Histoires Naturelles," Harvard Univ. Press, 1960. Teaching: Scarsdale Art Center, NY, 1968-69; Cooper Union, 1969-70; Five Towns Art Center, NY, 1970-71. **Sources:** WW73; Falk, *Exh. Record Series.*

STEINACHER, Teresa A. *[Painter] 20th c.*
Addresses: NYC. **Exhibited:** S. Indp. A., 1929, 1932. **Sources:** Marlor, *Soc. Indp. Artists.*

STEINBACH, Herb *[Painter] 20th c.*
Addresses: Peoria, IL. **Exhibited:** PAFA Ann., 1960. **Sources:** Falk, *Exh. Record Series.*

STEINBACK, I. L. (Mrs.) *[Artist] early 20th c.*
Addresses: Active in Los Angeles, 1906-09. **Sources:** Petteys, *Dictionary of Women Artists.*

STEINBACKER, Charles H., Jr. *[Painter] 20th c.*
Addresses: Phila., Pa. **Exhibited:** PAFA Ann., 1936. **Sources:** Falk, *Exh. Record Series.*

STEINBERG, Edith (Mrs. Milton) *[Art director] b.1910, NYC / d.1970.*
Addresses: Waltham, MA; NYC. **Studied:** Hunter College, NY; Butler Univ., Indianapolis, B.A. **Comments:** Position: exec. director, Brandeis Creative Arts Awards Program. **Sources:** WW66.

STEINBERG, George F. *[Painter] 20th c.*
Addresses: Chicago, IL. **Member:** Chicago SA. **Exhibited:** AIC, 1919. **Sources:** WW19.

STEINBERG, Herbert *[Painter] 20th c.*
Addresses: Brooklyn, NY. **Exhibited:** PAFA Ann., 1953. **Sources:** Falk, *Exh. Record Series.*

STEINBERG, Isador N *[Painter, designer, cartoonist, teacher] b.1900, Odessa, Russia.*
Addresses: NYC. **Studied:** School Design & Library Arts, scholarship; ASL; NYU; Grand Chaumière, Paris France; also with John Sloan & Max Weber. **Exhibited:** AIGA, 1941 (prize); "Fifty Books of the Year," 1939 (award); Newark AC, 1935. **Work:** Commissions: USA courses in Botany, Surveying, Lettering, Mechanical Drawing & others. **Comments:** Positions: consultant, book production & illustration, Pentagon, 1943; owner, York Studios, New York. Publications: illustrator, "Evolution of Physics," "Artist's Materials and Techniques," "Tools of War," "Military Roentgenology," "Exploring Science" & others. Teaching: lecturer, School of Design; instructor in advertising design, Columbia Univ. Extension. **Sources:** WW73; WW47.

STEINBERG, Nathaniel P. *[Etcher, painter, illustrator] b.1893, Jerusalem, Palestine / d.1966, Chicago, IL.*
Addresses: Chicago, IL. **Studied:** AIC; also with Walcott, Bellows, Sterba;W. Reynolds; Seyffert. **Member:** Palette & Chisel Acad., Chicago (pres., 1960-61); Chicago North Shore AA; Wash. WCC; Chicago Soc. Etchers; Southern Soc. Etchers. **Exhibited:** in many museums and galleries in U.S., London and Paris. Indiana Soc. Etchers, 1947 (prize); SAGA, 1950 (prize); Chicago Soc. Etchers, 1935 (prize), 1949 (prize); Paris Salon, 1937 (Print chosen by SAGA); Pallette & Chisel Club,1953(gold medal), prize,1959 (prize); Chicago Art Gld., 1955 (prize); Union Lg. Club, Chicago, 1957 (Bruce Parsons award);1964 (Preston Bradley award). **Work:** Fed. Court, Chicago; Smithsonian Inst.; Herzl H.S., Chicago; Four Arts, Palm Beach, FL. **Comments:** Position: staff artist, *Chicago American*, 1938-. **Sources:** WW66; WW47, which puts birth at 1895.

STEINBERG, Saul *[Cartoonist, painter, designer] b.1914, Romania / d.1999.* *STEINBERG*
Addresses: NYC (immigrated 1942). **Studied:** studied architecture at the R. Politecnico, Milan, Italy, 1933-40. **Exhibited:** MoMA, 1946; Betty Parsons Gal., 1952; Sidney Janis Gal., 1952, 1973 (solo); Inst. Contemporary Art, London, 1952; AIC, 1949; Obelisco, Rome, 1951; Galerie Maeght, Paris, 1953 (solo); Kunstmuseum, Basel, 1954 (solo); Stedeljik Mus., Amsterdam, 1953 (solo); Museo de Arte, Sao Paulo, Brazil, 1952 (solo); Galerie Blanche, Stockholm, 1953 (solo); Hanover, 1954 (solo); AFA, 1953-55 (solo); U.S. Pavillion, Brussels World's Fair, 1958 (mural)WMAA, 1947-56 (biennials), 1978 (retrospective). **Work:** NMAA; MoMA; MMA; FMA; Detroit IA; Victoria & Albert Mus., London; murals, Plaza Hotel, Cincinnati; four Am. Export Lines ships. **Comments:** His most famous image was an amusing cartoon of a New Yorker's view of America, whereby, looking west from Manhattan, little else appears across the United States, stretching all the way to the Pacific ocean. Appearing first as a *New Yorker* cover in 1976, it was widely distributed as a poster. During his career, Steinberg produced 85 covers for the *New Yorker* as well as 642 drawings. In 1949 he began making drawings on boxes and chairs. He made several collages in the 1960s, and in the 1970s made table-like assemblages. His books include *All in Line* (1945); *The Art of Living* (1949); *The Passport* (1954); *The Labyrinth* (1960); *The New World* (1965); *The Inspector* (1973); and *The Discovery of America* (1993). He also illustrated for *Fortune; Vogue; Town & Country,* and others. He married artist Hedda Sterne in 1947 (they separated in the 1960s). **Sources:** WW66; WW47; *NY Times, 13 My 1999;* Harold Rosenberg, *Saul Steinberg* (exh. cat., WMAA, 1978); Baigell, *Dictionary.*

STEINBOMER, Dorothy H *[Sculptor, art librarian] b.1912, Bayonne, NJ.*
Addresses: San Antonio, TX. **Studied:** Our Lady of the Lake College, B.A. & M.L.S.; Univ. of the Americas, Mexico City, M.F.A.; also with Harding Black, Etienne Ret, Michael Frary, Dan Lutz & Fletcher Martin. **Member:** Stained Glass Assn. Am.; Crafts Council; Craft Guild San Antonio; San Antonio Art League (pres., 1956-58); Mexican-Am. Cultural Exchange Inst. (pres., 1965). **Exhibited:** Texas FAA, 1957; Witte Mem. Mus, 1957 & 1960; Texas A&M Univ., 1959; Artisans Gallery, Houston, 1960; Craft Guild San Antonio, 1962-965; numerous studio shows of stained glass in Southwest. **Work:** Commissions: stained glass windows, Jefferson Methodist Chapel, Redeemer Lutheran Church, Northwood Presbyterian Church & Aldersgate Methodist Church, San Antonio, TX; fused glass hanging cross, First Presbyterian Church, Midland, TX; fused glass & metal sculpture, Holiday Inn, Dallas, TX; screen, McClaugherty Chapel, San Antonio; fused glass sculpture, Medical Center, Houston, TX. **Comments:** Teaching: lecturer, visual arts series, St. Mary's Univ.; asst. professor & art librarian, 1967-. Collections arranged: Community Arts Forum, San Antonio; Faith into Form, Church Arch. Guild Nat. Exhib., Dalls 1964; two int. exhibs. for Hemisfair, San Antonio, 1968. **Sources:** WW73.

STEINBROCKER, Ann *[Painter] b.1932.*
Addresses: NYC. **Exhibited:** WMAA, 1961. **Sources:** Falk, *WMAA.*

STEINBURG, Henry H. *[Fresco painter] d.1920, Wash., DC.*
Addresses: Wash., DC, active 1877-1905. **Sources:** McMahan, *Artists of Washington, DC.*

STEINECKE, Henry F. *[Engraver, seal engraver and die sinker] d.19.*
Addresses: NYC, 1858-59. **Sources:** G&W; NYBD 1858-59.

STEINEGER, Agnes *[Painter] 19th/20th c.; b.Christiana, Norway.*
Exhibited: Paris, France, Universal Expo., 1889 (hon. mention), 1900 (hon. mention); Soc. of Wash. Artists, 1892. **Sources:** McMahan, *Artists of Washington, DC.*

STEINEGGER, Henry *[Lithographer] b.c.1831, Switzerland / d.1893.*
Addresses: San Francisco, 1856-80. **Comments:** He was an employee of Joseph Britton and Jacques J. Rey (see entries)and

became a partner in 1859, when it was renamed Britton & Co.; and in 1867, Britton, Rey & Co. In 1875 Steinegger drew views of communities in Nevada, California and Idaho, which his firm printed. The land boom of the 1880's brought him to Southern California. **Sources:** G&W; 8 Census (1860), Cal., VII, 1312; Peters, *California on Stone*. More recently, see Reps, 209; P&H Samuels, 463.

STEINER, Michael *[Sculptor] b.1945, New York, NY.*
Addresses: New York, NY. **Exhibited:** Light Show, Inst. Contemporary Art, Phila., 1964; Larry Aldrich Mus., Ridgefield, CT, 1968; Minimal Art, Gemeentemuseum, The Hague, Holland, 1968; 8 American Sculptors, Pioneer Court, Chicago, 1968; WMAA, 1970, 1973; Norman MacKenzie Art Gallery, Univ. Sask., Regina, 1970. Awards: Guggenheim Award, 1971. **Work:** Storm King AC; Boston MFA; MoMA. **Comments:** Preferred media: steel, aluminum, brass. Teaching: instructor, Emma Lake Workshop, Univ. Sask., Regina, 1969; visiting artist, Cranbrook AI, Bloomfield Heights, MI, 1969. **Sources:** WW73; Terry Fenton, article, *Art Int.* (1970).

STEINER, Ralph *[Photographer] b.1899 / d.1986.*
Addresses: Thetford, VT (1985). **Studied:** Dartmouth College; C.H. White School Photography, NYC, 1921-22. **Work:** AIC; MMA; MoMA; Princeton AM. **Comments:** Also a filmmaker.

STEINER-PRAG, Hugo *[Illustrator, graphic artist] b.1880, Prague, Czechoslovakia (came to U.S. in 1941) / d.1945, NYC.*
Comments: Position: teacher, NYU.

STEINFELD, Ellen *[Painter] b.1945, Orange, NJ.*
Addresses: Buffalo, NY. **Studied:** Carnegie-Mellon Univ., Pittsburgh, PA, B.F.A., 1967; Univ. Pittsburgh, M.Ed., 1968. **Comments:** Moved to Buffalo in 1978; received CAPS grant from the New York State Council on the Arts, 1982; Visual Artists Sponsored Project, New York State Council on the Arts, 1984. **Sources:** Krane, *The Wayward Muse*, 197.

STEINFELS, Melville P *[Painter, designer, illustrator, teacher, lecturer] b.1910, Salt Lake City, UT.*
Addresses: Adrian, MI; Park Ridge, IL. **Studied:** AIC; Chicago Sch Design. **Member:** Catholic AA. **Work:** Murals (buon fresco, fresco secco, mosaic, ceramic tile), St. Ignatius Auditorium, Chicago; Our Lady of Lourdes Church, Indianapolis; Church of the Epiphany, Chicago, Loyola Univ., Chicago, St. Mary's Capuchin Sem, Crown Point, IN, Newman Club, Ann Arbor, MI, St. Mary Magdalen Church, Melvindale, MI. Commissions: eight murals, Resurrection Mausoleum, Justice, IL. **Comments:** Teaching: artist-in-residence, Siena Heights College, 1945-50; instructor in drawing, painting & design. **Sources:** WW73; WW47.

STEINHARDT, Martin *[Painter] 20th c.*
Addresses: Jersey City, NJ, 1934. **Exhibited:** S. Indp. A., 1934. **Sources:** Marlor, *Soc. Indp. Artists*.

STEINHILBER, Walter *[Painter] b.1879.*
Addresses: NYC. **Member:** GFLA; Woodstock AA. **Sources:** WW27; addit. info. courtesy Woodstock AA.

STEINHOUSE, Tobie (Thelma) *[Painter, printmaker] 20th c.; b.Montreal, Quebec.*
Addresses: Quebec, PQ. **Studied:** Sir George Williams Univ.; ASL New York, with Morris Kantor & Harry Sternberg, 1946-47;École Beaux-Arts, Paris; Atelier 1917, Paris, France, with W. S. Hayter, 1961-62. **Member:** Royal Can. Acad. Arts (assoc. member); Can. Group Painters (pres., 1966-68); L'Atelier Libre Recherches Graphique; Soc. Can. Painter-Etchers & Engravers; Can. Soc. Graphic Art. **Exhibited:** Galerie Lara Vincy, France, 1957 (solo); Montreal MFA, 1959 & 1963; Second Int. Biennial Engraving, Santiago, Chile, 1965; First & Third Brit Int. Print Biennial, Bradford, England, 1968 & 1972; Ninth Int. Biennial Art, Menton, France, 1972;1958-72 (six solos); L'Atelier Renée Le Sieur, Quebec, PQ, 1970s. Awards: Sterling Trust Award, Soc. Canadian Painter-Etchers & Engravers, 1963; Jessie Dow First Prize Award, Montreal MFA, 1963; Govt. Canada Centennial

Medal Hon., 1967. **Work:** Nat. Gallery Canada, Ottawa; Montreal MFA, Quebec; Confederation Art Gallery, Charlottetown, PEI; Ministry of External Affairs of Canada, Moscow Embassy, USSR; McMichael Conserv. Collection, Kleinburg, Ontario. Commissions: Songes et Lumiére (portfolio of 8 color engravings), Reverberations (portfolio of color engravings), 1970, The Edge of Day, 1971 & Songers et Lumiére, 1972, Graphic Guild Montreal. **Comments:** Positions: judge, Can. Soc. Graphic Art & Soc. Can. Painter-Etchers & Engravers Exhib., 1970. **Sources:** WW73; Guy Viau, *La Peinture Moderne au Canada Français* (Ministére Affaires Cult., Quebec, 1964); Guy Robert, *École de Montreal* (Collection Artistes Can., 1965); V. Nixon, "Tobie Steinhouse-Artist," *Vie des Arts Magazine* (summer, 1972).

STEINIGER, Meta See: **STEININGER, Meta**

STEININGER, Meta *[Painter] 20th c.*
Addresses: NYC. **Sources:** WW13; Petteys, *Dictionary of Women Artists*.

STEINITZ, Kate Trauman *[Painter, art librarian and historian] b.1889, Beuthen, Germany / d.1975.*
Addresses: Los Angeles, CA. **Studied:** with Lovis Corinth, Berlin, Germany; Univ Berlin, with Woefflin; Acad. de la Grand Chaumière and the Sorbonne, Paris; Tech. Hochschule Hannover, with Schubring. **Member:** Société Anonyme; AFA; Verband Deutscher Kunsthistoriker. **Exhibited:** WFNY, 1939; NYPL, 1940; Beekman Towers Hotel, NYC, 1942 (solo); LACMA, 1968 (solo). Awards: Grant, US State Dept, 1951; grant to Italy, Kress. Found., 1969. **Work:** Hanover Provincial Mus., Germany; LACMA. **Comments:** Positions: resident librarian, Elmer Belt Lib. of Vinciana, Los Angeles, 1945-61; thereafter, hon. curator. Publications: *Leonardo da Vinci's Manuscripts*, (1948); *Leonardo da Vinci's Trattato Della Pittura* (1956); *Kurt Schwitters Erinnerungen & Gesprache* (Zurich, Arche, 1963, English version, 1968). Contributed articles to *ArtNews, Magazine of Art, Burlington,* and *Graphic Arts Council Newsletter* (vol. 7, no. 4); plus many other articles and reviews. **Sources:** WW73; 47, which cites 1893 as birth date.

STEINKE, Bettina (Mrs. Don Blair) *[Painter, illustrator] b.1913, Biddeford, ME.*
Addresses: NYC; Santa Fe, NM in 1976. **Studied:** Fawcett Art Inst., Newark, NJ; Cooper Union, New York, NY; Phoenix Art Inst., New York. **Member:** SI, 1941; Nat. Acad. Western Art. **Exhibited:** Watercolor Show, Curacao, Neth., 1947; Well Known Personalities, Philbrook Mus., 1954 (solo), The Eskimo, Winnipeg, 1956 (solo) & Portraits Around US, Oklahoma City, 1968 (solo). **Work:** Nat. Cowboy Hall of Fame & Western Heritage, Oklahoma City, OK; Fort Worth (TX) Mus.; Gilcrease Mus., Tulsa, OK; Philbrook Mus., Tulsa; also in private collections in US & abroad. **Comments:** Preferred media: oils, pastels, charcoal. Specialty: Native American subjects and portraits. Illustrator: NBC Symphony Orchestra, 1937; *Lamp*, 1950-53; various magazines & books. Traveled with her husband, photographer Don Blair, to Central and South American and the Arctic. **Sources:** WW73; WW47; P&H Samuels, 463.

STEINKE, Herbert A. *[Landscape painter] b.1894, Wausau, WI / d.1982, Albany, NY.*
Studied: Chicago Acad. FA, 1923; Yale Sch. FA with Eugene Savage, 1925. **Exhibited:** WFNY, 1939. **Comments:** His favored subject was the Adirondacks; he also painted harbor scenes. Position: teacher, Chicago Acad. FA; New Haven, CT high schools; director, Art Education, Albany area schools for 30 years. **Sources:** info courtesy James Kieley, West Haven, CT.

STEINKE, William (Bill) *[Illustrator, cartoonist] b.1887, Slatington, PA.*
Addresses: Irvington, NJ. **Studied:** G. McManus; "Vet" Anderson. **Member:** Am. Assn. Cart. & Caric. **Sources:** WW31.

STEINLE, Caroline (Carrie) Frances *[Painter, decorator] b.1871, Cincinnati, OH / d.1944, Newprt, KY.*

Addresses: Cincinnati. **Comments:** Worked at Rookwood Pottery, Cincinnati, 1886-1925. **Sources:** Petteys, *Dictionary of Women Artists.*

STEINMANN, Herbert (Mr. & Mrs.) *[Collectors] 20th c.*
Addresses: NYC. **Sources:** WW73.

STEINMETZ, E. M. A. *[Illustrator] 20th c.*
Addresses: Phila., PA. **Sources:** WW13.

STEINMETZ, Grace Ernst Titus *[Painter, lecturer] 20th c.; b.Lancaster, PA.*
Addresses: Manheim, PA. **Studied:** PAFA; Barnes Foundation; Millersville State College, B.S.; Univ. Penn., M.S. **Member:** Nat. Soc. Painters Casein & Acrylic; Echo Valley Art Group; Royal Soc. Arts (fellow). **Exhibited:** AWCS, 1968; Painters & Sculptors Soc. NJ, 1969; Knickerbocker Soc., 1970; Moore College Art, 1970; Nat. Soc. Painters Casein & Acrylic, 1972. **Awards:** best of show, Lancaster Co. AA, 1967; award for non-traditional watercolor, P&S Soc. NJ, 1968; Grumbacher First Prize, Nat. Soc. Painters Casein & Acrylic, 1969. **Work:** Univ. Southern Florida, Lakeland; Franklin & Marshall College; Elizabethtown (PA) College; Millersville (PA) State College; Lancaster Co. AA. **Comments:** Preferred media: oils, casein, acrylics. Teaching: assoc. professor of art history, Elizabethtown College, 1964-65, adjunct professor of oil painting, 1969. **Sources:** WW73.

STEINMETZ, Morgan See: STINEMETZ, Morgan

STEIN (STEINBERG), Helen C.

STEINVALL, Igor *[Painter] 20th c.*
Exhibited: S. Indp. A., 1928. **Comments:** Possibly Steinvaloff, Igor, which see. **Sources:** Marlor, *Soc. Indp. Artists.*

STEINVALOFF, Igor *[Painter, teacher, writer, lecturer] b.1897, Brooklyn, NY.*
Addresses: NYC. **Studied:** ASL. **Member:** Soc. Indep. Artists. **Exhibited:** Salons of Am., 1930, 1931, 1934; S. Indp. A., 1930, 1932, 1936-38, 1941-44. **Sources:** WW40.

STEIR, Pat *[Artist] b.1938.*
Addresses: NYC. **Exhibited:** WMAA, 1972-73, 1977, 1983. **Sources:** Falk, *WMAA.*

STEKETEE, Helen *[Painter] b.1882, Grand Rapids.*
Addresses: Grand Rapids, MI/Holland, MI. **Studied:** M. Alten; H. Breckenridge; A. Krehbiel. **Member:** Detroit SWPS; NAWPS; Gloucester AA. **Exhibited:** Mich. Painters Exhib., Detroit AI, 1931. **Sources:** WW40.

STEKETEE, Sallie Hall (Mrs. Paul F.) *[Painter] b.1882, Brazil, IN.*
Addresses: Grand Rapids, MI. **Studied:** Cincinnati Art Acad. **Member:** NAWPS; Hoosier Salon. **Exhibited:** Hoosier Salon, Chicago, 1926 (prize), 1928 (prize), 1929 (prize), 1931 (prize). **Work:** Daughters of Indiana, Chicago. **Sources:** WW40.

STEKETER, P. V. (Mrs.) *[Miniature painter]*
Exhibited: Calif. SMP, 1917. **Sources:** Petteys, *Dictionary of Women Artists.*

STELL, H. Kenyon *[Educator, painter] b.1910, Adams, NY / d.1990.*
Addresses: Cortland, NY. **Studied:** Syracuse Univ., B.FA. (illus.) & certificate art educ.; New York Univ., M.A. (educ. admin.); Syracuse Univ. **Member:** Nat. Art Educ. Assn.; College Art Assn. Am. **Exhibited:** Nassau-Suffolk Art League, Garden City, NY, 1946; Assoc. Artists Syracuse, MFA,1948; State Univ. Art Faculties Exhib., 1954-56. **Awards:** 15 year citation, Nat. Art Educ. Assn., 1960. **Work:** Marine Midland Bank, Cortland, NY. **Comments:** Preferred media: acrylics, oils, wood. Positions: chmn. art, State NY Teachers College Faculty Assn., 1950; director of Art Show, 1951 & member art advisory committee, NY State Fair; pres., Cortland College Chapter, Am. Assn. Univ. Professors, 1952 & director & organizer, Art in Western Europe, study abroad program, summer 1963, State Univ. NY College Cortland; juror art exhibs., Roberson Mem. Show, Buffalo Soc.

Artists, 1962-70; consultant, Marine Bank Art Collection, 1969. Teaching: art instructor & supervisor, Toaz Jr. H.S. & Huntington H.S., Huntington, NY, 1939-47; prof. art & chmn. dept., State Univ NY College Cortland, 1947-66, prof. art history, 1966-, visiting prof. art, Univ. Maine, Orono, summer 1951. Research: John Trumbull. **Sources:** WW73.

STELL, Thomas M., Jr. *[Painter, lecturer, teacher] b.1898, Cuero, TX.*
Addresses: San Antonio, TX. **Studied:** Rice Inst., 1922; Waterman Scholarship for study at ASL, 1924; NAD with George Bridgeman, George Luks and Charles Hawthorne; Augustus V. Tack; Columbia Univ., M.F.A., 1931. **Member:** Lone Star Printmakers. **Exhibited:** NAD (Prix de Rome Competition, two honorable mentions); Allied Artists, Dallas, 1933; Texas State Fair Exhib., 1933; Lawrence Art Gal., Dallas, 1936; GGE, 1939; 48 States Competition, 1939. **Work:** WPA mural, USPOs, Teague and Longview, TX and Perry, OK; Forest Ave. H.S., Dallas; private collections. **Comments:** Positions: teacher, Dallas Art Inst., 1928-29, 1932; instructor of drawing and painting, Dallas Architectural Club, 1929-; artist and regional director, WPA, 1934; teacher, Trinity Univ., Univ. Texas. Stell also painted portraits. **Sources:** WW40; Stewart, *Lone Star Regionalism,* 187-88 (w/repros.), *Lone Star Regionalism,* 188-89 (w/repro.).

STELLA, Frank *[Painter, multi-media sculptor] b.1936, Malden, MA.*
Addresses: NYC. **Studied:** Phillips Acad., with Patrick Morgan; Princeton Univ., with William Seitz & Stephen Greene, 1954-58. **Exhibited:** "Sixteen Americans," MOMA, 1960; Corcoran Gal biennials, 1963, 1967; WMAA, 1963-83; Int. Biennial Exhib Paintings, Tokyo, Japan, 1967 (1st prize); Documenta IV, Kassel, Germany, 1968; "The Art of the Real," MOMA, 1968; PAFA Ann., 1968; Phila. Mus. Art, 1968; MOMA, 1970 (retrospective); Lawrence Rubin Gal, NYC, 1970s; Leo Castelli Gal., NYC. **Work:** MoMA; WMAA; PMA; MMA; NMAA; LACMA; AIC; Pasadena Mus.; Albright-Knox Art Gallery, Buffalo, NY; Walker Art Center, Minneapolis, MN; most major collections. **Comments:** Stella emerged as an important young artist in 1960 when he exhibited (in "Sixteen Americans," at MOMA), a group of paintings that addressed formal issues (such as symettry and repetition of patterning) that were also being explored by minimalist sculptors. Over the next several years Stella began shaping his canvases and allowing the lines and geometrical forms within each canvas to vary according to the shape of the canvas. Several series resulted, including his "Irregular Polygon" series. In 1970 his work underwent a change. In contrast to his earlier flat and geometric canvases, he began constructing relief-pictures out of shapes--primarily curves and angles made of aluminum and painted in brilliant, flamboyant colors. Two resulting series include the "Exotic Birds" and "Indian Birds." **Sources:** WW73; Baigell, *Dictionary;* William Rubin, *Frank Stella* (exh. cat., MOMA, 1970); L. Rubin, *Frank Stella Paintings 1958-1965: A Catalogue Raisonné* (New York, 1986); Robert Rosenblum, *Frank Stella* (Harmondsworth, 1971); Lawrence Alloway, *Systemic Painting* (Guggenheim Mus., 1966); Gregory Battcock (editor), *Minimal Art: A Critical Anthology* (Dutton, 1968); Falk, *Exh. Record Series.*

STELLA, John *[Painter] 20th c.*
Addresses: Chicago area. **Exhibited:** AIC, 1951. **Sources:** Falk, *AIC.*

STELLA, Joseph *[Painter, illustrator] b.1877, Muro Lucano, Italy / d.1946, Astoria, NY.* *Jos. Stella*
Addresses: NYC (1896-on). **Studied:** ASL, 1897; NY Sch. Art; Shinnecock Summer Sch. with Chase, 1898-1900, 1902; Florence, 1909. **Member:** Am. Soc. PS&G. **Exhibited:** CI, 1910 (solo); Armory Show, 1913; S. Indp. A., 1917, 1936, 1941; WMAA, 1922-46, 1994 (retrospective); Salons of Am., 1922-23, 1926-27, 1930; AIC, 1930-31, 1938; Newark Mus., 1939 (solo); PAFA Ann., 1944; Corcoran Gal. biennial, 1945; ACA Gal., NYC, 1940s; MoMA, 1960 (solo); Richard York Gal., NYC (solos:

1988, 1990, 1998). **Work:** AIC; BM; WMAA; WMA; MMA; MoMA; Newark Mus. ("New York Interpreted" series, 1920-22); Soc. Anonyme coll., Yale Univ. Art Gal. ("Brooklyn Bridge, c. 1919); Iowa State Educ. Assoc., Des Moines. **Comments:** Immigrated in 1896 to NYC where he studied medicine and pharmacology. His early illustrations appeared in *Century* and *Everybody's* magazines; and from 1902-08 his series of drawings of Pittsburgh steelworkers appeared in *Survey Graphic* magazine; however, he soon became best known for his paintings which were influenced by both Futurist and Symbolist movements. It was his dynamic Brooklyn Bridge pictures that helped build his status and he wrote passionately about the bridge as "a shrine containing all the efforts of the new civilization of Ameria." Throughout his career he explored themes ranging from the mystical and symbolic to the commonplace, and was also passionate and prolific in capturing blooming plants, leaves, shells, and feathers in silverpoint, colored pencil, watercolor, and oils. Stella was an international figure and in 1931, while in Paris, he became so enraged when he was not invited to exhibit with the 38 "Artistes Americains Moderne de Paris," that he clubbed one of the organizers into unconsciousness with his cane. Author: Stella's typescript, "Discovery of America: Autobiographical Notes," which includes "Brooklyn Bridge, A Page of My Life," is located at the WMAA. **Sources:** WW40; exh. cats.; *Joseph Stella: The Tropics* (1988), *Joseph Stella: 100 Works on Paper* (1990), and *Joseph Stella: Passion and Reverence* (1998), (all Richard York Gal., NYC); Irma P. Jaffe, "Joseph Stella and Hart Crane: The Brooklyn Bridge," *American Art Journal* vol.1, no.2 (Fall, 1969): 98-107; Irma P. Jaffe, *Joseph Stella* (Cambridge: Harvard Univ. Press, 1970); John I.H. Bauer, *Joseph Stella* (New York, 1971); Pisano, *The Students of William M. Chase*, 22; A. Davidson, *Early American Modernist Painting*, 101-03, 197-98, Diamond, *Thirty-Five American Modernists* p.40; *For Beauty and for Truth*, 89 (w/repro.); Baigell, *Dictionary;* Falk, *Exh. Record Series.*

STELLAR, Hermine J. *[Painter, teacher] b.Austria / d.1969.* **Addresses:** Chicago, IL. **Studied:** AIC; Sorolla, Spain; G. Bellows; L. Wilson. **Member:** Chicago SA; AC, Chicago. **Exhibited:** Chicago AC; Chicago SA; AIC. **Comments:** Position: teacher, AIC & Univ. Nebraska. **Sources:** WW40.

STELLENWERF, Kenneth C. *[Painter] 20th c.* **Addresses:** Bay Shore, NY. **Studied:** ASL. **Exhibited:** Salons of Am., 1929; S. Indp. A., 1929. **Sources:** WW25.

STELLMAN, Edith K. *[Painter] b.1877, Ohio / d.1957, Carmel, CA.* **Addresses:** Menlo Park, CA; Carmel, CA. **Exhibited:** PPE, 1915; San Francisco AA, 1923-25; Oakland Art Gallery, 1928; Calif. Artists, San Diego, 1926. **Sources:** Hughes, *Artists of California,* 533.

STELLWAGEN, Charles K. *[Painter of portraits, landscapes and animal subjects] b.1818, Philadelphia, PA.* **Addresses:** Philadelphia, active 1838-43; Washington, DC. **Studied:** with Emanuel Leutze, Düsseldorf, Germany. **Exhibited:** Artists Fund Soc. Phila. & PAFA, 1838, 1841, 1843; Wash.AA, 1860. **Work:** Western Reserve Hist. Soc. **Comments:** He moved to Washington sometime between 1847-50 and was employed there in 1850 as a draftsman. He was a life-long friend of Emanuel Leutze. *Cf.* Stillwagon. **Sources:** G&W; Rutledge, PA; 7 Census (1850), D.C., II, 199. More recently, see McMahan, *Artists of Washington, DC.*

STELSON, Sylvia *[Still life painter] b.1828 / d.1872, Boston.* **Sources:** Petteys, *Dictionary of Women Artists.*

STELZER, Michael Norman *[Sculptor] b.1938, Brooklyn, NY.* **Addresses:** Brooklyn, NY. **Studied:** Pratt Inst., 1956; ASL, 1960-62; Nat. Acad. School Fine Arts, Edward Mooney traveling scholarship, 1966 & NSS Joseph Nicolosi grant, 1967; also with Nathaniel Choate, 1964, Michael Lantz, 1964-67 & Donald DeLur, 1968 & 1969. **Member:** NAA; Salmagundi Club; Allied

Artist Am. **Exhibited:** AAPL Grand Nat., 1963; Nat. Arts Club, 1963-64; NAD, 1964-67 & 1970-71; All. Artists Am., 1967 & 1971; NSS Lever House Exhib., 1968-72. **Awards:** Helen Foster Barnett Prize, NAD, 1966; Dr. H. DeBellis First Prize Sculpture, Salmagundi Club, 1969; first prize sculpture, New Rochelle AA, 1971. **Work:** Commissions: relief painting, Worcester Polytech. Inst., 1964. **Comments:** Teaching: instructor in sculpture, private classes, Brooklyn Heights, NY, 1968-. **Sources:** WW73; article, *Pen & Brush* (1966); "Opportunities Offered the Young Sculptor" (1967) & "Interpreting the Human Figure" (1968), *Nat. Sculpture Review.*

STELZNER, Raymond *[Painter] b.1896, Germany.* **Addresses:** Milwaukee, WI. **Studied:** Wisc. School Art; ASL. **Member:** ASL (pres.); Wisc. P&S. **Sources:** WW24.

STEMPEL, Frederick William, Jr. *[Painter, commercial artist] b.1887, New Orleans, LA / d.1959, New Orleans, LA.* **Addresses:** New Orleans, active 1905-19. **Member:** New Orleans Art League, 1908. **Exhibited:** NOAA, 1915. **Sources:** *Encyclopaedia of New Orleans Artists,* 365.

STEMPEL, Henry *[Painter]* **Addresses:** New Orleans, active 1861-66. **Exhibited:** C. H. Zimmerman's New Orleans, 1867. **Sources:** *Encyclopaedia of New Orleans Artists,* 365.

STENBERY, Algot *[Painter, teacher, illustrator] b.1902, Cambridge, MA.* **Addresses:** NYC. **Studied:** Hartford Art School, with Albertus Jones; Boston Mus. Art School, with Frederick Bosley; ASL, with Kimon Nicolaides. **Member:** An Am. Group; ASL; Am. Artists Congress; United Am. Artists. **Exhibited:** MMA; BM; New School Soc. Res.; Roerich Mus.; Jacques Seligman Gal.; Gimbel Gal., Phila.; Prosperi Gal., Greenwich, 1975 (solo); Walker Art Gal., 1937 (solo); PAFA Ann., 1938; WFNY, 1939; WMAA, 1944-45; Long Island AA, 1961; AWCS, 1966; Nat. Soc. Casein Painters, 1970; SC, 1970; Arch. Lg.; "NYC WPA Art" at Parsons School Design, 1977. **Work:** MMA; G.R. Dick Collection; Edith Wetmore Collection. Commissions: murals, Works Project Admin., Harlem Housing Project Social Roomm, 1934 & Post Office, Wayne, MI, 38 tiles, Chrysler Bldg., New York, 1936 & Liner Bremen grand staircase, 1968; American Sugar Refining Co. **Comments:** Preferred media: gouache, oils. Teaching: instructor, drawing & painting, Cooper Union, 1933-40; instructor, drawing & painting, Am. Artists School, 1940-42. Illustrator, "Grapes of Wrath," John Steinbeck (New British edition); "Time to Remember," Margaret Henrichsen; "The Sojourner," Marjorie Kinnan Rawlings; "Autumn's Brightness," Daisy Newman; "Troubling Shute;" "The Bridges at Toko-ri," James A. Michener; and many others. **Sources:** WW73; WW47; *New York City WPA Art,* 84 (w/repros.); Falk, *Exh. Record Series.*

STENFIELD, Larry *[Painter, sculptor] mid 20th c.* **Addresses:** NYC. **Studied:** NAD; ASL; with Charles W. Hawthorne in Provincetown. **Exhibited:** MPA; ACA Gal.; Corcoran Gal. Art; Weintraub Gal.; Noah Goldowsky Gal.; "NYC WPA Art" at Parsons School Design, 1977. **Work:** Archives Am. Art. **Comments:** WPA artist. Subject matter: people and events. **Sources:** *New York City WPA Art,* 84 (w/repros.).

STENGEL, George J. *[Painter] b.1872, Newark, NJ / d.1937, Ridgefield, CT.* **Addresses:** Yonkers, NY, 1891; Ridgefield, CT. **Studied:** ASL; Académie Julian, Paris. **Member:** SC; Yonkers AA; Allied AA; AFA; Silvermine Guild; Guild Am. Painters; AAPL. **Exhibited:** NAD, 1891; S. Indp. A., 1917; Corcoran Gal biennials, 1921, 1935; PAFA Ann., 1922, 1930; Allied AA, 1930. **Work:** Mexican Gov., Pres. Palace, Chapultepec. **Comments:** Specialized in marines and Mexican landscapes. Marlor gives a birthdate of 1876. **Sources:** WW38; Falk, *Exh. Record Series.*

STENGEL, Hans *[Painter, caricaturist, writer, critic] b.1895, Sheboygan, WI / d.1928, NYC.* **Addresses:** NYC. **Member:** Soc. Independent Artists. **Exhibited:**

S. Indp. A., 1921. **Work:** caricatures, people in the theatrical world; magazines; newspapers. **Comments:** Position: critic, *New York Evening Journal.* **Sources:** WW25.

STENLAUF, Stephen *[Painter] 20th c.*
Addresses: NYC. **Exhibited:** PAFA Ann., 1940. **Sources:** Falk, *Exh. Record Series.*

STENNING, Walter *[Painter] 20th c.*
Addresses: Detroit, MI, 1931. **Exhibited:** S. Indp. A., 1931. **Sources:** Marlor, *Soc. Indp. Artists.*

STENSEN, Matthew Christopher *[Painter] b.1870, Norway / d.1942, Oakland, CA.*
Addresses: Richmond, CA. **Studied:** Minnesota School Art. **Member:** Bay Region AA. **Exhibited:** Minnesota State Fair, 1920 (prize); Chicago Norwegian Club Exhib., 1929 (prize); Bay Region AA, 1935; Santa Cruz AL, 1936 (prize); Oakland Art Gallery, 1939; GGE, 1940. **Work:** East Bay AA, Oakland, CA. **Comments:** Immigrated to the U.S. in 1895. **Sources:** WW40; Hughes, *Artists in California,* 534.

STENSON, W. C. *[Painter] 20th c.*
Addresses: Minneapolis, MN. **Sources:** WW25.

STENVALL, John F(rancis) *[Painter, craftsperson, teacher, writer, comm a, graphic artist, cartoonist] b.1907, Rawlins, WY.*
Addresses: Chicago, IL. **Studied:** Univ. Nebraska, B.F.A.; AIC; ATC; Stanford Univ., M.A. **Member:** Chicago SA; AL Chicago; CAA; Illinois Art Educ. Assn. (pres., 1957-58); Around Chicago Art Educ. (pres., 1954); NAEA; Midwest Des. Lg. **Exhibited:** AIC, 1936 (prize); MoMA, 1936, 1941; S. Indp. A., 1936; WFNY 1939; Wichita Art Mus., 1934; Phila. Soc. Etchers, 1934; Univ. Minnesota, 1938; Phila. WCC, 1935, 1938; Rockefeller Center, 1936; BM, 1937; Musée du Jeu de Paume, Paris, 1938; CM, 1938, 1939; AIC, 1934-38, 1940, 1941, 1946; Chicago Soc. Art, 1934-1941; Swedish-Am. Exhib., 1938, 1939, 1955; Chicago Graphic Group, 1937, 1938; Leonard Linn Gal., 1953 (solo); Oldschlager Gal., 1955-56 (solo); Nelson Gal., 1953 (solo), all Chicago. **Work:** U.S. Govt. **Comments:** Positions: instructor, New Trier H.S., Winnetka, IL; editor, *Western AA* magazine, 1956-58; Ed. Bd., NAE Ed., Illinois Art. Educ. Assn. Yearbook, 1954. Contributor to *School Arts* magazine and *Arts & Activities* magazine. **Sources:** WW59; WW47.

STENZLER, Erna *[Painter] 20th c.*
Addresses: Phila., Elkins Pk., PA. **Exhibited:** PAFA Ann., 1946, 1953. **Sources:** Falk, *Exh. Record Series.*

STEPHAN, Elmer A. *[Illustrator, teacher, drawing specialist, lecturer] b.1892, Pittsburgh / d.1944.*
Addresses: Pittsburgh, PA. **Studied:** J. Greenwood; Univ. Pittsburgh. **Member:** AFA; EAA (pres.) SA; SI. **Comments:** Illustrator: "Practical Art Drawing Books," "Let's Go Fishing"; illustrator/editor, "Inspirational Art Books." Positions: teacher, Pittsburgh Pub. Sch. (1928-44) and Carnegie Inst. **Sources:** WW40.

STEPHAN, John *[Painter] b.1906, Maywood, IL.*
Addresses: Chicago, IL. **Exhibited:** Chicago Artists, AIC, 1934 (prize); Betty Parsons Gal, NYC, 1940s; WMAA, 1950. **Comments:** During the 1930s, he exhibited widely in Chicago; and in New York during the 1940s. However, he was best known as publisher of *Tiger's Eye* (1947-49), an avant-garde art magazine which involved artists such as W. Baziotes and Barnett Newman. **Sources:** WW40; *Archives of American Art Journal* vol.27, No. 2, 1987, p.36.

STEPHANI, Adolph *[Painter] 20th c.*
Addresses: NYC. **Exhibited:** S. Indp. A., 1939, 1941, 1944. **Sources:** Marlor, *Soc. Indp. Artists.*

STEPHEN, Gary *[Painter] b.1942.*
Addresses: NYC. **Exhibited:** WMAA, 1969-73. **Sources:** Falk, *WMAA.*

STEPHEN, Jessie *[Painter, teacher] b.1891, Delaware, OH.*
Addresses: Wayne, NE/Delaware, OH. **Studied:** Ohio State

Univ.; J.R. Hopkins; G.B. Wiser. **Comments:** Position: teacher, State Teachers College, Wayne, NE. **Sources:** WW33.

STEPHEN, Marjorie *[Painter] 20th c.*
Exhibited: S. Indp. A., 1941. **Sources:** Marlor, *Soc. Indp. Artists.*

STEPHEN, Olin Dows See: **DOWS, Olin**

STEPHENS *[Portrait painter] mid 19th c.*
Addresses: Indiana, active 1835. **Sources:** G&W; Burnet, *Art and Artists of Indiana,* 398.

STEPHENS, A. P. *[Painter] late 19th c.*
Addresses: NYC, 1896. **Exhibited:** NAD, 1896. **Sources:** Naylor, *NAD.*

STEPHENS, Aileen Powers *[Painter] b.1889, Kansas / d.1982, Palm Springs, CA.*
Addresses: Palm Springs, CA. **Studied:** with her mother; AIC, with Lorado Taft; Europe; San Miguel de Allende, Mexico. **Exhibited:** several solo exhibits. **Comments:** Daughter of Esther G. Powers (see entry). **Sources:** Hughes, *Artists of California,* 534.

STEPHENS, Alice Barber (Mrs. Charles H. Stephens) *[Illustrator, painter, teacher, photographer, engraver] b.1858, near Salem, NJ / d.1932, Moylan, PA.*
Addresses: Phila., Moyland, PA. **Studied:** PAFA with T. Eakins (made some wood engravings of his work for him); J. Dalziel (wood engraving), Phila. School Des. for Women; Académie Julian and Acad. Colarossi, Paris. **Member:** Plastic Club, 1897 (founder). **Exhibited:** PAFA, 16 annuals between 1879-1905 (1890 Mary Smith Prize); Boston AC, 1883-84, 1886; NAD, 1884; Paris Salon, 1887; Plastic Club; Universal Expo, Paris, 1890 (bronze medal); Columbian Expo., Chicago, 1893; Atlanta Expo, 1895 (medal); Expo of Women's Work, Earl's Court, London, 1899 (gold medal for illus. of Elliot's *Middlemarch*); AIC, 1905. **Work:** LOC; Phila. Hist. Soc. **Comments:** Painter in oil, watercolor, charcoal (portraits, landscapes). During the first decade of the century she adopted an art nouveau style similar to that of Jessie Wilcox Smith, Elizabeth Shippen Green, and Violet Oakley. After 1912 her style became more decorative and sentimental. She was one of the most successful illustrators of the late 19th century. Illustrator of books for Louisa May Alcott, Lucy Lillie, Arthur Conan Doyle, Kate Douglas Wiggins, Nathaniel Hawthorne; for *Harper's,* Century,*Scribner's* and *Collier's.* Teaching: Phila. Sch. Des. for Women (where she started the first life-drawing class just for women). **Sources:** WW31; Helen Goodman, article in *American Artist* (Apr., 1984, p.46); Tufts, *American Women Artists,* cat. nos. 43-44; Rubinstein, *American Women Artists,* 145-46; Falk, *Exh. Record Series.*

STEPHENS, Charles Arthur Lloyd *[Painter] d.1914, (committed suicide at home).*
Addresses: Brooklyn, NY.

STEPHENS, Charles H. *[Illustrator, teacher] b.c.1855 / d.1931, Pittsburgh, PA.*
Addresses: Phila., Moylan, PA. **Member:** Phila. Sketch Club (pres.); PAFA (vice-pres.). **Exhibited:** PAFA Ann., 1879-80. **Work:** PAFA. **Comments:** Specialty: illustrations of Native Americans. Owned a collection of Native American art distinguished for the beauty and rarity of its specimens; it was exhibited at the Univ. Pennsylvania Mus. Husband of illustrator Alice Barber Stephens (see entry). **Sources:** WW31; P&H Samuels, 464; Falk, *Exh. Record Series.*

STEPHENS, C(lara) J(ane) *[Painter] b.1877, Great Britain / d.1952.*
Addresses: Portland, OR, from c.1913. **Studied:** ASL with K. Cox, W.M. Chase, F.V. DuMond. **Member:** Soc. Independent Artists. **Exhibited:** Portland (OR) Soc. Art, 1911 (solo); San Francisco AA, 1918; S. Indp. A., 1921-22, 1924-25, 1927, 1931; Salons of Am., 1922, 1925-27, 1929-31; NYC, 1925 (solo); Seattle FAS, 1920 (prize), 1925 (prize); Oakland Art Gallery,

1928. **Comments:** Came to Portland as a child. Position: teacher, Portland Art Mus., 1917-38. **Sources:** WW40; Trenton, ed. *Independent Spirits,* 125.

STEPHENS, Curtis *[Designer, educator]* b.1932, Athens, GA. **Addresses:** Champaign, IL. **Studied:** Univ. Georgia, M.F.A. **Exhibited:** Designed for Production, Mus. Contemporary Crafts, 1964; Objects USA, Johnson's Wax Collection, Smithsonian Inst., 1969; 24th & 25th Illinois Invitational Exhib., Illinois State Mus., 1971 & 1972. **Work:** Objects USA, Johnson's Wax Collection; Illinois State Mus., Springfield. **Comments:** Preferred media: plastics. Positions: designer, Callaway Mills, LaGrange, GA, 1963-66. Teaching: asst. prof. art, LaGrange College, 1961-63; asst. prof. art, Univ. Northern Michigan, 1966-68; assoc. prof. art & design, Univ. Illinois, Champaign-Urbana, 1968-. **Sources:** WW73; Lee Nordness, *Objects: USA* (Viking Press, 1970); Jay Hartley Newman & Lee Scott Newman, *Plastics for the Craftsman* (Crown, 1972).

STEPHENS, D(aniel) Owen *[Painter]* b.1893, Phila. / d.1937, Balboa, Canal Zone (while en route home from Peru,. **Addresses:** Pittsburgh, PA; Moylan, PA. **Studied:** PAFA, with W. Lathrop, N.C. Wyeth. **Member:** Phila. Alliance. **Exhibited:** PAFA Ann., 1933. **Sources:** WW33; Falk, *Exh. Record Series.*

STEPHENS, Frank L. *[Painter, illustrator, commercial artist]* b.1932, Augusta, GA. **Studied:** Phila. College Art; Hussian School of Art. **Member:** Artist Guild Delaware Valley. **Exhibited:** Awards: Artist Guild Delaware Valley, 1970 (gold medal, prize, best illustration, award of excellence); Graphic AA Delaware Valley, 1968 (gold medal), 1969 (award), 1971 (medal for poster des.). **Comments:** Position: library graphics manager, Phila. Free Library. **Sources:** Cederholm, *Afro-American Artists.*

STEPHENS, George Frank *[Sculptor, craftsperson, teacher, lecturer]* b.1859, Rahuway, NJ / d.1935, Gilpin Point, near Denton, MD. **Addresses:** Phila., PA, 1884; Arden, DE. **Studied:** PAFA. **Member:** Phila. Sketch Club; AC Phila.; NAC. **Exhibited:** PAFA Ann., 1879-85, 1889, 1907-08; NAD, 1884. **Comments:** He was co-founder of Arden and Ardentown, the single tax colonies near Wilmington, DE, and Gilpin Point. Positions: teacher, PAFA, Drexel Inst., & Spring Garden Inst., Phila. **Sources:** WW31; Falk, *Exh. Record Series.*

STEPHENS, Henry Louis *[Illustrator and caricaturist]* b.1824, Philadelphia, PA / d.1882, Bayonne, NJ. **Addresses:** Philadelphia,1850's; NYC, c.1859. **Comments:** In New York City, he worked at first for Frank Leslie (see entry). A few years later he became an illustrator for Harper Brothers. Best known as a caricaturist and illustrator of books and magazines, he also painted in watercolors. **Sources:** G&W; CAB; Thieme-Becker; Phila. CD 1852+; NYCD 1860+; Hamilton, *Early American Book Illustrators and Wood Engravers,* 463-66.

STEPHENS, Luther *[Engraver and plate printer]* b.c.1790. **Addresses:** Boston, 1850. **Comments:** His son, William Stephens, also was an engraver (see entry). **Sources:** G&W; 7 Census (1850), Mass., XXIV, 698 [as Stephens, engraver]; Boston CD 1850-53 [as Stevens, plate printer].

STEPHENS, Nancy Anne *[Sculptor, film maker]* b.1939, Santa Barbara, CA. **Addresses:** Kansas City, MO. **Studied:** Univ. Kansas Art Dept., 1957; Northwestern Univ. Theatre, 1958-59; Univ. Kansas Theatre, 1959-62; Kansas City AI, 1963. **Member:** Kansas City Writers, Artists & Musicians (directing committee, 1972-); New Tendencies Int. Movement, Europe. **Exhibited:** New Center US Art Series, 1963-64; Art Research Center Series, 1966-72; Sir George Williams Univ., Montreal, PQ, 1967; Anonima Studio, NYC, 1968; Novo Tendencija 4, Zagreb, Yugoslavia, 1969. **Work:** Art Research Cenyer, Kansas City, MO; Galeria Grada

Zagreba, Zagreb, Yugoslavia. Commissions: tapestry, Kansas City Parks & Recreation Dept., MO, 1969; graphics, Harrison St. Rev. & Westport Trucker, 1971-72. **Comments:** Preferred media: magnets, ceramics, plastics, fluids. Positions: lithoartist, Hallmark Cards, Kansas City, 1962-64; director, watercolor, ceramics & sculpture, Kansas City (MO) Parks & Recreation Dept., 1966-70; editor & contributor, *Art Research Center Magazine,* 1966-1; pres., Art Research Center, Kansas City, 1972-. Publications: contributor, *Harrison St. Rev.,* 1972 & *Westport Trucker,* 1971-72. **Sources:** WW73; Donald Hoffman, articles, *Kansas City Star,* 1966-72; Yves Robillard, article, art section, *Montreal La Presse,* Sept., 1967; Lawrence Alton et al., articles, *New York Element* (1968, 1970 & 1971).

STEPHENS, Richard *[Painter, cartoonist, lecturer, teacher, commercial artist]* b.1892, Oakland, CA / d.1967, San Mateo, CA. **Addresses:** San Francisco, CA; San Mateo, CA. **Studied:** Univ. California; Scripps College; Calif. College Arts & Crafts; Calif. School FA; Andre L'Hote, Julian Acad., Paris, France. **Member:** Calif. WCS; Art & Art Dir. Club; San Francisco Advertising Club. **Exhibited:** Drawing Exhib., San Francisco, 1940; Oakland Art Gal., 1930-40, 1945, 1949; Santa Cruz, CA, 1940, 1948, 1949; Calif. WCS, 1950, 1952; Scripps College, 1951; Gump's Gal., San Francisco, 1935; Raymond & Raymond, 1933; City of Paris, San Francisco, 1948-1952, 1955; Richmond, A, 1953; Sherman & Clay Gal., San Francisco & San Mateo, 1961; Howland Gal., San Francisco, 1961; Winblad Gal., San Francisco, 1964. Awards: prizes, San Mateo Fair, 1954, 1960. **Work:** Scripps College. **Comments:** Position: founder & instructor, Acad. Art, San Francisco. Illustrator: "Glen Warner's Book for Boys," 1932; "Live English." Contributor cartoons to *Sunset, College Humor, American Artist, Western Advertising, Judge* magazines. **Sources:** WW66.

STEPHENS, Robert K. *[Painter, teacher, craftsperson]* b.1906, Scranton, PA. **Addresses:** Providence, RI/Provincetown, MA. **Studied:** Syracuse Univ.; ASL; NY School Fine & Applied Art; RISD; J.R. Frazier. **Member:** Provincetown AA; Providence AC; Rhode Island WCC; Utopian Club, Providence. **Exhibited:** Providence AC, 1938; Phila. WC Ann., 1938; AIC, 1939. **Work:** AMNH; Roger Williams Park Mus., Providence. **Comments:** Position: director, Rhode Island Lg. Arts & Crafts. **Sources:** WW40.

STEPHENS, Theodore (Courtney) Barber *[Sculptor]* 20th c. **Studied:** ASL. **Exhibited:** S. Indp. A., 1936. **Sources:** Marlor, *Soc. Indp. Artists.*

STEPHENS, Thomas *[Engraver]* mid 19th c. **Addresses:** NYC, 1858. **Sources:** G&W; NYBD 1858.

STEPHENS, Thomas Edgar *[Painter]* 20th c.; b.Cardiff, South Wales. **Addresses:** New York 3, NY. **Studied:** Cardiff Univ. School FA; Heatherly Sch., London; Acad. Julian, Paris. **Member:** SC; NAC; Univ. Club, Wash., DC; Savage Club, London. **Work:** White House, Wash., DC; NGA; U.S. Supreme Court; U.S. Treasury Dept.; U.S. Senate; Pentagon, Wash., DC; Walter Reed Hospital; West Point Military Acad.; U.S. Naval Acad.; N.Y. Genealogical Soc.; Eisenhower Mus., Abilene, KS; Legion of Honor Gal., Paris; U.S. Embassy, London; IBM; Cornell Univ.; Columbia Univ.; Harvard Univ.; Ft. Benning Inf. School; Harry Truman Lib. **Sources:** WW59.

STEPHENS, Thomas Michael *[Sculptor, designer]* b.1941, Elkins, AR. **Addresses:** Kansas City, MO. **Studied:** Univ. Kansas, 1959-63, four years independent study. **Member:** New Tendencies Movement, Europe; Kansas City Writers, Artists & Musicians (directing committee, 1972-). **Exhibited:** Exhib. Series, New Center US Art, 1963-64 & Art Res. Center, 1966-72; Sir George Williams Univ., Montreal, PQ, Canada, 1967; Anonima Studio, NYC, 1968; Buffalo State Univ., NY, 1968; Novo Tendencija 4,

Zagreb, Yugoslavia, 1969. Awards: fine arts guest lecturer & exhibitor, Northwest Misouri State College, 1965; humanities guest lecturer & exhibitor, William Jewell College, 1966; Kansas City Assn. Trusts & Foundations individual faculty development grant, 1970. **Work:** Jewish Community Center, Kansas City, MO; Rockhurst College, Kansas City; Art Res. Center, Kansas City; Galerija Grada, Zagreba, Zagreb, Yugoslavia. Commissions: landscaping, bldgs. & sculpture for ten playgrounds, Parks & Recreation Dept, Kansas City, MO, 1966-67; design & art works, Midway Cafe, Kansas City, 1971-72; design, Green Bindery, Kansas City, 1972. **Comments:** Preferred media: plastics, steel, aluminum. Positions: production designer, Topeka Civic Theatre, KS, 1961-62; director, New Center US Art Coop Gallery, Kansas City, 1964; a t supervisorr & design consultant, Kansas City Parks & Recreatio· Dept. MO, 1964-1967; contributor/editor, *Art Res. Center Magazine*, 1966-72; coordinator, Art Res. Center, Kansas City, 1969-72. Publications: contributor, "Novo Tendenciji 4 Catalogue," 1969; contributor, "Bit Int. Journal Art & Cybernet," 1969; contributor, "Harrison St. Rev.," 1970 & 1972; contributor, "The Shelter," 1971 & "Westport Trucker," 1972. Teaching: lecturer in history & science in art, Jewis Community Center, Kansas City, 1970-71; lecturer research in art, Art Res. Center, Kansas City, 1970-72; lecturer art & technology, Kansas City AI, March 1971. **Sources:** WW73; Donald Hoffman, articles, art section, *Kansas City Star*, 1966-2; Yves Robillard, article, art section *Montreal La Presse*, 9/1967; Larry Alton et al., "Testament of ARC," *New York Element*, 7/1970 & 7/1971.

STEPHENS, Walter H. *[Painter] 20th c.*
Addresses: San Francisco, CA. **Exhibited:** Oakland Art Gallery, 1928. **Sources:** Hughes, *Artists of California*, 534.

STEPHENS, William *[Engraver] b.c.1832.*
Addresses: Boston, active1850. **Comments:** Listed with his father Luther Stephens, engraver (see entry). **Sources:** G&W; 7 Census (1850), Mass., XXIV, 698.

STEPHENSON, Byron P. *[Critic] b.1852, England / d.1915.*
Addresses: NYC. **Comments:** Came to the U.S. at an early age. Positions: *New York Herald*; editor, *Town Topics*; critic, *New York Evening Post*.

STEPHENSON, Erik W. A. *[Painter] b.1943, St. James, Jamaica.*
Studied: Jamaica School Art; ASL; Edinburgh College Art.
Exhibited: Brooklyn Mus., 1969; Columbia Univ., 1969.
Sources: Cederholm, *Afro-American Artists.*

STEPHENSON, Gladys Marion *[Painter] b.1904, Enid, OK / d.1934.*
Addresses: Corning, IA. **Studied:** Iowa Univ., B.A.; Art Inst. Chicago; Wayman Adams, NYC. **Exhibited:** Stevens Hotel, Chicago; All Illinois Exhibit, second year of Chicago Fair, 1934; Freeport, IL. **Work:** Mt. Morris, IL. **Comments:** Left about 90 oil paintings, a large portion portraits. Positions: teacher, Charles City, IA; teacher, H.S., Freeport, IL. **Sources:** Ness & Orwig, *Iowa Artists of the First Hundred Years*, 198.

STEPHENSON, J. G. *[Painter] 20th c.*
Addresses: Stamford, CT. **Member:** GFLA. **Sources:** WW27.

STEPHENSON, Jessie Bane *[Painter] 20th c.*
Addresses: NYC. **Exhibited:** Salons of Am., 1932; S. Indp. A., 1932. **Sources:** Falk, *Exhibition Record Series.*

STEPHENSON, John H. *[Sculptor, educator] b.1929, Waterloo, Iowa.*
Addresses: Ann Arbor, MI. **Studied:** Univ. Northern Iowa, B.A.; Cranbrook Acad. Art, M.F.A. **Exhibited:** Fiber, Clay and Metal, St. Paul AC, 1964; Concorso Int. Della Ceramica Arte, Faenza, 1965; Objects USA, Smithsonian Inst., Washington, DC, 1970; Crafts 1970, Boston City Hall, MA, 1970; Arts USA II, Northern Illinois Univ. Mus., DeKalb, IL, 1971; Deson-Zaks Gallery, Chicago, IL, 1970s. Awards: Rackham research grants, Japan, 1962 & mixed media, 1969, Univ. Michigan; Medaglia Oro Della Citta Faenza, 1965. **Work:** Int. Mus. Ceramics Faenza, Italy;

Everson Mus., Syracuse, NY; Detroit IMI) Mus. Art; Parrish Art Mus., South Hampton, NY; St. Paul (MN) Art Center. Commissions: The Wall (ceramic mural), Int. Market, Ann Arbor, MI, 1971. **Comments:** Preferred media: mixed media, ceramics, metals. Teaching: ceramics instructor, Cleveland Inst. Art, 1958-59; prof. ceramics, Univ. Michigan, Ann Arbor, 1959-. **Sources:** WW73.

STEPHENSON, Lee Robert *[Etcher, lithographer] b.1895, San Bernardino, CA.*
Studied: with Armin Hansen, William Wilke, Myron Oliver.
Member: San Francisco AA; Calif. SE; Carmel AA. **Sources:** Hughes, *Artists of California*, 534.

STEPHENSON, Peter *[Sculptor and cameo portraitist] b.1823, Yorkshire (England) / d.c.1860, Boston, MA.*
Addresses: Boston,1843; Rome 1845-47; Boston, 1847 and after.
Exhibited: Boston Athenaeum, 1847-. **Work:** American Antiquarian Society. **Comments:** Stephenson came to America with his parents in 1827 and lived on farms in New York and Michigan until he was old enough to be apprenticed to a watchmaker in Buffalo (NY). He soon turned to cutting cameo portraits and carving busts and went to Boston in 1843, where he stayed for two years, saving money to go to Italy. After his return from Rome, Stephenson continued to specialize in cameos, though he also did some portrait busts and ideal figures. **Sources:** G&W; Lee, *Familiar Sketches of Sculpture and Sculptors*, 191-94, contains an autobiographical account of the artist; Gardner, *Yankee Stonecutters*, 72; Boston CD 1847-61; Swan, BA; Washington Art Assoc. Cat., 1857, 1859; 7 Census (1850), Mass., XXV, 731; *Antiques* (Sept. 1946), 170, repro.

STEPHENSON, Robert S. *[Architect, mural painter] 20th c.*
Addresses: NYC. **Sources:** WW08.

STEPHENSON, Thomas *[Engraver] b.c.1814, Ohio.*
Addresses: Philadelphia, 1860. **Comments:** His wife was also from Ohio, but their children (ages 20 to 16) were born in Philadelphia. **Sources:** G&W; 8 Census (1860), Pa., LVIII, 323.

STEPHEY, Eva (Lee) *[Painter] b.1866, McComb County, IL / d.1943, Los Angeles, CA.*
Addresses: Los Angeles, CA. **Member:** Calif. AC. **Exhibited:** P&S of Los Angeles, 1920-31. **Sources:** WW25; Hughes, *Artists in California*, 534.

STEPPAT, Leo Ludwig *[Sculptor, educator] b.1910, Vienna, Austria.*
Addresses: Madison, WI. **Studied:** Acad. FA, Vienna, M.F.A.
Member: CAA; Committee on Art Educ., MoMA. **Exhibited:** WMAA, 1954-62; PAFA Ann., 1954, 1960; Illinois P&S exhib., 1955; WAC, 1958; Milwaukee AC, 1956-58; AFA traveling exhib., 1954-55; Nat. Ecclesiastical exhib., NY, 1950; Forum Gal., NY, 1955; Wisconsin Salon, 1955-57; Kootz Gal., 1954 (solo); Indiana Artists, John Herron AI, 1950-52; Springfield, IL, 1951; BMA, 1947; CGA, 1942, 1944, 1945, 1947; Whyte Gal., Wash., DC, 1944 (solo); Secession Gal., Vienna, 1936; Kunstlerhaus, Vienna, 1933. Awards: prizes, Wisconsin Salon, 1955-57; WAC, 1958; Milwaukee AC, 1956-58; John Herron AI, 1951, 1952; War Dept., Pub. Bldg. Admin., Wash., DC, 1941; medal, Vienna, Austria, 1930, 1932. **Work:** WMAA; Smithsonian Inst.; Museo Nacional, Mexico City; Guggenheim Mus.; Milwaukee AI.
Comments: Positions: instructor, Am. Univ., Wash., DC, 1947-49; asst. professor, Indiana Univ., 1949-52; assoc. professor, Univ. Mississippi, 1952-54; director, Forum Gal., NY, 1955; assoc. professor, Univ. Wisconsin, Madison, WI, 1955-. Contributor to *College Art Journal.* **Sources:** WW59; Falk, *Exh. Record Series.*

STERBA, Antonin *[Painter, etcher, teacher] b.1875, Hermanec, Czechoslovakia / d.1963, Chicago, IL.*
Addresses: Chicago, Evanston, IL. **Studied:** AIC with J.F. Smith; Académie Julian, Paris with J.P. Laurens and Constant, 1901.
Member: Cliff Dwellers; Assn. Chicago P&S; Chicago Galleries Assn.; Chicago Soc. Etchers; Bohemian Artists Club. **Exhibited:** Bohemian AC, 1921 (gold), 1923 (medal); PAFA Ann., 1923-24;

Corcoran Gal biennial, 1923; AIC, 1938 (prize);Mun. Art Lg., 1938 (prize); Chicago Gal. Assn., annually, 1930 (prize); Assn. Chicago P&S, 1943 (medal); prize, Mun. Art Lg., 1938 (medal); Pasadena, CA (solo); Chicago (solo).; Nashville, TN (solo); Shreveport, LA (solo); Little Rock, AR (solo); San Antonio, TX (solo); Beloit College (solo).; Elgin Acad. Art (solo). **Work:** portraits, Northwestern Univ.; DePauw Univ.; Baylor Univ.; State Mus., Springfield, IL; NGA. **Comments:** Teaching: Am. Acad. Art, Chicago. **Sources:** WW59; WW47; Falk, *Exh. Record Series*.

STERCHI, Eda Elizabeth *[Painter (portraits & figures), block printer] b.1885, Olney, IL.*
Addresses: Olney, IL; Phoenix, AZ. **Studied:** AIC; Grande Chaumière, L. Simon (1910-14), both in Paris; Inst. Carthage, Tunisia. **Exhibited:** AIC (solo);Chicago Soc. Artists; Santa Barbara Mus. Art; Mus. New Mexico; Phoenix (AZ) Art Mus.; Boston, MA; Soc. Indep. Artists; NYC; Paris, France; Tunisia. **Comments:** Awards: French decoration, "Palmes Académique"; Tunisian decoration, "Nichan Iftikhar." **Sources:** WW59; WW47.

STERINBACH, Natalie *[Painter] b.1910, New York, NY.*
Addresses: Forest Hills 75, NY. **Studied:** ASL, with Morris Kantor, Sam Adler, Camilo Egas. **Member:** NAWA; Lg. Present Day Artists (pres., 1959); AEA; Brooklyn Soc. Artists. **Exhibited:** NAWA, 1954, 1956, 1958-61; Contemporary Art Gal., 1955-58; Lg. Present Day Artists, 1956, 1957, 1959-61; NY City Center, 1956; Village Art Festival, 1958; Japan-Am. Women Artists Exchange, Tokyo & Riverside Mus., NY, 1960; Brooklyn Soc. Artists, 1959-61; Saks Fifth Ave., 1961;Panoras Gal., 1957 (solo). Award: prize, Village AC. **Sources:** WW66.

STERL, Robert *[Painter] 20th c.*
Exhibited: AIC, 1932, 1934. **Sources:** Falk, *AIC.*

STERLING, Annie E. *[Painter] 19th c.*
Addresses: Bridgeport, CT, 1878, 1882. **Exhibited:** NAD, 1878, 1882; PAFA Ann., 1882. **Sources:** Falk, *Exh. Record Series.*

STERLING, Antoinette *[Sculptor] 20th c.*
Addresses: Macdougal Alley, NYC. **Comments:** Lived with Alice Morgan Wright. **Sources:** WW15.

STERLING, Charles O. *[Engraver] 19th/20th c.*
Addresses: Wash., DC, active 1901-1920. **Sources:** McMahan, *Artists of Washington, DC.*

STERLING, Helen A. *[Painter] d.1976, Jackson Heights, NYC.*
Addresses: NYC, 1923. **Studied:** ASL. **Exhibited:** S. Indp. A., 1923. **Sources:** Marlor, *Soc. Indp. Artists.*

STERLING, (Helen) Ethel A. (Mrs. E.M.) *[Painter] d.1941, Jackson Heights, NYC.*
Addresses: NYC, 1923. **Exhibited:** S. Indp. A., 1923, 1927. **Sources:** Marlor, *Soc. Indp. Artists.*

STERLING, James Elias *[Painter] b.1908, Reading, PA.*
Addresses: NYC. **Studied:** M. Denis, in Paris; D. Frisia, in Milan. **Exhibited:** Art Gal., NY, 1937; PAFA Ann., 1954; WMAA, 1956. **Sources:** WW40; Falk, *Exh. Record Series.*

STERLING, Julian H. *[Painter] 19th c.*
Addresses: Bridgeport, CT, 1880s. **Exhibited:** NAD, 1881-84; PAFA Ann., 1882-84. **Sources:** Falk, *Exh. Record Series.*

STERLING, Lewis Milton *[Painter] b.1879, Sterling, IL.*
Addresses: Cashmere, WA, 1941. **Exhibited:** Soc. of Seattle Artists, 1908; SAM, 1935. **Sources:** Trip and Cook, *Washington State Art and Artists, 1850-1950.*

STERLING, Lindsey Morris (Mrs. Charles B.) *[Sculptor, illustrator] b.1876, Mauch-Chunk, PA / d.1931, Englewood, NJ.*
Addresses: Edgewater, NJ/NYC, Essex County, NY. **Studied:** Cooper Union with G. Brewster; ASL with J. Fraser; Bartlet & Bourdelle, in Paris. **Member:** NSS; NAWPS; New Haven PCC; Allied AA; Plainfield AA. **Exhibited:** Salon Soc. Artistes Français, 1910; AIC, 1912-28; PAFA Ann., 1912-31; Pan-Pacific

Expo, San Francisco, 1915 (medal); NAWPS, 1916, 1923; Soc. Indep. Artists, 1928-29; Newark AC, 1931 (medal); NSS; Arch. Lg.; NAD; Allied Artists Am., 1927; Ferargil GAls., 1929; Windsor Hotel, NYC, 1931; New Haven PCC (prize). **Comments:** Specialties: bas-reliefs; small bronzes. Illustrated for scientific publications. Position: staff artist, AMNH, from 1901. **Sources:** WW29; Petteys, *Dictionary of Women Artists;* Falk, *Exh. Record Series.*

STERLING, Mary E. *[Amateur painter in oils] mid 19th c.*
Addresses: Painesville, OH, c.1860. **Sources:** G&W; Lipman and Winchester, 180.

STERLING, Regina M. *[Painter]*
Addresses: Painesville, OH, c.1860. **Sources:** Petteys, *Dictionary of Women Artists.*

STERLING, Robert (Mrs.) *[Patron] 20th c.*
Addresses: NYC. **Sources:** WW66.

STERLING, Ruth *[Painter] 19th/20th c.; b.St. Louis.*
Addresses: St. Louis, MO; NYC. **Exhibited:** SNBA, 1893; PAFA Ann., 1896-99. **Sources:** WW01; Fink, *American Art at the Nineteenth-Century Paris Salons*, 392; Falk, *Exh. Record Series.*

STERN, Alexander *[Painter, etcher, illustrator] b.1904, Bridgeport, CT.*
Addresses: San Francisco, CA. **Studied:** Columbia Univ.; Calif. School of FA. **Member:** Peninsula AA (co-founder). **Exhibited:** San Francisco AA, 1924, 1925. **Work:** MMA; NY Public Lib. **Comments:** Position: staff, *San Francisco Chronicle.* **Sources:** Hughes, *Artists in California,* 534.

STERN, Alfred Charles *[Sculptor] b.1936, New York, NY.*
Addresses: New York 17, NY; Flushing 65, NY. **Studied:** PIA School, B. Arch. **Work:** Co-designer, "Noon City," lobby of Lorillard Bldg., NY. **Sources:** WW59.

STERN, Arthur Lewis (Mr. & Mrs.) *[Collectors] b.1911; 1913, Rochester, NY; NYC.*
Addresses: Rochester, NY; Phila., Pa. **Studied:** Mr. Stern: Yale Univ., B.A.; Harvard Law School, J.D.; Mrs. Stern: Goucher College, B.A.; Rochester Inst. Technology. **Member:** Mr. Stern: member board of directors, Memorial Art Gallery, Rochester, NY, 1960-, pres., 1967-69; Mrs. Stern: chairman art selection committee, Memorial Art Gallery, 1964-. **Exhibited:** PAFA Ann., 1949. **Comments:** Collection: modern painting and sculpture; Greek, Asian and European artifacts. **Sources:** WW73; Falk, *Exh. Record Series.*

STERN, Caroline (Mrs.) *[Painter] b.1894, Germany.*
Addresses: NYC. **Studied:** Académie Julian, Paris. **Member:** AWCS. **Exhibited:** AWCS. **Sources:** WW59; WW47, which puts birth at 1893.

STERN, Charles *[Painter] 20th c.*
Exhibited: S. Indp. A., 1937. **Sources:** Marlor, *Soc. Indp. Artists.*

STERN, Ethel Louise *[Painter, etcher, teacher] b.1880, Buffalo, NY.*
Addresses: Buffalo, NY. **Studied:** ASL; Buffalo ASL. **Sources:** WW21.

STERN, Gerson *[Engraver] b.c.1824, Bavaria (Germany).*
Addresses: NYC, 1860-at least 1863. **Comments:** His children (5 to 1) were born in New York. **Sources:** G&W; 8 Census (1860), N.Y., LIV, [930]; NYCD 1863.

STERN, H Peter *[Collector] 20th c.*
Addresses: Mountainville, NY. **Studied:** Harvard Univ., A.B.(magna cum laude), 1950; Columbia Univ., M.A., 1952; Law School, Yale Univ., LLB, 1954. **Comments:** Positions: vice-pres., Ralph E. Ogden Foundation, Mountainville, NY; trustee, Vassar College; trustee, Int. Fund Monuments, New York; trustee, Hudson Valley Philharmonic Soc.; trustee, Nat. Temple Hill Assn., Vail's Gate, NY, 1964-71; trustee, Old Mus. Village of Smith's Cove, Monroe, NY, 1967-71; vice-chmn., Mid-Hudson Pattern for Prog., 1968-; pres.& member board trustees, Storm King AC.

Collection: contemporary paintings, graphics and sculpture.
Sources: WW73.

STERN, Harold Phillip [Museum director, writer] b.1922, Detroit, MI / d.1977.
Addresses: Washington, DC. **Studied:** Center Japanese Studies, Univ. Michigan, B.A., M.A. & Ph.D. **Member:** Japan-Am. Soc. Washington; Am. Oriental Soc. **Exhibited:** Awards: Freer fellowship, 1950. **Comments:** Positions: advisor, two Japanese Govt. loan exhibs., 1953 & 1965-66; advisor, Korean Govt. Loan Exhib., 1957-58; asst. director, Freer Gallery Art, Washington, DC, 1962-72, director, 1972-. Publications: author, "Masterpieces of Korean Art," 1957 & "Hokusai: Paintings and Drawings in the Freer Gallery of Art," 1960; co-editor, "Art Treasures from Japan," 1965; author, "Master Prints of Japan," Abrams, 1969. Teaching: lectures on Ukiyoe, Tokugawa painting, life in 14th century Japan, Korean imperial treasures & Japanese art to museums, galleries, universities & Japan Soc.; instructor in Ukiyoe painting, Univ. Michigan, hon lecturer. **Sources:** WW73.

STERN, Helen [Painter] 20th c.
Addresses: Chicago area. **Exhibited:** AIC, 1928, 1932. **Sources:** Falk, AIC.

STERN, Jan Peter [Sculptor] b.1926.
Addresses: Santa Monica, CA. **Studied:** Syracuse Univ. College Fine Arts, BID; New School Social Res. **Exhibited:** Phoenix Art Mus., 1967; Mus. Contemporary Art, 1968; Saint Louis Art Mus., 1968; San Francisco Mus. Art, 1970; Marlborough Gallery, New York, 1970. **Work:** Nat. Collection Smithsonian Inst., Capitol Mall, Washington, DC; Pasadena Art Mus.; Joseph H. Hirshhorn Mus.; Univ. Michigan Inst. Science & Technology; Atlantic Richfield Collection. Commissions: monumental sculptures, Prudential Center, Boston, 1966; Maritime Plaza, Golden Gateway Center, San Francisco, 1967, Alcoa Hdqtrs., Chicago, 1968; Cardinal Spellman Retreat House, NYC, 1969 & Los Angeles City Hall Mall, 1972. **Comments:** Preferred media: highly polished stainless steel, metals. **Sources:** WW73; "Monumental Sculpture Show," Artforum (Feb., 1968); Louis Redstone, "Art in Architecture," 1968 & Garrett Eckbo, "The Landscape We See," 1969, McGraw, documented by Nat. Educ. TV.

STERN, Lester L. [Painter] 20th c.
Addresses: Paterson, NJ, 1944. **Exhibited:** S. Indp. A., 1944. **Sources:** Marlor, Soc. Indp. Artists.

STERN, Lionel [Painter, graphic designer] mid 20th c.
Addresses: NYC. **Studied:** Pratt Inst., 1929. **Exhibited:** NAD; Int. WC Exhib.; Am. WC Soc.; Macy Gal.; AIC; Marie Sterner Art Gal.; "NYC WPA Art" at Parsons School Design, 1977. **Work:** Chase Manhattan Collection; Baltimore Mus.; Carnegie Inst.; Cincinnati Art Mus.; City of St. Louis Art Mus.; John Herron Art Inst.; William Rockhill Nelson Gal. Art; Mary Atkins Mus. FA; Worcester Mus. Art; Univ. Wisconsin; Wisconsin Union. **Comments:** WPA artist in easel painting division, who was sent to New Hampshire and later painted in Arizona. After the WPA Stern worked as a graphic designer. New York City WPA Art, 85 (w/repros.).

STERN, Louise S. [Painter, etcher] b.1901, Baltimore, MD.
Addresses: NYC/West End, NJ. **Exhibited:** Salons of Am., 1926; S. Indp. A., 1926. **Sources:** WW32.

STERN, Lucia [Painter, sculptor, craftsperson, lecturer] b.1900, Milwaukee, WI.
Addresses: Milwaukee, WI. **Studied:** Columbia Univ.; Univ. Wisconsin. **Member:** Wisc. P&S Soc.; Springfield Art Lg.; Wisconsin Des. Craftsmen. **Exhibited:** AIC, 1944; Mus. Non-Objective Painting, 1944-52; Springfield AL, 1945-51; CMA; Detroit IA, 1945 (solo); Milwaukee AI, 1942 (solo), 1945 (prize), 1946 (prize); Salon de Realites Nouvelles, Paris, France, 1948, 1951, 1952. **Work:** Smith College Mus.; Milwaukee AI; Mus. Non-Objective Painting, NY. **Comments:** Lectures: History of Art. **Sources:** WW59; WW47.

STERN, Max [Painter] 19th c.
Addresses: Phila., PA. **Exhibited:** PAFA Ann., 1888. **Sources:** Falk, Exh. Record Series.

STERN, Mildred B. See: **MILLER, Mildred Bunting**

STERN, Rosalyn [Painter] mid 20th c.
Addresses: NYC. **Exhibited:** Corcoran Gal biennial, 1947; WMAA, 1947; PAFA Ann., 1948. **Sources:** Falk, Exh. Record Series.

STERN, Sam Tilden [Painter, designer, lithographer, teacher, craftsperson] b.1909, NYC.
Addresses: Brooklyn, NY. **Member:** AG; Pittsburgh WCS. **Exhibited:** Midtown Gal., NY (solo); Marie Harriman Gal., NYC (solo); Wunderly Gal., Pittsburgh (solo). **Work:** murals, Warner and Enright Theatres, Pittsburgh. **Comments:** Specialties: fabric; glass; stage/movie set design. Position: staff artist, 20th Century Fox. **Sources:** WW40.

STERN, Sol J. [Painter] 20th c.
Addresses: East Savannah, GA. **Sources:** WW25.

STERNBERG, Harry [Painter, educator, lithographer, lecturer, drawing artist] b.1904, NYC.
Addresses: Glen Cove, NY; Escondido, CA. **Studied:** ASL; also graphics with Harry Wickey. **Member:** Art Lg. Am.; Am. Artists Congress; United Am. Artists. **Exhibited:** AIC; WMAA, 1933-53; PAFA Ann., 1939, 1946, 1949; Am. Acad. Arts & Letters, New York, 1972 (purchase award); ACA Gallery, NYC, 1970s. Awards: JS Guggenheim Mem. Foundation fellowship, 1963. **Work:** MoMA; MMA; WMAA; NYPL; LOC; FMA; PMA; CMA; Victoria & Albert Mus., London; Bibliothèque Nationale, Paris; de Young Mem. Mus., San Francisco; Pub. Lib., Newark; AGAA; 50 Fine Prints of the Year, 1931, 1933, 1934, 1938; WPA murals, USPOs in Chicago, Chester & Sellersville, PA. **Comments:** Preferred media: acrylics. Publications: author, "Silk Screen Color Printing" & "Modern Methods and Materials of Etching," McGraw; author, "Composition, Woodcut & Abstract-Realist Drawing," Pitman. Teaching: instructor in painting & graphics, ASL, 1934-68; instructor in graphics, New School of Social Research, 1942-45; head dept. art, Idyllwild School Music & Art, Univ. Southern Calif., 1959-69. **Sources:** WW73; Falk, Exh. Record Series.

STERNBERG, Lenore B. (Mrs.) [Painter] 20th c.
Addresses: Buffalo, NY. **Exhibited:** Western NY Artists, 1935 (prize), 1936; AIC, 1937-38; Corcoran Gal biennial, 1939. **Sources:** WW40.

STERNE, Dahli [Painter, sculptor] b.1901, Stettin, Germany.
Addresses: New York, NY. **Studied:** Kaiserin Auguste Victoria Acad., B.A.; also with Albert Pels, Ludolf Liberts & Josef Shilhavy, US. **Member:** AAPL; Catherine Lorillard Wolfe Art Club; Artists Equity Assn.; 50 Am Artist; Nat. Soc. Arts & Letters (vice-pres., 1971-72). **Exhibited:** Nat. Arts Club, 1953-58; Allied Artists Am., 1955; 50 Am. Artists, 1955-58; College Mt. St. Vincent, New York. Awards: Citation, Oklahoma AA, 1954; award, AAPL, 1955; gold medal, Ogunquit AC, 1957. **Work:** Oklahoma City AC; Evanston MA; Florida Southern College; Seton Hall Univ.; Gracie Mansion, New York. **Comments:** Preferred media: oils. Positions: art director, Nat. Council Jewish Women. **Sources:** WW73.

STERNE, Frank [Painter] 20th c.
Exhibited: AIC, 1937. **Sources:** Falk, AIC.

STERNE, Hedda [Painter, teacher] b.1916, Bucharest, Roumania.
Addresses: Came to U.S. in 1941, settled in NYC. **Studied:** private study in Paris, Bucharest & Vienna. **Exhibited:** Art of this Century Gal., NYC, 1940s; Betty Parsons Gal, NYC, 1947-1970s; PAFA ann., 1948-64 (6 times); WMAA, 1949-67; Corcoran Gal biennials, 1949-63 (4 times); AIC; "Painting & Sculpture Today," Indianapolis AA, 1965-66; Flint Inst. Invitational, 1966-67; Art Inst. Newport Ann., 1967 (1st prize); "The Visual Assault," Univ. Georgia, 1967-68 & Barnard College, 1968; Univ. Colorado,

1968; Phillips Collection, Westmoreland Mus., 1969; Montclair Art Mus., 1977 (retrospective). Other awards: Fulbright fellowship to Venice, 1963; Tamarind fellowship, 1967. **Work:** Univ. Illinois; MMA; MoMA; Univ. Nebraska; AIC. **Comments:** After coming to the U.S. as a refugee, Sterne became a well-known surrealist and Abstract Expressionist. Her work became increasingly non-objective in the 1950s. Throughout her career she has also painted strange, over-sized portraits of friends, such as Elaine De Kooning and Harold Rosenberg. Teaching: instructor in art history, Carbondale College, 1964; conducted workshop for art teachers, NY State Council Arts, 1968. She married artist Saul Steinberg in 1947 (they separated in the 1960s). **Sources:** WW73; Rubinstein, *American Women Artists*, 275-76; Robert Motherwell & Reinhardt (editor), *Modern Artists in America* (Wittenborn, 1951); Nathaniel Pousette-Dart (editor), *American Painting Today* (Hastings, 1956); Herbert Read, *The Quest & The Quarry* (Rome-New York Art Foundation Inc., 1961); Falk, *Exh. Record Series*.

STERNE, Maurice H. *[Painter, sculptor, mural painter]* b.1878, Libau, Latvia / d.1957, Mount Kisco, NY.
Addresses: (Came to NYC in 1889/citizen, 1904); Taos, NM; Mount Kisco, NY/Provincetown, MA. **Studied:** T. Eakins, NAD, 1894-99, in 1904 won NAD Traveling Scholarship to study in Europe, remaining overseas until 1915 (see comments); Cooper Union Art School. **Member:** NA; Associated Artists, NYC; Sculptors Guild; NIAL. **Exhibited:** NAD, 1900-50 (prizes, 1935, 1945); PAFA Ann., 1900-07, 1931-56 (prize 1939, medal 1949); Boston AC, 1901-03; S. Indp. A., 1917, 1936, 1941; Corcoran Gal biennials, 1919-57 (16 times, incl. gold medal, 1930); Salons of Am., 1923-25, 1930; Third Biennial Int., Rome, 1925 (represented U.S.); AIC, 1928 (Logan medal); P&S Los Angeles, 1930; MoMA,1933 (solo); GGE, 1939 (prize); WMAA. **Work:** MMA; WMAA; MoMA; BM; BMFA; CMA; Worcester AM; Detroit IA; San Diego FASoc.; AIC; RISD; AGAA; Yale Univ.; Kaiser Friedrich Mus., Berlin; Cologne Mus., Germany; Tate Gal., London; Fairmount Park, Philadelphia, PA; murals, Dept. Justice, Wash., DC. (Francis Henry Taylor called his Rogers-Kennedy Memorial in Worcester, MA, "The greatest piece of outdoor statuary in America."). **Comments:** At the beginning of his career Sterne spent almost ten years studying and traveling overseas, visiting France, where he admired Cezanne and Monet, spending 1907 in Greece, 1908-11 in Italy, and traveling to Greece, Egypt, India, and Burma in 1911, and finally, from 1912-15, living on the island of Bali. He became well-known for his Bali studies, which show an affinity to the work of Gauguin and Cezanne. Sterne returned to NYC in 1915, and that summer was the first of many spent in Provincetown. Sterne moved to Taos in 1916, and married his first wife, the impressario of high society, Mable Dodge. In Taos, he modeled in clay and painted and sketched Native Americans, but in 1918 he returned to Italy and soon thereafter divorced. In 1933, he became the first American artist given a solo show at MoMA. Sterne's style changed dramatically in 1945, after he became ill while summering in Provincetown. He began painting freely brushed, richly colored marinescapes that were more spontaneous than his earlier work. Sterne also painted on Monhegan Island, ME. Teacher: ASL; Calif. School of FA, 1935-36. **Sources:** WW53; WW47; Falk, *Exh. Record Series;* Baigell, *Dictionary; 300 Years of American Art*, 749; C.C. Mayerson, *Shadows and Light: Life, Friends, and Opinions of Maurice Sterne* (1966); Hughes, *Artists of California*, 534; P&H Samuels (report alternate birthdate of 1877, 464-65); Curtis, Curtis, and Lieberman, 186; Crotty, 47.

STERNER, Albert (Edward) *[Painter, etcher, lithographer, lecturer, writer]* b.1863, London, England (of Am. parents) / d.1946, NYC.
Addresses: Newport, RI; NYC, 1894; Pittsfield, MA. **Studied:** Birmingham, England; Académie Julian, Paris with Boulanger and Lefebvre; also with Gérôme in Paris. **Member:** ANA, 1910; NA,

1935; AWCS; NIAL; Am. Soc. PS&G; SAE. **Exhibited:** Paris Salon, 1891; PAFA Ann., 1893-99, 1908-13, 1921, 1929-37, 1943-44; NAD, 1894, 1935 (prize); Paris Expo, 1900 (medal); Pan-Am. Expo, Buffalo, 1901 (medal); Munich, 1905 (gold); Corcoran Gal biennials, 1907-43 (8 times); Newport AA, 1912 (inaugural); S. Indp. A., 1917, 1920, 1936; AIC. **Work:** CI; MMA; Toronto Mus.; BM; South Kensington Mus.; Victoria and Albert Mus., London; Kunstgewerbe Sch, Mus. Pinacothek, Munich; Kunstgewerbe Schule, Dresden; Royal Print Coll., Italy; Honolulu Acad. A.; NYPL; LOC; Speed Mem. Mus., Louisville, Ky.; Yale Univ. Library; Harvard Club, Steinway Hall, NYC; portrait and dec., National Golf Links of America. **Comments:** Spending periods of time in the U.S. as well as abroad, he created and exhibited paintings throughout his career, but he primarily won recognition as an illustrator and lithographer. Illustrator: "Ten Tales of Francois Coppee," "Prue and I," by G.W. Curtis, "Eleanor," "Marriage of William Ashe," "Fenwicks' Career," by Mrs. H. Ward; article, "The Cezanne Myth," Harper's (between 1893 and 1905); Prosper Merimee's "Carmen" (translated from original 36 drawings). Author: "Prints Without Ideas," "Odilon Redon"; article in Prints. **Sources:** WW40; *300 Years of American Art*, 575, which cites a death date of 1957; Falk, *Exh. Record Series*.

STERNER, Harold *[Painter, writer]* b.1895, Paris, France / d.1976, NYC.
Addresses: NYC. **Studied:** St. George's School, Newport, RI; MIT, B.S. **Member:** AFA; BAID. **Exhibited:** WMAA, 1918, 1943-56; Grand Central Gal, NYC, 1940s; Julien Levy Gal., NYC, 1940s; Wakefield Gal., NYC 1940 (solo); PAFA Ann., 1943, 1945; Corcoran Gal biennials, 1943, 1945; AIC, 1943; MMA (AV), 1944; CAM, 1944; CI, 1946, 1948; Knoedler Gal., 1955 (solo); British-Am. Art Center, 1951 (solo). **Work:** BMFA. **Sources:** WW59; WW47; Wechsler, 31; Falk, *Exh. Record Series*.

STERNFELD, Edith Alice *[Painter, educator, sculptor, lecturer, teacher, craftsperson]* b.1898, Chicago, IL.
Addresses: Grinnell, IA. **Studied:** Northwestern Univ., B.A.; AIC, B.A.E.; Univ. Iowa, M.A.; Cranbrook Acad. Art; Claremont Grad. School, and with Eliot O'Hara, Grant Wood, Florence Sprague, Jean Charlot, Rex Brandt; Layton School Art; Anthony Angarola; Ross Moffett; Frank L. Allen.; B. Miller; at first Stone City Colony. **Member:** CAA; Iowa AG; Western AA; AAPL; AAUW. **Exhibited:** AIC; Wisconsin P&S; AWCS; Philadelphia WCC; Baltimore WCC; California WCS; Washington WCC; Kansas City AI; Joslyn Mem., 1937 (prize), 1940 (prize); WFNY, 1939; Iowa WC Exhib., 1945 (prize), 1953 (prize); Milwaukee AI, 1929-30 (prizes); Iowa AC, 1932; Iowa State Fair, 1932, 1933 (prize); Iowa Art Salon, 1939 (prize); All-Iowa Exh., 1937 (prize); Des Moines, Iowa; Denver Art Mus.; Mid-Am. Artists; Springfield (MO) Art Mus. Awards: Chicago Tribune Comp., 1953 (prize); numerous prizes in regional exhib. **Comments:** Lectures: painting. Position: art professor, chmn. dept. art, 1930- & chmn. Div. FA, 1944-46, 1951-53, Grinnell (IA) College. **Sources:** WW59; WW47; Ness & Orwig, *Iowa Artists of the First Hundred Years*, 199.

STERNFELD, Harry *[Painter]* 20th c.
Addresses: Pittsburgh, PA. **Member:** Pittsburgh AA. **Sources:** WW25.

STERNFELS, Edna *[Painter]* 20th c.
Addresses: Mt. Vernon, NY. **Member:** S. Indp. A. **Exhibited:** S. Indp. A.S. Indp. A., 1921, 1937. **Sources:** WW25.

STERNHAGEN, Gertrude F. (née Hussey) *[Sculptor]* b.c.1890, Asbury Park, NJ / d.1976.
Addresses: Washington, DC, 1927-39. **Exhibited:** Soc. Wash. Artists Exhib., 1931. **Sources:** McMahan, *Artists of Washington, DC.*

STERRETT, Cliff *[Cartoonist]* b.1883, Fergus Falls, MN / d.1964.
Addresses: Bronxville, NY/Ogunquit, ME. **Studied:** Chase School Art, NYC, 1901-03. **Member:** SI. **Comments:** In 1912, he

created the internationally popular comic strip, "Polly and Her Pals" (King Features Syndicate). **Sources:** WW59; WW47; *Famous Artists & Writers* (1949).

STERRETT, Virginia Frances *[Illustrator, teacher]* b.1900, Chicago, IL / d.1931, Los Angeles County.
Addresses: Altadena, CA. **Exhibited:** AIC; Pasadena AI; P&S Los Angeles, 1929; Little Gallery, Monrovia, 1929; Los Angeles County Fair, 1929; Calif. State Fair, 1930. **Sources:** Hughes, *Artists in California*, 535.

STERRITT, James A. *[Sculptor]* 20th c.
Addresses: Lawrence, KS; Quakertown, PA. **Exhibited:** PAFA Ann., 1960, 1964, 1968. **Sources:** Falk, *Exh. Record Series*.

STERRY, Thomas N. *[Engraver]* mid 19th c.
Addresses: Norwich, CT, 1860. **Sources:** G&W; New England BD 1860.

STETCHER, Karl *[Portrait painter and craftsman]* b.1831, Germany / d.1924, Wichita, KS.
Addresses: Came to NYC at an early age. **Sources:** G&W; *Art Annual*, XXI, obit.

STETH, Raymond *[Graphic artist]* mid 20th c.
Exhibited: LOC, 1940; South Side Community Art Center, Chicago, 1941; Fort Huachuca, AZ, 1943. **Sources:** Cederholm, *Afro-American Artists*.

STETSON, Charles Walter *[Painter, etcher, critic]* b.1858, Tiverton Four Corners, RI / d.1911, Rome, Italy.
Addresses: Providence, RI (1869-1890s); Pasadena, CA (late 1890s-1900); Rome, Italy. **Studied:** self-taught. **Member:** Providence AC (founder). **Exhibited:** Providence AC, 1880s; Boston AC, 1882-84, 1901; PAFA Ann., 1882-83, 1901-02; NY Etching Club, 1886; AIC; BMFA; Cincinnati AM; St. Louis AM; Corcoran Gal., 1913 (memorial exhib.); PPE, 1915; Spencer Mus. Art, Kansas, 1982 (solo); Parrish AM, 1984 ("Painter-Etchers" exhib.). **Work:** de Young Mus., San Francisco. **Comments:** A painter of romantic and mystical landscapes, during the 1880s he was a leading figure in the development of the Providence Art Club, along with E. Bannister, S. Burleigh, and G.W. Whitaker. In the 1880s he painted in the Canadian maritime provinces with Whitaker, and was teaching etching in 1882. In 1883, he received an important commission to etch copies of paintings owned by the Boston collector, Beriah Wall. By the late 1890s he had moved to Pasadena, CA, where he found his "dream trees" (eucalypti). Thereafter, he moved to Rome where he lived as an expatriate for many years. Art critics of his day thought his works were alligned with those of Albert P. Ryder, while late 20th c. historians compare him with Inness and Dewing. **Sources:** WW10; Hughes, *Artists of California*, 535; exh. cat., *Painters of Rhode Island* (Newport AM, 1986, p.24); *American Painter-Etcher Movement*; C. Bert, *Sketches* (Providence, No.1, Dec. 1990); Falk, *Exh. Record Series*.

STETSON, Earl (Mrs.) See: **CRAWFORD, Brenetta Herrman**

STETSON, Edward Meriam *[Painter, basket weaver]* b.1872, New Bedford, MA / d.1953, New Bedford, MA.
Addresses: New Bedford, MA, active 1907-53. **Studied:** Harvard; with Chas. H. Woodbury, Ogunquit School; R. Swain Gifford and Kleiminger, in South Dartmouth. **Member:** New Bedford Art Club. **Exhibited:** New Bedford Art Club, 1907-19; Thumb Box Exhib., 1910, 1911. **Work:** Old Dartmouth Hist. Soc. **Sources:** *Charles Woodbury and His Students*; Blasdale, *Artists of New Bedford*, 177-78 (w/repro.).

STETSON, Elizabeth *[Painter]* 20th c.
Addresses: Melrose Pk., PA. **Exhibited:** PAFA Ann., 1941. **Sources:** Falk, *Exh. Record Series*.

STETSON, Katharine Beecher *[Sculptor, landscape painter, teacher]* b.1885, Providence, RI / d.1979.
Addresses: NYC, until 1917; Pasadena, CA, from 1919-62.

Studied: Rome, with da Pozzo, Sabate, Noël, Breck; PAFA, with Chase, Anshutz, Kendall, Poore, Beaux; H.D. Murphy; B. Harrison; L. Ochtman; F.T. Chamberlin. **Member:** McD. Assn.; Pasadena SA. **Exhibited:** Int. Expo, Rome, 1911; PAFA, 1912, 1914-16, 1919, 1926; PAFA Ann., 1916-17, 1921-22, 1925, 1928-30; RISD; NAD, 1914-16, 1919, 1925; Arch. Lg., 1915, 1917; AIC, 1915-17, 1926; LACMA, 1921-26, 1925 (medal); Pasadena SA, 1924-51, 1940 (prize); Los Angeles County Fair, 1925 (prize),1927 (prize). **Work:** LACMA. **Comments:** Daughter of feminist activist and author Charlotte Perkins Gilman ("The Yellow Wallpaper") and artist Charles W. Stetson.She married the painter F. Tolles Chamberlin. **Sources:** WW47; Hughes, *Artists in California*, 535; Falk, *Exh. Record Series*.

STETSON, Sylvia C. *[Painter]* late 19th c.
Addresses: Boston, active 1868-78. **Exhibited:** NAD, 1868, 1869; MA Charitable Mechanic Assoc., 1878. **Sources:** Campbell, *New Hampshire Scenery*, 159.

STETTER, Lydia J. *[Artist]* late 19th c.
Addresses: Active in Washington, DC, 1888. **Sources:** Petteys, *Dictionary of Women Artists*.

STETTHEIMER, Florine *[Painter, designer]* b.1871, Rochester, NY / d.1944, NYC.
Addresses: NYC. **Studied:** ASL, with K. Cox & Henri, 1892-95; Berlin, Stuttgart, and Munich, Germany. **Member:** Soc. Indep. Artists. **Exhibited:** Knoedler Galleries, NYC, 1916 (lst and only solo in her lifetime); Soc. Indep. Artists, 1917-26; Salon d'Automne, 1922; CI, 1924; WMAA, 1932, 1944; Salons of Am., 1934; PAFA Ann., 1944; MoMA, 1946 (posthumous exh.); Durlacher Bros. Gal., NYC, 1948, 1963; Wadsworth Atheneum, Hartford, 1948; Vassar College Art Gal., 1949, 1980 (retrospective); Detroit IA, 1950; Low Mem. Library, Columbia Univ., NYC, 1973; Inst. Contemporary Art, Boston, 1980. **Work:** PMA; LACMA; AIC; MMA; MOMA; PAFA; Yale Univ. Art Gal., New Haven, CT. **Comments:** Known for her wry, whimsical, and deliberately naive paintings of family & friends, flowers, and scenes set in NYC. From 1906 to 1914 she traveled through Europe with her mother and two sisters, Ettie (who became a novelist under the pen name of Henry Waste) and Carrie (who spent years building a doll house--now at the Mus. of the City of New York--which contained miniature replicas of modern works, made by the artists themselves). The women visited Paris, Switzerland, Rome, and Germany, returning to the U.S. at the outbreak of WWI. Settling in NYC the sisters became famous for entertaining leading artists (including Marcel Duchamp) at their Alwyn Court apartment. Stettheimer's first and only solo show, held at Knoedler's in 1916, was largely ignored by critics, and thereafter the artist limited herself to exhibiting only in group or unjuried shows. In 1934 she designed stage sets for Virgil Thompson and Gertrude Stein's "Four Saints in Three Acts." Her last series of paintings were tributes to Manhattan, called *Cathedrals of New York*. **Sources:** WW29; Tufts, *American Women Artists*, cat. no. 74; Rubinstein, *American Women Artists*, 193-96; Baigell, *Dictionary*; Petteys, *Dictionary of Women Artists*; Parker Tyler, *Florine Stettheimer: A Life in Art* (New York, 1963); Henry McBride, *Florine Stettheimer* (MOMA, 1946); Falk, *Exh. Record Series*.

STETTINIUS, Samuel Enredy *[Portrait painter in watercolors and oils]* b.1768, Friedrichgratz, German Silesia / d.1815, Baltimore , MA.
Addresses: Pennsylvania, 1791-1815. **Comments:** He emigrated to America in 1791 and lived for some years in Hanover (PA). He also published the first newspaper in Hanover. **Sources:** G&W; Millar, "Stettinius, Pennsylvania Portrait Painter."

STEUART, Elizabeth Howard (Mrs. William D.) *[Painter]* 20th c.
Addresses: Baltimore, MD. **Sources:** WW25.

STEUART, Emily Nourse *[Painter, teacher]* b.1893, Washington, DC / d.1990, Washington, DC.

Addresses: Washington, DC. **Studied:** George Washington Univ.; Teachers College, Columbia Univ.; & with Henry Snell, George Pearse Ennis, Charles Martin. **Member:** Wash. AC; Wash. WCC; Eastern AA; AFA; Twenty Women Painters of Wash. **Exhibited:** Wash. AC; Wash. WCC, 1930, 1933, 1934, 1937, 1938; Greater Wash. Independent Exhib., 1935. **Comments:** Position: art instructor, Western H.S., Washington, DC, 1927-55. **Sources:** WW53; WW47. More recently, see McMahan, *Artists of Washington, DC.*

STEUART, LeConte *[Etcher, lithographer, block printer, painter, teacher] b.1891, Glenwood, UT.*
Addresses: Kaysville, UT. **Studied:** PAFA, with Carlson, Goetz, DuMond, Garber. **Work:** Springville (UT) H.S.; Ogden (UT) City Collection; Utah State Collection, Salt Lake City. **Sources:** WW33.

STEUART, M. Louisa *[Painter, teacher] 20th c.; b.Baltimore.*
Addresses: Baltimore, MD, 1894; Cascade, P.O., MD. **Studied:** with A. Thayer; H. Newell; in Paris with J. Rolshoven & Courtois; W. Chase. **Member:** Baltimore WCC. **Exhibited:** NAD, 1894. **Sources:** WW33.

STEUART, Sarah R. *[Painter] 20th c.*
Addresses: Montclair, NJ. **Sources:** WW06.

STEUERNAGEL, Herman *[Painter, cartoonist] b.1867, Germany / d.1956, Puyallup, WA.*
Addresses: Puyallup, WA, c.1936-56. **Studied:** Berlin, Weimar and Bremen, Germany; Paris, France. **Exhibited:** Tacoma Art League, 1940. **Comments:** Creator of large theater sets which he sold to theaters throughout the world. Position: art director, Pathe Film Co., c.1909-17. **Sources:** Trip and Cook, *Washington State Art and Artists, 1850-1950.*

STEUVER, Celia M. *[Painter, etcher] 20th c.; b.St. Louis.*
Addresses: St. Louis, MO. **Studied:** St. Louis Sch. FA; École des Beaux-Arts, Paris; Germany; Vienna. **Member:** Albrecht Durer Verein, Kunstler Genossenschaft, Vienna; Calif. PM; Calif. SE. **Exhibited:** City Art Mus., St. Louis, 1911 (solo). **Sources:** WW25.

STEVEN, Francis Simpson *[Painter] 20th c.*
Addresses: NYC. **Sources:** WW15.

STEVENS, Alice Barber *[Painter]*
Exhibited: Boston AC, 1880, 1881, 1883; AIC. **Sources:** *The Boston AC.*

STEVENS, Almira E. *[Painter, teacher] b.c.1861, NYC / d.1946, Yonkers.*
Addresses: Yonkers, NY. **Studied:** CUA School; Paris; Munich; Dresden. **Comments:** Specialties: watercolors, oils, decorated chinaware. **Sources:** WW24.

STEVENS, Ambrose *[Lawyer and amateur artist]*
Addresses: NYC, active c.1847. **Exhibited:** Am. Inst., 1847 (paintings of a horse and a cow). **Sources:** G&W; Am. Inst. Cat., 1847, 1849; NYCD 1846-49.

STEVENS, Amelia *[Sketch artist] mid 19th c.*
Comments: Made a drawing of the ruins of the Mormon Temple at Nauvoo (IL) about 1857. **Sources:** G&W; Arrington, "Nauvoo Temple," Chapt. 8.

STEVENS, Angelina V. *[Portrait painter] 20th c.; b.Siena, Italy.*
Addresses: Springfield, MA/Rockport, MA. **Studied:** E.L. Major; W.L. Stevens; Mass. Normal School; Boston Univ.; Sch. FA, Florence, Italy. **Member:** Springfield AG. **Sources:** WW40.

STEVENS, Beatrice *[Painter] b.1876, NYC.*
Addresses: Pomfret, CT. **Exhibited:** Salons of Am., 1934; AIC. **Sources:** WW21.

STEVENS, Bernice A. *[Craftsman, teacher] 20th c.; b.Evansville, IN.*
Addresses: Gatlinburg, TN. **Studied:** Evansville College, B.S.; Univ. Tennessee, M.S. in crafts; Gatlinburg Craft School; Ringling

School Art.; Saugatuck Sch. Painting. **Member:** Hoosier Craft Old; AAUW; So. Highland Handicraft Gld.; 12 Des.-Craftsmen. **Exhibited:** Huntington, WV, Nat. Jewelry Exhib., 1955, and Rochester, NY, 1956, circulated by Smithsonian Inst.; Southern Highlands Fair, 1948-50, 1959-65; Evansville Tri-State Exhibs., 1940-56; Hoosier Craft Gld., 1950-56; Louisville, KY, 1955; John Herron AI, 1955; Ft. Wayne traveling exhib., 1955; Des.-Craftsmen, USA, 1960; Plum Valley Exhib. (GA), 1963-1965. Awards: Delta Kappa Gamma Fellowship, 1955; Ford Foundation, 1955-56. **Comments:** Positions: instructor in arts & crafts, Evansville Pub. Schools, 1927-55; jewelry, Evansville College, 1947-55; jewelry, Cherokee, NC, summer, 1954-63; conducted craft survey of the Southern Highlands for Southern Appalachian Studies, sponsored by Ford Foundation; educ. director, Southern Highlands Handicraft Gld., 1959-63; crafts instructor for the State Department, to youth leaders in Malaya, 1960-61 (3 mos.); pres. & producer for shop of 12 designer-craftsmen, Gatlinburg. Contributor to *School Arts* magazine, *Creative Crafts, Ford Times, Handweaver & Craftsman* magazines. **Sources:** WW66.

STEVENS, Charles *[Sculptor] 20th c.*
Addresses: Scotch Plains, NJ. **Exhibited:** WMAA, 1952. **Sources:** Falk, *WMAA.*

STEVENS, Charles J. *[Engraver] b.1822, New York State.*
Addresses: New Orleans, active 1852-60. **Comments:** Worked with Thomas H. Shields (see entry) before opening his own establishement. **Sources:** G&W; 8 Census (1860), La., VIII, 200; New Orleans CD 1852-56, 1859. More recently, see *Encyclopaedia of New Orleans Artists,* 365.

STEVENS, Charles K. *[Illustrator] b.1877 / d.1934.*
Addresses: NYC. **Studied:** Chase Art School; ASL. **Comments:** Specialty: brilliantly colored poster type of book jacket for more than 1,000 books, 1914-34.

STEVENS, Clara Hatch (Mrs.) *[Painter] b.1854, Harrodsburg, KY.*
Addresses: Lake Bluff, IL. **Studied:** O. D. Grover in Chicago; ASL with J.C. Beckwith; W. Chase; R.M. Shurtleff; Puvis de Chavannes. **Member:** All-Illinois SFA; North Shore AL. **Exhibited:** AIC, 1897; Century of Progress Expo, Chicago, 1933. **Work:** frieze, Hall of Honor, Women's Bldg., World's Columbian Expo, Chicago, 1893; panel, Hall of Science, Century of Progress Expo, Chicago, 1933. **Sources:** WW40.

STEVENS, Dalton See: **STEVENS, (Edward) Dalton**

STEVENS, Daniel *[Engraver] mid 19th c.*
Addresses: Hartford, CT, 1854-60. **Sources:** G&W; Hartford CD 1854-60.

STEVENS, Dorothy *[Etcher, painter] b.1888, Toronto, Ontario, Canada / d.1966, Toronto, Ontario, Canada.*
Addresses: Toronto, Ontario. **Studied:** Slade School, London. **Member:** Chicago SE. **Exhibited:** Pan-Pacific Expo, San Francisco, 1915 (medal). **Sources:** WW24.

STEVENS, Dwight Elton *[Designer, painter, educator] b.1904, Sharon, OK.*
Addresses: Stillwater, OK. **Studied:** Oklahoma A&M College, B.S. in Arch.; Cincinnati Art Acad. **Member:** Beaux-Arts Soc.; Nat. Inst. Arch. Educ.; SSAL; AIA; Calif. WCS. **Exhibited:** Denver AM, 1943; Oakland Art Gal., 1943; AWCS, 1946; SSAL, 1946; Oklahoma AA, 1944-46; CM, 1925 (prize); Philbrook AC; Calif. WCS; PMA; Dallas MFA; Delgado MA; Oklahoma A&M College (solo). Awards: prizes in arch. des., national and regional comp.; Oklahoma Chapter, AIA, 1954. **Comments:** Positions: professor of arch. des., dept. arch., Oklahoma State Univ., Stillwater, OK. Lectures: Gothic art and architecture of the church; "The Student and Design Practices." **Sources:** WW66; WW47.

STEVENS, E. W. *[Painter] late 19th c.*
Addresses: Phila., PA, 1882. **Exhibited:** NAD, 1882. **Sources:** Naylor, *NAD.*

STEVENS, Edith See: **PARSONS, Edith Barretto Stevens (Mrs.)**

STEVENS, Edith Briscoe *[Painter, sculptor] b.1896, Phila. / d.1931, Gloucester, MA.*
Addresses: Hartford, CT. **Studied:** A.E. Jones; H. Leith-Ross; G.E. Browne. **Member:** CAFA; New Haven PCC; Springfield AL; Gloucester SA; Rockport AA. **Exhibited:** PAFA Ann., 1905; New Haven PCC, 1931 (prize). **Work:** Beach Collection, Storrs, CT. **Sources:** WW29; Falk, *Exh. Record Series.*

STEVENS, (Edward) Dalton
[Illustrator] b.1878, Gouchland, County, VA / d.1939.
Addresses: NYC. **Studied:** Vanderpoel, in Chicago; Chase School, NYC; Paris. **Comments:** Illustrator: "Mary Regan," by L. Scott, "The Crystal Stopper," by Leblanc, "Peter Rough"; *Cosmopolitan, Redbook, McCall's, Liberty*; covers for McFadden Pub. Co. **Sources:** WW38.

STEVENS, Edward John, Jr. *[Painter, educator] b.1923, Jersey City, NJ / d.1988.*
Addresses: Jersey City, NJ. **Studied:** NJ State Teachers College, Newark, B.A., 1943; Columbia Univ. Teachers College, M.A., 1944, Art Extension, 1944-47, with Henry Varnum Poor & George Picken. **Member:** Phila. WCC; Audubon Artists. **Exhibited:** PAFA Ann., 1945, 1951; PAFA, 1963; Pasadena AI, 1946; BM, 1945, 1946; AIC, 1947, 1949; WMAA; Soc. Four Arts, Palm Beach, FL; Phila. Art All., 1946; Weyhe Gal., 1944-71 (22 solos); WMAA Ann., 1954; BM Int. Watercolor Exhib., 1955; Newark Mus. NJ Triennial, 1964; NAD, 1968 (Henry Ward Ranger Fund Purchase Award). **Awards:** Artist of Year, Hudson Artists, 1954; bronze medal, NJ Tercentenary, 1964. **Work:** WMAA; NJ State Mus, Trenton; AIC; PAFA; Honolulu Acad Arts, Hawaii. **Comments:** Preferred media: gouache. Teaching: painting instructor, Newark School Fine & Indust. Art, 1947-59 & coord. director, 1959-. **Sources:** WW73; WW47; Falk, *Exh. Record Series.*

STEVENS, Elisabeth Goss *[Writer, art critic] b.1929, Rome, NY.*
Addresses: Scarsdale, NY. **Studied:** Wellesley College, B.A., 1951; Columbia Univ., M.A. (high honors), 1956. **Comments:** Positions: editorial assoc., *Art News,* 1964-65; art critic, *Washington Post,* 1965; free lance art critic & writer, 1965-. Publications: author, "The Gallery," art column in *Wall Street Journal,* 1970-; author, "An Archeological Find Named Iris Love," *New York Times Magazine,* 3/7/1971; author, "The Urban Museum Crisis" (ser.), *Washington Post,* 6-7/1972; author, articles, *Atlantic, New Republic, Saturday Review, Bookworld, Art Am., Arts* & many others. **Sources:** WW73.

STEVENS, Elizabeth *[Painter] late 19th c.*
Studied: with Collin. **Exhibited:** Paris Salon, 1896. **Sources:** Fink, *American Art at the Nineteenth-Century Paris Salons,* 392.

STEVENS, Elizabeth T. *[Painter] 20th c.*
Addresses: Hartford, CT. **Member:** Hartford AS. **Sources:** WW25.

STEVENS, Ellen Jane *[Artist] late 19th c.*
Addresses: Active in Washington, DC, 1888-98. **Sources:** Petteys, *Dictionary of Women Artists.*

STEVENS, Esther (Mrs. Walter T. Barney) *[Painter] b.1885, Indianapolis, IN / d.1969, La Jolla, CA.*
Addresses: San Diego, CA. **Studied:** Stanford Univ.; San Francisco Inst. of Art; ASL with R. Henri. **Member:** San Diego AG. **Exhibited:** Soc. Indep. Artists, 1917; San Francisco AA, 1922 (gold); Gump's, San Francisco; San Diego FA Gallery; Calif.-Pacific Int. Expo, San Diego, 1935 (bronze medal). **Sources:** WW24; Hughes, *Artists in California,* 535; Trenton, ed. *Independent Spirits,* 75.

STEVENS, Eugene *[Painter] 20th c.*
Exhibited: Salons of Am., 1931; S. Indp. A., 1931-32, 1944. **Sources:** Falk, *Exhibition Record Series.*

STEVENS, Frances Simpson *[Painter] b.c.1890.*
Addresses: NYC. **Exhibited:** Armory Show, 1913; Expo Libera Futurista Int., Gal. Futurista, Rome, 1914 (only Am. to participate); Braun Gal., NYC, 1916 (solo); Peoples Art Guild, NYC, 1917; Penguin Club, 1917; Soc. Indep. Artists, 1917 (first ann. exh.). **Work:** Louise & Walter Arensberg Coll., PMA. **Comments:** Part of futurist movement. Pettys reports that only one of her works is believed to still survive, "Dynamic Velocity of Interborough Rapid Transit Station". Nothing was known of her from 1919, when she married Prince D. N. Galitzine, until 1950 when she was in Patton, CA. **Sources:** Marlor, *Soc. Indep. Artists;* Petteys, *Dictionary of Women Artists.*

STEVENS, Francis G. *[Engraver] 19th/20th c.*
Addresses: Wash., DC, active 1905. **Sources:** McMahan, *Artists of Washington, DC.*

STEVENS, Frederick Wiley *[Amateur painter] b.Goshen, IN / d.1932, Wash., DC.*
Addresses: Wash., DC, 1919 and after. **Member:** Cosmos Club, Wash., DC. **Sources:** McMahan, *Artists of Washington, DC.*

STEVENS, G. J. *[Painter] 20th c.*
Exhibited: Salons of Am., 1923. **Sources:** Marlor, *Salons of Am.*

STEVENS, George *[Engraver] b.1815, London (England).*
Addresses: NYC, 1860. **Comments:** His children, ages 4 to 20 years, were born in New York. **Sources:** G&W; 8 Census (1860), N.Y., XLII, 993.

STEVENS, George W. *[Miniaturist] mid 19th c.*
Addresses: Boston, 1840-42. **Comments:** After 1842 he was listed as upholsterer and chairmaker. **Sources:** G&W; Boston CD 1840-58; Bolton, *Miniature Painters.*

STEVENS, George W(ashington) *[Musdir, painter, writer, lecturer] b.1866, Utica, NY / d.1926.*
Addresses: Toledo, OH. **Studied:** J.F. Murphy, in NYC. **Member:** SC; Assn. Mus. Dir. (pres.); Am. Fed. Photogr. Socs., (pres., 1909-10); Nat. Inst. Social Sciences; Egypt Exploration Soc. (hon. secretary); Faculty of Arts, London (vice-pres.). **Comments:** Author: "The King and the Harper and other Poems," "Things." Position: director, TMA, from 1903. **Sources:** WW25.

STEVENS, H. Hoyt (Mrs.) *[China painter] 19th/20th c.*
Addresses: Active in Colorado Springs, late 1900s. **Exhibited:** Colorado College, 1900. **Sources:** Petteys, *Dictionary of Women Artists.*

STEVENS, Harry L., Jr. *[Painter] 20th c.*
Addresses: Germantown, PA, 1935. **Exhibited:** PAFA Ann., 1935. **Sources:** Falk, *Exh. Record Series.*

STEVENS, Helen B. (Mrs. T.W.) *[Etcher] b.1878, Chicago.*
Addresses: Santa Fe, NM. **Studied:** AIC; F. Brangwyn, in England. **Member:** Chicago SE; Pittsburgh AA. **Exhibited:** Pan-Pacific Expo, San Francisco, 1915 (medal); AIC. **Comments:** Positions: etching instructor & asst. curator of prints, AIC, 1909-12. **Sources:** WW40.

STEVENS, J. Shand *[Painter] 20th c.*
Addresses: Woodside, L.I., NY, 1931. **Exhibited:** S. Indp. A., 1931. **Sources:** Marlor, *Soc. Indp. Artists.*

STEVENS, John *[Painter, panoramist] b.1819, Utica, NY / d.1879.*
Addresses: Rochester, MN, 1853 and after. **Work:** Minnesota Historical Society; Gilcrease Museum at Tulsa, OK (two surviving versions of his panorama). **Comments:** In 1858 he turned to house and sign painting and then scenery painting. Probably about 1863 he painted the first of several versions of his moving panorama of the Sioux Massacre of 1862; other versions, brought up to date with scenes of current interest, followed in 1868, 1870, and 1874, and Stevens made a handsome profit from their exhibition in the Middle West. **Sources:** G&W; Heilbron, "Documentary Panorama"; Heilbron, "The Sioux War Panorama of John Stevens"; *American Processional,* 246; *The New Yorker,* March 6, 1943, 13; P&H Samuels, 465.

STEVENS, John *[Sculptor, painter] b.1935, Detroit, MI.*
Studied: San Francisco Acad. Art, with D. Faralla, Lundy Siegriest and Tony Delap. **Exhibited:** San Francisco Ann. Art Festival; Oakland & Richmond Art Centers, CA; New Mission Gallery; San Francisco Art Center; 20th Century West Galleries, NYC; Fred Hobbs Gallery, San Francisco; Dickson Art Center, 1966. **Sources:** Cederholm, *Afro-American Artists.*

STEVENS, John Calvin *[Landscape painter, architect] b.1855, Boston, MA / d.1940, Portland, ME.*
Addresses: Portland, ME. **Member:** FAIA; Arch. Lg.; Maine Chap. AIA; Portland SA (pres.); AFA; Brushians (later group). **Exhibited:** Boston AC. **Comments:** He was twenty years younger than many members of the Brushians group. His nickname in the group was "The Old Man." Wrote articles for the *Pine Tree Magazine.* **Sources:** WW40; Campbell, *New Hampshire Scenery,* 159.

STEVENS, Joseph Travis *[Illuminator, engrosser] b.1922, Marietta, OK.*
Addresses: Shreveport, LA. **Studied:** East Central College, Ada, OK, B.A. in Educ.; Centenary College, Shreveport, LA. **Member:** Nat. Soc. Arts & Letters; Prof. Draftsmen's Soc. of Shreveport. **Exhibited:** Louisiana State Mus. (solo), 1961; Shreveport Art Show, 1957; Shreveport Library, 1961. **Work:** William H. Francis Mem., 1957; Charles I. Thompson Mem., 1958; Herman Brown Memorial; Tribute to Schiller, for Chancellor Konrad Adenauer, 1958; mural, Illumination for St. Andrew's Church, Roswell, NM, 1952; St. Mark's, Shreveport, 1962; numerous scrolls. **Comments:** Contributor manuscript illuminations to *Shreveport Magazine,* 1960 & *Shreveport Times,* 1957. Lectures: Neo-Gothic Illuminations, History & Demonstration of Technique. **Sources:** WW66.

STEVENS, Kelly Haygood *[Painter, craftsperson, teacher] b.1896, Mexia, TX.*
Addresses: Austin, TX in 1962. **Studied:** Texas School for Deaf; Gallaudet College, Washington, DC; Corcoran School Art, with Brooke, Messer; Trenton (NJ) School Indust. Arts, with McGinnis; Paris, with deaf painter J. Hanan (1920s), L. Biloul, H. Morisset (1933); Spain, with V. de Zubiaurre; New York School FA; Louisiana State Univ. **Member:** SSAL; Texas FAA; Louisiana Teachers Assn. **Exhibited:** Dallas Mus. FA; Roerich Mus.; State Art Gal., Shreveport, LA; SSAL; Texas FAA; Madrid, Brussels, Paris. **Comments:** Position: teacher, New Jersey School for the Deaf (8 yrs.). Known for depictions of Indian ceremonials and dances. **Sources:** WW59; WW47; P&H Samuels, 465.

STEVENS, Lawrence ("Steve") Tenney *[Sculptor, painter, graphic artist, lecturer, teacher] b.1896, Brighton, MA / d.1972.*
Addresses: Bedford, NY, 1929; NYC, 1933; Mt. Vernon, NY, 1939; Tempe, AZ. **Studied:** BMFA School; Tufts Medical School; Am. Acad., Rome; also with John Wilson, Bela Pratt, Philip Hale & Charles Grafly. **Member:** NSS; Alumni BMFA School; Grand Central Art Gal. **Exhibited:** Arch. League, 1925 (winter exhib.),1926; AIC, 1926, 1928; NAD, 1927, 1928; BMFA, 1925, 1926, 1931; Grand Central Art Gal.; Boston AC, 1925; PAFA Ann., 1929, 1933, 1939; Fine Arts Bldg., Pomona, CA, 1937 (nat. competition for sculpture); Philbrook Art Center, 1944, 1945, 1946; Calif. State Fair, Pomona, 1934 (prize); Invitational Sculpture Exhib., Philadelphia, PA, 1952. **Awards:** Prix de Rome, 1922; fellwoship Am. Acad. in Rome; Tiffany Foundation scholar, 1923-25. **Work:** Univ. Pennsylvania; BM; Perry Clinic, Tulsa; Woodward, OK; Central H.S., Chamber of Commerce, both Tulsa; Will Rogers Mem., Clareniore, OK.; Fairgrounds, Dallas, TX; Pomona, CA; Scripps College, Claremont, CA; Brookgreen Gardens; Philbrook Art Center, Tulsa, OK; Civic Center, Scottsdale, AZ; Phoenix (AZ) Art Mus.; Ball Mus., Muncie, IN. **Commissions:** John Harrison, bronze, Fairmont Park Assn. City Art Committee, Philadelphia, 1930; six heroic statues, Texas Centennial, Dallas, 1936; Protecting Hand, Woodmen Accident & Life Ins. Co., Lincoln, NE, 1956; rodeo series (nine bronzes), Valley Nat. Bank, Phoenix, AZ, 1959-70; terra cotta bas-reliefs, history of Palm Springs, CA, Security First Nat. Bank, 1960.

Comments: Visited Wyoming and Arizona in 1929. After WWII he moved to Tulsa, OK and to Tempe, AZ in 1954. Preferred media: marble, bronze, wood. Specialty: western animals. Positions: in charge of sculpture, Texas Centennial, Dallas, 1936. **Sources:** WW73; WW47; P&H Samuels, 465-66; Falk, *Exh. Record Series.*

STEVENS, Lester See: **STEVENS, W(illiam) Lester**

STEVENS, Lizzie *[Artist] late 19th c.*
Addresses: Active in Detroit, MI. **Exhibited:** Michigan State Fair, 1883. **Sources:** Petteys, *Dictionary of Women Artists.*

STEVENS, Louisa A. J. *[Painter] late 19th c.*
Exhibited: NAD, 1868, 1870. **Sources:** Naylor, *NAD.*

STEVENS, Louisa Bancroft *[Painter, designer, craftsworker, landscape architect, lecturer, teacher] b.1872, Lawrence, MA.*
Addresses: Boston, MA. **Studied:** H.C. Walker; F. Benson; E. Tarbell; G. Lowell; E. Andre, Paris. **Member:** Boston SAC (master craftsman); Copley Soc. **Sources:** WW40.

STEVENS, Lucy Beatrice *[Painter, illustrator] b.1876, NYC / d.1947, Putnam, CT.*
Addresses: Pomfret, CT; NYC. **Studied:** NY art schools. **Exhibited:** Arch. Lg., NY; Boston & Pomfret, CT. **Comments:** Painted landscapes & murals; illustrated books and magazines. **Sources:** Petteys, *Dictionary of Women Artists.*

STEVENS, M. L. (Mrs.) *[Artist] early 20th c.*
Addresses: Active in Los Angeles, 1905-07. **Sources:** Petteys, *Dictionary of Women Artists.*

STEVENS, Marian *[Painter] b.1885, Wash., DC / d.1974, St. Leonard, MD.*
Addresses: Wash., DC, 1912-58; Attica, NY (1965)/St. Leonard, MD. **Studied:** ASL, with George Bellows; CGA. **Member:** Wash. SA. **Exhibited:** Greater Wash. Independent Exhib., 1935; NAWA, 1935, 1937, 1938; Wash. WCC, 1933, 1939; Soc. of Wash. Artists; Albright Gallery, Buffalo, NY; George Washington Univ. Library, 1965 (solo). **Comments:** Position: director, Mus. of the Attica Hist. Soc. **Sources:** WW40; McMahan, *Artists of Washington, DC.*

STEVENS, May *[Painter] b.1924, Boston, MA.*
Addresses: NYC. **Studied:** Mass. College Art, B.F.A., 1946; ASL, 1947; Acad. Julian, Paris, 1949. **Member:** Artists Equity Assn. New York. **Exhibited:** Galerie Huit (cooperative gallery run by American students), Paris, c. 1950; PAFA Ann., 1964, 1966; NIAL, 1969; Recent Acquisitions & Women Artists From Permanent Collection, WMAA, 1970; Am. Women Artists Invitational, Hamburg, Germany, 1972. **Awards:** New England Ann. Landscape Prize, Silvermine Guild Artists, CT, 1958; Childe Hassam Purchase Award, NIAL, 1968 & 1969; MacDowell Colony fellowship, 1971-72. **Work:** WMAA; Washington Univ.; Saint Louis, MO; Jacksonville (FL) Mus.; Schenectady Mus., NY; Brooklyn Mus. **Comments:** Painter of political themes in 1960s and 1970s. In the mid 1970s she also began drawing from history, myth, and her own life to create paintings about the lives of women. Teaching: painting instructor, School Visual Arts, 1962-; adjunct lecturer art, Queens College (NY), 1964-; visiting artist, Ball State Univ., 1968. **Sources:** WW73; Rubinstein, *American Women Artists,* 398-401; A. L. Chanin, preface to catalogue for solo exhib. (Galerie Mod, 1955); Howard Devree, preface to catalogue for solo exhib. (De Aenlle Gallery, 1961); Barry Schwartz, *Humanism in Modern Art* (Praeger, 1973); Falk, *Exh. Record Series.*

STEVENS, Mildred Lapson *[Painter, teacher, lecturer, writer, screenprinter, designer] b.1923, New York, NY.*
Addresses: Monrovia, CA. **Studied:** BM School Art; ASL; Am. School Des., NY; Jepson AI, Los Angeles. **Member:** Conn. WC Soc.; Los Angeles AA; Pasadena AA; Soc. Western Artists; Los Angeles Art Teachers Assn.; Nat. Art Teachers Assn.; AEA. **Exhibited:** Conn. WC Soc., 1945-1947, 1952; San Gabriel Valley Artists, Pasadena Mus. Art, 1958; BM; MMA; Gregor Beaux-Arts, 1946 (solo); Long Beach Art Gal., 1953; Pasadena Mus. Art,

1954, 1958; Santa Barbara Mus. Art, 1954; Oakland Art Mus., 1954; deYoung Mem. Mus., 1954; San Diego FA Gal., 1954; Monrovia Pub. Lib., 1957, 1958; Mid-Valley Art Lg., 1958 (solo); Pasadena Pub. Lib., 1958; Los Angeles AA, 1958; Los Angeles Arboretum, 1958. Awards: gold medal, City-wide Exhib., Rockefeller Center, 1935; scholarships, ASL, BM School Art, Am. Sch. Des.; prizes, Gregor Beaux-Arts, Hartford; Wadsworth Atheneum; Los Angeles County Fair, 1951 (2). **Comments:** Position: art teacher, Pasadena City College, Los Angeles. Contributor to *Popular Science, Life* magazine (original des. for new toys). **Sources:** WW59.

STEVENS, Nelson *[Painter, graphic artist, educator] b.1938, Brooklyn, NY.*
Studied: Ohio Univ., B.F.A., 1962; Kent State Univ., M.F.A., 1969. **Member:** AFRICOBRA; College AA; Nat. Conference of Artists. **Exhibited:** Nat. Center of Afro-American Artists, 1970, 1972; Studio Mus., Harlem, 1970, 1972; Howard Univ., 1970, 1972; Karamu House, Cleveland, 1972 (solo); Kent State Univ., 1972; Neighborhood Art Center, Akron, OH, 1972; Florida A&M. **Sources:** Cederholm, *Afro-American Artists.*

STEVENS, Roger B. *[Painter] 20th c.*
Addresses: NYC. **Exhibited:** S. Indp. A., 1931. **Sources:** Marlor, *Soc. Indp. Artists.*

STEVENS, Ruth Tunander (Mrs.) *[Engraver, craftsperson, teacher, block printer] b.1897, Calumet, MI.*
Addresses: Seattle, WA. **Studied:** Univ. Wash.; A. Archipenko. **Member:** Northwest PM; Seattle Weavers Gld. **Exhibited:** Northwest PM, 1928-41; Seattle Weavers Gld. **Comments:** Positions: teacher, Seattle (WA) H.S. (1926-41), King's Country (WA) "Federal Way Schools" (1943-46). **Sources:** WW47.

STEVENS, Sarah E. *[Painter] 20th c.*
Addresses: Roland Park, MD. **Member:** Baltimore WCC. **Sources:** WW25.

STEVENS, Stanford *[Painter, writer, teacher] b.1897, St. Albans, VT.*
Addresses: Tucson, AZ; Tequisquiapan, Qro. **Studied:** Harvard Univ., A.B.; Acad. Julian, Paris; ASL. **Member:** AWCS. **Exhibited:** nationally and internationally. **Work:** Wood Art Gal., Montpelier, VT; Rockland (ME) Art Gal.; IBM; Ford Collection. **Comments:** Author: "Plants of Sun and Sand." **Sources:** WW59; WW47.

STEVENS, Thomas Wood *[Mural painter, etcher, writer] b.1880, Daysville, IL / d.1942, Tucson, AZ.*
Addresses: Chicago, IL. **Studied:** AIC; Armour Inst. Tech., Chicago; F. Brangwyn, in London; Sorolla, in Madrid; ASL. **Exhibited:** Salons of Am., 1930; AIC; S. Indp. A., 1930-32. **Comments:** Position: director, Goodman Theater, AIC, 1924-30. **Sources:** WW33; Marlor, *Salons of Am.*

STEVENS, Vera (Mrs. Anderson) *[Painter, teacher] b.1895, Hustontown, PA.*
Addresses: Provincetown, Waltham, MA. **Studied:** PM School IA; & with George Elmer Browne. **Member:** NAWA; CAFA; Provincetown AA; New Haven PCC; Boston AC. **Exhibited:** Paris Salon, 1929; Soc. Indep. Artists, 1929; CAFA; Springfield Art Lg.; New Haven PCC; NAD; PAFA Ann., 1932; NAWA, 1933 (prize). **Comments:** (Also known as Vera Stevens Anderson) Spec. in bold, floral still lifes. Position: instructor, Shore Country Day School, Beverly, MA. **Sources:** WW59; WW47; Falk, *Exh. Record Series.*

STEVENS, Walter Hollis *[Painter, educator] b.1927, Mineola, NY / d.1980, Knoxville, TN?.*
Addresses: Knoxville, TN. **Studied:** Drake Univ., B.F.A., 1951; Univ. Illinois, Urbana, M.F.A., 1955. **Member:** Tennessee WCS; Knoxville WCS. **Exhibited:** Contemporary Arts, Inc., NYC, 1960 (solo) & 1964 (solo); Contemporary Arts, Traveling Exhib. to South Am., 1960 & 1965; Mid-South Exhib., Brooks Mem. Art Gallery, Memphis, TN, 1962-66, 1969 & 1971; Seven Delta Exhibs., Arkansas Art Center, 1961-70; Three Watercolor USA

Exhibs., Springfield, MO, 1968-72; Rothery's, Knoxville, TN, 1970s. Awards: first purchase awards, Alabama Watercolor Nat., Birmingham Mus., 1957 & 1960; first purchase award, Central South Exhib., Nashville, 1966; purchase award, Tennessee Watercolorists, Chattanooga, 1972. **Work:** Birmingham (AL) Mus. Art; Arkansas AC, Little Rock; Mint Mus. Art, Charlotte, NC; Oklahoma AC, Oklahoma City; Tennessee FAC, Nashville. **Comments:** Preferred media: watercolors, acrylics, oils. Teaching: painting prof., Univ. Tennessee, Knoxville, 1957-. **Sources:** WW73; "New Talent Issue," *Art in Am.* (1957); Robert Schlageter, *Walter H. Stevens* (Mint Mus., 1959).

STEVENS, Will Henry *[Painter, educator, drawing specialist] b.1881, Vevay, IN / d.1949.* _Slevens 38_
Addresses: New Orleans, LA. **Studied:** Cincinnati Art Acad. with Nowottny, Duveneck, and Meakin; ASL, NYC, with Jonas Lie, Van Dearing Perrine. **Member:** Fellowship, Tiffany, 1932. **Exhibited:** New Gallery, NYC, c.1901; Richmond, IN, 1914; SSAL, 1925; AIC, 1940, 1947; Delgado Mus. Art, 1946; New Orleans Arts & Crafts Club; Newcomb College Art Gal., 1945; Black Mountain College, 1945; & numerous traveling exhib.; Asheville Mus. Art, NC, 1967 (retrospective); R. York Gal., NYC, 1987, 1991 (solos). **Work:** BMFA; J.B. Speed Mem. Mus.; Richmond (IN) Art Assoc.; IBM Collection; Delgado Mus. Art; Univ. Oklahoma; galleries, Des Moines, Shreveport, LA; Washington State Univ. Mus. Art, Pullman ("River Shore below Vevay"); Tennessee State Mus. **Comments:** A pioneer among abstract painters of the South during the 1930s. During the 1920s, he painted traditional landscapes, but by the 1930s he was mixing realism with abstraction, and many paintings evolved into complete abstraction, especially in the 1940s. Earlier, in Cincinnati, he worked for a short time at the Rookwood Pottery. From 1921-48, he taught at Newcomb College, New Orleans, and at his own Stevens School of Art, Gatlinburg, TN, in the summers. He visited and painted in Valley Town, NC and Gatlinburg, TN. **Sources:** WW53; WW47; Gerdts, *Art Across America*, vol. 2: 275-76 (with repro.); Kelly, "Landscape and Genre Painting in Tennessee, 1810-1985, 114-116 (w/repros.); exh. cat., R. York Gal. (NYC, 1991); *American Abstract Art*, 199.

STEVENS, William *[Lithographer] b.c.1832, Hamburg (Germany).*
Addresses: NYC, 1860. **Comments:** His wife was Irish and their children, the oldest aged 5, were all born in New York. **Sources:** G&W; 8 Census (1860), N.Y., XLV, 790-91.

STEVENS, William C. *[Landscape painter] b.1854, Barre, MA / d.1917.*
Work: WMA. **Comments:** Practiced medicine until 1897, when he took up painting professionally. **Sources:** WW17.

STEVENS, W(illiam) D(odge) *[Illustrator] b.1870, Tidioute, PA.*
Addresses: NYC. **Studied:** AIC, with Vanderpoel, Grover; Paris. **Member:** AG. **Sources:** WW47.

STEVENS, W(illiam) Lester W.LESTER STEVENS.
[Landscape painter, teacher] b.1888, Rockport, MA / d.1969, Greenfield, MA.
Addresses: Rockport, MA, until 1934; Boston, Springfield, Conway, MA. **Studied:** with Parker S. Perkins in Rockport; BMFA Sch.; in Europe after WWI. **Member:** NA; ANA, 1935; AWCS; Rockport AA (founder, 1923); Gallery on Moors; Springfield (MA) AL; Gld. Boston Artists; Phila. WCC; NYWCC; New Haven PCC; Gloucester SA; North Shore AA, 1923-69; Boston WCC. **Exhibited:** NAD, 1906 (at age 18); AIC, 1911-38; PAFA Ann., 1912-37; Corcoran Gal biennials, 1914-28 (5 times, incl. 4th prize, 1921); CAFA, 1924 (prize); 1927 (prize); AWCS, 1928 (prize); New Haven PCC, 1929 (prize), 1933 (prize), 1942 (prize); Springfield AL, 1925 (prize), 1932 (prize),1953-55 (prizes); Quincy, 1932 (medal); Springville, UT, 1931 (prize), 1941 (prize); Women's Club, MA, 1930-33 (prizes),1934 (prize), 1937 (prize), 1938 (prize); Salons of Am.,

1934; Meriden Art & Crafts Assn., 1938-42 (prizes); Wash. Ldscp. Club, 1939 (prize); Wash. WCC, 1942 (prize); Wash. Art Club, 1941 (prize); Rockport AA, 1953 (prize), 1956 (prize), 1957 (prize); North Shore AA, 1953 (prize); Ogunquit, ME, 1952-54 (prizes), 1956 (prizes); Gloucester, MA, 1958 (prize). **Work:** Canton AI; Hickory Mus. Art; Asheville Mus. Art; Rochester Mem. Art Gal.; Springfield Mus. FA; Boston AC; Birmingham (AL) Public Library; Gloucester (MA) H.S.; Rockport (MA) H.S.; Tewksbury (MA) State Sanitorium; Mint Mus. Art; WPA murals, USPOs, Dedham, Rockport, both in Massachusetts; Boston City Club; :Louisville (KY) AM; Springville (UT) AA; Wilson, Wolcott, Gavin schools, all in Boston. **Comments:** He left Rockport in 1934 for western Mass., settling in Conway in 1944. Nicknamed "Steve," he was considered eccentric, and compulsive about painting outdoors every day. He produced about 5,000 paintings. After a summer painting on Monhegan, he said "I've done 60 — and got 6 good ones!" His early works have a heavy impasto in oil while his later works are often of light washes in acrylic on masonite. He taught for short periods at Boston Univ. and Princeton, but held frequent classes at his Conway studio as well as in Wash., DC and at the Springfield MFA. He took his students to Asheville, NC, New Orleans, Charleston SC, Quebec and Gaspé, Canada; and in the 1930s Stevens ran a summer art school at Grand Manan. **Sources:** WW59; Charles Movalli, article in *American Artist* (Apr., 1986, p.52); WW47; Curtis, Curtis, and Lieberman, 116, 186; Falk, *Exh. Record Series;* info. courtesy North Shore AA.

STEVENS, William Oliver *[Painter, illustrator, writer, lecturer, teacher] b.1878, Rangoon, Burma.*
Addresses: Birmingham, MI. **Comments:** Position: teacher, Cranbrook School, Birmingham. **Sources:** WW27.

STEVENS, Zeletus *[Engraver] b.c.1828, Vermont.*
Addresses: Northfield, VT, 1850. **Sources:** G&W; 7 Census (1850), Vt., X, 133.

STEVENSON *[Portrait painter]*
Addresses: Pittsburgh, PA, 1813. **Sources:** G&W; FARL question file.

STEVENSON, A. B. (Miss) See: **STEVENS, Alice Barber**

STEVENSON, A Brockie *[Painter] b.1919, Montgomery Co, PA.*
Addresses: Washington, DC. **Studied:** PAFA; Barnes Foundation, Merion, PA; Skowhegan School Painting & Sculpture. **Exhibited:** American Artists Report the War, Nat. Gallery Art, London, England, autumn 1944; four shows, Painting & Sculpture Ann., PAFA Ann., 1948-51; four shows, Soc. Bellas Artes Peru, Lima, 1953-56; Washington Art, State Univ. NY, Potsdam & Albany, 1971; Eight Washington Artists, Columbia Mus. Art, SC, 1971; Pyramid Galleries Ltd., Washington, DC, 1970s. **Work:** CGA; Nat. Collection Fine Arts, Washington, DC; PAFA; State Univ., Potsdam, Univ. Massachusetts, Amherst. **Comments:** Preferred media: acrylics. Positions: war artist correspondent, European Theater Operations Southern Base Sect., USA, England, 1943-44 & Off. Chief Eng., France, 1944-45. Teaching: instructor in composition, School Fine Arts, Washington Univ., 1960-62; assoc. professor design, Corcoran School Art, Washington, DC, 1965-. **Sources:** WW73; "Art by Armed Forces," *Life Magazine* July 6, 1942; Lincoln Kirstein, "Am. Battle Art, 1588-1944," *Magazine Art* (May, 1944); Paul Richards, review, *Washington Post,* June 21, 1970; Falk, *Exh. Record Series.*

STEVENSON, A. May *[Landscape painter]; b.Philadelphia.*
Addresses: Philadelphia, active c.1853 and after. **Exhibited:** PAFA, 1853-61 (southeastern Pennsylvania scenes). **Sources:** G&W; Rutledge, PA.

STEVENSON, Amy E(leanor) *[Painter] 20th c.; b.St. Sylvester, Canada.*
Exhibited: Salons of Am., 1934, 1936. **Sources:** Marlor, *Salons of Am.*

STEVENSON, Amy Leanor *[Painter, craftsperson, designer, teacher, illustrator, lecturer, decorator] 20th c.; b.St. Sylvestre, Quebec, Canada.*
Addresses: NYC. **Studied:** CUA School; NAD; ASL, and with Hawthorne, Savage, Brackman; S. Skou; Ezra Winter. **Member:** Artists All. Am.; Gotham Painters; Catherine L. Wolfe Art Club; AAPL; NAC. **Exhibited:** Artists All. Am., 1928 (prize); Arch. Lg.; Soc. Independent Artists, 1937, 1941; AWCS, 1946; WMA, 1946, 1953, 1954; Salons of Am.; Anderson Gal., NY; Tiffany Fnd.; Nat. Rug Des. Comp. (prize); Barbizon-Plaza Gal.; Catherine L. Wolfe AC, 1953, 1954; NAC, 1954, 1955; Calgary (Canada) All. Art Centre, 1956 (solo); NAD, 1956; Village Art Center, 1958. Awards: Tiffany Fnd. Fellowship, 1923. **Comments:** Designed rugs, for Capitol Palace, Manila, P.I.; Veterans Mem. Civic Center, Detroit, MI; designer, Persian Rug Mfg. Co. **Sources:** WW59; WW47.

STEVENSON, Barbara *[Painter, mural painter] b.1912, St. Louis, MO.*
Addresses: California, mid-1930s. **Studied:** St. Louis School of FA. **Exhibited:** CPLH, 1940. **Work:** murals: Ventura, CA, Post Office; St. Louis High School; Veterans Hospital, Washington, DC; Salinas, CA, Hospital; Oak grove Grammar School, Monterey, CA; Modern South St. Louis Grammar School. WPA artist. **Comments:** Married to Ellwood Graham (see entry), she sometimes used the pseudonym *Judith Diem.* **Sources:** Hughes, *Artists in California,* 535.

STEVENSON, Beulah (Elsie) *[Painter, lithographer, etcher, teacher] b.1890, Brooklyn, NY / d.1965, Brooklyn, NY.*
Addresses: Brooklyn, NY. **Studied:** ASL, with John Sloan, and with Hans Hofmann, Provincetown, Mass. **Member:** NAWA (board directors, 1949-); Fed. Mod. P&S; Creative AA; NY Soc. Women Artists (pres.); SAGA; Phila. Pr. Club; Brooklyn Soc. Artists (vice-pres.); Provincetown AA;SAGA; AIC. **Exhibited:** S. Indp. A., 1917-44 ; PAFA Ann., 1917, 1937; BM (prize); NAWA, 1930 (prize); Brooklyn Soc. Artists (price); Chicago; Wash., DC; Phila.; Paris; Fifteen Gal., NY, 1940 (solo); Phila. Pr. Club; AIC; WMAA; Riverside Mus.; CM; Portland Mus. Art; Mus. New Mexico, Santa Fe (solo); 9 solos in New York City; and many other museums and galleries in U.S. and abroad including Paris and London. **Work:** NYPL; Norfold Mus.; Brooklyn Mus.; LOC. **Comments:** Her still lifes, landscapes and figure pieces were mostly done in a semi-abstract style, showing rhythmic patterns. **Sources:** WW59; WW47; Pisano, *One Hundred Years.the National Association of Women Artists,* 81; Falk, *Exh. Record Series.*

STEVENSON, Branson Graves *[Painter, designer, etcher, lithographer, craftsperson] b.1901, Franklin County, GA / d.1989, Los Altos, CA, or Great Falls, MT?.*
Addresses: Living in Great Falls, MT in 1976. **Studied:** Inst. Nac., Panama; College Great Falls, MT; also with R. Luiz; Margarite Wildenhain, Bernard Leach & Shoji Hamada. **Member:** SAE; Great Falls AA; C. M. Russell Mus. (director, 1953-); Montana Hist. Soc. & Art Gallery (member, board trustees, 1964-); life member & fellow Montana Inst. Arts. **Exhibited:** SAE, 1943, 1944; NAD, 1944; LOC, 1944, 1945; CI, 1944, 1945; Los Angeles Mus. Art, 1936; SAM; GGE, 1939; Retrospective exhib., Russell Gallery, 1970; solo show, Yellowstone Art Center, Billings, MT, 1972; Montana Hist. Soc., 1972; Northern Montana College, 1972; Oregon Arts Commission, Eugene, 1972; Glass Art Shop, Great Falls, MT, 1970s. Awards: purchase prize for Rhubarb (lithograph), Univ. Oregon; awards for emulsion wax watercolors, etching, drawings & lithographs, Montana State Fair. **Work:** Montana Inst. Arts, Helena; C. M. Russell Gallery, Great Falls; Montana Hist. Soc., Helena; Univ. Oregon, Eugene. Commissions: fresco mural, Great Falls, 1945; Story of Paper (glass mural), Great Falls Public Library; 1968; documentary TV film, Jr. League, Great Falls, 1971; 138 proofs of lithographs, First Nat. Bank, Great Falls, 1971-72. **Comments:** Preferred media: graphics. Positions: founder, director, secretary & trustee, Archie Bray Foundation, Helena, 1951-. Publications: contribu-

tor, *Craft Horizons, Ceramic Industry, Montana Arts* & others. Teaching: lecturer humanities, College Great Falls, 1963-. Collection: etchings and graphics, including etchings by Rembrandt and Seymore Haden, sculpture by C. M. Russell and painting by Florencio Molino Campos. **Sources:** WW73; Kathleen Cronin, article, *Mobil World* (1971); Ray Steele, "Branson G. Stevenson, The Man and His Works," KRTV, 1972; WW47.

STEVENSON, Charles Mathew *[Painter, commercial artist]* *b.1885, New Brunswick, Canada / d.1968, Palo Alto, CA.* **Addresses:** Boston, MA; Idaho; Montana; San Francisco, CA; Menlo Park, CA. **Studied:** San Francisco. **Member:** Palo Alto AC. **Comments:** Worked as a gold miner and sheep herder in his youth and studied art while working in the shipyards in San Francisco. Specialty: still lifes, landscapes, portraits. **Sources:** Hughes, *Artists inCalifornia,* 535.

STEVENSON, Claudia *[Painter, teacher]* *20th c.; b.Bolivar, IN.* **Addresses:** Cicero, IL; Rochester, IN. **Studied:** AIC; NY School Fine & Applied Art; Cape Cod School Painting; Charles Hawthorne; Wellington J. Reynolds. **Exhibited:** Corcoran Gal biennial, 1937; NAD; AIC; Hoosier Salon. **Comments:** Position: art director, J. Sterling Morton H.S., & Morton Jr. College, Cicero, IL, 1924-46. **Sources:** WW53; WW47.

STEVENSON, Dorothea (Mrs. Richard R. Casady) *[Painter, educator, lecturer]* *b.1910, Dallas.* **Addresses:** Oklahoma City, OK. **Studied:** Univ. Oklahoma, M.F.A.; Académie Julian, Paris; Florentine Acad.,Florence, Italy; & with Raymond Jonsen; I. Annette; O.B. Jacobson; N. Sheets; E. Bisttram; M. Avery. **Member:** Oklahoma State AA; Women Painters of the West. **Exhibited:** Kansas City AI, 1931, 1932; Rockefeller Center, NY, 1934; Oklahoma State AA, 1939 (prize), 1942 (prize); Philbrook AC, 1940; Albuquerque, NM, 1940; Dallas MFA, 1942; Los Angeles MA, 1945, 1946; Oklahoma City (several solos). **Work:** Univ. Oklahoma; murals, Classen H.S., Wilson Elementary Sch., Oklahoma City, OK. **Comments:** Position: director, school of art, Univ. Oklahoma City, 1940-43; art lecturer,U niv. Southern California, Los Angeles, CA, 1945-46. **Sources:** WW53; WW47.

STEVENSON, Edna Bradley *[Painter, etcher, educator, lecturer]* *b.1887, Hebron, NE.* **Addresses:** Living in Oklahoma City , OK in 1962. **Studied:** AIC, 1907; Académie Julian, Paris, 1936; Oklahoma City Univ., 1929; Florence, Italy, 1937; N. Sheets; M. Avey; E. Bisttram, in Taos, 1932-34; F. Becker; D. Donaldson; Univ. Calif., Los Angeles, 1949; Univ. Illinois, 1904-06; and with Snow Froelich, 1921 & others. **Member:** Oklahoma State AA; NEA; NAEA; Oklahoma Educ. Assn. **Exhibited:** Philbrook AC; Oklahoma State AA; Oklahoma AC (solo); Oklahoma City Univ., 1958; Oklahoma Medical Research Fnd., 1958; Oklahoma State Fair; Santa Fe, NM; Harwood Gal., Taos, NM. **Comments:** Position: head of art dept., Classen H.S., 1921-43; art director, Oklahoma City (OK) Univ., 1943-58 (retired). **Sources:** WW59; WW47; P&H Samuels, 466.

STEVENSON, Edward M. *[Painter]* *20th c.* **Addresses:** NYC. **Exhibited:** Soc. Indep. Artists, 1934. **Sources:** Marlor, *Soc. Indp. Artists.*

STEVENSON, Elaine Louise *[Craftsworker, educator, teacher, painter]* *b.1891, Port Huron, MI.* **Addresses:** Kalamazoo, MI. **Studied:** J. Norton; R. Quint; Western Michigan Univ.; AIC, B.A.E.; Ohio State Univ., M.A.; Cranbrook Acad. Art; Columbus School Art; & with Emma M. Church. **Member:** Kalamazoo AI. **Exhibited:** Michigan State Fair, Detroit, 1936 (prize); Kansas City AI; Norton Gal., West Palm Beach, FL; & in Michigan & Ohio. **Comments:** Position: asst. professor, art educ. & fine art, Western Michigan Univ., Kalamazoo, MI, 1917-60. **Sources:** WW59; WW47.

STEVENSON, Elizabeth *[Portrait painter]* *late 19th c.* **Addresses:** Active in Indianapolis, 1883-c.1890. **Sources:** Petteys, *Dictionary of Women Artists.*

STEVENSON, Florence Ezzell *[Painter, lecturer]* *b.1894, Russellville, AL.* **Addresses:** Chicago, IL. **Studied:** Athens (AL) College, grad.; Conservatory Art & Music, Tuscaloosa, AL, grad.; School Art Inst. Chicago, grad.; C. Buehr; S. Davis. **Member:** AAPL; South Side AA; SSAL; All-Illinois Soc. FA; No-Jury Soc. Art, Chicago; Lg. Am. Pen Women; Chicago Municipal Art Lg.; Ridge AA, Chicago; Vanderpoel AA; Arts Club, Chicago; AAPL; Int. Platform Assn. **Exhibited:** All-Illinois Soc. FA, 1936 (gold); South Side AA, 1939 (prize); Illinois Fed. Women's Club, 1938 (prize), 1945 (prize); Lg. Am. Pen Women, 1941 (prize); AIC, 1937, 1938; The Parthenon, Nashville, TN; Brooks Mem. Art Gal.; Smithsonian Inst.; Birmingham Pub. Lib., 1943 (solo); Ridge AA, Chicago. Other awards: Mrs. Frank G. Logan Prize; various prizes, Nat. Lg. Am. Pen Women, 1945-57. **Work:** Gage Park School, Chicago; Munic. Bldg., Russellville, AL; Morgan Park H.S., Chicago; Hanover College; Sutherland School, Chicago; Vanderpoell Collection, Chicago. **Commissions:** oil painting, Century of Progress, Rosenwald Mus. Science & Indust., Chicago, 1933-34. **Comments:** Preferred media: oils, watercolors. Designer: covers, *Literary Digest, La Révue Moderne* (Paris), *The Art World.* Positions: advisory member, Marquis Biog. Library Soc.; trustee, Vanderpoel Art Gallery, Chicago. Teaching:lecturer on art, various groups; head, dept. art, Conservatory Art & Music, Tuscaloosa, AL. **Sources:** WW73; article & reproduction, *Christian Science Monitor;* WW47.

STEVENSON, G. *[Painter]* *20th c.* **Exhibited:** PAFA Ann., 1904 ("Will He Come?"). **Comments:** Cf. Grace Stevenson of NYC. **Sources:** Falk, *Exh. Record Series.*

STEVENSON, Gordon *[Portrait painter, educator]* *b.1892, Chicago, IL.* **Addresses:** NYC; Sullivan County, NY. **Studied:** AIC; and in Madrid, Spain with Sorolla. **Member:** AWCS; Am. Veteran's Soc. Art; Century Assn. **Exhibited:** Olympic Exhib., Berlin, 1936 (medal); AIC; NAD; European traveling exhib. American Portraits; solos throughout eastern U.S. Awards: John Quincy Adams traveling scholarship, 1911-12. **Work:** BM; Rutgers Univ.; Harvard Univ.; College of City NY; Rockefeller Inst. **Sources:** WW59; WW47.

STEVENSON, Grace *[Painter]* *20th c.* **Addresses:** NYC. **Exhibited:** AIC, 1905 ("The Wood Pile," "Meditation"). **Comments:** Cf. G. Stevenson, whose work was exhibited in PAFA Ann., 1904. **Sources:** Falk, *AIC.*

STEVENSON, Hamilton *[Limner portraitist]* *late 18th c.* **Addresses:** Charleston, SC,1774; Jamaica, 1780; Charleston, 1782 and after. **Comments:** With his brother John Stevenson he opened a drawing and painting academy in Charleston (SC) in November 1774. **Sources:** G&W; Prime, I, 8-10; Rutledge, *Artists in the Life of Charleston.*

STEVENSON, Hannah M. *[Portrait painter]* *late 19th c.* **Addresses:** Active in Detroit, MI, 1887-90; Cleveland, OH. **Sources:** Petteys, *Dictionary of Women Artists.*

STEVENSON, Harold *[Painter]* *b.1930.* **Addresses:** NYC. **Exhibited:** WMAA, 1963. **Sources:** Falk, *WMAA.*

STEVENSON, Horatio S. *[Painter, teacher]* *early 20th c.; b.New Castle, PA.* **Addresses:** Pittsburgh, PA, 1890-91. **Studied:** NAD; Académie Julian, Paris with Bouguereau and T. Robert-Fleury. **Member:** Pittsburgh AS; Pittsburgh AA. **Exhibited:** NAD, 1890-91. **Comments:** Positions: director, Stevenson Art School; summer school at Allegheny. **Sources:** WW10.

STEVENSON, James *[Engraver]* *b.c.1834, Ireland.* **Addresses:** Philadelphia, active 1850. **Comments:** His mother was Irish, with real property valued at $10,000; her four daughters, aged 19 to 25, were born in Germany. **Sources:** G&W; 7

Census (1850), Pa., XLIX, 764.

STEVENSON, John *[Limner portraitist)] late 18th c.*
Addresses: Charleston, SC, active 1773. **Comments:** He and his brother, Hamilton Stevenson (see entry), opened a drawing and painting academy in Charleston in 1774. Both were in Jamaica in 1780, but apparently only Hamilton returned to Charleston in 1782. John's repertory included history, landscape, portrait, and miniature painting, family and conversation pieces, etc. **Sources:** G&W; Prime, I, 9-10; Rutledge, *Artists in the Life of Charleston.*

STEVENSON, John E. *[Painter] 20th c.*
Addresses: Chicago area. **Exhibited:** AIC, 1936, 1938. **Sources:** Falk, *AIC.*

STEVENSON, John S. *[Painter] 19th c.*
Addresses: Phila., PA. **Exhibited:** PAFA Ann., 1879-81, 1884-85. **Sources:** Falk, *Exh. Record Series.*

STEVENSON, Mary See: **CASSATT, Mary Stevenson**

STEVENSON, Mary Anna *[Painter] 20th c.*
Addresses: Phila., PA. **Sources:** WW17.

STEVENSON, Ralph T. *[Painter] 20th c.*
Exhibited: PAFA Ann., 1903. **Sources:** Falk, *Exh. Record Series.*

STEVENSON, Robert Bruce *[Sculptor, lecturer] b.1924, San Diego, CA.*
Addresses: Los Angeles, CA. **Studied:** Univ. Calif., Los Angeles, B.A., 1950; San Fernando Valley State College, M.A., 1965. **Exhibited:** Looking West, Joslyn Art Mus., Omaha, NE, 1970; Traveling Embassy Show, U.S. Info Agency, 1971; Fine Arts Gallery, San Diego Rental Gallery, 1971; Dimension in Plastics, Jewish Community Center Gallery, 1972; Long Beach Mus. Tenth Ann., 1972. Awards: Downey Mus. Purchase Prize, New Talent Show, 1968; purchase award, Long Beach Mus. Tenth Ann., 1972. **Work:** Downey Mus.; LACMA; Long Beach (CA) Art Mus. Commissions: large plexiglass structure, Charles Cowles, LACMA, 1965-66; two large plexiglass struct, Joseph Hirschhorn, Nat. Gallery, Washington, DC, 1966 & Mrs. & Mrs. J. L. Wolgin, Phila. Art Mus., 1968. **Comments:** Preferred media: plexiglass. Positions: visiting artist, Proj. Advan. Creative Art, San Bernardino, Inyo & Mono Co., 1968. Teaching: art lecturer, Los Angeles City Schools, 1954-. **Sources:** WW73; Susan Ellis, "They're Taking Odd Shapes," *Los Angeles Herald Examiner,* Jan. 8, 1967; "Design for Living; Robert Stevenson," *Arts Magazine* (Sept.-October, 1967); William Wilson, "Juried Show in Long Beach," *Los Angeles Times,* April 1, 1968.

STEVENSON, Ruth Rolston *[Painter, teacher, etcher] b.1897, Brooklyn, NY.*
Addresses: NYC. **Studied:** Pratt Inst., diploma, with Walter Beck; ASL with John Sloan. **Member:** Nat. Arts Club (art commission, 1961); AWCS; NAWA; Pen & Brush Club (art committee, 1950); AAPL. **Exhibited:** Nat. Art Club, New York, 1923, 1931, 1953, 1955, 1957 (gold medal for Mountain Garden, water color); Holland, 1956; AAPL, 1959 (award for Wood Companions, oil); NAWA, 1949-56; 1960; AWCS, 1954, 1955, 100th Travel Exhib., 1967; Pen & Brush Club, 1971 & 1973 (awards 1951, 1954; solo for Double Bouquet Watercolor1972 & 1973); AAPL, 1959; Small Paintings Exhib., 1928; SC, 1955. **Work:** watercolor landscape, Norfolk Mus.; watercolor portrait, Huntington Mus., WV; oil mural, Seamans Church Inst., NYC. Commissions: 20 children's portraits in private collections, 1928; 5 children's portraits in Rome, Italy, 1971; oil landscape of New York, in Chile, South Am., 1971. **Comments:** Preferred media: watercolors, oils, pencil. Teaching: art instructor, Pratt Inst., 1920-24 & Newark Public School Fine & Indust. Art, 1927-36. **Sources:** WW73.

STEVENSON, Suzanne See: **SILVERCRUYS, Suzanne (Mrs Edward Ford Stevenson)**

STEVENSON, Thomas C. *[Painter] b.1920, Palo Alto, CA.*
Addresses: Menlo Park, CA. **Studied:** with his father; Rudolph Schaeffer Sch. of Des.; with Farmer and Mendelowitz at Stanford.

Member: Palo Alto AC. **Exhibited:** Calif. WC Soc., 1940. **Comments:** Son of Charles M. Stevenson (see entry). He is also a physician. Preferred medium: watercolors. **Sources:** Hughes, *Artists of California,* 536.

STEVENSON, Thomas H. *[Landscape and miniature painter, teacher of painting] mid 19th c.*
Addresses: Cleveland, OH, 1841-45. **Work:** Wisconsin Historical Society (a series of ten views on the Fox and Wisconsin Rivers); Wisconsin State Museum (three views of Indian battlegrounds). **Comments:** T.H. Stevenson was a miniature painter and teacher in Cleveland. This is probably the Thomas H. Stevenson who appeared at Madison and Milwaukee (WI) in 1855. During the next three years he worked in partnership with Samuel M. Brookes (see entry). Their joint work included a series of ten views on the Fox and Wisconsin Rivers and three views of Indian battlegrounds. **Sources:** G&W; WPA (Ohio), *Annals of Cleveland;* Butts, *Art in Wisconsin,* 74-75; Milwaukee CD 1856, BD 1858.

STEVENSON, Wendell Adam *[Painter] b.1915, Chicago.*
Addresses: Forest Park, IL. **Studied:** Flint (MI) Inst. Art; AIC. **Exhibited:** AIC, 1936, 1940. **Work:** Door County (WI) Hist. Soc.; Home for Incurables, Diversey Methodist Church, Chicago Community Methodist Church, Forest Park. **Comments:** Illustrator: "Variety of Verses," "Little Bits of Loveliness," "God, Flag, and Country," by F.L. Stevenson. **Sources:** WW47.

STEVERS, Belle *[Painter] 20th c.*
Addresses: Lyndhurst, NJ. **Exhibited:** PAFA Ann., 1951. **Sources:** Falk, *Exh. Record Series.*

STEVICK, Marie E. *[Painter] b.1876, Pennsylvania / d.1953, San Bernardino, CA.*
Addresses: San Francisco, CA, 1922-28. **Exhibited:** Oakland Art Gallery, 1928. **Sources:** Hughes, *Artists of California,* 536.

STEVICK, Richenda (Mrs.) *[Sculptor, ceramic artist] 20th c.*
Addresses: San Francisco, CA; Berkeley, CA. **Exhibited:** San Francisco AA, 1925; Calif.-Pacific Int. Expo, San Diego, 1935. **Sources:** Hughes, *Artists in California,* 536.

STEWARD, Alfred *[Engraver] b.c.1825, New York.*
Addresses: NYC, 1860. **Comments:** He resided with his wife Paulina. **Sources:** G&W; 8 Census (1860), N.Y., LIV, 31.

STEWARD, Frank *[Artist] mid 20th c.*
Exhibited: MoMA, 1943. **Sources:** Cederholm, *Afro-American Artists.*

STEWARD, Joseph *[Portrait painter and silhouettist] b.1753, Upton, MA / d.1822.*
Addresses: Hampton, CT,1789-96. **Comments:** After graduating from Dartmouth in 1780, Steward entered the ministry. He was married in 1789. Ill health forced him to give up preaching and he turned to painting about 1793. He opened a portrait studio at Hartford in 1796 and the following year opened a museum in the State House. He continued to paint as late as 1815; in his later years he also resumed preaching. **Sources:** G&W; "Joseph Steward and The Hartford Museum," Connecticut Historical Society *Bulletin,* XVIII (Jan.-April 1953), 13 repros.; French, *Art and Artists in Connecticut;* WPA (Mass.), *Portraits Found in N.H.,* 27; WPA (Mass.), *Portraits Found in Mass.,* nos. 2040-41; Stauffer, nos. 2522, 2657; Flexner, *The Light of Distant Skies.*

STEWARD, Mary Jane *[Landscape painter] 19th c.*
Addresses: Alexandria, VA, 1830s to 1850s. **Work:** Wash. Lodge, Alexandria, VA (drawing:*George Washington's Town House,* 1856). **Sources:** Wright, *Artists in Virginia Before 1900;* McMahan, *Artists of Washington, DC.*

STEWARDSON, Edmond (Edmund) Austin *[Sculptor] late 19th c.; b.Philadelphia, PA.*
Addresses: Phila., PA. **Studied:** Académie Julian, Paris with Chapu, 1886-89. **Exhibited:** Paris Salon 1888, 1890; PAFA Ann., 1891, 1905. **Sources:** Fink, *American Art at the Nineteenth-Century Paris Salons,* 393, which lists his name as Edmond;

PAFA, Vol. II, in which his name appears as Edmund.

STEWART *[Painter]* 20th c.
Addresses: Clinton Prison. **Exhibited:** S. Indp. A., 1935.
Sources: Marlor, *Soc. Indp. Artists.*

STEWART, A. E. (Mrs.) *[Painter]* mid 19th c.
Addresses: Chicago, IL, active 1855. **Exhibited:** Illinois State
Fair, 1855 (prize for a flower painting). **Sources:** G&W; Chicago
Daily Press, Oct. 15, 1855.

STEWART, A. Isabelle (Miss) *[Painter]* late 19th c.
Addresses: Boston, MA. **Exhibited:** Boston AC, 1887-89.
Sources: *The Boston AC.*

STEWART, Albert F. See: **STUART, Albert F.**

STEWART, Albert T. *[Sculptor]* b.1900, Kensington, England
/ d.1982, Claremont, CA.
Addresses: immigrated 1908; NYC, 1927-39/Bayside, NY,
1936/Westbury, CT, 1938; Claremont, CA. **Studied:** Beaux-Arts
Inst. Design; ASL; also with Paul Manship. **Member:** NSS; Arch.
Lg.; ANA, 1937; NA, 1945. **Exhibited:** NAD, 1927 (prize), 1931
(prize), 1955 (citation); PAFA Ann., 1927-1928 (gold), 1931-
43;AIC, 1928-39; Los Angeles County Fair, 1940 (first prize),
1949 (second prize); Arch. Lg. (prize); Pasadena Art Inst., 1948
(prize) & Chaffey AA, 1951 (prize). **Work:** Fogg Mus. Art;
Reading Mus. Art; Sripps College; MMA; Seamen's Inst., NY;
tablets, Williams College, Williamstown, MA, Amherst College;
Buffalo City Hall; Baptistry door, St. Bartholomew's Church, NY;
mem. for Am. soldiers, Thiaucourt Cemetery, France; auditorium,
Kansas City; Court House, St. Paul, MN; pediment, Dept. Labor,
Wash., DC; Court House, Mineola, NY; U.S. Mint, San Francisco;
medal for U.S. Navy for Nicaraguan campaign; panels, Home
Owners Loan Corp. Bldg., Wash., DC. **Comments:** WPA artist.
Teaching: Scripps College, Claremont, c.25 years. **Sources:**
WW73; WW47; Falk, *Exh. Record Series.* More recently, see
Hughes, *Artists in California,* 536.

STEWART, Alexander *[Landscape, marine, and ornamental
painter, restorer]* late 18th c.; b.Scotland.
Addresses: Philadelphia, 1769. **Studied:** in Glasgow and
Edinburgh. **Sources:** G&W; Prime, I, 9.

STEWART, Annette S. *[Painter]* 20th c.
Addresses: NYC. **Exhibited:** S. Indp. A., 1928. **Sources:**
Marlor, *Soc. Indp. Artists.*

STEWART, Arthur *[Painter]* b.1915, Marion, AL.
Addresses: Birmingham, AL. **Studied:** Auburn Univ.; Art Inst.
Chicago; also with Kelly Fitzpatrick. **Member:** Birmingham AA
(vice-pres.), 1965-66; Alabama Watercolor Soc. (pres.), 1965-67);
Alabama Art League; Alabama AA. **Exhibited:** Art in War
Traveling Exhib., *Life Magazine,* 1941-42; four Southeastern
Ann., 1949-59; Norfolk Mus. Arts & Sciences Traveling Exhib.,
1964; Alabama Watercolor Soc., 1969-70; Am. Watercolor Soc.
Awards: purchase award for Spanish Bouquet, Norfolk Mus. Arts
& Sciences, 1964; award for Early Light, Meade Co., 1964;
Harriete Murray Award for Rosalie, Birmingham Centennial
Exhib., 1972. **Work:** Birmingham (AL) Mus. Art; Montgomery
(AL) Mus. Art; Norfolk (VA) Mus. Arts & Sciences; Atlanta AA;
also in collection of Queen Elizabeth II, England. Commissions:
four murals (with Kelly Fitzpatrick), Bank of Tallassee, AL.
Comments: Preferred media: watercolors, oils, acrylics.
Positions: chmn., Beaux Arts Ball, Birmingham Mus. Art, 1959,
member board, 1965-66. Teaching: instructor in drawing,
Birmingham Mus. Art; private instructor. **Sources:** WW73;
Alfred Frankfurter, "Parisian Scenes," *San Francisco Chronicle*
1949; Richard Howard, *Arthur Stewart Florals* (Crescenzi
Gallery, 1967).

STEWART, Catherine See: **WILLIAMS, Catherine
Stewart**

STEWART, Catherine T. *[Watercolorist]* early 20th c.
Addresses: Active in Phila. **Exhibited:** PAFA, 1925. **Sources:**
Petteys, *Dictionary of Women Artists.*

STEWART, Charles *[Engraver of portraits in mezzotint]* mid
19th c.
Addresses: NYC, 1841. **Sources:** G&W; Fielding's supplement
to Stauffer, 38.

STEWART, Clara N. *[Artist]* early 20th c.
Addresses: Active in Washington, DC, 1908-09. **Sources:**
Petteys, *Dictionary of Women Artists.*

STEWART, Dan R. *[Painter]* 20th c.
Addresses: Birmingham, MI. **Exhibited:** PAFA Ann., 1960.
Sources: Falk, *Exh. Record Series.*

STEWART, David *[Painter, teacher]* b.1879, Glasgow,
Scotland.
Addresses: NYC. **Studied:** ASL; NY Univ., B.S. in Educ.; &
with H. Siddons Mowbray, Frank DuMond. **Member:** NYWCC;
SC; Bronx Art Gld.; AAPL; Gotham Painters; Yonkers AA.
Exhibited: S. Indp. A., 1934-36, 1940-41, 1943-44; AWCS; All.
Artists Am.; Bronx Art Gld.; Yonkers AA; NAC, 1942; Gotham
Painters; Audubon Artists; NYWCC, 1936, 1937; Am. WCS-
NYWCC, 1939; SC. **Comments:** Position: teacher, Pub. Sch. Bd.,
NY, 1940. **Sources:** WW59; WW47; Marlor, *Soc. Indp. Artists.*

STEWART, Deb. S. *[Painter]* 20th c.
Addresses: Baltimore County, MD. **Sources:** WW13.

STEWART, Dorothy N. *[Painter]* b.1891, Phila.
Addresses: Active in Santa Fe, NM, from 1925. **Sources:**
Petteys, *Dictionary of Women Artists.*

STEWART, Dorothy S. *[Painter]* 20th c.; b.Brooklyn, NY.
Addresses: Baldwin, NY. **Studied:** ASL; Nat. Acad. School Fine
Art, New York; also with Edgar Whitney, Paul Puzinas &
Anthony Toney. **Member:** Catharine Lorillard Wolfe Art Club
(director, 1970; 2nd vice-pres., 1971-74); Allied Artists Am.
(chmn., public relations committee, 1972-); Nat. Art League; Art
League Nassau Co. (treasurer, 1959-61); AAPL. **Exhibited:** Nat.
Arts Club 71st Ann. Watercolor Exhib., New York, 1969; Allied
Artists Am. 56th & 58th Ann., 1969 & 1971. Catharine Lorillard
Wolfe Art Club 73rd-75th Ann., 1969-71 & Am. Watercolor So.c
105th Ann., 1972, Nat. Acad. Galleries; AAPL Grand Nat., Lever
House, New York, 1972; Garden City Galleries Ltd, Garden City,
NY, 1970s. Awards: M. Grumbacher Award, Nat. Art League 41st
Ann., 1971; first prize oil painting, Gregory Mus., 1972;
Washington Sq. Bus. & Prof. Women's Club Award, Washington
Sq. Outdoor Art Exhib., 1972. **Work:** Gregory Mus., Hicksville,
NY; Mercy Hospital, Rockville Centre, NY. **Comments:** Preferred
media: oils, watercolors. Publications: contributor, "Prize-Winning
Art-Book 7," Allied Publ., Inc., Fort Lauderdale, FL, 1967.
Teaching: art instructor, Malverne Sr. H.S., NY, 1965-66.
Sources: WW73.

STEWART, Douglas *[Museum director]* b.1873, Pittsburgh /
d.1926.
Addresses: Pittsburgh, PA. **Comments:** Position: director,
Carnegie Mus., Pittsburgh.

STEWART, E. H. *[Painter]* 20th c.
Addresses: Chicago, IL, 1926. **Exhibited:** S. Indp. A., 1926.
Sources: Marlor, *Soc. Indp. Artists.*

STEWART, Edith Hoyt *[Painter]* 20th c.; b.Milford, MA.
Addresses: Baltimore, MD. **Studied:** W.S. Robinson; H.B. Snell;
W.L. Lathrop; C.Y. Turner. **Sources:** WW25.

STEWART, Edward B. *[Painter]* late 19th c.
Studied: with Boulanger and Lefebvre. **Exhibited:** Boston AC,
1881-86; Paris Salon, 1887. **Sources:** Campbell, *New Hampshire
Scenery,* 159; Fink, *American Art at the Nineteenth-Century Paris
Salons,* 393.

STEWART, Eleanor S. *[Sculptor]* 20th c.
Exhibited: S. Indp. A., 1938. **Comments:** Possibly Stewart,
Eleanor, b. Brooklyn, NY-d. 1945, White Plains, NY. **Sources:**
Marlor, *Soc. Indp. Artists.*

STEWART, Elmer H. *[Painter]* 20th c.

Exhibited: Salons of Am., 1926. **Sources:** Marlor, *Salons of Am.*

STEWART, Esther (Lippincott) *[Painter, teacher, lecturer, designer] b.1895, Moorestown, NJ.*
Addresses: Washington, DC, d.1939-62; Vienna, VA; Colorado Springs, CO. **Studied:** Swarthmore College; PM School IA; PAFA; Corcoran Sch. Art. **Member:** Soc. Wash. Artists; Colorado Springs Art Gld. **Exhibited:** Corcoran Gal biennial, 1943; PMG; Whyte Gal.; Wash. Pub. Lib.; Colorado Springs, Canon City, Rocky Ford, CO. **Work:** murals, numerous hotels & dept. stores; Fairfax County (VA) Court House; Arabian Embassy; Quantico Marine Club. **Comments:** Position: art chmn., Virginia Cooperative Educ. Assn., 1944-46; trustee, Virginia Art All., VMFA, Richmond, VA, 1945, 1946; trustee, Colorado Springs FAC, 1956-. **Sources:** WW59; WW47.

STEWART, Ethelyn Cosby *[Painter, craftsperson, graphic artist, designer, decorator, lithographer, educator] b.c.1900, Arlington, NJ.*
Addresses: NYC. **Studied:** CUA School; W.E. Cox; E. Carlsen. **Exhibited:** NAD; PAFA Ann., 1936. **Work:** PAFA; Smithsonian Inst. **Sources:** WW59; WW47; Falk, *Exh. Record Series.*

STEWART, Frances De F. (Mrs.) *[Painter] 20th c.*
Addresses: NYC. **Exhibited:** Argent Gal., 1937 (solo); NAWPS, 1935-38. **Sources:** WW40.

STEWART, Frederick D. See: **STUART, Frederick D.**

STEWART, Gertrude Ellis *[Painter] 20th c.*
Exhibited: Salons of Am., 1928, 1929. **Sources:** Marlor, *Salons of Am.*

STEWART, Grace Bliss (Mrs.) *[Painter, writer] b.1895, Atchison, KS / d.1969, Bronx, NY.*
Addresses: NYC. **Studied:** ASL, and with Charles Hawthorne, H.B. Snell & F.L. Mora. **Member:** NAWA; Pen & Brush Club; New Hampshire AA. **Exhibited:** Salons of Am., 1934, 1936; All. Artists Am., 1937; NAWA, 1930-46; Toronto, Ontario, 1937; North Shore AA; Gloucester AA; PBC; Dayton AI; Ogunquit AC; Salons of Am.; Palm Beach AA; Newport AA; Pen & Brush Club (several prizes); New Hampshire AA; Laconia, N.H. (prize); Paris, France; Amsterdam, Holland; solo traveling exhib. to U.S. museums for 4 years; New York City (5 solos). **Comments:** Author: "In and Out of the Jungle," "Jumping into the Jungle," & "The Good Fairy" (1930). **Sources:** WW59; WW47; Petteys, *Dictionary of Women Artists*, cites birth date of 1885.

STEWART, Gustav L(urman), Jr. *[Painter] 20th c.*
Exhibited: Salons of Am., 1936. **Sources:** Marlor, *Salons of Am.*

STEWART, J. R. *[Painter] 20th c.*
Addresses: Cleveland, OH. **Member:** Cleveland SA. **Sources:** WW27.

STEWART, Jack *[Painter, educator] b.1926, Atlanta, GA.*
Addresses: New York, NY. **Studied:** With Steffen Thomas, Atlanta; Yale Univ. School Fine Arts, B.F.A.; Columbia Univ. School Arch. **Exhibited:** PAFA, 1953; New York City Center Show, 1956; Inform & Interpret, Nat. Fed. Arts Nat. Traveling Show, 1965-66; Art East Shows, New York, 1965-68; Grippi & Wadell Gallery, 1963-64. **Work:** Commissions: mural on facade of Versailles Hotel, Miami Beach, FL, 1955; six mosaic murals on SS Santa Paula, Grace Lines, 1957; mural on facade of Hotel Aruba Caribbean, Netherlands Antilles, 1958; two mosaic murals in public school 1928, Manhattan, NY, 1958; stained glass for offices of Cinerama, Inc., NYC, 1960. **Comments:** Preferred media: acrylics. Publications: contributor, "Mosaic Art Today," 1959; editor, "Modern Mosaic Techniques," Watson Guptill, 1967; author of short articles on drawing & mosaic, *Jefferson Encyclopedia,* World, 1969; contributor, "The Art of Mosaic," 1969. Teaching: lecturer on art & arch., New School Social Res., 1953-58; instructor in design, Pratt Inst., 1955-61; lecturer drawing & painting, Columbia Univ., 1967-; assoc. professor, drawing & painting, Cooper Union School Art & Arch., 1960- & chmn. dept., 1971-. **Sources:** WW73.

STEWART, Janet A. *[Etcher] 20th c.*
Addresses: Somerworth, NH. **Sources:** WW24.

STEWART, Jan(et) (Crouse) (Mrs. F. P.) *[Craftsman, painter, designer, teacher] b.1904, Mansfield, OH.*
Addresses: Miami Beach, FL. **Studied:** PM School IA; Chicago Acad. FA; & with Stanislaw Szukalski. **Member:** Hoosier Salon. **Exhibited:** Midland Acad., South Bend, IN; Hoosier Salon. **Work:** Hoosier Salon. **Comments:** Restorer of ceramics. **Sources:** WW53; WW47.

STEWART, Jarvis Anthony *[Educator, painter] b.1914, Marville, MO / d.1981.*
Addresses: Delaware, OH. **Studied:** St. Joseph Jr. College, 1932-33; Phillips Univ., B.F.A., 1942, with E. J. McFarland; Ohio State Univ., M.A., 1947; also with Ernest Thurn, Pablo O'Higgins Felipe Cossio & Hoyt Sherman. **Work:** Columbus (OH) Gallery Fine Arts; Otterbein College, Westerville, OH; Phillips Univ., Enid, OK. **Comments:** Preferred media: acrylics, oils. Positions: asst. for murals, Am. Hotels Corp., Robidoux Hotel, Saint Louis, MO, 1939-40. Teaching: design instructor, Phillips Univ., 1942-43; professor of design & art hist., Ohio Wesleyan Univ., 1943-. Research: craftsmen of the Mexican Bajio; sociology of art. **Sources:** WW73.

STEWART, Jarvis K. (Mrs.) *[Artist] late 19th c.*
Addresses: Active in Flint, MI, 1893-99. **Sources:** Petteys, *Dictionary of Women Artists.*

STEWART, Jeanne M. *[Painter] b.1868, Quincy, IL.*
Addresses: Chicago, IL, c.1907; Seattle, WA, 1909. **Studied:** AIC; J. Paterson, in Edinburgh, Scotland. **Exhibited:** Soc. of Seattle Artists, 1908; Wash. State Arts & Crafts, 1909; Alaska Yukon Pacific Expo, 1909; AIC. **Sources:** WW08; Trip and Cook, *Washington State Art and Artists.*

STEWART, John A. *[Portrait painter] mid 19th c.*
Addresses: NYC, 1851. **Exhibited:** NAD. **Sources:** G&W; Cowdrey, NAD.

STEWART, John Lincoln *[Educator, writer] b.1917, Alton, IL.*
Addresses: LA Jolla, CA. **Studied:** Denison Univ., A.B., 1938; Ohio State Univ. (M.A., 1939; Ph.D., 1947); Denison Univ., hon. D.A., 1964. **Exhibited:** Awards: Dartmouth faculty fellow, 1962-63. **Comments:** Positions: provost & advisor to chancellor arts, Univ. Calif., 1947-49; assoc. dir., Hopkins AC, Dartmouth College, 1962-64. Publications: author, "John Crowe Ransom," Univ. Minnesota Press, 1962; author, "The Burden of Time, The Fugitives and Agrarians," Princeton Univ. Press, 1965. Teaching: from asst. prof. to prof., Dartmouth College, 1949-64; prof. Am. lit. & provost, John Muir College, Univ. Calif., San Diego, 1964-. Research: contemporary American and British literatures. **Sources:** WW73.

STEWART, John P *[Printmaker, sculptor] b.1945, Fort Leavenworth, KS.*
Addresses: Greensboro, NC. **Studied:** Univ. Colorado, B.F.A., 1967, with Roland Reiss & Wendel Black; Univ. Calif., Santa Barbara, M.F.A., 1969. **Exhibited:** Northwest Printmakers 40th Int. Seattle Art Mus., 1969; Art on Paper, Greensboro, NC, 1971; Whitney Mus. Recent Acquisitions, New York, 1972; Objective Drawings; 100 Acres, New York, 1972; Pyramid Gallery, Washington, DC, 1972 (solo). **Work:** CGA; WMAA; Kalamazoo (MI) Art Inst.; Santa Barbara Mus. Art; Peabody Mus., Nashville, TN. **Comments:** Teaching: printmaking instructor, Univ. North Carolina, Greensboro, 1969-. **Sources:** WW73.

STEWART, Joseph *[Painter] b.1859, Humboldt, KS / d.1929, Wash., DC.*
Addresses: Wash., DC, 1924. **Exhibited:** S. Indp. A., 1924-25, 1927; Salons of Am., 1925-28. **Sources:** Falk, *Exhibition Record Series.*

STEWART, Joseph *[Amateur painter, lawyer] b.1859, Humboldt, KS / d.1929, Wash., DC.*
Addresses: Wash., DC. **Studied:** George Wash. Univ.; self-taught

as an artist. **Exhibited:** Soc. of Independent Artists, 1924-27. **Sources:** McMahan, *Artists of Washington, DC.*

STEWART, Joseph Augustus Edward *[Textile designer, painter]* b.1864, Bristol, England / d.1943.
Addresses: Montclair, NJ. **Comments:** CAme to the U.S. in 1875. Positions: designer, Pacific Mills, Converse & Co.

STEWART, Julius LeBlanc *JLStewart*
[Portrait and figure painter]
b.1855, Philadelphia, PA / d.1919.
Addresses: Paris, France (1865-c.1918). **Studied:** as a boy with E. Zamacois, c.1870-71; with Gérôme, 1873-74; with F. Madrazo, c.1875 — all in Paris. **Member:** Paris SAP; Soc. Nat. des Beaux-Arts, 1899. **Exhibited:** PAFA Ann., 1877-1913 (9 times); Paris Salon, 1878, 1879, 1882-88, (1885, prize), 1890 (medal), 1892; NAD, 1883, 1885; 1904, 1919; SNBA, 1895-01, 1908; Brooklyn AA, 1887; Paris Exposition, 1889 (6 paintings); Berlin, 1891 (gold), 1895 (gold); Antwerp, 1894; Munich, 1897 (gold), 1901 (gold); Corcoran Gal annual, 1908; Pan-Pacific Expo, San Francisco, 1915; Vance Jordan FA, NYC, 1998 (solo). Other awards: Order of Leopold of Belgium, 1895; French Legion of Honor, 1895, Officer, 1901. **Work:** AIC; PAFA; Detroit Inst. Art; Essex Club, Newark, NJ; Albright-Knox Mus., Buffalo, NY; Drexel Univ. Mus.; Wadsworth Atheneum, Hartford, CT; Telfair Acad., Savannah, GA; Walters AG, Baltimore. **Comments:** From the 1880s through the first decade of the 20th century, Stewart ranked with John S. Sargent as one of the most popular expatriate American painters in Paris. Stewart's family settled in Paris when he was ten years old. His earliest painting is dated 1876, and his last exhibited work was in 1915. He won fame for portraying Parisian celebrities and fashionable woman in elegant interiors. By 1895, he was also exhibiting nudes painted *en plein air,* followed by figures in landscapes and Venetian views. By 1905 he had experienced a religious crisis and conversion. At the beginning of WWI his service in the Red Cross ambulance brigade resulted in his nervous breakdown and he returned to the U.S. **Sources:** WW17; Baigell, *Dictionary*; *300 Years of American Art,* vol. 1: 487; D.Dodge Thompson, "A Parisian from Philadelphia", *Antiques* (Nov., 1986), p.1046; Detroit Inst. of Arts, *The Quest for Unity: American Art Between World's Fairs, 1879-1893,* 243-245; Falk, *Exh. Record Series.*

STEWART, Lawrence O. *[Sculptor, painter and illustrator];* b.Des Moines, IA.
Addresses: Des Moines, IA. **Studied:** Charles Atherton Cumming; Art Inst. Chicago, under Charles J. Mulligan; Beaux Arts, NYC. **Exhibited:** Art Inst. Chicago; Holllywood (CA) Artists; Pomona (CA) Artists; Buffalo, NY; Iowa Art Salon, 1927, 1931, 1934, 1935; Younkers Tea Room Galleries, 1934 (solo); Iowa Artists Club, 1931 (prize). **Work:** Lincoln H.S. **Comments:** Author, "Rainbow Bright." Position: professor art, Drake Univ., 1915-17; free lance artist. **Sources:** Ness & Orwig, *Iowa Artists of the First Hundred Years,* 199-200.

STEWART, LeConte *[Painter, graphic artist, educator, lecturer, lithographer, teacher, educator]* b.1891, Glenwood, UT.
Addresses: Salt Lake City, UT; living in Kaysville, UT in 1974. **Studied:** Univ. Utah; ASL with Carlson, Goltz, DuMond, Blumenschein, Miller, 1911-13 (spent the summer in Woodstock and the winter in NYC); PAFA; & with Edwin Evans, George Bridgman, & others. **Member:** Utah State AA. **Exhibited:** Utah State Fair, 1915 (prize), 1937 (prize); Utah AI, 1916 (prize), 1941; Art Barn, 1938 (Utah State prize); Painters of the West, 1928; Colo. Graphic AC, 1938-40; Utah AA, 1945; Ogden Palette Club, 1945 (solo), 1955; Heyburn, ID, 1946; Boulder (CO) Womens's Club, 1946; Springville, UT, 1940; Utah AI, 1941; Salt Lake City, 1955 (solo); Boulder (CO) Women's Club, 1946. **Work:** Utah State College; Springville (UT) H.S.; Ogden City College; Univ. Utah; Utah Agricultural College; Kaysville City College; Springville, Utah; Ricks College, Rexburg, Idaho; Heyburn (ID) Public School Collection; murals, Hotel Ben Lomond, Ogden; L.D.S. Temples, Canada, Hawaii, Arizona; Denver State House. **Comments:** Position: head of art dept., prof. of art, Univ. Utah, Salt Lake City,

UT, 1938-56 (retired). Lectures: graphic arts; mural painting. **Sources:** WW59; WW47; P&H Samuels, 466.

STEWART, Leize (Mrs. Duncan M.) See: **ROSE, Leize**

STEWART, Louise M. *[Painter]* 20th c.
Addresses: Baltimore, MD. **Sources:** WW25.

STEWART, Luella M. See: **HOLDEN, Luella M. Stewart (Mrs. Hendrick S.)**

STEWART, M. Augusta *[Painter]* late 19th c.
Exhibited: NAD, 1881. **Sources:** Naylor, *NAD.*

STEWART, M. L. *[Painter]* 19th c.
Addresses: Yonkers, NY. **Exhibited:** PAFA Ann., 1891 ("Roses"). **Sources:** Falk, *Exh. Record Series.*

STEWART, Mabel *[Painter]* late 19th c.
Addresses: Wayland, MA, 1891; Newton, MA, 1893. **Exhibited:** NAD, 1891, 1893. **Sources:** Naylor, *NAD.*

STEWART, Mai *[Artist]*
Addresses: Active in Detroit, MI. **Exhibited:** Detroit School Art, 1893. **Sources:** Petteys, *Dictionary of Women Artists.*

STEWART, Marie H. *[Painter, designer, craftsperson, teacher, writer]* b.1887, Eaton, OH.
Addresses: Indianapolis, IN; Oxford, OH. **Studied:** PIA School; John Herron AI; Butler Univ., B.F.A., M.S. **Member:** Indiana State Teachers Soc.; NEA; NAEA; AAUW; Indianapolis AA; Indiana Art Club. **Exhibited:** Hoosier Salon, 1941, 1942 (prize), 1943, 1945; PIA School; Indiana Artists, 1936-51; John Herron AI, 1957; CM, 1957; Oxford Art Club, 1952-57; Cincinnati Mus., 1957-58. Awards: Lincoln tablet des.,1907. **Comments:** Contributor to *Design Magazine, School Arts Magazine.* Author: "Legal Status of Indiana Teachers"; co-author, radio script "Art Adventures." Positions: supervisor of art, Indianapolis Pub. Schs., 1918-43; asst. director of art, in charge of art educ., Indianapolis, IN, 1943-52 (retired). **Sources:** WW59; WW47.

STEWART, Marion Louise *[Painter, decorator]* 20th c.; b.Buffalo, NY.
Addresses: East Aurora, NY. **Studied:** Radcliffe College, A.B.; École des Beaux-Arts, Fontainebleau, France, with Guerin, Despujols; Columbia Univ.; ASL. **Member:** The Patteran. **Exhibited:** Albright Art Gal., 1938 (prize), 1939, 1940; WFNY, 1939; CI, 1941; Great Lakes Exhib., 1939. **Sources:** WW59; WW47.

STEWART, Mazie Matilda *[Painter]* b.1876, Washington, IA.
Addresses: Washington, IA. **Studied:** Zoe Hamilton Carter, Washington, IA. **Exhibited:** Iowa Federation Women's Clubs, Sioux City, 1937; Iowa Artists Exhibit, Mt. Vernon, 1938. **Sources:** Ness & Orwig, *Iowa Artists of the First Hundred Years,* 200.

STEWART, N. Neale *[Painter]* 19th c.
Addresses: Boston, MA. **Exhibited:** Boston AC, 1886-91. **Sources:** *The Boston AC.*

STEWART, Oliver J. See: **STUART, Oliver J.**

STEWART, Patricia Kaye *[Art administrator]* b.1947, El Paso, TX.
Addresses: Chicago, IL. **Studied:** Univ. Penn., B.A.; Columbia Univ. **Comments:** Positions: curator, Mus. Contemporary Art, 1972-. Publications: author, "Comix," 1972. Collections arranged: Comix, Mus. Contemporary Art, Chicago, 1972 & arrangements, selections & cataloging all exhibs., 1972-. **Sources:** WW73.

STEWART, Pythias See: **STUART, Pythias**

STEWART, Reba *[Painter, teacher]* b.1930, Hudson, MI.
Addresses: Baltimore, MD. **Studied:** BMFA School FA; Yale Univ., School Art & Arch., B.F.A., M.F.A. **Exhibited:** Boston Printmakers, 1954-56, 1958-60; Inst. Contemporary Art, Boston, 1955 (5-man); Boston Printmakers, travelling exhib., 1955, 1958-59; Swetzoff Gal., Boston, 1957-61; Nat. Graphic Art Exhibition

of Japan, Tokyo, 1958; De Cordova & Dana Mus., 1959; Boston Art Festival, 1955-1962; New Haven Art Festival, 1960; AIC, 1961; Swetzoff Gal., 1955, 1958, 1960 (all solos); Boylston Street Print Shop, Boston, 1956; Yoseido Gal., Tokyo, 1957; Gal. Lemon, Tokyo, 1957; Loan Exhib. of print through USIS to Japan, 1957-58; Yamada Contemporary Art Gal., Kyoto, 1958; Fitchburg, MA, 1958; Deerfield Acad., 1961. **Awards:** Clarissa Bartlett Traveling Fellowship, BMFA, 1955; prizes, Boston Printmakers, 1955 and the Patrick Gavin Mem. Prize, 1959; Portland Art Festival, 1960. **Work:** Commission, IGAS for woodcut of an Edition of 200, 1957; work in collections of FMA; BMFA; Brandeis Univ.; Wellesley College; Wheaton College; Fitchburg Mus. Art; William Lane Fnd., Leominster, MA. **Comments:** Positions: instructor in graphic arts, Boston Mus. School FA, 1955-56; Boston Center for Adult Educ., 1955-56; design & drawing, Monticello College, Alton, IL, 1961-63; drawing, painting, design & color, Maryland Institute, College of Art, Baltimore, 1963-65. **Sources:** WW66.

STEWART, Robert B. *[Painter] 20th c.*
Addresses: NYC/Phila., PA. **Member:** SI; Artists Gld. **Sources:** WW31.

STEWART, Robert W. *[Illustrator] 20th c.*
Addresses: NYC. **Sources:** WW24.

STEWART, S. *[Landscape painter] early 19th c.*
Exhibited: American Acad., 1820 (landscape " Carriage Fording a River", by the late S. Stewart of Boston). **Sources:** G&W; Cowdrey, AA & AAU.

STEWART, Sarah Bartram *[Miniature painter] 20th c.*
Addresses: Montclair, NJ. **Sources:** WW15.

STEWART, Sophie de B. *[Painter] 19th/20th c.*
Exhibited: Wash. WCC, 1910 ("A Quiet Home"). **Sources:** McMahan, *Artists of Washington, DC.*

STEWART, Sue Vashon *[Painter, teacher] b.1898, St. Louis, MO / d.1988, Wash., DC.*
Addresses: Wash., DC. **Studied:** Boston School of Art and Design; BMFA School. **Comments:** Position: teacher, public schools, Wash., DC, 1921-63. **Sources:** McMahan, *Artists of Washington, DC.*

STEWART, T. J. (Mrs.) See: **HORTON, Dorothy E. (Mrs T. J. Stewart)**

STEWART, William Branks *[Medical illustrator, painter, educator, lecturer] b.1898, Airdrie, Scotland.*
Addresses: New Orleans, LA. **Studied:** Glasgow School Art, D.A.; & with D. Forrester Wilson, W. Somerville Shanks, James Dunlop, & others. **Member:** New Orleans Art Lg. (vice-pres.); Assn. Medical Illustrators (board governors). **Exhibited:** Assn. Clinical Pathologists, Kansas City, 1936 (medal), Chicago, 1944 (medal); AMA,1937 (medal); New Orleans Art Lg., 1935-43, 1944 (medal, prize), 1945 (prize); Delgado Mus. Art, 1941 (solo). **Comments:** Co-illustrator: Morris' "Textbook of Human Anatomy," 1933; Tice's "Practice of Medicine," 1932. Illustrator: "The Structure of the Human Body," 1945. Contributor to medical journals. Position: assoc. professor, 1946-, director of medical illus., 1934-, Louisiana State Univ. School of Medicine, New Orleans, LA. **Sources:** WW53; WW47.

STEWART, William D. (Mrs.) *[Painter] 20th c.*
Addresses: Roland Park, MD. **Sources:** WW17.

STEWART, William H. *[Engraver] b.c.1831, England.*
Addresses: Philadelphia, 1856-60. **Comments:** His wife, Catherine, was a native of Ireland; they had five children, ages 8 years to 7 months, all born in Pennsylvania, *Cf.* William H. Stewart, the artist. **Sources:** G&W; 8 Census (1860), Pa., LII, 655; Phila. CD 1856 [as William F.], 1858-60+.

STEWART, William H. *[Listed as "artist"] b.c.1829, New Brunswick.*
Addresses: Philadelphia, 1850-54. **Comments:** His wife was Catherine, 29, a native of Pennsylvania. *Cf.* William H. Stewart,

the engraver. **Sources:** G&W; 7 Census (1850), Pa., LIII, 326; Phila. CD 1851-54.

STEWART, William Wright *[Painter] b.1865, Phila., PA.*
Addresses: Paris, France, 1898-1901. **Studied:** Gerome, Constant, Laurens,Ferrier, L. Simmonet, Paris. **Exhibited:** Paris Salon, 1896, 1897, 1898; PAFA Ann., 1898-99; AIC. **Sources:** WW01; Fink, *American Art at the Nineteenth-Century Paris Salons,* 393; Falk, *Exh. Record Series.*

STEWART, Worth *[Painter] 20th c.*
Addresses: Butte, MT. **Sources:** WW13.

STEWEL, Gustav *[Lithographer] b.c.1832, Germany.*
Addresses: Baltimore, 1850. **Comments:** He lived with, and was probably employed by, August Hoen (see entry). **Sources:** G&W; 7 Census (1850), Md., V, 418.

STICK, Frank *[Illustrator] 20th c.*
Addresses: Interlaken, NJ. **Sources:** WW19.

STICKLEY, Gustave *[Furniture designer] b.1858, Osceola, WI / d.1942, Syracuse, NY.*
Comments: In 1884 he established a furniture factory in Binghamton, NY to carry out some of Ruskin's ideas. Position: founder/editor, *The Craftsman.*

STICKNEY, Lela Mabel (Mrs.) *[Craftsman, designer, decorator] b.1872, Chelsea, MA.*
Addresses: Arlington Heights, MA. **Studied:** with Denman Ross, Franz Bischoff, Marshall Frye, S.W. Safford. **Member:** Boston SAC; Mineral Art Lg.; Professional Woman's Club, Boston. **Exhibited:** Boston Soc. Arts & Crafts (prize); Ferargil Gal.; Anderson Gal.; & in Boston, Swampscott (prize), Cambridge, Arlington, Lowell, MA. **Sources:** WW53; WW47.

STICKNEY, Lucy May See: **MATHEWSON, Lucy May (Stickney)**

STICKNEY, Mary West *[Painter] 20th c.*
Addresses: Buffalo, NY. **Sources:** WW04.

STICKNEY, Mehitabel *[Painter] early 19th c.*
Work: Memorial painting, 1825. **Comments:** **Sources:** G&W; Lipman and Winchester, 180.

STICKROTH, Harry I. *[Painter, teacher] d.1922.*
Addresses: NYC. **Studied:** Am. Acad.,Rome; Lazarus schol. for mural painting, 1914-17. **Exhibited:** AIC, 1922. **Work:** mur. dec. (with B. Faulkner), Cunard Bldg., NYC. **Comments:** Position: teacher, AIC, Chicago, IL. **Sources:** WW17.

STIDOLPH *[Engraver] mid 19th c.*
Addresses: Boston, 1842. **Sources:** G&W; Boston BD 1842.

STIDUN, James *[Portrait painter] mid 19th c.*
Work: Hist. Soc. of Penn. (portraits of Stephen Smith ,1795-1873, and Mrs. Smith, née Harriet Lee). **Sources:** G&W; information courtesy the late William Sawitzky.

STIEBEL, Augustus *[Lithographer] b.c.1832, Germany.*
Addresses: Baltimore, 1860. **Sources:** G&W; 8 Census (1860), Md., IV, 642.

STIEFFEL, Hermann *[Amateur landscape and battle painter] b.1826, Wiesbaden, Germany / d.After 1882, or 1886.*
Work: Smithsonian Institute (watercolors:"The Attack on General Marcy's Train near Pawnee Fort, Kansas, Sept. 23, 1867; "A view of Fort Keogh in the Montana Territory," c.1879); Beinecke Library, Yale Univ. **Comments:** Printer in NYC who enlisted in 1857. He served for 25 years as a private in Company K, 5th U.S. Infantry. **Sources:** G&W; *American Processional,* 26, 249, 250; P&H Samuels, 467.

STIEGELMEYER, Norman *[Sculptor] d.1937.*
Addresses: Mill Valley, CA. **Exhibited:** WMAA, 1967. **Sources:** Falk, *WMAA.*

STIEGLITZ, Alfred
[Photographer, dealer, patron, writer, publisher] b.1864, Hoboken, NJ / d.1946, NYC.
Addresses: NYC (1871-on). **Studied:** CCNY; Berlin Polytechnic, 1881. **Member:** Camera Club, NYC (vice-pres., 1896). **Exhibited:** S. Indp. A., 1917 (exhibited "The Steerage"); Salons of Am., 1930. **Work:** IMP; AIC; BMFA; CMA; PMA; Univ. New Mexico; MoMA; Princeton; master set of all his images at NGA; his personal collection at MMA; his papers at Yale Univ. **Comments:** The most influential photographer-dealer in America of the 20th century, his publications and exhibitions had a profound impact on the emergence of modernism in the U.S. In 1934, more than 20 writers and artists contributed to *America and Alfred Stieglitz;* and, in what is perhaps the best appraisal, one writer states, "A most incessant talker, [Steiglitz] raised his voice for more than half a century to proclaim his powers as a prophet, soothsayer and arbiter of all matters pertaining to the free spirit of mankind." In 1883, Steiglitz became fascinated by the camera and rose from an amateur to the height of the profession, stressing photography as an art in itself. In 1890, he began what he called the "battle of photography" and in 1902 became the prime force behind the founding of the Photo-Secession. His most famous image is "Steerage" (1907). He opened the Little Galleries of the Photo-Secession (later called "291") at 291 Fifth Ave. (1905-17) where, besides his own work, he discovered and championed some of the outstanding photographers of the day. He was also the editor of *Camera Notes* (1897-1903) and the quarterly *Camera Work* (1903-17). Stieglitz also championed modern painters and sculptors, beginning with drawings by Rodin. In 1925 he established the Intimate Gallery, and in 1929 opened his last gallery, An American Place. In 1947, a memorial exhibition at MoMA included photographs by Stieglitz and his collection of work by artists he had sponsored, such as Cezanne, Matisse, Picasso, and the American modernists, Demuth, Dove, Hartley, Marin, Maurer, Walkowitz, Weber, and Georgia O'Keeffe (whom he married in 1924); and photographers Ansel Adams, Paul Strand, Minor White, Edward Weston and others of the "straight style." **Sources:** WW24; William I. Homer, *Alfred Stieglitz and the American Avant-Garde* (Boston: New York Graphic Soc., 1977); William I. Homer, *Alfred Stieglitz and the Photo-Secession* (Boston, Little, Brown, and Co., 1983); Sue Davidson Lowe, *Stieglitz: A Memoir/Biography* (New York: Farrar, Straus, Giroux, 1983); Barbara Buhler Lynes, *O'Keeffe, Stieglitz and the Critics, 1916-1929* (Ann Arbor, MI: UMI Research Press, 1989); Baigell, *Dictionary;* Witkin & London, 243-44.

STIEGLITZ, Elizabeth (L.) *[Painter] b.1897 / d.1956.*
Addresses: NYC. **Exhibited:** S. Indp. A., 1917. **Comments:** Alfred Stieglitz's niece, she later married Donald Davidson. **Sources:** Marlor, *Soc. Indp. Artists;* Sue Davidson Lowe, *Stieglitz: A Memoir/Biography* (New York: Farrar, Straus, Giroux, 1983), 171-72, 208-9, 213-16, 220-22,.

STIEGMAN, Edward *[Painter] 20th c.*
Exhibited: S. Indp. A., 1936. **Sources:** Marlor, *Soc. Indp. Artists.*

STIEN *[Painter] 20th c.*
Addresses: Clinton Prison. **Exhibited:** S. Indp. A., 1935. **Sources:** Marlor, *Soc. Indp. Artists.*

STIEPEVICH, Vincent G. *[Portrait and genre painter] b.1841, Russia / d.c.1910.*
Addresses: NYC and Brooklyn, NY, 1878-96. **Member:** Artists Fund Soc. **Exhibited:** Brooklyn AA, 1878-82, 1891; NAD, 1878-91; PAFA Ann., 1885, 1888-91; Boston AC, 1891-96; AIC. **Sources:** WW10; Falk, *Exh. Record Series;* Naylor, *NAD;* Marlor, *Brooklyn AA.*

STIERLIN, Margaret Emily *[Craftsman, designer, sculptor, teacher] b.1891, St. Louis, MO.*
Addresses: Chicago, IL. **Studied:** Univ. Missouri, A.B.; AIC & with Emil Zettler. **Member:** Chicago Art Lg.; Chicago Potters Gld.; Indust. Des. Alliance, Chicago. **Exhibited:** AIC, 1935, 1936, 1940, 1941, 1943; Syracuse Mus. FA, 1940; Springfield Mus. Art, 1941. **Awards:** Am. traveling scholarship, AIC,1932. **Work:** Springfield (IL) Mus. Art. **Comments:** Specialty: scientific modeling, arch. modeling, stone and wood carving, toy design. Position: instructor in modeling, Jr. Dept., AIC, 1932-38; instructor in ceramics, Hull House, Chicago, 1939-. **Sources:** WW53; WW47; Petteys, *Dictionary of Women Artists,* reports alternate birth date of 1895.

STIEVEL, Gustav See: **STEWEL, Gustav**

STIFFLER, Eugenie May Pack *[Portrait and miniature painter] b.1870, North Carolina / d.1959, Redlands, CA.*
Addresses: Redlands, CA. **Member:** Riverside AA. **Exhibited:** Artists Fiesta, Los Angeles, 1931; Riverside AA, Los Angeles City Hall, 1941. **Sources:** Hughes, *Artists of California,* 536.

STIFFLER, Iva Haverstock *[Painter] b.1887, Butler, IN.*
Studied: Herron AI with Forsyth & Wheeler. **Sources:** Petteys, *Dictionary of Women Artists.*

STIFFT, Michael *[Engraver] b.c.1822, Poland.*
Addresses: New Orleans, 1860-77. **Comments:** His wife Bertha was from Prussia; Solomon, age 4, was born in Ohio; Wolff, age 2, in Louisiana. In 1870 he was listed as a watchmaker. **Sources:** G&W; 8 Census (1860), La., VI, 70; New Orleans CD 1870. More receently, see *Encyclopaedia of New Orleans Artists,* 365.

STIHA, Vladin *[Painter] b.c.1910, Belgrade, Yugoslavia.*
Addresses: Living in Santa Fe, NM in 1973. **Studied:** Vienna Acad. FA, Austria; Italy with C. Savierri. **Exhibited:** in Europe; Argentina. **Comments:** Emigrated to Argentina at the end of WWII and lived there until 1958 when he moved to Brazil. Settled in Santa Fe in 1968, and specialized in Pueblo Indian genre. **Sources:** Peggy and Harold Samuels, 467.

STILES, Gertrude *[Painter] 19th c.*
Addresses: Jacksonville, IL. **Exhibited:** AIC, 1898. **Sources:** Falk, *AIC.*

STILES, Jeremiah *[Portrait and animal painter, civil engineer and surveyor] b.1771, Keene, NH / d.1826.*
Sources: G&W; Worcester (MA) Society of Antiquity, *Collections,* VI (1885), 169-70, 205-06; Stiles, "Jeremiah Stiles, Jr."

STILES, Joseph E(dwin) *[Painter, lithographer, teacher, comm] b.1931, Spring Hill, KS.*
Addresses: San Jose, CA. **Studied:** Univ. Kansas, B.F.A.; Univ. New Mexico, M.A.; ASL, with Louis Bouche, Will Barnet. **Member:** AAUP. **Exhibited:** Balt. WCC, 1953; CM, 1954; Terry AI, 1952; Kansas Painters, 1953, 1954, 1960; Missouri Valley, 1953; Friends of Art Biennial, 1958; Wichita AA, 1960; Joslyn Art Mus., 1960; Air Capitol Annual, Wichita, 1960; Topeka Art Gld., 1960; Nelson Gal. Art, 1958, 1960; Oklahoma AC, 1953 (solo); Baker Univ., 1958; Gal. Guidea, San Francisco, 1961; Birger Sandzen Gal., 1959. **Award:** prize, Kansas Painters, 1953; Huntington Hartford Fnd. Fellowship, 1960-61. **Comments:** Positions: instructor, Univ. Kansas, 1959-60. **Sources:** WW66.

STILES, Mark D. *[Painter] late 19th c.*
Addresses: NYC, 1881-82. **Exhibited:** NAD, 1881-82. **Comments:** May be the artist listed as Marquis D. Stiles. **Sources:** Naylor, *NAD.*

STILES, Marquis D. *[Painter] late 19th c.*
Addresses: NYC, 1889. **Exhibited:** NAD, 1889. **Comments:** May be the artist listed as Mark D. Stiles. **Sources:** Naylor, *NAD.*

STILES, Patti *[Painter] 20th c.*
Addresses: NYC. **Sources:** WW25.

STILES, Samuel *[Portrait painter and banknote engraver] b.1796, East Windsor, CT / d.1861, Brooklyn, NY.*
Comments: He was a partner with Abner Reed (see entry) in engraving firm of Reed, Stiles & Co., in Hartford, CT, from 1821-24. In 1824 he joined with Vistus Balch (see entry) at first in

Utica, NY, but in 1828 opened their bank note and portrait engraving firm in NYC as Balch, Stiles & Co. (1828-30); then Balch, Stiles, Wright & Co. (1831-32); and finally Stiles & Company (1833-35). **Sources:** G&W; Bolton, "Workers with Line and Color in New England"; Stauffer; NYCD 1828-59; 7 Census (1850), N.Y., XLVII, 327; "Stiles Family Memorial" (unpub. ms, CT Hist. Soc.).

STILES, William M. *[Engraver] mid 19th c.*
Addresses: Philadelphia, 1850. **Sources:** G&W; Phila. BD 1850.

STILES & COMPANY *[Engravers]*
Addresses: NYC, 1833-35. **Comments:** Formed by Samuel Stiles when he left Balch, Stiles, Wright & Co (see entry). **Sources:** G&W; NYCD 1833-35.

STILL, Clyfford *[Painter, teacher, lithographer] b.1904, Grandin, ND / d.1980.*

Clyfford - 1948

Addresses: New Windsor, MD, 1973. **Studied:** ASL, 1925 (for less than one year); Spokane Univ., B.A., 1933; Washington State College, M.A. **Exhibited:** SFMA, 1943 (solo); Art of This Century Gal., 1946; Betty Parsons Gal., NYC, 1947, 1950, 1951 (all solos); AIC, 1947, 1949; Fifteen Americans Traveling Exhib., MoMA, 1952; The New American Painting, MoMA and circulating to Europe, 1958-59; The New American Painting and Sculpture, MoMA, 1969; Albright-Knox Art Gallery, 1959 (retrospective); Documenta II, Kassel, Germany, 1959; Univ. Penn., 1964 (solo); MMA, 1979 (solo). **Work:** SFMA; MoMA; WMAA; BMA; Albright-Knox Art Gallery, Buffalo, NY; Detroit IA; Phillips Collection, Wash., DC. **Comments:** Pioneer Abstract Expressionist. In the 1930s Still's paintings became increasingly abstract and powerful, and in the early 1940s Surrealist elements entered his work. By 1947, Still was working on a large scale, with expansive color areas disrupted by violent, jagged-edged forms. Teaching: faculty member, Yaddo, 1934, 1935; Wash. State College, 1933-41; Richmond Prof Inst., College William & Mary, 1943-45 (during which made he made a series of 21 lithographs); Calif. School Fine Arts, 1946-50; originated "Subject of the Artist," NYC, 1947-48, Brooklyn College, 1952; Univ. Penn., 1963 & Hunter College, 1952. Author: artist's statement, included in Dorothy C. Miller, ed., *15 Americans* (exh. cat., MOMA, New York, 1952); artist's statement, in *Paintings by Clyfford Still* (Albright-Knox Art Gallery, Buffalo, 1959). **Sources:** WW73; WW47; John P. O'Neill, *Clyfford Still* (exh. cat., MMA, 1979); Baigell, *Dictionary; 300 Years of American Art*, 914.

STILL, Constance Draper Seely *[Painter] b.1901, Ohio / d.1971, Los Angeles, CA.*
Addresses: Los Angeles, CA. **Exhibited:** P&S Los Angeles, 1936, 1937. **Sources:** Hughes, *Artists in California*, 536.

STILL, Roy *[Illustrator] 20th c.*
Addresses: NYC. **Sources:** WW19.

STILLMAN, Alexander *[Collector, painter] b.1914, New York, NY.*
Addresses: Chicago, IL; Barrington, IL. **Studied:** AIC, M.A. **Comments:** Author: "Mayan Art", 1935. **Sources:** WW66.

STILLMAN, Amelia Esther *[Still life & portrait painter, teacher] b.1834, Alfred, NY / d.1902, Alfred, NY.*
Studied: Abigail Allen, Alfred Acad.; Chicago; Leroy, NY; MMA; Corcoran Art Gal. **Comments:** Art teacher, Alfred Acad., 1870-95. **Sources:** Petteys, *Dictionary of Women Artists*.

STILLMAN, Ary *[Painter] b.1891, Russia / d.1967.*

Ary Stillman

Addresses: Sioux City, IA, 1907; NYC; Paris, France. **Studied:** AIC; NAD; ASL; André Lhôte in Paris; also in Spain and Italy. **Member:** Fed. Mod. P&S; S. Indp. A. **Exhibited:** Salon des Beaux-Arts, Paris, 1926, 1927, 1933; Salon d'Automne, 1928; Salon des Tuileries, 1930, 1933; PAFA, 1929, 1949; PAFA Ann., 1934, 1937, 1946; Salons of Am., 1935, 1936; S. Indp. A., 1935-38, 1944; CI, 1943, 1945; WMAA, 1948-52; BM, 1944, 1949, 1951, 1953; CAM, 1929 (solo); Corcoran Gal biennials, 1939,

1949; AIC, 1929, 1934, 1947, 1952; Houston MFA, 1935; CPLH, 1937; deYoung Mem. Mus., 1947; VMFA, 1951; Nelson Gal. Art, Kansas City, 1947; Wadsworth Atheneum, 1944; Inst. Modern Art, Boston, 1945. **Work:** New Britain (CT) Mus. Art; MFA of Houston; Sioux City AC. **Sources:** WW59; WW47; Ness & Orwig, *Iowa Artists of the First Hundred Years,* 200; Falk, *Exh. Record Series.*

STILLMAN, C. *[Painter] 20th c.*
Addresses: San Francisco, CA. **Exhibited:** Calif. Hist. Soc. Maritime Show, 1970s. **Sources:** Hughes, *Artists of California,* 536.

STILLMAN, E Clark *[Collector] b.1907, Eureka, Utah.*
Addresses: NYC. **Studied:** Univ. Michigan, A.B. & A.M. **Comments:** Collection: traditional Congolese sculpture; manuscript and printed "Books of Hours." Research: African sculpture; medieval and modern book illumination and illustration. **Sources:** WW73.

STILLMAN, Effie *[Sculptor] 20th c.; b.London, England.*
Addresses: London, England/NYC. **Studied:** C. Desvergnes, Paris. **Exhibited:** PAFA Ann., 1901, 1905. **Sources:** WW04; Falk, *Exh. Record Series.*

STILLMAN, Emma Maynicke *[Listed as "artist"] 19th/20th c.*
Addresses: Wash., DC, active 1885-1917. **Exhibited:** Brooklyn AA, 1869; Centennial Expo, Phila., PA, 1876. **Sources:** Wright, *Artists in Virgina Before 1900.*

STILLMAN, George *[Painter, printmaker, photographer, teacher] b.1921, Laramie, WY / d.1997.*
Addresses: Ontario, CA. **Studied:** With his father; Univ. Calif. Berkeley, 1941-42; Calif. School FA, 1945; Mexico; Arizona State Univ., B.F.A., M.F.A., 1970. **Member:** Sausalito Six. **Exhibited:** GGE (prize); SFMA, 1949 (Ann Bremer Award); Bender Foundation grant, 1949; Guadalajara and Mexico City, 1951. **Work:** Oakland (CA) Mus.; High Mus.; Arizona State Univ.; Metrop. Mus. Art; Smithsonian Inst. **Comments:** Drafted into service during WWII. Teacher, Univ. Guadalajara, late 1950s; faculty member, art dept. Columbus College, GA; prof. art and chairman, art dept., Central Washgton State Univ., 1972-88; prof. emeritus. **Sources:** "Modernism in California Printmaking," Nov. 1998, The Annex Galleries.

STILLMAN, George K. *[Wood engraver] b.1821, Massachusetts.*
Addresses: Cincinnati, active 1840-60. **Comments:** His wife Mary was a native of Georgia. In 1850 they had two children, ages 4 and 1, both born in Ohio. **Sources:** G&W; 7 Census (1850), Ohio, XXII, 56; Cincinnati CD and BD 1840-60.

STILLMAN, H. Ary See: **STILLMAN, Ary**

STILLMAN, Lisa *[Sculptor] b.U.S. (lived most of her life in London) / d.1946, London, England.*

STILLMAN, Marie *[Painter] early 20th c.*
Addresses: Active in Boston, c.1905-07. **Comments:** *Cf.* also with Marie Stillman, London, England (see entry). May also be the same as Marie Spartali Stillman (b.1844 in England, d. 1927; and married to William J. Stillman, 1871). **Sources:** Petteys, *Dictionary of Women Artists.*

STILLMAN, Marie *[Painter] 20th c.*
Addresses: London, England. **Sources:** WW10.

STILLMAN, Rufus Cole *[Painter] 20th c.*
Exhibited: S. Indp. A., 1942. **Sources:** Marlor, *Soc. Indp. Artists.*

STILLMAN, William James *[Landscape painter, writer] b.1828, Schenectady, NY / d.1901, Surrey, England.*
Addresses: NYC, c.1851; Cambridge, MA, 1856-60; Brooklyn, NY, 1884; Surrey (England), 1898-1901. **Studied:** Union College, 1848; F.E. Church, 1848-49. **Member:** ANA. **Exhibited:** NAD,

1851-59, 1884; Boston Athenaeum. **Comments:** After graduating from Union College in 1848, he studied landscape painting under Frederic E. Church for a year, then visited England, where he began a long friendship with Ruskin. After participating in Kossuth's rebellion in Hungary about 1851, Stillman returned to America and opened a studio in NYC. In 1855 he founded the art magazine *Crayon*, but he retired from its direction after a year. Between 1856-61 he took painting trips to the White Mountains of NH. He was in Europe when the Civil War broke out and soon after was appointed American Consul at Rome, which post he held until 1865. After three more years in a consular post in Crete, he settled in England. Much of his later life was spent in Rome as a special correspondent of the London *Times* and he also wrote many books on art, archaeology, and contemporary events. His *Autobiography of a Journalist* was published in 1901. **Sources:** G&W; DAB; Cowdrey, NAD; Cowdrey, AA & AAU; Rutledge, PA; Swan, BA; Washington Art Assoc. Cat., 1857; Graves, *Dictionary;* repro., Met. Mus., *Life in America.* More recently, see Campbell, *New Hampshire Scenery,* 160-162.

STILLMAN-MYERS, Joyce *[Painter] b.1943, NYC.*
Addresses: NYC. **Studied:** ASL; Pratt Inst; Post College, M.A. in painting. **Exhibited:** Many solo and group shows throughout the U.S. **Comments:** She belonged to the school of super-realist painters. **Sources:** Pisano, *One Hundred Years.the National Association of Women Artists,* 81.

STILLSON, Blanche *[Painter, teacher] 20th c.; b.Indianapolis.*
Addresses: Indianapolis, IN. **Studied:** Forsyth; Hawthorne. **Member:** Indiana Artists Club; Hoosier Salon. **Sources:** WW33.

STILLWAGON, G. B. *[Teacher of mezzotint and landscape painting] mid 19th c.*
Addresses: Indianapolis, 1845; Bowling Green,1868. **Comments:** *Cf.* Stellwagen. **Sources:** G&W; Peat, *Pioneer Painters of Indiana,* 239.

STILLWELL, John E. (Dr.) *[Patron] b.1853 / d.1930, NYC.*
Comments: His art collection was the result of a series of trips to all parts of the world. In 1927 his collection, including works by Raphael, El Greco, Titian, Murillo and other masters, was sold and some of the best pieces are now in MMA.

STILLWELL, Sarah S. *[Illustrator] b.1878, Phila. / d.1939.*
Addresses: Phila., PA. **Studied:** H. Pyle. **Exhibited:** Pan-Am. Expo, Buffalo, 1901 (medal); PAFA Ann., 1903-06; AIC, 1904. **Sources:** WW10; Falk, *Exh. Record Series.*

STILLWELL, Wilbur Moore *[Educator, writer, designer, printmaker, lecturer, cartoonist, illustrator, mural painter] b.1908, Covington, IN / d.1974.*
Addresses: Vermillion, SD. **Studied:** Kansas State Teachers College, B.S. Educ.; Univ. Iowa, M.A.; Kansas City (MO) Art Inst. **Exhibited:** PAFA, 1934; Kansas City AI, 1933 (prize), 1936 (prize), 1939; Kansas City Art Exhib., Topeka, 1939 (prize), 1940, 1941, (first award in lithography); Missouri Artists, 1938; Oklahoma Artists Exhib., Tulsa, 1940 (prize); Sedalia, 1932 (prize); State Fair, Hutchinson, KS, 1939 (prize); Midwestern Artists Exhib., Kansas City, 1933, 1936 & 1939; Nat. Watercolor Show, PAFA, 1934; Missouri Artists Exhib., 1938; AAPL, New York, 1966 (medal, for distinguished service Am. art); Nat. Gallery Art, 1966 (medal, distinguished service educ. in art). **Work:** Mus. Nat. Hist., Kansas Univ., Lawrence. **Comments:** Preferred media: oils. Positions: teacher, Univ. South Dakota (from 1941), Emporia School Art, Kansas (1940). Nat. co-director, Am. Art Week, 1965-66. Publications: co-author, "New--Blottergraph Printing," 3/1956; "Transwax--A New Art Process," 2/1958; "Mobile Printing," 3/1961; "Scraper Paper," 9/1961 & "Waxbrush Printing," 2/1962, *School Arts* magazine. Teaching: professor of art, Univ. South Dakota, Vermillion, 1941-. Research: picture design and composition. **Sources:** WW73; WW47.

STILSON, Ethel M. *[Painter] 20th c.*
Addresses: Cleveland, OH. **Member:** NAWPS; Cleveland Women's AC. **Sources:** WW29.

STIMETS, Adelaide Negus *[Painter] 19th/20th c.*
Addresses: Jersey City, NJ, 1891. **Exhibited:** Boston AC, 1891; NAD, 1891; AWCS, 1898. **Sources:** WW01.

STIMMEL, George *[Painter, lithographer, etcher, illustrator, designer] b.1880, NYC / d.1964.*
Addresses: Hackensack, NJ. **Studied:** PIA School; Phila. AL; PAFA. **Member:** Scenic Art Un.; Hackensack AC; New Jersey AA; Knoedler Gal., NYC; Phila. Print Club; Ridgefield Park AA. **Exhibited:** SC; Salons of Am., 1934. **Comments:** Early in his career, he painted stage sets for the old Metropolitan Opera House and silent movie houses in NY and NJ. From c.1915-30, he painted watercolors and etched street scenes of NYC in the style of the "Ashcan School." His etchings were reproduced in *Print Quarterly.* After 1930, he focused on watercolor, producing New England landscapes and snow scenes. **Sources:** exh. flyer, Matthews Gal., Bergenfield, NJ (c.1980s).

STIMPSON, Helen Townsend *[Painter] b.1886, Brooklyn, NY.*
Addresses: Hartford, CT. **Studied:** NAD; CUA School; & with Emil Carlsen, Charles Hawthorne. **Member:** Copley Soc.; Springfield Acad. Art; CAFA; Rockport AA; Hartford Soc. Women Painters; New Haven PCC; North Shore AA. **Exhibited:** CAFA, 1923-56, (1932, prize); New Haven PCC, 1925-56, (1941, prize); Hartford SWP, 1928-56, (1940, prize); Salons of Am., 1934. **Sources:** WW59; WW47.

STIMSON, Anna K(atherine) *[Sculptor] b.1892, NYC.*
Addresses: Phila., PA/Bolton Landing, NY. **Studied:** C. Graftly. **Member:** Phila. All.; Phila. WCC; PAFA (fellow). **Exhibited:** PAFA Ann., 1920. **Sources:** WW33; Falk, *Exh. Record Series.*

STIMSON, Eleanor *[Painter] late 19th c.*
Addresses: NYC, 1883. **Exhibited:** NAD, 1883. **Sources:** Naylor, *NAD.*

STIMSON, John Ward *[Painter, illustrator, teacher, writer, lecturer] b.1850, Paterson, NJ / d.1930.*
Addresses: Corona, CA; NYC, 1881-83. **Studied:** Yale Univ., 1872; École des Beaux-Arts, Paris, with Cabanel, Jaquesson de la Chevreuse; Italy (6 years); Belgium; Holland; England. **Exhibited:** NAD, 1881-83. **Comments:** Positions: teacher/director, MMA School, 5 years; teacher, ASL, Artist-Artisan Inst., NYC & School Fine & Indust. Arts, Trenton; asst. editor, *Arena* magazine. Author: "The Gate Beautiful," "The Law of the Three Primaries," "Wandering Chords." **Sources:** WW29.

STINCHFIELD, Estelle *[Mural painter, portrait painter, block printer, drawing specialist, lecturer, teacher] b.1878, Brownville, CO. / d.1945.*
Addresses: Greeley, CO. **Studied:** J.E. Thompson; Univ. Denver; Columbia; P. Tudor-Hart, London; Paris with Lhote, O. Friesz. **Member:** NAWPS. **Exhibited:** NAWPS. **Work:** mural, Guggenheim Hall, Univ. Northern Colorado, Greeley. **Comments:** Position: teacher, Colorado State College Educ., (Now Univ. Northern Colorado). **Sources:** WW40.

STINEMETZ, Morgan *[Illustrator, painter, etcher] b.1890, Wash., DC.*
Addresses: NYC; Oceanic, NJ; Orangeburg, NY. **Exhibited:** Soc. Wash. Artists, 1910, 1912; Armory Show, 1913; Soc. Indep. Artists, 1917. **Sources:** WW19; McMahan, *Artists of Washington, DC;* Brown, *The Story of the Armory Show.*

STINER, Louis *[Engraver] b.c.1824, Germany.*
Addresses: NYC penitentiary, 1860. **Comments:** He served time for petty larceny. **Sources:** G&W; 8 Census (1860), N.Y., LXI, 186.

STINER, Walter *[Painter] 20th c.*
Exhibited: S. Indp. A., 1938. **Sources:** Marlor, *Soc. Indp. Artists.*

STINSKI, Gerard Paul *[Painter, collector]* b.1929, Menasha, Wis.
Addresses: Fairfax, CA. **Exhibited:** Southeastern Regional, Atlanta, GA; Tidewater AA, Norfolk, VA; Zantman Galleries, Carmel, CA & Conacher Galleries, San Francisco, CA, 1970s. **Work:** Private & corporate collections. Commissions: Del Monte Foods, Gallo Wineries, Consolidated Foods (Nathan Cummings Collection). **Comments:** Preferred media: oils. Collection: sixteenth century drawings including Raphael; pre-Columbian sculpture, Etruscan and early Christian santos. **Sources:** WW73; *Haddad's Fine Art Reproductions* (1972).

STINSON, Alice E. *[Listed as "artist"]* 20th c.
Addresses: Wash., DC, active 1920-35. **Exhibited:** Greater Wash. Independent Exhib., 1935. **Sources:** McMahan, *Artists of Washington, DC.*

STINSON, Charles A. *[Painter]* 20th c.
Addresses: Phila., PA. **Sources:** WW24.

STINSON, Donald R. *[Craftsman, educator]* late 20th c.
Studied: School of Arts & Crafts, Frankfurt, Germany, 1953-54; Barnsdall Art Center, Los Angeles, 1960-62. **Member:** Black Art Council; Art West Associated, Los Angeles. **Exhibited:** First Wilshire Methodist Church, Los Angeles; Barnsdall All City Watts Festival; Mills College; Oakland Mus., 1971. **Sources:** Cederholm, *Afro-American Artists.*

STINSON, Harry (Edward) *[Sculptor, educator, lecturer]* b.1898, Wayland, IA / d.1975, San Diego, CA.
Addresses: Iowa City, IA; NYC. **Studied:** Univ. Iowa, B.A., M.F.A.; Cumming School Art; NAD; ASL; Robert Aitken; Charles Hawthorne; Ivan Olinsky; George Bridgman; Charles A. Cumming. **Member:** Iowa AG; AAUP; Audubon Artists; Sculpture Center; CAA; AFA. **Exhibited:** NAD, 1929; PAFA Ann., 1930-31, 1936, 1948; Clay Club, NY, 1944-46; Iowa Exh., Chicago, 1937 (medal); Kansas City AI, 1935 (prize); Nebraska AA, 1942; Sculpture Center, 1944-46, 1948-64; Grand Central Palace, 1950; Bennington College, 1949, 1956; Nebraska AA, 1950; Des Moines Art Center, 1953, 1956, 1958; Audubon Artists, 1954-58; NAD, 1929, 1955; Staten Island Mus., 1955, 1956; Washington Art Club, 1954; Philadelphia Art All., 1952. **Work:** memorial, statues, Lake View, Council Bluffs, Iowa City, IA. **Comments:** Position: teacher, Univ. Iowa, 1921-40; professor, Hunter College, New York, NY, 1940-. **Sources:** WW66; WW47; Ness & Orwig, *Iowa Artists of the First Hundred Years,* 200; Falk, *Exh. Record Series.*

STINSON, Joseph Whitla *[Painter, lawyer, diplomat]* 20th c.
Addresses: Wash., DC, 1930s; NYC. **Exhibited:** NYWCC; Philadephia WCC; AIC; CGA; Salons of Am.; Greater Wash. Independent Exhib., 1935. **Sources:** WW19; McMahan, *Artists of Washington, DC.*

STINSON, Lucile Short (Mrs.) *[Painter]* b.1888, Ogallala, NE / d.1981, Denver, CO.
Studied: Univ. Iowa; pastels with Elsie HAynes; in Denver with Robert Graham. **Exhibited:** Denver Artists Guild; Univ. Denver; Univ. Colorado; Hendrick-Bellamy Gal., Denver; sols in Denver, Yellowstone Park, WY & Santa Fe, NM. **Sources:** Petteys, *Dictionary of Women Artists.*

STINSON, William H. *[Engraver, lithographer, and plate printer]* mid 19th c.
Addresses: Boston, 1853-59. **Comments:** 1855-58, of Holland & Stinson (see entry). **Sources:** G&W; Boston BD and CD 1853-59.

STIPE, William S *[Painter]* b.1916.
Addresses: Chicago, IL. **Studied:** Univ. Iowa, B.A. & M.A., 1936; Mus. School, Boston, with Karl Zerbe, 1940; Inst. Design, Chicago, 1947. **Exhibited:** AIC; Denver Art Mus.; Mus. Fine Arts, Boston; Butler IA; Columbia (SC) Mus. Art; Culver-Stockton College, Canton, MO (solo) & Illinois Arts Council Gallery, Chicago, 1972 (solo). Awards: second prize, Washington, DC Watercolor Club, 1949; Pauline Palmer Second Prize, 59th Ann.

Chicago Show, AIC, 1956; first prize for painting, Old Orchard Art Fair, Skokie, IL, 1970. **Work:** Springfield (MO) Art Mus.; Ohio Univ., Athens; Northern Trust Co., Chicago; Int. Minerals & Chemical Corp., Skokie, IL; Kansas State Univ., Manhattan. Commissions: wall painting, Evanston Chamber Commerce, Davis L. Bus Stop, 1971. **Comments:** Teaching: faculty member, Northwestern Univ., 1948. **Sources:** WW73.

STIRLING, Dave *[Painter, lecturer, writer]* b.1888/89, Corydon, IA.
Addresses: Estes Park, CO. **Studied:** Chicago Acad. FA; Cumming Art School. **Exhibited:** Studio in the Woods, Rocky Mountain Nat. Park, 1922-56 (solo); Youngs Gal., Chicago (solo). Award: hon. D.F.A., Kansas Wesleyan Univ., 1954; hon. D. Aesthetics, Sterling College, Sterling, KS, 1957. **Comments:** Specialty: Rocky Mountain subjects. Position: resident landscape painter, Rocky Mountain National Park, CO. **Sources:** WW59; WW47; Ness & Orwig, *Iowa Artists of the First Hundred Years,* 200-201.

STIRLING, Glen *[Graphic artist, writer, lecturer]* 20th c.
Addresses: Hollywood, CA. **Exhibited:** Wash., WCC, 1938; Festival Allied Artists, Los Angeles (prize). **Work:** FA Gal., San Diego; Public Schools, Los Angeles; City Hall, Long Beach; cover, "Calif. Arts and Arch.," 1937. **Sources:** WW40.

STIRLING, William Arthur *[Painter of a self-portrait]* 18th/19th c.
Work: Sheldon Museum at Middlebury, VT (self-portrait, painted c.1800). **Comments:** This may be the William Arthur Sterling who married Maria Ducoster Barrett at Boston, April 25, 1802. **Sources:** G&W; WPA (Mass.), *Portraits Found in Vt.;* Sterling, *The Sterling Genealogy,* 1248.

STIRNAMAN, Marilou (Mrs.) *[Landscape painter, teacher, painter]* b.1907, Santa Clara, CA.
Addresses: Watsonville, CA. **Exhibited:** Santa Cruz, 1935. **Sources:** WW40.

STIRNWEIS, Shannon *[Illustrator, painter]* b.1931, Portland, OR.
Addresses: NYC. **Studied:** Univ. Oregon; Art Center School, Los Angeles, with R. Brown, J. LaGatta, J. Henninger, Pruett Carter. **Work:** U.S. Air Force; U.S. Army Hist. Mus.; Dept. of the Interior; Calif. Fed. Savings Collection. **Comments:** Positions: illustrator, U.S. Army, in Europe. Special assignments for various U.S. government agencies to the Berlin Wall, the Everglades, Arizona and Alaska. Illustrator: *Sportsman's Magazine, Field and Stream,* and many other magazines, as well as for book publishers, movie posters and advertising campaigns. In later years he concentrated on painting historical scenes of the Old West. **Sources:** W & R Reed, *The Illustrator in America,* 306.

STIRRETT, Wylie *[Portrait painter, mural painter]* b.1915, Wash., DC.
Addresses: Los Angeles. **Studied:** with J. F. Smith; S. L. Reckless; B. Miller; Art Center School, Los Angeles. **Member:** Calif. WCS. **Exhibited:** Los Angeles Mus., 1935 (third prize). **Comments:** Position: teacher, Hammond Hall, Los Angeles. **Sources:** WW40.

STITES, John Randolph *[Portrait, genre, landscape, and still life painter]* b.1836, Buffalo, NY / d.After 1884.
Addresses: NYC, 1863, 1882-87; Chicago, 1870-80. **Exhibited:** NAD, 1863-86; PAFA Ann., 1882-85, 1887; Brooklyn AA, 1883-84; Boston AC, 1885-86. **Work:** Chicago Historical Society (three portraits). **Sources:** G&W; Champlin and Perkins; Falk, *Exh. Record Series;* information courtesy H. Maxson Holloway, Chicago Hist. Soc.; NYCD 1883-87.

STITES, Raymond Somers *[Art historian, writer, lecturer]* b.1899, Passaic, NJ / d.1974.
Addresses: Yellow Springs, OH; Garrett Park, MD. **Studied:** Brown Univ., M.A. & Ph.B.; RISD; Univ. Vienna, Ph.D. **Member:** College Art Assn. Am.; Am. Archaeology Soc.; Ohio Valley AA. **Exhibited:** MMA; Denver Archaeology Mus.; Dayton

Art Inst.; Am. Mus. Natural Hist. **Comments:** Positions: curator in charge educ., Nat. Gallery Art, Washington, DC, 1948-70, asst. to director educ. services, 1968-70; director, Cult. Films, Inc. Teaching: lectures on Leonardo da Vinci; chmn. dept. art & aesthetics, Antioch College, 1930-48. Publications: author, *The Sculptures of Leonardo da Vinci* (1930), *The Arts and Man* (1940) & *The Self Psychoanalysis of Leonardo da Vinci* (1969); co-author, *Sublimations of Leonardo da Vinci* (Smithsonian, 1970); contributor to art magazines. **Sources:** WW73; WW47.

STITT, Herbert D. See: **STITT, Hobart D.**

STITT, Hobart D. *[Painter] b.1880, Hot Springs, AR.* **Addresses:** Pikesville, MD. **Studied:** St. Louis Acad. FA; PAFA; Howard Pyle, Fred Wagner, and Robert Spencer. **Exhibited:** PAFA Ann., 1922, 1925; AIC, 1925. **Work:** Wilmington SFA; Little Rock AM; Princeton Univ. **Comments:** Specialty: landscapes and equestrian subjects. **Sources:** WW40; P&H Samuels, 467; Falk, *Exh. Record Series.*

STIVERS, Harley Ennis *[Illustrator] b.1891, Nokomis, IL.* **Addresses:** Scarsdale, NY/Belmar, NJ. **Studied:** AIC. **Member:** SI; Artists Guild. **Comments:** Illustrator: *Saturday Evening Post, Ladies Home Journal, Cosmopolitan.* **Sources:** WW40.

STOAKS, Caroline *[Painter, printmaker, illustrator, designer, teacher] b.1892, Pendleton, OR.* **Studied:** Thomas School Music & Art; Am. Acad. Art, Chicago; Portland AI; Seattle AI; AIC. **Exhibited:** Seattle AI; Portland; AIC; Cordon Club, Chicago, 1948-61; All-Illinois Soc. FA, 1949-61. **Sources:** Petteys, *Dictionary of Women Artists.*

STOBIE, Charles S. *[Painter] b.1845, Baltimore, MD / d.1931, Chicago.* **Studied:** St. Andrews, Scotland. **Exhibited:** Omaha, 1890. **Work:** Colorado State Hist. Soc.; Stenzel Collection. **Comments:** Early Denver painter; he was also an Indian scout and buffalo hunter. Among his friends were Wm. Cody, Wild Bill Hickock, and F. Remington. Lived with Utes in Colorado. Contributed "Crossing the Plains to Colorado in 1865," *The Colorado Magazine,* 1933. **Sources:** Peggy and Harold Samuels, 467-68.

STOCK, Ames and R. *[Painter] 20th c.* **Exhibited:** Salons of Am., 1924. **Sources:** Marlor, *Salons of Am.*

STOCK, Ernest R(ichard) *[Painter] 20th c.* **Addresses:** NYC, 1924. **Exhibited:** S. Indp. A., 1924-25, 1927-28, 1935; WMAA, 1927. **Sources:** Falk, *WMAA.*

STOCK, Joseph Whiting *[Portrait painter] b.1815, Springfield, MA / d.1855, Springfield, MA.* **Addresses:** Springfield, MA and elsewhere in New England; Orange County, NY, from 1852. **Studied:** mostly self-taught; some instruction and criticism from Franklin White (a student of Chester Harding). **Member:**. **Exhibited:** Smith College Mus. Art, 1977; Conn. Valley Hist. Mus., Springfield, MA, c.1996 (retrospective). **Work:** Rockefeller Folk Art Center, Williamsburg, VA; BMFA; Springfield MFA; Connecticut Valley Hist. Mus., Springfield, MA; New Bedford Free Public Library; Newark (NJ) Mus.; New York Hist. Assoc., Cooperstown, NY; Shelburne (VT) Mus.; NGA, Wash., DC; Margaret Woodbury Strong Mus., Rochester, NY; NYHS; Old Dartmouth Hist. Soc.; Shelburne (VT) Mus. **Comments:** Due to an accident at age 11 which paralyzed him from the waist down, Stock used a wheelchair for the remainder of his life. He was primarily a self-taught artist and at the beginning of his career diligently copied pictures by his teacher Franklin White, also copying the popular prints distributed by Nathaniel Currier. He began painting professionally in 1832. His first portraits were of relatives and locals, but by 1834 he had gained recognition and was traveling from household to household and visiting new towns. He worked principally in Springfield and the surrounding area, but also traveled as far as New Bedford (MA), New Haven (CT), and Providence, Warren, and Bristol (RI). Stock kept a personal journal (detailed in Tomlinson) from 1832-46 that describes his early efforts and training, and records over 900 portraits painted between 1842-45. His popularity can be seen by the increase in his prices, which rose from $8 in 1836 to $15-$25 by 1843. In 1846, he was in partnership with O.H. Cooley, a daguerreotypist in Springfield, MA. In 1852, Stock moved to Orange County, NY, where he continued painting, traveling to the towns of Middletown, Goshen, and Port Jervis. The detailed inventory of his estate shows a library rich in literature, history, and religion, and a large collection of books, magazines, and manuals on art. Included were drawing manuals such as Charles Davies's *A Treatise on Shades and Shadows and Linear Perspective* (1832), books such as *National Portrait Gallery of Distinguished Americans* (1836), and engraving collections (*American Scenery,* 1840). Stylistically, his work emulates the social portraits of artists like Chester Harding. Stock also painted miniatures, landscapes (many made after engravings), and even marines. **Sources:** G&W; Clarke, "Joseph Whiting Stock," in Lipman and Winchester, 113-20; Museum of Modern Art, *American Folk Art,* 29-30; Rockefeller Folk Art Coll., *American Folk Art;* Springfield CD 1852. More recently, see Baigell, *Dictionary;* Juliette Tomlinson, ed., *The Paintings and the Journal of Joseph Whiting Stock* (Middletown, CT: Wesleyan Univ. Press, 1976); Vlach, *Plain Painters,* 40-54; Blasdale, *Artists of New Bedford,* 178-79 (w/repros.); Muller, *Paintings and Drawings at the Shelburne Museum,* 130 (w/repro.).

STOCKBRIDGE, Dana W. *[Painter] b.1881, Haverhill, MA / d.1922.* **Addresses:** Lowell, MA. **Studied:** Harvard; Pape School Art. **Sources:** WW21.

STOCKBRIDGE, Mary G. See: **ALLEN, Mary G(ertrude) Stockbridge**

STOCKBURGER, William Harold *[Painter, designer, teacher] b.1907, Marine City, MN.* **Addresses:** NYC. **Studied:** Univ. Detroit; ASL; & with John Carroll. **Member:** North Shore AA. **Exhibited:** AWCS; VMFA; PAFA; Contemporary A. Gal.; SFMA; AIC; A. Market, Detroit; Ferargil Gal.; North Shore AA; NYWCC, 1937. **Work:** Montclair A. Mus.; Esmond Mills, Esmond, R.I. **Sources:** WW53; WW47.

STOCKER, Arnold *[Painter] 20th c.* **Addresses:** NYC. **Exhibited:** S. Indp. A., 1924, 1926-29; Salons of Am., 1930. **Sources:** Marlor, *Salons of Am.*

STOCKER, Frank Anthony *[Lithographer] b.c.1812, Prussia (Germany).* **Addresses:** Boston, 1846-60. **Comments:** His wife also was a native of Prussia, but their children were born in Massachusetts. **Sources:** G&W; 8 Census (1860), Mass., XXVIII, 373; Boston CD 1850, 1860.

STOCKFLETH, Julius *[Marine painter] b.1857 / d.1935.* **Sources:** PHF files.

STOCKFLETH, Lucy Grey *[Painter] b.1890, Bozeman, MT / d.1947, San Francisco, CA.* **Addresses:** Santa Cruz, CA. **Exhibited:** Oakland Art Gallery, 1928. **Sources:** Hughes, *Artists of California,* 537.

STOCKING, Elizabeth Lyman (Mrs. William) *[Portrait and figure painter] 19th c.* **Addresses:** Detroit, MI, 1878-80. **Exhibited:** Angell's Gal.; Detroit AA; Michigan State Fair, 1878. **Sources:** Gibson, *Artists of Early Michigan,* 223.

STOCKING, Lily Lyman *[Painter] 19th c.; b.Hartford, CT.* **Addresses:** Detroit. **Comments:** Painted fruit & flowers in oil & watercolor. **Sources:** Petteys, *Dictionary of Women Artists.*

STOCKLIN, Grace Nina *[Painter, designer, teacher] b.1913, Menominee, MI.* **Addresses:** Chicago, IL. **Studied:** AIC. **Exhibited:** AIC, 1939 (prize); Joslyn Mem., Omaha, NE. **Comments:** Position: teacher,

AIC. **Sources:** WW40.

STOCKMAN, Helen Park (Mrs.) *[Painter, sculptor, teacher] b.1896, Englewood, NJ.*
Addresses: Englewood, NJ. **Studied:** J. Lie; L. Mora; R. Henri. **Member:** Palisade AA. **Exhibited:** Soc. Indep. Artists, 1921-22; WMAA, 1926. **Sources:** WW33.

STOCKTON, Anne *[Painter] 20th c.*
Exhibited: Salons of Am., 1930. **Sources:** Marlor, *Salons of Am.*

STOCKTON, Francis Richard *[Wood engraver and illustrator, better known as a writer] b.1834, Philadelphia / d.1902, West Virginia, near Harper's Ferry.*
Addresses: Philadelphia and NYC, c.1852-66; West Virginia, near Harper's Ferry, 1899-1902. **Comments:** On graduating from high school at 18, he worked as a wood engraver which he gave up c.1866 to write stories for *Riverside Magazine* and others. From 1873-81 he was assistant editor of *St. Nicholas.* Stockton was the author of many humorous novels, including *Rudder Grange* and *The Casting Away of Mrs. Lecks and Mrs. Aleshines,* and stories, of which the best known is "The Lady or the Tiger?" His home for many years was in New Jersey. **Sources:** G&W; DAB; CAB; Phila. CD 1856-60; Hamilton, *Early American Book Illustrators and Wood Engravers,* 320.

STOCKTON, John Drean *[Steel & copperplate engraver] b.1836, Philadelphia / d.1877, Philadelphia.*
Addresses: Philadelphia, 1836-77. **Comments:** A brother of Francis R. Stockton (see entry).He went to work as an engraver about 1859, but soon turned to journalism. He was manager of the *Philadelphia Press* for a time, associated with the *New York Tribune* in 1866, editor of the *Philadelphia Post* from 1867 to 1872. From 1873 until his death he was drama and music critic for the *New York Herald.* **Sources:** G&W; CAB; DAB, under Frank R. Stockton; Phila. CD 1859-60.

STOCKTON, Pansy *[Painter] b.c.1894, Eldorado Springs, MO or OK / d.1972, Colorado Springs, CO.*
Addresses: Active in Durango and Denver, CO; Santa Fe, NM. **Comments:** Known for sun paintings and landscapes. **Sources:** Petteys, *Dictionary of Women Artists.*

STOCKWELL, Carroll *[Painter] b.1943.*
Studied: CGA School, Wash., DC. **Exhibited:** CGA; Barnet-Aden Gallery, Wash., DC; Nordness Galleries, NYC; State Armory, Wilmington, DE, 1971-72. **Sources:** Cederholm, *Afro-American Artists.*

STOCKWELL, Frances Taft *[Painter] b.1865, Orange, NJ.*
Addresses: NYC. **Exhibited:** AIC, 1892; PAFA Ann., 1901. **Sources:** WW06; Falk, *Exh. Record Series.*

STOCKWELL, Francis F. *[Engraver] mid 19th c.*
Addresses: Boston, 1859-60 and after. **Sources:** G&W; Boston CD 1859-60+.

STOCKWELL, Mary I. *[Painter] 19th c.*
Addresses: Asheville, NC. **Exhibited:** AIC, 1892. **Sources:** Falk, AIC.

STOCKWELL, Samuel B. *[Painter, panoramist] b.1813, Boston / d.1854, Savannah, GA.*
Exhibited: St. Louis, New Orleans, and Charleston, 1848-. **Comments:** The son of an actor, Stockwell was first an actor, then scene painter at Boston's Tremont Theatre, during the 1830's. He also painted scenery at Charleston (1841), Mobile (1843), and New Orleans (1843, 1846). Sometime after 1842 he settled in St. Louis, where his daughter was born in 1845. Stockwell worked for a time with Henry Lewis on a panorama of the Mississippi, but the partnership was dissolved and both completed separate versions in 1848. After exhibiting his panorama with great success in St. Louis, New Orleans, and Charleston, Stockwell brought it to Boston, where he remained for several years. In 1852-53 he was back in St. Louis painting scenes for the theater. He died of yellow fever. P&H Samuels report that none of his paintings is known to survive. **Sources:** G&W; Arrington, "Samuel B.

Stockwell and His Mississippi Panorama," unpub. manuscript; Arrington, "The Story of Stockwell's Panorama"; Delgado-WPA cites *Picayune,* Dec. 16, 1843, Dec. 3, 1848, and *Courier,* Jan. 2, 1849; Rutledge, *Artists in the Life of Charleston;* 7 Census (1850), Mass., XXV, 751. More recently, see additional contemporary news accounts cited in *Encyclopaedia of New Orleans Artists,* 366; Peggy and Harold Samuels, p.468.

STODART, Adam *[Lithographer] mid 19th c.*
Addresses: NYC, 1835. **Comments:** He was Nathaniel Currier's (see entry) first partner. Before and after 1835 Stodart was in the music business. **Sources:** G&W; Peters, *Currier & Ives,* I, 19-20; Peters, *America on Stone;* NYCD 1835-60.

STODART, G. *[Stipple engraver] mid 19th c.*
Comments: Engraver of a stipple portrait of David Stoner, published in America in 1835, and a portrait of Washington, published in London. This may be George Stodart, an English stipple engraver who did reproductions of sculpture for the *Art Journal* for about 30 years until his death, December 28, 1884. It is not known whether he ever worked in America. **Sources:** G&W; Stauffer; *Art Journal* (1885), 64; Thieme-Becker.

STODDARD, Alice Kent *[Portrait painter] b.1884, Watertown, CT / d.1976, Newtown, PA.*
A.K STODDARD 1934
Addresses: Phila., PA. **Studied:** Phila. School Des. for Women; PAFA with Thomas Eakins, Anschutz, Wm. Merritt Chase. **Member:** ANA, 1938. **Exhibited:** PAFA Ann., 1908-48 (as Stoddard), 1952-53 (as Pearson), 1964 (as Stoddard) (prize 1911, 1913; gold medal 1926); Corcoran Gal. biennials, 1910-41 (15 times); Pan.-Pacific Expo, San Fran., 1915; Sesqui-Cent. Int. Expo, Phila., 1926; NAD, 1917 (medal), 1928 (medal); Phila. AC, 1913 (prize), 1916 (gold); CGA; Albright Art Gal.; BM; Wilmington Art Club; PM; Phila. Art All.; Woodmere Art Gal., Phila.; Newport, RI; AIC; CAFA. **Awards:** Cresson Scholarships, 1905, 1906, 1907; PAFA (fellowship); Monhegan (ME) Mus., 1984 (posthumous). **Work:** PAFA; Delgado Mus. Art; Reading, PA; Dallas, TX; portraits, Supreme & Fed. Court Judges, PA. **Comments:** Birth date possibly 1885. Made battlefield paintings during WWI. Married Joseph T. Pearson in 1948. Also painted on Monhegan Island (ME). **Sources:** WW59; WW47; Curtis, Curtis, and Lieberman, 50, 59, 142, 170, 186; Falk, *Exh. Record Series.*

STODDARD, B(eatrice) M(usetta) (Mrs.) *[Painter, craftsperson, lecturer, teacher] 20th c.; b.Carson, IA.*
Addresses: Indianapolis, IN/Nashville, IN. **Studied:** R. Johonnot, Maud Mason. **Member:** Indiana Artists Club. **Exhibited:** Pan-Pacific Expo, San Francisco, 1915. **Sources:** WW27.

STODDARD, Donna Melissa *[Art administrator, educator, writer, painter] b.1916, Saint Petersburg, FL.*
Addresses: Lakeland, FL. **Studied:** Florida Southern College, B.S., 1937; Pittsburgh Art Inst.; Penn. State College, Medicine, 1942; NY School Interior Design, 1953; Univ. Tampa, 1959; Univ. Florida 1960; Philathea College, hon. LHD, 1968. **Member:** Am. Assn. Univ. Women; Florida Fed. Art; College Art Assn. Am.; Nat. AA; Southeastern College AA; Royal Soc. Art, London (fellow); Am. Assn. Univ. Prof. **Exhibited:** Awards: Florida Southern College, 1942; AAPL, 1951; Am. Cult. Award, 1952; Grumbacher Award, 1953; Miami Women's Club Gold Medal, 1953. **Comments:** Positions: exec. dept. official art, Florida Southern College, 1940-; WEDU-TV Co. art chmn, art auction, 1968-69. Publications: contributor, *Design Magazine.* Collections arranged: directed Florida Int. Art Exhib., 1952; organized & installed permanent contemporary art collection, Florida Southern College. **Sources:** WW73.

STODDARD, Elizabeth M. (Mrs.) *[Painter] 20th c.*
Addresses: Hartford, CT. **Member:** Hartford AS. **Sources:** WW29.

STODDARD, Enoch V. *[Painter] b.1883.*
Studied: Académie Julian, Paris with Royer. **Sources:** Fehrer,

The Julian Academy.

STODDARD, Eva Mary (Mrs. Eugene K.) *[Painter]; b.Madison, SD.*
Addresses: Des Moines, IA. **Studied:** Adrian Dornbush and Lowell Houser. **Member:** Des Moines Women's Club (art committee). **Exhibited:** Des Moines Women's Club, 1937 (prize), 1938 (prize); Iowa Art Salon, 1938 (award); Great Hall, Iowa State College; Des Moines Public Library; Iowa Artists Exhibit, Mt. Vernon, 1938; Younker Bros., Des Moines. **Sources:** Ness & Orwig, *Iowa Artists of the First Hundred Years,* 201.

STODDARD, Frederick L(incoln) *[Mural painter, illustrator] b.Coaticook, Quebec, Canada / d.1940.*
Addresses: Gloucester, MA. **Studied:** St. Louis Sch. FA; Académie Julian, Paris with J.P. Laurens, Constant, T. Robert-Fleury, Ferrier, and Bouguereau, 1891-92. **Member:** North Shore AA; SC. **Exhibited:** Paris Salon, 1893, 1895, 1896; St. Louis Expo, 1904 (medal); AIC. **Work:** murals: City Hall, St. Louis; H.S., St. Louis; Hebrew Tech. Sch. for Girls, NYC; Eastern District H.S., NYC; Mem. Church, Baltimore, Md.; Sawyer Free Lib., Eastern Ave Sch., Forbes Sch., Gloucester. **Comments:** Fink gives birthplace as St. Louis, MO. **Sources:** WW40; Fink, *American Art at the Nineteenth-Century Paris Salons,* 393.

STODDARD, Herbert C. *[Painter, educator] b.1910, Brooklyn, NY.*
Addresses: Sarasota, FL. **Studied:** College Arch., Univ. Virginia; College Arch., New York; Ringling School Art, Sarasota, FL. **Member:** Artists Equity Assn.; Florida Artists Group. **Exhibited:** Sarasota AA, Ringling Mus, 1955-59; Tampa AI; Soc. Four Arts, Palm Beach, FL; Sarasota AA Ann.; Florida Art Group. **Awards:** prizes, Sarasota AA, Manatee AC & Clearwater AI. **Comments:** Positions: dir., Sarasota School Art, 1957-. Teaching: New College, FL. **Sources:** WW73.

STODDARD, Laura L. *[Painter] 20th c.*
Addresses: Chicago, IL. **Member:** Chicago NJSA. **Exhibited:** Salons of Am., 1923; S. Indp. A., 1923. **Sources:** WW25.

STODDARD, Musette Osler (Mrs.) *[Painter, craftsworker, teacher, lecturer] 20th c.; b.Carson, IA.*
Addresses: Nashville, IN. **Studied:** AIC & with Ralph Johonnot, Charles Hawthorne, Maude Mason. **Member:** Brown County Artists Guild; Indiana Art Club; Indiana Weaver's Guild; Hoosier Salon; Indiana Ceramic Club. **Exhibited:** Pan-Pacific Expo, 1915 (silver medal). **Comments:** Position: supervisor of art, Hilltop School, Nashville, IN. **Sources:** WW59; WW47; Ness & Orwig, *Iowa Artists of the First Hundred Years,* 201.

STODDARD, Paul *[Painter] 20th c.*
Exhibited: AIC, 1930. **Sources:** Falk, *AIC.*

STODDARD, Seneca Roy *[Landscape photographer] 19th/20th c.*
Work: LOC (major collection). **Comments:** A prominent Eastern landscape photographer, from 1873-1915 he made views of the Adirondack Montains, Lake George, and vicinity which were published as a number of books. He also made a difficult but dramatic photograph of the Statue of Liberty at night, shot with a magnesium flash. **Sources:** Welling, 253, 330-331.

STODDARD, Whitney Snow *[Art historian] b.1913, Greenfield, Mass.*
Addresses: Williamstown, MA. **Studied:** Williams College, B.A., 1935; Harvard Univ. (M.A., 1938 ; Ph.D, 1941) with Koehler, Post & Sachs. **Member:** College Art Assn. Am.; Soc. Arch. Historians; Medieval Acad. Am.; Int. Center Medieval Art (vice-pres., 1972). **Exhibited:** Awards: Fulbright advanced research grant, 1954. **Comments:** Publications: author, "The West Portraits of Saint-Denis and Chartres," Harvard Univ. Press, 1952; author, "Adventure in Architecture, Building the New St. Johns," 1958; author, "Monastery and Cathedral in France," 1968 & "The Facade of Saint-Gilles-du-Gard," 1972, Wesleyan Univ. Press. Teaching: art instructor to professor & chmn. dept., Williams College, 1938-at least 1969. Research: Provencal Romanesque

sculpture. **Sources:** WW73.

STODDART, Edna (Lehnhardt) (Mrs.) *[Painter, etcher, lithographer] b.1893, Oakland, CA / d.1966, Mexico.*
Addresses: Oakland, CA. **Studied:** Univ. California; Mills College; Calif. School FA; Calif. College Arts & Crafts; with Felix Ruvolo, Mark Rothko, Jean Varda. **Member:** San Francisco AA; San Francisco Women Artists; AEA; Calif. WCS; Mills College Ceramic Gld. **Exhibited:** San Francisco AA (prize, 1947); Calif. State Fair; Riverside Mus.; VMFA; Oakland Art Gal.; Walnut Creek (CA) Art Festival; CPLH; Santa Cruz, CA; Rotunda Gallery, San Francisco (solo); Fenner Gallery, Oakland (solo); Santa Barbara Mus. Art; Pasadena AI; LACMA. Awards: prizes, U.S. Govt., 1941; San Francisco Women Artists, 1952. **Work:** SFMA; Fort Stanton Hospital, New Mexico. **Sources:** WW53.

STOEHR, Lottee (Mrs.) *[Painter] 20th c.*
Addresses: NYC. **Exhibited:** S. Indp. A., 1917. **Sources:** Marlor, *Soc. Indp. Artists.*

STOEHR, William H. *[Painter] 20th c.*
Exhibited: Salons of Am., 1935. **Sources:** Marlor, *Salons of Am.*

STOERZER, Henry *[Painter] 20th c.*
Addresses: Milwaukee, WI. **Member:** Wisc. P&S. **Sources:** WW25.

STOESSEL, Oskar *[Etcher, painter, teacher] b.1879, Neonkirchen, Austria.*
Addresses: NYC. **Studied:** in Europe. **Member:** AAPL; CAA. **Exhibited:** CGA (solo); Harlow Gal. (solo); Austria (several medals & prizes). **Work:** MMA; British Mus.; & in Germany, Austria, Romania. **Comments:** Contributor: *Print Collector's Quarterly,* London; & other art publications in Europe. Folio of etchings of many prominent persons. **Sources:** WW59; WW47.

STOFFA, Michael *[Painter, lecturer] 20th c.; b.Hlinne, Czech.*
Addresses: Rockport, MA. **Studied:** Newark School Fine & Indust. Arts, scholarship, 1942; PAFA; ASL. **Member:** North Shore AA; Jardin de Arte, Mexico City. **Exhibited:** Foreign Friends of Acapulco, Hilton Hotel, Acapulco, Mexico, 1969 & 1970; Greenwich Village Art Exhib., NYC, 1969 & 1970; Sullivan Parque, Mexico City, Mexico, 1969-72; North Shore AA, Gloucester, MA, 1972; North Atlantic Exhib., East Gloucester, MA, 1972. Awards: popular award, Westfield AA, 1968; Bruce Stevens Award, Greenwich Village Show, 1968. **Work:** Commissions: portrait of J. F. Kennedy, Munic. Bldg., Clark Court House, NJ, 1964; portrait of Dr. Lozo, Edison, NJ, 1965; many other portrait commissions in Westfield, NJ area. **Comments:** Preferred media: oils. Teaching: instructor of painting & still life portraits, Rahway AC & New Brunswick AC, NJ, 1959-67; also private classes in own studio, 1959-69. **Sources:** WW73.

STOHLBERG, Milton *[Painter] 20th c.*
Addresses: Chicago area. **Exhibited:** AIC, 1934. **Sources:** Falk, *AIC.*

STOHLBERG, Phoebe Erickson See: **ERICKSON, Phoebe**

STOHR, Julia Collins (Mrs. Peter C.) *[Painter] b.1866, Toledo, OH.*
Addresses: Chicago; Lovell, ME. **Studied:** CUA School; ASL with Beckwith, Chase, J. A. Weir, Freer, W.L. Lathrop; Paris. **Member:** Art Workers Guild, St. Paul; Minnesota State Soc.; Chicago WCC; NAWPS. **Exhibited:** AIC, 1894-1915; WMAA, 1921-27. **Sources:** WW33.

STOHR, Julie *[Painter] b.1895, St. Paul, MN / d.1979, Pennsylvania.*
Addresses: Lovell, ME; Monterey, CA; New Hope, PA. **Studied:** AOC' Paris with Simon & Menard; Henri & Bellows in NYC. **Member:** Carmel Arts & Crafts Club; Soc. Indep. Artists. **Exhibited:** NAWPS; Soc. Indep. Artists, 1917, 1920-21, 1923-27, 1939; Anderson Gals., NYC, 1929 (solo); Salons of Am., 1930-32. **Comments:** Daughter of Julia Collins Stohr (see entry). Her

name appears as Stohr and Roe (Mrs. Robert Roe). **Sources:** WW31; Petteys, *Dictionary of Women Artists,* cites alternate birth date of 1896.

STOIANOVICH, Marcelle *[Painter] 20th c.*
Addresses: Metuchen, NJ. **Studied:** College d'Art Appliqué à'Industrie, Paris, France. **Exhibited:** Salon des Artistes Français, Paris, France; Maison Française, Columbia Univ., NYC; Assoc. Am. Artists, New York; American Club, Athens & Macedonian Center, Salonika, Greece; Venable Gallery, Washington, DC. Awards: hon. mention for watercolor, Beaux-Arts, Paris, 1950; hon. mention, Soc. Artistique de Clichy, Paris, 1952. **Work:** Commissions: posters for Am. Christmas Fund, Paris; book jacket designs for Doubleday & Co; hand-made jewelry. **Sources:** WW73.

STOJANA, Gjura *[Painter, sculptor, mural painter] b.1885, Brisout, France / d.1974, Los Angeles, CA.*
Addresses: Los Angeles, CA/Santa Fe, NM in 1975. **Studied:** Europe and the Orient. **Member:** Archaeological Inst. Am.; Calif. AC. **Exhibited:** Mus. New Mexico Inaugural, 1917; LACMA, 1918, 1921, 1928; Salons of Am., 1925; S. Indp. A., 1925; AIC, 1936-37. **Work:** Biological Mus., Univ. Calif., La Jolla (murals); de Young Mus.(mural); Mus. Archaeology, Santa Fe; LACMA; Bullock's Wilshire, Los Angeles (mural); Golden Gate Park Mus., San Francisco. **Comments:** He immigrated to the U.S. in 1901. He was in the Pacific in 1922 and settled in Los Angeles upon his return. In 1928 he returned to his original legal name. Position: staff, *San Francisco Chronicle.* **Sources:** WW21; Hughes, *Artists in California,* 537; P&H Samuels, 461.

STOKES, Dudley R. *[Mural painter, portrait painter, designer] b.1911, Phila.*
Addresses: NYC/Provincetown, MA. **Studied:** C.W. Hawthorne; G.B. Bridgman; F.V. DuMond. **Member:** Provincetown, AA. **Sources:** WW40.

STOKES, Frank W(ilbert) *[Painter, illustrator, explorer] b.1858, Nashville, TN / d.1955, NYC.*
Addresses: Phila., PA; Paris, France; NYC. **Studied:** PAFA with T. Eakins, Académie Julian, Paris with Boulanger, Lefebvre, 1885-90; École des Beaux-Arts with Gérôme; Acad. Colarosi with Collin. **Exhibited:** PAFA Ann., 1879-92 (8 times); Paris Salon, 1886, 1888, 1890; Medaille d'Argent, Prix Alphonse de Mntherot, Soc. de Géographie de Paris; S. Indp. A. **Work:** mural, AMNH; Soc. Géographie de Paris. **Comments:** A specialist in Arctic and Antarctic scenes, he was an artist/member with the Peary Greenland Expeditions, 1892, 1893-94; the Swedish Antarctic Expedition, 1901-02; and the Amundsen-Ellsworth Expedition, 1926. Contributor: illustr., *Lippincotts', Scribner's, Century.* **Sources:** WW40; Fink, *American Art at the Nineteenth-Century Paris Salons,* 393; Falk, *Exh. Record Series.*

STOKES, John *[Painter] mid 19th c.*
Addresses: NYC, 1864-66. **Exhibited:** NAD, 1864, 1866; Boston AC, 1881.
Work: Tennessee State Mus. **Comments:** Active 1864-81. **Sources:** Kelly, "Landscape and Genre Painting in Tennessee, 1810-1985," 72-73 (w/repro.).

STOKES, Joseph F. *[Engraver] b.c.1842, Philadelphia.*
Addresses: Philadelphia, 1860-61. **Comments:** He was the son of John Stokes, tailor, a native of Ireland. **Sources:** G&W; Phila. CD 1860 [as John F.], 1861 [as Joseph F.]; 8 Census (1860), Pa., LI, 231 [as Joseph].

STOKES, Rhoda Bradley *[Folk painter] b.1901, Franklin County, MS.*
Addresses: Liberty, MS. **Comments:** Her paintings record her childhood on a farm and life in the bayou of southern Louisiana. **Sources:** Dewhurst, MacDowell, and MacDowell, 171.

STOKES, Rose Pastor *[Painter] early 20th c.*
Addresses: NYC. **Exhibited:** S. Indp. A., 1925. **Sources:** Marlor, *Soc. Indp. Artists.*

STOKES, Thomas Phelps *[Painter] b.1934, New York, NY.*
Addresses: Cheyne Walk, London. **Exhibited:** Collectors Exh., Cleveland (OH) Mus., 1964; Mem. Gal.-Albright-Knox Art Gal., Buffalo, NY, 1966; Phillips Coll., Wash., DC, 1969; Gift of Time, Mus. New Mexico, Santa Fe, 1970; Univ. Art Gal., Virginia Polytechnic Inst. & State Univ., Blacksburg, VA, 1971; Betty Parsons Gal., NYC, 1970s. **Comments:** Preferred media: oils. **Sources:** WW73; John Canaday, review, *New York Times,* May 4, 1968 & Sept. 27, 1969; Anita Feldman, "Thomas Stokes" (summer, 1968) & review (fall, 1969), *Arts Magazine;* C. Ratcliff, article, *Art Int.* (Nov., 1969).

STOKSTAD, Marilyn Jane *[Art historian, educator] b.1929, Lansing, MI.*
Addresses: Lawrence, KS. **Studied:** Carleton College (B.A., 1950); Michigan State Univ., 1953; Univ. Michigan (Ph.D., 1957). **Member:** College AA. Am. (bd. dir., 1971); Medieval Soc. Kansas (pres., 1968-70); Midwest College Art Conf. (pres., 1964-65); Soc. Arch. Historians (bd. dir., 1971); Am. Assn. Univ. Prof. (nat. council, 1972-). **Comments:** Research: Medieval art, especially sculpture; Irish art. Positions: research cur., medieval art, Nelson Gallery, Kansas City, 1969-. Awards: Fulbright fellowship, 1951-52. Publications: author, "Handbook of the Museum of Art," University of Kansas, 1962; author, "Notes on a Barcelon Silver Reliquary," *Regist.,* Vol. 2, No. 9-1910; author, "Renaissance Art Outside Italy," *Art Horizons,* 1968; author, "Three Apostles from Vich," *Nelson Gallery Bulletin,* Vol. 4, No. 1911. Teaching:Univ. Kansas, 1958-70s. **Sources:** WW73.

STOLL, Berry Vincent (Mrs.) *[Collector] b.1906, Louisville, KY.*
Addresses: Louisville, KY. **Studied:** Bryn Mawr College; Louisville Art School. **Comments:** Positions: vice-pres., J. B. Speed Art Mus., Louisville. Collection: paintings and antiques. **Sources:** WW73.

STOLL, Beverly See: **PEPPER, Beverly Stoll**

STOLL, Frederick H. *[Sculptor] early 20th c.*
Addresses: Brooklyn, NY. **Exhibited:** PAFA Ann., 1923. **Sources:** WW25; Falk, *Exh. Record Series.*

STOLL, John (Theodor) (Edward) *[Etcher, painter, sculptor, illustrator, mural painter] b.1889, Göttingen, Hanover, Germany / d.1974, Mill Valley, CA.*
Addresses: San Francisco, CA; San Anselmo, CA. **Studied:** Acad. FA, Dresden, Germany; Calif. Sch. FA. **Member:** San Francisco AA; Calif. SE (pres., 1948-54). **Exhibited:** Int. PM, Los Angeles, 1930-1953; Calif. SE, 1924 (prize), 1936 (prize), 1948 (prize), 1950 (prize); Grand Central Art Gal., Phila.; GGE, 1939; Detroit Inst. Art; AIC; CAM; CMA; Honolulu Acad. Art; SAM; Boise, ID, 1938, 1942; Stanford Univ.; SFMA, 1941-42; Univ. Nevada, 1943; LOC, 1949; CI, 1949; Palacio des Bellas Artes, Mexico City; & in Madrid, Spain; Rome, Italy; Caracas, Venezuela, 1954. **Work:** CPLH; SFMA; Mills College; Oakland Art Gal.; Calif. Hist. Soc.; Buckingham Palace, London; Marine Mus., San Francisco; Achenbach Found., San Francisco; Ain Harod and Tel-Aviv Mus., Jerusalem; mem. mural & sculpture, Sailors Union of the Pacific; Ashland Pub. Lib.; San Francisco Pub. Lib. **Comments:** Lectures on etching. **Sources:** WW59; WW47.

STOLL, Rolf *[Portrait painter, lecturer, teacher, drawing specialist] b.1892, Heidelberg, Germany.*
Addresses: Cleveland, OH; Lake Worth, FL. **Studied:** Acad. FA, Karlsruhe; Acad. FA, Stuttgart, Germany; W. Truebner. **Member:** Cleveland Pr. Club; Cleveland SA. **Exhibited:** PAFA Ann., 1930, 1932; PAFA, 1933, 1937; CI, 1941; GGE, 1939; WFNY, 1939; AIC, 1940; CM, 1943; CMA, 1925-54 (prizes, 1925-26, 1933-34, 1937-38, 1940-44); Butler AI, 1932, 1934-37, 1942-44 (prizes, 1942-43). **Work:** CMA; Columbus Gal. FA; Univ. Nebraska; Army Medical Lib., Wash., D.C.; Western Reserve Univ.; Munic. Coll., Case Sch. App. Sc., Fed. Reserve Bank, Bd. Educ. Bldg., all in Cleveland, OH; U.S. Supreme Court; Ohio Supreme Court; NAD; Duke Univ.; Rutgers Univ.; Univ. Akron; mural, USPO,

East Palestine, OH; Dayton AI; TMA; Nebraska AA; Savings Bank, Buffalo; Med. Lib., Cleveland; Huntington Polytech Inst., Cleveland. **Comments:** Teaching: Cleveland Inst. Art, 1928-37. Lectures: history of art. **Sources:** WW59; WW47; Falk, *Exh. Record Series.*

STOLL, Toni *[Painter]* b.1920, New York, NY.
Addresses: Highland Park, NJ. **Studied:** Syracuse Univ. (B.F.A.); Rutgers Univ. (grad. school). **Member:** AAPL; Hunterdon AA; Guild Creative Art; Central NJAA; AFA. **Exhibited:** AAPL, Nat. Arts Club, 1961-62; Smithsonian Ins., Wash., DC, 1961-63; New Jersey P&S, Jersey City Mus., 1961-66; Fairleigh Dickenson Univ., Madison, 1963; Douglass College, Rutgers Univ. NJ Centennial, New Brunswick, 1964; Guild of Creative Art, Shrewsbury, NJ, 1970s. Awards: Grumbacher first prize for best in oils, 1960 & 1962, Drew Univ. second prize, 1963 & hon. men., 1964, AAPL Shows. **Work:** New Brunswick (NJ) Pub. Lib.; Long Beach Island (NJ) Jewish Community Center. **Comments:** Preferred media: oils, watercolors. Positions: art liaison chmn., Anshe Emett Mem. Temple Art Show, 1959-60; judge, Roebling-Boehm Art Scholar Comp., 1962, Spring Conf. Exh. Gen. Fed. Women's Clubs NJ, 1964 & Cinema Theater Children's Exh., Menlo Park, 1968. Teaching: Lafayette School, Highland Park, NJ, 1953-58; private instruction, 1953-. **Sources:** WW73; "Toni Stoll Exhibition," *NJ Music & Arts* (1963); Paula Hasslocher, *Women Artists of New Jersey* (Fairleich Dickenson Univ. Press, 1964); Waylande Gregory, "Highland Park Artist Chosen," *Daily Home News,* New Brunswick, 1965.

STOLL, Vivian Campbell See: **CAMPBELL, Vivian (Vivian Campbell Stoll)**

STOLLER, Alexander *[Sculptor]* b.1902, NYC.
Addresses: West Stockbridge, MA. **Studied:** ASL. **Member:** NSS. **Exhibited:** WMAA, 1936, 1938, 1941; Delphic Studios, NY, 1937 (solo); WFNY 1939; AIC. **Sources:** WW53; WW47.

STOLLER, Helen Rubin *[Painter, graphic artist, designer]* b.1915, NYC.
Addresses: NYC. **Studied:** CUA School. **Exhibited:** 48 States Competition, 1939. **Sources:** WW40.

STOLLER, Robert *[Painter]* mid 20th c.
Addresses: Jamaica, NY. **Exhibited:** PAFA Ann., 1954. **Sources:** Falk, *Exh. Record Series.*

STOLOFF, Carolyn *[Painter]* 20th c.; b.NYC.
Addresses: NYC. **Studied:** Univ. Illinois; Columbia Univ. (B.A.); ASL; Atelier 1917;Xavier Gonzalez; Eric Isenburger; Hans Hofmann; also poetry with Stanley Kunitz. **Exhibited:** WMAA; PAFA; Audubon Artists; NAWA; New Jersey P&S. Awards: silver anniversary medal, 1967 & hon. ment., 1972, Audubon Artists; Nat. Council Arts grant for poetry, 1968; Helene Wurlitzer Found. residence grant for poetry, 1972 & 1973. **Comments:** Teaching: Manhattanville College, chmn. dept. art, 1956-63, lecturer, art & English, as of 1973. **Sources:** WW73.

STOLOFF, Irma Levy *[Sculptor]* 20th c.; b.NYC.
Addresses: NYC. **Studied:** ASL with Alexander Stirling Calder, Boardman Robinson, Howard Giles, Yasuo Kuniyoshi & Alexander Archipenko. **Member:** Audubon Artists (exec. board, 1965-0); NAWA (sculpture jury, 1952-54, 1968-70 & 1972-74; finance committee, 1965-66; program committee, 1970); Silvermine Guild Artists; New York Soc. Women Artists (exh. committee, 1966); Artists Equity Assn. **Exhibited:** Salons of Am., 1931; Allied Artists Am., 1966, NY Soc. Women Artists, 1970, Audubon Artists, 1971 & NAWA, 1972, NAD Galleries; Nat. Arts Club Ann., 1969. Awards: Barstow Prize for sculpture, NAWA, 1953; Excalibur Award for sculpture, Catharine Lorillard Wolfe Art Club, 1968; Mr. & Mrs. Michael J. Solomone Prize for sculpture, Audubon Artists, 1971. **Work:** Sculptures, Butler IA & Rose Art Mus., Brandeis Univ., Waltham, MA; sculpture & watercolor, Norfolk (VA) Mus. & Sheldon Swope Art Gallery, Terre Haute, IN; watercolor, Gibbs Art Gallery, Charleston, SC. Commissions: portraits, bas-reliefs & figure compositions, public & private com-

missions. **Comments:** Teaching: private instruction. **Sources:** WW73; "Datos Biographicos de Irma Stoloff," *Espacios* (Mexico City, Nov., 1953); "Irma Stoloff y la Escultura Abstracta," *La Prensa* (Nov., 1953); Cornelia Justice, "The Artists Outpouring," *Ledger Star,* 1968.

STOLTENBERG, Donald Hugo *[Painter, printmaker]* b.1927, Milwaukee, WI.
Studied: Inst. Design, Illinois Inst. Technology (B.S., visual design). **Member:** Boston PM (board member, 1970s). **Exhibited:** "Venice Observed," Fogg Mus., Cambridge, MA, 1956; Boston Arts Festival, 1956-61 (grand prize, 1957; 1st prize in painting, 1959); Corcoran Gal. biennials, 1963; De Cordova Mus, 1971 (landscape); Am. Art Exh., AIC; Kanegis Gal, Boston; Portland Mus. Arts Festival (first purchase prize). **Work:** BMFA; AGAA; De Cordova Mus., Lincoln, MA; Portland (ME) Mus. Art; Springfield (MA) Art Mus. **Comments:** Teaching: De Cordova Mus. School; RISD. **Sources:** WW73.

STOLTENBERG, Hans John *[Painter, teacher]* b.1879, Flensburg, Germany.
Addresses: Wauwatosa, WI; Brookfield, WI. **Studied:** Milwaukee AI; D.C. Watson. **Exhibited:** Awards: prizes, *Milwaukee Journal* Competition, 1918; Milwaukee AI, 1920, 1940. **Work:** Oshkosh Mus.; Madison Hist. Mus.; Milwaukee AI; Whitewater State Teachers College; Kenosha Hist. Mus.; Carroll College; Concordia College, Milwaukee; Mt. Mary College, Milwaukee; H.S., Pub. Lib., Technical H.S, Masonic Temple, Wauwatosa, WI; Country Day School, Milwaukee; Vanderpoel Coll. **Sources:** WW59; WW47.

STOLZ, Ernst *[Painter]* b.1901, Augsburg, Germany.
Addresses: Michigan; Berkeley, CA. **Studied:** Univ. Munich; Calif. College Arts & Crafts. **Exhibited:** San Francisco AA, 1937; GGE, 1939; St. Mary's College, Moraga, 1970s (solo). **Comments:** Immigrated to the U.S. in 1927 and settled in California in 1930. His paintings are in the style of the German Impressionist School. Preferred media: oil, watercolors, acrylic. **Sources:** Hughes, *Artists of California,* 538.

STOMPS, Walter E., Jr. *[Painter, educator]* b.1929, Hamilton, Ohio.
Addresses: Hamilton, OH. **Studied:** Miami Univ. (B.F.A.); AIC with Boris Anisfeld, Paul Weighardt, Isabelle MacKinnon & Edgar Pillet; Syracuse Univ. **Exhibited:** AIC, 1959 (James Nelson Raymond Award); Everson Mus. Painting Exh., Syracuse, NY, 1963; Ohio Painting & Sculpture Exh., Dayton, 1966 (purchase award); Nat. Drawing & Sculpture Exh., Muncie, IN, 1967; Ohio Print & Drawing Exh., Dayton, 1968 (purchase award); Cincinnati Invitational, 1972; Dayton (OH) Art Inst., 1970s. **Work:** CMA; Dayton Art Inst.; Miami Univ., Oxford, OH. Commissions: Center City Murals Project, Dayton, OH, Nat. Endowment Arts, 1972; General Motors (Frigidaire), Dayton. **Comments:** Preferred media: acrylics. Publications: illustrator, "Dayton USA," 1972. Teaching: Dayton Art Inst. School, 1963-, chmn. fine arts dept., 1969-. **Sources:** WW73.

STONE, Agnes Harvey (Mrs. Harlan F.) *[Landscape, marine & still-life painter]* b.1873 / d.1958.
Addresses: Chesterfield, NH, 1899; Wash., DC, early 1920s and after. **Studied:** self-taught. **Exhibited:** Wash. WCC; CGA, 1941 (solo); VMFA, 1943 (solo); George Washington Univ. Lib., 1953 (solo). **Work:** CGA; Phillips Coll. **Sources:** McMahan, *Artists of Washington, DC.*

STONE, Alex Benjamin *[Art dealer, collector]* b.1922, Sczuczyn, Poland.
Addresses: Moline, IL. **Studied:** St. John's Univ.; Kansas State Univ. (D.V.M.); Stanford Univ. Medical School. **Member:** AFA; MoMA; Davenport Art Mus. (acquisitions committee). **Comments:** Positions: bd. dir., Friends Art, Davenport, IA, 1971- Specialty of gallery: 19th c. Am. landscapists; contemp. Am. and European prints. Collection: Eclectic—15th c. Venetians to 20th c. surrealists. **Sources:** WW73.

STONE, Alice Balch (Mrs. Robert B.) *[Painter, sculptor, craftsperson,]* b.1876, Swampscott, MA. / d.1926.
Addresses: Jamaica Plain, MA/Chocorua, NH. **Studied:** C. Rimmer; W.D. Hamilton; J. Wilson. **Member:** Boston SAC; Boston AC; NAWPS. **Exhibited:** Boston AC, 1895; PAFA Ann., 1929, 1931-32; Doll & Richards, Boston, 1929 (solo). **Work:** pottery plaque, Jackson Mem. Bldg.; Boston Floating Hospital; Judge Baker Child Guidance Center, Boston. **Sources:** WW40; Falk, *Exh. Record Series.*

STONE, Alice May *[Painter]* early 20th c.
Addresses: Baltimore, MD, 1925. **Sources:** WW25.

STONE, Alice (Mrs.) *[Painter]* b.1859.
Addresses: NYC, 1888; 1890; Boston, 1895. **Exhibited:** NAD, 1888; PAFA Ann., 1890, 1895 (landscapes). **Sources:** Falk, PAFA, Vol. II, which shows that her addresses were same as those of William Stone of NYC & Boston (see entry); Naylor, *NAD.*

STONE, Alice Wadsworth (Mrs.) *[Watercolorist]* b.1855, West Easton, NY / d.1917, Brooklyn, NY.
Addresses: Brooklyn, NY.

STONE, Allan *[Art dealer]* b.1932, NYC.
Addresses: NYC; Northeast Harbor, ME. **Studied:** Phillips Acad., Andover, MA (B.A.); Harvard Univ. (B.A.); Boston Univ. (LL. B.); Columbia Univ. **Comments:** Specialty of gallery: 20th century American art. **Sources:** WW66.

STONE, Allen *[Painter, lecturer]* b.1910, New York, NY.
Addresses: Long Island City 4, NY. **Studied:** NAD with Sidney Dickinson, Leon Kroll, Raymond Neilson, Ivan Olinsky; ASL with Maxwell Starr. **Member:** ASL; Am. Veterans Soc. Art; Royal Soc. Art (fellow), London; F.I.A.L. **Exhibited:** CAA traveling exh.; Laguna Beach AC; Soc. Independent Artists; Minnesota State Fair; Minneapolis, MN; All. Artists Acad., NY; Tallahassee, FL; Grand Central Art Gal., Lynn Kottler Gal.; Munic. Gal., NY; Insel Gal., NY, 1958; NY City Center; Barbizon Plaza Gal.; NAD; BM; Fleurs de Lys Gal., NY; Showplace Gal., NY Awards: prizes, Army Regional Exh., FL, 1946; citation, Florida Southern College, 1953; Am. Veterans Soc. Art, 1957; David Knapp Mem. award; Stuyvesant award. **Work:** Grumbacher Collection; Mus. City of New York; Florida Southern College; Burke Found.; Grand Central Hospital, NY; Seton Hall Univ. **Comments:** Position: instructor, Caton Rose Inst. FA, Long Island & School Adv. Art, Newark, NJ; artist, Grumbacher Research Labs., NY. Compiled books on art techniques of famous present day illustrators, 1951; contributed illustr. to many national magazines. Gave lectures and demonstrations in New York and New Jersey. **Sources:** WW66.

STONE, Andress See: **STONE, (Ruth) Andress**

STONE, Anna Belle (Mrs. D.M.) *[Painter, printmaker]* b.1874, Dewitt, IA / d.1949, Seattle, WA.
Addresses: Seattle, WA. **Studied:** Boston School Art; Scripps College, Claremont, CA; Univ. Washington with M. Sheets; P. Cafferman; Ella S. Bush; J.H. Rich; E. Tolknen. **Member:** Northwest WCS; Seattle AM; Women Painters of Washington (pres.); Nat. Lg. Am. Pen Women. **Exhibited:** Laguna Beach AM; CPLH; PAM; Henry Gal., Seattle; Frederick & Nelson, Little Gal., Seattle, several shows, 1946 (solo); SAM, 1929 (prize), 1939 (prize); Downtown Gal., Seattle, 1938 (solo); State Fair, Puyallup, 1931-34 (prize), 1935, 1936 (prize), 1937-50; Women Painters of the West, 1939 (prize). **Work:** Seattle Mus. **Sources:** WW47; Ness & Orwig, *Iowa Artists of the First Hundred Years,* 201; Trip and Cook, *Washington State Art and Artists,* 1850-1950. Trip and Cook cite a birth year of 1869 and the year of her death as 1950.

STONE, Anna Smith R. (Mrs. Francis) *[Painter]* b.1861, New Bedford, MA / d.1934, South Dartmouth, MA.
Addresses: Active in New Bedford, MA area, 1900-34.
Exhibited: New Bedford Art Cl. Loan Exh., 1908 (watercolor). **Sources:** Blasdale, *Artists of New Bedford,* 180 (w/repro.).

STONE, Arthur John *[Silversmith]* b.1847, Sheffield, England / d.1938.
Addresses: Gardner, MA. **Studied:** Sheffield Eng. Sch. Arts. **Member:** Boston SAC (master craftsman); Phila. ACG. **Exhibited:** Boston SAC, (medal). **Work:** gold pyx-ciborium, Church of the Advent; Sarah Wyman Whitney chalice, Trinity Church, Boston; altar pieces, Chapel of St. Andrews, Church of St. James, Chicago; altar, Cranbrook Sch., Bloomfield Hills, MI; altar book, St. Stephens Church, Phila.; bowls, Yale; MMA. **Sources:** WW38.

STONE, Beatrice (Mrs. Jacob C.) *[Sculptor]* b.1900, NYC / d.1962, NYC.
Addresses: NYC. **Studied:** Smith College; Heinz Warneke; O. Maldarelli; Jacques Loutchansky (Paris). **Member:** NSS; All. Artists Am.; NAWA; NY Soc. Women Artists; NY Ceramic Soc.; Scarsdale AA. **Exhibited:** PAFA Ann., 1938-42, 1949-53, 1960; AIC, 1942, 1944; NAD, 1940; Arch. Lg., 1944; CAFA; NYSWA, 1939; S. Indp. A., 1939; All. Artists, NYC; NAWA, 1942 (prize); Audubon Artists, 1946; WMAA, 1949; PMA, 1949; Van Dieman-Lilienfeld Gal., 1952 (solo); San Diego FA Soc., 1953 (solo); deYoung Mus. Art, San Francisco, 1953 (solo); Atlanta AA, 1958 (solo); St. Louis Art Mart, 1958 (solo). Awards: prizes, Huntington award, 1943; Scarsdale AA; Westchester Arts & Crafts Assn. **Work:** Ethical Culture Soc.; Hudson Gld.; Aluminum Corp. of Am. **Sources:** WW59; WW47; Falk, *Exh. Record Series.*

STONE, Benjamin Bellows Grant *[Landscape artist, writer]* b.1829, Watertown, now Belmont, MA / d.1906, Catskill, NY.
Addresses: Catskill, NY, 1906 and before. **Studied:** Benjamin Champney; Jasper F. Cropsey. **Exhibited:** NAD, 1866; Boston Athenaeum; Boston AC. **Work:** Greene County Hist. Soc., NY. **Comments:** He served as an army officer during the Civil War; thereafter he devoted himself to painting, journalism, and politics. He was particularly noted for his charcoal landscapes. **Sources:** G&W; Bartlett, *Simon Stone Genealogy,* 313; Boston CD 1850-52, BD 1853; Cowdrey, NAD; Swan, BA; *Art News,* Aug. 18, 1906, obit.

STONE, Benjamin, Jr. *[Engraver, music printer]* mid 19th c.
Addresses: Boston, 1852-60 and after. **Sources:** G&W; Boston CD 1852-60+.

STONE, C. Sanpietro *[Painter]* early 20th c.
Addresses: Springfield, MA. **Sources:** WW19.

STONE, C. W. (Mrs.) *[Artist]* late 19th c.
Addresses: Active in Detroit, c.1880-91. **Sources:** Petteys, *Dictionary of Women Artists.*

STONE, Carrie *[Artist]* late 19th c.
Addresses: Active in Kalamazoo, MI. **Exhibited:** Michigan State Fair, 1871. **Sources:** Petteys, *Dictionary of Women Artists.*

STONE, Catherine *[Painter]* mid 20th c.
Exhibited: Salons of Am., 1935. **Sources:** Marlor, *Salons of Am.*

STONE, Cornelia Perrin *[Painter]* early 20th c.
Addresses: Newburyport, MA, active 1906-34. **Exhibited:** Boston AC, 1906; Doll & Richards, 1934 (solo). **Sources:** WW19.

STONE, Don *[Painter]* b.1929, Council Bluffs, IA.
Exhibited: BMFA. **Comments:** Taught at the Vesper George School of Art and the New England School of Art, both in Boston; and also conducted a summer school of painting on Monhegan Island, ME. **Sources:** Curtis, Curtis, and Lieberman, 105, 186.

STONE, E. Bristol *[Painter]* early 20th c.; b.Phila.
Addresses: Paris, France. **Studied:** Chase; Paris, with Simon, Menard. **Exhibited:** PAFA Ann., 1904, 1910; AIC, 1907. **Sources:** WW13; Falk, *Exh. Record Series.*

STONE, Edmund *[Marine painter]* early 19th c.
Addresses: Beverly, MA, c.1820. **Comments:** He painted many pictures of the ship *George* of Salem about 1820. **Sources:** G&W; Robinson and Dow, *The Sailing Ships of New England,* I, 64.

STONE, Edward L. *[Painter] early 20th c.*
Addresses: Roanoke, VA. **Comments:** Position: staff, Stone Printing Co., Roanoke, VA. **Sources:** WW25.

STONE, Eliza Goodridge See: **GOODRIDGE, Eliza (Eliza Goodridge Stone)**

STONE, Elizabeth *[Portrait painter] b.1811 / d.1872.*
Addresses: NYC, 1868. **Exhibited:** PAFA, 1868. **Sources:** G&W; Rutledge, PA.

STONE, Elizabeth Jane (Lenthall) *[Engraver] b.Wash., DC / d.1892, Wash., DC.*
Addresses: Wash., DC. **Comments:** Wife of engraver William Stone (see entry). An 1840 map of Wash., DC was signed by her. **Sources:** McMahan, *Artists of Washington, DC.*

STONE, Ellen J. (Miss) *[Painter] 19th/20th c.*
Addresses: NYC, active 1875-1910. **Member:** NYWAC; NAC. **Exhibited:** NAD, 1875-97; Art Club, Phila., 1898; Boston AC; AIC. **Sources:** WW10.

STONE, Emmy *[Painter] mid 20th c.*
Addresses: Chicago area. **Exhibited:** AIC, 1948. **Sources:** Falk, *AIC.*

STONE, Esther F. (Miss) *[Painter] 19th/20th c.*
Addresses: Brooklyn, NY; NYC, 1883. **Exhibited:** NAD, 1883. **Sources:** WW01; Naylor, *NAD.*

STONE, Fern Cunningham (Mrs. Ernest) *[Painter, teacher, lecturer, craftsperson] b.1889, Defiance, Ohio.*
Addresses: Pacific Palisades, CA. **Studied:** Defiance College; Van Emburg School Art, Plainfield, NJ; Fontainebleau School FA, France; John Carlson; George Elmer Browne. **Member:** NAWA; Toledo AA; Nat. Art Found., Hollywood (dir.); Nat. Lg. Am. Pen Women (pres., Santa Monica Chapt.); Miami AA; Sarasota AA; St. Petersburg AA; Santa Monica AA; AAPL; Nat. FA Found., Hollywood; Fontainebleau Alumni Assn.; Pacific Palisades AA. **Exhibited:** Cleveland, OH; Argent Gal.; Butler AI; Toledo Mus. Art; Greeneville (SC) Art Mus.; Studio Gld.; Penn.-Ohio traveling exh.; Florida AC; NY Munic. Exh.; Miami Women's Club; Sarasota Art Gal.; Tampa Univ.; Palladium, Hollywood; AAPL; Pacific Palisades AC. **Awards:** prizes, Pacific Palisades AA. **Work:** Bryan Pub. Lib.; Defiance H.S. **Comments:** Position: nat. art chmn., Nat. Soc. Arts & Letters, Santa Monica. **Sources:** WW59.

STONE, Francis Hathaway *[Painter] b.1856, New Bedford, MA / d.1941, New Bedford.*
Addresses: New Bedford. **Exhibited:** Nonquitt Casino Exh., 1900. **Comments:** Husband of Anna Smith Rotch (see entry). **Sources:** Blasdale, *Artists of New Bedford*, 180.

STONE, Frank F(rederick) *[Sculptor] b.1860, London, England / d.1939, Los Angeles, CA.*
Addresses: Los Angeles. **Studied:** R. Belt. **Member:** Am. Numismatic Soc. **Exhibited:** PAFA Ann., 1906, 1912; San Antonio State Fair (first prize); Alaska-Yukon-Pacific Expo, 1909 (gold); Panama-Calif. Int. Expo, San Diego, 1915; Calif. Liberty Fair, 1918. **Work:** "Gladstone," from life, Treasury Office, "Cardinal Manning," Lambeth Palace, London; Mark Twain Medallion," Sacramento State Lib. **Sources:** WW38; Hughes, *Artists in California*, 528; Falk, *Exh. Record Series.*

STONE, Fred *[Listed as "artist"] mid 19th c.; b.Massachusetts.*
Addresses: NYC, active 1860. **Comments:** Possibly Frederick Stone, varnisher, in 1860 directory. **Sources:** G&W; 8 Census (1860), N.Y., LI, 703; NYCD 1860.

STONE, George *[Wood engraver & carver] b.c.1811, New York State.*
Addresses: Philadelphia, 1850-59. **Comments:** His wife was a native of Pennsylvania; a son Henry was born c.1842 in Maryland and a daughter Caroline in New York c. 1846. **Sources:** G&W; 7 Census (1850), Pa., LII, 823; Phila. CD 1850-55, BD 1854, 1856.

STONE, George H. *[Painter] early 20th c.*
Addresses: Columbus, OH. **Member:** Columbus PPC. **Sources:** WW25.

STONE, George J. *[Painter] b.1860 / d.1932, Pueblo, CO.*
Addresses: NYC.

STONE, George Melville *[Painter] b.1858, Topeka, KA.*
Addresses: Topeka, KS. **Studied:** Académie Julian, Paris with Boulanger and Lefebvre, 1887; Bonnât, Paris; H. Mosler in NYC. **Exhibited:** Paris Salon, 1888; AIC. **Sources:** WW25; Fink, *American Art at the Nineteenth-Century Paris Salons*, 393.

STONE, Gilbert L. *b.1940, Brooklyn, NY / d.1984.*
Studied: Parsons Sch. Des.(scholarship); NYU. **Exhibited:** Art Dir. Clubs (awards); SI (3 gold medals); Frank Rehn Gal., NYC. **Work:** BM; Joseph Hirshhorn Coll.; Smithsonian Inst. **Comments:** Illustr.:*Playboy, McCall's* and other magazines. Teaching: School of Visual Arts, NYC. **Sources:** W & R Reed, *The Illustrator in America*, 343.

STONE, Helen *[Illustrator, designer, painter] b.1903, Englewood, NJ.*
Addresses: NYC. **Studied:** NY School Fine & Applied Art; Paris, France. **Exhibited:** Delphic Studios, NY, 1932 (solo); Fed. Art Exh., NY, 1944. **Comments:** Illustr.: "Horse Who Lived Upstairs," 1944; "Plain Princess," 1945; "Bundle Book"; "The Most Wonderful Doll in the World"; "A Tree for Me"; "Little Ballet Dancer"; "Cats and People," and many others. Contrib.: *Horn Book.* Lectures on book printing. **Sources:** WW59; WW47.

STONE, Helen Loasley *[Painter] early 20th c.*
Addresses: Welland, Ontario. **Member:** Buffalo SA. **Sources:** WW25.

STONE, Henry *[Pioneer lithographer, engraver, portrait painter] mid 19th c.; b.England.*
Addresses: Came to U.S. as a child, family settled in Elizabethtown, NJ; Washington, DC, c.1818-c.46. **Comments:** Stone introduced lithography to Washington, DC, in 1822. He worked in the patent office, 1837-46, first as draftsman, then as assistant examiner. Probably related to William J. Stone (see entry). **Sources:** G&W; Wright and McDevitt, "Henry Stone, Lithographer," repros. and checklist; Stauffer; Stokes, *Historical Prints.* active c.1822-46.

STONE, Hilliard M. *[Artist] mid 20th c.*
Addresses: Texarkana, TX. **Exhibited:** PAFA Ann., 1952. **Sources:** Falk, *Exh. Record Series.*

STONE, Horatio *[Sculptor] b.1808, Jackson, Washington County, NY / d.1875, Carrara, Italy.*
Addresses: NYC, 1841-47; Washington, DC, 1848 and after. **Member:** Wash. AA (a founder/pres., 1857). **Exhibited:** NAD, 1849, 1869; Maryland Inst., 1857 (medal); Wash. AA, 1857-60. **Work:** U.S. Capitol, Wash.; CGA; Nat. Portrait Gal. **Comments:** Although his family planned on him becoming a farmer, he became a physician, practicing in NYC from 1841-47. Stone took up sculpture as a full-time career, however, in 1848 when he moved to Washington (DC). Stone was an important figure in the establishment of the National Gallery of Art. During the Civil War he served as a surgeon. He made at least two visits to Italy, in 1856, and in 1875. **Sources:** G&W; DAB; Fairman, *Art and Artists of the Capitol;* Clement and Hutton; Cowdrey, NAD; Washington Art Assoc. Cat., 1857, 1859. More recently, see, McMahan, *Artists of Washington, DC.*

STONE, Isabel M. *[Painter] late 19th c.*
Addresses: Phila., PA. **Exhibited:** PAFA Ann., 1884. **Sources:** Falk, *Exh. Record Series.*

STONE, Iva Goldhamer *[Painter, teacher] b.1917, Cleveland, OH.*
Addresses: Cleveland, OH; Shaker Heights, OH. **Studied:** Cleveland Sch. Art. **Comments:** Teaching: advertising layout, Cleveland (OH) Sch. Art. **Sources:** WW59; WW47.

STONE, J. M. See: **STONE, James M.**

STONE, James M. *[Painter] b.1841, Dana, MA.*
Addresses: Boston, MA, 1890-91. **Studied:** Munich, with Seitz
& Lindenschmit. **Member:** Boston AC, 1876. **Exhibited:** Boston
AC, 1877-81; PAFA Ann., 1879, 1882; NAD, 1890-91. **Work:**
portrait of F.W. Tilton, for Phillips Acad., Andover, MA.
Comments: Spent his career in Boston, where he was an instruc-
tor at the School of the Museum of the Fine Arts. **Sources:**
Clement and Hutton (as J.M. Stone); Falk, *Exh. Record Series.*

STONE, John *[Painter] late 19th c.*
Addresses: Chester County, PA, 1880; Embreeville, PA.
Exhibited: NAD, 1880; PAFA Ann., 1881. **Sources:** Falk, *Exh.
Record Series.*

STONE, John Lewis, Jr. *[Painter, instructor] b.1937,
Presidio, TX.*
Addresses: Fort Worth, TX. **Studied:** Fort Worth Mus. FA; Texas
Christian Univ.; Univ. Texas, Arlington; PAFA. **Exhibited:** 34th &
35th Ann., SMPS&G, Wash., DC (Borjorne' Egli Award); Heritage
Hall Mus., Ft. Worth, 1970 (first prize in drawing); Cross Gal.,
1971 & 1972 (solos); Snyder Mus. Fine Art, 1971 (Beggs Award
for watercolor); Longview Invitationals, 1971 & 1972; Gross
Gals., Fort Worth, TX, 1970s. **Comments:** Preferred media:
watercolors, oils, tempera. Teaching: watercolor workshop, Texas
Christian Univ. **Sources:** WW73.

STONE, Julia *[Painter] 20th/21th c.*
Addresses: NYC. **Exhibited:** PAFA Ann., 1896-97. **Sources:**
WW10; Falk, *Exh. Record Series.*

STONE, L. I. (J.) *[Painter] early 20th c.*
Addresses: NYC. **Exhibited:** S. Indp. A., 1917. **Sources:**
Marlor, *Soc. Indp. Artists.*

STONE, Leo *[Painter] mid 20th c.*
Addresses: E. Orange, NJ, 1943. **Exhibited:** S. Indp. A., 1943-
44. **Sources:** Marlor, *Soc. Indp. Artists.*

STONE, Leona *[Painter] 20th c.*
Addresses: NYC. **Member:** SPNY; NAWPS. **Sources:** WW21.

STONE, Lewis Collins *[Painter] late 19th c.; b.St. Louis, MO.*
Addresses: St. Louis, MO. **Studied:** St. Louis Sch. FA; Académie
Julian, Paris with J.P. Laurens, Baschet, and Bouguereau, 1895.
Exhibited: SNBA, 1897; St. Louis Expo, 1898. **Sources:** WW98;
Fink, *American Art at the Nineteenth-Century Paris Salons,* 393.

STONE, Lewis-Collins See: **STONE, Lewis Collins**

STONE, Louis K. *[Abstract painter, designer, teacher] b.1902,
Findlay, OH / d.1984, Lambertville, NJ.*
Addresses: Lambertville, NJ. **Studied:** Cincinnati Art Acad.,
1923; PAFA with Daniel Garber; ASL, 1926-27; Hans Hofmann in
Munich & St. Tropez; Andre Lhote, Paris. **Exhibited:** WFNY
1939; Am. Artists Congress, 1937, 1938; Newark Mus.; Phila. Art
All.; Woodstock, NY; Jacksonville, FL; Creative Arts Program,
Princeton, NJ (juried by John Marin, Alfred Barr and Lee Gatch);
New Hope, PA; Am. Artists Congress, State Mus., Trenton, NJ,
1958, & traveling exh. **Work:** mural panels, Florida State College
for Women, Tallahassee, FL. **Comments:** From 1927-33 Stone
traveled with his wife Caroline through Europe and for a time
rented Cézanne's studio. While in France, Stone became friends
with Marsden Hartley. From 1933-35, the Stones ran the Stone-
Morris School of Fine Arts in Jacksonville, FL. From 1935-on,
they lived in Lambertville, NJ, and he taught classes in abstract
and nonobjective painting along with Charles Evans, and C.F.
Ramsey in New Hope, PA. **Sources:** WW59; WW47; Pedersen
and Wolanin, *New Hope Modernists,* 48; *American Abstract Art,*
199.

STONE, M. Bainbridge *[Painter] early 20th c.*
Addresses: Baltimore, MD. **Member:** Baltimore WCC. **Sources:**
WW29.

STONE, Madeline Masters (Mrs.) *[Sculptor] b.1877 /
d.1932, Wash., DC.*
Addresses: Paris, France; Wash., DC. **Studied:** G. Borglum;
Bourdelle in Paris. **Work:** bust of Lincoln as a youth & head of

John Payne for Am. Red Cross Headquarters. **Sources:**
McMahan, *Artists of Washington, DC.*

STONE, Margaret *[Listed as "artist"] b.c.1815,
Massachusetts.*
Addresses: NYC, 1860. **Comments:** Possibly the Margaret
Stone, "maps," in 1860 directory. **Sources:** G&W; 8 Census
(1860), N.Y., LIII, 889; NYCD 1860.

STONE, M(argaret) Anthony (Mrs. Harold R.) *[Painter,
designer, teacher, lecturer] b.1910, West Barrington, RI.*
Addresses: Larchmont, NY. **Studied:** Vassar College (A.B.); Art
Center School, Los Angeles; Agnes M.Rindge; C.K. Chatterton;
Stanley Reckless. **Member:** AAPL; NAWA. **Exhibited:** NAWA,
1940-45; NAD, 1943, 1945; San Francisco; Phila.; Wichita, KS;
Portales, NM; Chicago; Los Angeles; Seattle; Portland, OR,1937
(prize), 1938 (prize), 1939 (prize); Rockefeller Center, NYC.
Work: Lewis & Clark H.S., City Hall, Spokane, WA. **Comments:**
Lectures: French School of Painting. **Sources:** WW53; WW47.

STONE, Marianna *[Painter] early 20th c.*
Addresses: Fort Washington, PA. **Sources:** WW10.

STONE, Marie L. *[Painter] late 19th c.; b.New York.*
Addresses: NYC, active 1866-88. **Exhibited:** Paris Salon, 1878-
81; Boston AC, 1884-86; AIC. **Sources:** Fink, *American Art at
the Nineteenth-Century Paris Salons,* 393.

STONE, Marie W(heeler) *[Painter] b.1874, California /
d.1920, San Francisco.*
Addresses: NYC; San Francisco. **Member:** NAWA; NYSP;
NAC. **Exhibited:** World's Columbian Expo, Chicago, 1893.
Sources: WW19; Hughes, *Artists in California,* 538.

STONE, Mary L. *[Painter] late 19th c.*
Addresses: NYC, 1868-77. **Exhibited:** NAD, 1866-84; Phila.
Soc. Artists, 1881; PAFA Ann., 1887-88. **Sources:** Petteys,
Dictionary of Women Artists; Falk, *Exh. Record Series.*

STONE, Mary Young *[Painter] late 19th c.*
Studied: Wm. Chase & Rhoda Holmes Nicholls at Shinnecock
Summer School, c.1891-1902; Gloucester, MA. **Comments:**
Specialty: watercolors. Known paintings are a beach scene of
Shinnecock and a scene of Gloucester harbor, dated 1898.
Sources: Pisano, *The Students of William M. Chase,* 23.

STONE, Maysie *[Sculptor] mid 20th c.; b.NYC.*
Addresses: Phila., PA; NYC. **Studied:** Cornell Univ.; Univ.
Wisconsin (B.A.); PAFA; & with Charles Grafly, Albert Laessle;
Chester Springs Sch.; M. Ramos, in Paris. **Member:** APPL.
Exhibited: PAFA Ann., 1927-28, 1935; NAD; Arch. L.; Salon de
Printemps, Paris; Smithsonian Inst.; AEA. **Sources:** WW59;
WW47; Falk, *Exh. Record Series.*

STONE, Mildred B. *[Painter] mid 20th c.*
Addresses: Houston, TX. **Exhibited:** Soc. Wash. Artists, 1937;
MFA, Houston, 1938-39. **Sources:** WW40.

STONE, N. *[Genre painter] early 19th c.*
Addresses: Prattsville, NY, c.1830. **Sources:** G&W; Lipman and
Winchester, 180.

STONE, Orrin F(urse) *[Painter, lithographer, block printer]
b.1895, Oxford, MI / d.1975, Pasadena, CA.*
Addresses: Pasadena, CA. **Sources:** WW33.

STONE, Pauline *[Painter] early 20th c.*
Addresses: East Orange, NJ. **Sources:** WW19.

STONE, Rosalie *[Painter] early 20th c.*
Exhibited: Salons of Am., 1934. **Sources:** Marlor, *Salons of Am.*

STONE, Ruby *[Painter, teacher, lecturer] b.1900, Alexandria,
LA.*
Addresses: Houston, TX. **Studied:** Dallas AI; SAL;
Fontainebleau School FA. **Exhibited:** Texas Centenn., Dallas,
1936; MFA, Houston, 1939; CGA. **Work:** murals, Highland Park
Town Hall, Dallas; Teachers College, Commerce, TX. **Sources:**
WW40.

STONE, (Ruth) Andress *[Painter, craftsperson, graphic artist, writer] b.1914, St. Louis, MO.*
Addresses: Shreveport, PA. **Studied:** Univ. Missouri (B.F.A.); AIC; Kansas City AI; Charles Schroeder; John McCrady; Ross Braught. **Member:** Shreveport Art Club; Louisiana Artists, Inc.; Stafford Springs Artists Colony; Louisiana Crafts Council; Nat. Soc. Arts & Letters; Royal Soc. Art, London (fellow); Mississippi Art Colony. **Exhibited:** Little Rock, AR; Allisons Wells, MS; New Orleans, 1955, 1964, 1965; Shreveport Regional, 1954-60; Baton Rouge, 1957, 1958, 1960, 1961-64; Joslyn Art Mus.; Nedlson Gal. Art; Jackson, MS, 1960; Tulsa, OK, 1955 (solo); Philbrook AC. Awards: prizes, Missouri State Fair, 1946, 1948-51; Mississippi AA, 1947, 1948; Louisiana State Fair, 1955-57; "Holiday in Dixie" exh., 1955, 1964; Regional Artists Exh., 1955, Allison's Wells Art Colony, 1960; Artist of the Year Award, Shreveport *Journal,* 1964. **Work:** stained glass mural, Lakeshore Baptist Church, Shreveport; panels All State Investment Co. Bldg., Shreveport. **Comments:** Author: "Enameling on Copper," 1952. Teaching: Southfield School, Shreveport, LA, 1956-61. **Sources:** WW66.

STONE, Sasha *[Painter] early 20th c.*
Addresses: Berlin, Germany. **Exhibited:** S. Indp. A., 1923. **Sources:** Marlor, *Soc. Indp. Artists.*

STONE, Seymour Millais *[Painter] b.1877, Poland.*
Addresses: NYC. **Studied:** AIC; ASL; Académie Julian, Paris with Lefebvre; Royal Acad. Munich with Loeftz; A. Zorn in Sweden; J.S. Sargent in London. **Member:** Royal Soc. Art, London; AAPL. **Exhibited:** CGA; AIC; Guild Hall, London, England; NY Hist. Soc.; A&M College, Charlottesville, VA. Awards: Knight Commander of Merit of Constantinian Order of St. George, 1921. **Work:** port., Peekskill Military Acad., NY; Peekskill Lib.; Rollins College; Ft. Worth Club; Brown Univ.; Univ. Virginia; Smithsonian Inst.; State House, Montgomery, AL; Army & Navy Club, NY; U.S. Military Acad., West Point; Texas Mem. Mus., Austin; White House, Wash., DC; Republican Club, NYC; Chicago; Ft. Worth (TX) Club; numerous portraits of royalty, painted in Europe. **Comments:** He came to the U.S. at age 6. **Sources:** WW59; WW47.

STONE, Stanford Byron *[Painter, designer, illustrator, teacher, lecturer] b.1906, Denver, CO.*
Addresses: Brooklyn, NY. **Studied:** College City of NY; ASL; B. Robinson; K. Nicolaides; G. Bridgman; DuMond. **Member:** NAC; Brooklyn SA; New Rochelle AA; Art Lg. Nassau: All. Artists Am.; Yonkers Mus. Science & Art. **Exhibited:** Salons of Am., 1930; PAFA Ann., 1930; NAD, 1934, 1935; Montross Gal., 1941 (solo); Community Gal., 1939 (solo); All. Artists Am., 1932-36, 1938-39, 1941, 1943-44; Huntington Mus., 1941 (solo); Neville Pub. Mus., 1942; Kenosha Art Mus., 1942; ASL, 1939. **Work:** port., 69th St. Armory, NYC. **Comments:** Illustrator of children's books. Teaching: Hoboken Indust. Sch., 1939-46; Stone Atelier P.; indust. art advisor & director, freelance agency. **Sources:** WW59; WW47; Falk, *Exh. Record Series.*

STONE, Stephen A. (Mr. & Mrs.) *[Collectors] mid 20th c.*
Addresses: Newton Centre, MA. **Sources:** WW66.

STONE, Sylvia *[Sculptor] b.1928, Toronto, Ontario.*
Addresses: NYC. **Studied:** privately in Canada; ASL. **Exhibited:** Tibor de Nagy Gallery, 1967-69 (solos) & Andre Emmerich Gallery, 1972 (solo); 14 Sculptors—Industrial Edge, Walker Art Center, Minneapolis, MN, 1969; WMAA biennials, 1968-73; Plastic Presence, Jewish Mus., Milwaukee Art Center & San Francisco, 1970. Awards: CAPS Award, New York State, 1971. **Work:** WMAA; Hartford (CT) Atheneum; Xerox Corp., New York; Larry Aldrich Mus., Ridgefield, CT. Commissions: Sunrise Mall, New York, commissioned by Tankoos-Muss Corp., 1973. **Comments:** Large-scale environmental sculptor. Preferred media: plexiglas. **Sources:** WW73; Rubinstein, *American Women Artists,* 365-66; *Two Hundred Years of American Sculpture,* 313; M. Friedman, "Sylvia Stone: Industrial Edge," *Art Int.* (1970); Irv Sandler, "Sylvia Stone at Emmerich," *Art in America* (1972).

STONE, Vera See: **NORMAN, Vera Stone (Mrs.)**

STONE, Viola Pratt (Mrs. Joseph H.) *[Painter, sculptor] b.1872, Omaha, NE / d.1958, Long Beach, CA.*
Addresses: Long Beach, CA. **Studied:** Omaha Art School, 1893; Kansas City A, with J.L. Wallace & Edna Kelley, 1903-07; A. Blumberg; W.E. Schofield, 1935-37. **Member:** Long Beach AA. **Exhibited:** Long Beach AA, 1933 (prize); Ebell Club, 1934 (prize), 1935 (prize). **Sources:** WW53; WW47.

STONE, Walter King *[Painter, illustrator, decorator, lecturer, teacher, writer] b.1875, Barnard NY / d.1949, Ithaca, NY.*
Addresses: Wash., DC, active 1898-1902; Ithaca, NY. **Studied:** PIA School; A. Dow. **Member:** Soc. Wash. Artists; Iroquois AA. **Exhibited:** Wash. WCC, 1899; Soc. Indep. Artists, 1917, 1918. **Work:** Rochester Mem. Gal.; Cooper-Herwitt Mus. **Comments:** Illustr.: "Log of the Sun," by W. Beebe, three books by W.P. Eaton. Teaching: Cornell Univ. **Sources:** WW40; McMahan, *Artists of Washington, DC.*

STONE, Willard *[Sculptor] b.1916, Oktaha, OK.*
Addresses: Living in Locust Grove, OK in 1976. **Studied:** Bacone Univ. **Member:** Nat. Acad. Western Art. **Work:** Mus. New Mexico. **Comments:** Received grant as artist-in-residence at Gilcrease Mus. Worked in wood. **Sources:** P&H Samuels, 468.

STONE, William *[Painter] 19th/20th c.*
Addresses: NYC, 1888-90; Boston, MA, in 1895. **Exhibited:** NYC, 1888-90; AIC, 1890, 1936; PAFA Ann., 1890, 1892, 1895. **Comments:** PAFA, Vol. II., shows that his adresses in New York & Boston (1890-95) were same as those of Mrs. Alice Stone (see entry). **Sources:** Falk, *Exh. Record Series;* Naylor, *NAD.*

STONE, William Ellsworth *[Painter] b.1895, Limaville, OH.*
Addresses: Alliance, OH. **Studied:** Youngstown College; Charles Murphy; Louis Evans; Clyde Singer; G. De Armond. **Member:** All. AG; Ohio WCC; NYWCC. **Exhibited:** AWCS, 1939; Butler AI, 1941 (prize), 1944-46 (prizes),1947-52, 1956 (prize), 1957 (solo); Parkersburg FAC; Canton AI, 1943 (prize); Massillon, OH; Athens, OH; Stark Co., Canton, OH, 1928 (prize); Akron AI, 1948; All. AG, 1955 (prize); Phila. Art All., 1957; Midland, PA, 1958 (prize). **Work:** Butler AI. **Sources:** WW59; WW47.

STONE, William J. *[Engraver, lithographer, sculptor] b.1798, London / d.1865, Washington, DC.*
Addresses: Washington, DC, 1815-66. **Studied:** Peter Maverick (engraving). **Comments:** He was brought to America by an uncle in 1804 and educated at Holmesburg, PA. He established an engraving firm in Wash., DC, and handled most of the engraving needs of the Federal Government before retiring in 1840. His work included several maps of Washington and the 1823 facsimile of the Declaration of Independence. His wife also engraved maps. Henry Stone (see entry) was probably a brother or cousin. **Sources:** G&W; Peters, *America on Stone;* Stauffer; Washington *Star,* Jan. 19, 1865, obit. More recently, see McMahan, *Artists of Washington, DC.*

STONE, William Oliver *[Portrait painter] b.1830, Derby, CT / d.1875, Newport, RI.*
Addresses: New Haven, CT, c.1850; NYC,1851 and after. **Studied:** Nathaniel Jocelyn. **Member:** NA. **Exhibited:** NAD, 1861-75; Brooklyn AA, 1862-75. **Comments:** After studying under Nathaniel Jocelyn, he had a studio in New Haven for several years. In NYC he became a successful painter of portraits, especially of women and children. **Sources:** G&W; DAB; CAB; Clement and Hutton; NYBD 1854-60+; Cowdrey, NAD; Rutledge, PA; *Art in America* (April 1925), 156, 158, and (Jan. 1939), 44-46.

STONEBARGER, Virginia *[Painter] b.1926, Ann Arbor, MI.*
Addresses: Hartland, WI. **Studied:** Antioch College (B.A., 1950); Colorado Springs FAC, 1950-51; ASL, 1951-52; Hans Hofmann School, 1954; New York Univ., 1954 & 1956; Univ. Wisc.-Milwaukee (M.S., 1972). **Member:** Wisc. P&S. **Exhibited:** Univ. Minnesota, 1954; Art: USA, 1958; Univ. Wisconsin, 1959; Milwaukee AC, 1959-61; Lakeland College, 1969 (solo) & Univ.

Wisconsin, 1971 (solo). **Awards:** Watertown, WI, 1958 & Milwaukee AC, 1960; Danforth Found. fellowship, 1969. **Comments:** Teaching: Univ. Lake School, Hartland, WI, 1959-62; Watertown (WI) Adult Voc. School, 1967-68; Co. Tech Inst., 1970-72. **Sources:** WW73.

STONEHILL, George *[Mural painter] b.1888 / d.1943, NYC.*
Addresses: NYC. **Studied:** AIC; Europe. **Exhibited:** Salons of Am., 1934.

STONEHILL, Mary (Mrs. George) *[Painter, designer] b.1900, NYC / d.1951, NYC.*
Addresses: NYC. **Studied:** Parsons Sch. Des.; ASL; École des Beaux-Arts, Fontainebleau; Acad. Moderne, Paris. **Member:** NWMP; Arch. Lg.; Sch. Art Lg., NY. **Exhibited:** Salons of Am., 1934; La Tausca Pearls Traveling Exh., 1945-46; Arch. Lg.; Univ. Virginia. **Work:** Univ. Virginia; murals, Wash. Irving H.S., Seaman's Inst., Halloran Hospital, all in NYC. **Comments:** Illustrator: "Social Studies." **Sources:** WW47.

STONER, Corinne M. (Mrs. Walter H.) *[Painter, teacher] early 20th c.*
Addresses: Waterloo, IA. **Studied:** Am. Acad., Chicago; Iowa State Teachers College, Cedar Falls. **Exhibited:** Iowa Art Salon, 1935; Mem. Union, Iowa State College, 1935. **Comments:** Teaching: West H.S., Waterloo, IA, 1931-37. **Sources:** Ness & Orwig, *Iowa Artists of the First Hundred Years,* 201.

STONER, Harry *[Painter, sculptor, illustrator] b.1880, Springfield, OH.*
Addresses: NYC. **Member:** SI; Art Gld. **Exhibited:** AWCS; NAD; PAFA Ann., 1933; Phila. WCC; Corcoran Gal. biennial, 1916; Chicago WCC; Arch. Lg.; AIA; AIC; TMA; SI; AFA traveling exh. **Work:** glass mosaic curtain, Nat. Theatre of Mexico, Mexico City. **Sources:** WW53; WW47; Falk, *Exh. Record Series.*

STONER, John Lawrence *[Painter, printmaker] b.1906, Sacramento, CA / d.1976, Julian, CA.*
Addresses: Point Loma, CA. **Studied:** Otto H. Schneider & E. Devol, San Diego Acad. FA. **Member:** San Diego AG. **Exhibited:** San Diego FA Gallery, 1927; Arizona Art Exh., Phoenix, 1931 (prize); Calif.-Pacific Int. Expo, San Diego, 1935. **Work:** Bank of America, Julian; San Diego Mus.; San Diego FA Soc.; woodcut s., Kansas City. **Comments:** Married to Mary E. Stoner (see entry), they operated their own commercial art business from 1930-38. From 1938-73 he worked for the Rohr Aircraft Co. and painted in his free time. **Sources:** WW40; Hughes, *Artists in California,* 538.

STONER, Joseph John *[Lithographer, agent, publisher] b.1829, Highspire, PA / d.1917, Berkely, CA.*
Addresses: mainly Madison, WI, interrupted by travel; California, 1902-17. **Comments:** After a four year apprenticeship in Harrisburg, PA to learn the trade of chair-ornamenting, he moved West and appeared in the 1864 Cincinnati directory as a map and book agent. In 1864 he married Harriet Louise Daggett from Madison, WI, in the home of his partner E.Kellog. They moved to New Orleans for a short time and returned to Madison in 1865. He started working for A. Ruger (see entry) in 1868, becoming a partner in Ruger & Stoner in 1869. He seems to have been more important as a publisher than as an artist. In 1872 he began publishing under his name alone, and hired H. Brosius (see entry) to draw for him, but published some of Ruger's views as well. In the following years he spent much of his time away from Madison, traveling with Brosius or going to Texas, for example, to obtain subscriptions and promote sales for prints of San Antonio and Austin, this time drawn by A. Koch(see entry).A.F.Poole(see entry) drew New England communities, to be published by Stoner, and H. Wellge made drawings for him, many in the west. J.Warner (see entry) and C. Drie (see entry) drew for him as well. In 1885 he bought a farm near Madison and retired, but joined Ruger once again in 1891 to publish four views of towns in North Carolina. He lived in Wisconsin until 1902, when he moved to Hayward and then Berkeley, CA. **Sources:** Reps,209-212 (pl.73).

STONER, Kenneth F. *[Collector, patron] b.1919, Collamer, PA.*
Addresses: NYC. **Studied:** Penn. State Univ. (B.S.L.A.). **Comments:** Position: landscape arch., Clarke and Rapuano, 1946- . Collection: primitive & modern American and European art. **Sources:** WW66.

STONER, Mary Elizabeth Shropshire *[Painter, graphic artist, wood block printer] b.1906, Chattanooga, TN.*
Addresses: San Diego, CA; Townsend, MT. **Studied:** San Diego Acad. FA with DeVol & Schneider. **Exhibited:** San Diego FA Gal., 1927; Calif.-Pacific Int. Expo, San Diego, 1935. **Comments:** Married to John L. Stoner (see entry) and together they operated their own commercial art business. **Sources:** Hughes, *Artists in California,* 538.

STONER, Olive *[Painter, teacher] early 20th c.; b.Pleasantville, PA.*
Addresses: Phila., PA. **Studied:** PAFA with Snell, Breckenridge, Garber, A.B. Carles, F. Wagner; Phila. Sch. Des. for Women. **Member:** Phila. Art All.; AG of Tiffany Found. **Exhibited:** PAFA Ann., 1930. **Sources:** WW33; Falk, *Exh. Record Series.*

STONEY, Eleanor E. *[Painter] early 20th c.*
Addresses: Pittsburgh, PA. **Member:** Pittsburgh, AA. **Exhibited:** S. Indp. A., 1917. **Sources:** WW25.

STONIER, Lucille Holderness (Mrs. Harold) *[Painter, craftsperson, commercial artist] b.1890, Uvalde, TX.*
Addresses: Asheville, NC. **Studied:** College of Pacific, Stockton, CA; Chouinard AI; Parsons School Des.; Eliot O'Hara; Lester W. Stevens; S. Peter Wagner. **Member:** Lg. Am. Pen Women; Asheville (NC) Art Gld.; Black Mountain AC; Palm Beach Art Lg.; SSAL. **Exhibited:** Lg. Am. Pen Women, 1941 (prize), 1945, 1946, 1955 (prize); Norton Gal., 1942 (solo); West Palm Beach AL, 1938, 1942, 1943, 1945, 1946; Asheville AG, 1936, 1940 (solo); Palm Beach AL, 1938 (prize), 1944 (prize); Florida State Fed., 1944 (prize); Orlando, FL, 1952 (solo); Little Art Gal., 1954 & Victorian Gal., 1955 (solo), Asheville; Southeastern States Exh.; Manor Hotel Gal. **Awards:** First Nat. Bank Exh., Asheville, 1955. **Work:** Norton Gal., West Palm Beach, FL; Veteran's Hospital, Otean, NC. **Comments:** Teaching: Polytechnic H.S., Los Angeles, 1914-31. **Sources:** WW59; WW47, which puts birth at 1886.

STONOROV, Oskar *[Architect, sculptor] b.1905.*
Addresses: Charlestown, PA. **Studied:** A. Maillol; V.A. Lurcat in Paris; Ecole Polytech. Fed., Zurich, Switzerland. **Exhibited:** Soviet Palace Comp., Moscow, 1932 (prize). **Work:** PWA housing projects in Phila., Camden, NJ. **Comments:** Co-author(with W. Boesiger): "Le Corbusier, His Work up to 1929," 1929. **Sources:** WW40.

STOODLEY, Charles E. *[Painter] early 20th c.*
Addresses: Schenectady, NY, 1933. **Exhibited:** S. Indp. A., 1933, 1936. **Sources:** Marlor, *Soc. Indp. Artists.*

STOOL, Louis *[Painter] mid 20th c.*
Addresses: Jersey City, NJ, 1933. **Exhibited:** S. Indp. A., 1933-44. **Sources:** Marlor, *Soc. Indp. Artists.*

STOOPENDALL, G. *[Illustrator] 19th/20th c.*
Addresses: NYC. **Comments:** Position: staff, *Truth,* NYC. **Sources:** WW98.

STOOPS, Herbert Morton *[Illustrator, painter] b.1887, Idaho / d.1948, Mystic, CT.*
Addresses: Oakland, CA; Chicago, IL; NYC/Mystic, CT (Mason's Island). **Studied:** Utah State College; AIC, 1910s. **Member:** SC; AAPL; SI; Artists Guild NY; Mystic AA (founding mem.). **Exhibited:** NAD, 1940 (Isidor Medal for easel painting); Mystic AA, 1940. **Work:** Hist. Soc. Pennsylvania. **Comments:** Western illustrator, specializing in Old West and military subjects. Worked for *San Francisco Call,* c.1910; *Chicago Tribune,* early 1910s; then settled in NYC after WWI. Sometimes signed his work as "Jeremy Cannon" or "Raymond Sisley." Stoops

was working on a series of covers for *Blue Book*, commemorating the 48 states, when he died. He had completed 17. **Sources:** WW47; Hughes, *Artists in California*, 539; P&H Samuels, 469; *Art in Conn.: Between World Wars*.

STOOPS, Jack Donald *[Film maker, educator] b.1914, Los Angeles, CA.*
Addresses: Seattle, WA. **Studied:** Univ. Calif., Los Angeles (B.A.); Univ. Southern Calif. (M.A.); Columbia Univ. (Ed.D.); Leicester College Arts, England. **Member:** Nat. Art Educ. Assn. (bd. mem., 1964-67); Pacific AA (pres., 1953-65). **Exhibited:** Awards: awards for films, Discovering Color, Biennale Venezia, Italy, 1961 & Discovering Creative Pattern, Edinburgh Film Festival, Scotland, 1965; Golden Eagle Award, Council Int. Nontheatrical Events, 1971. **Work:** art films in U.S. public schools. **Comments:** Publications: author, articles, *Art Educ.*, 1956-70; author, "School Arts," 1958; author, "Craft Horizons," 1965. Teaching: Univ. Calif., Los Angeles, 1950-65; Univ. Tennessee, Knoxville, 1965-66; Univ. Washington, 1968-. **Sources:** WW73.

STOPER, Frank *[Lithographer] b.c.1820, Austria.*
Addresses: Philadelphia, 1860. **Comments:** His wife and three children were also born in Austria, before 1853. **Sources:** G&W; 8 Census (1860), Pa., LII, 418.

STORCH, Earl G. Von *[Painter] early 20th c.*
Addresses: NYC. **Exhibited:** S. Indp. A., 1932. **Sources:** Marlor, *Soc. Indp. Artists*.

STORCK, Karl *[Sculptor] late 19th c.*
Addresses: Phila., PA. **Exhibited:** PAFA Ann., 1878-79. **Sources:** Falk, *Exh. Record Series*.

STORER, A. *[Painter] late 19th c.*
Addresses: NYC, 1881. **Exhibited:** NAD, 1881. **Sources:** Naylor, *NAD*.

STORER, Catherine (Miss) *[Landscape painter] mid 19th c.*
Addresses: Albany, NY, c.1830. **Exhibited:** Boston Athenaeum, 1833; Am. Acad., 1835; Am. Art Union, 1846, 1849. **Comments:** **Sources:** G&W; Swan, BA; Cowdrey, AA & AAU.

STORER, Charles *[Painter] b.1817 / d.1907.*
Addresses: Boston, MA, 1883; Providence, RI. **Member:** Boston AC. **Exhibited:** NAD, 1883; Boston AC, 1896-98. **Sources:** WW10; *The Boston AC.*

STORER, Florence *[Illustrator] early 20th c.*
Addresses: Boston, c.1913. **Comments:** Position: staff, *Youth's Companion*, Boston. **Sources:** WW13.

STORER, Maria Longworth Nichols (Mrs. Bellamy) *[Ceramicist, painter] b.1849, Cincinnati, OH / d.1932, Paris, France.*
Addresses: Cincinnati, OH; Paris, France. **Studied:** Cincinnati Art Acad. with Thomas Noble, 1887-90; Cincinnati Art Mus. with Frank Duveneck, 1890-91. **Exhibited:** Paris Expo, 1889 (100 medals for pottery); Columbian Expo, Chicago, 1893; SNBA,1899 (vase; she was listed as Mme. Bellamy-Storer); Paris Expo. Universelle, 1900 (gold medal); PAFA Ann., 1902. **Comments:** Created works of decorative art in bronze. Founded the Rookwood Pottery Co., Cincinnati, in 1880, to compete with Louise McLaughlin's Cincinnati Art Pottery Club. Rookwood had an important role in the American art pottery movement. Widowed in 1885, she married Bellamy Storer in 1886. In 1890 she sold the pottery company and began studying painting. **Sources:** WW47; Petteys, *Dictionary of Women Artists;* Jeanne M. Weimann, *The Fair Women*, 416-419; Fink, *American Art at the Nineteenth-Century Paris Salons; The Golden Age: Cincinnati Painters of the Nineteenth Century*, 29-30; Falk, *Exh. Record Series*.

STOREY, A. M. (Mrs.) *[Painter] early 20th c.*
Exhibited: Salons of Am., 1934. **Sources:** Marlor, *Salons of Am.*

STOREY, Helen Wood (Mrs.) *[Painter] early 20th c.*
Addresses: NYC. **Exhibited:** S. Indp. A., 1922-24. **Sources:** Marlor, *Soc. Indp. Artists*.

STOREY, John *[Painter] mid 20th c.*
Exhibited: Salons of Am., 1934. **Sources:** Marlor, *Salons of Am.*

STOREY, Ross Barron *[Illustrator] b.1940, Dallas, TX.*
Addresses: NYC; San Francisco. **Studied:** Famous Artists Course; Art Center School, Los Angeles. **Exhibited:** Art Dir. Clubs, NYC, Los Angeles, Denver, Dallas (awards); SI, 1976 (gold medal). **Comments:** Illustrator: New York *Journal American*, *National Geographic*, *This Week* and other magazines; also for major paperback publishers. Teaching: Pratt Inst.; School of Visual Arts, NYC. **Sources:** W & R Reed, *The Illustrator in America*, 346.

STORK, Francis W. *[Artist] mid 20th c.*
Addresses: Phila., PA. **Exhibited:** PAFA Ann., 1951, 1953-54. **Sources:** Falk, *Exh. Record Series*.

STORK, Lisl (Mrs. C. W.) *[Painter] b.1888, Salzburg, Austria.*
Addresses: Phila., PA. **Studied:** H. McCarter. **Exhibited:** PAFA Ann., 1933. **Sources:** WW33; Falk, *Exh. Record Series*.

STORM, Anna Alfrida *[Painter, craftsperson, teacher] b.1896, Sweden / d.1967, Seattle, WA.*
Addresses: Evanston, IL/Greeley, CO. **Studied:** A.W. Dow. **Member:** Chicago SE; Chicago NJSA. **Exhibited:** Seattle FAS, 1923 (prize); S. Indp. A., 1928. **Comments:** Teaching: State Teachers College, Greeley. **Sources:** WW33.

STORM, G. F. *[Stipple engraver, etcher] mid 19th c.; b.England.*
Addresses: Philadelphia, c.1834 and after. **Exhibited:** London, 1828 (portrait). **Comments:** His stay in America is said to have been brief. **Sources:** G&W; Stauffer; Graves, *Dictionary*.

STORM, George *[Portrait painter] b.1830, Johnstown, PA / d.1913, Lancaster, PA.*
Addresses: Harrisburg, PA, 1850 and after. **Work:** portraits of many Penn. state officials. **Sources:** G&W; *Art Annual*, XI, obit.

STORM, Halvard *[Painter] early 20th c.*
Addresses: Brooklyn, NY. **Exhibited:** S. Indp. A., 1920. **Sources:** Marlor, *Soc. Indp. Artists*.

STORM, Howard *[Painter] b.1946, Newton, Mass.*
Addresses: Alexandria, KY. **Studied:** Denison Univ; apprenticeship, J. Ferguson Stained Glass Studio, Weston, MA; San Francisco Art Inst. (B.F.A., 1969); Univ. Calif., Berkeley (M.A., 1970; M.F.A., 1972). **Member:** College AA Am. **Exhibited:** San Francisco Art Inst. Centennial, SFMA, 1971; 73rd Western Ann., Denver Mus., 1971; San Francisco Art Inst., 1969 (solo), Roswell Mus., 1971 (solo) & Berkeley Mus., 1972 (solo); Artium Orbis Gal., Santa Fe, NM, 1970s. Awards: Eisner Prize, Univ. Calif., Berkeley, 1972; purchase award, Preview '1973; purchase award, Huntington Galleries. **Work:** Roswell (NM) Mus.; Denison Univ., Granville, OH; Mount St. Joseph College, Cincinnati; Kentucky Arts Commission, Frankfort. **Comments:** Preferred media: acrylics. Positions: artists-in-residence grant, Roswell Mus., 1971-72. Teaching: Northern Kentucky State College, 1972-. **Sources:** WW73.

STORM, Larue *[Painter, sculptor] mid 20th c.; b.Pittsburgh, PA.*
Addresses: Miami, FL. **Studied:** Univ. Miami (A.B. & M.A.); ASL, Woodstock, NY; printmaking with Calvaert Brun, Paris; study in Los Angeles & Michigan. **Exhibited:** 50 Fla Painters, Ringling Mus, Sarasota, Fla, 1955; Corcoran Gal biennials, 1957; Butler IA, 1958-60; Miami Six, El Paso (TX) Mus., 1965; "Florida Creates," various Florida mus., 1971. **Work:** Lowe Mus., Coral Gables, FL; Columbia (GA) Mus. Art; Norton Gallery Art, West Palm Beach, FL. **Comments:** Preferred media: graphics. Publications: author, "Jose Guadalupe Posada: Guerrilla Fighter of the Throwaways," Carrell, 1970. Teaching: Univ. Miami, 1967-70s. **Sources:** WW73.

STORMS, Christian S. *[Saddler and amateur artist]* mid 19th c.
Addresses: NYC, c.1842 and after. **Exhibited:** Am. Inst., 1842 (watercolor), 1844 (drawing of NY State Arsenal). **Sources:** G&W; Am. Inst. Cat., 1842 (as C.C. Storms), 1844; NYCD 1844.

STORMS, John *[Genre painter]* mid 19th c.
Addresses: NYC, 1835. **Exhibited:** Am. Acad., 1835. **Sources:** G&W; Cowdrey, AA & AAU; NYCD 1835 only.

STORRS, Frances Hudson (Mrs. William M.) *[Painter]* early 20th c.; b.NYC.
Addresses: Harford, CT, from c.1905. **Studied:** Chase; Hawthorne; Hale. **Member:** CAFA; North Shore AA; Hartford Art Soc. **Work:** Morgan Mem., Hartford. **Sources:** WW40.

STORRS, John (Henry Bradley) *[Sculptor, painter, engraver]* b.1885, Chicago, IL / d.1956, Mer, France.
Addresses: Chicago/Orleans, France, 1915-38; permanently at Orleans, thereafter. **Studied:** Arthur Bock in Hamburg, Germany, 1906-08; AIC, 1908-09, with Charles J. Mullligan, briefly with Bela Pratt at BMFA School, 1910; Caroline Wade & L. Taft; PAFA, 1911-11, with Grafly; Paul Bartlett, Paris, 1911; Académie Julian, Paris, 1912; Rodin in Paris, 1913-14. **Member:** Soc. Anonyme; Chicago AC; Cliff Dwellers; Tavern Club. **Exhibited:** Salon d'Automne, Paris, 1913; Soc. Nat. des Beaux Arts, 1914; Paris Spring Salon, 1914; Pan-Pacific Expo, 1915; Gal. de Luxembourg, Paris, 1917, 1919 ("Exh. of Artists of the American School"), 1920; AIC, 1917 (etchings), 1918, 1927-39 (annuals); Folsom Gal., 1920 (1st solo), which traveled to the Arts Club, Chicago; Soc. Anonyme, 1923 (solo); Milwaukee AI, 1925 (solo); Salons of Am., 1924, 1934; "Int. Exh. of Modern Art Arranged by Soc. Anonyme," Brooklyn Mus., 1926; Brummer Gal., NYC, 1928 (solo); Knoedler Gal., NYC, 1928 (solo, silverpoint drawings); Albert Roulier Gals., Chicgao, 1928-38 (solos); Downtown Gal., NYC, 1930-35 (paintings); Century of Progress Expo, Chicago, 1933; PAFA Ann., 1934; WMAA, 1933 (annual); 1935 (Abstract Painting in America), 1986 (solo); "Exh. of Contemporary Sculpture," Carnegie Inst., 1938; Municipal Library, Orleans, France, 1949 (solo); Stirling & Francine Clark Art Inst., Williamstown, MA, 1980. **Work:** LACMA; WMAA; AIC; figure of Ceres, for top of Chicago Board Trade building, 1928. **Comments:** Avant-garde sculptor who spent much of his career in France (he married a French author in 1915 and split his time between Ameria and France until 1938). About 1918 he began modeling and carving figures that combined elements of Cubism and Futurism, as well as decorative motifs from Native American art (which he began collecting after a trip West in 1915). Storrs' figural works became more architectonic and abstract in the early 1920s, and in the mid-1920s he began a series of columnar non-objective sculptures that celebrated skyscraper forms. Storrs was passionate about the beauty of the modern skyscraper and wrote of his belief that sculpture should respond to these forms (see John Storrs, "Museum of Artists," *Little Review*, vol. 9, winter, 1922). About the same time, and into the 1930s, Storrs explored other non-representational forms in sculptural compositions which more strongly reflected a machine aesthetic. Storrs began painting in 1930, but returned to non-commissioned sculpture in 1934. During WWII, he was interned in a Nazi prison camp for six months (at Compeigne, 1941-42) and jailed for another six months in a Nazi prison (at Blois, 1944). **Sources:** WW40; *John Storrs & John Flannagan: Sculpture & Works on Paper* (Williamstown, Mass.: Stirling and Francine Clark Art Inst., 1980); Noel Frackman, *John Storrs* (exh. cat., WMAA, 1986); Fort, *The Figure in American Sculpture*, 224-26 (w/repro.); W. Homer, *Avant-Garde Painting and Sculpture in America*, 136; *American Abstract Art*, 199; Falk, *Exh. Record Series*.

STORY *[Portrait painter]* 19th c.
Work: NJ Hist. Soc. owns portrait of William Paterson (1793-1871). **Sources:** G&W; NJ Hist. Soc., *Proceedings*, X (April 1925), 154.

STORY, Ala *[Staff specialist in art]* b.1907, Hruschau, Austria.
Addresses: Great Barrington, MA; Santa Barbara, CA. **Studied:** Lycee Weiner Neustadt, Austria; Acad. FA, Vienna; Univ. Vienna. **Member:** Cosmopolitan Club, NY. **Comments:** Positions: secretary, Galerie des Beaux Arts, London, 1928-30; secretary, Redfern Gal., London, 1930-32; director, Wertheim Gal., London, 1932-34; co-partner/director, Storran Gal., London, 1934-35; co-partner/director, Redfern Gal., 1935-37; British Art Center, NY, 1938-40; founding dir./pres., American-British Art Center, NY, 1940-52; co-founder/vice-pres., Falcon Films (first U.S. Art Documentary color and sound film company), 1947-; director, Santa Barbara (CA) Mus. Art, 1952-57; staff specialist in art, Univ. Calif., Santa Barbara. **Sources:** WW66.

STORY, Benjamin *[Illustrator]* b.1927.
Addresses: NYC/Port Washington, NY. **Member:** GFLA. **Sources:** WW27.

STORY, D. *[Painter]* late 19th c.
Addresses: NYC, 1882. **Exhibited:** NAD, 1882. **Sources:** Naylor, *NAD*.

STORY, George H(enry) *[Portrait & genre painter, museum curator]* b.1835, New Haven, CT / d.1923, NYC.
Addresses: Portland, ME, 1858; NYC, c.1865-1923. **Studied:** Charles Hine & L. Bail in New Haven; Europe. **Member:** ANA, 1875; Lotos Club; Artists Fund Soc. **Exhibited:** Maine, 1859 (medal); NAD, 1867-96; Brooklyn AA, 1867-86; Centenn. Expo, Phila., 1876 (medal); PAFA Ann., 1876-88 (4 times). **Work:** MMA; NGA; Wadsworth Atheneum, Hartford. **Comments:** After studying at New Haven he went to Europe for a year. After two years in Washington, DC and a year in Cuba, he settled in NYC. Positions: curator, MMA, 1889-1906, acting dir., 1904-05; collection consultant, Wadsworth Atheneum, Hartford, 1899-. **Sources:** G&W; *Art Annual*, XX, obit.; Clement and Hutton; WW21; Art in Conn.: Early Days to the Gilded Age; Falk, *Exh. Record Series*.

STORY, Ina (Clifford) Perham (Mrs. Fred) *[Painter]* b.1888, San Francisco, CA / d.1979, Santa Barbara, CA.
Addresses: Mamaroneck, NY; Santa Barbara, CA. **Studied:** Calif. College Arts & Crafts; ASL; Armin Hansen in Monterey; Europe; Hans Hofmann in Berkeley, CA. **Exhibited:** East West Gal., San Fran., 1927; S. Indp. A., 1931-32; Salons of Am., 1932, 1934; SFMA, 1935; San Fran. AA, 1924, 1932(medal), 1939; Soc. Women Artists, San Fran., 1936 (prize); GGE, 1939; Ojai, CA, 1977 (solo). **Comments:** Preferred media: oil and watercolor. Specialty: still lifes, landscapes, portraits, figure studies. **Sources:** WW40; Hughes, *Artists in California*, 539.

STORY, James E. *[Painter]* late 19th c.
Addresses: NYC, 1866. **Exhibited:** NAD, 1866. **Sources:** Naylor, *NAD*.

STORY, Julian Russell *[Painter]* b.1857, Walton-on-Thames, England / d.1919.
Addresses: Paris, France; Phila., PA/Vallombrosa, Italy. **Studied:** F. Duveneck in Florence; Académie Julian, Paris with Boulanger & Lefebvre, 1879-82; Gervix & Humbert in Paris. **Member:** ANA, 1906; SAA, 1892; Paris SAP; London Soc. Port. Painters; Chevalier, Legion of Honor, 1901. **Exhibited:** Paris Salon, 1883, 1885-87, 1889 (medal) 1890-93, 1896, 1898, 1899; PAFA Ann., 1888-95, 1901-18; Berlin, 1891 (gold); Paris Expo, 1900 (medal); Pan-Am. Expo, Buffalo, 1901 (medal); Pan-Pacific Expo, San Francisco, 1915 (medal). **Work:** Minneapolis Inst.; CAM, St. Louis; Telfair Acad., Savannah, GA; Peabody Inst., Balt. **Comments:** Son of William W. Story. **Sources:** WW17; Fink, *American Art at the Nineteenth-Century Paris Salons*, 394; Falk, *Exh. Record Series*.

STORY, Marion *[Miniature painter]* d.1907.
Addresses: Port Chester, NY. **Comments:** Son of William W. Story. Death in 1907 by suicide.

STORY, Stephen *[Landscape painter, conservator] d.1988.*
Addresses: Saranac Lake, NY. **Studied:** Pratt Inst. School Art, 1930s. **Exhibited:** Adirondack Mus, Elizabethtown, NY (solo); Lake Placid AC (solo). **Comments:** His career in restoring paintings began at the MMA in 1930s, and he worked privately thereafter. At the same time, he produced his own paintings, but it was not until after his 1976 move to Saranac Lake that he began to paint in earnest, producing many landscapes of the Adirondacks. **Sources:** PHF files courtesy H. Kohn.

STORY, Thomas C. *[Portrait & historical engraver] mid 19th c.*
Addresses: NYC, 1837-44. **Comments:** In 1844 he was of Story & Atwood (see entry). **Sources:** G&W; Stauffer; NYBD 1844.

STORY, Thomas Waldo *[Sculptor] b.1855, Barbarini Palace, Rome / d.1915, NYC.*
Addresses: Rome, Italy. **Work:** statue, House of Commons, London; bronze door, Morgan Lib., NYC; drinking fountain, Hopedale, MA. **Comments:** Son of William Wetmore Story. **Sources:** WW08.

STORY, William Easton *[Painter, museum director] b.1925, Valley City, ND.*
Addresses: Muncie, IN. **Studied:** AIC (B.F.A.); Ball State Teachers College (M.A.); Stanley Wm Hayter. **Member:** Am. Assn. Mus.; Midwest Mus. Assn. **Exhibited:** WMAA ann., 1957; Corcoran Gal. biennial, 1957; CAM Second Interior Valley Comp., 1958; Artistas Brasileiros E. Am., MoMA-São Paulo, Brazil, 1960; "Collages by American Artists," Ball State Univ. Art Gal., 1972. **Work:** Butler IA; Ball State Univ. Art Gallery, Muncie, IN. **Comments:** Positions: asst. director, Am. Mus. in Britain, Bath, England, 1966-68; director, Parrish Art Mus., Southampton, 1968-69; director, Ella Sharp Mus., Jackson, MI, 1969-72; director, Ball State Univ. Art Gal., 1972-. **Publications:** contributor, *America in Britain*, 1967 & 1968. Teaching: asst. professor art & supervisor, art gallery, Ball State Univ., Muncie, 1956-66. Collections arranged: "Metals in Muncie," Ball State Univ. Art Gal., 1959; "American Trompe L'Oeil" & "John Ferren — Paintings," Parrish Art Mus., Southampton, NY, 1969. **Sources:** WW73.

STORY, William Wetmore
[Sculptor, writer] b.1819, Salem, MA / d.1895, Vallombrosa, Italy.
Addresses: Rome, Italy (from 1851). **Studied:** Harvard, grad. 1838, received law degree in 1840; sculpture, Italy, 1847. **Exhibited:** London Exposition, 1862. **Work:** Boston Pub. Lib.; Harvard Univ. (statue of Josiah Quincy); MMA; NMAA; Boston Athenaeum; Essex Inst.; M.H. de Young Mus., San Francisco; PAFA; Brooklyn Mus. Outdoor works: Mount Auburn Cemetary, Cambridge, Mass. (memorial statue of his father, Justice Joseph Story); Frances Scott Key Monument, Golden Gate Park, San Francisco; Chief Justice John Marshall, Capitol grounds, Wash., DC. **Comments:** Romantic sculptor of ancient subjects and portraits. The son of Associate Justice Joseph Story of the U.S. Supreme Court, William Wetmore Story practiced law in Boston for about five years before his father's death in 1845. Although Story was only an amateur atist at the time, he was granted the commission to design his father's memorial. He traveled to Rome in 1847 and 1849 in order to gather ideas and complete the model for the sculpture. Story returned to Boston in 1850 and briefly went back to his law practice but soon decided to give up law completely and take up sculpture as his career. He returned to Rome in the summer of 1851 and remained there for the rest of his life, with the exception of several visits back to America. Story became best known for his ideal pieces, such as "Cleopatra" (1858, replica in MMA), "Lybian Sibyl" (early 1860s, NMAA), and the "Medea" (1864, replicas at MMA and Essex Inst.). He established an international reputation but was most popular in England, where he was very highly regarded. Story was also known as a poet and essayist and was close friends with the leading literary figures of the day, including Robert and Elizabeth Browning, Nathaniel Hawthorne, and Henry James (his biographer). Story's two sons, Julian Russell and Thomas Waldo Story (see entries), also became artists. **Sources:** G&W; Henry James, *William Wetmore Story and His Friends;* Fairman, *Art and Artists of the Capitol;* CAB; Clement and Hutton; Taft, *History of American Sculpture;* Swan, BA; 7 Census (1850), Mass., XXV, 583. More recently, see Craven, *Sculpture in America,* 274-81; Baigell, *Dictionary.*

STORY & ATWOOD *[Portrait, historical & landscape engravers] mid 19th c.*
Addresses: NYC, 1844. **Comments:** Partners were Thomas C. Story and John M. Atwood. **Sources:** G&W; NYBD 1844.

STOTE, Theodore *[Engraver] b.c.1806, Germany.*
Addresses: NYC, active 1860. **Comments:** His wife and three older children (25 to 13) were born in Germany, while three younger children (10 to 4) were born in New York. **Sources:** G&W; 8 Census (1860), N.Y., LXII, 596.

STOTESBURY, Helen Mather See: COE, Helen Stotesbury (Mrs. Arthur Paul)

STOTHARD, James (or R.) *[Signpainter] mid 19th c.*
Addresses: NYC, c.1847. **Exhibited:** Am. Inst., 1847 (flower painting in watercolors). **Comments:** James Stothard, Jr., of the same address, exhibited two watercolors at the Institute in 1846, and R. Stothard, of 14 Madison St., exhibited an oil painting in 1847. **Sources:** G&W; NYCD 1845-46; Am. Inst. Cat., 1846, 1847.

STOTLER, Charles C(lifton) *[Painter] early 20th c.*
Addresses: Wash., DC, active 1913-39. **Member:** Soc. Wash. Artists. **Exhibited:** Soc. Wash. Artists, 1913-25; Wash. WCC, 1924, 1926-27. **Sources:** WW27; McMahan, *Artists of Washington, DC.*

STOTLER, Ilka Marie *[Painter] mid 20th c.*
Addresses: Edgewood, PA/Wilkinsburg, PA. **Member:** Pittsburgh AA. **Exhibited:** S. Indp. A., 1942. **Sources:** WW25.

STOTT, John H. *[Stone, seal & gem engraver] mid 19th c.*
Addresses: Boston, 1836-49. **Comments:** This is probably the John Stott, English heraldic artist at Boston about 1850, listed by Bowditch. **Sources:** G&W; Boston CD 1836-49, BD 1841-49; Bowditch, "Early Water-Color Paintings of New England Coats of Arms," 206.

STOTT, William *[Engraver] mid 19th c.*
Addresses: Philadelphia, 1849-53. **Sources:** G&W; Phila. BD 1849-53.

STOTTER, Charles C. *[Painter] early 20th c.*
Addresses: Washington, DC. **Sources:** WW19.

STOTTLEMEYER, Margaret A. R. *[Painter] b.1859, Maryland.*
Addresses: NYC; Wash., DC, active 1920s-40s. **Studied:** NAD. **Member:** Wolfe AC. **Exhibited:** Lorraine Gallery, 1929 (solo); CGA, 1933 (solo). **Comments:** WPA artist. **Sources:** WW40; McMahan, *Artists of Washington, DC.*

STOTTS, William See: STOTT, William

STOUFFER, J. Edgar *[Sculptor] early 20th c.*
Addresses: Baltimore, MD. **Member:** Charcoal Club. **Exhibited:** PAFA Ann., 1917. Award: Rinehart Scholarship to Paris, 1907-11. **Sources:** WW33; Falk, *Exh. Record Series.*

STOUGH, Bessie See: CALLENDER, Bessie Stough

STOUGHTON See: PEALE, Anna Claypoole

STOUGHTON, E. W. (Mrs.) *[Painter] late 19th c.*
Addresses: NYC, 1877-81. **Exhibited:** NAD, 1875-81. **Sources:** Naylor, *NAD.*

STOUT, Edna See: STAPLES, Edna Fisher Stout (Mrs. Arthur C.)

STOUT, Franklin *[Listed as "artist" or draftsman] b.c.1825, Philadelphia.*
Comments: He was the son of George Stout, whipmaker. He was listed as an artist in the 1850 and 1860 Philadelphia censuses and as a draftsman in the 1871 directory. **Sources:** G&W; 7 Census (1850), Pa., XLIX, 170; 8 Census (1860), Pa., LVIII, 75; Phila. CD 1871.

STOUT, George H. *[Engraver] b.1807 / d.1852.*
Addresses: NYC, 1807. **Comments:** He was a son of James DeForest Stout. He was active as an engraver from 1831 until his death, at which time he was in partnership with Jacob Hyatt (see entries). **Sources:** G&W; Stout, *Stout and Allied Families,* 181; NYCD 1831-51; NYBD 1837-51; obit., Barber, "Deaths Taken from the N.Y. Evening.

STOUT, George Leslie *[Art consultant, museum conservator] b.1897, Winterset, IA / d.1978.*
Addresses: Menlo Park, CA. **Studied:** Grinnell College; Univ. Iowa (B.A., 1921); Harvard Univ. (A.M., 1929); Clark Univ., 1955 (hon. Litt.D.). **Comments:** Positions: head conservationist, Fogg Art Mus., Harvard Univ., 1929-47; director, Worcester AM, 1947-54; director, Isabella Steward Gardner Mus., Boston, 1955-70. Publications: co-author, "Painting Materials," Van Nostrand Reinhold, 1942; author, "The Care of Pictures," Columbia Univ. Press, 1948; author, "Treasures of the Isabella Stewart Gardner Museum," Crown, 1969. **Sources:** WW73; WW47.

STOUT, Ida McClelland *[Sculptor, teacher] b.Decatur, IL / d.1927, Rome, Italy.*
Addresses: Chicago, IL. **Studied:** AIC with A. Polasek. **Member:** Chicago AG; MacDowell Club; Chicago Gal. Assn. **Exhibited:** AIC, 1916-26; PAFA Ann., 1925. **Work:** Mary W. French Sch., Decatur, IL; Hillyer Gal., Smith College; *Chicago Daily News* Fresh Air Sanitarium for Children, Lincoln Park; mem. tablet, Englewood H.S., Chicago. **Sources:** WW27; Falk, *Exh. Record Series.*

STOUT, Isabel *[Painter] mid 20th c.*
Addresses: Phila., PA. **Exhibited:** PAFA Ann., 1941. **Sources:** Falk, *Exh. Record Series.*

STOUT, James *[Engraver] early 19th c.*
Addresses: Philadelphia, 1811. **Sources:** G&W; Brown and Brown.

STOUT, James DeForest *[Engraver & seal cutter] b.1783, NYC / d.1868, NYC.*
Addresses: NYC, active c.1804- 40. **Comments:** Except for 1833-34 when he was in the partnership of Stout & Warner (see entry), Stout seems to have worked independently or with his engraver sons: John B., George H., James V., and William C. Stout (see entries). He was also an uncle of Andrew Varick Stout (1812-83), teacher and banker of NYC. **Sources:** G&W; Stout, *Stout and Allied Families,* 181, 292; NYCD 1804-40, 1850, as engraver, 1853-57, as late engraver.

STOUT, James Varick *[Engraver, die sinker] b.1809, NYC / d.1860, NYC.*
Addresses: NYC, 1809-60. **Comments:** He was a son of James DeForest Stout. Stauffer states that he was active in NYC in the mid-thirties, but his name is absent from the directories. **Sources:** G&W; Stout, *Stout and Allied Families,* 181; Stauffer; Barber, "Deaths Taken from the N.Y. Evening Post."

STOUT, John Benjamin *[Engraver, seal cutter] b.1805, NYC / d.1877, Bridgeport, KY.*
Comments: He was the eldest son of James DeForest Stout. John B. Stout & Co., engravers and seal sinkers, was listed in NYC directories from 1829-31, but Stout soon after became a physician and surgeon. **Sources:** G&W; Stout, *Stout and Allied Families,* 181, 293; NYCD 1829-31.

STOUT, Loren *[Illustrator] b.1891, Kansas City, MO / d.1942, NYC.*
Member: SI. **Comments:** Position: staff, *Kansas City Star.*

STOUT, Myron Stedman *[Painter] b.1908, Denton, TX.*
Addresses: Provincetown, MA. **Exhibited:** WMAA, 1958; MoMA, 1959; Jewish Mus., 1963; Guggenheim Mus., 1964-65; Corcoran Biennial, 1969; Richard Bellamy Gal., NYC, 1970s. **Work:** Brooklyn Mus.; Carnegie Mus.; Guggenheim Mus.; MoMA. **Comments:** Minimalist abstract painter active in Provincetown, MA, 1938, 1946-on. **Sources:** WW73; Provincetown Painters, 261.

STOUT, Richard Gordon *[Painter] b.1934, Beaumont, TX.*
Addresses: Houston, TX. **Studied:** Cincinnati Art Acad., 1952-53; School AIC (B.F.A., 1957); Univ. Texas (M.F.A., 1969). **Exhibited:** Momentum Mid Continental Exh., Chicago, 1956-57; Second Int. Triennial Oriental Coloured Graphic, Basel, Switzerland, 1961; Hallmark Int., 1962; One Hundred Contemp. Am. Draftsmen, Univ. Michigan, 1963; Marion Koogler McNay Art Inst., 1964 & 1971; Houston (TX) Gals., 1970s. Awards: first painting award, Dallas MFA, 1964; Longview Purchase Prize, Jr. Service Lg., 1965 & 1972; Texas FAA Awards, 1966 & 1971. **Work:** MFA, Houston, TX; Dallas MFA; Marion Koogler McNay AI, San Antonio, TX; Rice Univ.; Univ. Houston. Commissions: mural, Texas FAA for Hemisfair, now in library lobby, Univ. Houston, 1968. **Comments:** Preferred media: acrylics. Teaching: MFA, Houston, 1958-67; Univ. Houston, 1967-. **Sources:** WW73.

STOUT, Virginia Hollinger (Mrs.) *[Painter] b.1903, New Hope, PA.*
Addresses: Coronado, CA. **Studied:** PAFA. **Member:** Penn. SMP; San Diego Art Gld.; Brooklyn SMP. **Exhibited:** Penn. SMP, 1938 (medal); PAFA, 1938 (medal). Awards: PAFA Fellowship. **Work:** PMA; U.S. District Court, Trenton, NJ. **Sources:** WW53; WW47.

STOUT, William *[Lithographer] b.1825, England.*
Addresses: Philadelphia, 1860. **Sources:** G&W; 8 Census (1860), Pa., LV, 536.

STOUT, William *[Listed as "artist"] b.c.1811, Ohio.*
Addresses: NYC, 1850. **Sources:** G&W; 7 Census (1850), N.Y., XLVIII, 380.

STOUT, William Cill *[Engraver and artist] b.1820, NYC.*
Addresses: NYC, 1840- at least 1868. **Comments:** He was a son of James DeForest Stout. In 1868 he was granted letters of administration for his father's estate. Of Stout & Hegeman (see entry) in 1859-60. He later moved to California. **Sources:** G&W; Stout, *Stout and Allied Families,* 181; NYCD 1849; NYBD 1851-60; Barber, "Index of Letters of Administration of New York County, 1743-1875"; 7 Census (1850), N.Y., XLI, 827.

STOUT & HEGEMAN *[Engravers] mid 19th c.*
Addresses: NYC, 1859-60. **Comments:** Partners were William C. Stout and George Hegeman (see entries). **Sources:** G&W; NYBD 1859-60, CD 1859.

STOUT & HYATT *[Engravers] mid 19th c.*
Addresses: NYC, 1850-52. **Comments:** Partners George H. Stout and Jacob Hyatt (see entries). The partnership ended with Stout's death in February 1852. **Sources:** G&W; NYBD and CD 1850-51.

STOUTENBURGH, Emily Maverick See: **MAVERICK, Emily**

STOVALL, Luther McKinley (Lou) *[Printmaker] b.1937, Athens, GA.*
Addresses: Washington, DC. **Studied:** RISD; Howard Univ. (B.F.A.). **Exhibited:** Prints & Posters, CGA, Du Pont Center, Wash., DC, 1969-71; Johns Hopkins Center Advanced Int. Study, Wash., DC, 1970-71; Atlantic Christian College, NC, 1972; Frostburg College, MD, 1972; Traveling Exh. Prints & Posters, Balt. Mus. Art, 1972-73. Awards: Sterm grant, 1968-72; individual artist grant, 1972 & workshop grant, 1972, Nat.Endowment Arts. **Work:** Nat. Coll. FA, Smithsonian Inst., Wash., DC; Ringling Mus.; CGA; Wash. Post Co. Commissions: poster, VISTA, Wash., DC, 1969; poster, Peace Corps, Wash., DC, 1970; poster,

Houston MFA, 1970; posters, CGA, 1970 & 1971; "Bikes Have Equal Rights" (poster), DC Dept. Motor Vehicles, Washington Ecol. Center, 1970-72. **Comments:** Positions: dir., Workshop, Inc., 1968-. Teaching: master printmaking & silkscreen workshop, CGA, 1969-72. **Sources:** WW73; "Silkscreen Printmaking" (film), produced on WTOP-TV, 1969; Jay Jacobs, "We Have to Like the Way You Look," *Art Gallery* (March, 1970).

STOVALL, Queena Dillard *[Folk painter] b.1887, Lynchburg, VA.*
Studied: self-taught; briefly with Pierre Daura, Randolph-Macon Woman's College. **Exhibited:** Lynchburg College, 1974 (solo). **Comments:** She painted approx. 45 works, between 1949-67, showing a strong attention to detail and accuracy in the depiction of people. **Sources:** Dewhurst, MacDowell, and MacDowell, 172; Petteys, *Dictionary of Women Artists.*

STOVER, A. *[Landscape painter] late 19th c.*
Addresses: Brooklyn, NY, 1872. **Exhibited:** NAD, 1872; Brooklyn AA, 1873-82. **Comments:** Exhibited works indicate that Stover painted up the Hudson River, to the Adirondacks and Lake George; also on Long Island, the Delaware Water Gap, and even in Holland. **Sources:** *Brooklyn AA.*

STOVER, Adele T. Closs *[Painter] mid 20th c.*
Addresses: San Francisco, CA. **Exhibited:** San Francisco Soc. Women Artists, 1931; Soc. for Sanity in Art, CPLH, 1943. **Sources:** Hughes, *Artists in California,* 539.

STOVER, Allan James *[Painter, illustrator] b.1887, West Point, MS. / d.1967, San Diego County, CA.*
Addresses: Corvallis, OR; San Diego County, CA. **Studied:** Cleveland Sch. Art. **Member:** Calif. WCS. **Exhibited:** S. Indp. A., 1920. **Work:** dec., Masonic Temple, Corvallis. **Comments:** WPA artist. Illustrator: "Oregon's Commercial Forests." **Sources:** WW40; Hughes, *Artists in California,* 539.

STOVER, Carl Marx *[Painter] b.1905, California / d.1975, Santa Rosa, CA.*
Addresses: Santa Rosa, CA. **Exhibited:** Oakland Art Gal., 1933. **Sources:** Hughes, *Artists in California,* 539.

STOVER, Wallace *[Portrait painter, illustrator] b.1903, Elkhart, IN.*
Addresses: Elkhart, IN. **Studied:** Herron AI; W. Forsyth; C. Wheeler; P. Hadley; M. Richards. **Member:** Indiana Artists Club; Hoosier Salon. **Exhibited:** Herron AI, 1925 (prize), 1927 (prize). **Sources:** WW33.

STOW, Bessie Ellis *[Painter] 19th/20th c.*
Addresses: San Francisco, CA; NYC. **Exhibited:** San Francisco Sketch Club, 1894-99. **Sources:** Hughes, *Artists of California,* 539.

STOW, Isabelle *[Painter] 19th/20th c.*
Addresses: Buffalo, NY. **Sources:** WW01.

STOW, John *[Designer] late 18th c.*
Comments: He designed the fire-mark of the Insurance Company of North America, cast iron on wood, Philadelphia, 1774. **Sources:** G&W; Lipmnan, *American Folk Art,* 17, repro. 85.

STOW, Marie Martin *[Portrait painter] b.1831 / d.1920.*
Addresses: Active in Ohio. **Sources:** Petteys, *Dictionary of Women Artists.*

STOWE, Harriet Beecher *[Amateur painter of flowers & landscapes, writer] b.1811, Litchfield, CT / d.1896.*
Studied: Hartford Female Seminary. **Exhibited:** Hartford, 1875. **Work:** Stowe-Day Found. Coll., Hartford, CT. **Comments:** Most famous as the author of "Uncle Tom's Cabin," she also painted in Brunswick, ME, where she lived with her husband, a professor at Bowdoin College. Her mother, Roxana Foote Beecher, was also a painter. **Sources:** Petteys, *Dictionary of Women Artists.*

STOWE, Helen See: **PENROSE, Helen Stowe**

STOWELL, M. Louise *[Painter, illustrator, craftsperson, teacher] 19th/20th c.; b.Rochester.*
Addresses: Rochester, NY. **Studied:** ASL with A.W. Dow. **Member:** Rochester SAC; NYWCC. **Exhibited:** PAFA Ann., 1895-1903; AIC, 1897-1907; AWCS; NYWCC. **Comments:** Specialty: watercolors. **Sources:** WW31; Petteys, *Dictionary of Women Artists;* Falk, *Exh. Record Series.*

STOWELL, Royal *[Painter] early 20th c.*
Addresses: NYC. **Member:** Lg. AA. **Exhibited:** Salons of Am., 1925. **Sources:** WW24; Marlor, *Salons of Am.*

STOWITTS, Hubert (Julian) *[Mural & portrait painter, sculptor, designer, dancer, choreographer] b.1892, Rushville, NE / d.1953, San Marino County Hospital.*
Addresses: Los Angeles, CA. **Studied:** Univ. Calif., 1915; self-taught in art. **Exhibited:** CPLH; LACMA; SAM, 1931 (solo); Brussels Royal Mus., 1932; Boston Mus., 1933; Monterey Peninsula Mus. & LACMA, 1986 (retrospectives). **Work:** portrait, Benito Mussolini, posed at Chighi Palace, Rome. **Comments:** Illustrator: with 60 color plates, "The Work of Stowitts for Fay-Yen-Fah." Toured the world for six years as lead male dancer with Pavlova's Ballet Russe; Folies Bergère, Paris; M.G.M., Hollywood, etc. During his dance career he found time to paint in both oil and tempera. He was especially interested in depicting the people of Java, Bali, India, and gypsy life in Spain. He produced a group of 150 tempera works called "Vanishing India." Despite appearing in a number of movies from 1932-on, he became reclusive, immersed in Hinduism, and eventually died destitute and forgotten. **Sources:** WW40; Hughes, *Artists in California,* 540; Kay McEnroe, article, *California Antiques & Fine Art* (June, 1986, p.19).

STOWMAN, Annette Burr *[Painter] b.1909, Paris, France.*
Addresses: Edgewater, FL. **Studied:** Vassar College (A.B., 1929); ASL, 1956-58. **Member:** Burr Artists (parliamentarian, 1966-); ASL (life member); New Smyrna Beach Artists Workshop (program chmn., 1969-70); Daytona Beach AC; Florida Fed. Art. **Exhibited:** Yorktown Heights Regional Show, NY, 1957; NYC Center Gal., NY, 1961; Nat. Artists Club Exh., 1962; Colorama Gallery, NY World's Fair, 1965; Volusia Co., Florida Regional Show, 1968; Burr Artists, NYC, 1970s. **Awards:** second prize, Yorktown Heights Art Show, 1957; hon. mention, Nat. Artists Club, 1962; equal award, Volusia Co. Art Show, 1968. **Work:** Hickory Art Mus., NC; Greenville (SC) Mus. Art; Tamahassee DAR School, SC; Riveredge Foundation Collection, Canada. **Comments:** Preferred media: oils. Teaching: Dayton Com. College Div. Continuing Educ., 1970-. **Sources:** WW73.

STOZANA, George See: **STOJANA, Gjura**

STRAAT, Kent *[Cartoonist] b.1901 / d.1936.*
Addresses: Westport, CT (1920s-on). **Comments:** Position: advertising illustr., J. Walter Thompson agency, NYC. **Sources:** *Community of Artists,* 93.

STRABALA, Bernard Howard See: **BROTHER ATHANASIUS**

STRACKER, Angella *[Painter] early 20th c.*
Addresses: Phila., PA. **Exhibited:** S. Indp. A., 1926. **Sources:** Marlor, *Soc. Indp. Artists.*

STRAFER, Harriette Rosemary *[Painter, decorator, miniaturist] b.1873, Covington, KY / d.1935, Covington, KY.*
Addresses: Cincinnati, OH. **Studied:** Cincinnati Art Acad.; in Paris with Mrs. MacMonnies, Collin & Courtois. **Exhibited:** SNBA, 1897; Soc. Western Artists; Cincinnati Spring Exh., 1898; PAFA Ann., 1901; ASMP, NYC, 1900s. **Comments:** Married Talbot Mundy. Fink gives birthplace as Cincinnati, OH. **Sources:** WW13; Fink, *American Art at the Nineteenth-Century Paris Salons,* 394; Petteys, *Dictionary of Women Artists;* Falk, *Exh. Record Series.*

STRAHALM, Franz S. (Frank) *[Landscape painter, mural painter, lecturer, teacher] b.1879, Vienna, Austria / d.1935, Dallas, TX.*
Addresses: Mexico City in 1909; San Antonio in 1911; Dallas, TX. **Studied:** Vienna with his father; Hamburg Art School; Italy;

France. **Member:** Alliance; SSAL. **Exhibited:** S. Indp. A., 1925, 1928. **Work:** mural, Mem. Lib., Shreveport, LA; Power & Light Co., Dallas; Little Rock AM; Ney Mus., Austin. **Comments:** Position: teacher/founder, San Antonio School Fine Painting, 1919. **Sources:** WW33; P&H Samuels, 469.

STRAHAN, Alfred W(infield) *[Landscape painter, illustrator] b.1886, Baltimore, MD / d.1965.*
Addresses: Woodlawn, MD. **Studied:** S.E. Whiteman; H. Pennington. **Member:** Charcoal Club. **Exhibited:** Gleason FA, Boothbay Harbor, ME, 1990. **Comments:** Painted scenes along the mid-Atlantic coast and the Chesapeake Bay region. **Sources:** WW40.

STRAHAN, Charles *[Engraver] early 19th c.*
Addresses: Philadelphia, 1818-19. **Sources:** G&W; Brown and Brown.

STRAHAN, Ida Whaley *[Painter] early 20th c.*
Addresses: Montclair, NJ. **Exhibited:** S. Indp. A., 1917. **Sources:** Marlor, *Soc. Indp. Artists.*

STRAHL, Leonard *[Painter] mid 20th c.*
Addresses: Detroit, MI. **Exhibited:** PAFA Ann., 1960. **Sources:** Falk, *Exh. Record Series.*

STRAIDY *[Portrait painter] mid 19th c.*
Addresses: NYC, active c.1845. **Comments:** He is said to have been a jeweler. Possibly the Charles Straede, watchmaker, in NYC directories, 1842-51. **Sources:** G&W; *Art Digest* (Oct. 1, 1932), 16; NYCD 1842-51.

STRAIGHT, Michael *[Collector] b.1916, Southampton, NY.*
Addresses: Washington, DC. **Studied:** Cambridge Univ. (M.A.). **Comments:** Collection: 15-17th c. French and Italian paintings. **Sources:** WW73.

STRAIGHT, Wesley J. *[Painter] 19th/20th c.*
Addresses: San Jose, CA, 1880s; San Bernardino, CA, 1919-22. **Exhibited:** Calif. State Fair, 1880, 1888. **Comments:** Specialty: landscapes and coastal scenes. **Sources:** Hughes, *Artists in California,* 540.

STRAIN, Daniel J. *[Portrait painter] 19th/20th c.*
Addresses: Paris, France; Boston, MA. **Studied:** Académie Julian, Paris with Boulanger & Lefebvre; Jacquesson de la Chevreuse, also in Paris. **Member:** BAC. **Exhibited:** Paris Salon, 1880-82; PAFA Ann., 1883; Boston AC, 1884-86. **Sources:** WW25; Fink, *American Art at the Nineteenth-Century Paris Salons,* 394; Falk, *Exh. Record Series.*

STRAIN, Frances *[Painter] b.1898, Chicago / d.1962, Chicago.*
Addresses: Chicago, IL. **Studied:** AIC with Bellows & Randall Davey; Santa Fe with John Sloan; in Paris c.1921; ASL. **Member:** Un. Am. Artists; Chicago SA; The Chicago Ten. **Exhibited:** Soc. Indep. Artists, 1921-29; AIC, 1923-44; Chicago Romany Club (solo); Chicago Womans AID Club (solo); Kraushaar Gals., NYC, 1928; Newark Mus.; State Mus. New Mexico. **Comments:** Worked for FAP Easel Division, 1936. Married Fred Biesel. **Sources:** WW40; Petteys, *Dictionary of Women Artists.*

STRAIN, Oma Gail (Miss) *[Educator, painter] 20th c.; b.Crawfordsville, IA.*
Addresses: San Jose, CA; San Pedro, CA. **Studied:** State Univ. Iowa (B.A.; M.A.); Grant Wood; Alexander Archipenko. **Member:** Delta Phil Delta; Nat. Educ. Assn.; Pacific AA.; Cincinnati Women's AC; San Jose Art Lg. **Exhibited:** Des Moines; Iowa Artists, 1932; Iowa Fed. Women's Clubs, 1932; Iowa City, 19367 (solo); Iowa Art Salon, 1934; CM, 1943; Cincinnati Women's AC, 1942-44; Oakland Art Gal., 1944; Santa Cruz Art Lg., 1945; San Jose Art Leg., 1946; Haggin Mem. Gal., Stockton, CA; Pomona, CA (solo). **Comments:** Teaching: Drake Univ., Des Moines, IA, 1930-36; Norwood (OH) H.S., 1939-44; San Jose State College, 1944-46; Stockton, CA, 1946-48; Sr. H.S., Los Angeles City Schools, 1948-. Contrib.: *Design, School Arts*

magazines. **Sources:** WW59; WW47; Ness & Orwig, *Iowa Artists of the First Hundred Years,* 202.

STRAIT, C(lara) Barrett (Mrs.) *[Painter] mid 20th c.*
Addresses: Wash., DC, active 1906; Richmond, VA; Black Mountains, NC, 1940s. **Exhibited:** Soc. Indep. Artists, 1917-18. **Sources:** WW19; McMahan, *Artists of Washington, DC.*

STRALEM, Donald S *[Collector, patron] b.1903, Port Washington, NY. / d.1976.*
Addresses: NYC. **Studied:** Harvard Univ., 1924; Cambridge Univ., 1925. **Member:** Fogg Art Mus. (overseers committee). **Comments:** Positions: pres., Palm Springs (CA) Desert Mus. Collection: Impressionists, naifs. **Sources:** WW73.

STRANAHAN, Clara C. Harrison (Mrs.) *[Writer] b.1831, Westfield, MA / d.1905.*
Addresses: Brooklyn, NY. **Comments:** Founder/trustee: Barnard College. Author: "History of French Painting," 1888.

STRANBERG, Helen E. *[Painter] early 20th c.*
Addresses: Chicago. **Exhibited:** AIC, 1923, 1925, 1927. **Sources:** Falk, *AIC.*

STRAND, Paul *[Photographer, cinematographer] b.1890, NYC / d.1976, Oregeval, France.*
Addresses: France (1948-on). **Studied:** Lewis Hine, 1909. **Exhibited:** Stieglitz's "291" Gal., 1916; S. Indp. A., 1917; Anderson Gal. NYC, 1925; Intimate Gal., NYC, 1929; Am. Place, 1945; MoMA, 1945, 1956; Kreis Mus., Germany, 1969; PMA, 1971; MMA, 1998. **Work:** Strand Archive at Center for Creative Phography, Tucson; PMA (large collection); BMFA; MoMA; MMA; Univ. New Mexico; NOMA; Nat. Gal., Wash., DC; Yale Univ. AG; SFMA. **Comments:** One of the primary "straight" photographers of the 20th century, he began his first experiments with abstraction in 1915, and close-ups of machines, 1917-23. From 1919-on he shot landscapes, achitecture, and portraits. From the 1920s-40s, he was also a filmmaker, producing "Manhatta" with C. Sheeler, 1921; and "The Wave" in Alvarado, Mexico, 1933; and he worked on documentary films through WWII. His photographs appeared in Stieglitz's *Camera Work* (1916 & 1917). His photo books include: *Photographs of Mexico* (1920); *Time in New England* (1950); *La France de Frofil* (1952); *Un Paese* (1954); *Tir a'Mhurain* (1962); *Paul Strand: A Retrospective Monograph* (1971). **Sources:** Witkin & London, 246; Baigell, *Dictionary.*

STRAND, Rebecca See: **JAMES, Rebecca Salsbury (Mrs. William H.)**

STRANG, Allen John *[Architect, designer] b.1906, Richland Center, WI.*
Addresses: Madison, WI. **Studied:** G. Harding; H. Sternfeld; Univ. Pennsylvania. **Member:** Madison AA; Wisc. Assn. Arch.; Madison Tech. Club. **Exhibited:** traveling exh., MoMA; AFA; Univ. Penn., 1931 (prize). **Comments:** Contributor: drawings, *Pencil Points, T-Square Club Journal, Architectural Forum, Architectural Record, House & Garden.* **Sources:** WW40.

STRANG, Nora *[Artist] late 19th c.*
Addresses: Active in Addison, MI, 1895. **Sources:** Petteys, *Dictionary of Women Artists.*

STRANG, Ray C. *[Painter, illustrator] b.1893, Sandoval, IL / d.1957, Tucson, AZ.*
Addresses: Weston, CT (1920s); Tucson, AZ (c.1938-on). **Studied:** AIC, 1915 (wounded in WWI, then returned to AIC until 1920); ASL; NY School Fine & Applied Art; SI School. **Comments:** Specialty: cowboy genre and western scenes. **Sources:** P&H Samuels, 469-70; *Community of Artists,* 76.

STRANGE, Edith Grimes *[Painter, educator] late 20th c.*
Studied: Howard Univ. (B.A.); American Univ. (M.A.); Teachers College, Wash., DC. **Exhibited:** Smith-Mason Gal., 1971; CGA; Howard Univ.; Margaret Dickey Gal.; DCAA, Anacostia Neighborhood Mus., Smithsonian Inst. **Work:** U.S. Embassies, Malta & Luxembourg. **Comments:** Specialty: mixed media.

Sources: Cederholm, *Afro-American Artists.*

STRANGE, Emile *[Painter] late 19th c.*
Addresses: Hoboken, NJ. **Exhibited:** AIC, 1892. **Sources:** Falk, *AIC.*

STRANGE, Joseph W. *[Designer, engraver] mid 19th c.*
Addresses: Bangor, ME, 1855-56. **Sources:** G&W; *Maine Register,* 1855-56.

STRANGE, Mil(l)icent *[Painter] 19th/20th c.*
Exhibited: Wash. WCC, 1913-15. **Sources:** McMahan, *Artists of Washington, DC Cf.* Millicent Strange Edson. **Bibliography:** Petteys, *Dictionary of Women Artists.*

STRANGE, William G. *[Landscape painter] late 19th c.*
Addresses: Richmond, VA. **Exhibited:** Richmond, VA, 1877. **Sources:** Wright, *Artists in Virgina Before 1900.*

STRANSKY, Josef *[Patron] b.1875, Czechoslovakia / d.1936.*
Addresses: NYC. **Comments:** After studying music in Leipzig and Vienna, he went to Prague where he was conductor of the Royal Opera from 1898 to 1903. Subsequently, he conducted orchestras in Hamburg, Berlin, and Dresden; he conducted the New York Philharmonic Orchestra from 1911-23. He also studied art, and assembled one of the most comprehensive chronological collections of French art of the 18th, 19th and 20th centuries now in existence. Associated with Wildenstein and Co., since 1924.

STRASBURGER, Christopher *[Sculptor] mid 19th c.*
Addresses: Troy, NY, 1859. **Sources:** G&W; N.Y. State BD 1859.

STRASEN, Barbara *[Sculptor] b.1942.*
Addresses: San DIego, CA. **Exhibited:** WMAA, 1975. **Sources:** Falk, *WMAA.*

STRASSER *[Painter of miniatures on enamel] mid 19th c.*
Exhibited: PAFA, 1847 (as Strosser); Maryland Hist. Soc., 1848 (as Strasser). **Comments:** The only persons of this name listed in Philadelphia between 1846-50 are M. Strasser, tobacconist, and John Strosser, machinist. **Sources:** G&W; Rutledge, PA; Rutledge, MHS; Phila. CD 1846-50.

STRASSER, Edna W. *[Painter] early 20th c.*
Addresses: NYC. **Exhibited:** S. Indp. A., 1934. **Sources:** Marlor, *Soc. Indp. Artists.*

STRASSER, Frederick *[Portrait painter] mid 19th c.*
Addresses: NYC, 1858. **Sources:** G&W; NYBD 1858.

STRASSER, Susan B. *[Sculptor] mid 20th c.*
Exhibited: S. Indp. A., 1943. **Sources:** Marlor, *Soc. Indp. Artists.*

STRASSER, William *[Painter] early 20th c.*
Addresses: NYC. **Exhibited:** S. Indp. A., 1919. **Sources:** Marlor, *Soc. Indp. Artists.*

STRATER, Henry *[Painter] b.1896, Louisville, KY / d.1987.*
Addresses: NYC; Ogunquit, ME. **Studied:** ASL; PAFA with Arthur Charles & Charles Grafly; Acad. Julian, Paris, 1918; Acad. Grande Chaumière, Paris; École M. Denis, Paris with Edouard Vuillard; Acad. San Fernando, with Sorolla; Ignacio Zuloaga in Spain. **Member:** Salons of Am.; Portland Soc. Art; Louisville AA; Princeton Arch. Soc.; Players Club; Louisville AC; College AA; Ogunquit AA (pres., 1946-48); Soc. Four Arts; Palm Beach AI. **Exhibited:** Salon Automne, Paris, 1922; Salons of Am., 1925-36; Whitney Studio Club Portrait Exhib., 1926; BM Watercolor Ann., 1926; S. Indp. A., 1926, 1928-29; Corcoran Gal. biennials, 1930-43 (5 times); PAFA Ann., 1932-41 (6 times); IBM Gal. Science & Art, GGE, San Francisco, 1939 (second prize),1940; Soc. Four Arts, 1947 (third prize for oil); Norton Gal. Art, 1960 (first prize for drawing); Frank Rehn Gal., NYC, 1970s. **Work:** oils, Speed Mem. Mus.; Kentucky Mus.; Louisville, KY; Hamilton Easter Field Found. Collection, NY; Montross Gal., NYC; PMA; Art Mus. Princeton Univ., NJ; Detroit IA; CAM, St. Louis & Butler IA, Youngstown, OH. **Comments:** A painter from 1920-50, he is best known as the founder (in 1952) and director of the Museum of Art of Ogunquit, ME. Publications: illustrator, "14 Cantos,

Ezra Pound," Three Mountains Press, Paris, France, 1923; contributor, "Living American Art," 1935-1937; author, "24 Drawings by Henry Strater," Anthoenson Press, 1958; editor, "Henry Strater," 1962; editor, "Henry Strater, New Paintings," Frank Rehn Gal., 1967. **Sources:** WW73; Edward F. Fry, foreword, *H. S.* (1962); Sarah Landsdell, "An Adventure in Color," *Courier-Journal Sun Illus. Magazine,* 1965; Betty Chamberlain, "Henry Strater; Form and Adventure;" Falk, *Exh. Record Series.*

STRATHEARN, Robert P. (Bert) *[Painter, etcher, cartoonist] b.c.1875, probably Ventura County, CA.*
Addresses: California in 1968. **Work:** Nat. Cowboy Hall of Fame. **Comments:** Cartoonist: *Los Angeles Times; Express.* Specialty: cowboy genre. Began producing etchings, oil paintings and watercolors c.1935. **Sources:** P&H Samuels, 470.

STRATON, Warren B. *[Painter] early 20th c.*
Exhibited: Salons of Am., 1934. **Sources:** Marlor, *Salons of Am.*

STRATTON, Alza (Mrs. Alza Stratton Hentschel) *[Painter, designer, teacher, commercial artist, illustrator, lecturer, writer] b.1911, Lexington, KY.*
Addresses: Burlington, KY. **Studied:** Univ. Kentucky (A.B.); NAD; Cincinnati Art Acad. with W.E. Hentschel. **Member:** Prof. Artists Cincinnati; Cincinnati Woman's Art Club; SSAL; AAPL; PBC. **Exhibited:** Art All., NY, 1930 (prize); CM; Syracuse MFA, 1944; Cincinnati Crafters, 1954 (prize); Woman's Art Club, 1950 (prize). **Work:** IBM; mural, Guiguot Theatre, Iroquois Polo Club, Lexington, KY; Western & Southern Life Ins. Bldg., Cincinnati (in collab. with W.E. Hentschel). **Comments:** Designer: stage sets, textiles, furniture. Teaching: Cincinnati(OH) Art Acad., to 1948; asst. to W.E. Hentschel, mural painting, 1948-. **Sources:** WW59; WW47.

STRATTON, Dorothy (Dorothy Stratton King) *[Painter, printmaker] 20th c.; b.Worcester, MA.*
Addresses: La Jolla, CA. **Studied:** Pratt Inst. (cert., 1942); Brooklyn Mus. School, NY, 1942-43; Univ. Calif., Los Angeles Summer School, 1956 & 1957, with Rico Lebrun; Univ. Calif., Los Angeles, 1961; Univ. Calif., San Diego, 1966-67. **Member:** Artists Equity Assn. (publicity committee, 1946-50); Westwood AA (life member; pres., 1956-57); Arts Council, Univ. Calif., Los Angeles (fine arts committee rep., 1957-62); La Jolla Mus. Art (registrar & membership secretary, 1964-65; chmn. art reference library, 1966-70); Fine Arts Soc. & Art Guild Committee, Fine Arts Gal. San Diego (chmn. art guild committee, 1963-66; vice-chmn., 1972-). **Exhibited:** Pasadena (CA) Art Mus., 1959 (solo), La Jolla (CA) Mus. Art, 1962 (solo) & Tunisian Committee Cut Coop. U.S. Info Service, Tunis, 1965 (solo); Art In Embassies Program, 10 countries, 1965-72; Calif. Soc. PM Nat., Richmond AC, 1972. Awards: first prize West Comp., Motorola, Inc., 1962; first purchase prizes, Regional Exhib., Southwestern College, 1963; Kogo Time-Life Awards & first purchase prizes, Art Guild Exh., FA Gal. San Diego, 1963. **Work:** Long Beach (CA) Mus. Art; Tunisian Ministry Cultural Affairs, Tunis; Los Angeles Munic. Art Collection, City Hall; Art In Embassies Permanent Collection, Dept. of State, Washington, DC; Southwestern College, Chula Vista, CA. **Comments:** Positions: miniature set decorator, George Pal Prod., 1945-46; gallery receptionist & ed. publicity, Munic. Art Dept., Los Angeles, 1952-61. **Sources:** WW73.

STRATTON, Ernest Hapgood *[Painter] early 20th c.*
Addresses: Boston, MA. **Sources:** WW24.

STRATTON, F. *[Painter] early 20th c.*
Addresses: Indianapolis, IN. **Comments:** Affiliated with Herron AI. **Sources:** WW25.

STRATTON, Grace Hall *[Craftsman, designer, teacher] b.1877, Cambridge, MA.*
Addresses: Boston, MA. **Studied:** BMFA School. **Member:** Boston Soc. Arts & Crafts. **Comments:** Position: instructor, Boston (MA) Sch. Occupational Therapy, 1936-46; designer of embroideries and restorer of antique textiles. **Sources:** WW59; WW47.

STRATTON, Howard Fremont *[Painter, teacher] b.1861, Salem, OH / d.1936.*
Addresses: Phila., PA. **Studied:** PM School IA (member of the first class graduated). **Exhibited:** PAFA Ann., 1878, 1881-91. **Comments:** Teaching: PM School IA, c.1880-1921. **Sources:** Falk, *Exh. Record Series.*

STRATTON, Mary Chase Perry (Mrs. Wm. H.) *[Ceramicist] b.1867, Hancock, MI. / d.1961.*
Addresses: Detroit, MI, 1893- past 1900. **Studied:** Univ. Mich.; Wayne Univ.; Cincinnati AI; Detroit Mus. Art School; in NYC. **Member:** Detroit SAC; Detroit Soc. Women P&S (charter mem.); Boston SAC; Detroit Mus. Art Founders Soc. **Exhibited:** Detroit Art Club, 1895; AIC, 1920 (prize); Charles Gergus Binns medal, 1947 (most outstanding contrib. to ceramic indus.). **Work:** mosaic/tile dec., Dudley Peter Allen Mem. Art Mus., Oberlin, OH; Shrine of the Immaculate Conception, St. Matthews Church, Wash., DC; St. Patrick's Church, Phila.; House of Hope Presbyterian Church, St. Paul; Union Cathedral, Detroit; Detroit AI; Cranbrook Mus., Bloomfield Hills, MI; Freer Gal., Wash., DC. **Comments:** Painted portraits & figures on canvas and ceramic tiles. Co-founder with Horace J. Caulkins of the Pewabic Pottery Co., Detroit, c.1903. Well-known for experiments with iridescent and lustre glazes. **Sources:** WW40; Gibson, *Artists of Early Michigan,* 195; Petteys, *Dictionary of Women Artists.*

STRATTON, Mattie E. *[Artist] early 20th c.*
Addresses: Active in Los Angeles, 1903-15. **Sources:** Petteys, *Dictionary of Women Artists.*

STRATTON, William Buck *[Architect] b.1865, Ithaca, NY.*
Addresses: Detroit, MI. **Studied:** Cornell Univ. **Member:** AIC; Detroit SAC; Detroit Mus. Art Founders Soc.; Scarab Club. **Sources:** WW40.

STRATTON, William D. *[Designer, engraver, draftsman] d.1892.*
Addresses: Boston, 1850 & after. **Exhibited:** Boston Athenaeum, 1859-60; Boston AC, 1874. **Sources:** G&W; Swan, BA; Boston CD 1850-60+.

STRATTON, William F. *[Engraver, writing instructor] mid 19th c.*
Addresses: Boston, active c.1827-44. **Comments:** He was listed as an engraver from 1827-33, as proprietor of a writing academy 1836-37, 1839, and again as an engraver 1841-44. **Sources:** G&W; Boston CD 1827-44.

STRAUB, Elizabeth *[Sculptor, teacher] b.1910.*
Addresses: NYC. **Member:** Clay Club NY. **Sources:** WW40.

STRAUCHEN, Edmund R. *[Illustrator] b.1910.*
Addresses: Cincinnati, OH. **Comments:** Illustrator: *Cincinnati Enquirer, Times-Star, Hygeia, Methodist Book Concern, The Arts, American Red Cross.* **Sources:** WW40.

STRAUS, Ada Gutman *[Painter] early 20th c.*
Addresses: Baltimore, MD. **Sources:** WW25.

STRAUS, Gustav (Mrs.) See: **BLOCH, Julia (Mrs. Gustav Straus)**

STRAUS, (Malcolm) Mitteldorfer *[Painter, illustrator, decorator, designer] b.1880, Richmond, VA / d.1936.*
Addresses: Richmond, VA. **Studied:** ASL of Wash.; Europe; Africa. **Member:** AWCS; SI; NYWCC. **Exhibited:** S. Indp. A., 1917. **Sources:** WW47.

STRAUS, Meyer *[Landscape painter, scenic artist] b.1831, Bavaria, Germany / d.1905, San Francisco, CA.*
Addresses: Ohio; New Orleans, active 1869-72; Chicago, IL; San Francisco, CA, 1875-1905. **Exhibited:** Wagener's and Meyer's, New Orleans, 1869; World's Fair, New Orleans (hon. men.); San Francisco AA annuals; Mechanics' Inst. Fairs; Bohemian Club, San Francisco; Calif. State Fair, 1891 (medal). **Work:** Oakland Mus.; Soc. Calif. Pioneers; Sierra Nevada Mus., Reno. **Comments:** Immigrated to the U.S. around 1848 and became a citizen in 1890. After working as a scenic artist in the South for a few years, he settled in San Francisco and continued theater work until 1877, when he started devoting full time to fine art painting. He took sketching trips to Yosemite, Marin County, the Monterey Peninsula and Oregon. His Pacific coast scenes were sold at auction in New Orleans, 1891. **Sources:** *Encyclopaedia of New Orleans Artists,* 366; Hughes, *Artists in California,* 540.

STRAUSER, Dorothy (Mrs. Sterling) *[Painter, craftsperson, collector] early 20th c.*
Addresses: East Stroudsburg, PA. **Studied:** George J. Keller, Bloomsburg State Teachers College. **Exhibited:** Everhart Mus.; Burliuk Mus.; Bertha Schaeffer Gallery; Frank Lee Gallery. **Comments:** Specialty: hooked rug pictures. Married Sterling Strauser (see entry) in 1928. She and her husband were important collectors and supporters of folk art. **Sources:** info. courtesy James S. Sittig, Shawnee-on Delaware, PA.

STRAUSER, Sterling Boyd *[Painter, collector] b.1907, Bloomsburg, PA / d.1995, East Stroudsburg, PA.*
Addresses: East Stroudsburg, PA. **Studied:** George Keller; Bloomsburg State College. **Member:** Folk Art Soc. Am. **Exhibited:** Salons of Am., 1934; Art USA, NYC, 1958; Everhart Mus., 1958 (award); Munic.l Art Gal., Davenport, IA, 1959; Lehigh Univ., 1961; William Penn Mus., Harrisburg, PA, 1973; Worthington Ave. Gal.; Zimbalist Gal., NYC; Worthington Ave. Gal., Shawnee-on Delaware, PA, 1990s. **Work:** Cheekwood Mus., Nashville, TN; Everhart Mus; Lehigh Univ.; Vanderbilt Univ.; Am. Mus. in Britain, Bath, England; Allentown Art Mus.; Cigna Mus., Phila.; East Stroudsburg Univ. Coll. Art; Randolph-Macon College; The White House, Wash., DC. **Comments:** Expressionist artist. With his wife Dorothy, he was also collector and promoter of American folk art. Position: teacher, Mt. Pocono schools; office manager, boilerworks, East Stroudsburg, PA, until 1962. Illustrator: *Unicorn-A Magazine of Poetry,* 1940, *Mademoiselle,,* 1956. He painted in his spare time and took many sketching trips into the Pocono Mountains with his wife. He was friend to, and influenced many painters, and was called "The Great Momentalist" by David Burliuk (see entry). His friend and biographer Jim Sittig describes him as a "Romantic American Expressionist." **Sources:** info. courtesy James S. Sittig, Shawnee-on Delaware, PA.

STRAUSS, Arvid *[Painter] mid 20th c.*
Addresses: Chicago area. **Exhibited:** AIC, 1951. **Sources:** Falk, *AIC.*

STRAUSS, Betty *[Painter] b.1905, NYC.*
Addresses: NYC/Paris, France. **Studied:** Columbia; L. Kroll, at NAD; ASL; Lhote & L. Gottlieb in Paris. **Member:** NAWPS; Int. Assn. Women P&S; Studio Guild. **Exhibited:** Salons of Am., 1934. **Sources:** WW40.

STRAUSS, Carl Sumner *[Etcher, illustrator, painter] b.1873, Jamaica Plain, MA.*
Addresses: Grisons, Switzerland. **Studied:** BMFA Sch. with F. Benson and E. Tarbell; Koehler; Académie Julian, Paris, 1896-97. **Member:** Chicago SE; FA Soc., Florence, Italy. **Exhibited:** Black & White Int. Exh., Florence, 1914 (prize). **Work:** etchings, Uffizi Gal., Florence; Dresden and Munich Cabinet of Prints; Nat. Gal. Modern Art, Rome; Mun. Art Gal., Milan; Hamburg and Bremen Kunsthallen; art coll. of King of Italy; Kunsthaus, Zurich; Kunsthaus-Chur, Grisons; NGA. **Comments:** Illustrator: 20 colored etchings to be used as illustrations for "The Marble Faun," pub. Limited Editions Club, NY. **Sources:** WW40.

STRAUSS, Charles Earl *[Cartoonist, commercial artist, teacher] b.1911, Jeffersonville, IN.*
Addresses: Frenchtown, NJ. **Studied:** Oberlin College (A.B.); Chicago Acad. FA; ASL with Rudolph Weisenborn; Grande Chaumière, Paris, France. **Comments:** Teaching: Grand Central Sch. Art; Frenchtown (NJ) Pub. Schs.; NY Sch. Visual Arts. Contributed cartoons to *Saturday Evening Post, Boys Life, New York Journal American, New York Times,* and others. **Sources:** WW59.

STRAUSS, Glenn Vernon [Landscape painter] b.1870, Baxton, IL.
Addresses: Crawfordsville, IN/Gibson City, IL. **Studied:** AIC.
Exhibited: AIC, 1896-1901. **Sources:** WW08.

STRAUSS, Joseph [Painter] mid 20th c.
Studied: ASL. **Exhibited:** S. Indp. A., 1936. **Sources:** Marlor, Soc. Indp. Artists.

STRAUSS, Malcolm A. [Illustrator, portrait painter, writer] b.1883, NYC / d.1936.
Addresses: NYC. **Comments:** Illustrator: covers for magazines & commercial advertising art. Author of books on fiction. **Sources:** WW01.

STRAUSS, Morris See: **STRAUSS, Moses (or Morris)**

STRAUSS, Moses (or Morris) [Lithographer] mid 19th c.
Addresses: Boston, 1853-56. **Sources:** G&W; Boston CD 1853-54 as Moses, 1855 as Morris; BD 1855-56.

STRAUSS, Raphael [Portrait painter] b.1830, Bavaria, Germany / d.1901.
Addresses: Cincinnati, active 1859-97. **Studied:** Munich.
Member: Cincinnati AC. **Exhibited:** AIC, 1897. **Work:** Cincinnati Art Mus.; Univ. Kentucky Art Mus., Lexington.
Comments: Began painting steamboats in an Eastern city. Came to Cincinnati, OH in 1859, where he painted portraits for over thirty years and had a studio with John Aubery (see entry) for almost 20 years. Strauss painted children and many of the leading citizens of Cincinnati. **Sources:** G&W; Cincinnati CD 1859-97; WW01; *Cincinnati Painters of the Golden Age*, 104-105 (w/illus.); Jones and Weber, *The Kentucky Painter from the Frontier Era to the Great War*, 66 (w/repro.).

STRAUTHER, D. H. See: **STROTHER, David Hunter**

STRAUTIN, Wally (Miss) [Portrait painter, mural painter] b.1898.
Addresses: NYC. **Studied:** Cooper Union. **Member:** Un. Am. Artists; S. Indp. A. **Exhibited:** S. Indp. A., 1929-44. **Sources:** WW40.

STRAUTMANIS, Edvins [Painter] b.1933.
Addresses: Chicago, IL. **Exhibited:** WMAA, 1968. **Sources:** Falk, *WMAA*.

STRAVINSKY, Theodore [Painter] mid 20th c.
Exhibited: AIC, 1941. **Sources:** Falk, *AIC*.

STRAWBRIDGE, Anne West (Miss) [Painter, writer] b.1883, Phila., PA / d.1941, Abingdon, PA.
Addresses: Phila., PA. **Studied:** W.M. Chase; PAFA. **Member:** Plastic Club; Phila. Art All.; Soc. Independent Artists. **Exhibited:** PAFA Ann., 1909, 1912, 1920-22, 1926; Soc. Independent Artists, 1924-26; Phila. Sesquicentenn. Expo, 1926. **Comments:** Author: *Dawn After Danger* (1934), and *The Black Swan* (1935). **Sources:** WW40; Petteys, *Dictionary of Women Artists;* Falk, *Exh. Record Series.*

STRAWBRIDGE, Edward Richie [Painter] b.1903, Philadelphia, PA.
Addresses: Norristown, PA; Philadelphia, PA. **Studied:** Univ. Virginia; PM School IA; T. Oakley; C. Hawthorne at Cape Cod School Art; PAFA, Chester Springs; R. Miller. **Member:** Phila. Art All.; AWCS; SC; Phila. Sketch Club; Phila. WCC; Palo Alto AC; NYWCC; Germantown AL; Provincetown AA; Soc Western Artists. **Exhibited:** PAFA Ann., 1930-32, 1941-43; Palo Alto (CA) Art Club, 1933; NAD, 1942; Buck Hill AA, 1936; Newport AA, 1933, 1934; Provincetown AA, 1939; Benjamin West Soc., 1936; Phila. Art All., 1937, 1944; McClees Gal., Phila., 1939. **Work:** Phila. WCC; Univ. Penn. **Comments:** Preferred media: oils, watercolors. **Sources:** WW73; WW47; Falk, *Exh. Record Series.*

STRAWBRIDGE, Margaret La Rue [Painter] b.1919, Merion.
Addresses: Merion, PA/Cape Cod, MA. **Studied:** G.T. Gemberling. **Member:** Phila. Print Club. **Exhibited:** Phila. Print

Club, 1935 (prize), 1936 (prize), 1938 (prize). **Sources:** WW40.

STRAWN, Melvin Nicholas [Painter, sculptor, designer, teacher, serigrapher] b.1929, Boise, Idaho.
Addresses: Oakland, CA; Cherry Hills Village, CO. **Studied:** Chounaird AI; Los Angeles Co. AI; Jepson AI; Calif. College Arts & Crafts (B.F.A. & M.F.A.); Rico Lebrun; Richard Haines; Leon Goldin. **Member:** San Francisco AA; Nat. Ser. Soc.; Bay PM (co-director); I-25 Artists All.; College AA Am. **Exhibited:** Nat. Ser. Soc., 1954, 1955; SFMA, 1954; Am. Color Pr. Soc., 1955; Ball State Teachers College, 1955; LOC, 1955; Bay PM, 1955; Oakland AM, 1951, 1952, 1954; Richmond AC, 1953, 1955; Calif. State Fair, 1952, 1954; Am. Painters Exh., France, 1954-55; Boise Art Gal., 1950 (solo); Labaudt Gal., San Francisco, 1951; CPLH, 1952; Texas Western College, 1953; Gray Shop, Oakland, 1953; Gump's, San Francisco, 1954; Colorado State Univ. Centennial Exh., 1970 (first purchase award); Cedar City Nat., Utah, 1972; I-25 Artists All., Colorado Springs FAC, 1972. **Work:** Oakland AM; Antioch College; Colorado State Univ. Commissions: environmental design (sculpture), Ottawa College, KS, 1972. **Comments:** Preferred media: oils. Teaching: art instructor, Midwestern Univ., Michigan State Univ., Antioch College & Univ. Denver, 1956-72; chmn. art dept., Antioch College, 1966-69; director, school art, Univ. Denver, 1969-. **Sources:** WW73.

STRAYER, Paul [Illustrator] b.1885, Park Ridge, IL.
Addresses: Living in Illinois in the 1940s. **Studied:** AIC.
Exhibited: AIC, 1918. **Work:** murals, Marshall Field, Chicago.
Comments: Illustr.: Houghton Mifflin, Doubleday, etc.; Western covers for Street & Smith; "Fighting Caravans" by Zane Grey, *Country Gentleman Magazine.* **Sources:** P&H Samuels, 470.

STREAN, Maria Judson (Mrs.) [Miniature painter] b.1865, Washington, PA / d.1949, Pittsburgh, PA.
Addresses: NYC; Pittsburgh, PA. **Studied:** ASL with Cox & Weir; Paris with Prinet & Dauchez. **Member:** ASMP; AWCS; Penn. SMP; All. Artists Am.; NAWA; NYWCC. **Exhibited:** PAFA Ann., 1902-03, 1916-18, 1925; Boston AC, 1905; Cragsmoor, NY, 1917; Penn. SMP, 1921 (medal); Salons of Am., 1929, 1934; NAWA, 1930 (prize); ASMP, 1902, 1939 (prize); Pan-Am. Expo, Buffalo, 1901 (prize); Calif. SMP, 1932 (prize); AIC. **Work:** MMA; BM; PMA; Swarthmore College. **Sources:** WW47; Falk, *Exh. Record Series.*

STREAT, Thelma Johnson [Portrait painter, designer, graphic artist] b.1912, Yakima, WA.
Addresses: San Francisco. **Studied:** Portland AM School, 1934-35; Univ. Oregon, 1933-36. **Member:** San Francisco AA.
Exhibited: de Young Mus., 1941; Raymond & Raymond Galleries, NYC, 1942; SFMA; Am. Contemp. Gal., 1943; Little Gal., Beverly Hills, CA, 1943; AIC, 1943; Am. Negro Expo, Chicago, 1940; South Side Com. AC, Chicago, 1945; Newark Mus., 1971. **Work:** MoMA. **Comments:** WPA artist. **Sources:** WW40; Cederholm, *Afro-American Artists.*

STREATFEILD, Josephine [Portrait painter] b.1882, London.
Addresses: NYC. **Studied:** Slade School, London, with F. Brown. **Member:** Phila. PC; Soc. Women Artists, London; Alliance. **Comments:** Specialties: pastel and oil portraits; copies of old paintings. **Sources:** WW33.

STREATOR, Harold Arthur [Painter] b.1861, Cleveland, OH / d.1926.

H.A STREATUR

Addresses: Cleveland, OH; Pasadena, CA (since c.1919).
Studied: ASL; BMFA Sch. **Member:** SC, 1906. **Exhibited:** AIC, 1898, 1900, 1902; PAFA Ann., 1900-01, 1910, 1912. **Sources:** WW25; Falk, *Exh. Record Series.*

STRECKER, Herman *[Sculptor, naturalist, author] b.1836, Philadelphia, PA / d.1901, Reading, PA.*
Comments: His first work as a sculptor was done when he was but twelve years old. One of his best known works was the Soldiers' Monument at Reading. He devoted his leisure to the study of zoology and butterflies, and published several works on the latter subject. His collection of butterflies numbered more than 300,000. **Sources:** G&W; *Art Annual*, IV, obit.

STREET, A. W. *[Painter] late 19th c.*
Addresses: Chicago. **Exhibited:** AIC, 1891. **Sources:** Falk, *AIC*.

STREET, Agnes *[Painter] early 20th c.*
Addresses: Chicago, IL. **Exhibited:** AIC, 1914. **Sources:** WW17.

STREET, Austin *[Portrait & landscape painter] b.c.1824, District of Columbia.*
Addresses: Phila., PA. **Exhibited:** Artists' Fund Soc.; PAFA Ann., 1843-61, 1876. **Comments:** He was a son of Robert Street. Semon states that his name was Austin Del Sarto Street and that he was born in 1829. **Sources:** G&W; 7 Census (1850), Pa., LIII, 199; Rutledge, PA; PAFA, Vol. II; Phila. CD 1849-60+; Semon, "Who was Robert Street?".

STREET, Claude Lorrain *[Portrait painter] b.1834, Philadelphia?.*
Comments: He was a son of Robert Street, and was painting professionally in 1858. **Sources:** G&W; Semon, "Who Was Robert Street?"; 7 Census (1850), Pa., LIII, 460; Phila. BD 1858.

STREET, Eleanor Conger *[Painter] early 20th c.*
Addresses: Chicago. **Exhibited:** AIC, 1904. **Sources:** Falk, *AIC*.

STREET, Frank *[Illustrator, painter, teacher] b.1893, probably Kansas City, MO / d.1944, Englewood, NJ.*

FRANK STREET

Addresses: Leonia, NJ. **Studied:** ASL; H. Dunn School Illustration with C. Chapman. **Member:** SI; SC; Woodstock AA. **Comments:** Work appeared in *Saturday Evening Post, Collier's, Cosmopolitan, Ladies' Home Journal.* **Sources:** WW40; P&H Samuels, 470; Woodstock AA.

STREET, Franklin *[Listed as "artist"] b.c.1814, Pennsylvania.*
Addresses: Philadelphia, 1850. **Sources:** G&W; 7 Census (1850), Pa., LV, 398.

STREET, Naomi Scudder *[Painter, block printer, decorator, designer, teacher] b.1803, Huntington, LI, NY.*
Addresses: Huntington, LI, NY. **Studied:** ASL. **Member:** NAWPS; Brooklyn Soc. Modern Artists. **Exhibited:** S. Indp. A., 1931. **Sources:** WW40.

STREET, Reuben C. See: **STREET, Rubens**

STREET, Robert *[Portrait, histori-cal, religious & landscape painter, collector] b.1796, Germantown, Philadelphia, PA / d.1865.*

By R.STREET 1833

Addresses: Philadelphia (c.1815-on). **Exhibited:** PAFA, 1815-61; Wash., DC, 1824; Artists' Fund Hall, Phila., 1840 (over 200 of his own paintings and "old masters"). **Work:** Montclair AM; Delaware AM. **Comments:** Primarily a portraitist, most of his career was spent in Philadelphia. In 1824, his star rose when he painted a portrait of Andrew Jackson in Wash., DC. Of his six children by three wives, at least four were artists: Austin, Claude L., Rubens C., and Theophilus (see entries). **Sources:** G&W; Street, *The Street Genealogy*, 378; death date courtesy the late William Sawitzky; Semon, "Who Was Robert Street?"; Karolik Cat.; 7 Census (1850), PA; Cowdrey, AA & AAU; Phila. BD 1838-53; Anderson, "Intellectual Life in Pittsburgh: Painting," 291; *300 Years of American Art*, vol. 1, 115.

STREET, Rubens *[Portrait painter] b.1826, Philadelphia?.*
Addresses: Philadelphia, active 1840s. **Exhibited:** Artist's Fund Soc., 1840s; PAFA, 1840s. **Comments:** He was a son of Robert Street. Semon gives his full name as Rubens Correggio Street. In 1850 he was living with his father. **Sources:** G&W; Semon, "Who Was Robert Street?"; 7 Census (1850), Pa., LIII, 406; Rutledge, PA; Stauffer, no. 423.

STREET, S. P. (Miss) *[Painter] mid 19th c.*
Addresses: Richmond, VA. **Exhibited:** Fair of the Mechanics Inst., Richmond, 1858 (hon. men.). **Sources:** Wright, *Artists in Virginia Before 1900.*

STREET, Sarah Wilson *[Painter] b.1912, Wilmington.*
Addresses: Wilmington, DE. **Studied:** Wilmington Acad. Art; Corcoran Sch. Art; Geo Wash. Univ.; Sarah Lawrence College; ASL; G. Derujinsky; P. Mangravite. **Member:** AC, Wilmington. **Exhibited:** Wilmington Soc. FA (prize); PAFA Ann., 1939; AC, Wilmington. **Sources:** WW40; Falk, *Exh. Record Series.*

STREET, Theophilus *[Portrait painter] b.c.1829.*
Addresses: Philadelphia, active 1850. **Comments:** He was a son of Robert Street, and living with his father in 1850. **Sources:** G&W; 7 Census (1850), Pa., LIII, 460; Semon, "Who Was Robert Street?".

STREETER, Donald (Davis) *[Block printer, craftsperson, drawing specialist, illustrator, lithographer] b.1905, Vineland.*
Studied: PM Sch. IA; PAFA; ASL. **Member:** Phila. Print Club. **Exhibited:** Phila. Print Club, 1932 (prize). **Comments:** Illustrator: "I'm Sorry if I have Offended" and "Other Sob Ballads," by Clarence Knapp. **Sources:** WW40.

STREETER, Julia Allen (Mrs. George L.) *[Painter] b.1877, Detroit.*
Addresses: Baltimore, MD/Green Lake, NY. **Studied:** Detroit Art School with J. Gies & F.P. Paulus. **Member:** Baltimore WCC; Baltimore Indep. AA; Arundell Club. **Exhibited:** Baltimore Charcoal Club, 1924 (prize). **Sources:** WW33.

STREETER, Leander R. *[Miniature painter] mid 19th c.*
Addresses: Baltimore & Richmond, 1835; Lowell, MA, 1848-61. **Comments:** After 1848 he was listed as "agent." This is probably Leander Richardson Streeter, born August 1812 at Haverhill (MA), son of the Rev. Sebastian Streeter, later minister of the First Universalist Church of Boston. **Sources:** G&W; Lafferty (as Streeler); *Richmond Portraits;* Lowell BD 1848, CD 1849-61; Streeter, *Genealogical History of the Descendants of Stephen and Ursula Streeter,* 129-30.

STREETER, Muriel *[Painter] b.1934.*
Addresses: Bridgewater, CT. **Exhibited:** Corcoran Gal. biennial, 1947; WMAA, 1949. **Sources:** Falk, *Exhibition Records Series.*

STREETER, Tal *[Sculptor] b.1934, Oklahoma City, OK.*
Addresses: Millbrook, NY. **Studied:** Univ. Kansas (B.F.A.; M.F.A.); Colorado Springs FAC with Robert Motherwell; Colorado College; Seymour Lipton, three years. **Exhibited:** American Sculpture, Sheldon Mem. Art Gallery, Lincoln, 1970; P&S Today, Indianapolis Mus. Art, 1970; Cool Art & Highlights of the Season, Larry Aldrich Mus., Ridgefield, CT, 1970; Red Line in the Sky: Tal Streeter's Kites, Univ. Kansas Mus. Art, Lawrence, 1972; Outdoor Sculptors Indoors, Storm King AC, Mountainville, NY, 1972; WMAA; A. M. Sachs Gal. NYC, 1970s; Lippincott Large-Scale Sculpture, North Haven, CT, 1970s. **Awards:** State Univ. NY Int. Studies grant, Japan, 1969; Fulbright professorship, Korea, 1971. **Work:** MoMA; SFMA; Wadsworth Atheneum, Hartford, CT; Nat. Coll. FA, Smithsonian Inst., Wash., DC; Smith College MA. **Commissions:** sculpture, Arkansas AC, Little Rock; two sculptures, Great Southwest Park, Atlanta, GA; sculpture, Sheldon Mem. Art Gal., Lincoln, NE; Sculpture in Environment, NYC Parks Dept.; sculpture, Hong-Ik Univ., Seoul, Korea. **Comments:** Preferred media: steel. Publications: co-author, "Seymour Lipton, The Sculptor's Way," 1961 & author, "Kite: Red Line in the Sky," 1972, Univ. Kansas Mus. Art; author, "Red Line to the Sky: Notebook for a Contemporary Monument," *Space Design,* 1971; author, "Japan's Flying Art: Kites," Weatherhill/Lippincott, 1972. Teaching: visiting artist, Fairleigh Dickinson Univ., Madison Campus, 1962; visiting artist-in-resi-

dence, Dartmouth College, 1963; visiting artist, Univ. North Carolina, Greensboro, 1972-73. **Sources:** WW73; Mark Sadan, "Sculpture Song," (film biography), Film-Makers Coop, 1966; E. Amel, "New York City's Endless Column," *Space Design,* 1970; Joseph Love, "Dolmens in the Vast Field of a Domed Sky," Minami Gallery, 1971.

STREETMAN, Christine Norman (Mrs. Sam, Jr.)
[Sculptor, decorator, designer] b.1903.
Addresses: Houston, TX. **Studied:** MFA School, Rice Inst., Houston; NY School Interior Dec.; Texas State College for Women. **Exhibited:** Houston Artists Exh., 1938; So. Texas Artists Exh., MFA, Houston. **Comments:** Specialty: design ornaments. **Sources:** WW40.

STREETOR, W. Day *[Painter] 19th/20th c.; b.St. Louis, MO.*
Addresses: NYC, 1895; Oakwood, NY. **Studied:** St. Louis Sch. FA; Académie Julian, Paris with J.P. Laurens & Constant. **Exhibited:** NAD, 1895; PAFA Ann., 1899, 1902. **Sources:** WW01; Falk, *Exh. Record Series.*

STREETT, Tylden Westcott *[Sculptor, educator] b.1922, Baltimore, MD.*
Addresses: Baltimore, MD. **Studied:** Johns Hopkins Univ.; St John's College; Maryland Inst. College Art (B.F.A. & M.F.A.) with Sidney Waugh & Cecil Howard; also asst. to Lee Lawrie. **Member:** NAA; Artists Equity Assn. **Exhibited:** CGA, 1960; Baltimore MA, 1969; Phoenix Gals., Balt., 1970s. **Awards:** Rinehart traveling fellowship, 1953; Louis Comfort Tiffany Found. Award, 1956; John Gregory Award, 1962. **Work:** Commissions: arch. sculpture, Kirk-in-the-Hills, Bloomfield Hills, MI, 1957; arch. sculpture (with Lee Lawrie) West Point, NY, 1958; arch. sculpture, Wash., DC Cathedral, 1959, Roland Park Presbyterian Church, 1959 & Kuwait Embassy, Wash., DC, 1965. **Comments:** Publications: author, "Plaster Casting Using a Waste Mold" (film), 1970. Teaching: Maryland Inst. College Art, Balt., 1959-60s; Jewish Community Center, Balt., 1963-65. **Sources:** WW73.

STREIGHT, Howard *[Landscape painter] b.1836, Brown County, OH / d.1912, San Jose, CA.*
Addresses: Chicago, IL; Denver, CO, 1870-90; Mountain View, CA, 1890-1912. **Exhibited:** San Diego, 1895. **Work:** Stanford Mus.; Nat. Gallery, London; Denver Pub. Lib. **Comments:** Teaching: Chicago Female College. In Colorado, he turned to landscapes and painted many scenes for the Kansas Pacific Railroad. His very detailed mountain scenes often include glowing sunsets. His best-known work is the "Cross on the Mountain." **Sources:** Hughes, *Artists in California,* 540.

STREMANT, Ida Louise *[Painter] early 20th c.*
Addresses: NYC. **Exhibited:** S. Indp. A., 1926-27. **Sources:** Marlor, *Soc. Indp. Artists.*

STRENGELL, Marianne *[Designer, designer, decorator, teacher] b.1909.*
Addresses: Bloomfield Hills, MI. **Studied:** Atheneum, Helsingfors, Finland. **Exhibited:** Triennale, Milan, Italy, 1933 (gold); Cranbrook Mus.; traveling exhs., AFA & MoMA. **Work:** Nat. Mus., Stockholm; City Hall, Helsingfors. **Comments:** Specialty: textile design. Teaching: Cranbrook Acad. Art. **Sources:** WW40.

STRESAY, Mathilde *[Painter] early 20th c.*
Exhibited: Salons of Am., 1934. **Sources:** Marlor, *Salons of Am.*

STRETCH, Lillian R. *[Painter] early 20th c.*
Addresses: Seattle, WA. **Sources:** WW24.

STRICKER, Rosamond *[Craftsperson, painter] mid 20th c.*
Addresses: Portland, OR. **Exhibited:** Portland Art Mus., 1935; San Francisco AA, 1938. **Sources:** Hughes, *Artists of California,* 540.

STRICKLAND, Charles Hobart *[Painter] late 19th c.; b.New York.*
Studied: Académie Julian, Paris with Bouguereau & T. Robert-

Fleury, 1882-90. **Exhibited:** Paris Salon, 1886-91, 1893. **Sources:** Fink, *American Art at the Nineteenth-Century Paris Salons,* 394.

STRICKLAND, Fred *[Landscape painter, wood carver] b.1880, England / d.1956, Portland, OR.*
Addresses: Portland, OR. **Work:** St. Mark's Church, Portland. **Comments:** Immigrated to the U.S. in 1905. Teaching: Benson Tech., Portland, OR, 27 years. **Sources:** WW24; Hughes, *Artists in California,* 540.

STRICKLAND, George *[Landscape and architectural draftsman, portrait painter] b.1797, Philadelphia / d.1851, Washington, DC.*
Addresses: Lancaster, OH, 1817; active Washington, DC, late 1830s-51. **Studied:** his brother, William Strickland. **Exhibited:** PAFA, 1814 (scene from Scott's *Marmion*), 1826 (sepia drawings of Philadelphia scenes, then being engraved for Childs' *Picturesque Views.*). **Comments:** He was a younger brother of William Strickland (see entry), under whom he studied drawing, painting, and engraving. Unsuccessful in his attempt to become an architect, he taught drawing for a while at the Franklin Institute, but sometime in the 1830s moved to Washington and became a Patent Office clerk. **Sources:** G&W; Gilchrist, *William Strickland,* 1, 137; Rutledge, PA; *Analectic Magazine,* XI (1818), opp. 23; *Portfolio* (June 1946), 232; *American Collector* (March 1941), 7; letter, A.R. Johnson, Congressional Cemetery, to Miss Anna Wells Rutledge, December 22, 1952 (NYHS files). Hageman, 122.

STRICKLAND, James *[Painter, sculptor] late 20th c.; b.Detroit.*
Studied: Accad. Di Belle Arte, Rome; Acad. Grande Chaumière, Paris. **Comments:** Specialty: mixed media. **Sources:** Cederholm, *Afro-American Artists.*

STRICKLAND, Lilly Teresa *[Artist] late 19th c.*
Addresses: Active in Detroit. **Studied:** Maud Mathewson. **Exhibited:** Mathewson studio exh., 1893. **Sources:** Petteys, *Dictionary of Women Artists.*

STRICKLAND, Phyllis Alba *[Painter] b.1915, Portland, OR.*
Addresses: San Francisco, CA; Detroit, MI, 1956. **Studied:** Chouinard AI; Art Center Sch., Los Angeles; S. Bell; R. Munsell. **Member:** Laguna Beach AA. **Exhibited:** P&S Ann., Portland Mus., 1939; Soc. for Sanity in Art, CPLH, 1940; Laguna Beach AA. **Comments:** Daughter of Fred Strickland (see entry). **Sources:** WW40; Hughes, *Artists in California,* 540.

STRICKLAND, Thomas J *[Painter] 20th c.*
Addresses: Miami, FL. **Studied:** Newark (NJ) School Fine & Indust. Arts; Am. Art School & Nat. Acad. Fine Arts, NYC, with Robert Philip. **Member:** Grove House, Miami; Hollywood (FL) Arts & Crafts Guild; Miami AC; Miami Palette Club. **Exhibited:** Metrop. Young Artists First Ann., 1958 & AAPL, 1958 & 1961, Nat. Arts Club; Butler IA Fine Arts Festival, Youngstown, OH, 1963; Seventh Grand Prix Int. Peinture Cote d'Azur, Cannes, France, 1971; Art Show Temple Beth Am, Miami, 1972. **Awards:** Digby Chandler Prize, Knickerbocker Artists Exh., 1965; first prize, Hollywood Arts & Crafts Guild Ann. Mems. Art Exh., 1972; first prize, Seven Lively Arts Festival Circle Art Show, Hollywood, 1972. **Sources:** WW73.

STRICKLAND, William *[Architect, engraver, painter, draftsperson] b.1788, Navesink, NJ / d.1854.*
Addresses: Philadelphia, 1809-45; Nashville, TN, 1845-54. **Member:** PAFA (dir., 1819-46). **Comments:** Strickland was apprenticed in 1803 to the architect Benjamin H. Latrobe, with whom he remained about two years. After a season of scene painting at the Park Theatre in NYC, Strickland began his independent career as an architect in Philadelphia in 1809, though for a number of years he supplemented his income by surveying, engraving, and painting. His first important architectural commission came in 1818, the 2nd Bank of the United States, and many others followed during the next two decades. Although he employed vari-

ous styles, Strickland is generally associated with the Greek Revival in America. He visited Europe with his family in 1838, making many watercolor sketches which have been preserved. In Nashville (TN) and was engaged as architect of the Tennessee State Capitol there until his death. **Sources:** G&W; Gilchrist, *William Strickland, Architect and Engineer, 1788-1854,* contains the best account of his life, a checklist of his work, and many illustrations. See also: DAB; Stauffer; Stokes, *Iconography,* pl. 80; Rutledge, *PA.*

STRICKLER, J. R. *[Painter] late 19th c.*
Addresses: Brooklyn, NY, 1886. **Exhibited:** NAD, 1886. **Sources:** Naylor, *NAD.*

STRICKLER, Jacob *[Fraktur painter] b.1770, Shenandoah County, VA / d.1842, Shenandoah County.*
Addresses: Shenandoah County, late 18th-early 19th c. **Sources:** Wright, *Artists in Virgina Before 1900.*

STRIDER, Marjorie Virginia *[Sculptor] b.1935, Guthrie, OK.*
Addresses: NYC. **Studied:** Kansas City (MO) Art Inst.; Oklahoma Univ. (B.F.A.). **Exhibited:** AFA Traveling New York Show, 1966; Park College, Kansas City, 1968 (solo); WMAA, 1970; Collage of Indignation II, New York Cultural Center, 1971; Hoffman Gallery, New York, 1973 (solo). **Work:** Albright Knox Mus., Buffalo, NY; Larry Aldrich Mus., NY. **Comments:** Preferred media: plastics. Publications: author, "Moving Out-Moving Up," *Art News,* 1/1971; author, "Radical Scale," *Art & Artists,* 1/1972; illustrator & contributor, "Modern American Painting & Sculpture," Abrams, 1972. Teaching: School Visual Arts, New York, 1968-; Univ. Iowa, summer 1970; Univ. Georgia, summer 1972. **Sources:** WW73; M. Kirby, chapter, I *The Art of Time* (1969) & L. Lippard, chapter, *Conceptual Art* (1972), Dutton; M. Compton, chapter, *Movements of Modern Art,* Hamlyn, 1970.

STRIDER, Maurice *[Painter, educator, photographer] b.1913, Lexington, KY.*
Studied: Fisk Univ. (A.B.); Univ.Kentucky (M.A.; Southern Educ. Found. Fellowship); Univ. Cincinnati; Southern Univ. **Exhibited:** Fisk Univ., 1934; Atlanta Univ. (John Hope Purchase Award); Morehead State Univ., 1970; CI, 1971; Southern Illinois Univ., 1972; Illinois State Univ., 1973. Awards: Goode Publishing Co. Award, Texas; Chicago *Defender* Award, 1973. **Work:** Atlanta Univ.; Fisk Univ.; Univ. Massachusetts. **Sources:** Cederholm, *Afro-American Artists.*

STRIEBEL, John Henry *[Cartoonist, illustrator] b.1892 / d.1962.*
Addresses: Woodstock, NY. **Studied:** A. Dasburg; H.L. McFee. **Member:** Woodstock AA. **Work:** Woodstock AA. **Comments:** Illustrator: "Show Girl" (in Liberty); "Chicago Tribune"; "Dixie Dugan" (comic strip for McNaught Syndicate). Creator: "Pantomime Strip," syndicated by Associated Ed., Chicago. **Sources:** WW40; addit. info. courtesy Woodstock AA.

STRIEBY, George F. W. *[Fresco & decorative painter] b.1841, Gruenstadt, Germany.*
Addresses: NYC; Wash., DC, 1860 & after. **Comments:** Came to the U.S. in 1853. He worked as an apprentice with Emmerick Carstens in Wash., DC and participated in the decorating work at the Capitol before and after the Civil War. He later had his own firm. **Sources:** McMahan, *Artists of Washington, DC.*

STRIETMANN, William Hurley *[Painter] b.1880, Ohio / d.1941, Piedmont, CA.*
Addresses: Oakland, CA. **Studied:** Univ. Cincinnati, College of Medicine. **Exhibited:** Bohemian Club, 1940. **Comments:** A physician, he painted landscapes in his spare time. **Sources:** Hughes, *Artists in California,* 541.

STRIFFLER, Albert Christian *[Landscape painter] b.1861 / d.1818.*
Addresses: Brooklyn, NY.

STRIKER, Kenneth (Louis) *[Painter, printer, advertising designer] b.1908, St. Louis, MO.*
Addresses: Seattle, WA. **Studied:** Univ. Wash. **Member:** Northwest PM. **Sources:** WW32.

STRIMPPLE, Olga Maria Jorgensen (Mrs. Thorwood) *[Painter, batik artist] b.1896, Kennard, NE.*
Studied: Chicago Acad. FA; with Augusta Knight. **Exhibited:** Nebraska Artists, Omaha; Chicago Coliseum, 1923. **Sources:** Petteys, *Dictionary of Women Artists.*

STRINGER, Addison M. *[Sketch artist] late 19th c.*
Addresses: New Orleans, active 1880-87. **Sources:** *Encyclopaedia of New Orleans Artists,* 366.

STRINGER, Mary Evelyn *[Educator] b.1921, Huntsville, MO.*
Addresses: Columbus, MS. **Studied:** Univ. Missouri (A.B.); Univ. North Carolina (A.M.); Harvard Univ. (traveling fellowship, 1966-67) with Ernst Kitzinger. **Member:** College Art Assn.; Medieval Acad.; Int. Center Medieval Art; Southeastern College Art Conf. **Exhibited:** Awards: Fulbright scholarship, 1955-56; Danforth Found. teacher study grant, 1959-60 & 1964-65. **Comments:** Publications: author, "Review of Andrew Martindale," *Gothic Art,* 1969; author, "Composite Nativity-Adoration of English Medieval Alabasters," *NC Mus. Art Bulletin,* 1970. Teaching: Mississippi State College Women, 1947-. **Sources:** WW73.

STRINGFIELD, Vivian F. *[Painter, illustrator, craftsperson, teacher] b.c.1882, California / d.1933, Los Angeles, CA.*
Addresses: Pasadena, CA, 1918; Los Angeles through 1933. **Studied:** Hopkins AI; Pratt Inst.; D. Donaldson; R.H. Johonnot. **Member:** Southern Calif. Art Teachers Assn.; Boston SAC; Chicago AG. **Exhibited:** Pan-Calif. Expo, San Diego, 1915 (medal); Battey Gal., Los Angeles, 1918; LACMA, 1918 (solo), 1919 (solo); P&S Los Angeles, 1920, 1926. **Comments:** Teaching: Pasadena, 1918-. **Sources:** WW33; Hughes, *Artists in California,* 541.

STRINGHAM, H. Hollingsworth *[Painter] early 20th c.*
Addresses: NYC. **Exhibited:** Salons of Am., 1934; S. Indp. A., 1934. **Sources:** Falk, *Exhibition Record Series.*

STRISIK, Paul *[Painter] b.1918, Brooklyn, NY.*
Addresses: NYC/Rockport, MA.
Studied: ASL with Frank Vincent Dumond. **Member:** Rockport AA (pres., 1968-72); ANA; AWCS; Allied Artists Am.; Knickerbocker Artists. **Exhibited:** annually, AWCS, NAD, Allied Artists Am. & other nat. shows. Awards: bronze medal of honor, Nat. Arts Club, 1970; best in show, AAPL Grand Nat., 1972; Obrig Prize, NAD, 1972. **Work:** Parrish Mus. Art, Southampton, NY; Percy H. Whitney Mus., Fairhope, AL; Mattatuck Mus., CT; Utah State Univ.; Union Carbide & Chemical Coll. **Comments:** Preferred media: oils, watercolors, acrylics. Primarily a painter of the New England landscape, particularly that of Vermont and Maine, Strisik worked in many other locations in this country and abroad, including Monhegan Island (ME). Publications: author, "Watercolor Page," *Am. Artist,* 4/1970; author, *The Art of Landscape Painting,* Watson-Guptill, publisher. **Sources:** WW73; Curtis, Curtis, and Lieberman, 173, 186.

STROBEL, Louisa Catherine *[Amateur miniature painter] b.1803, Liverpool, England / d.1883, NYC.*
Comments: She was of American parents, and was brought to the United States for the first time in 1812, but from 1815-30 she lived in Bordeaux (France), where her father was American Consul. Miss Strobel studied miniature painting in Bordeaux, but apparently never worked professionally. After her return to America in 1830, she married the Rev. Benjamin Martin who had charges in Washington, New Hampshire, Albany (NY), and after 1852 in NYC, where Mrs. Martin died. **Sources:** G&W; Information courtesy Mrs. Wilson Noyes of Savannah (GA), who cites the Carolina AA and an article on Mrs. Martin by her son,

Dr. Daniel Strobel Martin, read at an Educ.l Assoc. in Albany after her death (copy at Carolina AA).

STROBEL, Max [Topographical draftsman] mid 19th c.
Addresses: Active in 1853 in St. Paul & in the Rockies.
Comments: He served briefly as artist of the Stevens Pacific Railroad Survey of 1853 and later the same year joined Frémont's expedition. He made a number of sketches in Minnesota, including a view of St. Paul in 1853. **Sources:** G&W; Taft, *Artists and Illustrators of the Old West*, 273; Stokes, *Historical Prints*, pl. 85a; P&H Samuels, 470-71.

STROBEL, Oscar A. [Painter, lithographer, illustrator, educator, decorator, writer] b.1891, Cincinnati, OH / d.1967.
Addresses: Scottsdale, AZ. **Studied:** Duveneck; Rabes; Henri; Herrman; Munich & Berlin, Germany. **Exhibited:** Texas Expo, 1930 (prize). **Work:** Austin Club, Security Trust Bank, Austin, TX; German Embassy, Wash., DC; Valley Bank & Trust Co., Phoenix, AZ; murals, Westward Ho Hotel, Phoenix, AZ; San Marcos Hotel, Chandler, AZ; Greyhound Bus Depots, Phoenix, Flagstaff, AZ; San Diego, CA; Reno, NV. **Comments:** Teaching: Judson School, Phoenix, 1940. Artist, Brown & Bigelow Calendars. **Sources:** WW59; WW47; P&H Samuels, 471.

STROBEL, Thomas C [Painter, graphic artist] b.1931, Bellemeade, TN.
Addresses: Barrington Hills, IL. **Studied:** AIC (B.F.A.); Univ. Chicago; private study in Germany. **Member:** Chicago Art Club; North Shore AC; Evanston AC. **Exhibited:** Albright-Knox Art Gal., Buffalo, NY, Worcester (MA) Mus. Art; CMA; Walker AC, Minneapolis, MN; AIC, 1965. Awards: gold medal, *Chicago Sun Times*, 1960; Fulbright Award painting, Düsseldorf, Germany, 1960-61; Graham Found. grant, 1968-69. **Work:** State Art Acad., Germany; Krannert Mus., Univ. Illinois; AIC; Int. Minerals & Chemical Corp.; IBM Coll. **Comments:** Teaching: Northwestern Univ., Evanston, IL. **Sources:** WW73.

STROBRIDGE, Hines [Engraver and/or lithographer] mid 19th c.
Addresses: Cincinnati, 1856-60 and after. **Comments:** He was with Middleton, Wallace & Co., 1856-58; Middleton, Strobridge & Co., 1859-64; Strobridge, Gerlacher & Wagner, 1864-67; and Strobridge & Co., 1867-? **Sources:** G&W; Cincinnati CD 1856-60; Peters, *America on Stone*.

STROCK, John Montgomery [Painter] d.1932.
Exhibited: Gloucester SA. **Comments:** Impressionist painter specializing in marine scenes; active in Boston and Gloucester, 1919-30. **Sources:** PHF files.

STRODE, (Catherine) Joane (Mrs. Blakley) See: **CROMWELL, Joane Strode (Mrs. J. C. Christian)**

STROH, Earl [Artist] mid 20th c.
Exhibited: PAFA Ann., 1958. **Sources:** Falk, *Exh. Record Series*.

STROHL, Clifford (Harrison) [Painter] b.1893, South Bethlehem.
Addresses: Bethlehem, PA. **Studied:** J. Dieudonne; O.G. Wales; PAFA. **Sources:** WW25.

STROHM, Gusta R. [Painter] late 19th c.
Addresses: Active in Beatrice, NE, 1888. **Comments:** Said to have painted first homestead in the U.S. **Sources:** Petteys, *Dictionary of Women Artists*.

STROM, Gustaf Adolf [Painter] b.1872, Sweden.
Addresses: Chicago, IL. **Exhibited:** AIC, 1902-11. **Sources:** WW13.

STROM, Nils [Painter] b.1905, Sweden.
Addresses: NYC. **Studied:** ASL. **Exhibited:** Morgan Gal., NY, 1939; Vendome Gal., NY, 1940 (solo). **Work:** "Commonsense," "The Nation". **Sources:** WW40.

STROMBOTNE, James [Abstract painter] b.1934, Watertown, SD.
Addresses: Laguna Beach, CA. **Studied:** Pomona College (B.A.);

Claremont Grad. School (M.F.A.). **Exhibited:** WMAA, 1959-63; CI, 1964; AFA, 1964; New School Social Res., NYC, 1964, 1968; Corcoran Gal. biennial, 1967. Awards: Honnold traveling fellowship, Pomona College, 1956; Guggenheim fellowship, 1962-63; Tamarind Lithography Workshop fellowship, 1968. **Work:** WMAA; Pasadena AM; CAM; Amon Carter Mus. Western Art; Santa Barbara Mus. **Comments:** Teaching: Inst. Creative Arts, Univ. Calif., 1965-66. **Sources:** WW73.

STROMSTED, Alf(red) J(orgen) [Painter, teacher, graphic artist] b.1898, Loedingen, Norway / d.1979.
Addresses: Summit, NJ. **Studied:** Norwegian Inst. Tech. (E.E.); Annot Art Sch., NYC; Rudolf Jacobi. **Member:** Summit AA; Soc. Indep. Artists, NYC (dir., 1941-43); Soc. Naval Arch. & Marine Engineers; Assoc. Artists New Jersey; Woodstock AA. **Exhibited:** S. Indp. A., 1933-36, 1938, 1941-43; Salons of Am., 1934-36; Corcoran Gal. biennials, 1939, 1941; CI, 1944-46; PAFA Ann., 1944-45, 1949; Pepsi-Cola, 1946; Portland (OR) Art Mus.; BM; Montclair AM; Albright Art Gal.; Artists of Today, Newark, NY, 1944 (prize); Contemp. Art Gal., NY, 1938 (solo); Municipal Art Gal., NY; Stauanger Art Soc., Norway; Museo Nationale, Rio de Janeiro; São Paulo, Brazil; Audubon Artists; Springfield MFA; Newark Mus.; Montclair AM; in traveling exhs. to various colleges; PAFA; NAC, 1953 (prize); State Exhib., East Orange, NJ (prize). **Work:** PAFA. **Comments:** Teaching: Summit AA, New Jersey. **Sources:** WW59; WW47; Woodstock AA; Falk, *Exh. Record Series*.

STRONG, Barbara [Sculptor] mid 20th c.
Exhibited: S. Indp. A., 1938, 1941-42. **Sources:** Marlor, *Soc. Indp. Artists*.

STRONG, Beulah [Painter, illustrator] b.1866, New Orleans, LA.
Addresses: Auburndale, MA, 1894. **Studied:** ASL; Académie Julian, Paris with Lefebvre and Boulanger, 1887-91. **Exhibited:** Boston AC, 1886, 1892; Paris Salon, 1888; SNBA, 1890; NAD, 1894. **Comments:** Illustrated books by Eliza C. Hall. Teaching: Potter College, Bowling Green, KY, 1893-1901; Belmost College, Nashville, TN, 1902-05; Smith College, Northampton, MA, from 1907. Friend of painter Elizabeth Nourse. **Sources:** Fink, *American Art at the Nineteenth-Century Paris Salons*, 394.

STRONG, Charles Ralph [Painter, educator, sculptor] b.1938, Greeley, CO.
Addresses: Cincinnati, OH; Redwood City, CA. **Studied:** Coronado School FA, 1957; San Francisco AI (B.F.A., 1962; M.F.A., 1963); also with Elmer Bischoff, Jack Jefferson, Frank Lobdell & James Weeks. **Exhibited:** Calif. Works of Paper 1950-71, Univ. Art Mus., Berkeley, CA, 1972; Richmond (CA) Art Center, 1969 (solo), Gal. Smith-Anderson, Palo Alto, CA (solo) & Chief Joseph Series, Crown College, Univ. Calif., Santa Cruz, 1972 (solo); Painted Images, Oakland Mus., 1971. Awards: Fulbright fellowship to England, 1964. **Work:** de Saisset Art Gallery, Univ. Santa Clara, CA; Oakland (CA) Mus.; San Francisco AI. **Comments:** Preferred media: acrylics. Teaching: San Francisco State College, 1965-68; Stanford Univ., summer 1970 & 1971; College Notre Dame, CA, 1970-. **Sources:** WW73; WW19.

STRONG, Clara Lathrop [Painter] early 20th c.
Exhibited: Salons of Am., 1926. **Sources:** Marlor, *Salons of Am.*

STRONG, Constance Gill [Painter, teacher] b.1900, NYC.
Addresses: Gary, IN. **Studied:** Pratt Inst.; Univ. Pennsylvania. **Member:** Palette & Pencil Club. **Exhibited:** Lake County Fair, Crown Point, IN, 1926-28 (prize). **Sources:** WW33.

STRONG, Cornelia Adèle See: **FASSETT, Cornelia Adèle**

STRONG, Elizabeth [Painter] b.1855, Hartford, CT. / d.1941, Carmel, CA. E. STRONG
Addresses: Grew up in Oakland, CA; Paris, 1870s; Monterey, CA, early 1880s; Paris, c.20 years; Carmel, CA. **Studied:** San Francisco School Des. with Virgil Williams; Wm. Chase,

Shinnecock School, 1870s; M. Van Marcke, Cabinel, Collin, Paris, 1870s; Jeune Fille School Art, Paris. **Member:** Carmel AA (co-founder, 1927). **Exhibited:** Paris Salons 1883-88; Boston AC, 1885-1907; St. Botolph Club, BBoston, 1890 (solo); PAFA Ann., 1891-97 (4 times); AIC, 1894-95; Calif. Midwinter Expo,1894; Mark Hopkins Inst., 1906; Alaska-Yukon Expo, 1909 (silver medal); Calif. State Fair, 1930; St. Botolph Club, Boston. **Work:** Dartmouth Art Club; Roxbury Hunting Club, Boston; Electric Club, NYC; Ebel Club, Oakland, CA. **Comments:** Specialty: animal paintings. **Sources:** WW40; Hughes, *Artists in California,* 541; *Art by American Women: Selections from the Collection of Louise and Alan Sellars,* 118; Fink, *American Art at the Nineteenth-Century Paris Salons,* 394; Falk, *Exh. Record Series.*

STRONG, George H. *[Engraver on copper & wood] mid 19th c.*
Addresses: Buffalo, NY, 1858-60. **Sources:** G&W; Buffalo BD 1858-60.

STRONG, Howard *[Listed as "artist"] mid 19th c.*
Addresses: Chicago, active 1858-60. **Exhibited:** Chicago Art Union, spring of 1859 (Union's first show). **Sources:** G&W; Andreas, *History of Chicago,* II, 556-57 (citation courtesy H. Maxson Holloway, Chicago Hist. Soc.).

STRONG, Isobel Osbourne See: **OSBOURNE, Isobel**

STRONG, J. P. *[Painter] b.1852 / d.1900.*
Work: Peabody Mus., Salem, MA (marine watercolor). **Sources:** Brewington, 369.

STRONG, John McLaren *[Painter] early 20th c.*
Addresses: Woodstock, NY. **Exhibited:** S. Indp. A., 1917. **Sources:** Marlor, *Soc. Indp. Artists.*

STRONG, Joseph D. *[Landscape and portrait painter] b.1852, Bridgeport, CT / d.1899, San Francisco, CA.*
Addresses: San Francisco, CA, 1879-82; Hawaii, 1882-; Samoa, c. 1890-95; San Francisco, CA, c. 1895-death. **Studied:** Calif. School Des.; with V. Williams (when it opened in 1874); Munich with Piloty & a Mr. Wagner, 1875-79. **Member:** Bohemian Club, San Francisco. **Exhibited:** Royal Acad., Munich, mid-1870s (medal); NAD, 1879; Hawaiian Hotel, Honolulu, 1885, (two-man exh., with Jules Tavernier: views of Hawaiian volcanoes & landscapes). **Work:** Silverado Mus., St. Helena, CA; Bernice P. Bishop Mus., Honolulu; Iolani Palace, Honolulu. **Comments:** Son of a minister and brother of Elizabeth Strong (see entry), he went to the Hawaiian Islands as a boy (before 1859) and in 1859 moved with his family to Oakland, CA. After study in Calif. and Munich he established a good reputation in San Francisco. In 1879 he married artist Isobel Osbourne, the daughter of Fanny Osbourne (see entries), and the couple moved to Honolulu, Hawaii in 1882. He is one of three "old masters" of Hawaii known the Volcano School. There he was greeted with much interest, immediately receiving portrait commissions from important Hawaiian officials. He also executed black-and-white gouache drawings (of the region), which he sent to American and European magazines for illustration, and landscapes which sold well and brought commissions from royal patrons. He painted three monumental works for King Kalakaua — one historical landscape (now in Tokyo) and two views of Honolulu from the Islands (now at the Iolani Palace)--in 1885/86. As the official artist of the Hawaiian Embassy aboard the ship *Kaimiloa* to Samoa in 1887, he produced a number of views which sold very well. About 1890, Isobel and Joseph Strong moved to Samoa, joining Fanny Osbourne and her new husband Robert Louis Stevenson. After the Strongs divorced in the mid 1890s he returned to California. **Sources:** There is some conflict on death date: Hughes, *Artists of California,* 541 (provides death date of April 5, 1899); P&H Samuels, 471 (gives death year as 1900); Forbes, *Encounters with Paradise,* 177-78, 188-89 (gives death year as 1899).

STRONG, Julia E. *[Painter] late 19th c.*
Exhibited: NAD, 1885. **Sources:** Naylor, *NAD.*

STRONG, Katherine J. See: **SUMMY, Katherine J. Strong**

STRONG, Louise *[Artist] late 19th c.*
Addresses: Active in Marshall, MI, c.1883. **Sources:** Petteys, *Dictionary of Women Artists.*

STRONG, M. Louise *[Artist] late 19th c.*
Addresses: Active in Grand Rapids, MI, 1890. **Sources:** Petteys, *Dictionary of Women Artists.*

STRONG, Margt. L. *[Artist] early 20th c.*
Addresses: Active in Washington, DC, 1916. **Sources:** Petteys, *Dictionary of Women Artists.*

STRONG, Peggy *[Painter, teacher] b.1912, Aberdeen, WA / d.1956, Eugene, OR.*
Addresses: Tacoma, WA. **Studied:** Univ. Washington; Sarkis Sarkisian; Frederic Taubes; Mark Tobey. **Member:** Tacoma AA; Women Painters Wash.; San Francisco Soc. Women Artists. **Exhibited:** PAM, 1936-38; SAM, 1936-37, 1938 (prize), 1939 (prize), 1940-47; SFMA, 1937-38; Memphis, TN, 1939 (prize); U.S. Treasury Dept., 1940 (prize); Women Painters Wash., 1942 (prize); West Seattle AC, 1945 (prize); Rockefeller Center, NY, 1938; Nat. Jr. Lg. Exh. 1939; GGE, 1939; VMFA, 1940; San Francisco Soc. Women Artists, 1940; Tacoma AA, 1937, 1947-48; Oakland Art Gal., 1941; Everett Wash., 1943; Cincinnati AM; Frederick & Nelson, Seattle, 1948, 1949 (solo); Univ. Washington, 1950; Rotunda Gal., San Francisco, 1950; All. Artists Gld., Menlo Park, CA, 1949-52. **Work:** SAM; murals, Naval Officer's Club, Dutch Harbor, Alaska; Tacoma Union Depot; USPO, Wenatchee, WA. **Comments:** WPA artist. **Sources:** WW53; WW47.

STRONG, Ray Stanford *[Landscape painter, muralist] b.1905, Corvallis, OR.*
Addresses: Berkeley, CA. **Studied:** C.L. Kellar; Calif. School FA; ASL; F.V. DuMond; F. van Sloun; M. Dixon. **Member:** Soc. Western Artists; Palo Alto AC; Calif. Soc. Mural Artists; Santa Barbara AA; Marin Soc. Artists; ASL, San Francisco; ASL, NY. **Exhibited:** CGA; de Young Mus.; CPLH; Gump's, San Francisco; Maxwell Galleries, San Francisco; PAFA; NAC, 1930 (prize), 1931 (prize). **Work:** NMAA; Lassen, Rainier, White Sands National Parks; Daly City H.S.; College of Marin; mural, Keene Valley Congregational Church, NY; Roosevelt Jr. H.S., San Jose, CA; White House, Wash., DC; USPO, San Gabriel, CA; Decatur, TX. **Comments:** He executed dioramas for the San Diego Expo in 1935 and the GGE of 1939. Position: diorama painter, U.S. Forest Service, 1935-38, National Park Service, 1940-41; educ. director, Northern Calif. Assn. Coops. WPA artist. **Sources:** WW40; Hughes, *Artists of California,* 541-542.

STRONG, Thomas W. *[Wood engraver, lithographer] mid 19th c.*
Addresses: NYC, 1842-51. **Exhibited:** Am. Inst., 1842 (two frames of wood engravings). **Comments:** After 1851 listed as publisher. In 1844-45 he was doing work for the *New York Herald.* **Sources:** G&W; Am. Inst. Cat., 1842; NYBD 1844, 1846, 1848; NYCD 1851-57; Peters, *America on Stone;* Hamilton, *Early American Book Illustrators and Wood Engravers;* Arrington, "Nauvoo Temple," Chapt. 8; *Antiques* (July 1945), 33 *Portfolio* (Aug. 1948), 18.

STRONG, Walter *[Listed as "artist"] b.1822, New York.*
Addresses: NYC, 1850. **Sources:** G&W; 7 Census (1850), N.Y., L, 550.

STRONGITHARM, M. (Miss) *[Painter] late 19th c.*
Exhibited: NAD, 1864-65. **Sources:** Naylor, *NAD.*

STROOBANT, L. *[Lithographer] mid 19th c.*
Addresses: Philadelphia, active 1853-55. **Comments:** Color lithographs for *The Florist and Horticultural Journal,* published in Philadelphia, 1853-55. **Sources:** G&W; McClinton, "American Flower Lithographs," 362.

STROOCK, Barbara *[Sculptor]* mid 20th c.
Studied: ASL. **Exhibited:** S. Indp. A., 1939. **Sources:** Marlor, *Soc. Indp. Artists.*

STROSSER See: **STRASSER**

STROTHER, David Hunter *[Illustrator, portrait & landscape draftsman]* b.1816, Martinsburg, WV / d.1888, Charleston, WV.
Studied: Jefferson College, Phila.; Samuel F.B. Morse in NYC; in France and Italy, 1840-43. **Exhibited:** NAD, 1838, 1853; PAFA Ann., 1855, 1878; Wash. County MFA, Hagerstown, MD, 1998 (drawings). **Comments:** After returning from Europe in 1844 he worked in NYC as an illustrator for various magazines and books. In 1853 he began contributing a series of illustrated articles on Southern life for *Harper's Monthly,* under the pseudonym "Porte Crayon." Many of these were reprinted in a volume entitled *Virginia Illustrated* (1857). After serving in the Union army during the Civil War, he was brevetted brigadier-general. After1865 he resided in Berkeley Springs, WV, where he continued to write for *Harper's.* From 1879-85 he was U.S. Consul-General at Mexico City. **Sources:** G&W; DAB; Willis, "Jefferson County Portraits"; Cowdrey, NAD; Rutledge, PA; PAFA, Vol. II; Rutledge, MHS; obit., Boston *Transcript,* March 9, 1888. More recently, see Bibliography: *Encyclopaedia of New Orleans Artists,* 366; Campbell, *New Hampshire Scenery,* 162.

STROTHER, Joseph Willis *[Painter, instructor]* b.1933, New Orleans, LA.
Addresses: Athens, GA. **Studied:** Louisiana College (B.A.); Univ. Georgia (M.A. & Ed.D.). **Member:** Nat. Art Educ. Assn.; College AA Am. **Exhibited:** Mead Painting of Year, Atlanta, 1961; four shows, Nat. Art on Paper, Greensboro, NC, 1964-69; NC Artist Ann., 1971; Georgia Artist Ann., 1972. **Awards:** purchase award, Chattahooche AA, 1969; award, Ocala Jr. College, 1969; purchase award, NC School Mental Health Extension, Chapel Hill, 1971. **Work:** Chattahooche AA Col.; NC Nat Bank Coll.; Wachovia Bank State Coll.; Georgia Mus.; Dillard Coll., Weatherspoon Gal., Univ. NC, Greensboro. **Comments:** Preferred media: acrylics. Teaching: Marietta (GA) City Schools, 1957-61; Montgomery Conty, MD, 1961-64; Univ. NC, Greensboro, 1964-66; Univ. Georgia, 1966-. **Sources:** WW73.

STROTHMANN, Fred
[Illustrator, cartoonist, painter] *Strothmann.*
b.1880, NYC / d.1958.
Addresses: Flushing, NY. **Studied:** Carl Hecker Art School, NY; Berlin Royal Acad.; Paris. **Member:** SI. **Comments:** Illustrator of books by Mark Twain, Carolyn Wells, Ellis P. Butler, Lucille Gulliver, & others, as well as national magazines. **Sources:** WW53; WW47, which cites a birth date of 1879.

STROUD, Arthur *[Sculptor, marble & stone carver]* b.c.1861, New Orleans, LA / d.1893, New Orleans.
Addresses: New Orleans, active 1880. **Sources:** *Encyclopaedia of New Orleans Artists,* 366.

STROUD, Clara *[Painter, craftsperson, designer, writer, block printer, teacher]* b.1890, New Orleans, LA.
Addresses: Herbertsville, NJ. **Studied:** Pratt Inst. (B.A., 1912; M.F.A., 1915); Gustave Cimiotti (c.1917); Winold Reiss (1919); Jay Hambidge (1921-22); Ralph Johonnot (1921-22); Hilton Leech (winters, 1930s-40s, at Ringling School of Art, Sarasota, FL; also with Stanley Woodward); Eliot O'Hara; Yale Sch. FA. **Member:** NAWPS (secy., 1927-29); NYWCC; AWCS (life mem., 1984); Manasquan River Group of Artists, 1939-on (founding mem.); AAPL (1st vice-chmn., NJ Chapt.); Asbury Park Soc. FA; Sarasota AA; St. Augustine AA; Shore Points Art Guild (founding mem.); Allied Artists of Venice, Florida; NJWCS; Essex (NJ) WCC; Newark Keramic Soc.; Guild of Creative Art (founding mem.,1960). **Exhibited:** Arch. Lg, NYC, 1912 (illuminated page); Handicraft Club of Baltimore at Peabody Inst., 1913 (wall hanging and silk bag); Am. Inst. Architects, 1914 (oils); "Paintings of a Group of NJWomen," Edison Shop, E. Orange, NJ, 1916; Soc.

Independent Artists, 1917, 1919-20; "Long Island Artists," Ardsley Gal, Brooklyn, NY, 1919; Brooklyn Soc. Artists, 1920; Brooklyn WCC at Pratt Inst., 1920-22; Salons of Am., 1922, 1924; Brooklyn Mus., 1923 (int. watercolor exh.), 1925 (int. oil exh.); Arts Club, Wash., DC, 1924; Ringling MA, Sarasota, 1935; Argent Gallery, NYC, 1938; Phila. WCC, 1938; PAFA; Baltimore Mus. Art; with art associations in St. Petersburg, Clearwater, Miami, Venice, St. Augustine, Bradenton, all in Florida (1930s-40s); Rochester Mus.; AAPL, 1939-64 (prizes annually); AWCS, 1940s-60s (prizes); Montclair AM (NJ) 1941, 1946, 1953-54 (prizes); Plainfield AA, 1946; "Sixty Paintings by New Jersey Artists," New Jersey State Mus. (Trenton), c.1953; Stroud Studio Exhs. (summers, 1940s-50s); Rahway AC, 4th Ann. State Exh., 1954; AC of the Oranges, NJ State Show, 1954; Monterey Art Festival (CA) 1960. **Comments:** Critic and contrib. *Keramic Studio News.* Illustr.: covers for *Every Day Art; Craftsman Magazine.* Christmas cards for Raphael Tuck Co., London (and publisher of her own cards, sold through Brentanos and Hartmans in NYC). Teaching: E. Orange (NJ) H.S., 1913-18; Pratt Inst.; Traphagen Sch. Art; Newark Art Sch.; Mabel Weld Studio; Plainfield Sch.l; Delaware State Adult Educ.; Syracuse Univ. College Art; Shore Points Art Guild, 1938. **Sources:** WW59; WW47; *Who's Who of American Women; Who's Who in the East; National Social Directory (1960).*

STROUD, Ida Wells (Mrs.) *[Painter, teacher, ceramicist, craftswoman]* b.1869, New Orleans, LA / d.1944.
Addresses: New Orleans, active 1896-1902; Newark, NJ/Point Pleasant, NJ. **Studied:** Temple Grove Seminary, Saratoga Springs, NY, 1886 (grad); Andrés Molinary in New Orleans, late 1880s; William M. Chase, 1890s; ASL, c.1900; Pratt Inst., c.1900 with A.W. Dow; Anna S. Fisher; Gustave Cimiotti, 1915 (summer); Ossip Linde in Westport (CT), c.1917 (summer); Adelaide Robineau (ceramics) at Syracuse, 1921-24 (4 summers); Henry B. Snell, 1924 (summer); Amagansett Summer Art Sch with Francis W. Swain, 1936. **Member:** New Orleans AA, 1896-97; Manasquan River (NJ) Artists Group, 1932 (founder); NAWA; AAPL, 1939; NYWCC; Newark AC; Essex Co. WCC; Asbury Park Soc. Fine Arts. **Exhibited:** New Orleans AA, 1896-97, 1902; AWCS, 1900s-30s (prizes); AIC, 1914; PAFA; Architectural Lg, NYC; Newark Week Show, Kresge Dept. Store, 1931-42 (prizes); East Orange Pub. Lib., NJ; Pratt Institute, Brooklyn; AAPL, Springlake, NJ, 1939 (prize); Argent Gal., NYC; Montclair AM; Newark AC. **Comments:** Ida Stroud and her daughter, Clara (see entry) were at the forefront of a nationwide movement during the first three decades of the 20th century that helped establish watercolor as a medium uniquely suited to the spirit of American artists. During this period, she was also a highly influential art teacher at the Newark School Fine & Indust Art. An important annual AWCS award — the Ida & Clara Stroud Award — is endowed in their name. Ida was also a highly skilled member of the Arts & Crafts Movement, and produced ceramics with Robineau. Teaching: Newark (NJ) School Fine & Indust. Art; Stroud Studio, Point Pleasant, NJ, 1920-on; prof. of design, Summer Sch of Art, Syracuse Univ., College of Fine Arts, 1921-24 (4 summers). **Sources:** WW40; *Encyclopaedia of New Orleans Artists,* 366-67.

STROUD, Laura D. See: **LADD, Laura D. Stroud (Mrs. Westray)**

STROUD, Peter Anthony *[Painter, educator]* b.1921, London, Eng.
Addresses: New York, NY. **Studied:** Teacher Training College, London Univ.; Centralo Hammersmith Schools Art, 1948-53. **Exhibited:** CI, 1961 & 1964; Guggenheim Mus. Int., 1964; The Responsive Eye, MoMA, 1965; European Painters Today, Jewish Mus., New York, 1968; Max Hutchinson Gallery, NYC, 1970s. **Awards:** Pasadena Mus. fellowship, 1964. **Work:** Tate Gallery, London; Guggenheim Mus., NYC; LACMA; Detroit IA; Pasadena (CA) Art Mus. **Commissions:** murals, Int. Union Arch. Congress Bldg., London, 1961, State School Leverkusen, Germany, 1963 & Manufacturers Hanover Trust Co., New York,

1969. **Comments:** Preferred media: acrylics. Teaching: professor of visual studies, Bennington College, 1963-68; professor of painting, Rutgers Univ. Grad. School, New Brunswick, 1968-. **Sources:** WW73; Lawrence Alloway, Catalog Introduction, *Int. Contemporary Art* (London, 1961); Dore Ashton, "Peter Stroud's Relief-Paintings," *Studio Int.* (1966); John Coplans, "Interview with Peter Stroud," *Artforum* (1966).

STROUD, Richard *[Painter, educator]* b.1940, Tarrytown, NY. **Studied:** NAD; Brooklyn Mus. Sch.; New Sch. Soc. Research; BMFA Sch.;. **Exhibited:** Brandeis Univ., 1969; Studio Mus., Harlem; BMFA, 1970; Gallery 7; Franconia College; Brookline (MA) Pub. Lib. **Comments:** Teaching: De Cordova Mus., Lincoln, MA; Emerson College, Boston; BMFA Sch.; Student Center Art Studio, MIT. **Sources:** Cederholm, *Afro-American Artists.*

STROUD, Thomas *[Listed as "artist"]* b.c.1817, Pennsylvania. **Addresses:** Philadelphia, 1850. **Comments:** The only person with this name listed between 1848-54 is Thomas Stroud, locksmith, in 1851. **Sources:** G&W; 7 Census (1850), Pa., LI, 150; Phila. CD 1848-54.

STROUP, Jon *[Writer]* b.1917, Cleveland, OH. **Addresses:** New York 22, NY. **Comments:** Author: monthly column on current art events and books for *Town and Country* magazine. **Sources:** WW53.

STROUSE, Margaret F. See: **MANN, Margaret Strouse (Mrs.)**

STROUSE, Raphael See: **STRAUSS, Raphael**

STRUBING, Louisa Hayes *[Painter, sculptor, craftsperson]* b.1881, Buffalo. **Addresses:** Eggertsville, NY. **Studied:** Buffalo Albright Art Sch.; R. Reid. **Member:** Buffalo SA; Buffalo AG. **Sources:** WW33.

STRUBLE, Eva E. *[Teacher]* b.Branchville, NJ / d.1932, Bloomfield, NJ. **Comments:** Director of Art, State Normal School, Newark, NJ.

STRUCK, Herman G. *[Landscape painter, illustrator]* b.1887, Wandsbeck, Germany / d.1954, Novato, CA. **Addresses:** Milwaukee, WI; Oregon; Mill Valley, CA. **Studied:** Mark Hopkins Inst. Art; AIC. **Member:** San Francisco AA; Marin Soc. Artists; Soc. Western Artists. **Exhibited:** San Francisco AA, 1924; Oakland Art Gallery, 1928; Gump's, San Francisco; Maxwell Gallery, San Francisco; Santa Barbara Mus. Art; Rouze's Gallery, Fresno; Marin Soc. Artists, 1956; Calif. State Fair, Sacramento, 1930 (prize); 48 States Comp., 1939. **Work:** murals, States Restaurant, San Francisco. **Comments:** Position: illustr., *Sunset Magazine.* **Sources:** WW40; Hughes, *Artists of California,* 542.

STRUDWICK, Clement *[Painter]* b.1900, Columbia, TN. **Addresses:** Hillsboro, NC. **Studied:** ASL with G. Luks; L.F. Biloulle in Paris. **Member:** Southern NAD; NC Prof. Artists Club. **Exhibited:** NC Fed. of Women's Clubs Exh., 1932 (prize). **Sources:** WW40.

STRUNK, Herbert J(ulian) *[Sculptor, painter, graphic artist, designer, craftsperson, illustrator, etcher, cartoonist]* b.1891, Shakopee, MN / d.c.1950. **Addresses:** Narrowsburg, NY. **Studied:** St. Paul AI; with F.E. Triebel. **Exhibited:** St. Paul AI, 1912 (prize), 1915 (prize); Nassau County, NY, 1928 (prize); Rockefeller Center, NYC; Hispanic Mus.; Scranton AM; Am. Art Gal., 1932; Salons of Am., 1932, 1934. **Work:** Eldred & Narrowburg (NY) Sch.; bronze mem., Court House, Monticello, NY. **Sources:** WW47.

STRUNSKY, Bertha B. *[Painter]* early 20th c. **Exhibited:** Salons of Am., 1928, 1930. **Sources:** Marlor, *Salons of Am.*

STRUNZ, William Frazee *[Mural painter]* b.1868, Tom's River, NJ. **Addresses:** Paris, France. **Studied:** Académie Julian, Paris, 1892;

École des Beaux-Arts and Acad. Colarossi, also in Paris. **Member:** Lg. AA, Europe. **Sources:** WW08.

STRUPPECK, Jules (Julius) *[Sculptor, educator, writer]* b.1915, Grangeville, LA. **Addresses:** New Orleans, LA. **Studied:** Univ. Oklahoma (B.F.A.); Louisiana State Univ. (M.A.). **Exhibited:** AFA Traveling Exh., 1941; Bertha Schaefer Gal., 1953; New Orleans AA, 1953 (award); WMAA, 1954; Arch. Lg., 1954; SFMA, 1966. **Awards:** prizes, Gal. Art, Miami, Bertha Schaefer Gal. & Marine Hospital, New Orlean. **Work:** Univ. Oklahoma; Lowe Gal. Art, Miami; Bertha Schaefer Gal.; Marine Hospital, New Orleans; Court House, New Iberia, LA; USPO, Many, LA. **Comments:** Publications: author, "The Creation of Sculpture," Holt, Rinehart & Winston, 1952; contributor, *Design Magazine.* Teaching: Newcomb College, Tulane Univ., New Orleans, LA. **Sources:** WW73; WW47.

STRUSBERG, Julie H. See: **STURSBERG, Julie H.**

STRUSS, Karl *[Photographer, cinematographer]* b.1886, NYC / d.1981. **Addresses:** NYC, through c.1917; Hollywood, CA (after WWI). **Studied:** evening photography classes with Clarence White, Columbia Univ., 1908-12. **Member:** Photo-Secession; Pictorial Photographers of Am. (founded 1916). **Exhibited:** Int. Exh. of Pictorial Photography, Albright Art Gal., Buffalo; 1910; S. Indp. A., 1917. **Comments:** Pictorialist photographer who specialized in NYC subjects. He introduced the technique of multiple platinum printing (see discussion by Homer) which allowed an enhancement of the depths of shadows in the printing process. He also designed a long focal length camera lens (called the Struss Pictorial Lens) that was placed into commercial production in 1915. His photographic work was reproduced in Stieglitz's *Camera Work,* 1912. Struss moved to Hollywood after WWI and became a noted cinematographer. **Sources:** William I. Homer, *Alfred Stieglitz and the Photo-Secession* (Boston, Little, Brown, and Co., 1983), 148-55; Marlor, *Soc. Indp. Artists.*

STRUTHERS, Helen Von L. *[Painter]* early 20th c. **Addresses:** Phila. PA; East Orange, NJ, c.1913. **Exhibited:** PAFA Ann., 1910. **Sources:** WW13; Falk, *Exh. Record Series.*

STRUTHERS, Irva *[Miniaturist]* early 20th c. **Addresses:** Phila. PA. **Exhibited:** Am. Art Soc., 1902 (medal); PAFA Ann., 1902-03. **Sources:** WW04; Falk, *Exh. Record Series.*

STRUVE, Robert L. *[Painter]* b.1864, New Orleans, LA / d.1900, New Orleans. **Addresses:** New Orleans, active c.1881-1900. **Exhibited:** New Orleans AA, 1894. **Comments:** Assisted Antonio R. Bagnetto (see entry) and Harry H. Dressel (see entry) before becoming associated with Robert W. Bohm (see entry) from 1886-1900. They painted scenery for theatres in N.O. and Mobile as well as floats and other artwork for carnival parades. **Sources:** *Encyclopaedia of New Orleans Artists,* 367.

STRUVEN, Gertrude Stanwood (Mrs.) *[Painter, etcher, teacher]* b.1874, West Newbury, MA. **Addresses:** Wilmette, IL (living in Lanesville, MA, 1927). **Studied:** J. DeCamp; E. Major; W. Meyerowitz; T. Bernstein; C. Lasar, in Paris. **Member:** North Shore AA; Gloucester SA; Soc. Indep. Artists. **Exhibited:** Soc. Indep. Artists, 1921. **Sources:** WW40.

STRY, Irene *[Painter]* mid 20th c. **Exhibited:** S. Indp. A., 1937-38. **Sources:** Marlor, *Soc. Indp. Artists.*

STRYKE, Anna Clegg *[Illustrator]* b.1884, Phila. **Studied:** Cornell Univ. **Comments:** Illustrated scientific journals, including "The Spider Book," by J. Comstock; "Handbook of Nature Study." Teaching: Cornell Univ., 1914-15. **Sources:** Petteys, *Dictionary of Women Artists.*

STRYKER, Don *[Painter]* early 20th c. **Addresses:** Grand Rapids, MI. **Member:** Grand Rapids AA; Lg.

AA. Sources: WW24.

STRYKER, Lytiek *[Painter] early 20th c.*
Exhibited: Salons of Am., 1934. Sources: Marlor, *Salons of Am.*

STRYPE, Frederick C. *[Wood engraver] mid 19th c.*
Addresses: NYC, active 1848. Comments: Of Butler & Strype (see entry), also listed as a draftsman. Sources: G&W; NYBD 1848; NYCD 1848.

STUART, Albert F. *[Engraver] b.1824, Pennsylvania.*
Addresses: Philadelphia, 1845-60 and after. Comments: He was a junior partner in Wagner & Stuart (see entry). Sources: G&W; 7 Census (1850), Pa., LIII, 168; 8 Census (1860), Pa., LIV, 617; Phila. CD 1845-60+.

STUART, Alexander Charles *[Marine painter] b.c.1831, Scotland or Poland / d.1898, Chester, PA.*
Work: Atwater Kent Mus., Phila.; Delware Hist. Soc.; BMFA; Mariner's Mus.; Mystic Seaport Mus.; Peabody Mus.; U.S. Naval Acad., Annapolis; Mus. of the City of Mobile, AL. Comments: He was listed in the NYC census in 1860, living with his wife Dora (a Texan) and their two children, aged 2 years and 3 months, who were born in New York. He served in the U.S. Navy, 1863-66, then spent the rest of his life along the Delaware River area (Phila., Camden, Chester, Wilmington) where he painted ship portraits. He worked for shipbuilders, but was also a heavy drinker, and an 1884 newspaper from Eustis (FL) even carried his advertisement as a gynecologist. Signature note: He signed his works simply, "Stuart" and sometimes used a monogram of an anchor conjoined with an S. Sources: G&W; 8 Census (1860), N.Y., XLV, 25; NYCD 1863; A. Peluso, article, *Maine Antique Digest* (Nov. 1989, p.18-C).

STUART, Anne *[Painter] mid 20th c.*
Addresses: Chicago area. Exhibited: AIC, 1948-49. Sources: Falk, *AIC*.

STUART, Catherine Baker *[Painter, teacher] b.1905, Columbus, OH.*
Addresses: Columbus, OH. Studied: A. Schille; Ohio State Univ. Member: Columbus AL; Ohio WCS. Exhibited: Columbus AL, 1928 (prize). Sources: WW40.

STUART, Charles Gilbert *[Landscape, portrait & genre painter] b.c.1785 / d.1813, Boston.*
Exhibited: PAFA, 1811; Boston Athenaeum, 1827. Comments: He was a son of Gilbert Stuart (see entry). Probably a pupil of his famous father, although Dunlap states that Stuart refused to teach his son. Sources: G&W; Morgan, *Gilbert Stuart and His Pupils*, 46-48; Swan, "Gilbert Stuart in Boston," 66; Rutledge, PA; Swan, BA; Flexner, *The Light of Distant Skies*.

STUART, David *[Art dealer, lecturer] b.Scotland, SD / d.1984.*
Addresses: Los Angeles, CA. Studied: Otis AI, Los Angeles. Member: Art Dealers AA. Comments: Positions: dir., David Stuart Galleries. Specialty of gallery: contemporary painting and sculpture; pre-Columbian and African arts. Sources: WW73.

STUART, Donald R. *[Painter] early 20th c.*
Addresses: Brooklyn, NY. Sources: WW25.

STUART, Duncan Robert *[Painter] mid 20th c.*
Addresses: Norman, OK; Raleigh, NC. Exhibited: AIC, 1947; WMAA, 1951-54. Sources: Falk, *Exhibition Record Series*.

STUART, Ellen D. *[Painter] early 20th c.*
Addresses: Texas; Paris, France. Studied: Stuart Hall at Staunton, VA; Chase at NY; Acad. Colarossi and Académie Julian, Paris; König in Holland; Sturm in Dresden. Exhibited: Paris Salon, 1908; Am. Girls Club; British Women's Exh. Sources: WW10; Petteys, *Dictionary of Women Artists*.

STUART, Frederick D. *[Artist, engraver] b.1816, New York.*
Addresses: Washington, DC, after 1850-71. Work: NMAH. Comments: He went on one of the early exploring expeditions to the Pacific Northwest and contributed some illustrations to the

1844 *Narrative of the U.S. Exploring Expedition.* In the 1860 census he was listed as an engraver. In 1862 he was off on another exploring expedition; from 1864-66 he was in the Navy; and from 1867 he was listed as a hydrographer. Sources: G&W; 8 Census (1860), D.C., II, 423; Rasmussen, "Artists of the Explorations Overland," 58; Washington CD 1853-71 (as Stuart or Stewart).

STUART, Frederick G. *[Engraver] mid 19th c.*
Addresses: Boston, 1855. Comments: Of Stuart & Fowler (see entry) Cf. Frederick T. Stuart. Sources: G&W; Boston CD and BD 1855.

STUART, Frederick T. (or I.) *[Engraver, painter] b.1837 / d.1913, Brookline, MA.*
Addresses: Boston, MA/Newton Centre, MA (since 1857). Member: Boston SWCP; Boston AC. Exhibited: Boston AC, 1880-1907; PAFA Ann., 1891 (watercolor landscapes), 1901; AIC. Sources: G&W; *Art Annual*, XI, obit (WW13); Stauffer; Boston CD 1857-60+; 8 Census (1860), Mass., XXVII, 53 (as Stewart); Falk, *Exh. Record Series*. Cf. Frederick G. Stuart.

STUART, Gilbert Charles *[Portrait painter] b.1755, North Kingstown, RI / d.1828, Boston, MA.*
Studied: began painting at an early age, taking lessons from Samual King in Newport about 1761; Cosmo Alexander, 1769-72. Member: Am. Acad.; NAD (hon. mem., 1830). Exhibited: Royal Acad., London; NAD, 1828; PAFA, 1811-28 (and posthumously); Brooklyn AA, 1864, 1872, 1912; Boston AC, 1878. Work: NGA, Wash., DC ("Vaughn Portrait" and "Lansdowne Portrait" of G. Washington); BMFA ("Athenaeum Portrait" of Washington, on deposit from Boston Athenaeum); PAFA (replica ,"Lansdowne Portrait"); Brooklyn Mus (replica ,"Lansdowne Portrait"); White House (replica ,"Lansdowne Portrait"); NPG, Wash, DC; NPG, London; MMA ("Matilda Stoughton de Jaudens" 1794); Athenaeum, Newport, RI. Comments: One of the most important portrait painters of colonial America and the early Republic. In 1769 he met the visiting Scottish artist, Cosmo Alexander (see entry), at Newport, RI, who was convinced by a local doctor to make Stuart (then only fourteen years old) his apprentice. The two worked in Philadelphia (1770-71) and then traveled south in 1771, briefly visiting Williamsburg, VA, and Charleston, SC, before departing for Edinburgh (Scotland). Alexander died suddenly in August 1772 and Stuart was stranded in Edinburgh for a short time, but eventually earned his way back to his Rhode Island home in 1773. For the next two years he painted portraits in Newport but in 1775, just before the colonies claimed independence, he left for London. There he found the competition for society portraits to be heavy and he struggled for several years until he joined the studio of fellow expatriate Benjamin West. From 1777-82 he was both assistant and student in West's studio, focusing his attention on face painting while West worked at his grand history paintings. Stuart also absorbed the lessons he learned from the work of Joshua Reynolds and Gainsborough, developing what would become his own philosophy and working method for portrait making. Setting up his own studio in 1782, Stuart achieved considerable success, earning almost immediate recognition when his full-length "Skater" (1782, NGA) captured great public interest at the Royal Academy showing of 1782. But it was portraiture that Stuart loved and what kept him in high demand in London. Despite his success, he left for Ireland in 1787 when he became embroiled in debt. Living in Dublin, he built up a large and devoted following until debt again drove him out, this time back to the U.S., in 1792. From 1793-94, Stuart worked in NYC and Philadelphia; from 1794-1803 in Germantown, PA; from 1803-05 he was in Washington, DC; in 1805 at Bordentown, NJ; and the rest of his life was spent in Boston. In late 1794, Stuart painted the first of three life portraits of George Washington (these include "The Vaughn" Portrait, 1794-95, reproduced on the American dollar bill; the "Athenaeum" Portrait, 1796; and the full-length "Lansdowne" Portrait, 1796); from these three portraits, he painted 104 known likenesses of the President. In addition to his Washington portraits, other great portraits

include "Mrs. Richard Yates" (1793, NGA) and "Mrs. Perez Morton." Stuart worked without preliminary drawing, painting directly on the canvas and laying in layers of luminous color washes with a loose, slashing brush stroke. The resulting spontaneity and his ability to capture the particular character of the sitter was what made him fashionable and unique in his day. Identification of his portraits painted in Ireland and England, as well as a number of unfinished works, is problematic. **Sources:** G&W; Whitley, *Gilbert Stuart* (1932); and Flexner, *Gilbert Stuart* (1955); Park, *Gilbert Stuart, an Illustrated Descriptive Catalogue* (1926); Morgan, *Gilbert Stuart and His Pupils;* Jane Stuart, "Anecdotes of Gilbert Stuart by His Daughter," *Scribner's Monthly Magazine* (July 1877): 377. More recently, see *Gilbert Stuart: Portraitist of the Young Republic* (exh. cat., Wash., DC: National Gallery of Art, 1967); Baigell, *Dictionary; 300 Years of American Art,* 64-65; Liz Smith, "The Artist as Magpie" *Art & Auction* (May, 1986), p.107; Falk, *Exh. Record Series.*

STUART, James E(verett)
[Landscape painter] b.1852, Dover, ME / d.1941, San Francisco, CA.

Addresses: Chicago, IL; San Francisco, CA. **Studied:** in Sacramento with Wood, 1868-73; San Francisco Sch. Design with V. Williams, R.D. Yelland, Hill & Keith, 1873-78; NYC. **Member:** Soc. Indep. Artists; NAC; Bohemian Club; San Francisco AA; AAPL. **Exhibited:** PAFA Ann., 1894; Am. Art Soc., 1902 (bronze medal); AIC; Soc. Indep. Artists, 1918-19, 1921. **Work:** Kalamazoo (MI) Art Assn.; Michigan State Library; Oregon Hist. Soc.; Joslyn Mem., Omaha; Reno Arts and Crafts Club; Oakdale Public Library; Oakland Mus.; Los Angeles Mus. History, Science & Art; Los Angeles Art Assn.; Southwest Mus., Los Angeles; Municipal Art Commission, Los Angeles; Doheny Library; Univ. Southern Calif., Los Angeles; Calif. State Lib., Sacramento; Crocker Gal., Sacramento; de Young Mus., San Francisco; Golden Gate Park Mus., San Francisco; Bancroft Lib., UC Berkeley; Montana Hist. Soc.; Washington State Hist. Soc.; White House, Washington, DC; Witt Art Lib., London. **Comments:** The grandson of portrait painter Gilbert Stuart (see entry), he is said to have painted more than 5,000 paintings during his long and successful career. After studying in San Francisco, he opened a studio in Portland, OR, from which he took numerous painting excursions. In 1891-92 he opened a studio in Tacoma, WA, where he stayed until the early 1890s, producing many works of historical importance. In 1892, he was living in NYC, then Chicago (15 years), until he moved back to San Francisco in 1912. He was successful in selling his paintings for huge sums to prominent people, including John D. Rockefeller. He was the originator of a new method of painting on aluminum and wood. **Sources:** WW40; Hughes, *Artists of California,* 542; Trip and Cook, *Washington State Art and Artists,* 1850-1950; Falk, *Exh. Record Series.*

STUART, James Reeve *[Portrait painter and teacher] b.1834, Beaufort, SC / d.1915, Madison, WI.*
Addresses: Madison, WI,1872. **Studied:** Univ. Virginia; Harvard; Boston, with J. Ames; Royal Acad., Munich, 1860. **Exhibited:** NAD, 1885. **Work:** Wisc. State Hist. Mus. (thirty-five portraits); Univ. Wisc. **Comments:** He attended the University of Virginia and Harvard College and in Boston studied under Joseph Ames. He went to Germany for further study, entering the Royal Academy at Munich in 1860. After the Civil War he worked for a time in Savannah (GA) and Memphis (TN), spent three years in St. Louis, before settling permanently in Wisconsin. Although he taught at Milwaukee College and the University of Wisconsin for a few years, Stuart was best known as a portrait painter. **Sources:** G&W; Butts, *Art in Wisconsin,* 116-19 (repro. p. 115); Karolik Cat.

STUART, Jane *[Portrait painter] b.c.1812, Boston, MA / d.1888, Newport, RI.*
Addresses: Newport, RI, 1828 and after. **Studied:** with her father, Gilbert Stuart in Boston. **Exhibited:** NAD, 1829-45. **Work:**
Redwood Lib.; Newport Art Mus.; Rhode Island Hist. Soc.; Colby College; Bowdoin College; New Britain Mus. of American Art; CGA; Harvard Univ.; De Young Mem. Mus.; Essex Inst., Salem; Wadsworth Atheaneum. **Comments:** She was the youngest child of Gilbert Stuart (see entry), from whom she received her early training by acting as his assistant and watching him instruct other artists. After her father's death in 1828, the family was penniless, and it was Jane who set up a studio in Boston and supported the family by painting copies of her father's famous portraits of George Washington. She soon developed a following for her own portraits and miniatures. Stuart also painted and exhibited several genre pictures (NAD). Although she and her mother and three sisters moved to Newport, RI, she continued to maintain her Boston studio until the 1850s, when a fire destroyed much of her work and almost all the correspondence and mementos of her father's life. She was a colorful and well-liked figure in Newport, impoverished again in later years and living with her sister in a small house, quietly bought for them by wealthy friends. **Sources:** G&W; Jane Stuart, "Anecdotes of Gilbert Stuart by His Daughter," *Scribner's Monthly Magazine* (July 1877): 377; Powel, "Miss Jane Stuart, 1812-1888"; Morgan, *Gilbert Stuart and His Pupils,* 49-51; 8 Census (1860), Mass., XXVIII, 58; Cowdrey, AA & AAU; Cowdrey, NAD; Swan, BA; Rutledge, PA; Rutledge, MHS; Boston *Transcript,* April 30, 1888, obit. More recently, see Rubinstein, *American Woman Artists,* 43-45; add'l info. courtesy of Elinor Nacheman, Pawtucket, RI.

STUART, Joseph Martin *[Painter, museum director] b.1932, Seminole, OK.*
Addresses: Brookings, SD. **Studied:** Univ. New Mexico (B.F.A., 1959; M.A., 1962). **Member:** Am. Soc. Arch. Hist.; South Dakota Mem. AC; Brookings Area Arts Council (director); Brookings FA Club. **Exhibited:** 10th & 11th Mid-Am. Exh., Nelson Mus., Kansas City, MO, 1960 & 1961; Western Artists 68th Ann., Denver Art Mus., 1962; Mus. Art, Univ. Oregon, Eugene, 1963; Northwest Artists 50th & 52nd Ann., SAM, 1964 & 1966; Jonson Gal., Univ. New Mexico, Albuquerque, 1969. **Awards:** first prize in painting, Cheney Cowles Mem. Mus., Spokane, WA, 1965; Salt Lake AC Purchase Award, 1967. **Work:** Art Mus., Univ. New Mexcio, Albuquerque; Jewett Gallery, College Idaho, Caldwell; Melick Library Coll., Eureka (IL) College; Salt Lake City (UT) AC. **Commissions:** mural, Donald B. Anderson, Roswell, NM, 1961. **Comments:** Preferred media: acrylics. **Positions:** curator, Mus. Art, Univ. Oregon, 1962-63; director, Boise Gallery Art, 1964-68; director, Salt Lake AC, 1968-71; director, South Dakota Mem. AC, Brookings, 1971-; director, research project; Surv. Art in South Dakota, State & Nat. Endowment on the Arts grant, 1972-74. **Publications:** author, "Nature in Abstract-Expressionism," *Roswell Mus. Bulletin,* 1960; author, "The Need for Art Education in the Public Schools," *Pacific AA Review,* 1962; author, "An Interview with Billy Apple," *Boise AA Bulletin,* 1966; author, "Stimuli," *Utah Arch.,* fall, 1969. **Teaching:** Univ. Utah, 1969; South Dakota State Univ., 1971-. **Collections arranged:** Jannis Spyropoulos: Paintings, Roswell Mus. & Art Center, NM, 1962; Edward Kienholz: Sculpture, Boise (ID) Gal. Art, 1967; Lure of the West, Salt Lake AC, 1971. **Sources:** WW73.

STUART, Kenneth James *[Art director, illustrator, designer, teacher] b.1905, Milwaukee, WI / d.1993, Wilton, CT.*
Addresses: Phila., Conshohocken, PA; Wilton, CT. **Studied:** PAFA with Arthur B Carles; J. Pascin; H. McCarter; Acad. Colarossi, Paris. **Member:** SC; Art Dir. Club, Phila. **Exhibited:** PAFA Ann., 1934; Art Dir. Club, 1941 (prize), 1962 (Award for distinctive merit); Soc. Illustrator, 1963 (three citations for merit). **Awards:** New York Type Dirs. Club Award, 1963. **Work:** Hitler, LOC. **Comments:** **Positions:** magazine & book illustrator & painter, 1944; art editor, *Saturday Evening Post,* Philadelphia, 1944-62; art director, *Reader's Digest,* New York, 1962-. **Teaching:** head, dept. illustr. & advertising, Moore College Art, Phila., 1939-44, board managers, 1944-56. **Sources:** WW73; WW47; Falk, *Exh. Record Series.*

STUART, Luella M. *[Painter] 19th/20th c.*
Addresses: Syracuse, NY. **Exhibited:** NAD. **Sources:** WW01.

STUART, Mabel *[Painter] late 19th c.*
Addresses: Cambridge, MA. **Exhibited:** PAFA Ann., 1895.
Sources: Falk, *Exh. Record Series.*

STUART, Mabel See: **STEWART, Mabel**

STUART, North *[Painter] early 20th c.*
Addresses: Wash., DC. **Sources:** WW13.

STUART, Oliver J. *[Engraver] b.c.1826, New York.*
Addresses: NYC, 1850-59. **Sources:** G&W; 7 Census (1850),
N.Y., L, 376; NYBD 1859.

STUART, Pythias *[Lithographer] b.c.1840, Georgia.*
Addresses: Philadelphia, active 1860. **Comments:** Pythias D.
Stewart, photographer, was in Philadelphia in 1871. **Sources:**
G&W; 8 Census (1860), Pa., LVI, 821; Phila. CD 1871.

STUART, R. A. See: **STUART, Ronald A.**

STUART, R. James *[Illustrator] early 20th c.*
Addresses: NYC. **Sources:** WW19.

STUART, Ronald A. *[Painter] late 19th c.*
Addresses: Boston, MA. **Exhibited:** Boston AC, 1882, 1885,
1891. **Sources:** *The Boston AC.*

STUART, Signe Nelson See: **NELSON, Signe (Signe Nelson Stuart)**

STUART-DODGE, Elsie *[Painter] late 19th c.; b.Boston, MA.*
Studied: Merson; Collin. **Exhibited:** Paris Salon, 1896. **Sources:**
Fink, *American Art at the Nineteenth-Century Paris Salons*, 395.

STUART & FOWLER *[Engravers] mid 19th c.*
Addresses: Boston, 1855. **Comments:** Partners were Frederick G.
Stuart and Edward W. Fowler (see entries). **Sources:** G&W;
Boston CD and BD 1855.

STUBBS, Jesse C. *[Commercial artist] mid 20th c.;
b.Tennessee.*
Studied: Roger Williams College; AIC. **Exhibited:** Harmon
Found., 1930; Smithsonian Inst., 1930; Pen & Palette Club, 1934.
Sources: Cederholm, *Afro-American Artists.*

STUBBS, Kenneth *[Painter, teacher] b.1907, Georgia.*
Addresses: Wash., DC. **Studied:** E. Weisz; M.M. Leisenring; R.
Meryman; B. Baker; Corcoran School Art; E. Webster in
Provincetown, MA. **Member:** Soc. Wash. Artists; Beachcombers,
Provincetown. **Exhibited:** Corcoran Gal. biennials, 1937-53 (7
times); Corcoran Gal., 1940 (solo). **Work:** mural, Barber School,
Highland Park, MI. **Comments:** Teaching: Corcoran School Art.
Sources: WW40.

STUBBS, Mary H(elen) *[Painter, illustrator, craftsperson,
teacher] b.1867, Greenville, OH.*
Addresses: Chicago, IL. **Studied:** Cincinnati Art Acad.;
Académie Julian, Paris. **Member:** Cincinnati Women's AC;
Cincinnati Ceramic Club. **Exhibited:** Columbian Expo, Chicago,
1893 (prize). **Sources:** WW33.

STUBBS, Stanley A. *[Museum curator] mid 20th c.*
Addresses: Santa Fe, NM. **Comments:** Position: cur., collections.
Sources: WW59.

STUBBS, William Pierce *[Marine
painter] b.1842, Orrington, ME /
d.1909, Medfield, MA.* **⁻W P. Stubbs.**
Addresses: North Bucksport, ME; Boston, MA; Charlestown,
MA. **Exhibited:** Int. Marine Exh., Boston, 1889. **Work:** Mariner's
Mus.; Mystic Seaport Mus.; Peabody Mus.; Beverly Hist. Soc.;
Phila. Marine Mus.; Smithsonian. **Comments:** Son of a shipmas-
ter, he was likely master of his father's ship from 1863-73. By
1871 he painted what is likely his first ship portrait, and by 1876
he was listed as a marine painter in the Boston city directory,
sharing a studio with Wesley Webber. Later, he had a studios in
East Boston, and Charleston where it is likely that Badger was his
student. After the death of his wife and daughter, he sank into

manic depression, spoke of "spirit magnetism," and was commit-
ted in 1894 to Worcester State Hospital, and then to the Medfield
State Hospital in 1899 where he died. **Sources:** G&W; *Old-Time
New England* (Jan.-Mar. 1952), 68; *Art in America* (Feb. 1951),
16; A.J. Peluso, article, *Maine Antique Digest* (July, 1981, p.16-
B); Lisa Halttunen, article, *The Log* (Mystic Seaport Mus., Fall
1981, p.95).

STUBENRAUCH, Augustus *[Engraver, die sinker] mid 19th c.*
Addresses: NYC, 1860. **Comments:** Probably a brother of
Charles Stubenrauch (see entry) and his partner in the fifties.
Sources: G&W; NYCD 1860; NYBD 1854-57.

STUBENRAUCH, Charles *[Engraver, die sinker] mid 19th c.*
Addresses: NYC, 1854-58; St. Louis, 1859. **Comments:**
Augustus Stubenrauch (see entry) probably was his brother and
partner in NYC. **Sources:** G&W; NYBD 1854-58; St. Louis CD
and BD 1859.

STUBER, Dedrick B(randes) *[Landscape painter] b.1878,
NYC / d.1954, Los Angeles, CA.*
Addresses: Los Angeles, CA (since 1925). **Studied:** Bridgman; J.
Onderdonk; C. Peters; ASL. **Member:** Los Angeles P&S; Laguna
Beach AA; Glendale AA. **Exhibited:** Wilshire Gal., Los Angeles,
1920s. **Work:** NMAA; Pasadena Art Mus. **Comments:** Specialty:
pastoral landscapes of Southern California. **Sources:** WW40;
Hughes, *Artists of California*, 542.

STUBERGH, Katherine Marie *[Sculptor] b.1911, San
Francisco, CA / d.1960, Los Angeles, CA.*
Addresses: Los Angeles, CA. **Comments:** Did busts of people in
the movie industry as well as bronze plaques. **Sources:** Hughes,
Artists of California, 542.

STUCH, Emil H. *[Illustrator] 19th/20th c.*
Addresses: Wash., DC, active 1900-1905. **Work:** U.S. National
Arboretum. **Comments:** Position: illus., U.S. Dept. Agriculture.
Sources: McMahan, *Artists of Washington, DC.*

STUCK, Emil H. See: **STUCH, Emil H.**

STUCK, Jack *[Painter] b.1923.*
Addresses: Los Angeles, CA. **Exhibited:** WMAA, 1965.
Sources: Falk, *WMAA.*

STUCKEN, Ferdinand *[Portrait & historical painter] d.1878.*
Addresses: Düsseldorf (Germany), 1848; NYC, 1856 and after.
Exhibited: NAD. **Sources:** G&W; Thieme-Becker; Cowdrey,
NAD; NYBD 1856-60.

STUCKI, Margaret Elizabeth *[Painter, writer] b.1928, West
New York, NJ.*
Addresses: Oneonta, NY; Florida; Coupeville, WA. **Studied:**
Barnard College (B.A.); ASL with Robert Brackman, Reginald
Marsh; Columbia Univ. Teachers College (M.A., 1959); NY
Univ., 1962; Freedom Univ. (Ph.D., 1975). **Exhibited:** AAPL,
1963, 1975; Wichita AA, 1967; Swiss Center Art Gal., NYC,
1975; Hall of Flags, Capitol Bldg., ME, 1978. **Work:** Yager Mus.,
Hartwick College, Oneonta, NY; Lutheran Church of the
Atonement, Oneonta; Univ. Cincinnati; Bethune-Cookman Art
Mus.; commissions: portraits of all past presidents, Michigan
Technol. Univ., 1969-79; Oneonta Madonna Triptych, Hartwick
Rev.; Cape Canaveral Mermaid Triptych, Bird's Meadow Publ.
Co.; In the Shadow of the Cross, Temple Baptist Church,
Tallahassee, FL. **Comments:** Teaching: Hartwick College, NY,
1962-71; Shelton College, Cape Canaveral, 1971-74; Rollins
College, Patrick AF Base, FL, 1971-75; Brevard Community
College, Cocoa, FL. Positions: assoc. ed., *Hartwick Review,*
Oneonta, NY, 1968-71; art ed., *Christian Educator;* art consultant,
Am. Kidney Fund, 1975; art columnist, *New Am. Review, 1977.*
Married to Fred Karl Scheibe (see entry). **Sources:** *Who Is Who
in American Art.*

STUDAV, Rokmael *[Sculptor, painter] early 20th c.*
Addresses: NYC. **Exhibited:** S. Indp. A., 1925. **Sources:**
Marlor, *Soc. Indp. Artists.*

STUDLEY, Amelia Goodman (Mrs.) *[Painter] late 19th c.*
Addresses: Providence, RI, 1867-69. **Exhibited:** NAD, 1867-69.
Sources: Naylor, *NAD*.

STUDWELL, Theodore *[Painter] late 19th c.*
Addresses: NYC, 1895. **Exhibited:** NAD, 1895. **Sources:**
Naylor, *NAD*.

STUEBNER, Joseph A. *[Painter] early 20th c.*
Addresses: Evanston, IL. **Sources:** WW19.

STUEMPFIG, Walter, Jr. *W. STUEMPFIG*
[Painter, teacher] b.1914,
Germantown section of Phila., PA / d.1970, Ocean City, NJ.
Addresses: Phila., PA; Collegeville, PA, 1938-43; NYC;
Gwynedd Valley, PA, after 1949. **Studied:** Univ. Penn.; PAFA,
1931-34, with H. McCarter (Cresson Scholarship, 1934).
Member: NIAL; Century; ANA, 1951; NA, 1953. **Exhibited:**
PAFA Ann., 1933-66; AIC, 1935-45; M.H. de Young Mus., 1946
(first museum solo); Corcoran Gal. biennials, 1941-63 (7 times,
incl. silver medal, 1947); Durlacher Bros. Gal., NYC, 1940s-61
(solos); NAD, 1953 (prize); WMAA; Toronto AM, 1949; Walker
AC, Minneapolis, 1954; R. York Gal., NYC, 1994 (solo). **Work:**
PAFA; WMAA; PMA; MMA; AIC; CGA. **Comments:** Known
for his landscapes of the Philadelphia area and Jersey shore.
Teaching: PAFA, 1948-70. **Sources:** WW40; *300 Years of
American Art*, vol. 2: 955; exh. cat., R. York Gal. (NYC, 1994);
Falk, *Exh. Record Series*.

STUEVER, Celia M. *[Etcher, painter] early 20th c.; b.St.
Louis.*
Addresses: St. Louis, MO, c.1915-31. **Studied:** St. Louis Sch.
FA; Acad. Julian, Paris with Bouguereau and Ferrier; Vienna;
Munich. **Member:** Chicago SE; Calif. SE; NYSE; Calif. PM.
Exhibited: Soc. Indep. Artists, 1918. **Work:** City Art Mus., St.
Louis; LOC; NYPL. **Sources:** WW32.

STUFFERS, Anthony *[Illustrator] b.1894, The Hague,
Holland / d.1920, Chicago.*
Exhibited: AIC, 1918, 1920. **Comments:** Brought to U.S. in
1900. Specialty: black and white illustrations.

STUHL, Edward F. *[Painter] b.1887, Budapest, Hungary /
d.1984, Mount Shasta, CA.*
Addresses: Mount Shasta, CA. **Studied:** Munich Acad. FA.
Work: Sisson Hatchery Mus., Mt. Shasta. **Comments:**
Immigrated to the U.S. in 1910 and settled in California after
1915. A naturalist, he worked for the Big Basin National Park
until 1937. He painted views of Mount Shasta and its flora, while
working as a caretaker of the Sierra Club Lodge. **Sources:**
Hughes, *Artists of California*, 543.

STULER, Jack *[Photographer, educator] b.1932, Homestead,
PA.*
Addresses: Tempe, AZ. **Studied:** Phoenix College, 1957; Arizona
State Univ. (B.A., 1960) with Van Deren Coke, 1961 (M.F.A.,
1963); workshop with Ansel Adams, 1966. **Member:** Soc.
Photography Educ.; Inst. Cultural Exchange Through Photography
(mem. advisory board, 1966-). **Exhibited:** Three Photographers,
George Eastman House, 1963; Photography '63/Int. Exh., 1963,
George Eastman House; Photography In Twentieth Century, Nat.
Gallery Canada, 1967; Am. Photography: The Sixties, Sheldon
Mem. Art Gallery, Univ. Nebraska, Lincoln, 1966; Photography
USA, De Cordova Mus., Lincoln, MA, 1968. **Awards:** first award
Biennial Photography, Phoenix Art Mus., 1967; Best of Show,
Third Southwestern Art Invitational, Yuma FAA, 1967. **Work:**
George Eastman House, Rochester, NY; Gen. Aniline Films,
NYC; Univ. Collections, Arizona State Univ., Tempe; Yuma (AZ)
Art Center; Phoenix College. **Comments:** Publications: contrib.,
"Photography in the Twentieth Century," *Horizon*, 1967,
"Photography Ann.," 1969, "Being Without Clothes," *Aperture
15:3*, 1970 & "Camera," Lucerne, Switzerland, 11/1971.
Teaching: Arizona State Univ., 1966-, summer fellowship, 1968.
Sources: WW73; Nathan Lyons, "The Younger Generation," *Art
Am.* (Dec., 1963).

STULL, George P. *[Painter] early 20th c.*
Addresses: Phila. PA. **Sources:** WW06.

STULL, H. O. *[Painter] mid 20th c.*
Exhibited: S. Indp. A., 1936. **Sources:** Marlor, *Soc. Indp. Artists.*

STULL, Henry *[Painter, illustrator, cartoon-
ist] b.1851, Hamilton, Ontario, Canada /
d.1913.* *Henry Stull 1879*
Addresses: Brooklyn, NY; New Rochelle, NY.
Member: Coney Island Jockey Club. **Work:** Jockey Club, NYC;
Univ. Kentucky Art Mus., Lexington. **Comments:** Eventually a
specialist in painting thoroughbred race horses, when Stull came
to NYC in 1870 he was intent on a career in acting. He painted
stage scenery, and in 1873 joined the staff of *Leslie's* as an illus-
trator. In 1876, he was illustrating and cartooning for the horse
and sporting publication, *The Spirit of the Times*. By the late
1870s, he began to focus on painting his speciality, horses. He
was most productive between 1890-1910, often visiting the horse
farms of Kentucky. Late in his career he traveled to Europe on
commission. **Sources:** Jones and Weber, *The Kentucky Painter
from the Frontier Era to the Great War*, 66 (w/repro.); *300 Years
of American Art*, vol. 1, 452.

STULL, John DeForest *[Painter] b.1910, Chicago, IL /
d.1972, Newark, NJ.*
Addresses: Leonia, NJ. **Studied:** Yale Univ. (B.F.A., 1933);
Columbia Univ. (M.F.A., 1936). **Exhibited:** Prix de Rome, 1938
(hon. men.); Carnegie Inst., 1944; Vendome Gal., NYC;
Downtown Gal., NYC; NJ State Mus., 1980. **Comments:** Assisted
Ezra Winters in painting murals for the Radio City Music Hall,
and worked for the WPA. Positions: art dir., Norcross Co. (greet-
ing card mfg.), 1940s; chmn., art dept., Leonia H.S., 1953-on.
Sources: info compiled by James Hamilton, courtesy Jos. B.
Lehn.

STULL, Wed Ray *[Painter] mid 20th c.*
Exhibited: S. Indp. A., 1936. **Sources:** Marlor, *Soc. Indp. Artists.*

STULTS, Elwin Martin, Jr. (Larry) *[Painter, designer]
b.1899, Orwell, OH.*
Addresses: Cabbage Key, FL; Boca Grande, FL. **Studied:** AIC;
CI (B.A.); Charles Hawthorne; Edmund Giesbert; Francis Chapin.
Member: Florida Art Group; Art Dir. Club, Chicago; Pittsburgh
AA. **Exhibited:** North Shore AA; Evanston (IL) Art Center;
Massillon Mus. Art; Sarasota AA; Florida Art Group. **Sources:**
WW59; WW47.

STUMAN, Jack Bates Huddleston *[Designer, architect]
b.1908, Canton.*
Addresses: Elberton, GA/Canton, GA. **Studied:** Atelier(GA)
Marble Co.; Canton; Fincher Art Classes; London Art Sch.,
Cleveland. **Member:** Soc. Mem. Des. & Draftsmen of America.
Exhibited: Soc. Mem. Des. & Draftsmen, Chicago, 936.
Comments: Designer: public and private memorials. Contributor:
design, "Art in Bronze and Stone," January 1937. Position: design
staff, Premier Studios. **Sources:** WW40.

STUMM, Maud *[Painter, illustrator, craftsperson] 19th/20th
c.; b.Cleveland, OH.*
Addresses: NYC, active 1870-1935. **Studied:** ASL with K. Cox
& H.S. Mowbray; O. Merson, in Paris. **Exhibited:** AIC, 1894;
PAFA Ann., 1894; Boston AC, 1895; AWCS; Soc. Am. Artists.
Comments: Painted in oil, watercolor and pastel, including a
series of portraits of Sarah Bernhardt. Also did illustrations for
calendars. **Sources:** WW10; Petteys, *Dictionary of Women
Artists;* Falk, *Exh. Record Series.*

STUMP, John C. *[Painter] b.1902, Santa Rosa, CA / d.1977,
Marin County, CA.*
Addresses: Sausalito, CA. **Studied:** Univ. Calif., Berkeley (M.A.)
with Ray Boynton, Hope Gladding, Eugen Neuhaus, Perham
Nahl, Guest Wickson. **Exhibited:** San Francisco AA, 1924;
Modern Gallery, San Francisco, 1926. **Comments:** Position: head
librarian, Mechanics' Inst., San Francisco, 46 years. **Sources:**
Hughes, *Artists of California*, 543.

STUMP, Pamela *[Painter] mid 20th c.*
Addresses: Saginaw, MI. **Exhibited:** PAFA Ann., 1958. **Sources:** Falk, *Exh. Record Series.*

STUMPF, Anselm *[Painter] b.1832, Baden, Germany / d.1900, New Orleans, LA.*
Comments: Father of John Ernest Stumpf (see entry). **Sources:** *Encyclopaedia of New Orleans Artists*, 367.

STUMPF, John Ernest *[Painter] b.1857, New Orleans, LA / d.1939, New Orleans.*
Addresses: New Orleans, active 1874-1930. **Comments:** Son of Anselm Stumpf (see entry). **Sources:** *Encyclopaedia of New Orleans Artists*, 367.

STUNTZ, Helen *[Painter, decorator] b.1871, Terrace Park, OH / d.1949.*
Addresses: Cincinnati. **Studied:** Cincinnati Art Acad. **Comments:** Worked for Rookwood Pottery, Cincinnati, 1892-96. Married Thomas P. Walker in 1896 and gave up painting. **Sources:** Petteys, *Dictionary of Women Artists.*

STURDEVANT, Austa Densmore (Mrs.) *[Portrait painter] b.1855, Meadville, Blooming Valley, PA / d.1936, Kingston, NY.*
Addresses: Cragsmoor, NY. **Studied:** Allegheny College; Metropolitan School FA; ASL with Mowbray, Beckwith; Collin in Paris. **Exhibited:** Columbian Expo, Chicago, 1893; Paris Salon, 1895 (prize), 1896. **Sources:** WW10; Fink, *American Art at the Nineteenth-Century Paris Salons*, 395.

STURDEVANT, S. *[Portrait engraver] early 19th c.*
Addresses: Lexington, KY?, c.1822. **Sources:** G&W; Fielding's supplement to Stauffer.

STURDEVANT, Thomas *[Listed as "artist"] b.c.1838, Pennsylvania.*
Addresses: Philadelphia, 1860. **Comments:** He was apparently the son of Elizabeth and the late Joseph Sturdevant. Listed only in 1861 directory. **Sources:** G&W; 8 Census (1860), Pa., LI, 555; Phila. CD 1861.

STURDIVANT, H. M. *[Seal engraver] mid 19th c.*
Addresses: Philadelphia, 1857-60. **Comments:** In 1857 of Sturdivant & Maas (see entry). **Sources:** G&W; Phila. CD 1857-60; BD 1858-59, as M.M. Sturdivant.

STURDIVANT, Isabelle *[Painter] b.1867, California / d.1915, San Francisco, CA.*
Addresses: San Francisco, CA. **Studied:** Mills College, Oakland, CA. **Exhibited:** San Francisco AA, 1903. **Work:** Calif. Hist. Soc. **Comments:** Specialty: still lifes. **Sources:** Hughes, *Artists of California*, 543.

STURDIVANT, M. M. See: **STURDIVANT, H. M.**

STURDIVANT, Natalie Christine Daly *[Landscape painter] b.1875, San Francisco, CA / d.1919, San Anselmo, CA.*
Addresses: San Anselm, CA. **Studied:** William Keith. **Comments:** (Natalie C. Daly) Sister-in-law of Isabelle Sturdivant (see entry). **Sources:** Hughes, *Artists of California*, 543.

STURDIVANT & MAAS *[Engravers] mid 19th c.*
Addresses: Philadelphia, 1857. **Comments:** Probably H.M. Sturdivant (see entry) and the printer William Maas (see entry). **Sources:** G&W; Phila. CD 1857.

STURGEON, J. V. *[Miniaturist] mid 19th c.*
Addresses: NYC, 1833; Charleston, 1835-36. **Exhibited:** Am. Acad., 1833. **Sources:** G&W; Cowdrey, AA & AAU; Rutledge, *Artists in the Life of Charleston.*

STURGEON, John *[Video artist] b.1946.*
Addresses: Venicve, CA. **Exhibited:** WMAA, 1975. **Sources:** Falk, *WMAA.*

STURGEON, Ruth (Barnett) *[Painter, etcher, craftsperson, teacher] b.1883, Sterling, KS.*
Addresses: Council Bluffs, IA/Sterling, KS; California, 1932. **Studied:** L.C. Catlin; G. Senseney; H.B. Snell. **Member:** Western

AA. **Sources:** WW24.

STURGES, Annie A. See: **STURGIS, Annie A.**

STURGES, Dwight Case *[Etcher, cartoonist, illustrator, painter] b.1874, Boston (Charleston), MA / d.1940, Boston, MA.*
Addresses: Boston, MA. **Studied:** Cowles Art School, Boston. **Member:** Chicago SE; Calif PM; AFA; Soc. Am. Etchers. **Exhibited:** Chicago SE, 1915 (prize), 1926 (prize); Pan-Pacific Expo, San Francisco, 1915 (medal); AIC, 1924 (prize); Salons of Am., 1924; Calif. PM, 1927 (prize). **Work:** BMFA; AIC; Oakland (CA) Mus.; LOC; Nat. Gal.; NYPL; TMA; Vanderpoel AA, Chicago; Los Angeles Mus. **Comments:** Position: *Boston Globe* art dept., 1901. **Sources:** WW40; Brewington, 370.

STURGES, Katharine *[Painter, illustrator] b.1890, Chicago, IL / d.1979.*
Addresses: Roslyn, NY. **Studied:** AIC; Japan. **Member:** Artists Gld. **Exhibited:** Salons of Am., 1934; AIC. **Comments:** Illustr.: *Little Pictures of Japan* (ed. O.K. Miller) and other children's books; fashion drawing for *Harper's Bazaar* and others. Married to Clayton and mother of Hilary Knight (see entries). Also appears as Knight. **Sources:** WW33.

STURGES, Lee *[Etcher] b.1865, Chicago, IL / d.1954?, Melrose Park, IL?.*
Addresses: Melrose Park, IL. **Studied:** AIC; PAFA; Chicago Acad. Des. **Member:** SAE; Chicago SE; AFA. **Exhibited:** AIC, 1923 (medal). **Work:** AIC; Smithsonian Inst.; Calif. State Lib. **Sources:** WW53; WW47.

STURGES, Lillian *[Illustrator, painter, writer, teacher] mid 20th c.; b.Wilkes-Barre, PA.*
Addresses: Pittsburgh, PA. **Studied:** PM School IA; CI (B.A.); E.F. Savage, H.S. Hubbell; PAFA, at Chester Springs. **Member:** Author's Club; Pittsburgh AA; Pittsburgh WCC; Nat. Educ. Assn. **Exhibited:** CI, 1920-46; Hist. Soc. Western Penn. **Comments:** Illustrator: "Treasury of Myths"; "Bible A-B-C". Author: "Money for Cats." Color covers for the *Junior Magazine* of the United Presbyterian Church, 1956-. **Sources:** WW59; WW47.

STURGIS, Annie A. *[Sculptor] early 20th c.*
Addresses: NYC. **Exhibited:** PAFA Ann., 1912 (as Sturges). **Sources:** WW13; Falk, *Exh. Record Series.*

STURGIS, D. N. B. *[Illustrator, architect] 19th/20th c.*
Addresses: NYC. **Sources:** WW01.

STURGIS, F. S. *[Painter] late 19th c.*
Addresses: Boston, MA. **Exhibited:** Boston AC, 1882, 1885. **Sources:** *The Boston AC.*

STURGIS, Katharine *[Painter] b.1904, Long Island, NY.*
Addresses: Cambridge, MA/West Dover, VT. **Studied:** H. Giles; E. Horter. **Exhibited:** WMAA,1945

STURGIS, Mabel R(ussell) *[Painter, craftsperson] b.1865, Boston.*
Addresses: Boston, MA/Manchester, MA. **Studied:** BMFA School; Ch. Woodbury. **Member:** Copley Soc., 1889; AFA; North Shore AA. **Exhibited:** Boston AC, 1896-99; Copley Soc.; PAFA Ann., 1903, 1906-09; AFA; North Shore AA; NAD, 1907; Corcoran Gal. biennials, 1908, 1912. **Sources:** WW40; *Charles Woodbury and His Students;* Falk, *Exh. Record Series.*

STURM, Dorothy *[Artist] mid 20th c.*
Addresses: Memphis, TN. **Exhibited:** WMAA, 1956. **Sources:** Falk, *WMAA.*

STURM, Justin *[Sculptor, writer, painter] b.1899, Nehawka, NE.*
Addresses: Redding, CT; Westport, CT. **Studied:** Yale Univ. (A.B.). **Exhibited:** Ferargil Gal., 1934; Karl Freund Gal., NY,

1938. **Work:** many portrait busts of prominent people. **Comments:** Author: "The Bad Samaritan," 1926. Contributor: *Harper's, Collier's, Pictoria Review, Redbook* magazines. **Sources:** WW53; WW47.

STURM, William F. *[Wood engraver] b.NYC / d.1912.*
Addresses: Hoboken, NJ (since 1877).

STURMAN, Gene *[Sculptor] b.1945.*
Addresses: Venice, CA. **Exhibited:** WMAA, 1975. **Sources:** Falk, *WMAA.*

STURN, Hermann *[Lithographer] mid 19th c.*
Addresses: NYC 1854-72. **Comments:** Of Snyder Black & Sturn (see entry). **Sources:** G&W; NYCD 1854-72.

STURSBERG, Julie H. *[Painter] early 20th c.*
Member: Lg. AA. **Exhibited:** WMAA, 1921-27; Salons of Am., 1922-24, 1927. **Comments:** Her name also appears as Strusberg. **Sources:** Falk, *Exhibition Record Series.*

STURTEVANT, Edith Louise *[Painter, educator] b.1888, Utica, NY.*
Addresses: Easton, PA. **Studied:** PAFA; CI; NY Univ (B.S. in Educ.); McCarter; Breckenridge; Garber; J. Pearson; PAFA fellowship; Cresson traveling scholarship. **Member:** Phila. Plastic Club; Nat. Educ. Assn.; Easton AG. **Exhibited:** CGA; PAFA (prize); BMA; AIC; Phila. Plastic Club; Phila. AC. **Work:** PAFA; Easton Woman's Club. **Comments:** Position: art supervisor, Easton (PA) School District, Easton, 1922-. **Sources:** WW59; WW47.

STURTEVANT, G. A. (Mrs) *[Painter] early 20th c.*
Addresses: San Francisco. **Sources:** WW13.

STURTEVANT, Harriet H. *[Painter, designer] b.1906, Manchester, NH.*
Addresses: Jackson Heights, NY. **Studied:** Albright Art School; Parsons School Design, New York & Paris, 1928-30. **Member:** AWCS; Pen & Brush Club; Allied Artists Am.; Wolfe Art Club; Knickerbocker Artists. **Exhibited:** Long Island Art League, 1953-56, 1964 (prizes 1953 &1964); AWCS, 1956, 1961-62, 1964; Audubon Artists, 1954, 1959, 1961; Watercolor: USA, 1962-63; NAD, 1963; Nat. Arts Club, 1954-64 (prizes, 1957 & 1963); All. Artists Am., 1954-64; Wolfe Art Club, 1954, 1965 & 1967 (prizes, 1957, 1960, 1963; gold medal, 1967); Knickerbocker Artists, 1958-64 (prizes, 1962 & 1964); Soc. Painters in Casein, 1960, 1964; Pen & Brush Club, 1969 (solo). **Comments:** Positions: designer, Norcross Cards, 16 years; free-lance designer, 1964-. **Sources:** WW73.

STURTEVANT, Helena *[Painter] b.1872, Middletown, RI / d.1946, Newport, RI.*
Addresses: Newport, RI. **Studied:** BMFA School with E. Tarbell; Acad. Colarossi, Paris, with Blanche and L. Simon. **Member:** Newport AA (director); AFA; College AA; NAWPS; AAPL. **Exhibited:** NAD, 1902, 1911, 1943; PAFA, five annuals, 1905-17; Newport AA, 1912 (innaugural); AIC, 1913; Paris Salon, 1927; WFNY, 1939; GGE, 1939; Copley Gals., Boston, MA. **Work:** Newport City Hall; NYPL (etching); Berkeley Mem. Chapel, Newport, RI "Sister of Louisa" altar piece. **Comments:** Best known for her paintings of Newport historic buildings and the area coastline. **Sources:** WW40; Falk, *Exh. Record Series.*

STURTEVANT, Louisa Clark *[Designer, painter, teacher] b.1870, Paris, France.*
Addresses: Newport, RI. **Studied:** BMFA Sch.; F. Benson; E. Tarbell; Simon, Collin & Blanche in Paris. **Member:** AAPL; Newport AA. **Exhibited:** PAFA; Pan-Pacific Exp, 1915 (medal). **Comments:** Designer of stained glass & textiles. Sister of Helena (see entry). Teaching: Newport AA. **Sources:** WW59; WW47.

STURTEVANT, Pearl F. *[Painter] early 20th c.*
Exhibited: San Francisco AA, 1917. **Sources:** Hughes, *Artists of California,* 543.

STURTEVANT, Wallis Hall (Peter Ladd) *[Painter, illustrator] b.1897, Greenfield, MA.*

Addresses: Springfield, MA. **Studied:** ASL; Massachusetts State Teachers College; Univ. Louisville; Wilson; Randall; Winter. **Comments:** Illustr.: *Old Times in the Colonies; Days of the Leader; Weedon's Modern Encyclopaedia;* auth./illustr., *The Story of Hansel and Gretel and the Gingerbread Castle.* **Sources:** WW59; WW47.

STUTTERD, Harry Jerome *[Painter] b.1880, NYC / d.1956, Oakland, CA.*
Addresses: Oakland, CA. **Exhibited:** Oakland Art Gallery, 1928. **Comments:** Teaching: Polytechnic College, Oakland. **Sources:** Hughes, *Artists of California ,* 543.

STUTTMAN, Joy Lane *[Painter, etcher, teacher] b.1929, Chicago, IL.*
Addresses: NYC. **Studied:** Univ. Chicago (B.Ph.); Mills College, Oakland, CA (B.A.); Tschacbasov; Hans Hofmann. **Member:** NAWA; Woodstock AA; Comn. on Art Educ. **Exhibited:** NAWA; NY City Center; Washington Univ., St. Louis, MO; Sun Gal., Provincetown, MA; John Heller Gal., NY (solo); Caricature Coffee Shop, NY. **Comments:** Teaching: children's classes, Contemporaries Workshop, NY. **Sources:** WW59.

STUTZMAN, Vernon Raymond *[Painter] b.1902, Sharon Center, IA.*
Addresses: Iowa City, IA. **Studied:** Meyer Both; School Applied Art, Battle Creek, MI; Iowa State College; State Univ. Iowa with Grant Wood, Emil Ganso & Francis McCray. **Exhibited:** CAFA, 1940, 1941; Grand Rapids Art Gal., 1940; Northwest Pr. M., 1945; Springfield AM, 1943, 1945; Oklahoma AC, 1940, 1941; Kansas City AI, 1938-1941; Iowa Art Salon, 1934; Midwestern Exh., Kansas City, 1938; All-Iowa Exh.,1940 (traveling exh.). **Sources:** WW53; WW47; Ness & Orwig, *Iowa Artists of the First Hundred Years,* 203.

STUVE, Clementine *[Painter] late 19th c.*
Addresses: Springfield, IL. **Exhibited:** AIC, 1899. **Sources:** Falk, *AIC.*

STUVE, William Carl *[Painter, woodcarver] b.1894, Sterling, NE / d.1965, Alameda, CA.*
Addresses: Alameda, CA. **Studied:** AIC. **Work:** Elk's Club, Croll's Bar, Alameda. **Comments:** Position: head, art dept., Neptune Beach Amusement Park; painter, Kaiser Shipyards. He painted impressionist landscapes and did woodcarvings in his spare time. **Sources:** Hughes, *Artists of California,* 543.

STYKA, Adam *[Painter, illustrator] b.1890, Kielce, Poland / d.c.1970, probably NYC.*
Studied: with his father, Jan, and his brother, Thaddeus; École des Beaux-Arts, Paris, 1908-12. **Comments:** Specialty: Western and Arab genre. Also painted in North Africa. **Sources:** P&H Samuels, 473.

STYLES, Betty *[Painter] mid 20th c.*
Addresses: San Leandro, CA. **Exhibited:** Oakland Art Gallery, 1939; Bay Region AA, 1940. **Sources:** Hughes, *Artists of California,* 543.

STYLES, D. *[Portrait & landscape painter] mid 19th c.*
Addresses: NYC, active 1848-52. **Exhibited:** NAD, 1848-52. **Sources:** G&W; Cowdrey, NAD.

STYLES, George C(harles) *[Etcher, architect, craftsperson] b.1892.*
Addresses: Bridgeport, CT. **Studied:** York Sch. Art with R. Windass. **Exhibited:** King's prize in architecture, 1911; Assn. Royal College Art, 1914 (prize). **Sources:** WW31.

STYLES, George William *[Painter, engraver, block printer, craftsperson, lecturer] b.1887, Sutton, England / d.1949.*
Addresses: Detroit, MI. **Studied:** Sch. Arts & Crafts, London; Detroit Sch. Des.; G.E. Browne; P. Honore. **Member:** SC, Detroit; Michigan Acad. Sciences, Arts & Letters; AFA; Detroit MA Founders Soc. **Exhibited:** Detroit, 1921 (prize), 1927 (prize); Detroit IA, 1915, 1920-21, 1925-29; Am. Art Exh., Detroit, 1926-29; Balt. WCC; Detroit WCC, 1946. **Work:** Pub. Lib., Fordson

H.S., both in Dearborn, MI; SC, Detroit; Souheastern H.S., Detroit; State of Michigan, Lansing. **Comments:** Designer: medal, Detroit Board Educ. **Sources:** WW47.

STYLES, William B. *[Painter] late 19th c.*
Addresses: NYC, 1888-93. **Exhibited:** NAD, 1888-93; PAFA Ann., 1893. **Sources:** Falk, *Exh. Record Series.*

W. B Styles

SUAW See: **DU SUAW**

SUBA, Miklos *[Painter] b.1880, Hungary / d.1944.*
Addresses: NYC. **Studied:** Europe. **Exhibited:** Salons of Am., 1926; WMAA, 1946. **Comments:** Came to U.S., 1924. **Sources:** Falk, *Exhibition Record Series.*

SUBA, Susanne (Mrs. McCracken)
[Painter, illustrator, lecturer] b.1913, Budapest, Hungary.

Suba

Addresses: Chicago, IL; NYC. **Studied:** Pratt Inst., grad. **Member:** AIGA; Soc. Typographic Artists, Chicago. **Exhibited:** AIC, 1942 (solo); BM, 1943 (prize); Art Dir. Club, Chicago, 1945 (med.)-46 (med.); Art Dir. Cl., NYC, 1946 (med.); Am. Inst. Graphic Art (prize); MoMA, 1946; Raymond & Raymond Gal., San Fran., 1946 (solo); Jr. Lg. Gal., Boston, 1939 (solo); A-D Gal., NYC, 1940; Ansdell Gal., London, England; Hammer Gal., NYC; Kalamazoo IA. **Work:** MMA; BM; AIC; Mus City of New York; Kalamazoo (MI) Inst. Art. **Comments:** Illustrator: *The Elegant Elephant,* 1944; *This is On Me,* 1942; *Spots by Suba; The Lure of Mr. Lucas,* 1935, *Life Without Principle; Henry David Thoreau,* 1936, *Stringe, The No-Tail Cat,* 1938. Author/illustrator: *My Paintbook.* Contributor: *Publishers' Weekly, A-D* magazine. **Sources:** WW73; WW47.

SUBLETT, Carl C. *[Painter, educator] b.1919, Johnson Co., KY.*
Addresses: Knoxville, TN. **Studied:** Western Kentucky Univ.; Univ. Study Center, Florence, Italy; Univ. Tennessee. **Member:** Dulin Gal. Art, (advisory bd., 1971-) Knoxville WCS; Tenn. Watercolorists; MoMA; Port Clyde (ME) Arts & Crafts Soc. **Exhibited:** several exhibs., Southeastern Art Ann., Atlanta, GA, Paintings of Year, Atlanta & New Painters of South, Birmingham, AL; Watercolor USA, Springfield, MO, 1964-72; AWCS, 1972. **Awards:** Rudolph Lesch Award, AWCS, 1972; purchase awards, Am. Collection, Hunter Gal. Art, 1972 & Collection Tenn. Art Lg. & Parthenon, Nashville, 1972; Collectors Gal., Nashville, TN, 1970s. **Work:** Dulin Gal. Art, Knoxville, TN; Hunter Gal. Art, Chattanooga, TN; Mint Mus., Charlotte, NC; Stephens College, Springfield, MO; Tenn. Arts Commission, Nashville, TN. **Comments:** Preferred media: watercolors, oils, acrylics. Publications: contributor, "Artist and Advocates" Mead Corp.; contributor, Nat. Drawing Soc. Teaching: assoc. professor art, Univ. Tenn., 1966-. **Sources:** WW73; Margaret Harold, *Prize Winning Watercolors* (Allied, 1964).

SUCH, B. J. *[Painter] late 19th c.*
Addresses: NYC, 1878. **Exhibited:** NAD, 1875, 1878. **Sources:** Naylor, *NAD.*

SUCK, Adolph *[Painter] 19th/20th c.*
Addresses: Boston, MA, active 1897-1901. **Member:** Boston Art Student's Assn., 1897. **Exhibited:** Boston AC, 1897, 1898. **Sources:** WW01.

SUDDERFIELD, Serene *[Painter] mid 20th c.*
Addresses: Brooklyn, NY, 1933. **Exhibited:** Soc. Independent Artists, 1933. **Sources:** Marlor, *Soc. Indp. Artists.*

SUDDUTH, Newman S. *[Painter, illustrator] b.1898, Wash., DC / d.1967, Wash., DC.*
Addresses: Wash., DC. **Exhibited:** Landscape Club of Washington, 1929-46 (medal), 1947-49; Greater Wash. Indep. Exhib., 1935. **Comments:** Position: staff artist, *Washington Evening Star,* until 1961. Specialty: portraits of political figures and war heroes, landscapes, local scenes. **Sources:** McMahan, *Artists of Washington, DC.*

SUDLER, A. E. *[Painter] 20th c.*
Addresses: Baltimore, MD. **Sources:** WW25.

SUDLOW, Robert N. *[Painter, educator] b.1920, Holton, KS.*
Addresses: Lawrence, KS. **Studied:** Univ. Kansas (B.F.A.); Univ. Calif., Berkeley; Calif. Col. Arts & Crafts, Oakland (M.F.A.); Acad. Grande Chaumière, Paris, France; Acad. Andre Lhote, Paris. **Exhibited:** PAFA Ann., 1947-49; Contemprary Painting Invitational, Ashland Col., Ohio, 1971; Wichita Art Mus., 1971; U.S. Senate, Wash., DC, 1971; Spiva AC, 1971 (solo); Nelson Art Mus. Summer Invitational, 1972; Nelson-Atkins Art Galleries, Kansas City, MO, 1970s. **Awards:** Huntington Hartford fellowship, 1957-59; Villa Montalvo fellowship, 1960. **Work:** City Art Mus., Saint Louis, MO; Mulvane AC, Washburn Univ., Topeka, KS; Joslyn Art Mus., Omaha, NE; Stephens College, Columbia, MO. **Comments:** Preferred media: oils. Teaching: prof. painting & sculpture, Univ. Kansas, 1947-; Watkins faculty fellow, 1958; instructor in drawing & painting, Spiva AC, 1971. **Sources:** WW73; Falk, *Exh. Record Series.*

SUELL, Lulu M. *[Painter] early 20th c.*
Addresses: Toledo, OH. **Exhibited:** PAFA Ann., 1922. **Sources:** Falk, *Exh. Record Series.*

SUERTH, Ursula *[Painter] 20th c.*
Addresses: Chicago, IL. **Sources:** WW19.

SUFFOLK, Jesse B. *[Painter] early 20th c.*
Addresses: Pittsburgh, PA. **Studied:** Académie Julian, Paris, 1910. **Member:** Pittsburgh AA. **Sources:** WW17.

SUFFRINS, N. M. (Mrs.) *[Portrait painter] mid 19th c.*
Addresses: Active in Indianapolis, 1865-66; Muncie, IN, 1868. **Sources:** Petteys, *Dictionary of Women Artists.*

SUFI, Ahmad Antung *[Sculptor] b.1930, Palembang, Indonesia.*
Addresses: Brooklyn, NY. **Studied:** Craft Students League, NY; New School Social Res., scholarship, 1966; Educ. Alliance; Haystack Mountain School Arts & Crafts. **Member:** Heights-Hills Artists Coop; Artist-Craftsmen New York; U.N. Art Club; Sculptors Guild. **Exhibited:** Art exhib. for benefit of UNICEF, U.N. Art Gal., 1967; Int. Art Exhib., Minneapolis/Saint Paul, MN, 1972; Artist-Craftsmen New York Summer Show, 1972; Gal. 1991, Brooklyn, 1972; Sculptors Guild, Inc., 1972. **Awards:** second prize, Brooklyn Heights Promenade Art Show, 1971; best in sculpture, Artist-Craftsmen New York Ann. Show, 1972. **Work:** Commissions: loft bed & interior design, Buck Clark, NYC, 1968; mural-window (plexiglas), Mrs. Teannie Clark, New York, 1971; resin sculpture, Mrs. Ruth Ann Pippenger, Brooklyn, NY, 1972. **Comments:** Preferred media: bronze, concrete, polyester, resin. Teaching: instructor in glass craft, private studio, 1970-. Art interests: works are non-representational in the traditional sense, yet externalized somewhat in the order of constructivism principle. **Sources:** WW73; Article (1967) & Dinky Di, article (1972), *U.N. Secretarial News;* Corine Coleman, article, *Phoenix Newspaper,* 1972.

SUGARMAN, George *[Sculptor, painter] b.1912, NYC.*
Addresses: NYC. **Studied:** City College New York (B.A.); Atelier Zadkine, Paris, 1951. **Exhibited:** WMAA Sculpture Ann., 1960-73; Pittsburgh Int., Carnegie Inst., 1961 (2nd prize for sculpture); Sao Paulo Biennal, Brazil, 1963; Sculpture of the Sixties, LACMA, 1967; Int. Pavilion, Venice Biennal, 1969. Other awards: Longview Foundation grants, 1961-63; Nat. Art Council Award, 1966. **Work:** sculptures: Walker AC, Minneapolis, MN; Kunstmuseum, Zurich, Switzerland; Albert List Family Collection, NYC; Kaiser Wilhelm Mus., Krefeld, Germany. Lithographs: MoMA. Commissions: wood wall sculpture, Ciba-Geigy Chem Co., 1960; metal sculptures, Xerox Data Systems, El Segundo, CA, 1969, South Mall Project, Albany, 1970, First Nat. Bank, Saint Paul, MN, 1971; Greenfield School, Phila., 1972. **Comments:** Preferred media: metal, acrylics. Teaching: assoc. professor sculpture, Hunter College, 1960-70; visiting professor sculpture, Grad. School Art & Arch., Yale Univ., 1967-68.

Sources: WW73; A. Goldin, introduction to catalogue (Kunsthalle, Basel, Switzerland, 1969); I. Sandler, Sugarman-Sculptural Complex (First Nat. Bank Saint Paul, 1971); H. Freed, audio-visual tape, 1972.

SUGARMAN, Tracy *[Illustrator] b.1921, Syracuse, NY.*
Addresses: Westport, CT. **Studied:** Syracuse Univ., 1943; BMA School, with Reuben Tam. **Member:** SI; Westport Artists (pres.). **Comments:** Made over 100 drawings of the student-voter registrations in Mississippi in the early 1960s, many of which were used in national magazines and newspapers, documentaries and exhibitions. Auth./illustrator: *Stranger at the Gates*, (Hill and Wang, 1966). Illustrator for major book publishers. **Sources:** W & R Reed, *The Illustrator in America*, 273.

SUGGS, Eldridge III *[Painter] b.1939.*
Studied: Michigan State Univ.; Hunter College, NYC; Pratt Inst.; Hofstra Univ., Hempstead, NY; Univ. Hawaii, Honolulu. **Exhibited:** Greenwich Village Art Show ,1967 (hon. men. & travel award), 1969; Convent of the Sacred Heart, NYC, 1969; Phila. Civic Center, 1969; Brooklyn Mus., 1970 (prize); East Rockaway Jewish Center, 1970; Westbury Pub. Lib., 1970 (solo). **Sources:** Cederholm, *Afro-American Artists*.

SUGIMOTO, Albert H. *[Painter] mid 20th c.*
Exhibited: Corcoran Gal biennials, 1957, 1959. **Sources:** Falk, *Corcoran Gal.*

SUGIMOTO, Henry Y(uzuru) *[Painter, instructor, graphic artist] b.1904, Los Angeles, CA.*
Addresses: Hanford, CA, until 1950; NYC. **Studied:** Calif. College Arts & Crafts (B.F.A.); Calif. School Fine Arts; UCal; Segonzac; Acad. Colarossi, Paris. **Member:** San Francisco AA; Calif. WCS; Fnd. Western Artists; Calif. Lg. Writers & Artists; Art Center, San Francisco; Washington Printmaker Soc.; Nika-Kai AA, Tokyo. **Exhibited:** Salon d'Automne, Paris, 1931; Calif.-Pacific Expo, 1935; SFMA, 1935; San Francisco AA, 1936 (prize); Los Angeles AA; San Francisco Lg. Art, 1936; Hanford (CA) Pub. Lib., 1937 (solo); Fnd. Western Artists, 1937 (Art Concour Award); Arkansas State Exhib., 1946; GGE, 1939 (Fine Arts Exhib., recognition medal); U.S. Exhib., Mod. World Exhib., Tokyo, Japan, 1950; PAFA Ann., 1953; Salon Artistes Français, Paris, 1963; Months of Waiting, Doc. Painting Traveling Exhib., 1972 (recognition plaque for Months of Waiting, Los Angeles Co. Board Supervisors); Wiener Gal, NYC, 1970s. **Work:** Mus. Crecy, France; CPLH; Calif. College Arts & Crafts H.S., Pub. Lib., Hanford, CA; Hendrix College Fine Art Mus., AR; Wakayama Mod. Art Mus, Japan; Univ. Arkansas Art Mus. **Comments:** Preferred media: oils, watercolors, wood. Positions: art consultant, War Relocation Authority, 1943-45. Teaching: Denson H.S., Arkansas, 1943-44. Research: documentary painting of the War Relocation Centers of Japanese during World War II. Publications: Illustrator,"Songs for the Land of Dawn" (1949), "Toshio and Tama" (1949) & "New Friends for Susan," 511; contributor, "Beauty Behind Barbed Wire" (1952) & "Nisei" (1969). **Sources:** WW73; WW47; *New America* (Life & War Relocation Authority, 1946); Falk, *Exh. Record Series.*

SUGLIO, Joseph *[Painter] mid 20th c.*
Addresses: Buffalo, NY. **Exhibited:** Artists Western NY, 1938, 1939; Albright Art Gal., Buffalo. **Sources:** WW40.

SUHAY, Eugene J. *[Painter] mid 20th c.*
Exhibited: Salons of Am., 1925. **Sources:** Marlor, *Salons of Am.*

SUHR, Frederic *[Painter, illustrator, designer] b.1889, Brooklyn, NY.*
Addresses: NYC/Cambridge, MD. **Studied:** ASL; PIA School; Bridgman; Fogarty; Dufner. **Member:** SC; SI; Art Dir. Club. **Sources:** WW40.

SUHR, William *[Painter] b.1896, Kreutzberg, Germany.*
Addresses: Detroit, MI; NYC. **Studied:** RA, Royal Arts & Crafts School, Berlin; Arts & Crafts School, Hanover. **Exhibited:** Corcoran Gal biennials, 1930, 1932; SFMA; AIC; PAFA Ann., 1932-33. **Comments:** Restorer of paintings for Detroit AI, CMA,

TMA & de Young Mem. Mus., San Francisco. **Sources:** WW40; Falk, *Exh. Record Series.*

SUI, Wesley C. *[Painter] mid 20th c.*
Addresses: Chicago area. **Exhibited:** AIC, 1929. **Sources:** Falk, *AIC.*

SUIB, Joseph *[Painter] b.1874, California.*
Exhibited: Soc. Indep. Artists, 1918, 1925; WMAA, 1920-28; Salons of Am., 1933. **Sources:** Marlor, *Salons of Am.*

SUINA, Theodore *[Painter] mid 20th c.*
Addresses: Bernarlillo, NM. **Exhibited:** First Nat. Exhib., Am. Indian Painters, Philbrook AC, 1946. **Sources:** WW47.

SUKEY, Grover C. *[Sculptor] 20th c.*
Addresses: Minneapolis, MN. **Sources:** WW15.

SULLER, Joseph C. *[Painter] mid 20th c.*
Addresses: Brooklyn, NY. **Exhibited:** Soc. Indep. Artists, 1931; Salons of Am., 1934. **Sources:** Marlor, *Salons of Am.*

SULLINS, Robert M *[Painter, educator] b.1926, Los Angeles, CA / d.1991.*
Addresses: Oswego, NY. **Studied:** Univ. Wyoming, 1946-47; Univ. Illinois, 1947-48; Univ. Wyoming (B.A., art, 1950, M.A., art, 1958; Fulbright fellowship, 1959-60; Inst. Allende, San Miguel Allende, Mexico (M.F.A.), 1966. **Member:** College Art Assn. Am. **Exhibited:** Jason Gal., New York, 1966 (solo); Aspect/Aegis Gal., New York, 1968 (solo); Childe Hassam Exhib., Am. Acad. Arts & Letters, 1969; Kinetic Art Show, Albright-Knox Art Gal., Buffalo, NY, 1970; Am. Drawing Biennial, XXIV, Norfolk Mus. Arts & Sciences, 1971; Abe Rothstein-Horizon Galleries, Newton Center, MA, 1970s. **Awards:** Robert Ahl Mem. grant, 1960; State of NY research fellowship, 1971. **Work:** Norfold (VA) Mus. Arts & Sciences; Northern Illinois Univ., DeKalb; Civic Center, Scottsdale, AZ; Inst. Int. Educ., NYC. Commissions: Crucifixion (mural), St. Joseph's Catholic Church, Rawlins, WY, 1961; Upstatescape (painting), State Univ. NY, College Oswego, 1966; mural, The Flame Room, Rawlins, 1967; kenetic machine, Mirrors, Motors & Motion Show, Rochester (NY) Mus., 1970. **Comments:** Preferred media: acrylics, polyester resins. Positions: art supervisor, Public Schools Rawlins, WY, 1955-59. Teaching: art professor, State Univ. NY College Oswego, 1960-. **Sources:** WW73.

SULLIVAN, Alice Dieudonnée Chase (Mrs. Arthur) *[Painter, illustrator] b.1887, NYC. / d.1971, Virginia.*
Addresses: Manhasset, NY. **Studied:** with her father, W.M. Chase. **Member:** Douglaston AL. **Exhibited:** Douglaston AL, 8th St. Gal, NYC, 1940. **Comments:** Painted still lifes & landscapes. **Sources:** WW40.

SULLIVAN, Arthur B. *[Painter] 20th c.*
Addresses: NYC. **Member:** SC; SI. **Sources:** WW29.

SULLIVAN, Charles *[Portrait, landscape, and historical painter] b.1794, Frankford, PA / d.1867, Marietta, OH.*
Addresses: Wheeling (VA, now WV), 1827-33; Marietta, OH, 1833-67. **Studied:** Thomas Sully, Philadelphia. **Comments:** Sullivan painted in and around Philadelphia and spent several winters in Georgia and Tennessee. **Sources:** G&W; Reiter, "Charles Sullivan (1794-1867)"; Clark, *Ohio Art and Artists*, 104-06; Rutledge, PA.

SULLIVAN, Charles C. *[Sculptor] 19th/20th c.*
Addresses: Wash., DC, active 1920. **Sources:** McMahan, *Artists of Washington, DC.*

SULLIVAN, D. Frank *[Painter, designer, teacher] b.1892.*
Addresses: Pittsburgh, PA/Trevett, ME. **Studied:** Boston, with V. George, E.L. Major, R. Andrew. **Member:** Pittsburgh AA. **Work:** Brownsville, PA; Pittsburgh pub. schs. **Comments:** Position: head, Connelly Trade School, Pittsburgh. **Sources:** WW40.

SULLIVAN, E. *[Miniature painter, engraver] early 19th c.*
Addresses: Lynchburg, VA, 1819-20. **Sources:** Wright, *Artists in Virginia Before 1900.*

SULLIVAN, Edmund J. *[Illustrator] 19th/20th c.*
Addresses: NYC.
Comments: Position: illustrator, Century Co., NYC. **Sources:** WW01.

SULLIVAN, Francis *[Portrait painter] d.1925.*
Addresses: NYC.

SULLIVAN, Gene *[Painter, illustrator] mid 20th c.; b.Sauquoit, NY.*
Addresses: NYC. **Studied:** Parsons School Design; ASL; also with Everet Shinn, New York. **Member:** AWCS; PAFA. **Exhibited:** NAD, 1949; AWCS Exhibs., 1949-70; Allied Artists Am.; Audubon Artists, 1950-53; Ferargil Art Gal. (solos); Grand Cent Art Gal., 1956 (solo). Awards: gold medal for watercolor, Catharine Lorillard Wolfe Art Club; Albers Mem. Award, 1954. **Comments:** Positions: director, Gene Sullivan Art Gal., New York, 1956-57; free lance designer & illustrator, various magazines & companies. Teaching: instructor in interior delineation, Pratt Inst., 1945-49; private instructor in oils & watercolors. **Sources:** WW73.

SULLIVAN, Hattie *[Painter] 20th c.*
Addresses: Yonkers, NY. **Sources:** WW24.

SULLIVAN, J. Banigan *[Painter] mid 20th c.*
Exhibited: Salons of Am., 1934. **Sources:** Marlor, *Salons of Am.*

SULLIVAN, James See: **SULLIVAN, Jim**

SULLIVAN, James Amory *[Painter, teacher] b.1875, Boston, MA.*
Addresses: Paris, France, 1908; Boston, MA/Ashfield, MA. **Studied:** Académie Julian, Paris with J.P. Laurens, 1898; Alex. Harrison, also in Paris. **Exhibited:** PAFA Ann., 1908. **Sources:** WW25; Falk, *Exh. Record Series.*

SULLIVAN, Jeremiah *[Sculptor] d.1895, Wash., DC.*
Addresses: Wash., DC, active 1825 and after. **Comments:** European artist who came to the U.S. to work on the sculptural decorations at the Capitol. He and Thomas McIntosh (see entry) were involved in carving relief panels of wreaths and arrows. **Sources:** McMahan, *Artists of Washington, DC.*

SULLIVAN, Jim *[Painter] b.1939, Providence, RI.*
Addresses: NYC. **Studied:** RISD (Fulbright scholarship & B.F.A., 1961); grad. work, Stanford Univ., 1962-63. **Exhibited:** WMAA, 1965-72; Lyrical Abstraction, Larry Aldrich Mus., CT & WMAA, 1970-71; Beautiful Painting, Columbus Gal. Fine Arts, OH, 1971; MoMA, 1971; Indiana Mus. Art, Indianapolis, 1972; Paley & Lowe, Gal., Inc., NY, 1970s. Awards: Guggenheim Foundation grant, 1972. **Work:** WMAA; Worcester (MA) Art Mus.; Albany (NY) State Mus. **Comments:** Preferred media: acrylics. Teaching: asst. professor of painting, Bard College, 1965-. **Sources:** WW73; David Shirey, art review, *New York Times,* October 23, 1971; Peter Schsedahl, review with reprod., *Art in Am.,* (Feb., 1972); Carter Ratcliff, "Whitney Annual Part I," *Artforum* (April, 1972).

SULLIVAN, John *[Listed as "artist"] b.c.1824, Germany.*
Addresses: NYC, 1850. **Comments:** Possibly John A. Sullivan, who exhibited at the Boston AC in 1883. **Sources:** G&W; 7 Census (1850), N.Y., XLVI, 823; *The Boston AC.*

SULLIVAN, Kathleen B. *[Painter] mid 20th c.*
Addresses: Phila., PA. **Exhibited:** PAFA Ann., 1933. **Sources:** Falk, *Exh. Record Series.*

SULLIVAN, Lillie *[Illustrator] d.1903, Wash., DC.*
Addresses: Wash., DC. **Work:** Us. National Arboretum. **Comments:** Position: chief illustrator, entomology, Dept. of Agriculture, Wash., 1877-92. Was considered the foremost illustrator of insects in the world. **Sources:** McMahan, *Artists of Washington, DC.*

SULLIVAN, Louise Karrer (Mrs. William) *[Painter] b.1876, Port Huron, MI.*

Addresses: Boston/Brookline, MA. **Studied:** BMFA Sch. with P.L. Hale. **Member:** Copley Soc.; Rockport AA. **Exhibited:** Corcoran Gal biennial, 1923; PAFA Ann., 1923, 1928, 1930. **Sources:** WW33; Falk, *Exh. Record Series.*

SULLIVAN, Margaret C. *[Painter, teacher] 20th c.*
Studied: PAFA. **Sources:** WW25.

SULLIVAN, Max William *[Art administrator, craftsman] b.1909, Fremont, MI.*
Addresses: Providence, RI; Fort Worth, TX. **Studied:** Western Michigan Univ. (A.B., 1932); Harvard Univ. (A.M., 1941); Providence College (hon. LL.D, 1950); A.N. Kirk; J. Enser. **Member:** Providence AC; Am. Inst. Architects; Fort Worth Club; Am. Assn. Mus.; Harvard Club. **Exhibited:** Hackley Art Gal.; AGAA. **Comments:** Positions: director, exhib. New England handicrafts, Worcester Mus. Art 1942-43; consultant, MMA, 1943-44; dean school, RISD, 1945-47; pres. corp., 1947-55; dir., Portland Art Mus., Portland AA & Mus. Art School, 1956-61, secy., board trustees, 1957-60; dir., Everson Mus. Art, Syracuse, NY, 1961-71; program dir., Kimbell Art Mus., Fort Worth, TX, 1971-. Teaching: instr., Cranbrook School, 1933-35; instr. in arts & crafts, Middlesex School, Concord, MA, 1935-38; hd. art dept., Groton School, MA, 1938-42; consultant art educ., Harvard School Educ., 1940-42; dir. educ., RISD, 1944-45. Research: contemporary arch. and sculpture; classical studies, especially Magna Graecia. Publications: auth./ed., "Contemporary New England Handicrafts," Worcester Art Mus., 1943; contrib./ed., "Calligraphy; The Golden Age & Its Modern Revival," Portland Art Mus., 1958; contrib., "Everson Dedication Portfolio," 1969 & "American Ship Portraits & Marine Painting," 1970, Everson Mus., Syracuse, NY; contrib., catalogue of the collection, Kimbell Art Mus., Fort Worth, TX, 1972. **Sources:** WW73; WW47.

SULLIVAN, Owen *[Engraver] d.1756.*
Comments: He had his ears cropped and cheeks branded for counterfeiting at Providence (RI) in 1752; hanged at NYC in May 1756 for a repetition of the same offense. **Sources:** G&W; Dow, *Arts and Crafts in New England,* 13.

SULLIVAN, P. J. *[Painter] mid 20th c.*
Exhibited: Soc. Indep. Artists, 1937. **Sources:** Marlor, *Soc. Indep. Artists.*

SULLIVAN, Pat *[Cartoonist] b.1887, Sydney, Australia / d.1933.*
Addresses: NYC. **Studied:** Pasquin, Sydney. **Comments:** He drew his first cartoons in London. Upon coming to NYC he created a comic strip for the "World," and afterwards joined the McClure Syndicate for which he originated "Sambo Johnson," "Old Pop Perkins," "Johnny Bostonbeans" and "Obliging Oliver." When the animated cartoon was introduced in motion pictures, he collaborated with Raoul Barre in a series on the adventures of "Sambo Johnson." He was the creator of the most popular animated cartoon, "Felix the Cat," which he put on the screen for Famous Players. **Sources:** WW32.

SULLIVAN, Paul D. *[Listed as "artist"] b.1865, Wash., DC.*
Addresses: Wash., DC, active 1899-1901. **Sources:** McMahan, *Artists of Washington, DC.*

SULLIVAN, R. *[Miniature painter] early 19th c.*
Addresses: Lynchburg, VA, active 1820. **Sources:** Wright, *Artists in Virginia Before 1900.*

SULLIVAN, Roy T. *[Sculptor] 19th/20th c.*
Addresses: Wash., DC, active 1920. **Sources:** McMahan, *Artists of Washington, DC.*

SULLIVAN, Virginia J. *[Teacher, painter, sculptor] mid 19th c.*
Addresses: New Orleans, active 1856-57. **Comments:** Taught china and glass decoration and for publicity, raffled off her own work. **Sources:** *Encyclopaedia of New Orleans Artists,* 368.

SULLIVANT, T(homas) S(tarling) *[Illustrator]*

b.1854, Columbus, OH. / d.1926.
Addresses: Phila., PA/Jamestown, RI. **Studied:** PAFA with Bensell, Moran. **Member:** SI; Phila. Sketch Club. **Sources:** WW25.

SULLY, Alfred *[Amateur watercolorist] b.1820, Philadelphia / d.1879, Fort Vancouver, Wash. Territory.*
Work: Oakland (CA) Art Mus.; Bancroft Library, Univ. of Calif., Berkeley; Beinecke Rare Book Library, Yale Univ. **Comments:** Son of Thomas Sully (see entry). He graduated from West Point in 1841 and had a long military career which included service during the Mexican War; a post as Quartermaster at Monterey (CA) from 1848 to 1853; an assignment to build Fort Ridgley in Minnesota during the 1850s; service during the Civil War; and service as commander of an expedition against the Indians in the Northwest in 1865. He was transferred to Fort Vancouver in 1870. He recorded events and his surroundings throughout his career, working primarily in watercolor. Among his known works are a view of Monterey from 1849 and a series of views of Minnesota forts from the fifties; his scenes of the Mexican War and the Gold Rush are highly sought after and very rare. **Sources:** G&W; Hart, *Register of Portraits,* 14; Van Nostrand and Coulter, *California Pictorial,* 50-51. More recently, see P&H Samuel; Hughes, *Artists in California,* 544.

SULLY, Blanche *[Amateur painter and sketcher] b.1814, Phila. / d.1898, Phila.*
Addresses: Phila. **Comments:** A daughter of Thomas Sully (see entry). She traveled with her father on several of his painting trips, including to England in 1838 when he painted a portrait of Queen Victoria; and to Charleston in 1841, when she made some sketches of Charleston scenes. Her sisters Rosalie, Ellen, and Jane were also painters. **Sources:** G&W; Hart, *Register of Portraits,* 13; Biddie and Fielding, *Life and Works of Thomas Sully,* 49-52; Rutledge, *Artists in the Life of Charleston,* 151, 163.

SULLY, Ellen Oldmixon *[Amateur painter] b.1816, Philadelphia / d.1896.*
Studied: Thomas Sully. **Work:** Hist. Soc. Penn. (her copies of her father's portraits of Charles Carroll of Carrollton and Bishop William White). **Comments:** She was a daughter of Thomas Sully (see entry) and the sisters of artists Blanche, Rosalie, and Jane. She married John Hill Wheele in 1836. **Sources:** G&W; Hart, *Register of Portraits,* 14; Sawitzky, *Hist. Soc. of Pa. Cat.*

SULLY, George Washington *[Painter] b.1816, Norfolk, VA / d.1890, Covington, LA.*
Addresses: New Orleans, active c.1835-41. **Comments:** Was in Florida 1832-34 & 1839, where he made numerous sketches. In New Orleans he painted watercolor scenes of sites in the city and by 1862 he and his family had moved to Covington. Nephew of Thomas Sully (see entry). **Sources:** *Encyclopaedia of New Orleans Artists,* 368.

SULLY, Jane Cooper See: **DARLEY, Jane Cooper Sully (Mrs. W.H.W.)**

SULLY, Julia *[Portrait and genre painter] late 19th c.*
Exhibited: Richmond AC, 1896. **Comments:** Granddaughter of Robert M. Sully, she directed the Virginia Art Index in recording all historic portraits under the auspices of the Conservation Commission of Virginia. **Sources:** Wright, *Artists in Virgina Before 1900.*

SULLY, Kate *[Painter] 20th c.*
Addresses: Rochester, NY. **Member:** Rochester AC. **Sources:** WW29.

SULLY, Lawrence *[Miniaturist, portrait painter, fancy painter] b.1769, Kilkenny, Ireland / d.1804, Richmond, VA.*
Addresses: Came with parents to U.S. 1792; active Richmond , VA, 1792-1804. **Studied:** trained as a miniaturist in England. **Comments:** The elder brother of Thomas Sully (see entry). Established himself as portraitist in Richmond (VA) in 1792 and as the first resident artist of that city achieved considerable success. He was later joined by his brother Thomas and the two spent

a brief period in Norfolk (1801). Lawrence Sully died as a result of injuries received in a brawl in Richmond. Thomas later married Lawrence's widow and helped bring up his brother's children, including Mary Chester Sully who married John Neagle.
Sources: G&W; *Richmond Portraits,* 232-33; Hart, *Register of Portraits,* 11; Prime, II, 33. More recently, see Gerdts, *Art Across America,* vol. 2: 14.

SULLY, Mary Stuart *[Painter, teacher, writer] b.c.1842, New Orleans, LA / d.1915, New Orleans, LA.*
Addresses: New Orleans, active 1884-96. **Exhibited:** World's Indust. & Cotton Cent. Expo, 1884-85; W. J. Warrington's, 1887; New Orleans AA, 1887; Dallas State Fair, 1888 (first prize for watercolor, 2 first prizes for china painting). **Comments:** Watercolorist, china painter & designer of Easter cards. **Sources:** *Encyclopaedia of New Orleans Artists,* 368.

SULLY, Robert Matthew *[Portrait and miniature painter] b.1803, Petersburg, VA / d.1855, Buffalo, NY (on his way to Wisconsin).*
Addresses: Primarily Richmond, VA; London, England, 1927; Washington, DC, 1931. **Studied:** Thomas Sully (his uncle), Philadelphia; England. **Exhibited:** Royal Academy, London, 1825-27; PAFA Ann., 1827, 1831-32, 1876 (posthumously); NAD; Boston Atheneum. **Work:** Wisconsin Hist. Society; Virginia Hist. Soc.; College of William and Mary. **Comments:** Established his career in Richmond beginning in 1828; he was working in Philadelphia, Richmond, and Washington in 1831-32, but thereafter worked mainly in Richmond. Painted many portraits of John Marshall during the Constitutional Convention of 1829-30. Also painted a number of Indian portraits. **Sources:** G&W; Hart, *Register of Portraits,* 11; Bolton, *Miniature Painters;* Graves, *Dictionary;* Rutledge, PA; Cowdrey, NAD; Cowdrey, AA & AAU; Swan, BA; Wisconsin State Hist. Soc., *Historical Collections,* II, 68. More recently, see Gerdts, *Art Across America,* vol. 2: 16-17; Wright, *Artists in Virgina Before 1900.*

SULLY, Rosalie Kemble *[Miniature and landscape painter] b.1818, Philadelphia / d.1847, Philadelphia.*
Addresses: Philadelphia. **Exhibited:** Apollo Assoc., 1839 (five landscapes). **Comments:** Daughter of Thomas Sully (see entry). Her sisters Blanche, Ellen, and Jane were also painters. **Sources:** G&W; Hart, *Register of Portraits,* 14; Bolton, *Miniature Painters;* Cowdrey, AA & AAU. More recently, see Rubinstein, *American Women Artists,* 47; Petteys, *Dictionary of Women Artists.*

SULLY, Thomas *[Portrait, miniature, and figure painter, teacher] b.1783, Horncastle, Lincolnshire (England) / d.1872, Philadelphia.* 𝐵. 1831.
Addresses: Philadelphia, from 1808, with frequent travel. **Studied:** received first lessons in painting from his brother-in-law Jean Belzons and his own brother Lawrence Sully; Henry Benbridge, Norfolk, 1801; traveled to London, 1809-10, took a studio with Charles Bird King and studied with Benjamin West and Thomas Lawrence. **Member:** PAFA. **Exhibited:** PAFA , 1811-70 (and posthumously, 1876-78, 1905); NAD, 1827-52, 1864; Brooklyn AA, 1863-64, 1872, 1912. **Work:** PMA; PAFA; Am. Philos. Soc., Phila.; MMA; BMFA; NMAA; NPG; Yale Univ. Art Gal.; Detroit Inst. Art; Penn. Hist. Soc. has Sully's own register of the over 2000 portraits and over 500 subject paintings (all by title) painted by him. **Comments:** Youngest son of Matthew and Sarah Chester Sully, both actors. In 1792 the family moved to Charleston (SC). Thomas remained there until 1801 when an argument with his teacher, Belzons, apparently led him to leave Charleston and move to Richmond, VA, joining his brother Lawrence. The two brothers also worked briefly in Norfolk, VA, (1801), where Thomas may have studied briefly with Henry Benbridge. After Lawrence's untimely death in 1804, Thomas married Lawrence's widow and moved to NYC. Two years later he relocated to Hartford, CT, and then Boston, but in 1808 settled permanently in Philadelphia. After returning from a year's study in London (1809-10), Sully rose to become the leading portrait painter in Philadelphia, a position he held until his death. He was

a truly Romantic portraitist, imbueing his sitters with a poetic quality that was enhanced by his fluid, painterly, brush work and soft pastel palette. He painted many of the most famous people of his day, including Andrew Jackson (CGA) and Thomas Jefferson (Amer. Philos. Soc.). In 1838 he went to England to paint a portrait of the new Queen Victoria (the original oil study is in the MMA); he also made occasional professional visits to Baltimore, Boston, Washington, Charleston, and Providence. Of his nine children, six survived infancy and all were either amateur or professional artists (Alfred, Blanche, Ellen, Jane, Rosalie, and Thomas), while his step-daughter Mary Chester Sully married the portrait painter John Neagle. **Sources:** G&W; Hart, *A Register of Portraits Painted by Thomas Sully;* Biddle and Fielding, *Life and Works of Thomas Sully;* Rutledge, PA; Graves, *Dictionary;* Cowdrey, NAD; Rutledge, MHS; Swan, BA; Cowdrey, AA & AAU; *Richmond Portraits;* Karolik Cat.; Penna. Acad., *Catalogue of Memorial Exhibition of Portraits by Thomas Sully;* Sully, "Recollections of an Old Painter"; Flexner, *The Light of Distant Skies;* Ormsbee, "The Sully Portraits at West Point." More recently, see Baigell, *Dictionary;* Gerdts, *Art Across America,* vol. 1 and 2; *Encyclopaedia of New Orleans Artists,* 368; *300 Years of American Art,* 96.

SULLY, Thomas Wilcocks *[Portrait and miniature painter]* b.1811, Philadelphia / d.1847, Philadelphia.
Addresses: Philadelphia, active 1830's-40's. **Exhibited:** PAFA; Artists' Fund Soc. **Comments:** A son of Thomas Sully (see entry) and sometimes known as Thomas Sully, Jr. **Sources:** G&W; Hart, *Register of Portraits,* 13; Rutledge, PA; Phila. CD 1841-47; Bolton, *Miniature Painters;* Thieme-Becker.

SULZER, Grace (Miss) *[Painter]* late 19th c.
Addresses: NYC, 1892. **Exhibited:** NAD, 1892. **Sources:** Naylor, *NAD.*

SUMAN, Lawrence *[Painter, commercial artist, illustrator, craftsperson]* b.1902, NYC / d.1986, Sierra Madre, CA.
Addresses: Sierra Madre, CA. **Studied:** Syracuse Univ.; Corcoran Sch. Art; & with Edmund Tarbell, Richard Munsell. **Member:** Calif. Art Potters Assn. **Exhibited:** LACMA, 1941; Laguna Beach AA; 1942; American Drawing Biennial, 1964. **Comments:** Position: designer, Walt Disney Productions, 1942-43; owner, A. L. Suman Properties, Sierra Madre, CA. **Sources:** WW59; WW47; more recently, see Hughes, *Artists in California,* 544.

SUMBARDO, M(artha) K(uhn) *[Painter, craftsperson, teacher]* b.1873, Hamburg, Germany / d.1961, Seattle, WA.
Addresses: Seattle, WA. **Studied:** Steinhard Sch. of FA, Hamburg; Stuttgart, Munich, Venice. **Exhibited:** Soc. Indep. Artists, 1930. **Comments:** Married to an Italian artist in her 20s and widowed quite young, she married American art collector Charles L. Sumbardo and moved to Seattle, WA. Specialty: copies of old master paintings. **Sources:** WW24; Trip and Cook, *Washington State Art and Artists.*

SUMERLIN, Mabel Ernestine Journeay *[Painter]* b.1879, San Diego, CA / d.1956, San Diego, CA.
Addresses: San Diego, CA. **Studied:** with Charles Fries and Nicolai Fechin. **Member:** San Diego Art Guild. **Exhibited:** San Diego FA Gallery, 1927; Calif.-Pacific Int. Expo, 1935. **Sources:** Hughes, *Artists in California,* 544.

SUMIO, Arima *[Painter]* mid 20th c.
Studied: ASL. **Exhibited:** Salons of Am., 1925; Soc. Indep. Artists, 1925. **Sources:** Marlor, *Salons of Am.*

SUMM, Helmut *[Painter, educator, engraver, screenprinter, block printer]* b.1908, Hamburg, Germany.
Addresses: Milwaukee, WI. **Studied:** Univ. Wisconsin (grad., 1930); Marquette Univ. (M.Ed., 1946); also with Umberto Romano, Carl Peters, Robert von Neumann, W.H. Varnum, R.S. Stebbins, H.W. Annen. **Member:** Wisc. WCS; Wisc. P&S (pres., 1963), Delta Phi Delta; Wisc. PM; Wisc. Educ. Assn.; Milwaukee PM. **Exhibited:** AIC; John Herron AI, 1946; LOC, 1944-45; Phila. Pr. Club, 1945-46; Kearney Mem. Exhib., 1946; Wisc. PM,

1943-46; Wisc. P&S, annually; Wisc. Salon, 1941, 1943, 1965 (watercolor award); Milwaukee AI, 1945 (prize), 1946 (prize); Midwest Mem. Exhib., Milwaukee, 1946; Soc. Am. Etchers, NAD Gals., 1948; Univ. Oklahoma Nat., 1950; AWCS Traveling Exhib., 1960; Am. Inst. Architects, 1963 (award for oil painting); Beloit & Vicinity Exhib., 1964 (purchase award for oil); Milwaukee AC Friends of Art, 1964-72. **Work:** Milwaukee AC Collection; Milwaukee AI; Milwaukee Journal Gallery Wisc. Art; Univ. Wisc.-Green Bay Contemporary Art Collection; Lakeland College Collection Wisc. Art; Gimbel's Airscapes, Milwaukee. **Commissions:** murals, Mem. Service Inst., Madison; St. John's Lutheran School, Glendale, WI, 1956 & Home for Aged Lutherans, Milwaukee, 1957; oil painting, Cudahy YMCA, WI. **Comments:** Preferred media: oils, watercolors, graphics. Illustrator: Wisconsin Art Calendar, 1936, 1937, 1938; Am. Blockprint Calendar, 1937. Publications: author, University of Wisconsin Extension art programs, WTMJ. Teaching: art instructor, Milwaukee Public Schools, 1931-48; director dept. art, Univ. Wisc.-Milwaukee Extension, 1948-56, program art & art educ., Univ. Wisc.-Milwaukee & Extension, 1956-. **Sources:** WW73; WW47; Don Key (author), "Review of Theodore's Gallery," 1965 & Violet Dewey (author), "What's New in Art," 1967, *Milwaukee Journal;* reproduction, *Wisc. Beautiful,* 1967.

SUMMA, Emily B.(Mrs.) *[Painter]* b.1875, Mannheim, Germany.
Addresses: St. Louis, MO. **Studied:** St. Louis Sch. FA; Bissell; Dawson-Watson. **Member:** St. Louis AG; St. Louis AL. **Exhibited:** Corcoran Gal biennial, 1916; St. Louis AG Exh., 1917 (prize). **Sources:** WW29.

SUMMER, (Emily) Eugenia *[Painter, sculptor]* b.1923, Newton, MS.
Addresses: Columbus, MS. **Studied:** Mississippi State College Women (B.S.); Columbia Univ. (M.A.); AIC; Calif. College Arts & Crafts; Penland School Crafts, NC; Seattle Univ. **Member:** College Art Assn. Am.; Mississippi AA; Am. Crafts Council; Southern Assn. Sculptors; Kappa Pi. **Exhibited:** Contemporary Am. Paintings, Soc. Four Arts, Palm Beach, FL, 1960; AFA Circulating Exhib., many US mus., 1961-62; Art In Embassies Program, U.S. State Dept., Rio de Janeiro, Brazil, 1966-67; many Mid-South Exhibs., Brooks Mem. Art Gal., Memphis, TN; Eighth Decade: Painters Choice, Georgia College, Milledgeville, 1971. Awards: Dumal Milner Purchase Award, 1962 & jurors award, 1968, Nat. Watercolor Exhib., Jackson; first prize in watercolor painting, Mid-South Exhib., Brooks Gal., 1965; also recipient Mississippi State College Women grants for studying & producing works in plastics. **Work:** Mississippi AA, Munic Art Gal., Jackson; First Nat. Bank Collection, Jackson; Nat. Bank Commerce Collection, Columbus, MS; First Nat. Bank, Laurel, MS; Sears Roebuck Collection, Laurel. **Comments:** Preferred media: acrylics, polyesters, wood, metal. Teaching: assoc. professor art, Mississippi State College Women, 1950-. **Sources:** WW73.

SUMMER, Eugenia See: **SUMMER, (Emily) Eugenia**

SUMMERFORD, Ben Long *[Painter, educator]* b.1924, Montgomery, AL.
Addresses: Vienna, VA. **Studied:** Am. Univ. (B.A. & M.A.); École Beaux-Arts, Paris (on Fulbright fellowship, 1949-50); Karl Knaths; Jack Tworkov. **Exhibited:** Fulbright Painters, WMAA, 1959; Jefferson PI Gal, Wash., DC, 1964 (solo), 1967 (solo). **Work:** CGA; Phillips Gal., Wash., DC; Fort Wayne (IN) Mus. Art. **Comments:** Preferred media: oils. Teaching: professor of painting, Am. Univ., 1950- & chmn. art dept., 1957-70s. **Sources:** WW73.

SUMMERFORD, Joe *[Painter]* mid 20th c.
Exhibited: Corcoran Gal biennial, 1951. **Sources:** Falk, *Corcoran Gal.*

SUMMERHILL, Emma F. *[Painter]* 20th c.
Addresses: Brooklyn, NY. **Exhibited:** Salons of Am., 1930, 1934; Soc. Indep. Artists, 1930-31, 1934. **Sources:** Marlor,

Salons of Am.

SUMMERS, Carol *[Printmaker] b.1925, Kingston, NY.*
Addresses: NYC. **Studied:** Bard College (B.A., 1951). **Member:** Print Council Am. (artist advisory board); Print Club Phila. **Exhibited:** WMAA, 1966. Awards: Italian Govt. grant, Italy, 1955; Louis Comfort Tiffany Foundation fellowships, 1955 & 1961; Guggenheim Foundation fellowship, 1959. **Work:** NYPL; MMA; MoMA; Victoria & Albert Mus., London; Bibliot. Nat., Paris. **Comments:** Preferred media: wood. **Sources:** WW73.

SUMMERS, Dudley Gloyne *[Painter, illustrator] b.1892, Birmingham, England / d.1975.*
Addresses: Woodstock, NY. **Studied:** New School Art, Boston (M.A.); ASL; D.J. Connah; C. Chapman; G. Bridgman; F.R. Gruger. **Member:** SC; SI; Woodstock AA. **Exhibited:** Montclair AM. **Work:** Four Chaplains, Nat. Conference Christians & Jews, New York; Sojourner Truth, State Univ. NY College, New Paltz; Woodstock AA. **Comments:** Preferred media: oils, casein. Publications: illustrator, *Saturday Evening Post, American Boy, Red Book, Cosmopolitan & Boy's Life.* Teaching: illustration instructor, New York School Design; instructor painting, Plainfield, NJ. **Sources:** WW73; WW47; Woodstock AA.

SUMMERS, Elizabeth F. *[Painter, lithographer, teacher] b.1888, Moberly, MO.*
Addresses: Kansas City, MO. **Studied:** E. Lawson; J.D. Patrick; A. Kostellow; I. Summers. **Member:** Kansas City SA. **Exhibited:** Missouri State Fair, Sedalia, 1929 (prize); Midwest Art Exhib., Kansas City AI, 1930 (med). **Sources:** WW01.

SUMMERS, F. M. *[Painter] late 19th c.*
Addresses: Phila., PA. **Exhibited:** PAFA Ann., 1881 (portrait in crayon). **Sources:** Falk, *Exh. Record Series.*

SUMMERS, Felix D. *[Painter] mid 20th c.*
Exhibited: Salons of Am., 1934. **Sources:** Marlor, *Salons of Am.*

SUMMERS, H. E. *[Painter] 20th c.*
Addresses: Indianapolis, IN. **Sources:** WW13.

SUMMERS, Ivan F. *[Painter, etcher] b.1886, Mt. Vernon, IL / d.1964, Woodstock, NY?.*
Addresses: Woodstock, NY. **Studied:** ASL; St. Louis Sch. FA. **Member:** SC; Woodstock AA. **Exhibited:** St. Louis AG, 1916 (prize); ASL, 1916 (prize). **Sources:** WW33; Woodstock AA.

SUMMERS, Lilly R. (Miss) *[Painter] b.1873, New Orleans, LA / d.1920, New Orleans, LA.*
Addresses: New Orleans, active 1890-99. **Studied:** Andres Molinary; New Orleans AA, 1890. **Member:** New Orleans AA, 1896-97. **Exhibited:** New Orleans AA, 1890, 1894, 1897, 1899; Atlanta Expo.,1896. **Sources:** WW01; *Encyclopaedia of New Orleans Artists,* 369.

SUMMERS, William Henry *[Cartoonist] b.1897, Springarten, IL.*
Addresses: East Cleveland, OH. **Work:** Huntington Lib., San Marino, CA; Univ. Georgia; Univ. Arkansas; Northwestern Univ.; Christian Brothers Univ., Ft. Worth, TX; Columbus Gal. FA. **Comments:** Position: cartoonist, *The Cleveland News.* **Sources:** WW40.

SUMMERT, Herbert *[Illustrator] 20th c.*
Addresses: Indianapolis, IN. **Sources:** WW08.

SUMMERVILLE, Stephen *[Engraver] b.c.1814, England.*
Addresses: NYC, 1850; Boston, 1855-56; Philadelphia, 1860-71. **Comments:** He left England after 1841. **Sources:** G&W; 7 Census (1850), N.Y., XLI, 692; 8 Census (1860), Pa., LXII, 339; NYBD 1850; Boston CD 1855, BD 1855-56; Phila. CD 1871.

SUMMEY, Mary Williamson (Mrs. C. Smith) *[Craftsperson] b.1887, South Carolina / d.1980.*
Addresses: New Orleans, active 1909-20. **Studied:** Newcomb College, 1906-09. **Exhibited:** New Orleans AA, 1910-11. **Sources:** *Encyclopaedia of New Orleans Artists,* 369.

SUMMY, Anne Tunis *[Painter] b.1912, Baltimore, MD / d.1986.*
Addresses: Naples, FL. **Studied:** Phila. Acad. Fine Arts; Inst. Allende, Mexico. **Member:** Nat. Soc. Painters in Casein & Acrylic; Phila. Art All.; Peale Club. **Exhibited:** Butler IA Art Midyear Show, 1968; Women in Fine Arts, Moore Col. Art, Phila., 1968-69; BMA Invitational, 1969; PAFA Fellowship Shows, Phila., 1969-70; William Penn Mem. Mus., 1971 (solo); Camp Hill Gal., Harrisburg, PA, 1970s. Awards: Newman Medal, 1968 & Lorne Medal, 1969, Nat. Soc. Painters in Casein & Acrylics; Landscape Painters Penn. Purchase Award, Bloomsburg College, 1970. **Work:** William Penn Mem Mus Contemp Collection, Harrisburg, Pa; Court Art Trust, Washington, DC; Bloomsburg College, PA; Rehoboth Art League, DE. **Commissions:** Portrait, Armstrong Cork Co., Lancaster, PA, 1969. **Comments:** Preferred media: acrylics. **Sources:** WW73; article, *La Rév. Mod.* (Jan., 1970).

SUMMY, Katherine J. Strong *[Painter, teacher] b.1888, Wash., DC.*
Addresses: Wash., DC; East Gloucester, MA. **Studied:** George Washington Univ. (B.A.); Teachers College, Columbia Univ. (B.S.; M.A.); Ernest Thurn; Hans Hofmann. **Member:** Wash. AC; Wash. WCC (secy., 1953-57). **Exhibited:** Soc. Wash. Artists, 1933-41; Wash. WCC, 1938-52; Wash. Art Club; NGA; Greater Wash. Indep. Exh., 1935. **Comments:** Positions: art instructor, Coolidge H.S., Washington, DC, 1916-54 (retired); Wash. Arts Admission Board, 1956-58. **Sources:** WW59; WW47. More recently, see McMahan, *Artists of Washington, DC.*

SUMNER, Amy (Draper) (Mrs.) *[Miniature painter] 20th c.; b.London, England.*
Addresses: NYC. **Studied:** Westminster Sch. Art, London. **Member:** Lyceum Club, London. **Sources:** WW13.

SUMNER, Donna Long (Mrs.) *[Painter (landscapes, miniatures)] late 19th c.*
Studied: AIC, 1897, with Frank Vanderpoel; miniature painting with Kate Lee Bacon, Chicago. **Exhibited:** Broadmoor Art Acad., Colorado Springs. **Sources:** Petteys, *Dictionary of Women Artists.*

SUMNER, J. (Miss) *[Painter] late 19th c.*
Exhibited: NAD, 1880. **Sources:** Naylor, *NAD.*

SUMNER, Laura W. Y. (Mrs.) *[Painter] mid 20th c.; b.Middletown, CT.*
Addresses: Greenwich, CT/Raquette Lake, NY. **Studied:** V.D. Perrine. **Member:** PBC; Palisade AA; Silvermine GA; Soc. Indep. Artists. **Exhibited:** Salons of Am., 1922, 1928, 1929; Soc. Indep. Artists., 1926. **Sources:** WW33.

SUMNER, William H. *[Printer, engraver, and lithographer] mid 19th c.*
Addresses: Boston, 1857-58. **Comments:** Of Emery N. Moore & Company (see entry). **Sources:** G&W; Boston CD 1857-58.

SUNAMI, Soichi *b.1885, Okayama, Japan / d.1971, NYC.*
Studied: ASL. **Exhibited:** Salons of Am., 1925; Soc. Indep. Artists, 1925-28, 1931. **Sources:** Marlor, *Salons of Am.*

SUND, Roland Wallace *[Landscape painter, block printer] b.1913, Worcester.*
Addresses: Worcester, MA. **Studied:** self-taught. **Comments:** Specialty: bookplates. **Sources:** WW40.

SUNDBERG, Anna M. *[Painter] early 20th c.*
Addresses: Chicago, IL. **Exhibited:** AIC, 1913. **Sources:** WW15.

SUNDBERG, Carl Gustave *[Painter] b.1928, Erie, PA.*
Addresses: Erie, PA. **Studied:** Albright Art School, Univ. Buffalo, grad.; study with Joseph Plaucan, Virginia Cuthbert, Albert Blaustien, Letterio Calipia & Robert Bruce. **Member:** Erie AC (pres., 1967-69); Erie Arts Council (vice-pres., 1970-71); Albright-Knox Art Gal.; Chautauqua AA. **Exhibited:** Chautauqua Nat. Jury Shows, NY, 1967-72; Midyear Shows, Butler IA, Youngstown, 1968, 1970 & 1972; Washington & Jefferson Nat.

Exhib., Washington, PA, 1969 & 1972; Mississippi Nat. Arts Festival, 1970; Audubon Artists, NYC, 1971; Galerie 8, Erie, PA, 1970s. Awards: purchase prize, Mid Year Show, Butler IA, 1970; purchase prize, Juried Arts Seventh Nat. Exhib, Tyler MA, 1970; prize for non-traditional, Chautauqua Exhib., 1972. **Work:** Butler IA; Tyler (TX) Mus. Art; Erie (PA) Pub. Mus.; Erie (PA) Public Library; Union Bank Erie, Pa; Albright-Knox Rental Art Gallery. Commissions: porcelain coat of arms, Episcopal Diocese of Erie, 1968; six porcelain panels (mod. motif coins), Union Bank, Erie, 1969. **Comments:** Preferred media: porcelain, enamels, graphics. Positions: artist-designer, Erie Ceramic Arts Co., 1953-; dir., Galerie 8, Erie, 1967-. Teaching: painting instr., Erie AC, 1964-. Specialty of gallery: paintings & graphics of well known area & national artists. **Sources:** WW73; Clyde, article, *Youngstown Vindicator,* June 28, 1970; Ada C. Tanner, article, *Chautauqua Daily,* August 17, 1970; Peggy Krider, art demonstration film produced by Villa Maria College, 1970.

SUNDBERG, Carl W. *[Industrial designer] b.1910, Calumet, MI.*
Addresses: Detroit 26, MI; Birmingham, MI. **Studied:** Wicker School Aer. **Member:** Soc. Plastics Indust.; Soc. Indust. Des.; Soc. Plastics Engineers. **Exhibited:** Mid-Am. Expo, Cleveland, 1945; Design of Crosley Bldg., WFNY1939. Awards: Modern Plastics Award, 1937. **Comments:** Position: partner, Sundberg-Ferar, Detroit, MI, as of 1953. Contributor of articles on industrial design to *Modern Plastics, Industrial Marketing, Mechanics Illustrated.* Lectures: industrial design--plastics. **Sources:** WW53.

SUNDBERG, Wilda (Regelman) *[Painter] b.1930, Erie, PA.*
Addresses: Erie, PA. **Studied:** Albright Art School, Univ. Buffalo, 1949-51; Gannon College, Erie, 1964-66; also with Joseph Plaucan, Al Blaustein & Virginia Cuthbert. **Member:** Erie AC (bd. directors, 1971-72); Albright Knox Art Gal.; Chautauqua AA; Erie Arts Council. **Exhibited:** Nat. Chautauqua Jury Show, NY, 1969-71; Catharine Lorillard Wolfe Art Club, NAD, NYC, 1970; Muse Art Gal., Springfield (MO) Art Mus., 1971; Albright Knox Mem. Gal., Buffalo, NY, 1971; Galerie 8, Erie, PA, 1970s. Awards: Chautauqua Nat. Watercolor Award, Chautauqua AA, 1970; third award watercolor, Edinboro, Penn. Summer Gal., 1970. **Work:** Erie Public Library. **Comments:** Preferred media: watercolors. Positions: fashion illustrator, Erie Dry Goods, 1951-55. Teaching: private instructor, Erie, 1964-66; art instructor, Erie AC, 1964-72. **Sources:** WW73; Peggy Krider (producer), "Watercolor Demonstration" (film), Villa Maria College, Erie, 1970; Ada Tanner, article, *Chautauqua NY News,* 1970; Meg Loncharic, "Women In the Arts," *Erie Times,* 1970.

SUNDBLOM, Haddon H. **(Sunny)** *[Illustrator] b.1899, Muskegon, MI / d.1976.* ~~SUNDBLOM~~
Addresses: Chicago, IL. **Studied:** night school; correspondence courses; AIC (4 years); Am. Acad. Art (over 3 years). **Member:** SI. **Comments:** Eminent commercial artist, who created many of the now famous images for the Coca-Cola Co.(Santa Claus), Colgate, Maxwell House, Proctor & Gamble and others. He formed his own studio in 1925, together with Howard Stevens and Edwin Henry. Many of their students became known illustrators, such as Earl Blossom, Matt Clark, Coby Whitmore and others. **Sources:** WW47; *300 Years of American Art,* 887.

SUNDERLAND, Elizabeth Read *[Art historian] b.1910, Ann Arbor, MI.*
Addresses: Durham, NC. **Studied:** Univ. Michigan (A.B.); Univ. Munich, Germany; Radcliffe College (A.M. & Ph.D.). **Member:** Am. Assn. Arch. Historians; Mediaeval Acad. Am.; College Art Assn. Am.; Soc. Amis Arts Charlieu (hon. mem.); La Diana (hon. mem.). **Comments:** Positions: director, Soc. Arch. Historians. Teaching: instructor in fine art, Duke Univ., 1939-42; asst. professor of fine art, Wheaton College (MA), 1942-43; asst. professor fine art, Duke Univ., 1943-51, assoc. professor, 1951-71, professor of art history, 1971-, endowment research grant, Italy 1965-66. Research: medieval arch. of the 8th-11th centuries. Publications:

author, "Charlieu à l'Époque Médiévale," Lyon, 71: contributor to *College Art Journal, Journal Soc. Arch. Historians, Art Bulletin, Speculum, Journal Arch. Inst. Japan* & others. **Sources:** WW73.

SUNDIN, Adelaide Althin Toombs (Mrs. Olof G.) *[Ceramic sculptor, craftsperson, lecturer, teacher] b.1915, Boston, MA.*
Addresses: Boston, MA; Hudiksvall, Sweden. **Studied:** Mass. Sch. Art; MIT (B.S. in Educ.); with Cyrus Dallin, Raymond Porter. **Exhibited:** PAFA, 1941; NAD, 1942; CGA, 1942; Copley Soc., Boston, 1941; Boston Art Club, 1942; Soc. MSP&G, Wash., DC; Boston Art Festival; Doll and Richards, Boston, 1949 (solo); Veerhof Gal., Wash., DC, 1952; Hudiksvall Mus., Sweden; Gavle Mus., Gavle, Sweden; Artisans Shop, Balt., 1952. Awards: medal, Mass. Sch. Art, 1936. **Work:** portraits in porcelain, Boston, NYC, Baltimore, Wash., DC, St. Louis, Los Angeles, Wilmington, & in Sweden. **Comments:** Lectures: ceramics. Specialty: porcelain portraits of children. **Sources:** WW59.

SUNDSTROM, Carl G. *[Painter] late 19th c.*
Addresses: Wissahickon, PA. **Exhibited:** PAFA Ann., 1891. **Sources:** Falk, *Exh. Record Series.*

SUNKEL, Robert Cleveland *[Art historian, sculptor] b.1933, Clarksville, TX.*
Addresses: Maryville, MO. **Studied:** Kilgore College, TX (A.A.); Texas Christian Univ. (B.F.A. & M.F.A.); Herron School Art, Indiana Univ.; Temple Univ.; Northern Illinois Univ. **Member:** Soc. Arch. Historians; Am. Assn. Univ. Prof.; College Art Assn. Am.; Mid- Am. College Art Conference; AFA. **Comments:** Preferred media: wood. Positions: curator, Percival De Luce Mem. Collection, Northwest Missouri State Univ., 1971-. Teaching: art instructor, Henderson State College, 1958-60; art instructor, Northwest Missouri State Univ., 1960-63, acting chmn. dept., 1963-71, asst. professor, 1971-. Research: English Baroque and Palladian architecture, particularly the work of Wren, Gibbs and Hawksmoor. **Sources:** WW73.

SUNTER, H(arry) J. (T.) *[Painter] b.1850.*
Addresses: NYC, 1888; Wash. DC., 1889. **Exhibited:** NAD, 1888; PAFA Ann., 1888-89. **Sources:** Falk, *Exh. Record Series.*

SUOZZI, Con(stantin) N. *[Cartoonist] b.1916, NYC.*
Addresses: Jackson Heights 70, NY. **Comments:** Contributed cartoons to *Esquire, Saturday Evening Post, Look, True, Wall St. Journal, Saturday Review, This Week, American Weekly, Parade, New Yorker* & others. **Sources:** WW59.

SUPLEE, Andrew Callender *[Engraver] b.c.1829, Philadelphia.*
Addresses: Philadelphia, active 1850 and after. **Comments:** He was the son of Jonas Suplee, carpenter, and listed variously as watch engraver, copperplate and steel engraver, letter and ornamental engraver, and general engraver. **Sources:** G&W; 7 Census (1860), Pa., LI, 76; 8 Census (1860), Pa., LXII, 319; Phila. CD 1850-60+.

SUPPO, Jules Leon *[Wood carver] b.1881, Geneva, Switzerland / d.1964, Larkspur, CA.*
Addresses: San Francisco, CA. **Studied:** École des Beaux-Arts, Paris. **Work:** Carmel Mission; Vedanta Soc. San Francisco. **Sources:** Hughes, *Artists in California,* 544.

SURENDORF, Charles (Frederick) *[Engraver, painter, teacher, blockprinter, cartoonist, lecturer, writer] b.1906, Richmond, IN / d.1979, Columbia, CA.*
Addresses: Logaport, IN; San Francisco, Columbia, CA. **Studied:** AIC; ASL; Ohio State Univ.; Mills College. **Member:** Calif. SE; San Francisco AA; Northwest Printmakers; Mother Lode AA; Richmond AA; New Orleans AA; Indiana Soc. Printmakers. **Exhibited:** Corcoran Gal biennial, 1932; CM, 1933, 1935-36; SFMA, 1936-46 (prize 1937); PAFA Ann., 1937; AV, 1942; deYoung Mem. Mus., 1946; LACMA, 1936; AIC, 1938, 1940; NAD, 1941, 1946; Albany Inst. Hist. & Art, 1945; Phila. Pr. Club, 1940, 1941 (prize), 1942 (prize), 1946; Northwest PM, 1938, 1941-42, 1944-46; John Herron AI, 1933 (prize), 1935

(prize), 1938 (prize), 1946; SAM, 1938 (prize), 1945 (prize); Calif. SE, 1938 (prize), 1941 (prize), 1942 (prize), 1944 (prize), 1945 (prize), 1950-54 (prizes); GGE, 1939 (prize), 1946; Wichita AM, 1935-38, 1941; Phila. Art All., 1938; Tri-State Exhib., Indianapolis, 1945 (prize), 1946 (prize); Indiana Artists, 1929-31 (prizes), 1933 (prize), 1934 (prize),1940 (prize); Hoosier Salon, 1930 (prize), 1948, 1952 (prize); San Francisco AA, 1938 (prize); Richmond AA, 1938 (prize); Delgado MA, 1949; New Orleans AA, 1949; LOC, 1949; Indiana Printmakers, 1949, 1951; SAGA, 1940, 1950 (prize); Calif. State Lib., 1951 (prize), 1952 (prize), 1954 (prize). **Work:** SFMA; Mills College; LOC; Wichita AA; Richmond (IN) Art Mus.; pub. sch., Indianapolis; library, Logansport; Tahiti MA; Richmond (IN) Art Gal. **Comments:** Position: director, first San Francisco Art Festival; director, Mother Lode Art Sch. & Gal., Columbia, A. Illustrator: "Mr. Pimney," 1945. WPA printmaker in California, 1930s. **Sources:** WW59; WW47; exh. cat., Annex Gal. (Santa Rosa, CA, n.d., c.1988); Hughes, *Artists in California*, 544; Falk, *Exh. Record Series.*

SURGOINE, Jeanne *[Sculptor] mid 20th c.*
Addresses: Chicago area. **Exhibited:** AIC, 1935. **Sources:** Falk, *AIC.*

SURHOFF, John *[Painter] mid 20th c.*
Exhibited: Salons of Am., 1925; AIC. **Sources:** Marlor, *Salons of Am.*

SURIA, Tomás de *[Sketch a, engraver] b.1761, Spain.*
Addresses: Active in California, 1791. **Studied:** Royal Acad. of San Fernando, Madrid, with Jeronimo Antonio Gil. **Work:** Museo Naval, Madrid. **Comments:** Worked as engraver in Mexico City (1788-91), before joining the Malaspina round-the-world-expedition as official artist. The group reached California in September 1791 and Suria made at least 19 drawings, ink washes, and watercolors of the Monterey settlement. Among these are a sketch of the Presidio at Monterey (Naval Museum at Madrid). Six engravings from his watercolors were reproduced in the report of the expedition, published in Madrid in 1885 under the title *Viaje politico-cientifico abrededor del mundo por las corbetas Descubierta y Atrevida.* Also taking part in the expedition was José Cardero (see entry), a sailor who made sketches of the settlement. Also appears as De Suria. **Sources:** G&W; *Antiques* (Nov. 1953), 371. More recently, see Van Nostrand and Coulter, *California Pictorial*, 6-7; Hughes, *Artists in California*, 544; Gerdts, *Art Across America*, vol. 3: 223.

SURIO, Dario *[Painter] 20th c.*
Addresses: Jackson Heights, NY. **Sources:** WW66.

SUROVEK, John Hubert *[Painter, museum director] b.1946, East Chicago, IN.*
Addresses: Daytona Beach, FL. **Studied:** Ball State Univ. (B.S.); also with Fred Messersmith & Alice Welty Nichols. **Member:** Southeastern Mus. Conf.; Am. Assn. Mus.; Florida Fed. Arts; Nat. Art Educ. Assn.; Florida Art Educ Assn. **Comments:** Preferred media: acrylics, watercolors. Positions: chmn. art dept., Hagerstown School Corp., 1968-69; director, Mus. Arts & Sciences, Daytona Beach, FL, 1972-. Publications: co-author, "Motivational Handbook for Schools," ESEA Title III, 9/1969. Teaching: instructor in humanities & art, Deland (FL) Sr. H.S., 1969-71, admin. asst., 1970-. Collections arranged: Cuban Paintings--Finest Collection in the World, Gift of Gen. & Mrs. Fulgenco Batista; Florida Invitational: First Annual (limited to 12 southeastern artists), 1972. **Sources:** WW73.

SURREY, Milt *[Painter] b.1922, NYC.*
Addresses: Westbury, NY. **Exhibited:** Soc.Four Arts, Palm Beach, FL, 1969; NAC, 1969; Cape Coral Nat. Art Show, FL, 1970; George Walter Vincent Smith AM, Springfield, MA, 1970; Parrish AM, Southampton, NY, 1970. Awards: John Knecht Mem. Award, Berwick Arts Festival, 1969; third place award, Garden Valley Nat. Art Show, 1969; second place award, Roslyn Art Show, 1970. **Work:** CAM; Columbia (SC) Mus. Art; Detroit IA; Evansville (IN) Mus. Art; Miami (FL) MoMA. **Comments:**

Preferred media: oils. **Sources:** WW73.

SURREY, Philip Henry *[Painter] b.1910, Calgary / d.1990.*
Addresses: Montreal 217, PQ. **Studied:** Winnipeg School Art, with Lemoine Fitzgerald; Vancouver School Art, with Frederick Varley & Jock Mcdonald; ASL with Alexander Abels. **Exhibited:** Hamilton Art Gal. Winter Exhibs., 1958-71; 25 Quebec Painters, Montreal Mus. Fine Arts, 1961; Master Can. Painters & Sculptors, London, 1963; solo retrospective, Peintre dans la Ville, Mus. Art Contemporain, Montreal 1971 & Center Cult. Canada, Paris, 1972; Galeries Gilles Corbeil, Montreal, PQ, 1970s. Awards: first prize, Montreal Spring Show, 1953; second prize, Winnipeg Show, 1960. **Work:** Nat. Gallery Canada, Ottawa; Art Gallery Ontario, Toronto; Montreal MFA; Mus. Quebec, Quebec City; Art Gallery Hamilton, Ontario. **Comments:** Preferred media: acrylics, oils, watercolors, pastels. Teaching: drawing instructor, Sir George Williams Univ. **Sources:** WW73; J. De Roussan (author), "Le Peintre des Reflets de la Ville," *Vie Arts,* 1963 & "Philip Surrey," Ed. Lidec, Montreal, 1968; Robert Ayre (author), "The City and the Dream," *Canadian Art,* 1964.

SURVAGE, Leopold *[Painter] mid 20th c.*
Exhibited: AIC, 1930-31. **Sources:** Falk, *AIC.*

SURVILLIERS, Comtesse de See: **BONAPARTE, Charlotte Julie**

SUSAN, Robert S. *[Painter] b.1888, Amsterdam, Holland.*
Addresses: Phila., PA. **Studied:** PM School IA; Phila. Graphic Sketch Club; PAFA, 1911-13, Cresson traveling scholarship; Spain; France. **Member:** Phila. Art All.; Pen & Pencil Club. **Exhibited:** PAFA, 1912 (prize), 1913 (prize), 1914 (prize), 1920 (medal); PAFA Ann., 1915-43; San Francisco, (medal); AIC. **Work:** PAFA; Phila. Graphic Sketch Club. **Sources:** WW53; WW47; Falk, *Exh. Record Series.*

SUSSMAN, Arthur *[Painter] b.1927, Brooklyn, NY.*
Addresses: Albuquerque, NM. **Studied:** Syracuse Univ. (B.F.A.); Brooklyn Mus. School Art. **Exhibited:** Inst. Cultural Relations, Mexico City, 1961 (solo); Malaga, Spain, 1963 (solo); Miami MOMA, 1964 (solo); Artists House, Haifa, Israel, 1964 (solo); Bernard Black Gallery, NY, 1965 (solo); Brandywine Galleries Ltd, Albuquerque, NM & New West, Albuquerque, NM, 1970s. Awards: Oriental Studies Foundation grant, 1962. **Work:** New Mexico MFA, Santa Fe; Oklahoma AC. **Comments:** Teaching: artist-in-residence, Univ. Albuquerque. **Sources:** WW73.

SUSSMAN, Edward W. *[Painter] mid 20th c.*
Exhibited: Soc. Indep. Artists, 1939. **Sources:** Marlor, *Soc. Indp. Artists.*

SUSSMAN, Margaret *[Craftsman, painter, sculptor, graphic artist] b.1912, NYC.*
Addresses: NYC. **Studied:** Smith College (B.A.); Grand Central Art Sch.; ASL; & with William McNulty, George Bridgman, Will Barnet, Harry Sternberg. **Member:** Artist-Craftsmen of NY; NAC; Pen & Brush Club. **Exhibited:** NAC, 1940 (prize), 1945 (prize), 1946; NAD, 1943; Audubon Artists, 1945; All. Artists Am., 1943, 1944; Phila. Pr. Club, 1944; Veterans Exhib., ASL, 1944; Contemporary Art Gal., 1943; NY Soc. Craftsmen, 1954-55; Staten Island MA, 1954-55. **Comments:** Position: silversmith & jeweler; instructor, Craft Students Lg., Y.W.C.A., NYC. **Sources:** WW59; WW47.

SUSSMAN, Richard N. *[Painter, printmaker, designer] b.1908, Minneapolis, MN / d.1971.*
Addresses: Richmond, CA. **Studied:** Minneapolis Sch. Art; ASL; G. Grosz; H. Hofmann. **Exhibited:** PAFA, 1941; BM, 1940; MMA (AV), 1942; AIC, 1943; CPLH, 1946; de Young Mem. Mus., 1944; Uptown Gal., NYC, 1940 (solo); WMAA, 1960. **Work:** MMA; stained glass windows for churches in many cities. **Sources:** WW47.

SUTCH, Marian *[Painter] 20th c.*
Addresses: Pittsburgh, PA. **Member:** Pittsburgh AA. **Sources:** WW25.

SUTER, Mary (Marie) S. *[Painter] late 19th c.*
Addresses: Wash., DC. **Exhibited:** Wash. WCC, 1897 (watercolors). **Sources:** McMahan, *Artists of Washington, DC.*

SUTER, Walter Paul *[Ceramicist] b.1901, Basle, Switzerland.*
Addresses: Larchmont, NY. **Studied:** Sch. Fine & Applied Art, Basle, Switzerland. **Member:** Am. Ceramic Soc.; Soc. Swiss PS & Arch. **Exhibited:** Robineau Mem. Exhib., Syracuse MFA, 1932 (prize). **Work:** terra cotta panels in patio of Detroit IA; Carillon Tower, Mountain Lake, FL; Hartford (CT) County Courthouse; elevator towers, Delaware River Bridge, Phila. **Comments:** Position: affiliate, American Encaustic Tiling Company, NYC. **Sources:** WW40.

SUTHERLAND, Charles E. *[Portrait painter] late 19th c.*
Addresses: Detroit, MI. **Exhibited:** Michigan State Fair, 1879. **Sources:** Gibson, *Artists of Early Michigan, 225.*

SUTHERLAND, Charles Vedder *[Painter] 20th c.*
Addresses: Chicago, IL. **Studied:** Académie Julian, Paris with J.P. Laurens, 1912. **Exhibited:** AIC, 1914. **Sources:** WW17.

SUTHERLAND, Claire D. *[Painter] mid 20th c.*
Addresses: NYC. **Exhibited:** Salons of Am., 1934, 1935; Soc. Indep. Artists, 1934-35. **Comments:** (Mrs. George Cormack) **Sources:** Falk, *Exhibition Record Series.*

SUTHERLAND, F. L. *[Painter] early 20th c.*
Addresses: Chicago. **Exhibited:** AIC, 1915. **Sources:** Falk, *AIC.*

SUTHERLAND, Garnet *[Painter] 20th c.*
Addresses: Indianapolis, IN. **Sources:** WW25.

SUTHERLAND, Minnie *[Painter] 20th c.*
Addresses: Seattle, WA. **Sources:** WW21.

SUTHERLAND, Sandy *[Painter, writer] b.1902, Cincinnati, OH.*
Addresses: NYC. **Studied:** ASL ; Mech. Inst., NY. **Member:** All. A. Am. (dir.); AWCS (recording secy., treasurer); Grand Central Art Gal.; ASL (life member); NAC. **Exhibited:** MMA Exhib. Am. Watercolors, 1952; AWCS, 1970; All. A. Am., 1971; Grand Central Art Gals., 1972; NAC, 1972. Awards: AWCS prize for non-member, 1951; Hoe Medal for free hand drawing, Mech. Inst., 1955; first award of merit for painting, Kenneth Taylor Gal., 1958. **Work:** Kenneth Taylor Gallery; NAC. **Comments:** Preferred media: oils, watercolors. Publications: author, "Figure Sketching in Watercolor," 1963 & "Painting in Oil on Paper," 1968, *Am. Artist.* **Sources:** WW73.

SUTLIPP, Henry *[Engraver] b.c.1814, England.*
Addresses: NYC, 1850. **Comments:** His wife was French; their three children (10 to 1) were born in New York. **Sources:** G&W; 7 Census (1850), N.Y., LVII, 124.

SUTO, Joseph *[Metalwork, etcher, sculptor, painter] b.1889, Hungary.*
Addresses: Cleveland, OH. **Studied:** A. Blazys; H.G. Keller. **Member:** Cleveland SA; Print Club, Cleveland. **Exhibited:** CMA. **Sources:** WW40.

SUTRO, Florence Edith Clinton (Mrs. Theodore)
[Painter, writer] b.1865, England / d.1906.
Addresses: NYC, 1892. **Exhibited:** NAD, 1892. **Comments:** Author: "Women in Music." Also a musician.

SUTRO, Lucy E. *[Painter] late 19th c.*
Addresses: Phila., PA. **Exhibited:** PAFA Ann., 1889-91. **Sources:** Falk, *Exh. Record Series.*

SUTER, H. R. *[Painter] 20th c.*
Addresses: Provincetown, MA. **Sources:** WW15.

SUTER, Joseph *[Painter, wood carver] mid 20th c.*
Addresses: Culver City, CA. **Exhibited:** Artists Fiesta, Los Angeles, 1931; Public Works of Art Project, Los Angeles, 1934. **Work:** Huntington Park (CA) P.O. **Sources:** Hughes, *Artists in California, 544.*

SUTTER, Walter Samuel *[Painter] b.1888, San Francisco, CA / d.1938, San Francisco.*
Addresses: San Francisco. **Exhibited:** San Francisco AA, 1925-27; Beaux Arts Club, San Francisco, 1927; San Diego FA Gallery, 1927; Calif. State Fair, 1930. **Work:** Sierra Nevada Mus., Reno. **Sources:** Hughes, *Artists in California, 544.*

SUTTMAN, Paul *[Sculptor] b.1933, Oklahoma / d.1993.*
Addresses: NYC. **Studied:** Univ. New Mexico (B.F.A., 1956); Cranbrook Acad. Art (M.F.A., 1958). **Member:** NSS, 1991 (hon. fellow). **Exhibited:** Univ. Michigan, 1962 (solo); Sculpture From Hirshhorn Collection, Guggenheim Mus., 1962; Sculptors From Midwest, John Herron Inst., 1963; Biennale Sculpture Contemporaine, Rodin Mus., Paris, 1968, 1970; U.S. Info Service Traveling Exhib., Istanbul & Ankara, Turkey, 1972; After Surrealism, Metaphors & Sinides, Ringling Art Mus., Sarasota, FL, 1972; D. Morris Gallery, Detroit, 1970s; Terri Dintenfass, NYC, 1962-73 (solos); Dartmouth College, 1973 (solo); Texas A&M Gal., 1981 (solo); F. Bader Gal., Wash., DC, 1990, 1994 (solos). Awards: Rackham Foundation research grant, Italy, 1960; Fulbright fellow, Paris, Inst. Int. Educ., 1963; Prix de Rome fellow, Am. Acad. Rome, 1965-68. **Work:** Hirshhorn Mus.; MoMA; Macomb College AM; Kalamazoo IA; Roswell MA; San Diego MFA; Dartmouth College; Univ. Michigan; Mt. Holyoke MA; Herron Inst.; Arizona State Univ.; Montclair AM; Princeton AM; Albuquerque Mus.Milwaukee AM; Middlebury College. Commissions: two figures, Eastland Shopping Center, Detroit, 1965; figure, Martha Cooke Bldg., Univ. Michigan, 1968. **Comments:** Preferred media: bronze, marble. Teaching: instructor in sculpture, Univ. Michigan, Ann Arbor, 1958-62; artist-in-residence, Dartmouth Col., 1973; Univ. New Mexico, 1975-79; Texas A&M, 1980-82; Columbia Univ., 1983-85. **Sources:** WW73; "The Bronze Man," Nat. Educ. TV, 1960; add'l info courtesy his widow, Mrs. Paul Sutton, 1995.

SUTTON, A. M. (or A. N.) *[Artist] late 19th c.*
Addresses: Active in Los Angeles, 1888-94. **Sources:** Petteys, *Dictionary of Women Artists.*

SUTTON, Alice Marion See: **BACON, Alice Sutton (Mrs. George)**

SUTTON, Bernice Perry (Mrs. Louis F.) *[Painter] mid 20th c.*
Addresses: Akron, NY. **Studied:** CI & with Judson Smith. **Member:** The Patteran. **Exhibited:** Pittsburgh AA, 1936-45; The Patteran, 1942-46; Syracuse MFA, 1941-45. **Sources:** WW53; WW47.

SUTTON, Cantey Venable *[Painter] 20th c.*
Addresses: Raleigh, NC. **Sources:** WW25.

SUTTON, E. *[Painter] late 19th c.*
Addresses: Monteagle,TN. **Exhibited:** AIC, 1888. **Sources:** Falk, *AIC.*

SUTTON, E. (Miss) *[Painter] late 19th c.*
Addresses: NYC. **Exhibited:** NAD, 1882-85. **Sources:** Naylor, *NAD.*

SUTTON, Frank (Mrs.) *[Painter] 20th c.*
Addresses: Seattle, WA. **Sources:** WW21.

SUTTON, Frederick D. *[Painter] late 20th c.*
Addresses: NYC. **Exhibited:** AIC, 1890, 1907-08. **Sources:** Falk, *AIC.*

SUTTON, Frederick H. *[Painter] 20th c.*
Addresses: Flushing, NY. **Sources:** WW10.

SUTTON, G. B. *[Painter] late 19th c.*
Addresses: Amenia, NY, 1864-70; Newark Valley, NY, 1873. **Exhibited:** NAD, 1864-73. **Sources:** Naylor, *NAD.*

SUTTON, George Miksch *[Painter, illustrator, writer, lecturer, mus curator] b.1898, Lincoln, NE / d.1982.*
Addresses: Ann Arbor, MI; Norman, OK. **Studied:** Bethany College (B.S., 1919); Univ. Pittsburgh, 1923-25; Cornell Univ.

(Ph.D., 1932); Bethany College (Sc.D., 1952); L.A. Fuertes. **Member:** Cranbrook Inst. Science; Wilson Ornithology Soc. (past pres.); Arctic Inst. North Am.; Cooper Ornithology Soc.; Am. Geograph. Soc.; Am. Ornithologist Union (councilman). **Exhibited:** Awards: John Burroughs Award, 1962; Knight Cross Order of the Falcon, Iceland, 1972. **Comments:** Positions: emer. curator birds, Stovall Mus, 1968-; ornithologist, Oklahoma Biol. Surv. Publications: author/illustrator, "Mexican Birds," 1951 & "Iceland Summer," 1961; author/illustrator," Oklahoma Birds" Univ. Oklahoma Press, 1967; author/illustrator, "High Arctic," 1971 & " At a Bend in a Mexican River," 1972, Eriksson. Teaching: George Lynn Cross emer. research professor zoology, Univ. Oklahoma. **Sources:** WW73; WW47.

SUTTON, Harry, Jr. *[Painter] b.1897, Salem, MA.*
Addresses: Andover, Boston, MA. **Studied:** BMFA Sch.; Académie Julian, Paris. **Member:** Boston SWCP; Boston GA. **Exhibited:** PAFA Ann., 1923, 1928, 1931; AIC, 1932. **Sources:** WW40; Falk, *Exh. Record Series.*

SUTTON, Henry W. *[Engraver] late 19th c.*
Addresses: Wash., DC, active 1892. **Sources:** McMahan, *Artists of Washington, DC.*

SUTTON, James F. *[Dealer] b.1843 / d.1915.*
Addresses: Bedford Hills, NY. **Comments:** One time a member of the firm of A. A. Vantine & Co., and one of the first Americans to visit China and bring back objects of art. In 1880 he founded the Kurtz Gal., which later became the auction house known as the American Art Assn.

SUTTON, James H. *[Engraver] 19th/20th c.*
Addresses: Wash., DC, active 1901. **Sources:** McMahan, *Artists of Washington, DC.*

SUTTON, Jay A. *[Painter] mid 20th c.*
Addresses: NYC. **Studied:** ASL. **Exhibited:** Soc. Indep. Artists, 1934; Salons of Am., 1935. **Sources:** Falk, *Exhibition Record Series.*

SUTTON, Kate M(onteath) *[Painter] mid 20th c.*
Addresses: Dover, NJ, 1930. **Exhibited:** Soc. Indep. Artists, 1930, 1934; Salons of Am., 1934. **Sources:** Marlor, *Salons of Am.*

SUTTON, M. *[Photographer, daguerreotypist, portrait painter] mid 19th c.*
Addresses: Detroit, MI. **Exhibited:** Michigan State Fair, 1857. **Sources:** Gibson, *Artists of Early Michigan,* 225.

SUTTON, Rachel McClelland (Mrs. W. S) *[Painter] b.1887, Pittsburgh, PA.*
Addresses: Pittsburgh, PA. **Studied:** CI; Chatham College; Woodstock Summer Sch. Art; ASL. **Member:** Pittsburgh AA; Pittsburgh WCS. **Exhibited:** Pittsburgh SA, 1932 (prize); CI, 1935-46; Allegheny County Garden Club, 1943 (prize); Pittsburgh AA, 1919-58; Butler AI; Indiana, PA, 1945; Pittsburgh WCS, 1945-58 (prize, 1954); Arts & Crafts Center, Pittsburgh. **Work:** Pittsburgh Pub. Schs. **Comments:** Specialty: portraits, Western Pennsylvania landscapes, views of Pittsburgh. While her early paintings were impressionist oils on canvas, her interest shifted to watercolor in 1945. **Sources:** WW59; WW47.

SUTTON, Ruth Haviland *[Portrait painter, lithographer, block printer, teacher] b.1898, Springfield, MA / d.1960, Nantucket, MA.*
Addresses: first came to Nantucket in 1924; made it her permanent residence by 1936. **Studied:** PM School IA, c.1924-25; Grand Central Art Sch., 1926-28; ASL with Geo. Bridgman and Mahonri Young, 1934-35; with Frank S. Chase on Nantucket, 1924; Henry B. Snell in Boothbay, ME, 1927; printmaking with George C. Miller; Jerry Farnsworth in Sarasota, FL, 1935. **Member:** CAFA; North Shore AA; NAWA; Nantucket AA (founder, 1945); Springfield AG; Boston SAC; Boston Printmakers, (founder, 1947). **Exhibited:** Springfield AL, 1926 (prize), 1927 (prize), 1928 (prize), 1928-35; Soc. Indep. Artists, 1928; NAWA, 1928, 1929, 1945-46; LOC, 1945-46; CI, 1945; NAD, 1927, 1945-46; CAFA, 1928-46 (prize 1931); Northwest PM, 1944-56; Springfield AG, 1928-40; Assoc. Jr. Lg., Boston, 1930 (prize); Jr. Lg., Springfield, 1931 (prize); Worcester, MA, 1931 (prize); Jr. Lg., Providence, 1932; Hartford, 1937; K. Taylor Gal., Nantucket, 1940s; Kennedy Gal., NYC; CI; Sarasota AA. **Work:** Aston College, Springfield, MA; Springfield Mus. FA; LOC; Northampton (MA) Pub. Lib.; CI; New Britain (CT) Inst.; NYPL; Boston Pub. Lib.; mural, Mus. Natural Hist., Springfield, MA.; Nantucket Hist. Assn. **Sources:** WW47; WW59; add'l info. courtesy Nantucket Hist. Assn.

SUTTON, W. *[Portrait painter] mid 19th c.*
Comments: Painted a portrait of a girl with a music book, about 1820. Lipman and Winchester list two artists by this name, both portrait painters, one active about 1840 and the other about 1850. **Sources:** G&W; info courtesy Harry Stone of NYC; Lipman and Winchester, 180.

SUTTON-BRUCE, Laura See: BRUCE, Laura S.

SUYDAM, E(dward) H(oward) *[Etcher, block printer, lithographer, illustrator] b.1885, Vineland, NJ / d.1940, Charlottesville, VA.*
Addresses: Phila., PA. **Studied:** Thornton Oakley, at PM School IA. **Member:** Phila. WCC; Phila. Print Club; Phila. Sketch Club; SI; Calif. PM. **Exhibited:** Wanamaker Prize, 1916, 1917; PAFA (gold medal, prize). **Work:** NYPL; Calif. State Library; Royal Ontario Mus., Toronto. **Comments:** Illustrator: "Highlights of Manhattan," "Washington Past and Present," "Fabulous New Orleans," "Old Louisiana," "La Fitte the Pirate," "Chicago," "Nights Abroad"; *Harpers, Forum, Country Life,* & other periodicals. **Sources:** WW40; P&H Samuels, 474-75.

SUYDAM, Henry *[Landscape painter] b.c.1802 / d.After 1883.*
Addresses: NYC, active c.1859-71; Geneseo, NY, 1878. **Exhibited:** Washington AA, 1859; NAD, 1863-78. **Comments:** He was the brother of James A. Suydam (see entry).A number of his canvases are owned by members of the family. **Sources:** G&W; Baur, "A Tonal Realist: James Suydam," 226; Washington Art Assoc. Cat., 1859. More recently, see Campbell, *New Hampshire Scenery,* 162.

SUYDAM, James Augustus *[Landscape painter] b.1819, NYC / d.1865, North Conway, NH.* *Suydam*
Addresses: NYC, 1861-65. **Studied:** NYU, c.1839; with Miner C. Kellogg, traveling in Europe (Russia, Turkey, Greece and Asia Minor), 1842-45. **Member:** ANA, 1858; NA, 1861 (treasurer, 1865); Century Assn. **Exhibited:** NAD, 1856-66; Brooklyn AA, 1861-62, 1865, 1867; PAFA, 1863-64. **Work:** NAD; Century Assn. **Comments:** Although little is known about his life and works, he appears to have been born into a wealthy NYC merchant family, and until c.1854, he was in business with his brother, John R. Suydam. He made painting excursions to Greece with his friend and teacher, Miner Kellogg, also traveling across the U.S., to upstate New York and along the coast of New England. Upon his death at age 46, Suydam left to the National Academy $50,000 and his collection of paintings by American and European artists. **Sources:** G&W; Baur, "A Tonal Realist, James Suydam"; Tuckerman, *Book of the Artists;* Clement and Hutton; CAB; Cowdrey, NAD; Swan, BA; N.Y. *Evening Post,* Sept. 16, 18, 1865; NYCD 1843-65. More recently, see Workman, *The Eden of America: Rhode Island Landscapes,* 40; Campbell, *New Hampshire Scenery,* 162-163; Baigell, *Dictionary.*

SUZEN, Joseph *[Painter] late 19th c.*
Addresses: New Orleans, active 1894-96. **Comments:** Painted frescoes and was in partnership with Robert Lee Singer in J. Suzen & Co. **Sources:** *Encyclopaedia of New Orleans Artists,* 369.

SUZUKI, James *[Painter] mid 20th c.*
Addresses: NYC. **Exhibited:** Corcoran Gal biennials, 1957-61 (3 times); WMAA, 1958. **Sources:** WW66; Falk, *Exhibition Records Series.*

SUZUKI, Katsko (Katsko Suzuki Kannegieter) *[Art dealer]* late 20th c.; b.Nagoya, Japan.
Addresses: NYC. **Studied:** Kinjyo Female College, Nagoya; Bunka Fukuso Gakuin, Tokyo, Japan. **Comments:** Positions: director & pres., Suzuki Graphics, Inc., NYC, 1970-; juried Sumi-E Soc. Am. Exhib., 5/1972. Specialty of Gallery: graphics; many int. artists. **Sources:** WW73; article, *Graphics: New York* (Sept., 1970); McCnow, article, *High Fashion* (Dec., 1970); Kawabata , article, *Bungei Syunju Weekly* (Jan., 1971).

SUZUKI, Sakari *[Painter, designer, teacher]* b.1898, Iwateken, Japan.
Addresses: Chicago, IL. **Studied:** Calif. School Fine Arts, San Francisco; ASL, Metrop. scholarship, 1934. **Member:** United Scenic Artists Am. **Exhibited:** CGA, 1934; Berkshire Mus.; Soc. Indep. Artists, 1935; ACA Gal., New York, 1936 (solo); CAA Exhib.; NJ College for Women, 1945; Am. Artists Congress, 1936 (prize); Artists Gal., New York, 1948 (solo),1951 (solo); PAFA Ann., 1952; Mandel Bros. Art Gal., Chicago, Ill, 1955 (solo); Terry Nat. Art Exhib., Miami, 1952 (hon. men.). **Work:** High Mus. Art, Atlanta, GA; Dept. Labor, Washington DC. Commissions: mural, Willard Parker Hospital, NYC, 1937. **Comments:** Preferred media: oils. Positions: scenic artist, Munic. Opera, St. Louis, MO, 1953-55; scenic artist, Starlight Theatre, Kansas City, MO, 1956-69; scenic artist, Gen. Motors Futurama, 1962-64; scenic artist, Lyric Opera, Chicago, 1965-70. Teaching: painting instructor, Am. Artists School, New York, 1938-40. **Sources:** WW73; WW47; Falk, *Exh. Record Series*.

SUZUKI, Yashichi *[Painter]* mid 20th c.
Addresses: NYC. **Exhibited:** Salons of Am., 1928; Soc. Indep. Artists, 1928-30. **Sources:** Falk, *Exhibition Record Series*.

SVENDSEN, Charles C. *[Painter, educator]* b.1871, Cincinnati, OH / d.1959, Cincinnati, OH.
Addresses: Cincinnati, OH. **Studied:** Cincinnati Art Acad., 1885-88; Académie Julian, Paris with Bouguereau and Ferrier, 1896; Acad. Colarossi, Paris. **Member:** AAPL; Scandanavian-Am. Artists. **Exhibited:** St. Louis Expo, 1904 (medal); Detroit AI; CAM; AIC; Soc. Indep. Artists; PAFA; SAA; & in Palestine & Egypt. **Work:** Vanderpoel Collection; murals, St. Xavier Church, Cincinnati, Dayton, and Toledo, OH; Washington, DC; Cincinnati Art Mus. **Comments:** Primarily a church decorator. He toured Egypt and Palestine in 1898. Position: Commissioner FA. for Holland and Belgium, The Tennessee Centennial and Int. Exp. **Sources:** WW59; WW47; *Cincinnati Painters of the Golden Age*, 105 (w/illus.).

SVENDSEN, Svend R. *[Landscape painter]* b.1864, Christiania, Norway / d.1934.
Addresses: Chicago, IL. **Studied:** Ed. Ertz at Académie Delécluse, Paris, 1890s. **Exhibited:** AIC, 1895-1909, 1915, 1920; Nashville Expo, 1897; PAFA Ann., 1898-1900, 1902; Milch Gal., NYC, 1920s. **Comments:** Impressionist painter of landscapes and still life in oil, pastel, and watercolor. **Sources:** WW15; Falk, *Exh. Record Series*.

SVENDSON, Knut O. *[Landscape painter]* early 20th c.
Addresses: Westwood, MA (1920s). **Exhibited:** AIC, 1920, 1923. **Sources:** Falk, *AIC Ann. Exh. Records*.

SVENSON, John Edward *[Sculptor, collector]* b.1923, Los Angeles, CA.
Addresses: Green Valley Lake, CA. **Studied:** Claremont (CA) Grad. School; sculpture with Albert Stewart. **Member:** NSS (fellow); Soc. Medalists, New York. **Exhibited:** Otis Art Inst. Galleries, Los Angeles 1960; Lang Galleries, Scripps College, Claremont, 1961; LACMA, 1962; Newman Galleries, Phila., 1971; Kennedy Galleries, NYC, 1972. **Awards:** first prize, Greek Theater, Los Angeles, 1951 & 1954; award for excellence in sculpture, Am. Inst. Arch., 1957 & 1961; first prize, Laguna Art Festival, 1961. **Work:** Los Angeles Co. Fair Collection, Pomona, CA; Ahmanson Center, Los Angeles; Na. Orange Show Permanent Collection, San Bernardino, CA Commissions: bronze, wood and fibreglass sculpture for five Santa Fe Fed. Savings & Loan bldgs; two hist. panels, San Gabriel Mission Chapel, CA, 1958; bldg. facade & cast stone free form, Purex Corp., Lakewood, CA, 1960; over life size bronze groups, Home Savings & Loan, CA, 1963-72; bronze Alaska Tlingit medal, Soc. Medalists Ann. Issue, 1972. **Comments:** Preferred media: wood, bronze. Positions: art director, Los Angeles Co. Fair, 1957-; trustee, Alaska Indian Arts, Inc., Port Chilkoot, 1967-. Collections: Northwest Coast Indian; Pre-Columbian Inca, Mexican & others; sculptures by Antoine Barye & Paul Manship; paintings by Ramos Martinez & Henry Lee McFee. **Sources:** WW73.

SVENSSON, C. W. *[Painter]* 20th c.
Addresses: NYC. **Member:** GFLA. **Sources:** WW25.

SVET, M. (Mrs. Dore Schary) *[Painter]* b.1912, Newark, NJ.
Addresses: NYC. **Studied:** Faucett Art School; NAD; ASL, with George Bridgman & Frank V Dumond; also with Carl Von Schleusing, Newark. **Member:** AFA; Los Angeles AA. **Exhibited:** Assoc. Am. Artists, 1951 (solo) & 1956 (solo); Vigeveno Gallery, Westwood, CA, 1954 (solo); Los Angeles AA Biann., Nessler Gal., NY, 1962-64 (solo) & Corcoran Rental Gal., Washington, DC, 1964 (solo). **Work:** Los Angeles City Hall; Brandeis Univ.; Fairleigh Dickinson College, Teaneck, NJ. **Sources:** WW73.

SVININ, Pavel Petrovitch *[Genre, landscape, and portrait painter in watercolor]* b.c.1787, Russia / d.1839, St. Petersburg.
Studied: Svinin was educated at a school for the nobility in Moscow and at Academy of Fine Arts of St. Petersburg. **Member:** Acad. Fine Arts of St. Petersburg. **Exhibited:** PAFA, 1812. **Work:** MMA (over fifty watercolors of American scenes). **Comments:** He was born on either June 8, 1787 (Yarmolinsky) or June 19, 1788 (White). He entered the service of the Foreign Office and in 1811 came to America as secretary to the Russian Consul-General, with headquarters at Philadelphia. During his two years in the U.S., he traveled often from Maine to Virginia, painting American scenes (now owned by the Metropolitan Museum). After returning to Russia, Svinin published his *A Picturesque Voyage in North America*, as well as books on the Mediterranean and England. From 1818 to 1830 he was also the editor of a patriotic magazine, traveled widely in Russia, and wrote on many subjects. **Sources:** G&W; A sketch of his life by Abraham Yarmolinsky, as well as reproductions of Svinin's American watercolors, are included in Yarmolinsky, ed., *Picturesque United States of America, 1811, 1812, 1813* (New York, 1930). A more recent account of Svinin is White, "A Russian Sketches Philadelphia, 1811-1813." See also Rutledge, PA; *American Processional*.

SVOBODA, Josef Cestmir *[Painter, designer, lithographer, lecturer]* b.1889, Smichov-Prague, Czechoslovakia.
Addresses: Dallas, TX. **Studied:** AIC; with Ralph Clarkson, Walter Ufer, Charles Hawthorne; A. Sterba; H. Larwin. **Member:** Bohemian AC, Chicago; Taos SA; Dallas AA. **Exhibited:** AIC, 1921-30, 1932, 1933, 1935, 1936, 1938, 1941; Dallas MFA; Harwood Gal., Taos, NM; Santa Fe, NM; Arizona State Exhib., 1926 (prize); Bohemian AC, 1924; Newcomb Macklin Gal., Chicago. **Work:** John Toman Pub. Lib., Chicago. **Comments:** Position: art director, Herbert Rogers Co., Dallas, TX. **Sources:** WW53; WW47.

SVOBODA, Vincent A. *[Painter, cartoonist]* b.1877, Prague, Czechoslovakia / d.1961.
Addresses: Brooklyn, NY. **Studied:** NAD; C.Y. Turner; J.Q. Ward. **Member:** SC; All. Artists Am.; Cartoonists Club. **Exhibited:** NAD (prize); SC, 1935 (prize), 1937 (prize). **Comments:** Position: editorial cartoonist, *Brooklyn Eagle*, NY, 1940-52 (retired). **Sources:** WW59; WW47.

SWACEY, May Payne *[Painter] 20th c.*
Addresses: Minneapolis, MN. **Sources:** WW17.

SWAIM, Curran *[Portrait painter] b.1826, Randolph County, NC / d.1897, Jasper County, MO.*
Addresses: South Bend, IN, 1856-69; McHenry County, IL,1869-78. **Comments:** Of Swaim & Clark, South Bend (see entry). **Sources:** G&W; Peat, *Pioneer Painters of Indiana;* Indiana BD 1860; Gerdts, *Art Across America*, vol. 2: 279.

SWAIM & CLARK *[Portrait painters] mid 19th c.*
Addresses: South Bend, IN, 1860. **Comments:** Curran Swaim and -- Clark. **Sources:** G&W; Indiana BD 1860.

SWAIN *[Engraver] mid 19th c.*
Comments: His work appeared in *Our World: or, The Slaveholder's Daughter* (N.Y., 1855). **Sources:** G&W; Hamilton, *Early American Book Illustrators and Wood Engravers*, 437.

SWAIN, Alice E. Caven (Mrs. Frank) *[Painter, teacher, illustrator, commercial artist] b.1893, Price Hill, Cincinnati, OH.*
Addresses: Ronkonkoma, NY; West Palm Beach, FL, from 1940. **Studied:** Cincinnati Art Acad., with Grace Young; Herman Wessel; F. Duveneck; L.H. Meakin; D. Garber. **Comments:** Worked for Rookwood Pottery in Cincinnati. Conducted an art school on Long Island, NY with her husband. **Sources:** WW40; Petteys, *Dictionary of Women Artists.*

SWAIN, Anna *[Watercolorist] 18th/19th c.*
Addresses: Active in Nantucket, MA, c.1830. **Comments:** *Cf.* Harriet Swain. **Sources:** Petteys, *Dictionary of Women Artists.*

SWAIN, C. (Miss) *[Portrait painter] mid 19th c.*
Addresses: Newburyport, MA, 1861; Boston, MA, 1866. **Exhibited:** Boston Athenaeum, 1860-65 (crayon portrait and other portraits); NAD, 1861, 1866. **Sources:** G&W; Swan, BA.

SWAIN, Corinne Rockwell *[Painter] 20th c.*
Addresses: Phila., PA. **Member:** New Century Club. **Sources:** WW25.

SWAIN, Etta M. *[Painter] b.1857.*
Addresses: Phila., PA. **Exhibited:** PAFA Ann., 1878, 1885 (portraits in crayon & water color). **Sources:** Falk, *Exh. Record Series.*

SWAIN, Francis W(illiam) *[Painter, etcher, illustrator] b.1892, Oakland, CA / d.1937, San Francisco, CA.*
Addresses: Cincinnati, OH/San Fran., CA. **Studied:** San Francisco; Duveneck, in Cincinnati; PAFA; F.V. Sloun. **Member:** Cincinnati AC; Calif. SE. **Work:** dec., Westwood Sch., Cincinnati. **Sources:** WW31; Hughes, *Artists in California*, 545.

SWAIN, Harriet *[Portrait painter in watercolors] mid 19th c.*
Addresses: Nantucket, MA, 1830. **Comments:** Possibly related to William Swain (see entry) who was at Nantucket in 1828. *Cf.* Anna Swain. **Sources:** G&W; Lipman and Winchester, 180.

SWAIN, Jerre (Mrs. Saint E.) *[Painter, teacher] b.1913, Yoakum, TX.*
Addresses: Houston, TX. **Studied:** Mary Hardin-Baylor College, Belton, TX; Univ. Colorado; MFA of Houston; & with Emil Bisttram, Max Beckmann. **Member:** Texas FAA; Houston Art Lg.; Taos AA; Houston AA. **Exhibited:** Assoc. Art Gal., Houston (solo); Mus. FA of Houston; Elisabeth Ney Mus. Art; Little Theatre & Jr. Lg. of Houston; Blue Door Art Gal., Taos, NM; Edinburgh, Scotland (solo); Shamrock Hotel, Houston. **Work:** St. James Episcopal Church, Houston, TX. **Sources:** WW59; WW47.

SWAIN, P(hilip) S(tarbuck) *[Marine painter, teacher] b.1838, Nantucket, MA.*
Addresses: NYC. **Sources:** WW21.

SWAIN, Roland T. *[Sketch artist] mid 19th c.*
Comments: Delineator of the ship *Phebe*, January 23, 1835, for Orin A. Beebe, Greenport, Long Island (N.Y.). **Sources:** G&W; Taylor Collection of Ship Portraits in the Peabody Museum of

Salem, *Catalogue*, no. 97.

SWAIN, Ruth Newton *[Portrait painter, sculptor, teacher] b.1907, Los Angeles, CA.*
Addresses: Los Angeles, CA. **Studied:** S.Z. Reckless; M. Sheets; J. Charlot; L. Katz; M. Gage. **Member:** Calif. AC. **Exhibited:** Los Angeles Col. Fair, Pomono, 1934. **Comments:** Position: teacher, Chouinard Art School, 1935-36. **Sources:** WW40; Hughes, *Artists inCalifornia*, 545.

SWAIN, Sylvia B. *[Artist] 19th/20th c.*
Addresses: Active in Detroit, c.1900. **Sources:** Petteys, *Dictionary of Women Artists.*

SWAIN, W. *[Painter] 20th c.*
Addresses: Tacoma, WA. **Member:** Tacoma FAA. **Sources:** WW25.

SWAIN, William *[Portrait painter] b.1803, Newburyport, MA / d.1847, Norfolk, VA.*
Addresses: Nantucket,1828; New Bedford, Newburyport, MA,1830; NYC,1833-39; Norfolk (VA), 1841; NYC, 1844-46. **Studied:** Royal Acad., London, 1841; and in Paris, Rome, Florence, until 1844. **Member:** ANA, 1837-47. **Exhibited:** Boston Athenaeum, 1828; NAD, 1833-38, 1841, 1845-56. **Work:** Virginia Hist. Soc.; Nantucket Hist. Assoc.; Old Dartmouth Hist. Soc. **Comments:** Swain opened his first studio in Newburyport, MA, in 1824. He sought commissions in Nantucket, New Bedford, NYC, and Vorfolk, VA. He was Nantucket's most prolific portraitist, painting more than 100 portraits of ship captains, merchants, lawyers, and other professionals and their wives. He had a studio in NYC by 1833. He was the grandfather of the noted Pennsylvania artist, Violet Oakley (see entry). **Sources:** G&W; Belknap, *Artists and Craftsmen of Essex County,* 13; Boston Athenaeum Cat., 1828; Cowdrey, NAD; NYCD 1834, 1837, 1839; NYBD 1846; Blasdale, *Artists of New Bedford*, 180-81 (w/repro.); add'l info. courtesy Nantucket Hist. Ass'n.

SWAINE, P. S. *[Painter] 20th c.*
Addresses: Nantucket, MA. **Sources:** WW15.

SWALLEY, John F. *[Painter, etcher] b.1887, Toledo.*
Addresses: Toledo, OH. **Studied:** A.W. Dow; W. Darling; E. Dean; I. Abramovsky; K. Kappes. **Member:** Toledo Print Club; Artklan-Toledo; Ohio WCS. **Comments:** Position: pres., The Publisher Press Co., Inc., Toledo. **Sources:** WW40.

SWALLOW, W(illiam) W(eldon) *[Sculptor, painter, teacher] b.1912, Clark's Green, PA.*
Addresses: Allentown, PA. **Studied:** PM School IA; Univ. Pennsylvania; Muhlenberg College, 1948 (hon. degree, D.F.A.). **Member:** Audubon Artists; Phila. WCC; Lehigh Valley Art All. **Exhibited:** PAFA Ann., 1941-50; NAD, 1943-45; Audubon Artists, 1945 (prize); Syracuse MFA, 1940 (prize), 1941 (prize), 1946 (prize), 1949 (prize), 1952 (prize); Wichita AA, 1946; Lackawanna County AA, 1940-45; Lehigh Valley AA, 1940-46; Lehigh Univ., 1940-46; PM School IA, 1935 (prize); AV, 1942 (prize); NSS, 1946 (prize);Woodmere Art Gal., 1951-53 (prizes), 1957 (prize), 1958 (prize); Citation, Cedar Crest College, 1954 (prize). **Work:** Syracuse MFA; Scranton MA; MMA; Allentown AM; IBM Collection. **Comments:** Position: art director, South Whitehall Sch., Allentown, 1936-46; head, art dept., Parkland Sch., Allentown, PA. **Sources:** WW59; WW47; Falk, *Exh. Record Series.*

SWALWELL, Arlene *[Painter] 19th/20th c.*
Addresses: Everett, WA. **Studied:** Los Angeles, CA; Univ. of Wash.; with Mark Tobey. **Member:** Women Painters of Wash. (charter mem.). **Exhibited:** Everett Drama League; Women Painters of Wash., 1931, 1932. **Sources:** Trip and Cook, *Washington State Art and Artists.*

SWAN, Barbara *[Painter] b.1922, Newton, MA.*
Addresses: Brookline, MA. **Studied:** Wellesley College (B.A., 1943); Boston Mus. Sch., with Karl Zerbe; with Harold Rotenberg, George Demetrios; Cape Ann Art Sch. **Exhibited:** Carnegie Ann., 1949; Contemporary American Painting, Univ.

Illinois, 1950; View 1960, Inst. Contemporary Arts, Boston, MA, 1960; Brooklyn Mus. Biennial Print Exhib., 1965; New England Landscape Painting, De Cordova Mus., 1971; Alpha Gal., Boston, MA, 1970s. **Awards:** Albert Whiting traveling fellowship, BMFA, 1948; assoc. scholarship, Inst. Independent Study, Radcliffe College, 1961-63; George Roth Prize, Philadelphia Print Club, 1965. **Work:** Philadelphia MA; Boston MA; Worcester Mus.; Fogg AM; Boston Pub. Library. **Comments:** Preferred media: graphics. Teaching: painting instructor, Wellesley College, 1946-49; art instructor, Milton Acad., 1951-54; painting & drawing instructor, Boston Univ., 1960-65. **Sources:** WW73.

SWAN, Curtis *[Illustrator] b.c.1921, Minneapolis, MN / d.c.1997, Norwalk, CT.*
Studied: PI School Art. **Comments:** For fifty years, he was the principal artist for "Superman" comics. **Sources:** undated obit., c.1997.

SWAN, Edith C. *[Painter] early 20th c.*
Addresses: Boston, MA. **Exhibited:** PAFA Ann., 1906. **Sources:** Falk, *Exh. Record Series.*

SWAN, Eleanor G. *[Painter] early 20th c.*
Exhibited: Soc. Indep. Artists, 1917-18. **Sources:** Marlor, *Soc. Indp. Artists.*

SWAN, Emma Levinia *[Still-life and portrait painter, teacher] b.1853, Providence / d.1927.*
Addresses: Providence, RI. **Studied:** A.H. Thayer. **Member:** Providence AC. **Work:** Providence AC. **Comments:** Her still life paintings won acclaim and were compared with those of her Providence studio neighbor, E.C. Leavitt. She held annual exhibitions in her studio and upon her death, she was regarded as a "leading flower painter" and the "dean of Rhode Island Women artists." **Sources:** WW27; C. Bert, *Sketches* (Providence, No.2, Dec. 1991).

SWAN, Florence (Wellington) *[Designer, teacher] b.1876, Cambridge, MA.*
Addresses: Boston, MA. **Studied:** A.M. Sacker. **Member:** Boston SAC (master). **Work:** mem. tables, Beneficent Congreg. Church, Providence; St. James' Church, Salem. **Sources:** WW31.

SWAN, Helen Clark *[Painter] mid 20th c.*
Addresses: Montclair, NJ. **Exhibited:** Soc. Indep. Artists, 1934. **Sources:** Marlor, *Soc. Indp. Artists.*

SWAN, James *[Painter, patron, attorney] b.1864, Hawick, Scotland / d.1940, Grosse Ile, MI.*
Addresses: Detroit, MI, 1890-1900 and after. **Member:** Detroit AC & Hopkin Club (co-founder). **Exhibited:** Soc. Indep. Artists, 1926. **Comments:** Preferred medium: watercolor. Immigrated to the U.S. in 1881. **Sources:** Gibson, *Artists of Early Michigan*, 225.

SWAN, James Gilchrist *[Painter, writer, anthropologist, indian agent, cartographer] b.1818, Medford, MA / d.1900, Port Townsend, WA.*
Addresses: Port Townsend, WA. **Work:** Smithsonian Inst.; Washington State Hist. Soc. **Comments:** Pioneer who developed an early interest in the Northwest coast and homesteaded in 1852 on the shore of Southwest Washington to harvest oysters for the San Francisco market. His diaries and sketches constitute an important part of the history of the region, documenting life and various aspects of natural history. Specialty: Native Americans of the Northwest; early settlements. **Sources:** Hughes, *Artists in California*, 545.

SWAN, Joe *[Painter, teacher] b.1914, ND.*
Addresses: Minneapolis, MN. **Member:** Un. Am. Artists. **Exhibited:** Univ. Minnesota; Minnesota State Fair; Hanley Gal., Minneapolis; Twin City Exhib., Minneapolis, 1939 (prize). **Work:** mural, State Normal Sch.; altarpiece, Methodist Church, Madison, SD. **Comments:** Position: teacher, Walker Art Gal., Minneapolis. **Sources:** WW40.

SWAN, John M. *[Painter] mid 20th c.*
Addresses: London, England. **Exhibited:** WMAA, 1920; AIC, 1934. **Sources:** WW04.

SWAN, Lillian G. *[Painter] 20th c.*
Addresses: St. Paul, MN. **Sources:** WW17.

SWAN, Lucille *[Painter] mid 20th c.*
Addresses: Chicago, IL. **Exhibited:** AIC, 1911; Anderson Gal., NYC, 1929 (solo). **Sources:** WW13.

SWAN, Marshall W. S. *[Educator] b.1917, Brockton, MA.*
Addresses: Oslo, Norway. **Studied:** Harvard Univ. (A.B., A.M., Ph.D.). **Member:** Soc. for Advancement of Scandinavian Studies. **Comments:** Position: asst. professor, Tufts College, Medford, MA, 1942-46; curator/dir., Am. Swedish Hist. Mus., Phila., 1946-49; public affairs officer, Am. Embassy, The Hague, Holland, 1951-55; U.S. Info Service, Milan, Italy, 1955-57; cultural attaché, Am. Embassy, Rome. Italy, 1957-58; public affairs officer, Am. Embassy, Oslo, Norway, 1958-63; asst. chief of training, U.S. Info Agency, Wash., DC, 1963-. Contributor: publications of the Bibliographical Soc. of Am., *Journal of English Literary History*, & others; editor, two vols. of Scandinavian Studies. Lectures on Am. painting. **Sources:** WW66.

SWAN, Mary Ferris *[Painter] 20th c.*
Addresses: Shanghai, China. **Sources:** WW19.

SWAN, Paul *[Portrait painter, sculptor] b.1884, Ashland, IL / d.1972, Bedford Hills, NY.*
Addresses: NYC/Paris. **Studied:** Lorado Taft; J. Vanderpoel; NYC; Paris. **Exhibited:** P&S of Los Angeles, 1923; Salons of Am., 1927; Soc. Indep. Artists, 1927. **Work:** King Theatre, London; Edgewater Gulf Hotel, Mississippi. **Comments:** Born either 1884 or 1899. Also a dancer in movies. **Sources:** WW25; Hughes, *Artists in California*, 545.

SWAN, Robert G. *[Painter] mid 20th c.*
Exhibited: AIC, 1942. **Sources:** Falk, *AIC.*

SWAN, Russell William *[Landscape painter] b.1908, Wanamingo, MN / d.1963, Monterey, CA.*
Addresses: Monterey, CA. **Studied:** Otis Art Inst.; Carmel Inst. of Art, with John Cunningham. **Member:** Carmel AA; Laguna Beach AA; Soc. of Western Artists. **Work:** Monterey Peninsula Mus. of Art. **Comments:** Specialty: Impressionist desert landscapes and harbor scenes. **Sources:** Hughes, *Artists in California*, 545.

SWAN, Sally See: **CARR, Sally Swan**

SWAN, Virginia *[Painter] mid 20th c.*
Addresses: NYC. **Exhibited:** Soc. Indep. Artists, 1930. **Sources:** Marlor, *Soc. Indp. Artists.*

SWAN, Walter Buckingham *[Painter, writer, lecturer] b.1871, Boston, MA.*
Addresses: Council Bluffs, IA; Omaha, NE. **Studied:** Lowell School Des.; BMFA with Sargent, Colcord, Kingsbury; Creighton Univ., Omaha, NE; Boston; Paris; London. **Member:** North Shore AA; Gloucester SA; Ogunquit AC; Springfield AL; Soc. Indep. Artists. **Exhibited:** Soc. Indep. Artists, 1938, 1940; U.S. Nat. Mus., Wash., DC, 1942, 1943 (75 watercolors sponsored by Mexican Ambassador. Exhibited in many cities of the U.S. under auspices of Pan-American Union). **Comments:** Had summer studio at Lake Okoboji and painted annually in the Amana Colonies. Was designer for paper mills in Holyoke, MA and Springfield, MA for some years. **Sources:** WW59; WW47; Ness & Orwig, *Iowa Artists of the First Hundred Years*, 203.

SWANBERG, Charles Willard *[Painter, commercial artist] b.1923, Vashon Island, WA.*
Addresses: Seattle, WA. **Member:** Puget Sound Group of Northwest Painters. **Exhibited:** Henry Gallery, 1951, 1959. **Comments:** Preferred media: tempera, acrylics. Position: instr., Burney Sch. of FA, Seattle. **Sources:** Trip and Cook, *Washington State Art and Artists.*

SWANK, Grace Genevra *[Painter] b.1892, Melrose, VA / d.1977, Woodstock, NY.*
Addresses: Woodstock, NY, 1959 and after. **Studied:** Columbia Univ. Exten., 1924-25; NAD, 1927-37; with Ross, Bridgman, von Schlegel, Hofmann and Vytlacil; 1954 with Barnet. **Member:** ASL; NAD; NAWA; Woodstock AA. **Exhibited:** Woodstock AA; Woodstock Guild of Craftsmen; Soc. Indep. Artists. **Work:** private collections. **Comments:** Her work ranges from realistic to abstract. **Sources:** Woodstock AA.

SWANN, Alice L. *[Listed as "artist"] 19th/20th c.*
Addresses: Wash., DC, active 1892-1902. **Sources:** McMahan, *Artists of Washington, DC.*

SWANN, Eliza C. *[Illustrator] 19th/20th c.*
Addresses: Wash., DC, active 1879-97. **Work:** Fruit Laboratory, Beltsville, MD; U.S. National Arboretum. **Comments:** Position: illus., U.S. Department of Agriculture. **Sources:** McMahan, *Artists of Washington, DC.*

, Erwin *[Collector, patron] b.1906, NYC / d.1973.*
Addresses: NYC. **Studied:** Univ. Virginia, 1919; Univ. Wisconsin, 1920; New York Univ., 1921. **Comments:** Positions: editor, *Countrybrook,* 1940-46; member advisory council, dept. art history & archaeology, Columbia Univ., New York. Publications: author, "Red Squares," 1968. Collections: French impressionist art; modern European and American art; Indian and Far Eastern; original drawings of caricature and cartoon artists of the eighteenth, nineteenth and twentieth centuries. Art interests: founder, Swann Collection caricature and cartoon; producer films on art and cultural subjects. **Sources:** WW73.

SWANN, James *[Etcher, commercial artist] b.1905, Merkel, TX / d.1985, Chicago, IL.*
Addresses: Chicago, IL. **Studied:** Sul Ross State Teachers College. Alpine, TX. **Member:** SAGA; Calif. Printmakers; Prairie Printmakers (secretary/treas.,1946-on); Chicago SE (secretary/treas., 1937-46); Dallas Print & Drawing Soc. **Exhibited:** SAE; Calif. SE; NAD; CI; LOC; & other major print exhib.; Chicago SE, 1940 (prize); Calif. PM, 1943 (prize); SSAL, 1936 (prize); Paris Salon, 1937 (medal); Shope prize, NYC, 1953. **Work:** Cedar Rapids MA; Smithsonian Inst.; AIC; NYPL.; Los Angeles MA; MMA; Dallas MFA; Illinois State Lib.; Newark Mus.; Pub. Lib., Sherman, TX. **Comments:** From the 1930s-60s, he produced more than 250 works in all printmaking media, and was regarded as one of the Midwest's most respected printmakers. Contributor to *American Artist* magazine; *Chicago Tribune;* others. Lectures: Print Collecting; Etching Process. **Sources:** WW59; WW47; biography, Cedar Rapids MA (c.1990).

SWANN, Lilian See: **SAARINEN, Lily (Lilian) Swann**

SWANN, Samuel Donovan (Don) *[Engraver, writer] b.1889, Fernandina, FL.*
Addresses: Baltimore, MD. **Studied:** St. Johns College, Annapolis, MD. **Member:** Etchcrafters Art Gld. (director); SAE; Baltimore WCC; AAPL. **Work:** Nat. Cathedral; MMA; J. P. Morgan Lib.; BMA; VFMA; LOC; Enoch Pratt Lib., Balt., MD; Princeton Univ. Lib.; U.S. Naval Acad., Annapolis, MD; Sweet Briar College, VA; Randolph-Macon College, Lynchburg, VA. **Comments:** Co-author/illus.: "Colonial and Historic Homes of Maryland" (100 Etchings), 1938. Lectures & demonstrations on etchings and their making. **Sources:** WW59; WW47.

SWANN, Valetta *[Painter] mid 20th c.*
Exhibited: AIC,1942. **Sources:** Falk, *AIC.*

SWANSON, Bennet A. *[Painter, lithographer, teacher] b.1900, Winthrop, MN / d.1968, St. Paul, MN.*
Addresses: St. Paul, MN. **Studied:** St. Paul IA; ASL; & with Andre Lhote, Paris, France; Stockhold, Galanesse. **Exhibited:** AIC, 1942; Paris Salon, 1927; Milwaukee, 1944; Minnesota State Exhib., 1920, 1922-26, 1933 (prizes), 1936 (prize); Minneapolis IA, 1923; Twin City Exhib., 1926 (prize), 1934 (prize). **Work:** Univ. Minnesota; Walker AC; Minneapolis IA; Nat. Red Cross, Wash., DC; mural, Field House, Ft. Snelling, MN; numerous hospitals, schools, pub. bldgs., throughout U.S. **Comments:** Positions: teacher, Art Crafts Center, St. Paul; artist, General Outdoor Advertising Co., Minneapolis. Anthony White gives year of birth as 1897. **Sources:** WW59; WW47.

SWANSON, David *[Sculptor] mid 20th c.*
Addresses: Santa Barbara, CA. **Exhibited:** GGE, 1939. **Work:** Santa Ynez Valley, CA, High School; Santa Barbara High School. **Comments:** WPA artist. **Sources:** Hughes, *Artists in California,* 545.

SWANSON, Dean *[Museum curator] b.1934, Saint Paul, MN.*
Addresses: Minneapolis, MN. **Studied:** Univ. Minnesota (B.A. & M.A.). **Comments:** Positions: asst. curator, Walker AC, Minneapolis, MN, 1962, assoc. curator, 1964, chief curator, 1967- . Teaching: teaching asst., Univ. Minnesota, 1957-60. Collections arranged: Robert Rauschenberg, 1965; Nicholas Kurshenick, 1968; Richard Lindner, 1969; Joan Miró Sculptures, 1971. **Sources:** WW73.

SWANSON, Elin (M.) *[Painter] mid 20th c.*
Addresses: Upper Falls, MA. **Exhibited:** Soc. Indep. Artists, 1925, 1928-29. **Comments:** Possibly Swanson, Elinor. **Sources:** Marlor, *Soc. Indp. Artists.*

SWANSON, Elinor *[Painter] mid 20th c.*
Addresses: NYC. **Exhibited:** Soc. Indep. Artists, 1924. **Comments:** Possibly Swanson, Elin. **Sources:** Marlor, *Soc. Indp. Artists.*

SWANSON, Eric Hjalmar *[Marine painter] b.1882, Sweden / d.1960.*
Addresses: San Francisco, CA (since 1930). **Studied:** self-taught. **Comments:** Was at sea by 1896 and later worked as a longshoreman in San Francisco where he had a studio. **Sources:** Brewington, 372.

SWANSON, George *[Cartoonist] mid 20th c.; b.Chicago, IL.*
Addresses: Bronxville, NY. **Studied:** Chicago Acad. FA. **Comments:** He began his comic strip career in Cleveland with "Salesman Sam" and "High Pressure Pete." In 1943, he created his most popular strip, "The Flop Family" (King Features Syndicate). **Sources:** *Famous Artists & Writers* (1949).

SWANSON, George Alan *[Painter, illustrator, ceramicist, writer] b.1908, Hoboken, NJ / d.1968.*
Addresses: Bloomfield, NJ. **Studied:** Newark Sch. Fine & Indust. Art, with John Grabach, 1931; Sweet Hollow art colony, Bloomsbury, NJ, 1931-33; etching with Will Barnet; ceramics with Julia Hamlin Duncan, in NYC. **Member:** New Jersey AA; NY Zoological Soc. (life mem.). **Exhibited:** Contemporary Club, Newark, 1930s; Montclair AM, 1938, 1939; NJ Gal., Newark, 1940 (first prize), 1941 (first prize); Artists of Today, 1942, 1944; Newark Mus., 1944; Riverside Mus., 1945; Soc. Venezolana de Ciencias Naturales, Caracas, Venezuela, 1942, 1945; Waldorf Atsoria Ballroom (two solos); MoMA (ceramics); MMA (ceramics). **Work:** Newark Mus.; MoMA (dance archives). **Comments:** A naturalist artist, he descended deepsea to sketch rare tropical fish for Dr. Wm. Beebe on his famous Tropical Expeditions with the NY Zoological Soc., 1934-46, and continued with seven more related scientific expeditions into the Pacific, Central and South America, and the West Indies. Later, he produced final paintings from the sketches, and these were used to illustrate Beebe's book, *Half Mile Deep.* Swanson also ran his own art school in Bermuda, 1934-35. From 1937-42 he also documented in watercolors and drawings the Ballet Russe and other troupes that danced in NYC. Author/illustrator: "Weird Dwellers of the Deep" in *Popular Science* (1944); "Jungle Studio" in *Animal Kingdom* magazine (1946). Positions: freelance designer, wallpaper and fabrics; designer for Norcross, Inc. **Sources:** WW59; WW47; add'l info courtesy Shannon FA, New Haven, CT.

SWANSON, Jack N. *[Painter, sculptor] b.1927, Duluth, MN.*
Addresses: Living in Carmel Valley, CA in 1976. **Studied:** College Arts & Crafts, Oakland. **Work:** Cowboy Hall Fame, Read Mullan Gallery, Diamond M (TX). **Sources:** P&H Samuels, 474.

SWANSON, Jonathan M. *[Painter, sculptor, medalist]* b.1888, Chicago, IL / d.1963.
Addresses: NYC. **Studied:** AIC, with J. Vanderpoel. **Member:** NY Numismatic Club. **Exhibited:** PAFA Ann., 1924-25; Salons of Am., 1934. **Work:** portraits of ten club presidents and the King of Italy, Numismatic Club, NYC; three portrait medals, French Mint Exhib. **Sources:** WW40; Falk, *Exh. Record Series.*

SWANSON, William *[Painter]* 20th c.
Addresses: North Branch, MN. **Sources:** WW17.

SWANTEES, Ethel Lucile (M.) *E. Swantces*
[Painter, etcher, lithographer, teacher] b.1896, Madison, WI.
Addresses: NYC; Alfred, NY; Middlebury, CT. **Studied:** ASL; John Sloan, Harry Wickey. **Member:** Soc. Indep. Artists. **Exhibited:** Soc. Indep. Artists, 1934-38, 1940-42, 1944; Corcoran Gal biennial, 1937; Dallas MFA; MMA (AV), 1942; NAD, 1939, 1945; Mattatuck Mus.,1943 (solo), 1946; Modernage Gal., 1945 (solo, prize). **Comments:** Teaching: Westover Sch. Middlebury, CT, 1942-50s. **Sources:** WW59; WW47.

SWARS, Ethel See: **MAXON, Ethel (Mrs. Paul G. Swars)**

SWART, Elmer E(llsworth) *[Painter]* b.1864 / d.1945, Bronx, NY.
Exhibited: Salons of Am., 1934. **Sources:** Marlor, *Salons of Am.*

SWART, Gabriel *[Engraver]* b.1895, Boston, MA / d.1984, Wash., DC.
Addresses: London, England; Wash., DC; Albany, NY, 1920s-1935. **Comments:** Raised in England, he returned to the U.S. in 1917. Position: staff: Bureau of Engraving and Printing; Qualye Bank Note Co., Albany; Public Works Admin., Wash., DC; Coast and Geodetic Survey. Founded his own company c.1942.
Sources: McMahan, *Artists of Washington, DC.*

SWARTHWOUT, Mary Cooke (Mrs.) *[Former museum director]* mid 20th c.; b.Cleveland, OH.
Addresses: Royal Oak, MI. **Studied:** Lewis Inst., Chicago; Oberlin College. **Member:** AAMus. **Comments:** Position: director, Montclair (NJ) Art Mus., 1932-52 (retired). **Sources:** WW53.

SWARTS, Margaret Cross *[Graphic artist]* mid 20th c.
Exhibited: Soc. Indep. Artists, 1940. **Sources:** Marlor, *Soc. Indp. Artists.*

SWARTZ, Harold C. *[Sculptor, lithographer, teacher]* b.1887, San Marcial, N. Mex.
Addresses: Los Angeles, CA (since 1923). **Studied:** Berlin; Paris. **Member:** Sculptors Gld., Southern Calif.; Calif. AC; Calif. PS; Municipal Art Comm. **Exhibited:** LACMA, 1923 (solo); Arcadia Exh., 1923 (prize); Pomona Expo, 1923 (prize); AIC, 1925, 1929; Pacific Southwest Expo, 1928 (gold); Calif. AC. 1932 (prize). **Work:** LACMA; Los Angeles Coliseum; Hart Park, Orange, CA; John Marshall High School, Hollywood, CA. **Comments:** Positions: commercial artist, Cleveland, Chicago, NYC; teacher, Otis AI & Chouinard AI, both in Los Angeles. **Sources:** WW40; Hughes, *Artists in California,* 545.

SWARTZ, Ira W. *[Artist]* mid 20th c.
Addresses: Great Neck, NY. **Exhibited:** PAFA Ann., 1964. **Sources:** Falk, *Exh. Record Series.*

SWARTZLANDER, Frank *[Painter]* mid 20th c.
Addresses: Doylestown, PA. **Exhibited:** PAFA Ann., 1931-33, 1936-37; Corcoran Gal biennial, 1937. **Sources:** Falk, *Exh. Record Series.*

SWARZ, Sahl *[Sculptor, painter, teacher]* b.1912, NYC.
Addresses: Cliffside Park, NJ. **Studied:** Clay Club New York; ASL. **Member:** CAFA; Clay Club, NYC.; Sculpture Center (assoc. director, 1934-53). **Exhibited:** Syracuse MFA, 1938, 1940; CAFA, 1938; Clay Club, 1934-46; BM, 1936; Berkshire Mus., 1941; Rochester Mem. Art Gal., 1940; Springfield MA, 1936; Lyman Allyn Mus., 1939; Plainfield (NJ) AA, 1943; Newark Mus., 1944; PAFA Ann., 1946-66 (7 times); WMAA Ann., 1948-

64; Illinois Biennial, 1957 & 1959; Dept. State Traveling Exhib., 1958; Bronzetto Int. Padua, Italy, 1959 & 1961; Sculpture Center, NYC, 1970s. **Awards:** Am. Acad. Arts & Letters grant, 1955; J. S. Guggenheim Mem. Foundation grants, 1955 & 1958; Govt. Purchase Prize, NJ State Mus., 1965. **Work:** WMAA; Minneapolis Inst. Fine Arts; NJ State Mus., Trenton; Richmond (VA) Mus. Fine Arts; Rose Art Mus., Brandeis Univ., Waltham, MA. **Commissions:** Guardian (bronze), Brookgreen Gardens Mus., SC, 1939; Equestrian Mem. to Gen. Bidwell, Buffalo, NY, 1949; symbolic wood figures, U.S. Courthouse, Statesville, NC, 1945; USPO: Statesville, NC, Linden, NJ; mall sculpture, Pittsburgh, MA, 1971; fountain sculpture, State of NJ, Spruce Run Recreational Park, 1972. **Comments:** Preferred media: bronze, steel. Publications: author/illustrator, "Blueprint for the Future of American Sculpture," 1944; author, "Monograph on Ilse Erythropel." Teaching: asst. director & teacher, Clay Club, Sculpture Center, NYC 1931-46; sculpture instructor, Brandeis Univ., 1964-65; sculpture instructor, Univ. Wisc.-Madison, 1966; asst. professor sculpture, Columbia Univ., 1966-; sculpture instructor, New School Soc. Res., 1967-70. **Sources:** WW73; WW47; Falk, *Exh. Record Series.*

SWARZC, Dorothea See: **GREENBAUM, Dorothea Schwarcz**

SWARZENSKI, Georg *[Research fellow]* b.1876, Dresden, Germany / d.1957.
Addresses: Boston 15, MA; Brookline 46, MA. **Studied:** Univ. Freiburg, Leipzig, Berlin, Munich, Vienna; Univ. Heidelberg (LL.D., Ph.D.). **Member:** Mediaeval Acad. Am. **Comments:** Position: research fellow, Sculpture & Mediaeval Art, BMFA, 1939-. Author: various publications & books on Renaissance and mediaeval art. Contributor to numerous magazines,with articles covering research in history of art, contemporary art, and museum problems. **Sources:** WW53.

SWARZENSKI, Hanns Peter *[Art historian, writer]* b.1903, Berlin, Germany.
Addresses: Boston, MA. **Studied:** Univ. Bonn (Ph.D., 1927); Fogg Art Mus., Harvard Univ., 1927-28. **Member:** Am. Acad. Arts & Sciences. **Work:** Berlin State Mus; NGA; BMFA. **Comments:** Positions: research fellow, Inst. Advanced Study, Princeton, NJ, 1936-48; acting curator sculpture, Nat. Gallery Art, Wash., DC, 1944-46. Author: "Deutsche Buchmalerei des 13. Jahrhunderts," 1936; "The Berthold Missal," 1943; "Monuments of Romanesque Art," 1953. Co-author: "English Sculptures of the 12th Century," 1952. Teaching: special lectures on medieval art, Warburg Inst., Univ London, 1946-54. Collections arranged: Rathbone Years, Boston Mus. Fine Arts, 1972. Research: Medieval manuscripts, metalwork and sculpture. **Sources:** WW73.

SWASEY, Charles E. *[Painter]* late 19th c.
Addresses: Yonkers, NY, 1868-69. **Exhibited:** NAD, 1868-69. **Sources:** Naylor, *NAD.*

SWASEY, David L. *[Painter]* mid 20th c.
Addresses: Phila., PA. **Exhibited:** PAFA Ann., 1933 (portrait). **Sources:** Falk, *Exh. Record Series.*

SWASEY, Henry Street *[Painter]* b.1864, Benicia, CA / d.1954, Berkeley, CA.
Addresses: Berkeley, CA. **Exhibited:** Soc. of Calif. Pioneers exhib. of Calif. paintings, 1959. **Work:** St. Mary's College, Moraga, CA. **Comments:** Son of William Swasey (see entry). **Sources:** Hughes, *Artists in California,* 546.

SWASEY, William F. *[Amateur artist]* b.1823, Bath, ME / d.1896, San Francisco, CA.
Addresses: California, 1845. **Comments:** He was known only for a drawing of San Francisco made in the 1840's and lithographed in 1886. He worked for Sutter and Thomas Larkin. After service in California during the Mexican War he settled in San Francisco and was elected secretary to the Town Council. Father of Henry Swasey (see entry). **Sources:** G&W; Van Nostrand and Coulter,

California Pictorial, 48; Peters, *California on Stone.*; Hughes, *Artists in California,* 546.

SWAWITE, Augusta Anna *[Painter]* mid 20th c.
Addresses: Chicago area. **Exhibited:** AIC, 1944. **Sources:** Falk, AIC.

SWAY, Albert *[Painter, illustrator, etcher, lithographer, cartoonist, teacher]* b.1913, Cincinnati, OH.
Addresses: Cincinnati, OH; NYC. **Studied:** Cincinnati Art Acad.; ASL. **Member:** Cincinnati Assn. Prof. Art; Cincinnati AC; SAE; SAGA. **Exhibited:** AIC, 1936, 1938; PAFA Ann., 1936; Corcoran Gal biennial, 1939; GGE, 1939; Paris Salon, 1937; Stockholm, Sweden, 1937-38; Soc. Indep. Artists, 1938; WFNY, 1939; SAE; LOC, 1943-45; Albright-Knox Art Gal., 1951; SAGA, 1951-on; Royal Soc. Painters, Etchers & Engravers, London, England, 1954; Am.-Japan Contemporary Print Exhib., Tokyo, 1967. Awards: first prize in graphics, Cincinnati Mus. Assn., 1939. **Work:** MMA; NYPL; CI; Penn. State Univ.; Soc. New York Hospitals. **Comments:** Contributor: cartoons in *Saturday Review, New Yorker.* Publications: illustrator, "Lamb's Sectional Histories of New York State," Frank E. Richards; illustrator of filmstrips on New York State history produced by Our York State, NY, 1950-; medical illustrator, "A Syllabus for Health Visitors," Navajo Tribal Council, Arizona, 1960; medical illustrator, "Respiratory Diseases," Nat. Tuberculosis Assn., 1961; medical illustrator, "Hepatic Excretory Function" (ser. filmstrips), Am. Gastroenterol Assn., 1972; also medical illustrator in science journals. Teaching: instructor of drawing & painting, New York Hospital Lg., 1963-64. **Sources:** WW73; WW47; Falk, *Exh. Record Series.*

SWAYNE, H(ugh) N(elson) *[Painter, etcher, teacher]* b.1903, Hickman.
Addresses: Hickman, KY. **Studied:** W.H. Stevens; C.M. Saz; G.P. Ennis; J. Costigan. **Member:** Louisville AA; SSAL; Natchitoches Artists Colony. **Exhibited:** Louisville AA, 1928 (prize); Baton Rouge, 1929 (prize); PAFA Ann., 1932. **Sources:** WW33; Falk, *Exh. Record Series.*

SWAYNE, William Marshall *[Sculptor]* b.c.1828, Pennsbury Township, Chester County, PA / d.1918, Chester County.
Addresses: Chester County, active c.1850; Washington, DC, 1859, 1864; Chester County, c.1862-1918. **Studied:** self-taught. **Exhibited:** Wash. AA, 1860; NAD, 1864; PAFA Ann., 1876-78. **Work:** Smithsonian Inst. (Pres. Lincoln); National Mus. of American Art (plaster bust of William Darling); Chester County Hist. Soc.; PAFA. **Comments:** He modeled his first bust in 1850, and moved to Washington, DC, where he executed busts of Lincoln and others before returning to Chester County. **Sources:** G&W; Pleasants, *Yesterday in Chester County Art;* "Works by William Marshall Swayne," in *Chester County Collections,* XVI (1939), 503-04; 8 Census (1860), D.C., II, 375; Falk, *Exh. Record Series.* More recently, see McMahan, *Artists of Washington, DC.*

SWAYZE, Della F. *[Artist]* late 19th c.
Addresses: Active in Grand Haven, MI, 1897. **Sources:** Petteys, *Dictionary of Women Artists.*

SWAZO, Patrick (Patrick Swazo Hinds) *[Painter, lecturer]* b.1929, Tesuque Pueblo, NM / d.1974.
Addresses: Santa Fe, NM. **Studied:** Calif. College Arts & Crafts (B.A.); Mexico City College; AIC. **Exhibited:** CPLH, 1963; SFMA, 1966; Heard Mus., Phoenix, 1968; Philbrook AC, Tulsa, OK, 1969; Mus. New Mexico Southwest Biennial, Santa Fe, 1970. Awards: first award, Scottsdale Nat. Indian Art Exhib., 1966, 1967, 1970 & 1971; first award, Center Indian Art, Wash., DC, 1968; first award, Heard Mus., Phoenix, 1970. **Work:** Oakland (CA) Art Mus.; Am. Indian Hist. Soc., San Fran.; Bureau Indian Affairs, Wash., DC; Heard Mus., Phoenix, AZ; Mus. Northern Arizona, Flagstaff. **Comments:** Preferred medium: oils. Publications: illus., "The Indian Historian," Dec., 1967. Teaching: instructor in oil painting & sketch class, Arts & Crafts Coop, Inc., Berkeley, CA, 1968-69; lecturer on Indian art, Navajo College, AZ, 1972; lecturer on Indian art, Colorado College, Colorado Springs, 1972. **Sources:** WW73; Clara Lee Tanner, *The Bialse*

Collection of Southwest Indian Painting; Dorothy Dunn, *American Indian Painting;* J.O. Snodgrass, *American Indian Painters.*

SWEENEY, Dan *[Illustrator]* b.1880, Sacramento, CA / d.1958.
Addresses: San Francisco, CA, until the early 1930s; NYC. **Comments:** Illustrator: *San Francisco Chronicle, Overland Monthly, Colliers,* theatre and travel posters. Specialty: western and marine subjects. **Sources:** P&H Samuels, 474.

SWEENEY, Dennis *[Engraver]* b.c.1822, Ireland.
Addresses: Boston, active 1850. **Sources:** G&W; 7 Census (1850), Mass., XXV, 539; Boston CD 1851.

SWEENEY, Frances Haines *[Painter]* mid 20th c.
Addresses: Chicago area. **Exhibited:** AIC, 1928. **Sources:** Falk, AIC.

SWEENEY, James Johnson *[Art administrator, lecturer]* b.1900, Brooklyn, NY.
Addresses: NYC. **Studied:** Georgetown Univ. (A.B., 1922 & hon. LH.D., 1963); Jesus College, Cambridge Univ., 1922-24; Sorbonne, Paris 1925; Univ. Siena, 1926; (hon. D.F.A.), Grinnell College (1957), Univ. Michigan (1960), Notre Dame (1961) & Univ. Buffalo (1962); (hon. LH.D.), Rollins College (1960), College of the Holy Cross (1960) & Univ. Miami (1968); Ripon College, (hon. ArtsD., 1960). **Member:** Assn. Int. Art les Moyens Audio-Visuels (vice-pres., 1972-); Arts Club Chicago (hon. mem.); Buffalo Fine Arts Acad. (hon. mem.); Int. Council MoMA (hon. mem.); Am. Inst. Interior Designers (hon. mem.); Royal Soc. Antiquaries of Ireland (Dublin); La Société de l'Histoire de L'Art Français, La Société des Africanistes (Paris); Century Assn.; Grolier Club. **Exhibited:** Awards: Chevalier, Legion d'Honneur, France, 1955; Officer, Ordre des Arts et des Lettres, Paris, 1959; Art Am. Award, 1963. **Comments:** Positions: assoc. editor, *Transition,* 1935-38; visiting lecturer, NYU, 1935-40; director painting & sculpture, MoMA, 1945-46; dir., Guggenheim Mus., 1952-60; dir., MFA, Houston, TX, 1961-68, consulting dir., 1968; gal. consultant, Nat. Capital Development Commn., Canberra, Australia, 1968-; mem. vis. committee, Visual & Performing Arts, Harvard Univ., & Fine Arts, Fogg Art Mus., 1969-; adv. purch., Arts Council Northern Ireland, Belfast, 1970-72; art advisor, Israel Mus., 1972-. Teaching: lecturer, universities and mus., 1935-on. Curator of exhib. around the world, including Univ. of Chicago, MoMA, Art Gallery, Toronto, VMFA, MIT, MoMA, Paris, Tate Gallery, London, Honolulu Acad. Arts. Publications: author, "Vision and Image," 1968; "African Sculpture," 1970; "Joan Miro," 1970; "Alexander Calder," 1971; "Pierre Soulages," 1972. **Sources:** WW73.

SWEENEY, Joseph Henry *[Painter, designer]* b.1908, Elkins, WV.
Addresses: Milwaukee. WI. **Studied:** AIC. **Exhibited:** Wisc. Memo. Union, Madison, 1935. **Comments:** Position: indust. designer, Kirby, Cogeshall, Steinau Co., Milwaukee. **Sources:** WW40.

SWEENEY, Mary B. *[Painter]* 20th c.
Addresses: Phila., PA. **Sources:** WW25.

SWEENEY, Nora (Mrs. Samuel Gordon Smyth) *[Illustrator, painter]* b.1897, Phila., PA.
Addresses: Upper Darby, PA. **Studied:** W.H. Everett; E. Horter. **Exhibited:** Watercolor Ann., PAFA. **Comments:** Illustrator: juvenile subjects. **Sources:** WW40.

SWEENEY, Sarah Catherine *[Portrait painter, writer, lecturer]* b.1876, Nashville, TN.
Addresses: NYC. **Studied:** C.C. Cooper; Volk; Metcalf; Hawthorne; Chase; Twachtman; Maynard; Cooper Union; ASL; NY School Art. **Sources:** WW25; Petteys, *Dictionary of Women Artists.*

SWEENEY, Thomas T. *[Engraver]* mid 19th c.
Addresses: NYC, 1854. **Sources:** G&W; NYBD 1854.

SWEENEY, William K. *[Painter, illustrator] 20th c.*
Addresses: Baltimore, MD. **Member:** Charcoal Club. **Exhibited:** PAFA Ann., 1900-03 (series of lion's head). **Sources:** WW25; Falk, *Exh. Record Series.*

SWEENY, Barbara Eleanor *[Museum curator] mid 20th c.; b.Philadelphia, PA.*
Addresses: Philadelphia, PA. **Studied:** Wellesley College (B.A., 1926). **Comments:** Positions: asst. John G. Johnson Collection, Phila., 1931-56, assoc. curator, 1956-69. Publications: author, "Catalogue Italian Paintings," J. G. Johnson Collection, 1966 & "Catalogue Flemish-Dutch Paintings," J. G. Johnson Collection, 1972. Teaching: art history instructor, Rosemont College, 1928-29, history of painting, 1939-42. **Sources:** WW73.

SWEENY, Miriam Townsend (Miss) *[Painter] mid 20th c.*
Addresses: Poughkeepsie, NY. **Exhibited:** Soc. Indep. Artists, 1929. **Sources:** Marlor, *Soc. Indp. Artists.*

SWEENY, Robert O. *[Painter] b.1831 / d.1902.*
Addresses: Minnesota, active c.1852. **Work:** Minnesota Hist. Soc. **Comments:** Artist of a number of scenes in Minnesota. Possibly the R.O. Sweeny, portrait painter, listed in Philadelphia in 1860. **Sources:** G&W; Information courtesy Bertha L. Heilbron, Minnesota Historical Society; Phila. CD 1860; Heilbron, "Pioneer Homemaker," two repros. of St. Paul scenes.

SWEENYE, Albert E. *[Listed as "artist"] 19th/20th c.*
Addresses: Wash., DC, active 1920s. **Comments:** Position: assistant to DeLancy Gill, creating illustrations at the Smithsonian Institution's Bureau of American Ethnology. **Sources:** McMahan, *Artists of Washington, DC.*

SWEET, Frederick Arnold *[Museum curator, writer] b.1903, Sargentville, ME.*
Addresses: Chicago, IL. **Studied:** Harvard Univ. **Member:** Chicago AC. **Comments:** Author: "The Hudson River School and the Early American Landscape Tradition," 1945; "Early American Room," 1936. Editor: "George Bellows," 1946. Contributor: *The Art Quarterly, Art News, Antiques.* Position: curator, Renaissance art, BM, 1932-36; director, Portland (ME) Art Mus., 1936-39; asst. curato, painting & sculpture AIC, from 1939. **Sources:** WW47.

SWEET, Ralph *[Etcher, painter] b.1892, Rochester, MN / d.1961, San Francisco, CA.*
Addresses: Berkeley, CA; San Francisco, CA. **Studied:** Univ. Minnesota; Johns Hopkins Univ., Baltimore. **Member:** Assn. Medical Illustrators (pres.); San Francisco AA; Soc. Western Artists. **Exhibited:** Kingsley AC, Sacramento, 1930-32; San Francisco Artists' Cooperative, 1961 (solo). **Comments:** Position: medical illustrator, Mayo Clinic, four years, Univ. Calif., Berkeley and a clinic in Woodlands, CA, 1923-32. **Sources:** Hughes, *Artists in California,* 546.

SWEET, Silas A. *[Engraver] b.c.1813, Maine.*
Addresses: Boston, active 1850. **Comments:** He lived in Boston with his wife and four children. **Sources:** G&W; 7 Census (1850), Mass., XXVI, 43.

SWEET, Simeon *[Portrait painter] b.c.1826, Ohio.*
Addresses: Cincinnati, 1850. **Sources:** G&W; 7 Census (1850), Ohio, XXI, 1027.

SWEET, Stanley A. *[Painter] mid 20th c.*
Exhibited: Salons of Am., 1924. **Sources:** Marlor, *Salons of Am.*

SWEET, William *[Portrait painter] d.1840.*
Addresses: Urbana (OH), active 1838. **Comments:** Possibly the same as the young portrait painter named Sweet who is said to have died at Springfield (OH) in 1843. **Sources:** G&W; *Antiques* (March 1932), 152; Martin, "The City of Springfield," 493. More recently, see Hageman, 122.

SWEETING, Earl(e) R. *[Painter] mid 20th c.*
Exhibited: Salons of Am., 1931, 1932. **Sources:** Marlor, *Salons of Am.*

SWEETLAND, Augusta Ladd *[Painter] d.1881, Yosemite.*
Addresses: San Francisco, CA. **Work:** Yosemite National Park Mus. **Sources:** Hughes, *Artists in California,* 546.

SWEETLAND, Ernest John *[Painter, inventor] b.1880, Carson City, NV / d.1950, San Francisco, CA.*
Addresses: San Francisco, CA. **Exhibited:** Bohemian Club, 1935-41; Soc. for Sanity in Art, CPLH, 1942. **Sources:** Hughes, *Artists in California,* 546.

SWEETLAND, Lucy W. *[Artist] late 19th c.*
Addresses: Cazenovia, NY, 1876. **Exhibited:** NAD, 1876. **Sources:** Naylor, *NAD.*

SWEETSTER, J. P. *[Marine painter] late 19th c.*
Work: Peabody Mus., Salem, MA (marine watercolor). **Comments:** A captain of merchant ships, he was active in Maine, 1882. **Sources:** Brewington, 372.

SWEEZEY, Nelson *[Sculptor and designer of monuments] mid 19th c.*
Addresses: NYC, 1849-52. **Sources:** G&W; NYBD 1849-52.

SWEEZY, Carl *[Painter after 1920; Indian policeman; farmer; historical informant; teacher; prof. baseball player] b.c.1879, near Darlinton, OK / d.1953, Lawton, OK.*
Studied: Mennonite Mission Schools, Darlington, OK & Halstead, KS; Carlisle Indian School, PA; Chilocco Indian School, OK. **Exhibited:** Am. Indian Expo, Ann., Anadarko, OK; Am. Indian Week Ann., Tulsa, OK; Thomas Gilcrease Inst., Tulsa, OK; Heard Mus., Phoenix, AZ, also, "Shared Visions: Native Am. Painters & Sculptors in the 20th C.," 1991-92; Oklahoma Hist. Soc. Mus., Oklahoma City; Oklahoma MA; Philbrook MA, 1947-65 (Am. Indian Paintings from the Permanent Collection) ,1984-85 (Indianischer Künstler), also Indian Art Annuals; Univ. Oklahoma Anthropology Dept.; Mus. Plains Indian, Browning, MT; Marion Koogler McNay AM, San Antonio, TX. **Work:** Canadian Mus. Natural Hist., Ottawa; Gilcrease Inst., Tulsa, OK; Heard Mus., Phoenix, AZ; Oklahoma Hist. Soc.; U.S. Dept. Interior, Wash., DC; National Mus. Am. Indian, Smithsonian, Wash., DC; Univ. Oklahoma, Norman; Philbrook MA, Tulsa; Southwest Mus., Los Angeles. **Comments:** A member of the Arpaho tribal nation, he was born on the old Cheyenne-Arpaho reservation and given the name Wattan, Waatina, meaning "black." Preferred media: oil, watercolor, enamel. **Sources:** info. courtesy of Donna Davies, Fred Jones Jr. Mus. Art, Univ. of Oklahoma.

SWEIGERT, Cloyd Jonathan *[Cartoonist, painter] b.1897, Santa Clara Valley / d.1973, Palo Alto, CA.*
Addresses: San Francisco, CA; Palo Alto, CA. **Studied:** Univ. Calif., Berkeley. **Member:** Bohemian Club; Palo Alto Art Club. **Exhibited:** Bohemian Club, 1939; de Young Mus., 1943; Palo Alto Medical Clinic, 1979. **Awards:** Freedom Foundation Award, 1951, 1952; Christopher medal, 1953. **Work:** San Jose Hist. Mus.; LOC. **Comments:** Position: staff, San Francisco *News,* seven years; cart., San Francisco *Chronicle,* 1932-1973. **Sources:** Hughes, *Artists in California,* 546.

SWELL, Marion B. *[Painter] mid 20th c.*
Exhibited: Salons of Am., 1934. **Sources:** Marlor, *Salons of Am.*

SWENEY, Fred *[Illustrator, writer] b.1912, Holidaysburg, PA.*
Addresses: Sarasota, FL. **Studied:** Cleveland School Art. **Exhibited:** Awards: Nat. Offset Lithographic Award, 60 Lithographic Award, 1961 & Graphic Arts Award, 1962, Brown & Bigelow. **Comments:** Preferred media: oils. Positions: supervisor, Leece-Neville Co.; artist/illustrator, Brown & Bigelow, 1949-. Publications: author/illustrator, "Techniques of Drawing and Painting Wildlife," 1959, "Drawing and Painting Birds," 1961 & "Painting the American Scene in Watercolor," 1964; illustrator, *Nat. Geography;* author/illustrator & contributor, *Sports Afield Magazine.* Teaching: instructor, Ringling School Art, 1949-. **Sources:** WW73; J.M. Ethridge, *Contemporary Authors* (Gale, 1962).

SWENGEL, Faye (Mrs. Faye Swengel Badura) *[Painter]* *b.1904, Johnstown, PA / d.1991.*
Addresses: Lumberville, New Hope, PA. **Studied:** PAFA with Daniel Garber, Arthur B. Carles; Barnes Fnd. **Exhibited:** Soc. Indep. Artists, 1928; Corcoran Gal biennials, 1935-47 (3 times); CM; PAFA Ann., 1935-1942 (prize), 1946; PAFA, 1937 (medal) 1940-56 (prizes, medals, 1940, 1946); NAD; VMFA; MMA, 1943; AIC, 1943; Phila. Art All., 1953; Pyramid Club, Phila., 1956. Awards: PAFA (fellow); Cresson traveling scholarship, PAFA, 1925. **Work:** PAFA. **Comments:** Craftsperson-restorer of antique paintings. **Sources:** WW59; WW47; Falk, *Exh. Record Series.*

SWENNING, R. T. (Miss) *[Artist]* *early 20th c.*
Addresses: Active in Los Angeles, c.1905-10. **Sources:** Petteys, *Dictionary of Women Artists.*

SWENSEN, Mary Jeanette Hamilton (Jean) *[Painter, lithographer]* *b.1910, Laurens, SC.*
Addresses: Denver, CO. **Studied:** Columbia Univ., with Hans Mueller (B.S., 1956), with Arthur Young (M.A., graphic arts, 1960); Fine Arts School for Am., Fontainebleau, France, with Lucien Fontanerosa; Arizona State Univ., with Prof. Arthur Hahn, five summers. **Member:** Soc. Western Artists; Delta Phi Delta. **Exhibited:** Soc. Western Artists, de Young Mus, San Francisco, 1964; Nat. Art Roundup, Las Vegas, 1965; Fine Arts Bldg., Colorado State Fair, Pueblo, 1965. Awards: hon. men. for drawing, Soc. Western Artists, 1964. **Work:** Two lithographs, MMA; one lithograph, Nat. Graphic Arts Collection, Smithsonian Inst.; Wash., DC; one lithograph, Graphic Arts Collection, NYPL Main Branch; one lithograph, Laurens Public Library, SC. **Comments:** Preferred media: watercolor, graphics. **Sources:** WW73.

SWENSON, Anne *[Painter, instructor]* *mid 20th c.; b.Stafford Springs, CT.*
Addresses: Staten Island, NY. **Studied:** ASL; also with William Fisher, Vincent Drennan, Paul Giambertone & Tetsuya Kochi. **Member:** Burr Artists (dir., 1967-72); Gotham Painters; Composers, Author & Artists Am., Inc. (treasurer, NYC Chapt., 1970-72). **Exhibited:** Staten Island Mus., NYC, 1955-61; Art & Sci. Mus., Statesville, NC 1967; Civic Art Center, Rapid City, SD, 1968; NAC, 1969; Wash. Mus. Fine Arts, Hagerstown, MD, 1971. Awards: Anna B. Morse Gold Medal, Gotham Painters, 1966; Composers, Authors & Artists Am., NYC Chapt., 1969 (second place award for watercolor), 1971 (hon. men. for oil). **Work:** St Peter's Rectory, Staten Island, NY. **Comments:** Preferred media: oils, watercolors. Publications: illustrator, Indian Assn. Am.; author, "Rugs Through the Ages," *New Bulletin Staten Island Mus.,* Vol. 9, No. 3. Teaching: lecturer/demonstrator of mosaic, Staten Island Mus., 1959-; art instructor & head dept., St. Peter's Elem. School, Staten Island, 1960-62. **Sources:** WW73; "Bibliography with Photos or Works," *Staten Island Advan.* (1959, 1960 & 1969); Anne Swenson, *Composers, Authors & Artists of Am.,* Vo. 26, No. 1 & Vol. 26, No. 4.

SWENSON, Carl Edgar *[Painter, designer, illustrator]* *b.1897, Fairdale, IL.*
Addresses: Rockford, IL. **Member:** Rockford AA. **Exhibited:** Rockford AA Annual Exh., 1935 (prize), 1936 (prize); AIC. **Comments:** Position: asst. art director, H.H. Monk & Assoc., Rockford, IL. **Sources:** WW40.

SWENSON, Eleanor Bryant *[Museum curator]* *b.1921, Montclair, NJ.*
Addresses: New York 28, NY. **Studied:** Smith College (A.B.); NY Univ. **Comments:** Position: asst. curator, paintings & sculpture, BM, Brooklyn, NY,1943-47; assoc. curator, CGA, Washington, D.C., 1947-. Lectures: Special Aspects of European Painting from Medieval to Modern; Development of American Techniques and Styles. **Sources:** WW53.

SWENSON, Gottfrida *[Painter]* *b.1882, Sweden.*
Addresses: Duluth, MN. **Studied:** K. Heldner; Delecluse, Paris. **Member:** Duluth AS. **Exhibited:** Duluth AS: Arrowhead Exhib., (prize). **Sources:** WW33.

SWENSON, Howard William *[Sculptor, decorator, graphic artist]* *b.1901, Rockford, IL / d.1960.*
Addresses: Rockford, IL. **Studied:** Corcoran Sch. Art; O. Nordmark. **Member:** Rockford AA; Potters Gld. Greater Chicago; Artists Union; Swedish-Am AA, Chicago. **Exhibited:** Soc. Wash. Art; CGA; Phila. Pr. Club; Rockport AA.; Maryland Inst. **Work:** LOC; Masonic Cathedral, Rockford, IL. **Comments:** WPA artist. Position: director, Garden Fair Gall, Rockford, IL. **Sources:** WW59; WW47.

SWENSON, Ole (Valerie K.) *[Painter]* *b.1907, Kansas City, MO.*
Addresses: Long Island City, NY. **Studied:** A. Bloch. **Member:** MacDowell Soc.; Swedish-Am. AA. **Comments:** Position: asst. editor, *The Prof. Artists Quarterly.* **Sources:** WW40.

SWENSON, Valerie *[Painter]* *b.1907, Kansas City, MO.*
Addresses: Shandaken, NY. **Studied:** Kansas City AI; Univ. Kansas, B.F.A. **Member:** Woodstock Gld. Artists & Craftsmen. **Exhibited:** Woodstock Gld. Artists & Craftsmen; exhibs. in Chicago, Philadelphia and New York; AMNH (solo); Argent Gal., NY; Albany Inst. Hist. & Art. **Comments:** Author/illus.: "A Child's Book of Trees," 1953; "A Child's Book of Reptiles and Amphibians," 1954; "A Child's Book of Stones and Minerals," 1955; "Bees and Wasps," 1959; "The Year," and illustrations for many nature books and magazines. **Sources:** WW66.

SWEORDS, Margaret *[Sculptor]* *mid 20th c.*
Addresses: Chicago area. **Exhibited:** AIC, 1942, 1946. **Sources:** Falk, *AIC.*

SWERDLOFF, Sam *[Painter]* *b.1910, Wisconsin / d.1984.*
Addresses: Baltimore, MD, 1931-36; NYC, 1936-. **Studied:** Colt Sch. Art, Madison, WI; Univ. Wisconsin. **Member:** Artists Union of Baltimore (co-founder); Am. Artists Congress; Artists Union of NY (officer). **Exhibited:** Madison and Milwaukee, WI (prizes); Baltimore, MD (prizes); WPA Exhib. at CGA, 1934; Am. Artists; "NYC WPA Art" at Parsons School Design, 1977. **Work:** WPA murals, Baltimore, NYC; several museums and private collections. **Comments:** Worked with Public Works of Art Program, 1934; WPA Fed. Art Project, NY, 1938-39. Also worked as a freelance journalist in the late 1920s and 1930s. Founded a public relations agency, NY, 1942; served in WWII. **Sources:** *New York City WPA Art,* 85 (w/repros.).

SWETT, Alice A. *[Landscape painter, teacher]* *b.1847, Allston, MA / d.1916.*
Addresses: Allston, MA. c/1897-1913/Monhegan Island, ME (summers). **Studied:** BMFA School. **Member:** Copley Soc., 1897. **Exhibited:** Boston AC, 1887-1900. **Comments:** An art teacher in the Allston (MA) schools, she was among the first women artists to establish a studio on Monhegan Island (ME), c.1900, which she shared with William Claus. She made many extended painting trips abroad. **Sources:** WW13; Shettleworth & Bunting, *An Eye for the Coast* (Tilbury House Pub., Gardiner, ME, 1998); Curtis, Curtis, and Lieberman, 42-43, 50, 186.

SWETT, Cyrus A. *[Engraver]* *mid 19th c.*
Addresses: Portland, ME,1839; Boston, 1849-after 1860. **Comments:** May have been a partner in Swett & Powers (see entry), engravers and lithographers of Boston, active 1851. **Sources:** G&W; Stauffer; Fielding's supplement to Stauffer; Boston BD and CD 1849-60+. See also Pierce and Slautterback, 155.

SWETT, Lucia Gray See: **ALEXANDER, Lucia Gray Swett**

SWETT, Moses *[Lithographer]* *b.1804 / d.1838, probably Washington, DC.*
Comments: Originally an ornamental painter, Swett began his career as a lithographer in 1826 by working for the Pendleton's; and in 1828 helped launch Senefelder Lithographic Co. (see entry) serving as superintendent of that firm until the first part of 1829. Swett returned briefly to Pendleton but then moved on to form the firm of Endicott & Swett with George Endicott in (see entries).

As a firm they were active in Baltimore, 1830-31 and in NYC, 1831-34. The partnership dissolved c. 1834 and Swett was in Washington (DC) by 1837 at which time he was associated with P. Haas (see entry). **Sources:** G&W; Peters, *America on Stone;* NYCD 1832-36; *Portfolio* (Aug. 1948), 6-7, and (Dec. 1948), back cover. Stokes, *Historic Prints; Antiques* (Nov. 1932), 167. More recently, see Reps, 320 (cat. no. 1277); Pierce and Slautterback, 150-51, repros. 24 and 38.

SWETT, Ruth Doris *[Etcher] b.1901, Southern Pines, NC.*
Addresses: Southern Pines, NC; Winter Park, FL; Deer Isle, ME. **Studied:** Chouinard AI; ASL; & with William McNulty, Frank Nankivell,Margery Ryerson; G. Bridgman; E.O. Verner. **Member:** North Carolina SA; Wash. WCC; Orlando SA.; Rockport AA; AFA; SSAL; Allied Artists, Winter Park; Southern Printmakers. **Exhibited:** SAE, 1936; Wash. WCC, 1939; NGA, 1936; Int. Printmakers, CA,1936; Southern Printmakers; Florida Fed. Artists, 1939 (medal); Rockport AA. **Work:** LOC; St. Mary's Sch., Raleigh, NC; etching, published as frontispiece, "Beech Mountain Folk Songs." **Sources:** WW53; WW47.

SWETT, William Otis, Jr. *[Marine & landscape painter] b.1859, Worcester, MA / d.c.1938, Atlanta, GA.*
Addresses: NYC; Dover Plains, NY/Ogunquit, ME. **Studied:** Whistler; H.G. Dearth; Munich; Paris; Belgium; Holland. **Member:** SC, 1903; Chicago AG; S. Indp. A. **Exhibited:** SNBA, 1899; AIC, 1889-1904; PAFA Ann., 1904, 1906; S. Indp. A., 1917. **Sources:** WW38; Fink, *American Art at the Nineteenth-Century Paris Salons*, 395; Falk, *Exh. Record Series.*

SWETT-GRAY, Naomi (Mrs. Leon Gray) *[Painter, writer] b.1889, Portland, OR.*
Addresses: Seattle, WA. **Studied:** Portland Art Mus. Art School. **Exhibited:** Oregon Soc. Artists, 1933. **Sources:** Trip and Cook, *Washington State Art and Artists.*

SWETT & POWERS *[Engravers and lithographers] mid 19th c.*
Addresses: Boston, 1851. **Work:** Boston Athenaeum (large lithograph drawing of iron light house on Minot's Ledge). **Comments:** Identity of the partners is not certain. Swett could be Cyrus A. Swett, engraver; Powers is most likely James T. Powers (see entries on each). **Sources:** G&W; Boston BD 1851. More recently, see Pierce and Slautterback, 155.

SWETZOFF, Hyman *[Art dealer] 20th c.*
Addresses: Boston, MA. **Sources:** WW66.

SWEZEY, Agnes *[Painter] 20th c.*
Addresses: NYC. **Sources:** WW25.

SWICK, Rosemary Goldfein *[Painter] mid 20th c.*
Addresses: Chicago area. **Exhibited:** AIC, 1947-48, 1950. **Sources:** Falk, *AIC.*

SWIFT, Ann Waterman *[Painter of a romantic scene in watercolors] early 19th c.*
Addresses: Poughkeepsie, NY, c.1810. **Sources:** G&W; Lipman and Winchester, 181.

SWIFT, Anne *[Sculptor] mid 20th c.*
Addresses: Chicago area. **Exhibited:** AIC, 1935. **Sources:** Falk, *AIC.*

SWIFT, C(aroline) L. *[Painter] 19th/20th c.*
Addresses: NYC, 1888; Boston, MA, 1889. **Exhibited:** NAD, 1888; Boston AC, 1889, 1891. **Comments:** Active 1888-1912. **Sources:** Naylor, *NAD* (as C.L. Swift); *The Boston AC.*

SWIFT, Clement Nye *[Painter, writer, photographer] b.1846, Acushnet, MA / d.1918, Acushnet, MA.*
Addresses: London; France; NYC. **Studied:** Adolph Yvon and M. Henri Harpignies; artists colony at Pont Aven, 1870-71. **Exhibited:** Paris Salon, 1870, 1872, 1874, 1875, 1877-81; NAD, 1877, 1879-82, 1896; Ellis's Fine Art Gal., New Bedford, 1875; PAFA Ann., 1879, 1881; H. S. Hutchinson & Co., New Bedford, 1895; New Bedford Art Club, 1908-15, 1917; BAC, 1891-1901.

Work: Kendall Whaling Mus.; New Bedford Free Public Library; Acushnet Town Hall and Acushnet Public Library, Acushnet, MA; Millicent Library, Fairhaven, MA; Old Dartmouth Hist. Soc. **Comments:** Specialties: animals; marine. **Sources:** WW01; Blasdale, *Artists of New Bedford*, 182-83 (w/repros.); Fink, *American Art at the Nineteenth-Century Paris Salons*, 395; Falk, *Exh. Record Series.*

SWIFT, Dick *[Printmaker, educator, lithographer, illustrator] b.1918, Long Beach, CA.*
Addresses: Long Beach, CA. **Studied:** Los Angeles State College (B.A.); Claremont Grad. School (M.F.A.); Chouinard AI; ASL; H.L. McFee; W. Barnet; J. Corbino. **Member:** Am. Color Print Soc.; Los Angeles Print Soc. (pres., 1968-69). **Exhibited:** AIC, 1944 & traveling exhib.; Minneapolis IA; Rochester Mem. Art Gal.; CI; CM; Dayton AI; CAM; Soc. Liberal Artists Omaha; NAD, 1944-46; SAM, 1945; Laguna Beach AA, 1943-45; LACMA, 1944; Ebell Club, 1941 (prize); Long Beach AA, 1942 (prize), 1943 (prize), 1944 (prize); Contemp. Art Gal., 1945 (solo) (prize); Santa Barbara Mus. (solo); Otis AI; CPLH; Pasadena MA; PAFA, 1965-69. Awards: prizes, Am. Color Print Soc., 1965, Phila. MA, 1968 & Otis AI, 1969. **Work:** San Jose College; Univ. Illinois; Cincinnati Mus. Assn.; Drake Univ.; Zanesville AI; mural, Indust. Des. & Builders, Los Angeles. **Comments:** Preferred media: graphics. Teaching: art professor, Calif. State Univ., Long Beach, 1958-. **Sources:** WW73; WW47.

SWIFT, Emma See: **MACRAE, Emma Fordyce (Mrs. Homer Swift)**

SWIFT, Florence Alston (Williams) *[Painter, craftsperson, designer] b.1890, San Francisco, CA / d.1977.*
Addresses: Berkeley, CA. **Studied:** Hans Hofmann Sch. Art; with V. Vytlacil; Univ. Calif.; Calif. Sch. FA; Calif. College Arts & Crafts. **Member:** Am. Abstract Artists ; San Fran. AA; All. Artists Am.; San Fran. Soc. Women Artists. **Exhibited:** Oakland Art Gallery, 1917; SFMA (solo); CPLH; GGE, 1939; All. Artists Am.; San Fran. AA, 1916, 1920 (medal), 1923, 1925; San Fran. Soc. Women Artists, 1950 (prize), 1951 (prize); Calif. State Fair (prize); Sacramento State Fair, 1927; WMAA. **Work:** Mills College; SFMA; mosaic, Art Bldg., Univ. Calif., Berkeley. **Comments:** Specialty: mosaics. **Sources:** WW59; WW47. More recently, see Hughes, *Artists in California*, 546.

SWIFT, George A. *[Amateur painter] b.1865, Dartmouth, MA / d.1945, North Dartmouth, MA.*
Studied: Swain Free School Design; Boston (architecture). **Exhibited:** New Bedford Art Club, 1916. **Work:** Kendall Whaling Mus., Sharon, MA; Old Dartmouth Hist. Soc. **Sources:** Blasdale, *Artists of New Bedford*, 183 (w/repro.).

SWIFT, Herbert Ivan See: **SWIFT, Ivan**

SWIFT, Homer (Mrs.) See: **MACRAE, Emma Fordyce (Mrs. Homer Swift)**

SWIFT, Ivan *[Painter, architect, craftsperson, etcher, writer] b.1873, Wayne, MI / d.1945, Detroit, MI.*
Addresses: Detroit, MI/Harbour Springs, MI. **Studied:** AIC; with Freer; Von Sulza; Ochtman; Chase; NYC. **Member:** NAC; PS; Michigan Acad. Science, Arts & Letters; Midland Authors, Chicago; Executive Council of Michigan Authors. **Exhibited:** PAFA Ann., 1907; Soc. Indep. Artists, 1922, 1925, 1928, 1937; Salons of Am., 1923; Soc. Art, Poetry & Music, Detroit, 1936 (prize); Michigan Art, 1937 (prize); AIC. **Work:** Detroit Lib.; 20th Century Club, Lockmoor Club, Detroit; Univ. Nebraska; Michigan Fair Gal.; Harbor Springs H.S.; Michigan State Lib.; Delgado Mus., New Orleans; Harbor Springs Pub. Lib.; Detroit IA; Vanderpoel AA. **Comments:** Author: "Fagots of Cedar," "The Blue Crane and Shore Songs," "Nine Lives in Letters." **Sources:** WW40; Gibson, *Artists of Early Michigan*, 225; Falk, *Exh. Record Series.*

SWIFT, Margaret G. *[Painter, teacher] b.1874, Phila. PA.*
Addresses: Phila., PA. **Studied:** PAFA; PM School IA; W.C. Chase; C. Beaux; H. Breckenridge; C. Schuyler; E. Horter.

Member: Phila. Art All. **Work:** PAFA; Royal Gal., Oslo; Luxembourg Mus., Paris. **Sources:** WW40.

SWIFT, Marilyn *[Painter] b.1945, Derby, CT.*
Studied: College of New Rochelle; deCordova and Dana Mus. Sch.; Mass. School Art. **Comments:** Painting locations include Monhegan Island (ME). **Sources:** Curtis, Curtis, and Lieberman, 63, 186.

SWIFT, Samuel *[Critic] b.1873, Newark, NJ / d.1941, NY Hospital.*
Studied: Univ. Penn., 1894. **Member:** MacDowell Club. **Comments:** Position: art critic, *New York Evening Mail,* from 1896-1907.

SWIFT, S(tephen Ted) *[Illustrator, etcher] mid 20th c.*
Addresses: Palo Alto, CA. **Studied:** P.J. Lemos; L.P. Latimer; Calif. College Arts & Crafts. **Comments:** Specialty: wood block printing, etching. Position: staff artist, *School Arts* magazine. **Sources:** WW31.

SWIFT, William J. *[Painter] b.1834, New Bedford, MA / d.1911, New Bedford, MA.*
Addresses: Active in New Bedford, 1865-1911. **Work:** Old Dartmouth Hist. Soc. **Sources:** Blasdale, *Artists of New Bedford,* 184 (w/repro.).

SWIGART, Ednah Knox *[Painter] early 20th c.*
Addresses: Brooklyn, NY, c.1909; Sheffield, IL, c.1913. **Sources:** WW13.

SWIGGETT, Grace Kiess (Mrs.) *[Painter, illustrator, block printer, craftsperson, lecturer, teacher, writer] mid 20th c.; b.Cincinnati, OH.*
Addresses: Indiana, Minnesota & Washington State, c.1905-30; Wash., DC, 1930-40. **Studied:** Indiana Univ.; Columbia; Cincinnati Univ. Chicago Univ.; R. Johonnot; J.P. Haney; L.H. Meakin; V. Nowottny; W.O. Beck; F. Duveneck; O. Humann; A. Dow. **Member:** Women's AC of Cincinnati; Soc. Wash. Artists. **Exhibited:** Women's AC of Cincinnati, 1929; Soc. of Wash. Artists; Takoma Park, MD, Lib., 1936 (solo). **Comments:** Was active as a teacher and artists in Indiana, Minnesota and Washington state from c.1905-30. **Sources:** WW33; McMahan, *Artists of Washington, DC.*

SWIGGETT, Jean Donald *[Educator, painter, designer] b.1910, Franklin, IN.*
Addresses: San Diego, CA; LA Mesa, CA. **Studied:** Chouinard Inst. Fine Art, Los Angeles, 1930-31; San Diego State College (A.B., 1934); Univ. Southern Calif. (M.F.A., 1939); Claremont Grad. School, 1950-52. **Member:** All. Artists Council, San Diego; Art Guild Fine Art Soc., San Diego (pres., 1951-52). **Exhibited:** GGE, 1939; LACMA, 1935-41, 1946; SAM, 1941; San Diego FAS, 1937-39; SFMA, 1936, 1938; Wichita AM; Calif. State Fair, Sacramento, 1938 (prize); Los Angeles County Fair, Pomona, 1938 (prizes); Southwest Exhib., Tucson AC, 1968; Long Beach MA Ann., 1968; Calif.-Hawaii Regionals, San Diego Fine Arts Gallery, 1971 & 1972 (Award); Reality-Illusion, Downey MA, 1972; Calif. State Expos Art Exhib., 1972; San Diego AI Ann., 1971 (award); Riverside (CA) AC Ann., 1972. **Work:** Long Beach (CA) Mus. Art; Fine Arts Gallery, San Diego, CA; Univ. Southern Calif.; Polytech. H.S., Long Beach. Commissions: murals, Post Office, Franklin, IN,1939 & SS President Jackson & SS President Adams, 1940-41. **Comments:** Preferred media: oils. Teaching: asst. drawing teacher, Univ. Southern Calif., 1940-41; painting instructor, Wash. State College, 1941-42; professor of painting & drawing, Calif. State Univ., San Diego, 1946-. Research: Romanesque architecture and sculpture. **Sources:** WW73; WW47.

SWIKERT, Lura (Lora) *[Artist] late 19th c.*
Addresses: Active in Detroit, 1893. **Sources:** Petteys, *Dictionary of Women Artists.*

SWINBURNE, Katherine *[Sculptor] late 19th c.*
Studied: Mme. Leon Bertaux. **Exhibited:** Paris Salon, 1878. **Sources:** Fink, *American Art at the Nineteenth-Century Paris Salons,* 394.

SWINDELL, Bertha *[Miniature painter] b.1874, Baltimore / d.1951.*
Addresses: Baltimore, MD. **Studied:** Bryn Mawr College; Drexel Inst.; PAFA; C.W. Hawthorne; W.M. Chase; G. Bridgman; Breckenridge; Académie Julian, Paris with Laforge; R. E. Miller in Paris; S. Forbes in England. **Member:** Baltimore WCC; Penn. SMP. **Exhibited:** Enoch Pratt Lib., Baltimore; BMA; PAFA; NY Acad. FA; Smithsonian Inst. **Sources:** WW47.

SWINDEN, Albert *[Abstract painter] b.1901, Birmingham, England / d.1961.*
Addresses: Chicago, IL (immigrated from Canada). **Studied:** AIC; J. Wicker Sch. FA, Detroit; ASL, c.1928; Hans Hoffman at ASL, 1932. **Member:** American Abstract Artists (founder/secretary, 1939). **Exhibited:** ASL's first exhib. of abstract art, 1932; Salons of Am., 1934; WFNY, 1939 (Chilean pavilion). **Work:** WPA murals for Williamsburg Housing Project., 1938-40. **Comments:** An abstract painter of the 1930s-40s, he began to introduce figures into his work in the 1950s. A studio fire in 1941 destroyed much of his work. Author: "On Simplification" in American Abstract Artists yearbook, 1938. **Sources:** *American Abstract Art,* 199.

SWING, David Carrick *[Landscape painter, teacher, mural painter] b.1864, Cincinnati, OH / d.1945, Phoenix, AZ.*
Addresses: Phoenix, AZ (since 1917). **Exhibited:** GGE, 1939. **Work:** Phoenix Public Library; Phoenix Masonic Temple. **Comments:** Position: director, Los Angeles Engraving Co., 1905-14; teacher, Phoenix Jr. College. **Sources:** P&H Samuels, 474.

SWING, Jeannette (Jennie) G. Carick *[Painter, decorator] b.1868, Cincinnati, OH.*
Addresses: Cincinnati, OH. **Studied:** Cincinnati AA; Pratt Inst. **Member:** Cincinnati Women's AC. **Comments:** Worked at Rookwood Pottery, 1900-04. Teaching: Cincinnati Public Schools, until 1937. Married a Mr. Lewis but used the name "Mrs. Evans." **Sources:** WW19; Petteys, *Dictionary of Women Artists.*

SWING, Jennie *[Portrait painter] mid 19th c.*
Addresses: Active in Richmond, IN, 1865. **Sources:** Petteys, *Dictionary of Women Artists.*

SWING, Laura See: KEMEYS, Laura Swing (Mrs.)

SWINNERTON, Edna Huestis (Mrs. Radcliffe Swinnerton) *[Miniature pointer] b.1882, Troy, NY / d.1964.*
Addresses: New York 21, NY. **Studied:** Emma Willard Art Sch.; Cornell Univ.; ASL. **Member:** Penn. SMP; ASMP. **Exhibited:** Pan-Pacific Expo, 1915; Chicago World's Fair, 1933; ASMP; Penn. SMP, 1906-59 (medal, 1951). **Work:** many portrait commissions; permanent collection, PMA. **Sources:** WW59.

SWINNERTON, James Guilford *[Illustrator, cartoonist, landscape painter] b.1875, Eureka, CA / d.1974, Palm Springs, CA.*
Addresses: NYC, 1919; West Hollywood, CA. **Studied:** San Francisco Art Sch., with W.R. Keith and E. Carlsen. **Member:** Calif. AC; Bohemian Club; Acad. Western Painters. **Exhibited:** Soc. Indep. Artists, 1918; PAFA Ann., 1919; Stendahls, Los Angeles, 1920s; Bohemian Club, 1922; San Francisco AA, 1923; Salons of Am., 1923; GGE, 1939 (only Western artist); All-Calif. Exhib. 1934; AIC. **Work:** Gardena, CA High School; Palm Springs Desert Mus., CA. **Comments:** His comic strip for Hearst newspapers in 1892 was among the first. In NYC he created "Little Jimmy" and "Little Tiger." In 1903 he moved to Colton, CA to recover from tuberculosis, and became best known for his desert landscapes. By the 1930s-40s he was drawing "Canyon Kiddies" for *Good Housekeeping,* and animation cartoons for Warner Brothers Studios. His work has inspired other Western painters such as Bill Bender and George Marks. **Sources:** WW40; Hughes, *Artists in California,* 547; P&H Samuels, 475; *300 Years of American Art,* 724; Falk, *Exh. Record Series.*

SWIN(S)BURNE, A(nna) T. (Mrs. Henry H.) *[Painter] 19th/20th c.*

Addresses: NYC, active 1900-1904. **Member:** NY Women's AC. **Sources:** WW04; WW01; Petteys, *Dictionary of Women Artists.*

SWINTON, Alfred *[Wood engraver, painter, and illustrator]* *b.1826, England / d.1920, Hackensack , NJ.*
Addresses: NYC as early as 1851; Hackensack , NJ. **Comments:** In 1852 he was in partnership with Augustus Fay (see entry). Best known for his Civil War subjects. **Sources:** G&W; *Art Annual,* XVIII, obit.; Am. Inst. Cat., 1851; NYCD 1852-54.

SWINTON, Frederick *[Painter and possibly lithographer]* *mid 19th c.; b.Staten Island, NY.*
Exhibited: Am. Ins., 1842 (four watercolor drawings).
Comments: Probably the same as: F.J. Swinton of Staten Island, who exhibited still life and animal paintings at the National Academy in 1837 and the Apollo Association in 1839; F.I. Swinton, lithographer of two caricatures after J. Maze Burbank about 1840; and F. Swinton of NYC or Albany who lithographed some of the plates in the Endicotts' "Life in California" (1846). For this last, *American Processional* gives the dates (1821-1910). **Sources:** G&W; Am. Inst. Cat., 1842; Cowdrey, NAD; Cowdrey, AA & AAU; *Portfolio* (Jan. 1954), 104; Peters, *California on Stone; American Processional,* 242.

SWINTON, George *[Painter, writer]* *b.1917, Vienna, Austria.*
Addresses: Winnipeg. **Studied:** McGill Univ. (B.A., 1946); Montreal School Art & Design, 1947; ASL. **Exhibited:** Winnipeg Art Gallery (2 retrospectives); 4 Canadian Biennials; 3 Montreal Spring Exhibs.; 11 Winnipeg Shows; 31 solos; Upstairs Gallery, Winnipeg, 1970s. **Awards:** 3 Canadian Council grants. **Work:** Nat. Gallery Canada; Vancouver Art Gal.; Winnipeg Art Gal.; Hamilton Art Gal.; Confederation AC, Charlottetown. **Comments:** Preferred media: oils, watercolors. Publications: author, "Eskimo Sculpture/Sculpture Esquimaude," 1965; illustrator, "Red River of the North," 1967; co-author, "Sculpture/Inuit," 1971; author, "Sculpture of the Eskimo," 1972. Teaching: lecturer in art, Smith College, 1950-53; professor art, Univ. Manitoba, 1954-, adjunct professor anthropoogy, 1970-. Research: prehistoric and contemporary Eskimo art. **Sources:** WW73.

SWINTON, Marion *[Painter]* *early 20th c.; b.NYC.*
Addresses: NYC/Hackensack, NJ. **Studied:** Chase. **Exhibited:** Soc. Indep. Artists, 1917. **Sources:** WW17; Marlor, *Soc. Indp. Artists.*

SWINTON & FAY *[Wood engravers]* *mid 19th c.*
Addresses: NYC, 1852-55. **Comments:** Alfred Swinton and Augustus Fay (see entries). **Sources:** G&W; NYCD 1852-53; Hamilton, *Early American Book Illustrators and Wood Engravers,* 233, 383.

SWIRE, Morris L. *[Sculptor, medalist]* *b.1894, NYC / d.1967, NYC.*
Sources: info courtesy D.W. Johnson, *Dictionary of American Medalists* (pub. due 2000).

SWIRE, O. L. *[Portrait painter]* *early 20th c.*
Work: PAFA (portrait of an unidentified girl). **Sources:** G&W; WPA (Pa.), "Cat. of Portraits in the PAFA."

SWIRNOFF, Lois (Lois Swirnoff Charney) *[Painter, lecturer]* *b.1931, Brooklyn, NY.*
Addresses: Cambridge, MA. **Studied:** Cooper Union (cert. of grad. 1951); Yale Univ., with Josef Albers (B.F.A., 1953, M.F.A., 1956). **Exhibited:** Americans in Italy, Munson-Williams-Proctor Inst., Utica, NY; American Fulbright Painters, Duveen-Graham Gal., New York, 1957; Boston Arts Festivals, 1963-64; Affect/Effect, La Jolla (CA) Mus., 1968. **Awards:** Fulbright fellowship to Italy, 1951-52; fellowship of Radcliffe Inst. Indep. Study, 1961, 1962 & 1963; Univ. Calif. fellowship for jr. faculty, 1967. **Work:** Addison Gallery Am. Art, Andover; Radcliffe Inst., Harvard Univ.; Jewett AC, Wellesley College. **Comments:** Preferred media: acrylics, gouache, oils. Teaching: art instructor, Wellesley College, 1956-60; asst. professor art, Univ. Calif., Los Angeles, 1963-68; lecturer, visual & environmental studies, Harvard Univ., 1968-. **Sources:** WW73.

SWISHER, Allan Lee *[Portrait painter]* *b.1888, Kansas.*
Addresses: NYC/Paris,France. **Studied:** H.M. Walcott; Académie Julian, Paris with J.P. Laurens, 1913. **Exhibited:** AIC, 1912-13, 1916-17; WMAA, 1921-26. **Sources:** WW40.

SWISHER, Amy Margaret *[Craftsman, etcher, educator, screenprinter, block printer, designer, lecturer]* *b.1881, Groveport, OH.*
Addresses: Oxford, OH; Delaware, OH. **Studied:** Ohio Wesleyan Univ. (B.L.); Teachers College, Columbia Univ. (B.S., M.A.); and with Hans Hofmann, Albert Heckman, Elsa Ulbricht, A.W. Dow, C.J. Martin. **Member:** Ohio Educ. Assn.; Nat. Educ. Assn.; Women's AC, Cincinnati; Oxford AC; AFA; Western AA; Weavers Group of Delaware. **Exhibited:** Cincinnati Women's AC, 1936 (prize); Ohio Union, Ohio Univ.; Delaware County Fair. **Award:** Carnegie Fellowship, to Harvard Univ. **Comments:** Position: head, dept. art educ., 1920-49, professor art educ. emeritus, Miami Univ., Oxford, OH, 1949-. **Sources:** WW59; WW47.

SWISHER, P. M. *[Illustrator]* *20th c.*
Addresses: Phila., PA. **Sources:** WW21.

SWISSHELM, Jane Grey *[Painter, writer]* *19th c.*
Studied: self-taught. **Sources:** Petteys, *Dictionary of Women Artists.*

SWITKIN, Abraham *[Painter]* *mid 20th c.*
Exhibited: Soc. Indep. Artists, 1942. **Sources:** Marlor, *Soc. Indp. Artists.*

SWITZER, George *[Industrial designer, lecturer]* *b.1900, Plymouth, IN.*
Addresses: NYC. **Studied:** J. Norton; Univ. Illinois; Chicago Acad. FA; AIC. **Member:** AI Graphic Arts; Art Dir. Club, NY; Soc. Typographical Artists; Nat. Art Soc. **Work:** indust. des., Hormel & Co., IBM, Johnson & Johnson, Eagle Pencil Co., Westinghouse, Studebaker, Rolls Royce, DuPont. **Comments:** Specialized in packaging design, created the wrapper for "Wonder Bread." **Sources:** WW40.

SWITZER, Gilbert *[Painter]* *mid 20th c.*
Addresses: NYC. **Exhibited:** PAFA Ann., 1941-42. **Sources:** Falk, *Exh. Record Series.*

SWITZER, Maurice *[Illustrator]* *b.c.1871, New Orleans, LA / d.1929, NYC.*
Addresses: New Orleans, active 1895-97; NYC, c.1900-29. **Member:** New Orleans AA, 1897. **Comments:** Illustrated the "Owl" in N. O. and later had a successful advertising career in New York. **Sources:** *Encyclopaedia of New Orleans Artists,* 370.

SWITZER, Patty *[Miniature painter]* *b.1902, Illinois / d.1972, Los Angeles, CA.*
Addresses: Hollywood, CA. **Studied:** Am. Sch. Min. Painting with M. Welch and E. D. Pattee; CUA Sch. **Member:** Bay Region AA. **Exhibited:** NYC; New Jersey; SMPS&G, Wash., DC, 1964. **Sources:** WW27; Hughes, *Artists in California,* 502.

SWITZER, Robert *[Painter]* *mid 20th c.*
Exhibited: AIC, 1926. **Sources:** Falk, *AIC.*

SWOPE, Daniel Paul *[Engraver]* *19th/20th c.*
Addresses: Wash., DC, active 1901-05. **Sources:** McMahan, *Artists of Washington, DC.*

SWOPE, Emma Ludwig (Mrs. W. D.) *[Craftsman, designer, teacher]* *b.1891, Spillville, IA.*
Addresses: Ithaca, NY; Freeville, NY; Fallbrook, CA. **Studied:** AIC; Washington State College, Pullman, WA (B.A.); Columbia Univ. (M.A.); & with Ralph Pearson; New York School Fine & Applied Arts; Europe; Woodstock, NY; Albert Heckman; Belle Boas; Elsie Ruffini; George Cox. **Member:** New York Soc. Craftsmen. **Exhibited:** Art Center, NY; Cornell Univ.; New York Soc. Craftsmen, 1941 (prize). **Comments:** Owner/manager: Des. & Crafts Workshop. Positions: teacher, Polytechnic Inst., Billings, MT, 1917, 1919; teacher, State College of Washington, 1919-25; teacher, American Albania School Agriculture, Kavaje, Albania, 1926-27; New York Public Schools, 1920-29; extension work,

State College of Home Economics, Cornell Univ., 1930-36; Juvenile Dept., Art Inst. Chicago; art teacher, George Jr. Republic, Freeville, NY; teacher, George Washington School, Elmira, NY (retired 1954). **Sources:** WW59; WW47; Ness & Orwig, *Iowa Artists of the First Hundred Years,* 203.

SWOPE, H. Vance [Painter] b.1877, southern IN / d.1926, NYC.
Addresses: NYC/Ogunquit, ME. **Studied:** Hanover College, IN; NAD; Académie Julian, Paris with B. Constant, 1890-92; Cincinnati Art Acad, 1892-96. **Member:** Gld. Am. Painters.; AWCS; SC; NY Arch. Lg.; Allied AA. **Exhibited:** Soc. Indep. Artists, 1917-18; AIC, 1923-24; PAFA Ann., 1926. **Work:** Pub. Lib., Seymour, IN. **Comments:** He painted figures, landscapes, and marines in both oil and watercolor. Fielding lists 1879 birth date while *Who's Who in New York State* says March 4, 1877. **Sources:** WW25; Falk, *Exh. Record Series;* addl info, exhib. flyer, Matthews Gal, Bergenfield, NJ, c.1980s.

SWOPE, Kate F. (Mrs.) [Painter] *K. Swope*
b.1879, Louisville, KY.
Addresses: NYC. **Studied:** NAD; with Edgar Ward and M. Flagg in NY; and with B.R. Fitz. **Member:** Louisville AL. **Exhibited:** NAD; SSAL, 1895 (gold); Louisville AL, 1897 (prize); AIC; Trans-Mississippi Expo, Omaha; Phila. Art Club. **Comments:** Painted allegorical and sacred subjects, gardens and figures in oil and pastel. **Sources:** WW25; Petteys, *Dictionary of Women Artists.*

SWOPE, Virginia Vance [Painter] mid 20th c.; b.Louisville, KY.
Addresses: NYC/Leonardo, NJ, 1925. **Studied:** DuMond; Mora; Carlson; Penfield; Bridgman. **Sources:** WW25.

SWORD, James Brade
[Landscape, portrait, and genre *J. B Sword. 79*
painter] b.1839, Philadelphia, PA /
d.1915, Philadelphia, PA.
Addresses: Philadelphia, PA c.1863 and after. **Studied:** PAFA, 1861; Geo. W. Nicholson, 1863; W.T. Richards. **Member:** Phila. Artists Fund Soc.; Phila. SA (pres.); AC Phila. (founder). **Exhibited:** Brooklyn AA, 1873-84; NAD, 1876-92; PAFA Ann., 1876-90, 1902-06; Boston AC, 1881-85; New Orleans Expo, 1885 (medal); AAS, 1902 (gold), 1903 (gold); AIC, 1895-1908. **Work:** U.S. Capitol (portrait); University of Pennsylvania. **Comments:** As a boy, Sword was raised in China and attended high school in Philadelphia. He quit school in 1855 to become a civil engineer, working on various canal and tunnel projects. During the early 1860s he turned to painting and soon became prominent in Philadelphia's art organizations. He painted widely along the New England and Mid Atlantic shore, and in the Adirondack Mountains. **Sources:** G&W; WW15; Fairman, *Art and Artists of the Capitol,* 466; *Art Annual,* XIII, obit.; *American Collector* (Oct. 1945); Campbell, *New Hampshire Scenery,* 163; Falk, *Exh. Record Series.*

SWYNEY, John [Sketch artist] mid 19th c.
Addresses: Boston, active 1854. **Comments:** Delineator of a locomotive engine built at the Globe Locomotive Works in Boston in 1854, lithographed by J.H. Bufford. **Sources:** G&W; *Portfolio* (Jan. 1945), 104.

SYKES, Annie Gooding [Painter] b.1855, Brookline, MA / d.1931, Cincinnati, OH.
Addresses: Cincinnati, OH, 1882-1931. **Studied:** Lowell Inst., Boston, 1877; BMFA Sch., 1878-82; Cincinnati Art Acad. with T.S. Noble and F. Duveneck, 1884-94. **Member:** Cincinnati Woman's AC (founding member; pres., 1903); NAWA; NYWCC; AWCS. **Exhibited:** Cincinnati Centennial Exhib., 1888; Boston AC, 1890-97; NYWCC, 1891-1916; World's Columbian Expo, Woman's Bldg., 1893; Cincinnati Woman's AC, 1893-1929; Cincinnati Art Mus., 1895-1926 (including annuals; two-person show in 1908 with Emma Mendenhall; and three-person show, 1910, with Mendenhall and Dixie Selden); Traxel & Maas Gal., Cincinnati, 1895, 1917 (solos); AIC, 1896-1920; AWCS, 1902, 1924; Phila. WCC, 1903-20; PAFA Ann., 1903; Soc. of Western

Artists, 1904, 1909; NAWA,1918; Ohio WCS, 1927-31; Appalachian Gal., Morgantown, WV, 1989 (solo); Spanierman Gal., NYC, 1998 (retrospective). **Comments:** A first-generation American Impressionist, Sykes specialized in watercolors, focusing on garden, floral, landscape, and shoreline subjects. Raised in Boston, she was among the very first women to enter the BMFA School. Her career was spent mostly in Cincinnati, where she was a leading member of the art community. During the summers she painted along the New England coast in places such as Nonquitt (where she had a summer home) and Gloucester, Mass., and Cape Porpoise, Maine. Her watercolors of 1895-1915 are brilliant in color and bear striking comparisons with those by Childe Hassam; thereafter, she developed a bold post-impressionist style. In 1901, just five years after her first exhibition at the Art Institute of Chicago, she was asked to be on the jury for their prestigious annual watercolor exhibition. She made painting trips to Europe (1906 & 1909), Bermuda (1913), and Texas. **Sources:** WW29; Christine Williams Ayoub, *Annie Gooding Sykes* (privately published, 1990); Peter H. Falk and Audrey Lewis, *Annie Gooding Sykes* (exh. cat., Spanierman Gal., NYC, 1998); Falk, *Exh. Record Series.*

SYKES, Charles Henry [Cartoonist] b.1882, Athens, AL / d.1942.
Addresses: Cynwyd, PA. **Studied:** B.W. Clinedist at Drexel Inst., Phila. **Member:** Phila. Sketch Club. **Comments:** Cartoonist: *Evening Public Ledger,* Phila., 1914-42. **Sources:** WW31.

SYKES, Frederick J. [Landscape painter] b.1851, England / d.1926.
Addresses: Brooklyn, NY; Union Vale, NY. **Exhibited:** Hirschl & Adler Gal., NYC, 1992 (solo), 1997 (solo). **Comments:** Bright colors, absence of atmospheric perspective, and compressed space link the works of this enigmatic painter with those of Levi Wells Prentice. During the 1880s, he lived in Brooklyn; paintings from the 1890s indicate he was working in the Hudson River valley, the Catskills, and along the Delaware River. In 1900, he painted the volcanoes and jungles of Mexico.

SYKES, G. H. [Painter] 20th c.
Addresses: NYC. **Exhibited:** Soc. Indep. Artists, 1917-18. **Sources:** Marlor, *Soc. Indp. Artists.*

SYKES, John [Topographical artist] b.1773, England / d.1858.
Work: Hydrographic Office of the Admiralty (sketches of the voyage to the South Pacific); Bancroft Lib., UC Berkeley. **Comments:** Sykes entered the Royal Navy as a boy and in 1792 served as artist on Vancouver's voyage of discovery in the North Pacific, 1792-94. His sketches are in the possession of the Hydrographic Office of the Admiralty; three of his California views appeared in Vancouver's 1798 report. Sykes later saw action in the Napoleonic wars, was made rear admiral in 1838, and admiral shortly before his death. **Sources:** G&W; Van Nostrand and Coulter, *California Pictorial,* 8-10; Rasmussen, "Art and Artists in Oregon" (citation courtesy David C. Duniway).

SYKES, Lyman R. [Listed as "artist"] b.c.1820, Massachusetts.
Addresses: New London, CT, 1850. **Comments:** His mother and 18-year-old brother were natives of Vermont. **Sources:** G&W; 7 Census (1850), Conn., X, 259.

SYKES, Maltby See: SYKES, (William) Maltby

SYKES, S. D. Gilchrist [Painter] 20th c.; b.Cheshire, England.
Addresses: Providence, RI; Brookline, MA. **Studied:** BMFA School. **Member:** Copley Soc.; North Shore AA. **Exhibited:** PAFA Ann., 1925. **Sources:** WW40; Falk, *Exh. Record Series.*

SYKES, Viola R. [Painter] 20th c.
Addresses: NYC. **Studied:** ASL
Soc. Indep. Artists, 1927; Salons of Am., 1928. **Sources:** Falk, *Exhibition Record Series.*

SYKES, (William) Maltby [Painter, printmaker, graphic artist, lecturer] b.1911, Aberdeen, MS.

Addresses: Auburn, AL. **Studied:** ASL and with Arthur Bairnsfather,Wayman Adams, George C. Miller, John Sloan, Diego Rivera, Andre Lhote, Fernand Leger & Stanley William Hayter. **Member:** Alabama Art Lg.; Alabama WCS; CAA; Southeastern AA; Birmingham Art Club; SAGA; AFA; SC.; Am. Assn. Univ. Prof. **Exhibited:** Alabama Art Lg., 1934-43, 1944 (prize), 1945 (prize); New Orleans AA, 1937 (prize), 1945 (prize), 1948, 1949 (prizes); Alabama State Fair, 1939 (prize), 1941 (prize); Birmingham AC, 1939-40, 1941 (prize), 1942 (prize), 1943, 1948, 1949 (prizes); Mint Mus. Art, 1944, 1945 (prize); SSAL, 1934, 1935, 1937, 1939-44, 1945 (prize); Alabama WCC, 1941 (prize), 1943 (prize); Phila. WCC, 1938; Wash. WCC, 1944; AWCS, 1941 (prize), 1943 (prize),1945; CI, 1945, 1946; LOC, 1945, 1948-51; Phila. Pr. Club, 1945, 1956 (Curator's Choice Exhib); Northwest Printmakers, 1945, 1946; NAD, 1946, 1949; Albany Pr. Club, 1945; Mississippi AA, 1943-46; Albany Inst. Hist. & Art, 1948, 1949, 1951(Purchase Award, Print Club Albany, 1963); AEA, 1950, 1951; AIGA, 1949 (award); Bradley Univ., 1952; BM, 1949-52; Chicago Soc. Etchers., 1952; CM, 1952 (Int. Biennial Contemporary Color Lithography); Delgado Mus. Art,1945-50; Laguna Beach AA, 1948; PAFA, 1937, 1950; SAM, 1945, 1946, 1949, 1950, 1952; SAGA, 1951, 1952; L.D.M. Sweat Mem. Mus., 1952; Wichita AA, 1948-50; Salon d'Automne, Paris, 1951; MMA, 1952 (Am. Watercolors, Drawings & Prints); Contemporary Am. Graphic Art US Info Agency & Tour Abroad, 1961; Am. Color Print Soc., 1965 (Philip & Esther Klein Award); sabbatical award, Nat. Endowment Arts, 1967-68. **Work:** Alabama State Capitol Bldg.; Alabama Dept. Archives & Hist.; Montgomery Mus. FA; Alabama Supreme Court Bldg.; Univ. Alabama; Birmingham Law Lib.; Birmingham Board Educ.; Mobile Board Educ.; SectionHist. Properties, Wash., DC; Alabama College; Alabama Polytechnic Inst.; Oklahoma A&M College; MoMA; Stedelijk Mus., Amsterdam; MMA; BMFA; PMA. Commissions: color engravings, ed. 210 prints, Trellis, 1955, Cathedral Interior 1958 & Floating Still Life, 1962, Int. Graphic Arts Soc. **Comments:** Teaching: art professor, Auburn Univ., 1942-, artist-in-residence, 1968-. Publications: contributor, American Prize Print of the 20th Century, 1949; author, "The Multimetal Lithography Process," *Artists Proof,* 1968; contributor, "Printmaking Today," Holt, Rinehart & Winston, revised edition, 1972; contributor, "Art of the Print," Abrams, 1973. **Sources:** WW73; WW47.

SYLVA, S. M. *[Painter, sculptor] mid 20th c.*
Addresses: NYC. **Studied:** Raphael Soyer; Charles Alston. **Exhibited:** MMA; Bronx Mus. Arts; Fordham Univ.; "NYC WPA Art" at Parsons Sch. Design, 1977. **Comments:** WPA artist. Worked on Easel and Mural Projects, 1935-39. **Sources:** *New York City WPA Art,* 86 (w/repros.).

SYLVESTER, E. W. *[Museum director] 20th c.*
Addresses: Newport News, VA. **Sources:** WW59.

SYLVESTER, F(red-erick) O(akes) F.O.Sylvester ———
[Mural and landscape painter, teacher] b.1869, Brockton, MA / d.1915, St. Louis, MO.
Addresses: New Orleans, active 1891-93; St. Louis, MO/Elsah, IL. **Studied:** Mass. Normal Art Sch., Boston. **Member:** SEA; St. Louis AG; 2 x 4 Soc. **Exhibited:** New Orleans AA, 1891; Tulane Univ., 1892; Portland Expo, 1905 (medal); St. Louis Expo, 1904 (medal); SWA Chicago, 1906 (prize); AIC. **Work:** mural, Central H.S., St. Louis; Central H.S., Decatur, IL; Noonday Club, St. Louis. **Comments:** Author: *The Great River* (poems and pictures). Positions: teacher, Newcomb College, New Orleans (1891-92), Central H.S., St. Louis (1892-1913). **Sources:** WW13; *Encyclopaedia of New Orleans Artists,* 370.

SYLVESTER, Harry E(lliott) *[Painter, wood engraver] b.1860, North Easton, MA / d.1921, Boston.*
Addresses: Topsfield, MA. **Studied:** J.A. Fraser; C. Hassam; engraving, with G.E. Johnson. **Member:** Boston AC. **Exhibited:** Boston AC, 1884-1900. **Work:** CI. **Sources:** WW19.

SYLVESTER, Herbert M. *[Painter] 20th c.*
Exhibited: Soc. Indep. Artists, 1917. **Sources:** Marlor, *Soc. Indp. Artists.*

SYLVESTER, Ida Pond (Mrs.) *[Painter] b.NYC / d.1935.*
Addresses: Passaic, NJ. **Studied:** Snell; Graecen; Ennis. **Member:** NAWPS; AWCS. **Exhibited:** PAFA Ann., 1894. **Sources:** WW33; Falk, *Exh. Record Series.*

SYLVESTER, Lawrence F. *[Painter] 20th c.*
Exhibited: Soc. Indep. Artists, 1941-43. **Sources:** Marlor, *Soc. Indp. Artists.*

SYLVESTER, Lucille *[Painter, writer, graphic artist, illustrator] b.1909, Russia.*
Addresses: NYC. **Studied:** ASL, with Robert Brackman, Robert Phillip, and G. Bridgman; Académie Julian, Paris with Pierre Montezin and Adler. **Member:** Knickerbocker Artists (first vice-pres., 1962-65; board directors, 1969-71); NAWA; AAPL (fellow); Audubon Artists; Catharine Lorillard Wolfe Art Club; ASL (life member). **Exhibited:** Municipal Gal., NY, 1936; Hammer Gal., 1939 (solo); NAD, 1944-1945 (First Ann. Contemporary Drawings), 1955 (Allied Artists Am. Ann., NAD Galleries); NAWA, 1941-42, 1944, 1946; Audubon Artists, 1944-45; All. Artists Am., 1938, 1940, 1942, 1944; Studio Gld.; Vendome Gal.; Decorators Club; Argent Gal.; NJ College for Women; Knickerbocker Artists Ann., 1952 (first prize); Nat. Arts Club, New York,1957; Catharine Lorillard Wolfe Art Club Ann., 1957 (Lewis & Lewis Award), 1959 (Grumbacher Mat Award); Mus. Art, Springville, UT, 1968. **Comments:** Preferred media: oils. Positions: juror, Queensboro Outdoor AA, 1952; chmn. jury of awards, Third Ann. Art Exhi. Jewish Teachers Ann. New York, 1963. Illustrator of juvenile books. Author: "The Meaning of Art" (play), *Plays* magazine, 11/1947; "This Changing World: the Story of the Flag," 1948; "Loyal Queen Esther," 1956; author/illustrator: "Portrait in Prose and Paint," 12/1964; six hist. articles on New York, 1968-69. Teaching: Jr. High schools, New York. **Sources:** WW73; article, *New York Times,* March 27, 1938.

SYLVESTER, Pamela Hammond (Mrs. Elmer) *[Teacher and painter] b.1874, Macclesfield, England.*
Addresses: Council Bluffs, IA. **Studied:** With Frederick Oakes Sylvester and abroad. **Exhibited:** St. Louis; Iowa Art Salon; Omaha, NE; Council Bluffs, IA; Iowa Artists Exhibit, Mt. Vernon; Five States Exhibit. **Work:** Council Bluffs Public Library; Council Bluffs "Nonpareil"; Abraham Lincoln H.S., St. Louis, MO. **Comments:** Came to America at age six. Subjects: landscapes, farms, gardens, orchards in Iowa, Nebraska, Missouri, Illinois, Colorado, California, England and Scotland. Position: teacher, St. Louis, MO. **Sources:** Ness & Orwig, *Iowa Artists of the First Hundred Years,* 204.

SYLVESTER, Raymond F. *[Painter, designer, decorator] b.1912, Pasco, WA.*
Addresses: Seattle, WA. **Studied:** Univ. Wash.; AIC. **Exhibited:** SAM, 1937, 1939, 1945. **Sources:** Trip and Cook, *Washington State Art and Artists,* 1850-1950.

SYLVESTRE, Guy *[Art critic, writer] b.1918, Sorel, PQ.*
Addresses: Ottawa, Ont. **Studied:** College Ste. Marie, Montreal; Univ. Ottawa, M.A. **Member:** Fed. Canadian Artists; Soc. Écrivains Can.; Canadian Library Assn.; Royal Soc. Can. Acad.Française. **Comments:** Positions: editor, *Gants du Ciel,* 1943-46; nat. librarian, Nat. Library, Ottawa, 1970s. Publications: author, *Anthologie de la Poesie Canadienne-Française,* Beauchemin, 1964; author, *Panorama des Letters Canadiennes Françaises,* 1964 & *Literature in French Canada,* 1967, EOQ; author, *Écrivains Canadiens,* HMH, 1964 & McGraw, 1967; author, *Structures Sociales du Canada Français,* Laval, 1966. **Sources:** WW73.

SYLVESTRE, R. Curel *[Painter] 20th c.*
Exhibited: Salons of Am., 1925. **Sources:** Marlor, *Salons of Am.*

SYLVIA, Louis *[Painter] b.1911, New Bedford, Mass.*
Addresses: Dartmouth, MA. **Studied:** Swain School Design;

NAD; ASL; also with Harry Neyland & Aldro Hibbard.
Exhibited: Jordan Marsh Co., Boston, 1963; Mystic(CT) Art
Festival, 1963-72; Int. Platform, Washington, DC, 1966-72; Post
Office, New Bedford, 1970; Wamsutta Club, New Bedford, 1972.
Awards: awards for watercolor & oil, Dartmouth Art Festival,
1959; first awards for watercolor, Mystic Art Festival, 1963 &
1964; first purchase award, Florida Seaside Art Festival, 1972.
Work: Sandjford Mus., Norway; Sharon (MA) Mus.; Lisbon
Mus., Portugal. **Commissions:** First Nat. Bank, New Bedford,
1966-72; Bank of Italia, New York, 1967; Pocasset Country Club,
RI, 1968; West Hartford (CT) Bank, 1969-70; South Eastern
Bank, New Bedford, 1970. **Comments:** Teaching: art instructor,
Roosevelt Jr. H.S., New Bedford, 1957-65. **Sources:** WW73; arti-
cles, *New York World's Fair* (1938); *Yachting Magazine* (1941) &
New Mar Marine Co. (1972).

SYLVIAC, Francois *[Painter] 20th c.*
Addresses: NYC. **Exhibited:** Soc. Indep. Artists, 1927. **Sources:**
Marlor, *Soc. Indp. Artists.*

SYMES, John *[Landscape and portrait painter] d.1888,*
Suspension Bridge (Niagara Falls).
Addresses: Niagara Falls, NY, 1847 and after. **Comments:** He
was also deputy postmaster for a time and captain of the excur-
sion steamer *Maid of the Mist.* **Sources:** G&W; info courtesy
Orrin E. Dunlap (letter to NYHS, Oct. 28, 1945).

SYMINGTON, James *[Genre painter] b.1841, Baltimore,*
MD. / d.After 1915.
Addresses: NYC, 1887-93. **Studied:** NAD; ASL. **Member:**
AWCS; Arch. Lg., 1893; SC, 1888. **Exhibited:** Brooklyn AA,
1875-85; PAFA Ann., 1879-81, 1889; Boston AC, 1881-1907;
NAD, 1887-93; AIC, 1889-1914. **Sources:** WW17; Falk, *Exh.*
Record Series.

SYMINGTON, Juanita Le Barre*; b.Hamilton, Ontario,*
Canada.
Addresses: Hamilton, Ontario/ Rockport, MA. **Studied:** Royal
Hamilton Conservatory; with John Carlson. **Member:** Federation
of Canadian Artists; Rockport AA; North Shore AA. **Exhibited:**
Suffolk Mus., Long Island, 1947-49 (prizes). **Work:** H.R.H.
Queen Elizabeth. **Comments:** Position: art director, Appleby
College. **Sources:** *Artists of the Rockport Art Association* (1956).

SYMINTON, Emily *[Painter] 20th c.*
Addresses: Los Angeles, CA; NYC. **Studied:** Chouinard School
of Art. **Exhibited:** Oakland Art Gallery, 1939; All-Calif. Exhib.,
1939; Los Angeles County Fair, Pomona, 1941; Calif. WCS,
1944-48. **Sources:** Hughes, *Artists in California*, 547.

SYMMERS, Agnes Louise (Mrs. James K.) *[Landscape*
painter, writer] b.1887, University, VA.
Addresses: Rye, NY, 1923; University, VA. **Studied:** ASL; F.V.
DuMond; Henri; Lhote. **Member:** PBC; NAC; SSAL; Albermarle
AL. **Exhibited:** Soc. Indep. Artists, 1923-24, 1926-28, 1931,
1940-41; Salons of Am., 1925, 1927, 1928, 1930, 1931, 1934;
Montross Gal., NYC, 1932 (solo). **Comments:** Author: "Beyond
the Serpentine Wall," 1936 (brochure); "Letters of a Javanese
Princess," 1922 (translated from Dutch). **Sources:** WW40.

SYMMES, Adelaide Fisher (Mrs. Roscoe M.) *[Painter]*
19th/20th c.; b.Framingham, MA.
Addresses: Boston, MA. **Studied:** Cowles Sch. Art, Boston.
Exhibited: Boston AC, 1900. **Sources:** WW13.

SYMMES, Marion Ladd *[Painter, teacher] 20th c.;*
b.Somerville, MA.
Addresses: Massachusetts. **Studied:** Mass. School of Art; with A.
Hibbard, Elizabeth M. Loingier, Mae Bennett-Brown. **Member:**
Rockport AA; North Shore AA; Winchester AA; Winchester
Studio Guild; Copley Soc. **Exhibited:** Boston City Club (solo).
Comments: Position: teacher, Wilmington and Malden, MA, pub-
lic schools.

SYMMES, Peyton S. *[Sketch artist] mid 19th c.*
Addresses: Cincinnati, 1840. **Comments:** Did profiles in pencil.
Sources: G&W; info courtesy Edward H. Dwight, Cincinnati Art

Museum.

SYMMONDS, Albert *[Painter] b.c.1902, Riceville, PA.*
Addresses: Fullerton, CA. **Member:** Calif. WCS; Ebell Club, Los
Angeles. **Exhibited:** First Nat'l Trust & Savings, Fullerton, 1931
(solo); Calif. WC Soc., 1933; Fullerton Bldg. & Loan Assoc.,
1937 (solo). **Comments:** Specialty: watercolors. **Sources:**
WW40; Hughes, *Artists in California*, 547.

SYMMS, George Gardner *[Painter] b.1840, OH.*
Addresses: New Orleans, active 1876-83. **Sources:**
Encyclopaedia of New Orleans Artists, 370.

SYMON, Abigail (Gail) *[Painter, educator] 20th c.; b.Boston,*
MA.
Addresses: East Norwalk, CT. **Studied:** NAD; ASL; Grand
Central Art Sch.; Otis AI; L. Kroll; I. Olinksy; G. Beal. **Member:**
Audubon Artists; CAFA; Silvermine Gld. Artists; New Haven
PCC. **Exhibited:** Silvermine Gld. Artists (also solo), 1929-44,
1945 (prize), 1946; Audubon Artists, 1945; Montross Gal., 1938
(solo), 1941; Riverside Mus., 1938, 1941, 1946; AGAA, 1945;
Babcock Gal., 1942; Argent Gal., 1944; Macbeth Gal., 1945;
Salpeter Gal.; New Haven PCC, 1951 (prize); CAFA, 1953
(prize), 1959 (prize). **Comments:** Specialty: portraits. Position:
director, Silvermine College Art, New Canaan, CT, 1950-63, dean
emeritus, 1964-. **Sources:** WW66; WW47.

SYMON, Augustus D. *[Miniaturist and portrait painter,*
teacher of drawing and miniature painting] early 19th c.
Addresses: Salem, MA, 1820; possibly Charleston, SC, 1821.
Comments: He advertised in Salem (MA) in early September
1820 as Augustus D. Symon. In November 1820 and 1821
Charleston (SC) newspapers included an advertisement for
Augustus D. or A.D. Simon. It is possible they are the same per-
son. **Sources:** G&W; Belknap, *Artists and Craftsmen of Essex*
County, 13; Rutledge, *Artists in the Life of Charleston.*

SYMONS, Gardner See: SYMONS, (George) Gardner

SYMONS, (George) Gardner　*Gardner Symons*
[Landscape and marine painter]
b.1863, Chicago, IL / d.1930,
Hillside, NJ.
Addresses: Ravenswood IL (address was that of his parents),
1899-1902; Brooklyn, NY, 1908-; NYC/Colrain, MA. **Studied:**
AIC; Paris; Munich; London, 1902-09. **Member:** ANA, 1910;
NA, 1911; Royal Soc. British Artists; Union Int. des Beaux-Arts
et des Lettres; SC, 1900; NAC (life); Chicago SA; Century Assn.;
Calif. AC; Inst. Arts & Letters; Chicago Gal. Art; AFA.
Exhibited: AIC, 1899-1902 (under Simon), 1909-24); PAFA
Ann., 1901, 1910-29; NAD, 1909 (Carnegie prize), 1919 (prize);
SC, 1910 (prize); Boston AC, 1901; Buenos Aires Expo, 1910
(bronze medal); NAC, 1912 (gold medal); Corcoran Gal biennials,
1910-28 (9 times; incl., bronze medal, 1912); CI, 1913; Concord
AA (6th annual exhib.); Soc. Indep. Artists, 1917. **Work:** MMA;
CGA; Cincinnati Mus. Art; TMA; AIC; City Art Mus., St. Louis;
Dallas AA; Brooklyn Inst. Mus.; Minneapolis IA; CI; Fort Worth
Mus.; Butler AI; LACMA; NAC; Des Moines AA; Lincoln (NE)
AA; Cedar Rapids AA, Iowa; Mus. Art, Erie, PA; Rochelle(IN)
AA; Union Lg. Club, Chicago; Hyde Park AA, Chicago.
Comments: Born George Gardner Simon. Owing to his concerns
about anti-semitism, he changed his name to Symons when he
returned from study in England and settled in Brooklyn in 1909.
Thus, his early paintings are signed "Simon." He was a plein-air
painter who combined elements of Realism and Impressionism in
his work. Best known for his winter landscapes of the Berkshire
Hills, Deerfield Valley, and Gloucester — all in Massachusetts.
He also painted nearly annually in Cornwall, England and also
traveled to Southern Calif. (first arriving there in 1896 with his
friend, Wm. Wendt). Later, he had studios in Montecito, then
Laguna Beach. Most of his career, however, was spent in the East,
splitting his time between NYC and his country home in Colrain,
MA. **Sources:** WW29; WW08 (as Simon); *300 Years of*
American Art, 558; Falk, *Exh. Record Series.*

SYMS, Samuel See: **SIMS, Samuel**

SYNDER, W. L. *[Illustrator] late 19th c.*
Comments: Active 1870s-80s. W. L. Snyder was listed as a staff artist for *Harper's Weekly.* There is also reference to a W. P. Snyder who may be the same artist. **Sources:** Peggy and Harold Samuels, 454.

SYROP, David *[Painter] 20th c.*
Exhibited: Salons of Am., 1927, 1928. **Sources:** Marlor, *Salons of Am.*

SZABO, Laszlo *[Portrait painter, teacher, lecturer] b.1895, Budapest, Hungary.*
Addresses: Buffalo, NY. **Studied:** Royal Acad. Art, Budapest; Académie Julian & École des Beaux-Arts, Paris; ASL. **Member:** Pan Arts Soc.; Buffalo Soc. Art; Rationalists Art Cl.; Gld. All. Artists; Genesee Group; Batavia Soc. Art; Royal Soc. Art, London (fellow); ASL; Daubers Club; FA Lg. **Exhibited:** All. Artists, 1940 (gold), 1944 (prize); Buffalo SA annually, 1938 (prize), 1943 (prize), 1946 (prize), 1947 (prize), 1950 (prize), 1951-54 (prizes); Gld. All. A, 1939 (prize), 1940 (prize), 1944 (prize), 1949 (prize), 1950 (prize), 1952 (prize), 1964 (prize); Albright A. Gal.; Rundall Gal., Rochester; Rationalists A. Cl., traveling exhs. in Rochester, Albany, Binghampton, Auburn, N.Y.; Batavia Soc. A.; Genesee Group; PAFA; Ogunquit A. Center; Sheldon Swope A. Gal.; Daubers Cl. & Cayuga Mus., Auburn, N.Y.; Buffalo Mus. Science; Pan A. Soc, 1955 (gold medal); FA League, Buffalo, 1958 (silver medal), 1963 (gold medal), 1964 (Grumbacher Prize); solo: Town Cl., Kowalski Gal., Twentieth Century Cl., Pub. Lib., Shea's Buffalo Theatre, Buffalo Pub. Lib.; YMCA and Williams Gal., all in Buffalo, N.Y. **Awards:** Gainsborough prize, 1959; Rembrandt prize,1956, 1960; Diestel prize, 1957; McDonald prize, 1957; Talens & Son, Inc. prize, 1961; Buffalo Symphony Orchestra prize, 1963. **Work:** Erie County Hall, Buffalo, NY; Niagara Sanatorium, Lockport, NY; Buffalo Consistory, Riverside H.S., Liberty Bank, all of Buffalo; Swope Art Gal.; NY State Hist. Assn., Ticonderoga, NY; NY State Supreme Court, Buffalo; East Aurora Trust Co., and St. John Vianney Seminary, both East Aurora, NY; Domestic Relations Court, Buffalo; Veterans Admin. Hospital, Buffalo. **Sources:** WW66; WW47.

SZANTO, Louis P. *[Painter, etcher, illustrator] b.1889, Vacz, Hungary / d.1965.*
Addresses: NYC. **Studied:** Acad. Art, Budapest, Hungary; Munich; Academie Julian, Paris with J.P. Laurens, 1913. **Member:** Royal Acad. Soc.; Art Club, Budapest; Mural Painters Gld.; Soc. Mural Painters. **Exhibited:** Century of Progress, Chicago, 1934; WFNY, 1939, Europe. **Work:** Hungarian Mus. A.; murals, Bellevue Hospital, N.Y.; St. Clement Pope Church, Poughkeepsie, N.Y.; Worcester Acad., Mass.; State Mus., Des Moines, Iowa; Univ. Del.; Soc. for Savings Bank, Cleveland, OH; Manhattan Savings Bank, NY; Farm Bureau, Columbus, OH; Thompson Products Co., Cleveland; Ohio Oil Co., Findlay, OH; Cities Service Co., NY; Pittsburgh Fnd. **Comments:** Illustration: "Imitation of Christ"; series of illus. for "Break-through in Science," 1958. **Sources:** WW59; WW47.

SZARAMA, Judith Layne *[Printmaker, instructor] b.1940, Stamford, CT.*
Addresses: Miami, FL. **Studied:** Swain School Design, New Bedford, M.A., diploma. **Member:** Mangrove (rec. secretary, 1970). **Exhibited:** Prints & Drawings, Baker Gallery, Coconut Grove, FL, 1967 (solo); SAGA 51st Print Ann., Kennedy Gallery, NYC, 1971; 33 Miami Artists, Miami AC, 1971; 9th Nat. Biennial Print Exhib., Silvermine Guild Artists, New Canaan, CT, 1972; Drawings, Fort Lauderdale (FL) Mus. Arts, 1972. **Awards:** Mint Mus. Purchase Award, 1970; best in show (graphics), YMHA-YWHA, Miami & Temple Beth Am., Miami, 1971-72. **Work:** Mint Mus, Charlotte, NC; Miami Art Ctr, Fla; Miami Pub Libr Lending Print Collection. **Commissions:** Flight-tourist attractions on schedule of airline, Eastern Air Lines, Hartley Training Center, Miami, 1969. **Comments:** Preferred media: pencil, graphics.

Positions: tech. illustrator, Eastern Air Lines, Miami, 1967-70. Teaching: instructor in anatomy & figure drawing, etching & painting, Miami AC, 1970-. **Sources:** WW73; Frank Laurent," Art," 1968 & Bob Watters, "Where to Let Your Art Hang Out," 1971, *Village Post,* Coconut Grove.

SZATHMARY, Bela *[Painter] 20th c.*
Addresses: NYC. **Exhibited:** Soc. Indep. Artists, 1922. **Sources:** Marlor, *Soc. Indp. Artists.*

SZATON, John J. *[Sculptor] b.1907, Ludlow, MA.*
Addresses: Chicago, IL. **Studied:** Chicago Acad FA; Chicago Sch. Art; AIC; & with Edouard Chassaing, Lorado Taft. **Exhibited:** AIC, 1930, 1935; PAFA Ann., 1940; NAD, 1941; CM, 1941; AV, 1942; Polish AC, Chicago, 1942; Soc. for Sanity in Art, 1940. **Work:** panels, plaques, decorations: Recreation Bldg., Hammond, IN; Pilsudski plaque, Springfield, MA; Lincoln Mem., Vincennes, IN; Northwest Armory, Chicago. **Sources:** WW53; WW47; Falk, *Exh. Record Series.*

SZEKELY, Joseph *[Painter] 20th c.*
Addresses: NYC. **Exhibited:** Soc. Indep. Artists, 1932-33. **Sources:** Marlor, *Soc. Indp. Artists.*

SZEKESSY, Curt *[Etcher] 20th c.*
Addresses: NYC. **Member:** Brooklyn SE. **Sources:** WW27.

SZITA, A. *[Painter] 20th c.*
Exhibited: Soc. Indep. Artists, 1938. **Comments:** Possibly Szita, Alexander. **Sources:** Marlor, *Soc. Indp. Artists.*

SZUBAS, Friedel *[Painter] b.1915.*
Addresses: NYC. **Exhibited:** WMAA, 1963. **Sources:** Falk, *WMAA.*

SZUCS, Victor *[Painter, graphic artist] 20th c.*
Addresses: NYC. **Exhibited:** Nat. Acad. Ann., 1937; 48 States Comp., 1939. **Sources:** WW40.

SZUKALSKA, Heen W. *[Painter] 20th c.*
Addresses: Chicago area. **Exhibited:** AIC, 1923. **Sources:** Falk, *AIC.*

SZUKALSKI, Stanislaus *[Sculptor, painter] b.1895, Krakow, Poland.*
Addresses: Chicago, IL; Hollywood, CA, c.1934. **Studied:** Poland. **Exhibited:** AIC, 1916 (prize); Public Works of Art Project, Southern Calif., 1934. **Sources:** WW17; Hughes, *Artists of California,* 548.

SZWED, Stanley J. *[Painter] 20th c.*
Addresses: Pasaic, NJ. **Exhibited:** PAFA Ann., 1947. **Sources:** Falk, *Exh. Record Series.*

SZWEJKOWSKI, Adam *[Painter] 20th c.*
Addresses: Chicago area. **Exhibited:** AIC, 1934-38. **Sources:** Falk, *AIC.*

SZYK, Arthur *[Illustrator] b.1894, Lodz, Poland / d.1951.*
Addresses: New Canaan, CT. **Studied:** Acad. FA, Krakow; Académie Julian, Paris, 1909-11. **Exhibited:** Poland (prize); George Washington Medal for U.S. **Award:** Officer of Palms, France. **Comments:** Szyk (pronounced "schick") arrived in the U.S. in 1940, producing anti-Nazi cartoons for *Esquire* and *Colliers.* However, he is best known as the manuscript illuminator of *Song of Songs* (1917), *Temptation of St. Anthony* (1924), *George Washington and His Times* (1931), *Rubaiyat* (1939), *Hagadah* (1941), and *New Order* (1942). His final works, a series of prints illustrating the history of the United Nations, was produced as color lithographs, but remained incompleted at his death. **Sources:** WW47; print cat., courtesy L.J. Brown.

SZYNALIK, John J. *[Painter] 20th c.*
Addresses: Chicago, IL. **Exhibited:** Artists Chicago Vicinity Exhib., AIC, 1937. **Sources:** WW40.

Caricature of John Twachtman, by Robert Blum, 1885.

T

TAAKE, Daisy *[Sculptor, illustrator, painter, teacher] b.1886, St. Louis.*
Addresses: St. Louis, MO. **Studied:** AIC; St. Louis Sch. FA; L. Taft. **Exhibited:** AIC, 1919; St. Louis Art League Fountain Comp.; Century of Progress, 1934; WFNY, 1939. **Work:** Washington Univ., St. Louis. **Comments:** Position: teacher, Soldan H.S., evenings, St. Louis. **Sources:** WW40.

TABACHNICK, Anne *[Figurative painter] b.1928, NYC / d.1995.*
Studied: Hans Hoffmann in NYC. **Exhibited:** Circle in the Square Gal., 1951 (first solo); Ingber, 1970s-80s; E. Meyerovich Gal., San Fran., 1990s. **Sources:** obit., *Art News* (Sept., 1995).

TABARY, Celine Marie *[Painter, designer, teacher, illustrator] b.1908, Vermelles, France.*
Addresses: Wash., DC. **Studied:** France. **Member:** Wash. Soc. A.; Societe des Artistes Lillois; A. Gld., Wash.; Washington WC Cl.; CGA. **Exhibited:** Salon des Artistes Française, Paris, 1938-39; PC, 1940, 1945, 1946-50; Am.-British A. Center, 1944; Inst. Mod. A., Boston, 1944, 1947-48, 1950; NAD, 1945, 1948, 1950, 1952; PMG, 1940, 1945-46; Wash., DC Pub. Lib., 1946, 1954; Whyte Gal., 1941-44, 1947-48, 1950-51; Barnett Aden Gal., 1943-46; Howard Univ., 1941-42; U.S. Nat. Mus., 1940, 1944 (prize), 1946, 1951 (prize), 1954, 1956-58; CGA, 1940, 1944, 1945-50, 1956-58; Wash. WC Cl., 1947-52; BMA, 1952; Dupont A. Gal., 1950 (solo); Playhouse Theatre, 1956-57; Pyramid Cl., Phila., 1957; Wash. Soc. A., 1957 (prize); Art Mart, 1956-58 (1957, solo); Watkins Gal., Wash., DC, 1958. Numerous exhs. in France. **Work:** Barnett Aden Gal.; Palais National, Haiti. **Comments:** Position: instr., Howard Univ., Wash., DC, 1945-50; Morgan State Col., Balt., Md., 1954-55. **Sources:** WW59; WW47.

TABASKI See: **SAUL, Chief Terry**

TABB, Gladys Clark (Mrs.) *[Painter, teacher] b.1890, Gilroy, CA / d.1969, San Francisco, CA.*
Addresses: Oakland, CA. **Studied:** Stanford Univ. (A.B.);

Columbia Univ.; Cal. Col. A. & Crafts; &with Alon Bement, Arthur Dow, Frederic Taubes. **Member:** Bay Region AA; Lg. Am. Pen Women. **Exhibited:** Bay Region AA, 1935; Santa Cruz A. Lg., 1938; GGE 1939; Oakland A. Gal., 1941, 1943, 1945; San F. AA, 1943; CPLH, 1946. **Comments:** Position: teacher, College of Holy Names, Oakland, CA, 15 years. **Sources:** WW53; WW47. More recently, see Hughes, *Artists in California*, 549.

TABER *[Ornamental, sign, and house painter] mid 19th c.*
Addresses: Charleston, SC, 1837. **Sources:** G&W; Rutledge, *Artists in the Life of Charleston.*

TABER, Deborah Smith *[Painter] b.1796, New Bedford, MA / d.1879, New Bedford.*
Exhibited: Old Dartmouth Hist. Soc., 1983. **Work:** Old Dartmouth Hist. Soc.; Art Mus., Princeton Univ., Princeton, NJ. **Comments:** Painted portraits of family and friends into sketchbooks; also decorated linens with pen and ink. **Sources:** Blasdale, *Artists of New Bedford*, 185 (w/repro.).

TABER, Dorothea *[Painter] mid 20th c.*
Addresses: Worcester, MA. **Studied:** ASL. **Exhibited:** S. Indp. A., 1917, 1923; WMAA, 1920-21. **Sources:** WW24.

TABER, Edward Martin *[Painter, illustrator, writer] b.1863, Staten Island, NY / d.1896, Washington, CT.*
Addresses: NYC. **Comments:** Author: *Stowe Notes, Letters, and Verses* (Houghton Mifflin, NYC, 1913). **Sources:** WW98.

TABER, Florence *[Illustrator] late 19th c.*
Exhibited: Louis Prang & Co., 1882 ((prize, card design contest). **Sources:** Petteys, *Dictionary of Women Artists.*

TABER, Isaac Walton *[Illustrator] b.1860, New Bedford, MA / d.1933, NYC.*
Studied: Cooper Union Art School, NYC. **Exhibited:** PAFA Ann., 1880-81, 1893; New Bedford Free Public Library. **Comments:** His name sometimes appears as Walton Taber. One of the foremost illustrators of his day; chosen to illustrate the first editions of Rudyards Kipling's "Captains Courageous", and Frank Bullen's "Cruise of the Cachalot", among others. Favorite subject: marine scenes. Contributed to many magazines such as *Century* and *St. Nicholas*. **Sources:** Blasdale, *Artists of New Bedford*, 186; Falk, *Exh. Record Series.*

TABER, Isaiah West *[Landscape and portrait painter, photographer, illustrator] b.1830, New Bedford, MA / d.1912, San Francisco, CA.*
Addresses: San Francisco. **Work:** Honeyman Collection; Bancroft Library, Univ. of Calif., Berkeley (pen and ink drawings). **Comments:** First went to San Fran. during the gold rush; later was one of the first to open a photo gallery in Syracuse, NY. Joined Bradley & Rulofson Gal. in San Francisco, 1864-71. Opened his own photo gallery in San Francisco, 1871; became prominent for both portraits and landscapes. Named Commissioner to Yosemite Valley, 1888. Lost 30 tons of portrait negatives and 20 tons of landscape negatives in the San Francisco Fire, 1906. Later printed C.E. Watkins' negatives and from these made illustrations for *Century* magazine. **Sources:** Hughes, *Artists in California*, 549; P & H Samuels, 476; Welling, 239.

TABER, J. W. *[Illustrator] 19th/20th c.*
Addresses: NYC. **Member:** SC. **Sources:** WW01.

TABER, Phoebe Thorn Merritt Clements *[Painter] b.1834, Millbrook, NY / d.1916, Los Angeles, CA.*
Addresses: Detroit and Grand Rapids, MI, 1871-93; Los Angeles, CA, 1907-. **Studied:** CUA Sch.; Académie Julian, Paris. **Exhibited:** Paris Salon; Detroit Inst. of Arts, until 1889. **Comments:** (Phoebe T. Clements) Married Prof. C.P. Clements, 1857, and Major Taber, 1873. Specialty: still lifes of fruits and flowers. **Sources:** Hughes, *Artists in California*, 549.

TABER, Sarah A. See: **COFFIN, Sarah Taber (Mrs. William H.)**

TABER, Sarah A.M. *[Primitive painter] b.1800 / d.1873.*
Addresses: active in Eastern U.S., perhaps in Pennsylvania.
Sources: Petteys, *Dictionary of Women Artists.*

TABER, Walton See: **TABER, Isaac Walton**

TABER-PRANG ART COMPANY See: **CHARLES TABER AND COMPANY**

TABER ART COMPANY See: **CHARLES TABER AND COMPANY**

TABLADA, Jose Juan *[Painter] b.1871, Mexico City, Mexico / d.1945, NYC.*
Addresses: NYC. **Exhibited:** S. Indp. A., 1924. **Sources:** Marlor, *Soc. Indp. Artists.*

TABLADA, Nena *[Painter] mid 20th c.*
Addresses: Forest Hills, L.I., NY. **Exhibited:** S. Indp. A., 1925-27, 1929, 1935. **Sources:** Marlor, *Soc. Indp. Artists.*

TABLER, Hazel (Mrs.) *[Painter] mid 20th c.*
Addresses: Osceola, IA. **Exhibited:** Iowa A. Salon, 1934; Iowa Ar. Exh., Mt. Vernon, 1938. **Sources:** WW40.

TABOR, Frank A. *[Painter, teacher] b.1855, NYC / d.1934, Tacoma, WA.*
Addresses: Tacoma, WA, 1910-34. **Studied:** Paris, France; Germany. **Exhibited:** Alaska Yukon Pacific Expo., 1909. **Comments:** Scenic artist, who was commissioned by the government to paint the Pacific Northwest for the Worlds Fair in Chicago, 1893. He later painted illustrations for several railroads, to be used in scenic tourist catalogs. **Sources:** Trip & Cook, *Washington State Art and Artists.*

TABOR, Robert Byron *[Mural painter, portrait painter, illustrator] b.1882, Independence, IA.*
Addresses: Independence, IA; Olathe, KS. **Studied:** Cedar Rapids under Leon Zeman; mostly self-taught. **Member:** Nat. A. Gld., Chicago; Ozark A. Gld.; NSMP. **Exhibited:** Iowa Art Salon, 1934 (prize); Nat. Exh. American Art, NY, 1936; American Federation Arts Traveling Exhibition; Iowa State Col.; Cedar Rapids Art Assoc.; Little Gallery; MoMA, 1934; CGA, 1934; AFA; Colorado Springs FA Center, 1940, 1941; Ogunquit Art Center, 1951; Joslyn Art Mus., 1953, 1954; Waterloo (Iowa) AA, 1954 (solo); Innes Gal., Wichita, 1955 (solo); Kansas City AA, 1957; Cedar Rapids, 1957 (solo); Independence, IA, 1958 (solo). **Work:** White House, Wash., DC; Lane Ins. Co.; Independence (IA) Public Library; murals in Des Moines, Independence, Estherville, IA; WPA mural, USPO, Independence, IA. **Sources:** WW59; WW47; Ness & Orwig, *Iowa Artists of the First Hundred Years,* 204.

TABUENA, Romeo Villalva *[Painter] b.1921, Iloilo City, Panay Island.*
Addresses: Guanajuato, Mexico. **Studied:** Univ. Philippines, with Diosdado Lorenzo; ASL, Thekla M. Barneys grant, 1952-53, with Will Barnet; Acad Grande Chaumière, Paris, with Goertz. **Member:** Art Assn. Philippines. **Exhibited:** Assoc Am Artists Galleries, New York, 1953 (solo); Palace Fine Arts, Mexico City, 1962 (solo), 1969 (solo); Prize Winners Show, WMAA, 1953; Tabuenna Ten Yrs. Retrospective, Philippine A. Gal., Manila, 1959; Eighth Biennal Sao Paulo, MoMA, Brazil, 1965; Galleria de Arte Misrachi, Mexico City, Mex., 1970s; Tasende Gal., Acapulco, Mex., 1970s. **Awards:** Gold medal in painting, Sch. Fine Arts, Univ. Philippines, 1941; second prize, Art Assn. Philippines Ann., 1949. **Work:** New York Pub Libr Print Div; Philippine Nat Mus, Manila; Palace Fine Arts, Mexico City; MoMA, Mexico City; MoMA, Sao Paulo, Brazil. **Commissions:** Filipiniana (mural), Govt. Philippines, for Washington Embassy, 1957. **Comments:** Preferred media: acrylics, oils, watercolors. Positions: art dir., *Eve News,* Manila, 1949-52. **Publications:** auth., "Tabuena" (Watercolor page), *Am. Artist Mag.,* 1956; auth., "Painting a Still Life," in: Painting in acrylics, Watson-Guptill,

1965. Teaching: lectr., "Art of today," Far Eastern Univ., 1951. **Sources:** WW73; Emily Genauer, *Romeo V Tabuena, What's New* (Abbot Labs, 1955); Lyd Arguilla, *Ten years of Tabuena's art* (Philippine Art Gallery, 1959); Arias de la Canal, *Tabuena--sensibilidad, disciplinada 7 poetica* (El Norte, Mex., 1969).

TACCARD, Patrick *[Painter] b.1879, NYC.*
Addresses: Liberty, NY. **Exhibited:** Orange County. Agriculture Soc., 1938 (prize); Walker Gal., NY, 1929; Am. P. Today, Albright Gal., 1939. **Sources:** WW40.

TACK, Augustus Vincent *[Painter, muralist, teacher] b.1870, Pittsburgh, PA / d.1949, NYC.*
Addresses: NYC, 1895; Deerfield, MA. **Studied:** Mowbray, La Farge, both in NY, c. 1889-90; Merson, in Paris, early 1890s. **Member:** ASL, NY (life); CAFA; New Haven PCC; Century Assn.; Intl. Soc. AL; Arch. Lg., 1900. **Exhibited:** SAA, 1889 (prize); NAD, 1895; Boston AC; PAFA Ann., 1895-1906, 1925, 1933-34; AIC, 1899-1934; Corcoran Gal biennials, 1908-39 (9 times); Exh. of Amer. Ptg., Venice, 1924; BMA, 1927, 1934; Venice Biennale, 1930; Amer. Exh., Budapest, 1930; John Herron AI, Indianapolis, 1931; Yale Univ., 1931; Century of Progress Expo., Chicago, 1934; "Living Americans," MoMA, 1934; Wildenstein Gal., NYC, 1934; Wash. County Mus. of Fine Arts, Hagerstown, MD,1938; CI, 1928; Howard Univ. Art Gal., 1940; Abbot Acad., Andover, 1941; "Modern Religious Art," Inst. of Contem. Art, Boston, 1944; Exh. of Amer. Ptg., Tate Gal., London, 1946. **Work:** MMA; Phillips Collection (large coll.); CMA; Newark Mus.; Speed Mem. Mus., Louisville, Ky.; Murals: Legislative Chamber, New Parliament Bldgs., Winnipeg; Paulist Church, NYC; Chapel of The Cenacle Convent, Newport, RI; St. James Church, South Deerfield, Mass.; dec., Governor's Reception Room, Nebr. State Capitol, Lincoln. **Comments:** Tack became a sought-after muralist in the 1920s, painting a number for Catholic churches and government buildings. He was also in high demand and earned much money as a society portraitist, even during the Great Depression, but his abstract paintings were rarely purchased. These mystical and evocative abstract works, mostly painted between WWI and WWII, did attract the attention of Duncan Phillips who bought 28 of them for Wash., DC, Gallery. Tack is said to have inspired Morris Louis and other Washington painters. **Sources:** WW40; McMahan, *Artists of Washington, DC;* Baigell, *Dictionary;* The American Studies Group, *Augustus Vincent Tack, 1870-1949* (1968); The Phillips Collection Catalogue (Washington, DC, 1952); Falk, *Exh. Record Series.*

TACKE, R. R. *[Artist] mid 20th c.*
Addresses: Staten Island, NY. **Exhibited:** PAFA Ann., 1952. **Sources:** Falk, *Exh. Record Series.*

TADAMA, F(okko) *[Painter, teacher] b.1871, Bandar, India / d.1937, Seattle, WA.*
Addresses: Katwijk aan Zee, Holland; Seattle, WA. **Studied:** Amsterdam Acad. FA.; with C.L. Dake; Normal School for Art teachers, Rykes Mus., Academy of Fine Arts, Amsterdam; Rijks Mus. Sch. A.; Paris; Antwerp; Düsseldorf. **Member:** Seattle FA Soc. **Exhibited:** Amsterdam, 1898 (prize); Paris Salon, 1901; SFMA; Seattle Pub. Lib., 1913 (solo). **Work:** SFMA; New Royal Theatre, Victoria, BC; Press C., Seattle; Indst. Exh. Bldg., Seattle. **Comments:** Position: teacher, Seattle Pub. Sch.; artist, Nat'l Theater Supply Co.; dir., founder, Tadama Art Sch., Seattle, est. 1914. Married to marine painter Tarmine Groenveld. Both sold their numerous paintings of Dutch landscapes both in Holland and in the export market. An Impressionist painter, Tadama had a low-key use of color. He designed the front of the White-Henry-Stewart Building in Seattle and produced Northwest landscapes, urban scenes, and portraits of prominent citizens of the locale. He remarried and continued a successful career as a painter and teacher until the Great Depression began, when he joined the ranks of W.P.A. Federal Art Projects artists as an easel painter. He resumed painting Dutch coastal scenes as he had done forty years earlier. He died of a self-inflicted gunshot wound in Seattle, 1937. **Sources:** WW25; Trip and Cook, *Washington State Art and*

Artists; Martin-Zambito Fine Art, Seattle, Wash.

TADASKY *[Painter] mid 20th c.*
Exhibited: PAFA Ann., 1966. **Sources:** Falk, *Exh. Record Series.*

TADD, Edith J. See: **LITTLE, Edith Tadd (Mrs.)**

TADD, J. Liberty *[Painter, teacher, lecturer] b.1863, England.*
Addresses: Phila., PA. **Member:** AC Phila. **Comments:** Position: principal, Public Industrial A. Sch. Phila., where he introduced ambidextrous drawing. **Sources:** WW15.

TADEMA, F. *[Painter] 20th c.*
Addresses: Seattle, WA. **Member:** Seattle FAS. **Sources:** WW15.

TAFFS, C. H. *[Illustrator] 20th c.*
Addresses: NYC. **Member:** SI; Artists Gld. **Sources:** WW33.

TAFLINGER, Elmer E. *[Painter] b.1891, Indianapolis.*
Addresses: Indianapolis, IN. **Studied:** ASL; G. Bridgman. **Exhibited:** PAFA Ann., 1929; Ind. Painters, 1930 (prize); AIC, 1931. **Sources:** WW40; Falk, *Exh. Record Series.*

TAFLINGER, Ethel Cline (Mrs. Emil) *[Illustrator, writer] b.1894, Paris, IL.*
Addresses: Paris, IL/Crooked Lake, Angola, IN. **Studied:** AIC. **Comments:** Illustrator: *Child Life, Youth, Wee Wisdom.* **Sources:** WW32.

TAFT, Charles Phelps *[Patron] b.1843, Cincinnati / d.1929.*
Addresses: Cincinnati, OH. **Member:** Cincinnati Mus. Assn., 1887 (trustee), 1914-27 (pres.). **Comments:** His collection of paintings and porcelains and his gift of $1,000,000 formed the nucleus of the Cincinnati A. Mus.

TAFT, Elsey R. *[Painter] mid 20th c.*
Addresses: San Diego, CA, 1930s. **Exhibited:** San Diego Art Guild, 1939. **Sources:** Hughes, *Artists in California,* 549.

TAFT, Katherine Upron *[Painter, instructor] 19th/20th c.*
Addresses: Spokane, WA, 1935. **Exhibited:** Interstate Fair, 1906; Alaska Yukon Pacific Expo., 1909; Wash. State Comm. of FA, 1914. **Comments:** Preferred medium: watercolor. Position: instr., Brunot Hall, 1906. **Sources:** Trip and Cook, *Washington State Art and Artists.*

TAFT, Lorado Zadoc *[Sculptor, writer, lecturer, teacher] b.1860, Elmwood, IL / d.1936, Chicago, IL.*
Addresses: Chicago, IL/Oregon, IL. **Studied:** Univ. Illinois, 1880; École des Beaux Arts, Paris, with Dumont, Bonnassieux, Thomas. **Member:** NSS, 1893; ANA, 1909; NA, 1911; Nat. Acad. AL; Chicago PS; AFA; AIA (hon.), 1907; Illinois State Art Comm.; Nat. Comm. FA, 1925-29. **Exhibited:** Paris Salon, 1882, 1885; Columbian Expo, Chicago, 1893 (medal); PAFA Ann., 1899-1900; Pan-Am. Expo, Buffalo, 1901 (medal); St. Louis Expo, 1904 (medal); Pan-Pac. Expo, San Francisco, 1915 (medal); AIC. **Work:** AIC; monument, Seattle, WA; fountain, Paducah, KY; Bloomington, IL; Wash., DC; Chicago; Denver; Danville, IL: Ogle County Soldier's Mem., Oregon, IL; Elmwood, IL; Univ. Illinois; Muskegon, MI; Sand Springs, OK; Mem. to Victor Lawson, Chicago; pylons (main entrance) Louisiana Capitol, Baton Rouge. **Comments:** Significant sculptor and teacher just prior to and at the turn of the 20th century. Fort comments that although his style was later considered conservative and out of fashion, his writings endured. Positions: teacher, AIC, 1886-1906; lecturer, AIC , 1886-1929; Univ. Chicago, Univ. Illinois. Author: *History of American Sculpture* (1903); *Modern Tendencies in Sculpture* **Sources:** WW33; P&H Samuels, 476; Fink, *American Art at the Nineteenth-Century Paris Salons,* 395; Fort, *The Figure in American Sculpture,* 227 (w/repro.); Falk, *Exh. Record Series.*

TAFT, R. D. *[Painter] mid 20th c.*
Exhibited: San Francisco AA, 1917; Oakland A. Gal., 1928. **Sources:** Hughes, *Artists in California,* 549.

TAFT, Zulime (Zuhl) (Mrs. Hamlin Garland) *[Sculptor] late 19th c.*
Addresses: Active in Chicago and Paris. **Studied:** with

MacMonnies in his studio, Paris, 1895-96. **Comments:** Sister of Lorado Taft. She, along with Bessie Potter Vonnoh, Janet Scudder, and other women sculptors, assisted him in preparing sculptures for the World's Columbian Exposition in Chicago (1893). After the fair, Taft and Janet Scudder left for Paris. **Sources:** Petteys, *Dictionary of Women Artists;* Rubinstein, *American Women Artists,* 95; Mary Smart, *A Flight with Fame: The Life and Art of Frederick MacMonnies* (Sound View Press, Madison, CT, 1997), includes several references to Taft.

TAGARIS, Andrew Athan *[Painter] mid 20th c.*
Addresses: Cleveland, OH. **Exhibited:** S. Indp. A., 1925. **Sources:** Marlor, *Soc. Indp. Artists.*

TAGAWA, Bunji *[Painter, illustrator, Sculptor] b.1904, Tokyo, Japan.*
Addresses: Brooklyn, NY. **Exhibited:** WMAA, 1933; S. Indp. A., 1938-39. **Comments:** Illustrator: "Chiyo's Return". **Sources:** WW40.

TAGGART, Edwin Lynn *[Painter, sculptor, etcher, illustrator] b.1905, Richmond, IN.*
Addresses: San Mateo, CA/Richmond, IN. **Studied:** R.L. Coates; F.F. Brown; B. Waite; Calif. Sch. A. & Cr. **Member:** Ind. AC; Junior AA. **Exhibited:** Wayne County Fair (5 prizes). **Award:** U.C.T. Art Med., 1925. **Work:** murals, Morton H.S., Richmond, Ind. **Sources:** WW33.

TAGGART, George Henry *[Portrait painter] b.1865, Watertown, NY.*
Addresses: Port Washington, LI, NY. **Studied:** Académie Julian, Paris with Bouguereau, Ferrier, and Lefebvre, 1888, 1890. **Member:** Soc. Intl. des Beaux-Arts et des Lettres; Buffalo SA; S Indp. A. **Exhibited:** Paris Salon, 1892; PAFA Ann., 1894; Utah State Exh. (prize); Expo Toulouse, France (prize); Salon d'Automne, Paris (prize); S. Indp. A. **Work:** Palace of Governor, City of Mexico; Brigham Young Univ.; State Capitol, Salt Lake City, Utah; City Hall, Watertown, NY; Tusculum Col., Greenville, Tenn.; Welch Mem. Lib., Baltimore, Md; Royal Palace, Berlin (private coll.); Chemists C., NY. **Sources:** WW59; WW47; Fink, *American Art at the Nineteenth-Century Paris Salons,* 395; Falk, *Exh. Record Series.*

TAGGART, John G. *[Portrait and historical painter] mid 19th c.*
Addresses: Albany, NY, 1846-49; at Saratoga Springs, NY, 1852; at NYC, 1853-64. **Sources:** G&W; Albany CD 1846-48; Cowdrey, NAD; NYCD 1853-60; NYHS Cat.

TAGGART, Lucy M. *[Figure painter] early 20th c.; b.Indianapolis, IN.*
Addresses: Indianapolis, IN/Gloucester, MA. **Studied:** Forsyth; Chase; Hawthorne; Europe. **Member:** NAC (life); Art Workers' Club for Women; North Shore AA; NAWPS; Grand Central AG; AFA. **Exhibited:** PAFA Ann., 1910, 1912. **Work:** John Herron A.M., Indianapolis. **Comments:** Specialized in elegant women in interiors. Maintained a studio in Indianapolis until c.1940. **Sources:** WW40; Gerdts, *Art Across America,* vol. 2: 271-72; Falk, *Exh. Record Series.*

TAGGART, Mildred Hardy (Mrs.) *[Portrait painter, illustrator, designer, block printer] b.1896, Corsicana, TX.*
Addresses: Chevy Chase, MD. **Studied:** Corcoran Sch. Art, with Messer; ASL, with G. Bellows, Henri, F.V. DuMond; Abbott Sch. Fine & Commercial Art, with S.B. Chase, H. Inden. **Comments:** Articles: *Art Digest; Washington Star,* 1937. **Sources:** WW40.

TAGGART, Richard (T.) *[Painter, designer, writer, teacher] b.1904, Indianapolis, IN.*
Addresses: Altadena, CA. **Studied:** Paul Hadley, Jean Mannheim, Alson Clark. **Member:** Pasadena SA; P. & S. Cl., Los A., Cal.; Cal. AC; Carmel AA; Laguna Beach AA. **Exhibited:** GGE, 1939; Pasadena SA; Cal. AC; Carmel AA; Laguna Beach AA; John Herron AI; Purdue Univ.; Univ. Southern California; Stanford Univ. (solo); Pomona Col. (solo); Nicholson's Gal., Pasadena (solo); Stendahl Gal., Los Angeles; Calif. State Fair, 1934 (prize),

1939 (prize). **Work:** Pomona Col., Claremont, Cal.; Huntington Hospital, Pasadena. **Comments:** Position: visiting a., instr., Pomona Col., 1940-41; special in., Mt. Wilson Observatory, 1944; art dir., exec. producer, "Inspiration for Christmas," 16mm. color film, Esto Publ. Co., 1955; "Speaking of Sculpture," 1957; "Mildred Brooks Makes an Etching," 1958 (both films for Esto Publ. Co.); dir., producer, 16mm. films, Argonaut Productions, Altadena, Cal., 1954-. **Sources:** WW59; WW47.

TAGUE, Robert Bruce [Mural painter, architect, teacher] b.1912.
Addresses: Chicago, IL. **Studied:** Chicago Sch. Des.; Armour Inst. Tech. **Member:** SC; Assn. Am. Inst. Arch. **Exhibited:** AIC. **Work:** mural, in collaboraton with R.J. Schwab, WGN Studio Bld., Chicago. **Sources:** WW40.

TAHIR, Abe M., Jr. [Art dealer] b.1931, Greenwood, MS.
Addresses: New Orleans, LA. **Studied:** Univ Miss. (B.B.A.); George Washington Univ. (M.B.A.). **Comments:** Positions: dir, Tahir Gallery. Specialty of gallery: original prints. **Sources:** WW73.

TAHOMA, Quincy [Painter, muralist] b.1921, near Tuba City, AZ / d.1956, Santa Fe, NM.
Studied: Albuquerque Indian School, 1936-40; Santa Fe Indian School (post-graduate work). **Work:** Gilcrease Inst.; Mus. Am. Indian; Mus. New Mexico; Philbrook AC; Southwest Mus. **Comments:** Navaho painter, who worked briefly in Hollywood movie studios then as a full-time artist in Santa Fe. **Sources:** P&H Samuels, 476-77.

TAILOR, Stephen [Painter] mid 19th c.
Addresses: Pier 1, North River, NYC; 1847. **Exhibited:** American Institute (1847 : painting of the steamship *Atlantic*). **Sources:** G&W; Am. Inst. Cat., 1847.

TAINTOR, Daisy Josephine (Mrs.) [Painter, block printer, designer] early 20th c.
Addresses: NYC. **Studied:** Cincinnati A. Acad.; John Herron AI Sch.; PM Sch IA; F.A. Parsons. **Member:** Nat. AAI. **Sources:** WW33.

TAINTOR, Musier See: **LEE, Musier (Mrs. Lawrence Lee)**

TAIPALE, Teppo [Painter, graphic artist] b.1906, Kenosha, WI.
Addresses: Madison, WI. **Studied:** AIC; Layton A. Gal. Sch., Milwaukee. **Exhibited:** Wis. Sal. A., Wis. Univ., Madison, 1938. **Sources:** WW40.

TAIRA, Frank [Painter, sculptor] b.1913, San Francisco, CA.
Addresses: San Francisco; NYC, since 1944. **Studied:** Calf. School of FA, 1935-38; Columbia Univ., 1945; ASL, 1956; New School for Social Research, 1957. **Exhibited:** Oakland Art Gal., 1939; SFMA, 1939; Calif. Sch.of FA, 1940 (first prize); Cambridge, MA, 1943 (first prize); NAC, 1968 (prize); NAD, 1976. **Comments:** Of Japanese descent, he was interned in a relocation camp in Utah from 1942-44. Preferred media: oil, watercolor. **Sources:** Hughes, *Artists in California*, 549.

TAIT, Agnes Gabrielle (Mrs. William McNulty) [Painter, lithographer, illustrator] b.1894, Greenwich Village, NY / d.1981, Santa Fe, NM.
Addresses: NYC, active 1931-39; Providence, RI, 1940s; Santa Fe, NM, 1941 and after. **Studied:** NAD, with Leon Kroll, Charles Hinton, Francis Jones; Académie des Beaux Arts, Paris. **Member:** NAWA, 1930. **Exhibited:** AIC, 7 annuals, 1915-36; WMAA, 1920-28; Cooperstown AA, 1928 and after; Dudensing Gal., NYC, 1928; PAFA Ann., 1930, 1935, 1941; Salons of Am., 1932, 1934; Ferargil Gals., NYC, 1933 (solo), 1945 (solo); Corcoran Gal. biennial, 1934; NAD, 4 annuals, 1934-44; WFNY, 1939; 48 Sts. Comp., 1939; Ferargil Gal., NY; LOC, 1943; Fine Arts Mus., New Mexico, 3 traveling shows, 1947-50, 1950-51, 1955-56; El Paso (TX) Pub. Lib., 1955; Albany Inst. History & Art, 1958; Eleanor Bedell's The Shop, Santa Fe, NM, 1963; Arvada Center for the Arts and Humanities, Colorado, 1984 (posthumous retro-

spective traveling exhib.). **Work:** NYPL; NMAA; MMA; LOC; Mus. New Mexico; murals, Bellevue Hospital, NY; USPO, Laurinsburg, NC. **Comments:** Illustrator: *Peter & Penny of the Island* (1941); *Heide* (1947); *Paco's Miracle* (1961). WPA artist. One of her WPA paintings, "Skating in Central Park" (1934, NMAA) was reproduced as a Christmas card by Hallmark. Her birth date has sometimes erroneously appeared as 1897. **Sources:** WW59; WW47; *Rediscovery: A Tribute To Otsego County Women Artists*, exhib. brochure (Hartwick Foreman Gal, 1989), 19-21; Lydia M. Peña, The Life and Times of Agnes Tait (exhib. cat., Arveda Ctr. for Arts and Humanities, Arveda, CO, and Roswell Mus., Roswell, NM, 1984); Falk, *Exh. Record Series;* add'l info. courtesy David F. Hughes, Vicksburg, MS; Petteys, *Dictionary of Women Artists*.

TAIT, Arthur Fitzwilliam [Painter] b.1819, Livesey Hall, near Liverpool (England) / d.1905, Yonkers, NY.
Addresses: Morrisania, NY, 1861-69; NYC, 1870-74; 1878-97; Long Lake, NY, 1876; Yonkers, NY, 1898-1900. **Studied:** taught himself by copying paintings at the Royal Inst., Manchester, England. **Member:** ANA, 1853; NA, 1858. **Exhibited:** PAFA, 1852-69; NAD, 1852-60, 1861-1900; Boston AC, 1891; Phila. AC, 1898; Brooklyn AA, 1863-86; AIC. **Work:** MMA; Denver AM; Amon Carter Mus.; Brooklyn Mus.; Yale Univ. AG; Shelburne (VT) Mus.; Addison Gal. Am. Art; Corcoran Gal.; Adirondack Mus.; PMA. **Comments:** Specialist in sporting, animal, and frontier scenes. Tait worked for a Manchester art dealer store as a teenager and taught himself to paint. He became interested in frontier life when he assisted George Catlin with his traveling Indian gallery in Paris and England. In 1850, Tait moved to NYC and established a camp in the Adirondack Mountains, spending his summers there and using the setting as the basis of his paintings. Currier & Ives lithographed many of his sporting and frontier scenes and he became an extremely popular artist. Tait also became known for his still lifes--mostly images of dead game hung against a wall. He is known to have collaborated on paintings with J.M. Hart, and made a series on Indians and Western life with Louis Maurer. **Sources:** G&W; WW04; DAB; Peters, *Currier & Ives*, I, 99-110; Keyes, "A.F. Tait in Painting and Lithograph"; Cowdrey, "Arthur Fitzwilliam Tait"; Cowdrey, NAD; Naylor, NAD; Swan, BA; Cowdrey, AA & AAU; Rutledge, PA; Washington Art Assoc. Cat.; Baigell, *Dictionary; 300 Years of American Art*, 187; Muller, *Paintings and Drawings at the Shelburne Museum*, 130.

TAIT, Cornelia Damian [Painter, sculptor] mid 20th c.; b.Philadelphia, PA.
Addresses: Hatboro, PA. **Studied:** Graphic Sketch Cl.; Fleisher Arts Mem.; Temple Univ., with Alexander Abels & Boris Blai (B.S., educ.); Tyler Sch. Fine Arts, with Raphael Sabatini (B.F.A., honors, M.F.A.). **Member:** AEA; Woodmere Art Gal.; Phila. A. All.; Nat. Forum Prof. Artists; Violet Oakley Mem. Found. **Exhibited:** Nat. Exhib., Pittsburgh, Pa., 1961 & Ecclesiastical Crafts Exhib., Cleveland, 1962, Church Archit. Guild Am.; Art with Architecture & Regional Paintings Exhibs., 50th Anniversary of Phila. A. All., 1965; PAFA Regional, Phila., 1966; Signs in Cloth, nat. traveling exhibs. in 36 major USA cities, 1968-71; Int. Graphics Collectors' Exhib., E. Stroudsburg State Teachers Col., 1966. Awards: purchase awards, Temple Univ., 1957-60; Mania Blai Painting Award, Tyler Sch. Fine Arts, 1958; painting award, Phillips Mill Art Assn., 1965. **Work:** Temple Univ. Permanent Collection, Phila.; Tyler Art Sch., Elkins Park, Pa.; Nara Philos Study Ctr., Duncannon, Pa.; Christian Endeavor Bldg., World Hq., Columbus Ohio; St Mary's Romanian Orthodox Church Mus., Cleveland, OH. Commissions: three murals on musical themes, Morris Rotenberg, Philadelphia, 1946; portraits of church donors, Romanian-Orthodox Cathedral, Detroit, Mich, 1949; 21 altar screen paintings, Holy Trinity Romanian-Orthodox Cathedral, Detroit, 1949-50; portrait of founder of Christian Endeavor, comn. by Joseph Holton Jones, Columbus, 1955. **Comments:** Preferred media: oils. Publications: contribr., "Process of Underpainting" (film), 1952; contribr., *Friends J,*1952; contribr., "New Leaves,"

1965 & 1966; contribr. articles for newspapers, 60's. Teaching: instr. art, Settlement Music Sch., 1942-44; instr. sculpture, PMA, 1944-45; instr. art & supvr., Buckingham Friends Sch., 1950-53; supvr. art, Albington Township Cult. Ctr., 1963. Research: Byzantine architecture & monuments; folk art in Romania; folk arts of the Southwest Indians. **Sources:** WW73; "Look up & live,"1967-68; "Lamp unto my Feet,"1968, 1969, CBS TV.

TAIT, John Robinson *[Landscape painter] b.1834, Cincinnati, OH / d.1909, Baltimore, MD.*
Addresses: Baltimore, MD, 1876-1909. **Studied:** After graduating from Bethany College (VA) in 1852, he went to Europe for three years to write and sketch as an amateur. He went to Europe again in 1859 to study painting at Düsseldorf and remained for twelve years; in 1873 he made a third visit to Germany. A. Weber, in Düsseldorf; A. Lier, H. Baisch, in Munich (all 1859-71). **Member:** Charcoal C. **Exhibited:** Paris Salon, 1864, 1876; Cincinnati Indst. Expo, 1871 (med.), 1872 (med.); NAD, 1876-89; PAFA Ann., 1877-89; Boston AC, 1882-89. **Work:** Peabody Institute, Baltimore. **Sources:** G&W; WW08; CAB; *Art Annual,* VII, obit.; Rutledge, PA; Clark, *Ohio Art and Artists,* 494; Fink, *American Art at the Nineteenth-Century Paris Salons,* 395; Falk, *Exh. Record Series.*

TAIT, Katharine Lamb See: **LAMB, Katharine Stymetz (Katarine Lamb Tait)**

TAIT, Nina Stirling (Mrs.) *[Painter] early 20th c.*
Addresses: NYC, c.1909-13. **Studied:** ASL. **Exhibited:** S. Indp. A., 1917-18. **Sources:** WW13.

TAITE, Augustus *[Portrait painter in oils] mid 19th c.*
Addresses: Albany, NY, c.1840. **Sources:** G&W; Lipman and Winchester, 181.

TAJIRI, Shinkichi *[Sculptor, educator] b.1923, Los Angeles, CA.*
Addresses: Castle Scheres, Baarlo (Limburg). **Studied:** AIC, with Ossip Zadkine; with F. Leger, Paris, France; Acad. Grande Chaumière, Paris. **Exhibited:** AIC, 1947-48; Stedelijk Mus, Amsterdam, 1960-67; Venice Biennial, 1962; Andre Emmerich Gal., NYC, 1965; Kunsthalle, Basel, Switz., 1969; Kunsthalle Lund, Sweden, 1971; Court Gal., Copenhagen, Denmark, 1970s. Awards: Golden Lion, Eighth Int. Festival Amatuer Films, Cannes, France, 1955; Mainichi Shibum prize for sculpture, Mainchi Newspapers, Tokyo, 1963; Grand Prix, The Wet Dream Film Festival, Amsterdam, 1970. **Work:** Stedelijk Mus, Amsterdam; MoMA; Louisiana, Copenhagen; Roysman Mus, Rotterdam; CNAC, Paris. Commissions: AKU fountain, 1960. **Comments:** Teaching: guest prof. sculpture, Minneapolis Col. Art & Design, 1964-65; prof. sculpture, Hochschule für Bildende Künste, West Berlin, Ger., 1969-on. Publications: ed., "Ferdi," 1969; auth., "Shake Well before Using," 1969; auth., "The Wall," 1970; auth., "Mayday," 1970; auth., "Land Mine," 1970. **Sources:** WW73; L. Freed, *Seltsame Spiele* (Barmeyer & Nikel, 1969).

TAKACH, Bela De Gy *[Painter] early 20th c.*
Addresses: Chicago area. **Exhibited:** AIC, 1908. **Sources:** Falk, AIC.

TAKAEZU, Toshiko (Miss) *[Ceramic craftsman, teacher] b.1922, Hawaii.*
Addresses: Cleveland 6, OH. **Studied:** Honolulu Acad. A.; Univ. Hawaii; Cranbrook Acad. A. **Exhibited:** Syracuse Nat., 1951, 1953-54, 1956, 1958; Wichita Nat. Dec. A. & Ceramics, 1951-53, 1955, 1958-61; St. Paul, 1952; Miami Nat. Ceramics, 1953, 1955, 1958; Wisconsin Des.-Craftsmen, 1955; Univ. Wisconsin, 1955 (solo); Bonnier's, NY, 1955 (solo); So. Illinois Univ., 1957, 1959; Akron Inst. A., 1958; Ball State T. Col., 1958; Contemp. Crafts, Columbus, 1958; Murray State T. Col., 1958; Staten Island Mus. Hist. & A., 1958; Univ. Nebraska, 1955; Milwaukee A. Center, 1959; Texas Christian Univ., 1959; Univ. Michigan, 1960; Mich. State Univ., 1960 (solo); Louisville A. Center, 1960; CMA, 1957-61; Butler Inst.; Midwest Des.; First Unitarian Church, Cincinnati,

1960; AIC, 1960 (solo); Albright A. Gal., 1960; Des Moines A. Center, 1960; Cleveland Inst. A., 1961 (solo); Clarke Col., 1961 (solo); St. Mary's Col., Notre Dame, 1961 (solo); George Peabody Col., 1961 (solo); Honolulu Acad. A., 1959 (2-man); Lake Erie Col., 1960 (2-man); Cleveland Women's Cl., 1958 (2-man); Las Vegas (N.M.) Highlands Univ., 1958 (3-man); International: Ostend Exh., 1959-61; Brussels Fair, 1958; Intl. Cultural Exchange, 1960. **Work:** CMA; Detroit Inst. A.; Smithsonian Inst.; Albion Col.; Murray State T. Col.; Univs. of Michigan, Eastern Michigan, Utah State, Michigan State, Northern Illinois; St. Paul Gal. A.; Butler Inst. Am. A.; Des Moines A. Center; Bangkok Mus., Thailand; Springfield Mus. A.; Cranbrook Mus. A.; Muskegon A. Mus.; Cleveland AA. **Comments:** Position: instr., ceramics, Cleveland Institute of Arts, 1956-and on. **Sources:** WW66.

TAKAHASHI, K. *[Painter] late 19th c.*
Addresses: San Francisco, CA, 1890s. **Member:** San Francisco AA. **Exhibited:** Mechanics' Inst., 1893; World's Columbian Expo, Chicago, 1893; Calif. Midwinter Int'l Expo, 1894. **Comments:** Specialty; watercolor landscapes, marines, figures and still lifes. **Sources:** Hughes, *Artists in California,* 550.

TAKAI, Teiji *[Painter] b.1911, Osaka, Japan.*
Addresses: NYC. **Studied:** Shinano Bashi Art Inst., Osaka. **Member:** Memberships: Niki Art Assn.; Int. Artist Assn. **Exhibited:** Poindexter Gal., NYC, 1959-72 (several solos); WMAA, 1959, 1961; Corcoran Gal biennials, 1961, 1963; Carnegie Intl, Pittsburgh, 1961-62; Takashimaya Tokyo, 1967 (retrospective). Other awards: Okada Prize, 1940; Fukushima Prize, 1964. **Work:** Corcoran Gal.; Mod. Art Mus., Tokyo, Japan; Columbia Mus., SC; Uniontown A. Cl., Pa.; Wakayama Mod. Art Mus., Japan. **Comments:** Preferred media: oils. Teaching: vis. prof. art, Winthrop Col., fall 1970 & 1972. **Sources:** WW73.

TAKAL, Alphonse *[Painter] mid 20th c.*
Exhibited: AIC, 1935. **Sources:** Falk, *AIC.*

TAKAL, Peter *[Painter] b.1905, Bucharest, Romania.*
Addresses: NYC. **Studied:** Paris, France. **Member:** Print Cl. Phila. (juror, 1958); AEA; Print Coun. Am.; Soc. Am. Graphic Artists; Am. Color Print Soc. (juror, 1959). **Exhibited:** PAFA Biennial, Philadelphia, 1953-67; WMAA, 1955-63 & 1969; Recent Drawings USA, MoMA, 1956; American Prints Today, traveling exhib., Print Coun. Am., 1959, 1962 & 1963; White House, Wash., DC, 1966 & 1970; plus more than 50 solo shows in USA & abroad, 1932-72; Weyhe Gallery, NYC, 1970s. Awards: fel., Yaddo Found., 1961; purchase award, Third Nat. Print Exhib., Pasadena Art Mus., 1962; Ford fel., Tamarind Lithography Workshop, 1963-64. **Work:** MoMA; MMA; WMAA; CMA; LACMA; plus in over 100 mus collections in USA & abroad. Commissions: City Roofs (print), 1956 & Trees & Fields (print), 1957, Print Club Cleveland; four prints, Int. Graphic Arts Soc., New York, 1956-65; Meditation (print), Assoc. Am. Artists, New York, 1958; suite of 20 lithographs, Tamarind Lithography Workshop, Los Angeles, 1964; two prints, Hollander Workshop, New York, 1969. **Comments:** Teaching: Lectr. art, CMA, 1958; lectr. art, Beloit Col., 1965; lectr. art, Cent Col., 1968. Publications: auth., "Selected Works of Peter Takal, Drawings & Poems," Int. Univ. Press, 1945; co-auth., "Peter Takal at the Strozzina," Palazzo Strozzi (catalogue), 1960; auth., "Between the Lines," *Artists Proof,* Vol I, No 2; illusr., "Mother & Child in Modern Art," Duell, 1964; auth., "About the Invisible in Art," Lyman Wright Art Ctr., 1965. **Sources:** WW73; Pierre Mornand, *Takal portraitiste lineaire evocateur de l'insaisissable* (Le Courrier Graphique, 1937); Norman Kent, "What is good drawing?," *Am. Artist Mag.* (1945); Leonia E. Prasse & Louise Richards, *Recent works of Peter Takal* (Cleveland Mus Art, 1958).

TAKE, Henry Scott *[Painter] late 19th c.; b.New York.*
Studied: Laurens; Legros. **Exhibited:** Paris Salon, 1883. **Sources:** Fink, *American Art at the Nineteenth-Century Paris Salons,* 395.

TAKEHITA, Natsuko *[Painter] mid 20th c.*
Addresses: Chicago area. **Exhibited:** AIC, 1948-51. **Sources:** Falk, *AIC*.

TAKEMOTO, Henry Tadaaki *[Craftsman, sculptor] b.1930, Honolulu, Hawaii.*
Addresses: Los Angeles, CA. **Studied:** Univ. Hawaii (B.F.A.); Los Angeles Co. Art Inst. (M.F.A.). **Exhibited:** Second Int. Exhib. Contemp. Ceramics, Ostend, Belg., 1959; Third Int. Exhib. Contemp. Ceramics, Prague, Czech., 1962; Studio Potter Exhib., Victoria & Albert Mus., London, Eng., 1966-70; Objects: USA Johnson Wax Coll. Contemp. Crafts, Smithsonian Inst., Wash., DC, 1970-73; Contemp. Ceramic Art, US, Can., Mex., Japan, Kyoto & Tokyo, 1971-72. Awards: double purchase prize, Wichita Art Assn., 1959; silver medal for sculpture, Ostend, Belg., 1959; bronze medal, Mus. Contemp. Crafts, NY, 1960. **Work:** Smithsonian Inst. **Comments:** Preferred media: ceramics. Positions: designer & glaze chemist, Interpace Corp., 1969-. Teaching: instr. ceramics, Calif. Sch. Fine Arts, San Fran.; instr. ceramics, Scripps Col., 1965-69. **Sources:** WW73.

TAKIS, Nicholas *[Painter, designer, educator] b.1903, NYC / d.1965.*
Addresses: NYC. **Studied:** ASL; NY Sch. A.; NY Evening Sch. Indst. A. **Member:** Audubon A. **Exhibited:** CM, 1939; Audubon A., 1945; Salons of Am.; Valentine Gal. **Work:** Indiana State T. Col.; Maitland Gal., Fla.; Brooklyn Pub. Lib.; Indiana Mus. Mod. A. **Comments:** *Cf.* Nicholas Takis, sculptor, painter. **Sources:** WW53; WW47.

TAKIS, Nicholas *[Sculptor, painter] mid 20th c.*
Addresses: NYC. **Exhibited:** Iolas Gal., NY, 1963 (solo). **Sources:** WW66.

TAKSA, Desha A. Milcinovic *[Painter, screenprinter, designer, sculptor, teacher, lithographer] b.1914, Zagreb, Yugoslavia.*
Addresses: NYC. **Studied:** Europe; Acad. Zagreb, Yugoslavia, with Ivan Mestrovic. **Member:** AAPL; Greenwich SA. **Exhibited:** Art Dir. Club, traveling exh., 1930-36; Arden Gal., 1943; Dance Int., NY, 1940; AAPL, 1940-42; Witte Mem. Mus., 1944 (solo); Kansas City, MO; Oakland Art Gal., 1943; Dallas Mus. FA, 1944; LOC, 1946; Morgan Lib., New Haven, CT, 1946; Greenwich, CT, 1946. **Work:** Greenwich (CT) Lib.; Witte Mem. Mus., San Antonio, TX. **Comments:** Illustr.: *Adventures in Monochrome.* **Sources:** WW53; WW59 (as Desha A. Milcinovic); WW47 (as Desha A. Milcinovic Taksa, with Desha [alone] listed as a cross-reference name).

TALBERT, Zel E. *[Miniature painter] b.1869, West Elkton, OH / d.1954, Taft, CA.*
Addresses: West Elkton, OH; Los Angeles, Ca, ca.1908. **Member:** P&S of Los Angeles. **Sources:** WW06; Hughes, *Artists in California,* 550.

TALBOT, Catherine Porter *[Painter] b.1859, Machias, ME / d.1938.*
Addresses: Portland, ME. **Studied:** in Europe. **Exhibited:** Boston AC, 1899, 1900. **Comments:** Painted landscapes in pastel and watercolor. **Sources:** WW98; Petteys, *Dictionary of Women Artists.*

TALBOT, Cornelia Brackenridge (Mrs. M.W.) *[Painter] b.1888, Natrona, PA / d.1925, Natrona.*
Addresses: Norfolk, VA. **Studied:** PAFA; H. Breckenridge; Carnegie Tech. Inst. **Exhibited:** Pittsburgh AA, 1916 (prize). **Comments:** (Cornelia Brackenridge). **Sources:** WW24.

TALBOT, Grace Helen *[Sculptor] b.1901, North Billerica, MA.*
Addresses: NYC; Syosset, NY. **Studied:** Harriet W. Frishmuth. **Member:** NSS; NAWA. **Exhibited:** Arch. L., 1922 (prize); PAFA Ann., 1922-30; NAWA, 1925 (med); AIC. **Comments:** (Mrs. Darley Randall). **Sources:** WW59; WW47; Falk, *Exh. Record Series.*

TALBOT, Hattie Crippen *[Painter] b.1878, Jackson City, MO / d.1944, Los Angeles, CA.*
Addresses: Los Angeles, CA. **Exhibited:** Ebell Salon, Los Angeles; Calif. AC, 1928. **Sources:** Hughes, *Artists in California,* 550.

TALBOT, Henry S. *[Painter] 19th/20th c.*
Addresses: Boston, MA. **Member:** Boston AC. **Exhibited:** Boston AC, 1877-1907. **Work:** Minneapolis Inst. A. **Sources:** WW25.

TALBOT, Jarold Dean *[Painter, craftsperson, mus dir, teacher, lecturer] b.1907, Solano, NM.*
Addresses: Des Moines, IA; Peoria, IL; Decatur, IL. **Studied:** Drake Univ.; Cumming School Art; Grand Central School Art; Tiffany Fnd.,1937; and with Ivan Olinsky. **Member:** Peoria Art League; CAA. **Exhibited:** Grand Central Galleries; Minneapolis Art Inst.; Iowa State Fair, 1936 (prize), 1940 (prize); Cornell Col., Mt. Vernon, Iowa, 1940 (prize); All-Iowa Exh., Chicago, 1937 (prize); Carson Pirie Scott Co., Chicago, 1937 (prize); 48 States Comp., 1939; Nat. Exh. American Art, NY, 1937; NAD, 1938; CGA, 1940; Kansas City AI, 1942; Joslyn Mem., 1936; Audubon A; Old Northwest Territory Exh.; CM, 1958. Awards: numerous prizes in Iowa exhibitions; grand award and 1st prize, Jacksonville, 1958. **Work:** panels, Iowa State Hist. Bldg. **Comments:** Position: instructor, Grand Central School Art, 1937-38; supervisor, Federal Art Project, Des Moines, IA; Ottumwa Art Center, 1939-42; Bradley Polytechnic Inst., Peoria, IL; art professor, Millikin Univ.; director, Decatur Art Center; Decatur, IL. **Sources:** WW59; WW47; Ness & Orwig, *Iowa Artists of the First Hundred Years,* 204-05.

TALBOT, Jesse *[Landscape, portrait, and figure painter] b.1806 / d.1879.*
Addresses: Paterson, NJ, 1844-47; NYC, 1865-73; Roundout, NY, 1876; Hartford, CT, 1894-98. **Member:** ANA, 1842. **Exhibited:** NAD, 1838-60, 1865-98; Apollo Assoc.; Brooklyn AA, 1870. **Comments:** Talbot's landscapes were scenes chiefly in New York, New Jersey, and New England. He was possibly born in 1807 (Smith). **Sources:** G&W; Bénézit; Smith; Cowdrey, NAD; Cowdrey, AA & AAU; Rutledge. PA; Hinton, *History and Topography; Home Book of the Picturesque.*; Campbell, *New Hampshire Scenery,* 163; BAI, courtesy Dr. Clark S. Marlor.

TALBOT, Marshall *[Crayon portrait artist] mid 19th c.*
Addresses: Philadelphia. **Exhibited:** PAFA (1856: crayon portraits). **Sources:** G&W; Rutledge, PA.

TALBOT, Sophia Davis *[Painter, lecturer, teacher] b.1888, Boone County, IA.*
Addresses: Mattoon, IL; Melrose, IA. **Studied:** Iowa State Univ.; Cumming Sch. Art. **Member:** AAPL; Soc. for Sanity in Art; Artists Gld. of Eastern Illinois; All-Illinois Soc. FA; Nat. Lg. Am. Pen Women; Mattoon Writers' Club; AFA. **Exhibited:** Women Painters of Am., Wichita, KS, 1938; All-Illinois Soc. FA, 1939-41; Denver AM, 1941; Wawasee Art Gal., 1942 (prize)-43; Drake Hotel, Chicago, 1942 (solo); Eastern Illinois Teachers Col., 1942 (solo), 1949 (with Fred Conway); Mattoon, IL, 1942 (solo); Central Illinois Artists, 1943-44; Swope Art Gal., 1947 (prize)-48 (prize), 1950 (prize)-51 (prize), 1953 (prize), 1956 (prize); Nat. Lg. Am. Pen Women, 1950 (prize), 1952 (prize), 1957; Ogunquit AC, 1950-51; Magnificent Mile Exhib., Chicago, 1951; Wurlitzer Gal., Chicago, 1955; Illinois State Fair, 1955. **Work:** Hawthorne, Lowell & Lincoln Schools, Mattoon, IL; Admin. Bldg. & Booth Mem. Lib., Eastern Illinois State College; Lincoln School, Brookfield, IL; mural, Nat. Bank of Mattoon. **Comments:** Position: instr. drawing, State Univ. Iowa, 1914-17; privately, 1927-51. **Sources:** WW59; WW47.

TALBOT, William (H. M.) *[Sculptor] b.1918, Boston, MA / d.1980.*
Addresses: Washington, CT. **Studied:** PAFA, 1936 & 1941; with George Demetrios, Gloucester, MA, 1937-40; Acad. Beaux Arts, Paris, France, 1945-46. **Member:** Sculptors Guild (pres., 1965-68, v. pres. publ., 1968-72); Arch. Lg. **Exhibited:** PAFA Ann., 1940-41, 1949 (prize), 1953, 1966; NAD, 1941; Int. Sculpture Exh., 1949; Philadelphia Mus. Third Int., 1949; De Cordova & Dana

Mus. Sculpture Exhib., 1949; WMAA, 1950-53, 1963; S. Gld., 1952; Sculpture Center, NY, 1950-52; Arts Cl. Chicago, 1972; Frank Rehn Gal., NYC, 1970s. **Awards:** Prix de Rome, Am. Acad. Rome, 1941; Cresson traveling fel., 1941 & Steele Sculpture Prize, 1949, PAFA; Penrose award, CAFA, 1950. **Work:** WMAA; St. Lawrence Univ., Canton, NY; Earlham Col., Richmond, Ind.; Bryn Mawr Col., Pa.; St. John's Church, Washington, Conn. **Commissions:** Fountain (with Carl Koch & G. Kepes), Fitchburg Youth Libr., Mass., 1950; fountain, Nat. Coun. State Garden Clubs Am. Nat. Hq., St. Louis, Mo., 1959; Mem. (sculpture & stairwell at rehab. ctr.), Mrs. Charles Belknap for Barnes Hosp., St. Louis, Mo., 1964. **Comments:** Preferred media: concrete, stained glass. Teaching: vis. prof. sculpture, dept. archit. & design, Univ. Mich., spring 1949. **Sources:** WW73; Peter Blake, article, In: *Archit. Forum* (1951); Edward Renouf, "The Sculpture of William Talbot," *Harvard Art Rev.* (spring-summer, 1967); D. Meilach, *Contemporary Art with Stone* (Crown, 1969); Falk, *Exh. Record Series.*

TALBOTT, Anna Mathilda Wares *[Painter, teacher]* b.c.1810, Kentucky / d.1882, Indianapolis, IN.
Addresses: Active in Louisville, KY, 1838; Indianapolis, 1853-82. **Sources:** Petteys, *Dictionary of Women Artists.*

TALBOTT, Katharine *[Sculptor]* b.1908, Wash., DC.
Addresses: Berkeley, CA. **Studied:** H.P. Camden; A. Fairbanks; R. Laurent. **Exhibited:** exh. of Oreg. Artists, Sculptors and Designers, Portland Mus. Art, 1932 (prize). **Sources:** WW40.

TALBURT, H. M. *[Editorial cartoonist]* 20th c.
Addresses: Washington 5, DC. **Comments:** Syndicated editorial cartoonist. **Sources:** WW66.

TALCOTT, Allen Butler *[Landscape painter]* b.1867, Hartford, CT / d.1908, Old Lyme.
Addresses: NYC/Old Lyme, CT. **Studied:** Trinity College, 1890; ASL; Académie Julian, Paris with J.P. Laurens and Benjamin-Constant, 1890-92. **Member:** SC, 1901. **Exhibited:** Paris Salon, 1893, 1895; PAFA Ann., 1895, 1902-09; NAD, 1898; St. Louis Expo, 1904 (medal); Boston AC, 1908; AIC; Cooley Gal., Old Lyme, CT, 1991, 1995 (solos). **Comments:** Famous for his paintings of trees. **Sources:** WW08; Fink, *American Art at the Nineteenth-Century Paris Salons,* 395; Art in Conn.: The Impressionist Years; Falk, *Exh. Record Series.*

TALCOTT, Dudley Vaill *[Sculptor, illustrator, writer, painter]* b.1899, Hartford, CT.
Addresses: Farmington, CT. **Exhibited:** AIC, 1940; Valentine Dudensing Gal., 1927, 1947; MOMA, 1930; WMAA, 1937; Grace Horne Gal., Boston; Phillips Acad., Andover, Mass. **Work:** panels, figures, etc., WFNY 1939; Hartford Nat. Bank & Trust Co., New London, Conn. branch; des., wrote & illus. brochure for Helio Aircraft Corp., Norwood, Mass., 1954, 1955. **Comments:** Author, I., "Noravind," 1929; "Report of the Company," 1936. **Sources:** WW59; WW47.

TALCOTT, Sarah W(hiting) *[Painter]* b.1852, West Hartford, CT / d.1936.
Addresses: Elmwood, CT. **Studied:** W.M. Chase and K. Cox in NYC; Académie Julian, Paris with Lefebvre, Bouguereau, Robert-Fleury, and Ferrier. **Member:** CAFA (life member); Hartford Art Club. **Exhibited:** Paris Salon, 1895. **Sources:** WW38; Fink, *American Art at the Nineteenth-Century Paris Salons,* 395.

TALCOTT, V(irginia) Huntington *[Painter]* mid 20th c.
Studied: ASL. **Exhibited:** S. Indp. A., 1935. **Sources:** Marlor, *Soc. Indp. Artists.*

TALCOTT, William *[Portrait painter]* mid 19th c.
Addresses: Massachusetts between 1820 and 1846. **Work:** American Antiquarian Society, Worcester (MA). **Sources:** G&W; WPA (Mass.), *Portraits Found in Mass.,* II, 543.

TALEN, Waldemar Appolonius *[Sculptor, carver, architect, draftsperson]* b.1812, Ober, Finland / d.1882, New Orleans, LA.
Addresses: New Orleans, 1858-68. **Sources:** G&W; New Orleans CD 1858, 1860-61, 1866. More recently, see

Encyclopaedia of New Orleans Artists, 371.

TALFORD, Florence L. *[Artist]* late 19th c.
Addresses: Active in Detroit, MI, c.1896. **Studied:** Detroit Art Acad. **Comments:** *Cf.* Florence L. Talfourd. **Sources:** Petteys, *Dictionary of Women Artists.*

TALFOURD, Florence L. *[Painter, miniaturist]* 19th/20th c.
Addresses: Roselle, NJ. **Exhibited:** PAFA Ann., 1900-01. **Comments:** *Cf.* Florence L. Talford. **Sources:** WW98; Petteys, *Dictionary of Women Artists;* Falk, *Exh. Record Series.*

TALIABUE, Carlo *[Painter, sculptor]* b.1894, Cremona, Italy / d.1972, Walnut Creek, CA.
Addresses: San Francisco, CA. **Studied:** Royal Academy of Art, Milan. **Member:** Soc. for Sanity in Art; Burlingame Art Soc.; Diablo AA. **Exhibited:** Kingsley AC, Sacramento, 1934; Soc. for Sanity in Art, CPLH, 1940s (awards). **Work:** Sutter's Ford Mus., Sacramento; Mark Hopkins Hotel; Sir Francis Drake Hotel; Bank of America; Opera House and War Memorial Bldg., San Francisco; Univ. of San Francisco; Oakland Mus.; WWI Memorial Montecatini, Italy. **Comments:** He immigrated to California in 1924, and settled in San Francisco in the late 1930s, when he executed statuary on Treasure Island for the GGE. **Sources:** Hughes, *Artists in California,* 550.

TALIAFERRO, Elizabeth Stewart (Mrs. W.F.) *[Portrait painter]* b.1869, Newark, NJ.
Addresses: Nuttall, Gloucester County, VA. **Studied:** ASL. **Member:** SSAL. **Exhibited:** S. Indp. A., 1928-33; Salons of Am., 1929-32, 1934; SSAL, Montgomery, AL, 1938. **Sources:** WW40.

TALIAFERRO, Henrietta Lee See: **MONTAGUE, Hariotte Lee Taliaferro (Mrs. Jeffry)**

TALIAFERRO, Lucene See: **GOODENOW, (Taliaferro)**

TALIAFERRO, Maria Eva *[Landscape painter]* b.1820, Petersburg, VA / d.1906, Petersburg, VA.
Addresses: Petersburg, VA. **Work:** priv. colls. **Sources:** Wright, *Artists in Virgina Before 1900.*

TALLANT, Richard H. *[Painter, illustrator]* b.1853, Zanesville, OH / d.1934, Estes Park, CO.
Addresses: Salt Lake City, UT, 1889-91; Devil's Gulch, Estes Park, CO (since 1891). **Studied:** self-taught. **Member:** Denver AC, 1886-87. **Work:** Murray and Harmsen collections. **Comments:** Lived in mining camps as a youth. Specialty: Western subjects including mountains and Native Americans. **Sources:** P&H Samuels, 477-78.

TALLEUR, John J. *[Printmaker]* b.1925, Chicago, IL.
Addresses: Lawrence, KS. **Studied:** AIC; Univ. Chicago (B.F.A.), 1947; Iowa State Univ. (M.F.A., 1951). **Member:** AEA; Delta Phi Delta; Print Coun Am. **Exhibited:** AIC,1947. **Work:** MoMA; CI; MMA; WMAA; AIC. **Commissions:** Lakeside Studios, 1972; Jewish Community Ctr., Kansas City, Mo., 1972. **Comments:** Preferred media: intaglio. Teaching: instr. printmaking, Carleton Col., 1947-49; instr. printmaking, Saint Paul Gal. & Sch. Art, 1949; prof. printmaking, Univ. Kans., 1953-. **Sources:** WW73; Bret Waller, *John Talleur* (Univ. Kans. Mus. Art, 1966).

TALLMADGE, Thomas Eddy *[Etcher]* b.1876, Wash., DC.
Addresses: Evanston, IL. **Studied:** MIT. **Member:** Cliff Dwellers; Chicago SE; NAD; AIC Alumni; F., AIA; Plan Comm., City of Evanston; Governing Life Member AIC. **Exhibited:** AIC, 1909, 1920, 1922, 1925, 1936. **Work:** Cliff Dwellers C., Chicago. **Comments:** Author: "Story of Architecture in America," "Story of England's Architecture." Positions: chairman, Bd. Art Advisors, State of Ill.; Advisory Comm. of Architects, Restoration of Williamsburg, Va.; dir., Historical Am. Bldg. Survey. **Sources:** WW40.

TALLMAN, Essie Marie *[Painter, poster designer]* b.1877, Camanche, IA.
Addresses: Iowa. **Studied:** Douglas Lind and C. Boehm in Davenport and Camanche. **Exhibited:** NYC and Newark, NJ; throughout Iowa; in Paris; NAD, 1936. **Sources:** Petteys,

Dictionary of Women Artists.

TALLMAN, M(artha) G(riffith) (Mrs. Walter B.) *[Painter] b.1859, Llanidloes, North Wales / d.1930, NYC.* **Addresses:** NYC/Kent, CT. **Studied:** F.S. Church; NAD; ASL; Mrs. Coman; J. Peterson. **Member:** Pen and Brush Club; NYWCC; NAWPS; AFA. **Exhibited:** AIC, 1918 ; S. Indp. A., 1920. **Sources:** WW29.

TALLMAN, W(illiam) B. *b.1880 / d.1945, White Plains, NY.* **Exhibited:** Salons of Am., 1922. **Sources:** Marlor, *Salons of Am.*

TALLON, William John *[Sculptor, illustrator, painter, lecturer] b.1917, Manchester.* **Addresses:** Chicago, IL/Manchester, CT. **Studied:** Univ. Chicago. **Exhibited:** Ar. Chicago, Vicinity Ann., AIC, 1939; Big 10 Traveling Exhib., 1939. **Sources:** WW40.

TALVACCHO, Helen Steiner *[Painter] b.1921, Akron, OH.* **Addresses:** Cleveland, OH. **Studied:** Cleveland Inst. Art (four yr. cert.); Univ. Akron. **Member:** Nat. League Am. Pen. Women (Western Reserve Br., v. pres. & treas., 1966-). **Exhibited:** Butler Nat., Youngstown, OH, 1963; Am. Vet. Show, NYC, 1966; Cooperstown Art Assn., NY, 1966 & 1968; Catherine Lorillard Wolfe A. Cl., NYC, 1968; Knickerbocker Artists, NAC, 1971; Malvina Freedson Gal., Lakewood, OH, 1970s. **Awards:** first in prints, Cleveland Mus. May Show, 1949; second in oils, Nat. League Am. Pen. Women, Wash., 1958 & Salt Lake City, 1970. **Comments:** Preferred media: oils, watercolors. **Sources:** WW73.

TAM, Geraldine King *[Painter, teacher] b.1920, Toronto, Canada.* **Addresses:** NYC; Hawaii, 1980-on. **Studied:** McMaster Univ., Ontario Col. of Ed., U. of Toronto; Teachers Col., Columbia Univ. **Comments:** Was an instructor at the Dalton School in New York City prior to moving to Hawaii in 1980. She and her husband Reuben Tam (see entry) spent many summers painting on Monhegan Island (ME). **Sources:** Curtis, Curtis, and Lieberman, 79)w/repro.), 186.

TAM, Reuben *[Painter, educator, graphic artist] b.1916, Kapaa, Kauai, HI / d.1991.* **Addresses:** NYC/Monhegan Island, ME. **Studied:** Univ. Hawaii (B.A., 1937), (fifth year cert., 1938); Calif. School Fine Arts; Columbia Univ., with Meyer Schapiro; New School Soc. Res. **Member:** Honolulu AA; Honolulu Printmakers; Nat. Serigraph Soc. **Exhibited:** GGE, 1939 (IBM Grand Nat. Prize); Honolulu AA, 1939 (prize), 1940 (first solo)1941 (prize); Honolulu Printmakers, 1940 (prize); Nat. Exhib. Am. Artists, 1938; VMFA, 1940, 1946; Pittsburgh Intl, CI, 1944-45, 1964, 1967; Corcoran Gal biennials, 1947-63 (6 times); PAFA Ann., 1945-54, 1962-66; LACMA, 1945; Albright Art Gal., 1946; AIC, 1946-49; WFNY, 1939; CPLH, 1940 (solo); Crocker Art Gal., 1940 (solo); Contemporary Am. Painting, WMAA, 1941-65; Downtown Gal., NY, 1945 (solo); Guggenheim fellowship, 1948; Contemporary Am. Painting, Krannert Art Mus., Univ. Illinois, Urbana, 1949-69; Am. Painting, MMA, 1953; Kerr Gal., NYC, 1970s; "Landscape in Maine, 1820-1970," Colby College Art Mus., Maine, 1970; Brooklyn Mus. Biennial, 1952 (first prize) & 1956 (first prize); Am. Acad. Arts & Letters, 1978 (Award in Art). **Work:** IBM Collection; Honolulu Acad. Arts; Massillon Mus. Art; NYPL; MoMA; MMA; WMAA; BM; NMAA; Kauai Mus., Lihue. **Comments:** Preferred media: oils, acrylics, inks. Tam made his summer home on Monhegan Island, Maine, for many years, and also painted in Hawaii (where he was born). According to critic Montica Swain, Tam was "a man of two islands." Teaching: Kauai, briefly; Brooklyn Mus. Art School, 1946-70s; Oregon State Univ., summer 1966; Oregon State System Higher Education, summer 1971. **Sources:** WW73; WW47; Burrey, "Reuben Tam: Painter of the Intimate Landscape," *Arts Magazine* (Feb., 1958); Nordness & Weller, *Art USA Now* (Viking, 1962); Gussow, "A Sense of Place: the Artist & the American Land," *Saturday Review* (1972); Curtis, Curtis, and Lieberman, 128, 187; Forbes, *Encounters with Paradise*, 215, 265-66.

TAMARA, Antonia (Mrs. A. T. Aisenstein) *[Painter, lithographer] mid 20th c.; b.Russia.* **Addresses:** Berkeley, CA, 1930s. **Studied:** Munich, Germany and Berkeley, CA with Hans Hofmann. **Member:** San Francisco Mural Soc.; Nat'l League of American Pen Women; San Francisco Soc. of Women Artists. **Exhibited:** SFMA, 1935, 1940s. **Sources:** Hughes, *Artists in California*, 550.

TAMAYO, Rufino *[Painter] b.1899, Oaxaca, Mexico / d.1991, Mexico.* **Addresses:** Mexico City, Mexico. **Studied:** MoMA; Mus. Art Mod., Paris, France; Mus. Art Mod., Rome, Italy; Mus. Royale, Brussels, Belg.; Philips Mem. Gal., Wash., DC. **Member:** Inst. & Acad. Arts & Lett.; Acad. Arte, Buenos Aires, Arg.; Acad. Diseno, Florence, Italy. **Exhibited:** S. Indp. A., 1923; San Francisco Mus Art, 1953 (solo); Kunsternes Hus Oslo, Norway, 1959 (solo); Phoenix Art Mus, Ariz, 1968 (solo); Biennal Venice; Perl's Gal., NYC, 1970s. **Awards:** Oficiel Legion d'Honeur, France; Comendator Repub. Italiana; Premio Nac. Mex. **Work:** Commissions: murals, Govt. Mex., Palace Fine Arts, Mexico City, 1952, Mus. Nac. Antropologia, Mexico City, 1964 & UN, New York, 1972; murals, Dallas Mus. Fine Arts, 1953 & UNESCO Bldg., Paris, 1958. **Sources:** WW73.

TAMBAK, Estelle *[Painter] b.1913, Philadelphia, PA.* **Studied:** self-taught. **Exhibited:** participated in group exhibitions and had many solo shows. **Work:** represented in numerous private collections. **Comments:** Began painting in 1944; known for her primitive style. Painting locations include Monhegan Island (ME). **Sources:** Curtis, Curtis, and Lieberman, 151, 187.

TAMBELLINI, Aldo *[Painter, sculptor] b.1930, Syracuse, NY.* **Addresses:** NYC. **Studied:** Syracuse Univ. (B.F.A., 1954); Univ. Notre Dame, teaching fel. (M.F.A., 58) with Ivan Mestrovic; Grad. Sch. Archit. & Allied Arts, Univ. Ore., teaching fel. **Exhibited:** TV As Creative Medium, Howard Wise Gal., NYC, 1967; Vision & TV, Rose Art Mus., Brandeis Univ., Waltham, Mass., 1970; Cineprobe, MoMA, 1970; Black Film Ser., Jewish Mus., New York, 1970; Black Video No 3, WMAA, 1970. **Awards:** Syracuse Mus. Prize, 1952; Int. Grand Prix, Oberhausen Film Festival, Ger., 1969. **Work:** Black Film Ser., MoMA Film Arch. Commissions: relief, Le Moyne Col., Syracuse, 1965; Black Gate Cologne, WDR TV, Cologne, Ger., 1968; 0 + 0, Intermedia Inst., New York, 1971. **Comments:** Preferred media: mixed media. Publications: illusr. & contribr., Black Issue, *Arts Can.*, 1967; auth., "Impermanence," *Arts Can.*, 1968; auth., "Radican Software," First Video Newsletter, 1970. Teaching: instr. painting & sculpture, Syracuse Mus. Fine Arts, 1951-53; instr. sculpture, Pratt Inst., 1964; instr. creative electrography, Dist. 5, New York, 1969-. **Sources:** WW73; J. Margoles, "TV the Next Medium," *Art Am.* (1969); G. Youngblood, *Expanded Cinema* (Dutton, 1970); Kultermann, *Art & Life* (Praeger, 1971).

TAMBURINI, Arnaldo Casella, Jr. *[Portrait painter, landscape painter] b.1885, Italy / d.1936, Chicago, IL.* **Addresses:** NYC; Pasadena, CA. **Exhibited:** Vose Gallery, Boston, 1926. **Work:** Uffizi Gallery, Florence. **Comments:** Of noble birth, he won an art contest at age 15 and became court painter to the Italian king, as his father had been before. He went on to paint some of the most important people of his time, traveling to Canada in 1901 to paint the Prime Minister, and NYC to paint the Archbishop of New York. He and his wife, miniature painter Dolores Dolja Dunifer, settled in NYC in 1914. He portrayed kings and queens, Enrico Caruso in Havana, Cuba (1920), and Pope Pius X in the Sistine Chapel (1923). After further travel to Australia and Hawaii, he moved to California in 1926. **Sources:** Hughes, *Artists in California*, 550.

TAMBURINO, Toto *[Painter] mid 20th c.* **Addresses:** NYC, 1930. **Studied:** ASL. **Exhibited:** S. Indp. A., 1930; Salons of Am., 1934. **Sources:** Falk, *Exhibition Record Series.*

TAMKE, Anna Roch *[Painter] mid 20th c.*
Addresses: NYC. **Exhibited:** S. Indp. A., 1927-29, 1934.
Sources: Marlor, *Soc. Indp. Artists.*

TAMOTSU, Chuzo F. See: **TAMOTZU, Chuzo**

TAMOTZU, Chuzo *[Painter] b.c.1888, Kagoshima, Japan /
d.1975, Santa Fe, NM.*
Addresses: NYC, 1920-48; from 1948-75 he lived in John Sloan's
former studio in Santa Fe, NM. **Studied:** self-taught; ASL.
Member: Artists Equity (a founder); Am. Artists Congress;
Woodstock AA. **Exhibited:** S. Indp. A., 1924-38; Salons of Am.,
1924, 1927-32; PAFA Ann., 1933-34; AIC; WPA Art Exhib.,
Parsons Sch. Des., NYC, 1977. **Work:** Field Fnd., NYC;
Berkshire Mus., Pittsfield, MA. **Comments:** Came to NYC in
1920. Served as a war artist with the U.S. army during WWII.
Worked with WPA until he was dismissed because he was not a
U.S. citizen. **Sources:** WW40, cites birth date of 1891; *New York
City WPA Art*, 86 (w/repros.); Woodstock AA cites birth date of
1888; Marlor, *Salons of Am.* cites birth date of 1887; Falk, *Exh.
Record Series.*

TANAKA, K. *[Painter] mid 20th c.*
Addresses: San Francisco, CA. **Exhibited:** East West Art Soc. of
San Francisco, 1922; San Francisco AA, 1925; P&S of Los
Angeles, 1931 (prize). **Sources:** Hughes, *Artists in California*,
550.

TANAKA, Yas(h)ushi *[Painter, teacher] b.1886, Japan.*
Addresses: Seattle, WA, 1901-1920; Paris, 1920. **Studied:** F.
Tadama; mainly self-taught. **Member:** Seattle FAS. **Exhibited:**
Wash. State Comm. of FA, 1914; PPE, 1915; Seattle FA Soc.,
1920. **Comments:** Position: teacher, Seattle FA Soc. **Sources:**
WW24; Trip and Cook, *Washington State Art and Artists.*

TANBERG, Ella Hotelling (Mrs.) *[Portrait painter] b.1862,
Janesville, WI / d.1928, Hollywood, CA.*
Addresses: Hollywood, CA/Laguna Beach, CA, c.1919.
Member: West Coast Arts Inc.; Soc. of Independent Artists;
Janesville AL; Chicago AC; Calif. AC; Laguna Beach AA.
Exhibited: Calif. AC; AIC; S. Indp. A., 1919, 1922. **Work:**
Janesville Art Lg. **Sources:** WW27; Hughes, *Artists in
California*, 550.

TANDLER, Rudolph (Frederick) *[Painter, lithographer,
teacher] b.1887, Grand Rapids, MI.*
Addresses: The Principia College, Elsah, IL/Woodstock, NY.
Studied: G. Bellows; J. Sloan; A. Dasburg. **Member:** Soc. Indep.
Artists, St. Louis; New Hats; St. Louis AG; Woodstock AA.
Exhibited: S. Indp. A., 1920-30, 1936, 1940; Salons of Am.,
1925, 1931-32; Detroit AI, 1930 (gold); City Mus. St. Louis
(prize); AIC. **Comments:** Position: teacher, Principia College.
Sources: WW40; Woodstock AA.

TANEJI, Moichiro Tsuchiya *[Painter] b.1891, Ogaki City,
Japan.*
Addresses: NYC. **Studied:** Japan. **Member:** Penquins. **Sources:**
WW21.

TANGUEY, Yves See: **TANGUY, Yves**

TANGUY, Kay (Mrs. Yves) See: **SAGE, Kay**

TANGUY, Yves *[Painter] b.1900,
Paris, France / d.1955, Woodbury,* YVES TANGUY.27
CT.
Addresses: Woodbury, CT, 1939-55. **Exhibited:** with Surrealists
in Paris, from 1926; Cubism and Abstract Art, MOMA, 1936;
Fantastic Art, Dada, and Surrealism, MOMA, 1936; Julien Levy
Gal., NYC, solos, 1935, 1936; Art of the Century Gal., NYC,
1940s; AIC, 1941, 1947; PAFA Ann., 1947, 1950-51, 1953
(medal); MOMA, 1955 (retrospective). **Work:** MOMA; PMA;
Albright-Knox Mus., Buffalo; AIC; Guggenheim Mus.; LACMA.
Comments: One of the leading painters of Surrealism in Paris (he
joined the group in 1925). Immigrated to the U.S. in 1939.
Married to Kay Sage (see entry). Contributor to journal, *La
Révolution Surréalist.* **Sources:** James Thrall Soby, *Yves Tanguy*

(MOMA, 1955); Maurice Nadeau, *The History of Surrealism*
(New York, 1965); Alfred H. Barr, Jr., ed. *Fantastic Art, Dada,
and Surrealism* (exh. cat., MOMA, 1936); Bénézit; Falk, *Exh.
Record Series.*

TANIA, (Schreiber) *[Sculptor, painter] b.1924, Warsaw,
Poland.*
Addresses: East Hampton, NY. **Studied:** McGill Univ. (M.A.,
1942); Columbia Univ., 1942-44; ASL, with Yasuo Kuniyoshi,
Morris Kantor, Vaclav Vytlacil & Harry Sternberg, 1948-51.
Exhibited: two-person show, New York Univ. Loeb Ctr., 1964 &
1967; Univ. Va., 1962 & 1968; Milwaukee Art Inst., 1965; Univ.
Del., 1965; four-person show show, MoMA, 1969; Bertha
Schaefer Galleries, NYC, 1970s. **Work:** Rose Art Mus., Brandeis
Univ.; New York Univ.; Morgan State Col.; New York Civic Ctr.
Synagogue. Commissions: two walls, comn. by New York City,
Vest Pocket Parks, Brooklyn & Bronx, 1967-68. **Comments:**
Teaching: instr. fundamentals of design & drawing, NY Univ.,
1963-69. **Sources:** WW73.

TANIER, George *[Sculptor] mid 20th c.*
Exhibited: S. Indp. A., 1937-39, 1941. **Sources:** Marlor, *Soc.
Indp. Artists.*

TANKARD, Muriel *[Painter] mid 20th c.*
Addresses: NYC. **Exhibited:** S. Indp. A., 1933. **Sources:**
Marlor, *Soc. Indp. Artists.*

TANKSLEY, Ann *[Painter, educator] b.1934, Pittsburgh, PA.*
Addresses: Great Neck, NY. **Studied:** Carnegie Inst. Technol.
(B.F.A.). **Member:** Where We At. **Exhibited:** 15 Women, NC
A&T State Univ., Greensboro, 1969; Freedomways Exhib.,
Hudson River Mus., Yonkers NY, 1971; USA 1971, Carnegie
Inst., Pittsburgh, 1971; Acts of Art, NYC, 1972; Black Women
Artist, Mount Holyoke Col., South Hadley, Mass., 1972; Acts of
Art, NYC, 1970s; Kaufman Gal., Pittsburgh; Hewlett Gal.; Devon
Gal. **Work:** Johnson Publ. Co., Chicago, Ill. **Comments:**
Preferred media: oils. Teaching: instr. art, Queens Youth Ctrs.
Arts, NY, 1959-62; instr. art, Art Ctr. Northern NJ, 1963; substi-
tute instr. art, Malvern Pub. Schs., 1971-. **Sources:** WW73;
Cederholm, *Afro-American Artists.*

TANKU, Wu *[Painter] mid 20th c.*
Exhibited: S. Indp. A., 1942. **Sources:** Marlor, *Soc. Indp. Artists.*

TANNAHILL, Mary H. *[Miniaturist] b.1868, Warrenton, NC
/ d.1951, Warrenton, NC.*
Addresses: NYC/Provincetown, MA. **Studied:** NYC, with Weir,
Twachtman, Cox, Mowbray. **Member:** Penn. Soc. Min. Painters;
NAWPS; Provincetown AA; NYSWA. **Exhibited:** NYWCC,
1898; Am. Soc. Min. Painters, NYC, 1902; PAFA Ann., 1903,
1915; NAWPS, 1914 (prize)-32 (prize); S. Indp. A., 1917, 1922,
1925; Salons of Am., 1922, 1924-26, 1928, 1930; AIC. **Work:**
Newark (NH) Mus.; Bibliothèque Nationale, Paris. **Comments:**
Marlor cites birth date of 1863. **Sources:** WW40; Petteys,
Dictionary of Women Artists; Falk, *Exh. Record Series.*

TANNAHILL, Robert H. *[Collector] 20th c.*
Addresses: Grosse Pointe Farms, MI. **Sources:** WW66.

TANNAHILL, Sallie B. *[Block printer, illustrator, lecturer,
teacher, writer] b.1881, NYC / d.1947, Youngstown (OH)
Hospital.*
Addresses: NYC. **Studied:** A.W. Dow; V. Preissig. **Comments:**
Author: "P's and Q's," "Fine Arts for Public School
Administrators." Position: art teacher, Teachers College Columbia,
for 35 years. **Sources:** WW40.

TANNAR, Harold Drake *[Painter, teacher] mid 20th c.*
Addresses: East Orange, NJ. **Member:** A. Center of the Oranges.
Exhibited: NJ State Exh., Montclair Mus., 1936 (prize).
Comments: Position: t., Adult Edu., East Orange. **Sources:**
WW40.

TANNEN *[Copperplate engraver] early 19th c.*
Comments: Work appeared in *The Pleasures of Memory and
Other Poems* (NY, 1802). G&W thought this was probably

Benjamin Tanner (see entry). **Sources:** G&W; Hamilton, *Early American Book Illustrators and Wood Engravers*, 86.

TANNER, Benjamin *[Engraver] b.1775, NYC / d.1848, Baltimore.*
Addresses: NYC until 1799, then moved to Philadelphia where he lived until shortly before his death. **Studied:** apprenticeship under Peter C. Verger. **Comments:** He was the teacher of Henry S. Tanner, his younger brother, and also established two engraving firms: Tanner, Kearney & Tiebout (see entry), banknote engravers, 1817-24, and Tanner, Vallance, Kearney & Co. (see entry), general engravers, 1818-20. In 1835 he gave up general engraving to produce check and note blanks by a process he had invented and called stereographing. He retired in 1845. **Sources:** G&W; DAB; NYCD 1794-99; Phila. CD 1800-45; Rutledge, PA; Stauffer; Dunlap, *History*, II, 47; *American Collector* (April 1942), 3; *Panorama* (Feb. 1947), cover.

TANNER, H(enry) O(ssawa) *[Painter, illustrator, educator, photographer] b.1859, Pittsburgh, PA / d.1937, Etaples, France.* *H.O. Tanner*
Addresses: Phila., PA, 1880-88; Atlanta, GA, 1888-90; Paris, France/Trepied, par Etaples, Calais, France, 1891-. **Studied:** PAFA with T. Eakins, 1880-82; Académie Julian, Paris with J.P. Laurens, Constant, Bouguereau, and Lefebvre, 1889-94. **Member:** ANA, 1909; NA, 1927 (the first Black artist to be elected); Paris SAP; American AA, Paris; American AC, Paris; American Artists Prof. League, European chapter; Societé Artistique de Picardie; Soc. International de Peinture et Sculpture. **Exhibited:** Paris Salon, 1894-99 (prize, 1896); PAFA Ann., 1880-1909 (prize 1900); Methodist Headquarters, Cincinnati, 1890; NAD, 1885-87, 1891; Earse's Galleries, Phila., 1892-93; Paris Expo, 1900 (med.); Phila. AC, 1900; Pan-Am. Expo, Buffalo, 1901 (med.); St. Louis Expo, 1904 (med.); Soc. of American Artists, 1904; CI, Ann., 1905, 1908; AIC, 1906 (prize); American Art Galleries, NYC, 1908; Corcoran Gal biennials, 1910-35 (6 times); Thurber's Gal, Chicago, 1911; Knoedler Gal, NYC, 1913; Anglo-American Art Exh., London, 1914; Pan.-Pac. Expo, San Fran., 1915 (gold); Grand Central Art Galleries, NYC, 1920-30, 1967-68; Mus. of Hist., Science & Art, Los Angeles, 1920; NY Pub. Lib., 1921; Vose Gal., Boston, 1921; Tanner Art League, 1922; Nat'l Arts Club Galleries, NYC, 1927 (bronze med.), 1967; Grand Central Gal., 1930 (prize); American Artists' Prof. League, Simonson Galleries, Paris, 1933; Century of Progress, Chicago, 1933-34; Phila. A. All., 1945; Howard Univ., 1945, 1967, 1970; Xavier Univ., 1963; UCLA Art Galleries, 1966; NY City Col.; Harlem Cultural Council; NY Urban League, 1967; Morgan State Col., Baltimore, 1967; Spelman Col., Atlanta, 1969; Smithsonian Inst., 1969-70; Univ. of Texas Art Mus., 1970; Phila. Civic Center, 1970. **Awards:** Chevalier, Legion of Honor, French Government,1923. **Work:** Musée d'Orsay and the Louvre, Paris; PMA; PAFA; MMA; CI; AIC; Wilstach Coll., Phila; Hackley A. Gal., Muskegon, Mich.; Des Moines Assn. FA; LACMA; NOMA; Fisk Univ.; Mus. African A. (lg. coll.), Fred Douglass Inst, Wash., DC; Hampton Inst., VA; High Mus., Atlanta, GA; Howard Univ.; Milwaukee Art Center; Houston Mus. of FA; NY Pub. Lib.; Atlanta Univ. Lib. **Comments:** An expatriate painter, Tanner was one of the first African-American artists to achieve international prominence when his "Rising of Lazarus" was purchased by the French government in 1897 for the Luxembourg Museum. He favored religious subjects, a reflection of his early training, for his father was a Bishop of the African Methodist Episcopal Church in Pittsburgh. As a student at PAFA, Tanner developed a close friendship with T. Eakins. Unable to develop a patronage base in Phila., Tanner moved to Atlanta in 1888 and opened a photography studio; when this failed he began teaching classes at Clark University. His paintings and sketches of local black people drew the attention of a patron, Bishop Joseph Hartzel, who purchased an entire exhibition of Tanner's work, enabling him to go Europe for further study. Tanner studied for several years at the Acad. Julian and also painted in Brittany (1894). He began focusing on religious subject matter about 1896 and soon enjoyed critical and

financial success, gaining the attention of patrons and institutions. Tanner made Paris his home for the remainder of his life, although in 1897 a Philadelphia patron, Rodman Wanamaker, sent Tanner to the Holy Land to gather material for more religious works. He later returned to Palestine and also visited Egypt and Morocco. In addition to his religious pictures, Tanner also painted genre scenes and landscapes. **Sources:** WW33; Driskell, *Hidden Heritage*, 29-30; Jennifer Harper, "The Early Religious Paintings of Henry Ossawa Tanner: A Study of the Influences of Church, Family, and Era," *American Art* (Fall 1992); Marcia Mathews, *Henry Ossawa Tanner* (1969); Baigell, *Dictionary*; Cederholm, *Afro-American Artists*; Fink, *American Art at the Nineteenth-Century Paris Salons*, 395; Falk, *Exh. Record Series*.

TANNER, Henry Schenck *[Engraver and mapmaker] b.1786, NYC / d.1858, Brooklyn.*
Addresses: Philadelphia, c.1811-50; NYC, 1850-58. **Comments:** A younger brother of Benjamin Tanner from whom he learned engraving. He did some general engraving, but was best known for his excellent work as a cartographer. His *New American Atlas*, published in five parts between 1818 and 1823, is still regarded as a model. He retired to New York in 1850. **Sources:** G&W; DAB; N.Y. *Evening Post*, May 18, 1858; Phila. CD 1811-43; Dunlap, *History* (1918).

TANNER, James L. *[Craftsman] b.1941, Jacksonville, FL.*
Addresses: Good Thunder, MN. **Studied:** Florida A&M Univ. (B.A., 1964); Aspen Sch. Contemporary Art, summer 1964; Univ. Wisconsin, Madison (M.S., 1966; M.F.A., 1967). **Member:** Nat. Council Educ. Ceramic Arts; Am. Craftsman Council; Minnesota Craftsman Council (bd. dirs., 1972-73). **Exhibited:** Young America 1969, Mus. Contemporary Crafts, 1969; Objects USA, circulated by Smithsonian Inst., 1969-70; Glass 2000 BC-1971 AD, John Michael Kohler AC, Sheboygan, WI, 1971; Reflections on Glass, Long Beach MA, 1971-72; Toledo Glass Nat., 1972. **Work:** Johnson Wax Collection, Smithsonian Inst., Wash., DC; N. Hennepin State Jr. College, Minneapolis; Mankato State College, MN. **Comments:** Preferred media: wood, glass, ceramics. **Sources:** WW73; Daniel Wilson & David Wayne, *With These Hands* (1970); Lee Nordness, *Objects USA* (1970).

TANNER, Jesse *[Engraver] early 19th c.*
Addresses: Philadelphia, 1803. **Comments:** G&W indicates this may be a printer's error for Benjamin Tanner. **Sources:** G&W; Phila. CD 1803.

TANNER, Juliet Lavinia *[Painter] b.1833 / d.1909.*
Addresses: Phila., PA. **Exhibited:** PAFA Ann., 1878-91 (7 times). **Comments:** Painted still lifes in pastel. **Sources:** Petteys, *Dictionary of Women Artists*; Falk, *Exh. Record Series*.

TANNER, W(illiam) Charles *[Portrait painter, illustrator, mural painter, draftsperson] b.1876, Canada / d.1960, Santa Monica, CA.*
Addresses: St. Charles, IL; Riverside, CA. **Studied:** AIC; with Wm. Chase, NYC; with Tarbell in Boston. **Exhibited:** Ebell Salon, Los Angeles, 1924; AIC. **Work:** Mission Inn, Riverside. **Comments:** Position: illust., David C. Cook Publications; drafts., architectural firm, 35 years. Specialty: historic scenes of early California. **Sources:** WW13; Hughes, *Artists in California*, 551.

TANNER-RATNER, F. Berthel *[Painter] mid 20th c.*
Addresses: NYC. **Studied:** ASL. **Exhibited:** S. Indp. A., 1918-19, 1927. **Sources:** Marlor, *Soc. Indp. Artists*.

TANNER, KEARNEY & TIEBOUT *[Banknote engravers] early 19th c.*
Addresses: Philadelphia, 1817-24. **Comments:** Partners were Benjamin and Henry S. Tanner, Francis Kearney, and Cornelius Tiebout (see entries on each). **Sources:** G&W; Phila. CD 1817-20; DAB, under Benjamin Tanner.

TANNER, VALLANCE, KEARNEY & COMPANY *[General engravers] early 19th c.*
Addresses: Philadelphia, 1817-19. **Comments:** Members were Benjamin and Henry S. Tanner, John Vallance, and Francis

Kearney (see entries). Vallance apparently dropped out about 1819 and the firm was listed the following year as Tanner, Kearny & Co. **Sources:** G&W; Phila. CD 1818-19; Brown and Brown; DAB, under Benjamin Tanner.

TANNHAUSER, Siegfried *[Painter] mid 20th c.*
Exhibited: S. Indp. A., 1938. **Sources:** Marlor, *Soc. Indp. Artists.*

TANNING, Dorothea (Mrs. Max Ernst) *[Painter, sculptor]*
b.1910, Galesburg, IL.
Addresses: NYC, 1930s-46; Sedona, AZ, 1946-53; Paris, France (since 1950s). **Studied:** Knox Coll., Galesburg, IL; AIC, 1933. **Exhibited:** J. Levy Gal., NYC, 1942; "31 Women," Art of this Century Gal., NYC, 1943; PAFA Ann., 1946; AIC; C. Valentine Gal., NYC; Buchholtz Gal., NYC; S. Indp. A.; Centre National d'Art Contemporain, Paris, 1974 (retrospective). **Work:** AIC; MoMA. **Comments:** Surrealist artist. She began painting in a Surrealist mode in 1936, after viewing the exh. "Fantastic Art, Dada and Surrealism" at the Museum of Modern Art. Tanning's Surrealism took the form of a meticulous realism in which she depicted the psychological fears and joys of childhood and womanhood. Tanning continued to treat these themes throughout her career and they can be seen in her sculpture of the 1970s. She married Max Ernst in 1946, after which they painted in Sedona, Arizona, 1946-53, before settling permanently in Paris. **Sources:** Wechsler, 24-25; Baigell, *Dictionary;* Trenton, ed. *Independent Spirits,* 130-32, 150-51; Rubinstein, *American Women Artists,* 293-95; Alain Bosquet, *La Peinture de Dorothea Tanning* (Paris, 1966); Falk, *Exh. Record Series* (Note: Rubinstein and Trenton cite birth date as 1910, in contrast to Wechsler and Baigell who cite 1913).

TANSSEN, T. *[Painter] mid 19th c.*
Work: 1831 view of Baltimore, owned by the Enoch Pratt Free Library of Baltimore. The painting was bought in Australia. **Sources:** G&W; Pleasants, *250 Years of Painting in Maryland,* 50-51.

TANTURIER *[Miniaturist] late 18th c.*
Addresses: From Paris; Philadelphia in 1794. **Sources:** G&W; Prime, II, 35.

TAPLEY, J. J. Wooding *[Painter] 20th c.*
Addresses: Belfast, ME. **Sources:** WW15.

TAPP, Marjorie Dodge *[Painter] 20th c.*
Addresses: Shawnee, OK. **Member:** Oklahoma AA. **Sources:** WW27.

TAPPAN, Augusta T. *[Painter] 19th/20th c.*
Addresses: Wash., DC. **Studied:** ASL of Washington. **Exhibited:** Boston AC, 1891, 1893; PAFA Ann., 1893; ASL at the Cosmos Club, 1902. **Sources:** McMahan, *Artists of Washington, DC;* Falk, *Exh. Record Series.*

TAPPAN, Ebenezer *[Engraver] b.1815, Manchester, MA / d.1854.*
Addresses: Boston, 1838-54. **Comments:** With the Boston Bank Note Company (see entry), 1841-42, and Tappan & Bradford (see entry), 1849-54. He was a brother of George H. and William H. Tappan (see entries). **Sources:** G&W; Tappan, *Tappan-Toppan Genealogy,* 49; Boston CD 1838-54.

TAPPAN, George Hooper *[Engraver] b.1833, Manchester, MA / d.1865.*
Addresses: Boston, 1855-65. **Comments:** With Smith & Knight (see entry), 1857-59. Ebenezer and William H. Tappan were his brothers (see entries). **Sources:** G&W; Tappan, *Tappan-Toppan Genealogy,* 49; Boston CD 1855-59.

TAPPAN, Roger *[Painter] 19th/20th c.*
Addresses: Boston, MA. **Member:** B. A. Students' Assn., 1898; Boston AC. **Exhibited:** Boston AC, 1892-1900; PAFA Ann., 1898-99. **Sources:** WW98; Falk, *Exh. Record Series.*

TAPPAN, William Henry *[Topographical artist and engraver, author] b.1821, Manchester, MA / d.1907, Manchester.*
Addresses: Boston, early 1840's; traveled West, settled in Clark County, WA, c.1854; Manchester, MA, 1876-1907. **Work:** Wisconsin Hist. Soc. (50 drawings from trip to Lake Superior & Oregon,1848-49). **Comments:** He went to Lake Superior in 1848 as a member of Louis Agassiz's expedition and the following year traveled to Oregon. In 1854 he served on the first Territorial Council. During the 1880s, he served in the Massachusetts Legislature and the Senate, and authored a book on the history of Manchester. His brothers George H. Tappan and Ebenezer Tappan were artists (see entries). **Sources:** G&W; Tappan, *Tappan-Toppan Genealogy,* 49-50; Settle, *The March of the Mounted Riflemen,* foreword; Boston BD 1844-47; Rasmussen, "Artists of the Explorations Overland, 1840-1860," 61.

TAPPAN & BRADFORD *[Engravers and lithographers] mid 19th c.*
Addresses: Boston, 1849-54. **Work:** Boston Athen. **Comments:** Partners were Ebenezer Tappan and Lodowick Bradford (see entries). They employed a number of artists to draw for them, including Gustavus Pfau, Samuel Worcester Rouse, and Benjamin Smith. The firm produced high quality prints, among them "View of the Water Celebration, on Boston Common, October 25, 1848" (Boston Ath.). Many of the firm's prints are unsigned, but there has been speculation that Bradford himself may have been the anonymous house artist. **Sources:** G&W; Boston CD 1849-54; Pierce & Slautterback, 155.

TAPPE, Herman Patrick *[Painter] b.1876 / d.1954, NYC.*
Addresses: NYC. **Exhibited:** S. Indp. A., 1917. **Sources:** Marlor, *Soc. Indp. Artists.*

TARBELL, Edmund C(harles) *[Painter, teacher] b.1862, West Groton, MA / d.1938.* *[signature: Edmund C. Tarbell]*
Addresses: Boston, 1889-90; Dorchester, MA, 1891; Boston, 1893-1913, Wash, DC, 1917-22; Boston/New Castle, NH. **Studied:** apprenticed to a lithographer at age 15; Boston Normal A. Sch.; BMFA Sch., with O. Grundmann, 1879; Académie Julian, Paris with Boulanger and Lefebvre, 1884-86; W.T. Dannat in Paris, c.1886-88. **Member:** ANA, 1904, NA, 1906; Boston GA; Ten Am. Painters; U.S. Public A. Lg., 1896; National A. Comm., Wash., DC. **Exhibited:** Paris Salon, 1886; Boston AC, 1887-1909; NAD (prizes, 1890, 1894; medals, 1908, 1929); PAFA Ann., 1892-1913, 1920-38 (gold 1895 & 1911); St. Botolph Cl., Boston (including 1898 solo); World's Columbian Expo., Chicago, 1893; AC Phila., 1895 (gold); SAA, 1893 (prize); Tenn. Expo., Nashville, 1897 (prize); with Ten American Painters, 1898-1919; WMA, 1900 (prize), 1904 (prize); Boston Charitable Mechanics' Assn. (med.); Paris Expo, 1900 (med.); CI, 1901 (prize), 1904 (prize), 1909 (prize), 1928-29 (prize); AIC, 1907 (prize); Corcoran Gal biennials, 1907-37 (14 times; incl. gold medal, 1910); P.-P. Expo, San Fran., 1915 (prize); Newport AA, 1935 (prize); mem. exh., BMFA, 1938. **Work:** CGA; Cincinnati AM; RISD; BMFA; WMA; PAFA; Wilstach Coll., Phila.; NMAA; MMA; Worcester Art Mus.; Canajoharie (NY) Lib. and Art Gal.; FA Acad., Buffalo; NPG, Wash.; War Dept., Wash., DC; Butler AI; Mass. Senate Chamber, State House, Boston; Worcester Art Mus.; Smith Col. **Comments:** Tarbell began formal art studies with Grundmann at the BMFA, where he met and became friends with Frank Benson (see entry). Tarbell was considered the leader of the Boston Impressionists, and his numerous devout students were called "Tarbellites." His Impressionist works were primarily built around figures of women, shown in brilliantly, colorful outdoor scenes. Around 1900 he began focusing on interior scenes, usually showing young women reading, sewing, or in conversaton; these, in the handling of light and color recall Vermeer. Tarbell insisted on the importance of technique and his well-crafted portraits came into high demand in Wash., DC, where he painted Presidents Wilson and Hoover, among others (in 1919 he was chosen by the National Committee to create a pictorial record of Allied leasders of WWI). Teaching: BMFA Sch. (1889-1912), Corcoran Sch. A. (1917-22). **Sources:** WW38; Baigell, *Dictionary; 300 Years of American Art,* 570; Gerdts, *American Impressionism,* 114-18, 201-03, 315 (note 14); Patricia Jobe Pierce, *Edmund C. Tarbell and*

the *Boston School of Painting 1889-1980* (Hingham, Mass., 1980); Falk, *Exh. Record Series.*

TARBELL, Edmund N. *[Wood engraver] b.c.1831, New York.*
Addresses: NYC in 1854; Boston, 1857-60. **Comments:** In 1860 he was a boarder in the house of Hammatt Billings (see entry). **Sources:** G&W; 8 Census (1860), Mass., XXVIII, 645; NYBD 1854; Boston BD 1857-60.

TARBELL, Fanny *[Painter] late 19th c.*
Studied: William Merritt Chase. **Comments:** Specialized in floral subjects while living in Denver, Colo., during the late 19th century. Some of her works were reproduced as chromolithographs by Louis Prang. Tarbell later took up portraiture after studying with Wm. M. Chase. **Sources:** Gerdts, *Art Across America*, vol. 3: 120.

TARBELL, Virginia *[Painter] late 19th c.*
Addresses: NYC, 1888. **Exhibited:** NAD, 1888. **Sources:** Naylor, *NAD.*

TARBUCK, Raymond Dumville *[Painter] b.1897, Pennsylvania / d.1986, San Diego, CA.*
Addresses: San Diego, CA. **Comments:** Specialty: watercolors of San Diego County. **Sources:** Hughes, *Artists in California*, 551.

TARK, Henry P. *[Painter] mid 20th c.*
Exhibited: Salons of Am., 1935; S. Indp. A., 1935-37, 1940. **Sources:** Marlor, *Salons of Am.*

TARKINGTON, Booth *[Illustrator, writer] b.1869, Indiana / d.1946.*
Addresses: Richmond, IN. **Studied:** Princeton, 1893.
Comments: An illustrator, although best known for his many novels, including "The Gentleman from Indiana," 1899; "The Two Vanrevels," 1902; "Alice Adams," and many others, including one on collecting art. **Sources:** WW08.

TARLETON, Mary Lightfoot See: **KNOLLENBERG, Mary Tarleton (Mrs Bernard)**

TARLETON, Mary Livingston *[Landscape & miniature painter] mid 20th c.; b.Stamford, CT.*
Addresses: Great Neck, NY, c.1913-33. **Studied:** C. Hassam; C.W. Hawthorne; W.M. Chase; ASL. **Member:** NAWPS. **Sources:** WW31.

TARNOPOL, Gregoire *[Painter, collector] b.1891, Odessa, Russia / d.1979.*
Addresses: NYC. **Studied:** Acad. Art, Munich; Acad. Art, Saint Petersburg; Acad. Art, Copenhagen. **Exhibited:** Barzansky Gal., NYC, 1941. **Comments:** Preferred media: gouache. Collection: French modern; from Delacroix to Picasso. **Sources:** WW73.

TARR, A. R. *[Painter] 20th c.*
Addresses: Phila. PA. **Sources:** WW06.

TARR, William *[Sculptor] b.1925, NYC.*
Addresses: NYC. **Exhibited:** Sculpture Ann., WMAA, four, from 1962-68; Am. Sculpture Show, Flint Inst. Fine Arts, 1965. **Awards:** Purchase award, Ford Found., 1962; cert. merit, Munic. Art Soc., 1968. **Work:** WMAA; AIC. Commissions: Morningside Heights (welded steel), 1968 & Martin Luther King, Jr. Mem. (welded steel), 1972, Bd. Educ., New York; concrete sculpture, Buchanan Sch., Wash., DC, 1969. **Comments:** Preferred media: steel. **Sources:** WW73.

TARRELL, Charles J. *[Painter] late 19th c.*
Exhibited: NAD, 1868. **Sources:** Naylor, *NAD.*

TARRISSE, Annie V. *[Listed as "artist"] late 19th c.; b.Baltimore, MD.*
Addresses: Wash., DC, active, 1890. **Comments:** Daughter of John Tarrisse (see entry). **Sources:** McMahan, *Artists of Washington, DC.*

TARRISSE, John *[Listed as "artist"] b.France / d.Before 1890.*
Addresses: Wash., DC, active 1872. **Comments:** Father of Annie and John E. Tarrisse (see entries). **Sources:** McMahan, *Artists of Washington, DC.*

TARRISSE, John E. *[Listed as "artist"] 19th/20th c.; b.Wash., DC.*
Addresses: Wash., DC, active 1890. **Comments:** Son of John and brother of Annie Tarrisse (see entries). **Sources:** McMahan, *Artists of Washington, DC.*

TARTAKOFF, Boris *[Painter] early 20th c.*
Addresses: NYC. **Exhibited:** S. Indp. A., 1917. **Sources:** Marlor, *Soc. Indp. Artists.*

TARTOUE, Pierre *[Painter] early 20th c.*
Addresses: NYC. **Exhibited:** S. Indp. A., 1922. **Sources:** Marlor, *Soc. Indp. Artists.*

TAS, Jeanne *[Painter] mid 20th c.*
Addresses: NYC. **Exhibited:** S. Indp. A., 1933-34. **Sources:** Marlor, *Soc. Indp. Artists.*

TASAKOS, Elsie M. Norden (Mrs. Eyerdam) *[Painter, teacher] b.1889, Willamina, OR.*
Addresses: Seattle, WA, 1941. **Studied:** Univ. of Wash.; Otis Art Inst., Los Angeles. **Exhibited:** Pacific Northwest Artists Annual Exh., 1924. **Sources:** Trip and Cook, *Washington State Art and Artists.*

TASCA, Fausto *[Portrait and mural painter] b.1885, San Zenone, Italy / d.1937, Los Angeles, CA.*
Addresses: Los Angeles, CA. **Work:** murals: Citizen Trust & Savings Bank, Los Angeles; Church of St. Mary of the Rosary, Los Angeles; Church of the Fisherman, San Diego. **Comments:** Immigrated to America in 1913. **Sources:** Hughes, *Artists in California*, 551.

TASCONA, Antonio Tony *[Painter, sculptor] b.1926, St. Boniface, Canada.*
Addresses: Winnipeg, Canada. **Studied:** Winnipeg Sch. Art (dipl.); Univ. Man. Sch. Fine Arts. **Member:** Winnipeg A. Gal.; Can. Artists Representation; assoc. Royal Can. Acad. Arts. **Exhibited:** Walker Art Ctr. Biennial, Minneapolis, 1958, Expos Concours Artistiques, Montreal Beaux Arts, 1963 & Quebec Mus., 1964; Can. Prints & Drawings, Cardiff Commonwealth Arts Festival, Wales, 1965; Nat. Gal. Can. Traveling Exhib. Australia, 1967; Nat. Gal. Can. Biennial, Ottawa, 1968. **Awards:** Purchase awards, Western Ont. Ann., 1965 & 1966; Arts Medal Awards, Royal Archit. Inst. Can., Ottawa, 1970; Can. Coun. Arts Award fel., 1972. **Work:** Winnipeg A. Gal., Man.; Confederation A. Gal. & Mus. Charlottetown, PEI; A. Gal. Ont., Toronto; Nat. Gal. Can., Ottawa; Can. Coun. Coll., Ottawa. Commissions: aluminum bas relief, Man. Centennial Art Ctr., 1967-68; lacquer painting on aluminum, Winnipeg YWCA, 1968; sculpture, Fletcher Argue Bldg., Univ. Man., 1969; epoxy resin disks in steel rings, Fed. Dept. Pub. Works for Freshwater Inst., Univ. Man., 1972. **Sources:** WW73; Rene Ostiguey, "Western Canadian art," *Vie Arts Montreal* (1966); Anita Aarons, *Royal Inst. Can.* (1970); P. Fry, "Tony Tascona," *Arts Can. Mag.* (1972).

TASEV, Atanas *[Painter] b.1897, Sofia, Bulgaria.*
Addresses: Wash., DC. **Studied:** A. Acad., Prague, and in Sofia, Bulgaria. **Exhibited:** Czechoslovakia and Bulgaria, 1920 and after; United Nations Club, Wash., DC (solo); CGA, 1949; George Washington Univ., 1950. **Work:** Nat. Mus., Sofia; Dept. Edu., Prague; PMG; Phillips Coll.; numerous priv. colls. oin Europe. **Comments:** Specialty: primarily portraits, also landscapes and city views. **Sources:** WW59; McMahan, *Artists of Washington, DC.*

TASKER, Stanley *[Painter] mid 20th c.*
Addresses: Winter Pk., FL. **Exhibited:** PAFA Ann., 1954. **Sources:** Falk, *Exh. Record Series.*

TASKEY, Harry LeRoy *[Painter, etcher, lithographer, illustrator, block printer, teacher] b.1892, Rockford, IN / d.1958, Flemington, NJ.*

Addresses: NYC; Milford, NJ. **Studied:** ASL; Grande Chaumière, Paris; Hiram (Ohio) Col.; Sloan; Henri; Bridgman; Von Schlegell; H. Lever; H. Boss; B. Robinson; H. Sternberg. **Member:** Am. Veterans Soc. A.; Audubon A.; Phila. SE; Ind. Soc. PM. **Exhibited:** S. Indp. A., 1930-31; BM, 1931, 1935; AIC, 1931, 1935; Phila. A. All., 1932; LOC, 1932; Am. Pr.M., 1932; PAFA Ann., 1932; Syracuse Mus. FA, 1934; CGA, 1934; NAD, 1935; Tex. Centenn. Expo, 1936; WMAA, 1938; Am Veterans Soc. A., 1945; CM; SAGA, 1949-51. **Work:** MMA; NYPL; Syracuse Mus. FA; Montgomery Mus. FA; Mus. City of NY; John Herron AI; Wilmington Soc. FA; New Britain A. Mus. **Sources:** WW59; WW47; Falk, *Exh. Record Series.*

TASSENCOURT, Beatrice Edwards *[Painter] early 20th c.*
Addresses: Chicago. **Exhibited:** AIC, 1919. **Sources:** Falk, *AIC.*

TATE, Claire (Miss) *[Painter] mid 20th c.*
Addresses: NYC. **Exhibited:** S. Indp. A., 1924. **Sources:** Marlor, *Soc. Indp. Artists.*

TATE, James R. *[Painter] mid 20th c.; b.Buxton, England.*
Addresses: Rockport, MA/Toronto, Canada. **Studied:** Ontario Col. of Art; with P.C. Sheppard, R.C.A., Archibald Barnes, R.C.A., Emile Gruppe. **Member:** Arts & Letters Club, Toronto; N.S.A.A.; R.A.A.; Rockport AA. **Work:** Queens Univ., Kingston, Ontario. **Comments:** Specialty: portraits. **Sources:** *Artists of the Rockport Art Association* (1956).

TATE, Mary Lee *[Painter] mid 20th c.; b.Kentucky.*
Studied: Univ. of Cincinnati (B.A.); Cincinnati Art Academy; Univ. of Chicago. **Exhibited:** NY Pub. Lib., 1921; Smithsonian Inst., 1930; Harmon Fnd., 1928-31. **Sources:** Cederholm, *Afro-American Artists.*

TATE, Sally *[Portrait painter, illustrator, lecturer] b.1908, Sewickley, PA.*
Addresses: Westport, CT. **Studied:** Vesper George Sch. A.; Parsons Sch. Des.; & with Bernard Keyes, Heinrich Moore, Jose Pillon. **Member:** Pen & Brush Cl. **Exhibited:** children's illus., Springfield Lib.; Lucien Labault Gal., San F. **Comments:** Author, I., "The Furry Bear"; "The Wooly Lamb"; & other children's stories; I., textbooks. Lectures: Children's Illustrations. **Sources:** WW59; WW47.

TATLOCK, Anne Fisher *[Sculptor, portrait painter] b.1916, Petersham, MA.*
Addresses: Boston, MA. **Studied:** A. Iacovleff; J. Sharman; BMFA Sch. **Exhibited:** Assn. Jr. Lgs. Am. Exhib., 1939 (prize). **Sources:** WW40.

TATMAN, Virginia Downing *[Craftsman, painter] b.1917, Kenosha, WI.*
Addresses: Kenosha, WI. **Studied:** Univ. Wis.-Milwaukee. **Member:** Wis. Designer-Craftsmen; Greater Kenosha Art Coun. (v. pres.). **Exhibited:** Wis. State Fair; Wis. Designer-Craftsmen Ann.; Milwaukee Art Ctr. Ann. Summer Fair; Kenosha Pub. Mus. (solo). **Awards:** prizes, Winter Art Fair, Kenosha, 1969, Kenosha Art Assn., 1969 & Kenosha Art Fair, 1972. **Comments:** Positions: former cur., Kenosha Pub. Mus. Teaching: instr. art, Kenosha Tech. Inst.; instr., State Wis. DVR. **Sources:** WW73.

TATNALL, Henry Lea *[Landscape and marine painter] b.1829, Brandywine Village, DE / d.1885, Wilmington, DE.*
Addresses: Wilmington, DE, 1856-. **Member:** Delaware Artists' Association (first president). **Exhibited:** PAFA Ann., 1883. **Comments:** At first a farmer and lumber merchant, he moved to Wilmington in 1856 and soon after opened a studio there, where he painted marines and landscapes which met with great popular success. Tatnall was called the father of Delaware art. **Sources:** G&W; CAB; Falk, *Exh. Record Series.*

TATORE, Frank *[Sculptor, medalist] b.1907 / d.1990.*
Sources: info courtesy D.W. Johnson, *Dictionary of American Medalists* (pub. due 2000).

TATRO, Amy *[Mural painter, decorator, teacher] b.1906, Hartford.*

Addresses: Hartford, CT. **Studied:** Yale, with E.C. Taylor, E. Savage; M. Kantor; ASL. **Comments:** Position: t., MacMurray Col., Jacksonville, Ill. **Sources:** WW40.

TATSCHL, John *[Craftsman, sculptor] b.1906, Vienna, Austria.*
Addresses: Albuquerque, NM. **Studied:** Teachers Col., Vienna; Acad. Appl. Art & Acad. Fine Arts, Master Sch. Sculpture, Vienna. **Exhibited:** Southwest Exhibits regularly, 1946-56. **Awards:** purchase awards, Roswell Mus. & Mus. N. Mex.; Univ. N. Mex. res. grants, 1950 & 1953; Am. Inst. Architects Award for art in archit., 1963. **Work:** Mus. N. Mex., Santa Fe. **Commissions:** mural, US Post Off., Vivian, La.; ten stained glass windows, St. Michael Church, Albuquerque; stained glass windows, Am. Bank Commerce, Albuquerque; stained glass for churches, Las Cruces, Los Alamos & Albuquerque, N. Mex.; fountain, Roswell Mus. **Comments:** Preferred media: wood, glass, bronze. Teaching: asst. prof., Park Col., 1943-46; prof. art, Univ. N. Mex., 1946-. **Sources:** WW73.

TATSUDO, Ido *[Painter] mid 20th c.*
Exhibited: AIC, 1931. **Sources:** Falk, *AIC.*

TATTERSALL, George *[Draftsman, watercolorist, landscape and animal painter, architect, writer and illustrator] b.1817, Hyde Park Corner, London (England) / d.1849, London (England).*
Comments: He was a son of the founder of Tattersall's, London's famous horse-auction house. At the age of 18 he illustrated a guide to the English Lakes. In 1836 he visited America and filled a portfolio with watercolor sketches of American scenes; this portfolio was owned by the Old Print Shop in 1948. Under the pen-name, "Wildrake," he subsequently became a well-known writer and illustrator of books on sporting architecture, horses, and hunting. **Sources:** G&W; DNB; G&W acquired information courtesy Old Print Shop.

TATTI, Benedict Michael *[Sculptor, painter, teacher] b.1917, NYC.*
Addresses: NYC. **Studied:** ASL; Masters Inst. Roerich Mus., with L. Slobodkin; Da Vinci Art Sch., with A. Piccirilli; State Univ. NY; ASL, with William Zorach & O.Zadkine; Hans Hofmann Sch. Art, with Hans Hofmann. **Member:** Brooklyn SA.; Am. Soc. Contemp. Artists; Sculptors League, NYC; P&S Soc. NJ (v. pres., early 1970s). **Exhibited:** Brooklyn SA, 1943-44 (prize), 1945-46; Soldier A. Exh., NGA, 1945 (prize); MMA (AV), 1942; Tribune A. Gal., 1946 (solo); PAFA Ann., 1950, 1954; MoMA, 1960; Claude Bernard Gal., Paris, France, 1960; Roko Gal., New York, 1967; Alexander Gallery, NYC, 1970s. **Awards:** Artist-in-residence, Nat. Ctr. Experiments TV, San Francisco, Calif., 1969; grant, creative arts prog., NY State Coun. Arts, 1972; medal of hon. for sculpture, P&S Soc. NJ, 1972. **Work:** Harper's Row, Mr. & Mrs. Cass Canfield, NYC; Mr. & Mrs. Zero Mostel, NYC; Dr. Maurice Hexter, Fedn. Jewish Philanthropies, NYC; Boccour Paints, Mr. & Mrs. Sam Golden, NJ; Lasdon Found.; Mr. & Mrs. Lloyd Lasdon, NYC. **Commissions:** sundial, RW Bliss for Dumbarton Oaks, Wash., DC, 1952; bison, E. Taylor for Tokyo Park, Japan, 1960; D'Aragon Mem., A D'Aragon, Hartsdale, NY, 1969; medallions of D. Sarnoff, D. Eisenhower & Mark Twain, Newell & Lennon, New York. **Comments:** Positions: consult. restoration, Alexander Sculpture Studio, 1946-72; sculptor-designer, Loewy-Smith Assocs., 1952-65. Teaching: instr. sculpture & hd. dept., HS Art & Design, 1965-; instr. sculpture, Craft Stud. League, 1966-67. **Sources:** WW73; WW47; Falk, *Exh. Record Series.*

TATUM, Arminta J. (Mrs. Andrew) *[Painter, china painter, teacher] b.1881 / d.1961, Tacoma, WA.*
Addresses: Tacoma, WA. **Exhibited:** Tacoma Civic Arts Assoc., 1932. **Sources:** Trip and Cook, *Washington State Art and Artists.*

TATUM, Claibourne Randolph *[Painter] mid 20th c.*
Addresses: San Francisco, CA. **Member:** San Francisco AA. **Comments:** Member of Frank Van Sloun's (see entry) painting crew for murals in the rotunda of the Palace of FA, 1936.

Sources: Hughes, *Artists in California,* 551.

TATUM, V(ictor) Holt *[Block printer] b.1894, Cincinnati.*
Addresses: Cincinnati, OH. **Studied:** C.W. Boebinger. **Sources:** WW32.

TAUBE, Walter *[Painter] 20th c.*
Addresses: Minneapolis, MN. **Sources:** WW24.

TAUBER, James *[Designer] b.1876 / d.1912.*
Addresses: NYC. **Comments:** Designer: floats for the Hudson-Fulton celebration; original scenery for the Hippodrome pageant.

TAUBES, Frederic K. *[Painter, writer, educator, teacher, lecturer, lithographer] b.1900, Lwow, Poland (or Lemberg, Aus.) / d.1981, Haverstraw, NY.*
Addresses: Haverstraw, NY. **Studied:** Munich Art Acad., with F. von Stuck & M. Doerner; Bauhaus, Weimar, with J. Itten; Acad. Vienna; schools in Florence and Paris. **Member:** fel., Royal Soc. Arts; fel., Int. Soc. Arts & Lett. **Exhibited:** CI, 1936-46; Corcoran Gal biennials, 1939-57 (9 times); PAFA Ann., 1937-44, 1949-51, 1958-60; VMFA, 1938-46; AIC, 1935-46. Many solo exhibs in mus & galleries in USA. **Awards:** Col. in State N. Mex.; hon. citizen of San Antonio, Tex.; hon. citation, New Iberia. **Work:** MMA; SFMA; De Young Mem. Mus., San Francisco; San Diego Mus. of Art.; High Mus. A.; Santa Barbara Mus. A.; Mills Col. Collection, Oakland; A. Assn., Bloomington, IL; William Rockhill Nelson Gal., Kansas City. **Comments:** After settling in the U.S. in 1930, Taube established a reputation as a society portraitist, while also producing figurative works throughout his long career. He was a dedicated student of old master and modern painting techniqes and wrote articles and books on the subject. Research: Formulator of Taubes Varnishes & Copal Painting Media. Teaching: Mills Col., 1938; Univ. Hawaii, 1939; Carnegie vis. prof. art, Univ. Ill., 1940-41; vis. prof. art, Univ. Wis., 1945; Univ. Okla., Colo. State Col.; States Teachers Col., Lansing, Mich.; NY Univ.; CUASch., 1943; lectr. art, Royal Col. Art, Royal Soc. Art, Slade Sch., London Univ., John Ruskin Sch. Art, Oxford Univ., Edinborough Col. Art, Camberwell Sch. Art & Crafts. Publishing positions: contrib. ed., Taubes Page, *Am. Artist Mag.,* 1943-59; American ed., *The Artist Mag.* with the Taubes Page as ed. feature, in 1973; contribr., Encycl. Britannica: Yearbooks Grolier Encycl & others. Author: *The Technique of Oil Painting,* 1941; *The Mastery of Oil Painting* (on Flemish techniques); *You Don't Know What You Like,* 1942. **Sources:** WW73; WW47; *300 Years of American Art,* 892; Falk, *Exh. Record Series.*

TAUBES, Minna See: **HARKAVY, Minna R(othenberg)**

TAUCH, Edgar Henry *[Sculptor, painter] b.1900, Texas / d.1967, San Francisco, CA.*
Addresses: San Francisco, CA. **Exhibited:** San Francisco AA, 1924, 1925. **Sources:** Hughes, *Artists of California,* 551.

TAUCH, Waldine Amanda *[Sculptor, collector, painter, teacher] b.1892, Schulenburg, TX / d.1986.*
Addresses: San Antonio, TX. **Studied:** Pompeo Coppini in NYC and Chicago. **Member:** NAWA; SSAL; NAWPS; Soc. Western Sculptors; Coppini Acad. FA (sponsor, 1957-, pres. emer., 1960-); NSS (fellow); Am. Acad. Arts & Letters; Panhandle Plains Hist. Soc & Mus. (director arts, 1972-73); AAPL (fellow). **Exhibited:** S. Indp. A., 1927; NSS Traveling Show, 1931; Women Painters & Sculptors, NYC, 1932; Coppini Acad. FA, 1954-; SFMA; Witte Mem. Mus.; NAD; NAWA. **Work:** Witte Mem. Mus., San Antonio, TX; mon., City Hall Square, San Antonio; Canton, TX; Panhandle Plains Hist Mus, Campos, TX; Gonzales, TX; Wesleyan Mus., GA; Richmond, KY.; mem., Winchester, KY; George Washington Jr. H.S., Mount Vernon. Commissions: heroic monument to Bedford, IN, State IN, 1922; The Doughboy Statue, Am. Legion, Austin, TX, 1931; Moses Austin Monument, State TX, 1941; Higher Education, commissioned by Mr. & Mrs. Andrew Casoles for Trinity Univ., TX, 1968; Gen. Douglas MacArthur, Howard Payne College, Brownwood, TX, 1969. **Comments:** Collections: Paintings by Van Driest, Rolla Taylor,

Harold Roney & Frank Garvari. Positions: teacher, Trinity Univ. (San Antonio), Acad. Art (San Antonio). **Sources:** WW73; WW47; Shaffer, "Making the Texas Ranger of to-day," *San Antonio Express* (1961); John Field, *Unveiling of Gen Douglas MacArthur;* Petteys, *Dictionary of Women Artists,* reports birth date of 1894.

TAULBEE, Dan J. *[Painter, art dealer] b.1924, Charlo, MT.*
Addresses: Butte, MT. **Studied:** pvt. instructors. **Member:** Grand Cent. Watercolorists Soc. **Exhibited:** Farnsworth Mus. Show; Peabody Mus. Show; NAD; Burr's Int. Show; Grand Central Galleries, NYC, 1970s; La Galleria, La Jolla, CA, 1970s. Awards: gold medal, Burr Gallery. **Work:** Farnsworth Mus., Maine; Peabody Mus., Cambridge, Mass.; Plains Indian Mus., Browning, Mont.; CM Russell Mus., Helena, Mont.; Southern Plains Mus., Anadarko, Okla. **Comments:** Preferred media: oils, watercolors. Positions: owner, Heritage Am. Art Gal., Butte, Mont. Specialty of gallery: historical Indian art & Western Americana. Art interests: pictorial history of the Plains Indian. **Sources:** WW73.

TAUSEND, Henry C. *[Painter] 20th c.*
Addresses: Niles, MI. **Sources:** WW15.

TAUSEND, Henry E. *[Painter] mid 20th c.*
Addresses: Norwood, OH. **Exhibited:** Salons of Am., 1923-25. **Sources:** WW13.

TAUSS, Herbert *[Illustrator] b.1929, NYC.*
Addresses: NYC. **Studied:** High Sch. of Indust. Arts, NYC. **Exhibited:** numerous awards, medals, SI, Art Dir. Club, NYC, *Communication Arts* magazine. **Comments:** He did his first illustrations in 1949 for *Pageant* magazine and subsequently counted many national publications as his clients. He also painted numerous paperback novel covers, including the *Kent Chronicles,* and books for "The Franklin Library." **Sources:** W & R Reed, *The Illustrator in America,* 307.

TAUSSIG, Bertha Henicke *[Painter, engraver] b.1868, NYC / d.1907, San Francisco, CA.*
Addresses: San Francisco, CA. **Exhibited:** San Francisco Sketch Club, 1894-98. **Sources:** Hughes, *Artists in California,* 551.

TAUSZKY, D(avid) Anthony *[Portrait painter] b.1878, Cincinnati, OH / d.1972, Pasadena, CA.*
Addresses: NYC; Altadena, CA. **Studied:** ASL, with Blum; Académie Julian, Paris with J.P. Laurens and Constant, 1899. **Member:** SC, 1907; CAFA; Allied AA; Laguna Beach AA; P&S of Los Angeles; Southern Calif. PS; Pasadena SA; Grand Central AG. **Exhibited:** PAFA Ann., 1912; Southby and Stendhal Galleries, Los Angeles; Grand Central Galleries, NY; S. Indp. A., 1918; Pasadena AI, 1928 (prize); AIC, 1928; Santa Ana, 1928 (prize); Allied AA, 1929 (prize); SC, 1929 (prize); CAFA, 1931 (prize); Salons of Am., 1934; Civic Art Exh., Pasadena, 1937 (prize). **Work:** Criminal Court, Vienna; portraits, Wingate Sch., Haaren H.S., both in NYC; Denver AM; Mutual Fire Insurance Bldg., Hartford, Conn. **Sources:** WW40; Falk, *Exh. Record Series.*

TAUTAKAWA, Edward *[Landscape painter] mid 20th c.*
Addresses: Spokane, WA, 1950. **Exhibited:** Wash. Art Assoc. **Sources:** Trip and Cook, *Washington State Art and Artists.*

TAUZIN, Theophile E. *[Painter] 19th/20th c.; b.Natchitoches Parish, LA.*
Addresses: New Orleans, active 1898-1902. **Studied:** Lassassaign, Natchitoches; Dallas, TX. **Exhibited:** Dallas Fair (first prize). **Sources:** *Encyclopaedia of New Orleans Artists,* 371.

TAVENIER, Jules See: **TAVERNIER, Jules**

TAVERNIER, Jules *[Painter, illustrator] b.1844, Paris / d.1889, Honolulu (alcoholism).*
Addresses: NYC; San Francisco, CA; Monterey, CA; Honolulu, Hawaii. **Studied:** École des Beaux-Arts, Paris, with F. Barries, 1861. **Member:** San Francisco AA

(vice-pres.); Palette Club (a founder); Bohemian Club, San Francisco, 1874 (a founder). **Exhibited:** Paris Salon, 1865-70; NAD, 1877; New Orleans World's Fair, 1885; Mechanics' Inst. Fair, 1877 (medal); 1885; Calif. Midwinter Expo, 1894; Hawaiian Hotel, Honolulu, 1885, (two-person exhib., with Joseph Strong: views of Hawaiian volcanoes and landscapes); Honolulu Art Soc., 1920. **Work:** Oakland Mus.; Bancroft Lib., UC Berkeley; Calif. Hist. Soc.; Denver Pub. Libr.; Honolulu Academy of FA; Gilcrease Inst.; Harrison Mem. Library, Carmel; Kansas State Hist. Soc.; Monterey Peninsula Mus. of Art; Wichita Pub. Libr.; Yosemite National Park Mus.; Bohemian Club; Olympic Cl., San Francisco; de Young Mus.; Shasta State Hist. Monument; Beaverbrook Art Gal., New Brunswick, Canada; Volcano National Park, Hawaii; Soc. of Calif. Pioneers. **Comments:** Fought in the Franco-Prussian War; left for London, 1871 and worked there as an illustrator. Came to NYC in 1872. Illustrator: *New York Graphic, Harper's.* Teamed with P. Frenzeny on Western sketching tour for *Harper's;* settled in San Francisco, 1874-84. Perhaps San Francisco's most popular "bohemian;" constant debts forced him to leave for Hawaii. Considered to be one of the three "old masters" of Hawaii known as the Volcano School. **Sources:** Hughes, *Artists in California,* 551-52; Forbes, *Encounters with Paradise,* 190-98.

TAVI, Felix *[Painter] mid 20th c.*
Studied: ASL. **Exhibited:** S. Indp. A., 1939. **Sources:** Marlor, *Soc. Indp. Artists.*

TAVOLARA, Augusto *[Painter] mid 20th c.*
Addresses: Secaucus, NJ. **Exhibited:** S. Indp. A., 1923. **Sources:** Marlor, *Soc. Indp. Artists.*

TAVSHANJIAN, Artemis (Mrs. Charles Karagheusian) *[Painter, miniature painter] b.1904, Englewood, NJ.*
Addresses: NYC. **Studied:** M.R. Welch; R.G. Eberhard. **Member:** ASMP; NAWA. **Exhibited:** NAWA, 1933 (prize); Grand Central Gal., 1933 (prize), 1939 (prize). **Work:** Wellesley Col. **Sources:** WW47.

TAWNEY, Lenore *[Weaver] mid 20th c.; b.Lorain, OH.*
Addresses: NYC. **Studied:** Univ. Ill., 1943-45; Inst. Design, Ill., with Archipenko, 1946-47; also with Martha Taipale, Finland, 1954. **Exhibited:** Brussels World's Fair, 1959; Kunstgewerbe Mus., Zurich, 1964; solo shows, AIC, Contemp. Crafts Mus., Seattle World's Fair & Staten Island Mus., New York, 1961; Willard Gallery, NYC, 1970s. **Work:** Mus. Contemp. Crafts, NYC; MoMA; Kunstgewerbe Mus., Zurich; Brooklyn Mus., NY; Cooper-Hewitt Mus. **Comments:** Preferred media: cloth, collages. **Sources:** WW73.

TAWNEY, Mabel *[Amateur painter] b.1879 / d.1976, Chillicothe, IL.*
Addresses: Chillicothe. **Comments:** Watercolor painter, few of whose works are now known. **Sources:** Petteys, *Dictionary of Women Artists.*

TAYES, U. S. S. Grant *[Painter] b.1885, Missouri.*
Addresses: Jefferson City, MO. **Exhibited:** Harmon Fnd., 1930, 1933, 1935; Atlanta Univ., 1944; St. Louis Pub. Lib., 1929-33; St. Louis Art Guild, Art League, Urban League; Lincoln Univ., MO. **Sources:** Cederholm, *Afro-American Artists.*

TAYLER, John *[Engraver] mid 19th c.*
Addresses: NYC, 1843-44, 1847-48. **Sources:** G&W; NYCD 1843-44, 1847-48; NYBD 1844.

TAYLEY, J. U. *[Painter] mid 20th c.*
Exhibited: Salons of Am., 1934. **Sources:** Marlor, *Salons of Am.*

TAYLOR *[Painter] mid 19th c.*
Comments: Painter of "An American Slave Market," 1852. **Sources:** G&W; Met. Mus., *Life in America.*

TAYLOR *[Miniaturist] mid 18th c.*
Addresses: Philadelphia in 1760. **Sources:** G&W; Bolton, *Miniature Painters.*

TAYLOR, A. M. *[Watercolor landscape painter] early 19th c.*
Addresses: New York State, c.1825. **Sources:** G&W; Lipman and Winchester, 181.

TAYLOR, Al *[Sculptor, painter] b.1948, Springfield, MO / d.1999, NYC.*
Addresses: NYC (1970-on). **Studied:** Kansas City AI; Yale-Norfolk (CT) summer session; WMAA indep. study program. **Exhibited:** Alfred Kren Gal, NYC, 1986 (1st solo); L. Monk Gal, NYC; Nolan/Eckman, NYC; Lucerne Kunstmuseum, Switz., 1999 (retrospective). **Work:** MoMA; Brooklyn Mus; BMFA. **Comments:** Known for his quirky linear sculpture, often made from found materials. **Sources:** obit., *NY Times* (8 Apr. 1999).

TAYLOR, Alexander H. *[Portrait painter] b.c.1820, England.*
Addresses: NYC, 1849-50. **Exhibited:** an artist by this name exhibited two genre paintings at the Artists' Fund Society in Philadelphia in 1840. **Sources:** G&W; NYBD 1849-50; Rutledge, PA; 7 Census (1850), N.Y., XLI, 230.

TAYLOR, Alice Bemis (Mrs. F. M. P.) *[Patron] b.1942.*
Addresses: Colorado Springs, CO. **Comments:** She was responsible for having the Colorado Springs FA Center built. It opened in 1936.

TAYLOR, Alida F. *[Painter] mid 20th c.*
Exhibited: S. Indp. A., 1942. **Sources:** Marlor, *Soc. Indp. Artists.*

TAYLOR, Ann *[Painter] mid 20th c.*
Exhibited: S. Indp. A., 1941. **Sources:** Marlor, *Soc. Indp. Artists* (speculates that this is possibly Ann Russele Taylor, who attended ASL).

TAYLOR, Anna *[Painter] b.1847, Mystic, CT / d.1925.*
Addresses: Mystic, CT, 1876; Yonkers NY; NYC. **Exhibited:** NAD, 1876-77 (game birds; gulls); Brooklyn AA, 1876-77 (game birds). **Comments:** Taylor married landscape painter Arthur Parton in 1877, living in Yonkers, NY, and gave up painting to raise four children. **Sources:** info courtesy of David Stewart Hull, NYC.

TAYLOR, Anna Heyward *[Painter, craftsperson, decorator, block printer] b.1879, Columbia, SC / d.1956.*
Addresses: Charleston, SC. **Studied:** South Carolina Col. for Women (A.B.); Univ. South Carolina, and with William Chase, Charles Hawthorne, DuMond; W. Lathrop; Nordfeldt; Meijer. **Member:** NY Soc. Craftsmen; SSAL; Carolina AA; NAWA; Phila. Pr. Club; Am. Color Pr. Soc.; Women Geographers. **Exhibited:** S. Indp. A., 1927; WFNY, 1939; Phila. Pr. Club, 1937 (prize); Marie Sterner Gal., NYC (solo); Milch Gal., NYC; Grace Horne Gal., Boston; Gibbes Art Gal., Charleston, SC; Wash. AC; Berkshire (MA) Mus. Art; Mus. Nat. History, NYC; PAFA; NAD: SSAL; Gibbes Art Gal., 1950; Columbia (SC) Mus. Art,1950; Brooklyn Botanical Gardens. **Work:** IBM; PMA; FMA; Berkshire MA; Charleston MA; Pittsfield, MA; des./textiles, AMNH; Brooklyn (NY) Botanic Gardens Collection. **Comments:** Specialties: textiles; screens. **Sources:** WW53; WW47; Petteys, *Dictionary of Women Artists;* Falk, *Exhibition Record Series.*

TAYLOR, Baker *[Wood engraver and job printer] mid 19th c.*
Addresses: Albany, NY, 1855-60. **Sources:** G&W; Ford, "Some Trade Cards and Broadsides," 12, repro.

TAYLOR, Bayard *[Landscape painter, illustrator, best known as an author and traveler] b.1825, Kennett Square, PA / d.1878, Germany.*
Exhibited: NAD. **Comments:** Apprenticed to a printer but at the age of 19 he published a first volume of poems and bought his remaining time in order to become a journalist. In 1844 he made his first visit to Europe as a traveling correspondent for several newspapers; on subsequent travels he visited and wrote articles and books about California, the Near and Far East, Africa, Russia, etc. He was on Perry's expedition to Japan in 1853 and in 1862 was secretary to the American delegation in St. Petersburg. His books were sometimes illustrated with his own landscape sketches, some of which he also exhibited at the National Academy. He also published many volumes of verse, novels, and a very suc-

cessful translation of Goethe's *Faust*. Taylor was named Minister to Germany in 1878 and was also a professor of German at Cornell. **Sources:** G&W; DAB cites several biographies; Cowdrey, NAD; *Yesterday in Chester County Art;* Perry, *Expedition to Japan;* Van Nostrand and Coulter, *California Pictorial,* 122; *Art in America* (April 1940), 76; P&H Samuels, 479.

TAYLOR, Beatrice M. *[Painter] 20th c.*
Addresses: Pittsburgh, PA. **Member:** Pittsburgh AA. **Sources:** WW21.

TAYLOR, Benjamin John *[Painter, designer] b.1908, Fairfield, IA.*
Addresses: Fairfield, IA. **Exhibited:** Iowa Art Salon, 1928 (prize), 1929, 1937. **Comments:** Position: staff, *Fairfield Daily Ledger.* **Sources:** WW40.

TAYLOR, Bertha Fanning *[Painter, lecturer, writer, teacher, critic, museum curator] b.1883, NYC.*
Addresses: Norfolk, VA/NYC. **Studied:** Hunter Col. Woman's Art Sch.; Cooper Union, with Bryson Burroughs; Univ. Montpellier, France; Sorbonne; Ecole Louvre; Atelier d'Art Sacred, with Maurice Denis; G. Desvallieres. **Member:** Col. Art Assn. Am.; Am. Artists Prof. League; PBC; Tidewater Artists (pres.); Artistes Moderne, Americain et Anglais, Paris (founder & dir.). **Exhibited:** Paris Salon, 1937 (med.); PBC 1942 (med.), 1944-45; Société National des Beaux-Arts, 1930-39; Salon d'Automne, 1930-39; Salon des Tuileries, 1930-39; Salon des Artistes Indepéndants, 1930-39; Musée du Jeu de Paume, all in Paris; Ferargil Gal., 1940; Garden City Community Cl., 1941 (solo); Harlow Gal., 1944; Sharon Conn., 1941 (solo); Norfolk Mus., 1966 (solo). Awards: Medaille da Bronze, Ministere l'Educ., France; award, City of Norfolk, 1970; award, Fedn. Women's Clubs, 1972. **Work:** Sacred Maternity (oil), Norfolk Mus; Sermon on the Mount (oil), St. Peter's Church Sun Sch., Spotswood, NJ; portraits of Bishop Brown & Rev. Payton Williams, Crist & St. Luke's Church, Norfolk, Va; Guild House. Commissions: Virgin & St. Hubert (murals), Mrs. Morgan Richards, Paris, France, 1937; small portable reredos, commissioned by chaplain for Navy Chapel, Norfolk, 1948. **Comments:** Preferred media: oils, watercolors, graphics. Positions: lectr., Louvre Mus., Paris, 1929-39; critic, *New York Herald-Tribune's* Paris Edition, 1930-32, 1932-39; cur. collections, Hermitage Found., 1945-49. Publications: auth., "Form & Feeling in Painting," 1959; auth., "My Fifteen Years in France," 1968. Teaching: Lectr art theory, classes, clubs & libraries, 1939-; lectr. art hist., Hermitage Found. 1945-49; lectr. art appreciation, Norfolk Div., Col. William & Mary, 1949-52; oil painting, Norfolk Mus. Art Class, 1952-60. Research: Medieval & eleventh century of the French School; Renaissance period of the Italian School. **Sources:** WW73; WW47.

TAYLOR, Bessie *[Landscape and still life painter] late 19th c.*
Addresses: Norfolk, VA. **Exhibited:** Norfolk, VA, 1885-86. **Comments:** Preferred medium: watercolor. **Sources:** Wright, *Artists in Virgina Before 1900.*

TAYLOR, Bessie Barrington *[Painter] b.1895, Rutledge, AL.*
Addresses: Bradenton, FL/Andalusia, AL. **Studied:** Univ. Alabama; Alabama State Teachers Col.; Ringling Sch. Art. **Member:** SSAL; Art Lg., Manatee County, Bradenton. **Exhibited:** SSAL, Montgomery, AL, 1938. **Work:** Benjamin Mus., Ellenton, FL. **Sources:** WW40.

TAYLOR, Brie *[Painter] mid 20th c.*
Exhibited: Corcoran Gal biennials, 1959, 1961. **Sources:** Falk, *Corcoran Gal.*

TAYLOR, Carol *[Sculptor] b.1888, NYC.*
Addresses: NYC. **Studied:** ASL; P. Hamon; Académie Julian, Paris with P. Landowski; A. Archipenko; G. Rossi in Italy. **Member:** NAWPS. **Sources:** WW40.

TAYLOR, Cecelia Evans *[Sculptor] b.1897, Chicago.*
Addresses: Williamsville, NY. **Studied:** Arthur Lee. **Member:** Buffalo SA; The Patteran. **Exhibited:** Albright Art Gal., 1932

(prize), 1933 (prize); Artists Western NY Exhib., 1937 (prize). **Sources:** WW40.

TAYLOR, Charles Andrew *[Painter, educator] b.1910, Philadelphia, PA.*
Addresses: Philadelphia, PA. **Studied:** Graphic Sketch Cl.; Fleisher Mem. School; also with Maurice Molarsky. **Member:** Da Vinci All.; Pen & Pencil Cl.; Salmagundi Cl.; AWCS; Phila. WCC (pres.); Audubon Artists; Phila. A. All.; All. Artists Am. **Exhibited:** Phila. WCC, 1929-42; PAFA Ann., 1930, 1933, 1939; NAD Ann.; AWCS; CGA; AIC; Phila. WCC; Corcoran Gal biennial, 1939; AIC, 1941; Carnegie Inst., 1941, 1943; Phila. Art All.; Woodmere Art Gal. Awards: prizes, Phila. Artists All., 1954, 1955; Second Altman figure prize, NAD, 1955; Grumbacher award, 1958; Am. Artist Magazine medal, 1960; Seley purchase prize, Salmagundi Club, 1961. **Work:** Graphic Sketch Club, Phila.; U.S.S. Saratoga; NY Univ. College Eng.; PMA; Montclair Mus.; Woodmere Art Gal.; Harcum Jr. College; NAD. **Comments:** Preferred media: oils, watercolors. **Sources:** WW53; WW47; WW73; article, *The Studio* (Sept., 1955); article, *Am. Artist Magazine* (May, 1960); article, *Charette* (May, 1963); Falk, *Exh. Record Series.*

TAYLOR, Charles Jay *[Illustrator, painter, landscape painter, teacher] b.1855, New York / d.1929.*
Addresses: NYC, until 1913; Pittsburgh, PA. **Studied:** ASL; NAD; E. Johnson, in NYC; London; Paris. **Member:** SI, 1910; Pittsburgh AA; Pittsburgh Arch. Lg.; The Players; Phila. AC; SC. **Exhibited:** NAD, 1869-86; Brooklyn AA, 1875-78, 1885; PAFA Ann., 1876, 1901-16; Boston AC, 1884-85; Pan-Am. Expo, Buffalo, 1901 (drawing prize); Pan-Pacific Expo, San Francisco, 1915 (medal, hors concours [jury of awards]); Corcoran Gal biennials, 1916, 1926; Sesqui-Centenn. Expo, Phila., 1929 (medal); AIC. **Work:** CI. **Comments:** Illustrator: "The Taylor-Made Girl," "Short Sixes," by H.C. Bunner, "England," other books. Position: teacher, Carnegie Technical Schools, Pittsburgh, 1911-29. **Sources:** WW27; Falk, *Exh. Record Series.*

TAYLOR, Charles M., Jr. *[Painter] b.1891 / d.1955.*
Addresses: Phila., PA. **Studied:** PAFA. **Sources:** WW25; Marlor, *Soc. Indp. Artists* (gives birth and death info and lists Taylor's name as appearing in relation to the 1927 exhibition, although he apparently did not show work that year).

TAYLOR, Charles Ryall *[Painter in oils] mid 19th c.*
Sources: G&W; Lipman and Winchester, 181.

TAYLOR, Clara Potter Davidge *[Painter] d.1921, Smithtown, NY.*
Addresses: Plainfield, NH. **Member:** art colony at Cornish (NH). **Comments:** Wife of Henry Fitch Taylor, they owned the Old Kingsbury Tavern which they rented in summers to the various members of the Cornish art colony. In 1909 she first introduced her husband to Stephen Parrish and the two men became close friends. She drowned in a marsh on her brother's estate. **Sources:** *Granite State Monthly* (vol. 57, 1925); tls, V. Colby, Cornish Hist. Soc. (1982).

TAYLOR, Cora Blin (or Bliss) *[Painter, lithographer, lecturer, teacher] b.1895, Cincinnati, OH.*
Addresses: Saugatuck, MI. **Studied:** AIC; ASL with L. Seyffert; L. Kroll; C. Hawthorne; in Paris with Lhote. **Member:** Chicago Gal. Art; Michigan Acad. Art. **Exhibited:** AIC, 1925 (prize), 1930 (prize)-1934; Detroit IA, 1955 (prize); Minneapolis IA. **Work:** Chicago Pub. Sch.; FA Bldg. Assoc., Chicago. **Comments:** Position: dir., Taylor Art Sch. **Sources:** WW47; WW59, where her middle name is given as Bliss.

TAYLOR, Della Brown *[Caramicist, educator, poet] b.1922, Charleston, West Virginia.*
Studied: West Virginia State Col.; Boston Univ. (MA, 1945); BMFA Sch.; Mass. College of Art; McGill French Summer school. **Member:** American Craftsman's Council; Nat'l

Conference of Artists. **Exhibited:** BMFA; Charleston Civic Center; Kanawha County Centennial Exh.(prize); 31st Allied Artists Exh.(prize). **Comments:** Positions: prof. of art, West Virginia State Col.; art critic, *Charleston Gazette,* and *Gazette/Mail.* **Sources:** Cederholm, *Afro-American Artists.*

TAYLOR, Dorothy Keene *[Painter] early 20th c.*
Addresses: NYC. **Exhibited:** S. Indp. A., 1917. **Sources:** Marlor, *Soc. Indp. Artists.*

TAYLOR, Edgar (Dorsey) *[Painter, teacher, printmaker] b.1904, Grass Valley, CA / d.1978, Los Angeles, CA.*
Addresses: Berkeley, CA. **Studied:** France, Italy, Munich with Hans Hofmann, 1929; Univ. California (B.A., M.A.). **Member:** San Francisco AA. **Exhibited:** AIC, 1941-46; San Francisco AA, 1936, 1937 (med.), 1938-39, 1943-46; Texas FAA, 1942 (prize), 1944 (prize); SFMA, 1945 (prize)-46 (prize); AFA Traveling Exhib., 1940, 1948; CI Traveling Exhib., 1940; GGE, 1939; Texas General Exhib., 1941-43; LACMA, 1945, 1948, 1949; deYoung Mem. Mus., 1950; Oakland Art Gal.; Pasadena (CA) Mus., 1959 (solo); Crocker Gal., Sacramento, 1963 (solo); Smithsonian Inst., 1968 (solo); Univ. of Texas, 1969 (solo); Univ. of Maine, 1971(solo). Awards: Taussig traveling fellowship, Univ. California, 1932. **Work:** SFMA; Crocker Mus.; LOC; NMAA; UCLA; Piedmont High School (mosaic murals). **Comments:** Position: instructor, Univ. California, Berkeley, 1945-46; Univ. Southern California, 1951-52. Author: *Baja California Woodcuts,* Plantin Press, 1969. Member of a group of twenty artists who produced lithographs for the "Chronicle Contemporary Graphics" project of 1940. **Sources:** WW59; WW47; exh. cat., Annex Gal. (Santa Rosa, CA, n.d., c.1988); more recently, see Hughes, *Artists in California,* 552.

TAYLOR, Edgar J. *[Painter, illustrator] b.1862, Brooklyn, NY.*
Addresses: Westbrook, CT; Brooklyn, NY, 1899. **Studied:** NAD; ASL, with Beckwith; Brooklyn A.rt Gld., with Eakins. **Member:** Brooklyn AC; CAFA; Soc. Indep. Artists; AAPL. **Exhibited:** PAFA Ann., 1888; NAD, 1899. **Sources:** WW31; Falk, *Exh. Record Series.*

TAYLOR, Edith A. *[Painter] 20th c.*
Addresses: NYC. **Exhibited:** S. Indp. A., 1925. **Sources:** Marlor, *Soc. Indp. Artists.*

TAYLOR, Edith Belle (Mrs. W. M.) *[Painter] 20th c.*
Addresses: Columbus, OH. **Exhibited:** WC Ann., PAFA, 1936; Butler AI, 1939. **Sources:** WW40.

TAYLOR, Editha *20th c.*
Exhibited: Salons of Am., 1926. **Sources:** Marlor, *Salons of Am.*

TAYLOR, Edward DeWitt *[Painter, etcher, printer, book designer] b.1871, Sacramento, CA / d.1962, San Francisco, CA.*
Addresses: San Francisco, CA. **Studied:** with A. Hansen; G. Piazzoni. **Member:** Calif. SE; San Francisco AA; Am. Inst. GA. **Exhibited:** San Francisco AA, 1923, 1925; SFMA, 1935; print, Calif. SE, 1937 (prize); Oakland Art Gal., 1939; GGE, 1939. **Work:** SFMA; Piedmont (CA) H.S. (mosaic mural). WPA artist. **Comments:** Position: designer, Taylor and Taylor, printers, San Francisco. **Sources:** WW40; Hughes, *Artists of California,* 552.

TAYLOR, Edwin C(assius) *[Landscape and figure painter, teacher] b.1874, Detroit, MI / d.1935.*
Addresses: New Haven, CT/Liberty, ME. **Studied:** ASL; Kenyon Cox. **Member:** New Haven PCC. **Exhibited:** Corcoran Gal annual, 1907; LOC (dec. with K. Cox). **Comments:** Many of his students won the Fellowship of the American Academy in Rome. Teaching: Yale Univ., 1908-35. **Sources:** WW33.

TAYLOR, Eliza Ann *[Shaker artist (Ink and watercolor drawings)] mid 19th c.*
Addresses: New Lebanon, NY, 1844-45. **Work:** Peabody Mus., Salem, MA. **Sources:** G&W; Lipman and Winchester, 181; Brewington, 377.

TAYLOR, Elizabeth Edith *[Painter] b.1875, Middlebury, VT / d.1938, Bristol, VT.*
Addresses: Bristol, VT; NYC before 1920; Pensacola, FL, late 1920's-early 1930's; Bristol, VT. **Work:** Shelburne (VT) Mus. **Sources:** Muller, *Paintings and Drawings at the Shelburne Museum,* 131 (w/repro.).

TAYLOR, Elizabeth Shuff *[Painter, printmaker] early 20th c.*
Addresses: Milwaukee, WI, 1912-13; Chicago, c.1913-mid 1920s; New Berlin, IL/Provincetown, MA. **Studied:** With Cox and Alphonse Mucha. **Member:** Chicago SA; Society Independent Artists; Provincetown Printers. **Exhibited:** AIC, 1910-21; PAFA Ann., 1916-17; Provincetown (MA) AA, 1919, 1920; S. Indp. A., 1920-21. **Work:** Detroit IA. **Sources:** WW33; Petteys, *Dictionary of Women Artists;* Falk, *Exh. Record Series.*

TAYLOR, Elizabeth Vila See: **TAYLOR-WATSON, Elizabeth Vila (Mrs. A. M.)**

TAYLOR, Elizabeth Wheeler *[Sculptor, painter] b.1905, Scranton.*
Addresses: Scranton, PA. **Studied:** Mt. Holyoke College; Yale; PAFA; Fontainebleau Sch., France; P.P. Jennewein. **Member:** Lackawanna County AA. **Comments:** Position: director, Everhart Mus. Hist., Science & Art, Scranton, PA. **Sources:** WW40.

TAYLOR, Eloise B. *[Painter] 20th c.*
Addresses: Chicago area. **Exhibited:** AIC, 1939-41. **Sources:** Falk, *AIC.*

TAYLOR, Emily Heyward Drayton (Mrs. J.M.) *[Miniature painter, painter] b.1860, Phila. / d.1952.*
Addresses: Phila., PA. **Studied:** C. Ferrere, in Paris; PAFA. **Member:** Penn. SMP (pres.); Plastic Club; Art Alliance, Phila. (founder); AFA; Acorn Club. **Exhibited:** PAFA Ann., 1893-1905; PAFA, 1919 (medal), 1920 (prize), 1924 (prize); Royal Min. Soc., London, 1896; Paris Salon, 1897; Wash. WCC, 1898; Phila. WCC, 1898; Earl's Court Expo, London, 1900 (gold); for services on jury, Charleston Expo, 1902 (gold); Pan-Pacific Expo, San Francisco, 1915 (medal). **Comments:** Painted over 400 miniature portraits in her lifetime. Among her sitters were Pres. & Mrs. McKinley, Dr. S. Weir Mitchell, George Hamilton, and Cardinal Mercier. Co-author with Edith Wharton, "Heirlooms in Miniature." **Sources:** WW40; Fink, *American Art at the Nineteenth-Century Paris Salons,* 395; obit., *Phila. Inquirer,* June 20, 1952; Falk, *Exh. Record Series.*

TAYLOR, Ethel C. *[Painter] 20th c.; b.Taylor's-on-Schroon, NY.*
Addresses: NYC/Schroon Lake, NY. **Studied:** K.H. Miller. **Member:** Artists Gld. **Exhibited:** S. Indp. A., 1918. **Comments:** Illustrator: *Vanity Fair, Vogue, Town and Country, Scribner's, Harper's, Theatre, New York Times, New York Sun, New York Herald Tribune.* **Sources:** WW40.

TAYLOR, Eugen L. *[Painter, mural painter] b.1898, New Jersey / d.1955, San Diego, CA.*
Addresses: NYC; San Diego, CA, since ca. 1925. **Studied:** NY School of Fine and Applied Arts. **Exhibited:** San Diego FA Gallery, 1927. **Comments:** In San Diego he painted decorative murals in theaters and restaurants, several in partnership with Anita Brown (see entry). **Sources:** Hughes, *Artists of California,* 552.

TAYLOR, Eugene F. (Mr. & Mrs.) *[Collectors] 20th c.*
Addresses: Greenburgh, NY. **Sources:** WW66.

TAYLOR, Everett Kilburn *[Painter] b.1866, S. Orange, NJ / d.1952, S. Orange, NJ.*
Addresses: NYC. **Exhibited:** Boston AC, 1894; S. Indp. A., 1939, 1941. **Comments:** In 1929, he made pencil drawings of European scenes of Venice, Paris, and Dalmatia. **Sources:** *The Boston AC;* add'l info. courtesy Preveti Gal., NYC.

TAYLOR, Fannie E. *[Artist] late 19th c.*
Addresses: Active in Washington, DC, 1899. **Sources:** Petteys, *Dictionary of Women Artists.*

TAYLOR, Fanning See: **TAYLOR, Bertha Fanning**

TAYLOR, Farwell M. *[Painter] b.1905, Conawa, Oklahoma Territory / d.1977, Marin County, CA.*
Addresses: San Francisco, CA. **Studied:** Calif. Sch. FA; P.L. Labaudt. **Exhibited:** Corcoran Gal biennial, 1932; SFMA, 1935; Int. WC Ann., AIC, 1938; San Francisco AA, 1937-39. **Comments:** Position: staff, *New York Herald*, 1920s; staff, *San Francisco Examiner*, after 1930. Specialty: watercolors. **Sources:** WW40; Hughes, *Artists of California*, 552.

TAYLOR, Fay Morgan *[Painter] b.1910, Pittsburgh, PA.*
Addresses: San Francisco, CA, 1930-1949; Mill Valley, CA. **Studied:** Univ. of Washington; Calif. School of FA; UC Berkeley. **Exhibited:** San Francisco AA annuals; SFMA, 1935; Rotunda Gallery, City of Paris, San Francisco. **Comments:** Married to Farwell Taylor (see entry) in 1935. A modernist painter, she maintained a studio with her husband. **Sources:** Hughes, *Artists of California*, 552.

TAYLOR, Frances *[Painter] 20th c.*
Addresses: Brooklyn, NY. **Exhibited:** Salons of Am., 1922-24. **Sources:** WW19.

TAYLOR, Francis Henry *[Museum director, educator, critic, writer, lecturer] b.1903, Philadelphia, PA / d.1957.*
Addresses: NYC; Stonington, CT. **Studied:** Univ. Pennsylvania, A.B., D.F.A., 1941 (hon.); Tufts College, L.H.D.; Amherst College; Yale Univ.; & in Europe. **Member:** Am. Philosophical Soc., Phila.; Am. Acad. Arts & Sciences, Boston (fellow); AA Mus. (vice-pres.); Assn. Art Mus. Dir. **Exhibited:** Awards: Carnegie Fellowship, Princeton Univ., 1926-27; Guggenheim Fellowship, 1931; Commander Royal Order of Vasa (Sweden); Chevalier Order of the Crown (Belgium); Commander Order of Merit (Ecuador). **Comments:** Positions: asst. curator, 1927-28, curator medieval art, 1928-31, PMA; director, WMA, 1931-40; director, MMA, NYC, 1940-; chmn. advisory committee, Walters Art Gal., Baltimore, 1934-44; regional director for New England States, FAP, 1933-34; chmn., Nat. Council for Art Week, 1940; advisory committee on art, Dept. State, visiting &lecturing in Latin America, 1942; member, Am. Comm. for Protection & Salvage of Artistic & Historical Monuments in War Areas, 1943-46; trustee, Univ. Pennsylvania & board member, School FA; trustee, Am. Acad. in Rome; trustee, Archaeological Inst. Am., Mus. City of New York; member, visiting committee, art & archaeology dept., Princeton Univ. & Amherst College, also Dumbarton Oaks College & Library, Harvard University. Trustee, AFA; Officier, Legion of Honor, France,1951; Officer, of Orange-Nassau, Holland. Author of numerous monographs & articles on art & archaeological subjects. **Sources:** WW53; WW47.

TAYLOR, Frank H(amilton) *[Illustrator] b.1846 / d.1927.*
Addresses: Phila., PA. **Member:** Phila. Sketch Cub. **Exhibited:** Boston AC. **Sources:** WW13.

TAYLOR, Frank J. *[Painter] 20th c.*
Addresses: NYC. **Studied:** ASL. **Exhibited:** S. Indp. A., 1921. **Comments:** Possibly Taylor, Frank Johnson-living in 1932. **Sources:** Marlor, *Soc. Indp. Artists*.

TAYLOR, F(rank) Walter *[Illustrator] b.1874, Phila., PA / d.1921.* *I. Wallis Taylor* *Paris. 1908*
Addresses: Phila., PA/ Frontenac, Jefferson County, NY. **Studied:** PAFA (traveling scholarship to Paris). **Member:** SI, 1905; Phila. WCC. **Exhibited:** PAFA Ann., 1895, 1901, 1905; Pan-Pacific Expo, San Francisco, 1915 (medal). **Comments:** Preferred medium: charcoal. Illustrator: "Fisherman's Luck," by H. Van Dyck, "Marriage a la Mode," by Mrs. Humphry Ward, "The Iron Woman," by M. Deland. **Sources:** WW19; Falk, *Exh. Record Series*.

TAYLOR, Fred B. *[Painter] b.1868, China, ME / d.1960, Walnut Creek, CA.*
Addresses: Oakland, CA; Walnut Creek, CA. **Studied:** self-taught; with Percy Gray, ca. 1925. **Comments:** Owner of a chain of drugstores, he painted his own advertising cards and painted watercolors and oils of the area around his home after retirement. **Sources:** Hughes, *Artists of California*, 553.

TAYLOR, Frederick Bourchier *[Painter, sculptor] b.1906, Ottawa, Ont.*
Addresses: San Miguel de Allende, Gto. **Studied:** McGill Univ, BArch, 1930; Univ London Goldsmiths Col Art, with Stanley Anderson; London Co Coun Sch Arts & Crafts; Byam Shaw Sch Painting, with Ernest Jackson. **Member:** Royal Can Acad Arts (coun & comts, 1949-); Can Soc Graphic Art; Soc Can Painter-Etchers & Engravers. **Exhibited:** Ont Soc Artists, Toronto, 1931-; Royal Can Acad Arts, Toronto, 1931-1972; many group & Int traveling exhibs in Can, USA & Mex, 1931-1972; Royal Inst Painters, London, 1936. **Work:** Nat Gallery Can, Ottawa; Pub Archives can, Ottawa; Art Gallery Ont, Toronto; Montreal Mus Fine Arts; Mus Que, PQ; plus many others. **Commissions:** Etching, Govt Can, Ottawa, 1932; etchings & paintings for corps in Can & USA, 1932-1972; portrait paintings, McGill Univ, 1941-1966; series of paintings, Algoma Steel Corp. Saulte Ste Marie, Ont, 1946-1947; plus many other pvt commissions. **Comments:** Preferred Media: Oils. Positions: Chmn Que region, Fedn Can Artists, 1944-1945, nat v pres, 1945-1946. **Dealer:** Galeria San Miguel, San Miguel de Allende, Gto. **Teaching:** Instr & lectr drawing & modeling, McGill Univ Sch Archit, 1940-1943. **Sources:** WW73.

TAYLOR, George A. *[Painter] early 20th c.*
Work: Shelburne (VT) Mus. **Comments:** Taylor served in France during WWI. **Sources:** Muller, *Paintings and Drawings at the Shelburne Museum*, 131.

TAYLOR, Grace Gray *[Artist] late 19th c.*
Addresses: NYC, 1888. **Exhibited:** NAD, 1888. **Sources:** Naylor, *NAD*.

TAYLOR, Grace Martin *[Painter, educator, block printer] b.1903, Morgantown, WV.*
Addresses: Charleston, WV. **Studied:** PAFA; WVa Univ. (A.B., M.A.); Ohio Univ.; AIC; ASL; Bisttram Sch. Art; Hans Hofmann Sch. Fine Arts; with Breckenridge, A.B. Carles, Garber, H. McCarter; B. Lazzell; F. Pfeiffer; H. Hofmann. **Member:** Provincetown A. Assn.; All. A. WVa. (pres., 1935-36); Am. Assn. Univ. Prof.; Int. Platform Assn. **Exhibited:** NAD, 1944 & 1948; Va. Intermont Col., 1948 (first prize for prints, Seven State Exhib.); Huntington Gals., 1954 (first prize & jurors award, Three State Ann.); AWCS, 1958-59; Am. Drawing Biennial, Norfolk Mus., 1965; Contemp. Gal., Palm Beach, Fla., 1967; Artist of the Year, WVa. Univ., 1958 (solo); WVa. Rhododendron Arts Festival, 1971 (Citizen of the Yr. in Art in WVa). **Work:** Am. Color Print Soc.; Laskin Gals., Charleston, WVa.; Hallmark Co.; Charleston Art Gal., WVa; pvt. colls. **Comments:** Preferred media: oils, casein, acrylics, graphics. Positions: dean, Mason Col. Music & Fine Arts, 1950-55, pres., 1955-56. Teaching: assoc. prof. art & hd. dept., Mason Col. Music & Fine Arts, 1934-56; assoc. prof., Morris Harvey Col., 1956-68; lectr., WVa Univ. Div. Exten. Credit, 1967-71. Research: art education in colleges & universities of the East. Art Interests: Creative production & teaching. Collection: portfolios of drawings & watercolors; paintings in all media. Also appears as Martin-Taylor. **Sources:** WW73; Haas & Packer, *Instruction in Audiovisual Aids* (1950) & Morris Davidson, *Painting with Purpose* (1964, Prentice-Hall).

TAYLOR, H. L. (Mrs.) *[Painter]*
Addresses: New Orleans, active c.1891. **Exhibited:** Artist's Assoc. of N.O., 1891. **Comments:** Possibly Mrs. Harry L. Taylor, born Louise Hincks, from Evanston, IL, died New Orleans, 1936. **Sources:** *Encyclopaedia of New Orleans Artists*, 371.

TAYLOR, H. M. *[Sketch artist] mid 19th c.*
Comments: Pencil drawing of a schoolhouse in Delaware, c.1850. **Sources:** G&W; Lipman and Winchester, 181.

TAYLOR, Harriet Ward Foote (Mrs. Herbert A.)
[Designer] b.1874, Guilford, CT.
Addresses: Cleveland, OH/Little Compton, RI. **Studied:** M. Ware; Hartford Art Sch. **Member:** Boston SAC; NY Needle and Bobbin Club; Texas AC of Cleveland. **Comments:** Specialty: embroideries. **Sources:** WW40.

TAYLOR, Harry *[Painter] 20th c.*
Addresses: Chicago area. **Exhibited:** AIC, 1941. **Sources:** Falk, AIC.

TAYLOR, Helen Campbell *[Painter] b.1900, Chicago.*
Addresses: Chicago, IL. **Studied:** W. Reynolds; G. Oberteuffer; H. Amiard Obetteuffer. **Exhibited:** Artists Chicago Vicinity Ann., AIC, 1936, 1938, 1939. **Sources:** WW40.

TAYLOR, Helen J(ackson) *[Painter] b.1903, Kenilworth, IL.*
Addresses: Barrington, IL. **Studied:** AIC. **Exhibited:** Artists Chicago Vicinity Ann., AIC, 1929; PAFA Ann., 1932. **Work:** Joseph Sears Pub. Sch., Kenilworth. **Sources:** WW40; Falk, *Exh. Record Series.*

TAYLOR, Helena M. *[Painter] 20th c.*
Addresses: Phila., PA. **Studied:** PAFA. **Exhibited:** PAFA Ann., 1939. **Sources:** WW21; Falk, *Exh. Record Series.*

TAYLOR, Henry C. (Hank) *[Painter, mural painter] b.1906, Kalispell, MT / d.1987, Tacoma, WA.*
Addresses: Monesano, WA. **Studied:** Seattle Art Inst.; Calif. College of Arts and Crafts. **Member:** Puget Sound Group of Northwest Painters. **Comments:** Specialty: Northwest landscapes and native peoples. **Sources:** Trip and Cook, *Washington State Art and Artists, 1850-1950.*

TAYLOR, Henry Fitch HENRY F. TAYLOR
[Painter, sculptor, writer]
b.1853, Cincinnati, OH / d.1925, Plainfield, NH.
Addresses: Cos Cob, CT, 1888-/ Cornish, NH. **Studied:** Acad. Julian, Paris, with Boulanger & Lefebvre, 1880-86. **Member:** SAA, 1891; NAC; Am. Assn P&S (board of trustees); Salons of America (board of directors, 1922-23). **Exhibited:** NAD, 1889; Phila.; London; Paris; Rome; New York; Chicago; San Fran.; PAFA Ann., 1893-94; Armory Show, 1913; S. Indp. A., 1919; Salons of Am., 1922-25; N. Goldowsky Gal., NYC, 1966 (solo). **Work:** WMAA. **Comments:** He began as an Impressionist landscape painter and lived in the art colony at Cos Cob, but in 1913 he was one of the founders of the AAPS, helping to organize the 1913 Armory Show in NYC; thereafter, his style changed to abstraction influenced by the cubists and futurists. Many of his works were sold at auction c.1966. Positions: manager, Madison Gal., NYC, 1908-. Auth.: *The Taylor System of Color Harmony.* **Sources:** WW25; *Vermont Journal* (Sept. 11, 1925; p.8, col. 2); *Granite State Monthly* (vol. 57, 1925); William C. Agee, "Rediscovery: Henry Fitch Taylor," *Art in Amreica* vol. 44 (Nov. 1966): pp.40-43; A. Davidson, *Early American Modernist Painting,*251-52; Brown, *The Story of the Armory Show;* Baigell, *Dictionary;* Falk, *Exh. Record Series.*

TAYLOR, Henry Weston *[Illustrator, teacher, designer] b.1881, Chester, PA.*
Addresses: Chester, PA. **Studied:** PAFA, with McCarter, Breckenridge; Drexel Inst. **Member:** Phila. AC. **Comments:** Illustrator: *Saturday Evening Post, Cosmopolitan, Good Housekeeping,* & other national magazines. **Sources:** WW53; WW47.

TAYLOR, Henry White *[Painter, teacher, illustrator] b.1899, Otisville, NY / d.1943, Atlanta, GA.*
Addresses: Clearwater, FL/Ridley Pk., Quakertown, PA. **Studied:** Mass. Sch. A.; PAFA; H. Breckenridge, in East Gloucester, Mass. **Member:** AAPL; Phila. Alliance; Fla. Fed. A. **Exhibited:** PAFA Ann., 1927; Chester County AA, 1934 (prize), 1935 (prize). **Comments:** Position: Dir., AM, Mus. Sch. A., Clearwater. **Sources:** WW40; Falk, *Exh. Record Series.*

TAYLOR, Hilda Grossman *[Illustrator] 20th c.*
Addresses: Riverdale, NY. **Member:** SI. **Sources:** WW27.

TAYLOR, Horace *[Painter, illustrator] b.1864 / d.1921, Swamp Lake, WI.*
Addresses: NYC. **Comments:** Illustrator: newspapers. Specialty: watercolors. **Sources:** WW08.

TAYLOR, Ida C. *[Portrait painter, painter] b.Le Roy, NY / d.1940, Le Roy, NY.*
Addresses: Le Roy, NY. **Studied:** W.M. Hunt; Académie Julian, Paris. **Member:** Rochester AC. **Work:** portraits, Hist. Mus., Buffalo; Episcopal Church, Masonic Temple, both in Le Roy; De Veaux Sch., Niagara Falls, N.Y.; Alpha Chapter House, Trinity Col., Hartford. **Sources:** WW40.

TAYLOR, Irene *[Painter] 19th c.*
Exhibited: Mechanics' Inst., San Francisco, 1893. **Sources:** Hughes, *Artists of California,* 553.

TAYLOR, J. E. (Dr. & Mrs.) *[Collectors] 20th c.*
Addresses: Bala-Cynwyd, PA. **Sources:** WW73.

TAYLOR, James *[Listed as "artist"] b.c.1836, Wales.*
Addresses: NYC in 1860. **Sources:** G&W; 8 Census (1860), N.Y., LVI, 959.

TAYLOR, James Earl *[Painter, etcher] b.1899, Greenfield, IN.*
Addresses: Morris Plains, NJ. **Studied:** Wittenberg College, A.B.; Ohio State Univ., Ph.D.; Cincinnati Art Acad. **Member:** Cincinnati AC. **Exhibited:** SAM, 1942; Butler AI, 1940, 1943; Hoosier Salon, 1940; CM,1939-42. **Sources:** WW53; WW47.

TAYLOR, James Earl *[Painter and illustrator of the West] b.1839, Cincinnati, OH / d.1901, NYC.*
Studied: Univ. Notre Dame, 1855. J.E. Taylor 1880
Exhibited: Brooklyn AA, 1876.
Comments: He graduated from Notre Dame at the age of 16, painted a Revolutionary War panorama two years later, and in 1861 joined the Union Army. In 1863 he became an artist-correspondent for *Leslie's.* After the Civil War he went West on many occasions to portray the Indians and frontier life on the Great Plains. He left *Leslie's* in 1883 to work independently as an illustrator and watercolorist. **Sources:** G&W; Taft, *Artists and Illustrators of the Old West,* 297; *Art Annual,* IV, obit.

TAYLOR, James L. *[Wood engraver and designer] b.1831, Massachusetts.*
Addresses: Boston from 1850 until after 1860. **Comments:** Member of the firm of Taylor & Adams (see entry), 1850 until after 1860. **Sources:** G&W; Boston CD 1850-60+; 7 Census (1850), Mass., XXIV, 436.

TAYLOR, James William Jr. *[Painter] b.1902, South Bend, IN.*
Addresses: South Bend, IN. **Studied:** Dartmouth College, A.B. **Exhibited:** John Herron AI, 1942, 1943, 1945-48, 1950-52; Hoosier Salon,1940-50 (prizes,1943, 1944, 1948, 1949); Butler AI, 1943, 1944, 1950; AIC, 1942-44, 1948, 1951; Old Northwest Territory Exhib., 1950, 1951. Awards: L. S. Ayers, Indianapolis,1947. **Sources:** WW53; WW47.

TAYLOR, Jay *[Painter] 20th c.*
Studied: ASL. **Exhibited:** S. Indp. A., 1940. **Sources:** Marlor, *Soc. Indp. Artists.*

TAYLOR, Jean *[Painter] 20th c.*
Addresses: San Fran., CA. **Exhibited:** 48 Sts. Comp., 1939. **Sources:** WW40.

TAYLOR, Jean(ne) *[Painter] late 20th c.; b.Roselle, NJ.*
Addresses: Wash., DC. **Studied:** Jersey City State Col., BA; Pratt Inst.; ASL; Univ. of Ghana (summer, 1969). **Exhibited:** PAFA Ann., 1954; Smith-Mason Gallery, Wash., DC, 1971; DC Teachers Col.; DC Artists Assn.; Anacostia Neighborhood Mus.-Smithsonian Inst.; Exposure '69 Art Show. **Sources:** Cederholm, *Afro-American Artists;* Falk, *Exh. Record Series.*

TAYLOR, John *[Landscape painter] b.1745, Bath / d.1806, Bath.*
Addresses: Philadelphia, 1783. **Studied:** London. **Comments:** Described in 1783 in a Philadelphia newspaper as "a native of this city." English sources give Bath as Taylor's birthplace. Popular for his landscapes with figures and cattle. **Sources:** G&W; Prime, I, 10; DNB; Redgrave, *Dictionary of Artists of the English School.*

TAYLOR, John C. E. *[Painter, educator, drawing specialist] b.1902, New Haven, CT.*
Addresses: West Hartford, CT. **Studied:** Acad Julian, Paris, France, 1926-1928; also with Walter Griffin, France, 1926-1928; Yale Univ, MA, 1940. **Member:** CAFA; Rockport AA; North Shore AA; Washington AA, CT; Gloucester SA; Springfield A. Lg.; SC. **Exhibited:** Spring Salon, Paris, 1928; Springfield AL, 1935 (prize); Palm Beach A. Center, 1935 (prize); CAFA, 1935 (Cooper prize); Corcoran Gal biennials, 1935, 1939; AV, 1942; AV Traveling Exhib, 1945-1946; Pepsi-Cola, 1946; New Orleans AA, 1946 (second prize); Rockport AA, 1955 (black & white prize); Trinity Col, Harford, 1970 (retrospective). **Work:** New Britain Mus Am Art. Commissions: Designs for wood carvings, 1957-1962 & crypt chapel doors, 1972, Trinity Col Chapel, Harford, CT; Westover award tablet, Westover Sc, Middlebury, CT, 1958; design for wood carvings, St James Church, Glastonbury, CT, 1962. **Comments:** Preferred Media: Oils, Pencil. Positions: Scholar-in-residence, Loomis Sch, 1970-1972. A. Jewell (auth), Exploring realism & abstraction, New York Times, 1931; F. Berkman (auth), Much avant-garde art profonation of nature, Harford Times, 1970; J. Goldenthal (auth), Taylor work in retrospect, Hartford Courant, 1970. Teaching: T., Lawrenceville (N.J.) School (1940); Mem faculty art, Trinity Col, 1941-1956, prof art hist, 1956-1970, head fine arts dept, 1945-1964; instr art hist, Loomis Sch, 1955-1972; **Sources:** WW73; E A Jewell, "Exploring realism & abstraction, *New York Times,* 1931; F. Berkman, "Much avant-garde art profonation of nature," *Hartford Times,* 1970; J. Goldenthal, "Taylor work in retrospect," *Hartford Courant,* 1970; *Artists of the Rockport Art Association* (1946).

TAYLOR, John H. *[Painter] 20th c.*
Addresses: Norwalk, CT/NYC. **Studied:** ASL. **Member:** S. Indp. A. **Exhibited:** S. Indp. A., 1921, 1925. **Sources:** WW25.

TAYLOR, John R.(or K.)M. *[Painter] 20th c.*
Addresses: Wash., DC, active 1905-1940s. **Exhibited:** Wash. WCC, 1926-1939. **Sources:** WW40; McMahan, *Artists of Washington, DC.*

TAYLOR, John (Williams) "Jack" *[Painter, lithographer, etcher] b.1897, Baltimore, MD / d.1983, Shady, NY.*
Addresses: Los Angeles, 1916; NYC, 1923; Woodstock, NY, 1924 and after. **Studied:** J. Francis Smith Art School, 1920-22; ASL, Los Angeles, with S. McDonald Wright, 1923; ASL, with Boardman Robinson, 1926-27; in Paris, 1929. **Member:** NA; Woodstock AA (life member; trustee, 1965-70). **Exhibited:** Baltimore WCC, 1939 (prize); VMFA, 1946 (medal, prize), 1948; CI, 1941, 1943-45, 1950; MMA (AV), 1942, PAFA Ann., 1942, 1947-54; NAD, 1945, 1961; John Herron AI, 1945, 1946; TMA, 1945; Univ. Nebraska, 1945; AIC, 1934-37, 1941, 1942; BM, 1945; WMAA, 1938, 1939, 1943, 1959; WMA, 1940; Corcoran Gal biennial, 1947. Awards: citation & grant, Am. Acad. Arts & Letters, 1948; Guggenheim fellowship, 1954. **Work:** oil, VMFA; oil, Mus. New Britain (CT) Inst.; MMA; WMAA; Muskegon (MI) Mus.; Canajoharie (NY) Mus. Art; gouache, John Herron Mus., Indianapolis, IN; oil, NAD Ranger Fund Collection, New York, NY; oil, Morse Gallery Art, Rollins College, FL; Woodstock AA. Commissions: mural painting for Richfield Springs Post Office, NY, commissionedby Dept. Interior Sect. Fine Arts, 1942; Public Library, Newark, NJ. **Comments:** Preferred media: oils, gouache, watercolor, graphics. Publications: contributor, "The art of the artist," Crown, 1951. Teaching: ASLk; Woodstock Summer School, 1948-54; Tulane Univ., 1956, 1958 & 1959; Univ. Florida, 1960-62. **Sources:** WW73; Lawrence Campbell, "Poet of the Levee & the Level Sands," *ASL New York News,* Sept. 1, 1950 & John Taylor, *Art News* (March, 1963); Ray Bethers, *How*

Paintings Happen (Norton, 1951); Falk, *Exh. Record Series.*

TAYLOR, Joseph Richard *[Sculptor, painter, lecturer, educator, teacher] b.1907, Wilbur, WA.*
Addresses: Norman, OK. **Studied:** Univ. Washington, B.F.A., M.F.A.; Columbia Univ. **Member:** Oklahoma AA. **Exhibited:** SAM, 1932 (prize); IBM (prize); Kansas City AI, 1932 (medal), 1934 (medal), 1935 (prize); Univ. Nebraska, 1940 (medal); PAFA Ann., 1935, 1937; WFNY, 1939; AV, 1944; Oakland Art Gal., 1945. **Work:** Fuller Art Gal., Seattle, WA; Univ. Nebraska; IBM Collection; Oklahoma State Capitol Office Bldg.; Univ. Oklahoma. **Comments:** Position: art instructor, Univ. Oklahoma Art School, Norman, OK. **Sources:** WW53; WW47; Falk, *Exh. Record Series.*

TAYLOR, Joshua Charles *[Art administrator, art historian] b.1917, Hillsboro, OR / d.1981.*
Addresses: Washington, DC. **Studied:** Mus Art Sch, Portland, Ore, 35039; Reed Col, BA, 1939, MA, 1946; Princeton Univ, MFA, 1949, PhD, 1956. **Member:** Asn Art Mus Dir; Col Art Asn Am (bd mem); Int Inst Consery of Hist & Artistic Works; Benjamin Franklin fel Royal Soc Arts. **Exhibited:** Awards: Quantrell Award, Univ Chicago, 1956. **Comments:** Positions: Dir, Nat Collection Fine Arts (NMAA, Wash. DC), 1970-. Publications: Auth, *William Page, the American Titian,* 1957; *Learning to look,* 1957; *Futurism* (MOMA, NY,1961); *Graphic works of Umberto Boccioni,*1961; *Vedere prima di Credere,* 1970; coauth, *The Hand and the Spirit: Religious Art in America* (Univ CA, Berkely, Univ Art Mus, 1972); *America as Art* (Harper & Row, 1976); *The Fine Arts in America* (Univ Chicago Press, 1979); edited, *Nineteenth-Century Theories of Art* (Univ CA Press, 1987). Teaching: Instr theatre, Reed Col, 1939-1941. Areas of expertise: Nineteenth & twentieth century painting & artistic theory in Italy & United States. **Sources:** WW73.

TAYLOR, Joy *[Painter] 20th c.*
Addresses: Chicago area. **Exhibited:** AIC, 1934, 1940. **Sources:** Falk, *AIC.*

TAYLOR, Jude *[Engraver] mid 19th c.*
Addresses: Pawtucket, RI in 1857. **Comments:** Of Payne & Taylor (see entry) **Sources:** G&W; Pawtucket and Woonsocket BD 1857.

TAYLOR, Katherine *[Painter] 20th c.*
Addresses: Wash., DC, active 1902-1910. **Studied:** Corcoran School Art. **Exhibited:** Wash. WCC, 1902, 1904, 1906. **Sources:** WW08; McMahan, *Artists of Washington, DC.*

TAYLOR, Kathryn M. *[Painter] 20th c.*
Exhibited: S. Indp. A., 1938. **Sources:** Marlor, *Soc. Indp. Artists.*

TAYLOR, Katrina Van Hook (Mrs.) See: **VAN HOOK, Katrina**

TAYLOR, Kenneth *[Painter] 20th c.*
Addresses: NYC. **Exhibited:** S. Indp. A., 1933-34. **Sources:** Marlor, *Soc. Indp. Artists.*

TAYLOR, Kyle *[Educator] b.1906, Portland, OR.*
Addresses: Lewiston, Idaho. **Studied:** Univ. Washington, B.F.A., M.F.A.; Univ. Oregon. **Member:** Nat. Educ. Assn.; Idaho Educ. Assn. **Comments:** Position: head art dept., Lewiston (ID) State Normal School, 1931-. **Sources:** WW53.

TAYLOR, Lawrence Newbold *[Block printer, illustrator] b.1903, Haverford, PA. / d.1980.*
Addresses: Haverford, PA/Glen Moore, PA. **Studied:** PM Sch IA. **Member:** Phila. Sketch Cl.; Print Cl.; Phila. Alliance; Wayne Art Center. **Comments:** Illustrator: "To the South Seas," by Gifford Pinchot. **Sources:** WW40; add'l info. courtesy Anthony R. White, Burlingame, Ca.

TAYLOR, Loron A. *[Cartoonist] b.1900 / d.1932, Cleveland, OH.*
Comments: Position: comic-strip work, a feature service newspaper association.

TAYLOR, Louis C. *[Painter] late 19th c.; b.Bangor, ME.*
Addresses: NYC, 1888. **Studied:** With Boulanger, Lefebvre.
Exhibited: Paris Salon, 1887; NAD, 1888. **Sources:** Fink,
American Art at the Nineteenth-Century Paris Salons, 396.

TAYLOR, Louise *[Painter] 20th c.*
Addresses: Chicago area. **Exhibited:** AIC, 1928. **Sources:** Falk,
AIC.

TAYLOR, Margaret C. See: **FARRELL, Margaret C.
Taylor**

TAYLOR, Margaret M. See: **FOX, Margaret M. Taylor
(Mrs. George L.)**

TAYLOR, Margaretta Bonsall *[Landscape painter, illustra-
tor] b.1880, Phila.*
Addresses: Phila., PA, 1908. **Studied:** PAFA, with W.M. Chase,
C. Beaux; Ferraris Studio, Rome. **Exhibited:** PAFA Ann., 1901,
1903. **Comments:** Specialty: watercolors. **Sources:** WW08; Falk,
Exh. Record Series.

TAYLOR, Marie Carr *[Painter; sculptor] b.1904, Saint
Louis, MO.*
Addresses: St. Louis, MO; NYC. **Studied:** St. Louis Sch. FA; J.
Farnsworth; ASL; Wash Univ Sch Art, 1923-1924. **Member:** S.
Indp. A., St. Louis; Sculptors Guild, NY; Nat Soc Arts & Lett.
Exhibited: St. Louis AG Exh., City Art Mus., 1933 (prize); PAFA
Ann., 1950; Kansas City Art Inst; Southern Ill Univ, Carbondale,
1952; Brooks Mem Art Gallery, Memphis, Tenn, 1955; Sculpture
1969, Span Int Pavillion, 1969; Joslyn Mus Art; NAWA (prize);
Cleveland Art Mus. (prize). **Work:** Cleveland Art Mus.
Commissions: Main altar, St Paul's Church, Peoria, Ill, 1960;
Jefferson Mem Nat Expansion, Saint Louis Riverfront, for
Mansion House, Saint Louis, 1967. **Sources:** WW73; WW40; M.
King, "Christmas Exhibits at Saint Louis Galleries," *Saint Louis
Post Dispatch,* Dec 14, 1969; Dona Z Meilach, *Creative Carving*
(Turtle, 1969) & *Contemporary Stone Sculpture* (Oracle, 1970);
Falk, *Exh. Record Series.*

TAYLOR, Mary *[Teacher and painter] b.1895, Murray, IA /
d.1970.*
Addresses: NYC/Monhegan Island, ME. **Studied:** Cumming
School Art; Iowa Univ.; NAD, with Charles Hawthorne and Ivan
G. Olinsky.; Tiffany Foundation; Cape Cod Sch. Art. **Exhibited:**
NAD, 1935 (as Mary Taylor Winter), 1941 (as Mary Taylor);
Tiffany Foundation; Municipal Art Galleries; Provincetown AA;
AIC. **Comments:** Was married to fellow artist, Andrew Winter,
and exhibited as both Mary Taylor and Mary Taylor Winter.
Painted on Monhegan Island (ME), where she and her husband
resided for a number of years. Positions: art supervisor, High
School, Fort Morgan, CO, 1921-23; Alcuin Private School, NYC.
Sources: WW40; Ness & Orwig, *Iowa Artists of the First
Hundred Years,* 205; Curtis, Curtis, and Lieberman, 170, 187;
Petteys, *Dictionary of Women Artists.*

TAYLOR, Mary Aldis (Mrs. George Dominick) *[Painter,
decorator] b.1859 / d.1929.*
Comments: Worked at Rookwood Pottery, Cincinnati, 1883-85.
Sources: Petteys, *Dictionary of Women Artists.*

TAYLOR, Mary B. *[Painter] late 19th c.*
Addresses: NYC, 1880. **Exhibited:** NAD, 1880. **Sources:**
Naylor, *NAD.*

TAYLOR, Mary Perkins See: **PERKINS, Mary Smyth**

TAYLOR, Minnie C(ora) *[Miniature painter, ceramicist]
b.1856, Bangor, ME / d.1944, San Francisco, CA.*
Addresses: San Francisco, CA. **Studied:** San Francisco School of
Des., with Yelland and Kunath; with Franz Schwartz in Chicago,
Mme. Laforge in Paris; Boston; NYC; Munich. **Member:**
Ceramic Club of San Francisco. **Exhibited:** Calif. Midwinter Int.
Expo, 1894; Pan-Pacific Expo, San Francisco, 1915. **Comments:**
Specialty: miniatures on ivory. Cf. Minnie M. Taylor. **Sources:**
WW15; Hughes, *Artists of California,* 553; Petteys, *Dictionary of
Women Artists.*

TAYLOR, Minnie M. *[Artist]*
Addresses: Active in Los Angeles, c.1911-23. **Comments:** Cf.
Minnie C. Taylor. **Sources:** Petteys, *Dictionary of Women Artists.*

TAYLOR, N. H. *[Engraver] mid 19th c.*
Addresses: Chillicothe, OH, 1853. **Sources:** G&W; Ohio BD
1853.

TAYLOR, P(aul) F(orrester) *[Painter, archl] b.1898, Phila.*
Addresses: Phila., PA. **Studied:** G.W. Dawson. **Member:** Phila.
WCC; Phila. Alliance; AIA. **Exhibited:** PAFA Ann., 1933.
Sources: WW33; Falk, *Exh. Record Series.*

TAYLOR, Peter *[Engraver] mid 19th c.*
Addresses: Lowell, MA, 1834-37. **Sources:** G&W; Belknap,
Artists and Craftsmen of Essex County, 5.

TAYLOR, Prentiss *[Lithographer,
instructor] b.1907, Washington, DC /
d.1991, Washington, DC?* *Prentiss Taylor*
Addresses: Arlington, VA. **Studied:** ASL with Charles W
Hawthorne, Charles Locke, Eugene Fitsch, Anne Goldthwaite.
Member: A.N.A. (graphics class); Soc Am Graphic Artists;
Philadelphia Watercolor Club; Artists Equity Assn (bd mem,
1971); A. Gld., Wash., D.C.; Wash. SE; Wash. WCC; Wash. Ldscp
Cl; Soc Washington Printmakers (press, 1943-). **Exhibited:**
Greater Wash. Indp. Exh., 1935 (prize); VMFA, 1943 (purchase
awards in watercolors, Va Artists); Irene Leach Mem., 1945,
1946; AIC, 1933 (Chicago Int Watercolors & Prints), and later;
PAFA; Phila. Pr. Cl.; Phila. A. All.; A. Gld., Wash., D.C., 1942,
1944, 1946; Nat Print Exhib, LOC, Wash., DC, 1943-on (purchase
awards in several annual exhibs); WMAA, 1936-47; "Painting in
the US, 1949," CI; Corcoran Gal biennials, 1949, 1951; Am
Drawing Biennials, Norfold Mus, Va, 1960s; NAD, 1954 (Cannon
prize in graphic arts); Franz Bader Gal, Wash, DC., 1970s. **Work:**
BMFA; AGAA; MOMA; LOC; Phillips Collection, Washington,
DC; Smithsonian Inst, Washington, DC; NYPL; MMA; WMAA;
PMA; BMA; PMG; LOC; VMFA; Norfolk Mus. A. & Sc.; Gibbes
Mem. A. Gal.; SAM. Commissions: Mural in tempera for bath,
commissioned by Mr & Mrs RF Flint, New Haven, Conn, 1940;
mural in oil, Christian Sci HQ, Washington, DC, 1949.
Comments: Preferred Media: watercolors, graphics. Positions:
Pres, Artists Guild Washington; pres, Washington Watercolor
Club; art therapist, St Elizabeth Hosp, Washington, DC, 1943-
1954; art therapist, Chestnut Lodge, Rockville, Md, 1958-70s.
Illustrator: *Negro Mother,* 1931; *Scottsboro Limited,* 1932; *Why
Birds Sing,* 1933; *American Herb Calendar,* 1937. Teaching: Am
Univ, Wash., DC, 1955-70s. Research: Art as psychotherapy;
How art may reintegrate the disordered mind; Talent/status vs
expectancy achievement. **Sources:** WW73; L. Ward,
"Printmakers of Tomorrow," *Parnassus* (Mar, 1939); H.H.
Salpeter, "Prentiss Taylor" *Coronet* (Apr, 1939).

TAYLOR, R. *[Painter] 19th/20th c.*
Addresses: Wash., DC. **Sources:** WW19.

TAYLOR, R. B. *[Painter] 20th c.*
Addresses: Toledo, OH. **Member:** Artklan. **Sources:** WW25.

TAYLOR, Rachel *[Listed as "artist"] 19th c.*
Addresses: Wash., DC. **Exhibited:** Wash. WCC, 1897.
Comments: Cf. R. Taylor. **Sources:** McMahan, *Artists of
Washington, DC.*

TAYLOR, Rachel *[Watercolorist] b.1887, Holmdel, NJ /
d.1974, Delaware.*
Studied: Pratt Inst.; Columbia Univ. **Comments:** Positions: art
teacher & head of art dept. Oneonta State Teachers College, NY,
1939-44; co-founder, Kinaolha Co-op Art School, Cragsmoore,
NY, 1944. **Sources:** Petteys, *Dictionary of Women Artists.*

TAYLOR, Ralph *[Painter, printmaker, teacher] b.1897, Russia.*
Addresses: Philadelphia, PA. **Studied:** Graphic Sketch Cl.; PAFA
with H. McCarter; also in Italy, France & England. **Member:**
Philadelphia Art Alliance; Philadelphia Print Club; Phila. Graphic
Sketch Cl.; All. A. Am. **Exhibited:** PAFA Ann., 1921-29, 1949;
PAFA (Mary Butler Mem Prize for "Concert," 1954); Corcoran

Gal biennial, 1923; Phila. AC, 1928; Bower Gal., N.Y., 1930 (solo); Woodmere A. Gal.; Graphic Sketch Cl.; State T. Col., Indiana, Pa.; Rochester Mem Gal, 1926; NAD, 1930; All.A.Am., 1944; Da Vinci Alliance, 1959 (Da Vinci Gold Medal for City at Night); Philadelphia Art Alliance, 1963 (award for "Animated Conversation"). **Work:** Fleisher Art Mem; La France Art Inst; PAFA; Graphic Sketch Cl. **Comments:** Preferred Media: oils. Teaching: Graphic Sketch Club, Philadelphia, 1920-23; Commercial Illus Studios, NYC, 1928-30. **Sources:** WW73.

TAYLOR, Renwick *[Painter] b.1898.*
Addresses: Brooklyn, NY. **Exhibited:** PAFA Ann., 1927; Nat. Gal., Wash., D.C., 1930 (prize). Award: Pulitzer traveling scholarship, 1925. **Work:** dec., Foxwood Sch., Flushing, N.Y. **Sources:** WW33; Falk, *Exh. Record Series.*

TAYLOR, Richard Lippincott Denison *[Cartoonist, painter] b.1902, Fort William, Ontario.*
Addresses: Blandford, MA. **Studied:** Ontario College Art, Canada; Los Angeles School Art & Des.; Central Tech. School, Toronto, and privately. **Exhibited:** Walker Gal., NY, 1940 (solo); Butler AI, 1940; Albright Art Gal., 1941; AGAA, 1941; BM, 1941; AIC, 1941-42, 1946-47; BMFA, 1941; Rouillier Gal., Chicago. 1941; Valentine Gal., NY, 1941; MMA, 1942; WMAA, 1943-48; Carnegie Inst., 1946; Flint IA, 1943; Hudson Gal., Detroit, 1951. **Work:** *New Yorker* magazine originals in many private collections, U.S. and abroad. Watercolor drawings: MMA; BMFA; Albright Art Gal.; Wichita Mus. Art; Univ. Nebraska. **Comments:** Contributor of illus., cartoons, to *New Yorker* magazine, *Saturday Evening Post, Colliers, Esquire, American, Town & Country, Mademoiselle, Life, McCalls,* and others. Author/illustrator: "Introduction to Cartooning," 1947; "By the Dawn's Ugly Light," 1953; "The Better Taylors" (coll. cartoons), 1944. Illustrator: "Sir Galahad & Other Rimes," 1936; "I Didn't Know It Was Loaded," 1948; "One for the Road," 1949; "Fractured French," 1950; "Compound Fractured French," 1951; "Never Say Diet," 1954, and many other books. **Sources:** WW59; WW40.

TAYLOR, Robert *[Art critic, writer] b.1925, Newton, Mass.*
Addresses: Marblehead, MA. **Studied:** Colgate Univ, AB, 1947; Brown Univ Grad Sch, 1948. **Comments:** Positions: Art critic, Boston Herald, 1952-1967; Boston corresp, Pictures on Exhibit, 1954-1959; mem staff, Boston Globe Mag, 1968-. **Publications:** Auth, In red weather, 1961; ed, publs, Inst Contemp Art, Boston, 1967. Teaching: Vis lectr, Wheaton Col, 1960-. **Sources:** WW73.

TAYLOR, Robert F. *[Listed as "artist"] 19th/20th c.*
Addresses: Wash., DC, active 1890-92. **Comments:** R. Taylor. **Sources:** McMahan, *Artists of Washington, DC.*

TAYLOR, Rod A. *[Sculptor, ceramicist] b.1932, Wash., DC.*
Studied: Virginia State Col.; American Univ.; Howard Univ.; Catholic Univ.; Virginia Union Univ. **Exhibited:** Smithsonian Inst., 1964 (prize); CGA, 1965; Catholic Univ., 1967; Howard Univ., 1967; Smith-Mason Gallery, 1965; The Little Art Gallery, Raleigh, NC, 1968; Saratoga Springs Art Fair, 1964 (1st prize); Atlanta Univ. Ann. (prize, 1965); Scan Art Fair, Wash., DC, 1966. **Sources:** Cederholm, *Afro-American Artists.*

TAYLOR, R(olla) S. *[Landscape painter, etcher, teacher] b.1874, Galveston, TX / d.1929.*
Addresses: San Antonio, TX in 1941. **Studied:** San Antonio Art League; J. Arpa; San Francisco, with A. W. Best; F. Fursman, in Michigan; J. Onderdonk. **Member:** Texas FAA; Chicago NJSA; San Antonio Art League; San Antonio AG; AFA. **Exhibited:** S. Indp. A., 1925-27; Salons of Am., 1929. **Sources:** WW40.

TAYLOR, Rosemary *[Craftsman] 20th c.; b.Joseph, OR.*
Addresses: Lumberville, PA. **Studied:** Cleveland IA; New York Univ.; Greenwich House. **Member:** NJ Designer-Craftsman; Artist-Craftsmen NY; Am. Craft Council. **Exhibited:** Only Originals, NJ, 1970 (solo); West Chester College, PA, 1971 (solo); Artisan Gallery, Princeton, NJ, 1972 (solo); Warren Library, 1972; & Georg Jensen, 1972 (solo). **Comments:** Preferred media: stoneware. **Publications:** contributor, *McCall's Needlework &*

Craft Magazine. **Sources:** WW73.

TAYLOR, Roy W. *[Cartoonist] b.1882 / d.1914.*
Addresses: Wash., DC. **Comments:** Positions: Car., Philadelphia North American; Staff, New York World, Chicago Tribune.

TAYLOR, Ruth Permelia *[Educator, painter, graphic artist, engraver] b.1900, Winsted, CT.*
Addresses: Brooklyn, NY. **Studied:** PIA School; ASL, and with J. Freeman; George Bridgman; Kimon Nicolaides. **Member:** NAWA (chmn., watercolor jury, 1957-59, 1962-63; nominating committee, 1964-65); Brooklyn SA; Am. Soc. Contemporary Art (1st vice-pres., 1956-58; rec. secretary, 1958-59; chmn. committee, 1965-66); Pen & Brush Club. **Exhibited:** NAWA, 1935-65,(Grumbacher prize,1961), and traveling exhibs.; NYWCC, 1936; AWCS, 1937, 1951; LOC, 1944; BM, 1941-46, 1952; Fifteen Gal., 1940 (solo); Argent Gal., 1937-58; Newark Art School, 1938-45; Riverside Mus., 1956 (prize); Brooklyn Soc. Art, 1948-65, and traveling exhibs.; P&S Soc., New Jersey, 1965; Pen & Brush Club, 1951-65. **Comments:** Position: instructor, Newark (NJ) Art School, 1926-28; asst. professor, PIA School, Brooklyn, NY, 1925-56 & assoc. professor, 1956-. **Sources:** WW66; WW47.

TAYLOR, S. Guy *[Painter] 20th c.*
Addresses: Upper Montclair, NJ. **Exhibited:** S. Indp. A., 1917. **Sources:** Marlor, *Soc. Indp. Artists.*

TAYLOR, Samuel T. *[Portrait painter] 19th c.*
Addresses: Virginia, mid 19th century. **Work:** Valentine Mus., Richmond, VA. **Sources:** Wright, *Artists in Virginia Before 1900.*

TAYLOR, Sandra J. *[Painter] b.1936, Los Angeles, CA.*
Addresses: San Francisco, CA. **Studied:** Univ. Calif., B.A., with William Brice & Sam Amato; Iowa State Univ., M.A., with Byron Burford. **Member:** College Art Assn. Am. **Exhibited:** 13th Ann. Drawing & Small Sculpture Show, Ball State Univ., Muncie, IN, 1967; 4th Ann. Nat. Drawing Exhib., Bucknell Univ., Lewisburg, PA, 1968; Invited Artist Civic Center Art Show, San Francisco & Hayward Area Festival Show, 1969-71; Rental Gallery Exhib., San Francisco Mus. Art, 1971; Northern Calif. 18th Ann. Open Art Exhib., Pauls Gallery, Sacramento, 1972; John Bolles Gallery, San Francisco, CA, 1970s. **Work:** Univ. Iowa; Macy's Corp., NYC; John S. Bolles Collection, San Francisco, CA; Univ. Calif. Research Library, Los Angeles. **Comments:** Preferred media: oils, acrylics, inks. Positions: gallery asst., John Bolles Gal., 1970-71. **Sources:** WW73; Thomas Albright, reviews, *San Francisco Chronicle*, 1968 & 1971; Cecil McCan, reviews, *West Art* (1968) & *Art Week* (1971); E. M. Polley, review, *Sunday Times-Herald*, 1971.

TAYLOR, Sarah C. *[Painter, teacher] 20th c.*
Addresses: Phila., PA. **Studied:** PAFA. **Sources:** WW25.

TAYLOR, Sibion Guilford *[Painter] mid 20th c.*
Exhibited: Corcoran Gal biennial, 1947. **Sources:** Falk, *Corcoran Gal.*

TAYLOR, Sidney P. *[Listed as "artist"] mid 20th c.*
Addresses: Wash., DC, active 1920-35. **Exhibited:** Greater Washington Independent Exh., 1935. **Sources:** McMahan, *Artists of Washington, DC.*

TAYLOR, Stillman *[Painter] mid 20th c.*
Addresses: NYC. **Exhibited:** S. Indp. A., 1933. **Sources:** Marlor, *Soc. Indp. Artists.*

TAYLOR, T. *[Engraver] mid 19th c.*
Comments: Engraver of landscapes published in NYC in 1860. **Sources:** G&W; Stauffer.

TAYLOR, Thomas *b.c.1817, New York.*
Addresses: NYC in 1860. **Comments:** G&W indicates this may be the Thomas Taylor listed in city directories as "flowers" or "art flowers." **Sources:** G&W; 8 Census (1860), N.Y., LVIII, 274; NYCD 1855-63.

TAYLOR, Thomas *[Painter, decorator] b.1854, Scotland / d.1915.*
Addresses: Brooklyn, NY. **Comments:** Position: t., Pratt Inst.

TAYLOR, Thomas *[Illustrator] 19th/20th c.*
Addresses: Wash., DC, active 1885-1890. **Work:** U.S. National Arboretum. **Comments:** Position: illus., U.S. Department of Agriculture. **Sources:** McMahan, *Artists of Washington, DC.*

TAYLOR, Vernon C. *[Painter, craftsperson] b.1906, San Bernardino, CA / d.1946, San Bernardino.*
Addresses: San Bernardino, CA. **Studied:** USC School of Arch.; with F. Tolles Chamberlain, Paul Sample, John H. Rich, Merrill Gage. **Exhibited:** P&S of Los Angeles, Stendahl Gal., 1942 (third prize). **Comments:** Position: teacher, public schools; staff, Judson Stained Glass Studios, Walt Disney Studio, 20th Century Fox Studios. **Sources:** Hughes, *Artists in California*, 553.

TAYLOR, Virginia (Mrs. William L.) See: **SNEDEKER, Virginia (Mrs. William L. Taylor)**

TAYLOR, W. H. *[Painter] mid 19th c.*
Work: In 1957 the work was in the possession of the New Brunswick (NJ) chapter of the D.A.R. (view, c.1850, of the Manning homestead near New Brunswick). **Sources:** G&W; info courtesy Donald A. Sinclair, Rutgers University.

TAYLOR, W. Irving *[Portrait painter] late 19th c.*
Addresses: Norfolk, VA, 1879-81. **Work:** Virginia Hist. Soc. **Sources:** Wright, *Artists in Virgina Before 1900.*

TAYLOR, Walter *[Illustrator] b.1874, Phila.*
Addresses: Phila., PA. **Studied:** PAFA; Europe. **Member:** SI. **Sources:** WW08.

TAYLOR, Walter R. (or S.) *[Designer] b.c.1813, England.*
Addresses: Boston, 1848-81. **Comments:** From 1867-77 he was agent for a china and glass decorating factory. **Sources:** G&W; 7 Census (1850), Mass., XXV, 405; Boston CD 1848-81.

TAYLOR, Wayne *[Sculptor] b.1931.*
Addresses: NYC. **Exhibited:** WMAA, 1968. **Sources:** Falk, *WMAA.*

TAYLOR, William *[Miniature and landscape painter] b.1764 / d.1841.*
Studied: Yale College, graduated. **Comments:** He taught school at New Milford (CT) and then became a merchant. He was an amateur artist; his 1790 portrait by Ralph Earl shows him sitting at an easel at work on a landscape. **Sources:** G&W; *Antiques* (Jan. 1933), 13; Dexter, *Yale Biographies and Annals, 1778-92* (citation provided G&W courtesy of the late William Sawitzky); *American Collector* (Nov. 1945), 12.

TAYLOR, William *[Ornamental painter] b.c.1829, Ohio.*
Addresses: Pittsburgh, PA in 1850. **Sources:** G&W; 7 Census (1850), Pa., III, 64.

TAYLOR, William Francis *[Painter, illustrator, lithographer] b.1883, Hamilton, Ontario, Canada / d.1970.*
Addresses: Lumberville, Bucks County, PA. **Member:** SC; Asbury Park Soc. FA. **Exhibited:** Province of Ontario, 1902 (med.); S. Indp. A., 1917; SC, 1924 (prize), 1927 (prize), 1932 (prize); Phila. AC, 1924 (prize). **Work:** Phila. Art Alliance. **Sources:** WW40.

TAYLOR, William H. C. *[glass decorator and pastel artist] b.1865, New Bedford, MA / d.1935, New Bedford.*
Addresses: Active in New Bedford, MA, 1883-1934. **Work:** Old Dartmouth Hist. Soc. **Comments:** Worked in the glass industry at Smith Bros and for Ullman Manufacturing Co., framemakers and art novelties manufacturer. By 1898 he was again working as a glass decorator and was designing for Taylor, Baron and Co. from 1901-08. **Sources:** Blasdale, *Artists of New Bedford*, 186-87 (w/repro.).

TAYLOR, William Henry *[Painter] b.1908, Alabama.*
Exhibited: Alabama State Teachers Col. 1932; Harmon Fnd., 1928, 1933, 1935; State Armory, Wilmington, DE, 1971. **Sources:**

Cederholm, *Afro-American Artists.*

TAYLOR, W(illiam) L(add) *[Illustrator, painter] b.1854, Grafton, MA / d.1926.*
Addresses: Wellesley, MA. **Studied:** ASL; Acad. Julian, Paris, with Boulanger & Lefebvre, 1884-85. **Member:** SI, 1905; Copley Soc., 1907. **Exhibited:** Boston AC, 1881-93; Armory Show, 1913. **Work:** Kendall Whaling Mus. **Comments:** Series of illustr.: "The 19th Century in New England," "The Pioneer West," "Pictures from the Psalms," "Pictures from the Old Testament," "Our Home and Country." Also a popular illustr. for *Ladies Home Journal*, where his pictures were reproduced as prints and mass-distributed. Specialty: Biblical subjects. **Sources:** WW25.

TAYLOR, William Lindsay *[Painter, sculptor] b.1907, Paisley, Scotland.*
Addresses: NYC; Woodside, NY. **Studied:** ASL; BAID; & with Nicolaides, Miller & Sloan; Tiffany Fnd., Oyster Bay, NY. **Exhibited:** PAFA Ann., 1934, 1938, 1940; VMFA, 1939, 1940; GGE 1939; AV, 1942; Pepsi-Cola, 1945; Arch. Lg., 1936; ASL Awards: Tiffany Fnd. Fellowship,1930. **Work:** ASL; mural, St. Zephrin Church, La Tuque, Quebec, Canada. **Sources:** WW53; WW47; Falk, *Exh. Record Series.*

TAYLOR, William N(icholson) *[Painter, architect] b.1882, Cincinnati.*
Addresses: NYC. **Studied:** Académie Julian, Paris, 1906; also with L. Bernier. **Member:** Mural P.; NSS; BAID; Beaux-Architects; Société des Architects Français; Lyme AA. **Sources:** WW33.

TAYLOR, Will(iam) S. *[Mural painter, teacher] b.1882, Ansonia, CT.*
Addresses: Providence, RI/Lyme, CT. **Member:** AIA; Mural P.; SC; Allied AA; CAFA; Providence AC; Lyme AA. **Work:** sixteen panels relating to early life of Alaskan and British Columbian Indians, and three murals showing development of man through material culture, J.P. Morgan Mem. Hall, AMNH; murals, City Park Chapel (Brooklyn, N.Y.), Providence Street Jr. H.S. (Worcester, Mass.). **Comments:** Position: t., Brown Univ. **Sources:** WW40.

TAYLOR, William Watts *[Craftsperson, patron] b.1846 / d.1913.*
Addresses: Cincinnati, OH. **Member:** Cincinnati Mus. Assn. **Exhibited:** Award: honorary degree, Harvard. **Comments:** Position: pres., Rookwood Pottery Co.

TAYLOR, Wyclif *[Painter, draftsperson] b.1879, Medina, NY / d.1966, Portola Valley, CA.*
Addresses: Southern California, 1896. **Exhibited:** Riverside AA, Los Angeles City Hall, 1941. **Sources:** Hughes, *Artists in California*, 553.

TAYLOR, Wynne Byard (Mrs. Edward J.) *[Sculptor] b.1904, NYC.*
Addresses: South Londonderry, VT. **Studied:** Bourdelle; Archipenko; Laurent. **Member:** NAWPS. **Exhibited:** S. Indp. A., 1937. **Sources:** WW40.

TAYLOR-WATSON, Elizabeth Vila (Mrs. A. M.) *[Portrait & miniature painter] b.1863, New Jersey / d.1949.*
Addresses: Boston, Cambridge, MA, 1896-1910; Plymouth, MA. **Studied:** BMFA Sch. with E. Tarbell, F. Benson, J. De Camp. **Member:** Boston Art Students' Assoc., 1887; Copley Soc., 1887; Boston AC. **Exhibited:** PAFA Ann., 1896-1907, 1910, 1922; Tennessee Centennial Expo, Nashville, 1897 (medal); Poland Springs Art Gal., 1898; Phila. AC, 1898; BMFA (prize); Trans-Mississippi Expo, Omaha, NE, 1898; Springfield AC; Vose Gal., Boston; Boston AC, 1894-1904; Corcoran Gal. annuals, 1907-08; Copley Soc. **Work:** Circuit Court, Boston, MA; many portrait commissions. **Comments:** She painted at Fenway Studios, 1906-49. **Sources:** WW10; WW53; WW47; Vose Galleries, *Mary Bradish Titcomb and Her Contemporaries*, 52; Petteys, *Dictionary of Women Artists;* Falk, *Exh. Record Series.*

TAYLOR & ADAMS *[Wood engravers and designers] mid 19th c.*
Addresses: Boston, 1850-60 and after. **Comments:** Partners were James L. Taylor and Thomas W. Adams (see entries). **Sources:** G&W; Boston CD 1850-60+.

TAYSOM, Wayne Pendleton *[Sculptor, educator] b.1925, Afton, WY.*
Addresses: Corvallis, OR. **Studied:** Univ. Wyo.; Columbia Univ.; Univ. Utah (B.F.A.); Ecole Beaux-Arts, Paris; Teachers Col., Columbia Univ. (M.A.); Cranbrook Acad. Art. **Member:** Am. Assn. Univ. Prof.; Portland Art Assn. **Exhibited:** solo show, 1954 & Paper Works, 1972, Portland Art Mus.; Seattle World's Fair, 1962; Am. Crafts Coun., Western Craftsmen, 1964; Hunnicutt Art Gal., Hawaii, 1967. Awards: purchase prize, Portland Art Mus., 1956. **Work:** Portland Art Mus.; Ore. State Univ. mem. Union; Corvallis Clin., Ore.; Univ. Ore. Erb. Mem. Union, Eugene; US Nat. Bank Ore., Portland. Commissions: archit. sculpture, Lane Co. Courthouse, Eugene; Masonic Temple; Corvallis Br., US Nat. Bank Ore.; fountain & doors, Ore. State Univ. Libr.; coun. chamber doors, Salem Civic Ctr., Salem Ore.; many portrait & pvt. comns. **Comments:** Teaching: prof. sculpture, Univ. Ore., 1951-52; prof. art, Ore. State Univ., 1953-. **Sources:** WW73.

TCHAIKA, Georgs *[Painter, sculptor] mid 20th c.*
Exhibited: S. Indp. A., 1942. **Sources:** Marlor, *Soc. Indp. Artists.*

TCHAKALIAN, Sam *[Painter, printmaker, teacher] b.1929, Shanghai, China.*
Addresses: San Francisco, CA, 1947. **Studied:** San Francisco State (B.A., 1952, M.F.A., 1958). **Exhibited:** annually, San Francisco Mus. Modern Art, 1958-65; SFMA, 1964; CPLH, 1967, 1969; Portland Art Mus., 1968; WMAA, 1969; Oakland Mus., 1978 (retrospective); Fresno Art Mus.; Modernism Gal., San Francisco; Susan Caldwell Gal., NY; Portland Center Visual Arts; Nat. Mus. Contemporary Art, Seoul, Korea; San Francisco Art Inst. (Adaline Kent Award); Nat. Endowment Arts grants, 1981, 1989. **Work:** Brooklyn Mus.; San Francisco Mus. Modern Art; Oakland Mus.; Univ. Calif., Berkeley; Palm Springs Desert Mus.; Sheldon Mem. Art Gal., Univ. Nebraska; Albright-Knox Art Gal., Buffalo, NY; Nat. Mus. Contemporary Art, Seoul, Korea; Milwaukee Art Center. **Comments:** Teaching: faculty member, San Francisco Art Inst., 1966-. **Sources:** "Modernism in California Printmaking," Nov. 1998, The Annex Galleries.

TCHELITCHEW, Pavel
[Painter] b.1898, Russia / d.1957, Italy.
Addresses: NYC; Italy, 1954-on.
Studied: Moscow; Academy of Art, Kiev. **Exhibited:** PAFA Ann., 1944, 1950, 1956-58; WMAA, 1945-52; AIC. **Work:** MMA; MoMA; Nelson Gal., Kansas City, MO; Santa Barbara Mus., CA; Tretyakow Art Gal., Moscow; Wadsworth Atheneum, Hartford, CT. **Comments:** Born on his family's estate near Moscow, he fled to Kiev from the 1917 Revolution, and later to Berlin, where he worked as a stage designer. In 1923 he went to Paris, and fled Paris in 1939 to settle in the U.S. Known for his almost surrealist renderings of the human body without its skin, similar to anatomical studies. Spent time in Weston, CT at the estate of Alice DeLamar, patroness of Westport artists. **Sources:** PHF files; Art in Conn.: Between World Wars; *300 Years of American Art*, 876; Falk, *Exh. Record Series.*

TCHENG, John T. L. *[Painter] b.1918, Shanghai, China.*
Addresses: Fort Thomas, KY. **Studied:** S.C. Chao, Shanghai; C.C. Wang, NYC. **Member:** Cincinnati Art Club. **Exhibited:** 11 solo shows from coast to coast, 1956-. **Comments:** Preferred media: inks, oils. Research: Chinese calligraphy; modern painting. **Sources:** WW73.

TCHERNIAWSKY, Charles *[Painter] mid 20th c.*
Exhibited: AIC, 1937-38, 1940. **Sources:** Falk, *AIC.*

TEACHOUT, David *[Painter] mid 20th c.*
Exhibited: Corcoran Gal biennial, 1967. **Sources:** Falk, *Corcoran Gal.*

TEAGUE, Donald *[Painter, illustrator] b.1897, Brooklyn, NY / d.1991.*
DONALD TEAGUE N.A.
Addresses: Carmel, CA in 1976. **Studied:** ASL, 1916-17 with DuMond, Bridgman; London, with N. Wilkinson, 1918, again at ASL, with D. Cornwell, 1919-20. **Member:** NA, 1948; AWCS; Audubon Artists; All. A. Am.; SC; CAA; Am. A. Prof. League; SI; Nat. Acad. Western Art. **Exhibited:** MMA; BM; AIC; TMA; CAFA; NAD, 1932 (prize), 1962 (Morse Gold Medal); New Rochelle AA, 1935 (prize); SC, 1936 (prize), 1939 (prize); Stendahl Gal., Los Angeles, 1944 (solo); AWCS, 1944 (prize), 1953 & 1964 (gold medal of honor); Mus. Watercolor, Mexico City, Mexico; AIC; Royal Watercolor Soc., London, England; Kyoto Mus., Japan. **Work:** VMFA; Frye Mus., Seattle, WA; Air Force Acad., Colorado Springs, CO; Mills College Art Gallery, Oakland, CA; State of Calif. Collection, Sacramento. **Comments:** Preferred media: watercolors. Illus., *Collier's, Saturday Evening Post.* Signed *Collier's* illustrations with another name, Edwin Dawes. **Sources:** WW73; WW47; Ernest Watson, "Donald Teague, Illustrator," *Am. Artist* (1944).

TEAGUE, Emmett Byron *[Painter, etcher] b.1896, Missouri / d.1971, Paradise, CA.*
Addresses: Oakland, CA. **Studied:** Calif. Col. of A. and Cr. **Member:** Bay Region AA. **Exhibited:** Schwartz Galleries, NYC, 1941. **Sources:** Hughes, *Artists in California,* 553.

TEAGUE, Walter Dorwin *[Industrial designer, advertising artist] b.1883, Decatur, IN / d.1960, Flemington, NJ.*
Addresses: NYC. **Studied:** ASL; G. Bridgman. **Member:** Am. Soc. Indst. Des. (f. & past pres.); AIGA (past pres.); Royal Des. for Industry, Great Britain (hon.); SI, 1913; Arch. Lg.; Grolier C. **Exhibited:** he was on the Board of Design, WFNY, 1939, and was responsible for the gear-shaped design of the Ford Building and its Cycle of Production exhibit; the diorama for U.S. Steel; and other exhibits at the fair. **Comments:** Positions: senior partner, Walter Dorwin Teague Assoc., NYC; des. counsel for: Eastman Kodak Co. (for over thirty years); Boeing Airplane Co.; Ford Motor Co.; A.B. Dick Co.; E.I. Du Pont de Nemours Co.; Scripto, Inc.; Ritter, Inc.; Polaroid Corp.; Sevel, Inc.; Texaco Co.; Barcalo Mfg. Co. Among his (and his firm's) designs were the Baby Brownie camera, c. 1935; the Marmon 16 automobile, 1932; and service station designs for Texaco, 1934-37. Lecturer on Design, Harvard Univ.; NY Univ.; Univ. Wisconsin; MIT; McGill Univ.; Am. Univ., Beirut, etc. Author: "Design This Day"; "Land of Plenty" "Flour for Man's Bread" (with Dr. John Storck); "You Can't Ignore Murder" (with Ruth Mills Teague). **Sources:** WW59; WW40; Jeffrey Meikle, *Twentieth Century Limited: Industrial Design in America, 1925-39,* Philadelphia: Temple Univ. Press, 1979.

TEAL, W. P. *[Painter] early 20th c.*
Addresses: Cincinnati, OH. **Comments:** A bold Impressionist landscape of gardens by the shore in Rockport, Mass. was advertised by David David, Phila., c.1990. **Sources:** WW17.

TEALE, Earle Grantham *[Illustrator] b.1886 / d.1919.*
Addresses: NYC. **Studied:** ASL; Stanford Univ.(arch. des.). **Comments:** Specialty: automobiles. Illus., automobile adv.; catalog for *Canadian Pacific Railway.* He was killed in a garage by a car entering from the sunlit outside. **Sources:** WW19.
TEALE

TEALL, Gardner C. *[Painter, illustrator] b.1878.*
Addresses: NYC/Brewster, MA. **Exhibited:** AIC, 1902, 1909. **Sources:** WW10.

TEASDALE, Mary See: **TEASDEL, Mary (H.)**

TEASDEL, Mary (H.) *[Painter, teacher] b.1863, Salt Lake City / d.1937, Los Angeles, CA.*
Addresses: Salt Lake City, UT; Los Angeles, CA by 1931.

Studied: Univ. Deseret, 1886; with Harwood, 1891; with G.DeF. Brush, ASL, 1897; Académie Julian, Paris with Constant, 1900-03; also with Simon, Collin, Garrido, and Whistler in Paris. **Member:** Utah SA; Women Painters of the West; Calif. AC; Calif. WC Soc. **Exhibited:** SNBA, 1899; International French Expo; Paris Salon, 1902; Vienna; Berlin; Utah State Fair, 1908 (first prize). **Work:** Carnegie Public Library; Univ. Utah; Utah Capitol. **Comments:** She was the first woman artist from Utah to gain recognition in Utah exhibitions and at the Paris Salon. Specialty: watercolor portraits, landscapes and floral still lifes. She was an art teacher in Utah and Los Angeles. **Sources:** WW21; Hughes, *Artists in California*, 553-554; P&H Samuels, 481; Fink, *American Art at the Nineteenth-Century Paris Salons*, 396.; Trenton, ed. *Independent Spirits*, 217-18.

TEATER, Archie Boyd *[Painter] b.1901, Jackson Hole, WY.* **Addresses:** NYC. **Exhibited:** S. Indp. A., 1936, 1944. **Sources:** Marlor, *Soc. Indp. Artists*.

TEBAULT, Sallie Bradford Bailey Grantland (Mrs. C.H.) *[Painter, sculptor] b.1843, Baldwin County, GA / d.1926.* **Addresses:** New Orleans, active c.1866-1926. **Studied:** Phila. Acad. FA, c.1864-66. **Exhibited:** Columbian Expo, Chicago, 1893; Atlanta Expo. **Comments:** Amateur artist who married a physician and moved to N.O., where she continued to paint and exhibit china, landscapes, portraits and sculpture. **Sources:** *Encyclopaedia of New Orleans Artists*, 371; Petteys, *Dictionary of Women Artists*.

TECO See: **SLAGBOOM, Teco**

TEDD, J. Gilmore *[Painter] mid 20th c.* **Addresses:** Sunnyside, LI, NY. **Exhibited:** S. Indp. A., 1932, 1934. **Sources:** Marlor, *Soc. Indp. Artists*.

TEDESCHI, Paul Valentine *[Painter, educator] b.1917, Worcester, MA.* **Addresses:** New Haven, CT. **Studied:** Vesper George Sch. Art, Boston; AIC; Yale Univ. (B.F.A. & M.F.A.); Columbia Univ. **Exhibited:** AIC; Boston Festival Art; Providence Festival Art; Silvermine Guild Artists; Conn. WC Soc.; CAFA. **Awards:** New Haven Paint & Clay Club Purchase Prize, 1949; Silvermine Guild Artists, 1958. **Comments:** Teaching: asst. prof. art, Southern Conn. State Col., 1954-69, chmn. dept. fine arts, 1954-55, assoc. prof. art, 1969-. **Sources:** WW73.

TEDFORD, Elsie Mae (Mrs. Donald S.) *[Painter] b.1901, Abington, MA.* **Addresses:** Columbus, NM; Española, NM. **Studied:** ASL; Tiffany Fnd.,1929; H. Lever; K.H. Miller; K. Nicolaides. **Exhibited:** NAD, 1931, 1933; G-R-D Gal., 1933-34; Studio Gld.; Albion College; New Mexico State Mus., 1949, 1953-58; El Paso Pub. Lib., 1950; Southwestern Carnival, 1950-51; P&S New Mexico, 1949-51; State Rodeo Show, 1955 (prize). **Work:** IBM. **Comments:** Also appears as Elsie Mae Ford. **Sources:** WW59; WW47.

TEDLIE, Harry *[Painter] b.1898, Philadelphia, PA / d.1983, Woodstock, NY.* **Addresses:** NYC; Woodstock, NY. **Studied:** Birge Harrison and John Carlson; ASL. **Member:** Salon of America, 1930s; American Abstract Artists; Woodstock AA. **Exhibited:** Woodstock AA, 1926-80; S. Indp. A., 1928-30, 1932, 1944; Salons of Am., 1934; Rudolph Galleries, Palm Beach & NYC, 1940s-50s; American Abstract Artists, 1950s-60s; Dave Findlay Galleries, NYC, 1998. **Work:** Woodstock AA. **Comments:** Preferred media: oil, gouache, watercolor. **Sources:** info courtesy of J. Young, Woodstock, NY; Woodstock AA.

TEE-VAN, Helen Damrosch (Mrs. John) *[Painter, illustrator, craftsperson, designer, writer] b.1893, NYC / d.1976.* **Addresses:** NYC; Sherman, CT. **Studied:** New York School Display; also with George De Forest Brush & Jonas Lie. **Member:** Soc. Woman Geographers; Soc. Animal Artists; New York Zoological Soc. (life mem.). **Exhibited:** NAD, 1917; CAM,

1917; CM, 1917; PAFA, 1923; AMNH, 1925; LACMA, 1926; Ainslie Gal., 1927; Warren Cox Gal., 1931; Gibbes Mem. Art Gal., 1935; Buffalo Mus. Sc., 1935; Berkshire Mus., 1936; Argent Gal., 1941. **Work:** Bronx Zoo, New York. Commissions: murals & display, Berkshire Mus., Pittsfield, 1938-39; murals & exhibs., New York Zoological Soc., 1941-62 (color plates of flora and fauna of British Guiana, the Arcturus, Haitian and Bermuda Oceanographic Expeditions under W. Beebe, 1922, 1924, 1925, 1927, 1929-33). **Comments:** Preferred media: oils, watercolors. Positions: scientific artist, scientific artist tropical res. & artist on NY expeditions, tropical dept., 1922-62, New York Zoological Soc. Publications: author/illustrator, *Red Howling Monkey*, Macmillan, 1926; illustrator, *Story of the Platypus*, 1959; author/illustrator, *Insects Are Where You Find Them*, 1963; author/illustrator, *Small Mammals Are Where You Find Them*, 1966; illustrator, *Story of Alaskan Grizzly*, 1969, Knopf; plus many natural history book illustrations for various scientific & juvenile books. Art interests: undersea landscape; black & white illustrations. Also known as Helen Therese Damrosch. **Sources:** WW73; WW47; Falk, *Exh. Record Series*.

TEED, D(ouglas) Arthur *[Painter] b.1863, Utica, NY / d.1929.* **Addresses:** Scranton, PA, 1912; Detroit, MI. **Studied:** Paris; London; Rome. **Exhibited:** Boston AC, 1896; Intl. Expo, Rome, 1911; PAFA Ann., 1912. **Work:** East Aurora, NY; Canton, Ohio. **Sources:** WW25; Falk, *Exh. Record Series*.

TEEGEN, Otto *[Designer, architect, writer, teacher] b.1899, Davenport, IA.* **Addresses:** NYC. **Studied:** Harvard. **Member:** BAID; Soc. Beaux Arts Architects; Alumni in Architecture, Harvard (pres.); Committee on Education, Am. Inst. Architecture. **Exhibited:** Award: Harvard Traveling Fellowship, 1925-27. **Comments:** Assistant to Joseph Urban in design of exterior color and lighting for Century of Progress Expo, Chicago, 1933; in charge of color and collaborating on lighting, Cleveland Expo, 1936; coordinating architect of Shelter Div., New York World's Fair, 1939. Contributor; articles, *Architecture*. Position: architecture director & trustee, BAID. **Sources:** WW40; Ness & Orwig, *Iowa Artists of the First Hundred Years*, 205-06.

TEEL, E. *[Engraver of portraits and landscapes] b.c.1830 / d.Before 1860, Hoboken, NJ.* **Addresses:** NYC; Cincinnati, c.1854. **Sources:** G&W; Stauffer.

TEEL, George A. *[Painter] 19th/20th c.* **Studied:** Chas. H. Woodbury, Ogunquit Sch. **Exhibited:** Boston A. Cl. 1882, 1883, 1886; Paris Salon, 1887. **Comments:** Exhibited a woodcut at the Paris Salon. **Sources:** *Charles Woodbury and His Students*; Fink, *American Art at the Nineteenth-Century Paris Salons*, 396.

TEEL, Lewis Woods *[Painter, illustrator] b.1883, Clarksville, TX.* **Addresses:** El Paso, TX in 1948. **Comments:** Specialties: Southwestern desert in oil; portraits in pastel. **Sources:** P&H Samuels, 481-82.

TEESDALE, Christopher H. *[Painter] b.1886, Eltham, England.* **Addresses:** Cleburne, TX. **Member:** Tex. FAA; Cleburne AA. **Work:** port., Cleburne Pub. Sch., Masonic Temple, Cleburne; Ft. Worth Pub. Sch. **Sources:** WW40.

TEETZEL & CO. *[Engravers] late 19th c.* **Addresses:** New Orleans, active 1876-78. **Comments:** Partners were George E. Teetzel and Max Chapsky, also as Teetzel and Chapsky and Chapsky and Teetzel. **Sources:** *Encyclopaedia of New Orleans Artists*, 371-72.

TEFFT, Charles (or Carl) Eugene *[Sculptor, teacher, lecturer] b.1874, Brewer, ME.* **Addresses:** Guilford, ME. **Studied:** Artist-Artisan Inst.; Blankenship; Ruckstuhl. **Member:** NSS. **Exhibited:** NAD; NSS; Arch. Lg. **Work:** fountain, Bronx Mus.; AMNH; Statuary Hall,

Wash., DC; statue, Bangor, Maine; monument, Ft. Lee, NJ. **Sources:** WW47.

TEGGIN, Andrew *[Painter] late 19th c.*
Addresses: NYC, 1885-99. **Exhibited:** NAD, 1885-99. **Sources:** Naylor, *NAD.*

TEICH, Rex *[Painter] mid 20th c.*
Addresses: Chicago area. **Exhibited:** AIC,1950. **Sources:** Falk, *AIC.*

TEICHERT, Minerva Kohlhepp (Mrs.) *[Mural painter, writer, teacher, illustrator] b.1889, Ogden, UT. / d.1976.*
Addresses: Living in Cokeville, WY in 1974. **Studied:** Mark Hopkins AI, San Francisco; AIC, with Vanderpoel, 1912; Sterba; ASL, with Henri, K.H. Miller, Bridgman, 1914-17. **Member:** Utah AI. **Work:** State Capitol, Wyoming; Cokeville H.S., WY; South H.S., Salt Lake City; LDS Temple, Manti, Utah. **Comments:** Married and settled in Idaho on a ranch. Wrote about and painted the landscape, cowboys, and other Western subjects. She turned to LDS subjects in 1935, painting hundreds of murals and easel paintings for churches, schools and private patrons. She also educated her children, published several popular songs and wrote political pamphlets. **Sources:** WW40; P&H Samuels, 482; Trenton, ed. *Independent Spirits,* 209, cites birth date of 1888, 237-38.

TEICHMAN, Sabina *[Abstract painter, sculptor] b.NYC / d.1983.*
Addresses: NYC/Truro, MA, 1934-on. **Studied:** Columbia Univ. (B.A. & M.A.); also with Charles J. Martin and Arthur J. Young. **Member:** Audubon Artists (corresp. secy.); Provincetown Art Assn. **Exhibited:** Argent Gal., NYC 1947 (first solo); Saltpeter Gal., NYC, 1949, 1952, 1954 (solos); Shore Studios, Boston, 1955 (solo); ACA Gal., NYC, 1957 (solo); WMAA Ann; Art USA, 1958; Provincetown AA; Butler Inst. Am. Art Ann.; Audubon Artists Ann.; ACA Galleries, NYC, 1970s Awards: prize for painting, Womens Westchester Cntr., 1950. **Work:** WMAA; Butler Inst. Am. Art; Smithsonian Inst.; Fogg Mus. Art, Harvard Univ.; SFMA. **Comments:** Preferred media: oils, watercolors, clay. **Sources:** WW73; WW40; Baur & Goodrich, *Art of the 20th Century;* Baron, *31 Contemporary Artists;* Crotty, 79; *Provincetown Painters,* 226.

TEICHMUELLER, M. (Mrs. Minette T. Pohl) *[Painter] b.1872, La Grange, TX.*
Addresses: San Antonio, TX. **Studied:** Sam Houston Normal Sch.; San Antonio Acad. Art; H.D. Pohl. **Work:** White House, Wash., DC; mural, USPO, Smithville, TX. **Comments:** Position: teacher, San Antonio Acad. Art. **Sources:** WW59; WW47.

TEICHNER, Joseph *[Painter] b.1888, Gyoma, Hungary.*
Addresses: NYC, Fieldston, NY. **Studied:** J. Carlson; NAD. **Member:** Brooklyn SA; Allied AA. **Exhibited:** Salons of Am., 1930-31; S. Indp. A., 1930; PAFA Ann., 1932. **Sources:** WW40; Falk, *Exh. Record Series.*

TEIGEN, Peter *[Painter, architect] b.1895, Minneapolis, MN / d.1936, Glenveigh Castle, County Donegal, Ireland.*
Addresses: Cambridge, MA; Princeton, NJ. **Studied:** Ross; Jacovleff; Schoukhaieff; Harvard; Univ. Minn., 1915. **Exhibited:** PAFA Ann., 1931. **Comments:** Positions: t., Princeton Univ. (1928-36), Smith Col. **Sources:** WW25; Falk, *Exh. Record Series.*

TEIJELO, Gustave *[Lithographer, printer, photographer] b.1862, Cadiz, Spain / d.1898, New Orleans, LA.*
Addresses: New Orleans, active 1884-97. **Comments:** Reportedly came to New Orleans c.1874. **Sources:** *Encyclopaedia of New Orleans Artists,* 372.

TEILMAN, Gunvar Bull See: **BULL-TEILMAN, Gunvor (Mrs.)**

TEILMAN, Herdis Bull *[Art administrator, curator] mid 20th c.; b.Paris, France.*
Addresses: Pittsburgh, PA. **Studied:** Barnard Col. (B.A.); NY

Univ. Inst. Fine Arts, 1961; Univ. Paris Inst. Art & Archeol., 1961-62; NY Univ. Inst. Fine Arts, 1963-64, with Lopez-Rey & Horst Gerson. **Member:** Am. Assn. Mus. **Comments:** Positions: secy.-registr., Nat. Serigraph Soc., 1961; asst., Kunst Arbeidsplassen, Oslo, Norway, 1962-63; cur. painting & sculpture, Newark Mus., NJ, 1968-70; asst. dir., Mus. Art, Carnegie Inst., 1970-. Collections arranged: Forerunners of Am. Abstraction, Mus. Art, Carnegie Inst., winter 1971. Publications: auth., "Frank Wilbert Stokes (1858-1955)," Meltzer Gallery, NYC, 1960; contribr., "The Museum," Vol 1921, Nos 3 & 4, Newark Mus., NJ; auth., "Forerunners of American Abstraction," Carnegie Inst., 1971; contribr., *Carnegie Mag.,* Carnegie Inst. & Libr., Pittsburgh, 1971-72. **Sources:** WW73.

TEISSEIRE, Armand *[Portrait painter and teacher] mid 19th c.*
Addresses: San Francisco, 1856-78. **Sources:** G&W; San Francisco CD 1856-78.

TEITEL, Eve D. *[Painter] mid 20th c.*
Addresses: Chicago area. **Exhibited:** AIC, 1935. **Sources:** Falk, *AIC.*

TEITZ, Richard Stuart *[Art administrator, art historian] b.1942, Fall River, MA.*
Addresses: Worcester, MA. **Studied:** Yale Univ. (A.B.); Harvard Univ. (M.A.). **Member:** Col. Art Assn. Am.; Assn. Art Mus. Dirs.; Int. Coun. Mus.; Am. Assn. Mus. **Comments:** Positions: dir., Wichita Art Mus. Kans., 1967-69; assoc. dir., Worcester Art Mus., Mass., 1969-70, dir., 1970-. Publications: auth., "Masterpieces of Etruscan Art," 1967; auth., "Masterpieces of Religious Art," 1967; auth., "American Victoriana," 1969. Teaching: instr. archit. hist., Boston Archit. Ctr., Mass., 1963-66; instr. art hist., Clark Univ., 1966-67. Collections arranged: Etruscan Art, 1967, Victorian Art, 1969, Am. Contemp. Art, 1969, Toulouse-Lautrec, 1971, Marisol, 1971 & Escher, 1971. Collection: old master drawings. Research: classical and Renaissance art. **Sources:** WW73.

TEIXEIRA, Oswaldo *[Painter] mid 20th c.*
Addresses: Brazil, 1939. **Exhibited:** S. Indp. A., 1939. **Sources:** Marlor, *Soc. Indp. Artists.*

TEJADA, M. S. de *[Miniaturist] mid 19th c.*
Addresses: New Orleans, 1843-44. **Sources:** G&W; Delgado-WPA cites New Orleans CD 1843-44.

TEKA, Eulalie *[Painter] late 19th c.; b.Boston, MA.*
Studied: Trémont; Mlle. M. Ravenz; Henner; Carolus-Duran. **Exhibited:** Paris Salon, 1874, 1876, 1878-80. **Sources:** Fink, *American Art at the Nineteenth-Century Paris Salons,* 396.

TELBERG, Val *[Photographer] b.1910, Russia / d.1995, Sag Harbor, NY.*
Exhibited: Lawrence Miller Gal., NYC, 1990s (solo). **Comments:** Between 1947-56, he produced photomontages with a "stream of consciousness" approach, resulting in surreal imagery. **Sources:** press release, Lawrence Miller Gal. (NYC, 1990s).

TELBERG, Vladimir (G.) *[Painter] mid 20th c.*
Addresses: NYC. **Exhibited:** S. Indp. A., 1944. **Sources:** Marlor, *Soc. Indp. Artists.*

TELFER, John R. *[Wood engraver and designer] mid 19th c.*
Addresses: Cincinnati, 1850-58. **Sources:** G&W; Cincinnati CD 1850-58.

TELFER, Robert *[Wood engraver] mid 19th c.*
Addresses: Philadelphia, 1849-57. **Comments:** Of Telfer & Lawrie (see entry), 1849, and Scattergood & Telfer (see entry), 1852-54. **Sources:** G&W; Phila. CD 1849-57; Hamilton, *Early American Book Illustrators and Wood Engravers,* 151.

TELFER, William D. *[Painter] late 19th c.*
Addresses: Brooklyn, NY, 1866-76. **Exhibited:** NAD, 1866-76. **Sources:** Naylor, *NAD.*

TELFER & LAWRIE *[Engravers] mid 19th c.*
Addresses: Philadelphia, 1849. **Comments:** Partners were Robert

Telfer and Alexander Lawrie (see entries). **Sources:** G&W; Phila. CD 1849.

TELIEZ, J. *[Painter] 20th c.*
Addresses: NYC. **Sources:** WW13.

TELLANDER, A. Frederic *[Painter] b.1878, Paxton, IL.*
Addresses: Evanston, IL. **Studied:** Rome; Paris. **Member:** Assn. Chicago PS; Chicago Gal. Assn. **Exhibited:** Englewood Women's C., 1921 (prize); AIC, 1923 (prize); FA Bldg., 1927 (prize); Mun. AL, 1927 (prize); Assn. Chicago PS, 1926 (gold); Chicago Gal. Assn., 1926-32. **Work:** Lawrence Col., Beloit Col., both in Wis.; Ill. Athletic C., Union Lg. C., Chicago; Chicago Mun. Comm. **Sources:** WW40.

TELLER, Grif *[Landscape painter] b.1899, Newark, NJ.*
Addresses: Little Falls, NJ, 1928-on. **Studied:** Fawcett Sch., Newark, NJ; ASL; R. Johonnot in VT; John F. Carlson in Woodstock, NY. **Member:** SC. **Exhibited:** Salons of Am., 1922; NAD; Grand Central AG; SC; Montclair AM, (purchase prize), 1946 (hon. men.); Montclair Women's Cl; NJ Gallery, Newark, 1934 (hon. men.), 1936 (1st prize), 1941 (hon. men.); Westfield AA, 1965 (hon. men.), 1968 (hon. men.); many NJ towns; Clarke Gal., Stowe, VT. **Work:** Montclair AM.
Comments: A commercial landscape painter employed by the Osborne Co., a major calendar publisher, from 1919-1954. Called the "Rembrandt of the Rails," he was particularly known for his paintings of trains used for the Penn. Railroad wall calendars, 1928-58. His landscapes have appeared in *Vermont Life*. **Sources:** info courtesy Clarke Gal., Stowe, VT.

TELLER, Jane (Simon) *[Sculptor] mid 20th c.; b.Rochester, NY.*
Addresses: Princeton, NJ. **Studied:** Rochester Inst. Technol.; Barnard Col. (B.A.); also with Ibram Lassaw. **Member:** Sculptors Guild; Artists Equity Asn. **Exhibited:** NJ State Mus., Trenton, 1965-72; Newark Mus., NJ, 1968; Sculptors Guild Ann., Lever House, NYC, 1970; Hudson River Mus., Yonkers, NY, 1971; MoMA; WMAA. **Awards:** purchase award, NJ State Mus., 1971; Nat. Assn. Women Artists; 50th Anniversary Exhib. prize, Phila. A. All. **Work:** Olsen Found, Stamford, Conn; Geigy Collection, Ardsley, NY; NJ State Mus, Trenton. **Commissions:** Menorah (iron & plexiglass) & Eternal Light (iron & plexiglass), Temple Judea, Doykstown, Pa, 1969; Magic Muse (wood sculpture), NJ State Mus, 1972. **Comments:** Preferred media: wood, graphics. **Sources:** WW73; David R. Campbell, "Art & Architecture," *Craft Horizons* (June, 1962); *Art & Architecture* (Aujourd 'Hui, 1963); David Van Dommellen, "Walls--enrichment & ornamentation," *Funk & Wagnalls* (1965).

TELLING, Elisabeth *[Portrait painter, etcher, lecturer, educator] b.1882, Milwaukee, WI / d.1979, New Haven, CT.*
Addresses: Chicago; Guilford, CT. **Studied:** Chicago Acad. FA with W. P. Henderson; Smith College; in Munich, with Heymann; with George Senseney in Provincetown; Hamilton E. Field in Maine. **Member:** Soc. Women Geographers; Chicago AC; Chicago SE. **Exhibited:** AIC, 1915-1922 (solo), 1937 (solo); Milwaukee AI, 1923, 1924; Marie Sterner Gal., 1933 (solo), 1937 (solo); Rouillier Gal., Chicago, 1933; Courvoisier Gal., San Francisco, 1936; Gibbes Art Gal., 1937; CGA, 1937; Northwestern Univ. Lib., 1937; Univ. Michigan, 1937; Quito, Ecuador, 1954; Field Mus. Nat. Hist. Mus., Chicago, 1957. **Work:** Calif. State Lib., Pasadena; Calif. PM; Tulane Univ.; Bishop Art Gal. Honolulu; AIC; Los Angeles MA. **Sources:** WW59; WW47.

TEMELES, Gertrude *[Painter] mid 20th c.*
Exhibited: AIC, 1949. **Sources:** Falk, *AIC*.

TEMES, Mortimer (Robert) *[Cartoonist, designer] b.1928, Jersey City, NJ.*
Addresses: Hazlet, NJ. **Studied:** ASL, with William McNulty, Jon Corbino, Frank Reilly & Robert B. Hale, 1947-49; NY Univ, 1949-53 (B.A., 1953). **Member:** Nat. Cartoonists Soc.; Mag. Cartoonist Guild; Am. Col. Pub. Relations Assn. **Comments:** Positions: prof. free lance cartoonist, 1950-; dir. spec. serv., Newark Col. Eng., 1958-. **Publications:** illusr., "Engineers &

engineering--some definitions," 1968; illusr., "Making Tomorrow Happen," 1970; cartoons have appeared in many nat. mags. & in many cartoon anthologies. **Sources:** WW73.

TEMPLE, Alan H. (Mr. & Mrs.) *[Collectors] 20th c.*
Addresses: Scarsdale, NY. **Comments:** Collection: contemporary art. **Sources:** WW73.

TEMPLE, C. M. *[Painter] 20th c.*
Addresses: Salt Lake City, UT. **Sources:** WW15.

TEMPLE, Grace Lincoln *[Listed as "artist"] 19th/20th c.*
Addresses: Wash., DC, active 1901-1910. **Member:** Wash. Soc. of FA. **Sources:** McMahan, *Artists of Washington, DC*.

TEMPLE, Harry C. *[Painter] 20th c.*
Member: GFLA. **Sources:** WW27.

TEMPLE, Ruth A. (Mrs. Samuel) See: **ANDERSON, Ruth A. (Mrs. Samuel Temple)**

TEMPLE, William G. *[Painter] mid 20th c.*
Addresses: Phila., PA. **Exhibited:** PAFA Ann., 1936, 1939. **Work:** PAFA, 1936 (prize). **Sources:** WW40; Falk, *Exh. Record Series*.

TEMPLEMAN, Albin Frederick *[Painter, teacher] b.1911, Sacramento, CA / d.1986, Oakland, CA.*
Addresses: Oakland, CA. **Studied:** Univ. California (M.A.); & with Hans Hofmann. **Exhibited:** Kingsley AC, Sacramento, 1933; San F. AA, 1937-1946; Sacramento, Cal.; Oakland A, Gal. **Work:** SFMA. **Sources:** WW53; WW47. More recently, see Hughes, *Artists in California*, 554.

TEN-EYCK, Doris See: **GRASSO, Doris (Ten-Eyck)**

TEN BROECK, Albertina (Mrs. John Sanders) *[Silhouettist] b.1760 / d.1840.*
Addresses: Columbia County, NY. **Comments:** Cut and shaded silhouettes showing her father's "bouwerie" in Columbia County (NY), probably in the 1770's or 1780's. **Sources:** G&W; Runk, *Ten Broeck Genealogy*, 68, 111-113, repros. on p. 26, 66.

TENENBAUM, George *[Sculptor] mid 20th c.*
Exhibited: S. Indp. A., 1936. **Sources:** Marlor, *Soc. Indp. Artists*.

TENER, George E. (Mrs.) *[Painter] 20th c.*
Addresses: Sewickley, PA. **Member:** Pittsburgh AA. **Sources:** WW21.

TEN EYCK, Catryna (Catryna Ten Eyck Seymour) *[Painter] b.1931, NYC.*
Addresses: NYC. **Studied:** Smith Col.; ASL. **Member:** Southern Vt. Artists, Inc; Cooperstown Art Assn. **Exhibited:** Seventh Ann. Nat. Print Exhib., Springfield Col., Mass., 1971; Thirty-Sixth Ann. Exhib., Cooperstown Art Assn., NY, 1971; Sixtieth Am. Ann. Exhib., Art Assn. Newport, RI, 1971; Fifty-First Ann. Nat. Exhib. Paintings, Ogunquit Art Ctr., Maine, 1971; Ann. Juried Exhib., Sharon Creative Arts Found., Conn., 1971; Tunnel Gallery, NYC, 1970s Awards: first prize for graphics, Springfield Art League, 1971. **Work:** CPLH; Denver Art Mus., Colo.; Honolulu Acad. Arts, Hawaii; Albany Inst. Hist. & Art, NY; Munson-Williams-Proctor Inst., Utica, NY. **Comments:** Preferred media: graphics, acrylics. **Sources:** WW73.

TEN EYCK, John (Adams) III *[Painter, etcher, teacher] b.1893, Bridgeport, CT / d.1932, Stamford, CT/Westerly, RI?.*
Addresses: Stamford, CT/Westerly, RI. **Studied:** NY Sch. F. & Appl. A.; ASL; L. Mora; K.H. Miller; J. Pennell; C. Hawthorne; B.J.O. Nordfeldt. **Member:** SI, 1922; SC, 1926; Société des Artistes Indp., Paris; S.Ind.A., 1918; Arch. Lg., 1928; Brooklyn S. Mod. A. **Exhibited:** S. Indp. A., 1919-21, 1925-26, 1928; WMAA, 1920-28; Salons of Am. 1924-25. **Comments:** Position: t., Kihn-Ten Eyck Art Sch., Stamford, Conn. **Sources:** WW31.

TEN EYCK, Richard *[Wood engraver] mid 19th c.*
Addresses: NYC, 1846-54. **Exhibited:** American Institute. **Comments:** 1855-66 listed as "president" of unnamed company. **Sources:** G&W; NYCD 1846-66; Am. Inst. Cat., 1846, 1850 , 1851.

TEN EYCK, Richard, Jr. *[Wood engraver]* 19th/20th c.
Addresses: NYC, 1856-1903. **Sources:** G&W; NYCD 1856-1903; Am. Inst. Cat., 1847-48, possibly intended for Richard Ten Eyck.

TENGGREN, Gustaf Adolf *[Illustrator, painter, designer, lithographer]* b.1896, Magra Socken, Sweden / d.1970.
Addresses: West Southport, ME. **Studied:** Slojdforening Skola & Valand Sch. FA, Gothenburg, Sweden. **Exhibited:** 48 Sts. Comp., 1939; Los Angeles County Fair, 1939; Am.-Swedish Hist. Mus., Phila., 1945 (Nordfeldt & Tenggren); Am.-Swedish Inst., Minneapolis, 1950 (solo); Akron AI, 1952; Boothbay Harbor, ME, 1948 (solo), 1949-52; WMA; Oklahoma AC; AWCS; Wash. WCC; Phila. A. All.; Maine Art Gal., Wiscasset, ME, 1957. Awards: Herald-Tribune award, 1946. **Comments:** Illustrator: "Ring of the Niebelung," 1932; "Saldom and Golden Cheese," 1935; "The Tenggren Mother Goose"; "The Tenggren Tell It Again"; "Sing for Christmas"; "Sing for America"; "Tenggren's Cowboys and Indians"; "Pirates, Ships and Sailors"; "Tenggren's Arabian Nights," 1957; "Canterbury Tales," 1961. Position: art director, Walt Disney Studios, Hollywood. **Sources:** WW66; WW40.

TENKACS, John *[Painter]* b.1883, Hungary.
Addresses: Cleveland, OH. **Studied:** Royal Hungarian Acad. FA; Cleveland Sch. A. WPA artist. **Sources:** WW40.

TENNANT, Allie Victoria *[Sculptor]* b.1892, St. Louis, MO / d.1971.
Addresses: Dallas, TX. **Studied:** Aunspaugh Art School, Dallas; ASL, with George Bridgman, Edward McCartan, 1927-28, 1933 with Eugene Steinhof; European travels. **Member:** fellow, NSS, 1934; Dallas AA (dir.); SSAL; Texas Sculptors Group, 1943 (a founder/pres.); "Dallas 13". **Exhibited:** Nashville AA, 1927 (prize); Dallas Public Art Gal., 1928 (prize), 1929 (prize), 1930 (prize), 1932 (prize); Lawrence Art Gal., Dallas, 1930s, with the "Dallas 13"; SSAL, 1932 (prize), 1933 (prize); 1936 (prize); Dallas MFA, 1935 (Kiest Mem. Fund Purchase Prize); PAFA Ann., 1935; AIC, 1935; Kansas City AI, 1935; Dallas AA, 1936 (prize); Texas Centennial, 1936; Arch. League, 1938; WFNY, 1939; Nat. Exhib. Am. Artists, NYC, 1939; WMAA, 1940; NSS, 1940; CI, 1941. **Work:** "Tejas Warrior," Texas Hall of State Bldg., Fair Park, Dallas; Brookgreen Gardens, SC; Hockaday Sch., Southwest Medical College, Aquarium, Mus. FA, Womans Club, all of Dallas, TX; memorials, José Antonio Navarro, Corsicana and James Butler Bonham, Bonham, TX; relief, USPO, Electra, TX; Baylor Univ., Dallas; Centennial Expo, Dallas; Maple Lawn Sch. **Comments:** A leading sculptor in Dallas during the 1930s, she designed the 9-ft. gilded bronze figure of a Tejas Indian warrior for the facade of the newly erected Hall of State building in Dallas (1936). She was the only sculptor-member of the "Dallas 13." Position: sculpture teacher, Dallas AI. **Sources:** WW59; WW47; Rubinstein, *American Women Sculptors*, 283; Stewart, *Lone Star Regionalism*, 187-88 (w/repros.),190 (w/repro.); Falk, *Exh. Record Series*.

TENNANT, Thomas R. *[Painter]* late 19th c.; b.Leeds, England.
Addresses: New Orleans, active c.1886-87; St. Louis, MO. **Exhibited:** Seebold's, 1886; Artist's Assoc. of N.O., 1886. **Comments:** Exhibited as an amateur painter. Father of sculptor Allie Victoria Tennant (see entry). **Sources:** *Encyclopaedia of New Orleans Artists*, 372.

TENNENT, Madge (Madeline Grace) Cook (Mrs. Hugh Cowper) *[Painter]* b.1889, Dulwich, England / d.1972, Honolulu, HI. *Madge Tennent 1948*
Addresses: Cape Town, South Africa; New Zealand; Samoa, 1917; Honolulu, HI, 1923. **Studied:** Acad. Julian and with Bouguereau. **Member:** The Seven, 1929 (a founder). **Exhibited:** Wertheim Gal., London; Bernheim-Jeune Gals., Paris; Ferargil Gal., NYC (solo); Drake Hotel, Chicago (solo); San Francisco FA Gal. (solo); Honolulu Acad. Arts, 1925; AIC, 1931; S. Indp. A.,

1931; CPLH, 1932; Salons of Am., 1935; P&S of Los Angeles, 1937; GGE, 1939; New Zealand and Union South Africa; Grossman-Moody Gal., Honolulu; Gump's, Honolulu; Honolulu Advertiser Gal., 1968. **Work:** Tennent Art Foundation Gal., Honolulu (large collection). **Comments:** Helped support her family with portraits commissions. She stopped working in 1965 for health reasons. **Sources:** WW40; Forbes, *Encounters with Paradise*, 210-11, 267-68; Petteys, *Dictionary of Women Artists*.

TENNENT, W. *[Delineator]* mid 18th c.
Comments: Delineator of a view of Nassau Hall, Princeton (NJ) in 1763, known through an engraving by Henry Dawkins. The artist may have been William Mackay Tennent (?-1810), a graduate of Princeton in 1763 and trustee from 1785 to 1808. **Sources:** G&W; Stokes, *Historical Prints*, pl. 19a; Princeton University, *General Catalogue, 1746-1906*.

TENNEY, Adna *[Portrait and miniature painter]* b.1810, Hanover, NH / d.1900, Oberlin, OH.
Studied: received a few weeks of training from Francis Alexander in Boston, 1844. **Work:** Dartmouth College and the State House, Concord (NH). **Comments:** Tenney was a farmer who turned to painting in his thirties. He worked as an itinerant artist in New Hampshire, as well as in NYC, Baltimore, and along the Mississippi (c.1856). He later moved to Winona (MN) and spent his last years at Oberlin (OH). **Sources:** G&W; Tenney, *The Tenney Family*, 230, repro. preceding 281; Boston BD 1857; New England BD 1860 (Concord, N.H.); G&W has information courtesy Mrs. Rowland M. Cross, NYC, granddaughter of the artist.

TENNEY, Alice *[Mural painter, lithographer, lecturer]* b.1912, Minneapolis,MN.
Addresses: Crystal Bay, MN. **Studied:** ASL. **Exhibited:** S. Indp. A., 1933, 1935; Salons of Am., 1934; Corcoran Gal biennial, 1943. **Work:** murals, Hotel Nicollet; Westminster Presbyterian Church, Minneapolis. **Sources:** WW40; Falk, *Exhibition Records Series*.

TENNEY, Burdell *[Painter]* mid 20th c.
Addresses: Phoenix, AZ. **Exhibited:** Ariz. PS, Phoenix, 1938; Nat. Exh. Am. A., Rockefeller Ctr., NYC, 1938. **Sources:** WW40.

TENNEY, M. B. *[Portrait painter]* mid 19th c.
Addresses: In New England, c.1840. **Sources:** G&W; Sears, *Some American Primitives*, 288.

TENNEY, Ulysses Dow *[Portrait painter]* b.c.1826, Hanover, NH / d.After 1904.
Addresses: Manchester, NH in 1849-64, and briefly at nearby Concord and Hanover; New Haven, CT, after 1864. **Studied:** briefly with Adna Tenney (his uncle), Roswell T. Smith, and Francis Alexander. **Exhibited:** NAD, 1869. **Sources:** G&W; Tenney, *The Tenney Family*, 432-33; Manchester BD 1854-60.

TENNEY, Vera (Mrs. B.) *[Painter]* mid 20th c.
Addresses: Everett, WA, 1948. **Exhibited:** Pacific Northwest Artists Annual Exh., 1948. **Sources:** Trip and Cook, *Washington State Art and Artists*.

TENNHARDT, Elsa *[Painter]* mid 20th c.
Exhibited: Salons of Am., 1934. **Sources:** Marlor, *Salons of Am.*

TENNYSON, Laura (Mrs. Arthur A.) See: **MITCHELL, Laura M. D. (Mrs. Arthur Tennyson)**

TENNYSON, Merle Berry *[Painter, instructor]* b.1920, Brandon, MS.
Addresses: Jackson, MS. **Studied:** Miss. State Col. Women (B.S.); Univ. Miss. (M.A.); also with Ida Kohlmeyer, New Orleans, Andrew Bucci, Washington, Alvin Sella, Alex Russo, Frederick, Md. & Tom Chimes, Philadelphia. **Member:** Miss. Art Assn. (pres., 1966-67, exec. comt. & bd. dirs., 1967-); Miss. Arts Ctr. (bd. gov., 1967-); Millsaps Col. Arts & Lect. Ser. (bd. dirs.); Miss. Art Colony (bd. dirs., 1969-). **Exhibited:** Nat. Arts & Crafts, Miss. Arts Festival, Jackson, 1965, 1969, 1970 & 1971; Frontal Images, Miss. Art Assn., Jackson, 1967-69; Mid-South

Exhib., Brooks Mem. A.Gal., Memphis, Tenn., 1968 & 1969; 47th Regional, Shreveport, 1969; Delta Ann., Ark. Art Ctr., Little Rock, Ark., 1969 & 1971. Awards: purchase awards, Regional, 1969 & Lafont Art Colony, S. Cent. Bell Tel., 1970; best in show award, Edgewater Ann., 1971. **Work:** RW Norton A. Gal., Shreveport, La; Bankers' Trust Co, First Nat. Bank, First Fed. Savings & Loan & Miss. Art Assn., Jackson, Miss. Commissions: paintings, comn. by Mr. & Mrs. Francis Stevens, Wash., DC, 1970 & William D. Rowell, Jackson, Miss. **Comments:** Preferred media: acrylics, oils. Teaching: instr. drawing & painting, Univ. Miss. Continuation Study Prog., Millsaps Col., 1958-66. Publications: auth., "Painting and Ceramics used as Occupational Therapy in Working with the Mentally ill," 1958. **Sources:** WW73.

TENSFELD, J(ohn) *[Landscape and portrait paiter] late 19th c.*
Addresses: California, c.1871; Brooklyn, NY, 1873. **Exhibited:** NAD, 1873; Brooklyn AA, 1873-81. **Work:** San Jose Hist. Mus. **Sources:** *Brooklyn AA;* Hughes, *Artists in California,* 554.

TEODECKI, W. G. *[Artist] mid 20th c.*
Addresses: Phila., PA. **Exhibited:** PAFA Ann., 1951. **Sources:** Falk, *Exh. Record Series.*

TEPLITZKY, Joseph *[Sculptor] b.1882, Russia / d.1965, Los Angeles, CA.*
Addresses: Los Angeles, CA. **Exhibited:** All.-Calif. Exhib., 1939. **Sources:** Hughes, *Artists in California,* 554.

TEPPER, Gene (U.S.N.R.) *[Painter, sculptor] mid 20th c.*
Addresses: U.S. Naval Air Station. **Exhibited:** S. Indp. A., 1942. **Sources:** Marlor, *Soc. Indp. Artists.*

TEPPER, Natalie (Nat) Arras *[Painter, designer, lecturer, teacher] b.1895, NYC / d.1950, Woodstock, NY.*
Addresses: Woodstock, NY. **Studied:** NY Sch. Fine & Applied Art; G. Wiggins; E. Pape; R. Laurent; A. Heckman; J. Koopman; J. McManus; H. Troendle in Switzerland; Munich. **Member:** AFA; NAWA; Woodstock AA; Studio Gld. **Exhibited:** Salons of Am., 1934; NAWA, 1938-46; Albany Regional Exh., annually; All. Artists Am.; CGA; AFA Traveling Exh., 1936; Brooklyn SA; WFNY, 1939; GGE, 1939; in Canada. **Work:** Ft. Hamilton & Lincoln H.S., NYC; Am. Lib. Color Slides. **Comments:** Teaching: Ft. Hamilton H.S. & Lincoln H.S., NYC. **Sources:** WW47; Woodstock AA.

TEPPER, Saul *[Illustrator] b.1899, NYC / d.1987.*
Addresses: NYC. **Studied:** Dodge, Lawlor, Dunn. **Member:** SI; A. Gld. **Exhibited:** Illustration House, NYC, 1988 (solo). **Comments:** A master of the epic theme, he illustrated novels by Pearl Buck, Damon Runyon, and Stephen Vincent Benét. His works also appeared in *McCall's, Delineator, Cosmopolitan, American,* and *Saturday Evening Post.* **Sources:** WW53; WW47.

TERA, George Sugimori *[Painter] b.1887, Japan.*
Addresses: NYC. **Studied:** F.V. Dumond; H. Read. **Exhibited:** PAFA Ann., 1916-17 (portraits). **Sources:** WW24; Falk, *Exh. Record Series.*

TERA, Jesaburo S. *[Painter] mid 20th c.*
Exhibited: S. Indp. A., 1928. **Sources:** Marlor, *Soc. Indp. Artists.*

TERADA, Edward Takeo *[Portrait painter, mural painter, miniature painter, sculptor, block printer, designer, drawing specialist, etcher, lithographer, teacher] b.1908, Chico, CA.*
Addresses: San Fran., CA. **Studied:** Calif. Sch. FA; O. Oldfield; S. Yoshida, in Japan. **Member:** San Fran. AA; A. Ctr., Calif.; S. Mural Ar.; Japanese Ar. of San Fran.; Los Angeles AA. **Exhibited:** Calif. State Fair, 1928 (prize); Am. Legion, 1928 (prize). **Work:** fresco, Coit Mem. Tower, San Fran. **Comments:** Contributor: weekly woodblock prints, *Hokubei Asahi Daily News.* **Sources:** WW40.

TERAN, Peter *[Painter] mid 20th c.*
Addresses: Chicago area. **Exhibited:** AIC, 1946-47, 1949. **Sources:** Falk, *AIC.*

TERCHKOVITCH, Constantin *[Painter] mid 20th c.*
Exhibited: AIC, 1938-39. **Sources:** Falk, *AIC.*

TEREBOVA, Francina *[Sculptor] b.1892, Czechoslovakia / d.1949, Kentfield, CA.*
Addresses: Marin County, CA. **Studied:** Prague; Sweden; AIC; Calif. School of FA. **Exhibited:** Oakland Art Gal., 1928; GGE, 1939; PAFA Ann., 1942. **Comments:** Came to U. S. c.1900. Specialty: driftwood sculptures. **Sources:** Hughes, *Artists in California,* 554; Falk, *Exh. Record Series.*

TERENZIO, Anthony *[Painter, educator] b.1923, Settefrati, Italy.*
Addresses: Storrs, CT. **Studied:** Pratt Inst. (B.F.A.); Columbia Univ. (M.A.); Am. Art Sch., with Raphael Soyer & Jack Levine. **Exhibited:** Brooklyn Artists Biennial, Brooklyn Mus., NY, 1949; Butler Inst. Am. Art Biennial, Ohio, 1957; Boston Arts Festival, 1958; Eight From Connecticut, Wadsworth Atheneum, Hartford, 1960; New England Drawing Exhib., Smith Col., Northampton, Mass., 1964. Awards: Emily Lowe Award, 1950; first award, Ann. Conn. Artists, Norwich Art Assn., 1957 & 1960. **Work:** Lowe Ctr., Syracuse Univ. **Comments:** Preferred media: oils. Teaching: prof. painting & drawing, Univ. Conn., 1955-. **Sources:** WW73; Baker (auth), Prize winning paintings-1960, Allied, 1961.

TERESA See: **BAKOS, Teresa**

TERESI, Joseph Anthony *[Painter, instructor] b.1921, NYC.*
Addresses: Northfield, IL. **Studied:** Harrison Art Sch., Chicago, Ill., scholar; AIC, with Max Kahn & John Fabion; Columbia Col.,Ill.; also with David Olere, Paris, France & Karl Eberle, Frankfurt, Ger. **Exhibited:** Kerrigan-Hendrick Gal., Chicago, 1962; Manfred Kuhnard Gal., 1963; solo shows, Raymond Burr Galleries, Beverly Hills, Calif., 1963 & Vincent Price Gal., Beverly Hills, 1964; Fair is our Land, Americana Galleries, 1965. **Work:** Evanston Sch. Syst. Collection, Ill.; Edward G. Robinson Coll., Calif.; Vincent Price Coll., Calif.; Manfred Kuhnard Gal., Glendale, Calif.; Americana Galleries, Northfield, Ill. **Comments:** Preferred media: oils. Teaching: instr. oil painting & drawing, Americana Art Sch., 1965-. **Sources:** WW73.

TERESKY, James *[Painter] mid 20th c.*
Exhibited: Salons of Am., 1934. **Sources:** Marlor, *Salons of Am.*

TERIGGI, A. M. *[Miniaturist and chalk artist] early 19th c.*
Addresses: Philadelphia, 1824. **Exhibited:** PAFA (1820-26; 1824: miniature portrait of the Comtesse de Survilliers [Charlotte Bonaparte]). **Comments:** Also appears as A.F. or E.M. Terriggi. **Sources:** G&W; Rutledge, PA.

TERKEN, John Raymond *[Sculptor, medalist, teacher, lecturer] b.1912, Rochester, NY / d.1993.*
Addresses: New York 23, NY; East Meadow, NY. **Studied:** Beaux Arts Inst. Design, with Chester Beach, Lee Lawrie & Paul Manship; NY Sch. Fine & Indust. Arts; Columbia Sch. Fine Arts; also European art ctrs. **Member:** fel., Nat. Sculpture Soc. (mem. coun., 1962-, secy., 1968-70); fel., Hudson Valley Art Assn.; assoc. Int. Inst. Conservators; Acad. Artists Assn.; Art League Nassau Co.; AAPL. **Exhibited:** New Jersey P. &S., 1948; Syracuse Mus. FA, 1950; Am. A. Week, 1957; Meriden A. & Crafts, 1948-1953, 1957; NAD, 1968; NAC, 1970; Hudson Valley Art Assn., Westchester, NY, 1971; Acad. Artists Assn., Springfield, Mass., 1971; Nat. Sculpture Soc., NYC, 1972. Awards: Tiffany Found. Award, 1947, 1949; Lindsey Morris Mem. Prize, Nat. Sculpture Soc., 1958, 1965; Coun. Am. Artists Award, Am. Artists Prof. League, 1972. **Work:** Roswell Mus., N. Mex.; Grand Cent. Galleries, NYC; Gregory Mus., Hicksville, NY. Commissions: monument, Am. Soc. Prev. Cruelty Animals Hq., NYC, 1955; S.S. "United States"; Saratoga Racing Mus.; Central Presbyterian Church, New York City; Thomas Edison H.S., Queens; Pub. Sch. #11, Brooklyn; Benjamin Franklin Mem., Franklin Nat. Bank, Garden City, NY, 1961; Eagle Fountain, Salisbury Park, East Meadow, NY, 1961; New Horizons, Hempstead Town Plaza, 1969; Richard Henry Dana Monument,

San Juan Capistrano Hist. Soc., Calif., 1972. **Comments:** Preferred media: bronze. Positions: advert. mgr., Nat. Sculpture Rev., 1949-65, mem. ed. bd., 1970-, mem. Bd. Coop. Educ. Serv., Long Island Dist., 1969-, deleg to Fine Arts Fedn. New York, 1970-. Teaching: lectr. sculpture, East Meadow High Sch., 1951-. **Sources:** WW73.

TERLEMEZIAN, P. *[Painter] mid 20th c.*
Exhibited: S. Indp. A., 1924; Salons of Am., 1925. **Sources:** Falk, *Exhibition Record Series.*

TERMOHLEN, Karl Emil *[Painter] b.1863, Copenhagen, Denmark.*
Addresses: Chicago /S. Elgin, Maywood, IL. **Exhibited:** AIC, 1901, 1904, 1906; PAFA Ann., 1902. **Sources:** WW08; Falk, *Exh. Record Series.*

TERN, C. H. *[Landscape frescoes] early 19th c.*
Addresses: Stoddard, NH, c.1825. **Comments:** He was called "the singing tramp," and he painted pictures to pay for his room and board. **Sources:** G&W; Lipman and Winchester, 181; Brewington, 377.

TERPNING, Howard A. *[Painter, illustrator] b.1927, Oak Park, IL.*
Addresses: Chicago, IL; NYC. **Studied:** American Academy of Art; Chicago Academy of FA. **Member:** Cowboy Artists of America, 1979. **Exhibited:** Cowboy Artists of America, annuals (awards); National Academy of Western Art (Priz de West); Peking, China; Grand Palais, Paris, France. **Comments:** Illus., advertising, major national magazines, motion pictures. He did posters for the movies *Cleopatra,* and *The Sound of Music.* He moved West, and concentrated on Western paintings later in his career. **Sources:** W & R Reed, *The Illustrator in America,* 307.

TERRA, Daniel J. *b.1912 / d.1997.*
Addresses: Chicago/Wash., DC. **Comments:** Founder of the Terra Museum of American Art (1980) and the Museum of American Art in Giverny, France (1992). From the late 1970s-on, his acquisitions had an important effect, particularly on the market for American Impressionism. He served as finance chairman of Pres. Reagan's 1980 campaign. He later served as ambassador-at-large for cultural affairs throughout the Reagan administration. He was founder and chairman of a chemical and ink company, Lawter Int'l, of Northbrook, IL.

TERRELL, Allen Townsend *[Sculptor, painter, teacher] b.1897, Riverhead, NY / d.1986, NYC.*
Addresses: NYC. **Studied:** Columbia Univ. Sch. Archit. (cert. proficiency, 1921); ASL, with Edward McCartan; PAFA, Albert Laessle; Ecole Am. Fontainebleau, France; Académie Julian, Paris; also with Charles Despiau. **Member:** NSS; All. A. Am; AWCS; NAC; AAPL; Fontainebleau Assn. (trustee, 1940). **Exhibited:** S. Indp. A., 1924, 1933; Salon d'Automne, 1931; NAD, 1932-34, 1937, 1972 (Dessie Greer Prize of sculpture); PAFA Ann., 1933, 1935-37; AWCS, 1942-45; Dec. C., NY, 1939 (solo); Stendahl Gal., 1944 (solo); Pasadena AI, 1944 (solo); Village A. Ctr., 1943 (prize); Arch. L., 1939 (prize); NYC, 1941 (prize); IBM, 1945 (prize); NAC, 1959 (bronze medal of hon. for sculpture); All. A. Am., 1965 (compt. prize for sculpture). **Work:** York C., NYC; IBM Coll.; Suffolk Co Hist Soc, Riverhead; MMA; Mus City New York; BM. **Commissions:** Vermil ye Medal, Franklin Inst, Phila., Pa, 1935; childrens playroom (1939) & cabin in class lounge (with John Marsman), 1946, aboard SS America, US Lines. **Comments:** Designer: Vermilye med., Franklin Inst., Phila. Teaching: instr. watercolor & still life, Parsons Sch. Design, 1934-35; Parsons Sch. Des., 1944, 1946. **Sources:** WW73; WW47; Falk, *Exh. Record Series.*

TERRELL, Elizabeth E. *[Painter] b.1908, Toledo, OH.*
Addresses: Woodstock, NY. **Studied:** Ringling Sch. Art; ASL. **Member:** An Am. Group; Woodstock AA. **Exhibited:** PMG, 1936; WFNY, 1939; 48 States Competition, 1939 (prize); An Am. Group, 1939-42; PAFA Ann., 1940, 1942, 1947; BM, 1941, 1945; AIC, 1940-41; WMAA; MoMA; AV, 1943; Univ. Arizona, 1943;

VMFA, 1946; Univ. Iowa Summer Show,1945; ACA; MMA, 1943; "NYC WPA Art" at Parsons School Design, 1977. **Work:** MMA; Newark Mus.; Univ. Arizona; Edward Bruce Mem. Coll.; murals, USPOs, Conyers, GA and Starke, FL. **Comments:** WPA artist. **Sources:** WW53; WW47; *New York City WPA Art,* 26 (w/repros.); Falk, *Exh. Record Series.*

TERRELL, Richard *[Portrait painter] early 19th c.*
Addresses: Lexington, KY in 1795; Indiana, 1825 and later. **Comments:** In 1825, at Madison he painted a life portrait of Lafayette. In 1828 he arrived in Indianapolis, where he was prepared to paint signs and banners as well as portraits. A few portraits survive. Nothing is known of his career after 1828. **Sources:** G&W; Peat, *Pioneer Painters of Indiana,* 57-58, 148-49, 239, repro. pl. 63; Burnet, *Art and Artists of Indiana,* 60.

TERRIBERRY, W. S. *[Painter] 20th c.*
Addresses: NYC. **Sources:** WW13.

TERRIGGI, A. F. (or E. M.) See: **TERIGGI, A. M.**

TERRIZZI, Anthony T. *[Sculptor] early 20th c.*
Addresses: NYC. **Exhibited:** Arch. L., 1915 (prize). **Sources:** WW15.

TERRON, Andrew *[Painter] early 20th c.*
Exhibited: WMAA, 1918-28; S. Indp. A., 1922. **Sources:** Falk, *WMAA.*

TERRY, Agnes *[Listed as "artist"] 19th/20th c.*
Addresses: Wash., DC, active 1888-1891. **Exhibited:** Soc. of Wash. Artists, 1891 (still lifes). **Sources:** McMahan, *Artists of Washington, DC.*

TERRY, Alice (Mrs. B. F. Johnson) *[Painter, sculptor] b.1925, NYC / d.1988, Key West, FL.*
Addresses: Bearsville, NY; Key West, FL, c.1982. **Studied:** Pembroke College (B.A.). **Member:** Woodstock AA; Key West Art & Hist. Soc. (bd. dir.). **Exhibited:** Camino Gal., NY, 1959; Ellison Gal., Ft. Worth, TX, 1959-60; Martha Jackson Gal., NY, 1960; Fleischmann Gal., NY, 1959; David Anderson Gal., NY; 1960, 1961; HCE Gal., Provincetown, 1961; Krannert AM, Urbana, IL, 1961; WMAA, 1954; Fleischmann Gal., NY, 1958 (solo); Albright-Knox Art Gal.; McNay AI, San Antonio; Hacker Gal., NY, 1962 (solo); Rose Fried Gal., NY, 1963; Univ. Miami Mus., 1965. **Work:** NYU; Guggenheim MA; Woodstock AA; Hirshhorn Coll. **Sources:** WW66; addit. info. courtesy Woodstock AA which cites Rhode Island as her birthplace.

TERRY, Clarissa *[Amateur painter in watercolors] early 19th c.*
Addresses: East Windsor, CT. **Comments:** Painted two views of Stafford Springs (CT) in 1816. **Sources:** G&W; *Portfolio* (April 1945), 188-89, repros.

TERRY, Duncan Niles *[Designer, craftsman] b.1909, Bath, ME / d.1989.*
Addresses: Bryn Mawr, PA; Rosemont, PA. **Studied:** BMFA Sch.; Cent. Sch. Arts & Crafts, London; Acad. Moderne, Paris; H.H. Clark; F. Leger; BMFA Sch. Traveling School. **Member:** Phila. A. All.; Stained Glass Assn. Am. **Exhibited:** Dartmouth Col.; Gibbes Mem. A. Gal.; Tricker Gal., NYC; Woodmere A. Gal.; Phila. A. All.; London. **Work:** Commissions: carved glass windows, Riverside Church, NYC, 1950 & St. James Episcopal Church, Long Branch, NJ, 1962-67; windows & wood & stone Mem., Trinity Cathedral, Trenton, NJ, 1960-72; glass murals/panels, hotels in Baltimore, Phila.; Bryn Mawr Col.; windows, doors & Mem, All St's Church, Torresdale, Pa, 1960-1972; stained glass, Bnai Emunah Synagogue, Tulsa, Okla, 1962; windows, doors, facade & mosaic mural, St Mary's Church, Kittaning, Pa, 1967. **Comments:** Preferred media: glass. Art interests: developing new techniques in glass decoration and using them alone and in combination with established techniques. **Sources:** WW73; WW47.

TERRY, Edith (Blanche) *[Painter] mid 20th c.*
Exhibited: S. Indp. A., 1920. **Sources:** Marlor, *Soc. Indp. Artists.*

TERRY, Eliphalet *[Animal and landscape painter] b.1826, Hartford, CT / d.1896.*

Addresses: Hartford, CT for several years; NYC, c.1851.
Studied: in Rome under his cousin, Luther Terry, 1846-47.
Exhibited: American Art-Union; NAD, 1862-75; Brooklyn AA, 1868-69. **Comments:** Terry was primarily a painter of cattle, horses, and fish. In 1860, he went to Yellowstone with W. J. Hays. **Sources:** G&W; Terry, *Notes of Terry Families.* 79; French, *Art and Artists in Connecticut,* 163; Cowdrey. NAD; Cowdrey, AA & AAU; NYBD 1851; P&H Samuels, 482-83.

TERRY, Emalita Newton *[Painter, instructor] mid 20th c.; b.San Angelo, TX.*
Addresses: Las Vegas, NV. **Studied:** Howard Payne Col. (dipl.); also with Xavier Gonzalez, NYC, Jose Arpa, Seville, Spain, Adele Brunet, Dallas, Tex. & New York & Will Stevens, New Orleans, La. **Member:** Tex. WC Soc.; All. A. Coun.; Art League Las Vegas. **Exhibited:** Tex. Fine Arts Assn., Laguna Gloria Gal., 1952-58; D.D. Feldman Contemp. Exhib., Dallas, 1955-57; Art League Houston, Houston Fine Arts Mus., Tex., 1957; Nat. Assn. Women Artists 66th Exhib., Nat. Acad. Galleries, NYC, 1958; Art League Las Vegas, Art League Galleries, 1967; Nevada Frames Galleries, Las Vegas, NV, 1970s. Awards: distinguished art serv. award, Tex. A&M Col., 1952-53; two awards of merit, M. Grumbacher, 1955-57; Emily Goldman Mem. Award, Nat. Assn. Women Artists, 1958. **Work:** M. Grumbacher, NYC; Art League Las Vegas, Nev.; Laguna Gloria Gal., Austin, Tex.; Mus. Fine Arts, San Antonio, Tex.; Tex. A&M Univ., College Station. **Comments:** Preferred media: watercolors, acrylics, oils, graphics. Positions: dir. gallery, Tex. A&M Univ., 1951-59; bd. dirs., Tex. Fine Arts Assn., 1954-57, chmn. & v. pres. bd. dirs., 1957-59; instr. art theory & appreciation & adv., Jr. League Las Vegas, 1971-72. Teaching: instr. painting & drawing, Tex. A&M Univ., 1949-59; instr. painting & drawing, Terry's Art Studio, Las Vegas, 1959-. **Sources:** WW73.

TERRY, Fannie S. *[Painter] late 19th c.*
Addresses: NYC, 1865. **Exhibited:** NAD, 1865. **Sources:** Naylor, *NAD.*

TERRY, Florence Beach (Mrs.) *[Painter] b.1880, Hays, KS.*
Addresses: Seattle, WA. **Studied:** Univ. of Wash.; NY School of Art; with Wm. Chase; Kansas City Art Inst; with G. Estabrooks, Robert Henri. **Exhibited:** SAM, 1936, 1939, 1940. **Sources:** Trip and Cook, *Washington State Art and Artists.*

TERRY, Hilda *[Cartoonist, writer] b.1914, Newburyport, MA.*
Addresses: NYC. **Studied:** ASL; NAD; NY Univ. **Member:** Nat. Cartoonists Soc. (talent pool ed., 1971-72). **Exhibited:** Awards: Wohelo award, Camp Fire Girls; best Waste-Not cartoon, *New York Times,* 1942. **Work:** commissions: Fulton Fish Market (acrylics), San Marg, NYC, 1971. **Comments:** In 1941, she became known for her comic strip, "Teena" (King Features Syndicate) which, from 1946-49 was produced as a comic book series. In the early 1970s, she became interested in creating animated cartoons for computerized sports stadium scoreboards, and was animation artist for the Kansas City Royals Baseball Club, 1972. She married the cartoonist, Gregory d'Alessio. Teaching: cartooning, New Sch. Social Res., 1968; New York Phoenix Sch. Art & Design, 1969-71. Positions: pres., Hilda Terry Prod., 1973 and Hilda Terry Gal., NYC. Author: *Originality in Art,* 1954; assoc. ed., *Art Collectors Almanac,* 1965. **Sources:** WW73; *Famous Artists & Writers* (1949).

TERRY, J. E. *[Painter] late 19th c.*
Addresses: NYC, 1885; Orange, NJ, active 1885-1891.
Exhibited: NAD, 1885; Boston AC, 1891. **Sources:** *The Boston AC.*

TERRY, John Coleman *[Cartoonist, illustrator] b.1880, San Francisco, CA / d.1934, Coral Gables, FL.*
Addresses: San Francisco, CA. **Studied:** M. Hopkins AI.
Comments: Illustrator: *San Francisco Call,* 1900; active with his brother Paul in the early animated cartoon films and helped him institute "Terry Toons" for the motion pictures, 1912. Creator: "Scorchy Smith," boy aviator strip.

TERRY, Luther *[Portrait and figure painter] b.1813, Enfield, CT / d.1869, Rome, Italy.*
Addresses: Rome (1838-on). **Studied:** Philip Hewins in Hartford. **Member:** hon. mem., professional, of the NAD in 1846. **Exhibited:** American Art-Union; Boston Athenaeum; NAD, 1863, 1866, 1874; Brooklyn AA, 1865, 1869. **Comments:** An expatriate painter, Terry went to Italy in 1837 and settled permanently in Rome the following year. In 1861, he married the widow of Thomas Crawford, the sculptor. **Sources:** G&W; CAB; Cowdrey, NAD; Cowdrey, AA & AAU; Swan, BA; NYBD and CD 1846; Sherman, "Some Recently Discovered Early American Portrait Miniaturists," 294, 296 (repro.); represented at NYHS and MHS.

TERRY, Marion (E.) *[Painter, art critic] b.1911, Evansville, IN.*
Addresses: Madeira Beach, FL. **Studied:** Albright Art Sch.; Univ. Buffalo; also with Xavier Gonzalez. **Member:** Fla. Art Group; Fla. Fedn. Arts; Pen & Brush Cl.; Village Art Ctr., NYC. **Exhibited:** Southeastern Ann.; Ford Motor Co. traveling exhibs., 1955, 1957-58; Fort Worth, Tex., 1958; Fla. Gulf Coast Art., Clearwater, 1971; Saint Petersburg AC; Laura's Art Center, Largo, FL, 1970s; Mirell Gal., Miami, FL, 1970s. Awards: award for "Horses in the Surf," Gulf Coast, 1971; award for "Pennsylvania Town," 1971 & award for "Reflections," 1972, Art Guild, Treasure Island, FL. **Work:** New York Hosp. Soc., NY; Univ. Bank, Coral Gables, FL; Abbott Labs., Chicago, Ill.; Ford Motor Co., Dearborn, Mich.; Honeywell Mfg. Co., Philadelphia, Pa. Commissions: Living War Mem. (476 portraits of every Dade Co serviceman who lost his life in World War II); seven paintings, Com. Bank, Winter Park, Fla; four paintings, First Nat. Bank, Winter Park; City Nat. Bank, Clearwater, Fla. **Comments:** Preferred media: oils, acrylics. Positions: pres. & hd. fine arts dept., Terry AI, 1944-54. Publications: illusr., cover for 50th anniversary & auth., articles, in: *Saint Petersburg Times;* art critic, *Gulf Beach J.* Teaching: instr. painting, Craft Village, Saint Petersburg, 1944-69; instr. painting, C.of C., Madeira Beach, FL, 1969-72; instr. pvt. classes. **Sources:** WW73.

TERRY, Marion J. *[Artist] late 19th c.*
Addresses: Brooklyn, NY, 1891. **Exhibited:** NAD, 1891.
Sources: Naylor, *NAD.*

TERRY, (Miss) *[Painter, sketch artist] late 19th c.*
Addresses: New Orleans, active c.1882-89. **Studied:** Southern Art Union, 1882. **Exhibited:** Southern Art Union, 1882 (prize); Cotton Palace, 1889. **Sources:** *Encyclopaedia of New Orleans Artists,* 372.

TERRY, Roland *[Painter] b.1917, Seattle, WA.*
Addresses: Seattle, WA, 1941. **Exhibited:** SAM, 1937-40.
Sources: Trip and Cook, *Washington State Art and Artists.*

TERRY, Roy H. (Hap) *[Painter, commercial artist] b.1910, Los Angeles, CA.*
Addresses: Mercer Island, WA. **Studied:** E. Ziegler. **Member:** NW WC Soc.; Seattle Art Director's Soc.; Puget Sound Group of Northwest Painters. **Exhibited:** SAM, 1934-53. **Sources:** Trip and Cook, *Washington State Art and Artists.*

TERRY, Sarah F. *[Primitive painter] early 19th c.*
Addresses: Active in Massachusetts, 1800-20. **Sources:** Petteys, *Dictionary of Women Artists.*

TERRY, W. Eliphalet See: **TERRY, Eliphalet**

TERRY, Wayne *[Painter] mid 20th c.*
Addresses: Indianapolis, IN. **Exhibited:** AIC, 1949; PAFA Ann., 1952. **Sources:** Falk, *Exh. Record Series.*

TERRY, William D. *[Banknote engraver] d.c.1858.*
Addresses: Active in Providence, RI from 1830-36; Boston, 1843-58. **Comments:** In 1836 he organized the Boston firm of Terry, Pelton & Co. (see entry), which lasted only until the next year; from 1838 to 1842 his whereabouts are unknown. Mrs. Terry is listed in 1859, which suggests that Terry died in the latter part of 1858 or early 1859. **Sources:** G&W; Providence CD 1830, 1832, 1836; Boston CD 1836-37, 1843-59; Stauffer.

TERRY, PELTON & CO. *[Banknote engravers] mid 19th c.*
Addresses: Boston, 1836-37. **Comments:** William D. Terry, Oliver Pelton, and (in 1836) George G. Smith (see entries on each). **Sources:** G&W; Boston CD 1836-37.

TERRYLL, Richard See: **TERRELL, Richard**

TERWILLIGER, Edwin *[Painter] b.1872, Mason, MI.*
Addresses: Chicago, IL. **Member:** Palette and Chisel Acad. FA; Chicago SE. **Sources:** WW40.

TERWILLIGER, R. L. *[Painter] 20th c.*
Addresses: Chicago, IL. **Sources:** WW19.

TESAR, Joseph *[Illustrator] 20th c.*
Addresses: Rockville Center, NY. **Member:** SI. **Sources:** WW47.

TESCHMAKER, F. *[Printmaker] mid 19th c.*
Comments: Artist of one of the Endicotts' "Life in California" prints, published in 1846. Peters identifies the artist with Henry F. Teschemacher, who came to California about 1846 as a ship's clerk and remained to become a ship agent, real estate agent, and "capitalist." **Sources:** G&W; Peters, *California on Stone;* San Francisco CD 1854-82.

TESKE, Josephine K. *[Painter] mid 20th c.*
Exhibited: S. Indp. A., 1942. **Sources:** Marlor, *Soc. Indp. Artists.*

TESLOF, Jean *[Painter] mid 20th c.*
Exhibited: Salons of Am., 1931. **Sources:** Marlor, *Salons of Am.*

TESSIER, Lydia *[Painter] mid 20th c.*
Addresses: Berkeley, CA, 1925; San Francisco, CA, 1938. **Exhibited:** San Francisco AA, 1925. **Sources:** Hughes, *Artists in California,* 554.

TESSIN, Germain *[Sculptor] b.c.1829, France.*
Addresses: New Orleans in 1860. **Sources:** G&W; 8 Census (1860), La., VI, 902.

TESTA, Angelo *[Painter] mid 20th c.*
Addresses: Chicago area. **Exhibited:** AIC,1947, 1949. **Sources:** Falk, *AIC.*

TESTA, Ernest Pochin *[Painter] late 19th c.*
Addresses: NYC, 1867. **Exhibited:** NAD, 1867. **Sources:** Naylor, *NAD.*

TESTER, Jefferson *[Painter] b.1900, Mountain City, TN.*
Addresses: New Rochelle, NY. **Studied:** AIC. **Exhibited:** Worcester MA, 1945; AIC, 1944; Critics Choice Exh., 1945; CI,1945; NAD, 1945; Babcock Gal., NYC. **Sources:** WW53; WW47.

TESTORI, William C. *[Painter] mid 20th c.*
Addresses: Brooklyn, NY. **Exhibited:** S. Indp. A., 1925. **Sources:** Marlor, *Soc. Indp. Artists.*

TETHEROW, Michael *[Sculptor] b.1942.*
Addresses: NYC. **Exhibited:** WMAA, 1970. **Sources:** Falk, *WMAA.*

TETLEY, William Birchall *[Portrait and miniature painter; teacher of painting, drawing, and dancing] late 18th c.*
Addresses: Came to NYC in 1774 from London. **Sources:** G&W; Gottesman, *Arts and Crafts in New York City,* I, 6-7.

TETTLETON, Robert Lynn *[Painter, educator] b.1929, Ruston, LA.*
Addresses: Oxford, MS. **Studied:** La. Polytech. Inst. (B.A., 1950); La. State Univ., Baton Rouge (M.A., 1953). **Member:** Fla. Art Educ. Assn.; Southeastern Col. Art Assn. (pres., 1969-70); Gainesville Fine Arts Assn. (pres., 1965); Am. Assn. Univ. Prof. **Exhibited:** La. Art Comn., Baton Rouge, 1952; Delgado Mus., New Orleans, La., 1953; Gainesville Fine Arts Assn., Fla, 1961; Mid-South Art Show, Brooks Mem. A. Gal., Memphis, Tenn., 1969; solo shows, Little Theater, Monroe, La., 1954 & Mary Buie Mus., Oxford, Miss., 1970. **Comments:** Preferred media: oils. Teaching: instr. art, Northeast La. State Col., 1955-56; asst. prof. art, Univ. Fla., 1961-65; prof. art & chmn. dept., Univ. Miss.,

1965-. **Sources:** WW73.

TEUBNER, George W. *[Engraver] mid 19th c.*
Addresses: NYC, 1840-44. **Sources:** G&W; NYBD 1840-44.

TEUIL, Val *[Listed as "artist"] late 18th c.; b.Holland.*
Addresses: Came to America about 1793; worked in New Jersey for a few years before returning to Holland. **Work:** Crayon portrait of Gerrit Boon of Trenton is at the Oneida Historical Society, Utica (NY). **Sources:** G&W; WPA (Mass.), *Portraits Found in New York.*

TEULON, Edward A. *[Engraver] b.c.1826, Nova Scotia.*
Addresses: Worked in Boston from 1849 until after 1860. **Sources:** G&W; 7 Census (1850), Mass., XXV, 31; Boston CD 1849-60+.

TEULON, Matthew H. *[Engraver and printe] mid 18th c.*
Addresses: Boston, 1860 and after. **Sources:** G&W; Boston BD 1860 [as engraver]; Boston CD 1863 [as printer].

TEVIS, Edwin Enos *[Illustrator, teacher] b.1898, Toledo.*
Addresses: NYC/Westport, CT. **Studied:** AIC; ASL. **Sources:** WW40.

TEW, David *[Engraver] late 18th c.*
Addresses: Philadelphia, 1785. **Sources:** G&W; Brown and Brown.

TEW, Marguerite R. *[Sculptor] b.1886, Magdalena, NM. / d.1975, Los Angeles, CA.*
Addresses: Phila., PA, 1913-15; San Marcial, NM, 1916; Los Angeles, CA. **Studied:** PM Sch. IA; PAFA, Grafly, 1913 (Cresson traveling scholarship). **Member:** Calif. AC, from 1917, 1924 (prize); NAWA. **Exhibited:** PAFA Ann., 1913, 1915-16; AIC; Calif. AC, 1924 (prize). **Work:** Mayan ornament, South West Mus., Los Angeles. **Sources:** WW40; Falk, *Exh. Record Series.*

TEWI, Thea *[Sculptor] mid 20th c.*
Addresses: Forest Hills, NY. **Studied:** ASL; Greenwich House, with Lou Duble; Clay Club, with D. Denslow; New Sch. Social Res., with Seymour Lipton. **Member:** Sculptors League (pres., 1971-); League Present Day Artists (hon. pres.); Nat. Assn. Women Artists (chmn. sculpture jury, 1969-72); Am. Soc. Contemp. Artists; Artists-Craftsmen New York. **Exhibited:** 18th-20th Ann. New Eng. Exhib., Silvermine Guild Artists, 1965 & 1967-69; NAC Exhib. Relig. Art, 1966; Erie Summer Festival Arts, Pa. State Univ., 1968; Sixth Biennial of Sculpture, Carrara, Italy, 1969. **Awards:** spec. award for outstanding merit in craftsmanship, Artists-Craftsmen New York, 1967; medal of hon. & first prize for sculpture, NAWA, 1969; first prize for sculpture Am. Soc. Contemp. Artists, 1971. **Work:** Nat. Collection Fine Arts, Smithsonian Inst.; Cincinnati AM; Norfolk Mus. Arts & Sci., Va.; Notre Dame Univ., Ind.; Am. Ins. Co. Corp. Coll., Galveston, Tex. **Comments:** Preferred media: stone. **Sources:** WW73; D. Meilach, *Contemporary Stone Sculpture* (Crown, 1970); Margaret Harold, *Prize Winning Sculpture & Prize Winning Art* (Allied); *Int. Encycl. Art* (Ancona, Italy).

TEWKSBURY, Fanny B. W(allace) *[Floral and landscape painter, teacher] b.1852, Boston, MA. / d.After 1934.*
Addresses: Newtonville, MA, 1885; Boston, MA, 1887-99; Phila., PA, 1901. **Studied:** Sch. Design, MIT, R. Turner, all in Boston. **Member:** NYWCC; Phila. WCC; N.Y. Women's AC. **Exhibited:** Brooklyn AA, 1879-85; Boston AC, 1882-1907; PAFA Ann., 1885-1901; AIC, 1891-1907; NYWCC, 1897-98. **Comments:** Exhibited works indicate she painted landscapes, including shoreline scenes, in Conn. and Mass., primarily in watercolor. She also painted many floral still lifes in watecolor. **Sources:** WW33; Petteys, *Dictionary of Women Artists;* Falk, *Exh. Record Series.*

TEXIER, Alfred M. *[Sketch artist] d.c.1890.*
Addresses: New Orleans, active ca.1884-85. **Exhibited:** World's Indust. and Cotton Cent. Expo., 1884-85. **Comments:** Cotton broker who painted landscapes, marine scenes and profiles. **Sources:** *Encyclopaedia of New Orleans Artists,* 372.

TEXOON, Harry *[Painter] mid 20th c.*
Addresses: NYc. **Studied:** ASL. **Exhibited:** S. Indp. A., 1924-30.
Sources: Marlor, *Soc. Indp. Artists.*

TEXOON, Jasmine *[Painter, instructor] b.1924, NYC.*
Addresses: NYC. **Studied:** Nat. Acad. Design, with Gilford Beal, H. Hildebrandt & Charles Hinton, four yrs. with honors; Brooklyn Mus. Art Sch., with Bocour; ASL, with Byron Browne. **Member:** life mem. ASL; Burr Artists; Centro Studi E Scambi Internazionale Rome, Italy. **Exhibited:** Raymond Duncan Gallery, Paris France, 1962, 1965, 1968 & 1969; Lynn Kotler Gallery, New York, 1963; Int Exhib Drawings, Florence, Italy, 1971; solo shows, Manhattan Col, New York, 1955 & Burr Gallery, New York, 1959. Awards: Scholar, High Sch Music & Art, 1944; hon for art work, Nat Acad Design Sch, 1947; Prix de Paris, Ligoa Duncan Gallery, 1962, 1965, 1968 & 1969. **Work:** Christ the King (mural), Marian Col. Art Gal. Permanent Collection, Fond du Lac, Wis.; relig. mural, Monastery St. Lazarro Mus., Venice, Italy; painting, Col. Armeno Permanent Collection, Venice; relig. paintings, St. Mary's Convent, Yonkers & Church Holy Cross Sch., New York. Commissions: painting of home, Mr. & Mrs. Zambetti, Sr., New York, 1950; painting of boy & his dog, Mr. & Mrs. Russell, New York, 1954; three landscapes, Mr. & Mrs. Alexander Walker, Yonkers, 1967; portrait of a little girl, Donata Pellegrini, Yonkers, 1968. **Comments:** Preferred media: oils. Positions: occup. therapist for prof. patients, Bronx, NY, 1955-62; occup. therapist, Rockland State Hosp., 1964-. Teaching: instr. pvt. classes, 1949-61 & 1971-; instr. art, New York City Bd. Educ., 1957-. **Sources:** WW73; Article, In: *J. Am.* (1959); "Leonardo da Vinci," *Cahiers d'Art* (1970); *Enciclopedia Internazionale Degli Artisti* (Bugatti, 1970).

TEYRAL, Hazel Janicki See: **JANICKI, Hazel**

TEYRAL, John *[Painter, instructor, designer] b.1912, Yaroslav, Russia.*
Addresses: Lakewood, OH; Cleveland, OH. **Studied:** Cleveland Inst. Art with Henry G. Keller; BMFA Sch.; Grande Chaumière, Paris; Accad. Belli Arti, Florence, Italy (on Fulbright grant, 1949-50); AlexanderJacovleff. **Member:** Cleveland SA. **Exhibited:** CI, 1941; BMFA, 1942; Butler AI, 1943-45 (prize); Milwaukee AI, 1946; VMFA, 1946; CMA, 1932-61 (prizes); 1030 Gal., Cleveland 1945 (solo); MMA; Corcoran Gal biennial, 1947; Univ. Nebr. **Work:** CMA; City of Cleveland, OH; Butler Inst. Am. Art; Pepsi Cola Coll.; Montclair Mus. Art, NJ. Commissions: mural, President Garfield Mem., Cleveland; many portraits of prominent persons. **Comments:** Teaching: BMFA Sch., 1936-37; Cleveland Inst. Art, 1939-41; U.S. Army, 1942-43. Collections arranged: "32 Realists," Cleveland Inst. Art, 1972. **Sources:** WW73; WW47.

THACHER, Amy Clark *[Painter] 19th/20th c.*
Addresses: NYC, 1883-98; Orange, NJ, 1900-03; Yarmouthport, MA. **Member:** NY Women's AC. **Exhibited:** NAD, 1883-84 (as A.C. Thacher), 1898; Salons of Am., 1924. **Sources:** WW13; Naylor, *NAD;* Marlor, *Salons of Am.*

THACHER, Elizabeth *[Painter] b.1899, Brookline, MA.*
Addresses: Brookline, MA. **Studied:** Boston with Leslie Thompson; P. Hale; W. James; F. Bosley. **Exhibited:** PAFA Ann., 1927, 1929; Boston Jr. Lg., 1929. **Sources:** WW40; Petteys, *Dictionary of Women Artists;* Falk, *Exh. Record Series.*

THACHER, John Seymour *[Museum director] b.1904, New York, NY.*
Addresses: Washington, DC. **Studied:** Yale Univ. (B.A., 1927); Univ. London (Ph.D., 1936). **Member:** Century Assn.; Cosmos Club; Int. Inst. Conserv. Mus. Objects (assoc.); Pierpont Morgan Lib. (fellow); Grolier Club. **Comments:** Positions: asst. to dir., Fogg Mus. Art, Cambridge, MA, 1936-40, asst. dir., 1940-46, exec. off., Dumbarton Oaks Res. Lib. & Coll., 1940-45, acting dir., 1945-46, dir. & treas., 1946-69; trustee, Harvard Univ.; trustee & assoc. in fine arts, Yale Univ., 1953-; treas., Byzantine Inst., Inc., Wash., DC. Publications: auth., "Paintings of Francisco de Herrara, the elder,'" *Art Bulletin,* 1937. **Sources:** WW73.

THACKARA, James *[Engraver, stationer] b.1767, Philadelphia, PA / d.1848, Phila.*
Addresses: Phila. **Comments:** From 1791 to about 1797 he was in partnership with John Vallance. Later he worked with his son William Thackara. He was also Keeper of the Pennsylvania Academy after 1826. **Sources:** G&W; Stauffer; Phila. CD 1791-1846; Hamilton, *Early American Book Illustrators and Wood Engravers,* 529.

THACKARA, William *[Engraver] b.1791, Philadelphia, PA / d.1839.*
Addresses: Philadelphia, 1818-24 & later. **Comments:** Son of James Thackara. He was active as an engraver in Philadelphia from 1818-24, part of that time in association with his father; after 1824 he was listed as a conveyancer. **Sources:** G&W; Stauffer; Phila. CD 1818-40.

THACKARA & VALLANCE *[Engravers] late 18th c.*
Addresses: Philadelphia, 1791-97. **Comments:** Partners were James Thackara and John Vallance. **Sources:** G&W; Phila. CD 1791-94; Prime, II, 74; Brown and Brown.

THACKENTO, John Cosmo *[Painter] b.1880, Ukraine / d.1956, Los Angeles, CA.*
Addresses: Los Angeles, CA. **Exhibited:** Artists Fiesta, Los Angeles, 1931. **Sources:** Hughes, *Artists in California,* 555.

THAIN, Howard A. *[Painter] b.1891, Dallas, TX / d.1959.*
Addresses: NYC. **Studied:** S. Ostrowsky; A. Sterba; F.V. DuMond; R. Henri; V. Anspaugh; F. DeF. Schook; J. Hambidge; ASL. **Member:** S. Indp. A.; Bronx AG; SSAL. **Exhibited:** S. Indp. A., 1921-24, 1927, 1929, 1930; Salons of Am., 1922-30; WMAA, 1922-27. **Sources:** WW33.

THAL, J. *[Painter] early 20th c.*
Addresses: Toledo, OH. **Member:** Artklan. **Sources:** WW25.

THAL, Sam(uel) *[Etcher, sculptor, painter, lecturer] b.1903, NYC / d.c.1964, Boston, MA.*
Addresses: Boston, MA. **Studied:** ASL; NAD; Beaux-Arts Acad.; BMFA Sch. **Member:** SAE; Boston Arch. Club. **Exhibited:** Doll & Richards, Boston, annual solos; Rockport AA; Inst. Mod. Art, Boston; CAFA, 1943 (prize); SAE, 1941-43 (prizes); LOC, 1945 (prize); NAD (prize); U.S. Nat. Mus. **Work:** BMFA; LOC; Bibliothèque Nat., Paris; Boston Pub. Lib.; Marblehead AA; Tufts Medical College; CAFA; MMA; Penn. State Univ.; Rogers Bros. Shoe Co., Boston; CI; arch. s., panels, Cincinnati Bell Telephone Bldg.; Harvard Medical Sch.; Rindge Technical Sch., Cambridge, MA; East Boston Airport; Harvard Univ. Dormitory; sculpture, B'nai Israel, Rockville, CT. **Comments:** Teaching: The Garland School, Boston, Mass. Auth./illustr.: "The Okinpochee Bird Family." **Sources:** WW59; WW47; add'l info. courtesy Anthony R. White, Burlingame, CA, who has death date of 1963.

THALHEIMER, Fannie B. *[Painter] early 20th c.*
Addresses: Baltimore, MD. **Exhibited:** S. Indp. A., 1924-25; Salons of Am., 1926. **Sources:** WW25.

THALINGER, E. Oscar *[Painter, teacher] b.1885, Alsace-Lorraine / d.1965.*
Addresses: Chesterfield, St. Louis, MO; Manchester, MO. **Studied:** St. Louis Sch. FA, Washington Univ.; Munich, Germany; Gruber. **Member:** St. Louis AG; 2x4 Soc.; Group 15; St. Louis County AA; Gateway AA; AEA. **Exhibited:** S. Indp. A., 1917; AIC, 1927, 1932; PAFA Ann., 1928, 1930, 1932; Aaron Gal., Chicago, c.1990 (retrospective). **Work:** CAM. **Comments:** Registrar for the Cleveland AM (1914-52), he painted at night in his studio. His landscapes of the Ozarks date from the late 1920s-early 1930s, and he turned to abstraction in the 1950s. Teaching: People's AC, St. Louis, MO. **Sources:** WW59; exh. flyer, Aaron Gal., Chicago (c.1990); WW47; Falk, *Exh. Record Series.*

THALINGER, Frederic Jean *[Sculptor] b.1915, St. Louis, MO / d.1965.*
Addresses: Croton-Hudson, NY. **Studied:** Antioch College (A.B., 1939); Washington Univ. Sch. FA, 1940; one summer at AIC; Grant Wood; ceramics with Harold Nash, Univ. Cincinnati.

Exhibited: Kansas City AI, 1937; AIC, 1940-41; CAM, 1943; Syracuse MFA, 1937 (prize); New-Age Gal., NY, 1946; St. Louis Art Guild, 1940 (prize); TMA; PAFA Ann., 1948; PMA; St. Louis AM, 1960; Illinois State Mus., 1941 (prizes, 1942, 1961); WFNY, 1964. **Awards:** Beaux-Arts Exh., 1939; Traveling Fellowship, Washington Univ., St. Louis, MO, 1939. **Work:** Syracuse Mus. FA; Illinois State Mus.; Antioch College, Yellow Springs, OH; sculpture, USPO, Jenkins, KY; Francis Cabrini Housing Project, Chicago, IL. **Comments:** He carved in wood, stone, and soap; sculpted clay and welded metals. **Sources:** WW53; WW47; PHF files courtesy E.J. Thalinger; Falk, *Exh. Record Series.*

THALL, S. (Dr.) *[Painter] early 20th c.*
Exhibited: Salons of Am., 1934. **Sources:** Marlor, *Salons of Am.*

THALL, Victor *[Painter] mid 20th c.*
Addresses: NYC. **Exhibited:** WMAA, 1949-50. **Sources:** Falk, *WMAA.*

THALLON, Florence N. *[Landscape & floral painter] 19th/20th c.*
Addresses: Sebago, ME, c.1900; Boston, MA, c.1905. **Exhibited:** Brooklyn AA, 1875-78, 1886; Boston AC, 1899-1905.
Comments: Exhibited works indicate she painted primarily in watercolor, and traveled to Oregon as well as to Venice, Italy. **Sources:** WW06.

THARIN, Selma *[Painter] early 20th c.*
Addresses: Charleston, SC. **Sources:** WW25.

THARP, Newton J. *[Landscape & portrait painter] b.1867, Mt. Pleasant, IA / d.1909, NYC.*
Addresses: San Francisco, CA. **Studied:** San Francisco School Des.; École des Beaux-Arts. **Exhibited:** Calif. Agricultural Soc., 1883; San Francisco Sch. Design, 1886 (silver med.); Mechanics' Inst., 1896, 1897; Calif. State Fair, 1895. **Sources:** Hughes, *Artists in California,* 555.

THARP, Rose B. *[Painter] early 20th c.*
Addresses: Jacksonville, FL. **Sources:** WW25.

THARSILLA, (Sister M.) See: **SISTER M. THARSILLA**

THATCHER, Earl *[Illustrator, painter] 19th/20th c.*
Addresses: NYC; Phila., PA, 1892, 1930. **Exhibited:** PAFA Ann., 1892, 1930. **Comments:** Illustrator: *Harper's.* **Sources:** WW01; Falk, *Exh. Record Series.*

THATCHER, Edward (Ned) W. *[Painter] early 20th c.*
Addresses: Columbus, OH. **Member:** Columbus PPC; Woodstock AA. **Sources:** WW25; Woodstock AA.

THATCHER, George W. *[Wood engraver] b.c.1833, New York.*
Addresses: NYC. **Exhibited:** Am. Inst., 1851. **Comments:** He was listed as a wood engraver in 1854, at which time he was a partner in the NYC engraving firm of Cocheu & Thatcher (see entry for Henry Cocheu). Thatcher was listed as an artist in the 1860 census. His personal property in 1860 was valued at $20,000. **Sources:** G&W; 8 Census (1860), N.Y., LVI, 697; Am. Inst. Cat., 1851; NYBD 1854.

THATCHER, Isabel *[Artist] d.1995.*
Member: Woodstock AA. **Sources:** Woodstock AA.

THATCHER, Jane Dyer *[Painter] mid 19th c.*
Addresses: Thought to be active in Leadville, CO, c.1856. **Sources:** Petteys, *Dictionary of Women Artists.*

THATCHER, S. B. *[Artist] early 20th c.*
Addresses: Active in Los Angeles, c.1902-16. **Comments:** *Cf.* Sarah B. Thatcher. **Sources:** Petteys, *Dictionary of Women Artists.*

THATCHER, Sarah B. *[Artist] b.Michigan / d.1942.*
Addresses: Los Angeles for 50 years. **Comments:** *Cf.* S.B. Thatcher. **Sources:** Petteys, *Dictionary of Women Artists.*

THATER, Marie Louise *[Illustrator] early 20th c.*
Addresses: Chicago, IL. **Studied:** PAFA. **Sources:** WW25.

THAW, A(lexander) Blair *[Painter] d.1937.*
Addresses: Wash., DC, active 1924-35. **Member:** Wash. AC. **Exhibited:** Soc. Wash. Artists; Wash. WCC. **Comments:** Married to Florence Thaw (see entry). **Sources:** WW25; McMahan, *Artists of Washington, DC.*

THAW, Florence (Mrs. Alexander Blair) *[Portrait painter] b.1864, NYC / d.1940, Wash., DC.*
Addresses: Sussex, England, c.1903; Wash., DC/North Hampton, NH, 1924-40. **Studied:** A. Thayer; B. Harrison; Académie Julian, Paris. **Member:** Soc. Wash. Artists; NY Cosmopolitan Cub; Wash. Art Club. **Exhibited:** Soc. Wash. Artists; Wash. Art Club; PAFA Ann., 1903, 1905; NAD; Yorke Gal., 1925, 1928, 1929. **Work:** NAD. **Sources:** WW38; McMahan, *Artists of Washington, DC;* Petteys, *Dictionary of Women Artists;* Falk, *Exh. Record Series.*

THAXTER, Edward R. *[Sculptor] late 19th c.*
Exhibited: AIC, 1888. **Sources:** Falk, *AIC.*

THAYER, Abbott H(anderson)
[Portrait, figure & landscape painter, muralist] b.1849, Boston, MA / d.1921, Dublin, NH.
Addresses: NYC, Scarborough, NY (1879-1901)/Dublin, NH (summers, then permanently after 1901). **Studied:** H.D. Morse, 1865; Brooklyn Art Sch. with J.B. Whittaker, 1867; NAD with Wilmarth, 1868; École des Beaux-Arts, Paris, with Gérôme & H. Lehmann, 1875. **Member:** ANA, 1898; NA, 1901; SAA, 1879; NIAL; Soc. delle Belle Arti Denominata de San Luca, Rome; NSMP; Artists Fund Soc. **Exhibited:** Brooklyn AA, 1866-78, 1884; NAD, 1868-80, 1894, 1898 (Clark prize), 1908, 1915 (Saltus medal), 1921; Brooklyn Acad. Des., 1868 (gold); Mass. Charitable Mech. Assn. (gold); Paris Salon, 1877, 1878; SAA, 1880s; PAFA Ann., 1879-91 (gold), 1894-1909, 1914; Paris Expo, 1889 (med.), 1900 (gold); Columbian Expo, Chicago, 1893 (med. for "Virgin Enthroned"); Boston AC, 1896; Corcoran Gal. biennials, 1907-19 (6 times); AIC; NMAA, 1999 (retrospective). **Work:** NMAA; CGA; MMA; BMFA; NGA; WMA; Freer Gal., Wash., DC; RISD; Wadsworth Atheneum, Hartford; Smith College; Cincinnati Mus. Art; murals, Bowdoin College, Brunswick, ME. **Comments:** Thayer is best known for his idealized depictions of young women in the mode of angels, madonnas, and ethereal virgins. He also painted still lifes (mostly flowers), and later in his career painted impressionist landscapes around the Dublin-Mount Monadnock area. He was a popular artist in his day, praised by critics and admired by collectors and the public. From 1894 until the end of his life, he focused much of his energy on studying the laws of protective coloration in nature, publishing (with his son Gerald) *Concealing Coloration in the Animal Kingdom* (1908); some of these theories were adapted for camouflage by British Navy during WWI, and known as "Thayer's Law." Thayer died of a stroke, although he had committed himself to a hospital in 1918 because of his suicidal impulses. His first wife, Kate Bloede Thayer, was an artist, as was his second wife Emma Beach Thayer. **Sources:** WW19; Baigell, *Dictionary; 300 Years of American Art,* vol. 1: 443; "Abbott Thayer: The Nature of Art," *American Art Review* vol.11, no.3 (June 1999): pp. 180-85; Detroit Inst. of Arts, *The Quest for Unity,* 134-36; Nelson C. White, *Abbot H. Thayer, Painter and Naturalist* (Hartford, 1967); *Selection VII: American Paintings from the Museum's Collection, c. 1800-1930* (RISD, 1977), 118-122; Campbell, *New Hampshire Scenery,* 163; Fink, *American Art at the Nineteenth-Century Paris Salons,* 396; Falk, *Exh. Record Series.*

THAYER, Albert R. *[Painter, etcher, teacher] early 20th c.; b.Concord, MA.*
Addresses: Boston, MA. **Studied:** Eric Page; Edmund C. Tarbell; Aldro T. Hibbard. **Member:** Rockport AA. **Exhibited:** PAFA Ann., 1912; BM; Rockport AA. **Sources:** WW13; *Artists of the Rockport Art Association* (1956); Falk, *Exh. Record Series.*

THAYER, Alice Bemis (Mrs. Charles P.) *[Landscape & marine painter] b.1864, Boston.*

Addresses: Evanston, IL. **Studied:** Cowles Art Sch., Boston; R. Turner; A.W. Buhler; Colarossi Acad., Paris. **Member:** Chicago WCC. **Exhibited:** Boston AC, 1891; AIC, 1902-15. **Sources:** WW17.

THAYER, Benjamin W. *[Lithographer, engraver] mid 19th c.*
Addresses: Boston, 1841-53. **Comments:** His associates in Benjamin W. Thayer & Co. were John H. Bufford and John E. Moody (see entries). In 1854 Thayer's occupation was given as "broker". **Sources:** G&W; Boston CD 1841-54; Peters, *America on Stone.*

THAYER, Charles S. (Mrs.) *[Painter] early 20th c.*
Addresses: Hartford, CT. **Member:** Hartford AS. **Sources:** WW25.

THAYER, Eliza T. *[Sculptor] mid 20th c.*
Addresses: Newtown Square, PA. **Exhibited:** PAFA Ann., 1932-51 (6 times). **Sources:** Falk, *Exh. Record Series.*

THAYER, Elizabeth Hamilton See: **HUNTINGTON, Elizabeth Hamilton Thayer (Mrs.)**

THAYER, Ellen Bowditch See: **FISHER, Ellen (Nelly) Thayer (Mrs. Edward)**

THAYER, Emma (Emmeline Buckingham) Beach (Mrs. Abbott H.) *[Painter] b.1850 / d.1924.*
Addresses: Peekskill, NY; Monadnock, NH. **Studied:** with her husband, A.H. Thayer. **Exhibited:** AIC, 1890, 1891, 1917; PAFA, 1891; New England. **Comments:** Specialty: flower studies in oil and pastel. **Sources:** WW24; Falk, *Exh. Record Series.*

THAYER, Emma Homan (Mrs. Elmer A.) *[Painter, illustrator] b.1842, NYC. / d.1908, Denver.*
Addresses: Chicago, 1882; Denver from 1882-. **Studied:** Rutgers; NAD; ASL (one of the original mem.) with Chase, Church. **Exhibited:** NAD, 1882. **Comments:** Married George A. Graves in 1859 and Elmer Thayer, 1877. Author/illustr.: "Wild Flowers of Colorado," 1885, "Wild Flowers of the Pacific Coast," 1887, "An English-American, " 1890. **Sources:** WW06; P&H Samuels, 483.

THAYER, Ethel Randolph See: **THAYER, Polly (Ethel) (Mrs. Donald C. Starr)**

THAYER, Florence E. *[Painter] early 20th c.*
Addresses: Worcester, MA. **Sources:** WW24.

THAYER, Gerald H(anderson) *[Painter, writer, lecturer, teacher] b.1883, Cornwall, NY.* **G.H.T**
Addresses: Monadnock, NH. **Studied:** A. H. Thayer. **Work:** MMA; BM. **Comments:** Son of Abbot H. Thayer and his first wife, Kate Bloede Thayer. Co-auth. (with his father): *Concealing Coloration in the Animal Kingdom;* auth., *The Nature-Camouflage Book, The Seven Parsons and the Small Iguanodon.* **Sources:** WW27.

THAYER, Gladys See: **REASONER, Gladys Thayer (Mrs. David)**

THAYER, Grace *[Painter] early 19th c.; b.Boston, MA.*
Addresses: Boston, MA, active 1885-1925. **Studied:** BMFA Sch.; Mme. Hortense Richard, Paris. **Member:** Copley Soc., 1885. **Exhibited:** Trans-Mississippi Expo, Omaha, NE, 1898; Paris Salon, 1898 (drawing); Boston AC, 1903-07. **Sources:** WW25; Fink, *Am. Art at the 19th c. Paris Salons,* 396.

THAYER, H. B. (Mrs.) *[Painter] early 20th c.*
Addresses: Wash., DC. **Exhibited:** Soc. Wash. Artists, 1924. **Comments:** Cf. Harriet Thayer. **Sources:** McMahan, *Artists of Washington, DC;* Petteys, *Dictionary of Women Artists.*

THAYER, Harriet Barnes (Mrs.) *[Painter] early 20th c.*
Addresses: Wash., DC. **Exhibited:** Soc. Wash. Artists, 1908. **Comments:** Cf. Mrs. H.B. Thayer. **Sources:** WW25; McMahan, *Artists of Washington, DC;* Petteys, *Dictionary of Women Artists.*

THAYER, Horace *[Lithographer?] b.1811, Hartwick, NY.*
Addresses: Warsaw, NY; NYC. **Comments:** He came to NYC in 1845 from Warsaw (NY) to become a partner of the Kelloggs. The partnership was dissolved after about a year and Thayer went into the map-publishing business. In 1854 he went back to Warsaw where he had established a map-roller manufactory. In 1859 he returned to map-publishing in NYC but by 1864 was again in Warsaw. In 1866 he moved to the nearby village of Johnsonburg and he was still there in 1874. **Sources:** G&W; Young, *History of the Town of Warsaw,* 376; Thayer, *Memorial of the Thayer Name,* 240, 242; NYCD 1846-54, 1858-65; Peters, *America on Stone.*

THAYER, Kate Bloede (Mrs. Abbott) *[Painter] d.1891.*
Addresses: NYC. **Studied:** Brooklyn Art School. **Comments:** First wife of Abbott H. Thayer. She and son Gerald were the subjects of Abbott Thayer's 1886 picture "Mother and Child," now at the Mus. of Art, RISD. After the death of two baby boys within a two-year period, she became depressed and entered a hospital in 1888. Mrs. Thayer stayed at a series of hospitals and asylums until her death in 1891. **Sources:** *Selection VII: American Paintings from the Museum's Collection, c. 1800-1930* (Providence: Museum of Art, Rhode Island School of Design, 1977), 118-122 (under Abbott Thayer).

THAYER, Lucy *[Painter] mid 20th c.*
Addresses: NYC. **Exhibited:** PAFA Ann., 1936. **Sources:** Falk, *Exh. Record Series.*

THAYER, (Miss) *mid 19th c.*
Addresses: Brooklyn, NY, 1868. **Exhibited:** NAD, 1868. **Sources:** Naylor, *NAD.*

THAYER, Polly (Ethel) (Mrs. Donald C. Starr) *[Painter] b.1904, Boston, MA.*
Addresses: Boston, MA. **Studied:** BMFA School with P. Hale; ASL with H. Wickey. **Member:** Boston Gld. Artists; Boston AC; NAWPS. **Exhibited:** PAFA Ann., 1928-42 (6 times); NAD, 1929 (prize); S. Indp. A., 1931; Boston Tercentenary Exh. (medal); NYC, 1941; Phila., 1942, 1956 (solo); Boston, MA, 1950, 1955 (solo); Boston Art Festival, 1957. **Work:** PAFA; BMFA; AGAA; Springfield Art Mus. **Comments:** Known as Polly. Painted at Fenway Studios, 1932-36. **Sources:** WW59; WW47; Vose Galleries, *Mary Bradish Titcomb and Her Contemporaries,* 53; Falk, *Exh. Record Series.*

THAYER, Raymond L. *[Painter] b.1886, Sewickley, PA / d.1955.*
Addresses: NYC. **Studied:** K.H. Miller. **Member:** AG; SI; AWCS. **Exhibited:** AIC, 1914, 1929. **Sources:** WW33.

THAYER, Robert H. *[Collector] mid 20th c.*
Addresses: Washington, DC. **Sources:** WW66.

THAYER, Sanford *[Portrait & genre painter] b.1820, Cato, NY / d.1880, Syracuse, NY.*
Addresses: NYC, 1844; Brooklyn, 1848; Syracuse, 1845, 1862-79. **Exhibited:** NAD, 1862-79. **Comments:** Married in 1850 and settled in Syracuse **Sources:** G&W; Thayer, *Memorial of the Thayer Name,* 490; Cowdrey, NAD; G&W has information courtesy Mr. Julian Denton Smith; Syracuse CD 1855+; *American Art Review,* I (1881), 169.

THAYER, Theodora W. *[Miniature painter, teacher] b.1868, Milton, MA / d.1905.*
Addresses: Cambridge, MA; NYC. **Studied:** Joseph DeCamp in Boston. **Member:** ASMP (a founder); Copley Soc., 1894. **Exhibited:** PAFA Ann., 1899-1901; ASMP; Pan-Am. Expo, Buffalo, 1901 (bronze medal); SAA, 1898. **Comments:** Thayer was a teacher at NY School Art and ASL. **Sources:** WW04; Petteys, *Dictionary of Women Artists;* Falk, *Exh. Record Series.*

THEAD, Louis *[Painter] late 19th c.*
Addresses: Flatbush, NY. **Exhibited:** AIC, 1897. **Sources:** Falk, *AIC.*

THECLA, Julia *[Painter, designer, graphic artist, sculptor, lithographer] mid 20th c.; b.Chicago, IL.*
Addresses: Chicago, IL. **Studied:** AIC; Elmer Forsberg.

Member: Chicago AC; Women Artists Salon, Chicago; Chicago NJSA (dir.). **Exhibited:** MoMA, 1943; Art of This Century, 1942-45; AIC, 1931-33, 1935-37, 1940, 1942-45; SFMA, 1945; CI; MMA. Awards: prizes, Chicago Newspaper Gld.; Illinois State Fair; Florida Southern College; AIC. **Work:** AIC; Newark Mus. **Comments:** A Surrealist, she worked in small formats, but was relatively isolated from the main Surrealist movement. **Sources:** WW59; WW45; Wechsler, 33.

THEES, Henry W. D. *[Painter, mural painter] b.1882, Hamburg, Germany / d.1942, Los Angeles, CA.*
Addresses: Los Angeles, CA. **Member:** P&S Los Angeles. **Sources:** Hughes, *Artists in California*, 555.

THEIS, Gladys Huling (Mrs.) *[Sculptor] b.1903, Bartlesville, OK.*
Addresses: Albuquerque, NM. **Studied:** Oklahoma A&M College; Cincinnati Art Sch.; Corcoran Sch. Art; Paris; Miller; Malfrey; Despiau; C.J. Barnhorn; M. Miller. **Exhibited:** Soc. Wash. Artists, 1931 (prize), 1932; New Mexico Art Lg., 1937, 1950-54; Albuquerque, NM, 1937 (solo); Southwestern Art Exh., 1940; State Mus., NM, 1940-54; Albuquerque, 1950-54 (prize, 1951); NAWA, 1950 (prize), 1952 (prize). **Work:** CM; Tulsa H.S., Tulsa Univ., Boston Ave. Church, all in Tulsa, OK; Oklahoma A&M College; Univ. Mexico; 25 portraits, Daufelser Sch. Music. **Sources:** WW59; WW47.

THEISS, J(ohn) W(illiam) *[Painter, writer] b.1863, Zelienople, PA.*
Addresses: Los Angeles, 1894-mid 1920s; Springfield, OH 1925-on. **Studied:** San Fran. with L.P. Latimer & A. Anderson. **Member:** Los Angeles Painters Club; Springfield AL. **Exhibited:** Blanchard Gal., Los Angeles, 1908-1909. **Comments:** He was a Lutheran minister from 1886-1904. Specialty: watercolor. Auth.: *German Lyrics, Gepflückt Am Wege*, 1897, *In der Feierstunde*, 1907, *Anthology of German Lyrics*, 1913, *Heimwärts*, 1922, *California Sketches*, 1935. **Sources:** WW33; Hughes, *Artists in California*, 555.

THEK, Paul *[Sculptor] b.1933, Brooklyn, NY.*
Addresses: Cologne, Germany. **Studied:** Cooper Union; ASL; Pratt Inst., 1951-54; in Europe. **Exhibited:** The Stable Gallery, 1964, 1967 & 1969 (all solos); Documenta IV, Kassel, 1968 & Cologne, 1969; Stedelijk Mus., Amsterdam, 1969; Nat. Mus., Stockholm, 1969; two-man show, Galerie 1920, Amsterdam, 1969. Awards: Fulbright fellowship, 1967. **Work:** Commissions: sets & costumes for Area (ballet), Nederlands Dans Theater, 1969. **Sources:** WW73.

THELIN, Valfred P. *[Painter, lecturer] b.1934, Waterbury, CT / d.1991, Maine.*
Addresses: Ogunquit, ME. **Studied:** Layton Sch. Art; AIC; Int. Design Conf. Center, Insel Mainau, Germany; plus art seminars in six European countries & Mexico. **Member:** Ogunquit AA (pres., 1971-72); Rockport AA (life mem.; juror); PAFA; Sarasota AA (juror demonstrations, 1972-73); Phila. WCS. **Exhibited:** Watercolor USA, Springfield (MO) Mus. 1963-72; AWCS, NAD Gals., NYC, 1963-72; The Franklin Mint; Tucson FA Center; SFMA; Calif. WCS; Nat. Gal. Art; Art in the Embassies, sponsored by Smithsonian Inst., Wash., DC, 1968-73; Landscape 1 & Art Expo 1972, De Cordova Mus, Lincoln, MA, 1970 & 1972; Six by Eight (eight watercolorists invited from the USA), Philbrook Art Mus., Tulsa, OK, 1971. Awards: Jurors Award of Distinction, Hermann FA Mus., 1968; John Singer Sargeant Award, Watercolor USA, Springfield Mus., 1968; Henry Ward Ranger Award, Audubon Artists exh., NAD, 1959; Barse Miller Mem. Award, AWCS, 1974. **Work:** MoMA; Reading (PA) Mus.; Springfield (MA) Mus.; Fort Wayne (IN) Mus.; Butler Inst. Am. Art, Youngstown, OH; CGA; Inst. Norteamericano, Mexico City; Beaux Arts, Mexico City; Ogunquit (ME) Mus. Am. Art. **Comments:** Preferred media: watercolors, acrylics. Publications: contrib.,*Art in Am.*, 3/1967, 1968 & 1972 & *The Art Gallery*, 1971 & 1972. Auth.: *Master Class in Water Color* (Watson-Guptill, 1975). **Sources:** WW73; Joshua Kind, "Chicago," *Art*

News (Feb., 1966); Safer, "New York Reviews," *Arts Magazine* (April, 1968); B. Sheaks, *Painting with Acrylics* (Davis, June, 1972); *Ogunquit, Maine's Art Colony, A Century of Color, 1886-1986* (exh. cat., Ogunquit: Barn Gallery Assoc., Inc., 1986); add'l info. courtesy Selma Koss Holtz, Waban, MA.

THEMAL, Joachim H(ans) *[Painter, teacher] b.1911, Koeslin, Germany.*
Addresses: New York 3, NY; Pleasantville, NY. **Studied:** in Dresden with Ernst Wagner; Berlin. **Member:** AEA. **Exhibited:** AWCS, 1958. Awards: Hallmark award, 1952; Huntington Hartford Fellowship, 1956; Yaddo Fellowship, 1958. **Work:** Mus. Mod. A., Seattle; Univ. Kentucky; Zanesville AI; Grand Rapids A. Gal.; Richmond AA; Florence (SC) Mus. Art; Mills College, Oakland; Univ. Georgia; Fleming Mus., Univ. Vermont; Evansville Mus. Art; Wagner Lutheran College, Staten Island; Delgado Mus. Art; Univ. Delaware. **Comments:** Positions: art instr. and art therapist, Cottage School, Pleasantville, NY as of 1959. **Sources:** WW59.

THEMMEN, Charles *[Landscape painter] mid 19th c.*
Addresses: Springfield, MA in 1856. **Exhibited:** Brooklyn AA, 1861-68. **Comments:** Possibly the same as C. Themmer who had three paintings in the American Art-Union sale in 1852, two of them French scenes. **Sources:** G&W; New England BD 1856; Cowdrey, AA & AAU.

THEMMER, C. See: **THEMMEN, Charles**

THEOBALD, Elisabeth Sturtevant (Mrs. Samuel) *[Sculptor, painter] b.1876, Cleveland, OH / d.1939.*
Addresses: NYC. **Studied:** Chase; Mora; Hawthorne; F.C. Gottwald; H. Matzen. **Member:** NAWA; Studio Guild. **Exhibited:** S. Indp. A., 1917-18; Salons of Am., 1934. **Sources:** WW38.

THEOBALD, R. C. *[Painter] early 20th c.*
Addresses: Los Angeles, CA. **Member:** Calif. AC. **Sources:** WW19.

THEOBALD, Samuel, Jr. *[Painter, etcher, teacher] b.1872, Baltimore, MD.*
Addresses: NYC. **Studied:** Johns Hopkins Univ.; NAD; Andre Castaigne. **Exhibited:** Corcoran Gal. biennials, 1930, 1935; Albright Art Gal.; Los Angeles Mus. Art; NAD; Soc. Indep. Artists. **Sources:** WW53; WW47.

THEODORE, Pan *[Sculptor, teacher] b.1905, Lemnos, Greece.*
Addresses: NYC. **Studied:** DaVinci Art Sch.; BAID; ASL. **Exhibited:** PAFA Ann., 1942, 1947; NAD, 1944; Soc. Indp. A., 1944. **Work:** numerous portrait busts. **Sources:** WW53; WW47; Falk, *Exh. Record Series.*

THEODOS, Milton *[Painter] early 20th c.*
Addresses: NYC, 1929. **Exhibited:** S. Indp. A., 1929. **Sources:** Marlor, *Soc. Indp. Artists.*

THEPOT, Roger François *[Painter] b.1925, Landeleau, France.*
Addresses: Toronto, Ontario. **Member:** Réalités Nouvelles; Royal Canadian Acad. **Exhibited:** Construction & Geometry in Painting, Galerie Chalette, New York, 1960; École de Paris, Galerie Charpentier, Paris, 1961; Prix Europe de Peinture, Ostende, Belgium, 1962; Thirteen French Artists, Nippon Gallery, Tokyo, Japan, 1967; Canada 1967, MoMA, New York, 1967; Gallery Moos Ltd., Toronto, Ontario, 1970s. Awards: Baxter Award, 1967. **Work:** MoMA; Musée d'Art Mod., Paris, France; Nat. Gallery, Ottawa, Canada; Art Gallery Ontario, Toronto; Mendel Art Gallery, Saskatoon, Canada. **Comments:** Preferred media: acrylics, gouache. Teaching: Ontario College Art, 1967-. **Sources:** WW73; M. Seuphor, *La Peinture Abstraite* (Flammarion, 1962); G. Rickey, *Constructivism--Origins & Evolution* (Braziller, 1967); *Roger Francois Thepot* (Ed. Prisme, 1972).

THERIAT, Charles J(ames) *[Painter]* *b.1860, NYC / d.1937.*
Addresses: Paris, Melum, Seine-et-Marne, France. **Studied:**
Académie Julian, Paris with Lefebvre and Boulanger, 1880-85.
Member: Paris SAP. **Exhibited:** Paris Salon, 1885, 1886, 1890-
92, 1894, 1896, 1898; Paris Expo, 1889, 1900; PAFA Ann., 1891,
1893, 1896-97; Pan-Am. Expo, Buffalo, 1901 (med.); Paris Salon
1896; AIC. **Sources:** WW13; Fink, *American Art at the
Nineteenth-Century Paris Salons*, 396; Falk, *Exh. Record Series.*

THESSMAN, Charles *[Fresco painter]* *late 19th c.*
Addresses: Wash., DC, active 1877. **Sources:** McMahan, *Artists
of Washington, DC.*

THETEY, August *[Portrait painter]* *b.c.1806, Italy.*
Addresses: Cincinnati in 1850. **Sources:** G&W; 7 Census
(1850), Ohio, XXII, 317.

THETFORD, William E. *[Painter, art collector]* *b.1813,
London, England / d.1903, Brooklyn, NY.*
Addresses: NYC. **Comments:** He came to NYC in 1836.
Sources: G&W; *Art Annual*, V, obit.

THEUERKAUFF, (Carl) R(udolph) *[Painter]* *b.1875,
Germany / d.1926.*
Addresses: Rochester, NY. **Studied:** self-taught. **Member:** SC;
Rochester AC; Geneseeans. **Sources:** WW25.

THEUERKAUFF, Rudolph See: **THEUERKAUFF,
(Carl) R(udolph)**

THEURET, Dominique *[Lithographer]* *b.c.1812, France.*
Addresses: New Orleans, active in 1837 and from 1849-54.
Comments: Worked in association with Charles Risso (see entry)
in 1837. His advertisements indicated he could do work in
English, Spanish, French, and Portuguese. **Sources:** G&W; 7
Census (1850), La., V, 85; New Orleans CD 1837, 1849-54
(Delgado-WPA). More recently, see *Encyclopaedia of New
Orleans Artists.* 372.

THEUS, Jeremiah *[Portrait painter]* *b.c.1719, Canton Grison
(Switzerland) / d.1774, Charleston, SC.*
Addresses: Charleston, SC, c.1740-74. **Studied:** early training is
unknown. **Work:** Carolina AA/Gibbes Art Gal., Charleston, SC;
Joseph Manigualt House, Charleston. **Comments:** Came to South
Carolina with his parents about 1735. By 1740 he was settled in
Charleston and advertising his services as a portrait and decora-
tive painter. Over the next three decades, Theus painted at least
150 portraits around Charleston and its surrounding plantations.
He was the dominant portraitist in South Carolina and the majori-
ty of his patrons were members of the wealthy planter and mer-
chant families comprising the elite of Charleston society. His styl-
ish portraits reflect a Rococo sensibility and are distinguished by
his bright, crisp, coloring and precise attention to detail in render-
ing the fashionable attire worn by his sitters. Examples include
"Mrs. Barnard Elliott" and "Colonel Barnard Elliott" (Carolina Art
Assoc.), and "Elizabeth Wragg Manigualt" (Manigualt House).
Sources: G&W; Middleton, *Jeremiah Theus, Colonial Artist of
Charles Town.* More recently, see Craven, *Colonial American
Portraiture*, 357-61; Saunders and Miles, 183-86.

THEVENAZ, Paul *[Painter]*
*b.1891, Geneva, Switzerland /
d.1921, Greenwich Hospital, NYC.*
Comments: Came to U.S. in 1917 anb served in the American
Army during WWI.

THEW, Garret See: **THEW, (Robert) Garret**

THEW, Robert *[Landscape engraver]* *mid 19th c.; b.England.*
Addresses: in NYC & Cincinnati until c.1860; England thereafter.
Comments: Came to America c.1850. **Sources:** G&W; Stauffer.

THEW, (Robert) Garret *[Sculptor, painter]* *b.1892, Sharon,
CT. / d.1964.*
Addresses: Westport, CT (1923-on). **Studied:** Syracuse Univ.;
Krouse College FA; ASL with E. Penfield, W. Biggs; Woodstock
Sch. Landscape Painting with J.F. Carlson. **Member:** AG. **Work:**
Newark Mus. **Comments:** From his Garret Thew Studio he sold

his bronze sculpture, lamp bases, signs, and weathervanes. He
returned to landscape painting late in life. **Sources:** WW33;
Community of Artists, 76.

THIBAUD, Henry W. *[Painter, photographer]* *early 20th c.*
Addresses: New Orleans, active 1904-08. **Sources:**
Encyclopaedia of New Orleans Artists, 373.

THIBAULT, Aimée *[Miniaturist]* *b.1780, Paris / d.1868,
France.*
Addresses: NYC, c.1834. **Exhibited:** Salon, Paris, 1804-10.
Work: NY Hist. Soc. (several miniatures of New Yorkers).
Comments: She came to America about 1834 and worked for a
short time in NYC, where she was known to the family of Louis
F. Binsse. **Sources:** G&W; Thieme-Becker; Bénézit; Dunlap,
History; G&W has information courtesy of Henry B. Binsse of
Washington (D.C.); *Catalogue of the Belknap Collection.*

THIBAULT, E. A. (Miss) *[Painter, sketch artist]* *late 19th c.;
b.New Orleans, LA.*
Addresses: New Orleans, active 1882-84. **Studied:** Southern Art
Union, 1882. **Exhibited:** Southern Art Union, 1882. **Sources:**
Encyclopaedia of New Orleans Artists, 373.

THIEBAUD, (Morton) Wayne *[Painter, set designer, educa-
tor]* *b.1920, Mesa, AZ.*
Addresses: Davis, CA. **Studied:** Sacramento State College (B.A.,
1951; M.A., 1952). **Exhibited:** DeYoung Mem Mus, 1962 (solo);
Dayton Art Inst.; Int. Contemp. Art, Houston, TX; SFMA; São
Paulo Biennale, Brazil, 1968; Norton Simon Mus., 1968 (solo);
WMAA. **Awards:** Golden Reel Film Festival Award, 1956;
Scholastic Art Awards for films Space & Design, 1961; Creative
Res. Found. grant, 1961. **Work:** MoMA; WMAA; MMA; LOC;
AIC; CGA; PMA; SFMA; Dallas MFA; Houston MFA; Newark
Mus., NJ; Oakland AM, CA; Albright-Knox Art Gallery;
Washington Gallery Mod. Art; Wadsworth Atheneum.
Commissions: fountain mobile structure, Calif. State Fair, 1952;
mosaic mural, Munic. Utility Dist. Bldg., Sacramento, 1959; pro-
ducer 11 educ. motion picture, Bailey Films, Hollywood, CA.
Comments: Thiebuad began working in an Abstract Expressionist
gestural style in the early to mid-1950s, choosing as his subject
matter everyday objects, such as gumball machines. By the late
1950s he had subdued his flashy, gestural brushstroke, and was
portraying pies, cakes and soup cans in bright posterlike colors,
usually set against a blue horizon and arranged in neat rows. He is
often associated with the Pop Art movement but the sensuous tex-
ture of his canvases differs from the slick, smooth handling of
most Pop artists. In the mid to late 1960s Thiebaud began focus-
ing on figurative works; and in the 1970s his favored subject was
the San Francisco landscape. **Publications:** auth., *American
Rediscovered*, 1963; *Delights,* 1965. **Positions:** set designer,
Universal Studios, 1950s. **Teaching:** Sacramento City College,
1951; San Francisco Art Inst., 1958; Univ. Calif., Davis, 1960-;
Cornell Univ., 1966; Viterbo College, 1969. **Sources:** WW73;
300 Years of American Art, 968 ; Baigell, *Dictionary;* John
Coplans, *Wayne Thiebaud* (exh. cat., Norton Simon Mus., 1968);
Sam Hunter (ed.), *New Art around the World: Painting and
Sculpture* (Abrams, 1966); Lucy R. Lippard, *Pop Art* (Praeger,
1966); Allen S. Weller, *The Joys and Sorrows of Recent American
Art* (Univ. Illinois Press, 1968).

THIEBAUD, Wayne See: **THIEBAUD, (Morton) Wayne**

THIEDE, Henry A. *[Illustrator]* *b.1871, Germany.*
Addresses: Evanston, IL. **Member:** Palette & Chisel Club.
Exhibited: Palette & Chisel Club, 1929 (prize); AIC. **Sources:**
WW33.

THIEL, Charles A. (Mrs.) *[Amateur artist, writer]* *late 19th c.*
Addresses: Active in New Orleans, c.1896. **Sources:** Petteys,
Dictionary of Women Artists.

THIEL, Johannes *[Painter]* *early 20th c.*
Exhibited: AIC, 1930. **Sources:** Falk, *AIC.*

THIEL, Richard G. *[Craftsman, sculptor, teacher] b.1932, Madison, WI.*
Addresses: Sioux City, IA. **Studied:** Univ. Wisconsin (B.S.; M.S.). **Member:** Am. Craftsmens Council; Midwest Des.-Craftsmen; Wisc. Des.-Craftsmen. **Exhibited:** Young Americans, 1956; Fiber-Clay-Metal, 1958; Midwest Des.-Craftsmen, 1957; Wisc. Des.-Craftsmen, 1954-58; Sioux City, 1957-58; Six States Exh., 1958. **Awards:** prizes, Wisc. Des.-Craftsmen, 1954, 1956, 1958; Area Show, Sioux City, 1957-58; Iowa May Show, 1958. **Comments:** Teaching: Sioux City Pub. Schs. **Sources:** WW59.

THIELCKE, Henry D. *[Portrait painter] d.Before 1878.*
Addresses: NYC in 1842; Chicago, 1855-66. **Exhibited:** NAD, 1842 (exhibited and copied Inman's portrait of John Watt II [1749-1836]). **Comments:** His widow, Rebecca, was listed in 1878. **Sources:** G&W; Cowdrey, NAD; G&W has information courtesy of Harry M. Allice, Montreal; Chicago BD 1855, CD 1855-66, 1878.

THIELE, Charles F. *[Engraver] mid 19th c.*
Addresses: Cleveland, OH in 1857. **Sources:** G&W; Cleveland BD 1857.

THIELE, Robert *[Painter] b.1941.*
Addresses: Miami Beach, FL. **Exhibited:** WMAA, 1975. **Sources:** Falk, *WMAA.*

THIEM, Herman C. *[Painter, architect, illustrator] b.1870.*
Addresses: Rochester, NY. **Studied:** Mechanics Inst.; S. Jones; C. Raschen. **Member:** Rochester AC; Picture Painters Club. **Sources:** WW33.

THIEM, Rudolph *[Sculptor] late 19th c.; b.Germany.*
Addresses: New Orleans, active c.1882-86. **Studied:** Berlin. **Exhibited:** Grunewald's Music Store, 1882; Wash. Artillery Hall, N.O., 1883; Am. Expo, 1885-86. **Comments:** He modeled statues in clay which were then cast in white bronze by Paul Riess (see entry) and electroplated in copper. In 1883 they produced a full-length portrait of Gen. Robert E. Lee. **Sources:** *Encyclopaedia of New Orleans Artists,* 373.

THIEME, Anthony *[Painter, designer, teacher] b.1888, Rotterdam, Holland / d.1954, Rockport, MA.*
Addresses: NYC & Boston, but primarily Rockport, MA, from 1920s; St. Augustine, FL, winters,1950s. **Studied:** Royal Acad., Holland; in Italy & Germany; George Hacker; Guiseppe Mancini; Garlobini; Guardaciona. **Member:** AWCS; SC; CAFA; Boston AC; Providence WCC; Boston SAC; North Shore AA; Springfield Art Lg.; Rockport AA; NYWCC; AAPL; Gloucester SA; Phila. Art All.; PC; NAC. **Exhibited:** NAD, 1930-34; AIC, 1928-32; PAFA Ann., 1928-35; Corcoran Gal. biennials, 1930, 1932; CAM, 1933; LACMA, 1930; 1931 (prize); Albright Art Gal., 1932; Detroit Inst. Art, 1931; SC, 1929 (prize), 1931 (prize); Springville, UT, 1928 (prize), 1931 (prize); Gloucester AA, 1928 (prize); Springfield AL, 1927 (prize), 1928 (prize); North Shore AA, 1930 (prize); CAFA, 1930 (prize); Jordan Marsh Exh., 1944 (med.); NYWCC, 1930 (prize); Tercentenary Exh., Boston, 1930; Ogunquit AC, 1930; New Haven PCC, 1931 (prize); Wash. WCC, 1931 (prize); Buck Hill Falls AA, PA, 1938 (prize); Royal Acad., London; Royal Mus. FA, Brussels; France and Holland. **Awards:** medals, Contemp. New England Artists, 1944, 1947-48; Dow award, St. Augustine, FL, 1949; Miami, FL, 1949. **Work:** BMFA; Pittsfield (MA) Mus. Art; Albany Inst. History & Art;Dayton AI; City of New Haven Coll.; Springville, UT; Univ. Iowa; MMA; SAM; Montclair Art Mus.; LACMA; New Britain Mus. Art; Buck Hill Falls, PA; Beach Coll. **Comments:** Came to U.S. about 1920. One of the artists responsible for making Rockport, MA a popular destination for painters. He was known for his scenes of Rockport's streets, shore, and village. Teaching: Thieme Sch. Art, Rockport, MA. **Sources:** WW53; WW47; 71-73; John L. Cooley, *Rockport Sketch Book: Stories of Early Art and Artists* (Rockport, MA: Rockport Art Assoc., 1965); Falk, *Exh. Record Series.*

THIERY, Gustave *[Wood engraver] mid 19th c.*
Addresses: San Francisco, 1858. **Comments:** Also listed as "comedian." **Sources:** G&W; San Francisco BD and CD 1858.

THIERY BROTHERS, (Charles & Edward) *[Engravers] mid 19th c.*
Addresses: San Francisco. **Comments:** Listed as partners in an engraving firm, 1858. Charles was listed as a jeweler in 1860 and enameler in 1868. **Sources:** G&W; San Francisco BD 1858; CD 1860, 1868.

THIESSEN, (Charles) Leonard *[Critic, sculptor, printmaker, painter, art administrator, writer] b.1902, Omaha, NE.*
Addresses: Omaha, NE. **Studied:** Univ. Nebraska, Lincoln; Royal Acad. Art Sch., Stockholm, Sweden; Acad. Grande Chaumière, Paris, France; Heatherley Sch. Art, London, England; Creighton Univ. (hon. D.F.A., 1972). **Exhibited:** Young Contemp., London, 1949; Royal Soc. British Artists, London, 1949; Nat. Soc., London, 1949; Midwest Biennial, Joslyn, 1952; Mid-America, Kansas City, 1953. **Work:** NebraskaAA; AG, Lincoln, NE; Alfred East Mem. Gal., Kettering, Northants, England; Joslyn Art Mus., Omaha, NE; Sheldon Art Gallery, Lincoln, NE; Univ. Nebraska, Omaha; Kansas Wesleyan Univ., Salina; Herbert Inst. Art, Augusta, GA. Commissions: mural in cocktail room, Paxton Hotel, Omaha, 1938; baptistry triptych, St. Paul's PE Church, Omaha, 1941; hist. dioramas (with Bill J. Hammon), Nebraska Hist. Soc., Lincoln, 1952-53; mural dec. for power house, Lewis & Clark Reservoir, Corps of Engineers, Yankton, SD, 1955; exterior mosaic (with Bill J. Hammon), Pershing Mem. Auditorium, City of Lincoln, 1955-56. **Comments:** Positions: state dir., FAP, WPA, Des Moines, 1940-42; exec. secy., Nebraska Arts Council, 1966-. Publications: art ed., *Omaha World-Herald,* 1939-71. **Sources:** WW73; WW47, which puts birth at 1901.

THIESSEN, Leonard See: **THIESSEN, (Charles) Leonard**

THIVEATT, Theodore *[Painter] late 19th c.*
Exhibited: SNBA, 1895. **Sources:** Fink, *American Art at the Nineteenth-Century Paris Salons,* 396.

THOBURN, Jean *[Painter, teacher, writer, illustrator, sculptor, craftsperson] b.1887, Calcutta, India.*
Addresses: Pittsburgh, PA. **Studied:** CI; Goucher College (B.A.); Teachers College, Columbia Univ.; NY Sch. Fine & Applied Art; Arthur Dow; Barse Miller; Millard Sheets; Dong Kingman; Eliot O'Hara. **Member:** Pittsburgh WCS; Pittsburgh AA. **Exhibited:** PAFA, 1937, 1939; Ogunquit AC, 1939; Pittsburgh AA, 1926, 1936-52 (prize, 1944); Pittsburgh WCS, 1945, 1953 (prize); Women's Club, Chautauqua, NY, 1951; Pittsburgh Arts & Crafts Center, 1952 (solo). **Work:** One Hundred Friends of Art, Pittsburgh, PA. **Comments:** Teaching: Peabody H.S., Pittsburgh, PA, 1911-53; Pittsburgh Arts & Crafts Center. Illustr.: children's stories including "Away in a Manger," 1942; Auth./illustr.: "Downey-True Story of an Irish Setter," 1957. **Sources:** WW59; WW47.

THODE, C. C. *[Miniaturist, drawing master] early 19th c.*
Addresses: Charleston, SC, in 1806. **Sources:** G&W; Rutledge, *Artists in the Life of Charleston.*

THOELE, Lillian (Caroline Anne) *[Painter, illustrator, commercial artist, designer] b.1894, St. Louis, MO.*
Addresses: St. Louis, MO. **Studied:** PAFA; St. Louis Sch. FA.; Chester Springs Summer Sch.; Summer Sch., Saugatuck, MI. **Member:** St. Louis Advertising Club; St. Louis AG; Artists Union; Am. Fed. Advertising; Eight WP, St. Louis; Soc. Independent Artists; Am. Artists All.; Women Painters of St. Louis; Art Dir. Club (Nat.). **Exhibited:** CAM, 1918-46; St. Louis AG, 1918-46; Missouri State Fair; St. Louis Pub. Lib., 1939; Terry AI, 1952; Soc. Independent Artists (prize); Am. Artists All. (prize); Kirkwood, MO; Sheraton Hotel; Boatmen's Bank Bldg.; Am. Slide Co. traveling exh., 1957 (6 slides of paintings). **Work:** murals, Am. Youth Found. Camps, Shelby, MI, New Ossipee, NH;

Gundlack Pub. Sch., St. James Church, German General Orphans Home, Crippled Children's Home, all of St. Louis; Monsanto Co.; Antimite Co., Southwestern Tel. Co., St. Louis. **Comments:** Illustrator: text books and children's stories. **Sources:** WW59; WW47.

THOENER, Charles H. *[Landscape painter] b.1844 / d.1924.* **Addresses:** Yonkers, NY. **Comments:** Represented by M. Knoedler & Co., NYC, for 30 years.

THOENY, William *[Painter] b.1888, Austria / d.1949, NYC.* **Addresses:** NYC (from c.1938-on). **Studied:** Munich, Germany. **Exhibited:** Paris World's Fair, 1937; WMAA, 1944; Knoedler Gal., NYC; Carnegie Inst., 1943-47; PAFA Ann., 1944 (medal for best landscape), 1945-48; Corcoran Gal. biennials, 1945, 1947. Awards: Austrian Gold Cross of Merit with Crowns and Swords. **Work:** MMA; PAFA; De Young Mem. Mus., San Fran.; Gratz Mus., Austria; Nat Gal. of Prague; Nat. Gal. of Muncih. **Comments:** Expressionist painter, renowned in Austria, where he formed several "Secessions," including one in Gratz. Illustrated writings of Dostoevski, Balzac, Edgar Allen Poe and others. Left Austria for Switzerland in 1931, eventually establishing himself in Paris before moving to the U.S. He was the son-in-law of artist Frank Herrman (see entry), with whom he stayed in NYC and Elberon, NJ. **Sources:** Benezit (as Wilhelm Thöny); Falk, *Exh. Record Series.*

THOL, Henry *[Cartoonist] b.1896 / d.1944.* **Addresses:** Brooklyn, NY. **Studied:** CUA Sch. **Comments:** Position: cart., Bell Newspaper Syndicate and Consolidated News Features, 1924-44.

THOLENARR, Theo *[Sculptor] early 20th c.* **Addresses:** NYC. **Sources:** WW04.

THOLEY *[Painter, pastel artist, engraver, lithographer] mid 19th c.* **Addresses:** Philadelphia, 1848. **Comments:** He came to Philadelphia from Alsace-Lorraine in 1848, accompanied by his sons Charles and Augustus, who had been trained by him. They were employed by Philadelphia publishers and did some banknote work for the U.S. Government. The father may have been the Michael Tholey, painter, listed in directories from 1851-56. **Sources:** G&W; Peters, *America on Stone;* Phila. CD 1851-56.

THOLEY, Augustus *[Lithographer, pastel portraitist] d.1898.* **Addresses:** Philadelphia, from 1848. **Comments:** Son of -- Tholey. He came to Philadelphia in 1848 and worked mainly as a lithographer, although he and his brother Charles later specialized in pastel portraits. **Sources:** G&W; Peters, *America on Stone.*

THOLEY, Charles P. *[Lithographer, pastel portraitist] d.1898.* **Addresses:** Philadelphia. **Comments:** Son of -- Tholey and brother of Augustus. He was active as a lithographer by at least 1860; he and Augustus later turned from lithography to pastel portraits. **Sources:** G&W; Peters, *America on Stone;* Phila. CD 1860, 1870.

THOM, James *[Sculptor] b.1799, Ayrshire, Scotland / d.1850, NYC.* **Addresses:** moved to U.S. by 1834, when he was working in New Orleans; Newark, NJ, after 1836; Ramapo, NJ; NYC. **Exhibited:** British Inst., London, as early as 1815; PAFA, 1850 (stone sculptural group illustrating Burns' "Tam O'Shanter;" this was listed in PAFA cat. as being owned by the Franklin Inst., Phila.). **Work:** possibly at the Franklin Inst., Phila. **Comments:** James Crawford Thom (see entry) was his son. **Sources:** G&W; Bénézit; Graves, *Dictionary;* New Orleans *Courier,* March 22 and Oct. 7, 1834, and *Merchants' Daily News,* Feb. 27, 1834; Gardner, *Yankee Stonecutters;* Rutledge, PA.

THOM, James Crawford *[Portrait, landscape, and genre painter] b.1835, NYC / d.1898, Atlantic Highlands, NJ.* **Addresses:** Ramapo, NJ (1840s-53); NYC (1853-59, 1873-74); France (1859-66); London (1866-73); NJ (1880s-on).

Studied: NAD, 1853; in France (1859) with Th. Couture, Corot, H. Picou, and P.E. Frère in Écouen. **Exhibited:** NAD,1857-98; Royal Acad., London 1864-73 (when his address was Brentford, England); Boston Athenaeum; Brooklyn AA, 1865, 1873-85; PAFA Ann., 1865, 1881, 1888; AIC, 1889. **Comments:** The son of James Thom (see entry), the sculptor. His landscapes show the influence of both Corot and the second generation Hudson River School painters, and his genre scenes often included children at play. Thom died of pneumonia. **Sources:** G&W; Smith; Thieme-Becker; Cowdrey, NAD; NYCD 1858-59; Graves, *Dictionary;* Swan, BA; Rutledge, PA; PAFA, Vol. II; *300 Years of American Art,* vol. 1, 266.

THOM, Robert Alan *[Illustrator, painter] b.1915, Grand Rapids, MI / d.1980.* **Addresses:** Birmingham, MI. **Studied:** Columbus (OH) Inst. FA; Robert Brackman. **Member:** SI; Bloomfield AA; Birmingham, MI (founding pres.). **Exhibited:** Vancouver (BC) Art Gal.; Smithsonian Inst.; Sheldon Swope Gal. Art; Oregon Mus. Nat. Hist.; Pioneer Mus., Stockton, CA. **Work:** Parke, Davis Co; Bohn Aluminum & Brass Co; Univ. Maryland; Cranbrook Acad. Arts; Nat. Assn. Retail Druggists Hdqtrs., Chicago. **Comments:** He is best known for the two series of paintings on the history of pharmacy and medicine, which were exhibited, reproduced in advertisements, and won numerous awards. Publications: auth./illlustr., article on Wine Festival, Burgundy, France, *Gourmet Magazine,* 1961. Thom died in an auto accident. **Sources:** WW73.

THOMA, Eva *[Painter] early 20th c.* **Addresses:** Norman, OK, c.1917. **Sources:** WW17.

THOMAN, Josef *[Painter] early 20th c.* **Addresses:** NYC. **Exhibited:** Corcoran Gal. biennial, 1910. **Sources:** WW13; Falk, *Corcoran Gal.*

THOMAN, William *[Graphic artist] 20th c.* **Addresses:** Milford, CT. **Exhibited:** S. Indp. A., 1937. **Comments:** Possibly Thoman, William F., b. 1884-d. 1959, Milford, CT. **Sources:** Marlor, *Soc. Indp. Artists.*

THOMAS, Al *[Portrait painter] mid 19th c.* **Work:** Hist. Soc. Pennsylvania (portrait of Benjamin Hutton Devereux, c.1835). **Sources:** G&W; Sawitzky, *Hist. Soc. of Pa. Cat.*

THOMAS, Alice B. *[Painter] b.1857, Collinwood, Ontario, Canada / d.c.1945, Fresno, CA.* **Addresses:** Los Angeles, CA, 1917 and after. **Studied:** Bishop Strachan's School, Toronto, Canada. **Exhibited:** Toronto Indust. Exh., 1897; Royal Canadian Acad., 1901-16; Pasadena Art Inst., late 1920s; Calif. AC; Kanst Gals., MacDowell Club, Nicholson Gal., all in Los Angeles. **Comments:** Preferred media: watercolors for about 20 years, then oils. Her date of death is variably cited as 1939 or 1945. **Sources:** WW24; Hughes, *Artists in California,* 555; add'l info. courtesy of Kirk R. Edgar, Long Beach, CA.

THOMAS, Allan F. *[Designer, illustrator, engraver, painter, lithographer, block printer] b.1902, Jackson, MN.* **Addresses:** Stevens Point, WI. **Studied:** PAFA, 1925, 1927 (Cresson Traveling Scholarship); G. Harding; D. Garber; H. McCarter; England; France. **Member:** NSMP. **Exhibited:** Phila. WCC, 1926-28, 1929 (gold), 1930, 1932; AIC, 1929, 1930, 1933; Detroit Inst. Art, 1934-36; Arch. Lg., 1939; FAP, Wash., DC, 1937-41; PAFA, 1926 (prize); Art Dir. Club, NY and Chicago. **Work:** PAFA; murals, Upjohn Sch., Kalamazoo, MI; St. John's Church, Radio Station WIBM, Jackson H.S., all of Jackson, Mich.; 1st Nat. Bank, Stevens Point, WI; Hotel Mead, Wisconsin Rapids;WPA murals, USPO, Crystal Falls, Clare, MI; Wabasha, MN, Hackley Hospital, Muskegon, MI; Minn. State Prison. **Comments:** Illustr. national magazines and leading publishers. **Sources:** WW59; WW47.

THOMAS, Alma Woodsey *[Painter] b.1891, Columbus, GA / d.1978, Washington, DC.* **Addresses:** Wilmington, DE, 1915-21; Washington, DC, from

1924 (with the exception of c.1931-34, in NYC). **Studied:** Miner Teachers Normal School, Washington, DC, c.1912-15; Howard Univ. (B.S., 1924); Teachers College, Columbia Univ. (M.F.A., 1934); American Univ., 1950-60; also in Europe, 1958, under auspices Tyler Sch. FA, Temple Univ. **Member:** AFA; CGA; Soc. Wash. Artists; Wash. WC Assoc.; Smithsonian Inst.; District of Columbia AA. **Exhibited:** American Univ., 1958 (first solo); Anacostia Neighborhood Mus.-Smithsonian Inst.; DuPont Theater Art Gal., Wash., DC, 1960 (solo); Soc. Wash. Artists, 1963 (prize), 1968 (prize), 1971 (prize); Howard Univ. Gal. Art, 1966 (retrospective), 1970; BMFA, 1970; CI; Franz Bader Gallery, Wash., DC, 1968 & 1970s; La Jolla (CA) Mus. Art, 1970; Baltimore Mus., 1971; Fisk Univ. Gal. Art, Nashville, TN, 1971 (solo), 1997; WMAA, 1972 (solo); CGA, 1972 (solo); Martha Jackson West Gal., NYC, 1973 (solo), 1976 (solo); Columbus (GA) Mus. Arts & Sciences, 1978 (solo, traveled to Huntsville, AL, Mus. and Studio Mus. in Harlem, NY); Jackson (MS) State College; State Armory, Wilmington, DE; Wesleyan Univ. Center for the Arts, Middletown, CT; United Negro College Exh., District of Columbia AA; Wash., DC, Project of the Arts, 1985; San Antonio (TX) Mus. Art, 1994 (traveling exh.); Michael Rosenfeld Gal., NYC, 1996-97; Fort Wayne (IN) Mus. Art, 1998. **Awards:** Howard Univ., 1963 (purchase prize); Am.-Austrian Soc. Art Exh. Award, 1968; Int. Women's Year Award, 1976. **Work:** MMA; WMAA; NMAA; CGA; Hirshhorn Mus.; Phillips Collection; National Mus. of Women in the Arts, Wash., DC; Nat. Air & Space Mus.; George Washington Univ. Gal. Art; Akron (OH) Art Mus.; African Am. Mus., Phila., PA; Chase Manhattan Bank; Columbus (OH) Mus.; Fort Wayne Mus. Art; Georgetown Univ.; Howard Univ. Gal. Art; Fisk Univ. Gal. Art, Nashville, TN; Univ. Iowa; La Jolla (CA) Mus.; Mus. African-Am. Art (formerly Barnett-Aden Collection), Tampa, FL; New Jersey State Mus.; Tougaloo (AL) College. **Comments:** Washington Color School painter. Beginning in the late 1950s, after having painted in a realistic style for years, Thomas became interested in abstract art and color. She began painting brightly colored abstract pictures, employing a method of flattened thumbprint pats of color that soon became her trademark. In 1966 (when she was seventy-four years old), she was given a restrospective at Howard University that brought her critical praise and more exhibitions. Thomas taught art to children for over forty years. Positions: teacher, Wilmington, DE, schools, 1915-21; teacher, Washington, DC, schools, 1924-60; founder, vice-pres., Barnett-Aden Gal., Washington, DC. Note: Her correct birth date is 1891, although previously reported as 1896. **Sources:** WW73; Sachi Yanari, et al., *Alma W. Thomas: A Retrospective of the Paintings* (Rohnert Park, CA: Pomegranate, 1998); Cederholm, *Afro-American Artists;* Bearden and Henderson, *A History of African-American Artists;* Cedric Dover, *American Negro Art* (Studio, 1960); McMahan, *Artists of Washington, DC;* Rubinstein, *American Women Artists,* 330-31; add'l info. courtesy Jacqueline Francis, New Haven, CT.

THOMAS, Amand *[Listed as "artist"] b.c.1828, Alsace, France / d.1899, New Orleans, LA.*
Addresses: New Orleans, active 1860. **Sources:** *Encyclopaedia of New Orleans Artists,* 373.

THOMAS, Arthur See: **THOMAS, (Conrad) Arthur**

THOMAS, B. Heide (Mrs. John A.) *[Collector, painter] b.1913, NYC.*
Addresses: NYC; Truro, MA. **Studied:** ASL; Bridgman; Sloan; Benton; Leger; Grosz; Vytlacil; Kantor. **Exhibited:** NAD Ann.; AA Artists; Columbia Univ. Club, 1963; Provincetown AA, 1965. **Comments:** Position: volunteer, Friends of the AFA. Collection: graphics, watercolors, oils, including works by Grosz, Reichel, Da Silva, Picasso, Gropper, Dufy, and others. **Sources:** WW66.

THOMAS, Bernard P. *[Painter, muralist] b.1918, Sheridan, WY.*
Addresses: Living in Boynton Beach, FL in 1975. **Studied:** Woodbury College; École des Beaux-Arts (scholarship). **Comments:** Specialty: "ranchscapes". **Sources:** P&H Samuels, 483.

THOMAS, Byron *[Painter, lithographer, teacher] b.1902, Baltimore, MD / d.1978, Woodstock, VT?.*
Addresses: NYC; Woodstock, VT. **Studied:** ASL. **Exhibited:** WMAA, 1934-41; PAFA Ann., 1941-44, 1946, 1948; CI, 1943-45 (prize, 1943); AIC, 1937 (prize), 1942-44; MMA, 1943; NY, 1940, 1944, 1956 (solos). **Work:** MoMA; Herron AI; AIC; PAFA; Springfield Art Mus.; IBM Coll. **Comments:** Teaching: CUA Sch., 1931-50. Illustr. & war correspondent: *Life* magazine. **Sources:** WW59; Falk, *Exh. Record Series.*

THOMAS, C. B. *[Painter] early 20th c.*
Addresses: NYC, 1929. **Member:** Mural Painters. **Sources:** WW29.

THOMAS, Carrie E. *[Painter] late 19th c.*
Exhibited: NAD, 1878. **Sources:** Naylor, *NAD.*

THOMAS, Charles *[Engraver] b.1817, Rhode Island.*
Addresses: NYC, 1850. **Sources:** G&W; 7 Census (1850), N.Y., XLVIII, 35.

THOMAS, Charles H. *[Portrait &* C.H. Thomas
miniature painter] mid 19th c.
Addresses: NYC in 1838-39. **Exhibited:** NAD; Apollo Assoc. **Sources:** G&W; Cowdrey, NAD; Cowdrey, AA & AAU; Bolton, *Miniature Painters.*

THOMAS, Charlotte R. *[Listed as "artist"] d.1907, Wash., DC.*
Addresses: Wash., DC, active, 1888-89. **Sources:** McMahan, *Artists of Washington, DC.*

THOMAS, (Conrad) Arthur *[Mural painter] b.1858, Dresden, Germany / d.1932.*
Addresses: Pelham, NY. **Studied:** Hofman; Grosse; Schilling. **Member:** AFA; New Rochelle AA. **Work:** murals, City Hall, St. Louis; Court House, Auburn, IN; Sinton Hotel, Cincinnati, OH; murals, Court House, South Bend, IN; Seelbach Hotel, Louisville, KY; Radisson Hotel, Louisville, KY; Sts. Peter & Paul Cathedral, Phila. **Comments:** Came to U.S. in 1892. **Sources:** WW31.

THOMAS, Cyrus W(ood) *[Painter] early 20th c.*
Addresses: NYC, 1931. **Exhibited:** S. Indp. A., 1931. **Sources:** Marlor, *Soc. Indp. Artists.*

THOMAS, Dago F. *[Miniature painter] b.1842, Aix-la-Chapelle, France / d.1924, Baldwin Park, CA.*
Addresses: NYC, 1889-98; Baldwin Park, CA. **Studied:** with his father, Düsseldorf Acad.; Brussels; Rome. **Member:** Calif. SMP. **Exhibited:** AIC, 1889; NAD, 1888-98; SAA, 1898; SL, 1898; San Diego Expo, 1915 (gold), 1916 (med.);. **Sources:** WW25.

THOMAS, Daniel W. *[Engraver] b.c.1836, New York.*
Addresses: NYC in 1860. **Sources:** G&W; 8 Census (1860), N.Y., LX, 965; NYCD 1862.

THOMAS, Dora *[Painter] early 20th c.*
Addresses: NYC. **Sources:** WW13.

THOMAS, Doris Huntsman (Mrs. Bruce) *[Painter, wood carver] b.1907, Spokane, WA.*
Addresses: Gigg Harbor, WA, 1945. **Studied:** Univ. Wash. **Exhibited:** Temple Theater, Tacoma, 1933 (solo); Pacific Coast P&S Lg., 1935; Western Wash. Fair, 1937; Univ. Puget Sound, 1939, 1940; Tacoma FAA, 1940; Tacoma Art Lg., 1940. **Sources:** Trip and Cook, *Washington State Art and Artists.*

THOMAS, Eakins See: **EAKINS, Thomas**

THOMAS, Ed B. *[Educator, lecturer] b.1920, Cosmopolis, Wash.*
Addresses: Seattle, WA. **Studied:** Columbia Univ.; New York Univ.; Univ. Wash. (B.A. & M.F.A.). **Member:** Pacific AAn (first vice-pres., 1960-62); Wash. AA; Nat. Comt. on Art Educ.; AA Mus.; Northwest PM. **Exhibited:** Nat. Serigraphy Soc.; SFMA; SAM; regional exh., 1950-. **Awards:** prize for sch. telecasts, Am. Exh. of Educ. Radio-TV Programs, Ohio Univ., 1956. **Work:** Commissions: recorder TV series for sch. use—"Man's Story, Treasure Trips, Our Neighbors, The Japanese, Electronic Tour of Masterpieces of Korean Art," 1958, "Van Gogh," 1959 &

"Treasures of Japan," 1960, SAM. **Comments:** Positions: cur. educ., SAM & Seattle AC Pavilion, 1951-54, educ. dir., 1954-61, asst. dir., 1961-63, assoc. dir., 1963-67; arts adv. bd., Seattle World's Fair, 1958-62; bd. trustees, Allied Artists Seattle, 1959-62; secy., Fine Arts, Inc, 1962; vice-pres., Western Assn. Art Mus., 1963-964. Publications: auth., *Guide to Life's Illuminations Exhibit,* Time, Inc., 1958; auth., *Mark Tobey,* 1959; ed. & narrator, "Chinese Ink & Watercolor" (film), 1961. Teaching: lecturer, weekly TV art program, Seattle, 1951-; instr. art history, Cornish Sch., Seattle, 1952-58; from visiting prof. & lecturer to assoc. prof. art, Western Wash. State College, 1967-. **Sources:** WW73.

THOMAS, Edward Kirkbride *[Painter, decorator] b.1817, Philadelphia, PA / d.1906, Detroit, MI.*
Addresses: Detroit, MI. **Work:** Minneapolis Inst. Art (view of Fort Snelling, MN). **Comments:** Of colonial ancestry, he fought in the Seminole War and the Civil War. He made several views of Fort Snelling, MN and other drawings and sketches for the Army Ordinance Department in South Carolina. **Sources:** Gibson, *Artists of Early Michigan,* 227.

THOMAS, Elaine Freeman *[Educator, art administrator] b.1923, Cleveland, OH.*
Addresses: Tuskegee Inst., AL. **Studied:** Northwestern Univ., Evanston, 1944; Tuskegee Inst. (B.S., magna cum laude, 1945); Black Mountain College, 1945, with Josef Albers & Robert Motherwell; NY Univ., Bodden fellowship (M.A., 1949) with Hale Woodruff; Mexico City College, 1956; Berea College, 1961; NY Univ., 1962; Univ. Paris, 1966; Southern Univ. Workshop, 1968; Columbia Univ., 1970. **Member:** AA Mus.; College AA Am.; Nat. Art Educ. Assn.; Nat. Conf. Artists; Alabama Art Lg. **Exhibited:** Festival of Arts, St. Paul, MN; Mexico City WC Show, 1956; Beaux Arts Guild, 1957-68; Religious Art Show, Auburn, AL, 1966; Tuskegee Inst., 1956, 1962, 1966-67, 1968, 1972; Art Faculty Show, Birmingham, 1966; Univ. Florida, Traveling Exh.; Festival of Negro Arts, Miami, FL, 1968; Mus. FA, Montgomery, AL, 1968, 1972; Univ. Cincinnati, 1969; Winston-Salem Univ., 1970 (solo); Talladega College, AL, 1972. Awards: distinguished participation, AAPL, 1968; Beaux Arts Festival Award. **Comments:** Teaching: asst. prof. art & chmn. dept., Tuskegee Inst., 1945-. Position: mus. dir. & cur., George W. Carver Mus., 1961-. Collections arranged: Winston-Salem State Univ., 1970 (solo); Discovery 1970, Univ. Cincinnati; George Washington Carver Exh., White House, 1971 (solo); Alabama Black Artists Exh., Birmingham Festival Art, 1972. **Sources:** WW73; Cederholm, *Afro-American Artists.*

THOMAS, Eleanor Clark *[Painter, teacher] 20th c.; b.Gloucester, MA.*
Studied: Mass. Sch. Art; Salem Teachers College; Boston Univ. Art Sch.; Rockport Summer School; Estabrook Studio Des., Boston, MA. **Member:** Rockport AA. **Comments:** Teaching: schools in Falmouth, MA. **Sources:** *Artists of the Rockport AA* (1946).

THOMAS, Elizabeth Haynes *[Painter] 19th/20th c.; b.Phila.*
Addresses: Phila.; Provincetown, MA. **Studied:** PAFA; Paris. **Exhibited:** AIC, 1896-1904; PAFA Ann., 1890-91 (prize), 1893-1903, 1915-20; Phila. AC, 1898; Corcoran Gal. biennials, 1921, 1923. **Sources:** WW25; Falk, *Exh. Record Series.*

THOMAS, Elizabeth Reynolds Finley (Mrs. Edward R.) *[Portrait & watercolor painter] 19th/20th c.*
Addresses: NYC. **Studied:** Académie Julian, Paris with Bouguereau & Ferrier; ASL. **Member:** NY Women's AC. **Exhibited:** PAFA, 1895; NAD, 1899, 1901-11. **Comments:** Also exhibited as Elizabeth R. Finley. Marlor cites an Elizabeth [Finley] Thomas, b.1900 in St. Paul, MN-d.1955, living in NYC and exhibiting at the Soc. Indep. Artists in 1937, who may be the same artist. **Sources:** WW21; Falk, *Exh. Record Series.*

THOMAS, Ella *[Painter] b.1894, Crockett, TX / d.1947, Santa Barbara, CA.*
Addresses: NYC; San Diego, CA. **Exhibited:** Boston AC, 1900; Chew Gal., Pasadena, CA, 1907; San Diego FA Gal., 1927.

Comments: A black artist, she specialized in watercolors of Southern California landscapes and Dutch interiors. **Sources:** WW98; Hughes, *Artists in California, 555.*

THOMAS, Ellen *[Painter] b.1895, Augusta, GA.*
Addresses: Augusta, GA. **Studied:** A.K. Cross. **Member:** SSAL; Georgia AA. **Exhibited:** Montgomery MFA. **Sources:** WW40.

THOMAS, Emma Warfield *[Painter, teacher, writer] mid 20th c.; b.Philadelphia, PA.*
Addresses: Philadelphia, PA. **Studied:** PAFA; Beaux; W.M. Chase; T.P. Anshutz; C. Grafly; H.H. Breckenridge. **Member:** Phila. Art All.; Phila. Plastic Club; PAFA (fellow). **Work:** PAFA. **Comments:** Author/ed.:"Fragment—A Journal for Artists." **Sources:** WW59; WW47.

THOMAS, Estelle L. *[Painter, illustrator, teacher] 20th c.; b.NYC.*
Addresses: Pittsburgh, PA. **Studied:** Pittsburgh Sch. Des. for Women; Univ. Pittsburgh; CI; Parsons Sch. Des.; Charles Hawthorne; John Sloan; H. Keller; M. Borgard; NY Sch. Fine & Applied Art. **Member:** Pittsburgh AA; Pittsburgh WCS. **Exhibited:** Pittsburgh AA, 1910-46, 1954; PAFA Ann., 1934; Jenner A.rt Gal., 1953-55; CI, 1954, 1955; Pittsburgh WCS, 1945, 1954; Pittsburgh Arts & Crafts Center. **Comments:** Teaching: Pittsburgh Pub. Sch., 1910-46. **Sources:** WW59; WW47; Falk, *Exh. Record Series.*

THOMAS, Florence Todd (Mrs. T. D.) *[Illustrator] b.1909, Peoria, IL.*
Addresses: Cleveland, OH. **Studied:** Cleveland Sch. Art. **Exhibited:** CMA, 1936 (prize). **Sources:** WW40.

THOMAS, Francis See: **DAVIS, Francis Thomas (Mrs. Charles H.)**

THOMAS, G. W. *[Painter] early 20th c.*
Addresses: NYC. **Member:** GFLA. **Sources:** WW27.

THOMAS, Genevieve M. *[Sculptor] early 20th c.*
Addresses: Boston, MA. **Exhibited:** PAFA Ann., 1930. **Sources:** Falk, *Exh. Record Series.*

THOMAS, Genie *[Landscape & still life painter] late 19th c.*
Addresses: Norfolk, VA. **Exhibited:** Norfolk, VA, 1886. **Sources:** Wright, *Artists in Virginia Before 1900.*

THOMAS, George *[Engraver] b.c.1815, Germany.*
Addresses: New Orleans, 1844; Philadelphia, 1844-50; Louisville, KY, 1859. **Comments:** At New Orleans in 1844, as a stencil and wood engraver; at Philadelphia, 1844-50, as a wood engraver; at Louisville (KY) in 1859, of Thomas & German (see entry), wood engravers and lithographers. **Sources:** G&W; 7 Census (1850), Pa., L, 916; New Orleans *Picayune,* Jan. 30, 1844 (cited by Delgado-WPA); Phila. BD 1844, 1849-50; Louisville BD 1859-60.

THOMAS, George *[Engraver] b.c.1815, Scotland.*
Addresses: NYC in 1860. **Comments:** His wife was also Scottish, but their daughter Salinia was born in New York about 1840. **Sources:** G&W; 8 Census (1860), N.Y., LX, 852.

THOMAS, George *[Lithographer] b.c.1836, Pennsylvania.*
Addresses: Philadelphia in 1860. **Sources:** G&W; 8 Census (1860), Pa., LII, 442.

THOMAS, George H. *[Wood engraver & designer, book illustrator] b.1824 / d.1868.*
Addresses: NYC, c.1846; London, 1861. **Studied:** apprenticeship in London; Italy. **Exhibited:** NAD, 1861. **Comments:** After working for some time in Paris, he came to NYC about 1846 and worked there for two years as an engraver and illustrator for one of the pictorial magazines. He returned to Europe in 1848, studied for a time in Italy, and later did pictorial reporting for the *Illustrated London News.* He became well known for his paintings of royal occasions and as a book illustrator. **Sources:** G&W; Clement and Hutton.

THOMAS, George R. *[Educator, designer, painter, lithographer, lecturer]* b.1906, Portsmouth, VA.
Addresses: Durham, NH. **Studied:** Univ. North Carolina, 1924-25; CI, Barch, 1930; Columbia Univ., 1938; study in Europe. **Member:** Am. Inst. Arch.; Am. Assn. Univ. Prof.; NH AA; Council Lg. New Hampshire Arts & Crafts; New Hampshire Soc. Arch. **Comments:** Publications: contrib., articles on arch. design & educ. to various publ. Teaching: Univ. New Hampshire, Durham, 1931-40s; Mary Washington College, 1935. **Sources:** WW73; WW47.

THOMAS, Georgia Seaver *[Painter]* early 20th c.
Addresses: Los Angeles, CA, 1925-32. **Member:** Calif. AC. **Exhibited:** Calif. AC, 1930. **Sources:** WW25; Hughes, *Artists of California,* 556.

THOMAS, Glenn *[Illustrator]* mid 20th c.
Addresses: NYC. **Member:** SI. **Sources:** WW47.

THOMAS, Grace Thornton (Mrs.) *[Ceramicist, teacher]* b.1880, Genoa, NE.
Addresses: Altadena, CA. **Studied:** Maryland Inst.; Newark Sch. Fine & Indust. Art; Greenwich House, NYC; M. Mason. **Member:** San Diego FAS; San Diego AG. **Sources:** WW40.

THOMAS, Helen M. Haskell (Mrs. Stephen) *[Painter]* b.1860, Marysville, CA / d.1942, La Crescenta, CA.
Addresses: San Francisco, before 1892; Paris; NYC; La Crescenta, CA. **Studied:** Univ. Calif.; Paris with Courtois. **Exhibited:** Paris Salon, 1897 (pastel drawing). **Comments:** She married Stephen S. Thomas (see entry) in 1892 in London, England. A portrait of her by her husband, entitled *Lady and Dog* hangs in the Metropolitan Museum. **Sources:** Hughes, *Artists in California,* 556.

THOMAS, Henry *[Portrait painter]* mid 19th c.
Addresses: Philadelphia. **Exhibited:** In 1832 he exhibited a portrait of Junius Brutus Booth as Richard III and in 1838 a copy of John Neagle's "Pat Lyon at the Forge;" PAFA Ann., 1876-78 ("Portrait of J.B. Booth as Richard III"). **Sources:** G&W; Rutledge, PA; PAFA, Vol. II; Fielding.

THOMAS, Henry *[Engraver]* b.c.1821, New York.
Addresses: NYC in 1860. **Sources:** G&W; 8 Census (1860), N.Y., LVI, 975.

THOMAS, Henry Atwell *[Lithographer, portrait artist]* b.1834, NYC / d.1904.
Addresses: Brooklyn, NY. **Exhibited:** AWCS. **Comments:** A pioneer in the lithographic business; particularly noted for his theatrical portraits. Brother-in-law of N. Sarony (see entry). **Sources:** G&W; *Art Annual,* V, obit.; Peters, *America on Stone.*

THOMAS, Henry Wilson *[Sculptor]* d.1930, Florence, Italy.
Addresses: New Rochelle, NY. **Comments:** Position: ed., New York newspapers.

THOMAS, Hermann E. *[Painter]* mid 20th c.
Exhibited: S. Indp. A., 1935-37, 1941. **Sources:** Marlor, *Soc. Indp. Artists.*

THOMAS, Hinemkoa Vaughn *[Painter]* early 20th c.
Addresses: NYC. **Exhibited:** S. Indp. A., 1922. **Sources:** Marlor, *Soc. Indp. Artists.*

THOMAS, Howard *[Educator, painter, engraver, lithographer, block printer]* b.1899, Mt. Pleasant, OH / d.1971, Carrboro, NC.
Addresses: Athens, GA. **Studied:** AIC; Univ. Southern Calif.; Univ. Chicago; G. Bellows; L. Seyffert; J. Binder; R. Davey. **Member:** SSAL; Wisc. Art Fed; Wisconsin P&S (pres.); Georgia AA; Southeastern AA; CAA. **Exhibited:** Milwaukee AI, 1926 (prize), 1930 (prize), 1933, 1936 (med.), 1956 (med.); AIC, 1935-42; Wisc.n P&S, 1924-42; Phila. WCC, 1938-39, 1941, 1946-47; Wisc. Salon, 1934-41 (prizes, 1938, 1941); Corcoran Gal. biennials, 1945; SSAL, 1945-46; Georgia AA, 1945 (prize), 1946 (prize), 1950 (prize), 1951 (prize); Southeastern AA, 1946-57 (prizes, 1946, 1949, 1954, 1956); MMA, 1950, 1952; BM, 1953,

1955; Duveen-Graham Gal., NYC, 1955, 1957; Va. Intermont, 1954 (prize); Soc. Four Arts, 1955 (prize), 1957 (prize); WMAA. **Work:** Milwaukee AI; Marine Hospital, Carville, LA; Univ. Wisc.; Univ. North Carolina; Univ. Georgia; Agnes Scott College; Bay View H.S., Milwaukee; Milwaukee Pub. Sch.; State Teachers College, Milwaukee; Atlanta AI; Telfair Acad.; Columbus Mus. Art; Georgia Mus. Art; 3 Am. Embassies. **Comments:** Positions: dir. art educ., Milwaukee State Teachers College, 1930-42; hd. art dept., Woman's College, Univ. NC, 1943; hd. dept. art, Agnes Scott College, 1943-45; art prof., Univ. Georgia, Athens, 1945-; visiting lecturer, Assn. Am. Colleges, 1948-; art specialist, State Dept., lecturing Far East, 1957. Contrib.: *American Artist.* **Sources:** WW59; WW47.

THOMAS, Howard Ormsby *[Painter, graphic artist, designer, craftsperson]* b.1908, Chicago, IL / d.1971.
Addresses: Evanston, IL. **Studied:** AIC. **Member:** Chicago Art Club. **Exhibited:** PAFA, 1941; ASMP, 1942; Elgin Acad. Art, 1941; AIC, 1940-42; Springfield Mus. Art, 1940-41; Marshall Field, Chicago, 1949-50, 1955-56; Evanston AC, 1952-57; Evanston Women's Club, 1952, 1955; Chicago Art Club, 1955-57. **Work:** St. Cletus Church, La Grange, IL; Nichols Sch., Evanston. **Sources:** WW59; WW47.

THOMAS, I. I. See: **THOMAS, J. J.**

THOMAS, Isaiah *[Engraver, author]* b.1749, Boston, MA / d.1831, Worcester, MA.
Addresses: Boston until 1775; Worcester, MA. **Member:** He was the founder and first president of the American Antiquarian Society. **Comments:** Engraver of a few cuts in *The History of the Holy Jesus* (Boston, c. 1770). Thomas was apprenticed to a printer and by the age of 17 was already considered one of the finest printers in America. He worked chiefly in Boston until 1775 and thereafter at Worcester (MA). After his retirement in 1802, he wrote *The History of Printing in America;* **Sources:** G&W; DAB; Fielding's supplement to Stauffer.

THOMAS, J. J. *[Artist]* mid 19th c.
Comments: Delineator of views of Aurora Village and Skaneateles (NY), published c. 1830. **Sources:** G&W; *Portfolio* (Feb. 1951), 128, repros.

THOMAS, J. S. *[Painter]* 19th c.
Addresses: Phila., PA, 1876-77. **Exhibited:** PAFA Ann., 1876-77 (portraits & still lifes, some in crayon). **Sources:** Falk, *Exh. Record Series.*

THOMAS, John *[Engraver]* b.c.1824, Pennsylvania.
Addresses: At Philadelphia in 1860. **Exhibited:** WMAA, 1958. **Comments:** His wife Emma and children Marie and Samuel were also born in Pennsylvania. In the same house, though listed as a separate family unit, were Marie (see entry), Susan, and Thomas Thomas. **Sources:** G&W; 8 Census (1860), Pa., LIV, 208.

THOMAS, Joseph *[Sculptor]* b.c.1829, France / d.1847.
Addresses: New Orleans, active 1847. **Comments:** He died of yellow fever the same year he arrived from France. **Sources:** *Encyclopaedia of New Orleans Artists,* 374.

THOMAS, Joseph F. *[Wood engraver]* mid 19th c.
Addresses: NYC, 1832-46. **Sources:** G&W; Am. Adv. Directory, 1832; NYBD 1846.

THOMAS, Kate (Mrs) *[Commercial artist]* b.c.1842, Ireland / d.1883, New Orleans, LA.
Addresses: New Orleans, active 1876-80. **Sources:** *Encyclopaedia of New Orleans Artists,* 374.

THOMAS, Kathryn *[Artist]* early 20th c.
Addresses: Active in Los Angeles, c.1905-12. **Sources:** Petteys, *Dictionary of Women Artists.*

THOMAS, Kenetha *[Painter]* 20th c.
Exhibited: AIC, 1940. **Sources:** Falk, *AIC.*

THOMAS, Larry Erskine *[Painter]* b.1917, Baltimore, MD.
Studied: Walter Vincent Smith Mus.; Mass. State Col.; Oakwood

Junior Col.; ASL; Jea Morgan School of Art; Cairo Mus. **Exhibited:** State Armory, Wilmington, DE, 1971; Internat'l & "Silver Jubilee" Expos, Ethiopia (gold med); USIA, "This is Ethiopia," Ethiopia; Smith-Mason Gallery, Wash., DC; Anacostia Neighborhood Mus.-Smith. Inst.; Wesleyan Univ.; United Mutual Galleries (solo); Pub. Lib., Springfield, MA; US Dept. of State; Cedar Lane Unitarian Church; Bennett Col. **Work:** Howard Univ.; US Dept. of State; M.S. Mussilloyd, Rotterdam, Netherlands; Anacostia Mus.-Smith. Inst.; Haile Selassie I, Emperor of Ethiopia; Haile Selassie I Univ., Ethiopia; priv. colls. **Comments:** Position: progran manager, Anacostia Neighborhood Mus.-Smithsonian Inst. **Sources:** Cederholm, *Afro-American Artists.*

THOMAS, Lenore *[Sculptor] b.1909, Chicago.*
Addresses: Accokek, MD. **Studied:** AIC. **Member:** Am. A. Cong; Ar. Union. **Exhibited:** WMAA, 1936. **Work:** carving in limestone, Resettlement Comm., Hightstown, N.J.; Sch., Town Ctr., Greenbelt, Community, Berwyn, Md.; USPOs, Fredonia, Kans., Covington, Va. WPA artist. **Sources:** WW40.

THOMAS, Lillian Margaret *[Miniature painter] mid 20th c.; b.Shamokin, PA.*
Addresses: Philadelphia, PA. **Studied:** Graphic Sketch Cl.; PAFA; & with A. Margaretta Archambault. **Member:** Pa. Soc. Min. P. **Exhibited:** AFA; PMA. **Sources:** WW53.

THOMAS, Lionel Arthur John *[Painter, sculptor] b.1915, Toronto, Ontario.*
Addresses: West Vancouver, BC. **Studied:** John Russell Acad.; Toronto; Ont. Col. Art, Toronto; Calif. Sch. Fine Art, San Francisco; also with Hans Hofmann, Provincetown, Mass. **Member:** Assoc. Royal Can. Acad.; Am. Craftsmen Coun.; Am. Soc. Archeologists; Can. Fedn. Artists; Ont. Crafts Found. **Exhibited:** Awards: Allied Arts Medal, Royal Archit. Inst. Can., 1956. **Work:** Fla. State Col., Lakeland; Nat. Gal., Ottawa; Art Gal. Toronto; Vancouver Art Gal.; Univ. Victoria, BC. Commissions: bronze fountain, Edmonton City Hall, 1958; Vancouver Pub. Libr., 1961; enamel doors, St. Thomas More Col., Saskatoon, Sask., 1962; BC Prov. Govt. Mus., Victoria, 1968; oil on panels, (with L&P Thomas), Stud. Union Bldg., Univ. BC, 1969. **Comments:** Preferred media: enamel, oils. Positions: chmn., Comt. Appl. Design BC Govt., Victoria, 1965-68. Teaching: assoc. prof. design, Sch. Archit., 1950-64; assoc. prof. design, Univ. BC, 1964. **Sources:** WW73; Rene Boux, "New star," *Can. Art;* Stephen Franklin, "Artist and a briefcase," *Weekend Mag.* (1958); article, In: *BC Beautiful* (spring, 1970).

THOMAS, Marian *[Portrait, landscape and still life painter] b.1899, Sulphur Springs, TX.*
Studied: Southern Methodist Univ. with Olive Donaldson; Bert Phillips; Broadmoor Art Acad. **Exhibited:** Southern States AA; Harwood Studio, Taos, NM. **Sources:** Petteys, *Dictionary of Women Artists.*

THOMAS, Marie *[Listed as "artist"] b.c.1826, Pennsylvania.*
Addresses: Philadelphia in 1860. **Comments:** Living in Philadelphia in 1860 with Susan, gentlewoman, and Thomas Thomas, clerk. In the same house lived the family of John Thomas (see entry), engraver, probably Marie's brother. **Sources:** G&W; 8 Census (1860), Pa., LIV, 208.

THOMAS, Marjorie *[Artist] early 20th c.*
Addresses: active in Detroit, MI, c.1910. **Member:** Detroit Soc. Women P&S. **Sources:** Petteys, *Dictionary of Women Artists.*

THOMAS, Marjorie Helen *[Painter, illustrator] b.1885, Newton Center, MA. / d.1978, Mesa, AZ.*
Addresses: Scottsdale, AZ, from 1909 (still living there in 1948). **Studied:** BMFA Sch., with Tarbell; Benson; R. Hale; Louis Kronberg; J.P. Wicker. **Member:** Phoenix FA; Arizona AG. **Exhibited:** Boston AC, 1906-08; PAFA Ann., 1924, 1928; North Shore AA; S. Indp. A., 1927. **Work:** Governor's Office, Phoenix, AZ; Santa Fe R.R. Collection. **Comments:** PWAP artist in Arizona, 1934. Thomas painted the Salt River Valley. Illustrator, "Old Bill Williams at Chochetopa Pass," in "Old Bill Williams,"

Favour, 1936. **Sources:** WW40; P&H Samuels, 483.; Trenton, ed. *Independent Spirits,* 148, 154; Falk, *Exh. Record Series.*

THOMAS, Mary (Alice) Leath *[Painter, educator, craftsperson, teacher] b.1905, Hazelhurst, GA / d.1959, Athens, GA?.*
Addresses: Athens, GA. **Studied:** Georgia State Col. for Women (B.S.); Duke Univ. (M. Edu.); Woman's Col., Univ. North Carolina. **Member:** Assn. Georgia A.; SSAL; Southeastern AA; Nat. A. Edu. Assn. **Exhibited:** PAFA, 1941; Mint Mus. A., 1942, 1943; ACA Gal., NY, 1943; North Carolina A., 1940-44 (prizes, 1941, 1942), 1947 (prize); Piedmont Festival, Winston-Salem, N.C., 1943; SSAL, 1941-43 (prize, 1942), 1945, 1946 (prize); Assn. Georgia A., 1945-55 (prizes, 1948-50, 1952); MMA, 1952; BM, 1953, 1955; LOC, 1952; Gibbes A. Gal., 1958; Norfolk Mus. A., 1958; Atlanta Paper Co., 1958; Univ. Georgia, 1957 (2-man); Weyhe Gal., NY. **Work:** Albemarle, NC Pub. Sch.; Fed. Women's C., Cary, NC; U.S. State Dept. purchase for U.S. Embassies abroad (2); Univ. Georgia; VMFA; Atlanta AI; North Carolina A. Soc.; Telfair Acad.; Gibbes A. Gal. **Comments:** Positions: asst. prof., Woman's Col., Univ. North Carolina, 1938-44; prof., Stephens Col., Columbia, Mo., 1944-45; assoc. prof., Univ. Georgia, Athens, Ga., 1945-51; art supv., Athens, Ga. City Schs., 1949-56. **Sources:** WW59; WW47.

THOMAS, Mary L(ouise) See: **FINLEY, Mary L(ouise) (Mrs. Irvin C. Thomas)**

THOMAS, Michael *[Listed as "artist"] b.c.1834, Pennsylvania.*
Addresses: Living in a theatrical boarding house in Philadelphia in 1860. **Sources:** G&W; 8 Census (1860), Pa., LII, 64.

THOMAS, Myra L. *[Painter] mid 20th c.*
Addresses: NYC; Ault, CO. **Exhibited:** S. Indp. A., 1921-22, 1926-29, 1934; Salons of Am., 1927, 1929. **Sources:** Marlor, *Salons of Am.*

THOMAS, N. E. (Mrs.) *[Artist] late 19th c.*
Addresses: Active in Port Huron, MI, 1889-93. **Comments:** Mrs. Nahum or Nehum Thomas? **Sources:** Petteys, *Dictionary of Women Artists.*

THOMAS, Nellie *[Artist] late 19th c.*
Addresses: Detroit, MI. **Studied:** With Fannie E. McGarry. **Exhibited:** Western AA, 1870. **Sources:** Petteys, *Dictionary of Women Artists.*

THOMAS, Norman Millet *[Mural painter, etcher] b.1915.*
Addresses: Portland, ME/Long Island, ME. **Studied:** A. Bower; Portland Sch. F. & Appl. A.; NA. **Member:** Portland SA; SC. **Exhibited:** 48 States Comp., 1939. Award: Pulitzer F., NA, 1938, 1939. **Sources:** WW40.

THOMAS, Paul K. M. *[Painter, sculptor, writer, lecturer, teacher, illustrator] b.1875, Philadelphia, PA.*
Addresses: New Rochelle, NY. **Studied:** PAFA; Cecilia Beaux; William Chase; Charles Grafly. **Member:** AAPL; Lotos Club. **Exhibited:** PAFA Ann., 1898-1909; St. Louis Expo, 1904 (med.). **Work:** portraits, Bryn Mawr College; Univ. Chicago; Williams College; Western Reserve Univ.; Yale Univ.; Smith College; Univ. Pennsylvania; Tokyo; Madrid; Rome. **Sources:** WW53; WW47; Falk, *Exh. Record Series.*

THOMAS, P(ercival) Clinton *[Painter] 20th c.*
Addresses: Ozone Park, L.I., NY. **Exhibited:** S. Indp. A., 1934-35, 1937, 1940. **Sources:** Marlor, *Soc. Indp. Artists.*

THOMAS, Reynolds *[Painter, sculptor] b.1927, Wilmington, DE.*
Addresses: Genoa, Italy. **Studied:** PAFA; Univ. Fine Arts, Mex. **Member:** Am. Fedn. Arts; Int. Art Guild, Monte Carlo, France. **Exhibited:** Int. Grand Prix Contemp. Art, Monte Carlo, Monaco, 1972; solo shows, Hotel de Paris, Monte Carlo, An Wk Celebration, 1966, Country Art Gal., Long Island, NY, 1962, 1967, 1968 & 1971; Int. Art Ctr., Milan, Italy, 1971, Galleria al Porto, Arenzano, Italy, 1971, Kennedy Galleries, 1964 & 1965 & Galerie Michel-Ange, Chateau Perigor, Monte Carlo, 1972;

Galleria al Porto, Genoa, Italy, 1970s. Awards: Thouron prize, 1952 & scholar, 1954, PAFA; prizes, Del Art Ctr. (5); Int. grand prize & trophy (painting), La Stanza Letteraria, Rome Italy, 1972. **Work:** Del. Art Ctr., Wilmington; Northern Trust Co, Chicago, Ill.; Hempstead Bank, Long Island, NY; Farnsworth Mus., Rockland, Maine; Northern Ind. Art Assn. Permanent Collection, Hammond. Commissions: twelve oil painting of Alpine scenes, Garcia Ski Corp., Teaneck, NJ, 1969; HSH Princess Grace de Monaco (portrait), Palace, Monaco, 1971; pvt. commissions. **Sources:** WW73.

THOMAS, Richard S. *[Sculptor] b.1872, Phila., PA.*
Addresses: Bordentown, NJ/Seaside Park, NJ. **Studied:** A. Zeller; C. Grafly; E. Maene. **Member:** Trenton AC; Mem. Craftsmen Am. **Exhibited:** PAFA Ann., 1925, 1931, 1936-37. **Comments:** Position: senior partner, Thomas and Bowker Memorial Granite Works, Bordentown. **Sources:** WW40; Falk, *Exh. Record Series.*

THOMAS, Robert Chester *[Sculptor] b.1924, Wichita, KS / d.1987.*
Addresses: Goleta, CA. **Studied:** David Green, Pasadena, CA, 1946-47; Ossip Zadkine, Paris, France, 1948-49; Univ. Calif., Santa Barbara (B.A., 1951); Calif. College Arts & Crafts (M.F.A., 1952). **Exhibited:** Int. Salon de Mai, Paris, France, 1949; SFMA, 1952-53, 1956-57; Santa Barbara Mus. Art, 1955 (solo), 1966 (retrospective); La Jolla (CA) Art Center, 1960 (solo); Adele Bednarz Galleries, Los Angeles, 1970-72 (solo); Adele Bednarz Galleries, Los Angeles, 1970s. Awards: bronze medal for sculpture, City of Los Angeles, 1949; silver medal for sculpture, Calif. State Fair, 1954; purchase prize for sculpture, Santa Barbara Mus. Art, 1959. **Work:** Santa Barbara (CA) Mus. Art; Univ. Calif., Santa Barbara; Joseph H. Hirshhorn Coll., Wash., DC. Commissions: painted wood sculpture, J. Magnin, Century City, CA, 1966; bronze figure, Class of 1967, Univ. Calif., Santa Barbara, 1967; ceramic fountain, comn. by Phyllis Plous, Santa Barbara, 1968. **Comments:** Preferred media: stone, wood, bronze. Teaching: Univ. Calif., Santa Barbara, 1954-. **Sources:** WW73.

THOMAS, Robert S. *[Painter] early 20th c.*
Exhibited: Salons of Am., 1934. **Sources:** Marlor, *Salons of Am.*

THOMAS, Roland *[Painter] b.1883, Kansas City, MO.*
Addresses: Independence, MO. **Studied:** W. Chase; R. Henri; F.V. DuMond. **Member:** Kansas City AG; Am. Artists, Munich. **Exhibited:** Mo. State Art Exh., 1912 (prize). **Work:** Elverhoj A. Gal., Milton, N.Y.; American AC, Munich; murals, Curtiss Bldg.; murals, Hudson Brace Motor Co., Kansas City, Mo. **Sources:** WW25.

THOMAS, Roy Irwin *[Painter] mid 20th c.*
Exhibited: Salons of Am., 1927. **Sources:** Marlor, *Salons of Am.*

THOMAS, Ruth See: **FELKER, Ruth Kate (Mrs. W. D. Thomas)**

THOMAS, Ruth *[Painter, critic] b.1893, Washington, DC.*
Addresses: Newport, RI. **Studied:** Corcoran Sch. Art; Cecilia Beaux; Winold Reiss; A. Sterner; J. Elliot; H. Sturtevant. **Member:** Newport AA. **Exhibited:** Newport AA, 1925-46; NAWA, 1930-34 (prize, 1933); Palm Beach AC, 1934; Vose Gal., Boston (solo); Argent Gal (solo); Junior Lg., Baltimore, MD (solo). **Comments:** Contrib.: art reviews to art magazines & newspapers. **Sources:** WW53; WW47.

THOMAS, Samuel E. *[Painter] early 20th c.*
Addresses: Chicago. **Exhibited:** AIC, 1923-24. **Sources:** Falk, AIC.

THOMAS, Steffen Wolfgang *[Sculpture, painter, graphic artist, lecturer] b.1906, Fürth, Germany / d.1990.*
Addresses: Atlanta, GA. **Studied:** Sch. Appl. Arts, Nürnberg, Ger.; Acad. Fine Arts, Munich, Ger., with Herman Hahn, Bernhart Bleeker & Josef Wakerle. **Member:** SSAL; Atlanta AA. **Exhibited:** Glas Palast, Munich, 1927; High Mus, 1936 (solo); NSS, 1948; Southeastern Art Show, Atlanta Art Assn., 1949-1951; Nat. Soc. Miniature Arts, Smithsonian Inst., 1952. Awards: first & purchase prize for Head of Youth, City of Fürth, 1925; hon

mention, Fine Arts Acad., Munich, 1928. **Work:** City of Fürth, Bavaria; Univ. Ala.; State T. Col., Jacksonville, Ala.; Emory Univ; High Mus., Atlanta, GA; Pub. Lib., Atlanta; Agnes Scott Col., Decatur, GA; State Capital, Atlanta; Women's Better Govt. Lg., Atlanta; Atlanta Univ.; Ga. Am. Legion, Atlanta; Am. Col. Surg., Chicago, IL; Univ. Edinborough, Scotland. Commissions: marble portrait bust, comn. by Martha Berry, Berry Sch. Libr., Rome, Ga., 1936; bronze portrait bust George Washington Carver, Tuskegee Inst., Ala., 1945; bronze monument to Gov. Eugene Talmadge, Talmadge Mem. Comt., State Capitol Grounds, Atlanta, 1949; bronze Ala. Confederate monument, State of Ala., Vicksburg Nat. Mil. Park, Miss., 1951; aluminum bas relief murals, Fulton Nat. Bank, Atlanta, 1954. **Comments:** Preferred media: bronze. Positions: art dir., Ga. Nat. Youth Admin., 1939-42. **Sources:** WW73; WW40; Katerine Barnwell, "Artist's Studio or Lion's Den," *Atlanta J.-Constitution Mag.,* Mar. 4, 1962; Ann Carter, "Reaching Higher," *Sun Atlanta J.-Constitution,* Feb. 2, 1969; Ethel Kerlin & staff, "Mr. Steffen Thomas," WETV, 1969.

THOMAS, Stephen Seymour *[Painter] b.1868, San Augustine, TX / d.1956, La Crescenta, CA.* **S.TH.**
Addresses: La Crescenta, CA (lived in Paris, 1888-1914; NYC, 1914-19; then settled in CA). **Studied:** ASL with W.M. Chase and C. Beckwith, 1885-88; Académie Julian, Paris with Lefebvre, Constant, and Doucet, 1888-90; École des Beaux-Arts, Paris. **Member:** Los Angeles AA; Paris S. Am. P.; Pasadena AS. **Exhibited:** World's Indust. and Cotton Cent. Expo., 1884-85; Columbian Expo., Chicago, 1893; PAFA Ann., 1893-1902 (5 times); Tulane Univ., 1894; Paris Salon, 1891-1895 (hon. men.), 1896-1898, 1901 (gold), 1904 (prize), 1905-1910; Paris Expo, 1900 (medal); Munich, 1901 (gold); Pan-Am. Expo, Buffalo, 1900 (medal); Hors Concours, 1904 (gold medal); Chevalier Legion of Honor, 1905; PPE, 1915; LACMA, 1935 (solo); AIC. **Work:** MMA; Albright Gal.; Buffalo Mus. Art; Chamber of Commerce, New York Life Bldg., Courtroom, Hall of Records, all in NYC; John Herron AI; Houston MFA; Winona (MN) Mus.; Los Angeles Mus. History, Science & Art; Athenaeum, Pasadena; State House, Trenton, NJ; MIT; port. Woodrow Wilson, White House; Nat. Liberal Club, London; Univ. Calif.; Trinity College; Syracuse Univ; Nat. Acad. Sciences, Wash., DC; Chamber of Commerce, Cleveland; Am. College Surgeons, Chicago; Morrison Library, Univ. Calif.; Huntington Mem. Hospital, Pasadena; Good Samaritan Hospital, Los Angeles. **Comments:** Pioneer Texas genre and landscape painter and international portrait painter. He was successful as an artist at an early age and painted portraits of many notables in the U.S. as well as Europe. He met his wife Helen M. Haskell Seymour (see entry) in Paris. **Sources:** WW40; *Encyclopaedia of New Orleans Artists,* 374; Hughes, *Artists in California,* 556; P&H Samuels, 483-84; Fink, *American Art at the Nineteenth-Century Paris Salons,* 396; Falk, *Exh. Record Series.*

THOMAS, Susan Spencer *[Painter] early 20th c.*
Exhibited: PAFA Ann., 1904. **Comments:** Represented by Haseltine Gal., Phila., PA. **Sources:** WW13; Falk, *Exh. Record Series.*

THOMAS, Vernon (Mrs.) *[Painter, illustrator, etcher,] b.1894, Evanston, IL.*
Addresses: Chicago, IL. **Studied:** R. Clarkson; C. Hawthorne; W.J. Reynolds. **Member:** NAC; Chicago SE; Cordon Club. **Exhibited:** AIC, 1929-30. **Work:** City of Chicago Coll. **Comments:** Specialty: children. **Sources:** WW40.

THOMAS, Winfield Scott *[Painter, writer] b.1900, Haverhill, MA.*
Addresses: Haverhill, MA. **Studied:** BMFA Sch.; with L.P. Thompson, P.L. Hale, B. Keyes & with Robert W. Broderick, Sidney M. Chase. **Member:** Merrimack Valley AA; Boston S.Indph.A.; Ogunquit A. Ctr. **Work:** Andover (Mass.) Jr. H.S.; Haverhill (Mass.) H.S.; Haverhill Pub.Lib.,175 water colors of old Haverhill houses. **Sources:** WW53; WW47.

THOMAS & GERMAN *[Wood engravers and lithographers]* mid 19th c.
Addresses: Louisville, KY, 1859. **Comments:** Partners were George Thomas and Charles W. German (see entries). **Sources:** G&W; Louisville BD 1859.

THOMASITA, (Sister) See: **SISTER THOMASITA, (Mary Thomasita Fessler)**

THOMASON, Eugene (H.) *[Painter]* mid 20th c.
Studied: ASL. **Exhibited:** S. Indp. A., 1928; Salons of Am., 1931, 1932. **Sources:** Falk, *Exhibition Record Series.*

THOMASON, Frances Quarles *[Painter]* early 20th c.; b.Van Buren, AR.
Addresses: Paris, France, 1907-15. **Studied:** NYC; Paris. **Exhibited:** St. Louis Expo, 1904 (med); PAFA Ann., 1905-14; Intl. AL, Paris, 1908 (prize); AIC. **Work:** St. Louis C. **Sources:** WW17; Falk, *Exh. Record Series.*

THOMASON, John (W.) *[Painter]* early 20th c.
Addresses: NYC. **Exhibited:** S. Indp. A., 1933-34. **Comments:** Possibly Thomason, John William, Jr., b. 1893-d. 1944. **Sources:** Marlor, *Soc. Indp. Artists.*

THOMASON, John William, Jr. *[Illustrator, writer]* b.1893, Huntsville, TX / d.1944, San Diego.
Studied: Southwestern Univ., 1909-10; Houston Normal Inst., 1910-11; Univ. Texas, 1912-13; ASL, 1913-15. **Comments:** Professional soldier, cited for heroism; assistant to Sec. of Navy, 1933. Author/Illustrator: "Fix Bayonets," 1925; books on the Texas Rangers, Davy Crockett, Custer. **Sources:** P&H Samuels, 484.

THOMASON, R. S. *[Painter]* mid 20th c.
Exhibited: Salons of Am., 1928, 1930-36. **Sources:** Marlor, *Salons of Am.*

THOMASON, Rosemary *[Painter]* mid 20th c.
Addresses: Garden Grove, CA. **Exhibited:** Calif. WC Soc., 1931-33. **Sources:** Hughes, *Artists in California,* 556.

THOMES, Aubigne (Eveleth) *[Painter]* early 20th c.
Addresses: Portland, ME. **Exhibited:** S. Indp. A., 1925. **Sources:** Marlor, *Soc. Indp. Artists.*

THOMETZ, Bess *[Painter]* mid 20th c.
Addresses: Chicago area. **Exhibited:** AIC, 1940. **Sources:** Falk, AIC.

THOMPKINS, Clementina *[Painter]* b.1848, Georgetown, DC / d.1931, NYC.
Studied: Peabody A. Inst., Baltimore; Brussels; Paris, with Bonnât. **Exhibited:** Paris Salon, CGA; Centenn. Expo, Phila., 1876 (med). **Work:** Boys' C. NYC.

THOMPKINSON, Flora *[Portrait painter]* late 19th c.
Addresses: Active in Kalamazoo, MI. **Exhibited:** Michigan State Fair, 1885. **Sources:** Petteys, *Dictionary of Women Artists.*

THOMPSON *[Portrait painter]* mid 19th c.
Addresses: Troy, N.Y. **Exhibited:** National Academy in 1835. **Sources:** G&W; Cowdrey, NAD.

THOMPSON, A. C. (Miss) *[Portrait painter]* mid 19th c.
Addresses: NYC. **Exhibited:** National Acad., 1859. **Sources:** G&W; Cowdrey, NAD.

THOMPSON, A. E. ? *[Painter]* mid 19th c.
Comments: Painter of a view of Wetumpka Bridge (AL), 1847. **Sources:** G&W; Karolik Cat., 495-97, repro.

THOMPSON, A. G. (Mrs.) *[Painter]* late 19th c.
Exhibited: NAD, 1867. **Sources:** Naylor, *NAD.*

THOMPSON, A. W. (Mrs.) *[Artist]* late 19th c.
Addresses: NYC, 1877-78. **Exhibited:** NAD, 1877-78. **Sources:** Naylor, *NAD.*

THOMPSON, Aaron B. *[Sketch artist]* late 19th c.
Addresses: New Orleans, active 1874. **Comments:** His drawings depicting the Battle of Liberty Place were reproduced as wood engravings in "Frank Leslie's Illustrated Newspaper", 1874. **Sources:** *Encyclopaedia of New Orleans Artists,* 374.

THOMPSON, Adele Underwood (Mrs.) *[Painter, teacher, critic]* b.1882, Grosbeck, TX.
Addresses: Corpus Christi, TX. **Studied:** AIC; Newcomb College, Tulane Univ.; Ellen A. Holmes; Xavier Gonzalez. **Member:** SSAL; Nat. Lg. Am. Pen Women; Texas FAA; Corpus Christi Art Found.; South Texas Art Lg. **Exhibited:** NGA, 1946; Nat. Lg. Am. Pen Women; Nat. Mus., Wash., DC; Caller-Times Exh.; SSAL; Texas FAA; Corpus Christi Art Found.; Corpus Christi Mus., 1953 (solo); Ballinger (TX) Lib.; Texas FAA, 1953; Kingsville College, 1954; Corpus Christi Little Theatre, 1954. **Awards:** prizes, Corpus Christi Art Found., 1945-46, 1948; Kingsville (TX) Fair, 1947, 1949; WC exh., 1954; Casein exh., 1954. **Sources:** WW59.

THOMPSON, Agnes J. *[Painter]* 19th/20th c.
Addresses: St. Louis, MO; Los Angeles, c.1932. **Sources:** WW01; Petteys, *Dictionary of Women Artists.*

THOMPSON, Alan *[Painter, illustrator, designer]* b.1908, South Shields, England.
Addresses: Alexandria, VA; Old Greenwich, CT. **Studied:** CI; Pittsburgh AI; & with Alexander Kostellow, Clarence Carter. **Member:** Pittsburgh AA. **Exhibited:** CI, 1941; Pittsburgh AA, 1939-1941 (prize); Butler AI, 1939, 1940 (prize); Parkersburg FA Center, 1940; All. A. Am., 1952 (prize). **Awards:** Hallmark, 1949 (prize). **Work:** Pittsburgh Faculty Cl.; Pittsburgh Pub. Sch.; mural, USPO, Pittsburgh, PA. **Comments:** Position: illus., New Yorker Studio, Wash., DC from 1946. des., art dir., Young & Rubicam, NYC. **Sources:** WW59; WW47.

THOMPSON, Alfred *[Painter]* late 19th c.
Addresses: NYC, 1887. **Exhibited:** NAD, 1887 ("The Panoply of War"). **Comments:** NAD exh. records for 1887 list Alfred Wordsworth Thompson (see entry) as exhibiting "By the Summer Sea" and "Danger in the Desert" and provide an address of 52 East 23rd Street, NYC. In the same year is a listing for Alfred Thompson of 446 W. 57th St., NYC, exhibiting "The Panoply of War." The different addresses would suggest they are different artists, but the subject of "The Panoply of War" is similar to ones painted by Alfred Wordsworth Thompson. **Sources:** Naylor, *NAD.*

THOMPSON, Alfred Wordsworth *[Landscape, historical & portrait painter]* b.1840, Baltimore, MD / d.1896, Summit, NJ.
Addresses: Paris (1861-68); NYC (1868-96); Summit, NJ (1884-on). **Studied:** Baltimore (law); Gleyre in Paris, 1861-62; E. Lambinet, A. Pasini, 1862-68. **Member:** ANA, 1873; NA, 1875; SAA, 1877 (founder-mem.). **Exhibited:** Paris Salon, 1865; NAD, 1867-96; Brooklyn AA, 1868-84, 1891; PAFA Ann., 1868, 1876, 1881, 1888, 1892; Leonard Auction Room, Boston, 1876; Phila. Centennial, 1876; Paris Expo, 1878; Boston AC, 1890; AIC. **Work:** BMFA; NYHS; Union League Club, NYC; Albright-Knox AG, Buffalo; Chrysler Mus., Norfolk, VA. **Comments:** Thompson studied law with his father in Baltimore, but in 1859 decided to become an artist and opened a studio in Baltimore. In 1860, during the first year of the Civil War, he was an illustrator for *Harper's* and the *Illustrated London News,* but in 1861 he left to study in Paris. He also traveled to Italy and Germany before establishing his studio in NYC in 1868. He made several return trips to France, Spain, North Africa, and the Mediterranean. In addition to his travel landscapes, many of his exhibited works were of colonial revolutionary subjects. *Cf.* Alfred Thompson. **Sources:** G&W; DAB; Clement and Hutton; CAB; Rutledge, PA; diaries owned by NYHS. More recently, see Campbell, *New Hampshire Scenery,* 164; Wright, *Artists in Virginia Before 1900;* Fink, *American Art at the 19th C. Paris Salons,* 396; *300 Years of American Art,* vol. 1, 304; Falk, *Exh. Record Series.*

THOMPSON, Almerin D. *[Portrait painter] b.c.1819, Massachusetts.*
Addresses: Philadelphia in 1850. **Sources:** G&W; 7 Census (1850), Pa., LIII, 633; Phila. CD 1850.

THOMPSON, Arad *[Portrait painter] b.1786, Middleboro, MA / d.1843, Middleboro, MA.*
Studied: Graduated from Dartmouth in 1807. **Comments:** A younger brother of Cephas Thompson (see entry). He is said to have painted portraits about 1808-10; he also practiced medicine. **Sources:** G&W; Weston, *History of the Town of Middleboro*, 240; Fielding.

THOMPSON, Ben *[Cartoonist] b.1906, Central City, Neb.*
Addresses: Naugatuck, CT. **Studied:** Univ. Washington Sch. FA; AIC. **Member:** Nat. Cartoonists Soc. **Comments:** Position: staff cart., *Seattle Post Intelligencer, Seattle Times, Bellingham Herald, N.Y. Journal-American;* magazine, newspaper and advertising cartoons as of 1966. Contributor cartoons to: *Sat. Eve. Post; Look; Redbook; Better Homes & Gardens; True,* and other leading national magazines; King Features Syndicate; McNaught Syndicate. **Sources:** WW66.

THOMPSON, Benjamin (Count Rumford) *[Amateur artist] b.1753, Woburn, MA / d.1814, Auteuil, France.*
Studied: studied medicine in Boston before the Revolution. **Work:** His notebook of the period prior the Revolution, filled with drawings and caricatures, is now at the New Hampshire Historical Society. **Comments:** A Loyalist, he left for England in 1775 and served in civil and military offices during the Revolution. Later he was knighted by George III and created Count Rumford of the Holy Roman Empire for services rendered to the Elector of Bavaria. Count Rumford was an important pioneer physicist, noted particularly for his experiments on heat and light and for his inventions of heating and cooking stoves. His latter years were spent at Auteuil, near Paris. **Sources:** G&W; DAB; *Historical New Hampshire* (Nov. 1948), 1-19; Allen, *Early American Book Plates.*

THOMPSON, Bertha *[Craftsperson, jeweler] mid 20th c.; b.England.*
Addresses: Woodstock, NJ. **Studied:** A.W. Dow; G. Gebelin; T. Christiansen. **Member:** Boston SAC (master craftsman). **Sources:** WW40.

THOMPSON, Bob (Robert Louis) *[Painter] b.1937, Louisville, KY / d.1966, Rome.*
Addresses: Provincetown, MA, summers, 1958-59, NYC, c. 1960-66. **Studied:** Univ. Louisville, 1955-58; Boston Univ.; BMFA Sch., 1955. **Exhibited:** Provincetown Art Festival, 1958; Univ. Arizona, 1964; AIC, 1964; Dayton AI, 1964; Fairleigh Dickinson Univ., 1964; Yale Univ., 1964; Rockford College, 1965; Bird in Art Exh., Audubon Soc., 1965; AFA, 1960-61, 1964-65; New Sch. Social Research, NY, 1965; Arts in Louisville Exh., 1958; Delancey St. Gal., NY, 1960; Zabriskie Gal., NY, 1960; NYC Center Gal., 1960; AFA Traveling Show, 1960-61, 1963-64; Superior St. Gal., Chicago, 1961; The Drawing Shop, NYC, 1961 (solo); El Cosario Gal., Spain, 1963; Martha Jackson Gal., NY, 1963-64, 1968; Richard Grey Gal., Chicago, 1964, 1965, (solo); Paula Johnson Gal., NY, 1964 (solo); East End Gal., Provincetown, MA, 1965 (solo); Donald Morris Gal., Detroit, 1965 (solo), 1970 (solo); J.B. Speed Mus., Louisville, KY, 1965, 1971 (solo); Long Island Univ., 1966; Downtown Salutes the Arts Show, NYC, 1966; Brooklyn College, 1969; Phila. Art All., 1969; Mt. Holyoke College, 1969; Musée Rath, Paris; BMFA, 1970; La Jolla Mus. of Art, 1970; "Bob Thompson," WMAA, 1998. **Award:** John Hay Whitney Fellowship Grant, 1962-63. **Work:** Mint Mus. Art; Am. Republic Life Ins. Co., Des Moines; Chrysler Mus., Provincetown, MA; Container Corp. Coll. **Comments:** After graduating from art school, Thompson moved from Louisville, KY, to Provincetown, MA, in the summer of 1958 or 1959, meeting figurative expressionists Lester Johnson, Red Grooms, Mimi Gross, and Gandy Brodie. He then moved to NYC and later traveled to Paris, Rome, and Madrid. He gained tremen-

dous success in a career cut short by his early death just before his 29th birthday. Thompson painted in a bold, figurative style, often taking subjects traditional to art history, such as "Flagellation of Christ" and "St. George and the Dragon," and reworking them with modern references. **Sources:** WW66; Roberta Smith, "Trajectory of a Brief Career Hints at What Might Have Been," *New York Times,* September 25, 1998, Section E, p. 33; *Provincetown Painters,* 241 (repro.), 286; Cederholm, *Afro-American Artists.*

THOMPSON, Bradbury See: **THOMPSON, (James) Bradbury**

THOMPSON, C. Mortimer *[Painter] 20th c.*
Addresses: Knoxville, TN. **Sources:** WW13.

THOMPSON, Carrie *[Painter] late 19th c.*
Addresses: Quincy, CA. **Exhibited:** Calif. Agricultural Soc., 1883. **Comments:** Specialty: watercolors. **Sources:** Hughes, *Artists in California,* 556.

THOMPSON, Cephas *[Portrait painter] b.1775, Middleboro, MA / d.1856, Middleboro.*
Addresses: Middleboro, MA until 1856. **Work:** Shelburne (VT) Mus. **Comments:** Largely self-taught, Thompson had a successful career as a portraitist and was particularly well known in the South where he wintered for many years. There are records of his being at Baltimore in 1804, at Charleston in 1804, 1818, and 1822, at Richmond in 1809-10, and at New Orleans in 1816. His three children, Cephas Giovanni, Jerome B., and Marietta (see entries), were also artists; and his brother Arad Thompson (see entry) is said to have painted portraits. **Sources:** G&W; CAB; *Richmond Portraits,* 233-34; Weston, *History of the Town of Middleboro,* 389-90; Lafferty; Rutledge, *Artists in the Life of Charleston;* Delgado-WPA; Swan, BA; WPA (Mass.), *Portraits Found in Maine,* no. 320; Muller, *Paintings and Drawings at the Shelburne Museum,* 132 (w/repro.).

THOMPSON, Cephas Giovanni *[Portrait & genre painter] b.1809, Middleboro, MA / d.1888, NYC.*
Studied: with his father & David C. Johnston. **Member:** ANA, 1847, 1861-88. **Exhibited:** NAD, 1838, 1840-46, 1858, 1860-68, 1870-72, 1875, 1878, 1888; Brooklyn AA, 1861-79; New Bedford Art Club Loan Exhib., 1908. **Work:** New York Hist. Soc., NY; MMA; Old Dartmouth Hist. Soc. **Comments:** The son of Cephas Thompson (see entry), he commenced his career at Plymouth in 1827. Before settling in NYC in 1837, he had worked in Boston, Bristol (RI), and Philadelphia. In the 1840s he was in New Bedford, MA for a short time, doing portraits of leading citizens. From 1849-52 he was at Boston. In 1852 he went abroad with his family and spent seven years in Italy where he became a friend of Hawthorne. He returned to NYC in 1859 and remained there until his death. **Sources:** G&W; DAB; CAB; Karolik Cat., 489; Swan, BA; Cowdrey, NAD; Cowdrey, AA & AAU; Rutledge, PA; Boston BD 1849-52; Rutledge, MHS; *Antiques* (Feb. 1942), 110; 7 Census (1850), Mass., XXV, 703; Blasdale, *Artists of New Bedford,* 187 (w/repro.).

THOMPSON, Charles A. *[Landscape painter] mid 19th c.*
Addresses: NYC, 1852-55. **Exhibited:** NAD. **Sources:** G&W; Cowdrey, NAD, as C.A.; NYCD 1854, as Charles A.

THOMPSON, Charles W. *[Engraver] mid 19th c.*
Comments: Listed in NYC directories from 1841 to 1847 as painter, jeweler, lumber, and engraver; from 1850 as engraver. Possibly the same as Charles W. Thompson, of Grosvenor & Thompson (see entry), wood engravers at Cincinnati in 1849-50. **Sources:** G&W; NYCD 1841-47, 1850-60; Cincinnati CD and BD 1849-50.

THOMPSON, Charlotte Victoire *[Painter, block printer] mid 20th c.*
Addresses: Los Angeles, CA. **Exhibited:** Artists Fiesta, Los Angeles, 1931. **Sources:** Hughes, *Artists in California,* 556.

THOMPSON, Clara A. *[Painter] early 20th c.*
Addresses: Hartford, CT. **Member:** CAFA. **Sources:** WW17.

THOMPSON, Conrad *[Painter] late 20th c.; b.Mobile, AL.*
Studied: Howard Univ. (B.A.). **Exhibited:** Smith-Mason Gal., Wash., DC, 1971; Howard Univ.; Smithsonian Inst.; Dept. of Agriculture; Dept. of Commerce; DCAA Anacostia Mus.-Smithsonian Inst. **Comments:** Position: dir., Naval Ship Engineering Center, Management Information Center & Graphics Support Facility in Prince Georges Center. **Sources:** Cederholm, *Afro-American Artists.*

THOMPSON, D. George *[Watercolorist, portrait and landscape engraver] b.England / d.c.1870, NYC.*
Addresses: NYC in 1856. **Comments:** Stauffer says that he was born in England and spent his early years in India. **Sources:** G&W; Stauffer; Hinton, *History and Topography of the U.S.,* repro.; *American Collector* (Oct. 1947), 43, and (Dec. 1947), 3, repros.

THOMPSON, Daniel V. *[Painter, author] mid 20th c.*
Comments: He rediscovered the art of egg tempera painting at the Courtauld Institute, and revived the medium with his book, *The Practice of Tempera Painting* (1936). His disciple, Lewis York, produced the step-by-step illustrations for the book. **Sources:** PHF files.

THOMPSON, Della (Mrs. K. M.) See: **SHULL, Della F. (Mrs. K. M. Thompson)**

THOMPSON, Dolly S. *[Listed as "artist"] b.c.1790, England.*
Addresses: Baltimore in 1850, 1853-54. **Sources:** G&W; 7 Census (1850), Md., V, 915; Lafferty.

THOMPSON, Dorothea See: **LITZINGER, Dorothea M. (Mrs. John W. Thompson)**

THOMPSON, Dorothy Ashe *[Painter] early 20th c.*
Addresses: Westport, CT. **Exhibited:** S. Indp. A., 1927-28. **Sources:** Marlor, *Soc. Indp. Artists.*

THOMPSON, Dorothy Burr *[Art historian, lecturer] b.1900, Delhi, NY.*
Addresses: Princeton, NJ. **Studied:** Bryn Mawr Col. (A.B., 1923, European fel., 1923, A.M., Ph.D., 1931); Wooster Col.(hon. D.F.A., 1972). **Member:** Archaeol. Inst. Am. (exec. comt., 1948-); corresp. mem. Deutsches Archäologisches Inst. **Comments:** Positions: acting dir., Royal Ont. Mus., 1946-47. Publications: auth., "Terracottas from Myrina in Museum of Fine Arts, Boston," privately publ., 1934; auth., "Swans & Amber" (translations of Greek lyrics), Univ. Toronto Press, 1949; auth., "Troy, the Terracotta figurines of the Hellenistic Period," Princeton Univ. Press, 1963; auth., "Ptolemaic Oinochoai and Portraits in Faince," Oxford Press, 1973; contribr. various journals. Teaching: lectr. archaeol. for circuit, Archaeol. Inst. Am., 1940-; lectr. classical archaeol., Univ. Toronto, 1943-47; prof. classical archaeol., Univ. Pa., 1952 & 1968; vis. lectr. archaeol., Oberlin Col., 1968; prof. classical archaeol., Princeton Univ, 1969-70; vis. lectr., Univ. Sydney, 1972. Collections arranged: Comment in Clay (spec. exhib., Royal Ont. Mus., 1947. Research: Classical greek subjects such as figurines, garden art & pvt. life. **Sources:** WW73.

THOMPSON, Edith Blight (Mrs.) *[Painter] b.1884, Phila., PA.*
Addresses: London, England. **Studied:** F.V. DuMond; L. Mora. **Member:** Newport AA. **Exhibited:** S. Indp. A., 1917; WMAA, 1918; Paris Salon, 1927 (prize); Royal Acad., London, 1932-33; NAD; Newport AA; Knoedler Gals., London, 1936. **Comments:** Specialty: interiors, flowers, landscapes. **Sources:** WW33; Petteys, *Dictionary of Women Artists,* cites alternate birth dates of 1882 & 1884.

THOMPSON, Edmund Burke *[Publisher] b.1897, NYC.*
Addresses: Windham, CT. **Studied:** Columbia. **Member:** AI Graphic A. **Exhibited:** MoMA, 1932 (prize). **Work:** "Fifty Books of the Year," 1932, 1934, 1935, 1936, 1937. Printing/publishing activities under name of Hawthorn House. **Sources:** WW40.

THOMPSON, Eleanor Shepherd *[Educator, designer, craftsperson, writer, graphic artist, painter, lecturer] mid 20th c.; b.Tillsonburg, Ontario, Canada.*
Addresses: Elmhurst, NY. **Studied:** Univ. Toronto (B.A., M.A.); Ontario Col. A.; Parsons Sch. Des.; Univ. Paris, France; Columbia Univ. (Ph.D.); & abroad. **Member:** St. John's (Newfoundland) AC; NAWA; Univ.Women's C., St. John's Newfoundland; AFA. **Exhibited:** Ontario SA; NAWA; N.Y. Soc. Craftsmen. **Work:** men's Cl., St. John's, Newfoundland. **Comments:** Position: dir., Govt. Normal Sch., Toronto, Canada; prof., hd. Related A., Oklahoma A. & M. Col., Stillwater, Okla.; l., Col. City of NY; supv., A. Consultant, Nat. Handicrafts Project,Govt. of Newfoundland; book des., Advertising Manager, Kenworthy Edu. Service, Buffalo, NY. Author: "Training Girls for Art Vocations," 1935; "Textile Design," 1939. Contributor to: *Toronto Star Weekly;* "The School," publication of Univ. Toronto. **Sources:** WW53; WW47.

THOMPSON, Ellen K. Baker See: **BAKER, Ellen Kendall (Mrs. Harry Thompson)**

THOMPSON, Ernest Seton *[Painter, illustrator] b.1860, South Shields, England.*
Addresses: NYC; Wash., DC, active 1890s. **Studied:** Paris, with Gérôme, Bouguereau, Ferrier. **Work:** National Arboretum. **Comments:** Position: illus., U.S. Department of Agriculture. **Sources:** WW01; McMahan, *Artists of Washington, DC.*

THOMPSON, Ernest Thorne *[Painter, educator, graphic artist, lithographer, teacher, illustrator] b.1897, St. John, New Brunswick, Canada / d.1992, Round Pond, ME?.*
Addresses: New Rochelle, NY. **Studied:** Mass. Sch. Art, with Major, Hamilton, Andrew; BMFA Sch., with Bosley; Europe. **Member:** AAPL; Chicago SE; Ind. S. PM; Southern PM; SC; AWS; All. A. Am.; Maine Gal.; Kennebec AA; Pemaquid Group; Hudson Valley AA; Maine WC Soc.; New Rochelle AA; SI. **Exhibited:** Salons of Am., 1925 and nationally in graphic arts exh., 1927-1946; Chicago, 1927 (McCutcheon award); Fifty Prints of the Year 1928 (prize); Cunningham prize, 1929; New Rochelle, N.Y., 1937 (prize), 1940 (prize), 1946 (prize); 100 Prints of the Year, 1940; Bibliothéque Nationale, Paris; Victoria & Albert Mus., London, 1928; WC exhs., 1947, 1965; Exchange Exh., Royal WC Soc., London, and AWS, 1963. Awards: Lesch Medal of Honor, 1958; Lily Saportas award, 1964. **Work:** Bibliotheque Nationale, Paris; NYPL; U.S. Nat. Mus.; Univ. Notre Dame; murals, Oliver Hotel, South Bend, Ind.; St. Patrick's Church, McHenry, IL; Nat. Coll. FA (Smithsonian). **Comments:** Position: Prof. A., Col. New Rochelle, N.Y., 1929-; Pres., All. A. Am., 1965-. Made painting/etching trips to Monhegan Island (ME). **Sources:** WW66; WW47; Curtis, Curtis, and Lieberman, 132, 187.

THOMPSON, Ettie L. *[Landscape painter] mid 20th c.*
Exhibited: Oakland Art Gallery, 1927. **Sources:** Hughes, *Artists in California,* 556.

THOMPSON, (F.) Raymond, Jr. See: **THOMPSON, Ray (F. Raymond)**

THOMPSON, F(loyd) Leslie *[Etcher, painter, designer, comm a, teacher, lecturer] b.1889, Chicago, IL / d.1965, Glen Ellyn, IL.*
Addresses: Chicago, IL; Gen Ellyn, IL. **Studied:** George Sensensy; Bertha Jacques; DeForest Shook; Anthony Buchta; Saugatuck Sch. Art. **Member:** Artists Gld., Chicago; Austin, Oak Park & River Forest Art Lg.; Cliff Dwellers; Calif. PM; Am. Color Print Soc.; Chicago SE (secy., 1946). **Exhibited:** Southern PM; Chicago SE, Calif. PM & Am. Color Pr. Soc., annually. Awards: prizes, Chicago SE, 1948, 1955; Chas. Muller prize, 1939; Georgia, 1940; Nat. Art Ann., 1945; Graphic prize, 1954. **Work:** AIC; Smithsonian Inst.; Nat. Coll. FA (Smithsonian). **Comments:** Lectures: color aquatint etching & printing. **Sources:** WW59; WW47.

THOMPSON, Frances Louise *[Painter, miniaturist, lecturer, teacher] b.1879, Hagerstown, MD.*
Addresses: Wash., DC, active 1902-23. **Studied:** ASL; Maryland

Inst.; Académie Julian, Paris with J.P. Laurens. **Member:** Wash. AC; Soc. Wash. Artists. **Exhibited:** PAFA Ann., 1903; Soc. Wash. Artists; Wash. WCC; Wash. AC. **Work:** Maryland Hist. Soc. **Comments:** Specialty: portraits, miniatures. **Sources:** WW04; WW29; McMahan, *Artists of Washington, DC;* Petteys, *Dictionary of Women Artists;* Falk, *Exh. Record Series.*

THOMPSON, Francis Alpheus *[Painter] b.1838, Maine / d.1905, possibly Santa Barbara, CA.*
Work: Santa Barbara Hist. Soc. (8 works). **Sources:** G&W has information courtesy Katharine Hastings, Santa Barbara Hist. Soc.; Brewington, 378.

THOMPSON, Fred *[Etcher] early 20th c.*
Addresses: Waltham, MA. **Sources:** WW19.

THOMPSON, Fred D. *[Painter] b.1851 / d.1930.*
Addresses: Providence, RI. **Member:** Providence WCC. **Exhibited:** S. Indp. A., 1925-26. **Sources:** WW29.

THOMPSON, Frederic Louis *[Painter, sculptor] b.1868, Middleboro, MA / d.After 1933.*
Addresses: NYC/Chilmark, MA. **Studied:** G.H. McCord; Salvatore Bilotti; Swain Free School Design. **Member:** SC; Soc. des Beaux-Arts. **Comments:** Felt he was inspired by the spirit of R. Swain Gifford to paint works similar to those of the deceased Gifford. Later acquitted of attempting to poison his wife. **Sources:** WW25; Blasdale, *Artists of New Bedford,* 188-89 (w/repro.).

THOMPSON, Frederick *[Painter, teacher] b.1904, NYC / d.1956.*
Addresses: NYC. **Studied:** NY Sch. Des.; ASL with Frank V. DuMond; Douglas J. Connah. **Member:** AAPL. **Exhibited:** NAD, 1941; Corcoran Gal. biennials, 1943, 1945; Albany Inst. Hist. & Art, 1941; All. Artists Am., 1942; Berkshire Mus., 1941 (solo); NY Univ.,1943 (solo). **Sources:** WW53; WW47.

THOMPSON, Frederick A. *[Painter] d.1919.*
Addresses: Portland, ME. **Member:** Brushians (Maine, later group). **Comments:** Position: architect. Contrib. *Pine Tree Magazine.* He was the second member of the Brushians group to be nicknamed, "The Deacon." **Sources:** Casazza, *The Brushians,* 10-11.

THOMPSON, Fred(erick) H. *[Pictorialist photographer] b.1844, Deering Center, ME / d.1909.*
Addresses: Portland, ME. **Comments:** In 1908, after collaborating with Wallace Nutting (see entry) he founded the Thompson Art Co. in Portland, ME, and became one of the primary competitors (along with David Davidson and Charles H. Sawyer) to Nutting's control of the tourist and middle class market for hand-colored pictorialist photographs. His images included New England landscapes, colonial interior scenes, tall-masted sailing ships. Perhaps too competitive, he committed suicide by ingesting cyanide. His son, Frederick M. Thompson, ran the business from 1909-23. **Sources:** Ivankovitch, 224.

THOMPSON, Fred(erick) M. *[Pictorialist photographer] b.1876 / d.1923.*
Studied: Tufts Univ. **Comments:** The son of Fred H. Thompson, he successfully continued his father's business and added new pictorialist images. The business peaked from 1910-20, but closed upon his death. He continued to sign both his and his father's images as "Fred Thompson." **Sources:** Ivankovitch, 224.

THOMPSON, Gabriel *[Painter] early 20th c.*
Addresses: Paris, France. **Sources:** WW10.

THOMPSON, George Albert *[Landscape painter, teacher] b.1868 / d.1938.*
Addresses: New Haven, CT, 1898; Mystic, CT. **Studied:** Yale Univ Sch. FA; John La Farge; in Paris with Merson, Blanc, Courtois, Girardot. **Member:** New Haven PCC (first pres., 1905); Mystic AA (founder, 1913, pres., 1930); CAFA. **Exhibited:** NAD, 1898;

SAA 1898; PAFA Ann., 1899-1901, 1907-16; Corcoran Gal. biennials, 1916-23 (4 times); New Haven PCC, 1924 (prize); AIC. **Work:** Bruce Mus., Greenwich, CT; Nat. Gal., Uruguay. **Comments:** Best known for his Connecticut landscapes and coastal scenes, particularly his atmospheric nocturnes painted around the harbors of Bridgeport, Norwalk, Mystic, and New Haven. Teaching: Yale Univ. Sch FA. **Sources:** WW38; Falk, *Exh. Record Series.*

THOMPSON, George Louis *[Designer] b.1913, Winnetoon, NE / d.1981.*
Addresses: NYC. **Studied:** Univ. Minn. (B.S.A.); MIT (M.S.). **Exhibited:** 5 Steuben Traveling Exh., 1936-53; WFNY, 1939; Designs in Glass by 27 Contemp. Artists, New York, 1940; British Artists in Crystal, New York, 1954; Poetry in Crystal, New York, 1966. **Awards:** Boston Soc. Arch. Prize & class medal, MIT, 1936. **Work:** MMA; Palais Louvre, Paris, The Hermitage, Leningrad, USSR; William Rockhill Nelson Gallery Art, Kansas City, MO; Nat. Gallery Mod. Art, New Delhi, India. Commissions: Eisenhower Cup, comn. by his cabinet, Washington, DC, 1953; Papal Cup, Cardinal Spellman, New York, 1956; Lafayette Medallion, Collection Press René Coty, France, 1957; Ange Stele, Kennedy Found., 1962; Eleanor Roosevelt Mem., Eleanor Roosevelt Lib., 1971. **Comments:** Positions: sr. designer, Steuben Glass, New York, 1936-. **Sources:** WW73; *Poetry in Crystal* (1963) & *Five Masterworks* (1972, Steuben Glass).

THOMPSON, Georgette Rosamond *[Painter, designer, illustrator, craftsperson, teacher] b.1905, New Orleans, LA.*
Addresses: New Orleans. **Studied:** Newcomb College, Tulane Univ. (B. Des.); Chicago Acad. FA; ASL; Will Stevens; Ruth Van Sickle Ford; Woodward; Werntz; G.D. Smith. **Member:** New Orleans AA; SSAL. **Exhibited:** New Orleans AA, 1927-46 (prize, 1933); SSAL, 1927-40 (prize, 1930); Chicago No-Jury Soc., 1928; Soc. Indp. A., 1937, 1941. **Work:** New Orleans Assn. Commerce; Louisiana College, Pineville, LA. **Sources:** WW59.

THOMPSON, Gilbert *[Painter, topographer] b.1839, Blackstone, MA / d.1909, Wash., DC.*
Addresses: Wash., DC. **Exhibited:** Wash. WCC. **Comments:** Worked in the printing trade after his schooling and enlisted in the U.S. Army in 1861. He took part in Western explorations and surveys; and during 1890-98, commanded the Engineer Battalion of the DC militia. From 1880 he was employed with the U.S. Geological Survey, continuing to paint in his spare time. **Sources:** McMahan, *Artists of Washington, DC.*

THOMPSON, Guy H. *[Painter] early 20th c.*
Addresses: New Harbor, ME. **Exhibited:** S. Indp. A., 1930-31. **Sources:** Marlor, *Soc. Indp. Artists.*

THOMPSON, H. G. *[Painter] 20th c.*
Exhibited: Salons of Am., 1934; S. Indp. A., 1935. **Sources:** Marlor, *Salons of Am.*

THOMPSON, Hannah *[Impressionist painter, etcher, craftsperson, teacher] b.1888, Philadelphia, PA / d.Pasadena, CA.*
Addresses: Pasadena, CA, active 1916-27. **Studied:** William Chase; Ronald Pissano. **Member:** Calif. AC; Calif. SE. **Exhibited:** Calif. AC, 1918; Calif. PM, 1916-25. **Sources:** WW27; Hughes, *Artists of California,* 556.

THOMPSON, Harriet L. *[Illustrator] early 20th c.*
Addresses: Wash., DC, active 1915-20. **Work:** U.S. Nat. Arboretum. **Comments:** Position: illustr., U.S. Dept. of Agriculture. **Sources:** McMahan, *Artists of Washington, DC.*

THOMPSON, Harriette K. *[Miniature painter] early 20th c.*
Addresses: Hartford, CT. **Sources:** WW24.

THOMPSON, Harry *[Painter] 19th/20th c.; b.London.*
Addresses: Buffalo, NY, 1908, 1910. **Studied:** Paris, with Maréchal and Busson. **Exhibited:** Paris Salon, 1882 (prize), 1884 (med.); Paris Expo 1889 (med.); AIC, 1908 (with Buffalo address). **Comments:** There is some confusion surrounding this artist. Bénézit and Thieme-Becker list him as a British artist who

exhibited in Paris and died in London in 1901. However, in the WW10 (American Annual, vol. 10), a Harry Thompson is listed as living in Buffalo, born in London, and with the same exhibition record as that listed for the Harry Thompson in Bénézit. The latter dictionary also reports that Harry Thompson was married to Ellen Kendall Baker (see entry), who in WW08 was listed as living Puteaux, France, and Buffalo, NY. This must mean that the previously reported death date is incorrect (perhaps it was 1910, not 1901?). **Sources:** WW10; Bénézit; Thieme-Becker; Falk, *AIC*.

THOMPSON, Harry Ives *[Portrait and figure painter, teacher] b.1840, West Haven, CT / d.1906, West Haven, CT.* **Addresses:** New Haven, CT, 1878-82; Paris, France, 1890. **Studied:** Benjamin H. Coe, 1861. **Exhibited:** PAFA Ann., 1877, 1879-80, 1884; NAD, 1877-90. **Comments:** Started out as a storekeeper and became an artist in 1861. Taught drawing in New Haven, c.1864 -67, where he gained a local reputation as a portrait painter. **Sources:** G&W; French, *Art and Artists in Connecticut*, 147-48; Smith. More recently, see Campbell, *New Hampshire Scenery*, 164; Falk, *Exh. Record Series*.

THOMPSON, Helen Foht *[Painter] b.1900, Cleveland, OH.* **Addresses:** Poland, OH. **Studied:** Elmira (NY) College; Youngstown (OH) College; Clyde Singer. **Member:** Friends of Am. Art. **Exhibited:** Mill Creek Park Art Exh., 1940 (prize); Mahoning County Fair, 1942 (prize); Parkersburg FA Center, 1942-1946; Bridgeport, CT, 1942; Ohio Valley Exh., Athens, OH, 1944, 1946; Massillon Mus., 1942-44, 1946; State Teachers College, Indiana, PA, 1946; Butler AI, 1941, 1943-46 (prize). **Sources:** WW53; WW47.

THOMPSON, Helen Lathrop (Mrs. Laurence M.) *[Painter] b.1889, Wilkes-Barre, PA.* **Addresses:** Vineyard Haven, MA. **Studied:** Wilkes-Barre Inst.; Vassar College (A.B.); Corcoran Sch. Art; Wayman Adams Sch. Art; Famous Artists Sch. **Member:** Lg. Am. Pen Women; Nat. Soc. Pastellists; Wash. Soc. FA. **Exhibited:** Woman's Univ. Club, Phila., 1939 (solo); Alexandria, VA, 1944 (solo; prize); Univ. Binghamton, NY (solo); Martha's Vineyard, MA, 1959-61; Wash. Soc. FA. **Sources:** WW59; WW47.

THOMPSON, Helen S. (Mrs. Henry S.) *[Painter] early 20th c.* **Addresses:** Concord, MA. **Member:** Concord AA. **Sources:** WW25.

THOMPSON, Henry *b.c.1800, Ireland.* **Addresses:** NYC in 1860. **Sources:** G&W; 8 Census (1860), N.Y., XLV, 513.

THOMPSON, Henry Clark *[Painter] early 20th c.* **Addresses:** Bogota, NJ. **Exhibited:** S. Indp. A., 1928. **Comments:** Possibly Thompson, Rev. Henry C., b. 1863-d. 1940, Dover, NJ. **Sources:** Marlor, *Soc. Indp. Artists*.

THOMPSON, Herbert E. *[Museum conservator] b.1877, Lexington, MA / d.1932.* **Addresses:** Waltham, MA. **Comments:** Restorer of paintings: BMFA; CGA; Freer Art Gal., Wash., DC; Nat. Gal. Art, Ottawa, Canada; Gardner Mus., Boston.

THOMPSON, Hiram H. *[Mural painter, portrait painter.] b.1885, Cincinatti, OH.* **Addresses:** NYC. **Studied:** AIC; Chicago Acad. FA;. W. Ufer. **Member:** Palette & Chisel Acad. FA. **Exhibited:** Davenport Munic. Art Gal., 1930 (prize). **Work:** mural, Am. Commercial Bank, Davenport, IA; Davenport Munic. Art Gal. **Sources:** WW40.

THOMPSON, J. Woodman *[Painter] early 20th c.* **Addresses:** Pittsburg, PA. **Member:** Pittsburg AA. **Sources:** WW21.

THOMPSON, James *[Portrait painter] mid 19th c.; b.Scotland.* **Addresses:** Charleston, SC in January 1827. **Comments:** Sailed from Belfast (Ireland) in October 1826. He had relatives at Pawtucket (RI). **Sources:** G&W; Rutledge, *Artists in the Life of Charleston*, 133.

THOMPSON, (James) Bradbury *[Designer, art director] b.1911, Topeka, KS.* **Addresses:** Riverside, CT. **Studied:** Washburn Univ. (A.B., 1934; D.F.A., 1965). **Member:** Art Dirs. Club (first vice-pres.; exec. comt.); SI; Am. Inst. Graphic Arts (bd. dirs.); Alliance Graphique Int.; Nat. Soc. Art Dirs. (rep., 1958-64). **Exhibited:** Int. Exh. Graphic Art, Paris, France, 1955, London, England, 1956, Milan, Italy, 1961, Amsterdam, 1962 & Hamburg, Germany, 1964; traveling solo exh., Am. Inst. Graphic Art, 1958. **Awards:** Wash. Univ. Distinguished Service Award; Gold T-Square Award, Nat. Soc. Art Dirs., 1950; multiple awards, Art Dirs. Club. **Work:** Commissions: book design for *Annual of Advertising Art*, 1943 & 1954, *Graphic Arts Production Yearbook*, 1948 & *500, Westvaco Inspirations & American Classics*, 1939-72, *Homage to the Book*, 1968 & *The Quality of Life*, 1968. **Comments:** Positions: art dir., Capper Publ., 1934-38; art dir., Rogers, Kellogg, Stillson, Inc., 1938-41; art dir., Off. War Info, 1942-45; art dir., *Mademoiselle*, 1945-59; publ. art dir., Street & Smith Publ., 1945-59; consult. Westvaco Corp., 1945-; des. dir., *Art News & Art News Ann.*, 1945-72; art dir., *Living for Young Homemakers*, 1947-49; consult., Famous Artists Schs., 1959-; consult., McGraw Hill Publ., 1960-; consult., Time-Life Books, 1964-70; consult., *Harvard Bus. Review*, 1964-67; consult., Field Enterprises Educ. Corp., 1964-; consult., Cornell Univ., 1965-. Publications: auth., *The Monalphabet*, 1945 & *Alphabet 1926*, 1950. Teaching: Sch. Art & Arch., Yale Univ., 1956-; bd. gov., Phila. College Art, 1956-59. **Sources:** WW73.

THOMPSON, Janet Reid *[Painter] early 20th c.* **Addresses:** Wausau, WI/Chicago ,IL. **Exhibited:** AIC, 1923. **Sources:** WW24.

THOMPSON, Jared D. *[Portrait painter, line engraver] mid 19th c.* **Addresses:** NYC in 1852 and later. **Studied:** Nathaniel Jocelyn at New Haven in 1850. **Exhibited:** Nat. Acad., 1852-53. **Sources:** G&W; Rice, "Life of Nathaniel Jocelyn"; Cowdrey, NAD; NYCD 1852; Stauffer.

THOMPSON, Jerome B. *[Portrait, landscape & genre painter] b.1814, Middleboro, MA / d.1886, Glen Gardner, NJ.* **Addresses:** NYC, 1835-52; England, 1852-c.55; Long Island, NY and Glen Gardner, NJ, from c. 1855. **Studied:** England, independently, 1852. **Member:** ANA, 1851. **Exhibited:** Am. Acad. FA, 1835; NAD, 1835-86; PAFA, 1851-52, 1863, 1865; Brooklyn AA, 1861-81. **Work:** BM; BMFA. **Comments:** Son of portraitist Cephas Thompson (see entry) who discouraged his Jerome's artistic desires (he wanted him to farm) and destroyed many of his paintings. As a teenager, Jerome moved to Barnstable, MA, with his sister and worked as a sign and ornamental painter. In 1835, he opened a portrait a studio in NYC. His "Pic Nic, Camden, Maine" (BMFA), which was exhibited at the NAD in 1850 and the next year at the PAFA, won him recognition and launched his career in genre-landscape painting. From 1852-c.1855, he went to England for independent study. On his return he settled on a farm at Mineola, Long Island, later moving to a farm at Glen Gardner, NJ. He painted in the Berkshires (of Massachusetts) and in Vermont. Many of his sentimental genre-landscape scenes were distributed as lithographs, further ensuring his financial success, and he appears to have stopped exhibiting in 1865. **Sources:** G&W; DAB; Karolik Cat., 492-93; Cowdrey, NAD; Naylor, NAD; Cowdrey, AA & AAU; NYCD 1837-53; Swan, BA; Rutledge/Falk, PA, vol. 1; Falk, PA, vol. 2; *Encyclopaedia of New Orleans Artists*, 375; P & H Samuels, 484-85; Baigell, *Dictionary*; *300 Years of American Art*, vol. 1, 163.

THOMPSON, Joanne *[Painter, sculptor] mid 20th c.;
b.Chicago, IL.*
Addresses: San Clemente, CA. **Studied:** Univ. Colorado;
Gilkerson, Los Angeles. **Member:** AAPL; Artists Guild Chicago;
Acad. Artists; Wolfe Prof. Women's Club. **Exhibited:** Nat. Arts
Club Gal., NYC, 1965-69; Mus. FA, Springfield, MA, 1965-70;
AAPL Grand Nat., New York, 1966-70; Hammond Mus.,
Westchester, NY, 1968; Am. Gals., 1968 & 1970 (solos);
Showcase Gallery, Laguna Beach, CA, 1970s. **Awards:** Best of
Show/Jury's Choice, Orange Co. Fair, CA, 1964; hon men. for
still life, Acad. Artists, 1967; first prize for sculpture, Mt.
Prospect, IL, 1968. **Work:** Am. Gals., Northfield, IL. **Comments:**
Preferred media: oils, bronze, conté. Teaching: oil painting, Am.
Gals., 1967-68. **Sources:** WW73; Catharine Lorillard Wolfe Prof.
Women's Show, catalogues (Nat. Art Club Gallery, 1965-69);
Grand Nat. Show, catalogue (AAPL, 1970); *The Art of Technique
and Color* (Grumbacher, 1973).

THOMPSON, John *[Wood engraver] b.c.1804, Ireland.*
Addresses: Philadelphia in 1860. **Sources:** G&W; 8 Census
(1860), Pa., LX, 643.

THOMPSON, John *[Portrait & miniature painter, silhouettist]
early 19th c.*
Addresses: NYC, 1803-05; Halifax (NS), 1809; Kingston
(Jamaica); Charleston, SC, 1810. **Comments:** In Charleston, he
advertised that he could execute portraits, miniatures, profiles, fig-
ures for rings and lockets, transparencies, views of estates, coats
of arms, antiquities for antiquarians, landscapes, birds, flowers,
and patterns for ladies to draw or work. **Sources:** G&W; NYCD
1803-05; Piers, "Artists in Nova Scotia," 119-20; Rutledge, *Artists
in the Life of Charleston.*

THOMPSON, John C. *[Wood engraver] mid 19th c.*
Addresses: Providence, RI, 1852-60. **Sources:** G&W;
Providence CD 1852, 1854-60; New England BD 1856, 1860.

THOMPSON, John D. (or G.) *[Engraver] late 19th c.*
Addresses: Wash., DC, active 1865-92. **Comments:** Position:
staff, U.S. Coast and Geodetic Survey. **Sources:** McMahan,
Artists of Washington, DC.

THOMPSON, John Edward *[Painter, designer, teacher]
b.1882, Buffalo, NY / d.1945.*
Addresses: Denver, CO. **Studied:** ASL-Buffalo with L.W.
Hitchcock; ASL-NYC; Académie Julian, Paris with J.P. Laurens,
1907; also with Blanche, Cottet & Tudor-Hart in Paris. **Member:**
Denver AG; Denver Art Mus. **Exhibited:** Corcoran Gal. biennials,
1935, 1937; WFNY, 1939; Denver Club, 1929 (prize); AIC.
Work: Nat. Bank Bldg., Polo Club, St. Martin's Chapel, Art Mus.,
all in Denver; CGA. **Comments:** Teaching: Univ. Denver.
Sources: WW40.

THOMPSON, John H. (Mrs.) *[Artist] late 19th c.*
Addresses: Detroit, MI. **Exhibited:** Detroit, Michigan State Fair,
1878; Detroit Mus. Art, 1886 (first annual show). **Sources:**
Petteys, *Dictionary of Women Artists.*

THOMPSON, John W. *[Painter] early 20th c.*
Addresses: NYC. **Studied:** ASL. **Exhibited:** S. Indp. A., 1928-
30, 1932. **Sources:** Marlor, *Soc. Indp. Artists.*

THOMPSON, Juliet Hutchings *[Painter] b.1873, NYC /
d.1956, NYC.*
Addresses: Washington, DC, c.1894-c.1905; NYC, from c.1905.
Studied: Corcoran Art Sch.; ASL, Wash., DC; Académie Julian,
Paris with J.P. Laurens & Constant, c.1899; Kenneth H. Miller
(probably at the W.M. Chase school). **Member:** NY Women's AC;
NY Munic. Art Soc.; NAC; Soc. Wash. Artists; Wash. WCC; Soc.
Indep. Artists; The Pastellists (formed in 1910, holding four exhs.
until its demise in 1915; Thompson was an officer in the group,
other members included Elmer MacRae, Leon Dabo, Arthur
Davies, William Glackens and Jerome Myers). **Exhibited:** PAFA
Ann., 1894; Atlanta Expo., 1895 (bronze); Soc. Wash. Artists;
Wash. WCC, 1898; Paris Salon, 1899; NAD, 1901-25; The
Pastellists at Folsom Gals., Jan., 1911 & Dec., 1911; NAC, Feb.,

1914; S. Indp. A., 1917; Knoedler Gal., 1921, NYC (solo);
Salons of America, 1922-23; Brown-Bigelow Comp., 1925
(prize); Marie Sterner Gals., NYC, 1940 (solo), 1941 (solo);
Pinacotheca, NYC, 1943 (solo); Bonestell Gal., NYC, 1945
(solo). **Work:** NMAA; Phillips College, Wash., DC. **Comments:**
Specialized in pastel portraits. After moving back to her native
NYC c.1905, she continued her association with Washington, DC,
exhibiting there in the 1920s and 1930s and maintaining a friend-
ship with Alice Pike Barney (see entry). Thompson painted a por-
trait of Mrs. Coolidge at the White House in 1927; she also pro-
duced likenesses of President Coolidge, President Wilson, and
Wilson's cabinet. **Sources:** WW33; McMahan, *Artists of
Washington D.C.;* Petteys, *Dictionary of Women Artists;* American
Pastels in the Metropolitan Museum of Art (New York:
Metropolitan Museum of Art, distributed by Harry N. Abrams,
1989), 20-21; Falk, *Exh. Record Series.*

THOMPSON, Kate E. *[Painter, architect, teacher, writer]
b.1872, near Middletown, Orange County, NY.*
Addresses: Pompton Plains, NJ. **Studied:** ASL with K.H. Miller,
G. Bridgman. **Member:** AAPL. **Work:** mural, Office Dir. Pub.
Health. **Sources:** WW40.

THOMPSON, Katherine *[Painter] early 20th c.*
Addresses: NYC. **Exhibited:** S. Indp. A., 1923. **Sources:**
Marlor, *Soc. Indp. Artists.*

THOMPSON, Kenneth Webster *[Illustrator, painter]
b.1907, NYC.*
Addresses: NYC. **Studied:** E. Pape; H. Ballinger; W. Adams;
Grand Central Sch. Art; George Pierce Ennis. **Member:** SI (life
mem.; dir.); AWCS; Nantucket AA (dir.); Artists Guild (dir.).
Exhibited: AWCS,1936-38; SI; AG; Nantucket AA. **Awards:**
eight awards, NY Art Dir. Club; thirteen awards, Chicago Art Dir.
Club; three awards, NJ Art Dir. Club. **Work:** wartime illustra-
tions, LOC. **Comments:** Preferred media: gouache, watercolors.
Publications: illustr., *The Continent We Live On* (series), 1962-68;
illustr., *The Sea,* 1966. **Sources:** WW73.

THOMPSON, Launt *[Sculptor] b.1833, Abbeyleix, County
Queens, Ireland / d.1894, Middletown, NY.*
Addresses: Albany, NY, 1847; NYC, 1857-82. **Studied:** E.D.
Palmer, Albany 1848-57. **Member:** NA, 1862. **Exhibited:** NAD,
1862-82; Brooklyn AA, 1862, 1866; PAFA Ann., 1878.
Comments: Came to U.S. in 1847. He worked in Albany under
Erastus Dow Palmer for nine years. In 1857, he moved to NYC
where he became a successful sculptor, producing portraits and
ideal figures. In 1867 he spent several months in Rome; he
returned to Italy in 1875 for a six-year stay. **Sources:** G&W;
DAB; Taft, *History of American Sculpture;* Cowdrey, NAD; Falk,
Exh. Record Series.

THOMPSON, Laura Jones (Mrs. Richard H.) *[Painter,
educator] b.1899, Muncie, IN / d.1963.*
Addresses: Winnetka, IL. **Studied:** Northwestern Univ. (B.M.E.);
Columbia Univ. (B.S.; M.A.); AIC; George Buehr; Charles
Longabaugh. **Member:** Muncie AA; North Shore AA; All-Illinois
Soc. FA; Hoosier Salon. **Exhibited:** CGA, 1943; Denver AM,
1936; Hoosier Salon, 1940-46; Evanston Woman's Club, 1940-46
(prizes, 1941, 1942); Stevens Hotel, Chicago (solo); Drake Hotel,
Chicago (solo); Winnetka Community House, ann.; Winnetka
Woman's Club, 1940-46. **Work:** Winnetka Woman's Club.
Sources: WW53; WW47.

THOMPSON, Leslie Prince *[Painter, teacher, architect]
b.1880, Medford, MA / d.1963.*
Addresses: Newton Centre, MA. **Studied:** Mass. Normal Art
Sch.; BMFA Sch. (won 1904 Paige Traveling Scholarship); E.L.
Major; E.C. Tarbell. **Member:** NA, 1937; Newport AA; Gld.
Boston Artists; St. Botolph Club. **Exhibited:** PAFA annuals,
1901-35 (gold 1919, prize 1927); St. Louis Exp., 1904 (med.);
Corcoran Gal. biennials, 1907-37 (15 times); NAD, 1911 (prize);
Newport AA, 1914 (prize); Pan-Pacific Expo., 1915 (med.);
Sesqui-Centennial Expo., Phila., 1926 (med.); Boston AC, 1900-

928 (prize); AIC. **Comments:** Painted at Fenway Studios, Boston, 1909-10, 1920-24, 1925-47. Teaching: BMFA Sch., 1913-30. **Sources:** WW59; WW47; Vose Galleries, *Mary Bradish Titcomb and Her Contemporaries*, 35; Falk, *Exh. Record Series*.

THOMPSON, Lewis Eugene *[Painter, educator, critic, writer, lecturer]* *b.1894, Hillsdale, MI.*
Addresses: Dayton 3, Ohio. **Studied:** Hillsdale College; Univ. Michigan; in Europe and Canada. **Member:** North Shore Artists Gld.; Inst. Aeronautical Science; Dayton Wright Air Mail Soc.; Am. Air Mail Soc.; Aviation Comn., Dayton. **Exhibited:** Chicago, 1939; No-jury exh., Chicago, 1941, 1942; McGuire Gal., Richmond, IN, 1956; Barn Colony Studio, Decatur, 1956; U.S. Air Force Mus., Dayton. Awards: prizes, Chicago, 1939; Dayton, 1950. **Work:** State of Michigan Coll.; U.S. Govt.; Republic of France; State of North Carolina; USPO Dept.; Pentagon, Wash., DC; Munic. Airport, Decatur; lib., Air Force Sch. Tech., Dayton; religious paintings & ports., Emmanuel Catholic Church, Mt. Enon Baptist Church, Allen Methodist Church, all in Dayton; St. John's Methodist Church, St. Johns, OH. **Comments:** Position: art instr., So. Michigan, 1922-36; chief, art dept., Aircraft Laboratories, Wright-Patterson Field, Dayton, OH, 1942-47; private & public instr., 1924-. Auth.: "American Aviation History." **Sources:** WW59.

THOMPSON, Lockwood *[Collector]* *b.1901, Cleveland, OH.*
Addresses: Cleveland, OH. **Studied:** Williams College (A.B., 1923); Harvard Law Sch. (LL.B., 1926). **Comments:** Positions: mem. adv. council, CMA, 1949; mem. int. council, MoMA, 1962. Collector of contemporary art. **Sources:** WW73.

THOMPSON, Lorin Hartwell, Jr. *[Mural painter, decorator, etcher, illustrator, lithographer, teacher]* *b.1911, Pittsburg, PA.*
Addresses: Pittsburg, PA. **Studied:** A. Kostellow, N. MacGilvary; S. Rosenberg, E. Warner, E.M. Ashe; CI. **Member:** Pittsburg AA. **Exhibited:** 48 States Comp., 1939 (prize); AIC. **Work:** WPA murals, USPOs, Altoona, PA, Mercer PA, Pascagoula, MS; murals, Aluminum Co. Am.; Mellon inst., Pittsburg; Somerset (PA) H.S.; Duquesne Club, Pittsburg. **Comments:** Teaching: Ad-Art Studio Sch., Pittsburg. **Sources:** WW47.

THOMPSON, Louise B. *[Painter]* *b.c.1895, Wash., DC / d.1961, Wash., DC.*
Addresses: Wash., DC. **Member:** Wash. AC (charter mem.). **Sources:** McMahan, *Artists of Washington, DC*.

THOMPSON, Louise Guthrie *[Painter, teacher]* *b.1902, Oklahoma.*
Addresses: Los Angeles, CA, active 1930s. **Studied:** UCLA. **Member:** Calif. WCS; Calif. Art Teachers Assoc. **Comments:** Teaching: UCLA, 1928. **Sources:** WW40; Hughes, *Artists in California*, 56.

THOMPSON, Lovett *[Sculptor, painter, jeweler, craftsman]* *mid 20th c.*
Exhibited: Brandeis Univ.; Studio Mus., Harlem, 1969-70; BMFA, 1970; Nat. Center Afro-Am. Artists, 1969. **Sources:** Cederholm, *Afro-American Artists*.

THOMPSON, M. A. (Mrs.) *[Artist]* *late 19th c.*
Addresses: NYC, 1877; Los Angeles, c.1893-95. **Exhibited:** NAD, 1877. **Sources:** Petteys, *Dictionary of Women Artists*.

THOMPSON, M. P. (Mrs.) *[Artist]* *late 19th c.*
Addresses: NYC, 1879. **Exhibited:** NAD, 1879. **Sources:** Naylor, *NAD*.

THOMPSON, Malcolm Barton *[Painter, sculptor]* *b.1916, Coraopolis, PA.*
Addresses: Georgetown, CT. **Studied:** Pratt Inst. (grad.); ASL; illustr. with Nicolas Riley. **Exhibited:** Soc. Casein Artists, New York, 1970; Slater Mem. Mus., Norwich, CT, 1971; Conn. WCS, Hartford, CT, 1971; Mainstreams 1971, Marietta, OH, 1971; AWCS, New York, 1972; Lord & Taylor Galleries, NYC,1970s. Awards: Marjorie Salembier Award, Conn. Classic Arts, 1968; first prize, New Canaan Art Show, 1970; Grumbacher Acrylic Award, AAPL, 1971. **Work:** Commissions: U.S. Army in Action

Ser., Pentagon, 1949. **Comments:** Preferred media: acrylics, watercolors. Teaching: McLane Art Inst., New York, 1938-40. **Sources:** WW73.

THOMPSON, Margaret A. Howard *[Sculptor]* *mid 20th c.*
Addresses: Washington, DC. **Exhibited:** Soc. Wash. Artists, 1937-38, 1940; Wash. SMPS&G, 1939. **Sources:** WW40.

THOMPSON, Margaret Whitney (Mrs. Randall) *[Sculptor]* *b.1900, Chicago, IL.*
Addresses: Phila., PA; Wellesley Hills, MA. **Studied:** PAFA; Charles Grafly; Schoukieff in Paris. **Member:** Phila. Art All. **Exhibited:** PAFA Ann., 1921. **Sources:** WW31; Falk, *Exh. Record Series*.

THOMPSON, Marguerite See: **ZORACH, Marguerite Thompson (Mrs. William)**

THOMPSON, Marietta Tintoretto *[Miniaturist]* *b.1803, Middleboro, MA / d.1892, Raynham, MA.*
Addresses: NYC, 1831; active in New Bedford, MA area, 1831-41. **Work:** Old Dartmouth Hist. Soc. **Comments:** Daughter of Cephas and sister of Cephas G. and Jerome B. Thompson (see entries). Their artistic leanings discouraged by their father, Marietta and Jerome left home in the early thirties and, after working a short time in Barnstable (MA), settled in NYC in 1835. Marietta is said to have been quite successful as a miniaturist. **Sources:** G&W; Thompson, *A Genealogy of Descendants of John Thomson, of Plymouth*, 75; DAB, under Jerome B. Thompson; Blasdale, *Artists of New Bedford*, 189-91 (w/repro.).

THOMPSON, Marjorie See: **THOMAS, Marjorie**

THOMPSON, Martin E. *[Architect]* *b.c.1786 / d.1877, Glen Cove, Long Island.*
Member: NA (a founder in 1826). **Exhibited:** NAD (drawings). **Comments:** Starting as a carpenter in NYC early in the 19th century, Thompson made his name as an architect with his designs for the 2nd Bank of the United States and the Merchants' Exchange. From 1827 he was in partnership with Ithiel Town. He retired in 1864 to Glen Cove, LI. **Sources:** G&W; DAB; Cowdrey, NAD; NYCD 1823-52.

THOMPSON, Marvin Francis *[Painter, block printer, etcher]* *b.1895, Rushville, IL.*
Addresses: Chicago, IL. **Studied:** Chicago Acad. FA; L. Ritman; D. Viciji. **Exhibited:** AIC, 1925-26, 1932. **Work:** "Hunters," Pere Marquette Hotel, Peoria, IL. **Comments:** Specialty: Southwest. **Sources:** WW40.

THOMPSON, Mary See: **CARRIEL, Mary (Mrs. C. A. Thompson)**

THOMPSON, Mary See: **BIRGE, Mary Thompson (Mrs. Edward)**

THOMPSON, Mary Tyson See: **TYSON, Mary (Mrs. Kenneth Thompson)**

THOMPSON, Mildred *[Painter, sculptor]* *late 20th c.*
Addresses: Germany. **Studied:** Hamburg, Germany. **Exhibited:** Salons of Am., 1934; Howard Univ., 1961, 1970. **Sources:** Cederholm, *Afro-American Artists*.

THOMPSON, Mills See: **THOMPSON, (William) Mills**

THOMPSON, Morley P. *[Painter]* *early 20th c.*
Addresses: San Francisco, CA. **Exhibited:** Oakland Art Gallery, 1932. **Sources:** Hughes, *Artists in California*, 557.

THOMPSON, Myra *[Painter, sculptor]* *b.1860, Manry County, TN.*
Addresses: Nashville, Spring Hill, TN; NYC; Paris, France, 1909. **Studied:** Augustus St. Gaudens, French, Injalbert, Eakins at NAD, PAFA, ASL & Acad. Grand Chaumière. **Member:** S. Indp. A. **Exhibited:** PAFA Ann., 1887-88, 1909; S. Indp. A., 1918-23. **Comments:** Painted portraits, landscapes, and flowers in oil; sculpted portraits busts and statues. **Sources:** WW25; Petteys, *Dictionary of Women Artists*; Falk, *Exh. Record Series*.

THOMPSON, Nellie Louise *[Miniature painter, sculptor]* 19th/20th c.; b.Jamaica Plain, Boston.
Addresses: Boston, MA. **Studied:** Sir J. Linton; South Kensington Sch., London, with Alyn Williams, Miss Ball Hughes, London; Cowles Art Sch., Boston, with De Camp; H.B. Snell; J. Wilson; R.N. Burnham; B. Pratt; C. Dallin. **Member:** Copley Soc., 1893; MacD. C. (allied member); North Shore AA; Gloucester SA; Boston SS. **Exhibited:** Boston AC, 1887, 1896-1905; Copley Gal., Boston, 1911 (solo); PAFA Ann., 1921. **Sources:** WW33; Petteys, *Dictionary of Women Artists;* Falk, *Exh. Record Series.*

THOMPSON, Paul Leland *[Painter, craftsperson]* b.1911, Buffalo, IA.
Addresses: Washington, DC; Plainfield, NJ. **Studied:** Calif. Sch. FA; Corcoran Sch. Art; Heinrich Pfieffer, Provincetown, MA. **Member:** Soc. Wash. Artists; Landscape Club Wash.; Artists Equity NY; Artists Equity NJ; NJWCS; Hunterdon Co. AC; Plainfield AA. **Exhibited:** Corcoran Gal. biennial, 1945; Honolulu Acad. Art, 1936 (prize); SAM, 1937, 1939; Soc. Wash. Artists,1944-46 (prize, 1946); Landscape Club Wash., 1945 (prize), 1946; Int. Gal., Wash., DC, 1946 (solo); Wash. Pub. Lib., 1946; CPLH Nat. Exh., San Fran., 1949; Nat. Watercolor Exh., NAD, 1956; AC Oranges, 1957 (first prize for watercolor); Statewide Exh., Hunterdon Co. AC, 1964-67, 1972 (first prize for oil painting, 1964; second prize for oil painting, 1967); Barton Barry Gal., Scotch Plains, NJ, 1970s. **Work:** Marine Ins. Co, Pittsburgh, PA; Fairleigh Dickinson Univ., Rutherford, NJ. Commissions: two murals, Shiloh Baptist Church, Plainfield, NJ, 1957. **Comments:** Preferred media: oils, acrylics, watercolors. **Sources:** WW73; WW47.

THOMPSON, Ralston Carlton *[Painter, educator]* b.1904, Ironton, OH.
Addresses: Springfield, OH. **Studied:** Wittenberg Univ. (A.B., 1925); Dayton AI, 1925-26; Chicago Acad FA, 1932-33; Ohio State Univ. (M.F.A., 1938); Columbia Univ. **Member:** Archaeological Inst. Am.; CAA. **Exhibited:** Columbus Gal. FA, 1937-39; AIC, 1943 (Int. Exh. Watercolors), 1946 (Ann. Exh. Am. Watercolors & Drawings), 1948; Newport AA, 1944; Dayton AI, 1944, 1945-48 (prizes), 1950-51 (prizes); Ohio Valley Exh., Athens, OH, 1944, 1945-46 (prizes); Denver Art Mus., 1944; Oakland Art Gal., 1945; Butler AI, 1944-45, 1946-48 (prizes); Los Angeles Mus. Art, 1945; VMFA, 1946; NAD, 1945, 1947-48, Pepsi-Cola, 1946; Springfield AA, 1946, 1948 (prizes); Corcoran Gal. biennials, 1947, 1959; Ohio State Fair, 1948-51 (prizes); Canton AI, 1950 (prizes); Walker AC;Syracuse Mus. FA; PAFA; Oakland Art Gal.; CM; Decatur AC; William Rockhill Nelson Gal. Art; Swope Art Gal.; Muncie Art Gal.; SFMA; CI, 1955; "Drawings USA," St. Paul (MN) Gal. Art, 1961; "Art Across America," Mead Corp., 1965. **Work:** Cincinnati (OH) Art Mus.; Butler Inst. Am. Art, Youngstown, OH; Dayton AI; Columbus (OH) Gal. FA; Chubb Gal., Ohio Univ., Athens; Wittenberg College; Canton AI; mural, Ohio Steel Co., Lima. **Comments:** Teaching: Cincinnati Art Acad., 1949-50; mem. visual arts working artists adv. panel, Ohio Arts Council, 1967-69; Ohio State Univ., 1935-41; chmn. fine arts dept., Wittenberg Univ., 1941-65, prof. fine arts, 1947-69. **Sources:** WW73; WW47.

THOMPSON, Ray (F. Raymond) *[Illustrator, writer, cartoonist, teacher]* b.1905, Philadelphia, PA.
Addresses: Fort Washington, PA. **Studied:** PAFA; Spring Garden Inst., Phila.; Graphic Sketch Club; PM Sch IA; Temple Univ., 1926-27 & 1950-52; Mus. Sch. Art, Phila.; Spring Garden Inst., Phila.; Charles Morris; Price Sch. Journalism & Advertising, Phila. **Comments:** Position: car., "Myra North," comic strip, N.E.A. Service, 1934-39; comic panel, "Homer the Ghosts," *NY Herald-Tribune* Syndicate. Preferred medium: watercolors. Publications: auth./illustr., *You Can Draw a Straight Line!,* 1963; auth./illustr., *Washington Along the Delaware,* 1970; auth./illustr., *Washington at Germantown,* 1971; auth./illustr., *Betsy Ross, Last of Philadelphia's Free Quakers,* 1972. **Sources:** WW73; WW47.

THOMPSON, Richard *[Painter]* b.1945.
Addresses: Albuquerque, NM. **Exhibited:** WMAA, 1975, 1981. **Sources:** Falk, *WMAA.*

THOMPSON, Robert Louis See: **THOMPSON, Bob (Robert Louis)**

THOMPSON, Robert W. *[Painter, sculptor]* mid 20th c.
Addresses: Berkeley, CA, active late 1930s. **Exhibited:** San Francisco AA, 1937. **Sources:** Hughes, *Artists in California,* 557.

THOMPSON, Rodney *[Illustrator]* early 20th c.
Addresses: NYC. **Member:** SI, 1912. **Sources:** WW13.

THOMPSON, Russ *[Painter]* b.1922, Kingston, Jamaica.
Studied: Pratt Inst.; Carlyle College; NY Sch. Mod. Photography. **Exhibited:** MoMA; BM, 1968; Nordness Gals., NYC; Phila. Civic Center; Ruder & Finn FA, 1969; Smithsonian Inst.; Mount Holyoke College, 1969; BMFA, 1970; RISD, 1969; Mem. Art Gal., Rochester, NY, 1969; SFMA, 1969; Contemp. Arts Mus., Houston, TX, 1970; NJ State Mus., 1970; Roberson Center for the Arts & Sciences, Binghampton, NY, 1970; UC Santa Barbara, 1970; Plaza Hotel, NYC; Westchester Art Soc. Gal. (prize); Nassau Community College; Brooklyn Pub. Lib.; Allentown (PA) Art Festival; Quinnipiac College, CT; Parrish Art Mus.; NY State Pavillion; Huntington Township Art Lg. Awards: Mitchell College, CT; BM; Armonk Lib. Show Award; Bedford Hills Lib. Show Award. **Work:** Frederick Douglass Inst., Wash., DC; Spiro & Levinson Co.; Unigraphic Co. **Sources:** Cederholm, *Afro-American Artists.*

THOMPSON, S. B. *[Painter]* early 20th c.
Addresses: Jersey City, NJ. **Exhibited:** S. Indp. A., 1928. **Sources:** Marlor, *Soc. Indp. Artists.*

THOMPSON, Sears *[Painter]* early 20th c.
Addresses: New England. **Comments:** See mention under T. Bailey.

THOMPSON, Seymour *[Painter]* mid 20th c.
Addresses: NYC. **Member:** SI. **Sources:** WW47.

THOMPSON, Susie Wass *[Painter]* b.1892, Addison, ME.
Addresses: Addison, ME. **Member:** Kennebec Valley AA; AFA. **Exhibited:** Solos: Colby College, 1959-60, Northeast Harbor, ME, 1958, 1962, 1963 & 1965, Pietrantonio Gal., NYC, 1963; Blue Hills, ME, 1966 & Rochester, NY; Stanford Univ., Research Inst., 1957 (solo); Bowdoin College, 1957; Maine St. Art Festival, 1960-61. **Work:** Univ. Maine, Orono. **Sources:** WW73.

THOMPSON, Thomas *[Landscape, marine & portrait painter, lithographer]* b.1775, England / d.1852, New York.
Addresses: active in and around NYC, 1828-52. **Member:** ANA, 1834. **Exhibited:** English & Irish views; New England & Hudson River landscapes & marines. **Comments:** A native of England who is said to have come to America as early as 1813. **Sources:** G&W; Little, "Thomas Thompson, Artist-Observer of the American Scene," six repros.; Cummings, *Historic Annals,* 235; Stokes, *Iconography,* III, 593; Cowdrey, NAD; Cowdrey, AA & AAU; Rutledge, PA; Brooklyn CD 1841-47; Thieme-Becker; BAI, courtesy Dr. Clark S. Marlor, reports birth date of 1767.

THOMPSON, Thomas Hiram *[Painter]* b.1876, San Francisco, CA.
Addresses: Spokane, WA, 1902, 1903. **Studied:** self-taught. **Member:** Spokane (WA) Art Lg. **Exhibited:** San Francisco AA, 1902; Spokane, WA, 1902 (gold medal), 1903 (gold medal). **Comments:** Preferred media: oil, watercolor, pastel. **Sources:** Hughes, *Artists in California,* 557.

THOMPSON, Victor King *[Sculptor, architect]* b.1913, Columbus, OH.
Addresses: Columbus, OH. **Studied:** E. Frey; Ohio State Univ. **Member:** Columbus AL. **Exhibited:** Columbus Gal. FA, 1937 (prize). **Sources:** WW40.

THOMPSON, Walter W(hitcomb) *[Painter, lecturer, teacher]* b.1882, Palatka, FL / d.1948.
Addresses: Mayesville, SC. *[signature: Walter W. Thompson]*
Studied: Univ. Florida; W.T. Robinson; C.W. Reed; V. George; New Sch. Des., Boston; J. Enneking. **Member:** North Shore AA; AAPL; Sumter (SC) AA; Georgia AA; Savannah AC; Beaufort FAA (pres.); Carolina AA. **Exhibited:** Telfair Acad. Art, 1935-37, 1939; Savannah AC; Coker College, Hartsville, SC, 1935, 1939-41; Gibbes Art Gal., 1937, 1939; North Shore AA, 1943-46; Mint Mus. Art, 1942, 1944-46; Macbeth Gal.; Ainslie Gal.; Milch Gal. **Work:** Lander College, Greenwood, SC. **Comments:** Positions: co-founder/dir., Beaufort (SC) Art Colony; dir., Beaufort (SC) Art Sch.; teacher, Beaufort (SC) Pub. Sch.

THOMPSON, Wilfred *[Painter]* late 19th c.
Addresses: NYC. **Exhibited:** PAFA Ann., 1896-97. **Sources:** Falk, *Exh. Record Series.*

THOMPSON, William *[Portrait painter, muralist]* mid 19th c.
Addresses: Worcester, MA in 1837; Harvard, MA in 1841. **Sources:** G&W; Sears, *Some American Primitives,* 3-5; information courtesy Clarence S. Brigham, Am. Antiq. Soc.

THOMPSON, William A. *[Engraver]* 19th/20th c.
Addresses: Wash., DC (active 1865-92). **Exhibited:** Boston AC. **Comments:** Position: staff, U.S. Coast and Geodetic Survey. **Sources:** McMahan, *Artists of Washington, DC.*

THOMPSON, William John *[Portrait, miniature & genre painter]* b.1771, Savannah, GA / d.1845, Edinburgh, Scotland.
Addresses: London (1796-1812); Edinburgh (1812-on). **Member:** Royal Scottish Acad. (acad., 1829). **Exhibited:** Royal Acad., 1796. **Sources:** G&W; Bolton, *Miniature Painters;* Graves, *Dictionary.*

THOMPSON, William M. *[Engraver]* mid 19th c.
Addresses: Active in NYC from 1833-60. **Comments:** In the 1830s he was listed both as Thompson and Tompson. He was also an importer of English refined steel and copper plates for engravers. **Sources:** G&W; NYCD 1833-60; Am. Inst. Cat., 1850.

THOMPSON, (William) Mills *[Painter, decorator, mural painter, writer]* b.1875, Wash., DC.
Addresses: Wash., DC, active 1898-1907; Saranac Lake, NY, 1933. **Studied:** Corcoran Sch. Art; ASL, Wash.; ASL, NYC. **Member:** Wash. WCC; Soc. Wash. Artists; Cosmos Club; SC; Wash. Soc. FA; Phila. WCC. **Exhibited:** ASL, Wash., Cosmos Club, 1902. **Comments:** Contributed to the decorations at the LOC in 1896 and the Siam Building at the St. Louis Expo. Position: art ed., *Saturday Evening Post,* after 1907. **Sources:** WW33; McMahan, *Artists of Washington, DC.*

THOMPSON, William Norman *[Painter, lithographer, designer, illustrator]* b.1913, Washington, DC.
Studied: Abbot Sch. Des., Wash., DC; NAD; Corcoran Sch. Art. **Member:** Artists Gld. Wash. **Exhibited:** Artists Gld. Wash., 1944-46; "48 States Comp.," 1939. **Comments:** Illustr.: "Right of Fair Trial," 1942. Positions: art dir., U.S. Office Educ., 1936-43; art dir., Naval Aviation News, U.S. Navy, 1943-46. **Sources:** WW53; WW47.

THOMPSON, William R. *[Painter]* mid 20th c.
Exhibited: Corcoran Gal. biennial, 1951. **Sources:** Falk, *Corcoran Gal.*

THOMPSON, Willis *[Listed as "artist"]* early 20th c.
Addresses: Wash., DC. **Member:** Cosmos Club, 1905-44. **Sources:** McMahan, *Artists of Washington, DC.*

THOMPSON, Wilmer N. *[Painter]* mid 20th c.
Addresses: Seattle, WA (1940s). **Exhibited:** SAM, 1945-46. **Sources:** Trip and Cook, *Washington State Art and Artists.*

THOMPSON, Winifred Dorothy Gilliland *[Painter, designer, block printer, craftsperson, teacher]* b.1906, Memphis,

TN / d.1945, Camp Adair Army Hosp., OR.
Addresses: Albuquerque, NM. **Studied:** G. Cassidy; N. Hogner; K. Adams; R. Jonson; F. Parsons; E. Steinhof. **Member:** Art Lg. New Mexico; Albuquerque Art Guild. **Exhibited:** Albuquerque, 1934 (prize), 1935 (prize); Art Lg. New Mexico, 1936 (prizes); Prof. Artists Exh., State Fair, NM, 1939 (prizes). **Sources:** WW40.

THOMPSON, Woodman *[Painter, designer]* mid 20th c.; b.Pittsburg, PA.
Addresses: NYC. **Studied:** A.W. Sparks; G. Sotter, R. Holmes. **Member:** Pittsburg AA. **Comments:** Founder: Dept Stagecraft, CI. Specialties: set des.; mural paintings. **Sources:** WW40.

THOMPSON, Woodworth *[Painter]* mid 19th c.
Work: MMA (oil painting of Bruton Parish Church, Williamsburg, VA). **Sources:** Wright, *Artists in Virginia Before 1900.*

THOMPSON, Wordsworth See: **THOMPSON, Alfred Wordsworth**

THOMPSON & CROSBY *[Wood engravers]* mid 19th c.
Addresses: Providence, RI, 1852-54. **Comments:** Partners were John C. Thompson and James Crosby. **Sources:** G&W; Providence CD 1852, 1854.

THOMS, Herbert (Dr.) *[Etcher]* b.1885, Waterbury, CT.
Addresses: New Haven/Old Lyme, CT. **Member:** New Haven PCC; SC. **Exhibited:** WFNY, 1939. **Work:** New Haven PCC; Paris Expo, 1937. **Sources:** WW40.

THOMSEN, Sandor Von Colditz *[Sculptor]* b.1879, Chicago, IL / d.1914.
Addresses: Chicago, IL. **Studied:** L. Taft. **Comments:** Also a lawyer.

THOMSON *[Artist]*
Comments: Delineator of engraved portraits of Bishop Alexander V. Griswold and the Rev. Thomas F. Sargent. **Sources:** G&W; Stauffer, nos. 1992, 2716.

THOMSON *[Engraver]* mid 19th c.
Comments: His work appeared in *The Pictorial History of the American Navy* (N.Y., c. 1845). **Sources:** G&W; Hamilton, *Early American Book Illustrators and Wood Engravers,* 280.

THOMSON, Adele U(nderwood) (Mrs.) *[Painter, teacher]* b.1887, Grosbeck, TX.
Addresses: Corpus Christi, TX. **Studied:** AIC; Newcomb College, Tulane Univ., E.A. Holmes; W. Stevens; X. Gonzales. **Member:** SSAL; Lg. Am. Pen Women; Texas FAA; Corpus Christi Art Found.; South Texas Art Lg. **Exhibited:** NGA, 1946; Lg. Am. Pen Women; *Caller-Times* Exh., Corpus Christi; SSAL; Texas FAA, 1953 (solo); Corpus Christi Art Found., 1945 (prize), 1946 (prize); Corpus Christi Mus., 1953 (solo); Ballinger (TX) Lib. (solo); Kingsville College, 1954 (solo); Corpus Christi Little Theatre, 1954 (solo). **Sources:** WW47; Petteys, *Dictionary of Women Artists,* cites birth date as 1882.

THOMSON, Campbell *[Herald & coach painter, landscape painter, and gilder]* late 18th c.
Addresses: Williamsburg, VA in April 1774. **Sources:** G&W; *Virginia Gazette,* April 14, 1774.

THOMSON, Carl L. *[Art dealer, designer]* b.1913, Brooklyn, NY.
Addresses: NYC. **Studied:** Pratt Inst. with Arthur Schweider. **Member:** Salmagundi Club (vice-pres. & mem. bd. dirs.). **Exhibited:** Salmagundi Club Ann. Watercolor & Oil Shows, 1959-72. Awards: graphic arts award, Printing Industs. Am., 1969; cert. special merit, Printing Industs. Metrop New York, 1970. **Work:** Salmagundi Club; Burr Artists Group. **Comments:** Preferred medium: watercolors. Positions: advert. des., C. Thomson Assoc., 1947-59; art dir., Am. Home Prod. Corp., 1959-70; owner, Thomson Gallery, New York, 1970-. Teaching: Salmagundi Club, 1961-63. Specialty of gallery: contemporary and representational fine art. **Sources:** WW73.

THOMSON, Charles R. *[Painter] early 20th c.*
Exhibited: Salons of Am., 1927, 1934. **Sources:** Marlor, *Salons of Am.*

THOMSON, Edgar L. *[Painter] late 19th c.*
Addresses: Phila., PA. **Exhibited:** PAFA Ann., 1881. **Sources:** Falk, *Exh. Record Series.*

THOMSON, Frances Louise See: **THOMPSON, Frances Louise**

THOMSON, G. Forrest *[Sculptor] early 20th c.*
Addresses: Wash., DC, active 1920. **Sources:** McMahan, *Artists of Washington, DC.*

THOMSON, George *[Painter] b.1868, Claremont, Ontario / d.1965.*
Addresses: Ontario, Canada. **Studied:** F.V. DuMond; W.L. Lathrop; H. R. Poore. **Member:** CAFA; New Haven PCC. **Exhibited:** CAFA, 1915 (prize); AIC. **Sources:** WW33; *Art in Conn.: The Impressionist Years.*

THOMSON, H. V. *[Painter] early 20th c.*
Addresses: NYC. **Exhibited:** S. Indp. A., 1931. **Sources:** Marlor, *Soc. Indp. Artists.*

THOMSON, H(enry) G(rinnell) *[Painter] b.1850, NYC / d.1937.*
H.G. Thomson
Addresses: NYC, 1881-82; Wilton, CT (1885-on). **Studied:** Univ. Michigan, c.1870; privately with W.M. Chase, 1879; NAD; ASL. **Member:** S. Indp. A.; SC; Silvermine GA; AFA; AAPL; Wilton Lib. Assn. (founder, 1895). **Exhibited:** NAD, 1881-97; PAFA Ann., 1893-97; AWCS, 1898; SAA,1898; S. Indp. A., 1917-37; Salmagundi Club, c.1922-29; Salons of Am., 1931, 1933; AIC; Wilton Pub. Lib., 1937 (mem. exh.); Cooley Gal., Old Lyme, CT, 1988 (retrospective). **Comments:** While working under W.M. Chase he painted luxuriant still lifes and interiors; with his move to Connecticut in 1885 he turned toward Impressionist landscape painting bearing stylistic affinities with those of J.A. Weir and Willard Metcalf. In 1899, he painted in Alaska during the Goldrush. **Sources:** WW38; exh. cat., Cooley Gal., Old Lyme, CT (1988); Falk, *Exh. Record Series.*

THOMSON, James See: **THOMPSON, James**

THOMSON, James P. *[Wood engraver] mid 19th c.*
Addresses: Cincinnati, 1859-60. **Comments:** Of Davenport & Thomson (see entry) **Sources:** G&W; Cincinnati CD 1859, BD 1860.

THOMSON, John See: **THOMPSON, John**

THOMSON, Josephine N. (Mrs. J. C.) *[Painter] b.1872, Indianapolis, IN / d.1928, NYC.*
Addresses: NYC. **Studied:** Acad. Colarossi. **Member:** Pen & Brush Club; NAWPS; Allied AA; NYWAC. **Exhibited:** S. Indp. A., 1917. **Sources:** WW27.

THOMSON, Kate Chandler *[Painter] b.1870, San Francisco, CA / d.1948, Mill Valley, CA.*
Addresses: San Francisco, CA; Paris, France; London, England, ca. 1918-45; Mill Valley, CA, 1946-48. **Member:** Royal Soc. Arts (fellow); Royal SMP (vice-pres.). **Exhibited:** San Francisco AA, 1889; Mark Hopkins Inst., 1898; Mechanics' Inst., 1899; Oakland Art Fund, 1905; Walkers Galleries, London, 1932 (solo); United Artists' Exh., Royal Acad. Arts, 1942; Studio 12, San Francisco, 1948 (solo); St. Helena (CA) Lib., 1987 (retrospective). **Work:** Royal Soc. Arts; Royal WCS; Imperial War Mus.; Victoria & Albert Lib.; Chichester Cathedral; Royal Family. **Comments:** She spent WWI in Paris and helped at a bureau for refugees. Positions: illustr., *Selborne Magazine* and other British periodicals in London. After surviving WWII in London, she returned to California. Specialty: watercolors of floral miniatures, portraits, scenes of Paris, Rome and London. **Sources:** Hughes, *Artists in California*, 557.

THOMSON, Lucia B. *[Painter, journalist, pianist] b.1880, San Francisco, CA / d.1958, Mill Valley, CA.*
Addresses: San Francisco, CA; Mill Valley, CA. **Exhibited:** Mark Hopkins Inst., 1897. **Comments:** Sister of Kate Ch. Thomson (see entry). **Sources:** Hughes, *Artists in California*, 557.

THOMSON, M. Ruth *[Painter] early 20th c.*
Addresses: Bronx, NY. **Exhibited:** S. Indp. A., 1923. **Sources:** Marlor, *Soc. Indp. Artists.*

THOMSON, Mattibel *[Painter] mid 20th c.*
Exhibited: S. Indp. A., 1940. **Sources:** Marlor, *Soc. Indp. Artists.*

THOMSON, Meave See: **GEDNEY, Meave Thomson**

THOMSON, Rodney F. *[Illustrator, etcher] b.1878, San Francisco, CA.*
Addresses: NYC. **Studied:** Partington Sch. Illus. **Member:** Chicago SE; Artists Guild. **Sources:** WW32.

THOMSON, Sara K. *[Painter] early 20th c.*
Addresses: Ossining, NY. **Sources:** WW04.

THOMSON, Sarah *[Portraits in oil] 18th/19th c.*
Addresses: Massachusetts, c.1800. **Sources:** G&W; Lipman and Winchester, 181.

THOMSON, V. *[Painter] early 20th c.*
Exhibited: Salons of Am., 1934. **Sources:** Marlor, *Salons of Am.*

THOMSON, William *[Painter] 19th/20th c.*
Addresses: NYC. **Exhibited:** NAD, 1898; NYWCC, 1898. **Sources:** WW01.

THOMSON, William T. *[Portrait painter, illustrator, craftsperson] b.1858, Phila., PA.*
Addresses: Phila., PA. **Studied:** PAFA. **Member:** AC Phila.; Phila. Sketch Club; AAS; Phila. AA. **Exhibited:** Omaha Expo, 1898; PAFA Ann., 1900, 1902-03; AIC; AAS, 1902 (med.). **Sources:** WW40; Falk, *Exh. Record Series.*

THON, William *[Painter] b.1906, NYC.*
Addresses: Brooklyn, NY; Port Clyde, ME. **Studied:** ASL, 1924-25; Bates College (hon. D.F.A., 1957).
Thon
Member: ANA; Salmagundi Club; Brooklyn Soc. Art; Brooklyn P&S; All. Artists Am.; NIAL; Am. Acad. Arts & Letters (fellow). **Exhibited:** Salons of Am., 1934; Corcoran Gal. biennials, 1939-53 (7 times); VMFA, 1939-46; AIC, 1940-46; WMAA, 1941-58; PAFA Ann., 1941-66; Kansas City AI, 1942-46; Albright Art Gal., 1944-46; Pepsi-Cola Exh., 1944-46; BM, 1942 (prize), 1945 (prize); NAD, 1944 (prize), 1969 (Altman Prize); SC, 1942 (prize); Philadelphia WCC, 1968 (Dawson Medal); AWCS, 1970 (Gold Medal of Honor); Midtown Gal., NYC, 1970s. **Work:** Swope Art Gallery; MMA; Butler Inst. Am. Art; Munson-Williams-Proctor Inst., Utica, NY; CPLH; Bloomington (IL) AA; Farnsworth Gal., Rockland, ME. **Comments:** Positions: trustee, Am. Acad. in Rome. **Sources:** WW73; WW47; Falk, *Exh. Record Series.*

THÖNY, Wilhelm See: **THOENY, William**

THOR, Vic *[Painter] early 20th c.*
Exhibited: Salons of Am., 1934. **Sources:** Marlor, *Salons of Am.*

THORAME, Jean Pierre *[Professor of painting] mid 19th c.*
Addresses: Orleans College, New Orleans, 1822-32. **Sources:** G&W; Delgado-WPA cites CD 1822, 1827, 1830, 1832, and *Courier*, Sept. 27, 1824, Jan. 17, 1832.

THORBERG, Trygve *[Sculptor] early 20th c.*
Addresses: Brooklyn, NY. **Sources:** WW17.

THOREAU, Sophia *[Amateur artist] b.1819, Concord, MA / d.1876, Bangor, ME.*
Comments: Youngest sister of Henry David Thoreau. She was born in Concord (MA) and spent almost all her life there, moving to Bangor (ME) only a few years before her death. She painted in 1839 the only known life portrait of her brother, and she also

made a drawing of his cabin by Walden Pond. **Sources:** G&W; Sanborn, *Henry David Thoreau* (1892), 10, (1917), 338; *Art Digest* (Dec. 1, 1932), 16, repro.

THOREK, Max (Dr.) *[Photographer]* b.1880, Hungary. **Addresses:** Chicago, IL. **Member:** Royal Photogr. Soc., Great Britain (fellow); Fort Dearborn Camera Club; Chicago Camera Club; Pictorial Photogr. Am. **Comments:** Awards: 31 first prizes, 20 second prizes, 12 third prizes, 6 fourth prizes, 7 fifth prizes, 1 gold, 11 silver, 4 bronze, 45 honorable mentions, 25 certificates of merit, all during the year 1929. Most of his collection was destroyed in a fire. **Sources:** WW30.

THORESON, Maren Beerskee *[Landscape painter]* b.1882, Norway / d.1956, Camarillo, CA. **Addresses:** Los Angeles, CA. **Exhibited:** Calif. State Fair, 1937. **Sources:** Hughes, *Artists in California*, 557.

THORME, Dorthea *[Painter, sculptor, printmaker]* mid 20th c. **Addresses:** Los Angeles, CA, 1930s. **Exhibited:** Artists' Fiesta, Los Angeles, 1931; LACMA, 1940. **Sources:** Hughes, *Artists in California*, 557.

THORN, Anna L(ouise) *[Painter]* b.1878, Toledo, OH. **Addresses:** Toledo, OH. **Exhibited:** S. Indp. A., 1923. **Sources:** Marlor, *Soc. Indp. Artists.*

THORN, J. C. *[Painter]* b.1835 / d.1898. **Comments:** Painter of a landscape entitled "The Locks," sold in Philadelphia in 1938. **Sources:** G&W; Sherman, "Unrecorded Early American Painters" (Oct. 1943).

THORN, Linton *[Wood engraver]* d.After 1838. **Addresses:** NYC. **Exhibited:** NAD, 1835. **Sources:** G&W; Cowdrey, NAD; Lossing, *Memorial of Alexander Anderson*, 80.

THORNBERRY, Bernice *[Painter]* early 20th c. **Addresses:** Chicago, IL. **Member:** Chicago NJSA. **Sources:** WW25.

THORNBURG, Cleo Sara *[Printmaker]* mid 20th c. **Addresses:** Chicago area. **Exhibited:** AIC, 1948. **Sources:** Falk, AIC.

THORNBURG, Florence B. *[Artist]* late 19th c. **Addresses:** Los Angeles, 1887-91. **Sources:** Petteys, *Dictionary of Women Artists.*

THORNBURGH, F. K. *[Painter]* early 20th c. **Addresses:** NYC. **Studied:** Académie Julian, Paris, 1894-95. **Member:** GFLA. **Sources:** WW27.

THORNBY, Max See: **TORNBY, Max**

THORNDIKE, Charles Hall *[Landscape painter]* b.1875, Paris / d.1935. **Addresses:** Paris, France. **Studied:** Académie Julian, Paris with J.P. Laurens, 1893. **Member:** Paris AAA; Assn. Salon d'Automne; French Acad. (officer). **Exhibited:** PAFA Ann., 1912-13. **Comments:** Born to American parents. **Sources:** WW21; Fehrer, *The Julian Academy*; Falk, *Exh. Record Series.*

THORNDIKE, Charles Jesse (Chuck) *[Cartoonist, writer, illustrator, teacher, designer]* b.1897, Seattle, WA. **Addresses:** North Miami, FL. **Studied:** Univ. Wash.; Seattle Art Sch.; Calif. Sch. FA; Lee F. Randolph; Rudolph Schaefer; Harold Von Schmidt; Johonnot. **Member:** Jockey Club, Miami. **Exhibited:** Cartoon Mus., Orlando, FL; Traveling Exh. U.S. Army, Europe. **Work:** Smithsonian Inst., Wash., DC; Mus. Natural Hist., NYC; Mus. Arts & Sciences, Miami, FL; Cartoonists Exchange, Pleasant Hill, OH; Washington Sch. Art, DC. **Comments:** Positions: art dir., General Motors Acceptance Corp., NYC, 1928-31; art dir., U.S. Navy, 1941-46. Teaching: Commercial Art Sch., 1934-35; New York Sch. Des., 1935-36; Terry Art Sch., Miami, FL, 1948-51; Univ. Miami, 1951-70s. Contrib.: "The Artist," London, England; "Professional Arts Monthly." Auth./illustr.: "The Secrets of Cartooning," House Little Bks, 1935; "The Art of Cartooning," 1938; "The Art & Use of the

Poster," 1937; "Arts & Crafts for Children," 1938; "Seeing America the Easy Way," 1940; "Life Drawing and Anatomy," 1941; "Drawing for Money," 1941; Oddities of Nature (syndicated newspaper feature), 1948; co-auth., "It's Fun to Draw;" "Jr.'s Fun to Draw." **Sources:** WW73; WW47.

THORNDIKE, George Quincy *[Landscape painter]* b.1827, Boston, MA / d.1886, Boston. **Addresses:** NYC 1857-64, 1867; Newport, RI, 1865, 1868; Boston, 1885. **Studied:** Harvard College, 1847; in Paris, 1847. **Member:** ANA, 1861. **Exhibited:** NAD, 1857-85; Brooklyn AA, 1862; PAFA, 1861-63; Boston Athenaeum, 1857. **Comments:** An artist of apparently poor health, he studied in Paris and then remained in France for ten years. He shared a studio in the village of Dinard with painter John Lewis (his future brother-in-law). In 1857, Thorndike returned to NYC, and during the 1860s, he kept a studio at the Tenth Street Studio Bldg (NYC) and in Newport, RI where he painted Tonalist landscapes. Little is known about his 1868-86 period, except that by 1885 he was living in Boston. **Sources:** G&W; CAB; Thieme-Becker; Clement and Hutton; Harvard University, *Quinquennial Catalogue* (1890); Cowdrey, NAD; Rutledge, PA; Swan, BA. More recently, see Campbell, *New Hampshire Scenery*, 164; Robert Workman, *The Eden of America* (RISD, 1986, p.42).

THORNDIKE, John James *[Engraver]* b.c.1829, Massachusetts. **Addresses:** Boston, 1850-52. **Comments:** Lived with Nathaniel R. Thorndike, oil manufacturer. **Sources:** G&W; 7 Census (1850), Mass., XXVI, 327; Boston CD 1850-52.

THORNDIKE, Willis Hale *[Cartoonist, illustrator]* b.1872, Stockton, CA / d.1940, Los Angeles, CA. **Addresses:** San Francisco, CA; NYC; Los Angeles, CA. **Studied:** San Francisco AI; ASL; Académie Julian, Paris with J.P. Laurens and Constant, 1893. **Comments:** Positions: staff, *San Francisco Chronicle*, 1890s, *New York Herald* and *Baltimore Sun*, until 1915. **Sources:** WW13; Hughes, *Artists in California*, 558.

THORNE, Anna Louise *[Painter, etcher, lecturer, block printer]* b.1866, Toledo, OH. **Addresses:** Toledo, OH. **Studied:** AIC; Chicago Acad. FA; ASL; William Chase; Naum Los; Delacluse, M. Castelucho, Lhote, all in Paris, France. **Member:** Ohio Women Artists; Detroit Women P&S; Toledo Women Artists Soc.; Michigan Acad. Sciences, Arts & Letters. **Exhibited:** Salon de Français, Paris; PMA; NY Miniature Soc.; Scarab Club (prize); Detroit, MI (solo); Toledo Mus. Art (prize). **Work:** Toledo Zoo; murals, Toledo Pub. Lib., and in children's dept. **Sources:** WW59; WW47. More recently, see, Gibson, *Artists of Early Michigan*, 227. He states 1878 as her year of birth.

THORNE, Diana *[Illustrator, writer]* b.1895, Winnipeg, Canada. **Addresses:** NYC. *Diana Thorne* **Studied:** W. Strang. **Member:** Chicago SE; Calif. PM; NAWPS. **Comments:** Auth./Illustr.: "The Dog Basket," "The Human Comedy," "Your Dogs and Mine," "Wild animals," "Tails Up," "Polo," 1936 "Cats as Cats Can," 1937 "Kiki the Kitten." Illustr.: "Igloo," by J. Waldo, "A Mile of Freedom," by Helen Train Hilles, "Rrou," Maurice Genevoix. **Sources:** WW40.

THORNE, Henry Vane *[Landscape painter, teacher]* b.1826, England / d.Milwaukee, WI. **Addresses:** Milwaukee. **Comments:** A son of the English Lady Vane. He came to America and settled in Milwaukee in 1847, before he had reached his 21st birthday. **Sources:** G&W; Butts, *Art in Wisconsin*, 81.

THORNE, Irene C. *[Painter]* mid 20th c. **Addresses:** Drexel Hill, PA. **Exhibited:** PAFA Ann., 1936. **Sources:** Falk, *Exh. Record Series.*

THORNE, Joan *[Painter]* b.1943. **Addresses:** NYC. **Exhibited:** WMAA, 1972, 1981. **Sources:**

Falk, *WMAA*.

THORNE, John *[Scenic & panoramic artist] mid 19th c.*
Addresses: NYC in 1859. **Comments:** Probably the same as the English artist, aged 24, of the same name, who was at NYC in 1850. **Sources:** G&W; NYBD 1859; 7 Census (1850), N.Y., XLVI, 170.

THORNE, Linton See: **THORN, Linton**

THORNE, Thomas Elston *[Painter, art historian] b.1909, Lewiston, ME.*
Addresses: Guilford, CT, 1940; Williamsburg, VA, from 1943 until at least 1973. **Studied:** Portland Sch. Fine & Applied Art (cert., 1932); Yale Sch. FA (B.F.A., 1940); ASL with Reginald Marsh; A. Bower; Savage. **Member:** M. Assn. Univ. Prof.; College AA Am.; Virginia Art All.; Virginia Hist Soc.; Virginia Mus. FA; 20th Century Gallery; Assn. Preservation Virginia Antiquities; Boston AC; Gloucester SA; Boston Soc. Indp. A. **Exhibited:** PAFA, 1930 (Watercolor Show); Boston Soc. Indp. A., 1935-38; NYWCC, 1937, 1940; VMFA, 1945; Int. Watercolor Show, Baltimore, MD, 1946; Am. Drawing Ann., Norfolk, VA, 1961; Irene Leehe Mem. Exh., Norfolk, 1962. **Work:** Hobart College, Geneva, NY; murals, St. Lawrence Church, Portland; Old Williamsburg (painting), College William & Mary, Williamsburg, VA; Jamestown Creek (painting) & Deep Creek (painting), Colonial Williamsburg Found., VA. **Commissions:** "The Circus" (mural), Maine General Hospital, Portland, ME; 1932 (donated by Alexander Bower to children's ward); "James Blair" (mural), James Blair H.S., Williamsburg, 1961. **Comments:** Research: early painting in Virginia. Teaching: College William & Mary, 1940-70s. Publications: contrib., "The Earliest American Nude," *William & Mary Quarterly,* 1950; contrib., "Southern American Painting," 1954 & contrib., "William Byrd & the Duchess," 1963, *Magazine Antiques*; contrib., "Charles Bridges, Limner," *Art in Virginia,*. 1969. **Sources:** WW73; WW47.

THORNE, Vivianne E. *[Painter] early 20th c.*
Addresses: NYC. **Exhibited:** S. Indp. A., 1926. **Sources:** Marlor, *Soc. Indp. Artists.*

THORNE, Ward (Cheney) *[Painter] b.c.1910.*
Exhibited: S. Indp. A., 1940-41. **Sources:** Marlor, *Soc. Indp. Artists.*

THORNE, William *[Painter] b.1864, Delavan, WI / d.1956.*
Addresses: Delavan, WI; NYC, 1888-99. **Studied:** Académie Julian, Paris with J.P. Laurens, Constant, Lefebvre, and Doucet, 1889-90. **Member:** ANA, 1902, NA, 1913; SAA, 1893. **Exhibited:** NAD, 1888-99 (medal, 1888); Paris Salon, 1890, 1891 (prize), 1893; PAFA Ann., 1894; Pan-Am. Expo, 1901 (medal); Corcoran Gal. annuals, 1907-08. **Work:** CGA. **Sources:** WW53; WW47; Fink, *American Art at the Nineteenth-Century Paris Salons,* 396; Falk, *Exh. Record Series.*

W.T.

THORNSCHEIN, Isidor *[Portrait painter] b.1886 / d.1947.*
Addresses: NYC.

THORNTON, Alice Green *[Painter, block printer, lithographer, lecturer, teacher] b.1903, Shawnee, OK.*
Addresses: Edmond, OK. **Studied:** J. Martin; A. Young; Cox; Upjohn; B. Boas; Columbia. **Member:** Provincetown AA; Oklahoma AA; Mid-Western AA; Edmond AL. **Exhibited:** Annual Mid-Western Exh., Kansas City AI, 1932 (prize). **Comments:** Teaching: Central State Teachers College, Edmond, OK. **Sources:** WW40.

THORNTON, Amy G. *[Painter] b.c.1845 / d.1913, Brooklyn, NY.*
Addresses: Brooklyn, NY.

THORNTON, Anna Foster (Mrs. Harrison R.) *[Painter, block printer, illustrator] b.1905, Baltimore, MD.*
Addresses: Alexandria, VA; Baltimore, MD. **Studied:** Maryland Inst. (traveling scholarship, 1930); ASL. **Member:** Balt. AA; Balt. WCC. **Exhibited:** Salons of Am., 1934; PAFA, 1934. **Sources:** WW53; WW47; Falk, *Exh. Record Series.*

THORNTON, Anna Maria See: **BRODEAU, Anna Maria**

THORNTON, Arthur J. *[Painter] mid 20th c.*
Addresses: Bronx, NY. **Exhibited:** S. Indp. A., 1943-44. **Sources:** Marlor, *Soc. Indp. Artists.*

THORNTON, D. Calvert *[Painter] mid 20th c.*
Exhibited: S. Indp. A., 1937. **Sources:** Marlor, *Soc. Indp. Artists.*

THORNTON, Ellen (Nelly) See: **FISHER, Ellen (Nelly) Thayer (Mrs. Edward)**

THORNTON, (Eugene Von Note) 'Gene *[Illustrator, painter] b.1898, Hamilton, MO.*
Addresses: Kansas City, MO; NYC, 1951. **Studied:** C. Wilimovsky; L.L. Balcolm. **Member:** Kansas City SA. **Exhibited:** PAFA Ann., 1951. **Comments:** Contrib.: illustr./ed. features, *Foreign Service* magazine, *Household* magazine, *The Rotarian*; advertising illustr. **Sources:** WW40; Falk, *Exh. Record Series.*

THORNTON, Henry La Verne *[Sculptor] b.1906, Herrin, IL.*
Addresses: Hammond, IN. **Studied:** R. Josset; J. Martin. **Member:** Hoosier Salon; Hammond Lg. P&S. **Comments:** Position: tech. dir., Hammond Community Theatre. **Sources:** WW40.

THORNTON, John Havens *[Artist] b.1933.*
Addresses: Boston, MA. **Exhibited:** WMAA, 1967. **Sources:** Falk, *WMAA.*

THORNTON, Margaret Jane *[Illustrator, portrait painter, decorator] b.1913, Grove City, OH.*
Addresses: Grove City, OH. **Studied:** A. Schille; M. Russell, Columbus Art Sch. **Member:** Columbus AL. **Exhibited:** Ohio State Fair, 1938 (prize), 1939 (prizes). **Comments:** Teaching: Columbus Art Sch.; Maramor, Columbus. **Sources:** WW40.

THORNTON, Nancy M. *[Artist, teacher] mid 19th c.*
Addresses: Active in Oregon, 1847. **Comments:** Perhaps the first non-native artist to reside in Oregon. **Sources:** Trenton, ed. *Independent Spirits,* 107.

THORNTON, William *[Architect, draftsman, painter, author] b.1759, Virgin Islands (island of Jost Van Dyke) / d.1828, Washington, DC.*
Addresses: Philadelphia, 1788-94; Washington, DC, 1793-1828. **Studied:** Scotland. **Comments:** Thornton settled in America in 1787 and became a citizen the following year. While in Philadelphia he designed the Library Company building there and was associated with John Fitch in experiments in steam navigation. After the acceptance of his design for the U.S. Capitol at Washington in 1793, Thornton moved to Washington, where he spent the rest of his life. From 1794 to 1802 he was one of the commissioners for the District of Columbia and from 1802-28 he was in charge of the Patent Office. He also found time to write novels and scientific treatises, design private homes and public buildings, and draw and paint "with facility." His wife, born Anna Maria Brodeau (see entry), painted miniatures. **Sources:** G&W; DAB; Stauffer; Bolton, *Miniature Painters;* White, *The Jeffersonians,* 208-10.

THORP, Carl M. *[Painter] b.1912, Lubbock, TX.*
Addresses: California, 1928-c.1957. **Studied:** State Teachers College, San Diego; Acad. FA, San Diego, with Braun, Mitchell, Schneider. **Member:** Soc. Western Artists; Northern Calif. AA. **Sources:** Hughes, *Artists in California,* 558.

THORP, Earl Norwell *[Sculptor] d.1951.*
Addresses: Danbury, CT, 1947. **Member:** NSS. **Work:** USPO, Wrightsville, GA. **Comments:** WPA artist. **Sources:** WW47.

THORP, Hattie E. See: **ULLRICH, Hattie Edsall Thorp (Mrs. Albert H.)**

THORP, Rose B. *[Painter] early 20th c.*
Exhibited: Salons of Am., 1925. **Sources:** Marlor, *Salons of Am.*

THORP, William (Mrs.) *[Painter] early 20th c.*
Addresses: Meadville, PA, 1919. Sources: WW19.

THORP, Zephaniah *[Engraver] mid 19th c.*
Addresses: NYC, 1855-58. Sources: G&W; NYCD 1855-58.

THORPE, Carlton *[Painter] mid 20th c.*
Exhibited: NYPL, 1921; Atlanta Univ., 1942; Tanner Art Lg., 1944. Sources: Cederholm, *Afro-American Artists.*

THORPE, Dorothy Carpenter *[Craftsman, designer]* b.1901, Salt Lake City, UT.
Addresses: Glendale, CA. Studied: L.D.S. Univ., Salt Lake City, UT; Univ. Utah. Exhibited: glassware, Assistance Lg., Hollywood, 1939 (prize); Mus. Mod. Art, Wash., DC; Los Angeles Mus. Art, 1955; traveling exh., State Dept., 1956; NGA, 1956; Marshall Field, Chicago; Dallas, Houston & San Antonio, TX.; Seattle, WA & with leading firms in U.S. Work: CI.
Comments: Designer: table ensembles, linen, glassware. Sources: WW59; WW47.

THORPE, Edward *[Etcher] early 20th c.*
Addresses: East Orange, NJ. Sources: WW10.

THORPE, Everett Clark *[Painter, educator, illustrator, teacher, cartoonist]* b.1907, Providence, UT.
Addresses: Logan, UT in 1976. Studied: Los Angeles County AI; Utah State Univ. (B.S., 1942; M.F.A., 1951); Syracuse Univ.; Hans Hofmann Sch. Art; Otis AI; O. Oldfield; R.M. Pearson; R. Stackpole; Grosz; Nordfeldt; Sepeshy; Zerbe. Member: Nat. Soc. Mural Painters; Utah State Inst. FA; Fed.; All. Artists; Am. Assn. Univ. Prof.; Ogden AG; Logan Art Group. Exhibited: Utah State Inst. FA, 1946 (prize); CGA, 1941; Nat. Art Week, Wash., DC, 1938, 1939; Denver AM; Utah AC; 1938-45; Utah Univ., 1938-46; Utah Art at New York Madison Square, Hawthorn & Provincetown; Springville Nat.; Utah Biennial; Tucson Invitational; Maxwell Galleries. Awards: Terry Int., 1955; Springville Int., 1965-1967; Utah purchase award, Utah Inst., 1972. Work: Springville Nat. Gallery; Maxwell Galleries; Utah Inst. FA; Utah State Capitol Bldg.; Sigman Phi Epsilon Nat. Headquarters, Richmond, VA. Commissions: six murals, Sigman Phi Epsilon, Utah State Univ.; Provo Fed. Bldg., Fed. Govt., 12 Fonders; mural at state capitol, Utah State Univ. & Cache Co.; Tabernacle, Logan Stake; History of Communication, Utah State Univ. Lib., Senior Class 1969. Comments: Preferred media: oils, collages, acrylics, metalics. Publications: sports illustr., *Salt Lake Tribune*, 1938-40; sports illustr., *Deseret News*, 1941-; illustr., *New Art Education*, 1955; illustr., "Sayings of a Saint," 1960; illustr., "History of Biology," 1960. Teaching: Utah State Univ., 1934-. Art interests: portrait painting; mural design; sports & portrait illustration. Sources: WW73; *Looking Back on Everett Thorpe* (Merrill Gallery Art); Lendhart, *An American Artist* (Univ. Wyoming Press, 1971).

THORPE, Freeman *[Portrait painter]* b.1844, Geneva, OH / d.1922, Hubert, MN.
Addresses: Wash., DC. Exhibited: Soc. Wash. Artists, 1905; Nat. Gal. Art, 1950 (portrait of House Speaker Joseph Cannon). Work: portraits, Presidents, gov. officials, Wash., DC; Eisenhower Gal., Abilene, KS (Lincoln, delivering the Gettysburg Address). Comments: Studied art after the Civil War and had a special portrait studio on the roof of the U.S. Capitol in Wash., DC by 1870. Sources: McMahan, *Artists of Washington, DC.*

THORPE, George H. *[Engraver, copperplate printer]* mid 19th c.
Addresses: St. Louis, 1853-59. Sources: G&W; St. Louis CD 1853 (p. 36); BD 1854, 1859.

THORPE, Jayta Pauline (Polly Thorpe) *[Textile designer]* b.1912.
Addresses: Stamford, CT. Studied: G. Wiggins; NY Sch. Applied Des. for Women. Member: Springfield Art Lg.; Lyme AA. Exhibited: Salons of Am., 1934. Sources: WW40; Marlor, *Salons of Am.*

THORPE, John *[Painter] mid 19th c.*
Addresses: London (1834-73); NYC (1876). Exhibited: Royal Acad., London, 1834-73; NAD, 1868, 1876. Work: NY Hist. Soc. Sources: Brewington, 380.

THORPE, T. W. *[Painter] mid 19th c.*
Addresses: NYC. Exhibited: Am. Inst., 1856 (specimen of painting on a fire engine [No. 48]). Sources: G&W; Am. Inst. Cat., 1856.

THORPE, Thomas Bangs *[Landscape & portrait painter, author, journalist]* b.1815, Westfield, MA / d.1878, NYC.
Addresses: Louisiana, 1836-54; NYC, 1854-on; Brooklyn, NY, 1862-67. Studied: John Quidor, NYC. Exhibited: Am. Acad., 1833; in New Orleans: St. Charles Hotel, 1842; J.B.Steel's Bookstore, 1848, 1850; Phoenix House, 1850; Lyceum Lib., 1851; NAD, 1862-67; Brooklyn AA, 1864-78; PAFA Ann., 1876. Work: Louisiana State Legislature (portrait of Zachary Taylor). Comments: He showed an early interest in painting, exhibiting at the American Academy as early as 1833. In 1836 he left college to go to Louisiana, where he remained until 1854, dividing his time between painting and writing and editing. Returning to the East in 1854 he settled in NYC, practiced law for a short time, edited a newspaper, and served as an officer in the Civil War. After the war he became city surveyor of NYC and in 1869 an officer in the Customs House. Thorpe was the author of several articles on American artists, including Charles Loring Elliott. Sources: G&W; DAB; Cowdrey, AA & AAU; Cowdrey, NAD; NYCD 1854-60; G&W has information courtesy Milton Rickels, Porterville (CA), who is writing a biography of Thorpe; *Encyclopaedia of New Orleans Artists*, 375; Falk, *Exh. Record Series.*

THORSEN, Lars (Captain) *[Painter, etcher, framemaker]* b.1876, Norway / d.1952.
Addresses: Noank, CT. Studied: CAGA; Mystic AA; SC. Exhibited: S. Indp. A., 1923; CAGA, 1937 (prize). Work: Beach Coll., Storrs, CT; New Haven & Hartford Railway Co.; murals, Mariner's Savings Bank, New London, CT; Art Mus., Norway; Dayton AI; Mystic Seaport Mus. Comments: A sailor-artist, he often depcited ships in oil, watercolor, etching, and monotype. He also created a frame of 1,220 interlocking pieces of pine without any glue or nails. Sources: WW40; exh. cat., *Art and Artists of the Mystic Area* (Mystic AA, 1976).

THORSON, Louise *[Painter] early 20th c.*
Addresses: NYC. Member: Lg. AA. Sources: WW24.

THORWARD, Clara Schafer (Mrs.) *[Painter, craftsperson, etcher, teacher]* b.1887, South Bend, IN.
Addresses: NYC; South Orange, NJ. Studied: AIC; Cleveland Sch. Art; ASL; Hans Hofmann; Henry G. Keller; Thurn Sch. Modern Art. Member: Boston, SAC. Exhibited: CMA, 1925 (prize), 1926 (prize); Art Lg. Northern Indiana, 1932 (prize), 1938 (solo); Salons of Am., 1934; Montclair AM, 1939; Ringling AM, Sarasota, FL, 1939; Hoosier Salon; Lock Gal., Sarasota, 1939 (solo); Morton Gal., NY, 1940 (solo); Plaza Hotel, NY, 1940 (solo); Witte Mem. Mus., 1944 (solo); Palace FA, Mexico City, 1946 (solo); Acad. FA, Guatemala (solo); Int. Club, San Salvador (solo); Oklahoma AC (solo); Nat. Lg. Am. Pen Women, 1950 (prize). Sources: WW59; WW47; Marlor, *Soc. Indp. Artists,* cites a Clara S. Thorwood, who may be the same artist.

THORWOOD, Clara S. *[Painter] early 20th c.*
Addresses: NYC. Exhibited: Soc. Indp. Artists, 1926. Comments: Cf. Clara S. Thorward. Sources: Marlor, *Soc. Indp. Artists.*

THOURON, Henry Joseph *[Mural painter, teacher]* b.1851, Philadelphia, PA / d.1915, Rome, Italy.
Addresses: Phila., 1881, 1894. Studied: PAFA; Rome; Paris with Bonnât. Member: AC Phila.; Phila. WCC; Arch. Lg., 1903; U.S. Public Art Lg., 1897; PAFA fellow, 1909-15 (pres.). Exhibited: NAD, 1881, 1894; PAFA Ann., 1884-1905 (5 times); PAFA, 1901 (medal); Boston AC, 1885, 1896. Work: Cathedral St. Paul & St.

Peter Phila.; holy water fonts of green bronze, St. Patrick's Church. **Comments:** Teaching: PAFA. **Sources:** WW15; Falk, *Exh. Record Series.*

THOYSE, Thomas Bangs *[Artist] b.1815, Westfield, MN / d.1875, NYC.*
Addresses: active in Brooklyn, NY, 1862-78. **Sources:** BAI, courtesy Dr. Clark S. Marlor.

THRALL, A. N. *[Listed as "artist"] mid 19th c.*
Addresses: New Harmony, IN in 1850. **Sources:** G&W; Posey County BD 1850 (citation courtesy Wilbur D. Peat).

THRALL, Arthur *[Printmaker, educator] b.1926, Milwaukee, WI.*
Addresses: Appleton, WI. **Studied:** Wisc. State College, Milwaukee (B.S. & M.S.); Univ. Wisc.-Madison; Univ. Illinois, Urbana; Ohio State Univ. **Member:** SAGA; Boston PM; Calif. Soc. PM. **Exhibited:** Carnegie Int. Print Exh., Pittsburgh, 1951; Corcoran Gal. biennials, 1951-63 (5 times); "Young American Printmakers," MoMA, 1953; Smithsonian Inst., 1960 (solo); 14th Ann., BM, 1963 (purchase prize); PAFA annual, 1964; 143rd annual, NAD, 1967 (Cannon Prize); Assoc. Am. Artists, NYC, 1970s. Awards: Louis Comfort Tiffany Found. fellowship in graphics, 1963. **Work:** Butler Inst. Am. Art, Youngstown, OH; LOC; AIC; BM; Smithsonian Inst. Commissions: 100 print ed., NY Hilton Hotel, 1962. **Comments:** Preferred media: intaglio, acrylics. Teaching: Milwaukee-Downer College, 1956-64; Lawrence Univ., 1964-70s; Univ. Wisc-Madison, 1966-67. **Sources:** WW73; M. Fish, *Arthur Thrall, Wisconsin Architect* (1965); M. Harold, *Prize-Winning Graphics* (Margaret Harold Publ., 1965 & 1966); D. Anderson, *The Art of Written Forms* (Holt Rinehart & Winston, 1969).

THRALL, Donald *[Painter] mid 20th c.*
Addresses: Plymouth, MI. **Exhibited:** WMAA, 1953. **Sources:** Falk, *WMAA.*

THRALL, L. Campeau *[Painter] mid 20th c.*
Exhibited: S. Indp. A., 1935-36. **Sources:** Marlor, *Soc. Indp. Artists.*

THRASH, Dox *[Painter, etcher, lithographer, writer, lecturer designer, sculptor] b.1892, Griffin, GA / d.1965, Phila., PA.*
Addresses: Phila., from late 1920s. **Studied:** AIC with Seyffert, Poole, 1917-18 (before and after his service in WWI); Phila. Graphic Sketch Club with Earl Horter & with H.M. Norton, Phila., 1920s. **Member:** Phila. Pr. Club. **Exhibited:** Graphic Sketch Club, Phila., 1933-35; CGA, 1935; CI, 1937-38; PAFA, 1934-35, 1938-39; WFNY 1939-40; Am. Negro Expo., Chicago, 1940; South Side Community AC, Chicago, 1941; Atlanta Univ., 1942; Phila. Civic Center Mus.; PMA; Phila. Art All., 1942 (solo); Smithsonian Inst., 1948 (solo); James A. Porter Gallery, 1970; Newark Mus., 1971; Free Lib., Phila., 1987; Dolan/Maxwell Gal., Phila., 1989. **Work:** Print Dept., Free Lib., Phila. (collection of WPA prints); LOC; BMA; Lincoln Univ.; PMA; Bryn Mawr College; West Chester (PA) Mus. FA; NYPL; U.S. Govt. **Comments:** Worked for the Phila. Graphic Arts Div. of the WPA, 1935-42, producing portraits and urban and rural scenes related to African-American life. During these years he (along with Michael J. Gallager and H. Mesibov) developed an innovative graphic technique, an intaglio process that came to be called a cartograph. In order to support himself, he worked at many odd jobs throughout his life, including railroad worker, steamship steward, house painter, and laborer (at Phila. Navy Yard). Contributor to: *Art Digest.* Lectures: modern art appreciation. **Sources:** WW59; WW47; Cederholm, *Afro-American Artists.*

THRASHER, Elizabeth Asenath *[Painter, costume designer] b.1909 / d.1989, Puyallup, WA.*
Addresses: Puyallup, WA. **Exhibited:** Western Wash. Fair; locally. **Sources:** Trip and Cook, *Washington State Art and Artists.*

THRASHER, George See: **THRESHER, George**

THRASHER, Harry Dickinson *[Sculptor] b.1883, Plainfield, NH / d.1918, France during WWI.*

Addresses: Baltic, CT; NYC. **Studied:** A. Saint-Gaudens; Am. Acad., Rome (scholarship) 1911-14. **Member:** Mural Painters; NSS, 1917. **Exhibited:** PAFA Ann., 1917. **Sources:** WW17; Falk, *Exh. Record Series.*

THRASHER, Leslie *[Painter, illustrator] b.1889, WV / d.1936.*
Addresses: NYC/Setauket, NY. **Studied:** PAFA with Pyle, Chase, Anshutz; in Paris. **Member:** SC. **Comments:** He became a commercial artist at seventeen, and from 1924-30 painted hundreds of covers for *Liberty.* His covers, like those of Norman Rockwell, are full of character and homely American humor — yet in six years at *Liberty* Thrasher painted more covers than did Rockwell in his whole career with the *Sat. Eve. Post*! Thrasher died of smoke inhalation after fire destroyed his summer home. **Sources:** WW33; add'l info. courtesy Illustration House (NYC, essay #12).

THREADGILL, Robert *[Painter] b.1930, Salisbury, NC.*
Studied: Pratt Inst. (B.F.A.). **Exhibited:** Ligoa Duncan Gal., NYC, 1965 (prize); Raymond Duncan Gal., Paris, 1966; Lincoln Inst., 1967 (solo); Acts of Art Gal., NYC, 1972 (solo), 1973 (solo). **Work:** Nat. Archives; LACMA; Acts of Art Gal., NYC. **Sources:** Cederholm, *Afro-American Artists.*

THRESHER, Brainard B. *[Painter, craftsperson] early 20th c.*
Addresses: Dayton, OH. **Member:** SWA (assoc.). **Sources:** WW08.

THRESHER, George *[Marine painter, teacher of drawing & painting] early 19th c.*
Addresses: active in NYC, 1806-12; Philadelphia, 1813-17. **Work:** Mariners Mus., Newport News, VA; Yale Univ. AG. **Comments:** In Philadelphia he opened an academy for writing, drawing, painting, and bookkeeping. He was said to have taught previously in Europe. **Sources:** G&W; *Antiques* (Oct. 1945), 230+; NYCD 1809 (McKay); G&W has information courtesy Clarence S. Brigham, Am. Antiq. Soc.; Brewington, 381.

THROCKMORTON, Cleon (Francis) *[Painter, lecturer] b.1897 / d.1965, Atlantic City, NJ.*
Addresses: NYC. **Member:** Wash. AC; Guggenheim Fellowship, 1935. **Exhibited:** Corcoran Gal. biennials, 1919, 1921; Salons of Am., 1923; WMAA, 1924, 1926-27. **Work:** scenic designs for "Emperor Jones," "Desire Under the Elms," "The Verge," "Patience," "Wings of Chance," "All God's Chilluns Got Wings," "Criminal at Large," "House of Connelly," "In Abraham's Bosom" (Pulitzer prize), "Alien Corn," "Porgy". **Sources:** WW40.

THROCKMORTON, Roberta *[Artist] early 20th c.*
Addresses: Active in Washington, DC, 1910. **Sources:** Petteys, *Dictionary of Women Artists.*

THROOP, Benjamin F. *[Engraver, plate printer] b.c.1837, Washington, DC.*
Addresses: active in Washington from c.1858. **Comments:** A son of John Peter Van Ness Throop. In the late 1860s he was employed by the Treasury. **Sources:** G&W; 8 Census (1860), D.C., II, 392, 585; Washington CD 1858-71.

THROOP, Daniel Scrope *[Engraver] b.1800, Oxford, NY / d.Elgin, IL.*
Addresses: Utica, NY, 1824; Hamilton, NY, 1930; Elgin, IL. **Comments:** Younger brother of John P.V.N. and Orramel H. Throop (see entries). **Sources:** G&W; Fielding's supplement to Stauffer; Hamilton, *Early American Book Illustrators and Wood Engravers, 397.*

THROOP, Frances Hunt *[Still life painter] late 19th c.; b.NYC.*
Addresses: NYC, 1886-94. **Studied:** ASL; A. Stevens; Carroll Beckwith. **Exhibited:** Paris Salon, 1887, 1888; Woman's AC of NY, 1890 (one of the first members); Boston Brooklyn AA, 1885, 1891; NAD, 1886-94 (5 times); AIC. **Sources:** Petteys, *Dictionary of Women Artists;* Fink, *American Art at the Nineteenth-Century Paris Salons, 397.*

THROOP, George Addison (Mrs.) See: **GOLDSMITH, Deborah**

THROOP, John Peter Van Ness *[Copperplate & general engraver, lithographer] b.1794, Oxford, NY / d.c.1861, Washington, DC.*
Addresses: Washington, DC, c.1830-c.1860. **Comments:** Older brother of Orramel H. and Daniel S. Throop (see entries). He worked for Baltimore and NYC publishers. In Washington He was listed as J.V. or J.V.N. Throop. Sherman states that he also painted miniatures. Benjamin F. Throop (see entry) was his son. **Sources:** G&W; Fielding's supplement to Stauffer; Peters, *America on Stone;* Washington CD 1834-62; 7 Census (1850), D.C., I, 447; 8 Census (1860), D.C., II, 392; Sherman, "Unrecorded American Miniaturists."

THROOP, Orramel Hinckley *[Engraver] b.1798, Oxford, NY.*
Addresses: NYC in 1825; New Orleans in 1831-32; Wash., DC in 1846. **Comments:** He engraved landscapes and vignettes, as well as maps, charts, address cards and business forms. Probably a brother of John P.V.N. and Daniel S. Throop (see entries). **Sources:** G&W; Fielding's supplement to Stauffer; Delgado-WPA cites *La. Advertiser,* March 24, 1831, *Courier,* June 1, 1832, and *Emporium,* Sept. 28, 1832. More recently, see *Encyclopaedia of New Orleans Artists,* 376; McMahan, *Artists of Washington, DC.*

THRUM, Patty Prather See: **THUM, Patty P(rather)**

THRUSH, Helen Alverda *[Painter, teacher] b.1903.*
Addresses: Phila., PA. **Studied:** PM Sch. IA; Univ. Penn.; Columbia; Barnes Found., Merion, PA. **Member:** Southeastern AA. **Comments:** Contrib.: *School Arts; Design* magazines. Teaching: Univ. North Carolina. **Sources:** WW40.

THULIN, Emil O. *[Painter] early 20th c.*
Addresses: Chicago, IL. **Studied:** Académie Julian, Paris, 1919. **Exhibited:** AIC, 1920-22, 1925. **Sources:** WW24.

THULIN, Walfred *[Craftsperson] b.1878, Sweden / d.1949.*
Addresses: Belmont, MA/Stonington, ME. **Member:** Boston SAC; Copley Soc. **Exhibited:** Boston SAC, 1919 (medal). **Comments:** He emigrated to the U.S. in 1900, and soon his talent in woodcarving drew him into the Carrig-Rohane workshop (see entry) with H.D. Murphy and Ch. Prendergast. From 1912-40s, he ran his own shop in Boston. He signed his frames with his carved "WT" monogram. **Sources:** WW40; add'l info. courtesy Eli Wilner Co., NYC.

THULSTRUP, Thure (Bror) de
[Illustrator, painter] b.1848, Stockholm, Sweden / d.1930, NYC.
Addresses: New Orleans, LA active ca.1902; NYC. **Studied:** Paris, 1871 (following service in the French Foreign Legion). **Member:** Century Club; Players Club; AWCS; SI; John Ericksson Soc. **Exhibited:** Boston AC, 1881-83; AIC; Pan-Am. Expo, 1901; Louisiana Historical Soc., 1903; Art NAD, 1880-89; Brooklyn AA, 1881-84; Assoc. of New Orleans, 1904; St. Louis Expo, 1904. Award: Swedish Knight, Order of Vasa. **Comments:** A specialist in depicting military history, Thulstrup immigrated to Canada in 1875, at age 27, and then to NYC. For some years he was on the staff of the *New York Daily Graphic* and *Leslie's.* He was staff artist on *Harper's* for twenty years, covering the inaugurations of four Presidents and the funeral of General Grant. He went to New Orleans to make studies and sketches for the large historical painting "Hoisting American Colors, Louisiana Cession, 1803," which was exhibited in 1903-04. In his capacity of illustrator he visited most of the countries of Europe and went to Russia in 1888 to sketch the Kaiser of Germany on his visit to the Czar. He later produced some of the best-known paintings of American Colonial life. **Sources:** WW29; *Encyclopaedia of New Orleans Artists,* 107-08.

THUM, Patty P(rather) *[Painter, illustrator, writer] b.1853, Louisville, KY / d.1926.*
Addresses: Louisville, KY, 1885-99. **Studied:** H.V. Ingen, Vassar College; ASL with Chase, Mowbray, Wiles; MMA Sch. FA.; Thomas Eakins, mid-1880s at Student's Guild, Brooklyn AA. **Member:** Louisville AC. **Exhibited:** Columbian Expo, Chicago,

1893; NY State Fair, 1898; Trans-Mississippi Expo, Omaha, NE, 1898; Soc. Landscape Painters, 1898; Cincinnati; St. Louis Expo, 1904; NAD, 1885-99. **Work:** Louisville Pub. Lib.; Univ. Kentucky Art Mus., Lexington. **Comments:** Specialty: flowers, landscapes, portraits. Some of her works were lithographed and distributed throughout the country. Position: art critic, *Louisville Herald.* **Sources:** WW25; add'l info courtesy of Francis Smith, Bardstown, KY; Jones and Weber, *The Kentucky Painter from the Frontier Era to the Great War,* 66-67 (w/repro.).

THUM, William M. *[Painter] 19th/20th c.*
Addresses: Louisville, KY. **Member:** Louisville Art Lg. **Sources:** WW98.

THUN, Frederick *[Painter] b.1855.*
Addresses: Phila., PA. **Exhibited:** PAFA Ann., 1884 (watercolor). **Sources:** Falk, *Exh. Record Series.*

THURBER, Alice Hagerman (Mrs. Thomas L.) *[Painter, craftsperson, teacher] b.1871, Birmingham, MI / d.1952.*
Addresses: Birmingham, MI. **Studied:** J. Gies; Detroit Commercial Art Sch.; AIC with St. Pierre; F. Fursman; W.W. Kreghbeil; F.L. Allen. **Member:** Detroit Soc. Women P&S; Chicago NJSA; Detroit Soc. Indep. Artists; Michigan Acad. Sciences, Arts & Letters. **Exhibited:** Michigan IA, State Fair, 1915 (prizes); 1916 (prizes); 1928 (prize); 1935 (prize); S. Indp. A., 1929-31. **Work:** Comm. House, Birmingham, MI; painting, Michigan Lg. House, Univ. Michigan, Ann Arbor. **Comments:** Painted flowers and landscapes in oil and watercolor. **Sources:** WW40.

THURBER, Caroline Nettleton (Mrs.) *[Portrait painter] 19th/20th c.; b.Oberlin, OH.*
Addresses: Brookline, MA; Paris, France; Wash. DC., 1902. **Studied:** Helmick in Wash., DC; Académie Julian, Paris with J.P. Laurens & Benjamin-Constant, 1897-1901; also in Germany, Italy, England. **Member:** Copley Soc.; Boston AG. **Exhibited:** NAD, 1898; Paris Salon, 1899; AIC, 1899-1901; PAFA Ann., 1900-02;. **Work:** portraits; Smith College; Mt. Holyoke College; Oberlin College; Boston Univ.; Supreme Courts, Iowa, Rhode Island. **Comments:** (Mrs. Dexter) Specialty: portraits of many distinguished authors and educators. **Sources:** WW40; Fink, *American Art at the Nineteenth-Century Paris Salons,* 397; Falk, *Exh. Record Series.*

THURBER, Edna *[Painter] b.1887 / d.1981.*
Member: Woodstock AA. **Sources:** Woodstock AA.

THURBER, George W. *[Engraver] b.c.1827, New York.*
Addresses: NYC in 1850. **Sources:** G&W; 7 Census (1850), N.Y., XLVIII, 36; NYCD 1850.

THURBER, James Grover *[Illustrator, cartoonist, writer] b.1894, Columbus, OH / d.1961.*
Addresses: NYC. **Studied:** Ohio State Univ. **Comments:** Illustrator: *Columbus Dispatch, Paris Tribune, New York Evening Post, New Yorker.* **Sources:** WW40.

THURBER, Rosemary *[Painter, illustrator] b.1898.*
Addresses: Birmingham, MI. **Studied:** R. Herzberg; W. Sesser; K. Conover; K.H. Miller; F.V. DuMond; W.J. Duncan; ASL. **Member:** Detroit Soc. Women P&S; Three AC, NYC; Detroit Artists Market; Michigan AA. **Exhibited:** Three AC Gal., 1930 (prize); Detroit AI, 1935 (prize); S. Indp. A., 1930-32; 1935, 1939-40. **Sources:** WW40.

THURLO, Frank *[Landscape painter] b.1828, Newburyport, MA / d.1913, Newburyport.*
Addresses: Newburyport. **Comments:** Originally a carpenter, his shops in Newburyport advertised pictures, frames, and photographs. Self-taught, he was said to have introduced Martin Johnson Heade to Newburyport's marshes. Thurlo's own paintings, largely watercolors, depict the landscape of northeastern Essex county, particularly along the Merrimac River and views of the Plum Island marshes. **Sources:** G&W; *Art Annual,* XI, obit.; C.L. Snow, exh. cat., "Newburyport Area Artists (1981).

THURLOW, Helen *[Painter, illustrator, educator, engraver, designer] b.1889, Lancaster, PA.*
Addresses: NYC; Norwalk, CT. **Studied:** PAFA. **Member:** SI; Artists Gld. **Exhibited:** AIC, 1913; Awards: PAFA (2 Cresson traveling scholarships, fellowship, prize). **Work:** Lancaster (PA) Pub. Lib.; Muhlenberg College, Allentown, PA. **Sources:** WW59; WW47.

THURLOW, Sarah W. *[Portrait painter] late 19th c.*
Addresses: Active in Grand Rapids, MI, 1886-94. **Sources:** Petteys, *Dictionary of Women Artists.*

THURM, Arnold *[Painter] mid 20th c.*
Addresses: New Rochelle, NY. **Exhibited:** WMAA, 1952. **Sources:** Falk, *WMAA.*

THURMAN, Sue (Mrs.) *[Museum director] mid 20th c.*
Addresses: Boston, MA. **Comments:** Position: dir., Inst. Contemp. Art, Boston, 1961-. **Sources:** WW66.

THURMOND, Ethel Dora *[Painter, teacher] b.1905, Victoria, TX.*
Addresses: Victoria, TX. **Studied:** Univ. Texas; Sul Ross State Teachers College, Alpine, TX (B.S.; M.A.); Univ. Colorado; Xavier Gonzales; Paul Ninas; J. Woeltz. **Member:** Texas FAA; SSAL; Victoria AL. **Exhibited:** SSAL, 1938-39; *Caller-Times* Exh., Corpus Christi, TX, 1944-45; Texas FAA traveling exh., 1935; Southeast Texas Exh., 1937-39; Texas General Exh., 1940, 1945; Texas-Oklahoma Exh., 1941; Houston MFA, 1938. **Work:** mural, Victoria (TX) H.S.; Victoria (TZ) College. **Comments:** Teaching: Victoria Jr. College. **Sources:** WW59; WW47.

THURN, Dorothy Maria *[Painter, illustrator, writer] b.1907, Providence, RI.*
Addresses: Providence, RI. **Studied:** RISD; J. Goss. **Member:** Providence WCC. **Work:** WMA. **Sources:** WW40.

THURN, Ernest *[Painter, writer, lecturer, teacher, lithographer] b.1889, Chicago, IL.*
Addresses: Boston, Gloucester, MA. **Studied:** Hans Hofmann in Munich; Académie Julian, Paris; Andre Lhote in Paris. **Member:** Gloucester AA. **Exhibited:** AIC, 1916, 1928-29; WMAA, 1928; Salons of Am., 1928, 1929; S. Indp. A., 1928; Corcoran Gal. biennial, 1930; PAFA Ann., 1931-32. **Comments:** Teaching: Erskine Sch., Boston; dir., Thurn Sch. of Modern Art, Boston & Gloucester, MA. **Sources:** WW53; WW47; Falk, *Exh. Record Series.*

THURST, Celestine See: **THUST, Celestine (or Thurst)**

THURSTON, B. *[Engraver, designer] mid 19th c.*
Addresses: Portland, ME in 1855-56. **Sources:** G&W; *Maine Register,* 1855-56.

THURSTON, Charles W. *[Painter, illustrator] 19th/20th c.*
Addresses: Paris, France/Somerville, MA. **Exhibited:** Boston AC, 1897. **Sources:** WW10.

THURSTON, E. L. *[Listed as "artist"] 19th/20th c.*
Addresses: Wash., DC. **Comments:** Teaching: Columbia Univ./Corcoran Scientific School. **Sources:** McMahan, *Artists of Washington, DC.*

THURSTON, Elizabeth *[Painter] early 19th c.*
Comments: Memorial painting in watercolors on silk, Canaan (CT), 1820. **Sources:** G&W; Lipman and Winchester, 181.

THURSTON, Elmer M. *[Painter] early 20th c.*
Addresses: Rochester, NY. **Member:** Rochester AC. **Sources:** WW17.

THURSTON, Eugene Bonfanti *[Landscape painter, cartoonist, designer, teacher] b.1896, Memphis, TN / d.1993, El Paso, TX.*
Studied: Dey de Ribcowsky in El Paso, after Army service in WWI; Texas A&M College; Univ. Texas; Texas Western College. **Member:** El Paso Arts Gld (founder, 1928); Del Norte Arts & Crafts Gld, 1934; Far SW Texas Artists, 1935; NIAL, 1946; El Paso AA, 1949; Texas FAA; SC. **Work:** Panhandle-Plains Hist.

Mus., Canyon, TX. **Comments:** Positions: dir. of a greeting card business, early 1920s; teacher, El Paso public schools, 25 years. **Sources:** *Early El Paso Artists* (Texas Western, 1983); info courtesy Holly Thurston Cox, his daughter.

THURSTON, Fanny R. (Miss) *[Painter] late 19th c.*
Addresses: New London, CT, 1885. **Exhibited:** Boston AC, 1880-81; NAD, 1885. **Comments:** Active 1881-85. **Sources:** *The Boston AC.*

THURSTON, Florence *[Painter] early 20th c.*
Addresses: Minneapolis, MN. **Sources:** WW17.

THURSTON, George A. *[Painter] early 20th c.*
Addresses: Rochester, NY. **Sources:** WW24.

THURSTON, Gerald (Edwin) *[Industrial designer] b.1914, Delaware, OH.*
Addresses: Jersey City, NJ; Cranford, NJ. **Studied:** AIC; Helen Gardner. **Member:** IDI; Illuminating Engineering Soc. **Exhibited:** IDI, 1951-52; AID, 1950-51; MoMA, 1950-52; Chicago, 1950-52; traveling exh. in Europe. **Comments:** Position: des., New Metal Crafts, Chicago; des., Lightolier, Inc., NYC. **Sources:** WW59.

THURSTON, Ida *[Painter] late 19th c.*
Addresses: Three Oaks, MI, 1885. **Exhibited:** Michigan State Fair, 1885. **Sources:** Gibson, *Artists of Early Michigan,* 228.

THURSTON, Jack L. *[Illustrator] b.1919, St. Catherines, Ontario, Canada.*
Addresses: Westchester County, NY in 1975. **Studied:** Buffalo AI; Jepson's FA Sch.; Art Center, Hollywood. **Comments:** Served Naval Intelligence during WWII as a sculptor of scale models of enemy terrain. Thurston was an art director in Rochester, NY and specialized in motion pictures illustration while in NYC; he also painted for book publishers. **Sources:** P&H Samuels, 486.

THURSTON, Jane McDuffie (Mrs. Carl) *[Painter, etcher, sculptor] b.1887, Ripon, WI / d.1967, Pasadena, CA.*
Addresses: Pasadena, CA. **Studied:** AIC, 1910-12; J. Mannheim; R. Miller; C.P. Townsley. **Member:** Women Painters of the West; Calif. AC; Pasadena SA; Calif. WCS; Laguna Beach AA. **Exhibited:** Women Painters of the West, 1922 (prize); West Coast Arts, 1923 (prize); Calif. AC, 1925 (prize); Pasadena Art Inst., 1927; Calif. WCS, 1930, 1946; LACMA, 1945-46; Pasadena SA, 1946, 1955; Los Angeles Tower Gal., 1955; Pomona (CA) College, 1946; San Gabriel Valley Exh., 1949, 1951. **Work:** Pasadena AI. **Comments:** Publ.: "Enjoy Your Museum," series of booklets; producer of Esto Programs "Madonna of the Renaissance" (by permission of NGA), filmstrip, 1954; "Inspiration for Christmas," 16mm film, 1955 (author of continuity); produced by Jane Thurston, released by Esto, filmstrip, "Say Hello to Modern Art," 1957; films: "Speaking of Sculpture," 1957; "The Art of Etching." 1958. **Sources:** WW59; WW47. More recently, see Hughes, *Artists in California,* 558.

THURSTON, John *[Painter] early 20th c.*
Addresses: NYC. **Exhibited:** S. Indp. A., 1928. **Sources:** Marlor, *Soc. Indp. Artists.*

THURSTON, John K. *[Painter] b.1865, Gloucester.*
Addresses: Gloucester, MA. **Member:** Boston AC. **Exhibited:** Boston AC, 1897; AIC, 1902, 1906. **Sources:** WW10.

THURSTON, Neptune *[Sketch artist] mid 18th c.*
Addresses: Newport, RI. **Comments:** Slave in Newport (RI), c.1765-70, whose sketches on barrel heads are said to have interested Gilbert Stuart (see entry) as a boy. **Sources:** G&W; Porter, *Modern Negro Art,* 16-17.

THURSTON, Persis G. *[Drawing teacher] mid 19th c.*
Studied: Mount Holyoke Female Seminary from 1841-45.
Comments: Thurston taught at Mount Holyoke Female Seminary from 1845-47 and made a view of the seminary which was lithographed. **Sources:** G&W; *American Collector* (Feb. 1945), 7. May be the amateur artist who made silhouettes of mission families and some sketches in Hawaii in the late 1830s. Her father was a missionary, Asa Thurston. The drawings were engraved and

reproduced by the Lahainaluna Seminary press from c.1836-44. Forbes, *Encounters with Paradise*, 86-87.

THURSTON, Samuel H. *[Artist] late 19th c.*
Addresses: NYC, 1871. **Exhibited:** NAD, 1871. **Sources:** Naylor, *NAD*.

THURTLE, Gladys Finch *[Miniature painter] b.1893, Michigan / d.1981, Los Angeles, CA.*
Addresses: Southern California. **Exhibited:** Calif.-Pacific Int. Expo, San Diego, 1935; Calif. SMP, 1936. **Sources:** Hughes, *Artists in California, 558.*

THURWANGER, Charles *[Lithographer] b.c.1841, New York.*
Addresses: Philadelphia, 1860. **Comments:** Son of Mme. Veneria Thurwanger (see entry), with whom he was living in Philadelphia in 1860. **Sources:** G&W; 8 Census (1860), Pa., LIV, 515.

THURWANGER, John *[Lithographer] mid 19th c.*
Addresses: Philadelphia in 1860. **Comments:** Son of Mme. Veneria Thurwanger (see entry), with whom he was living in Philadelphia in 1860. **Sources:** G&W; 8 Census (1860), Pa., LIV, 515; not listed in Phila. CD.

THURWANGER, Joseph *[Lithographer] b.c.1836, New York.*
Addresses: Philadelphia in 1860 until at least 1870. **Comments:** Son of Mme. Veneria Thurwanger (see entry), with whom he was living in Philadelphia in 1860. Still there in 1870. **Sources:** G&W; 8 Census (1860), Pa., LIV, 515; Phila. CD 1861-70.

THURWANGER, Martin T. *[Lithographer] b.Mulhausen (Alsace) / d.1890, Paris (France).*
Addresses: Philadelphia, c.1848. **Studied:** art & lithography in Paris. **Comments:** Thurwanger was in business in Paris with a brother. Sometime about 1848-50 he was brought to America by the Smithsonian Institution and he worked for about 18 months in Philadelphia, but he returned to Paris and worked there until his death. **Sources:** G&W; Peters, *America on Stone; Portfolio* (Feb. 1954), 131, repro.

THURWANGER, Veronica (or Verena) (Mme.) *[Portrait, genre & religious painter] b.1813, Germany.*
Addresses: NYC; Philadelphia. **Exhibited:** PAFA, 1852-53. **Comments:** She married Francis Thurwanger sometime in the early thirties. Her husband sold liquors in NYC during the 1840s, then moved to Philadelphia where he was listed as a trimmer in 1854-56 and as "pictures" in 1857. Listed as Thurwanger's widow after 1857-63. Her three sons—Charles, John, and Joseph (see entries)—were lithographers. **Sources:** G&W; 8 Census (1860), Pa., LIV, 515; NYCD 1841-48; Phila. CD 1854-64; Rutledge, PA.

THUST, Celestine (or Thurst) *[Painter] late 19th c.*
Addresses: NYC, 1891. **Exhibited:** NAD, 1891. **Sources:** Naylor, *NAD*.

THWAITES, Antoinette G. *[Painter] mid 20th c.*
Addresses: Chicago area. **Exhibited:** AIC, 1941. **Sources:** Falk, *AIC.*

THWAITES, Charles Winstanley *[Painter, lithographer, teacher] b.1904, Milwaukee, WI.*
Addresses: Milwaukee, WI; Santa Fe, NM. **Studied:** Univ. Wisc.; Layton Sch. Art. **Exhibited:** AIC, 1930-32, 1936-37, 1940-42, 1945; PAFA, 1936, 1938; PAFA Ann., 1945; CI, 1941, 1945; Corcoran Gal. biennials, 1939-47 (3 times); VMFA, 1946; MMA (AV), 1942; Pepsi-Cola, 1946; SFMA, 1946; Contemp. Art Gal., 1944 (solo); Milwaukee, 1944; Kearney Mem. Exh., 1946; Milwaukee AI, 1927-46 (prizes, 1933, 1936, 1939, 1941, 1943, 1944); Univ. Wisc., 1936-38, 1945; 48 Sts. Comp., 1939 (prize); CPLH, 1946 (prizes & medal); Wisc. P&S, 1933 (prize), 1936 (prize); Mus. New Mexico, Santa Fe, 1955-68 (8 exhs.); St John's College, 1965 (solo); Southwest Biennials & Fiesta Ann., 1966-68; traveling exhs., 1966-68; Fed. Rocky Mountain States Eight States Exh., 1968. **Work:** Univ. Wisc.; Univ. Mexico; Marquette Univ.; Milwaukee Fed. Court; Milwaukee Co. Court; Milwaukee AC. **Commissions:** WPA murals, USPOs in Greenville, MI,

Plymouth, Chilton, WI& Windom, MN; portraits, pres. of St. John's College, Annapolis, MD & Santa Fe, NM. **Sources:** WW73; article, *The Studio* (London, Vol. 131, No 634); Francis V. O'Connor, *Federal Art Patronage* (Univ. Maryland, 1966); Forbes Watson, *American Painting Today* (AFA); WW47; Falk, *Exh. Record Series.*

THWAITES, William H. *[Landscape painter, engraver, designer, illustrator] mid 19th c.*
Addresses: NYC, 1854-60; London, 1863. **Exhibited:** NAD, 1854, 1858, 1860 (English & Welsh views), 1863; Brooklyn AA, 1868-71. **Comments:** Work reproduced in "Beyond the Mississippi." **Sources:** G&W; Cowdrey, NAD; Hamilton, *Early American Book Illustrators and Wood Engravers*, 474-75. More recently, see Campbell, *New Hampshire Scenery*, 164; P&H Samuels, 486.

THWAITS See: **THWAITES, William H.**

THWING, J. (ohn) Franklin *[Painter] b.1867, Wisconsin / d.1944, San Rafael, CA.*
Addresses: Chicago, IL; San Francisco, CA, 1920s, 1930s; San Rafael, CA. **Exhibited:** AIC, 1899, 1905. **Sources:** WW06; Hughes, *Artists in California, 558.*

THWING, Leroy L. *[Painter] mid 20th c.*
Addresses: Allston, MA. **Work:** Index Am. Des., WPA. **Sources:** WW40.

THYNG, J. Warren *[Landscape painter] b.1840, Lakeport, NH / d.1927, North Woodstock, NH.*
Addresses: Salem, MA; NH; Akron, OH. **Studied:** George Loring Brown; NAD. **Work:** New Hampshire Hist. Soc. **Comments:** Teaching: Mass. State Normal Art Sch., 11 years; New Hampshire public Schools; teacher/founder, Akron Sch. Design. **Sources:** Campbell, *New Hampshire Scenery*, 164-165.

THYSSENS, Francis *[Portrait painter] mid 19th c.*
Addresses: Evansville, IN in 1860. **Sources:** G&W; Evansville CD 1860 (citation courtesy Wilbur D. Peat); Indiana BD 1860.

TIBBETS, George W. *[Wood engraver] b.c.1830, New York.*
Addresses: Cleveland, OH in the 1850s. **Sources:** G&W; 7 Census (1850), Ohio, XI, 258; Cleveland CD 1857.

TIBBETS, Marion *[Painter] 20th c.*
Addresses: Seattle, WA. **Member:** Seattle FAS. **Sources:** WW21.

TIBBETS, Marion C(ornelia) *[Painter] b.1875, Columbus, OH.*
Studied: Ohio State Univ.; with E. Torkner, James Hopkins, Mabel DeBra King; ASL, with D. Romanowsky; with Stanley Woodward. **Member:** Columbus Art League; Ohio WC Soc.; Rockport AA; NAWA. **Exhibited:** Columbus, OH (solos). **Work:** priv. colls. **Comments:** Position: teacher, Seattle schools. **Sources:** *Artists of the Rockport Art Association* (1946, 1956).

TIBBETTS, Frank E. *[Painter] 20th c.*
Addresses: Columbus, OH. **Member:** Columbus PPC. **Sources:** WW25.

TIBBETTS, George W. See: **TIBBETS, George W.**

TIBBITTS, Armand *[Painter] early 20th c.*
Addresses: Buffalo, NY. **Sources:** WW17.

TIBBLES, Yosette (or Susette) La Flesche (Mrs. Thomas H.) *[Painter, illustrator, teacher, writer] b.1854, Bellevue, NE / d.1903, Lincoln, NE.*
Studied: New Jersey; Univ. Nebraska, Omaha. **Comments:** An Omaha and a prominent reformist, she was an interpreter for the Ponca Indians until 1882, when she married Thomas H. Tibbles. **Sources:** P&H Samuels, 486; Trenton, ed. *Independent Spirits*, 264.

TIBBOTT, Elizabeth (Winship) *[Painter] b.1868, Philadelphia, PA.*
Studied: ASL, Wash., DC. **Exhibited:** ASL, Wash., DC, at the Cosmos Club, 1902. **Sources:** McMahan, *Artists of Washington, DC.*

TIBBS, Charlotte Eliza *[Painter, designer] b.1877, Buffalo, NY.*
Addresses: Biloxi, MS. **Studied:** F.A. Parsons; J.C. Johansen; C.W. Hawthorne; P. de Lemos; M. Alton. **Member:** SSAL; Gulf Coast AA; NOAA. **Work:** Biloxi Pub. Schs. **Sources:** WW40.

TIBBS, Thomas S. *[Museum director, lecturer] b.1917, Indianapolis, IN.*
Addresses: La Jolla, CA. **Studied:** Univ. Rochester, A.B., M.F.A.; Columbia Univ. **Member:** Am. Assn. Mus; Assn. Art Mus. Dir.; Royal Soc. Art, London (fellow). **Exhibited:** Craftsmanship in a Changing World, 1956; Louis Comfort Tiffany Retrospective, 1958; Six Decades of American Painting, 1961; Affect & Effect, 1968; Jose de Rivera Forty Year Retrospective, 1972. **Comments:** Positions: assoc. dir. educ., Rochester Mem. Art Gal., 1947-52; dir., Huntington Gals., WV, 1952-56; dir., Mus. Contemporary Crafts, New York, 1956-60; dir., Des Moines AC, 1960-68; dir., La Jolla Mus. Contemporary Art, 1968-. Teaching: lecturer art history, Calif. State Univ., San Diego, 1969-. **Sources:** WW73.

TICE, Charles Winfield *[Portrait, landscape, and still life painter] b.1810, Montgomery, NY / d.1870, Newburgh, NY.*
Addresses: He spent most of his life in Newburgh. **Exhibited:** NA (1837-49). **Work:** Represented at Newburgh Bay Hist. Soc. **Sources:** G&W; Letter of Miss Mary V. Rogers, President of the Historical Society of Newburgh Bay and the Highlands, to D.H. Wallace, May 22, 1955; Cowdrey, NAD.

TICE, Clara *[Painter, printmaker, caricaturist, illustrator, poet] b.1888 / d.1973, Forest Hills, NY.*
Addresses: Brooklyn, NY. **Exhibited:** Indep. Artists, NYC, 1917; Gal. Braun, NYC, 1915; WMAA, 1922. **Comments:** NYC Dadaist. Her career ended when she became blind. **Sources:** WW24; Petteys, *Dictionary of Women Artists.*

TICE, Tempe *[Painter] 19th/20th c.; b.Batavia, OH.*
Addresses: Indianapolis, IN. **Studied:** Indiana Art School with T.C. Steele, Forsyth, and Ottis Adams. **Comments:** Teacher, John Herron AI, Indianapolis, since its founding. **Sources:** WW17; Petteys, *Dictionary of Women Artists.*

TICHENOR, George W. *[Engraver] late 19th c.*
Addresses: Wash., DC, active 1877. **Sources:** McMahan, *Artists of Washington, DC.*

TICHENOR, Lee (Mrs.) *[Painter] late 19th c.*
Addresses: San Francisco, CA/Monterey Peninsula, active c.1860-80; Berchtesgarden, Germany. **Exhibited:** San Francisco AA, 1876. **Work:** Monterey AA. **Sources:** Hughes, *Artists in California*, 558.

TICKNOR, George *[Author, teacher, and amateur artist] b.1791, Boston, MA / d.1871.*
Comments: He was professor of Romance languages and belles-lettres at Harvard (1819-35); a founder of the Boston Public Library; and author of *History of Spanish Literature* and *Life of William Hickling Prescott.* His 1803 watercolor of Dartmouth College has been reproduced. **Sources:** G&W; DAB; *Antiques* (Sept. 1944), frontis. and 127.

TIDBALL, John Caldwell *[Topographical artist] b.1825, Ohio County, WV / d.1906, probably Montclair, NJ.*
Studied: graduated from West Point in 1848. **Exhibited:** Boston AC. **Work:** Oklahoma Historical Society (four of his original sketches from Whipple's report). **Comments:** In 1853-54 he was with Lt. Whipple's survey along the 35th parallel; four of the illustrations in Whipple's report were by Tidball. He later served with distinction in the Civil War, rising from lieutenant to brigadier-general. According to Peggy and Harold Samuels, he began the playing of "Taps" for military funerals, to avoid the alarm from a volley. **Sources:** G&W; DAB; Taft, *Artists and Illustrators of the Old West,* 256-57; P&H Samuels, 486-87.

TIDD, Marshall M. *[Lithographer, watercolorist] b.1828 / d.1895, Woburn, MA.*
Addresses: Boston from 1853-70. **Work:** Dartmouth College. **Comments:** Tidd probably was English. He drew the illustrations on woodblocks for wood engravings to illustrate Lucy Crawford's "History of the White Mountains," but they were never cut. He was also an engineer. **Sources:** G&W; Peters, *America on Stone;* Mass. BD 1853; Boston BD 1854-60+; Campbell, *New Hampshire Scenery,* 165.

TIDDEN, Agnes Lilienberg *[Painter] early 20th c.*
Addresses: Houston, TX. **Sources:** WW25.

TIDDEN, John C(lark) *[Painter, illustrator, teacher] b.1889, Yonkers, NY.*
Addresses: NYC; Houston, TX, 1918-31. **Studied:** PAFA, Cresson Schol. **Member:** SSAL; SI. **Exhibited:** PAFA, 1914 (prize); PAFA Ann., 1918, 1920. **Work:** Univ. C., Houston; Univ. Pa. **Sources:** WW47; Falk, *Exh. Record Series.*

TIDOLDI, John C. *[Listed as "artist"] b.1817, Italy.*
Addresses: Philadelphia in 1850. **Comments:** His wife was Irish; one son, aged 3, was born in New York, and a six-month-old son was born in Philadelphia. **Sources:** G&W; 7 Census (1850), Pa., LIII, 1012.

TIEBOUT, Cornelius *[Engraver, painter] b.1773, NYC / d.1832, New Harmony, IN.*
Addresses: NYC, 1796; Philadelphia, 1799-1825; New Harmony, IN. **Studied:** Apprenticed to a silversmith, under whom he learned to engrave; in 1793 he went to London to study under James Heath for three years. **Comments:** DAB and Brewington give 1777 as birthdate. Earliest known work is dated 1789. From 1817-24 he and his brother were members of the banknote engraving firm of Tanner, Kearney & Tiebout (see entry). During the winter of 1825-26 Tiebout and his daughter Caroline went to New Harmony, IN, and for the next seven years Tiebout taught engraving in the New Harmony school and did much of the engraving for Thomas Say's volumes on shells and insects; Caroline Tiebout was employed to color these engravings. **Sources:** G&W; Stauffer; DAB; NYCD 1792-1800; Phila. CD 1802-25; Stokes, *Historical Prints;* Stokes, *Iconography;* Lockridge, *The Old Fauntleroy Home,* 79-80; *Richmond Portraits;* Burnet, *Art and Artists of Indiana,* 23.

TIEBOUT, Mlle. See: **THIBAULT, Aimée**

TIEL, Ella Sheldon (Mrs.) *[Painter] early 20th c.*
Addresses: London, England/Phila., PA, c.1903. **Studied:** PAFA. **Exhibited:** PAFA Ann., 1903; AIC, 1916. **Sources:** WW25; Falk, *Exh. Record Series.*

TIEMANN, A. *[Painter] early 20th c.*
Addresses: Milwaukee, WI. **Sources:** WW17.

TIEMER, Gertrude *[Painter] b.1897, East Orange, NJ / d.1967, NYC.*
Exhibited: Soc. Indep. Artists, 1922, 1926, 1941; WMAA, 1927-28; Salons of Am., 1930, 1932, 1933. **Comments:** Also appears under Tiemer-Wille and Wille. **Sources:** Marlor, *Salons of Am.*

TIEMER-WILLE, Gertrude (Mrs. Frederick) See: **TIEMER, Gertrude**

TIERKEL, Arnold F. *[Painter] mid 20th c.*
Addresses: Phila., PA. **Exhibited:** PAFA Ann., 1948. **Sources:** Falk, *Exh. Record Series.*

TIERNAN, Michael *[Listed as "artist"] b.c.1832, Ireland.*
Addresses: New Orleans in 1850. **Sources:** G&W; 7 Census (1850), La., V, 5.

TIERS, Mary *[Painter] d.Before 1902.*
Studied: ASL, Wash., DC, 1890s. **Exhibited:** ASL, Wash., DC, at the Cosmos Club, 1902. **Sources:** McMahan, *Artists of Washington, DC.*

TIERS, Montgomery C. *[Portrait painter] mid 19th c.*
Addresses: NYC in 1851-52. **Exhibited:** NA. **Sources:** G&W; Cowdrey, NAD; NYBD 1852.

TIERS, Walter A. *[Painter] late 19th c.*
Addresses: Germantown, PA. **Exhibited:** PAFA Ann., 1891 (landscape in water color). **Sources:** Falk, *Exh. Record Series.*

TIESLER, Herbert Hans *[Marine painter] b.1894, Germany / d.1975, Napa, CA.*
Addresses: Sausolito, Oakland, Napa, CA. **Work:** Maritime Mus. **Sources:** Hughes, *Artists in California*, 558.

TIETHOF, A. *[Painter] d.c.1920.*
Addresses: NYC. **Exhibited:** S. Indp. A., 1917. **Sources:** Marlor, *Soc. Indp. Artists.*

TIETJENS, Marjorie Hilda Richardson *[Painter] b.1895, New Rochelle, NY.*
Addresses: NYC; Las Cruces, NM, from 1943. **Studied:** Royal Drawing Soc., England; British Acad., Rome. **Sources:** Petteys, *Dictionary of Women Artists.*

TIFFAN, William H. *[Listed as "artist"] b.c.1820, New York.*
Addresses: Washington County, OR, 1850. **Sources:** G&W; 7 Census (1850), Ore. (G&W has information courtesy David C. Duniway, Oregon State Archivist).

TIFFANY, Lillian *[Painter, etcher] b.1900, Wash., DC.*
Addresses: New City, NY. **Studied:** G.B. Bridgman; L. Kroll; R.P.R. Neilson; A.S. Covey. **Member:** Studio G. **Comments:** Illustrator: American Kennel Gazette; Spur mag. Specialty: dogs. **Sources:** WW40.

TIFFANY, Louis C(omfort) *[Painter, craftsperson] b.1848, NYC / d.1933, NYC.*
Addresses: NYC, 1869-74, 1877-92); Oyster Bay, NY. **Studied:** Geo. Inness in NYC; L. Bailley in Paris. **Member:** ANA, 1871; NA, 1880; SAA; AWCS; Arch. L., 1889; Century A.; NAC; NY Soc. FA; NY Mun. AS; AIGA; NSS; AFA; Société Nationale des Beaux-Arts; Imperial Soc. FA, Japan; Chevalier Legion of Honor, France, 1900. **Exhibited:** NAD, 1867-92; Paris Salon, 1868 (his name may have been misspelled as Jiffany); Brooklyn AA, 1868-83; Boston AC, 1877; PAFA Ann., 1879-80, 1889; AIC, 1888-91, 1910-12, 1932; SNBA, 1894-99; Paris Expo., 1900 (gold); Dresden Expo., 1901 (gold); Turin Expo., Dec. A., 1901; St. Louis Expo., 1904; Corcoran Gal annual, 1908; Pan.-Pac. Expo., San Fran., 1915 (gold); S. Indp. A., 1920-22; Sesqui-Centenn. Expo., Phila., 1926 (gold); MMA, 1998 (retrospective). **Work:** MMA, L.C. Tiffany Fndtn., Oyster Bay, NY. **Comments:** He was the son of the founder of the well-known jewelry firm of Tiffany & Co. Early in his career he was a painter, specializing in Orientalist scenes, largely inspired by his 1869 trip to North Africa with Samuel Colman. In 1874, he was painting in Brittany. In 1879, he gave up painting and became president and art director of the Tiffany Studios, which produced the famous Tiffany Favrile glass that he originated, as well as the lamps with leaded glass shades. In 1918 he established the Louis Comfort Tiffany Foundation for art students at Oyster Bay, Long Island, and deeded to it his art collections, gallery, chapel, country estate, and $1 million. **Sources:** WW31; Fink, *American Art at the Nineteenth-Century Paris Salons*, 359, 397; Falk, *Exh. Record Series*.

TIFFANY, Marguerite Bristol *[Painter, weaver, teacher, craftsperson, lecturer] 20th c.; b.Syracuse, NY.*
Addresses: Paterson, NJ. **Studied:** Syracuse Univ. (B.S.); Columbia Univ. (M.A.); Newark Sch. Fine & Appl. Arts (cert.); Parsons Sch., NYC (cert.); NY Univ.; and with Emile Walters, Iceland & William Zoroch, New York. **Member:** AAPL, NJ chap. (corresp., secy., 1961-68); Paterson Art League (pres., 1958-60); Fair Lawn Art Assn.; Ridgewood Art Assn.; Eastern Arts Assn. (chmn. speaker's conv., 1940; exec. bd., 1944-48). **Exhibited:** NJ State Ann., Montclair Mus., 1933, 1934, 1935, 1937; Am. Womans Assn., New York, 1941-42; Panhellenic House Assn., New York, 1942-43; Ogunquit Art Ctr. Ann., Maine, 1941-70; Am. Artists Prof. League Ann., Spring Lake, NJ, 1941-71; Paterson (NJ) AA, 1934, 1936, 1946; Englewood (NJ) AA; American House, NY. 1941-42; State Fedn. Womens Clubs NJ, 1972 (hon. mention). Awards: cert., contrib. art educ., Eastern Arts Assn., 1960. **Comments:** Preferred media: oil. Positions: art comt., NJ chmn., Metrop. Opera Guild, 1952-58; state pres., Nat.

League Am. Penwomen, 1966-68; NJ state pres., Assoc. Handweavers, 1968-70. Publications: auth., "Art and Picture Study" (monogr.), NJ Dept. Educ., 1930; *Educ. Mag.* (art issue), 2/1946; contribr., "Art Education in Principle and Practice," 1933; Art room planning guide, Dept. Educ., Trenton, NJ, 1960-63; illusr., two articles, *Newark Sunday News*, 4/1912 & 4/14/1970. Teaching: Prof art, Rutgers Univ, 1925-40; William Paterson Col., 1929-56; Fairleigh Dickinson Univ, 1956-65. **Sources:** WW73; WW47.

TIFFANY, Mary Adeline *[Genre painter] late 19th c.; b.Hartford, CT.*
Addresses: Hartford, CT. **Studied:** Henry Bryant, Gladwin, and Tryon; Conn. School Design. **Exhibited:** Hartford Centennial Loan Exhib. **Comments:** Teacher of drawing and music, Natchaug and Springfield, CT. **Sources:** Petteys, *Dictionary of Women Artists.*

TIFFANY, William Shaw *[Portrait and landscape painter, illustrator] b.1824 / d.1907, NYC.*
Addresses: Boston, MA (in 1846); Baltimore, MD (1854-on). **Studied:** Harvard, 1845; Académie Julian, Paris with Benjamin-Constant; also with Ary Sheffer, T. Couture, and C. Troyon, early 1850s-54. **Exhibited:** Maryland Historical Society, 1856-93. **Work:** Mem. Hall, Harvard. **Comments:** He was a friend of William Morris Hunt. Illustrator of Tennyson's *Mary Queen*. **Sources:** G&W; *Art Annual*, VI, obit.; Boston BD 1846; Lafferty; Rutledge, MHS; Swan, BA.

TIFT, Mary Louise *[Printmaker] b.1913, Seattle, WA.*
Addresses: Corte Madera, CA. **Studied:** Univ. Wash. (B.F.A.); Art Ctr. Col. Design; San Francisco State Col. **Member:** Calif. Soc. Printmakers (coun. mem., 1970-72); Los Angeles Printmakers Soc.; Print Club Philadelphia. **Exhibited:** first & second Nat. Print Invitational, Fine Arts Gal., San Diego, Calif., 1969 & 1971; Second Brit. Biennale Prints, Yorkshire, Eng., 1970; Fifth Int. Triennal Colored Graphics, Grencehn, Switz., 1970; Graphics 1971, circulated by Smithsonian Inst.; Fifth Int. Print Biennale, Cracow, Poland, 1972. Awards: purchase awards, Pratt Graphic Int. Miniature Print Show, 1968, Northwest Printmakers Int., 1969 & Print Club Philadelphia, 1969. **Work:** PMA; SAM; Achenbach Print Collection, CPLH; Bell Tel. Co. Ill. Print & Drawing Collection, Chicago; Standard Oil Co. Calif., San Francisco. **Comments:** Preferred media: graphics. Positions: coordr. design, San Francisco Art Inst., 1957-60. Teaching: asst. prof. design, Calif. Col. Arts & Crafts, Oakland, 1949-57. **Sources:** WW73.

TIGER, Jerome Richard *[Painter, sculptor, laborer, prize fighter] b.1941, Tahlequah, OK / d.1967.*
Addresses: Muskogee, OK. **Studied:** Cleveland Engineering Inst., 1963-64. **Exhibited:** All-Am. Indian Days Ann., Sheridan, WY (grand prize, 1965); Arizona State Mus., Tucson, AZ; "First Ann. Invitational Exh. of Am. Indian Paintings," U.S. Dept. Interior, Wash., DC, 1964-65; National Exh. Am. Indian Art, Oakland, CA, 1966 (prize); Gilcrease Inst., Tulsa, OK; Heard Mus., Phoenix, AZ, "Shared Visions: Native Am. P&S in the 20th Century," 1991-92; "Native Am. Painting," Amarillo (TX) Art Center, 1981-83; Oklahoma Hist. Soc., Oklahoma City; Philbrook Art Mus., annuals (prizes) & "Indianische Künstler," 1984-85; "Inter-Tribal Indian Ceremonials," annually, Gallup, NM (prizes); Marion Koogler McNay Art Mus., San Antonio, TX; Mus. of NM, Santa Fe (prizes); "Midwest Prof. Artists Benefit Art Show," Tulsa, OK; "Native Am. Paintings," organized by Joslyn Art Mus., 1979-80; Oklahoma Mus. Art; Oklahoma AC, Oklahoma City; "Scottsdale Nat. Indian Art Exh.," annuals (prizes); Marymount College, Tarrytown, NY; Presbyterian Convention, Ridgecrest, NJ. **Work:** U.S. Dept. Interior, Wash., DC; Five Civilized Tribes Mus., Muskogee, OK; Gilcrease Inst., Tulsa; Nat.l Mus. Am. Indian, Smithsonian Inst.; Mus. New Mexico, Santa Fe; Philbrook Mus. Art, Tulsa; Woolaroc Mus., Bartlesville, OK; Muskogee Pub. Lib. Murals: Calhoun's Dept. Store, Muskogee, OK. **Comments:** Native American, affiliated with the Creek and Seminole nations. His tribal name was Kocha. Illustr. cover for book by Foreman, 1989. Preferred media: oil, watercolor, tempera, casein, pencil,

pen & ink. **Sources:** info. courtesy of Donna Davies, Fred Jones Jr. Mus. Art, Univ. of Oklahoma.

TIGERMAN, Stanley *[Painter, architect] b.1930, Chicago, IL.* **Addresses:** Chicago, IL. **Studied:** Mass. Inst. Technol., 1948-49; Inst. Design, 1949-50; Yale Univ. (B.A. Arch., 1960 & March, 1961). **Member:** Am. Inst. Architects; Yale Art Assn. (past pres.); Ill. Arts Coun. (archit. adv. comt., 1968-69). **Exhibited:** Soc. Contemp. Artists Show, AIC, 1965; Eight Chicago Artists, Walker Art Ctr., Minneapolis, Minn., 1965; solo shows, Evanston Art Ctr., Ill., 1969, Art Res. Ctr., Kansas City, Mo., 1969 & Springfield Arts Assn., Ill., 1970. **Awards:** Graham Found. fel. advan. study fine arts, 1965; honor awards, Nat. Am. Inst. Architects & Housing & Urban Develop, 1970 & Chicago Chap. Am. Inst. Architects, 1971. **Work:** commissions: modular structure, Metrop. Structures, Chicago, 1971. **Comments:** Preferred media: acrylics. Positions: prin., Stanley Tigerman & Assocs., Chicago, 1962-. Publications: contribr., "Young Architects in America", *Zodiac Int.*, 1964; contribr., "Instant City," *Archit. Jour Hui*, 1966; contribr., "City Shape 1921," Toshi Jutaku, Tokyo, 1968; auth., "Formal Generators of Structure," Leonardo, 1968. Teaching: prof. archit. & art, Univ. Ill., Chicago Circle, 1965-71. **Sources:** WW73; RAM Stern, *New directions in American architecture* (Braziller, 1969); Faulkner & Ziegfield, *Art today* (Holt, Rinehart & Winston, 1969); Dahinden, *Urban structures of the future* (Praeger, 1972).

TIKHANOV, Mikhail Tikhonovich *[Painter] b.1789, Russia / d.1862.* **Studied:** St. Petersburg Acad. FA, 1815-17. **Comments:** Born a serf, Tikhanov was eventually freed and circumnavigated the globe under Capt. Vasilii Golovnin, providing ethnographic and anthropologic details of the voyage, including depictions of Hawaiian islanders. He was later institutionalized for mental illness. **Sources:** Forbes, *Encounters with Paradise.*

TILBURNE, Albert Roanoke *[Painter, illus, gallery owner, painting restorer] b.1887, New Albany, IN / d.1965, NYC.* **Studied:** Europe, 1908 to c.1913: Académie Julian, Paris, with Laurens; Berlin, Germany (also studied music). **Exhibited:** Petit Salons, Paris, c. 1909-10; "Artists of the Old West," NYC, 1952 (with Frederic Remington and Charles Russell); National Antiques Show, NYC, 1956 (showed his series "Pioneer Western Saga"); "Tales and Trails of the Old West," Franklin National Bank, West Hempstead, NY, 1957. **Work:** John Judkyn Memorial, Bath, England; Coll. of Queen Wilhelmina of Holland; Pioneer Village, Minden, NE. **Comments:** Specialized in scenes of the Old West. His father operated a Wild West show that traveled throughout the U.S. and Canada until c.1898. Tilburne studied art in Europe, returning to the U.S. about 1913, afterwhich he journeyed throughout the West, making sketches and drawings of Western life. Served in World War I and returned to the states in 1921, thereafter establishing a successful career as a painter and illustrator, with his Western work reproduced in leading fiction magazines. Also executed other historical themes, including a series of paintings related to the life of Benjamin Franklin. While most of his career was spent in NYC, Tilburne also lived in Carmel, Cal., and Alexandria, Va., and owned art galleries in all three places. **Sources:** Information, including exhibition brochures and news clippings, courtesy of Mrs. Simone Prada, daughter of the artist.

TILDE, Tante See: **SCHLEY, M(athilde) Georgina**

TILDEN, Alice Foster *[Portrait painter, etcher, sculptor, teacher] b.c.1898, Brookline, MA.* **Addresses:** Boston/Rockport, Milton, MA. **Studied:** BMFA Sch.; W.M. Chase; Lucien SImon in Paris. **Member:** Copley Soc., 1898; Rockport AA; Boston AC; North Shore AA. **Exhibited:** PAFA Ann., 1906, 1908, 1916; Lg. Am. Pen Women Exhib., Wash., D.C., 1934 (prize), 1936 (prize); Copley Soc., Boston; Charles E. Cobb Gal., Boston, 1906 (solo); Boston AC; Rockport AA; North Shore AA; Speed Memorial Mus., Louisville; S. Indp. A., 1922. **Sources:** WW40; *Artists of the Rockport Art Association* (1946); Falk, *Exh. Record Series.*

TILDEN, Anna M(eyer) *[Sculptor, painter] b.1897, Chicago, IL. / d.1963, Haddonfield, NJ.* **Addresses:** Oak Park, IL. **Studied:** AIC with A. Polasek; Midway Studios, Chicago, with L. Taft. **Member:** Chicago PS; Chicago Gal. Assn.; Austin Oak Park, River Forest AL. **Exhibited:** AIC, 1918-31; Oak Park (IL) Art Lg., 1927-on. **Work:** World War Mem., River Forest, IL. **Comments:** Teacher at AIC. **Sources:** WW40; Petteys, *Dictionary of Women Artists.*

TILDEN, Douglas *[Sculptor, teacher, writer] b.1860, Chico, CA / d.1935, Berkeley, CA.* **Addresses:** Oakland, CA. **Studied:** briefly with F. Marion Wells; with Virgil Williams, San Francisco School of Des.; NAD Ward, Flagg; Gotham Students' Lg., with Mowbray; Académie Julian, Paris, 1875-76; also with Choppin in Paris. **Member:** NSS; NAC; San Fran. AA, 1904. **Exhibited:** Paris Salon, 1889-92 (prize 1890), 1894, 1898; World's Columbian Expo, 1893; Paris Expo, 1900 (med); Louisiana Purchase Expo., 1904; Alaska-Yukon-Pacific Expo, Seattle, 1909 (gold); Pan-Pacific Expo., 1915,. **Work:** AIC; "The Baseball Player/Our National Game," Golden Gate Park, San Fran.; Portland, Oreg.; Monterey County Public Lib.; Calif. School for the Deaf, Berkeley); Los Angeles. **Comments:** Deaf by scarlet fever at age five, he attended the Institute for the Deaf, Dumb and Blind in Berkeley, graduated in 1879 and taught there until 1887. He also taught at the Hopkins AI, from 1894-1901 (first instructor of sculpture). One of America's premier sculptors, he became known for his naturalistic depictions of athletes, sportsmen, and American heroes. Among his best-known works was his "The Baseball Player/Our National Game" (1890-91, made for Golden Gate Park and reproduced in reduced versions by Tiffany's of New York). He was a devoted activist on behalf of the deaf and served as president of the Calif. Assoc. of the Deaf in 1910. Tilden became reclusive after 1926 and his work output dwindled; he is said to have died penniless and alone. Also appears as Douglas-Tilden. **Sources:** WW25; Hughes, *Artists in California*, 558-559; Fink, *American Art at the Nineteenth-Century Paris Salons*, 397; Detroit Inst. of Arts, *The Quest for Unity*, 258-59.

TILDEN, George T. *[Painter] 20th c.* **Addresses:** Boston, MA. **Member:** Boston AC. **Sources:** WW08.

TILDEN, Scott *[Painter] b.1912, San Francisco, CA.* **Addresses:** Marin County, CA. **Studied:** College of Marin, CA; with George Demont Otis. **Exhibited:** San Rafael City Hall and Pub. Lib., 1973; Marin Civic Center, 1976; Stinson Beach Art Center, 1983; Glendale Federal, Terra Linda, CA, 1986. **Work:** San Rafael Pub. Lib. and City Hall. **Comments:** Preferred medium: watercolors. Specialty: landscapes and Marin County landmarks. **Sources:** Hughes, *Artists in California*, 559.

TILDESLEY, Florence K. *[Painter] early 20th c.* **Addresses:** Brooklyn, NY. **Member:** Brooklyn SA. **Exhibited:** S. Indp. A., 1917-18; Salons of Am., 1922. **Sources:** WW27.

TILESIUS VON TILENAU, Wilhelm Gottlief *[Artist and naturalist] b.1769, Mühlhausen (Alsace) / d.1857.* **Comments:** He was with the Krusenstern expedition sent out by Czar Alexander I of Russia in 1803 to inspect Russian colonies in the North Pacific. He made many sketches, including some of California scenes in 1806, and they were used to illustrate Langsdorff's *Bemerkungen auf einer Reise um die Welt* (1812). **Sources:** G&W; Van Nostrand and Coulter, *California Pictorial*, 12-15.

TILGE, Sallie *[Painter] late 19th c.* **Addresses:** Phila., PA. **Exhibited:** PAFA Ann., 1879, 1881 (portraits in pastel & water color). **Sources:** Falk, *Exh. Record Series.*

TILGNER, Arthur *[Painter] mid 20th c.* **Studied:** ASL. **Exhibited:** S. Indp. A., 1942. **Sources:** Marlor, *Soc. Indp. Artists.*

TILL, Anne (M.) Hamilton *[Painter] d.1935.* **Addresses:** NYC. **Studied:** ASL. **Exhibited:** S. Indp. A., 1920,

1922-23; WMAA, 1922-23; Salons of Am. **Sources:** Falk, *Exhibition Record Series.*

TILL, Harry *[Painter] early 20th c.*
Addresses: Phila., PA. **Member:** Phila. AA. **Sources:** WW17.

TILLCOCK, Harry N. *[Painter] mid 20th c.*
Addresses: Los Angeles, CA, 1920s. **Exhibited:** P&S Los Angeles, 1920, 1921; Pasadena Art Inst., 1930. **Sources:** Hughes, *Artists in California,* 559.

TILLER, Frederick *[Engraver] mid 19th c.*
Addresses: Philadelphia, 1831-35. **Comments:** Frederick W. Tiller, printer, was listed 1836-39 and 1847-50. **Sources:** G&W; Phila. CD 1831-50.

TILLER, Robert *[Landscape engraver] early 19th c.*
Addresses: Philadelphia, 1818-24. **Comments:** Father of Robert Tiller, Jr. (see entry) **Sources:** G&W; Phila. CD 1818-24; Stauffer.

TILLER, Robert, Jr. *[Engraver of portraits in stipple and subjects in line] mid 19th c.*
Addresses: Philadelphia, 1825-35. **Comments:** Son of Robert Tiller (see entry). **Sources:** G&W; Phila. CD 1825-35; Stauffer.

TILLERY, Mary *[Painter, teacher] mid 20th c.; b.Scotland Neck, NC.*
Addresses: Raleigh, NC. **Studied:** Meredith Col.; N.Y. Sch. F. & Appl.A., Paris; PAFA Country Sch.; Breckenridge Sch. P. **Member:** SSAL; N.C. Professional Artist's C. **Comments:** Position: t., Meredith Col., Raleigh, N.C. **Sources:** WW33.

TILLEY, Lewis Lee *[Painter] b.1921, Parrot, GA.*
Addresses: Colorado Springs, CO. **Studied:** High Mus. Sch. Art, 1937-39; Emory Univ., 1937-39; Univ. Ga. (BFA, 1942); Colorado Springs Fine Arts Ctr., with Boardman Robinson, Adolph Dehn & John Held, 1942-45; Inst. Allende, Mex. (M.F.A., 1968). **Exhibited:** Am. Fedn. Arts; Graphic Arts Chicago; Denver Ann. & Biennal, Artists West of the Mississippi; Washington Cathedral Religious Exhib. Awards: first purchase award for oil, Canyon City Blossom Festival, 1969; first purchase award for oil, Colo. State Fair, 1970. **Work:** Post Card No 2, Colorado Springs Fine Arts Ctr., Colo.; Canon City Art Ctr., Colo.; State Fair Colo. Collection: Ga. Art Assn.; Southern States Art League. Commissions: mural in bird house, Broadmoor Cheyenne Mountain Zoo, Colorado Springs, 1958; dragon wall mural, Victor Hornbein House, Denver, Colo., 1959; mural in bd. dirs. rm., First Nat. Bank Colorado Springs, 1959; four polyester resin sculptures, Colorado Springs Eye Clin., 1960; exterior wall mural, Horace Mann Jr. HS, Colorado Springs, 1962. **Comments:** Preferred media: oils, acrylics. Positions: producer & dir., Alexander Film Co., 1958-62; communications media adv., US Agency Int. Develop., Ind. Univ., 1962-64. Publications: auth., *History of Writing & Painting,* 1963; illusr., *English with the Twins,* 1963; illusr., *History of Medicine,* 1963; ed., *The Story of Nok Culture,* 1963. Teaching: instr. painting, life drawing & design, Colorado Springs Fine Arts Ctr., 1945-51; assoc. prof. art, painting, graphic design & drawing, Southern Colo. State Col., 1965-. Art interests: film making. **Sources:** WW73; "Discovery No 49," *Mod. Photog.* (1958).

TILLIM, Sidney *[Painter] b.1925, Brookly, NY.*
Addresses: NYC. **Studied:** Syracuse Univ. (B.F.A., 1950). **Exhibited:** PAFA Ann., 1954; Contemp. Realism in Figure & Landscape, Wadsworth Atheneum, Hartford, Conn., 1964; Realism Now, Vassar Col. Art Gal., Pougkeepsie, NY, 1968; Aspects of New Realism, Milwaukee Art Ctr., 1969; 22 Realists, 1970 & Ann., 1972; WMAA; Richard Bellamy, NYC, 1970s. **Work:** Michener Collection, Univ. Tex., Austin; Ludwig Collection, Neue Galerie, Aachen, Ger.; Weatherspoon Art Gal., Univ. NC, Greensboro; Mus. Art, Ogunquit, Maine; Joseph H. Hirshhorn Mus. & Sculpture Garden. **Comments:** Preferred media: oils. Positions: contrib. ed., *Arts,* 1959-65; contrib. ed., *Artforum,* 1965-69. Teaching: instr. art hist. & drawing, Pratt Inst., 1964-68; instr. art hist. & painting, Bennington Col., 1966-.

Sources: WW73; Falk, *Exh. Record Series.*

TILLINGHAST, Archie Chapman *[Painter, designer, teacher] b.1909, Stonington, CT.*
Addresses: Wequetequock, CT; Westerly, RI. **Studied:** Newark Sch. Fine & Indust. Art. **Exhibited:** Lyman Allyn MA; Montclair AM; Newark Mus.; MoMA; Mystic (CT) Art Club. **Comments:** WPA artist. **Sources:** WW59; WW47.

TILLINGHAST, C. A. (Miss) *[Still-life painter] late 19th c.*
Addresses: Active Providence/Fall River area, RI, c.1888. **Sources:** Petteys, *Dictionary of Women Artists.*

TILLINGHAST, Mary Elizabeth *[Craftsperson, painter] b.NYC / d.1912, NYC.*
Addresses: NYC. **Studied:** John La Farge (assisted him with his windows), in NYC; Paris, with Carolus-Duran & Henner. **Member:** NAC. **Exhibited:** NAD, 1898; Columbian Expo, Chicago, 1893 (medal); PAFA Ann., 1902; Charleston Expo, 1902 (gold & bronze medals). **Work:** stained window, Home for Friendless Children; window, Grace Church; N.Y. Hist. Soc. Bldg.; new Allegheny Observatory; Hotel Savoy. **Comments:** Was the first to realize the difference that the electric lighting of churches was destined to make in the spectacular effect of window designs. **Sources:** WW10; Falk, *Exh. Record Series.*

TILLMAN, D. Norman *[Painter, commercial artist] b.1899, Pennsylvania.*
Studied: PAFA; priv. instr. **Member:** Mahoning Soc. of Painters, Youngstown, OH. **Exhibited:** Harmon Fnd., 1928-31; Smithsonian Inst., 1929; Interracial Committee Exh., 1933; Cleveland YMCA, 1934; Fine Arts Bldg., Cleveland, 1935 (solo); American Negro Expo., Chicago, 1940. **Sources:** Cederholm, *Afro-American Artists.*

TILLMAN, Ruth *[Painter] mid 20th c.*
Addresses: Lakewood, OH. **Member:** Cleveland Women's AC. **Sources:** WW27.

TILLOTSON, Alexander *[Painter, mus dir, educator, teacher, lecturer] b.1897, Waupan, WI.*
Addresses: Milwaukee, WI; Topeka, KS. **Studied:** Milwaukee Sch. F. & App. A.; Milwaukee State T. Col. (B.A.); Columbia Univ. (M.A.); ASL with Kenneth Hayes Miller, Maurice Sterne, Andrew Dasburg, Max Weber. **Member:** Kansas State Fed. A.; Am. Assn. Univ. Prof.; Great Plains Mus. Assn.; Wisc. PS; Kans. State Fed. A.; CAA; Wisc. Ar. Fed. **Exhibited:** PAFA Ann., 1932-33, 1935-36; Corcoran Gal biennials, 1932, 1935; Exh. Am. A., NY, 1936; AIC, 1936, 1940; WFNY 1939; Milwaukee AI, 1926 (prize), 1927 (prize), 1928-34, 1935 (prize), 1936-38, 1940 (prize); Univ. Minn., 1938; Univ. Chicago, 1944; Springfield (Mo.) Mus. A., 1946; Kansas State Col., 1952-1954; Kansas State Fair, 1955 (prize); William Rockhill Nelson Gal. A., 1955; Kansas State Biennial, 1958, 1960; Kansas Centennial Exh., 1961. Awards: prize, Topeka A. Gld., 1955. **Work:** Milwaukee AI; Mulvane A. Center. **Comments:** Position: teacher, Milwaukee Secondary Sch., 1926-43; dir., Layton Sch. A. (Milwaukee); prof., hd. a. dept., dir., Mulvane A. Mus., Washburn Mun. Univ., Topeka, Kans., 1945-63. **Sources:** WW66; WW47; Falk, *Exh. Record Series.*

TILLOTSON, Hilda *[Painter] mid 20th c.*
Exhibited: Salons of Am., 1925. **Sources:** Marlor, *Salons of Am.*

TILLOU, Elizabeth *[Still life painter in watercolors] mid 19th c.*
Addresses: Brooklyn, NY, c.1830. **Sources:** G&W; Lipman and Winchester, 181.

TILLOU, Virginia *[Painter] b.1906, Centerville, PA.*
Addresses: Buffalo, NY. **Studied:** Albright A. Sch., Buffalo, 1927-29; Provincetown Summer Sch. of Art, Mass., 1929; painting with Edwin Dickinson and William Hekking, 1934; State Univ. of New York at Buffalo with Alfred Blaustein and Seymor Drumlevitch. **Member:** Patteran Soc. (charter member, 1933); Buffalo SA. **Comments:** Staff artist at Buffalo Mus. of Science, contributing to the murals for two years. **Sources:** Krane, *The Wayward Muse,* 196.

TILLY, Gertrude E. *[Miniaturist] early 20th c.*
Exhibited: PAFA Ann., 1904. **Sources:** Falk, *Exh. Record Series.*

TILMAN, C. B. *[Artist] 19th/20th c.*
Addresses: Los Angeles. **Sources:** Petteys, *Dictionary of Women Artists.*

TILMAN, C. D. See: **TILMAN, C. B.**

TILT, Maude M. *[Sculptor] 19th/20th c.*
Addresses: Chicago, IL, c.1898. **Exhibited:** AIC, 1897, 1899; PAFA Ann., 1898, 1900. **Sources:** WW01; Falk, *Exh. Record Series.*

TILTEN, John Rollin See: **TILTON, John Rollin**

TILTON, Benjamin W. *[Engraver] mid 19th c.*
Addresses: NYC, 1859. **Comments:** Of Waters & Tilton (see entry) **Sources:** G&W; NYCD 1859.

TILTON, Florence See: **AHLFELD, Florence Tilton (Mrs. Fred)**

TILTON, George H. *[Painter] b.1860, Littleton, NH / d.1931, Littleton, NH.*
Addresses: Franconia, NH. **Studied:** Edward Hill. **Work:** Priv. colls. **Sources:** Campbell, *New Hampshire Scenery*, 165-166.

TILTON, John Kent *[Museum director, craftsperson, writer, lecturer, historian] b.1895, Jersey City, NJ.*
Addresses: NYC. **Studied:** Columbia Univ.; PIA Sch. **Member:** AAMus.; Assoc., AID; Benefit Memb., Philadelphia Textile Inst.; Nat. Soc. Interior Designers. **Exhibited:** AID Home Furnishings Shows. **Comments:** Positions: custodian, wallpaper, Cooper Union; dir., Scalamandre Museum of Textiles, NYC, as of 1966. Author: ten brochures upon silk, woven & printed textiles and the periods of textile design. Contributor to: *American Fabrics; American Collector; Interiors; Art in America* magazines. Lectures: The Decorative Periods of Textile Design and Their History. **Sources:** WW66.

TILTON, John Rollin *[Landscape painter, chiefly in watercolors] b.1828, Loudon, NH / d.1888.*
Addresses: Rome, Italy, 1861, 1874. **Exhibited:** PAFA Ann., 1860-61, 1881 (more than 60 landscapes exhibited); Boston Athenaeum; NAD, 1861, 1874; Boston AC, 1877; Brooklyn AA, 1881. **Comments:** He went to Italy in 1852 and lived in Rome until his death. He was a neighbor and close friend of William Wetmore Story. He traveled in Italy, Switzerland, Germany, Greece, and Egypt. **Sources:** G&W; DAB; CAB; Clement and Hutton; Swan, BA; Rutledge, PA; James, *William Wetmore Story.*; Campbell, *New Hampshire Scenery*, 166; Falk, *Exh. Record Series.*

TILTON, Olive See: **BIGELOW, Olive Tilton (Mrs. Herbert Pell)**

TILTON, Paul Henry *[Painter] 19th/20th c.; b.Rome, of Am. parents.*
Addresses: Princeton, NY, 1899. **Studied:** Carolus-Duran. **Exhibited:** Paris Salon, 1884; NAD, 1899. **Sources:** WW01; Fink, *American Art at the Nineteenth-Century Paris Salons*, 397.

TILTON, Ralph J. *[Painter] 20th c.*
Addresses: Sacramento, CA. **Exhibited:** S. Indp. A., 1930. **Sources:** Marlor, *Soc. Indp. Artists.*

TILYARD, Philip Thomas Coke *[Portrait painter] b.1785, Baltimore (MD) / d.1830.*
Addresses: Baltimore (MD). **Studied:** with his father, a glazier and journeyman sign painter; possibly with Thomas Sully. **Exhibited:** Peale Museum (Jan.-Feb. 1949). **Work:** Baltimore MA. **Comments:** Trained as a sign and ornamental painter, he began portraiture in Baltimore about 1814 with some success. In 1816, he won $20,000 in the lottery and invested in a dry goods store, but the business failed. In 1822, he resumed portraiture and was headed for a successful career when went insane and died December 21, 1830. **Sources:** G&W; Hunter, "Philip Tilyard," 14 repros.; Municipal Museum of Baltimore, *The Paintings of Philip Tilyard*, catalogue of exhibition at Peale Museum, Jan.-Feb. 1949; Pleasants, *250 Years of Painting in Maryland*, 44; *300 Years of American Art*, vol. 1, 99.

TIM, Mildred (Mrs.) *[Painter] mid 20th c.*
Addresses: NYC. **Studied:** ASL. **Exhibited:** S. Indp. A., 1923-24, 1926-27. **Sources:** Marlor, *Soc. Indp. Artists.*

TIMBREL, Clarence O. *[Painter] b.1869, Mahaska County, IA.*
Addresses: Des Moines, IA. **Studied:** Garrett Nollen, 1891. **Exhibited:** Iowa Art Salon, Des Moines, 1938. **Sources:** WW40; Ness & Orwig, *Iowa Artists of the First Hundred Years*, 206.

TIMECHE, Bruce *[Painter, carver] b.1923, Shungopovi, AZ.*
Addresses: Phoenix, AZ, 1967. **Studied:** Kachina School Art, 1958. **Work:** Mus. Am. Indian; Mus. Northern Arizona; Southwest Mus. North Am. Indian, Marathon, FL; First nat. Bank and Desert Hills Motel, Phoenix. **Comments:** Painter of realistic genre scenes, portraits, and carver of Kachina dolls. **Sources:** P&H Samuels, 487.

TIMKEN, Georgia See: **FRY, Georgia Timken (Mrs. John H.)**

TIMM, Herman *[Painter] b.1887, Neindorf, Germany / d.1975, Moodus, CT.*
Studied: self-taught naive painter in oils. **Exhibited:** NAD, 1962; Golden Age Exh., NYC Parks Dept., 1966 (Grand Prize). **Comments:** Timm emigrated to NYC in 1929 and worked as a brick layer. In 1956, at age 69, he was given a paint set by his daughter. He immediately began producing paintings in a charming and sometimes humorous naive style. Although he flirted with abstraction, his direction was clearly as a naif. In 1962, his "The Melting Pot" (which bore a patriotic theme) was accepted in the NAD's annual exhibition, and his address was given as the Bronx. Shortly after, he moved to Moodus, CT where he painted scenes of country life. He signed as "H. Timm." **Sources:** the artist's daughter, courtesy Arthur Hammer.

TIMMAS, Osvald *[Painter] b.1919, Estonia.*
Addresses: Toronto 19, Ontario. **Studied:** Tartu State Univ.; Atelier Schs. Tartu & Tallinn, Estonia, with Nicholas Kummits & Gunther Reindorff. **Member:** Assoc. Royal Can. Acad. Arts; AWCS; Can. Soc. Painters WC (dir., 1967-69); Ont. Soc. Artists (v. pres., 1971-). **Exhibited:** Can. Watercolors, Drawing & Prints, Nat. Gal. Can., Ottawa, 1966; Audubon Artists, 1966-69 (medal & award for creative aquarelle, 1967 & 1968); AWCS, 1966-67, 1969; NAD, 1967-68, 1971; Royal Can. Acad. Arts, Nat. Gal. Can., 1970; Merton Gallery, Toronto 7, Ont., 1970s; Gallerie Fore 405 Selkirk Ave, Winnipeg, 1970s. Awards: Major Award for Watercolor Painting, Coutts-Hallmark Co. Can., 1969 & 1970; John Labatt Ltd. Award, 1971. **Work:** London Art Mus., Ont.; Art Gal. Hamilton; Art Gal. Windsor; Canton Art Inst., OH; Rodman Hall Art Ctr., St. Catharines, Ont. **Comments:** Preferred media: watercolors, acrylics, oils. **Sources:** WW73; Anthony Ferry, "A Floating World," Feb 20, 1965 & "It's Now Time for Timmas," Nov 11, 1965, *Toronto Star;* Stevens, "Osvald Timmas," *La Rev Mod* (Nov 1966).

TIMME, E. A. *[Engraver] mid 19th c.*
Addresses: Chicago in 1859. **Sources:** G&W; Chicago BD 1859.

TIMMER, Antoine *[Painter] mid 20th c.*
Exhibited: S. Indp. A., 1935. **Sources:** Marlor, *Soc. Indp. Artists.*

TIMMERMAN, P. F. *[Sculptor] 20th c.*
Addresses: Minneapolis, MN. **Sources:** WW15.

TIMMERMAN, Walter *[Painter] early 20th c.*
Addresses: Kansas City, Kansas. **Sources:** WW17.

TIMMINS, H. A. (Mrs.) *[Painter] early 20th c.*
Addresses: Chicago, IL, c.1909. **Exhibited:** AIC, 1907. **Sources:** WW10.

TIMMINS, Harry L. *[Illustrator, teacher] b.1887, Wilsonville, NE / d.1963.*
Addresses: Hollywood, CA; Encino, CA.
Studied: AIC. **Member:** SI; GFLA; SC.
Exhibited: Carmel, Hollywood and San Fran., CA galleries.
Comments: Illustrated: *The Chicago* (for *Rivers of America* series), 1942. Contributed illustrations to: *Ladies' Home Journal, Cosmopolitan, Collier's, This Week, MacLean's, Toronto Star,* and others. Publicity for motion picture studios, 1953-55. **Sources:** WW59; WW47.

TIMMINS, William Frederick *[Painter, illustrator, designer] late 20th c.; b.Chicago, IL.*
Addresses: Noroton, CT; Carmel, CA. **Studied:** Am. Acad. Art, Chicago; ASL, with George Bridgman; Grand Cent. Art Sch., New York, with Harvey Dunn & Mario Cooper. **Member:** SI; Westport AA; Carmel Art Assn.; Soc. Western Artists. **Exhibited:** Perry House Gallery, 1969 (solo), 1970s; Carmel Valley Gallery, Carmel Valley, CA, 1970s. **Work:** House of Four Winds, Calif. Hist. Bldg., Monterey. Commissions: mural, Independent Savings & Loan Assn., Salinas, CA, 1972; also many comns. for pvt. portraits & paintings. **Comments:** Preferred media: oils. Publications: illusr., "Robin Hood and His Merry Men" 1956; "Cowboys," 1958; *Boy Scout Handbook,* 1968 & *Winnie the Pooh,* Western Publ., 1968. National ads. in newspapers, magazines and direct mail. **Sources:** WW73.

TIMMONS, Edward J. Finley *[Painter, lecturer, teacher] b.1882, Janesville, WI / d.1960.*
Addresses: Chicago, IL. **Studied:** AIC; with R. Clarkson, Sorolla, Spain; England; Holland, with Melchers; France; Italy. **Member:** Chicago ASL; Chicago PS; Ill. Acad. FA. **Exhibited:** PAFA Ann., 1908; S. Indp. A., 1925; Mun. Al, AIC, 1929 (prize); Carmel AA, 1940. **Work:** Univ. Chicago; Univ. Ark.; Univ. Ill.; Beloit Col.; Capitol, Des Moines, Iowa; Janesville AL, San Diego Gal. FA, Nat. Bank of Mattoon (Ill.); Mt. Clair (Ill.) Community House; Capitol, Cheyenne, Wyo.; Visitation Col., Dubuque, Iowa; Louis Berghoff Coll., Wilmette, Ill.; Santa Fe Railroad; Polytechnique Inst., Blacksburg, Va.; Meyer Mem., Michael Reese Hospital, Mun. A. Coll., Bell Sch., Chicago. **Comments:** Lectures: The Great Architectural Painters Throughout the Ages. **Sources:** WW40; Falk, *Exh. Record Series.*

TIMONTE, Alphonse *[Sculptor] mid 19th c.*
Addresses: Buffalo, NY in 1858. **Sources:** G&W; Buffalo BD 1858.

TIMOTHY, David *[Painter] early 20th c.*
Addresses: Knoxville, PA. **Member:** Pittsburgh AA. **Sources:** WW24.

TINDALE, Edward H. *[Painter] b.1879, Hanson, MA.*
Addresses: Brockton, MA/S. Hanover, MA. **Studied:** Munich Acad. with C. Marr, H. von Hayeck, Loeftz. **Sources:** WW29.

TINDALL, Robert Elton *[Painter, teacher, craftsperson] b.1913, Kansas City, MO.*
Addresses: Independence, MO. **Studied:** Kansas City AI (B.F.A.); Univ. Kansas City (B.A., M.A.), and with Thomas Hart Benton, Edward Lanning, Burnett Shryock. **Member:** A. Gld., Inc.; Community AA. **Exhibited:** Carnegie Inst., 1941; Denver A. Mus., 1940, 1942; Assoc. Am. A., 1942; CAM, 1941, 1944-45; William Rockhill Nelson Gal. A., 1942, 1944, 1946, 1951; Evansville (Ind.) Pub. Mus., 1944 (solo); Denison Univ., 1944 (solo); Woman's City Cl., Kansas City, 1958 (solo); FA Gal., Independence, Mo., 1958 (solo). Award: Vanderslice scholarship, 1938. **Work:** St. Benedict's Col., Atchison, Kans. **Comments:** Position: pres., A. Gld., Inc.; treas.; exh. chm., Community AA of Independence, Mo. **Sources:** WW59.

TINDEL, Annette M. *[Sculptor] mid 20th c.*
Addresses: Phila., PA. **Exhibited:** PAFA Ann., 1930, 1936, 1941. **Sources:** Falk, *Exh. Record Series.*

TING, Ken *[Artist] b.1945.*
Addresses: NYC. **Exhibited:** WMAA, 1975. **Sources:** Falk, *WMAA.*

TING, Walasse *[Painter] b.1929, Shanghai, China.*
Addresses: NYC. **Exhibited:** Paul Facchetti, Paris, France, 1954; Martha Jackson Gal., 1960; Galerie Birch, 1963; WMAA, 1966; Galerie ed France, 1968; Lefebre Gal., 1971. **Awards:** Guggenheim fel., 1970. **Work:** MoMA; Guggenheim Mus., New York; Carnegie Inst., Pittsburgh, Pa.; Stedelijk Mus., Amsterdam, Holland; Israel Nat. Mus., Jerusalem. **Comments:** Publications: auth., *My Shit & My Love,* 1961; auth., *One Cent Life,* 1964; auth., *Chinese Moonlight,* 1967; auth., *Hot & Sour Soup,* 1969; auth., *Green Banana,* 1971. **Sources:** WW73.

TINGEY, Thomas *[Marine painter] b.1750, London, England / d.1829, Wash., DC.*
Addresses: Philadelphia, PA (1783); Kingston, NJ (1797); Wash., DC (1804-on). **Work:** Mariners Mus., Newport News, VA; Peabody Mus., Salem, MA. **Comments:** He served in the Royal Navy (1771) and by 1781 was on merchant ships. After the Revolution he was a commander of American merchant ships, and finally settled in Wash., DC, where he was Commandant of the Washington Navy Yard. When the British invaded Washington in 1814, he ordered the Navy Yard burned. **Sources:** Brewington, 382.

TINGLE, Minnie (Mrs.) *[Painter] b.1875, Missouri / d.1926, Los Angeles, CA.*
Addresses: Los Angeles, CA. **Studied:** Hardin College. **Member:** Calif. AC; Laguna Beach AA (charter mem.). **Exhibited:** LACMA, 1925 (set of paintings of all the Calif. missions, which she donated to the museum after exhib.); Los Angeles Athletic Club, 1925. **Sources:** WW25; Hughes, *Artists in California,* 559.

TINGLER, Chester J. *[Painter, decorator, designer] b.1886, Buffalo, NY.*
Addresses: Coral Gables, FL; Marathon, FL. **Studied:** ASL, Buffalo; ASL, N.Y. **Member:** AFA; AAPL; Am. Ar. Cong.; Miami AL; Fla. A. Group. **Exhibited:** Century of Progress, Chicago, 1933 (prize); VMFA; WFNY, 1939; Wash. A. Gal.; Miami Beach; Worth Ave. Gal., Palm Beach; Ferargil Gal.; Norton Gal. A., West Palm Beach; Soc. Four A. (prize); Terry AI. **Work:** mural, Miami H.S.; USPO, Sylvester, GA. **Sources:** WW59; WW47.

TINGLEY, Blanche *[Painter] early 20th c.*
Addresses: San Francisco, CA. **Sources:** WW15.

TINGLEY, Eleanor L. *[Sculptor] mid 20th c.*
Addresses: Plainfield, NJ. **Exhibited:** PAFA Ann., 1936. **Sources:** Falk, *Exh. Record Series.*

TINGLEY, George Edward *[Photographer] b.1864, Old Mystic, CT / d.1956, Mystic, CT.*
Comments: A pictorialist landscape photographer, his platinum prints were illustrated in the British *Photographer's Magazine* (cover, 1895) and lauded in *Photogram* (1899). He won silver and bronze medals in the national pictorialist salons for pictorialist photography. **Sources:** exh. cat., *Art and Artists of the Mystic Area* (Mystic AA, 1976).

TINGLEY, Onie *[Painter] mid 20th c.*
Addresses: Anadarko, OK. **Exhibited:** S. Indp. A., 1926. **Sources:** Marlor, *Soc. Indp. Artists.*

TINKELMAN, Murray Herbert *[Painter, designer, illustrator, teacher] b.1933, Brooklyn, NY.*
Addresses: Brooklyn 19, NY. **Studied:** CUASch.; Brooklyn Mus. A. Sch., with Reuben Tam. **Member:** SI. **Exhibited:** Nat. Soc. Painters in Casein, 1956; NY City Center, 1956; 2-man: Panoras Gal., 1956, 1957, 3-man, 1958, solo, 1956; Davida Gal., 1958 (solo); Art: USA, 1958; BM, 1958; deCordova and Dana Mus.; SI, 1959-1961(gold &silver medals); Art Dir. Club (awards); Soc. of Publication Des. (awards). **Awards:** Max Beckmann scholarship, BMSchA, 1955-56; prizes, N.Y. City Center, 1958;

BMSchA. Alumni Exh., 1958; Artists Guild "Artist of the Year,"1970. **Comments:** Important illustrator, both through his work and teaching. Contr. illus., *Sat. Eve. Post; Musical America; Metronome; American Heritage; Herald Tribune; Grolier Society,* and others. Illus., c.25 children's books for major publishers, also fantasy and *Zane Grey* Western book covers. He made a series of drawings for the National Park Service, and has often appeared on the op-ed page of the *New York Times.* Positions: t., Parsons School Des.; prof., Syracuse Univ. **Sources:** WW66; W & R Reed, *The Illustrator in America,* 345.

TINKER, Edward Larocque *[Collector, writer, patron] 20th c.; b.NYC.*
Addresses: NYC. **Studied:** Columbia University (A.B.); New York University (LL.B.). **Member:** various learned societies and clubs, including The Council on Foreign Relations, Society of American Historians, The American Academy of Political and Social Sciences, The Northwestern Council for Latin American and inter-American Studies; The Pan-American Society, English Speaking Union, Order of Lafayette, American Society of French Legion of Honour. **Exhibited:** Awards: Palmes Academiques, French Government, 1933; Chevalier, Legion of Honour, 1939; Two Medals, French Academy; Hon. Doctor to Laws, Middlebury College, 1949; Hon. Doctor de Filosofia y Letras, University of Madrid; Columbia University medal "For Service"; Award, The Americas Foundation, 1962; Hon. Doctor of Letters, Columbia University, 1963; Knight Commander, Order of Queen Isabella of Spain. **Comments:** Positions: incorporated "The Tinker Foundation," to work for better understanding between the peoples of the New World; honorary curator, Hall of the Horsemen of the Americas, University of Texas; chancellor, American Antiquarian Society, Worcester; vice-president, Spanish Institute; vice-president, National Institute of Social Sciences; Board of Managers, American Bible Society; president-emeritus and founder, Uruguayan-American Society; member of the Advisory Council, School of International Affairs, Columbia University; lectured in Mexico for The Carnegie Endowment for International Peace, 1943; lectured in Argentina and Uruguay for the Department of State, 1945. Author: "Lafcadio Hearn's American Days," 1924; "Toucoutou", 1928; monographs on various facets of Creole life and literature; "Old New Orleans" (in collab. with Mrs. Tinker). Contributed a weekly column to the Sunday Literary Section of *The New York Times,* "New Editions, Fine and Otherwise". Collection: prints, paintings and equestrian gear of the Latin cattle riders; donated his collection, together with books relating to them, to the University of Texas, Austin. **Sources:** WW66.

TINKEY, John *[Wood engraver] early 20th c.; b.NYC.*
Addresses: Westfield, NJ. **Studied:** J.D. Felter, in NYC. **Member:** S. Am. Wood Engravers. **Exhibited:** Columbian Expo, Chicago, 1893, (med); Pan-Am. Expo, Buffalo, 1901. **Sources:** WW13.

TINKHAM, Alice Spencer *[Painter] late 19th c.*
Addresses: Grundmann Studios, Boston, MA. **Exhibited:** Boston AC, 1881, 1883, 1896; AIC. **Comments:** *The Boston AC.*

TINKHAM, Foster *[Engraver] mid 19th c.*
Addresses: NYC, 1846. **Sources:** G&W; NYBD 1846.

TINKHAM, J. F. (Mrs.) *[Artist] late 19th c.*
Addresses: Active in Grand Rapids, MI, c.1881. **Sources:** Petteys, *Dictionary of Women Artists.*

TINNE, Margaret S. *[Painter] mid 20th c.*
Addresses: Cincinnati, OH. **Exhibited:** Cincinnati Woman's AC, 1934; Cincinnati AM, 1939. **Sources:** WW40.

TINNING, George Campbell *[Painter] b.1910, Saskatoon, Sask.*
Addresses: Montreal 109, PQ. **Studied:** Elliot O'Hara Sch., Maine; ASL. **Member:** Assoc. Royal Can. Acad. Art; Can. Soc. Painters Watercolor. **Exhibited:** Waddington Galleries Inc, Montreal 109, PQ, 1970s. Awards: Dow awards for watercolor,

1942 & 1948, Montreal Mus. Fine Arts. **Work:** Nat. Gal. Art, Ottawa, Ont., Can.; Montreal Mus. Fine Arts, PQ; Ford Motor Co., Dearborn, Mich.; Charlottetown Art Mus., Prince Edward Island; Montreal Star, PQ. Commissions: mural on stair wall, Jenkins Valve Co., Lachine, Que., 1960; mural, pres. lounge, Bank Montreal, 1961; murals, Ritz Carlton Hotel, Montreal, 1967. **Comments:** Preferred media: watercolors, acrylics. Positions: war artist, hist. sect., Can. Army, 1943-46. Publications: auth., *Can. Art,* Spring 1949; auth. & illusr., *Lincoln Mercury Times,* 1950-59. Teaching: pvt. classes. **Sources:** WW73.

TINSLEY, Charles (indentured servant of) *[Limner, landscape painter] late 18th c.*
Addresses: Newcastle, VA. **Comments:** Indentured servant of Charles Tinsley who was a resident of Newcastle (VA), advertised in the *Virginia Gazette* of October 21, 1773, that he had "got" a man who was "a good Limner, Landscape Painter & and an excellent Hand at Painting all Sorts of Signs, Coats of Arms, and Ciphers on Carriages." **Sources:** G&W; Williamsburg, *Virginia Gazette,* Oct. 21, 1773.

TINSLEY, William *[Portrait painter] mid 19th c.*
Addresses: Albany, NY, 1852. **Sources:** G&W; Albany BD 1852.

TINTNER, Leontine See: **CAMPRUBI, Leontine**

TIPPERMAN, Philip *[Painter] mid 20th c.*
Exhibited: S. Indp. A., 1938. **Sources:** Marlor, *Soc. Indp. Artists.*

TIPPIT, Jack D. *[Cartoonist, commercial artist] b.1923, Stamford, TX.*
Addresses: Lubbock, TX. **Studied:** Texas Tech. Col.; Syracuse Univ. (B.F.A.). **Comments:** Contributor of cartoons to: *Sat. Eve. Post; Look; American Weekly; Sports Illustrated; American Legion; King Features Syndicate.* **Sources:** WW66.

TIPSON, Grace M. *[Painter] mid 20th c.*
Addresses: Oakland, CA, 1902-28. **Exhibited:** Oakland Art Gallery, 1928. **Comments:** Also known as (Mrs.) Grace T. Cole. **Sources:** Hughes, *Artists in California,* 559.

TIR, Norma *[Painter] mid 20th c.*
Addresses: Chicago area. **Exhibited:** AIC, 1941. **Sources:** Falk, *AIC.*

TIRANA, Rosamond (Mrs. Edward Corbett) *[Painter] b.1910, NYC.*
Addresses: Provincetown, MA; Wash., DC. **Studied:** Swarthmore Col. (B.A., 1931); London Sch. Econs., 1931-32; Univ. Geneva, 1931 & 1932 (grad. work); painting with Bernice Cross, E.R. Rankine & Hans Hofmann. **Member:** Am. Fedn. Arts. **Exhibited:** Corcoran Gal., 1956-59 & 1966; Provincetown Art Assn., Mass., 1957-65; Warrenton, Va. Area Exh., 1959; Wash. A. Assn., 1958-60; Art for Embassies, Nat. Collection Fine Arts, 1968, US Embassy, Turkey, 1969; One-man: Artists' Gal., Provincetown, 1960; Thenen Gal., N.Y., 1962, 1964; Franz Bader Gal., Wash., DC, 1963, 1965, 1969. Awards: prizes, Lycée Mooiere, Paris, France, 1924; Va. Regional Exhib., 1959; Washington Post Area Competition, 1959. **Comments:** Positions: for corresp., *Chicago Daily News, London Clarion & Milwaukee Leader,* 1932-34; dir., Franz Bader Gal., Wash., DC, 1959-. **Sources:** WW73.

TIRANOFF, Alexander *[Painter] mid 20th c.*
Exhibited: S. Indp. A., 1938. **Sources:** Marlor, *Soc. Indp. Artists.*

TIRRELL, George *[Painter] mid 19th c.*
Addresses: San Francisco, CA, active 1860; New Orleans, LA, 1874-75. **Comments:** A scene painter in Robinson's Theatre in San Francisco, he painted huge panoramic views of California, and continued as a scenic artist in New Orleans. **Sources:** Hughes, *Artists in California,* 559; *Encyclopaedia of New Orleans Artists,* 376.

TIRRELL, John *[Listed as "artist"] b.c.1826, Massachusetts.*
Addresses: Sacramento, CA. **Comments:** His personal property was valued at $40,000 and he was connected in some way with one T.J. Hagemann. **Sources:** G&W; 8 Census (1860), Cal., V, 15.

TISCH, Annette Pauline *[Painter] mid 20th c.; b.NYC.*
Addresses: NYC/Truro, MA. **Member:** NAWPS; AWCS.
Exhibited: AIC, 1930. **Sources:** WW33.

TISCH, William *[Painter] early 20th c.*
Addresses: NYC. **Exhibited:** S. Indp. A., 1917. **Sources:**
WW19.

TISCHLER, Marian Clara *[Painter] mid 20th c.*
Addresses: Cincinnati, OH. **Member:** Cincinnati Women's AC.
Sources: WW27.

TISCHLER, Victor *[Painter, lithographer, illustrator, teacher, craftsperson] b.1890, Vienna, Austria / d.1951, France.*
Addresses: Mamoroneck, NY. **Studied:** Beaux-Arts Acad.,
Vienna. **Exhibited:** Paris, 1936 (prize), 1938 (prize); Vienna,
1934, (prize); CI, 1943, 1945; WMAA, 1945; CMA, 1945; Pepsi-
Cola, 1946; Kansas City AI, 1946; PAFA Ann., 1948; numerous
solo exh., U.S. abroad. **Work:** de Young Mem. Mus.; Santa
Barbara Mus. A.; Stendahl Gal., Los Angeles, NYPL; Passedoit
Gal., NYC; Europe. **Sources:** WW47; Falk, *Exh. Record Series.*

TISDALE, Elkanah *[Miniature painter, designer, and engraver] b.1771, Lebanon, CT / d.After 1834.*
Addresses: NYC from 1794 to 1798; Hartford, CT. **Exhibited:**
American Academy; American Art-Union; Brooklyn AA, 1872.
Comments: Visited Albany with Benjamin Trott about 1798. He
was a founder of the Hartford Graphic and Bank Note Engraving
Company, and designed vignettes for them, but appears to have
done no engraving in that connection. He left Hartford in the late
1820s, probably for his native town of Lebanon, and was living in
1834. **Sources:** G&W; French, *Art and Artists in Connecticut,*
37-38; NYCD 1794-95, 1798, 1809-10; Bolton, "Benjamin Trott,"
262; Cowdrey, AA & AAU; Stauffer.

TISDALE, John B. *[Portrait painter] b.1822, Mobile, AL (probably) / d.1885, Mobile, AL.*
Addresses: Mobile, AL, 1844; New Orleans; St. Louis;
Independence; Lexington, MO; Mobile, AL. **Comments:** Early in
1844 Tisdale became acquainted with Alfred S. Waugh (see entry)
in Mobile. They worked together there for nearly a year, then
moved on to New Orleans and St. Louis. They hoped to join
Frémont's Third Expedition as artists but were turned down and
from July 1845 to May 1846 they divided their time between
Independence and Lexington (MO). From June 1846 to June 1847
Tisdale served as a private in Doniphan's Regiment, Missouri
Mounted Volunteers, seeing service in New Mexico and
California. A sketch of "The Volunteer," which appeared in
Hughes' account of the Doniphan Expedition with the signature:
J.D. Tisdell, was undoubtedly the work of Tisdale. By 1855
Tisdale was back in Mobile where he seems to have spent the rest
of his life. In later years he served as deputy sheriff and county
assessor. His name disappears from the Mobile directory after
1885. **Sources:** G&W; McDermott, *Travels in Search of the
Elephant,* xii-xiii, 1 ff.; Hughes, *Doniphan's Expedition;* informa-
tion from records in the Adjutant General's Office, Dept. of the
Army, National Archives.

TISHLER, Harold *[Designer-craftsman, teacher] b.1895, Odessa, Russia.*
Addresses: Jackson Heights, NY. **Studied:** Kunstgewerbe Schule,
Vienna, Austria, and with Michael Powolny, Joseph Hoffmann.
Member: N.Y. Soc. Craftsmen. **Exhibited:** MMA; BM; Roerich
Mus.; Syracuse Mus. FA; VMFA; Phila. A. All; N.Y. Soc.
Craftsmen; N.Y. Soc. Cer. Arts; Intl. Expo, Paris, 1937 (gold &
silver med). **Sources:** WW59; WW47.

TISON, Claire See: **KENNARD, Claire Tison**

TITCOMB, Caroline King *[Painter] late 19th c.*
Addresses: Chicago. **Exhibited:** AIC, 1891, 1895. **Sources:**
Falk, *AIC.*

TITCOMB, James *[Painter] early 20th c.*
Exhibited: AIC, 1909. **Sources:** Falk, *AIC.*

TITCOMB, Mary Bradish *[Painter, illustrator] b.c.1858, Windham, NH / d.1927, Marblehead, MA.*
Addresses: Boston, MA. **Studied:** Massachusetts Normal Art
School; BMFA Sch. with Tarbell, Benson, and Hale, 1902-09;
Académie Julian, Paris. **Member:** Copley Soc., 1895; NYWCC;
NAWA; CAFA; North Shore AA. **Exhibited:** PAFA(watercolor
exhib.), 1904-08, 1910, 1912, 1914-17, 1921; PAFA Ann., 1905,
1908-19, 1921-24, 1926-27; AIC (watercolors, pastels & minia-
tures by American artists), 1905-09, 1922-13, 1916; AIC (oils &
sculpture by American artists), 1906-08, 1911-15; Woman's Club
of Brockton, 1906-16, 1919-22; Boston AC (watercolors & pas-
tels), 1906-1908; Boston AC (oils), 1907-08, 1915-16, 1920-21;
American WC Soc. annuals, 1907-10, 1912; NYWCC annual,
1907-16; Poland Spring Art Gallery, ME, 1907-16; Albright-Knox
Gal. (Buffalo FA Academy, watercolor exhib.), 1908; NAD annu-
al, 1910-12, 1914-15; NAD (winter exhib.), 1911-13, 1915;
BMFA, 1911; City Art Mus., St. Louis, MO, 1913, 1916, 1920;
NAWA, 1914, 1916-20, 1922-27; Copley Gal., Boston, 1913
(solo), 1914, 1917, 1919; Corcoran Gal biennials, 1910, 1914,
1923; Kansas City FA Inst., MO, 1914; Pan-Pacific Int. Expo, San
Francisco, 1915; Art Assoc. of Newport, RI, 1914-17, 1920-23;
Concord AA, MA, 1916-17; Orange Lib. , Orange, MA, 1916
(solo); CAFA, 1917 (hon. mention), 1919, 1921, 1925; Gallery-
on-the-Moors, East Gloucester, MA, 1917-22; Vose Galleries,
Boston, MA, 1917, 1998; Worcester Art Mus., 1917; Doll &
Richards Gallery, Boston, MA, 1918, 1919; Brockton Pub.
Lib.,1919; North Shore AA, East Gloucester, 1924-27;
Marblehead AA, 1923-1926 (prize), 1927; Women's City Club of
Boston, MA, 1917, 1927 (memorial); Vose Galleries, "Mary
Bradish Titcomb and Her Contemporaries," 1998. **Work:** White
House, Washington, DC; Vose Galleries. **Comments:** Titcomb
started out as a teacher (Windham schools, MA, 1875- c.1886; dir.
of drawing, Brockton public schools, 1887-1901). She traveled
extensively during the summers to hone her artistic skills in such
places as Sebago, Monhegan, and Ogunquit, ME, Round Lake,
NY, Europe (France, Holland, Spain), the White Mountains of
NH, Canada, California, Arizona, and Mexico. Beginning around
1917 — when she joined other women painters who later called
themselves "The Group" — her painting evolved from traditional
Boston Impressionism to one that integrated the stylistic ideas of
modernism. She painted at Grundman Studios in 1907-17, and at
the Fenway Studios, 1917-on. **Sources:** WW27; Campbell, *New
Hampshire Scenery,* 166; Vose Galleries, *Mary Bradish Titcomb
and Her Contemporaries,* 1-21; Curtis, Curtis, and
Lieberman,187; Falk, *Exh. Record Series.*

TITCOMB, Virginia Chandler (Mrs. John Abbot)
[Sculptor, painter, writer] 19th/20th c.; b.Otterville, IL.
Addresses: Brooklyn, NY, 1884-. **Member:** Patriotic Lg. of
Revolution, 1884 (founder). **Comments:** (Virginia Chandler).
Specialty: bas-reliefs. **Sources:** WW06.

TITCOMB, William H. *[Painter and teacher] b.1824, Raymond, NH / d.1888.*
Addresses: Cambridge and Boston, 1860 and later. **Comments:**
He took up painting after trying his hand at the dry goods trade
and from about 1860 was a successful teacher in Cambridge and
Boston. As a painter, he specialized in New Hampshire views.
Sources: G&W; Boston *Transcript,* Feb. 11, 1888; Swan, BA;
Cambridge BD 1860; Campbell, *New Hampshire Scenery,* 166-67.

TITEL, Irving *[Painter] mid 20th c.*
Addresses: Chicago area. **Exhibited:** AIC, 1950-51. **Sources:**
Falk, *AIC.*

TITIEV, Jacob *[Painter] mid 20th c.*
Exhibited: Salons of Am., 1934. **Sources:** Marlor, *Salons of Am.*

TITLOW, Harriet W(oodfin) *[Painter] b.1875, Hampton, VA / d.1943, Springfield, OH.*
Addresses: Jersey City, NJ. **Studied:** Henri; ASL. **Member:**
NAWPS; N.Y. Soc. Women A. **Exhibited:** S. Indp. A., 1917-19.
Sources: WW33.

TITONE, Seymour *[Painter] mid 20th c.*
Addresses: Birchrunville, PA. **Exhibited:** PAFA Ann., 1953.
Sources: Falk, *Exh. Record Series.*

TITSWORTH, Julia *[Painter, illustrator] b.1878, Westfield,
MA / d.1941, Chico, CA.*
Addresses: Bronxville, NY; Piedmont, CA, 1923; Chico, CA.
Studied: AIC; R. Collin, in Paris. **Member:** NAWA; AFA.
Exhibited: S. Indp. A., 1930; Salons of Am., 1930, 1934;
Oakland Art Gallery, 1932; AIC. **Sources:** WW29; Hughes,
Artists in California, 559.

TITTLE, Grant Hillman *[Printmaker, designer] b.1932,
Haleyville, AL.*
Addresses: Athens, GA. **Studied:** Auburn Univ. (B.F.A.), with
Maltby Sykes; Pratt Inst. (M.F.A.), with Walter Rogalski; also
with Max Kahn, Chicago, Dolf Reiser, London & Henry Cliff,
Bath, Eng. **Member:** Col. Art Assn. Am.; Exp. Art & Technol.
Exhibited: One-man shows, Metal Multiples & Medallions, Pratt
Inst., 1970 & EG Gal., New York, 1970; Sixth Ann. Piedmont
Graphics Exhib., Mint Mus., 1970; Colorprint USA Exhib., Tex.
Christian Univ., Lubbock, 1971; Ga. Artists, High Mus., Atlanta,
1972. Awards: first purchase award in Sixth Graphics Ann., Mint
Mus., 1970. **Work:** Univ. Chicago, Ill.; Alcoa Aluminum, Pan-
Am. Bldg., New York; Mint Mus., Charlotte, NC; Pratt Inst.,
Brooklyn, NY. **Comments:** Positions: designer, Sears Nat.
Display Dept., 1956-58; art prod. mgr., Sci. Res. Assoc., 1958-60;
assoc. designer, Bud Donahue & Assocs., 1962-65. Teaching:
tutor/lectr., lithography & design, Bath Acad. Art, Corsham, Eng.,
1966-68; asst. prof. printmaking & design, Univ. Ga., 1970-.
Sources: WW73; A Stasik (ed.), *Artist Proof* (Pratt/New York
Graphics Soc., 1972); C. Romano & J. Ross (ed.), *Printmaking:
Techniques and Innovations* (McMillan, 1972); *Colorprint USA
1971* (Tex. Christian Univ., 1972).

TITTLE, Walter Ernest *[Painter, etcher, writer] b.1883,
Springfield, OH / d.1966, Carmel, CA.*
Addresses: Danbury, CT. **Studied:** N.Y. Sch. A. and ASL with
W.M. Chase, Robert Henri, F.L. Mora. **Member:** SAE; Chicago
SE; Cal. Pr. M.; AAPL; Royal SA, London. **Exhibited:** NAD;
Royal Acad., London; S. Indp. A.; Corcoran Gal biennial, 1937;
PAFA; LOC (solo); AIC (solo); CGA (solo); U.S. Nat. Mus., 1943
(solo); 1946 (solo); NAC, 1931 (prize); Chicago SE, 1934 (prize);
Calif. PM, 1932 (med). **Work:** Nat. Port. Gal., British Mus.,
Victoria & Albert Mus., London, England; Johns Hopkins Univ.;
Masonic Temple, Springfield, Ohio; U.S. Nat. Mus; LOC; BM;
CI; AIC; Boston Pub.Lib; NYPL; CMA; Columbus Gal. FA;
TMA; Calif. State Lib.; Fitzwilliam Mus., Cambride; Univ. Va.;
Lib., Arlington, MA. **Comments:** Author/Illustrator: *Colonial
Holidays, The First Nantucket Tea Party.* Contributed articles to:
Century, Scribner's; Illustrated London News. **Sources:** WW53;
WW47.

TITUS, Aime Baxter (Mr.) *[Painter, teacher, illustrator]
b.1883, Cincinnati, OH. / d.1941, San Diego, CA.*
Addresses: San Diego, CA. **Studied:** San Fran. School of FA;
ASL, with Harrison, Mora, Bridgman, DuMond, Chase. **Member:**
San Diego FAS (Dir.); Calif. AC; San Diego Art Guild.
Exhibited: P.-P. Expo, San Fran., 1915 (silver med); Panama-
Calif. Int'l Expo, San Diego, 1915 (bronze med). **Sources:**
WW33; Hughes, *Artists in California,* 560.

TITUS, Ellen *[Painter] mid 19th c.*
Addresses: Jackson, MI, 1876. **Exhibited:** Michigan State Fair,
1876. **Sources:** Gibson, *Artists of Early Michigan,* 228.

TITUS, Francis *[Sculptor and carver] b.c.1829, Bavaria /
d.Before 1863.*
Addresses: NYC from c.1854-60. **Comments:** His widow,
Gertrude, was listed in the 1863 directory. Gottfried Titus (see
entry) was very likely a brother. **Sources:** G&W; 8 Census
(1860), N.Y., LIV, 1003; NYCD 1855-63.

TITUS, Franz M. See: TITUS, Francis

TITUS, Gottfried *[Painter] mid 19th c.*
Addresses: In NYC from 1858. **Comments:** His address in 1863
was the same as that of Francis Titus (see entry) in 1857, suggest-
ing that they were related. **Sources:** G&W; NYCD 1857-63.

TITUS, Lela J. *[Painter] b.1889, San Diego, CA / d.1984, San
Diego, CA.*
Addresses: San Diego, CA. **Exhibited:** Calif.-Pacific. Int'l Expo,
San Diego, 1935. **Comments:** Sister of A. B. Titus (see entry).
Sources: Hughes, *Artists in California,* 560.

TITUS, Millard W. *[Landscape painter, designer, decorator]
b.1890, Dallas.*
Addresses: Chicago, IL. **Member:** All-Ill. SFA. **Exhibited:** All-
Ill. SFA, 1936 (prize); AIC. **Sources:** WW40.

T'NAIN, Howard *[Painter] early 20th c.*
Studied: WMAA, 1922. **Sources:** Falk, *WMAA.*

TOASPERN, Otto *[Painter, illustrator] b.1863, Brooklyn, NY.
/ d.1940.*
Addresses: NYC. **Studied:** Royal Acad. FA, Munich, with Gysis,
Nauen. **Exhibited:** Boston AC, 1891. **Sources:** WW10.

TOBEN, Elizabeth (Lizzie) *[Amateur artist] late 19th c.*
Addresses: Active in Detroit, MI, 1885-91. **Sources:** Petteys,
Dictionary of Women Artists.

TOBERENTZ, Robert *[Sculptor] 19th/20th c.*
Addresses: NYC, 1888. **Exhibited:** NAD, 1888. **Sources:**
WW01.

TOBEROFF, Isidore *[Painter] mid 20th c.*
Addresses: NYC. **Exhibited:** S. Indp. A., 1944. **Sources:**
Marlor, *Soc. Indp. Artists.*

TOBEY, Alton S. *[Painter, lecturer] b.1914, Middletown, CT.*
Addresses: Hartford, CT; Larchmont, NY. **Studied:** Yale Univ.
School Fine Arts (B.F.A., 1937; M.F.A., 1947). **Exhibited:**
CAFA, 1934-37; 48 States Comp., U.S.P.O. Station, East
Hartford, CT, 1939 (prize); City Center Gals., 1950-53; Riverside
Mus., 1952-54; Norfolk Mus. Arts & Sciences, 1966; Loeb
Center, NYU, 1969-71. **Work:** two murals, Smithsonian Inst.,
Washington, DC; Jewish Mus., NYC; NAD, Edwin Abbey
Collection, NY. Commissions: mural for Campfield Ave. Library,
commissioned by Charles Goodwin, 1937; murals for East
Hartford Post Office, 1938 (now destroyed); Life of Gen
MacArthur (six murals), Edwin Abbey Mural Fund for MacArthur
Mem., 1965; two murals on anthropology, Smithsonian Mus.
Natural Hist., 1967; fourteen murals on Am. history, commis-
sioned by director of Project 1914, Chadds Ford, PA, 1970.
Comments: First known for his portraits. In the late 1940s he
began to paint common objects in three dimensions. After that he
worked in a style with no straight lines, in two dimensions. In the
1980s he did a series of realistic paintings. Also produced illustra-
tions, ceramic plates and other works. Preferred media: oils,
acrylics. Positions: pres., Mamaroneck Art Guild; director, Artists
Equity New York, 1970-; vice pres., Nat. Soc. Mural Painters,
1972-. Teaching: instructor & lecturer, styles, techniques & histo-
ry of art, Yale School Fine Arts, 1945-49; lecturer history of art,
City College New York, 1950-51. **Sources:** WW73; WW40; Art
in Conn.: Between World Wars.

TOBEY, Barney *[Painter] mid 20th c.*
Exhibited: Salons of Am., 1934. **Sources:** Marlor, *Salons of Am.*

**TOBEY, Edith See: MCCARTNEY, Edith (Mrs.
Edward Sprogue Tobey)**

TOBEY, Edith Allerton Tower (Mrs.) *[Painter] b.1879, New
Westdale, MA / d.1973, Sullivan, IL.*
Studied: mainly self-taught; with John Hussian, PMA.
Exhibited: Plastic Club Phila. (solo). **Sources:** Petteys,
Dictionary of Women Artists.

TOBEY, Frank Clinton *[Painter, photographer] b.1865, New
Bedford, MA / d.1892, New Bedford.*
Addresses: New Bedford, MA. **Work:** Old Dartmouth Hist. Soc.

Sources: Blasdale, *Artists of New Bedford,* 190 (w/repro.).

TOBEY, Mark *[Painter, musician, poet, teacher]* b.1890, Centerville, WI / d.1976, Basel, Switzerland.
Addresses: NYC, 1911-22; Seattle, NYC, Paris & Chicago, 1923-31; Seattle, 1938-60; Basel, Switzerland, 1960-on. **Studied:** AIC, before 1911; Teng Kwei, in Seattle, 1923-24; calligraphy in Japan, 1934. **Member:** Am. Acad. Arts & Letters. **Exhibited:** S. Indp. A., 1921-22, 1931; Portland (Oreg.) AM, 1939 (prize); WFNY, 1939; SAM, 1935 (solo), 1942 (solo) & 1971 (solo); SFMA, 1945 (solo); PAFA Ann., 1945-58; WMAA, 1951 (solo), AIC, 1955 (solo); Corcoran Gal biennials, 1953, 1963; Venice Biennial, 1958 (Grand natl. prize for painting); Art in Am., 1958 (prize); Mus. Arts Decoratifs, 1961 (solo); CI, 1961 (first prize for painting); MoMA, 1962 (retrospective). **Work:** SAM; MMA; MoMA; WMAA; BMFA; AIC; SFMA; Detroit IA; NMAA; Phillips Col., Wash., DC. Commissions: mural for library at Olympia, WA, 1958; mural for library, Wash. State Univ., 1962; mural for opera house, Seattle, WA, 1964. **Comments:** Important modernist whose Baha'i religious beliefs and studies of Zen Buddhism and oriental calligraphy influenced his abstract "white writing" painting technique of tangled linear strokes. He traveled often throughout his career, visiting China and Japan in 1934, but Seattle remained his home until he moved to Switzerland in 1960. Positions: catalogue illustrator, Chicago, c. 1909; fashion illustrator and caricaturist, NYC, c. 1911-22. Teaching: resident artist, Darlington Hall, England, 1931-39. **Sources:** WW73; WW40; Baigell, *Dictionary;* William C. Seitz, *Mark Tobey* (exh. cat., MOMA, 1962); Colette Roberts, *Mark Tobey* (Grove, 1960); *Tobey, the World of a Market* (Univ. Wash. Press, 1964); Wieland Schmied, *Tobey* (Ed. Pierre Tisne, Paris, 1966); Trenton, ed. *Independent Spirits,* 117; Falk, *Exh. Record Series.*

TOBEY, S. Edwin *[Painter]* late 19th c.
Exhibited: Boston AC, 1879, 1880. **Comments:** *Cf.* Samuel Tobey. **Sources:** *The Boston AC.*

TOBEY, Samuel *[Copperplate and steel engraver]* mid 19th c.
Addresses: Philadelphia, 1858-59. **Comments:** Before and after 1858-59 he was listed variously as bookkeeper, agent, and envelope manufacturer. **Sources:** G&W; Phila. CD 1850-60+.

TOBIAS, Abraham Joel *[Painter, sculptor, lithographer, teacher, lecturer, designer, illustrator, architect]* b.1913, Rochester, NY.
Addresses: Queens, NY. **Studied:** CUA School, 1930-31; ASL, 1931-33; Rutgers Univ.; Fed. Art Project, New York, 1938-40. **Member:** Am. Artists Congress. **Exhibited:** MoMA, 1939; BM, 1937-39; SFMA, 1941; ACA Gal., 1936; Delphic Studios, 1935-37; New Sch. Soc. Research (solo); Everhart Mus., 1939 (solo); Howard Univ., 1938 (solo); post office mural commission, Nat. Fine Arts Commission, 1940; Arch. Lg., New York, 1952 (award for mural painting); "NYC WPA Art" at Parsons School Design, 1977. **Work:** BM; LACMA; NYPL; Howard Univ., Wash., DC; Rochester (NY) Public Library. Commissions: USPO, Clarendon, AR; "The Student "(fresco mural), Howard Univ., Wash., DC, 1945; two war mem. fresco panels, James Madison H.S., Brooklyn, 1952; acrylic mural, Domestic Relations Court, Dept. Public Works, New York, 1956; two plexiglass panels for entrance, Polytechnical Inst. Brooklyn, 1958; mosaic & terrazzo mural, Henrietta Szold School, New York Board Educ., 1960. **Comments:** Preferred media: plastics, metals, stones. Positions: art dir., intelligence div., U.S. Air Forces, Wash., DC, 1943-44; graphic designer, Office Strategic Services, Wash., DC, 1944-45; Metropolitan Opera Guild, 1946; teacher, Howard Univ., Washington, 1943-46; artist-in-residence, Adelphi Univ., 1947-57; lecturer mural painting, Assn. Am. Colleges Program, 1952 & 1955; art instructor, Polytechnical Inst. Brooklyn, 1970-. Publications: author, "Mural Painting," Feb., 1957 & author, "A Mural Painting for Science & Technology," March, 1969, *Am. Artist Magazine.* **Sources:** WW73; WW47; Joseph L. Young, *Mosaics: Principles & Practice* (Reinhold, 1964); Lawrence N.

Jensen, *Synthetic Painting Media* (Prentice Hall, 1964); Louis Botto, "In the Know," *Look Magazine* (1969); *New York City WPA Art,* 87 (w/repros.).

TOBIAS, Corinne W. *[Artist]* early 20th c.
Addresses: Active in Washington, DC, 1908. **Sources:** Petteys, *Dictionary of Women Artists.*

TOBIAS, Julius *[Sculptor, painter, instructor]* b.1915, NYC / d.1999.
Addresses: NYC. **Studied:** Atelier Fernand Leger, Paris, 1949-52. **Exhibited:** PAFA, 1958; MoMA Traveling Exhib., Tokyo, 1959; New Eng. Exhib., Silvermine, Conn., 1960; WMAA, 1968; Indianapolis Mus. Art, Ind., 1970; Max Hutchinson Gal., NYC, 1970s; 55 Mercer St., NYC, 1970s; SUNY, Stony Brook, NY, 1992 (traveling retro.). Awards: NY Cult. Coun. Found. Creative Artists Pub. Serv. Prog. grant, 1971; Guggenheim fel., 1972-73; two Pollock-Krasner awards and NEA grants. **Work:** Pasadena Mus. Art, Calif.; Albright-Knox Mus., Buffalo; Brooklyn Mus.; Herbert F. Johnson Mus. of Art, Cornell Univ. **Comments:** Known for his Minimalist sculptures in the 1960s/70s. In the 1950s Tobias explored Abstract-Expressionism and Constuctivism. During the 1960s he began producing large all-white paintings which soon became cubicle-structures onto which geometrical sculptural forms such as beams and curblike bars were added. These grew in size and weight (he began using cast-concrete) and eventually were being shown by themselves in galleries. Tobias also evolved some of these environments into the shapes of crosses and pews. During the 1980s Tobias focused on figurative painting in an expressionist mode, treating themes such as the Holocaust and violence. Teaching: instr. painting, New York Inst. Technol., 1966-71; instr. sculpture, Queens Col (NY), 1971-. **Sources:** WW73; Corrine Robbins, "Six Artists and the New Extended Vision," *Arts Mag.* (Sept.-Oct., 1965); Barbara Rose, "A Gallery without Walls," *Art Am.* (Mar.-Apr., 1968); James R. Mellow,"Two Sculptors Worlds Apart," *New York Times,* Jan. 31, 1971; obit., *New York Times,* June 25, 1999.

TOBIAS, Thomas J. *[Collector, museum official]* b.1906, Charleston, SC / d.1970.
Addresses: Charleston, SC. **Studied:** College of Charleston (B.S.). **Comments:** Positions: trustee, secretary, vice-president, 1946-64, president, 1964-67, Carolina Art Association, which operates the Gibbes Art Gallery (a community art gallery), Charleston, S.C. **Sources:** WW66.

TOBIN, Captain *[Marine painter]* late 18th c.
Work: National Maritime Mus. **Comments:** Captain in the Royal Navy, he made several watercolor paintings of ships in Hampton Roads, VA, 1794-96. **Sources:** Wright, *Artists in Virginia Before 1900.*

TOBIN, Frederick *[Painter]* mid 19th c.
Comments: Painter of six oils depicting California scenes in 1850, including a view of San Francisco. "The only clue to the artist's identity is contained in a dealer's note in an auction catalogue which reads: "The following statement was pencilled on the back of one of the old frames from which this and the following four paintings were taken: "Painted by Fred Tobin, 1850, recently Secretary to the Society of Foreign Artists." A search through contemporary San Francisco directories and art catalogues has failed to turn up any further information about this artist." **Sources:** G&W; Van Nostrand and Coulter, *California Pictorial,* 78-79.

TOBIN, George Timothy *[Illustrator, etcher, painter, teacher]* b.1864, Weybridge, VT / d.1956.
Addresses: New Rochelle, NY; Albans, VT. **Studied:** ASL, with George de Forest Brush. **Member:** ASL; AAPL; New Rochelle AA. **Exhibited:** N.Y. WC Cl.; PAFA; Northern Vt. A., 1951, 1952; New Rochelle AA,1915-1946. **Work:** FMA; Smithsonian Inst.; Daniel Webster Sch., New Rochelle, NY; port. of prominent men. **Comments:** I., "Bible Stories," 1922; "Wind Blown Stories," 1930; "The Blue Highway," 1932; & other books. Contributor to: national magazines. **Sources:** WW53; WW47.

TOBIN, Lucy M. (Mrs. M.J.) *[Painter]* b.1868, Davenport, IA.
Addresses: Des Moines, IA. **Studied:** Laura Putnam, Cornell Col.; Charles A. Cumming; Celestina Thust, 1892, NYC. **Exhibited:** Sioux City, 1936; Iowa Federation Women's Clubs Exhibit. **Comments:** Position: teacher, Tilford Acad., Vinton, IA. **Sources:** Ness & Orwig, *Iowa Artists of the First Hundred Years*, 206.

TOBLER, Emil See: **HUGENTOBLER, Emil J.**

TOBRINER, Haidee *[Landscape painter]* b.1878, San Francisco, CA / d.1968, San Francisco.
Addresses: San Fran., CA. **Studied:** Mark Hopkins Inst., with Arthur Mathews. **Exhibited:** Mark Hopkins Inst., 1906. **Sources:** WW13; Hughes, *Artists in California*, 560.

TOCH, Maximilian *[Paint expert]* b.1865 / d.1946, NYC.
Comments: A recognized chemist who lectured at NAD on "Paint, Paintings and Restoration," and published books on these subjects.

TOCK, Jean *[Painter]* mid 20th c.
Addresses: Boston, MA. **Exhibited:** AIC, 1947. **Sources:** Falk, *AIC*.

TODAHL, J(ohn O.) *[Painter, illustrator]* b.1884, Crookeston, MN.
Addresses: Milford, CT. **Studied:** AG of Authors Lg. A. **Work:** CGA. **Comments:** Illustrator: "Cruise of the Cuttlefish;" national magazines, such as *Scribner's*. **Sources:** WW25.

TODD *[Engraver]* early 19th c.
Comments: Of Gray & Todd (see entry), engravers of astronomical plates published in Philadelphia in 1817. Possibly the same as A. Todd. **Sources:** G&W; Stauffer.

TODD, A. *[Engraver]* early 19th c.
Comments: Engraver of a small bust portrait of Washington, published in 1812 for the Washington Benevolent Society, Concord (NH). **Sources:** G&W; Stauffer.

TODD, Albert M. *[Patron]* b.1850, Nottawa, MI.
Comments: A founder of three art museums, he began early in life to collect rare books and eventually owned 10,000 rare books and many valuable illuminated manuscripts. He purchased works of art on his first trip to Europe (1875). Most of his works of art have been given to educational institutions in Kalamazoo.

TODD, Anne Ophelia *[Designer, mural painter, teacher]* b.1907, Denver, CO.
Addresses: NYC. **Studied:** CI; ASL; BAID. **Member:** A. Des. Group. **Exhibited:** f., Tiffany Fnd., 1928-29, 1931; WMAA, 1936. **Comments:** Position: t., Manhattanville Col., NYC. **Sources:** WW40.

TODD, Arthur J. *[Painter]* mid 20th c.
Exhibited: AIC, 1927. **Sources:** Falk, *AIC*.

TODD, Bianca *[Painter]* b.1889, NYC / d.1952, Beverly Hills, CA.
Addresses: NYC. **Studied:** ASL; in Europe; & with Kenneth Hayes Miller, Walt Kuhn. **Member:** NSMP; NAWA; East Hampton Gld.; NAWPS; AFA; Munic. AS. **Exhibited:** Santa Barbara, CA, 1933 (prize); Salons of Am., 1934; NAWA, 1937 (prize); Argent Gal., 1939 (solo). **Work:** collaborated with Fred W. Ross on murals, Courthouse, Terre Haute, IN. **Comments:** Position: dir., Argent Gal., NYC. **Sources:** WW53; WW47.

TODD, C(harles) Stewart *[Painter, designer, craftsperson]* b.1886, Owensboro, KY.
Addresses: Cincinnati, OH. **Studied:** Cincinnati A. Acad.; & with Alfred Snell; A. Herter. **Member:** Boston SAC; Cincinnati Professional A.; Cincinnati MacDowell S. **Exhibited:** CM, 1914-46; Cincinnati Professional A., 1934-46; Closson Gal., 1920 (solo), 1922 (solo); Loring Andrews Gal., Cincinnati, 1940 (solo); AIC (solo). Awards: Master Craftsman, Boston SAC, 1923. **Comments:** Specialty: batik. **Sources:** WW53; WW47.

TODD, E. A. (Mrs.) *[Painter]* late 19th c.
Addresses: NYC, 1886. **Exhibited:** NAD, 1884, 1886. **Sources:** Naylor, *NAD*.

TODD, Edwin *[Sculptor, painter, teacher, lecturer]* b.1913, Sedalia, MO.
Addresses: Parkville, MO. **Studied:** Univ. Iowa; Columbia. **Exhibited:** Kansas City AI, 1939. **Comments:** Position: t., Park Col. **Sources:** WW40.

TODD, Frances Carroll *[Painter]* mid 20th c.; b.NYC.
Addresses: Charlottesville, VA; Wash., DC. **Studied:** Corcoran Sch. A.; Phila. Sch. Des., with H.B. Snell; Univ. W.Va., with E. Clark; Webster Art Sch., Provincetown, Mass; H. Breckenridge; C.C., Critcher E. Graecen; G.P. Ennis; Grand Central Sch. A.; Yand Sch. FA, Wash. **Member:** Georgetown A. Group; Soc. Wash. A.; Albemarle AA, Charlottesville, Va.; Wash. AC. **Exhibited:** CGA; Soc. Wash. A., 1953; AAPL, 1953-1956; Wash. A. Cl., annually; Collectors Corner, Georgetown, Wash., D.C., 1955. **Sources:** WW59; WW47.

TODD, G. *[Painter]* 19th/20th c.
Addresses: Wash., DC. **Exhibited:** Wash. WCC, 1897. **Comments:** This could be Miss G. Todd, who exhibited at the Greater Wash. Independent Exh., 1935. **Sources:** McMahan, *Artists of Washington, DC*.

TODD, George [?] *[Profilist]* early 19th c.
Addresses: Charleston, SC, 1807; in Baltimore about 1810. **Work:** Md. Hist. Soc. **Comments:** He could also be the "Todd" of Bache & Todd, who advertised in New Orleans in 1804 as silhouettists and patentees of the "physiognotrace" for taking profiles (it is likely that Bache is the profilist William Bache). Cf. Pamela Todd. **Sources:** G&W; Rutledge, *Artists in the Life of Charleston*, simply as Todd; Carrick, *Shades of Our Ancestors*, 41, as George [?]. See also *Encyclopaedia of New Orleans Artists*, under entry for "Bache & Todd."

TODD, H. Stanley *[Portrait painter]* b.1872, St. Louis, MO / d.1941, Northport, NY.
Addresses: NYC. **Studied:** Académie Julian, Paris with J.P. Laurens and Benjamin-Constant, 1893. **Member:** SC, 1900. **Exhibited:** Paris Salon, 1895, 1896; NAD, 1898; Pan-Am. Expo, Buffalo, 1901 (prize); St. Louis Expo, 1904 (med). **Sources:** WW10; Fink, *American Art at the Nineteenth-Century Paris Salons*, 397.

TODD, Heber C. *[Painter]* 19th/20th c.
Addresses: Boston, MA. **Exhibited:** Boston AC, 1894-97. **Sources:** *The Boston AC*.

TODD, June Aston *[Painter]* mid 20th c.
Addresses: Oakland, CA. **Exhibited:** San Francisco AA, 1938, 1940. **Comments:** Specialty: watercolors. **Sources:** Hughes, *Artists in California*, 560.

TODD, Kathleen B. *[Painter]* early 20th c.
Addresses: Phila., PA. **Exhibited:** PAFA Ann., 1902. **Sources:** Falk, *Exh. Record Series*.

TODD, Marie Childs *[Woodcarving, painter, teacher]* 20th c.; b.Indianapolis.
Addresses: Indianapolis, IN. **Studied:** AIC; Pratt Inst.; with Charles Woodbury. **Member:** Indiana Artists Club; Hoosier Salon, Chicago; John Herron AA. **Work:** three paintings in Pub. Sch., Indianapolis. **Comments:** Position: teacher, Shortridge H.S., Indianapolis. **Sources:** WW40; Petteys, *Dictionary of Women Artists*.

TODD, Marjorie *[Sculptor]* mid 20th c.
Addresses: Toledo, OH. **Exhibited:** TMA, 1936 (prize). **Sources:** WW40.

TODD, May (Mrs.) See: **AARON, May Todd (Mrs.)**

TODD, Michael Cullen *[Sculptor, painter]* b.1935, Omaha, NE.
Addresses: Encinitas, CA. **Studied:** Univ. Notre Dame (B.F.A.,

1957); UCLA (M.A., 1959). **Member:** MoMA; WMAA; Fine Art Gal., San Diego. **Exhibited:** four WMAA, Ann. 1964-70; Sculpture of 60's, LACMA, 1965 & Philadelphia Mus., 1966; Living Am. Art, Maeght Found., France, 1971; var. exhibs. large scale sculpture, Lippincott Corp. Awards: Woodrow Wilson fel., 1959; Fulbright fel., France, 1961. **Work:** WMAA; LACMA; Southwestern Col., Chula Vista, Calif. **Comments:** Preferred media: steel, aluminum. Teaching: instr. sculpture, Bennington Col., 1966-68; asst. prof. sculpture, Univ. Calif., San Diego, 1968-. **Sources:** WW73; T. Garver, *Recent Sculpture 1968-1970,* (Univ. Calif., Los Angeles & Salk Inst., 1969); L. Goldberg, *Sculpture, Circle Series, 1970-1972* (Art Gallery, Calif. State Univ., Fullerton, 1972).

TODD, Nell Margaret *[Painter, teacher] b.1882, Minneapolis.* **Addresses:** Minneapolis, MN. **Studied:** R. Koehler, Minneapolis; Henri& Dow in NY. **Member:** Minneapolis SFA; Attic Club. **Sources:** WW17.

TODD, Pamela *[Profilist] early 19th c.* **Addresses:** NYC, active 1812-21. **Comments:** She was the widow of Isaac Todd, M.D. (last listed 1811). She also ran a boardinghouse from 1819-21. From 1822-27 she was listed without occupation. *Cf.* George(?) Todd. **Sources:** G&W; NYCD 1812-27.

TODD, Peggy M. *[Painter] mid 20th c.* **Addresses:** Decker, IN. **Exhibited:** PAFA Ann., 1949. **Sources:** Falk, *Exh. Record Series.*

TODD, Russell C. *[Painter] mid 20th c.* **Addresses:** Seattle, WA. **Exhibited:** SAM, 1949; Henry Gallery, 1951. **Comments:** Preferred medium: watercolor. **Sources:** Trip and Cook, *Washington State Art and Artists.*

TODD, Thomas *[Printer] 20th c.* **Addresses:** Boston, MA. **Member:** Boston SAC. **Sources:** WW32.

TODD, William *[Watercolorist] mid 19th c.* **Comments:** Painter of a watercolor view of Mobile (AL), which was engraved by William James Bennett and published in 1841. He may have been the Todd whose panorama of an overland trip to California was exhibited in New Orleans in 1857. **Sources:** G&W; Stokes, *Historical Prints;* New Orleans *Picayune,* April 14, 1857 (courtesy J. Earl Arrington).

TODD, William B., Jr. *[Draftsman, topographer] b.1826, Scotland.* **Addresses:** Wash., DC, active, 1860-1892. **Member:** Wash. AC, 1876-77. **Sources:** McMahan, *Artists of Washington, DC.*

TODD, Willoughby *[Sculptor] mid 20th c.* **Exhibited:** S. Indp. A., 1943. **Sources:** Marlor, *Soc. Indp. Artists.*

TODDY, Jimmy See: **BEATIEN YAZZ, (Jimmy Toddy)**

TODHUNTER, Alice S. Cardall *[Painter] b.1883, Dayton, OH / d.1969, Marin General Hospital.* **Addresses:** San Francisco, CA; NYC; Mill Valley, CA. **Studied:** G. Piazzoni, 1902; Mark Hopkins Inst.; NAD, with Robert Henri; CGA. **Member:** Palo Alto AC. **Comments:** Married to F. Todhunter (see entry). Specialty: portraits and still lifes. **Sources:** Hughes, *Artists in California, 560.*

TODHUNTER, Francis (Augustus) *[Draftsperson, etcher, illustrator, printmaker] b.1884, San Francisco, CA / d.1963, San Francisco.* **Addresses:** San Francisco/Mill Valley, CA. **Studied:** Mark Hopkins Inst., with Stanton and Mathews; NAD; Calif. Sch. FA; F. Van Sloun and Piazzoni. **Member:** Calif. SE; San Fran. AA; Bohemian C.; Soc. of Western Artists; AAPL; Marin Soc. of Artists. **Exhibited:** Bohemian Cl., 1922-63; San Francisco AA annuals, from 1922; Bay Region AI, 1938 (prize); GGE, 1939; Soc. for Sanity in Art, 1930s-1940s. **Work:** Bohemian Cl. **Comments:** Position: art dir., McCann-Erickson Inc., San Fran. **Sources:** WW40; Hughes, *Artists in California, 560.*

TODSWER, Harry *[Engraver] b.1846, MD.* **Addresses:** New Orleans, active 1880-85. **Sources:** *Encyclopaedia of New Orleans Artists, 376.*

TODTLEBEN, Richard *[Painter] early 20th c.* **Addresses:** Chicago, IL. **Exhibited:** AIC, 1908, 1911. **Sources:** WW13.

TOEPFERT, O. A. *[Painter] 20th c.* **Addresses:** Cincinnati, OH. **Sources:** WW13.

TOERRING, Helene *[Painter, craftsperson, designer] 20th c.; b.Davenport, IA.* **Addresses:** Phila. PA/Brant Beach, NJ. **Studied:** AIC; ASL; PAFA. **Member:** Phila. A. All. **Exhibited:** Los Angeles Mus. Hist., Sc., A.; PAFA. **Sources:** WW40.

TOFANELLI, Alva *[Painter] b.1916, Oakland, CA.* **Addresses:** Oakland, CA. **Studied:** Dick Gremke; Calif. Col. of Arts and Crafts. **Member:** San Francisco Women Artists; East Bay AA. **Exhibited:** San Francisco AA, 1936; San Francisco Women Artists from 1965; Museo Italo Americano, San Francisco, 1979-81. **Sources:** Hughes, *Artists in California, 560.*

TOFEL, Jennings *[Painter, illustrator, writer] b.1891, Tomashow, Poland / d.1959, NYC.* **Addresses:** NYC. **Studied:** CCNY. **Exhibited:** Salons of Am., 1927, 1929, 1931; WMAA, 1940; numerous solo exhibitions in U.S. and abroad. **Work:** WMAA; Brandeis Univ.; Butler AI; Tel-Aviv Mus., Israel. **Comments:** Author: "B. Kopman" (monograph); two monograph for Societé Anonyme, article in American Caravan, essay on "Stieglitz" in "America and Alfred Stieglitz." **Sources:** WW59; WW47.

TOFFT, Carle Eugene *[Sculptor] b.1874, Brewer, ME.* **Addresses:** NYC. **Studied:** Blankenship; Ruckstuhl. **Member:** NSS. **Sources:** WW04.

TOFFT (OR TOFFTS), Peter See: **TOFT, Peter Petersen**

TOFT, Peter Petersen *[Painter, illustrator] b.1825, Kolding, Denmark / d.1901, London, England.*

P.Toft 9/85-

Addresses: San Francisco, CA; Kolding, 1869; London, England, 1870; Copenhagen in 1890. **Studied:** Denmark. **Work:** Oakland Mus.; Bancroft Library, UC Berkeley; Montana Hist. Soc. **Comments:** Arrived in San Francisco in 1850 by ship. He made many painting excursions into Oregon, Washington and British Columbia and signed his name variably as Tofft, Tufts, Toffts, Toft or monogram "T" in a circle. Illustrator, *Harper's,* 1867. **Sources:** Hughes, *Artists in California, 561;* P&H Samuels, 487-88.

TOGNELLI, Pio Oscar *[Sculptor] b.1880, Pietra Santa, Italy / d.1942, San Francisco, CA.* **Addresses:** San Francisco, CA. **Studied:** Academia dell Belle Arti, Florence. **Comments:** Immigrated to Northern Calif. at the turn of the century. He contributed sculptures to Trasure Island for the GGE, 1939, and sculpted ornamentations on several buildings of UC Berkeley. Position: hd. of art dept., Gladding-McBean Company. **Sources:** Hughes, *Artists in California, 561.*

TOGNELLI, William *[Sculptor] b.1905, San Francisco, CA.* **Addresses:** San Francisco, CA. **Studied:** with his father; Calif. School of FA. **Comments:** Son of Pio Tognelli (see entry), he assisted his father and stopped sculpting after his father's death. **Sources:** Hughes, *Artists in California, 561.*

TOH-YAH See: **NAILOR, Gerald A. (or Lloyde)**

TOIGO, Daniel Joseph *[Painter, educator] b.1912, Albia, IA / d.1992.* **Addresses:** Los Angeles, CA. **Studied:** apprenticeship with Herb Olsen, Dale Nichols & Ben Stahl; Chouinard Art Inst., with William Moore. **Member:** fel., Am. Artists Prof. League; Am. Inst. Fine Arts; Calif. A. Cl.; San Gabriel Fine Arts Assn. (dir., 1967-); Valley Artists Guild. **Exhibited:** Los Angeles All City Art

Festival, 1967-71; Frye Mus., Seattle, Wash., 1968; Santa Paula Ann. Art Exhib., 1968-71; Am. Artists Prof. League Grand Nat., 1968-72; Calif. State Fair, Sacramento, 1970-71. **Awards:** Los Angeles All City Purchase Award, Howard Ahmanson, 1968 & 1969; San Diego Art Inst. Award, Walter Scott, 1968; Am. Artists Prof. League Award, 1971. **Work:** paintings, State Capitol Bldg., Sacramento, Calif., San Diego Art Inst., Calif., Santa Paula Chamber of Commerce, Calif. & Ahmanson Collection, Los Angeles, Calif. **Comments:** Preferred media: oils, watercolors. Teaching: private inst.r landscape, 1945-. **Sources:** WW73; "Artist--Dan Toigo" (film), Chico State Col., 1970.

TOIRY, Mr. See: **TOIRY, Pierre**

TOIRY, Pierre *[Portrait painter] mid 19th c.*
Addresses: New Orleans in 1830. **Sources:** G&W; New Orleans CD 1830 (Delgado-WPA).

TOJETTI, Domenico *[Painter] b.1806, Rome, Italy / d.1892, San Francisco, CA.*
Addresses: Rome, Italy; Guatemala; San Francisco, CA. **Studied:** Rome, with Camuccini and Murani. **Exhibited:** San Francisco AA, 1872-83; Calif. Midwinter Int'l Expo, 1894; Univ. of San Francisco, 1959 (retrospective). **Work:** Oakland Mus.; Vatican Collection; de Young Mus. **Comments:** While in Rome, he earned commissions from Popes Gregory XVI and Pius IX, was made a Marquis of the Church and decorated by the Kings of Naples and Bavaria. Position: dir., Guatemala Academy of FA, 1867-1871; teacher, San Francisco School of Des., late 1870s. Specialty: religious art, frescoes, murals, portraits. Father of Edward and Virgillo Tojetti (see entries). **Sources:** Hughes, *Artists in California*, 561.

TOJETTI, Edward *[Painter, mural and frescoe painter] b.1852, Rome, Italy / d.1930, San Francisco, CA.*
Addresses: Italy, until 1867; Guatemala, until 1871; San Francisco, CA. **Studied:** with his father. **Work:** Bohemian Club, San Francisco; murals, old St. Ignatius' Church and College; des. San Fran. Diamond Palace, all were destroyed by the fire of 1906. **Comments:** Son of Domenico Tojetti(see entry), he was in partnership in 1889 with W. P. Busch (see entry) and often collaborated on murals with his father and brother. **Sources:** Hughes, *Artists in California*, 561.

TOJETTI, Katherine *[Artist] late 19th c.*
Addresses: NYC, 1885. **Exhibited:** NAD, 1885. **Sources:** Naylor, *NAD*.

TOJETTI, Virgilio *[Genre and mural painter] b.1851, Rome / d.1901, NYC.*
Addresses: San Francisco, CA, 1871-ca.1883; NYC, 1874-86, 1888; Paris, 1887. **Studied:** his father; Paris with Bouguereau, Gérome. **Exhibited:** Boston AC, 1882; PAFA Ann., 1882-85; NAD, 1874-88; Brooklyn AA, 1883-86. **Work:** de Young Mus.; murals, NYC residence of Charles T. Yerkes; Savoy Hotel; Hoffman House; Flagler College, St. Augustine, FL. **Comments:** Son of D. Tojetti (see entry). **Sources:** Hughes, *Artists in California*, 561; Falk, *Exh. Record Series*.

TOKITA, Kamekichi *[Painter] b.1897, Japan.*
Addresses: Seattle, WA. **Studied:** mostly self-taught. **Member:** Group of Twelve. **Exhibited:** SAM, 1931-38. **Sources:** WW40.

TOKSVIG, Harald *[Painter] 20th c.*
Addresses: NYC. **Sources:** WW21.

TOLAND, P. *[Landscape painter] mid 19th c.*
Addresses: Reading, PA. **Exhibited:** Artists' Fund Society, 1841. **Sources:** G&W; Rutledge, PA.

TOLEDO, José Rey *[Painter, muralist, teacher] b.1915, Jémez Pueblo, NM.*
Addresses: Laguna, NM, in 1967. **Studied:** Albuquerque Indian School; New Mexico Univ. (M.A., art educ., 1955). **Work:** Gilcrease Inst.; Mus. Am. Indian; Mus. New Mexico. **Comments:** WPA painter, 1940-41; instructor, Santa Fe & Albuquerque Indian schools, 1949-57. Member of San Ildefonso watercolor movement

until 1960s. Also signed as Morning Star (Shobah Woonhon). **Sources:** P&H Samuels, 488.

TOLEGIAN, Manuel J. *[Painter, mural painter, illustrator, designer, writer, inventor] b.1911, Fresno, CA / d.1983, Sherman Oaks, CA.*
Addresses: NYC, 1936-40; Sherman Oaks, CA. **Studied:** ASL with J. Sloan, T.H. Benton, J.S. Curry, and G. Grosz. **Exhibited:** PAFA Ann., 1936, 1938, 1940; Corcoran Gal biennials, 1935-43 (5 times); WMAA, 1937, 1940-41; CI, 1939; GGE, 1939; WFNY 1939; AIC, 1938, 1943; SFMA, 1941; Ferargil Gal., 1936-39 (all solo); CPLH (solo); Crocker A. Gal (solo).; San Diego FA Soc (solo); Assoc. Am. A., 1941 (solo). **Work:** Univ. Arizona; CPLH; Crocker A. Gal.; PMG; Chapel, St. Lazaro Island, Italy; Mardikian Coll., Beirut, Lebanon; Pub. Lib., Chico, Cal. **Comments:** Illustrator: "The Dove Brings Peace," 1944; "Dinner at Omar Khayyam's," 1944. Author: "Perception and the Language of Painting." **Sources:** WW59; WW47; Falk, *Exh. Record Series*.

TOLENE *[Painter] mid 20th c.*
Addresses: Picuris Pueblo, NM. **Exhibited:** S. Indp. A., 1932 (Indian Tribal Art). **Sources:** Marlor, *Soc. Indp. Artists*.

TOLER, Mary Mathilda Wilke *[Painter] b.1897, Lake Benton, MN / d.1981.*
Addresses: Pacific Grove, CA. **Studied:** Ben Messick, Long Beach, CA. **Member:** Carmel AA. **Exhibited:** locally. **Comments:** Specialty: representational landscapes, still lifes, Calif. missions. **Sources:** Hughes, *Artists in California*, 561.

TOLER, William Pinkney *[Portrait and landscape painter] b.1826, Caracas, Venezuela / d.1899, San Leandro, CA.*
Addresses: Washington, DC; San Francisco, CA; San Leandro, CA. **Exhibited:** Oakland Mus., 1971 (tropical show). **Sources:** Hughes, *Artists in California*, 562.

TOLERTON, David *[Sculptor] mid 20th c.*
Addresses: San Francisco, CA.
Exhibited: WMAA, 1962. **Sources:** Falk, *WMAA*.

TOLFORD, Irina Poroshina (Mrs. Joshua) *[Painter] b.1905, Vernl, Russia.*
Addresses: Boston, MA; Rockport, MA. **Studied:** McNulty Corbino. **Member:** Rockport AA. **Exhibited:** Rockport AA, 1939-1958. **Awards:** prizes, Rockport AA, 1954, 1955. **Work:** Ohio AI traveling coll.; Women & Children's Hospital, Boston. **Sources:** WW59; *Artists of the Rockport Art Association* (1956).

TOLFORD, Joshua *[Painter, illustrator] b.1909, Thorp, WI.*
Addresses: Boston, MA. **Studied:** Layton Sch. A.; BMFA Sch.; and with Anthony Thieme. **Member:** Rockport AA. **Exhibited:** Rockport AA, 1938-1958. **Comments:** Illus., "Uncle Andy's Island," 1950; "Henry Ford," 1951; "Whirligig House," 1951; "Storm Along," 1952; "Texas Trail Drive," 1953; "On Your Own Two Feet," 1955; "Who Rides By?" 1955; "Bud Plays Football," 1957; and many other books. Textbooks: "Arrivals and Departures," 1957; "High Trails," 1958; "Widening Views," 1958. **Sources:** WW59.

TOLGESY, Victor *[Sculptor] b.1928, Miskolc, Hungary / d.1980.*
Addresses: Ottawa, Ontario. **Member:** Assoc. Royal Can. Acad. Art. **Exhibited:** Sculpture 1967, Toronto, 1967; Royal Can. Acad. Show, 1967 & Montreal & Charlottetown, 1971; 11th Winnipeg Show, 1968; Ont. Soc. Artists 100th Ann. Exhib., Toronto, 1972. **Awards:** Can. Coun. sr. fel., 1965; sculpture prize, Royal Can. Acad., Waterloo Univ., 1967; sculpture prize, Soc. Can. Artists, 1971. **Work:** Nat. Gal. Can., Ottawa; Etherington Art Ctr., Queen's Univ., Kingston, Ont.; Charlottetown Confedn. Art Gal., Prince Edward Island, Can.; Waterloo Univ., Ont.; Willistead Art Gal., Windsor, Ont. Commissions: Hungarian freedom monument, Can.-Hungarian Fedn., Toronto, 1966; sculpture for Expo '1967, 1967; sculpture, Jeffrey Hall, Queen's Univ., 1971; sculptures, Ottawa Pub. Libr., 1972. **Comments:** Preferred media: steel. **Sources:** WW73.

TOLIAS, T. J. *[Listed as "artist"] b.1873, LA.*
Addresses: New Orleans, active 1900. **Comments:** Black artist.
Sources: *Encyclopaedia of New Orleans Artists*, 377.

TOLLE, Augustus *[Engraver and lithographer] mid 19th c.*
Addresses: Albany, NY, 1856-60. **Comments:** Of A.J. Hoffman
& Co. ,1856-57; alone, 1858-60. **Sources:** G&W; Albany CD
1856-60.

TOLLES, Sophie Mapes (Mrs.) *[Painter] late 19th c.;*
b.NYC.
Addresses: NYC, 1876-83. **Studied:** P. Rothermel, Phila., 1864;
NAD; Cooper Inst., NYC; Paris, with E. Luminais. **Member:**
Ladies Art Assoc., NYC (vice-pres.). **Exhibited:** NAD, 1876-83;
Brooklyn AA, 1875-82. **Sources:** Clement and Hutton.

TOLLEY, Augustus See: **TOLLE, Augustus**

TOLMAN, Emile Ferdinand *[Painter] b.1899, Boston, MA.*
Addresses: Paris, France. **Studied:** Académie Julian, Paris.
Sources: WW13.

TOLMAN, George R. *[Painter, architect, illustrator] b.1848,*
Boston / d.1909.
Addresses: Boston, MA. **Exhibited:** Boston AC, 1890, 1898.
Comments: Specialty: watercolors. **Sources:** WW01.

TOLMAN, John, Jr. *[Itinerant portrait painter] early 19th c.*
Addresses: In Salem and Boston, MA, 1815-16; in Charleston,
SC, 1816; Richmond, VA, 1818. **Sources:** G&W; Belknap,
Artists and Craftsmen of Essex County, 13; Rutledge, *Artists in
the Life of Charleston; Richmond Portraits*, 243.

TOLMAN, L. A. *[Portrait painter] mid 19th c.*
Addresses: Boston, 1858-60. **Sources:** G&W; Boston BD 1858-
60.

TOLMAN, Nelly Summerhill McKenzie (Mrs. Ruel P.)
[Miniature painter] b.1877, Salisbury, NC / d.1961, Wash., DC.
Addresses: Wash., DC. **Studied:** Corcoran Sch. Art; Wash. Soc.
Min. PS&G. **Member:** Penn. Soc. Min. Painters; Wash. Soc. Min.
PS&G. **Exhibited:** AAPL, 1940 (prize), 1947 (prize); Wash. Soc.
Min. PS&G, 1946 (prize). **Work:** NCFA; PMA. **Comments:**
Married to Ruel Pardee Tolman(see entry). **Sources:** WW59;
WW47. More recently, see McMahan, *Artists of Washington, DC.*

TOLMAN, Robert *[Portrait painter, teacher] b.1886, Boston,*
MA.
Addresses: NYC. **Studied:** Académie Julian, Paris with J.P.
Laurens; Acad. Colarossi; A. Gilbert; Bridgman; Johansen.
Sources: WW40; Art in Conn.: The Impressionist Years.

TOLMAN, Ruel Pardee *[Museum director, painter,*
etcher, writer] b.1878, Brookfield, VT / d.1954, Wash.,
DC.
Addresses: California, 1897-1902; Wash., DC. **Studied:** Mark
Hopkins Inst.; Los Angeles School of Art and Design; Univ.
California; Corcoran Sch. A.; ASL; NAD. **Member:** Int. Assn.
Printing House Craftsmen (hon.); Wash. WC Cl.,(hon.); Chicago
SE (hon.); Min. P., S. & Gravers Soc., Wash. D.C.; F., Royal Soc.
A., London; Wash. Pr. M.; Wash. AC (charter mem.). **Exhibited:**
Soc. of Wash. Artists; Wash. WCC; Wash. AC; Landscape Club of
Wash.; Soc. of Independent Artists; S. Indp. A.; Greater Wash.
Independent Exh., 1935. **Work:** Amherst Wilder Charity, St. Paul,
Minn.; U.S. Nat. Mus. **Comments:** Husband of Nelly Tolman (see
entry). Position: acting dir., NGA, 1932-37; NCFA, 1937-46; cur.,
Div. Graphic A., U.S. Nat. Mus., 1946; dir., NCFA, 1946-
48,Wash., DC. Contributor to: *Antiques Magazine*, with articles on
American miniatures, especially those of Edward G. Malbone.
Author: "The Life and Work of Edward Greene Malbone,
Miniature Painter," 1952. Lectures: American Miniature Painting.
Sources: WW53; WW47. More recently, see McMahan, *Artists of
Washington, DC.*

TOLMAN, Stacy *[Portrait and*
landscape painter, teacher]
b.1860, Concord, MA / d.1935.
Addresses: Pawtucket/Providence, RI. **Studied:** Otto Grundman,

in Boston; Académie Julian, Paris with Boulanger and Lefebvre,
1883-85; also with Cabanel in Paris. **Member:** Providence AC;
Providence WCC; Boston AC. **Exhibited:** Paris Salon, 1885;
Boston AC, 1887-99; PAFA Ann., 1900; Corcoran Gal annual,
1907; AIC. **Comments:** In the early 1900s he traveled throughout
Europe with S.R. Burleigh, and his Providence studio was in
Burleigh's "Fleur de Lys" building in Providence. Teaching:
RISD. **Sources:** WW33; exh. cat., *Painters of Rhode Island*
(Newport AM, 1986, p. 25); Fink, *American Art at the
Nineteenth-Century Paris Salons*, 397; Falk, *Exh. Record Series.*

TOLOCZKO, Raymond A. *[Painter] mid 20th c.*
Addresses: Chicago area. **Exhibited:** AIC, 1951 (prize). **Sources:**
Falk, *AIC.*

TOLPO, Carl (Axel Edward) *[Sculptor, painter] b.1901,*
Ludington, MI.
Addresses: Stockton, IL. **Studied:** Augustana Col.; Univ.
Chicago; AIC; F.O. Salisbury, in London. **Member:** All-Ill. SFA.
Exhibited: Swedish-Am. Exh., 1939, 1946; Chicago Lake Shore
C., 1943; Ill. State Mus., 1941 (solo); All-Ill. SFA, 1938 (solo),
1939 (solo), 1941 (solo), 1942 (solo); NSS, 1967. **Work:**
Augustana Col.; Augustana Hospital Swedish-Am. Hist. Mus.,
Phila.; Mun. Court, Chicago; Inst. Med., John Marshall Law Sch.,
Chicago; Ill. Capitol; Chicago City Opera Co. Heroic Lincoln
Head Bronze, Lincoln Mus., Wash., DC; Grand Canyon of the
Yellowstone, Washington, DC. Commissions: 14 oil portraits of
gov., lt. gov., senate pres. & speakers, State of Ill., 1955-72; plus
many pvt. commissions, 1929-. **Comments:** Preferred media:
plaster, oils. Teaching: lectr., "Fine Use of the Creative Order,"
1969. **Sources:** WW73; WW47.

TOLPO, Lily *[Sculptor, painter] b.1917, Chicago, IL.*
Addresses: Stockton, IL. **Studied:** Chicago Acad. Fine Arts.
Exhibited: Former All-Ill. Soc. Fine Arts, 1941 (solo); Freeport
Country Club, Ill., 1972 (solo). **Work:** Commissions: comns.
from educators in pub. schs., 1964-70; gigantic chandelier sculp-
ture in Rotunda of New Lake Co. Court House Complex,
Waukegan, Ill., 1970; plus many pvt. comns. **Comments:**
Preferred media: plaster, oils, acrylics. Art interests: noted for
original technique of biographical portrait painting. **Sources:**
WW73.

TOLSON, Edgar *[Sculptor] b.1904.*
Addresses: Compton, KY. **Exhibited:** WMAA, 1973. **Sources:**
Falk, *WMAA.*

TOLSON, Magdalena Welty (Mrs. Norman) *[Painter,*
craftsperson, teacher] b.1888, Berne, IN.
Addresses: Ft. Wayne, IN/Lake George, MI. **Studied:** AIC.
Exhibited: Kansas City AI, 1922 (prize). **Work:** Kansas City AI.
Sources: WW40; WW13.

TOLSON, Norman *[Painter, etcher, illustrator, designer,*
teacher] b.1883, Distington, Cumberland, England.
Addresses: Ft. Wayne, IN/Lake George, Clare County, MI.
Studied: A. von Jan, in Munich; AIC; London Art Sch. **Member:**
Kansas City AS; Ill. SFA; South Side AS; AIC. **Exhibited:** AIC,
1917 (prize); Kansas City AI, 1921 (prize), 1924 (prize); All-Ill.
SFA, 1929 (prize); S. Indp. A., 1924; Wash. Bi-Centenn. Ill.
Comm. Award: 1933 (gold). **Work:** panels, La Salle Hotel,
murals, Stevens Hotel, Pub. Sch., Chicago; Country C., Lake
Geneva, Wis. **Comments:** Position: t., Layton Sch. A.
(Milwaukee), Beloit Col. (Wis.). **Sources:** WW40.

TOLTI, John (Jean) (Giovanni) *[Lithographer, engraver]*
b.c.1822, Italy.
Addresses: New Orleans from about 1849 to the 1860's.
Comments: (Jean Tolti). From 1856 to 1859 he was in partner-
ship with Charles Carnahan and in 1860 with Dennis or Dionis
Simon. **Sources:** G&W; New Orleans *Bee*, Dec. 20, 1849
(Delgado-WPA); 7 Census (1850), La., V, 55 [as T. Tolti]; 8
Census (1860), La., VIII, 15 [as Jean Tolti]; New Orleans CD
1856-60 (Delgado-WPA).

TOLTI & CARNAHAN *[Lithographers and engravers] mid 19th c.*
Addresses: New Orleans, 1856-59. **Comments:** Members were John (Jean) Tolti and Charles Carnahan. **Sources:** G&W; New Orleans CD 1856-59 (Delgado-WPA).

TOLTI & SIMON *[Lithographers] mid 19th c.*
Addresses: New Orleans, 1860. **Comments:** Members were John (Jean) Tolti and Dennis or Dionis Simon. **Sources:** G&W; New Orleans CD 1860 (Delgado-WPA). More recently, see *Encyclopaedia of New Orleans Artists.*

TOMAJAU, William Hurant *[Painter] 20th c.*
Addresses: Worcester, MA. **Sources:** WW24.

TOMANEK, Joseph *[Painter] b.1889, Straznice, Czechoslovakia.*
Addresses: Chicago, IL. **Studied:** A.H. Krehbiel; A. Sterba; K.A. Buehr; AIC; Hynais, in Prague. **Member:** Bohemian AC, Chicago; Assn. Chicago PS; Palette and Chisel Acad. FA; Chicago Gal. Assn.; All-Ill. SFA; Austin-Oak Park-River Forest Al. **Exhibited:** Bohemian AC, 1920; Chicago Gal. Assn., 1939 (prize); Palette and Chisel Acad. FA, 1939 (gold); AIC. **Work:** John Vanderpoel AA, Chicago. **Sources:** WW40.

TOMAS, Benito Luciano *[Painter] mid 20th c.*
Addresses: Bronx, NY. **Exhibited:** S. Indp. A., 1944. **Sources:** Marlor, *Soc. Indp. Artists.*

TOMASIC, Irene *[Painter] mid 20th c.*
Exhibited: S. Indp. A., 1941. **Sources:** Marlor, *Soc. Indp. Artists.*

TOMASO, Rico *[Painter, illustrator] b.1898, Chicago, IL.*
Addresses: NYC. **Studied:** AIC; with D. Cornwell, H. Dunn, J.W. Reynolds. **Member:** SI. **Exhibited:** Grand Central Art Gal., Jean Bohne, Inc., both NYC. **Comments:** Illustrator: "Son of the Gods," by Rex Beach, "The Parrot," by Walter Duranty, and "Tagoti," Cynthia Stockley. **Sources:** WW40.

TOMB, Robert *[Engraver] b.c.1832, Ireland.*
Addresses: Northern Liberties, Philadelphia, 1850. **Sources:** G&W; 7 Census (1850), Pa., XLIX, 164.

TOMEI, Lucille V. *[Sculptor, painter, teacher] b.1904, St. Joseph, MO.*
Addresses: Pittsburgh, PA. **Studied:** Univ. Kansas; Kansas City AI; Univ. Pittsburgh; & with Charles Sasportas; Jane Heidner; G. Gray. **Member:** Pittsburgh AA. **Exhibited:** Kansas City AI, 1937 (prize), 1938 (prize), 1939; Contemporary Am. A., Topeka, 1939. **Work:** Immaculata H.S., Ft. Leavenworth Mus., Ft. Leavenworth, Kan.; Churchill Country Cl., Cathedral of Learning, Pittsburgh. Pa.; Kansas Hist. Mus.; Max Adkins Studios, Pittsburgh. Pa. **Comments:** Position: teacher, St. Mary's Col., Leavenworth. **Sources:** WW53; WW47.

TOMES, Margaret *[Painter] 19th/20th c.*
Addresses: Wash., DC, active 1891-1905; Tennessee, 1910-12; NYC, 1914-22. **Studied:** ASL, Wash., DC. **Member:** Wash. Soc. of FA. **Exhibited:** ASL at the Cosmos Club, 1902; Soc. of Wash. Artists; Wash. WCC. **Sources:** McMahan, *Artists of Washington, DC.*

TOMKINS, Lewis *[Lithographer] b.c.1841, England.*
Addresses: Philadelphia in 1860. **Comments:** Living in in the same house as Henry Rawlings, die sinker (see entry). **Sources:** G&W; 8 Census (1860), Pa., LII, 252.

TOMKINS, Margaret (Mrs. James FitzGerald) *[Painter, teacher] b.1916, Los Angeles, CA.*
Addresses: Seattle, Lopez Island, WA; Spokane, WA, 1941. **Studied:** Univ. So. Calif. (B.F.A., M.F.A.); with P. Sample; D. Lutz; Prendergast. **Member:** Calif. WC Soc; Laguna Beach AA. **Exhibited:** LACMA, 1939; Monticello Col., IL, 1939; WFNY, 1939; SFMA; Calif. WC Soc., 1940; SAM, 1940-41 (solo); PAFA Ann., 1948, 1951; Henry Gal., 1950; Bellevue Art Mus., 1950 (solo); WMAA; MMA; San Francisco MoMA; NAD, 1948 (pur-

chase prize). **Work:** SAM. **Comments:** In her life, Tomkins received the most recognition in the 1940s-50s for her paintings, inward adaptations of Surrealism, based on her metamorphic observations and Automatism. Over time her work evolved into Abstract Expressionism, Color Field experiments and non-objective personal expressions. In 1959 most of her life work and that of her husband, James FitzGerald, was destroyed in a fire. She continues to work into the 1990s despite a stroke suffered in the late 1980s. Position: teacher, Sch. Art, Univ. Wash., 1939; and Spokane Art Center. **Sources:** WW40; Hughes, *Artists in California,* 562; Trip and Cook, *Washington State Art and Artists;* addl info courtesy Martin-Zambito Fine Art, Seattle, WA; Wechsler, 32; Trenton, ed. *Independent Spirits,* 121-22; Falk, *Exh. Record Series.*

TOMLIN, Bradley Walker *[Painter] b.1899, Syracuse, NY / d.1953.*
Addresses: NYC; Woodstock, NY. **Studied:** Syracuse Univ., 1921; Jeannette Scott; Acad. Colarossi; Grande Chaumière, 1923-24. **Member:** Fed. Mod. P.&S.; Woodstock AA. **Exhibited:** AIC; Montross Gal., 1924 (solo), 1927 (solo); WMAA, 1925-52; PAFA Ann., 1929-37, 1945-49; Corcoran Gal biennials, 1932-53 (7 times); Rehn Gal., 1931 (solo), 1942; Betty Parsons Gal., 1950; "15 Americans," MoMA, 1952; Hofstra Univ., 1975 (retrospective). Other awards: Hiram Gee Fellowship, Syracuse Univ. **Work:** MMA; WMAA; BM; PAFA; PMG; AGAA; Cranbrook Acad. Art; Univ. Illinois; Univ. Iowa; MoMA; Newark Mus.; BMA; Woodstock AA. **Comments:** A lyric Abstract Expressionist. Tomlin turned to abstraction in the late 1930s, employing a cubist spatial structure with surrealist motifs. In 1947/48 he began painting totally abstract works, mostly in black and white, in which thick calligraphic lines danced across the canvas. Over the next five years, Tomlin favored more geometric forms, such as rectangles, dashes, dots, crosses, and t-shapes, working them into shifting, rhythmic patterns across the entire painting surface. He enjoyed a long friendship with Frank London (see entry). Positions: commercial illus., Condé Nast publications, 1922-29. **Sources:** WW53; WW47; *Woodstock's Art Heritage,* 136-37; Baigell, *Dictionary;* Jeanne Chenault, *Bradley Walker Tomlin* (exh. cat., Hofstra Univ., 1975); Falk, *Exh. Record Series.*

TOMLINSON, Anna C. *[Painter] 20th c.*
Addresses: Roxbury, MA. **Sources:** WW19.

TOMLINSON, Dorothea See: **MARQUIS, Gulielma Dorothea Tomlinson**

TOMLINSON, Florence Kidder *[Painter, instructor, engraver, illustrator, block printer, designer] b.1896, Austin, IL / d.1979, Madison, WI?.*
Addresses: Madison, WI. **Studied:** Colt School Art (diploma); Stillwater Art Colony; Univ. Minnesota Summer School; Univ. Wisconsin, teachers certificate; also with Ralph Pearson, O. Hagen, Frederick Taubes & Myra Werten. **Member:** AEA; Wisconsin P&S; All-Illinois SFA; Madison AA (bd. mem. & chmn. tours, 1958-61); Madison Art Guild (pres., 1945-47); Nat. Lg. Am. Pen Women (pres. Madison branch, 1952-54; state art chmn., 1955; state pres., 1966-68). **Exhibited:** Northwest Printmakers 18th Int., Seattle, WA, 1946; LOC, 1944, 1945-54 (Nat. Exhib. Prints); Milwaukee AI, 1940, 1942-45; Laguna Beach AA, 1945; NAD, 1942-43; Albright Art Gal., 1943; Madison Art Salon, 1940-43, 1945; Wisconsin Mem. Union, 1929 (prize); Madison, WI, 1941 (prize)-42 (prize); Wisconsin State Fair, 1938 (prize), 1942-44 (prize, each yr.); Madison AG, 1944-46 (prize, each yr.); Walker Art Gal. Regional Exhib., Minneapolis, 1946; Joslyn AM, 1948; Rochester Mem. Art Gal., 1953; Madison Bank & Trust Co., 1954 (solo); Madison AA, 1958 (solo); Dover (DE) State College, 1967 (solo); Jamesville, WI, 1969 (solo); SAGA, Kennedy Gals., NYC, 1953; Wisconsin Painters & Sculptors, Milwaukee AI, 1961. Awards: purchase award for Eve (wood engraving), Milwaukee AI, 1944; award for Sharkies (oil painting), Wisconsin Salon Art, 1956; first award for Dreams (lithograph), Nat. Lg. Am. Pen Women, 1964. **Work:**

Milwaukee AI; lithograph, Nat. Lg. Am. Pen Women, Wash., DC; two oil paintings, Oshkosh (WI) Paper Co.; oil painting, Madison (WI) Pub. Lib. Commissions: History of Cooperation (mural in oil), Midland Coop, Inc., Minneapolis, MN, 1948; Trade & Industry (mural in oil), Madison (WI) Tech. College, 1955. **Comments:** Preferred media: oils, watercolors. Teaching: instr. figure & portrait painting & design, Madison Adult Vocational Sch., day & eve, 1930-62; instr. art, Shorewood Sch, 1940-41; instr. drawing, Univ. Wis. Summer Art Tour Europe, 1961. Illustrator/contributor: "Design in Nature's Silhouettes," *Country Life in Am.* (1939); "Wood Engravings," *Wisconsin Hort.* (1944); *Am. Bee Journal*, 1948 & 1949; "Block Prints are Fun," *Nature Magazine* (1956); *House & Garden*. **Sources:** WW73; Al Sessler, "The Tomlinson Exhibition," 1952; Elizabeth Gould, "A Thing About Clowns," *Wisconsin State J.* (1968); Frank Custer, "Mrs. Tomlinson's Record," *Capitol Times* (Nov., 1961); Dorish Goodhue, "About Our Cover," *Pen Woman* (Jan., 1969).

TOMLINSON, Frank *[Listed as "artist"] b.c.1839, Connecticut.*
Addresses: NYC in 1860. **Comments:** Living in NYC in 1860 with his father, William A. Tomlinson (see entry). **Sources:** G&W; 8 Census (1860), N.Y., LXI, 378.

TOMLINSON, Gulielma Dorothea Tomlinson Marquis See: **MARQUIS, Gulielma Dorothea Tomlinson**

TOMLINSON, Henry W(elling) *[Painter] b.1875, Baltimore, MD / d.1949, Las Cruces, NM.*
Addresses: Salisbury, CT/NYC. **Studied:** E.S. Whiteman, Baltimore; ASL, with Cox and Brush. **Exhibited:** PAFA Ann., 1902, 1909; Salons of Am., 1929, 1931; AIC. **Sources:** WW31; Falk, *Exh. Record Series.*

TOMLINSON, William *[Engraver] b.c.1833, Pennsylvania.*
Addresses: In Philadelphia in 1860. **Sources:** G&W; 8 Census (1860), Pa., L, 426.

TOMLINSON, William A. *[Listed as "artist"] mid 19th c.; b.Connecticut.*
Addresses: In NYC in 1860. **Comments:** His property was valued at $20,800. Frank Tomlinson (see entry) was his son. **Sources:** G&W; 8 Census (1860), N.Y., LXI, 378.

TOMMANSI, Joseph *[Painter] 20th c.*
Addresses: Kansas City, MO. **Sources:** WW24.

TOMPKINS, Abigail Brown *[Watercolor painter] late 19th c.*
Addresses: Newark, NJ, 1882-83. **Exhibited:** NAD, 1882-83. **Sources:** Petteys, *Dictionary of Women Artists.*

TOMPKINS, Alan *[Painter, educator, illustrator, lecturer, sculptor] b.1907, New Rochelle, NY.*
Addresses: Bloomfield, CT. **Studied:** Columbia Univ. (B.A.); Yale Univ. (B.F.A.). **Member:** Conn. Acad. (v. pres., 1970-72); Conn. WC Soc. **Exhibited:** AIC, 1936; mural sketches & traveling exh., U.S. & abroad; Herron AI, Indianapolis; Ind. Artists Ann., 1937-38; AIC Ann., 1938; PAFA Ann., 1939; Sweat Mem. Mus., 1943; CAFA Ann., 1952-71 (first prize for painting, 1968-70). **Work:** commissions: mural paintings comn. by US Treas. Dept. for post off. at Indianapolis, Ind., 1936, Martinsville, Ind., 1937 & Boone, NC, 1940; mural painting, Gen. Elec. Co, Bridgeport, Conn., 1944; mural painting, Cent. Baptist Church, Hartford, Conn., 1958. **Comments:** Preferred media: oils. Positions: dir., Hartford Art Sch., Univ. Hartford, 1957-69; comnr., Fine Arts Comn., Hartford, 1959-69; v. chancellor, Univ. Hartford, 1960-. Teaching: t., John Herron AI (1934-38); instr. painting, Cooper Union Art Sch., 1938-43; lectr. painting, Columbia Univ., 1946-51; prof. painting & art hist., Univ. Hartford, 1951-. Research: 20th century art. **Sources:** WW73; WW47; Falk, *Exh. Record Series.*

TOMPKINS, Clementina *[Portrait and figure painter] b.1848, Wash., DC / d.1931, NYC.*
Addresses: Paris, France. **Studied:** Peabody AI, Baltimore, MD; with Bonnat; École de Beaux Arts; Brussels. **Exhibited:** Paris Salon, 1873-75, 1877, 1880, 1881; U.S. Centennial Expo,

Philadelphia, 1876; Corcoran Gal. **Work:** BMFA; PAFA. **Sources:** McMahan, *Artists of Washington, DC;* Fink, *American Art at the Nineteenth-Century Paris Salons,* 398-98.

TOMPKINS, Corene Cowdery See: **COWDERY, Corene**

TOMPKINS, Eunice W. *[Artist] early 20th c.*
Addresses: Active in Washington, DC, 1916-17. **Sources:** Petteys, *Dictionary of Women Artists.*

TOMPKINS, Evelyn *[Painter] b.1882, Georgia.*
Studied: YWCA Art School; Fawcett Art School, Newark, NJ. **Exhibited:** Harmon Fnd., 1928, 1933, 1935; Brooklyn YWCA; Harlem YWCA, 1935; NJ State Mus., 1935. **Sources:** Cederholm, *Afro-American Artists.*

TOMPKINS, Florence (Lusk) *[Painter, teacher] b.1883, Wash., DC / d.1963, Pasadena, CA.*
Addresses: Pasadena, CA, 1932-on. **Studied:** Corcoran Sch. Art, and with Conrad Buff, Einar Hansen and others. **Member:** Calif. WC Soc.; Calif. AC; Women Painters of the West; Artists of the Southwest; Nat. Soc. Arts & Letters; Laguna Beach AA; Glendale AA; Los Angeles Art Lg.; Pasadena Soc. Artists; Pasadena FA Club; Pasadena AA. **Exhibited:** solos: Pasadena, Altadena, La Jolla, Los Angeles, Whittier, San Gabriel, Glendale, all in California, 1934-53. Awards: prizes, Los Angeles Friday Morning Club, 1941, 1942, 1946, 1947, 1949, 1951, 1952; Calif. AC, 1941; Ebell Club, Los Angeles, 1942-44, 1951; Glendale AA, 1947; Bowers Mus., Santa Ana, 1947; Greek Theatre, Los Angeles, 1948, 1949; Artists of the Southwest, 1952. **Sources:** WW59.

TOMPKINS, Frances L(ouise) *[Painter] b.1877, Newark, NJ.*
Addresses: Brooklyn, NY. **Studied:** ASL, with Henri, J. Sloan, K.H. Miller, M. Weber. **Member:** S. Indp. A. **Exhibited:** S. Indp. A., 1917-18, 1920, 1922. **Sources:** WW25.

TOMPKINS, F(rank) H(ector)(L.) *[Painter] b.1847, Hector, NY / d.1922.* *F.H.Tompkins. 82*
Addresses: Cleveland, OH, 1881; Brookline, MA; Boston, MA, 1889-96. **Studied:** ASL; Cincinnati Sch. Des.; Royal Acad., Munich, with Loeffts. **Member:** Boston AC; Copley S. **Exhibited:** Mass. Charitable Mechanics' Assn (gold); Boston AC, 1881-1909; NAD, 1881-96; PAFA Ann., 1887, 1891-95; Corcoran Gal annuals/biennials, 1907-14 (3 times); AIC; S. Indp. A., 1917-19. **Work:** Boston AC; PAFA; BMFA. **Sources:** WW21; Falk, *Exh. Record Series.*

TOMPKINS, (Frank) Van Vleet See: **TOMPKINS, Van Vleet**

TOMPKINS, Helen *[Painter, teacher] b.1883, Westfield, NJ.*
Addresses: NYC/Palenville, NY. **Studied:** NAD; NYU Sch. Arch. **Sources:** WW40.

TOMPKINS, Laurence *[Sculptor, painter] b.1897, Atlanta, GA / d.1972.*
Addresses: NYC. **Studied:** BAID; ASL; Slade Sch., London; Grande Chaumière, Paris; D. Edstrom. **Member:** NSS. **Exhibited:** S. Indp. A., 1918; Royal Acad., London; Paris Salon, 1924; NAD; Reinhardt Gal., NYC, 1938 (solo); Carstairs Gal., NYC, 1939 (solo); WFNY, 1939 (solo); WMAA, 1941; PAFA Ann., 1941-42, 1948. **Work:** monuments, Augusta, Ocella, Atlanta, Ga.; Luxembourg Mus., Paris, France. **Sources:** WW53; WW47; Falk, *Exh. Record Series.*

TOMPKINS, Margaret *[Painter] mid 20th c.*
Addresses: Seattle, WA. **Exhibited:** AIC, 1947. **Sources:** Falk, AIC.

TOMPKINS, Marjorie J. *[Painter] 20th c.*
Addresses: Nyack, NY. **Sources:** WW24.

TOMPKINS, Van Vleet *[Painter] mid 20th c.*
Addresses: NYC. **Studied:** S. Indp. A. **Exhibited:** WMAA, 1918-28; S. Indp. A., 1919-22, 1934. **Sources:** WW25.

TOMPKINSON, Flora *[Portrait painter] late 19th c.*
Addresses: Kalamazoo, MI. **Exhibited:** Michigan State Fair, 1885. **Sources:** Gibson, *Artists of Early Michigan*, 228.

TOMPSETT, Ruth R. *[Painter, teacher] b.1889, Omaha, NE.*
Addresses: Omaha. **Studied:** NY School Art; AIC; Pratt Inst.; with Hawthorne. **Exhibited:** Omaha & Kansas City. **Sources:** Petteys, *Dictionary of Women Artists*.

TOMPSON, William M. See: **THOMPSON, William M.**

TOM TWO ARROWS See: **DORSEY, Thomas**

TONDA See: **FONDA, Anna L.**

TONDEL, Alice B. *[Painter] mid 20th c.; b.Cambridge, MA.*
Addresses: Rockport, MA (summers). **Studied:** Wheelock School, Boston; with Alma LeBrecht, John Buckley. **Member:** Cambridge AA; Rockport AA (chairman, 1944-47). **Exhibited:** Cambridge War Bond Rally; Cambridge AA; Rockport AA. **Work:** priv. colls. **Sources:** *Artists of the Rockport Art Association* (1946, 1956).

TONER, Paul *[Art dealer] b.1948, NYC.*
Addresses: NYC. **Studied:** State Univ. NY Stony Brook Inst. Fine Arts. **Comments:** Positions: dir., John Weber Gal., 1971-. Specialty of gal.: minimal sculpture; conceptual art. **Sources:** WW73.

TONETTI, F(rancois) M(ichel) L(ouis) *[Sculptor] b.1863, Paris, France / d.1920, NYC.*
Addresses: NYC. **Studied:** École des Beaux-Arts, with Falguière; with Noel and MacMonnies, also in Paris. **Member:** NSS; Arch. Lg., 1901. **Exhibited:** Paris Salon, 1892 (prize); St. Louis Expo, 1904 (med); PAFA Ann., 1907, 1917; AIC, 1916. **Work:** He sculpted the figure "L'Art" (now in the LOC) based on St. Gaudens's sketches, but when it was exhibited at the Paris Salon, St. Gaudens claimed it entirely as his own, reneging on his promise to give Tonetti full credit; Musée Luxembourg, Paris; NY Custom House; NYPL; figure symbolizing the "Battle of the Marne". **Comments:** In Paris, he worked as MacMonnies's studio assistant on the "Brooklyn Arch" and on the fountain for the 1893 Worlds Columbian Expo, Chicago. **Sources:** WW19; Falk, *Exh. Record Series;* add'l info courtesy Adina Gordon.

TONETTI, Mary Lawrence (Mrs.F.M.L.) *[Sculptor] b.1868 / d.1945, Snedens Landing, Rockland County, NY.*
Addresses: NYC. **Studied:** Académie Julian, Paris; August Saint-Gaudens. **Exhibited:** Columbian Expo., Chicago, 1893. **Comments:** After her marriage to F.M.L. Tonetti, she curtailed most of her own work. Although she assisted her husband for a while, she appears to have stopped sculpting altogether during the WWI period. **Sources:** WW17; Petteys, *Dictionary of Women Artists.*

TONEY, Anthony *[Painter, educator, writer] b.1913, Gloversville, NY.*
Addresses: NYC; Katonah, NY.
Studied: Syracuse Univ. (B.F.A., 1934); Teachers College, Columbia Univ. (M.A. & Ed.D., 1955); École des Beaux-Arts; Academie Grande Chaumière, 1937-38. **Member:** NA, 1971; Audubon Artists (bd. mem., 1965-); AL Am.; Unified Am. Artists; NSMP; AEA (bd. dirs., 1971-); Int. Inst. Arts & Letters. **Exhibited:** Pinacotheca; Mortimer Brandt Gal.; Corcoran Gal biennials, 1949-57 (4 times); AIC; S. Indp. A.; MoMA; WMAA; Mortimer Levitt Gal.; Wakefield Gal., 1941 (solo); Santa Barbara Mus. Art, 1944 (solo); ACA Gal., regularly since 1949; Artists Gal., 1948 (solo); PAFA Ann., 1950-54, 1964-66; NAD Ann., 1960-72, (prizes, Ranger Fund Purchase Award, 1966); Audubon Aritsts Ann., 1955-72 (1968, prize, medal of honor); CI, 1949; WMAA Ann., 1950-60; Nat. Inst. Arts & Letters, 1968 (Childe Hassam Purchase Award); ACA Gal, NYC, 1970s; "NYC WPA Art" at Parsons School Design, 1977. **Work:** WMAA; NAD; Syracuse Univ., NY; Univ. Illinois, Urbana; St. Lawrence Univ., Canton, NY. Commissions: murals, Bowne Hall, 1968 & 6 panels, Brockway Cafeteria, St. Mary's Dormitory, Roslyn, NY, 1971; Mrs. Mollie Bergman, 1972 & Diana Lucas, NYC, 1972.

Toney [signature]

Comments: Painted murals for WPA project, 1935-36. Fought in Spain, 1938-39 and returned to NYC where he again worked for WPA, 1940-41. He served in the U.S. Air Force, 1942-46. Preferred media: oils. Publications: contributor, *Reality*, 1955; contributor, "Tune of the calliope," 1957; editor, "150 master-pieces of drawing," 1965; author, "Creative painting and drawing," 1966. Teaching: Hofstra Univ., 1952-55; New School Social Res., 1952-; Five Towns Music & Art Foundation, 1952-70s. **Sources:** WW73; WW47; *New York City WPA Art,* 87 (w/repros.); Falk, *Exh. Record Series.*

TONGE, Gilbert Ross *[Painter, mural painter] b.1886, San Francisco, CA / d.1970, Santa Cruz County, CA.*
Addresses: Los Angeles, CA; Sausolito, CA. **Studied:** Mark Hopkins Inst. **Member:** Calif. AC; P&S of Los Angeles. **Work:** murals: Pabst Brewery, Los Angeles; many restaurants, clubs and hotels in Los Angeles and San Diego. **Comments:** Specialty: red-wood forest; murals. **Sources:** Hughes, *Artists in California*, 562.

TONIERE, Gaetano *[Listed as "figure maker"] mid 19th c.*
Addresses: Boston in 1850. **Sources:** G&W; Boston CD 1850.

TONK, Ernest A. *[Painter, mural painter, illustrator, writer] b.1889, Evanston, IL / d.1968, Garden Grove, CA.*
Addresses: Chicago, IL; Cashmere, WA; Glendale, CA, 1923; Garden Grove, CA. **Studied:** AIC. **Member:** Laguna Beach AA; Glendale AA. **Work:** Chelan Co., WA, Hist. Soc.; Carey Mus., Cashmere, WA. **Comments:** Cowboy artist active in Calif. and Wash. who went West from Chicago in 1908. Position: staff, MGM and Universal Pictures. **Sources:** Hughes, *Artists in California*, 562.

TONKIN, John Carter *[Craftsman, teacher] b.1879, Mullicahill, NJ.*
Addresses: Durham, NH; Dover, NH. **Member:** Boston SAC; NH Lg. A. & Crafts. **Work:** Univ. NH. **Comments:** Position: instr., Emeritus, Univ. New Hampshire, Durham, NH. **Sources:** WW59; WW47.

TONKIN, L(inley) M(ansen) (Mrs.) *[Painter, etcher, lithographer, lecturer, writer] 20th c.; b.Sherman, TX.*
Addresses: Taos, NM/Denison, TX. **Studied:** ASL; J. Carlson; I. Wiles; C. Carleton. **Member:** Assn. Okla. A.; SSAL; Chicago SE; Calif. PM. **Work:** Tex. Tech. Col., Lubbock. **Sources:** WW33.

TONNAR, Jo(seph) *[Painter] mid 20th c.*
Addresses: Phila., PA. **Exhibited:** PAFA Ann., 1936, 1940; Corcoran Gal biennial, 1937. **Sources:** Falk, *Exh. Record Series.*

TONNELLIER, Francois *[Wood engraver] b.c.1827, France.*
Addresses: Boston in 1850. **Sources:** G&W; 7 Census (1850), Mass., XXV, 54.

TONNY, Kristian *[Painter] mid 20th c.*
Exhibited: AIC, 1937, 1939. **Sources:** Falk, *AIC.*

TONSBERG, Gertrude Martin *[Painter] b.c.1903, Boston / d.1973.*
Addresses: Boston, MA/East Gloucester, MA.
Studied: Mass. Sch. A.; BMFA Sch.; ASL with Wm. McNulty; NAD with Leon Kroll. **Member:** North Shore AA; Rockport AA; Gloucester SA; Boston AC; S. Indp. A.; Gld. Boston Artists. **Exhibited:** PAFA Ann., 1933-34; Springfield AL, 1935; Pioneer Valley Ass'n, 1952; Vose Gal., Boston, 1960 (solo); Ogunquit MA, 1962; Bakker Gal., Boston, c.1980s (memorial exh.). **Work:** Woodrow Wilson Jr. H.S., Jeremiah Burke Sch., both in Boston; Worcester AM. **Comments:** Position: tech. dir., Hatfield's Color Shop, Boston. **Sources:** WW40; exh. cat., Bakker Gal., Boston (c.1980s); Falk, *Exh. Record Series.*

Tonsberg [signature]

TOOBEY, Katherine *[Painter] 20th c.*
Addresses: San Francisco, CA. **Exhibited:** AIC, 1940; PAFA Ann., 1940. **Sources:** Falk, *Exh. Record Series.*

TOODLES, John E. *[Painter] b.1893, Wash., DC.*
Studied: self-taught. **Exhibited:** Harmon Fnd., 1929-30, 1933; YMCA Exh., Indianapolis; YMCA Exh., New Orleans; Smithsonian Inst., 1929. **Sources:** Cederholm, *Afro-American*

Artists.

TOOHEY, Sara (Sallie) Alice *[Painter, decorator, pottery designer]* b.1872, Cincinnati / d.1941, Mt. Adams, Cincinnati. **Addresses:** Cincinnati. **Studied:** Cincinnati Art Acad; Paris (scholarship). **Comments:** Worked for Rookwood Pottery, Heeekin Can Co., and others. **Sources:** Petteys, *Dictionary of Women Artists.*

TOOKER, Edward B. *[Brassfounder, painter]* mid 19th c. **Addresses:** NYC. **Exhibited:** American Institute (1842: portrait in oil). **Sources:** G&W; Am. Inst. Cat., 1842.

TOOKER, George *[Painter]* b.1920, Brooklyn, NY.

TOOKER

Addresses: NYC. **Studied:** Harvard Univ. (A.B., 1942); ASL, 1943-44, with Reginald Marsh, Kenneth Hayes Miller, and Harry Sternberg. **Member:** NAD, 1970; NIAL, 1983. **Exhibited:** WMAA biennials, 1947-69; Hewitt Gal., NYC, 1951, 1955 (solos); Corcoran Gal biennials, 1951, 1963; PAFA Ann., 1952, 1966; Isaacson Gal., NYC, 1960, 1962 (solos); Durlacher Bros., NYC, 1964, 1967 (solos); Dartmouth Col., 1967 (solo); SFMA (retrospective, traveled to WMAA, Mus. Contemp. Art, Chicago, and Indianapolis MA); David Tunkl Gal., Los Angeles, 1981; Univ. VT, 1987 (solo); Gibbs MA, SC, 1987; M. Del Rey Gal., NYC, 1988 (solo); Univ. VA, 1989 (solo); Addison Gal. Am. Art, 1994 (solo); Ogunquit MA, 1996 (solo); DC Moore Gal., NYC, 1997-98 (solos). **Awards:** NIAL grant, 1960. **Work:** WMAA; MoMA; MMA; SFMA; NMAA; Walker Art Ctr, Minneapolis; Johnson Collection, Smithsonian Inst.; Dartmouth Col. **Comments:** An artist whose "narrative surrealism" portrays the human condition in a depersonalized, modern society. Tooker has favored egg tempera as his medium, basing his technique on Italian Renaissance painting, a method he learned from Jared French and Paul Cadmus in 1945. Teaching: ASL. **Sources:** WW73; exh. cat., DC Moore Gal. (NYC, 1998); exh. cat., David Tunkl Gal. (Los Angeles, 1981); *300 Years of American Art,* 969; Baigell, *Dictionary;* Falk, *Exh. Record Series.*

TOOKER, Marion Farwell *[Painter]* b.1882, Chicago. **Addresses:** Paris, France/Chicago, IL. **Studied:** Du Mond; Mora; R. Miller, Paris. **Member:** Women's Int. Soc., Paris, London. **Exhibited:** AIC, 1904. **Sources:** WW13.

TOOLE, John *[Portrait, historical and landscape painter]*

John Toole.

b.1815, Dublin, Ireland / d.1860, Charlottesville, VA. **Addresses:** Charlottesville, VA. **Studied:** probably self-taught. **Exhibited:** Fair of the Mechanics Inst., Richmond, VA, 1855 (prize). **Work:** Univ. of Virginia; Virginia State Lib.; priv. colls. **Comments:** Came to live with his uncle at age eleven and painted by 1832. **Sources:** Wright, *Artists in Virginia Before 1900.*

TOOLEY, James, Jr. *[Miniature, portrait, and landscape painter]* b.1816 / d.1844. **Addresses:** Cincinnati, OH, active 1837; Philadelphia, 1842; Natchez, MS, 1843. **Work:** Natchez Hist. Soc.; Stokes Collection at NY Public Library. **Comments:** A view of Natchez (MS) after a sketch by Tooley was lithographed by Risso & Browne (see entry) of NYC about 1835. At Natchez he painted a miniature of Thomas Sully (see entry). Auguste Edouart (see entry) cut Tooley's silhouette in Philadelphia in December 1843 and in Natchez in April 1844. **Sources:** G&W; Sherman, "Newly Discovered American Miniaturists," 98; Stokes, *Historical Prints;* Rutledge, PA; Jackson, *Ancestors in Silhouette.* More recently, see Reps, cat. no. 1974. Hageman, 122.

TOOMBS, Adelaide Althin *[Ceramic sculptor, craftsperson, lecturer, teacher]* b.1915, Boston, MA. **Addresses:** Boston, MA; Roxbury, MA. **Studied:** Mass. Sch. A.; MIT (B.S. in Edu.), and with Cyrus Dallin, Raymond Porter. **Member:** Boston Soc. A. & Crafts. **Exhibited:** Mass. Sch. A., 1936 (med); PAFA Ann., 1941; NAD, 1942; CGA, 1942; Copley Soc., Boston., 1941; Boston A. Cl., 1942; Soc. Min. S., P. &

Gravers, Wash. DC; Boston A. Festival; Doll and Richards, Boston, 1949 (solo); Veerhof Gal., Wash. DC, 1952 (solo); Artisans Shop, Balt., 1952 (solo). **Work:** portraits in porcelain, Boston, NYC, Baltimore,Wash., DC, and Wilmington. **Sources:** WW53; WW47; Falk, *Exh. Record Series.*

TOOMER, Fannie *[Landscape painter]* late 19th c. **Addresses:** Auburn, AL; Norfolk, VA. **Exhibited:** Norfolk, VA, 1885. **Sources:** Wright, *Artists in Virginia Before 1900.*

TOOMEY, R. W. *[Painter]* b.1882, Columbus. **Addresses:** Columbus, OH. **Member:** Columbus PPC. **Sources:** WW25.

TOONE, Lloyd *[Mixed media artist]* b.1940, Chase City, VA. **Studied:** Hampton Inst. (B.S.); NY City Col. (M.F.A.); Manhattan Col. (M.A.). **Exhibited:** Ruder & Finn Fine Arts, NYC, 1969; BMFA, 1970; Phila. Civic Center Mus.; Nassau Community Col., Garden City, NY, 1969; C.W. Post Col., Brookville, NY, 1969 (purchase award); RISD, 1969; Internat'l House, NYC, 1970-71; River View Galleries, NY, 1971; Acts of Art Gal., NYC, 1971; Pascacs Valley Chapter of Hadassah, Westwood, NJ; Great Neck Lib., NY, 1972; Dutchess Community Col., NY, 1972. **Work:** C.W. Post Col.; New Hampshire Col. **Sources:** Cederholm, *Afro-American Artists.*

TOOR, Nishan *[Sculptor, designer]* b.1888, Armenia / d.1966, Altadena, CA. **Addresses:** Altadena, CA. **Studied:** Europe. **Member:** Pasadena SA; San Gabriel Artists Guild. **Exhibited:** Paris Salon, 1920s; Ferargil Galleries, NYC, 1929; AIC, 1930-31; FA Gal., San Diego; Salons of Am., 1934; Pasadena Jr. Chamber of Commerce, 1936 (prize); LACMA, 1937 (Cole Prize); Pasadena, 1937 (prize); Pasadena Playhouse, 1939 (med); GGE, 1939; WFNY, 1939. **Work:** war men., Paris; Pau AM, France. **Sources:** WW40.

TOOTE, Will Howe *[Painter]* 19th/20th c.; b.Grand Rapids, MI. **Studied:** Laurens; Constant. **Exhibited:** Paris Salon, 1899. **Sources:** Fink, *American Art at the Nineteenth-Century Paris Salons,* 398.

TOPANELIAN, Fanny N. (Mrs. Edward) *[Painter]* 20th c. **Addresses:** Worcester, MA. **Sources:** WW24.

TOPCHEFSKY, Alexi *[Painter]* mid 20th c. **Addresses:** Chicago area. **Exhibited:** AIC, 1940, 1942, 1944.

TOPCHEVSY, Morris *[Painter, etcher, lecturer, writer]* b.1899, Bialistock, Poland / d.c.1950. **Addresses:** Chicago, IL. **Studied:** San Carlos Acad., Mexico; A.H. Krehbiel; AIC. **Member:** AL, Chicago; Am. A. Cong.; Chicago Artists Univ.; Chicago SA. **Exhibited:** AIC, 1923-46; NAD, 1942. **Work:** murals, Abraham Lincoln Ctr., Chicago; Holmes Sch., Oak Park, Ill. **Comments:** Author: "American Today," 1937. Position: art dir., Lincoln Ctr., Chicago. **Sources:** WW47.

TOPLIFF, G. F. *[Painter]* late 19th c. **Addresses:** Boston, MA. **Exhibited:** Boston AC, 1879-1889. **Sources:** *The Boston AC.*

TOPOL, Robert Martin *[Collector]* b.1925, NYC. **Addresses:** Mamaroneck, NY. **Exhibited:** Greer Gal., NYC. **Comments:** Collection: frescos, oils & sculptures. **Sources:** WW73.

TOPOLSKI, Feliks *[Painter]* mid 20th c. **Exhibited:** AIC, 1941. **Sources:** Falk, *AIC.*

TOPP, Esther (Mrs. James G. Edmonds) *[Educator, painter]* b.1893, Pittsburgh, PA / d.1954. **Addresses:** Pittsburgh, PA. **Studied:** Cornell Univ.; Carnegie Inst. (B.A.). **Member:** Pittsburgh AA; Pittsburgh WCS. **Exhibited:** Carnegie Inst., 1933, 1940-46; Pittsburgh AA, 1921-46 (prizes,1923, 1924, 1926,1929, 1930, 1945). **Work:** Pittsburgh Pub. Sch.; Penn. State College; mural, Mary Biesecker Pub.Lib., Somerset, PA. **Comments:** Born Esther Topp, married to James G. Edmonds, she is not to be confused with Esther Topp Edmonds Fahey (see entry).Position: art instructor, 1921-30, asst. prof. of

art, 1930-42, assoc. prof. of art, 1942-, Carnegie Inst., Pittsburgh. **Sources:** WW53; WW47.

TOPPAN, Charles *[Banknote engraver] b.1796, Newburyport, MA / d.1874, Florence (Italy).*
Addresses: Philadelphia; NYC. **Studied:** a pupil of Gideon Fairman (see entry) at Philadelphia as early as 1814. **Comments:** He was employed by Murray, Draper, Fairman & Co. (see entry) and other banknote engraving firms in Philadelphia until about 1835 when he became a partner in Draper, Toppan, Longacre & Co (see entry). From 1819 to about 1822 he was in England with Fairman and Jacob Perkins (see entry). From 1835 to his retirement about 1860 Toppan was a partner in the following banknote firms: Draper, Toppan, Longacre & Co. (1835-39); Draper, Toppan & Co. (1840-44); Toppan, Carpenter & Co. (1845-50); Toppan, Carpenter, Casilear & Co. (1851-55); and Toppan, Carpenter & Co. (1856-61) (see entries). About 1855 he moved from Philadelphia to NYC and there was a leader in the founding of the American Bank Note Co., of which he was the first president (1858-60). **Sources:** G&W; Belknap, *Artists and Craftsmen of Essex County*, 5; Stauffer; Toppan, *100 Years of Bank Note Engraving*, 3-4, 8-10; Phila. CD 1830-61; NYCD 1856-62; 7 Census (1850), Pa., LI, 232. Charles Toppan was the author of a brief "History and Progress of Banknote Engraving," which appeared in *Crayon*, I (1855), 116-17.

TOPPAN, Charles, Jr. *[Engraver] b.c.1826, Connecticut.*
Addresses: In Philadelphia in 1850. **Comments:** Son of Charles Toppan (see entry) **Sources:** G&W; 7 Census (1850), Pa., LI, 232.

TOPPAN, Harriet *[Engraver] b.c.1834, Philadelphia, PA.*
Comments: Daughter of Charles Toppan (see entry); listed as an engraver in the 1850 Census. **Sources:** G&W; 7 Census (1850), Pa., LI, 232.

TOPPAN, CARPENTER & CO. *[Banknote engravers] mid 19th c.*
Addresses: Philadelphia. **Comments:** Organized by Charles Toppan (see entry) of Philadelphia in 1845, with Samuel H. Carpenter (see entry) and others; became Toppan, Carpenter, Casilear & Co. (1850-55); again as Toppan, Carpenter & Co. from 1856 to 1861. The headquarters were in Philadelphia, with branches in NYC and Cincinnati. This firm was one of the components of the American Bank Note Company after 1858. **Sources:** G&W; Phila. CD 1845-61; Stauffer; Toppan, *100 Years of Bank Note Engraving*, 12.

TOPPAN, CARPENTER, CASILEAR & CO. *[Banknote engravers] mid 19th c.*
Addresses: Philadelphia. **Comments:** Formed in 1850 when John W. Casilear (see entry) joined Toppan, Carpenter & Co. Other members of the firm included William C. Smillie, Henry E. Saulnier, and the three Jocelyns--Nathaniel, Simeon Smith, and Simeon Starr (see entries). After Casilear left the company in 1855 it was again known as Toppan, Carpenter & Co. The head office was in Philadelphia and there were branches in NYC and Cincinnati. **Sources:** G&W; Phila., CD 1851-55; Rice, "Life of Nathaniel Jocelyn"; Cincinnati CD 1853; NYCD 1851-55.

TOPPI, Mario *[Painter] mid 20th c.*
Exhibited: AIC, 1931-32, 1934, 1939. **Sources:** Falk, *AIC*.

TOPPING, James *[Landscape painter, lithographer] b.1879, Cleator Moor, Cumberland, England / d.1949.*
Addresses: Oak Park, IL. **Studied:** AIC; England. **Member:** Chicago Gal. Assn.; Palette & Chisel Acad., Chicago; Ill. Acad. FA; Chicago P. & S.; Brown County AA; Austin, Oak Park & River Forest AL; Chicago Lith. C.; Hoosier Salon. **Exhibited:** PAFA Ann., 1924; AIC, 1924 (prize), 1925-31, 1926 (prize), 1929 (prize); Chicago Gal. Assn., 1927 (prize); Hoosier Salon, 1938 (prize), 1940 (prize); Brown County AA; Nashville, Ind; Min. AL, Chicago, 1923 (prize); Palette and Chisel Acad., 1924 (gold), 1927 (med); Assoc. Chicago P & S, 1942 (med.); Oak Park AL, 1930 (med.); Business Men's AC, Chicago, 1929; Nat. Exh. Am.

A., NYC, 1936; Joslyn Mem.; Hummell Mem. Prize, 1940. **Work:** State Mus., Springfield, Ill.; Joslyn Mem.; Oak Park C.; Chicago Pub. Sch.; Palette & Chisel Acad. FA, Chicago; Chicago Gal. Assn.; H.S., Kenilworth, Ill. **Sources:** WW47; Falk, *Exh. Record Series.*

TORAL, Maria Teresa *[Engraver, designer] late 20th c.; b.Madrid, Spain.*
Addresses: Mexico. **Studied:** Escuela Artes y Oficios, Madrid; Taller Ciuadadela, Inst. Nac Bellas Artes, Mex.; also with Guillermo Silva Santamara & Yukio Fukasawa. **Member:** Salon Plastica Mexicana; Pratt Ctr. Contemp. Printmaking. **Exhibited:** Bienal de Chile, 1963; Salon del OPIC, Mex., 1966; Exposicon Solar, Inst. Bellas Artes, Mex., 1968; Salon de Grabado, Salon Plastica Mexicana, 1969, 1970 & 1972; Int. Miniature Prints Exhib., Pratt Graphics Ctr., New York, 1969 & 1971; Galeria Misrachi, México DF, Mex., 1970s. **Work:** Mus. Arte Mod., Mex.; Mus. Arte Contemporaneo, Chile; Univ. Mus., Tex.; Living Arts Found., NYC; Joods Historisch Mus., Amsterdam. **Comments:** Preferred media: inks, oils, collage. **Sources:** WW73; Margarita Nelken, *Siete anos de grabado de Maria Teresa Toral* (Acta Politecnica, 1968).

TORAM, Mr. See: **THORAME, Jean Pierre**

TORAN, Alfonso T. *[Painter, decorator, designer, lecturer, writer, teacher] b.1896, Naples, Italy.*
Addresses: NYC; Hollywood, FL. **Studied:** in Italy. **Member:** WMAA. **Exhibited:** Awards: received in Italy, France and U.S. **Work:** murals, Hotels Delmonico, Pierre, New Yorker, Waldorf-Astoria, NYC; Texaco Co.; Chrysler Bldg.; etc. **Comments:** Position: dir., Creative Studios of Art & Decoration, NYC, 1935-. **Sources:** WW59; WW47.

TORBERT, John Bryant *[Cartographer, draftsman, illustrator] b.1867, Wash., DC.*
Addresses: Wash., DC. **Studied:** Columbia (now George Wash.) Univ. **Comments:** Position: staff, U.S. Geological Soc., U.S. Post Office Department; illus., Smithsonian Inst.'s Bureau of American Ethnology; historical cartographer, Jamestown Expo., 1907. **Sources:** McMahan, *Artists of Washington, DC.*

TORBERT, Marguerite Birch *[Designer, writer] b.1912, Faribault, MN.*
Addresses: Minneapolis, MN. **Studied:** Univ. Minn (B.A.); Univ. Iowa (M.A.). **Comments:** Positions: cur. of design & ed., *Design Quart.*, Walker Art Ctr., 1950-63; film dir., Minnimath, Nat. Sci. Found., 1965-70; interior designer, Int. Design Ctr., 1972-. **Sources:** WW73.

TORBETT, Charles W. *[Engraver] mid 19th c.*
Addresses: Boston, 1836-42. **Sources:** G&W; Boston CD 1836-42.

TORCZYNER, Harry *[Lawyer, writer, promoter] b.1911, Antwerp, Blegium / d.1998, NYC.*
Addresses: NYC, 1946-on. **Studied:** Univ. Brussels; Univ. Heidelberg; Columbia Univ. Sch. Law. **Comments:** Promoted Belgian artists to the U.S. market, particularly the works of the surrealist painter, René Magritte — about whom he wrote books and articles. He also wrote *Forgery in Art and the Law* (1954). **Sources:** obit., *New York Times* (Apr., 1998).

TORGERSON, William *[Marine painter] late 19th c.*
Addresses: active Chicago 1873-90. **Work:** chromolithograph portraits of Cunard Steamship Co. ocean liners in BMFA and Chicago Hist. Soc. **Sources:** Brewington, 383.

TORGOV, Vladimir *[Painter] mid 20th c.*
Addresses: Brooklyn, NY. **Exhibited:** S. Indp. A., 1935-36, 1943. **Sources:** Marlor, *Soc. Indp. Artists.*

TORJESEN, William *[Painter] mid 20th c.*
Addresses: Brooklyn, NY. **Exhibited:** Salons of Am., 1934; S. Indp. A., 1944. **Sources:** Falk, *Exhibition Record Series.*

TORKANOWSKY, Vera *[Painter] mid 20th c.*
Exhibited: PAFA Ann., 1954 (still life). **Sources:** Falk, *Exh. Record Series.*

TORMEY, James *[Painter, designer]* late 20th c.; b.NYC.
Addresses: NYC. **Studied:** Pratt Inst; ASL, with William Zorach, five yrs. **Exhibited:** NAD, 1969-72; All. A. Am., 1971; Audubon Artists, 1971-72; Gal. Madison 1990, NYC. **Comments:** Preferred media: oils. **Sources:** WW73.

TORNBY, Max *[Painter]* mid 20th c.
Addresses: Great Neck, LI, NY. **Exhibited:** S. Indp. A., 1929. **Sources:** Marlor, *Soc. Indp. Artists.*

TORO, Francis *[Lithographer, painter]* b.c.1833, Spain.
Addresses: New Orleans, active 1870-77. **Sources:** *Encyclopaedia of New Orleans Artists*, 377.

TORR, Helen *[Painter]* b.1886, Roxbury, PA / d.1967, Bayshore, LI, NY.
Addresses: Phila., PA, 1917. **Studied:** Drexel Inst., Phila.; PAFA. **Exhibited:** Soc. Indep. Artists, 1917; Opportunity Gal., NYC, 1927; An American Place, NYC, 1933 (duo with Arthur Dove); Heckscher Mus., 1972 (retrospective), 1989 (exh. of Arthur Dove and Helen Torr); Graham Gal., NYC, 1980 (solo), 1997 (solo). **Comments:** Painter of landscape, still lifes, and nature subjects. In 1913, she married cartoonist Clive Weed. In 1919, she met Arthur Dove, and by the 1920s her paintings reflected the abstract shapes and forms of the early modernist aesthetic. In 1932, she married Dove but stopped painting in 1937 to care for him full time after he suffered a heart attack. Her pictures are not large, and the objects she depicted are often imbued with a sense of animism. **Sources:** press release, Graham Gal. (NYC, 1997); Anne Cohen DiPietro, *Arthur Dove and Helen Torr: The Huntington Years* (Heckscher Mus., 1989); Pettys *Dict. Women Artists* 703.

TORRANCE, H. C. *[Painter]* 20th c.
Addresses: Pittsburgh, PA. **Studied:** Pittsburgh AA. **Sources:** WW21.

TORRANCE, James Robson, Jr. *[Portrait and landscape painter]* b.1903, Chicago, IL / d.1941, Novato, CA.
Addresses: Fairfax, CA, 1930. **Studied:** ASL, with George Bridgman; Calif. School of FA. **Exhibited:** SFMA, 1935. **Comments:** Position: art dir., Gerth-Knollin Ad. Agency. **Sources:** Hughes, *Artists in California*, 562.

TORRANCE, Nadine Porter *[Painter, etcher]* b.1900, Oregon / d.1974, San Francisco, CA.
Addresses: San Francisco, CA. **Studied:** UC Berkeley; Calif. School of FA. **Member:** Soc. for Sanity in Art. **Comments:** Married to William Torrance (see entry). Position: WPA Art Education Program, 1930s; draftsperson, U.S. Navy, 20 years. **Sources:** Hughes, *Artists in California*, 562.

TORRANCE, William Fairfield *[Landscape painter]* b.1900, Chicago, IL / d.1985, Santa Cruz, CA.
Addresses: NYC; Baltimore, MD; Marin County, CA. **Studied:** arch., with his father and at Columbia Univ.; PAFA and Beaux Arts School, 1920s. **Exhibited:** Marin Soc. of Artists; Soc. of Western Artists. **Comments:** Worked as an architect in NYC and Baltimore before moving to California with his brother, James Torrance (see entry). Position: dir., Torrance Art Gallery, San Anselmo. Preferred medium: watercolor, later acrylic. Married to Nadine Torrance (see entry). **Sources:** Hughes, *Artists in California*, 563.

TORRANS, Eliza See: **COCHRAN, Eliza (Mrs. Thomas, Jr.)**

TORRANS, Rosella (or Rosalba) *[Landscape painter]* early 19th c.
Addresses: Active in Charleston, SC, c.1808. **Comments:** Ramsay's *History of South Carolina* (1809) speaks of her and her sister, Mrs. Eliza Cochran (see entry), as the leading female artists of South Carolina. **Sources:** G&W; Rutledge, *Artists in the Life of Charleston;* Ramsay, *History of South Carolina*, II, 269-70. Dunlap, *History*, II, 472, mistakenly gives her name as Rosalba Torrens.

TORRE, Peter, Jr. *[Sketch artist, architect, draftsperson]* b.c.1880, New Orleans, LA / d.1953, New Orleans.
Sources: *Encyclopaedia of New Orleans Artists*, 377.

TORREANO, John Francis *[Painter, lecturer]* b.1941, Flint, MI.
Addresses: NYC. **Studied:** Cranbrook Acad. Art (B.F.A., 1963); Ohio State Univ. (M.F.A., 1967); also with Robert King & Hoyt L. Sherman. **Exhibited:** Am. Fedn. Arts Traveling Exhib.; Erasable Structures, Visual Arts Gal., New York; Ann. Exhib. Contemp. Am. Painting, 1969 & Lyrical Abstraction, 1971, WMAA; Butler Inst. Am. Art, 1972. **Work:** WMAA; Larry Aldrich Mus. Contemp. Art, Ridgefield, Conn.; Michener Collection, Univ. Tex. **Comments:** Preferred media: acrylics. Teaching: asst. prof. painting, Univ. S. Dak., 1967-68; instr. painting, Sch. Visual Arts, 1969-70; vis. artist, AIC, 1972. **Sources:** WW73; C. Ratcliff, "New York Lett.," *Art Int.* (1970) & "Painterly vs Painted," *Art News Ann.* (1971); B. Richardson, "California Review," *Arts Mag.* (1971).

TORRENS, Eliza See: **COCHRAN, Eliza (Mrs. Thomas, Jr.)**

TORRENS, Rosalba See: **TORRANS, Rosella (or Rosalba)**

TORRES, Garcia J. *[Painter]* early 20th c.
Addresses: NYC. **Member:** S. Indp. A. **Exhibited:** S. Indp. A., 1921; WMAA, 1922. **Sources:** WW21.

TORRES, John, Jr. *[Sculptor, art administrator]* b.1939, Bronx, NY.
Addresses: Providence, RI. **Studied:** Md. State Col., 1956-57; Mich. State Univ., 1958-59; New Sch. Soc. Res., 1959-62; ASL, 1959-68; Brooklyn Mus. Sch., 1963-64; RI Sch. Design (B.F.A., 1972); also with Arnold Prince, Seymour Lipton & William Zorach. **Member:** ASL (bd. mem.); Afro Art Ctr. (bd. mem.); Salmagundi Club. **Exhibited:** WMAA, 1971; Nat. Collection Fine Art, Smithsonian Inst., Wash., DC, 1971; solo shows, RI Sch. Design, 1970 & Guest of Govt. Mex., 1970. **Awards:** Ford Found. grant for Vt summer, also scholarship; Edward MacDowell Colony fel., 1964-67, 1971; Nat. Endowment grant; Nat'l Assn. of the Arts, purchase prize; Nora Kubic Grant; Pearlson-Sturgis Grant; Lindsay Trust Grant; *Boston Globe* Grant; Wyman Fnd. Grant; Artist in the Schools Grant for Barrows, Alaska; Ford/AIA Grant to Educate Arch. **Comments:** Preferred media: stone. Positions: dir. Vt. proj., ASL,; admin. asst. to dean, RI Sch. Design. Teaching: lectr., Afro art hist., Brown Univ.; assoc. sculpture, RI Sch. Design. **Sources:** WW73; Patterson, *Encyclopedia of Black Cultural Contributions;* Fax, *Seventeen Black Artists,* Dodd, article In: *Sepia Mag.* (July, 1968); Cederholm, *Afro-American Artists.*

TORRES-GARCIA, J. See: **TORRES, Garcia J.**

TORREY, Charles *[Marine painter]* b.1859, Boston, MA / d.1921, Brookline, MA.
Work: Peabody Mus., Salem, MA (oil). **Comments:** Agent for a NYC textile house and amateur painter. **Sources:** Brewington, 383.

TORREY, Charles Cutler *[Engraver]* b.1799, Beverly or Salem, MA / d.1827, Nashville, TN.
Addresses: Working in Salem in 1820; moved to Nashville, TN in 1823. **Comments:** Brother of Manasseh Cutler Torrey (see entry). **Sources:** G&W; Torrey, *The Torrey Families,* I, 210; Belknap, *Artists and Craftsmen of Essex County,* 5; Stauffer; *American Collector* (Nov. 1944), 17.

TORREY, Elliot (Bouton) *[Painter]* b.1867, East Hardwick, VT / d.1949, San Diego, CA.
Addresses: San Diego, CA (since 1923). **Studied:** Bowdoin Col., 1890; Florence; Paris. **Member:** San Diego FAS. **Exhibited:** BAC, 1898; Corcoran Gal biennial, 1912; AIC, 1912, 1914; S. Indp. A., 1917. **Work:** AIC; CMA; Akron AI; San Diego Fine

Elliot Torrey

San Diego Fine Arts Mus. **Comments:** Specialties: children; seascapes. **Sources:** WW40.

TORREY, Eugene *[Painter] 19th/20th c.; b.Chicago, IL.*
Addresses: Los Angeles, 1890s-26. **Studied:** Gérome. **Exhibited:** Paris Salon, 1879; Paris, 1886; Blanchard Gal., Los Angeles, 1905. **Comments:** Specialties: Calif. missions, 1890's; military subjects, after 1910. **Sources:** Fink, *American Art at the Nineteenth-Century Paris Salons,* 398.

TORREY, Franklin *[Sculptor] b.1830, Scituate , MA / d.1912, Florence, Italy.*
Addresses: Florence, Italy, since c.1860. **Comments:** Son of David (1787-1877) and Vesta Howard Torrey (1790-1866). He studied in Rome, was American Consul General at Genoa, and at one time proprietor of the Carrara Marble Works. The American Church in Florence was built under his supervision. He spent over fifty years in Italy. **Sources:** G&W; Torrey, *Torrey Families,* I, 193, 280; *Art Annual,* X, obit.

TORREY, Fred M(artin) *[Sculptor, painter] b.1884, Fairmont, WV / d.1967, West Des Moines, IA.*
Addresses: Chicago, IL. **Studied:** AIC; C.J. Mulligan. **Member:** Chicago Soc. P. & S. **Exhibited:** PAFA Ann., 1924, 1934; Dayton AI; WFNY, 1939; AIC; Chicago World's Fair.Award; Assn. Chicago P. & S., 1950 (gold med). **Work:** S./med./mem./busts, Chautauqua, N.Y.; Westley Hospital, Chicago; Paradise Theatre, Chicago; Haines County Court House, Jackson, Miss.; Norton Mem. Hall, Chautauqua, NY; La. State Medical Sch., New Orleans; Capitol, Baton Rouge, La.; medals, Univ. Chicago; Brown Univ; Northwestern Univ.; Swedish Hall of Fame, Phila.; Pub. Sch., Bloomington, Ill.; Paradise Theatre, 124th Field Artillery Bldg., both in Chicago; Haish Lib., DeKalb, Ill.; Schs., Charleston, Ill.; bronze doors, Highland Park Pub. Lib., Mich.; mem. tables, Ontario, Canada; busts, Houston; port. statue, Winchester, Ill.; equestrian statues, Springfield, Ill.; Mun. mem., Topeka, Kans.; Am.-Swedish Hist. M., Phila; panels, Science Bldg., Eastern Illinois State T. Col.; doors, McGregor Pub. Lib., Highland Park, Mich.; port. reliefs Wesley Hospital, Chicago; Lincoln's Tomb, Springfield, Ill.; tablet, Creche Home, Omaha, Neb.; fountain, Bester Mem. Plaza, Chautauqua, N.Y.; Munn mem., Topeka; Harris mem., Sterling Colo.; medal for Am. Life Convention, Chicago. **Sources:** WW59; WW47; Falk, *Exh. Record Series.*

TORREY, George Burroughs *[Portrait painter] b.1863, NYC / d.1942, Honolulu, HI.*
Addresses: NYC, 1893; Paris, 1898; Honolulu, HI, 1912. **Studied:** NYC; Paris. **Exhibited:** NAD, 1893, 1898; S. Indp. A., 1917-18; Award: Order of the Savior, 1904, by the King of Greece. NAD, 1898. **Comments:** Was known for portraits of King George of Greece, Theodore Roosevelt and Wm. H. Taft. In Hawaii he painted businessmen and governors. **Sources:** WW17; Forbes, *Encounters with Paradise,* 205.

TORREY, Helena J. *[Artist] late 19th c.*
Addresses: Active in Detroit, 1891 and Grand Rapids, MI, 1898-97. **Sources:** Petteys, *Dictionary of Women Artists.*

TORREY, Hiram Dwight *[Landscape and still life painter] b.1820, New Lebanon, NY / d.1900, Delanco, NJ.*
Addresses: Milwaukee, WI, 1851; Reading, PA, c.1853-62; Phila., PA, 1878; Delanco, NJ. **Exhibited:** PAFA Ann., 1855, 1878. **Comments:** After his first marriage in 1849, he moved out to Milwaukee where he had a studio in 1851. From about 1853 to 1862 he lived in Reading (PA). After his second marriage in 1862 he apparently took his family abroad, for a son was born in Glasgow (Scotland) in 1870. **Sources:** G&W; Torrey, *Torrey Families,* I, 237, and II, 237; Butts, *Art in Wisconsin,* 102; Rutledge, PA; letter, Earl L. Poole, Director, Reading Public Museum and Art Gallery, to Miss Anna Wells Rutledge, Jan. 8, 1953 (NYHS files); PAFA, Vol. II.

TORREY, Juliette E. *[Still life painter] mid 19th c.*
Addresses: Philadelphia, 1832. **Sources:** G&W; Rutledge, PA.

TORREY, Kate S. (Mrs.) *[Artist] late 19th c.*
Addresses: Active in Grand Rapids, MI, 1899. **Exhibited:** NAD, 1886; AIC, 1892, 1899. **Sources:** Petteys, *Dictionary of Women Artists.*

TORREY, Mabel Landrum (Mrs. Fred) *[Sculptor, lecturer, teacher] b.1886, Sterling, CO / d.1974.*
Addresses: Chicago, IL. **Studied:** State Teachers Col., Greeley, CO; AIC with C.J. Mulligan. **Member:** Chicago Soc. P&S; Chicago Gals. Assn. **Exhibited:** Chicago Gal. Assn., 1930 (prize); AIC, 1915-55; South Bend (IN) Pub. Lib.; Women's World Fair, Chicago, 1922; Chicago World's Fair, 1933-34; Garfield Park Conservatory, Chicago; O'Brien Gals., Chicago. **Work:** statues, reliefs, mem., Washington Park, Denver, CO; Omaha Children's Lib.; Proctor Hospital, Cincinnati, OH; Univ. Chicago Nursery Sch.; State Normal College, Greeley, CO; Univ. Chicago; Decatur, IL; Crane Sch., Cincinnati; many portraits of children; fountain, Wellsboro, PA; South Bend, (IN) Lib. **Comments:** Sculpted neo-classical figures, children, and mother and child subjects in bronze and marble. Also made small porcelain figures, portraits. Lectured to art clubs and organizations and had a studio at Taft's Midway Studios. She assisted her husband, also a sculptor (see entry), on large pieces. **Sources:** WW59; WW17; WW47.

TORREY, Manasseh Cutler *[Portrait and miniature painter] b.1807, Salem, MA / d.1837, Pelham, VT.*
Addresses: Salem, MA, 1831-37. **Studied:** pupil of Henry Inman (see entry). **Member:** A.N.A., 1833. **Exhibited:** National Academy in 1833; Boston Athenaeum. **Comments:** A younger brother of Charles Cutler Torrey (see entry) **Sources:** G&W; Torrey, *Torrey Families,* II, 73; Bolton, "Manasseh Cutler Torrey"; Swan, BA; Cowdrey, NAD; Clark, *History of the NAD;* Belknap, *Artists and Craftsmen of Essex County,* 14; repro., *Essex Institute Hist. Coll.,* 86 (April 1950), 164.

TORRY, Eugene *[Portrait, animal and landscape painter] late 19th c.*
Addresses: Kalamazoo, MI, 1883-87. **Exhibited:** Detroit's Great Art Loan, 1883; Michigan State Fair, 1885 (prize). **Sources:** Gibson, *Artists of Early Michigan,* 228.

TORRY, William J. (Mrs.) *[Landscape painter] late 19th c.*
Exhibited: Brooklyn AA, 1876-79. **Sources:** *Brooklyn AA.*

TORSCH See: **TORSCH, John W.**

TORSCH, John W. *[Wood engraver] b.1832, Maryland.*
Addresses: Baltimore (MD), 1860. **Comments:** This is possibly Torsch, who was in Richmond, VA in 1862, sketching scenes of nearby Civil War battles. He and (John) King (see entry), intended to publish these as engravings. **Sources:** G&W; 8 Census (1860), Md., V, 302 [three months later he was boarding out, see III, 956]; Baltimore CD 1858-60. More recently, see Wright, *Artists in Virginia Before 1900.*

TORTORE, Bartholomew *[Painter] b.1832, Piedmont, Italy / d.1906.*
Addresses: Santa Clara, CA. **Studied:** Academy of FA, Rome, Italy. **Work:** Immaculate Conception Church, Seattle, WA; Faculty Club, Santa Clara College; St. Joseph's Church, San Jose. **Comments:** Went to California in c.1870. Position: teacher, Santa Clara College, 1878-1904. He was a lay Jesuit, specializing in religious art. **Sources:** Hughes, *Artists in California,* 563.

TOSCHIK, Larry *[Painter, commercial artist, writer] b.1925, Milwaukee, WI.*
Addresses: Pine, AZ in 1976. **Member:** Nat. Acad. Western Art. **Comments:** Positions: art director after WWII; commercial artist, Phoenix, c.1947; graphics dept., Arizona State Univ., 1964; painter, Ducks Unlimited, 1967. Contributed to *Arizona Wildlife Sportsman Magazine,* juvenile books, wildlife manuals. **Sources:** P&H Samuels, 489.

TOSE, Frank *[Painter, craftsperson] b.1884, Whitby, England / d.1944, San Francisco, CA.*
Addresses: San Francisco, CA. **Comments:** Position: staff, Academy of Science. He made several trips to Africa and created

habitat groups and dioramas in the Calif. Hall of Sciences in Golden Gate Park. Specialty: exotic birds. **Sources:** Hughes, *Artists in California,* 563.

TOTH, Steven, Jr. *[Designer, painter] b.1907, Philadelphia, PA.*
Addresses: Alhambra, CA. **Studied:** Cleveland Sch. A.; & with Henry G. Keller, Sandor Vago, R. E.Wilhelm, J. F. Faysash. **Member:** Akron SA. **Exhibited:** Akron AI, 1930-1940; Butler AI, 1937, 1939. **Work:** mural, Akron (Ohio) Armory. **Sources:** WW53; WW47.

TOTTEN, Donald Cecil *[Painter, mural painter] b.1903, Vermillion, SD / d.1967, Long Beach, CA.*
Addresses: Long Beach, CA. **Studied:** USC; Otis Art Inst.; ASL of Los Angeles; with Stanton MacDonald-Wright. **Exhibited:** Plummer Gal., Los Angeles; Downey, CA, Mus.; Pasadena Mus.; Long Beach Mus.; Santa Barbara Mus.; Whittier AA Gal. **Work:** Waite Elementary School, Norwalk, CA; Holliston Methodist Church, Pasadena (mural). WPA artist. **Comments:** Position: teacher, high schools and colleges. Specialty: abstracts. **Sources:** Hughes, *Artists in California,* 563.

TOTTEN, George Oakley, Jr. *[Painter] b.1865, NYC / d.1939, Wash., DC.*
Addresses: Wash., DC, early 1890s. **Studied:** Columbia Univ. (Mc. Kim Traveling Scholarship); Ecole des Beaux Arts, Paris. **Member:** Wash. Soc. of FA; Wash. Handicraft Guild (pres., 1922). **Exhibited:** Wash. WCC. **Sources:** WW01; McMahan, *Artists of Washington, DC.*

TOTTEN, Ralph James *[Painter, author, diplomat] b.Nashville, TN / d.1949, Wash., DC.*
Addresses: Wash., DC. **Exhibited:** local galleries; CGA; the old National Mus. **Comments:** Born in 1877/80. After a distinguished thirty-year career in the U.S. Foreign Service, he devoted his time to painting and graphic art. **Sources:** McMahan, *Artists of Washington, DC.*

TOTTEN, Vicken von Post (Mrs. George O.) *[Sculptor, painter, illustrator, lecturer] b.1886, Sweden / d.After 1940.*
Addresses: Wash., DC. **Studied:** Académie of Beaux-Arts, Stockholm. **Member:** Grand Central A. Gal.; Women's Soc. PS, Stockholm. **Exhibited:** Stockholm; Paris; Brooklyn Mus.; CI; AIC; Arch. League, NYC; CGA, 1924, 1928; Greater Wash. Independent Expo., 1935; American Federation of Arts Traveling Exh. **Work:** Metropolitan Church of Immaculate Conception, Wash., DC; A. Industry M., Copenhagen Nat. M., Stockholm; murals, USPOs, Waterbury, CT, Spencer, W.Va.; Fed. Bldg., Newark, NJ. WPA artist. Designer of the "Spirit of Flight" Charles A. Lindbergh award. **Comments:** Married to George O. Totten (see entry) in 1921. She had her own art school in Wash., DC, c.1921-41. **Sources:** WW40; McMahan, *Artists of Washington, DC.*

TOULIS, Vasilios (Apostolos) *[Printmaker, painter] b.1931, Clewiston, FL.*
Addresses: NYC. **Studied:** Univ. Fla. (B.Des.), with Fletcher Martin & Carl Holty; Pratt Inst. (B.F.A.), with Richard Lindner, Fritz Eichenberg, Jacob Landau & Walter Rogalski. **Member:** Am. Assn. Univ. Prof. **Exhibited:** Brooklyn Mus., NY, 1966; Fleisher Mem, Philadelphia, Pa., 1966; Mus. Arte Mod., Mexico City, 1967; Int. Miniature Print Exhib., 1968; New Paltz Nat. Print Exhib., 1968. **Awards:** Tiffany Found. grant in printmaking, 1967. **Work:** US State Dept., Wash., DC; Mus. Arte Mod., Mexico City, Mex.; Caravan House, NYC Commissions: portfolio of prints, Ctr. for Contemp. Printmaking, 1968. **Comments:** Positions: printmaking adv. to dir., Hudson River Mus., NYC. Teaching: lect., Serigraphic Printmaking, Univ. RI, 1967 & Pratt Inst. seminar, 1969; hd. graphic workshop, Pratt Inst., 1966-, instr. printmaking, 1969-71, asst. prof. & hd undergrad. printmaking, 1971-. **Sources:** WW73.

TOULMIN, Ashby *[Painter] mid 20th c.*
Addresses: University, LA. **Exhibited:** 48 States Comp., 1939. **Comments:** Position: affiliated with Dept. FA, Univ. La. **Sources:** WW40.

TOURNOUX, J. *[Sculptor] late 19th c.*
Addresses: NYC, 1881. **Exhibited:** NAD, 1881. **Sources:** Naylor, *NAD.*

TOUSEY, Maud(e) See: **FANGEL, Maud Tousey**

TOUSEY, T. Sanford *[Illustrator, writer] early 20th c.*
Addresses: Active in NYC, 1924-48. **Comments:** Art Editor/Illustrator: children's books. **Sources:** P&H Samuels, 489.

TOUSIGNANT, Claude *[Painter, instructor] b.1932, Montreal, PQ.*
Addresses: Montreal, PQ. **Studied:** Sch. Art & Design, Montreal; Acad. Ranson, Paris, France. **Member:** Artistes Prof de Montreal; Royal Can. Acad Arts. **Exhibited:** Guggenheim Mus., NYC, 1965; Can. Art, Paris, Rome & Brussels; Lausanne, Switz., 1968; Mass. Inst. Technol., Cambridge; Wash. Gal. Mod. Art. **Awards:** prize, Salon de la Jeune Peinture, 1962 & Centennial Exhib., 1967. **Work:** Nat. Gal. Can.; Phoenix Art Mus., Ariz.; Larry Aldrich Mus., Ridgefield, Conn.; York Univ.; Mus. Contemp. Art, Montreal & Quebec. **Comments:** Positions: pres., Calude Tousignant, Inc. Teaching: instr. design, Sch. Art & Design, Montreal. **Sources:** WW73.

TOVISH, Harold *[Sculptor] b.1921, NYC.*
Addresses: Brookline, MA. **Studied:** Columbia Univ., 1940-43; Ossip Zadkine Sch. Sculpture, Paris, France, 1949-50; Acad. Grande Chaumière, Paris, 1950-51. **Member:** Boston Visual Artists Union. **Exhibited:** 28th Venice Biennial, Italy, 1956; Carnegie Int., 1958; Recent Sculpture: USA, MoMA, 1959; WMAA; Guggenheim Int Award Exhib, Guggenheim Mus.,1968; Terry Dintenfass, Inc, NYC, 1970s. **Awards:** Grant, Am. Inst. Arts & Lett., 1960 & 1971; sculptor-in-residence, Am. Acad., Rome, 1966; Guggenheim fel., 1967. **Work:** WMAA; BMFA; PMA; AIC; MoMA. Commissions: Epitaph (sculpture), State of Hawaii, 1970. **Comments:** Preferred media: bronze. Teaching: asst. prof. sculpture & drawing, Univ. Minn., 1951-54; vis. prof. sculpture, Univ. Hawaii, 1964-70; prof. sculpture & drawing, Boston Univ., 1971-. **Sources:** WW73; H. Harvard Arneson, "New Talent," *Art in Am.* (1954) & Harold Tovish, catalogue (Watson Gallery, 1967).

TOVISH, Marianna See: **PINEDA, Marianna (Marianna Pineda Tovish)**

TOWBIN, Phoebe *[Artist] d.1994.*
Member: Woodstock AA. **Sources:** Woodstock AA.

TOWBRIDGE, Vaughn. *[Painter, etcher] b.1879 / d.1941.*
Sources: Falk, *Dictionary of Signatures.*

TOWENE, Charles H. *[Illustrator] 20th c.*
Addresses: New Rochelle, NY. **Member:** New Rochelle, AA. **Sources:** WW25.

TOWER, Edith Allerton See: **TOBEY, Edith Allerton Tower (Mrs.)**

TOWER, F. B. *[Author and illustrator] mid 19th c.*
Comments: Author and illustrator of a book on the Croton Aqueduct, built in the 1840's to bring water to NYC. Tower may have been one of the engineers employed in its construction. **Sources:** G&W; Tower, *Illustrations of the Croton Aqueduct* (New York, 1843); Stokes, *Iconography,* III, 875-76.

TOWER, Flora *[Sculptor] mid 20th c.*
Exhibited: WMAA, 1925. **Sources:** Falk, *WMAA.*

TOWER, Roderick (Mrs.) *[Painter] mid 20th c.*
Addresses: NYC. **Exhibited:** S. Indp. A., 1925. **Sources:** Marlor, *Soc. Indp. Artists.*

TOWERS, Glen O. *[Painter] mid 20th c.*
Exhibited: AIC, 1929. **Sources:** Falk, *AIC.*

TOWERS, J. *[Watercolor portraits] mid 19th c.*
Addresses: Upper New York State, c.1850. **Sources:** G&W; Lipman and Winchester, 181.

TOWLE, Edith *[Painter] 20th c.*
Addresses: Chicago, IL, c.1913. **Sources:** WW13.

TOWLE, Erwin W. *[Painter] mid 20th c.*
Exhibited: S. Indp. A., 1940. **Sources:** Marlor, *Soc. Indp. Artists.*

TOWLE, Eunice Makepeace (Mrs. N.C.) *[Portrait painter] b.c.1806, Norton, MA, or NH / d.1894, Wash., DC.*
Addresses: Wash., DC, c.1841-60. **Exhibited:** Wash. AA, 1860.
Work: Avery Hall, Columbia University, NYC (portrait of Martin Van Buren, 1782-1862); Wheaton College, Norton, MA. **Comments:** Her father was Van Buren's physician. **Sources:** G&W; G&W has information courtesy Professor Vanderpool, Columbia University. More recently, see McMahan, *Artists of Washington, DC.*

TOWLE, H. Ledyard *[Mural painter, portrait painter, teacher] b.1890, Brooklyn, NY. / d.1973, Merry Point, VA.*
Addresses: NYC. **Studied:** Adelphi Col.; Pratt Inst.; ASL, with Du Mond, Chase. **Member:** SC; Allied AA; CAFA; S. Indp. A.; NAC. **Exhibited:** PAFA Ann., 1912, 1916; Yonkers Expo, 1913 (med); AIC; S. Indp. A. **Work:** Mun. Bldg., NYC; Ohio Wesleyan Univ. **Comments:** Positions: teacher, NY Evening Sch. Indst. A., Fawcett Sch. Indst. A. (Newark, NJ). **Sources:** WW19; Falk, *Exh. Record Series.*

TOWN, Harold Barling *[Painter, writer] b.1924, Toronto, Canada / d.1990.*
Addresses: Toronto 5, Ontario. **Studied:** Ont. Col. Art (grad., 1944); (hon. L.H.D.), York Univ., 1966. **Member:** Royal Can. Acad. **Exhibited:** Sixth Sao Paulo Biennial, 1961; Cezanne & Structure in Modern Painting, Guggenheim Mus., 1963; Documenta, Kassel, Ger., 1964; Can. Govt. Pavilion, Expo '1967, Can, 1967 & Expo '1970, Osaka, Japan, 1970; Mazelow Gallery, Toronto 319, Ont., 1970s; solo shows, Venice Biennial, Italy, 1956, 1964 & 1972. **Awards:** fel., Inst. Cult. Hispanica, Arte de Am. y Espana, Madrid, 1963; medal serv., Order Can., 1968. **Work:** Tate Gal., London, Eng; MoMA; Stedelijk Mus., Amsterdam, Holland; Guggenheim Mus., New York; Nat. Gal. Can. Commissions: mural on canvas, Ont. Hydro Comm., St. Lawrence Seaway Power Proj., 1957; decorative exterior enamel frieze, North York Pub. Libr., Toronto, 1959; two part mural & sculptural screen, Toronto Int. Airport, Malton, Can. Govt., 1962; mural & collage, Tel. Bldg., Toronto, 1964; mural on canvas, Queens Park Proj., Ont. Govt., 1969. **Comments:** Positions: mem. bd. gov., Ont. Art Col., 1971. Publications: illusr., "Love Where the Nights are Long," 1962; auth., "Enigmas," 1964; co-auth., "Drawings of Harold Town," 1969; auth., "Silent Stars, Sound Stars, Film Stars," 1971. **Sources:** WW73; Herbert Read, *A Concise History of Modern Painting* (Praeger, 1959); J. Russel Harper, *Painting in Canada* (Univ. Toronto Press, 1966); R. Fulford, "The Multiplicity of Harold Town," *Arts Can.* (Apr., 1971).

TOWNA, Arthur *[Illustrator] 19th c.*
Comments: Illustrator: *Judge*, NYC. **Sources:** WW98.

TOWNE, Ann Sophia See: **DARRAH, Ann Sophia Towne (Mrs. Robert K.)**

TOWNE, Constance (Gibbons) (Mrs. F.T.) *[Portrait painter, sculptor] b.1868, Wilmington, DE.*
Addresses: Norton, CT. **Sources:** WW17.

TOWNE, Eugene *[Painter] b.1907, San Francisco, CA.*
Addresses: Carmel, CA. **Studied:** with Jade Fon, George Post, Eliot O'Hara. **Member:** Soc. of Western Artists; Carmel AA. **Exhibited:** Northern Calif.; Berkeley Festival of Arts, 1966 (second prize); Monterey Peninsula Mus. of Art, 1968 (purchase prize); Monterey County Fair, 1969 (best of show and first prize). **Work:** Monterey Peninsula Mus. of Art; Nat'l Monument Mus. of Aztec, NM. **Comments:** Specialty: watercolors. **Sources:** Hughes, *Artists in California, 563.*

TOWNE, L. Benson *[Painter] 20th c.*
Addresses: Cincinnati, OH. **Sources:** WW19.

TOWNE, Rosalba (Rosa) M. *[Flower painter, botanical illustrator] b.1827 / d.1909.*
Addresses: Philadelphia, 1860-66; Shoemakertown, PA, 1868-69. **Member:** PAFA (associate member, 1869). **Exhibited:** PAFA Ann., 1868-69, 1877-83. **Work:** Botanical Museum, Harvard University (watercolors of flowers and shrubs). **Comments:** Daughter of John and Sarah Robinson Towne. Her parents lived in Pittsburgh, Boston (1833-40), and Philadelphia (1840-51). A sister, Ann Sophia (see entry), married Robert K. Darrah and was an artist; a brother, John Henry Towne (1818-75) was a Philadelphia merchant who endowed the Towne Scientific School of the University of Pennsylvania. **Sources:** G&W; Towne, *The Descendants of William Towne*, 106-07; Rutledge, PA. More recently Rubinstein *American Women Artists* 67; Falk, *Exh. Record Series.*

TOWNER, Flora L. *[Painter] 19th/20th c.*
Addresses: Albany, NY, 1889-97. **Exhibited:** AIC, 1888; NAD, 1889-97; PAFA Ann., 1889-92, 1898 (flower paintings). **Sources:** WW01; Falk, *Exh. Record Series.*

TOWNER, Xarifa (Hamilton) (Miss) *[Painter] early 20th c.*
Addresses: NYC; Los Angeles, CA, 1909; Laguna Beach, CA, 1913-15. **Studied:** Twachtman, Metcalf, Hawthorne, Christy in NYC. **Member:** Calif. AC. **Exhibited:** McBurney Gal., Los Angeles, 1911-13; Maryland Hotel, Los Angeles, 1912; Calif. AC, 1915. **Sources:** WW17; Hughes, *Artists in California, 563.*

TOWNLEY, Clifford *[Painter] 20th c.*
Addresses: Leonia, NJ. **Member:** SC. **Sources:** WW25.

TOWNLEY, Frances Brown (Mrs.) *[Painter] b.1908, Waterbury, CT.*
Addresses: Englewood, NJ, 1940. **Studied:** Yale; PAFA. **Member:** Phila. Alliance; New Haven PCC; New Haven BPC; Boston AC; NAWA. **Exhibited:** Waterbury Annual, 1934 (prize). **Work:** St. Thomas Church, New Haven. **Sources:** WW40.

TOWNLEY, Hugh *[Sculptor, printmaker] b.1923, Lafayette, IN.*
Addresses: Bristol, RI. **Studied:** Univ. Wis., 1946-48; also with Ossip Zadkine, Paris, 1948-49; London Co. Coun. Arts & Crafts, 1949-50. **Exhibited:** New Talent Show, MoMA, 1955; Carnegie Inst. Biennial, 1958; Am. Painting & Sculpture, Univ. Ill., 1961,1963; WMAA, 1962-63; 65th Am. Painting & Sculpture Exhib., AIC, 1964;Graphics Gal., San Francisco, CA, 1970s. Awards: grant for creative work in art, NIAL, 1967; artist fel., Tamarind Lithography Workshop, 1969; Gov. Award, State of RI Coun. Arts, 1972. **Work:** MoMA; WMAA; BMFA; Fogg Mus. Art, Harvard Univ.; LACMA. Commissions: cast concrete reliefs & archit. walls, Old Stone Bank, Bristol, RI, 1965; wood relief, Bristol Hosp., Conn., 1969; three concrete pieces, Class of 1965, Brown Univ., Providence, RI, 1970; three hanging wood sculptures, Retail Planning Corp., Nashville, Tenn., 1971; three concrete pieces, State of Ky. Comprehensive Training Ctr., Somerset, Ky., 1972. **Comments:** During the 1950s, he emerged as one of the leading figures in carved wood and carved wood relief wall pieces, utilizing a unique vocabulary of mythology and totems. Preferred media: wood, concrete. Teaching: instr. sculpture & drawing, Layton Sch. Art, Milwaukee, Wis., 1951-56; asst. prof. sculpture, Beloit Col., 1956-57; asst. prof. sculpture & drawing, Boston Univ., 1957-61; prof. art, Brown Univ., 1961-on; vis. prof., Univ. Calif., Berkeley, 1961; vis. lectr., Harvard Univ., 1967; vis. prof., Univ. Calif., Santa Barbara, 1968; vis. lectr., Ft. Wright Col., 1971. **Sources:** WW73; Frank Getlein, article in *Art Am.* (Dec., 1956).

TOWNS, Elaine *[Painter] b.1937, Los Angeles, CA.*
Studied: UCLA (B.A., 1960, M.S., 1962). **Exhibited:** LACMA, 1960; Safety Savings & Loan Assn., 1961; Masters Exh., Univ. of CA, 1962; James Phelan traveling Exh., 1963; Long Beach Mus. of Fine Arts, 1961; Univ. of GA, 1963; Exposicion de Artistas Becarios Fulbright, Madrid, 1964; exh. of prints by American Negro Artists, Soviet Union, 1966-67; Los Angeles Schools Artmobile Exh., 1968-69; Brockman Gal., 1970. Awards:

Fulbright Grant to Spain, 1963-64. **Sources:** Cederholm, *Afro-American Artists.*

TOWNSEND, Armine (Mrs. Edward H.) *[Painter] b.1898, Brooklyn, NY.*
Addresses: Massillon, OH. **Studied:** Buffalo AI, and with Althea Hill Platt, William B. Rowe. **Exhibited:** Albright Art Gal., 1945; Buffalo AI, 1944; Greenwich Soc. Art, 1946-50; Canton AI, 1952-58; Massillon Mus., 1952-57 (solo), (chmn. art exhib. committee, 1955-58); Akron AI, 1957; Little Gal., North Canton, Ohio, 1958 (solo). Awards: prizes, Greenwich Soc. Art, 1948, 1950. **Sources:** WW59.

TOWNSEND, Charles *[Amateur painter] b.1836 / d.1894.*
Addresses: Arrochar, Staten Island, NY. **Exhibited:** NAD, 1859. **Comments:** Son of William H. and Cornelia Maverick Townsend, grandson of Peter Maverick (see entry); an accountant by profession **Sources:** G&W; Stephens, *The Mavericks;* Cowdrey, NAD.

TOWNSEND, Charles E. (or C.) *[Landscape and animal painter] mid 19th c.*
Addresses: Fort Lee, NY, 1871-78. **Exhibited:** Brooklyn AA, 1869-70, 1879-80; NAD 1871-79. **Comments:** Exhibited works indicate he painted animals, and landscapes in Newtown, CT, and in the Lehigh Valley, PA. This may be the same artist listed in G&W, from the NYCD 1832; *Am. Adv. Directory,* 1832. **Sources:** *Brooklyn AA.*

TOWNSEND, Charles W. *[Painter] early 20th c.*
Addresses: Brooklyn, NY, 1918. **Exhibited:** S. Indp. A., 1918. **Sources:** Marlor, *Soc. Indp. Artists.*

TOWNSEND, Charlotte *[Listed as "artist"] b.c.1824, New Jersey.*
Addresses: Philadelphia in 1860. **Comments:** Lived in Philadelphia in 1860 as a boarder in the home of the portrait painter John Neagle (see entry). **Sources:** G&W; 8 Census (1860), Pa., LII, 507.

TOWNSEND, Cora Alice *[Painter, woodcarver] b.c.1853, NYC / d.1898, Arcachon, France.*
Addresses: New Orleans, active 1889-91. **Studied:** Newcomb Col., 1887. **Exhibited:** Artist's Assoc. of N.O., 1889-91. **Comments:** Amateur painter of still lifes and flowers. She was a member of a Southern family and daughter of the famous Southern poet Mary A. Townsend. Married twice to J.M. Rascon and Bannister Smith-Monro, she resided in Europe after her second marriage, c.1895. **Sources:** *Encyclopaedia of New Orleans Artists,* 378.

TOWNSEND, Ernest Nathaniel *[Painter, teacher, illustrator] b.1893, NYC / d.1945.*
Addresses: NYC; Norwalk, CT, 1927. **Studied:** P. Cornoyer; G. Maynard; C.Y. Turner; T. Fogarty. **Member:** SC; Yonkers AA; Allied AA; AAPL; AWCS Artists' F. **Exhibited:** PAFA Ann., 1927 (seascapes); SC, 1938 (prize); AIC. **Work:** N.Y. Hist. Soc. **Sources:** WW40; Falk, *Exh. Record Series.*

TOWNSEND, Ethel Hore (Mrs. John) *[Painter, craftsman] b.1876, Staten Island, NY.*
Addresses: Glen Ridge, NJ. **Studied:** MMA Sch. Art; ASL; H.B. Snell; Orlando Rouland, NYC. **Member:** NYWCC; AWS; Woman's Art Club NY; Artists Fellowship; AC of the Oranges. **Exhibited:** PAFA, 1895, 1898, 1902; NYWCC (prize); Boston AC, 1907-08; AIC, 1908. **Sources:** WW59; WW40; *The Boston AC;* Falk, *Exh. Record Series.*

TOWNSEND, Eugene Coe *[Designer, sculptor] b.1915, Mechanicsburg, IL.*
Addresses: Jacksonville, FL. **Studied:** Rollins Col., Fla.; J.E. Davis. **Exhibited:** 4 A. Soc., Palm Beach; Allied AS, Winter Park, Fla. **Work:** 4 A. Soc., Palm Beach. **Comments:** Position: supv., WPA Fla. **Sources:** WW40.

TOWNSEND, F. E. *[Painter] mid 20th c.*
Addresses: NYC. **Exhibited:** S. Indp. A., 1924. **Sources:** Marlor, *Soc. Indp. Artists.*

TOWNSEND, Frances *[Landscape painter, teacher] b.1863, Wash., DC.*
Addresses: Yakima, WA, 1924. **Studied:** R. Harshe; M. de Neal Morgan; A. Patterson. **Member:** Seattle FAS. **Sources:** WW24.

TOWNSEND, Frances B. (Miss) *[Painter] b.Boston / d.1916.*
Addresses: Boston, MA, through at least 1905; Arlington Heights, MA. **Studied:** Florence, Italy; J. Dupré, in Paris; BMFA Sch. **Member:** Boston WCC; Copley Soc., 1880. **Exhibited:** PAFA Ann., 1891, 1894-97; NAD, 1894-95; Mass. Charitable Mechanics Centenn., 1895 (medal); Atlanta Expo, 1895 (gold); Boston AC, 1890-1905; AIC, 1891-1905; Poland Springs Art Gal., 1898. **Comments:** Specialty: animals. **Sources:** WW17; Falk, *Exh. Record Series.*

TOWNSEND, Frances Platt See: **LUPTON, Frances Platt Townsend**

TOWNSEND, George *[Listed as "artist"] b.c.1824, New York State.*
Addresses: NYC; 1850. **Sources:** G&W; 7 Census (1850), N.Y., XLVI, 611.

TOWNSEND, Geraldine *[Painter] mid 20th c.*
Addresses: San Francisco, CA. **Exhibited:** Oakland Art Gal., 1929. **Sources:** Hughes, *Artists in California,*563.

TOWNSEND, Harry E(verett) *[Painter, illustrator, etcher, block printer, engraver, decorator] b.1879, Wyoming, IL / d.1941.*
Addresses: Norwalk, CT. **Studied:** AIC; H. Pyle; NAD; Paris; London. **Member:** SI; Allied AA; Arch. League, NYC; Brooklyn SE; Conn. AA; Westport A.; Darien G. of Seven A.; SC; Silvermine GA; SC. **Exhibited:** SC, 1920 (Shaw Prize); PAFA Ann., 1910, 1912, 1927; Corcoran Gal. biennial, 1928; AIC. **Work:** War College; Smithsonian; MMA; NYPL; murals, H.S., East and West Norwalk, Conn.; City Hall, Norwalk. **Comments:** Position: artist, with the A.E.F. during WWI. **Sources:** WW40; Falk, *Exh. Record Series.*

TOWNSEND, Helen Elizabeth *[Painter, teacher] b.c.1893, Effingham, IL / d.1980, Silver Spring, MD.*
Addresses: Wash., DC. **Studied:** Wilson Normal school; American Univ.; CUA Sch ; School of Fine and Applied Art, NYC; CGA; with Despujols, Strauss, Ballande, Fountainebleau Sch. FA. **Member:** Wash. SA; Wash. AC; SSAL. **Exhibited:** Greater Wash. Independent Exh., 1935; Maryland Inst.; George Wash. Univ. Gal.; Chicago, IL; NYC; Europe. **Comments:** Position: teacher, MacFarland Jr. H.S. **Sources:** WW40; McMahan, *Artists of Washington, DC.*

TOWNSEND, Henry L. L. *[Engraver] b.c.1823, Connecticut.*
Addresses: NYC in 1850. **Sources:** G&W; 7 Census (1850), N.Y., XLVIII, 70; NYCD 1850.

TOWNSEND, Horace *[Critic, writer] b.1859, Claughton, England / d.1922, NYC.*
Addresses: NYC. **Comments:** Author: several plays and books; catalogues for the Am. Art Assn. Positions: staff, *New York Tribune,* 1883-1900; later, London correspondent, *New York Herald;* later, *Chicago Record, Philadelphia Record, The Public Ledger.*

TOWNSEND, James Bliss *[Critic] b.1855, NYC / d.1921.*
Addresses: NYC. **Comments:** Positions: ed., *American Art News;* cr., *New York World, New York Herald.*

TOWNSEND, Kate A. *[Painter] mid 20th c.*
Addresses: Chicago area. **Exhibited:** AIC, 1927, 1928 (prize), 1930. **Sources:** Falk, *AIC.*

TOWNSEND, L. R. *[Painter] late 19th c.*
Exhibited: Calif. Midwinter Expo, 1894. **Sources:** Hughes, *Artists in California,* 563.

TOWNSEND, Lee *[Painter] b.1895, Wyoming, IL / d.1965, Milford, NJ.* **LT**
Addresses: Westport, CT. **Studied:** H. Dunn; AIC.
Exhibited: Salons of Am., 1934, 1936; PAFA Ann., 1934-44 (5 times); AIC, 1935-46; Mus. Mod. Art, Wash., DC, 1937; Corcoran Gal biennials, 1937-41 (3 times); Nat'l Mus. of Racing, Saratoga Springs, NY, 1999. **Comments:** An Expressionist painter whose subjects often depict horse racing. **Sources:** WW40; Falk, *Exh. Record Series.*

TOWNSEND, Maria Maverick See: **MAVERICK, Maria Ann**

TOWNSEND, Marvin J. *[Cartoonist] b.1915, Kansas City.*
Addresses: Kansas City, MO. **Studied:** Kansas City Art Inst.; Col. Com. Art Sch. **Exhibited:** Awards: cert. of merit, Dict. Int. Biog. **Work:** Syracuse Univ. Permanent Collection, NY.
Comments: Preferred media: inks. Publications: strips, gag cartoons & illus. for trade, business & prof. mags, 1941-; auth., "Bert "(cartoon strip), *Nat. Safety News,* 1958-; auth., "Moontoons Jokes & Riddles," 1970; auth., "Ghostly Ghastly Cartoons," 1971. **Sources:** WW73.

TOWNSEND, Mary Stuard See: **MASON, Mary Stuard Townsend (Mrs. William Clarke)**

TOWNSEND, Myrtie B. *[Sculptor] b.1870.*
Addresses: Phila., PA. **Exhibited:** PAFA Ann., 1889. **Sources:** Falk, *Exh. Record Series.*

TOWNSEND, Olivia See: **KINGSLAND, Olivia DeCourcy**

TOWNSEND, Pauline Frances (Mrs. Frank L.) *[Painter and lecturer] b.1870, Ottumwa, IA.*
Addresses: Tulsa, OK. **Studied:** Simpson Col., Indianola, IA; Etta M. Budd; Saugatuck, MI; AIC; Frederic Freesman, Albert Krehbeil, Grant Wood. **Member:** Federated Club Woman (district art chairman). **Exhibited:** Midwest Exhibition, Kansas City; Iowa Artists Cl.; three solo exhibits, two in Oklahoma, one in Red Oak, IA; Oklahoma Federation Women's Clubs, 1922 (gold medal); Tulsa, 1935 (prize). **Work:** Tulsa Univ.; First Presbyterian Church, Tulsa. **Comments:** Position: teacher, Iowa schools. Lectures: "Application of Art to Everyday Life," "Great Value of Art in Education." **Sources:** Ness & Orwig, *Iowa Artists of the First Hundred Years,* 207-08.

TOWNSEND, Ruth *[Painter] mid 20th c.*
Addresses: NYC. **Exhibited:** S. Indp. A., 1918, 1924-25; WMAA, 1924-27. **Sources:** WW19.

TOWNSEND, Sarah Gore Flint (Mrs.) *[Craftsperson, curator] b.1874, Arequipa, Peru / d.1924.*
Addresses: Boston. **Studied:** Boston SAC (master craftsman), 1901. **Comments:** Position: cur. Textiles, BMFA for 18 years.

TOWNSEND, William H. *[Listed as "artist"] mid 19th c.*
Addresses: New Haven, CT, 1850. **Comments:** Lived with his father, William Townsend , at New Haven (CT) in 1850 **Sources:** G&W; 7 Census (1850), Conn., VIII, 582.

TOWNSEND & ORR *[Panoramists?] mid 19th c.*
Exhibited:. **Comments:** Proprietors and, possibly, painters of a panorama of the Hudson River, shown in NYC in 1849. **Sources:** G&W; Odell, *Annals of the New York Stage,* V, 499-500.

TOWNSHEND, Henry H. *[Painter] 20th c.*
Addresses: New Haven, CT. **Sources:** WW17.

TOWNSLEY, C(hannel) P(ickering) *[Painter, teacher] b.1867, Sedalia, MO / d.1921, London.*
Addresses: care of Frank Brangwyn, London, England/Los Angeles, CA. **Studied:** W.M. Chase; Académie Julian, Paris, 1880-81; Acad. Delacluse, Paris. **Member:** SC; Calif. AC.
Exhibited: PAFA Ann., 1913; Throop Inst., Los Angeles, 1914; Friday Morning Cl., Los Angeles, 1917; NAD; LACMA, 1918; Mus. of NM, 1919; American WC Soc., NYC; Int'l Exhib., CI; AIC; Stendahl Gal., Los Angeles, 1923. **Work:** Santa Fe RR

Collection; LACMA. **Comments:** Positions: teacher/manager, W.M. Chase's Shinnecock Sch. and some of his European classes; also taught at Stickney A. Sch., Pasadena (1914-18), Otis AI (1918-21), and London Sch. A. **Sources:** WW21; Hughes, *Artists in California,* 564; Falk, *Exh. Record Series.*

TOY, Ruby Shuler *[Painter] mid 20th c.*
Addresses: Wash., DC. **Exhibited:** S. Wash., A., 1937-39. **Sources:** WW40.

TOYE, Frank E.W. *[Commercial artist, painter] b.1860, New Orleans, LA / d.1917, New Orleans.*
Addresses: New Orleans, active 1879-1915. **Comments:** Painted carnival floats. **Sources:** *Encyclopaedia of New Orleans Artists,* 378.

TOZZER, A. Clare *[Painter] early 20th c.*
Addresses: Cincinnati, OH. **Member:** CIncinnati Woman's Art Club, c.1915-27. **Sources:** WW27; Petteys, *Dictionary of Women Artists.*

TRABOLD, A. *[Illustrator] early 20th c.*
Addresses: Hoboken, NJ. **Sources:** WW13.

TRACE, Marian A. *[Painter] early 20th c.*
Addresses: San Francisco, CA. **Exhibited:** San Francisco AA, 1924, 1925; Modern Gallery, San Francisco, 1926. **Sources:** Hughes, *Artists in California,* 564.

TRACE, Theodora *[Painter, sculptor] early 20th c.*
Addresses: San Francisco, CA. **Exhibited:** San Francisco AA, 1924, 1925. **Sources:** Hughes, *Artists in California,* 564.

TRACEY, John Martin See: **TRACY, John Martin (or J. W.)**

TRACY, Bartlett See: **TRACY, (Lois) Bartlett (Mrs.)**

TRACY, Elizabeth (Mrs. Elizabeth Tracy Montminy) *[Painter] b.1911, Boston, MA.*
Addresses: Austin, TX. **Studied:** Radcliffe College (B.A.); ASL.
Exhibited: PMG, 1936; GGE 1939; WMA, 1938; Arch. League, 1938; CGA, 1939; Abbot Acad. Gal., Andover, MA, 1939; CPLH, 1946; NAD, 1946; Dallas Mus. FA, 1944-46. Awards: Guggenheim Fellowship, 1941. **Work:** murals, Munic. Bldg., Saugus, MA; City Hall, Medford, MA; Salinas y Rochay Cia, Dept. Store, Mexico City; WPA mural, USPO, Milton, MA; Downers Grove, IL; Kennebunkport, ME. **Sources:** WW53; WW47.

TRACY, G. P. See: **TRACY, S. (or G.)**

TRACY, Glen *[Painter, illustrator, teacher] b.1883, Hudson, MI.*
Addresses: Cincinnati, OH. **Studied:** Nowottny; Meakin; Duveneck. **Member:** Cincinnati AC. **Exhibited:** AIC, 1920; Detroit AI, 1924 (prizes); S. Indp. A., 1927. **Work:** Detroit Inst. Art; CMA. **Comments:** Position: teacher, Center Acad. Commercial Art, Cincinnati. **Sources:** WW40.

TRACY, Henry Prevost *[Illustrator] b.1888 / d.1919, Denver, CO.*
Addresses: NYC. **Comments:** Specialty: posters.

TRACY, Henry R. *[Painter] b.1833, Oxford, NY.*
Addresses: Boston, MA. **Studied:** Boston. **Exhibited:** AIC, 1902, 1904. **Sources:** WW06.

TRACY, John Martin (or J. W.) *[Animal painter] b.1844, Rochester, OH / d.1893, Ocean Springs, MS.* **J.M.Tracy**
Addresses: San Francisco, CA, 1870-72; St. Louis, MO, mid 1870s-81; Greenwich, CT, 1881-c.90. **Studied:** Oberlin College; Northwestern Univ.; École des Beaux-Arts, Paris, c.1867-69; on second trip to Paris, with Adolphe Yvon, I.A. Pils, Carolus-Duran, Paris, c.1873; San Francisco School of Des., c.1870. **Exhibited:** Paris Salon, 1876; NAD, 1880-91; Brooklyn AA, 1882-84; PAFA Ann., 1882. **Work:** Soc. of Calif. Pioneers. **Comments:** Best known for his paintings of trained gun dogs in the field, and for his paintings of thoroughbred horses. Although under-aged, he

served in the Civil War. He made two trips to study in Paris, then established himself as a portrait painter in St. Louis. After moving to Greenwich, CT, in 1881, he focused upon his hunting dog paintings. **Sources:** Hughes, *Artists in California,* 564; Fink, *American Art at the Nineteenth-Century Paris Salons,* 398; *300 Years of American Art,* vol. 1, 396; Falk, *Exh. Record Series.*

TRACY, (Lois) Bartlett (Mrs.) *[Painter, writer, teacher, lecturer]* b.1901, Jackson, MI.
Addresses: Englewood, FL. **Studied:** S. Parsons; J.J. Pfister; H. Leech; Ringling Sch. Art; E. Lawson; S. Woodward; Rollins College, 1929; with Hans Hofmann, 1945-1946; Michigan State Univ., M.A., 1958; New College Workshop, 1965, with Balcomb Greene, Afro, James Brooks, Marca-Relli & Sid Solomon.
Member: Gulf Coast Group; New Hampshire AA (pres.); PBC; Florida AA; Four Artists Soc., Palm Beach; Am. Assn. Univ. Prof.; Florida Artists Group; Sarasota Art Assn.; Galerie Inst. New York; Int. Fine Arts Gallery, Fort Meyers; NAWA (board member); Pen & Brush (board member); Assoc. Artists NC (board member). **Exhibited:** AFA, traveling exh., 1937, 1938, 1942-46; Nat. Exh. Am. Artists, NY, 1938; S. Indp. A., 1937, 1940-41; SSAL, 1935, 1936; Great Lakes Expo; State Library, Concord, NH, 1940; Studio Guild, 1936; Norlyst Gal., 1945; Florida Fed. Artists, 1933-35 (prizes); Sarasota AA, 1937 (prize), 1938 (prize); Clearwater Mus. Art, 1946 (prize); WFNY, 1939 (medal); Allied Arts, Winter Park, FL, 1929 (prize), 1930 (prize); Ringling Mus., 1931 (prize), 1938 (prize); Central Florida Expo, 1932 (prize); Florida State Bldg., Great Lakes Expo, 1936; Miami Women's Club, 1938 (prize). Many exhibitions, NAWA, 1940-1960; many Florida Artists Group Traveling Shows, 1940-1972; Assoc. Artists NC Traveling Shows, 1960-1963; Audubon Artists, New York; Southeastern Shows, Atlanta, GA; Dealers: Center Street Gallery, Winter Park, FL; Fine Arts Gallery, Fort Meyers, FL, 1970s. Awards: first award, Florida Artists Group, 1968; watercolor award, Southeastern Annual, High Mus. Art. **Work:** Air & Space Mus., Smithsonian Inst., Washington, DC; Norton Gallery Art, Palm Beach, FL; Univ. Virginia, Charlottesville; Univ. North Carolina, Chapel Hill; Southeastern College, Univ. Kentucky. **Comments:** Preferred media: acrylics, oils. Publications: author, "Painting Principles and Practices," 1965, 1967, 1969 & 1971; author, "The Art of Art." Teaching: instructor, Extension, Univ. Virginia, 1952-1959 & 1964-1965; head dept. art, Clinch Valley College, 1953-58; head dept. art, Southeastern College, Univ. Kentucky, 1964-1966; head dept. art, Edison Jr. College, Ft. Myers, FL, 1968-. **Sources:** WW73; "Cosmic Artist," *Yankee* (July, 1949).

TRACY, Margaret L. *[Painter]* b.1873.
Addresses: Plainfield, NJ. **Exhibited:** AIC, 1895. **Sources:** Falk, *AIC.*

TRACY, S. (or G.) *[Landscape painter]* mid 19th c.
Addresses: Chicago, IL. **Exhibited:** Chicago Art Union in the winter of 1859-60. **Comments:** Groce & Wallace speculated this could possibly be the Simon P. Tracy, Senior 2d Lieutenant of Battery 2, 2d Illinois Light Artillery, who died in service on September 9, 1863. **Sources:** G&W; Andreas, *History of Chicago,* II, 276-7, 556-7; repro., *Chicago History* (Spring 1951), 323.

TRADER, Effie Corwin *[Painter, miniaturist]* b.1874, Xenia, OH.
Addresses: Cincinnati, OH. **Studied:** Duveneck; Cincinnati Art Acad.; L.T. Dubé, in Paris. **Member:** Cincinnati Women's AC; Cincinnati MacD. Club; Nat. Lg. Am. Pen Women; Aenn. Soc. Min. Painters. **Exhibited:** AIC, 1902, 1907, 1916; PAFA Ann., 1903. **Comments:** Painted large oil portraits and miniatures on ivory. **Sources:** WW40; Falk, *Exh. Record Series.*

TRAHER, William Henry *[Painter, lecturer, illustrator, designer, printmaker, lithographer, block printer]* b.1908, Rock Springs, WY / d.1984, Denver, CO.
Addresses: Denver, CO. **Studied:** NAD, 1930-1933; Yale Univ., School Fine Art, 1938-1939; L. Kroll; A. Covey; C.S. Chapman.

Member: Denver Art Mus. (board of trustees, 1950-1953); Denver Artists' Guild (pres., 1950-52; honorary life member); Int. Platform Assn. **Exhibited:** AIC, 1936 (Fifth Int. Exhib. Lithography & Wood Engraving); Nat. Exh. Am., NYC, 1936; MOMA,1936 (New Horizons in American Art); Rocky Mtn. PM, 1936 (prize); Municipal Art Committee, New York, 1937 (Second Nat. Exhib. Am. Art); BAID, 1938 (prize, second nat. exhib.); 48 States Competition, 1939; Denver Art Mus.,1935 (solo) 1936, 1962 (Surrealism, exhib. from MOMA); Art Directors Club, New York, 1950 (Fine Art in Advertising); Sixth Southwest Int. Exhib., 1955 (medal for originality). Awards: Purchase prize, Penny Art Fund, Colorado Federation Woman's Clubs, 1936. **Work:** Iowa State Univ.; Denver Art Mus.; Colorado State Hist. Soc.; Rocky Mtn. Nat. Park; Diorama backgrounds, Denver Mus. Natural Hist. Commissions: Cole Jr. High, Denver, CO, 1935 & De Witt (AK) Post Office, 1941, US Treas Dept.; cloud recognition mural, Williams Air Force Field, AZ, 1943; wilderness murals, Columbia Savings & Loan, Pueblo, CO, 1968; four landscape murals, Saint Louis Arch, Nat. Park Service, 1970; plus twenty-two dioramas. **Comments:** Preferred media: acrylics. Positions: art director, Philip H. Gray Advertising Agency, 1945-1947; artists & researcher, Jeppesen Map Co., Denver, 1952-1953; technical illustrator, Lowry Air Force Base, Denver, 1953-1954; chief artist, Denver Mus. Natural Hist., 1954-. Illustrator: "Stars & Men," Bobbs, New York & Arnolds, London, 1939; "Wyoming Design, Series," Container Corp., 1949; "Index of American Design," Christensen, 1954; US Golf Assn. Annual, 1960. Author: "The Artist Cornered," *Photog. Soc. Am. Journal,* 1965. **Sources:** WW73; D. Bear, "Some Younger Artists of Colorado," *Parnassus* (Apr, 1937); J. Devran, "Studio in a Cigarette Case," *Rocky Mountain Life* (Jan, 1948).

TRAHERN, William Edward *[Portrait and landscape painter]* mid 19th c.; b.Jackson, MI.
Addresses: Richmond, VA; Norfolk, VA, 1866. **Studied:** Univ. of Tennessee. **Work:** Virginia Hist. Soc. **Sources:** Wright, *Artists in Virgina Before 1900.*

TRAIN, Anne See: **TRUMBULL, Anne Leavenworth (Mrs. Wm.)**

TRAIN, Charles Russell *[Nautical and landscape painter]* b.1879, Annapolis, MD / d.1968, Wash., DC.
Addresses: Wash., DC. **Studied:** self-taught. **Exhibited:** local galleries; Soc. of Wash. Artists. **Comments:** A naval career officer, he rose to rear admiral before his retirement. He started painting aboard ships. **Sources:** McMahan, *Artists of Washington, DC.*

TRAIN, Daniel N. *[Ship carver]* 18th/19th c.
Addresses: NYC from 1799-c.1811. **Studied:** Pupil of William Rush. **Comments:** Is known to have done the carving for the war ships *Adams* and *Trumbull* in 1799. **Sources:** G&W; Marceau, *William Rush,* 14; Pinckney, *American Figurehead Carvers,* 80, 202; NYCD 1799-1811.

TRAIN, H. Scott *[Illustrator]* mid 20th c.
Addresses: Astoria, NY. **Studied:** SI. **Sources:** WW40.

TRAJAN, Turku *[Sculptor]* b.1887, Gyulafehérvár, Austria-Hungary / d.1959, NYC.
Addresses: NYC, 1908. **Studied:** AIC with Albin Polasek; at Beaux-Arts Inst. Design with John Gregory and Elie Nadelman; ASL. **Member:** Sculptors Gld. (vice-pres.). **Exhibited:** Salons of Am., 1925-27, 1929-32; AIC, 1930; MoMA, Wash., DC, 1938; Sculptors Gld., NYC, 1938-40; Valentine Gal., NYC, 1944 (solo); WMAA; Albert Landary Gal., NY, 1960 (retrospective). **Comments:** Trajan's work distinguishes itself in several ways: Keen's cement is the primary material used; works appear unfinished; letters and words have been incorporated into the surface. **Sources:** WW40; Fort, *The Figure in American Sculpture,* 228 (w/repro.).

TRAKAS, George *[Sculptor]* b.1944.
Addresses: NYC. **Exhibited:** WMAA, 1973, 1979. **Sources:** Falk, *WMAA.*

TRAMBEL, Boris [Painter] mid 20th c.
Addresses: Pelham Bay Park, NY. **Exhibited:** S. Indp. A., 1939-44. **Sources:** Marlor, Soc. Indp. Artists.

TRAMUTOLOA, Barbara Adrian See: **ADRIAN, Barbara (Mrs Franklin Tramutola)**

TRANE, Susan Miller [Educator] b.1881, La Crosse, WI.
Addresses: La Crosse, WI. **Studied:** AIC (B.A.E.); Univ. Chicago (Ph.B., M.A.). **Comments:** Position: supv. art, Columbus, Ind., 1920-22; hd. dept. art, Ball State T. Col., Muncie, Ind., 1922-48 (retired). **Sources:** WW53.

TRANK, Lynn [Painter] mid 20th c.
Exhibited: AIC, 1946. **Sources:** Falk, AIC.

TRANKLA, Mary [Painter] mid 20th c.
Addresses: Chicago area. **Exhibited:** AIC, 1933. **Sources:** Falk, AIC.

TRANO, Clarence E. [Painter, printmaker] b.1895, Minneapolis, MN / d.1958, Whittier, CA.
Addresses: California. **Studied:** Charlie Russell. **Member:** Calif. SE. **Sources:** Hughes, Artists in California, 564.

TRANQUILLITSKY, Vasily Georgievich [Painter, designer, teacher] b.1888, Russia / d.1951, Napa, CA.
Addresses: San Francisco, CA. **Studied:** Imperial Russian Sch. A., Kiev; Krizitski, Russia. **Member:** Northwest FAS. **Exhibited:** SAM; Fed. A. Gal., San Fran.; murals, Calif. Bldg., GGE, 1939. **Work:** murals, Merchants Exchange, Seattle. **Sources:** WW40.

TRANSLOT, Eugene (Mrs.) See: **STEVENS, Amelia**

TRANTHAM, H(arrell) E. [Painter] b.1900, Abilene, TX.
Addresses: Abilene, TX. **Member:** Texas FAA; SSAL; Bd.Dir., Abilene MFA, 1945-46. **Exhibited:** Int. Print Exh., 1943; Kansas City AI; Texas General Exh.,1940-1946; Texas FA Assn., 1940-1946; SSAL, 1940-1946; Ft. Worth Pub. Gal.,1940 (prize), 1942 (prize), 1945 (prize). **Work:** Ft. Worth Pub. A. Gal. **Comments:** Position: bd. dir., Texas FA Assn., 1945-46; Abilene (Tex,) Mus.A., 1945-46. **Sources:** WW53; WW47.

TRANTHAM, Ruth N. (Mrs. Harrell E.) [Painter] b.1903, Caps, TX.
Addresses: Abilene, TX. **Member:** SSAL; Texas FA Assn.; Abilene Creative AC. **Exhibited:** Texas General Exh., 1943-1945; regularly in Texas local & regional exh; Ft. Worth, Tex., 1944 (prize); Abilene, Tex., 1945 (prize); Fed. C., San Antonio, Tex., 1946 (prize). **Comments:** Married to Harrell E. Trantham (see entry). **Sources:** WW53; WW47.

TRANUM, Honor (Mrs.Carl K.) See: **SPINGARN, Honor (Mrs. Carl K. Tranum)**

TRAPHAGEN, Ethel (Mrs. William R. Leigh) [Designer, teacher, illustrator, writer, lecturer] b.1882, NYC / d.1963.
Addresses: NYC. **Studied:** CUA Sch.; NAD; ASL; NY Sch. Fine & Applied Art; Paris. **Member:** Am. Woman's Assn.; Nat. All. Art & Indust. **Exhibited:** Awards: prize, The New York Times Comp., 1913 (prize); CUA Sch. (med.); Merité Libanaise, Lebanese Govt., 1941. **Comments:** Women's clothing designer. Founder (with her husband, painter William R. Leigh), dir., Traphagen Sch. Fashion, NYC. Extensive collection of regional costumes and library of 16,000 vols. Teaching: CUA Sch.; Brooklyn Teachers Assn.; NY Univ.; etc. Pub. & ed.: Fashion Digest magazine. Auth.: Costume Design and Illustration, 1918; Fashion Work as a Career Book of Knowledge Annual, 1942. Contrib.: Professional Arts Quarterly, North American Review, & other publications. **Sources:** WW59; WW47.

TRAPHAGEN, Neilson [Painter] early 20th c.
Addresses: Brooklyn, NY. **Sources:** WW24.

TRAPIER, Pierre (Pinckney) (Alston) [Painter, graphic artist, illustrator, writer] b.1897, Wash., DC / d.1957, Wash., DC.
Addresses: Wash., DC. **Studied:** George Washington Univ.; Mahoney Sch. A., Wash. DC; Corcoran Sch. A.; Académie Julian, Paris. **Exhibited:** Salons of Am., 1934; Rockefeller Center, N.Y.; CGA, 1937 (solo); AFA; Santa Barbara Mus. A.; Charleston, S.C.; & abroad; Burr Gal, NYC, 1958. **Comments:** Contributor of articles on history of art to newspapers. Executed series of paintings of great cities of the U.S. & Europe. **Sources:** WW53; WW47.

TRAPP, August [Lithographer] b.c.1840, Germany.
Addresses: NYC in 1860. **Sources:** G&W; 8 Census (1860), N.Y., XLII, 692.

TRAQUAIR, James [Stonecutter and portrait sculptor] b.1756 / d.1811, Philadelphia, PA.
Addresses: Philadelphia from c.1802-11. **Sources:** G&W; Scharf and Westcott, History of Philadelphia, II, 1066.

TRASHER, Harry D. [Sculptor] early 20th c.
Addresses: NYC. **Studied:** Am. Acad., Rome, 1911-14. **Sources:** WW15.

TRASK, John E. D. [Painter, teacher] b.1871, Brooklyn, NY / d.1926, Philadelphia, PA.
Member: Phila. AC; T-Square C.; Sesquil Centenn Expo (dir. FA), PAFA (dir.); U.S. Comm. General, Intl. FA Expos in Buenos Aires (Argentina), Santiago (Chile), both in 1910; P.-P. Expo, San Fran., 1915 (dir.). **Sources:** WW21.

TRASK, Mary Chumer (Mrs. G.G.) [Painter] early 20th c.
Addresses: NYC/Newburgh, NY. **Exhibited:** AIC, 1910-11, 1913; S. Indp. A., 1917-19, 1925-29, 1931. **Sources:** WW15.

TRASK, Spencer [Patron] b.1844 / d.1909.
Addresses: NYC/Saratoga Springs, NY. **Comments:** In 1900, he and his wife, Katrina, founded the artists' colony, "Yaddo," in Saratoga Springs. Similar to the MacDowell Colony in NH, Yaddo's mission continues to provide artists with uninterupted time to think, work, and create within a supportive community. Trask built the world's first electric power company, Consolidated Edison; and was founder and chairman of The New York Times. Since 1900, more than 5,500 creative artists have benefited from Yaddo, including Milton Avery (see entry) and composer Aaron Copeland. Together, Yaddo artists have won 50 Pulitzer Prizes and 46 National Book Awards. **Sources:** PHF files.

TRASK, Stella Gertrude [Landscape painter] b.1869, Portland, ME / d.1940, Oakland, CA.
Addresses: Oakland, CA, since 1878. **Studied:** Mark Hopkins Inst.; with Latimer, Judson, Best. **Exhibited:** Golden Gate Park Mus., 1916; San Francisco AA, 1903, 1917. **Sources:** Hughes, Artists in California, 564.

TRAUBEL, M(artin or Morris) H. [Lithographer] b.1820, Frankfurt-am-Main (Germany) / d.1897, Phila. (suicide).
Addresses: Philadelphia, c.1850. **Studied:** in Germany. **Comments:** Established the firm of Traubel, Schnabel & Finkeldey (see entry). From 1853 to 1869 he headed the firm of M.H. Traubel & Co. He committed suicide in 1897. **Sources:** G&W; Peters, America on Stone [as Morris]; 7 Census (1850), Pa., L, 227 [as Martin, aged 25]; Phila. CD 1854+.

TRAUERMAN, Margy Ann [Painter, instructor] 20th c.; b.Sioux Falls, Dak.
Addresses: New York, NY. **Studied:** Iowa State Univ, BFA; Am Acad Art; ASL New York, with Jacob Getlar Smith. **Member:** Soc Painters & Sculptors NJ; Am Watercolor Soc. **Exhibited:** Am Watercolor Soc Ann, 1953-1968; Pa Acad Fine Arts Ann, 1953 & 1961; NY Figurative Painting, New York & traveling exhib, 1971; solo shows, Chatham Col, Pittsburgh, Pa, 1961, Patrons of Art, McAllen, Tex, 1971 & 1st Gallery, 1972. **Awards:** Hon mention, Knickerbocker Artists Ann, 1957; award, 1967 & medal, 1968, Painters & Sculptors Soc NJ. **Comments:** Preferred media: watercolors. **Dealer:** 1st St Gallery, New York, NY. **Teaching:** Instr art, Art & Design HS, New York, 1952- **Sources:** WW73; David Loeffler Smith, "Celebrated Women Artists" (Jan, 1962) & "Heritage of the Thirties" (Oct, 1962), both in Am Artist.

TRAUTSCHOLD, Manfred [Artist] late 19th c.
Addresses: Montclair, NJ, 1890. **Exhibited:** NAD, 1890. **Sources:** Naylor, NAD.

TRAUTWINE, John Cresson *[Architect] b.1810 / d.1883.*
Addresses: Philadelphia. **Exhibited:** Artists' Fund Society (1844: designs for a monument and a fountain). **Sources:** G&W; Rutledge, PA; Phila. CD 1844.

TRAVANTY, Leon E. *[Painter] mid 20th c.*
Addresses: Chicago, IL; Milwaukee, WI, 1962. **Exhibited:** PAFA Ann., 1960, 1962. **Sources:** Falk, *Exh. Record Series.*

TRAVARELLI, Andy *[Painter] b.1942.*
Addresses: Boston, MA. **Exhibited:** WMAA, 1973. **Sources:** Falk, *WMAA.*

TRAVATO, J. Salvatore *mid 20th c.*
Exhibited: Salons of Am., 1931. **Sources:** Marlor, *Salons of Am.*

TRAVER, C(harles) Warde *[Painter, writer, lecturer, teacher] b.1880, Ann Arbor, MI.*
Addresses: NYC/Wuanita Hot Springs, CO. **Studied:** Royal Acad., Munich, with Von Marr; Millet; Snell. **Exhibited:** S. Indp. A., 1917. **Comments:** 1889 is also given for his birthdate. **Sources:** WW27.

TRAVER, Geo(rge) A.
[Painter] b.1864, Corning, NY / d.1928, NYC. *Geo. A. Traver.*
Addresses: NYC, 1900. **Studied:** Weir; T. Dewing; H.S. Mowbray. **Member:** SC. **Exhibited:** AWCS, 1898; NAD, 1900; Salons of Am., 1925; Milwaukee AI, 1928; Art. Ctr., NYC. **Work:** BM. **Sources:** WW27.

TRAVER, Marion Gray *[Painter] b.1892, Elmhurst, LI, NY.*
Addresses: New York 19, NY. *Marion Gray Traver*
Studied: with her father, G.A. Traver. **Member:** All. Artists Am.; NAWA; PBC; Catherine Lorillard Wolfe AC; Three Arts Club. **Exhibited:** S. Indp. A., 1920, 1931; Wolfe AC, 1926 (prize), 1927 (prize),1928 (prize), 1944 (prize); Exp. Women's Art & Indst., 1928 (medal); NAD, 1930, 1931 (prize), 1932, 1935, 1936; Corcoran Gal biennial, 1932; NAWA, 1925-46 (prizes,1930, 1934, 1938-41); All. Artists Am., 1929-46 (prizes,1931, 1942); Int. AC, London, 1931; Salons of Am., 1931, 1934; BM; Montclair AM; Milwaukee AI; Dayton AI; Grand Rapids AM; WFNY 1939; AFA traveling exh.; Staten Island Inst. Arts & Sciences; Columbia Univ.; Union Lg. Club, NY; Argent Gal. Other awards: prizes, War Workers Jury prize, 1943; Hoffman prize, 1945. **Comments:** An Impressionist painter known for her New England landscapes and winter scenes. She also produced some painterly monotypes and shared a studio in NYC with her father until his death. **Sources:** WW59; WW47; Petteys, *Dictionary of Women Artists,* cites alternate birth date of 1896.

TRAVERS, David *[Editor] mid 20th c.*
Addresses: Los Angeles, CA. **Comments:** Position: editor, *California Arts & Architecture.* **Sources:** WW66.

TRAVERS, Gwyneth Mabel *[Graphic, artist] b.1911, Kingston, Ontario.*
Addresses: Kingston, Ontario, Canada. **Studied:** Queen's Univ. (B.A., 1933); Queen's Summer Sch.; also with Andre Bider, Ralph Allen & George Swinton. **Exhibited:** Can. Painter-Etchers & Engravers, Toronto, Ont., 1957-70; Winnipeg, Show, Man., 1958-60; Nat. Gal. Can. Biennial, Ottawa, 1958-71; Agnes Etherington Art Centre, Queen's Univ., Kingston, 1960-69 & solo show woodblock prints, 1972; Brockville IODE Invitational, 1969 & 1971. Awards: Reid award, Can. Painter-Etchers & Engravers, 1958; Dept. Educ., PQ, 1963 & first prize in graphics, 1965, Expos Provincial. **Work:** Acadia Univ., Wolfsville, NS; Nat. Gal. Can., Ottawa; Queen's Univ., Kingston; Montreal Mus. Fine Arts, PQ; Winnipeg Art Gal., Man. **Sources:** WW73.

TRAVERS, W. T.R. *[Painter] late 19th c.*
Exhibited: PAFA Ann., 1878 ("Portrait of Abraham Lincoln"). **Sources:** Falk, *Exh. Record Series.*

TRAVERSI, Gemma B. *[Painter] b.1902, Switzerland / d.1968, San Francisco, CA.*
Addresses: San Francisco, CA. **Member:** Marin Soc. of Artists. **Sources:** Hughes, *Artists in California,* 564.

TRAVIS, Diane *[Painter] b.1892, NYC.*
Addresses: Houston, TX; New Orleans, LA, 1932; Tulsa, OK, 1933. **Studied:** H. Giles; A. Stillman; ASL. **Member:** SSAL; Oklahoma Northwest AA; NOAA. **Exhibited:** Salons of Am., 1926; Oklahoma Northwest AA, 1931 (prize); PAFA Ann., 1932-33; Dallas Fair, 1935 (prize); S. Indp. A., 1936. **Sources:** WW40; Falk, *Exh. Record Series.*

TRAVIS, Emily L. *[Painter] b.1872, California / d.1915, San Francisco, CA.*
Addresses: San Francisco, CA. **Studied:** G. Piazzoni. **Exhibited:** Washington State Arts and Crafts, Seattle, 1908; San Francisco AA, 1911; Del Monte Art Gallery, Carmel, 1914; Golden Gate Park Mem. Mus., 1916. **Sources:** Hughes, *Artists in California,* 564.

TRAVIS, Kathryne Hail *[Painter, teacher] b.1894, Ozark, AR / d.1972.*
Addresses: Beverly Hills, CA; Ruidoso, NM; Dallas, TX. **Studied:** Galloway College, AIC; Cincinnati Acad. FA; Ohio Mechanics Inst.; Chicago Acad. FA; with George Bellows, Randall Davey and Robert Henri. **Member:** Kathryne Hail Travis Art Club, Dallas (hon.); AAPL; SSAL; Highland Park SA; Dallas MFA. **Exhibited:** DMFA, Parkland Hospital, Jr. H.S., Highland Park, all in Dallas; H.S., Bonham, TX; Los Angeles (solo); Seattle, WA; Arkansas; Oklahoma; Texas State Fair. **Comments:** Position: co-founder with her husband, Olin, Dallas Art Inst., 1926; dir./founder, Gallery of Art & School of Painting, Ruidoso, NM. **Sources:** WW66; WW40; Trenton, ed. *Independent Spirits,* 184, 201-02.

TRAVIS, Olin (Herman) *[Painter, lecturer, lithographer, illustrator, etcher] b.1888, Dallas, TX / d.1976.*
Addresses: Dallas, TX in 1976. **Studied:** AIC, 1904-14 with Kenyon Cox; with R. Jerome Hill in Dallas; Clarkson; Norton; Walcott; Sorolla; C.F. Browne. **Member:** Chicago SA; Texas FAA; Highland Park AA; SSAL; San Antonio AI (director); Dallas AI (founder; director, 1926-44); Lone Star Printmakers. **Exhibited:** AIC, 1920, 1922; Rockefeller Center; GGE, 1939; Texas Centennial; solo exhibits: Chicago, San Antonio, Denver, Dallas; SSAL, 1930 (prize), 1932 (prize); San Francisco Nat., CA; plus many other group & solo shows including New York, NY, Saint Louis, MO, Milwaukee, WI, Houston, Dallas & Abilene, Texas & Oklahoma Univ. Awards: gold medal for portraiture, Art Inst. Chicago School; first landscape award, Southern States Art League, Memphis, TN; plus many others. **Work:** Texas Fine Arts Mus., Austin; Highland Park AM.; Dallas MFA; Elisabet Ney Mus. Commissions: Eutra, East Texas Room, Hall of State, Dallas; Love Field Airport, TX; habitat backgrounds for Dallas Mus. Natural History & Corpus Christi Mus., TX. **Comments:** Married Kathryn Hail, a former student and established a joint studio in Chicago. They returned to Dallas in 1926 when they founded the Dallas AI. In 1927 they founded a summer art colony in the Ozarks in Cass, AR. In the 1930s he painted Colorado landscapes. Preferred media: oils. Positions: director, Dallas Art Assn., eight yrs. Teaching: teacher, AIC; Chicago Commercial Art School, until c.1913; instructor of art, San Antonio Art Inst., TX; instructor of art, Austin College, Sherman, TX. **Sources:** WW73; WW47; P & H Samuels, 489.

TRAVIS, Paul Bough *[Painter, etcher, lithographer, teacher, lecturer] b.1891, Wellsville, OH / d.1975, Cleveland Heights, OH.*
Addresses: Cleveland, OH; Cleveland Heights, OH. **Studied:** Cleveland Sch. A.; H.G. Keller. **Member:** Am. Soc. for Aesthetics; Cleveland Soc. for Aesthetics (Pres., 1946); Cleveland MoMA; Archaeological Inst. Am. (treas., 1950-56). **Exhibited:** CMA, 1920-1958 (prizes,1921, 1930-31, 1938-40, 1952, 1955-58); PAFA Ann., 1930, 1932, 1934; BM, 1931, 1935; MoMA; AIC, 1931, 1932, 1938; GGE, 1939; CI, 1931, 1932; Corcoran Gal

biennials, 1930, 1932; Pasadena AI, 1946; Butler AI, 1936-1958 (prize, 1940); Ohio WC Soc., 1955 (prize), 1956 (prize). Cleveland AA, prizes in 1921-22, 1925, 1928-31, 1934, 1936. **Work:** CMA; Rochester Mem. A. Gal.; Springfield (Mass.) Mus. A.; Butler AI; Ohio WCS; BM; Cleveland Mus. Natural Hist.; Univ. Utah; NYPL; Akron AI. **Comments:** Teaching: Western Reserve Univ., Cleveland, 1956-on. **Sources:** WW59.

TRAVIS, Stuart *[Decorator, craftsperson, illustrator, teacher]* b.1868 / d.1942.
Addresses: Andover, MA. **Comments:** Position: T., Phillips Acad., Andover, 12 yrs.

TRAVIS, William D.T. *[Religious painter, illustrator, civil war combat artist]* b.1839 / d.1916, Burlington, NJ.
Addresses: Burlington, NJ. **Comments:** A Civil War artist, he made a series of 35 views of the Army of the Cumberland. Also painted religious subjects. **Sources:** G&W; *Art Annual*, XIII, obit.

TRAYLOR, Bill *[Folk painter]* b.1854, Benton, AL / d.1947, Montgomery, AL.
Exhibited: R.H. Oosterom Gal., NYC, 1980 (solo); Corcoran Gal., 1982 ("Black Folk Art in America"); Warren Wilson College, NC, 1984 (solo); Randolph Street Library, Chcago, 1988 (solo); Hirschl & Adler Gal., NYC, 1986-97 (four solos). **Comments:** Born a slave on the George Traylor plantation near Benton, AL, it was not until 1938 that he moved to Montgomery, AL. Here, he slept in the back room of a funeral parlor, and began drawing whimsical images of people, dogs, mules, horses, and birds on cardboard and found paper. His drawings were made between 1939-42, and his favorite color was a bright blue. In 1942, he moved to Detroit, living with one of his twenty children, but returned to Montgomery in 1946. **Sources:** Cederholm, *Afro-American Artists*; exh. review, *New York Times* (Feb., 1997); auction cat., "Bill Traylor Drawings from the Collection of Joe and Pat Wilkinson" (Sotheby's, NYC, Dec. 3, 1997).

TREACY, Rachel *[Painter]* b.1904, Vallejo, CA / d.1984, Los Altos, CA.
Addresses: Los Altos, CA. **Studied:** San Diego State College; Calif. School of FA. **Member:** San Francisco Soc. of Women Artists. **Exhibited:** SFMA; de Young Mus. **Sources:** Hughes, *Artists in California*, 564.

TREADWAY, Martha (Chamberlin) *[Painter]* b.1918, Davidson, CT.
Addresses: Boston, MA. **Studied:** Child-Walker Sch.FA, Boston, 1935-37; with John F. Folinsbee; with John Chetcuti, George Demetrios; BMFA Sch. **Member:** Rockport AA. **Sources:** *Artists of the Rockport Art Association* (1956).

TREADWELL, Grace A(nsley) (Mrs. Abbot) *[Painter, lecturer]* b.1893, Martha's Vineyard Island, MA.
Addresses: Trumbull, CT. **Studied:** Boston Mus. School, four years; ASL, one year; Acad. Grande Chaumière, Paris, France, one year. **Member:** NAWA (pres., 1946-49; chmn. watercolor jury, 1951; board member, 10 years); Pen & Brush Club (chmn. watercolor jury, 1953). **Exhibited:** NAWA, 20 years; Mus. & Galleries USA Traveling Exhib.; BM; Allied Artists, New York; Mississippi AA (awards); High MA; PBC, many awards, 1946 (prize); NAC, New York. Other awards: United Hospital, New York. **Work:** Albright-Knox Gallery, Buffalo, NY; Govt. Offices, Hartford, CT; St. Mark's Church, NYC; First Prebyterian Church, NY; Father Flannigan's Boys Home, NE; Grace Church, Trumbull, CT. Commissions: Last Supper, Episcopal Minister, Smithport, PA; Madonna for St. George's Church, Mrs. Henry Hill Pierce, New York; Nativity, dedicated to Mr. Bird S. Coler, Bird S. Coler Hospital, New York; St. Joseph's Manor, Mother Bernadette de Lourdes (Carmelite Order), Trumbull. **Comments:** Preferred media: oils, watercolors. Teaching: lecturer, watercolor for young children, St. George's Church, 1949; lecturer, watercolor for young children, Bird S. Coler Hospital, 1962-66; lecturer, oil for adults, St, Joseph's Manor, 1966-72. Art interests: teaching art to young children with special attention to retarded & cerebral palsy children. **Sources:** WW73; WW47.

TREADWELL, Helen *[Painter, designer, mural painter]* b.1902, Chihuahua, Mexico.
Addresses: NYC. **Studied:** Vassar Col.; Sorbonne, Paris, France. **Member:** NSMP (pres., 1963-68); Arch. League (first v. pres, 1952-54, 1964-66, mem. exec. comt.); US Comm. Int. Assn. Art (treas.); Fine Arts Fedn. New York (v. pres.); AEA. **Exhibited:** Arthur Newton Gal., 1934; Arch. Lg., 1946; Arthur Newton Gal. (solo); Rockefeller Ctr. (solo); Archit. League (solo); Crespi Gal. & Contemp. Gal., 1934-65 (solo). Awards: spec. award for mural paintings in Munic. Bldgs., Chile, 1936; pres. medal for extraordinary serv. in promotion of relationship between archit. & fine arts of mural painting & sculpture, Archit. League,1969. **Work:** commissions: many murals in hotels & clubs in US, Waldorf-Astoria, New Yorker, Beekman, Delmonico, Astor, all in NYC; Belvue-Stratford, Phila.; Hotel Utah, Salt Lake City, Utah; Hotel Bermudiana, Hamilton, Bermuda, Hotel O'Higgins, Chile, Chase Manhattan Bank, San Juan PR, Marine Midland, NY & others; five mosaic murals, New York Pub. Sch. Syst.; many others in ships, trains & pvt. homes; mosaic panels, Church of the WORD Lutheran, Rochester, NY. **Sources:** WW73; WW47.

TREADWELL, Jona *[Portrait painter]* mid 19th c.
Addresses: Readfield, ME in 1840, active in New England (probably Maine) at least until 1851. **Sources:** G&W; Lipman and Winchester, 181; WPA (Mass.), *Portraits Found in Maine*, 223-24.

TREADWELL, S. Lydia (Miss) *[Etcher]* mid 20th c.
Addresses: St. Paul, MN. **Exhibited:** S. Indp. A., 1918-19, 1924. **Sources:** WW19.

TREAGA, Genoza *[Listed as "figure-maker" sculptor]* b.c.1814, Italy.
Addresses: Philadelphia, PA. **Comments:** Living in 1850 with his brother, Santonio Treaga, (see entry) and four other figure makers — Louis Jamacie and the three Lagurane brothers (John, Peter, and Santonio)(see entries). **Sources:** G&W; 7 Census (1850), Pa., L, 859.

TREAGA, Santonio *[Listed as "figure maker" sculptor]* b.c.1810, Italy.
Addresses: Philadelphia. **Comments:** Living in Philadelphia in 1850 with his brother, Genoza Treaga, (see entry) and four other figure makers — Louis Jamacie and the three Lagurane brothers (John, Peter, and Santonio)(see entries). It appears that Santonio Treaga employed all of them. **Sources:** G&W; 7 Census (1850), Pa., L, 859.

TREANOR, Aline Jean *[Critic, writer]* b.1895, Worthington, IN.
Addresses: Oklahoma City, OK. **Studied:** Indiana Univ. (A.B.); Grad. study, Northwestern Univ. **Member:** Phi Beta Kappa, Indiana Univ.; Theta Sigma Phi, Oklahoma Chapter. **Comments:** Positions: critic, *Palm Beach News*, 1945-46; critic and Sunday art section editor, *Toledo Blade*, 1946-53; Critic, *Daily & Sunday Oklahoman*, 1954-62; Art editor, *Oklahoma City Advertiser*, 1963- **Sources:** WW66.

TREASE, Sherman *[Landscape painter, etcher, illustrator, photographer]* b.1889, Galena, KS / d.1941, San Diego, CA.
Addresses: San Diego, CA (since late 1920s). **Studied:** Sch. Appl. Art, Battle Creek, Mich.; with A.H. Knott. **Member:** FAS, San Diego; San Diego AG; Spanish Village A. Ctr., San Diego (Pres.). **Exhibited:** Joplin (Mo.) AL, 1921 (prize); Calif.-Pacific Int'l Expo, San Diego, 1935. **Work:** San Diego Mus.; Joplin Art League. **Comments:** Illustrator: "Square Riggers Before the Wind," 1939. **Sources:** WW40; Hughes, *Artists in California*, 565.

TREASTER, Richard A *[Painter, instructor]* b.1932, Lorain, OH.
Addresses: Lakewood, OH. **Studied:** Cleveland Inst. Art (B.F.A.). **Member:** Am Watercolor Soc. **Exhibited:** 200 Yrs. Am. Watercolor, MMA, 1966; View of Contemp. Am. Watercolor, Cleveland Inst. Art, 1968; Mainstream Int., 1968-72; Watercolor USA, 1972; Cleveland May Show, 1972. Awards: Mainstreams Award of Excellence, Marietta Col., 1969; Emily Goldsmith

Award, AWCS, 1969; Ohio Fine Arts Coun. honorarium, 1971. **Work:** Butler Inst. Am. Art, Youngstown, Ohio; Canton Art Inst., Ohio; Miami Univ., Oxford, Ohio; Lehigh Univ., Bethlehem, Pa.; NAD. **Comments:** Preferred media: watercolor, tempera. Dealer: AB Closson Jr Co, Cincinnati, OH. Teaching: Instr painting, Cooper Sch Art, Cleveland, 1966-1967; instr painting, Cleveland Inst Art, 1966- **Sources:** WW73; Ralph Fabri, "Medal of Merit," *Today's Art* (Aug, 1966); Norman Kent, "Richard Treaster — American Artist," *Am Artist* (Jan, 1972).

TREAT, Albert *[Landscape painter]* b.1850, Reading, PA / d.1884, Reading, PA.
Addresses: Reading, PA. **Comments:** The son of a coachmaker, he attended public schools where he developed his artistic talent. In his father's business he became a "grainer" and continued landscape painting in his spare time. **Sources:** Malmberg, *Artists of Berks County,* 39.

TREAT, Alice E. *[Painter]* early 20th c.
Addresses: Minneapolis, MN. **Sources:** WW13.

TREAT, Eleanor (Nellie) Louise *[Landscape and portrait painter]* b.1861, Sacramento, CA / d.1943, San Francisco, CA.
Addresses: San Francisco, CA. **Studied:** San Francisco School of Des., with Virgil Williams. **Member:** Women's Sketch Club (co-founder). **Exhibited:** Sketch Club, 1890s; San Francisco AA annuals, 1885-1923; Calif. Industr. Expo, San Diego, 1926.
Sources: Hughes, *Artists in California,* 565.

TREBILCOCK, Paul *[Painter]* b.1902, Chicago, IL.
Addresses: Chicago, IL; NYC, from 1937. **Studied:** Univ IL; AIC; & also study in Europe; Seyffert. **Member:** NAD; Century Assn; Chelsea Arts Club, London, Eng.; Cliff Dwellers; Chicago AC. **Exhibited:** ASL-Chicago, 1923 (prizes); AIC, 1925 (prize), 1926 (William Randolph Hearts prize), 1928 (Logan Medal & first prize), 1929 (gold), 1934 (prize); Chicago Gal. Assn., 1926 (med); Corcoran Gal biennials, 1926-32 (3 times); PAFA Ann., 1927-32, 1937, 1941; NAD, 1931 (first Hallgarten prize); Newport AA, 1931 (med); Portraits, Inc., 1970s. **Work:** AIC; Albright A. Gal.; Cranbrook Mus; Cincinnati Mus; US Embassy, London, Eng; plus many univs & cols. Commissions: portraits; Univ. Ill.; Univ. Chicago; Northwestern Univ.; Johns Hopkins Univ.; Columbia; Univ. Rochester; The Waldorf-Astoria, NYC; Joselyn Mem., Omaha, Nebr. Many portraits of prominent persons. **Comments:** Preferred Media: oils. Contributor: *American Artist.* **Sources:** WW73; Ernest Watson, "Paul Trebilcock," *Am Artist Mag* (Dec, 1944); "Paul Trebilcock, Portrait Painter," In: *Twenty Painters and How They Work* (Watson-Guptill, 1950); WW47; Falk, *Exh. Record Series.*

TREBILCOOK, Amaylia See: **CASTALDO, Amaylia (Mrs. Trebilcock)**

TREDENNICK, Ernestine *[Painter]* mid 20th c.
Exhibited: Kingsley AC, Sacramento, 1936-38. **Comments:** Specialty: watercolor. **Sources:** Hughes, *Artists in California,* 565.

TREES, Clyde C. b.1885, Center, IN / d.1960, White Plains, NY.
Addresses: NYC (1919-on). **Member:** A. Fellowship; Subscriber memb., NAD; life memb., Treas. & Memb. Council, NSS; Arch. Lg.; SC; Municipal A. Soc. **Exhibited:** Awards: Medal of Honor, NSS, 1958. **Comments:** Positions: Pres., Medallic Art Co., N.Y.; Treas., NSS; Memb., Finance Com., A. Fellowship; Member, Commission of Fine Arts of the City of New York, 1959-.
Sources: WW59.

TREFETHEN, Jessie Bryan *[Painter, educator, etcher, lecturer]* b.1882, Peaks Island, Portland, ME / d.1978, Portland, ME.
Addresses: Oberlin, OH; Portland, ME. **Studied:** Mt. Holyoke College, B.A.; PAFA; in Europe; & with Emil Carlsen, Daniel Garber, Henry McCarter, Joseph Pearson, & others. **Exhibited:** PAFA; Sweat Mem. Mus.; Oberlin College, 1949; Upsula College, 1949, 1963; Bowdoin College, 1950; Farnsworth Mus., 1950; solos: Allen AM, Oberlin College, 1941 (prize), 1942 (prize),

1944 (prize), 1945 (prize). Awards: Cresson traveling scholarship, PAFA, 1915; PAFA Fellowship. **Work:** Allen AM, Oberlin, OH. **Comments:** Specialty: watercolor land and seascapes of Maine. Lectures: French Painting & Sculpture, etc. Positions: head, art dept., Knox Sch., Cooperstown, NY, 1923-26; asst. prof. FA, 1926-44, assoc. prof. FA, 1944-47, emeritus, 1947-, Oberlin (OH) College. **Sources:** WW59; WW47.

TREFONIDES, Steven *[Painter, photog]* b.1926, New Bedford, MA.
Addresses: Boston 16, MA. **Studied:** Swain Sch. Des.; Vesper George Sch. A., Boston; BMFA Sch., with Karl Zerbe, David Aronson. **Exhibited:** AIC, 1949; Awards: Tiffany Fnd., 1952; Portland (Me.) A. Festival, Grand Prize, 1958. **Work:** paintings: Wadsworth Atheneum; Portland A. Mus.; New Britain A. Mus.; de Cordova & Dana Mus.; Brandeis Univ.; Exeter Acad.; Deerfield Academy; photographs: MMA. **Comments:** Positions: Instr., Vesper George Sch. A., 1955-57; Brookline (Mass.) Adult Program, 1948-. Contributor to *New York Times; Art in America* magazine. **Sources:** WW59.

TREFRY, Harold Ernest *[Painter, printmaker]* b.1897, Boston, MA / d.1983, Placentia, CA.
Addresses: Southern California, since c.1920. **Studied:** Chouinard Art Inst.; Otis Art Inst.; Art Center School, all Los Angeles; with Morley Fletcher in Santa Barbara (printmaking). **Exhibited:** Los Angeles County Fairs (many prizes). **Work:** NMAA. **Sources:** Hughes, *Artists in California,* 565.

TREGANZA, Ruth Robinson (Mrs.) *[Painter, architect, designer, teacher]* b.1877, Elmira, NY.
Addresses: NYC. **Studied:** J.M. Hewlett; L.C. Tiffany; A.W. Dow; H.W. Corbett; ASL. **Member:** NAWPS; AFA. **Exhibited:** PAFA Ann., 1922; Salons of Am., 1926-27; S. Indp. A., 1926-27. **Comments:** Position: teacher, Columbia Teachers College. **Sources:** WW31; Falk, *Exh. Record Series.*

TREGO, D. D. (Mrs. Jonathan K.) *[Still life painter]* 19th c.
Addresses: Detroit, MI, 1874-80, Phila., PA, 1883. **Member:** Detroit AA. **Exhibited:** Detroit, MI; PAFA Ann., 1883. **Comments:** Wife of artist Jonathan Trego and mother of William Thomas Trego (see entries). **Sources:** Gibson, *Artists of Early Michigan,* 228; Falk, *Exh. Record Series.*

TREGO, Edward Comly *[Painter]* 20th c.
Addresses: Bryn Athyn, PA. **Sources:** WW17.

TREGO, Jonathan K(irkbridge) *[Portrait, genre, and animal painter]* b.1817, Bucks County, PA / d.After 1888, Philadelphia, PA.
Addresses: Phila., PA, 1865-74; Detroit, MI, 1874- 1880; Phila., 1880 until at leas 1888. **Member:** Detroit Artists Assoc. **Exhibited:** PAFA Ann., 1852-53, 1855, 1858, 1859 ("Sunny Hours," figures by Trego, landscape by Isaac L. Williams), 1865-68, 1882, 1887-88; NAD, 1883, 1887; Michigan State Fairs, several, the last one being 1880. **Comments:** Specialized in western genre scenes and portraits. Born into a Quaker family in Bucks Co., Trego lived in Philadelphia 1852-55; at Yardleyville (Bucks Co.), 1858-59; and was back in Philadelphia by 1865. He and his family moved to Detroit, MI, in 1874 and he exhibited there until 1880. Exhibition records indicate he was back in Philadelphia that same year. He was the husband of D.D. Trego (see entry) and father of William Trego (see entry). **Sources:** G&W; Shertzer, *Historical Account of the Trego Family,* 70-76; Rutledge, PA; Phila. CD 1852-55, 1865-68. More recently, see Gibson, *Artists of Early Michigan,* 228; Gerdts, *Art Across America,* vol. 2: 240, 242; Falk, *Exh. Record Series.*

TREGO, William Brooke Thomas *[Portrait and genre painter]* b.1859, Yardley, PA / d.1909, North Wales, PA. W.T.Trego
Addresses: Phila., PA; Detroit, MI, c.1874-c. 1880; Phila., 1880s; North Wales, PA, 1891-96. **Studied:** with his father; PAFA with Eakins; Académie Julian, Paris with T. Robert-Fleury and W.A. Bougereau, 1887-90. **Exhibited:** Michigan State Fairs, 1878,

1879; PAFA Ann., 1880, 1882 (Toppan Prize)-1883, 1891, 1895, 1902; AIC, 1889; Paris Salon, 1889, 1890; NAD, 1891, 1896; AAS, 1902 (med); Paris Salon, 1888. **Work:** PAFA. **Comments:** He was Jonathan K. Trego's (see entry) son and became an artist of note in Detroit and Philadelphia in the 1870s-90s. Trego painted more than 200 battle paintings and was an expert on military uniforms. He sought a precise realism in his paintings despite the fact that his hands were partially paralyzed (since birth). Because he began painting early in life, he became known as the "boy artist." **Sources:** WW08; *In This Academy,* 118; Fink, *American Art at the Nineteenth-Century Paris Salons,* 398; Gibson, *Artists of Early Michigan,* 229; Gerdts, *Art Across America,* vol. 2: 242; Falk, *Exh. Record Series.*

TREIDLER, Adolph *[Illustrator] b.1886, Westcliffe, CO / d.1981.*
Addresses: NYC. **Studied:** Calif. Sch. Des, San Fran.; with Robert Henri. **Member:** SI (life mem.; chmn., Pictorial Publicity Com., during WWII; A. Dir. Cl.; A. Gld. **Exhibited:** WMAA, 1923; AIC, 1930. **Comments:** Illus., *McClure's,* 1908, *Harper's, Century, Scribner's* and other national magazines, also advertising campaigns. He designed *Liberty Loan* and recruiting posters during WWI, and later painted posters in Bermuda for the Bermuda Tourist Offices among others, traveling the world. **Sources:** WW53; WW47; add'l info. courtesy of R. Reed, Short Hills, NJ.

TREIMAN, Joyce Wahl *[Painter, printmaker, sculptor, teachear] b.1922, Evanston, IL / d.1991.*
Addresses: Winnetka, IL; Pacific Palisades, CA, 1960. **Studied:** Stephens College; State Univ. Iowa, B.F.A., with Philip Guston and Lester Longman; Graduate Fellowship in 1943. **Member:** NAD, 1990. **Exhibited:** Paul Theobald Gal., Chicago, 1942 (solo); Oakland Art Gal., 1943; Denver AM, 1944; VMFA, 1946; American Painting, AIC, 1945-60 (Logan Prize, 1951); John Snowden Gal., 1946 (solo); American Painting & Sculpture, Univ. Illinois, 1950-63; WMAA, 1951-61; CI, 1955 & 1957; PAFA Ann., 1958; Felix Landau Gal., Los Angeles, 1961; Recent Painting: The Figure, MOMA,1962. **Awards:** Tiffany fellowship, 1947; Tamarind Lithography fellowship, Ford Foundation, 1962; Logan Prize (Herron Art Inst.); Pauline Palmer Prize (AIC); Nat. Endowment Arts (Visual Arts Fellowship Grant); Woman of Year, 1965 (Los Angeles *Times*). **Work:** WMAA; AIC; Denver (CO) Art Mus.; Oberlin Allen Art Mus.; Grunwald Foundation, Univ. Calif., Los Angeles; Oakland (CA) Mus.; Los Angeles County Mus. Art; Univ. Calif., Santa Cruz; Portland Mus. Art; MMA. **Comments:** Preferred media: oils. Dealers: Forum Gallery, New York, NY; Adele Bednarz Gallery, Los Angeles, CA. Teaching: teacher, Winnetka, IL, 1955-59; visiting prof. painting, Art Center College Design, summer 1968; visiting prof. painting, San Fernando Valley State College, 1968-69; visiting lecturer painting, Univ. Calif., Los Angeles, 1969-70. **Sources:** WW73; WW47; "Modernism in California Printmaking," The Annex Galleries, Nov. 1998,; Falk, *Exh. Record Series.*

TRELEAVEN, T. C. Poat *[Painter] late 19th c.*
Addresses: Brooklyn, NY, 1891. **Exhibited:** NAD, 1891. **Sources:** Naylor, *NAD.*

TREMAINE, Edna A. *[Painter] 20th c.*
Addresses: Boston, MA. **Comments:** Affiliated with Mass. Normal A. Sch., Boston. **Sources:** WW21.

TREMBLEY, Ralph *[Lithographer] b.c.1817, New York.*
Addresses: Pennsylvania; NYC, 1848-at least 1863. **Comments:** Married a New Yorker, but their first four children were born in Pennsylvania between about 1839 and about 1847. He was working as a lithographer in NYC from about 1848 to 1851 and as a clerk in 1863. **Sources:** G&W; 7 Census (1850), N.Y., LV, 137; NYBD 1850-51, 1863; repro., *Portfolio* (March 1948), 150.

TREMEAR, Charles H. *[daguerreotypist] b.1866 / d.1943, Detroit, MI.*
Comments: Operated the tintype and daguerreotype studio at Henry Ford's Greenfield Village, 1929-43.

TRENAN, M. R. *[Sculptor] 20th c.*
Addresses: Los Angeles, CA. **Exhibited:** Los Angeles County Fair, 1929; Artists Fiesta, Los Angeles, 1931. **Sources:** Hughes, *Artists of California,* 565.

TRENCH, Isabel *[Painter] 20th c.*
Addresses: New Brighton, NY. **Sources:** WW17.

TRENCHARD, Edward *[Marine painter] b.1850, Philadelphia, PA / d.1922, West Islip, NY.*
Addresses: NYC (1870s). **Studied:** Phila., with Ed. Moran; NYC; Europe. **Exhibited:** NAD, 1874-76; Brooklyn AA, 1873-76, 1886. **Comments:** He painted shoreline scenes from Long Island Sound to Maine. **Sources:** Brewington, 384.

TRENCHARD, Edward C. *[Engraver] b.c.1777, Salem, NJ / d.1824, Brooklyn, NY.*
Addresses: Philadelphia, PA, through 1796; Boston, 1796-98. **Studied:** engraving with his uncle, James Trenchard, Philadelphia. **Comments:** Went to England in 1793, returning later that year with English engraver Gilbert Fox. In 1794, Edward and James Trenchard were among the founders of the short-lived Columbianum. Edward was active as an engraver in Boston, 1796-98. He entered the U.S. Navy in 1800, remaining in the service and eventually rising to the rank of Captain. In 1814 he married a daughter of Joshua Sands of Brooklyn. **Sources:** G&W; Sellers, *Charles Willson Peale,* II, 74-75; Maclay, *Reminiscences of the Old Navy,* 2-4; Stauffer; CAB; Boston CD 1798 [as Trenchard & Dixon]; Hamilton, *Early American Book Illustrators and Wood Engravers,* 72.

TRENCHARD, James *[Engraver, die sinker, and seal cutter] b.1747, Penns Neck, Salem County, NJ / d.England.*
Addresses: Philadelphia, as early as 1777, until c. 1795. **Studied:** engraving from James Smither. **Comments:** Editor of the *Columbian Magazine* for some years and in 1794 a founder of the Columbianum. His nephew, Edward C. Trenchard, and James Thackara (see entries) were among his pupils. Trenchard went to England in the mid-1790s and is believed to have remained there for the rest of his life. **Sources:** G&W; Smith; Stauffer; Phila. CD 1785-93; Sellers, *Charles Willson Peale,* II, 75; *Portfolio* (Aug. 1947), 20, repro.; Prime, I, 29.

TRENCHARD & HALLBERG *[Drawing masters] late 18th c.*
Addresses: Active in Baltimore in 1788. **Sources:** G&W; Prime, II, 52-53.

TRENCHARD & WESTON *[Engravers] early 19th c.*
Addresses: Philadelphia, 1800. **Comments:** Possibly Edward C. Trenchard and Henry W. Weston (see entries). **Sources:** G&W; Brown and Brown.

TRENHOLM, George Francis *[Designer, typographer] b.1886, Cambridge, MA.*
Addresses: Wellesley Farms, MA. **Studied:** Mass. Sch. A.; C. Heil; H. Jahn; V. Preissig. **Member:** Stowaways; Artists G.; Typophiles and S. of Printers. **Comments:** Designer: Trenholm Old Style, cursive and bold type faces for Barnhart Brothers and Spindler, Chicago; Nova type face, Intertype Corp., Brooklyn. Award: Book Type Face, Nat. Bd. on Printing Type Faces, 1935. **Sources:** WW40.

TRENHOLM, Portia Ashe Burden (Mrs. Charles L.) *[Amateur painter] b.1812 / d.1892, Nashville, TN.*
Addresses: Active in and around Charleston, SC in the 1840s or 1850s. **Work:** A.A. Rockefeller Folk Art Center. **Comments:** Specialty: landscapes, fruit and flower pictures. Her husband was a member of a wealthy cotton-exporting family. **Sources:** G&W; Dewhurst, MacDowell, and MacDowell, 172.

TRENHOLM, William Carpenter *[Marine painter] late 19th c.*
Comments: An apochryphal ship painter whose works first appeared at New England auctions in 1985. The paintings typically bear 1890s dates and the "W.C. Trenholm" signature with a distinctive devil's tail flourish. He was proposed as having a birth date of 1856 or 1861 in Maine, and as having been the contempo-

rary and friend of W.P. Stubbs., but no information on this artist can be verified. His signature has most likely been added to many anonymous, albeit vintage, ship paintings.

TRENKAMP, Henry Jr. *[Painter]* 20th c.
Addresses: Cleveland, OH. **Sources:** WW25.

TRENT, Victor P(edrotti) *[Painter, designer, decorator]* b.1891, Austria.
Addresses: White Plains, NY. **Studied:** K.B. Loomis. **Exhibited:** S. Indp. A., 1944. **Work:** murals, Fulton Sch., Mt. Vernon; Battle Hill Sch., White Plains; Pocantico Hills Sch., Tarrytown, N.Y. **Comments:** Affiliated with WPA, N.Y. **Sources:** WW40.

TRENTHAM, Eugene *[Painter, teacher]* b.1912, Gatlinburg, TN.
Addresses: Austin, TX. **Studied:** Charles M. Kassler. **Exhibited:** Denver Pub. Sch (prize); Denver A. Mus., 1936 (prize), 1938 (prize); Tex. General Exh., 1941 (prize), 1944 (prize), 1945 (prize); PAFA Ann., 1942 (prize); Corcoran Gal biennials, 1937-41; GGE, 1939; WFNY, 1939; PMG, 1936; MoMA, 1941; CI, 1941, 1949; MMA (AV), 1941, 1942; WMAA, 1942; AIC, 1943; AGAA. **Awards:** Guggenheim fellow, 1939. **Work:** Denver A. Mus.; West Denver H.S.; Colorado H.S., Wheatridge, Colo.; St. Vincent's Hospital, Santa Fé, N.M.; City Court House, Pueblo, Colo.; murals, East Denver H.S.; USPO, O'Neill, Neb.; WPA artist. **Comments:** Teaching: Univ. Texas, Austin, 1940. **Sources:** WW53; WW47; Falk, *Exh. Record Series.*

TRESCH, John F.J. *[Painter]* 19th c.
Addresses: NYC, 1881, 1884. **Exhibited:** NAD, 1881, 1884; PAFA Ann., 1885. **Sources:** Falk, *Exh. Record Series.*

TRESCOTT, Elizabeth W. *[Artist]*
Addresses: Active in Washngton, DC, c.1903. **Sources:** Petteys, *Dictionary of Women Artists.*

TRESSLER, Anne K. (Mrs.) *[Craftsman, educator, screen-printer, writer, teacher]* b.1910, Rockford, IL.
Addresses: Madison, WI. **Studied:** Univ. Wisconsin. B.S., M.S.; Columbia Univ. **Comments:** Author. Ed.,"Norwegian Design in Wisconsin," 1946. Position: Dir., Wisconsin Union Workshop, Univ. Wisconsin, Madison, Wis., 1943-46. **Sources:** WW53; WW47.

TRESTED, Richard *[Engraver and die sinker]*
Addresses: NYC, 1820. **Sources:** G&W; NYCD 1820.

TREVETT, Mary *[Portrait painter]* 20th c.
Addresses: Carmel, CA, 1932. **Member:** Carmel AA. **Exhibited:** Oakland Art Gallery, 1934. **Sources:** Hughes, *Artists of California*, 565.

TREVITS, Joe See: **TREVITTS, Joseph**

TREVITTE, Laura M. *[Painter]* 20th c.
Addresses: NYC. **Sources:** WW19.

TREVITTS, Joseph *[Painter, teacher]* b.1890, Ashland, PA.
Addresses: Manistee, MI. **Studied:** PAFA with H. Breckenridge, C. Beaux, J.T. Pearson, Jr., D. Garber, P. Hale, E. Carlsen, R. Vonnoh, J.A. Weir, T. Anshutz; A. Zorroga, B. Nandin, and J. Blanche in Paris (on Cresson traveling scholarship, PAFA, 1913); E. Peixotto; R.F. Logan. **Member:** Mich. Acad. Sc. A. & Letters; Scarab C. **Exhibited:** PAFA annual, 1916; NAD; Corcoran Gal biennial, 1916; Univ. Michigan; Hackley A. Gal.; Newcomb Macklin Gal., Chicago; Ryerson Lib., Grand Rapids, Mich.; Willard Pub. Lib., Battle Creek, Mich.; Terry AI; Manistee Pub. Lib. **Work:** Reading (PA) Pub. Mus.; Pub. Sch., Pub. Lib., Masonic Temple, Mission Covenant Church, all in Manistee, Mich.; Hotel Chippewa, Manistee; Michigan Lg. of Women's Cl., Detroit, Mich. **Sources:** WW59; WW47; Falk, *Exhibition Records Series.*

TREVOR, Doris E. (Mrs. B. C.) *[Painter, graphic artist, teacher, lecturer]* b.1909, Havre de Grace, MD.
Addresses: Jacksonville, FL. **Studied:** La France Sch. A., Phila.; Moore Inst.; Phila. Sch. Des. for Women. **Member:** St. Augustine

AC. **Exhibited:** Fla. Fed. A. (traveling); Jacksonville A. Center; Va. MFA, 1939. **Work:** Pub. Lib., Jacksonville. **Comments:** Positin: T., Jacksonville A. Center. **Sources:** WW40.

TREZEVANT, Marye Brooks *[Cartoonist, photographer]* b.1872, Memphis, TN / d.1903, Pass Christian, MS.
Addresses: New Orleans, active 1897-1904. **Studied:** Tulane U., 1898; Howard Chandler Christy, NYC, 1900. **Member:** ASL, 1900. **Exhibited:** Artist's Assoc. of N.O., 1899; Press Artist's League, NYC, 1900. **Sources:** *Encyclopaedia of New Orleans Artists*, 378.

TRIANO, Anthony Thomas *[Painter, art administrator]* b.1928, Newark, NJ.
Addresses: Kearny, NJ. **Studied:** Newark Sch Fine & Indust Art, 1946-1950; with Rueben Nakian, 1947-1952; also with Samuel Brecher. **Exhibited:** Five Newark Artists, Newark Mus, 1958; East Hampton Collectors, Guild Hall, Long Island, NY, 1962; Gallery Selections, JL Hudson Gallery, Detroit, Mich, 1964; New Jersey & the Artist, NJ State Mus, Trenton, 1965; Boochever Art Collection, Paterson State Col, 1968; plus others including over twelve solo shows. **Awards:** 25th Ann NJ State art award, Montclair Mus, 1957; purchase award, Newark Mus, 59. **Work:** Newark Mus, NJ; Lowe Mus, Coral Gables, Fla; Paterson State Col, Wayne, NJ; Hartford Art Found, Conn; Seton Hall Univ, South Orange, NJ; plus others. **Comments:** Preferred Media: Oils. Positions: US Govt art surveyor & consult, 1972. Publications: Illusr, Exploring nature's rythms, 1960 & illusr, Duck fever, 1961, Abbott Labs contribr, H & G colors for your personal bed & bath, 1956 & contribr, House of color, 1967, House & Garden. Teaching: Artist-in-residence & prof art, Seton Hall Univ, 1970- **Sources:** WW73; Mike Berg, *The Life & World of Triano* (Seton Hall Univ, 1968); William Sheppard, "Inside the arts," produced on WNYC-TV by Brooklyn Col, 1970; D Simon, "Profiles," TV prog produced by Seton Hall Univ, 1971.

TRIBBLE, Dagmar Haggstrom *[Painter]* b.1910, NYC.
Addresses: NYC; Princeton, NJ. **Studied:** Parsons Sch. Des. (N.Y. and Paris); ASL; Farnsworth Summer Sch. **Member:** AWCS; NAWA; NAC. **Exhibited:** New Jersey Soc. Women's Cl., 1950 (prize); AWS, 1952; Montclair A. Mus., 1951; NAWA, 1952-1956 (prize 1955 and prior); NAC, 1951-1957; Essex WC Cl., 1954 (prize), 1955; Women's Cl. of Orange, 1951 (solo), 1954 (prize), 1955; Wellfleet A. Center, 1955 (solo); Rutgers Univ.(prize). **Sources:** WW59; WW47.

TRIBE, George J. *[Painter]* 20th c.
Addresses: Worcester, MA. **Sources:** WW24.

TRIBE, Reginald V. *[Cartoonist]* b.1891, Procidence, RI / d.1956, Hyannis, MA.
Addresses: Active in New Bedford, MA area, 1910-34.
Comments: Positions: cartoonist, *New Bedford Evening Standard*, 1910; reporter; assistant manager and then manager, Empire Theatre, New Bedford, 1922-24; telegraph editor, *New Bedford Times*, 1924; cartoonist, *Springfield Union*, Springfield, MA; feature editor and cartoonist, *Springfield Sunday Republican*, Springfield, MA. Sculpted papier-mâché figures as a hobby. **Sources:** Blasdale, *Artists of New Bedford*, 190-91 (w/repro.).

TRICCA, M(arco) A(urelio) *[Painter, sculptor]* b.1880, Alanno (Abruzzi), Italy / d.1969, NYC.
Addresses: NYC (1912-on). **Studied:** Sch. Liberal Arts, Rome, c.1908-11. **Exhibited:** S. Indp. A., 1917, 1918, 1925-44; SIA, 1917-18, 1925-44; Salons of Am., 1923-26, 1934-36; PAFA Ann., 1933, 1937; Corcoran Gal biennials, 1935; AIC, 1935-38; Mortimer Brandt Gal., 1944 (with W. Pach and J. Sloan); BM; Whitney Studio Club, 1925 (solo); WMAA (solo); Contemporary Artists, 1940 (solo); Graham & Sons Gal., 1957 (solo); Long Island Univ. (solo restrospective, 1973); Univ. of Minnesota (solo); "NYC WPA Art" at Parsons School Design, 1977. **Awards:** Shilling award, 1944, 1948. **Work:** AIC; WMAA; Wadsworth Atheneum; Butler IA; Neuberger Mus., Purchase, NY. **Comments:** Came to U.S. in 1912, and worked as a WPA artist. A nervous breakdown in 1944 caused him to stop painting and

become reclusive, but he resumed painting in 1954. **Sources:** WW59; WW47; *New York City WPA Art,* 88 (w/repros.); Falk, *Exh. Record Series.*

TRICHON *[Engraver]* mid 19th c.
Comments: Work appeared in *Faggots for the Fireside.* (New York, 1855); one plate was also signed V. Foulquier. **Sources:** G&W; Hamilton, *Early American Book Illustrators and Wood Engravers,* 180.

TRICKER, Florence *[Painter, sculptor, teacher]* 20th c.;
b.Phila.
Addresses: NYC; Phila., PA. **Studied:** Phila. Sch. Des for Women; E. Daingerfield; H.B. Snell; D. Garber; C. Grafly; S. Murray; A. Laessle. **Member:** Phila. Alliance; Plastic C. **Exhibited:** PAFA Ann., 1918-19, 1923; Graphic Sketch C. (gold); Plastic C. (med, prizes); Tampa AI, 1924 (prize). **Work:** Graphic Sketch C. **Comments:** Owner/Director: Tricker Galleries of Ecclesiastical A. **Sources:** WW40; Falk, *Exh. Record Series.*

TRICOV, Mae (H.) *[Painter]* d.1906, Wash., DC.
Addresses: Wash., DC, 1903-06. **Member:** Wash. WCC. **Exhibited:** Wash. WCC, 1903, 1904. **Sources:** McMahan, *Artists of Washington, DC;* Petteys, *Dictionary of Women Artists.*

TRIDLER, Avis *[Painter, sculptor, lecturer, etcher, craftsperson]* b.1908, Madison, WI.
Addresses: San Fran., CA. **Studied:** Labandt; Boynton; Stackpole; DuMond. **Member:** San Fran. Women A.; San Fran. FAC. **Sources:** WW31.

TRIEBEL, C. E. *[Sculptor]* 20th c.
Addresses: NYC. **Studied:** NSS; Arch. Lg., 1902. **Sources:** WW04.

TRIEBEL, F(rederic) Ernest *[Painter, sculptor]* b.1865, Peoria, Il.
Addresses: College Point, NY; Florence, Italy, 1889. **Studied:** A. Rivalta. **Member:** Academicien of Merit, Roman Royal Acad., San Luca, Rome; NSS. **Exhibited:** Museo Nazionale di Antropologie, Florence, 1889, 1891 (med); NAD, 1889; PAFA Ann., 1904. **Work:** Soldiers' Mon. Peoria, Ill.; Iowa State Mon., Shiloh, Tenn,; Miss. State Mon., Vicksburg; Robert G. Ingersoll statue, Peoria; statues of late Senators Shoup and Rice, Statuary Hall, Wash., D.C.; Otto Pastor Mon., Petrograd, Russia; bronze, Imperial Mus., Japan; Dante medal, Sons of Italy; Dante plaque; various H.S. and Pub. Libs. **Comments:** Position: Superintendent of Sculpture/Secretary for Intl. Jury on Awards, Columbian Expo, Chicago, 1893. **Sources:** WW40; Falk, *Exh. Record Series.*

TRIER, Henry *[Painter]* 20th c.
Exhibited: AIC, 1938-39. **Sources:** Falk, *AIC.*

TRIESTER, Kenneth *[Painter, sculptor]* b.1930, NYC
Addresses: Miami, FL. **Studied:** Univ Miami; Univ Fla, BArch, 1953. **Member:** Blue Dome Soc, Miami; Fla Sculptural Soc; Southern Asn Sculptors. **Exhibited:** Greenwich Gallery, New York; Mus Fine Arts, Columbus, Ga; Lowe Art Gallery, Coral Gables, Fla; Contemp Art Mus, Houston, Tex; High Mus, Atlanta, Ga; plus several solo shows. **Awards:** First prize for Four Conversations (sculpture), Nat Ceramic Exhib, Lowe Art Gallery, 1953. **Work:** Norton Gallery, Palm Beach, Fla; Miami MOMA, Fla; Fla Supreme Ct, Tallahassee. Commissions: Family of God (limited ed of bronze menoras), 1969 & series of six bronze plaques depicting hist of Jews, United Jewish Appeal; series of ten paintings depicting 4,000 yr hist of Jews, Temple Israel, Miami. **Comments:** Publications: Contribr articles to many archit, sch & bldg publs. Art Interests: Photopainting, a new technique of combining photographs & paintings. **Sources:** WW73.

TRIFON, Harriette *[Painter, sculptor]* 20th c.; b.Phila., PA.
Addresses: Valley Stream, NY. **Studied:** Pratt Inst, grad; Adelphi Univ; ASL New York. **Exhibited:** Birmingham Mus Art, 1955; Hofstra Univ Nat Show, 1958; PAFA, 1959; Corcoran Gallery Art, 1960; Brooklyn Mus Print Show, NY, 1961; Loring's Art Gallery, Cedarhurst, NY, 1970s. **Awards:** Birmingham Mus Art, 1955; Hofstra Univ, 1958; Long Island Artists Nat Show, 1962. **Work:**

Birmingham Mus Art, Ala; Jewish Mus, NYC; Staten Island Mus, NY; Woodward Found, Washington, DC; Abilities Inc Bldg, Hempstead, NY. **Comments:** Positions: Dir art gallery, Woodmere-Hewlett Libr, 1970-; dir art, St Albans Naval Hosp, for '52 Orgn, 1970-1971. Teaching: Owner & instr art, Harriette Trifon Creative Workshop, 1959-. **Sources:** WW73.

TRIFYLLIO, Demetrius A. See: **TRIFYLLIS, Demetrius**

TRIFYLLIS, Demetrius *[Painter]* 20th c.
Addresses: NYC. **Exhibited:** S. Indp. A., 1921; Salons of Am., 1934. **Comments:** His name appears as Trifyllis and Trifyllio. **Sources:** WW21; Marlor, *Soc. Indp. Artists;* Marlor, *Salons of Am.*

TRIGGS, Floyd W(ilding) *[Cartoonist, writer]* b.1872, Winnebago, IL / d.1919, Stamford, CT.
Addresses: Darien, CT. **Studied:** AIC. **Exhibited:** AIC, 1899. **Comments:** Cartoonist: Christian Science Monitor. **Sources:** WW21.

TRIGGS, James Martin *[Illustrator, painter, writer]* b.1924, Indianapolis, IN.
Addresses: Living in Larchmont, NY in 1974. **Studied:** Cornell Univ.; Pratt Inst.; with Steven Dohanos and Coby Whitmore. **Comments:** Specialty: Western tromp l'œil, Western still-lifes. Illustrator, *Argosy* covers; author/illustrator, books and articles on aviation subjects, 1950s; illustrator, guns and other Western still-life subjects, in *Guns Magazine, American Rifleman, Guns Annual, Gun Digest,*1960s; and ads for various gun companies. **Sources:** Peggy and Harold Samuels, 490.

TRIMBLE, Corinne C. *[Sculptor]* 19th/20th c.
Addresses: Norwood, OH. **Sources:** WW01.

TRIMBLE, William J. *[Listed as "artist"]* b.c.1854, LA.
Addresses: New Orleans, active 1903-17. **Sources:** *Encyclopaedia of New Orleans Artists,* 379.

TRIMM, Adon *[Painter]* b.1897, Grand Valley, PA / d.1959, Buffalo, NY.
Addresses: Jamestown, NY. **Member:** Soc. for Sanity in Art, Chicago, IL. **Exhibited:** Albright A. Gal., 1933, 1934; Soc. for Sanity in Art, Chicago, 1941; Chautauquqa, N.Y., 1940-1942 (solo); Jamestown, N.Y., 1941, 1942; Erie, PA, Pub. Mus., 1951 (solo); Rochester Inst. Tech., 1952 (solo); Terry AI, 1952; Ogunquit A. Center; Canton (Ohio) AI, 1955. Award: prize, Chautauqua Soc. A., 1955. **Work:** Capitol Bldg., Albany, N.Y. **Comments:** Position: Dir., Chautauqua County Soc. A., Jamestown, N.Y. **Sources:** WW59; WW47.

TRIMM, George Lee *[Painter, illustrator, teacher]* b.1912, Jamestown, NY.
Addresses: Camillus, NY. **Studied:** Syracuse Univ., B.F.A. **Member:** NSMP. **Exhibited:** solo exh.: Syracuse, N.Y., 1946, Army paintings. **Work:** St. Lawrence Univ.; Ohio State Univ.; U.S. War Dept., Wash., D.C.; Engineer Corps, Wash., D.C.; murals, Ft. Belvoir, Va.; Waldes Kohinoor, Inc., Long Island City, N.Y.; Le Moyne Univ.; Brighton Town Hall, Rochester, N.Y.; Syracuse, N.Y., war memorial; St. Joseph Hospital, Syracuse. **Comments:** Position: Hd. A. Dept., 6th Army Univ., Osaka & Kyoto, Japan, 1945. **Sources:** WW59; WW47.

TRIMM, Lee S. *[Painter]* b.1879, Ft. Larned, KS.
Addresses: Syracuse, NY. **Studied:** with De Forest Carr. **Member:** Soc. for Sanity in Art, Chicago, Ill.; Jamestown Sketch Cl. (Founder). **Exhibited:** Soc. for Sanity in Art, Chicago, 1941; Utica Lib., 1938-1940 (solo); Daytona Beach, Fla., 1941; Assoc. A. Syracuse, 1937; Jamestown, N.Y. **Work:** portraits, Syracuse Univ.; Gettysburg Acad.; Puerto Rico Missionary Col.; & in many libraries. **Sources:** WW59; WW47.

TRIMM, Wayne H *[Illustrator]* b.1922, Albany, NY.
Addresses: Chatham, NY. **Studied:** Cornell Univ, 1940; Augustana Col, BS, 1948; Kans State Univ, 1949; Col Forestry, Syracuse Univ, MS, 1953. **Member:** Columbia Co Arts & Crafts; Soc Animal Artist; hon mem Tuscarora Indian Tribe; Am

Ornithologists Union. **Exhibited:** Am Bird Artists Traveling Exhib, sponsored by Audubon Artists; Joslyn Mus Art; Buffalo Mus Sci; San Jose State Univ; New York Coliseum Sportsman's Show; plus others. **Work:** Commissions: Dioramas, Springfield Mus Art; three murals, Jug End Barn, South Egremont, Mass, 1961; three ecol dioramas, Augustana Col, 1967; movie for Audubon Screen Tour, 1968-1969; Cleveland Mus Art. **Comments:** Positions: Staff artist, NY State Conserv Dept & Conserv Educ Div, 1953-. Teaching: Lect, Conversation, Wildlife Painting & Alaskan Bowhunting. Publications: Illusr, "Manual of Museum Techniques," 1948 & *The Mammals of California and its Coastal Waters,* 1954; illusr, *Collier's Encyc,* 1960-1961; *Field Paintings for the Birds of Tikal,* 1963-1964 & *The Birds of Colorado,* 1966; contribr, illus to *Audubon Mag & NY State Conservationist.* **Sources:** WW73.

TRIMMER, George Dewey *[Painter] 20th c.*
Addresses: Chicago area. **Exhibited:** AIC, 1924-29. **Sources:** Falk, *AIC.*

TRINCHARD, Junius Brutus *[Sculptor] mid 19th c.*
Addresses: New Orleans, 1841-42, 1846. **Sources:** G&W; New Orleans CD 1841-42, 1846; *Encyclopaedia of New Orleans Artists,* 379.

TRIPLER, Charles E. *[Artist] late 19th c.*
Addresses: NYC, 1884. **Exhibited:** NAD, 1884. **Sources:** Naylor, *NAD.*

TRIPLETT, Beryl May *[Educator, painter] b.1894, Mendota, MO.*
Addresses: Fayette, MO. **Studied:** Northeast Missouri State T. Col., B.S.; Missouri Univ., M.A.; Columbia Univ.; Univ. Colorado; & with Henry Lee McFee, Millard Sheets. **Member:** Western AA; MO. State T. Assn. **Comments:** Position: Assoc. Prof. A., Central Col., Fayette. Mo., 1927-. Lectures: American Regionalists; Contemporary Art. **Sources:** WW53; WW47.

TRIPLETT, Fred J. *[Museum director] b.1921, Vallejo, CA.*
Addresses: Huntington, W. VA. **Studied:** San Jose State Col., A.B.; Stanford Univ., M.A. **Member:** AAMus. **Comments:** Positions: Instr. Des., Univ. Minnesota, Duluth Branch, 1948-57; Dir., Huntington Galleries, Huntington, W. Va., 1957-. **Sources:** WW59.

TRIPLETT, Margaret Lauren *[Educator, painter] b.1905, Vermillion, SD.*
Addresses: Norwich, CT. **Studied:** Univ. Iowa, B.A., B.M.FA; Yale Univ., M.A.; also with Grant Wood; ASL; Thurn School Modern Art, Boston; School Mus. FA, Boston, 1928-29; ASL, Boothbay Harbor; International School Art. **Member:** EAA; Connecticut Art Assn. (pres., 1954-1956); Connecticut WCS; Mystic Art Assn. (board directors, 1972); life member Nat. Educ. Assn.; Norwich AA, Meriden Arts & Crafts. **Exhibited:** AWCS, 1940; CM, 1940; New Haven PCC, 1939; Clay C., 1939; Portland Mus. Art, 1939; Iowa Art Salon, 1932-34, 1938 (prize); Joslyn Memorial, 1933, 1938; Iowa Artists Exhibit, Mt. Vernon, 1938; All Iowa Exhibition, Carson Pirie Scott, 1937; Buena Vista College; CAFA, 1937, 1938; Connecticut WCC, 1939, 1940; De Cordova & Dana Mus.; Slater Mus. Art; Lyman Allyn Mus. Awards: Jesse Smith Noyes Found grant, 1969; Dubuque Woman's Club (medal). **Work:** Munson-Williams-Proctor Inst., Utica, NY; Slater Mem. Mus., Norwich, CT. **Comments:** Positions: trustee, Hartford Art School, Univ. Hartford, 1962-1970. Publications: co-author, "The Norwich Art School, a Study of the Directors, in Combination with an On-going Study of Former Students," 1971. Teaching: art instructor, Norwich Art School, 1929-1943, director, 1943-1970, retired. Research: Study of students of the Norwich Art School. **Sources:** WW73; WW47; Ness & Orwig, *Iowa Artists of the First Hundred Years,* 208.

TRIPOVICH, Frances *[Painter] 20th c.*
Exhibited: S. Indp. A., 1938. **Sources:** Marlor, *Soc. Indp. Artists.*

TRIPP, B. Wilson *[Painter] 20th c.*
Addresses: Providence, RI. **Member:** Providence AC. **Sources:**

WW27.

TRIPP, Lyman Winfield Scott *[Glass decorator, landscape and still-life painter] b.1861, Acushnet, MA / d.1946, Dartmouth, MA.*
Addresses: Active in New Bedford, MA area, 1881-1945. **Comments:** Positions: glass decorator, S. R. Bowie & Co.,; F. B. Aulich; Pairpoint Glass Co. **Sources:** Blasdale, *Artists of New Bedford,* 191 (w/repro.).

TRIPP, Otis Jerome *[Painter] b.1905, Acushnet, MA / d.1976, Wareham, MA.*
Addresses: Active in New Bedford, MA area, 1920-76. **Studied:** Swain Free Shcool Design with Otis Cook, early 1930s. **Exhibited:** Swain Free School Design, 1935 (award); Jordan Marsh 40th Ann. Art Exhib., Boston, c.1970. **Sources:** Blasdale, *Artists of New Bedford,* 192 (w/repro.).

TRIPP, William Henry *[Photographer] b.1880, New Bedford, MA / d.1959, New Bedford, MA.*
Addresses: Active in New Bedford, MA, 1899-1959. **Exhibited:** Paint and Clay Club, New Bedford, 1913; New Bedford Art Club, 1907-11; Thumb Box Exhib., 1910. **Comments:** A banker who became curator of the Old Dartmouth Hist. Soc. Published "There Goes Flukes," 1938. **Sources:** Blasdale, *Artists of New Bedford,* 192-93 (w/repro.).

TRIPPE, Frederick K. *[Listed as "artist"] 19th/20th c.*
Addresses: Wash., DC, 1897. **Sources:** McMahan, *Artists of Washington, DC.*

TRISCOTT, S(amuel) P(eter) R(olt) *[Marine painter, photographer, teacher] b.1846, Gosport, England / d.1925, Monhegan Island, ME.*
Addresses: Boston, MA; Monhegan Island, ME. **Studied:** Philip Mitchell, Royal Inst. Painters in watercolors, both in London. **Member:** Boston AC; Boston SWCP. **Exhibited:** Boston Art Club, 1880-1905; Brooklyn AA, 1881-82; AIC, 1889-1902; PAFA Ann., 1892-93, 1895, 1898; AWCS, 1898. **Comments:** A specialist in watercolors, he was also an influential teacher in this medium who came to Boston in 1871. He settled at Monhegan in the 1890s, and he and William Claus were the first artists to make extensive use of artistic photography on Monhegan, providing the illustrations for A.G. Pettigill's article, "Monhegan: Historical and Picturesque" in *New England Magazine* (Sept., 1898). For the next two decades, Triscott commercially promoted and sold his pictorialist photographs of Monhegan's cliffs and surf. **Sources:** WW24; Campbell, *New Hampshire Scenery,* 167; Shettleworth & Bunting, *An Eye for the Coast* (Tilbury House Pub., Gardiner, ME, 1998); Falk, *Exh. Record Series.*

TRISSEL, James Nevin *[Painter, educator] b.1930, Davenport, Iowa.*
Addresses: Colorado Springs, CO. **Studied:** State Univ Iowa, BA; Colo State Col, MA; State Univ Iowa, MFA. **Exhibited:** One-man show, Beloit Col, 1957; Wis Salon, 1958; El Paso Biennial, 1964 & 1966; solo show, Colorado Springs Fine Arts Ctr, 1966 & 1972. **Work:** Univ Wis; Beloit Col; Colo Col; Colorado Springs Fine Arts Ctr. **Comments:** Preferred Media: Oils. Positions: Actg dir, Wright Art Ctr, Beloit Col, 1958-1959; dir, Univ Exten Prog in Art, Univ Calif, Los Angeles, 1962-1964. Teaching: Instr art, Beloit Col, 1958-1960; asst prof art & art theory, Univ Calif, Los Angeles, 1960-1964; assoc prof art & art hist, Colo Col, 1964-, chmn dept art, 1971-. **Sources:** WW73.

TRISSEL, Lawrence E. *[Painter, designer, illustrator, commercial artist] b.1917, Anderson, IN.*
Addresses: Indianapolis, IN; Carmel, IN. **Studied:** John Herron AI, B.F.A.; & with Eliot O'Hara, Francis Chapin, Max Kahn. **Exhibited:** BAID, 1938 (med); Ind. AC, 1941 (prize), 1944 (prize), 1951 (prize); Ohio Valley Exh.; 1944 (prize); Ind. State Fair, 1941 (prize), 1950 (prize); Hoosier Salon, 1946 (prize); CM, 1940; CI, 1941; Oakland A. Gal., 1940, 1944; PAFA, 1941; VMFA, 1946; Butler AI, 1944; Exhibition Momentum, 1953, 1954; Indiana A., 1953, 1954;1444 Gallery, 1958. **Work:** U.S.

Govt.; Ball State T. Col. **Comments:** Position: A. Dir., A. Sidener & Van Riper Advertising Agency, 1944-45; Keeling & Co., Indianapolis, Ind., 1945-48; Mark Gross Assoc., 1940-50, Adv. Mgr., 1951-53; Adv. A., Caldwell, Larkin & Sidener-Van Riper, Inc., 1953-. **Sources:** WW59; WW47.

TRIST, T. J. *[Landscape painter] mid 19th c.*
Addresses: NYC. **Exhibited:** NAD in 1852. **Sources:** G&W; Cowdrey, NAD.

TRIVELLA, Ralph Herman *[Ceramic designer, potter, teacher] b.1908, Columbus.*
Addresses: Proctorsville, VT. **Studied:** Ohio State Univ., A.E. Baggs. **Member:** Columbus AL; Ohio WCS. **Exhibited:** Nat. Des. Contest, 1928 (prize). **Comments:** Positions: T., Columbus Pub. Sch.; Fletcher Farm, Proctorsville. **Sources:** WW40.

TRIVIGNO, Pat *[Painter, educator] b.1922, New York, NY.*
Addresses: New Orleans, LA. **Studied:** Tyler Sch Art; New York Univ; Columbia Univ, BA, MA. **Exhibited:** WMAA; AIC; PAFA Ann., 1952, 1960; Am Acad Arts & Lett; Univ Ill Biennial; Saidenberg Gallery, NYC; plus 12 solo shows through 1973. **Work:** Guggenheim Mus; Brooklyn Mus, NY; Everson Mus, Syracuse, NY; New York Times, NY; Delgado Mus, New Orleans, La. Commissions: Murals, Lykes Steamship Lines. **Comments:** Preferred Media: Acrylics, Oils. Positions: Bd trustees, Delgado Mus, New Orleans, La. Teaching: Prof art, Tulane Univ La, 1950- **Sources:** WW73; Articles, In: *New York Times,* Oct 8, 1950 & Jan 10,1960; R Pearson, *Modern Renaissance in American Art* (Harper); John Alford (exh. cat., Seligman Gallery); Falk, *Exh. Record Series.*

TRNKA, Anna Belle Wing (Mrs.) *[Miniature painter, painter] b.1876, Buffalo, NY / d.1922.*
Addresses: Buffalo. **Studied:** L.W. Hitchcock; G. Bridgman. **Member:** Buffalo Soc. Art; NY Soc. Craftmen. **Exhibited:** Pan.-Am. Expo., Buffalo, 1901 (prize); St. Louis Expo., 1904 (med.); AIC, 1914; Pan.-Pac. Expo., San Fran., 1915 (med.); Nat. Soc. Craftsmen. **Sources:** WW 24.

TRO, Peter *[Painter] 20th c.*
Addresses: Brooklyn, NY. **Exhibited:** S. Indp. A., 1933. **Sources:** Marlor, *Soc. Indp. Artists.*

TROBAUGH, Roy (B.) *[Painter] b.1878, Delphi.*
Addresses: Delphi, IN. **Studied:** ASL; J.H. Twachtman. **Member:** Ind. AC. **Sources:** WW29.

TROBRIAND, Regis de *[Painter] late 19th c.*
Addresses: NYC, 1861. **Exhibited:** NAD, 1861. **Sources:** Naylor, *NAD.*

TROCCOLI, Giovanni Battista *[Painter, craftsperson] b.1882, Lauropoli, Italy / d.1940, Santa Barbara, CA.*
Addresses: Newton Center, MA/Santa Barbara, CA. **Studied:** D. Ross; Académie Julian, Paris, 1900, 1904. **Member:** Copley S.; Boston SAC; Boston GA; AFA. **Exhibited:** Boston AC, 1907; PAFA Ann., 1909-13, 1917, 1921-29; Corcoran Gal biennials, 1910-35 (9 times); CI, 1911 (prize); AIC, 1913 (med); Pan.-Pac. Expo., San Fran., 1915 (gold); NAD, 1922 (prize); Tercentenary Hall, Boston, 1930 (prize); GGE, 1939. **Work:** Detroit AI; BMFA. **Sources:** WW38; Falk, *Exh. Record Series.*

TROCHE, E. Gunter *[Museum director] b.1909, Stettin, Germany / d.1971.*
Addresses: San Francisco 15, CA. **Studied:** Univ. Vienna; Univ. Munich, Ph.D. **Member:** Renaissance Soc. Am.; Deutscher Verein fuer Kunstwissenschaft; Roxburghe Cl. of San Francisco. **Comments:** Positions: Asst. Cur., State Museums, Berlin, 1932-36; Cur., Municipal Museum, Breslau, 1936-38; Cur., 1938-45, Dir., 1945-51, Germanic National Museum, Nuremberg, Germany; Dir., Achenbach Foundation for Graphic Arts, California Palace of the Legion of Honor, San Francisco, Cal. as of 1966. Arranged exhs., "The Printmaker, 1450-1950," 1957; "German Expressionists," 1958. Author: "Italian Painting in the 14th and 15th Centuries," 1935; "Painting in the Netherlands, 15th and 16th Centuries," 1936; many museum catalogs and numerous

articles and book reviews in professional magazines. **Sources:** WW66.

TROEBER, Carl *[Painter] 20th c.*
Addresses: Newark, NJ. **Sources:** WW24.

TROEGER, Elizabeth See: TROGER, Elizabeth E.

TROENDLE See: TRONDLE

TROENDLE, Joseph F. *[Listed as "artist"] mid 19th c.*
Comments: Employed by a firm of photographers in Louisville (KY) in 1859. Possibly the J.F. Troendle who exhibited at the National Academy in 1858 several portraits and landscapes. **Sources:** G&W; Louisville CD 1859; Cowdrey, NAD.

TROGDON, Doran S. *[Painter] 20th c.*
Addresses: Phila., PA. **Exhibited:** PAFA Ann., 1923; AIC, 1924. **Sources:** WW24; Falk, *Exh. Record Series.*

TROGER, Elizabeth E. *[Painter] 19th/20th c.; b.McGregor, IA.*
Addresses: Chicago, IL; Hinsdale, IL, 1898. **Studied:** with Robert-Fleury; Merson and Collin, in Paris. **Exhibited:** Paris Salon, 1897; PAFA Ann., 1898; NAD and AIC, 1898. **Comments:** Fink cites Chicago as her place of birth. Both Fink and Petteys spell her name Troeger. **Sources:** WW01; Petteys, *Dictionary of Women Artists;* Fink, *American Art at the Nineteenth-Century Paris Salons,* 398; Falk, *Exh. Record Series.*

TROLLER, Fred *[Sculptor] 20th c.*
Exhibited: PAFA Ann., 1966. **Sources:** Falk, *Exh. Record Series.*

TROMKA, Abram *[Painter, etcher, screenprinter] b.1896, Poland / d.1954, Queens, NY.*
Addresses: NYC. **Studied:** At Henry Street Settlement with Nora Hamilton; with George Bellows, Robert Henri. **Member:** Artists Lg. Am.; Am. Artists Congress; Assoc. Artists New Jersey; AEA; Brooklyn SA. **Exhibited:** Salons of Am., 1931, 1932, 1934; S. Indp. A., 1932, 1935; Springfield (MA) Mus. Art, 1937; George Walter Vincent Smith Mus. Art, 1938; traveling exhib. silk screen prints, U.S.S.R.; BM, 1932 (solo); ACA Gal., 1933-61; BM, 1946 (prize), 1952 (prize); Long Island Art Festival (prize); PAFA, 1932; John Herron AI, 1938; Am. Artists Congress, 1938, 1939; BM, 1933, 1935, 1937, 1942; WMAA; AIC, 1938, 1942; AWCS, 1941-44; CI, 1941, 1944, 1945; VMFA, 1944; MMA, 1943; de Young Mem. Mus., 1943; Albright Art Gal., 1942; CGA Traveling Exhib., 1937; Riverside Mus., 1943; 1945; LOC, 1944, 1945; 100 Prints of the Year, 1944, 1945; Los Angeles Mus. Art, 1945; NAD, 1945, 1946; Albany Inst. Hist. & Art, 1945; Butler AI, 1944, 1948 (prize); Phila. Artists All., 1944; State Mus., Trenton, NJ, 1950; Newark Mus., 1950,1951; Wichita Art Mus., 1952; "NYC WPA Art" at Parsons School Design, 1977. **Work:** Boston Public Library; MMA; Newark Public Library; Iowa State College; CAM; CI; BM; U.S. State Dept., Washington, DC; Smithsonian Inst.; LOC; Corcoran Mus. **Comments:** WPA artist for its duration. Illustrator: "House on Henry Street," Lillian D. Wald, 1915. **Sources:** WW53; WW47; *New York City WPA Art,* 88 (w/repros.).

TROMMER, Marie *[Writer, critic, painter, teacher] b.1895, Kremenchug, Russia.*
Addresses: Brooklyn, NY. **Studied:** CUASch, and with Douglas Volk, Wayman Adams; S. Halpert; C. Curran; ASL. **Member:** Brooklyn S. Modern A.; Brooklyn WCC; Cooper Union Alumni Assn. **Exhibited:** Soc. Indp. A.; All. A. Am.; Salons of Am.; Brooklyn Soc. A.; Brooklyn WCC, 1936 (solo); Brooklyn Heights Exh., 1955; Women's Intl. Exp., 1959-1961. Awards: prizes, Avalon Poetry Organization, 1959; Explorer Magazine, 1960; 50th Anniversary Honorary Plaque, Cooper Union Alumni Assn., 1964. **Work:** Corona Mundi, N.Y.; Biro-Bidjan Mus., Russia; Women's Nat. Inst.; N.Y. Hist. Soc.; Mus. City of N.Y.; N.Y. Pub. Lib.; LOC; Long Island Hist. Soc.; Mus. Natural Hist., N.Y.; Theodore Roosevelt House, N.Y.; BM Lib.; and others; books in hand-made covers, Brooklyn Pub. Lib.; Cooper Union Sch. & Mus.; translations into Russian from Robert Frost's poetry, Brooklyn Pub. Lib., 1963. **Comments:** Author/Illustrator: "America in My Russian Childhood," 1941; others. Translator: "Russian Essays, Sketches

& Poems 1943. **Contributor:** articles, Jewish publications. **Sources:** WW66; WW47.

TROMPETER, David *[Painter]* 20th c.
Addresses: NYC. **Exhibited:** S. Indp. A., 1929-30. **Sources:** Marlor, *Soc. Indp. Artists.*

TRONDLE *[Portrait painter]* mid 19th c.
Addresses: NYC between 1856 and 1860. **Comments:** He was variously listed: Karl J. Trondle (1856); Conrad J. Trondle (1857); Charles J. Trondle (1858); John Troendle and Joachim Troendle (1859); John Troendle and Jacob Trondle (1860). **Sources:** G&W; NYCD 1856-60; NYBD 1859-60.

TRONNES, E. *[Painter]* 20th c.
Addresses: Chicago area. **Exhibited:** AIC, 1915. **Sources:** Falk, *AIC.*

TROSKY, Helene *[Printmaker, writer]* 20th c.; b.Monticello, NY.
Addresses: Purchase, NY. **Studied:** New Sch Soc Res, with Kuniyoshi Egas; Manhattanville Col, BA, with Al Blaustein & John Ross. **Member:** Silvermine Guild; Conn Acad Fine Arts; Westchester Art Soc (exec dir & chmn bd, 1960-); Artists Equity New York; NAWA. **Exhibited:** NAWA and Nat Acad Design Galleries, 1967-69; Conn Acad Fine Arts, 1967 & 1968; Charles Z Mann Gallery, 1967 & 1969; Silvermine Guild, 1968-1970; solo show, Hudson River Mus, Yonkers, NY, 1969; Raydon Gallery, NYC; Charles Z Mann Gallery, NYC, 1970s. **Awards:** Westchester Art Soc Award, 1967; Northern Westchester Award, 1968; NAWA, 1969. **Comments:** Teaching: Art dir, Westchester Co Music & Art Camp, 1965, 1966, 1971 & 1972; lectr art hist, Brandeis Univ Women, 1966-; instr printmaking, Manhattanville Col, 1971-. Positions: Columnist, "Muse roundup," column, *Harrison Independent Greenburgh Rec & Yonkers Rec,* 1960-; art consult, Westchester Libr. **Sources:** WW73.

TROST, Carrie (Caroline) *[Teacher, painter]* b.1878, New Orleans, LA / d.1953, New Orleans, LA.
Addresses: New Orleans, active 1893-1931. **Studied:** George David Coulon. **Exhibited:** Tulane U., 1893. **Sources:** *Encyclopaedia of New Orleans Artists,* 379.

TROST, Henry, Jr. *[Lithographer]* b.1863, New Orleans, LA / d.1890, New Orleans, LA.
Addresses: New Orleans, active 1887-90. **Sources:** *Encyclopaedia of New Orleans Artists,* 379.

TROSTLER, Emil E. *[Painter]* 20th c.
Addresses: Brooklyn, NY. **Studied:** ASL. **Exhibited:** S. Indp. A., 1929, 1935. **Sources:** Marlor, *Soc. Indp. Artists.*

TROTH, Celeste Heckscher *[Painter, illustrator]* b.1888, Ambler, PA.
Addresses: Philadelphia, PA. **Studied:** PAFA; and with C. Ricciardi; & in Rome, with Sigda Pozza. **Member:** Phila. Artists All. **Exhibited:** PAFA; Woodmere Art Gal.; Warwick Gal., Artists All., Cosmopolitan Club, Nat. Lg. Am. Pen Women, all in Phila.; Douthitt Gal., NY, 1941 (solo); McClees Gal., Phila. **Awards:** Fellowship, PAFA. **Work:** Protestant Episcopal Cathedral, Roxborough, PA; Acad. Music, Phila., PA; Woodmere Art Gal., Chestnut Hill, PA. **Sources:** WW59; WW47.

TROTH, Emma *[Miniaturist, illustrator, teacher]* b.1869, Phila.
Addresses: Phila., PA. **Studied:** Hovendon; Vonnoh; Pyle; PAFA. **Exhibited:** PAFA Ann., 1895, 1899, 1902-05. **Sources:** WW25; Falk, *Exh. Record Series.*

TROTH, Henry *[Photographer]* b.1860 / d.1945.
Addresses: Phila. PA. **Exhibited:** Awards: 30 medals worldwide. **Comments:** A founder of the Photographic Salon, c.1900.

TROTT, Benjamin *[Itinerant miniature and portrait painter]* b.1770, Boston, MA / d.1843, Washington, DC.
Member: Society of Artists, 1806-19. **Work:** NYHS; Univ. Kentucky Art Mus., Lexington. **Comments:** Active in NYC in 1793-94, where he was associated with Gilbert Stuart; he followed

Stuart to Philadelphia and was there from 1794-97. He traveled to Albany and Phila. in 1798, and was again in NYC 1798-99. He was in Phila. again in 1804, went to Lexington, Kentucky, the following year, but settled back in Phila. in 1806 and remained there until 1819. During this period he lived with Thomas Sully (see entry). In 1819-20 he went to Norfolk (VA) and Charleston (SC). He returned to Phila. about 1823 but soon after moved to Newark (NJ), remaining there until 1829. From 1829-33 he was living in NYC; in 1833-34 he was at Boston; from 1838-41 he was in Baltimore. **Sources:** G&W; Bolton, "Benjamin Trott"; Dunlap, *Diary;* Dunlap, *History;* DAB; Bolton and Tolman, "Catalogue of Miniatures by or Attributed to Benjamin Trott"; Rutledge, PA; Cowdrey, AA & AAU; obit., Washington *National Intelligencer,* Nov. 29, 1843. More recently, see NYHS Catalogue (1974), cat. no. 1344; Jones and Weber, *The Kentucky Painter from the Frontier Era to the Great War,* 67 (w/repro.); Gerdts, *Art Across America,* vol. 2: 47, 155.

TROTTA, Giuseppe *[Painter]* b.1884, Avigliano, Italy / d.1957, Queens, NY.
Addresses: Flushing, NY. **Exhibited:** AIC, 1913, 1920, 1922; PAFA Ann., 1913, 1917-18, 1925; Corcoran Gal biennials, 1919-26 (4 times); S. Indp. A., 1940-42. **Sources:** WW27; Falk, *Exh. Record Series.*

TROTTA, Joseph H. See: **TROTTA, Giuseppe**

TROTTER, Anna M. *[Painter]* 20th c.
Addresses: NYC. **Sources:** WW15.

TROTTER, Mary Kempton *[Genre and figure painter]* b.1857, Phila., PA.
Addresses: Phila., PA, 1882-84; Paris, France, 1891; NYC, 1897. **Studied:** T. Eakins, Phila. Beaux-Arts Academy; T. Robert-Fleury. **Exhibited:** NAD, 1882, 1884, 1891, 1897; PAFA Ann., 1880-98 (9 times; prize 1882); Paris Salon, 1885, 1887, 1889; SNBA, 1890-94, 1897, 1899; Phila. WCC; SAA; Boston AC; St. Louis Expo, 1898; AIC; NYSF. **Sources:** WW01; Fink, *American Art at the Nineteenth-Century Paris Salons,* 359 (Fink notes that her name appeared incorrectly in records as Irotter), 398; Falk, *Exh. Record Series.*

TROTTER, Newbold Hough (or N. W.) *[Animal and landscape painter]* b.1827, Philadelphia, PA / d.1898, Philadelphia, PA.

N.H.Trotter.

Addresses: Philadelphia, PA, 1872-75, 1881, 1883; Boston, MA, 1880. **Studied:** PAFA; The Hague, with T. van Starkenborg; mostly self-taught. **Member:** A. Fund S.; Phila. SA. **Exhibited:** PAFA Ann., 1858-69, 1876-87; Boston Athenaeum; NAD, 1871-86; Brooklyn AA, 1881-82; Phila. AC, 1898. **Work:** War Dept.; Penn. RR; Smithsonian; Valley Nat. Bank, Arizona. **Comments:** He apparently traveled in the western plains and California; also made a trip to North Africa. **Sources:** G&W; *Art Annual,* I, obit.; CAB; Rutledge, PA; Swan, BA; Met. Mus., *Life in America,* repro.; *Portfolio* (May 1951), 213, repro.; WW98; P&H Samuels, 490 (report death place as Atlantic City, NJ); Falk, *Exh. Record Series.*

TROTTER, Priscilla *[Painter, illustrator]* 20th c.; b.Boston, MA.
Addresses: Rockport, MA. **Studied:** BMFA Sch.; PAFA, with George Harding, Henry McCarter, Daniel Garber; Cresson traveling scholarship, 1925; Grand Central Art Sch., with Harry Ballinger. **Member:** Rockport AA; North Shore AA. **Comments:** Illus., national magazines and girl's books. **Sources:** *Artists of the Rockport Art Association* (1956).

TROTTER, Robert (Bryant) *[Painter, designer, illustrator]* b.1925, Norfolk, VA.
Addresses: Norfolk, VA. **Studied:** Maryland Inst. FA, with Howard Frech, Jacques Maroger; ASL, with Julian Levi, John Carroll. **Member:** ASL; AEA; Tidewater A.; Maryland Inst. Alumni. **Exhibited:** Ogunquit A. Center, 1951; Norfolk Mus. A. & Sciences, 1952 (solo); Butler Inst. Am. A., 1952, 1954, 1956, 1958, 1960; L.D.M. Sweat Mus., 1953; PAFA, 1953; G.W.V.

Smith Mus., 1953, 1954; Sheppard Mem. Lib., 1954 (solo); Springfield Mus., 1958; Delgado Mus., 1954; Ball State Col., 1956-1965; Vanderbilt Univ., 1957 (solo); Wichita AA, 1959; Norfolk Mus. A.; 1951, 1953, 1954, 1955, 1957-1964; Jersey City Mus., 1952, 1958; Massillon Mus., 1952, 1954, 1957; Canton AI, 1953; VMFA, 1953, 1959; Pa. State T. Col., 1953; Ohio State Fair, 1953, 1954; Ohio WC Soc., 1953; Wilmington A. Center, 1953-1955; Bishop Col., 1954; Va. Beach AA, 1959; Valentine Mus., 1960: Montgomery Mus. FA, 1961, 1965; W. Va. Wesleyan Col., 1962; Mint Mus. A., 1962; Newport AA, 1962; Cooperstown AA 1962; Smithsonian traveling exhs.; other traveling exhs., Norfolk Mus. A., 1954, 1962, 1964; VMFA, 1953, 1959; Canton AI, 1953, Ohio WC Soc., 1953; Studio Gld., 1954, 1955, 1956; Va. State Col., 1965. **Work:** Norfolk Mus. A. & Sc.; Massillon Mus.; Humble Oil Co. Coll.; Montgomery Mus. FA; mural and mem. port., St. Agnes Church, Mingo Junction, Ohio; mem. painting, High Street Methodist Church, Franklin, Va. Work included in Prize Winning Paintings, 1961. **Comments:** Contributor illus. to *Blue Jackets Manual.* Positions: Hd. A. Dept., College of Steubenville, Ohio, 1952-54; Dir., Studio Sch., Steubenville, 1954-55; Hd., Visual Presentation Div., U.S. Naval Aviation Safety Center, Norfolk, Va. 1955-. **Sources:** WW66.

TROUARD *[Sculptor] mid 19th c.; b.Louisiana.*
Addresses: New Orleans in 1848 and at Paris in 1850.
Comments: Described in New Orleans *Courier,* July 6, 1848, and *Bee,* Dec. 28, 1850 as "a young, self-taught native of Louisiana." *Cf.* Justinian Trudeau. **Sources:** G&W; *Encyclopaedia of New Orleans Artists,* 379, which lists Mr. D. Trouard as a sculptor from France, who did portrait busts of blacks in 1848 and by 1850 wanted to return to France.

TROUARD, Mr. D. See: **TRUDEAU, Justinian**

TROUBETZKOY, Amelie Rives *[Writer, portrait and landscape painter] b.1863, Richmond, VA / d.1945, Albemarle County, VA.*
Addresses: NYC/Castle Hill, Albemarle County, VA. **Studied:** Mobile, AL, 1870; Paris, France, 1889. **Comments:** Primarily a writer of novels, poems, stories and plays, she painted for her own pleasure throughout her life. Married to Pierre Troubetzkoy (see entry) in 1896. **Sources:** Wright, *Artists in Virgina Before 1900.*

TROUBETZKOY, Paul *[Sculptor] b.1866, Lago Maggiore / d.1938.*
Addresses: Paris, France/Lago Maggiore, Milan, Italy. **Studied:** Italy; Russia; France. **Exhibited:** PAFA Ann., 1898-99, 1903-04; Paris Expo, 1900 (prize). **Work:** Luxembourg, Paris; National Gal., Rome; National Gal., Venice; Mus. of Alexander III, Petrograd; Treliakofsky Gal.; Moscow; Nat. Gal., Berlin; Royal Gal., Dresden; Leipzig Gal.; AIC; Detroit Inst.; TMA; Buffalo FA Acad.; de Young Mus.; Golden Gate Park Mus.; Mus. Buenos Aires; Brera Mus., Milan. **Sources:** WW38; Falk, *Exh. Record Series.*

TROUBETZKOY, Pierre *[Portrait painter] b.1864, Milan, Italy / d.1936, Charlottesville, VA.*
Addresses: London, England, 1894-96; Cobham, Albemarle County, VA. **Studied:** Ranzoni; Cremona. **Member:** S. Wash. A. **Work:** portraits, Nat. Gal. (Edinburgh), Nat. Portrait Gal., London; Town Hall of Dover; Inst. de Valencia de Don Juan, Madrid; Univ. Va., Charlottesville. **Comments:** Russian nobleman who came to the U.S. in 1896. Married to Amelie Rives (see entry) that same year; they made their home in Wash., D.C., NYC and Albemarle County, VA. **Sources:** WW33; Wright, *Artists in Virgina Before 1900.*

TROUCHE, Auguste Paul *[Landscape painter] b.Charleston, SC / d.1846, Charleston, SC.*
Addresses: Charleston, SC, 1835-46. **Sources:** G&W; Rutledge, *Artists in the Life of Charleston.*

TROUK, Adell Henry *[Teacher] b.1855, Vienna, Austria / d.1934, New Haven, CT.*
Addresses: NYC. **Exhibited:** S. Indp. A., 1932-33. **Comments:**

Positions: T., Vienna, Russia, Brazil, Europe; established a fine arts school in NYC, 1920. She also appers as Adell Henrie Trouk-Delor. **Sources:** Marlor, *Soc. Indp. Artists.*

TROUK-DELOR, Adell Henrie See: **TROUK, Adell Henry**

TROUNSTINE, Syl. F. *[Painter] 20th c.*
Addresses: Cincinnati, OH. **Member:** Cincinnati AC. **Sources:** WW24.

TROUSSET, Leon *[Painter] 19th c.; b.France.*
Addresses: California, active 1870s, 1880s. **Work:** Oakland Mus.; Santa Cruz Mus.; Amon Carter Mus., Ft. Worth, TX; Carmel Mission; Mus. of NM; Our Lady of Refuge Parish, Castroville, CA; Calif. State Lib.; Philadephia Academy of Natural Sciences. **Sources:** Hughes, *Artists of California,* 565.

TROUT, Dorothy Burt See: **TROUT, (Elizabeth) Dorothy Burt**

TROUT, (Elizabeth) Dorothy Burt *[Painter, illustrator, teacher] b.1896, Fort Robinson, NE. / d.1977, Wash., DC.*
Addresses: Wash., DC. **Studied:** Corcoran Sch. Art with E.C. Messer, B. Perrie, C. Critcher; Europe; Provincetown with C.W. Hawthorne; E.A. Webster; H. Giles. **Member:** Soc. Wash. Artists; WCC; Provincetown AA; Wash. AC (charter mem.). **Exhibited:** Wash. AC, 1922 (solo), 1927 (solo), 1970 (solo). **Comments:** Married Charles Judson Watts in 1931. Teaching: Washington DC public schools. **Sources:** WW33; McMahan, *Artists of Washington; DC* Petteys, *Dictionary of Women Artists,* cites birth date of 1892.

TROUTMAN, Ivy *[Painter] 20th c.*
Addresses: Bangor, ME. **Exhibited:** S. Indp. A., 1924. **Sources:** Marlor, *Soc. Indp. Artists.*

TROUVELOT, L. *[Lithographer] mid 19th c.*
Addresses: Boston, 1860. **Sources:** G&W; Boston BD 1860.

TROVA, Ernest Tino *[Sculptor, painter] b.1927, Saint Louis, MO.*
Addresses: Saint Louis, MO. **Studied:** self-taught. **Exhibited:** Documenta IV, Kassel, Ger; Los Angeles Co Mus Art, Calif; Guggenheim Mus; Jewish Mus, New York; Nat MOMA, Tokyo, Japan; WMAA; Pace Gallery, NYC, 1970s. **Work:** paintings, MOMA; Tate Gallery, London; Am Container Corp; sculpture, MOMA, WMAA; Guggenheim Mus; City Art Mus, Saint Louis. **Comments:** Between 1959 and 1963 Trova made assemblages and collages from urban refuse. By 1961 he had begun exploring his Falling Man theme in painting, evolving the subject into sculpture as well. In the early 1970s he created his Profile Cantos series. **Sources:** WW73; Baigell, *Dictionary.*

TROVATO, Anna *20th c.*
Studied: ASL. **Exhibited:** S. Indp. A., 1932; Salons of Am., 1934. **Sources:** Falk, *Exhibition Record Series.*

TROVATO, Joseph S. *[Painter, curator] b.1912, Guardavalle, Italy / d.1983, Utica, NY.*
Addresses: Clinton, NY. **Studied:** ASL New York; Nat Acad Design; Sch Related Arts & Sci, Utica, NY; Muson-Williams-Proctor Inst Sch Art; Hamilton Col, hon DFA, 1963. **Exhibited:** Munson-Williams-Proctor Inst; Utica Col; Albany Inst Hist & Art; EW Root Art Ctr, Hamilton Col; Everson Mus Art; S. Indp. A. **Work:** Munson-Williams-Proctor Inst; Utica Col; Libr Cong, Washington, DC. **Comments:** Came to US c.1920. Positions: Asst to dir, Munson-Williams-Proctor Inst, 1939-; in charge exhib prog, Edward W Root Art Ctr, Hamilton Col, 1958-; field researcher for NY State, Arch Am Art for The New Deal and the Arts, 1964-1965; consult, NY State Coun on the Arts. Teaching: Vis asst prof art, Hamilton Col, 1965-1966. Collections Arranged: Charles Burchfield, 1962; 50th Anniversary Exhib of the Armory Show, 1963; Edward Hopper, 1964; Learning About Pictures from Mr Root, 1965; 125 Years of New York Painting and Sculpture for NY State Coun on the Arts; The Nature of Charles Burchfield (Mem Exhib incl catalogue), Munson-Williams-Proctor Inst,

1970. Publications: Contribr, *Art in Am.* **Sources:** WW73.

TROWBRIDGE, Alexander B. *[Landscape painter, architect, lecturer, writer]* b.1868, Detroit, MI.
Addresses: Wash., DC, 1920s, 1930s; Winter Park, FL. **Studied:** Cornell; Ecole des Beaux-Arts, Paris, with M. Lambert. **Member:** Arch. Lg.; Soc. Beaux-Arts Arch.; AFA. **Exhibited:** Smithonian, 1935 (solo). **Comments:** Position: dir., American Federation of Arts, 1928-29. Contributor: "Planning and Building the City of Washington." **Sources:** WW40; McMahan, *Artists of Washington, DC.*

TROWBRIDGE, Carrie A. *[Artist]* late 19th c.
Addresses: Newark, NJ, 1886. **Exhibited:** NAD, 1886. **Sources:** Naylor, *NAD.*

TROWBRIDGE, Gail *[Painter, lithographer, teacher]* b.1900, Marseilles, IL.
Addresses: Provincetown, MA; East Orange, NY. **Studied:** Columbia Univ., B.S., M.A. **Member:** NAWA; N.Y. Soc. Women A.; Provincetown AA; Artists of Today, Newark, N.J.; Com. A. Edu.; Assoc. A. New Jersey. **Exhibited:** NAWA, 1938-1946 (prize, 1940); Argent Gal., 1945 (prize); Women's Intl. AC, England, 1946; MMA, 1942; Newark Mus.; N.Y. Soc. Women A., 1945, 1946; Riverside Mus., 1944; Wash. AC, 1945 (solo); Artists of Today, Newark (solo); Montclair A. Mus.; Assoc. A. New Jersey, 1958; Hunterdon County A. Center. **Work:** Newark Mus. **Comments:** Position: Supv. A.Edu., Elementary Sch., Millburn, N.J., 1930-59. Lectures: Children's Art Work. **Sources:** WW59; WW47.

TROWBRIDGE, Helen (Fox) *[Sculptor]* b.1882, New York.
Addresses: Port Washington, LI, NY; Glen Ridge, NJ. **Sources:** WW17.

TROWBRIDGE, Henrietta Funsch (Mrs.) See: FUNSCH, Edyth Henrietta (Mrs.)

TROWBRIDGE, Irene Underwood (Mrs. Miles C.) *[Painter, craftsperson, graphic artist, teacher]* b.c.1898, Pittsburg, KS.
Addresses: Sherwood Forest, MD. **Studied:** AIC. **Member:** Nat. Lg. Am. Pen Women; AAPL(DC director). **Exhibited:** Fed. Women's Club, MD, 1936 (prize); Wash., DC, 1938 (prize); Soc. Wash. Artists, 1939; Maryland Inst., 1939; Int. House, Wash., DC, 1939 (solo). **Work:** Fed. Women's Club, Wash., DC. **Comments:** Position: head, art dept., College of Steubenville, OH; staff, Army Map Service, Wash., DC. **Sources:** WW53; WW47. More recently, see McMahan, *Artists of Washington, DC.*

TROWBRIDGE, Lucy Parkman *[Painter]* 19th/20th c.
Addresses: New Haven, CT, c.1892; NYC, c.1898-1900. **Member:** New Haven PCC, 1900 (charter exh.). **Exhibited:** SAA, 1898; Soc. Beaux-Arts, Paris, 1896-98. **Comments:** She also appears as Lucy Trowbridge Ingersoll. Committee member for Columbian Expo, Chicago, 1893. **Sources:** WW01; Fink, *American Art at the Nineteenth-Century Paris Salons*, 398.

TROWBRIDGE, M. O. (Mrs.) *[Portrait painter]* late 19th c.
Addresses: Indianapolis, IN, 1879-93. **Sources:** Petteys, *Dictionary of Women Artists.*

TROWBRIDGE, N. C. *[Listed as "artist"]* b.c.1830, Massachusetts.
Addresses: New Orleans in 1860. **Sources:** G&W; 8 Census (1860), La., VI, 491.

TROWBRIDGE, Stella *[Painter]* 20th c.
Exhibited: S. Indp. A., 1921. **Sources:** Marlor, *Soc. Indp. Artists.*

TROWBRIDGE, Vaughan *[Etcher, painter]* b.1869, NYC. / d.1945, Paris, France.
Addresses: Paris, France/NYC. **Studied:** Geo. deF. Brush and J.H. Boston, in NYC; Académie Julian, Paris with J.P. Laurens and Constant, 1897. **Comments:** Specialty: street scenes in aquatint. Illustrator: *Paris and the Social Revolution.* **Sources:** WW17.

TROXEL, Annette Shevelson *[Painter]* mid 20th c.
Addresses: Chicago area. **Exhibited:** AIC, 1948. **Sources:** Falk, AIC.

TROY, Adrian *[Engraver, painter, illustrator, lecturer]* b.1901, Hull, England / d.1977, Memphis, TN.
Addresses: Chicago, IL. **Member:** Am. Ar. Cong.; Chicago Soc. Ar. **Exhibited:** Phillips Memorial Gallery, Wash., DC; AIC, 1938; WFNY, 1939; LOC; SFMA, 1941, 1944, 1946; WMAA, 1942; PMG; Fort Huachuca, Ariz., 1943. **Work:** CI; AIC; Evansville State Hospital; Univ. Ill.; Chicago Normal Col. **Sources:** WW53; WW47; Cederholm, *Afro-American Artists;* add'l info. courtesy Anthony R. White, Burlingame, CA.

TROY, C. P. *[Landscape painter]* 19th c.
Addresses: Petaluma, CA. **Exhibited:** Calif. State Fair, Sacramento, 1880. **Sources:** Hughes, *Artists of California*, 566.

TROY, Edouard de See: **TROYE, Edward**

TROY, Lota Lee *[Craftsperson, designer, teacher]* b.1874, Guilford County, NC. / d.1963.
Addresses: New Orleans, LA/Greensboro, NC. **Studied:** Greensboro Coll, NC, 1888-1902; A.W. Dow; AIC; J. Mason; W. Roach. **Member:** NOAA; SSAL; Southeastern AA; Gld. Bookworkers, N.Y. **Exhibited:** NOAA, 1914. **Comments:** Position: Dir., Sch. A., Newcomb College, 1928-1940. Specialized in bookbinding and design as well a teaching drawing, watercolor and art education. **Sources:** WW40; *Encyclopaedia of New Orleans Artists*, 380.

TROY, Minerva Elizabeth *[Painter, teacher, craftsperson]* b.1878, Vassar, MI.
Addresses: Port Angeles, WA, 1941. **Studied:** with Gustave Kalling; Franz Bishoff. **Exhibited:** Clallum County Fair, 1938; Woman Literary Club, 1937. **Comments:** Position: teacher, WPA. Was chosen to design postage stamp for Olympic Nat. Park. **Sources:** Trip and Cook, *Washington State Art and Artists, 1850-1950.*

TROYE, Edward *[Animal, portrait, and figure painter]* b.1808, near Lausanne, Switzerland / d.1874, Georgetown, KY.
Addresses: primarily in Kentucky. **Studied:** possibly with Jacques-Laurent Agasse, an animal painter. **Exhibited:** PAFA, from 1832; St. Charles Exchange, New Orleans, 1845; City Hotel, New Orleans, 1853; Odd Fellows' Hall, New Orleans, 1857. **Work:** VMFA; Yale Univ. Art Gallery, New Haven, CT; Bethany College, WV (replicas of Troyes' series of five "Oriental Paintings"); Univ. Kentucky Art Mus., Lexington, KY; U.S. Capitol Bldg; Historic Columbia Fndtn, SC. **Comments:** A specialist in portraits of race horses, he grew up in London, the son of a French refugee sculptor, Jean-Baptiste de Troye. The younger Troye came to the U.S. via the West Indies in 1828, settling in Philadelphia in 1831 and working for *Sartain's Magazine.* In 1832, in the one and only time he showed his horse paintings at the PAFA, he drew the attention of racehorse breeders, and his career was launched. Over the next several years, he traveled through Virginia; Charleston, SC (1833); Tennessee; and Kentucky (1834); painting on commission. He returned to Kentucky in 1837, remaining there (with some travel) until 1849 further cementing his reputation as a painter of prize racehorses. From 1849-55, he lived in Mobile, AL, teaching painting at Spring Hill College. In 1855-56, Troye visited the Near East with Alexander Keene Richards, a Kentucky horseman. There Troye painted Arabian horses for Richards and also did a series of "Oriental Paintings" which he later showed in New Orleans (1857) and New York City. Although Troye continued to travel the South after returning from his trip to the Near East, most of the years between 1857-69 were spent in Kentucky. Among his most famous racehorse pictures from this period is "The Undefeated Asteroid" (1864, VMFA). He visited New Orleans in 1844, 1853, and 1857. In 1867, he published the first but only volume of a

proposed series, *The Race Horses of America*. In 1869, Troy moved to Huntsville, AL. **Sources:** G&W; DAB; Fairman, *Art and Artists of the Capitol*, 319-20; *Panorama* (Oct. 1945), 12; Rutledge, *Artists in the Life of Charleston;* Rutledge, PA; Cowdrey, AA & AAU; WPA Guide, *Alabama; Picayune,* Dec. 18, 1844, *Courier,* Jan. 19, 1853, and *Orleanian,* April 2, 1857; Met. Mus., *Life in America; Encyclopaedia of New Orleans Artists,* 380; Gerdts, *Art Across America,* vol. 2: 83 (repro.), 158-59 (repro.); Jones and Weber, *The Kentucky Painter from the Frontier Era to the Great War,* 67-68 (w/repros.) ; *300 Years of American Art,* vol. 1, 141.

TRUAX, Sarah Elizabeth *[Painter, miniature painter, teacher]* b.*Marble Rock, IA / d.1959, National City, CA.*
Addresses: San Diego, CA, from 1917. **Studied:** AIC, 1907-09; & with John Vanderpoel, Freer, Clarkson, Howard Pyle, Alphonse Mucha, Joaquin Sorolla. **Member:** San Diego Artists Gld.; La Jolla AA; Baltimore WCC; Women Painters of the West; Calif. Soc. ASL Chicago; Art Guild Member of FA Assoc. of San Diego (secretary, treasurer, 1917-37); Baltimore WCC; California Soc. Min. Painters; FA Soc. of San Diego; California Women of Prominence. **Exhibited:** Pan-Pacific Expo, 1915 (medals), 1951 (medal); Los Angeles County Fair, 1928 (prize); GGE, 1939; California-Pacific Int. Expo, 1935; PAFA, 1927-30, 1932; Brooks Mem. Art Gal.; Detroit Soc. Arts & Crafts, 1928, 1929; Los Angeles Soc. Min. Painters; Grand Central Art Gal., 1930; Oklahoma College for Women; Ft. Worth Mus. Art; Witte Mem. Mus.; Pacific Southwest Exh., Long Beach, CA; BMA; San Diego FA Soc., 1926-39, 1945, 1946; Sacramento (CA) State Fair, 1930-1936 (medal); Phoenix (AZ) State Fair, 1932; Pennsylvania Soc. Min. Painters; Am. Soc. Min. Painters; La Jolla AA. **Work:** San Diego FA Soc.; Women's Club, Lidgerwood, ND; First Unitarian Church, San Diego, CA. **Comments:** Position: teacher, San Diego AG, 1925-29. **Sources:** WW59; WW47; Ness & Orwig, *Iowa Artists of the First Hundred Years,* 208-09.

TRUBACH, Ernest Sergei *[Painter, graphic artist, writer, lecturer, teacher]* b.*1907, Ukraine, Russia.*
Addresses: NYC. **Studied:** NAD. **Member:** Rockport A. Group; Am. Ar. Cong.; United Am. Ar.; Allied Ar. Am. **Exhibited:** NAD, 1928 (prize), 1930 (prize), 1929 (Mooney Traveling F.), 1929 (med); PAFA Ann., 1930, 1938, 1946; S. Indp. A., 1931, 1937, 1940; AIC, 1937, 1940; CI, 1938; Corcoran Gal biennial, 1939; WFNY, 1939; GGE, 1939; VMFA, 1946; Nierendorf Gal., 1946; ACA Gal., 1946; Art of This Century, 1946. **Work:** Biro-Bidjan Mus., Russia; Fed. Bldgs., Wash., DC; Mt. Morris Hospital, NY; Port Chester (NY) Jr. H.S.; Theodore Roosevelt H.S., NY; Barnard Col. **Sources:** WW47; Falk, *Exh. Record Series.*

TRUBACH, Serge E. *[Painter, graphic artist, writer, lecturer, teacher]* b.*1909, Russia.*
Addresses: New York 16, NY. **Studied:** NAD. **Member:** Rockport A. Group. **Exhibited:** Carnegie Inst., 1938; PAFA, 1938, 1946; CGA, 1939; WFNY, 1939; GGE, 1939; VMFA, 1946; Nierendorf Gal., 1946; ACA Gal., 1946; Art of This Century, 1946. **Work:** Biro-Bidjan Mus., Russia; Fed. Bldgs., Wash. D.C.; Mt. Morris Hospital, N.Y.; Port Chester Jr. H. S., Long Island, N.Y.; Theodore Roosevelt H.S., N.Y.; Barnard Col. **Sources:** WW53.

TRUBEE, John *[Painter, teacher]* b.*1895, Buffalo, NY / d.1964, NYC.*
Addresses: New York, NY. **Studied:** Lafayette Col; ASL; in Paris; & with Henri, Leger, Ozenfant, Rodin, Marchand. **Member:. Exhibited:** Salons of Am., 1934; NAD, 1938; AFA traveling exh. **Sources:** WW53; Marlor, *Salons of Am.;* WW47.

TRUBNER, Henry *[Art historian]* b.*1920, Munich, Germany.*
Addresses: Seattle, WA. **Studied:** Fogg Art Mus, Harvard Univ, BA & MA. **Member:** Asia Soc (mem adv comt); Japan Soc; Oriental Ceramic Soc, London; Col Art Asn Am; Am Oriental Soc. **Comments:** Positions: Cur Oriental art, Los Angeles Co Mus Art, 1947-1958; cur Far Eastern Dept, Royal Ont Mus, Toronto, 1958-1968; cur Dept Asiatic Art, Seattle Art Mus, Wash, 1968-. Publications: Auth, "Chinese Ceramics," Los Angeles Co Mus Art,

1952; auth, "Arts of the T'ang Dynasty," 1957; auth, "Arts of Han Dynasty," Viennese Art Soc, 1961; co-auth, "Art Treasures from Japan," 1965-1966; auth, "Ceramic Art of Japan: 100 Masterpieces from Japanese Collections," Kodansha Int, Tokyo, 1972. Teaching: Assoc prof Asian art, Univ Toronto, 1958-1968. Collections Arranged: Chinese Ceramics; Arts of T'ang Dynasty, Los Angeles Co Mus Art, 1952 & 1957; Arts of Han Dynasty, Chinese Art Soc, Asia House, 1961; Ceramic Art Japan: 100 masterpieces From Japanese Collections, Seattle Art Mus, Nelson Art Gallery, Asia House & Los Angeles Co Mus Art, 1972-1973. Research: Japanese ceramics. **Sources:** WW73.

TRUCHAS MASTER *[Painter]* 18th/19th c.
Addresses: New Mexico. **Comments:** Active 1780-1840. Previously known as the "Calligraphic Santero," an Hispanic creator of religious images, now named for his two major works located in the church of Nuestra Señora del Rosario de las Truchas, near Santa Fe, NM. **Sources:** Eldredge, et al., *Art in New Mexico, 1900-1945,* 208.

TRUCKSESS, Frances See: **HOAR, Frances**

TRUCKSESS, F(rederick) C(lement) *[Painter, teacher]* b.*1895, Brownsburg, IN.*
Addresses: Boulder, CO. **Studied:** E.C. Taylor; E. Savage; W. Forsyth. **Member:** Boulder AG; Prospectors. **Exhibited:** Ind. State Fair, 1922 (prize); Denver A. Mus., 1933 (prize). **Work:** Jefferson Sch., La Fayette, Ind.; stage curtain and mural, Univ. Colo. **Sources:** WW40.

TRUDEAU, James De Berty, Dr. *[Painter, sculptor]* b.*1817, Jefferson Parish, LA / d.1887, New Orleans, LA.*
Addresses: New Orleans, active 1840, 1856-87. **Exhibited:** American Expo., 1885-86. **Comments:** Born on his family's sugar plantation near New Orleans, he was educated as a physician in Europe and the U.S. He became a friend of John James Audubon (see entry) and assisted his friend's research on birds. He made watercolor drawings (ca.1837-38) of bird eggs collected by Audubon on his Labrador expedition, and Audubon named the Trudeau tern after him. In 1840 Trudeau joined Victor Tixier on an expedition to St. Louis, MO and the Osage Indian country and briefly returned to N.O. by the end of the year, but resumed his medical practice in NYC, 1843-52. By 1856 he was established in N.O., where he practiced and lived for the rest of his life. As an artist he became known for his work with pencil and brush and his humorous statuettes of N.O. citizens from the past. **Sources:** *Encyclopaedia of New Orleans Artists,* 381.

TRUDEAU, Justinian *[Sculptor]* b.c.*1827, Louisiana.*
Addresses: Active in New Orleans from 1849 to 1854. **Comments:** In 1850 he exhibited his self-portrait. *Cf.--Trouard.* **Sources:** G&W; 7 Census (1850), La., VII, 309; Delgado-WPA cites *Courier,* June 27, 1849, *Bee,* Aug. 24, 1850, and New Orleans CD 1851-54.

TRUDEAU, Yves *[Sculptor]* b.*1930, Montreal, PQ.*
Addresses: Montreal, PQ. **Studied:** Ecole Beaux Arts Montreal, sr matriculant with Marie Mediatrice. **Member:** Can Conf Arts (councellor, 1967-1968); Asn Sculpteurs Quebec (pres, 1960-1966); Int Conf Mus; Int Asn Plastic Art. **Exhibited:** Third Int Contemp Sculpture Biennial, 1966 & Panorama Sculpture Quebec, 1970, Mus Rodin, France; Int Sympt Sculpture, Ostrava, 1969; solo show, Mus Quebec, 1970; Biennale Middle-heim, Anvers, Belg, 1971; Premiere Biennale Petite Sculpture, Budapest, Hungary, 1971. **Awards:** Can Coun Awards, 1963 & 1969; Ministere Educ Quebec Award, 1970-1971. **Work:** Mus Quebec; Galerie Nat Can; Mus Art Contemporain Montreal; Mus Art Prague, Czech; Mus Plein Air D'Ostrava, Czech. **Commissions:** Vivace, J M C Camp Musical, Mont-Orford, PQ, 1960; Vie Interieur, comn by N D De L'Enfant, Sherbrooke, PQ, 1966; Phare Du Cosmos, Expo 1967, Universe Plaza, 1967; concrete relief, Univ Sherbrooke; bronze relief, Ecole Arts & Metiers De Riviere-Du-Loup, PQ, 1968. **Comments:** Preferred media: bronze, plexiglass, steel. Publications: auth, article, in: *Metiers D'Arts Quebec,* 1963; co-auth, catalogue, *Galerie Nat Can,* 1966;

auth, catalogue, *Confrontation 67,* 1967. Teaching: Prof sculpture, Ecole Beaux-Arts Montreal, 1967-1969; prof sculpture concept & metal, Univ Quebec, Montreal, 1969-. **Sources:** WW73; Robert Guy, *Yves Trudeau, sculptor* (Asn Sculpteurs Quebec, 1971).

TRUE, Allen Tupper *[Painter, illustrator, decorator]* b.1881, Colorado Springs / d.1955, Denver, CO.
Addresses: Denver, CO. **Studied:** Univ. Denver; CGA School; H. Pyle, 1902-08; F. Brangwyn, in London, 1910s; France, 1924. **Member:** Denver AA; Mural Painters; Arch. Lg.; Royal Soc. A., England (fellow). **Work:** decorator (assisted F. Brangwyn), Pan-Pacific Expo, 1915; dome of Missouri Capitol; murals, Wyoming Capitol; Montana Nat. Bank, Billings; Public Library, Greek Theatre, Civic Center, Voorhees Mem. Arch, Colorado Nat. Bank, Mountain States Telephone Bldg., all in Denver; pendentives in dome, Missouri Capitol, Jefferson City; Taylor Day Nursery, Colorado Springs; Indian pottery design applied to barrel vault ceiling, U.S. Nat. Bank Bldg., Denver; color consultant, Power Plant, Boulder Dam; murals, Brown Palace Hotel, Denver. **Comments:** Illustrator: *Harper's, Collier's, Saturday Evening Post;* "Song of the Indian Wars." Designed bucking horse for Wyoming license plates. **Sources:** WW40; Peggy and Harold Samuels, 490-91.

TRUE, Benjamin C. *[Engraver, seal engraver, and die sinker]* mid 19th c.
Addresses: Cincinnati, 1850-60. **Sources:** G&W; Cincinnati CD 1850-60.

TRUE, Daniel *[Die sinker and seal engraver]* mid 19th c.
Addresses: Albany, NY, 1853-60. **Comments:** Of True & Pilkington in 1856-57. **Sources:** G&W; Albany CD 1853-60.

TRUE, Dorothy *[Painter]* 20th c.
Addresses: NYC. **Studied:** ASL. **Exhibited:** S. Indp. A., 1917-18. **Sources:** WW17.

TRUE, Frank Leslie *[Painter]* b.1877, Iowa / d.1963, Santa Cruz, CA.
Addresses: Santa Cruz, CA. **Member:** Santa Cruz Art League. **Comments:** Specialty: coastal scenes and landscapes of Northern Calif. **Sources:** Hughes, *Artists of California,* 566.

TRUE, George A. *[Etcher, painter]* b.1863, Funchal, Madeira.
Addresses: Detroit, MI. **Studied:** Western Reserve Sch. Des., Cleveland. **Member:** Detroit Fine Arts Soc.; Detroit WC Soc.; Hopkin Club; Scarab Club. **Exhibited:** AIC, 1897-98. **Comments:** He settled in Detroit in 1863. **Sources:** WW19; Gibson, *Artists of Early Michigan,* 229.

TRUE, Grace H(opkins) (Mrs. E.D.A.) *[Painter]* b.1870, Frankfort, MI.
Addresses: Melbourne City, FL. **Studied:** J.P. Wicker; F. Fursman. **Member:** Orlando AA; SSAL; Detroit Soc. Women P&S, (member, 1911). **Exhibited:** Tampa Fed. Artists, 1930 (prize); Orlando Fair, 1939 (prize); Detroit Soc. Women P&S. **Sources:** WW40.

TRUE, Lilian Crawford (Mrs. John P.) *[Illustrator]* 20th c.; b.Boston.
Addresses: Waban, MA. **Studied:** Cowles Art Sch., Boston, with T. Juglaris. **Comments:** Worked for leading Boston publishers. **Sources:** WW08.

TRUE, Luella (Evelyn) Shaylor Harmon See: **HARMON, Luella (Evelyn) Shaylor**

TRUE, Marguerite Neale *[Painter]* d.1964, Wash., DC.
Addresses: Wash., DC, active early 1900s-1964. **Member:** Soc. of Wash. Artists; Wash. WCC; Wash. AC. **Sources:** WW29 (as Neale); McMahan, *Artists of Washington, DC* (as True).

TRUE, Virginia *[Painter, educator]* b.1900, Saint Louis, MO.
Addresses: Ithaca, NY; South Yarmouth, MA. **Studied:** John Herron AI, dipl painting, 1924 with William Forsyth; PAFA, scholar, with Merriman, 1925; John Herron Art Inst, BAE, 1931; Cornell Univ, MFA, 1937, with Christian Midjo; Columbia Univ,

summer; Univ Colo, summer; D. Garber; H. Breckenridge; C. Grafly; also in Rome, Italy, 1955. **Member:** NAWA; Prospectors; Am Fedn Arts; Cornell Andrew Dickson White Mus Art Assoc; Mus Fine Arts, Boston; Provincetown Art Assn. **Exhibited:** Denver AM, 1932 (prize), 1933 (prize); Kansas City AI, 1935 (prize); Rochester Mem. A. Gal., 1939 (prize); Annual Colo. Artistst Exh., 1932-33 (prize); Midwest Artists Exhib, Kansas City AI, 1934 (prize); AWCS; NAWA; CI; Cornell Univ.; Rochester Mem Art Gallery Ann Regional, NY, 1939 (Nelson Eddy Purchase Prize); Trends Am Art, CI, 1941; Retrospective Exhib, Andrew Dickson White Mus Art, Cornell Univ, 1965. **Work:** Painting, Colo State Univ, Fort Collins, portraits, Univ Colo, Boulder; portrait, Purdue Univ Lafayette, Ind; carved wood panel, Cornell Univ, Ithaca, NY. Commissions: Mural, hist of home econ, Col Home Econ, Cornell Univ, 1937. **Comments:** Preferred Media: Acrylics, Pastels, Ink, Oils. Positions: Bk designer & art consult, Barnes & Noble, 1948. Dealer: Cobb House Gallery, Barnstable, MA. Teaching: Art instr, John Herron Art Inst, 1926-1928; art instr, Univ Colo, Boulder, 1929-1936; from instr art to prof, Cornell Univ, 1936-1965, prof & head dept housing & design, 1945-1965, emer prof, 1965-; arts instr, Cape Cod Art Assn, summers 1968-1969. **Sources:** WW73; WW47.

TRUE & PILKINGTON *[Seal engravers and die sinkers]* mid 19th c.
Addresses: Albany, NY, 1856-57. **Comments:** Partners were Daniel True and James E. Pilkington (see entries). **Sources:** G&W; Albany CD 1856-57.

TRUEBLOOD, Stella *[Painter]* 20th c.
Addresses: St. Louis, MO. **Member:** St. Louis AG. **Sources:** WW27.

TRUELOVE, Brian *[Designer, commercial artist]* 20th c.; b.Scotland.
Studied: London, England; with Harry De Maine, Stanley Woodward. **Member:** Rockport AA; SC; North Shore AA. **Sources:** *Artists of the Rockport Art Association* (1946).

TRUEMAN, A. S. *[Painter]* 20th c.
Addresses: NYC. **Member:** GFLA. **Sources:** WW27.

TRUESDELL, Edith P(ark) *[Painter, blockprinter, teacher]* b.1888, Derby, CT. / d.1986, Carmel, CA.
Addresses: Brookvale, CO/Carmel Valley, after 1964. **Studied:** BMFA Sch., with Tarbell, Benson, Hale, Bosley. **Member:** Calif. AC; Calif. WC Soc.; Laguna Beach AA; Carmel AA. **Exhibited:** Denver AM; Denver Public Library; Laguna Beach AA; Laguna Beach Anniversary Exh., 1924 (prize); Univ. Calif., Los Angeles, 1927, 1931; Calif. WCC; Pacific Grove AC (solo); Los Angeles County Exh., Pomona, 1928 (prize); Calif. AC, Los Angeles, 1930 (gold); Los Angeles Fiesta Exh., 1931 (prize); Calif. WCS, 1934 (prize); Mus. School Centennial, Boston, 1977; Pat Carey Gal., San Francisco, 1979 (solo), 1980 (solo); Sebastian Moore Gal., Denver, 1983 (solo). **Work:** Denver Art Mus. **Comments:** Painted in oil and acrylics; also designed wallpaper. Active in Los Angeles, from 1924, in Colorado, and New England. Positions: teacher, Waynflete School, Portland, ME & YWCA Workshops, Boston. **Sources:** WW40; Petteys, *Dictionary of Women Artists.*

TRUESDELL, Gaylord Sangston *[Painter]* b.1850, Waukegan, IL / d.1899.
Addresses: Phila., PA; Paris, France; NYC, 1899. **Studied:** PAFA; Acad. Des Beaux-Arts, Paris, with Morot, Cormon. **Exhibited:** PAFA Ann., 1881-98 (5 times); Paris Salon, 1886-88, 1890-95, 1897-99; Paris Expo, 1889 (med); Salon de Champs Elysees, Paris, 1892 (med); NAD, 1899; AIC; Omaha Expo. **Comments:** Specialty: sheep. **Sources:** WW98; Fink, *American Art at the Nineteenth-Century Paris Salons,* 398; Falk, *Exh. Record Series.*

TRUETTNER, William *[Art administrator]* 20th c.
Addresses: Washington, DC. **Comments:** Positions: Cur 18th & 19th century painting & sculpture, NMAA. **Sources:** WW73.

TRUEWORTHY, Jessie (Jay) *[Painter] b.1891, Lowell, MA / d.1980, Newport Beach, CA.*
Addresses: Pasadena, CA. **Studied:** Pasadena AI; with Vesper George, Boston; Mabel Welch, N.Y.; Ejnar Hansen, Robert Frame, California; A. Woelever; E.S. Bush. **Member:** Laguna Beach AA; Calif. Soc. Min. P.; Pa. Soc. Min. P.; Pasadena AA. **Exhibited:** LACMA, 1935 (prize); PAFA, 1939-1941; Calif. Soc. Min. P., 1940 (prize); Ebell C., Los Angeles, 1944 (prize); PAFA, 1941-45; CGA, 1939, 1941; Chicago Centenn.; Grand Central A. Gal.; NYPL; BM; Brooklyn Soc. Min. P.; Smithsonian; Concord, Durham, N.H.; Pasadena A. Mus.; Dartmouth. N.H.; Laguna Beach AA. **Work:** LACMA. **Comments:** Specialty: miniatures. **Sources:** WW59; WW47. More recently, see Hughes, *Artists of California,* 566.

TRUEX, Van Day *[Painter, designer] b.1904, Delphos, KS.*
Addresses: NYC; Ménerber, France. **Studied:** Parsons Sch Design, New York, NY; Kans Wesleyan, MA. **Exhibited:** Carstairs Gal., N.Y., 1939 (solo); WMAA, 1943. **Awards:** Chevalier, Legion d'honneur, France, 1951. **Work:** Calif Palace Legion of Honor, San Francisco; Mus Univ Kans, Manhattan; Nelson Rochill Mus, Kansas City, Mo; PAFA; MMA. **Comments:** Designer, Yale & Towne Mfg Co, 1951-1953; designer, Tiffany & Co, 1951-. **Dealer:** Graham Gallery, New York, NY. **Teaching:** Pres, Parsons Sch Design, 1941-1951. **Sources:** WW73; WW40.

TRUIST, Sigmund *[Engraver] b.1822, Germany.*
Addresses: Philadelphia in 1850. **Sources:** G&W; 7 Census (1850), Pa., XLIX, 657.

TRUITT, Anne (Dean) *[Sculptor] b.1921, Baltimore, MD.*
Addresses: Washington, DC. **Studied:** Bryn Mawr Col, BA, 1943; Inst Contemp Art, Washington, DC, 1948-1949, with A. Giampietro; Kenneth Noland; Dallas Mus Fine Arts, 1950. **Exhibited:** Andre Emmerich, NYC, 1963 (solo) and periodically thereafter; Minami Gal., Tokyo, Japan, 1964-67 (2 solos); "Seven Sculptors," Inst Contemp Art, Phila., Pa, 1965; "American Sculpture of the 60's," LACMA, 1967; "The Pure & Clear: American Innovations," PMA, 1968; WMAA biennials, 1968, 1970, 1973; WMAA, solo, 1973; CGA, 1974 (solo); "Washington, Twenty Years," Baltimore Mus Art, Md, 1970; Pyramid Gallery, Wash., DC, 1970s; "200 Years of American Sculpture" WMAA, 1976; Univ. of Virginia Art Mus., Charlottesville, 1976 (solo). **Awards:** Guggenheim fel, 1971; Nat Endowment Arts, 1972. **Work:** CGA; NMAA; Saint Louis Mus Art, Mo; Univ Ariz Mus Art, Tucson. **Comments:** Minimalist sculptor. In 1961, she took tall, vertical boxes in wood (constructed to her specifications by carpenters) and painted them with simple bands of color. Most of her sculpture has been of this type. Truitt has spoken of them as "three-dimensional paintings" (see *Anne Truitt: Sculpture and Painting*) and they have been discussed as having a metaphorical presence. Preferred media: woods, acrylics. **Sources:** WW73; Rubinstein, *American Women Artists,* 361; Gregory Battcock, *Minimal Art, a Critical Anthology,* (Dutton, 1968); Clement Greenberg, "Changer: Anne Truitt, American Artist Whose Painted Structures Helped to Change the Course of Amerian Sculpture," *Vogue* (May 1968); *Two Hundred Years of American Sculpture,* 315-16; *Anne Truitt: Sculpture and Painting* (Charlottesville: Univ. of Virginia Art Mus., 1976).

TRUITT, Una B. (Mrs. J.J.) *[Painter, writer, lecturer, teacher] b.1896, Joaquin, TX.*
Addresses: Houston, TX. **Studied:** Houston Univ., A.B., M.A.; Mrs. J.O. Mills; P. Tate. **Member:** Assoc. Artists Houston; Houston AC. **Exhibited:** Local & state exh., 1932-46; Dallas MFA, 1938; Houston MFA, 1938, 1939. **Work:** Nacogdoches College FA, TX. **Comments:** Position: art supervisor, Houston City Sch., 1925-38; supervisor art for Crippled Children, Houston, TX, 1928-46. **Sources:** WW59; WW47.

TRULLINGER, John Henry *[Painter] 20th c.*
Addresses: Paris, France. **Sources:** WW10.

TRUMAN, Edith S. *[Illustrator] 20th c.; b.NYC.*
Addresses: NYC. **Studied:** K. Cox; W.A. Clark; H. Pyle.

Sources: WW08.

TRUMAN, Edward *[Portrait painter]*
Work: Massachusetts Historical Society (Governor Thomas Hutchinson of Massachusetts, 1741); The National Gallery owns his portrait of Jonathan Sewell. **Sources:** G&W; Burroughs, *Limners and Likenesses;* Smithsonian Institution, *Annual Report,* 1948.

TRUMAN, Ella S. *[Painter] 20th c.*
Addresses: New Haven, CT. **Studied:** S. Indp. A. **Exhibited:** S. Indp. A., 1921-22. **Sources:** WW27.

TRUMBULL, Alice See: **MASON, Alice Trumbull**

TRUMBULL, Anne Leavenworth (Mrs. Wm.) *[Painter] b.1865 / d.1930.*
Studied: Paris, c.1884. **Comments:** (Née Train). After her marriage to William Trumbull (a descendant of John Trumbull) in 1891 she ceased painting. Her daughters, Margaret T. Jennings and Alice T. Mason were artists; as was her granddaughter, Emily Mason. **Sources:** Petteys, *Dictionary of Women Artists.*

TRUMBULL, Edward *[Painter] 20th c.*
Addresses: Pittsburgh, PA. **Member:** Pittsburg AA. **Comments:** Position: affiliated with Carnegie Inst. **Sources:** WW15.

TRUMBULL, Gordon (or Gurdon) Jr. *[Painter] b.1841, Stonington, CT / d.1903.*
Addresses: Hartford, CT, 1861-67. **Studied:** F.S. Jewett, Hartford; James Hart, NYC. **Exhibited:** NAD, 1861-67; Snedecor's Gal., NYC, 1874; Centennial Exhib., Phila., 1876. **Comments:** His earliest paintings were landscapes and flowers but he eventually specialized in fish, accurately rendered and alive. Some of his fish works were chromolithographed and became very popular. **Sources:** *Art in Conn.: Early Days to the Gilded Age;* Clement and Hutton.

TRUMBULL, John *[Historical, portrait, miniature, religious, and landscape painter, amateur architect, cartographer] b.1756, Lebanon, CT / d.1843, NYC.*
Addresses: NYC.
Studied: Harvard Univ. 1773; advice from J.S. Copley in Boston, 1773; Benjamin West in London, 1780s. **Member:** Am. Acad FA (pres., 1817-35). **Exhibited:** Am. Acad FA; Brooklyn AA, 1872 (group of portraits). **Work:** Yale Univ. Art Gallery, New Haven CT (largest collection); Harvard Univ.; NGA; NYHS; U.S. Capitol bldg., Wash., DC; Wadsworth Atheneum (view of Niagara Falls). **Comments:** One of the great painters of the early Republic, he is best remembered for his life's quest to document the leaders of the Revolutionary War and its events. His "Declaration of Independence" (1799, Yale Univ.) is perhaps his most universally-recognized image. He was the son of Jonathan Trumbull, the Revolutionary Governor of Connecticut. Although a childhood accident had blinded him in one eye, Trumbull was determined to become an artist and in 1773 sought out John Singleton Copley for advice and criticism. He served as an officer in the Continental Army from 1775, resigning his post in 1777 after a disagreement over the date of his commission. Trumbull then studied briefly in Boston and in 1780 went to London, entering Benjamin West's studio and meeting Gilbert Stuart. Soon thereafter, however, anti-British statements made by Trumbull put him in prison for almost eight months under suspicion of being a spy. In 1784, he returned to West's London studio where he remained until 1789, also visiting Paris in those years. In 1785 he began work on what would be the focus of his entire career, a series of paintings marking important events in the Revolution, beginning with "Death of General Warren at the Battle of Bunker's Hill" (1786, Yale Univ.) and "The Death of General Montgomery in the Attack on Quebec" (1786, Yale Univ.). Trumbull returned to the U.S. in 1789 and began making portrait studies of important individual participants in the War, and producing engravings of his historical pictures. He also

fulfilled portrait and miniature commissions, traveling throughout the country. In 1794, he returned to London as secretary to John Jay, remaining there until 1804 as a commissioner under the Jay Treaty. In 1799 he finally completed his famous *Declaration of Independence* (Yale) after years of carefully recording in miniature, in preparation for the final work, portraits of thirty-six of the major participants. Trumbull opened a studio in NYC in 1804, but in 1808 returned once again to London, remaining this time until 1816. Shortly after resettling in NYC, Trumbull began work on fulfilling a prestigious commission by the U.S. Congress to decorate the Capitol rotunda with four historical murals: "The Declaration of Independence" (based on his previous painting); "The Surrender of General Burgoyne at Saratoga;" "The Surrender of Lord Cornwallis at Yorktown;" and "The Resignation of General Washington at Annapolis." Over the next several years Trumbull devoted much of his time to painting the portrait heads for the works, finally completing the entire cycle in 1824. From 1817 to 1834 Trumbull served as president of the American Academy of Fine Arts (founded in NYC in 1802 and originally called the New York Acad. of the Fine Arts). Trumbull's adversarial and strident attitude, which sometimes kept artists and students from using the collection for study, eventually led to a bitter struggle with Samuel F.B. Morse and others, resulting in the founding of the rival National Academy of Design in 1825 (the American Academy eventually dissolved in 1841). In 1831, Trumbull sold his life's collection to Yale University for an annuity, and this formed the nucleus of the Yale University Art Gallery. Trumbull's wife, Sarah Hope Harvey was also an artist. **Sources:** G&W; In 1841, Trumbull's *Autobiography* was published, and in 1953 it was edited and supplemented by Theodore Sizer, who also edited an illustrated catalogue, *The Works of Colonel John Trumbull.* See also: Irma Jaffe, *John Trumbull, Patriot Artist of the American Revolution* (1975); Helen Cooper, ed. *John Trumbull: The Hand and Spirit of a Painter* (exh. cat., Yale Univ., 1982); Baigell, *Dictionary; 300 Years of American Art,* vol. 1, 66.

TRUMBULL, Sarah Hope Harvey (Mrs. John) *[Fruit and flower painter] b.1774, near London, England / d.1824, NYC.*
Addresses: NYC, 1804-08; London, 1808-16; NYC, 1816-24. **Exhibited:** American Academy, 1816, 1817; PAFA, 1818. **Comments:** Sarah Hope Harvey married John Trumbull (see entry) in London in 1800. The couple remained there until 1804, at which time they moved to NYC. They were again in London 1808 to 1816, returning permanently to NYC in 1816. **Sources:** G&W; Sizer, *The Autobiography of Colonel John Trumbull,* 350-65 ("Who Was the Colonel's Lady?"); Cowdrey, AA & AAU; Rutledge, PA.

TRUMP, Aileen E.H. *[Painter, printmaker] 20th c.*
Addresses: Chicago area. **Exhibited:** AIC, 1940, 1950. **Sources:** Falk, *AIC.*

TRUMP, R. N.V. *[Painter] 19th c.*
Addresses: Phila., PA. **Exhibited:** PAFA Ann., 1877-78. **Sources:** Falk, *Exh. Record Series.*

TRUMP, Rachel Bulley (Mrs. Charles C.) *[Portrait painter, lecturer] b.1890, Canton, OH.*
Addresses: Merion, PA. **Studied:** Syracuse Univ. B.P. **Member:** Phila. Plastic Club; Woodmere Art Gal. **Exhibited:** Phila. Plastic Club, 1938 (gold); Woodmere Art Gal.; 1943 (prize); NAWA; Phila. Art All.; N.Y. State Fair Grounds. **Work:** Circuit Court, Richmond, VA; Haverford (PA) Sch.; Haverford Friends Sch.; Woman's Medical College, Phila. **Comments:** Lectures, demonstrations of portrait painting for art groups and clubs. **Sources:** WW59; WW47.

TRUMPLER, Carrie E. *[Painter] early 20th c.*
Addresses: Phila., PA. **Sources:** WW04.

TRUMPORE, William L. *[Painter] b.1867 / d.1917, Jersey City, NJ.*
Work: White House. **Comments:** Specialty: floral scenes.

TRUNG, F. *b.c.1827, Germany.*
Addresses: NYC in 1850. **Sources:** G&W; 7 Census (1850), N.Y., XLII, 147.

TRUNK, Herman, Jr. *[Painter] b.1899, NYC / d.1963, Brooklyn, NY.*
Addresses: Brooklyn, NY. **Studied:** CUASch.; PIASCh; ASL; H.L. McFee; H. Lever. **Member:** Brooklyn Soc. Modern Artists; Am. Veterans Soc. Art; Delaware AA; Woodstock AA. **Exhibited:** Salons of Am.1923, 1924, 1933; S. Indp. A., 1924-25, 1927, 1929; AIC, 1927; WMAA, 1928-36. **Work:** WMAA; Nicaragua Seminary College. **Sources:** WW59; WW47; Woodstock AA cites birth date of 1894; as does Marlor, *Salons of Am.*

TRURAN, William *[Painter] 20th c.*
Exhibited: San Francisco AA, 1917. **Comments:** Specialty: watercolors. **Sources:** Hughes, *Artists of California,* 566.

TRUSLOW, Neal A. *[Painter] 20th c.*
Addresses: New Bedford, MA, 1907; NYC. **Sources:** WW15; Blasdale, *Artists of New Bedford,* 193.

TRUSSELL, Frances Lewis *[Painter] 20th c.*
Exhibited: S. Indp. A., 1928. **Sources:** Marlor, *Soc. Indp. Artists.*

TRUTZSCHLER, Wolo *[Caricaturist, mural painter] b.1902, Berlin, Germany / d.1989, San Francisco.*
Addresses: Los Angeles. **Studied:** self-taught. **Comments:** Full name, Baron Wolff Erhardt Anton Georg Trutzschler von Falkenstein. Immigrated to the U.S. in 1922 and moved to Los Angeles in 1927. Illustr., writer, five children's books. He was also a puppeteer and is credited with drawing Edgar Bergen's dummy. Position: caricaturist, San Francisco *Chronicle.* **Sources:** Hughes, *Artists in California,* 566.

TRYE, Dorothy See: **TRUE, Dorothy**

TRYON, Benjamin Franklin (or F. B.) *[Landscape painter] b.1824, NYC / d.1896.*
Addresses: Worked principally in Boston, 1869-73. **Studied:** Pupil of Richard Bengough and James H. Cafferty. **Exhibited:** NAD, 1866-1873. **Sources:** G&W; Swan, BA; Clement and Hutton. More recently, see Campbell, *New Hampshire Scenery,* 167.

TRYON, Brown (Mrs.) *[Portrait painter] mid 19th c.*
Addresses: Hoboken, NJ. **Exhibited:** NAD, 1858-59. **Comments:** Probably the same as Mrs. E.A. Tryon and Margaret B. Tryon. **Sources:** G&W; Cowdrey, NAD.

TRYON, D(wight) W(illiam) *[Landscape painter, teacher] b.1849, Hartford, CT / d.1925, South Dartmouth, MA.* **D.W. TRYON**
Addresses: Hartford, CT, 1873-75; NYC, 1882-92; South Dartmouth, MA, since 1883. **Studied:** École des Beaux-Arts, Paris; J. de la Chevreuse; briefly with C.F. Daubigny, A. Guillemet, H. Harpignes, all 1876-81. **Member:** ANA, 1890; NA, 1891; SAA, 1882; AWCS; NIAL. **Exhibited:** PAFA Ann., 1879, 1887-1912; Paris Salon, 1881; Mech. Fair, Boston, 1882 (bronze medal); Brooklyn AA, 1882-92; Boston AC, 1882-1909; Am. Art Assn., NYC, 1886 (gold), 1887 (gold); NAD, 1873-92 (Third Hallgarten Prize, 1887); AIC, 1888 (Ellsworth Prize); Chicago Interstate Expo, 1889 (Palmer Prize); SAA, 1889 (Webb Prize); Munich Expo, 1892 (first class gold medal); Columbian Expo, Chicago, 1893 (medal); Cleveland Interstate Expo, 1895 (first prize); Tennessee Centennial, Nashville, 1897 (first prize); CI, 1898 (gold), 1899 (chronological medal); Pan-Am. Expo, Buffalo, 1901 (gold); St. Louis Expo, 1904 (gold); Corcoran Gal annuals/biennials, 1908-12 (3 times); Pan-Pacific Expo, San Francisco, 1915 (silver medal); New Bedford Art Club, 1920; Montross Gal., NYC; Univ. Connecticut, 1971 (retrospective). **Work:** Freer Gallery, Wash., DC (large collection); NMAA; NGA; PAFA; CGA; MMA; TMA; WMA; PAFA; Herron AI; Detroit AI; Art Mus., Montclair; Hackley Art Gal., Muskegon, MI; RISD; Butler AI, Youngstown, OH; Tryon Gallery (given to the college by the artist), Smith College; Wadsworth Atheneum,

Hartford; Old Dartmouth Hist. Soc., MA; Benton Mus., UConn. **Comments:** Tryon was an important Tonalist and influential teacher. His Barbizon-inspired landscapes were muted in tone and poetic in spirit. During the 1890s, his palette lightened, and he increasingly worked in pastels. Charles Lang Freer was a devoted patron of Tryon. Successful and highly lauded, Tryon bequeathed his works to Smith College where he taught for nearly 40 years (1885-1923). **Sources:** WW24; Blasdale, *Artists of New Bedford,* 193-95 (w/repro.); *Connecticut and American Impressionism* 173-74 (w/repro.); Fink, *American Art at the Nineteenth-Century Paris Salons,* 398-99; Art in Conn.: The Impressionist Years;Baigell, *Dictionary;* Henry White, *The Life and Art of Dwight William Tryon* (1930); Wanda Corn, *The Color of Mood: American Tonalism, 1880-1900* (exh. cat., de Young Mus., San Francisco, 19720; Falk, *Exh. Record Series.*

TRYON, E. A. (Mrs.) *[Portrait painter] mid 19th c.* **Exhibited:** NAD. **Comments:** Probably the same as Margaret B. and Mrs. Brown Tryon. **Sources:** G&W; Cowdrey, NAD.

TRYON, Horatio L. *[Sculptor or marble-worker] b.c.1826, New York.* **Addresses:** Active in NYC from 1852. **Sources:** G&W; 8 Census (1860), N.Y., LX, 823 and 1171; NYCD 1852-62.

TRYON, John *[Listed as "artist"] b.c.1801, New York.* **Addresses:** Active in NYC from 1845 to 1851. **Sources:** G&W; 7 Census (1850), N.Y., XLVIII, 324; NYCD 1845-51.

TRYON, Kate Allen (Mrs. James B.) *[Painter] b.1865, Naples, ME / d.1952.* **Studied:** RISD; Boston MFA. **Work:** Westbrook College, Portland, ME. **Comments:** Painted English views, portraits, landscapes and was especially interested in American birds. **Sources:** Petteys, *Dictionary of Women Artists.*

TRYON, Margaret B. *[Portrait painter] mid 19th c.* **Addresses:** NYC, 1860-61. **Exhibited:** NAD, 1857 (as M.P. Tryon of Hoboken, NJ). **Comments:** Listed as Margaret T.B. Tryon, artist, in 1861 Hoboken directory. Probably the same as Mrs. Brown Tryon and Mrs. E.A. Tryon. **Sources:** G&W; NYBD 1860-61; Cowdrey, NAD; Jersey City and Hoboken CD 1861.

TRYON, S. J. (Mrs.) *[Painter] late 19th c.* **Exhibited:** Boston AC, 1873, 1878-1881. **Sources:** *The Boston AC.*

TSAI, Wen-Ying *[Sculptor, painter] b.1928, Amoy, China.* **Addresses:** Paris 17, France. **Studied:** Univ Mich, ME, 1953; ASL New York, 1953-1957; Grad Faculty Polit & Social Sci, New Sch Social Res, 1956-1958. **Exhibited:** The Responsive Eye, 1965 & The Machine Show, 1968, MOMA, New York; Cybernetic Serendipity, Inst Contemp Arts, London, 1968; Third Salon Int Galleries Pilotes, Mus Cantonal Beaux Arts, 1970; Pittsburgh Int, Carnegie Inst Mus Art, 1970. **Awards:** Whitney fel, 1963; fel of Ctr Advan Visual Studies, Mass Inst Technol, 1969-1971; design in steel award, Am Iron & Steel Inst, 1971. **Work:** Tate Gallery, London, Eng; Centre Nat D'Art Contemporain, Paris, France; Kaiser Wilheim Mus, Krefeld, Ger; Albright-Knox Art Gallery, Buffalo, NY; Whitney Mus Am Art, New York, NY. **Comments:** He was interested in the use of electronic controls and scientific instruments in kinetic art. Preferred Media: stainless steel. Positions: Proj engr, Guy B Panero, Engineers, New York, 1956-1960; proj mgr, Cosentini Assocs, Engineers, New York, 1962-1963. Dealer: Galerie Denise René, Paris 8, France. **Sources:** WW73; "Art for Tomorrow-the 21st century," produced on CBS-TV, 1969; Jonathan Benthall, "Cybernetic Sculpture of Tsai," *Studio Int* (Mar, 1969); Fred Barzyk, "Video Variations" (with Boston Symphony Orchestra), produced on WGBH-TV, 1971.

TSATOKE, Monroe *[Painter] b.1904, Saddle Mountain, OK / d.1937, Oklahoma.* **Studied:** self-taught from age of 11; some lessons from Mrs. Susie Peters; Mrs. Willie Baze Lane; Edith Mahier, at Univ. Okla., 1926. **Member:** Susie Peters' Fine Arts Club (1926), Anardko, Ok. **Exhibited:** First Int. Art Expo, Prague, Czech., 1928; NYC,

1930s. **Work:** Mus. Am. Indian; Mus. New Mexico; Philbrook Art Center; Stark Mus., Orange, TX; Gilcrease Inst. **Comments:** One of the "Five Kiowas" (the others were Spencer Asah, Jack Hokeah, Steven Mopope, and Lois Smoky), a group of Native American artists who were brought to the Univ. of Oklahoma by Oscar B. Jacobson (see entry) in 1926 and provided with studio space and materials; they subsequently attracted international interest at the Prague Expo, 1928. He was exhibiting in NYC by the 1930s. When he became sick with tuberculosis, he joined the Native American Church and began a series of paintings about his religious experiences in the Peyote faith (published posthumously). His son Lee Monette Tsatoke was also an artist. **Sources:** Oscar B. Jacobson, *Kiowa Indian Art* (1929) and *Am. Indian Painters* (1950); Schimmel, *Stark Museum of Art,* 132-35, 228; P&H Samuels, 491.

TSCHACBASOV, Nahum *[Painter, printmaker, teacher] b.1899, Baku, Russia / d.1984.* **Addresses:** NYC. **Studied:** Lewis Inst., Chicago; Armour Inst. Technology; Columbia Univ.; also in Paris, France; L. Gottlieb. **Member:** Am. Artists Congress, United Am. Artists; An Am Group; Woodstock AA. **Exhibited:** "Galerie Zak," Paris, 1934 (solo); Gal. Secession, 1935 (solo); ACA Gal., 1936, 1938, 1940, 1942, 1946 (solo); S. Indp. A., 1936; PAFA Ann., 1941-52; CI, 1944, 1945; AIC, 1943-47; Corcoran Gal biennials, 1945, 1947; MoMA, 1945; WMAA; VMFA, 1944-46; Walker AC, 1945, 1946; MMA, 1944, 1946; Perls Gal., NYC, 1944-48; Univ. Texas, 1946 (solo); Pepsi-Cola Exhib. (award, 1947); New Orleans Arts & Crafts Club (solo); Vigeveno Gal.; Los Angeles (solo);1030 Gal., Cleveland; John Heller Gal., NYC, 1950-51. **Work:** MMA; WMAA; BM; Jewish Mus.; Walker AC; Johnson MA; State Dept., Washington, DC; DMFA; Tel-Aviv Mus, Israel; PAFA; Phila. MA; Hirschhorn Mus.; Butler IA, Youngstown, OH; plus many others. **Comments:** He began as an abstract painter, then turned to social protest realism, and by the late 1930s, Surrealism. He expressed his dissatisfaction with the abstract expressionists of the New York School of the 1950s, and developed a style that was mythic and figurative while combining elements of surrealism and geometric abstraction. Positions: owner, Tschacbasov School Fine Arts; pres., Am. Arch. World Art, Inc. Publications: two portfolios of etching, 1947; author & publisher, *The American Library Compendium and Index of World Art* (1961); and *An Illustrated Survey of Western Art.* Also, contributor of articles to ASL. **Sources:** WW73; Falk, *Exh. Record Series;* addit. info. Woodstock AA.

TSCHAEGLE, Robert *[Lecturer, writer, museum curator, sculptor, critic] b.1904, Indianapolis, IN.* **Addresses:** Indianapolis 8, IN. **Studied:** AIC; Univ. Chicago, Ph.B., A.M.; Univ. London; & with Lorado Taft. **Member:** CAA. **Exhibited:** AIC; Hoosier Salon; John Herron AI; NAD. **Comments:** Position: Instr., Hist. A., Univ. Missouri, 1935-36; Asst. Cur., John Herron A. Mus., Indianapolis, Ind., 1937-41; Master, Park Sch., Indianapolis, Ind. Contributor to: Herron AI Bulletins. **Sources:** WW59; WW47.

TSCHAMBER, Hellmuth George *[Painter, teacher, commercial artist] b.1902, Heidelberg, Germany.* **Addresses:** Jamaica 34, NY. **Studied:** Brooklyn Mus. Sch. A.; Germany. **Member:** SC; AAPL; All. A. Am.; Long Island A. Lg.; Hudson Valley AA. **Exhibited:** S. Indp. A., 1944; AWS, 1949, 1951; All. A. Am., 1953-1955; regularly in local and regional exhs. **Awards:** prizes, AAPL, 1947; gold medal, All. A. Am., 1955; many regional awards. **Work:** Univ. Florida; Hempstead H.S.; East Williston Pub. Lib.; City Hall, New York City. **Comments:** Contributor to: architectural magazines and newspapers. **Sources:** WW59.

TSCHECH, Will *[Painter] 20th c.* **Exhibited:** AIC, 1936. **Sources:** Falk, *AIC.*

TSCHIRF, Hubert *20th c.*
Exhibited: Salons of Am., 1934. **Sources:** Marlor, *Salons of Am.*

TSCHUDI, Rudolf *[Painter, teacher] b.1855, Schwanden-Glarus, Switzerland / d.1923, Cincinnati, OH.*
Addresses: Cincinnati, OH. **Studied:** H. Ruch in Glarus.
Member: Cincinnati AC. **Exhibited:** Ohio Mechanics Inst., 1874 (prize); St. Louis Expo, 1904 (medal). **Work:** Evanston School, Cincinnati; Art Mus., Glarus, Switzerland; Cosmopolitan Bank, Cincinnati. **Comments:** Specialty: landscapes, portraits, still life, including historical subjects with Indians. **Sources:** WW21.

TSCHUDY, H(erbert) B(olivar) *[Painter, writer] b.1874, Plattsburg, OH / d.1946, NYC.*
Addresses: NYC. **Studied:** ASL. **Member:** Fifteen Gal., N.Y.; AWCS; Phila. WCC; Brooklyn S. Modern A. **Exhibited:** S. Indp. A., 1917, 1935-44; AIC, 1918,1924-38; Salons of Am., 1924. **Work:** Brooklyn Mus.; State Mus., Santa Fe, N. Mex.; Aquarium, AMNH; Pub. Lib., Yellow Springs, Ohio; Antioch Col., Ohio; Nat. Mus., Warsaw, Poland; Nat. Mus., Sofia, Bulgaria. **Sources:** WW40.

TSCHUDY, Rudolf See: **TSCHUDI, Rudolf**

TSE, Wing Kwong *[Painter] b.1902, Canton, China.*
Addresses: San Francisco, CA. **Studied:** Mills School, Hawaii; USC. **Exhibited:** GGE, 1939. **Comments:** Fled to Hawaii in 1914 and moved to Los Angeles in 1922. Specialty: Chinese mythological subjects, interiors and still lifes. **Sources:** Hughes, *Artists of California,* 566-567.

TSE-YE-MU *[Painter] 20th c.*
Exhibited: S. Indp. A., 1934; AIC, 1935. **Sources:** Falk, *Exhibition Record Series.*

TSELOS, Dimitri Theodore *[Art historian, writer] b.1901, Kerasea, Greece.*
Addresses: St Paul, MN. **Studied:** Univ Chicago, PhB, 1926, MA, 1928; Princeton Univ, Carnegie Found scholarships, 1928-1932; MA, 1929, MFA, 31 PhD, 1933; Inst Fine Arts, New York Univ, 1929-1930, with Richard Offner & Walter Cook; also with Charles R Morey. **Member:** Col Art Asn Am (dir, 1955-1960); Archaeol Inst Am; Soc Archit Historians; Am Asn Univ Prof; Minn Hist Soc. **Comments:** Teaching: From instr medieval & mod art to assoc prof, Inst Fine Arts, New York Univ, 1931-1949; lectr mod art, Swarthmore Col, 1937-1941; lectr mod art, Univ Southern Calif, summers, 1937-1941; vis prof, Vassar Col, 1944-1946; prof art, Univ Minn, 1949-1971, emer prof & consult, 1971-. **Awards:** Fulbright res grants, Greece, 1955-1956 & 1963-1964. **Research:** Medieval painting; modern architecture; modern Greek art. **Publications:** Auth, "Exotic Influences in the Architecture of FL Wright," *Mag Art,* 1953; auth, "The Sources of the Utrecht Psalter Miniatures," 1955; auth, "Modern Illustrated Books," 1959; auth, "Defensive Addenda on the Origins of the Utrecht Psalter," *Art Bull,* 1967; auth, "F L Wright and World Architecture," *J Archit Historians,* 1969. **Sources:** WW73.

TSENG YU-HO, Betty See: **ECKE, Betty Tseng Yu-Ho**

TSINAJINIE, Andrew Van *[Painter, illustrator] b.1918, Rough Rock, AZ.*
Addresses: Living in Scottsdale, AZ in 1967. **Studied:** Santa Fe Indian School. **Work:** AMNH; Corcoran; Gilcrease Inst.; Mus. New Mexico; Univ. Oklahoma; Philbrook AC. **Comments:** Navaho painter of ceremonial scenes, war and hunting, Navaho genre, etc. Spelled his name in various ways: Tsihnahjinnie, Tsinajininie, Tsinajininie, Tsinnaijinnie, etc. Used hogan and barn motifs above his signature in 1950s. **Sources:** P&H Samuels, 492.

TSIREH, Awa See: **AWA, Tsireh (Alfonso Roybal)**

TSISETE, Percy *[Painter] 20th c.*
Addresses: Santa Fe, NM. **Exhibited:** First Nat. Exh., Am. Indian P., Philbrook A. Center, 1946. Affiliated with Santa Fe Indian School. **Sources:** WW47.

TSO, Chen-Hu *[Painter] 20th c.*
Addresses: China, 1924. **Exhibited:** S. Indp. A., 1924. **Sources:** Marlor, *Soc. Indp. Artists.*

TSOSIE, Paul *[Painter] 20th c.*
Exhibited: S. Indp. A., 1933 (sand painting).

TSUCHIDANA, Harry Suyemi *[Painter] b.1932, Waipahu, Hawaii.*
Addresses: Honolulu, HI. **Studied:** Honolulu Acad Arts, Hawaii; Corcoran Sch Art, Washington, DC. **Exhibited:** Young Talent, Corcoran Gallery Art, Washington, DC, 1956; Ankrum Gallery, Los Angeles, Calif, 1967; solo shows, Libr of Hawaii, Honolulu, 1961, Gima's Gallery, Honolulu, 1963 & Contemp Arts Ctr Hawaii, Honolulu, 1966. **Awards:** John Hay Whitney fel, 1959. **Work:** Honolulu Acad Arts; State Found Cult & Arts, Honolulu: Free Libr Philadelphia, Pa. **Comments:** Preferred Media: oils. **Sources:** WW73.

TSUTAKAWA, George *[Sculptor, painter] b.1910, Seattle, WA / d.1997.*
Addresses: Seattle, WA. **Studied:** Japan; with Alexander Archipenko, 1936; Univ Wash Sch Art, BFA, 1937, MFA, 1950. **Member:** Puget Sound Group of Northwest Painters; Artists Equity Assoc. **Exhibited:** SAM, 1934, 1936, 1949, 1971 (solo); Henry Gallery, Seattle, 1951; 3rd Biennial, Sao Paulo, Brazil, 1955; San Francisco Painting & Sculpture Ann, SFMA, 1955, 1958 & 1960; 3rd Pac Coast Biennial, Santa Barbara Mus Art, Calif, 1959; 66th Ann Exhib Western Art, Denver Art Mus, Colo, 1960; Int Art Festival, Amerika Haus, Berlin, E Ger, 1966. **Awards:** Award for Obos No 5 (wood), Santa Barbara Mus Art, 1959; awards for Obos No 9 (wood), SFMA & Denver Art Mus, 1960. **Work:** Seattle Art Mus, Wash; Denver Art Mus, Colo; Santa Barbara Mus Art, Calif; Henry Art Gallery, Univ Wash, Seattle. Commissions: Fountain of Wisdom (bronze), Seattle Pub Libr, 1960; Waiola (fountain sculpture in bronze), Ala Moana Ctr, Honolulu, Hawaii, 1966; Garth Fountain (bronze), Nat Cathedral, Washington, DC, 1968; bronze fountain sculpture, Franklin Murphy Sculpture Garden, Univ Calif, Los Angeles, 1969; fountain sculpture in bronze, Jefferson Plaza, Indianapolis, Ind, 1971. **Comments:** Preferred Media: bronze, watercolors. Teaching: Prof art, Univ Wash, 1946-. **Sources:** WW73; Henry Seldis, "Pacific Heritage: Exhibition Review," *Art in Am* (Feb, 1965); Gervais Reed, "The Fountains of George Tsutakawa," *Am Inst Archit J* (July, 1969); Marcell R Heinley, "George Tsutakawa, Fountain Sculptor," *Designers West* (Feb, 1970); Trip and Cook, *Washington State Art and Artists.*

TSUZUKI, Byron T. *20th c.*
Studied: ASL. **Exhibited:** Salons of Am., 1926-29; S. Indp. A., 1926-27. **Sources:** Falk, *Exhibition Record Series.*

TUBBS, Calla (Caroline) See: **DORE, Calla Tubbs**

TUBBS, Ruth H. *[Painter, teacher] b.1898, Grand Forks, ND.*
Addresses: Hastings, NE. **Comments:** Taught at Hastings (NE) H.S. **Sources:** Petteys, *Dictionary of Women Artists.*

TUBBY, Joseph *[Landscape and portrait painter] b.1821, Tottenham, England / d.1896, Montclair, NJ.*
Addresses: Kingston, NY, 1832-?; Brooklyn, NY, 1883-84; Montclair, NJ, 1885-96. **Studied:** briefly with a portrait painter named Black (in Kingston?). **Exhibited:** NAD, 1851-60, 1884; PAFA Ann., 1883. **Comments:** Born to a Quaker family who emigrated to America and settled in Kingston, NY. A close friend of Jervis McEntee, Tubby was Kingston's leading landscape painter in the mid-nineteenth century. He painted scenes around Kingston and the Esopus and Rondout creeks. He also did decorative painting and portraits. Although he painted in a Hudson River style for most of his career, during his late years in Montclair, NJ, he began painting in a style close to that of George Inness's own late manner. **Sources:** G&W; Senate House Museum, "Exhibition of Paintings by Joseph Tubby"; Cowdrey, NAD. More recently, see Gerdts, *Art Across America,* vol. 1: 172, 243; Falk, *Exh. Record Series.*

TUBBY, Josiah Thomas *[Painter, etcher, architect]* *b.1875, Brooklyn NY.* / *d.1958.*
Addresses: Portland, ME. **Studied:** Columbia; Ecole des Beaux-Arts, Paris; A. Bower; C.H. Woodbury, Ogunquit Sch.; G.B. Bridgman. **Member:** SC; State of Maine A. Comm. (Chm.); AIA; Portland SA; Hayloft AC. **Exhibited:** SC; Portland SA; Brick Store Mus., Kennebunk, Maine. **Sources:** WW47.

TUBESING, Henry *[Wood engraver]* *mid 19th c.*
Addresses: Buffalo, NY, 1855-59. **Sources:** G&W; Buffalo BD 1855-58; N.Y. State BD 1859.

TUBESING, Walter *[Painter]* *20th c.*
Addresses: Minneapolis, MN. **Sources:** WW24.

TUBIS, Seymour *[Painter, sculptor]* *b.1919, Philadelphia, PA.*
Addresses: Santa Fe, NM. **Studied:** Temple Univ; Philadelphia Mus Sch; ASL New York; with George Braque; Acad Grande Chaumiére, Paris, France; Inst d'Arte, Florence, Italy; also with Hans Hofmann. **Member:** Life mem ASL New York; Soc Am Graphic Artists; Col Arts Asn Am; Santa Fe Designer/ Craftsmen. **Exhibited:** Carnegie Int, Pittsburgh, Pa, 1948; Nat Exhib Prints, Drawings & Watercolors,MMA, 1952; Travelling Exhib Am Prints, Royal Soc London, Eng, 1954; Int Exhib Graphics, Seattle Art Mus, 1968; solo show, Retrospective of Painting & Sculpture, Mus N Mex, Santa Fe, 1964; The New West, Albuquerque, NM; Daniel Frishman Gallery of Art, Osterville, MA. **Awards:** Noyes Mem prize for intaglio, Soc Am Graphic Artists, 1948; fourth purchase award in painting, Joe & Emily Lowe Found, 1950; first prize in painting, Am Newspaper Guild, 1952. **Work:** MMA; Libr of Cong; Soc Am Graphic Artists, New York; Pa State Col; Univ Calgary, Alta, Can. **Comments:** Preferred Media: Oils, Intaglio, Bronze, Wood, Bone. **Teaching:** Instr painting, design & graphic arts, Inst Am Indian Arts, 1962-, chmn dept fine arts, 1965-. **Positions:** Artist-designer, *New York Times*, 1959-62. **Publications:** Contribr, *72nd Annual, Royal Soc Painters, Etchers & Engravers*, 1954; contribr, *Western Review*, Western N Mex Univ, 1966; illusr, *Pembroke Mag*; illusr, *Yerma, Santa Fe N Mex*, 1971; contribr, *Indian Painters & White Patrons, El Palacio*, 1971. **Sources:** WW73; Michelle Seuier, "Les Exposition Seymour Tubis," *Opera* (July 26, 1950); John MacGregor, "Seymour Tubis Experiments with Printmaking," *Pasatiempo* (August 27, 1967).

TUCCIARONE, Wilma McLean *[Craftsman, designer]* *b.1875, Hempstead, NY.*
Addresses: Hempstead, NY. **Studied:** N.Y. State Col. Ceramics, Alfred Univ., B.S. in App. A.; & with Charles Binns, Marion Fosdick, Clara Nelson. **Member:** Eastern AA; Nassau County A. Lg. **Exhibited:** SC; Portland SA; Brick Store Mus., Kennebunk, Me. **Comments:** Position: A. Instr., Hempstead H.S., Hempstead, N.Y., 1935-. **Sources:** WW53; WW47.

TUCHMAN, Maurice *[Museum curator]* *b.1936, Jacksonville, FL.*
Addresses: Los Angeles, CA. **Studied:** Nat Univ Mex; City Col New York, BA 1957; Columbia Univ, MA 59. **Exhibited:** Awards: Fulbright scholar, 1960-61. **Comments:** Collections Arranged: Five Younger Calif Artists, 1965; Edward Kienholz, 1966; Irwin-Price, 1966; John Mason, 1966; Am Sculpture of 1960s, 1967; Soutine, 1968; Art & Technol, 1971; 11 Los Angeles Artists, Arts Coun Gt Brit, 1971. Positions: Art ed mod art sect, Columbia Encycl, 1962; mem curatorial & lect staff, Guggenheim Mus, 1962-64, organizer, summer 1964; sr cur, Los Angeles Co Mus Art, 1964-70s. Publications: Auth, (catalogues), "New York School," 1965, "American Sculpture of the 60's," 1967, "Soutine," 1968, "Art and Technology, "1971, 1971 & "11 Los Angeles Artists," 1971. **Sources:** WW73.

TUCKER, Adah *[Landscape painter, photographer]* *b.1870, Helena, NE.*
Studied: NYC with Chase, Mora, Connah, Miller, and Parker; in Europe. **Sources:** Petteys, *Dictionary of Women Artists.*

TUCKER, Alice See: **DE HAAS, Alice Preble Tucker**

TUCKER, Alice *[Flower painter in watercolors]* *early 19th c.*
Addresses: New Bedford, MA, 1807. **Sources:** G&W; Lipman and Winchester, 181.

TUCKER, Allen *[Painter, architect, writer, lecturer, teacher]* *b.1866, Brooklyn, NY* / *d.1939, NYC.*

Allen Tucker
1915

Addresses: NYC/Castine, ME. **Studied:** Columbia; ASL; J. Twachtman. **Member:** AAPS (founder); Soc. Indep. Artists (co-founder). **Exhibited:** AIC; PAFA annuals, 1904-11, 1917-20, 1927-39; Corcoran Gal. biennials, 1910-37 (9 times); Armory Show, 1913; Soc. Indep. Artists, 1917-22, 1924, 1926-28, 1936, 1939; Whitney Studio Club (WMAA), 1918 (first solo); Paris Salon; NYC; Phila. **Work:** RISD; Brooklyn Mus.; MMA; Albright Gal., Buffalo; PMG; WMAA; Staten Island Inst. Arts & Sciences, NY. **Comments:** He was one of the founders of the AAPS, which organized the 1913 Armory Show in NYC. Auth.: "Design and the Idea," "There and Here." Teaching: ASL, 1920-28. **Sources:** WW38; *300 Years of American Art*, 598; Falk, *Exh. Record Series;* Brown, *The Story of the Armory Show.*

TUCKER, Benjamin *[Portrait and job painter]* *b.1768, Newburyport, MA.*
Addresses: Newburyport, MA, 1796. **Sources:** G&W; Belknap, *Artists and Craftsmen of Essex County,* 14.

TUCKER, Caroline Sill *[Landscape painter]* *b.c.1851* / *d.1939, Pittsfield, MA.*
Addresses: Pittsfield, MA. **Sources:** Petteys, *Dictionary of Women Artists.*

TUCKER, Charles Clement *[Painter]* *b.1913, SC.*
Addresses: Charlotte, NC. **Studied:** ASL New York, scholar & with Frank Vincent DuMond, Ivan G Olinsky & George B Bridgman. **Member:** Allied Artist Am; Hudson Valley Art Asn; life mem ASL New York; Am Artist Prof League; Int Platform Asn. **Exhibited:** MMA, 1942; NAD, 1950; Coun Am Artist Socs, New York, 1966; Hudson Valley Art Asn, New York, 1968-72; Allied Artist Am, New York, 1971-72. **Awards:** First award, NC Nat Exhib, 1958-59; dirs award, Coun Am Artist Soc, 1966; Artist of the Year, Charlotte-Mecklenburg BiCentennial, 1968. **Work:** Comt Rm For Affairs, Washington, DC; Mass Inst Technol, Cambridge, Mass; Mint Mus Charlotte, NC; Fourth Circuit Ct Appeals, Richmond Fed Bldg, Va; Univ NC, Charlotte. **Comments:** Preferred Media: Oils. Art Interests: Portraits. **Sources:** WW73; Harold H Martin, & Harper Gault, "Gay Banker," *Sat Eve Post* (Nov 23, 1946); Legette Blythe, *Miracle in the Hills* (McGraw, 1953) & *Call Down the Storm* (Holt, 1958).

TUCKER, Cornelia V. *[Sculptor]* *b.1897, Loudonville, NY.*
Addresses: Phila., PA; NYC; Sugar Loaf, NY. **Studied:** with Grafly and at PAFA; ASL. **Exhibited:** PAFA Ann., 1925-29; AIC, 1929; S. Indp. A., 1933. **Sources:** Petteys, *Dictionary of Women Artists;* Falk, *Exh. Record Series.*

TUCKER, Elizabeth S. *[Painter]* *late 19th c.*
Addresses: Boston, MA. **Exhibited:** Boston AC, 1885, 1889-90. **Sources:** *The Boston AC.*

TUCKER, James Ewing *[Museum curator, painter]* *b.1930, Rule, TX.*
Addresses: Greensboro, NC. **Studied:** Midwestern Univ; Univ Tex, Austin, BFA; Univ Iowa, MFA. **Exhibited:** Garden Gallery, Raleigh, NC, 1970s. **Awards:** Purchase awards, Miss Art Asn, 1959-60, Winston-Salem Gallery Contemp Art, 1961 & NC Mus Art, 1963. **Work:** Miss Art Asn, Jackson; NC State Univ, Raleigh; Pine Bluff Art Ctr, Ark; Witte Mus, San Antonio. **Comments:** Preferred Media: Oils, Watercolors, Graphics. Positions: Cur, Weatherspoon Art Gallery, 1959-70s, ed "Bull," 1965. Collections Arranged: Art on Paper, 1965-72, Cone Collection & Dillard Collection, Weatherspoon Art Gallery. **Sources:** WW73.

TUCKER, Jimmie *[Sketch artist, painter]*
Addresses: New Orleans, active ca.1887-89. **Studied:** William

Jennings Warrington, 1887; Academy of Fine Arts, 1889.
Exhibited: W.J.Warrington's Studio, 1887; Academy of Fine Arts, 1889. **Sources:** *Encyclopaedia of New Orleans Artists,* 381.

TUCKER, John J. *[Portrait painter] mid 19th c.*
Addresses: Texas; Cincinnati in 1841. **Sources:** G&W; Cist, *Cincinnati in 1841,* 140.

TUCKER, John Noel *[Painter] 20th c.*
Addresses: Chicago area. **Exhibited:** AIC, 1935. **Sources:** Falk, *AIC.*

TUCKER, Joshua *[Painter] b.1800, Massachusetts / d.After 1880.*
Addresses: Boston. **Work:** Abby Aldrich Rockefeller Folk Art Ctr, Williamsburg, VA; BMFA. **Comments:** Trained as a teacher, he became an itinerant doctor who worked throughout the South and in Cuba. He returned to Boston and became a prominent dentist. Tucker was known for his abilities as a draftsman, but also made delicate watercolors, somewhat primitive in technique, recording local views. **Sources:** Finch, *American Watercolors,* 49-50 (w/repro.).

TUCKER, M. Virginia (Miss) *[Painter] late 19th c.*
Addresses: NYC, 1867-83. **Exhibited:** NAD, 1867-83. **Sources:** Naylor, *NAD.*

TUCKER, Marcia *[Art historian, educator] b.1940, NYC.*
Addresses: New York, NY. **Studied:** Ecole du Louvre & Acad Grande Chaumiere, Paris, France, 1959-60; Conn Col, BA(fine arts), 1961; New York Univ Inst Fine Arts, MA, 1969.
Comments: Teaching: Instr art, Univ R I, summer 1966 -68; instr art, Cit Univ New York, fall 1967 & spring 1969; instr art, Sch Visual Arts, 1969-70s. Collections Arranged: Anti-Illusion: Procedures/Materials, 1969, Robert Morris, 1970, The Structure of Color, 1971 & James Rosenquest: Retrospective Exhibition, 1972, plus many others, WMAA. Positions: Cur, William N Copley Collection, 1963-66; ed assoc, *ArtNews,* 1965-69; assoc cur, WMAA, 1969-70s. Publications: Auth, *Robert Morris* (catalogue), Praeger; auth, "Robert Natkin,"*ArtNews,* 1968; auth, *Ferdinand Howald Collection of American Paintings* (catalogue), 1969; auth, "Phenaumanology," *Artforum* (Dec. 1970); auth, "The Anatomy of a Brush Stroke: Recent Paintings by Joan Snyder," *Artforum* (May 1971). **Sources:** WW73.

TUCKER, Mary B. *[Portraits in watercolors] mid 19th c.*
Addresses: Concord and Sudbury, MA, c.1840. **Sources:** G&W; Lipman and Winchester, 181.

TUCKER, Nion (Mrs.) *[Collector] 20th c.*
Addresses: Hillsborough, CA. **Sources:** WW73.

TUCKER, Peri *[Writer, illustrator, painter] b.1911, Kashau, Austria-Hungary.*
Addresses: Akron, OH; Largo, FL. **Studied:** Columbus Sch Fine Arts; also with R.E. Wilhelm; E C Van Swearingen. **Member:** Akron Women's A. Lg. **Exhibited:** Touring Show, Ohio Watercolor Soc, 1943; Canton, Ohio, 1944-46; Massillon, Ohio, 1944, 1946; Regional Ann, Akron Art Inst, Ohio, 1940-46; Regional Invitational, Sci Ctr, Saint Petersburg, Fla, 1968-69; Fla Gulf Coast Art Ctr, Belleair, Fla, 1967 (solo). **Comments:** Preferred Media: Watercolors, Inks. Illustrator: "Big Times Coloring Book," 1941, "The Quiz Kids," 1941; other books for children. Positions: Free lance writer & artist, 1967-.
Publications: Children's bk illusr, Saalfield Publ Co, 1938-51; art writer & news artist, *Akron Beacon J,* 1942-51; art writer & news artist, *Saint Petersburg Times,* 1952-66. **Sources:** WW73; WW47.

TUCKER, Samuel A. *20th c.*
Exhibited: Salons of Am., 1927. **Sources:** Marlor, *Salons of Am.*

TUCKER, William E. *[Engraver of portraits, landscapes, and subject plates and banknotes] b.1801, Philadelphia / d.1857, Philadelphia.*
Studied: Learned engraving from Francis Kearney. **Comments:** Active as an engraver from the early 1820's **Sources:** G&W;

Stauffer; Phila. CD 1823-57; DAB, under Kearney; 7 Census (1850), Pa., LII, 991.

TUCKERMAN, Ernest *[Painter] late 19th c.; b.New York.*
Studied: with Gérome, Barrias. **Exhibited:** Paris Salon, 1870, 1873, 1878, 1880. **Sources:** Fink, *American Art at the Nineteenth-Century Paris Salons,* 399.

TUCKERMAN, Lilia McCauley (Mrs. Wolcott) *[Painter] b.1882, Minneapolis, MN / d.1962, Carpinteria, CA.*
Addresses: Settled in California by 1919, active in Carpinteria, CA until 1962. **Studied:** Corcoran School of Art; Charles Woodbury, Ogunquit Sch.; G.S. Noyes; DeWitt Parshall.
Member: AFA; San Francisco AA; NAWA; NAC; Soc. Wash. Artists; Santa Barbara Artists; Calif. AC; San Diego Artists Gld.
Exhibited: Calif. State Fair, 1928, 1931, 1935; NAD, 1930; Women's Int. Exh., London, 1930; NAWA, 1931, 1933, 1935, 1937-39, 1941-64; NAC, 1928-29, 1931, 1933-37, 1940, 1945, 1948-58; Soc. Wash. Artists, 1923-26, 1928-29, 1931, 1934-1937; Ogunquit, ME, 1933-35, 1937-40, 1945, 1948-53, 1956-58; Santa Barbara Mus. Art, 1944, 1949, 1951-53; Argent Gal., 1938 (solo); San Diego Artists Gld., 1954; Santa Paula, CA, 1954; Bar Harbor, ME,1956 (solo); "Charles H. Woodbury and His Students," Ogunquit Mus. of Am. Art, 1998. **Work:** mural, St. Paul Church, triptych, Trinity Episcopal Church, Santa Barbara, CA; backgrounds for animal groups, Santa Barbara Mus. Natural Hist. **Comments:** Specialty: landscapes and murals. **Sources:** WW59; WW47; P&H Samuels, 492; *Charles Woodbury and His Students.*

TUCKERMAN, Sophie May (Mrs.) See: **ECKLEY, Sophia May Tuckerman (Mrs.)**

TUCKERMAN, Stephen Salisbury *[Marine and landscape painter, teacher of drawing] b.1830, Boston, MA / d.1904, Standsford, England.*
Addresses: Boston, through 1872; Europe thereafter (Holland, 1882). **Studied:** drawing, in Birmingham, England, before 1860; W.M. Hunt, in Boston; Paris, 1860. **Exhibited:** Centenn. Expo, Phila., 1876; Boston, 1876 (solo show of 40 landscapes); NAD, 1882; PAFA Ann., 1883. **Work:** Bostonian S., Old St. House.
Comments: After studying in Birmingham (England), Tuckerman returned to his hometown of Boston to head the New England School of Design. After a year of study in Paris in 1860, Tuckerman returned to Boston and taught drawing until 1864, at which time he began to focus on his painting. After 1872 he spent most of his time in Europe. He was at the Hague in 1884.
Sources: G&W; CAB; *Art Annual,* V, obit; Clement and Hutton; Falk, *Exh. Record Series.*

TUDGAY, John and Frederick *[Marine painters] mid 19th c.; b.England.*
Work: Sailors' Snug Harbor, Staten Island, NY; Peabody Mus., Salem, MA; Mariners Mus., Newport News, VA; museums in Germany and Norway. **Comments:** Although English, John and Frederick Tudgay are listed here because they collaborated on painting portraits of American ships, and signed together, 1857-65. Frederick [1841-1921] was possibly the son of John.
Sources: Brewington *Dictionary of Marine Artists* 385-386; postcard showing "The Clipper Bark Wildfire" built in Amesbury, Mass., 1853, and owned by Hargous Bros., NYC (Hanover Square Gal., NYC, Sept., 1993).

TUDOR, Robert M. *[Painter] mid 19th c.*
Addresses: Philadelphia, PA. **Exhibited:** PAFA Ann., 1858-60, 1867-69, 1876-78, 1888-89. **Sources:** G&W; Philadelphia CD 1858-60+; Falk, *Exh. Record Series.*

TUDOR, Rosamond *[Portrait painter, etcher, teacher, lecturer] b.1878, Bourne, MA / d.1949, Milton, MA.*
Addresses: Redding, CT; Marblehead, MA. **Studied:** BMFA Sch., with Benson, Tarbell; Hawthorne; Bicknell. **Member:** AAPL; Bridgeport AA; Redding AA (pres.). **Exhibited:** NAD; WMAA; S. Indp. A., 1917-19, 1921-22, 1926-28; Doll & Richards, Boston, 1922 (solo), 1924 (solo); Dudensing Gals., NYC (solo); Salons of Am., 1922; PAFA Ann., 1926; Bridgeport

AA, 1942 (prize); Guatemala City, Guatemala, 1941. **Work:** Zahm Mem. Lib., Notre Dame Univ., IN. **Comments:** Married H.H. Higginson in 1899, then W. Starling Burgess in 1904. Mother of Tasha Tudor (see entry). Position: dir., Migratory Artists Gld., Norton Sch., Claremont, CA, 1945-. Marlor cites the place of death as Milton, MA. **Sources:** WW47; Falk, *Exh. Record Series.*

TUDOR, Tasha (Mrs. Th. L. McCready) *[Illustrator, writer]* b.1915, Boston, MA.
Addresses: Webster, NH; Contoocook, NH. **Studied:** BMFA Sch. **Exhibited:** Currier Gal. Art. **Work:** commissions: creator of the Tasha Tudor Christmas Cards. **Comments:** Publications: author/illustrator, *Alexander the Gander*, 1939; *Snow before Christmas* 1941; *The White Goose*, 1943; *A is for Annabelle*, (Walck, 1954, Rand, 1971); *One is One* (Hale, 1956, Rand, 1971); *Corgiville Fair* (T Y Crowell, 1971). Illusr.,*Andersen's Fairy Tales*, 1945; *Doll's House* (Viking Pres., 1961 & 1970); *The Secret Garden* (Lippincott, 1962 & Dell, 1971); plus many others. **Sources:** WW73; WW47.

TUDOR, Virginie *[Painter]* late 19th c.
Studied: with Ravenez. **Exhibited:** Paris Salon, 1877. **Comments:** Exhibited a drawing at the Paris Salon. **Sources:** Fink, *American Art at the Nineteenth-Century Paris Salons*, 399.

TUERO, Armando M(oreda) Y. *[Painter]* 20th c.
Addresses: Brooklyn, NY. **Exhibited:** S. Indp. A., 1927-29. **Sources:** Marlor, *Soc. Indp. Artists.*

TUERSTENBERG, Paul W. *20th c.*
Exhibited: Salons of Am., 1934. **Sources:** Marlor, *Salons of Am.*

TUFTS, Florence Ingalsbe *[Painter]* b.1874, Hopeton, CA / d.1954, Berkeley, CA.
Addresses: Berkeley, CA. **Studied:** with Godfrey Fletcher in Monterey; with Spencer Macky, Calif. School of FA. **Member:** San Francisco AA; San Francisco Beaux Arts Club. **Exhibited:** San Francisco AA annuals, 1923-25, 1937 (prize), 1939; S. Indp. A., 1925; Oakland A. Gal., 1928,1934; Calif. State Fair, 1930; Club Beaux Arts, San Francisco, 1928; San Diego FA Gallery, 1927; SFMA, 1925, 1939 (solo); GGE, 1939. **Comments:** Specialty: watercolors. **Sources:** WW40; Hughes, *Artists of California*, 567.

TUFTS, John Burnside *[Painter]* b.1869, Boston, MA / d.1942, Berkeley, Ca.
Addresses: San Francisco, CA; Berkeley, CA. **Studied:** with E. Charlton Fortune; Calif. School of FA; with Hans Hofmann at UC. **Member:** San Francisco AA. **Exhibited:** San Francisco AA, 1917, 1923-28; Delphian Club of Calif., 1921; Sculptor, 1925; Oakland Art Gallery, 1928, 1939; Dan Diego FA Gallery, 1928; San Francisco Beaux Arts Gallery, 1928; Santa Cruz Art League, 1929; SFMA, 1935, 1937 (solo); GGE, 1939. **Comments:** Married to Florence Ingalsbe Tufts (see entry) in 1895. **Sources:** Hughes, *Artists of California*, 567.

TUFTS, Marion *[Sculptor]* mid 20th c.
Addresses: Chicago, IL. **Exhibited:** Artists Chicago Vicinity, Ann., AIC, 1933, 1935-36, 1939. **Sources:** WW40.

TUFTS, Peter See: **TOFT, Peter Petersen**

TUGENDHAFT, Charles *[Painter]* b.1872, Austria / d.1937, Covington, LA.
Addresses: New Orleans, active 1905-1908. **Sources:** *Encyclopaedia of New Orleans Artists*, 381.

TUKE, Gladys *[Sculptor, craftsperson, teacher]* b.1899, Linwood, WV.
Addresses: Phila., PA, until 1942; White Sulphur Springs, WV. **Studied:** Corcoran Sch. Art; PAFA; and with Albert Laessle, Maxwell Miller, Charles Tennant. **Member:** Phila. Art All.; Southern Highland Handicraft Gld. **Exhibited:** PAFA Ann., 1936-51 (8 times); Woodmere Art Gal, 1941 (prize), 1960; Handcraft Fairs, Asheville, NC and Gatlinburg, TN. **Awards:** Fellowship, PAFA. **Comments:** Specialty: sculpture of horses. Position:

instructor, sculpture & ceramics, S&P Art Colony, Greenbrier Hotel and Ashford General Hospital, both in White Sulphur Springs, WV. Demonstrations of sculpture for clubs and organizations. **Sources:** WW59; WW47; Falk, *Exh. Record Series.*

TULK, Alfred James *[Painter, mural painter]* b.1899, London, England / d.1988, North Haven, CT.
Addresses: NYC; Stamford, CT, 1934-65; North Haven, CT, 1965-88. **Studied:** Oberlin College, c.1915-17; NAD, cert.; ASL, cert.; Yale Univ. Sch. Art, BFA, 1919-23; Inst Bellas Artes, Guanajuato, Mexico, M.F.A., 1964-65. **Member:** NSMP; New Haven Arts council; North Haven Art Guild (advisor); Arch. Lg.; AIGA; Greenwich Soc. Artists; Stamford Museum; Sarasota AA; Falmouth Artists Guild. **Exhibited:** Exhibited widely in group shows and solo exhib. in Texas, New Mexico, Tennessee, Georgia, Alabama, Florida, NYC, Massachusetts, Connecticut, including Sarasota AA; Bradenton Art Gal.; Paris Convention Center, France; Eli Whitney Mus., CT, annually, 1979-87; Brenda Taylor Gal., NYC; BAID, 1922 (bronze medal); Recent Paintings, Art Mus., Stamford, CT, 1960 (solo),1962 (solo), Recent Paintings, Stiles College, Yale Univ., New Haven, 1965 (solo); Exhib. of Paintings, Mus. Art, Birmingham, 1968 (solo); Instructors Show, Art League, Bradenton, FL, 1968 (solo); Expressionistic Paintings, United Gt. Hall, New Haven, CT, 1971 (solo) and others. **Awards:** drawing prize, Yale Art School, 1921; first prize for oil painting, Greenwich Art School, 1958. **Work:** Oberlin College; Bates College; Yale kUniv.; Hospice of Conn.; Falmouth (MA) Hospital; Yale New Haven Hospital; Nieghborhood Music School, Hamden, CT; painting, Birmingham (AL) Mus. Art; portrait painting, Orlando (FL) Public Library. Commissions: stained glass window, College West Africa, Monrovia, Liberia, 1940; murals for lobby, Salvation Army Hosp., Flushing, NY, 1948; Iconastasis, Franciscan Monastery, New Canaan, CT, 1952; mural for reception room, DA Long Co. Bldg., Hamden, CT, 1959; three murals, Picuris Indian Pueblo, Penasco, NM, 1963. **Comments:** Tulk worked as an assistant for mural artists until 1930. He and his family went on painting trip to Liberia, West Africa and stayed for almost two years. Upon his return to the U.S. in 1933, he resumed mural work, executing commissions for stained glass and mosaics as well. He continued until the 1960s, completing over 300 large murals for hotels, theatres, churches and private homes. He did camouflage work during WWII and also painted triptychs for battlefield altars. His Stamford studio was burned in 1954, causing him an emotional and financial set back. He rebuilt, however, and after 1965 turned to Abstract Expressionism. Preferred media: oils, watercolors. Positions: director, dept. mural painting, Rambusch Decorating Co., New York, NY, 1926-46; gen. designer, Karl Hackert Studios, Chicago, IL, 1946-72; assoc. designer, Studios of George Payne, Paterson, NJ, 1948-52. Teaching: instr. drawing & painting, Dept. Adult Educ., City of Stamford, 1954-58; instr. drawing & painting, Dept Adult Educ., City New Haven, 1963-67; instr. drawing & painting, Art Guild North Haven, 1965-70. **Sources:** WW73; WW47; addit. info. courtesy of Sheila T. Payne, Falmouth, MA, daughter of the artist.

TULLIDGE, John *[Painter, mural painter, teacher]* b.1836, Weymouth, England / d.1899.
Addresses: Salt Lake City, UT, 1863. **Studied:** little formal art training. **Member:** Soc. Utah Artists. **Work:** Latter Day Saints temples, theatre. **Comments:** Position: teacher, Deseret Acad. FA, 1863-. **Sources:** WW98; Peggy and Harold Samuels, 492-93.

TULLOCH, W(illiam) A(lexander) *[Painter, illustrator, lecturer, teacher]* b.1887, Venezuela, South America.
Addresses: NYC. **Studied:** W. Turner; Grand Central Sch. Prof. Illus. **Member:** Salons of Am.; S. Indp. A. **Exhibited:** S. Indp. A., 1926-32; Salons of Am., 1927-31, 1934. **Sources:** WW40.

TULLY, Angela *[Painter]* 20th c.
Addresses: NYC. **Exhibited:** PAFA Ann., 1895; S. Indp. A., 1930, 1934, 1940-41, 1944. **Sources:** Falk, *Exh. Record Series.*

TULLY, Christopher *[Engraver]* late 18th c.
Addresses: Philadelphia, 1775. **Comments:** Invented a wool-

spinning machine **Sources:** G&W; Fielding.

TULLY, Sydney Strickland (Miss) *[Sculptor, painter]* b.1860, Toronto.
Addresses: Toronto, Ontario. **Studied:** Legros, in London; Paris, with Constant, Robert-Fleury, Courtois; Lazar; in England; Shinnecock, with W.M. Chase. **Member:** Assn. RCA; OSA; '91 Club, London. **Sources:** WW01.

TUM SUDEN, Richard *[Painter, sculptor, graphic artist, teacher]* b.1936, New York, NY.
Addresses: New York, NY. **Studied:** BM Schl. A.; Wagner Col., A.B.; Cooper Union Schl. A.; Hunter Col., N.Y., M.A.; N.Y. Univ. **Exhibited:** AIC, 1965; Tibor de Nagy Gal., N.Y. **Awards:** Art in America, 1964; Yaddo Fnd., 1964. **Work:** MModA; Larry Aldrich Collection. **Comments:** Positions: Instr., Art History, Hunter College, N.Y.; Special assignment, Board of Education, New York City, to Staten Island Institute of Arts & Sciences. **Sources:** WW66.

TUNBERG, William *[Sculptor]* b.1936.
Addresses: Venice, CA. **Exhibited:** WMAA, 1968. **Sources:** Falk, *WMAA*.

TUNICK, Susan *[Painter]* b.1946.
Addresses: NYC. **Exhibited:** WMAA, 1973. **Sources:** Falk, *WMAA*.

TUNIS, Edwin (Burdett) *[Writer, illustrator, painter, designer, engraver]* b.1897, Cold Spring Harbor, NY / d.1973, Reisterstown, MD?.
Addresses: Reisterstown, MD. **Studied:** Md Inst; also with CY Turner, Joseph Lauber & Hugh Breckenridge. **Member:** Baltimore WCC; Pen Club; Author's Guild. **Exhibited:** WFNY, 1939. **Awards:** Gold medal for Wheels, Boys' Club Am, 1956; Edison Fund Award for Colonial Living, 1957. **Work:** Commissions: Murals, McCormick & Co, Baltimore, Title Guarantee Co & City Hosp, Baltimore, Md; Aberdeen Proving Ground. **Comments:** Publications: Illustrator; "Eat, Drink and Be Merry in Maryland," 1932, "You'll Find It in Maryland," 1945, "Seventeen." Auth & illusr, "Frontier Living," 1961, "Colonial Craftsmen," 1965; "Shaw's Fortune," 1966 & "Young United States," 1968, World Publ; "Chipmunks on the Doorstep," TY Crowell, 1971. Contributor: *House Beautiful, Better Homes and Gardens.* **Sources:** WW73; WW47.

TUNSTALL, Ruth Neal *[Painter, printmaker, educator]* b.1945, Denver, CO.
Studied: Detroit Mus. of Art; The Gallery, Detroit; Tarkio Col., Missouri; Delta Col., Bay City, MI; Saginaw Valley Col., MI; Detroit Soc. of Arts & Crafts School; Univ. of Colorado Extension; Univ. of Buffalo, BA; Univ. of Dallas, MA (graduate scholarship; travel scholarship to Europe, 1970). **Exhibited:** 1st Methodist Church, Dallas, 1967 (solo); Univ. of Dallas, 1969-70; Univ. of Buffalo, NY, 1965; Detroit Soc. of Arts & Crafts, 1966; Studio 23, Bay City, MI, 1966-67 (prizes); Delta Col., Bay City, MI, 1966; Ann. Regional Art Exh., Univ. of MI, Ann Arbor, 1967-68; Detroit Soc. of Arts & Crafts Art School, 1967; Saginaw, MI, Mus. (prizes, watercolor, 1966, 1968); Mt. Holyoke Col., 1968; NAACP, Bay City, MI, 1968; Jewish Community Center, Fort Worth, TX, 1969; Univ. of Dallas, 1969; Atlanta Univ., 1970 (award); Women's Club of Dallas, 1971. **Work:** priv. colls. **Comments:** Position: instr., Davis Art Center, Davis, CA. **Sources:** Cederholm, *Afro-American Artists.*

TUPPER, Alexander Garfield *[Writer]* b.1885, Gloucester / d.c.1950.
Addresses: NYC/Gloucester, MA. **Studied:** J.H. Twachtman; F. Duveneck. **Member:** NAC; North Shore AA; Gloucester SA. **Sources:** WW47.

TUPPER, Luella *[Painter, interior decorator]* 20th c.; b.Morris, IL.
Addresses: Oak Park, IL; Orange Park, FL. **Studied:** PIASchool; W.M. Clute, in Chicago; Marshall Fry, H.B. Snell, both in NY. **Member:** Iowa Artists Club 1935. **Exhibited:** AIC, 1911; Am.

WC Soc.; Soc. Western Artists; Iowa Artists Club, 1934-35. **Comments:** Specialty: interior decorating, 1939. Positions: associate, Harris Emery Store; Younker Bros., Des Moines. **Sources:** WW13; Ness & Orwig, *Iowa Artists of the First Hundred Years,* 209.

TUQUA, Edward *[Portrait painter]* mid 19th c.
Addresses: Westport, CT, c.1830. **Sources:** G&W; Sherman, "Newly Discovered American Portrait Painters."

TURANO, Don *[Sculptor, medalist]* b.1930, New York, NY.
Addresses: Washington, DC. **Studied:** Sch Indust Art, with Albino Cavalido; Corcoran Sch Art, with Heinz Warneke; Skowhegan Sch Painting & Sculpture, with Ho Tovish; Rinehart Sch Sculpture, with R Puccinelli. **Member:** Nat Sculpture Soc; assoc Washington Relig Art Comn. **Exhibited:** PAFA Ann., 1962; St Louis Mus, Mo, 1964; Univ Colo, Boulder, 1965; Audubon Ann, Nat Acad Design Galleries, 1966; Xerox Corp, rochester, NY, 1971. **Awards:** First prizes, Corcoran Gallery Art, 1966, Festival Relig Art, 1967 & George Washington Univ, 1968. **Work:** Commissions: Silver & wood mace, Am Col Physicians, Philadelphia, Pa, 1964; carved oak panels, First Presby Church, Royal Oak, Mich, 1965; limestone figures, Cathedral of St Peter & St Paul, Washington, DC, 1969; four arks (locust wood), Temple Micah, Washington, DC, 1971; silver Medallion, Univ Notre Dame, Inst, 1972. **Comments:** Preferred Media: Bronze, Wood. Dealer: Downeast Gallery, Washington, DC. Teaching: Instr sculpture, George Washington Univ, 1961-65; instr sculpture, Corcoran Sch Art, 1961-65. **Sources:** WW73; Falk, *Exh. Record Series.*

TURCAS, Ella Dallett (Mrs. Jules) *[Painter]* 19th/20th c.; b.NYC.
Addresses: NYC, active 1897-1913. **Studied:** Chase. **Member:** NY Women's AC. **Exhibited:** SAA, 1898; PAFA Ann., 1898, 1905; St. Louis Expo, 1904; Boston AC, 1904, 1906; AIC, 1904. **Sources:** WW113; Falk, *Exh. Record Series.*

TURCAS, Jules *[Landscape painter]* b.1854, Cuba / d.1917.
Addresses: NYC, 1893, 1899. **Member:** Lotos C.; SC, 1908; Allied AA; Century. **Exhibited:** NAD, 1893, 1899; SAA, 1898; Pan.-Am. Expo, Buffalo, 1901 (med); PAFA Ann., 1902, 1905-06; AAS, 1902 (med); St. Louis Expo, 1904 (med); Boston AC, 1904-1908; Corcoran Gal annuals, 1907-08; AIC; Colley Gal, Old Lyme, CT, 1999 (solo). **Comments:** A colleague of H.W. Ranger and A.B. Talcott, he painted in the Barbizon tradition in Old Lyme, Conn. **Sources:** WW15; Falk, *Exh. Record Series.*

TURCK, Ethel Ellis de (Mrs. A. Eugene Beimers) *[Painter]* 20th c.
Addresses: Phila., PA. **Studied:** PAFA. **Member:** NAWPS; Plastic C. **Sources:** WW27.

TURE, N. A. 19th c.
Comments: Responsible during the last half of the 19th century for great movement for artists to paint outdoors "en plein air," particularly during the peak of the Hudson River School through the era of Impressionism. When Utah artist Henry Culmer was asked who was his greatest teacher, he replied: "N. A. Ture."

TUREAUD, F. (Miss or Mrs.) *[Painter]*
Addresses: New Orleans, active ca.1890-93. **Member:** Artist's Assoc. of N.O., 1890, 1893. **Exhibited:** Artist's Assoc. of N.O., 1890, 1892. **Sources:** *Encyclopaedia of New Orleans Artists,* 382.

TURINI, Giovanni *[Sculptor]* b.1841, Italy / d.1899.
Addresses: NYC, 1874-80. **Exhibited:** NAD, 1874, 1880. **Work:** statue of Garibaldi; Washington Square, NYC.

TURK, Francis H. *[Landscape painter]* mid 19th c.
Addresses: NYC. **Exhibited:** NAD in 1842-43. **Comments:** He was listed in the directories as a clerk in the post office (1844-47) and a lawyer (1848). **Sources:** G&W; Cowdrey, NAD; NYCD 1844-48.

TURK, Rudy H *[Museum director, art historian] b.1927, Sheboygan, Wis.*
Addresses: Tempe, AZ. **Studied:** Univ Wis; Univ Ten; Ind Univ; Univ Paris, Fulbright scholar, 1956-57. **Member:** Western Asn Art Mus; Asn Am Mus; Western Asn Art Depts & Univ Mus; Col Art Asn Am. **Exhibited:** Awards: Award of merit, Calif Col Fine Arts, 1965. **Comments:** Positions: Art historian & dir art gallery, Univ Mont, 1957-60; dir, Richmond Art Ctr, 1960-65; asst dir, Fine Arts Gallery San Diego, 1965-67; dir Univ Art Collections, Ariz State Univ, 1967-70s. Teaching: Assoc prof art, Ariz State Univ, 1967-70s. Collections Arranged: The Works of John Roeder, Richmond Art Ctr, Calif, 1961-62; Contemporary Glass, Fine Arts Gallery San Diego, 1967; Paintings by Tom Holland, 1968, The World of David Gilhooly, 1969 & Enamels by June Schwarcz, 1970, Ariz State Univ. Research: Contemporary art; eighteenth century French art; humanities; American ceramics. Collection: Eighteenth century French prints; contemporary American art. Publications: Auth, "IL Udell," Univ Art Collections, Tempe, 1971; co-auth, "Scholder/Indians," Northland, 1972; co-auth, "The Research for Personal Freedom," William C Brown, Vols I & II, 1972. **Sources:** WW73.

TURKALT, Josip *[Artist] 20th c.*
Addresses: S. Bend, IN. **Exhibited:** PAFA Ann., 1960. **Sources:** Falk, *Exh. Record Series.*

TURKENTON, Netta Craig (Mrs.) *[Painter, portrait painter, teacher] b.c.1884, Washington, DC.*
Addresses: Washington, DC. **Studied:** Corcoran Sch. Art; PAFA; with W.M. Chase. **Member:** Soc. Wash. Artists; fellow, AFA; PAFA. **Exhibited:** PAFA, 1910; Baltimore Charcoal Club; AFA traveling exh.; Soc. Wash. Artists; Corcoran Gal, 1908; Greater Wash. Independent Exh., 1935. **Comments:** Teaching: Art League, Wash., DC. **Sources:** WW53; WW27; WW47; Falk, *Exh. Record Series.*

TURKU, Trajan *[Painter] 20th c.*
Addresses: NYC. **Exhibited:** PAFA Ann., 1954. **Sources:** Falk, *Exh. Record Series.*

TURLAND, George *[Marine painter] b.1877, Northhampton, England / d.1947, Laguna Beach, CA.*
Addresses: Laguna Beach, CA. **Member:** Laguna Beach AA. **Sources:** Hughes, *Artists of California, 567.*

TURLE, Sarah Alibone Leavitt *[Painter] b.1868, Mauch Chunk, PA. / d.1930, Duluth, MN.*
Addresses: Duluth, MN, after 1896. **Studied:** C. Beaux; E.D. Pattee; L.F. Fuller; PAFA, before 1896; ASL, 1916-17. **Exhibited:** Am. Soc. Miniature Painters; PAFA, 1925; AIC. **Work:** Tweed Mus., Duluth, MN. **Comments:** Specialty: miniatures on ivory in watercolor. **Sources:** WW25; Petteys, *Dictionary of Women Artists,* reports birth date as 1865.

TURLE, Walter *[Painter] 20th c.*
Addresses: Duluth, MN. **Sources:** WW17.

TURMAN, W. T. (Mrs.) See: **DODGE, Hazel (Mrs. W.T. Turman)**

TURMAN, William T. *[Painter, educator, cartoonist] b.1867, Graysville, IN.*
Addresses: Terre Haute, IN; Taft, CA. **Studied:** Union Christian Col.; AIC; PAFA; J.F. Smith; A. Brook; D. Garber; Chicago Acad. FA; A. Sterba; A.T. Van Laer. **Member:** Indiana A. Cl; PBC,Terre Haute; Western AA; Brown County Gal. Assn. **Exhibited:** Hoosier Salon, 1921-52 (prize, 1932), 1955; Indiana A. Cl (prize), 1939-45; S. Indp. A., 1928; Swope A. Gal., 1943-46; Indiana State Fair (prize); Indiana State T. Col. **Work:** Indiana State T. Col.; Pub. Schs. in Columbia City, Terre Haute, Jasonville, Harrison Twp., in Indiana; Swope A. Gal.; Turman Township H.S.; Terre Haute Pub. Schs.; Pub. Lib., Throntown, Ind.; Pub. Lib., Merom, Ind. **Comments:** Position: Prof. A., Hd. A. Dept., Indiana State T. Col., 40 years; Pres. Bd. Managers, Sheldon Swope A. Gal., Terre Haute, Ind., 1941-57. Author: "New Outlook Writing System." **Sources:** WW59; WW47.

TURNBALL, Grace H. See: **TURNBULL, Grace Hill (Miss)**

TURNBULL, Agnes *[Painter] 20th c.*
Addresses: NYC. **Exhibited:** S. Indp. A., 1926-28; Salons of Am., 1928-30. **Sources:** Marlor, *Salons of Am.*

TURNBULL, Daniel Gale *[Painter] 20th c.*
Addresses: Woodstock, NY. **Studied:** ASL. **Exhibited:** S. Indp. A., 1917, 1920. **Sources:** Marlor, *Soc. Indp. Artists.*

TURNBULL, Darl B. *[Painter] 20th c.*
Addresses: Chicago area. **Exhibited:** AIC, 1948. **Sources:** Falk, *AIC.*

TURNBULL, Gale *[Painter, etcher] b.1889, Long Island City, NY.*
Addresses: Los Angeles, CA. **Studied:** Guerin; Preissig; Lasar. **Member:** Am. Ceramic Soc.; Paris Groupe PSA. **Work:** Luxembourg Mus., Paris; Brooklyn Mus., N.Y. **Comments:** Position: A. Dir., Vernon Kilns, Los Angeles. **Sources:** WW40.

TURNBULL, Grace Hill (Miss) *[Sculptor, painter, writer] b.1880, Baltimore, MD / d.1976, Baltimore, MD.*
Addresses: Baltimore, MD. **Studied:** Maryland Inst. Art, Baltimore; ASL, with Joseph De Camp; PAFA, with William Chase & Cecillia Beaux; outdoor painting with Willard Metcalf; E. Keyser. **Member:** NSS (fellow); NAWA; BMA. **Exhibited:** Corcoran Gal biennials, 1910-23 (4 times); other Corcoran exhs, 1917, 1920, 1941, 1948; PAFA annuals, 1908-21, 1933-35, 1942-50, 1960; Maryland Inst., 1909-10, 1920, 1932 (prize), 1938-40, 1945; NSS,1908, 1916, 1943, 1948-51; AIC, 1912 (25th Ann.), 1914-16, 1920, 1936, 1941; Paris, 1914 (prize); Salon des Beaux-Arts, Paris, 1914; Pan-Pacific Expo, 1915; Arch. Lg., 1921, 1933, 1937, 1951; Salons of Am., 1922; S. Indp. A., 1922, 1924; BMA, 1926, 1929-33, 1937-49, 1951-52 (prize in 1937, 1939, 1944-47); Texas Centenn., 1936; WFNY, 1939; NAWA, 1931-36, 1939, 1941-42, 1944, 1946-47, 1950 (Anna Hyatt Huntington prize 1932, 1944, 1946); NAD; MMA (AV), 1942 (purchase prize); PMA. Other awards: Gimbel award, Phila., 1932; Phi Beta Kappa, Southwestern Univ., 1956. **Work:** Painting & sculptures, Baltimore Art Mus.; sculpture in Corcoran Art Gallery, Washington, DC, Worcester (MA) Art Mus. & MMA; Eastern H.S., Baltimore. **Comments:** Preferred media: marble, wood, oils, pastels. Publications: author, "Tongues of Fire," 1928; editor, "The Essence of Plotinus," 1934; editor, "Fruit of the Vine," 1950; author, "Chips from my Chisel," 1951; author, "The Uncovered Well," 1952. Art interests: presented the Reese Memorial Monument to Baltimore City; also gave scholarships to art students. **Sources:** WW73; WW47; Falk, *Exh. Record Series.*

TURNBULL, James Baare *[Painter, graphic artist] b.1909, St. Louis / d.1976, Jacksonville, FL.*
Addresses: Croton-on-Hudson, NY; Woodstock, NY. **Studied:** St. Louis Sch. FA; Washington Univ. School FA, Seattle; PAFA. **Member:** Am. Artists Congress; Pieces of Eight; St. Louis Artists Guild; Artists Union; Artists Equity; Woodstock AA. **Exhibited:** Walker Gal., NYC, 1938; WMAA, 1938-48; PAFA Ann., 1938; AIC, 1938-46; East End Gal., Provincetown, 1960-64; Gal., Inc., Albany, NY, 1963; Rudoph Gal., Coral Gables, 1961; O'Meara Gal., Danbury, CT, 1962; Onatrio East Gal., Chicago, 1966 (solo); St. Louis Mus. Art, 1935-36, 1946; Corcoran Gal biennial, 1937; St. Louis Artists Guild, 1936; Am. Artists Congress, 1939; WFNY, 1939; MMA, 1944; LACMA, 1945; NAD, 1955, Henry Street Settlement, NYC, 1958; U.S. Dept. Defense, 1960; Woodstock AA, 1963, 1966, 1979, 1982, 1987; Englewood Armory Art Show, 1964; Wichita Art Mus., 1982; Woodstock Hist. Soc., 1985; ACA Gal., NYC, 1986; Haggerty Mus. Art, Marquette Univ., 1987; 48 States Comp; Sragow Gal., NYC, 1990. **Work:** WMAA; Springfield Mus.; Univ. Arizona; PMG; Louisnana Marine Hospital; WPA murals, U.S.P.O., Fredericktown, Jackson, both in MO and U.S.P.O., Purcell, OK; 905 Stores, Inc., St. Louis (collab. with Joe Jones); Woodstock AA. **Comments:** American realist painter who later turned to making animal sculpture with moving parts. Positions: director, WPA Arts Project, Missouri, 1938;

artist/war correspondent, *Life* magazine; Abbott Laboratories. **Sources:** WW47; *Woodstock's Art Heritage,* 138-39; *American Scene Painting and Sculpture,* 63 (w/repro.); Woodstock AA; Falk, *Exh. Record Series.*

TURNBULL, Murray *[Educator] 20th c.*
Addresses: Honolulu, Hawaii. **Comments:** Position: Chm., Art Department, University of Hawaii. **Sources:** WW59.

TURNBULL, Rupert Davidson *[Painter] b.1899, E. Orange, NJ / d.1943.*
Studied: ASL; Acad, Scandinave and Acad. Lhote, Paris. **Member:** Am. Abstract Artists (founding mem; 1937-42). **Work:** NMAA; Phila. MA. **Comments:** He began painting biomorphic abstractions c.1930. Teaching: ASL; CUASch; Design Laboratory. Co-Author: *Egg Tempera Paintng: Manual of Technique* (with Vytlacil, 1936). **Sources:** Diamond, *Thirty-Five American Modernists* p.25; *American Abstract Art,* 200.

TURNBULL, Ruth *[Commercial artist] b.1917, Lincoln, NE.*
Addresses: Des Moines, IA. **Studied:** AIC; Chicago Acad. FA. **Exhibited:** AIC. **Comments:** Positions: artist, Gimbels dept. store, Milwaukee, WI; artist, Younkers Advert. Dept. **Sources:** Ness & Orwig, *Iowa Artists of the First Hundred Years,* 209.

TURNBULL, Ruth *[Sculptor] b.1912, New City, NY.*
Addresses: Hollywood, CA. **Studied:** E. Buchanan. **Sources:** WW29.

TURNER, Alan *[Artist] b.1943.*
Addresses: NYC. **Exhibited:** WMAA, 1975. **Sources:** Falk, *WMAA.*

TURNER, Alfred M. *[Painter, teacher] b.1851, England / d.1932, West New Brighton, NY.*
Addresses: NYC (immigrated 1892). **Studied:** his father Edward. **Member:** AWCS. **Exhibited:** NAD, 1880-94; PAFA Ann., 1881; Brooklyn AA, 1882-85; Boston AC, 1886, 1892, 1893; AIC. **Work:** NYU; FDR Mus., Hyde Park, N.Y. **Comments:** Teaching: CUA Sch, for 12 years. **Sources:** WW29; Falk, *Exh. Record Series.*

TURNER, Alice See: **ROBERTS, Alice Turner (Mrs. G. Brinton)**

TURNER, Arthur See: **TURNER, (Charles) Arthur**

TURNER, August D. *[Painter] b.1919.*
Addresses: NYC, 1891; Albany, NY; Etaples Pas-de-Calais, France. **Exhibited:** NAD, 1891; Paris Salon; PAFA Ann., 1909. **Work:** Imperial Palace, Petrograd (during the Czar's reign). **Sources:** WW10; Falk, *Exh. Record Series.*

TURNER, Beatrice *[Portrait painter] b.Philadelphia, PA / d.c.1948, Newport, RI.*
Addresses: Newport, RI. **Studied:** PAFA, at age 18. **Comments:** She was raised by dominating Philadelphia Main Line parents who withdrew her from PAFA because of the nude models. She became reclusive, dressed in Victorian garb, painted her house black, and apparently painted thousands of self-portraits. In 1950, *Life* magazine ran a photo spread, "Lonely Spinster Paints 1,000 Portraits of Herself." She lived at the family's Victorian home in Newport, RI. Upon her death, she left a large fund to the Phila. Mus. Art to purchase art by contemporary American artists. However, her executors burned most of her 3,000 paintings at the city dump in 1948. A small number of paintings still survive in Newport, and these formed the core of a 1993 exhibition at her home, now the Cliffside Inn in Newport. **Sources:** Sheldon Bart, *Beatrice* 1998.

TURNER, Bruce Backman *[Painter] b.1941, Worcester, Mass.*
Addresses: Rockport, MA. **Studied:** Began his art training under the direction of his father. **Member:** Am Artists Prof League; Copley Soc Boston; North Shore Arts Asn; Chautauqua Art Asn; Salmagundi Club. **Exhibited:** Ogunquit Art Ctr Ann Exhibs, Maine, 1971-72; Am Artists Prof League Grand Nat, NYC, 1971-72; Hudson Valley Art Asn Ann, White Plains, NY, 1972;

Chautauqua Art Asn Nat Exhib, 1972; North Shore Arts Asn Ann, East Gloucester, Mass, 1972. Awards: Mrs Helen Logan Award for Ogunquit Spume, Chautauqua Nat, 1972; hon mention for Open Sea, Ogunquit nat, 1972. **Work:** In pvt collections throughout the US. **Comments:** In 1970 Turner began exhibiting his work throughout New England and New York. Preferred Media: Oils. Positions: Owner, Bruce Turner Gallery, Rockport, Mass. Teaching: Pvt classes in oil painting, Rockport, Mass, 1971-72. Specialty: landscapes and seascapes. Painting locations include Monhegan Island (ME). **Sources:** WW73; Curtis, Curtis, and Lieberman, 66, 187.

TURNER, (Charles) Arthur *[Painter, instructor] b.1940, Houston, TX.*
Addresses: Houston, TX. **Studied:** N Tex State Univ, BA, 1962; Cranbrook Acad Art, Bloomfield Hills, Mich, MFA, 1966, with Zoltan Shepeshy. **Member:** Southwestern Watercolor Soc; Tex Fine Arts Asn; Tex Watercolor Soc; Col Art Asn Am. **Exhibited:** Artist of Southeast & Tex, Isaac Delgado Mus, New Orleans, 1961; Prings 1966, State Univ NY Potsdam, 1966; Drawing Soc Nat, Am Fedn Art, NYC, 1970; 24th Am Drawing Biennial, Norfolk Mus Art, Va, 1971; The Other Coast, Calif State Col, Long Beach, 1971; Smither Gallery, Dallas, TX, 1970s. Awards: Award in 34th Ann Painting & Sculpture Exhib, Dallas Mus Fine Arts, 1963; second award, Southwestern Watercolor Soc 7th Ann, 1971; first purchase award, Beaumont Art Mus 20th Ann, 1971. **Work:** MFA, Houston, Carrol Reese Mus, E Tenn State Univ, Johnson City; Alcoa Aluminum Co, Detroit, Mich; The Galleries, Cranbrook Acad Art; Del Mar Col, Corpus Christi, Tex. **Comments:** Preferred Media: Oils, Acrylics, Charcoal. Teaching: Asst prof painting, Madison Col(Va), 1966-68; instr painting, Sch Art, Mus Fine Arts, Houston, 1969-70s. **Sources:** WW73; Richard Hutchens, "Arthur Turner--Painter," *Forum* (Summer, 1968); R. Hutchens, "Arthur Turner," *Facets,* (June, 1969).

TURNER, Charles F.H. *[Painter] b.1848, Newburyport, MA. / d.1908.*
Addresses: Boston, MA. **Studied:** O. Grundmann, in Boston. **Member:** Unity AC; Boston AC (Pres.). **Exhibited:** Boston AC, 1884-1907; PAFA Ann., 1887; AIC. **Sources:** WW10; Falk, *Exh. Record Series.*

TURNER, Charles Louis *[Painter] 20th c.; b.Illinois.*
Addresses: Pasadena, CA. **Studied:** with Edith White; San Francisco School of Des.; Italy; France; Germany. **Exhibited:** Mark Hopkins Inst., 1897-98, 1904; Bentz Art Store, Los Angeles, 1912, 1915; San Rosas Hotel, Capistrano, 1916; Battery Gallery, Los Angeles, 1917-18. **Sources:** Hughes, *Artists of California,* 567.

TURNER, C(harles) Y(ardley) *[Mural painter, illustrator, teacher] b.1850, Baltimore / d.1918, NYC.*
Addresses: Baltimore, MD; NYC, 1882-95. **Studied:** Maryland Inst., Baltimore, 1870; NAD; ASL, 1872-78; Académie Julian, Paris with J.P. Laurens, 1878-81; also with Munkacsy and Bonnât in Paris. **Member:** ANA, 1883; NA, 1886; AWCS; Mural Painters; Arch. Lg., 1896; ASL (founder); Artists Aid Soc.; Century Assn.; SC.; Charcoal Club; Cosmos Club. **Exhibited:** Brooklyn AA, 1876-82; Boston AC, 1881-88; NAD, 1877, 1882-95 (prize, 1884); PAFA Ann., 1889, 1892; Pan-Am. Expo, Buffalo, 1901 (medal); St. Louis Expo, 1904 (medal); Corcoran Gal annual, 1908; Arch. Lg., 1912 (medal). **Work:** MMA; Brooklyn Mus.; Union League Cl., NYC; Mus. New Mexico. Murals: Court House, Baltimore; Hudson County Court House, Jersey City; Essex County Court House, Newark; Hotel Raleigh, Wash., DC; Mahoning County Court House, Youngstown, OH; Appellate Court, NYC; St. Andrew's Methodist Episcopal Church, NYC; De Witt Clinton H.S., NYC; Manhattan Hotel, NYC; Hotel Martinique, NYC; Hotel Waldorf-Astoria, NYC; Wisconsin State Capitol Bldg. **Comments:** Along with Abbott Thayer and John LaFarge, he was one of the great American mural painters. He was kept busy by commissions for major public buldings around the country. In the1880s, he also painted some landscapes of

Long Island. Position: teacher, ASL, 1881-84; assistant director of decoration, Chicago World's Fair, 1893. **Sources:** WW17; McMahan, *Artists of Washington, DC; East Hampton: The 19th Century Artists' Paradise;* Falk, *Exh. Record Series.*

TURNER, Dick *[Cartoonist] b.1909, Indianapolis, IN.*
Addresses: Vero Beach, FL. **Studied:** John Heron Art inst; De Pauw Univ, AB; Chicago Acad Fine Arts; Cleveland Art Sch. **Member:** Nat Cartoonist Soc. **Comments:** Preferred Media: Inks. Publications: Auth & illusr, "Carnival" (cartoon panel), 1940-. **Sources:** WW73.

TURNER, Dorothy Ling (Pulfrey) *[Painter, drawing specialist] b.1901, Providence, RI.*
Addresses: Lancashire, England. **Studied:** J. Sharman; A. Heintzelman. **Member:** St. Helens AC. **Exhibited:** AIC, 1923. **Sources:** WW40.

TURNER, E. (Miss) *[Artist] early 19th c.*
Exhibited: PAFA, 1813 (drawing or watercolor entitled "The Lady of the Lake"). **Sources:** G&W; Rutledge, PA.

TURNER, Edward *[Etcher] late 19th c.; b.New York.*
Exhibited: Paris Salon, 1893. **Sources:** Fink, *American Art at the Nineteenth-Century Paris Salons,* 399.

TURNER, Elizabeth *[Painter] 20th c.*
Addresses: Chicago area. **Exhibited:** AIC, 1945, 1949. **Sources:** Falk, *AIC.*

TURNER, Elmer P. *[Landscape painter] b.1890 / d.1966, probably Taos, NM.*
Addresses: Taos, NM, 1926-1966. **Exhibited:** PAFA Ann., 1930, 1933. **Comments:** Married to Ila McAfee, a painter. Career was ended by a physical disability. **Sources:** Peggy and Harold Samuels, 493; Falk, *Exh. Record Series.*

TURNER, Emery S. *b.1841 / d.1921, Saranac Lake, NY.*
Comments: Head of Anderson Art Galleries. Served in the Civil War.

TURNER, Evan Hopkins *[Museum director] b.1927, Orono, Maine.*
Addresses: Philadelphia, PA. **Studied:** Harvard Univ, AB, MA, PhD; Stir George Williams Univ, hon LHD, 1965; Swarthmore col, hon LHD, 1967. **Member:** Nat Endowment Arts (chmn mus panel); Am Asn Mus (mem coun); Asn Art Mus Dirs (chmn prof practices comt); Benjamin Franklin fel Royal Soc Arts; Am Fedn Arts (bd mem). **Comments:** Positions: Lectr & res asst, Frick Collection, New York, NY, 1953-56; gen cur & asst dir, Wadsworth Atheneum, Hartford, Conn, 1955-59; dir, Month Mus Fine Arts, 1959-64; dir, Philadelphia Mus Art, 1964-70s. Teaching: Adj prof art hist, Univ PA, 1970-. Research: Thomas Eakins; eighteenth century American sculpture. **Sources:** WW73.

TURNER, Evelyn See: **GAY-TURNER, Evelyn**

TURNER, Frances Lee (Mrs. E.K.) *[Painter, teacher] b.1875, Bridgeport, AL.*
Addresses: Atlanta, GA. **Studied:** Corcoran Art Sch.; ASL; K. Cox; G.E. Browne; D. Garber; G.P. Ennis; W. Stevens; R.H. Nicholls. **Member:** Georgia AA; Atlanta AA; Atlanta AG; Riverside (CA) AA. **Exhibited:** Atlanta AA, 1923 (prize). **Work:** White House. **Comments:** Contributor: *Atlanta Journal.* Position: teacher, Emory Univ. **Sources:** WW40.

TURNER, George B. *[Sculptor] 19th/20th c.*
Addresses: Wash., DC, active, 1909-1913. **Exhibited:** Soc. of Wash. Artists, 1909, 1911. **Sources:** McMahan, *Artists of Washington, DC.*

TURNER, George Richard (Dick) *[Cartoonist] b.1909, Indianapolis, IN.*
Addresses: Vero Beach, FL; Leesburg, IN. **Studied:** DePauw Univ., A.B.; Chicago Acad. **Member:** Nat. Cartoonists Soc.; Press Cl. **Exhibited:** Nat. Cartoonists Soc. exhibitions. Cartoon "Carnival" feature appears in some 300 daily and Sunday papers, U.S. and abroad. **Sources:** WW66.

TURNER, George W. See: **FOX, R. Atkinson**

TURNER, Hamlin *[Painter] b.1914, Boston, MA.*
Addresses: Marblehead, MA. **Studied:** Harvard Col. **Member:** Marblehead A. Gld. (Bd. Gov.). **Exhibited:** Boston A. Festival, 1953-54; DeCordova & Dana Mus., 1954; Lamont Gal., Exeter, N.H., 1953; Brookline Pub. Lib., 1953; Long Wharf Studios, Boston, 1954-55; Neptune Gal., Marblehead, 1955; King Hooper Gal., Marblehead, 1951-58; Music Theatre Gal., Beverly, Mass., 1956-1958; Marblehead A. Gld., 1958-65; Jordan-Marsh, Boston, 1958; Springfield Mus. A., 1960; Eastern States Exh., 1960; Beverly Farms Exh., 1962-63; World House Gal., 1963-64; Houghton Lib., Harvard Univ.; Lynn (Mass.) A. Festival, 1964; Marblehead A. Festival, 1963 (prize winner). **Work:** General Electric Co., Mass.; Lamont Mus., Exeter, N.H.; Seaboard Life Ins. Co., Miami; Coe Chevrolet Corp., Augusta, Me.; Moses Brown Acad., R.I.; Mass. Inst. Technology; Royal Norwegian Embassy, Brazil. **Sources:** WW66.

TURNER, Harriet French *[Painter] b.1886, Giles County, VA / d.1967.*
Addresses: Roanoke, VA. **Member:** Roanoke FAC. **Exhibited:** Roanoke FAC, 1953-54, 1956; Hollins College, 1959 (solo); Colonial Williamsburg, 1962 (solo). **Work:** A.A. Rockefeller Folk Art Collection, Colonial Williamsburg; Hollins College Collection. **Comments:** Colonial Williamsburg officials produced a film on the artist and her work, "Folk Artist of the Blue Ridge". This film was awarded prizes at the Columbus and the San Francisco Film Festivals. It was also designated the "best travel film" in Virginia. **Sources:** WW66.

TURNER, Helen Maria (Miss) *[Painter, miniature painter] b.1858, Louisville, KY / d.1958, New Orleans, LA.*
Addresses: New York City (from c.1896); New Orleans, LA (early 1930s-on). **Studied:** New Orleans AA, with A. Molinary, Brors A. Wickstrom, late 1880s-early 90s; ASL, With Kenyon Cox, S. Douglas Volk, 1895-99; CUA School, 1898-1901, 1904-05, with S.Douglas Volk; Columbia, 1899-1900; Wm. M. Chase, in Europe, 1904-05, 1911. **Member:** ANA, 1913; NA, 1921 (third woman to be elected to full academician status); NYWCC; NAC; APPL; SSAL; NOACC; NOAA; AWCS. **Exhibited:** NYWCC, 1897; PAFA Ann., 1898-1933; SAA (Min.P.), 1900; Milch Gal., NYC, 1917 (first solo); New York Women's AC, 1921 (prize); NAWA (prize); NAD, 1913 (prize), 1921 (prize), 1927 (prize); AIC, 1913 (prize); NAC, 1922 (prize), 1927 (gold); Pennsylvania Soc. Min. P.; Grand Central AG; Corcoran Gal biennials, 1914-30 (8 times); St. Louis AM, 1917; New Orleans Mus.of Art, 1948; traveling retrospective to Cragsmoor Library, Akron AM, Jersey City Mus., and Owensboro MFA, KY, 1983-84. **Work:** MMA; CGA; Detroit Inst.; Nat. AC; PMG; Houston Art Mus.; Norfolk Mus., VA; Newark Art Mus.; Highland Park Soc. Arts, Dallas; Montclair Art Mus.; Jersey City Mus.; New York Hist. Soc.; Sweet Briar College; Rockford AA; Zigler Mus.; Detroit IA; NOMA; Syracuse; Akron Art Mus.; High Mus.; Speed Mus.; Tweed Mus., Duluth; Brooks G., Memphis; Montgomery MFA. **Comments:** An Impressionist painter of landscapes, figures, and portraits, she was also part of the revival of miniature painting during the late 1890s-1910s. She spent summers at Cragsmoor, NY, 1906-26, then moved to New Orleans in the early 1930s and painted past age 90. Position: art instructor, St. Mary's Acad., Dallas, TX, 1893-94; teacher, YMCA Art School, NYC, 1902-19. **Sources:** WW53; *Natl Cycl. Am. Biog.* (p.114); *Who's Who in the South* (1950, p.926); *Who's Who in Am* (1937-38, p.2455); exh. cat., Cragsmoor Free Lib., NY (1983); Tufts, *American Women Artists,* cat. no. 56; Petteys, *Dictionary of Women Artists;* Falk, *Exh. Record Series.*

TURNER, Henry *[Portrait painter] mid 19th c.*
Addresses: Rappahannock County, VA in 1845. **Sources:** G&W; Willis, "Jefferson County Portraits."

TURNER, Herbert B. *[Painter, sculptor] b.1926, MT Vernon, NY.*
Addresses: DE Mar, CA. **Studied:** U.S. Military Acad., B.S.;

ASL; NAD; Am. A. Sch. **Member:** San Diego A. Gld.; A. Center of La Jolla; San Diego AI. **Exhibited:** A. Center of La Jolla, 1954-58; San Diego FA Gal., 1954-58; Vista A. Gld., 1957-58; San Diego County Fair, 1954-56, 1958; Oceanside A. Lg., 1954-1958. Awards: John and Anna Stacey Scholarship, 1955-57; prizes, Vista A. Gld., 1955-56; Carlsbad-Oceanside A. Lg., 1955 (3), 1956-57; San Diego A. Gld., 1955; San Diego AI, 1956, 1958; Rancho Santa Fe Exh., 1956, 1958; San Diego County Fair, 1958. **Sources:** WW59.

TURNER, Hermine *[Painter] 20th c.*
Addresses: Glen Ridge, NJ. **Exhibited:** S. Indp. A., 1919. **Sources:** Marlor, *Soc. Indp. Artists.*

TURNER, Ila McAfee See: **MCAFEE, Ila Mae**

TURNER, J. L. See: **TURNER, L.**

TURNER, J. M. W. *[Watercolor painter] b.1775 / d.1851.*
Exhibited: NAD, 1862. **Sources:** Naylor, *NAD.*

TURNER, J. T. *[Portrait painter] early 19th c.*
Addresses: Active in NY; Pittsburgh, PA, 1811-12; Chillicothe, OH,1813, Cincinnati,1814-16;Maysville KY,1817-20. **Comments:** An itinerant painter who was the teacher of James Bowman (see entry) in Chillicothe, OH, in 1816, and the teacher of Aaron H. Corwine (see entry) in 1817 at Maysville, KY. **Sources:** G&W; Anderson, "Intellectual Life of Pittsburgh: Painting," 288; Knittle, *Early Ohio Taverns,* 44; G&W has information courtesy R.E. Banta and Edward H. Dwight. More recently, see Gerdts, *Art Across America,* vol. 2: 179, 180, 231. Hageman, 122.

TURNER, James *[Heraldic engraver?] mid 18th c.*
Addresses: Marblehead, MA in May and June 1752. **Comments:** He made or painted escutcheons and engraved a coffin plate for the funeral of William Lynde. Bowditch thinks he is to be distinguished from the other James Turner listed. **Sources:** G&W; Bowditch, manuscript notes on American engravers of coats of arms.

TURNER, James *[Engraver and silversmith] d.1759, Philadelphia, PA.*
Addresses: Boston, 1744-48; Philadelphia, c.1758. **Comments:** His woodcut view of Boston appeared on the cover of *The American Magazine* in 1744 and 1745. Died of small pox. Possibly the same as James Turner, below, although Bowditch thinks they are to be distinguished. **Sources:** G&W; Stauffer; Hamilton, *Early American Book Illustrators and Wood Engravers,* 12, 43; Dow, *Arts and Crafts in New England,* cites obit. in Boston *Evening Post,* Dec. 10, 1759; Prime, I, 29; Bowditch, notes on heraldic painters and engravers.

TURNER, James H. *[Painter] 20th c.*
Addresses: Wash., DC, active 1920-1950. **Member:** Landscape Club of Wash. **Exhibited:** Greater Wash. Independent Exh., 1935. **Sources:** McMahan, *Artists of Washington, DC.*

TURNER, Janet Elizabeth *[Printmaker, educator] b.1914, Kansas City, MO / d.1988, Chico, CA.*
Addresses: Chico, CA. **Studied:** Stanford Univ, AB, 1936; Kansas City Art Inst, with Thomas H Burton, Dipl, 1941; Claremont Col, with Millard Sheets & Henry McFee, MFA, 1947; Columbia Univ, EdD, 1960. **Member:** Assoc NAD; Soc Am Graphic Artists; Nat Asn Women Artists; Am Color Pring Soc; Los Angeles Printmaking Soc. **Exhibited:** American Painting Today, 1950 & Watercolors & Prints, 1952,MMA; Ninth Nat Exhib, Libr of Cong, Washington, DC, 1951; Fourth Int Bordighera Biennale, Italy; Galerie Internationale, NYC; Bay Window, Mendocino, CA. **Awards:** Guggenheim fel, 1953; Tupperware Art Found fel, 1956 ; NAD, Cannon prize, 1961. **Work:** MMA; Philadelphia Mus Art, Pa; Victoria & Albert Mus, London; Bibliotheque Nat, Paris, France; Libr of Cong, Washington, DC. **Comments:** Preferred Media: Graphics, Mixed Media. Positions: Pres, Nat Serigraph Soc, 1957-59, v pres, 1959-62. Publications: Illusr, *The Yazoo, Rinehard,* 1952. Teaching: Instr art, Girl's Collegiate Sch, 1942-47; asst prof art, Stephan F Austin State Col, 1947-56; from asst prof to prof art, Chico State

Col, 1959-70s. **Sources:** WW73.

TURNER, Jean Leavitt (Mrs. Leroy C.) *[Painter, illustrator, sculptor, teacher, lecturer] b.1895, NYC / d.1962, Campbell, CA.*
Addresses: San Francisco; Victorville, CA; Campbell, CA. **Studied:** PIA Sch.; CUA Sch.; Ethel Traphagen. **Member:** AAPL; Lg. Am. Pen Women. **Exhibited:** CPLH, 1938-39; AAPL, 1940-46; Lg. Am. Pen Women, 1940, 1941; Laguna Beach, 1953 & various So. Calif. exhs. **Comments:** Illustr.: *Progress Books* (1-2-3 grade), 1926. Lectures: The Importance of Art in Our Everyday Life; Training the Art Student for the Professional Field. Position: dir., Jean Turner AC. **Sources:** WW59; WW47.

TURNER, John *[Artist] late 19th c.*
Addresses: NYC, 1890. **Exhibited:** NAD, 1890. **Sources:** Naylor, *NAD.*

TURNER, John *[Painter] 20th c.*
Addresses: Boston, MA; Contoocook, NH, 1927. **Member:** Chicago NJSA. **Exhibited:** Salons of Am., 1927; S. Indp. A., 1927. **Comments:** *Cf.* John P. Turner of Pennsylvania. **Sources:** WW25; Falk, *Exh. Record Series.*

TURNER, John P. *[Painter] 20th c.*
Addresses: Chester Springs, PA, 1933; Phila., PA, 1936. **Exhibited:** PAFA Ann., 1933, 1936. **Comments:** *Cf.* John Turner of Boston & New Hampshire. **Sources:** Falk, *Exh. Record Series.*

TURNER, Joseph *[Patron] b.1892, New York, NY / d.1973.*
Addresses: New York, NY. **Studied:** Jefferson Med Col, BS, MD. **Comments:** Art Interests: Kodachrome photography (non-profit) of works of art & donating the transparencies to museums & universities. **Sources:** WW73.

TURNER, Josie *[Portrait and landscape painter] late 19th c.*
Addresses: Norfolk, VA. **Exhibited:** Norfolk, VA, 1885-86. **Sources:** Wright, *Artists in Virginia Before 1900.*

TURNER, L. *[Portrait, landscape, and genre painter] mid 19th c.*
Addresses: Brooklyn, NY, 1832-44. **Comments:** As L. Turner, portrait painter, 1832-33; as J.L. Turner, artist, 1834-44. Presumably the Turner of Brooklyn who exhibited as the Apollo Association in 1839. **Sources:** G&W; Brooklyn CD 1832-44; Cowdrey, AA & AAU.

TURNER, LeRoy *[Mural painter, designer, drawing specialist, teacher] b.1905, Sherwood, ND.*
Addresses: Stillwater, MN. **Studied:** C. Booth; St. Paul Sch. Art; Univ. Minn.; E. Kinzinger, in Munich, Germany. **Work:** mural, Central H.S., St. Paul. **Comments:** Position: T., Stillwater A. Colony, Minn. **Sources:** WW40.

TURNER, Leslie *[Illustrator] b.1900, Cisco, TX.*
Addresses: Wichita Falls, TX/Tobe, CO. **Comments:** Illustrator: *Saturday Evening Post, Ladies' Home Journal, Pictorial Review.* **Sources:** WW40.

TURNER, Lottie B. *[Painter, teacher] 20th c.*
Addresses: NYC/Saginaw, MI, from 1897; Washington, DC, 1898. **Studied:** PIASch; Beck; Prellwitz; Paddock; Johonnot; Collins; Haney; Snell; Watson. **Exhibited:** AIC, 1916-17. **Comments:** Supervisor of drawing, NYC Elementary Schools, 1913-21. **Sources:** WW21; Petteys, *Dictionary of Women Artists.*

TURNER, Lucy (C.) *[Painter] 20th c.*
Addresses: Hollis, L.I., NY. **Exhibited:** S. Indp. A., 1917, 1920. **Sources:** Marlor, *Soc. Indp. Artists.*

TURNER, Marian Jane *[Painter] b.1908, Chester.*
Addresses: Chester, PA. **Studied:** Phila. Sch. Des. for Women; PAFA. **Member:** Phila. Alliance; Plastic Club. **Work:** Phila. Alliance; PAFA. **Sources:** WW40.

TURNER, Marie De Vidier *[Drawing teacher, painter, author and illustrator] mid 19th c.; b.Sweden.*
Addresses: Boston, active 1824; Cincinnati, active 1833. **Comments:** Taught painting in New York before advertising drawing academy in Cincinnati. Author and illustrator [?] of *The*

Young Ladies' Assistant in Drawing and Painting (Cincinnati, 1833) and *Rudiments of Drawing and Shadowing Flowers* (n.p., n.d.). **Sources:** G&W; LC, Union Cat.; Drepperd, "American Drawing Books." Hageman, 122.

TURNER, Matilda Hutchinson *[Miniature painter]* b.1869, Jerseyville, IL.
Addresses: Philadelphia, PA. **Studied:** Marietta (OH) College; Drexel Inst., with Steinmetz; PAFA, and with William Chase, Cecilia Beaux, Margaretta Archambault, Sargent Kendall. **Member:** PAFA (life); Fellow, PAFA (life); Penn. Soc. Min. Painters; Phila. Plastic Club. **Exhibited:** PAFA Ann., 1912; PAFA, 1925-45; BM, 1928-29; ASMP, 1929, 1932; Baltimore WCC, 1930; Century of Progress, Chicago, 1933; Calif. Soc. Min. Painters, 1937, 1944, 1948 -52; Smithsonian, 1944-45; also in Indianapolis, SFMA, Memphis, Charleston, Richmond, Washington, 1955. **Awards:** Fellowship, PAFA. **Work:** PMA. **Comments:** Author: "The Christmas Boy and Other Children's Stories". **Sources:** WW59; WW47; Falk, *Exh. Record Series.*

TURNER, Nellie D. *[Painter]* late 19th c.
Addresses: Kalamazoo, MI. **Exhibited:** Michigan State Fair, 1885. **Sources:** Gibson, *Artists of Early Michigan,* 230.

TURNER, Noel *[Sculptor]* 20th c.
Addresses: NYC. **Exhibited:** S. Indp. A., 1931; PAFA Ann., 1932; Salons of Am., 1934. **Sources:** Falk, *Exhibition Record Series.*

TURNER, Raymond *[Sculptor]* b.1903, Milwaukee, WI / d.1985.
Addresses: NYC. **Studied:** Milwaukee Art Inst.; Layton School Art; Wisconsin State Univ. (scholarship); Cooper Union Art School; BAID. **Member:** Fellow, Nat. Sculpture Soc.; East Hampton Guild. **Exhibited:** AIC, 1926; Detroit Inst. Art, 1927 (August Helbig Prize for Man); NAD, 1932-33, 1935, 1967; PAFA Ann., 1936, 1940; WFNY, 1939; Salon d'Automne, Paris, 1928; NSS, 1949, 1950 & 1972; Medallic Art Co., 1950; Argent Gal., 1951; Allied Artists Am., 1966 (Pauline Law Prize); "NYC WPA Art" at Parsons School Design, 1977. **Award:** Guggenheim Foundation fellowship, 1928. **Work:** "Four Freedoms," Rockefeller Plaza, NYC, 1942; schools in NYC and Brooklyn; Fort Wadsworth, Staten Island, NY; Smithsonian Inst., Washington, DC; Baseball Hall of Fame, Cooperstown, NY. **Commissions:** commemorative coins of Eddie Rickenbacker, Nat. Commemorative Soc., Robert E. Lee, Nat. Commemorative Soc., 1968, Fats Waller, Am. Negro Commemorative Soc., 1970, Theodore Roosevelt, Int. Fraternal Commemorative Soc., 1970 & Emily Dickinson, Soc. Commemorative Femmes Célèbres, 1970. **Comments:** WPA artist. Preferred media: wood, bronze. **Sources:** WW73; WW47; *New York City WPA Art,* 89 (w/repros.); Falk, *Exh. Record Series.*

TURNER, Richard Sydney *[Cartoonist]* b.1873 / d.1919.
Addresses: Newburgh, NY. **Comments:** He was cartoonist for Poughkeepsie Evening Star, Newburgh News, Union and American.

TURNER, Robert Chapman *[Educator, ceramist]* b.1913, Port Washington, NY.
Addresses: Alfred Station, NY. **Studied:** Swarthmore Col, BA; Pa Acad Fine Arts; State Univ NY Col Ceramics, Alfred Univ, MFA. **Member:** Nat Coun Educ Ceramic Arts (pres, 1968-69); NY State Craftsmen (bd mem, 1955-68); Am Crafts Coun (trustee, 1958-60); Int Acad Ceramics, Geneva, Switz. **Exhibited:** Int Ceramic Exhib, Palais Miramar, Brussels, Belg, 1958, Nat Mus Art, Buenos Aires, Arg, 1963 & Victoria & Albert Mus, London, Eng, 1972; Objects USA, traveling exhib sponsored by Johnson Wax Co, 1970; solo show, Bonniers, New York, NY, 1957. **Awards:** Prize, Ceramic Nat Exhib, Everson Mus, Syracuse, 1951, 1954 & 1966; silver medal, Cannes, France, 1954 & silver medal, Prague, 1962, Int Exhib Ceramics. **Work:** Walker Art Ctr, Minneapolis; Univ Ill, Urbana; Smithsonian Inst, Washington, DC; Los Angeles Co Fair Asn; State Univ NY Albany. **Comments:** Preferred Media: Clay. **Teaching:** Instr ceramics, Black Mountain Col, 1949-51; prof ceramic art, State Univ NY Col Ceramics, Alfred Univ, 1958-70s; instr ceramic art, Penland Sch Crafts, summers, 1969-71. **Sources:** WW73; Daniel Rhodes, "Robert Turner" (1957) & Howard Yana Shapiro, "Bob Turner" (1972), *Craft Horizons.*

TURNER, Ross Sterling *[Painter, illustrator, craftsperson, teacher, writer]* b.1847, Westport, Essex County, NY / d.1915, Nassau, Bahamas.
Addresses: Boston, Salem, MA; Wilton, Hillsboro County, NH; NYC, 1886. **Studied:** early career as a mechanical draftsman; Royal Acad., Munich, 1876; also with Frank Currier in Munich. **Member:** NYWCC; AWCS; Boston WCC; Copley S., 1891. **Exhibited:** PAFA Ann., 1882, 1890-1902; NAD, 1886; Boston AC; Harcourt Studios, Boston, 1890; Pan-Am. Expo, Buffalo, 1901 (med); AWCS, 1908 (prize); Doll & Richards Gal., Boston; AIC. **Work:** BMFA; Peabody Mus., Salem. **Comments:** A highly influential teacher of watercolor. Although not a student of Frank Duveneck, he was considered one of the "Duveneck Boys" in Venice, late 1870s. He returned to Boston in 1882 and spent summers, with Childe Hassam and others, as part of the artist colony at Celia Thaxter's island home, Appledore, Isle of Shoals, NH. From 1892-on, he made painting trips to Bermuda. Author: *Art for the Eye — School Room Decoration.* Other specialties: illuminated manuscripts. **Teaching:** Mass. Normal A. Sch. (1909-); MIT. **Sources:** WW19; exh. cat., *Painters of the Harcourt Studios* (Lepore FA, Newburyport, MA, 1992); Falk, *Exh. Record Series.*

TURNER, Samuel R. *[Painter, architect]* 19th/20th c.
Addresses: Wash., DC, active 1876-1905. **Member:** Wash. AC, 1876-77. **Sources:** McMahan, *Artists of Washington, DC.*

TURNER, Shirley *[Miniature painter, craftsperson, teacher]* early 20th c.; b.NYC.
Addresses: NYC; Brooklyn, NY, 1897. **Studied:** A.W. Dow, in NYC; Académie Julian, Paris with Constant and Lefebvre. **Member:** Brooklyn AC. **Exhibited:** Paris Salon, 1892; NAD, 1897; SAA, 1898; PAFA Ann., 1898-99, 1902; Louisville AL, 1898. **Sources:** WW13; Fink, *American Art at the Nineteenth-Century Paris Salons,* 399; Falk, *Exh. Record Series.*

TURNER, Theodore Roy *[Painter, educator]* b.1922, Frederick Hall, VA.
Addresses: Charlottesville, VA. **Studied:** Richmond Prof Inst, Col William & Mary, BFA, 1943; New Sch Soc Res, New York, NY, 1946-50, painting with Abraham Rattner & printmaking with Louis Shanker; NY Univ Inst Fine Arts, MA, 1950. **Member:** Va Ctr Creative Arts (adv bd, 1971-72). **Exhibited:** Brooklyn Mus Print Ann, 1951,1955; Am Fedn Arts Traveling Exhib Prints, 1955; Va Mus Biennials, 1959, 1967, 1971; Watercolor USA, Springfield, Mo, 1964; solo shows, Babcock Galleries, New York, 1968 -69; Dealer: Babcock Galleries, New York, NY. **Awards:** Cert distinction & purchase award, Va Mus Fine Arts, 1959; purchase award, 20th Watercolor Nat, Miss Art Asn, 1961; painting award, 18th Irene Leache Mem, Norfolk Mus, 1966. **Work:** New York Pub Libr Print Collection; Va Mus Fine Arts, Richmond; Miss Art Asn, Jackson; Dartmouth Col, Hanover, NH; Univ Va, Charlottesville. **Comments:** Preferred Media: Watercolors, Oils. **Teaching:** Instr medieval archit, Dartmouth Col, 1950-52; assoc prof painting, Univ Va, 1952-70s, acting chmn McIntire Dept Fine Arts, 1962-67; vis artist, Roanoke Fine Arts Ctr, Va, 1971. **Sources:** WW73; Sue Dickinson, "Theodore Turner," *Richmond Times-Dispatch,* June 23, 1968; "Theodore Turner," *New York Mag* (June 24, 1968); Larry Campbell, "Theodore Turner's watercolors," *Art News* (Dec, 1969).

TURNER, Virginia *[Painter]* mid 20th c.
Exhibited: Corcoran Gal biennial, 1947. **Sources:** Falk, *Corcoran Gal.*

TURNER, W. *[Landscape painter]* mid 19th c.
Addresses: NYC. **Exhibited:** NAD, 1828. **Sources:** G&W; Cowdrey, NAD.

TURNER, W. A. *[Engraver] mid 19th c.*
Addresses: New Orleans, 1856. **Sources:** G&W; New Orleans CD 1856 (Delgado-WPA).

TURNER, Walter E. *[Painter] late 19th c.*
Addresses: NYC, 1885, 1892. **Exhibited:** NAD, 1885, 1892. **Sources:** Naylor, *NAD.*

TURNER, William Greene *[Sculptor and medallist] b.c.1832 / d.1917, Newport, RI.*
Addresses: Newport, RI. **Exhibited:** PAFA Ann., 1878. **Work:** Commodore Oliver Hazard Perry statue, Newport. **Sources:** G&W; *Art Annual,* XV, obit.; Thieme-Becker; Falk, *Exh. Record Series.*

TURNER & FISHER *[Wood engravers and stationers] mid 19th c.*
Addresses: Philadelphia, 1840's. **Comments:** Frederick Turner and Abraham Fisher (see entries) were the partners. The firm was listed under wood engravers only in 1844. **Sources:** G&W; Phila. BD 1844; Phila. CD 1843-49.

TURNEY, Dennis *[Lithographer] b.c.1828, Pennsylvania.*
Addresses: NYC in 1850. **Comments:** *Cf.* Dennis Twomy. **Sources:** G&W; 7 Census (1850), N.Y., XLIII, 78.

TURNEY, Ester *[Painter] 20th c.*
Addresses: Norman, OK. **Comments:** WW19 lists this artist as Esther Turvey. **Sources:** WW17; Petteys, *Dictionary of Women Artists.*

TURNEY, Olive *[Painter] b.1847, Pittsburgh / d.c.1939.*
Addresses: Pittsburgh, PA/Scalp Level, PA. **Studied:** Pittsburgh Sch. Des. for Women. **Member:** AAPL. **Exhibited:** Pittsburgh Sch. Des. for Women, 1872 (gold). **Sources:** WW33; Petteys, *Dictionary of Women Artists,* reports death date c.1933.

TURNEY, Winthrop D. (Mrs.) See: **RICHMOND, Agnes M.**

TURNEY, Winthrop Duthie *[Painter] b.1884, NYC / d.c.1957.*
Addresses: Brooklyn, NY. **Studied:** ASL; and with George De Forrest Brush, Frank DuMond, Louis Loeb. **Member:** Fifteen Gal. Group; Brooklyn SA; Brooklyn PS; All. Artists Am.; AAPL; 50 American Artists; Art Fellowship. **Exhibited:** S. Indp. A., 1917-27; PAFA Ann., 1918, 1921; Salons of Am., 1922-25; All. Artists Am., 1944 (prize), 1947 (prize); AWCS, 1937, 1940, 1944-46; NAD, 1944-45, 1946; AAPL, 1952-1954 (prizes); Newark Mus.; Milwaukee AI; WMAA, 1929; MoMA. **Work:** BM; Des Moines AC; Hickory (NC) Mus. Art. **Sources:** WW59; WW47; Falk, *Exh. Record Series.*

TURNURE, Arthur *[Painter, publisher] b.1857, NYC / d.1906.*
Addresses: NYC. **Studied:** Princeton, 1876. **Member:** Arch. Leg., 1887; (founder) Grolier C., NYC, ca. 1890. **Comments:** Began the paper known as "The Art Age," which he let die to begin "The Art Interchange." Later became art director for *Harper's,* where he arranged a richly illustrated edition of Lew Wallace's "Ben Hur." **Sources:** WW06.

TUROFF, Muriel Pargh *[Sculptor, painter, craftsman] b.1904, Odessa, Russia.*
Addresses: Riverdale 71, NY; Coral Gables, FL. **Studied:** NAD; Art Students League New York; Pratt Inst; Univ Colo.; Am. A. Sch. **Member:** N.Y. Soc. Ceramic A.; N.Y. Soc. Craftsmen; Artists Equity Asn; Fla Sculptors; Blue Dome Art Fel (treas, 1964-68); Am Craftsmen's Coun; Fla Craftsmen. **Exhibited:** Syracuse Mus Art, NY, 1945-46; AAUW travelng exh., 1946-47; Mus Natural Hist, New York, 1958; N.Y. Soc. Ceramic A., 1948-55; N.Y. Soc. Craftsmen, 1948-55; Jewish Mus., N.Y., 1957-58; Cooper Union Mus, New York, 1960; Lowe Mus Beaux Arts, Miami, Fla, 1968; YM-YWHA, Miami, Fla 1971. Awards: Blue ribbon for best in show, Blue Dome Art Fel, 1966; second prize, YM-YWHA, 1971. **Work:** Smithsonian Inst Portrait Gallery, Washington, DC; Jewish Mus, New York, NY. **Comments:**

Preferred Media: Metals, Enamels. Teaching: Instr., Henry Hudson Day Camp, 1943; Instr art & ceramics, Riverdale Neighborhood House, New York, 1943-47; Kingsbridge Veteran's Hospital, 1944-45; instr ceramics in occup ther, Vet 72. Publications: Auth, *How to Make Pottery,* Crown, 1949. **Sources:** WW73.

TURPIN, Fay *20th c.*
Exhibited: Salons of Am., 1934; AIC, 1924-26. **Sources:** Marlor, *Salons of Am.*

TURPIN, James *[Engraver and die sinker] mid 19th c.*
Addresses: NYC, 1849. **Sources:** G&W; NYBD 1849.

TURRELL, Arthur *[Artist] late 19th c.*
Exhibited: NAD, 1868. **Sources:** Naylor, *NAD.*

TURRELL, Charles James *[Miniature painter] b.1845, London, England / d.1932, White Plains, NY.*
Addresses: Ridgefield, CT, 1920s. **Studied:** Mr. Sargeant, London (accord. to Strickler, this is possibly the miniaturist Frederick Sargent, who died in 1899 and exh. at the Royal Acad.). **Exhibited:** Brooklyn AA, 1868; Royal Academy, London, 1873-1904; PAFA Ann., 1901. **Work:** Worcester Art Mus. **Comments:** Turrell came to NYC as a young man, and exhibited his "cabinet portraits." He found his greatest success as a miniature painter, exhibiting annually at the Royal Academy for three decades. On his frequent visits to England, his sitters included Queen Victoria, Queen Mary, Queen Alexandra, Queen Maud of Norway, Gladstone and other notables. In America he painted members of the Vanderbilt, Whitney and Morgan families of NY, the Armorys of Boston and the McCormicks and Ryersons of Chicago, among others. **Sources:** WW25; Falk, *Exh. Record Series;* Strickler, *American Portrait Miniatures,* 112, who cites a birth date of 1846.

TURSBURG, Julie *[Painter] 20th c.*
Exhibited: WMAA, 1922. **Sources:** Falk, *WMAA.*

TURTAZ, Lewis *[Miniature painter and teacher of drawing] mid 18th c.*
Addresses: Charleston, SC in 1767. **Comments:** He was from Lausanne (Switzerland). **Sources:** G&W; Rutledge, *Artists in the Life of Charleston,* 118; Prime, II, 11.

TURTLE, Arnold E. *b.1892, Birmingham, England / d.1954.*
Addresses: Chicago (1922-on). **Studied:** Leeds (England) Inst.; AIC. **Exhibited:** Chicago Gal. Ass'n, 1928, 1930 (solos), 1955 (memorial exh. at Oak Park, IL); Allerton Club, 1931 (solo); Palette & Chisel Club, 1931 (solo), 1937 (gold medal); AIC, 1935-36; New Orleans Art Lg.; Delgado MA; Harmansons Royal St. Bookstore. **Work:** Valparaiso Univ.; Historic New Orleans Collection. **Sources:** PHF files, info courtesy Oak Park Lib.; *Complementary Visions,* 90.

TURVEY, Esther See: **TURNEY, Ester**

TURZAK, Charles *[Painter, printmaker, cartoonist, illustrator, designer] b.1899, Streator, IL / d.1986, Orlando, FL.*
Addresses: Chicago, IL (to 1958); Orlando, FL (1958-0n). **Studied:** AIC. **Member:** Artists Lg. of Orange Cnty; Orlando MA. **Exhibited:** AIC, 1940 (prize); Maitland Art Cntr, 1993 (solo); Mary Ryan Gal., NYC, 1990s. **Work:** LOC; murals, USPOs, Chicago and Lemont, IL. **Comments:** The strongest of his works are highly stylized woodblock prints from the 1930s-40s. He also worked as a WPA muralist. During the 1950s-70s, he painted in a variety of abstract syles; by the 1970s-80s he was also painting floral still life and sailing themes. Position: A. Dir., *Today's Health Magazine* (1942-on). Illustrator: *Abraham Lincoln —Biography in Woodcuts* (1933); *Benjamin Franklin — Biography in Woodcuts* (1935). **Sources:** WW59; WW47; add'l info courtesy Joan Turzak Van Hees (1994).

TUTHILL, Abraham Gulielmus Dominy *[Portrait painter] b.1776, Oyster Pond, Long Island, NY / d.1843, Montpelier, VT.*
Studied: With Benjamin West in England, 1800, remaining in London for seven years with an additional year in Paris. **Work:** Shelburne (VT) Mus.; Jefferson Co. Hist. Soc., Watertown, NY.

Comments: After returning to America he moved about a good deal, gaining a reputation as a fine portraitist. He is known to have been in NYC in 1808 and 1810, in Pomfret (VT) about 1815, in Watertown (NY) and Sackets Harbor (NY) in 1817-20, in Utica or Plattsburgh (NY) about 1819-20, in Buffalo (NY) in 1822, Detroit (MI) in 1825, Rochester (NY) about 1827, Vermont again in 1830-31, Cincinnati in 1831-36, and Buffalo from 1837-40. His last years were spent in the home of a sister in Montpelier (VT). **Sources:** G&W; Frankenstein and Healy, *Two Journeyman Painters,* 46-63, with 18 repros. and checklist; Ulp, "Art and Artists in Rochester," 30; Cist, *Cincinnati in 1841,* 140 [as Turtle]; Cincinnati CD 1831; Hageman, 123; Muller, *Paintings and Drawings at the Shelburne Museum,* 133 (w/repros.); Gerdts, *Art Across America,* vol. 1: 187-88.

TUTHILL, Corinne *[Painter, muralist, craftsperson, educator, block printer, designer, craftsperson]* b.1892, Lawrenceburg, IN.
Addresses: Florence, AL. **Studied:** Columbia Univ., B.S., M.A. **Exhibited:** Provincetown, MA; Wash., DC; Morton Gal., NYC; SSAL. Awards: Carnegie scholarship, Harvard Univ., 1942. **Comments:** Contributor: articles, *School Arts, Design.* Position: head, art dept., State Teachers College, Florence, AL, 1933-. **Sources:** WW59; WW47, which puts birth at 1891.

TUTHILL, Daniel *[Engraver]* b.c.1835, New York.
Addresses: NYC in 1860. **Sources:** G&W; 8 Census (1860), N.Y., XLIII, 266.

TUTHILL, Ella (Mrs. Albert Gedney) See: **VAN DYKE, Ella (Tuthill)**

TUTHILL, John *[Painter]* 20th c.
Addresses: Phila., PA. **Exhibited:** S. Indp. A., 1928. **Sources:** Marlor, *Soc. Indp. Artists.*

TUTHILL, Joshua *[Painter]* 19th c.
Addresses: Saginaw, MI. **Exhibited:** Michigan State Fair, 1875. **Comments:** Preferred media: watercolor, pastels. **Sources:** Gibson, *Artists of Early Michigan,* 230.

TUTHILL, Margaret H. *[Painter]* 20th c.
Addresses: Chicago, IL. **Exhibited:** AIC, 1916-17. **Sources:** WW17.

TUTHILL, Mary E. *[Painter, sculptor]* b.1880 / d.1951, Brooklyn, NY.
Addresses: Booklyn, NY. **Exhibited:** AIC, 1913, 1916; S. Indp. A., 1938. **Sources:** WW17.

TUTHILL, Sarah *[Teacher]* 19th c.
Addresses: Farmington, Conn. **Comments:** A respected art instructor at Miss Porter's Sch., Farmington, Conn., she was devoted to teaching the Ruskinian aesthetic of botanical natural- ism. She retired from teaching about 1881 at which time her nephew Robert Brandegee took her place. **Sources:** Gerdts, *Art Across America,* vol. 1: 111; *Art in Conn.: Early Days to the Gilded Age* (under Brandegee).

TUTHILL, T. *[Painter]* 20th c.
Addresses: NYC. **Exhibited:** S. Indp. A., 1917. **Sources:** Marlor, *Soc. Indp. Artists.*

TUTHILL, William H. *[Engraver and lithographer]* mid 19th c.
Addresses: NYC. **Comments:** Active from 1825 until after 1830 **Sources:** G&W; Stauffer; Peters, *America on Stone;* NYCD 1830-32.

TUTOR, H. G. *[Painter]* 20th c.
Addresses: Chicago area. **Exhibited:** AIC, 1935. **Sources:** Falk, *AIC.*

TUTTLE, Adrianna *[Miniature painter]* b.1870, Madison, NJ.
Addresses: Newark, NJ. **Studied:** Chase. **Member:** Penn. Soc. Min. Painters; NAWPS; Am. Soc. Min. Painters. **Exhibited:** AIC, 1916. **Sources:** WW40.

TUTTLE, Catherine Snell *[Painter]* b.1893, California / d.1971, Los Angeles, CA.
Addresses: Monrovia, CA. **Exhibited:** Artists Fiesta, Los Angeles, 1931. **Sources:** Hughes, *Artists of California,* 568.

TUTTLE, Charles F. *[Engraver]* b.c.1841, OH / d.1893.
Addresses: New Orleans, active 1869-93; NYC, 1878-79. **Studied:** with Carolus-Duran. **Exhibited:** NAD, 1876-79; Paris Salon, 1889. **Sources:** *Encyclopaedia of New Orleans Artists,* 384; Fink, *American Art at the Nineteenth-Century Paris Salons,* 399.

TUTTLE, Charles M. *[Painter]* 20th c.
Addresses: Woodstuck, NY. **Sources:** WW25.

TUTTLE, David H. *[Wood engraver]* mid 19th c.
Addresses: NYC, 1858-60. **Sources:** G&W; NYBD 1858, 1860.

TUTTLE, Emerson See: **TUTTLE, (Henry) Emerson**

TUTTLE, Franklin *[Artist]* late 19th c.
Addresses: NYC, 1888, 1890. **Exhibited:** NAD, 1888, 1890. **Sources:** Naylor, *NAD.*

TUTTLE, George W. *[Artist]* mid 19th c.
Addresses: NYC, 1840's and 1850's. **Exhibited:** American Institute (1851: bust or statuette of Jenny Lind in wax and some "lithophanes" or transparent pictures). **Comments:** Also a dealer in "patent elastic baby jumpers" and fancy goods **Sources:** G&W; NYCD 1847-54; Am. Inst. Cat., 1851.

TUTTLE, Helen Norris *[Painter, educator]* b.1906, Croton-on-Hudson, NY.
Addresses: Bryn Mawr, PA. **Studied:** Bryn Mawr Col., A.B.; Univ. Pennsylvania, M.S. in Edu.; & with Thomas Benton, Edward Forbes, Josef Albers; B. Robinson; Lhote. **Member:** Phila. A. All.; AAPL. **Exhibited:** PAFA Ann., 1932, 1935; PAFA, 1936, 1954-55; Phila. AC, 1937; Bryn Mawr A. Center, 1938, 1944 (solo); Phila. A. All., 1939, 1956; Haverford Col., 1940. **Comments:** Position: Supv. A., Pub. Sch., Landale, Pa., 1941-45. Instr., Des., Hist. & Appreciation of Art, Rosemont Col., Rosemont, Pa., 1947-60s. **Sources:** WW59; WW47; Falk, *Exh. Record Series.*

TUTTLE, (Henry) Emerson *[Curator, teacher, etcher, engraver]* b.1890, Lake Forest, IL / d.1946, New Haven, CT.
Addresses: New Haven, CT/Nantucket, MA. **Member:** Soc. Am. E.; Chicago SE. **Work:** AIC; British Mus., London; Memorial A. Gal., Rochester, N.Y.; Bibliothéque Nationale, Paris; Mus. FA, Yale. **Comments:** Specialty: etchings of birds. Position: T./Curator, Gal. FA, Yale, 1930. **Sources:** WW40.

TUTTLE, Hudson *[Panorama painter]* mid 19th c.
Exhibited: In NYC (1855: Creation). **Comments:** There was a Hudson Tuthill, shipwright, active in NYC from 1825 to 1831. N.Y. *Herald,* Oct. 8, 1855 (cited by J. Earl Arrington); NYCD 1825-31. **Sources:** G&W; N.Y. *Herald,* Oct. 8, 1855 (cited by J. Earl Arrington); NYCD 1825-31.

TUTTLE, Isabelle Hollister (Mrs. Henry) *[Painter]* b.1895.
Addresses: New Haven, CT/Nantucket, MA. **Studied:** F. Chase; G. Wiggins; Yale. **Member:** New Haven PCC; NAWPS; CAFA. **Exhibited:** NAWPS, 1931 (prize); CAFA, 1934 (prize). **Sources:** WW40.

TUTTLE, Joseph W. *[Engraver]* mid 19th c.
Addresses: Boston, 1837-60. **Comments:** Of Morse & Tuttle. **Sources:** G&W; Boston CD 1837-60.

TUTTLE, Macowin *[Painter, illustrator, engraver, teacher, writer, lecturer]* b.1861, Muncie, IN / d.1935, Buck Hill Falls, PA.
Addresses: NYC. **Studied:** W.M. Chase; Duveneck; Académie Julian, Paris with J.P. Laurens. **Member:** NAC; SC; Paris AAA. **Work:** MMA; Mus. City of N.Y.; NGA; LOC; Yale. **Comments:** Specialty: engravings on wood direct from nature. **Sources:** WW33.

TUTTLE, Marjorie *[Sculptor]* 20th c.
Addresses: Chicago area. **Exhibited:** AIC, 1933, 1935. **Sources:** Falk, *AIC.*

TUTTLE, Mary McArthur T(hompson) (Mrs. H.)
[Painter, illustrator, writer] b.1849.
Addresses: Hillsboro, OH. **Studied:** McMickin Art Sch.,
Cincinnati, with T.S. Noble; Graef, in Berlin; Seitz, in Munich.
Exhibited: Boston AC, 1881; St. Louis Expo, 1904; Tremont
Temple, Boston. **Work:** portrait, Cornell Univ.; Crusade.
Comments: Author: "Historical Chart of the Schools of Painting."
Sources: WW15; Petteys, *Dictionary of Women Artists*.

TUTTLE, Mildred C. See: **JORDAN, Mildred C.**

TUTTLE, Otis P. *[Engraver] mid 19th c.*
Addresses: Boston, 1841-44. **Sources:** G&W; Boston CD 1841-
43, BD 1842, 1844.

TUTTLE, Plymmon Carl *[Designer, etcher, lithographer,*
painter] b.1914, Cleveland, OH.
Addresses: NYC. **Studied:** Cleveland Sch. Art; John Huntington
Polytechnic Inst.; Corcoran Sch. Art; & with Otto Egge, Frank
Wilcox, Paul Travis, Richard Lahey. **Exhibited:** Washington WC
Club, 1945-46. **Comments:** Position: lithographic artist & design-
er, Reserve Lithograph Co., Cleveland, OH, 1933-42; artist, Coast
& Geodetic Survey, Washington, DC, 1942-44; supervisor, Visual
Presentation Section, Chief of Staff, Military Intelligence, War
Dept., Washington, DC, 1944-1946. **Sources:** WW53; WW47.

TUTTLE, Richard *[Sculptor, painter] b.1941, Rahway, NJ.*
Addresses: New York, NY. **Studied:** Trinity Col (Conn); Cooper
Union, 1962-64. **Exhibited:** One-man shows, Betty Parsons
Gallery, 1965-68 & 1970, Galeria Schmela, Dusseldorf, 1968 &
Nicholas Wilder Gallery, Los Angeles, 1969; Anti Illusion:
Procedures/Materials, WMAA, 1969; Corcoran Gallery Art 31st
Biennial, 1969; Soft Art, NJ State Mus., 1969; Am Paintings Of
60's, Am Fedn Arts, 1969; WMAA, 1975 (solo). **Work:** WMAA;
James A Michener Found; Nat Gallery, Can; CGA; Kaiser-
Wilhelm Mus., Ger.; Drawings, Betty Parsons Collection;.
Comments: Mixed-media artist. His oeuvre has included painted
wood reliefs, crushed canvas octagons, cloth octagons, paper
octagonals, free standing sculptures, wire/graphic/shadow wall
pieces, and direct wall paintings. Publications: Contribr, *Art Int.*
Sources: WW73; Baigell, *Dictionary; Two Hundred Years of*
American Sculpture, 218-19, 316; Marcia Tucker, *Richard Tuttle*
(exh. cat., WMAA, 1975); "The Avant Garde: Subtle, Cerebral,
Elusive," *Time* (Nov 22, 1968); "This is the Loose Paint
Generation," *Nat Observer* (Aug 4, 1969); Robert Pincus-Witten,
"The Art of Richard Tuttle," *Artforum* (Feb, 1970).

TUTTLE, Ruel Crompton *[Portrait painter, mural painter]*
b.1866, Windsor.
Addresses: Greenfield, MA. **Studied:** ASL, with Mowbray, J.A.
Weir; MIT. **Member:** CAFA; Wash. WCC; NYWCC; AWCS;
Hartford AS. **Exhibited:** AIC, 1911-23. **Work:** Lib., Trinity Col.,
Hunt Mem., First Methodist Episcopal Church, Town and Country
Club, Wadsworth Atheneum, all in Hartford, Conn., John Fitch
Sch., Windsor, Conn. **Sources:** WW40.

TUTTLE, Tessie B. *[Painter] late 19th c.; b.San Francisco, CA.*
Exhibited: Paris Salon, 1888. **Sources:** Fink, *American Art at*
the Nineteenth-Century Paris Salons, 399.

TUTTLE, Walter (Ernest) *[Illustrator, painter] b.1883,*
Springfield.
Addresses: NYC/Springfield, OH. **Studied:** Chase; Henri; Mora.
Comments: Author/Illustrator: "The First Nantucket Tea Party".
Sources: WW13.

TUZO, J. Miss *[Painter, teacher]*
Addresses: New Orleans, active 1881-82. **Exhibited:** Southern
Art Union, 1882. **Comments:** Position: T, Southern Art Union.
Sources: *Encyclopaedia of New Orleans Artists*, 384.

TWACHTMAN, John
Henry *[Landscape painter,*
etcher, teacher] b.1853,
Cincinnati, OH / d.1902, Gloucester, MA.
Addresses: NYC, 1888, 1894-97; Greenwich, CT (c.1889-1902).
Studied: Ohio Mechanics Inst.; McMicken Sch. Des., Cincinnati
with Duveneck, 1875; Royal Acad., Munich with Loefftz, 1875-
77; went to Venice with Duveneck & W.M. Chase, 1877; Acad.
Julian, Paris, with Boulanger & Lefevbre, 1883-85. **Member:**
SAA, 1879; Am. AC, Munich; Ten Am. Painters; NY Etching
Club; Tile Club; Player's Club. **Exhibited:** Brooklyn AA, 1878-79
(Venetian scenes); PAFA Ann., 1879, 1893-1902, 1906-09 (gold
1895); Boston AC, 1881-82, 1896-97; Paris Salon, 1884; SAA,
1888 (prize); Columbian Expo, Chicago, 1893 (medal); Am. Art
Gals., NYC, 1893 (work by Weir & Twachtman); St. Botolph
Club, Boston, 1893 (work by Weir & Twachtman); CI, 1899
(prize); NAD, 1879-98; An Exh. by Ten American Painters,
Durand-Ruel Gals., NYC, 1898 (The Ten's first exh.) & St.
Botolph Club, Boston, 1898; AIC, 1901 (solo); Durand-Ruel
Gals., NYC, 1901 (solo); Knoedler Gals., NYC, 1904 (memorial
exh.); Armory Show, 1913; Lotos Club, NYC, 1917; Cincinnati
AM, 1966 (retrospective), 1999 (retrospective); Parrish AM, 1984
("Painter-Etchers" exh.); Spanierman Gal., NYC, 1968, 1987,
1989 (solos); High Mus. of Art, Atlanta, 1999. **Work:** MMA;
NMAA; MoMA; Mus. New Mexico; BM; AIC; PAFA; Smith
College Mus. Art; Cincinnati Art Mus.; WMAA; Lyman Allyn
Mus., New London, CT; Parrish AM. **Comments:** One of the
leading American Impressionists and a member of the "Ten
American Painters" group. When he died in 1902, his place was
filled by Wm. M. Chase. Twachtman's early style reflected the
influence of Duveneck and the Munich school, while his residence
in Paris (1883-85) saw the evolution of a more abstract
Whistlerian style. He traveled widely illustrating for *Scribner's*
(1888-93), and painted in Yellowstone Park in 1895; however,
most of his mature works were painted on his 17-acre farm in
Greenwich, where his palette become lighter, expressing poetic
and subtle nuances of tone. During his Gloucester period (sum-
mers 1900-02) he reintroduced black in his paintings. In 1903, the
American Art Gal., NYC, auctioned 98 of his estate paintings for
$16,610. Signature note: He usually signed with a mix of upper
and lower case letters. His earlier signature usually bears the
German form with two "n"s. He also used the monogram "JHT."
Posthumous editions of his etchings are signed by his son, Julian
A. Twachtman (see entry), as "JHT per A.T." Teaching:
McMicken Sch., Cincinnati, 1877; summer classes at Cos Cob,
CT, 1890-on; Gloucester, MA, 1900-02. **Sources:** WW01;
Richard Boyle, exh. cat. (Cincinnati AM, 1966); Richard Boyle,
John Twachtman (Watson Guptill, NY, 1979); *Twachtman in*
Gloucester: His Last Years, 1900-1902, essays by John Douglass
Hale, Richard J. Boyle, and William H. Gerdts (NYC: Spanierman
Gal., 1987); *In the Sunlight: The Floral and Figurative Art of J.H.*
Twachtman, essays by Lisa N. Peters, William H. Gerdts, John
Douglass Hale, and Richard J. Boyle (NYC: Spanierman Gal.,
1989); Lisa N. Peters, *John Twachtman: An American*
Impressionist (High Museum of Art, Atlanta, Ga, 1999); P&H
Samuels, 493-94; *Cincinnati Painters of the Golden Age*, 105-108
(w/illus.); *Connecticut and American Impressionism* 174-75
(w/repro.); *American Painter-Etcher Movement* 49; Fink, *Amer.*
Art at the 19th C. Paris Salons, 399; Brown, *The Story of the*
Armory Show.

TWACHTMAN, J(ulian) Alden *[Painter] b.1882,*
Cincinnati.
Addresses: NYC;
Greenwich, CT.
Studied: his father, John H.; Niemeyer; Bonnât, in Paris.
Exhibited: PAFA Ann., 1898 (flower paintings in water color);
Armory Show, 1913. **Sources:** WW17; Falk, *Exh. Record Series;*
Brown, *The Story of the Armory Show*.

TWACHTMAN, Martha ("Mattie") Scudder (Mrs. John H.) *[Painter, etcher] b.1861, Avondale, OH / d.1936, Greenwich, CT.*
Addresses: NYC, 1882; Greenwich, CT after 1888. **Studied:** Thomas S. Noble at Cincinatti Sch. Des., 1876; Europe, 1879-80; learned to etch with Cincinnati Etching Club, 1880. **Member:** Cincinnati Etching Club. **Exhibited:** BMFA Exhibition of Am. Etching, 1881; NAD, 1882; SAA; AWCS; Phila. SA; Inter-State Industrial Exposition (Chicago); "Women Etchers of America" exh., 1888; Ohio Valley Centennial, 1888; NY Etching Club, 1893, 1889, 1893. **Work:** Boston Mus. **Comments:** After her marriage to painter John Henry Twachtman in 1881, the couple traveled to England, Holland, Belgium, Munich and Venice, carrying etching materials with them so that they could draw directly on plates from nature. **Sources:** P. Peet, *American Women of the Etching Revival,* 64.

TWARDOWICZ, Stanley John (Jan) *[Painter, photographer, lithographer, teacher] b.1917, Detroit, MI.*
Addresses: Detroit, MI; Northport, NY. **Studied:** Meinzinger Art School, Detroit, 1940-44; AIC; F. de Erdely; F. Chapin; D. Lutz; Skowhegan School P&S, Maine, summers 1946 & 1947. **Member:** Scarab Club, Detroit. **Exhibited:** Detroit IA, 1942, 1943 (prize), 1944, 1945 (prize), 1946; CPLH, 1946; Milwaukee AI, 1944, 1946; Scarab Club, 1944, 1945; J.L. Hudson Gal., Detroit, 1946; Kalamazoo AI, 1946; PAFA Ann., 1950, 1966; Guggenheim Mus., 1954; AIC, 1954, 1955 & 1961; CI, 1955; MoMA, 1957-69 (5 exhs.); Mus. FA, Boston, 1966; WMAA; Peridot-Washburn Gallery, NYC, 1970s. **Awards:** Guggenheim Found. fellowship, 1956-57. **Work:** MoMA; LACMA; Milwaukee AC; AFA; NYU. **Comments:** Teaching: Ohio State Univ., 1946-51; Hofstra Univ., 1965. **Sources:** WW73; WW47; Falk, *Exh. Record Series.*

TWARDZIK, Henry F. *[Painter, craftsperson, teacher] b.1900, Oswiencium, Poland.*
Addresses: Boston, MA/Rockport, MA. **Studied:** Connick; Connoli; Hopkinson; Wilcox; Albright Sch. FA. **Member:** New England Soc. Contemp. A.; Buffalo SA. **Exhibited:** S. Indp. A., 1927; Spring Exh., Buffalo, 1928 (prize); Salons of Am., 1928; PAFA Ann., 1930. **Work:** Nat., Mus., Poland. **Sources:** WW33; Falk, *Exh. Record Series.*

TWEEDALE, Florence *[Artist]*
Addresses: Active in Salem, MI, 1893-95. **Sources:** Petteys, *Dictionary of Women Artists.*

TWEEDY, Richard *[Painter] 20th c.*
Addresses: NYC. **Studied:** Mowbray and Chase; ASL. **Member:** Paris AAA. **Exhibited:** S. Indp. A., 1917-19. **Sources:** WW10.

TWIBILL, George W. *[Portrait painter] b.c.1806, Lampeter, Lancaster County, PA / d.1836, NYC.*
Studied: Studied under Henry Inman (see entry). **Member:** N.A., 1833. **Comments:** His promising career was cut short by his death. **Sources:** G&W; CAB; Cowdrey, NAD; Cowdrey, AA & AAU; represented at NYHS and NAD.

TWICHELL, Gertrude Stevens *[Writer, craftsperson] 20th c.; b.Fitchburg.*
Addresses: Boston, MA/Fitchburg, MA. **Studied:** RISD; Sch. Appl. A. & Cr., Boston; Mass. Sch. A. **Member:** Boston SAC (Master Craftsman). **Exhibited:** Intl. Expo, Paris, 1937; Am.Fed. A. (traveling), 1937, 1938. **Comments:** Specialties: metal work; enameling. Contributor: articles, *Industrial Arts, Handicrafter.* **Sources:** WW40.

TWIETZ, John *[Painter] 20th c.*
Addresses: Chicago. **Exhibited:** AIC, 1905. **Sources:** Falk, *AIC.*

TWIGG, Eliza Sophia Wills *[Painter] b.1856, Hinsborough, UT / d.1903, Redlands, CA.*
Addresses: Redlands, CA. **Work:** Scripps College, Claremenot, CA. **Comments:** Grandmother of Phillip Dike (see entry). **Sources:** Hughes, *Artists of California,* 568.

TWIGG, William Albert (Mrs.) See: **DUPALAIS, Virginia Poullard (Mrs. W. Twigg)**

TWIGG-SMITH, William *[Painter, illustrator] b.1883, Nelson, New Zealand / d.1950, Kona, HI.*
Addresses: Honolulu, HI, 1916; France, 1917; Hawaii, 1919-on. **Studied:** AIC, c.1896; H.M. Walcott. **Member:** Hawaiian SA; Chicago ASL. **Exhibited:** Hawaiian Soc. Artists, 1917; Honolulu Art Soc., 1920; Honolulu Acad. Art, 1925. **Work:** Univ. Hawaii; Honolulu Acad. Arts. **Comments:** Painted Oriental marine subjects in Hawaii, as well as urban scenes. Illustrator, Hawaiian Sugar Planters Assn. **Sources:** WW40; Forbes, *Encounters with Paradise,* 209-10.

TWIGGS, Leo Franklin *[Painter, educator] b.1934, St Stephen, SC.*
Addresses: Orangeburg, SC. **Studied:** Claflin Col, Orangeburg, SC; AIC; NY Univ, with Jason Seley & Hale Woodruff; Univ Ga, with Sam Adler. **Member:** Col Art Asn Am; Nat Art Educ Asn; Nat Conf Artists (chmn, educ div, 1972); Guild SC Artists; SC Arts Comn (comnr, 1970-1972). **Exhibited:** Univ. of Cincinnati School of Art & Des.; Lincoln Univ.; Columbia Mus. of Art, SC; Mint Mus., Charlotte, NC; Sch Pub Health Art Exhib, Univ N C, 1971; Nat Exhib Black Artists, Washington, DC, 1971; Artists USA, CI, 1971-1972; Salute to Black Artists, N J State Mus, Trenton, 1972; Scholastic Mag Nat Art Competition, 1972. **Awards:** Best in show, Nat Conf Artists, 1969; merit prize, Guild SC Artists, 1970; award of distinction, Smith Mason Gallery, 1971. **Work:** Johnson Publ Co, Chicago; Spring Mills, New York; Wachovia Bank & Trust Co, NC; Atlanta Univ, Ga; Citizens & Southern Bank, SC; American Craftsmen Council; Afro-American Slide Depository. **Comments:** Preferred media: batik. Positions: comnr, SC Arts Comn, 1970-. Publications: auth, articles, in: *Explor Educ,* 1970, *Design Mag,* 1972, *Negro Educ Rev,* 1972, *Sch Arts,* 1972 & *Mus News,* 1972. Teaching: assoc prof art, SC State Col, 1964-. Research: Using a method of art criticism with Black under-privileged children. **Sources:** WW73; J Edward Atkinson, *Black Dimensions in Contemporary American Art* (1970); Ruth Waddy & Samella Lewis, *Black Artists on Art,* Vol II (1971); Mary Mebane, article, In: *Instr Mag* (1972); Cederholm, *Afro-American Artists.*

TWIGGS, Russell Gould *[Painter, lithographer] b.1898, Sandusky, OH / d.1991.*
Addresses: Pittsburgh, PA. **Studied:** Carnegie-Mellon Univ. **Member:** Assn. A. Pittsburgh; Abstract Group, Pittsburgh, 1942; Pittsburgh Plan Art. **Exhibited:** AIC, 1939, 1946, 1947 (Abstr & Surrealist Painting); SFMA, 1937; San Diego FA Soc., 1941; Assn. A. Pittsburgh, 1942-45; CI, 1942-45, five Exh., 1955-1967; PAFA Ann., 1946, 1949; Abstract Group, 1945, 1946; San Fran. A. Assn., 1934; WMAA Ann., 1955; MOMA Drawing Show, 1956; Corcoran Gal biennial, 1957; Pittsburgh Plan For Art, 1970s. **Awards:** Carnegie Inst Group Prize, Assoc Artists Pittsburgh, 1949; second prize for painting, Cincinnati Art Mus, 1955; Mrs Henry J Heinz, II Award, 1962. **Work:** WMAA; Wadsworth Atheneum, Hartford, CT; CI; BM; Westmoreland Co Mus Art, Greensburgh, Pa. **Comments:** Preferred Media: acrylics. Positions: Massier, Carnegie-Mellon Univ, 1924-. **Sources:** WW73; Paul Lancaster, "The artist," *Wall St J* (1957); Paul Chen, *Russell Twiggs retrospective* (Westmoreland Co Mus Art, 1964); Connie Kienzle, "Russell Twiggs," *Roto-Pittsburgh Press* (1971); WW47; Falk, *Exh. Record Series.*

TWINING, Yvonne See: **HUMBER, Yvonne Twining**

TWISS, Lizzie E. *[Drawing specialist, teacher, musician] b.1866.*
Addresses: Napavine, WA; Seattle, WA, 1887, 1888. **Studied:** Annie Wright Seminary, Tacoma, 1888; Goucher Academy, Montecano, WA, 1898. **Exhibited:** Wash. State Hist. Soc., 1963. **Comments:** Position: teacher, public schools. **Sources:** Trip and Cook, *Washington State Art and Artists,* 1850-1950.

TWITCHEL, Thomas *[Engraver] b.c.1815, New York.*
Addresses: Cincinnati in 1850. **Sources:** G&W; 7 Census

(1850), Ohio, XXI, 599.

TWITCHELL, Asa Weston (or A. M.)
[Portrait painter] b.1820, Swanzey , NH / d.1904, ~AW~
Slingerlands, NY.
Addresses: He spent most of his life in Albany, NY. **Exhibited:**
NAD, 1866-95; American Art-Union. **Sources:** G&W; Twitchell,
Genealogy of the Twitchell Family, 290-91; Cowdrey, NAD;
Cowdrey, AA & AAU; Albany CD 1848-60+.

TWITTY, James (Watson) *[Painter, educator] b.1916, Mt*
Vernon, NY.
Addresses: Arlington, VA. **Studied:** ASL with Edwin Dickinson,
Stephen Greene & Morris Kantor; Univ Miami with Xavier
Gonzalez & Eliot O'Hara. **Member:** Life mem ASL New York.
Exhibited: Corcoran Gal biennial, 1965; other Corcoran exh,
1966 (solo), Lehigh Univ, Bethlehem, Pa, 1967, Valley House
Gal, Dallas, 1969, Findlay Gal, NYC, 1971; McNay Art Inst, San
Antonio, Tex, 1972. Awards: Award of merit, Allied Artists Am,
1961; second prize, Soc Washington Artists, 1965; hon mention,
First Ann Exhib, Miami, Fla, 1966. **Work:** NMAA; Baltimore
Mus Art; Corcoran Gallery; High Mus Art, Atlanta; Dallas MFA.
Comments: Preferred Media: acrylics, oils. Teaching: Corcoran
Sch Art, 1964-70s; George Washington Univ, 1964-70s. **Sources:**
WW73.

TWOHY, Julius (Land Elk) *[Painter] b.1902, White Rocks,*
Ute Indian Reservation, UT.
Addresses: Seattle, WA. **Studied:** mostly self-taught. **Member:**
Wash. Artists Union. **Exhibited:** SAM, 1935-1938; NYWF, 1939.
Work: WPA artist. **Comments:** Perferred media: oil, watercolor.
Specialty: Native American life and art. **Sources:** Trip and Cook,
Washington State Art and Artists, 1850-1950.

TWOMBLY, Cy *[Painter] b.1928, Lexington, VA.*
Addresses: Rome, Italy. **Studied:** BMFASch., 1948-1949;
Washington & Lee Univ, 1950; ASL, 1951; Black Mountain Col,
NC, 1951, with Franz Kline & Robert Motherwell. **Exhibited:**
NYU, 1967; WMAA biennials, 1967-73; Milwaukee, Wis, 1968
(solo); Nicholas Wilder Gallery, 1969 (solo); Herron Inst Art,
Indianapolis, Ind, 1969; Leo Castelli Gallery, NYC, 1970s;
WMAA,1979 (retrospective); many more exh. in the U.S., Italy,
Germany, France, Switzerland, Belgium, The Netherlands.
Awards: VA Mus Fine Arts fel for travel in Europe & Africa,
1952-1953. **Work:** MoMA; WMAA; NMAA; pvt collections in
New York, Chicago, Washington, DC & Europe. **Comments:**
Internationally renowned 20th-century American painter. He is
best known for his works combining abstract elements in the form
of calligraphic marks, or "doodles," with titles that often allude to
Roman mythology. He traveled and lived in North Africa, Spain
and Italy from 1951-53, settling in Rome thereafter. Teaching:
Head art dept, Southern Sem & Jr Col, Buena Vista, VA, 1955-
1956. **Sources:** WW73; Baigell, *Dictionary; 300 Years of*
American Art; Cy Twombly: Paintings and Drawings, 1954-1977
(exh. cat., WMAA, 1979); Pierre Restany, *Lyrisme et Abstraction*
(Edizioni Apollinairi, Milan, 1960).

TWOMBLY, H. M. (Miss) *[Listed as "artist"] mid 19th c.*
Addresses: Boston in 1860. **Comments:** In partnership with Miss
A.H. Dennett (see entry). **Sources:** G&W; Boston BD 1860.

TWOMY (?), Dennis *[Lithographer] b.c.1835, Pennsylvania.*
Addresses: NYC in 1860. **Comments:** *Cf.* Dennis Turney.
Sources: G&W; 8 Census (1860), N.Y., XLIII, 740.

TWORKOV, Jack *[Painter, teacher]*
b.1900, Biala, Poland / d.1982. ~Tworkov~
Addresses: Came to NYC in 1913, remaining
there while also working in Provincetown, MA, 1923-35 and
1954-on. **Studied:** Columbia Univ, 1920-1923, hon LHD, 1972;
NAD, 1923-1925; ASL, 1925-1926, with Guy Pen du Bois and
Boardman Robinson. **Exhibited:** PAFA Ann., 1929, 1942, 1948-
49, 1962; AIC, 1942; NGA, 1941; WMAA, 1941,1951-81; ACA
Gal., 1940 (solo); Baltimore Mus., 1948 (solo); MoMA, 1964 (ret-
rospective); "New American Painting," intl traveling exh, Nionia,

1958; Osaka Festival, Gutai 9, 1958; Documenta II, Kassel, Ger,
1959; "American Abstract Expressonists," Guggenheim Mus,
1961; Corcoran Gal biennials, 1949-63 (5 times; incl. gold medal,
1963). Other awards: Guggenheim fellow, 1971. **Work:** Albright-
Knox Art Gallery, Buffalo, NY; CMA; MoMA; NMAA; WMAA;
Kent State Univ.; RISD; Walker Art Center; Yale Univ. WPA
mural in Marine Hospital, Carville, IA. **Comments:** Abstract
Expressionist whose gestural brush style of the late 1940s and
early 1950s showed DeKooning's influence (Tworkov opened a
studio next to DeKooning in 1948). Tworkov soon evolved his
own style in the 1950s, using bold colors and imposing a more
gridlike structure on his work. By 1960 these horizontal and verti-
cal elements had grown, dominating the canvas. Positions; WPA
artist, 1934-41. Teaching: Leffingwell prof art & chmn dept, Yale
Univ, 1963-69; Cooper Union, 1970-72; Columbia Univ, spring
1973. **Sources:** WW73; WW47; L. Slate, *Jack Tworkov* (film
produced by Nat Educ TV, 1963); Ed Bryant, *Jack Tworkov*
(WMAA, 1964); Provincetown Painters, 232; *300 Years of*
American Art, 893; Baigell, *Dictionary;* D. Ashton, *The Unknown*
Shore (Little, 1962); Falk, *Exh. Record Series.*

TWOSE, George M.R. *[Painter] 20th c.*
Addresses: NYC. **Exhibited:** S. Indp. A., 1918. **Sources:**
Marlor, *Soc. Indp. Artists.*

TWYMAN, Joseph *[Architect, painter, teacher, craftsperson]*
b.1842, Ramsgate, England / d.1904, Chicago.
Addresses: Chicago, IL. **Studied:** London, with Pugin,
Christopher, Dresser, William Morris. **Member:** South Park
Improvement; Workshop Assn.; Chicago Arch. C.; Morris Soc.
Sources: WW04.

TYERS, Emily Mygatt *[Painter] 19th/20th c.*
Addresses: Dobbs Ferry, NY; NYC, active 1895-1910.
Exhibited: PAFA Ann., 1895-97; Boston AC, 1898, 1900.
Sources: WW01; Falk, *Exh. Record Series.*

TYLER, Alfred J. *[Painter] b.1933, Chicago, IL.*
Studied: AIC; La Escuela Nacional de Artes Plasticas, Mexico
City. **Exhibited:** Mus. of Science & Indust., Chicago; La Petite
Gallery, Evanston, IL (solo); Malcolm X Community College
(solo); South Side Community Art Center Traveling Show;
Lincoln Congregational Church (solo); Oak Park, IL, Lib. **Work:**
Univ. of Ill.; Kendall Col., Evanston, IL; State of Ill. Centennial
Coll., Springfield; DuSable Mus. of African-American Hist.,
Chicago; Johnson Pub. Co.; Sexton Elementary School, Chicago.
Comments: Position: artist, S.M. Edison Chemical Co. **Sources:**
Cederholm, *Afro-American Artists.*

TYLER, Alice Kellogg See: **KELLOGG, Alice DeWolf**
(Mrs. Orno Tyler)

TYLER, Anna *[Painter, printmaker] b.1933, Chicago, IL.*
Studied: AIC; La Esmeralda, Mexico City. **Exhibited:** Nat'l Col.
of Education, Evanston, IL (solo); Mus. of Science & Industr.,
Chicago; Afam Studio Gallery; Oak Park Pub. Lib. **Work:** State
of Ill. Centennial Coll., Springfield; DuSable Mus. of African-
American Hist., Chicago; Johnson Pub. Co. **Sources:** Cederholm,
Afro-American Artists.

TYLER, Audubon *[Painter] 20th c.*
Addresses: Chicago area. **Exhibited:** AIC, 1925, 1928. **Sources:**
Falk, *AIC.*

TYLER, Bayard H(enry) *[Portrait and landscape painter]*
b.1855, Oneida, Madison County, NY / d.1931, Yonkers.
Addresses: NYC, 1888-90; Yonkers, NY; Catskill, NY. **Studied:**
Syracuse Univ., ASL; NAD; T. Kaufman. **Member:** Lotos C.; SC;
Yonkers AA; NYWCC. **Exhibited:** NAD, 1888-90; Corcoran Gal
biennials, 1910, 1923; Wash. SA, 1913 (prize); Yonkers AA, 1927
(prize). **Work:** CGA; State Coll., Albany, N.Y.; Banking Dept.,
Albany; Insurance Underwriters, N.Y.; Aetna Insurance Co., N.Y.;
North River Insurance Co., N.Y.; Standard C., Chicago; Holden
Mem., Clinton, Mass.; Hackley Mem. Sch., Tarrytown; Albright
Mem. Lib., Scranton; Wells Col., Aurora; Twenty-second
Regiment Armory, N.Y.; Women's Col., New London. **Sources:**

WW29.

TYLER, Benjamin Owen *[Engraver or lithographer] mid 19th c.*
Comments: Engraver or lithographer of a print of General William Henry Harrison, 1840. According to Tyler's own description it was "one of the most splendid prints ever published in this or any other country containing all the principal events in the life of Gen. Harrrison." He threatened to turn the print into Van Buren propaganda if the Whigs failed to subsidize him. Groce & Wallace speculated that this may be the Benjamin Owen Tyler, born in Buckland (MA) September 24, 1789, who made a facsimile of the Declaration of Independence. **Sources:** G&W; NYHS owns three letters from Tyler to Luther Bradish, dated New York, June 27, and July 1, 1840; Brigham, *The Tyler Genealogy,* I, 366.

TYLER, Carolyn Dow *[Miniature painter] early 20th c.; b.Chicago.*
Addresses: Chicago, IL. **Studied:** AIC, with Mrs. Virginia Reynolds; ASL, Chicago. **Member:** Chicago SA; Chicago WCC; Chicago Soc. Min. Painters; Chicago AC; Cordon. **Exhibited:** AIC, 1899-1929; Royal Soc. Min. Painters, London. **Sources:** WW40; Petteys, *Dictionary of Women Artists.*

TYLER, Charles H. *[patron] d.1931.*
Comments: He left his large collection of furniture, silver, books and prints to Boston Museum of Fine Arts.

TYLER, Edmond Goddard *[Painter] b.c.1858 / d.1882, Suspension Bridge, NY.*
Addresses: New Orleans, active c.1868. **Exhibited:** Grand State Fair, 1868 (hon. mention). **Sources:** *Encyclopaedia of New Orleans Artists,* 384.

TYLER, Edward *[Listed as "artist"] b.c.1833, New York.*
Addresses: NYC in 1850. **Sources:** G&W; 7 Census (1850), N.Y., LV, 420.

TYLER, Ernest F(ranklin) *[Painter, architect, designer] b.1879, New Haven, CT.*
Addresses: NYC/Cooperstown, NY. **Studied:** Yale; Columbia. **Member:** Soc. Beaux-Arts, Arch.; Arch. Lg.; Century A.; Nat. Soc. Mural P. **Exhibited:** Arch. Lg., 1937 (solo); WFNY, 1939. **Work:** dec., Am. Telephone & Telegraph Bldg.; Equitable Life Assurance Soc.; Riverside Church, both in NYC; Essex County Court House; Essex County Hall of Records, Newark; Masonic Temple, Scranton; Trinity Cathedral, Pittsburgh; Worcester (Mass.) War Mem.; Woolsey Hall, Yale; Christ Church, Greenwich Conn.; Baltimore Trust Co., Bank Bldg., Baltimore; U.S. Supreme Court Bldg. (two rooms); Old Trinity Church, Collegiate Church, St. Nicholas N.Y.; Christ Church, Cooperstown, N.Y.; portrait, AGAA; (in association with E.W. Jenney) Sun Life Assurance Soc., Montreal; Woolworth Bldg., N.Y.; Wis. State Capitol; Union Central Life Bldg.; Cincinnati; Hibernia Bank and Trust Co., New Orleans; Houses of Parliament, Ottawa, Canada; Seamen's Bank for Savings, N.Y.; First Nat. Bank, Jersey City; Standard Oil Co. Bldg., N.Y.; New Palmer House Hotel, Chicago; New Aeolian Co. Bldg., N.Y.; Nat. Acad. Sciences Bldg., Wash.; War Mem. Bldg., Nashville; Union Planters Bank, Memphis; Columbia Univ., dining hall; Cat. **Sources:** WW40.

TYLER, George Washington *[Portrait painter] b.c.1803, NYC / d.1833, NYC.*
Addresses: NYC, early 1830s. **Member:** A.N.A., 1832. **Sources:** G&W; Bolton, *Portrait Painters in Oil;* Cowdrey, NAD; NYCD 1830-32; Clark, *History of the NAD,* 272.

TYLER, Hugh C. *[Painter] 20th c.*
Addresses: Knoxville, TN. **Studied:** ASL. **Exhibited:** PAFA Ann., 1914; Salons of Am., 1926; S. Indp. A., 1926. **Sources:** WW24; Falk, *Exh. Record Series.*

TYLER, James G(ale) *[Marine painter, illustrator] b.1855, Oswego, NY / d.1931, Pelham, NY.*
Addresses: NYC, 1882-99; Greenwich, CT (1870s-1931).

JAMES G. TYLER

Studied: briefly with Archibald C. Smith in NYC, 1870.
Member: Brooklyn AC; SC, 1893; A. Fund. S.; Greenwich SA. **Exhibited:** NAD, 1880-99; Providence AC, mid 1880s; Boston AC, 1884-1899; Brooklyn AA, 1879-86, 1891; PAFA Ann., 1885-90; AIC; S. Indp. A., 1919, 1921. **Work:** CGA; Tokyo Mus.; Wadsworth Athenaeum, Hartford; Omaha, NE; Mariner's Mus., NYHS. **Comments:** He painted pictures of every America's Cup race since 1900, and his illustrations appeared in *Harper's, Century, Literary Digest* and other magazines. He spent most of his life in NYC, but during the mid 1880s had a studio in Providence, RI. In 1930, at age 75, he made his last coverage of the races off Newport and created his characteristically vivid portrayals of the Shamrock and Enterprise, which were later shown at the Union League Club. Tyler's marine pictures were so popular that he repeated in a formulaic way his theme of a sailing ship returning to harbor at night, with red port and green starboard running lights glowing. Even during his lifetime, forgeries of his works were discovered. **Sources:** WW29; exh. cat., *Painters of Rhode Island* (Newport AM, 1986, p.22); Art in Conn.: Early Days to the Gilded Age (cites birthplace as Greenwich, CT); Falk, *Exh. Record Series.*

TYLER, Margaret Yard *[Painter, teacher, writer, lecturer] b.1903, NYC.*
Addresses: Wash., DC. **Studied:** Corcoran Sch.; PAFA; M. Sterne. **Member:** Soc. Wash. Artists. **Exhibited:** Indp. Artists Exh., Wash., D.C., 1936 (prize); S. Indp. A., 1941. **Comments:** Position: Dir., Yard Sch. FA, Wash., D.C. **Sources:** WW40.

TYLER, May Belle *[Painter] 20th c.*
Addresses: Active in Los Angeles, 1911-32. **Sources:** Petteys, *Dictionary of Women Artists.*

TYLER, Muriel *[Painter] 20th c.*
Addresses: Los Angeles, CA. **Exhibited:** AIC, 1947. **Sources:** Falk, AIC.

TYLER, Owen (Mrs.) *[Painter] 20th c.*
Addresses: Louisville, KY, 1915. **Member:** Cincinnati Women's AC. **Sources:** WW15.

TYLER, Phil *[Western painter] b.1914*
Member: NWS. **Sources:** Falk, *Dict. of Signatures.*

PHIL TYLER NWS

TYLER, Ralph *[Engraver] mid 19th c.*
Addresses: Lowell, MA, 1837. **Sources:** G&W; Belknap, *Artists and Craftsmen of Essex County,* 5.

TYLER, Stella T. Elmendorf See: **TYLOR, Stella T. Elmendorf (Mrs.)**

TYLER, Thomas *[Sign and ornamental painter] mid 19th c.*
Addresses: Columbus, OH in 1826. **Sources:** G&W; Knittle, *Early Ohio Taverns,* 44.

TYLER, Valton *[Printmaker] b.1944, Texas City, TX.*
Addresses: Dallas, TX. **Studied:** Dallas Art Inst, TX, 1967. **Exhibited:** First Fifty Prints, Valton Tyler, Pollock Galleries, Southern Methodist Univ, Dallas, Tex, 1972; Eighth Ann New Talent Fifty Prints, Valton Tyler, Tyler Mus Art, 1972. **Work:** Tyler Mus Art, Tex. **Comments:** Preferred media: aquatint. Dealer: Valley House Gallery, Dallas, TX. **Sources:** WW73; Reynolds, *The Fifty Prints — Valton Tyler* (Southern Methodist Univ Press, 1972).

TYLER, William H. *[Wood engraver] b.c.1839, Massachusetts.*
Comments: Lived with his parents in Boston in June 1860. By September 1860 he was in NYC. **Sources:** G&W; 8 Census (1860), Mass., XXVII, 764; 8 Census (1860), N.Y., XLIII, 51.

TYLER, William Richardson *[Painter] b.1825 / d.1896.*
Addresses: Troy, NY, 1862-66. **Exhibited:** NAD, 1862-1867, 1878.
Comments: He painted in the White Mountains of New

W R Tyler

Hampshire and Keene Valley, in the Adirondacks, northern New York. **Sources:** Campbell, *New Hampshire Scenery,* 168; *Keene Valley: The Landscape and Its Artists.*

TYLOR, Stella T. Elmendorf (Mrs.) *[Sculptor, painter, teacher]* 20th c.; b.San Antonio, TX.
Addresses: Madison, WI. **Studied:** with Robert Henri in NY, 1908-11; in Canada and Europe, 1912-15. **Member:** Wisc. P&S. **Exhibited:** NYC, San Francisco, San Antonio, & Austin. **Comments:** Painted landscapes and flowers. Taught at Madison (WI) schools. Her last name sometimes appears as Tyler. **Sources:** WW27; Petteys, *Dictionary of Women Artists.*

TYNG, Griswold *[Painter, illustrator, designer, educator, lecturer, graphic artist, writer]* b.1883, Dorchester, MA.

Griswold Tyng

Addresses: Jamaica Plain, MA; Orleans, MA. **Studied:** Mass. Sch. A., and with Joseph deCamp, Howard Pyle and others. **Member:** Assn. A. & D. of New England. **Work:** public relations posters and related material for Liberty Loan and the Boston Common Tercentenary. **Comments:** Official A., U.S. Army, World Wars I and II. Author: "History of the Engraving Processes," 1941. Specialty: educational publicity illus. & researcher for Boston City Planning Board; Public Relations and Design Service; Graphic A. Consultant. **Sources:** WW59; WW47.

TYNG, Lucien Hamilton (Mrs.) *[Painter, patron]* b.1874, NYC / d.1933, Nassau, Bahamas.
Addresses: NYC. **Exhibited:** as late as 1932; S. Indp. A., 1928. **Comments:** Specialty: landscapes, Oriental subjects, scenes of Southampton. Her New York studio had been the center of an indoor art market where she and her husband, with the aid of a committee, offered the opportunity to struggling artists to show their work through private and aution sales. **Sources:** Petteys, *Dictionary of Women Artists.*

TYNG, Margaret Fuller (Mrs. Griswold Tyng) *[Painter]* 20th c.
Addresses: Boston, 1906-12; Jamaica Plains, MA, from c.1915. **Member:** Guild Boston Artists. **Exhibited:** PAFA, 1903, 1906, 1910-12 (as Fuller), 1922 (as Tyng); Pan-Pacific Expo, San Francisco, 1915 (silver medal); Guild Boston Artists, 1920 (solo), 1935 (solo); AIC. **Sources:** WW29; Petteys, *Dictionary of Women Artists; Falk, Exh. Record Series.*

TYRA, Francis Joseph, Jr. *[Painter]* 20th c.
Exhibited: AIC, 1937. **Sources:** Falk, *AIC.*

TYRE, Philip Scott *[Painter, etcher, architect]* b.1881, Wilmington, DE / d.1937, Phila., PA.
Addresses: Phila., PA. **Studied:** PAFA, with Anshutz, H.R. Poore. **Member:** Phila. AC; AFA; Union Lg.; Am. Soc. Civil Engineers. **Exhibited:** S. Indp. A., 1932; Corcoran Gal biennial, 1935. **Sources:** WW33.

TYREE, Emma P. *[Artist]* late 19th c.
Addresses: Active in Washington, DC, 1891-92. **Sources:** Petteys, *Dictionary of Women Artists.*

TYRENE 20th c.
Exhibited: Salons of Am., 1934. **Sources:** Marlor, *Salons of Am.*

TYRRELL, Ethel *[Painter]* 20th c.
Exhibited: S. Indp. A., 1937. **Sources:** Marlor, *Soc. Indp. Artists.*

TYRRELL, Harry *[Mural painter]* b.1872, England / d.1962, San Francisco, CA.
Addresses: NYC; Southern California, 1917-1962. **Work:** murals: St. Agnes Church, San Francisco; Chinese Telephone Exchange, San Francisco; Oakland Hotel; Cliff House, San Francisco; Godeau Funeral Home, San Francisco. **Comments:** Painted murals in homes of movie stars. He was also an avid horseman. **Sources:** Hughes, *Artists of California,* 568.

TYRSON, Peter Falkenström *[Landscape painter, sculptor, craftsperson, blockprinter]* b.1853, Grimeton, Sweden / d.1950.

Tyrson

Addresses: Madison, CT/Friendship Island, ME. **Studied:** NAD; ASL; W.M. Chase; A. Zorn; Académie Julian, Paris, 1870s. **Comments:** Immigrated to the U.S. in 1890s, settling in Connecticut. He produced landscape paintings in an Impressionist style that later turned toward fauvism. He also created color woodblock prints. **Sources:** WW33; Fehrer, The Julian Academy.

TYSON, Carroll Sargent, Jr. *[Painter]* b.1877, Philadelphia, PA / d.1956, Philadelphia, PA.
Addresses: Philadelphia, PA/Maine (summers). **Studied:** PAFA with with W.M. Chase, T. Anshutz, and C. Beaux; in Munich, Germany, with C. Marr and Thor. **Member:** NA; Phila. AC; Soc. Indp. A. **Exhibited:** PAFA annuals, 1904-1954 (medal 1915); Corcoran Gal biennials, 1908-45 (16 times); Pan.-Pac. Expo, 1915 (med); S. Indp. A., 1917; Phila. AC, 1930 (gold); WMAA, 1932, 1934; Wildenstein Gal., 1938, 1946 (solo); AIC. Awards: PAFA fellow. **Work:** Phila. AC; PMA; Pa. State Col. **Sources:** WW53; WW47; Falk, *Exh. Record Series.*

TYSON, Charles R, (Mrs.) *[Collector]* 20th c.
Addresses: Philadelphia, PA. **Sources:** WW73.

TYSON, Dorsey Potter *[Etcher]* b.1891, Baltimore, MD / d.1969, Baltimore, MD?.
Addresses: NYC. **Work:** Grand Central A. Gal. **Comments:** Specialty: colored Oriental etchings. **Sources:** WW40.

TYSON, Emily D. *[Painter]* late 19th c.
Addresses: Boston, MA. **Exhibited:** Boston AC, 1876, 1884-1886. **Sources:** *The Boston AC.*

TYSON, Mary (Mrs. Kenneth Thompson) *[Painter]* b.1909, Sewanee, TN.
Addresses: NYC. **Studied:** Grand Central Art Sch. with George Pearse Ennis, Howard Hildebrandt & Wayman Adams; E. Greacen; E. Pape; New Sch. Social Res. with Julian Levi. **Member:** AWCS; Pen & Brush Club; Easthampton Guild Hall; Nantucket AA. **Exhibited:** Baltimore WCC, 1930; Salons of Am., 1934; AGAA, 1935; BM, 1935, 1937; Phila. WCC, 1934, 1936; AWCS, 1936-40, 1943-44; Montross Gal.; Contemp. Art; Morton Gal.; Harlow Gal.; Nantucket AA, 1952-1958; Watercolors by Contemp. Am., Addison Gal., 1968; Allied Artists, 1970; Bruce Mus., Greenwich, CT, 1971 (solo). Awards: solo award, 1968, Elizabeth Morse Genius Mem. award, 1970 & second brush award, 1971, Pen & Brush Club. **Work:** Nantucket AA Permanent Coll.; Amherst Coll.; Guild Hall Coll. **Comments:** Preferred medium: watercolors. **Sources:** WW73; WW47.

TYSON, (Mrs. George) *[Painter]* 20th c.
Addresses: Boston, MA. **Member:** Boston WCC. **Sources:** WW29.

TYTELL, Louis *[Painter]* b.1913, New York, NY.
Addresses: New York, NY.
Studied: City College New York, B.S., 1934; Columbia Univ., M.A., 1935; Skowhegan School Painting & Sculpture; New School Social Res.

Louis Tytell

Exhibited: WFNY, 1940; 200 American Watercolors, Whitney Mus. Am. Art; Nat. Gallery Art; Carnegie Inst., 1941; 110 American Painters, Walker Art Center, 1944; Detroit Art Inst., 1941; MMA; Cleveland Mus.; SFMA; W. Nelson Rockhill Gal., 1945; PAFA Ann., 1949, 1966; BM, 1951, 1952; Harry Salpeter Gal., 1951 (solo); Roko Gal., NYC, 1962, 1965, 1968, 1970, 1972; Corcoran Gal.; Albright Art Gal., 1956; Nat. Acad. Design Ann., 1962, 1966, 1968; Nat. Inst. Arts & Letters, 1967; New York Studio School, 1972, 1975; "NYC WPA Art" at Parsons School Design, 1977. Awards: Library of Congress, 1954 (purchase award for permanent print collection); Tiffany fellowship,

1962; Am. Inst. Arts & Letters, 1967 (grant). **Work:** Newark Mus.; Corcoran Gal., LOC; Univ. North Carolina. **Comments:** WPA artist. Preferred media: oils. Dealer: Roko Gallery, New York, NY. Teaching: chairman art dept., H.S. Music & Art, 1961-67; assoc. prof. art, City College New York, 1967-69; chairman art dept., H.S. Music & Art, 1969. **Sources:** WW73; *New York City WPA Art,* 89 (w/repros.); Falk, *Exh. Record Series.*

TYTUS, Robb de Peyster *[Illustrator] b.Asheville, NC / d.1913, Saranac Lake, NY.*
Addresses: Tyringham, MA. **Studied:** Yale, 1897. **Comments:** While traveling in the East he made sketches for American magazines; later he became interested in archaeology, and with Percy E. Newbury, the English archaeologist, made numerous excavations. He was twice elected to the Mass. House of Representatives.

TZARAVELA, Zacharoula *[Painter] 20th c.*
Addresses: Brooklyn, NY. **Studied:** ASL. **Exhibited:** S. Indp. A., 1925-26. **Sources:** Marlor, *Soc. Indp. Artists.*

TZSCHUMANSKY, Stanilaus See: **SCHIMONSKY, Stanislas**

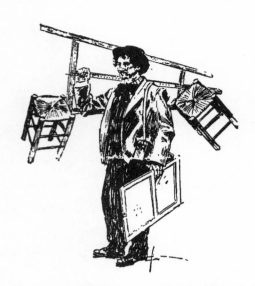

Edward Cucuel: *A Nouveau (a first-year student at Gérôme's Atelier).*
From W. C. Morrow's *Bohemian Paris of Today,* 1899.

U

UBALDI, Lorraine Marianelli See: **MARIANELLI, Lorraine D.**

UBALDI, Mario Carmelo *[Sculptor, designer, teacher]* b.1912, Monarch, WY.
Addresses: Lombard, IL. **Studied:** Indust. Mus. Art, Rome, Italy; AIC. **Member:** Renaissance Soc., Univ. Chicago; United Am. Artists, Chicago. **Exhibited:** AIC, 1937-42, 1943 (medal), 1944 (prizes), 1945, 1953; WFNY 1939; CGA; Univ. Chicago, 1942; Marc Gal., New Orleans, LA, 1940 (solo); Palmer House, Chicago, 1952 (solo); Midwest traveling exh., 1953; Univ. Chicago, 1953; Art Center, Chicago, 1954, 1956; Marshall Field Gal., Chicago, 1958. **Work:** Pasteur School, Chicago; Chicago Commons Settlement House. **Comments:** Teaching: AIC. **Sources:** WW59; WW47.

UBOGY, Wolf *[Painter]* b.1901, Derevitchi, Ukraine.
Addresses: NYC. **Studied:** Educ. All., Inwood Park. **Exhibited:** Contemporary Art Center; ACA; 1199 Gal.; Reynold Gal.; S. Indp. A., 1940; Bell Gal.; "NYC WPA Art" at Parsons Sch. Design, 1977. **Work:** mural, Jamaica H.S. **Comments:** Worked on the WPA mural project with Itaro Ishigaki and Philip Guston. Preferred media: oil, watercolor, acrylic. **Sources:** *New York City WPA Art,* 90 (w/repros.).

UCHIMA, Ansei *[Printmaker, painter]* b.1921, Stockton, CA.
Addresses: NYC. **Member:** SAGA; Japan Print Assn. **Exhibited:** Tokyo Int. Print Biennials, 1957 & 1960; Grenchen Int. Print Triennials, 1958, 1961 & 1970; Fifth São Paulo Int. Biennial, 1959; WMAA, 1966; Vancouver Int. Print Exh., 1967; 35th Venice Int. Biennial, 1970. **Awards:** Guggenheim fellowship, 1962-63 & 1970-71. **Work:** AIC; Rijks Mus., Amsterdam; LOC; Phila. Mus.; MMA. **Comments:** Preferred media: wood. Teaching: Sarah Lawrence College, 1962-; Columbia Univ., 1968. **Sources:** WW73.

UDINOTTI, Agnese *[Sculptor, painter]* b.1940, Athens, Greece.
Addresses: Scottsdale, AZ. **Studied:** Arizona State Univ. (B.A. & M.A.). **Exhibited:** Solos: Vorpal Gals., San Francisco, 1968 &

1971, Art Forms Gal., Athens, 1969 & 1971 & Arizona Chapter Arts & Humanities Traveling Exh., 1971-72; Southwestern Biennial, Phoenix Art Mus., 1971; 6th Ann., Yuma FAA, 1972. **Awards:** Hellenic Am. Union Sculpture Award, 1968; Sculpture Prize, Phoenix Art Mus. First Biennial, 1971; Solomos Prize for Sculpture, Panos Nikoli Tselepi, Athens. **Work:** Phoenix (AZ) Art Mus.; Arizona Western College, Yuma; Yuma FAA; Glendale Community College, AZ; Ministry of Educ., Athens; Scottsdale (AZ) Civic Center. **Commissions:** sculpture, commissioned by Mrs. Eugene T. Savage, Yuma, 1962; steel doors, Wilson Jones & Assocs., Scottdale, AZ, 1970 & Imagineering, Tucson, AZ, 1972; relief, comn. by Mrs. M. Ehrlich, Phoenix, 1970; steel diptych, comn. by Har Oude Jans, Amsterdam, Holland, 1972. **Comments:** Preferred media: steel, oils. Teaching: workshop leader welded sculpture, Orme Sch. FA Program, Mayer, AZ, Feb. 1971 & Feb. 1972; Univ. Southern Calif., summer 1972. **Sources:** WW73; Seiden Meilach, *Direct Metal Sculpture* (Crown, 1966) & *Creating Art from Anything* (Reilly & Lee, 1968).

UDVARDY, John Warren *[Sculptor, painter]* b.1936, Elyria, Ohio.
Addresses: Bristol, RI. **Studied:** Skowhegan School Painting & Sculpture, scholarship, summer 1957; Cleveland IA (scholarship, 1955-58; B.F.A., 1963); Yale Univ. (scholarship, 1964-65; M.F.A., 1965). **Exhibited:** Solos: Michael Walls Gal., San Fran., 1967, Bristol (RI) Art Mus., 1969, Cleveland Inst. Art, 1970 & Ann. Brown Mem., Providence, RI, 1971; Young New England Painters, Sarasota (FL), Portland (ME) & Manchester (NH), 1969. Lenore Gray Gal., Providence, RI, 1970s. **Awards:** Mar C. Page European Traveling scholarship, Cleveland IA, 1960-61. **Work:** Cleveland Inst Art, Ohio; Columbia Broadcasting Syst, New York; NY; Fogg Mus, Cambridge, Mass; Princeton Univ, NJ. **Commissions:** Design of symbol & emblem for Ecology Action RI, 1970. **Comments:** Preferred media: wood, canvas, metals, plastic; one of the first artists to use flourescent paints. Positions: regional judge, Nat. Scholastic Comp., 1967; critic & guest lecturer, Atlanta (GA) School Art, March, 1970; visiting critic, RISD, May 1970 & May 1971. Publications: illustr., *Los,* Fall 1968 & Spring 1970. Teaching: Cleveland IA, 1962-63; Yale Univ., 1964-65; Brown Univ., 1965-70s. **Sources:** WW73.

UELSMANN, Jerry *[Photographer]* b.1934, Detroit, MI.
Addresses: Gainesville, FL. **Studied:** Rochester Inst. Techn. with Ralph Hattersley & Minor White (B.F.A., 1957); Indiana Univ. with Henry Holmes Smith (M.S., 1958; M.F.A., 1960). **Member:** Soc. Photography Educ. (founding member); Royal Photography Soc. Great Britain (fellow). **Exhibited:** Jacksonville Art Mus., 1963 (solo); "Photography in Am. 1850-1965," Yale Univ. Art Gal., 1965; Photography in the Twentieth Century, George Eastman House in collab. with Nat. Gal. Canada, 1967; MoMA, 1967 (solo); PMA, 1970 (solo); AIC, 1972 (solo); Witkin Gal., NYC, 1970s. **Awards:** Guggenheim fellowship, 1967; grant, Univ. Florida, 1970; photography fellowship, Nat.Endowment Arts, 1973. **Work:** MoMA; Phila. Mus. Art; AIC; Nat. Gallery Canada, Ottawa; Int. Mus. Photography, George Eastman House, Rochester, NY. **Comments:** Important figure in helping to reestablish the validity of the manipulation of the photographic image. Known for his surrealist-like multiple-image prints in which he has combined up to 12 negatives. Teaching: Univ. Florida, 1960-. Publications: contrib., *Contemporary Photographer,* 1964; *Camera,* 1967; *Aperture,* 1967, 1968 & 1970; *Life,* 1969; *Infinity.* **Sources:** WW73; Baigell, *Dictionary; Jerry N. Uelsmann,* monograph (Aperture Inc., 1970); W.E. Parker, *Eight Photographs: Jerry Uelsmann* (Doubleday, 1970); John Ward, *The Criticism of Photography as Art: the Photographs of Jerry Uelsmann* (Univ. Florida Press, 1970).

UERKVITZ, Herta (E. W. E.) *[Painter, writer]* b.1894, Wisconsin.
Addresses: Everett, WA. **Exhibited:** Seattle FA Soc., 1921. **Work:** Seattle FA Soc. **Sources:** WW21.

UEYAMA, Tokio *[Painter, commercial artist]* b.1890, Wakayama, Japan / d.1954, Los Angeles, CA.

Addresses: Los Angeles, CA. **Studied:** Tokyo; PAFA. **Member:** Los Angeles AA. **Exhibited:** EastWest Art Soc. San Fran., 1922; P&S Los Angeles, 1922-35; Miiyako Hotel, Los Angeles, 1936; GGE, 1939. **Work:** State College, PA. **Sources:** WW31; Hughes, *Artists of California,* 569.

UFER, Mary See: **FREDERIKSEN, Mary Monrad**

UFER, Walter *[Painter]* b.1876, Louisville, KY / d.1936, Santa Fe, NM.
Addresses: Chicago, IL/Taos, NM, from 1914.
Studied: Hamburg; Royal Applied Art Sch., Dresden, 1894-96; Royal Acad.; Dresden, 1897-98; AIC; J. Francis Smith Art Sch., Chicago, 1901-03; W. Thor, Munich, 1911-13. **Member:** ANA, 1920; NA, 1926; Chicago SA; SC; Taos SA, 1913; Boston AC (hon.); NAC (life mem.); Allied AA; Fellow, Royal SA; CAFA; New Mexico Painters; Modern SA, Los Angeles. **Exhibited:** Corcoran Gal. biennials, 1916-35 (9 times); other Corcoran Gal. exhs., 1923 (solo); AIC, 1916 (prize), 1923 (gold); PAFA Ann., 1916-29 (gold 1923); NAD, 1918 (prize), 1921 (prize), 1926 (gold, prize); Illinois Painters, 1918 (prize); Int. Exh., CI, 1920 (third prize); CAFA, 1922 (prize); Phila. AC, 1922 (gold); Salons of Am., 1922, 1923; Kentucky Painters, Nashville, 1925 (prize).
Work: MMA; LACMA; Gilcrease Inst.; Mus. New Mexico; Cowboy Hall Fame; AIC; Springfield (IL) State House; Brooklyn Inst. Arts & Sciences; PAFA; Maryland Inst., Baltimore; Harrison Collection, Mus. History, Science & Art, Los Angeles; Chicago Municipal Collection; Corcoran Gal.; Tulsa (OK) Art Assn.; Rockford (IL) Art Assn.; Joliet (IL) Art Assn.; Union League Club, Chicago; Nat. AC, NY; Wichita (KS) Art Assn.; Dubuque (IA) Art Assn; Houston Mus. FA. **Comments:** The son of a German-born engraver, he worked as an apprentice lithographer in his youth. He supported himself with his trade while studying, and married Mary Fredericksen in 1911. In 1913 they painted in Paris, Italy and North Africa before returning to Chicago. He moved to New Mexico in 1914 and began painting outside. In response to the intense light, his palette lightened, and his favorite subjects were Indians in their daily activities. He became well known and very successful through these paintings, but after about 10 years his fortunes declined. **Sources:** WW33; Sotheby's, "The American West: the John F. Eulich Collection," May 20, 1998; P&H Samuels, report deathplace as Albuquerque, NM, 495; Eldredge, et al., *Art in New Mexico, 1900-1945,* 208; *300 Years of American Art,* 726; Falk, *Exh. Record Series.*

UGLOW, Alan *[Artist]* b.1941.
Addresses: NYC. **Exhibited:** WMAA, 1975. **Sources:** Falk, *WMAA.*

UHL, Emmy *[Sculptor]* b.1919, Bremen, Germany.
Addresses: Mt. Vernon, NY. **Studied:** Hudson River Mus., Yonkers, NY. **Member:** Yonkers AA. **Exhibited:** Yonkers AA Ann., NY, 1967-70; Westchester Art Soc. Ann., NY, 1969-71; North Shore Community AC, Long Island, NY, 1970; Knickerbocker Artists Ann., NYC, 1970-72; Audubon Artists, New York, 1971; Sindin Harris, Hartsdale, NY, 1970s. **Awards:** Armbruster Award, Yonkers AA, 1967; Knickerbocker Artists Award Merit, 1972. **Sources:** WW73; Jerry G. Bowles, review, *Art News,* June, 1970; Carter Ratcliff, review, *Art Int.,* June, 1970; Beatrice Dain, "Gallery Previews in New York," *Pictures on Exhib.,* June, 1970.

UHL, Grace E. *[Painter, teacher]* b.1871, Shenandoah, IA. / d.1963, Los Angeles, CA.
Addresses: Paris, France; Los Angeles, CA; Cincinnati, OH. **Studied:** R. Mille & L. Simon in Paris; ASL; J.L. Wallace. **Exhibited:** Trans-Mississippi Expo, Omaha, NE, 1898. **Sources:** WW13; Hughes, *Artists of California,* 569.

UHL, Jerome Phillips *[Portrait, landscape & still life painter, illustrator]* b.1875, Ohio / d.1951, Wash., DC.
Addresses: Wash., DC. **Studied:** ASL of Wash.; Paris, France. **Exhibited:** NYC, c.1900. **Comments:** Son of S. Jerome Uhl (see entry). Specialty: portraits. His illustrations appeared in *Harper's, Scribner's, Pearson's,* and other national magazines. **Sources:**

McMahan, *Artists of Washington, DC.*

UHL, Katherine *[Lithographer]* mid 20th c.
Comments: WPA printmaker in California, 1930s. **Sources:** exh. cat., Annex Gal. (Santa Rosa, CA, n.d., c.1988).

UHL, Margaret C. *[Artist]* late 19th c.
Addresses: NYC, 1890-96. **Exhibited:** NAD, 1890, 1896. **Sources:** Naylor, *NAD.*

UHL, S. Jerome, Sr. *[Portrait, landscape and cityscape painter]* b.1842, Holmes County, OH / d.1916, Cincinnati, OH.
Addresses: Wash., DC, active 1888-1901; NYC, 1892; Phila., PA, 1907; Cincinnati, OH. **Studied:** Augusta Emile, Carolus-Duran, Puvis de Chavannes, all in Paris. **Member:** Soc. Wash. Artists, Wash. WCC. **Exhibited:** Paris Salon, 1885; Soc. Wash. Artists, Wash. WCC, 1891-98; NAD, 1892, 1898. **Work:** Wash., DC; State Bldg., Columbus, Ohio; CGA (portrait of Grover Cleveland); Nat. Mus. Am. Art; National Lg. Women Voters. **Comments:** Teaching: ASL, Wash., DC. Specialty: portraits. **Sources:** WW08; McMahan, *Artists of Washington, DC;* Fink, *American Art at the Nineteenth-Century Paris Salons,* 399.

UHL, William *[Portrait, theatrical scene painter, teacher of drawing & painting]* mid 19th c.
Addresses: Charleston, SC, 1844. **Sources:** G&W; Rutledge, *Artists in the Life of Charleston.*

UHLE, Bernard *[Painter]* mid 19th c.
Addresses: Philadelphia, PA. **Member:** Phila. AC. **Exhibited:** PAFA Ann., 1878-1891, 1895, 1905, 1919. **Work:** Atwater Kent Museum ("An Election Day Bonfire, 5th and Chestnut Streets, Philadelphia", 1854). **Sources:** G&W; *American Processional,* 245, repro. 158; WW25; Falk, *Exh. Record Series.*

UHLE, G. Anton *[Portrait painter]* mid 19th c.
Addresses: Philadelphia, 1856-60. **Sources:** G&W; Phila. CD 1856-60+.

UHLER, A. Lenox (Mrs.) See: **ABBOTT, Anne Fuller (Mrs. A. Lenox Uhler)**

UHLER, Anne Fuller Abbott See: **ABBOTT, Anne Fuller (Mrs. A. Lenox Uhler)**

UHLER, Ruth Pershing *[Painter, teacher, lecturer]* b.1895, Gordon, PA / d.1967.
Addresses: Houston, TX/Santa Fe, NM (1935-56). **Studied:** Phila. Sch. Des. for Women; Jean Charlot; L. Seyffert; H.B. Snell. **Member:** Houston Artists' Gal.; SSAL; Texas FAA; MoMA; Contemporary AA, Houston; Arts Council (vice-pres., 1964-65). **Exhibited:** Mus. FA, Houston, 1931 (prize). **Work:** Mus. FA, Houston; mural, Houston Pub. Lib.; Nelson Gal., Kansas City & Houston City Halls (collab. with Grace S. John). **Comments:** Best known for abstraction of Southwestern landscapes. Studied Native American arts and crafts in Santa Fe. Teaching: Mus. Sch. Art, Houston. Lectures: American painting & design. **Sources:** WW66; WW47 (gave birth year as 1898); Trenton, ed. *Independent Spirits,* 204, provides birth date of 1895 and death date of 1967.

UHLMAN, Rosamond *[Painter]* mid 20th c.
Exhibited: AIC, 1936. **Sources:** Falk, *AIC.*

UHLMANN, A. G. *[Painter]* mid 20th c.
Addresses: Phila., PA. **Exhibited:** Corcoran Gal. biennial, 1941; PAFA Ann., 1941, 1943. **Sources:** Falk, *Exh. Record Series.*

UIBEL, Karl B. *[Painter]* early 20th c.
Addresses: Phila., PA. **Exhibited:** PAFA Ann., 1932. **Sources:** Falk, *Exh. Record Series.*

ULBER, Althea *[Painter, designer, sculptor, craftsperson]* b.1898, Los Angeles, CA.
Addresses: Los Angeles; La Cresenta, LA. **Studied:** Chouinard AI; F. Tolles Chamberlin, Hans Hofmann in Munich, Joseph Binder & S.McD. Wright. **Member:** NSMP; Art Teacher's Assoc. Southern Calif.; Calif. AC. **Exhibited:** Pasadena AI, 1928; Calif. State Fair, 1930; Pottinger Gal., Los Angeles, 1938; LACMA

(prize). **Work:** LACMA; H.S., Los Angeles; fabric design, Johnson & Faulkner, Arthur H. Lee, NY. **Comments:** WPA artist. Daughter of Julius Ulber (see entry). Teaching: Children's Dept., Chouinard AI, Los Angeles, CA, 1921-41, 1952-. **Sources:** WW53; WW47.

ULBER, Julius E. *[Painter] b.1838, Germany / d.1921, Los Angeles, CA.*
Addresses: Los Angeles, CA. **Comments:** Specialty: landscapes with houses and figures. Father of Althea Ulber (see entry). **Sources:** 569.

ULBERTI, Joseph *[Listed as "artist"] b.c.1808, Sardinia.*
Addresses: Philadelphia in 1860. **Sources:** G&W; 8 Census (1860), Pa., LI, 508.

ULBRICHT, Elsa Emilie *[Educator, craftsperson, designer, lithographer, painter, lecturer] b.1885, Milwaukee, WI / d.1980.*
Addresses: Milwaukee 8, Wis. **Studied:** Wisc. Sch. Art; PIA Sch.; Milwaukee State Teachers College; Alexander Mueller; Francis Chapin; W.M. Clute; F. Fursman; S. Sorenson; E.G. Starr; G. Senseney. **Member:** Wisc. P&S; Wisc. Designer-Craftsmen; Nat. Educ. Assn.; Midwest Des.-Craftsmen; Am. Craftsmen's Council; Western AA; Milwaukee AI; Milwaukee PM. **Exhibited:** Wisc. Union; Wisc. P&S; Wisc. Designer-Craftsmen; Milwaukee AI; Am. Craftsmens Conference, Ravina Park, IL. **Award:** prizes, Wisc. Union, Madison, WI; Milwaukee AI, 1925, 1926, 1930, 1936; Wisc. Salon, 1938. **Work:** Univ. Minnesota; Milwaukee AI; Wisc. Artists Blockprint Calendar. **Comments:** Teaching: Wisconsin State College, Milwaukee, WI, 1911-55; dir., Summer School Painting, Saugatuck, MI, 1947-58. Illustr.: pamphlets on various crafts. Lectures: crafts. Contrib.: *Design* magazine; articles on weaving and marionettes. **Sources:** WW59; WW47.

ULBRICHT, John *[Painter] mid 20th c.*
Addresses: Mexico, 1952; Denver, CO, 1953. **Exhibited:** PAFA Ann., 1952-53. **Sources:** Falk, *Exh. Record Series.*

ULEN, Jean Grigor (Mrs. Paul) *[Etcher, painter, teacher] b.1900, Cleveland, OH.*
Addresses: Lakewood, OH/Frankfort, MI. **Studied:** Cleveland Sch. Art; H. Tonks, at Slade Sch., London; Univ. London. **Member:** Cleveland PM. **Exhibited:** CMA, 1925 (prize), 1926 (prize), 1930 (prize), 1931 (prize), 1933 (prize), 1936 (prize); May Show, CMA 1937 (prize), 1938 (prize). **Work:** CMA. **Comments:** Teaching: West Tech. H.S., Cleveland. **Sources:** WW40.

ULEN, Paul V. *[Painter, etcher, writer] b.1894, Frankfort.*
Addresses: Lakewood, OH/Frankfort, MI. **Studied:** Cleveland Sch. Art; H. Tonks, Slade Sch., London; Univ. London; Cent. Sch. Arts & Crafts, Sir J. Cass Sch., London. **Member:** Cleveland PM. **Exhibited:** CMA 1930 (prize), 1932 (prize), 1933 (prize); May Show, CMA, 1937 (prize). **Work:** Cleveland Mus. Art; Werner Coll., City of Cleveland. **Comments:** Co-auth.: "Making Prints." Teaching: West Tech. H.S., Cleveland. **Sources:** WW40.

ULIANOFF, Vsevolod *[Mural painter] b.1880, Russia / d.1940, Los Angeles, CA.*
Addresses: Russia; Los Angeles, CA, from c.1920. **Member:** Los Angeles AA. **Exhibited:** Calif. WCS, 1923-24; P&S Los Angeles, 1932 (cash prize), 1938; WPA, 1934. **Work:** Grauman's Chinese Theatre lobby, Hollywood; Breakers Hotel, Long Beach, CA; Catalina Island Casino Theatre; United Artists Theatre, Los Angeles. **Sources:** Hughes, *Artists in California, 569.*

ULIN, Dene *[Collector, art consultant] b.1930, Detroit, MI.*
Addresses: NYC. **Studied:** Conn. College; AIC. **Comments:** Positions: advisor to purchasers of fine arts, in relationship with 40 New York galleries & dealers, for paintings, sculpture & drawings; exclusive agent in the U.S. for William Accorsi, toy sculpture & Luba Krejci, lace constructions. Collections arranged: personal collection & representative artists shown, J. Walter Thompson Co., New York, Neiman-Marcus, Dallas, Salcowitz, Houston, Hall's, Kansas City, Cooper Union Mus., New York, Tiffany's windows, New York & Joan Rivers Show, NBC-TV,

1969. Collection: contemporary art. **Sources:** WW73.

ULKE, Henry *[Portrait painter, printmaker, photographer] b.1821, Frankenstein, Germany / d.1910, Washington, DC.*
Addresses: NYC, 1852-53; Philadephia, PA, 1853-60; Washington, 1860-1910. **Studied:** Breslau & Berlin with Wilhelm Wach, Peter Cornelius; Weimar, 1868-70. **Member:** Wash. AC. **Exhibited:** NAD, 1854; Centennial Expo, Philadelphia, 1876; PAFA Ann., 1876. **Work:** White House; Depts. of Defense & Treasury; Nat. Mus. Am. Hist.; NMAA; NGP. **Comments:** He joined the revolutionary party in Germay, was wounded, captured and imprisoned during the 1848 uprising. He came to America after being released and worked in NYC as a designer and illustrator for *Harper's* and *Leslie's*. In 1860, after having lived in Phila. for several years, he moved to Washington where he opened a portrait and photography studio. Ulke painted many portraits of high government officials and civic leaders, including Lincoln's Cabinet and Pres. Grant. He was the first artist to convert photographs into india ink paintings. **Sources:** G&W; Fairman, *Art and Artists of the Capitol,* 356; *Art Annual,* VIII, 401; NYBD 1854-57. More recently, see McMahan, *Artists of Washington, DC;* Falk, *Exh. Record Series.*

ULKE, Julius *[Topographer, artist] b.1833, Frankenstein, Germany / d.1910, Wash., DC.*
Addresses: Wash., DC. **Comments:** Younger brother of Henry Ulke (see entry). **Sources:** McMahan, *Artists of Washington, DC.*

ULLMAN, Alice Woods (Mrs. Eugene P.) *[Illustrator, painter] early 20th c.; b.Goshen, IN.*
Addresses: Paris, c.1905-21; Provincetown, MA, 1917-25. **Studied:** T.C. Steele, Forsyth & Chase; in Paris. **Member:** NAWPS; NAC; NY Woman's AC. **Sources:** WW25; Petteys, *Dictionary of Women Artists.*

ULLMAN, Allen *[Painter] mid 20th c.*
Addresses: NYC. **Exhibited:** WMAA, 1946. **Sources:** Falk, *WMAA.*

ULLMAN, Charlotte (Pauline) *[Painter] early 20th c.*
Addresses: White Plains, NY. **Studied:** ASL. **Exhibited:** Salons of Am., 1924; S. Indp. A., 1924-25. **Sources:** Falk, *Exhibition Record Series.*

ULLMAN, Eugene Paul
[Painter, lecturer] b.1877, New York, NY / d.1953, Paris, France. *Eugene Paul Ullman*
Addresses: NYC; Paris, France, 1906-1913; Westport, CT. **Studied:** NAD; W.M. Chase; Académie Julian, Paris, 1899; James McNeill Whistler in Paris. **Member:** SC; Lotos Club; Salon des Jeunes (hon.); Salon des Beaux-Arts, Am. Artists Assn., Paris Soc. Am. P&S (chmn.), all of Paris, France; Salon des Indépendants, Paris; New Soc. Artists; SC, 1902. **Exhibited:** Boston AC, 1902; PAFA Ann., 1902, 1905-09, 1912-13, 1944-45 (1906, gold); St. Louis Expo, 1904 (medal); WMA, 1906 (prize); Corcoran Gal. biennials, 1908-45 (4 times); Pan-Pacific Expo, San Francisco, 1915 (medal); S. Indp. A.,1917; St. Louis World's Fair, 1924 (medal); Orleans, France, 1925 (medal); Carnegie Inst., 1943-45; John Herron AI (prize); AIC. **Work:** French Govt. Coll.; BM; John Herron AI. **Comments:** The larger part of his career was spent in Paris as an expatriate painter of elegant figures in parks and interiors. **Sources:** WW53; WW47; Falk, *Exh. Record Series.*

ULLMAN, George W. *[Collector, patron, writer] b.1880, NYC.*
Addresses: Phoenix, AZ. **Studied:** France. **Comments:** Auth.: "Captive Balloons". Collection: French furniture and paintings, Louis XV and Louis XVI periods. **Sources:** WW66.

ULLMAN, George W. (Mrs.) *[Collector] mid 20th c.*
Addresses: Phoenix, AZ. **Comments:** Collections: French furniture and paintings, Louis XV and Louis XVI periods; Haitian paintings; contemporary paintings of Philip Curtis. **Sources:** WW73.

ULLMAN, Harold P. *[Collector] b.1899, Chicago, IL.*
Addresses: Los Angeles, CA. **Studied:** Univ. Michigan, Sch. Engineering. **Comments:** Positions: bd. mem., LACMA, 1959-

64; bd. mem., Pasadena Art Mus., 1965-; bd. mem., Grunwald Center Graphic Arts, Univ. Calif., Los Angeles. **Collection:** Rouault graphics; sculpture from India and Nepal; primitive art. **Sources:** WW73.

ULLMAN, Jane F. *[Ceramic sculptor] mid 20th c.*
Addresses: Beverly Hills, CA. **Exhibited:** Los Angeles P&S, 1936 (prize); All-Calif. Exh., 1939. **Sources:** WW40; Hughes, *Artists of California,* 569.

ULLMAN, Julius *[Landscape and mural painter] b.1866, Windsheim, Bavaria, Germany / d.1952, Kent, WA.*
Addresses: Seattle, WA. **Studied:** Kunst Akademie Karlsruhe & Kirchbach Studio, Munich, both Germany. **Exhibited:** Nüremberg, 1894; Munich, 1896; Seattle, WA, 1932 (solo). **Sources:** Trip and Cook, *Washington State Art and Artists.*

ULLMAN, Nathan *[Painter] mid 20th c.*
Addresses: NYC. **Exhibited:** S. Indp. A., 1934-35. **Sources:** Marlor, *Soc. Indp. Artists.*

ULLMAN, Paul *[Painter] b.1906, Paris, France / d.1944.*
Addresses: Stonington, CT. **Exhibited:** WMAA, 1941, 1944; AIC, 1944. **Comments:** Born of American parents in Paris, Ullman spent most of his life in France. **Sources:** Falk, *Exh. Record Series.*

ULLMARK, Andrew V. *[Painter] b.1865, Sweden.*
Addresses: Chicago, IL. **Studied:** AIC. **Exhibited:** AIC, 1899, 1906. **Sources:** WW08; Falk, *AIC.*

ULLRICH, Albert H. *[Painter] b.1869, Berlin, Germany.*
Addresses: Wilmette, IL. **Studied:** AIC; abroad; C.E. Boutwood; F. Freer; Frank Duveneck; Gari Melchers. **Member:** Cliff Dwellers, AC, Palette & Chisel Acad., Galleries Assn., Tavern Club, all of Chicago. **Exhibited:** AIC; Chicago AC; Cliff Dwellers; Chicago Galleries Assn.; Palette & Chisel Acad. **Sources:** WW53; WW47.

ULLRICH, B(eatrice) *[Painter, lithographer, photographer, designer] b.1907, Evanston, IL / d.1987, San Francisco, CA?.*
Addresses: Chicago, IL; Ann Arbor, MI; San Francisco, CA, 1973. **Studied:** Northwestern Univ. (B.A. with honors in English, 1930); AIC (B.F.A., 1934); Boris Anisfeld; Francis Chapin; Edward Weston, 1942; Univ. Chicago (M.A., 1948); K. Blackhear; E. Zettler. **Member:** Laguna Beach AA; San Francisco AA; Calif. WCS; Artists Equity Assn. (secy., Chicago Chapt., 1955-56; nominating comt.); San Francisco Woman Artists; Friends of Photography; Bay Area Photography (secy., 1971). **Exhibited:** AIC, 1937-39; PAFA Ann., 1938; SFMA, 1938-41; Laguna Beach AA, 1938 (Kistler Print Prize); Oakland Art Gal., 1938; Los Angeles County Fair, Pomona, 1938, 1939; MMA; GGE, 1939; WFNY, 1939; Corcoran Gal. biennial, 1939; SAM, 1940; Portland AM, 1939; BMA, 1939; Denver AM, 1940; Albright Art Gal., 1940; Montalvo Found., 1940; Central Am. Traveling Exh., 1940-41; Riverside Mus., 1940; San Diego FA Soc., 1940; Delgado MA, 1940-42; SFMA, 1939 (group show, hon. men.); 1940 (solo),1970 (photography, solo); Painting in the United States, CI, 1941, 1943-44; Univ. Arizona, 1943; Detroit IA, 1944; G. Place Gal., Wash., DC, 1944 (solo); Photography at Mid Century, Eastman House, Rochester, NY, 1960; Western Assn. Art Mus. Traveling Exhs., 1966-69. **Awards:** hon. award, Newspaper Photography Awards, Nat. Salon, Wash., DC, 1959. **Work:** Univ. Arizona, Tucson; photography in Hall of Justice, San Francisco, CA; Midwest Color Slide Art Coll., Chicago Main Pub. Lib. **Comments:** [Note: she also appears as Mrs. James Donald Prendergast (1947); B. Zuckerman; and B. Ullrich-Zuckerman (1973)]. **Publications:** contrib., *Am. Heritage,* Feb. 1965; reproduced painting, Mardi Gras. **Sources:** WW47; WW73 (as B. Ullrich-Zuckerman); Falk, *Exh. Record Series.*

ULLRICH, Edmund W. *[Painter] b.1889, Ironton, OH / d.1951, New Orleans, LA.*
Addresses: New Orleans, active 1913-18. **Member:** NOAA, 1914. **Exhibited:** NOAA, 1914-15, 1918. **Comments:** Later managed and owned a glass company. **Sources:** WW15;

Encyclopaedia of New Orleans Artists, 385.

ULLRICH, Hattie Edsall Thorp (Mrs. Albert H.) *[Painter] b.1870, Evanston, IL.*
Addresses: Chicago, IL, c.1903-10. **Studied:** AIC with C.E. Boutwood & J.H. Vanderpoel. **Exhibited:** AIC, 1901-12. **Sources:** WW10.

ULLRICH, William Charles *[Etcher, architect] b.1897, Germany / d.1977, Coronado, CA.*
Addresses: Los Angeles, CA. **Exhibited:** Artists Fiesta, Los Angeles, 1931. **Sources:** Hughes, *Artists of California,* 569.

ULLRICH-ZUCKERMAN, B. See: **ULLRICH, B(eatrice)**

ULM, John Louis (Dink) *[Illustrator, cartoonist] b.1907, McKeesport, PA.*
Addresses: McKeesport, PA. **Studied:** Art Sch. **Exhibited:** **Awards:** prizes, WFNY 1939; "PT" Boat insignia, U.S. Navy. **Work:** Huntington Lib., San Marino, CA. **Comments:** Position: art dir., *Daily News,* McKeesport, PA, 22 years. **Sources:** WW59.

ULMAN, Elinor Elizabeth *[Teacher, painter, illustrator, cartoonist] b.1910, Baltimore, MD.*
Addresses: Seattle, WA (1935-37); Wash., DC/Oquossoc, ME (late 1930s-on). **Studied:** Iowa State College (B.S. in landscape arch.); Wellesley College (B.A.); Mills College, 1932; Calif. Sch. FA. **Member:** Baltimore Artists Union; Am. Artists Congress. **Exhibited:** CPLH, 1931-33, 1938; De Young Mus., 1933; San Francisco AC, 1933 (solo), 1938 (solo); Oakland Art Mus., 1932; S. Indp. A., 1934; SAM, 1935-37; PAFA Ann., 1938; Univ. of Puget Sound; Corcoran Gal. biennials, 1937, 1957. **Comments:** Illustr., U.S. Dept. Agriculture, 1946. Auth.: "Art Therapy at an Outpatient Clinic," *Psychiatry* magazine, 1953. Preferred media: oils, watercolor. Position: art instructor, director, Recreation Program, Dept. Pub. Health, DC, 1953-55; art therapist, General Hospital, Wash., DC, 1955-; faculty member, Wash. Sch. Psychiatry, 1957-. **Sources:** WW59; WW47; Hughes, *Artists in California,* 569; Falk, *Exh. Record Series;* Trip and Cook, *Washington State Art and Artists,* cites 1909 birth date at Enumclaw, WA.

ULMANN, Doris *[Portrait photographer, teacher] b.1884, NYC. / d.1934.*
Addresses: NYC. **Studied:** School Ethical Culture; Columbia; White School Photography, 1914. **Work:** Univ. Oregon (thousands of prints and negatives); IMP; LOC; Univ. New Mexico; Berea College, KY. **Comments:** Internationally known portrait photographer who is best remembered for her pictorial documentation of rural life of the poor in Appalachia and South Carolina, 1915-34. Auth./Illustr.: *Roll, Jordan, Roll.* Teaching: Columbia Univ. **Sources:** Witkin & London, 259.

ULMER, F. *[Painter] early 20th c.*
Addresses: Shrub Oak, NY. **Exhibited:** S. Indp. A., 1932. **Sources:** Marlor, *Soc. Indp. Artists.*

ULMER, Francis F. (Mrs.) *early 20th c.*
Exhibited: Salons of Am., 1925. **Sources:** Marlor, *Salons of Am.*

ULMSCHNEIDER, Frank J. *[Painter] early 20th c.*
Addresses: Shore Wood, WI. **Member:** Wisc. P&S. **Exhibited:** S. Indp. A., 1927. **Sources:** WW27.

ULP, Clifford (McCormick) *[Teacher, painter, illustrator, lecturer, writer, decorator] b.1885, Olean, NY / d.1957.*
Addresses: Rochester 8, NY. **Studied:** Rochester Inst. Tech.; ASL; Emile Gruppe; Charles Woodbury; William Chase; F.W. Taylor. **Member:** Eastern AA; Rochester AC; Iroquois AA; Memorial Art Gal.; Rationalists. **Exhibited:** Rochester AC, 1920-52; Rationalists, 1935-45; Genesee Group, 1946-52; Finger Lakes Exh., 1941-43; Elmira, Cortland, Auburn, Geneva, NY. **Awards:** Rochester AC, 1938; Rochester Mus. Arts & Sciences, 1943 (fellowship). **Work:** NGA; murals, Rochester Dental Dispensary; St. Monica's Church, Rochester, NY; Nat. Gal. **Comments:** Auth.: "Models in Motion." 1931, "If You are Considering Applied Art,"

1935; articles, *Art Digest.* Illustr.: *Saturday Evening Post, Country Gentleman.* Position: dir., applied art, Rochester Inst. Technology, Rochester, NY, 1921-52 (retired). **Sources:** WW53; WW47.

ULREICH, Eduard Buk *[Painter, sculptor, designer, illustrator]* *b.1889, Guns, Austria-Hungary.*
Addresses: NYC, 1920s-30s; San Francisco, 1962. **Studied:** Kansas City AI; PAFA; Mlle. Blumberg. **Member:** Guild of Free Lance Artists. **Exhibited:** AIC; PAFA, 1914-15, 1929-31, 1934, 1939; WMAA; Anderson Gal., NY, 1923 (solo); AIC, 1925; Art Directors Club, 1924 (prize), 1927, 1929, 1932 (med.); Nat. Comp., World's Fair, Chicago; Dudensing Gal., NY, 1927, 1929, 1930; Corcoran Gal., 1928, 1930; Hug Gal., Kansas City, 1924, 1926; Phila. Art All., 1939; Bonestell Gal., 1941; Gump's Gal., San Francisco, 1943; Assoc. Am. Artists, 1953; Crespi Gal., NY, 1955; Paris; Vienna; S.Indp. A.; Lesser Gal., San Francisco, 1955; Galerie du Quartier, 1958. **Work:** interiors, des., Edgewater Beach Hotel, Chicago; Methodist Temple, Chicago; Victor Red Seal Records; Dudensing Gal., NY; murals, Ilg. Ventilating Co., Chicago; marble mosaic, Century of Progress Expo., Chicago; mural, Radio City Music Hall; Woodside, Long Island, Pub. Lib.; Barricini Candy Co., NY; USPO, Columbia, MO; Tallahassee, FL; Concord, NC; New Rockford, ND. **Comments:** WPA artist. **Sources:** WW59; P&H Samuels, 495.

ULREICH, Nura Woodson (Mrs. Edward B.)
[Lithographer, teacher, illustrator] b.Kansas City, MO / d.1950, New Rochelle, NY.
Addresses: NYC. **Studied:** Kansas City AI; ASL; Chicago Acad. FA; J. Sloan; F.R. Gruger. **Exhibited:** AIC; Corcoran Ga.l biennials, 1928-39 (3 times); Salons of Am.; S. Indp. A., 1928, 1941; PAFA Ann., 1929-31. **Work:** Walker AC; San Diego FA Soc.; BMA; AIC. **Comments:** She was known by her brush name, "Nura." Auth./illustr.: *The Buttermilk Tree; The Mitty Children Fix Things; Nura's Garden of Betty and Booth;* other children's books. Marlor cites place of death as New Rochelle, NY. Also appears as Mrs. Eduard Buk. **Sources:** WW47; Falk, *Exh. Record Series.*

ULRICH, Amy G. (Mrs. Russell) *d.1966, Seattle, WA.*
Addresses: Seattle, WA. **Member:** Women Painters of Wash., 1946. **Exhibited:** SAM, 1945. **Comments:** Preferred medium: oil. **Sources:** Trip and Cook, *Washington State Art and Artists, 1850-1950.*

ULRICH, Charles Frederic
[Painter] b.1858, NYC / d.1908, Berlin, Germany. C·F·VLRiCH·
Addresses: NYC, 1882-85; Europe (Paris, 1887). **Studied:** NAD: Royal Acad., Munich; Loefftz & Lindenschmidt in Munich, early 1880s. **Member:** ANA, 1883; SC, 1884; Pastelists; SAA. **Exhibited:** Brooklyn AA, 1882; NAD, 1882-87 (first recipient of the Clarke prize, for "The Land of Promise," 1884); Paris Salon, 1884; Am. AA, NY, 1886 (prize); AIC, 1888-89; Paris Expo, 1889 (prize); Columbian Expo, Chicago, 1893 (medal); London, England; Munich, Germany. **Work:** MMA; CGA. **Comments:** His work shows some influence of the Munich school, but with a more precise handling of form, and his appreciation for the Dutch masters is apparent in his use of dark, rich colors and the detail he renders in costumes and still lifes. He favored working class scenes. Ulrich lived abroad from the late 1880s, returning to NYC for visits. **Sources:** WW08; Fink, *American Art at the Nineteenth-Century Paris Salons,* 399; Baigell, *Dictionary; 300 Years of American Art,* 518.

ULRICH, Edward *[Painter] early 20th c.*
Addresses: Phila., PA. **Sources:** WW15.

ULRICH, Frances *[Sculptor] mid 20th c.*
Addresses: Chicago area. **Exhibited:** AIC, 1933. **Sources:** Falk, AIC.

ULRICH, Fred J. *[Painter] 19th/20th c.*
Addresses: Irvington, NJ. **Exhibited:** AWCS, 1898. **Sources:** WW01.

ULRICH, Louis W. *[Painter] 19th/20th c.*
Addresses: Newark, NJ, 1897; Irvington, NJ, 1898. **Exhibited:** NAD, 1897, 1898; AWCS, 1898; ACP, 1898; AIC, 1919. **Sources:** WW01.

ULRICH, Paula *[Painter] early 20th c.*
Addresses: NYC, 1928. **Exhibited:** S. Indp. A., 1928. **Sources:** Marlor, *Soc. Indp. Artists.*

ULRICH, Vic *[Painter] 19th/20th c.; b.Chicago.*
Addresses: Chicago, IL. **Studied:** AIC; Munich. **Exhibited:** AIC, 1898. **Sources:** WW01.

UMANS, George *[Painter] mid 20th c.*
Exhibited: S. Indp. A., 1940-42. **Sources:** Marlor, *Soc. Indp. Artists.*

UMBSTAETTER, Nellie Littlehale See: **MURPHY, Nelly Littlehale (Mrs. H. Dudly)**

UMLAUF, Carolynn *[Artist] b.1942.*
Addresses: NYC. **Exhibited:** WMAA, 1975. **Sources:** Falk, *WMAA.*

UMLAUF, Charles *[Sculptor] b.1911, South Haven, MI.*
Addresses: Austin, TX. **Studied:** AIC with Albin Polasek; Chicago School Sculpture with Viola Norman. **Exhibited:** San Francisco, 1941 (prize); IBM, 1941 (prize); Texas General Exh., 1941-46 (prize 1943, 1946); AIC, 1937 (prize), 1938 (prize), 1941-42, 1944; WFNY, 1939; AV, 1942; WMAA, 1946-56; CGA, 1945; PAFA Ann., 1947-54, 1960-62, 1966; Denver; Los Angeles; Third Int Sculpture Exh., PMA, 1949; Am. Sculpture, 1951, MMA, 1951; Int. Religion Biennial, Salzburg, Austria, Germany, Spain & England, 1958-59; 20th Ceramic Int., Everson Mus., Syracuse, NY & tour, 1959-60; Dalzell Hatfield Gals., Los Angeles, CA; Valley House Gal., Dallas, TX, 1970s. Awards: Guggenheim grant, 1949-50; purchase award, Ford Found., 1960; grant, Univ. Texas, 1966. **Work:** Krannert Art Mus., Univ. Illinois, Urbana; Des Moines AC, Iowa; MMA; Oklahoma AC; Mus. Fine Arts, Houston, TX; plus nine other Texas museums. Commissions: marble reredos relief, St. Michael & All Angels Church, Dallas, TX, 1961; "Spirit of Flight" (bronze fountain sculpture), at entrance of Lovefield Airport, Dallas, 1961; "Torch Bearers" (bronze), acad. center entrance, Univ. Texas, Austin, 1963; "Icarus" (bronze), in lobby of Phillips Petrol Bldg., Bartlesville, OK, 1964; "Family Group" (three figural bronze), at entrance of Houston Mus. Natural Science, Texas, 1972. **Comments:** Preferred media: bronze, marble. Teaching: Univ. Texas, Austin, 1952. **Sources:** WW73; Gibson A. Danes, *The Sculpture of Charles Umlauf, Sculptor* (Univ. Texas Press, 1967); Earl Miller (director), "Bronze Sculpture- (in the Making)," produced by Univ. Texas, 1969; WW47; Falk, *Exh. Record Series.*

UNDERHILL, Ada *[Painter] early 20th c.*
Addresses: Glen Ridge, NJ. **Sources:** WW24.

UNDERHILL, Georgia Edna *[Painter] 19th/20th c.*
Addresses: Brooklyn, NY, 1895-1901. **Exhibited:** PAFA Ann., 1895 (watercolor); NAD, 1899 ("The Intruder"). **Sources:** WW01; *Art by American Women:. the Collection of L. and A. Sellars,* 33; Falk, *Exh. Record Series.*

UNDERHILL, Katharine *[Sculptor] b.1892, NYC.*
Addresses: NYC/South Ashfield, MA. **Studied:** E. Norton. **Sources:** WW17.

UNDERHILL, M. J. (Miss) *[Printmaker] late 19th c.*
Addresses: active in New Rochelle, NY. **Exhibited:** Columbian Expo, Chicago, 1893. **Sources:** Petteys, *Dictionary of Women Artists.*

UNDERHILL, William *[Painter] late 19th c.*
Addresses: NYC, 1882-83; Bridgeport, CT, 1886. **Exhibited:** NAD, 1882-86. **Sources:** Naylor, *NAD.*

UNDERWOOD, Addie *[Painter] early 20th c.*
Addresses: Lawrence, KS. **Sources:** WW17.

UNDERWOOD, Clarence F(rederick) *[Illustrator, painter]* b.1871, Jamestown, NY / d.1929.
Addresses: NYC. **Studied:** ASL; Académie Julian, Paris with J.P. Laurens, Constant, and Bouguereau, 1896. **Member:** SI, 1910. **Comments:** Position: staff, *New York Press.* **Sources:** WW27.

UNDERWOOD, (Claude) Leon See: **UNDERWOOD, (George) (Claude) Leon**

UNDERWOOD, Elisabeth Kendall (Mrs.) *[Sculptor, painter]* b.1896, Gerrish Island, ME / d.1976, Arlington, VA.
Addresses: South Salem, NY.; Washington, DC. **Studied:** Yale School FA.; ASL. **Member:** Cosmopolitan Club; Wash. Art Club. **Exhibited:** AWCS; NAD; Playhouse Gal., Ridgefield, CT; Cosmopolitan Club; Wash. Art Club; New Haven PCC; NYWCC; Newport AA; George Wash. Univ., Wash., DC, 1956. **Comments:** Daughter of William Sargent and Margaret Stickney Kendall and wife of Pierson Underwood (see entries). **Sources:** WW59; WW47. More recently, see McMahan, *Artists of Washington, DC.*

UNDERWOOD, Ethel B. *[Miniature painter]* early 20th c.
Addresses: NYC, active 1901-11. **Exhibited:** ASMP, 1901-11 (8 annuals; fourteen miniatures). **Comments:** Her biography is unknown but research by an owner of one of her works led to the hypothesis that she might be Ethel Brinkerhoft Underwood, born in Boston in 1874, the daughter of a physician and great-grand-daughter of the founder of Underwood meats; she is known to have been living in NYC about 1910 and died in upstate New York after 1950. **Sources:** WW08; Tufts, *American Women Artists, 1830-1930,* cat. no. 32. (repro.).

UNDERWOOD, Evelyn Notman *[Painter]* b.1898, St. Catharines, Ontario / d.1983.
Addresses: East Aurora, NY. **Studied:** Pratt Inst. (grad.); Berkshire Summer Sch. Art (grad.); State Univ. NY College Buffalo; State Univ. NY Buffalo; Millard Fillmore Co.; Charles Burchfield; Millard Sheets; Ernest Watson; Rex Brandt. **Member:** Int. Platform Assn.; Buffalo Soc. Artists (secy., 1958-59; council mem.); Nat. Lg. Am. Pen Women (art chmn., 1966-68; delegate, Assoc. Art Org. Western NY, 1968-72). **Exhibited:** Butler IA 19th Ann., Youngstown, OH, 1954; Indust. Niagara Art Exh., 1965; Int. Platform Assn. Art Shows, Sheraton Hotel, Wash., DC, 1970 & 1971; Burchfield Center, State Univ. NY College Buffalo, 1970 & 1972; Nat. Lg. Am. Pen Women Regionals, NYC. **Awards:** purchase award & first prize, Ten Yellow Step Gal., 1953; first prize, Nat. Lg. Am. Pen Women; Regional Shows. **Work:** Roswelll Park Inst., Buffalo, NY; Veterans Hospital, Buffalo. **Comments:** Preferred medium: watercolors. Publications: illustr., *Bulletin Millard Fillmore Hospital,* 1956; illustr., cover, *Pen Woman,* Vol. 1947, No. 4. Teaching: Buffalo Public Schools, 1950-51; Arcade Central School, NY, 1963-64. Collection: landscape and travel paintings. **Sources:** WW73.

UNDERWOOD, (George) (Claude) Leon *[Painter, sculptor, illustrator, etcher, writer, lecturer]* b.1890, London.
Addresses: London, England. **Exhibited:** CI, 1923 (prize); WMAA, 1928 (sculpture). **Work:** Manchester Art Gal., England; The Whitworth Art Gal., Manchester; British Mus., London; Victoria and Albert Mus., London. **Comments:** Illustr.: "The Music from Behind the Moon," by James Branch Cabell, pub. John Day Co.; wood engravings and verses for "Animalia." **Sources:** WW25; Falk, *WMAA.*

UNDERWOOD, George L. *[Painter]* late 19th c.
Addresses: Boston, MA. **Exhibited:** Boston AC, 1882, 1884. **Sources:** *The Boston AC.*

UNDERWOOD, J. A. (Lt.) *[Illustrator]* mid 19th c.
Comments: Contributor of some illustrations in *Narrative of the United States Exploring Expedition* (1844). **Sources:** G&W; Rasmussen, "Artists of the Explorations Overland, 1840-1860."

UNDERWOOD, Leon See: **UNDERWOOD, (George) (Claude) Leon**

UNDERWOOD, Louise *[Painter]* mid 20th c.
Exhibited: S. Indp. A., 1940. **Sources:** Marlor, *Soc. Indp. Artists.*

UNDERWOOD, Mary Stanton *[Portrait painter]* early 20th c.; b.Glens Falls, NY.
Addresses: Wausau, WI, 1904-08. **Studied:** AIC; Chase & DuMond in NY. **Exhibited:** AIC, 1902, 1904, 1906. **Sources:** WW08.

UNDERWOOD, Paul A. *[Scholar]* mid 20th c.
Addresses: Washington, DC. **Sources:** WW66.

UNDERWOOD, Pierson *[Painter, printmaker, sculptor]* b.1899, Evanston, IL / d.1963, South Salem, NY (summer home).
Addresses: Wash., DC. **Studied:** Cambridge Univ.; Sorbonne, Paris; Yale Univ. **Member:** Wash. AC. **Exhibited:** NAD; George Washington Univ. Lib., 1956. **Comments:** Married to Elizabeth Kendall Underwood (see entry) in 1920. **Sources:** McMahan, *Artists of Washington, DC.*

UNDERWOOD, Thomas *[Banknote engraver]* b.1795 / d.1849, Lafayette, IN.
Addresses: Philadelphia, c.1825-43. **Comments:** He was a part-ner in the following firms: Fairman, Draper & Underwood (1825-27), Draper, Underwood & Co. (1827-33), Draper, Underwood, Bald & Spencer (1833-35), Underwood, Bald & Spencer [& Hufty] (1835-43), and Danforth, Underwood & Co. (1839-42)(see entries for each). **Sources:** G&W; Stauffer; Phila. CD 1825-43; NYCD 1835-43.

UNDERWOOD-FITCH, Alice (Mrs.) *[Miniature painter]* early 20th c.
Addresses: Paris, France. **Sources:** WW10.

UNDERWOOD, BALD, & SPENCER *[Banknote engravers]* mid 19th c.
Addresses: Philadelphia and NYC, 1835-36. **Comments:** Partners were Thomas Underwood, Robert Bald, and Asa Spencer (see entries). After Samuel Hufty joined the firm, about 1836, its name was changed to Underwood, Bald, Spencer & Hufty. It con-tinued this way until 1843, when it became Danforth, Bald, Spencer & Hufty (see entry). **Sources:** G&W; Phila. CD 1835-43; NYCD 1835-43.

UNGER *[Miniature painter]* mid 19th c.
Addresses: Montrose, PA in 1845. **Comments:** This may be the same as L.P. Unger, who worked in Williamsburg, VA in 1852 and probably 1856 as well. **Sources:** G&W; Carolina Art Assoc. Cat., 1936; Wright, *Artists in Virginia Before 1900.*

UNGER, Edith *[Painter]* early 20th c.
Exhibited: S. Indp. A., 1917. **Sources:** Marlor, *Soc. Indp. Artists.*

UNGER, Frank L. *[Artist, literary critic]* b.1851, Iowa / d.1916.
Member: Bohemian Club, San Fran. (one of first members); Lambs Club, NY. **Comments:** According to Ness & Orwig, the *Des Moines Register* reported that "for a number of years he was confidential secretary to Mrs. Charles Yerkes, wife of former Chicago street car magnate." **Sources:** Ness & Orwig, *Iowa Artists of the First Hundred Years,* 209.

UNGER, Gladys B. *[Painter, miniature painter]* 19th/20th c.
Studied: Académie Julian, Paris with Constant. **Sources:** Fehrer, *The Julian Academy.*

UNGER, Valeria mid 20th c.
Exhibited: Salons of Am., 1934. **Sources:** Marlor, *Salons of Am.*

UNIACKE, William E., Jr. (Mrs.) *[Painter]* early 20th c.
Addresses: New Orleans, active c.1901-04. **Exhibited:** New Orleans AA, 1901. **Sources:** *Encyclopaedia of New Orleans Artists,* 385.

UNIACKE, William E., Sr. *[Painter, gilder]* b.1829, County Cork, Ireland / d.1894, New Orleans, LA.
Addresses: New Orleans, active 1852-87. **Comments:** Came to New Orleans in 1847. In 1887 his son William E., Jr. succeeded

him in the business. **Sources:** *Encyclopaedia of New Orleans Artists*, 385.

UNIACKE & KONRAD *[Painters, gilders] mid 19th c.*
Addresses: New Orleans, active 1870-75. **Exhibited:** Grand State Fair, 1870 (diploma for best anatomical drawing). **Comments:** Partners were William E. Uniacke, Sr., and Adolph D. Konrad. **Sources:** *Encyclopaedia of New Orleans Artists*, 385.

UNITT, Edward G. *[Scenic painter] early 20th c.*
Addresses: NYC. **Member:** Artists Aid Soc. **Sources:** WW27.

UNKART, E. (Mrs.) *[Portrait and figure painter] mid 19th c.*
Addresses: NYC; Brooklyn, NY. **Exhibited:** NAD, 1837 (as a pupil of Christian Mayr); Apollo Assoc., 1840. **Sources:** G&W; Cowdrey, NAD; Cowdrey, AA & AAU.

UNRUH, Jack Neal *[Illustrator, teacher] b.1935, Pretty Prairie, KS.*
Addresses: Dallas, TX. **Studied:** Wash. Univ., St. Louis, MO (B.F.A.) with Bob Cassel. **Member:** SI; Dallas Illustrators; Dallas Soc. Visual Communications. **Comments:** Illustr.: *Redbook, National Geographic,* and other magazines, also annual reports for major companies. Teaching: East Texas State Univ., 1969-78. **Sources:** W & R Reed, *The Illustrator in America,* 347.

UNSWORTH, Edna Ganzhorn *[Painter, teacher] b.1890, Baltimore, MD / d.1972, Sonoma County, CA.*
Addresses: Long Beach, CA. **Studied:** Maryland Inst.; PAFA; C. Beaux. **Member:** Long Beach AA; Laguna Beach AA; Calif. AC. **Exhibited:** Arizona State Fair, 1929 (prize); Calif. Artists Exh., Pasadena, 1930 (prize); Oakland Art Gal., 1932. **Sources:** WW33; Hughes, *Artists of California,* 569.

UNSWORTH, Robert Burdet *[Etcher, painter, commercial artist] b.1888, Canada / d.1970, Santa Rosa, CA.*
Addresses: San Francisco, CA, 1918-33. **Member:** Long Beach Businessmen's Sketch Club (co-founder); Calif. SE; P&S Los Angeles, 1927. **Sources:** Hughes, *Artists of California,* 570.

UNTERMAN, Ruth *[Painter, gallery director, teacher] b.1920, Oak Park, IL.*
Addresses: Chicago, IL; Evanston, IL. **Studied:** Univ. Illinois (B.S.); Illinois Inst. Tech., Inst. of Design (M.S., Art Educ.). **Member:** AEA (bd. dir., Chicago Chapt.); Chicago Soc. Art. **Exhibited:** "5 Chicago Artists", Assoc. Art Gal., Wash., DC, 1962; Art Directions, NY, 1961 (2-man); Illinois Inst. Tech, 1960; Deerfield H.S., 1962; Hillel Found., Northwestern Univ., 1962, 1964. Awards: prizes, New Horizons, 1960; Evanston AC, 1960; Art Directions, NYC, 1961 (purchase); North Shore Art Lg., 1962. **Comments:** Positions: advisory comt., Bernard Horwich Jewish Community Center, Chicago, 1963-65; dir./co-owner, Ontario East Gal., Chicago. **Sources:** WW66.

UNTERMYER, Irving (Judge & Mrs.) *[Collectors] mid 20th c.*
Addresses: NYC. **Comments:** Collection: porcelains. **Sources:** WW73.

UNTERSEHER, Chris Christian *[Sculptor] b.1943, Portland, OR.*
Addresses: Reno, NV. **Studied:** San Francisco State College (B.A., 1965); Univ. Calif., Davis (M.A., 1967). **Member:** Am. Crafts Council. **Exhibited:** Objects USA, Johnson Wax Coll., int. traveling show, 1969-73; 20 Americans, Mus. Contemp. Crafts, New York, 1971; Hansen-Fuller Gal., San Francisco, 1967-70 (solo); Trains, De Young Mus, San Francisco, 1968 (solo); Allan Stone Gals., New York, 1969 (solo); Wenger Gal., San Francisco, CA, 1970s. Awards: purchase award, Mem. Union Art Gal., Univ. Calif., Davis, 1968; purchase award, Ann. Graphics Comp., Nevada Art Gal., Reno, 1971. **Work:** Objects USA, Johnson Wax Coll., Racine, WI; Allan Stone Gals. Coll., NYC; Jim Newman Found., San Francisco, CA; Mem. Union Art Gal. Coll., Univ. Calif., Davis. **Comments:** Preferred medium: ceramics. Teaching: Univ. Calif., Davis, 1968-69; Univ. Cincinnati, 1969-70; Univ. Nevada, Reno, 1970-. **Sources:** WW73; David Zack, "Art News: Nut Art in Quake Time," *Newsweek* (1970); Nordness, *Objects:*

USA (Viking, 1970); Lowell Darling, *Clay without Tears* (Art Center World, 1971).

UNTHANK, Alice Gertrude *[Painter, craftsperson, teacher, lecturer, writer, graphic artist] b.1878, Economy, Wayne County, IN.*
Addresses: Superior, WI. **Studied:** Earlham College; Teachers College, Columbia Univ.; Univ. Nebraska (A.B.); Univ. Chicago (M.A.); Pedro de Lemos; J. E. Bundy; Martha Walter; C.C. Rosencrantz; K. Heldner; O. Frieze & E. Scott in Paris. **Exhibited:** Arrowhead Exhib., Duluth, MN, 1928 (prize); Am. Lib. Color Slides, 1941 (prize); West Duluth, MN, 1929 (prize); Hoosier Salon Indiana traveling exhib., 1929-30; Terry AI, 1952 ; Nat. Art Week, Superior, WI, 1940, 1941; Douglas County Hist. Mus., Superior, WI, 1945 (solo); Frankfurt & West Lafayette, IN. **Work:** Carroll College, Waukesha, WI; Wisc. State College. **Comments:** Teaching: Training Dept., Superior (WI) State Teachers College, 1923-50s; Nat. Educ. Assn., Art Educ. Commmittee, College Art Faculties, 1940-42. Contrib.: *School Arts, Design, Wisc. Journal of Educ.* **Sources:** WW59; WW47.

UNTHANK, William S. *[Portrait painter] b.1813, Richmond, IN / d.1892, Council Bluffs, IA.*
Addresses: Richmond, Centerville, Indianapolis & Port Royal, IN; Cincinnati, OH; Council Bluffs, IA. **Sources:** G&W; Peat, *Pioneer Painters of Indiana,* 164-65, 239.

UNVER, George *[Portrait painter] early 20th c.*
Addresses: Kansas City, MO. **Exhibited:** Kansas City AI, 1923 (medal); PAFA Ann., 1929. **Sources:** WW31; Falk, *Exh. Record Series.*

UNWIN, Nora Spicer *[Painter, printmaker, illustrator] b.1907, Surbiton, England / d.1982, Wayland, near Boston, MA.*
Addresses: Peterborough, NH (1946-on). **Studied:** Leon Underwood Studio; Kingston School Art; Royal College Art, ARCA; George Demetrios, Boston; Donald Stoltenberg, De Cordova Mus., Lincoln. **Member:** NAD; SAGA; Boston PM (exec. bd.); Boston WCS; New Hampshire AA; Royal Soc. Painter-Etchers. **Exhibited:** Royal Acad., London; Bibliothèque Nat., Paris; Worcester(MA) Art Mus.; Springfield (MA) Mus. Art; MMA; Sharon (NH) Arts Center, 1990 (retrospective). Awards: prize for graphics, NAD, 1958; prize for watercolor, Boston WCS, 1965; prize for graphics, Cambridge AA, 1968. **Work:** Brit Mus., London; Victoria & Albert Mus, London; MMA; LOC; Wiggin Coll., BPL. **Comments:** Preferred media: watercolor, collage, wood engraving. Publications: auth./illustr., *Proud Pumpkin, Joyful the Morning* (1963), *Two Too Many* (1963); *The Midsummer Witch* (1966), *Sinbad the Cygnet* (John Day Co, 1970). **Sources:** WW73; biography and cat. raisonné by Linda McGoldrick (Bauhan/Sharon Arts Center, 1990).

UPCHURCH, Mary B. *[Miniature painter] early 20th c.*
Addresses: active in Evansville, IN, c.1921. **Sources:** Petteys, *Dictionary of Women Artists.*

UPDEGRAFF, Sallie Bell *[Craftsperson, painter] b.1864, Belmont County, OH.*
Addresses: Wash., DC. **Studied:** John Herron AI Sch. **Exhibited:** Indiana State Fair, 1921 (prize); Fed. WC Exh., Wash., 1934 (prize); Greater Wash. Independent Exh., 1935. **Work:** "Ceramic Studio". **Sources:** WW40.

UPDIKE, Bertha Jane *[Landscape painter] b.1871, Penn Yan, NY / d.1943, Van Nuys, CA.*
Addresses: Van Nuys, CA. **Sources:** Hughes, *Artists of California,* 570.

UPDIKE, Daniel Berkeley *[Typographer] b.1860 / d.1941.*
Addresses: Boston. **Studied:** AIGA (hon.). **Exhibited:** AIGA (gold). **Comments:** Position: head/founder, Merrymount Press (founded in 1893).

UPDYKE, Leroy Dayton *[Painter, mural painter] b.1876, Elmira, NY / d.1959, Seattle, WA.*
Addresses: Seattle/Hoodsport, WA. **Comments:** Painted murals for the world fairs in NYC and San Francisco, CA, together with

his friend Melvin Bearden (see entry). **Sources:** Trip and Cook, *Washington State Art and Artists.*

UPHAM, B. C. *[Illustrator] late 19th c.*
Addresses: NYC. **Comments:** Affiliated with Cooper Union Art School, NY. **Sources:** WW98.

UPHAM, Charles *[Sketch artist, illustrator] late 19th c.*
Addresses: New Orleans, active c.1883-91. **Comments:** Staff artist for *Frank Leslie's Illustrated Newspaper,* he came to New Orleans in 1883 on a trip through the South. He later also made drawings of the World's Industrial and Cotton Centennial Exposition and the French Market. Possibly the same as C. Upham, who drew a series of views of Williamsburg, VA, and sketched the laying of the cornerstone of the Lee Monument in Richmond, VA, all published in *Leslie's* in 1887. **Sources:** *Encyclopaedia of New Orleans Artists,* 386; Wright, *Artists in Virgina Before 1900.*

UPHAM, Elsie Dorey (Mrs.) See: **DOREY, Elsie (Mrs. Elsie Dorey Upham)**

UPHAM, Hervey *[Printer, lithographer] b.1820, Salem, MA / d.After 1889.*
Addresses: Boston, active 1852-77. **Work:** Boston Athen. **Comments:** He was as a partner in Hutchinson, Upham, & Co. (see entry), a printing firm briefly active in Boston in 1852/53. In 1853 he became a partner in the lithographic and printing firm of Upham & Colburn (see entry). He continued to be active until 1877 and was also a church deacon in Chelsea, MA, where he lived. In 1889 Upham was living in his father's hometown of Boerne, TX. **Sources:** G&W; Boston CD 1853-60+ [as a lithographer only in 1853]. More recently, see Pierce and Slautterback, 133, 140, 158.

UPHAM, W. H. *[Illustrator] late 19th c.*
Addresses: Boston, MA. **Studied:** Académie Julian, Paris, 1897. **Comments:** Position: illustr., *National Magazine,* Boston. **Sources:** WW98.

UPHAM & COLBURN *[Lithographers and printers] mid 19th c.*
Addresses: Boston, active 1853. **Work:** Boston Athenaeum owns two tinted lithographs printed by this firm. **Comments:** Partners were Hervey Upham and Charles H. Colburn (see entries). **Sources:** G&W; Boston CD 1853. More recently, see Pierce and Slautterback, 133, 157, 158, fig. 71.

UPJOHN, Anna Milo *[Painter] b.Dover NY / d.1951, New Milford, CT.*
Addresses: New York and Paris, from c.1915; New Milford, CT, c.1940. **Studied:** Castelucho, in Paris. **Member:** NAWPS. **Exhibited:** S. Indp. A., 1934; NAWPS, 1938, 1936, 1937, 1938; Studio Gld., NY (solo). **Sources:** WW40.

UPJOHN, Degen *[Painter] mid 20th c.*
Exhibited: S. Indp. A., 1938. **Sources:** Marlor, *Soc. Indp. Artists.*

UPJOHN, Everard Miller *[Art historian, teacher, writer, lecturer] b.1903, Scranton, PA / d.1978.*
Addresses: NYC; Hightstown, NJ. **Studied:** Harvard Univ. (A.B., 1925; M. Arch., 1927). **Member:** Athenaeum, NY. **Comments:** Teaching: Univ. Minnesota, Minneapolis, 1925-35; Columbia Univ., 1935-70s. Research: history of Am. arch. Publications: auth., *Richard Upjohn, Architect & Churchman,* 1939; co-auth., *History of World Art,* 1949, revised edition, 1958; contrib., *Encyclopedia American,* 1950; co-auth., *Highlights, an Illustrated History of Art,* 1963. **Sources:** WW73.

UPJOHN, Millie *[Caricaturist] early 20th c.*
Addresses: NYC, c.1905-08. **Sources:** WW08.

UPJOHN, Richard *[Architect, amateur landscape painter] b.1802, Shaftesbury (England) / d.1878, Garrison, NY.*
Addresses: New Bedford, MA; 1829; Boston, 1834. **Comments:** The renowned architect, known for his Gothic revival (Trinity Church, NYC, 1839-46) and Romanesque revival churches (Bowdoin College Chapel, Brunswick, ME, 1845-55), was also an amateur landscape painter. **Sources:** G&W; Everard Miller

Upjohn, *Richard Upjohn, Architect & Churchman* (New York, 1939).

UPLEY, John *[Painter] mid 20th c.*
Addresses: Farmingdale, NY. **Exhibited:** S. Indp. A., 1933-37. **Sources:** Marlor, *Soc. Indp. Artists.*

UPP, George *[Painter] mid 19th c.*
Addresses: Des Moines, 1869. **Work:** Iowa Historical Bldg. **Comments:** Specialty: portraits. **Sources:** Ness & Orwig, *Iowa Artists of the First Hundred Years,* 209-10.

UPSHUR, Annie *[Landscape painter] late 19th c.*
Addresses: Norfolk, VA. **Exhibited:** Norfolk, VA, 1885. **Sources:** Wright, *Artists in Virgina Before 1900.*

UPSHUR, Bernard *[Woodcutter] b.1936.*
Studied: Maryland State College; Hunter College, NY; NY Univ.; Fordham Univ.; South East Asia Program, India. **Exhibited:** Univ. Maryland, Eastern Shore (solo). **Sources:** Cederholm, *Afro-American Artists.*

UPSHUR, Martha R(obinson) (Mrs. Francis W.) *[Painter] b.1885, Richmond, VA.*
Addresses: Richmond, VA. **Studied:** T. Pollak. **Member:** NAWPS; Richmond Acad. **Exhibited:** Salons of Am., 1934; Richmond Acad., 1937 (prize). **Work:** William & Mary College, Richmond Div., VA; Medical College Virignia, Richmond. **Sources:** WW40.

UPSON, Jefferson T. *[Listed as "artist"] mid 19th c.*
Addresses: Buffalo, NY, 1860. **Sources:** G&W; Buffalo BD 1860.

UPTEGROVE, Sister M. Irena See: **SISTER MARY IRENA UPTEGROVE**

UPTON, Ethelwyn *[Painter] d.1921.*
Addresses: NYC. **Member:** NAWPS. **Sources:** WW19.

UPTON, Florence Kate *[Painter, illustrator] b.1873, NYC / d.1922.*
Addresses: NYC; London, England. **Studied:** his father at NAD; K. Cox; Académie Julian, Paris, with R. Collin; G. Hitchcock in Holland. **Member:** Soc. Nat. des Beaux-Arts, Paris. **Exhibited:** AIC; Int. Expo, Nantes, 1905 (medal); PAFA Ann., 1907-09, 1911; Corcoran Gal. annual, 1908. **Comments:** Illustr./creator: *Golliwog* series of children's books. **Sources:** WW21; Falk, *Exh. Record Series.*

UPTON, Lewis Maylon *[Landscape painter] b.1879, Oakland, CA / d.1943, Berkeley, CA.*
Addresses: NYC; San Francisco, CA; Berkeley, CA. **Studied:** arch., NYC; Maurice Logan, Calif. College Arts & Crafts. **Member:** AIA. **Exhibited:** San Fran. AA, 1903; Oakland Art Fund, 1905. **Comments:** Position: arch., W. Faville, San Francisco; arch., Fed. Housing Admin. **Sources:** Hughes, *Artists in California,* 570.

UPTON, Louise See: **BRUMBACK, Louise Upton (Mrs. Frank F. B.)**

UPTON, Roger Moulton *[Painter, illustrator, cartoonist, mural painter] b.1900, Peabody, MA / d.1988, Avalon, CA.*
Addresses: Pasadena, CA; Avalon, CA. **Studied:** self-taught. **Member:** Catalina AA (co-founder & first pres., 1961). **Exhibited:** Pasadena YMCA, 1915 (first prize for comic art); other shows in Southern Calif. **Work:** murals: Avalon Casino, Catalina Islan. **Comments:** Specialty: local landmarks, marines, still lifes, nudes and portraits. **Sources:** Hughes, *Artists of California,* 570.

URBACH, Amelia *[Painter] mid 20th c.; b.Norfolk, VA.*
Addresses: San Antonio 1, TX. **Member:** Texas FAA. **Exhibited:** AIC, 1940; All. Artists, Dallas, 1937-40; San Antonio Ann., 1942-51; Texas Panorama (AFA), 1943; Texas FAA, 1943-52; Texas General, 1940-52. **Work:** Dallas MFA; Witte Mem. Mus. **Sources:** WW53; WW47.

URBAIN, Eugene J. *[Painter] b.1855, Belgium / d.1934, San Francisco, CA.*
Addresses: San Fran. **Comments:** Immigrated to the U.S. in the late 1890s. **Sources:** Hughes, *Artists of California*, 570.

URBAN, Albert *[Painter, sculptor, screenprinter, teacher] b.1909, Frankfurt, Germany / d.1959, NYC.*
Addresses: New York 11, NY. **Studied:** Kunstschule, Frankfurt, with Max Beckmann, Willi Baumeister. **Exhibited:** Frankfurt, Germany, 1931 (prize); Phila. Pr. Club, 1942; PAFA Ann., 1944-45, 1947-48; Phila. Art All., 1946; Swarthmore College, 1942; Carnegie Inst., 1945-58; NGA, 1947; LOC, 1945 (prize); de Young Mem. Mus., 1945 (solo); AIC, 1944; Univ. Illinois, 1950-58; Albright Art Gal., 1948; WMAA, 1944-47; NAD, 1944-47; NYPL, 1945; WAC, 1947; Corcoran Gal. biennials, 1957, 1959; other Corcoran Gal. exhs., 1944-47; Univ. Colorado, 1956-58. **Work:** MMA; BMFA; AGAA; BM; NGA. **Comments:** Position: head, Urban Prints, NYC. **Sources:** WW59; Falk, *Exh. Record Series*.

URBAN, Emmy *mid 20th c.*
Exhibited: Salons of Am., 1930. **Sources:** Marlor, *Salons of Am.*

URBAN, Joseph *[Scenic designer, illustrator, architect] b.1872, Vienna / d.1933.*
Addresses: NYC. **Studied:** Imperial and Royal Acad. FA, Vienna; Polytechnicum, Viena; Baron Carl Hasenauer. **Exhibited:** Awards: Kaiser Prize, for illustration of Edgar Allan Poe's "The Mask of the Red Death," 1897; Austrian State Grand medal (for other illustrations); St. Louis Expo, 1901 (gold), Arch. Lg., NY, 1933 (gold). **Work:** Boston Opera House (dir.), 1911; Ziegfeld productions, NY; designed interior of municipal bldg., Vienna; Czar Bridge, Leningrad; Palace of Khedive, Egypt; Schloss of Count Carl Esterhazy near Pressburg Hungary; designer many bldg. in U.S.; color treatment for entire Century of Progress Expo, Chicago. **Comments:** Came to the U.S. in 1911. His mastery of materials, forms and colors made him internationally recognized as the greatest scenic designer. Urban also designed pavillions in Austria, and made stage settings for a religious pageant.

URBAN, Mychajlo (Michael) Raphael *[Sculptor, painter] b.1928, Luka, Ukrainian SSR.*
Addresses: Chicago, IL. **Studied:** Univ. Chicago, 1956-59; School Art Inst. Chicago (B.F.A., 1959); Illinois Inst. Technology with Misch Kohn, 1964-65. **Exhibited:** Ravinia Festival Art Exh., Highland Park, IL, 1959; 64th Ann. Artists Chicago & Vicinity, 1961; PAFA Ann., 1966; 13th Ball State Univ. Ann., Muncie, IN, 1967; 150 Years Illinois Traveling Show, 1969-71; Michael Wyman Gal., Chicago, IL, 1970s. Awards: Edward L. Ryerson For Traveling fellowship, 1959; prizes, AIC & Univ. Wisconsin-La Crosse, 1965. **Work:** Concordia Teachers College, River Forest, IL. **Comments:** Preferred media: plywood, acrylics, welded steel. Teaching: Evanston AC, 1970-. **Sources:** WW73; D. Z. Meilach, *Contemporary Art with Wood* (Crown, 1968) & *Creative Carving* (Reilly & Lee, 1969); Falk, *Exh. Record Series*.

URBAN, Reva *[Painter, sculptor] b.1925, Brooklyn, NY / d.1987.*
Addresses: NYC. **Studied:** ASL (Carnegie scholarship, 1943-45). **Exhibited:** Pittsburgh Int., 1958-; First Biennale Christlicher Kunst der Gegenwart, Salzburg, Austria, 1958; Continuity & Change, Wadsworth Atheneum, Hartford, CT, 1962; Documenta III, Kassel, Germany, 1964; Seven Decades-Crosscurrents in Modern Art 1895-1965, exh. at ten New York galleries, 1965. **Work:** MoMA; AIC; Univ. Mus., Berkeley, CA; Finch College Mus., New York; Averthorp Gal., Jenkintown, PA. **Comments:** Preferred media: oils, aluminum. **Sources:** WW73; Sam Wagstaff, Jr., *Reva, Am. Abstract Painters & Sculptors* (1962); Peter Selz, *Reva Urban, Catalogue* (1965) & *Univ. Art Collections* (1966).

URBAN, Robert *[Teacher, painter] b.1915 / d.1947.*
Addresses: Cambridge, MA. **Studied:** Princeton. **Comments:** Teaching: Harvard.

URBANI, F. *[Sculptor and carver] mid 19th c.*
Addresses: Charleston, SC in 1850. **Comments:** He offered to repair marble statues, model busts and statues, and do bronzing and imitation iron work. **Sources:** G&W; Rutledge, *Artists in the Life of Charleston*.

URGEGORI, Galinino *[Painter] early 20th c.*
Addresses: NYC. **Exhibited:** S. Indp. A., 1934. **Sources:** Marlor, *Soc. Indp. Artists*.

URIBE, G(ustavo) Arcilla *[Painter, sculptor] b.1895, Bogota, Columbia.*
Addresses: Chicago, IL. **Studied:** S. Cuellar; F.A. Cano; E. Zerda; D. Cortes. **Member:** Nat. Cir. Bellas Artes, Bogota. **Exhibited:** AIC, 1922 (prize). **Sources:** WW25.

URIBE, Raul *[Painter] mid 20th c.*
Addresses: Chicago area. **Exhibited:** AIC, 1941-42. **Sources:** Falk, *AIC*.

URICH, Louis J. *[Painter, designer, sculptor, teacher] b.1879, Paterson, NJ.*
Addresses: Elmhurst, NY. **Studied:** ASL; CUA Sch.; BAID. **Exhibited:** NAD, 1914 (prize); PAFA Ann., 1915, 1917; S. Indp. A., 1917, 1925. **Comments:** Teaching: NYC high schools. **Sources:** WW40; Falk, *Exh. Record Series*.

URIS, Nuni *[Painter] mid 20th c.*
Exhibited: S. Indp. A., 1938. **Sources:** Marlor, *Soc. Indp. Artists*.

URNER, Joseph (Walker) *[Sculptor, painter, etcher] b.1898, Frederick, MD.*
Addresses: Frederick, MD. **Studied:** Baltimore Polytechnic Inst.; Maryland Inst.; Ettore Cadorin; Dwight Williams. **Member:** SSAL. **Exhibited:** Cumberland Valley Artists, annually (prize), 1939). **Work:** Alabama mon., Gettysburg, PA; Tancy mon., Frederick, MD; Cedar Lawn Mem.; presentation port., Gen. A.A. Vandergrift, U.S.M.C.; Gov. Johnson mon. and Amon Burgee mon., both Frederick, MD. **Sources:** WW59; WW47.

URQUHART, Alice Rosalie *[Craftsperson, teacher, illustrator] b.1854, NYC / d.1922, New Orleans, LA.*
Addresses: New Orleans, active 1886-1922. **Studied:** Newcomb College, 1887, 1890-93, 1896-97, 1900-08. **Member:** Five or More Club, 1892-93. **Exhibited:** Tulane Univ., 1890, 1892-93; Artist's Assoc. of N.O., 1890-92, 1894, 1896, 1901; Columbian Expo, Chicago, 1893; Newcomb Art Alumn. Assoc., 1909-10, 1913-14; Newcomb, 1911; Atlanta, GA. **Comments:** One of the first women in the crafts program at Newcomb College, she produced a variety of crafts that were sold locally, including pottery, metalwork, bookplates, postcards and pictorial calendars. Her most noted paintings were watercolor landscapes and still lifes. Seven of her pastel drawings were used in the book "Diary of a Refugee", 1910, a Civil War account. Sister of Elise Urquhart (see entry). **Sources:** *Encyclopaedia of New Orleans Artists*, 386.

URQUHART, E. (Miss) *[Listed as "artist"] late 19th c.*
Addresses: New Orleans, active c.1890. **Studied:** Artist's Assoc. of N.O., 1890. **Exhibited:** Artist's Assoc. of N.O., 1890. **Comments:** This could be Elise or Emma Urquhart (see separate entries for each). **Sources:** *Encyclopaedia of New Orleans Artists*, 386.

URQUHART, Elise *[Teacher, artist] b.c.1858, Louisiana / d.1912, New Orleans, LA.*
Addresses: New Orleans, active 1910. **Comments:** She was principal of her own school where her sister Alice Rosalie Urquhart (see entry) also taught. **Sources:** *Encyclopaedia of New Orleans Artists*, 386.

URQUHART, Emma J. *[Craftsperson] b.1865 / d.1929.*
Addresses: New Orleans, active c.1901-17. **Studied:** Newcomb College, 1901-09. **Comments:** She was primarily a pottery decorator. **Sources:** *Encyclopaedia of New Orleans Artists*, 386.

URQUHART, Tony *[Sculptor, painter] b.1934, Niagara Falls, Ontario.*
Addresses: Waterloo, Ontario. **Studied:** Albright Art School

(diploma, 1956); Univ. Buffalo (B.F.A., 1958); Yale Univ. Summer School (fellowship, 1955). **Member:** Canadian Artists Representation (nat. secy., 1968-72); Canadian Conf. Arts (bd. gov., 1970-73, second vice-pres., 1971). **Exhibited:** CI, 1958; Guggenheim Int., NYC, 1958; Paris Biennial, France, 1963; Art Am. & Spain, Madrid, Barcelona, Rome & Paris, 1964; Sculpture '67, Toronto, 1967; Nancy Poole Studio, London & Toronto; BauXi Gallery, Vancouver, BC, 1970s. **Awards:** Baxter Award, Ont. Soc. Artists Exh., 1961; Canadian Council fellowship, 1963 & 1967. **Work:** Nat. Gal. Canada, Ottawa; Art Gal. Ontario, Toronto; Winnipeg Art Gal.; Walker AC, Minneapolis, MN; MoMA. Commissions: 12 murals, Niagara Falls, Skylon Tower, CPR Restaurants, 1965; mural, Prov. Ontario Govt. Bldg., 1967. **Comments:** Preferred media: plywood. Positions: artist-in-residence, Univ. Western Ontario, 1960-63 & 1964-65. Teaching: Univ. Buffalo, 1957-58; McMaster Univ., 1966-67; Univ. Western Ontario 1967-72; Univ. Waterloo, 1972. Publications: illustr., *A Sketchbook of Canadian & European Drawings,* 1963 & *The Broken Ark — A Book of Beasts,* 1971. **Sources:** WW73; J. Russell Harper, *Painting in Canada* (Univ. Toronto Press, 1966); John Chandler *Drawing Reconsidered,* 1970; Dorothy Cameron, "A Reunion with Tony Uquhart," (April 15, 1971, Arts Canada).

URRUTIA, Lawrence *[Art administrator]* b.1935, Los Angeles, CA.
Addresses: La Jolla, CA. **Comments:** Positions: asst. dir., La Jolla Mus. Contemporary Art, CA. Collections arranged: Projections: Anti Materialism, 1970, Continuing Surrealism, 1971 & Helen Lundeberg, 1972. **Sources:** WW73.

URRY, Steven *[Sculptor]* b.1939, Chicago, IL.
Addresses: NYC. **Studied:** AIC, 1957-59; Univ. Chicago (B.A., 1959). **Exhibited:** Hemisphere, Am. Pavillion, TX, 1968; Univ. Nebraska Ann., 1970; WMAA, 1970; AIC, 1970; Chicago 8 Sculptors, Pioneer Plaza Center. **Work:** AIC. Commissions: monumental sculpture, Lib. Bldg., Loyola Univ., IL, 1969. **Comments:** Preferred medium: aluminum. **Sources:** WW73.

URSULESCU, Michael Marius *[Painter, lithographer, craftsperson, teacher]* b.1913, Echka, Yugoslavia / d.1960, Chicago, IL?.
Addresses: Evanston, IL. **Studied:** AIC. **Exhibited:** AIC, 1938-46 (awards, 1941, 1943); VMFA, 1944; Pepsi-Cola, 1946; Detroit Inst. Art., 1937-39, 1942 (prize), 1944, 1945; PAFA Ann., 1948. Other awards: Lathrop traveling scholarship, Chicago, 1935. **Work:** Detroit Inst. Art. **Sources:** WW53; WW47; Falk, *Exh. Record Series.*

URUNUELA, Manuel de *[Painter]* 19th/20th c.
Addresses: San Francisco, CA. **Exhibited:** Mark Hopkins Inst., 1898. **Work:** Calif. Hist. Soc. **Sources:** Hughes, *Artists of California,* 570.

URWILER, Benjamin *[Lithographer]* b.c.1830, Pennsylvania.
Addresses: Philadelphia in 1860. **Comments:** Next door was John Urwiler, 31, lithographic printer. **Sources:** G&W; 8 Census (1860), Pa., LXI, 465.

URY, Adolfo Muller See: **MULLER-URY, Adolph Felix**

USHENKO, Audrey Andreyevna *[Painter, instructor]* b.1945, Princeton, NJ.
Addresses: Valparaiso, IN. **Studied:** Indiana Univ. (B.A., 1965); School AIC; Northwestern Univ. (M.F.A., 1967) with George M. Cohen. **Member:** New AA; College AA Am. **Exhibited:** Indiana Artists Salon, Indianapolis Mus., 1966-68; Evanston, IL, 1967; Phalanx Four & Phalanx Five, Chicago, 1967 & 1968; Sloan Gals., Valparaiso, IN, 1968 (solo) & 1970 (solo); South Bend, IN, 1972. **Comments:** Preferred medium: oils. Teaching: Valparaiso Univ., 1968-. Research: late 18th c. English topographical watercolors. **Sources:** WW73.

USHER, Carrie E. *[Portrait painter]* 19th/20th c.
Addresses: San Francisco, CA, 1883-89; San Jose, CA, 1905-06; Santa Monica, CA, 1912-16. **Exhibited:** Calif. Agricultural Soc., 1883; San Francisco AA, 1889. **Sources:** Hughes, *Artists of California,* 570.

USHER, Leila *[Sculptor, painter]* b.1859, Onalaska, WI / d.1955, NYC.
Addresses: Boston, MA; New York 19, NY. **Studied:** ASL; in Paris; George Brewster in Cambridge; Augustus Saint-Gaudens; H.H. Kitson in Boston; Paris. **Exhibited:** Atlanta Expo, 1895 (bronze medal); Boston AC, 1896-1900; PAFA Ann., 1899-1903, 1910, 1914-18; St. Louis Expo, 1904; Pan-Pacific Expo, San Franc., 1915 (prizes); S. Indp. A., 1917-18, 1920, 1933; NSS; Salons of Am., 1930, 1934. **Work:** portrait, bas-reliefs, med.: Harvard Univ.; Johns Hopkins Univ.; Bryn Mawr College; Rochester Univ.; Bowdoin College; Tuskegee & Hampton Univ.; Royal Danish Mint & Metal Coll.; FMA; Nat. Mus., Wash., DC; Smithsonian Inst.; mon., Arlington Nat. Cemetery; Grand Canyon; Agassiz Mus., Cambridge. **Sources:** WW53; WW47; Petteys, *Dictionary of Women Artists;* Falk, *Exh. Record Series.*

USHER, Ruby W(alker) *[Painter, miniature painter, etcher, illustrator]* b.1889, Fairmont, NE / d.1957, Los Angeles, CA.
Addresses: Hollywood, CA. **Studied:** Chicago Acad. Art; Carnegie Inst.; Am. Sch. Min. Painters; Grand Central Sch. Art. **Member:** Women Painters of the West; Calif. AC; ASMP; AAPL; Calif. SMP; Soc. for Sanity in Art. **Exhibited:** Ebell Club, Los Angeles; PAFA; Oakland Art Gal.; GGE, 1939; Calif. State Fair, 1937-41 (prizes); Women Painters of the West, 1940, 1942, 1944, 1946 (prizes); LACMA, 1940 (prize), 1943 (prize); Calif. SMP, 1938 (prize) , 1944 (prize); CPLH, 1944 (prize) ; SFMA, 1945; New Jersey Print Exh., 1933 (prize). **Work:** Oakland Art Gal.; Gardena H.S.; PAFA. **Sources:** WW53; WW47.

USRY, Katherine Bartlett (Mrs.) *[Painter, graphic artist, teacher]* 20th c.
Addresses: Columbus, OH. **Studied:** AIC; Columbia Univ.; Berkshire Summer Sch.; NY Sch. Fine & Applied Design for Women; Ohio State Univ.; H.B. Snell; Venice. **Member:** Ohio WCS; Cincinnati AC; NAWPS; Columbus Art Lg. **Exhibited:** Ohio State Univ., 1939 (solo); NAWPS, 1937, 1938. **Comments:** Position: art dir., South H.S., Columbus, OH. **Sources:** WW40.

USTILLA, Edward F. *[Painter]* mid 20th c.
Exhibited: Corcoran Gal. biennial, 1961. **Sources:** Falk, *Corcoran Gal.*

USTINOV, Plato *[Sculptor]* b.1903 / d.1990.
Sources: info courtesy D.W. Johnson, *Dictionary of American Medalists* (pub. due 2000).

USUI, Bumpei *[Painter]* b.1898, Nagano, Japan / d.1994.
Addresses: NYC. **Member:** Woodstock AA. **Exhibited:** Sculptor, 1924-31; Salons of Am., 1924, 1925, 1926, 1928-32, 1934; Ann. AIC, 1938; PAFA Ann., 1938; Fed. Arts Project, Wash., DC, 1938. **Sources:** WW40; Falk, *Exh. Record Series;* addit. info. courtesy Woodstock AA.

UTER, Laurent *[Dealer, engraver, gilder, publisher]* b.c.1814, Lorraine, France / d.1891, New Orleans, LA.
Addresses: New Orleans, active c.1868-91. **Comments:** Was an importer of French mirrors and framemaker from c.1843. After the Civil War he also imported engravings and artwork made in France. In 1868 he advertised the sale of a series of four lithographs issued by A.L. Boimare, a publisher in Paris. Uter eventually became one of the largest art dealers in the city and continued his business until his death. **Sources:** *Encyclopaedia of New Orleans Artists,* 387.

UTESCHER, Gerd *[Sculptor]* mid 20th c.
Addresses: Phila., PA. **Exhibited:** PAFA Ann., 1960, 1968. **Sources:** Falk, *Exh. Record Series.*

UTLEY, William L. (Col.) *[Portrait painter]* 19th c.
Addresses: Ohio, active c.1830. **Work:** Western Reserve Hist. Soc.(portrait of the Hamilton Utley Family, 1838). **Sources:** G&W; Frary, "Ohio Discovers Its Primitives," 41; Hageman, 123.

UTLEY, Winsor *[Painter, musician, teacher]* b.1920, Los Angeles, CA / d.1989, Seattle, WA.

Addresses: Seattle, WA. **Member:** Artists Equity Assoc., Seattle; Puget Sound Group of NW Painters. **Exhibited:** SAM, 1945, 1948 (solo), 1951 (solo), 1955 (solo); Henry Gal., 1950, 1951, 1959; PAFA Ann., 1951; Northwest WCS, 1960. **Work:** Univ. Wash., Meany Hall (mural, "Tribute to Beethoven"). **Comments:** Trained as a musician, he took up painting through the encouragement of Mark Tobey. Teaching: Cornish Art School, Seattle, 1953. **Sources:** Trip and Cook, *Washington State Art and Artists;* Falk, *Exh. Record Series.*

UTPATEL, Frank Albert Bernhardt *[Engraver, painter, illustrator, block printer] b.1905, Waukegan, IL / d.1980, Mazomanie, WI.*
Addresses: Mazomanie, WI. **Studied:** Milwaukee AI; AIC; John Steuart Curry; Layton School Art, Milwaukee. **Member:** Soc. Am. PM; Soc. Wisc. Painters, Printmakers. **Exhibited:** CMA, 1935; Am. Art Gal., 1939; AIC, 1940; Milwaukee AI, 1939 (prize), 1940 (prize); Wisc. State Fair, 1940-41 (prizes); Layton Art Gal., 1940 (solo); Meuer's Art Gal., 1940; Wisc. Mem. Union, 1938-41; Madison Art Exh., 1940 (prize), 1941 (prize); NAD, 1941, 1945; SAM, 1941 (prize), 1942; CAFA, 1941; PAFA, 1941, 1945; WMAA, 1942, 1943; LOC, 1944, 1956; CI, 1944; Laguna Beach AA, 1944. Other awards: Wisc. Salon, 1940. **Work:** Milwaukee AI; Univ. Wisconsin: Layton Art Gal. **Comments:** Illustr.: "Village Day," 1946, "Lives Around Us," 1942; other books. Contrib.: wood engravings, *American Mercury, Tomorrow, Outdoors,* and other publications. **Sources:** WW59; WW47.

UTTECH, Thomas M. *[Painter] b.1942.*
Addresses: Milwaukee, WI. **Exhibited:** WMAA, 1975. **Sources:** Falk, *WMAA.*

UTTER, Bror *[Painter] mid 20th c.*
Addresses: Ft. Worth, TX. **Exhibited:** WMAA, 1953. **Sources:** Falk, *WMAA.*

UTZ, Thornton *[Illustrator, portrait painter] b.1914, Memphis, TN.*
Addresses: Sarasota, FL. **Studied:** Memphis with Burton Callicot; Am. Acad. Art, Chicago. **Member:** Chicago Artists Guild; AAPL. **Comments:** Teaching: AIC. He took part in the joint Soc. of Illustrators-Air Force Art Program, and received a citation for documenting the airlift of Hungarian refugees. He also received the Gov. Bryant (FL) Award for his "Freedom" posters. His portrait commissions include ones for Pres. Jimmy Carter and family and Princess Grace of Monaco. **Sources:** W & R Reed, *The Illustrator in America,* 280.

UYLDERT, Emil *[Painter, sculptor] mid 20th c.*
Addresses: Hempstead, LI, NY. **Exhibited:** S. Indp. A., 1935. **Sources:** Marlor, *Soc. Indp. Artists.*

UZAFOVAGE, Louise A. *[Painter] b.1862, Salem, OR / d.1934, Tacoma, WA.*
Addresses: Tacoma, WA, for 42 years. **Member:** Tacoma Art Lg. **Exhibited:** Western Wash. Indust. Expo, 1891, 1892. **Sources:** Trip and Cook, *Washington State Art and Artists.*

UZIELLI, Giorgio *[Collector] b.1903, Florence, Italy.*
Addresses: NYC. **Studied:** Univ. Florence (LL.D.). **Member:** Am.-Italy Soc. (pres.). **Comments:** Collection: Aldine editions (first editions of Dante; paintings and bronzes). **Sources:** WW73.

UZZELL, Onestus Kilpatrick *[Portrait painter, teacher] b.1904, Little Rock, AR / d.1955, Hollywood, CA.*
Addresses: Hollywood, CA. **Exhibited:** Found. Western Art, 1936; P&S Los Angeles, 1937-38; Southern Calif. Art, San Diego FA Gal., 1937; All Calif. Exh., 1939; GGE, 1939. **Sources:** Hughes, *Artists in California,* 570.

Self-caricature by William Paxton.
Archives of American Art

V

VACA, Salvatore *[Sculptor] mid 20th c.*
Exhibited: Calif. AC, 1934; Painters of Los Angeles, 1934.
Sources: Hughes, *Artists in California.*

VACCARO, Nick Dante *[Painter, educator] b.1931, Youngstown, OH.*
Addresses: Lawrence, KS. **Studied:** Univ. Washington (B.A., 1958); Univ. Calif., Berkeley (M.A., 1960); David Park.
Exhibited: Butler IA, 1956 & 1959; SFMA Ann., 1958; Riverside Mus. Print Int., New York, 1959; CPLH, 1961; Mid-Am., Nelson Gal., Kansas City, 1964-66 & 1970. Awards: purchase awards, SFMA, 1958, Dallas MFA, 1961 & Montgomery MFA, 1962.
Work: San Francisco AA; Dallas MFA; Montgomery MFA, AL; Univ. Calif., Berkeley; Youngstown (OH) Univ. Commissions: mosaic, Pacific Coast Paper Mills, Seattle, WA, 1957.
Comments: Preferred media: mixed media. Publications: illustr., *Texas Quarterly,* Vol. 5, No 1; illustr., *Image,* Univ. Texas, Austin, 1963; auth., "Gorky's Debt," *Art J.,* 1963. Teaching: Univ. Texas, 1960-63; Univ. Kansas, 1963-, chmn. dept. art, 1963-67; visiting artist, Penn. State Univ., 1970. **Sources:** WW73.

VACCARO, Patrick Frank (Patt Vaccaro) *[Printmaker, painter] mid 20th c.; b.New Rochelle, NY.*
Addresses: Poland, OH. **Studied:** Ohio State Univ.; Youngstown State Univ. (B.S., art educ.). **Member:** Hunterdon AC; Boston PM; Am. Colorprint Soc.; P&S Soc. NJ; Springfield Art Lg.
Exhibited: Boston Library Tour Italy, 1955-59; Boston Printmakers Ann., BMFA, 1955-; Am. Colorprint Soc. Ann., Phila., 1959-; Butler Inst. Am. Art Midyears, Youngstown, 1962-67; CMA Nat. U.S. Tour, 1967; American Art Society, Newport News, VA, 1970s. Awards: medal of honor in graphics, P&S Soc. NJ, 1963; Quaker Storage Award, Am. Colorprint Soc., 1969; first in ceramics, Butler Inst. Am. Art, 1970. **Work:** U.S. Govt. for foreign embassies; Butler Inst. Am. Art, Youngstown, OH; St. Peters College, Jersey City, NJ; Farnsworth Mus., Wellesley College, MA; Canton (OH) Art Inst. Commissions: preservation print, Friends Am. Art, Youngstown, 1969. **Comments:** Preferred medium: oils. Positions: trustee, Soc. North Am. Artists, 1971-72. Publications: illustrator, *Christian Herald, Together, Methodist*

Monthly, 1969; illustrator,"Strategy," Presby-Westminster Press, 1971-72. Teaching: Youngstown Public Schools, 1952-; Youngstown State Univ., 1959-70. **Sources:** WW73.

VACHELL, Arthur Honeywell *[Painter] b.1864, Kent, England.*
Addresses: San Luis Obispo, CA; Carmel, CA. **Studied:** briefly in Italy. **Exhibited:** San Francisco AA, 1910; Hotel Del Monte, 1910; Hotel Appleton, Watsonville, 1916. **Comments:** Sketching partner and friend of Sydney Yard (see entry) and Mary DeNeale (see entry). Specialty: watercolors of landscapes, coastals and garden scenes. **Sources:** Hughes, *Artists in California,* 571.

VACHON & GIRON *[Engravers] mid 19th c.*
Addresses: San Francisco, 1858. **Comments:** Partners were Achille Vachon and Marc Giron. **Sources:** G&W; San Francisco CD and BD 1858.

VAFIADES, George *[Painter] mid 20th c.*
Addresses: NYC. **Exhibited:** S. Indp. A., 1925-26. **Sources:** Marlor, *Soc. Indp. Artists.*

VAGANOV, Benjamin G. *[Painter, craftsperson, lecturer, teacher] b.1896, Archangel, Russia / d.1981, Salt Lake City, UT.*
Addresses: San Diego, CA. **Studied:** in Russia; mainly self-taught. **Member:** San Francisco AA; San Diego AC; Escondido Art Soc.; AAPL. **Exhibited:** Calif. State Fair, 1931, 1949; Kingsley AC, Sacramento, 1933; GGE, 1939; Am. Veterans Soc. Artists, 1944, 1945; San Francisco AA, 1943, 1958; Oakland Art Gal., 1944-45; Southern California Art Exh., 1940; San Diego FAS, 1940-42 (prizes). **Work:** San Diego FA Soc.; Carnegie Lib., Escondido, CA; mural, House of Pacific Relations, San Diego, CA; dioramas, San Diego County Visual Educ. **Comments:** Immigrated to the U.S. in 1923 and eventually settled in California after working in the Oregon lumber industry. A modernist painter, he also used the pseudonym Venia. WPA artist. **Sources:** WW53; WW47. More recently, see Hughes, *Artists in California,* 571.

VAGG, Raymond *[Painter] mid 20th c.*
Exhibited: Salons of Am., 1932. **Sources:** Marlor, *Salons of Am.*

VAGIS, Polygnotos, (George) *[Sculptor] b.1894, Thasos, Greece / d.1965, NYC.*
Addresses: NYC; Hicksville, NY, 1947; Bethpage, Long Island, NY, 1959. **Studied:** CUA Sch.; BAID. **Member:** AEA; Fed. Mod. P&S; Sculpture Guild; Am. Artists Congress. **Exhibited:** PAFA Ann., 1922, 1925, 1928; S. Indp. A., 1931; P&S Gal., 1932 (solo); BM, 1932-33, 1938; Kraushaar Gal., 1934 (solo); Chicago World Fair, 1934; Rockefeller Center, 1934; WMAA, 1936-62; CGA, 1934, 1937; Mus. Mod. Art Gal., Wash., DC, 1938; Valentine Gal., 1938 (solo); Sculpture Guild, 1938-42; WFNY 1939; Carnegie Inst., 1940-41; BMFA, 1944; Wadsworth Atheneum, 1945; PMA, 1940; MMA, 1942, 1952; Buchholz Gal., 1945; Wildenstein Gal., 1945-46; Hugo Gal., 1946 (solo); deYoung Mem. Mus., 1947; Rochester Mem. Art Gal., 1947; St. Paul Gal. Art, 1947; Nelson Gal. Art, 1947; MFA of Houston, 1947; MoMA, 1951; Levittown Art Festival, 1951 (prize); Iolas Gal., 1955 (solo); Audubon Artists, 1955 (gold medal). Awards: WMAA grant; Shilling prize, 1945; NIAL grant, 1957. **Work:** BM; WMAA; MMA; MoMA; ASL; TMA; Tel-Aviv Mus., Israel; mem. monument, Bethpage, Long Island, NY. **Comments:** Contributor: article/illustrator, *Trend, Review du Vrai et du Beau, Creative Art, L'Illustration.* **Sources:** WW59; WW47; Falk, *Exh. Record Series.*

VAGO, Sandor *[Painter, teacher, lecturer] b.1887, Hungary.*
Addresses: Cleveland Heights, OH. **Studied:** Royal Acad., Budapest; Royal Acad., Munich. **Member:** Nat. Salon, Budapest (founder); Royal AA, Budapest (founder); Royal Acad., Budapest (founder); Cleveland SA; AAPL. **Exhibited:** Budapest, 1913 (prize); CMA, 1924-26 (prizes); Corcoran Gal biennials, 1926, 1928; PAFA Ann., 1925; Newark Mus., 1926 (prize); Albright A. Gal.; S. Indp. A., 1931; Rochester Mem. Art Gal.; All. Artists

Am.; Cleveland AG (prize). **Work:** Bluffton Col.; Univ. Dayton; Fed. Circuit Court, Cincinnati; City Hall, Pub. Lib., schools, clubs, stores, all in Cleveland; Cleveland Plain Dealer; Cleveland Hermit Cl.; Cleveland Mid-Day Cl.; CMA; Nat. Salon, Budapest; Case School Applied Science, Cleveland. **Comments:** Lectures: portrait painting. **Sources:** WW53; WW47; Falk, *Exh. Record Series.*

VAIKSNORAS, Anthony, Jr. *[Painter, designer, illustrator]* b.1918, Du Bois, PA.
Addresses: Cleveland, OH. **Studied:** Cleveland School Art. **Member:** Cleveland SA. **Exhibited:** CI, 1941; VMFA, 1946; CMA, 1946 (prize); Butler AI; Norfolk Mus. Arts & Sciences; Milwaukee AI, 1946; Eldorado Pencil Comp., 1939 (prize); Strathmore Comp., 1939 (prize); Corcoran Gal. biennials, 1947, 1955. **Work:** CMA. **Comments:** Contributor: illustrations, "Art in the Armed Forces" & "To All Hands an Amphibious Adventure," 1943. **Sources:** WW53; WW47.

VAIL, Aramenta Dianthe *[Miniaturist]* mid 19th c.
Addresses: Newark, NJ, 1837-38; NYC ,1839-45. **Exhibited:** NAD, 1831-41; Apollo Assoc.; Am. Inst. **Sources:** G&W; Newark CD 1837-38; Cowdrey, AA & AAU; Cowdrey, NAD; Am. Inst. Cat., 1845; Bolton, *Miniature Painters.*

VAIL, Eugene Lawrence *[Painter]* b.1857, Saint-Servan, France / d.1934.

Eug. Vail

Addresses: Paris, France. **Studied:** ASL with C. Beckwith and W.M. Chase; Académie Julian, Paris; École des Beaux-Arts, Paris with Cabanel, Dagnan-Bouvert, Collin. **Member:** Soc. Nat. des Beaux-Arts; Paris SAP; Société de Peintres et Sculpteurs; Providence AC; Legion of Honor, 1984. **Exhibited:** Paris Salon, 1883-88, 1893-94, (prize, 1886; medal, 1888); PAFA Ann., 1883, 1888, 1892, 1902-04; AIC, 1894, 1903, 1906; SNBA, 1899; Paris Expo, 1889 (gold); Berlin (prize); Munich (medal); Providence AC, late 1890s; Antwerp (medal); St. Louis Expo, 1904 (medal); Liege Expo, 1905 (medal). **Work:** Brooklyn Mus.; CGA; RISD; Nat. Gal. Art; Nat. Mus. Am. Art; Wheaton College; Worcester Art Mus.; Wash. County MFA; Luxembourg Mus.; several European mus. **Comments:** He was born in France of American parents and studied and exhibited in the U.S. before returning permanently to France around 1900. He lived alternatively in Paris and Venice, painting floral still lifes, marines, and street and canal scenes. **Sources:** WW25; Fink, *American Art at the Nineteenth-Century Paris Salons,* 399; add'l info. courtesy of Elinor Nacheman, Pawtucket, RI; exh. cat., *Painters of Rhode Island* (Newport AM, 1986, p. 23); Falk, *Exh. Record Series.*

VAIL, James H. Clopton *[Painter]* mid 20th c.
Addresses: Chicago area. **Exhibited:** AIC, 1942. **Sources:** Falk, AIC.

VAIL, Joseph *[Chairmaker and amateur artist]* mid 19th c.
Addresses: NYC. **Exhibited:** Am. Inst., 1846 (landscape in bronze). **Sources:** G&W; NYCD 1845-46; Am. Inst. Cat., 1846.

VAIL, Laurence *[Sculptor]* b.1891, Paris, France / d.1968, France.
Exhibited: Mus. Non-Objective Art, 1945 (56 bottles). **Comments:** A Surrealist sculptor employing "junk and absurdist aesthetics," he was active in NYC, London, and Paris during the 1920s-30s, and in Paris and London during the 1930s-40s. In addition to his well-known stuffed bottles of the early 1940s, he also created bizarre constructions made of various found objects. **Sources:** Wechsler, 26.

VAIL, Pegeen *[Painter]* mid 20th c.
Addresses: NYC. **Exhibited:** PAFA Ann., 1947. **Sources:** Falk, *Exh. Record Series.*

VAIL, Robert D. *[Painter]* 20th c.
Addresses: Columbus, OH. **Member:** Columbus PPC. **Sources:** WW25.

VAIL, Robert William Glenroie *[Museum director, educator, critic, writer, lecturer]* b.1890, Victor, NY.

Addresses: Albuquerque, NM. **Studied:** Cornell Univ. (B.A.); Library School, NYPL; Columbia Univ.; Univ. Minnesota. **Comments:** Position: librarian, NY State Library, 1940-44; dir., NY Hist. Soc., 1944-60; assoc. in history, Columbia Univ., NYC; Rosenbach lectures in Bibliography, Univ. Pennsylvania. Awards: hon. degree, Litt. D., Dickinson Col., 1951; L.H.D., Clark Univ., 1953; NY Hist. Soc. Gold Medal for Achievement in History, 1960. Author: "The Voice of the Old Frontier"; "Knickerbocker Birthday: A Sesquicentennial History of the New York Historical Society," 1954; "The Case of the Stuyvesant Portraits," 1958; many monographs. Ed.: "Sabin's Dictionary of Books on America." **Sources:** WW66; WW47.

VAILL, Leila H. *[Painter]* mid 20th c.
Studied: ASL. **Exhibited:** S. Indp. A., 1941. **Comments:** Her married name was Feitzer. **Sources:** Marlor, *Soc. Indp. Artists.*

VAILLANT, Louis D(avid) *[Mural painter]* b.1875, Cleveland, OH / d.1944.
Addresses: NYC/Wash., CT. **Studied:** Mowbray, ASL. **Member:** Arch. Lg., 1902; Mural Painters. **Exhibited:** NAD, 1910 (prize); PAFA Ann., 1911; AIC. **Work:** stained glass windows, Meeting House, Ethical Culture School, NYC; First Nat. Bank Titusville, PA. **Sources:** WW40; Falk, *Exh. Record Series.*

VAILLANT, (Mme.) *[Miniaturist]* mid 19th c.
Addresses: NYC in 1825. **Sources:** G&W; Bolton, *Miniature Painters.*

VAILLARD, Ida V. *[Artist]* 19th/20th c.
Addresses: Active in Grand Rapids, MI, 1900. **Sources:** Petteys, *Dictionary of Women Artists.*

VAINI, Pietro *[Artist]* d.1876.
Addresses: NYC, 1874-75. **Exhibited:** NAD, 1874-75. **Sources:** Naylor, *NAD.*

VAKIAN, Reuben *[Sculptor]* mid 20th c.
Exhibited: AIC, 1924. **Sources:** Falk, *AIC.*

VALAPERTA, Giuseppe *[Sculptor]* b.Milan, Italy / d.c.1817.
Addresses: Wash., DC, 1815. **Comments:** A native of Milan, Valaperta worked in Genoa; in Madrid for Joseph Bonaparte, King of Spain; and in France at the palace of Malmaison before Napoleon's downfall in 1815. He arrived in Washington (DC) in the fall of 1815 and for two years was employed as a sculptor at the National Capitol, where his eagle can still be seen on the frieze of the south wall of Statuary Hall. He also carved in ivory and modelled red wax portraits of Jefferson, Gallatin, Madison, Monroe, and Jackson, and was recommended by William Thornton and Benjamin Latrobe (see entries) for the Washington statue commissioned by North Carolina and later executed by Canova. Valaperta disappeared from his Washington boarding house in March 1817, leaving a will, and is thought to have committed suicide, as he was never heard of again. **Sources:** G&W; Wall, "Joseph Valaperta"; Fairman, *Art and Artists of the Capitol,* 31-32, 452; Washington *National Intelligencer,* Nov. 4, 1815 (G&W has citation courtesy Miss Anna Wells Rutledge).

VALAPERTI, Guiseppe See: **VALAPERTA, Giuseppe**

VALDENUIT, Thomas Bludget de *[Engraver and crayon portraitist]* b.1763 / d.1846.
Addresses: Baltimore, 1795; NYC, 1796. **Comments:** An ex-officer of the French army, Valdenuit came to America and opened a drawing school in Baltimore with one Bouché in November, 1795. The following year he moved to NYC and became the partner of C.B.F.J. de Saint-Mémin (see entry) in the profile and portrait engraving business. Valdenuit is said to have returned to France sometime after February, 1797. **Sources:** G&W; Pleasants, *250 Years of Painting in Maryland,* 31; Norfleet, *Saint-Mémin in Virginia,* 14-16; Rice, "An Album of Saint-Mémin Portraits," 24-25; *Art Quarterly* (winter, 1951), 349, 352; Stauffer; Fielding's supplement to Stauffer.

VALDES, Emely *[Painter]* mid 20th c.
Exhibited: Salons of Am., 1933; S. Indp. A., 1933-35. **Sources:**

Falk, *Exhibition Record Series.*

VALE, Stella *[Artist] late 19th c.*
Addresses: Active in Wash., DC, 1899. **Sources:** Petteys, *Dictionary of Women Artists.*

VALENCIA, Antonio H. *[Lithographer] late 19th c.*
Addresses: New Orleans, active 1884-87. **Sources:** *Encyclopaedia of New Orleans Artists,* 388.

VALENCIA, August Warren *[Painter] b.1906, San Francisco, CA.*
Addresses: San Francisco, CA. **Studied:** with his father; John Garth; Calif. Sch. FA. **Exhibited:** Soc. for Sanity in Art, CPLH, 1941; Oakland Mus.; Santa Cruz Art League, 1940s; Rosemead Pub. Lib., 1978. **Comments:** Son of Manuel Valencia (see entry) he was a mechanical engineer, who painted in his spare time. **Sources:** Hughes, *Artists in California,* 571.

VALENCIA, Ethel See: **GRAU, Ethel Valencia**

VALENCIA, Mabel Eadon *[Painter] b.1874, Leeds, England / d.1962, Hayward, CA.*
Addresses: San Jose, CA. **Studied:** Sheffield, England; W.F. Jackson at CGA. **Work:** San Jose Hist. Soc. **Comments:** Position: illustrator, *War Cry,* San Francisco. Married to Manuel Valencia (see entry), she painted and also raised nine children. **Sources:** Hughes, *Artists in California,* 571.

VALENCIA, Manuel *[Landscape painter] b.1856, Marin County, CA / d.1935, Sacramento, CA.*
Addresses: San Francisco. **Studied:** attended Santa Clara College but was primarily self-taught; had a few lessons with Jules Tavernier; Esquela de Belles Artes, Mexico City. **Work:** Bohemian Club; Huntington Art Gal., San Marino; Oakland Mus.; San Jose Hist. Mus.; Sierra Nevado Mus., Reno, NV; State Capitol, Sacramento. **Comments:** A member of one of California's earliest families, he is known for his landscapes and historic scenes of Northern California and Colorado. He married Mabel Eadon Valencia (see entry), and they had nine children. It was not until later in his career, in San Francisco in 1912, that he exhibited regularly and found success. Positions: staff artist, *San Francisco Chronicle;* illustrator for the Salvation Army newspaper. **Sources:** Hughes, *Artists in California,* 571; P&H Samuels, 496.

VALENCIN, (Signor/Mr.) *[Artist] mid 19th c.; b.Spain.*
Addresses: NYC in December 1830. **Exhibited:** NYC, 1830 (Chinese views, including views in Europe and a goddess of liberty). **Sources:** G&W; NY *Evening Post,* Dec. 7, 1830 (described as Signor Valencin).

VALENKAMPH, Theodore Victor Carl **T.V.C.V.**
[Marine painter] b.1868, Stockholm, Sweden / d.1924, Gloucester, MA.
Addresses: Gloucester, since 1899. **Member:** Boston AC. **Exhibited:** Boston AC, 1906, 1908. **Sources:** WW10.

VALENTA, Yaroslav Henry *[Painter, graphic artist] b.1899, Czechoslovakia.*
Addresses: Brooklyn, NY. **Studied:** Portland (OR) AM School. **Member:** Am. Artists Congress; United Am. Artists. **Exhibited:** Fed. Art Gal., NYC; Am. Artists Congress. **Comments:** WPA artist. **Sources:** WW40.

VALENTE, Alfred (Alfredo) *[Painter] mid 20th c.*
Addresses: Chicago, IL; NYC, 1946. **Member:** Chicago NJSA. **Exhibited:** PAFA Ann., 1946. **Sources:** WW25; Falk, *Exh. Record Series.*

VALENTEE, Edward N. *[Painter] early 20th c.*
Addresses: Baltimore, MD. **Member:** Baltimore WCC. **Sources:** WW25.

VALENTI, Angelo *[Painter, designer, decorator, illustrator] 20th c.; b.Massarosa, Tuscany, Italy.*
Addresses: NYC. **Studied:** self-taught. **Member:** AIGA. **Comments:** Illustrations and woodcuts, "Leaves of Grass," by

Walt Whitman, pub. Grabhorn Press; 35 other books; hand illuminations, Golden Cross Press, Bronxville, NY. **Sources:** WW40.

VALENTI, Paul *[Etcher, writer, lecturer, teacher] b.1887, NYC.*
Addresses: St. Louis, MO. **Studied:** C. Boito; L. Beltrami; G. Moretti. **Member:** AIA; St. Louis AG. **Exhibited:** Int. Competition for Design of Royal Palace, Sofia, Bulgaria, 1913 (prize). **Sources:** WW27.

VALENTIEN, Albert R. *[Painter, ceramic artist] b.1862, Cincinnati, OH / d.1925, San Diego, CA.*
Addresses: San Diego, CA, 1908-25. **Studied:** Cincinnati Art Acad. with Thomas Slatterwhite Nobel, Duveneck. **Member:** Cincinnati AC; San Diego AG; Jury of Awards, Pan-Calif. Expo, San Diego, 1916. **Exhibited:** Cincinnati Expo, 1898; SWA; Omaha Expo, 1898; PAFA Ann., 1899; Paris Expo, 1900 (silver med.); Blanchard Gal., Los Angeles, 1908; Pan-Pac. Expo, San Francisco, 1915; Pan-Calif. Expo, San Diego, 1916. **Work:** San Diego Mus. of Natural History (wildflowers of California, 52 portfolios); State Lib., Calif., Sacramento (50 paintings of wildflowers); Bowers Mus., Santa Ana; State Capitol Bldg, Sacramento. **Comments:** Position: staff, Wheatley Potters, Cincinnati; Rookwood Potteries, 1881-1905. He and his wife Anna Marie Valentien settled in San Diego in 1908 and established the Valentien Pottery Company. Commissioned by Ellen Browning Scripps to record California's wildflowers, he produced 1200 watercolors between 1908-18. **Sources:** WW24; WW47; Gerdts, *Art Across America,* vol. 3: 330-31; Falk, *Exh. Record Series.*

VALENTIEN, Anna Marie Bookprinter *[Sculptor, ceramist, painter, teacher] b.1862, Cincinnati, OH / d.1947, San Diego, CA.*
Addresses: San Diego, CA, 1908-47. **Studied:** Cincinnati Art Acad. with Duveneck (1883-97); with Rodin at Académie Colorossi and with Injalbert, Bourdelle, Paris, 1899-1900. **Member:** AGFAS, San Diego; La Jolla AA. **Exhibited:** Atlanta Expo., 1895 (gold); Pan-Calif. Expo., San Diego, 1915 (gold), 1916 (golds); Sacramento State Fair, 1919 (prize); Acad. FA, San Diego, 1931 (medal). **Comments:** Positions: staff, Rookwood Potteries, Cincinnati, 1884-1905; teacher, San Diego Normal Sch. (1914-16), H.S. (1917-38). Married artist Albert R. Valentien in 1887 and settled in San Diego in 1908. There the couple established the Valentien Pottery Company. Important figure in the development of the Arts and Crafts Movement in San Diego. **Sources:** WW53; WW47; Gerdts, *Art Across America,* vol. 3: 330-31.

VALENTINE, Charles M. *[Portrait and miniature painter] mid 19th c.*
Addresses: Germantown, PA in 1836; at Philadelphia in 1838 and 1840. **Exhibited:** Artists Fund Soc., 1836. **Sources:** G&W; Rutledge, PA; Phila. BD 1838, CD 1840.

VALENTINE, D'Alton *[Illustrator, etcher, teacher] b.1889, Cleveland / d.1936.*
Addresses: NYC. **Studied:** Ufer; J.W. Reynolds. **Member:** SI; AG; Players; SC; Dutch Treat Club. **Exhibited:** WMAA, 1921. **Sources:** WW31.

VALENTINE, Deane (Mrs.) *[Painter] early 20th c.*
Addresses: Minneapolis, MN. **Sources:** WW24.

VALENTINE, DeWain *[Sculptor] b.1936, Fort Collins, CO.*
Addresses: Venice, CA. **Studied:** Univ. Colorado, (B.F.A., 1958; M.F.A., 1960); Yale-Norfolk Art School, Yale Univ. fellowship, 1958. **Exhibited:** WMAA Ann., 1966, 1968 & 1970; Sculpture of the Sixties, LACMA, 1966; Plastic Presence, Jewish Mus., New York, Milwaukee AC & SFMA, 1969; 14 Sculptors: The Industrial Edge, Walker AC, 1969; AIC Am. Ann., 1970. **Work:** WMAA; LACMA; Pasadena AM; Milwaukee AC; Stanford Univ. AM. **Comments:** Preferred media: polyester resin. Teaching: Univ. Colorado, 1958-61; Univ. Calif., Los Angeles, 1965-67. **Sources:** WW73; Kurt Von Mier, "An Interview with DeWain Valentine," (May, 1968) & Plagens, "Five Artists — Ace Gallery"

(Oct., 1971), *Artforum;* EA Danielli, "DeWain Valentine," *Art Int.* (Nov.,1969).

VALENTINE, Dorothy Hsiton *[Painter, lithographer, mural painter]* mid 20th c.
Addresses: San Francisco, CA; Berkeley, CA, 1930s. **Exhibited:** SFMA, 1935. **Sources:** Hughes, *Artists in California,* 572.

VALENTINE, Edward Virginius *[Sculptor, teacher]* b.1838, Richmond, VA / d.1930.
Addresses: Richmond, VA, 1868-72. **Studied:** began modelling portrait busts before he was 20; studied painting under William James Hubard, 1850s; Jouffrey, Couture, Paris, 1859-60; sculpture with Bonanti, Rome, 1861; German sculptor August Kiss, Berlin, 1861-65. **Member:** Richmond AC (founder). **Exhibited:** NAD, 1868-72. **Work:** statues, Mem. Chapel, Lexington, VA; Richmond; Fredericksburgh, VA; New Orleans; U.S. Capitol, Wash., DC. **Comments:** While in Berlin he received four photographs of Gen. Robert E. Lee, from which he modeled a statuette which was sold in Liverpool for the benefit of the Southern cause. In 1865 he opened a studio in Richmond, where he made busts and statues of Confederate heroes. His most famous work is the recumbent statue of General Lee in the Lee Mem. Chapel at Lexington, VA, although some critics have pronounced his "Andromache and Astyanax" in the Valentine Mus., at Richmond, his masterpiece. Also characteristic of his work were his depictions of the lives of Blacks, made just after the Civil War and sold in Northern cities. Valentine was prominent in the Richmond art community, he was a teacher at the Richmond Art Club and was president of the Valentine Museum in Richmond. **Sources:** G&W; *Richmond Portraits,* 234-35; Fairman, *Art and Artists of the Capitol;* DAB; CAB; WW29; Gerdts, *Art Across America,* vol. 2: 21, 23.

VALENTINE, Elias *[Portrait and general engraver]* early 19th c.
Addresses: NYC, 1810-18. **Sources:** G&W; Stauffer.

VALENTINE, Francis Barker *[Painter, designer, teacher, comm a, lecturer]* b.1897, Buffalo, NY.
Addresses: Buffalo, NY; Hamburg, NY. **Studied:** Albright Art School; Yale School FA, (B.F.A.); PAFA; Daniel Garber; S. Kendall. **Member:** The Patteran; Buffalo Soc. Art; Albright Art Gal.; Prof. Artists Gld., Buffalo; Commercial AG, Buffalo. **Exhibited:** Albright Art Gal., annually (prizes, 1945, 1954; silver medal, 1955); Hamburg, NY, 1953 (solo); Hamburg Fair, 1955-58 (3 prizes); Crane Branch Library, Buffalo, 1957 (solo); Erie County Fair, 1958, 1960, 1963 (prizes each year); Hotel Statler, Buffalo; Buffalo Soc. Art (silver medal); The Patteran; Grand Central Art Gal.; Riverside Mus.; Yale Club; Great Lakes Traveling Exhib. **Work:** IBM, Buffalo; YMCA, Buffalo; Charlotte Ave. School, Hamburg, NY; Hamburg Public Library. **Comments:** Positions: illustrator/layouts, Dunlop Tire & Rubber Co.; teacher, Albright Art School, Buffalo, NY, 1932-; senior artist, Buffalo & Erie Co. Public Library, Buffalo, NY, 1966. **Sources:** WW66; WW47.

VALENTINE, Herbert Eugene *[Combat artist]* b.1841, South Danvers, MA / d.1917, West Somerville, MA.
Comments: A private in the Union forces, he was at Fort Monroe and Newport News in 1863, and at Portsmouth, the Battle of Cold Harbor and the Petersburg campaign in 1864. His numerous sketches appeared in his book *The Story of Company F, 23rd Massachusetts Volunteers in the War for the Union, 1861-1865,* published 1896. **Sources:** Wright, *Artists in Virgina Before 1900.*

VALENTINE, Jane H. *[Miniature painter]* b.1866, Bellefonte, PA. / d.1934.
Addresses: Phila., PA; Ruxton, MD. **Studied:** W.M. Chase & C. Beaux, PAFA. **Member:** Phila. Alliance; Phila. Print Club. **Exhibited:** PAFA Ann., 1900, 1903-04, 1922. **Work:** Albright Art Gal., Buffalo. **Sources:** WW38; Falk, *Exh. Record Series.*

VALENTINE, John *[Listed as "artist"]* b.c.1810, England.
Addresses: NYC in 1860. **Sources:** G&W; 8 Census (1860), N.Y., LIII, 376.

VALENTINE, Josephine Deane *[Painter]* b.1873, Varna, Canada / d.1945, Varna.
Addresses: Michigan; St. Louis, MO; Los Angeles, 1933. **Member:** Calif. AC; Laguna Beach AA; Beverly Hills AA; Women Painters of the West; Santa Monica AA. **Sources:** WW25; Hughes, *Artists in California,* 572.

VALENTINE, Julius *[Portrait painter]* b.c.1817, Germany.
Addresses: Baltimore in 1850. **Sources:** G&W; 7 Census (1850), Md., IV, 676.

VALENTINE, Marion Kissinger (Mrs. Hans G.) *[Mural painter, craftsperson, designer, teacher]* b.1901, Milwaukee.
Addresses: Milwaukee, WI. **Studied:** Layton School Art. **Member:** Wisc. Soc. Applied Art (pres.); Wisc. P&S. **Exhibited:** Milwaukee AI, 1930-35 (prizes). **Comments:** Teaching: Layton School Art. **Sources:** WW40.

VALENTINE, Robert *[Painter, illustrator]* b.1879, Bellefonte.
Addresses: Bellefonte, PA. **Studied:** Anshutz; Carlson; Hale; Wear; Vonna. **Sources:** WW31.

VALENTINE, Samuel *[Engraver]* mid 19th c.
Addresses: NYC, 1840. **Sources:** G&W; NYBD 1840.

VALENTINE, William Winston *[Portrait and landscape painter]* mid 19th c.; b.Richmond, VA.
Addresses: Richmond, VA. **Comments:** An older brother of Edward V. Valentine (see entry), he worked in the family store for a while, then turned painter, and finally became a teacher and philologist. **Sources:** G&W; *Richmond Portraits,* 199.

VALENTINER, W(illiam) R(einhold) *[Museum director-consultant; art historian, writer]* b.1880, Karlsruhe, Germany / d.1958.
Addresses: Los Angeles, CA. **Studied:** Univ. Leipzig; Univ. Heidelberg (Ph.D.). **Comments:** Position: editor, *Art In America* (1913-31),*Art Quarterly* (1938-45); consultant, LACMA, 1953. Contributor: U.S. & European periodicals. Author: "Rembrandt und seine Umgebung," 1905; "The Art of the Low Countries," 1914; "Frans Hals," 1923; "Pieter de Hooch," 1930; "Origins of Modern Sculpture," 1945. Co-author: "Catalogue Raisonné of the Works of the Most Important Dutch Painters of the 17th Century," Vol. I. Also catalogues of the Johnson, Goldman, Mackay, Widener & other important collections. **Sources:** WW53; WW47.

VALENTINO, William *[Painter]* mid 20th c.
Addresses: NYC, 1930. **Exhibited:** S. Indp. A., 1930. **Sources:** Marlor, *Soc. Indp. Artists.*

VALERIO, A. Mastro *[Painter]* early 20th c.
Addresses: Chicago. **Exhibited:** AIC, 1919. **Sources:** Falk, *AIC.*

VALERIO, Pietro *[Painter]* mid 20th c.
Exhibited: Salons of Am., 1934. **Sources:** Marlor, *Salons of Am.*

VALERIO, Silvio B. *[Painter, craftsperson]* b.1897, Boston.
Addresses: NYC. **Studied:** ASL; Grand Central School Art with A. Woelfle; H. Nichols. **Member:** SC; Allied Artists Am.; Artists Fellowship. **Exhibited:** SC, 1935 (prize); Allied AA (prize). **Work:** Vanderpoel AA, Chicago. **Sources:** WW40.

VALFRAMBERT, Marzilie (Mlle.) *[Teacher of grammar and drawing]* mid 19th c.; b.France.
Addresses: New Orleans, 1822-23. **Studied:** pupil of "the late Imperial Castle of Ecouen". **Comments:** She was formerly drawing teacher at the "Royal House of St. Denis". **Sources:** G&W; Delgado-WPA cites *Courier,* May 8, 1822. More recently, see *Encyclopaedia of New Orleans Artists,* 388.

VALIER, Biron (Frank) *[Painter, printmaker]* b.1943, West Palm Beach, FL.
Addresses: Belmont, MA. **Studied:** Yale Univ. (M.F.A.); Cranbrook Acad. Art (B.F.A.); Univ. Arkansas; Woodstock AA Graphic Workshop; ASL; Norton Gal. & School Art; Palm Beach Jr. College; Florida State Univ.; Mexico City Col. **Member:** Boston Visual Artist's Union; AFA. **Exhibited:** NAD Ann., NYC, 1965; Young Printmakers 1967 Traveling Exhib., 1967; New

Talent Show, Alpha Gal., Boston, 1969; Landscape II, DeCordova Mus., Lincoln, 1971; Food Show, Inst. Contemporary Art, Boston, 1972; Athena Gal., New Haven, CT, 1970s. Awards: purchase prize, Butler IA, 1966; award of merit, Florida State Fair Fine Arts Exhib., 1966 & 1968; purchase prize, DeCordova Mus., Boston Printmakers Exhib., 1971. **Work:** Butler IA; DeCordova Mus., Lincoln, MA; BMFA; Norton Gal. Contemp. Coll., West Palm Beach; Print Coll., Boston Pub. Lib. **Comments:** Preferred media: collages. Publications: contributor, "Paula's Dream World of Trains," 1972. Teaching: art instructor, Wheelock College, 1969-72; part-time instructor, Rhode Island College, fall 1972. Art interests: acrylic & aluminum collages. **Sources:** WW73; Peter Fierz, "New Talent: James Piskoti, Biron Valier," *Kunstnachrichten* (Nov., 1969); Robert Taylor, "Biron Valier's Work Tough, Bold," *Boston Globe* (Nov. 10, 1972); Katherine Nahum, "Biron Valier: Trains of Thought," *Newton Times*, (Nov. 8, 1972).

VALK, Ella Snowden *[Miniature painter]* b.1866, Virginia / d.1942, Los Angeles, CA.
Addresses: NYC; Santa Barbara, CA. **Studied:** NYC; Paris, France; with Laurens, Constant, Geoffroy. **Member:** NAWA. **Exhibited:** Paris Salon, 1894; PPE, 1915; S. Indp. A., 1917. **Sources:** WW27; Hughes, *Artists in California*, 572; Fink, *American Art at the Nineteenth-Century Paris Salons*, 399.

VALLANCE, John *[Engraver]* b.c.1770, Scotland / d.1823, Philadelphia, PA.
Addresses: Philadelphia from 1791-1823. **Member:** associated with PAFA from 1811-17. **Comments:** From 1791-97 he was with Thackara & Vallance (see entry) and from 1817-19 with Tanner, Vallance, Kearney & Co. (see entry). **Sources:** G&W; Philadelphia *National Gazette and Literary Register,* June 16, 1823, obit.; Phila. CD 1791-1824; Society of Artists and Penna. Acad. Cats., 1811-23; Prime, II, 74; Stauffer; Hamilton, *Early American Book Illustrators and Wood Engravers,* 476.

VALLANGCA, Robert V. *[Painter]* b.1907, Lapog, Phillipines / d.1979, San Francisco, CA.
Addresses: San Francisco, CA. **Studied:** Calif. College of Arts & Crafts; Bufano; John Garth; Diego Rivera. **Exhibited:** San Francisco AA, 1936. **Comments:** Specialty: portraits, landscapes, street scenes of San Francisco. **Sources:** Hughes, *Artists in California*, 572.

VALLE, Maude Richmond Fiorentino *[Painter, illustrator, writer, teacher, art critic]* b.1868, near St. Paul, MN / d.1969, Mill Valley, CA.
Addresses: Denver, CO/Mt. Morrison, CO. **Studied:** ASL with K. Cox,Wm. M. Chase, G. Brush, C. Beckwith; Acad. Julian, Paris with Lefebvre, Constant & Beaury-Sorel; Acad. Delecluse, Paris. **Member:** Denver AG. **Comments:** Art critic, *Rocky Mountain News,* Denver, CO. Also appears as Florentino-Valley, Fiorentino-Valle. **Sources:** WW40; WW25.

VALLE, Maude Richmond Florentino See: **VALLE, Maude Richmond Fiorentino**

VALLEE, Jack (Land) *[Painter]* b.1921, Wichita Falls, TX / d.1986.
Addresses: Oklahoma City, OK. **Studied:** Midwestern Univ.; ASL, with Reginald Marsh, Howard Trafton & Frank DuMond. **Member:** All. A. Am.; Wash. WCC; AWCS; NAC; Oklahoma AA. **Exhibited:** AWCS, 1958-65 (5 shows); CAFA, 1959-65; Holyoke Mus., 1964 & 1968; Fisher Gal., Wash., DC, 1965 & 1968. Awards: Oklahoma Art Festival, 1962-64; McDowell Colony fellowship, 1963; Watercolor; USA, 1964. **Work:** Springfield Mus. Art; Univ. Oklahoma; Oklahoma AC; Berkshire Mus., Pittsfield, MA; Holyoke Mus. Art. **Comments:** Vallee came to the ASL after serving with the Marines in the South Pacific in World War II. He first went to Monhegan Island in 1949 and sum-mered there for the next thirty years. Preferred media: watercolor. Position: visiting professor of art, Univ. Oklahoma. **Sources:** WW73; Curtis, Curtis, and Lieberman, 55, 187.

VALLÉE, Jean Francois de *[Miniaturist and silhouettist]* 18th/19th c.; b.France.
Addresses: Philadelphia, 1794, 1798; Charleston, SC, 1803, 1805, 1806; New Orleans, 1810, 1815. **Comments:** In 1785 he discussed with Jefferson the possibility of coming to America and the same year opened a cotton mill near Alexandria, VA. When it failed he became an itinerant painter. In 1794 he was listed as a boardinghouse keeper in Philadelphia. He cut a silhouette of Washington in 1795 and painted a miniature of Andrew Jackson in New Orleans in 1815, after the Battle of N.O. **Sources:** G&W; Jefferson, *Writings* (Monticello ed.), V, 131-32; Phila. CD 1794, 1798; Rutledge, *Artists in the Life of Charleston;* Hart, "Life Portraits of Andrew Jackson," 799; Hart, "Life Portraits of Washington," 303; American-Anderson Art Galleries, Sales Cat., April 2-3, 1937; Jackson, *Silhouette,* 150; Bassett, *Correspondence of Andrew Jackson,* II, 209, 262, VI, 462, 468; *Encyclopaedia of New Orleans Artists,* 388.

VALLEE, P. R. *[Miniaturist]* early 19th c.
Addresses: New Orleans, 1810. **Comments:** Possibly the same as Jean Francois de Vallée. **Sources:** G&W; Delgado-WPA cites *La Courier,* Oct. 10, 1810; Rutledge, *Artists in the Life of Charleston,* 126, cites the same issue of the *Courier* in reference to J.F. de Vallée.

VALLEE, William Oscar *[Painter]* b.1934, South Paris, ME.
Addresses: Anchorage, AK. **Studied:** Univ. Alaska. **Member:** Alaska Art Guild (pres. & chmn., 1964); Alaska WCS (pres., 1963-); Am. Soc. Photogrammetry; AAPL. **Exhibited:** Anchorage Fur Rendezvous, 1963 (prize); Easter Arts Festival 1963 (prize); Alaska Festival Music & Art, 1963 & 1964; Anchorage Petroleum Club, 1963 (solo); Anchor Galleries, 1963 (solo). Other awards: Artist of the Month, Alaska Art Guild, 1963. **Comments:** Preferred media: watercolors. Positions: instituted (in co-operation with AAPL), "American Art Week," 1963; treasurer, Soc. Alaskan Arts, 1963; co-founder, Alaska-Int. Cultural Arts Center, secy., 1964-; bd. directors & co-founder, Anchorage Community Art Center; pres. & chmn. board, Alaska Map Service, Inc. **Sources:** WW73.

VALLEJO, Napoleon Primo *[Painter]* b.1850, Casa Grande, Sonoma, CA / d.1923, San Francisco, CA.
Addresses: Sonoma, CA; San Francisco, CA. **Studied:** College of Santa Clara. **Work:** Soc. Calif. Pioneers; Vallejo Home State Park, Sonoma. **Sources:** Hughes, *Artists in California*, 572.

VALLETTE, Edwin F. *[Letter, ornamental, and general engraver]* b.c.1829, Pennsylvania.
Addresses: Philadelphia from 1848 to after 1860. **Comments:** His brother James (see entry) also was an engraver. **Sources:** G&W; 7 Census (1850), Pa, LIII, 53; Phila. CD 1848-60+.

VALLETTE, James *[Engraver]* b.c.1831, Pennsylvania.
Addresses: Philadelphia in 1850. **Comments:** At Philadelphia in 1850 with his mother Sarah and brother Edwin Vallette (see entry). **Sources:** G&W; 7 Census (1850), Pa., LIII, 53.

VALLETTE, Ralph L. *[Engraver]* b.1875 / d.1937.
Addresses: Wash., DC. **Comments:** Position: engraver, Bureau of Engraving and Printing. **Sources:** McMahan, *Artists of Washington, DC.*

VALLINDER, W. *[Painter]* early 20th c.
Addresses: Minneapolis, MN. **Sources:** WW24.

VALLOMBROSA, Medora Hoffman *[Amateur artist]* b.c.1858 / d.c.1921.
Addresses: Active in Medora, ND, 1883-86. **Exhibited:** France; AAPL, 1952 (posthumous prize). **Sources:** Petteys, *Dictionary of Women Artists.*

VALOIS, Edward *[Lithographer]* mid 19th c.
Addresses: NYC from the 1840s-60s. **Comments:** He worked with G.W. Fasel (see entry) and others. **Sources:** G&W; Peters, *America on Stone;* NYCD 1856-60; *Portfolio* (March 1943), 158; *Portfolio* (June 1945), 231; Am. Inst. Cat., 1851.

VALSEY, Seth M. *[Sculptor] mid 20th c.*
Addresses: Chicago area. **Exhibited:** AIC, 1930. **Sources:** Falk, *AIC.*

VALTMAN, Edmund *[Cartoonist] b.1914, Tallinn, Estonia.*
Addresses: Hartford, CT. **Studied:** private studios, 1936-39; Tallinn Art & Applied Art School, 1942-44. **Member:** Assn. Am. Ed. Cartoonist; Nat. Cartoonists Soc.; CAFA. **Exhibited:** The Great Challenge, Editorial Cartoon Exh., Washington, Tokyo & London, 1958-59; Politics 1960, Columbia Univ., NYC, 1960; Int. Salon Cartoons, Montreal, Canada, 1968-71; World Cartoon Festival, Knokke-Heist, Belg., 1971; Trinity College, Hartford, CT, 1965 (solo). Awards: Pulitzer Prize for Cartooning, Columbia Univ., 1962; Frank Tripp Award, Gannett Newspapers, 1963; Public interest award, Nat. Safety Council, 1958. **Work:** Lyndon Johnson Lib., Austin, TX; Univ. Southern Mississippi Library; Univ. Cincinnati (OH) Lib.; State Hist. Soc. Missouri, Columbia; Wichita (KS) State Univ. Lib. **Comments:** Preferred media: india ink. Collection: editorial cartoons. **Sources:** WW73.

VALUE, Jane (Miss) See: **CHAPIN, Jane Catherine Louise Value (Mrs. S. D.)**

VAN, Louisa *[Painter] late 19th c.; b.New York.*
Studied: Mlle. Bricon. **Exhibited:** Paris Salon, 1881 (drawing). **Sources:** Fink, *American Art at the Nineteenth-Century Paris Salons,* 399.

VAN, Luther *[Painter] b.1937, Savannah, GA.*
Studied: New Sch. Social Research; ASL. **Exhibited:** BMFA, 1970. **Sources:** Cederholm, *Afro-American Artists.*

VAN AALTEN, Jacques *[Painter, teacher, lecturer] b.1907, Antwerp, Belgium.*
Addresses: Detroit, MI, 1944-47; NYC. **Studied:** NAD, 1926-30 (grad.); ASL, 1932-34; Acad. Grande Chaumière, Paris, France, 1955; Tulane Univ., 1970-71. **Member:** Rockport AA (life mem.); ASL (life mem.); Nat. Soc. Mural Painters; Isaac Delgado Mus. AA. **Exhibited:** NAD; WMAA; BAID; Arch. Lg.; Soc. Indep. Artists; Municipal Artists, NYC, 1941; Detroit IA, 1946; Isaac Delgado Mus. Art, New Orleans, LA, 1958-59; Rockport AA, 1962-71; Louisiana Artists Group, Louisiana Art Commission Gal., Old Capitol Bldg., Baton Rouge. Awards: Sydam Medal, 1930; Tiffany scholarship, 1930. **Work:** fresco mural, Textile H.S., NYC; portrait of Pope Pius XII, Vatican Mus. Permanent Collection, Rome, Italy; Religious Ministry Bldg., Jerusalem; Truman Library, Independence, MO; Louisiana State Art Collection, New Capitol Bldg., Baton Rouge; Rockport AA. **Comments:** Teaching: Nassau Conservatory Art, Long Island, NY, 1940; Van Aalten Studio School, Detroit, 1944-47. **Sources:** WW73; WW47.

VANACORE, Frank *[Painter, graphic artist] b.1907, Phila.*
Addresses: Phila., PA. **Studied:** Barnes Found.; Merion, PA. **Exhibited:** PAFA Ann., 1938, 1949; Pr. Club, Phila.; Butler AI. **Sources:** WW40; Falk, *Exh. Record Series.*

VAN ALLEN, Eleanor *[Artist] late 19th c.*
Addresses: Active in Grand Rapids and Saginaw, MI, c.1883-87. **Sources:** Petteys, *Dictionary of Women Artists.*

VAN ALLEN, Gertrude Enders (Mrs. Robert) *[Painter, craftsperson, teacher] b.1897, Brooklyn, NY.*
Addresses: Port Washington, LI, NY, 1940; Southbury, CT, 1953. **Studied:** CUA Sch.; PIA Sch.; NYU (B.S.; M.A. in Art Educ.); Ralph Pearson; Louis Wolchonok; G.L. Nelson; A. Fisher; L. Skidmore; W. Taylor; H. Reiss. **Member:** NAWA; Conn. Craftsmen; Nassau AL; Cape Cod AA. **Exhibited:** Salons of Am.; S. Indp. A.; Silvermine Gld. Artists; Conn. Craftsmen; Vendome Art Gals., NYC, 1942 (solo). **Comments:** Position: art supervisor, Children's Center, NYC, 1953. Also appears as Lafon. **Sources:** WW53; WW47 (under Van Allen); WW59 (under Lafon); Petteys, *Dictionary of Women Artists.*

VAN ALSTINE, Mary J. (Mrs. Leslie H.) *[Teacher and painter] b.1878, Chicago, IL.*
Addresses: Gilmore City, IA; Whittier, CA. **Studied:** Boothbay Harbor Colony, ME; Otis Art Inst.; Stone City; Robert Brockman, Grant Wood, Anson Cross. **Member:** Iowa Artists Club. **Exhibited:** Iowa Fed. Women's Club, 1932; Iowa Artists Club, 1933, 1935; Iowa Art Salon, 1934; Iowa Artists Exh., Mt. Vernon, 1938; Joslyn Mus., Omaha, NE. **Sources:** WW47; Ness & Orwig, *Iowa Artists of the First Hundred Years,* 210.

VAN ALSTYNE, Archibald C. *[Steel engraver] mid 19th c.*
Addresses: Albany, NY, 1857-59. **Sources:** G&W; Albany CD 1857-59.

VAN ALSTYNE, Mary *[Still-life painter on velvet] mid 19th c.*
Addresses: Massachusetts, c.1825. **Sources:** G&W; Lipman and Winchester, 168.

VANAMEE, Esther *[Painter] mid 20th c.*
Exhibited: Salons of Am., 1936. **Sources:** Marlor, *Salons of Am.*

VANARDEN, George *[Listed as "artist" picture cleaner in the directory] b.c.1806, England.*
Addresses: Baltimore in 1860. **Sources:** G&W; 8 Census (1860), Md., III, 980; Baltimore CD 1859.

VAN ARNAM, Margaret Newton *[Painter] mid 20th c.*
Addresses: Seattle, WA, 1951. **Exhibited:** SAM, 1947. **Sources:** Trip and Cook, *Washington State Art and Artists.*

VAN ARSDALE, Arthur *[Painter] early 20th c.*
Addresses: Edmond, OK. **Member:** Oklahoma AA. **Sources:** WW27.

VAN ARSDALE, Dorothy Thayer *[Art administrator] b.1917, Malden, MA.*
Addresses: Clermont, FL. **Studied:** Simmons College (B.S., bus. admin.). **Member:** Am. Assn. Mus. **Exhibited:** Awards: Knight, Order Dannebrog, King of Denmark, 1971. **Comments:** Positions: chief, traveling exhib. service, Smithsonian Inst., Wash., DC, 1964-70; dir., Dorothy T. Van Arsdale Assocs., Traveling Exhib. Service & Gal., FL. Publications: contributor, "Paintings & Drawings" (1966), "Sculptures & Drawings" (1966), "Islamic Art from the Collection of Edwin Binney 3rd" (1966) & "Carl-Henning Pedersen" (1969); contributor & editor, "140 years of Danish Glass" (1968). Collections arranged: Art Treasure of Turkey (1966), Tunisian Mosaics (1967), Colonial Art from Ecuador (1968) & Swiss Drawings (1969), Washington, DC & nat. tour; Selection of New Belgian Painting, Florida & nat. tour (1971). **Sources:** WW73.

VAN ARSDALE, M. Emma See: **VAN ARSDELE, M. Emma**

VAN ARSDALE, Ruth *[Illustrator] early 20th c.*
Addresses: NYC. **Sources:** WW19.

VAN ARSDELE, M. Emma *[Painter] late 19th c.*
Addresses: Plainfield, NJ, 1882-86. **Exhibited:** NAD, 1881-86. **Sources:** Naylor, *NAD.*

VANARTSDALEN, James *[Engraver] b.c.1811, Pennsylvania.*
Addresses: Philadelphia from c.1849 to after 1860. **Sources:** G&W; 8 Census (1860), Pa., LXII, 78 [as Vanassdelen]; Phila. CD 1849-60+.

VAN ASDALE, Walter *[Illustrator] early 20th c.*
Addresses: NYC. **Sources:** WW19.

VAN ATTA, Helen Ulmer *[Collector] b.1914, Midland, TX.*
Addresses: Dallas, TX. **Member:** Art Collectors Club. **Comments:** Collection: contemporary American art. **Sources:** WW73.

VAN AUKEN, Cornelia See: **CHAPIN, Cornelia Van Auken**

VAN BAALEN, Frances *[Painter] late 19th c.*
Addresses: Roxbury, MA. **Exhibited:** Boston AC, 1896. **Sources:** *The Boston AC.*

VAN BAERLE, Edward *[Painter]* mid 20th c.
Addresses: NYC. **Exhibited:** S. Indp. A., 1936, 1940-41, 1944.
Sources: Marlor, *Soc. Indp. Artists.*

VAN BEEST, Albert *[Marine and landscape painter, teacher]*
b.1820, Rotterdam, Holland / d.1860, NYC.
Addresses: New Bedford, MA and NYC. **Studied:** perhaps with
Jan Hendrik van de Laar. **Exhibited:** Boston Athenaeum, 1857;
New Bedford Art Exhib., 1858, 1861(memorial); Brooklyn AA,
1864, 1872, 1878. **Work:** Free Public Lib. (New Bedford); Old
Dartmouth Hist. Soc. (New Bedford); Kendall Whaling Mus.,
Sharon, MA; NYPL; BMFA; New Bedford Free Pub. Lib.; Old
Dartmouth Hist. Soc. **Comments:** After serving in the Dutch
Navy (as artist of the Dutch fleet), Van Beest traveled to Iceland,
Brazil, Patagonia, and the Falkland Islands before coming to the
U.S. c.1855. He appears to have divided his time between New
Bedford (MA), where he was in October 1855 and again in 1857,
and NYC, where he lived in 1856 and from 1858 until his death.
While at New Bedford in 1857, Van Beest shared a studio with his
best known pupil, William Bradford. Blasdale reports that his
temperament was reflected in his choice of dramatic subjects for
his art. **Sources:** G&W; CAB; Thomas, "The American Career of
Albert Van Beest," with 10 repros. and bibliography which cites
A.J. Barnouw, "A Life of Albertus Van Beest" in the Rotterdam
Year Book for 1919; NYCD 1856, 1858-60; Swan, BA, 200;
Tuckerman, *Book of the Artists.* See also Brewington 34; Blasdale,
Artists of New Bedford, 195-97 (w/repros.).

VAN BENSCHOTEN, Clare D. *[Painter, graphic artist]* mid
20th c.
Addresses: NYC. **Member:** AWCS; NAWA. **Exhibited:** S. Indp.
A., 1929-30; AWCS, 1934, 1936, 1938; NAWA, 1935-38.
Sources: WW47.

VAN BENTHUYSEN, Will *[Illustrator]* b.1883,
Leavenworth, KS / d.1929.
Addresses: NYC. **Work:** series of illustrated stories on animals at
the Bronx Zoo, in New York World. **Comments:** Specialty: wild
animal life. Position: staff, *New York World,* 26 yrs.

VAN BERG, Solomon *[Collector]* 20th c.
Addresses: NYC. **Sources:** WW66.

VAN BLARCOM, Charles *[Painter]* early 20th c.
Addresses: Brooklyn, NY. **Exhibited:** S. Indp. A., 1917.
Sources: Marlor, *Soc. Indp. Artists.*

VAN BLARCOM, Mary (Mrs. Milbauer) *[Painter, screen-
printer, lithographer, craftsperson]* b.1913, Newark, NJ /
d.1953, Point Pleasant Beach, NJ.
Addresses: Point Pleasant Beach, NJ. **Studied:** Wellesley
College. **Member:** Nat. Ser. Soc. (bd. trustees, 1945-52; 1st vice-
pres., 1949-51); NAWA; AEA; Am. Color Pr. Soc.; New Jersey
AA (dir.); Artists of Today. **Exhibited:** Montclair Art Mus., 1941-
45, 1947-51 (prize, 1948); S. Indp. A., 1942-44; Artists of Today,
1942-46; Elisabet Ney Mus., 1943; Northwest PM, 1944, 1946-
49; Laguna Beach AA, 1945-47, 1949; NAWA, 1945-50 (prize,
1946); LOC, 1946-47; Mint. Mus. Art, 1946; MoMA traveling
exh., 1945-47; Carnegie Inst., 1947; Serigraph Gal., 1946, 1951
(solo); Am. Color Pr. Soc., 1947-52; Newark Mus., 1947-48,
1951; Calif. State Lib., 1947, 1949; Nat. Ser. Soc., 1949 (prize),
1950 (prize); Univ. Chile, 1950; NJ State Mus., 1950; Phila. Art
All., 1951; Main Gal., NY, 1952. **Work:** Newark Pub. Lib.; U.S.
Govt.; AAUW, NYPL; Tel-Aviv Mus.; Alabama Polytechnic Inst.;
Princeton Pr. Club; Howard Univ.; U.S. State Dept. **Sources:**
WW53; WW47.

VAN BLITZ, Samuel E. *[Sculptor, architect]* b.1865, Utrecht,
Holland / d.1934.
Addresses: Paterson, NJ. **Comments:** He lived in France,
England, and Palestine. Position: repair and restoring art objects,
MMA.

VAN BOSKERCK, Robert Ward (or P. W.) *[Landscape
painter]* b.1855, Hoboken, NJ / d.1932, NYC.
Addresses: NYC, 1882-1900. **Studied:** R.S. Gifford; A.H. Wyant.

Member: ANA, 1897; NA, 1907; SAA, 1887. **Exhibited:**
Brooklyn AA, 1879-85, 1892; NAD, 1880-1900; PAFA Ann.,
1880, 1900; Boston AC, 1881-85; AIC, 1888-91, 1912-13; AWCS,
1898; CI, 1898; SL, 1898. Pan-Am. Expo, Buffalo, 1901; St.
Louis Expo, 1904 (medal); Corcoran Gal. annuals/biennials,
1907-08, 1930; S. Indp. A., 1919. **Work:** Union Lg.; Lotos Club,
Fencers Club, both in NYC; Layton Art Gal. Milwaukee;
Hamilton Club, Brooklyn Mappin Art Gal., England. **Sources:**
WW31; Falk, *Exh. Record Series.*

VAN BRAKLE, John (W.) *[Painter]* mid 20th c.
Addresses: NYC. **Exhibited:** S. Indp. A., 1943-44. **Sources:**
Marlor, *Soc. Indp. Artists.*

VAN BRENT, George *[Painter]* mid 20th c.
Addresses: Pelham, NY. **Exhibited:** S. Indp. A., 1929. **Sources:**
Marlor, *Soc. Indp. Artists.*

VAN BRIGGLE, Anne See: **RITTER, Anne Louise
Lawrence Gregory (Mrs. E. A.)**

VAN BRIGGLE, Artus *[Painter, craftsperson]* b.1869,
Felicity, OH / d.1904, Colorado Springs, CO.
Addresses: Colorado Springs, CO. **Studied:** Art Acad.,
Cincinnati, 1886, with Frank Duveneck; Julian Acad., 1894, with
Benjamin-Académie Julian, Paris, with J.P. Laurens & B.
Constant, 1893. **Member:** Cincinnati AC; Assoc. Soc. Western
Artists. **Exhibited:** AIC, 1896-97; St. Louis Expo, 1904 (med.);
Paris Salon, 1903 (awards); Cincinnati Expo., 1898. **Work:**
Cincinnati AM. **Comments:** Positions: staff, Rookwood Pottery,
Cincinnati, 1887. Moved to Colorado in 1899 and established Van
Briggle Pottery. He died there of tuberculosis. **Sources:** WW04;
Cincinnati Painters of the Golden Age, 108 (w/illus.).

VAN BRIGGLE, Leona Vera *[Painter, decorator]* b.Felicity,
OH / d.1953, Cincinnati, OH.
Comments: Worked at Rookwood Pottery, Cincinnati, 1899-
1904. Sister of Artus Van Briggle (see entry). **Sources:** Petteys,
Dictionary of Women Artists.

VAN BRUNT, James Ryder *[Artist]* b.1820, Brooklyn, NY /
d.1916, Brooklyn, NY.
Addresses: Active in Brooklyn, 1837-1912. **Sources:** BAI, cour-
tesy Dr. Clark S. Marlor.

VAN BRUNT, Jessie *[Painter, stained glass designer,
craftsperson, calligrapher]* b.1863 / d.1947.
Addresses: California, active early 1930s; NYC & Brooklyn.
Studied: J. La Farge. **Work:** gave stained glass windows to
churches throughout the world; his work can be found in Mission
Inn, Riverside, CA; Pullen House, Skagway, AK; St. Martin's
Church, Atlin, BC; St. Andrew's Church, Labrador; English
Reform Church, Amsterdam; The Little Church Around the
Corner, NYC. **Comments:** Specialty: designer, stained glass win-
dows. Illustr./auth.: *California Missions,* Los Angeles, 1932.
Positions: art director, Packer Collegiate Inst.; active in New York
School Applied Design. **Sources:** Hughes, *Artists in California,*
572.

VAN BRUNT, R. *[Painter]* mid 19th c.
Addresses: active in Brooklyn, NY & elsewhere on Long Island,
1857-76. **Work:** Long Island Hist. Soc. (sketches). **Comments:**
Specialized in landscapes in watercolors. **Sources:** G&W;
Portfolio (June 1945), 21-22, repro.

VAN BUREN, A. A. *[Painter]* 19th/20th c.
Member: Louisville AL. **Comments:** Position: staff, D.H.
Baldwin & Co., Louisville, KY. **Sources:** WW01.

VAN BUREN, Amelia V. *[Artist, photographer]* 19th/20th c.
Addresses: Active in Detroit, MI, 1880, 1890-1900. **Exhibited:**
Angell's Gals., Detroit, 1880. **Sources:** Petteys, *Dictionary of
Women Artists.*

VAN BUREN, Raeburn
[Illustrator, cartoonist, lecturer]
b.1891, Pueblo, CO / d.1987.
Addresses: Great Neck, NY. **Studied:** ASL, 1913. **Member:** Nat.

Cartoonist Soc.; SI (life member); Artists & Writers Soc. **Exhibited:** SI. Awards: Cartoonist of the Year, B'nai B'rith, Phila., 1958. **Work:** Boston Univ. Lib.; Syracuse Univ. **Comments:** Positions: creator of comic strip "Abbie & Slats," syndicated by United Feature Syndicate, over 200 daily newspapers. Illustrator: "Stag at Eve," "Star of the North"; *Saturday Evening Post, Collier's, Redbook, New Yorker, McClure Syndicate, King Features Syndicate, Life; Esquire.* Teaching: lectures on comic strip art. **Sources:** WW73; WW47.

VAN BUREN, Richard *[Sculptor] b.1937, Syracuse, NY.*
Addresses: NYC. **Studied:** Mexico City College; Univ. Mexico; San Francisco State College. **Exhibited:** Primary Structures, Jewish Mus., New York 1966; Whitney Sculpture Ann., WMAA, 1968 & 1970. **Work:** MoMA; Walker AC, Minneapolis, MN. Commissions: 3-unit wall sculpture, Walker AC, 1971. **Sources:** WW73; Phyllis Tuchman, "An Interview with Richard Van Buren," *Artforum* (Dec., 1969); Carter Ratcliff, "Solid Color," *Art News* (May, 1972).

VAN BUREN, Stanbery *[Painter] 19th/20th c.; b.Zanesville, OH.*
Addresses: Columbus, OH. **Studied:** Lahaye in Paris; Twachtman in NYC. **Exhibited:** PAFA Ann., 1902, 1904 (seascapes & landscapes). **Sources:** WW17; Falk, *Exh. Record Series.*

VAN BUSKIRK, Janet Oremi *[Painter] mid 20th c.*
Addresses: NYC. **Exhibited:** S. Indp. A., 1918, 1920, 1922, 1924-26; AIC, 1921. **Sources:** Falk, *Exhibition Record Series.*

VAN BUSKIRK, Karl *[Portrait painter] b.1887, Cincinnati, OH / d.1930, NYC.*
Addresses: Chicago. **Studied:** Duveneck in Cincinnati. **Exhibited:** AIC, 1920. **Work:** Treasury Bldg., Wash., DC. **Comments:** Position: staff artist, New York newspaper, Mexican border, 1916. **Sources:** WW13.

VAN CAMP, Thomas *[Painter] late 19th c.*
Addresses: Phila., PA. **Exhibited:** PAFA Ann., 1888. **Sources:** Falk, *Exh. Record Series.*

VANCE, Bruce B. *[Painter] mid 20th c.*
Exhibited: AIC, 1925. **Sources:** Falk, *AIC.*

VANCE, Elise See: **MONCURE, Elise (Lisa) Vance**

VANCE, Florestee *[Painter] b.1940, Ferriday, LA.*
Studied: Chicago Teachers College; Illinois Inst. of Technology; Univ. Ghana; Univ. Science & Technology, Ghana. **Exhibited:** Dixie Square Art Fair, 1970; Englewood Art Fair, 1970; Afam Art Gallery, 1970. **Sources:** Cederholm, *Afro-American Artists.*

VANCE, Fred Nelson *[Landscape painter, mural painter] b.1880, Crawfordsville, IN / d.1926.*
Addresses: Indianapolis, IN. **Studied:** Smith Acad., Chicago; Acad. Julian, Paris with J.P. Laurens, 1902; Acad. Colarossi & Vitti Acad., Paris; Gérôme & Max Bohm, also in Paris; E. Vedder in Rome. **Member:** Brown County Art Gal. Assn.; Hoosier Salon; Indianapolis Circle Français (pres.); Paris AAA; Indiana Art Club. **Sources:** WW25.

VANCE, Frederick T. (or J.) *[Painter] late 19th c.*
Addresses: Eagleswood, Perth Amboy, NJ, 1866; NYC (active 1866-83); Genessee, NY, 1883. **Exhibited:** NAD, 1866-83; Brooklyn AA, 1874-81; Boston AC, 1881. **Sources:** *Brooklyn AA.*

VANCE, George Wayne *[Ceramist, sculptor] b.1940, Macomb, IL.*
Addresses: Boulder, CO. **Studied:** Knox College (B.A., 1962); Univ. Iowa (M.A., 1968); Univ. Colorado (M.F.A., 1972). **Member:** Am. Crafts Council. **Exhibited:** All Iowa Artist, Des Moines AC, 1967; Tenth Ann. Rochester Festival Religious Art, NY, 1968 (first prize); Iscals, Texas Tech. College Mus., 1969; Kitchen Keramik Exh., Sheldon Mem. Gal., 1969; Midwest Biennial, Joslyn Mus., Omaha, NE, 1970-72. Other awards: first prize sculpture 1970 & jurors award, 1971, Own Your Own, Southern Colorado State College. **Work:** Wisc. State Univ.,

Platteville. Commissions: "Casserole," Sheldon Mem. Gal., Lincoln, NE, 1969. **Comments:** Preferred media: clay. Teaching: Dakota State College, 1968-70. **Sources:** WW73; Paul Arnold, article, *Craft Horizons* (1968); Ray Schemore, article, *Craft Horizons* (1970).

VANCE, Mae Howard *[Painter, designer, illustrator, ceramist] mid 20th c.; b.Rushsylvania, OH.*
Addresses: Washington, DC. **Studied:** Cleveland Sch. Art, 1919-21; Corcoran Sch. Art, 1923-25. **Member:** Lg. Am. Pen Women. **Exhibited:** Indep. Artists, Wash., DC; Lg. Am. Pen Women. **Work:** F.D. Roosevelt Coll.; White House, Wash., DC. **Comments:** Illustr.: "Birthplaces of Presidents of US". **Sources:** WW59; WW47; McMahan, *Artists of Washington D.C.*, 220 (indicates Vance was still living in Wash., DC as of 1977.

VANCE, Nan *[Painter] mid 20th c.*
Exhibited: Salons of Am., 1933. **Sources:** Marlor, *Salons of Am.*

VANCE, Robert H. *[Daguerreotypist] d.1876, NYC.*
Comments: Best known as the Gold Rush photographer who, in 1849, began making large-scale documentary daguerreotypes in San Francisco and Placerville. In 1851, he exhibited more than 300 of these works in NYC. He sold his San Francisco gallery in 1861 to Charles L. Weed and returned East. His collection of great historical importance but has never been discovered, and individual works rarely appear at auction. **Sources:** Welling, 74-75; Newhall, *The Daguerreotype in America,* 154.

VANCE, Virginia See: **SWOPE, Virginia Vance**

VAN CISE, Monona Colby *[Painter, teacher] b.1859, Oconomowoc, WI / d.1933, Laramie, WY.*
Addresses: Algona, IA; Laramie, WY; Idaho; Colorado; California; again in Laramie, 1931-33. **Studied:** AIC. **Exhibited:** AIC, 1896; Pennsylvania; San Francisco; Oakland Art Gal., 1928. **Comments:** Specialty: landscapes of Colorado, Wyoming, the Pacific Coast, also floral still lifes. Teacher, Laramie, WY, 1899-1930s. **Sources:** Hughes, *Artists in California,* 573; Petteys, *Dictionary of Women Artists.*

VAN CLEEF, Augustus D. *[Painter, etcher, critic, writer] b.1851, Millstone, NJ / d.1918.*
Addresses: Jersey City, NJ, 1878-79; NYC, 1881-82. **Exhibited:** NAD, 1877-82; AWCS, 1881; NY Etching Club, 1883-84; Parrish AM, 1984 ("Painter-Etchers" exh.). **Work:** Parrish AM. **Comments:** An enigmatic painter-etcher whose NYC studio was in same building with S. Colman and J. & G. Smillie during the 1880s. For several years he was an art critic for the *New York Herald,* and for about three years he was asst. editor of *American Art News.* At one time he was also librarian for Knoedler & Co. He etched landscapes, but exhibited floral still life paintings most frequently at the NAD. **Sources:** *American Painter-Etcher Movement* 51.

VAN CLEVE, Helen Mann (Mrs. Eric) *[Painter, sculptor, writer, designer] b.1891, Milwaukee, WI / d.1975, Santa Barbara County, CA.*
Addresses: Berkeley, CA, 1920s-30s; Pacific Palisades, CA, 1940s-62. **Studied:** BMFA Sch. with Bela Pratt; Grande Chaumière, Paris; AIC; UC Berkeley; Eliot O'Hara; Oscar Van Young; Rex Brandt; Frederic Taubes; Eva Withrow; Cora Boone. **Member:** Pacific Palisades AA; Soc. for Sanity in Art; Westwood AA; Soc. of Western Artists. **Exhibited:** San Diego FA Soc., 1932; Salons of Am., 1934; Montclair AM, 1934; Kennebunk Village, 1934; Gump's, San Francisco; Rockefeller Center, 1934; Santa Barbara MA, 1940, 1944-45; CPLH, 1940-45; Laguna Beach AA, 1944; Oakland Art Gal., 1948; Westwood Village AA, 1949-52; deYoung Mem. Mus., 1949-51; Springville, UT, 1951-52; Pacific Palisades AA, annually; Santa Cruz, CA; Santa Paula, CA. Award: prize, Wisconsin State Fair. **Work:** CPLH; San Diego Pub. Lib. **Comments:** Auth./illustr.: children's books. **Sources:** WW59; WW47; Hughes, *Artists in California,* 573.

VAN CLEVE, James *[Marine painter] b.1808, Lawrenceville, NJ / d.1888, Sandwich, Ontario.*

Work: Chicago Hist. Soc.; Buffalo Hist. Soc.; Yale Univ. Art Gal. **Comments:** A shipmaster, in 1841, he built the first wheel propeller vessel on the Great Lakes. **Sources:** Brewington, 85.

VAN CLEVE, Kate *[Craftsperson, teacher, designer, lecturer, writer]* b.1881, Chicago, IL.
Addresses: Brookline, MA. **Studied:** Michigan Normal College (M. Educ.); PIA School. **Member:** Boston Weavers Guild (dir.); Texile Weavers Guild; Boston Soc. Art & Crafts. **Exhibited:** de Cordova and Dana Mus., 1952; WMA, 1952; Fitchburg Art Mus., 1954; Pittsfield Mus. Art, 1954; G.W.V. Smith Art Mus., 1955; Boston Soc. Art & Crafts, 1955; WMA, 1955. **Comments:** Position: instructor, weaving, Boston School Occupational Therapy, Boston, MA; Garden Studio, Brookline, MA; member, Craftsmen's Advisory Commission; dean of Textile Gld., Soc. Art & Crafts; Maryland directors, Mass. Assn. of Handicraft Groups. Lectures: weaving. Author: "Handloom Weaving for Amateurs," 1937; co-author: "Garden Studio Notebook of Handloom Weaving," 1932; "The Weaver's Quarterly." 1932-43. Contributor to *Handweaver & Craftsman.* **Sources:** WW59; WW47.

VAN CLEVE, Ruth (Mrs. Guy Emerson) *[Painter]* mid 20th c.
Exhibited: Salons of Am., 1930. **Sources:** Marlor, *Salons of Am.*

VANCO, John Leroy *[Art administrator, photographer]* b.1945, Erie, PA.
Addresses: Erie, PA. **Studied:** Allegheny College (B.A., art history & history); WMAA. **Exhibited:** Awards: best prof., ESFA Photography Exhib., 1972. **Comments:** Positions: exec director, Erie AC 1968-. Publications: author, "What Ever Happened to Louis Eilshemius?," 1967; contributor, *American Art & Western Wildlife,* 1972; illustrator, "Roger Misiewicz; Wolfman of the Blues," 1972. **Sources:** WW73.

VAN CORTLANDT, Katherine Gibson (Mrs. Augustus) *[Portrait painter, sculptor]* b.1895, NYC.
Addresses: Mt. Kisco, NY/Brandon, VT. **Studied:** H.V. Poor; J. Lie; V. Chernoff. **Member:** NAWPS; MoMA. **Work:** dec., ballroom, Porcupine Club, Nassau, BWI; Wood Art Gal., Montpelier, VT; Brookgreen Gardens, SC. **Sources:** WW40.

VAN COTT, Dewey *[Painter, teacher]* b.1898, Salt Lake City, UT / d.1932.
Addresses: Mt. Vernon, NY. **Studied:** AIC; Chicago Acad. FA; Yale; Académie Julian, Paris. **Exhibited:** Beaux-Arts Inst. (medals). **Comments:** Husband of Fern Van Cott. Positions: director, Springfield AI; art director, New Britain (CT) Schools, 1924; director, Mt. Vernon, from 1930.

VAN COTT, Fern H. (Mrs. Dewey) *[Painter, craftsperson]* b.1899.
Addresses: Salt Lake City, UT; New Britain, CT. **Studied:** D. Van Cott. **Member:** Springfield Painters. **Work:** Springfield AI. **Sources:** WW33.

VAN COTT, Herman *[Painter, decorator]* b.1901, Albany, NY.
Addresses: NYC. **Studied:** Chicago Acad. FA; AIC; Yale. **Member:** Arch. Lg.; Nat. Soc. Mural Painters; Mural Painters Gld. **Exhibited:** Salons of Am., 1932; NYWCC, 1938; murals; Operations Bldg., Court of States, WFNY, 1939. **Sources:** WW40.

VAN COTT, Sherrill *[Sculptor, painter]* mid 20th c.
Addresses: Sedro Woolley, WA, 1941. **Exhibited:** SAM, 1935, 1939. **Sources:** Trip and Cook, *Washington State Art and Artists.*

VAN COURT, Franklin (F. Van Court Brown) *[Painter]* b.1903, Chicago.
Addresses: Chicago, IL. **Studied:** AIC; NAD; C.W. Hawthorne; F.M. Grant; R. Henri; A. Angarola. **Member:** Chicago SA. **Exhibited:** Union Lg., Chicago, 1929 (prize); Chicago SA, 1931 (medal); AIC, 1931-36. **Sources:** WW49.

VAN DALEN, Pieter *[Painter, commercial artist]* b.1897, Amsterdam, Holland.
Addresses: Seattle, WA, 1951. **Studied:** Paris, Brussels; mostly self-taught. **Member:** Puget Sound Group of NW Painters. **Exhibited:** SAM, 1936. **Sources:** Trip and Cook, *Washington State Art and Artists.*

VAN DAYKE, Ella *[Painter]* mid 20th c.
Exhibited: S. Indp. A., 1936. **Sources:** Marlor, *Soc. Indp. Artists.*

VAN DE BOGART, Willard George *[Sculptor, designer]* b.1939, NYC.
Addresses: Pittsburgh, PA. **Studied:** Ohio Univ. (B.B.A., 1965); McGill Univ. with Dr. Donald Theall, 1969; Nat. Film Board Canada with Mark Slade, 1969; Calif. Inst. Art with Nam June Paik & Morton Subotnick, 1970-71 (M.F.A.). **Member:** Pittsburgh Indep. Filmmakers (founder, 1969); Experiments in Art & Technology; Am. Film Inst. **Exhibited:** Three Rivers Art Festival, Bell Telephone Theatre, Pittsburgh, 1970; Proposition for Unrealized Projects, Howard Wise Gal., NYC, 1970; Los Angeles Philharmonic Orchestra symphonies for Youth, Dorothy Chandler Pavilion, Los Angeles, 1971; Int. Glass & China Exhib., Atlantic City Convention Hall, NJ, 1971; Ninth Ann. New York Avant Garde Festival, Sea Port Mus., New York, 1972. **Awards:** A.W. Mellon Award, 1969; Robert Flaherty Scholarship Award, Int. Film Seminars, 1970; Calif. Inst. Arts Scholarship award, 1970. **Work:** Commissions: Third Eye (oil mural, with Leon Arkus), P.P.G. Indust. & Carnegie Mus. Art, Market Square, Pittsburgh, PA, 1971. **Comments:** Preferred media: media hardware. Teaching: instructor film arts, Ivy School Prof. Art, Pittsburgh, 1969-70; instructor media environment, Calif. Inst. Arts, 1970. Author: *Filmmakers Newsletter,* 1969-71; *Radical Software,* 1970 & 1972; article, *Arts* 1972; contributor, "Industrial Art Methods," 1972. **Sources:** WW73; Jean Lipman, "Period Rooms — The Sixties & Seventies," *Art in Am.* (1970); Jim Burns, *Arthropods — New Design Futures* (Praeger, 1972); Doug Davis, *Art into the Future* (Praeger, 1973).

VAN DE CASTELLE, H. Xavier *[Lithographer, illustrator]* b.c.1817, Belgium.
Addresses: San Francisco (by 1860). **Comments:** Associated with Britton & Company (see entry) beginning in 1860. He was active through 1899. **Sources:** G&W; Peters, *California on Stone;* 8 Census (1860), Cal., VII, 1323; San Francisco CD 1861; Hughes, *Artists in California,* 573.

VAN DELFT, John H. *[Portrait painter]* b.1913.
Addresses: Brooklyn, NY.

VAN DEN BERG, Willem *[Painter]* mid 20th c.
Exhibited: AIC, 1935. **Sources:** Falk, *AIC.*

VANDENBERGH, Louise See: **ALTSON, Louise (Louise Vandenbergh)**

VAN DEN BERGHEN, Albert Louis *[Sculptor]* b.1850, Vilvorde, Belgium.
Addresses: Wash., DC, active 1880. **Studied:** Brussels; NYC; Chicago. **Comments:** Of American descent, he came to the U.S. in 1876. **Sources:** WW08; McMahan, *Artists of Washington, DC.*

VAN DEN HENGEL, Walter *[Painter]* b.1877, Utrecht, Holland / d.1941.
Addresses: Phila., PA. **Studied:** Horties Botanical Gardens, Amsterdam, 1891-94 (apprenticeship); PAFA. **Member:** Phila. Art All.; Phila. Horticultural Soc. **Exhibited:** Woodmere Art Mus., 1991 (retrospective). **Work:** PAFA; Woodmere Art Mus. **Comments:** An Impressionist, he pursued painting as a passionate avocation. He emigrated to the U.S. via Canada, in 1909, working as a floral landscape designer in Georgia, Wash., DC, and then in Philadelphia. In 1918, he opened his own floral shop in Overbrook, PA; and later, another in Ardmore and a nursery known as Hengel Bros. He was a friend of Max Weyl and Frederick Harer. **Sources:** WW25; add'l info courtesy Jean Van den Hengel.

VANDERBECK, John Henry *[Lithographer]* b.c.1837, New York.
Addresses: NYC in 1860. **Sources:** G&W; 8 Census (1860), N.Y., LV, 832.

VANDERBILT, J. *[Painter] mid 20th c.*
Exhibited: Salons of Am., 1931. **Sources:** Marlor, *Salons of Am.*

VAN DER BOON, Georges *[Painter] mid 20th c.*
Addresses: NYC. **Exhibited:** S. Indp. A., 1931. **Sources:** Marlor, *Soc. Indp. Artists.*

VANDERBOSCH, Katherine Coyle *[Painter] b.1890, County Donegal, Ireland / d.1944, Los Angeles, CA.*
Addresses: Los Angeles, CA. **Exhibited:** Calif. State Fair, 1940. **Sources:** Hughes, *Artists in California*, 573.

VANDERBURG, Al *[Sculptor] b.1940.*
Addresses: NYC. **Exhibited:** WMAA, 1966. **Sources:** Falk, *WMAA.*

VANDERCOOK, Margaret Metzger (Mrs. John W.) *[Sculptor] b.1899, NYC / d.1936, Kingston, Ontario, Canada.*
Addresses: NYC. **Studied:** Wellesley College; G. Lober, in NYC; A. Rousaud, in Paris. **Member:** NAWPS. **Exhibited:** S. Indp. A., 1930; Salons of Am., 1930; Argent Gals., NYC, 1936 (memorial). **Comments:** With her husband she traveled widely through the jungles of Africa, South America and remote South Sea Islands, making portraits of the natives. Her work was frequently reproduced in Mr. Vandercook's books. **Sources:** WW33; Petteys, *Dictionary of Women Artists.*

VAN DEREK, Anton *[Painter, designer, craftsperson, teacher,] b.1902, Chicago, IL.*
Addresses: Provincetown, MA. **Member:** Provincetown AA; Eastern AA; Beachcombers Club. **Comments:** Specialty: metal work. Position: director, Child-Walker School Design. **Sources:** WW40.

VAN DEREN, Nancy *[Painter] b.1944.*
Exhibited: WMAA, 1972-73. **Sources:** Falk, *WMAA.*

VANDER HEIDEN, George N. *[Painter] mid 20th c.*
Exhibited: AIC, 1931. **Sources:** Falk, *AIC.*

VAN DER HEYDEN, Gerardus (Gerard) Theodorus *[Landscape and mural painter, illustrator, commercial artist] b.1885, Veghel, Holland / d.1981, Ambler, PA.*
Addresses: Europe until 1915; Detroit, MI, 1915-49; Peekskill, NY, 1949-63; Lafayette Hill, PA, 1963-81. **Studied:** Antwerp Acad., Belgium; Brussels AC; Acad. Arts, Düsseldorf, Germany. **Member:** Scarab Club, Detroit, MI. **Exhibited:** Gordon Gal., Detroit, MI, 1925; Scarab Club, 1920s-49; Croton Community AC, NY, 1949-63; Woodmere Art Mus. & Cheltenham AC, both in PA, between 1963-78. **Work:** Commissions: Michigan State Fair (Ford murals); General Motors (mural); Chrysler Corp. (12 works, history of automobiles). **Comments:** Position: staff artist, Ford Motor Co., General Motors, Detroit, MI. Illustrator: *Dearborn Independent.* He sometimes signed his works van, G.v.d.H. or simply G, with an H through it. **Sources:** info courtesy of Christine W. Porter, Plymouth Meeting, PA, incl. newspaper clippings and a biography written by the artist's daughter.

VANDERHOEF, John J. *[Engraver] mid 19th c.*
Addresses: NYC, 1857. **Comments:** Of White & Vander[h]oef (see entry). **Sources:** G&W; NYBD and CD 1857.

VANDERHOFF, Charles A. See: **VANDERHOOF, Charles A.**

VANDERHOOF, C. H. *[Artist] late 19th c.*
Addresses: NYC, 1877. **Exhibited:** NAD, 1877. **Sources:** Naylor, *NAD.*

VANDERHOOF, Charles A. *[Painter, etcher, illustrator, teacher, writer] b.1853, Middletown, NJ / d.1918, Middletown.*
Addresses: NYC, 1887-90. **Member:** Holland Soc., NYC; NY Etching Club; ASL. **Exhibited:** PAFA Ann., 1880-81; Royal Soc. Painters & Etchers, London, 1881 (with Duveneck, Parrish, the Morans, Smillie, et al.). **Work:** Stenzel collection; NYPL; NY Hist. Soc. **Comments:** He improved the process of drypoint etching. His subjects included harbor and architectural scenes in NYC, England, and Holland, plus Western landscapes and Civil War

scenes. Illustrator: *Harper's* ,1881, and *Century* 1880s. Position: teacher, CUA School, late 1880s. Author: "Sketching from Nature" *Art Amateur* (Mar., 1898) **Sources:** WW10; *Encyclopaedia of New Orleans Artists*, 389; P&H Samuels, 496; add'l info courtesy Carole Zicklin, NY Hist. Soc., including obit from *NY Herald* (April 3, 1918); Falk, *Exh. Record Series.*

VANDERHOOF, Elizabeth *[Painter] early 20th c.*
Addresses: NYC, c.1909. **Sources:** WW10.

VANDERHULE, Lavina Mathilda Bramble *[Painter] b.1839, Harland, VT / d.1906, Yankton, SD.*
Addresses: Yankton, SD. **Studied:** Harland Acad.; NYC. **Sources:** Petteys, *Dictionary of Women Artists.*

VAN DER KEMP, John Mayne *[Sculptor] late 19th c.; b.Philadelphia, PA.*
Studied: Jouffroy. **Exhibited:** Paris Salon 1886, 1887, 1890, 1891, 1893. **Sources:** Fink, *American Art at the Nineteenth-Century Paris Salons*, 399.

VAN DER KERCHE *[Portrait painter] mid 19th c.*
Comments: Painter of a portrait of Mrs. John Drew, the actress, in 1857, possibly at Philadelphia. **Sources:** G&W.

VANDERLAAN, Simon *[Painter, designer] b.1904, Muskegon, MI / d.1986, Los Angeles, CA.*
Addresses: Grand Rapids, MI; Chicago, IL; Los Angeles, CA. **Studied:** AIC; Chicago Acad. FA; Art Center Sch., Los Angeles; Chouinard Art Sch. **Exhibited:** LACMA; Found. Western Art. **Comments:** Teaching: Woodbury University, 19 years. **Sources:** Hughes, *Artists in California*, 573.

VANDERLIP, Anne A. *[Painter] late 19th c.*
Exhibited: NAD, 1886. **Sources:** Naylor, *NAD.*

VAN DERLIP, John Russell *[Patron] d.1935.*
Addresses: Minneapolis, MN. **Member:** AFA (dir.). **Comments:** Minneapolis AI (founder/pres.). The growth of Minneapolis AI had been attributed largely to his efforts and generosity.

VANDERLIP, Willard C. *[Lithographer] b.c.1837, Massachusetts.*
Addresses: Boston, 1860. **Comments:** Boarding in Boston in 1860 at the same house as George W. Simonds (see entry). **Sources:** G&W; 8 Census (1860), Mass., XXVII, 890; Boston CD 1860.

VANDERLIPPE, D. J. *[Carriage, sign & general painter] mid 19th c.*
Addresses: Charleston, SC in 1844. **Sources:** G&W; Rutledge, *Artists in the Life of Charleston.*

VANDERLYN, John *[Portrait, historical, and landscape painter, illustrator] b.1775, Kingston, NY / d.1852, Kingston.*
Studied: apprenticed to Thomas Barrow, art dealer in NYC, c.1792; Archibald Robertson, drawing, at the Columbian Acad. of Painting, NYC, c.1793-95; several months with Gilbert Stuart, Phila., in 1796; École des Beaux-Arts, Paris, with François André Vincent, Paris. **Member:** He was one of the second fifteen elected to the NAD in 1826, but he declined membership (see Clark, History). **Exhibited:** Paris Salon, 1800, 1804, 1808, 1810, 1812, 1841, 1845; Boston, after 1804; American Academy, NYC, 1816; PAFA, 1823-53 (and posthumously); NAD, 1830-51. Additionally, his works toured the U.S., traveling to: Baltimore, MD (1820), New Orleans (1821, 1828), Savannah, GA (1822), Charleston, SC (1822-23), Boston (1826), New Orleans again (1828, 1840s), and Havana, Cuba (1829); SUNY, 1970 (retrospective). **Work:** MMA; CGA; PAFA; Wadsworth Atheneum, Hartford, CT; de Young Mus., San Francisco, Calif.; NYHS (portraits); U.S. Capitol bldg., Wash., DC; Senate Statehouse, Kingston, NY ("Niagara Falls"); New York City Hall. **Comments:** One of the leading history painters of the early 19th century. Son of Nicholas and grandson of Pieter Vanderlyn (see entries). Even before beginning formal art instruction at about the age of seventeen, John Vanderlyn was studying Dutch prints and the work of Charles Lebrun on his own. Several years later, Vanderlyn's copy of a Stuart painting caught

the attention of of Aaron Burr, who arranged for the young artist to assist Stuart in his Philadelphia studio. Burr next sent Vanderlyn to Paris (1796), where he remained for five years absorbing the lessons of neoclassicism from Jacques-Louis David. He returned to NYC in 1801, visiting Niagara Falls where he made a number of sketches which were eventually engraved. In 1803 he again went to Europe, remaining this time for twelve years, spending two years in Rome and the rest in Paris. Vanderlyn produced his best-known historical pieces in this period, "The Death of Jane McCrea" (1804, Wadsworth Ath.), "Marius Amid the Ruins of Carthage" (1807, De Young Mus.), and "Ariadne Asleep on the Island of Naxos" (1812-14, PAFA.). Shown in France, "Marius" brought Vanderlyn fame and a gold medal from Napoleon in 1808. When Vanderlyn returned to America in 1815, he built a rotunda in City Hall Park, NYC, and exhibited his panorama "Palace and Gardens of Versailles" (MMA), as well as his "Jane McCrea," "Marius," "Ariadne," and other works. Over the next fifteen years, these works were shown in his Rotunda and toured the East coast and the South. Vanderlyn also involved himself in other projects, painting again at Niagara Falls in 1827 (and returning there in 1837) and trying to raise funds, unsuccessfully, at New Orleans (1828) to paint a panorama of the Battle of New Orleans. During all this time, he was also painting portraits in New York and elsewhere in order to support his history painting, which to his mind was the more noble and important effort. Back in NYC in 1829, a series of problems led the city to cancel his rotunda lease; this, along with heavy debts, a continuing battle with John Trumbull and the American Academy, as well as what he perceived as public indifference to his history paintings, left Vanderlyn bitter and frustrated. He briefly painted in Kingston, NY (1833, according to Gerdts) but did nothing major until his 1837 commission by the U.S. government to paint "The Landing of Columbus" for the Capitol Rotunda in Wash., DC. He later traveled to Paris and in the 1840s painted in New Orleans where he fulfilled portrait commissions and exhibited his Versailles panorama at Oak Alley plantation in St. James Parish, LA, 1847. Vanderlyn returned to Kingston several days before his death (see Gerdts). **Sources:** G&W; Flexner, *The Light of Distant Skies;* DAB; Dunlap, *History;* Clark, *History of the NAD,* 43; Tuckerman, *Book of the Artists;* Schoonmaker, *John Vanderlyn, Artist, 1775-1852,* a 19th century biography first published in 1950 by the Senate House Association, Kingston, N.Y. More recently, see Kenneth C. Lindsay, *The Works of John Vanderlyn* (exh. cat., SUNY, 1970); Baigell, *Dictionary; 300 Years of American Art,* 81; NYHS (1974), cat. 1296 +; *Encyclopaedia of New Orleans Artists,* 389; P&H Samuels, 496; Fink, *American Art at the Nineteenth-Century Paris Salons,* 399-400; Gerdts, *Art Across America,* vol. 1: 172; David Lubin, "Ariadne and the Indians: Vanderlyn's Neoclassical Princess, Racial Seduction, and the Melodrama of Abandonment," *Smithsonian Studies in American Art* (Spring 1984).

VANDERLYN, John, Jr. *[Portrait painter]* b.1805 / d.1876. **Addresses:** Savannah, GA in 1833; Charleston, SC in 1836; Kingston, NY, 1859. **Work:** NYHS (portrait of J.P. Sherwood). **Comments:** Nephew and godson of painter John Vanderlyn, he assisted his uncle with the management of his panorama displays and tours. Advertised as a painter, with J.P. Sherwood, In Charleston (SC), 1836; and worked as sign and portrait painter in Kingston in the 1850s. **Sources:** G&W; Hastings, "Pieter Vanderlyn," 298; N.Y. State BD 1859; Rutledge, *Artists in the Life of Charleston;* NYHS Catalogue (1974), cat. no. 1884 (repro.). More recently, see Gerdts, *Art Across America,* vol. 1: 172.

VANDERLYN, Nicholas *[House, sign & portrait painter] mid 18th c.* **Addresses:** Kingston, NY in 1766. **Comments:** He was a son of Pieter, father of John, and grandfather of John, 2d. (see entries). **Sources:** G&W; FARL, photo of signed portrait, dated 1741; *Ecclesiastical Records, State of New York,* I, 404; Schoonmaker, *History of Kingston,* 491; Hastings, "Pieter Vanderlyn," 296-99.

VANDERLYN, Pieter *[Portrait painter?]* b.1687, Holland / d.1778. **Addresses:** Province of NY, c.1718; Albany, NY, 1720s; Kingston, NY, until c.1778. **Work:** attributed works are at the Shelburne (VT) Mus. and the NYHS. **Comments:** Arrived in Hudson River Valley, presumably from Curaço, 1718. Although contemporary records do not mention him as a limner, it was said by his grandson, John Vanderlyn (see entry), that Pieter Vanderlyn painted portraits. With no signed portraits to work from, historians have had to make use of other tools, resulting in much speculation but leaving specific attributions still a matter of debate. Based on historical and stylistic evidence, James Thomas Flexner suggested in 1959 that the unsigned "De Peyster Boy with a Deer" (NYHS) might be Vanderlyn's work. More recent studies by Mary Black compared inscriptions on a group of paintings to several handwriting samples by Vanderlyn, resulting in some new, tentative attributions to the artist, including "Deborah Glen" (Abby Aldrich Rockefeller Folk Art Center), a painting previously attributed to the artist known only as the Gansevoort Limner. **Sources:** G&W; Hastings, "Pieter Vanderlyn"; Harris, "Pieter Vanderlyn"; *Colonial Laws of New York,* I, 1034, and II, 375; Flexner, "Pieter Vanderlyn, Come Home," *Antiques,* 75 (June, 1959): 546-49, 580. More recently, see Mary Black, "Pieter Vanderlyn, c.1687-1778," in *American Folk Painters of Three Centuries,* Jean Lipman and Tom Armstrong, eds. (New York, 1980); Saunders and Miles, 144-45, 146-147, 161-62; NYHS Catalogue (1974); Muller, *Paintings and Drawings at the Shelburne Museum,* 134 (w/repro.).

VAN DER MARCK, Jan *[Art historian, museum curator]* b.1929, Roermond, Netherlands. **Addresses:** Seattle, WA. **Studied:** Univ. Utrecht; Columbia Univ. **Member:** Am. Assn. Mus.; College Art Assn. Am.; AFA (nat. exhib. committee, 1968-). **Comments:** Research: art of the twentieth century with emphasis on contemporary. Positions: curator, Gemeentemuseum, Arnhem Netherlands, 1959-61; dept. director fine arts, Seattle World's Fair, WA, 1961-62; curator, Walker AC, Minneapolis, 1963-67; director, Mus. Contemporary Art, Chicago, 1967-70; dir., Valley Curtain Corp., 1971-72; curator contemporary art, Henry Gal., Univ. Washington, 1972-; contributing editor, *Art in Am.* Teaching: assoc. prof. art history, Univ. Washington, 1972. Collections arranged: Charles Biederman, 1965 & Lucio Fontana, 1966, Walker AC, Minneapolis, MN; Pictures to be Read/ Poetry to be Seen, 1967, Christo: Wrap In Wrap Out, 1969 & Art by Telephone, 1969, Mus. Contemporary Art, Chicago, IL. Awards: fellowship, Netherlands Org. Pure Res., 1954-55; fellowship, Rockefeller Foundation, 1957-59. Publications: author, "Romantische Boekillustratie in Belgie, Romen," 1956; auth.,"The Sculpture of George Segal," Abrams, 1973; plus many articles in periodicals including, *Art in Am., Arts Can., Art Int.* **Sources:** WW73.

VANDER MARK, Parthenia *[Designer, teacher] mid 20th c.; b.Phila.* **Addresses:** Woodbury, NJ. **Studied:** Columbia. **Member:** Artists Group, Nat. Educ. Assn. **Work:** series block prints, Gloucester County (NJ) historic prints, 1932. **Comments:** Teaching: State Teachers College, NJ. **Sources:** WW40.

VAN DER PAAS, Emilie *[Painter, sculptor, designer, decorator]* b.1906, City Island, NY. **Addresses:** NYC/Bermuda. **Studied:** F. MacMonnies; P. Manship; Florence; Paris. **Work:** paintings of tropical marine life for William Beebe, Bermuda Biological Station, 1932; paintings, Bermuda shore fishes for L. Mowbray, Curator, Bermuda Gov. Aquarium, paintings of marine life, Yale; Princetown Univ.; Miami Univ., Ohio; fish paintings, Bank of Bermuda, Hamilton; black and white drawings, Soc. Beaux Arts Arch., NY. **Sources:** WW40.

VANDERPOEL, Emily Noyes (Mrs. John Arent) *[Painter, writer, weaver]* b.1842, NYC. / d.1939, NYC. **Addresses:** NYC/Litchfield, CT. **Studied:** R.S. Gifford; W. Sartain. **Member:** NYWCC; New York Soc. Craftsmen; AWCS; AFA; Women's AC; NAD; NAC. **Exhibited:** Brooklyn AA, 1881;

AFA; Women's AC; NAD; NAC. **Exhibited:** Brooklyn AA, 1881; PAFA Ann., 1881, 1893 (as Noyes, and also as Vanderpoel), 1894; NAD, 1882; Boston AC, 1889; Columbian Expo, Chicago 1893 (bronze medal); S. Indp. A., 1918; AIC, 1924. **Work:** Nat. Mus., Wash., DC; Old Dartmouth Hist. Soc. **Comments:** Had a summer residence in South Dartmouth, MA, 1919-21. Author: *Color Problems; Chronicles of a Pioneer School; More Chronicles of a Pioneer School;* and *American Lace and Lace Makers,* 1924. **Sources:** WW38; Blasdale, *Artists of New Bedford,* 198 (w/repro.); Naylor, *NAD;* Falk, *Exh. Record Series.*

VANDERPOEL, James See: **VANDERPOOL, James**

VANDERPOEL, John See: **VANDERPOOL, John**

VANDERPOEL, John H. *[Painter, teacher, mural painter]* b.1857, Haarlemmer-Meer, Holland / d.1911, St. Louis.
Addresses: Chicago, IL, 1868-on. **Studied:** Turner Hall; old Chicago Acad. Des. (which became the AIC), with J.F. Gookins, L. Earle, H.F. Spread; Académie Julian, Paris with Boulanger and Lefebvre, 1885-88. **Member:** Chicago Art Lg., 1880 (founder); Chicago SA, 1887 (founder, pres., 1891-91, 1895, 1910); The Little Room (Chicago); Soc. Western Artists; NYWCC, 1895; AAC. **Exhibited:** AIC, 1891-1910; PAFA Ann., 1893-94; Chicago Artists Exh., 1898; St. Louis Expo, 1904 (medal). **Work:** Vanderpoel AA, Chicago. **Comments:** In 1871, at the age fourteen, he suffered a fall in a wrestling match in a gymnasium and became disabled for life, and when he was about thirty-five he lost the sight of one eye. Nevertheless, he became a highly influential teacher at the AIC from 1880-1906. His early paintings focus on Dutch genre scenes. During 1889-90, he conducted popular outdoor painting classes at St. Joseph, MI and Dayville, IL. In 1891, he and Charles Boutwood took students to the Rock River Valley at Oregon, IL, where Lorado Taft later established his Eagle's Next colony. He also taught classes at Delavan, WI until 1906. In 1906, he earned a strong reputation as muralist with his 60-foot mural for the Hotel Alexandria in Los Angeles. In 1909, he became head of the People's Univ. (University City, MO) and wrote *The Human Figure* which became a standard art instruction book. **Sources:** WW10; article by J.L. Buehler in *Beverly Review* (Aug. 12, 1987, p.25); Falk, *Exh. Record Series.*

VANDERPOEL, Matilda *[Painter, teacher]* b.Holland / d.1950, Chicago.
Addresses: Chicago, IL/Gold Hill, CO. **Studied:** AIC; David Ericson. **Exhibited:** AIC, 1903-23; Chicago Artists Guild; NYC; Phila. **Comments:** Probably sister of John H. Position: director/contributor, Vanderpoel Mem. Gal., Chicago. **Sources:** WW33; Petteys, *Dictionary of Women Artists.*

VAN DER POEL, Priscilla Paine *[Educator, painter, cartoonist, lect]* b.1907, Brooklyn, NY.
Addresses: Northampton, MA. **Studied:** Smith College (A.B. & A.M.); ASL; Brit. Acad. in Rome; also with Frank DuMond, George Bridgman, Sherrill Whiton. **Member:** CAA; Am. Assn. Univ. Prof.; Northampton Hist Assn.; Cosmopolitan Club, NY. **Exhibited:** Studio Club, Tryon Mus., Northampton, MA, 1936-45. **Comments:** Teaching: Smith College, 1935-70s. **Sources:** WW73; WW47.

VANDERPOELE, Charles *[Sculptor]* late 19th c.
Addresses: Detroit, MI, 1870-80. **Comments:** In partnership with Joseph Aerts as Aerts & Vanderpoele, 1870-71. **Sources:** Gibson, *Artists of Early Michigan,* 231.

VANDERPOOL, James *[Amateur portrait painter]* b.1765 / d.1799.
Work: Newark (NJ) Museum (portrait of his uncle James Van Dyke [1740-1828], 1787). **Comments:** Brother of John Vanderpool (see entry). **Sources:** G&W; *The Museum* (July 1949), 7-8; Vanderpoel, *Genealogy of the Vanderpoel Family,* 168-69.

VAN DERPOOL, James Grote *[Educator, art historian]* b.1903, NYC / d.1979.
Addresses: NYC. **Studied:** MIT (B.Arch.); Harvard Univ.

(M.F.A.); Am. Acad. Rome, Italy; Atelier Gromort; École Beaux Arts, Paris, France. **Member:** Int. Fund for Monuments (vice-chmn., 1968, trustee, 1969-); Save Venice, Nat. Committee (co-chmn. USA); Soc. Archit. Historians (nat. pres., 1955-57); College Art Assn. Am.; Am. Scenic & Hist. Preservation Soc. (trustee, 1936-). **Comments:** Art interests: historic preservation; Renaissance painting & eighteenth century American arts. Positions: consultant to various historical preservation projects, 1950-; archit. editor, *Columbia Encyclopedia,* 1952-54; chmn. design construction, Hist. St. Luke's Church, Smithfield, VA, 1952-56; co-editor, *Complete Library World Art,* 1957-62; exec. director, Landmarks Preservation Commission New York, 1962-65; chmn. design ballroom wing, Gracie Mansion, New York, 1964. Teaching: professor hist. archit., Univ. Illinois, 1932-39, head dept. art, 1939-46; professor archit. & head Avery Library, Columbia Univ., 1946-, acting dean & assoc. dean, 1959-61. Awards: George McAneny Medal, Am. Scenic & Hist. Preservation Soc., 1964; Benjamin Franklin fellowship, Royal Soc. Arts, London, 1965; fellowship, Am. Inst. Archit., 1968. Collection: Italian, Dutch & American paintings. Publications: contributor, *Encyclopedia Britannica.* **Sources:** WW73.

VANDERPOOL, John *[Portrait, banner & transparency painter]* b.c.1765.
Addresses: NYC, late 18th- early 19th c. **Work:** Newark (NJ) Museum (portrait of his aunt, Mrs. James Van Dyke, 1787). **Comments:** Brother of James Vanderpool (see entry). **Sources:** G&W; *The Museum* (July 1949), 7-8 and cover; Vanderpoel, *Genealogy of the Vanderpoel Family,* 168-69.

VANDERPOOL, Madeleine McAlpin *[Sculptor]* b.1912, Morristown, NJ.
Addresses: Princeton, NJ. **Studied:** M. Hernandez, in Paris; R. Davis; G.K. Hamlin. **Member:** NAWPS; Morristown AA. **Exhibited:** NA, 1935, 1936; NAWPS, 1937, 1938. **Sources:** WW40.

VAN DER REIS, G. (Mr.) *[Painter]* mid 20th c.
Addresses: NYC. **Exhibited:** S. Indp. A., 1944. **Sources:** Marlor, *Soc. Indp. Artists.*

VAN DER ROHE, Mies See: **MIES VAN DER ROHE, Ludwig**

VANDER SLUIS, George J. *[Painter, educator]* b.1915, Cleveland, OH / d.1984, Camillus, NY.
Addresses: Syracuse, NY. **Studied:** Cleveland Inst. Art; Colorado Springs FAC; Fulbright scholarship, Italy, 1951-52. **Exhibited:** AIC, 1941; Corcoran Gal. biennials, 1947, 1957; PAFA Ann., 1953; "American Paintings 1945-57," Minneapolis Inst. Arts, 1957; "Contemporary Painting & Sculpture," Univ. Illinois, 1961; "125 Years of New York Painting & Sculpture," NY State Expos, Syracuse, 1966; "American Art," White House, Wash., DC, 1966; "The Door," Mus. Contemporary Crafts, NYC, 1968; Krasner Gal, NYC, 1970s. Awards: Jurors award, Rochester Mem. Art Gal, 1958 & 1969. **Work:** Rochester Mem. AG, NY; Everson Mus. Art, Syracuse, NY; Munson-Williams-Proctor Inst., Utica, NY; State Univ. NY Albany, NY; Hamiline Univ., St. Paul, MN. Commissions: WPA mural for post office, Rifle, CO, 1940 & Riverton, WY, 1941, U.S. Govt. Section Fine Arts; wall painting for Hotel Syracuse, City Walls New York & NY State Council on Arts, 1971; Barn Door decorations in NY State, NY State Council on the Arts grant, 1966. **Comments:** Preferred media: acrylics. Teaching: Colorado FAC, 1940-42 & 1945-47; Syracuse Univ., 1947-. **Sources:** WW73; J. Albino, "Barn Door Painting," *Dodge News* (Nov., 1967); Falk, *Exh. Record Series.*

VAN DER STRAETEN, Vincent Roger *[Art dealer]* b.1929, NYC.
Addresses: NYC. **Member:** Art & Antique Dealers League Am. (vice-pres.). **Comments:** Positions: director, Van Der Straeten Gallery, New York. Specialty of gallery: contemporary American, English and French paintings, master graphics and sculpture. **Sources:** WW73.

VAN DER VEER, Mary *[Painter] b.1865, Amsterdam, NY.*
Addresses: Amsterdam, NY; Phila., PA; NYC. **Studied:** Phila.
Art Sch.; R.H. Nicholls; Chase in NY; PAFA; NAD with Edgar
Ward and Will Low; Whistler, in Paris; Holland. **Member:**
NYWCC; NAWPS. **Exhibited:** AIC, 1892-1913; PAFA Ann.,
1895-98, 1903-05, 1910; NYWCC, 1898; Louisville AL, 1898; St.
Louis Expo, 1904 (medal); NAD, 1898, 1911 (prize); Corcoran
Gal annual/biennial, 1907, 1910. **Comments:** Painted pastels of
flowers, Dutch peasants, portraits. **Sources:** WW40; Petteys,
Dictionary of Women Artists; Falk, *Exh. Record Series.*

VAN DER VELDE, Hanny (Mrs. A. W.) *[Painter] b.1883,
Rotterdam, Holland / d.1959.*
Addresses: Royal Oak, MI/Melbourne Beach, FL. **Studied:**
Rotterdam Acad. FA. **Member:** NAWPS; Detroit Soc. Woman
Painters (hon. mem.). **Exhibited:** Rotterdam, 1910 (prize);
Detroit, 1910-24 (prizes); Mich. State Show, 1926 (prizes);
Detroit AI, 1927 (prize); Mandelle Library, Kalamazoo, 1931
(solo); Delphic Studios, NYC, 1940. **Work:** Detroit AI; Grand
Rapids AA; Vanderpoel AA, Chicago, IL. **Sources:** WW40;
Petteys, *Dictionary of Women Artists.*

VANDER VELDE, Henry (F.) *[Painter, educator] b.1913,
Grand Rapids, MI.*
Addresses: South Laguna, CA. **Studied:** Univ. Michigan; NAD.
Member: Laguna Beach AA; Laguna Festival AA; Soc. Western
Artists. **Exhibited:** Nat. Art Roundup, Las Vegas, Nev., 1958
(prize); Nat. Orange Show, 1958 (prize); Laguna Festival Art,
1951-58; La Jolla Art Center bimonthly, 1951-58; Ferguson Gal.,
La Jolla. **Comments:** Teaching: Long Beach (CA) State College,
1959. **Sources:** WW59.

VAN DER VOORT, Amanda Venelia *[Painter] b.Alliance,
OH / d.1980.*
Addresses: Greenwich, CT. **Studied:** Pratt Inst. (grad.), Grand
Central School Art; Metropolitan School Art; Nat. Acad. School
Fine Arts; Columbia Univ.; NY Univ.; also with Helen Lorenz,
Ogdend Pleisner, Romanovsky, Robert Philipp, Dong Kingman &
Howard Hildebrandt. **Member:** Catharine Lorillard Wolfe Art
Club (dir. & chmn nat. exh., 1960-); Contemp. Art Club
Greenwich (art chmn., 1972-); Nat. Lg. Am. Pen Women (art
chmn., 1972-); NAD (fellow); Royal Soc. Arts, England (fellow);
Hudson Valley AA (dir. & recording secy., 1966-); Pen & Brush
(dir. & first vice-pres., 1967-); AAPL (dir. nat. board, 1970-).
Exhibited: All. Artists Am., 1956-57; AAPL, 1956-72; NAD,
1957; Hudson Valley AA, White Plains, NY, 1959-72; Acad.
Artists Assn., Springfield, MA, 1965-71. Awards: awards for fig-
ure painting, Catharine Lorillard Wolfe Art Club, 1970 & Art Soc.
Old Greenwich, 1971; best in show for oil portrait, Conn. State
Fed. Women's Clubs, 1972. **Work:** commissions: painting of El
Jardin, commissioned by W. Alton Jones, La Gorce Island, FL,
1961; portrait of Mrs. Rosen, Dr. Theodore Rosen, NYC, 1963;
flower painting, E. H. Blanchard, Warwick, NY, 1967; High St.,
Rockport, MA, Dr. J. Wolfe, Houston, TX, 1968; Gloxinias, com-
missioned by George E. Martin, Greenwich, CT, 1971.
Comments: Preferred media: oils, watercolors, graphics.
Sources: WW73.

VANDERWERKER, M(arguerite) (F.) (E.) (Miss)
[Painter] mid 20th c.
Addresses: Manasquan, NJ. **Exhibited:** S. Indp. A., 1923, 1925.
Sources: Marlor, *Soc. Indp. Artists.*

VAN DER WESTHUYZEN, J. M. *[Painter] early 20th c.*
Addresses: Chicago, IL. **Member:** Chicago NJSA. **Sources:**
WW25.

VAN DER WEYDE, Gertrude *[Painter] late 19th c.*
Addresses: New Orleans, active c.1891-92. **Studied:** Newcomb
College, 1892. **Exhibited:** NOAA, 1891-92; Tulane Univ., 1892.
Sources: *Encyclopaedia of New Orleans Artists,* 389-90.

VAN DER WEYDEN, Harry *[Painter] b.1868, Boston, MA.*
Addresses: Rye, Sussex, England; Pas de Calais, France, 1901-
09. **Studied:** Slade School, London (scholarship, 1887);

Académie Julian, Paris with J.P. Laurens, Lefebvre & Constant,
1890-91, 1895; Fred Brown in London. **Member:** Paris SAP;
Paris AAA; Inst. Oil Painting, London. **Exhibited:** Paris Salon,
1891 (gold), 1892, 1894-97; AIC, 1896-1913; SNBA, 1898, 1899;
Int. Expo, Antwerp, 1894 (medal); Atlanta Expo, 1895 (gold);
Paris Expo, 1900 (medal); PAFA Ann., 1901-03, 1905-09;
Munich, 1901 (gold); Vienna, 1902 (gold); Liege Expo, 1905
(medal); Corcoran Gal annual, 1908. **Work:** AIC; French Govt.,
1906, 1908. **Sources:** WW31; Fink, *American Art at the
Nineteenth-Century Paris Salons,* 400; Falk, *Exh. Record Series.*

VAN DER WOERD, Bart *[Decorator, designer, architect,
teacher, writer] 20th c.; b.Deventer, Holland.*
Addresses: NYC. **Studied:** Sch. Higher Arch., Amsterdam;
Middelbare Technische Sch., Utrecht, Holland. **Member:** Arch.
Lg.; NAAI. **Comments:** Designed modern rugs, textiles, furni-
ture, lamps, glassware; modern arch. and interiors. **Sources:**
WW40.

VAN DER ZEE, James *[Photographer] b.1886, Lenox, MA /
d.1983, NYC.*
Addresses: moved to NYC in 1905, opened his Harlem studio in
1916. **Studied:** self-taught. **Exhibited:** "Harlem On My Mind,"
MMA, 1969; Addison Gal., 1971; Studio Mus., Harlem, 1972;
"Roots in Harlem," Hudson River Mus., 1998. **Work:** Van Der
Zee Inst. (auspices of MMA); NOMA; NPG, Wash., DC.
Comments: From 1916-on, he was the most important docu-
menter of Harlem life. His rich body of work includes studio and
outdoor portraits of individuals, families, and community groups;
funeral portraits; and scenes of everyday activities in Harlem,
such as parades, couples strolling, women having their hair done,
and children learning to dance. Van Der Zee also photographed
prominent members of the Harlem community such as the singer
Mamie Smith and heavyweight boxing champions Jack Johnson
and Harry Wills. He was the official photographer for Marcus
Garvey, the leader of the "Back to African Movement" during the
1920s. Also appears as Derzee, James Van. **Sources:** James Van
Der Zee, *The Harlem Book of the Dead* (Dobbs Ferry, NY:
Morgan & Morgan, 1978); Lillian De Cock and Reginald
McGhee, eds. *James Van Der Zee,* with introduction by Regina A.
Perry (Dobbs Ferry, N.Y.: Morgan & Morgan, 1974); Witkin &
London, 261.

VAN DEUSEN, Allen W. *[Painter] late 19th c.*
Addresses: NYC. **Exhibited:** AIC, 1896. **Sources:** Falk, *AIC.*

VAN DEVANTER, Annie W. *[Still life & landscape painter]
19th/20th c.*
Addresses: Fort Defiance, VA. **Sources:** Wright, *Artists in
Virginia Before 1900.*

VAN DE VELDE, Alfred E. R. *[Painter] b.1892, Brugges,
Belgium.*
Addresses: Carlsbad, CA. **Studied:** Royal Acad. Brugges; Inst.
Art, Antwerp, Belgium. **Member:** SC; Long Island Art Lg.; La
Jolla AA; Laguna Beach AA; Desert AC; Carlsbad Art Lg.; San
Diego FAS. **Exhibited:** All. Artists Am., 1938; Int. Expo,
Brussels, 1912; Antwerp, Belgium, 1912; CAFA, 1931;
Springville, UT, 1931; Balzac Gal., NY, 1930; Barbizon-Plaza,
1940; SC; Boston, MA; Rockport, MA; Springfield, MA; Laguna
Beach AC; Carlsbad Art Lg.; Nat. Orange Show, 1953; Ostend,
Belgium, 1929 (solo); Albany Inst. Hist. & Art, 1930; Currier Gal.
Art; Cayuga Mus. Hist. & Art, 1943; Rochester, NY, 1944;
Bowers Mem. Mus., Santa Ana, CA, 1950; Long Beach, CA,
1952; Cortlandt (NY) Public Library, 1944; Ithaca Mus. Art,
1943; Binghampton Mus. Art, 1944; Laguna Beach AA, 1954; La
Jolla AA, 1954; Federal Savings Bank, San Diego, 1954; Los
Angeles, 1958; Palomar College, 1957. Awards: prizes,
Springville, Utah, 1931; Nassau Art Lg., 1945; Carlsbad Art Lg.,
1953, 1954; Southern California Expo, San Diego, 1954. **Work:**
Mus. Oostend, Belgium; Currier Gal. Art, Manchester, NH.
Sources: WW59.

VANDEVELDE, Petro *[Sculptor] mid 19th c.*
Addresses: NYC. **Exhibited:** American Inst., 1850 ("Slave in

Revolt"). **Sources:** G&W; Am. Inst. Cat., 1850; NYCD 1851.

VAN DE WALL, Constant *[Painter] mid 20th c.*
Exhibited: S. Indp. A., 1935. **Sources:** Marlor, *Soc. Indp. Artists.*

VAN DEWERKER, Kathleen *[Painter] mid 20th c.*
Addresses: Spokane, WA, 1950. **Member:** Washington AA.
Exhibited: SAM, 1945; Henry Gallery, 1951. **Sources:** Trip and Cook, *Washington State Art and Artists.*

VAN DE WIELE, Gerald *[Painter] b.1932, Detroit, MI.*
Addresses: NYC. **Studied:** AIC; Black Mountain College.
Exhibited: Albright-Knox Art Gal., Buffalo, NY, 1963; Riverside Mus., New York, 1964 & 1966; Smithsonian Inst. Traveling Exhib., 1968; Illinois Wesleyan Univ., Bloomington, 1968; Peridot Gal., New York, 1969. Awards: Nat. Council on the Arts grant, 1968. **Work:** BMA; Borg Warner Corp, Chicago; Singer Mfg. Co.; Owens Corning Fiberglass Corp; Coca-Cola Co. **Sources:** WW73.

VANDINE, Elizabeth (Mrs. Henry) *[Engraver] late 18th c.*
Comments: She and her husband, who was from New Jersey, were convicted of counterfeiting Continental money in 1776. **Sources:** Petteys, *Dictionary of Women Artists.*

VANDIVER, Mabel *[Painter] 20th c.*
Addresses: Norman, OK. **Member:** Oklahoma AA. **Sources:** WW27.

VAN DOORT, M. *[Portrait painter] early 19th c.*
Addresses: Massachusetts, c.1825. **Sources:** G&W; Lipman and Winchester, 181.

VAN DOREN, Charlotte A. *[Artist] late 19th c.*
Addresses: Active in Washington, DC, 1882-94. **Sources:** Petteys, *Dictionary of Women Artists.*

VAN DOREN, Harold (Livingston) *[Designer, painter, writer, lecturer] b.1895, Chicago, IL / d.1957.*
Addresses: Philadelphia, PA and Ardmore, PA. **Studied:** Williams College (B.A.); ASL; Grande Chaumière, Paris; Bridgman; Sterne; Rosen. **Member:** Soc. Indust. Des. **Exhibited:** Am. Acad. Des., 1927; TMA, 1932; Friends of Am. Art, Paris, 1924. Awards: prizes, Nat. All. Art & Indust., 1932; Mod. Plastics Comp., 1936, 1941; Lord & Taylor Am. Des. Award, 1941. **Comments:** Position: bd. of managers, Phila. Mus. Sch. Art; bd. of directors, Phila. Mus. Sch. Art. Lectures: History of Painting; Industrial Design. Contributor of articles: *Saturday Evening Post, The Arts, Machine Design* and other national magazines. Translator: Vollard's "Cezanne--His Life and Art," 1923; Co-translator: Vollard's "Renoir--An Intimate Record," 1925. Author: "Industrial Design, A Practical Guide," 1940. **Sources:** WW53; WW47.

VAN DORSSEN, G. *[Painter] early 20th c.*
Addresses: NYC. **Member:** Soc. Indep. Artists. **Sources:** WW24.

VAN DRESSER, William *[Portrait painter, etcher, illustrator] b.1871, Memphis / d.1950.*
Addresses: Boca Raton, FL. **Studied:** F.L. Mora; D. Connah; A. Dow; G. Bridgman; W.A. Clark. **Member:** Soc. Four Arts, Palm Beach, FL; Palm Beach AL; Grand Central AA; AAPL; SSAL. **Exhibited:** Soc. Four Arts, 1936-46; Palm Beach AL, 1940-46; Grand Central Art Gal. (solo); AIC. **Work:** portraits of prominent persons. **Comments:** Teaching: ASL, 1943-45. **Sources:** WW47.

VAN DROSKEY, M. (Mrs.) *[Etcher] early 20th c.*
Addresses: NYC. **Sources:** WW24.

VANDUZEE, Benjamin C. *[Wood engraver and designer] mid 19th c.*
Addresses: Buffalo, NY, 1849-60 and after. **Comments:** Of Vanduzee & Barton (see entry) from 1853 to 1859. **Sources:** G&W; Buffalo CD 1849-60+.

VAN DUZEE, Kate Keith *[Painter, craftsperson, drawing specialist, etcher] b.1874, Dubuque, IA.*
Addresses: Dubuque, IA. **Studied:** Arthur Dow; J.A.S. Monks; Charles Woodbury; J. Johansen; Adrian J. Dornbush. **Member:** Dubuque AA (secretary). **Exhibited:** Iowa Artists Club, 1935 (prize); Central States Fair; Little Gallery (solo); Waterloo AA; Joslyn Memorial; Woman's Club Loaning Library; AFA Traveling Exh.; Midwestern Exh., Kansas City; All Iowa Exh., Carson Pirie Scott; Cooperative Artists; Cornell College; Iowa State Fair, medals, 1913, 1917-20, 1921, 1922, 1923, 1929, 1930, 1934, 1936; Iowa State Fed. Women's Club, 1931 (medal); Dubuque AA, 1934 (prize), 1952 (special award). **Work:** Dubuque Pub. Lib.; Davenport Municipal Mus. **Sources:** WW53; WW47; Ness & Orwig, *Iowa Artists of the First Hundred Years,* 210-11; *Charles Woodbury and His Students.*

VANDUZEE & BARTON *[Wood engravers] mid 19th c.*
Addresses: Buffalo, NY, 1853-59. **Comments:** Partners were Benjamin C. Vanduzee and L.H. Barton (see entries). **Sources:** G&W; Buffalo CD 1853-59; Hamilton, *Early American Book Illustrators and Wood Engravers,* 180.

VAN DUZER, C. E. *[Painter] mid 20th c.*
Addresses: Cleveland, OH. **Exhibited:** PAFA Ann., 1958. **Sources:** Falk, *Exh. Record Series.*

VAN DYCK, Alida Bevier *[Artist] late 19th c.*
Addresses: NYC, 1895. **Exhibited:** NAD, 1895. **Sources:** Naylor, *NAD.*

VAN DYCK, James *[Portrait and miniature painter] mid 19th c.*
Addresses: Working in NYC in 1834-36 and 1843. **Exhibited:** NAD; American Academy. **Comments:** He painted a portrait of Aaron Burr. **Sources:** G&W; NYCD 1834-36, 1843; Cowdrey, NAD; Cowdrey, AA & AAU; Bolton, *Miniature Painters;* NYHS Cat. of Portraits.

VAN DYK, James *[Painter, educator] b.1930, Los Angeles, CA.*
Addresses: Philadelphia, PA. **Studied:** ASL; Yale School of Fine Arts (B.F.A.; M.F.A). **Member:** Tau Sigma Delta (Architectural Hon. Soc., hon. mem.). **Exhibited:** "Young Americans", 1962 & "Recent Paintings", 1962, both MoMA; Inst. Contemp. Art, Boston, 1962; De Cordova & Dana Mus., 1962; WAC, 1963. Awards: prizes, Silvermine Gld. Artists, 1958; New Haven Festival Art, 1958; Yale Univ. purchase award, 1958. **Work:** Joslyn Mus. Art; Yale Univ. Gal. FA; MoMA; Northeast Regional Lib.; Philadelphia. **Comments:** Illustrator: "Book of Isaiah", 1958. Teaching: Yale Univ.; Grad. Sch. FA, Univ. Pennsylvania, 1966. **Sources:** WW66.

VAN DYKE, Dirk *[Painter] mid 20th c.*
Addresses: NYC. **Exhibited:** S. Indp. A., 1934. **Sources:** Marlor, *Soc. Indp. Artists.*

VAN DYKE, E. *[Sketch artist] mid 19th c.*
Addresses: Detroit, MI, 1858. **Exhibited:** Michigan State Fair, 1858 (prize). **Sources:** Gibson, *Artists of Early Michigan,* 231.

VAN DYKE, Ella (Tuthill) *[Painter, educator, lecturer] b.1910, Schenectady, NY.*
Addresses: Schenectady, NY, 1947; Wenonah, NJ, 1959. **Studied:** Skidmore College (B.S.); Teachers College, Columbia Univ. (M.A.); École des Beaux-Arts, Fontainebleau, France; C.J. Martin; C. Lemeunier. **Member:** NAWA; Am. Assn. Univ. Prof.; Detroit Soc. Women P&S. **Exhibited:** PAFA, 1934; AIC, 1935; NAWA, 1935, 1943-45; Detroit Inst. Art, 1936; Albany Inst. Hist. & Art, 1935-36, 1944-46, 1949, 1952; Schenectady Mus., 1945-50, 1952; High Mus. Art, 1944; Cooperstown, NY, 1949-51; Argent Gal., 1942 (solo); Skidmore College, 1943; Univ. Connecticut, 1943; Mortimer Levitt Gal., 1951; Union College, 1951. **Comments:** Positions: art instructor, Central State Teachers College, Mt. Pleasant, MI, 1934-36; head art dept., Albion (MI) College, 1936-39; asst. professor art, Univ. Connecticut, 1939-43; designer, General Electric Co., Schenectady, NY, 1943-45; art teacher, Schonowe School, Schenectady, NY, 1948-53. **Sources:** WW59; WW47.

VAN DYKE, John Charles *[Critic, writer, teacher, lecturer] b.1856 / d.1932, NYC.*
Addresses: New Brunswick, NJ. **Member:** NIAL, since 1908. **Comments:** In 1932 Dr. Van Dyke published a large volume enti-

tled "Rembrandt and His School." It was a controversial work attempting to show that the tendency to attribute to the great painter a vast number of pictures differing in style was a mistake. He charged that only a possible fifty of nearly a thousand pictures attributed to Rembrandt were really the work of the Dutch master. The book called forth a storm of comment, criticism and protest on both sides of the Atlantic. He also edited the autobiography of Andrew Carnegie and wrote many essays on natural history, literature and genealogy. His works make up 35 volumes.

VAN DYKE, Katherine *[Painter]* *b.c.1889 / d.c.1969, Spain.*
Addresses: Minneapolis, MN; France; California. **Comments:** Specialty: portraits and landscapes. Van Dyke died in Spain while visiting her daughter. **Sources:** Hughes, *Artists in California*, 573.

VAN EK, Eve See: **DREWELOWE, Eve (Mrs. Jacob Van Ek)**

VAN ELTEN, Elizabeth F. Kruseman See: **DUPREZ, Elizabeth F. (Mrs. Albert)**

VAN ELTEN, Kruseman See: **KRUSEMAN VAN ELTEN, Hendrik-Dirk**

VAN ELTON, Hendrik See: **KRUSEMAN VAN ELTEN, Hendrik-Dirk**

VAN EMPEL, Jan *[Painter, writer] mid 20th c.; b.Amsterdam, Holland.*
Addresses: Franconia, NH. **Studied:** R. Henri; R. Kryzanowsky. **Exhibited:** S. Indp. A., 1922; Salons of Am., 1922; WMAA, 1922-23; PAFA Ann., 1929. **Work:** St. Peter's Church, Seward, Alaska; Canadian Nat. Railroad. **Sources:** WW29; Falk, *Exh. Record Series*.

VAN ERNST, Otto *[Painter] late 19th c.*
Addresses: Milwaukee, WI. **Exhibited:** AIC, 1888. **Sources:** Falk, *AIC*.

VAN EVERA, Caroline *[Painter] mid 20th c.*
Addresses: Coronado, CA, active 1932-35. **Exhibited:** SFMA, 1935; Calif.-Pacific Int. Expo, San Diego, 1935; PAFA Ann., 1943. **Work:** South Cache H.S., Hyrum, UT. **Sources:** Hughes, *Artists in California*, 574; Falk, *Exh. Record Series*.

VAN EVEREN, Jay *[Painter] b.1875, Mt. Vernon, NY / d.1947, Monterey, MA.*
Addresses: NYC. **Member:** Mural Painters. **Exhibited:** S. Indp. A., 1921-28; Salons of Am., 1922. **Sources:** WW29.

VAN FAVOREN, J. H. See: **VAN STAVOREN, Joseph H.**

VAN FELIX, Maurice *[Artist] b.1889, Lodz, Poland / d.1969, Pleasantville, NJ.*
Addresses: active in Brooklyn, NY, 1919-31. **Exhibited:** S. Indp. A., 1919; Salons of Am., 1934. **Sources:** BAI, courtesy Dr. Clark S. Marlor.

VAN FLEET, Ellen *[Sculptor] b.1944.*
Addresses: La Jolla, CA. **Exhibited:** WMAA, 1970. **Sources:** Falk, *WMAA*.

VAN FOSSEN, Abigail B. *[Watercolorist] mid 19th c.*
Addresses: Detroit, MI, 1852. **Exhibited:** Michigan State Fair, 1852 (prize). **Sources:** Gibson, *Artists of Early Michigan*, 231; Petteys, *Dictionary of Women Artists*.

VANGELDERIN, George *[Portrait painter] mid 19th c.*
Addresses: NYC, 1859. **Sources:** G&W; NYBD 1859.

VAN GENT, Cock *[Painter] b.1925, The Hague, Holland.*
Addresses: Gates Mills, OH. **Studied:** Art Acad., The Hague. **Exhibited:** SAM, 1947; SFMA, 1947; Vigeveno Gal., Los Angeles, 1948; Gemeente Mus., The Hague, 1948; Weyhe Gal., NY, 1950; Slater Mem. Mus., 1951; Kunstzaal de Plaats, Holland, 1952; Boston, 1953; NCFA, 1957; Butler IA, 1957; 1020 Art Club, Chicago, 1957; Philbrook Art Mus., 1958; Mills College, 1958; Graham Gal., NY, 1958; Rosicrucian Egyptian Mus., 1958; Colorado Springs FAC, 1958; Ft. Worth AC, 1960; Rosequist

Gal., Tucson, 1961. CMA exhib. sponsored by Catherwood Fnd. and circulated by Smithsonian Inst., 1957-59. **Award:** Catherwood Fnd. grant, 1952; Spaeth Fnd., 1959. **Work:** SAM; PMA; BMFA; Butler IA; AGAA; CMA; DMFA; Univ. Michigan; Slater Mem. Mus.; Rosenwald Collection; Dayton AI. **Sources:** WW66.

VAN GORDER, Luther Emerson *[Painter, illustrator]*
b.1861, Pittsburgh, PA / d.1931.
Addresses: NYC, 1885-98; Toledo, OH. **Studied:** Wm. M. Chase and C.Y. Turner in NYC; École des Beaux-Arts, Paris; also with Carolus-Duran, Paris; London. **Member:** NYWCC; Toledo Tile Club. **Exhibited:** AIC; NAD, 1885-98, 911; Brooklyn AA, 1886; PAFA Ann., 1888, 1896-97, 1901; AWCS; SAA; Boston AC, 1893-98; Phila. AC; Paris Salon. **Work:** TMA. **Comments:** Many of his exhibited works were French landscapes and Parisian street scenes. **Sources:** WW24; Falk, *Exh. Record Series*.

VAN GUNTEN, Adele *[Miniaturist] early 20th c.*
Addresses: Germantown, PA, c.1903-05. **Exhibited:** PAFA Ann., 1903-05. **Sources:** WW06; Falk, *Exh. Record Series*.

VAN HAELEN, John B. *[Painter] d.c.1896.*
Addresses: New Orleans, active 1870-91. **Sources:** *Encyclopaedia of New Orleans Artists*, 390.

VAN HAELEWYN, Hendrick S. *[Painter] mid 20th c.*
Exhibited: Salons of Am., 1925, 1934; S. Indp. A., 1926. **Sources:** Marlor, *Salons of Am.*

VAN HASE, David *[Engraver] b.1833, New York.*
Addresses: NYC in 1850. **Sources:** G&W; 7 Census (1850), N.Y., XLIX, 935.

VAN HELDEN, Caroline W. *[Painter] 19th/20th c.*
Addresses: Phila., PA. **Exhibited:** PAFA Ann., 1891, 1899. **Sources:** Falk, *Exh. Record Series*.

VAN HOESEN, Beth (Mrs. Mark Adams) *[Printmaker]*
b.1926, Boise, ID.
Addresses: San Francisco, CA. **Studied:** Stanford Univ. (B.A.); San Francisco Art Inst.; San Francisco State College; Escuela Esmeralda, Mexico; Acad Fountainebleau; Acad. Grande Chaumière; Acad. Julian. **Member:** San Francisco Women Artists; Bay Area PM. **Exhibited:** Two Decades of Am. Prints, 16th Nat. Print Exh., BM, 1947-68; 116th Ann. Exh., PAFA, 1965; Amerikanische Radierungen, touring exh. ten printmakers, U.S. Info Bureau; Contemp. Prints from Northern Calif., Art in Embassies Program, U.S. State Dept., 1966; Graphics '71, West Coast USA, Univ. Kentucky, 1971; Gump's Gal., San Francisco, CA & Hanson-Fuller Gal., San Francisco, 1970s. **Awards:** SFMA 25th Ann., 1961; Pasadena Mus. purchase award, Fourth Biennial Print Exh., 1964; Hawaii Nat. Biennial, 1971. **Work:** SFMA; Brooklyn Mus., NY; MoMA; Smithsonian Inst.; Victoria-Albert Mus., London, England. **Comments:** Preferred medium: intaglio. Publications: illustr., "A Collection of Wonderful Things, Scrimshaw," 1972. **Sources:** WW73; "One Woman Renaissance in Prints," *Esquire* (1955); "A Portfolio by Beth Van Hoesen," *Ramparts* (summer, 1964); Mendelowitz, *A History of American Art* (Holt, 1970).

VAN HOOK, David H. *[Painter, art administrator] b.1923, Danville, VA / d.1986.*
Addresses: Columbia, SC. **Studied:** Univ. South Carolina with Edmund Yaghijian. **Member:** Guild SC Artists; Am. Assn. Mus.; Southeastern Mus. Conf. **Exhibited:** Mint Mus., Charlotte, NC, 1966; Columbia Mus. Art, 1967; C&S Nat. Bank Exh., 1968; Pfeiffer College, Misenheimer, NC, 1969; Contemporary Artist of South Carolina Tricentennial Exh., Columbia, Greenville & Charleston, SC, 1970; Jefferson Place Gal., Wash., DC, 1970s. **Awards:** Rose Talbert Award, 1954; hon. award, Columbia Mus. Art, 1959; purchase prize, Guild SC Artists, 1961. **Work:** Jacksonville (FL) Mus. Art; Greenville Co. (SC) Mus.; C&S Nat. Bank, Columbia, SC; murals, Caughman Road School, Columbia; Columbia Mus. Art. **Comments:** Positions: registrar, Columbia Mus. Art, 1951-58, asst. to dir., 1958-60, cur. exhs., 1961-.

Collections arranged: Jasper Print Traveling Exhibit, 1971; Eight Washington Artists, 1971. **Sources:** WW73.

VAN HOOK, Katrina *[Critic, art historian, teacher, lecturer]* *b.1912, NYC.*
Addresses: Wash., DC, 1941-46; American Embassy, Ethiopia, 1959. **Studied:** Smith College; Radcliffe College; Univ. Paris. **Comments:** Contrib.: *Magazine of Art, Gazette des Beaux-Arts, CAA Journal.* Lectures: history of the Renaissance and modern art. Position: art history instr., Smith College, 1938-40; museum aide, NGA, 1941-43; supervisor of educ., 1943-45, NGA; art critic, *Washington Post,* 1945-46. **Sources:** WW59.

VAN HOOK, Nell *[Painter, sculptor, illustrator, teacher]* *b.1897, Richmond, VA.*
Addresses: Atlanta, GA, 1940; Rye, NY, 1973. **Studied:** Hamilton College; Columbia Univ.; NAD; ASL; Calder; Rittenberg. **Member:** SSAL; Georgia State AA; Georgia Prof. AL; Nat. Lg. Am. Pen. Women; AFA; Bureau Artists; Wolfe Art Club; CAA. **Exhibited:** Atlanta AA, 1928 (prize); C.L. Wolfe AC, 1935 (prize); Nat. Pen Women Am. (sculpture prize); Gloucester Soc. Arts (first in oils & first in sculpture). **Work:** Syracuse Mus.; Columbia Univ.; College Physicians & Surgeons, NYC; Gibney Found., CA; Univ. Kentucky; Erskin College, Due West, SC; Columbia; Mem. Art Gal., Rochester; murals: Peachtree Christian Church and Westminster Presbyterian Church, Atlanta, GA. Commissions: two paintings, World's Fair, New York; portrait, William Bender Coll. **Comments:** Preferred media: oils, clays, stone, bronze. Painted portraits and religious subjects. **Sources:** WW73; WW40; Petteys, *Dictionary of Women Artists.*

VAN HORN, Dora R. *[Painter]* mid 20th c.
Exhibited: S. Indp. A., 1936-37. **Sources:** Marlor, *Soc. Indp. Artists.*

VAN HORN, Ida *[Painter]* early 20th c.
Addresses: active in Chicago, c.1913-15. **Exhibited:** AIC, 1910-15. **Sources:** Petteys, *Dictionary of Women Artists.*

VAN HORN, Lucretia LeBourgeois *[Painter]* b.1882, St. Louis, MO / d.1970, Stanford University Hospital.
Addresses: Berkeley, CA. **Exhibited:** Oakland Art Gal., 1928; San Francisco AA, 1930. **Comments:** Preferred medium: watercolors, pastels. **Sources:** Hughes, *Artists in California,* 574.

VAN HORN, Mary S. *[Painter]* mid 19th c.
Addresses: active in Bucks County, PA, 1856. **Sources:** Petteys, *Dictionary of Women Artists.*

VAN HORNE, H. E. *[Painter]* late 19th c.
Addresses: Jersey City, NJ, 1877-78, 1881; NYC, 1880. **Exhibited:** NAD, 1877-81. **Sources:** Naylor, *NAD.*

VAN HORNE, Katherine (Mrs. Cecil A. Duell) *[Painter, decorator]* d.1918.
Addresses: active in Cincinnati, OH & Ft. Thomas, KY. **Comments:** Worked at Rookwood Pottery, 1907-18. **Sources:** Petteys, *Dictionary of Women Artists.*

VAN HORNE, Nelson *[Painter]* mid 20th c.
Addresses: NYC. **Exhibited:** S. Indp. A., 1930-31. **Sources:** Marlor, *Soc. Indp. Artists.*

VAN HOUSEN, Beth *[Painter, designer]* 20th c.
Addresses: Anchorage, AK. **Sources:** WW59.

VAN HOUTEANO *[Lithographer]* mid 19th c.
Comments: Contributed colored lithographs to *The Florist and Horticultural Journal,* published in Philadelphia, 1853-55. **Sources:** G&W; McClinton, "American Flower Lithographs," 362.

VAN HOUTEN, Raymond F. *[Painter]* 20th c.
Addresses: Cincinnati, OH. **Comments:** Position: staff, Rookwood Pottery, Cincinnati. **Sources:** WW13.

VAN HUSEN, John *[Limner and glazier]* mid 18th c.
Studied: apprenticed to Raphael Goelet, NYC, 1726. **Sources:** G&W; Groce, "New York Painting Before 1800."

VAN INGEN, Henry A. *[Genre painter, teacher]* b.1833, Holland / d.1899.
Addresses: NYC, 1860-66; Rochester, NY, 1861; Poughkeepsie, NY, from 1867. **Member:** AWCS. **Exhibited:** NAD, 1861-81; AWCS; PAFA, 1861-66; Brooklyn AA, 1881-82, 1884; Boston AC, 1881; AIC. **Comments:** Teaching: Vassar College, 1867 until at least 1881. **Sources:** G&W; *Art Annual,* I (1898), obit.; Naylor, NAD; Rutledge, PA.

VAN INGEN, Josephine (Josi) K. *[Painter]* 19th/20th c.
Addresses: Poughkeepsie, NY. **Exhibited:** NAD, 1898; PAFA Ann., 1898; Salons of Am., 1934. **Sources:** WW01; Falk, *Exh. Record Series.*

VAN INGEN, W(illiam) B(rantley) *[Painter, mural painter]* b.1858, Phila., PA / d.1955, Utica, NY.
Addresses: Phila., PA, 1882; NYC. **Studied:** PAFA with Schuessele, Eakins; La Farge; Bonnât, in Paris. **Member:** Arch. Lg., 1889; Mural Painters; AC Phila.; NAC; Lotos Club; Artists Aid Soc.; Artists Fund Soc. **Exhibited:** PAFA Ann., 1880-82, 1885, 1908; NAD, 1882; SAA, 1898; Pan-Am. Expo, Buffalo, 1901 (prize); AIC; S. Indp. A., 1927. **Work:** eight panels in U.S. Court House, Chicago; U.S. Courthouse, Indianapolis; U.S. Mint, Phila.; Capitol, Harrisburg, PA; Capitol, Trenton, NJ; LOC; Admin. Bldg., Panama Canal Zone, 1914-15; murals, NY State College, Albany. **Sources:** WW40; Falk, *Exh. Record Series.*

VAN INGEN, William H. *[Wood engraver and designer]* b.1831, New York.
Addresses: Philadelphia, from c.1853. **Studied:** apprenticed to Joseph and William Howland (see entries) in NYC about 1847-50. **Exhibited:** American Inst., c.1847-50. **Comments:** In partnership in Philadelphia with Henry M. Snyder (see entry) as Van Ingen & Snyder from 1853 until at least 1871. **Sources:** G&W; 8 Census (1860), Pa., LV, 854; Am. Inst. Cat., 1847-50; Hamilton, *Early American Book Illustrators and Wood Engravers;* Phila. CD 1854-71.

VAN INGEN & SNYDER *[Wood engravers and designers]* mid 19th c.
Addresses: Philadelphia, from 1853 until at least 1871. **Comments:** Partners were William H. Van Ingen and Henry M. Snyder (see entries). **Sources:** G&W; Hamilton, *Early American Book Illustrators and Wood Engravers;* Phila. CD 1856-71.

VAN KLEECK, Anne *[Sculptor]* b.1922, Marion, OH / d.1998, Tampa, FL.
Studied: Ohio Wesleyan Univ., 1946-49 (B.A., Ceramics, 1952); Ohio State Univ. (M.A., Sculpture); School of the Carmine, Venice Italy, lost wax casting. **Exhibited:** Ball Art Mus., Muncie, IN, 1951, 1956; Bevilacqua La Massa, Venice, Italy, 1959 (solo, invitational); Galleria S. Vidal, Venice, Italy, 1959 (solo); Gumps Gal., San Francisco, 1959; Butler Mus. Art, Youngstown, OH, 1959; Oakland Art Mus., Oakland, CA, 1962; La Jolla Mus. Art, 1969; America House, NYC, 1969; Seattle World's Fair; MoMA; Dalzell Hatfield Gals., Los Angeles, 1974 & 1975 (solo shows); Embarcadero Center, San Francisco, 1972; MMA. **Awards:** Ohio St. Fair, Governor's Award, 1951; Am. Craftsman, SW Regional, CA; Nat. Sculpture & Print, Muncie, IN; Sarasota (FL) Fine Arts, 1951; Wichita National Ceramic Show, traveling, 1951-52; National Contemporary Art in U.S., Pomona, CA; Syracuse Nat. Ceramic Show, 1951-52; West Palm Beach Ann., 1951; Columbus Art League Annual, 1953 (best in show); Palm Beach FA Exhib. **Work:** commissions: 20-ft bronze of St. Clare for City of Santa Clara, CA, 1965; 28-foot modular wall sculpture for Public Lib., Marion, OH, 1980; 6-foot wall sculpture for Berkeley (CA) Art Theatre, 1962; Great Western Bank, Oakland, CA, 1965; 6-foot articulate modules for Embarcadero II, San Francisco, 1974. **Comments:** Established bronze foundries in Murano, Italy and and Berkeley, CA. She cast sculpture for architectural commissions, one-person shows, and invitationals in the United States and Italy. Her work on a 20-foot bronze of St. Clare (cast at foundry in Switzerland) was greatly admired by Arp. She completed the Marion (OH) Library sculpture in less than a year by

devising a substitute method for lost-wax casting. Preferred media: cast bronze & ceramics. Teaching: instructor, 3-dimensional art, Univ. Florida, 1949-50; asst. professor fine arts, Ohio Wesleyan Univ., 1951-57; guest prof. with Aaron Bohrod, Ball State Teachers College, 1952. **Sources:** info. courtesy of Robert A. Blekicki, Sarasota, FL.

VAN KOERT, John Owen *[Painter, etcher, designer, block printer, lithographer, teacher] b.1912, Minneapolis.* **Addresses:** Milwaukee, WI. **Studied:** Univ. Wisconsin, Milwaukee State Teachers College; Columbia, Neillsville, WI. **Comments:** WPA artist. Teaching: Univ. Wisconsin. **Sources:** WW40.

VAN KONIJNEBURG, Willem A. *[Painter] early 20th c.* **Exhibited:** AIC, 1931. **Sources:** Falk, *AIC.*

VAN LAER, Alexander T(heobald) *[Landscape painter, teacher, writer, illustrator, lecturer] b.1857, Auburn, NY / d.1920, Indianapolis, IN.* **Addresses:** NYC (1877-84); Illinois & Ohio (1884-90); NYC/Litchfield, CT (1890-20); Princeton, NJ (1909-11). **Studied:** NAD, 1877-81; privately with R.S. Gifford, 1881; Geo. Poggenbeek (his cousin) in Holland, 1883. **Member:** Jacksonville (IL) AA, 1884; ANA, 1901; NA, 1909; AWCS (pres., 1910-14); NYWCC; CAFA; Artists Fund Soc.; NAC; SC (pres., 1897-1900 & 1905-08), 1892; Lotos Club; Soc. Painters of NY; Rembrandt C.; Jury of Awards, St. Louis Expo, 1904. **Exhibited:** NAD, 1880, 1892-1919; BAC, 1888-1909; AIC, 1889-1916; PAFA Ann., 1892-1916 (10 times); NYWCC, 1899; MacBeth Gal., NYC, 1900-12; Lotos Club, NYC, 1901, 1903; Carnegie Inst., 1900s; Charleston Expo, 1902 (gold medal); St. Louis Expo, 1904 (gold medal); Corcoran Gal biennials, 1907-14 (4 times); Mattatuck Mus., Waterbury, CT, 1998 (retrospective). **Work:** Lotos Club; Brooklyn Inst. Mus.; NGA; NAC; Montclair Mus., NJ; Herron AI, Indianapolis. **Comments:** A highly influential teacher and one of the leading tonalist landscape painters. From 1893-on he particularly enjoyed painting in Litchfield, CT, where he bought a house in 1911. Positions: director, Athenaeum Art Sch., Jacksonville, IL, 1884-85; head art dept., Buchtel College, OH (later Univ. Akron) 1886-90; lecturer, NYC Board Educ., 1890; art instructor, Merrill-Van Laer School, NYC, 1890-1909; director, Am. Art Study Course; summer classes at Chautauqua, NY, 1897-1902; NAD, 1905-06; Smith College, 1905-06; lectured extensively at MMA, AIC, and others. **Sources:** WW19; Ann Smith, exh. cat., Mattatuck Mus., Waterbury, CT, 1998; Falk, *Exh. Record Series.*

VAN LAER, Belle *[Miniature painter] b.1862, Phila.* **Addresses:** Johnsville, PA. **Studied:** Phila. Sch. Des. for Women, with S.J. Ferris, J.L.G. Ferris, H. Faber, L. Faber. **Member:** Plastic Club. **Sources:** WW25.

VAN LEER, Ella Wall *[Painter] mid 20th c.* **Addresses:** Berkeley, CA. **Exhibited:** Lg. Am. Pen Women, CPLH, 1928; Oakland Art Lg., 1928. **Sources:** Hughes, *Artists in California,* 574.

VAN LEER, W. Leicester (Mrs.) *[Collector] b.1905, Warwick, NY.* **Addresses:** NYC. **Studied:** Smith College; Mary Turlay Robinson. **Comments:** Collection: includes works by Delacroix, Matisse, Boudin, Dufy, Burchfield, Wyeth, Prendergast, Davies, Bishop, Homer, Segonzac, Marin, Cropsey, Utrillo, Beal, Andrew Wyeth and others. **Sources:** WW73.

VAN LESHOUT, Alexander J. *[Etcher, teacher] b.1868, Harvard, IL / d.1930, Louisville, KY?.* **Addresses:** Louisville, KY. **Studied:** ASL; AIC; C. Beckwith F. Freer; J.H. Vanderpoel; Holland; Paris. **Member:** SSAL; Chicago SE; Louisville AA. **Comments:** Position: director, Louisville Sch. Art, Conservatory of Music. **Sources:** WW29.

VAN LEYDEN, Ernst Oscar Mauritz *[Painter, sculptor, muralist] b.1892, Rotterdam, Holland.* **Addresses:** Los Angeles, CA, 1947; Seine et Oise, France, 1966.

Exhibited: VMFA, 1946; Pepsi Cola, 1946; LACMA (prize); Santa Barbara MA; San Diego FA Soc.; Syracuse Mus. FA; SFMA; Expo, Brussels (medal); Paris Expo, (medal); Amsterdam Expo, (medal); The Hague Expo, (medal); Venice, Italy, 1932 (prize); Stedelijk Mus., Amsterdam; Galerie International d'Art Contemporain, Paris, 1962 (solo); Andrew-Morris Gal., NY, 1963; WMAA, 1963; Anderson-Mayer Gal., Paris, 1964; Martha Jackson Gal., NY, 1965. **Work:** Tate Gal., London; Lisbon Mus., Portugal; Boymans Mus., Rotterdam; WMAA; Albright-Knox A. Gal.; Larry Aldrich Mus.; BM. **Comments:** Creator of special glass-tile technique for murals. Also appears as Leyden. **Sources:** WW66; WW47.

VAN LEYDEN, Karin Elizabeth *[Painter, designer, illustrator, muralist] b.1906, Charlottenburg, Germany.* **Addresses:** Los Angeles, CA, 1947; Seine et Oise, France, 1966. **Member:** Royal Soc. Mural Painters, Great Britain. **Exhibited:** Marie Sterner Gal., 1938; Nierendorf Gal., 1940; Wildenstein Gal., 1941; Syracuse MFA, 1941; Carroll Carstairs Gal., 1944; Bonestell Gal., 1946; San Diego FA Soc.; Santa Barbara MA; LACMA; SFMA; Felix Landau Gal., Los Angeles, 1953; Galleria Inez Amour, Mexico City, 1953; Bertha Schaefer Gal., NY, 1964, 1965; and extensively in Europe, including Paris, France, 1950; Vallauris, France, 1951; Corcoran Gal biennial, 1951; Venice Biennale, 1956; Galleria Bevalacqua La Masa, Venice, 1960. **Work:** in many museums throughout Europe; mural commissions in U.S.A. **Sources:** WW66; WW47.

VAN LITH, P. *[Painter] late 19th c.* **Addresses:** NYC, 1881. **Exhibited:** NAD, 1881. **Sources:** Naylor, *NAD.*

VAN LOAN, Dorothy Leffingwell *[Painter, lithographer] mid 20th c.; b.Lockport, NY.* **Addresses:** Hull's Cove, ME; Philadelphia, PA. **Studied:** PM School IA; PAFA, 1927-28 (Cresson traveling scholarship); Phila. Graphic Sketch Club. **Member:** Phila. Pr. Club. **Exhibited:** PAFA, 1927-28, 1932-33, 1935, 1940-45, 1956-57 (prize 1927-28, 1935, 1945); PAFA Ann., 1933-34, 1942-45; Salons of Am., 1934; Watkins Gal., Phila., 1935; Phila. Sketch Club, 1935 (gold), 1944-45; Phila. Art All., 1936 (gold), 1945 (solo); Marie Sterner Gal., 1937, 1939 (solo); Gimbel Gal., 1937 (solo); Phila. Pr. Club, 1941-43, 1944 (prize), 1946; Carnegie Inst., 1941-42, 1945-46; Ragan Gal., Phila., 1941-43; PMA, 1946; Woodmere Art Gal., 1941-45; MMA, 1942; NAD, 1943, 1945; S. Indp. A., 1944; An American Place, NYC. **Awards:** PAFA, 1944 (fellowship). **Work:** PMA; Am. Color Slide Soc.; La France AI, Phila. **Sources:** WW59; WW47; Falk, *Exh. Record Series.*

VAN LOEN, Alfred *[Sculptor, educator] b.1924, Oberhausen-Osterfeld, Germany / d.1994.* **Addresses:** NYC; Huntington Sta, NY. **Studied:** Royal Acad. Art, Amsterdam, Holland, 1941-46. **Member:** AEA; Am. Soc. Contemp Artists; Am. Crafts Council; Long Island Univ. Pioneer Club; Huntington Artists Group. **Exhibited:** PAFA Ann., 1950, 1954, 1960; NAD, 1964; WMAA,1957, 1967; Emil Walters Gal., NYC, 1968; Stony Brook Mus., 1968; Heckshere Mus., Huntington, NY, 1971; Harbor Gal., Cold Spring Harbor, NY, 1970s. **Awards:** first prize, Village AC, 1949; Louissa Robbins Award, Silvermine Guild Artists, 1956; first prize sculpture, Am. Soc. Contemporary Artists, 1964. **Work:** MMA; MoMA; Brooklyn Mus., NY; Nat. Mus., Jerusalem, Israel. Commissions: brass fountain, James White Community Center, Salt Lake City, UT, 1958; Peace Window, Community Church, New York, 1963; Crescendo, State Univ. NY Agric. & Tech. College Farmingdale, 1969; Jacob's Dream (brass), Little Neck Jewish Center, NY, 1970; bronze & acrylic portrait of Guy Lombardo, Hall of Fame, Stony Brook, NY, 1972. **Comments:** Preferred media: stone, acrylic. Publications: author, "Simple Methods of Sculpture," Channel Press, 1958; author, "Instructions to Sculpture," C.W. Post College, 1966; author, "Origin of Structure and Design," Hamilton Press, 1967; author, "Drawings by Alfred Van Loen," Harbor Gallery Press, 1969. Teaching: instructor, Hunter College, 1953-54; instructor, North Shore Community ACr., NY, 1955-61;

asst. professor sculpture, C.W. Post College, Long Island Univ., 1962-. **Sources:** WW73; Paul Moscanyi, *Alfred Van Loen* (Channel Press, 1960; Mark Smith, "Alfred Van Loen, Portrait," *Long Island Magazine,* 1964; "Sculptured Emotion of A.V.L.," *Modern Castings,* 1965; Falk, *Exh. Record Series.*

VAN LOO, Pierre *[Painter] b.1837, Ghent, Belgium / d.1858, New Orleans, LA.*
Addresses: New Orleans, active 1858. **Comments:** At the New Orleans Theatre at the time of his death. **Sources:** G&W; Delgado-WPA cites *Bee,* Feb. 13, 1858.

VAN LOON, Hendrik Willem *[Writer, illustrator] b.1882, Netherlands / d.1944.*
Addresses: Old Greenwich, CT. **Comments:** Came to U.S. in 1902. Author/illustrator: books on history and biography.

VAN LUPPEN, F. E. *[Painter, sculptor] late 19th c.*
Addresses: NYC, 1883. **Exhibited:** NAD, 1883. **Sources:** Naylor, *NAD.*

VAN METER, Mary *[Painter, educator] b.1919, Knox County, IN.*
Addresses: Vincennes, IN. **Studied:** Vincennes Univ. Jr. College (A.A., 1940); Indiana State Univ. (B.S., 1950); Indiana Univ. (M.A., 1956); also with Alma Eikerman, Alton Pickens & Jack Tworkov. **Member:** Northwest Territory Art Guild (pres., 1969, corresponding secy., 1971); Indianapolis Mus. Art; Indiana State Arts Commission; Hoosier Art Salon. **Exhibited:** Art for Religion, Lutheran Church, Indianapolis, IN, 1961; Old Bank Gal., 1967 (solo); Northwest Territory Art Guild Exhib., 1967 & Wabash Valley Exhib., 1968, Swope Art Gal., Terre Haute, IN; Old Bank Gal., Vincennes, IN, 1970s. Awards: Indiana Univ. certificate scholastic achievement, 1956; first prize, oil painting, Little Gal., Bloomfield, IN, 1960; first hon. men., print, Art for Religion, Lutheran Church, 1961. **Work:** Vincennes Univ. Art Dept Gallery, Inc.; Old Bank Gallery, Vincennes. **Comments:** Preferred media: acrylics. Publications: contributor, "Hoosier College Verse," Evansville Univ. Press, 1939-40; author, article on collecting dolls, *Hobbies Magazine,* 1956; author, "High School Art," *School Arts Magazine,* 1957; author, "Art Notes for Today's Collector," *Valley Advan.,* 1967-70; co-author, "Appreciation of the Visual Arts." Teaching: art instructor, Washington (IN) H.S., 1952-54, 1957-65; instructor of art & critic, Indiana Univ. School Educ., Bloomington, 1954-56; elementary art supervisor, Vincennes (IN) Public Schools, 1956-57; assoc. professor art, Vincennes Univ. Jr. College, 1966-71, professor art & art coordinator, 1971-. **Sources:** WW73; Theodore Bowie, "A Critical Guide" (film), Indiana Univ. AV Center, 1957.

VAN MILLET, George *[Painter, curator] b.1864, Kansas City / d.1952.*
Addresses: Kansas City, MO. **Studied:** Royal Acad. FA, Munich, with Gysis, Loefftz. **Member:** Municipal Art Com., Kansas City. **Exhibited:** AIC, 1900; Munich Acad. (medal). **Work:** Kansas City AI; Scottish Rite Temple, Chamber of Commerce, Pub. Lib., City Hall, all in Kansas City. **Comments:** In addition to being a successful landscape and genre painter, during the 1920s he acted as curator of the William Rockhill Nelson collections. **Sources:** WW40; exh. cat., *Missouri Artists* (Th. McCormick, 1984).

VANN, Esse Ball (Mrs.) *[Painter, teacher] b.1878, Lafayette, IN. / d.1955, Seattle, WA.*
Addresses: Richmond Beach and Woodinville, WA. **Studied:** Univ. Southern Calif.; E. Forkner; E.P. Ziegler. **Member:** Hoosier Salon; Women Painters of the West; Laguna Beach AA; Women Artists Wash. (pres.). **Exhibited:** SAM, 1935-50s; Hoosier Salon; Downtown Gallery, Seattle (solo); Vancouver Art Gallery, BC (solo). **Sources:** WW40; Trip and Cook, *Washington State Art and Artists;* Petteys, *Dictionary of Women Artists.*

VANN, Loli (Lilian) (Mrs. Oscar Van Young) *[Painter] b.1913, Chicago, IL.*
Addresses: Los Angeles, CA. **Studied:** AIC; Sam Ostrowsky. **Member:** Calif. WCS; Council All. Artists, Los Angeles; Los

Angeles AA. **Exhibited:** AIC, 1938, 1941-42, 1945; CI, 1946; Pepsi-Cola, 1946; CPLH, 1946; SFMA, 1944; Santa Barbara MA, 1944; Denver AM, 1943; Chaffey College, Ontario, CA, 1945; Oakland Art Gal., 1945; LACMA, 1941, 1943-44 (prize), 1945; Found. Western Artists, 1942-45; Los Angeles AA, 1944-46; Pasadena AI, 1945; Laguna Beach AA, 1945; MMA, Am. Painting; Corcoran Gal biennial, 1947; Chaffey Community AA (purchase prize); Calif. WCS (hon. men.). **Work:** Chaffey College, Ontario, CA; Hollenbeck H.S., Los Angeles. **Comments:** Preferred media: oils, watercolors, pastels. **Sources:** WW73; WW47.

VAN NAME, George W. *[Portrait painter] mid 19th c.*
Addresses: Cincinnati, 1850-53; Wash., DC, active 1884-87. **Work:** State of Missouri Hist. Soc. **Sources:** G&W; Cincinnati CD 1850; Ohio BD 1853. More recently, see McMahan, *Artists of Washington, DC.*

VAN NATTER, Hazel *[Sculptor] b.1895, Oklahoma / d.1980, Ft. Lauderdale, FL.*
Addresses: Wash., DC. **Studied:** Kansas City Art Inst.; Chicago School of Sculpture; CGA. **Member:** Soc. of Wash. Artists; Artists Guild of Wash.; Wash. Sculptors Group. **Exhibited:** CGA. **Comments:** Position: artist, Treasury Department, 25 years. Van Natter died in Ft. Lauderdale while visiting friends. **Sources:** McMahan, *Artists of Washington, DC.*

VANN AUSDALL, Wealtha Barr *[Portrait painter, lithographer, lecturer, teacher] mid 20th c.; b.Franklin, PA.*
Addresses: Oil City, PA. **Studied:** W. Barr; W.F. Bates; Moore Inst.; Phila. School Design for Women; Graphic Sketch Club; P.H. Balano. **Member:** Phila. Print Co., Plastic Club; Phila. AG. **Exhibited:** WFNY, 1939. **Work:** Drake Mem. Mus., Titusville, PA; Municipal Collection, Oil City, PA; Graphic Sketch Club, Phila. **Sources:** WW40.

VAN NESS, Beatrice See: **WHITNEY, Beatrice (Mrs. Van Ness)**

VAN NESS, C. W. *[Painter] mid 20th c.*
Addresses: St. Paul, MN. **Exhibited:** S. Indp. A., 1939. **Sources:** WW24; Marlor, *Soc. Indp. Artists.*

VAN NESS, Frank Lewis *[Portrait painter, illustrator] b.1866, Paw-Paw, MI.*
Addresses: Chicago, IL. **Studied:** G.P.A. Healy. **Exhibited:** Art Loan Exh., Detroit, 1885 (medal). **Sources:** WW10.

VAN NESS, Mary *[Artist] late 19th c.*
Addresses: NYC, 1890. **Exhibited:** NAD, 1890. **Sources:** Naylor, *NAD.*

VAN NESSE, Green A. *[Painter] mid 20th c.*
Exhibited: S. Indp. A., 1930. **Sources:** Marlor, *Soc. Indp. Artists.*

VANNINI, Freida (Mrs. Attillio) *[Painter] d.1955, Seattle, WA.*
Addresses: Seattle, WA, 1955. **Exhibited:** SAM & Frederick & Nelson, Little Gal., several times between 1933-55; Yakima, WA, 1951. **Comments:** Preferred media: oil, watercolor. **Sources:** Trip and Cook, *Washington State Art and Artists.*

VAN NORDEN, John H. *[Landscape painter] mid 19th c.*
Addresses: Waterford, NY. **Exhibited:** NAD, 1853, 1859. **Sources:** G&W; Cowdrey, NAD.

VAN NORDEN, Virginia *[Painter, decorator, teacher] b.1905, California / d.1985, Los Angeles, CA.*
Addresses: Los Angeles. **Exhibited:** P&S of Los Angeles, 1928; Calif. WCS, 1928. **Comments:** Teaching: UCLA. **Sources:** Hughes, *Artists in California,* 574.

VAN NORMAN, D. C. (Mrs.) *[Portrait painter] mid 19th c.*
Addresses: NYC, 1865, 1870-72. **Exhibited:** NAD, 1857-58, 1864-72. **Comments:** She was married to a minister. **Sources:** G&W; Cowdrey, NAD; NYCD 1859.

VAN NORMAN, Evelyn *[Painter] b.1900, Hamilton, Ontario, Canada.*

Addresses: New Rochelle, NY. **Studied:** ASL. **Member:** Alliance Française; Woodstock AA. **Exhibited:** S. Indp. A., 1925-27; Salons of Am., 1927-29; Corcoran Gal biennial, 1928; AIC, 1930 (gold); WFNY, 1939. **Sources:** WW40; Woodstock AA.

VAN NOSTRAND, Henry *[Wood engraver] mid 19th c.*
Studied: in 1847 he was an apprentice or employee of the Howlands (see entry). **Exhibited:** American Inst., 1847-49. **Sources:** G&W; Am. Inst. Cat., 1847-49.

VAN NOTTI, Henry *[Painter, etcher] b.1876, Lugano, Switzerland.*
Addresses: New Jersey (1903-on). **Studied:** Acad. FA in Turin and Milan, Italy. **Exhibited:** S. Indp. A., 1928. **Work:** WPA murals, rotunda and balcony of NY Courthouse, Foley Square. **Comments:** He produced oils and etchings of NYC scenes and architecture. **Sources:** info courtesy M.T. Kravetz.

VANNUCCI, Enrico *[Sculptor] mid 20th c.*
Addresses: Chicago area. **Exhibited:** AIC, 1927. **Sources:** Falk, AIC.

VANNUCHI, F. *[Wax modeller] b.c.1800, Italy.*
Addresses: Charleston, SC, 1845; New Orleans, 1852-62. **Exhibited:** in Charleston, 1845 (wax figures); NYC and Philadelphia, 1847 ("cosmorama" or collection of paintings of American views and historical scenes). **Comments:** He opened the American Museum and Waxworks in New Orleans about 1852 which was still flourishing in 1860, when Vannuchi's personal property was valued at $25,000. **Sources:** G&W; 8 Census (1860), La., VI, 202; Rutledge, *Artists in the Life of Charleston;* N.Y. *Herald,* June 15, 1847, and Phila. *Public Ledger,* Aug. 13, 1847 (courtesy J. Earl Arrington); *Orleanian,* Nov. 23, 1852, *Bee,* Jan. 3, 1853, and *Courier,* March 4, 1856 (courtesy Delgado-WPA); New Orleans CD 1855, 1858-59. More recently, see *Encyclopaedia of New Orleans Artists,* 390.

VAN OPSTAL, Andre E. *[Painter, commercial artist, decorator] b.1895, Belgium / d.1986, San Mateo, CA.*
Addresses: NYC; Philadelphia, PA; San Francisco, CA; San Mateo, CA. **Studied:** Royal Acad. FA, Antwerp. **Comments:** Immigrated to the U. S. in 1922. Specialty: landscapes, missions, marines, still lifes. **Sources:** Hughes, *Artists in California,* 574.

VAN ORDEN, Alice E(instein) *[Painter] mid 20th c.*
Exhibited: Salons of Am., 1924, 1926, 1931; S. Indp. A., 1935. **Sources:** Marlor, *Salons of Am.*

VAN ORDER, Grace Howard *[Painter, illustrator, teacher] b.1905, Baltimore.*
Addresses: Baltimore, MD. **Studied:** Maryland Inst.; PAFA, Chester Springs Summer School. **Member:** AAPL. **Exhibited:** Maryland Inst.; Baltimore MA; AAPL. **Comments:** Position: teacher, Park School, Baltimore, MD. **Sources:** WW40.

VAN ORMAN, John A. *[Illustrator] 20th c.*
Addresses: NYC. **Member:** SI. **Sources:** WW47.

VAN ORNUM, Willard *[Painter] early 20th c.*
Addresses: Earville, IL. **Exhibited:** AIC, 1914. **Sources:** WW15.

VANOSTEN, Joseph *[Listed as "artist"] b.1832, Pennsylvania.*
Addresses: Baltimore in 1860. **Sources:** G&W; 8 Census (1860), Md., III, 956.

VAN OSTRAM, Julia *[Artist] late 19th c.*
Addresses: active in Fowlerville, MI, 1899. **Sources:** Petteys, *Dictionary of Women Artists.*

VAN PAPPELENDAM, Laura *[Painter, teacher] b.1883, Donnelson, Lee County, IA. / d.1974.*
Addresses: Chicago, IL. **Studied:** AIC, 1904-11; Sorolla at AIC, 1909, 1911; G. Bellows at AIC, 1919; N. Roerich; Jacques Maroger. **Member:** Chicago SA; Chicago Gal. Art; Illinois Acad. FA. **Exhibited:** 250 exhibitions in the Chicago area, including AIC, 1921 (silver medal), 1931 (French gold medal), 1932 (Bower prize), 1933 (Logan prize), 1936 (silver medal), 1942 (Carr prize); Women Artists Salon of Chicago, 1942 (prize); Phila.

Sesquicentenn. Expo; Garfield Park Art Gal., Chicago, 1936; Chicago Gals. Assn., 1917 (solo); Keokuk, IA (solo); Madison and Milwaukee, WI (solos); WMAA; Riverside Mus. **Work:** Vanderpoel AA, Chicago; Illinois State Mus.; Lee Cnty Hist. Soc., Keokuk, IA; Oak Park (IL) Art League; Univ. Chicago. **Comments:** A Post-Impressionist painter, she taught at the AIC for 50 years, from 1909-59, and at the Univ. of Chicago for 30 years. She painted (summers) in Santa Fe, NM, 1920-27 and 1950-55. **Sources:** WW40; PHF files, article by S. D'Emilio, n.d.; Petteys, *Dictionary of Women Artists.*

VAN PARNEGH, Clara W. *[Painter] early 20th c.*
Addresses: NYC, 1903. **Sources:** WW04.

VAN PELT, Armond *[Painter] early 20th c.*
Exhibited: Salons of Am., 1927. **Sources:** Marlor, *Salons of Am.*

VAN PELT, Ellen Warren *[Painter] 19th/20th c.*
Addresses: University Park, CO, 1900. **Sources:** WW01.

VAN PELT, John V. *[Architect, painter] 19th/20th c.; b.New Orleans, LA.*
Addresses: NYC. **Exhibited:** Paris Salon, 1898. **Sources:** WW06; Fink, *American Art at the Nineteenth-Century Paris Salons,* 400.

VAN PELT, Margaret V. *[Painter] mid 20th c.*
Addresses: New Haven, CT. **Member:** AWCS. **Sources:** WW47.

VAN PHUL, Anna Maria See: **VON PHUL, Anna Maria**

VAN RAALTE, David *[Painter, designer, graphic artist] b.1909, NYC.*
Addresses: Bronx, NY/Lake Peekskill, NY. **Studied:** Jacobs; MMA School, NYC; H. Hofmann. **Member:** Salon Am.; Soc. Indep. Artists. **Exhibited:** Fed. Art Project Gal., NYC; Salons of Am., 1932; GGE, 1939. **Work:** Municipal Mus., Wiston-Salem, NC. **Comments:** WPA artist. **Sources:** WW40.

VAN RENSSELAER, Mariana Griswold (Mrs. Schuyler) *[Critic; writer on art, architecture, and landscape design] b.1851, NYC / d.1934.*
Addresses: NYC. **Studied:** Columbia, 1910 (hon. degree). **Member:** AIA; Am. Soc. Landscape Arch. **Exhibited:** AAAL, 1923 (gold). **Comments:** Author: an authoritative biography of Henry H. Richardson, 1888; "English Cathedrals," "Six Portraits," "Art Out of Doors," "History of the City of New York in the Seventeenth Century," 1909; also contributed articles to journals.

VAN REUTH, Edward Felix Charles *[Painter] b.1836, Holland / d.c.1925, near Baltimore, MD.*
Addresses: Baltimore, MD. **Sources:** McMahan, *Artists of Washington, DC.*

VAN ROEKENS, Paulette Victorine Jeanne (Mrs. Arthur Meltzer) *[Painter, teacher] b.c.1897, Chateau Thierry, France / d.1988.*
Addresses: Glenside/Phila., PA, 1918-27; Langhorne, PA, 1928-; Huntingdon Valley, PA, 1959. **Studied:** PAFA with Charles Grafly, J. Pearson; G. Seyffert; Moore Inst.; Graphic Sketch Club, Phila.; Samuel Murray; Henry B. Snell. **Member:** NAWPS. **Exhibited:** PAFA Ann., 1918-34, 1937-39; Phila. Plastic Club, 1920 (gold); AIC, 1921, 1923, 1925, 1927-30; CI, 1922-24; Phila. Sketch Club, 1923 (gold); Corcoran Gal. biennials, 1921-43 (9 times); Montclair AM; Mint MA; Woodmere Art Gal., 1946 (prize); Phila. AC; Columbus Gal. FA, 1930; Mystic AA; Boston AC; Newport AA; NAWPS (prize); Phila. Art All. (solo); Delaware Bookshop, New Hope, PA; Newman's Gal., Phila., 1960; Moore Inst., 1961 (retrospective). **Work:** PAFA; Phila. Graphic Sketch Club; PAFA; Penn. State College; Reading MA; Woodmere Art Gal.; Phila. Sch. Des. **Comments:** Impressionist painter noted for her scenes of city life, picnics, country fairs, and the ballet. Also painted still lifes. Teaching: Moore IA, Phila., 1923-61. **Sources:** WW59; WW47; Danly, *Light, Air, and Color,* 79; Petteys, *Dictionary of Women Artists;* Falk, *Exh. Record Series.*

VAN ROIJEN, Hildegarde Graham *[Painter, sculptor]* b.1915, Wash., DC.
Addresses: Wash., DC. **Studied:** Rollins College; American Univ.; Corcoran Gal. Sch. Art, Wash., DC. **Member:** AEA; Studio Gal. Wash., DC; Northern Virginia Artists. **Exhibited:** Int. Printmakers Show & Int. Watercolor Show, Smithsonian Inst.; Phillips Gal.; Am. House, Vienna, Austria; Virginia Mus., Richmond; Corcoran Gal. **Awards:** first for "Pride's Sin," Univ. Virginia, Charlottesville, 1971. **Work:** drawings of Egypt, Brooklyn Mus, NY. Commissions: watercolor, Jr. League Hdqtrs., Wash., DC. **Comments:** Preferred media: metal, graphics. Positions: art therapist, St. Elizabeth's Hospital, Washington, DC. **Sources:** WW73.

VAN ROSEN, Robert *[Painter]* b.1904, Kiev, Russia / d.1966.
Addresses: NYC in 1923. **Exhibited:** Int. Exh., Radio City, NYC; "NYC WPA Art" at Parsons School Design, 1977. **Work:** WPA works at Univ. Minnesota, Queens College, etc. **Comments:** Scenic designer, "Peter the Great," produced by Maurice Schwartz, 1925; "King Saul," "Princess Turandot," "Empress of Destiny," and others. Was also an easel painter with a surrealist style. WPA artists, 1937-39. **Sources:** *New York City WPA Art,* 90 (w/repros.).

VAN ROSEN, Robert E. *[Industrial designer, theatrical designer, painter, lecturer]* b.1904, Kiev, Russia / d.1966, NYC.
Addresses: came from Rumania to NYC, 1923; residing in NYC in 1966. **Studied:** Municipal Sch. FA, Chisinau, Rumania; Master Inst. Un. Art., NYC. **Member:** Soc. Am. Military Engineers; Defendam Assn. **Exhibited:** Salons of Am., 1934; Packaging Expo., Chicago, 1952 (grand award); Eng. Constr. prize, 1953. **Work:** Queens College; Univ. Minnesota (WPA work, 1937- 39). **Comments:** Designer of theatrical productions, Provincetown Playhouse, Yiddish Art Theatre, NY. Lectures: art and theatre; stagecraft, for CAA in MMA, MoMA, BM. Positions: editor, *Scenic Artists Almanac,* published by United Scenic Art; curator, Roerich Mus., 1926-28; art director, IBM Corp. (*Think* magazine), 1940-42; chief designer, Gardner Board & Carton Co., Middletown, OH, 1950-52; design engineer, Robert Gair Co., New London, CT, 1952-53; industrial designer, Packaging Consultant, 1953-; pres., Videometric Comparator Co., NYC. Developed the Van Rosen Videometric Comparator, a machine to test legibility and visual impact, used, c.1966, by Armstrong Cork Co.; Container Corp. of America; General Foods; Milprint, Inc.; National Analysts, Inc.; Schenley Industries, Inc.; Sunshine Biscuit Co.; Geyer, Morey, Madder & Ballard, Inc.; Int. Paper Co. **Sources:** WW66.

VAN ROSSUM, W. J. J. *[Collector]* mid 20th c.
Addresses: Netherlands, Antilles. **Sources:** WW66.

VAN RYDER, Jack *[Etcher, painter, writer, illustrator]* b.1898, Continental, AZ / d.1968.

JACK VAN RYDER 1927

Addresses: Tucson, AZ. **Studied:** C.M. Russel, in Montana. **Member:** SI. **Work:** Guild Hall, East Hampton, NY. **Comments:** Contributor: *Literary Digest.* Illustrator: "Dust of the Desert." Specialty: Arizona, ranch life, cowboys, Indians. **Sources:** WW40; P&H Samuels, 497.

VAN RYN, Agnes See: **LOWRIE, Agnes Potter**

VAN RYZEN, Paul *[Painter]* early 20th c.
Addresses: Duluth, MN. **Sources:** WW25.

VAN SANTVOORD, Anna T. *[Painter]* early 20th c.
Addresses: NYC, c.1915. **Sources:** WW15.

VANSAUN, Peter D. *[Engraver]* mid 19th c.
Addresses: NYC, 1859-60. **Comments:** Of Horlor & Vansaun (see entry). **Sources:** G&W; NYCD 1859-60.

VAN SCHAICK, Stephen W. *[Illustrator, painter]* late 19th c.
Addresses: NYC, 1869-72, 1883-99; Paris, 1874-76. **Exhibited:** NAD, 1869-99; PAFA Ann., 1881, 1883. **Sources:** Falk, *Exh. Record Series.*

VAN SCHOICK, J. A. *[Portrait painter]* mid 19th c.
Addresses: Philadelphia, active 1834-37. **Sources:** G&W; Rutledge, PA; Phila. CD 1837.

VAN SCIVER, Pearl Aiman (Mrs. Lloyd) *[Painter, teacher]* b.1895, Philadelphia, PA / d.1966.
Addresses: Phila., PA. **Studied:** Moore Inst.; PAFA, and with Leopold Seyffert, Violet Oakley, Paula Balano, Eliot O'Hara, Henry B. Snell, Lazar Raditz. **Member:** Phila. Plastic Club; Nat. Lg. Am. Pen Women; NAWA; Woodmere Art Gal. (vice-pres.); Violet Oakley Mem. Foundation (vice-pres.); Women's City Club. **Exhibited:** NAD, 1923; PAFA, frequently; PAFA Ann., 1927 (prize), 1945; Corcoran Gal., 1921; NAWA, 1936-38; Germantown AL, 1937; Phila. Plastic Club (1 silver, 2 gold medals); Chestnut Hill (medal); Allentown Mus.; Cape May County Court House, NJ; Woodmere Art Gal.; Rochester Mem. Art Gal. **Work:** Univ. Penn.; Mem. Art Gal., Rochester, NY; Cape May Co. (NJ) Court House; Allentown (PA) Art Mus.; Woodmere Art Gal., Chestnut Hill, PA.; Ogontz Jr. College; mural decorations in children's wards, Jefferson Hospital, Phila., and Germantown (PA) Hospital. **Comments:** Specialized in flowers, landscapes, mural decorations. Married interior designer Lloyd Van Sciver. She was very active in Philadelphia art organizations. Positions: vice-pres., Woodmere Art Gal., c.1946-56; board of directors, Moore IA, Philadelphia, PA; Phila. Mus. of Art. **Sources:** WW59; WW47; WW24 (as Aiman); Petteys, *Dictionary of Women Artists;* Falk, *Exh. Record Series.*

VAN SCOY, Claire *[Painter]* b.1885, Iowa / d.1968, Los Angeles, CA.
Addresses: Los Angeles, CA. **Studied:** Chouinard Sch. Art. **Exhibited:** Progessive AC, Laguna Beach, 1939. **Sources:** Hughes, *Artists in California,* 574.

VAN SHECK, Sidney W. Jirousek *[Painter, lithographer, teacher]* mid 20th c.; b.Prague, Czech.
Addresses: Birmingham, AL. **Studied:** Académie Julian, Paris; École des Beaux-Arts, Paris. **Member:** Boston Soc. Indep. Artists; Alabama AL; Birmingham AC; SSAL; NSMP. **Exhibited:** Am. Adv. Dir., 1939 (prize). **Work:** H. Burroughs Newsboy Found.; portrait of Pres. & Mrs. T.G. Masaryk, Prague; Richmond Theatre, North Adams, MA; Capitol, Little Rock, AR; Woodlaw Auditorium, Birmingham. **Sources:** WW40.

VAN SICKLE, Adolphus *[Artist and photographer]* b.1835, Delaware County, OH.
Comments: Son of Selah Van Sickle. His childhood was spent in Ohio, Illinois, and Michigan, but he was married in November 1871 at Elkhart (IN). Two years later he moved to Kalamazoo (MI) where he was in business as a photographer at least until 1880. **Sources:** G&W; Van Sickle, *A History of the Van Sickle Family,* 228; information in G&W was courtesy Wilbur D. Peat who cites Bartholomew's *History of Elkhart, Indiana* (1930).

VAN SICKLE, J. N. *[Portrait painter]* mid 19th c.
Addresses: Xenia, OH in 1855. **Sources:** G&W; Information courtesy Edward H. Dwight, Cincinnati Art Museum.

VAN SICKLE, Joseph L. *[Painter]* mid 20th c.; b.Anderson, IN.
Addresses: Nashville, TN; Elkhart, IN. **Studied:** John Herron Art Inst. (B.A.); Univ. Iowa (1945, M.A.). **Exhibited:** Tennessee State Fair, 1955 (grand prize; first prize); John Herron Art Inst., Indianapolis (Paton Studio Prize). **Work:** Tennessee State Mus. **Comments:** Painted figures, landscapes. Positions: designer, cabinets and equipment, RCA; teacher, Ward-Belmont Col., Nashville, five years; visiting artist, Vanderbilt Univ., early 1950s for two years. He operated an art studio and school on Music Row for three years. Head of art program, public schools, Elkhart, IN, late 1950s. **Sources:** Kelly, "Landscape and Genre Painting in Tennessee, 1810-1985," 128-29 (w/repro.).

VAN SICKLE, Selah *[Portrait and panorama painter]* b.1812, Cayuga, now Tompkins, County, NY / d.After 1880.
Work: La Porte (IN) Hist. Mus. **Comments:** Moved with his family to central Ohio in 1817. He was married in 1834 in

Delaware County (OH) and lived there until 1845 when he moved to Nauvoo (IL). There he painted a portrait of Brigham Young. Moved to St. Joseph County (MI) in 1846 and is known to have visited La Porte (IN) in 1849, when he painted a portrait now in the La Porte Historical Museum. In 1851 he moved back to Delaware County (OH) and in 1853-54 he painted a panorama of the life of Christ. He later made farming his career, working in Morrow County (OH) from 1857-63, Clinton County (MI) 1863-73, Marshall County (IA) 1873-76, and again in Clinton County (MI) where he was living in 1880. **Sources:** G&W; Van Sickle, *A History of the Van Sickle Family*, 207-09.

VAN SLOUN, Frank J. *[Painter, etcher, teacher] b.1879, St. Paul, MN / d.1938, San Francisco, CA.*
Addresses: San Francisco, CA. **Studied:** St. Paul School FA, 2 years; ASL with Robert Henri; Chase Sch. Art. **Member:** Int. des Beaux Arts et des Lettres, 1909; San Francisco AA; Calif. SE; Soc. Mural Painters; Carmel AA; Bohemian Club. **Exhibited:** Corcoran Gal. biennial, 1910; Pan-Pacific Expo, San Francisco, 1915 (medal); Galerie Beaux Arts, San Francisco, 1926; San Francisco AA, 1908-38; GGE, 1939; CPLH, 1942 (solo); Triton Mus., Santa Clara, 1958 (solo); Calif. Hist. Soc., 1975 (solo). **Work:** Mills College, Oakland; Canterbury Hotel, San Francisco; Elks Club, San Francisco; Calif. State Lib.; Bohemian Club (murals); Mayor's Office, Oakland City Hall; State Lib. and Court Bldg., Sacramento; Mark Hopkins Hotel, San Francisco; Oakland Mus. **Comments:** Together with Robert Henri (see entry) he helped found the Society of Independent Artists and their first exhibit. He attained recognition as a painter as well as an educator. Teaching: Calif. School of FA, 1917; ASL, 1919; Univ. Calif., Berkeley, 1926. **Sources:** WW33; Hughes, *Artists in California*, 574.

VAN SLYCK, Wilma Lucile *[Painter] b.1898, Cincinnati, OH.*
Addresses: Cincinnati, OH. **Studied:** H.H. Wessel; J.R. Hopkins; J.E. Weis; Hawthorne; I.C. Olinsky. **Member:** Cincinnati AC; S. Indp. A. **Exhibited:** Salons of Am., 1926-27; S. Indp. A., 1927-28. **Work:** Circ. Gal., Dayton AI. **Sources:** WW33; Petteys, *Dictionary of Women Artists*.

VAN SOELEN, Theodore *[Landscape and portrait painter, lithographer, writer, illustrator] b.1890, St. Paul, MN / d.1964, Santa Fe, NM.*
Addresses: Santa Fe, NM, since 1922/second studio in Cornwall, CT, by 1930s. **Studied:** St. Paul AI, 1908-11; PAFA, 1911-15 (Cresson travel scholarship to Europe; visited Holland, Italy, England, and France 1913-14). **Member:** ANA, 1933; NA, 1940; Century Assn.; fellow, PAFA, 1931. **Exhibited:** New Mexico Painters Soc.; Carnegie Inst.; PAFA Ann., 1915-1941; MMA; MoMA; SFMA; LACMA; San Diego FA Soc.; Corcoran Gal biennials, 1921-43 (11 times); AIC; NAD, 1927 (prize), 1930 (prize); New Mexico State Fair, 1944 (prize), 1945 (prize); Sesquicentennial Expo, Phila., PA, 1926 (medal). **Work:** PAFA; NAD; Everhart Mus., Scranton, PA; IBM; Mus. New Mexico, Santa Fe; Public School, Phila., PA; Public School, Denver, CO; LOC; murals, Grant County Court House (WPA project), Silver City, NM; WPA murals, USPOs Portales, (NM), Waureka (OK), Livingston (TX); Loomis Inst., CT; IBM Corp. **Comments:** After studying at PAFA, Van Soelen painted snow scenes with other Pennsylvania Impressionists, including Daniel Garber. However, when he became seriously ill with pneumonia and tuberculosis during the winter of 1916, his doctor advised him to go to Albuquerque (he also visited the Utah-Nevada mountains), where he established himself as a painter-illustrator of Western landscapes, ranch scenes. In 1922 he moved to Santa Fe and in 1926 became a permanent resident of Tesuque. Contributor: *Field & Stream.* **Sources:** WW59; P&H Samuels, 497; Eldredge, et al., *Art in New Mexico, 1900-1945*, 208; Danly, *Light, Air, and Color*, 80; Falk, *Exh. Record Series.*

VAN STAVOREN, Joseph H. *[Portrait painter] d.1893.*
Addresses: Cincinnati, OH, 1845-46; Niles, MI, 1851; Nashville, TN; Atlanta, GA, 1877-93. **Exhibited:** Fireman's Fair, Cincinnati, OH, 1845. **Work:** Notre Dame Univ. (portrait of Alexis

Coquillard at South Bend, IN, 1847). **Comments:** His last name has also appeard as Van Favoren. **Sources:** G&W; Cincinnati CD 1846 (s Van Stavoren); Peat, *Pioneer Painters of Indiana*, 139; Hageman, 123 (as Van Favoren); Gerdts, *Art Across America*, vol. 2: 68 (as Joseph H. Van Stavoren); Gibson, *Artists of Early Michigan*, 231 (as Van Stavoren).

VAN STOCKUM, Hilda See: **MARLIN, Hilda Van Stockum**

VANSTRYDONCK, Charles *[Lithographer] mid 19th c.*
Addresses: NYC, 1859. **Comments:** Of Verelst & Vanstrydonck (see entry). **Sources:** G&W; NYCD 1859.

VAN SWEARINGEN, Eleanore Maria (Mrs. E. K.) *[Printmaker, designer, craftsperson, teacher] b.1904, Luzon, Philippines.*
Addresses: Wash., DC. **Studied:** Bryn Mawr College (B.A.); Stanford Univ. **Member:** Honolulu PM. **Exhibited:** Honolulu AA, 1940, 1946; Phila. Print Club, 1946; Oakland Art Gal., 1935-36; Honolulu PM, 1940-42, 1945; Northwest PM, 1939; Phila. Artists All., 1938; Denver AM, 1940; Sydney, Australia, Art Mus., 1942. **Sources:** WW53; WW47.

VAN SWEARINGEN, Norma *[Painter] b.1888, San Marcial, NM.*
Addresses: Active in Santa Fe, 1910-on. **Exhibited:** Mus. New Mexico, Santa Fe, 1930. **Sources:** Petteys, *Dictionary of Women Artists*.

VAN SYCKLE, Sarah E. *[Artist] late 19th c.*
Addresses: Active in Grand Rapids, MI, 1889. **Sources:** Petteys, *Dictionary of Women Artists*.

VANT, Margaret Whitmore *[Craftsperson] b.1905.*
Addresses: Brighton, MA. **Studied:** Mass. School Art; G.J. Hunt. **Member:** Boston SAC (Master Craftsman). **Comments:** Specialty: jewelry. **Sources:** WW40.

VANT HOFF, Annaleida (Amaleida) (Mrs.) *[Painter] mid 20th c.*
Studied: ASL. **Exhibited:** S. Indp. A., 1939. **Sources:** Marlor, *Soc. Indp. Artists*.

VAN THORSEN, Peter H. *[Painter, decorator] b.c.1851, New Orleans, LA / d.1908, New Orleans.*
Addresses: New Orleans, active 1880-1908. **Sources:** *Encyclopaedia of New Orleans Artists*, 390.

VAN TRUMP, L. *[Painter] late 19th c.; b.Baltimore, MD.*
Exhibited: Paris Salon, 1892. **Sources:** Fink, *American Art at the Nineteenth-Century Paris Salons*, 400.

VAN TRUMP, Rebecca Newbold *[Portrait painter, miniature painter] 19th/20th c.; b.Philadelphia, PA.*
Addresses: Phila., PA; Paris, France. **Studied:** PAFA; Académie Julian, Paris with T. Robert-Fleury and Boulanger; A. Mollin, Corot & Courtois in Paris. **Exhibited:** PAFA Ann., 1879-1903 (12 times); Paris Salon, 1893; Phila. AC, 1898; Columbian Expo, Chicago, 1893; AIC. **Sources:** WW17; Fink, *American Art at the Nineteenth-Century Paris Salons*, 400; Falk, *Exh. Record Series.*

VAN TYNE, Peter *[Painter] b.1857, Flemington, NJ.*
Addresses: Lambertville, NJ. **Studied:** ASL; PAFA. **Exhibited:** Trenton Fair, 1925 (prize), 1926 (prize). **Sources:** WW40.

VANURANKEN, John *[Engraver] mid 19th c.*
Addresses: NYC, 1846-54. **Sources:** G&W; NYBD 1846, 1854.

VANUXEM, E. *[Painter] late 19th c.*
Addresses: Bristol, PA. **Exhibited:** PAFA Ann., 1881-82. **Sources:** Falk, *Exh. Record Series.*

VAN VALKENBURG, L. *[Painter] late 19th c.*
Addresses: NYC, 1884. **Exhibited:** NAD, 1884. **Sources:** Naylor, *NAD.*

VAN VALKENBURGH, Peter *[Painter, lithographer, teacher, writer] b.1870, Greenbush, WI / d.1955, Piedmont, CA.*
Addresses: Watsonville, CA/Piedmont, CA. **Studied:** Chicago

Acad. Art; AIC; Francis Smith; John Vanderpoel. **Member:** Calif. Writers Cl.; Illinois A. Cl. **Exhibited:** Oakland Art Gal. (solo); SFMA (solo); Claremont (CA) Art Gal. (solo); Faculty Club & Lib., Univ. Calif. (solo); Stanford Univ. (solo); Paul Elder Gal., San Francisco (solo); Iowa State College, Ames, 1939; Bureau of Reclamation, Denver, 1939. **Work:** Acad. Science, NY (portraits of Am. scientists); Stanford Univ.; Univ. California (1948-52, for Bancroft Library, Berkeley); Calif. Inst. Technology; Calif. Acad. Science, San Francisco; Oakland Pub. Lib.; Iowa State Col.; Bureau of Reclamation, Denver, CO; Univ. Southern California, Los Angeles. **Comments:** WPA printmaker in California, 1930s. **Sources:** WW53; exh. cat., Annex Gal. (Santa Rosa, CA, n.d., c.1988).

VAN VECHTEN, Duane *[Painter] mid 20th c.*
Addresses: Chicago area. **Exhibited:** AIC, 1928-29. **Sources:** Falk, *AIC.*

VAN VEEN, Pieter (J. L.) *[Painter] b.1875, The Hague, Netherlands / d.1961, Tacoma, WA.*
Addresses: NYC/Paris, France; Tacoma, WA, 1941. **Studied:** Royal Acad. Arts, The Hague, 1888-89; Barbizon, France with Henri Harpignies; 1898 with Auguste Renoir; Italy, Greece. **Member:** SC; NAC; New York Municipal AS; Allied AA. **Exhibited:** Salon d'Automne, 1905; Galerie Luxembourg, 1905; regularly at Paris Salons, 1905-15; S. Indp. A., 1917; NGA, 1928; France, Cross of Legion of Honor, 1929 (series of 36 paintings of the Gothic cathedrals); Salons of Am.,1934; Frye AM, 1998; widely in Europe and the U.S. **Work:** Butler AI; Collection H.H. Queen of Belgium; SAM; H.C. Henry Collection, Univ. Washington; BMFA; AIC; French Embassy, Wash., DC; Washington State Univ.; Pullman Nat. Art Club New York; Tacoma (WA) Art Mus. **Comments:** Van Veen had traveled, painted and exhibited in Europe before emigrating to the U.S. in 1915. About this time a studio flood in Paris destroyed his stored work. He traveled and painted landscapes in the West, in New England and in Illinois until 1923, when he rented a studio in Paris and began painting his series of French cathedrals. In 1925 he returned to NY and in 1931 began work on a series of floral still lifes. **Sources:** WW40; Kollar, Allan J., *The Paintings of Pieter J. L. Van Veen* (exhib. cat., Frye Art Museum, 1998).

VAN VEEN, Stuyvesant
[Painter, mural painter, educator]
b.1910, NYC / d.1977.
Addresses: Cincinnati, OH, 1947; NYC, 1973. **Studied:** PAFA; NAD; ASL; New York School Industrial Art; Columbia; Daniel Garber; Thomas Benton; David Karfunkel. **Member:** AWCS; Nat. Soc. Painters Casein (bd. directors, 1953); NSMP (treasurer, 1960); AEA (pres., 1958-59); NIAL; Mural AG; Am. Artists Congress; Artists Lg. Am. **Exhibited:** CI, 1929 & 1943; AIC, 1930-46; S. Indp. A., 1930; PAFA Ann., 1930, 1933-34, 1938; PAFA, 1940, 1941, 1943; BMFA, 1929, 1936; BM, 1929, 1936; CAM, 1929, 1936, 1939, 1943; Minnesota IA, 1929, 1936, 1939; WMAA, 1935-40; MoMA, 1934, 1937, 1939; CGA, 1935-36, 1939, 1941; Cincinnati AM, 1936-49; Syracuse MFA, 1939; NGA, 1942, 1944; McDonald Club, 1936 (prize); Ohio Valley Exhib., Athens, OH, 1945 (prize), 1946 (prize); Wright Field Army Artists, 1945 (prize); State Wide Army Artists Competition, 1945 (prize); NAD, 1965-69; Am. Acad. Arts & Letters, 1961 (Childe Hassam purchase award); Am. Soc. Contemporary Artists, 1966 (Nelson Whitehead Prize); Silvermine Guild Artists, 1968 (prize, New England Annual); "NYC WPA Art" at Parsons School Design, 1977; ACA Gal., NYC, 1970s. **Work:** Walker Art Center; Ohio Univ.; New Jersey State Mus., Trenton; MMA; Frick Collection; Norfolk (VA) Mus. Arts & Sciences; Newark (NJ) Mus.; Fairleigh Dickinson Univ., NJ; Smithsonian Inst.; NYHS. **Commissions:** WPA mural USPO, Pittsburgh ("Pittsburgh Panorama" mural, commissioned by U.S. Treasury Dept., 1937); "The Story of Pharmacy" (mural), New York World's Fair, World's Fair Corp, 1938; "Synthesis" (mural) & "Security" (mural), for courtrooms in Juvenile & Domestic Relations Court, Phila. (murals comm. by Philadelphia Art Commission); Riverside Mem.

Chapel, NY(WPA murals); Mackley Mem. Public Library, Juniata Park, PA (WPA murals); Fordham Hospital (WPA murals); Labor Bldg., Washington, DC (WPA murals); Queens Public Library; Westinghouse Corp., Trafford City, PA (WPA murals); Seagram Corp. (WPA murals); Wright-Paterson Air Force Base, Ohio Headquarters Bldg., U.S. Air Force, 1945, ("Bridge of Wings," mural); Ebbets Field Apts., Brooklyn, NY, HFH Corp., 1963 (Dodgers Victories, murals for seven lobbies). **Comments:** WPA artist. Preferred media: oils, watercolors, gouache. Teaching: art instructor, private classes, 1930-41; instructor & supervisor painting & drawing, Cincinnati Art Acad., 1946-49; assoc. prof. art, CUNY, 1949-73. Other positions: research asst., dept. anthropology, Columbia Univ., 1935-138; art dir., Cincinnati Ord. District, War Dept., 1942-43; co-founder & set designer, State Ins., Cincinnati Civic Theater, 1948-49; art & mural consultant, Int. Fair Consultants, 1962-63. Publications: illustrator, "The Fairy Fleet;" literary satires in *Nation; New Masses*; illustrator, *Fortune,* 1935; illustrator, "Gesture & Environment," Kings Crown, 1935-38, Mouton, 1972; illustrator, "The Rebel Mail Runner," *Holiday,* 1954; illustrator, "Garibaldi," Random, 1957; illustrator, "The Art of Making the Dance," Rinehart, 1960; illustrator & comment, "Gesture, Lace and Culture," rev. ed. **Sources:** WW73; WW47; *New York City WPA Art,* 91 (w/repros.); Falk, *Exh. Record Series.*

VAN VLECK, Durbin *[Wood engraver] mid 19th c.*
Addresses: San Francisco, 1856 until at least 1867. **Exhibited:** American Inst., 1851. **Sources:** G&W; Am. Inst. Cat., 1851; San Francisco CD 1856, BD 1858-59; Hamilton, *Early American Book Illustrators and Wood Engravers,* 345, 416.

VAN VLECK, Natalie *[Painter, craftsperson, framemaker] b.1901, NYC / d.1981, Woodbury, CT.*
Addresses: NYC (1912-28); Woodbury, CT (1928-on). **Studied:** ASL with Agnes Richmond (1914-19), Geo. Bridgman (1919), Robert Henri (1920), and Max Weber (1921-22). **Exhibited:** Brownell-Lambertson Gal, 1932 (solo); Town of Woodbury, 1937, 1938 (loan exhibitions). **Work:** Flanders Nature Center, Woodbury, CT. **Comments:** Van Vleck was among the earliest American women modernists, working in a cubist style in the early 1920s. Around 1924, she established a "Wood Carving" studio on 45th Street where she carved picture frames, screens, panels, cabinets, boxes, and other carved objects. She painted in Mallorca (1922), the Caribbean (1924, 1926, 1929), and spent the winters of 1930-32 on the island of Moorea near Tahiti. Her cubist-style paintings and woodblocks of the early 1920s evolved toward a form of regionalism, yet her works from Tahiti are unique in their rhythmical style, recalling the jungle fantasies of Henri Rousseau. In 1928, she settled at her family's farm in Woodbury, CT and designed and built her own English-style studio there; she designed every fixture, and even welded her own modernist aluminum furniture. She stopped painting in 1934, most likely because she devoted her full time to developing her 200-acre farm. Known as a woman of enormous energy, she single-handedly developed a successful turkey business, raised prize Hampshire sheep, and built an orchid greenhouse. In 1963 she fulfilled her dream of chartering her farm as the Flanders Nature Center, a land trust which maintains nature trails and conservancy programs. **Sources:** Peter Falk, *Natalie Van Vleck, A Life in Art and Nature* (Madison: Sound View Press, 1992); Art in Conn.: Between World Wars.

VAN VLECK, Natalie Johnson *[Portrait painter] early 20th c.*
Addresses: NYC. **Studied:** ASL. **Member:** S. Indp. A. **Exhibited:** S. Indp. A., 1918-22, 1924-27; Salons of Am., 1924-25; American-Anderson Gal, NYC, 1932. **Comments:** Mrs. Charles E. Van Vleck was a wealthy conventional portrait painter of New York's high society. Coincidentally, her contemporary, *Cf.* Natalie Van Vleck, was a distant cousin. **Sources:** WW25.

VAN VLIET, Willem *[Painter] mid 20th c.*
Addresses: Westbrook, ME. **Exhibited:** S. Indp. A., 1924-25. **Sources:** Marlor, *Soc. Indp. Artists.*

VAN VOAST, Virginia Remsen *[Painter, etcher, craftsperson]* b.1871, Columbia, SC.
Addresses: Cincinnati, OH. **Studied:** Cincinnati Art Acad.; Henry Sharp; George Pearse Ennis; Anthony Thieme. **Member:** Cincinnati Woman's AC; Cincinnati Professional Artists. **Exhibited:** Phila. WCC, 1934; Ohio PM, 1937; Cincinnati Mus., 1939. **Sources:** WW53; WW47.

VAN VOORHEES, Linn *[Illustrator]* mid 20th c.; b.Atlanta, GA.
Addresses: NYC. **Member:** SI. **Sources:** WW53; WW47.

VAN VOORHEIS, H. M. (Mrs.) *[Painter]* late 19th c.
Addresses: Jackson, MI, 1876. **Exhibited:** Michigan State Fair, 1876. **Comments:** Preferred medium: watercolor. **Sources:** Gibson, *Artists of Early Michigan*, 231.

VAN VOORHIS, Louise See: **ARMSTRONG, Louise (Mrs.) Van Voorhis**

VAN VORST, Garrett W. *[Painter]* early 20th c.
Addresses: NYC. **Member:** SC. **Sources:** WW25.

VAN VORST, Marie *[Painter, writer]* b.1867, NYC / d.1936, Florence, Italy.
Addresses: Rome, Italy, 1916-. **Comments:** A writer of novels, she turned to painting when she was 53, and in less than a year had painted more than fifty pictures.

VAN WAGENEN, Elizabeth Vass (Mrs.) *[Painter, teacher]* b.1895, Savannah, GA / d.c.1955, Philadelphia, PA.
Addresses: Danville, VA. **Studied:** ASL; E. Ambrose Webster; Henry Lee McFee; D. Garber; J.T. Pearson; K.H. Miller; G. Bridgman. **Member:** SSAL; Virginia Artists All.; AFA; Danville AC. **Exhibited:** Salons of Am., 1926-27; VMFA; Virginia Art Exhib., NY, 1937. **Comments:** Teaching: Stratford College, Danville, VA. **Sources:** WW53; WW47.

VAN WART, Ames *[Sculptor]* b.NYC / d.1927, Paris.
Addresses: NYC, 1872; Nevilly (Paris), France. **Studied:** Hiram Powers. **Member:** Century Assn. **Exhibited:** NAD, 1872; Paris Salon, 1904-05 (busts). **Work:** MMA. **Comments:** Active in NYC beginning in 1870. **Sources:** WW25; P&H Samuels, 497-98.

VAN WERVEKE, George *[Illustrator]* early 20th c.
Addresses: NYC. **Member:** SI; Artists Guild. **Sources:** WW33.

VAN WESTRUM, Anni Baldaugh See: **BALDAUGH, Anni von Westrum (Mrs. Frank)**

VAN WESTRUM, Anni Schade *[Painter]* early 20th c.
Addresses: NYC, 1911; active in Merchantville, NJ, c.1913-21. **Member:** CAFA. **Exhibited:** PAFA Ann., 1911. **Comments:** Cf. Anni Von Westrum Baldaugh, who is said to have came to the U.S. prior to WWI; it is very likely they are same person. **Sources:** Petteys, *Dictionary of Women Artists;* Falk, *Exh. Record Series.*

VAN WILLIS, A. See: **WILLIS, Edmund Aylburton**

VAN WILLIS, Edmund See: **WILLIS, Edmund Aylburton**

VAN WINCKEL, Dorothy D. (Mrs. E. T.) *[Educator, graphic artist, painter]* mid 20th c.; b.Chattanooga, TN.
Addresses: Fredericksburg, VA. **Studied:** Univ. Tennessee (B.S. in Educ.); Peabody College (M.A.); PAFA; Harvard Univ. (summer); ASL; Saugatuck (MI) Sch. Painting. **Member:** CAA; NAWA; AAUW; VMFA. **Exhibited:** Phila. Pr. Club, 1948; NAWA, 1948-49, 1955 and traveling exh. to Paris, 1948; LOC, 1949; SAGA, 1950; VMFA, 1945, 1947, 1951, 1955; Wash. WCC, 1948-51; Norfolk Mus. Arts & Sciences, 1948; Albany Pr. Club; Mary Washington College (solos). **Awards:** Carnegie Art Scholarship to Harvard, 1938; prizes, Phila. Pr. Club, 1948 (purchase); NAWA, 1949; Certificate of Merit, Bibliographical Soc. of the Univ. Virginia, 1951. **Comments:** Teaching: Mary Washington College of the Univ. of Virginia, Fredericksburg, VA. Co-sponsor with faculty members & the college of a selected Exh. of Modern Art by professional artists, in November of each year. Purchases made to add to college collection. **Sources:** WW66.

VAN WINKLE, Emma Farrington *[Painter]* b.1850, Bangor, ME / d.1931, San Francisco, CA.
Addresses: Ferndale, CA. **Studied:** Calif. Sch. Des. with Joullin, Yelland & Mathews. **Member:** San Francisco AA. **Exhibited:** Humboldt County Fair, Ferndale, CA, 1878; Rohnerville Fair, 1885 (first prize); Calif. State Fair, 1885, 1902; San Francisco AA, 1903. **Work:** de Young Mus. **Sources:** Hughes, *Artists in California*, 575.

VAN WINKLE, Evelyn *[Miniature painter, designer, graphic artist, printmaker]* b.1885.
Addresses: White Plains, NY. **Studied:** D. Volk; Gifford; J. Twachtman. **Member:** Westchester ACG; Studio Guild; Ten Talents GA&C (pres.). **Sources:** WW40.

VAN WINKLE, Lester *[Sculptor]* b.1944.
Addresses: Richmond, VA. **Exhibited:** WMAA, 1973. **Sources:** Falk, *WMAA.*

VAN WOLF, Henry *[Sculptor, painter]* b.1898, Regensburg, Bavaria / d.1982.
Addresses: Van Nuys, CA. **Studied:** Munich Art School, 1912-16; sculpture & bronze technique with Ferdinand von Miller, 1919-22, 1923-26. **Member:** NSS; AAPL; Calif. AC; San Fernando Valley AC; Am. Inst. Fine Arts (fellow); Valley Artist's Guild (founder, pres.); Fed. Int. Medaille; Traditional Artists Soc. (director council). **Exhibited:** BM, 1932; Springfield MA, 1938; All. Artists Am., 1936-37; Arch. Lg., 1937; Calif. AC, 1944-46; Los Angeles, 1945; Valley Art Guild, 1948-72 (seven awards); Los Angeles City Art Exhib., 1949, 1966 & 1970 (awards each year); Int. Contemporary Religious Sculptured Medals, Rome, Italy, 1963; Int. Exhib. Contemporary Sculptured Medals, Athens, Greece, 1966 & Paris, France, 1967; NSS (Nat. Award, 1962). **Work:** commissions: WPA work, USPO, Fairport, NY; Bethlehem Steel Co., NY; bronze statue of an American Indian (Fernando), Van Nuys Mall, CA; bronze mem. bust of Einstein, erected at Albert Einstein Medical Center, Phila.; sculpture group, Garden Grove, CA; sculptured bronze doors, St. Nicholas Episcopal Church, Encino, CA; bronze monument of Martin Luther King, Jr., Martin Luther King Elem. School, Compton, CA. **Comments:** WPA artist. **Sources:** WW73; WW47; article, *Enciclopedia Int Degli Artisti, 1970-71*; article, Margaret Harold publications of prize-winning sculpture book 7.

VAN WYCK, Matilda See: **BROWNE, Matilda (Mrs. F. Van Wyck)**

VAN WYCK, Prescott *[Painter]* mid 20th c.
Addresses: Summit, NJ. **Studied:** ASL. **Exhibited:** S. Indp. A., 1927. **Sources:** Marlor, *Soc. Indp. Artists.*

VAN YOUNG, Loli See: **VANN, Loli (Lilian) (Mrs. Oscar Van Young)**

VAN YOUNG, Oscar *[Painter, lithographer, instructor]* b.1906, Vienna, Austria / d.1993, Los Angeles, CA?.
Addresses: Los Angeles, CA. **Studied:** Acad. FA, Odessa, Russia; T. Geller; E. Armin; Sam Ostrowsky, Paris, France & Chicago; Calif. State Univ., Los Angeles (B.A.; M.A.). **Member:** Calif. WCS; Council All. Artists, Los Angeles; Chicago SA; Am. Artists Congress; United Am. Artists, Chicago. **Exhibited:** AIC, 1937-39, 1942, 1945-46 (Am. Paintings & Int. Watercolor Shows); GGE, 1939; Pepsi-Cola, 1945-46; NAD; VMFA, 1946; San Francisco AA, 1941-42, 1944-45; Corcoran Gal biennials, 1941, 1947; Oakland Art Gal., 1943, 1945; Santa Barbara MA, 1944, 1946 (solo); Denver AM, 1943, 1945; San Diego FAS, 1941; LACMA, 1941-42 (solo), 1943-45; Vigeveno Gal., 1942 (solo); SFMA, 1943 (solo); CPLH, 1946; Pasadena AI, 1945 (solo); Dayton AI, 1937; Kansas City AI, 1938; Calif. WC, 1943; Encyclopedia Britannica Collection (10 Painters of the West); Virginia Mus. biennial; Chaffey College, Ontario, CA (purchase prize); Frye Mus., Seattle, WA (purchase award); Maxwell Gal, San Francisco, CA, 1970s. **Work:** LACMA; Chaffey College,

Ontario, CA; Frye Mus., Seattle, WA; Int. Lithography & Engraving, City of Chicago; Santa Barbara (CA) Mus. ("Mother & Child," drawing). **Comments:** Preferred media: oils. Teaching: Otis AI, 1954-56; Pasadena City College, 1959-; Los Angeles State Univ., 1961-63. **Sources:** WW73; WW47; Arthur Millier, article, *Los Angeles Times;* Jules Langsner, article, *Art News;* Ronald D. Scofield, *California Painter Turns Against Early Realism* (San Barbara).

VAN ZANDT, Hilda (Mrs.) *[Painter, teacher] b.1892, Henry, IL / d.1965, Long Beach, CA.*
Addresses: San Pedro, CA. **Studied:** UCLA. **Member:** Calif. AC; Calif. WCS; Women Painters of the West. **Exhibited:** LACMA, 1928 (solo); Calif. WC. Soc., 1926-36; Wilshire Art Gals.; Los Angeles, 1929; Calif. AC, 1930. **Work:** Women's Club, Baldwin Park, CA. **Comments:** Teaching: Fremont H.S., Los Angeles. Her travels to South America, Africa and Spain are reflected in her paintings. **Sources:** WW40; Hughes, *Artists in California,* 575; Petteys, *Dictionary of Women Artists.*

VAN ZANDT, Origen A. *[Painter] 19th/20th c.*
Addresses: NYC, 1897. **Exhibited:** NAD, 1897; Phila. AC, 1898. **Sources:** WW01.

VAN ZANDT, Thomas Kirby *[Portrait and animal painter] b.1814 / d.1886.*
Addresses: Albany, NY, from c.1844 until his death. **Exhibited:** NAD, 1844. **Work:** Albany Inst. of History and Art. **Comments:** Van Zandt was a portraitist who also specialized in horses, vehicles, and riders. **Sources:** G&W; Cowdrey, NAD; Albany CD 1846-60+; *Panorama* (Dec. 1946), 45. More recently, see Gerdts, *Art Across America,* vol. 1: 175-76.

VAN ZANDT, William Thompson *[Portrait, miniature & genre painter] b.1819, NYC / d.c.1890.*
Addresses: NYC, active 1844-45. **Exhibited:** NAD, 1844-45. **Comments:** He was from a family of merchants and landowners that had owned a large part of lower Manhattan for more than 200 years. In 1838, at age 19, he went to Paris to study art. His family owned a large home on the Cour de la Reine near the Seine River. In 1848, his 10-year residence in Paris ended due to political unrest, and the family returned to NYC. He then painted society portraits, particularly of women, in oil and in watercolor miniature on ivory. His career in art appears to have ended in 1861. With the beginning of the Civil War, he became actively involved with his friend, Thomas Austin, in helping slaves escape to the North via the "Underground Railroad"; thereafter, family real estate management demanded his time and it appears he did not return to painting. **Sources:** G&W; Cowdrey, NAD; Cowdrey, AA & AAU; NYCD 1845; more recently, PHF files courtesy family heirs.

VARADAY, Frederic *[Illustrator, painter] b.1908, Budapest, Hungary.*
Addresses: NYC. **Studied:** Royal Hungarian Acad. **Member:** SI. **Comments:** Left Hungary in 1927 and worked in Istanbul, Paris and Berlin, before coming to the U.S. Illustrator: *Cosmopolitan, Good Housekeeping, The Saturday Evening Post,* and others. **Sources:** WW47; W & R Reed, *The Illustrator in America,* 246.

VARAIN, Dorothy *[Painter] b.1895, NYC.*
Addresses: NYC/Paris, France. **Exhibited:** S. Indp. A., 1922. **Sources:** Marlor, *Soc. Indp. Artists.*

VARBROUGH, Vivian S. *[Painter] mid 20th c.*
Exhibited: Salons of Am., 1934. **Sources:** Marlor, *Salons of Am.*

VARDA, Jean *[Painter] b.1893, Smyrna, Greece / d.1971, Mexico City, Mexico.*
Addresses: Paris, France; NYC; California. **Exhibited:** GGE, 1940. **Comments:** Immigrated to NYC in 1939 and went to California the following year. At first he lived in an old barn and later settled on a houseboat in Sausalito. Specialty: portraits, mosaics, collages. **Sources:** Hughes, *Artists in California,* 575.

VARECK, A. M. *[Painter] 19th/20th c.*
Addresses: Yonkers, NY. **Exhibited:** NYWCC, 1898. **Sources:**

WW01.

VARGA See: VARGAS, Alberto

VARGA, Ferenc *[Sculptor] 20th c.; b.Szekesfehervar, Hungary.*
Addresses: Delray Beach, FL. **Studied:** Acad. Fine Arts, Budapest, Hungary, with Prof. Eugene Broy & Prof Francis Sidlo; govt. scholarship, Italy, 1938 & France, 1942. **Member:** Fine Arts & Sciences Soc. of Church of Hungary, Budapest; Acad. Cath. Hungarica Sciences Atrib. Prov., Vatican City; NSS. **Exhibited:** Nat. Art Gallery, Budapest, 1942; Exhib. Ecclesiastical Arts Guild, Detroit, 1952; NSS, New York, 1959; Masters' Gallery, Toronto, Ontario, 1964 (solo); Eszterhazy Gallery, Palm Beach, FL, 1971. Awards: Lord Rotheremere Award, 1928 & Ball Ede scholarship, Govt. Hungary, 1942; Medal of Bethlehem Distinction, Fine Arts & Sciences Soc. of Church of Hungary, 1947. **Work:** Nat. Art Gal., Budapest; Mus. Fine Arts, Budapest; Vatican Mus., Rome, Italy; Mus. Zurich, Switzerland. Commissions: portrait, vice-regent of Hungary, Budapest, 1942; monument, City of Windsor, Ontario, Canada, 1950; group of statues, Ft. Lincoln Mem., Wash., DC, 1955; monument, City of Detroit, MI, 1966; bust, Ford Auditorium, Detroit, 1972. **Comments:** Preferred media: bronze, marble, wood. Teaching: Acad. FA, Budapest, 1928-40. **Sources:** WW73; Dr. E. Schwartz, *Ferenc Varga,* (Ons Volk, Brussels, 1949) & *Lasst uns nach Bethlehem eilen* (Am.-Ung. Verlag, Cologne, 1959); J.P. Danglade, "Magnificent Statue of the Christ by Sculptor Varga," *The Cemeterian* (Columbus, 1962).

VARGA, Margit V. *[Painter, writer] b.1908, NYC.*
Addresses: Brewster, NY, 1947; Bridgehampton, NY, 1973. **Studied:** ASL with Boardman Robinson, Robert Laurent; NAD; Columbia Univ. **Exhibited:** Salons of Am., 1930-31, 1934; S. Indp. A., 1930-31; RISD; Nebraska AA; GGE, 1939; Cranbrook Acad. Art, 1940; Dallas Mus. FA; Central Illinois Expo, 1939; VMFA; Pepsi-Cola; CI; AIC, 1937; PAFA Ann., 1938-52 (9 times); Corcoran Gal. biennials, 1939-53 (4 times); BM; Cincinnati AM; WMAA, 1941, 1951; Univ. Illinois, 1951; Midtown Galleries, NYC. **Work:** MMA; WMAA; Springfield (MA) Mus. FA; Univ. Arizona, Tucson; IBM Coll.; PAFA Commissions: mural for lobby, Kidder, Meade & Co., Paramus, NJ. **Comments:** She founded and ran the Painters and Sculptors Gallery in Greenwich Village from 1931-c.1933, to create a forum for lesser known artists and bring the arts to a wider audience. In her position at *Life Magazine* she further pursued these goals, successfully promoting American art and artists. Preferred media: oils. Positions: art editor, *Life Magazine,* 1936-56, asst. art director, 1956-60; art consultant, Time, Inc., 1960-70. Publications: co-author, "Modern American Painting," 1939; author, "Waldo Peirce," 1941; author, "Carol Brant," 1945; editor, "America's Arts & Skills," 1957; contributor, *Magazine Art,* Studio Publications. **Sources:** WW73; WW47; Pisano, *One Hundred Years.the National Association of Women Artists,* 84; Falk, *Exh. Record Series.*

VARGAS, Adelina (Mrs. Alexander Mastio) *[Sculptor] b.c.1869, Mexico City, Mexico / d.1945, New Orleans, LA.*
Addresses: New Orleans, active c.1879-1934. **Comments:** Assisted her father Francisco Vargas, Sr. (see entry) in the family business of making wax sculptures. She first suggested the modeling of black characters and other working class New Orleans people. Her half-brother Francisco Vargas, Jr. and half-sister Maria Vargas also worked in the business. **Sources:** *Encyclopaedia of New Orleans Artists,* 390.

VARGAS, Alberto *[Painter] b.1896, Peru / d.1982, Los Angeles, CA.*
Addresses: NYC (1916-31); Hollywood, CA (1931-40); NYC (1940s-50s). **Studied:** France and Switzerland, c.1911-16; came to NYC, 1916. **Exhibited:** San Francisco Art Exchange, 1986 (retrospective). **Comments:** A watercolorist of meticulous brush technique and a pioneer with the air brush, he is recognized as America's master of the "pin-up girl" portrait. From 1919-31, he painted lobby card portraits of the "Ziegfeld Follies" girls and then worked for major movie studios in Hollywood. He

is best known for his semi-nude illustrations of beautiful women which were featured in *Esquire* during the 1940s, when he signed his works as "Varga." In 1941, the *New Yorker* said he "could make a girl look nude if she were rolled up in a rug." His lubricious pin-up girls competed with those created by George Petty, and helped to sell millions of magazines; however, a 1946-50 contract dispute with *Esquire* left him in poverty. By 1961, Vargas was hired by *Playboy* and the "Vargas Girls" (with the "s" restored to his name) became topless and increasingly nude rather than suggestive and innocent. **Sources:** Hughes, *Artists in California,* 575; essay #16, Illustration House, NYC; add'l info. in Bryn Evans, "Alberto Vargas: Pinup Master" in *MassBay Antiques* (May, 1996, p.56).

VARGAS, Conception (Mrs. Carlos Alfonso) *[Sculptor]* b.1858, Mexico / d.1933, New Orleans, LA.
Addresses: New Orleans, active c.1879-1933. **Comments:** Daughter of Francisco Vargas, Sr. (see entry), who worked in the family wax modeling business. She created the wax flowers, fruits and other still life sculptures and accessories for the wax figures. Sister of Jesus and Francisco Vargas, Jr., half-sister of Adelina Vargas (see entry) and Maria Vargas. **Sources:** *Encyclopaedia of New Orleans Artists,* 391.

VARGAS, Francisco, Sr. *[Sculptor, teacher]* b.c.1824, Mexico City, Mexico / d.1915, New Orleans, LA.
Addresses: New Orleans, active c.1875-1915. **Exhibited:** World's Indust. & Cotton Cent. Expo, 1884-85 (Mexican figures); Pan-American Expo, Buffalo, NY, 1901; Louisiana Purchase Expo, 1904 (30-foot high "King Cotton"). **Comments:** Learned wax modeling in Mexico from a Jesuit priest. He went by covered wagon to Galveston, TX, New Orleans, c.1875, NYC, Buffalo, NY and back to New Orleans in1878. Vargas sculpted large works in plaster and clay and small ones in wax. His family business created figures and still lifes using beeswax over wooden armatures which were painted and decorated with bits of fabric dipped in wax. He received and executed with the help of his family numerous special commissions. Vargas was married three times and the father of Jesus, Francisco, Jr. and Conception Vargas (see entry) by his first wife; Adelina Vargas (see entry) by his second wife; Alta Gracia and Maria Vargas by his third wife, Guadaloupe Luna Vargas. **Sources:** *Encyclopaedia of New Orleans Artists,* 391-92.

VARGAS, Rudolph *[Sculptor]* b.1904, Uruapan, Mexico.
Addresses: Los Angeles, CA. **Studied:** San Carlos Acad. FA, Mexico City, Mexico. **Exhibited:** Santa Teresita Hospital, Duarte, 1972 (solo). **Work:** handcarved wooden Madonna, Vatican Mus., Rome, Italy; 30 works of handcarved wooden statues & panels, Santa Teresita Hospital, Duarte, CA; Life of Father Junipero Serra (five scenes), San Juan Capistrano Mission, scenes of life of Christ, San Fernando Mission. **Commissions:** large figures, Reno, NV; Albert Pyke (bronze bust), Scottish Rite Cathedral, Pasadena, CA. **Comments:** Positions: sculptor, Warner Bros Studios, 1967; sculptor, Walt Disney Studios, 1968-70. **Sources:** WW73; Phil Gilkerson, *Southland Artist* (1965); Garcia Mendez, *Ideas: Eventos Latinos* (1969); article, *Enciclopedia Internazionale Degli Artisti* (Bugatti Editore, 1970-71).

VARGAS Y CHAVEZ, Jaoquin Alberto See: **VARGAS, Alberto**

VARGE, Joseph *[Painter]* early 20th c.
Addresses: Chicago. **Exhibited:** AIC, 1920. **Sources:** Falk, *AIC.*

VARGISH, Andrew *[Painter, indst designer, educator, lecturer, teacher]* b.1905, St. Tomas, Austria-Hungary / d.1981, Poultney, VT?.
Addresses: Poultney, VT. **Studied:** Univ. Chicago (B.A.); Teachers College, Columbia Univ. (M.A.). **Member:** SAGA; Chicago Soc. Etchers. **Exhibited:** Chicago SE; SAGA, annually, 1929 (prize); PAFA; So. Vermont Artists; Brooklyn SE, 1930 (prize); Univ. Maine (solo); NAC, 1930 (prize). **Work:** LOC; NYPL; NGA. **Comments:** Illustrator: "Eleven Times Ourselves," F. Baer; "Sonnets from the Portuguese." Author/illustrator: poems,

"I Importune God." Position: director, art dept., Green Mountain Jr. College, Poultney, VT, from 1937. **Sources:** WW59; WW47.

VARGO, John *[Educator, painter]* b.1929, Cleveland, OH.
Addresses: Jamesville, NY. **Studied:** Cleveland IA with Louis Bosa. **Exhibited:** Cooperstown (NY) 35th Ann. Exh., 1970; Rochester (NY) Finger Lakes Exh., 1971; solos: Penn. State Univ., New Kensington, 1969, May Mem., Syracuse, 1970 & LeMoyne College, 1971. Awards: Eagan Pres. Plaza Award, 1964 & popular prize, 1964, NY State Fair; first prize for portrait painting, Cooperstown AA, 1970; award for painting, Mem. Art Gallery, Univ. Rochester, 1971. **Work:** Cleveland Mus. Art; Syracuse Univ., NY; Munson-Williams-Proctor Inst., Utica, NY; LeMoyne College, Syracuse. Commissions: The Erie Canal (mural), First Fed. Savings, Syracuse, 1960. **Comments:** Preferred media: tempera, watercolors. Positions: illustrator, Advance Art, Cleveland, 1951-58. Teaching: Syracuse Univ., 1958-. **Sources:** WW73; Anna W. Olmsted, review, April 19, 1970 & Ann. Hartranft, review, Dec. 12, 1971, *Syracuse Herald-Am.*; Gordon Muck, *Syracuse Post Standard,* Dec. 6, 1971.

VARIAN, Dorothy *[Painter, designer]* b.1895, NYC / d.1985, NYC.
Addresses: NYC/Bearsville, NY. **Studied:** Cooper Union Art School; ASL; J. Sloan; Kenneth Hayes Miller; Andrew Dasburg; George Bellows; Paris, France; Woodstock, NY, with John Carlson & Edward Chase. **Member:** Woodstock AA; Audubon Artists; Am. Soc. PS&G. **Exhibited:** Durand-Ruel Gal., Paris, France, 1922 (solo); Salons of Am.; CI, 1931, 1937, 1939, 1940, 1942-45; PAFA Ann., 1933, 1939-1940, 1943-48; Corcoran Gal. biennials, 1930-43 (6 times); VMFA, 1938, 1940; AIC, 1941; CAM, 1938, 1945; WMAA, 1920-52; WMA, 1938; NAD, 1945; Pepsi-Cola, 1944; Woodstock AA, annually; BM, 1953; Yale Univ., 1955; La Tausca traveling exhib., 1948; London, England, 1938; nine solo exhibs. through 1953; Long Island Univ., 1961; "NYC WPA Art" at Parsons School Design, 1977. Awards: prize, William Fox Competition, NY. **Work:** WMAA; Newark Mus.; PMG; Dartmouth College; Fisk Univ.; Ogunquit Mus. Art; Phillips Mem. Gallery; Woodstock AA. **Comments:** WPA artist. **Sources:** WW59; WW47; *New York City WPA Art,* 91 (w/repros.); add'l info. courtesy of Peter Bissell, Cooperstown, NY; Woodstock AA; Petteys, *Dictionary of Women Artists;* Falk, *Exh. Record Series.*

VARIAN, Elayne H. *[Art administrator, art historian]* mid 20th c.; b.San Francisco, CA.
Addresses: NYC. **Studied:** AIC; Univ. Chicago (M.A.). **Member:** Am. Assn Mus.; Int. Council Mus.; College Art Assn. Am.; Gallery Assn. NY State (co-director committee, 1972). **Comments:** Positions: asst. to president, Duveen Bros., Inc., 1953-62; director & curator, Contemporary Wing, Finch College Mus. Art, 1964-; advisor, NY State Council on Arts, 1967-; McDowell Colony fellow; director, Heathcote Art Foundation; president, Attingham Summer School, England; member, Mayor's Citizens Committee & Gov's. Citizens Committee; member, Artists' Cert. Committee, New York Dept.Cultural Affairs. Publications: contributor, *Art in Am., Arts Magazine, Art Int.* Teaching: instructor of museology, Finch College, 1965-72. Collections arranged: Art in Process, I, II, III & IV, 1965-69; Art Nouveau, 1969; Art Deco, 1970; N. Dimensional Space, 1970; Artists' Videotape Performances, 1971; Prints from Hollanders Workshop, 1972; Women in the Arts Festival, 1972; Mr. & Mrs. George Rickey's Private Collection: Constrictivist Art, 1972. **Sources:** WW73.

VARIAN, George Edmund *[Illustrator]* b.1865, Liverpool, England / d.1923.
Addresses: Brooklyn, NY. **Studied:** Brooklyn AG; ASL. **Member:** SC, 1905; Brooklyn AC. **Exhibited:** Paris Salon, 1907. **Comments:** Illustrator: *Seen in Germany* by R.S. Baker; *The Tragedy of Pelee* by G. Kennan; also, illus. for *McClure's,* 1902. He witnessed the destruction of St. Pierre on Martinique. **Sources:** WW19; P&H Samuels, 498.

VARIAN, Lester *[Lithographer]* b.1881, Denver, CO / d.1967, Denver.
Addresses: Denver, CO. **Exhibited:** Denver AM, 1934 (47 prints of Colorado scenes under WPA). **Sources:** WW40.

VARIAN, Mary *[Portrait painter]* mid 20th c.
Exhibited: Salons of Am., 1931. **Sources:** Marlor, *Salons of Am.*

VARLEY, John *[Engraver]* b.c.1816, Sweden.
Addresses: NYC in 1850. **Sources:** G&W; 7 Census (1850), N.Y., XLIII, 279.

VARNEY, Luella See: **SERRAO, Luella Varney (Mrs.)**

VARNEY, Walt *[Painter, sculptor]* b.1908, Anaconda, MT.
Addresses: North Bend, WA. **Studied:** Donald Hord, San Diego, CA. **Exhibited:** SAM. **Sources:** Trip and Cook, *Washington State Art and Artists.*

VARNI, L. E. *[Artist]* late 19th c.
Addresses: Brooklyn, NY, 1884. **Exhibited:** NAD, 1884.
Sources: Naylor, *NAD.*

VARNUM, William H(arrison) *[Painter, writer, teacher, craftsperson]* b.1878, Cambridge, MA / d.1946.
Addresses: Madison, WI/Monhegan, ME. **Studied:** Mass. Sch. Art.; J. De Camp; E.L. Major; Ogunquit Sch. with C. Woodbury; Académie Julian, Paris with J.P. Laurens, 1901. **Member:** Western AA; Wisc. P&S; Boston Art Club; Western AA; Wisc. Painters Soc. **Exhibited:** with member organizations. **Comments:** Author: "Industrial Arts Design," "Pewter Design and Construction," "Art in Commemorative Design," "Creative Design in Furniture." Position: teacher, Univ. Wisconsin. **Sources:** WW40; *Charles Woodbury and His Students.*

VARRONE, Aurelia A. *[Painter]* mid 20th c.
Addresses: Bronx, NY. **Exhibited:** S. Indp. A., 1944. **Sources:** Marlor, *Soc. Indp. Artists.*

VASA, (Vasa Velizar Mihich) *[Sculptor, educator]* b.1933, Yugoslavia.
Addresses: Venice, CA. **Studied:** Sch. Applied Art, Beograd, Yugoslavia, 1947-51 (dipl.); Acad. Applied Art, Beograd, 1952-54 (dipl.). **Exhibited:** New Modes in Calif. P&S, La Jolla (CA) Mus. Art, 1966; Univ. Illinois Biennial Exh. Contemp. P&S, Champaign, 1967; Am. Sculpture of the Sixties, LACMA, 1967; 73rd Western Ann., Inaugural Exh., Denver (CO) Art Mus., 1971; Vasa Sculptures, MoMA, Beograd, 1972. Awards: grant, UCLA, 1970; Judith Thomas Found. grant, 1971; Creative Arts Inst. appt., Univ. Calif., 1972-73. **Work:** MoMA, Beograd; Denver Art Mus.; Univ. New Mexico Art Mus., Albuquerque; Larry Aldrich Mus., Ridgefield, CT. Commissions: wood inlay mural, Hotel Metropolitan, Beograd, 1957; plastic sculpture, Frederick Weisman, Toyota Auto Industs., Japan, 1971; plastic sculpture, Max Palevsky, Palm Springs, CA, 1971; plastic sculpture, Winmar Co., Inc., Severence Center, Cleveland, OH, 1972. **Comments:** Preferred media: plastics. Teaching: Univ. Calif., Los Angeles, 1967-; Univ. Southern Calif., 1970-71. **Sources:** WW73; Joseph H. Krause, *The Nature of Art* (Prentice Hall, 1969); William Wilson, "Sculpture by Vasa in USC Show," *Los Angeles Times,* 1970; Donald Brewer, *Vasa Sculptures, catalogue (Mus. Modern Art, Beograd, 1972).*

VASGERDSIAN, Haroutin *[Painter, graphic artist, teacher, lecturer]* b.1906, Armenia.
Addresses: Cambridge, MA. **Studied:** Mass. Normal Art School; Copley Soc. **Member:** Bay State AG. **Exhibited:** Boston AC. **Work:** Armenian Apostolic Church, Boston. **Sources:** WW40.

VASILEOS *[Painter]* mid 20th c.
Addresses: Cambridge, MA. **Exhibited:** PAFA Ann., 1942.
Sources: Falk, *Exh. Record Series.*

VASILIEFF, Nicolas (Ivanovitch) *[Painter]* b.1892, Moscow, Russia / d.1970, Williamstown, MA. *N. Vasilieff*
Addresses: Lanesboro, MA. **Exhibited:** Salons of Am., 1925,
1932; AIC, 1945; PAFA Ann., 1945-60 (5 times); Corcoran Gal. biennials, 1953-59 (3 times); WMAA, 1955. **Comments:** Marlor cites birth year as 1888. **Sources:** WW66; Falk, *Exh. Record Series.*

VASS, Gene *[Painter, sculptor]* b.1922, Buffalo, NY.
Addresses: NYC. **Studied:** Univ. Buffalo (B.F.A., 1956-58).
Exhibited: Corcoran Gal. biennial, 1959; Carnegie Int., 1965; WMAA Ann.,1962, 1965 & New Acquisitions, WMAA, 1969; New Acquisitions, Guggenheim Mus., 1966; Select Artists, Des Moines (IA) Art Center, 1967. **Work:** MoMA; WMAA; Guggenheim Mus.; Albright-Knox Art Gallery, Buffalo; BMA.
Comments: Preferred media: oils, inks, woods. **Sources:** WW73.

VASSAULT, Theodora *[Painter]* late 19th c.
Exhibited: San Francisco AA, 1889. **Sources:** Hughes, *Artists in California,* 575.

VASSEUR, Hermann *[Engraver]* mid 19th c.
Addresses: NYC, 1850-52. **Sources:** G&W; NYBD 1850-52.

VASSI, Nina *[Painter]* mid 20th c.
Studied: ASL. **Exhibited:** Salons of Am., 1932, 1934 ; S. Indp. A., 1932, 1934. **Sources:** Falk, *Exhibition Record Series.*

VASSILIEFF, Nicolas (Ivanovitch) See: **VASILIEFF, Nicolas (Ivanovitch)**

VASSILIEFF, Varvara *[Painter]* mid 20th c.
Exhibited: Salons of Am., 1934. **Sources:** Marlor, *Salons of Am.*

VASSOS, John *[Designer, painter, illustrator, lecturer, writer]* b.1898, Greece.
Addresses: Norwalk, CT. **Studied:** Robert College, Constantinople; Fenway Art School, Boston; J.S. Sargent; BMFA Sch.; ASL, 1921-22; J. Sloan; New York School Design.
Member: Silvermine Guild Artists (pres.); Phila. Art All.; Indust. Designers Soc. Am. (chmn. board); Am. Artists Congress.
Exhibited: S. Indp. A.; NYPL; Toledo Pub. Lib.; New School Social Res.; Riverside Mus.; Silvermine Guild Artists. Awards: Indust. Design Inst., 1961 (silver medal); Am. Packaging (prize); Hellenic Univ. Club New York, 1963 (Paidea Award). **Work:** Athens Mus. and Athens Pub. Lib., Greece; Syracuse Univ. Commissions: design, U.S. Trade Fair pavilions at Karachi, Pakistan & New Delhi, India; mosaic mural, entrance of Military Electronic Center, Van Nuys, CA; mural, WCAU radio-TV station, Phila.; mural, Conadado Beach Hotel, Puerto Rico; mural, RCA Electronic Center; Palm Beach; developed hist. complex for city of Norwalk, CT. **Comments:** Came to U.S. in 1919. Positions: industrial designer, RCA Corp, 1938-; also designs for Remington, Du Pont, Savage Arms & others. Publications: contributor, art & design magazines also, articles to *Esquire, American Monthly.* Illustrator: *Woman's Home Companion, American, Forum, Esquire, New Yorker.* **Sources:** WW73.

VATEL, John *[Listed as "picture maker"]* late 18th c.
Addresses: NYC, 1790. **Sources:** G&W; NYCD 1790.

VAUDECHAMP, Jean Joseph *[Portrait painter]* b.1790, France / d.1866, France. *Vaudechamp*
Addresses: New Orleans, winters of 1832-36. **Comments:** William Dunlap in May 1834 reported that he had made $30,000 in three winters in New Orleans. He shared a studio with Aimable Desire Lansot (see entry) in 1834 and 1835. **Sources:** G&W; Cline, "Art and Artists in New Orleans"; Dunlap, Diary, III, 785; Delgado-WPA cites *Courier,* Nov. 28, 1832, and Dec. 26, 1833, and *Bee,* Dec. 28, 1833, Jan. 3, 1834, Nov. 30 and Dec. 1, 1836. More recently, see *Encyclopaedia of New Orleans Artists* 392-93.

VAUDRICOURT, A. de *[Lithographer, topographical draftsman, drawing and piano teacher]* mid 19th c.; b.France.
Addresses: New Orleans, 1835; Boston, 1844; NYC, 1845-46; Texas, 1850-51. **Comments:** Spent his early years in America in New Orleans. He did work for Bouvé & Sharp in Boston (1844), and lithographic work in NYC (1845-46). He served for about a year as artist with the boundary survey (under Emory) in Texas; at

this time he drew a view of the Plaza of El Paso which was published. He left the surveying team in a bitter dispute over artist's fees and disappeared over the Mexican border. Also appears as De Vaudricourt. **Sources:** G&W; Delgado-WPA cites *Courier,* Feb. 16, 1835; Peters, *America on Stone;* NYBD 1846; Taft, *Artists and Illustrators of the Old West,* 277-78; Stokes, *Historical Prints; Antiques,* June 1948, 459, repro. More recently, see Pierce & Slautterback, 182; P&H Samuels, 137.

VAUDRONS, John C. *[Painter] early 20th c.*
Addresses: NYC. **Sources:** WW06.

VAUGHAN, Agnes L. (Mrs.) *[Painter, teacher] d.1919.*
Addresses: NYC. **Comments:** Teaching: MMA.

VAUGHAN, Charles A. *[Portrait painter in oils] mid 19th c.*
Addresses: Cincinnati from 1844-56; St. Louis in 1859; Kentucky. **Exhibited:** Boston Athenaeum. **Work:** Univ. Kentucky Art Mus., Lexington, KY. **Sources:** G&W; Cincinnati BD 1844, 1856; Swan, BA; St. Louis BD 1859; Jones and Weber, *The Kentucky Painter from the Frontier Era to the Great War,* 69 (w/repro.).

VAUGHAN, Dana Prescott *[Educator] b.1898, Middleboro, MA.*
Addresses: NYC. **Studied:** Mass. School Art; PM School IA; Harvard Univ.; Brown Univ.; Univ. Upsala, Sweden. **Member:** New Hampshire Antiquarian Soc.; Eastern AA. **Exhibited:** Award: D.F.A., Moore Inst. Art, Science & Industry, Phila., PA. **Comments:** Positions: member, Corporation of Proctor Acad., Andover, NH; board of directors, NY School for the Deaf; head, Jr. School, 1928-42; dean, 1928-42, RISD; director, School. Indust. Art, Trenton, N.J, 1942-45; dean, CUA School, NYC, 1945-; board of trustees, Inst. of Trend Research, Hopkinton, NH; chmn. committee on accreditation, Nat. Assn. Schools of Design. Co-author: "Art Professions in the United States," 1950. Editor, *Eastern Arts Yearbook,* 1945, 1946. **Sources:** WW59.

VAUGHAN, David Alfred *[Painter, cartoonist, lecturer, teacher] b.1891, Selma, AL.*
Addresses: Costa Mesa, CA. **Studied:** Columbia Univ.; ASL; Kenneth Hayes Miller, Robert Henri. **Exhibited:** Salons of Am., 1924; Paris Salon; AIC, 1945; CPLH (medal), 1946; LACMA, 1942; Cedar City, UT, 1945-46; San Diego FAS, 1941 (solo), 1944 (solo), 1946 (solo); Pasadena AI, 1944 (solo); Santa Barbara Mus. Art, 1945 (solo); Palos Verdes Estates (CA) Art Gal., 1946; La Jolla Art Ctr., 1946 (solo); Laguna Beach AA, 1944 (solo), 1945. Awards: prizes, Alabama State Fair; Wanamaker prize. **Work:** San Diego FA Soc. **Sources:** WW53; WW47.

VAUGHAN, Edson S. *[Portrait painter] b.1901, Chula Vista, CA.*
Addresses: Santa Barbara, CA. **Studied:** F. Morley Fletcher; Cart Oscar Borg; Colin Campbell Cooper. **Member:** SC. **Exhibited:** Santa Cruz Art Lg., 1935 (prize). **Comments:** With the Army of Occupation in Korea, 1953. **Sources:** WW53.

VAUGHAN, Hector W. *[Engravers] mid 19th c.*
Addresses: NYC, 1850. **Comments:** Of McCann & Vaughan (see entry) **Sources:** G&W; NYCD 1850.

VAUGHAN, Helen See: **LEWIS, Helen V(aughan)**

VAUGHAN, James W. *[Engraver and painter] mid 19th c.*
Addresses: NYC, 1851-54. **Sources:** G&W; NYCD 1851-54.

VAUGHAN, Lester Howard *[Craftsman] b.1889, Taunton, MA.*
Addresses: Taunton, MA, 1947; Raynham, MA, 1959. **Member:** Boston SAC; Phila. ACG. **Exhibited:** Boston SAC (medal); AIC (prize). **Comments:** Specialty: metalwork. **Sources:** WW59; WW47.

VAUGHAN, N. J. *[Still life watercolor painter] mid 19th c.; b.United States.*
Sources: G&W; Lipman and Winchester, 181.

VAUGHAN, Reginald Wilmer *[Etcher] b.1870, Boston, MA / d.1958, Palo Alto, CA.*

Addresses: Santa Barbara, CA. **Studied:** Edward Borein. **Exhibited:** San Francisco AA, 1935. **Comments:** Descendant of a colonial American family, his grandfather and great-uncles having served with George Washington at Valley Forge. Specialty: desert landscapes, old whaling ships. **Sources:** Hughes, *Artists in California,* 575.

VAUGHAN, Royce *[Painter, photographer, sculptor, graphic artist, filmmaker] b.1930, Cleveland, OH.*
Studied: Princeton Univ. (scholarship); San Francisco State College (B.A., 1967). **Exhibited:** San Francisco AA, 1957; SFMA (purchase award); San Francisco Black Hist. Soc., 1967; San Francisco State College, 1967; Oakland Art Mus., 1968 (purchase award). Awards: Ford Fnd. Grant, 1970; Danforth Fellowship, 1958. **Work:** Oakland Mus.; San Francisco Art Commission; Black Hist. & Cultural Soc. **Comments:** Position: project director, ABLE, San Francisco State College. **Sources:** Cederholm, *Afro-American Artists.*

VAUGHAN, S. Edson *[Portrait painter] b.1901, Chula Vista, CA.*
Addresses: Santa Barbara, CA. **Studied:** F.M. Fletcher; C.O. Borg; S. Meyer; W. Adams. C.C. Cooper. **Member:** SC. **Exhibited:** Santa Cruz AL, 1935 (prize); Pasadena, 1933 (prize); Acad. Western Painters, LACMA, 1935 (prize). **Comments:** Son of Reginald Vaughan (see entry). **Sources:** WW47.

VAUGHAN, W. S. *[Painter] early 20th c.*
Addresses: Watertown, MA. **Exhibited:** AIC, 1919. **Sources:** WW19.

VAUGHN, Louis Oliver *[Painter] b.1910.*
Studied: NAD. **Exhibited:** Harmon Found., 1933; Assoc. Art Students, 1933; NYPL, 1933; YMCA, 1934; Harmon Collection Traveling Exh., 1934-35; Harlem Art Committee, YWCA, 1935. **Sources:** Cederholm, *Afro-American Artists.*

VAUGHN, Valda *[Painter] mid 20th c.*
Exhibited: Salons of Am., 1934. **Sources:** Marlor, *Salons of Am.*

VAUGHT, Larken G. *[Painter, designer, teacher] b.1904, Centerville, IA.*
Addresses: Whittier, CA. **Studied:** Los Angeles AI; Anna Hills; Dorothy Dowiatt; Frederic Schwakowsky; G.K. Brandriff. **Member:** Laguna Beach AA; Whittier AA. **Exhibited:** Whittier Art Gal.; Whittier AA, prizes, 1939, 1945, 1949, 1952, 1954; Laguna Beach Art Gal.; Laguna Beach AA, 1938 (prize); Little Gal., Taos, NM, 1957. **Comments:** Position: curator, Whittier Art Gal. **Sources:** WW59.

VAUPELL, Edna *[Painter] mid 20th c.; b.Kansas.*
Addresses: Redmond, WA. **Studied:** Univ. Washington; with E. Forkner. **Exhibited:** Women Painters Wash., SAM, 1937-57; Grant Studios, NYC, 1936, 1937; Oakland Art Mus., 1937, 1938; PAM, 1938. **Sources:** Trip and Cook, *Washington State Art and Artists.*

VAUTIN, N. *[Portrait painter] mid 19th c.*
Addresses: Boston, 1845-46. **Sources:** G&W; Boston BD 1845-46.

VAUTRINOT, Madolin *[Painter] b.1913, Egg Harbor, NJ.*
Addresses: Egg Harbor, NJ. **Studied:** CI; Country School, PAFA. **Member:** Pittsburgh AA. **Exhibited:** Pittsburgh AA, 1935 (prize), 1936 (prize). **Work:** murals, Republic Oil Co., Pittsburgh; Seaview (NJ) Golf Club; Atlantic City public schools; coll., 100 Friends of Art, Pittsburgh. **Sources:** WW40.

VAUX, Calvert *[Artist] late 19th c.*
Addresses: NYC, 1863-80. **Exhibited:** NAD, 1863-80. **Comments:** Of Vaux & Withers, Olmstead and Vaux, Vaux & Radford. **Sources:** Naylor, *NAD.*

VAUX, Richard *[Painter] b.1940, Greensburg, PA.*
Addresses: Holbrook, NY. **Studied:** Miami Univ. (B.F.A., 1963); Northern Illinois Univ. (M.F.A., 1969). **Exhibited:** NY State Pavilion, New York World's Fair; Dayton AI, 1963; Butler IA, 1968; Stamford (CT) Mus., 1970; Minnesota Mus. Art, St. Paul,

1971; Bertha Schaefer Gal., NYC & Artium Gal., Wash., NY, 1970s. **Awards:** awards for painting, Hofstra Univ. Ann., 1963 & Westchester Art Ann., 1970; award for drawing, Northern Illinois Univ. Ann., 1968. **Work:** Hofstra Univ., Hempstead, NY; Northern Illinois Univ.; Nassau Community College, Garden City, NY; CW Post College, Greenvale, NY; Adelphi Univ., Garden City. **Comments:** Preferred media: acrylics, oils, graphics. Teaching: asst. professor art, Adelphi Univ., 1964-. **Sources:** WW73.

VAVAK, Joseph *[Painter] b.1899, Vienna, Austria / d.1969, Hume, MO?.*
Addresses: Chicago, IL. **Studied:** AIC; ASL; A. Lhôte in Paris. **Member:** Chicago SA; Artists Union Chicago. **Exhibited:** AIC, 1914-45; Chicago SA, 1935 (gold medal); Corcoran Gal. biennial, 1943; Fort Huachuca, AZ, 1943; WMAA, 1945. **Work:** schools & other public institutions in Chicago and vicinity. **Comments:** White gives year of birth as 1891 and date of immigration as 1908. **Sources:** WW40; Cederholm, *Afro-American Artists.*

VAVRA, Frank Joseph *[Painter, decorator, craftsperson] b.1898, St. Paul, NE / d.1967, Denver, CO.*
Addresses: Bailey, CO (since 1928). **Studied:** G.W. Eggers, Denver Acad.; J. Thompson; R.A. Graham; Giverny with Monet during WWI. **Member:** Denver AG. **Exhibited:** Ann., Denver AM, 1936; Kansas City AI, 1935, 1936. **Work:** State Capitols, Denver, CO, Cheyenne, WY; Denver AM. **Comments:** Opened his first studio in Denver in 1923, specializing in landscapes, portraits, still life and scenes of his youth in Wyoming. Position: teacher, Univ. Denver. **Sources:** WW40; P&H Samuels, 498-99.

VAVRA, Jewel *[Painter] mid 20th c.*
Addresses: NYC. **Exhibited:** S. Indp. A., 1944. **Sources:** Marlor, *Soc. Indp. Artists.*

VAVRA, Kathleen H. *[Painter, designer] mid 20th c.*
Addresses: Bailey, CO. **Member:** Denver AG. **Exhibited:** Denver AM, 1936 (prize). **Sources:** WW40.

VAVRICKA, Frank J. *[Painter] mid 20th c.*
Addresses: Phila., PA, 1958-68. **Exhibited:** PAFA Ann., 1958, 1968. **Sources:** Falk, *Exh. Record Series.*

VAVRUSKA, Frank *[Painter, printmaker] mid 20th c.*
Addresses: Chicago. **Exhibited:** AIC, 1943-51, 1945 (prize), 1946 (prize), 1947 (prize). **Sources:** Falk, *AIC.*

VAWTER, John William *[Painter, illustrator, etcher] b.1871, Boone County, VA / d.1941.*
Addresses: Nashville, IN. **Member:** Hoosier Salon; Chicago Gal. Assn.; Brown County Art Gal. Assn. **Exhibited:** Marshall Field Gal., 1925 (prize); Hoosier Salon, 1935 (prizes); Nashville Gal., 1935 (prize). **Work:** Indianapolis Mus. Art ("Barnes Cabin on Owl Creek, Brown County"). **Comments:** Indiana landscape painter, arrived in Brown County in 1908. Illustrator: James Whitcomb Riley Series of books. **Sources:** WW40; Gerdts, *Art Across America,* vol. 2: 273 (with repro.).

VAWTER, Mary H(owey) Murray *[Portrait painter, landscape painter, writer] b.1871, Baltimore, MD / d.c.1950.*
Addresses: Nashville, IN. **Studied:** ASL; S.N. Randolph; S.E. Whiteman; I. Wiles; T.C. Corner; L. Kroeger; Maryland Inst.; Charcoal Club, Baltimore. **Exhibited:** S. Indp. A., 1931; Indiana Artists; J.B. Speed Mem. Mus.; Hoosier Salon; Pub. Lib., Mathews, VA. **Work:** Nashville Pub. Lib.; Court House, Franklin, IN. **Sources:** WW47.

VAYANA, Nunzio *[Painter, illustrator, lecturer] b.1887, Castelvetrano, Italy / d.1960, Ogunquit, ME.*
Addresses: Qgunquit, ME. **Studied:** Grosso; Morelli; Pisani. **Exhibited:** Venice AC, 1921 (prize); CAFA, 1924 (prize); I.E., Rome, 1925 (prize). **Comments:** Position: director, The Art Center, Ogunquit, ME. **Sources:** WW40.

VAZQUEZ, Paul *[Painter] b.1933, Brooklyn, NY.*
Addresses: NYC. **Studied:** Ohio Wesleyan Univ. (B.F.A., 1956); Univ. Illinois (Kate Neal Kinley fellowship; M.F.A., 1957).

Exhibited: PAFA 152nd Ann., 1957; Allen Stone Gallery, New York, 1970; Galerie Biesj, Amsterdam, Holland, 1970; Paley & Lowe, 1971 (solo) & 1972; Am. Painting, Chicago Inst. Am. Art, 1972. **Awards:** purchase award, Butler IA, 1958. **Work:** Butler IA; Univ. Illinois, Urbana; Ball State Teachers College, Munice, IN. **Comments:** Preferred media: oils. Teaching: Bennett College, 1963-66; Western Conn. State College, 1966-69; Univ. Bridgeport. **Sources:** WW73.

VEACH, Florence Helen *[Portrait painter] b.1898, Sacramento, CA / d.1946, San Francisco, CA.*
Addresses: Sacramento, CA; San Francisco, CA. **Member:** Kingsley AC, Sacramento. **Exhibited:** Crocker Gallery, Sacramento; San Francisco, CA. **Sources:** Hughes, *Artists of California,* 576.

VEASEY, Thomas *[Landscape painter] b.c.1820, Maine.*
Addresses: NYC in 1850; Tuckahoe, NY, 1874. **Exhibited:** NAD, 1846 (view of Passaic Falls, NJ); 1874. **Sources:** G&W; Cowdrey, NAD; 7 Census (1850), N.Y., LI, 17.

VEBELL, Edward T. *[Illustrator] b.1921, probably Chicago, IL.*
Addresses: living in Westport, CT in 1974. **Studied:** Professional Art Sch., Chicago; Harrison Art School with E. W. Ball; Am. Acad. Art; Commerical Art Inst. **Comments:** Correspondent for *Stars and Stripes* during WWII, then spent two years in Paris as an illustrator. Positions: free-lance illustrator, *Life, True, Reader's Digest, Outdoor Life,* and *Sports Illustrated.* Specialty: Western subjects, military and sports. **Sources:** P&H Samuels, 499.

VECCHIO, Louis *[Painter, sculptor, teacher] b.1879, NYC.*
Addresses: NYC. **Member:** W. Shirlaw; NAD. **Exhibited:** Boston AC, 1905, 1907; AIC, 1905, 1951; S. Indp. A., 1917. **Sources:** WW13.

VEDDER, C. F. *[Painter] late 19th c.*
Comments: Vedder called himself the "Lightning Artist" because he produced his small landscape paintings within three minutes at country and agricultural fairs where he was sponsored by the Walter A. Wood Mowing & Reaping Manufactory of Hoosick Falls, NY. The Wood company had won many awards for their reaping machines during the 1860s. Vedder painted his monochromatic landscapes in oil on cardboard which also bear the advertising of the Wood company. He also painted similar scenes directly on the Wood reaping machines as decorative embellishments. Although his paintings are rarely signed, the verso of one of his paintings bears the rubber stamp, "CF Vedder, Lightning Artist." **Sources:** PHF; PHF files.

VEDDER, Dorothy *[Portrait painter, art agent] b.1897, Wallace, ID / d.1934, New York.*
Addresses: active in Chicago; NYC; Washington, DC. **Studied:** Chicago. **Exhibited:** Ainslie Gal., NYC, 1924; S. Indp. A., 1926-27. **Sources:** Petteys, *Dictionary of Women Artists.*

VEDDER, Elihu *[Figure and mural painter, illustrator] b.1836, NYC / d.1923, Rome (Italy).*
Addresses: NYC, 1862-66, 1882; Rome, Italy (1866-on)/Isle of Capri. **Studied:** began to study art at age 12; with T.H. Matteson, in Sherburne, N.Y.; with Picot in Paris, 1856; with R. Bonaiuti in Florence. **Member:** ANA, 1863; NA, 1865; SAA, 1880; Mural Painters; Tile Club, 1861-65; NIAL. **Exhibited:** Brooklyn AA, 1863-72; Venice Biennale, 1867; NAD, 1862-82; Boston AC, 1873, 1876, 1880-81; PAFA Ann., 1880-85, 1893, 1898-99; Paris Expo, 1889 (prize); Pan-Am. Expo, Buffalo, 1901 (medal); AIC, 1913; Corcoran Gal. biennials, 1912, 1919. **Work:** NMAA; MMA; LOC (murals, 1896-97); Bowdoin College (murals, 1894); CI; BMFA; AIC; BM; RISD; Corcoran Gal.; SFMA; Hudson River Mus.; LACMA; Worcester MA. **Comments:** Vedder spent much of his childhood in Schenectady, NY. He went to France in 1856 and then to Italy for several years, returning to the U.S. in 1861 and spending the war years in NYC. In 1865 he again went abroad to settle perma-

nently in Italy. He made frequent visits to America, but Vedder's home was in Rome and he spent his summers on the Isle of Capri. Although he was well-known for his illustrations for *The Rubaiyat of Omar Khayyam* (1884), he was primarily a visionary painter of allegorical and mythical themes, infused with a mystical, haunting, sometimes bizarre imagery. His best known paintings are "The Questioner of the Sphinx" (1863, BMFA); "The Lair of the Sea Serpent" (1864-65, MMA); and "The Lost Mind" (1864-65, MMA). In his later years he also painted a number of large murals. He was the author of *Moods in Verse* (1914); *Doubt and Other Things* (1923); and his autobiography, *The Digressions of V* (1910). **Sources:** G&W; DAB; Tuckerman, *Book of the Artists;* Park, *Mural Painters in America;* WW21; Naylor, NAD; Falk, PA, vol. 2; Baigell, *Dictionary;* Regina Soria, *Perceptions and Evocations: The Art of Elihu Vedder* (exh. cat., NMAA, 1979); Detroit Inst. of Arts, *The Quest for Unity,* 136-38.

VEDDER, Eva Roos (Mrs. Simon H.) *[Painter] early 20th c.*
Addresses: London, England. **Exhibited:** PAFA Ann., 1910. **Sources:** WW13; Falk, *Exh. Record Series.*

VEDDER, Simon Harmon *[Painter, illustrator] b.1866, Amsterdam, NY.*
Addresses: London, England; NYC. **Studied:** MMA School, NYC; Académie Julian, Paris with Bouguereau and T. Robert-Fleury, 1887-88; École des Beaux-Arts with Gérôme and Glaize. **Exhibited:** Paris Salon 1889, 1891-96, 1898, 1899 (prize); AIC, 1890, 1899, 1913; Crystal Palace; London (medal); PAFA Ann., 1901-03. **Sources:** WW19; Fink, *American Art at the Nineteenth-Century Paris Salons,* 400; Falk, *Exh. Record Series.*

VEDOVELLI, Antonio *[Painter] mid 20th c.*
Exhibited: Corcoran Gal. biennial, 1947; PAFA Ann., 1949. **Sources:** Falk, *Exh. Record Series.*

VEEN, Mal *[Painter] mid 20th c.*
Addresses: NYC. **Exhibited:** S. Indp. A., 1944. **Sources:** Marlor, *Soc. Indp. Artists.*

VEENFLIET, Richard *[Painter] early 20th c.*
Addresses: Chicago, IL. **Member:** Cincinnati Art Club. **Exhibited:** AIC, 1913. **Comments:** Position: Strobridge Lithographic Co., Cincinnati. **Sources:** WW15.

VEGIS, Polygnotos (George) *b.1896, Thasos, Greece / d.1965, NYC.*
Exhibited: Salons of Am., 1934. **Sources:** Marlor, *Salons of Am.*

VEGLIA, Mario M. *[Sketch artist] mid 20th c.*
Addresses: Casmalia, CA. **Exhibited:** San Francisco AA, 1938; Oakland Art Gallery, 1940. **Sources:** Hughes, *Artists in California,* 576.

VEILER, Joseph *[Sculptor] mid 19th c.*
Addresses: New Orleans, 1840s. **Comments:** J.H. Veilex, sculptor at New Orleans in 1838, is presumed to be the same man. **Sources:** G&W; New Orleans CD 1838, 1841-44, 1849.

VEILLERET, Pierre *[Engraver] b.c.1835, Italy.*
Addresses: NYC in 1860. **Sources:** G&W; 8 Census (1860), N.Y., XLII, 422.

VELA, Alberto *[Painter] b.1920, Mexico City, Mexico.*
Addresses: Northfield, IL. **Studied:** Acad. Fine Arts, Mexico City; José Clemente Orozo & Carlos Ruano Llopis, Mexico. **Exhibited:** Gallery Otto, Vienna, 1967; Colline Gal., Paris, 1968; Northwest Gals., Seattle, Wash, 1969; Cabinet Comt. Opportunity for Spanish Speaking People, Wash., DC, 1970; Americana Gals., Chicago, 1971. **Work:** Commissions: posters, Plaza de Toros, Mexico City, 1948-49. **Comments:** Preferred medium: oils. **Sources:** WW73.

VELARDE, Pablita (Tse Tsan) *[Painter, illustrator, author, teacher, lecturer] b.1918, Santa Clara Pueblo, NM.*
Addresses: Living in Albuquerque, NM in 1976. **Studied:** U.S. Indian School, Santa Fe, 1936, with Dorothy Dunn; Tonita Pena. **Member:** Art Lg. New Mexico; Nat. League Am. Pen Women; Inter-Triban Indian Ceremonial Assn. **Exhibited:** Denver Art

Mus.; M.H. de Young Mem. Mus.; Mus. New Mexico; CPLH; Philbrook AC. **Awards:** Palmes Académiques, French Govt., 1955; grand prizes, Gallup Ceremonial, NM, 1955-59; New Mexico State Fair, 1959. **Work:** Commissions: murals, Maisel Bldg., Albuquerque, NM, 1940; Bandelier Nat. Mon. Mus., NM, 1946; Foote Cafeteria, Houston, 1957; Western Skies Hotel, Albuquerque, 1958; Denver Art Mus.; Gilcrease Inst.; Mus. New Mexico; Philbrook AC; State of New Mexico. **Comments:** Pueblo artist who toured U.S. with E.T. Seton in 1938; her work often depicts Pueblo dances and daily acitivites of women. Illustrator, cover of *Indians of Arizona;* author/ illustrator, "Old Father, the Story Teller," 1960. Teaching: assist. art teacher, Santa Clara Day Sch., 1938; painting demonstrations, KOB-TV, Albuquerque. **Sources:** WW73; P&H Samuels, 499; Trenton, ed. *Independent Spirits,* 157, 163-64.

VELI, Sheva See: **VELIKOVSKY, Elis(heva)**

VELIKOVSKY, Elis(heva) *[Sculptor] 20th c.*
Addresses: NYC. **Exhibited:** WMAA, 1946-47; S. Indp. A., 1942; PAFA Ann., 1947, 1952. **Sources:** Falk, *Exh. Record Series.*

VELLER, Louise K. (Mrs. E. A.) *[Painter] early 20th c.*
Exhibited: Salons of Am., 1929; S. Indp. A., 1928-29. **Sources:** Marlor, *Salons of Am.*

VELLUTO *[Panoramist] mid 19th c.*
Exhibited: In NYC, 1851 (panorama of the Crystal Palace). **Comments:** Assistant to Delamano in painting the panorama of the Crystal Palace **Sources:** G&W; N.Y. *Herald,* Dec. 2, 1851 (courtesy J. Earl Arrington).

VELONIS, Anthony *[Painter, designer, craftsperson, teacher] b.1911, NYC.* *A.Velonis '39*
Addresses: Ridgefield, NJ. **Studied:** College Fine Art, NYU. **Member:** Union Am. Artists. **Exhibited:** WFNY, 1939; NAS. **Comments:** Author: "Technique of Silk Screen Process," 1939. Position: teacher, Am. Art School, NYC. **Sources:** WW40.

VELORIC, Philip M. *[Artist] 20th c.*
Addresses: Landscowne, PA. **Exhibited:** PAFA Ann., 1950. **Sources:** Falk, *Exh. Record Series.*

VELSAR, Eunice D. *[Painter] mid 20th c.*
Addresses: Painter Islip, L.I., NY, 1934. **Exhibited:** Salons of Am., 1934; S. Indp. A., 1934-35

VELSEY, Seth M. *[Sculptor, painter, teacher, designer] b.1903, Logansport, IN / d.1967.*
Addresses: Indiannapolis, IN; Yellow Springs, OH. **Studied:** Univ. Illinois; Nat. Acad., Florence, Italy; AIC; Albin Polasek; Lorado Taft. **Exhibited:** AIC, 1925-37; Hoosier Salon, 1928 (prize); PAFA Ann., 1928; Indiana Artists, 1931 (prize); Hickox prize, 1934; Paris Salon, 1937 (medal). **Work:** Dayton AI; Wright Field, Dayton, Ohio; St. Peter's Church, Chillicothe, Ohio; WPA reliefs, USPO, Pomeroy, Ohio; St. Peter & Paul's Church, Reading, Ohio; St. Francis fountain, Yellow Springs, Ohio. Murals, Rike-Kumler Co., Dayton, Ohio; bronze group, Fels Research Inst., Yellow Springs, Ohio. **Comments:** Position: head, sculpture dept., Dayton AI, 1930-34; professor sculpture, Antioch College, Yellow Springs, OH, 1959-. **Sources:** WW66; WW47; Falk, *Exh. Record Series.*

VELSOR, Eunice D. See: **VELSAR, Eunice D.**

VENANZI, Carlo Gino *[Painter, etcher] b.1875, Assisi, Italy.*
Addresses: Kansas City, MO. **Studied:** Fine Art Institutes of Siena, Florence, Rome. **Member:** Académie Belle Arti, Perugia. **Sources:** WW21.

VENIA See: **VAGANOV, Benjamin G.**

VENIER-ALEXANDER, Anita *[Painter] 20th c.*
Addresses: Chicago area. **Exhibited:** AIC, 1934, 1942. **Sources:** Falk, *AIC.*

VENINO, Francis *[Painter and lithographer] mid 19th c.*
Addresses: Active in NYC during the 1850s. **Exhibited:** NAD, 1858 ("The Destruction of Carthage"). **Comments:** In 1852 his lithograph of Trumbull's "Surrender of Cornwallis" was published by N. Currier. In 1856 Venino was listed as a photographer; in 1858-59 as an artist. **Sources:** G&W; *Portfolio* (Feb. 1942), 7; NYCD 1856, 1858-59; Cowdrey, NAD.

VENNE, Jus *[Listed as "artist"] b.c.1818, Maine.*
Addresses: Tremont Hotel in New Orleans in October 1850.
Sources: G&W; 7 Census (1850), La., IV (1), 614.

VENNING, Frank L. *[Painter] 20th c.*
Addresses: Chicago, IL. **Exhibited:** AIC, 1917. **Sources:** WW17.

VENSANO, K. C. (Mrs.) *[Still life painter] late 19th c.*
Addresses: San Francisco, CA. **Exhibited:** San Francisco AA, 1883, 1885. **Work:** Oakland Mus. **Sources:** Hughes, *Artists in California,* 576.

VENTADOUR, Fanny See: **CRAIG, Fanny Eshleman (Mrs. Fountain B.)**

VENTRE, Lucian J. (Mrs.) *[Painter] 20th c.*
Addresses: Dubuque, IA. **Member:** Dubuque AA. **Sources:** WW24.

VENTRES, M. P. *[Painter] mid 20th c.*
Addresses: Active in Tucson, AZ, 1939-48. **Exhibited:** NY World's Fair, 1939 (tempera landscape). **Work:** Denver Art Mus. **Sources:** P&H Samuels, 499.

VENTRES, O. G. (Mrs.) *[Painter] 19th c.*
Addresses: Chicago. **Exhibited:** AIC, 1888-91. **Sources:** Falk, AIC.

VENTURINI, E. *[Painter] 19th c.*
Addresses: Phila., PA. **Exhibited:** PAFA Ann., 1882. **Sources:** Falk, *Exh. Record Series.*

VERBECK, Constantin *[Painter] early 20th c.*
Exhibited: Salons of Am., 1927. **Sources:** Marlor, *Salons of Am.*

VERBECK, George J. *[Etcher] b.1858, Belmont County, OH.*
Addresses: Chicago, IL. **Comments:** Specialty: animals. **Sources:** WW10.

VER BECK, Hanna (Mrs. Frank) See: **RION, Hanna (Mrs. Alpheus B. Hervey)**

VER BECK, William Francis (Frank) *[Illustrator, writer] b.1858, Belmont County, OH / d.1933.*
Addresses: Hockley, Essex, England. **Studied:** NYC. **Exhibited:** Boston AC, 1903; AIC, 1905, 1908. **Comments:** His childrens' stories with illustrations, especially his representations of comic animals, won for him a wide and appreciative public. He collaborated with Albert Bigelow Paine on *The Dumpies and the Arkansas Bear,* published in 1896, and *The Arkansas Bear Complete,* issued thirty-three years later. Other works include the Ver Beck Bear stories, Little Black Sambo series, *The Little Cat Who Journeyed to St. Ives, & The Donkey Child.* Designer: Ver Beck earthenware models. **Sources:** WW31.

VERBEEK, Gustave (A.) *[Painter, etcher, illustrator] b.1867, Nagasaki, Japan / d.1937.* **G.V.**
Addresses: Phila., PA; NYC. **Studied:** early training in Japan; Académie Julian, Paris, with Constant, Laurens, Girardot, Blanc; G. deF. Brush. **Member:. Exhibited:** PAFA Ann., 1900-02; S. Indp. A., 1917, 1920-21, 1923-24, 1934-35; AIC, 1935. **Comments:** Working as an illustrator in Phila., 1901. **Sources:** WW25; Falk, *Exh. Record Series.*

VERBINSKI,. E. Walukiewicz *[Painter] mid 20th c.*
Addresses: Kingston, PA. **Exhibited:** Soc. Indep. Artists, 1940-44. **Sources:** Marlor, *Soc. Indp. Artists.*

VERBRICK, Richard *[Miniature and portrait painter] b.1784, Somerset County, NJ.*
Addresses: Cincinnati, 1813-31; Johnson Co., IN, 1832-36, 1860;

Mercer Co., KY, 1840; OH, 1850. **Work:** Cincinnati Art Museum (portrait of Charles Cox, 1836). **Comments:** Moved with his family (his parents were of Dutch ancestry) to Mercer County, KY, in 1800. It appears he was living in Warren County, OH by 1806 (with his brother); and he advertised in Cincinnati in 1813. He worked in Ohio, Indiana, and Kentucky for many years and must have been quite successful as he acquired 200 acres of land in Indiana, finally settling there c.1860. His name appears as Verbrick, Verbryck, and Verbrycke. **Sources:** G&W; Cincinnati CD 1825, 1831; Hageman, 96-97 (incl. repro.).

VER BRYCK, Cornelius *[Landscape, historical, and portrait painter] b.1813, Yaugh Paugh, NJ / d.1844, Brooklyn, NY.*
Addresses: NYC, 1835-44. **Studied:** Samuel F.B. Morse, NYC, 1835. **Member:** NA. **Exhibited:** NAD. **Work:** NYHS. **Comments:** Worked primarily in NYC, but made professional visits to Alabama in 1837-38, to England and France in 1839, and a second visit to England in 1843. He was the brother-in-law of Daniel Huntington (see entry) and a close friend of Thomas Cole and Henry Peters Gray (see entry). At his death Cole praised him highly as a fine painter of landscapes and history pieces, whose works in that genre "were passed unnoticed by the multitude" (quoted in Cummings and NYHS catalogue, 1974). **Sources:** G&W; Sketch of "The Late Mr. Ver Bryck" by Thomas Cole in Cummings, *Historic Annals of the NAD,* 182-84; Cowdrey, NAD; Cowdrey, AA & AAU; CAB; NYHS (1974), cat. nos. 2134-35.

VERBRYCK, Richard See: **VERBRICK, Richard**

VER BRYCK, William *[Portrait painter] b.1823, NYC / d.1899, Milwaukee, WI.*
Addresses: NYC/summers in Milwaukee, WI, from 1851; New Orleans, LA, 1870-71; Milwaukee, WI, 1881-99. **Studied:** NAD. **Exhibited:** NAD, 1852-66. **Comments:** First visited Milwaukee in 1851, thereafter making professional visits every summer, finally settling there in 1881. **Sources:** G&W; *Art Annual,* II (1899, supp.), 84, obit.; Cowdrey, NAD; Cowdrey, AA & AAU; Butts, *Art in Wisconsin,* 97. More recently see Gerdts, *Art Across America,* vol. 2: 333.

VERBRYCKE, Richard See: **VERBRICK, Richard**

VERBURGH, Medard *[Painter] mid 20th c.*
Exhibited: Corcoran Gal biennial, 1930; AIC, 1941. **Sources:** Falk, *Exhibition Records Series.*

VERDI, Claudius *[Engraver] b.1825, Florence, Italy.*
Addresses: NYC, 1860. **Comments:** In the New York State penitentiary in NYC for grand larceny, July 1860. **Sources:** G&W; 8 Census (1860), N.Y., LXI, 187.

VER DUFT, Lee *[Writer and painter] b.1910, Prairie City, IA.*
Addresses: Prairie City, IA. **Studied:** Drake Univ. with Oma Strain & Florence Sprague; Art Inst. Chicago with Wilenski; Hatchet Hall Colony, Eureka Springs, AK, with Trew Hocker. **Exhibited:** Marion County Fiar; Drake Lounge; Municipal Art Inst. Show, Grant Park, Chicago; Iowa Art Salon, 1933 (honorable mention), 1934; Great Hall, Iowa State College, 1933; Municipal Art Show, Des Moines Library; Des Moines Municipal Shows, 1936-37; Jasper County Fair, 1934 (eight prizes, four honorable mentions). **Comments:** Disenchanted with the art world, he painted only for recreation after about 1934, and chose to become a writer. **Sources:** Ness & Orwig, *Iowa Artists of the First Hundred Years,* 212.

VERELST, Francis *[Lithographer] mid 19th c.*
Addresses: NYC, 1859. **Comments:** Of Verelst & Vanstrydonck (see entry) **Sources:** G&W; NYCD 1859.

VERELST & VANSTRYDONCK *[Lithographers] mid 19th c.*
Addresses: NYC, 1859. **Comments:** Members were Francis Verelst and Charles Vanstrydonck (see entries). **Sources:** G&W; NYBD and CD 1859.

VERGARA, George Romo *[Painter] b.1902, Mexico / d.1985, Los Angeles, CA.*
Addresses: Los Angeles, CA. **Exhibited:** P&S of Los Angeles,

CA, 1927; GGE, 1939. **Sources:** Hughes, *Artists in California*, 576.

VERGE-SARRAT, Henri *[Painter] early 20th c.*
Exhibited: AIC, 1928-39. **Sources:** Falk, *AIC.*

VERGER, Peter C. *[Sculptor, engraver, and hair worker] 18th/19th c.; b.Paris (France).*
Addresses: Active in NYC from 1795-97; Paris in 1806.
Comments: He was associated with John Francis Renault (see entry) in the publication of the latter's "Triumph of Liberty" print.
Sources: G&W; Gottesman, *Arts and Crafts in NYC, 1777-99*, no. 100-01, 111; NYCD 1796-97; Stauffer; Thieme-Becker.

VERGRIES, M. *[Teacher of drawing, mathematics, French, and piano] mid 19th c.*
Addresses: Charleston, SC in 1846. **Sources:** G&W; Rutledge, *Artists in the Life of Charleston.*

VERHAEGEN, Louis *[Sculptor] mid 19th c.*
Addresses: NYC, 1851-60. **Exhibited:** American Inst., 1856 (plaster figure of Tom Thumb and a marble bust of Daniel Webster). **Comments:** In 1851 he was a partner in the firm of Verhaegen & Peeiffer (unidentified artist). **Sources:** G&W; NYBD and CD 1851-60; Am. Inst. Cat., 1856.

VERHAEGEN & PEEIFFER *[Sculptors] mid 19th c.*
Addresses: NYC, 1851. **Comments:** Partners were Louis Verhaegen (see entry) and an unidentified Peeiffer or Pfeiffer.
Sources: G&W; NYBD 1851.

VERHAEREN, Carolus (Constantinus) *[Painter] b.1908, Antwerp, Belgium.*
Addresses: La Jolla, CA. **Studied:** with George DeVore in Canada. **Member:** Soc. Western Artists; Laguna Beach AA; La Jolla Art Center. **Exhibited:** Wales Gal., Tucson, AZ, 1950 (solo); Detroit IA; deYoung Mem. Mus., 1952; Oakland Art Mus.; Chihuahua and Monterrey, Mexico (solo). Awards: prizes, Indep. Artists, Phoenix, AZ, 1948; Carlsbad-Oceanside Exhib., 1950; Soc. Western Artists, 1952, 1955. **Sources:** WW59.

VERHELST, Wilbert *[Museum curator, sculptor, painter, teacher] b.1923, Sheboygan, WI.*
Addresses: Denver 15, CO. **Studied:** Univ. Denver, B.F.A., M.A.
Exhibited: San Francisco AA, 1953, 1957; Mississippi AA, 1950; Sarasota AA, 1956; AGAA, 1949; Utah State Univ., 1957; Denver Art Mus., 1949, 1950, 1952-56; Joslyn Mem. Mus., 1950, 1958; Nelson Gal. Art, 1950, 1957; Mus. New Mexico, 1957; WAC, 1958; Des Moines Art Center, 1958. Award: Art Faculty award, Univ. Denver, 1949. **Work:** Sioux City Art Center; Denver Art Mus.; sculpture, Lakeside Shopping Center, Lakeside, CO.
Comments: Positions: art teacher, 1948-52; asst. curator educ., 1952-55, assoc. curator, 1955-57, Denver Art Mus.; director, Sioux City Art Center, 1957-58; assoc. curator educ., Denver Art Mus., as of 1959. Author: "Creative Projects," 1955. Contributor to *School Arts* magazine. **Sources:** WW59.

VERHEYDEN, François (Isidore) *[Painter, etcher, teacher] b.1880, Hoeylaert, Belgium.*
Addresses: Concord, Provincetown, MA. **Studied:** Royal Acad. Brussels. **Exhibited:** WMAA, 1918; PAFA Ann., 1919; AIC, 1929. **Sources:** WW29; Falk, *Exh. Record Series.*

VERHEYDEN, P. Francois *[Sculptor] late 19th c.*
Addresses: NYC, 1886. **Exhibited:** NAD, 1886. **Sources:** Naylor, *NAD.*

VERIER, Joseph See: **VEYRIER, Joseph**

VERLEGER, Charles Frederick *[Artist and carver] mid 19th c.*
Addresses: Baltimore. **Comments:** As carver, 1851-54; as artist, 1855-57; as veterinary surgeon, 1858-59; and as herb doctor, 1860. **Sources:** G&W; Lafferty; Baltimore CD 1851-60.

VERMEER, Albert H. *[Cartoonist] b.1911, Oakland, CA / d.1980, Arcata, CA.*
Addresses: Arcata, CA. **Comments:** Positions: illustrator, *Oakland Post Enquirer*; creator, syndicated comic strip "Priscilla's

Pop." **Sources:** Hughes, *Artists of California*, 576.

VERMES, Madelaine *[Craftsman] b.1915, Hungary.*
Addresses: New York, NY. **Studied:** Alfred Univ.; Craft Students League; Greenwich House Potters. **Member:** Artist-Craftsmen New York; Nat. Lg. Am. Pen Women; York State Craftsmen.
Exhibited: Coliseum, NYC, 1957; Art League Long Island, NY, 1958; Int. Ceramic Arts, Smithsonian Inst., Washington, DC; Philadelphia Art Alliance; Brentano's Gallery, New York, 1957 (solo). **Work:** Cooper Union Mus.; Mus. Int. delle Ceramiche, Faenza, Italy. **Sources:** WW73.

VERMEULE, Cornelius Clarkson III *[Art historian, writer] b.1925, Queenstown, Ireland.*
Addresses: Boston, MA. **Studied:** Harvard Univ. (A.B., 1947; M.A. 1951); Univ. College, Univ. London, Ph.D., 1953. **Member:** College Art Assn. Am. (life member); Royal Numismatic Soc. (fellow); Am. Numismatic Soc. (life fellow; member council, 1960-); Archaeology Inst. Am. (life member); Hellenic & Roman Soc. (life member). **Work:** Mus. Fine Arts, Boston; Nat. Mus., Pylos, Hellas. **Comments:** Preferred media: bronze, marble. Positions: asst., Sir John Soane's Mus., 1951-53; curator classical art, Mus. Fine Arts, Boston, 1957-; acting director, 1972-; curator coins, Mass. Hist. Soc., Boston, 1969-. Publications: author, "European Art and the Classical Past," 1964; author, "Roman Imperial Art in Greece and Asia Minor," 1968; author, "Polykleitos," 1969; author, "Numismatic Art in America," 1971; co-author," Greek, Estruscan and Roman Art," 1972. Teaching: asst professor fine arts, Univ. Michigan, Ann Arbor, 1953-55; asst. professor archaeology, Bryn Mawr College, 1955-57; professor classics, Yale Univ., 1972-73. Collections arranged: many exhibs, Fogg Mus. Art, 1950-72; Sir John Soane's Mus., London; Mus. Fine Arts, Boston. Research: European painting, Greek and Roman art; numismatics. Collection: Greek and Roman art; drawings; all on loan to Museum of Fine Arts, Boston. **Sources:** WW73.

VERMILYE, (Anna) Josephine ((Mrs. Henry F.) *[Etcher, block printer, painter] b.1848, Mt. Vernon, NY / d.1940, Westfield, NJ?.*
Addresses: Westfield, NJ. **Studied:** J.F. Carlson; G. Bridgman; J.C. Johansen; Henri; B.J. Nordfeldt; A. Lewis. **Member:** AFA; NAWPS; Plainfield AA; Westfield AA; Phila. Print Club.
Exhibited: Salons of Am., 1926; NAWPS, 1931 (medal).
Comments: Née Schofield. Marlor cites place of death as Brooklyn, NY. **Sources:** WW40; Marlor, *Salons of Am.*

VERMILYE, Josephine See: **VERMILYE, (Anna) Josephine ((Mrs. Henry F.)**

VERMONNET, John *[Miniature and portrait painter] 18th/19th c.*
Comments: Frenchman who came to the U.S. in 1792 and worked in NYC that year. Worked in Baltimore, MD, from December 1792 to October 1793, Alexandria, VA, 1794 and 1797, Fredericksburg, VA, 1794 and Norfolk, VA, 1801-02. **Sources:** G&W; N.Y. *Daily Advertiser*, July 23, 1792 (courtesy Miss Helen McKearin); Prime, II, 37; Wright, *Artists in Virginia Before 1900.*

VERMORCKEN, Frederick M. *[Painter] b.1862, Brussels, Belgium.*
Addresses: NYC. **Studied:** Paris, with Carolus-Duran, Cabanel. **Member:** Phila. AC. **Exhibited:** PAFA Ann., 1890. **Sources:** WW06; Falk, *Exh. Record Series.*

VERMOSKIE, Charles *[Landscape painter, portrait painter, teacher] b.1904, Boston, MA.*
Addresses: Stoughton, MA. **Studied:** F.M. Lamb; Boston Sch. Des. **Exhibited:** S. Indp. A., 1925, 1930; Salons of Am., 1934.
Work: Stoughton Pub. Lib.; St. Peters Church, South Boston, MA. **Sources:** WW40.

VERN See: **WIMAN, Vern (Verna) (Miss)**

VERNAM, W. B. *[Painter] 20th c.*
Addresses: Brooklyn, NY. **Member:** Brooklyn SA. **Sources:** WW27.

VERNARELLI, Lucia *[Painter] 20th c.*
Addresses: NYC. **Exhibited:** WMAA, 1955. **Sources:** Falk, *WMAA.*

VERNE, Otto *[Painter] mid 20th c.*
Exhibited: Salons of Am., 1934. **Sources:** Marlor, *Salons of Am.*

VERNELLE, Bernard *[Portrait painter] mid 19th c.*
Addresses: New Orleans 1852-53. **Sources:** G&W; New Orleans CD 1852-53.

VERNER, Elizabeth O'Neill *[Etcher, painter, writer, lecturer] b.1883, Charleston, SC / d.1979, Charleston, SC.*
Addresses: Charleston, SC. **Studied:** PAFA; Central Sch. Art, London, England; Seiho Sch., Japan. **Member:** Charleston EC; SSAL; Carolina AA; Chicago SE; Miss.issippi AA; NOAA; Wash. WCC; Fellow, Castle Hill Art Colony, Ipswich, MA. **Exhibited:** Chicago SE; Phila. Artists All.; SAE; Calif. Printmakers; Kennedy & Co. (solo); Doll & Richards, Boston (solo); Carolina AA, 1956; Brevard (NC) Lib.; many national etching exhs. **Work:** MMA; LOC; BMFA; Mt. Vernon Assn.; Princeton Univ.; West Point Military Acad.; High MA; Hispanic Mus.; FMA, Harvard; Chicago SE; Montgomery (AL) Lib; Univ. South Carolina; City of Charleston College; Charleston Mus.; Honolulu Acad. Arts. **Comments:** Author: "Prints and Impressions of Charleston," 1939, "Other Places," 1944; "Mellowed by Time," 1941; "South Carolina University," 1955. Illustrator: "Charleston Edition of Porgy," "Southern Exposure," by P.M. Wilson, "The Carolina Low Country," "French and American Culture," by H.M. Jones. **Sources:** WW59; WW47.

VERNER, Frederick A. *[Painter]* *F.A. Verner 1876*
b.1836 / d.1928.
Addresses: NYC, 1866, 1878; Toronto, 1880. **Exhibited:** NAD, 1865-80; PAFA Ann., 1877 (Western landscapes in water color). **Sources:** Falk, *Exh. Record Series.*

VERNERT, Leon Job *[Portrait, genre, and landscape painter] mid 19th c.*
Addresses: Paris, 1858; Philadelphia, 1860; NYC, 1862. **Exhibited:** PAFA, 1858, 1860; NAD, 1862. **Sources:** G&W; Rutledge, PA.

VERNET, Charles *[Listed as "artist"] b.1820, France.*
Addresses: New Orleans in 1850. **Comments:** He left France between 1846-49. **Sources:** G&W; 7 Census (1850), La., V, 227.

VERNIER, Racine *[Painter] b.1898, Butler, IN.*
Addresses: Cedar Rapids, IA. **Studied:** Culver Military Acad. with D. Seabury; mostly self-taught. **Exhibited:** Iowa Art Salon, 1934 (honorable mention), 1935 (third prize), 1936; Woman's Clubs, 1934; Cornell College, Mt. Vernon, 1938; All States Exhib., Rockefeller Center, NYC, 1938. **Work:** WPA murals; Agriculture Bldg., State Fair Grounds, Iowa, 1938; Index Am. Des. **Sources:** WW40; Ness & Orwig, *Iowa Artists of the First Hundred Years,* 213.

VERNIER, Wesley *[Listed as "artist"] b.c.1820, Ohio.*
Addresses: NYC in 1850. **Sources:** G&W; 7 Census (1850), N.Y., XLVIII, 554.

VERNON, Alexandra *[Painter] b.1944, Reading, PA.*
Addresses: Los Angeles, CA. **Studied:** Study in Rome, London & New York. **Member:** Los Angeles AA. **Exhibited:** Las Vegas Art League Round-Up, 1969; I. Magnin & Co., Los Angeles, 1969 (solo); Exhib. Religious Art, First Fed. Savings & Loan Assn., Los Angeles, 1971; Ankrum Gallery Exhib. for Nat. Committee on U.S.-China Relations, Los Angeles, 1972; Los Angeles AA Galleries, 1970s. **Work:** Los Angeles AA Galleries; Las Vegas (NV) Art Club Mus.; Newport Harbor Art Mus., Balboa, CA. **Sources:** WW73; D. Simmons, "Collage by Alex Vernon," *Designers West* (July, 1972).

VERNON, Arthur G. *[Painter] b.1885, Vernon, CA / d.1919, Vernon, CA.*
Addresses: NYC; Los Angeles, CA. **Studied:** Brittany and NYC. **Member:** Calif. AC. **Comments:** Position: art critic, *Graphic,*

Los Angeles. Preferred medium: oil and watercolor. **Sources:** WW17; Hughes, *Artists of California,* 576.

VERNON, Cora Louise (Mrs. Arthur) *[Painter] early 20th c.*
Addresses: NYC, 1915; Southern Calif., c.1917. **Sources:** WW17.

VERNON, Della Alice Peppers *[Painter] b.1876, Iowa / d.1962, Stockton, CA.*
Addresses: San Diego, CA, 1901-08; Oakland, CA, 1909-10; Stockton, CA. **Member:** San Diego AA. **Work:** Athenian Niel Club, Oakland. **Sources:** Hughes, *Artists in California,* 576.

VERNON, Elba See: **RIFFLE, Elba Louisa (Mrs. Vernon)**

VERNON, Thomas *[Line engraver] b.c.1824, Staffordshire (England) / d.1872, London (England).*
Addresses: NYC, c.1853-55. **Studied:** Studied engraving in Paris and London. **Comments:** Executed art reproductions for the London *Art Journal.* Was employed in NYC chiefly on banknote work. He returned to England about 1856. **Sources:** G&W; *Art Journal,* XXIV, March 1, 1872, 75, obit.; Stauffer; Cowdrey, NAD; Clement and Hutton.

VEROBISH, Matt *[Painter] 20th c.*
Exhibited: S. Indp. A., 1941. **Sources:** Marlor, *Soc. Indp. Artists.*

VERPLANCK, Samuel *[Artist] late 19th c.*
Addresses: Fishkill, NY, 1868-72. **Exhibited:** NAD, 1868-72. **Sources:** Naylor, *NAD.*

VERRECCHIA, Alfeo *[Lithographer, painter, designer] b.1911, Providence, RI / d.1978, Warwick, RI.*
Addresses: Warwick, RI. **Studied:** RISD; Provincetown Sch. Art; John Frazier. **Member:** Contemp. Artists, Providence, RI. **Exhibited:** AFA traveling exh.; NAD, 1943; MMA (AV); Providence AC, 1943 (prize); LOC, 1943 (prize). **Work:** LOC. **Comments:** Position: pres., Gem-Craft, Inc., Cranston, RI. **Sources:** WW59; WW47.

VERREE, Joseph See: **VEYRIER, Joseph**

VERREES, Paul J. *[Painter, illustrator, etcher] b.1889, Turnhout, Belgium.*
Addresses: Scherpenberg, Westmalle, Belgium. **Studied:** J. de Vriendt; F. Lauwers; Royal Acad. FA, Antwerp; Higher Inst. FA, Belgium. **Member:** Brooklyn SE; Chicago SE. **Exhibited:** AIC, 1921 (medal). **Work:** AIC; State Library, CA; NYPL; Smithsonian Inst., Wash., DC; BMFA. **Comments:** Landscape, portrait, and still life painter; he also produced etchings of Venice scenes. A large group of his works was sold in August, 1998 by Gary Wallace Auctioneers in Chocorua, NH. **Sources:** WW29.

VERRICK, William *[Listed as "artist"] b.c.1826, Germany.*
Addresses: San Francisco in 1860. **Comments:** His wife was also German, but their children were born in California after 1855. **Sources:** G&W; 8 Census (1850), Cal., VII, 1305.

VERRIER, James *[Painter] 20th c.*
Addresses: Arlington, NJ. **Exhibited:** AIC, 1911, 1915. **Sources:** WW25.

VERSCHAEREN, Barth *[Painter] 20th c.*
Addresses: NYC. **Member:** S. Indp. A. **Exhibited:** S. Indp. A., 1921, 1922; Salons of Am., 1922, 1923. **Sources:** WW24.

VERSCHAEREN, Charles *[Painter] mid 20th c.*
Exhibited: S. Indp. A., 1922-23, 1931-33; Salons of Am., 1923, 1932-34. **Comments:** In 1923 he was known as Verschaeren, Charles; in 1932-33, as Verschuuren; and in 1934 as Verschmiren. **Sources:** Marlor, *Salons of Am.*

VERSCHMIREN, Charles See: **VERSCHAEREN, Charles**

VERSCHUUREN, Charles See: **VERSCHAEREN, Charles**

VERSEN, Kurt *[Designer]* b.1901, Sweden.
Addresses: Englewood, NJ; Tenafly, NJ. **Studied:** Polytech School, Charlottenburg, Germany. **Member:** IDI; Arch. Lg.; Nat. AAI; Soc. Des. Club. **Exhibited:** lighting displays, Century of Progress, 1933 (medal); San Diego Expo, 1935; WFNY, 1939; GGE, 1939; U.S. Pavilion, Paris Expo, 1937; Int. Expo, Paris, 1937 (medal); MoMA, 1933, 1937, 1941 (citation), 1947, 1951 (Good Des. Exhib., citation); Indust. Art, Good Design, Buffalo, Providence, & Indianapolis, 1948; Tokyo Indust. Design Exhib., 1950 (citation); State Dept. traveling exhib. **Work:** MoMA; lighting systems: Wadsworth Atheneum; Spring (MA) Mus. FA; Cincinnati Mus.; WMAA. **Comments:** Lectures: lighting, color, design. **Sources:** WW59; WW40.

VERSH, A(braham) A. *[Painter]* 20th c.
Exhibited: S. Indp. A., 1935-36. **Sources:** Marlor, *Soc. Indp. Artists.*

VERSHBOW, Arthur (Mr. & Mrs.) *[Collectors]* 20th c.; b.Boston, MA.
Addresses: Newton, MA. **Studied:** Mr. Vershbow, MIT, B.S. & M.S.; Mrs. Vershbow, Radcliffe College, A.B. **Comments:** Mr. Vershbow, born 1922; Mrs. Vershaw, born 1924, both in Boston, MA. Collection: Prints, particularly works by Redon, Piranesi and Callot; illustrated books, especially fifteenth to seventeenth centuries. **Sources:** WW73.

VER STEEG, Florence B(iddle) *[Painter]* b.1871, St. Louis, MO.
Addresses: St. Louis, MO. **Studied:** St. Louis Sch. FA; R. Miller; H. Breckenridge. **Member:** St. Louis AG; North Shore AA; Boston AC; All-Illinois SFA; Soc. Independent Artists, St. Louis. **Exhibited:** Kansas City AI, 1923 (prize); St. Louis AL, 1928 (prize); Missouri Artists, 1929 (prize); PAFA Ann., 1933; All-Illinois SFA (gold), 1935. **Work:** House of Detention, St. Louis. **Sources:** WW40; Falk, *Exh. Record Series.*

VERSTILLE, William *[Miniaturist and portrait painter]* b.c.1755 / d.1803, Boston.
Addresses: Phila., 1782, 1783; NYC, 1784; Salem, MA, 1802; Boston, 1803; sometime during 1790s in CT. **Sources:** G&W; Belknap, *Artists and Craftsmen of Essex County,* 14; Prime, II, 11; Gottesman, *Arts and Crafts in NYC,* II, no. 55; Felt, *Annals of Salem,* II, 79; Lipman, "William Verstille's Connecticut Miniatures," 7 repros. See also NYHS Catalogue (1974). 53, 606 (with repro.), 2381.

VERTES, Marcel *[Painter, illustrator, designer, scenic artist]* b.1895, Ujpest, Hungary / d.1961, Paris, France.
Addresses: New York 19, NY; Rue de la Faisanderie, Paris. **Studied:** Hungary; Acad. Julian, Paris. **Member:** Art Lg. Am.; Scenic Artists. **Exhibited:** "As They Were" (portraits of celebrities as children) in leading museums in U.S., under the sponsorship of AFA traveling exhibition service. **Work:** MoMA; Musée des Artes Moderne, Paris; Musée Carnavalet, Paris; Luxembourg Mus. Art, Paris; murals, Dallas, TX; Plaza Hotel, Waldorf-Astoria and Carlyle Hotel, NYC. **Comments:** Awards: Officer, Legion of Honor, 1955; two "Oscars," Academy Awards, for designing film "Moulin Rouge," 1954. Designer, ballets: "La Belle Hélène," Paris Opera, 1955; scenes: Ringling Bros.-Barnum & Bailey Circus entire show, 1956. Author/illustrator: "The Stronger Sex," "Art and Fashion," "Instants et Visages de Paris;" Limited Editions: "Parallelement," Paris, 1954; "Ombre de Mon Amour," Paris, 1956; "Daphnis et Chloe," Paris, 1954; "Éloge de Vertes," Paris, 1953; Art Documents Issue "Vertes," Lausanne, 1956. Contributor: *Vogue, Harper's Bazaar.* **Sources:** WW59; WW47.

VERVOORT, V. *[Portrait painter]* early 19th c.
Comments: Portrait of Captain Ward Chipman of Salem (MA) about 1819. **Sources:** G&W; Sherman, "Unrecorded Early American Painters" (Oct. 1934), 150.

VERY, Marjorie Vickers *[Painter, illustrator]* b.1896, Hyde Park, MA / d.1985, Westwood, MA.
Addresses: Westwood, MA. **Studied:** Carnegie Tech. School of Design, Pittsburgh, PA, 1914; BMFA School, 1915; New School, Boston, 1917-20; Phillip Little, 1921. **Member:** Boston WCS (first woman member elected, 1925); NYWCC; Glendale (Calif.) Art Assoc.; Boston WCC; Boston Soc. of Watercolor Painters; Copley Soc.; Gloucester Soc. of Artists; Rockport AA; Provincetown AA; NY Soc. of Women Artists; NAWA. **Exhibited:** New School, Boston, 1920-21; Gloucester Soc. Artists, 1924; North Shore AA, 1924; Hicks Gal., Boston, 1927 (solo); Boston WCS, 1927; Boston Soc. of Watercolor Painters, 1927-35, 1938, 1949-50, 1955-56, 1960, 1974; Copley Soc., 1927, 1952; NYWCC, 1931; Boston AC, 1933; Century C., Boston, 1936 (solo); Doll and Richards, Boston, 1937, 1940; "Boston Looks Ahead," BMFA, 1945 (grand prize, watercolor); Glendale (Calif.) Art Assoc., 1948 (hon. mention), 1950 (first place), 1951, 1960; Westwood (Mass.) Gal., 1967 (solo), 1975 (solo); Barrington (RI) College (now merged with Gordon College), 1968 (solo). **Comments:** Illustrator, dust jackets: William Faulkner, *The Marble Faun* (Boston, MA: Four Seasons Press, 1924); Conrad Aiken, *Nocturne of Spring Remembered* (Boston, MA: Four Seasons Press, first ed., 1917; reprint, 1925); Dorothy Whipple Fry, *Rainbows and Echoes from Fairyland* (Boston, MA: Four Seasons Press, 1927); dust jacket and book illustrations: Warren Wolf, *Buck and Tarheel: A Children's Story Book* (Boston: Bruce Humphries, Inc., 1936); and many others. Teaching: drawing, New School, Boston, 1920-24; private students throughout her career. Painted in many places: Gloucester, MA, with Marion Huse and Gertrude Koch, summers, 1921-23; Provincetown, 1924-27; Crawford Notch, NH, with Marion Huse, 1930; Gaspe Peninsular, Canada, and Quebec, Canada, with Alice Lively, 1933; Conn. River Valley, 1934-35; North Anson, ME, 1935-36. Painted full time for WPA, 1937-41, out of her Westwood (MA) home. Other painting trips: Sargentville, ME, summer, 1946; Cotuit, MA, summer,1947; Aries Pond, Cape Cod, summer, 1950; Staten Island, NY, 1952; West Virginia, 1954, 1966; Wash., DC, 1955, 1966; Williamsburt, VA, 1962; California, 1968-69. Painted Beacon Hill and Boston cityscapes in 1960s. **Sources:** WW25; info. courtesy Selma Koss Holtz, Waban, MA.

VERZYL, June Carol *[Art dealer, collector]* b.1928, Huntington, NY.
Addresses: Northport, NY. **Studied:** Parsons School Design. **Comments:** Positions: gallery director, Verzyl Gallery, Northport, NY, 1966-. Specialty of gallery: contemporary American paintings, sculpture and graphics. Collection: contemporary American, including Filmus, Refregier, Benda, Twardowicz, Clawson & Christopher; nineteenth century engravings. **Sources:** WW73.

VESARIA, Lillian *[Landscape painter]* 19th/20th c.
Exhibited: San Francisco Sketch Club, 1890s; San Francisco AA, 1901. **Sources:** Hughes, *Artists in California,* 576.

VESCE, Francesco *[Sculptor]* 20th c.
Addresses: Brooklyn, NY. **Exhibited:** PAFA Ann., 1923. **Sources:** WW25; Falk, *Exh. Record Series.*

VESCIA, Luke F. *[Sculptor]* 20th c.
Addresses: NYC. **Exhibited:** PAFA Ann., 1929-30; Salons of Am., 1934. **Sources:** WW10; Falk, *Exh. Record Series.*

VESELY, Godfrey Francis *[Landscape painter]* b.1886, Czechoslovakia / d.1966, Orange County, CA.
Addresses: Long Beach/Grass Valley, CA. **Studied:** self-taught; briefly with Puthuff and Richter. **Member:** Long Beach AA; Spectrum Club. **Work:** Nat. Hotel, Nevada City, CA; New Deal Cafe, Grass Valley, CA; Ebell Club, Long Beach. **Comments:** Specialty: desert landscapes of Utah, California, Arizona. **Sources:** Hughes, *Artists in California,* 576.

VESHCHILOV, Konstantin Alexandrovitch See: **WESTCHILOFF, Constantin A.**

VETHAKE, Adriana *[Painter of landscapes & buildings in watercolors]* 18th/19th c.
Addresses: Around NYC and Boston from 1795 to 1801. **Studied:** pupil of Archibald Robertson (see entry) of NYC.

Sources: G&W; *Portfolio* (Aug. 1950), 2-6; *Antiques* (Oct. 1950), 271.

VETR, Anton *[Painter] mid 20th c.*
Addresses: Chicago area. **Exhibited:** AIC, 1934. **Sources:** Falk, *AIC*.

VETTER, Cornelia Cowles (Mrs.) *[Painter] b.1881, Hartford, CT / d.1959.*
Addresses: Hartford, CT (1913); Cheshire, CT (by 1946-on). **Studied:** PIA Sch.; ASL; W.M. Chase Sch., NYC; with Robert Henri, 1909; Spain and Paris, with Anglada-Camarasa. **Member:** Three Arts Club, NYC (for women; founder); CAFA; Hartford Arts Club; Soc. Women P&S of Hartford; New Haven PCC. **Exhibited:** Stockbridge, MA; Springfield, MA; NYC; Hartford, CT; CAFA, 1930 (prize); New Haven PCC, 1932 (prize); Connecticut Gal., Marlborough, c.1988 (retrospective). **Work:** Juvenile Court, Hartford, CT. **Comments:** WPA artist. Also known as Cornelia Cowles. **Sources:** WW53; article in *Antiques & Arts Weekly* (n.d., c.1988); WW47; Art in Conn.: Between World Wars.

VETTER, George Jacob *[Painter, designer, block printer, craftsperson] b.1912.*
Addresses: Elmira, NY. **Studied:** H. Kelsey. **Member:** Elmira Sketch Club; Elmira AS. **Comments:** Specialty: wood engraver. **Sources:** WW40.

VEVANZI, Carlo Gino *[Painter] 20th c.*
Addresses: Kansas City, MO. **Sources:** WW17.

VEVERS, Anthony (Tony) Marr *[Painter, educator] b.1926, London, England.*
Addresses: Lafayette, IN. **Studied:** Yale Univ., B.A., 1950; Accad. Belle Arte, Florence, Italy, 1950; Hans Hofmann School, NYC, 1952-53. **Exhibited:** Am. Acad. Arts & Letters, NYC, 1964; "Younger Painters," Yale Univ., 1965; PAFA Ann., 1966; Evansville (IN) Mus. Show, 1967; 350th Anniversary Exhib. New England Art, MA, 1971; Babcock Gal., NYC, 1970s. **Awards:** grants, Nat. Council Arts, 1967 and Purdue Univ., 1970; New England Painting & Sculpture Prize, 1971. **Work:** New Orleans MA; Univ. Mass, Amherst; Purdue Univ., Lafayette, IN; Fairleigh Dickinson Univ., NJ; Hirshhorn Collection. **Comments:** Semi-abstract landscape painter active in Provincetown, MA, 1955-70s. Preferred media: oils, mixed media. Teaching: Univ. North Carolina, Greensboro, 1963-64; Purdue Univ., 1964-; Fine Arts Work Center, Provincetown, MA, 1970-72. **Sources:** WW73; Provincetown Painters, 247; Falk, *Exh. Record Series.*

VEYREER, Joseph See: **VEYRIER, Joseph**

VEYRIER, Joseph *[Portrait and miniature painter] early 19th c.*
Addresses: Philadelphia. **Comments:** Active 1813-17. The name is variously spelled: Veyrier, Verier, Verree, Veyreer. **Sources:** G&W; Phila. CD 1813-14, 1816-17; G&W has information courtesy Norris S. Oliver of East Orange (NJ) who owns a portrait by Veyrier.

VEZIN, Charles *[Painter, writer] b.1858, Phila., PA / d.1942, Coral Gables, FL.*

C. Vezin

Addresses: NYC/Old Lyme, CT. **Studied:** ASL with F.V. DuMond, W.M. Chase, G.E. Browne, J. Carlson, F.L. Mora; H.M. Turner; G.M. Bruestle. **Member:** SC. 1902; Brooklyn SA (Pres.); Brooklyn PS; NAC; Century Assn.; Lyme AA; SPNY; Allied AA; NYWCC; Yonkers AA; ASL (pres., 1911-15); SC, 1902 (pres., 1914). **Exhibited:** PAFA Ann., 1910, 1912; Corcoran Gal biennials, 1910, 1916; AIC, 1911; Soc. Wash. Artists, 1914 (prize); S. Indp. A., 1917; CAFA, 1925 (prize); Lyme AA, 1927 (prize); Hudson Valley AA (prize); Palm Beach Art Center, 1935 (prize); Allied AA, 1935 (prize). **Work:** NY Hist. Soc.; High Mus., Atlanta; Montclair (NJ) Mus. **Comments:** Began studying art at age 40 and gave up his drygoods business when he was 61 to paint fulltime, en plein air. Author of articles on art. Specialty: New York cityscapes, Brooklyn waterfront scenes. **Sources:** WW40; *Art in Conn.: The Impressionist Years; 300 Years of*

American Art; Falk, *Exh. Record Series.*

VEZIN, Frederick *[Painter, lithographer] b.1859.*
Addresses: Dusseldorf, Germany. **Studied:** Academy of Dusseldorf. **Exhibited:** PAFA Ann., 1893. **Work:** Municipal Gallery of Essen, Germany. **Sources:** Benezit; Falk, *Exh. Record Series.*

VHAY, John D. (Mrs.) *[Painter] 20th c.*
Addresses: Pontiac, MI. **Sources:** WW21.

VHAY, Louise M. *[Painter] early 20th c.*
Addresses: Active in Detroit, MI. **Exhibited:** Detroit Soc. Women P&S, 1911. **Sources:** Petteys, *Dictionary of Women Artists.*

VIAGGIO, Pietro *[Painter, sculptor] 20th c.*
Addresses: NYC. **Exhibited:** S. Indp. A., 1942. **Sources:** WW25; Marlor, *Soc. Indp. Artists.*

VIANCO, Ruth Hastings *[Painter, illustrator, craftsperson, teacher] b.1897, Rochester.*
Addresses: Rochester, NY. **Studied:** Mechanics Inst. **Member:** Rochester AC. **Exhibited:** Rochester AC, 1917 (prize), 1918 (prize). **Comments:** Specialty: watercolor. **Sources:** WW27.

VIANDEN, Heinrich (Henry) *[Landscape painter, teacher] b.1814, Poppelsdorf (Germany) / d.1899.*
Addresses: Milwaukee WI, 1849-99. **Studied:** trained as goldsmith and then studied steel engraving, etching, lithography, and porcelain painting, before studying with Peter von Cornelius, 1836-41, in Munich. **Exhibited:** Milwaukee Industrial Expositions, beginning 1881. **Work:** Milwaukee Art Mus. **Comments:** Left his home in Cologne in 1849 and settled with his family in Milwaukee where he became the leading landscape painter for the next fifty years. He was also a teacher at the German-English Academy, instructing many of the best-known Wisconsin artists of the late 19th century, including Carl von Marr. He helped establish and became the director of the Milwaukee Art Gallery, founded in 1874. **Sources:** G&W; Butts, *Art in Wisconsin,* 109-13; Thieme-Becker; Gerdts, *Art Across America,* vol. 2: 331-32, 333, 334.

VIAU, Joseph Marc-Antoine (Vicaire) *[Sculptor, marble and stone cutter] b.1809, Marseille, France / d.1847, New Orleans, LA.*
Addresses: New Orleans, active 1846. **Sources:** *Encyclopaedia of New Orleans Artists,* 394.

VIAVANT, George *[Painter, sketch artist] b.1872, New Orleans, LA / d.1925, New Orleans, LA.*
Addresses: New Orleans, LA. **Studied:** Parelli, Southern Art Union, 1884-93. **Exhibited:** New Orleans Cotton Centenn. Expo, 1884 (prize); NOAA, 1914. **Work:** Louisiana State Mus. **Comments:** Specialty: watercolors of local fauna, natures mortes. **Sources:** *Encyclopaedia of New Orleans Artists,* 394.

VIAVANT, (Mme.) *[Sketch artist] late 19th c.*
Addresses: New Orleans, active 1885-86. **Exhibited:** American Expo., 1885-86. **Comments:** Possibly Mrs. Emma Viavant who died in Covington, LA, in 1900. **Sources:** *Encyclopaedia of New Orleans Artists,* 394.

VIBBARTS, Eunice Walker See: **VIBBERTS, Eunice Walker (Mrs. Gerald)**

VIBBERTS, Eunice Walker (Mrs. Gerald) *[Painter, teacher] b.1899, New Albany, IN.*
Addresses: Scarsdale, NY; Greenwich, CT. **Studied:** PIA School; ASL; Beaux-Arts, Fontainebleau, France; A Fisher; F.V. DuMond; J. Despujols. **Member:** NAWA; Greenwich SA; Scarsdale AA; Westchester Arts & Crafts Gld.; Weschester AA; Louisville AA. **Exhibited:** NAWA, 1925-27, 1929-32, 1934, 1936-38, 1940-44, 1946, 1947, 1950; Scarsdale AA, 1929-45 (prizes, 1941, 1943); Salons of Am., 1934; Corcoran Gal biennial, 1941; Greenwich SA, 1943-44, 1945 (prize), 1946 (prize), 1947-50, 1952 (prize), 1953, 1954 (prize), 1955-58; Baekland prize, 1943. **Comments:** Teaching: Adult Educ., Rye, NY, 1940. **Sources:** WW59; WW47.

VIBBERTS, Grace Chamberlain (Mrs. Frank G.)
[Painter] b.1879 / d.1945, New Britain, CT.
Addresses: New Britain, CT. **Member:** NAWPS; Hartford Soc.
Women Painters. **Exhibited:** NAWPS, 1935-36; CAFA, 1933,
1938. **Sources:** WW40; Petteys, *Dictionary of Women Artists.*

VICAIRE See: **VIAU, Joseph Marc-Antoine (Vicaire)**

VICAJI, Ruston *[Painter] early 20th c.*
Exhibited: AIC, 1925. **Sources:** Falk, *AIC.*

VICE, Herman Stoddard *[Painter, illustrator] b.1884,
Jefferson, IN.*
Addresses: Chicago, IL. **Studied:** Chicago Acad. FA. **Member:**
South Side AA. **Exhibited:** AIC, 1922. **Sources:** WW40.

VICENTE, Esteban *[Painter] b.1904, Turegeno, Spain.*
Addresses: Bridgehampton, NY. **Studied:** Acad. Belles Artes,
Madrid, Spain. **Exhibited:** Eighth St. Art Show, 1949; Carnegie
Int., CI, Pittsburgh, PA; WMAA Ann.; André Emmerich, NYC,
1970s. Awards: purchase awards, 1960 & 1961 & Tamarind fel-
lowship, 1962, Ford Foundation; Childe Hassa purchase award,
Am. Acad. Arts & Letters, 1971. **Work:** WMAA; AIC; Honolulu
Acad Arts, Hawaii; MoMA; Nat.Collection Fine Arts,
Smithsonian Inst., Washington, DC. **Comments:** Preferred media:
oils, collage. Teaching: art instructor, Black Mountain College,
1948; art instructor, Univ. Calif., Berkeley, 1954 & 1958; art
instructor, New York Univ., 1959-69; art instructor, Yale Univ.,
1960-61; art instructor, Univ. Calif., Los Angeles, 1962; artist-in-
residence, Des Moines AC, 1965; artist-in-residence, Princeton
Univ., 1965-66 & 1969-72; artist-in-residence, Honolulu Acad.
Fine Arts, 1969. **Sources:** WW73; Elaine De Kooning, "Vicente
Paints a Collage," *Art News* (1952); David Shirey, article, *New
York Times,* April 22, 1972; John Ashberry, article, *Art News,*
May, 1972.

VICIC, Joseph *[Painter] mid 20th c.*
Addresses: NYC. **Studied:** ASL. **Exhibited:** S. Indp. A., 1930-
31; Salons of Am., 1934. **Sources:** Marlor, *Salons of Am.*

VICINO, Joseph *[Painter] b.1907 / d.1968.*
Member: Woodstock AA. **Sources:** Woodstock AA.

VICKERS, George Stephen *[Educator] b.1913, St.
Catharines, Ontario.*
Addresses: Toronto, Ontario. **Studied:** McMaster Univ., B.A.;
Harvard Univ., A.M. (Harvard Univ. jr. fellowship, 1939-42).
Comments: Publications: co-author, "Art and Man," 3 volumes,
1964; contributor, *Art Bulletin & Burlington Magazine.* Teaching:
professor, chmn. dept.fine art & council member, Univ. Toronto in
1973. **Sources:** WW73.

VICKERS, Minnie H. *[Sculptor] late 19th c.*
Addresses: Active in Denver, CO, c.1893. **Sources:** Petteys,
Dictionary of Women Artists.

VICKERS, Robert *[Educator] 20th c.*
Addresses: Delaware, OH. **Exhibited:** James A. Porter Gallery,
1970; Howard Univ., 1961. **Comments:** Position: director, dept.
fine arts, Ohio Wesleyan. **Sources:** WW59.

VICKERS, S(quire) J(oseph) *[Painter, architect, writer]
b.1872, Middlefield, NY / d.1947.*
Addresses: Grandview-on-Hudson, NY. **Studied:** Cornell Univ.
College of Architecture, 1900. **Member:** Arch. Lg. **Exhibited:** S.
Indp. A., 1920-34, 1937; Shepherd Gal., NYC, 1992 (retrospec-
tive). **Comments:** He was head of the architectural staff of the
NYC Rapid Transit Commission, 1906-42, and designed the
glazed tilework in 200 stations of the NYC subway system. He
also painted and exhibited oils of expressionist landscapes and
fantasy cities. **Sources:** WW27.

VICKERY, Charles Bridgeman *[Painter] b.1913,
Hindsdale, IL / d.1998.*
Addresses: Western Springs, IL. **Studied:** Art Inst. Chicago; Am.
Acad. Fine Art, Chicago; also with Ben Stahl. **Member:** Pallette
& Chisel Acad. (director, 1967-69); Rockport AA; North Shore
AA. **Exhibited:** Rockport (MA) AA; Union League Club;

Ackerman Gallery, London, England; Springfield (IL) Mus.;
Pallette & Chisel Acad., Chicago, 1968 (Diamond Medal); North
Shore AA, Gloucester, 1970 (Waters of the World Prize); Union
League Club Prize, 1972; W. Russell Button Gallery, Douglas,
MI. , 1970s. **Work:** Univ. Club, Chicago; Union League Club,
Chicago; prints, Royal Acad., London, England. **Comments:**
Preferred media: oils, acrylics. **Sources:** WW73; Eleanor Jewett,
article, *Chicago Tribune* 1945; C. J. Buillet, article, *Chicago
Daily News,* August, 1951.

VICKERY, Frederick P. *[Museum director] b.1880, San
Rafael, CA.*
Addresses: Sacramento 14, CA. **Studied:** Univ. California, B.S.;
Stanford Univ., M.A., Ph.D. **Comments:** Position: instructor, asst.
professor, Univ. Calif., Los Angeles, 1921-27; instructor,
Sacramento College, 1932-44; director, manager, E. B. Crocker
Art Gal., Sacramento, CA, 1944-. Contributor to: numerous scien-
tific & technical papers. **Sources:** WW53.

VICKERY, John *[Illustrator, designer painter] b.1906,
Victoria, Australia.*
Addresses: NYC. **Studied:** Nat. Gal. Art School, Melbourne,
Australia. **Member:** Victorian Art Soc.; New Melbourne AC;
Chelsea AC, London, England; SI. **Exhibited:** Art Dir. Club,
NYC, 1937, 1941, 1942; Art Dir. Club, Phila., 1943; Outdoor
Advertising Art, Chicago, IL. **Work:** Nat. Gal., Melbourne,
Australia. **Sources:** WW53; WW47.

VICKREY, Robert Remsen *[Painter] b.1926, New York, NY.*
Addresses: Southport, CT. **Studied:** Yale Univ. (B.A.); ASL; Yale
School Fine Arts (B.F.A.); also with Kenneth Hayes Miller &
Reginald Marsh. **Member:** AWCS; Audubon Artists; NAD.
Exhibited: WMAA; MoMA; Corcoran Gal biennials, 1951, 1963;
PAFA Ann., 1952-53, 1960, 1964; AWCS, 1956; NAD, 1958;
Santa Barbara MA; Houston MFA; Univ. Nebraska; Midtown Gal,
NYC, 1970s. Awards: Edwin Austin Abbey mural fellowship,
1949. **Work:** Syracuse Univ.; MMA; WMAA; Butler IA; Mus.
Arte Mod., Rio de Janeiro. **Comments:** Preferred media: tempera.
Covers for *Time* magazine; also portraits & book jackets.
Sources: WW73; Falk, *Exh. Record Series.*

VICTOR, Michael *[Lithographer] b.c.1833, France.*
Addresses: Philadelphia, 1860. **Comments:** Lived in Philadelphia
in 1860 in the home of Augustus Koellner. **Sources:** G&W; 8
Census (1860), Pa., LII, 135.

VICTOR, Sophie *[Painter] 20th c.*
Addresses: Detroit, MI. **Exhibited:** PAFA Ann., 1924. **Sources:**
WW25; Falk, *Exh. Record Series.*

VICTOREEN, Ann *[Painter] early 20th c.*
Addresses: Huntington, L.I., NY. **Exhibited:** Salons of Am.,
1932; S. Indp. A., 1932. **Sources:** Falk, *Exhibition Record
Series.*

VICTORY, George M. *[Painter] b.1878.*
Addresses: Philadelphia, PA. **Studied:** Self-taught. **Exhibited:**
Carlen Galleries, Phila.; Inst. Modern Art, Boston, 1943; Smith
College, 1943. **Work:** Nat. Archives. **Sources:** Cederholm, *Afro-
American Artists.*

VIDA, Everett G. *[Painter] 20th c.*
Exhibited: S. Indp. A., 1941. **Sources:** Marlor, *Soc. Indp. Artists.*

VIDAL, Hahn See: **VIDAL, (Margarita) Hahn**

VIDAL, (Margarita) Hahn *[Painter] b.1919, Hamburg,
Germany.*
Addresses: New York, NY. **Studied:** With Eduardo Couce Vidal.
Member: Grand Central Art Galleries; Hudson Valley AA;
AAPL. **Exhibited:** Mus. Bellas Artes, Rio de Janeiro, Brazil,
1952; Galeria Arg., Buenos Aires, 1955, 1957, 1960 & 1968;
Flowers from Argentina, Kennedy Gallery, NYC, 1961; Doll &
Richards, Boston, MA, 1963 & 1970; Flower Painters of the
World, Tryon Gallery, London, England, 1968; Grand Central Art
Galleries, NYC, 1970s. **Work:** Eduardo Sivori, Mus. Artes
Plasticas, Buenos Aires, Argentina; Juan B. Castagnino, Museo

Cuidad Rosario, Argentina; SAM; Mus. Mobile, AL; Hist. Mus. Taiwan, China. Commissions: Hahn Vial Room, Arvida Corp., Boca Raton Hotel & Club, FL, 1969. **Comments:** Preferred media: oils. **Sources:** WW73.

VIDAR, Frede *[Painter; mural, miniature, and portrait painter, educator] b.1911, Denmark / d.1967, Ann Arbor, Michigan.* **Addresses:** NYC, 1938; Montclair, NJ, 1947; Ann Arbor, MI, 1950s. **Studied:** Royal Acad., Denmark; Calif. School FA; École des Beaux-Arts, Paris; Julian Acad., Paris, France; Acad. FA, Munich, Germany. **Member:** Am. Acad. in Rome (Assoc.); San Francisco AA; NSMP; NJAA; AEA; Calif. Soc. Mural Painters. **Exhibited:** SFMA, 1935; GGE, 1939; PAFA Ann., 1938; 48 Sts. Comp., 1939; Corcoran Gal biennials, 1939-51 (4 times); Assoc. Am. Artists, 1949 (solo); Rackham Gal., Ann Arbor, MI, 1955; Univ. Michigan, 1959; AIC; WMAA. **Work:** MMoaA; Nat. Mus. Copenhagen; Palace Legion Honor; Newark Mus.; Pasadena AI; reproduction of war paintings for the Gen. MacArthur story, *Life Magazine,* 1955. **Comments:** Positions: army combat artist, 1942-46; documentary artist, *Life Magazine,* 1946, 1947; Abbott Laboratories, 1947, 1950; instructor, Washington Univ., St. Louis, 1950-51; *Life Magazine* war correspondent, Korea, 1950-51; assoc. professor art, dept. art, Univ. Michigan, 1953-. Awards: Chaloner fellowships, 1935-37; Guggenheim fellowship, 1946; Special Faculty Grant of the Rackham School Grad. Studies for studies of Byzantine structural forms and studies of life and culture of the Holy Mountain of Athos, 1957-. **Sources:** WW59; WW47; Falk, *Exh. Record Series.*

VIDRINE, Vincent V. *[Painter] mid 20th c.* **Addresses:** Chicago area. **Exhibited:** AIC, 1946, 1949. **Sources:** Falk, *AIC.*

VIEDER, Alfred *[Listed as "artist"] b.c.1825, New York.* **Addresses:** NYC in 1860. **Sources:** G&W; 8 Census (1860), N.Y., XLVI, 128.

VIELE, Herman Knickerbocker *[Topgraphical artist, engineer] d.1910, Wash., DC.* **Addresses:** Wash., DC, active 1887-1910. **Member:** Cosmos Club; Soc. of Wash. Artists (secretary, 1895). **Sources:** McMahan, *Artists of Washington, DC.*

VIELE, Sheldon K. *[Painter] 20th c.* **Addresses:** Buffalo, NY. **Sources:** WW17.

VIELEHR, Ernest G. *[Painter] 20th c.* **Addresses:** Chicago area. **Exhibited:** AIC, 1927. **Sources:** Falk, *AIC.*

VIENA, F. *[Artist] late 19th c.* **Exhibited:** NAD, 1885. **Sources:** Naylor, *NAD.*

VIERRA, Carlos *[Cartoonist, landscape and mural painter, photographer] b.1876, Moss Landing, CA / d.1937, Santa Fe, NM?.* **Addresses:** Santa Fe, NM, since 1904. **Studied:** NYC; San Francisco, with G. Piazzoni. **Exhibited:** Oakland Art Fund, 1905. **Work:** Mus. New Mexico; murals, Santa Fe AM; Balboa Park, San Diego, CA. **Comments:** He was a marine painter in NYC, 1901-03, before moving to New Mexico for health reasons. He is regarded as the first professional artist to have resided in Santa Fe. Specialty: architectural renderings of the old missions and adobes of New Mexico. **Sources:** WW19; Hughes, *Artists of California,* 577; P&H Samuels, 500-01; Eldredge, et al., *Art in New Mexico, 1900-1945,* 209.

VIERTEL, Paul A. *[Painter] 20th c.* **Addresses:** Columbus, OH. **Member:** Columbus PPC. **Sources:** WW25.

VIERTHALER, Arthur A. *[Craftsman, educator] b.1916, Milwaukee, WI.* **Addresses:** Madison, WI. **Studied:** Milwaukee State Teachers College (B.S.); Univ. Wisconsin (M.S.). **Exhibited:** Milwaukee Designers; Midwestern Designers; Smithsonian Traveling Exh.; Designer-Craftsmen Traveling Exhs.; Wisconsin State Fair.

Awards: Wisconsin Designer-Craftsmen; Madison AA; Mississippi River Exh., 1961. **Comments:** Teaching: lectures on pre-historic design, contemporary design, natural phenomena of design elements in minerals, gemstones, mining for gemstones & others; art instructor, Madison Public Schools; professor art, School Educ., Univ. Wisconsin in 1973. **Sources:** WW73.

VIESULAS, Romas *[Printmaker, educator] b.1918, Noreikiasi, Lithuania / d.1986, Rome, Italy.* **Addresses:** Philadelphia, PA. **Studied:** École des Arts et Metiers, Germany, grad.; École des Beaux Arts, Paris, France. **Member:** Print Club Philadelphia; SAGA. **Exhibited:** Inst Exhibs Graphic Arts, Ljubljana, Yugoslavia, 1959, 1961 & 1965; WMAA, 1966; Biennial Graphic Arts, Krakow, Poland, 1966, 1968 & 1970; Two Decades of American Prints 1947-68, Brooklyn Mus. 1969; 35th Biennial of Venice & Italy, 1970 (solo); Weyhe Gallery, NYC, 1970s. Awards: Guggenheim fellowships, 1958, 1964 & 1969; Tamarind fellowship, 1960; medal, Biennial Graphic Arts, Krakow, 1970. **Work:** MoMA; MOMA, Kamakura, Japan; Bibliothèque Nat. Paris; Art Gallery NSW, Sydney, Australia; Nat. Gallery Art, Washington, DC. Commissions: Spring (ed), Print Club, Phila., 1965; Up-on (100 prints), Int. Graphic Arts Soc., New York, 1968; Ascent (ed), Aquarius Press, 1970. **Comments:** Came to U.S. in 1951, to Italy in 1985. Preferred medium: graphics. Teaching: professor printmaking, Tyler School Art, Temple Univ., 1960-. **Sources:** WW73.

VIETS, Ivan *[Painter] 20th c.* **Exhibited:** S. Indp. A., 1938. **Sources:** Marlor, *Soc. Indp. Artists.*

VIETT, E. T. *[Sculptor] 20th c.* **Addresses:** Charleston, SC. **Sources:** WW04.

VIGIL, Romando *[Painter] 20th c.* **Exhibited:** S. Indp. A., 1933. **Sources:** Marlor, *Soc. Indp. Artists.*

VIGIL, Thomas *[Painter] mid 20th c.* **Exhibited:** AIC, 1935. **Sources:** Falk, *AIC.*

VIGNA, Gloriano *[Painter, sculptor, illustrator, architect, writer, teacher] b.1900, Paterson.* **Addresses:** Paterson, NJ. **Studied:** Bridgman; Du Mond; F. Vigna, in Turin, Italy. **Comments:** Decorator to the King and Queen of Italy. **Sources:** WW33.

VIGNEY *[Painter] mid 20th c.* **Exhibited:** AIC, 1939-40. **Sources:** Falk, *AIC.*

VIGNIER, A. *[Landscape painter] early 19th c.* **Addresses:** Philadelphia, 1811-14. **Exhibited:** PAFA & Soc. of Artists, 1811-28. **Comments:** One of his landscapes was a Swiss scene. **Sources:** G&W; Rutledge, PA; Dunlap, *History,* II, 472.

VIGNOLES, Charles Blacker *[Topographical draftsman, surveyor, and civil engineer] b.1793, England / d.1875.* **Addresses:** Charleston, SC, 1817-23. **Comments:** An English army officer who served briefly with Bolivar in South America, Vignoles came to Charleston (SC) in 1817 and soon after was appointed Assistant Surveyor-General of South Carolina. He also did considerable private work there and in Florida. Sometime before his departure in 1823, he drew a view of Charleston which was engraved in aquatint by William Keenan and published in Charleston about 1835. Vignoles returned to England in 1823 and became a prominent civil engineer, specializing in railroad construction. He was the author of *Observations upon the Floridas.* **Sources:** G&W; Stokes, *Historical Prints,* 59, cites O.J. Vignoles, *Life of Charles Blacker Vignoles* (London 1889); Rutledge, *Artists in the Life of Charleston.*

VIGOUREUX, Jean H. *[Painter] mid 20th c.* **Exhibited:** AIC, 1941. **Sources:** Falk, *AIC.*

VIGTEL, Gudmund *[Art administrator] b.1925.* **Addresses:** Atlanta, GA. **Studied:** Isaac Grunwald's School Art, Stockholm, 1943-44; Univ. Georgia (B.F.A., 1952; M.F.A., 1953). **Member:** Am. Assn. Mus.; Assn. Art Mus. Directors. **Comments:** Positions: admin. asst., Corcoran Gallery Art, 1954-57, asst. to director, 1957-61, asst. director, 1961-63; director, High Mus. Art,

1963-. Publications: numerous exhib. catalogues. Collections arranged: The New Tradition, 1963; An Anthology of Modern American Art, 1964; The Beckoning Land, 1971; The Modern Image, 1972; plus numerous others. **Sources:** WW73.

VIGUS, Mary S. *[Artist] 19th/20th c.*
Addresses: Active in Grand Rapids, MI, 1888-1900. **Sources:** Petteys, *Dictionary of Women Artists.*

VIK, Della B. *[Painter, photographer] b.1889, River Sioux, IA.*
Addresses: Active Rapid City, SD. **Studied:** Colorado Springs FAC; Gutzon Borglum. **Exhibited:** Rockefeller Center, NYC; Surbeck Center, South Dakota School Mines & Technology; South Dakota State Fairs. **Sources:** Petteys, *Dictionary of Women Artists.*

VILACEQUE, Léopoldine (Mrs.) *[Painter] late 19th c.; b.San Francisco, of Fr. parents.*
Studied: with Dessart, and Mmes. Thoret and Oriard. **Exhibited:** Paris Salon, 1880. **Sources:** Fink, *American Art at the Nineteenth-Century Paris Salons,* 400.

VILDER, Roger *[Sculptor] b.1938, Beyrouth, Lebanon.*
Addresses: Toronto, Ontario. **Studied:** Sir George Williams Art School, diploma; Sir George Williams Univ., B.F.A.; McGill Univ. **Member:** Quebec Sculptor Assn. (member exec. committee, 1969-); Assn. Artistes Prof. Quebec; Canadian Artist Rels. **Exhibited:** Artists 1968, Art Gallery Ontario, Toronto, 1968; Concours Quebec Prov., Mus. Contemporary Art, Montreal, 1968, 1969 & 1971; Some More Beginning, Brooklyn Mus., 1969; 11th & 12th Winnipeg Biennial, Manitoba, 1969-71; Kinetics, Hayward Gallery, London, England, 1970. Awards: Concours Artistique PQ, Mus. Contemporary Art, 1968; Canadian Arts Council grants, 1968-70 & 1971-72. **Work:** Mus. Contemporary Art, Montreal. Commissions: Kinetic works, World's Fair, Montreal, 1970-71 & Canadian Govt., Osaka, Japan, 1970; kinetic wall, Ministry External Affairs, Ottawa, 1971-72. **Comments:** Preferred media: kinetics. Positions: counr., Quebec Sculptors Assn., 1969-71; advisor & member exec. committee, soc Prof. Artists Quebec, 1970-71. Publications: author, "Sculpture and Lights, *Arts Canada,* Dec 1968; author, "Lumiere Cans L'art," *Forces,* spring 1969; editor, "London Exhibitions," *Arts Magazine,* 11/1970; author, "Technology and Art," *Studio Int.,* 11/1970; author, "Le Paradoze Magique de Roger Vilder," *Vie Arts,* fall 1971. Teaching: professor painting & sculpture, Mus. Art School, Montreal, 1967-69; professor advanced design, Sir George Williams Univ., 1969-70; professor painting & sculpture, College Old Montreal, 1969-. **Sources:** WW73; Frank Popper, "Kinetics art" (Studio Vista, London, 1970); Jasia Reichardt, "Kinetics," *Architectural Design,* (London, 1971).

VILES, Millie H. *[Painter] late 19th c.*
Addresses: Active in Washington, DC, 1880-88. **Sources:** Petteys, *Dictionary of Women Artists.*

VILLA, Carlos *[Painter] b.1936.*
Addresses: San Francisco, CA. **Studied:** San Francisco Art Inst., B.F.A., 1961; Mills College, M.F.A., 1963. **Exhibited:** Park Place Group, Daniel's Gallery, NYC, 1965; Park Place Invitational, Park Place Gallery, New York, 1965; Second Ann. Arp To Artschwager Exhib., Goldowsky Gallery, New York, 1967; Wyndham College, VT, 1968 & San Francisco Art Inst., 1969; WMAA, 1972. Awards: hon. mention, Richmond Art Center Ann., 1958. **Comments:** Teaching: asst., Mills College, 1961-63; asst., Studio 1, Oakland, CA, 1961-63; instructor, Telegraph Hill Neighborhood Center, Urban Arts, San Francisco, 1969-70; chmn. interdepartmental studies, San Francisco Art Inst., 1973; asst. professor art, Calif. State Univ., Sacramento. **Sources:** WW73; review (Dec., 1970) & Emily Wasserman, article (Jan., 1971), *Artforum.*

VILLA, Hernando Gonzalo *[Painter, illustrator, teacher, mural painter] b.1881, Los Angeles, CA / d.1952, Los Angeles, CA.*
Addresses: Los Angeles, CA. **Studied:** Los Angeles Sch. FA,

1905; England & Germany, 1906. **Exhibited:** San Francisco mural, Pan-Pacific Expo, 1915 (gold). **Work:** Laguna Beach Mus.; LACMA; Fort Worth Mus. of Art; Citizen's Trust & Savings Bank, Los Angeles (mural); Santa Fe RR collection; New Rialto Theatre, Phoenix, AZ (mural). **Comments:** Illustrator: *West Coast Magazine, Los Angeles Town Talks;* and the Santa Fe RR for 40 yrs. Specialty: scenes of the Old West and Native Americans, the Mexican vaquero, missions and landscapes. **Sources:** Hughes, *Artists in California,* 577; P&H Samuels, 501.

VILLAMIL, P. *[Portraitist] late 19th c.*
Addresses: Brooklyn, NY, 1867. **Exhibited:** NAD, 1867. **Sources:** Naylor, *NAD.*

VILLANI, James A. *[Painter] 20th c.*
Addresses: St. Albans, NY. **Member:** AWCS. **Exhibited:** NYWCC, 1937; AWCS-NYWCC, 1939. **Sources:** WW47.

VILLARD, Mariquita *[Lithographer] 20th c.*
Addresses: NYC. **Exhibited:** WMAA, 1942. **Sources:** Falk, *WMAA.*

VILLATORE, Alba *[Painter] mid 20th c.*
Exhibited: Salons of Am., 1934. **Sources:** Marlor, *Salons of Am.*

VILLENEUVE, Joseph Arthur *[Painter] b.1910, Chicoutimi, PQ.*
Addresses: Chicoutimi, PQ. **Exhibited:** Mus. Quebec; Vancouver Art Gallery; Galerie Art Can. Chicoutimi; Galerie Morency, Montreal, 1970s; Gallerie Waddington, Montreal. **Work:** Mus. Beaux Arts Montreal; Musee du Québec; Nat. Gallery Canada, Ottawa. **Sources:** WW73; Marcel Carriere (author), "Off. Nat. Film," 7/5/1965; Henri-Pierre Fortier (author)," Off. Radio-TV Française," 4/26/1972," Arthur Villeneuve's Quebec Chronicles" (exhib catalogue), Montreal Mus. Fine Arts.

VILLENEUVE, Nicholas *[Illustrator, cartoonist] 20th c.*
Addresses: Boise, ID. **Work:** Huntington Library, San Marino, CA; Carnegie Library, Boise. **Comments:** Position: illustrator & cartoonist, *Idaho Daily Statesman.* **Sources:** WW40.

VILLEPIQUE, Arthur *[Painter] 20th c.*
Addresses: Glen Rock, NJ. **Exhibited:** S. Indp. A., 1925. **Sources:** Marlor, *Soc. Indp. Artists.*

VILLERÉ, Elizabeth See: **FORSYTH, Elizabeth Villeré (Mrs. King L.)**

VILLERE, Elmire M. *[Listed as "artist"] 19th/20th c.*
Addresses: New Orleans, active 1899-1905. **Member:** NOAA, 1905. **Exhibited:** Louisiana Purchase Expo, 1904. **Comments:** She assisted Jennie Wilde (see entry) in the execution of two large maps depicting N.O. and the Mississippi River, which were exhibited at the St. Louis Expo. **Sources:** *Encyclopaedia of New Orleans Artists,* 395.

VILLON, Jacques *[Painter, printmaker] b.1875, Damville, France / d.1963, Puteaux, France.*
Member: Soc. Indep. Artists. **Exhibited:** Armory Show, NYC, 1913; Soc. Indep. Artists, 1917, 1921, 1923, 1941; Société Anonyme, NYC; Salons of Am., 1923; Carnegie Inst., 1950 (prize), 1952 (prize), 1955 (prize), 1958 (retrospective); MOMA, Paris, 1951 (retrospective); Venice Bien., 1950 (solo), 1956 (prize). **Work:** Yale Univ. Gal., New Haven; Guggenheim Mus.; MMA; MoMA, NYC; MOMA, Paris. **Comments:** Although he resided in France his entire life (except during WWII), Jacques Villon (pseudonym for Gaston Duchamp), brother of Marchel Duchamp, was listed in the American Art Annual for 1925 with an address c/o of Walter Pach, NYC. Villon's work had been seen at the Armory Show in NYC in 1913, and was subsequently shown at a number of American exhibitions, including the Society of Independent Artists, for which he gave addresses c/o Marchel Duchamp, NYC (1917) and Walter Pach again in 1921, 1923, 1941. Pach took an active interest in Villon's work, helping him show at group exhibitions and also organizing solo shows for him in NYC and Chicago, 1931-33. Villon's work in the early 1930s was concerned with color/spatial contrasts and had grown out of

his interest in and his study of the color theories of Chevrul. It was in relation to these works that Villon himself visited the U.S. in the 1930s (in 1935 and perhaps in 1931). **Sources:** WW25; Benezit.

VILMER, Colby *[Portrait painter] mid 19th c.*
Addresses: Rochester, NY in 1842. **Comments:** Undoubtedly the same as Colby Kimble. **Sources:** G&W; FARL cites letter of Mrs. M. Perkins Donnell, Nov. 10, 1941.

VINCENT, Ada S. (Mrs. John W.) *[Painter] 20th c.*
Addresses: Roland Park, MD. **Member:** Baltimore WCC. **Sources:** WW25.

VINCENT, Andrew McDuffie *[Painter, educator] b.1898, Hutchinson, KS.*
Addresses: Eugene, OR. **Studied:** AIC. **Member:** Portland AA; Am. Assn. Univ. Prof.; AAPL. **Exhibited:** AIC, 1928 (prize); GGE, 1939; SAM; Portland (OR) Art Mus.; San Francisco; Mills College; Denver, CO; Eugene, OR; Henry Gal., Univ. Washington, 1957; Maryhurst College, Oswego, OR, 1961 (solo); Warner Mus., Univ. Oregon; Fort Wright College, Spokane, WA. **Work:** SAM; Portland (OR) Art Mus.; WPA murals, USPO, Toppenish (WA), Salem (OR); mural, City Hall, Eugene, (OR). **Comments:** Positions: head, art dept., Univ. Oregon, Eugene, 1966; chmn., Lane County Art Commission. **Sources:** WW66; WW47.

VINCENT, Harriet S. *[Painter] early 20th c.*
Addresses: NYC. **Exhibited:** Macdowell Club, NYC, 1914 (solo). **Sources:** WW15; Petteys, *Dictionary of Women Artists.*

VINCENT, H(arry) A(iken) *[Painter] b.1864, Chicago, IL / d.1931, Boston, MA?.*
Addresses: Hyde Park, Chicago, 1892; NYC, 1897, 1908-28; Rockport, MA, 1918, 1932-; Boston, MA. **Studied:** self-taught. **Member:** ANA; SC; Allied AA; NYWCC; North Shore AA (charter member); Rockport AA (first pres., 1921). **Exhibited:** NAD, 1892, 1897; SC, 1907 (prize), 1916 (prize), 1918 (prize), 1925 (prize); PAFA Ann., 1908, 1912-13, 1918, 1925-31; Gal. on the Moors, 1919; NYWCC (prizes); AIC. **Work:** Butler AI; Illinois State Univ. **Comments:** Best known for his bold Impressionist marine and harbor scenes. **Sources:** WW29; Falk, *Exh. Record Series;* info. courtesy North Shore AA.

VINCENT, Tom *[Painter] b.1930, Kansas City, MO.*
Addresses: New York, NY. **Studied:** Kansas City Art Inst. (B.F.A. & M.F.A.). **Member:** PAFA; AWCS; United Scenic Artists. **Exhibited:** MoMA; Corcoran Gal biennials, 1957, 1959; PAFA Ann., 1962 (prize); Caravan de France Gal, NYC; Galerie Cernuschi, Paris, 1970s. Awards: Speiser Mem. Award for "Procession," 1962; Silvermine Guild Award for composition, 1969; Montclair Mus. Award for triptych, 1970. **Work:** Kansas City Art Inst.; Springfield (MO) Mus. Fine Arts; Atlanta (GA) Mus.; Montclair (NJ) Art Mus.; Milwaukee (WI) Art Center. Commissions: painting, Charles S. Gehrie S. Presto Int., 1940; Jazz (painting), Venice Film Festival, 1962; mural, Schering Corp., 1968; mural, Montclair Travel Bollinger, 1971. **Comments:** Preferred media: polymer, liquitex, oils. Teaching: drawing instructor, Montclair (NJ) Art Mus., 1970-. **Sources:** WW73; Russel O. Hoddy, *Polymer Painting* (Van Nostrand Reinhold, 1971); Falk, *Exh. Record Series.*

VINCENTI, Francis *[Sculptor] mid 19th c.; b.Italy.*
Addresses: Washington, DC, 1853-58; Richmond, VA. **Comments:** Employed at the Capitol in Washington, where he modelled several busts of visiting Indians and supplied anatomical models for other Capitol sculptors. After leaving Washington he worked for Edward V. Valentine (see entry) in Richmond for a time, then returned to Europe and was last heard of in Paris. **Sources:** G&W; Fairman, *Art and Artists of the Capitol,* 168-69.

VINCKLEBACK, William *[Listed as "artist"] b.1834, Germany.*
Addresses: NYC in 1850. **Sources:** G&W; 7 Census (1850),

N.Y., XLIII, 146.

VINER, Flossie A. *[Painter] mid 20th c.*
Addresses: Chicago area. **Exhibited:** AIC, 1940. **Sources:** Falk, AIC.

VINER, Frank Lincoln *[Sculptor, designer] b.1937, Worcester, Mass.*
Addresses: New York, NY. **Studied:** School Worcester Art Mus.; Yale Univ. (B.F.A., 1961; M.F.A., 1963). **Exhibited:** Eccentric Abstraction, Fischbach Gallery, New York, 1966; Options, Directions, Milwaukee Art Center & Mus. Contemporary Art, Chicago, 1968; WMAA Sculpture Ann., New York, 1968; Op Losse Schroeven/Square Tags in Round Holes, Stedelijk Mus., Amsterdam, 1969; A Plastic Presence, Jewish Mus., New York, Milwaukee Art Center & San Francisco Mus. Art, 1970; 55 Mercer Gallery, NYC, 1970s. **Work:** Rose Art Mus., Brandeis Univ.; Milwaukee Art Center; Riverside Mus., NYC. Commissions: five wearable sculptures, Berkshire Int. 1968; yellow environ room, Wadsworth Atheneum, Hartford, CT, 1969. **Comments:** Preferred media: vinyl, cheesecloth, dyes. Publications: contributor, "Art by Telephone" (recording), Mus. Contemporary Art, Chicago, 1969; contributor, "If I Had a Mind. Concept-Art Project-Art," 1971. Teaching: instructor fine art, School Visual Arts, New York, 1963-, visiting artist, Univ. Colorado, Boulder Grad. School Art, 1972; Rhinehart critic sculpture, Maryland Inst. Art, 1972. **Sources:** WW73; D. Judd, "Hard Edge Painting," *Arts Magazine* (Feb., 1963); H. Kramer, "And Now Eccentric Abstraction," *New York Times,* Nov., 1966; L. R. Lippard, *Collected Essays in Art Criticism* (1971).

VINER, Helen Sikorsky *[Painter] 20th c.*
Addresses: Stratford, CT. **Exhibited:** S. Indp. A., 1932. **Sources:** Marlor, *Soc. Indp. Artists.*

VINETTE, Barbara I. *[Artist] early 20th c.*
Addresses: Los Angeles, CA, c.1914-20. **Sources:** Petteys, *Dictionary of Women Artists.*

VINICKY, Charles *[Painter] mid 20th c.*
Exhibited: Salons of Am., 1934. **Sources:** Marlor, *Salons of Am.*

VINMAR, Charles *[Painter] 20th c.*
Addresses: NYC. **Member:** S. Indp. A. **Exhibited:** S. Indp. A., 1921. **Sources:** WW25.

VINSON, Charles Nicholas *[Painter] b.1927, Wilmington, DE.*
Addresses: Wilmington 2, DE. **Studied:** PAFA (Cresson traveling scholarship, 1952); in Mexico; with Hobson Pittman, Franklin Watkins, Walter Stuempfig. **Member:** Wash. Soc. FA; PAFA. **Exhibited:** PAFA, 1951 (prize); PAFA Ann., 1952-53; NAD, 1952; Penn. State Teachers College, 1951 (prize); Mexico City, 1948; Delaware AC, 1950, 1951 (prize). **Work:** Wash. Soc. FA. **Sources:** WW59; Falk, *Exh. Record Series.*

VINSON, L. C. *[Painter] 20th c.*
Addresses: Cleveland, OH. **Member:** Cleveland SA. **Comments:** Position: affiliated with Gage Gallery, Cleveland. **Sources:** WW27.

VINSON, Lyle *[Painter] 20th c.*
Addresses: Newark, NJ. **Studied:** Fawcett School Art with Ida W. Stroud. **Exhibited:** Lefevre Gallery, Newark, NJ, 1915. **Sources:** WW15.

VINSON, Marjorie Green (Mrs. Fleming G.) *[Painter] d.1946, Savannah, GA.*
Member: SSAL.

VINSON, Pauline *[Painter, lithographer] b.1915.*
Addresses: San Francisco, CA, 1930s; NYC. **Exhibited:** de Young Mus., 1939. **Comments:** Specialty: watercolors. Positions: illustrator, *Festivals in San Francisco,* 1939, *Around the World in San Francisco,* 1940, *Hilltop Russians in San Francisco,* 1941; illustrator, children's books, MacMillan Company. **Sources:** Hughes, *Artists in California,* 577.

VINTON, E. P. *[Portrait painter] 19th c.*
Work: Dartmouth College, Hanover, NH: portrait of John Wheeler (1798-1862). **Sources:** G&W; WPA (Mass.), *Portraits Found in N.H.,* 27.

VINTON, Frederic Porter
[Portrait painter] b.1846, Bangor, ME / d.1911.

Addresses: Boston, MA, 1880-94. **Studied:** Boston with W.M. Hunt; Lowell AI with W. Rimmer; Royal Acad., Munich, with Mauger and W. Diez, 1874; also with Piloty in Munich; briefly with Bonnât in Paris, 1874; Académie Julian, Paris with J.P. Laurens, 1875 (apparently the first American to study with him); returned to Boston, 1879. **Member:** NA, 1891; SAA, 1880; NIAL. **Exhibited:** Paris Salon, 1878, 1890 (prize); Boston AC, 1873-1909; PAFA Ann., 1879-1911 (5 times; gold medal 1909); NAD, 1880-94; Columbian Expo, Chicago, 1893 (gold); Atlanta Expo, 1900 (medal); Pan-Am. Expo, Buffalo, 1901 (gold); St. Louis Expo, 1904 (gold); Corcoran Gal annuals/biennials, 1907-08, 1910; BMFA, 1911 (mem. exhib.). **Comments:** Shared a studio with Edward A. Page. **Sources:** Fink, *American Art at the Nineteenth-Century Paris Salons,* 400; Falk, *Exh. Record Series.*

VINTON, L(illian) Hazlehurst *[Painter] b.1881, Boston, MA.*
Addresses: Paris, France, 1914; NYC/Essex, NY. **Studied:** S. Simi, Florence; Parish with R. Collin, Courtois, R. Miller; Woodbury. **Exhibited:** PAFA Ann., 1914, 1917. **Sources:** WW25; Falk, *Exh. Record Series.*

VINTON-BROWN, Pamela See: **RAVENEL, Pamela Vinton Brown**

VINTON-STRUNZ, Pamela (Mrs.) See: **RAVENEL, Pamela Vinton Brown**

VINTROUX, Kendall *[Cartoonist] b.1896.*
Addresses: Charleston, WV. **Work:** Huntington Lib., San Marino, CA. **Comments:** Affiliated with *Charleston Gazette.* **Sources:** WW40.

VINZENT, Alice H. *[Still-life painter] late 19th c.*
Addresses: Oakland, CA. **Exhibited:** Calif. State Fair, 1888; San Francisco AA, 1889, 1890. **Sources:** Hughes, *Artists of California,* 577; Petteys, *Dictionary of Women Artists.*

VIOGET, Jean Jacques *[Amateur watercolorist] b.1799, Switzerland / d.1855, near San Jose, CA.*
Addresses: Yerba Buena, CA, 1837; near San Jose, CA, 1843-55. **Comments:** Vioget served briefly in the French army and was apprenticed to a naval engineer. In 1834 he was commissioned to lay out streets that are now San Francisco's Pacific, Pine and Stockton. He went into business at Yerba Buena as a hotel keeper. He also made some surveys and maps for General Sutter before moving to San Jose. His watercolor of Yerba Buena in 1837 has been reproduced. **Sources:** G&W; Van Nostrand and Coulter, *California Pictorial,* 30-31; Peters, *California on Stone;* P&H Samuels, 501-02.

VIOGET, John J. See: **VIOGET, Jean Jacques**

VIOLA, William *[Video artist] b.1951.*
Addresses: Long Beach, CA. **Exhibited:** WMAA, 1975-87. **Sources:** Falk, *WMAA.*

VION, Alexander *[Artist] late 19th c.*
Addresses: NYC, 1862. **Exhibited:** NAD, 1862. **Sources:** Naylor, *NAD.*

VIRALT *[Painter] early 20th c.*
Exhibited: AIC, 1932. **Sources:** Falk, *AIC.*

VIRDEN, Rose *[Painter] b.1860.*
Addresses: Newark, NJ. **Exhibited:** PAFA Ann., 1885 (flower paintings). **Sources:** Falk, *Exh. Record Series.*

VIRDONE, Paul C(harles) *[Sculptor] 20th c.*
Addresses: NYC. **Exhibited:** S. Indp. A., 1941; WMAA, 1947. **Sources:** Falk, *WMAA.*

VIRET, Margaret Mary (Mrs. Frank Ivo) *[Painter, lecturer] b.1913, New York, NY.*
Addresses: Miami, FL. **Studied:** Terry Art School; Miami Art School; Miami Art Center; Univ. Miami; also with Dong Kingman, Eliot O'Hara, Xavier Gonzalez, Eugene Massin, Georges Sellier & Jack Amoroso plus many other prominent instructors. **Member:** Miami Art League (pres., 1955-56); Florida Fed. Art (vice-pres., 1956-58); Hibiscus Fine Arts Guild (hon. member); Coral Gables Art Club; Allied Arts North Miami (hon. member). **Exhibited:** Tampa Art Mus., 1955; Florida Fed. Art, 1955-56; Bass Art Mus., Miami Beach, 1955-57, 1962 & 1963; Lowe Art Gallery, 1960, 1962 & 1970; Am. Contemporary, Four Arts Soc., 1965. **Awards:** best watercolor for flowers, Florida Fed. Women's Clubs, 1961; best watercolor for marine, Bass Art Mus., 1962; best watercolor for flowers, Burdines Coral Gables Art Club, 1963. **Work:** Florida Fed. Art, De Bary; Mirell Gallery; Norton Gallery; Lowe Art Gallery; Bacardi Art Gallery, FL. **Commissions:** Cuba Home Scene, Miami Woman's Club, 1963; ballet scenes, Pauline Hill Co., Miami, 1965; Spring Flowers (watercolors), Florida C of C, 1969; Florida Everglades Scene for wall, Capt. Gene, 1970; Florida Flowers for wall, Laura, Pompano Beach, FL. **Comments:** Preferred media: watercolors, oils, acrylics. **Positions:** chmn., Dade Co. Art Commission, 1956-58; art director, Florida Fed. Women's Clubs, 1956-63; pres., Laramore Rader Poetry Group, Miami, 1970-72; art director, Miami Women's Club, 1967-73. **Teaching:** art instructor, Miami Art League, 1955-56; art instructor, adult classes, YWCA & YMCA, Miami, 1963-68; art instructor, adult classes, Dade Co. Schools, 1968-73. **Sources:** WW73; Violet Barker, *Dade County* (Community Press, 1963); Irene Gramling, *Sphinx* (Franklin Press, 1965 & 1966); Edna Chauser, *Cultural Alliance* (Chase, 1971).

VIRGA, Charles *[Artist] 20th c.*
Addresses: Brooklyn, NY. **Exhibited:** WMAA, 1952, 1958. **Sources:** Falk, *WMAA.*

VIRGIN, Norman L. *[Painter, illustrator] 20th c.*
Addresses: Virginia, IL. **Sources:** WW19.

VIRGINIO, DeMartin *[Painter] early 20th c.*
Exhibited: Salons of Am., 1927, 1929. **Sources:** Marlor, *Salons of Am.*

VIRGONA, Henry (Hank) P. *[Illustrator, painter] b.1929, Brooklyn, NY.*
Studied: Pratt Inst., with Francis Criss. **Exhibited:** SI (gold medal, many other awards); Art Dir. Clubs, NYC, NJ (awards); American Inst. Graphic Arts (awards); solos: RoKo, FAR, Summa & Wash. Irving Galleries, all NYC; Ritenhouse Gal., Phila; Calif.; Michigan; Florida; Connecticut. **Work:** MMA; NYPL; Smithsonian; Butler Inst.; Slater Memorial Mus. **Comments:** Illustrator: *Harper's, New York Times,* and other magazines. Illustrator for book publishers and advertising for major companies, including pharmaceuticals. Author of satirical etchings, *The System Works* (Da Capo Press, 1977). **Sources:** W & R Reed, *The Illustrator in America,* 347.

VIROLI, Nicoli *[Painter] mid 20th c.*
Addresses: Urbana, IL. **Exhibited:** AIC, 1945. **Sources:** Falk, *AIC.*

VIRRICK, William E. *[Painter] 20th c.*
Addresses: NYC. **Sources:** WW19.

VIRTUE, R. A. *[Painter] 20th c.*
Addresses: Chicago, IL. **Exhibited:** AIC, 1908. **Sources:** WW10.

VISCHER, Edward *[Landscape artist, lithographic artist, author] b.1809, Bavaria, Germany / d.1879, San Francisco, CA.*
Addresses: San Francisco, CA, c.1850. **Work:** Bancroft Library, UC Berkeley (portfolio of pen washes with color highlights of missions). **Comments:** Vischer went to Mexico at the age of 19 and spent fourteen years there in business. He traveled in South

America and represented the U.S. in Acapulco. In 1842 he was mistakenly imprisoned as a Mexican in California. After several years of travel in Europe and Asia, he returned to Mexico in 1847 and finally settled in California at the time of the Gold Rush. There he established himself as a merchant and agent in San Francisco. He took up sketching about 1852 and produced a great many California views which he published in several volumes, notably the *Pictorial of California* (1870). **Sources:** G&W; Peters, *California on Stone,* cites Francis P. Farquhar, *Edward Vischer: His Pictorial of California* (San Francisco, 1932); P&H Samuels, 502.

VISHER, Edward See: **VISCHER, Edward**

VISHNIAC, Roman *[Photographer] b.1897 / d.1990.*
Addresses: NYC (1940-on). **Work:** MoMA; LOC; NMAA. **Comments:** Known for his documentation of Eastern European Jews (1933-39), he immigrated to NYC in 1940 and did freelance portrait photography before becoming one of the world's foremost color microphotographers. Teaching: Yeshiva Univ., NYC; Fordham Univ; RISD. **Sources:** Witkin & London, 262.

VISMOR, Dorothy Anita Perkins (Mrs.) *[Painter, etcher, teacher] b.1911, Crown King, AZ.*
Addresses: Atlanta, GA. **Studied:** High Mus. School Art, Atlanta. **Member:** SSAL; Georgia AA; Atlanta AG; Atlanta AA. **Exhibited:** High Mus., 1935 (prize), 1937 (prize); All-Atlanta Art Exhib., 1937 (prize); YWCA, 1936 (solo); Carnegie Library, Atlanta, 1937 (solo). **Sources:** WW40.

VISSCHER, Max *[Engraver] mid 19th c.*
Addresses: Albany, NY, 1852. **Sources:** G&W; Albany BD 1852.

VISSER, Simon de *[Painter] late 19th c.*
Addresses: NYC, 1867. **Exhibited:** NAD, 1867. **Sources:** Naylor, *NAD.*

VISSER'T HOOFT, Martha See: **HOOFT, Martha Visser't**

VISSON, Vladimir *[Exhibition director] b.1904, Kiev, Russia.*
Addresses: New York, NY. **Studied:** Sorbonne, Paris, Faculté de Lettres. **Comments:** Position: director of exhibs., Wildenstein Gallery, NYC, 1945-. **Sources:** WW66.

VISTYN, James *[Landscape painter] b.1891, Cleveland, OH.*
Addresses: Cleveland, OH. **Studied:** Cleveland Sch. Art; Henry G. Keller; William J. Eastman; F.C. Gottwald; Berkshire Summer Sch. Art, Monterey, MA. **Member:** Springfield AL; Soc. Indep. Artists. **Exhibited:** Springfield AL, 1933 (prize), 1936 (prize); S. Indp. A., 1937. **Sources:** WW53; WW47.

VITACCO, Alice Pratt (L. Alice Wilson) *[Painter, illustrator, designer, decorator] b.1909, Mineola, NY.*
Addresses: Westport, CT, 1947; Easton, CT, 1959. **Studied:** L. V. Solon; NY School Applied Design for Women; Univ. Mexico; Winold Reiss, Kimon Nicolaides, Lucien Bernhard. **Member:** NAWA; Salons Am. **Exhibited:** Lexington Gal., NY, 1929, 1939 (prize); Wolfe Mem. prize, 1931; NAWA, 1936 (prize); Corcoran Gal biennial, 1945. **Comments:** Illustrator: "Mexican Popular Arts," 1939. **Sources:** WW59; WW47.

VITERBO, Dario *[Sculptor, graphic artist, painter] b.1890, Florence, Italy.*
Addresses: New York 11, NY. **Studied:** Florentine Acad., degree. **Member:** Sculptors Gld.; Salon d'Automne and Salon des Tuileries, Paris. **Exhibited:** Wildenstein Gal., NY (solo); Sculptors Gld., Paris (solos). Awards: prize, Int. Exhib. Dec. Arts, Paris (prize); Int. Exhib., Paris (gold medal); Venice (silver medal); Int. Exhib. Books, Rome, 1953 (silver medal). **Work:** Petit Palais, Jeu de Paume Mus., Paris; Uffizi Mus., Florence; MOMA, Milan; MMA; Univ. Arkansas; NYPL. **Comments:** Illustrator: "Il Libro di Tobia" with ten bronze plates, now in the collection of the NYPL. **Sources:** WW59.

VITO, Luis *[Painter] early 20th c.*
Addresses: Brooklyn, NY. **Exhibited:** Salons of Am., 1930; S. Indp. A., 1930. **Sources:** Falk, *Exhibition Record Series.*

VITOLO, Eda *[Painter] 20th c.*
Exhibited: S. Indp. A., 1942. **Sources:** Marlor, *Soc. Indp. Artists.*

VITOUSEK, Juanita Judy (Mrs. R. A.) *[Painter] b.1890, Silverton, OR / d.1988, Honolulu, HI.*
Addresses: Honolulu, HI, 1917. **Studied:** Univ. Calif.; Univ. Hawaii; with J. Charlot, Josef Albers, Millard Sheets. **Member:** AWCS; Honolulu AA; Honolulu P&S; The Seven, 1929 (a founder). **Exhibited:** Boston; Seattle; PAFA; Riverside Mus.; Dalzell Hatfield Gals., Los Angeles (solo); Calif. WC Soc.; Honolulu AS, 1934 (prize), 1937-38 (prize); Honolulu Acad. Arts, 1925, 1937 (prize), 1938 (prize), 1941 (solo). **Work:** SAM; Honolulu Acad. Arts. **Comments:** Specialty: landscape and floral studies. **Sources:** WW59; WW47; Forbes, *Encounters with Paradise,* 210, 261-62; Petteys, *Dictionary of Women Artists,* reports birth date of 1892.

VITTOR, Frank *[Sculptor] b.1888, Italy.*
Addresses: NYC. **Studied:** Bistolfi. **Member:** Acad. Berra, Milan, Italy; Wash. AC. **Work:** bust, Pres. Wilson, White House; Pittsburgh Chamber of Commerce. **Sources:** WW19.

VITTORI, Enrico *[Sculptor] 20th c.*
Addresses: Indianapolis, IN. **Sources:** WW19.

VIVASH, Ruth See: **ATHEY, Ruth C.**

VIVIAN, Calthea Campbell *[Landscape painter, etcher, teacher] b.1857, Fayette, MO / d.1943, Los Angeles, CA.*
Addresses: Sacramento; Woodland; Los Angeles; San Francisco; San Jose, 1911; Berkeley, CA, 1920s-1930s. **Studied:** Crocker AI, San Francisco; Arthur Mathews, Mark Hopkins AI, San Francisco; Paris, at Lasar Acad., Colarossi Acad. **Member:** San Francisco AA; San Francisco SE; Laguna Beach AA; Calif. AA; Calif. AC. **Exhibited:** Del Monte Gallery, Monterey; Mark Hopkins Inst., 1898; PPE, 1915; San Francisco AA, 1916; Salons of Am., 1924. **Awards:** Crocker Art School (gold medal); Calif. State Fair (silver medal). **Work:** Calif. Hist. Soc.; CPLH; Soc. of Calif. Pioneers; Bancroft Library, UC Berkeley; Massachusetts Hist. Soc.; Arkansas Auditorium Gal. **Comments:** Positions: instructor, San Jose Normal School; teacher, Calif. College of Arts and Crafts. Specialty: landscapes, missions, figures, French country scenes. **Sources:** WW33; Hughes, *Artists of California,* 578; P&H Samuels, 502.

VIVIAN, G. (or K.) *[Painter] 20th c.; b.Venice, Italy.*
Addresses: Jersey City, NJ, 1894-95; NYC, 1900. **Studied:** Royal Acad. FA, Venice. **Exhibited:** NAD, 1894-1900; AIC, 1902. **Sources:** WW06.

VIVIANO, Catherine *[Art dealer] 20th c.*
Addresses: New York, NY. **Sources:** WW66.

VIVIANO, Emanuel Gerald *[Sculptor, painter, blockprinter, teacher] b.1907, Chicago, IL / d.1980.*
Addresses: Chicago, IL, 1940; Westport, CT, 1959. **Studied:** AIC. **Member:** Woodstock AA. **Exhibited:** AIC, 1935-42; WFNY 1939; GGE, 1939; PAFA; Hartford Atheneum; Detroit IA. **Work:** BMA; Chicago Zoological Gardens; fountain, Illinois Medical Unit, Chicago; wall ceramics, Aurora, IL; Oak Park, IL. **Comments:** Position: instructor, sculpture & mosaic, Indiana Univ.; Columbia Univ., 1959. **Sources:** WW59; WW40; Woodstock AA.

VIVIEN, Arthur S. *[Painter] 20th c.*
Addresses: New Orleans, LA. **Sources:** WW17.

VIVIKA See: **HEINO, Vivika (Vivien Place)**

VIZATELLY, Frank *[Combat artist, illustrator] b.1830, London, England / d.1883, Kashgil, Sudan.*
Studied: Boulogne. **Work:** Harvard Univ. (drawings of battles in Virginia). **Comments:** A newspaper correspondent, draftsperson and co-founder of *Le Monde Illustré,* he came to America in 1861 and in 1862 decided to cover the Civil War from the side of the Confederacy. He was with Lee's forces along the Rapidan and in Richmond and Fredericksburg, VA. He stayed until the evacuation of Richmond and accompanied the fleeing party of Jefferson

Davis. In June 1864 he returned to England, covered the Civil War in Spain in 1868 and was killed while covering battles in Egypt. **Sources:** Wright, *Artists in Virginia Before 1900.*

VLAMINCK, Maurice de See: **DE VLAMINCK, Maurice**

VOCKEY, Theodore, Jr. *[Listed as "artist"] d.1901, Wash., DC.*
Addresses: Wash., DC, active 1884-98. **Sources:** McMahan, *Artists of Washington, DC.*

VODICKA, Ruth Kessler *[Sculptor, instructor] b.1921, New York, NY.*
Addresses: New York, NY. **Studied:** City College New York; with O'Connor Barrett, 1946-49; Sculpture Center, New York, 1948-52; ASL, 1956-57 & 1969; New School Soc. Res., 1965; New York Univ., 1969. **Member:** Am. Soc. Contemporary Artists; Audubon Artists; NAWA; Sculptors Guild (exec. board, 1972); Women in Arts. **Exhibited:** WMAA, 1952-57; PAFA Ann., 1953-54, 1958; AFA Travelling Exhib., 1957-58; Galerie Claude Bernard, Paris, France, 1960; Walk-Through-Dance-Through Sculpture, New York Cultural Arts Festival, Bryant Park, 1967; 1956-71 (9 solos). Awards: Joseph W. Beatman Award (top prize for best work in any medium & first prize), Silvermine Guild Artists, 1957; medal of honor, Painters & Sculptors Soc. NJ, 1962; Julia Ford Pew Prize, NAWA, 1966. **Work:** Norfolk (VA) Mus.; Montclair (NJ) State College; Grayson Co. State Bank, Sherman, TX. Commissions: Eternal Light (bronze sculpture), Temple of Jewish Community Center, Harrison, NJ, 1965. **Comments:** Preferred media: bronze, brass, wood. Publications: contributor, *Feminist Art Journal,* 1972; contributor, *Women & Art,* 1972. Teaching: sculpture instructor, Queens Youth Center, Bayside, 1953-56; sculpture instructor, Emanuel Midtown YM & WHA, New York, 1966-69; sculpture instructor, Great Neck Arrandale School, 1969-70. Art interests: total art-music, theatre, dance, literature, film, poetry, architecture & painting. **Sources:** WW73; Vivian Campbell, "Sculptor's Torch Pays Off," *Life Magazine* (1956); Fred W. McDarrah, *The Artist's World* (Dutton, 1961; Louis Calta, "Multi-Purpose Sculpture on View in Bryant Park," *New York Times,* October, 1967; Falk, *Exh. Record Series.*

VOEGTLING, Oliver *[Painter] early 20th c.*
Exhibited: Salons of Am., 1925. **Sources:** Marlor, *Salons of Am.*

VOELCKER, Rudolph A. *[Sculptor] b.1873.*
Addresses: Newark, NJ. **Member:** AAPL; Art Center of the Oranges. **Exhibited:** Newark AC, 1937 (prize); Kresge Gal., Newark, 1937 (prize), 1938 (prize); Art Center of the Oranges, 1939 (prize). **Sources:** WW40.

VOELTER, F. (Miss) *[Artist] late 19th c.*
Addresses: NYC, 1888. **Exhibited:** NAD, 1888. **Sources:** Naylor, *NAD.*

VOGDES, Joseph See: **MAAS & VOGDES**

VOGDES, M(argaret) (Strong) *[Painter] 20th c.*
Addresses: Phila., PA, 1879; NYC, 1925. **Exhibited:** PAFA Ann., 1879; S. Indp. A., 1925. **Sources:** Falk, *Exh. Record Series.*

VOGEL, Anna *[Painter] late 19th c.; b.New Orleans, LA.*
Studied: with Mme. L. Lemée. **Exhibited:** Paris Salon, 1879. **Sources:** Fink, *American Art at the Nineteenth-Century Paris Salons,* 400.

VOGEL, Christine *[Painter] late 19th c.; b.New Orleans, LA.*
Studied: Mme. L. Lemée. **Exhibited:** Paris Salon, 1880. **Sources:** Fink, *American Art at the Nineteenth-Century Paris Salons,* 400.

VOGEL, Donald *[Printmaker, instructor] b.1902, Poland.*
Addresses: New York, NY. **Studied:** Parson School Design; Columbia Univ., B.S., M.A. **Member:** SAGA. **Exhibited:** S. Indp. A., 1943; Brooklyn Mus., 1950; AFA Traveling Exhib., 1950; Royal Soc. Painters, Etchers & Engravers, 1954; Calif. Western Univ., San Diego, 1960; Pratt Graphic AC, 1964. Awards: Munson-Williams-Proctor Inst., 1943; Northwest

Printmakers, 1943 & 1946; LOC, 1950. **Work:** SAM; Penn. State Univ.; MMA; Munson-Williams-Proctor Inst.; SAGA. **Comments:** Publications: contributor to *Print Collector's Quarterly, La Revue Moderne, Am. Prize Prints, 20th Century* & others. Teaching: art instructor, H.S. Art & Design, New York. **Sources:** WW73.

VOGEL, Donald S. *[Painter, art dealer, lecturer, teacher] b.1917, Milwaukee, WI.*
Addresses: Dallas, TX. **Studied:** Corcoran Sch. Art; AIC; WPA Easel Project, Chicago. **Member:** "The Eight" Painters of Texas; Art Dealers Assoc. Am.; AFA; Dallas MFA. **Exhibited:** Cincinnati Art Mus, 1940, 1941; CI, 1941; NGA, 1941; Oakland Art Gal., 1941, 1942; AIC, 1940; Artists of Chicago & Vicinity Annual, 1940 & 42; San Fran. AA, SFMA, 1941-42; PAFA, 1941; AV, 1942; Texas General Exh., 1941-42, 1943 (prize), 1944 (prize), 1945, 1946 (award); Dallas All. Artists,1941-46; Am. Acad Rome, 1941 (prize), 1942 (bronze medal); Univ. Illinois Exh. Contemp. P&S, 1953; Southern Blue Print Co., award. **Work:** Fort Worth (TX) Art Center; Dallas (TX) MFA; Beaumont(TX) MA; Mobile(AL) Art Center; Philbrook AC, Tulsa, OK. **Comments:** Positions: dir., Valley House Gal. Specialty of gallery: paintings and sculpture of the 19th-20th c. Lectures: history & methods of etching. Publications: co-auth./ed., "Passion: Georges Rouault" (catalogue), 1962; co-auth., "Aunt Clara," 1966; ed., "The Paintings of Hugh H. Breckenridge" (catalogue), 1967; ed., "Valton Tyler," 1971; ed., "Velox Ward" (catalogue), 1972. Collections arranged: Clara McDonald Williamson, Nov., 1966 & Velox Ward, May, 1972, Amon Carter Mus. Art, Fort Worth; Valton Tyler, Southern Methodist Univ., Feb., 1972. **Sources:** WW73; WW47.

VOGEL, Edwin Chester *[Collector] b.1883 / d.1973.*
Addresses: NYC. **Comments:** Positions: chmn., Council Fine Arts & Archaeology, Columbia Univ., 1957-67, hon. chmn., 1967-. Collection: French Impressionists of the nineteenth & twentieth century; Chinese porcelain; English eighteenth century furniture. **Sources:** WW73.

VOGEL, Emil *[Listed as "artist"] mid 19th c.*
Addresses: Baltimore, 1858-80. **Sources:** G&W; Lafferty.

VOGEL, Joseph *[Mural painter, lithographer, designer, lecturer] b.1911, Austria.*
Addresses: NYC. **Studied:** NAD, with L. Kroll. **Member:** NSMP; Mural AG; Union Am. Artists. **Exhibited:** WMAA, 1938; WFNY, 1939. **Sources:** WW40.

VOGEL, Mildred L. (Mrs.) *[Painter] 20th c.*
Addresses: NYC. **Exhibited:** S. Indp. A., 1925. **Sources:** Marlor, *Soc. Indp. Artists.*

VOGEL, Valentine *[Painter, teacher, graphic artist] b.1906, St. Louis, MO / d.1965, St. Louis, MO.*
Addresses: St. Louis, MO; Cedar Hill, MO. **Studied:** K. Cherry; Washington Univ.; NAD; Grande Chaumière, Paris, France; Am. Acad. in Rome; C.W. Hawthorne; A. Angarola; Lhote. **Member:** St. Louis Soc. Indep. Artists; Lg. Am. Pen Women; AEA; St. Louis Woman's Advertising Club; St. Louis Art Lg.; St. Louis Art All; Am. Club, Paris. **Exhibited:** St. Louis AG, 1929 (medal), 1930 (prize); St. Louis AL (prizes); Kansas City AI, 1939 (medal); St. Louis Post-Dispatch, 1931 (prize); St. Louis Little Theatre, 1931 (prize); YMHA, 1944 (prize); AIC. **Work:** murals, Crunden Library, MO, Maryland School, Clayton, MO; Belvue School, University City, MO; St. Louis City Hospital; Public Library, Sikeston, MO; YMHA; University City H.S., St. Louis. **Comments:** Position: teacher, YMHA, St. Louis, 1947. **Sources:** WW59; WW47.

VOGELGESANG, Shepard *[Designer] b.1901, San Francisco, CA.*
Addresses: Whitefield, NH. **Studied:** MIT, B.S. in Arch. (traveling scholarship, 1926).; Staats Kunstgewerbe Schule, Vienna; Josef Hofmann. **Member:** Chicago AC; BAID; AIA; Artists Union Chicago; AFA. **Comments:** Positions/projects: designed

stage settings for Avery Mem. Hartford, CT and Univ. Chicago; designer & supervisor, interior color & mural projects, Century of Progress, 1933; asst. director, decorative artist, chief designer, Committee FA, GGE 1939; asst. director & exhibits designer, WFNY 1939. Contributor: *Architectural Record, Architectural Forum, Good Furnishing, Magazine of Art,* & other publications. **Sources:** WW59; WW47.

VOGELMAN, Gladys Lewis *[Painter] mid 20th c.*
Addresses: San Jose, CA. **Exhibited:** Oakland Art Gallery, 1937; GGE, 1940. **Sources:** Hughes, *Artists in California,* 578.

VOGLER, E. A. *[Lithographer] mid 19th c.*
Comments: View of the Square in Old Salem (NC), c.1845. **Sources:** G&W; *Antiques* (June 1951), 469, repro.

VOGLER, John *[Silhouettist, cabinetmaker, clockmaker, and silversmith] b.1783 / d.1881.*
Addresses: Salem, NC. **Work:** The Wachovia Museum in Salem has a Vogler Room devoted to the various works of this craftsman, including his silhouettes of himself and his wife and the machine by which he took them. **Sources:** G&W; Swan, "Moravian Cabinetmakers of a Piedmont Craft Center," 458, repro.

VOGNILD, Edna (Mrs. Enoch) *[Portrait painter, lecturer] b.1881.*
Addresses: Chicago, IL. **Studied:** AIC; C. Hawthorne; J. Johansen; H.B. Snell; Acad. Colorossi; Bileul Acad.; Acad. Delecluse. **Member:** All-Illinois Soc. FA; Northwest AL; Soc. Sanity Art; Municipal AL. **Exhibited:** AIC, 1914-22; All-Illinois Soc. FA, 1937 (gold medal). **Comments:** Married to Enoch Vognild. **Sources:** WW59, listed as Mrs. Ted Vognild (perhaps Ted was Enoch's nickname); WW47, listed as Edna (Mrs. Enoch) Vognild.

VOGNILD, Enoch M. *[Painter] b.1880, Chicago, IL / d.1928, Woodstock, NY.*
Addresses: Chicago, IL. **Studied:** AIC with Johansen and Vanderpoel; C. Woodbury in Ogunquit, Maine; Académie Julian, Paris, 1912; Acad. Delecluse, Paris. **Member:** ASL, Chicago; Chicago AI; Round Table; Chicago AC; Chicago AG; Chicago SA. **Exhibited:** Municipal AL, 1906 (prize); AIC, 1908-21; Norwegian Club, 1925 (prize). **Sources:** WW27; *Charles Woodbury and His Students.*

VOGT, Adolph *[Painter] b.1843, 1871.*
Addresses: Montreal, Canada, 1869. **Exhibited:** NAD, 1869. **Sources:** Naylor, *NAD.*

VOGT, Frederick *[Painter] 20th c.*
Addresses: Phila., PA. **Exhibited:** PAFA Ann., 1901. **Sources:** Falk, *Exh. Record Series.*

VOGT, Fritz G. *[Folk painter] late 19th c.*
Exhibited: Fenimore House Mus., 2000 (solo). **Work:** Fenimore House Mus. of the NY State Hist. Ass'n, Cooperstown, NY. **Comments:** Itinerant artst who worked in the Mohawk Valley region west of Albany, NY, during the 1890s. His views of villages and farms were often drawn with colored pencil and show multiple perspectives. About 200 of his works have been documented by the NY State Hist. Ass'n. **Sources:** press release (undated clipping).

VOGT, Helen Elizabeth *[Painter, printmaker] b.1910, Seattle, WA.*
Addresses: Edmonds, WA. **Studied:** Calif. College of Arts and Crafts; Univ. of Wash.; with Esse Vann. **Exhibited:** Western Wash. Fair. **Sources:** Trip and Cook, *Washington State Art and Artists, 1850-1950.*

VOGT, L(ouis) C(harles) *[Painter] b.1864, Cincinnati, OH / d.1939.*
Addresses: Cincinnati, OH; NYC, 1890. **Studied:** with H.S. Mowbray; F. Duveneck. **Member:** Cincinnati AC. **Exhibited:** NAD, 1890; Boston AC, 1890; AIC, 1911; PAFA Ann., 1912. **Work:** Cincinnati Art Mus. **Comments:** Travelled throughout the world. **Sources:** WW24; *Cincinnati Painters of the Golden Age,* 108 (w/illus.); Falk, *Exh. Record Series.*

VOIGHT, Charles A. *[Illustrator, cartoonist] b.1888 / d.1947.*
Addresses: NYC/Pelham Manor, NY. **Member:** SI, 1913; New Rochelle AA. **Comments:** Drew comic feature "Betty" for *New York Tribune* syndicate, 1919-42. **Sources:** WW27.

VOIGHT, Lewis Towson *[Portrait and miniature painter, fashion artist, and poet] mid 19th c.*
Addresses: Baltimore and elsewhere in Maryland, 1839-45; NYC, after 1845. **Comments:** In 1845 he was doing portrait work and fashion drawings for *Godey's Lady's Book,* and was still active in 1859. **Sources:** G&W; Pleasants, *250 Years of Painting in Maryland,* 53; NYBD 1850-59.

VOIGT, Henry E. F. *[Printer, lithographer, etcher, engraver] 19th c.; b.Germany.*
Addresses: NYC (active 1870s-80s). **Comments:** Director of the printing firm, Kimmel & Voigt, beginning in 1879 he worked closely with S.R. Koehler (see entry) in printing the etchings for Koehler's *American Art Review.* As a fine art printer, he used electroplating to coat the copper plates with steel, thereby allowing a far greater number of impressions in editions. He worked with many prominent American etchers through the 1880s. **Sources:** For a brief history of his activities, see Maureen C. O'Brien's essay in *American Painter-Etcher Movement* p.8-14.

VOIGT, Roben *[Sculptor, educator] b.1940, Phila.*
Addresses: Griffin, GA. **Studied:** Tyler School Art, M.F.A., with Boris Blai, Aldo Casanova, Raphael Sabatini & Adolf Dioda; San Francisco Art Inst., with Roger Jacobsen; Haystack School Crafts, Deer Isle, ME. **Member:** College Art Assn. Am.; Sculptors Guild; Georgia Art Educ. Assn. **Exhibited:** Sculpture, High Mus. Art, Atlanta, GA, 1968; Piedmont Arts Festival Ann., Atlanta, 1969; Agnes Scott College Invited Sculpture Show, Atlanta, 1970; Callaway Gardens Art Ann., La Grange, GA, 1971; Sculptors Guild Ann., Lever House, NYC, 1971. Awards: first prize in sculpture, Rittenhouse Square Clothesline Exhib., 1963; purchase prize, Wilmington Soc. Fine Arts Mus., 1965; first prize in sculpture, Coosa Valley Fair Art Show, Rome, GA, 1967. **Work:** Wilmington Soc. Fine Arts Mus. **Comments:** Preferred media: steel. Teaching: sculpture instructor, Wilmington (DE) Art Center, 1964-67; asst. professor art, Berry College, 1967-72; art consultant, Griffin-Spalding Co. (GA) Schools, 1972-. **Sources:** WW73; Clyde Burnett (author), article, *Atlanta Journal,* 11/27/1970.

VOIGTLANDER, Katherine *[Painter, teacher] b.1917, Camden, NJ.*
Addresses: Kansas City, MO, 1947; Mexico City, Mexico, 1959. **Studied:** Univ. Pennsylvania (B.F.A.); Kansas City AI; PAFA (Cresson traveling scholarship, 1938); Univ. Kansas City (B.A.); Thomas Benton; George Harding; Francis Speight. **Exhibited:** Kansas City AI, 1931, 1936; Denver, CO, 1939; Phila. AC, 1938; Woman Painters of Am., Wichita, KS, 1936 (prize); PAFA, 1940 (prize); Cumberland Valley Exhib., Hagerstown, MD, 1944 (prize), 1945-46. **Comments:** Illustrator: primers and story books, Linguistic Text Series, for Summer Inst. of Linguistics, Mexican Branch. Illustrator: "2,000 Tongues to Go," 1959. Position: teacher, Wilson College, Chambersburg, PA, from 1943; Washington County Mus., Hagerstown, MD, from 1946. **Sources:** WW59; WW47.

VOISIN, Adrien Alexander *[Sculptor, painter] b.1890, Islip, NY / d.1979, Palos Verdes, CA.*
Addresses: Southern California; Montana; Paris, France; San Francisco, CA, 1933; Spokane, WA; Palos Verdes, CA. **Studied:** with Sargent Kendall, Yale School of FA; Académie Colarossi, École des Beaux-Arts, École Nationale des Arts Decoratifs and at Ateliers Mercié and Injalbert, Paris. **Exhibited:** Exposition Coloniale, Paris; Int. Art Exhib., Paris, 1932 (gold medal); GGE, 1939. Award, Diplome d'Honneur, French Government. **Work:** Oregon State College, Corvallis; Lewis and Clark Memorial, Portland, OR; State House, Salem, OR. **Comments:** Specialty:

Native American busts and animal sculptures. After WWI, he executed architectural commissions in California, including some for Hearst Castle. **Sources:** Hughes, *Artists in California*, 578.

VOJDES, M(argaret Strong) See: **VOGDES, M(argaret) (Strong)**

VOJIK, William M. *[Painter] 20th c.*
Exhibited: S. Indp. A., 1937. **Sources:** Marlor, *Soc. Indp. Artists.*

VOLBRACHT, Heinrich *[Sculptor, carver] b.1841 / d.1897, Detroit, MI.*
Addresses: Detroit, MI, 1890-97. **Comments:** Position: instructor, Detroit Mus. of Art School. In partnership with Edward Wagner in Wagner & Volbracht. **Sources:** Gibson, *Artists of Early Michigan*, 232.

VOLCK, Adalbert John *[Caricaturist, painter, sculptor, craftsman] b.1828, Augsburg, Germany / d.1912, Baltimore, MD.*
Addresses: Baltimore, MD. **Studied:** Nürnberg; Munich. **Work:** Valentine Mus., Richmond, VA. **Comments:** A trained chemist, his revolutionary activities forced him to leave Germany in 1848. He spent a few years in St. Louis and in California before settling in Baltimore, where he taught chemistry at the Baltimore College of Dental Surgery and attended classes. He graduated in 1852 and worked as a dentist for many years. As a Confederate during the Civil War, he worked as as a caricaturist, signing his work "V. Blada." He supposedly served as a Confederate agent, smuggling supplies and dispatches across the Potomac and into Virginia, activities, which are recorded in some of his drawings. After the war he gave up political art for portraits and bronze and silver work. He was prominent in the social and artistic life of Baltimore. Frederick Volck (see entry), the sculptor, was his brother. **Sources:** G&W; DAB; Pleasants, *250 Years of Painting in Maryland*, 62; Met. Mus., *Life in America;* Rutledge, MHS; 8 Census (1860), Md., IV, 588. More recently, see Wright, *Artists in Virginia Before 1900.*

VOLCK, Fannie (Mrs.) *[Painter] 20th c.*
Addresses: Houston, TX. **Sources:** WW13.

VOLCK, Frederick *[Sculptor] b.1833, Bavaria / d.1891, probably Baltimore.*
Addresses: Baltimore, MD. **Work:** Peabody Inst., Baltimore; Virginia State Library. **Comments:** He was living in Baltimore with his brother Adalbert Volck (see entry) in 1860. During the Civil War he is said to have designed the head of Jefferson Davis for the Confederate ten-cent stamp. He was active in Baltimore after 1865. **Sources:** G&W; Information courtesy Anna Wells Rutledge; 8 Census (1860), Md., IV, 588; DAB, under Adalbert J. Volck. More recently, see Wright, *Artists in Virginia Before 1900.* Wright cites a birth date of 1822.

VOLCK, G. A. (Mrs.) *[Painter] 20th c.*
Addresses: Houston, TX. **Member:** Houston AL. **Sources:** WW25.

VOLCK, Hans H. *[Painter] 20th c.*
Addresses: Cleveland, OH. **Sources:** WW25.

VOLCKMANN, Viola Adelaide (Mrs. A. Buhler) *[Painter]*
Addresses: New Orleans, active 1889. **Exhibited:** Academy of Fine Arts, 1889. **Sources:** *Encyclopaedia of New Orleans Artists*, 395.

VOLEM, Franc *[Painter, teacher] b.1908, Milwaukee, WI.*
Studied: Layton School Art with Walter Quirt; with John Steuart Curry, Madison, WI; Rome, Italy. **Exhibited:** "NYC WPA Art" at Parsons School Design, 1977. **Comments:** Although he always signed as "Franc Volem," his birth name was Francesco Guglielmi. During WWII, he was an illustrator for the Canadian Armed Forces. He was a teacher for a number of years, but in 1973 began painting full time again and showing his work at exhibitions throughout the South. **Sources:** *New York City WPA Art*, 92 (w/repros.).

VOLETSKY, Esther Haber *[Painter] 20th c.*
Exhibited: S. Indp. A., 1937. **Sources:** Marlor, *Soc. Indp. Artists.*

VOLK, Douglas *[Painter, teacher, lecturer, writer, illustrator] b.1856, Pittsfield, MA / d.1935, Fryeburg, ME.*
Addresses: NYC (from 1879)/Centre Lovell, ME. **Studied:** St. Luke Acad., Rome, 1870; Paris, with Gérôme, 1873-78. **Member:** ANA, 1898; NA, 1899; SAA, 1880; NAC; Artists Fund Soc.; Artists Aid Soc.; Portrait Painters, Arch. Lg., 1912; Century Assn.; Int. SAL; Mural Painters; SI; Washington AC; AFA. **Exhibited:** Paris Salon, 1875, 1878; Brooklyn AA, 1879, 1881; PAFA Ann., 1879, 1896-1906, 1911, 1916-17, 1921-27 (gold 1916); AIC, 1888-1916; NAD, 1880-99 (1910, gold, 1915, prize); Louisville AL, 1898; Boston AC, 1899-1909; St. Louis Expo, 1898, 1904 (medal); Phila. Centenn., 1876; Columbian Expo, Chicago, 1893 (medal); SAA, 1899 (prize), 1903 (prize); Colonial Exhib., Boston, 1899 (prize); Pan-Am. Expo, Buffalo, 1901 (medal); Charleston Expo, 1902 (medal); Carolina AA, 1907 (gold); Corcoran Gal biennials, 1907-26 (9 times); NAC, 1915 (gold); Pan-Pacific Expo, San Francisco, 1915 (gold). Other awards: Officer of the Order of Leopold II, 1921. **Work:** Minneapolis Inst. of Art; murals designer, Capitol, St. Paul, MN; CI; MMA; CGA; NGA, Pittsfield (MA) Mus.; Des Moines (IA) Courthouse, 1913; Montclair (NJ) Mus.; Rochester Mem. Art Gal.; NAD; Hackley Art Gal., Muskegon, MI; Omaha Art Gal.; NGA; Albright Gal., Buffalo; Portland (ME) Mem. Art. Mus.; West Point. **Comments:** (His full name was Stephen Arnold Douglas Volk.) Volk specialized in figural works featuring idealized woman in languorous poses, wearing expressions as if lost in a daydream; he was also known for his portraits. Position: founder, Minneapolis School of Fine Arts, 1886 (he was director until 1893). Teaching: instructor, ASL, 1893-98; CUA Sch., 1906-12; NAD, 1910-17. Organizer, handicraft movement at Centre Lovell. His father was sculptor Leonard Volk. **Sources:** WW33; Detroit Inst. of Arts, *The Quest for Unity*, 65; P&H Samuels, 502-03; Fink, *American Art at the Nineteenth-Century Paris Salons*, 400; Falk, *Exh. Record Series.*

VOLK, Josephine See: **KECK, Josephine F(rancis) (Volk) (Mrs.)**

VOLK, Leonard Wells *[Sculptor] b.1828, Wellstown (now Wells, NY) / d.1895, Osceola, WI (on summer visit).*
Addresses: Chicago, IL, from c.1857. **Studied:** at age 16 began learning marble cutting from his father; after working several years in Bethany, Batavia, and Buffalo (NY), he studied drawing & modeling in St. Louis; went to Rome, 1855 to c.1857, with the help of Stephen A. Douglas (his wife's cousin). **Exhibited:** PAFA Ann., 1877; AIC, 1888. **Work:** State House in Springfield, IL (statues of Lincoln and Douglas). The Smithsonian Inst. has the original Lincoln life mask of which there are numerous replicas, including one at the PMA; there are numerous replicas of the resulting bust as well, including a bronze cast at MMA.
Comments: On his return from study in Europe, Volk opened a studio in Chicago where he spent the rest of his life, except for two more European visits. Best known for his war monuments and portraits, his most famous works are his statues of Stephen Douglas and Abraham Lincoln. The Lincoln likeness is of special significance because it was based on life casts of Lincoln's face, shoulders, and chest, taken in Volk's Chicago studio in April 1860 (a cast of Lincoln's hands was taken several months later). Volk was the only sculptor to make a life mask of Lincoln, and the bust subsequently served as a model for numerous sculptors who were creating their own portraits of Lincoln. Volk's son, Douglas Volk (1856-1935), was a painter. **Sources:** G&W; DAB; Taft, *History of American Sculpture;* Clement and Hutton; Gardner, *Yankee Stonecutters;* Chicago BD 1858+; Wilson, *Lincoln in Portraiture;* Craven, *Sculpture in America*, 240-42 and fig. 7.15; Falk, *Exh. Record Series.*

VOLK, Steven Arnold Douglas See: **VOLK, Douglas**

VOLK, Victor *[Painter, block printer, writer] b.1906, Milwaukee.*

Addresses: Milwaukee, WI. **Studied:** G. Moeller. **Member:** Wisc. P&S. **Exhibited:** Wisc. Salon, 1934 (prize); Wisc. P&S, 1936 (prize); AIC. **Work:** govt.-owned high schools (WPA work). **Sources:** WW40.

VOLKER, Clara Maude See: **VOLKERT, Clara Maude**

VOLKERT, Clara Maude *[Painter] b.1883, Cincinnati / d.1936.*
Addresses: Cincinnati, OH. **Studied:** Cincinnati Art Acad. with Duveneck, Nowottny, Meakin, Beck; ASL, with Mowbray. **Member:** Cincinnati Women's AC. **Exhibited:** Cincinnati Women's AC. **Sources:** WW13.

VOLKERT, Edward Charles *[Landscape painter] b.1871, Cincinnati / d.1935, Cincinnati.*
Addresses: NYC, 1898-1913; Old Lyme, CT by 1929/Ohio/NYC. **Studied:** Ohio Mechanics Inst.; Art Acad. Cincinnati with F. Duveneck, T. S. Noble and V. Nowottny; ASL with S. Mowbray, George DeF. Brush, William M. Chase. **Member:** ANA; NYWCC; AWCS; Alled AA; SC; Union Int. des Beaux-Arts et des Lettres; Cincinnati MacD. Soc.; Am. Soc. Animal PS; NAC; CAFA; AFA. **Exhibited:** PAFA Ann., 1898, 1909-13, 1918-19, 1932; Corcoran Gal biennials, 1910-23 (3 times); NYWCC, 1919 (prize); CAFA, 1925 (prize), 1929 (prize); PAFA, 1898; New Haven PCC, 1930 (prize); Lyme AA, 1932 (prize); AIC. **Work:** Cincinnati Art Mus. **Comments:** Primarily a portrait painter early in his career, he switched to landscapes, especially watercolors of cattle and rural scenes. **Sources:** WW33; *Cincinnati Painters of the Golden Age*, 108-09 (w/illus.); *Art in Conn.: The Impressionist Years;* Falk, *Exh. Record Series.*

VOLKHARDT, Frederick A. *[Painter] b.1868, Nebraska City, NE / d.1956, Palo Alto, CA.*
Addresses: San Francisco, CA; Berkeley, CA. **Studied:** AIC. **Member:** Palo Alto AC. **Exhibited:** Santa Cruz, CA, 1935. **Sources:** Hughes, *Artists of California*, 578.

VOLKMAN, Leon *[Painter] mid 20th c.*
Exhibited: Salons of Am., 1934. **Sources:** Marlor, *Salons of Am.*

VOLKMANN, Clara *[Artist] late 19th c.*
Addresses: NYC, 1892. **Exhibited:** NAD, 1892. **Sources:** Naylor, *NAD.*

VOLKMANN, Mary Gordon *[Painter] 20th c.*
Addresses: Bonita, CA. **Exhibited:** Calif.-Pacific Int. Expo, San Diego, CA, 1935; SFMA, 1935; San Francisco AA, 1938; GGE, 1939. **Sources:** Hughes, *Artists in California*, 578.

VOLKMAR, Charles *[Portrait and landscape painter] b.c.1809, Germany / d.After 1880.*
Addresses: Baltimore, active c.1842 until at least 1880; NYC, 1864, 1875, 1884; Tremont, NJ, 1882. **Exhibited:** Maryland Hist. Soc.; Wash. AA, 1857; NAD, 1864-94. **Work:** Peabody Inst., Baltimore, MD. **Comments:** He also lived in Greenpoint (LI) in 1881, Fremont (NY) in 1887, and Menlo Park (NJ) from 1891-94. **Sources:** G&W; 7 Census (1850), MD, V, 167; Baltimore CD 1842-60+; Lafferty; Rutledge, MHS; Washington Art Assoc. Cat., 1857.

VOLKMAR, Charles *[Painter, sculptor, etcher, craftsperson, teacher, ceramicist] b.1841, Baltimore, MD / d.1914.*
Addresses: Metuchen, NJ. **Studied:** Paris, sculpture with Barye & painting with Harpignies. **Member:** Arch. Lg., 1890; SC, 180; NAC. **Exhibited:** Paris Salon, 1875, 1877-80; PAFA Ann., 1877, 1883; Boston AC, 1881, 1884, 1892-94; Brooklyn AA, 1883, 1885; AWCS, 1898; AIC. **Comments:** At first a landscape and animal painter, he later became chiefly a potter. **Sources:** WW13; Fink, *American Art at the Nineteenth-Century Paris Salons*, 401; Falk, *Exh. Record Series.*

VOLKMAR, Leon *[Ceramist, painter, lecturer, teacher] b.1879, Paris, France (of Am. parents) / d.1959.*
Addresses: Bedford, NY, 1947; Laguna Beach, CA, 1959. **Studied:** NAD; C. Volkmar. **Member:** NY Ceramic Soc. (hon. pres.); Greenwich (CT) SA. **Exhibited:** AIC, 1953 (medal); Paris

Salon, 1937 (medal). **Work:** AIC; Detroit IA; Cranbrook Acad. Art; BMFA; BM; BMA; Newark Mus.; MMA. **Comments:** Position: teacher, Westchester Workshop, Westchester Co. Center, White Plains, NY, 1940. Lectures: ceramics. (retired 1951). **Sources:** WW59; WW47.

VOLKMER, Bernard *[Mural painter] b.1865, Germany / d.1929, Los Angeles, CA.*
Addresses: Los Angeles, CA. **Studied:** Art Institute of Cologne, Germany; École des Beaux-Arts, Paris. **Work:** Holy Cross Cathedral, Los Angeles. **Sources:** Hughes, *Artists in California*, 579.

VOLL, Joseph A. *[Painter] 20th c.*
Addresses: Pittsburgh, PA. **Member:** Pittsburgh AA. **Sources:** WW21.

VOLLEEN, Frank *b.c.1830, England.*
Addresses: NYC, 1860. **Comments:** Living in NYC in 1860 with his wife and a six-year-old child born in New York. **Sources:** G&W; 8 Census (1860), N.Y., XLVII, 165.

VOLLMBERG, Max *[Painter, teacher] 20th c.*
Addresses: Oakland, CA. **Studied:** Royal Academy Berlin, 1903-06. **Exhibited:** Babcock Gallery, NYC, 1926. **Comments:** Position: teacher, Calif. College of Arts and Crafts, Oakland, CA 1926-28. **Sources:** Hughes, *Artists of California*, 579.

VOLLMER, Adolph *[Painter] late 19th c.*
Addresses: NYC, 1882. **Exhibited:** NAD, 1882; PAFA Ann., 1882; Boston AC, 1883. **Sources:** Falk, *Exh. Record Series.*

VOLLMER, Agnes L. *[Painter] early 20th c.*
Addresses: Laguna Beach, CA. **Exhibited:** Artists Fiesta, Los Angeles, 1931. **Comments:** Specialty: watercolors. **Sources:** Hughes, *Artists of California*, 579.

VOLLMER, Clarence C. *[Painter] 20th c.*
Addresses: Chicago, IL. **Member:** GFLA. **Sources:** WW27.

VOLLMER, Grace Libby (Mrs.) *[Painter] b.c.1889, Hopkinton, MA. / d.1977, Santa Barbara, CA.*
Addresses: Laguna Beach, CA; Santa Barbara, CA. **Studied:** Otis Art Inst., with E. Vysekal and E.R. Shrader; with H. Hofmann in Munich & Berkeley, CA; with E. Payne and Anna Hills. **Member:** Laguna Beach AA; Calif. AC. **Exhibited:** Orange Co. (CA) Fair, 1927 (prize); Laguna Beach AA, 1935 (prize); 1936 (prize); Santa Barbara Mus. of Art, 1952 (solo). **Comments:** Specialty: still lifes, landscapes, portraits and figures. Daughter of a wealthy Boston publisher, she showed an interest in art at a very early age. Married in 1906, she and her family moved to Southern Calif. in the early 1920s. **Sources:** WW40; Hughes, *Artists in California*, 579, reports year of birth as 1884.

VOLLMER, Ruth (Landshoff) *[Sculptor] b.1903, Munich, Germany / d.1982.*
Addresses: NYC. **Member:** Am. Abstract Artist; Sculptors Guild. **Exhibited:** Univ. Colorado, 1961; MoMA Lending Serv., New York, 1963-; For Eyes & Ears, Cordier Ekstrom Gallery, New York, 1964; WMAA Ann., 1964-70; PAFA Ann., 1966; Second Salon Int. Galeries Pilotes, Lausanne, Switzerland, 1966; Betty Parsons Gallery, NYC, 1970s. **Work:** Nat. Collection Fine Arts, Smithsonian Inst., Washington, DC; MoMA; WMAA; NYU Art Collection; Rose Art Mus., Brandeis Univ. Commissions: MoMA Exhibs., Art in Progress, 15th Anniversary Exhib., 1944, Elements of Stage Design, toured USA, 1947-50 & several children's art dept. including Brussels World's Fair, 1958; relief mural for lobby, New York; sculpture to each of 15 founders on 25th anniversary, Committee Economic Development, 1967. **Comments:** Preferred media: plastics. Art interests: plastics, predominantly transparent metals fabricated & cast. **Sources:** WW73; B.H. Friedman, "The Quiet World of Ruth Vollmer," *Art Int.* vol. 9, No. 12; Robert Smithson, "Quasi-Infinities & the Waning of Space," *Arts Magazine*, vol. 41, No. 1; Sol LeWitt, "Paragraphs on Conceptual Art," *Artforum* (summer, 1967); Falk, *Exh. Record Series.*

VOLLMERING, Joseph *[Portrait and landscape painter]*
b.1810, Anhalt, Germany / d.1887, NYC.
Addresses: NYC, 1847-87. **Member:** ANA. **Exhibited:** NAD,
1864-84; Am. Art-Union. **Sources:** G&W; Fielding; 7 Census
(1850), N.Y., XLIII, 144; Cowdrey, NAD; Cowdrey, AA & AAU.

VOLLRATH, George J. *[Lithographer, printer, engineer]*
b.c.1863, New Orleans, LA / d.1915, New Orleans, LA.
Sources: *Encyclopaedia of New Orleans Artists*, 395.

VOLLUM, Edward P. *[Wood engraver] mid 19th c.*
Exhibited: American Institute, NYC, 1846. **Sources:** G&W; Am.
Inst. Cat., 1846.

VOLOVICH, Iakov *[Painter, teacher] b.1910, Kursk, Russia.*
Addresses: Brooklyn 5, NY. **Studied:** NAD; BAID; ASL; Hans
Hofmann School. FA, and in Amsterdam, Holland. **Exhibited:**
Critic's Show, 1946; Pepsi-Cola, 1946; Audubon Artists, 1946,
1947; All. Artists Am., 1948, 1955 (prize); Abstract Artists, 1949.
Work: murals, St. George Hotel, Brooklyn, NY; Aviation Bldg.,
Boise, ID; Army Air Base, Charleston, SC; portrait, Univ.
Chicago. **Sources:** WW59.

VOLOZAN, Denis A. *[Listed as "artist"] 19th c.; b.France.*
Addresses: Philadelphia between 1806-19 and possibly later.
Exhibited: Frequently at the PAFA (chiefly historical and figure
paintings, landscapes, and a few portraits). **Comments:** Dunlap
states that he was a Frenchman who worked principally in crayon,
taught drawing, and was the first instructor of John Paradise (see
entry). **Sources:** G&W; Rutledge, PA; Dunlap, *History*, II, 263.

VOLPE, Anton *[Sculptor] b.1853 / d.1910, NYC.*
Addresses: Phila., PA.

VOLSUNG, Eric *[Painter] 20th c.*
Exhibited: S. Indp. A., 1935. **Sources:** Marlor, *Soc. Indp. Artists.*

VOLTZ, Dorothy (Mrs. Gardiner S. Robinson) *[Painter]*
b.1911, Woodhaven, NY.
Addresses: Saratoga Springs, NY. **Exhibited:** S. Indp. A., 1933.
Sources: Marlor, *Soc. Indp. Artists.*

VOLZ, Gertrude *[Painter, sculptor] b.1898, NYC.*
Addresses: NYC. **Studied:** ASL. **Exhibited:** PAFA, 1927.
Sources: WW33.

VOLZ, Herman ("Roddy") *[Painter, lithographer, craftsper-
son] b.1904, Zurich, Switzerland / d.1990, Santa Clara, CA.*
Addresses: Came to San Francisco, CA, in 1933; Los Angeles,
CA, c.1944 to 1960s; San Jose, from the 1960s. **Studied:**
Commercial Art School, Zurich; Acad. FA, Vienna. **Member:**
Council All. Arts, Los Angeles; Calif WC Soc.; SFAA. **Exhibited:**
Paris Salon, 1937; LOC, 1945; SFMA, 1937-41; GGE, 1939;
Crocker Art Gal., 1942 (solo); Nat. Exhib., Berlin, Germany, 1927
(prize); San Francisco AA, 1937 (prize); Riverside Mus. **Work:**
SFMA; mosaic murals, San Francisco Jr. College. **Comments:** In
1939, Volz painted a large mural on facade of Federal Building on
Treasure Island. He worked as scenic artist and technical director
at Actor's Lab, Hollywood, 1944-48. Part of a group of twenty
artists who produced lithographs for the "Chronicle Contemporary
Graphics" project of 1940. Still active in the 1980s. **Sources:**
exh. cat., Annex Gal. (Santa Rosa, CA, n.d., c.1988); WW47;
WW53; Hughes, *Artists in California,* 579; add'l info. courtesy
Anthony R. White, Burlingame, CA.

VON ADLMANN, Jan Ernst *[Museum director, art histori-
an] b.1936, Rockland, Maine.*
Addresses: Long Beach, CA. **Studied:** Univ. Calif., Berkeley,
with Peter Selz; Free Univ. West Berlin; Univ. Vienna, with Fritz
Novotny; New York Univ. Inst. Fine Arts, with Robert Goldwater,
M.A. (history art). **Member:** Am. Assn. Mus.; College Art Assn.
Am.; Int. Council Mus.; Mountain-Plains Mus. Conference;
Western Assn. Art Mus. **Exhibited:** Awards: fellowship, Salzburg
Austro-Am. Soc., 1960; fellowship, Austrian Govt., 1961; fellow-
ship, Federal Republic West Germany, 1963. **Comments:**
Positions: asst. curator, Albright-Knox Art Gallery, NY, 1964-65;
director, Tampa Bay (FL) Art Center, 1967-69; director, Wichita

(KS) Art Mus, , 1969-72; director, Long Beach (CA) Mus. Art,
1972-. Publications: author, "Kitsch: The Grotesque Around Us"
(catalogue), 1970; author, "Max Klinger: A Glove, & Other
Images of Reverie & Apprehension" (catalogue), 1971; contribu-
tor, *Art News Magazine,* 1972; contributor, *Art Gallery Magazine,*
1972. Teaching: instructor art history, State Univ. NY Buffalo,
1965; visiting asst. professor art history, Univ. Colorado, 1966-67.
Collections arranged: Kitsch: The Grotesque Around Us, 1970;
Max Klinger: A Glove, and other Images of Reverie &
Apprehension, 1971; Civilization Revisited, 1971 & 1972.
Research: first U.S. exhib. & documentation of graphic works of
Max Klinger. **Sources:** WW73.

VON ALLESCH, Marianna *[Craftsperson, designer, teacher,
mural painter, lecturer] 20th c.; b.Ingolstadt, Germany.*
Addresses: NYC. **Studied:** Europe, with A. Niemayer, Bruno
Paul; Royal Acad., Berlin. **Exhibited:** WFNY 1939; GGE 1939;
Syracuse Mus. FA; extensively in Europe: Gov. Acad., Berlin
(med); Musée des Arts Decoratifs (prize), Paris; Salon d'Automne,
Paris (prize); Italy (prize); Japan (prize). **Work:** MMA; Detroit
Inst. Art; Los Angeles Mus. Art; Minneapolis IA; AIC;
Industralized Glass Industry (6,000 Glass Blowers) for German
Govt., Thuringen. **Comments:** Creator: Pulaski Modern Furniture.
Lectures: glass; interior decoration. Positions: designer of glass-
ware for Kensington Crystal Co.; owner, glass and ceramic shop,
NYC. Specialty: ceramic murals. **Sources:** WW59; WW47.

VON ALT, Joseph *[Painter] b.1874, NYC.*
Addresses: Bloomfield, NJ. **Studied:** NAD. **Member:** Country
Sketch Club. **Exhibited:** AIC, 1904. **Sources:** WW08.

VON ARNIM, Helene *[Painter] 20th c.*
Exhibited: AIC, 1930. **Sources:** Falk, *AIC.*

VON AUW, Emilie (Emily) *[Painter, sculptor, craftsperson,
designer, writer, lecturer, educator] b.1901, Flushing, NY.*
Addresses: Albuquerque, NM. **Studied:** NY School Fine &
Applied Art; Columbia Univ. (B.A., M.A.); Univ. New Mexico
(B.F.A.); Grande Chaumière, Paris; École des Beaux-Arts,
Fontainebleau, France; Acad. Art, Florence, Italy; Germany;
Holland. **Member:** New Mexico Art Lg. (board member);
Corrales AA; Nat Soc. Arts & Letters; Clay Club, NYC.
Exhibited: Brooklyn SA; Clay Club, NYC; NGA; Terry AI; New
Mexico Art Lg.; New Mexico State Fair (prize); Univ. New
Mexico; Plaza Gal.; Ramage Gal.; Albuquerque Artists; Jonson
Gal.; Botts Mem. Hall; Fez Club Gal.; Mus. New Mexico, Santa
Fe (traveling exhibs.). **Comments:** Positions: art professor, Univ.
New Mexico, 1940-45; director, Studio Workshop, Albuquerque,
NM, 1940-45; State Fair Mus. FA.; advisory board, Special Educ.
Center. **Sources:** WW59; WW47.

VON BARTELS, Hans *[Painter] b.1856 / d.1913.*
Exhibited: AIC, 1922-23. **Sources:** Falk, *AIC.*

VON BECKH, H. V. A. *[Sketch artist] mid 19th c.*
Comments: Artist with Captain J.H. Simpson's expedition to the
Great Basin of Utah in 1859. According to Simpson's report, Von
Beckh's sketches were redrawn as watercolors by John J. Young
(see entry), a topographer with the War Dept. The original sketch-
es are unlocated but Young's watercolors are in the National
Archives. **Sources:** G&W; Simpson, *Report of Explorations
across the Great Basin;* Taft, *Artists and Illustrators of the Old
West,* 268. More recently, see P&H Samuels, 503.

VON BELFORT, Charles *[Illustrator, printmaker] b.1906,
NYC.*
Addresses: Los Angeles, CA, active 1930s. **Studied:** with J.F.
Smith, F. Geritz. **Exhibited:** San Francisco AA, 1926 (prize),
1934 (medal); CGA, 1936. **Work:** Univ. Calif. Hospital, San
Francisco; Stanford Univ. Hospital. **Sources:** WW40; Hughes,
Artists of California, 579.

VON BERG, Charles L. (Capt.) *[Landscape and genre
painter, scout, hunter] b.1835, Bavaria, Germany / d.1918,
probably Colorado.*
Work: Denver Pub. Lib. **Comments:** Came to NYC in 1854. He

was a fur trader at Fort Snelling, St. Paul, MN and also lived in Iowa. During the Civil War and for the rest of his life he was a scout. **Sources:** P&H Samuels, 503.

VON BOTHMER, Dietrich Felix *[Museum curator, educator, writer, lecturer] b.1918, Eisenach, Germany.*
Addresses: New York, NY. **Studied:** Friedrich-Wilhelm Universität, Berlin; Wadham College, Oxford University (diploma in Classical Archaeology); Univ. California, Berkeley; Univ. Chicago; Univ. California, Ph.D. **Member:** Archaeological Inst. America; Society for the Promotion of Hellenic Studies (London); Deutsches Archaologisches Institut (Berlin); Vereinigung der Freunde Antiker Kunst (Basel). **Comments:** Author: "Amazons in Greek Art", 1957; "Ancient Art from New York Private Collections", 1960; "An Inquiry into the Forgery of the Etruscan Terracotta Warriors", 1961; "Comus Vasorum Antiquorum" U.S.A. fasc. 12, The Metropolitan Museum of Art fasc. 3 (1963). Frequent contributor to: *Bulletin of The Metropolitan Museum of Art.* Positions: book review editor, *American Journal of Archaeology,* 1950-57; part-time teacher, New York Univ. Inst. of Fine Arts; curator, Greek and Roman Art, Metropolitan Museum of Art, NYC. **Sources:** WW66.

VON BRABANT, Ago *[Painter] 20th c.*
Addresses: Farm Colony, S.I., NY. **Exhibited:** S. Indp. A., 1929. **Sources:** Marlor, *Soc. Indp. Artists.*

VON BRANDES, W. F. *[Painter of military subjects] mid 19th c.*
Addresses: NYC in 1847-48. **Exhibited:** American Art-Union, 1847-48. **Sources:** G&W; Cowdrey, AA & AAU.

VON BRANDIS, H. Ferdinand *[Painter] b.c.1820, Hannover, Germany / d.1951, Kenosha, WI.*
Exhibited: Detroit galleries. **Comments:** Specialty: military subjects. Died in a hunting accident. **Sources:** Gibson, *Artists of Early Michigan,* 232.

VON BUNYTAY, Stefan *[Etcher, draftsperson] mid 20th c.*
Exhibited: Magyar Artists Group of Los Angeles, 1933. **Work:** Silverado Mus., St. Helena, CA. **Sources:** Hughes, *Artists in California,* 579.

VON CHELMINSKI, Jan See: **CHELMINSKI, Jean V.**

VON DACHENHAUSEN, Friedrich W(ilhelm) *[Painter, designer, teacher] b.1904, Wash., DC.*
Addresses: Wash., DC. **Studied:** A. Ianelli; F. Poole; F. Spieler; Hermann; Rosse; C. Robinson; J. Reynolds; AIC; Nat. School Fine & Applied Art. **Member:** Soc. Min. PS&G, Wash., DC. **Work:** altar cards, Nat. Cathedral, Wash., DC. **Sources:** WW40.

VON DER LANCKEN, Frank *[Painter, lecturer, teacher, sculptor] b.1872, Brooklyn, NY / d.1950.*
Addresses: Tulsa, OK. **Studied:** PIA School, with H. Adams; ASL, with Mowbray; Académie Julian, Paris with J.P. Laurens and Constant. **Member:** SC; Tulsa AG; Oklahoma AA; Philbrook Mus., Tulsa; P&PMG. **Exhibited:** NAD, SAA, 1898; Arch. Lg.; Boston AC, 1899; Boston WCC; PAFA Ann., 1937 (gold); CM; CPLH, 1946; Rochester Mem. Art Gal.; Kent AA; Tulsa AA; Oklahoma AC; AFA, 1938; Syracuse MFA (solo); PIA School (solo); Highland Park Gal., Dallas (solo); Philbrook AC (solo); Chautauqua, NY (solo); Oklahoma State Exhib., 1943 (prize); Kentucky State Exhib., 1925 (medal); Rochester Expo, 1926 (medal); PAFA, 1937 (gold); Oklahoma AL, 1945 (medal); Kentucky Fed. Women's Club, 1925 (medal). **Work:** PAFA; SC; Univ. Rochester Library; Univ. Club, Rochester; Univ. Club, Tulsa; Hist. Bldg., Oklahoma City; Panhandle Bank, Amarillo, TX; Public Library, Tulsa; Rochester Inst. Tech.; Tulsa Central H.S. **Comments:** Positions: teacher, Rochester Inst. Tech., 1904-24; director, School Arts & Crafts, Chautauqua Inst., 1921-36; Univ. Tulsa (OK), 1935-45. **Sources:** WW47; Falk, *Exh. Record Series.*

VON DER LANCKEN, Guilia *[Designer, painter, teacher] 20th c.; b.Florence, Italy.*
Addresses: Tulsa, OK/New Milford, CT, 1940; White Plains, NY,

1966. **Studied:** Royal Acad. FA, Florence, Italy (awarded Diploma of Honor), with Rivalta, Caloshi, H. Fattori, A. Burchi, A. Zochhi; in Venice with Hopkinson Smith; NYU; Mechanics Inst., Rochester NY; Tulsa Univ., OK. **Member:** Southwest AA. **Exhibited:** Florence, Italy; Rochester Art Club; Chautauqua AA; Oklahoma City AC; Oklahoma Artists; Philbrook AC; Delgado MA; NAD; Washington WCC; NYWCC; Westchester Arts & Crafts; Hudson Valley AA; Tulsa Art Gld. (solo); Harrison, NY, 1965; Oklahoma State Art Exhib. (prize); Westchester Outdoor Exhib. (hon. mention); White Plains Woman's Club, 1964 (prize), 1965 (prize); Tulsa AA (prize); Yonkers AA, 1965 (prize). **Comments:** Position: editorial staff, *The Tulsa Teacher.* Author: "Music as a Stimulus to Creative Art." **Sources:** WW66; WW40.

VON DRAGE, Ilse *[Craftsperson] b.1907.*
Addresses: NYC. **Studied:** State School, Munich; F. Schmidt. **Comments:** Specialties: goldsmithing, enameling. Position: teacher, Crafts Students' League. **Sources:** WW40.

VONDROUS, John C. *[Painter, illustrator, etcher] b.1884, Bohemia, Europe.*
Addresses: East Islip, NY/Prague, Czechoslovakia. **Studied:** NAD, with E.M. Ward, G. Maynard, F.C. Jones, J.D. Smillie. **Member:** S.V.U. Manes; Graphic Arts Soc.; "Hollar," of Prague; Chicago SE, Calif. Printmakers. **Exhibited:** Pan-Pacific Expo, San Francisco, 1915 (medal); Chicago SE, 1917 (prize), 1918 (prize), 1919 (prize); Sesqui-Centenn. Expo, Phila., 1926 (medal); AIC. **Work:** Modern Gal., Prague; AIC; NYPL; Fogg Mus.; LOC; Victoria & Albert Mus., British Mus., both in London, Kupferstich Kabinett, Berlin. **Sources:** WW31.

VON EGLOFFSTEIN, F. W. (Baron) *[Topographical draftsman, survey artist, mapmaker] b.1824, Prussia / d.1898, London.*
Addresses: Travel through the West, 1853-58; NYC, 1864-73. **Work:** Newberry Library, Chicago. **Comments:** Came to America sometime before 1853 and remained for at least twenty years. Served on several Western exploring expeditions and surveys. He (as topographer) and Solomon Carvalho (as artist) accompanied Frémont's last expedition to the Rockies in 1853, but harsh weather and frostbite forced Von Egloffstein and Carvalho to drop out in Utah in February 1854. At Salt Lake City, Von Egloffstein joined Lt. Beckwith's Utah-to-California railroad survey (1854), the report of which included 13 illustrations by Egloffstein. In 1857 he joined Ives's Colorado River expedition, reaching the Grand Canyon in April 1858 and subsequently providing what is probably the first pictorial record of the Canyon. During the Civil War he served with the 103d Regiment, New York Volunteers, and was brevetted out as Brigadier General in 1865. From 1864 to 1873 he lived in NYC, where he was involved in developing the half-tone process of engraving. His *New Style of Topographical Drawing* was published in Washington in 1857. According to the recollection of his grandson, Von Egloffstein died in London in 1898. **Sources:** G&W; Taft, *Artists and Illustrators of the Old West,* 264. More recently, see P&H Samuels, 504; Hughes, *Artists of California,* 166.

VON EHRENWIESEN, Hildegard Rebay See: **REBAY, Hilla**

VON EICHMAN, Bernard James *[Painter] b.1899, San Francisco, CA / d.1970, Santa Rosa, CA.*
Addresses: San Francisco, CA; China, 1921-22; NYC; Monterey, CA. **Studied:** self-taught; briefly at Calif. College of Arts & Crafts. **Exhibited:** San Francisco AA annuals, 1927-32; Oakland Mus., Soc. of Six, 1972; Oakland Mus., 1977; SFMA, 1976. **Work:** Oakland Mus. **Comments:** Abstract painter, who burned much of his work shortly before his death. **Sources:** Hughes, *Artists in California,* 579.

VON EISENBARTH, August *[Painter, designer] b.1897, Hungary.*
Addresses: Bronxville, NY. **Studied:** Royal Hungarian Acad.; ASL. **Member:** Nat. Salon, Budapest; AWCS. **Work:** Nat. Salon, Budapest; AWCS; NYWCC. **Comments:** Specialties: watercolors;

adv. and textile des. **Sources:** WW40.

VON ERDBERG, Joan Prentice *[Museum curator] b.1908, Princeton, NJ.*
Addresses: Trenton, NJ. **Studied:** Bryn Mawr College; Radcliffe College; FMA School. **Comments:** Position: asst., 1939-42, asst. curator, decorative arts, 1942-43, assoc. curator, 1943-46, curator, ceramics & metalwork, 1946-47, PMA, Phila.; chargée de mission, Départment des Objets d'Art, Musée du Louvre, Paris, 1947-49. Contributor to *Burlington, Antiques, American Collector* magazines. Author: "Catalogue of the Italian Maiolica in the Cluny Museum," Paris, 1949; "Catalogue of the Italian Maiolica in the Walters Art Gallery," 1952 (with Marvin C. Ross). **Sources:** WW59.

VON ERFFA, Helmut *[Educator, painter, writer, lecturer] b.1900, Lueneburg, Germany.*
Addresses: New Brunswick, NJ. **Studied:** Bauhaus, Germany, with J. Itten, Paul Klee; Harvard Univ.; Princeton Univ. **Member:** CAA; Am. Arch. Soc.; Am. Oriental Soc. **Exhibited:** Chicago, 1927, 1928; Bryn Mawr College, 1936; Swarthmore Women's Club, 1945; Wadsworth Atheneum, 1930; PMA, 1946, 1965; Douglass College, 1949, 1955; FMA. **Work:** Rutgers Univ.; Wadsworth Atheneum. **Comments:** Contributor to *FMA Bulletin, College Art Journal, Ars Islamica, Art Quarterly*; article, "Benjamin West," *Artists in America*, 1957; "Benjamin West" in *Guide to Chapel of Royal Naval College*, Greenwich. Lectures: The Bauhaus; Origins of Modern Art: Goya; Benjamin West and Royal Academy, Frick Mus., NY; Yale Univ.; Modern Architecture, New Brunswick, NJ. Teaching: professor art history, Harvard Univ., 1930-32; Bryn Mawr College, 1935-36; Northwestern Univ., 1938-43; Swarthmore College, 1943-46; Rutgers Univ., 1946-64; Univ. New Mexico, 1964-66. **Sources:** WW66; WW47.

VON FALKENSTEIN, Claire See: **FALKENSTEIN, Claire (Mrs. C. L. McCarthy)**

VON FELIX, Maurice See: **VAN FELIX, Maurice**

VON FRANKENBERG, Arthur *[Painter] 20th c.*
Addresses: NYC. **Member:** GFLA. **Sources:** WW27.

VON FUEHRER, Ottmar F. *[Painter, illustrator, lecturer] b.1900, Austria / d.1967.*
Addresses: Pittsburgh, PA. **Studied:** Acad. Applied Arts, Vienna; Univ. Vienna; Carnegie Inst. Technology. **Member:** Assoc. Artists Pittsburgh; Pittsburgh WC Soc. **Exhibited:** Assoc. Artists Pittsburgh, annually; Pittsburgh WC Soc., annually. Awards: prize, Pittsburgh WC Soc. **Work:** murals, Carnegie Inst.; many backgrounds for dioramas; landscapes and portraits, in private collections. **Comments:** Contributor to *Carnegie Magazine* and to European publications. Lectures in U.S. and abroad. Position: staff artist, Natural Hist. Mus., Vienna, Austria; Florida State Mus., Gainesville, FL; chief staff artist, Carnegie Mus., Pittsburgh, PA. **Sources:** WW66.

VON GANG-GREBAN, Frederick *[Landscape painter] 19th/20th c.*
Addresses: Seattle, WA, 1916. **Exhibited:** Wash. State Comm. of FA, 1914. **Sources:** Trip and Cook, *Washington State Art and Artists, 1850-1950.*

VON GLEHN, Jane (Mrs. Wilfred Gabriel) See: **DE GLEHN, Jane Emmet (Mrs. W. G.)**

VON GLEHN, Wilfrid Gabriel See: **DE GLEHN, Wilfrid Gabriel**

VON GOTTSCHALCK, O(scar) H(unt) *[Painter, illustrator] b.1865, Providence, RI.*
Addresses: Hackensack, NJ. **Studied:** RISD; ASL. **Member:** SC, 1903. **Exhibited:** Salons of Am., 1934. **Sources:** WW21.

VON GROSCHWITZ, Gustave See: **VON GROSCHWITZ, (T. F.) Gustave**

VON GROSCHWITZ, (T. F.) Gustave *[Museum director, teacher, lecturer, writer] b.1906, NYC.*
Addresses: NYC, 1947; Iowa City, IA, in 1973. **Studied:** Columbia Univ. (B.A., 1927); NYU (CAA fellowship, 1945-46; M.A., 1949). **Member:** Print Council Am.; SAE; Am. Nat. Comt. Engraving. **Comments:** Awards: Am. Assn. Mus. grant, summer 1939. Teaching: Wesleyan Univ., 1938-45; Univ. Cincinnati, 1953-63. Other positions: cur. prints, Wesleyan Univ. Art Mus., 1938-45; senior cur. & cur. prints, Cincinnati Art Mus., 1947-63; director, Mus. Art, Carnegie Inst., 1963-68; assoc. dir., Mus. Art, Univ. Iowa, 1968-; trustee, Tamarind Lithography Workshop. Publications: ed., "Lehman Collection Catalogue"; contrib., *Print Collector's Quarterly, Art Bulletin,* and *Collier's Encyclopedia,* 1950. **Sources:** WW73; WW47.

VON GUNTEN, Roger *[Painter] b.1933, Zurich, Switz.*
Addresses: Mexico City 6, Mexico. **Studied:** Kunstgewerbeschule Zurich, 1948-53; Iberoamerican Univ., Mexico, 1959-60. **Exhibited:** 20th Biennial Watercolors, Brooklyn Mus., NY, 1958; Confrontation 1966, Mus. Bellas Artes, Mexico City, 1966; 2nd Bienal Coltejer, Medellin, Colombia, 1970; 11th Premi. Int. Dibuix, Barcelona, Spain, 1972. Awards: Soc. Amigos Acapulco First Prize, 2nd Festival Pictorico Acapulco, Mexico, 1964. **Work:** Mus. Arte Mod., Mexico City; Univ. Oaxaca, Mexico; Mus. Univ. Veracruzana, Xalapa, Mexico; Centro Arte Mod., Guadalajara, Mexico. Commissions: paintings, Mexico Pavilions Expo 1967, Montreal, 1967 & Hemisfair 1968, San Antonio, TX, 1968; murals, Mexico Pavilion, Expo 1967, Osaka, Japan, 1969 & Centro Arte Mod., Guadalajara, Mexico, 1970. **Comments:** Preferred media: oils, acrylics. **Sources:** WW73; J. Garcia Ponce, *Nueve Pintores Mexicanos* (Ed. Era, Mex., 1968) & *Aparicion de lo Invisible* (Ed. Siglo XXI, Mex., 1968).

VON GUTERSLOH, Paris *[Painter] 20th c.*
Exhibited: AIC, 1941. **Sources:** Falk, *AIC.*

VON HAELEWYN, Hendrick S. See: **VAN HAELEWYN, Hendrick S.**

VON HELM, Bertha *[Landscape and still life painter] late 19th c.*
Addresses: Shenandoah County, VA. **Work:** Shenandoah County Courthouse. **Sources:** Wright, *Artists in Virginia Before 1900.*

VON HELMOND, Adele See: **READ, Adele Von Helmold**

VON HELMS, Wallace C. *[Landscape painter] b.1878, California / d.1949, Oakland, CA.*
Addresses: Oakland, CA. **Studied:** with Yelland. **Exhibited:** Mark Hopkins Inst., 1898; Mechanics' Inst. fair, 1899; San Francisco AA, 1900. **Comments:** He was also a professional musician. **Sources:** Hughes, *Artists of California,* 579.

VON HERWIG See: **HERWIG, William Henry von**

VON HILLERN, Bertha (Miss) *[Landscape painter] late 19th c.*
Addresses: Boston, MA. **Exhibited:** PAFA Ann., 1880-84, 1888-90; Boston Art Dept., 1884 (joint exhib. with Maria A. Beckett); Boston AC, 1881, 1883, 1884; AIC. **Comments:** *Cf.* Bertha Von Helm. **Sources:** Falk, *Exh. Record Series.*

VON HOCHHOLZER, Conrad See: **HIGHWOOD, Conrad**

VON HOFSTEN, H(ugo Olof) *[Illustrator, painter] b.1865, Sweden.*
Addresses: Winnetka, IL. **Studied:** Royal Acad., Stockholm with M.E. Winge, O. Aborelius, A. Larson. **Member:** Forestry Painters of Chicago (organizer). **Exhibited:** Swedish Am. Artists, 1919 (prize); AIC. **Comments:** Also appears as Hofsten. **Sources:** WW31; WW13.

VON HUHN, Rudolf *[Painter, printmaker] b.1884, San Francisco, CA / d.1968, Wash., DC.*
Addresses: Wash., DC. **Exhibited:** American University, Wash.,

DC, 1947 (solo); WMAA; CGA, solos, 1952, 1962; Baltimore Mus. of Art, also 1953 (solo); Smithonian Inst., 1953 (solo); Catholic Univ., 1953 (solo); George Wash. Univ., 1953 (solo); Whyte Gallery, 1954 (solo); Norton Gallery of Art, 1954 (solo); Fort Worth Art Center, 1955 (solo); Veerhoff Gallery, 1957 (solo); Michigan State Univ., 1960 (solo). Awards: CGA; Wash. WCC. **Work:** CGA; Brooks Memorial Gallery; National Mus. of American Hist. **Comments:** In 1890 his family went to Germany, where he received his schooling and a degree in engineering, returning to the U.S. before WWI. He worked for the U.S. Government until 1947, and thereafter devoted all his time to art. **Sources:** McMahan, *Artists of Washington, DC.*

VONIER, Marie *[Artist] late 19th c.*
Addresses: Active in Detroit, MI, 1895. **Sources:** Petteys, *Dictionary of Women Artists.*

VON IWONSKI, Carl G. See: **IWONSKI, Carl G. von**

VON JOST, Alexander *[Painter, etcher] b.1888, Laurence, MA / d.1968.*
Addresses: Richmond, VA. **Studied:** Johns Hopkins Univ.; Maryland Inst. **Exhibited:** South Carolina State Fair, 1927 (prize); Richmond Acad. Arts & Sciences, 1933 (prize). **Work:** Hanover County Court House, VA; Confederate Mus., Richmond, VA; Supreme Court, William & Mary College, Williamsburg, VA; Richard Cimbal Lib., Phila.; Blues Armory, Richmond, VA; Univ. Virginia; Univ. Richmond; Virginia Military Inst., Lexington, VA; St. John Vianney Seminary, Richmond; Jefferson Davis Mem. Chapel, Richmond. **Comments:** Specialty: portraits. **Sources:** WW66; WW47.

VONK, William M. *[Painter] 20th c.*
Exhibited: S. Indp. A., 1936. **Sources:** Marlor, *Soc. Indp. Artists.*

VON KAMECKE, B. J. (Mrs.) *[Painter] 20th c.*
Addresses: NYC. **Exhibited:** S. Indp. A., 1929. **Sources:** Marlor, *Soc. Indp. Artists.*

VON KEITH, John H. *[Landscape painter, writer] 19th/20th c.*
Addresses: Los Angeles, CA, active 1884. **Comments:** Author: *Von Keith's Westward or 1000 Items on the Wonders and Curiosities of Southern Calif.*, 1887. **Sources:** Hughes, *Artists of California*, 580.

VON KELLER, Beatrice Been (Mrs.) *[Educator] b.1884, Skanee, MI.*
Addresses: Lyncburg, VA. **Studied:** Royal Acad., Stockholm, Sweden, with von Rosen, Cedarstrom; Univ. Chicago, Ph.B., M.A.; Sorbonne, Paris, France; NYU. **Comments:** Position: head, art dept., Randolph-Macon College for Women, Lynchburg, VA, 1928- ; acting director of FA, VMFA, Richmond, VA, 1942-45. Lectures on history & appreciation of art. **Sources:** WW53.

VON KREIBIG, E. *[Painter] 20th c.*
Exhibited: AIC, 1932. **Sources:** Falk, *AIC.*

VON KUBINYA, Alexander *[Painter] 20th c.*
Exhibited: AIC, 1930-31. **Sources:** Falk, *AIC.*

VON LANGSDORFF, George H. See: **LANGSDORFF, Georg Heinrich von**

VON LEHMDEN, Ralph *[Painter, designer] b.1908, Cleveland, Ohio.*
Addresses: Larchmont, NY, 1947; Chicago, IL, 1959. **Studied:** Cleveland Sch. Art; Northwestern Univ.; Western Reserve Univ.; Grand Central Sch. Art. **Member:** Chicago AC; SI; SC. **Exhibited:** AIC, 1940-41 (prizes), 1952-55, 1956 (prize); CI, 1941; NAD, 1942 (prize), 1953, 1954; Art Dir. Club, NY, 1949 (medal); CMA; Butler AI; Kansas City AI; Milch Gal. NYC. **Work:** paintings of the Arctic for Sec. of the Air Force, 1957. **Comments:** Position: advertising designer, *Chicago Tribune*, 1929-42, freelance, from 1946. **Sources:** WW59.

VON LIENEN, George *[Painter] 20th c.*
Addresses: Brooklyn, NY. **Exhibited:** S. Indp. A., 1933, 1935.

Sources: Marlor, *Soc. Indp. Artists.*

VON LOSSBERG, Victor F. *[Designer] 20th c.; b.Baltic Provinces, Russia.*
Addresses: NYC. **Studied:** Germany, with Olbrich, Darmstadt; Paris, with Remil, Ecole des Arts et Metiers. **Member:** Arch. Lg.; Alliance; Art-in-Trades Club. **Exhibited:** AIA, 1926 (medal); Arch. Lg., 1931 (medal). **Comments:** Specialties: metalwork & enamels. Positions: pres./designer, Edward F. Caldwell & Co., Inc. **Sources:** WW40.

VON MANIKOWSKI, Boles *[Painter, designer, sculptor, lecturer] b.1892, Kempen, Germany.*
Addresses: Corning, NY. **Studied:** ASL; AIC; Baer, Germany; & with Lars Hofstrup, Sascha Moldovan, Frederick Carder, Ernfred Anderson. **Exhibited:** S. Indp. A., 1936; Cayuga Mus. Hist. & Art, 1940-41; Blue Ridge, NC, 1942. **Sources:** WW59; WW47.

VON MARR, Carl *[Painter, illustrator, teacher] b.1858, Milwaukee, WI / d.1936.*
Addresses: Milwaukee, WI; Munich, Germany. **Studied:** Henry Viandon, Milwaukee; Weimar Acad., with Schaus, 1875; Berlin Acad., with Gussow; Munich, 1877, with Seitz, Gabriel Max, Lindenschmit; Acad. of Athens. **Member:** NIAL. **Exhibited:** PAFA Ann., 1881, 1893-95, 1909; NAD, 1881; Boston AC, 1882; Prize Fund Exhib., NYC, 1886 (gold); other medals: Vienna (1893, 1894) , Berlin (1891), Munich (1889, 1893), Dresden, Madrid (1892), Salzburg, Barcelona, Antwerp, Budapest, Lièe (1905), Anvers (1894). **Work:** TMA; MMA; Königsburg; Breslau, Munich; Budapest; West Bend Gal. of Fine Arts, West Bend, Wis. **Comments:** After studying in Munich he returned to Milwaukee (1880) to teach art, but found the venture unprofitable. In 1882, he returned to Munich where he spent most of his career as a successful expatriate. He was a professor at the Bavarian Acad. Arts from 1893-on, teaching most of the Americans who enrolled there. He visited family in Milwaukee only periodically but returned in 1929. Also appears as Marr. **Sources:** WW33; Gerdts, *Art Across America*, vol. 2: 331-32 (repro.); Falk, *Exh. Record Series.*

VON MEYER, Michael *[Sculptor, teacher] b.1894, Russia / d.1984, San Francisco, CA.*
Addresses: San Francisco, CA. **Studied:** Calif. School Fine Arts, San Francisco AA. **Member:** San Francisco AA. **Exhibited:** Calif. AA; CPLH; de Young Mem. Mus.; SFMA; San Francisco Women's AA, 1926 (prize); San Francisco AA, 1934 (medal); CGA, 1936; Crocker Gal. Art, Stockton; Oakland Art Gal., 1934 (bronze medal, 4th Ann. Sculpture),1936; GGE, 1939; WMAA, 1936; Pomeroy Galleries, San Francisco, 1966; Monterey Peninsula Mus. Art, 1969. **Work:** SFMA; CPLH; Univ. California Hospital; San Francisco City Hall; GGE 1939; *Daily Californian* Newspaper Bldg., Salinas; House Office Bldg., Washington, DC; USPO, Santa Clara, CA; Church of Transfiguration, Denver, CO; Marina Heights, Vallejo, CA. Commissions: St. Innocent Eastern Orthodox Church, Enrico, CA; St Therese's Shrine, Fresno, CA; Russian Orthodox Holy Trinity Cathedral, San Francisco; Russian Cath. Center and Serbian Cemetery, San Francisco; Beach Chalet, San Francisco; Catholic Russian Center, San Francisco; Fleishhacker Playground, San Francisco; statue, Art Comm., San Francisco; Stanford Univ. Hospital; Greek Mem. Park, San Mateo, CA. **Comments:** Contributor: *Asia, Art News, Pencil Points, Am. Artists Group, Univ. Calif. Press,* & other publications. **Sources:** WW73; WW47; E.M. Polley, "Art and Artists," *Sun Times Herald,* Vallejo, CA; Robert Hagan, "The Walls They Left Behind," *San Francisco Magazine* (1964).

VON MIKLOS, Josephine *[Industrial designer, writer] b.1900, Vienna, Austria.*
Addresses: New Canaan, CT. **Studied:** Univ. Vienna, Ph.D. **Member:** Arch. Lg.; Fashion Group; ADI. **Exhibited:** Arch. Lg., 1944; All-America Package Competition, 1941 (prize). **Work:** Designer for leading cosmetic manufacturers. **Comments:** Author/illustrator: "I Took a War Job," 1943. Contributor: *Modern Packaging, Modern Plastics* & other trade publications. Lectures:

design. **Sources:** WW53.

VON MINCKWITZ, Katherine *[Painter, graphic artist, sculptor, teacher]* b.1907, NYC. / d.c.1960.
Addresses: NYC. **Studied:** J. Sloan; H. Sternberg. **Exhibited:** AIC, 1936-37; Soc. Indep. Artists, 1936-37, 1941. **Comments:** Also known under married name of Goldsmith (Mrs. Theodore). **Sources:** WW40.

VON MULLER, Francis (Prof.) (Capt.) *[Painter]* 20th c.
Exhibited: S. Indp. A., 1937. **Comments:** (This listing includes Francis Zu Muller.) **Sources:** Marlor, *Soc. Indp. Artists.*

VONNAH, Robert William See: **VONNOH, Robert William**

VON NESSEN, Walter *[Designer]* d.1889, Iserlohn, Germany.
Addresses: NYC. **Studied:** B. Paul; Grenander. **Member:** Nat. AAI. **Comments:** Position: associate, Nessen Studio, Chase Brass & Copper Co., A.H. Heisey & Co. **Sources:** WW40.

VON NEUMANN, Angela *[Painter]* 20th c.
Addresses: Denver, CO. **Exhibited:** PAFA Ann., 1953. **Sources:** Falk, *Exh. Record Series.*

VON NEUMANN, Robert *Robert von Neumann*
A. *[Sculptor, educator]*
b.1923, Berlin, Germany.
Addresses: Saint Joseph, IL. **Studied:** School Art Inst. Chicago, B.F.A.; Univ. Wisconsin, M.S. **Member:** Am. Craftsmens Council. **Exhibited:** Aspects of Christian Art, Newark Mus. Art, 1956; Craftsmen in a Changing World, Mus. Contemporay Crafts, New York, 1957; American Crafts, Am. Pavilion, World's Fair, Brussels, Belgium, 1958; American Decorative Arts, Europe, U.S. & Near East, U.S. State Dept., 1959-61; Int. Sterling Silver Flatware Design Competition, Europe & U.S., 1960-61; Gilman Gallery, Chicago, IL, 1970s. Awards: chosen by competition to study with Baron Frik Fleming, Court Silversmith to King of Sweden, 1950; one of 21 awards, First Int. Design Competition for Sterling Silver Flatware, 1960; chosen by Int. Co-op. Commission to study Japanese handicraft industries, 1960. **Work:** Des Moines (IA) Art Center; Detroit (MI) Mus. Art; Newark (NJ) Mus. Art; Illinois State Univ., Normal; Indiana State College. Commissions: sculpture to illus. article in *Playboy Magazine,* 1969 & 1972. **Comments:** Preferred media: clay, wood, metals. Teaching: from instructor to asst. professor art, Iowa State Teachers College, 1950-55; professor art, Univ. Illinois, Urbana, 1955-. Publications: author, "The Decorative Arts; An Aesthetic Stepchild?," 1960; review of "The Arts of the Japanese Sword," 1963, *College Arts Journal;* author, "The Design and Creation of Jewelry," Chilton, 1960 & revised edition, 1972. **Sources:** WW73; Elizabeth Drews, "The Creative Personality" (series of films), Dept. Educ., Michigan State Univ., 1958.

VON NEUMANN, Robert Franz *[Painter, lecturer, teacher, block printer, engraver, lithographer]* b.1888, Rostock, Mecklenburg, Germany / d.1976, Milwaukee, WI.
Addresses: Milwaukee, WI (immigrated 1926). **Studied:** Royal Acad., Berlin; F. Bunke, in Weimar; Kunstgewerbe Mus., Berlin, with E. Doepler; M. Kock; H. Hofmann, in Munich. **Member:** SAE; Chicago SE; Wisc. P&S; Milwaukee PM; Southern PMS; Rockport AA. **Exhibited:** NAD; PAFA Ann., 1930, 1938; PAFA 1944 (prize); Corcoran Gal biennials, 1930, 1937; WFNY, 1939; GGE, 1939; CI; Minneapolis Inst. Art; Madison Salon; Milwaukee Journal, 1933 (prize); Madison AA, 1934 (prize); AIC, 1936 (prize); Palm Beach, FL, 1937 (prize); Milwaukee AI, 1938 (prize); 1941 (medal); SAE, 1942 (prize); LOC, 1943 (prize); Herron AI (prize); Wisc. State Fair, 1930 (prize); Wisc. P&S, 1934 (prize). **Work:** Univ. Wisconsin; Milwaukee AI; AIGA; LOC; Berlin, Germany; Milwaukee State Teachers College; Four Arts Soc., Palm Beach. **Comments:** Teaching: Milwaukee State Teachers College, 1940; AIC. **Sources:** WW47; Falk, *Exh. Record Series.*

VONNOH, Bessie (Onahotema) Potter (Mrs.) *[Sculptor]* b.1872, St. Louis, MO / d.1955, NYC.
Addresses: NYC/Lyme, CT. **Studied:** AIC with L. Taft, 1889-92 (also assisted Taft with sculptures for the Worlds Columbian Expo.); traveled to Paris, 1895-96, visiting Rodin's studio. **Member:** ANA, 1906; NA, 1921; NSS, 1898; Portrait Painters; Allied AA; NAC; NIAL; SAA. **Exhibited:** AIC, 1891-98; Worlds Columbian Expo, Chicago, 1893; PAFA Ann., 1894-99, 1903-06, 1911-21, 1927, 1931; Nashville Expo, 1897, (prize); Paris Expo, 1900 (med.); Boston AC, 1899, 1905, 1906; Pan-Am. Expo, Buffalo, 1901 (prize); St. Louis Expo., 1904 (gold); Armory Show, 1913; Brooklyn Inst., 1913 (solo); Pan.-Pac. Expo, San Francisco, 1915 (med.); CGA, 1919 (solo show); NAD, 1921 (gold); Phila. Art All., 1928 (prize). **Work:** MMA; BM; AIC; CGA; BMFA; NMAA; Denver Art Mus.; Amon Carter Mus.; CI; PAFA; CM; Detroit Inst. Art; Major General Crawford for Smith Mem., Fairmount Park, Phila.; Mem. Park, Batavia, NY; Am. Mus. Natural Hist., NY; Newark Mus.; Ft. Worth Mus. Art; Oregon State Col.; Highland SA, Dallas, TX; Brookgreen Gardens, SC; Col. Indust. Art, Denton, TX; Senate Bldg., Wash., DC; Balboa Park, San Diego, CA; Roosevelt Mem. Bird Fountain, Oyster Bay, NY; Frances Hodgson Burnett Fountain, Central Park, NYC; Laurence Col., Appleton, WI. **Comments:** Established a studio in Chicago in 1894, gaining early popularity for her plaster statuettes of society women. Upon her marriage to painter Robert Vonnoh (see entry) in 1899, she moved to NYC, establishing a joint studio with her husband and maintaining a summer home in Lyme, CT. Vonnoh was one of the most successful women artists of her generation and is recognized particularly for her small bronze statuettes featuring mothers and children, as well as for her garden sculpture and fountains depicting dancing children. In 1948 she married Dr. Edward Keyes, but he died within a year. **Sources:** WW53; WW47; Julie Alane Aronson, "Bessie Potter Vonnoh (1872-1955) and Small Bronze Sculpture in America" (Ph.D dissertation, University of Delaware, 1995); Fort, *The Figure in American Sculpture,* 228-29 (w/repro.); Rubinstein, *American Women Artists,* Falk, *Exh. Record Series;* Brown, *The Story of the Armory Show.*

VONNOH, Robert William *[Painter, teacher]* b.1858, Hartford, CT / d.1933, Riviera art colony, Nice, France.
Addresses: Boston, MA; Phila., PA, 1892; NYC, 1899/Grez-sur-Loing, France/Lyme, CT. **Studied:** Massachusetts Normal Art School, Boston, 1875-77; Académie Julian, Paris with Boulanger and Lefebvre, 1881-83 (Fehrer cites 1880-88); Paris again, 1887-91 (influenced by Bastien-Lepage and Monet). **Member:** ANA; 1900; NA, 1906; SAA, 1892; NAC; Arch. Lg.; Portrait Painters; Lotos Club; SC, 1904; fellow, PAFA; Allied AA; Munich Secession; CAFA; Gamut Club of Los Angeles; Paris AAA; L.C. Tiffany Foundation; Lyme AA. **Exhibited:** Paris Salon, 1883, 1888-91; PAFA Ann., 1883-1934 (prize 1926); SAA; St. Louis Expo, 1898; Cincinnati Expo, 1898; BAC, 1880-92; Mass. Charitable Mechanics Assn., Boston, 1884 (gold medal); Paris Salon, 1883, 1889 (hon. mention); Paris Expo, 1889 (bronze medal), 1891, 1900 (medal); Williams & Everett Gal., Boston, 1891 (first solo: 42 oils); Pan-Am. Expo, Buffalo, 1901 (medal); Charleston, 1902 (gold medal); NAD, 1892, 1899, 1904 (prize, 1904); Corcoran Gal biennials, 1907-26 (7 times); Pan-Pacific Expo, 1915 (gold medal); S. Indp. A., 1917; Old Lyme AA, 1917-c.1929; CAFA, 1920 (top prize); CGA, 1920 (prize); Newport AA, 1920 (prize); AIC. **Work:** PAFA; MMA; Butler AI; BM; Harrison Gal., LACMA; Wm. Benton MA, Univ. Connecticut; Indianapolis MA; College of Physicians, Phila.; Buffalo Club, NY; Union Lg. Club; Phila.; Dept. Justice, Wash., DC; Post Office Dept., Wash., DC; Am. Philosophical Soc., College of Physicians, both in Phila.; Brown Univ.; Mass. Hist. Soc., Boston; W. Wilson's family, White House; Capitol, Hartford, CT; Ft. Worth (TX) Mus.; County Court House, Bel Air, MD; CMA.
Comments: Although cited as one of the important artists in American Impressionism, few of his early works (1883-93) have been discovered. From 1887-91, he had a studio at Grez-sur-

Loing, France. Eliot Clark wrote that "Vonnoh must be considered historically one of the pioneer impressionists in America. At a time when Twachtman was still absorbed in tonal grays, Vonnoh was applying paint almost directly from the tube in a system of vibratory complimentary relations." Upon his return to the U.S. he accepted a prestigious position at PAFA, teaching portrait and figure painting (1891-96 and 1918-20). Among his students were Robert Henri, William Glackens, Maxfield Parrish, and Edward Redfield. In 1899, he married sculptor Bessie Potter Vonnoh (see entry). He also spent some time painting in Bermuda. **Teaching:** Mass. Normal Art Sch., Roxbury Evening Sch., Thayer Acad., all in Boston (1879-81), East Boston Evening Sch. and Cowles Art Sch. (1883-85), BMFA Sch. (1885-87). **Sources:** WW27; Baigell, *Dictionary;* Eliot Clark, "The Art of Robert Vonnoh," *Art in America* (August 1928); May B. Hill, article in *Antiques* (Nov., 1986, p.1014); *Connecticut and American Impressionism* 175 (w/repro.); Fink, *American Art at the Nineteenth-Century Paris Salons,* 401; Art in Conn.: The Impressionist Years; Falk, *Exh. Record Series.*

VON PERBANDT, Carl Adolf Rudolf Julius *[Landscape painter]* b.1832, Lagendorf, East Prussia, Germany / d.1911, Nahmgeist, East Prussia, Germany.
Addresses: NYC; San Francisco, CA, 1877-1903. **Studied:** Düsseldorf Acad. with Andreas Achenbach and Lessing. **Exhibited:** NAD, 1874; Mark Hopkins Inst., 1897; Mecahnics' Inst. Fairs, 1880-99; San Francisco AA, 1881, 1883, 1885. **Work:** Calif. Hist. Soc.; Oakland Mus.; Soc. of Calif. Pioneers; St. Mary's College, Moraga, CA. **Comments:** Came to NYC c.1870; by 1877 he was in San Francisco, painting landscapes. Shared a studio with Henry Raschen. They traveled among California Indian tribes; indeed, Perbandt lived at times with the Indians. Returned to East Prussia in 1903. Many of his paintings were lost in the earthquake and fire of 1906. Also appears as Perbandt. **Sources:** Hughes, *Artists in California,* 580; P&H Samuels, 505.

VON PHUL, Anna Maria *[Amateur watercolorist]* b.1786, Philadelphia, PA / d.1823, Edwardsville, IL.
Addresses: Lexington, KY, 1800-21; St. Louis, MO. **Studied:** Mary Beck, at her women's academy in Lexington (KY). **Work:** Missouri Historical Soc., St. Louis. **Comments:** On a visit to St. Louis in 1818 she made a number of portraits and genre-type pictures depicting people and scenes in St. Louis (Missouri Historical Soc.). She lived in St. Louis during her last years, though she died at the home of a sister in Edwardsville (IL). **Sources:** G&W; Van Ravensway, "Anna Maria Von Phul"; also repros. in *Antiques* (Sept. 1953), 195. More recently, see Petteys, *Dictionary of Women Artists.*

VON POVEN, Marianne *[Painter]* 20th c.
Addresses: Chicago area. **Exhibited:** AIC, 1935. **Sources:** Falk, AIC.

VON PRIBOSIC, Viktor *[Painter, blockprinter, designer]* b.1909, Cleveland, OH / d.1959, San Diego County, CA.
Addresses: Los Angeles, CA. **Member:** Los Angeles GAA. **Exhibited:** Los Angeles County Fair, Pomona, 1935 (prize), 1936 (prize); Woodcut Exhib., LACMA, 1937 (solo); Borden's Gal., Los Angeles, 1939 (solo); Los Angeles County Fair, Pomona, 1935 (prize), 1936 (prize). **Work:** FA Gal., San Diego. **Comments:** Specialties: modern furniture design; interior decoration. **Sources:** WW40.

VON RECKLINGHAUSEN, Max See: **RECKLINGHAUSEN, Max Von**

VON REHLING-QUINSTGAARD, J(ohann) W(aldemar) b.1877, Orsholtgaard, Denmark / d.1962, Copenhagen, Denmark.
Exhibited: Salons of Am., 1934. **Sources:** Marlor, *Salons of Am.*

VON RIDELSTEIN, Herbert *[Painter]* b.1873, Temesvar, Hungary / d.1935, San Francisco, CA.
Addresses: San Francisco, CA, 1926-1935. **Studied:** Munich Academy of FA, 1902-05; Académie de la Grande Chaumière,

Paris, two years. **Work:** Biltmore Hotel, Phoenix, AZ (mural). **Comments:** Baron von Ridelstein abandoned a career in the Austrian military to study art in Munich. He and his wife Maria von Ridelstein (see entry) together studied for two years in Paris and left for the Orient in 1913. During WWI he was captured by the Japanese and spent years in a Japanese concentration camp. After spending several years in Chile, they settled in San Francisco. Position: teacher, Fashion Art School, Scottish Rite Temple; Calif. College of Arts & Crafts (briefly). **Sources:** Hughes, *Artists of California,* 580.

VON RIDELSTEIN, Maria *[Painter, printmaker, teacher]* b.1884, Leipzig, Germany / d.1970, San Francisco, CA.
Addresses: San Francisco, CA, 1926-70. **Studied:** Munich Academy of FA; Paris; Rome. **Member:** Soc. Western Artists (cofounder & pres.); San Francisco Soc. of Women Artists; Am. WCS. **Comments:** Position: teacher, Yokohama, Japan; head, art dept., Colegio Aleman & teacher, College of the Irish Sisters, both in Valparaiso, Chile; teacher, Fashion Art School, Scottish Rite Temple, San Francisco & Calif. College of Arts & Crafts. Married to Herbert von Ridelstein (see entry). A realist painter, she took a vocal stand against modern art. **Sources:** Hughes, *Artists in California,* 580.

VON RIEGEN, William *[Cartoonist, illustrator, painter, teacher]* b.1908, New York, NY.
Addresses: Weehawken, NJ, 1940; Dumont, NJ, 1960s. **Studied:** ASL, with George Bridgman. **Member:** SI; ASL; Nat. Cartoonists Soc. **Exhibited:** Bredemeier Gal., Buffalo; Keppel Gal., NYC; ASL; MMA; SI; Louvre, Paris, France, and in many traveling exhibs. of cartoons throughout U.S. **Comments:** Illustrator: "Professional Cartooning," 1950; "Ever Since Adam and Eve," 1955. Contributor: cartoons and illustrations to *Saturday Evening Post, Look, Readers' Digest, Esquire, New Yorker, True, Argosy, Reader's Digest Humor Book, Saturday Review, Ladies Home Journal, Good Housekeeping, Christian Science Monitor, King Features.* Contributor: cartoons, "Twenty-Five Years of Cartooning," *Saturday Evening Post,* "Cartoon Album," *Esquire,* and other national magazines. Included in *Best Cartoons 1964.* Position: instructor, ASL, part-time; PIA School. **Sources:** WW66; WW40.

VON RINGLEHEIM, Paul *[Sculptor]* b.1934.
Addresses: NYC. **Exhibited:** 1964. **Sources:** Falk, *WMAA.*

VON RIPPER, Rudolph Charles *[Painter, illustrator]* b.1905.
Addresses: New Canaan, CT. **Studied:** Art Acad., Dusseldorf, Germany; Paris, France. **Exhibited:** PAFA Ann., 1953. **Awards:** Guggenheim Fellowship, 1945. **Work:** Univ. Chicago Library; MoMA; BM; NYPL; Courtauld Collection London, England; mural, William Beaumont General Hospital, El Paso, TX. **Comments:** Author/illustrator: "Ecraser L'Infame," 1938, "The Soul and Body of John Brown," 1941. Illustrator: *Time, Fortune* magazines. **Sources:** WW53; WW47; Falk, *Exh. Record Series.*

VON RUEMELIN, Adolph G.W. See: **WOLTER, Adolph G. (Adolph Gustav Wolter van Ruemelin)**

VON RYDINGSVARD, Karl *[Sculptor, craftsperson]* 20th c.
Addresses: NYC/Brunswick, ME. **Member:** Arch. Lg., 1904. **Comments:** Specialty; wood carving. **Sources:** WW10.

VON SALTZA, Charles Frederick *[Portrait painter, teacher]* b.1858, Sorby, Sweden (came to the U.S. in 1891) / d.1905.
Addresses: NYC, 1900. **Studied:** Acads. Stockholm, Antwerp, Brussels; L. Bonnât, in Paris. **Member:** Swedish AA; St. Louis AG; St. Louis Assn. P&S; SWA. **Exhibited:** St. Louis Expo, 1898; SWA, 1898; AIC; NAD, 1900. **Comments:** Also known as Carl F. Von Saltza. Positions: teacher, St. Louis Sch. FA, Columbia Teachers College (1899) & AIC. **Sources:** WW06.

VON SALTZA, Philip M. *[Painter, teacher]* b.1885, Stockholm, Sweden.
Addresses: North Castine, ME. **Studied:** ASL; H.E. Fields

Studio, Ogunquit, Maine. **Exhibited:** S. Indp. A., 1917, 1928; 48 Sts. Competition, 1939 (prize); Macbeth Gal., NY, 1938; WFNY, 1939; AIC, 1939; PAFA Ann., 1940. **Work:** murals, USPOs, St. Albans (VT) & Schuyler (NE) & Milford (NH). **Comments:** WPA artist. **Sources:** WW40; Falk, *Exh. Record Series.*

VON SALZEN, Charles *[Painter] mid 20th c.*
Exhibited: Salons of Am., 1934. **Sources:** Marlor, *Salons of Am.*

VON SCHLEGELL, David *[Sculptor] b.1920, St Louis, MO / d.1992.*
Addresses: New York, NY. **Studied:** Univ. Michigan, 1940-42; ASL, 1946-48. **Exhibited:** WMAA, 1957, 1964, 1966 ,1969, WMAA; CI, 1970; Sculpture for New Spaces, Walker AC, Minneapolis, MN, 1971; Middleheim Biennial, Belgium, 1971; Reese Palley, NYC, 1970s. Awards: purchase prize, Carnegie Int., 1967; St. Buttolph Award, 1969; Nat. Foundation Arts, 1969. **Work:** WMAA; CI, Pittsburgh, PA; Storm King AC, Mountainville, NY; MITA; NY State Albany Man Project. Commissions: sculpture, Lannon Foundation, Palm Beach, FL, 1969; sculpture, Storm King AC, Mountainville, 1970; sculpture, Harbor Towers, Boston, MA, 1972. **Comments:** Preferred media: stainless steel, aluminum. Teaching: visiting lecturer, sculpture, Univ. Calif., Santa Barbara, 1968; painting instructor, School Visual Arts, 1968-69; visiting sculpture instructor, Cornell Univ., 1969-70; director, studies sculpture, Yale Univ., 1971- **Sources:** WW73; Jacobs, *The Artist Speaks: DVS, Art in Am.* (May-June, 1968).

VON SCHLEGELL, G(ustav) William *[Painter, teacher] b.1884, St. Louis, MO / d.1950, White Plains, NY.*
Addresses: St. Paul, MN (1933); Harrison, NY. **Studied:** R. Koehler in Minneapolis; Univ. Minnesota; Carl Von Marr in Munich; Académie Julian, Paris with J.P. Laurens, 1901. **Member:** 2x4 Soc.; Soc. PS&G. **Exhibited:** Corcoran Gal biennial, 1910; PAFA Ann., 1910, 1915, 1934; Salons of Am., 1923, 1932, 1934 ; Mun. Exhib., NY, 1934. **Work:** St. Louis AM; PMG. **Comments:** Known as William Von Schlegell. Teaching: Ogunquit School Painting & Sculpture, Ogunquit, ME (summers). **Sources:** WW53; WW47; WW33; add'l info. courtesy Tom Veilleux Gal., Farmington, ME; Marlor, *Salons of Am.* [lists as two different artists: Gustav Von William Schlegell (b. 1884, St. Louis, still active 1953) and William Von Schlegell (b. 1877, St. Louis, d. 1950)]; Falk, *Exh. Record Series.*

VON SCHLIPPE, Alexy *[Painter, teacher] b.1915, Moscow, Russia / d.1988, Munich, Germany.*
Addresses: Norwich, CT. **Exhibited:** at New England galleries and in Munich, Germany. **Work:** Slater Mem. Mus., Norwich, CT. **Comments:** After arriving in the U.S. in 1954, he gave up his title as a Russian baron, became a citizen, and taught painting and art history at the Norwich (CT) Art School (1955-63), and at Univ. Connecticut (1963-83). His favorite subjects were mushrooms, gourds, and lemons; he also painted reclining figures. **Sources:** info courtesy J. Gualtieri, Slater Mem. Mus., Norwich, CT.

VON SCHMAUS, Fr. *[Artist] late 19th c.*
Exhibited: NAD, 1883. **Sources:** Naylor, *NAD.*

VON SCHMIDT, Harold *[Illustrator, painter, lecturer] b.1893, Alameda, CA / d.1982.*

HAROLD
V O N
SCHMIDT

Addresses: Westport, CT (1928-on).
Studied: Calif. College Arts & Crafts, 1912-13 with F. H. Meyers; San Francisco AI, 1915-18; Grand Central Art School, with Harvey Dunn, 1924; Worth Ryder; Maynard Dixon. **Member:** SI (pres., 1938-41); Westport AA (pres., 1950-51); Artists Gld.; AAPL. **Exhibited:** SI; Westport Artists Group. **Work:** Calif. State Capitol, Sacramento; Montana Hist. Soc.; U.S. Military Acad., West Point, NY; Baseball Hall of Fame, Cooperstown, NY; Air Force Acad., Denver; Cowboy Hall of Fame; commissioned to design the postage stamp commemorating Pony Express. **Comments:** A specialist in Western subjects, as a young man he worked as a cowboy, lumberjack, muleskinner, and longshoreman. He was also a sailor, hunter, rodeo rider, and competed in the 1920 Olympics in rugby. During WWII, he flew bombing missions over Germany. His long career as an illustrator began in NYC during the 1910s and for the next 20 years his works appeared frequently in *Saturday Evening Post.* Book Illustrator: "Death Comes to the Archbishop," "December Night," "Homespun" and other books.; contributor to national magazines. Position: artist/correspondent, King Features Syndicate, 1945; founder & faculty member, Famous Artists School, Westport, CT. **Sources:** WW59; WW47; P & H Samuels, 505; *Community of Artists,* 71.

VON SCHNEIDAU, Christian *[Painter, sculptor, etcher, illustrator, lecturer, teacher] b.1893, Smoland, Sweden / d.1976, Orange, CA.*
Addresses: Laguna Beach, CA, in 1973. **Studied:** Acad. FA, Sweden; AIC; J. Wellington Reynolds, Charles Hawthorne; Richard Miller; K. Buerh; H.M. Walcott; M. Bohm; G.E. Browne; H. Pushman. **Member:** Scandinavian-Am. Sculptors of the West (pres.); Soc. for Sanity in Art; Calif WCS; Fairbanks AG; Swedish Club, Los Angeles; Kern River Valley AA. **Exhibited:** AIC, 1915 (prize), 1916 (prize); Minnesota State Fair, 1916 (prize); Swedish-Am. Exhib., Chicago, 1917 (prize), 1919, 1920 (prize); Calif. State Fair, 1919 (prize), 1920 (medal), 1925 (prize), 1926 (prize), 1929; Southwest Mus., 1921 (prize); Expo, Park Mus., 1921 (prize); John Morton Mem. Hall Competition, 1928 (prize); Creative Art Center, CA, 1931 (prize); Scandanavian-Am. Sculptors of the West, Los Angeles Mus. Art, 1939 (prize); Grumbacher Award, 1968. **Work:** Portraits and murals in numerous theatres, churches, hotels & clubs throughout the U.S. and abroad: murals, Forum Theatre, Los Angeles; Southwest Baptist Church, Los Angeles; Calif Lutheran Hospital, Los Angeles; Angelical Lutheran Church, Los Angeles; Swedish Club of Chicago; 3 murals, John Morton Mem Mus., Phila; gift to Crown Prince of Sweden; dec., Columbia Studios, Los Angeles. **Comments:** Came to Minnesota in 1906. Position: director, C. von Schneidau School FA, Los Angeles & Palm Springs, from 1920; professor art, Bus. Men's Art Inst., Los Angeles; instructor portrait painting, Bakersfield AA & Cunningham Mem. Mus. **Sources:** WW73.

VON SCHOLLEY, Ruth *[Painter] 20th c.*
Addresses: Boston, MA. **Exhibited:** PAFA Ann., 1924. **Sources:** WW25; Falk, *Exh. Record Series.*

VON SCHROETTER, Hans *[Painter] 20th c.*
Addresses: Chicago area. **Exhibited:** AIC, 1932. **Sources:** Falk, *AIC.*

VON SCHULZENHEIN, T. *[Artist] late 19th c.*
Addresses: NYC, 1893. **Exhibited:** NAD, 1893. **Sources:** Naylor, *NAD.*

VON SCHWANENFLUEGEL, Hugo See: **SCHWANENFLUEGAL, Hugo Von**

VON SMITH, Augustus A. *[Portrait painter] mid 19th c.*
Addresses: Vincennes, IN from about 1835-c.1842. **Comments:** Burnet states that he was foreign-born and had a son who also was an artist. One of them was at New Orleans in 1842 in the firm of Brammer & Von Smith (see entry). **Sources:** G&W; Peat, *Pioneer Painters of Indiana,* 24, 240; Burner, *Art and Artists of Indiana,* 11, 400; New Orleans CD 1842; Gerdts, *Art Across America,* vol. 2: 253.

VON SODAL, L. E. *[Painter] 20th c.*
Comments: Affiliated with Art & Crafts Club, Meriden, CT. **Sources:** WW15.

VON STOSCH, Wilhelmina See: **NICHOLS, Wilhelmina (Mrs. Hobart)**

VON STUCK, Franz *[Painter] 20th c.*
Exhibited: AIC, 1924. **Sources:** Falk, *AIC.*

VON VELTHEIM, Marie *[Painter] 20th c.*
Exhibited: SNBA, 1899. **Sources:** Fink, *American Art at the*

Nineteenth-Century Paris Salons, 401.

VON VOIGTLANDER, Katherine *[Painter] b.1917, Camden, NJ.*
Addresses: Kansas City, MO. **Studied:** Kansas City AI; PAFA, 1938. **Exhibited:** Phila. AC, 1937; Denver AM, 1939; Women Painters Am., Wichita AM, 1936 (prize). **Sources:** WW40.

VON WEBBER *[Landscape painter] mid 19th c.*
Addresses: New York. **Exhibited:** American Art-Union, 1848 (landscape painting). **Sources:** G&W; Cowdrey, AA & AAU.

VON WESTRUM, Anni See: **BALDAUGH, Anni von Westrum (Mrs. Frank)**

VON WICHT, John G. F. *[Painter, graphic artist, designer, craftsperson, sculptor] b.1888, Malente-Holstein, Germany / d.1970, Brooklyn, NY.*
Addresses: Brooklyn, NY (immigrated 1923). **Studied:** private art school of Grand Duke of Hesse, c.1908; Darmstadt-Bauhaus Sch.; Berlin Acad. FA, Germany (printmaking). **Member:** Soc. Des.-Craftsman; NSMP; Scenic Artists Un.; Fed. Mod. P&S; Audubon Artists; Am. Abstract Artists; SAGA; Am. Soc. Contemporary Artists; Inst. Int. des Arts et Lettres. **Exhibited:** BM, 1924-25, 1939, 1943, 1950 (prize), 1951 (purchase), 1955 (prize), 1958 (prize), 1960 & 1964 (purchases); Salons of Am., 1927, 1931, 1934; PS Fed. Bldgs., 1936;WFNY, 1939 (murals); 48 States Comp., 1939; GGE, 1939; WMAA, 1940-67; MMA, 1941; Brooklyn SA, 1945 (prize); AIC, 1947; Corcoran Gal. biennials, 1947-61 (5 times); Berlin Acad. (prizes); Am. Soc. Contemp. Artists (prizes, 1945, 1948, 1950, 1952-54, 1957, 1960, 1961, 1964); PAFA Ann., 1947-68 (7 times; prize 1968); North Shore AA, 1951 (prize); Audubon Artists, 1952-55 (prizes), 1958 (medal); Phila. Pr. Club, 1953 (purchase), 1954 & 1957 (prizes); SAGA, 1954 (prize); Riverside Mus., 1958 & 1964; Boston Art Festival, 1958 (prize); Art USA, 1959; Ford Fnd., 1960 (purchase prize); Artists Gal., NY, 1944 (solo); Univ. Calif., Los Angeles, 1947; Mercer (GA) Univ.; Kleemann Gal., 1946-47; Passedoit Gal., NY, 1950-52, 1954, 1956-58; John Herron AI, 1953; Carl Schurz Mem. Fnd., 1954; Robles Gal., Los Angeles, 1959 (retrospective); Santa Barbara Mus., 1959 (retrospective); Pasadena Mus. Art, 1959; Bertha Schaefer Gal., NY, 1960, 1961-62, 1964; Barcelona, Spain, 1961, Paris, 1959; Liège, 1959; Madrid, 1959; Brussels, 1959; Barcelona, 1960; Galerie Neufville, Paris, 1962; San Juan, Puerto Rico, 1963; traveling exhib., U.S.A., 1963-64 (solo); Galerie Leonhart, Munich, 1964; M. Diamond FA, NYC, 1984. **Work:** murals, mosaics, stained glass in many cities of U.S. and Canada, including Carville, LA; Fed. Court House, Knoxville, TN; Court Room Bldg., Dept. Health, NY; Radio Station WNYC, NY; Pennsylvania R.R. Station, Trenton; Christ Church, NY; murals, USPO, Brewton, AL; Nat. Mus., Stockholm; Musée Nationale d'Art Moderne, Paris; Nat. Gal., Berlin, Germany; MMA; WMAA; LOC; Riverside Mus.; PMA; BMFA; BM; Kansas State College; John Herron AI; CM; de Cordova & Dana Mus.; Univ. Illinois; Bradley Univ.; MoMA; Yale Univ. Gal.; BMA; Chrysler Mus.; Jewish Mus., NY; Liege Mus., Belgium; Museo d'Arte Contemporains, Madrid. **Comments:** An abstract painter and printmaker, he was wounded and partially paralyzed during WWI. In 1938, he created WPA murals for WNYC radio station, with Stuart Davis, Byron Browne, and Louis Schanker. In 1954, he was awarded a residency at the MacDowell Colony (NH). Teaching: ASL, 1951, 1952 (summers);John Herron AI, Indianapolis, IN, 1953. **Sources:** WW66; WW47; Diamond, *Thirty-Five American Modernists* p.30; *American Abstract Art,* 200; Falk, *Exh. Record Series.*

VON WIEGAND, Charmion *[Abstract painter, writer] b.1898, Chicago, IL / d.1983.*
Addresses: NYC (c.1916-28); Moscow, Russia (1929-31); NYC. **Studied:** Barnard College, Columbia Univ.; also journal & playwriting with Minor Latham & Hatcher Hughes; Byzantine art history with Wittemore; Florentine painting with Richard Offner; oriental art with Riefstahl. **Member:** Am. Abstract Artists, 1941 (pres., 1951-53). **Exhibited:** Salons of Am., 1932; "Women,"

Peggy Guggenheim's Art of This Century, 1945; "Classic Tradition In Contemp Art," Walker Art Inst., 1953; WMAA, 1955, 1957; "Konkrete Kunst: 50 Years Develop," Zurich, Switzerland, 1960; "Art & Writing," Stedelijk Mus., Amsterdam & Baden Baden, Germany, 1963; "Mondrian, DeStijl & Their Impact," Marlboro-Gerson Gallery, 1964; Soc. Typographic Arts, Chicago, 1968 (prize); Sixth Biennale, Cranbrook Acad. Art, MI, 1969 (first prize in painting on Tibetan theme). **Work:** MoMA; WMAA; Cincinnati Art Mus; Seattle Art Mus; Hirshhorn Mus., Wash., DC. **Commissions:** painting, Container Corp Am. **Comments:** She began to paint in 1926 while undergoing psychoanalysis. He works are informed by Mondrian. Author: art critic for *New Masses* and editor of *Art Front* (1930s); "The Meaning of Mondrian," *Journal of Aesthetics,* 1943; "The Russian Arts" in *Encyclopedia Arts,* 1946; "The Oriental Tradition and Abstract Art" in *The World of Abstract Art;* "Memoir on Mondrian," *Arts Annual,* 1961. Collection: Tibetan art; constructivists. Marlor gives birth date of1895. **Sources:** WW73; Marlor, *Salons of Am.*

VON WITTKAMP, Andrew L. *[Physician and amateur artist] mid 19th c.*
Addresses: Philadelphia in the 1850s. **Work:** Karolik Collection (painting of a black cat in a chair). **Sources:** G&W; Karolik Cat., 522-23; *Art News* (Oct. 1951), 5, and cover.

VON WREDE, Ella *[Sculptor] b.1860, NYC.*
Addresses: Paris, France. **Studied:** Schluter, Dresden. **Sources:** WW01.

VONZOON, John *[Painter] 19th c.*
Addresses: San Francisco, CA. **Exhibited:** Calif. State Fair, Sacramento, CA, 1881. **Sources:** Hughes, *Artists in California,* 581.

VOORHEES, Clark G(reenwood) *[Landscape painter, etcher] b.1871, NYC / d.1933, Old Lyme, CT.* CLARK G VOORHEES
Addresses: Old Lyme, CT, 1904-33/Somerset, Bermuda, 1919-. **Studied:** Yale Univ. (chemistry); Columbia Univ. (M.A.); I. Wiles, in NYC, 1894; Académie Julian, Paris with J.P. Laurens and Constant, 1897-1900, 1906. **Member:** SC; Lyme AA (secretary); CAFA; Century Club; Mass. AA; Stockbridge(MA) AA; Grand Central AA, 1923 (a founder). **Exhibited:** PAFA Ann., 1901-04, 1908, 1921; St. Louis Expo, 1904 (bronze medal); NAD, regularly from 1901, 1905 (Hallgarten Prize); Boston AC, 1904; Corcoran Gal biennials, 1908-16 (3 times); Lyme AA, 1923 (prize), 1929 (Eaton Prize); AIC; CI; Brit. Commonwealth Expo, 1925. **Comments:** He was the first artist to discover Old Lyme in 1896, followed closely by H.W. Ranger. His work ranged from Tonalism to Impressionism. **Sources:** WW31; *Connecticut and American Impressionism* 175-76 (w/repro.); *Art in Conn.: The Impressionist Years;* Falk, *Exh. Record Series.*

VOORHEES, Donald Edward *[Painter] b.1926, Neptune, NJ.*
Addresses: Lincroft, NJ. **Studied:** Acad. Arts, Newark, NJ, with Stanley Turnbull, Avery Johnson & Edmund Fitzgerald; ASL with Mario Cooper; also with John Pike & Edgar Whitney. **Member:** NJ Watercolor Soc. (secretary, 1971-72, exhib. chmn., 1972-73); Guild Creative Art. **Exhibited:** NJ Watercolor Soc. State Ann., Morris Mus., 1954-72; Knickerbocker Artists Ann., Nat. Arts Club, 1971-72; Art Center Oranges State Ann., NJ, 1972; Am. Watercolor Soc. 105th Ann., 1972 & Nat. Traveling Exhib., 1972-73; Guild of Creative Art, Shrewsbury, NJ, 1970s. **Awards:** Mary Lawrence Mem. Award, NJ Watercolor Soc. State Ann., 1971; hon. mention, Ringwood Manor Mus. State Ann., 1971 & Garden State Arts Center Ann., 1971. **Comments:** Preferred media: watercolors. Positions: member, Art Advisory Commission, Monmouth Co. Board Freeholders, 1969-. Teaching: watercolor instructor, Guild Creative Art, Shrewsbury, NJ, 1964-; also private instructor. **Sources:** WW73.

VOORHEES, Henriette Aimee Le Prince (Mrs.) *[Craftsperson, lecturer, teacher] 20th c.; b.Leeds, England.*
Addresses: NYC. **Studied:** Mme. Le Prince, W.C.B. Upjohn; A.

Bement; C.C. Curran; C.F. Binns. **Member:** NY Soc.Craftsmen; NY Soc. Ceramic Arts; Phila. ACG; Boston SAC. **Exhibited:** WFNY, 1939. **Work:** Newark (NJ) Mus.; Litchfield (CT) Mus.; YMCA, NYC; Phila. **Comments:** Lecturer: Montclair AM, Princeton Women's Club; Am. Women's Assn. Specialties: pottery; modeling. Positions: partner/director, Inwood Pottery Studios; teacher, Westchester County Workshop; NYU (extension). **Sources:** WW40.

VOORHEES, Hope Hazard *[Painter, sculptor, block printer, teacher] b.1891, Coldwater, MI / d.Before 1970, Detroit, MI?.* **Addresses:** Detroit, MI/Provincetown, MA. **Studied:** Adrian Col.; with her husband Fritz Pfeiffer and Blanche Lazzell in Provincetown; Detroit Sch. Des.; Dickenson; Kolski; Roerich Inst. **Member:** Detroit Soc. Women PS; Provincetown AA. **Exhibited:** Wichita AM, 1931; S. Indp. A., 1931; LACMA, 1932; SAM, 1932; Adrian College, Detroit, 1940 (solo); Michigan St. Normal Col., 1941 (solo); PAFA, 1941; Buffalo, NY, 1945 (solo); Detroit Inst. A., 1946; Wellons Gal., NYC, 1955 (solo). **Comments:** Positions: A. Instr., Grosse Pointe Country Day Sch., 1920-42; Elmwood Franklin Sch., Buffalo, N.Y., 1943-49. **Sources:** WW40; WW47; WW59; Petteys, *Dictionary of Women Artists.*

VOORHEES, Jennie Straight (Mrs. George V.) *[Still life and portrait painter, teacher] b.1861, near Coldwater, MI / d.1940, Detroit, MI.* **Addresses:** Coldwater, Adrian, and Detroit, MI. **Studied:** with Frank Fowler in NYC. **Work:** Coldwater (MI) Library. **Comments:** Position: head, art dept., Adrian College. **Sources:** Gibson, *Artists of Early Michigan,* 232.

VOORHEES, Louis F. *[Painter, architect, teacher] b.1892, Adrian, MI.* **Addresses:** High Point, NC. **Studied:** Univ. Michigan; H. Breckenridge. **Member:** AIA; North Carolina Professional AC; North Shore AA. **Sources:** WW40.

VOORHEIS, M. J. (Mrs.) *[Painter] 20th c.* **Exhibited:** Oakland Art Gallery, 1928. **Sources:** Hughes, *Artists in California,* 581.

VOORHIES, Charles *[Painter] b.1901, Portland, OR.* **Addresses:** Portland, OR; San Francisco, CA, 1930s. **Studied:** Univ. of Penn. (arch.); with Maurice Stern. **Exhibited:** San Francisco AA, 1938; AIC. **Comments:** He worked as an assistant to Diego Rivera (see entry) in San Francisco. **Sources:** Hughes, *Artists in California,* 581.

VOORHIES, Stephen J. *[Painter] mid 20th c.* **Exhibited:** Salons of Am., 1934. **Sources:** Marlor, *Salons of Am.*

VOORSANGER, Ethel Arnstein *[Painter] b.1911, San Francisco, CA / d.1969, New Zealand (on a trip).* **Addresses:** San Francisco, CA. **Studied:** Calif. School of FA, with Blanch and Paizzoni. **Exhibited:** Labaudt Gallery, San Francisco; SFMA, 1935; Fresno, CA. **Work:** Jewish Community Center, San Francisco; Booker T. Washington Center, San Francisco; SFMA. **Comments:** On her many trips she painted primarily in watercolors, working in oil when she was in her studio. **Sources:** Hughes, *Artists of California,* 581.

VORHAUS, Elsa Rogow *[Painter] early 20th c.* **Exhibited:** Salons of Am., 1926, 1927. **Sources:** Marlor, *Salons of Am.*

VORHEES, James Paxton *[Sculptor, journalist, actor, writer] b.1855, Covington, IN.* **Addresses:** Wash., DC, until at least 1905. **Studied:** Georgetown College, Wash., DC. **Work:** U.S. Capitol. **Comments:** Son of Senator Daniel Vorhees. **Sources:** McMahan, *Artists of Washington, DC.*

VORHEES, Marion R. *[Painter] 20th c.* **Addresses:** Old Lyme, CT. **Exhibited:** PAFA Ann., 1950. **Sources:** Falk, *Exh. Record Series.*

VORIS, Anna Maybelle *[Art administrator] b.1920, Mount Rainier, MD.* **Addresses:** Alexandria, VA. **Studied:** George Washington Univ., B.A.; Catholic Univ. Am., M.; Johns Hopkins Univ. **Comments:** Positions: museum curator, Nat. Gallery Art, Washington, DC. **Sources:** WW73.

VORIS, Mark *[Educator, painter, designer, lecturer, engraver] b.1907, Franklin, IN / d.1974.* **Addresses:** Tucson, AZ. **Studied:** Franklin College; AIC; Inst. Allende, Mexico; Univ. Arizona; also with Paul Dougherty. **Member:** Tucson Ad Club; Arizona P&S Palette & Brush Club, Tucson; Tucson FAA; Tucson WCC. **Exhibited:** Rockefeller Center, 1938; Arizona State Fair, 1931 (prize); Stanford Univ.; M.H.de Young Mem. Mus., San Francisco; Cochise College; Univ. Arizona; Tucson AC. **Comments:** Teaching: art professor, College Fine Arts, Univ. Arizona, 1946-, acting head, dept. art, 1962-63. **Sources:** WW73.

VORIS, Millie Roesgen *[Painter, writer, lecturer, teacher] b.1859, Dudleytown, IN.* **Addresses:** Columbus, IN. **Studied:** with L.C. Palmer, Lottie Griffin, A. Berger, T. C. Steele, Jacob Cox, William Chase. **Member:** Nat. Soc. Arts & Letters; Chicago AC; Chicago AA; AFA; Palette Club, Chicago; Indiana AC. **Exhibited:** Hoosier Salon; Chicago World's Fair; Pettis Gal., Indianapolis; John Herron AI; Indiana AA; Block Auditorium, 1950. **Awards:** Chicago World's Fair (prize); Woman's Dept. Club, 1948; Marshall Field, Chicago; O'Brien Galleries, Chicago; PMA; John Herron AI; Hoosier Salon; Florida Art Club, Miami. **Work:** Berlin AM. **Comments:** Author: "Newspaper Jimmy." **Sources:** WW59.

VORLICEK, John *[Painter] mid 20th c.* **Addresses:** Phila., PA. **Exhibited:** Corcoran Gal biennial, 1967; PAFA Ann., 1968. **Sources:** Falk, *Exh. Record Series.*

VORST, Joseph Paul *[Portrait painter, mural painter, block printer, illustrator, lithographer, teacher] b.1897, Essen, Germany / d.1947, Overland, MO?.* **Addresses:** St. Louis, Overland, MO. **Studied:** Folkwang Acad., Essen; Acad. FA, Berlin, with Max Liebermann, Max Slevogt. **Member:** Am. Artists Congress. **Exhibited:** GGE 1939; WFNY 1939; AIC, 1937 (prize); Corcoran Gal biennials, 1939, 1943; VMFA; WMAA; William Rockhill Nelson Gal.; CAM, 1933 (prize), 1945 (prize); Kansas City AI, 1938 (prize); St. Louis AG, 1930 (prize), 1933 (prize); 48 Sts. Competition, 1939 (winner); PAFA Ann., 1940-41. **Work:** Davenport Mun. Art Gal.; Princeton Univ.; Carnegie Inst.; CAM; Springfield Mus.; WPA murals, USPO, Betheney, MO, Vandalia, MO, and Paris, AR. **Comments:** Author/illustrator: articles, "The Volcano"; lithograph, "The Fietemann"; woodcuts, "The Death Dance" (Kunstanstalt Ruhrland). Illustrator: *Esquire.* Position: Thomas Jefferson College, St. Louis, MO. **Sources:** WW53; WW47; Falk, *Exh. Record Series.*

VOS, Hubert *[Painter] b.1855, Maastricht, Holland / d.1935, New Yor, NY.* **Addresses:** NYC/Newport, RI. **Studied:** Acad. FA, Brussels; Cormon, in Paris. **Exhibited:** Paris, Amsterdam, Munich, Dresden, Brussels (gold medals); Union Lg. Club, NYC; Corcoran Gal.; Int. Expo, Paris, 1900; AIC, 1906. **Work:** Luxembourg Mus., Paris; Honolulu Acad. Arts. **Comments:** Came to U.S. in 1892 to act as art commissioner for Holland at the Columbian Expo, Chicago, 1893. His wife was from a royal Hawaiian family. He painted portraits in Hawaii which he added to his gallery of exotic people. He was the first Westerner to paint the portrait of the Dowager Empress Tzu Hsi of China. Specialties: Aboriginal races; portraits; interior; still lifes of Chinese porcelains. **Sources:** WW33; Forbes, *Encounters with Paradise,* 220-22.

VOS, Marius *[Painter] 20th c.* **Addresses:** NYC. **Member:** SC. **Sources:** WW21.

VOS, Oscar *[Painter] mid 20th c.* **Exhibited:** Salons of Am., 1934. **Sources:** Marlor, *Salons of Am.*

VOSBURG, Lillian *[Watercolorist] early 20th c.* **Addresses:** Active in Los Angeles. **Exhibited:** Ebell Club, 1906,

1907. **Sources:** Petteys, *Dictionary of Women Artists.*

VOSBURGH, Edna H. *[Painter] 20th c.; b.Chicago.*
Addresses: Paris, France. **Studied:** R. Miller, in Paris. **Sources:** WW08.

VOSBURGH, R. G. *[Illustrator] 19th/20th c.*
Addresses: NYC. **Studied:** Académie Julian, Paris, 1890.
Sources: WW15; Fehrer, The Julian Academy.

VOSE, Adairene See: **CONGDON, Adairene Vose (Mrs. Thomas R.)**

VOSE, Ann Peterson (Mrs. Robert C.) *[Painter, art dealer]* b.1912, Lancaster, MA / d.1998, Westwood, MA.
Addresses: Boston, MA. **Studied:** Windsor School, Boston, MA; with Bernard Keyes and Philip Hale at BMFASch.; with John Whorf; with Charles Hopkinson at the Child Walker School, Boston; Sarah Lawrence College; ASL, with John Sloan, Thomas Hart Benton and Alexander Brook. **Exhibited:** Vose Galleries, Boston, MA, 1930s (3 shows). **Comments:** She painted at Fenway Studios, 1938 until 1941, when she married Robert C. Vose, Jr., an art dealer in Boston (see Seth Morton Vose). **Sources:** Vose Galleries, *Mary Bradish Titcomb and Her Contemporaries,* 54.

VOSE, Peter Thatcher *[Marine painter, shipbuilder]* b.1796, Maine / d.1877.
Sources: Brewington, 396.

VOSE, Robert C., Jr. *[Art dealer]* b.1911 / d.1998, Boston, MA.
Addresses: Duxbury, MA. **Member:** New England Genealogical Soc. (pres.); Mass. Hist. Soc.; Pilgrim Soc. **Comments:** The fourth-generation director of Vose Galleries (see entry), after WWII he returned the gallery to national prominence, promoting paintings by masters of the Hudson River School and presenting rediscovery exhibitions of many of the leading American Impressionists. He also mounted the first retrospective of the long-forgotten Maxfield Parrish (see entry). **Sources:** obit., PHF files.

VOSE, Seth Morton *[Art dealer]* b.1831, Stoughton, MA / d.1910.
Addresses: Providence, RI. **Comments:** Founder of Vose Galleries (est. 1841) in Providence, RI. He was the first dealer to promote French Barbizon paintings in America, including the first American exhibition of Corot's works. In 1897, Robert C. Vose opened a branch in Boston where it remains active today. The Providence gallery was closed in 1910. The fourth generation — S. Morton II, Robert C., Jr., and Herbert P. Vose — focused the gallery on non-contemporary artists. The gallery is now (1990s) run by the fifth generation, making it the oldest family-owned art gallery in America. **Sources:** PHF files.

VOSE GALLERIES *[Art dealers] 19th/20th c.*
Addresses: Boston, MA. **Comments:** Established in Providence, RI, by Seth Vose in 1841, the gallery is now (1990s) the oldest family-owned art gallery in America. Vose was the first gallery to promote French Barbizon paintings in America, including the first American exhibition of Corot's works. In 1897, Robert C. Vose opened a branch in Boston and promoted many of the prominent American Impressionists, including Hassam, Benson, Tarbell, Enneking, and others. The Providence gallery was closed in 1910. The gallery survived the Great Depression and in the 1940s began promoting the landscapes of the Hudson River School. In 1962, the fourth generation — Robert C., Jr., S. Morton II, and Herbert P. Vose — moved the gallery from Copley Square to Newbury Street where it has been run by the fifth generation since 1984. **Sources:** PHF files.

VOSKA, Edward *[Painter] 20th c.*
Addresses: Chicago area. **Exhibited:** AIC, 1949. **Sources:** Falk, AIC.

VOSS, D. R. *[Painter] 19th/20th c.*
Addresses: NYC. **Exhibited:** NAD, 1898. **Sources:** WW01.

VOSS, Elsa Horne (Mrs.) *[Sculptor] 20th c.*
Addresses: Sheridan, WY, 1920s; Westbury, NY; Monkton, MD, 1938. **Member:** NAWPS. **Exhibited:** PAFA Ann., 1938. **Sources:** WW25; Petteys, *Dictionary of Women Artists;* Falk, *Exh. Record Series.*

VOSS, Etta *[Painter] early 20th c.*
Exhibited: Salons of Am., 1933. **Sources:** Marlor, *Salons of Am.*

VOSS, Nellie Cleveland *[Painter] b.1871, Northfield, MN / d.1963, Milbank, SD.*
Addresses: Milbank, SD, 1880-. **Sources:** Petteys, *Dictionary of Women Artists.*

VOTER, Thomas W. *[Museum director] 20th c.*
Addresses: Yonkers, NY. **Sources:** WW59.

VOTEY, Charles A. *[Wood engraver] mid 19th c.*
Addresses: NYC. **Exhibited:** American Institute, 1847. **Sources:** G&W; Am. Inst. Cat., 1847.

VOULKOS, Peter *[Sculptor, ceramicst, educator] b.1924, Bozeman, Mont.*
Addresses: Berkeley, CA. **Studied:** Montana State Univ., B.S.; Calif. College Arts & Crafts, M.F.A.; Montana State Univ., hon. L.H.D., 1968. **Exhibited:** AIC, 1957 (solo); Pasadena MoMA, 1958 (solo); Brussels World's Fair, 1958; MoMA, 1960 (solo); Seattle World's Fair, 1962; Int. Sculpture Exhib., Battersea Park, London, 1963; Los Angeles State College, 1964; WMAA, 1964, 1970; LACMA, 1965 (solo); Univ. Calif., Irvine, 1966. **Awards:** silver medal, Int. Ceramic Exhib., Ostend, Belgium, 1954; gold medal, Int. Ceramic Exhib., Cannes, France; Rodin Mus. Prize in Sculpture, I Paris Biennial, 1959. **Work:** Baltimore Mus. Art; Denver (CO) Art Mus.; Smithsonian Inst., Washington, DC; Japanese Craft Mus.; SFMA. Monuments: 30-ft. high sculp. for Hall of Justice, San Fran., 1971; 70-ft. sculp. for Highland Park, Ill., 1972; Federal Bldg., Honolulu, 1977. **Comments:** After 1955, Voulkos helped to redefine and redirect the field of ceramics with his unorthodox use of clay. He stacked slabs of clay forms, combining them with thrown elements, and sometimes joining the seams with brilliant epoxy paints. By the late 1950s he had made several large roughly textured ceramic sculptures. Voulkos turned to the lost-wax bronze process as his medium in the 1960s, fabricating his sculptures by combining his unique vocabulary of forms (such as the cylinder, the elbow, the dome) after they are cast. Teaching: instructor, Archie Bray Foundation, Black Mountain College, Los Angeles Co. Art Inst., Montana State Univ., Greenwich House Pottery & Teachers Co. & Columbia Univ.; professor art & design, Univ. Calif., Berkeley, 1959-. **Sources:** WW73; Baigell, *Dictionary; Two Hundred Years of American Sculpture,* 317.

VOUTE, Kathleen *[Painter, designer, illustrator] b.1892, Montclair, NJ.*
Addresses: Montclair, NJ. **Studied:** ASL; Grand Central Sch. Art; George Pearse Ennis Sch. Art; H. Turner; E. Greacen; G. Bridgman; H.B. Snell. **Member:** AWCS; NJWCS; Wash. WCC; AAPL. **Exhibited:** State Mus., Trenton, 1951; Riverside Museum, 1951; Montclair AM, 1930-32 (medal), 1933-51; AWCS, 1928-36, 39, 40; NJWCS, 1939-42, 1951-57; AAPL, 1931 (prize), 1939 (prize). **Comments:** Illustrator: "Runaway Cousins," 1936, "Quinito en Espana," 1940, "In Bible Days;" "Caroline"; "Whole World Singing"; "Zuska"; "Star Boy"; "Hidden Garden"; "World Upside Down"; "A Wish for Lutie"; "Sod House Adventure"; "Coon Holler"; "The Mysterious Trunk"; "The Magic Ring"; "The Trail-makers"; "A Yardstick for Jessica"; "Where'er the Sun"; "Out of the Salt-box"; and other books for children. **Sources:** WW66; WW47.

VOV WEIGAND, Charmion *[Painter] mid 20th c.*
Exhibited: Corcoran Gal biennial, 1963. **Sources:** Falk, *Corcoran Gal.*

VOYER, Jane *[Teacher of drawing, embroidery, and French] mid 18th c.*
Addresses: Charleston, SC, 1739-40. **Sources:** G&W; Rutledge,

Artists in the Life of Charleston.

VOYER, Sylvain Jacques *[Painter] b.1939, Edmonton, Alberta.*
Addresses: Alberta, Canada. **Studied:** Alberta College Art, Calgary, with Deli Sacilotto. **Member:** Canadian Artist Representation (rep., 1971 & 1972). **Exhibited:** Sixth Biennial Canadian Painting, 1965 & Canadian Watercolors, Prints & Drawings, 1966, Nat. Gallery Canada; Edmonton Art Gallery, 1971. **Work:** Nat. Gallery Canada, Ottawa; Edmonton Art Gallery; Willistead Art Gallery, Windsor, Ontario; Univ. Calgary. **Comments:** Preferred media: acrylics. Positions: board member, Edmonton Art Gallery, 1972-. **Sources:** WW73.

VOYSKA, Frank *[Painter] 20th c.*
Exhibited: S. Indp. A., 1937-39, 1941-43. **Sources:** Marlor, *Soc. Indp. Artists.*

VOYVODICH, Theodore B. *[Painter] 20th c.*
Addresses: NYC. **Exhibited:** S. Indp. A., 1932. **Sources:** Marlor, *Soc. Indp. Artists.*

VOZECH, Anthony *[Sculptor, teacher, lecturer] b.1895.*
Addresses: Berwyn, IL, 1934; Toledo, OH. **Studied:** A. Polasek; Indust. Art School, Prague, Czechoslovakia. **Member:** Bohemian Club, Chicago. **Exhibited:** Salons of Am., 1934; PAFA Ann., 1934, 1939; TMA, 1936 (prize), 1937 (prize), 1938 (prize), 1939 (prize); AIC. **Work:** Thayer Mus. Art, Univ. Kansas; Univ. Southern Calif.; Kingswood, Mansfield, OH; Bohemian Nat. Cemetery, Chicago; Toledo Public Library. **Sources:** WW40; Falk, *Exh. Record Series.*

VRANA, Albert S. *[Sculptor] b.1921, Cliffside Park, NJ.*
Addresses: Miami, FL. **Studied:** Univ. Miami. **Member:** Sculptors of Florida (vice-pres., 1965). **Exhibited:** Penland Show, Gal. Contemp. Art, Winston-Salem, NC, 1968; Lowe Art Gal., Univ. Miami, 1960 (solo), 1963 (solo); Fairleigh Dickinson Univ. Art Gal., Madison, NJ, 1964 (solo); ACA Gals., NYC, 1966 (solo); Berenson Gal., Miami, 1968, 1969 & 1972 (solos). **Awards:** Tiffany grant, 1963. **Work:** "Captive" (cast bronze), Atlanta (GA) Mem. Art Center; "War Flower" (bronze), Lowe Art Gal., Univ. Miami, FL; Fuego (wood), Univ. Miami. Commissions: sand cast stone relief for Miami Beach Pub. Lib. Rounda, City Miami Beach, FL, 1962; cast stone relief from styrofoam molds, U.S. Govt. for Fed. Office Bldg., Jacksonville, FL, 1966; cast stone relief from styrofoam molds, Morris Burk, Prof. AC, Miami, 1966; free-standing monument (ferro cement & bronze), Arlen House, Miami Beach, 1969; monumental mural (ferro cement & hammered bronze), State of Florida for Florida Univ., Miami, 1972. **Comments:** Preferred media: bronze, concrete. Publications: contrib., "Sculpture Form Plastics," 1967; contrib., "Spiel mit Form und Struktur," 1968; contrib.,"Contemporary Art with Wood," 1968; contrib. ,"Plastics as an Art Form," 1969; contrib.,"Contemporary Stone Sculpture," 1970. Teaching: Miami-Dade Jr. College, 1966-67; Penland School, summers 1968- **Sources:** WW73; Art Mandler, "Artist in Concrete" (film), produced by Portland Cement Assn., 1966; "Le Beton Sculpte par Moulage," *Batir Magazine*, Paris, 1967; Harry Forgeron, "Sculptured Structures Molded in Plastic Foam," *New York Times*, 1967.

VREELAND, Elizabeth L. Wilder (Mrs. Frederick K.) *[Painter] b.1896, Poona, India.*
Addresses: Montclair, NJ. **Studied:** NYC; London; Paris; Norway. **Exhibited:** S. Indp. A., 1927. **Sources:** WW25.

VREELAND, Francis William *[Painter] b.1879, Seward, NE / d.1954, Los Angeles, CA.*
Addresses: Hollywood, CA (since 1920s). **Studied:** O.W. Beck; V. Nowottny; G. Bridgman; Académie Julian, Paris, 1910. **Member:** Mural Painters; Arch. Lg.; Calif. AC; Artist Council, Los Angeles; Oklahoma AL; ACS, Southern Calif.; Art & Educ. Committee, Los Angeles Chamber of Commerce; Ch. Art Commission, Hollywood. **Exhibited:** Paris Expo, 1900; Paris Salon, 1911; LACMA, 1926 (solo). **Comments:** Position: staff,

Rookwood Potteries, Cincinnati, early 1900s; art director, Aeolean Company, NYC; assoc. editor, *America Printer*, NYC. **Sources:** WW40; Hughes, *Artists of California*, 581.

VREELAND, Marian See: **SMALLEY, Marian Frances Hastings**

VREY, Edmund *[Painter] 20th c.*
Addresses: Hackensack, NJ. **Exhibited:** S. Indp. A., 1928. **Sources:** Marlor, *Soc. Indp. Artists.*

VRIES, J. C. *[Painter] b.1804, Amsterdam, Holland / d.After 1850, Boston, MA.*
Studied: NAD, 1823; Brussels, 1825. **Sources:** Brewington, 397.

VROLDSEN, P(eder) E. *[Painter] 20th c.*
Addresses: NYC. **Exhibited:** S. Indp. A., 1924-29, 1934. **Sources:** Marlor, *Soc. Indp. Artists.*

VROMAN, Adam Clark *[Photographer] b.1856, La Salle, IL / d.1916.*
Addresses: Pasadena, CA (1892-on). **Work:** Pasadena Public Library (large collection of vintage platinum prints); Nat. Hist. Mus., Los Angeles; Southwest Mus., Los Angeles. **Comments:** An important documenter of the Hopi and Zuni tribes of Arizona and New Mexico, from 1895-1904 he captured scenes of their daily lives and ceremonial activities. He was a book collector and dealer who at first concentrated on Calif. landscapes and architectural subjects (1892-95). He also went to Japan, Yosemite, Europe and the Canadian Rockies. **Sources:** Eldredge, et al., *Art in New Mexico, 1900-1945,* 209; Witkin & London, 263.

V'SOSKE, Stanislav *[Craftsman, designer] b.1899, Grand Rapids, MI.*
Addresses: Grand Rapids, MI. **Studied:** Detroit Acad. FA, with Wecker, Count Kryizanowski; PAFA, with D. Garber; Oberteuffer; Henri; Bellows. **Member:** Soc. Designer-Craftsmen. **Exhibited:** MMA; MoMA; Dayton AI; Colorado Springs FA Center; Lord & Taylor, 1937 (prize); ADI medal, 1941. **Work:** MoMA. **Comments:** Position: designer/manufacturer, V'soske Hand Tufted Rugs. **Sources:** WW53; WW47.

VUCHINICH, "Vuk" *[Painter, sculptor, etcher] b.1901, Nikshitch, Montenegro, Yugoslavia / d.1974, Miami, FL.*
Addresses: NYC/Santa Barbara, CA. **Studied:** Univ. Serbia; I. Mestrovic; BAID, with R. Aitken; NAD, with C. Curran; F.C. Jones. **Member:** NSS; Kit Kat Club. **Exhibited:** CPLH; AIC; Brooklyn Mus. **Sources:** WW40; Hughes, *Artists of California*, 581.

VUCIN, Louis S. *[Painter] b.1884, Washington, DC / d.1962, Patton, CA.*
Addresses: Long Beach, CA. **Member:** Businessmen's Sketch Club (co-founder). **Exhibited:** GGE, 1939. **Sources:** Hughes, *Artists of California*, 581.

VUILLEMENOT, Fred A. *[Designer, painter, sculptor, illustrator] b.1890, Ronchamps, France / d.1952.*
Addresses: Toledo, OH. **Studied:** École des Beaux-Arts, Ronbiax, Paris, France; École des Arts Decoratifs, Paris; Lemaire; David; Rouard; E. Deully. **Member:** Toledo Fed. Art. **Exhibited:** Salon des Artistes Françaises, 1912; Paris & Lille, France, 1910-14 (medal); TMA (prize). **Work:** Gravereaux Mus., France, 1912. **Sources:** WW47.

VUKOVIC, Marko *[Painter, graphic artist] b.1892, Liska, Yugoslavia / d.1973.*
Addresses: Saugerties, NY, 1947; Woodstock, NY, 1959. **Studied:** self-taught and at NAD; Beaux Arts; ASL. **Member:** AEA; Woodstock Gld. of Arts & Crafts; Woodstock AA. **Exhibited:** Salons of Am., 1922, 1923, 1927, 1928, 1935; S. Indp. A., 1922, 1928, 1934; Dudensing Gal., NYC, 1928 (first solo); Newark Mus., 1930; WMAA, 1933; PAFA Ann., 1934, 1936, 1941; Yonkers Mus., 1940; Syracuse Mus. FA, 1941; Albany Inst. History & Art, 1946; Rochester Mem. Art Gal, 1942; Cornell Univ., 1942; NAD, 1942; Woodstock AA, 1945 (prize); Twilight Park AA, 1954 (prize); Gal. at Park West, Kingston, NY, 1996.

Work: Willard Parker Hospital, East Harlem Youth Center, NY; Newark Bd. Educ.; State Teachers College, New Paltz, NY; Franklyn K. Lane H.S., Brooklyn; Wood Art Gal.; Biggs Mem. H.S.; Saugerties (NY) Savings Bank. **Comments:** Came to the U.S. at age 18 and settled in NYC. He was a painting instructor in Woodstock and pursued a variety of media. Marlor lists birthplace as Dalamatia, Austria. **Sources:** WW59; WW47; Woodstock AA; Falk, *Exh. Record Series.*

VUKOVICH, Marion *[Painter] 20th c.*
Addresses: NYC. **Sources:** WW19.

VULDER AND STEELE, De *late 19th c.*
Addresses: NYC, 1870. **Exhibited:** NAD, 1870. **Sources:** Naylor, *NAD.*

VULETICH, Damo *[Painter] b.1886, Ragusa / d.1954, Oak Grove, CA.*
Addresses: NYC; San Francisco, CA; Monterey Peninsula, CA. **Member:** Carmel AA. **Exhibited:** San Francisco AA, 1919; Oakland Art Gallery, 1924; San Francisco AA, 1925. **Sources:** Hughes, *Artists inCalifornia,* 581.

VULTEE, Frederick L. *[Portrait painter] mid 19th c.*
Addresses: NYC, 1830-38. **Exhibited:** Apollo Association. **Comments:** After 1835 he was variously listed in the directories as a broker, boarding house, deputy sheriff, porter, lawyer, under sheriff, and secretary. **Sources:** G&W; Cowdrey, AA & AAU; NYCD 1830-69.

VUST, Ty *[Painter] late 19th c.*
Studied: with L. Cogniet. **Exhibited:** Paris Salon, 1883. **Sources:** Fink, *American Art at the Nineteenth-Century Paris Salons,* 401.

VYSEKAL, Edouard A(ntonin) *[Painter, teacher] b.1890, Kutna Hora, Czech. / d.1939, Los Angeles, CA.*
Addresses: Los Angeles, CA. **Studied:** Prague; AIC, with Vanderpoel; H.M. Walcott; S.M. Wright; M. Russell. **Member:** Chicago Palette & Chisel Club; Calif. AC; Modern Art Soc.; Acad. Western Painters; Laguna Beach AA; Calif. WCS. **Exhibited:** LACMA, 1916 (solo), 1921 (solo), 1926, 1929, 1940 (solo); Calif. PS, 1922 (prize); Calif. AC, 1922 (prize), 1923 (prize), 1924 (prize), 1926 (gold); Western Painters A., 1924 (prize); Soc. Western Artists, 1925 (medal); PS S., 1927 (prize); Calif. WCS, 1927 (prize), 1932 (prize); Pomona WCS 1927 (prize); West, 1927 (prize); Santa Cruz, 1927 (prize), 1929 (prize), 1935 (prize); San Diego Annual, 1929 (prize); Los Angeles AA, 1932 (prize), 1934 (prize); Oakland, 1936. **Work:** Barbara Worth Hotel, El Centro, CA; Mission Inn, H.S., both in Riverside, CA. **Comments:** Immigrated to the U.S. in 1907. He married his pupil, Luvena B. Vysekal (see entry). Positions: teacher, AIC, 1912-14; teacher, Otis AI, Los Angeles, 1922-39. **Sources:** WW38; Hughes, *Artists in California,* 582.

VYSEKAL, Luvena Buchanan (Mrs. E. A.) *[Painter] b.1873, Lemars, IA / d.1954, Los Angeles, CA.*
Addresses: Los Angeles, CA, since 1914. **Studied:** AIC, and with Vanderpoel, Harry M. Walcott, Norton, 1910-14; S. Macdonald Wright, Ralph Clarkson. **Member:** Calif. AC; Calif. WC Soc.; Calif. Progressives. **Exhibited:** LACMA, 1924 (prize), 1927, 1929, 1932; Arcadia, CA, 1923 (prize); Riverside, CA, 1929 (prize); Pomona, CA, 1924 (prize), 1928 (prize); Santa Cruz, CA, 1929 (prize); Laguna Beach, CA, 1929 (prize); Fed. Women's Club, 1924 (prize); Hollywood Club, 1927 (prize); California P&S, 1932 (prize); Oakland Art Gallery, 1932; Ebell Club, 1934 (prize). **Work:** Kansas State Agricult. Col.; Kansas State Capitol (Christian Hoffman); Los Angeles AI; murals, Barbara Worth Hotel, El Centro, CA. **Comments:** She married E.A. Vysekal (see entry) in Chicago, before they went West in 1914 on a mural commission. When her husband died in 1939, she became director of the Vysekal Studio Gallery in Hollywood. Sister of Ella Buchanan (see entry). **Sources:** WW53; WW47; Ness & Orwig, *Iowa Artists of the First Hundred Years,* 213; Hughes, *Artists in California,* 582; Trenton, ed. *Independent Spirits,* 75.

VYTLACIL, Elizabeth Foster (Mrs. Vaclav) *[Painter, teacher] b.1899, St. Paul, MN.*
Addresses: Paris, France. **Studied:** Minneapolis Inst. Art; Lhote, in Paris; Munich, with H. Hoffman, C. Von Marr. **Exhibited:** Minnesota State Fair (prize); Minnesota State AS (prize). **Sources:** WW33.

VYTLACIL, Vaclav *1430 V a c L a v V y t l a c i l*
[Painter, educator, lecturer] b.1892, NYC / d.1984, NYC.
Addresses: Rockland County, NY, 1940; Sparkill, NY, 1973. **Studied:** AIC; ASL; Bavarian Royal Acad. Art, Munich, Germany; Hans Hofmann in Munich, 1921 (Hofmann's first American student). **Member:** Fed. Mod. P&S; Am. Abstract Artists; ASL. **Exhibited:** AIC, 1913 (prize), 1914-20, 1936 (gold), 1937-41; PAFA Ann., 1915, 1945-64; Corcoran Gal biennials, 1916-49 (4 times); S. Indp. A., 1917; France, 1936 (gold); Soc. Am. Artists, 1914 (hon. mention); WMAA, 1938-62; CI, 1942, 1944 & 1945; Artists for Victory, MMA 1944; Philips Mem. Gal., 1955; M. Diamond FA, NYC, 1980-81 (solos). **Work:** WMAA; MMA; PAFA; Phillips Collection, Wash., DC; Rochester Mus. Art, NY; Milwaukee AI; Municipal Collection, Chicago; Mus. Dessau, Munich. **Comments:** An influential abstract painter in oils, acrylics, tempera. Between 1931-33, he produced abstract NYC scenes; and constructions from 1936-39. His students included Rauschenberg, Twombly, Bourgeois, Rosenquist, and Tony Smith. He also painted on Monhegan Island, ME. Positions: jury member for: Pepsi-Cola Nat. Art Competition, 1948; Nat. Exhib. Art, MMA, 1950. Teaching: Minneapolis School Art, 1917-21; Hans Hofmann summer school, Capri, Italy, 1924; artist-in-residence, Univ. Calif., Berkeley, 1928-29; Calif. College Arts & Crafts, summers 1936-37; chmn. dept. art, Queen's College, 1942-45; Colorado Springs Fine Art Center, 1951-53; Univ. Georgia, 1968; Florence Cane School Art and Dalton School, NYC, 1940; ASL, NYC, 1935-on. Co-author: *Egg Tempera Painting* (Oxford Univ. Press). **Sources:** WW73; WW40; Curtis, Curtis, and Lieberman, 121, 187; *American Abstract Art,* 201; Diamond, *Thirty-Five American Modernists;* Falk, *Exh. Record Series.*

VYTLACIL, William *[Painter] 20th c.*
Addresses: Mt. Lebanon, NYC. **Member:** Chicago WCC. **Exhibited:** AIC, 1911. **Sources:** WW21.

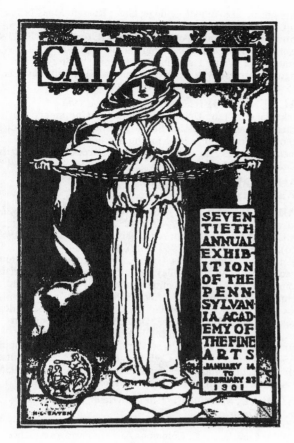

Cover of Annual Exhibition catalogue,
Pennsylvania Academy of the Fine Arts (1901)

W

WAAGE, Frederick O. *[Art historian, educator] b.1906, Philadelphia, PA.*
Addresses: Ithaca, NY. **Studied:** Univ. Pennsylvania (A.B., 1928); Princeton Univ. (M.A., 1929; M.F.A., 1935; Ph.D., 1943.). **Member:** College AA Am.; Archaeol. Inst. Am. **Comments:** Teaching: instr. archaeology, Cornell Univ., 1935-938, asst. prof. art hist. & archaeology, 1938-41, assoc. prof., 1941-45, chmn., dept. fine arts, 1942-60, prof. art hist. & archaeology, 1945-72, emer. prof., 1972-; visiting art lecturer, Elmira College, 1952-58; art lecturer, Ithaca College, 1958-72. Publications: author, "Numismatic Notes and Monographs," No. 1970, NY; author, "Antioch on the Orontes," Part 1, Vol. IV, Princeton, 1948; author, "Prehistoric Art," Dubuque, 1967; contributor, *Am. Journal Archaeology & Antique.* **Sources:** WW73.

WAANO-GANO, Joe *[Painter,* JOE WAANO GANO *lecturer, designer, illustrator, writer] b.1906, Salt Lake City, UT / d.1982.*
Addresses: Los Angeles, CA, 1946 and still there in 1976. **Studied:** Los Angeles Acad. FA; Christian von Schneidau Art Sch., 1924-28; T.N. Lukits Acad. Art; Hanson Puthuff Art Sch.; Univ. Southern Calif.; Dean Cornwell. **Member:** Calif. AC; San Fernando Valley AC; Valley Artists Guild (pres., 1951-52); Artists of the Southwest (bd. dir., 1951-); AAPL (fellow); Am. Inst. FA (fellow); Traditional Art Guild of Paramount (life mem.); P&S Los Angeles (bd. dir., 1950-64; pres., 1962-63). **Exhibited:** Calif. AC, 1946; Los Angeles Mus. Art, 1946; Los Angeles City Hall,

1946; AAPL, NYC, 1940-; Nat. Ann. Indian Art Exh., Indian Center, Los Angeles, 1955-69; Ann. Indian Artists Nat. Exh., Philbrook Mus., Tulsa, OK, 1957-; Nat. Am. Indian Exh., Scottsdale, AZ, 1960-; Center Arts Indian Am., Wash., DC, 1964-68. **Awards:** Kern County (CA) Fair, 1929 (prize); Gardena (CA) H.S., 1946 (prize); Chicago, 1933 (medal); award for Moonlight Madonna, Int. Madonna Festival, 1952; award for Flight of the Great Head, Tulsa Indian Womens Club, 1963; award for Chief Strong Bear, Greek Theatre, 1965. **Work:** Southwest Mus., Los Angeles; Gardena (CA) H.S.; History & Art Mus., Los Angeles; Cedar City (UT) H.S.; Bur Indian Affairs, Wash., DC. **Commissions:** Sioux Ghost Dance Chant (mural), ticket office, Rapid City, SD, 1930 & Sacred Deerskin Dance (mural); ticket office, San Francisco, 1944, Western Air Lines; mural for children's ward, Los Angeles General Hospital, 1930; Theme (mural) & Education (mural), Sherman Indian Inst., Arlington, CA, 1934. **Comments:** Preferred media: oils, watercolors, acrylics, charcoals. Designer: Indian Motifs for textiles. Lectures: Art of the American Indian. Publications: author/illustrator, "Art of the American Indian," *Western Art Review,* 1951. **Sources:** WW73; Ada Wallis, *Cherokee Indian, Gifted Artist* (Widening Horizons, 1960); Jeanne Snodgrass, "Joe Waano Gano," *Am. Indian Painters* (1968); Marion Gridley, "Joe Waano Gano," *Indians of Today* (1971); WW47; P&H Samuels, 506.

WAAS, Maurice A. *[Painter] late 19th c.*
Addresses: Phila., PA, 1881. **Exhibited:** PAFA Ann., 1880-83, 1887; NAD, 1881. **Sources:** Falk, *Exh. Record Series.*

WACEK, Ann J. *[Painter]; b.Iowa City, IA.*
Addresses: Iowa City, IA. **Studied:** AIC. **Exhibited:** Iowa Art Salon; other art exhibits in Iowa. **Comments:** Speciality: flowers. **Sources:** Ness & Orwig, *Iowa Artists of the First Hundred Years,* 213.

WACHSMANN, Helen *[Painter, sculptor] early 20th c.*
Addresses: NYC. **Exhibited:** S. Indp. A., 1931; Salons of Am., 1934. **Sources:** Falk, *Exhibition Record Series.*

WACHSTETER, George *[Illustrator] b.1911, Hartford, CT.*
Addresses: Elmhurst, NY. **Exhibited:** NBC Book of Stars, 1958 (solo traveling exh.). **Work:** NYPL Theatre Coll.; U.S. Steel Coll.; NBC Coll. **Comments:** Preferred media: inks, watercolors. Positions: illustrator for major advertising agencies, theatrical & motion picture productions, 1936-; illustrator for CBS, ABC, NBC radio & TV networks, 1937-; weekly contributor illustrations & caricature to drama pages, *New York Herald Tribune,* 1941-50; contributor illustrations & caricature drama & political pages, *New York Times,* 1942-50, TV artist, 1950-51; caricaturist for Theatre Guild on the Air, produced by U.S. Steel, 1945-63; drama artist, *New York Journal-Am.,* 1956-63, TV magazine cover artist, 1958-63; drama artist, New York World Tel., 1964-66; syndicated feature illustrator for Hallmark TV Drama series, 1964-69. Publications: illustrator, "NBC Book of Stars," Simon & Schuster, 1957. **Sources:** WW73.

WACHTEL, Elmer *[Landscape painter, illustrator, craftsperson, teacher] b.1864, Baltimore / d.1929, Guadalajara, Mexico.*
Addresses: Lanark, IL; Pasadena, CA, 1882-. **Studied:** briefly at ASL; criticism from W.M. Chase; London. **Member:** Los Angeles AA (co-founder); Ten Painters of Calif. **Exhibited:** Calif. Midwinter Int. Expo, 1894; Corcoran Gal. annual, 1907; LACMA, 1915 (solo). **Awards:** Mark Hopkins Inst., 1902, 1906. **Work:** Laguna Mus. Art. **Comments:** He is considered one of the foremost landscape painters of Southern Calif., whose work was well received by his contemporaries. In 1888 he was first violin for the Los Angeles Philharmonic Orchestra, sketching in his spare time, until he had enough money to go to NYC and study art. Married Marion K. Wachtel (see entry) in 1904, and moved to a studio on Mt. Washington; then again near the Sierra Madre. Together they took many painting excursions in a specially outfitted car. **Sources:** WW27; Hughes, *Artists of California,* 583; P&H Samuels, 506; *300 Years of American Art,* 580.

WACHTEL, Marion Kavanaugh (Mrs. Elmer) *[Painter, teacher] b.1876, Milwaukee, WI / d.1954, Pasadena, CA.* **Addresses:** Pasadena, CA. **Studied:** AIC with Vanderpoel; Wm. Chase, NYC; Wm. Keith in San Francisco. **Member:** Calif. WCS; Acad. Western Painters, Los Angeles; Friday Morning Club, Los Angeles; NYWCC; Pasadena SA; Pasadena Soc. Painters; Aquarelle Painters. **Exhibited:** LACMA, 1915, 1917; Stanford Univ., 1936; AIC. Awards: prizes, Pasadena SA, 1942, 1944. **Work:** Friday Morning Club, Los Angeles; Women's Club, Hollywood; Vanderpoel AA, Chicago; Vanderpoel Coll.; Fremont H.S., Los Angeles, CA; Gardena (CA) H.S.; State Bldg., Los Angeles, CA; Cedar Rapids (IA) Art Mus.; Calif. Club; Santa Fe R.R. Coll. **Comments:** Married Elmer Wachtel (see entry) in 1904 and moved to a studio at Mt. Washington and later near the Sierra Madre. They sketched in California, Arizona, the High Sierras, the sea coast and Mexico. Teaching: AIC, 1900s-04. Specialty: watercolor, oils (only after her husband's death) of landscapes & portraits. **Sources:** WW53; WW47; Hughes, *Artists in California,* 583; P&H Samuels, 506-07; Trenton, ed. *Independent Spirits,* 154.

WACHTEL, Roman *[Painter, graphic artist, designer] b.1908, Poland / d.1985.* **Addresses:** Woodstock, NY, 1962. **Studied:** Acad. FA, Austria; Arch. School, Vienna. **Member:** Woodstock AA. **Exhibited:** Parnassus Square Gal., Woodstock (retrospective); Marist College, 1976; Phoenix Gal., 1979 (solo). **Work:** Woodstock AA; Royal Mus. Antwerp; Albertina Coll., Vienna. **Comments:** Fled to Belgium during WWII; came to the U.S. in 1947. **Sources:** Woodstock AA.

WACHTEL, William *[Painter] b.1975, Lemberg, Galicia / d.1952, NYC.* **Addresses:** NYC. **Exhibited:** S. Indp. A., 1944. **Sources:** Marlor, *Soc. Indp. Artists.*

WACHTER, Beatrice E. *[Painter] mid 20th c.* **Addresses:** Brooklyn, NY. **Exhibited:** S. Indp. A., 1942-44. **Sources:** Marlor, *Soc. Indp. Artists.*

WACHTER, Charles L. *[Painter] early 20th c.* **Addresses:** NYC. **Exhibited:** S. Indp. A., 1917. **Sources:** Marlor, *Soc. Indp. Artists.*

WACHTER, Henry *[Painter] mid 20th c.* **Addresses:** NYC. **Exhibited:** S. Indp. A., 1933-34, 1938. **Sources:** Marlor, *Soc. Indp. Artists.*

WACHTER, Mileus *[Listed as "artist"] b.c.1790, Saxony.* **Addresses:** NYC, 1860. **Comments:** Lived in the home of Mrs. Leland Balch, NYC, in 1860. **Sources:** G&W; 8 Census (1860), N.Y., XLIV, 416.

WACK, Ethel Barksdale (Mrs. J. De B.) *[Painter] b.1898, Wilmington, DE. / d.1974, Santa Barbara, CA.* **Addresses:** NYC/Westport, NY; Santa Barbara, CA. **Studied:** I. Olinsky; Cecilia Beaux; Wayman Adams; V.W. Garder. **Member:** Nat. Soc. of Arts & Letters; Soc. Indep. Artists; Wilmington SFA. **Exhibited:** Soc. Indep. Artists. **Work:** Faulkner Memorial Art Gallery, Santa Barbara; Santa Barbara Pub. Lib.; Univ. of Virginia; Santa Barbara Hist. Soc. **Sources:** WW25; Hughes, *Artists in California,* 583.

WACK, Henry Wellington *[Painter, writer, lecturer, designer] b.1867, Baltimore, MD / d.1955, Santa Barbara, CA.* **Addresses:** Covina, CA; Santa Barbara, CA. **Studied:** L. Dabo; N.R. Brewer; H.S. Hubbell; F. Spenlove-Spenlove (London). **Member:** AAPL; Authors Club, New York & London; fellow, Royal Geographical Soc., London; Brooklyn SA; PS; Lime Rock AA; SSAL. **Exhibited:** S. Indp. A., 1920-21, 1928; Salons of Am., 1926, 1928, 1929. **Work:** Newark Mus.; High Mus. Art; Delgado Mus. Art; PAFA; Lincoln Mem. Univ., Harrogate, TN; Mary Washington College, Univ. Virginia; Hickory Mu°. Art; Vanderpoel Collection; Covina Public Library; Salisbury (CT) Public Librart; San Antonio; Ft. Worth, TX; Elks Club, St. Paul, MN; Whistle House, Lowell, MA; Library Collection,

Birmingham, AL; Antioch College, Ohio; Roerich Mus., NYC; NYPL; permanent exh., Catskill Mountain cabin of John Burroughs. **Comments:** Position: founder & first editor, *Field & Stream.* Author: books on camping and outdoor life; "In Thamesland"; "Victor Hugo and Juliet Drouet"; "Story of the Congo". **Sources:** WW53; WW47 reports Wack's birth date as 1875, as does Marlor, *Salons of Am.*

WACKENREUDER, Vitus *[Painter] mid 19th c.* **Work:** Bancroft Lib., Univ. Calif., Berkeley. **Comments:** He painted a gouache of Mission Santa Barbara in 1852 and made a map of San Francisco in 1861 for the San Francisco City Directory. He was also a civil engineer. **Sources:** Hughes, *Artists of California,* 583.

WACKERMAN, Dorothy See: **HUTTON, Dorothy Wackerman (Mrs.)**

WADDELL, John Henry *[Sculptor] b.1921, Des Moines, IA.* **Addresses:** Cottonwood, AZ. **Studied:** AIC (B.F.A.; M.F.A.; B.A.E.; M.A.E.). **Exhibited:** AIC, 1949-51; La Jolla Mus., 1962 (solo); Phoenix Art Mus., 1960 (solo), 1963 & 64 (solos); Hellenic Am. Union, Athens, Greece, 1966; Arizona, 1969 (touring solo show). Awards: Valley Beautiful grant, 1965-67; Arizona Commission on Art & Humanities grant, 1970-72; Nat. Found. Art & Humanities grant, 1971-72. **Work:** Phoenix (AZ) Art Mus.; Univ. Arizona, Tucson; Arizona State Univ., Tempe; Coe College; Eureka College. Commissions: "Dance Mother," Phoenix Art Mus., 1959-62; "That Which Might Have Been," Unitarian Church, Phoenix, 1963-64; "The Family," Maricopa Co. Complex, 1965-67; "Dance," Phoenix Civic Center, 1970-73. **Comments:** Preferred media: bronze. Teaching: Inst. Design, Chicago, 1955-57; Arizona State Univ., 1957-61. **Sources:** WW73.

WADDELL, Martha E. *[Painter, writer, graphic artist] b.1907, Ontario.* **Addresses:** Youngstown, OH. **Studied:** Butler AI. **Member:** NAWPS; Cleveland AC; Columbus AL; Youngstown Alliance. **Sources:** WW40.

WADDELL, Richard H. *[Art dealer] b.NYC / d.1974.* **Addresses:** NYC. **Studied:** Amherst College (B.A.); Columbia Univ. (M.S.). **Comments:** Positions: dir., Waddell Gallery, New York. Specialty of gallery: generally avant-garde, with emphasis on European artists, mainly sculptors. **Sources:** WW73.

WADDEY, John A. *[Engraver] 19th/20th c.* **Addresses:** Wash., DC, active 1872-1920. **Sources:** McMahan, *Artists of Washington, DC.*

WADDY, Ruth G. *[Painter, printmaker, editor] b.1909, Lincoln, NE.* **Studied:** Los Angeles City College; Otis AI; Univ. Minnesota. **Member:** Art West Associated North, Los Angeles (founder); Nat. Conference of Artists; Black Arts Council, Los Angeles. **Exhibited:** Safety S&L Assn., Los Angeles, 1965; Int. Buchmesse, Leipzig, Germany, 1965; Los Felis Jewish Community Center, Los Angeles, 1965; AWAN Negro Hist. Week, Los Angeles City Hall, 1963-69; Oakland Art Mus.; Graphik aus fünf Kontinenten, Leipzig; UCLA Art Center, 1966; Friendship Houses in the USSR, 1966; Nat. Conf. Artists, 1968 (prize); Independence Square, Los Angeles, 1969 (solo); Rainbow Sign Gal., Berkeley, 1972. Awards: Nat. Assn. of College Women Award, Los Angeles, 1963; Ruth Waddy Testimonial & Cash Award, 1972. **Comments:** Collector: prints for *Prints by American Negro Artists.* Co-editor, *Black Artists on Art.* **Sources:** Cederholm, *Afro-American Artists.*

WADE, Caroline D. *[Painter, watercolorist, teacher] b.1857, Chicago / d.1947, Chicago.* **Addresses:** Elmhurst, IL. **Studied:** AIC with H. F. Spread & L. C. Earle; George Robertson; Courtois & Rixens in Paris. **Member:** AFA; Chicago SA; SWA. **Exhibited:** Bohemian Club, Chicago, 1880-95; AWCS, 1893; PAFA Ann., 1893-95, 1901; Boston AC, 1896; AIC, 1891-1914; Trans-Mississippi, Omaha, 1898; Jacksonville (IL), St. Louis, Minneapolis, etc. **Comments:** Taught

at AIC from 1901. **Sources:** WW31; Petteys, *Dictionary of Women Artists;* Falk, *Exh. Record Series.*

WADE, Claire E. (Mrs.) *[Painter, teacher] b.1899, Ossining, NY.*
Addresses: Kew Gardens, NY; Oakland Gardens 64, NY. **Studied:** New York Univ. (B.S. in Educ.); Jerry Farnsworth; Umberto Romano. **Member:** NAWA. **Exhibited:** NAWA, 1943-1946; AWCS, 1943; Brooklyn SA, 1945-1946; Sarasota SA, 1942; Knickerbocker Artists, 1953, 1954; All. Artists Am. 1943, 1944, 1950. **Awards:** prizes, Art Lg. of Long Island, 1949; Farnsworth Sch. Art, Sarasota, FL. **Sources:** WW59; WW47.

WADE, Dilla M. *[Landscape painter, drawing specialist] b.1883, Colfax, WA / d.1964, Tacoma, WA.*
Addresses: Seattle, WA. **Member:** Tacoma Art League. **Exhibited:** Tacoma Art League, 1914, 1915. **Comments:** Daughter of Sarah Wade (see entry). **Sources:** Trip and Cook, *Washington State Art and Artists, 1850-1950.*

WADE, Elizabeth Virginia *[Sculptor] late 19th c.*
Addresses: Phila., PA, 1879. **Exhibited:** PAFA Ann., 1877-84; NAD, 1879. **Sources:** Falk, *Exh. Record Series.*

WADE, H. *[Lithographer] mid 19th c.*
Comments: Lithographer of a sheet music cover, "The Texas Quick Step;" published in NYC in 1841. *Cf.* William Wade. **Sources:** G&W; John Mayfield Collection, Washington, DC.

WADE, Hannah C. *[Listed as "artist"] b.c.1820, Pennsylvania.*
Addresses: Philadelphia Hospital for the Insane in June 1860. **Sources:** G&W; 8 Census (1860), Pa., LX, 799.

WADE, J. H. *[Portrait painter] early 19th c.*
Addresses: Cleveland, OH & throughout the South, 1810-23. **Sources:** G&W; Fielding.

WADE, Jane *[Art dealer] b.1925, Dallas, TX.*
Addresses: NYC. **Studied:** Univ. Arizona; in Europe; Curt Valentin Gallery, NYC; Otto Gerson Gallery, New York. **Member:** Art Dealers Assn. Am. **Comments:** Positions: secretary & asst., Curt Valentin Gallery, 1948-56; secretary & assoc., Otto Gerson Gallery, 1956-63; vice-pres., Marlborough-Gerson Gallery, 1963-64; juror, Mid-West Ann., William Rockhill Nelson Gallery Art, Kansas City, MO; owner & director, Jane Wade Ltd. Collections Arranged: Drawings by Sculptors, Smithsonian Inst. & US Tour. Specialty of gallery: twentieth century painting and sculpture. **Sources:** WW73; Jay Jacobs, "By Appointment Only," *Art Am.,* (July-Aug., 1967); "By Appointment Only," *Newsweek* (Sept. 4, 1967); "By Appointment Only," *Time* (Aug. 3, 1970).

WADE, Jean Elizabeth (Mrs. Emil J. Frey) *[Painter, illustrator] b.1910, Bridgeport, CT.*
Addresses: Bridgeport, CT; Trumbull 58, CT. **Studied:** Yale Univ. (B.F.A.). **Member:** NAWA; Audubon Artists; Silvermine GA; Bridgeport AL; Nat. Lg. Am. Pen Women. **Exhibited:** Audubon Artists, 1945; NAWA, 1945, 1946; New Haven PCC, 1945, 1948; Bridgeport Art Lg., 1945, 1946; Silvermine Guild Artists, 1945, 1946, 1956; Nat. Lg. Am. Pen Women, 1950, 1952-55; Chautauqua Exh., 1958; Little Studio, NY, 1956 (2-man). **Awards:** prizes, CAA, 1931; Bridgeport Art Lg., 1945, 1955; Nat. Lg. Am. Pen Women, 1953-55; Contemporary Arts & Crafts, 1953; Silvermine Guild Artists, 1955; Mystic AA, 1955. **Sources:** WW59; WW47.

WADE, Jeptha Homer *[Patron] b.1857, Cleveland, OH / d.1926.*

WADE, John *[Painter, educator]*
Studied: Phila. College Art; Temple Univ. **Exhibited:** Phila. Civic Center; State Armory, Wilmington, DE, 1971; Temple Univ.; Phila. Festival of Arts, 1967 (hon. men.); Allens Lane Art Center (prize); New England Regional Exh. (Silvermine Award); Woodmere Gallery (purchase prize); Phila. Art Teachers Assn. **Work:** Woodmere Gallery. **Comments:** Teaching: Temple Univ. **Sources:** Cederholm, *Afro-American Artists.*

WADE, John C. *[Engraver, painter, illustrator] b.c.1827, NYC.*
Addresses: NYC, c.1850-60. **Work:** Peabody Mus., Salem, MA (marine watercolor). **Comments:** Magazine illustrator, 1850-60. **Sources:** G&W; 7 Census (1850), N.Y., XLVIII, 127; NYBD 1854-60; Brewington, 399.

WADE, M. M. *[Marine painter] late 19th c.*
Addresses: New Bedford, MA (1886). **Sources:** Brewington, 400.

WADE, Murray Lincoln *[Painter, cartoonist] b.1876, Salem, OR / d.1961, Salem.*
Addresses: Salem. **Studied:** Mark Hopkins Inst., criticism from Wm. Keith. **Exhibited:** Oregon State Fair, 1894 (prize), 1895 (prize), 1900 (prize). **Comments:** Position: cartoonist, *Oregonian,* and *San Francisco Examiner.* **Sources:** Hughes, *Artists of California,* 583.

WADE, Philip *[Painter] mid 20th c.*
Exhibited: S. Indp. A., 1936. **Sources:** Marlor, *Soc. Indp. Artists.*

WADE, Robert *[Painter, teacher] b.1882, Haverhill, MA.*
Addresses: Bradford (Haverhill), MA. **Studied:** Eric Pape Sch. Art, and in Europe. **Exhibited:** AIC, 1926-27; PAFA Ann., 1929-30; S. Indp. A., 1932; nationally. **Work:** altar panels, St. Mary of Redford, Detroit, MI; St. James Church, Woonsocket, RI; murals, Boston Univ. Sch. Theology; Shove Mem. Chapel, Colorado College, Colorado Springs; Emanuel Church, Newport, RI; Lincoln Sch., La Junta, CO; designer for memorial window at Bradford Jr. College. **Comments:** Teaching: Pueblo Jr. College, Pueblo, CO, 1937-38; Bradford Jr. College, Bradford, MA, 1939-53. **Sources:** WW59; WW47; Falk, *Exh. Record Series.*

WADE, Robert Schrope *[Painter, photographer] b.1943, Austin, TX.*
Addresses: Dallas, TX. **Studied:** Univ. Texas, Austin (B.F.A., 1965); Univ. Calif., Berkeley (M.A., 1966). **Member:** Texas FA Soc. (bd. dir., 1970-72); College AA Am.; Artists Equity Assn. **Exhibited:** WMAA, 1969, 1973; Project South-Southwest, Fort Worth AC, 1970; solos: Kornblee Gallery, New York, 1971 & Chapman Kelley Gallery, Dallas, TX, 1971; Painting and Sculpture Today—1972, Indianapolis MA, 1972; Smither Gallery, Dallas, TX, 1970s. **Awards:** purchase prize, Oklahoma AC Ann., 1968; 34th Ann. Exh. Award, Fort Worth AC, 1971. **Work:** Oklahoma AC, Oklahoma City; Witte Mus., San Antonio, TX; McLennan College, Waco, TX; Mountainview College, Dallas, TX; Northwood Inst., Cedar Hill, TX. **Comments:** Teaching: McLennan College, 1966-70; Northwood Inst., 1970-70s, Dallas. **Sources:** WW73; Robert Pincus-Witten, "New York," *Artforum* (Dec., 1971); "Big D," *Newsweek* (Aug. 7, 1972); Janet Kutner, "The Houston-Dallas Axis," *Art in America* (Sept.-Oct., 1972).

WADE, Samuel *[Engraver] b.1820, Maryland.*
Addresses: NYC, 1848-60. **Comments:** In 1860 his fifteen-year-old son John was listed as an apprentice engraver. **Sources:** G&W; 8 Census (1860), New York, LXII, 637.

WADE, Sarah (Sadie) V. (Mrs. Florance M.) *[Landscape painter, china painter] b.1850, MO / d.1937, Tacoma, WA.*
Addresses: Seattle, WA. **Member:** Tacoma Art League. **Exhibited:** Tacoma Art League, 1914, 1915. **Comments:** Mother of Dilla Wade (see entry). **Sources:** Trip and Cook, *Washington State Art and Artists, 1850-1950.*

WADE, William *[Engraver, designer, draftsman] mid 19th c.*
Addresses: NYC, c.1844-52. **Exhibited:** Am. Inst., 1846 (panorama of the Hudson River). **Comments:** In 1844 he published an engraved panorama of the Hudson River from New York to Albany. *Cf.* H. Wade. **Sources:** G&W; Stokes, *Historical Prints;* NYCD 1845-52; Am. Inst. Cat., 1846.

WADE, Winifred *[Painter] early 20th c.*
Exhibited: Salons of Am., 1934. **Sources:** Marlor, *Salons of Am.*

WADEWITZ, Theo *[Printmaker] mid 20th c.*
Addresses: San Francisco, CA. **Exhibited:** GGE, 1940. **Sources:** Hughes, *Artists of California,* 583.

WADLER, R. C. *[Landscape painter]* early 20th c.; b.NYC. **Addresses:** Active in NYC, California, prior to 1926. **Studied:** NYC; Europe. **Exhibited:** Stendahl Gals., Los Angeles, 1926; Salons of Am., 1934. **Sources:** Marlor, *Salons of Am.;* Petteys, *Dictionary of Women Artists.*

WADLOW & COMPANY, Charles E. *[Lithographers]* mid 19th c. **Addresses:** NYC, 1854. **Sources:** G&W; NYBD 1854.

WADMAN, Lolita Katherine *[Painter, craftsperson, educator, illustrator]* b.1908, Minneapolis, MN. **Addresses:** London, KY; Greenbelt, MD. **Studied:** G. Mitchell, Minneapolis School Art & in Europe. **Exhibited:** Minneapolis IA, 1930-35; Minnesota State Fair, 1931-36 (prize). **Awards:** traveling scholarship, Minneapolis, 1932. **Comments:** (Mrs. David Granahan) Illustrator: "Upper Mississippi," 1936, "Finlandia," 1939, "Who Wants Apple," 1941, "The American People". **Sources:** WW53; WW47.

WADSWONT, Adelaide E. (Miss) See: **WADSWORTH, Adelaide E.**

WADSWORTH, Adelaide E. *[Painter]* b.1844, Boston, MA / d.1928, Boston. **Addresses:** Boston, 1875-95. **Studied:** W.M. Hunt; F. Duveneck; J. Twachtman; C.H. Woodbury, Ogunquit School; A. Dow. **Member:** Copley Soc., 1894. **Exhibited:** Boston AC, 1876-86; St. Botolph Club; NAD, 1875-95; Williams & Everett Gal., Boston, 1888; Boston galleries, all 1876-95; PAFA Ann., 1891-92, 1895, 1899; AIC; Soc. Indep. Artists, 1917-18. **Comments:** Painted landscapes and figures. **Sources:** WW27; *Charles Woodbury and His Students;* Falk, *Exh. Record Series.*

WADSWORTH, Alice See: **STONE, Alice Wadsworth (Mrs.)**

WADSWORTH, Charles E. *[Painter]* b.1917, Ridgewood, NJ. **Addresses:** Cambridge, MA. **Studied:** ASL. **Member:** AEA; Cambridge AA. **Exhibited:** DeCordova and Dana Mus., Lincoln, MA, 1951; Butler AI, 1951; NGA, 1941; CMA; Detroit Inst. Art; WMAA, 1955; PAFA, 1951; Boston Soc. Indep. Artists; BMFA; Farnsworth Mus.; Currier Gal. Art; Berkshire Mus.; Fitchburg AC; Wadsworth Atheneum; Corcoran Gal biennial, 1955. **Awards:** prize, Jordan-Marsh Co., Boston, 1951; Boston Art Festival, 1953; Cambridge AA, 1955. **Work:** Federal Hospital, Carville, LA; WMA; Munson-Williams-Proctor Inst.; Am. Inst. Arts & Letters (presented to Allentown AA). **Sources:** WW59.

WADSWORTH, Cora E. *[Painter]* early 20th c. **Exhibited:** S. Indp. A., 1924-25, 1927; Salons of Am., 1930. **Sources:** Falk, *Exhibition Record Series.*

WADSWORTH, Daniel *[Amateur artist, collector]* b.1771, New Haven, CT / d.1848, Hartford, CT. **Addresses:** Hartford. **Work:** Connecticut Hist. Soc.(two watercolor views of his own mansion). **Comments:** A Hartford merchant and nephew by marriage of John Trumbull (see entry), Wadsworth is remembered chiefly as the founder of the Wadsworth Athenaeum Gallery in Hartford in 1844. His own work in watercolors included sketches made on a trip to Quebec in 1819, some of which were engraved to illustrate his published account of the trip. **Sources:** G&W; Connecticut Hist. Soc. *Bulletin,* XIX (Jan. 1954), 22-25; French, *Art and Artists in Connecticut,* 9-11.

WADSWORTH, Emma L. *[Painter]* late 19th c. **Addresses:** NYC, 1899. **Exhibited:** NAD, 1899. **Sources:** Naylor, *NAD.*

WADSWORTH, Fanny S. *[Sculptor]* late 19th c. **Addresses:** Brooklyn, NY, 1890. **Studied:** Gaudez. **Exhibited:** NAD, 1890; Paris Salon, 1887-89. **Sources:** Fink, *American Art at the Nineteenth-Century Paris Salons,* 401.

WADSWORTH, Frances Laughlin *[Sculptor, painter]* mid 20th c.; b.Buffalo, NY. **Addresses:** Granby, CT. **Studied:** Albright Art School with Antoinette Hollister, Gutzon Borglum, Charles Teft & John Effl. **Member:** Nat. Lg. Am. Pen Women (pres., Hartford Branch, 1968-70); Acad. Artists, Springfield; CAFA; Hartford Soc. Women Painters; Hartford AC (pres., 1930-40). **Exhibited:** CAFA, 1930-58; Hartford Soc. Women Painters, 1930-58; Acad. Artists, Springfield, 1935-60; Nat. Lg. Am. Pen Women, 1956 & 1958; NSS, New York, 1970. **Awards:** Nat. Lg. Am. Pen Women, 1956-58. **Work:** Commissions: Safe Arrival (sculpture), Travelers Insurance Co., Hartford, CT; Founder's Monument, Am. School Deaf, West Hartford; Thomas Hooker, Soc. Descendants Founders of Hartford; Gallaudet Monument; portraits & garden sculpture. **Comments:** Teaching: Inst. Living, Hartford, 1930-58. **Sources:** WW73; Ursula Toomey, *The Charm of Her Sculpture* (Hartford, 1962).

WADSWORTH, Frank Russell *[Painter]* b.1874, Chicago / d.1905. **Addresses:** Chicago, Oak Park, IL. **Studied:** Chase, in NYC; AIC. **Member:** Chicago SA; Muncipal AL of Chicago. **Exhibited:** AIC, 1895-1906, 1904 (prize); PAFA Ann., 1896-97, 1904-06; SAA, 1898; Boston AC, 1909. **Sources:** WW04; Falk, *Exh. Record Series.*

WADSWORTH, Grace *[Painter, teacher]* b.1879, Plainfield, NJ. **Addresses:** NYC. **Studied:** Twachtman; Metcalf; Dow; Dielman. **Sources:** WW10.

WADSWORTH, Lillian (Mrs.) *[Painter]* b.1887. **Addresses:** Westport, CT. **Studied:** J.E. Fraser; S. Brown; Annot. **Member:** NYSWA. **Sources:** WW40.

WADSWORTH, Lucy G. *[Painter]* 19th/20th c. **Addresses:** Boston, MA. **Exhibited:** Boston AC, 1897-98. **Sources:** WW01.

WADSWORTH, Mytra M. (Mrs.) *[Painter]* b.1859, Wyoming, NY. **Addresses:** Winter Park, FL/Rochester, NY. **Studied:** L.M. Wiles; I. Wiles. **Member:** Rochester AC. **Sources:** WW25.

WADSWORTH, W. *[Engraver]* mid 19th c. **Addresses:** San Francisco in 1858. **Comments:** In 1860 he was one of the proprietors of the magazine *California Culturist.* **Sources:** G&W; San Francisco CD 1858, 1860.

WADSWORTH, Wedworth *[Landscape painter, illustrator, writer]* b.1846, Buffalo, NY / d.1927. **Addresses:** Brooklyn, NY; Durham, CT. **Member:** NYWCC; SC, 1890; Brooklyn AC. **Exhibited:** Brooklyn AA, 1884, 1886, 1891; PAFA Ann., 1887-88; Boston AC, 1888-1905; AIC. **Comments:** Primarily a watercolorist, he painted landscapes around the hills of Durham and the Connecticut shore. Author/illustrator: "Leaves from an Artist's Field Book." Illustrator: "The Song of the Brook," "A Winter's Walk with Cowper," "Under the Greenwood Tree with Shakespeare," "Through Wood and Field with Tennyson," "An Artist's Year." **Sources:** WW25; Falk, *Exh. Record Series.*

WADSWORTH, William *[Wood engraver, designer]* late 18th c. **Addresses:** Hartford, CT. **Comments:** His work appeared in Noah Webster's *American Spelling Book* (c. 1798) and *The Cannibal's Progress* (1798). **Sources:** G&W; Hamilton, *Early American Book Illustrators and Wood Engravers,* 14, 73.

WAEHNER, Tru Schmidt *[Painter]* mid 20th c. **Exhibited:** S. Indp. A., 1939. **Sources:** Marlor, *Soc. Indp. Artists.*

WAESCHE, Metta Henrietta *[Amateur artist]* b.1806 / d.1900. **Addresses:** Baltimore, MD. **Work:** Maryland Hist. Soc. (crayon and watercolor view of the Repold-Waesche House, 1822). **Sources:** G&W; Pleasants, *250 Years of Painting in Maryland,* 51, 52 (repro.).

WAESE, P(aul) H. *[Painter]* early 20th c. **Addresses:** Millburn, NJ. **Exhibited:** S. Indp. A., 1925. **Sources:** Marlor, *Soc. Indp. Artists.*

WAGANER, Anthony *[Statuary] mid 19th c.*
Addresses: NYC, 1834-35. **Sources:** G&W; NYCD 1834-35.

WAGEMAN, Michael A. *[Portrait painter] mid 19th c.*
Addresses: Newark, NJ, 1857-62. **Exhibited:** NAD, 1861-62.
Sources: G&W; Newark CD 1857; Essex, Hudson, and Union
Counties BD 1859.

WAGENER, Frank *[Art dealer] b.1827, Cologne, Germany /*
d.1890, New Orleans, LA.
Addresses: New Orleans, active 1866-87. **Member:** Southern Art
Union, 1880-81. **Comments:** Importer of French, English and
German engravings, lithographs and oil paintings. Partner with
Louis Meyer (1869-72). **Sources:** *Encyclopaedia of New Orleans
Artists,* 397.

WAGENHALS, Katherine Hamilton *[Painter] b.1883,*
Ebensburg, PA / d.1966, San Francisco, CA.
Addresses: Fort Wayne, IN; San Diego, CA. **Studied:** Smith
College; ASL; Acad. Moderne, Paris. **Member:** San Diego Art
Guild; Soc. of Western Artists. **Exhibited:** NY Arch. Lg.; Herron
AI, 1916 (prize); Corcoran Gal. biennial, 1916; PAFA Ann., 1916;
Southern Calif. art groups. **Work:** "The Visitor," Herron AI.
Comments: Position: staff, Herter Looms, NYC, 1900s.
Sources: WW24; Hughes, *Artists in California,* 584; Falk, *Exh.
Record Series.*

WAGER-SMITH, Curtis (Miss) *[Portrait painter, illustrator,*
writer] 19th/20th c.; b.Binghamton, NY.
Addresses: Willow Grove, PA. **Studied:** Sartain; Phila. with A.B.
Stephens, H. McCarter. **Member:** Plastic Club; SAL; City Park
Assn.; Women's Press Assn. **Exhibited:** Dallas Expo, 1890 (silver
medal); PAFA Ann., 1903. **Comments:** Illustrator: "Rhymes for
Wee Sweethearts,"Story Without an End," other children's books.
Sources: WW33; Falk, *Exh. Record Series.*

WAGGAMAN, Lewis *[Painter] mid 20th c.*
Addresses: Baltimore, MD. **Exhibited:** PAFA Ann., 1941.
Sources: Falk, *Exh. Record Series.*

WAGGENER, Oren Ross *[Painter] early 20th c.*
Addresses: Brooklyn, NY. **Studied:** ASL. **Exhibited:** S. Indp. A.,
1922. **Sources:** Marlor, *Soc. Indp. Artists.*

WAGGONER, Elizabeth *[Painter, craftsperson, writer]*
b.1932.
Addresses: Hollywood, CA. **Studied:** AIC, 5 years. **Member:**
Calif. AC. **Comments:** Positions: teacher, AIC, before 1908;
crafts , Univ. Southern Calif. College FA, 1908-10; Hollywood
Polytech. H.S., from 1910. **Sources:** WW25.

WAGGONER, William W. *[Wood engraver] mid 19th c.*
Addresses: Cincinnati,1853-59. **Sources:** G&W; Cincinnati CD
1853-59.

WAGNER *[Seal engraver] mid 19th c.*
Addresses: NYC. **Exhibited:** PAFA, 1834. **Sources:** G&W;
Penn. Acad. Cat., 1834.

WAGNER, A. *[Painter] early 20th c.*
Addresses: Toledo, OH. **Member:** Artklan. **Sources:** WW25.

WAGNER, A. M. (Miss) *[China painter] 19th/20th c.*
Addresses: Active in Los Angeles, 1892-1912. **Exhibited:** Calif.
State Fair, Sacramento, 1900. **Sources:** Petteys, *Dictionary of
Women Artists.*

WAGNER, Andrew *[Wood engraver, lithographer] mid 19th c.*
Addresses: Cincinnati, 1856-60. **Comments:** He worked for
Adolphus Menzel (see entry). **Sources:** G&W; Cincinnati CD
1856-60.

WAGNER, Blanche Collet *[Lecturer, painter, craftsperson]*
b.1873, Grenoble, France / d.c.1958, San Marino, CA.
Addresses: San Marino, CA. **Studied:** Clinton Peters, NYC; H.
Gazan, Paris, France; Alfonso Grosso, Seville, Spain. **Member:**
Calif. AC; Women Painters of the West; Los Angeles AA; Lg.
Am. Pen Women; Laguna Beach AA; Long Beach AA.
Exhibited: S. Indp. A., 1921-22; Berkeley Lg. FA, 1924; San

Francisco AA, 1924; Calif. State Fair, 1930; Southwest Mus., Los.
Angeles; Santa Ana (CA) Mus., 1935, 1936. **Awards:** prizes, Lg.
Am. Pen Women, 1939; San Francisco, 1939; Los Angeles, 1946.
Comments: Translator: "Streets of Mexico," 1937; author/illustra-
tor, "Tales of Mayaland." Lectures: "Mayas Costumes and
Customs"; "Headdresses Through the Centuries." **Sources:**
WW53; WW47; Hughes, *Artists of California,* 584.

WAGNER, Carrie Larietta *[Painter] late 19th c.*
Addresses: Los Angeles, CA, 1894. **Exhibited:** Mechanics's Inst.,
San Francisco, 1893. **Sources:** Hughes, *Artists of California,* 584.

WAGNER, Clara See: **FOLINGSBY, Clara Wagner**
(Mrs. George Frederick)

WAGNER, Daniel *[Miniature, portrait, landscape & still life*
painter] b.1802, Leyden, MA / d.1888.
Exhibited: NAD, 1839-73; Brooklyn AA, 1868, 1872; Centennial
Exh., Phila., 1876; PAFA Ann., 1883: "Deer in the Adirondacks"
(listed with both Maria and Daniel as artists). **Comments:** Wagner
spent most of his boyhood in Norwich (NY). He was injured by
an accident in childhood and took up portrait and miniature paint-
ing which he practiced successfully for many years in collabora-
tion with his sister, Maria Louisa Wagner (see entry). From the
late 1830s through about 1842, the two traveled together through-
out upstate New York as itinerant painters. From about 1842 to
about 1860 they had a studio in Albany; and from 1862-68 they
were in NYC. After 1868 they resided in Norwich. Among
Daniel's works were portraits of Erastus Corning, Martin Van
Buren, Silas Wright, Millard Fillmore, and Daniel Webster. He
also painted landscapes and still lifes. **Sources:** G&W; Norwich
Semi-Weekly Telegraph, Jan. 25, 1888, obit. (courtesy Anna Wells
Rutledge); Albany CD 1843-44, 1857; Cowdrey, NAD; Naylor,
NAD; NYCD 1862-68; *Antiques* (Jan. 1933), 12. More recently,
see Gerdts, *Art Across America,* vol. 1, 185-86 (repro.) and
Rubinstein, *American Women Artists,* 65-66; Falk, PA, vol. 2.

WAGNER, E. G. (Mrs.) *[Artist] early 20th c.*
Addresses: Active in Los Angeles, 1911-23. **Sources:** Petteys,
Dictionary of Women Artists.

WAGNER, Edward Q. *[Sculptor, wood carver] b.1855,*
Germany / d.1922, Detroit, MI.
Addresses: Detroit, MI, 1871-1900 and after. **Work:** sculptural
work on the St. Louis Fair Bldgs., 1904. **Comments:** Asociated
with Richard G. Reuther as Wagner & Reuther, 1885-87, with
Heinrich Volbracht (see entry) as Wagner & Volbracht, 1890-95.
He spent five years executing work for the Brazilian Govt., Rio de
Janeiro. **Sources:** Gibson, *Artists of Early Michigan,* 232.

WAGNER, Ernest *[Painter] mid 20th c.*
Exhibited: S. Indp. A., 1935. **Sources:** Marlor, *Soc. Indp. Artists.*

WAGNER, Frank Hugh *[Painter, sculptor, illustrator]*
b.1870, Milton, IN.
Addresses: Chicago, IL. **Studied:** AIC with Freer, Vanderpoel,
Von Salza. **Member:** Hoosier Salon. **Exhibited:** AIC, 1897, 1899.
Work: St. Joseph's Chapel, West Pullman, IL; Chapel Hall,
Danville, IN. **Sources:** WW40.

WAGNER, Frederick R. *[Painter,*
teacher] b.1864, Valley Forge, PA /
d.1940.
Addresses: Phila., PA. **Studied:** PAFA, with Eakins. **Member:**
Phila. Sketch Club; Phila. WCC. **Exhibited:** PAFA Ann., 1882-
1940 (prize, 1914); NAD, 1884; Corcoran Gal. biennials, 1907-
35 (11 times); AIC, 1906-26; CI, 1922 (prize). **Work:** PAFA;
Phila. AC; Reading AM; CMA. **Sources:** WW38; Falk, *Exh.
Record Series.*

WAGNER, George *[Sculptor, craftsperson] 19th/20th c.;*
b.Paris.
Addresses: NYC, 1881-88; Vincennes, France. **Studied:** Dumont
in Paris. **Exhibited:** NAD, 1881-88; Paris Salon, 1899.
Comments: Born to American parents in Paris. Specialty: stat-
uettes of silver, ivory, and precious stones. **Sources:** WW08;
Fink, *American Art at the Nineteenth-Century Paris Salons,* 401.

WAGNER, Gladys Noble *[Painter, sculptor] b.1907, Pennsylvania.*
Addresses: Cheltenham, PA. **Studied:** Temple Univ. Tyler Sch. Art (B.F.A.; M.F.A., 1959). **Member:** PAFA; Phila. Print Club; MoMA; Phila. MA; Peale Club, Phila. **Exhibited:** Phila. Print Club, 1969; Nat. Print & Watercolor Exh., PAFA, 1969; New York State Fair, Syracuse, 1969; PMA, 1970; Cheltenham AC Tenth Ann. Regional Sculpture Exh., Phila. Civic Center, 1971. **Awards:** Tyler alumni award, 1968 & 1970, Temple Univ.; first Addie Rubin Mem. Award, 22nd ann. award exh., 1969 & print exh. award, 1971, Cheltenham AC. **Work:** Albright-Knox Art Gallery, Buffalo, NY; Blank, Rome, Klaus & Comisky, Attorneys, Phila. **Comments:** Preferred media: stainless steel. Positions: co-founder/director educ., Cheltenham Sch. Fine Arts, Cheltenham Township Art Centre, 1940-, pres., 1941-42, chmn. board governors, 1942-43, established Aegean Sch. Fine Arts, Greece; council member, Expo Art & Technology, 1967; council member, Penn. Art Educ. Assn., 1969; director, art tours abroad, 1963 & 1966. Teaching: instructor of art & philosophy, 1951-56; art instructor, Oak Lane Co. Day Sch., Temple Univ. 1959-60, instructor of art educ., univ., 1960-65, instructor of art educ., elem. educ. teachers for state cert., 1962-63; instructor of philosophy of art educ., Cheltenham Township AC, 1961-, instructor of painting & sculpture, 1962-. Research: nature of a meaningful art education course for elementary education student teachers. **Sources:** WW73.

WAGNER, Gordon *[Painter] mid 20th c.*
Exhibited: Corcoran Gal. biennials, 1957, 1961. **Sources:** Falk, *Corcoran Gal.*

WAGNER, Harold *[Landscape painter] mid 20th c.*
Addresses: San Francisco, CA, 1930s. **Exhibited:** SFMA, 1935. **Work:** SFMA; Oakland Mus. **Sources:** Hughes, *Artists of California*, 584.

WAGNER, Henry S. *[Portrait engraver] mid 19th c.*
Addresses: Philadelphia from 1849-58. **Sources:** G&W; Phila. CD 1849-58; Stauffer.

WAGNER, Isaiah C. *[Amateur wood carver] b.1876, Massachusetts.*
Addresses: Active in New Bedford, MA area, 1904-18. **Exhibited:** New Bedford AC, 1916-17 (three wood carvings). **Sources:** Blasdale, *Artists of New Bedford*, 198-99.

WAGNER, J. F. (or E.) *[Landscape & topographical painter] mid 19th c.*
Addresses: Nashville, TN, active c.1840-60. **Sources:** G&W; *Portfolio* (Jan. 1943), 114, and (Feb. 1954), 141, repros.; Nashville CD 1860.

WAGNER, Jacob *[Landscape & portrait painter, framemaker] b.1855, Bavaria, Germany / d.1899, NYC.*
Addresses: Boston, MA, 1893-94. **Studied:** Lowell Inst., Boston; BMFA Sch., 1877 (inaugural class) with Otto Grundmann and William Rimmer. **Member:** Boston AC. **Exhibited:** Boston AC, 1886-98; PAFA Ann., 1887-97; AIC, 1891-98; NAD, 1893-94. **Work:** Colby College MA. **Comments:** He was apprenticed to the Boston framemaker, A.A. Childs, and later produced frames for Doll & Richards Gal. until c.1886. He painted Impressionist landscapes from southern New Hampshire to southern Massachusetts, but died at age 46. **Sources:** WW98; exh. cat., *Painters of the Harcourt Studios* (Lepore FA, Newburyport, MA, 1992); Falk, *Exh. Record Series.*

WAGNER, John Philip *[Painter] b.1943, Philadelphia, PA.*
Addresses: El Rancho, NM. **Studied:** Phila. College Art (B.F.A.); Maryland Inst. College Art (M.F.A.); special study with David Hare & Dennis Leon. **Exhibited:** Baltimore MA Regional Show, 1965; Soc. Illustrators Show, NYC, 1969; Southwest Fine Arts Biennial, Santa Fe, NM, 1970; Jamisons Galleries, Santa Fe, NM, 1970s. **Awards:** Rinehart Sch. Sculpture fellowship, 1965; Nat. Endowment Arts New Mexico State Artist-in-Residence grant,

1970-71. **Work:** Commissions: poly-chrome sculpture, Baltimore Parks Commission, MD, 1965. **Comments:** Positions: artist-in-residence, State Arts Commission, 1970-71. Publications: illustr., *Grove Press & Evergreen Review,* 1968-69; illustr., *Avante Garde Magazine,* 1969; illustr., *New Mexico Magazine,* 1969; illustr. of children's books for Macmillan & Crowell Collier, 1969-70; contrib., *Western Review,* 1972. Teaching: Maryland Inst. College Art, summer 1968. **Sources:** WW73.

WAGNER, Karl *[Painter] early 20th c.*
Addresses: Chicago area. **Exhibited:** AIC, 1930. **Sources:** Falk, *AIC.*

WAGNER, Lee A. *[Painter] early 20th c.*
Addresses: NYC. **Exhibited:** S. Indp. A., 1920. **Sources:** WW19.

WAGNER, Maria Louisa *[Miniature, portrait, landscape, still life & genre painter] b.c.1815 / d.c.1888, Norwich, NY.*
Exhibited: NAD, 1839-73; Brooklyn AA, 1863-72; Boston Athenaeum; Am. Art-Union; PAFA Ann., 1858-68, 1877, 1882-83 ("Deer in the Adirondacks" listed as by both Maria and Daniel). **Comments:** For many years, she and her brother Daniel Wagner (see entry) worked together as artists, beginning in their town of Norwich (in the Chenango Valley, NY), where they started as itinerant miniature painters. Together they worked in the Chenango Valley during the late thirties, visiting Binghamton, Utica, Whitestown, and Ithaca. With the help and encouragement of attorney William Seward (later Governor of New York), the sister and brother opened a studio in the state capital at Albany around1842, gaining many prestigious portrait commissions over the next twenty years, even traveling to Washington (DC) in 1852 to paint portraits of President Millard Fillmore's family. In 1862, Maria and Daniel moved to NYC and, while Daniel continued to paint portraits, both also took up landscape and floral still-life painting. Maria also began to exhibit genre scenes. About 1869 they moved to Newburgh (NY) and by 1871 they had returned to Norwich (NY). **Sources:** G&W; Norwich *Semi-Weekly Telegraph,* Jan. 25, 1888, obit. of Daniel Wagner (courtesy Anna Wells Rutledge); Cowdrey, NAD; Naylor, NAD; Swan, BA; Cowdrey, AA & AAU; Rutledge, PA, vol. 1; Falk, PA, vol. 2; *Antiques* (Jan. 1933), 12. More recently, see Gerdts, *Art Across America,* vol. 1, 185-86 (repro.) and Rubinstein, *American Women Artists,* 65-66.

WAGNER, Mary L. *[Painter] late 19th c.*
Addresses: Detroit, MI, 1878-83. **Exhibited:** locally; Michigan State Fair, 1878, 1879, 1883. **Comments:** Painted in watercolor & pastel. **Sources:** Gibson, *Artists of Early Michigan,* 232-233.

WAGNER, Mary North (Mrs. Frank H.) *[Painter, lecturer, writer, illustrator, book designer] b.1875, Milford, IN.*
Addresses: Chicago, IL/Saugatuck, MI/Milford, IN. **Studied:** J. Vanderpoel; F. Freer; W.M. Chase; F. Richardson; AIC. **Member:** Soc. Indep. Artists; Richmond (IN) AA; Hoosier Salon. **Exhibited:** Pan-Pacific Expo, San Francisco, 1915. **Comments:** Author/illustrator: "The Adventures of Jimmy Carrot," 1911; illustrator: "The Second Brownie Boo," by A.B. Benson. **Sources:** WW40.

WAGNER, May W. *[Painter] mid 20th c.; b.Chicago.*
Addresses: Rockport, MA. **Exhibited:** Allied Artists Am.; Sweat Mem. Mus., Portland, ME; Butler AI, Youngstown, OH; NAD. **Sources:** WW40.

WAGNER, Philip *[Lithographer] b.c.1811, Germany.*
Addresses: NYC, c.1843-49; Boston, 1850-53. **Sources:** G&W; 7 Census (1850), Mass., XXVI, 95; Boston CD 1852-53.

WAGNER, Richard Ellis *[Painter] b.1923, Trotwood, OH.*
Addresses: Telluride, CO. **Studied:** Antioch College; Dayton (OH) Art Inst.; Univ. Colorado (B.F.A. & M.F.A.). **Exhibited:** Recent Drawings, USA, MoMA, NYC, 1956; Art USA, Madison Square Garden, 1958; Boston Arts Festival, 1958, 1960 & 1962; Jefferson Arts Festival, New Orleans, LA, 1969; Youngstown Art Festival, Butler IA, 1970; Grand Central Art Gal., NYC, 1970s.

Awards: Purchase prizes, Denver Art Mus., 1950 & LOC, 1952; City of Manchester Award, Currier Gallery, Manchester, NH, 1956. **Work:** Denver Art Mus.; LOC; Dartmouth College, Hanover, NH; De Cordova Mus., Lincoln, MA; Rochester Mus., NY. Commissions: murals, Horizon House, Naples, FL, 1971. **Comments:** Preferred media: acrylics, oils. Publications: illustrator, *Ford Times,* 1958-70. Teaching: Dartmouth College, 1953-66. **Sources:** WW73.

WAGNER, Robert Leicester ("Rob") *[Portrait painter, illustrator, writer] b.1872, Detroit, MI / d.1942, Santa Barbara, CA.*
Addresses: Beverly Hills, CA. **Studied:** Univ. Michigan; Acad. Julian, Paris, 1893, 1902; Acad. Delecluse, Paris. **Member:** Calif. AC. **Exhibited:** Alaska-Yukon-Pacific Expo, Seattle, 1909 (medal); Pan-Pacific Expo, San Francisco, 1915 (medal); San Francisco AA, 1916. **Work:** Bohemian Club, San Francisco. **Comments:** Contributor: articles/illus., *Saturday Evening Post, Collier's, Liberty.* Editor: Rob Wagner's script. Also motion picture director. **Sources:** WW40; Hughes, *Artists of California,* 584.

WAGNER, Rosa A. *[Painter] early 20th c.*
Addresses: Rockville, MD. **Member:** Wash. WCC; Wash. AC. **Exhibited:** Wash. WCC, 1910-27; Soc. Wash. Artists, 1912, 1924; Greater Wash. Independent Exh., 1935. **Comments:** Preferred media: oil, watercolor. Specialty: floral still lifes. **Sources:** WW29; McMahan, *Artists of Washington, DC.*

WAGNER, Rudolph *[Lithographer] b.c.1836, Germany.*
Addresses: Philadelphia in 1860. **Comments:** His father, Joseph, was a hotel keeper who had come to Philadelphia before 1842. **Sources:** G&W; 8 Census (1860), Pa., LXII, 19.

WAGNER, S. Peter *[Painter, etcher, teacher] b.1878, Rockville, MD.*
Addresses: Rockville, MD. **Studied:** ASL; Corcoran Sch. Art; Grande Chaumière, Paris; & with Paul Pascall. **Member:** Pensacola AC; Wash. AC; AFA; Soc. Wash. Artists; SSAL; Landscape Club, Wash.; Wash. WCC; AWCS; Soc. Four Artists, Palm Beach, FL; St. Petersburg AC; Balt. WCC. **Exhibited:** AWCS; NYWCC; Landscape Club, Wash., DC, 1943 (prize), 1945 (prize); SC; Southern States Art Lg.; Maryland Inst.; Greater Wash. Independent Exh., 1935. Awards: Tampa AI, 1928; Florida Fed. Art, 1928, 1931, 1932. **Comments:** Positions: dir., Damariscotta Summer School of Art, Maine; dir., St. Petersburg Winter Sch. Art, 1938-44. **Sources:** WW59; WW47. More recently, see McMahan, *Artists of Washington, DC.*

WAGNER, Thomas S. *[Lithographer] mid 19th c.*
Addresses: Philadelphia, active 1840 to c.1865. **Comments:** A partner in Pinkerton, Wagner & McGuigan, 1844-45, and Wagner & McGuigan, 1846-58 (see entries). **Sources:** G&W; Phila. CD 1840-60+; Peters, *America on Stone.*

WAGNER, W. A. *[Engraver] mid 19th c.*
Comments: Engraver of one illustration in *Our World: or, The Slaveholder's Daughter* (N.Y., 1855). **Sources:** G&W; Hamilton, *Early American Book Illustrators and Wood Engravers,* 437.

WAGNER, William *[Engraver] mid 19th c.*
Addresses: York, PA. **Comments:** Active about 1820-60. His view of York Springs appeared in *Port Folio* in 1827. He was also the engraver of a portrait of the Rev. Jacob Goering (1755-1807) of York, the original of which is believed to have been painted by John Fischer (or Fisher). **Sources:** G&W; Stauffer; *Port Folio,* XLVII (1827), opp. 177; Penna. BD 1860.

WAGNER, William W. *[Engraver] b.c.1817, Pennsylvania.*
Addresses: Philadelphia from 1845 to after 1860. **Comments:** Active in the firm of Wagner & Stuart (see entry). **Sources:** G&W; 7 Census (1850), Pa., LV, 615; Phila. CD 1845-60+.

WAGNER & MCGUIGAN *[Lithographers] mid 19th c.*
Addresses: Philadelphia, 1846-58. **Comments:** Partners were Thomas S. Wagner and James McGuigan (see entries). This firm succeeded Pinkerton, Wagner & McGuigan (see entry). **Sources:**

G&W; Phila. CD 1846-58.

WAGNER & STUART *[General engravers, lithographic engravers, die sinkers] mid 19th c.*
Addresses: Philadelphia, 1845 until after 1860. **Comments:** Partners were William W. Wagner and Albert Stuart (see entries). **Sources:** G&W; Phila. CD 1845-60+.

WAGONER, Annie Resser *[Painter] 19th/20th c.*
Work: Chester Co. Hist. Soc., West Chester, PA (painting of old stone house, c.1892-1900). **Sources:** Petteys, *Dictionary of Women Artists.*

WAGONER, Charles *[Lithographer] b.c.1824, Germany.*
Addresses: Pittsburgh, PA in 1850. **Comments:** Cf. Wegner & Buechner. **Sources:** G&W; 7 Census (1850), Pa., III, 74.

WAGONER, Harry B.
[Landscape painter, sculptor] b.1889, Rochester, IN / d.1950, Phoenix, AZ. HBWAGONER
Addresses: Altadena, CA/Chicago/Palm Springs, CA. **Studied:** Homer Pollock; Paris. **Member:** Int. Soc. Sculptors; Pasadena S&P; Hoosier Salon; Int. Soc. SP&G. **Exhibited:** Stendahl Gallery, Los Angeles, CA, 1927. **Comments:** Known as a painter of desert landscape, since late 1920s. **Sources:** WW33; P&H Samuels, 507.

WAGONER, Robert *[Painter] b.1928, Marion, OH.*
Addresses: Long Beach, CA in 1968. **Comments:** Also a songwriter. **Sources:** P&H Samuels, 507.

WAGSTAFF, Charles Edward *[Portrait engraver on copper] b.1808, London.*
Addresses: Boston, c.1840-50s. **Comments:** Associate of Joseph Andrews (see entry). **Sources:** G&W; Stauffer; Boston CD 1851-52.

WAGSTAFF, John C. *[Miniaturist] mid 19th c.*
Addresses: NYC. **Exhibited:** American Inst., 1845 (miniature on ivory). **Sources:** G&W; Am. Inst. Cat., 1845.

WAGSTAFF, Myrtle *[Painter] late 19th c.*
Work: private collection, Moscow, ID (still life, c.1886). **Sources:** Petteys, *Dictionary of Women Artists.*

WAH, Bernard *[Painter] b.1939, Haiti.*
Studied: Centre de Ceramique, Port-Au-Prince, Haiti; Grande Chaumière, Paris. **Exhibited:** Calfou AC, Haiti, 1964; Studio Mus., Harlem, 1969. **Sources:** Cederholm, *Afro-American Artists.*

WAHL, Bernhard O. *[Painter] b.1888, Lardal, Norway.*
Addresses: Brooklyn 32, NY. **Studied:** Acad. Art, Oslo, Norway. **Member:** Norwegian Art & Crafts Club, Brooklyn, NY (co-founder, pres.); Brooklyn Soc. Artists; New Jersey P&S. **Exhibited:** BM, 1943-51; Riverside Mus., 1947, 1949-50; Vendome Gal., 1942; Staten Island Inst. Arts & Sciences, 1942, 1947; Jersey City Mus., 1947; Pan-Am. Gal., NY, 1945; Argent Gal., 1948; Hofstra College, 1945; Long Island Art Festival, 1946. **Sources:** WW59; WW47.

WAHL, Harold *[Painter, cartoonist] b.1898, Melrose, MN.*
Addresses: Bellingham, WA, 1903, 1953. **Studied:** Chicago Acad. FA. **Exhibited:** SAM, 1953, 1957; Governors Invitational Art Show, 1966; Frye Mus.; NYC. **Comments:** Position: cartoonist, McClatchy newspapers, CA; business exec., Bellingham, WA, retired 1948, to devote full time to painting. **Sources:** Trip and Cook, *Washington State Art and Artists, 1850-1950.*

WAHL, Joyce *[Painter] mid 20th c.*
Addresses: Chicago area. **Exhibited:** AIC, 1945. **Sources:** Falk, *AIC.*

WAHL, Theodore *[Lithographer, painter] b.1904, Dillon, KS / d.1993, Milford, NJ.*
Addresses: Milford, NJ. **Studied:** K. Mattern; A. Bloch; Univ. Kansas; L. Nye; R. Braught, Kansas City AI; Bolton Brown. **Member:** Delaware Valley AA; Hunterdon County AC. **Exhibited:** CM, 1950-52; Midwestern Art Exh., 1932-1936;

Grant Studio, 1937-39; Contemp. Artists, 1938; Indiana MOMA, 1940; New Hope, PA, 1949-56; Delaware Valley AA, 1946-58; Newark Art Fair, 1940; SAGA, 1953; Hunterdon AC, 1953-58. Awards: Midwestern Art Exhi., 1933 (medal); Kansas City AI, 1933 (gold). **Work:** Brooklyn Pub. Lib.; Hunter College; Univ. Louisiana; Univ. Wisconsin; NYPL; Smithsonian Inst.; Princeton Pr. Club; Newark MA. **Comments:** Position: head printer of lith., WPA, NYC; instr., Riegel Ridge, Milford, NJ, 1947-57. **Sources:** WW59; WW40.

WAHLBERG, Ruth *[Painter] mid 20th c.*
Addresses: Chicago area. **Exhibited:** AIC, 1947-50 (prize, 1947). **Sources:** Falk, *AIC.*

WAHLERT, Ernst Henry *[Sculptor, painter, teacher] b.1920, St. Louis, MO.*
Addresses: Dallas, TX; Denton, TX. **Studied:** Virginia Military Inst. (B.A.); Southern Methodist Univ. (M.A.); Temple Univ. (M.F.A.); Boris Blai; Raphael Sabatini; Raoul Josset. **Exhibited:** Tyler Sch. Fine Art Alumni exh.; New York Coliseum, 1956. **Work:** mural, President's Hall, Tyler Sch. FA, Phila., PA. **Comments:** Positions: instructor, art educ., Grand Prairie (TX) Public Schools, 4 years; Dallas Public Schools, 2 years; North Texas State College, 3 years. Author/illustr., instruction manual, "Technique of Making Rubber Molds of Sculptural Works," 1953-54. **Sources:** WW59.

WAHLMANN, Frederick *[Engraver, die sinker] mid 19th c.*
Addresses: NYC, 1849-54. **Sources:** G&W; NYBD 1849, 1854.

WAIDA, Robert *[Painter] early 20th c.*
Addresses: NYC. **Exhibited:** S. Indp. A., 1925. **Sources:** Marlor, *Soc. Indp. Artists.*

WAINRIGHT, Charles N. See: **FOX, R. Atkinson**

WAINWRIGHT, Anita Austin Jacobs *[Painter] b.1889, Greenwich, CT / d.1968, Berkeley, CA.*
Addresses: Greenwich, CT; Palo Alto, Berkeley, Carmel, CA. **Studied:** Rye, NY, Seminary; Cooper Union; ASL; School of Applied Des. for Women. **Member:** Carmel AA. **Exhibited:** Palo Alto AC, 1923. **Comments:** Married to Samuel Wainwright (see entry). Specialty: floral studies. Preferred medium: pastel. **Sources:** Hughes, *Artists of California,* 584-585.

WAINWRIGHT, Christine A. (Mrs. George) *[Landscape painter] 19th/20th c.*
Addresses: Seattle, WA. **Exhibited:** Wash. State Arts & Crafts, 1909. **Sources:** WW24; Trip and Cook, *Washington State Art and Artists,* 1850-1950.

WAINWRIGHT, Jeannette Harvey *[Painter] early 20th c.*
Addresses: Indianapolis, IN. **Sources:** WW24.

WAINWRIGHT, S. (amuel) H., Jr. *[Painter] b.1893, Kobe, Japan / d.1969, Casper, WY.*
Addresses: Greenwich, CT; Palo Alto, Berkely, Carmel, CA; Casper, WY. **Studied:** Japan; Washington Univ., St. Louis, MO; Columbia Univ.; NY Sch. FA. **Member:** Greenwich SA. **Exhibited:** Palo Alto AC, 1923; Oakland Art Gallery, 1942. **Comments:** Preferred medium: oil and pastel. **Sources:** WW25; Hughes, *Artists of California,* 585.

WAIT, Blanche E. *[Painter] b.1895 / d.1934.*
Addresses: Cincinnati, OH. **Member:** Cincinnati Women's AC. **Sources:** WW19.

WAIT, Carrie Stow (Mrs. Horace C.) *[Landscape painter, illustrator, writer] b.1851, New Haven, CT.*
Addresses: NYC. **Studied:** R.H. Nicholls, in NYC; A. Nugenholtz, in Holland. **Exhibited:** AIC, 1891-92. **Comments:** Specialty: watercolors. **Sources:** WW08.

WAIT, Erskine L. *[Painter] d.1898, Rahway, NJ.*
Addresses: Paris, 1885; Brooklyn, NY, 1886. **Member:** Brooklyn AC. **Exhibited:** NAD, 1885-86.

WAIT, Florence G. *[Painter] late 19th c.*
Addresses: NYC, 1885. **Studied:** with Homo. **Exhibited:** Paris

Salon, 1882, 1883 (drawings); NAD, 1885. **Sources:** Fink, *American Art at the Nineteenth-Century Paris Salons,* 401.

WAIT, Lizzie Frances *[Painter, craftsperson, teacher] 19th/20th c.; b.Boston.*
Addresses: Kingston, NY. **Studied:** BMFA Sch. with Tarbell, De Camp, Major, Benson. **Member:** Copley Soc., 1887. **Exhibited:** Boston AC, 1894-1907; AIC, 1901; PAFA Ann., 1904; Poland Springs (ME) Art Gal.; Trans-Mississippi Expo, Omaha; RISD; NYWCC; AIC. **Comments:** Preferred media: oil, watercolor. Drawing teacher, Groton (MA) School, 1893-1902. **Sources:** WW10; Petteys, *Dictionary of Women Artists;* Falk, *Exh. Record Series.*

WAITE, Alice L. *[Painter] late 19th c.*
Addresses: Toledo, OH. **Exhibited:** AIC, 1896. **Sources:** Falk, *AIC.*

WAITE, Blanche E. *[Painter] b.1895 / d.1934, Cihcinnati, OH.*
Addresses: Cincinnati. **Studied:** Duveneck & Meakin. **Member:** Cincinnati Woman's Art Club. **Exhibited:** Cincinnati Woman's Art Club. **Sources:** Petteys, *Dictionary of Women Artists.*

WAITE, Charles W. *[Painter] early 20th c.*
Addresses: Cincinnati, OH. **Studied:** Ohio Mechanics' Inst.; Duveneck. **Member:** Cincinnati AC. **Sources:** WW29.

WAITE, Clara Turnbull *[Painter] early 20th c.*
Addresses: Baltimore, MD. **Member:** Baltimore WCC. **Sources:** WW25.

WAITE, Emily Burling *[Painter, etcher, lecturer, writer] b.1887, Worcester, MA / d.1962.* EMILY BURLING WAITE
Addresses: Worcester, Boston, MA/Wash., DC, active 1920s, 1930s. **Studied:** WMA School; ASL; BMFA School; F. Luis Mora; Frank DuMond; Philip Hale; BMFA Sch. traveling scholarship to England, France, Belgium, Holland, Germany, Austria, Italy, Spain. **Member:** North Shore AA (charter mem.); NAWA; Newport AA; SAGA; Gld. Boston Artists; Am. Veterans Soc. Artists; AAPL; Worcester Gld. Artists & Craftsmen; SAE; SAGA; Chicago SE; Boston Soc. Arts & Crafts; Lg. Am. Pen Women; Wash. WCC. **Exhibited:** PAFA Ann., 1913-14, 1918; Pan.-Pacific Expo, 1915 (silver med.); Soc.Indep. Artists, 1917; Wash. WCC; Soc. Wash. Artists; Wash. AC; Corcoran Gal. biennials, 1912, 1914; NAD; SAGA, 1946; Chicago SE, 1945; Worcester County Artists, 1945; North Shore AA, 1946, 1955, 1958; Newport AA, 1946, 1955; Boston Soc. Arts & Crafts; AAPL, 1958; Worcester Gld. Artists & Craftsmen, 1958; Gld. Boston Artists, 1955, 1957-58; SAGA, 1955, 1958 (all solos); Chicago, 1955, NAWA. Other awards: award of merit, Am. Veteran's Soc. Artists, 1955; prizes, Lg. Am. Pen Women. **Work:** Clark Univ., Worcester, MA; Tufts College, Medford, MA; BMFA; Smithsonian Inst.; LOC; MMA; FMA; Episcopal Theological Sch., Cambridge, MA; WMA; Worcester City Hall. **Comments:** Lectures: Mechanics of Etching; History of Etching. Also appears as Mrs. Emily Burling Waite Manchester. **Sources:** WW59; McMahan, *Artists of Washington, DC;* Falk, *Exh. Record Series;* info. courtesy North Shore AA.

WAITE, Laura *[Oil & china painter] b.1891 / d.1978, Sterling, CO.*
Addresses: Logan County, CO. **Exhibited:** locally. **Sources:** Petteys, *Dictionary of Women Artists.*

WAITE, Lucretia Ann See: **CHANDLER, Lucretia Ann Waite (Mrs. Joseph)**

WAITE, Sarah Lenora *[Painter] 20th c.; b.Staten Island, NY.*
Addresses: Berkeley, CA. **Studied:** Univ. of Arts & Sciences, Toledo, OH; Cooper Union; Univ. of Chicago; Calif. College Arts & Crafts. **Exhibited:** San Francisco AA, 1903. **Comments:** Contrib.: *Life* magazine, *San Francisco Chronicle.* Teaching: Union H.S., Watsonville, CA, 1920s, 1930s. **Sources:** Hughes, *Artists of California,* 585.

WAITE, William J. *[Painter] early 20th c.*
Addresses: Worcester, MA. **Sources:** WW24.

WAITES, Edward P. *[Engraver] mid 19th c.*
Addresses: NYC, 1847-54. **Sources:** G&W; Am. Inst. Cat., 1847; NYBD 1854.

WAITT, Benjamin Franklin *[Wood engraver, sculptor]*
b.1817, Malden, MA.
Addresses: Philadelphia, c.1845-84. **Comments:** He was listed as a sculptor in the 1860 Census and the 1860 and 1862 directories; otherwise as an engraver and lithographer (1870). **Sources:** G&W; Corey, *The Waite Family of Malden, Mass.,* 67; Phila. CD 1845-84; 8 Census (1860) Pa., L, 498; Hamilton, *Early American Book Illustrators and Wood Engravers,* 530; 7 Census (1850), Pa., LII, 793, as Benjamin F. Watt, sculptor.

WAITT, Marian Parkhurst See: **SLOANE, Marian Parkhurst Webber Waitt (Mrs. George)**

WAITZ, Henry F. *[Painter] early 20th c.*
Addresses: Phila., PA. **Exhibited:** PAFA Ann., 1930. **Sources:** Falk, *Exh. Record Series.*

WAKEFIELD, A. B. (Miss) *[Painter] mid 19th c.*
Addresses: Portland, ME. **Studied:** perhaps with Charles Codman. **Comments:** Known for a landscape painted 1856 in the style of Chas. Codman. **Sources:** Petteys, *Dictionary of Women Artists.*

WAKEFIELD, J. E. *[Portrait & miniature painter] early 19th c.*
Comments: Advertised in *Norwalk Huron Reflector* in 1831, after returning from painting in Europe. **Sources:** Hageman, 123.

WAKEFIELD, James Antoine *[Painter] early 20th c.*
Addresses: New Orleans, active c.1915. **Exhibited:** NOAA, 1915. **Sources:** *Encyclopaedia of New Orleans Artists,* 397.

WAKEFIELD, Ruth See: **CRAVATH, Ruth (Mrs. Ruth Cravath Wakefield)**

WAKELAW, Frederick *[Engraver] b.c.1829, England.*
Addresses: Cincinnati, 1850. **Comments:** Lived with his father, William J. Wakelaw (see entry) in 1850. **Sources:** G&W; 7 Census (1850), Ohio, XXI, 662.

WAKELAW, William J. *[Engraver] b.c.1797, England.*
Addresses: Cincinnati in 1850. **Comments:** All of his children, ages 11 to 21 in 1850, were born in England. His eldest son, Frederick (see entry), was also an engraver. **Sources:** G&W; 7 Census (1850), Ohio, XXI, 662.

WAKEM, Mabel J. *[Painter] b.1879, Chicago, IL.*
Addresses: Wash., DC, active, c.1919-35; Chicago, IL. **Studied:** NYC, with C. Hawthorne, H. Breckenridge, R. Davey. **Member:** Wash. AC. **Exhibited:** Soc. Wash. Artists; Soc. Indep. Artists. **Sources:** McMahan, *Artists of Washington, DC.*

WAKEMAN, Clara *[Artist] late 19th c.*
Addresses: NYC, 1889. **Exhibited:** NAD, 1889. **Sources:** Naylor, *NAD.*

WAKEMAN, Marion D. Freeman (Mrs. Seth) *[Painter, etcher] b.1891, Montclair, NJ / d.1953, Northampton, MA/Martha's Vineyard, MA.*
Addresses: Northampton, MA/Martha's Vineyard, MA. **Studied:** Smith College (B.A.) with Tryon; in Switzerland; ASL with DuMond, Luks, Pennell, Hawthorne. **Member:** NAWA. **Exhibited:** NAD; Arch. Lg.; PAFA Ann., 1938; NAWA, annually (prize, 1942); Montclair Art Mus.; Smith College, 1938, 1948 (solo). **Work:** Smith College Mus. **Comments:** Illustrator: *The Curious Lobster,* 1937; *The Curious Lobster's Island,* 1939. **Sources:** WW53; WW47; Falk, *Exh. Record Series.*

WAKEMAN, R(obert) C(arlton) *[Sculptor] b.1889, Norwalk / d.1964, N. Haverhill, NJ.*
Addresses: Norwalk, CT. **Studied:** L. Lawrie; Yale; BAID. **Member:** NSS; NAC; Silvermine GA. **Exhibited:** Nat.

Aeronautic Assn., Wash., DC(prize); Brown and Bigelow medal. **Work:** Southern School Photog., McMinnville, TN; Dotha Stone Prineo Mem., Norwalk Pub. Lib., Masonic Temple, all in Norwalk; H.S., New Canaan, CT; U.S. Naval Acad., Annapolis, MD; Bok Singing Tower, Mountain Lake, FL; Dept. Justice Bldg., Wash., DC. **Comments:** WPA artist. **Sources:** WW40.

WAKEMAN, Thomas *[Watercolorist] b.1812, England / d.1878, Rome.*
Comments: Visited America about 1850 and painted over forty views of cities and towns from Boston south to Washington. Stokes states that Wakeman was a scene painter by profession. **Sources:** G&W; Mallett, supplement; Stokes, *Historical Prints; Antiques* (Oct. 1936), 174; Sotheby & Co., auction catalogue, June 18-21, 1951, pp. 12-14.

WAKEN, Mabel J. *[Painter] b.1879, Chicago, IL.*
Addresses: Chicago, IL/East Gloucester, MA. **Studied:** C. Hawthorne; H. Breckenridge; R. Davey. **Member:** Chicago AC; Wash. AC. **Exhibited:** Soc. Indep. Artists, 1935; Wash. DC art groups. **Sources:** WW33.

WAKWITZ, Ernest H. *[Painter] b.1894, Choctaw Indian Territory, OK / d.1977, Wash., DC.*
Addresses: Pueblo, CO, 1907-c.1914; Cleary, AK; Wash., DC area, 1930s and after. **Studied:** Univ. Denver. **Comments:** Born of German parents, he spent several years in his homeland, returning to the U.S. in 1907. Served with a British infantry unit during WWI, after which he worked as a trapper and artist. His paintings decorated the plane flown in the first around-the-world flight by Wiley Post and Harold Gatty in 1931. He himself made one of the first radio broadcasts from an airplane in 1934. Later he conducted art workshops in the Wash., DC area. **Sources:** McMahan, *Artists of Washington, DC.*

WALANKEE See: **RED CORN, James (Jim) Lacy**

WALBERG, Louise *[Landscape painter] 19th/20th c.*
Addresses: San Juan County, WA, 1909. **Exhibited:** Alaska Yukon Pacific Expo, 1909. **Sources:** Trip and Cook, *Washington State Art and Artists,* 1850-1950.

WALBURNE, Rand *[Painter] early 20th c.*
Addresses: Knoxville, TN. **Sources:** WW13.

WALCHER, Ferdinand Edward *[Painter] b.1895 / d.1955.*
Sources: advertisement for rediscovery exh., Jack Parker FA, St. Louis (1991).

WALCOFF, Muriel *[Painter] mid 20th c.*
Addresses: NYC. **Exhibited:** PAFA Ann., 1936 (landscape); WFNY, 1939. **Sources:** WW40; Falk, *Exh. Record Series.*

WALCOT, William E. *[Etcher] early 20th c.*
Addresses: NYC. **Studied:** Académie Julian, Paris with Bouguereau & Ferrier, 1904. **Member:** Calif. PM. **Sources:** WW25; Fehrer, The Julian Academy.

WALCOTT, Anabel "Belle" Havens (Mrs. Harry M.) *[Painter] b.1870, Havens Corners, Franklin Co., OH.*
Addresses: Newark, OH, 1901; Rutherford, NJ, 1940; Coronado, CA. **Studied:** ASL; Chase School Art; Whistler; Acad. Colarossi; Holland. **Exhibited:** Phila. Acad.; PAFA, 1901, 1904; AIC; NAD, 1903 (third Hallgarten prize); Paris Salon; St. Louis Expo. **Work:** St. Louis Club. **Sources:** WW59; Falk, *Exh. Record Series.*

WALCOTT, H(arry) M(ills) *[Painter, teacher] b.1870, Torrington, CT / d.1944, Coronado, CA.*
Addresses: Transbay, Coronado, CA (living in Rutherford, NJ, 1895, 1940). **Studied:** NAD; Académie Julian, Paris with J.P. Laurens & Constant, 1895-96. **Member:** ANA, 1903. **Exhibited:** Paris Salon, 1897-99 (prize, 1897); PAFA Ann., 1900-09, 1917; Pan-Am. Expo, Buffalo, 1901 (medal); Boston AC, 1902; SAA, 1902; NAD, 1895, 1903 (prize), 1904 (prize); CI, 1904 (prize); St. Louis Expo, 1904 (medal); Corcoran Gal. annual, 1907; Pan-Pacific Expo, San Francisco, 1915 (medal); AIC. **Work:** Richmond (IN) AA; Erie (PA) AA; Ohio State Univ., Columbus; Ohio Wesleyan Univ., Delaware; H.C. Frick Collection. **Sources:**

WW40; Fink, *American Art at the Nineteenth-Century Paris Salons*, 401; Falk, *Exh. Record Series.*

WALCOTT, Helen See: **YOUNG, Helen (Walcott)**

WALCOTT, Helen (Breese) *[Painter] b.1894, Rochester, NY.*
Addresses: Westport, CT. **Studied:** C.W. Hawthorne; E. Dickinson; J. Fraser. **Sources:** WW25.

WALCOTT, Mary Morris Vaux *[Painter, photographer] b.1860, Philadelphia, PA / d.1940, St. Andrews, NB.*
Addresses: Wash., DC, c.1914 and after. **Exhibited:** CGA; Smithsonian Inst.; Anderson Art Galleries, NYC; Na. Mus.Natural Hist., 1990; Nat. Mus. Am. Art, 1994 (incl. 50 botanical watercolors; photographic panoramas of the Rockies; 2 childhood sketchbooks). **Work:** Nat. Mus. Am. Art (700 works). **Comments:** Specialty: watercolors of flowering plants. Started painting as an eight year old child, inspired by the flora of the Canadian Rockies, where she spent many summers visiting her uncle, a mineralogist. Married Dr. Charles D. Walcott, sec. of the Smithsonian Inst. in 1914, and in 1925 more than 400 of her illustrations were published in the Smithsonian's *North American Wild Flowers.* **Sources:** McMahan, *Artists of Washington, DC.*

WALCOTT, Mattie *[Artist] late 19th c.*
Addresses: Active in Jackson, MI. **Exhibited:** Michigan State Fair, 1881. **Comments:** Probably daughter of Mrs. Mattie Walcott (see entry). Petteys, *Dictionary of Women Artists.*

WALCOTT, Mattie (Mrs. George D.) *[Artist] late 19th c.*
Addresses: Active in Jackson, MI. **Exhibited:** Michigan State Fair, 1877, 1881. **Comments:** Mother of Mattie Walcott (see entry). **Sources:** Petteys, *Dictionary of Women Artists.*

WALCUTT, David Broderick *[Portrait and landscape painter] b.1825, Columbus, OH.*
Addresses: Cincinnati as early as 1846; NYC, 1850; Cincinnati, 1858; St. Louis. **Exhibited:** Paris Salon, 1855; Am. Inst. **Comments:** Brother of George and William Walcutt (see entries) with whom he opened a small museum in Columbus, OH. **Sources:** G&W; Clark, *Ohio Art and Artists,* 114, 498; Cist, *Cincinnati in 1851;* NYBD 1850; Am. Inst. Cat., 1850; Cincinnati CD 1858, BD 1859; Fink, *American Art at the Nineteenth-Century Paris Salons,* 401.

WALCUTT, George *[Portrait and landscape painter] b.1825, Columbus, OH.*
Addresses: Columbus, OH; Kentucky. **Comments:** Brother of David B. and William Walcutt (see entries). **Sources:** G&W; Clark, *Ohio Art and Artists,* 114, 498; *Antiques* (March 1932), 152.

WALCUTT, William *[Sculptor and portrait painter] b.1819, Columbus, OH / d.1882.*
Addresses: Columbus, OH; NYC, c.1855, 1865; Cleveland, OH 1859-60. **Studied:** Columbus, NYC, Wash., DC; studied sculpture in London and Paris, 1852-55. **Exhibited:** NAD, 1865. **Comments:** Brother of David B. and George Walcutt (see entries). He began his artistic career as a portrait painter in Columbus in the early forties. On his return from Europe he opened a studio in NYC. In Cleveland (OH) he worked on his notable monument to Oliver Hazard Perry. For several years, he was employed by U.S. Customs to appraise imported artworks. His death date has been given as 1882 by Clark and 1895 by Gardner. **Sources:** G&W; Gardner, *Yankee Stonecutters,* 73; Clark, *Ohio Art and Artists,* 114, 139-40, 498; *Antiques* (March 1932), 152; Cist, *Cincinnati in 1851,* 204; Cowdrey, NAD; WPA (Ohio), *Annals of Cleveland;* Hamilton, *Early American Book Illustrators and Wood Engravers; Art Digest* (Jan. 15, 1935), 17.

WALD, Sylvia *[Painter] b.1914, Philadelphia, PA.*
Addresses: NYC. **Studied:** Moore Inst. Art, Phila. **Member:** AFA. **Exhibited:** WMAA, 1942, 1948, 1955; PAFA Ann., 1950, 1954; Second Biennial, São Paulo, 1953; Curator's Choice, Smithsonian Inst. & Tour US, 1954; AIC, 1940; 50 Years Am. Art, MoMA & Tour Europe, 1955; Am. Prints Today, 1962; U.S. Info Serv Show, Palacio Bellas Artes, Mexico, 1964; Tunnel Gallery,

NYC, 1970s. **Work:** MoMA; MMA; WMAA; NGA; BM. **Sources:** WW73; Seiberling, *Looking into Art* (Henry Holt, 1959); "The Art of Printmaking," *Master Prints from Nineteenth and Twentieth centuries* (LOC & Univ. Nebraska Art Gallery, 1966); Falk, *Exh. Record Series.*

WALDECK, C(arl) G(ustave) *[Portrait and landscape painter] b.1866, St. Charles, MO / d.1930.*
Addresses: Kirkwood, MO. **Studied:** Académie Julian, Paris with J.P. Laurens and B. Constant, 1894-96. **Member:** St. Louis AG; 2 x 4 Soc.; Officer d'Académie, Paris, 1904. **Exhibited:** Paris Salon, 1896; St. Louis Expo, 1904 (medal); Lewis & Clarke Expo, Portland, OR, 1905 (medal); PAFA Ann., 1908, 1912, 1918; MissouriState Expo. 1913 (gold); St. Louis AG, 1914 (prize), 1923 (prize); Soc. Western Artists, Indianapolis, 1914 (prize); St. Louis AL, 1915 (prize); St. Louis AM, 1906-47, 1923 (prize); AIC. **Sources:** WW29; Fink, *American Art at the Nineteenth-Century Paris Salons,* 401; Falk, *Exh. Record Series.*

WALDECK, Nina V. *[Painter, illustrator, etcher, teacher] b.1868, Cleveland, OH / d.1943.*
Addresses: Olmsted Falls, OH. **Studied:** W.M. Chase; M. Bohm; Académie Julian, Paris. **Member:** Orlando AA; Cleveland Women's AC; Woman's AA, Canada, 1894. **Work:** portrait, Women's Club, Cleveland; Ursuline Acad., Cleveland. **Sources:** WW40.

WALDEN, Dorothy DeLand (Mrs. Louis H.) *[Craftsperson] b.1893, Ovid, NY.*
Addresses: Norwichtown, CT. **Studied:** Rochester (NY) Athenaeum, Mechanics Inst.; Alfred Univ.; Cornell Univ.; Mt. Holyoke College. **Member:** Norwich AA; Soc. Conn. Craftsmen. **Comments:** Contributor: articles, "Weaving in the Summer Camp," *Handicrafter,* (May, June, 1930). **Sources:** WW40.

WALDEN, Ernest B. *[Painter, illustrator] b.1929 / d.1995.*
Studied: Dartmouth College; PAFA with Stuempfig, F. Watkins & H. Pitman after WWII. **Exhibited:** Springfield MFA, 1952 ; School Visual Arts, NYC, 1966; Audubon Artists, NAD, 1966; Phila. Print Shop, 1998 (solo). **Work:** Dartmouth College. **Comments:** Position: book jacket designer for Dodd Mead Pub., 1960s; chief artist for Gray's Watercolors, 1967-85. For his commercial work, he adopted the brush name "Davis Gray" after his favorite color, Davies' Gray. **Sources:** article, *Journal of the Print World* (Summer, 1998, p.36).

WALDEN, Jennelsie See: **HALLOWAY, M. Jennelsie Walden**

WALDEN, Lionel *[Marine painter] b.1861, Norwich, CT / d.1933, Chantilly, France.* **LIONEL WALDEN**
Addresses: Minnesota; Honolulu, HI/France. **Studied:** Carolus-Duran, in Paris. **Member:** AFA; NIAL; Paris SAP; Soc. Int. de Peinture et Sculpture, Paris. **Exhibited:** Crystal Palace Exh., London (medal); Paris Salon, 1887, 1888, 1890-91, 1893-99 (prize,1899), 1903 (medal); PAFA Ann., 1891, 1896-1914; Paris Expo, 1900 (medal); St. Louis Expo, 1904 (medal); Knight, French Legion of Honor, 1910; Pan-Corcoran Gal biennials, 1908, 1912; Pacific Expo, San Francisco, 1915 (medal); Chas. Cooke Home, Honolulu, 1917 (solo); Hawaiian Soc. Artists, 1917; Honolulu Art Soc., 1920; Honolulu Acad. Art, 1925; AIC. **Work:** Wilstach College, Phila.; Luxembourg Gal., Paris; Cardiff Mus., Wales.; Honolulu Acad. Art. **Comments:** Known in Paris as the "King of Bohemia." He arrived in Hawaii in 1911 and returned many times. Specialty: seascapes, but also made landscapes and volcano scenes. **Sources:** WW31; Forbes, *Encounters with Paradise,* 206-07, 209, 233-35; Fink, *American Art at the Nineteenth-Century Paris Salons,* 401; Falk, *Exh. Record Series.*

WALDEN, Louis Hart *[Craftsperson, teacher] b.1890, Scotland, CT.*
Addresses: Norwichtown, CT. **Member:** Norwich AA; Soc. Conn. Craftsmen. **Comments:** Teaching: Norwich Free Acad. & Walden School Handweaving, Norwichtown. **Sources:** WW40.

WALDEN, Mattie E. *[Artist] late 19th c.*
Addresses: Active in Saginaw, MI, 1877-85. **Sources:** Petteys, *Dictionary of Women Artists.*

WALDEN, Wanda Mathis *[Painter] b.1890, Newton, KS / d.1985, Los Angeles, CA.*
Addresses: St. Louis, MO; San Diego, CA. **Studied:** Everett G. Jackson in San Diego. **Exhibited:** GGE, 1939; San Diego Art Guild, 1936-41. **Sources:** Hughes, *Artists of California,* 585.

WALDHAUSER, Emile *[Lithographer, engraver] b.1859, Hungary / d.1908, New Orleans, LA.*
Addresses: New Orleans, active 1886-1908. **Sources:** *Encyclopaedia of New Orleans Artists,* 397.

WALDMAN, Paul *[Painter] b.1936, Erie, PA.*
Addresses: NYC. **Studied:** Brooklyn Mus. Art School; Pratt Inst. **Exhibited:** WMAA, 1967; Group Paintings & Prints, School Visual Arts, 1968; Second Kent (OH) Invitational, 1968; Group Show From Collection, Newark Mus, 1968; Dominant Female, Finch College Mus. Art, 1968; three shows, Knoedler Gallery, 1971. **Work:** paintings, New York Univ., Newark Mus. & White Mus., Cornell Univ.; drawing & lithographs, MoMA; sculpture collage, Rose Art Mus., Brandeis Univ. **Comments:** Positions: Ford Found. artist-in-residence, 1965. Teaching: Greenwich AC, spring 1963; New York Community College, 1963-64; Brooklyn Mus. Art School, 1963-67; Ohio State Univ., January, 1966; Univ. Calif., Davis, spring, 1966; School Visual Arts, 1966-. **Sources:** WW73.

WALDO, Edith Helena Mitchell *[Painter] b.1889, Canada / d.1973, Anaheim, CA.*
Addresses: Los Angles, CA. **Exhibited:** Santa Cruz Statewide, 1928; Artists Fiesta, Los Angeles, 1931; All-Calif. Show, 1939. **Sources:** Hughes, *Artists of California,* 585.

WALDO, E(ugene) L(oren) *[Painter, etcher, lithographer] b.1870, NYC.*
Addresses: Ponca City, OK. **Studied:** B. Sandzen. **Sources:** WW33.

WALDO, George Burrette *[Painter] late 19th c.*
Addresses: NYC, 1895, 1897. **Exhibited:** SNBA, 1894; NAD, 1895, 1897; SAA, 1898. **Sources:** WW98; Fink, *American Art at the Nineteenth-Century Paris Salons,* 401.

WALDO, Isabella Vaill *[Painter] b.1842, Bates County, MO / d.After 1900.*
Addresses: NYC, 1888-89. **Studied:** École Des Beaux Arts, 1883, with Charles Camino. **Exhibited:** Brooklyn AA, 1874-75, 1877, 1884; SNBA, 1883; NAD, 1888-89. **Comments:** Preferred medium: oil. **Sources:** Fink, *American Art at the Nineteenth-Century Paris Salons,* 401.

WALDO, J. Frank See: **WALDO, John Franklin**

WALDO, James Curtis *[Engraver, publisher] b.1835, Meredosia, IL / d.1901, New Orleans, LA.*
Addresses: New Orleans, active 1876-83. **Comments:** Had his own photoengraving business from 1876 and published numerous articles and pamphlets concerning N.O. **Sources:** *Encyclopaedia of New Orleans Artists,* 397.

WALDO, John Franklin *[Landscape and portrait painter, illustrator] b.1835, Chelsea, VT / d.1920, Los Angeles, CA.*
Addresses: Oshkosh, WI, 1864-84; Chicago, IL, 1884-94; Brooklyn, NY, 1898-1914. **Studied:** Chicago Acad. Des. with Henry Chapman Ford for a few months in 1871, but mostly self-taught. **Member:** Chicago Soc. Artists, 1889-93; Black & White Club, NYC. **Exhibited:** World's Ind. Expo, New Orleans, 1884-85; Milwaukee Ind. Expo, 1885; Chicago Soc. Artists, 1889, 1890, 1892 (Yerkes prize); AIC, 1891, 1892; NAD, 1899, 1903. **Work:** Oshkosh (WI) Public Mus. **Comments:** Preferred media: oil, watercolor, pen & ink. Teaching: Frank Bromley's School, Chicago, IL, 1886-88. He took sketching trips to Colorado and the Rocky Mountains, painting landscapes and scenes of American Indian life. **Sources:** info. courtesy of Edward P. Bentley,

Lansing, MI; BAI, courtesy Dr. Clark S. Marlor.

WALDO, Margaret J. *[Painter] early 20th c.*
Addresses: San Francisco, CA. **Exhibited:** S. Indp. A., 1923-24. **Sources:** Marlor, *Soc. Indp. Artists.*

WALDO, Ruth M(artindale) *[Painter] b.1890, Bridgeport, CT.*
Addresses: Plainfield, NJ. **Studied:** J. Lie; F.V. DuMond; C. Hawthorne. **Member:** Plainfield AA. **Sources:** WW33.

WALDO, Samuel Lovett *[Portrait painter] b.1783, Windham, CT / d.1861, NYC.*
Addresses: NYC (1809-on). **Studied:** Joseph Steward of Hartford, CT, c.1799; London, 1806-08, with B. West and J.S. Copley. **Member:** Am. Acad. FA (dir., 1817); NA, 1840-61 (founding member). **Exhibited:** NAD, 1861. **Work:** MMA ("Self Portrait" as well as works signed Waldo and Jewett); NY Hist. Soc.; NGA; Boston Athenaeum; Corcoran Gal. **Comments:** Waldo opened his own studio in Hartford in 1803 but soon after left for Litchfield, CT, and Charleston, SC, where he spent three years. From 1806-08 he worked and studied in London and on his return to America early in 1809, he opened a studio in NYC. About 1818 he went into partnership with his apprentice, William Jewett (see entry). Their firm, Waldo & Jewett (see entry), flourished for over thirty years until 1854, making it the longest-lived partnership of its kind in American art history. **Sources:** G&W; DAB; Sherman, "Samuel L. Waldo and William Jewett"; Rutledge, *Artists in the Life of Charleston;* Graves, *Dictionary;* NYCD 1811-60; Rutledge, PA; Cowdrey, AA & AAU; Cowdrey, NAD; Swan, BA; Dunlap, *History;* Karolik Cat.; N.Y. *Evening Post,* Feb. 18, 1861, and *The Crayon,* VII (1861), 98-99, obits. More recently, see Baigell and NYHS Catalogue (1974); Muller, *Paintings and Drawings at the Shelburne Museum,* 134-35 (w/repros.); Art in Conn.: *Early Days to the Gilded Age; 300 Years of American Art,* vol. 1, 95.

WALDO & JEWETT *[Portrait painters] mid 19th c.*
Addresses: Active NYC from c.1818-54. **Exhibited:** Am. Acad.; Apollo Assoc.; NAD; Artists Fund Soc. Phila. **Work:** MMA (several portraits signed Waldo & Jewett); NYHS. **Comments:** This was a highly successful partnership between Samuel L. Waldo and his former pupil William Jewett (see entries on each). They painted the portraits of many prominent New Yorkers during their thirty-odd years of activity. The works were often signed as Waldo & Jewett. Some scholars have believed that Waldo specialized in heads and hands and Jewett in costumes and backgrounds, but this is not absolutely accepted. **Sources:** G&W; NYCD 1820-54; Sherman, "Samuel L. Waldo and William Jewett"; Karolik Cat.; Cowdrey, AA & AAU; Cowdrey, NAD; Rutledge, PA; Vail, *Knickerbocker Birthday,* frontis. More recently, see Baigell and NYHS Catalogue (1974).

WALDRAFF, Charlotte S. *[Artist] early 20th c.*
Addresses: Active in Washgton, DC, 1917. **Sources:** Petteys, *Dictionary of Women Artists.*

WALDREN, William *[Painter, craftsperson] b.1924, NYC.*
Addresses: Mallorca, Spain. **Studied:** ASL; Acad. Julian, Paris, France, and in Spain. **Member:** ASL. **Exhibited:** MMA, 1952; Italy, 1953, 1955; Sarasota AA, 1952; Audubon Artists, 1955; Staten Island Inst. Arts & Sciences, 1955; Am. Painters in France, 1953; Galerie Craven, Paris, France (solo). Awards: purchase award, Bordighera, Italy, 1955; Audubon Artists, 1956. **Work:** Mus. Art, Bordighera, Italy. **Sources:** WW59.

WALDRON, Adelia (Mrs.) *[Listed as "oil painter"] b.c.1825, Kentucky.*
Addresses: San Francisco in 1860. **Comments:** Lived in San Francisco with her Vermont-born husband, Henry Waldron, merchant. **Sources:** G&W; 8 Census (1860), Cal., VII, 1400.

WALDRON, Anne A. *[Painter] b.New Brunswick, NJ / d.c.1955.*
Addresses: New Brunswick, NJ. **Studied:** Wellesley College; École des Beaux-Arts, Fontainebleau, France. **Member:** AWSC;

AAPL; Phila. Plastic Club; Balt. WCC; New Brunswick AC.
Exhibited: PAFA, 1925; AAPL; Balt. WCC; NAC; Irvington Art
Mus. Assn.; Montclair AA; Newark Art Club; AWCS, 1934, 1936,
1938, 1939; Fontainebleau Alumni, 1935; NYWCC, 1939; Phila.
Plastic Club. **Work:** Perth Amboy (NJ) Pub. Lib. **Sources:**
WW53; WW47.

WALDRON, J. (Miss) *[Painter] early 20th c.*
Exhibited: Salons of Am., 1934. **Sources:** Marlor, *Salons of Am.*

WALDRON, James MacKellar *[Curator, painter] b.1909,
Hazleton, PA / d.1974.*
Addresses: West Reading, PA. **Studied:** Kutztown State College
(B.S.); Tyler School Fine Arts, Temple Univ. (M.F.A.); Univ.
Calif., Los Angeles, summer 1937. **Member:** Int. Inst.
Conservation. **Exhibited:** Regional Exhs., Reading Pub. Mus. &
Art Gallery, 1936-69; Kutztown State College, 1949 (solo) &
Berks Art Alliance, Reading, PA, 1958 (solo). **Awards:** Gen.
Alumni Assn. Citation, Kutztown State College, 1961. **Work:**
Kutztown State College; Reading (PA) Pub. Mus. & Art Gal.;
Reading Mus., England; Wilson Public School, West Lawn, PA;
Gov. Mifflin Schools, Shillington, PA. **Commissions:** mural, First
Baptist Church, Reading, 1952. **Comments:** Positions: pres.,
county art supervisor, 1939-40; pres., Berks Art Alliance, 1950-
71. Publications: illustrator, "I Like You Because," PTA, West
Reading, 1947; illustrator, "Berks Country Stamp and Story,"
1948; illustrator, *Art Bulletin*, 1955; illustrator, *Berks County Hist.
Rev. Magazine.* Teaching: instructor/supervisor art, West Reading
(PA) School District, 1936-58; adjunct instructor art, Kutztown
State College, 1950-58; curator art, Reading Mus. & Art Gal.,
1958-71. Collections arranged: over 100 exhs., Reading Pub. Mus.
& Art Gal., 1958-68. Collection: drawings, paintings, lithographs
& etchings by contemporary and local artists, including Marlin,
Kuhns, Cadmus, Dehn, Kenneth Hayes Miller, Boardman
Robinson, Conrad Roland & Earl Poole. Research: Pennsylvania
German art. **Sources:** WW73.

WALDVOGEL, Emma (Mrs. Henry Ragan) *[Designer]
mid 20th c.; b.Schaffhansen, Switzerland.*
Addresses: Asilomar, CA. **Studied:** Kunstschule für Damen,
Zurich, Switzerland. **Comments:** Contributor to *House Beautiful.*
Sources: WW40.

WALE, T. *[Portraits in oil on wood] early 19th c.*
Addresses: White River Junction, VT, 1820. **Sources:** G&W;
Lipman and Winchester, 181.

WALES, Anna H. *[Portrait painter] 19th/20th c.*
Addresses: Whatcom County, WA, 1909. **Exhibited:** Alaska
Yukon Pacific Expo, 1909. **Sources:** Trip and Cook, *Washington
State Art and Artists,* 1850-1950.

WALES, Florence *[Painter] late 19th c.*
Addresses: Minnesota. **Exhibited:** AIC, 1894. **Sources:** Falk, *AIC.*

WALES, George Canning *[Marine painter, printmaker]
b.1868, Boston, MA / d.1940, Boston.*
Addresses: Brookline, MA. **Studied:** arch., MIT, 1885-88; etch-
ing with W.M. Paxton, 1917. **Member:** SAE; Boston GA.
Exhibited: Goodspeed's Boston, 1921 (first solo); Childs Gal.,
Boston, c.1988. **Work:** etchings, LOC; Nat. Mus.; NYPL;
Peabody Mus., Salem; Old Dartmouth His. Soc.; British Mus.,
Victoria and Albert Mus., both in London; Marine Mus., Boston;
Mus., Stavanger, Norway; Kendall Whaling Mus.; Mystic Seaport
Mus. **Comments:** He practiced architecture until 1924, but his
passion was capturing American ships in etching and lithography.
His prints date from 1918-35. In the mid 1930s he also designed a
series of ship plates for Wedgewood. Author/Illustrator: *Etchings
and Lithographs of American Ships* and *History of American
Sailing Ships.* He also contributed illustrations to *Yachting
Magazine,* and his prints appeared in *Fine Prints of the Year.*
Sources: WW40; exh. cat., Childs Gal. (Boston, n.d., c.1988).

WALES, Margaret Ager *[Painter] early 20th c.*
Addresses: NYC. **Exhibited:** S. Indp. A., 1930. **Sources:**
Marlor, *Soc. Indp. Artists.*

WALES, N. F. *[Portrait painter] early 19th c.*
Addresses: Charleston, SC, 1815. **Comments:** About 1810 he
painted portraits of Capt. and Mrs. Nathan Sage of Redfield (NY).
Sources: G&W; G&W has information courtesy Miss Mildred
Steinbach, FARL; Rutledge, *Artists in the Life of Charleston.*

WALES, Orlando G(ray) *[Painter, teacher] early 20th c.;
b.Phila., PA.*
Addresses: Allentown, PA. **Studied:** PAFA; W.M. Chase; A.
Mucha. **Member:** SC, 1908. **Exhibited:** AIC, 1906, 1909;
Corcoran Gal annual, 1907; S. Indp. A., 1919. **Sources:** WW33.

WALES, Susan M(akepeace) L(arkin) *[Landscape painter
(watercolorist)] b.1839, Boston / d.1927, Boston.*
Addresses: Boston, MA. **Studied:** W.M. Hunt; BMFA School;
Paris, with Carolus-Duran; V. Poveda, in Rome; Blommers, in
Holland. **Member:** Boston WCC; Copley Soc., 1879. **Exhibited:**
Boston WCC; Boston AC, 1876-86; PAFA Ann., 1892; AIC.
Sources: WW27; Falk, *Exh. Record Series.*

WALGREN, Anders Gustave *[Painter] early 20th c.*
Addresses: Rockford, IL. **Member:** Palette & Chisel Club,
Chicago. **Exhibited:** AIC, 1903-05. **Sources:** WW10.

WALINSKA, Anna (Mrs. Ossip) *[Painter, teacher] b.1926,
London, England.*
Addresses: NYC. **Studied:** Andre L'Hote and at Grande
Chaumière, Paris; NAD; ASL. **Member:** NAWA; Am. Soc.
Contemp. Art; Painters in Casein. **Exhibited:** S. Indp. A., 1931;
Salons of Am., 1932; PAFA Ann., 1935, 1960; CMA; MMA;
MoMA 1956; BMA, 1959; other exhs., in England, France, Japan,
Israel, Burma and U.S.A.; Jewish Mus., 1957 (retrospective, solo);
Gres Gal., Wash., DC, 1958; Monede Gal., 1961. **Awards:** prizes,
NAWA, 1957; Silvermine Gld. Artists, 1957; Am. Soc. Contemp.
Art, 1960 (2). **Work:** Newark Mus.; Riverside Mus., NY; Jewish
Mus., NY; Tel-Aviv Mus.; mus. of Safad and the Sholom Asch
Mus., Bat-Yam, Israel. **Comments:** Teaching: Master Inst. United
Arts, NYC, 1957-. Illustrator: "The Merry Communist"; "The
Gate Breakers", 1963. Marlor lists birth date as 1908-11.
Sources: WW66; Falk, *Exh. Record Series.*

WALINSKA, Rosa Newman (Mrs. Ossip) *[Sculptor, writer,
lecturer] b.1890, Russia / d.1953, NYC.*
Addresses: New York 25, NY. **Studied:** ASL; Robert Laurent;
Alexander Archipenko. **Member:** NAWA; AAPL; Lg. Present-
Day Artists. **Exhibited:** Salons of Am., 1932; WFNY 1939; Soc.
Indep. Artists, 1939; Am.-British AC; NAWA; Riverside Mus.;
New Sch. Soc. Research; Gld. Artists Gal.; Anderson Gal.;
Delphic Art Gal., 1939 (solo). **Work:** Plaque, Women's Peace
Soc., NY; mem., Lynn, MA. **Comments:** Author: "Ink and Clay,"
1942. Lectures: modern art & poetry. **Sources:** WW53; WW47;
Petteys, *Dictionary of Women Artists,* gives 1887 as an alternate
birth date.

WALKE, Henry *[Naval combat artist] b.1808, Virginia /
d.1896, Brooklyn, NY.*
Exhibited: Brooklyn AA, 1878. **Work:** Peabody Mus., Salem;
U.S. Navla Acad.; FDR Lib., Hyde Park, NY. **Comments:** His
surviving watercolors are almost all marine or naval scenes.
Walke entered the U.S. Navy in 1827 and retired with the rank of
rear-admiral in 1871. His earliest dated paintng (1837) was made
while aboard the U.S.S. *North Carolina.* His Mexican and Civil
War sketches were lithographed and published in *Naval Scenes in
the Mexican War* (1847-48) and Naval Scenes and Reminiscences
of the Civil War (1877). **Sources:** G&W; *Album of American
Battle Art,* 137-38; Perry, Expedition to Japan; Ramsay, "The
American Scene in Lithograph, The Album," 183; *Magazine of
Art* (March 1944), 108; Forbes, *Encounters with Paradise,* 124-
25; Brewington, 402.

WALKEER, Mary Simpson *[Artist] late 19th c.*
Comments: Active 1889. **Sources:** Petteys, *Dictionary of Women
Artists.*

WALKER *[Scene painter] mid 19th c.*
Addresses: NYC. **Comments:** At the Park Theatre in the 1827-28

and 1829-30 seasons and at the Olympic Theatre, NYC, in 1837. He also painted three scenes for Hanington in 1836-37. **Sources:** G&W; Odell, *Annals of the New York Stage;* N.Y. *Herald,* Dec. 7 and 22, 1836, and March 28, 1837 (G&W has information courtesy J. Earl Arrington).

WALKER, A. M. (Miss?) *[Marine and landscape painter] mid 19th c.*
Addresses: Philadelphia, 1840-44. **Exhibited:** PAFA, 1840-45; Artists' Fund Soc.; Apollo Assoc. (views in Pennsylvania, New Jersey, and NYC, plus a number of pictures of American naval vessels on Mediterranean and American seas). **Comments:** Her address in 1840-42 was the same as that of Miss E. Walker and Samuel G. Walker, secretary of the Fire and Inland Insurance Company. A.M. Walker, "gent.," is listed in Philadelphia directories, 1845-47. **Sources:** G&W; Rutledge, PA [as Miss A.M. Walker]; Cowdrey, AA & AAU [as A.M. Walker]; *American Collector* (June 1948), frontis.; Phila. CD 1840-46; Brewington, 402.

WALKER, A(lanson) B(urton)
[Cartoonist, illustrator] b.1878, Binghamton, NY / d.1947. *A.B.W.*
Addresses: Milford, CT. **Studied:** K. Cox.; B. Burroughs; C. Curran; F.V. DuMond. **Member:** SI. **Comments:** Contributor: illus./cartoons, *Life, Judge, Harper's, Scribner's, Century, The American Golfer, St. Nicholas;* book jackets for Harper's, Dodd Mead & Co., D. Appleton-Century, Payson & Clarke. **Sources:** WW40.

WALKER, Alice J. *[Painter] early 20th c.*
Addresses: New Haven, CT. **Member:** New Haven PCC. **Sources:** WW25.

WALKER, Angie *[Painter] 19th/20th c.; b.Boston, MA.*
Addresses: Cambridge, MA. **Exhibited:** SNBA, 1896; Boston AC, 1898. **Sources:** WW98; Fink, *American Art at the Nineteenth-Century Paris Salons,* 401.

WALKER, Anne *[Painter] early 20th c.*
Addresses: Baltimore, MD. **Comments:** Snallygaster artist, she is known to have painted with Charles Walther (see entry) in 1927 with his Middletown, MD, summer sketching class. **Sources:** WW25; exh. pamphlet, *Charles H. Walther: Maryland Modernist and the Snallygaster School* (Hagerstown, MD: Wash. County Mus. of FA, 1999).

WALKER, Annie E. A. *[Painter] b.1855, Alabama / d.1929.*
Addresses: Wash., DC, active 1901-1902, possibly longer. **Studied:** CUA Sch.; Julian Academy, Paris. **Exhibited:** Paris Salon, 1896; Howard Univ., 1937, 1950, 1952, 1967, 1970. **Work:** Howard Univ. Gal. Art; Nat. Mus. Am. Art. **Sources:** McMahan, *Artists of Washington, DC;* Cederholm, *Afro-American Artists.*

WALKER, Bryant *[Painter, attorney] b.1856.*
Addresses: Detroit, MI, 1881-1900 and after. **Member:** Founder's Soc., Detroit Mus. of Art. **Exhibited:** Michigan Artists Spring Show, 1879. **Sources:** Gibson, *Artists of Early Michigan,* 233.

WALKER, C. Bertram *[Painter] early 20th c.*
Addresses: Paris, France; Syracuse, NY. **Exhibited:** PAFA Ann., 1928. **Sources:** WW10; Falk, *Exh. Record Series.*

WALKER, C. W. *[Engraver on copper and wood] mid 19th c.*
Addresses: Buffalo, NY, 1858. **Sources:** G&W; Buffalo BD 1858.

WALKER, Challis (Mrs. J. J. Calendria) *[Sculptor] b.1913.*
Exhibited: S. Indp. A., 1941. **Sources:** Marlor, *Soc. Indp. Artists.*

WALKER, Charles Alvah *[Painter, etcher] b.1848, Loudon, NH / d.1920, Brookline, MA.* *C.H.Walker.*
Addresses: Boston, MA, 1885-92; Brookline, MA. **Studied:** self-taught. **Member:** Boston AC; London Print Sellers Assn.; Copley Soc., 1905. **Exhibited:** PAFA Ann., 1883, 1887; NAD, 1884-92;

Paris Salon, 1893 (two plates after Mauve and Daubigny, hon. mention); Boston AC, 1884-1909; Mass. Charitable Mechanic Assoc.; Corcoran Gal annuals/biennials, 1907-08, 1910; AIC. **Comments:** Developed the monotype process. While engaged in scientific research work at the Peabody Acad. Science at Salem he developed a talent for both wood and steel engraving. **Sources:** WW19; Campbell, *New Hampshire Scenery,* 169, who states his date of death in 1925; Falk, *Exh. Record Series.*

WALKER, Charles Howard *CHWalker*
[Painter, architect, illustrator, craftsperson, lecturer] b.1857, Boston, MA / d.1936.
Addresses: Boston, MA. **Member:** Boston SA; AIA, 1891; Copley Soc., 1903; Boston SAC (master craftsman); NAC; Printer's Soc., Boston. **Exhibited:** PAFA (gold); Arch.-in-Chief, Omaha Expo (gold); Cincinnati Mechanics' Assn. (medal); St. Louis Expo, 1904 (prize). **Comments:** Position: director, dept. des., BMFA. He was painting in Bermuda in the 1920s. **Sources:** WW10.

WALKER, Charles M. *[Painter] early 20th c.*
Addresses: Federalsburg, MD. **Exhibited:** S. Indp. A., 1924-25, 1927-28. **Sources:** Marlor, *Soc. Indp. Artists.*

WALKER, Charles Thomas *[Painter] late 19th c.*
Addresses: Chicago. **Exhibited:** AIC, 1897. **Sources:** Falk, *AIC.*

WALKER, Daniel *[Engraver] b.c.1827, Scotland.*
Addresses: NYC in 1860. **Comments:** Personal property valued at $2,000. **Sources:** G&W; 8 Census (1860), N.Y., XLIII, 405.

WALKER, Dickman *[Painter, sculptor] early 20th c.*
Addresses: Chicago area. **Exhibited:** AIC, 1932 (prize), 1933. **Sources:** Falk, *AIC.*

WALKER, Dugald Stewart See: **WALKER, Dugdale Steward**

WALKER, Dugdale Steward *[Illustrator, painter, designer, lithographer] b.1883, Richmond, VA / d.1937.*
Addresses: NYC. **Studied:** Richmond with A. Fletcher, H. Taliaferro Montague; G. Cootes, Summer School, Univ. Virginia; NY School Art; ASL. **Exhibited:** Calif.-Pacific Int. Expo, San Diego, 1935; AIC. **Work:** Valentine Mus., Richmond, VA; Virginia Mus. Art. **Comments:** Illustrator: "Hans Anderson's Fairy Tales," "Stories for Pictures," "The Gentlest Giant." **Sources:** WW33; Wright, *Artists in Virginia Before 1900; Hughes,* Artists in California.

WALKER, E. Barstow *[Painter] early 20th c.*
Exhibited: Salons of Am., 1929. **Sources:** Marlor, *Salons of Am.*

WALKER, E. L. *[Lithographic engraver] mid 19th c.*
Addresses: Philadelphia, 1856. **Sources:** G&W; Phila. BD 1856.

WALKER, E. Mildred *[Painter] early 20th c.*
Addresses: NYC. **Exhibited:** AIC, 1909-10. **Sources:** WW13.

WALKER, E. (Miss) *[Landscape painter] mid 19th c.*
Addresses: Philadelphia, PA. **Exhibited:** Artists' Fund Soc., 1840 (landscape after Joshua Shaw). **Comments:** She lived at the same address as A.M. Walker and Samuel G. Walker, secretary of the Fire and Inland Insurance Company. **Sources:** G&W; Artists' Fund Social Cat., 1840; Rutledge, PA [as Miss Elizabeth L. Walker].

WALKER, Earl *[Painter] b.1911, Indianapolis, IN.*
Studied: South Side Settlement House, Chicago, 1933-37. **Exhibited:** Art Craft Guild, Chicago, 1937; Fed. Project Gallery, 1938; Am. Negro Expo, Chicago, 1940; LOC, 1940; South Side Community AC, Chicago, 1941; Howard Univ., 1941; Fort Huachuca, AZ, 1943. **Comments:** WPA artist. **Sources:** Cederholm, *Afro-American Artists.*

WALKER, Elizabeth L. *[Primitive watercolorist] mid 19th c.*
Comments: Romantic watercolor scene, Massachusetts, 1840. **Sources:** G&W; Lipman and Winchester, 181.

WALKER, Eloise P. *[Painter] b.1864, LA.*
Addresses: New Orleans, active c.1889-1910. **Exhibited:** New

Orleans AA, 1889. **Sources:** *Encyclopaedia of New Orleans Artists,* 398.

WALKER, Emma J. *[Painter, teacher] 19th/20th c.*
Addresses: Wash., DC, active 1884-1920. **Comments:** Teaching: Annie E. Hoyle's School (later the Wash. School of Art and Design). **Sources:** McMahan, *Artists of Washington, DC.*

WALKER, Emma (Mrs. Lavenssler) *[Painter] b.c.1850, Montpelier, VT / d.1937.*
Addresses: Burlington, VT. **Studied:** self-taught. **Work:** Shelburne (VT) Mus. **Sources:** Muller, *Paintings and Drawings at the Shelburne Museum,* 135 (w/repro.).

WALKER, Ernest *[Painter] mid 20th c.*
Addresses: Phila., PA. **Exhibited:** PAFA, 1938; WMAA, 1939, 1941; AIC, 1939; WFNY, 1939. **Comments:** Affiliated with Phila. WCC. **Sources:** WW40.

WALKER, Ethel *[Painter] b.c.1861 / d.1951.*
Exhibited: AIC, 1930 (prize), 1931. **Sources:** Falk, *AIC.*

WALKER, Ethel Childe *[Painter] b.c.1865 / d.1885.*
Studied: Yale Art School for four years (one of the first women students). **Exhibited:** Yale Art School (posthumous). **Sources:** Petteys, *Dictionary of Women Artists.*

WALKER, Eveline *[Listed as "artist"] b.c.1827, Massachusetts.*
Addresses: NYC in 1860. **Sources:** G&W; 8 Census (1860), N.Y., LI, 703.

WALKER, F. Dula *[Painter] mid 20th c.*
Addresses: Chicago area. **Exhibited:** AIC, 1935. **Sources:** Falk, *AIC.*

WALKER, F. R. *[Painter] early 20th c.*
Addresses: Cleveland, OH. **Member:** Cleveland SA. **Sources:** WW29.

WALKER, Ferdinand G(raham) *[Painter] b.1859, Mitchell, IN / d.1927, New Albany, IN.*
Addresses: New Albany, IN. **Studied:** Académie Colarossi, Dagnan-Bouvret, Puvis de Chavannes, Blanche, Merson, all in Paris. **Member:** S. Indp. A.; Louisville AA; Chicago AG; Chicago NJSA; SSAL; Hoosier Salon. **Exhibited:** S. Indp. A., 1922, 1924. **Work:** Kentucky State Hist. Soc. Collection; Univ. Kentucky Art Mus., Lexington; Berea College; Agricultural College, MI; Lincoln Inst., Simpsonville, KY; Kentucky State Collection, Frankfort; State House, Indianapolis; Jefferson Davis Mem., Fairview, KY; Public Libraries, Louisville, Lexington, both in KY; New Albany, IN; Evansville College; Greenbrier College; Courier Journal Bldg., Univ. Louisville; public gallery, New Albany, IN; murals, St. Peter's Church, Louisville. **Comments:** Returned from Paris to settle in Washington, DC where he painted portraits of senators and congressmen. In the 1890s he established a studio in Louisville, where he worked as a portrait painter, although he occasionally painted landscapes and religious subjects. He retired in 1925. **Sources:** WW25; Jones and Weber, *The Kentucky Painter from the Frontier Era to the Great War,* 69-70 (w/repro.).

WALKER, Frances Antill L. *[Miniature painter] b.1872 / d.1916.*
Addresses: Brooklyn, NY. **Sources:** WW13.

WALKER, Frank *[Painter, architect] early 20th c.*
Addresses: Morristown, NJ. **Sources:** WW04.

WALKER, Gene Alden *[Painter, illustrator] 20th c.*
Addresses: New York 21, NY; Warren, PA. **Studied:** PIA School; NAD with Charles Hawthorne, Jerry Farnsworth. **Member:** NAC; NAWA; Pen & Brush Club; Audubon Artists; All. Artists Am.; SSAL. **Exhibited:** NAD, 1942-45; All. Artists Am.; Pen & Brush Club, 1945, 1946; Phila. WCC, 1933; NAC; NAWA, 1935-39, 1942, 1944-45; Carnegie Inst., 1945, 1946; Butler AI; 1945; AAPL, 1945. **Awards:** prizes, NAWA, 1943, 1946; NAD, 1943; Bridgeport, CT, 1942, 1945; Butler AI, 1948, 1949; Pen & Brush Club, 1949, 1953; All. Artists Am., 1946; John Herron AI, 1950,

1951; All. Artists Am., 1944 (prize). **Work:** Montgomery Mus. FA; NAD. **Comments:** Illustrator: "Range Plant Handbook" (U.S. Dept. Agriculture), 1937. **Sources:** WW59; WW47.

WALKER, George W. *[Painter, cartoonist] b.1895 / d.1930, Middletown, NY.*
Addresses: Cleveland, OH. **Member:** Cleveland SA. **Comments:** Creator: "Jazzbo Jones," "Things That Never Happen". **Sources:** WW29.

WALKER, Gertrude *[Drawing and painting teacher] late 19th c.*
Addresses: Active in New Bedford, MA, 1887. **Sources:** Blasdale, *Artists of New Bedford,* 199.

WALKER, Gilbert M. *[Illustrator] b.1927.*
Addresses: NYC in 1966. **Studied:** briefly at ASL; with Reginald Marsh and R. B. Hale. **Exhibited:** gold medals & distinctive merit awards in NYC and Wash., DC, also book awards. **Comments:** Specialty: action subjects, particularly military and Western. Positions: commercial artist while in H.S.; army artist, Korean War; illustrator, Washington, DC, after the Korean War; art teacher, CCNY, 1957-61. **Sources:** P&H Samuels, 507.

WALKER, H. L. *[Painter] early 20th c.*
Addresses: NYC. **Comments:** Affiliated with Walker Engraving Co., NYC. **Sources:** WW24.

WALKER, Harold E. *[Painter] b.1890, Scotch Ridge, OH.*
Addresses: Toledo, OH. **Studied:** A. Whiting; K. Kappes; F. Trautman; W.M. Darling; R. Moffett. **Member:** Toledo Artklan; Beachcombers. **Exhibited:** TMA, 1922 (prize), 1923 (prize). **Work:** Vanderpoel AA, Chicago. **Sources:** WW40.

WALKER, Helen See: **BOYD, Helen E(dward) Walker (Mrs. Theodore E.)**

WALKER, Helène *[Painter] early 20th c.*
Addresses: NYC. **Exhibited:** S. Indp. A., 1934. **Comments:** Possibly Helene Walker, ASL, active 1967. **Sources:** Marlor, *Soc. Indp. Artists.*

WALKER, Henry Babcock, Jr. *[Collector] b.1912, Evansville, IN / d.1966.*
Addresses: Evansville, IN. **Studied:** Princeton Univ. (A.B.). **Comments:** Collection: includes works by Bardone, Buffet, Cassatt, de Chirico, Corbellini, Jean Dufy, Edzard, Gromaire, Lawrence, Leger, Magritte, Metzinger, Petit, Phillip, and many others. **Sources:** WW66.

WALKER, H(enry) O(liver) *[Painter, mural painter] b.1843, Boston, MA / d.1929.*
Addresses: Belmont, MA; NYC, 1883-95. **Studied:** Bonnât, in Paris. **Member:** Cornish (NH) Colony; AFA; ANA, 1894; NA, 1902; SAA, 1887; Mural Painters; NIAL; Century Assn. **Exhibited:** Paris Salon, 1880, 1882; PAFA Ann., 1891-1908 (5 times); Boston AC, 1885; Columbian Expo, Chicago 1893 (medal); SAA, 1894 (medal); NAD, 1883-95 (prize, 1895); Pan-Am. Expo, Buffalo, 1901 (medal); St. Louis Expo, 1904 (medal); Charleston Expo, 1902 (gold); Worcester, 1907 (prize); Corcoran Gal. annuals, 1907-08; AIC. **Work:** mural paintings: LOC; Mass. State House, Boston; Appellate Court, NYC; Minnesota State Capitol, St. Paul; Newark, NJ; paintings: NGA; MMA. **Sources:** WW25; Fink, *American Art at the Nineteenth-Century Paris Salons,* 402; Falk, *Exh. Record Series.*

WALKER, Herbert Brooks *[Sculptor, museum director] b.1927, Brooklyn, NY.*
Addresses: Fairlee, VT. **Studied:** ASL with Harry Sternberg & Robert B. Hale, 1943; Yale School Fine Arts (B.F.A.) with R. Eberhardt, R. Zallinger, Graziani, R. Albers and De Konning. **Member:** ASL (life member); Yale Arts Alumni Assn. **Exhibited:** Stony Brook Mus., Long Island, NY, 1952 (solo); Barbados Mus., 1954 (solo); IORC, Abadan, Iran, 1958 (solo); Walker Mus., 1960-; Rodin Mus., 1970. **Work:** Photographs of Antionio Gaudis Work, MoMA; Barbados Mus, BWI; Walker Mus. **Commissions:** Paintings, movie, photographs Gahagan, Dredging, Orinoco River,

Venezuela, 1953-1954; paintings & photographs, U.S. Steel, Cerro Bolivar, Venezuela; earth sculpture, Walker Mus., 1960. **Comments:** Preferred media: sheet metals, bronze. Positions: materials production head, IROC, Abadan, Iran, 1958-59; director, Walker Mus., 1959-. Publications: illustrator, Gaudi, MoMA, 1957. Teaching: Thetford Acad., 1964-66. **Sources:** WW73; H. Brooks Walker, 1951, *EYE Magazine* (Yale Univ., 1967).

WALKER, Herman *[Painter] mid 20th c.*
Addresses: Spokane, WA, 1945. **Exhibited:** SAM, 1945-47. **Sources:** Trip and Cook, *Washington State Art and Artists, 1850-1950.*

WALKER, Herschell Carey *[Collector] mid 20th c.*
Addresses: NYC. **Member:** Art Collectors Club. **Sources:** WW73.

WALKER, Hobart Alexander *[Painter] b.1869, Brooklyn, NY.*
Addresses: NYC; Maplewood, NJ. **Exhibited:** S. Indp. A., 1917; PAFA Ann., 1918; AWCS, 1936, 1938; AWCS-NYWCC, 1939; AIC. **Sources:** WW40; Falk, *Exh. Record Series.*

WALKER, Horatio *[Painter] b.1858, Listowel, Ontario / d.1938.*
Addresses: came to NYC in 1885; Ile d'Orleans, Quebec, Canada, 1938. **Member:** ANA, 1890; NA, 1891; SAA, 1887; NIAL; Royal Inst. Painters in Water Colors, England; AWCS; SC; Artists Fund Soc.; Artists Aid A.; Rochester AC; NAC. **Exhibited:** Boston AC, 1884-1909; Am. Art Gal., NYC, 1887 (gold); AWCS, 1888 (prize), 1920 (prize); AIC, 1888-1927; Paris Expo, 1889 (medal); Columbian Expo, 1893 (gold); PAFA Ann., frequently 1895-1934; Pan-Am Expo, 1901 (gold); Charleston Expo, 1902 (gold); St. Louis Expo, 1904 (golds); Worcester, 1907 (prize); Corcoran Gal. biennials, 1907-32 (11 times); Pan-Pacific Expo, San Fran., 1915 (gold). **Work:** MMA; CGA; CAM, St. Louis; Albright Art Gal.; NGA; CI. **Comments:** Although Canadian, Walker spent many years in the United States. **Sources:** WW38; Falk, *Exh. Record Series.*

WALKER, Hudson D. *[Collector, art dealer, curator, art administrator] b.1907, Minneapolis, MN / d.1976.*
Addresses: Forest Hills, NY/Provincetown, MA (1943-on). **Studied:** Univ. Minnesota; Fogg Mus. Art, Harvard Univ. with Paul Sachs, Edward Forbes & Arthur Pope, 1928-30. **Member:** Beachcombers Club, 1946-on; Fine Arts Work Center, Provincetown (pres., 1971-); T. B. Walker Foundation (vice-pres. & trustee); AFA (trustee, 1944-71; pres., 1945-47); Artists Equity Assn. (hon. member; exec. director, 1947-53). **Comments:** In 1930-32 he ran the Goodman-Walker Art Gallery in Boston. In 1934 he became the first curator of the Univ. of Minnesota Gallery, Minneapolis. From 1936-40, he ran a gallery in NYC where he was most active promoting the work of Marsden Hartley, and curated a Hartley retrospective at MoMA. He owned a large art collection, and donated many works to the MMA, WMAA, the Addison Mus. Am. Art, and others. Author: "Marsden Hartley," *Kenyon Review* (1947). **Sources:** WW73; Crotty, 63.

WALKER, J. Edward *[Landscape painter] early 20th c.*
Addresses: Carmel, CA; Los Altos, CA. **Exhibited:** Carmel, 1913; Palo Alto AC, 1923; Berkeley Lg. FA, 1924; Santa Cruz Art Lg., 1929. **Work:** Oakland Mus. **Sources:** Hughes, *Artists of California,* 586.

WALKER, James *[Engraver] b.c.1839, New York.*
Addresses: NYC in 1860. **Comments:** Possibly the J.M. Walker who exhibited a wood engraving at the American Institute in 1856. **Sources:** G&W; 8 Census (1860), N.Y., LVIII, 262; Am. Inst. Cat., 1856.

WALKER, James *[Historical painter] b.1819, Northamptonshire, England / d.1889, Watsonville, CA.*

James Walker 1877

Work: U.S. War Dept. Bldg., Wash. (twelve Mexican War scenes); LACMA; Calif. Hist. Soc.; Denver Art Mus.; Bancroft Lib., Univ. Calif., Berkeley; Tennessee State Mus. **Comments:** Best-known as a military painter, although he also painted the California vaquero and portraits. His family settled near Albany, NY, in 1824 and later moved to NYC. Walker went to New Orleans as a young man, traveling to Mexico City where he was living when the Mexican War began. He joined the American forces as an interpreter and was the only American painter present during the siege of Mexico City. He returned to NYC in 1848 and, after a visit to South America, established a studio there. He worked Washington, DC, in 1857-62, painting "Battle of Chapultepec" for the U.S. Capitol. This was followed by many other historical canvases, including a number portraying Civil War battles. In the early 1870s he had opened a studio in San Francisco, although he returned to NYC in 1878. His final stay in California began in 1884. **Sources:** G&W; Fairman, *Art and Artists of the Capitol,* 212; Taft, *Artists and Illustrator of the Old West,* 303; 8 Census (1860), D.C., II, 375; Cowdrey, NAD; CAB; San Francisco *Morning Call,* Sept. 4, 1889, obit.; *Album of American Battle Art; Art Digest* (Oct. 1, 1944), 1; *Magazine of Art* (May 1944), 186; Peggy and Harold Samuels, 507-08; Kelly, "Landscape and Genre Painting in Tennessee, 1810-1985," 58-60 (w/repros.).

WALKER, James Adams *[Painter, printmaker] b.1921, Connersville, IN / d.1987.*
Addresses: Richland, MI. **Studied:** Western Michigan Univ. (B.S., 1946); Univ.Michigan, 1947-48; Teachers College, Columbia Univ. (M.A., 1949; prof. diploma, 1958); East Carolina Univ.,1949-56; Claremont Grad. School, 1959; Michigan State Univ. (M.F.A., 1961). **Member:** Michigan Acad. Science, Arts & Letters (chmn., fine arts section, 1965-67); Trumbull Art Guild (bd. dir. & bd. trustees, 1969-); Kalamazoo IA; Canton AI; Steel Valley Art Teachers Assn. **Exhibited:** 19th Nat. Competition Prints, LOC, Wash., DC, 1963; 14th & 15th Nat. BM Print Exh., 1964 & 1966; 32nd Nat. Graphic Arts Drawing Exh., Wichita (KS) AA, 1965; 11th Nat. Biennial Print Exh., Print Club Albany, NY, 1966. Awards: purchase award, 25th Ann. Michigan Acad. Science, Arts & Letters, 1966; Hugh J. Baker Mem. Prize for prints, 43rd Ann. Hoosier Salon, Indianapolis, IN, 1967; first print purchase award, Butler IA, 1968. **Work:** Dulin Gallery Art, Knoxville, TN; Flint (MI) Inst. Arts; Mercyhurst College, Erie, PA; Western Michigan Univ., Kalamazoo, MI; Butler IA. **Comments:** Publications: author, "Newsprint, Paste and Chicken Wire" (1950), "Let's Scribble a Mural" (1953) & "Buttermilk and Chalk Drawing" (1954), *School Arts* magazine; author, "Cypress Knees, *Industrial Arts Magazine,* 1959. Teaching: East Carolina Univ., 1949-56; Northern Community H. S., Flint, 1956-66; Nat. Music Camp, Interlochen, MI, summer 1963; Kent State Univ., Warren, OH, 1966-. **Sources:** WW73; Arne W. Randall, *Murals for Schools* (Davis Mass, 1956); Charles E. Meyer, *Papers of the Michigan Academy of Science, Arts and Letters* (Univ. Michigan Press, 1962); Eleanor Nelson, *Faculty focus* (Kent State Univ. Press, 1971).

WALKER, James L. *[Figure & ornamental painter, teacher] late 18th c.*
Addresses: Baltimore in 1792. **Comments:** In August of 1792 he opened a school where he taught figure and ornamental painting and architectural drawing. **Sources:** G&W; Prime, II, 37-38; folio broadside in LC (Evans, *American Bibliography,* VIII, no. 24979).

WALKER, Jean *[Painter] early 20th c.*
Exhibited: AIC, 1916; S. Indp. A., 1920. **Sources:** Falk, *Exhibition Record Series.*

WALKER, Jerome *[Painter, educator] b.1937, Peoria, IL.*
Addresses: Northfield, IL. **Studied:** AIC (scholarship); Chicago Acad. FA. **Member:** Artists Int. Assn., London; Inst Contemp Arts, London; Partic. Artists Chicago. **Exhibited:** AIC Vicinity Show, 1966; Univ. Chicago Momentum II, 1967; Festival of the Arts & Spectrum, McCormick Place, Chicago, Participating Artists of Chicago & Eye on Chicago, Inst. Technology, 1967. **Work:** Bernard Horwich Center, Chicago; Illinois Inst. Technology, Chicago; Inst. Contemporary Arts, London, England.

Comments: Preferred media: mixed media, graphics. Teaching: Chicago Acad. FA, 1971-. **Sources:** WW73.

WALKER, Jessie Alice (Mrs.) *[Etcher] b.1871.*
Addresses: NYC; Loubet, France; Phila., PA. **Member:** Chicago SE; Brooklyn AC. **Exhibited:** PAFA Ann., 1890; Boston AC, 1891-98. **Sources:** WW25; Falk, *Exh. Record Series.*

WALKER, John *[Museum director, writer, lecturer] b.1906, Pittsburgh, PA.*
Addresses: Washington, DC. **Studied:** Harvard Univ. (A.B.). **Exhibited:** Awards: John Harvard Fellow, Harvard Univ., 1930-31; hon. D.F.A., Tufts Univ., 1958; hon. D.F.A., Brown Univ., 1959; Litt.D., Univ. Notre Dame, 1959; hon. D.F.A., Washington & Jefferson Univ., 1960; hon. D.F.A., La Salle College, 1962. **Comments:** Positions: assoc. in charge, dept. fine art, Am. Acad. in Rome, 1935-39; trustee, Am. Acad. in Rome; AFA; trustee, Nat. Trust; trustee, Andrew Mellon Educational & Charitable Trust; visiting com. of Dumbarton Oaks; art com., New York Hospital; advisory council, College of Arts & Sciences, Georgetown University; advisory council, Inst. Fine Arts NY University; treasurer, White House Historical Association; chmn., Air Force Academy Fine Arts Committee; member, Citizens Stamp Advisory Committee; chief curator, 1939-56, dir., 1956-, National Gallery of Art, Washington, DC; visiting committee, dept. fine art & Fogg Mus., Harvard Univ. & Harvard Press. Co-author: "Great American Paintings from Smibert to Bellows," 1943; "Masterpieces of Painting from the National Gallery of Art," 1944; "Great Paintings from the National Gallery of Art," 1952; "Treasures from the National Gallery of Art", 1963. Author: "Paintings from America," 1951 (Spanish, 1954); "Bellini and Titian at Ferrara," 1957; "The National Gallery of Art, Washington, DC", 1964. Contrib.: *Gazette des Beaux-Arts, National Geographic* magazines. **Sources:** WW66; WW47.

WALKER, John Law *[Painter, etcher, engraver, craftsperson, teacher, mural painter] b.1899, Glasgow, Scotland.*
Addresses: Burbank, CA. **Studied:** L. Murphy; Millard Sheets. F. Tolles Chamberlin, Clarence Hinkle. **Member:** Calif. WCS; Los Angeles AA; Santa Monica AA. **Exhibited:** Pomona Fair, 1932 (prize); Pasadena AI, 1933 (prize); Calif. WCS, 1934 (prize); Santa Cruz Art Lg., 1934 (prize); Calif. State Fair, 1934 (prize); Southern Calif. Festival All. Artists, 1934 (prize); PAFA Ann., 1936; GGE, 1939; Oakland Art Gal., 1939. **Work:** WPA murals, USPOs, South Pasadena, CA; Lockhart, TX; Treasury Dept., Washington, DC. **Comments:** Teaching: Jr. College, Glendale, CA, 1940. **Sources:** WW53; WW47; Hughes, *Artists in California,* 586; Falk, *Exh. Record Series.*

WALKER, John P. *[Portrait painter] b.1855, Lynchburg, VA / d.1932, Richmond, VA.*
Addresses: Richmond, VA. **Work:** Confederate Mus., Union Theological Seminary, University of Richmond, Univ. of Virginia, Valentine Mus., Virginia Hist. Soc., all VA. **Comments:** He painted every Virginia Governor from 1850-1900, also Civil War veterans and college professors. **Sources:** Wright, *Artists in Virginia Before 1900.*

WALKER, Katherine *[Painter] late 19th c.*
Addresses: New Orleans, active 1886-92. **Studied:** Newcomb Coll., 1886-92. **Exhibited:** Artist's Assoc. of N.O., 1891-92. **Sources:** *Encyclopaedia of New Orleans Artists,* 398.

WALKER, Larry See: **WALKER, Lawrence**

WALKER, Laura See: **SALISBURY, Laura Walker (Mrs. William L.)**

WALKER, Lawrence *[Painter, educator] b.1935, Franklin, GA.*
Studied: Wayne State Univ. **Exhibited:** Wayne State Univ., 1955-56 (prizes), 1963, 1965, 1969; Scarab Club, Detroit, 1958 (hon. men.), 1961, 1963 (prize)-1964 (prize); Detroit Teachers Ann., 1958 (prize), 1960 (prizes), 1961 (prize, sculpture)-1963 (prize); Saginaw Art Mus., MI, 1958; Michigan WC Soc. Ann., 1961, 1963-64; Wash. WCC, 1963-64; Michigan Acad. Arts, Sciences &

Letters, 1963; Delta AA Ann., Antioch, CA, 1964 (prize), 1965 (hon. men.), 1966-67 (hon. men.; purchase award), 1968, 1969, 1971, 1972 (prize); Unitarian Fall Art Festival, Stockton, CA, 1964 (award), 1965 (prize), 1966 (Ben Gay Oil Award), 1967 (graphics award)-1969, 1971(painting award)-1972 (1st prize painting); Lodi AA Ann., CA, 1965 (prize)-1966, 1970 (prize, award)-1972; Stockton Art League Ann., 1967 (Frank Quinn Award, West Purchase Award, Museum Purchase Award), 1968 (hon. men.), 1969 (Jack Whipple Award for Contemporary Painting), 1972 (Rowland Award); and many others locally in Michigan & Calif. in the 1960s, early 1970s; Smith-Mason Gallery, Wash., DC, 1971; NJ State Mus., 1972; Smithonian Inst.; American WCS Annuals; Oakland Mus. Other awards: Univ. of the Pacific Summer Grant, 1970. **Work:** Univ. of Pacific; Pioneer Mus.; Haggin Art Galleries; Detroit Board of Education; Merced (CA) AA; Oakland Mus.; Delta Memorial Hospital, Antioch. **Comments:** Teaching: Univ. of Pacific, Stockton, CA. **Sources:** Cederholm, *Afro-American Artists.*

WALKER, Lissa Bell *[Mural painter] mid 20th c.; b.Forney, TX.*
Addresses: Boston 16, MA. **Studied:** NY School Fine & Applied Art; Frank Reaugh; Max Hagendorn; H.R. Poore; E. Albert. **Member:** NAC; Dallas AA; Reaugh AC. **Exhibited:** Mass. Horticultural Soc. (prize). **Work:** murals, Monticello Hotel, Charlottesville, VA. **Sources:** WW53; WW47.

WALKER, Louis *[Painter] late 19th c.*
Addresses: Phila., PA. **Exhibited:** PAFA Ann., 1879-80. **Sources:** Falk, *Exh. Record Series.*

WALKER, Lydia LeBaron (Mrs. Wm. H. P.) *[Designer, craftsperson, writer, decorator] b.1869, Mattapoisett, MA / d.1958.*
Addresses: Boston, MA. **Studied:** Arthur Cummings. **Member:** Boston Author's Club; PBC; Copley Soc., Boston. **Work:** Index Am. Des. **Comments:** Author: "Homecraft Rugs," 1929. Contrib.: *Women's Home Companion.* **Sources:** WW53.

WALKER, M. *[Primitive genre painter in watercolors] mid 19th c.*
Comments: Active about 1835. **Sources:** G&W; Lipman and Winchester, 181.

WALKER, M. Mulford (Mrs.) *[Painter] early 20th c.*
Addresses: NYC. **Sources:** WW08.

WALKER, Margaret (Beverley) Moore *[Portrait painter] b.1883, Darlington, SC.*
Addresses: Greenville, SC. **Studied:** Converse College (B.A.); CUA School; Charles Hawthorne; Richard Miller; B. Burroughs; W. Thor, in Munich; H. Hensche. **Member:** SSAL; Carolina AA; FA Lg. of Carolinas (pres., 1946-). **Exhibited:** SSAL, 1928-41; Nat. Exh. Am. Artists, NY, 1936-38; FA Lg. of Carolinas. **Work:** port., Fed. Court, City Hall, South Carolina Soc., Charleston; Supreme Court, Univ. South Carolina, Columbia; Clemson College; Furman Univ., Greenville, SC, Davidson College, NC. **Comments:** Position: founder/director, Greenville (SC) School Art. **Sources:** WW53; WW47.

WALKER, Margarita McKee See: **DULAC, Margarita (Mrs.McKee Walker)**

WALKER, Marian Blakeslee *[Craftsman, painter, designer, lecturer] b.1898, Rock Island, IL.*
Addresses: Kansas City 2, MO. **Studied:** Kansas City AI; Chicago Acad. FA; AIC; Wilomovsky; A. Angarola; I. Summers; Rosenbauer; E. Kopietz; Robinson. **Member:** Kansas City SA; Mid-Am. Artists; Kansas City AI Alum. **Exhibited:** Midwestern Art Exh., 1926-36; Kansas City Soc. Art, 1926-36; Mid-Am. Artists, 1951; All-Am. Women's Exh., Topeka, 1936. Awards: prizes, Kansas City AI, 1925, 1931; Missouri State Fair, Sedalia, 1930; Topeka, KS, 1936. **Work:** Scarritt School, Kansas City. **Comments:** Specialty: Tole ware. Position: pres., Marian Walker, Inc., Kansas City, MO, 1941-. Contrib.: articles on tole ware to *House Beautiful, House & Gardens,* and other national magazines.

Lectures on decorative art, color & design, tole ware. **Sources:** WW59; WW40.

WALKER, Marian D. Bausman (Mrs. Otis L.) *[Sculptor]* *b.1889, Minneapolis, MN.*
Addresses: Casper, WY. **Studied:** Minneapolis. **Member:** Minneapolis SFA. **Exhibited:** Minnesota State Arts Soc., 1914 (prize). **Sources:** WW33.

WALKER, Marjorie *[Painter] early 20th c.*
Exhibited: Salons of Am., 1934. **Sources:** Marlor, *Salons of Am.*

WALKER, Marks A. *[Painter] early 20th c.*
Addresses: NYC. **Exhibited:** S. Indp. A., 1917. **Sources:** Marlor, *Soc. Indp. Artists.*

WALKER, M(ary) E. Topping *[Landscape painter] late 19th c.*
Addresses: NYC, 1888-98. **Exhibited:** Brooklyn AA, 1891; NAD, 1888-98. **Sources:** WW98.

WALKER, Mary Evangeline (Mrs. Harold A. Landy) *[Painter, lecturer, teacher, illustrator] b.1894, New Bedford, MA / d.1957, Arlington, MA.*
Addresses: Boston, MA/Manomet, MA. **Studied:** NY School Applied Des. for Women with Albert Sterner; Columbia Univ.; BMFA Sch.; & with Philip Hale. **Member:** Newport AA; Boston AC; Copley Soc., Boston. **Exhibited:** Boston AC, annually; Copley Soc., Boston, 1928; PAFA; Jordan Marsh, annually. Awards: traveling scholarship, 1925. **Work:** Boston AC, portrait., Veteran's Bldg., Court House, Customs House, Public Works Bldg., Suffolk County Court, all of Boston; Radcliffe Col.; City Hall, Medford, MA; Masonic Hall, Batavia, NY; High School, Revere, MA; Jefferson Cl., Cambridge, MA; Am. Legion Post, Dorchester, MA; Latin School, Boston; Princeton Univ. Lib.; Harvard Univ. **Comments:** When she was 12, her first illustration was published by *Harper's Bazaar.* She may be best known for portraits she painted in Boston. Illustrator: *Homecraft Rugs,* 1929. Position: dir., "The Little Group," Boston, MA; mem., Art Commission, City of Boston, 1942-. **Sources:** WW53; WW47; Blasdale, *Artists of New Bedford,* 199-200 (w/repros.).

WALKER, May M. *[Artist] late 19th c.*
Addresses: Active in Detroit, MI, 1891. **Sources:** Petteys, *Dictionary of Women Artists.*

WALKER, May Mulford (Mrs. Richard) *[Painter, illustrator, art teacher] b.c.1873, NYC / d.1954, Richmond, VA.*
Studied: ASL; Irving WIles; Howard Christy. **Sources:** Petteys, *Dictionary of Women Artists.*

WALKER, Maynard *[Art dealer] mid 20th c.*
Addresses: NYC. **Comments:** Position: director, Maynard Walker Art Gallery, NYC. **Sources:** WW66.

WALKER, Mildred *[Painter, teacher] b.1867, Georgetown, MO / d.1937, Fayette, MO.*
Studied: New York and Paris, c.1890. **Comments:** Painted in oil, sketched in conté & charcoal. Taught painting, drawing, china painting & French, Orphan School of the Christian Church, MO (now William Woods College), 1891-92. Signed her paintings "MW." **Sources:** Petteys, *Dictionary of Women Artists.*

WALKER, Mort *[Cartoonist] b.1923, El Dorado, KS.*
Studied: Univ. Missouri (B.A.). **Member:** Nat. Cartoonists Soc. (pres., 1960); Newspaper Comics Council, Artists & Writers Assn. **Exhibited:** MMA, 1952; Brussels World's Fair, 1964; Musée Louvre, Paris, 1965; New York World's Fair, 1967; Expo, Montreal, 1969; Graham Gallery, NYC, 1970s. Awards: Reuben Award, 1954 & two Best Humor Strip Plaques, 1966 & 1969, Nat. Cartoonists Soc.; Silver Lady, Banshees Soc., 1955. **Work:** Bird Library, Syracuse Univ.; Boston Univ. Library; Kansas State Univ.; Montreal Humor Pavilion; Smithsonian Inst. **Comments:** Preferred media: ink. Positions: creator of "Beetle Bailey," King Features Syndicate, 1950-, "Hi & Lois," 1954-, "Sam's Strip," 1961-63 & "Boner's Ark," 1968-. Publications: editor, Nat. Cartoonists Soc. Album, 1961, 1965 & 1972; author, "Most,"

1971 & "Land of Lost Things," 1972; author, "Hi and Lois," 2 vols.; author & illustrator, "Beetle Bailey," 6 vols. **Sources:** WW73; many articles, books & TV specials.

WALKER, Myrtle Van Leuven *[Painter] early 20th c.; b.Summer, MI.*
Addresses: Crystal, MI. **Sources:** WW08.

WALKER, Nellie B. *[Landscape painter] b.1872, Stow, ME / d.1973.*
Addresses: Portland, ME. **Studied:** Benjamin T. Newman in Fryeburg, ME. **Comments:** Painted scenes of Portland and also worked there as a photo tinter, active up to the 1960s. **Sources:** Petteys, *Dictionary of Women Artists.*

WALKER, Nellie Verne *[Sculptor] b.1874, Red Oak, IA. / d.1973, Colorado Springs, CO.*
Addresses: Chicago, IL; Colorado Springs. **Studied:** AIC with Lorado Taft (as his apprentice and asst.) and in Paris. **Member:** NSS, 1911; Chicago SA; Soc., Women Sculptors; Chicago P&S; State Board Art Advisors, Illinois. **Exhibited:** Columbian Expo, Chicago, 1893; PAFA Ann., 1904; AIC, 1904-28 (1908, Grower prize; 1911, Scheffer prize); Municipal Art League, Chicago, 1907 (prize); NSS; Pan-Pacific Expo, 1915. **Work:** mem./statues/groups: U.S. Capitol, Washington, DC; AIC; Colorado Springs; Keokuk, IA; Marmette, WI; Cadillac, MI; panels, State College, Ames, IA; Roger Sullivan Jr. H.S., Chicago; Suffrage Memorial, Iowa State House, 1936; Learned and Barlow monuents, Omaha; Lincoln Monument near Vincennes, IN, 1938; Polish-American War Memorial, Chicago. **Comments:** Completed a death mask, a large bronze statue and a mem. monument for Winfield Scott Stratton while in Colorado Springs which led to many public and private commissions. **Sources:** WW47; Ness & Orwig, *Iowa Artists of the First Hundred Years,* 213; Falk, *Exh. Record Series.*

WALKER, Philip (Mrs.) *[Collector] mid 20th c.*
Addresses: Brookline, MA. **Comments:** Collection: paintings. **Sources:** WW73.

WALKER, Ralph (Mr. & Mrs.) *[Collectors] mid 20th c.*
Addresses: NYC. **Comments:** Collection: antiques and contemporary art. **Sources:** WW73.

WALKER, Robert Miller *[Educator] b.1908, Flushing, NY.*
Addresses: Swarthmore, PA. **Studied:** Princeton Univ. (B.A., 1932; M.F.A., 1936); Harvard Univ. (Ph.D., 1941). **Member:** College AA Am.; Soc. Arch. Historians; Phila. Print Club; Am. Archaeology Soc.; Print Council Am. **Exhibited:** Corcoran Gal. biennial, 1935. **Comments:** Teaching: Williams College, 1936-38; Swarthmore College, 1941-70s. **Sources:** WW73.

WALKER, Rosalie F. (Mrs. Stanley) *[Landscape and portrait painter, teacher] b.1905, Tacoma, WA / d.1967, Tacoma.*
Addresses: Tacoma. **Exhibited:** Tacoma Civic AA, 1932; Wash. State Hist. Soc., 1945. **Comments:** Specialty: religious paintings. Preferred media: oil, watercolor, pastels. Position: co-founder, pres., hist., Pacific Gallery Artists, Tacoma. **Sources:** Trip and Cook, *Washington State Art and Artists,* 1850-1950.

WALKER, Ryan *[Cartoonist] b.1870, Springfield, KY / d.1932, Moscow, Russia.*
Addresses: NYC. **Studied:** ASL. **Member:** John Reed Club. **Comments:** Contributor: *Life; Judge.* After being a socialist for many years, he had become a communist and was visiting Russia as the guest of the Soviet Govt. when he died. Positions: cartoonist, *Kansas City Times,* 1895; later for the *St. Louis Republic, Boston Globe, New York Call.* **Sources:** WW15.

WALKER, Samuel *[Portrait, figure & marine painter] mid 19th c.*
Comments: There was an artist by this name at London in 1850-52, when he exhibited at the Royal Academy; at Brooklyn and NYC in 1853-54, when he exhibited at the National Academy; at New Orleans in 1860-61; and at Philadelphia 1865-68, when he exhibited at the Pennsylvania Academy. It is uncertain whether all these references are to one man. **Sources:** G&W; Graves,

Dictionary; Cowdrey, NAD; Brooklyn CD 1853; New Orleans CD 1860-61; Rutledge, PA; Phila. CD 1866-68. More recently, see *Encyclopaedia of New Orleans Artists,* 398.

WALKER, Samuel Swan *[Itinerant portrait painter, miniaturist, teacher]* b.1806, Butler County, OH / d.1848, Cincinnati, OH.
Addresses: Cincinnati, OH. **Studied:** mostly self-taught; later a pupil and close friend of J. Insco Williams (see entry) in Richmond (IN). **Exhibited:** Soc. for Promotion of Useful Knowledge, Cincinnati, OH , 1841(four miniatures). **Work:** Ohio Hist. Soc., Columbus, OH, has a collection of material related to Walker, including a sketch for a miniature of John Insco Williams (1841), a pen and wash genre scene (1846), a sketch for the title page of a notebook (1826), and the Walker Family Papers which includes sketchbooks and letters from Samuel Walker to his wife, describing each place he visited and the people he painted; the Historic Southwest Ohio, Inc. owns a portrait in oil of Thomas Laws (1844). **Comments:** He was trained as a physician but gave up his practice in 1836 to become a portrait and miniature painter. He lived principally in Cincinnati, later at a prestigious address there with his wife and family. He himself traveled as an itinerant painter, covering Ohio as well as going to Pennsylvania in 1838-39. On his travels, he painted oil portraits, crayon portraits, and miniatures; he drew architectural renderings, a practice he also taught to carpenters and joiners; and he gave lessons in painting and drawing to interested people along the way. In 1840 he returned home to help his wife but went to Indiana in 1841 where he met J. Insco Williams (from whom Walker said he learned quite a bit). In 1844, Walker took a long trip to Kentucky, Ohio, and into Pennsylvania, to Erie and Pittsburgh; to Buffalo, NY; Boston, MA; Washington, DC (where he visited the Natural History Mus. and King's Painting Gallery); and to New Hampshire. On his way back he traveled to Baltimore, MD, Wilmington, DE and Philadelphia. In April, 1848, back in Ohio, he became extremely ill, and with a large family to support, he was forced to ask for food and help from his brother. **Sources:** G&W; Peat, *Pioneer Painters of Indiana,* 91, 240. More recently, see Hageman, 98-103, incl.repros.

WALKER, Simeon *[Portrait painter]* mid 19th c.
Addresses: Boston, 1845-46. **Comments:** Of Walker & Bowen. **Sources:** G&W; Boston CD 1845, BD 1846.

WALKER, Sophia Antoinette *[Painter, sculptor, etcher, craftsperson, writer, lecturer, teacher]* b.1855, Rockland, MA / d.1943, NYC.
Addresses: NYC/Palatine Bridge, NY, 1889-90. **Studied:** NYC with H.S. Mowbray and W.M. Chase; Académie Julian, Paris with Boulanger and Lefebvre. **Member:** NAC. **Exhibited:** Paris Salon, 1879, 1880; NAD, 1889-90; Soc. Indep. Artists, 1917. **Work:** State Normal Sch. Bridgewater, MA. **Sources:** WW21; Fink, *American Art at the Nineteenth-Century Paris Salons,* 402.

WALKER, Stuart *[Painter]* b.1904 / d.1940.
Addresses: Albuquerque, NM (1925-on). **Studied:** John Herron AI, Indianapolis; Frank Schoonover, Wilmington, DE. **Member:** Transcendental Painting Group, 1938-41. **Exhibited:** GGE, 1939; WFNY, 1939; M. Diamond FA, 1981. **Comments:** At first a representational painter of landscapes and still lifes, he ran a greeting card company with Brooks Willis. He turned to abstraction c.1930; however, poor health prevented him from realizing his full potential. **Sources:** WW40; Diamond, *Thirty-Five American Modernists; American Abstract Art,* 201.

WALKER, Sybil (Mrs. A. Stewart) *[Painter, designer, decorator]* b.1882, NYC.
Addresses: New York 21, NY. **Studied:** NY School Applied Des. for Women. **Member:** NAWA. **Exhibited:** Detroit IA; AIC; Soc. Indep. Artists; St. Louis World's Fair; Marie Sterner Gal.; Knoedler Gal.; Parrish Mus., Southampton, NY; AFA traveling exh.; Salons of Am. **Work:** BM; Parrish Mus., Southampton, NY; Tate Gal., London. England. **Sources:** WW59.

WALKER, T. Dart *[Portrait & marine painter]* d.1914, NYC.

WALKER, Thomas B. *[Patron]* b.1840, Xenia, OH / d.1928, Minneapolis.
Comments: He was a pioneer in the Midwest and won great wealth as a lumberman. Utilizing his fortune to advance the cause of art, as well as religion and charity, he enabled Minneapolis to establish one of the largest private art collections of the U.S. by building the Walker Art Galleries, to which he gave 8.000 pieces estimated to be worth $ 5.000.000 (in 1928). The Minneapolis Pub. Lib. and its museum also owe their origin to him.

WALKER, Wilhelmina *[Painter]* late 19th c.
Addresses: NYC (active 1898-1900). **Exhibited:** Boston AC, 1898. **Sources:** WW98.

WALKER, William *[Engraver]* mid 19th c.
Addresses: Philadelphia. **Comments:** Son of James Walker the Philadelphia engraver (see entry); they were working together as J. Walker & Son (see entry) 1858 and after. **Sources:** G&W; Phila. CD 1858-60+.

WALKER, William Aiken *[Genre, portrait, and landscape painter]* b.1838, Charleston, SC / d.1921, Charleston, SC.
Addresses: New Orleans, active 1876-1905; Charleston, SC. **Studied:** Düsseldorf, 1860s, but mostly self-taught. **Member:** Wednesday Club, Baltimore, 1865; Artist's Assoc. of New Orleans, 1890, 1893, 1897, 1899; Cup & Saucer Club. **Exhibited:** South Carolina Institute Fair, 1850 (at the age of 12); Courtenay's Bookstore, Charleston, 1858-59; Baltimore, 1870; Montgomery's, New Orleans, 1876; Southern Art Union, 1880; Boston AC, 1881; Blessing's, New Orleans, 1883, 1885; Lilienthal's, New Orleans, 1883; Seebold's, New Orleans, 1884; American Expo, 1885-86; Savannah, GA, after 1885; Artist's Assoc. of N.O., 1885-1905; Tulane Univ., 1892; Columbian Expo, Chicago, 1893; Louisiana Purchase Expo, 1903. **Work:** Historic New Orleans Coll.; BMFA; Rosenberg Lib., Galveston, TX. **Comments:** A prolific painter whose works are nostalgic and romantic fictions of antebellum plantation life. He started painting and exhibiting at a young age, and by 1860 was painting the fish and game that he caught. During the Civil War he served the Confederacy as a cartographer, afterwards settling in Baltimore as an artist, but he was actually an itinerant bachelor and dandy. He traveled extensively throughout the South during most winters, maintaining a summer studio in Arden, NC. Between 1876 and 1905, he returned to New Orleans almost every year and mass-produced small paintings depicting black cotton pickers which he hawked on New Orleans street corners as souvenirs for 50¢-$3 each. He also painted fish and game, and sold these paintings through the exclusive hunting and fishing lodges that he established himself in the South. In 1884, two of his large paintings, "The Levee-New Orleans" (1883) and "A Cotton Plantation on the Mississippi" (1883) were reproduced as chromolithographs by Currier & Ives. After 1890, he also painted landscapes. **Sources:** G&W; Bland Galleries, *Exhibition of Southern Genre Paintings by William Aiken Walker,* catalogue; Rutledge, *Artists in the Life of Charleston;* Karolik Cat.; *Portfolio* (April 1946), 186-87; *Art News* (Oct. 1949), 40; *American Heritage* (Autumn 1950), 55; *Encyclopaedia of New Orleans Artists,* 398-399; August P. Trovailoli and Roulhac D. Toledano, *William Aiken Walker: Southern Genre Painter* (1972); Trey Ellis, "Song of the South" in *Art & Antiques* (April, 1987, p.92); Baigell, *Dictionary; Complementary Visions,* 22.

WALKER, William B. (Mrs.) *[Painter]* late 19th c.
Addresses: Phila., PA. **Exhibited:** PAFA Ann., 1882. **Sources:** Falk, *Exh. Record Series.*

WALKER, William F. *[Music and plate engraver]* mid 19th c.
Addresses: Boston, 1857-60. **Comments:** Of Greene & Walker. Earlier he was listed as a music engraver. **Sources:** G&W; Boston CD 1854-60.

WALKER, William H(enry) *[Cartoonist, portrait painter, landscape painter]* b.1871, Pittston, PA / d.1938.
Addresses: Flushing, NY/Duxbury, MA. **Studied:** ASL.
Comments: Contributor: *Life*, 1898-24. Specialty: satirical/political cartoons. **Sources:** WW38.

WALKER & BOWEN *[Portrait painters]* mid 19th c.
Addresses: Boston, 1845-46. **Comments:** Partners were Simeon Walker and George P. Bowen (see entries). **Sources:** G&W; Boston CD 1845, BD 1846 [as Walker & Bower].

WALKER & SON, James *[Copper and steel engravers, die sinkers]* mid 19th c.
Addresses: Philadelphia, 1858-60 and after. **Comments:** The son was William Walker (see entry). **Sources:** G&W; Phila. BD 1858-60+.

WALKER FAMILY *[Gravestone sculptors]* 18th/19th c.
Addresses: Active in Charleston, SC, 1790s-1830s. **Comments:** The founder of the family business was Thomas Walker, a stone-cutter who came to Charleston from Edinburgh about 1793. He was active until 1836 and died in 1838, leaving the business to be continued by his sons James E., Robert D.W., and William S. Walker. Two other members of the family, possibly also sons of Thomas, were A.W. and C.S. Walker, apprentices of Thomas in 1831. **Sources:** G&W; Ravenel, "Here Lyes Buried," 194-95; Rutledge, *Artists in the Life of Charleston.*

WALKEY, Frederick P. *[Museum director]* b.1922, Belmont, MA.
Addresses: Lincoln, MA. **Studied:** Duke Univ.; Boston Mus. FA School; Tufts College (B.S.Educ.). **Member:** Am. Assn. Mus.; AFA. **Comments:** Positions: executive director, De Cordova Mus., Lincoln, MA, 1970s. **Sources:** WW73.

WALKEY, Winfield Ralph *[Painter, screenprinter]* b.1909, Brooklyn, NY / d.1954.
Addresses: Merrick, NY. **Studied:** PIA School, 1929-30; ASL with J.S. Curry, M. Kantor, H. Wickey, 1935-37. **Member:** Am. Artists Congress. **Exhibited:** FAP traveling exh.; T.R.A.P. Traveling Exh.; Rockefeller Center, NYC, 1938; Ferargil Gal., 1936; ACA Gal., 1938; Artists Congress, 1938, 1939. **Work:** WPA mural, USPO, Greer, SC. **Sources:** WW47.

WALKI, Theresa *[Wax modeler]* 19th c.
Work: sculptures of Maori man & woman, Phila. Mus. Art.
Sources: Petteys, *Dictionary of Women Artists.*

WALKINSHAW, Jeanie Walter (Mrs. Robert B.)
[Portrait painter, illustrator] b.1885, Baltimore, MD / d.1976, Mercer Island, WA.
Addresses: Seattle, WA. **Studied:** Edwin Whiteman, Rene Menard & Lucien Simon in Paris; Robert Henri, NY; Charcoal Club, Baltimore. **Member:** Portraits, Inc.; Women Painters of Wash (charter member).; Nat. Assoc. Women P&S; Nat. Lg. Am. Pen Women; Pac.-Northwest Acad. Art. **Exhibited:** Circle Int. des Femmes Peintres, Paris; CGA; Soc. Indep. Artists, 1922; SAM & Women Painters of Wash., 1931-58; Salons of Am. **Work:** Temple of Justice, Olympia, WA; Univ. Washington, Seattle; Seattle Hist. Soc.; Diocesan House, St. Mark's Cathedral, Seattle; Children's Orthopedic Hospital, Seattle. **Comments:** Illustrator: "On Puget Sound," 1929. **Sources:** WW59; Trip and Cook, *Washington State Art and Artists,* 1850-1950.

WALKINSHAW, Valerie B. *[Portrait painter]* b.1921, Seattle, WA.
Addresses: Seattle, WA. **Studied:** Cornish Art School Seattle. **Exhibited:** SAM, 1936; Western Wash. Fair, 1938. **Comments:** Daughter of Jeanie Walkinshaw (see entry). **Sources:** Trip and Cook, *Washington State Art and Artists,* 1850-1950.

WALKLEY, David Birdsey *[Painter]* b.1849, Rome, OH / d.1934, Rock Creek, OH.
Addresses: Philadelphia, PA; Cleveland, OH; NYC; Port Chester, NY; Hartford, CT/Rock Creek, OH. **Studied:** PAFA, 1867-71; Acad. Mosler, in Paris, 1878; ASL with W.M. Chase, 1885; Académie Julian, Paris with Boulanger and Lefebvre, 1886-87.

Member: SC, 1903; SAA; Pittsburgh AA. **Exhibited:** NAD; Phila. AC; Columbian Expo, Chicago, 1893; PAFA Ann., 1898; AIC; CGA; Pittsburgh, PA (solos). **Comments:** Teaching: Pittsburgh Sch. Des., 1879-84; ASL, late 1880s. Among the first artist-residents at Mystic, CT, c.1902-c.1915; he occasionally painted in Stonington, Noank and Mason's Island also. **Sources:** WW25; Chew, ed., *Southwestern Pennsylvania Painters,* 132, 133; *Connecticut and American Impressionism* 177 (w/repro.); Falk, *Exh. Record Series.*

WALKLEY, Win(field) Ralph *[Painter, screenprinter]* b.1909, Brooklyn, NY / d.1954.
Addresses: Merrick, NY. **Studied:** Pratt Inst., 1929-30; ASL, 1935-37; John Steuart Curry; Morris Kantor; Harry Wickey. **Exhibited:** FAP traveling exh.; T.R.A.P. traveling exh.; Municipal Art Gal.; Rosyln Art Studios, 1946 (1st prize for Watercolors, Pastels and Drawings); Rockefeller Center, NY, 1938; Ferargil Gal., 1936; ACA Gal., 1938; Artists Congress, 1938, 1939; "NYC WPA Art" at Parsons School Design, 1977. **Work:** PMG; mural, USPO, Greer, SC; NYC Customs House murals with Reginald Neal, 1935-36. **Comments:** WPA artist. **Sources:** WW53; *New York City WPA Art,* 92 (w/repros.).

WALKOWITZ, Abraham
[Painter, graphic artist, illustrator educator, lecturer] b.1880, Tuiemen, Siberia, Russia / d.1965, Brooklyn, NY.
Addresses: Came to NYC in 1889, settling in NYC; Brooklyn, NY, 1929-65. **Studied:** Cooper Union; Educ. Alliance, NYC; NAD with War, Maynard, F.C. Jones, 1894, 1898; Acad. Julian, Paris, with J.P. Laurens, 1906. **Member:** Am. Artists Congress; Am. Soc. PS&G; Soc. Indep. Artists (dir.; vice-pres.); People's AG, 1915 (founding mem.). **Exhibited:** Haas Gal., NYC, 1908 (first solo); Stieglitz Little Gal., 1912; Armory Show, 1913; Forum Exh., NYC, 1916; S. Indp. A., 1917-39; Salons of Am.; PAFA Ann., 1929, 1933-35; Corcoran Gal. biennials, 1930, 1935; Brooklyn Mus., 1939 (retrospective); AIC. **Work:** BM; MMA; AGAA; PMA; Hirshhorn Mus.; Kalamazoo IA; LOC; NYPL; WMAA; BMFA; Newark Mus.; Columbus Gal. FA; PMG; MoMA; Biro-Bidjan Mus., U.S.S.R; Univ. Gal., Univ. Minnesota, Minneapolis. **Comments:** Early American modernist artist. Walkowitz is best known for his numerous drawings of Isadora Duncan, whom he met at Rodin's Paris studio in 1906. Over the course of his career he made over 5000 drawings of Duncan in motion, often simply using gestural lines to suggest movement. Walkowitz returned to NYC from Paris in 1907. In 1909 he began making etchings and over the next decade produced numerous monotypes, often choosing the buildings of NYC and river views as his subject. He explored the NYC theme in charcoal drawings as well. He met Stieglitz about 1911 and thereafter became a fixture at the gallery, advising Stieglitz to show the art of children and encouraging him to give O'Keeffe a show in 1916. After "291" closed in 1917, Walkowitz's relationship with Stieglitz ended, and the artist's career suffered for lack of support. During the 1920s he painted realistic views and during the 1930s he addressed social themes. Auth.: "Isadora Duncan;" "From the Objective to the Non-Objective," 1945. **Sources:** WW59; WW47; Baigell, *Dictionary;* A. Davidson, *Early American Modernist Painting,* 34-40; Abram Lerner and Bartlett Cowdrey, "A Tape-Recorded Interview with Abraham Walkowitz," *Journal of the Archives of American Art* vol. 9 (Jan. 1969); Falk, *Exh. Record Series.*

WALL, A(lfred) Bryan *[Painter]* b.1861, Allegheny City, PA / d.c.1935, Pittsburgh, PA.
Addresses: Pittsburgh, PA, 1879. **Studied:** his father, A. Wall. **Member:** CI; Pittsburgh SA; AC Phila. **Exhibited:** NAD, 1879; PAFA Ann., 1898; AAS, 1907 (gold); Corcoran Gal. annual, 1908; AIC. **Work:** Butler IA; Westmoreland County Mus., Greensburg, PA. **Comments:** Son of Alfred S. Wall (see entry) and nephew of William C. Wall (see entry). He accompanied his father, uncle and others on sketching trips to Scalp Level as a young boy, and his

experiences led to his first exhibit at the NAD. Specialty: landscapes, pastoral scenes, most including sheep. **Sources:** WW33; Chew, ed., *Southwestern Pennsylvania Painters*, 134, 135, 136; Gerdts, *Art Across America*, vol. 1: 287; Falk, *Exh. Record Series.*

WALL, Alfred S. *[Landscape painter, portrait painter]* b.1825, Mt. Pleasant, PA / d.1896, Pittsburgh, PA.
Addresses: grew up in Mt. Pleasant, PA; Pittsburgh, PA, 1840s-96. **Studied:** self-taught. **Member:** CI (trustee). **Exhibited:** Pittsburgh AA, 1859, 1860; PAFA Ann., 1867, 1879. **Work:** Westmoreland Mus. Art, Greensburg, PA. **Comments:** He and his brother, William Coventry Wall (see entry), settled in Pittsburgh (PA) in the 1840s. He took yearly sketching trips to Scalp Level, along with Joseph R. Woodwell (see entry), George Hetzel (see entry) and others. He greatly influenced art and artists in Pittsburgh over many years. His son, Alfred Bryan Wall, was also an artist. **Sources:** G&W; G&W (gave birthdate of 1809 in England); Fleming, *History of Pittsburgh*, III, 626; Rutledge, PA; *Antiques* (Sept. 1945), 156; Smith. More recently, see, Chew, ed., *Southwestern Pennsylvania Painters*, 137-140 (Chew cites a birth date c.1825 and states that he was born shortly after his family moved to Mount Pleasant, PA, from England); Gerdts, *Art Across America*, vol. 1: 286-87 (cites birthyear of 1825 in Mt. Pleasant, PA); Falk, PA, vol.II.

WALL, Bernhardt T. *[Etcher, historian, writer, teacher, illustrator, commercial artist]* b.1872, Buffalo, NY / d.c.1955, Sierra Madre, CA?.
Addresses: Lime Rock, CT, 1940; Sierra Madre, CA in 1953. **Studied:** ASL, Buffalo; J.F. Brown; H. Reuterdahl; W. Aurbach-Levy. **Member:** Sierra Madre Art Gld.; Texas State Hist. Soc.; Missouri State Hist. Soc. **Exhibited:** Laguna Beach AA, 1945, 1946; Chicago SE. **Awards:** hon. degree, D.H.L., Lincoln Mem. Univ., 1939. **Work:** Grosvenor Lib., Buffalo, NY; New York Hist. Soc.; Lincoln Lib., Shippensburg, PA; Lincoln Mem. Univ.; Allegheny College; Harvard Univ.; Univ. Chicago; Univ. Indiana; Iowa State Univ.; Univ. Michigan; Illinois State Soc.; Brown Univ.; British Mus.; Columbia Univ.; Univ. California; Yale Univ.; LOC; Scripps College; Southwest Mus., Los Angeles; Princeton Univ.; Los Angeles Pub. Lib.; Newark Pub. Lib. **Comments:** Auth./illustr./ed.: "Abraham Lincoln" (85 volumes, etchings), 1931-42; "Thomas Jefferson" (13 volumes etchings), 1933-37; "The Odyssey of the Etcher of Books," 1945; & others. **Sources:** WW53; WW47.

WALL, Gertrude Rupel *[Craftsman, painter, graphic artist, teacher, writer, lecturer, designer, sculptor]* b.1881, Greenville, OH / d.1971, San Mateo County, CA.
Addresses: San Francisco. **Studied:** Denison Univ.; Oberlin College; Chicago Acad. FA; Herron AI; William Chase. **Member:** San Francisco Soc. Women Artists; Am. Ceramic Soc.; Marin Art Soc.; San Francisco Assn. Potters; Bay Region AA. **Exhibited:** Syracuse MFA; SFMA; CPLH; Auburn, NY, 1938; Haggin Art Gal., Stockton, CA (solo); de Young Mem. Mus., 1945 (solo); Oakland Art Gal., 1944 (solo). **Comments:** Teaching: Univ. Calif., Extension Div. **Sources:** WW53; WW47; Petteys, *Dictionary of Women Artists,* reports 1881 as an alternate birth date.

WALL, Hermann C. *[Illustrator, painter]* **H.C.W.** b.1875, Stettin.
Addresses: Wilmington, DE. **Studied:** H. Pyle. **Member:** SI, 1912. **Exhibited:** *Woman's Home Companion* cover contest, 1907 (prize); Strathmore Wash Drawing contest, 1908 (prize). **Sources:** WW19.

WALL, Lou E. *[Painter]* 19th/20th c.
Addresses: San Francisco, CA. **Studied:** Berlin & Paris with Skarbina & Courtois. **Member:** San Francisco AA. **Exhibited:** World's Columbian Expo, Chicago, 1893; Calif. Midwinter Int. Expo, 1894. **Sources:** Hughes, *Artists of California*, 586.

WALL, W. G. *[Painter]* early 20th c.
Addresses: NYC. **Sources:** WW08.

WALL, William Allen
[Portrait and landscape painter] b.1801, New Bedford, MA / d.1885, New Bedford, MA.
Addresses: New Bedford, MA. **Studied:** apprenticed to a watchmaker; painting with Thomas Sully (see entry) and perhaps with his father, William Sawyer Wall. **Exhibited:** NAD, 1836-37, 1858; Boston Athenaeum, 1836, 1840, 1842, 1847, 1859; New Bedford Art Exh., 1858; Benjamin W. Peirce's Gall., New Bedford, c.1870; Ellis's Fine Art Gal., New Bedford, 1882; New Bedford Art Club Loan Exh., 1908; Dartmouth Hist. Soc., 1978. **Work:** New Bedford Free Pub. Lib.; New York Hist. Soc., BMFA; Dukes County Hist. Soc., Edgartown, MA; Dartmouth College, Hanover, NJ; Old Dartmouth Hist. Soc. **Comments:** In 1831 he went abroad to study for the next two years in England, France, and Italy, where he traveled with Ralph Waldo Emerson. On his return he settled permanently in New Bedford. He was particularly noted for his paintings of early 19th-century New Bedford scenes. **Sources:** G&W; Robinson, "William Allen Wall of New Bedford," six repros.; Childs, "'Thar She Blows,'" cites the supplement to the 100th anniversary edition of the *New Bedford Mercury;* Cowdrey, NAD ; Swan, BA; Boston BD 1847; Stokes, *Historical Prints;* Blasdale, *Artists of New Bedford*, 200-202 (w/repros.).

WALL, William Archibald *[Landscape painter]* b.1828, NYC / d.After 1875.
Addresses: Newburgh, NY, in 1861, but seems to have resided in London for much of his career. **Exhibited:** Dublin, Ireland; Royal Acad., London, 1857-72; NAD, 1861. **Comments:** Son of William Guy Wall (see entry). **Sources:** G&W; Benezit; Christopher Wood, *Dictionary of Victorian Painters* (Woodbridge, Suffolk: Antique Collectors' Club, 1995).

WALL, William Coventry *[Landscape* **W.C.Wall.** *and portrait painter]* b.1810, Oxford, England / d.1886, Pittsburgh, PA.
Addresses: Pittsburgh, PA, from the early 1840s on. **Studied:** self-taught. **Exhibited:** locally; PAFA, 1855; Pittsburg Sanitary Fair, 1864. **Work:** Carnegie Inst., Pittsburgh ("Pittsburgh after the Fire, 1845, from Boyd's Hill"). **Comments:** Came to U.S. with his family, and settled in Mt. Pleasant, PA, sometime before 1825. Moved to Pittsburgh with his brother Alfred S. Wall (see entry), also an artist. Began working for J.J. Gillespie & Co. in 1843, selling art supplies and later making picture frames. He took up painting about the same time and became noted for his views of Pittsburgh and vicinity, and particularly for his views of the city after the fire of 1845. **Sources:** G&W; Glassburn, "Artist Reports on the Fire of 1845"; *Antiques* (Sept. 1945), 156; *Panorama* (Dec. 1946), 43; Rutledge, PA; Fleming, *History of Pittsburgh*, III, 626; letter, Rose Demorest, Carnegie Library of Pittsburgh, to Miss Anna Wells Rutledge, Oct. 31, 1950 (NYHS files). More recently, see. Chew, ed., *Southwestern Pennsylvania Painters*, 141-145; Gerdts, *Art Across America*, vol. 1: 286.

WALL, William F. *[Engraver]* b.1870.
Addresses: Wash., DC, active 1904-36. **Comments:** Position: staff, Bureau of Engraving and Printing. **Sources:** McMahan, *Artists of Washington, DC.*

WALL, William Guy *[Landscape* **W.G.Wall** *painter]* b.1792, Dublin, Ireland / d.After 1864, presumably Dublin, Ireland.
Member: NAD, founder. **Exhibited:** NAD, 1826-56; PAFA Ann., 1838-40 (and posthumously); Apollo Assoc.; Boston Athenaeum, 1828, 1830, 1836; Brooklyn AA, 1872. **Work:** NYHS; MMA. **Comments:** Early Hudson River painter. Wall was married in Dublin in 1812. Six years later he arrived in NYC (September 1, 1818), already an accomplished painter. His watercolor views of the Hudson River and NYC soon brought him wide recognition in America and twenty of them were engraved and published in the popular *Hudson River Portfolio*, which went through several editions between 1820-28. After the birth of his son, William Archibald Wall (see entry), in NYC in 1828, he moved to

Newport (RI), later moving on to New Haven (CT) and then to Brooklyn, NY. Wall returned to Ireland in 1837, settling in Dublin, where he began working with Master Hubard, the silhouettist, painting pictorial backgrounds. He continued to exhibit in Dublin during the 1840s and 1850s, also exhibiting once in London and several times in the United States (NAD in 1837, 1841, 1853, 1856). He returned to America in 1856 and settled in Newburgh (NY), remaining there as late as July 1862 (his son was living there as well). Soon after this he went back to Dublin and was living there in 1864, after which nothing is known of him. **Sources:** G&W; Shelley, "William Guy Wall and His Watercolors for the Historic *Hudson River Portfolio;*" Flexner, *The Light of Distant Skies;* Campbell, *New Hampshire Scenery,* 170; *300 Years of American Art,* 108.

WALLACE *[Assistant scene painter] mid 19th c.*
Addresses: NYC, 1857-59. **Comments:** At Wallack's Theatre. **Sources:** G&W; Odell, *Annals of the New York Stage;* *N.Y. Herald,* June 16, 1858 (G&W has information courtesy J. Earl Arrington).

WALLACE, A. H. *[Portrait painter] mid 19th c.*
Addresses: Brooklyn, NY, 1837. **Sources:** G&W; NYBD 1837.

WALLACE, Alexander *[Lithographer, photographer] late 19th c.*
Addresses: New Orleans, active 1887-89. **Sources:** *Encyclopaedia of New Orleans Artists,* 399.

WALLACE, Amy Spicer *[Painter] b.1871, Belle Plaine, MN / d.1943, Los Angeles, CA.*
Addresses: Minneapolis, MN; Los Angeles, CA. **Exhibited:** P&S Los Angeles, 1926; Artists Fiesta, Los Angeles, 1931; Laguna Festival Arts, 1941. **Comments:** Specialty: still lifes and landscapes. **Sources:** WW24; Hughes, *Artists in California,* 586.

WALLACE, Benjamin A. *[Portrait and miniature painter, writing master] mid 19th c.*
Addresses: Active in NYC from 1824-30. **Work:** NYHS. **Sources:** G&W; NYCD 1824-30; NYHS *Quarterly Bulletin* (July 1926), 60, 62.

WALLACE, Carleton (Mrs.) *[Painter] early 20th c.*
Addresses: Minneapolis, MN. **Sources:** WW21.

WALLACE, David Harold *[Art historian, art administrator] b.1926, Baltimore, MD.*
Addresses: Frederick, MD. **Studied:** Lebanon Valley College (B.A.); Columbia Univ. (M.A.; Ph.D.). **Comments:** Positions: asst. editor, NY Hist. Soc., New York, 1952-56; museum curator, Independence Nat. Hist. Park, Phila., 1958-68; asst. chief, Branch Mus. Operations, Nat. Park Service, 1968-71, chief, 1971-. Publications: co-author, "Dictionary of Artists in America," 1564-1860, NY Hist. Soc., 1957; author, "John Rogers, the People's Sculptor," 1967. Collections arranged: Peale-Sharples Collection of Early American Portraits, Independence Nat. Historical Park, Phila. Research: American artist biographies. **Sources:** WW73.

WALLACE, Ethel A. *[Portrait painter, designer, decorator] b.c.1885, Recklesstown (now Chesterfield), NJ / d.1968.*
Addresses: Active in NYC and abroad until 1925; New Hope, PA. **Studied:** PAFA with McCarter; W. Lathrop; C.F. Ramsey; C. Enright. **Member:** Phila. Art Alliance. **Exhibited:** NY studio of Mrs. Harry P.Whitney; Leicester Square Gal., London; Grand Central Gal., NYC; PAFA Ann., 1910; Corcoran Gal. biennial, 1910; AIC, 1913-14; WMAA, 1920-27; Soc. Indep. Artists, 1925

WALLACE, Ethel M. *[Painter] mid 20th c.*
Addresses: San Francisco, CA, 1930s. **Exhibited:** San Francisco Soc. of Women Artists, 1931, 1940; Oakland Art Gallery, 1932. **Comments:** She assisted Frank Van Sloun (see entry) with painting the murals in the rotunda of the Palace of Fine Arts in 1936. **Sources:** Hughes, *Artists of California,* 587.

WALLACE, Frances Revett *[Painter] b.1900, San Francisco, CA / d.1987, San Fran.*
Addresses: San Fran. **Studied:** Calif. Sch. FA; Schaeffer Sch.

Des. **Exhibited:** San Fran. Soc. Women Artists, 1940. **Sources:** Hughes, *Artists of California,* 587.

WALLACE, Frederick E. *[Portrait painter, teacher] b.1893, Haverhill, MA / d.1958.*
Addresses: Boston, MA. **Studied:** Mass. Normal Art Sch.; Julian Acad., Paris; E.L. Major; Joseph De Camp. **Member:** Gld. Boston Artists; Rockport AA; North Shore AA; Am. Veterans Soc. Art. **Exhibited:** PAFA Ann., 1923, 1928; New England Contemp. Art, 1944 (prize); Rockport AA; North Shore AA. **Work:** Mass. State House; Dartmouth College; New Hampshire State Teachers College; Boston City Club; Bridgewater Normal Sch.; Brooklyn Tech. H.S. **Sources:** WW53; WW47; Falk, *Exh. Record Series.*

WALLACE, Georgia Burns *[Painter] early 20th c.*
Addresses: Washington, CT; NYC. **Exhibited:** PAFA Ann., 1913. **Sources:** WW15; Falk, *Exh. Record Series.*

WALLACE, Harry Duff *[Designer, sketch artist, art glass craftsman] b.1875 / d.1952.*
Addresses: New Orleans, active 1903-47. **Exhibited:** NOAA, 1915. **Sources:** *Encyclopaedia of New Orleans Artists,* 399.

WALLACE, J. W. *[Painter] early 20th c.*
Addresses: Knoxville, TN. **Sources:** WW13.

WALLACE, James *[Sculptor in marble] mid 19th c.*
Addresses: New Orleans, 1852-56. **Sources:** G&W; New Orleans CD 1852-56.

WALLACE, John *[Painter] mid 20th c.*
Addresses: Webster Groves, MO. **Exhibited:** PAFA Ann., 1952. **Sources:** Falk, *Exh. Record Series.*

WALLACE, J(ohn) Laurie *[Painter, sculptor, teacher] b.1864, Garvagh, Ireland.*
Addresses: AIC, Chicago, 1885; Omaha, NE. **Studied:** T. Eakins. **Member:** Omaha AG (pres.). **Exhibited:** PAFA Ann., 1885, 1927. **Work:** Univ. Nebraska, Pub. Lib., Masonic Hall, All Saints Church, Clarkson Hospital, Federal Court, Trinity Cathedral, Creighton Medical Sch., Nebraska, Methodist Episcopal Hospital, Joslyn Mem., all in Omaha; Press Club, Chicago; NYC Athletic Club. **Sources:** WW40; Falk, *Exh. Record Series.*

WALLACE, Leontine Edith *[Painter] b.1896, Alameda, CA / d.1971, Carmel Valley, CA.*
Addresses: Carmel Valley, CA. **Studied:** Maurice Sterne, Andre L'Hote, Paris. **Exhibited:** San Francisco Soc. Women Artists, 1931; Santa Cruz Art Lg., 1932, 1942. **Comments:** Teaching: Marysville H.S. **Sources:** Hughes, *Artists in California,* 587.

WALLACE, Lewis *[Amateur painter, illustrator, writer] b.1827, Brookville, IN / d.1905, Crawfordsville, IN.*
Addresses: Indianapolis; Crawfordsville, IN. **Exhibited:** Indianapolis, 1878 ("The Dead Line at Andersonville"). **Comments:** Best known as the author of Ben Hur, "Lew" Wallace was a lawyer by profession, a prominent Civil War general, governor of New Mexico (1878-81), minister to Turkey (1881-85), and man of letters. His boyhood was spent in Indianapolis, where he worked for the painter Jacob Cox (see entry) as color-grinder for a time. Although his father prevented him from taking up art as a profession, in later life Wallace painted as an amateur and occasionally exhibited. His last years were spent in Crawfordsville. *Lew Wallace, an Autobiography* appeared the following year. **Sources:** G&W; DAB; Peat, *Pioneer Artists of Indiana;* Burnet, *Art and Artists of Indiana.*

WALLACE, Lillie T. (Mrs. Fred A.) *[Painter, craftsperson] early 20th c.; b.Manchester.*
Addresses: Andover, MA. **Studied:** Cornoyer; Mulhaupt. **Member:** North Shore AA; Rockport AA; Boston SAC. **Sources:** WW31.

WALLACE, Lucy (Mrs. Lucy Wallace de Lagerberg) *[Painter, craftsperson, designer, teacher] b.1884, Montclair, NJ.*
Addresses: Wading River, NY. **Studied:** NY School Fine & Applied Art; ASL; Kenneth Hayes Miller; John R. Koopman. **Member:** Boston Soc. Arts & Crafts. **Exhibited:** Corcoran Gal.

biennial, 1916; CAM; AWCS; Montclair Art Mus.; Phila. WCC; Paris Salon; Soc. Indep. Artists; Gld. Hall, Easthampton, NY; Sullolk Mus., Stoney Brook, LI; Parrish Mus. Art, 1957, 1958; Salons of Am. Awards: prize, New Haven PCC, 1923. **Sources:** WW59; WW47.

WALLACE, Mary Wyman (Mrs.) *[Painter] late 19th c.*
Addresses: Brooklyn, NY, 1872. **Exhibited:** Brooklyn AA, 1871-81; NAD, 1872; PAFA Ann., 1882. **Sources:** *Brooklyn AA;* Falk, *Exh. Record Series.*

WALLACE, Moira *[Portrait painter, mural painter] b.1910, Carmel, CA / d.1979, Monterey, CA.*
Addresses: San Francisco, CA. **Studied:** Fred Gray; Armin Hansen; Maurice Sterne. **Member:** San Francisco AA; Carmel AA. **Exhibited:** Gump's, San Francisco, 1927; SFMA; de Young Mus.; AIC, 1942; Carmel Mus.Art, 1967. **Work:** Monterey H.S.; Naval Postgraduate Sch., Monterey; Carmel H.S.; Mark Hopkins Hotel. **Sources:** Hughes, *Artists in California,* 587.

WALLACE, Oren J. *[Sculptor] mid 20th c.*
Addresses: Chicago area. **Exhibited:** AIC, 1932, 1935, 1937. **Sources:** Falk, *AIC.*

WALLACE, Oscar J. *[Listed as "artist"] mid 19th c.*
Addresses: Cincinnati, 1856. **Sources:** G&W; Cincinnati CD 1856.

WALLACE, Richard William *[Painter] late 19th c.*
Studied: Constant & Laurens. **Exhibited:** Paris Salon, 1899. **Sources:** Fink, *American Art at the Nineteenth-Century Paris Salons,* 402.

WALLACE, Robert R. *[Painter] early 20th c.*
Addresses: Minneapolis, MN. **Sources:** WW17.

WALLACE, Soni *[Painter] b.1931, London, England.*
Addresses: NYC. **Studied:** Silvermine Art Guild, New Canaan, CT; MoMA with Zolten Hecht; Pratt Graphics, NYC. **Member:** NAWA (program chmn., 1972); Am. Soc. Contemporary Artists; Silvermine Guild Artists; Washington AA. **Exhibited:** Conn. WCS 31st Ann., Fairfield Univ., 1969; Love/Peace, Am. Greetings Gallery, New York, 1969; Northwest PM, 41st Int. Exh., SAM, 1970; Pacem in Terris Gal., New York, 1970 (solo) & Danbury (CT) Lib. Gal., 1971 (solo); Silvermine Guild of Artists, New Canaan, CT, 1970s. Awards: award for watercolor show, Pen & Brush, New York, 1969; Max Granick Award, Am. Soc. Contemp. Artists, NY, 1971; award, Washington (CT) AA, 1972. **Work:** Gibbes Art Mus., Charleston, SC. Commissions: three covers for magazine, *Distinguished Resorts,* 1968, 1970 & 1971. **Comments:** Preferred media: watercolors, acrylics. **Sources:** WW73.

WALLACE, Thomas J. *[Sculptor] b.1851, Schenectady, NY.*
Addresses: Troy, NY, 1858-60; NYC, 1862, 1864. **Studied:** Plassmann; Elwell. **Exhibited:** NAD, 1862, 1864. **Comments:** From 1854-57 he was listed as a music teacher. **Sources:** G&W; Troy CD 1854-60; N.Y. State BD 1859. Bibliography: WW10.

WALLACE, William Henry *[Landscape painter, etcher] 19th c.*
Addresses: NYC. **Exhibited:** Brooklyn AA, 1875. **Work:** NYPL (etchings). **Comments:** An employee of a NYC insurance firm for many years, Wallace made hundreds of topographical drawings of NYC scenes from the 1850s-80s, in watercolor. He also etched about eighty plates from his own drawings. **Sources:** G&W; Stokes, *Historical Prints,* 101; *Portfolio* (Feb. 1945), 140-41, repros.

WALLACE, William R. *[Engraver and lithographer] mid 19th c.*
Addresses: Cincinnati, 1855-59. **Comments:** Of Middleton, Wallace & Company (see entry). Wallace dropped out in 1859 and the firm became Middleton, Strobridge & Company (see entry). **Sources:** G&W; Cincinnati CD 1856-58; Peters, *America on Stone.*

WALLASTER, John G. *[Lithographer] b.1868, Chicago, IL / d.1936, New Orleans, LA.*
Addresses: New Orleans, active 1893-1905. **Sources:** *Encyclopaedia of New Orleans Artists,* 400.

WALLE, Frank Leonard Charles *[Lithographer, engraver] b.1882, New Orleans, LA / d.1938.*
Addresses: New Orleans, active 1899-1933. **Sources:** *Encyclopaedia of New Orleans Artists,* 400.

WALLE, Frank P. *[Lithographer] b.c.1864, New Orleans, LA / d.1920, New Orleans.*
Addresses: New Orleans, active 1887-1920. **Comments:** Father of John A. Walle (see entry). **Sources:** *Encyclopaedia of New Orleans Artists,* 400.

WALLE, John A. *[Lithographer] b.c.1892, Louisiana.*
Addresses: New Orleans, active 1910-55. **Comments:** Son of Frank P. Walle (see entry). **Sources:** *Encyclopaedia of New Orleans Artists,* 400.

WALLE & CO. *[Lithographers] 19th/20th c.*
Addresses: New Orleans, active 1897-1929. **Comments:** Partners were John Walle, born in Germany c.1841; his son Bernard John Walle, born in N.O., died 1869; and Frederick W. Young. They used chromolithography extensively in the creation of commercial labels and did work for several carnival organizations. They were also credited as one of the first printing companies in the nation to mastre a four-color printing process. **Sources:** *Encyclopaedia of New Orleans Artists,* 400.

WALLEEN, Hans Axel *[Painter, illustrator] b.1902, Malmo, Sweden / d.1978.*
Addresses: Wilton, CT. **Studied:** PIA School. **Member:** AWS (pres., 1957-59; hon. vice-pres., 1959; 1st vice-pres., 1965-); All. Artists Am. **Exhibited:** AWCS, 1951-61; SC, annually; Swedish-Am. Exhs., Chicago (annuals). Awards: *Am. Artist* magazine Medal of Honor, 1959 and article with reproduction of work; prize, AAPL, 1955. **Comments:** Positions: faculty, PIA Sch., 1930-35; art advisor, William Esty Co., NYC, 1943-63. Illustrator, Junior Literary Guild edition of "Nuvat, the Brave" & "All American." **Sources:** WW66.

WALLEN, G. T. *[Painter] early 20th c.*
Exhibited: AIC, 1923. **Sources:** Falk, *AIC.*

WALLER, Edward L. *[Lithographer] mid 19th c.*
Addresses: Philadelphia, 1855-58. **Sources:** G&W; Peters, *America on Stone.*

WALLER, Frank *[Painter, architect] b.1842, NYC / d.1923.*
Addresses: Morristown, NJ; NYC, 1870-87. **Studied:** NY Free Acad.; J.G. Chapman, Rome, 1870; ASL, from 1874, with Chase. **Member:** Arch. Lg., 1887; NAC; ASL (founder & pres.). **Exhibited:** NAD, 1870-87; Brooklyn AA, 1873-84; Boston AC, 1876, 1884; PAFA Ann., 1879-84. **Comments:** Traveled to Egypt in 1872, making many studies which he used for future works. He also painted in Venice, Italy, and upper New York and New Hampshire; and in Bermuda. **Sources:** WW21; Clement and Hutton; Falk, *Exh. Record Series.*

WALLER, Harold B. (Mrs.) *[Painter] early 20th c.*
Addresses: Dallas, TX. **Sources:** WW24.

WALLER, Johannes O. *[Painter] b.1903, Munich, Germany / d.1945.*
Addresses: Chicago, IL, 1929; Evanston, IL. **Work:** murals/portraits for Levere Mem. Temple, nat. headquarters of Sigma Alpha Epsilon.

WALLER, John *[Engraver] mid 19th c.*
Addresses: Chicago, 1853-54. **Sources:** G&W; Chicago BD 1853-54.

WALLER, Robert *[Painter] b.1909, Anaheim, CA.*
Addresses: San Francisco, CA. **Studied:** P. Sample. **Exhibited:** San Fran. AA, 1937, 1939; GGE, 1939. **Sources:** WW40.

WALLESTEIN, Julius *[Portrait painter] mid 19th c.*
Addresses: Baltimore, 1849-50. **Sources:** G&W; Baltimore CD 1849-50; Lafferty.

WALLETT, William *[Painter] b.1907, Milwaukee, WI / d.1983.*
Addresses: Pasadena, CA. **Studied:** arch., USC; Dan Lutz; Paul Sample. **Exhibited:** P&S Los Angeles, 1934-36; Calif. WCS, 1930s-50s; GGE, 1939. **Comments:** Position: staff, Universal and Walt Disney Studios. **Sources:** Hughes, *Artists in California*, 587.

WALLEY, Abigail (Abbie) B. P. *[Landscape painter] b.1845, Boston, MA.*
Addresses: Brookline, MA. **Studied:** Sanderson; Langerfeldt; Bensa; Rice. **Member:** AFA; Copley Soc. **Exhibited:** James M. Hart Gal., Boston (solo); Boston AC, 1893, 1895, 1907; PAFA Ann., 1901; Soc. Indep. Artists, 1917. **Comments:** Specialty: gardens in watercolors and pastels. **Sources:** WW31; Falk, *Exh. Record Series*.

WALLEY, John Edwin *[Mural painter] b.1910, Sheridan, WY.*
Addresses: Chicago/Cody, WY. **Studied:** Chicago Acad. FA; Goodman Theatre of AIC; H. Ropp's Sch. Art. **Member:** Wyoming AA. **Exhibited:** AIC, 1936, 1938-39, 1949. **Work:** murals, Univ. Wyoming, Pub. Lib., Cody. **Sources:** WW40.

WALLIN, Carl E. *[Portrait & mural painter] b.1879, Sweden.*
Addresses: Chicago, IL. **Studied:** AIC Reed's Art Sch., Denver. **Member:** Chicago AA; All-Illinois FA; Swedish Artists Chicago; Chicago Gal. Art. **Exhibited:** Swedish Am. AA, 1925 (prize), 1928 (prize), 1929 (prize); Swedish Artists Chicago, 1928 (prize); PAFA Ann., 1932; AIC. **Work:** St. Adelbert's Church, Whiting, IN; Gothenburg Mus. (Sweden). **Sources:** WW40; Falk, *Exh. Record Series*.

WALLIN, Gustaf Theodore *[Painter] early 20th c.*
Exhibited: AIC, 1926. **Sources:** Falk, *AIC*.

WALLIN, Marlene *[Painter] mid 20th c.*
Exhibited: Corcoran Gal. biennial, 1961. **Sources:** Falk, *Corcoran Gal.*

WALLIN, Samuel *[Engraver and draftsman] mid 19th c.*
Addresses: NYC from 1838-51. **Exhibited:** NAD, 1843 (drawings). **Comments:** Wallin did some illustrations for *The Parthenon* (1851). Samuel Wallin, Jr. (see entry), engraver, was working with him in 1846. **Sources:** G&W; NYCD 1838-50; Cowdrey, NAD; NYPL Print Room catalogue.

WALLIN, Samuel, Jr. *[Engraver] mid 19th c.*
Addresses: NYC in 1846. **Comments:** He worked with and presumably the son of Samuel Wallin (see entry). **Sources:** G&W; NYBD 1846.

WALLING, Anna May *[Craftsman, painter, designer, teacher, lecturer, writer, lecturer, block printer, decorator] b.1881, Warwick, NY.*
Addresses: Middletown, NY. **Studied:** NYC; England, France & Germany; M. Fry; A. Heckman; A. Dow; G. Cornell; W. Reiss; D.W. O'Hara; M. Mason. **Member:** NY Keramic Soc.; NY Craftsman's Club; Des. Guild, NY. **Exhibited:** MMA; AMNH; Newark MA; Syracuse (NY) Craftsmen's Club; NY Keramic Soc. **Work:** Escutcheons, Dutch Reform Church, New Paltz, NY; and in Mexico; Hollywood; Kansas City, MO; Australia and in many states of the U.S. **Comments:** Contrib.: Keramic Studio. **Sources:** WW59; WW47.

WALLING, Dow *[Illustrator] mid 20th c.*
Addresses: Pelham Manor, NY. **Member:** SI. **Sources:** WW47.

WALLING, Henry F. *[Lithographer] mid 19th c.*
Addresses: Boston, 1854. **Comments:** Listed as lithographer in the business directory; in the city directories he was listed as an engineer. **Sources:** G&W; Boston BD 1854; Boston CD 1852-55.

WALLINGTON, Ethel *[Painter] mid 20th c.*
Exhibited: Corcoran Gal biennial, 1955. **Sources:** Falk, *Corcoran Gal.*

WALLIS, Frank *[Painter] 20th c.*
Addresses: NYC. **Studied:** ASL. **Exhibited:** S. Indp. A., 1931; NJ State Exh., Montclair AA, 1938; AIC, 1937, 1938; AWCS-NYWCC, 1939; Salons of Am. **Sources:** WW40.

WALLIS, Frederick I. *[Portrait painter] mid 19th c.*
Addresses: Chicago, 1859. **Sources:** G&W; Chicago BD 1859.

WALLIS, Katherine Elizabeth *[Sculptor, painter, poet] b.1861, Peterborough, Ontario, Canada / d.1957, Santa Cruz, CA.*
Addresses: Paris, France; Santa Cruz, CA. **Studied:** Edinburgh School, South Kensington School, London; Académie Colarossi, Paris; Oscar Waldmann; Dresden; Italy. **Exhibited:** Walker Art Gal., Liverpool; Royal Acad.; in Canada, 1904-35, at Montreal AA, Nat. Gal. Canada, Ontario Soc. Artists, Royal Canadian Acad.; Paris Expo Universiette, 1900; Dresden Germany Int. Expo, 1901; CPLH; Soc. for Sanity in Art, 1940, 1945. **Work:** MM; Nat. Gal. Canada; Petit Palais, Paris. **Comments:** Specialty: children and animal sculpture. **Sources:** Hughes, *Artists in California*, 587.

WALLIS, M. E. (Mrs.) *[Painter] late 19th c.*
Addresses: NYC, 1883. **Exhibited:** NAD, 1882-83. **Sources:** Naylor, *NAD*.

WALLIS, Mary Burton *[Painter, graphic artist] b.1916, Dubuque, IA.*
Addresses: Scarsdale, NY. **Studied:** ASL. **Member:** Young Am. Artists; NAWPS. **Exhibited:** Contemp. Art Gal., NY; FA Gal., NYC. **Sources:** WW40.

WALLIS, R. W. *[Painter] late 19th c.*
Exhibited: NAD, 1883. **Sources:** Naylor, *NAD*.

WALLIS, Zj(essa) Eula *[Painter] 20th c.*
Addresses: Laramie, WY. **Exhibited:** Soc. Indep. Artists, 1933-34. **Sources:** Marlor, *Soc. Indp. Artists*.

WALMSLEY, Elizabeth (Mrs.) *[Educator, lithographer, screenprinter] 20th c.; b.Barberton, Ohio.*
Addresses: Dallas 20, TX. **Studied:** Washington Univ. (B. Arch.); Texas Women's Univ. (M.A.); Bethany College; St. Louis Sch. FA; Colorado Springs FAC. **Member:** Assoc. Women in Arch.; Texas PM; Craft Gld. Dallas; AAUP. **Exhibited:** in southwestern print exhs.; Texas PM traveling exhs. **Awards:** prizes, Texas FA Soc.; Dallas Pr. Soc.; Southwestern Print Annual. **Comments:** Teaching: Southern Methodist Univ., 1950s-60s. Lectures: contemporary art & modern interiors. **Sources:** WW66.

WALMSLEY, Lucy *[Painter] early 20th c.*
Addresses: Noroton Heights, CT. **Exhibited:** S. Indp. A., 1918-19. **Sources:** WW19.

WALP, M(arguerite) Vignes (Mrs.) *[Painter, printmaker] b.1889, California / d.1983, Long Beach, CA.*
Addresses: Long Beach CA. **Member:** Calif. PM. **Exhibited:** Calif. PM, LACMA, 1918. **Sources:** WW25; Hughes, *Artists in California*, 587.

WALPOLE, Frederick Andrews *[Painter, illustrator] b.1861, Port Douglas, Essex County, NY / d.1904, Santa Barbara, CA (on a work related trip).*
Addresses: Chicago, IL; Portland, OR, 1882-1896; Wash., DC, 1896-1904. **Studied:** Chicago, with Sloan (possibly Junius R.). **Exhibited:** Carnegie-Mellon Univ., 1973-74 (solo, retrospective). **Work:** govt. agencies, Wash., DC; Smithonian Inst. **Comments:** A superb botanical artist, he created thousands of drawings and watercolors despite his early death. Positions: illustr., Lewis and Dryden Printing Co., Portland, 1886-96; botanical artist, U.S. Dept. Agriculture, Wash., DC, 1896-1904. In 1903 he set up an exhibit of his watercolors for the Louisiana Purchase Expo., St. Louis, MO. **Sources:** McMahan, *Artists of Washington, DC*.

WALRATH, Charles Preston *[Painter] b.1879, Success, MO / d.1971, Taft, CA.*
Addresses: Sacramento, CA. **Exhibited:** Kingsley Art Club, Sacramento, 1930-32. **Sources:** Hughes, *Artists of California*, 587.

WALSER, Floyd N. *[Etcher, painter, teacher] b.1888, Winchester, TX.*
Addresses: Framingham, MA. **Studied:** BMFA Sch.; Plowman; Spaulding; Kitson. **Member:** Framingham AL; Southern PM. **Exhibited:** SAGA; CMA; Southern PM traveling exh. **Sources:** WW59; WW47.

WALSH, Berengaria Fildes *[Painter] early 20th c.*
Addresses: Mt. Vernon, NY, 1930. **Exhibited:** S. Indp. A., 1930. **Sources:** Marlor, *Soc. Indp. Artists.*

WALSH, Clara A. *[Painter] early 20th c.*
Addresses: Lincoln, NE. **Sources:** WW04.

WALSH, David *[Lithographer] b.c.1837.*
Addresses: NYC in 1860. **Sources:** G&W; 8 Census (1860), N.Y., XLII, 900; NYCD 1858, 1860.

WALSH, Edward *[Topographical painter in watercolors] b.1756 / d.1832.*
Work: Clements Library, Univ. of Michigan. **Comments:** He was a surgeon attached to the 49th Regiment of the British Army, stationed near Niagara Falls for several years before the War of 1812. He made a number of watercolor views of Lake Erie and Buffalo Creek (NY), one of which was engraved in aquatint and published in London in 1811. On June 22, 1804, he made a painting of the Detroit settlement, from a point on the Canadian side of the Detroit River. **Sources:** G&W; Stokes, *Historical Prints*, 53. More recently, see, Gibson, *Artists of Early Michigan*, 235.

WALSH, Elizabeth Morse *[Painter] early 20th c.; b.Lowell, MA.*
Addresses: Lowell, MA. **Studied:** BMFA Sch. **Member:** Concord AA. **Exhibited:** PAFA Ann., 1918; Corcoran Gal. biennial, 1919. **Sources:** WW25; Falk, *Exh. Record Series.*

WALSH, Florence *[Painter] mid 20th c.*
Addresses: Chicago area. **Exhibited:** AIC, 1937. **Sources:** Falk, AIC.

WALSH, Florence *[Painter] early 20th c.*
Addresses: active in Los Angeles, 1913-16. **Comments:** *Cf.* Florence Walsh in Chicago. **Sources:** Petteys, *Dictionary of Women Artists.*

WALSH, Francis *[Engraver] b.c.1825, Canada.*
Addresses: Philadelphia in 1850. **Sources:** G&W; 7 Census (1850), Pa., LIV, 695.

WALSH, J. P. *[Painter] early 20th c.*
Addresses: Helena, MT. **Exhibited:** S. Indp. A., 1924. **Sources:** Marlor, *Soc. Indp. Artists.*

WALSH, J. Raymond (Mrs.) See: **REEVES, Ruth**

WALSH, James *[Engraver] b.c.1820, Irish.*
Addresses: NYC in 1860. **Comments:** His wife and children, ages 6 to 13 in 1860, were born in New York. **Sources:** G&W; 8 Census (1860), N.Y., XLII, 370.

WALSH, Jeremiah *[Landscape painter] mid 19th c.*
Addresses: NYC, 1859. **Sources:** G&W; NYBD 1859.

WALSH, John (F.) T. *[Painter] 20th c.*
Studied: ASL. **Exhibited:** S. Indp. A., 1937, 1942. **Sources:** Marlor, *Soc. Indp. Artists.*

WALSH, John Stanley *[Painter, writer] b.1907, Brighton, England.*
Addresses: Lachine, PQ. **Studied:** London Central School Art, England. **Member:** CWCS; Canadian Soc. Graphic Art. **Exhibited:** AWCS, 1961; Canadian Soc. Painter in Water Colour; Canadian Soc. Graphic Art; Royal Canadian Acad. Art; Montreal, New York & Toronto (solos). **Work:** Montreal MFA; Toronto

AM. **Comments:** Preferred media: watercolors.Publications: contributor, articles & illustrations, *Am Artists, New York Times, Esquire, Harpers's Bazaar & Field & Stream*. Teaching: lecturer on watercolor painting. **Sources:** WW73.

WALSH, Joseph W. *[Lithographer] b.c.1828, New York.*
Comments: Active from about 1850. He may have been the artist of this name who exhibited a portrait painting at the American Institute in 1842, although he would have been in his early teens at that time. **Sources:** G&W; 7 Census (1850), N.Y., L, 771; 8 Census (1860), N.Y., XLIV, 851; NYCD 1854-60; Am. Inst. Cat., 1842.

WALSH, Madge *[Etcher] early 20th c.*
Addresses: Chicago, IL. **Sources:** WW19.

WALSH, Margaret M. *[Painter] b.1892, Bellingham, WA.*
Addresses: Active in Flagstaff, AZ. **Exhibited:** San Marcos Hotel, Chandler, AZ, 1912. **Comments:** Painted Hopi Indians. **Sources:** Petteys, *Dictionary of Women Artists.*

WALSH, Noemi M. *[Jeweler-silversmith, teacher, craftsperson] b.1896, St. Louis, MO.*
Addresses: Richmond Heights, MO. **Studied:** Washington Univ., St. Louis, MO; commercial training in engraving & fine carving & restoration of antique jewelry; also study in Europe. **Exhibited:** St. Louis Art Gld.; Wichita, KS; Noonan-Kocian Gal.; CAM; Des-Craftsmen, 1953; Steinberg Mus., St. Louis, 1962-64. **Work:** various commissions in jewelry & silversmithing, including Chancellor's medallion, Washington Univ.; pins, Alton (IL) Mem. Hospital. **Comments:** Positions: instr. in jewelry & silversmithing, Washington Univ., St. Louis, 1928-65; Univ. College, St. Louis, 1942-65; jewelry des. consult. & private instr., jewelry & silversmithing. **Sources:** WW66; WW47.

WALSH, Richard M. L. *[Painter] 19th/20th c.; b.NYC.*
Addresses: NYC, active 1896-1910. **Studied:** ASL. **Member:** NAC. **Exhibited:** PAFA Ann., 1896-98; NAD, 1896-1900; Boston AC, 1902, 1906; AIC. **Sources:** WW10; Falk, *Exh. Record Series.*

WALSH, Thomas *[Painter] mid 20th c.*
Exhibited: Corcoran Gal. biennial, 1963. **Sources:** Falk, *Corcoran Gal.*

WALSH, W. Campbell *[Sculptor, painter, designer] b.1905, Altoona, PA.*
Addresses: Astoria, NY; New York 11, NY; Long Island, NY. **Studied:** PM Sch. IA; PAFA; George Harding, muralist; Henry McCarter, painter; J.T. Pearson. **Member:** NSMP (treas., 1963-66); Arch. Lg. NY; AEA; Artists Union; Soc. Indep. Artists. **Exhibited:** Corcoran Gal. biennial, 1937; PAFA Ann., 1938; VMFA; S. Indp. A.; Carnegie Inst.; NAD; Rockefeller Center; WMAA; Arch. Lg. (NSMP), 1961. **Awards:** prizes, Municipal AA, NY, 1938; Ohio Univ., 1948. **Work:** Ohio Univ.; mosaics, Providence Hospital, Holyoke, MA; St. Peters & Pauls Cathedral, Phila.; St. Stanislaus Novitiate, Lenox, MA; St. John the Evangelist, Silver Spring, MD; Boys Town (NE) School; St. Thomas More, Chicago; Meadowbrook Nat. Bank, Merrick, LI; murals, Bishop Clarkson Hospital, Omaha and Bishop Clarkson Nurses' Home (sculpture); First Nat. City Bank, NY; fresco, St. Cecelia Cathedral, Omaha; St. Mary's Seminary, Baltimore; Most Holy Rosary, Syracuse, NY; painting, Lady in the Retreat, Mt. Kisco, NY; sculpture, St. Mary's Cathedral, Trenton, NJ. **Sources:** WW66; WW40; Falk, *Exh. Record Series.*

WALSH-KIPKE, Alida *[Painter] mid 20th c.*
Exhibited: Corcoran Gal. biennials, 1963. **Sources:** Falk, *Corcoran Gal.*

WALSH & BAKER *[Wood engravers] mid 19th c.*
Addresses: NYC. **Exhibited:** Am. Inst., 1846. **Comments:** Their address was the same as that of Daniel T. Smith and William Roberts (see entries). Baker was probably William Jay Baker (see entry), later a partner of Daniel T. Smith; Walsh is otherwise unknown. **Sources:** G&W; Am. Inst. Cat., 1846; NYCD 1846.

WALTEMATH, William F. *[Painter] mid 20th c.*
Addresses: Rockville Center, LI, NY. **Exhibited:** S. Indp. A.,
1924, 1926, 1928, 1934; Walker Gal., NYC, 1937, 1939; PAFA
Ann., 1939; Salons of Am. **Sources:** WW40; Falk, *Exh. Record
Series.*

WALTENSPERGER, Charles E.
[Landscape and genre painter, illus- *Charles Waltensperger*
trator, designer] b.1871, Detroit, MI
/ d.1931, Detroit.
Addresses: Detroit. **Studied:** Joseph Gies; Julius Melchers;
Detroit Mus. Art Sch.; Acad. Julian, Paris, with B. Constant & J.P.
Laurens, c.1886-88. **Exhibited:** Detroit IA, 1886-1929; Hopkin
Club; Scarab Club; Crowley-Miller Gal., Detroit; Ch. Firby Gal.,
Birmingham, MI, c.1988. **Work:** Rijksmuseum, Amsterdam.
Comments: He travelled frequently to Europe, eventually settling
in Laaren, Holland, where he painted figures in interiors and peas-
ant genre scenes. Later, he spent his summers on the coasts of
Michigan and New England. Illustrator: books by "M. Quad;"
Detroit Free Press. Position: designer, Calvert Lithographing Co.
Sources: WW25; Gibson, *Artists of Early Michigan,* 235.

WALTER *[Painter] mid 20th c.*
Addresses: Dannemora, NY. **Exhibited:** S. Indp. A., 1936.
Sources: Marlor, *Soc. Indp. Artists.*

WALTER, Adam B. *[Engraver, chiefly in mezzotint] b.1820,
Philadelphia, PA / d.1875, Phila.*
Addresses: Phila., early 1840s-75. **Sources:** G&W; Stauffer; 7
Census (1850), Pa., LVI, 784; 8 Census (1860), Pa., LIV, 1026;
Phila. CD 1843-60+.

WALTER, Anne L. *[Painter] 19th/20th c.*
Addresses: Wash., DC, active 1918-35. **Exhibited:** Soc. Wash.
Artists, 1920s, 1930s; Greater Wash. Indep. Exh., 1935. **Sources:**
McMahan, *Artists of Washington, DC.*

WALTER, Christ See: **WALTER, Christian J.**

WALTER, Christian J. *[Painter] b.1872, Allegheny City
(Pittsburg), PA / d.1938, Pittsburgh, PA.*
Addresses: Pittsburgh, PA/ Ligonier, PA; Plimpton, OH. **Studied:**
self-taught. **Member:** Pittsburgh AA (pres., for 15 years); Art
Brotherhood, Pittsburgh (co-founder). **Exhibited:** PAFA Ann.,
1903-04, 1909, 1913, 1918; Pittsburgh AA, 1913 (prize), 1915
(prize), 1921 (prize), 1927 (prize), 1938 (retrospective); Corcoran
Gal. biennial, 1919; CI, 1937 (prize), 1939 (retrospective); CGA;
AIC; Phila. AC; Soc. Western Artists. **Work:** St. Petersburg (FL)
permanent collection; John Vanderpoel AA, Chicago; Penn. State
College; collection, 100 Friends of Art. **Comments:** Specialty:
landscapes around Ligonier, PA. He taught classes in his studio,
and outdoors in Ligonier. In addition to landscapes of
Pennsylvania and the Ohio River, he painted steel mills on com-
missions, and sunny beaches and waterscapes in Florida.
Sources: WW38; WW04. More recently, see, Chew, ed.,
Southwestern Pennsylvania Painters, 146, 147, 148; Falk, *Exh.
Record Series.*

WALTER, E. Barstow *[Painter] early 20th c.*
Addresses: Portland, ME. **Exhibited:** S. Indp. A., 1928. **Sources:**
Marlor, *Soc. Indp. Artists.*

WALTER, Edgar *[Sculptor] b.1877, San Francisco, CA /
d.1938, San Francisco.*
Addresses: NYC, 1910-12; San Francisco. **Studied:** Arthur
Mathews; D. Tilden; Perrin & Cormon in Paris. **Member:** San
Francisco AA; NSS, 1911. **Exhibited:** Paris Salon, 1898-1901
(prize), 1902-06; PAFA Ann., 1910, 1912; Pan-Pacific Expo, San
Fran., 1915 (prize); Helgesen Gallery, San Francisco, 1916; San
Francisco AA, 1916-20; NSS, 1923; SFMA, 1935; GGE, 1939;
MM; TMA. **Work:** San Francisco Opera House; MMA; fountain,
NYC, 1914; TMA. **Sources:** WW24; Hughes, *Artists of
California,* 588; Falk, *Exh. Record Series.*

WALTER, George M. *[Painter] early 20th c.*
Addresses: Columbus, OH. **Member:** Columbus PPC. **Sources:**
WW25.

WALTER, Harold F. *[Painter] mid 20th c.*
Addresses: Chicago area. **Exhibited:** AIC, 1951. **Sources:** Falk,
AIC.

WALTER, Hulda See: **PARTON, Hulda (Mrs. Daniel
Day Walter, Jr.)**

WALTER, J. H. *[Painter] early 20th c.*
Exhibited: Salons of Am., 1925, 1934. **Sources:** Marlor, *Salons
of Am.*

WALTER, J. W. *[Painter] early 20th c.*
Addresses: Wilkinsburg, PA. **Member:** Pittsburgh AA. **Sources:**
WW21.

WALTER, Jeanie See: **WALKINSHAW, Jeanie Walter
(Mrs. Robert B.)**

WALTER, John *[Sculptor] mid 19th c.*
Addresses: New Orleans, 1846. **Sources:** G&W; New Orleans
CD 1846.

WALTER, Joseph *[Marine artist] b.1783 / d.1856.*
Addresses: Bristol (England). **Comments:** Depicted the departure
of the steamship *Great Western* from Bristol and her arrival off
Tompkinsville, Staten Island (NY) in 1838. It is not known
whether Walter ever came to America. **Sources:** G&W; *American
Processional,* 131, 242; Stokes, *Historical Prints;* Stokes,
Iconography, repros.

WALTER, Joseph H. *[Painter] early 20th c.*
Addresses: Rockaway Park, NY. **Exhibited:** S. Indp. A., 1932-36.
Comments: Possibly Walter, Joseph H., ASL. **Sources:** Marlor,
Soc. Indp. Artists.

WALTER, Joseph (Josef) *[Painter, sculptor] b.1865, Galtuer,
Austria.*
Addresses: Brooklyn, NY. **Studied:** Loefftz; S. Herterich & J.
Hackl in Munich; Griebenkerl & Rumpler in Vienna. **Member:**
Dubuque AA. **Exhibited:** Dubuque Artists Exh., 1928 (first prize,
1929 (first prize)); Iowa Fed. Women's Clubs Exh., 1932; Iowa
Art Salon, 1933; PAFA Ann., 1935; WFNY, 1939;. **Work:**
Catholic churches at Decorah & Williamsburg, IA; murals,
Catholic churches, Spaulding and Madison, NE; six murals, Peter
and Paul's Church, Petersburg, IA; St. Joseph's Church, Peoria,
IL; St. Patrick Church, Dubuque; four paintings, church, Sherrill;
mural, Holy Ghost Church, Dubuque; painting, St Mary's Church,
Remsen; St. Joseph's Church, Garnavillo, IA; St. Joseph's
Convent, St. Joseph, MN; WPA sculpture, USPO, Fairfield, ME;
St. Francis Hospital, Freeport, IL. **Comments:** Came to the U.S.
in 1898. **Sources:** WW40; Ness & Orwig, *Iowa Artists of the
First Hundred Years,* 214; Falk, *Exh. Record Series.*

WALTER, Joseph Saunders *[Amateur artist] mid 19th c.;
d.La Guaira (Venezuela).*
Exhibited: Artists' Fund Soc., 1840 (Italian view, a Swiss scene
after Stanfield, and "Grace Darling"). **Comments:** Son of Thomas
Ustick Walter (see entry). He probably accompanied his father on
his visit to Europe in 1838. The younger Walter died of fever
while assisting his father in the construction of a breakwater in
South America. **Sources:** G&W; Rutledge, PA; DAB, under
Thomas U. Walter.

WALTER, L. *[Painter] 19th/20th c.*
Addresses: NYC, active 1887-1910. **Exhibited:** NAD, 1887;
Boston AC, 1908. **Sources:** WW10.

WALTER, Linda & Jerry *[Cartoonists] mid 20th c.*
Comments: Husband-wife cartoonist team who created the popu-
lar 1940s comic strip, "Susie Q. Smith" (King Features
Syndicate). **Sources:** *Famous Artists & Writers* (1949).

WALTER, Louis J(ohn) *[Painter] b.1889, Chicago, IL /
d.1955, Albany, NY.*
Exhibited: AIC, 1929-30; S. Indp. A., 1938. **Sources:** Falk, *AIC.*

WALTER, Louise Cameron *[Miniature painter] early 20th
c.; b.Pittsburgh.*
Addresses: Pittsburgh, PA. **Studied:** Académie Julian, Paris with

WALTER, Martha *[Painter]* b.1875, Phila., PA / d.1976. *Martha Walter*
Addresses: Studios in NYC & Gloucester,after WWI; frequent travel; Melrose Park, PA, 1940; Glenside, PA. **Studied:** PAFA with W.M. Chase (Cresson Traveling Scholarship in 1908); Académie Julian, Paris, 1903; Académie Grande Chaumière, Paris. **Member:** NAWA, 1914; PAFA (fellow). **Exhibited:** Paris Salon, 1904; PAFA Ann., 1905-45 (Mary Smith prize, 1909); PAFA, 1923 (gold); AIC, 19 annuals, 1906-38; Corcoran Gal. biennials, 1907-26 (7 times); NAD, 10 annuals, 1910-24; CM, 1914 (solo); NAWA, 1915 (prize); St. Louis City AM, 1918 (six women artists); Galeries Georges Petit, Paris, 1922 (solo); Salon d'Automne, 1924; Milch Galleries, NYC, frequently during the 1930s; Art Club, Chicago; 1941; Woodmere AM, 1955 (solo, including Ellis Island series); David David Art Gal., Phila, 1977 (retrospective), 1978 (solo), 1986 (solo); Nat. Arts Club, Wash., DC, 1985 (solo). **Work:** TMA; PAFA; Norfolk SA; PAFA; Milwaukee AI; Little Gal.; Cedar Rapids Iowa; AIC; Luxembourg Mus., Paris; DIA; Musée d'Orsay, Paris. **Comments:** A plein-air painter known for her colorful impressionist beach scenes of resorts such as Gloucester, Coney Island, Atlantic City, and along the French coast. In 1922, she painted a series of paintings depicting immigrants as they arrived at Ellis Island. Achieved international reputation, traveling and painting in France, England, Italy, Holland, Germany, Spain and North Africa. Teaching: NY School of Art; Brittany, France. **Sources:** WW40; *300 Years of American Art,* vol. 2: 725; Tufts, *American Women Artists, 1830-1930,* cat. no. 58; Petteys, *Dictionary of Women Artists;* exh. cat., David David (Phila., 1985); Falk, *Exh. Record Series.*

WALTER, May E. *[Collector, patron]* mid 20th c.
Addresses: NYC. **Comments:** Positions: mem., art advisory council, Univ. Notre Dame; secy., trustee & mem., exec. comt., Am. Craftsman's Council. Art interests: patron, NY Univ. Art Coll., Notre Dame Univ. Collection: 20th c. masters, includes cubism & futurism. **Sources:** WW73.

WALTER, Otis W. *[Painter]* early 20th c.
Addresses: Phila., Pittsburgh, PA. **Member:** Pittsburgh AA. **Exhibited:** PAFA Ann., 1936. **Sources:** WW21; Falk, *Exh. Record Series.*

WALTER, Ruby M. C. *[Listed as "artist"]* 19th/20th c.
Addresses: Wash., DC, 1920-35. **Exhibited:** Greater Wash. Indep. Exh., 1935. **Sources:** McMahan, *Artists of Washington, DC.*

WALTER, Solly H. *[Portrait painter, illustrator]* b.1846, Vienna, Austria / d.1900, Honolulu, HI.
Member: San Francisco AA; Bohemian Club. **Comments:** Came to the U.S. in 1878. Teacher/founder: school of drawing in San Francisco. **Sources:** Hughes, *Artists in California,* 588.

WALTER, Thomas Ustick *[Architect & architectural draftsman in watercolors]* b.1804, Philadelphia, PA / d.1887, Phila.
Addresses: Phila.; Washington, DC, 1851-65; Phila., 1865. **Studied:** bricklayer's trade from his father; architecture with William Strickland. **Member:** Am. Inst. Architects (1876-87; second president). **Exhibited:** Artists' Fund Soc., Apollo Assoc., PAFA, (many designs for buildings). **Comments:** He began his independent career in Philadelphia in 1830 and was very successful. He visited Europe with his son, Joseph S. (see entry), in 1838. From 1851-65 he was in charge of construction of the wings and dome of the U.S. Capitol and other government buildings in Washington. He returned to Philadelphia in 1865 and spent the rest of his life there in semi-retirement. **Sources:** G&W; DAB; Rutledge, PA; Cowdrey, AA & AAU.

WALTER, Valerie Harrisse *[Sculptor]* mid 20th c.; b.Baltimore, MD.
Addresses: Baltimore, MD. **Studied:** Mrs. Lefebvre's Sch.; Maryland Inst, Baltimore; ASL; with Ephraim Keyser, apprentice to Augustus Lukeman: Hunter College; College Notre Dame, MD; McCoy College, Johns Hopkins Univ. **Member:** Wash. AC;

SSAL. **Exhibited:** S. Indp. A., 1922, 1924; CGA (prize, 1934); NSS; NAD; PAFA Ann., 1925-28, 1937-38, 1962; BMA; Detroit IA; Paris Salon; SFMA; Hispanic Mus., New York; Salons of Am.; Soc. Wash. Artists Ann. (first prize for sculpture). **Work:** CGA; Gen Umberto Nohle, Aeronaut Ministry, Rome, Italy; John Daniel II & Bamboo, Baltimore Zoo. Commissions: marble bust, Geheimrat Carl van Noorden, Frankfurt, Germany & Vienna, 1934; bronze head, "Charlotte," commissioned by Mason Faulkner Lord, Baltimore, 1957; bronze bas-relief, Dr. & Mrs. W. Waldemar Argow, Unitarian Church, Baltimore, 1962; bronze, "Toni," commissioned by Mrs. Richard O'Brien; bronze bust, "Nathalie," commissioned by Mr. J. Sawyer Wilson. **Comments:** Preferred media: marble, teak, mahogany, bronze. **Sources:** WW73; WW47; Falk, *Exh. Record Series.*

WALTER, William F. *[Painter, teacher, cartoonist, designer]* b.1904, Washington, DC / d.1977.
Addresses: Washington 8, DC. **Studied:** Corcoran Sch. Art; Charles Hawthorne; W. Lester Stevens; Richard Meryman; B. Baker. **Member:** Soc. Wash. Artists; Landscape Club, Wash., DC; Wash. Art Club; Am. Polar Soc.; SSAL. **Exhibited:** New York City (solo); Harvard Univ.; Univ. Iowa; Wash. Art Club; in museums of the East & South. Awards: prizes, Landscape Club, 1939, 1941, 1953, 1955, 1957; U.S. Nat. Mus., 1939, 1954. **Work:** Arctic paintings for the U.S. Navy, 1946. **Comments:** Teaching: Abbott Sch. Art, Wash., DC, 1951-54. **Sources:** WW59; WW47.

WALTERS, Carl *[Painter, ceramic sculptor, craftsperson, teacher]* b.1883, Ft. Madison, IA / d.1955, Woodstock, NY.
Addresses: NYC, 1908; Portland, OR, 1912; NYC, 1919; Woodstock, NY/West Palm Beach, FL. **Studied:** Minneapolis School FA, 1905-07; with William Merritt Chase; New York School Art, 1908, with Robert Henri. **Member:** Woodstock AA; Am. Soc. PS&G; Boston Soc. Arts & Crafts. **Exhibited:** S. Indp. A., 1917; Whitney Studio Club, 1924; Dudensing Gal., 1927 (solo); Downtown Gal., annually, 1930-40 (solos); Copenhagen, Denmark, 1927; Stockholm, Sweden, 1928; MMA, 1928, 1940 (AV; prize); WMAA, 1924, 1929-45, 1951, 1952; AIC, 1932-45; PAFA Ann., 1938, 1943-45, 1951; Musée du Jeu de Paume, Paris, 1938; Syracuse MFA traveling exh. to Denmark, Sweden, Finland, 1937; Woodstock AA; Ogunquit Mus.; Salons of Am.; art galleries in NYC, Palm Beach & Woodstock, NY. Awards: Guggenheim Fellowships, 1935, 1936; Charles Binns medal, 1936. **Work:** MoMA; WMAA; MMA; AIC; Worcester (MA) Art Mus.; Davenport Mun. Art Gal.; CM; PMG; Minneapolis Inst. Art; Portland (OR) Mus. Art; New York State College Ceramics, Alfred Univ.; Detroit Inst. Art. **Comments:** Noted ceramic sculptor of the 1920s and 30s. Set up his first ceramic workshop at the artists' colony at Cornish, NJ and joined the Maverick art colony. His subjects were usually animals but also sometimes human figures, especially circus performers. Teaching: Norton School of Art, W. Palm Beach, FL, early 1950s. Contributed a chapter on ceramic sculpture to "The Sculptor's Way," by Putnam, 1939. **Sources:** WW53; WW15; WW47; Ness & Orwig, *Iowa Artists of the First Hundred Years,* 214; more recently, see *Woodstock's Art Heritage,* 140-141; addit. info courtesy of J. Young, Woodstock, NY; Fort, *The Figure in American Sculpture,* 229 (w/repro.); Woodstock AA; Falk, *Exh. Record Series.*

WALTERS, Doris Lawrence (Mrs.) *[Painter, commercial artist]* b.1920, Sandersville, GA.
Addresses: Melbourne, FL. **Studied:** Washington Sch. Art. **Member:** Melbourne AA; Florida Fed. Artists. **Exhibited:** Awards: Melbourne AA, 1954 (purchase), 1955. **Comments:** Contributor to Melbourne (FL) *Daily Times.* **Sources:** WW59.

WALTERS, Emile *[Painter, teacher]* b.1893, Winnipeg, Ontario, Canada / d.1977, Poughkeepsie, NY.
Addresses: NYC, Poughkeepsie, NY. **Studied:** AIC; PAFA; Tiffany Found. **Member:** Tiffany Found. AC; SC; Pittsburgh AA; Phila. AC; ASL. **Exhibited:** AIC, 1918 (prize), 1919 (prize), 1921; PAFA Ann., 1923, 1925; NAD, 1924 (prize); Nat. Art Exh., Springfield, UT, 1926 (prize), 1927 (prize); Nat. Gal., Ireland; LACMA; Brooklyn Mus.; Fogg Mus.; Mus. Edmunton, Alberta,

Canada; Mus. Rouen, France; Cambridge Univ., Mus., England; CI; Corcoran Gal. biennials, 1923-28 (3 times); Canadian Royal Acad., Toronto, Canada; Tate Gal., England; Kleeman Gal., NYC, 1935 (solo); Grace Nichols Gal., Pasadena, CA, 1939 (solo). Awards: decoration, Order of the Falcon, King Christian, Denmark, 1939. **Work:** Smithsonian Inst.; Phila. AC; 100 Friends of Art, Pittsburgh, PA; Mus. FA Houston; Heckscher Mus. FA; Mus. Art, Saskatoon, Canada; FMA; Glasgow (Scotland) Art Gal.; Grainger Mus., Melbourne, Australia; Mus. of Rouen, France; BM; SAM; Vanderpoel Coll.; Winnipeg (Canada) Mus. FA; Luxembourg Mus., Paris; Mun. Gal. Mod. Art, Dublin, Ireland; Nat. Mus., Helsinki, Finland; Mus. of Iceland, Reykjavik; Pomona College, Claremont, CA; CPLH; Newark Mus.; Los Angeles Mus. Art; Fleming Mus.; Mus. New Mexico, Santa Fe; Springfield (IL) Mus. Art; SAM; Springville, UT; NCFA; Theodore Roosevelt Assn.; United Nations Coll.; FMA; Univ. Mus., Bangkok, Thailand; Vatican Gal., Rome; Saskatchewan Mus.; Univ. Manitoba, Canada. **Comments:** Later specialized in views of Iceland, Greenland, and the Arctic regions. Teaching: Penn State College (summer session). **Sources:** WW66; WW47; *American Scene Painting and Sculpture,* 63 (w/repro.); Falk, *Exh. Record Series.*

WALTERS, Emrys L. *[Painter] early 20th c.*
Addresses: Columbus, OH. **Member:** Columbus PPC. **Sources:** WW24.

WALTERS, Evan J. *[Painter] b.1893 / d.1951.*
Addresses: NYC. **Exhibited:** S. Indp. A., 1917. **Sources:** Marlor, *Soc. Indp. Artists.*

WALTERS, Frank *[Painter] mid 20th c.*
Addresses: NYC. **Exhibited:** S. Indp. A., 1944. **Sources:** Marlor, *Soc. Indp. Artists.*

WALTERS, Henry *[Patron] b.1848, Baltimore, MD / d.1931.*
Addresses: NYC. **Comments:** For many years, admission fees gathered during part of the year to the Walters Art Gallery, his large three-story private gallery adjoining his Baltimore residence, were given to charity. There were 750 paintings in the collection, including Old Masters and the Massaranti collection purchased in 1902 and brought to this country from Italy on a specially chartered steamship. It is said that the Egyptian section could be duplicated in a private collection and the jades and watches formed an important group. Of the sculpture a replica of Rodin's "The Thinker" was the most notable. He bequeathed the Walters Art Gal. and the house adjoining with its entire contents to the City of Baltimore, as well as one-quarter of his $10,000,000 estate. He also willed $188,888 to the MMA.

WALTERS, John *[Engraver & miniature painter] late 18th c.*
Addresses: Philadelphia. **Comments:** In 1779 he was engraving and publishing in partnership with John Norman (see entry); the partnership was dissolved the same year and Walters became involved in a newspaper dispute with Norman and Thomas Bedwell (see entry). By 1782 Walters and Bedwell were in partnership as miniature and landscape painters, copyists, and heraldic artists. In 1784 Walters had added hair work and jewelry making to his repertory. **Sources:** G&W; Prime, I, 11-13, 26, 29-31; Bolton, *Miniature Painters.*

WALTERS, Josephine See: **WALTERS, M. Josephine**

WALTERS, M. Josephine *[Landscape painter] d.1883, Brooklyn, NY.*
Addresses: NYC, 1867-75; Brooklyn, NY, 1876-77; Hoboken, NJ, 1878-83. **Studied:** Asher B. Durand in NYC. **Member:** Brooklyn AA. **Exhibited:** Brooklyn AA, 1866-81; NAD, 1864-83, 1885; Am. Soc. Painters in WC; Yale Sch. FA, CT; San Francisco AA; Utica AA; Western Acad. Art; Century Assoc.; Cincinnati Acad. **Work:** NYHS; Downtown Club, Birmingham, AL. **Comments:** Known also as Josephine Walters and simply M.J. Walters. Specialty: Hudson River scenes, especially Adirondacks. Asher B. Durand called her his favorite woman student (Durand). Preferred media: oil. watercolor. **Sources:** G&W; Durand, *Life*

and Times of Asher B. Durand, 184; add'l. info courtesy of Stephanie A. Strass, Reston, VA.

WALTERS, Susane (Suzanne) *[Portrait painter] mid 19th c.*
Comments: Painter of a child's memorial portrait, 1852.
Sources: G&W; Garbisch Collection catalogue, 97, repro.

WALTERS, Valerie *[Sculptor] early 20th c.*
Exhibited: WMAA, 1922. **Sources:** Falk, *WMAA.*

WALTERS & NORMAN *[Engravers & printers] late 18th c.*
Addresses: Philadelphia, 1779. **Comments:** Partners were John Walters and John Norman (see entries). The partnership was dissolved the same year and the former partners became involved in a newspaper dispute over the ownership of certain plates.
Sources: G&W; Prime, I, 26, 29-31.

WALTHER, Charles H. *[Painter, teacher] b.1879, Baltimore, MD / d.1937.*
Addresses: Baltimore/Middletown, MD. **Studied:** Maryland Inst.; Académie Julian, Paris with J.P. Laurens, 1906; Blanche, L. Simon & Cottet in Paris. **Member:** Soc. of Indep. Artists, NYC (a founder); Baltimore Soc. of Indep. Artists (first pres., 1929); Charcoal Club, Baltimore; Baltimore Mus. A;. **Exhibited:** Peabody Inst. Gal., Baltimore, 1914; Montross Gal., 1915; S. Indp. A., 1922-30; Wash. County Mus. FA, Hagerstown, MD, 1934 (solo), 1999 (retrospecive); Baltimore Charcoal Club, 1936; also in Philadelphia, Chicago, and Washington DC. **Work:** Phillips Coll.; Baltimore Mus. A.; Wash. County Mus. FA, Hagerstown, MD; Cone Coll., Balt.; H.S., Balt. Stained glass, Zion Church amd Church Home Infirmary, Baltimore.
Comments: Abstract painter and leader of avant-garde artists in Baltimore in the early 20th century. Walther studied in Paris in 1906-08, and after returning to Baltimore collaborated with J. Wilmer Gettier in designing stained glass for several Baltimore churches. Walther became friendly with Charles Sheeler, Maurice Prendergast, and Walter Pach while visiting NYC for the Armory Show in 1913, and although they urged him to move to NYC and asked him to join them in the founding of the Soc. of Indep. Artists, he chose to return to and remain in Baltimore. By 1914, he had begun work on a series of abstractions or "improvisations" based on the work of the Italian Futurists, and he soon exhibited the works in Baltimore and NYC. Walther was a champion of modernism in Baltimore, experimenting with new styles and urging his students at the Md. Inst. to do so as well. This resulted in his dismissal from the school in 1929, but Walther continued to teach privately, and also held summer sketching sessions at his summer home in Middleton, MD. The popular summer school and its students came to be informally known as the Snallygaster School. In 1938, Walther died in a fatal car accident driving from Middletown. Teaching: Maryland Inst., 1900-06, 1908-29. **Sources:** WW38; exh. pamphlet, *Charles H. Walther: Maryland Modernist and the Snallygaster School* (Hagerstown, MD: Wash. County Mus. of FA, 1999).

WALTHER, Frederich W. *[Painter] b.1895, Württemberg, Germany.*
Addresses: Phila., PA. **Studied:** Pforzheim, Stuttgart, Strassbourg, Germany. **Member:** ASMP; AAPL. **Exhibited:** S. Indp. A., 1938. **Sources:** WW47.

WALTHER, Henry *[Fresco painter] b.c.1830, Germany.*
Addresses: Washington, DC in 1860. **Sources:** G&W; 8 Census (1860), D.C., I, 799.

WALTHEW, Adam *[Portrait painter, scenic artist] d.1886.*
Addresses: Detroit, MI. **Comments:** In partnership with his son, Thomas A. in A. Walthew & Son, later A. Walthew & Sons, including his other sons George and James Walthew. **Sources:** Gibson, *Artists of Early Michigan,* 235.

WALTMANN, Harry Franklin *[Painter] b.1871, Kilbuck, OH / d.1951, Dover Plains, NY.*
Addresses: NYC, 1896; Dover Plains, NY. **Studied:** ASL of Wash., DC; Académie Julian, Paris with J.P. Laurens and

Constant, 1898. **Member:** ANA, 1917; SC, 1897; Allied AA; NAC. **Exhibited:** Soc. Wash. Artists, 1891, 1892; NAD, 1896; Wash. AC, Cosmos Club, 1902; SC, 1909 (prize), 1916 (prize); PAFA Ann., 1912, 1918-21; NAC, 1927 (prize); Stockbridge AA, 1938 (prize); Salons of Am. **Work:** National Portrait Gallery (portrait of John Philip Sousa); Butler AI. **Comments:** Possibly spelled "Waltman." **Sources:** WW47; McMahan, *Artists of Washington, DC;* Falk, *Exh. Record Series.*

WALTNER, Beverly Ruland *[Painter]* mid 20th c.; b.Kansas City, MO.
Addresses: Coral Gables, FL. **Studied:** Yale Univ. with Joseph Albers; Univ. Miami (B.A.); Northern Illinois Univ. (M.F.A.); Kent State Univ., Blossom-Kent Art Program, with Richard Anuszkiewicz. **Member:** Chatauqua AA; Miami AC. **Exhibited:** 10th Midwest Biennial, Joslyn Art Mus., Omaha, NE, 1968; Mid-Am. I, Nelson Gallery Art, Kansas City & City Art Mus., St. Louis, 1968; 35th Ann. Midyear Show, Butler IA, 1970; 33rd Ann. Exh. Contemp. Am. Painting, Soc. Four Arts, Palm Beach, FL, 1971; Ann. Exh. Nat. Soc. Painters in Casein, Inc., Nat. Arts Club, NYC, 1972. **Awards:** top award, New Horizons in Painting, North Shore Art Lg., Chicago, 1966; first place, Chautauqua Exh. Am. Art, 1968 & Louis E. Seiden Mem. Award, 1970, Chautauqua AA. **Work:** Northern Illinois Univ., De Kalb. **Comments:** Preferred media: acrylics. Teaching: Barry College, Miami Stores, FL, 1970-71. **Sources:** WW73; Margaret Harold, "Top Award in New Horizons Exhibit," *Prize-Winning Art Book 7* (Allied Florida, 1967); Donald L. Hoffman, "The Color Image," *Kansas City Star,* Jan. 19, 1969; Bill von Mauer, "Colors Get Her Vivid Messages Across," *Miami News* Feb. 8, 1972.

WALTON, Cecile See: **ROBERTSON, Cecile Walton**

WALTON, Edward Austin *[Educator, designer, painter]* b.1896, Haddonfield, NJ.
Addresses: Philadelphia 3, PA. **Studied:** PM School Art (B.F.A.); Phila. Sketch Club. **Member:** Phila. WCC; Assoc., AID. **Exhibited:** PAFA, 1933-38, 1944. **Comments:** Positions: teacher, PM School IA; dir., Interior Des. Dept., Moore IA, Phila. Lectures: history of furniture. **Sources:** WW59; WW47.

WALTON, Florence Goodstein (Goodstein-Shapiro) *[Painter, art historian]* b.1931, New York, NY.
Addresses: Minneapolis, MN. **Studied:** Cooper Union, 1950-51; City College New York (B.S., art educ., 1952); Hans Hofmann Sch. FA, 1956-57; Univ. Minnesota (M.A., art history, 1973). **Member:** College AA Am.; Am. Inst. Archaeology; Exp. Art & Tech. **Exhibited:** AWCS, Smithsonian Inst., Wash., DC, 1963; Cooper Union Gal., New York, 1967; LACMA, 1969; Bonython Art Gal., Sydney, 1969; Tweed Gal., Univ. Minnesota, Duluth, 1971. Awards: STA award for excellence, AIC, 1954. **Work:** Bonython Gal., Sydney, Australia; Martin Luther King Coll., Atlanta, GA; Augsburg College Coll., Minneapolis; Juana Mordo Gal., Madrid, Spain; Merton Simpson Gal., New York. **Comments:** Preferred media: oils, charcoals, acrylics, pastels. Positions: art prog. dir., Emmanuel-Midtown Y Community Center, 1963-65; secretary & public rations dir., Aspects Gal., New York, 1964-66; dir., Artists Against War Exh., New York, 1967-68. Publications: author, "Lumen Room," *53* 1970. Teaching: Lakewood State Jr. College, 1971-. Research: pre-Hellenic Greek ware; Goya's black paintings; Indian Gupta architecture. **Sources:** WW73; "New Voices," *Village Voice* (March 1964); "Artist Paints Death," *Australian,* Sept. 30, 1969; "Shades of Whispering Glades," *Sydney Morning-Herald,* Sept. 30, 1969.

WALTON, Florence Louise See: **POMEROY, Florence Walton (Mrs. Ralph B.)**

WALTON, Frederick C. *[Painter]* early 20th c.
Addresses: Chicago, IL. **Exhibited:** AIC, 1908. **Sources:** WW10.

WALTON, Harry A., Jr. *[Collector]* b.1918, Covington, VA.
Addresses: Covington, VA. **Studied:** Univ. Virginia, 1937; Columbia Univ., 1939; Lynchburg College (A.B., 1939).

Member: Pierpont-Morgan Lib., NY (fellow); Univ. Virginia Bibliog. Soc. **Comments:** Collection: early books and manuscripts, Bibles, fine binding, Aldinae and first editions; works have been exhibited in libraries at: Trinity College, Washington, DC, College of William and Mary, Norfolk Museum of Arts and Sciences, University of Virginia and Lynchburg College. **Sources:** WW73.

WALTON, Henry *[Portrait, miniature & landscape painter, lithographer]* b.1804, England? / d.1865, Cassopolis, MI.
Addresses: Ithaca, NY, 1836-46; California, 1851-57; Michigan, 1857-. **Exhibited:** Ithaca, 1968-69. **Work:** Soc. Calif. Pioneers (watercolor: Grass Valley View); Oakland Museum, Oakland, CA (portrait of the miner William D. Peck); Addison Pub. Lib., NY; Shelburne (VT) Mus. **Comments:** Known chiefly for his lithographed views of upstate New York towns between 1836-50; although his living was from his portraits, many in watercolor, each signed, most dated, and with the name and age of the sitter. As early as 1829 he drew on stone for Pendletons of Boston, probably as an apprentice. At some time he also lithographed buildings. His last signed work for Pendleton was issued in 1831 and his name reappeared in 1836, when he took his first city view to Bufford (see entry) for printing. In 1851 he joined a gold-rush party that sailed to San Francisco. In 1857 he settled in Michigan. *Cf.* N. Walton. **Sources:** G&W; *Portfolio* (Oct. 1945), 40-44; Peters, *America on Stone; N.Y. World-Telegram and Sun,* Dec. 29, 1950, repro. of view of Watkins Glen (NY); *Antiques* (Nov. 1937), cover and 227; *Antiques* (June 1938), 311; Stokes, *Historical Prints.* More recently, see Reps, 212-213 (pl.11); P&H Samuels report that Walton was probably born in NYC c.1804 (or 1820) and died 1865 (or 1873), 509; Gerdts, *Art Across America,* vol. 1: 192 (gives dates as 1804-1865); Muller, *Paintings and Drawings at the Shelburne Museum,* 135 (w/repros.).

WALTON, Kalamian Art *[Painter]* early 20th c.
Exhibited: Salons of Am., 1934. **Sources:** Marlor, *Salons of Am.*

WALTON, Katherine Kent *[Portrait & miniature painter]* b.Annapolis, MD / d.1928, Annapolis.
Studied: Maryland Inst.; Charcoal Club. **Comments:** A descendant of Maryland's first governor. Restored some of the old painting at the U.S. Naval Acad. **Sources:** Petteys, *Dictionary of Women Artists.*

WALTON, Marion Putnam (Mrs.) *[Sculptor]* b.1899, New Rochelle, NY.
Addresses: NYC. **Studied:** Bryn Mawr College; ASL with Leo Lentelli & later with Mahonri Young; Acad. Grande Chaumière, Paris, with Antoine Bourdelle; Borglum School Am. Sculpture. **Member:** Sculptors Guild, 1937 (a founder); AEA; Fed. Mod. P&S; Am. Artists Congress. **Exhibited:** PAFA Ann., 1930-53 (11 times); MoMA, 1933; WMAA, 1938-41; Soc. Indep. Artists, 1942; MMA; BM; BNIA; WMA; Newark Mus.; AIC; SFMA; NSS; San Diego, CA; Lincoln, NE; Paris, France; Carnegie Inst.; Weyhe Gal., 1934 (solo); Dallas MFA; LACMA; Paris, France; WFNY, 1939; New Bertha Schaefer Gal., NYC, 1970s. **Work:** Lincoln (NE) Mus.; Univ. Nebraska; relief USPO, Pittston, PA. **Comments:** Direct carver. Preferred media: marble, bronze, wood. Teaching: Sarah Lawrence College, 1950-51. Contrib.: *Magazine of Art.* **Sources:** WW73; WW47; Fort, *The Figure in American Sculpture,* 230 (w/repro.); Falk, *Exh. Record Series.*

WALTON, N. *[Delineator]* mid 19th c.
Comments: Delineator of a view of Congress Hall, Saratoga (NY), engraved by Rawdon, Wright & Co. of NYC, 1828-31. Probably Henry Walton. **Sources:** G&W; Fielding, supplement to Stauffer, no. 1260.

WALTON, Sidney (W.) *[Still life painter]* b.c.1876, Ontario, Canada / d.1940, Detroit, MI.
Addresses: Detroit, MI, c.1909-40. **Studied:** Joseph Gies; Francis Paulus; Judson Smith; Chicago, IL; Toronto, Canada. **Member:** Scarab Club. **Exhibited:** Scarab Club. **Sources:** Gibson, *Artists of Early Michigan,* 236.

WALTON, William *[Painter, craftsperson, writer] b.1843, Phila., PA / d.1915.*
Addresses: NYC, 1876-86. **Studied:** PAFA; NAD, NYC; Carolus-Duran, in Paris. **Member:** Arch. Lg., 1888; Am. Fine Arts; NAC; Century. **Exhibited:** NAD, 1876-86; Brooklyn AA, 1879-86; PAFA Ann., 1879, 1882-85, 1898; Boston AC, 1881-84, 1896; AIC. **Work:** Calvary Church, NYC; Grace Church, Newark, NJ. **Comments:** Walton died in a drowning accident. Author: "Art and Architecture, World's Columbian Exposition, 1893." Specialty: designs for stained glass. **Sources:** WW15; Falk, *Exh. Record Series.*

WALTON, William *[Painter] mid 20th c.*
Exhibited: AIC, 1935; S. Indp. A., 1938, 1940, 1942; Corcoran Gal. biennials, 1951-59 (3 times). **Sources:** Falk, *Exh. Record Series.*

WALTON, William E. *[Listed as "artist"] b.c.1824, New Jersey.*
Addresses: NYC, 1859-62. **Comments:** Listed as tailor after 1862. Walton married a Connecticut woman, and had two sons born in Connecticut about 1846-48. **Sources:** G&W; NYCD 1859-66; 8 Census (1860), N.Y., LX, 1055.

WALTON, William Randolph *[Entomological artist, photographer, model maker, draftsman, cartoonist] b.1873, Brooklyn, NY.*
Addresses: Wash., DC, area, 1910 and after. **Studied:** Stevenson Art School, Pittsburgh, PA. **Comments:** Auth.: *Entomological Drawings and Draftsmen,* 1919. **Sources:** McMahan, *Artists of Washington, DC.*

WALTRIP, Mildred *[Painter, graphic artist, designer, illustrator] b.1911, Nebo, KY.*
Addresses: Chicago, IL in 1940; New York 14, NY. **Studied:** AIC; Northwestern Univ.; NY Univ., School Educ.; Moholy-Nagy; Alexander Archipenko; Fernand Leger. **Member:** NSMP; Int. Soc. General Semantics. **Exhibited:** AIC, 1935, Phila. Artists All.; Phila. Pr. Club, 1950; SAGA, 1951; Los Angeles Mus. Art. **Awards:** Raymond Fellowship, AIC, 1933. **Work:** Murals, Oak Park (IL) Pub. Sch.; Chicago Park Bd., Admin. Bldg.; Cook County Hospital, Chicago; Scott Field, Belleville, IL. **Comments:** Auth./Illustr.: "Guide Book to Cairo, Illinois," 1950-58; science textbooks, "Science for Better Living" (5 books); "Exploring Physics," 1952, revised 1959; "The Physical World," 1958; "New World of Chemistry," 1955; Children's books: "The First Book of Submarines," 1957; "The First Book of The Earth," 1958. Position: commercial artist, Grey Advertising Agency NYC. **Sources:** WW59; WW47.

WALTZ, Edith Easton *[Still life & landscape painter] b.1873, Des Moines, IA / d.1964, Riverside, CA.*
Addresses: Southern California. **Studied:** Nell Walker Warner; Millard Sheets; David Scott. **Member:** Laguna Beach AA; Riverside AA. **Exhibited:** Laguna Beach; Pomona, Los Angeles County Fair; Santa Cruz; Oakland; Santa Barbara; San Bernardino; Victorville (solo). **Sources:** Hughes, *Artists of California,* 588.

WALTZ, Olivette K. *[Painter] mid 20th c.*
Exhibited: S. Indp. A., 1938. **Sources:** Marlor, *Soc. Indp. Artists.*

WALUKIEWICZ, Anna C. *[Painter] mid 20th c.*
Addresses: Kingston, PA. **Exhibited:** S. Indp. A., 1940-44. **Sources:** Marlor, *Soc. Indp. Artists.*

WALUKIEWICZ, Josephine E. See: **VERBINSKI,. E. Walukiewicz**

WALZ, Charles *[Painter] b.1845, Sigmaringen, Germany / d.c.1911, Pittsburgh, PA.*
Addresses: Pittsburgh, PA. **Studied:** Albert Lauck Dalbey; Royal Acad. Art, Munich, Germany, early 1870s. **Exhibited:** Western Penn. Expo., 1889; CI, 1914, 1916. **Comments:** Specialty: portraits. **Sources:** Chew, ed., *Southwestern Pennsylvania Painters,* 147-149.

WALZ, John *[Sculptor] b.1844, Württemberg, Germany.*
Addresses: Phila., PA; Savannah, GA. **Studied:** Aimé Millet, Paris; Tilgner, Vienna. **Exhibited:** Paris Salon, 1881; PAFA Ann., 1891-92. **Comments:** Came to U.S. in 1859. Fink gives birthplace as Phila. **Sources:** WW10; Fink, *American Art at the Nineteenth-Century Paris Salons,* 402; Falk, *Exh. Record Series.*

WALZ, Mary *[Painter]; b.Springhill, IL.*
Addresses: Perry, IA. **Studied:** Cumming Art Sch.; Alice Seymour; AIC; NY Sch. Art; traveled abroad. **Member:** Iowa Artists Club. **Exhibited:** Iowa Artists Club; Iowa Art Salon. **Sources:** Ness & Orwig, *Iowa Artists of the First Hundred Years,* 214.

WALZAK, Leo A. *[Painter] early 20th c.*
Addresses: Baltimore, MD. **Exhibited:** S. Indp. A., 1934. **Sources:** Marlor, *Soc. Indp. Artists.*

WALZER, Marjorie Schafer *[Potter, painter] b.1912, NYC.*
Addresses: Westport, CT. **Studied:** ASL with Kuniyoshi, Bouche; Silvermine Gld. Artists with Albert Jacobson, Julius Schmidt. **Member:** Silvermine Gld. Artists; Conn. Crafts; NY Soc. Ceramic Artists. **Exhibited:** WMA, 1955; NY Ceramic Artists, 1955; Silvermine Gld. Artists, 1955, 1961 (solo); Conn. Crafts, 1954, and traveling exh., 1961; Smithsonian Inst. traveling exh., 1955-56; Georg Jensen, NY, 1960; Boston Art Festival, 1961; Eastern States Exh. with Smithsonian Inst. tour following, 1964; NY World's Fair, 1965; Soc. Conn. Craftsmen, 1965. **Awards:** Soc. Conn. Craftsmen ceramics award, 1965 (2). **Comments:** Positions: judge, NY Artist-Craftsmen Exh., 1960-61; consult., Raymond Loewy-William Snaith Assoc., to establish pottery workshop in Puerto Rico, 1962-65. **Sources:** WW66.

WAMELINK, H. J. *[Painter] early 20th c.*
Addresses: Cleveland, OH. **Member:** Cleveland SA. **Sources:** WW29.

WAMSLEY, Frank C. *[Sculptor] b.1879, Locust Hill, MO / d.1953, Hollywood, CA.*
Addresses: Hollywood, CA. **Studied:** AIC with C.J. Mulligan, A. Polasek; BAID; S. Borglum; J. Gregory; E. McCarten. **Member:** Artland Club; P&S Los Angeles; Calif. AC. **Exhibited:** AIC, 1916; PAFA Ann., 1925. **Work:** Hackley Art Gal., Muskegon, MI; Hollywood Crematory; mem. tablet, Covina, CA. **Comments:** Specialties: fountains; garden figures. **Sources:** WW33; Falk, *Exh. Record Series.*

WAMSLEY, Lillian Barlow *[Craftsman, sculptor, teacher, designer, block printer, lecturer] 20th c.; b.Ft. Worth, TX.*
Addresses: New York 3, NY. **Studied:** Columbia Univ.; Albert W. Heckman; Hans Reiss; Maude Robinson; C. Upjohn. **Member:** NY Keramic Soc. & Des. Gld. (hon.); NY Soc. Ceramic Artists. **Exhibited:** WFNY 1939; Boston Soc. Arts & Crafts, 1940; Oklahoma Art Exh., 1923; NY Keramic Soc., 1920-40; NY Ceramic Artists, 1920-40. **Awards:** prizes, Oklahoma Art Exh., 1923; NY Keramic Soc., 1931. **Comments:** Position: owner/dir., Pottery & Sculpture Studios, NYC, 1939-. Lectures: pottery. Contrib.: *Keramic Studio.* **Sources:** WW53; WW47.

WAMSLEY, Margaret See: **COLE, Margaret W(ard) (Mrs. Alphaeus P.)**

WANAMAKER, Lewis Rodman *[Patron] b.1863 / d.1928, Atlantic City, NJ.*
Addresses: Phila. **Studied:** Princeton. **Comments:** He aided the flights made by Lieutenant Commander Byrd to the North Pole and France, and he also sponsored three expeditions under the authority of the U.S. Bureau of Indian Affairs into the Indian Country. His lifelong interest in art brought him recognition as a connoisseur. Aside from his private collection of art treasures, there were many examples of the work of great painters in his NYC and Phila. stores. One of his principal gifts was that of an art collection to Princeton. The Paris AAA elected him president, and partly through his patronage, the American Art Students Club in Paris was founded. He was decorated as Commander of the Royal Victorian Order of Great Britain, Grand Officer of the

Order of the Crown (Italy), Officer of the Order of St. Sava (Serbia), and member of Order of the Liberator (Venezuela). He was a member of the MMA, the Sulgrave Inst., Wash., DC and numerous other organizations and clubs in this country and abroad.

WANDER, Oscar Henry *[Painter] early 20th c.*
Addresses: Elizabeth, NJ. **Exhibited:** Soc. Indep. Artists, 1929. **Sources:** Marlor, *Soc. Indp. Artists.*

WANDERSFORDE, James B. See: **WANDESFORDE, Juan B(uckingham)**

WANDESFORDE, Ivan B. See: **WANDESFORDE, Juan B(uckingham)**

WANDESFORDE, James B., Jr. *[Painter] b.1911, Seattle, WA.*
Addresses: Seattle, WA. **Studied:** Univ. Wash.; Cornish Art Scool, Seattle; Art Center Sch., Los Angeles. **Member:** Puget Sound Group of NW Painters. **Exhibited:** SAM, 1935, 1937, 1946; Frye Mus., 1963. **Sources:** Trip and Cook, *Washington State Art and Artists, 1850-1950.*

WANDESFORDE, Juan B(uckingham) *[Portrait, genre, and landscape painter] b.1817, Scotland / d.1902, Hayward, CA.*
Addresses: NYC in the early 1850s until after 1860; Centerport, Long Island, 1858; California by 1869. **Studied:** John Varley & Le Capelaine in England. **Member:** San Francisco AA (co-founder & first pres., 1872); Bohemian Club. **Exhibited:** NAD, 1861; Mecahnics Inst., San Francisco, from 1864; Calif. Art Union, 1865; San Francisco AA annuals, from 1872. **Work:** Oakland Mus.; Belknap Coll., NYHS; de Young Mus.; Hayward Area Hist. Soc. Mus.; Calif. Hist. Soc. **Comments:** He was the teacher of Mrs. Cornelia Fassett in NYC (see entry). In 1869 he illustrated *The Golden Gate,* published in San Francisco. **Sources:** G&W; Cowdrey, NAB; Cowdrey, AA & AAU; DAB, under Cornelia Fassett; NYCD 1858-60; Hamilton, *Early American Book Illustrators and Wood Engravers,* 481; Hughes, *Artists of California,* 588; P&H Samuels, 509.

WANDESFORDE, Robert H. *[Painter] b.1920, Seattle, WA.*
Addresses: Seattle, WA. **Member:** Seattle Art Dir. Soc.; Puget Sound Group NW Painters; Prof. Graphic Artists. **Exhibited:** SAM, 1947. **Sources:** Trip and Cook, *Washington State Art and Artists, 1850-1950.*

WANDS, Alfred James *[Painter, lithographer, teacher, lecturer] b.1904, Cleveland, OH.*
Addresses: Denver 7, CO. **Studied:** John Huntington Inst.; Western Reserve Univ. (B.S.); Cleveland Sch. Art; F.N. Wilcox; H.G. Keller; Académie Julian, Paris. **Member:** Denver Art Gld.; Ohio WCS; Carmel AA; Chicago Galleries Assn.; AAPL; Cleveland SA. **Exhibited:** Carnegie Inst., 1928; PAFA, 1924, 1926, 1928, 1932, 1934; PAFA Ann., 1926, 1929-30; WFNY 1939; AIC, 1934, 1954; Corcoran Gal. biennial, 1935; CMA, 1923-37, 1939, 1940; Kansas City AI, 1930-34; Denver Art Mus., 1931-51, 1953, 1954; MFA Houston, 1950, 1951; Denver Mus. Natural Hist., 1953 (solo); San Francisco AA, 1950-52. **Awards:** prizes, Paris Salon, 1936; CMA, 1923, 1930; Chaloner prize, NYC, 1926; CPLH, 1932; Denver Art Mus., 1932, 1945-51; Kansas City AI (medal); 1934; Denver Art Gld., 1958. **Work:** BM; CMA; CPLH; Cleveland Pub. Sch.; Denver Pub. Sch.; Denver Art Mus.: murals, Colorado Woman's College; Methodist Church, Sterling, CO; Kansas City AI; Denver Univ. **Comments:** Teaching: Cleveland IA, 1925-30; CMA, 1927-30; Colorado Women's College., 1930-47; founder/teacher, Wands Art Sch., Estes Park, CO, 1947-50s. **Sources:** WW59; WW47; Falk, *Exh. Record Series.*

WANEK, Vesta Blanch Jelinek *[Painter, illustrator] b.1872, Crete, NE.*
Studied: Doane College; Fremont Normal School; with Miss Greene in Lincoln, NE. **Exhibited:** Nebraska county fairs, 1891-1921. **Sources:** Petteys, *Dictionary of Women Artists.*

WANG, E. O. *[Painter] early 20th c.*
Addresses: Brooklyn, NY. **Member:** S. Indp. A. **Exhibited:** S.

Indp. A., 1921. **Sources:** WW25.

WANG, Fred M., Jr. *[Listed as "artist"] b.1872, New Orleans, LA / d.1900, New Orleans.*
Addresses: New Orleans, active 1886-90. **Studied:** Artist's Assoc. of N.O., 1886-87. **Member:** Black & White Club, 1887. **Exhibited:** Artist's Assoc. of N.O., 1886-87, 1890. **Sources:** *Encyclopaedia of New Orleans Artists,* 401.

WANG, Yinpao *[Painter, writer] b.1918, Suchow, China.*
Addresses: Yardley, PA. **Studied:** Chao Tung Univ. (B.A.); Univ. Pennsylvania (M.B.A.). **Member:** Royal Soc. Arts (fellow); Kappa Pi (hon. member); Harrisburg AA (life member); Phila. Art All. (artist member); Nat. Soc. Arts & Letters. **Exhibited:** ASL, 1938 (solo); Detroit AM, 1958 (solo); Columbia Univ., New York, 1968 (solo); Nat. Mus., Taipei, Taiwan, 1970 (solo); Jefferson Univ., Phila., 1971(solo). **Awards:** Merit Award, Grumbacher, 1954; int. awards, Am. Inst. Interior Designers, 1961 & 1963; special award, Int. Platform Assn., 1965. **Work:** Henry Ford Mus., Detroit, MI; Detroit AM; China Inst. in Am., NYC; Gracie Mansion, NYC; James Cash Penney Coll., NYC. **Comments:** Preferred medium: watercolor. Positions: founder, Peking AA, China, 1928-32; publ., Peking Pictorial, 1929-32; vice- pres., Chinese Art Lg. in New York, 1937-41. Publications: contrib., "The Mysterious Fifth Dimension" (1958); auth., "Techniques of Chinese Painting" (1970), "We Live in Art" (1970) & "Thoughts in Chinese Art" (1972). Teaching: ASL, 1937-38; Kwang Si Univ., 1946-47. **Sources:** WW73.

WANGELIN, Josie Kircher *[Landscape painter, block printer, craftsperson, designer, teacher] mid 20th c.; b.Belleville, IL.*
Addresses: St. Louis, MO. **Studied:** St. Louis Sch. FA; PIA Sch.; AIC; K. Cherry; D. Mulholland; F.B. Nuderscher; G. Goetsch. **Member:** St. Louis AC. **Exhibited:** Civic Lg. Art Exh., St. Louis. **Work:** decoration in handwrought silver for Children of the American Loyalty Lg. **Comments:** Specialty: handwrought jewelry. **Sources:** WW40.

WANGERHEIM, Albert *[Sketch artist, photographer] late 19th c.*
Addresses: New Orleans, active 1877. **Exhibited:** W.E. Seebold's, N.O., 1877. **Sources:** *Encyclopaedia of New Orleans Artists,* 401.

WANKELMAN, Willard F. *[Educator] mid 20th c.*
Addresses: Bowling Green, OH. **Comments:** Teaching: Bowling Green State Univ. **Sources:** WW59.

WANKER, Maude Walling (Mrs. C. C.) *[Painter, teacher, museum director, lecturer] b.1882, Oswego or Portland, OR.*
Addresses: Wecoma Beach, OR. **Studied:** Univ. Oregon; AIC; Portland Art Mus. School; C. Stevens; J. Stewart. **Member:** AAPL; Soc. Oregon Artists; Lincoln County AC, DeLake, OR; Portland AA; Oregon Artists All.; Master WCS Oregon; Coquille Valley AA. **Exhibited:** 1956-58 (many others prior); solos in Colorado, Illinois, Indiana, Kansas, Michigan, Missouri, Nevada, Oregon, Utah, Washington. Organized and conducted Oregon circuit shows. **Awards:** Honor Roll, AAPL; Woman of Achievement, Sigma Theta Phi, 1958. **Work:** Oregon Hist. Soc.; Oregon State Capitol; Portland Women's Club. **Comments:** Painted Oregon's historical sites and buildings, 1930-40. Positions: founder/dir., Lincoln County AC & Gal.; founder/dir., Oregon Coast AA, Master WCS of Oregon; instr., Coquille Valley AA. Lectures on art throughout the SAM, 1933-38; Portland Art Mus., annually; Pacific Northwest. **Sources:** WW59; WW47; P&H Samuels, 510.

WANN, Marion *[Painter, teacher] early 20th c.*
Addresses: Oklahoma City, OK. **Member:** Oklahoma AA. **Comments:** Teaching: Oklahoma City H.S. **Sources:** WW27.

WANSLEBEN, Lily *[Listed as "artist"] b.1856, Germany.*
Addresses: Wash., DC, active c.1881-89. **Sources:** McMahan, *Artists of Washington, DC.*

WANSLEBEN, William A. *[Painter, teacher] 19th/20th c.*
Addresses: Wash., DC. **Comments:** Teaching: Columbian (now George Washington) Univ., 1889-91. **Sources:** McMahan, *Artists*

of Washington, DC.

WAPAH NAYAH See: **WEST, Walter Richard ("Dick")** (Wapah Nayah)

WAPPENSTEIN, Joseph *[Engraver] mid 19th c.*
Addresses: Sandusky, OH in 1853; Cincinnati, 1859. **Comments:** In Cincinnati he specialized in banknote engraving. **Sources:** G&W; Ohio BD 1853; Cincinnati CD 1859-60.

WAPPLER, Edwin *[Painter] early 20th c.*
Addresses: Chicago area. **Exhibited:** AIC, 1929. **Sources:** Falk, AIC.

WARBOURG, Daniel See: **WARBURG, Daniel**

WARBOURG, Eugene See: **WARBURG, Eugene**

WARBRICK, John *[Engraver] b.c.1836, England.*
Addresses: Philadelphia, 1860. **Comments:** The son of George Warbrick, machinist, and brother of William Warbrick (see entry), also an engraver. **Sources:** G&W; Phila. CD 1860; 8 Census (1860), Pa., LVIII, 2.

WARBRICK, William *[Engraver] b.c.1840, England.*
Addresses: Philadelphia in 1860. **Comments:** He was a younger brother of John Warbrick, engraver (see entry). **Sources:** G&W; 8 Census (1860), Pa., LVIII, 2.

WARBURG, Daniel *[Sculptor, marble cutter] b.1836, New Orleans / d.1911.*
Addresses: New Orleans, active 1852-1911. **Comments:** Brother of the sculptor Eugene Warburg (see entry). Took over his brother's shop when Eugene left for Europe in 1852. His son Joseph Daniel Warburg, Jr. worked with him c.1889-91. **Sources:** G&W spelled as Warbourg; however, more recently, *Encyclopaedia of New Orleans Artists, 1718-1918*, 401-402, spells as Warburg; see also Porter, *Modern Negro Art*, 46-47.

WARBURG, Edward M. M. *[Collector] b.1908, White Plains, NY.*
Addresses: NYC. **Studied:** Harvard College (B.S., 1930); Brandeis Univ. (hon. D.H.L.); Jewish Inst. Religion, Hebrew Union College. **Comments:** Positions: member, archaeological expedition to photograph Islamic architecture, Iran, 1933; staff member, MoMA, 1934-35; trustee, Am.-Israel Cultural Foundation; chmn., Am. Patrons of Israel Mus.; founder/member, exec. committee, hon. trustee, MoMA; hon. trustee, Inst. Int. Educ. Teaching: Bryn Mawr College, 1931-33. **Sources:** WW73.

WARBURG, Eugene *[Sculptor, marble cutter] b.1825, New Orleans / d.1859, Rome.*
Addresses: New Orleans, active 1840s-early 1850s. **Studied:** Phillippe Garbeille in New Orleans; Paris (c.1852-55); Jouffroy. **Exhibited:** Paris Salon, 1855; Paris Expo, 1887; Howard Univ., 1967. **Work:** Virginia Hist. Soc. **Comments:** A free-born black of New Orleans, he established a studio in the 1840s and early 1850s and executed busts and cemetery sculpture. In 1850 his "Ganymede Offering a Cup of Nectar to Jupiter" was raffled in New Orleans for $500. In 1852 Warburg (the name also appears as Warbourg) went to Europe to escape the growing racial problems experienced by free Blacks in the South. After studying in Paris, he traveled to Belgium in 1856 and in that same year went to England where he was commissioned by the Duchess of Sutherland to produce a series of bas-reliefs based on *Uncle Tom's Cabin*. After visiting Florence in 1857, Warburg settled in Rome. Daniel Warburg was his brother (see entry). **Sources:** G&W, which spells last name as Warbourg; New Orleans *Bee*, Dec. 13, 1850, and obit., March 9, 1859; New Orleans CD 1852-53; Porter, *Modern Negro Art*, 46-47; Porter, "Versatile Interests of the Early Negro Artist;"*Encyclopaedia of New Orleans Artists*, spells the name as Warburg; see also Cederholm, *Afro-American Artists* (cites a death date of 1861); Fink, *American Art at the Nineteenth-Century Paris Salons*, 402.

WARBURG, James P. *[Painter] early 20th c.*
Exhibited: Salons of Am., 1934; S. Indp. A., 1936. **Sources:** Marlor, *Salons of Am.*

WARBURG, Phyllis P. *[Painter] mid 20th c.*
Exhibited: S. Indp. A., 1936. **Sources:** Marlor, *Soc. Indp. Artists.*

WARBURTON, James *[Engraver] b.1827 / d.1898, Pawtucket, RI.*
Sources: G&W; *Art Annual*, I, obit.

WARD *[Engraver] late 18th c.; b.England.*
Addresses: Philadelphia. **Comments:** Partner with John Norman (see entry) in Norman & Ward, engravers, Philadelphia, 1774. They also sold prints and taught drawing. **Sources:** G&W; Prime, I, 20.

WARD, Albert Prentiss *[Painter, sculptor, illustrator] early 20th c.*
Addresses: Rochester, NY. **Studied:** S.S. Thomas; Whistler. **Sources:** WW10.

WARD, Alfred R. *[Painter] mid 19th c.*
Exhibited: NAD, 1855. **Comments:** Probably a misprint for Alfred R. Waud (see entry). **Sources:** G&W; Cowdrey, NAD.

WARD, Amelia See: **BROWN, Amelia (Ward)**

WARD, Arthur E. *[Painter] early 20th c.*
Addresses: Portland, ME. **Exhibited:** S. Indp. A., 1927-28. **Sources:** Marlor, *Soc. Indp. Artists.*

WARD, Beatrice *[Painter] 20th c.; b.NYC.*
Addresses: Los Angeles, CA. **Studied:** Stickney School of Art; Jean Mannheim; Richard Miller; Elizabeth Borglum (sketching partner). **Member:** Los Angeles AA. **Comments:** Position: poster artist, Grauman's Chinese Theatre. **Sources:** Hughes, *Artists of California*, 589.

WARD, Bernard Evans *[Painter] b.1857, London, England.*
Addresses: Ohio/Florida. **Exhibited:** Royal Acad. Arts (gold); Florida Fed. Artists, annually. **Comments:** Came to Cleveland in 1913 and painted portraits of many residents.

WARD, C. M. *[Painter] early 20th c.*
Addresses: Boston, MA. **Member:** Boston AC. **Sources:** WW25.

WARD, Caleb *[Painter] mid 19th c.; b.Bloomfield, NJ.*
Addresses: NYC , 1826-33. **Comments:** Father of Jacob C. and Charles V. Ward (see entries). He may have been the engraver, C. Ward, of Jacob C. Ward's view of the scene of the Hamilton-Burr duel at Weehawken (NJ), published about 1830. **Sources:** G&W; Folsom, *Bloomfield, Old and New,* 21; Folsom, "Jacob C. Ward"; Stokes, *Historical Prints;* NYCD 1826-33.

WARD, Charles Caleb *[Genre, landscape & portrait painter] b.1831, St. John, NB / d.1896, Rothesay, NB.* *Charles C. Ward*
Addresses: NYC, 1850-51; New Brunswick, 1856; NYC 1868-72; Rothesay, NB, 1882-96. **Studied:** William Henry Hunt in London. **Exhibited:** NAD, 1850-83; Brooklyn AA, 1868-81; AIC. **Comments:** His grandfather left NYC for St. John's, NB, because of his Loyalist sympathies. As a young man Charles Ward was sent to London to learn the family business, but he took up painting instead. **Sources:** G&W; Green, "Charles Caleb Ward, Painter of the 'Circus is Coming,'" eight repros., checklist; Cowdrey, NAD; obit., Boston *Transcript*, Feb. 26, 1896.

WARD, Charles S. *[Landscape painter] b.1850, Geneva, IL / d.1937, Montecito, CA.*
Addresses: Los Angeles, CA, active 1892-1915. **Exhibited:** Chamber of Commerce, Los Angeles, 1894. **Comments:** Specialty: pastel. **Sources:** Hughes, *Artists of California*, 589.

WARD, Charles V. *[Landscape painter, daguerreotypist] mid 19th c.; b.Bloomfield, NJ.*
Addresses: NYC, 1829-30; Bloomfield, NJ 1847-?. **Exhibited:** NAD, 1829-30 (landscapes). **Comments:** The son of Caleb and brother of Jacob C. Ward (see entries). From 1845-47 he and his brother were itinerant daguerreotypists in South America, working in Santiago and Valparaiso (Chile), La Paz (Bolivia), Lima (Peru), and Panama. They returned to New Jersey in 1847 or 1848 with a

small fortune. Nothing is known of his subsequent career. **Sources:** G&W; Folsom, "Jacob C. Ward"; Folsom, *Bloomfield, Old and New,* 21; Cowdrey, NAD; Dunlap, *History,* II, 379-80; Met. Mus. *Bulletin* (1931), 165, repro.

WARD, Charles W. *[Painter] late 19th c.*
Exhibited: NAD, 1871. **Sources:** Naylor, *NAD.*

WARD, Charles W. *[Painter, muralist, graphic artist, printmaker, teacher] b.1900, Trenton, NJ / d.1962, Carversville, PA.*
Addresses: Trenton, NJ, 1933-36; Carversville, PA, from c. 1941. **Studied:** School Indust. Arts, Trenton, NJ, with Henry R. MacGinnis; PAFA, in Phila. and at country school in Chester Springs, PA, with Daniel Garber and Joseph T. Pearson, Jr. **Awards:** PAFA Cresson traveling scholarship, 1930. **Member:** New Hope AA; Trenton-Morrisville Art Group. **Exhibited:** NAD, 1926; PAFA Ann., 1933-41 (4 times); AIC; Ferargil Gal., NYC (solo); Phila. Sketch Club; New Hope Hist. Soc.; Everhart Mus., Scranton, PA; New Jersey State Mus., Trenton; Cauga MA, Auburn, NY (two-person); Cedar City, Utah; Crest Gal., New Hope (solo); Croyne & Lowndes Gal., NYC (solo); John A. Lee Cultural Center, Phila.; Lambertville (NJ) House (solo); Lehigh Univ., Bethlehem, PA (solo); Phillips Mill AA, New Hope; Rodman House, Doylestown, NJ (solo); Schofield Gal., Doylestown, NJ (solo); Bianco Gal., Buckingham, PA, summer,1998 (retrospective). **Work:** PMA; New Jersey State Mus., Trenton; Bucks Co. Playhouse Inn, New Hope, PA (mural); Everhart Mus., Scranton, PA; Solebury (PA) Sch.; WPA murals, USPOs, Trenton, NJ; Roanoke Rapids, NC. **Comments:** Bucks County artist who worked in Impressionist and Post-Impressionist styles. Also painted in New Jersey and Mexico. Taught privately. **Sources:** WW59; Lori Verderame, exhib. cat., Bianco Gal, Buckingham, PA, 1998 (there is also a cat. raisonné in preparation by the gallery); Falk, *Exh. Record Series.*

WARD, Clara T. *[Painter] early 20th c.*
Addresses: Perrysburg, OH. **Exhibited:** S. Indp. A., 1923. **Sources:** Marlor, *Soc. Indp. Artists.*

WARD, Clarence *[Educator, museum director, writer, lecturer, designer] b.1884, Brooklyn, NY.*
Addresses: Oberlin, OH. **Studied:** Princeton Univ. (A.B.; A.M.; Ph.D.). **Member:** Soc. Arch. Historians. **Comments:** Teaching: prof. hist. & appreciation of art, dir., Dudley Peter Alien Mus., Oberlin (OH) College, 1916-49, 1952-53; Berea (KY) College, 1950; Johns Hopkins Univ., 1950-51; Univ. of the South, Sewance, TN, 1953-55; Oberlin College, 1956-57. Author: "Mediaeval Church Vaulting," 1915. **Sources:** WW59; WW47.

WARD, Clinton O. *[Painter] b.1895, Wash., DC / d.1987, Wash., DC.*
Addresses: Wash., DC. **Studied:** PAFA; Corcoran Art Sch. **Member:** Wash. AC. **Exhibited:** Soc. Wash. Artists; Landscape Club Wash.; Greater Wash. Indep. Exh., 1935. **Sources:** McMahan, *Artists of Washington, DC.*

WARD, Cora *[Painter] mid 20th c.*
Addresses: NYC. **Sources:** WW66.

WARD, Coralie *[Painter] early 20th c.*
Exhibited: S. Indp. A., 1926. **Sources:** Marlor, *Soc. Indp. Artists.*

WARD, David B. *[Engraver, designer] mid 19th c.*
Addresses: Bangor, ME, 1855-56. **Sources:** G&W; *Maine Register* 1855-56.

WARD, Dora F(olsom) *[Painter] early 20th c.*
Exhibited: Salons of Am., 1923, 1924, 1934; S. Indp. A., 1923-26. **Sources:** Falk, *Exhibition Record Series.*

WARD, E. T. *[Artist] late 19th c.*
Addresses: NYC, 1870. **Exhibited:** NAD, 1870. **Sources:** Naylor, *NAD.*

WARD, Edgar Melville *[Genre & landscape painter] b.1839, Urbana, OH / d.1915, NYC.*
Addresses: NYC. **Studied:** his brother J.Q.A. Ward; Miami Univ.; NAD, 1865-70; École des Beaux-Arts, Paris, with A.

Cabanel, 1872-74. **Member:** ANA, 1875; NA, 1883; Century. **Exhibited:** Paris Salon (medal) 1876, 1878, 1879; NAD, 1868-1900; Brooklyn AA, 1879-86; PAFA Ann., 1879-83, 1898; Boston AC, 1880-90; William Bradford's studio, Union Wharf, Fairhaven; NYC. **Work:** MMA; Nat. Gal.; Luxembourg Mus., Paris. **Comments:** Younger brother of the sculptor John Quincy Adams Ward (see entry). He was a leading genre painter in his day. Ward's professional life was spent mainly in NYC, though he also spent some time in France painting in Brittany and several summers in Fairhaven, MA. In the summer of 1880 he painted genre scenes of Blacks in Virginia. In 1889 Ward became instructor in drawing in the National Academy's school. **Sources:** G&W; CAB; *Art Annual,* XII, obit.; Clark, *History of the NAD,* 139; Graves, *Dictionary;* Clement and Hutton; WW10. More recently, see Wright, *Artists in Virginia Before 1900;* Blasdale, *Artists of New Bedford,* 202-203 (w/repro.); Fink, *American Art at the Nineteenth-Century Paris Salons,* 402; Falk, *Exh. Record Series.*

WARD, Edgar Melville (Jr.) *[Painter, teacher] b.1887, France.*
Addresses: Kingston, NY. **Studied:** E. Carlsen; G.W. Maynard; E.M. Ward; F. Jones. **Member:** Woodstock AA. **Exhibited:** Albany Inst. History & Art; Woodstock AA Gal. **Work:** murals, Wells College, NY; Refectory, Jones Beach, NY; painting, H.S., Albany; Board Educ., Newark, NJ. **Sources:** WW40; addit. info. courtesy Woodstock AA.

WARD, Edith Barry *[Painter] 19th/20th c.*
Addresses: Wash., DC, active 1896-1902. **Member:** Wash. WCC. **Exhibited:** Wash. Soc. Artists, 1898; Wash. WCC., 1896-1902; PAFA Ann., 1902. **Comments:** Also known as Edith Bar Geohegan. **Sources:** WW98; McMahan, *Artists of Washington, D.C.;* Falk, *Exh. Record Series.*

WARD, Edith Grace *[Painter] b.1877, Sparta, WI / d.1970, Morgan Hill, CA.*
Addresses: Carmel, CA. **Studied:** Stanford Univ.; Pratt Inst.; Calif. College Arts & Crafts; E. O'Hara; R. Schaeffer. **Member:** Carmel AA. **Sources:** Hughes, *Artists of California,* 589.

WARD, Edmund F. *[Painter, illustrator, teacher] b.1892, White Plains.*

EFWARD 19

Addresses: White Plains, NY 1976. **Studied:** ASL with E. Dufner, G. Bridgman, T. Fogarty, 1910-12. **Member:** SI; SC; GFLA. **Exhibited:** AIC, 1925 (prize); PAFA Ann., 1925. **Work:** WPA mural, Federal Bldg., White Plains, NY. **Comments:** Illustrator: national magazines; books. Best known for illustrations for the Alexander Botts series in the *Post.* Teaching: ASL, 1924-25. Also signed E.F.W., E.W., E.F. Ward, and Edm.F. Ward. **Sources:** WW47; P&H Samuels, 510-11; Falk, *Exh. Record Series.*

WARD, Eleanor (Mrs.) *[Art dealer] mid 20th c.*
Addresses: NYC. **Sources:** WW66.

WARD, Elsie See: **HERING, Elsie Ward (Mrs. Henry)**

WARD, Enoch *[Painter] late 19th c.*
Addresses: Chicago. **Exhibited:** AIC, 1889-90. **Sources:** Falk, *AIC.*

WARD, Franklin T. *[Painter] early 20th c.*
Addresses: Boston MA. **Sources:** WW15.

WARD, G. M. *[Illustrator] mid 19th c.*
Comments: Illustrated volumes of poetry published in NYC in 1860 and 1867. **Sources:** G&W; Hamilton, *Early American Book Illustrators and Wood Engravers,* 482.

WARD, George *[Artist] mid 19th c.*
Exhibited: NAD, 1863. **Sources:** Naylor, *NAD.*

WARD, H. *[Watercolorist] mid 19th c.*
Addresses: Youngstown, OH, 1840. **Sources:** G&W; Lipman and Winchester, 181.

WARD, Harold L. (Mrs.) *[Painter] early 20th c.*
Addresses: Orchard Lake, MI. **Member:** Detroit Soc. Women

Painters. **Sources:** WW25.

WARD, Harold Morse *[Landscape painter] b.1889, Brooklyn, NY / d.1973, Sacramento, CA.*
Addresses: Sacramento, CA. **Studied:** Pratt Inst.; Paris.
Exhibited: GGE, 1939; CPLH, Soc. for Sanity in Art, 1943; Crocker Art Mus., 1960s. **Work:** Gov. Reception Room, Calif. State Capitol, Sacramento. **Comments:** A descendant of telegraph inventor Samuel Morse. Teaching: Colusa (CA) H.S., Sacramento Jr. College, 1923-49. Author/illustr.:, *The Thing Called Art.*
Sources: Hughes, *Artists of California,* 589.

WARD, Hattie L. Howard *[Watercolorist, painting teacher] 19th c.*
Addresses: Guilford, CT. **Comments:** Her sister Susan was also an artist. **Sources:** Petteys, *Dictionary of Women Artists.*

WARD, Heber Arden (Mrs.) *[Painter] early 20th c.*
Addresses: Denver, CO. **Member:** Denver AA. **Sources:** WW25.

WARD, Herbert *[Landscape painter, craftsman, designer] b.1896, Accrington, Great Harwood, England / d.1967, Providence, RI.*
Addresses: Olneyville, Providence, RI (1917-23); Pawtucket, RI (1923-on). **Studied:** art school in Blackburn, England; RISD.
Member: Utopian Club, RISD (pres., 1938). **Exhibited:** Providence Art Club, 1918 (hon. mention), 1920, 1922; RISD, 1921 (medal for silverware design); 1928 (50th Anniv. exh.).
Comments: He emigrated to the U.S. in 1913, settling in Providence, RI. Beginning in 1917, he was a silverware designer for Gorham Co., and by 1927 he was teaching at RISD. In 1948 he was appointed Chief Designer for Gorham's Bronze Division, where he designed numerous bronze plaques until his retirement in 1966. He painted landscapes around New England, including Lake Winnepesaukee, NH, and Boothbay, ME. **Sources:** info courtesy Douglas S. Ward.

WARD, Herbert T. *[Sculptor] b.1862 / d.1919, Neuilly, France.*
Comments: Ward was also an explorer.

WARD, Hilda *[Painter] b.1878 / d.1950.*
Addresses: Roslyn, NY. **Studied:** Robert Henri & Homer Boss, Independents School. **Member:** NYWCC. **Exhibited:** Armory Show, 1913; AIC, 1914-15; Soc. Indep. Artists, 1917, 1920; Pietrantonio Gal., NYC, c.1950s (solo). **Comments:** Expressionist painter who preferred oil and pastel. **Sources:** WW25; Petteys, *Dictionary of Women Artists.*

WARD, Irene Stephenson (Mrs. H. W.) *[Painter, lecturer] b.c.1898, Oakman, AL/Mt. Hope, AL.*
Addresses: Oakman, AL. **Studied:** Oakman College; Mississippi State College. **Member:** Birmingham AC; Alabama Art Lg.; SSAL. **Exhibited:** Alabama Art Lg., 1938-46; Birmingham Art Lg., 1938-46; VMFA, 1938; Toledo, OH, 1946; Soc. Indep. Artists, 1944 (prize); NAD, 1950; Birmingham, AL, 1950 (solo); Atlanta MA; Atlanta Pub. Lib.; MMA, 1957; Tuscaloosa, AL (solo); Jasper (AL) Art Club. Awards: prizes, VMFA, 1938; Fed. Women's Club, 1939 (prize); Montgomery, AL, 1938-46.
Comments: Born 1894 or 1898 according to Pettys. **Sources:** WW59; Petteys, *Dictionary of Women Artists.*

WARD, Irving *[Portrait painter, landscape painter] early 20th c.*
Addresses: Baltimore, MD. **Member:** Charcoal Club (charter member). **Sources:** WW24.

WARD, J. Stephen *[Painter] b.1876, St. Joseph, MO / d.1941.*
Addresses: Glendale, CA; Jacksonville, OR. **Studied:** N. Brewer; M. Braun. **Member:** Calif. AC; Artland Club; Los Angeles P&S; Glendale AA; Oregon SA. **Exhibited:** State Fair, Phoenix, AZ, 1923 (prize); Witte Mem. Mus., San Antonio, 1929 (prize); Oregon State Fair, 1930 (prize). **Work:** Hollywood (CA) H.S.; Clubb Coll., Kaw City, OK. **Sources:** WW33.

WARD, Jacob C(aleb) *[Landscape and still life painter, pioneer daguerreotypist] b.1809, Bloomfield, NJ / d.1891, Bloomfield.*
Addresses: NYC, c.1829-32; Bloomfield, NJ, and travel; London, 1852; Bloomfield, NJ, 1852-91. **Exhibited:** NAD, 1829-52; New Jersey Art Union, Trenton, 1850; Am. Academy; Apollo Assoc.; Am. Art-Union. **Work:** Nelson-Atkins Mus A, Kansas City, MO (view of "Natural Bridge," VA). **Comments:** Highly regarded Romantic landscape painter in his day. About 1830 he painted a view of the scene of the Hamilton-Burr duel at Weehawken, NJ (engraved by C. Ward). In 1835 he traveled to Virginia to paint the Natural Bridge. He painted in Minnesota Territory about 1836, sketching at Fort Snelling and the Falls of Saint Anthony. His "A View of Soaking Mountain" (present location unknown) was subsequently engraved for the *New-York Mirror.* Ward joined his brother, Charles V. Ward (see entry), in Chile in 1845 and for three years they took daguerreotype likenesses and also sketched scenery in Chile, Bolivia, Peru, and Panama, returning to New Jersey in 1847 or 1848 via Jamaica and Cuba. Ward's address was given as London when he exhibited at the NAD in 1852 but Bloomfield, NJ, seems to have remained his residence until his death in 1891. It appears that Ward concentrated on photography after 1852. Son of Caleb Ward (see entry).
Sources: G&W; Folsom, "Jacob C. Ward, an Old-time Landscape Painter"; Cowdrey, NAD; Cowdrey, AA & AAU; Stokes, *Historical Prints;* Met. Mus. *Bulletin* (1931), 165; Dunlap, *History,* II, 379-80. More recently, see Wright, *Artists in Virginia Before 1900* (cites a birthdate of 1801); Gerdts, *Art Across America,* vol. 1: pp. 234, 236; and vol. 2: p. 26; and vol. 3: p. 10.

WARD, James C. *[Sketch artist] mid 19th c.*
Comments: Made a sketch of San Francisco in November 1848 which appeared in Bayard Taylor's *El Dorado, or Adventures in the Path of Empire* (1850). **Sources:** G&W; Van Nostrand and Coulter, *California Pictorial,* 122; Jackson, *Gold Rush Album,* 10; Peters, *California on Stone.*

WARD, James F. *[Painter] b.1898, NYC / d.1947, NYC.*
Exhibited: Salons of Am., 1934. **Sources:** Marlor, *Salons of Am.*

WARD, Jean S. *[Painter] b.1868, Monroe, WI. / d.1945, Los Angeles, CA.*
Addresses: Los Angeles, CA. **Studied:** U.S. and Europe.
Member: Ebell Club, Los Angeles; Women Painters of the West; San Francisco AA. **Sources:** WW25; Hughes, *Artists in California,* 589, reports year of birth as 1857.

WARD, John F. *[Engraver] b.c.1828, New York.*
Addresses: NYC in 1860. **Sources:** G&W; 8 Census (1860), N.Y., XLIX, 600.

WARD, John P. E. *[Painter] early 20th c.*
Addresses: NYC. **Exhibited:** S. Indp. A., 1920, 1922. **Sources:** Marlor, *Soc. Indp. Artists.*

WARD, John Quincy Adams *[Sculptor] b.1830, Urbana, OH / d.1910, NYC.*
Addresses: Washington, 1857-60; NYC, 1860-1910. **Studied:** pupil & asst. in studio of Henry Kirke Brown, Brooklyn, 1849-56.
Member: ANA, 1862; NA, 1863 (pres., 1873-74); NSS, 1896.
Exhibited: NAD, 1862-96; Paris Expo., 1867 (Indian Warrior); PAFA Ann., 1894. **Work:** MMA; NYHS. Outdoors: statues of the "Indian Hunter," "The Pilgrim," and "Shakespeare," in Central Park, NYC; Henry Ward Beecher in Borough Hall Park, Brooklyn; George Washington, Sub-Treasury Bldg., Broad and Wall Streets, NYC; Pres. James A. Garfield, near the western face of the Capitol bldg., Wash. DC; statues of Commodore Perry at Newport, RI, and Israel Putnam at Hartford, CT; LOC rotunda; marble, pedimental figures, Stock Exchange, NYC; equestrian statues of Sheridan and Hancock in Phila.; full-size casting of "Indian Warrior," Delaware Park, City of Buffalo. **Comments:** One of the leading American sculptors in the second half of the 19th century, noted for his robust naturalism. He began his career assisting in the studio of his teacher H.K. Brown, who was him-

self noted for his naturalism at a time when the prevailing style was neoclassicism. Ward spent two years in Wash., DC, where he modelled the portraits of several leading politicians, including Hannibal Hamlin of Maine (who became Abraham Lincoln's Vice President). Ward established himself in NYC in 1860, and continued to fulfill commissions for portrait busts, but also began exploring ideal subjects. His first such project was "The Indian Warrior," for which he traveled West (for several months) to make preparatory sketches. In 1864 he exhibited the model at John Snedicor's Gallery in NYC, where it elicited praise in newspapers, leading several leading citizens to start a movement to raise funds for a large bronze version to be placed in Central Park. It was completed in 1867 (Central Park, NYC; original bronze statuette, NYHS). Ward also worked on another ideal subject "The Freedman" (1865,), but he became best known for his large outdoor bronze commemorative portraits, including "George Washington" (1883, Wall Street, NYC), "Pres. James A. Garfield" (1887, Wash. DC), and probably his most well-known work, the Henry Beecher Ward monument (1891, Brooklyn). He also produced architectural sculpture. He was the brother of Edgar Ward. **Sources:** G&W; WW10; Adams, *John Quincy Adams Ward;* DAB; Taft, *History of American Sculpture;* 8 Census (1860), D.C., II, 375; Clark, *History of the NAD;* Craven, *Sculpture in America,* 245-90; Baigell, *Dictionary;* P&H Samuels, 511; Falk, *Exh. Record Series.*

WARD, John R. *[Cartoonist] mid 20th c.*
Addresses: El Paso, TX. **Work:** Huntington Lib., San Marino, CA. **Sources:** WW40.

WARD, John (Talbot) (Jr.) *[Painter] b.1915, Wilkes-Barre, PA.*
Addresses: Philadelphia 44, PA. **Studied:** PAFA. **Exhibited:** CM, 1938; PAFA; Phila. Art All.; Phila. Sketch Club; Woodmere Art Gal. **Awards:** PAFA (fellowship);PAFA (Cresson traveling scholarship, 1936-37). **Work:** Mural, Christ Church, Stuart Manor, NY; decorations, St. Mary's Church, Burlington, NJ; St. Paul's Church, Westfield, NJ. **Comments:** Position: art dir., St. Mary's Hall, Burlington, NJ. **Sources:** WW53; WW47.

WARD, Joseph *[Lithographer, print & frame seller] mid 19th c.*
Addresses: Boston, 1848-49. **Sources:** G&W; Boston CD 1848-49; Peters, *America on Stone.*

WARD, Keith *[Painter] b.1906, Iola, KS.*
Addresses: Modesto, CA; East Coast; Palm Springs, CA. **Studied:** Calif. Sch. FA; AIC; Grand Central Sch. Art, NYC. **Member:** Desert Art Center, Palm Springs. **Exhibited:** Silvermine Guild, CT. **Comments:** Specialty: Impressionist landscapes, still lifes, marines and portraits. Position: illustr., children's books and national magazines such as *Life, Saturday Evening Post, Colliers.* **Sources:** Hughes, *Artists of California,* 589.

WARD, Lilly A. *[Artist (drawings), teacher] late 19th c.*
Addresses: Los Angeles, active from 1881. **Studied:** New Haven Art Sch. **Sources:** Petteys, *Dictionary of Women Artists.*

WARD, Louis *[Painter] mid 20th c.*
Addresses: NYC. **Exhibited:** S. Indp. A., 1934-35. **Sources:** Marlor, *Soc. Indp. Artists.*

WARD, Louisa Cooke *[Landscape & portrait painter, teacher] b.1888, Harwinton, CT.*
Addresses: Los Angeles 43, CA. **Studied:** Yale Sch. FA. **Member:** Yale Women of So. Calif.; Calif. Art Club; Brush & Palette Guild; Southland AA; Calif. Fed. Women's Club; Los Angeles County Fed. Women's Club (art chmn., 1946-48, 1950-52); Las Artistas (pres., 1950-51). **Exhibited:** Bridgeport Women's Art Club; Los Angeles City Hall; Los Angeles Lib., 1945 (prize); Las Artistas Exh., Los Angeles, 1946 (prize), 1948 (prize); Los Angeles City Hall, 1953 (prize); many women's clubs; Santa Monica Pub. Lib. (prize); Los Angeles Mus. Art; Carlsbad, CA; Greek Theatre, Los Angeles. **Sources:** WW59.

WARD, Lyle Edward *[Painter, educator] b.1922, Topeka, KS.*
Addresses: Clarksville, AR. **Studied:** Stevens Point State Teachers Wisconsin, 1943; Univ. Kansas City, 1950; Kansas City Art Inst. (B.F.A., 1951; M.F.A., 1952); Miron Sokole, NYC. **Member:** College AA Am.; Mid-Am Art Assn.; Southeast Art Conf. **Exhibited:** Corcoran Gal. biennial, 1959; Superior St. Gal., Chicago, 1960 (solo) & Univ. Mississippi, Oxford, 1972 (solo); "Contemporary Americans," Arkansas AC, Little Rock, 1966; Arkansas State Pavilion, Hemisfair, San Antonio, TX, 1968; "Inaugural Exh. Artists USA," SUNY Oswego, 1968; Reflections Gal., Atlanta, GA, 1970s. **Awards:** Arts Festival Award, Worthen Bank, Little Rock, 1960 & 1962; first prize, Delta Exh., Arkansas Center, 1963, 1965 & 1967; 18th Arts Festival Award, Fort Smith Festival Board, Arkansas, 1968. **Work:** Brooklyn Mus.; Mus. Art, Univ. Oklahoma, Norman; Mulvane Art Mus., Topeka. **Comments:** Preferred media: oils. Teaching: College of the Ozarks, Clarksville, AR, 1956-. **Sources:** WW73; Ed Albin, article, *Arkansas Gazette* (Little Rock, 1959); Margaret Harold, *Prize Winning Paintings,* book 6 (Allied Publications, 1966).

WARD, Lynd (Kendall) *[Illustrator, writer, lithographer, painter] b.1905, Chicago, IL / d.1985, Reston, VA.* *LYND WARD*
Addresses: Leonia, NJ; Cresskill, NJ. **Studied:** Teachers College, Columbia Univ. (B.S., 1926); Staatliche Akad. Graphische Kunst, Leipzig, Germany, 1926-27. **Member:** NAD; Artists Lg. Am.; Am. Artists Congress; SAGA (pres., 1953-59); SI. **Exhibited:** Am. Artists Congress; WFNY, 1939; NAD, 1949 (prize), 1962 (J.T. Arms prize); John Herron Art Inst.; LOC. Other awards: S.F.B. Morse Gold Medal, 1966; Rutgers Medal, 1969; S. Teller Gal., NYC, 1997 (retrospective). **Work:** LOC; NAD; Newark Mus; MMA; Montclair AM. **Comments:** Author/illustrator: *God's Man* (1929), *Madman's Drum* (1930), *Song Without Words* (1936), *Vertigo* (novels in woodcuts, 1937); *Nic of the Woods* (1965). **Sources:** WW73; WW47.

WARD, Mabel Raymond (Mrs.) *[Painter, teacher, etcher] b.1874, NYC.*
Addresses: NYC/Summit, NJ. **Studied:** Henri; Chase. **Member:** ASL; Art Workers Club; Calif. SE; Chicago SE. **Work:** NYPL. **Sources:** WW17.

WARD, Mary Holyoke *[Portrait painter, copyist] b.1800, Salem, MA / d.1880.*
Comments: Known to have made copies after Copley and Frothingham. In 1833 she married Dr. Andrew Nichols; she was a sister-in-law of Charles Osgood and aunt of Abel Nichols and Sarah Nichols (see entries on each). **Sources:** G&W; Belknap, *Artists and Craftsmen of Essex County,* 14; Nichols, "Abel Nichols, Artist.".

WARD, Mary K. *[Painter] late 19th c.*
Addresses: Chicago. **Exhibited:** AIC, 1889. **Sources:** Falk, *AIC.*

WARD, Mary Trenwith Duffy *[Portrait painter, illustrator, drawing specialist, teacher] b.1908.*
Addresses: Wash., DC/New Bern, NC. **Studied:** Ashton; A. Bessimer; F. Hamoney; Breckenridge. **Member:** Wash. Soc. Commercial Artists. **Comments:** Teaching: Columbia Tech. Inst., Wash., DC. **Sources:** WW40.

WARD, May E. *[Painter] b.1883, Sebago, ME.*
Addresses: Portland, ME. **Comments:** Operated an artist's studio in Bridgton, then moved to Portland where she operated a very successful art school. Primary medium was watercolors. **Sources:** Casazza, *The Brushians,* 17.

WARD, Myron *[Painter] late 19th c.; b.Vermont.*
Addresses: NYC, 1891-92. **Studied:** Bonnat. **Exhibited:** Paris Salon, 1877; NAD, 1891-92. **Sources:** Fink, *American Art at the Nineteenth-Century Paris Salons,* 402.

WARD, Nina B. *[Painter] early 20th c.; b.Rome, GA.*
Addresses: Phila., PA. **Studied:** St. Louis Sch. FA; NY School Art; PAFA (Cresson European scholarships, 1908, 1911). **Exhibited:** PAFA Ann., 1911-15, 1917-18; Corcoran Gal. bienni-

als, 1912, 1916. **Sources:** WW21; Falk, *Exh. Record Series.*

WARD, Olivia *[Sculptor] late 19th c.*
Addresses: Morristown, NJ, 1878. **Exhibited:** NAD, 1878.
Sources: Naylor, *NAD.*

WARD, Phillips *[Illustrator] early 20th c.*
Addresses: Staten Island, NY. **Sources:** WW08.

WARD, Prentiss *[Painter] early 20th c.*
Addresses: Rochester, NY. **Sources:** WW08.

WARD, Richard, Jr. *[Illustrator, cartoonist, sculptor, craftsperson] b.1896, NYC.*
Addresses: New York 14, NY. **Studied:** Margate College, England; Beaux-Arts. **Member:** SI. **Work:** Freelance. **Sources:** WW53; WW47.

WARD, Ruth Porter *[Painter] b.Statesville, NC / d.1936, Wash., DC.*
Addresses: Wash., DC. **Studied:** Tarbell; Meryman; Baker; Breckenridge; Tiffany. **Member:** Soc. Wash. Artists; Artists Group; L.C. Tiffany Found. **Exhibited:** Soc. Wash. Artists, 1932 (prize). **Sources:** WW38.

WARD, Samuel (Mrs.) *[Painter] early 20th c.*
Addresses: Silver Lake, NH. **Exhibited:** S. Indp. A., 1925-26. **Sources:** Marlor, *Soc. Indp. Artists.*

WARD, Sarah Gillette *[Painter] 19th/20th c.*
Addresses: Evanston, IL. **Exhibited:** Soc. Western Artists, 1898; AIC. **Sources:** WW01.

WARD, Susan *[Painter, decorator] 19th c.*
Addresses: Guilford, CT. **Comments:** Work included drawings, pottery decorations, decorative paintings; sister of Hattie Ward (see entry). **Sources:** Petteys, *Dictionary of Women Artists.*

WARD, (The Misses) *[Painters, teachers of drawing & painting] mid 19th c.*
Addresses: Charleston, SC, 1842. **Exhibited:** Apprentices' Lib., 1843 (landscapes & fancy pieces). **Comments:** Opened a seminary in Charleston (SC) in 1842. **Sources:** G&W; Rutledge, *Artists in the Life of Charleston.*

WARD, Theodora Van Wagenen *[Painter, printmaker] b.1890, South Orange, NJ.*
Addresses: NYC. **Studied:** Winold Reiss & Pola Gauguin. **Member:** AFA, NYC. **Sources:** Petteys, *Dictionary of Women Artists.*

WARD, Valerie D. (Mrs. Clinton) *[Painter] b.1898 / d.1986, Wash., DC.*
Addresses: Wash., DC. **Studied:** Corcoran Art Sch. **Comments:** Teaching: St. Alban's School, Wash., DC. **Sources:** McMahan, *Artists of Washington, DC.*

WARD, Velox Benjamin *[Painter] b.1901, Mount Vernon, TX.*
Addresses: Longview, TX. **Exhibited:** Heirloom House, Inc., Dallas, 1965; Texas P&S Exh., Dallas Mus. FA, 1966; The Sphere of Art, Hemisfair 1968, San Antonio, TX, 1968; Amon Carter Mus, 1972; Donald S. Vogel, Dallas, TX. **Work:** Smithsonian Inst.; Am. Nat. Coll.; Am. Nat. Ins. Co., Galveston, TX; Amon Carter Mus., Fort Worth, TX. Commissions: paintings of old homesteads for Johnnie Hartman, Dallas, TX, 1961; Mrs. Jean Roberts, Longview, TX, 1962; Mrs. Henry Foster, Longview, 1967; Mrs. Nila Boatner, Longview, 1969; Mrs. Joan Cotton, Longview, 1969. **Sources:** WW73.

WARD, William *[Painter of ship pictures] 18th/19th c.*
Addresses: Salem, MA, 1799-1800. **Sources:** G&W; Robinson and Dow, *The Sailing Ships of New England,* I, 64.

WARD, William *[Sculptor] late 19th c.; b.Leicester (England).*
Addresses: Utah in 1852; St. Louis; Salt Lake City, 1892.
Comments: He carved Utah's stone for the Washington Monument in Washington (DC), a lion for Brigham Young's house, and a bust of Shakespeare. He was also assistant architect of the Mormon Temple in Salt Lake City. He later left the church and went to St. Louis. In 1892 he returned to Salt Lake City to

teach drawing at the University of Utah. **Sources:** G&W; Arrington, "Nauvoo Temple."

WARD, William Winthrop *[Painter] 20th c.*
Addresses: San Francisco, CA, 1939; Mountain View, CA, 1941-45. **Exhibited:** Oakland Art Gallery, 1939; Soc. for Sanity in Art, CPLH, 1942. **Sources:** Hughes, *Artists of California,* 589.

WARD, Winifred *[Sculptor, writer] b.1889, Cleveland, OH.*
Addresses: NYC; Phila., PA. **Studied:** C. Grafly at PAFA. **Member:** Plastic Club; NAWPS; Soc. Indep. Artists. **Exhibited:** PAFA Ann., 1913-16, 1918; Soc. Indep. Artists, 1917. **Sources:** WW21; Falk, *Exh. Record Series.*

WARD DE LANCY, William See: **LANCEY-WARD, William de**

WARDEN, Ben W. *[Painter] early 20th c.*
Addresses: Columbus, OH. **Member:** Columbus PPC. **Sources:** WW25.

WARDEN, C. A. (Miss) *[Miniaturist] mid 19th c.*
Addresses: Philadelphia, 1842. **Exhibited:** Artists' Fund Soc., 1842. **Sources:** G&W; Rutledge, PA.

WARDEN, Ethel C. *[Listed as "artist"] 19th/20th c.*
Addresses: Wash., DC. **Studied:** ASL Wash., DC. **Exhibited:** ASL, Cosmos Club, 1902. **Sources:** McMahan, *Artists of Washington, DC.*

WARDEN, Frances Mitchell See: **WARDIN, Frances Mitchell**

WARDEN, William F(rancis) *[Painter] b.1872, Bath, ME.*
Addresses: Paris, France. **Studied:** Académie Julian, Paris with Constant & T. Robert-Fleury; Comèrre in Paris. **Member:** Cercle de l'Union Artistique, Paris; Paris AAA. **Exhibited:** Paris Salon, 1896-98. **Sources:** WW13; Fink, *American Art at the Nineteenth-Century Paris Salons,* 402.

WARDER, William *[Painter, writer] b.1920, Guadalupita, NM.*
Addresses: Albuquerque, NM. **Studied:** Bisttram Sch. FA (scholarship); Univ. New Mexico (B.F.A.; scholarship); ASL; UCLA. **Member:** AEA; Contemporary Am. AA. **Exhibited:** Mus. New Mexico, Santa Fe, 1942-46, 1948, 1949, 1954-55, traveling exh., 1954-58; Butler AI, 1946; New Mexico State Fair, 1954-55; Art: USA, 1958; Mus. New Mexico, Santa Fe, 1944 (solo), 1946 (solo), 1955 (solo), 1957 (purchase award). **Work:** murals, Raton (NM) Pub. Lib.; Ford Motor Co., Albuquerque. **Comments:** Teaching: Albuquerque Pub. Schs., 1948-50. Owner, Dollar Sign Co. Advertising, 1953-. **Sources:** WW59.

WARDIN, Frances Mitchell *[Painter] b.1888, Topeka.*
Addresses: Topeka, KS. **Studied:** R. Henri in NYC. **Sources:** WW15; Petteys, *Dictionary of Women Artists.*

WARDLAW, George Melvin *[Painter] b.1927, Baldwyn, MS.*
Addresses: Amherst, MA. **Studied:** Memphis Acad. Arts (B.F.A.), 1951; Univ. Mississippi, with David Smith & Jack Tworkov (M.F.A.), 1965. **Exhibited:** Am. Crafts, Smithsonian Inst., Wash., DC, 1952; Recent Still Life, RISD, 1966; Inside-Outside, Smith College MA, Northampton, MA, 1966; Contemp. Art at Yale, Yale Univ. Art Gal., New Haven, CT, 1966; Abstract Paintings, DeCordova Mus., Lincoln, MA, 1971. **Comments:** Preferred medium: acrylics. Teaching: State Univ. NY College New Paltz, 1956-63; Yale Univ., 1964-68; Univ. Massachusetts, Amherst, 1968-. **Sources:** WW73.

WARDLAW, J. D. (Mrs.) *[Sculptor] late 19th c.*
Addresses: New Orleans, active c.1888-90. **Exhibited:** Tulane Dec. Art Lg. for Women, 1888; Art Lg. Pottery Club, 1890. **Sources:** *Encyclopaedia of New Orleans Artists,* 402.

WARDLE, Alfred H. *[Silversmith, jeweler] b.1933, Englewood, NJ.*
Addresses: Barneveld, NY. **Studied:** Art Inst. Pittsburgh; School Am. Craftsmen, Rochester Inst. Technology (A.A.S. & B.S.); Syracuse Univ. School Art. **Member:** NY State Craftsmen.

Exhibited: Smithsonian Inst. Traveling Exh., 1958; Crafts Exh., MoMA, Caracas, Venezuela, 1961; RI Arts Festival Show, Providence, 1963; Three Rivers Arts Festival, Pittsburgh, PA, 1966 (solo); Munson Williams Proctor Inst., Utica, 1968. **Awards:** Young Americans second prize, Mus. Contemp. Crafts, 1954; hollow-ware first prize, RI Arts Festival, 1963; crafts first prize, Syracuse Regional Art Show, 1963-65. **Work:** Commissions: mem. punch bowl, Rochester Inst. Technology, 1956; silver chalice with gold cross, Grace Episcopal Church, Utica, NY, 1960; silver chalice, Westminster Presbyterian Church, Utica, 1962; large tree of life, Temple Addas Israel, Rome, NY, 1966; pres. mace, Mohawk Valley Community College, Utica, 1969. **Comments:** Preferred media: sterling silver, gold. Positions: color coordinator, restoration committee, Unitarian Church Barneveld, NY, 1970-72. Teaching: instr. metal arts, Norwich (CT) Free Acad., 1959-60; instr. silversmithing, Munson Williams Proctor Inst., 1960-. **Sources:** WW73; Nicolas Haney, Trilling & Lee, *Art for Young America* (Bennett Co., 1960).

WARDLE, Richard C. *[Portrait & historical engraver] mid 19th c.*
Addresses: NYC, 1848-49. **Sources:** G&W; NYBD 1848-49.

WARDMAN, John W(illiam) *[Painter, illustrator, blockprinter] b.1906, Leeds, England.*
Addresses: Los Angeles, CA. **Studied:** with. **Exhibited:** Michigan State Fair, 1929 (prizes); Soc. for Sanity in Art, CPLH, 1945; Portland (OR) Art Mus., 1935. **Work:** bookplates, Int. Bookplate Assn.; Los Angeles Mus. Hist., Science &. Art; Southwest Mus.; Mun. Art Committee, Los Angeles. **Sources:** WW40; Hughes, *Artists of California,* 589.

WARDROPE, William S. *[Lithographer] b.c.1823, Scotland.*
Addresses: NYC in 1860. **Comments:** His wife was English; one child, age 10 in 1860, was born in Scotland in 1850; a second child was born in New York in 1856. **Sources:** G&W; 8 Census (860), N.Y., XLVIII, 1.

WARDWELL, Alice *[Artist] b.1874 / d.1976.*
Member: Woodstock AA. **Sources:** Woodstock AA.

WARDWELL, Caroline Hill *[Miniaturist] b.1822 / d.After 1894.*
Addresses: active in Oxford County, ME; Lowell, MA, 1847. **Exhibited:** locally in Maine. **Work:** Maine Hist. Soc. (watercolor on ivory, 1844). **Comments:** Her brothers, George and William, were also painters. Married Stephen Barker in 1847 and settled in Lowell, MA. **Sources:** Petteys, *Dictionary of Women Artists.*

WARDWELL, James H. *[Painter] early 20th c.*
Addresses: NYC. **Exhibited:** PAFA Ann., 1909. **Sources:** Falk, *Exh. Record Series.*

WARDY, F. J. *[Printmaker] b.1936.*
Addresses: NYC. **Exhibited:** WMAA, 1972. **Sources:** Falk, *WMAA.*

WARE, Alice L. *[Painter] early 20th c.*
Addresses: Worcester, MA. **Exhibited:** PAFA Ann., 1902. **Sources:** Falk, *Exh. Record Series.*

WARE, Ellen Paine (Mrs. J. W.) *[Painter] b.1859, Jacksonport, AR.*
Addresses: Memphis, TN. **Studied:** St. Louis Sch. Art; Cincinnati Sch. Des. **Member:** Memphis AA. **Exhibited:** Memphis AA, 1920 (prize), 1921 (prize). **Sources:** WW31.

WARE, Evelyn L. *[Painter, educator] late 20th c.; b.Wash., DC.*
Studied: New York Univ.; Catholic Univ.; DC Teachers College; Univ. of Maryland; Univ. of Ghana. **Exhibited:** Smith-Mason Gallery, 1971; DC Teachers College; Wash. Artists in Southwest; DCAA, Anacostia Neighborhood Mus.-Smithsonian Inst. **Award:** DC Youth Commission Award. **Sources:** Cederholm, *Afro-American Artists.*

WARE, Florence Ellen *[Painter, illustrator, writer, lecturer, teacher] b.1891, Salt Lake City, UT / d.1971, Salt Lake City.*
Addresses: Laramie, WY; Laguna Beach, CA in 1932; Salt Lake City. **Studied:** Univ. Utah; Provincetown, MA, with C. Hawthorne; Hills; AIC; Calif. College Arts & Crafts. **Member:** Utah AI; Laguna Beach AA; SAC, NY. **Exhibited:** Utah AI, 1928 (prize); Springville, UT, 1931 (prize); Utah State Fair, 1939 (prize). **Work:** WPA murals, Laramie (WY) H.S., Appleton (WI) H.S.; Utah State Fair Assn.; port. sketch, Utah AI; H.S.; Whitman College, Walla Walla, WA; Stewart Sch., Univ. Utah; Ladies Literary Club, Salt Lake City; murals, School, Rowland Hall Chapel, Port Publishing Co., pub. lib., all in Salt Lake City; H.S., Richmond, UT; Univ. Utah. **Comments:** Painted landscapes & murals. Teaching: Univ. Utah, 1918-40s. **Sources:** WW40; P&H Samuels, 511; Trenton, ed. *Independent Spirits,* 224.

WARE, John *[Painter] mid 19th c.; b.Boston, MA.*
Exhibited: Paris Salon, 1866, 1868-70, 1890. **Sources:** Fink, *American Art at the Nineteenth-Century Paris Salons,* 402.

WARE, John H. *[Sculptor] mid 20th c.*
Addresses: Rosemont, PA. **Exhibited:** PAFA Ann., 1966. **Sources:** Falk, *Exh. Record Series.*

WARE, Joseph *[Sculptor] b.1827.*
Exhibited: Boston Athenaeum, 1846 (his first work, a bas relief in marble of St. John). **Sources:** G&W; Boston Athen. Cat., 1846; Swan, BA.

WARE, Loe M. *[Artist] 19th/20th c.*
Addresses: Active in Grand Rapids & Detroit, MI, c.1894-1901. **Sources:** Petteys, *Dictionary of Women Artists.*

WAREHAM, John Hamilton D(ee) *[Painter, craftsperson] 20th c.; b.Grand Ledge, MI.*
Addresses: Cincinnati, OH. **Studied:** Duveneck; Meakin. **Member:** Cincinnati Munic. AS; Cincinnati AC; MacD. Club; Cincinnati Mus. Assn. **Exhibited:** St. Louis Expo, 1904 (medal); dec., Ft. Pitt Hotel, Pittsburgh; Seelbach Hotel, Louisville, Hotel Sinton, Cincinnati. **Comments:** Position: pres., Rookwood Pottery Co., 1940. **Sources:** WW40.

WAREN *[Engraver] b.c.1824, Philadelphia.*
Addresses: Philadelphia, 1860. **Comments:** Lived in 1860 with his wife Sarah and five children, all born in Pennsylvania. **Sources:** G&W; 8 Census (1860), Pa., XLIX, 680.

WARES, Hazel Kitts *[Painter] b.1903, Oswego, NY.*
Addresses: Peru, VT. **Studied:** Corcoran Sch. Art. **Member:** AWCS; Academic Art, Springfield, MA; Londonderry Artists Gld., VT; Miller AC, Springfield, VT; Rockport AA; Southern Vermont AC. **Sources:** WW59.

WARFEL, Jacob Eshleman *[Portrait & landscape painter] b.1826, Paradise Township, PA / d.1855.*
Addresses: Lancaster County, PA; Richmond, VA, 1846. **Comments:** He is known to have painted one still life. He died of consumption. **Sources:** G&W; Lancaster County Hist. Soc., *Papers,* XVI (1912), 251-52; *Richmond Portraits,* 243; Wright, *Artists in Virginia Before 1900.*

WARFIELD, Majel *[Painter, illustrator] b.1905, New Orleans.*
Addresses: New Orleans, LA. **Studied:** F. Grant. **Member:** NOAA; SSAL. **Sources:** WW33.

WARGNY, Armand (Armond) *[Painter, etcher] early 20th c.*
Addresses: Chicago, IL. **Exhibited:** AIC, 1908, 1915-26; PAFA Ann., 1923. **Sources:** WW21; Falk, *Exh. Record Series.*

WARHANIK, Elizabeth Campbell (Mrs. Chas. A. Warhanik) *[Painter, printmaker] b.1880, Philadelphia, PA / d.1968, Seattle, WA.*
Addresses: Seattle, WA. **Studied:** Wellesley (classical literature); Univ. Wash.; Gustin; E. Forkner; C. Woodbury. **Member:** SAM; Women Painters Wash.(co-founder and first pres.); Northwest PM; Northwest WCS. **Exhibited:** Northwest Artists, Seattle, 1917 (prize); Univ. Wash., 1930 (prize); SAM, 1930 (solo), 1938 (solo); Women Painters Wash., 1937-39 (prizes); Seattle FA Soc.; Nat. Lg. Am. Pen Women; PAM, 1936, 1938; Grant Gal., NYC, 1937,

1938; Henry Seattle Fine Arts Soc., beginning in 1916, 1930 (solo); PAFA; Wichita AM; NY Am. Arts Alliance; Gallery, Seattle, 1950. **Comments:** After spending five years teaching in Japan, she moved to Seattle, joining her family; and in 1910 married Dr. Charles Warhanik. Related to N.C. Wyeth, she came from a family of artistic people; her sister was Catherine Campbell, illustrator of the "Dick and Jane" reading primers. She was adept in watercolor, oil and printmaking. her subject matter included landscapes, marine and city scenes, and floral still lifes, paintings of flowers from her own garden. **Sources:** WW40; Trip and Cook, *Washington State Art and Artists, 1850-1950; Charles Woodbury and His Students;* addit. info. courtesy Martin-Zambito Fine Art, Seattle, WA; Trenton, ed. *Independent Spirits,* 116.

WARHOL, Andy *[Painter, printmaker, craftsman, printmaker] b.1928, Cleveland, OH / d.1987, NYC.*
Addresses: NYC. **Studied:** Carnegie Inst. Tech. **Member:** Film Co-op. **Exhibited:** "The 1960's," MoMA, 1967; Jewish Mus., 1968; Documenta IV, Kassel, Germany, 1968; Directions I: Options, Milwaukee AC, 1968; WMAA, 1967, 1969; MOMA, 1989 (retrospective) Awards: Sixth Film Culture Award, 1964; Los Angeles Film Festival Award, 1964. **Work:** Warhol Mus., Pittsburgh, PA; Albright-Knox Art Gallery, Buffalo, NY; LACMA; MoMA; WMAA; Walker AC, Minneapolis. **Comments:** The most visible and often outrageous leader of the Pop Art movement of the 1960s. As both a painter and printmaker, he was the first artist to utilize the screenprint medium to elevate both common and famous photographic images from popular culture to fine art status. Among his most famous images appropriated from the commercial world were his Campbell Soup cans and Brillo boxes. It was in portraiture, however, that he gained his greatest fame, creating iconic images of Marilyn Monroe, Jackie Kennedy, Liz Taylor, Elvis Presley, and Mao. Numerous celebrities sat for their photographic portraits which were later printed by the silkscreen method by his crew of assistants at the "Factory" and then transformed by Warhol with added lines, vigorous brushwork, and fields of color. He died from unexpected complications after simple gall bladder surgery. Author: *A Philosophy of Andy Warhol: From A to B and Back Again* (Harcourt Brace Jovanovich, 1975); *The Andy Warhol Diaries,* edited by Pat Hackett (Warner Books, 1989). **Sources:** WW73; Paul Alexander, *Death and Disaster: The Rise of the Warhol Empire and the Race for Andy's Millions* (New York: Villard Books, 1994); Henry Geldzahler and Robert Rosenblum, *Andy Warhol: Portraits of the Seventies and Eighties)* (New York: Thames and Hudson, 1993); Kynaston McShine, ed. *Andy Warhol: A Retrospective* (exh. cat., MOMA, 1989); Frayda Feldman and Jorg Schnellmann, *Andy Warhol Prints: A Catalogue Raisonné* (New York: Abbeville Press, 1985); Carter Ratcliff, *Andy Warhol* (New York, Abbeville Press, 1983); Samuel Adams Green, *Andy Warhol,* catalogue (Inst Contemp Art, Philadelphia, 1965).

WARIN, Joseph *[Pen-and-ink artist] late 18th c.*
Comments: Made a pen-and-ink wash drawing of Pittsburgh (PA) in 1796. He was a traveling companion of General Victor Collot, a French officer, who made a journey through the western part of the United States from March to December 1796 for the purpose of gathering information for the French Minister at Philadelphia. **Sources:** G&W; Stokes, *Historical Prints,* 42, pl. 34a.

WARING, Amalia V. *[Miniature painter] early 20th c.*
Addresses: Paris, France. **Sources:** WW10.

WARING, Brooke *[Painter] 20th c.*
Addresses: Los Angeles, CA, 1930s. **Exhibited:** P&S Los Angeles, 1934-35; Public Works of Art Project, Southern California, 1934 (mural). **Work:** Ventura H.S. **Sources:** Hughes, *Artists of California,* 590.

WARING, Effie Blunt (Miss) *[Painter] 19th/20th c.; b.Chautauqua, NY.*
Addresses: Newport, RI, 1890-95; NYC, 1896, 1898. **Studied:** A.H. Thayer in Boston. **Member:** Newport AA; NY Woman's Art Club. **Exhibited:** PAFA Ann., 1894, 1898-99; NAD, 1896, 1898;

AIC, 1898. **Sources:** WW25; Falk, *Exh. Record Series.*

WARING, James D. *[Painter] early 20th c.*
Addresses: Montclair, NJ. **Sources:** WW24.

WARING, Laura Wheeler (Mrs. Walter Waring)
[Portrait, still life, genre & landscape painter, illustrator, teacher] b.1887, Hartford, CT / d.1948.
Addresses: Cheyney, PA/Brooklyn, NY; Phila., PA. **Studied:** PAFA (Cresson Traveling Scholarship), 1918-24; Académie de la Grande Chaumière, Paris, 1924-25; Chase; Boutet de Monvel; Prinet; McCarter; Violet Oakley. **Exhibited:** Phila. Civic Center; Harmon Found., 1927, 1928 (gold), 1930-31; Exh. Colored Artists, 1919 (prize); PAFA Ann., 1929; PAFA, 1935, 1938; Smithonian Inst., 1933; AIC, 1916, 1933; Texas Centennial, 1936; Howard Univ., 1937, 1939, 1949 (retrospective); AWCS; Am. Negro Expo, Chicago, 1940; CGA; Detroit Inst. Art. **Work:** portraits; Cheyney State Teachers College; U.S. Armory, NYC; Nat. Archives; Smithsonian Inst.; Nat. Portrait Gallery; commission: "Outstanding Americans of Negro Origin", Harmon Found. (jointly with Betsy G. Reyneau). **Comments:** Illustrator: "The Shadow," "The Upward Path." Contributor: *School Arts.* Positions: art teacher, Cheyney (PA) State Teachers College; director, Negro Art Exh., Phila. Expo. **Sources:** WW47; WW29; Cederholm, *Afro-American Artists;* Tufts, *American Women Artists,* cat. no. 25; Art in Conn.: Between World Wars; Petteys, *Dictionary of Women Artists,* reports birth date as 1877; Falk, *Exh. Record Series.*

WARING, Leila *[Miniature painter] early 20th c.*
Addresses: Charleston, SC. **Member:** SSAL; Carolina AA; AFA. **Sources:** WW33.

WARING, Sophia F. Malbone (Mrs. E. T.) *[Amateur miniaturist] b.1787 / d.1823.*
Addresses: Newport, RI; Charleston, SC. **Comments:** Wife of Dr. Edmund T. Waring. **Sources:** G&W; Carolina Art Assoc. Cat., 1935.

WARK, Robert Rodger *[Art administrator, art historian] b.1924, Edmonton, Alberta.*
Addresses: San Marino, CA. **Studied:** Univ. Alberta (B.A. & M.A.); Harvard Univ. (M.A. & Ph.D.). **Member:** College AA Am.; Assn. Art Mus. Directors. **Comments:** Positions: curator of art, Huntington Library & Art Gal., 1956-. Publications: editor, "Sir Joshua Reynolds, Discourses on Art," 1959; author, "Rowlandson's Drawings for a Tour in a Post-Chaise,"1963; author, "Early British Drawings in the Huntington Collection 1700-1750," 1969; author, "Drawings by John Flaxman in the Huntington Collection," 1970; author, "Ten British Pictures 1740-1840"; plus others. Teaching: Harvard Univ., 1952-54; Yale Univ., 1954-56; Calif. Inst. Technology, 1960-; Univ. Calif., Los Angeles, 1965-. Research: English art of the Georgian period. **Sources:** WW73.

WARKANY, Josef (Dr.) *[Etcher] b.1902, Vienna, Austria / d.1992, Cincinnati, OH?.*
Addresses: Cincinnati. **Exhibited:** Int. Etching & Engraving Exh., 1938; LOC, 1945, 1948; SAE, 1945; Ohio PM, 1938-44, 1957; CM, 1939, 1944 (solo); several group shows. Awards: prizes, Am. Physician's AA, 1938-41. **Sources:** WW59; WW47.

WARLOW, C. Joseph *[Painter] early 20th c.*
Addresses: Phila., PA. **Studied:** PAFA. **Exhibited:** PAFA Ann., 1917-18. **Sources:** WW21; Falk, *Exh. Record Series.*

WARMING, Peter *[Painter] early 20th c.*
Addresses: Chicago. **Exhibited:** AIC, 1902, 1904. **Sources:** Falk, *AIC.*

WARNACUT, Crewes *[Painter, etcher] b.1900, Osman, IL.*
Addresses: Inwood, IN. **Studied:** W. Forsyth; C. Hawthorne. **Member:** All-Illinois SFA; Hoosier Salon; Lg. Northern Indiana. **Exhibited:** All-Illinois SFA, 1929 (prize); Lg. Northern Indiana, 1929 (prize). **Sources:** WW33.

WARNDOF, Fred *[Painter] d.1939, Bryn Mawr, PA.*
Addresses: NYC. **Exhibited:** Salons of Am., 1932; S. Indp. A., 1932. **Sources:** Marlor, *Salons of Am.*

WARNE, Alice Schaeffer *[Teacher, painter] mid 20th c.*
Addresses: Los Angeles, CA. **Exhibited:** Kingsley Art Club, Sacramento, 1939. **Sources:** Hughes, *Artists of California,* 590.

WARNE, Thomas *[Engraver] b.c.1830.*
Addresses: Philadelphia in 1860. **Comments:** Lived with his wife Emma and children, Daniel and William in 1860. This may be the Thomas A. Warne, jeweler, listed in the 1866 directory. **Sources:** G&W; 8 Census (1860), Pa. XLIX, 207; Phila. CD 1866.

WARNEKE, Heinz *[Sculptor, teacher] b.1895, Bremen, Germany / d.1983, Connecticut.*
Addresses: NYC; Washington, DC/East Haddam, CT. **Studied:** Acad. FA, Berlin; Kunstschule, Bremen; Staatliche Kunstgewerbe Schule & Acad. (M.A.); Blossfeld; Haberkamp; Wakele. **Member:** ANA, 1939; NA; Am. Soc. PS&G; NSS (fellow); Salon des Tuileries (assoc.); New England SA; Int. Inst. Arts & Letters (life fellow); CAFA; MoMA. **Exhibited:** Salon des Tuileries, Paris, France, 1926 (prize), 1929; PAFA Ann., 1928-30, 1935 (Widener Gold Medal), 1938-52, 1958; AIC Ann., 1930 (medal); CAFA, 1935 (prize); MoMA Ann., New York, 1936-46; WMAA Ann.,1936-46; Wash. AA, 1943 (medal). Other awards: St Louis AG, 1924 (prize), 1925 (prize); Logan prize for best in show, 1930; first prize, Wash. DC Artists Ann., CGA, 1943-44. **Work:** Univ. Nebraska; AIC; AGAA; CGA; Brookgreen Gardens, Georgetown, SC; Santa Fe (NM)Mus.; The Immigrant, P. Samuel Mem., Fairmount Park Phila.; MoMA; BM; Masonic Temple, Ft. Scott, KS; Medical Soc., YMCA, City Hall, all in St. Louis; Nat. Coll. Am. Art, Smithsonian Inst. Commissions: "Prodigal Son" (granite), 1938, "Last Supper," tympanium at south portal, 1955 & entire decoration of clerestory at south transcept, 1956-60, Washington Cathedral, Wash., DC; Harlem Housing Project, NYC; Zoological Gardens, Wash., DC; Fairmount Park, Phila.; WPA statue, Post Office Dept. Bldg., Wash., DC; Dept. Interior Bldg.; granite elephant group, comn. by private group for Phila. Zoological Gardens, 1963; portrait plaque of Allen C. Dulles, private commission for CIA Bldg, Langley, VA, 1969. **Comments:** Preferred media: granite. Positions: mem., German Monuments Commission, World War I, Bucharest, Romania, 1914-18. Publications: author, "First & Last & Sculptor," *Magazine Art,* 2/1939. Teaching: head of sculpture, Warneke School Art, 1940-42; head sculpture, Corcoran School Art, 1943-68; sculpture professor, George Washington Univ., 1943-68. **Sources:** WW73; Olin Dows, "Art for Housing Tenants," *Magazine Art* (Nov., 1938); Walter Nathan, "Living Forms: The Sculptor Heinz Warneke," *Parnassus Magazine* (Feb., 1941); "New Last Supper," *Life Magazine* (Sept. 19, 1955); WW47; McMahan, *Artists of Washington, DC.;* Falk, *Exh. Record Series.*

WARNEKE, Jessie Gilroy Hall *[Artist, author] b.1889, Philadelphia, PA / d.1982, Middletown, CT.*
Addresses: Wash., DC/East Haddam, CT. **Studied:** Bryn Mawr College. **Exhibited:** New York; Santa Fe, NM; Wash., DC. **Comments:** Preferred media: oil, watercolor. Married to Heinz Warneke (see entry). **Sources:** McMahan, *Artists of Washington, DC.*

WARNER, Alfred *[General & seal engraver] mid 19th c.*
Addresses: NYC,1836-60. **Comments:** From 1836-41 he was in partnership with Charles Warner (see entry). This may be the Alfred Warren [*sic*], engraver, aged 40 and a native New Yorker, listed in the 1860 Census. **Sources:** G&W; NYCD 1836-60; 8 Census (1860), N.Y., XLVII, 187.

WARNER, Alice See: BURGESS, Alice Lingow (Mrs. W. H. Warner)

WARNER, Anna Justine Angelo (Mrs.) *[Artist] early 20th c.*
Addresses: Active in Wash., DC, 1904-25. **Sources:** Petteys, *Dictionary of Women Artists.*

WARNER, Anne Dickie *[Portrait painter] 20th c.*
Addresses: Wilmington, DE. **Studied:** PAFA with J. T. Pearson, Jr., D. Garber, H. Breckenridge (Cresson Scholarship, 1936); C. Hawthorne. **Member:** Wilmington SFA; Wilmington AC. **Comments:** Position: affiliated with Cranbrook Acad., Bloomfield Hills, MI. **Sources:** WW40.

WARNER, Boyd, Jr. *[Painter] b.1937, Kaibeto, AZ.*
Addresses: Phoenix, AZ. **Exhibited:** Scottsdale Nat. Indian Arts & Crafts Show, 1968-71; Inter-Tribal Ceremonial, Gallup, NM, 1968-72; Heard Mus. Indian Art Show, Phoenix, 1969-71; Arizona State Fair, Phoenix, 1969-71; 27th Indian Art Show, Philbrook AC, Tulsa, OK, 1972. Awards: Elkus Mem. Award, 1971 & first & second award in mixed media, 1972, Inter-Tribal Ceremonial; hon. men., Heard Mus. Indian Arts & Crafts, 1971. **Work:** Buck Saunders, Scottsdale, AZ; James T. Bialec, Phoenix, AZ; Dick Van Dyke, Cave Creek, AZ & Gen. Motors Corp., Detroit, MI. **Comments:** Preferred media: sand, watercolors, oils, acrylics. **Sources:** WW73.

WARNER, C. J. *[Engraver] late 18th c.*
Comments: Engraver in stipple of a portrait published in NYC in 1796. Possibly the same as George J. Warner, watchmaker of NYC, 1795-1811. **Sources:** G&W; Stauffer; NYCD 1795, 1799-1811.

WARNER, Catherine Townsend *[Primitive watercolorist] b.1785 / d.1828.*
Addresses: Rhode Island, c.1810. **Comments:** Memorial painting in watercolors on silk. **Sources:** G&W; Lipman and Winchester, 181.

WARNER, Charles *[Engraver] mid 19th c.*
Addresses: NYC, 1835-41. **Comments:** With Alfred Warner (see entry) from 1836. **Sources:** G&W; NYCD 1835-41.

WARNER, Charles E. *[Painter] early 20th c.*
Addresses: Chester Springs, PA. **Exhibited:** PAFA Ann., 1933. **Sources:** Falk, *Exh. Record Series.*

WARNER, Clifford Lewis *[Painter] b.1895, Michigan / d.1955, Hollywood, CA.*
Addresses: Hollywood, CA. **Exhibited:** Artists Fiesta, Los Angeles, 1931. **Sources:** Hughes, *Artists of California,* 590.

WARNER, (E.) Victor B(ell) *[Painter, lithographer] b.1908, Ipswich, England.*
Addresses: NYC/Provincetown, MA. **Studied:** T. Benton; R. Moffett; J. Bowes.; ASL. **Sources:** WW33.

WARNER, E. B. (Miss) *[Artist, drawing teacher] mid 19th c.*
Comments: Teaching: MIlwaukee (WI) College, 1851. **Sources:** Petteys, *Dictionary of Women Artists.*

WARNER, Earl *[Painter] mid 20th c.*
Addresses: Sacramento, CA. **Exhibited:** Kingsley AC, Sacramento, 1934-35. **Sources:** Hughes, *Artists of California,* 590.

WARNER, Earl A. *[Illustrator, teacher] b.1883 / d.1918, Battle Creek MI.*
Comments: Teaching: Peabody Teachers College, Nashville, TN.

WARNER, Everett (Longley) EVERETT WARNER
[Painter, etcher, teacher, lecturer, writer] b.1877, Vinton, IA / d.1963, Bellow Falls, VT.
Addresses: NYC; Wash., DC; Pittsburgh, PA; Wash., DC; Westmortland, NH. **Studied:** ASL (NYC and Wash., DC); Corcoran Art Sch., 1897-98; Académie Julian, Paris, 1903. **Member:** ANA, 1913; NA, 1937; Soc. Wash. Artists; Wash. WCC; Pittsburgh AA; AWCS; NAC; Paris AAA. **Exhibited:** PAFA Ann., 1898-1922, 1931 (medal, 1908); Boston AC, 1899-1909; Wash. WCC, 1902 (First Corcoran prize); Carnegie Inst., 1907-45 (solo, Dept. of Fine Arts, 1941); Veerhoff Gallery, 1906 (solo), 1909 (solo); Corcoran Gal. biennials, 1908-43 (9 times); Int. Expo, Buenos Aires, 1910 (silver medal); NAD, 1912 (Hallgarten Prize), 1937 (Second Altman Landscape Prize); SC, 1913 (William T. Evans Prize), 1914; Soc. Wash. Art, 1913 (bronze medal); Panama-Pacific Expo, 1915 (silver medal);

CAFA, 1917 (prize); AIC, 1919 (prize); Lyme AA, 1937 (W.O. Goodman Prize); Pittsburgh AA, 1934 (prize), 1940; WFNY, 1939; Wash. AC, 1949 (solo). **Work:** Carnegie Inst.; City Art Mus., St. Louis; RISD; Erie Public Lib.; Hanover College; Pennsylvania College for Women; CGA; PAFA; BMFA; TMA; Syracuse Mus. FA; CAM; AIC; NYPL; Gibbes Art Gal., Charleston, SC; Oklahoma Art Lg.; Mus. City of New York; New York Hist. Soc.; Cayuga Mus. History & Art. **Comments:** During his early career he painted in impressionist style, later moving towards realism. Painted in Gloucester (1908) and Quebec (c.1913). Originator of one of five systems of camouflage; in charge of Sub Section of Design of U. S. Naval Camouflage (1917). Fire destroyed much of his work still in his studio in 1972. Teaching: Carnegie Inst., Pittsburgh, PA, 1924-42. Contributor: *Traffic Quarterly, Illuminating Engineer, Atlantic Monthly, Century, Scribner's* and other national magazines. Publisher: *Etcher's Manual,* 1931. **Sources:** WW59; WW47; Ness & Orwig, *Iowa Artists of the First Hundred Years,* 214-15; McMahan, *Artists of Washington, DC (mistakenly places Vinton in Vermont, not Iowa);* Danly, *Light, Air, and Color,* 84-85; Falk, *Exh. Record Series.*

WARNER, Frances *[Painter] mid 20th c.*
Studied: ASL. **Exhibited:** S. Indp. A., 1938. **Sources:** Marlor, *Soc. Indp. Artists.*

WARNER, George D. *[Engraver] late 18th c.*
Comments: Engraver of a botanical plate for the *New York Magazine,* December 1791. **Sources:** G&W; Stauffer.

WARNER, Harriet E. *[Artist, architect] 19th c.*
Addresses: Active in Wisconsin. **Comments:** Carved pictures in ebony and silver; designed lake Geneva Seminary, WI. **Sources:** Petteys, *Dictionary of Women Artists.*

WARNER, Harry Backer, Jr. *[Writer] b.1922, Chambersburg, PA.*
Addresses: Hagerstown, MD. **Comments:** Positions: art critic & writer on art, Hagerstown (MA) *Herald-Mail,* 1943-. **Sources:** WW73.

WARNER, Helene *[Sculptor] mid 20th c.*
Addresses: Chicago IL. **Exhibited:** AIC, 1936; WFNY, 1939. **Sources:** WW40.

WARNER, Isabel Anna (Mrs. Willis) *[Painter] b.1884, Lee, IL.*
Addresses: Gilmore City, IA. **Studied:** Mrs. L.H. Van Alstine in Gilmore City, IA. **Member:** Ft. Dodge AG. **Exhibited:** Blanden Gal., Ft. Dodge, Iowa; Fed. Women's Club, Sioux City; Iowa Artists Exh., Mt. Vernon, 1938. **Sources:** WW40; Ness & Orwig, *Iowa Artists of the First Hundred Years,* 215.

WARNER, J. H. *[Mural landscape painter] mid 19th c.*
Addresses: Fitchburg, MA about 1840. **Sources:** G&W; Winchester, "A Painted Wall," repro.; Lipman and Winchester, 181.

WARNER, Jo *[Painter] b.1931, Clayton, NM.*
Addresses: NYC. **Studied:** Univ. Colorado, Boulder (B.F.A.); Skowhegan School Painting & Sculpture, Maine, with Jack Levine & Henry V Poor; ASL with Morris Kantor & Byron Brown. **Exhibited:** Tenth Street, Mus. Contemporary Art, Houston, TX, 1959; Recent American Painting & Sculpture, MoMA Circulating Exhib., 1961-63; West Side Artists-NYC, Riverside Mus., 1964; Phoenix Gallery, NYC, 1970s. **Comments:** Preferred medium: oils. **Sources:** WW73.

WARNER, Langdon *[Museum curator, educator] b.1881, Cambridge, MA / d.1955.*
Addresses: Cambridge, MA. **Studied:** Harvard College, Cambridge (M.A.). **Comments:** Position: curator, Oriental Art, FMA, Harvard Univ., Cambridge, MA. Author: "Japanese Sculpture of the Suiko Period," 1923; "Craft of the Japanese Sculptor." **Sources:** WW53; WW47.

WARNER, Leon *b.c.1822, France.*
Addresses: NYC in 1860. **Comments:** In NYC, 1860, with his wife Emma, also French. **Sources:** G&W; 8 Census (1860), N.Y., LIV, 649.

WARNER, Lilly Gillett *[Illustrator, flower painter] 19th c.; b.Hartford, CT.*
Comments: Illustr.: *St. Nicholas* magazine. **Sources:** Petteys, *Dictionary of Women Artists.*

WARNER, Margaret *[Illustrator, writer] b.1892, Mabbettsville, NY.*
Addresses: Wash., DC. **Studied:** Corcoran Sch. Art; Abbott Sch. Art, Wash., DC; NY Sch. Fine & Applied Art; Berkshire Summer Sch. Art. **Sources:** WW31.

WARNER, Marjorie *[Painter] 20th c.*
Addresses: Berkeley, CA. **Exhibited:** Bay Region AA, 1937; San Francisco AA, 1937, 1939. **Sources:** Hughes, *Artists of California,* 590.

WARNER, Mary *[Painter] b.1948.*
Exhibited: WMAA, 1975. **Sources:** Falk, *WMAA.*

WARNER, Mary E. *[Painter] early 20th c.*
Addresses: Phila., PA. **Sources:** WW04.

WARNER, Mary Loring (Mrs.) *[Painter] b.1860, Sheffield, MA.*
Addresses: Middletown, CT. **Studied:** F. de Haven; C.W. Eaton. **Member:** CAFA; New Haven PCC. **Exhibited:** PAFA Ann., 1895. **Sources:** WW40; Falk, *Exh. Record Series.*

WARNER, May See: **MARSHALL, May Warner (Mrs. Fred)**

WARNER, M(azie) L. *[Painter] early 20th c.*
Addresses: NYC. **Exhibited:** S. Indp. A., 1931. **Sources:** Marlor, *Soc. Indp. Artists.*

WARNER, Meta *[Painter, china painter (Colorado flowers)] late 19th c.*
Addresses: Colorado Springs, CO. **Sources:** Petteys, *Dictionary of Women Artists.*

WARNER, Myra *[Illustrator, painter] early 20th c.; b.Roca, NE.*
Addresses: Rochester, MN. **Studied:** AIC; Univ. Nebraska; M. Broedl. **Comments:** Specialty: medical illustration. **Sources:** WW25.

WARNER, Myrtle L(ouise) *[Painter, sculptor, illustrator, teacher] b.1890, Worcester, MA.*
Addresses: Sterling, MA/Cliff Island, ME. **Sources:** WW25.

WARNER, Nell Walker (Mrs. Emil Shostrom) *[Painter] b.1891, Nebraska / d.1970, Monterey County, CA.*
Addresses: La Crescenta, CA. **Studied:** P. Lauritz; Los Angeles Sch. Art & Des., 1916; F. Werner, N. Fechin, 1923-25;. **Member:** Calif. AC; Glendale AA; Women Painters of the West; Calif. WCS; Laguna Beach AA; Artland Club; Acad. Western Painters. **Exhibited:** Calif. Eisteddfod, 1925 (4 gold & silver medals); Southern Calif. Fair, 1925 (prize); Wilshire Gallery, Los Angeles, 1928; Phoenix, 1929 (prize); Texas State Exh., 1929 (prize); Sacramento State Exh., 1929 (prize); Santa Cruz Ann., 1930 (prize); Calif. State Ann., 1931 (prize); Phoenix (AZ) Ann., 1931 (prize); Ebell Club (prizes); Los Angeles Mus. Art, 1933 (prize); Beverly Hills, CA, 1933 (prize); Calif. AC, LACMA, 1936 (prize); GGE, 1940; Soc. for Sanity in Art, CPLH, 1945. **Work:** LACMA; Municipal Art Gallery, Phoenix, AZ. **Comments:** Specialties: flowers & landscapes. Married Bion Smith Warner in 1920 and Emil Shostrom in 1945. She traveled to Europe and took painting trips to Gloucester and Rockport, MA. **Sources:** WW40; Hughes, *Artists in California,* 590; Trenton, ed. *Independent Spirits,* 66-67 (w/repro.).

WARNER, Olin Levi *[Sculptor, medalist] b.1844, West Suffield, CT / d.1896, NYC.*
Addresses: NYC (since 1872). **Studied:** École des Beaux-Arts,

Paris, with Jouffroy, 1869-72; studio asst. to Jean Baptiste Carpeaux. **Member:** Assoc. of Amer. Artists (founder, 1877/renamed the SAA in 1878). **Exhibited:** NAD, 1873-91; Centennial Expos, 1876 (medallion portrait of Edwin Forrest); Brooklyn AA, 1877; Cottier's Gal., NYC, 1878-; PAFA Ann., 1879, 1894-95, 1898-99; Paris Salon, 1881; Boston AC, 1882, 1890; Columbian Expo, Chicago, 1893. **Work:** MMA; CGA; door for LOC; statue of William Lloyd Garrison, Boston, MA. **Comments:** One of the earliest sculptors to bring the Beaux-Arts style back to America. In the late 1870s, Warner greatly popularized the bas-relief portrait, producing a number of refined medallion portraits, including one of the actor Edwin Forrest which brought Warner praise when shown at the Phila. Centennial. His friendship with the art dealer Daniel Cottier also helped bring him to public attention as Cottier allowed him to exhibit work at his gallery. Two of Warner's most admired pieces were a portrait bust of his artist friend Julian Alden Weir (1880, CGA) and his bronze figure of the goddess "Diana" (1883, MMA). Warner received several prestigious commissions for monumental statues in the 1880s, including the full-length bronze of William Lloyd Garrison (Boston, MA). In 1889-91, Warner traveled though the Northwest, executing a series of portrait medallions of Native Americans. After this trip, he became busy with the World's Columbian Exposition, serving on the selection committee, designing the commemorative souvenir half-dollar, completing a statue and several portrait busts for the New York State Building, and exhibiting, among other works, his "Diana" and several of his Columbia River Indian medallions. When the exposition was over, Warner began work on a set of bronze doors for the Library of Congress. Unfortunately, he was killed in a bicycle accident having completed only one of the doors. **Sources:** Baigell, *Dictionary;* Craven, *Sculpture in America,* 406-09; *Two Hundred Years of American Sculpture,* 318; P&H Samuels, 511-12; Fink, *American Art at the Nineteenth-Century Paris Salons,* 402; Falk, *Exh. Record Series.*

WARNER, Pauline *[Painter, sculptor] b.1918, Seattle, WA.*
Addresses: Seattle, WA. **Studied:** Univ. Wash. **Member:** Soc. Seattle Artists. **Exhibited:** SAM, 1937, 1939. **Sources:** Trip and Cook, *Washington State Art and Artists,* 1850-1950.

WARNER, Ralph N. *[Mezzotint grainer] mid 19th c.*
Addresses: Philadelphia, 1848. **Sources:** G&W; Phila. BD 1848, under historical and portrait engravers.

WARNER, Stanley Bishop *[Painter] early 20th c.*
Addresses: Rye, NY. **Exhibited:** S. Indp. A., 1931. **Sources:** Marlor, *Soc. Indp. Artists.*

WARNER, Victor B(ell) See: **WARNER, (E.) Victor B(ell)**

WARNER, William A. *[Artist] late 19th c.*
Addresses: NYC, 1876. **Exhibited:** NAD, 1876. **Sources:** Naylor, *NAD.*

WARNER, William, Jr. *[Painter, mezzotint engraver] b.c.1813, Philadelphia, PA / d.1848, Phila.*
Addresses: Phila., c.1836-48. **Exhibited:** Artists' Fund Soc., PAFA, Apollo Assoc. (portraits, miniatures, landscapes, literary subjects). **Sources:** G&W; Stauffer; Rutledge, PA; Cowdrey, AA & AAU; Phila. BD 1838-39, 1846, 1849.

WARNER, Wilson Harley (Mrs.) See: **BURGESS, Alice Lingow (Mrs. W. H. Warner)**

WARNICK, John G. *[Engraver] d.1818.*
Addresses: Philadelphia from 1811-18. **Comments:** There was another John Warnick, engraver, listed in the 1811 directory at a different address, but this may have been a printer's error. **Sources:** G&W; Stauffer; Phila. CD 1811; repro., *Connoisseur* (March 1948), 48.

WARR, John *[Engraver] b.c.1798, Scotland.*
Addresses: in Philadelphia at least from 1828-60. **Comments:** His eldest son, William Warr, also was an engraver (see entry). **Sources:** G&W; 7 Census (1850), Pa., LIII, 179; 8 Census (1860), Pa., LVIII, 570; Phila. CD 1860.

WARR, William *[Engraver] b.c.1828, Pennsylvania.*
Comments: The son of John Warr, engraver (see entry); active in 1850. **Sources:** G&W; 7 Census (1830), Pa., LIII, 179.

WARRALL, William H(enry) *[Painter] early 20th c.*
Addresses: White Plains, NY. **Exhibited:** S. Indp. A., 1932. **Sources:** Marlor, *Soc. Indp. Artists.*

WARRE, Henry James (Sir) *[Topographical artist] b.1819, probably Durham, England / d.1898, probably England.*
Work: Am. Antiquarian Soc. (originals of Warre's views in Oregon and Washington); Public Archives, Ottawa, Canada. **Comments:** In 1845-46 he made a military reconnaissance of the Oregon country for the British Government, taking many sketches on the spot which were later engraved to illustrate his *Sketches in North America and the Oregon Territory* (1848). Warre later served as colonel of the Wiltshire regiment in the Crimean and New Zealand wars and retired with the rank of General. **Sources:** G&W; DNB; Rasmussen, "Artists of the Explorations Overland, 1840-60," 59-60; *American Heritage* (Summer 1953), 58-59, repros.; *American Processional,* 134; Stokes, *Historical Prints;* P&H Samuels, 512.

WARRELL, James *[Portrait & historical painter, scenic artist] b.c.1780 / d.Before 1854.*
Addresses: Philadelphia, 1793-c.99; Richmond, VA, 1804-c.39; visits to New Orleans, 1825, 1826-27; NYC, 1829-31. **Work:** Valentine Mus. Richmond. **Comments:** Emigrated to Philadelphia in 1793 with his parents, who were actors. Several years later, Warrell opened a dancing school there, but then moved to Petersburg, VA (where he painted scenery), and after that to Richmond, VA, where he opened another dancing school in 1804. A leg injury ended his dancing career in 1810 and he turned to painting, a practice he was familiar with through his experience in set design. Warrell painted portraits and historical works, in the latter category designing some original compositions but also copying paintings such as David's "Napolean Crossing the Alps" (Warrell's version is at Valentine Mus.). His most ambitious project however was his founding of the Virginia Museum which opened in 1817. Warrell showed reputed old master works, plaster casts of classical statues, and work by contemporary Americans such as Thomas Sully, Rembrandt Peale, Charles Bird King, and himself. He also showed natural history specimens. The museum became the Richmond stop for the big traveling pictures, including Vanderlyn's "Ariadne Sleeping on the Island of Naxos." The museum did well at first but the public soon lost interest despite Warrell's attempts to stimulate it by featuring circus performances, chemistry exhibits, and concerts. In 1826 he turned over its management to someone else and began traveling throughout the country for artistic work, designing theatrical curtains and stage sets. He spent time in New Orleans in 1825 and 1826-27, and was in NYC 1829-31. Between 1831-39 he seems to have divided his time between Richmond and NYC (he sold the museum to his brother-in-law, Richard Lorton in 1836). Nothing is known of him after 1839 but he died sometime before 1854, as in that year his widow disposed of some Richmond property. **Sources:** G&W; *Richmond Portraits,* 235-39; Rutledge, *Artists in the Life of Charleston;* Rutledge, PA; Cowdrey, NAD; Delgado-WPA cites *La. Gazette,* Feb. 21, 1825, *Courier,* March 10, 1826, and New Orleans CD 1827; NYCD 1829-31, 1833-34, 1839. More recently, see Gerdts, *Art Across America,* vol. 2: 16, 26, 343 (note 14).

WARREN, A. V. *[Painter] early 20th c.*
Addresses: Hastings-on-Hudson, NY. **Exhibited:** S. Indp. A., 1925. **Sources:** Marlor, *Soc. Indp. Artists.*

WARREN, A. W. *[Sketch artist] mid 19th c.*
Comments: His views of Civil War activities in and near Richmond, VA, were published in *Harper's Weekly,* 1864 and 1865. **Sources:** Wright, *Artists in Virginia Before 1900.*

WARREN, Andrew W. *[Marine & landscape painter] b.Coventry, NY / d.1873, NYC?.*
Addresses: Coventry, NY, 1855 & 1857,

1861-62; NYC, 1858-60, 1864-67. **Studied:** T.H. Matteson at Sherburne, NY. **Member:** ANA. **Exhibited:** NAD, 1861-72; Brooklyn AA, 1862-73, 1881. **Comments:** He shipped as cabinboy bound for South America in order to study the sea. Exhibited works indicate that much of his time was spent on Mt. Desert Island (ME). He also made a trip to Nicaragua, about 1867. **Sources:** G&W; Fielding; Tuckerman, *Book of the Artists,* 552; Cowdrey, NAD; NYBD 1858-59; Rutledge, PA; Swan, BA; *Portfolio* (May 1943), 208, repro.; Brewington, 405.

WARREN, Asa *[Portrait & miniature painter]* b.c.1800, New Hampshire / d.After 1860.
Addresses: Boston. **Work:** Worcester Art Mus. **Comments:** Father of Asa Coolidge Warren (see entry). The elder Warren was listed as a painter only in the Boston directories (business) for 1846 and 1847; in the city directories he was listed as a musician during the 1830s and 1840s. **Sources:** G&W; Boston BD 1846-47; Boston CD 1830-50; Bolton, *Miniature Painters;* Strickler, *American Portrait Miniatures,* 113.

WARREN, Asa Coolidge *[Engraver, illustrator, who also painted some portraits & landscapes]* b.1819, Boston, MA / d.1904, NYC.
Addresses: Boston; NYC, 1863; Washington, DC. **Studied:** apprenticeship under the Boston engraver, George Girdler Smith (see entry). **Comments:** A son of Asa Warren (see entry), miniature painter and musician (see entry), he worked for Joseph Andrews, the New England Bank Note Company (see entries), and the Boston publishers Ticknor & Field. He lost the use of his right eye in 1897 which forced him to give up engraving for five years, during which time he drew designs on wood for other engravers. In 1863 he went to NYC as an engraver of banknote vignettes and book illustrations and later he was employed in the Government Printing Office at Washington. During his last years he took up landscape painting. He illustrated the first edition of Whittier's Poems. **Sources:** G&W; Stauffer; *Art Annual,* V, 124, obit.; Boston BD 1842-60. More recently, see Campbell, *New Hampshire Scenery,* 170.

WARREN, Betty *[Painter]* 20th c.; b.NYC.
Addresses: Albany, NY. **Studied:** NAD; Cape Cod School Art with Henry Hensche. **Member:** Grand Central Art Gals.; NAC; AAPL; Nat. Lg. Am. Pen Women; Pen & Brush. **Exhibited:** Artists of the Mohawk, Hudson Region, Schenectady, NY, 1960-71; Allied Artists Am., New York, 1965 & 1967; AWCS, New York, 1966; NAC, 1969-1971; Knickerbocker Artists, New York; Grand Central Art Galleries, NYC, 1970s; over 25 solo shows in museums & galleries. Awards: purchase prize, Albany Inst. Hist. & Art, 1964; gold medal, Catharine Lorillard Wolfe; grand prize, Cooperstown 29th Ann. Exh. **Work:** Albany (NY) Inst. Hist. & Art; State Univ. NY, Albany; Hartwick College, Oneonta, NY; NY State Supreme Court, Albany; Grand Lodge Masons NY State, New York. **Comments:** Preferred media: oils, pastels. Teaching: Albany Inst. Hist. & Art, 1959-; co-owner & dir., Malden Bridge School Art, NY, 1965-. **Sources:** WW73; cover article, *Prize Winning Painting,* 1964 & 1965; Norman Kent (author), "The Paintings of Betty Warren," *Am. Artist,* 1967; review *Grand Central Gals. Yearbook,* 1967, 1969 & 1970.

WARREN, Caroline P. *[Painter]* b.1860.
Addresses: Phila., PA. **Exhibited:** PAFA Ann., 1885. **Sources:** Falk, *Exh. Record Series.*

WARREN, Charles *[Sketch artists, topographical engineer]* 19th c.
Comments: Served as a lieutenant in the Civil War and his sketches of Maj. Gen. Peck's headquarters and the 11th Pennsylvania Cavalry Camp at Suffolk were published as a lithograph after the war by E. Sachse & Co. **Sources:** Wright, *Artists in Virginia Before 1900.*

WARREN, Charles Bradley *[Sculptor]* b.1903, Pittsburgh, PA.
Addresses: Pittsburgh 2, PA. **Studied:** Carnegie Inst.; BAID. **Member:** Arch. Lg.; Pittsburgh AA; Pittsburgh Soc. Sculpture. **Exhibited:** Pittsburgh AA, 1930-41, 1950-55; Arch. Lg., 1940-42;

Soc. B. Pittsburgh, 1935-45, 1950-57; NSS, 1952. Awards: prizes, Carnegie Inst., 1936, 1941; Pittsburgh AA, 1936 (prize), 1937 (prize); CI, 1936 (prize), 1941 (prize). **Work:** North Carolina State College; Greek Catholic Seminary, Pittsburgh, Dept. Justice, Raleigh, NC; County Bldg., High Point, NC; Stevens Sch., Pittsburgh; Catholic H.S., Pittsburgh; St. Athanasius Church, West View, PA; St. Paul Orphanage, St. Francis Xavier, United Steelworkers Bldg., all of Pittsburgh; U.S. Steel Research Lab., Monroeville, PA; Mount St. Joseph, Wheeling, WV; many portrait reliefs; Stephen Foster Mem. Medal; St. George Activities Bldg., Pittsburgh; Kaufmann tablet, Pittsburgh; aluminum spandrel, Scott Township H.S., PA; stone panels, Prospect H.S.; medallion, Farmers Bank; Soldiers' Mem. Allegheny Cemetery, Pittsburgh; mem., Republic, PA. **Comments:** Specialties: arch. sculpture; medals. **Sources:** WW59; WW47.

WARREN, Constance Whitney *[Sculptor]* b.1888, NYC / d.1848, Paris, France.
Addresses: Paris, France from c.1912. **Exhibited:** Paris Salon, regularly. **Work:** MMA; Oklahoma State Capitol. **Comments:** Specialty: bronzes of cowboys, horses and dogs. After her marriage to Count Guy de Lasteyrie in 1912, she lived and worked in Paris. Around 1919 she began concentrating on sculpture. **Sources:** P&H Samuels, 512-13.

WARREN, Dudley Thompson *[Sculptor]* b.1890, East Orange, NJ.
Addresses: Roanoke, VA. **Member:** Richmond Acad. Arts. **Work:** "Age of Endearment," Church Home of the City of Baltimore. **Sources:** WW40.

WARREN, Edward Perry *[Patron]* b.Portland, ME / d.1928, London.
Addresses: London, England. **Comments:** He acted as collector for the Sch. of Classical Art at RISD, and the collection of Greek Art in the BMFA is due chiefly to him. He made many gifts to museums, including the University of Leipzig, and Bowdoin College. He bequeathed $65,000 for the establishment of a Greek lectureship at Corpus Christi, Oxford.

WARREN, Edward Vance *[Painter]* early 20th c.
Addresses: Brooklyn, NY. **Exhibited:** Salons of Am.; AIC. **Sources:** WW25.

WARREN, Eleanor *[Painter]* 19th/20th c.
Addresses: San Francisco, CA. **Exhibited:** Mechanics' Inst., San Francisco, 1896, 1899. **Sources:** Hughes, *Artists of California,* 590.

WARREN, Elisabeth B. (Mrs. Tod Lindenmuth) *[Painter, sculptor, illustrator, educator]* b.1886, Bridgeport, CT / d.1980, Rockport, MA?.
Addresses: St. Augustine, FL/Rockport, MA. **Studied:** Mass. School Art; Vesper George School Art; W.H. Bicknell, Provincetown, MA; Charles Simpson, England. **Member:** St. Augustine AC; Rockport AA; Palm Beach AL; Provincetown AA; Southern PM; SSAL. **Exhibited:** SAE; Chicago SE; Calif. PM; Southern PM; Phila. Pr. Club; Phila. Art All.; Rockport AA, 1955 (solo); Florida Fed. Art (prizes, 1937); 2-man exhs., 1955-58, with Tod Lindenmuth, St. Augustine; Tarpon Springs, Naples, FL; St, Petersburgh AA, 1956; Palm Beach AL; Soc. Four Arts, Palm Beach; Allentown (PA) Art Mus., 1958. **Comments:** Specialized in portraits of children in pastel. Illustrator of children's books. **Sources:** WW59; WW47.

WARREN, Ellen R. *[Painter]* late 19th c.
Addresses: Phila., PA, 1879-84. **Exhibited:** PAFA Ann., 1879-81, 1883-84 (portraits, flowers, & still lifes). **Sources:** Falk, *Exh. Record Series.*

WARREN, F. A. *[Painter]* early 20th c.
Addresses: Snow Hill, MD. **Member:** Pittsburgh AA. **Sources:** WW21.

WARREN, Fanny L. *[Painter]* early 20th c.
Addresses: NYC. **Exhibited:** AIC, 1918. **Sources:** WW19.

WARREN, Ferdinand Earl *[Painter, art administrator]*
b.1899, Independence, MO / d.1981.
Addresses: Brooklyn, NY; Decatur, GA. **Studied:** Kansas City
Art Inst. **Member:** ANA; AWCS; SC; AAPL; Allied AA.
Exhibited: AIC, 1936-43; PAFA Ann., 1936-38, 1943, 1949-51;
Richmond (VA) Ann., 1948-49; Corcoran Gal. biennials, 1937-49
(6 times); Art in the Embassies, U.S. Dept. State, 1966-70; NAD
Ann., New York; CI Int., Pittsburgh, PA. **Awards:** Kansas City AI,
1923 (medal); NAD, 1935 (prize); All. Artists Am., (prize);
AWCS, 1950 (silver medal); Butler IA, 1954 (purchase prize);
NAD, 1961 (Edwin Palmer prize). **Work:** MMA; BM; Rochester
Mem. Gal., Youngstown, OH; Currier Gal. Art, Springfield, NH;
NASA Permanent Coll., NGA, Wash., DC. Commissions: two war
bond posters, U.S. Treasury Dept., 1943; History of the Printed
Word (mural), Foote & Davies, Atlanta, GA, 1957; Robert Frost
(portrait from life), Agnes Scott College, Decatur, GA, 1958; cop-
per enamel cross, St. Agnes Episcopal Church, Atlanta, 1963;
Apollo 14 (painting), NASA, Wash., DC, 1971. **Comments:**
Preferred medium: oils. Positions: artist-in-residence, Univ.
Georgia, 1950-51; chmn. dept. art, Agnes Scott College, 1952-69.
Sources: WW73; Forbes Watson, *Painting Today;* Ernest Watson,
Composition in Landscape; WW47; Falk, *Exh. Record Series.*

WARREN, Frank C. *[Painter]* early 20th c.
Addresses: NYC. **Exhibited:** AIC, 1920. **Sources:** WW15.

WARREN, Garnet *[Illustrator]* b.1873, England / d.1937,
Hackensack, NJ.
Comments: Came to the U.S. in 1900. Positions:
cartoonist/writer, *New York Evening Telegram* and *New York
Herald.*

WARREN, George Henry (Mrs.) *[Collector]* b.1897,
Oakland, CA / d.1976.
Addresses: Newport, RI. **Exhibited:** Awards: Legion of Honor,
France. **Comments:** Collection: Cubist and abstract art. **Sources:**
WW73.

WARREN, George W. *[Engraver, lithographer]* mid 19th c.
Addresses: Albany, NY in 1853 and later. **Comments:** Of Pease
& Warren, engravers and lithographers (see entry). In 1854 he was
listed as a music teacher. **Sources:** G&W; Albany CD 1853-54.

WARREN, Harold B(roadfield) *[Landscape painter, illustra-
tor, instructor]* b.1859, Manchester England / d.1934.
Addresses: Cambridge, MA. **Studied:** Harvard with C.E. Norton,
C.H. Moore; BMFA Sch. **Member:** Copley Soc., 1891; Boston
Soc. Arch.; Boston SWCP; Boston SAC (Master). **Exhibited:**
NAD, 1884; Boston AC, 1886-1907; PAFA Ann., 1898, 1903;
AIC. **Work:** BMFA; CMA. **Comments:** Came to U.S. in 1876.
Specialty: watercolor. **Sources:** WW33; Campbell, *New
Hampshire Scenery,* 170; Falk, *Exh. Record Series.*

WARREN, Harold Edmond *[Designer, blockprinter, painter]*
b.1914, Alameda, CA.
Addresses: Oakland. **Studied:** Calif. Sch. FA; ASL. **Member:**
Bay Region AA. **Exhibited:** Oakland Art Gallery, 1939; GGE,
1939. **Comments:** Specialty: fabric des. **Sources:** WW40;
Hughes, *Artists of California,* 590.

WARREN, Harvey Allen *[Painter]* b.1916, Tacoma, WA.
Addresses: Seattle, WA. **Studied:** Univ. Washington. **Exhibited:**
SAM, 1937, 1939. **Sources:** Trip and Cook, *Washington State Art
and Artists,* 1850-1950.

WARREN, Helen *[Painter, teacher]* early 20th c.
Addresses: Wash., DC, active, 1918-20. **Exhibited:** Wash. WCC,
1918. **Sources:** WW19; McMahan, *Artists of Washington, DC.*

WARREN, Henry *[Limner]* mid 18th c.
Addresses: Williamsburg, VA in February 1769. **Comments:** In
an advertisement he offered to paint "night pieces" and "family
pieces," "or anything of the like (landscapes excepted)."
Sources: G&W; *Virginia Gazette,* Feb. 23, 1769.

WARREN, Henry *[Landscape, marine & figure painter]*
b.c.1793, England.

Addresses: Philadelphia from c.1822 at least until 1860.
Exhibited: PAFA, Artists' Fund Soc., Apollo Assoc. (British &
American views, as well as literary & religious paintings).
Comments: He may have been working in America as early as
1815, for a view of the Washington Monument in Baltimore was
engraved about that time by W.H. Freeman after a drawing by "H.
Warren". **Sources:** G&W; 7 Census (1850), Pa., LI, 912; Phila.
CD 1823-60; Rutledge, PA; Cowdrey, AA & AAU; Gage, *Artists'
Index to Stauffer.*

WARREN, Henry *[Lithographer]* mid 19th c.
Addresses: Buffalo, NY, 1856-57. **Comments:** In 1856 of Warren
& Buell (see entry). **Sources:** G&W; Buffalo CD 1856-57.

WARREN, Hilda *[Painter]* early 20th c.
Addresses: Boston, MA. **Exhibited:** Salons of Am., 1924, 1925;
S. Indp. A., 1928-29. **Sources:** Falk, *Exhibition Record Series.*

WARREN, Horace *[Painter]* mid 20th c.
Exhibited: S. Indp. A., 1941. **Sources:** Marlor, *Soc. Indp. Artists.*

WARREN, J. *[Miniaturist]* mid 19th c.
Addresses: Boston in January 1830. **Sources:** G&W; Sherman,
"Newly Discovered American Miniaturists," 98-99,repro.

WARREN, Jefferson Trowbridge *[Museum director]*
b.1912, Louisville, KY.
Addresses: Miami, FL. **Studied:** Univ. Minnesota, George T.
Slade scholarship, 1947 (B.A., magna cum laude; M.A.); in
Europe; Minneapolis School Art. **Member:** Am. Assn. Mus.;
Southeastern Mus. Conf.; Mus. Dirs. Council Greater Miami
(treasurer); Dade Co. Cultural Facilities Study Committee.
Comments: Positions: cur., Minneapolis Pub. Mus., 1946-57; del-
egate, UNESCO, 1950; dir., John Woodman Higgins Armory,
Worcester, MA, 1957-62; dir., Vizcaya-Dade Co. Art Mus, Miami,
FL, 1962-; superintendent, mus. div., Dade Co. Park & Recreation
Dept., Miami, 1962-. Publications: auth., "Exhibit Methods,"
9/1972; contrib. to various encyclopedias, professional journals &
popular magazines. **Sources:** WW73.

WARREN, John *[Painter]* mid 20th c.
Exhibited: AIC, 1940. **Sources:** Falk, *AIC.*

WARREN, Karl *[Painter]* mid 20th c.
Addresses: Chicago area. **Exhibited:** AIC, 1943, 1946. **Sources:**
Falk, *AIC.*

WARREN, Leonard D. *[Editorial cartoonist]* b.1906,
Wilmington, DE / d.1992.
Addresses: Westmont, NJ; Cincinnati, OH. **Comments:**
Positions: cartoonist, *Philadelphia Record,* 1927-46; ed. cartoon-
ist, *Cincinnati Enquirer,* 1947-. **Sources:** WW73; WW47.

WARREN, Lloyd b.1867 / d.1922.
Addresses: NYC. **Studied:** Paris. **Comments:** Position: director,
BAID. He was one of the chief movers of the plan of the Beaux-
Arts Society which established the atelier system of art training in
America. He established the Paris Prize, the most important archi-
tectural competition. He was killed in a fall from a window of his
NYC apartment.

WARREN, M., Jr. *[Portrait painter in watercolors]* mid 19th c.
Addresses: White Plains, NY in 1830. **Sources:** G&W; Lipman
and Winchester, 181; *American Provincial Painting,* no. 74.

WARREN, Marajane J. *[Painter]* early 20th c.
Addresses: Seattle, WA, 1932-37. **Exhibited:** SAM, 1934.
Sources: Trip and Cook, *Washington State Art and Artists,* 1850-
1950.

WARREN, Masgood A. Wilbert *[Sculptor, painter]* mid 20th c.
Addresses: NYC. **Studied:** ASL, 1932-35; NYU, 1935-39
(B.F.A. , mural painting, major); Temple Univ., Phila., 1961
(M.F.A., arch. sculpture, major). **Exhibited:** NAD; NAC; AWCS;
Allied Artists; Chicago; Atlanta; Los Angeles; Philadelphia; "NYC
WPA Art" at Parsons School Design, 1977. **Work:** busts/portraits
of famous people. **Comments:** WPA artist. **Sources:** *New York
City WPA Art,* 93 (w/repros.).

WARREN, Melvin C. *[Painter, illustrator]* b.1920, Los Angeles, CA.
Addresses: living in Clifton, TX in 1975. **Studied:** Texas Christian Univ., 1952 (fine arts); Samuel P. Ziegler. **Comments:** Specialty: Western art. **Sources:** P&H Samuels, 513.

WARREN, Peter Whitson See: **WHITSON, Peter (Peter Whitson Warren)**

WARREN, Robert H. *[Engraver]* 19th/20th c.
Addresses: Wash., DC, active 1904-20. **Comments:** Position: staff, Bureau of Engraving and Printing, Wash., DC. **Sources:** McMahan, *Artists of Washington, DC.*

WARREN, Roberta Frances *[Painter]* early 20th c.
Addresses: Chicago, IL. **Exhibited:** AIC, 1914-16. **Sources:** WW17.

WARREN, Sylvanna *[Painter, sculptor, writer]* b.1899, Southington, CT.
Addresses: NYC/Weston, CT. **Studied:** Dickinson; Dumond; Fogarty; Gruger; Sentilli; Calder; ASL. **Member:** NAC; NAWPS. **Exhibited:** Salons of Am.; S. Indp. A., 1932. **Sources:** WW31.

WARREN, Thomas *[Heraldic painter]* late 18th c.
Addresses: Boston. **Comments:** Advertised at Portsmouth (NH) in 1775. **Sources:** G&W; Bowditch, "Early Water-Color Paintings of New England Coats of Arms," 206.

WARREN, William Marshall *[Painter]* 19th/20th c.; b.Bremen, Germany.
Addresses: Boston, MA. **Studied:** Boston Univ. (A.B.; PH.D.); Europe, 1890-92; A. Hibbard; John Buckley; Ernest L. Major. **Comments:** Teaching: Boston Univ., 1896-; dean, College of Liberal Arts, 1905-37. He painted *en plein air* in Paris, Bruges, Florence and Switzerland. **Sources:** *Artists of the Rockport AA* (1946).

WARREN & BUELL *[Lithographers]* mid 19th c.
Addresses: Buffalo, NY, 1856. **Comments:** Partners were Henry Warren and Charles W. Buell (see entries). **Sources:** G&W; Buffalo CD 1856-57.

WARRENS, Robert J. *[Painter]* b.1933.
Addresses: Baton Rouge, LA. **Exhibited:** WMAA, 1975. **Sources:** Falk, *WMAA.*

WARRICK, Meta Vaux See: **FULLER, Meta Vaux Warrick (Mrs.)**

WARRINER, Susanne Gutherz *[Painter]* b.1880, Missouri.
Addresses: Wash., DC; South Montrose, PA, 1929; Glen Ridge, NJ, 1940s. **Exhibited:** Wash. DC, 1906-19. **Work:** Mississippi Dept. Archives & History, Jackson, MI. **Comments:** Daughter of Carl Gutherz (see entry). **Sources:** McMahan, *Artists of Washington, DC.*

WARRINGTON, Catharine R. *[Painter]* late 19th c.
Addresses: Phila., PA. **Studied:** Phila. Sch. of Des. for Women. **Exhibited:** PAFA Ann., 1888-89. **Sources:** Falk, *Exh. Record Series.*

WARRINGTON, William Jennings *[Painter, sketch artist, teacher]* b.1850, Atlanta, GA / d.1941, New Orleans, LA.
Addresses: New Orleans, active c.1887-89. **Comments:** Social worker, philanthropist and painter of portraits and landscapes, he was a well known and involved figure in the social and cultural scene of N.O. His portrait of Louisiana historian and author Charles Gayarre was privately commissioned for the State of Louisiana. **Sources:** *Encyclopaedia of New Orleans Artists*, 402-403.

WARSAGER, Hyman J. *[Etcher, engraver, lithographer, painter, illustrator]* b.1909, NYC / d.1974, NYC?.
Addresses: NYC. **Studied:** Hartford Art Sch.; MMA; PIASch; Grand Central Sch. Art; Am. Artists Sch. **Member:** Un. Am. Artists. **Exhibited:** S. Indp. A., 1936; San Fran. AA, 1938 (prize); WMAA, 1940-42. **Work:** BM; San Fran. AA; Wesleyan Univ., Middletown, CT. **Comments:** Contributor to *New Masses.*

Sources: WW40.

WARSAW, Albert Taylor *[Painter, designer, lithographer, illustrator, commercial artist]* b.1899, NYC.
Addresses: Flushing, NY. **Studied:** NAD; ASL; BAID. **Exhibited:** AWCS; Phila. WCC; PAFA. **Sources:** WW47.

WARSHAW, Howard *[Painter]* b.1920, NYC.
Addresses: Carpinteria, CA. **Studied:** Pratt Inst.; NAD; ASL. **Exhibited:** LACMA Centennial, 1950 (1st prize for oil painting & 1st prize for watercolor); Corcoran Gal. biennial, 1961; Guggenheim Mus.; PAFA Ann., 1945, 1954, 1958; WMAA; CI; AIC; MoMA-Paris; Silvan Simone Gal., Los Angeles, CA & Jacques Seligman Gal., NYC, 1970s. **Work:** CI; PAFA; Santa Barbara (CA) Mus. Art; LACMA; Univ. Southern Calif. Coll. Commissions: murals, Wyle Res., El Segundo, CA, 1953, Ortega Commons, Univ. Calif., Santa Barbara, 1960, Revelle Commons, Univ. Calif., San Diego, 1967, Bowdoin College Lib., Brunswick, ME, 1969 & Univ. Calif., Los Angeles, Reed Neurol Research Center, 1971. **Comments:** Preferred media: acrylics, offset lithography. Publications: author, "The Return of Naturalism as the Avant-Garde," Nation, 1960; author, "The Wild Goose Chase for Reality," *Center Magazine*, 1969. Teaching: Univ. Calif., Santa Barbara, 1955-70s. Art interests: originated a graduate program in which offset lithography and video tape are used as media for drawing. **Sources:** WW73; Russel Lynes, foreward to exh cat (Bowdoin College Mus. Art, November, 1972); Falk, *Exh. Record Series.*

WARSHAW, Lawrence *[Painter]* mid 20th c.
Exhibited: Corcoran Gal. biennial, 1963. **Sources:** Falk, *Corcoran Gal.*

WARSHAW, Sam(uel) *[Scenic artist, painter, teacher]* b.1891, Kovno, Russia / d.1954, Queens, NYC.
Addresses: Queens, NYC/ Great River, LI, NY (summers). **Studied:** Pruett Carter, Harvey Dunn, Norman Rockwell, at Adelphi College (1920s); G. Bridgman, K. Nicolaides at ASL, NY (1929); F.V. Dumond (1933). **Member:** NAC, c.1950; Kit Kat Art Group, c.1947; ASL (life member); United Scenic Artists Local Union 829 (founded 1918; charter member). **Exhibited:** NAC, group shows, 1950-53; Lynn Kottler Galleries, 1961 (retrospective, of Samuel Warshaw and his brother, Nathan). **Work:** mural, Timken Bearing Co. (commission); Firestone Exh., WFNY, 1939; thirty-foot portrait, Franklin D. Roosevelt for Ringling Bros. Barnum & Bailey, 1942; scenery for all Lindsay-Crouse productions on Broadway; for "Gypsy," "Annie Get Your Gun," "Harvey," "State of the Union," (and portrait of Ruth Hussey); "Eve of St. Mark," portrait of Jo Meilziner (famous stage designer). **Comments:** Warshaw discovered his talent as a child drawing on the sidewalks of New York's Lower East Side with chalk and coal. To support his family he started to work at age 14 and also began his art education in the evenings. While working as a scenic artist for theater productions, he pursued a fine arts career as well. He painted in oils until 1940, then began working in egg white tempera, producing a number of portraits and marine landscapes between 1940-47 in this medium. Thereafter, Warshaw painted primarily in watercolors. Painting for the love of it, Warshaw never sold his paintings; his collection is largely intact. Teaching: ASL, 1950 until his death in 1954 (replaced his mentor, Frank Vincent Dumond.) **Sources:** info courtesy of Florence Bloch, Craftsbury Common, VT and Ponte Vedra Beach, FL.

WARSHAWSKY, Abraham (or Abel) George *[Landscape & portrait painter]* b.1883, Sharon, PA / d.1962, Monterey, CA.
Addresses: Cleveland, OH; Paris, France. **Studied:** Cleveland Art Inst.; ASL & NAD with Mowbray, Loeb, Homer; Académie Julian, Paris. **Member:** Cincinnati AC; Nouvelle Salon, Paris; Carmel AA. **Exhibited:** Salon D'Automne, Paris; Cleveland, 1914 (solo); NAD; PAFA Ann., 1912, 1914, 1916-17; Corcoran Gal. biennials, 1912, 1939; CI; Raleigh Hotel, Wash., DC, 1938; Reinhardt Gal., 1938; Gump's, San Francisco, 1942. Award:

Chevalier of the Legion of Honor of France. **Work:** Frye Art Mus., Seattle; De Saisset Art Mus., Santa Clara; Akron Art Inst.; murals, Rorheimer Studio, Brooks Studio, both in Cleveland; CMA; Minneapolis AI; drawings AIC; Luxembourg Mus., Petit Palais, both in Paris; paintings, TMA; Canajoharie Art Gal., NY; Los Angeles Mus. Hist., Science & Art; CGA; Sweat Mem. Mus.; Monterey Peninsula Mus. Art; Luxembourg Mus., Paris; de Young Mus.; CPLH. **Sources:** WW40; Hughes, *Artists of California,* 590; Falk, *Exh. Record Series.*

WARSHAWSKY, Alexander L. *[Painter] b.1887, Cleveland / d.1945, Los Angeles, CA.*
Addresses: Paris, France; Los Angeles. **Studied:** NAD. **Member:** Paris AA; Group XYZ, Paris; CMA; Los Angeles MA. **Exhibited:** PAFA Ann., 1913; Armory Show, 1913; Calif. Art Club, 1934-37; P&S Los Angeles, 1937; Acad. Western Painters, 1937-38. **Work:** CMA; LACMA. **Sources:** WW40; Hughes, *Artists of California,* 590; Falk, *Exh. Record Series;* Brown, *The Story of the Armory Show.*

WARSINSKE, Norman George, Jr. *[Sculptor, painter] b.1929, Wichita, KS.*
Addresses: Bellevue, WA. **Studied:** Univ. Montana (B.A.); Kunstwerkschule, Darmstadt, Germany; Univ. Washington (B.A.). **Member:** Seattle Munic. Art Comn. (vice-pres., 1965-69); NW Craft Center (pres., 1965-). **Exhibited:** Northwest Ann., SAM, 1959-65; Northwest Sculpture Inst. Show, Portland Art Mus., 1961; Santa Barbara (CA) Invitational, 1963; Sculpture Invitational, LACMA, 1964; NW Craft Center, Seattle, 1969-70 (solo); Miller-Pollard, Inc., Seattle, WA, 1970s. Awards: first prize for sculpture, Bellevue Art Festival, 1960; best of all categories, Henry Art Gallery, 1966. **Work:** Commissions: steel screen, Univ. Unitarian Church, Seattle, WA, 1959; bronze fountains, King Co. Medical Bldg, Seattle, 1965 & Theodora Retirement Home, Seattle, 1966; brass & steel screen, Yellowstone Boy's Ranch, Billings, MT, 1969; gold leaf steel stabile, IBM bldg. lobby, Seattle, 1971. **Comments:** Preferred media: metal, bronze, steel. Publications: illustr., cover,*Am. Inst. Architects Journal,* 8/1971. Teaching: Univ. Washington, 1958-59. **Sources:** WW73; Louis Redstone, *Art in Architecture* (McGraw, 1968); M R. Heinley, "Norman Warsinske—Metal Artistry," *Designers W.* (June, 1970).

WARTHEN, Ferol Katherine Sibley ("Sybil") (Mrs. Lee) *[Painter, block printer] b.1890, Aberdeen, SD / d.1986, Potomac, MD.*
Addresses: NYC, 1920; Morristown, NJ, 1928; Wash., DC, 1935/Provincetown, MA, from 1949. **Studied:** Columbus Sch. Art; ASL, 1911-13; W.M. Chase; K.H. Miller; K. Knaths, 1939-49; B. Lazzell, Provincetown, MA, 1950s; Un'ichi Hiratsuka, Wash., DC, 1960s. **Member:** Soc. Wash. Artists; Phila. Color Print Soc.; Boston PM. **Exhibited:** Soc. Indep. Artists, 1937, 1944; NAD; Phila. WCC; Provincetown AA; Wash. Print Club; Wash. PM; Wash. WCC; galleries & museums in Italy, Israel, Japan, Alaska, Hawaii; U.S. National Mus., 1956 (with Angele Myrer); Nat. Mus. Am. Art, 1973-74 (solo), 1985; Provincetown AA, 1985 (retrospective). **Work:** Nat. Mus. Am. Art; BMFA; Miami Univ., Oxford, OH; Bezalel National Mus., Israel. **Comments:** Specialty: wood block prints. Married to Lee Warthen (see entry). **Sources:** McMahan, *Artists of Washington, DC.*

WARTHEN, Lee Roland *[Painter, illustrator] b.1893, Newark, OH / d.1949, McLean, VA.*
Addresses: New Jersey; Wash., DC, 1938 and after. **Studied:** Columbus Art School, 1910; ASL, 1911-13. **Exhibited:** Soc. Wash. Artists, 1937 (prize). **Comments:** Married Ferol Sibley Warthen (see entry) after WWI. Positions: free-lance illustrator, national magazines, 1930s; staff artist, U.S. Dept. Interior, 1936 (design and execution of exhibits and dioramas, paintings and illustrations); designer, Navy Department, 1943-46; medical illustrator, U.S. Army Inst. Pathology, 1947-49. **Sources:** Wright, *Artists in Virginia Before 1900.*

WARTHEN, Lee Roland (Mrs.) See: **WARTHEN, Ferol Katherine Sibley ("Sybil") (Mrs. Lee)**

WARTHOE, Christian *[Sculptor, writer, teacher] b.1892, Salten, Denmark.*
Addresses: Chicago 47, IL. **Studied:** Royal Acad. FA, Copenhagen, Denmark; Minneapolis Sch. Art; ASL; BAID. **Member:** NSS; Am. Veterans Soc. Art. **Exhibited:** Am. Veterans Soc. Art, 1939-42; NSS, 1941; NAD, 1942, 1943; Sculptors Gld., 1942. **Work:** Grand View College, Des Moines, IA; Silkeborg Mus. & Day Monument, Rudkobing, Denmark; in Germany; mem., Chicago. **Comments:** Contrib. to Danish American Press. **Sources:** WW59; WW47.

WARTIK, Pat *[Painter] mid 20th c.*
Exhibited: Corcoran Gal. biennial, 1953. **Sources:** Falk, *Corcoran Gal.*

WARTS, F. M. *[Painter] early 20th c.*
Addresses: NYC. **Sources:** WW15.

WARTZ, Michael *[Lithographer] b.c.1830, Darmstadt, Germany.*
Addresses: Philadelphia in 1860. **Comments:** With his German-born wife and two children, ages 3 and 1 in 1860, both born in Pennsylvania. **Sources:** G&W; 8 Census (1860), Pa., LII, 244.

WARWELL *[Limner] b.London (England) / d.1767, Charleston, SC.*
Addresses: Charleston, SC, 1765. **Comments:** With his wife Maria in 1765. He advertised his readiness to paint history pieces, heraldry, altar pieces, chimney, landscapes, window blinds, sea pieces, coaches, blinds, flowers, screens, fruit, scenery,"deceptive triumphal arches, ruins, obelisks, statues &c for groves and gardens". He also did gilding, picture cleaning, copying, and restoring, and wall painting. **Sources:** G&W; Rutledge, *Artists in the Life of Charleston,* 118, 223; Prime, I, 18. Listed as S.R. Wardell in Neuhaus, *History and Ideals of American Art,* 14.

WARWELL, Maria (Mrs.) *[Restorer of china & statuary] mid 18th c.*
Addresses: Charleston, SC, 1765. **Comments:** She came from London to Charleston (SC) with her husband, the painter Mr. Warwell (see entry). After his death in 1767 she advertised her skill in mending useful and ornamental china and statues in china, glass, plaster, bronze, or marble; if a piece was missing, she was ready to "substitute a composition in its room, and copy the pattern as nigh as possible. " **Sources:** G&W; Rutledge, *Artists in the Life of Charleston,* 224.

WARWICK, Edward *[Painter, engraver, educator, writer, lecturer, block printer, educator] b.1881, Philadelphia, PA / d.1973, Philadelphia?.*
Addresses: Philadelphia 19, PA. **Studied:** Univ. Pennsylvania; PM School IA; J.F. Copeland; C.T. Scott. **Member:** Phila. Art All.; Phila. WCC; Phila. Sketch Club; Phila. Print Club; Arms & Armours Club, NYC; Phila. AC. **Exhibited:** PAFA, annually; Pr. Club, WCC, Sketch Club, Phila. **Comments:** Position: instructor, 1932-47; dean, 1937-52 & dean emeritus, 1952-, PM School IA, Phila. Co-author: "Early American Costume." **Sources:** WW59; WW47.

WARWICK, Ethel Herrick (Mrs. Edward) *[Painter] 20th c.; b.NYC.*
Addresses: Phila. 19, PA, from c.1910. **Studied:** Moore Inst. Des.; PAFA; F. Wagner; H. Breckenridge; H.B. Snell; E. Horter; E. O'Hara. **Member:** Plastics Club, Art All., WCC, all of Phila.; Nat. Lg. Am. Pen Women. **Exhibited:** PAFA, annually (fellowship); PAFA Ann., 1916, 1920-24, 1943; AIC; Woodmere Art Gal.; Phila. Plastic Club (prizes); Nat. Lg. Am. Pen Women, annually. **Work:** Penn. State College; many portrait commissions. **Sources:** WW59; WW13; WW47; Petteys, *Dictionary of Women Artists;* Falk, *Exh. Record Series.*

WASDELL, Henry *[Engraver] b.c.1831, England.*
Addresses: NYC from 1859. **Sources:** G&W; 8 Census (1860), N.Y., LVIII, 783; NYBD 1859; NYCD 1863.

WASEY, Jane (Mrs. Mortellito) *[Sculptor] b.1912, Chicago, IL.*
Addresses: NYC; Palisades, NY. **Studied:** Acad. Julian, Paris

with Paul Landowsk, 1929-31; J. Bertran in Paris; Simon Moselsio in NYC, 1931-32; John Flanagan, 1932-33; Heinz Warneke, 1939. **Member:** Sculptor's Guild; NAWA; NSS; Audubon Artists. **Exhibited:** Montross Gal., 1933 (prize),1934 (solo); Newark Mus., 1934; Delphic Studio, 1935 (solo); WMAA, 1935-64; AIC, 1938; PAFA Ann., 1940-42, 1946-54, 1958-62, 1966; Brooklyn Mus; Univ. Chicago; S. Indp. A., 1940-41; Detroit IA; Philbrook AC, 1949 (solo); NAWA, 1951 (Mrs. John Henry Hammond Award); Weathervanes Contemp., New York, 1954 (solo); Arch. Lg., 1955 (Phillips Mem. Prize); Kraushaar Gals., 1956 (solo), 1971 (solo); Parrish AM & Guild Hall, NY (first prizes for sculpture). **Work:** Arizona State Univ., Tempe; Univ. Colorado; Dartmouth College; Univ. Nebraska; PAFA; WMAA; City Art Mus., St. Louis. **Comments:** Preferred media: stone, wood. Teaching: Bennington College, 1948-49, private instr., 1950-60. **Sources:** WW73; WW47; Brumme, *Contemp. Am. Sculpture;* Anton Henze, *Contemp. Church Art;* "Design for Learning," *Town & Country* (October, 1949); Falk, *Exh. Record Series.*

WASHBURN, Cadwallader Lincoln *[Painter, etcher, writer]* *b.1866, Minneapolis, MN / d.1965, Farmington, ME.*
Addresses: Brunswick, ME. **Studied:** MIT; Sorolla in Spain; Beanard in Paris; ASL with Mowbray & Chase in New York; also with Chase in Shinnecock, NY. **Member:** ANA; NAC; AFA; Wash. Art Club; SAGA. **Exhibited:** Paris Salon, 1896-1904 (prize, Paris AAA); AIC; SNBA, 1898; PAFA Ann., 1899-1903, 1907, 1939; Pan-Pacific Expo, 1915 (gold medal); DeYoung Mem. Mus., 1954 (solo); MIT, 1954; Bowdoin College, 1954; Atlanta AA, 1956; Telfair Acad., Savannah, 1958. **Work:** Luxembourg Mus., Bibliothèque Nat., Paris; Victoria & Albert Mus., London; Rijks Mus., Amsterdam; NGA; LOC; MMA; NYPL; PMA; Honolulu Acad. Art; MFA Houston. **Comments:** He was deaf and mute from childhood, known as the "silent artist," when he joined Chase's summer school in 1893, to return several more years. In 1903 he learned etching, and in 1904 he became a war correspondent for the *Chicago Daily News,* covering the Russian Japanese War of 1904-05, and the Madera Revolution in Mexico, 1910-12. **Sources:** WW59; WW47; Pisano, *The Students of William M. Chase,* 23; Falk, *Exh. Record Series.*

WASHBURN, Chester Austin, Jr. *[Painter, designer, graphic artist, lecturer]* *b.1914, Albuquerque.*
Addresses: Albuquerque, NM. **Member:** New Mexico Art League. **Exhibited:** Univ. New Mexico; Mus. New Mexico. **Sources:** WW40.

WASHBURN, Edward Payson *[Portrait & genre painter]* *b.1831, New Dwight in the Cherokee Nation, OK / d.1860.*
Addresses: New Dwight, OK, 1831-40; Arkansas, 1840; NYC; Norristown, AR. **Studied:** eighteen months in NYC with Charles L. Elliott (see entry); NAD. **Comments:** Edward began painting portraits at Fort Smith in 1851. He returned to Arkansas after his studies. In 1858 he painted his best known work, "The Arkansas Traveler." **Sources:** G&W; Reynolds, "Papers and Documents of Eminent Arkansans," 239; Brown, "Two Versions of the Arkansas Traveler," repro.; NYBD 1854.

WASHBURN, Gordon Bailey *[Gallery director]* *b.1904, Wellesley Hills, MA.*
Addresses: NYC. **Studied:** Deerfield Acad.; Williams College (A.B., 1928); Fogg Mus. Art, Harvard Univ.; Williams College (hon. M.F.A., 1938); Allegheny College (hon. D.F.A., 1959); Univ. Buffalo (hon. D.F.A., 1962); Washington & Jefferson College (hon. D.F.A., 1968). **Member:** College AA Am.; Assn. Art Mus. Dirs.; Am. Assn. Mus. **Exhibited:** Awards: Guggenheim fellowship, 1949-50; Chevalier, Legion of Honor, 1952. **Comments:** Positions: dir., Albright Art Gal., Buffalo, NY, 1931-42; dir., Mus. Art, RISD, 1942-49; dir. dept. fine arts, Carnegie Inst., Pittsburgh, PA, 1950-62; dir., Asia House Gallery, NYC, 1962-. Publications: auth., "Pictures of Everyday Life-Genre Painting in Europe, 1500-1900" (1954), "American Classics of the Nineteenth Century" (1957), "The 1958 Pittsburgh International

Exhibition of Contemporary Painting & Sculpture" (1958) & "Retrospective Exhibition of Paintings from Previous Internationals" (1958), Carnegie Inst.; auth., "Structure and Continuity in Exhibition Design: Nature & Art of Motion" (1965). Teaching: lectures on art history. Collections arranged: Pittsburgh International (triennially); French Painting 1100-1900 & Pictures of Everyday Life-Genre Painting in Europe, 1500-1900, Carnegie Inst.; American Painting in the 1950's, AFA, 1968; three exhs. per year, Asia House Gallery, 1962-69. **Sources:** WW73.

WASHBURN, Huldah M. Tracy (Mrs. Charles H.) *[Craftsperson] b.1864, Raynham, MA.*
Addresses: Taunton, MA. **Studied:** H. Sandham; L.A. Chrimes. **Member:** Boston SAC (Master Craftsman); Women's Educ. & Indust. Un. **Comments:** Specialty: needlework. **Sources:** WW40.

WASHBURN, Jeannette *[Painter, craftsperson, teacher]* *b.1905, Susquehanna, PA.*
Addresses: Jacksonville 8, FL. **Studied:** Florida State Women's College (A.B.); Syracuse Univ. (B.F.A.); ASL; Kenneth Hayes Miller. **Member:** Palm Beach Art Lg.; Florida Fed. Art; St. Augustine AA; Jacksonville Art Club. **Exhibited:** Butler AI, 1941; PBA, 1941; Norton Gal. Art; Tampa AI; State Circuit Exh., for Army & Navy Club, 1941-42; Blue Ridge, NC, 1941; Jacksonville Art Club, 1946, 1948-51 (prize), 1952; Florida Fed. Art, 1948-50, 1953-54; Jacksonville Art Mus., 1953-57 (prize), 1958; St. Augustine AA, 1952-56; Southside Branch Lib., Jacksonville, 1955; Florida Southern College, 1952; Manatee Art Lg., 1957; Jacksonville Art Festival, 1958. **Work:** Univ. Alaska; Jacksonville Pub. Sch. No. 11; Florida State Bd.Health. **Comments:** Positions: arts & crafts specialist, Am. Red Cross, assigned to Army hospitals, 1944-46; artist, Florida State Bd. Health, Jacksonville, FL, 1946-57. **Sources:** WW59; WW47.

WASHBURN, Jessie M. *[Painter] b.1860, Muscatine, IA / d.1942, Los Angeles, CA.*
Addresses: Laguna Beach, CA, 1925 & 1932. **Studied:** Paris with Auburtin, 1909. **Member:** Laguna Beach AA. **Sources:** WW25; Hughes, *Artists in California,* 591.

WASHBURN, Joan T. *[Art dealer] b.1929, NYC.*
Addresses: NYC. **Studied:** Middlebury College (B.A.). **Comments:** Positions: dir., Washburn Gallery, New York. Specialty of gallery: 19th-20th c. American and European painting and sculpture. **Sources:** WW73.

WASHBURN, Kenneth (Leland) *[Painter, educator, sculptor, teacher] b.1904, Franklinville, NY.*
Addresses: Ithaca, NY; San Carlos, CA. **Studied:** Cornell Univ. (B.F.A.; M.F.A.). **Member:** AWCS; Iroquois Assn.; Springfield (IL) AA. **Exhibited:** Texas Centennial, 1934; WFNY 1939; NAD, 1942-44; AWCS, 1942-45; PAFA Ann., 1940-42, 1946; Rochester Mem. Art Gal., 1943-1946; Finger Lakes Exh., 1941-46. **Awards:** prizes, Cortland County (NY) State Exh., 1945; Finger Lakes Exh., Auburn, NY, 1944. **Work:** Springfield (IL) Mus. Art; Binghamton (NY) Mus. Art; IBM Coll.; WPA murals, plaque, USPOs, Binghamton, NY; Moravia, NY; mem., Ten Broeck Acad., Franklinville. **Comments:** Teaching: Cornell Univ., Ithaca, NY, 1928-50. Positions co-dir., Washburn-White AC, San Carlos, CA, 1953-. Auth./illustr.: "Distant Wonder," by Schwab, 1936. **Sources:** WW59; WW47; Falk, *Exh. Record Series.*

WASHBURN, Louese B. (Mrs. Clayton) *[Painter, graphic artist, designer, craftsperson, writer, lecturer] b.1875, Dimock, PA / d.1959.*
Addresses: Jacksonville 8, FL. **Studied:** PIA School; Broadmoor Art Acad.; Colorado Springs FAC; Ross Moffett; Henry Varnum Poor; A. Dow; B. Robinson; W. Lockwood. **Member:** Palm Beach Art Lg.; Florida Fed. Art; Jacksonville AC; St. Augustine AC; NAWPS. **Exhibited:** FAP, 1941; Argent Gal., 1939, 1940; Univ. Alaska, 1935; Blue Ridge, NC, 1941; Tampa AI, 1922-41; Univ. Florida, 1930; Jacksonville Pub. Lib., 1935; Jacksonville Art Club, 1948-51; Jacksonville Pub. Lib., 1948-52; Vogue Art Gal., Jacksonville, 1952; Florida Fed. Art, 1953, 1954; Springfield Branch Lib., 1953-55; Jacksonville Art Mus., 1953-57. **Awards:**

prizes, Tampa, FL, 1924; Jacksonville AC, 1928; Florida Fed. Art, 1929, 1931, 1933, 1934, 1954; IBM purchase prize, 1941. **Work:** St. Luke's Hospital, Jacksonville, FL; Hope Haven Hospital for Crippled Children, FL; Thornwell Orphanage, Clinton, NC; Univ. Alaska. **Comments:** Painted still lifes & landscapes. **Sources:** WW59; WW47.

WASHBURN, Martha W. M. *[Sculptor] early 20th c.*
Addresses: Farm School, PA. **Exhibited:** PAFA Ann., 1907. **Sources:** Falk, *Exh. Record Series.*

WASHBURN, Mary Helen *[Painter, sketch artist] b.1862, New Orleans, LA / d.1934, New Orleans.*
Addresses: New Orleans, active 1894-98. **Studied:** Andres Molinary; New Orleans AA. **Member:** New Orleans AA,1896-97. **Exhibited:** New Orleans AA, 1894, 1896-97; New Orleans Press Club, 1898. **Comments:** Portrait painter from life or photographs, she also painted scenes of New Orleans and still lifes of flowers. **Sources:** *Encyclopaedia of New Orleans Artists*, 403.

WASHBURN, Mary (May) N(ightingale) *[Painter] b.1861, Greenfield, MA / d.1932, Greenfield.*
Addresses: Greenfield. **Studied:** Smith College with D.W. Tryon; H.G. Dearth; ASL. **Member:** Springfield Art Lg.; NAWPS. **Exhibited:** NAD; Boston AC, 1895, 1899; PAFA Ann., 1895-97, 1901; AIC. **Sources:** WW31; Falk, *Exh. Record Series.*

WASHBURN, Mary S. *[Sculptor] b.1868, Star City, IN.*
Addresses: Paw Paw, WV; Chicago, IL; Berkeley, CA. **Studied:** AIC; E. Sawyer, in Paris. **Member:** Berkeley Lg. FA. **Exhibited:** AIC, 1909-20; PAFA, 1913-15; PAFA Ann., 1914, 1916, 1920; Paris Salon, 1913; Pan-Pacific Expo, San Francisco, 1915 (bronze medal); Buffalo, NY, 1916; Indianapolis Mus., 1916-17; CI, 1917. **Work:** Milroy Park, Rensselaer, IN; medal, CI; mem. Logansport, IN; mon./Waite Mem., Rock Creek, Wash., DC; character sketch medallions, Berkeley Lg. FA; bust, Medical Lib., Chicago. **Sources:** WW29; Falk, *Exh. Record Series.*

WASHBURN, Miriam *[Painter] early 20th c.*
Addresses: Worcester, MA, c.1913. **Sources:** WW24.

WASHBURN, Roy E(ngler) *[Painter] b.1895, Vandalia, IL.*
Addresses: Evanston, IL. **Studied:** Duveneck; Meakin; J.R. Hopkins. **Member:** Cleveland SA. **Sources:** WW31.

WASHBURN, S. H. *[Painter] late 19th c.*
Addresses: Vergennes, VT. **Work:** Shelburne (VT) Mus. **Comments:** Active c.1875. **Sources:** Muller, *Paintings and Drawings at the Shelburne Museum*, 136 (w/repro.).

WASHBURN, William *[Engraver] b.c.1821, Vermont.*
Addresses: NYC in 1850. **Sources:** G&W; 7 Census (1850), N.Y., XLIII, 96.

WASHBURN, William Watson *[Dealer, colorer, restorer, photographer] b.1825, Peterboro, NH / d.1903, New Orleans, LA.*
Addresses: New Orleans, active 1870-85. **Exhibited:** Grand State Fair, 1866 (prize), 1868 (prize). **Comments:** Major 19th century daguerreotypist and photographer who maintained a studio in New Orleans from 1849 until his death. **Sources:** *Encyclopaedia of New Orleans Artists*, 403.

WASHINGTON, Elizabeth Fisher *[Landscape and miniature painter] b.1871, Siegfried's Bridge, PA / d.1953.*
Addresses: Philadelphia 4, PA. **Studied:** PM School IA; PAFA with Breckenridge, F. Wagner. **Member:** Art All., Plastic Club, Pr. Club, all of Phila.; Penn. SMP (treasurer); AWCS; Colonial Dames of Am.; Magna Carta Dames; PAFA (fellow). **Exhibited:** PAFA, 1912 (Cresson traveling fellowship), 1913 (Toppan Prize); PAFA Ann., 1916-44 (prize 1917, 1934); Carnegie Inst., 1920-22; Corcoran Gal. biennials, 1916, 1923; Pan-Pacific Expo, 1915; NAD, 1930; St. Louis AM, 1930; Woodmere Art Gal., 1941-45; Cape May, NJ, 1939-45; Phila. Art All.; Plastic Club; PMA; Phila. Sketch Club; AFA; Springville, UT, 1927 (prize); Salons of Am.; AIC; Newman Gal., Phila., 1949, c.1988 (retrospectives). **Work:** Springville (UT) H.S. Coll.; Munic. Coll., Trenton, NJ; Smith

College; New Century Club, Phila., PA; Pierce Business College, Phila; Boyertown (PA) Gal.; PMA; Allentown (PA) Gal.; Phila. Civic Club; Oak Lane Review Club, Phila.; Women's Club, West Chester, PA. **Comments:** An impressionist painter, she was the great-great grandniece of Pres. George Washington. **Sources:** WW53; exh. flyer, Newman Gal., Phila. (c.1988); WW47; Falk, *Exh. Record Series.*

WASHINGTON, Henry *[Painter, printmaker] b.1923, Boston, MA.*
Addresses: Boston, MA. **Studied:** Vesper George Sch. Art; Harvard Univ.; BMFA Sch.; Boston State College. **Member:** Boston Negro AA. **Exhibited:** Boston Negro AA Tour; Sunday-in-the-Park, Boston; Boston Pub. Lib., 1973. **Sources:** Cederholm, *Afro-American Artists.*

WASHINGTON, James W., Jr. *[Painter, sculptor] b.1911, Gloster, MS.*
Addresses: Seattle, WA. **Studied:** Nat. Landscape Int.; Mark Tobey. **Member:** Int. Platform Assn.; Artists Equity Assoc., Seattle (secy., 1949-53; pres., 1960-62). **Exhibited:** Tanner Art Lg., 1922; SAM, 1945; Henry Gallery, Seattle, 1950, 1951; Oakland Munic. Art Mus., 1957 (award for Bird Hatching); Third Pacific Coast Biennial, Santa Barbara (CA) Mus. Art, 1959; Williard Gal., NYC, 1960-64; Northwest Today, Seattle World's Fair, 1962 (award for Wounded Bird); Grosvenor Gallery Int. Exh., London, England, 1964; Expo '70, Osaka, Japan, 1970. Awards: govt. sculpture award, 1970. **Work:** SAM; SFMA; Oakland Mus. Commissions: The Creation (series 4), YWCA, Seattle, 1966; The Creation (series 6), Seattle Pub. Lib., 1967; The Creation (series 7-10), Seattle First Nat. Bank Main Branch, 1968; busts of hist. men, Progress Plaza, Phila., 1969; The Creation (series 5), Meany Jr. H.S., Seattle, 1970. **Comments:** Preferred media: oils, tempera, pastels, granite, marble. Positions: member, govt. council art, State of Wash., 1959-60 & state art commissioner, 1961-66. **Sources:** WW73; Ann Faber, "James Washington's Stone Sculpture Excellence," *Seattle Post Intelligence,* 1956; Pauline Johnson, "James Washington Speaks," *Art Educ. Journal* (1968); Cederholm, *Afro-American Artists.*

WASHINGTON, Timothy *[Painter, graphic artist] b.1946, Los Angeles, CA.*
Studied: Chouinard AI (B.F.A., 1969, scholarship). **Exhibited:** LACMA, 1971; Santa Barbara Mus. Art, 1971; Univ. Iowa, 1971-72; Oakland Mus., 1971. **Comments:** Specialty: mixed media. **Sources:** Cederholm, *Afro-American Artists.*

WASHINGTON, William De Hartburn *[Portrait & historical painter] b.1834, Clarke County, VA / d.1870, Lexington, VA.*
Addresses: in Washington, DC, 1856-60; Virginia; England, 1865-66; NYC, 1866-69. **Studied:** Phila.; Düsseldorf, Germany (3 years); with Emanuel Leutze. **Exhibited:** PAFA; Wash. AA, 1857-59 (first vice-pres.); NAD, 1866-69. **Work:** Virginia Military Inst.; Valentine Mus.; County Courthouse, Warrenton; Reading Pub. Mus. and Art Gallery, VA. **Comments:** Studied with E. Leutze in Washington and Düsseldorf, and served as a civilian draftsman during the Civil War. Teaching: Virginia Military Inst., 1869. **Sources:** G&W; Rutledge, PA; 8 Census (1860), D.C., I, 474; Washington CD 1858, 1860; Washington Art Assoc. Cat., 1857, 1859. More recently, see, Wright, *Artists in Virgina Before 1900;* McMahan, *Artists of Washington, DC,* under William Dickerson Washington.

WASHINGTON-ALLSTON See: **ALLSTON, Washington**

WASILE, Elyse *[Painter, designer] b.1920, NYC.*
Addresses: Nassau, Bahamas. **Studied:** Univ. Calif., Los Angeles. **Member:** IIC Nat. Gallery, London; Bahamas Hist. Soc. **Exhibited:** South Florida Fair & Expos, 1960; Bahamas Art Soc., Nassau, 1967; Nassau Art Gallery Ann., 1970s. Awards: blue ribbon, South Florida Fair & Expos, 1960. **Work:** Nassau Art Gallery, Bahamas; Commonwealth of Bahamas Post Office, Nassau. Commissions: murals, Widner Estate, Palm Beach, FL, 1951, Palm Beach Int. Airport, 1960 & Nassau Beach Hotel,

1961; definitive stamp issue (1915), P.O. Dept., Bahamas, 1971. **Comments:** Preferred media: acrylics, gouache, oils. **Sources:** WW73; Jody Allan, *Women in Unusual Jobs* (1967), Nancy Savage, "Paintings & Restoration," 1969 & "Stamp Designing," 1971, *Nassau Tribune.*

WASKOWSKY, Michaill *[Painter] mid 20th c.*
Addresses: Chicago, IL. **Exhibited:** AIC, 1938-40, 1946.
Sources: WW40.

WASMUTH, Lloyd Alfred *[Painter] mid 20th c.*
Addresses: Berkeley, Sacramento, CA. **Exhibited:** Oakland Art Gallery, 1936, 1942; Kingsley AC, 1940; San Francisco AA, 1940. **Sources:** Hughes, *Artists of California,* 591.

WASSER, Wilbur W. (Mrs.) See: **KLOSTER, Paula Rebecca (Mrs. Wilbur W. Wasser)**

WASSERBACH, Theodore C. *[Engraver] 19th/20th c.*
Addresses: Wash., DC, active 1877-1929. **Comments:** Position: staff, U.S. Coast and Geodetic Survey. **Sources:** McMahan, *Artists of Washington, DC.*

WASSERMAN, Albert *[Painter, designer] b.1920, NYC.*
Addresses: NYC. **Studied:** ASL, 1937-39, with Charles Chapman; NAD, 1938-40; Sidney Dickinson; U.S. Army Univ., France. **Member:** Allied Artists Am.; NJ P&S Soc.; Assoc. AWCS; Nat. Art League; Artists Equity Assn. **Exhibited:** NAD, 1941; Allied Artists Am., New York, 1941-72; NJP&S Soc., 1941-72; AWCS, New York, 1953-69; Audubon Artists, New York, 1960. **Awards:** Pulitzer Prize scholarship, 1940 & NAD, 1941, E.H. & E.C. Friedrich Prize, Allied Artists Am., 1941. **Work:** Traphagen Collection, AZ. **Commissions:** portraits, private commissions. **Comments:** Preferred medium: oils. **Positions:** graphic design consultant for various agencies, 1948-. Teaching: Jackson Heights AA, 1955-; Nat. Art League, 1967-69. **Sources:** WW73; Ethel Traphagen, *Fashion Digest* (1954).

WASSERMAN, Burton *[Painter, printmaker] b.1929, Brooklyn, NY.*
Addresses: Glassboro, NJ. **Studied:** Brooklyn College (B.A.) with Burgoyne Diller & Ad Reinhardt; Columbia Univ. (M.A. & Ed.D.). **Member:** Artists Equity Assn. (nat. pres., 1971-73); Am. Color Print Soc. (mem. exec. council, 1965-73); Phila. WCC (vice-pres., 1970-73). **Exhibited:** 21st Am. Drawing Biennial, Norfolk Mus. Arts & Sciences, 1965; USA Pavilion, Int. Expos, Osaka Japan, 1970; Color Prints of the Americas, NJ State Mus., 1970; Int. Graphics Exh., Montreal Mus. Art, 1971; Silkscreen: History of a Medium, Phila. Mus. Art, 1971-72; McCleaf Gallery, Phila., 1970s. **Awards:** Brickhouse Drawing Prize, 21st Am. Drawing Biennial, Norfolk Mus. Arts & Sciences, 1965; Ryan Purchase Prize, Art from NJ Ann. Exhib., NJ State Mus., 1967; Esther-Philip Klein Award, Am. Color Print Soc. Ann., 1970. **Work:** Phila. Mus Art; Montreal Mus. FA; Norfolk (VA) Mus. Arts & Sciences; Phila. Civic Center Mus.; NJ State Mus., Trenton. **Commissions:** relief triptych, Mr. & Mrs. Herbert Kurtz, Melrose Park, PA, 1971. **Comments:** Preferred media: oils, silkscreen, spray enamels. Publications: author, articles, *Am. Artist, Art Int.Art Educ., School Arts, Arts & Activities* & many more, 1959-72; author, "Modern Painting: The Movements, The Artists, Their Work," 1970 & co-author, "Basic Silkscreen Printmaking," 1971, Davis, MA; author, "Bridges of Vision: The Art of Prints and Tthe Craft of Printmaking," NJ State Mus., 1970. Teaching: Glassboro State College, 1960-. **Sources:** WW73.

WASSON, George Savary **Geo. S. Wasson.**
[Marine painter] b.1855, Groveland, MA / d.1926.
Addresses: Kittery Point, ME (1885-on). **Studied:** Boston; Royal Acad., Württemberg, Germany; Stuttgart. **Exhibited:** Boston AC, 1878-81; PAFA Ann., 1882. **Work:** Mystic Seaport Mus.; Peabody Mus., Salem, MA. **Comments:** After his studies Wasson came back to America to live on the coast of Maine. He also painted on Monhegan Island, ME. **Sources:** WW10; Brewington,

405; Curtis, Curtis, and Lieberman, 159, 187; Falk, *Exh. Record Series.*

WATANABE, Torajiro *[Painter] b.1886, Fukushima, Japan.*
Addresses: NYC/Woodstock, NY (Los Angeles since late 1920s). **Studied:** H. Read; C. Rosen. **Member:** Japanese AS; Woodstock AA. **Exhibited:** WMAA, 1922-27; S. Indp. A., 1922-27; Pasadena Art Inst., 1928; Salons of Am. **Sources:** WW25; addit. info. courtesy Woodstock AA.

WATARI, Takeo *[Painter] early 20th c.*
Addresses: Island Park, LI, NY. **Exhibited:** Salons of Am., 1922-26; S. Indp. A., 1930-34. **Sources:** Falk, *Exhibition Record Series.*

WATCHETAKER, George Smith *[Painter] b.1916, Elgin, OK.*
Addresses: living in Elgin, OK in 1967. **Studied:** Haskell, 1935. **Comments:** Comanche painter, decorator, sign painter. **Sources:** P&H Samuels, 513.

WATERBORY, Laura Prather (Mrs. George) *[Miniature & portrait painter] b.1862, Louisville, KY / d.1932, Corona, CA.*
Addresses: Corona, Riverside County, CA. **Studied:** Calif. Sch. Design with Virgil Williams. **Exhibited:** San Francisco AA, 1903; PPE, 1915; P&S Los Angeles, 1921. **Sources:** WW24; Hughes, *Artists in California,* 591, where her last name is spelled "Waterbury."

WATERBURY, Charles C. (Mr.) *[Painter] early 20th c.*
Addresses: NYC. **Exhibited:** S. Indp. A., 1925. **Sources:** Marlor, *Soc. Indp. Artists.*

WATERBURY, Edwin M. *[Painter] 19th/20th c.; b.Albion, IA.*
Addresses: Chicago, IL. **Studied:** ASL; W.M. Chase. **Exhibited:** AIC, 1897-98. **Sources:** WW01.

WATERBURY, Florence (Florance) *[Landscape painter] b.1883, NYC / d.1968, NYC.*
Addresses: Convent Station, NJ/Provincetown, MA. **Studied:** C.W. Hawthorne; G. Noël; C. Beaux; Rome; Peking; ASL. **Member:** NAWPS; Provincetown AA. **Exhibited:** Salons of Am.; Soc. Indep. Artists, 1922; Anderson Gals., NYC, 1929 (solo); Montross Gal., NYC, 1931 (solo), 1936 (solo). **Sources:** WW40.

WATERBURY, Laura Prather See: **WATERBORY, Laura Prather (Mrs. George)**

WATERHOUSE, Eleanor *[Painter] mid 20th c.*
Exhibited: S. Indp. A., 1941. **Sources:** Marlor, *Soc. Indp. Artists.*

WATERHOUSE, Mary S. *[Artist] late 19th c.*
Addresses: NYC, 1882-89. **Exhibited:** NAD, 1882-89. **Sources:** Naylor, *NAD.*

WATERHOUSE, Russell Rutledge *[Painter] b.1928, El Paso, TX.*
Addresses: El Paso, TX. **Studied:** Texas A&M Univ. (B.S., 1950); Art Center College Design, Los Angeles, 1954-56. **Exhibited:** Baker Collectors Gal., Lubbock, 1965; El Paso Mus. Art, 1972 (solo); Wichita Falls Texas Cultural Center & Mus, Art, 1972 (solo). **Work:** Texas Tech. Univ. Mus. Art, Lubbock; El Paso Mus. Art; Univ. Texas, El Paso. **Comments:** Preferred media: watercolors. Positions: member, Texas Commission Arts & Humanities, 1970-75. Publications: illustrator, "Goodbye to a River," Knopf, 1960; illustrator, "The Legal Heritage of El Paso," 1963 & "Pass of the North," 1968, Texas Western Press. **Sources:** WW73.

WATERMAN, Florence Z. *[Landscape painter] b.c.1870, Detroit, MI / d.1940, Detroit.*
Addresses: Detroit. **Member:** Detroit Soc. Women P&S. **Exhibited:** Michigan State Fair, 1878; Bohemian Club, 1894; Detroit Soc. Women P&S. **Sources:** Gibson, *Artists of Early Michigan,* 237.

WATERMAN, Hazel G. Umland *[Painter] b.1896, Sumner, IA.*
Addresses: Madison, WI. **Studied:** A.N. Colt. **Member:** Madison AG; Wisc. Commercial AG. **Work:** Burlington Hist. Soc.; Mount Mary College, Milwaukee. **Sources:** WW40.

WATERMAN, Marcus A. ("Mark")
[Landscape and figure painter] b.1834, Providence, RI / d.1914, Moderno, Italy.

Addresses: NYC, 1857-70; Prov., RI, 1862, 1867, 1869; Boston area (1870s-1909); Brescia, Lombardy (1909-on). **Studied:** Brown University (A.B., 1857). **Member:** ANA, 1861; AWCS; Boston PCC. **Exhibited:** Centennial Expo, Phila., 1876 ("Gulliver in Lilliput"); NAD, 1861-77; Brooklyn AA, 1864, 1872; PAFA Ann., 1861-62, 1866, 1876; Boston AC, 1883-1909; Corcoran Gal. biennial, 1910. **Work:** BPL; RISD; BMFA; Portland (ME) Pub. Lib.; Providence Pub. Lib.; Worcester MA; MMA. **Comments:** His studio was in NYC, 1857-70; then N. Easton, MA, and he finally in Boston in 1875 (with Frank Hill Smith and Thomas Robinson). He also traveled frequently to Vermont and Cape Cod. In 1878, he sold many of his paintings at a Williams & Everett auction (Boston) to finance his overseas trips, and from 1879-84 he traveled to Algeria (twice), France, Holland, and Spain. In 1908 he married, and the next year he and his wife settled in Italy, her native country. He made one or two return trips to the U.S. He was best known for his New England forest scenes, Cape Cod marines, and a series of scenes from the *Arabian Nights,* based on his Algerian experiences. **Sources:** G&W incorrectly says he was in NYC until 1874 because of Downes' article, "An American Painter: Mark Waterman," in *American Magazine of Art* (Jan., 1923, six repros.); *Art Annual,* XII (1915), 498, obit; *Art News* (April 11, 1914), 4, obit.; Clark, *History of the NAD,* 273; Cowdrey, NAD; Rutledge, PA; Falk, PA, vol. II; Clement and Hutton; CAB; WW13; *Early American Book Illustrators* (Princeton Univ. Lib., 1958); add'l info courtesy Richard McGrath, Southington, CT.

WATERMAN, Myron A. *[Cartoonist, sculptor] b.1855, Westville, NY / d.1937.*
Addresses: Kansas City, KS.

WATERMAN, N. T. (Mrs.) *[Artist] late 19th c.*
Addresses: active in Grand Rapids, MI, 1881. **Sources:** Petteys, *Dictionary of Women Artists.*

WATEROUS, H. L. *[Painter] early 20th c.*
Addresses: Cleveland, OH. **Member:** Cleveland SA. **Sources:** WW27.

WATERS, Almira *[Primitive watercolorist (still lifes)] mid 19th c.*
Addresses: Portland (ME), c.1830. **Sources:** G&W; Lipman and Winchester, 181.

WATERS, B(ertha) M. *[Illustrator, painter] 19th/20th c.*
Addresses: NY; Paris, France, 1902. **Exhibited:** PAFA, 1902. **Comments:** Position: illustr., *Brooklyn Life.* **Sources:** WW98; Falk, *PAFA II.*

WATERS, Charles J. B. *[Engraver] mid 19th c.*
Addresses: NYC, 1858-60. **Comments:** He was with the following firms: Brightly, Waters & Co. and C.J.B. Waters & Co. in 1858; Waters & Tilton, 1859; and Waters & Son, 1860. John W. Waters was his son (see entries). **Sources:** G&W; NYCD 1858-60.

WATERS, Claire Benoit (Mrs. Nelson F.) *[Painter] b.1905, Charlottetown, PEI, Canada.*
Addresses: Ames, IA. **Studied:** Mt. Allison School for Girls; Sackville, NB, Canada; Boston Mus. FA; pupil of Miss MacLeod & Mrs. McKiel; Lassell Ripley (awarded scholarship in Boston Mus. FA with Mr. Ripley). **Exhibited:** Iowa Art Salon; Great Hall, Iowa State College. **Sources:** Ness & Orwig, *Iowa Artists of the First Hundred Years,* 215.

WATERS, D. E. *[Watercolorist] mid 19th c.*
Comments: Painter of a watercolor, 1840. **Sources:** G&W; Lipman and Winchester, 181.

WATERS, E. A. *[Watercolorist] mid 19th c.*
Comments: Painter of a literary subject in watercolors, 1840. **Sources:** G&W; Lipman and Winchester, 181.

WATERS, George Fite *[Sculptor, teacher] b.1894, San Francisco / d.1961, Greenwich, CT.*
Addresses: Paris/Hossegor. **Studied:** Elwell at ASL; Rodin in Paris; Italy; London. **Member:** Soc. des Artistes Landais; Soc. Moderne. **Exhibited:** Salon des Artistes Françaises, 1932 (prize). **Work:** Dublin AG; Eastman Sch. Mus.; Rochester, NY; Ottawa Nat.; Portland, OR; NYU; St. Dustan's London; John Brown Mem. Park, Osawatomie, KS; Osso Films, Inc.; Stratford-on-Avon, England; bust, French Govt. **Sources:** WW40.

WATERS, George W. *[Landscape and portrait painter, illustrator, teacher] b.1832, Coventry, NY / d.1912, Elmira, NY.*
Addresses: NYC/Elmira, NY. **Studied:** NYC; Dresden & Munich (Germany). **Member:** Am. Art Union; Black and White Club, NYC; Century Club, NYC; Amateur AA, New York State. **Exhibited:** NAD, 1855-91; PAFA, including 1876; Boston Art Club, 1881; Buffalo, NY; Kansas City, MO; Detroit, MI; Denver, CO. **Work:** Western Reserve His. Soc., Cleveland, OH; Arnot Art Mus., Elmira, NY. **Comments:** Position: dir. art dept., Elmira College, Elmira (NY), 1869-1903. He took painting trips to the Adirondacks, White Mountains, NH, and elsewhere. In 1880 and 1886 he traveled and painted in Europe through the generosity of wealthy patrons. **Sources:** G&W; Fielding; Cowdrey, NAD; WW1898. More recently, see Campbell, *New Hampshire Scenery,* 170.

WATERS, Herbert (Ogden) *[Wood engraver, teacher, painter, block printer, lecturer] b.1903, Swatow, China.* *Herbert Waters*
Addresses: Warner, NH; Campton, NH. **Studied:** Harvard Univ.; Denison Univ. (Ph.B.); AIC; PM Sch. IA. **Member:** Southern PM Soc.; Gloucester SA; Merrimack Valley AA; SAGA; Boston PM; New Hampshire AA. **Exhibited:** WFNY, 1939; Phila. Pr. Club; Carnegie Inst.; Boston Art Festival. Awards: prizes, Indep. Soc. PM, 1945; New Hampshire AA, 1951, 1954, 1955; SAGA, 1955; Academic Artists, Springfield, 1955; Denison Univ., 1956. **Work:** prints, AGAA; RISD; Univ. New Hampshire; Dartmouth College; Middlebury College; Penn. State Univ.; Boston and NYPL; NAD; MMA; LOC; mural, Campton (NH) Baptist Church; mem. bookplate, Denison Univ. Lib.; Nashua (NH) Pub. Lib.; bookplate, New Hampshire State Lib.; woodcuts, *Yankee* magazine, 1936-37. **Comments:** Came to the U.S. c.1920. Teaching: Holdernem School for Boys, Plymouth, NH, 1946-. Illustr.: "New England Year," 1939; "New England Days," 1940 (and author); "Fragments," 1941. WPA artist. **Sources:** WW59.

WATERS, John *[Painter, illustrator, teacher] b.1883, Augusta, GA.*
Addresses: NYC. **Studied:** Chicago Acad. FA; ASL; Phoenix Art Inst., NY. **Exhibited:** NAC; New Rochelle AA. **Work:** Illinois Cunard Line; Curtiss Flying Service. **Comments:** Teaching: Phoenix Art Inst. **Sources:** WW40.

WATERS, John P. *[Engraver] mid 19th c.*
Addresses: NYC, 1849-60. **Sources:** G&W; NYBD 1849-59; NYCD 1850-60.

WATERS, John T. C. *[Painter] mid 20th c.*
Exhibited: S. Indp. A., 1940. **Sources:** Marlor, *Soc. Indp. Artists.*

WATERS, John W. *[Engraver] mid 19th c.*
Addresses: NYC, 1860. **Comments:** Of Waters & Son (see entry), engravers of NYC, 1860. His father was Charles J.B. Waters (see entry). **Sources:** G&W; NYBD 1860.

WATERS, Julia I. *[Painter] early 20th c.*
Addresses: Baltimore, MD. **Member:** Baltimore WCC. **Sources:** WW27.

WATERS, Kinsman *[Painter, craftsperson, teacher] b.1887, Columbus.*
Addresses: Columbus, OH. **Exhibited:** AWCS, 1936; Wash. WCC, 1939; AIC. **Sources:** WW40.

WATERS, Lottie A. *[Artist] early 20th c.*
Addresses: Active in Wash., DC, 1915. **Sources:** Petteys, *Dictionary of Women Artists.*

WATERS, Matthew *[Engraver] mid 19th c.*
Addresses: NYC, 1846. **Sources:** G&W; NYBD 1846.

WATERS, Paul *[Painter] b.1936, Phila., PA.*
Studied: Goddard College, VT; Harvard Univ.; Bank Street College; self-taught as an artist. **Exhibited:** BMFA, 1970; Newark Mus., 1971. **Comments:** Position: director, commmunity affairs, Newark Mus., NJ. **Sources:** Cederholm, *Afro-American Artists.*

WATERS, R. Kinsman See: **WATERS, Kinsman**

WATERS, Richard *[Painter, commercial artist] b.1936, Boston, MA.*
Studied: self-taught. **Exhibited:** BMFA, 1970. **Sources:** Cederholm, *Afro-American Artists.*

WATERS, Sadie (Sarah) *[Painter, illustrator] b.1869, St. Louis, MO / d.1900.*
Studied: Merson in Paris. **Exhibited:** Paris Salon, 1890, 1891, 1893, 1896, 1897, 1899; Paris Expo Universelle, 1900 (hon. men.); Royal Acad.; Walker Art Gal., Liverpool, 1897; Brussels, 1900; NYC and Ghent. **Comments:** Painted miniatures, religious subjects. **Sources:** Fink, *American Art at the Nineteenth-Century Paris Salons*, 402.

WATERS, Susan Catherine Moore (Mrs. William)
[Portrait, animal & still life painter, photographer] b.1823, Binghampton, NY / d.1900, Trenton, NJ.
Addresses: Binghampton, NY; Friendsville, PA, 1841; Mt. Pleasant, IA, 1855; Bordentown, NJ, 1866 and after. **Studied:** self-taught. **Exhibited:** Centenniel Exh. Phila., 1876. **Work:** NGA; NY State Hist. Assn; Wiltshire Coll., Richmond, VA (portrait of Mary E. Kingman, 1845); Newark Mus. (sheep in a landscape); Arnot AM, Elmira, NY; Cortland County (NY) Hist. Soc. **Comments:** She grew up in Friendsville, PA, earning her tuition at a female seminary by making drawings for her natural history teacher. In 1841 she married William Waters, a Quaker, who encouraged her talent. Between 1843-45 she was an active itinerant painter, following her husband through southern New York State and Pennsylvania. She painted animals and still lifes and made daguerreotypes and ambrotypes until her death. Her favorite subject was sheep, which she kept in her backyard. **Sources:** Rubinstein, *American Women Artists,* 66. Petteys, *Dictionary of Women Artists* 738.

WATERS & SON *[Wood engravers] mid 19th c.*
Addresses: NYC, 1860. **Comments:** Partners were Charles J.B. and John W. Waters (see entries). **Sources:** G&W; NYBD 1860.

WATERS & TILTON *[Engravers] mid 19th c.*
Addresses: NYC, 1859. **Comments:** Partners were Charles J.B. Waters and Benjamin W. Tilton (see entries). **Sources:** G&W; NYCD 1859.

WATERSON, Alicia (Mrs. G. Chychele) See: **ATKINSON, Alicia (Mrs. G. C. Waterston)**

WATERSTON, James R. *[Landscape painter and draftsman] mid 19th c.*
Addresses: NYC, 1846-60; Phila., 1848. **Exhibited:** Am. Inst., 1846-47; Am. Art-Union, 1847-52; NAD, 1855-59. **Comments:** His subjects were mainly Scottish, New York, and New Jersey scenes. **Sources:** G&W; Am. Inst. Cat., 1846, 1847; Cowdrey, AA & AAU; Cowdrey, NAD; NYBD 1854, 1856; NYCD 1860.

WATFORD, Frances Mizelle *[Painter, instructor] b.1915, Thomasville, GA.*
Addresses: Dothan, AL. **Studied:** Hilton Leech Art Sch., summers 1952-59; Sarasota Sch. Art, Portas Studio & Ringling Sch. Art, FL, summers 1959-64; special workshop with Dong Kingman, Columbus, GA, 1966; Famous Artist Sch. (grad., 1969). **Member:** Alabama Art Lg. (regional vice-pres., 1963-67);

Alabama WCS (regional vice-pres., 1956); Arts & Crafts Festival Dothan (receiving comt., 1971-72). **Exhibited:** Dothan-Wiregrass Art Lg., 1961-68; Bienniale Int. Vichy, France, 1964; Honored Exh., Birmingham, AL, 1966; Arts & Crafts Festival Dothan, 1971-72; Montgomery Mus. FA, 1961 (solo), Dothan, 1961 (solo), 1964 (solo) & 1970 (solo) & Columbus (GA) Mus. Arts & Crafts, 1966 (solo). Awards: purchase awards, 1958-61 & 1959 & Cline Award, 1966, Alabama Art Lg.,; dipl. d'honneur, Bienniale Vichy, 1964. **Work:** Montgomery (AL) Mus. FA; Birmingham (AL) Mus. Art; Houston Mem. Lib., Dothan, AL; Dothan (AL) H.S. Gal. Commissions: portraits, private collections, Dothan, 1958 & 1962, Elba, AL, 1960 & 1964 & Graceville, FL, 1960; murals, private collections, Dothan, 1964-66. **Comments:** Preferred media: watercolors, acrylics, oils. Positions: dir., Attic Gal., Dothan, 1958-. Teaching: Frances Watford Studio, Dothan, 1949-. Specialty of gallery: paintings in all media. **Sources:** WW73; "L'Art à L'Étranger," (October, 1963) & "En Province" (January, 1965), *La Révue Moderne;* Grace Burges, "Student Showcase," *Famous Artists Magazine* (November, 1971).

WATIES, Julius Pringle *[Painter] 18th c.*
Comments: Painter of a miniature of William Waties (1797-1847), probably in South Carolina. **Sources:** G&W; Carolina Art Assoc. Cat., 1935.

WATKINS, Carleton E. *[Landscape photographer] b.1829, Oneonta, NY / d.1916.*
Addresses: San Francisco, CA, from c. 1850. **Studied:** with daguerreotypist Robert Vance, California. **Exhibited:** "Era of Exploration" Exh., MMA, 1975. **Work:** MMA; Amon Carter Mus.; Boston Pub. Lib.; IMP LOC; Univ. New Mexico; NYPL; Oakland MA; Stanford; UCLA. **Comments:** One of the most important of the early Western landscape photographers, he is best known for his "mammoth-plate" views of Yosemite, 1861-70s and Oregon coast, c.1868. He also made huge photos in Hawaii in 1861. He also made stereoviews, which are rare. About 60 of his 115 large landscape views are known. Most of his work was lost in the San Francisco fire, 1906. Many of his negatives were later printed by I.W. Taber. Publications: *Yo-Semite Valley.* **Sources:** *Carleton E. Watkins: Pioneer Photographer,* intro. by Richard Rudigill (1978); Forbes, *Encounters with Paradise,* 94; Witkin & London, 265; Baigell, *Dictionary.*

WATKINS, Catherine W. (Mrs.) *[Landscape painter, lecturer, writer] b.1861, Hamilton, Ontario / d.1947, Los Angeles, CA.*
Addresses: Paris, France, 1911-14; Woodstock, NY, 1915-19; Los Angeles, CA from 1925. **Studied:** AIC; Paris with Dauchez, Simon Menard, Miller; Brangwyn in London; Sorolla in Madrid. **Member:** NAWA; Int. Art Un.; Am. Women's AA, Paris. **Exhibited:** PAFA Ann., 1911-12, 1914; AIC, 1912-13; Corcoran Gal. biennial, 1914. **Comments:** Lectures: Adventures in North China; Idling in Japan; Studio Life in Paris. **Sources:** WW40; Hughes, *Artists in California,* 591; Falk, *Exh. Record Series.*

WATKINS, Charles Law *[Painter, teacher, writer] b.1886, Peckville, PA / d.1945, New Haven, CT.*
Addresses: Bethesda, MD/Chatham, MA. **Studied:** Yale Univ.; Paris; but mostly self-taught. **Member:** Soc. Wash. Artists; Wash. AC. **Exhibited:** Soc. Indep. Artists, 1936 (prize), 1937 (medal); Whyte Gal., 1937 (solo); Corcoran Gal. biennial, 1939; PMG; Wash. Art Lg.; American Univ.; New Haven, CT, 1945 (memorial exh.). **Work:** PMG. **Comments:** Contrib.: articles, *Magazine of Art,* 1935. Positions: assoc. dir., PMG; dir., PMG Art Sch.; teacher, Hood College, Frederick, MD; chmn., art dept., American Univ. **Sources:** WW40; McMahan, *Artists of Washington, DC.*

WATKINS, Charlotte Elizabeth (Lottie) *[Painter, china painter, teacher] b.1865, Bay City, MI / d.1938, Tampa, FL.*
Addresses: Bay City, MI; Tampa, FL. **Exhibited:** galleries in the South. **Sources:** Gibson, *Artists of Early Michigan,* 237.

WATKINS, E. L. *[Painter] late 19th c.*
Exhibited: NAD, 1876. **Sources:** Naylor, *NAD.*

WATKINS, Edith F. *[Painter] early 20th c.*
Addresses: Brooklyn, NY. **Exhibited:** S. Indp. A., 1931.
Sources: Marlor, *Soc. Indp. Artists.*

WATKINS, Frances Emma *[Museum curator, writer, lecturer] b.1899, Denver, CO.*
Addresses: Los Angeles, CA; San Marino, CA. **Studied:** Univ.
Denver (A.B.); Univ. Southern California (Ph.D.). **Member:**
Western Mus. Conference; Keith AA. **Comments:** Position: asst.
curator, Southwest Mus., Los Angeles, 1929-46, in absentia, 1946-
56, consultant, 1956-. Author: "The Navaho," 1943; "Hopi Toys,"
1946; leaflets for Southwest Mus., Los Angeles. Contributor: *The
Masterkey, California History Nugget, Quarterly of Southern
California Hist. Soc., California Folklore Journal, Desert,
Westways,* and other publications. Lectures: Arts & Crafts of the
American Indian Women; American Indian Basketry, etc.
Sources: WW59; WW47.

WATKINS, Franklin Chenault *[Painter,
teacher] b.1894, NYC / d.1972.*
Addresses: Plymouth Meeting, PA; Naples, FL.
Studied: Univ. Virginia: Univ. Pennsylvania; PAFA, 1913-18.
Member: Assoc. Am. Acad. Design, 1951; NA, 1957; NIAL; Am.
Philos. Soc. **Exhibited:** PAFA Ann., 1920-68 (gold, 1941, 1944;
prizes, 1943, 1954); NAD, 1927; Corcoran Gal. biennials, 1928-
61 (12 times; incl. gold medal, 1939); Carnegie Intl., 1931 (1st
prize for "Suicide in Costume"); Second Inter-Am. Biennial
Mexico, Salon Honor, Palacio Bellas Artes, 1960 (solo); WMAA;
Kennedy Gals., NYC, 1970s. **Awards:** AIC, 1938 (prize); GGE,
1939 (prize); Paris Salon, 1937 (medal); first prize & Lehman
Prize, Carnegie Int., 1931; MoMA, 1950 (retrospective); PMA,
1964 (retrospective). **Work:** MMA; MoMA; WMAA; PMA;
PMG; PAFA; CGA; Smith College; Courtauld Inst., London,
murals, Rodin Mus., Paris; Detroit IA; Albright-Knox AG,
Buffalo. **Comments:** Known for his expressionistic realism from
the mid-1920s through the 1930s. After WWII he began exploring
religious themes. He was also a portraitist. Teaching: Tyler Sch.
Art (1940-43); PAFA, 25 years, 1943-retired, mem. bd. dir., 1970-
on. **Sources:** WW73; Baigell, *Dictionary;* Ben Wolf, *Watkins,
Portrait of Painter* (Univ. Penn. Press); "Watkins" (film), Phila.
Mus. Art; Andrew Carnduff Ritchie, *Franklin C. Watkins* (exh.
cat., MoMA, 1950); Falk, *Exh. Record Series.*

WATKINS, Gertrude May *[Painter, sculptor, teacher, lecturer] b.1890, Frankton, IN.*
Addresses: Chicago, IL/Momence, IL. **Studied:** AIC ; Laura Van
Pappelendam; Pedro de Lemos; Arthur Dow; Agnes Freman.
Member: Hoosier Salon; South Side AA; Western AA.
Comments: Teaching: Chicago H.S. **Sources:** WW40.

WATKINS, Gwen *[Educator] late 20th c.*
Studied: Xavier Univ., New Orleans; Wayne State Univ.; Univ. of
Michigan. **Exhibited:** Ann Arbor, 1967 (solo); Stouffers,
Northland, 1968 (solo); Normacel Gallery, Detroit, 1970.
Comments: Teaching: Metropolitan Arts Complex. **Sources:**
Cederholm, *Afro-American Artists.*

WATKINS, H. J. *[Portrait painter] late 19th c.*
Addresses: NYC, 1897. **Exhibited:** NAD, 1897. **Sources:**
Naylor, *NAD.*

WATKINS, Helen M. A. *[Painter] early 20th c.*
Addresses: Paughguag, NY. **Exhibited:** S. Indp. A., 1931-32.
Sources: Marlor, *Soc. Indp. Artists.*

WATKINS, James *[Painter] b.1925, Macon, GA.*
Studied: Soc. Arts & Crafts, Detroit, MI, 1949-52. **Exhibited:**
16th-22nd Atlanta Univ. Ann. (awards); Akron Art Inst. (solo);
Beaux Art Guild, Tuskegee, AL; Xavier Univ., 1963. **Sources:**
Cederholm, *Afro-American Artists.*

WATKINS, Kate E. *[Painter] b.1872.*
Addresses: Boston, MA. **Exhibited:** Boston AC, 1892. **Sources:**
The Boston AC.

WATKINS, Louise Lochridge *[Museum director, lecturer]
b.1905, Springfield, MA.*

Addresses: Longmeadow, MA. **Studied:** Skidmore College
(B.S.). **Member:** Am. Assn. Mus.; Springfield Art Lg.;
Springfield Photog. Soc. (hon. mem.). **Comments:** Positions:
asst., George Walter Vincent Smith Art Mus., 1936-38, asst. to
director, 1938-50, director, 1951-71; secretary-treas., New
England Mus. Assn., 1950-60; member, State Commission Art
Curriculum for Massachusetts Schools, 1968-70. Publications:
contributor, *George Walter Vincent Smith Art Mus. Bulletin.*
Teaching: lecturer on decorative arts, history of Cloisonné, history
of enameling & Chinese jades; instructor, George Walter Vincent
Smith Art Mus., Springfield, MA, 1936-38. Collections arranged:
Springfield Color Slide International Exhibition. **Sources:**
WW73.

WATKINS, Margaret *[Painter] early 20th c.*
Exhibited: Salons of Am., 1924. **Sources:** Marlor, *Salons of Am.*

WATKINS, Mary Bradley *[Painter] b.1911, Washington, DC.*
Addresses: Washington 7, DC. **Studied:** PMG Sch. Art.
Member: Soc. Wash. Artists; Wash. Artists Gld. **Exhibited:**
CGA, 1937; Soc. Wash. Artists, 1936-44; BMA, 1937, 1938;
Bignou Gal., 1939; Critics Choice, CM, 1945; Soc. Four Arts,
1945; PMG, 1936-1946; Artists Gld. Wash., 1941-46. **Work:**
PMG. **Sources:** WW53; WW47.

WATKINS, May Wilson See: **PRESTON, May (Mary)
Wilson (Mrs. James M.)**

WATKINS, Mildred *[Painter] b.1882.*
Addresses: Cleveland, OH. **Studied:** Cleveland Sch. Art; L.H.
Martin. **Member:** Boston SAC; Cleveland Women's AC.
Comments: Specialties: jewelry; silverware. **Sources:** WW27.

WATKINS, Susan *[Painter] b.1875, Lake County, CA / d.1913.*
Addresses: New York, 1890; Paris, France, 1896-1908; Norfolk,
VA, 1913. **Studied:** ASL; Académie Julian, Paris, with Collin,
1896-98. **Member:** ANA, 1912. **Exhibited:** Paris Salon, 1899
(hon. men.), 1901 (gold medal); PAFA Ann., 1902-13; St. Louis
Expo., 1904 (silver medal); Mark Hopkins Inst., San Francisco,
1906; Royal Acad., London; AIC; SAA; Corcoran Gal.; NAD,
1910 (Shaw prize); Chrysler Mus., Norfolk, VA, 1985 (retrospective). **Work:** Chrysler Mus., Norfolk, VA (bequeathed her collection); Calif. Hist. Soc. **Comments:** An expatriate Impressionist
painter who W.M. Chase once said was "the best woman painter
alive." She came from a prominent California family and moved
at age 15 to New York City. After her father died in 1896 she
lived in Paris, where she studied and sketched extensively in
museums and also recorded her travels. She married
Goldsborough Serpell in 1912 but became ill and lived the last
year of her life in Norfolk, VA. Many of her paintings are reminiscent of 17th century Dutch paintings in their tonal quality and
subjects, while she also created a large number of genre pieces.
Sources: WW13; article, *Antiques & Arts Weekly* (Dec. 13, 1985,
p.104); Pisano, *One Hundred Years.the National Association of
Women Artists,* 84; Fink, *American Art at the Nineteenth-Century
Paris Salons,* 403; Falk, *Exh. Record Series.*

WATKINS, William Henry *[Miniaturist, portrait painter]
mid 19th c.*
Addresses: Ohio, c.1840; Steubenville, OH, active 1819-25;
Cincinnati, OH, 1852 and after. **Comments:** He came with his
parents to Ohio from England or Wales about 1840, began his
career as an artist in Steubenville, and later worked in Cincinnati.
Sources: G&W; Clark, *Ohio Art and Artists,* 102. Hageman, 123.

WATKINS, William Reginald *[Designer, painter, lithographer, teacher, min painter] b.1890, Manchester, England.*
Addresses: Baltimore 14, MD. **Studied:** Maryland Inst.; Hans
Schuler; C.W. Turner; Maxwell Miller; AAPL. **Member:** Balt.
WCC (vice-pres., bd. gov., 1954-55); AAPL; Royal Soc. Art,
London (fellow); Balt. Art Dir. Club; Nat. Art Dir.; Maryland Inst.
Alum. Board. **Exhibited:** BMA, 1927-33; Peabody Gal., 1916-
1924; PAFA Ann., 1930; Mun. Mus., Balt., 1941-45, 1951;
Maryland Inst. (solo); Balt. Charcoal Club (solo); Grand Central
Art Gal.; Balt. WCC, 1950-52; Oklahoma AC; Univ. Maine;

Springfield, IL; Izmer, Turkey; Bronxville Pub. Lib.; Hilltop, Vagabond, Center Theatres, Balt. **Awards:** prizes, BMA; Timonium Fair, MD, 1930; Seton Hall Univ., 1958; Balt. WCC. **Work:** Maryland Jockey Club; Univ. Maryland; Seton Hall Univ.; murals, Owens-Illinois Corp, Wash., DC; mem., Univ. Maryland. **Comments:** Teaching: Maryland Inst.; Beaux-Arts Sch. Art; Univ. Maryland, Balt., MD; BMA, 1952-55. **Sources:** WW59; WW47; Falk, *Exh. Record Series.*

WATKINS-HATHAWAY, Abby *[Painter] 19th/20th c.; b.Detroit, MI.*
Studied: Vignal; Desjeux; R. Collin. **Exhibited:** Paris Salon, 1897. **Sources:** Fink, *American Art at the Nineteenth-Century Paris Salons,* 403.

WATKINSON, Ernest *[Painter] mid 20th c.*
Exhibited: S. Indp. A., 1936. **Sources:** Marlor, *Soc. Indp. Artists.*

WATKINSON, Helen (Louise) *[Painter, illustrator, craftsperson, teacher] early 20th c.; b.Hartford, CT.*
Addresses: NYC. **Studied:** A.W. Dow; M. Fry; H. Snell; W. Schumacher. **Member:** Lyceum Club, Paris. **Exhibited:** Corcoran Gal. biennial, 1916; S. Indp. A., 1917. **Sources:** WW17.

WATMOUGH, E. C. *[Landscape painter] mid 19th c.*
Addresses: Philadelphia. **Exhibited:** PAFA, 1847-48; Am. Art-Union, 1846. **Comments:** He was the artist of "Repulsion of the British at Fort Erie," lithographed and published in the *U.S. Military Magazine,* II, March 1841. Possibly he was the Edward C. Watmough, lawyer, listed in Philadelphia directories, 1825-37. **Sources:** G&W; Rutledge, PA; Cowdrey, AA & AAU; *Portfolio* (Dec. 1953), 93, repro.

WATMOUGH, Marjorie Ellen *[Painter] b.1884, Cleveland.*
Addresses: Phila., PA. **Studied:** PAFA with T. Anschutz, H. Breckenridge. **Member:** Plastic Club. **Exhibited:** PAFA Ann., 1908, 1910-12; Corcoran Ga.l biennial, 1910. **Sources:** WW10; Falk, *Exh. Record Series.*

WATRIN, T. T. *[Painter] mid 19th c.*
Comments: Painter of a miniature (1836) of Obadiah Romney Van Benthuysen (1787-1845) of Albany (NY). **Sources:** G&W; G&W has information courtesy Dr. H.W. Williams, Jr., Corcoran Gallery.

WATROUS, Elizabeth Snowden Nichols (Mrs. H. W.) *[Painter, writer] b.1858, NYC / d.1921, NYC.*
Addresses: NYC. **Studied:** Paris with Henner& Carolus-Duran. **Member:** NY Women's AC (pres., 1911-12); Pen & Brush Club; SPNY; NAWPS. **Exhibited:** Soc. Indep. Artists, 1917; NAD. **Comments:** Author of two novels, "Ti" and "It." **Sources:** WW19.

WATROUS, Harry W(illson) *[Painter] b.1857, San Francisco, CA / d.1940, NYC.*
Addresses: NYC/Lake George, NY (summers). **Studied:** Spain, 1881 (traveled with friend H. Humphey Moore); in Paris, 1882-86, first at Académie Julian with Boulanger and Lefebvre (1881-82); later with Bonnât. **Member:** ANA, 1894; NA, 1894; NA, 1895; NAD (pres. 1933-34); SAA 1905; Artists Aid Soc.; Lotos Club; Century Assn.; NAC; SC; SPNY; AFA; Tiffany Found. (pres.). **Exhibited:** Paris Salon, 1884, 1885; Boston AC, 1890; PAFA Ann., 1890-1937 (9 times; prize 1935); Pan-Am. Expo, Buffalo, 1901 (medal); St. Louis Expo, 1904 (gold); Corcoran Gal. biennials, 1907-39 (6 times); NAC, 1931 (medal); NAD, 1886, 1889-91, 1894-16, 1918-41 (medals, 1894, 1829, 1931; gold, 1934); Salons of Am.; AIC. **Work:** MMA; Montpelier (VT) Mus.; CAM, St. Louis; Buffalo FA Acad.; BM; Ft. Worth Mus.; CGA. **Comments:** Watrous grew up in NYC and returned there in 1886 after study in Paris. An academic portrait, genre, figure, landscape, and still-life painter, his work became more innovative after 1904 as he began to lose his eyesight. His figural paintings between 1905-18 often consisted of elegant women in exotic dress. From 1918-23, he focused on landscapes; after 1923, Watrous produced highly detailed, decorative still lifes, which

often included unusual combinations of Asian objects — such as small Buddhas, Oriental vases, and portions of Japanese prints as background — taken from his own collection. **Sources:** WW40; *300 Years of American Art,* 514; Fink, *American Art at the Nineteenth-Century Paris Salons,* 403; Gerdts, *Painters of the Humble Truth,* 231-32; Falk, *Exh. Record Series.*

WATROUS, James Scales *[Painter, art historian, teacher] b.1908, Winfield, KS.*
Addresses: Madison, WI. **Studied:** Univ. Wisc. (B.S.; M.A.; Ph.D.). **Member:** Madison AA; Wisc. P&S; Mid-Am. College AA (pres., 1959); College AA Am.(pres., 1962-64); Nat. Soc. Mural Painters. **Exhibited:** PAFA, 1939, 1940; CI, 1941. **Awards:** Milwaukee AI, 1937 (prize), 1941 (prize), 1942 (prize); Wisc. Salon Art, 1935 (prize), 1936 (prize); Inst. Advanced Educ. faculty fellowship, Italy, 1954; award of merit, Wisc. Chapter Am. Inst. Architects, 1962; Wisc. Gov. Award in Arts,1969. **Work:** Milwaukee AI; Univ. Wisc.; WPA murals, Wisc. Union, Fed. Bldg. (Park Falls), USPOs, Park Falls (WI), Grand Rapids (MN); Lawrence Univ.; Kansas State Univ.; Milwaukee AC. Commissions: Symbols of Printing (mural), Webcrafters Press, Madison, WI, 1952; Justice (aluminum), Wisc. Bar Center, Madison, 1958; The Conjurer (mosaic mural), Washington Univ., St. Louis, 1959; mosaics, Man: Creator of Order & Disorder, 1964 & Symbols of Communication, 1972, Univ. Wisc. **Comments:** Preferred media: mosaics. Publications: author, "The Craft of Old-Master Drawings," Univ. Wisc. Press, 1957. Teaching: Univ. Wisc.-Madison, 1936-, Hagen Professor of art hist., 1964-, chmn. dept. art hist., 1952-61. Research: technical studies in the fine arts. **Sources:** WW73; WW47.

WATROUS, Mary E. *[Painter] early 20th c.*
Addresses: Laguna Beach, CA, 1917-25. **Member:** Calif. AC. **Sources:** WW25.

WATSON, Adele (Fanny) *[Mural painter, painter, lithographer] b.1873, Toledo, OH / d.1947, Pasadena, CA.*
Addresses: NYC; Pasadena, CA. **Studied:** ASL; R. Collin, Paris. **Member:** AAPL. **Exhibited:** Art All. Am., 1918 (solo); Soc. Indep. Artists, 1917-21, 1936; Calif. Liberty Fair, 1918; P&S Los Angeles, 1925; Babcock Gals., 1930 (solo); Ferargil Gal., 1931 (solo); Bonestell Gal., 1943 (solo); Arch. Lg., 1946; TMA; San Diego MA; LACMA; Cannell & Chaffin Art Gal., Los Angeles, 1024; London; Pasadena AI, 1953 (memorial). **Comments:** Painted portraits & landscapes with spiritual figures. **Sources:** WW40; Trenton, ed. *Independent Spirits,* 75; Petteys, *Dictionary of Women Artists,* reports 1875 as alternate birth date.

WATSON, Agnes M. *[Illustrator, teacher, painter] early 20th c.; b.Phila.*
Addresses: Phila. **Studied:** PM Sch. IA; H. Pyle. **Member:** Plastic Club. **Exhibited:** PAFA Ann., 1887-91, 1895, 1901, 1913; AIC, 1901-02, 1907, 1912; Soc. Indep. Artists, 1919. **Sources:** WW21; Falk, *Exh. Record Series.*

WATSON, Agnes Pat(t)erson See: WATSON, Nan (Mrs. Forbes)

WATSON, Aldren Auld *[Illustrator, designer, painter, block printer, drawing specialist] b.1917, Brooklyn, NY.*
Addresses: Brooklyn, NY/Monterey, MA; Putney, VT. **Studied:** Yale Univ., 1939; ASL with George Bridgman, Charles Chapman, Robert Brackman, William Aurebach-Levy. **Member:** Authors Guild; AFA. **Exhibited:** Fifty Books Shows, Soc. Illustrators Ann. Awards: prize, Domesday Book Illustr. Comp., 1945. **Work:** 50 Color Prints, 1932; illus. books in libraries, U.S., Canada & Europe & in private collections. Commissions: mural, SS *Pres. Hayes,* Thomas Crowell Co. Office, 1964. **Comments:** Positions: textbook designer, D. C. Health & Co., Boston, 1965-66; chief editor curriculum oriented mat., Silver Burdett Co., Morristown, NJ, 1966-; official NASA artist, Apollo 8, 1968. Author/illustr.: "My Garden Grows," 1962 & "Maple Tree Begins," 1970, Viking Pres; "Hand Bookbinding," 1963 & 1968; "Very First Words for Writing and Spelling," Holt, Rinehart & Winston, 1966; "Village Blacksmith," Crowell, 1968. **Sources:** WW73; chapter, *Forty*

Illustrators and How They Work; WW40.

WATSON, Amelia Montague *[Painter, illustrator] b.1856, East Windsor Hill, CT / d.1934, Orlando, FL.*
Addresses: Windsor Hill, CT. **Exhibited:** Boston AC, 1891-94; AIC; NYWCC; AWCS. **Comments:** Author/illustrator: cover, frontispiece, "The Carolina Mountains," by M.W. Morley; Thoreau's "Cape Cod," "Thousand Mile Walk to the Gulf," John Muir. Specialty: Southern scenery. Teaching: Martha's Vineyard (MA) Summer School. **Sources:** WW33.

WATSON, Angele (Hamendt) (Mrs. Benj.) *[Painter] early 20th c.*
Exhibited: S. Indp. A., 1927-28, 1941; WMAA, 1928; Salons of Am., 1928, 1931. **Sources:** Marlor, *Salons of Am.*

WATSON, Anna M. *[Miniature painter] early 20th c.*
Addresses: NYC and Paris, c.1905-13. **Studied:** Paris. **Sources:** WW13.

WATSON, C. A. *[Lithographer] mid 19th c.*
Addresses: Philadelphia in 1835. **Comments:** Partner of John Frampton Watson (see entry) at Philadelphia in 1835. **Sources:** G&W; Phila. CD 1835.

WATSON, Charles A. *[Marine painter] b.1857, Baltimore, MD / d.1923, Easton, MD.*
Addresses: Balt. **Studied:** A. Castaigne; E.S. Whiteman; D. Woodward. **Member:** Balt. WCC; Charcoal Club (founder). **Exhibited:** PAFA Ann., 1906. **Sources:** WW24; Falk, *Exh. Record Series.*

WATSON, Clarissa H. *[Art dealer] 20th c.; b.Ashland, WI.*
Addresses: Long Island, NY. **Studied:** Layton Art School, Milwaukee, WI; Univ. Wisc.-Milwaukee; Milwaukee-Downer College, B.A.; Country Art School with Harry Sternberg. **Comments:** Positions: dir./founder, Country Art Sch., Westbury, Long Island, 1953-68; dir./co-founder, Country Art Galleries, Locust Valley & Southampton, Long Island, 1953-; art consult., Adelphi Univ., 1967-69; dir., film festivals, 7 Village Arts Council, Locust Valley, 1969-71; dir./producer, Mediaeval Christmas Festival, Locust Valley, 1970 & 1971-. Publications: author, "The Art Virus," *This Week Magazine,* 1964; author, "Ateliers of Paris," 1965 & "The Art Balloon," 1967, *Locust Valley Leader*; author, "Art as an Investment," *Oyster Bay Guardian,* Long Island, LI, 1966; editor, "The Artists' Cookbook," Stevenson, 1971. Collections arranged: Long Island Artists, Washington, DC, 1967; The Collector's Collections, Adelphi Univ., Garden City, Long Island, 1968; Gabriel Spat (1890-1967) Retrospective, Fine Arts Assn. Willoughby, Cleveland, OH, 1970; Nobility of the Horse in Art—To Save America's Wild Horses, Washington, DC, 1971. Specialty of gallery: 19th-20th c. American realism and American and European naifs. **Sources:** WW73.

WATSON, Dawson See: **DAWSON-WATSON, Dawson**

WATSON, Dudley Crafts *[Painter, educator, writer, lecturer, teacher] b.1885, Lake Geneva, WI / d.1972.*
Addresses: Chicago, IL; Highland Park, IL. **Studied:** AIC; Beloit College (D.F.A.); Alfred East, London; Sorolla. **Member:** Chicago AC; Cliff Dwellers Club. **Exhibited:** AIC, annually; Grand Central Art Gal. Awards: prizes, Milwaukee AI, 1923; AIC, 1911, 1926; Wisc. P&S, 1922 (prize); ASL, Chicago, 1908 (prize); decorated by Govt. of Ecuador, 1946. **Work:** Burlington (Iowa) Pub. Lib.; Milwaukee AI; Layton Gal. Art; IBM Collection; Wendell Phillips H.S., Chicago; H.S., Milwaukee; La Mars (IA) H.S.; Milwaukee Yacht Club; his archives are at Syracuse Univ. **Comments:** He established the Vanderpoel AA in Chicago, dedicated to the memory of John Vanderpoel, and collecting the art of Vanderpoel and his students. Positions: art editor, *Milwaukee Journal*; director, Milwaukee AI, 1914-24; educ. director., Minneapolis AI, 1922-23; radio commentator, WGN, Chicago; lecturer, AIC, Chicago, 1926-55; special lecturer, AIC, 1955-. Author: "Nineteenth Century Painting," 1931; "Twentieth Century Painting," 1932. Lectures: art and travel. Originator of

music-picture symphonies. **Sources:** WW59.

WATSON, Edith S(arah) *[Painter, photographer, illustrator] b.1861, East Windsor Hill, CT.*
Addresses: East Windsor Hill, CT. **Exhibited:** Boston AC, 1892, 1894; Pan-Pacific Expo, San Francisco, 1915; Bermuda. **Sources:** *The Boston AC.*

WATSON, Elizabeth H. *[Painter] 19th/20th c.*
Addresses: Philadelphia, PA. **Studied:** PAFA with William Sartain. **Exhibited:** PAFA Ann., 1885-88, 1896 (prize)-1903, 1909; AIC. **Sources:** WW33; Falk, *Exh. Record Series.*

WATSON, Elizabeth V. Taylor See: **TAYLOR-WATSON, Elizabeth Vila (Mrs. A. M.)**

WATSON, Ella (Mrs.) *[Landscape painter] b.1850, Worcester, MA / d.1917, Somerville, MA.*
Member: Boston SAC.

WATSON, Ernest William *Ernest W Watson*
[Block printer, illustrator, painter] b.1884, Conway, MA / d.1969, New Rochelle, NY.
Addresses: NYC/Monterey, MA. **Studied:** Mass. Sch. Art; PIA School; ASL. **Member:** Prairie PM; Rochester Pr. Club. **Work:** Smithsonian; NYPL; BM; LOC; Rochester Mem. Art Gal.; Los Angeles Mus. Hist., Science & Art; Columbus Gal. FA; Baltimore MA. **Comments:** Positions: founder/director, Berkshire Summer Sch. Art; editor of *American Artist.* **Sources:** WW40.

WATSON, Eva See: **WATSON-SCHÜTZE, Eva**

WATSON, Eva Auld (Mrs.) *[Block printer (lineolum cuts), painter]* *Eva Watson* *b.1889, Texas / d.1948, NYC.*
Addresses: Brooklyn, NY/Monterey, MA. **Studied:** M.O. Leiser, Pittsburgh Sch. Des.; PIA Sch. **Member:** AFA; Calif. PM. **Exhibited:** Pan-Pacific Expo, San Francisco, 1915 (prize). **Work:** Los Angeles MA. **Comments:** Author/illustrator: *Coptic Textile Motifs.* **Sources:** WW40.

WATSON, George *[Portrait painter] b.c.1817, Yorkshire, England / d.1892, Detroit, MI.*
Addresses: Detroit, MI. **Comments:** Partner in Watson & Baird, 1857-58; St. Alary & Watson, 1864-65; Watson & Brummitt, 1869-71. **Sources:** Gibson, *Artists of Early Michigan,* 237.

WATSON, Grace *[Painter] late 19th c.*
Addresses: Phila., PA. **Exhibited:** PAFA Ann., 1888, 1890-91. **Sources:** Falk, *Exh. Record Series.*

WATSON, Harry, Jr. *[Painter] b.1871, England / d.1936.*
Addresses: NYC. **Member:** S. Indp. A. **Exhibited:** S. Indp. A., 1921. **Sources:** WW25.

WATSON, Henry S(umner) *HY·S·WATSON·'9*
[Illustrator] b.1868, Bordentown, NJ / d.1933.
Addresses: NYC. **Studied:** PAFA with Eakins; Académie Julian, Paris with J.P. Laurens, 1901. **Member:** SI, 1904. **Comments:** Specialty: hunting scenes. Illustrator: *Outing* magazine. Position: editor, *Field and Stream.* **Sources:** WW31.

WATSON, Horace *[Etcher] early 20th c.*
Addresses: Berkeley, CA. **Member:** Calif. SE. **Sources:** WW27.

WATSON, Howard N. *[Painter] b.1929, Pottsfield, PA.*
Studied: Phila. State Univ.; Phila. College Art. **Member:** AWCS; Phila. WCC; Knickerbocker Artists. **Exhibited:** AWCS Shows; Allied Artists Am.; Audubon Artists; Knickerbocker Artists Shows; Phila. Civic Center; Lee Cultural Center, Phila.; Delaware Graphics Show (prize). **Work:** City of Phila. (calendars); RCA, IVB Bank; Archdiocese of Phila. (mural). **Sources:** Cederholm, *Afro-American Artists.*

WATSON, J. R. *[Amateur watercolorist] mid 19th c.; b.England.*
Exhibited: PAFA, 1829 (view on the Schuylkill and a view of Exeter, England). **Comments:** British naval officer who visited the United States and took several watercolor views, probably

shortly before 1820. The Tomb of Washington and the Falls of St. Anthony (MN) in Joshua Shaw's (see entry) *Picturesque Views of American Scenery* (1819) were after paintings by Captain Watson, R.N. A view of the Schuylkill River near Philadelphia after Captain J.R. Watson appeared in Cephas G. Childs' (see entry) *Views of Philadelphia from Original Views Taken in 1827-1830* (1830). The artist may have been Joshua Rowley Watson, born 1772, commissioned post-captain in the Royal Navy in 1798, and on active service at least until 1818. **Sources:** G&W; Shaw, *Picturesque Views;* Childs, *Views of Philadelphia;* Rutledge, PA; DNB [under Rundle Burges Watson]; Admiralty-Office, *List of the Flag Officers.,* 1818.

WATSON, Jean *[Painter] mid 20th c.; b.Philadelphia, PA.*
Addresses: Philadelphia 44, PA. **Studied:** PAFA with Earl Horter. **Member:** Phila. Art All.; NAWA; Phila. Pr. Club; AEA; Pen & Brush Club; PAFA (fellow); Woodmere Art Gal.; Plastic Club. **Exhibited:** PAFA Ann., 1935-66 (13 times); Corcoran Gal. biennials, 1937-41 (3 times); VMFA, 1938, 1940; WFNY 1939; GGE 1939; AIC, 1940; Carnegie Inst., 1941; CM, 1939, 1941; NAD, 1938, 1941, 1945; MMA, 1942; Audubon Artists, 1945; Lilienfeld Gal., 1940 (solo); Donovan Gal., Phila. 1952 (solo); NAWA, 1952, 1955; Argent Gal., 1955 (solo); 48 Sts. Comp., 1939; Woodmere Art Gal., 1957. Awards: fellowship, PAFA; prize, PAFA, 1943, 1951; Pen & Brush Club, 1954; medal, Phila. Plastic Club, 1935, 1938; Phila. Sketch Club, 1937. **Work:** Woodmere Art Gal., Phila.; WPA murals, USPOs, Madison, NC; Stoughton, MA. **Sources:** WW59; WW47; Falk, *Exh. Record Series.*

WATSON, Jesse Nelson *[Painter, etcher] b.1870, Pontiac, IL / d.1963, Glendale, CA.*
Addresses: Glendale, CA. **Studied:** self-taught. **Member:** P&S Club; Soc. for Sanity In Art; Acad. Western Painters; Pasadena SA; 2 x 4 Soc., St. Louis, MO; Long Beach AA; Santa Monica AA; Calif. WCS. **Exhibited:** Acad. Western Painters, 1931-38; St. Louis, MO, 1943; LACMA; SFMA; Oakland Art Gal.,1936; Pasadena SA; Santa Paula, Gardena, Glendale, San Pedro, CA; Ebell Club, Los Angeles, 1939 (prize); CPLH, 1945; AIC. **Sources:** WW53; WW47.

WATSON, John *[Portrait painter and draftsman] b.1685, Scotland, probably at Dumfries / d.1768, Perth Amboy, NJ.* *John Watson*
Addresses: Perth Amboy, NJ, by 1714. **Work:** New Jersey Hist. Soc., Newark, NJ (large coll. of his drawings); NYHS; Boscobel Restoration, Inc. (Garrison-on-Hudson, NY); Am. Antiquarian Soc. (Worcester, MA). **Comments:** Worked in various trades throughout his career, as a merchant, land speculator, money lender, and limner. Watson became known as portrait painter in 1720s working in New York and New Jersey. His success was gained primarily through his plumbago work (pencil miniatures on vellum), a type of drawing practiced in England that never really became popular in the colonies. Watson, however, did well with this medium (although only twenty drawings survive today), perhaps because the portraits were more affordable than painted miniatures and full-size oils. Some of the drawings are of classical and other ideal subjects as well. He apparently also painted numerous oil portraits but few survive and none are signed. In 1979, Mary Black argued that two paintings — "James Henderson with Two of His Daughters," 1726; and "Thysje Watson Henderson with Margaret, Tessie, and James Henderson," 1726 (Boscobel Restoration) — both of which were formerly attributed to the Van Rensselaer Limner, were actually the work of Watson. This new attribution was supported by a notation found in Watson's notebook (NYHS) which lists portraits and records payments for works painted in 1726. Watson made a trip to Scotland in 1730 and brought back to New Jersey his niece and nephew, as well as a collection of paintings which he exhibited in his house. He owned a large amount of property in Perth Amboy. **Sources:** G&W; Bolton, "John Watson of Perth Amboy, Artist," contains a bibliography of earlier writings on Watson; John Hill Morgan, *John Watson: Painter, Merchant, and Capitalist of New Jersey* (1941). More recently, see Mary Black, "Tracking Down John

Watson," *American Art and Antiques* 2, no. 5 (September-October 1979): 78-85; Saunders and Miles, 126-31 (with repros.); Baigell, *Dictionary.*

WATSON, John *[Lithographer] b.c.1816, Scotland.*
Addresses: NYC in 1850. **Sources:** G&W; 7 Census (1850), N.Y., XLIII, 88.

WATSON, John Frampton *[Lithographer] b.c.1805, Pennsylvania.*
Addresses: Philadelphia from about 1833 until after 1860. **Comments:** He was also listed as a daguerreotypist in 1841. In 1835 he was in partnership with C.A. Watson (see entry). **Sources:** G&W; Phila. CD 1833-60+; Peters, *America on Stone;* 7 Census (1850), Pa., LII, 997.

WATSON, John W. *[General & wood engraver] mid 19th c.*
Addresses: NYC, 1840s-50s. **Sources:** G&W; NYBD 1846, 1857.

WATSON, M. Anna See: **WATSON, Anna M.**

WATSON, Maavie F. *[Painter] 19th/20th c.*
Addresses: Tacoma, WA. **Exhibited:** Western Wash. Fair, 1906; Alaska Yukon Pacific Expo, 1909. **Sources:** Trip and Cook, *Washington State Art and Artists,* 1850-1950.

WATSON, Minnie *[Still life painter] late 19th c.*
Addresses: Active Saratoga, NY, 1878. **Studied:** D. W. Tryon in Hartford, CT, 1875; NYC, 1878. **Member:** Detroit Soc. Women P&S, from 1905. **Sources:** Petteys, *Dictionary of Women Artists.*

WATSON, Monique *[Sculptor] mid 20th c.*
Exhibited: Soc. Indep. Artists, 1941. **Sources:** Marlor, *Soc. Indp. Artists.*

WATSON, Nan (Mrs. Forbes) *[Painter] b.1876, Edinburgh, Scotland / d.1966, Wash., DC.*
Addresses: Buffalo, NY; NYC; Wash., DC/Harbor Springs, MI. **Studied:** Buffalo, NY; Paris, with Girardot, Prinet; Wm. Chase in NYC. **Exhibited:** Soc. Indep. Artists, 1917, 1920; NAD; PAFA Ann., 1920, 1933, 1938-42; Whitney Studio Gals., 1925, 1929; Wildenstein Gal., 1923; Gal. Durand-Ruel, 1923; Frank Rehn Gals., 1929; CGA, biennials, 1930-43 (7 times); Kraushaar Art Gal., 1932, 1937; Phillips Collection, Wash., DC; WFNY, 1939; Golden Gate Expo, 1940; Arts Club Wash., 1941 (solo); Wadsworth Atheneum, 1960 (solo). **Work:** WMAA; PMA; MMA; PMG; CGA. **Comments:** Specialty: portraits and still lifes. Her family came to the U.S. when she was a child and she received her first art instruction in Buffalo, followed by about 6 years in France. She painted steadily until her death. **Sources:** WW40; McMahan, *Artists of Washington, DC;* Falk, *Exh. Record Series.*

WATSON, Rhea D. *[Miniature painter] b.1874, Phila.*
Addresses: Phila. PA. **Studied:** PAFA, with T. Anshutz, Breckenridge. **Member:** Plastic Club. **Exhibited:** AIC, 1902, 1905; PAFA Ann., 1903. **Sources:** WW10; Falk, *Exh. Record Series.*

WATSON, Richard *[Sculptor] mid 19th c.*
Addresses: NYC, 1856. **Exhibited:** Fair of the Am. Inst., 1856 (plaster bust of the NYC architect, David Jardine). **Sources:** G&W; Am. Inst. Cat., 1856.

WATSON, Robert *[Painter] b.1923, Martinez, CA.*
Addresses: Scottsdale, AZ. **Studied:** Univ. Calif.; Univ. Illinois; Univ. Wisconsin. **Member:** Soc. Western Artists. **Exhibited:** Fifth Ann. Exh. Contemp. Am. Art, CPLH, 1952; Calif. State Fair, Sacramento, 1953; Exh. Contemp. Am. Art, Univ. Illinois, 1954; NAD, 1954. Awards: first prize, Calif. State Fair, 1954. **Work:** TMA; CPLH; Rochester (NY) Univ.; St. Mary's College, Moraga, CA. **Comments:** Preferred medium: oil on canvas. **Sources:** WW73; Arthur Watson, article, *Am. Artist* (September, 1953).

WATSON, Ruth Crawford (Mrs.) *[Painter] b.1892, Decatur / d.1936.*
Addresses: Decatur, AL. **Studied:** Colarossi Acad., Paris; Rome.

Member: Birmingham AC; Alabama AL; SSAL. **Work:** Old State Banking Building, Decatur; Montgomery (AL) MFA. **Sources:** WW33.

WATSON, Stewart *[Portrait, animal & historical painter]* mid 19th c.
Studied: France and Italy from c.1838-41. **Member:** ANA, 1836. **Exhibited:** NAD, 1834; Royal Acad. & others, 1843-47. **Comments:** He went abroad c.1837. Around 1843 he settled in London, and in 1858 he was listed as a resident of Edinburgh (Scotland). **Sources:** G&W; Cowdrey, NAD; NYCD 1835-36; Clark, *History of the NAD,* 273; Cowdrey, AA & AAU; *American Collector* (Nov. 1942), 8, repro.; Graves, *Dictionary.*

WATSON, Sue E. *[Sculptor]* early 20th c.
Addresses: Pittsburgh, PA. **Sources:** WW19.

WATSON, Thomas J. *[Engraver]* 19th/20th c.
Addresses: Wash., DC, active c.1887-1905. **Comments:** Position: staff, Bureau of Engraving and Printing. **Sources:** McMahan, *Artists of Washington, DC.*

WATSON, William R. *[Painter]* early 20th c.
Addresses: Chicago area. **Exhibited:** AIC, 1927. **Sources:** Falk, AIC.

WATSON-SCHÜTZE, Eva *[Painter, photographer]* b.1867, Jersey City, NJ / d.1935.
Addresses: Jersey City, NJ; Philadelphia, PA, 1882-1901; Chicago, IL/ Woodstock, NY. **Studied:** PAFA , 1882-88; Thomas Eakins; Thomas Anshutz. **Member:** Photographic Soc. Phila., 1899; Photo-Secession; Woodstock AA. **Exhibited:** Phila. Salon, 1898; S. Indp. A., 1918-20, 1926-30; Salons of Am., 1928, 1929; PAFA Ann., 1929; AIC, 1930-31. **Comments:** Her last name appears as Watson-Schütze and Schütze (or Schuetze). Greatly influenced by her early teacher Thomas Eakins (see entry), she took up photography as an art form, and opened her own studio in 1897. A split in the Photographic Soc. of Phila. led to the formation of the Photo-Secession with A. Stieglitz and other major art photographers of the time, including Watson-Schütze. In 1901 she married a professor of German at the Univ. of Chicago; and she and her husband became friends with a group of humanitarian idealists such as Jane Addams and John Dewey. In 1902 they built a house in Woodstock, NY, and she often spent six months out of the year there. A great majority of her photographic portraits are of people she liked and admired. Her few known paintings are much in the tradition of her teacher Eakins. **Sources:** William I. Homer, *Alfred Stieglitz and the Photo-Secession* (Boston, Little, Brown, and Co., 1983); *Woodstock's Art Heritage,* 142-143; Falk, *Exhibition Record Series.*

WATT, B(arbara) Hunter *[Painter, etcher, teacher, illustrator, writer, lecturer, designer]* 20th c.; b.Wellesley.
Addresses: Wellesley Hills, MA. **Studied:** Mass. Sch. Art; New Sch. Des., Boston; V. George; R. Andrew; E. Major; W.B. Hazelton; A.H. Munsel; J. De Camp; D.J. Connah. **Member:** Wellesley SA; Copley Soc., Boston. **Exhibited:** PAFA Ann., 1918. **Work:** murals, Twentieth Century Assn., Boston; Mass. Art Sch.; Wellesley (MA) Pub. Lib. **Comments:** Specialty: garden subjects. Contrib.: illustr./covers, *House Beautiful.* **Sources:** WW47; Falk, *Exh. Record Series.*

WATT, Francis S. See: WATTS, Francis S.

WATT, H. Parker *[Painter]* early 20th c.
Addresses: Chicago area. **Exhibited:** AIC, 1927-28. **Sources:** Falk, AIC.

WATT, William Clothier *[Painter, draftsman]* b.1869, Philadelphia, PA / d.1961, Carmel, CA.
Addresses: Carmel Highlands, CA. **Studied:** PAFA with R. Vonnah, T. Anshutz. **Member:** Phila. WCS; Phila. Sketch Club; Calif. WCS; Carmel AA. **Exhibited:** PAFA, 1889-1946; PAFA Ann., 1899, 1908-14, 1918, 1921; PPE, 1915 (silver medal); Int. WC Show, AIC, 1923-25, 1929; Calif. State Fair, 1930; Santa Cruz AL, 1936 (prize); GGE, 1939; Monterey Peninsula Mus., 1967 (solo), 1973 (solo). **Work:** Oakland Mus.; CPLH; de Young

Mus. **Sources:** WW40; Hughes, *Artists in California,* 592; Falk, *Exh. Record Series.*

WATT, William Godfrey *[Painter]* b.1885, NYC.
Addresses: Longmeadow, MA; Suffield, CT. **Studied:** W. Lester Stevens; Aldro T. Hibbard; Roger Wolcott; Harriet Loomis. **Member:** SC, 1903; Springfield AL; Deerfield Valley AA; Bridgeport AL; Am. Veterans SA; Rockport AA; North Shore AA. **Exhibited:** WMAA, 1918, 1920; Am. Veterans Soc. Art, 1940, 1945; Chicago, IL, 1945; San Francisco, CA, 1946; Springfield, MA; Hartford, CT; Westfield, MA; Burlington, VT; Gloucester, MA; AIC. Awards: prize, Bridgeport AA, 1945. **Sources:** WW59; WW47.

WATTAN See: SWEEZY, Carl

WATTERNS, Susan *[Painter]* early 20th c.
Addresses: Paris, France, c.1909. **Sources:** WW10.

WATTERS, William (Mrs.) See: PAGON, Katherine Dunn

WATTERWORTH, Mildred Ada Scott *[Painter, teacher]* b.1905, San Francisco, CA / d.1980, Marin County, CA.
Addresses: Marin County. **Studied:** Calif. School FA with R. Schaeffer; Jade Fon; Harlod Gretzner; Nat Levy; Herman Struck. **Member:** Soc. Western Artists (charter mem.); Marin WCS; Marin Soc. Artists. **Exhibited:** Soc. Western Artists, 1949-73; Marin County Art & Garden Center, 1956, 1966, 1968; Marin Soc. Artists, 1965; Lodi Grape Festival, 1967-73; Santa Rosa Statewide, 1970. **Sources:** Hughes, *Artists in California,* 592.

WATTLES, Andrew D. *[Portrait & landscape painter]* mid 19th c.
Addresses: Phila. from 1848-53. **Sources:** G&W; Phila. BD 1848-53; Rutledge, PA.

WATTLES, I. N. (Mrs.) *[Artist]* late 19th c.
Addresses: Active in Kalamazoo, MI. **Exhibited:** Michigan State Fair, 1885. **Sources:** Petteys, *Dictionary of Women Artists.*

WATTLES, J. Henry *[Portrait painter]* mid 19th c.
Addresses: Baltimore in 1842. **Comments:** Possibly the son of James L. Wattles (see entry). **Sources:** G&W; Baltimore CD 1842.

WATTLES, James L. *[Portrait painter]* mid 19th c.
Addresses: WIlmington, DE; Philadelphia in 1825; Baltimore from c.1829-54. **Work:** Maryland Hist. Soc. **Comments:** He is said to have been a rival of Alfred Jacob Miller (see entry) in Indian portraiture. He had a son who also was a portrait painter, possibly J. Henry Wattles (see entry). **Sources:** G&W; Pleasants, *250 Years of Painting in Maryland,* 49; Baltimore CD 1829-54 (Lafferty); Rutledge, PA.

WATTLES, W. *[Portrait painter]* mid 19th c.
Comments: Painter of a portrait (about 1821) of William Poultney Farquhar (1781-1831), owned by J. Harris Lippincott of Atlantic City (NJ). **Sources:** G&W; G&W has information courtesy WPA (N.J.), Hist. Records Survey.

WATTMAN, Myer *[Painter]* early 20th c.
Addresses: Phila., PA. **Exhibited:** PAFA Ann., 1933. **Sources:** Falk, *Exh. Record Series.*

WATTS, Alice Tetsell (Mrs.) *[Painter]* b.1876 / d.1973.
Addresses: Sterling, CO. **Studied:** self-taught; encouraged by Mabel Landrum Torrey. **Sources:** Petteys, *Dictionary of Women Artists.*

WATTS, Dorothy See: TROUT, (Elizabeth) Dorothy Burt

WATTS, Eva A. *[Painter]* b.1862, Chillocothe, MO.
Addresses: Active 1900, Boise, ID. **Sources:** Petteys, *Dictionary of Women Artists.*

WATTS, Francis S. *[Painter, illustrator]* b.1899, Scranton, PA.
Addresses: Wash., DC, active 1922-30. **Studied:** E.H. Nye; B. Baker. **Member:** Soc. Wash. Artists. **Exhibited:** Soc. Wash.

Artists; Wash. WCC; Landscape Club Wash. **Comments:** The name appears as Watts and Watt. **Sources:** McMahan, *Artists of Washington, DC* (as Watts); WW27 (as Watt).

WATTS, James W. *[Banknote, landscape & portrait engraver] d.1895, West Medford, MA.*
Addresses: Boston, 1848. **Comments:** Worked for the American Bank Note Company for many years. **Sources:** G&W; *Boston Transcript,* March 14, 1895, obit.; Boston BD 1848-60; Stauffer.

WATTS, Malcolm S(tuart) M(cNeal) *[Painter] b.1884 / d.1939, NYC.*
Addresses: NYC. **Exhibited:** S. Indp. A., 1930. **Sources:** Marlor, *Soc. Indp. Artists.*

WATTS, Melvin E. *[Museum curator] mid 20th c.*
Addresses: Manchester, NH. **Sources:** WW59.

WATTS, Robert M. *[Designer] b.1923, U.S.*
Addresses: Bangor, PA. **Studied:** Univ. Louisville (B.M.E., 1944); ASL, 1946-48; Columbia Univ. (A.M., 1951). **Member:** ASL (life mem.). **Exhibited:** New Media, New Forms II, Martha Jackson Gal., New York, 1960; Assemblage, 1961 & The Machine, 1968, MoMA; WMAA, 1964; Happening & Flexus, Kölnischer Kunstverein, Köln, Germany, 1971. Awards: Exp. Workshop Award, Carnegie Corp., 1964. **Work:** Mod. Museet, Stockholm; Houston Art Mus.; Albright-Knox Art Mus. Buffalo; Art Inst. Chicago. **Comments:** Preferred media: mixed media. Publications: co-author, "Newspaper," 1963; author, "Flexus, Assorted Events and Objects," 1964-72; author, "Postage Stamps, Fluxpost," 1965; contributor, "The Arts on Campus: The Necessity for Change," 1970; co-author, "Proposals for Art Education," 1970. Teaching: professor, film & mixed media, Rutgers Univ., New Brunswick, 1952-, university research council grant for film & mixed media, 1964-71; Carnegie Corp. visiting artists & consultant, Univ. Calif., Santa Cruz, 1968. **Sources:** WW73; Max Kosloff, "Pop Culture and the New Vulgarians," *Art Int.,* 1962; Brian O'Dougherty, "Art: Machines in Revolt," 1962; Grace Glueck, "If It's Art You Want.," 1967, *New York Times.*

WATTS, William C. See: **WATT, William Clothier**

WATTSON, A. Francis *[Painter] late 19th c.*
Addresses: NYC, 1898-99. **Exhibited:** NAD, 1898-99. **Sources:** WW98.

WAUD, Alfred R(udolph) *[Civil war and western illustrator, painter, photographer] b.1828, London, England / d.1891, Marietta, GA.*
Addresses: NYC, c.1858; Orange, NJ. **Studied:** School of Design, Somerset House, London; Royal Academy, London. **Exhibited:** NAD (not listed in Cowdrey, but apparently exhibited in 1858). **Work:** Chicago Hist. Soc.; Missouri Hist. Soc.; BMFA; Am. Heritage Publishing Co.; the largest collections of his work are at the Hist. New Orleans Collections (1,200 drawings) and the Lib. of Congress (1,150 drawings); his collection of approx. 1,200 vintage photographs of the Civil War by Brady, O'Sullivan, Gardner, et al. was sold privately in 1976 and distributed. **Comments:** One of the outstanding reportorial draughtsmen of the 19th century, he and his brother William (see entry) came to the United States about 1858. Alfred almost immediately became a staff artist for *Harper's Weekly* (1862-90). During the Civil War, Waud was "armed to the teeth, yet clad in the shooting jacket of a civilian," as he covered numerous battles. His "on the spot" illustrations also appeared in the *New York Illustrated News* (1860-62). In 1865, he was acclaimed by Harper's as the most important artist-correspondent of the Civil War (with T.R. Davis second). Beginning in 1866, he spent several years touring the post-bellum South and the West for *Harper's,* documenting reconstruction in the South and recording Indians and pioneer life as far west as the Rockies. He also contributed many illustrations to Bryant's *Picturesque America* (1872) and *Beyond the Mississippi* (1867). Harper's published his illustrations of the Dakota territory in 1880-81. After 1882, his activity was curtailed by ill health. His

son-in-law was Milton Burns (see entry). **Sources:** G&W; Taft, *Artists and Illustrators of the Old West,* 58-62; *Album of American Battle Art,* 166-67, and 16 repros; *Encyclopaedia of New Orleans Artists,* 403-404; P&H Samuels, 513-14. The most complete biography is Frederik E. Ray's *Alfred R. Waud: Civil War Artist* (Viking, 1974).

WAUD, William *[Civil war illustrator, architect, writer] b.c.1830, London, England / d.1878, Jersey City , NJ.*
Work: LOC; Hist. New Orleans Coll. **Comments:** Trained as an architect, he assisted Sir Joseph Paxton in the designing of the London Crystal Palace about 1851. He probably came to the United States with his brother, Alfred (see entry), about 1858 and was employed as an illustrator during the Civil War. His works appeared in *Frank Leslie's Illustrated Weekly* and *Harper's Weekly,* and his most notable series was his documentation of Admiral Farragut's 1862 siege of New Orleans. **Sources:** G&W; Taft, *Artists and Illustrators of the Old West,* 296; *Harper's Weekly,* Nov. 30, 1878; Rutledge, *Artists in the Life of Charleston.*; *Encyclopaedia of New Orleans Artists,* 404; P&H Samuels, estimate that he was born before 1828 (p. 514); more recently, see Frederik E. Ray, *Alfred R. Waud: Civil War Artist* (Viking, 1974).

WAUGH, Alfred S. *[Portrait sculptor, portrait & miniature painter, profilist, writer & lecturer] b.c.1810, Ireland / d.1856, St. Louis, MO.*
Comments: Waugh studied modelling in Dublin in 1827, then went on a tour of the Continent. In 1838 he modeled several busts at Raleigh (NC). He was in Alabama by July 1842, at Pensacola (FL) in the summer of 1843, and at Mobile (AL) in 1844. There he joined forces with John B. Tisdale (see entry), a young artist just beginning his career, and together they went to Missouri in 1845 and worked principally at Jefferson City, Independence, and Lexington for about a year. In 1846 Waugh made a trip to Santa Fe (NM), after which he painted portraits and miniatures in Boonville (MO) for a year. He moved to St. Louis in 1848 and there spent the rest of his life. During his eight years in St. Louis, Waugh turned out a number of busts and portraits, wrote several articles on the fine arts for the *Western Journal* and lectured on the same subject, and wrote an autobiography entitled *Travels in Search of the Elephant,* of which only the first part survives in manuscript. **Sources:** G&W; McDermott, ed., *Travels in Search of the Elephant: The Wanderings of Alfred S. Waugh, Artist, in Louisiana, Missouri, and Santa Fe, in 1845-1846.*

WAUGH, Alice Helen *[Teacher, painter]; b.St. Louis, MO.*
Addresses: Ames, IA. **Studied:** PAFA; Univ. Missouri; NY Sch. Fine & Applied Art; Paris; Ralph Helm Johonnot, Adrian Dornbush and Biloul. **Member:** Delta Phi Delta. **Exhibited:** Iowa Art Salon, 1932 (third prize); Great Hall, Iowa State College; Joslyn Mem., Omaha; Iowa Artists Exh., Mt. Vernon; Carson Pirie Scott, Chicago. **Work:** Home Economics Hall, Iowa State College. **Comments:** Teaching: Iowa State Teachers College; Iowa State College. Auth.: "Planning the Little House." **Sources:** Ness & Orwig, *Iowa Artists of the First Hundred Years,* 216.

WAUGH, Amy *[Painter] late 19th c.*
Addresses: Phila., PA, 1886. **Exhibited:** PAFA Ann., 1885 (still life); NAD, 1886. **Sources:** Falk, *Exh. Record Series.*

WAUGH, Coulton *[Painter, cartoonist, writer, lithographer, engraver, illustrator] b.1896, Cornwall, England / d.1973.*
Addresses: Newburgh, NY; Provincetown, MA. **Studied:** with his father, F. J. Waugh; ASL with Geo. Bridgman, F. V. DuMond, D. Volk. **Member:** Am. Artists Congress; Provincetown, AA. **Exhibited:** WMAA; NAD; PAFA Ann., 1930; AIC; CI, 1939, 1943, 1944, 1946; GGE, 1939; Provincetown AA, 1925-43; Hudson Walker Gal., NY, 1938 (solo); Lotte Jacobi Gal., NYC, 1955 (solo); Grand Central Art Gals., NYC, 1962, 1968, 1971; Cooperstown AA, 1964. Commissions: eight murals (with F.J. Waugh) for lobby, First Nat. Bank, Provincetown, 1931. **Work:** NY Board Educ.; Nat. Bank, Providence, RI; Peabody

Mus., Salem, MA; Mem. Hall, Plymouth, MA; Nat. Geo. Soc.; Syracuse Univ.; Univ. Wichita (KS); Cooperstown AA; Toledo Mus. Art; Mus. Art, Davenport, IA. Also, his work can be found in 321 libraries; the largest collection of his paintings is at the Edwin A. Ulrich Mus., Hyde Park, NY. **Comments:** He preferred the palette knife technique of painting. Illustr.: *Yachting, Fortune; American Sketch,* and *Harpers.* Auth.: *The Comics* (Macmillan, 1947); "Painting with Fire," *Amer. Artists Magazine* (Nov. 1962); "Techiques of Old Masters," *Amer. Artists Magazine* (April, 1964); "Keep out of the Mud," *Am. Artists Magazine* (Summer 1969); *How to Paint with a Knife* (Watson-Guptil, 1971). **Sources:** WW47; Falk, *Exh. Record Series.*

WAUGH, Eliza Young See: **WAUGH, Mary Eliza Young (Mrs. Sam)**

WAUGH, Frank A. (Dr.) *[Landscape architect] 20th c.* **Studied:** Chas. H. Woodbury. **Comments:** Teaching: Mass. State College, Amherst (now Univ. Massachusetts) Developed landscape architecture curriculum. The "Black Book" described Waugh as one of Woodbury's most important students. **Sources:** *Charles Woodbury and His Students.*

WAUGH, Frederick J(udd) *[Marine painter, illustrator] b.1861, Bordentown, NJ / d.1940, Provincetown, MA.*
Addresses: Paris, France, 1884; Phila., PA, 1886, 1891; Kent, CT, 1915-/Provincetown, MA, 1927-. **Studied:** with his father; PAFA with Thomas Eakins; Académie Julian, Paris with Bouguereau and T. Robert-Fleury, 1888-89 (earlier sources cite 1882-83, but Feher's later dates appear more plausible). **Member:** Royal Acad., Bristol, England; ANA, 1909; NA, 1911; SC, 1908; Lotos Club; NAC; CAFA; fellow, PAFA; Boston AC; Wash. AC; North Shore AA, 1924; AFA. **Exhibited:** PAFA Ann., 1881-97, 1906-40; NAD, 1884, 1886, 1891, 1910 (prize), 1929 (prize), 1935 (prize); Royal Acad. London, 1899-06; Corcoran Gal. biennials, 1908-39 (14 times); Buenos Aires Expo.,1910 (gold); Boston AC, (prize); AIC, 1912 (medal); CAFA, 1915 (prize); Pan-Pacific Expo, 1915 (medal); S. Indp. A., 1917; Phila. AC, 1924 (gold); CI, 1934-38 (prize); Buck Hill Falls AA, 1935 (prize). **Work:** MMA; AIC; TMA; NGA; Brooklyn Inst. Mus.; Montclair (N.J.) AM; PAFA; Butler AI; Bristol (England) Acad.; Walker Art Gal., Liverpool; Durban Art Gal., South Africa; Dallas AA; Austin AL; CAM, St. Louis; Currier Gal., Manchester, NH; the largest collection of his paintings is at the Edwin A. Ulrich Mus., Hyde Park, NY. **Comments:** Best known for his paintings of crashing surf on rocky shores, he wrote instruction books on how to paint the sea, such as *Painting by the Sea* and *Seascape Painting, Step by Step;* also, *Landscape Painting with a Knife.* Waugh once said it was his return voyage from Paris across the Atlantic that inspired him to become a marine painter. He painted along the New England coast, spending much time in Provincetown and also visiting other places such as Monhegan Island, ME. He was the son of Samuel Bell Waugh, portrait painter; and father of Coulton Waugh (see entries). Auth./illustr.: *The Clan of the Munes.* Early in his career he was illustrator for *London Graphic* and *London Daily Mail.* **Sources:** WW40; Curtis, Curtis, and Lieberman, 112, 187; Fink, *American Art at the Nineteenth-Century Paris Salons,* 403; Falk, *Exh. Record Series;* info. courtesy North Shore AA.

WAUGH, Henry W. *[Landscape, panorama & scenery painter] b.1835 / d.1865, England.*
Addresses: Indianapolis, IN, 1853-60; Rome, Italy, 1860-65. **Studied:** Rome, 1860-65. **Exhibited:** PAFA, 1862. **Comments:** Nephew of the panoramist Samuel B. Waugh (see entry). He arrived in Indianapolis, age 18 or 20, as a member of a theatrical troupe. During the winter of 1853-54 he assisted Jacob Cox of Indianapolis in painting a 30-scene temperance panorama. While in Indianapolis Waugh also did scene and banner painting and exhibited some landscapes. In order to earn money for study abroad, he became a circus clown under the name of "Dilly Fay." Eventually, he went to Rome for six years, but died of consumption in England on his way home. He was still at Rome when he exhibited at the Pennsylvania Academy. **Sources:** G&W; Burnet,

Art and Artists of Indiana, 93-97; Peat, *Pioneer Painters of Indiana,* 156-57; Rutledge, PA; *Encyclopaedia of New Orleans Artists,* 404.

WAUGH, Ida *[Painter, illustrator, chromolithographer, sculptor] b.Phila. / d.1919.*
Addresses: NYC; Montclair, NJ; Phila., active 1869 and after; Bailey Island, ME; Paris, France, 1892. **Studied:** her father, Sam B. Waugh; PAFA (1869); Académie Julian, Paris with Lefebvre, Académie Julian, Paris with Constant and Lefebvre, 1888; also with Callot and Delance in Paris. **Member:** PAFA (assoc. mem., 1869). **Exhibited:** PAFA Ann., 1863-1905, portraits, history paintings and allegories; Phila. Cent. Expo., 1876; NAD, 1880-96 (prize, 1896); Paris Salon, 1889, 1892; Boston AC, 1892. **Work:** College of Physicians, Phila. & Univ. Penn. Mus.(portraits); PAFA; Edwin A. Ulrich Mus., Hyde Park, NY. **Comments:** She was the daughter of Samuel Waugh (see entry) and Eliza Young Waugh (see entry) and sister of Frederick. Along with Mary Cassatt and Cecilia Beaux, she was selected for the Gallery of Honor in the Woman's Building at the World's Columbian Exposition in 1893. She was a painter of religious and allegorical subjects, a few landscapes and genre; and an illustrator of children's books. **Sources:** Fink, *American Art at the Nineteenth-Century Paris Salons,* 403; WW17; Falk, *Exh. Record Series.*

WAUGH, Mary Eliza Young (Mrs. Sam) *[Miniaturist] mid 19th c.*
Comments: Wife of Samuel B. Waugh, mother of Frederick Judd Waugh and Ida Waugh (see entries for each). **Sources:** G&W; Fielding; Neuhaus, *History and Ideals of American Art,* 300.

WAUGH, Samuel Bell *[Portrait and landscape painter] b.1814, Mercer, PA / d.1885, Janesville, WI.*
Addresses: Philadelphia after 1841, also in 1864, 1879; NYC 1844-45; Bordentown, NJ, 1853. **Studied:** J.R. Smith in Phila.; studying in France, England, and Italy, c.1833-41. **Member:** ANA, 1845 (hon. mem., 1847). **Exhibited:** PAFA Ann., 1842-69, 1876-85, 1905 (posthumously); an Italian panorama, in Phila., 1849-55; and another, "Italia," 1854-58; NAD, 1864, 1879. **Work:** NPG; Edwin A. Ulrich Mus., Hyde Park, NY; Am. Philo. Soc., Phila.; Univ. Pennsylvania. **Comments:** A well-known portrait painter (portraits of Lincoln and Grant) he was also highly regarded for his panoramas of Italy. Other artists in his family included his wife, Mary Eliza Young Waugh, their son, Frederick Judd Waugh, their daughter Ida Waugh, and a nephew, Henry W. Waugh (see entries). **Sources:** G&W; Smith; Graves, *Dictionary;* Rutledge, PA; Falk, PA, vol. II; Cowdrey, NAD; Cowdrey, AA & AAU; Clark, *History of the NAD,* 273; Phila. CD 1846-53; Swan, BA; Washington AA Cat., 1857, 1859; Phila. *Public Ledger,* Oct. 2, 1849, Sept. 12, 1854, Baltimore *Sun,* March 28, 1855, and New Orleans *Daily Picayune,* March 6, 1858 (G&W has info courtesy J. Earl Arrington); *Art Annual,* XVI, obit.; *American Collector* (May 1941), 10, repro.; *300 Years of American Art,* vol. 1, 162.

WAUGH, Sidney Biehler *[Sculptor, designer, teacher, writer] b.1904, Amherst, MA / d.1963.*
Addresses: New York 17, NY. **Studied:** Amherst College; MIT, 1920-23; Rome, 1924; École des Beaux-Arts, Paris with H. Bouchard, 1925-28; Am. Acad. in Rome, 1929-32; Amherst College (1938, hon. deg., M.A.); Univ. Massachusetts (1953, D.F.A.). **Member:** NSS (pres., 1948-50); ANA, 1936; NA, 1938; NAD (vice-pres., 1952-54); NIAL; NYC Arts Comm.; Century Assn.; NAC (hon. life mem.). **Exhibited:** PAFA Ann., 1934-47 (6 times). **Awards:** medal, Paris Salon, 1928, 1929; Saltus award, Am. Numismatic Soc., 1954; Prix de Rome, 1929; Croix de Guerre, French Govt. (2); Bronze Star; Knight of the Crown of Italy. **Work:** MMA; Victoria & Albert Mus., London; CMA; Toledo Mus. Art; AIC; John Herron AI; monument, Richmond, TX; Pulaski monument, Phila., PA; sculptures, Corning Bldg., NY; Smith College; Buhl Planetarium, Pittsburgh; Fed. Trade Comn. Bldg., Wash., DC; Dept. Justice Bldg., Wash., DC; Mead Art Bldg., Amherst College; Bethlehem Steel Co. Main Office

Bldg., Fed. Courts Bldg., Wash., DC; Mellon Mem. fountain, Wash., DC; Bank of the Manhattan Co., NY; Battle Mon., Florence, Italy; port. statues, Johns Hopkins Univ.; USPO Bldg., Wash., DC; Nat. Archives Bldg., Wash., DC; medals by Waugh: Pres. of Chile; Parsons Sch. Des.; Atoms for Peace award; Am. Inst. Arch.; Squibb Centennial. Work in the collections of prominent national and international figures. **Comments:** Auth.: "The Art of Glassmaking," 1938. Teaching: Rinehart Sch. Sculpture, Balt. WPA artist. **Sources:** WW59; WW47; P&H Samuels, 514; Falk, *Exh. Record Series.*

WAUGH, William *[Listed as "artist"] b.c.1820, Phila., PA.*
Addresses: Philadelphia in 1850. **Comments:** With his wife Mary and daughter Fanny in 1850. **Sources:** G&W; 7 Census (1850), Pa., LI, 123; not listed in Phila. CD 1848-54.

WAVPOTICH, F. Rado *[Painter] early 20th c.*
Addresses: Astoria, LI, NY. **Exhibited:** S. Indp. A., 1929.
Sources: Marlor, *Soc. Indp. Artists.*

WAXMAN, Bashka See: **PAEFF, Bashka (Mrs. Samuel Waxman)**

WAXMAN, Frances See: **SHEAFER, Frances B(urwell) (Mrs. Samuel Waxman)**

WAY, Agnes C. *[Painter] late 19th c.*
Addresses: Pittsburgh, PA, 1878. **Exhibited:** PAFA Ann., 1877-78, 1880; NAD, 1878. **Sources:** Falk, *Exh. Record Series.*

WAY, Andrew John Henry *[Still life, portrait & landscape painter] b.1826, Washington, DC / d.1888, Baltimore, MD.* *A.J.H.Way.*
Addresses: Baltimore, c.1858-on. **Studied:** John P. Frankenstein, c.1847 ; Baltimore with Alfred J. Miller in the late 1840s; atelier of Michel-Martin Drolling, Paris, 1850; Acad. Fine Arts, Florence, 1851. **Exhibited:** Wash. AA, 1858; NAD, 1861-85; Brooklyn AA; Royal Acad., London; Centennial Expo, Phila., PA, 1876 (medals); PAFA Ann., 1877-84, 1887; Carnegie-Mellon Univ., 1984. **Work:** Peabody Inst., Baltimore; Shelburne (VT) Mus. **Comments:** At first a portrait painter, he later became well known as a painter of still life, especially grapes and oysters. His son, George Brevitt Way (see entry), also was a painter. **Sources:** G&W; CAB; Pleasants, *250 Years of Painting in Maryland*, 60-61; Baltimore CD 1858-60+; 8 Census (1860), Md., VII, 584; Rutledge, MHS; Washington Art Assoc. Cat., 1857; *Gazette des Beaux Arts* (May 1946), 316, repro.; McMahan, *Artists of Washington, DC*; Muller, *Paintings and Drawings at the Shelburne Museum*, 136 (w/repro.); *For Beauty and for Truth*, 90 (w/repro.); Falk, *Exh. Record Series.*

WAY, Annie Leota *[Painter] late 19th c.*
Exhibited: Columbian Expo, Chicago, 1893. **Sources:** Petteys, *Dictionary of Women Artists.*

WAY, C. Granville *[Painter] b.1841 / d.1912.*
Addresses: Boston, MA. **Member:** Boston AC. **Exhibited:** Boston AC, 1873, 1877. **Sources:** WW13.

WAY, C. J. *[Artist] mid 19th c.*
Addresses: Montreal. **Exhibited:** NAD, 1863. **Sources:** Naylor, *NAD.*

WAY, Edna (Martha) *[Painter, educator, designer, teacher, lecturer] b.1897, Manchester, VT.*
Addresses: Athens, OH. **Studied:** Teachers College, Columbia Univ. (B.S.; M.A.); C. Martin; NY Sch. Fine & Applied Art, Paris. **Member:** Tri-State Creative Artists; AEA; Ohio WCS; Columbus Art Lg.; Studio Guild; NAWA. **Exhibited:** NAWA, 1937-46; PAFA, 1936-38, 1941-44; AWCS, 1936-39; Studio Gld., 1938-40; Southern Vermont Artists; Ohio WCS; Columbus Art Lg.; Springfield Art Lg.; Butler AI; CM; Huntington (WV) Gal., 1957 and prior. Awards: prizes, Stockbridge, MA, 1934; NAWA, 1936, 1944; Columbus Art Lg., 1939, 1943, 1946, 1955; Wash. WC, 1945, 1946; Ohio WCC, 1952. **Work:** AGAA; Fleming Mus. Art, Burlington, VT. **Comments:** Teaching: Ohio Univ., Athens, OH, 1926-. Lectures: art in everyday life. **Sources:** WW59; WW47.

WAY, F. L. (Miss) *[Painter] late 19th c.*
Addresses: Brooklyn, NY, 1880. **Exhibited:** NAD, 1880.
Comments: May be artist Frances L. Way. **Sources:** Naylor, *NAD.*

WAY, Frances L. *[Painter] late 19th c.*
Exhibited: Boston AC, 1890. **Comments:** Active 1890. May be artist Miss F.L. Way. **Sources:** *The Boston AC.*

WAY, George Brevitt *[Landscape painter] b.1854, Baltimore.*
Addresses: Baltimore, MD, 1877-81. **Studied:** Paris. **Exhibited:** PAFA Ann., 1877, 1880-82; NAD, 1877-81. **Sources:** WW04; Falk, *Exh. Record Series.*

WAY, Jeffery *[Painter] b.1942.*
Addresses: NYC. **Exhibited:** WMAA, 1973. **Sources:** Falk, *WMAA.*

WAY, Laura *[Artist, art teacher] early 20th c.*
Addresses: Colorado Springs, CO, 1913-17. **Sources:** Petteys, *Dictionary of Women Artists.*

WAY, Mary (Miss) *[Miniature painter, drawing mistress] early 19th c.*
Addresses: New London, CT; NYC from 1811-19. **Exhibited:** Am. Acad., 1818. **Sources:** G&W; Kelby, *Notes on American Artists*, 50-51; NYCD 1814-19 (McKay); Cowdrey, AA & AAU.

WAY, William *[Listed as "artist"] mid 19th c.*
Addresses: Baltimore, 1859. **Sources:** G&W; Baltimore BD 1859.

WAYBRIGHT, Marianna *[Painter] early 20th c.*
Addresses: Dayton, OH. **Sources:** WW10.

WAYCOTT, Hedley William *[Painter, craftsperson] b.1865, Corsham, Wiltshire, England / d.1938, Peoria, IL.*
Addresses: Peoria, IL. **Member:** All-Illinois SFA; Peoria Al. **Exhibited:** S. Indp. A., 1928, 1931. **Work:** Bradley Polytechnic Inst.; school & public library, both in Peoria. **Sources:** WW38.

WAYLAND, Adele Caillaud *[Sculptor, painter, craftsperson] b.1899, Oakland, CA / d.1979, Honolulu, HI.*
Addresses: San Francisco, CA. **Studied:** San Jose State Univ. (teaching); Calif. School FA. **Exhibited:** GGE, 1939. **Comments:** Specialty: terra cotta busts; Dresden bowls; painted ceramic tile. **Sources:** Hughes, *Artists in California*, 592.

WAYLAND, Peter *[Sculptor] early 20th c.*
Addresses: Chicago area; Phila., PA, 1932. **Exhibited:** AIC, 1931; PAFA Ann., 1932. **Sources:** Falk, *Exh. Record Series.*

WAYMAN, Nelson P. *[Painter] early 20th c.*
Addresses: Pittsburgh, PA. **Member:** Pittsburgh AA. **Sources:** WW21.

WAYNE, Hattie N. *[Painter]*
Addresses: Phila. **Work:** Penn. Hist. Soc. (portrait of Winfield Scott). **Sources:** Petteys, *Dictionary of Women Artists.*

WAYNE, June *[Painter, lithographer, tapestry maker, jewelry designer, speaker, writer] b.1918, Chicago, IL.*
Addresses: NYC; Los Angeles, CA, permanently in 1946. **Studied:** self-taught as an artist; Calif. Inst. Tech., Pasadena (technical drawing); Lynton Kistler's workshops on fine printing; Paris in 1957 with Marcel Durassier. **Member:** NAWA; SAGA; Phila. Print Club; Los Angeles AA; Soc. Wash. PM. **Exhibited:** Chicago, 1935 (first solo at age 17); Palacio de Bellas Artes, Mexico City, 1936; PAFA Ann., 1951; Oversize Prints, WMAA, 1955, 1971; Bienal Am. Artes Graficas, Colombia, 1971; Biennale Epinal Int. Estampes, France, 1971 & 1973 (Prix du Biennale); Concert of Tapestry, Gallery Demeure, Paris, 1972; Peter Plone Associates, Los Angeles, CA; Golden Eagle, Cine, Academy Award nomination in 1974. **Work:** Bibliothèque Nat., France; Bibliothèque Royale Bruxelles; MoMA; AIC; Nat. Coll. Fine Art, Smithsonian Inst., Wash., DC; Rosenwald Coll., Alverthorpe Gallery, Jenkintown, PA; LOC; Achenbach Found. Graphic Arts; Univ. Southern Calif. **Comments:** WPA artist. Wayne designed jewelry in New York City, did production illustration in Los

Angeles, radio script writing in Chicago, and was a lobbyist for the Artists' Union in Washington, DC. **Positions:** dir./founder, Tamarind Lithography Workshop; advisor, Tamarind Inst., Univ. New Mexico, 1960-; mem. bd. dir., Grunwald Graphic Arts Found., Univ. Calif., Los Angeles, 1965-; mem. exec. comt. & advisor to Chancellor, Arts Management Program, Graduate School Admin., 1969-; mem. overseers comt., School Visual & Environmental Arts, Harvard Univ., 1971-. **Sources:** WW73; Baskett (author), "The Art of June Wayne," Abrams, 1968; Pisano, *One Hundred Years.the National Association of Women Artists,* 84; "Modernism in California Printmaking," Nov. 1998, The Annex Galleries; Falk, *Exh. Record Series.*

WAYNICK, Lynne Carlyle (Black Eagle) *[Painter] b.1891, Sargent, NE / d.1967, Lacey, WA.*
Addresses: Burton, WA, 1941. **Studied:** mainly self-taught. **Comments:** Specialty: Northwest Native Americans. Adopted member of the Swinomish Tribe. **Sources:** Trip and Cook, *Washington State Art and Artists,* 1850-1950.

WAYSON, Charles A. *[Engraver] b.1885.*
Addresses: Wash., DC, active 1925-47. **Comments:** Position: staff, Bureau of Engraving and Printing. **Sources:** McMahan, *Artists of Washington, DC.*

WEADELL, (Miss) *[Illustrator] 19th c.*
Addresses: Chicago, IL. **Comments:** Illustrator: *Four O'Clock.* **Sources:** WW98.

WEARING, Dorothy Compton *[Painter] b.1917, Edgewater, AL.*
Addresses: Chicago 14, IL. **Studied:** Birmingham Southern College; Univ. Calif., Los Angeles. **Exhibited:** AIC, 1941, 1942; SSAL, 1938; San Antonio, TX, 1939. **Sources:** WW53; WW47.

WEARSTLER, Albert M. *[Painter, critic, writer] b.1893, Marlboro, OH / d.1955.*
Addresses: Youngstown, OH; Greenwood, VA. **Studied:** Cincinnati Art Acad. **Member:** Ohio WCS; Buckeye Art Club, Youngstown, OH; Albemarle AA; Phila. WCC. **Exhibited:** AWCS, 1944-51; Ohio WCS, 1938-50; Massillon, OH, 1941-46; Butler AI, 1936-38, 1940-42, 1944-45, 1948-51; Ohio Valley Artists, 1944-46; Portland, ME, 1942, 1946; Parkersburg (WV) AC, 1941-46; VMFA, 1949-51; Norfolk MA & Sciences, 1949-52; Univ. Virginia, 1948-52; Phila. WCC, 1951; Balt. WCC, 1950; Audubon Artists, 1951. **Work:** Butler AI. **Comments:** Position: art critic, *Youngstown Vindicator,* 1942-45; secretary, board of trustees, Butler AI, 1943-. **Sources:** WW53; WW47.

WEATHERBY, Evelyn Mae (Mrs.) *[Painter, etcher, lithographer, block printer, teacher] b.1897, NYC.*
Addresses: Jacksonville, FL. **Studied:** Cooper Union; ASL; K. Kappes; I. Abramofsky. **Member:** NAWPS; Ohio WCS; Toledo Women's AL; Toledo Soc. Indep. Artists; SSAL. **Exhibited:** TMA, 1937 (prize); Florida Fed. Art, 1939 (prize). **Comments:** Position: art instructor, Civic AI, Jacksonville. **Sources:** WW40.

WEATHERLY, Newton *[Painter] 20th c.*
Addresses: Geneva, NY. **Sources:** WW25.

WEATHERWAX, Ben K. *[Painter, wood carver] b.1909, Aberdeen, WA.*
Addresses: Aberdeen, WA. **Studied:** Univ. Oregon; with Lance Hart; in Chicago; with Robert Lahr, Leon Derbyshire. **Exhibited:** Wash. State Univ., 1929; Aberdeen, WA, 1930 (solo). **Sources:** Trip and Cook, *Washington State Art and Artists.*

WEATHERWAX, G. (Mrs.) *[Painter] 19th/20th c.*
Addresses: Yakima County, WA, 1909. **Exhibited:** Alaska Yukon Pacific Expo, 1909. **Sources:** Trip and Cook, *Washington State Art and Artists.*

WEAVER *[Portrait painter in oils on tin] 18th/19th c.; b.England?.*
Addresses: NYC about 1797. **Comments:** Painted a portrait of Alexander Hamilton; probably English (Dunlap). This was probably the Joseph Weaver, painter and japanner, who painted allegori-

cal decorations on a musical clock exhibited at Baker's New Museum in NYC in 1794 (Gottesman). Later references to apparently the same artist include: I. Weaver, miniaturist, at NYC in 1796 (NYCD); John Weaver, portrait painter on tin and wood, at Halifax (NS) in 1797-98 (Piers); William J. Weaver, portrait painter, at Charleston (SC) in 1806 when he advertised his portrait of Hamilton (Rutledge); W.J. Weaver, portrait painter on tin, who planned a professional visit to Salem (MA) in 1809 (Belknap); and P.T. Weaver, whom Fielding identified as the Weaver mentioned by Dunlap. Engravings after William J. Weaver's portraits of Dr. George Buist of Charleston and Dr. S. L. Mitchill of NYC were mentioned in Charleston in 1808-11 and 1823, respectively. **Sources:** G&W; Dunlap, *History,* II, 64; NYCD 1794; Gottesman, *Arts and Crafts in New York,* II, no. 1302; NYCD 1796 (McKay); Piers, *Robert Field,* 144; Rutledge, *Artists in the Life of Charleston,* 128, 224, 238; Belknap, *Artists and Craftsmen of Essex County,* 14; Fielding.

WEAVER, Ann Vaughan *[Sculptor, teacher] mid 20th c.; b.Selma, AL.*
Addresses: West Palm Beach, FL. **Studied:** NAD; ASL; CUA School; C. Keck; L. Kroll; J. Hovannes. **Exhibited:** MoMA, 1930; NSS, 1940-41; Seligmann Gal., NY, 1934; Clay Club, NY, 1939; Soc. Four Arts, Palm Beach, 1943-44 (prize), 1945 (prize); Norton Gal., 1943-45 (prizes), 1946; PAFA Ann., 1950. **Sources:** WW47; Falk, *Exh. Record Series.*

WEAVER, B. Maie *[Portrait painter, teacher] b.1875, New Hartford, CT.*
Addresses: New Hartford, CT; Holyoke. **Studied:** Mass. Sch. Art; Julian Acad., Grande Chaumière, Paris; & with Ross Turner, George Académie Julian, Paris with Mme. Laforge; also with Collin and M. Simone in Paris. **Member:** Springfield AL; Holyoke AL; NY Keramic Club. **Exhibited:** St. Petersburg, FL; Springfield (MA) MA; Sarasota, Fla.; Paris Salon; Soc. Indep. Artists Awards: prizes, Julian Acad., Paris. **Work:** State Lib., Hartford, CT. **Sources:** WW53; WW47.

WEAVER, Beulah Barnes *[Painter, sculptor, teacher] b.c.1882, Wash., DC / d.1957, Wash., DC.*
Addresses: Wash., DC. **Studied:** ASL; Corcoran Sch. Art; & with Peppino Mangravite, Karl Knaths. **Member:** Soc. Wash. Artists; Twenty Women Painters Wash. **Exhibited:** PMG; Anderson Gal., NY; Richmond, Va.; CGA (prize); NGA; Wash. Woman's Cl.(prize); Salons of Am., 1925, 1927-30; Corcoran Gal biennials, 1930, 1932; Indep. Artists Exh., Wash. DC, 1935 (purchase award); Soc. Wash. Artists, 1935 (prize), 1948 (prize). **Work:** PMG. **Comments:** Position: director/teacher, Madeira Sch., Greenway, VA, 1947; director/art teacher, Madeira Sch., Greenway, VA, 1953. **Sources:** WW53; WW47; more recently, see McMahan, *Artists of Washington, DC;* Petteys, *Dictionary of Women Artists,* cites alternate birth dates of 1880, 1882 & 1886.

WEAVER, C. *[Artist] late 19th c.*
Exhibited: NAD, 1883. **Sources:** Naylor, *NAD.*

WEAVER, Clara See: **PARRISH, Clara Weaver (Mrs. Wm. P.)**

WEAVER, (Claude) Lamar *[Painter] b.1918, Atlanta, GA.*
Studied: Morehouse College, with Hale Woodruff. **Exhibited:** Atlanta Univ., 1938-39, 1942-43; Dillard Univ., 1938; American Negro Expo., Chicago, 1940. **Sources:** Cederholm, *Afro-American Artists.*

WEAVER, Emma M(atern) (Mrs.) *[Painter, teacher] b.1862, Sandusky, OH.*
Addresses: Greencastle, IN. **Studied:** Cincinnati AA; ASL; Güssow, in Berlin; Paris. **Comments:** Floral still life painter and instructor at the art school of DePauw Univ., 1895; traveled in Holland. **Sources:** WW13; Gerdts, *Art Across America,* vol. 2: 279.

WEAVER, Florence M. *[Painter, decorator] b.1879, Iowa Falls, IA.*
Addresses: Des Moines 14, IA. **Studied:** Art Acad., Munich,

Germany; AIC; Snell, *Old Mexico,* 1934; with Eliot O'Hara, 1938. **Member:** Iowa Artists Club. **Exhibited:** Younker Bros. Tea Room Galleries, 1934; O'Hara Gal., Goose Rocks Beach, ME, 1938; Iowa Artists Club, 1934, 1935; Murhpy Calendar Co., Red Oak, IA (William Cochrane prize), purchase prize. **Sources:** WW53; WW47; Ness & Orwig, *Iowa Artists of the First Hundred Years,* 216.

WEAVER, George M. *[Panoramist] mid 19th c.*
Comments: Painter of a panorama of the overland route to California from sketches made by himself. By 1858 he had added the Isthmus of Panama route and eighty California scenes. **Sources:** G&W; MacMinn, *The Theater of the Golden Era in California,* 226 (courtesy J. Earl Arrington).

WEAVER, Grover O(pdycke) *[Painter] mid 20th c.;*
b.Montpelier, OH.
Addresses: Paris, France. **Studied:** AIC; Guerin; Colarossi, in Paris; Delecluse Acad., Paris. **Member:** Paris AAA. **Sources:** WW27.

WEAVER, Harold Buck *[Painter] b.1889, England / d.1961, Los Angeles, CA.*
Addresses: Los Angeles, CA. **Studied:** Maynard Dixon; with Edgar Payne. **Exhibited:** LACMA, 1921; San Diego FA Gallery, 1927; P&S Los Angeles, 1928. **Work:** Sports Palace, Phoenix, AZ (mural). **Comments:** He worked as a picture framer and painted Southwestern landscapes. **Sources:** Hughes, *Artists in California,* 593.

WEAVER, Henry G. (Mr. & Mrs.) *[Collectors] mid 20th c.*
Addresses: Grosse Pointe Farms, MI. **Sources:** WW66.

WEAVER, Howard Sayre *[Educator] mid 20th c.*
Addresses: New Haven, CT. **Comments:** Teaching: dean, Yale Univ. School Art, 1968-. **Sources:** WW73.

WEAVER, Inez Belva H. (Mrs. H. H.) *[Painter, lecturer, teacher] b.1872, Marshall County, IA.*
Addresses: Stromsburg, NE. **Studied:** E. Hornburger; L. W. Johnson in Harvard, NE. **Member:** Central Nebraska Artists Gld. **Exhibited:** Iowa State Fair, Des Moines, 1887 (prize); Nebraska State Fair, Lincoln, 1923 (prize); Alliance, NE, 1930. **Comments:** Positions: painter & designer, Memorial Works, Hamilton, MO; art teacher, Nebraska. **Sources:** WW33; Petteys, *Dictionary of Women Artists.*

WEAVER, Jack *[Sculptor] mid 20th c.*
Addresses: Chicago area. **Exhibited:** AIC, 1947. **Sources:** Falk, *AIC.*

WEAVER, Jay *[Painter] d.c.1960.*
Addresses: NYC. **Member:** AWCS. **Exhibited:** Soc. Indep. Artists, 1939. **Sources:** WW47.

WEAVER, John Barney *[Sculptor] b.1920, Anaconda, MT.*
Addresses: Edmonton, Alberta. **Studied:** AIC, Albert Kuppenheimer scholarship, 1941, diploma; also monumental sculpture with Albin Polasek. **Member:** NSS. **Exhibited:** Chicago & Vicinity, AIC, 1947; 1st Exhib. Old Northwest Territory, Springfield, IL, 1947; Denver Art Mus. 54th Ann., 1948; Wiss. P&S, Milwaukee Art Inst., 1951; 68th Exhib. Soc. Wash. Artists, Natural Hist. Bldg., Wash., DC, 1961; Montana Gallery & Book Shop, Helena, MT, 1970s. **Work:** Bronzes, Charles Russell, Statuary Hall, Wash., DC, Adm. Nimitz, Annapolis Naval Acad. Mus. & Trophies For The Brave, Canton Art Inst.; Miss Indian America, Montana State Hist. Soc., Helena; heads & figures, Anthrop Hall, Smithsonian Inst. Commissions: cast stone, War Memorial, Butte, Mont., 1944; three Indians, Nat. Geog. Soc., Wash., DC, 1963; bronzes, The Stake, Prove Mus. & Arch., Alta, 1967 & Chief Red Crow, Blood Tribal Council, Cardston, Alta, 1969; Archaic Indian, Grandfather Mountain Mus., NC, 1965. **Comments:** Preferred media: bronze. Positions: sculptor, Montana Hist. Soc., 1955-60; sculptor, Smithsonian Inst., 1961-66. Teaching: instructor, life drawing, Layton School Art, Milwaukee, 1946-51. **Sources:** WW73; R.T. Taylor, *Jack Weaver--Sculptor* (Montana Inst. Arts, 1955); Ruth Bowen,

"Alberta Art in Bronze," *My Golden West* (1970); B. Schwartz, "Talented Hands," CBC TV, Edmonton, Alta, 1970.

WEAVER, Kate E. *[Painter] late 19th c.*
Addresses: Phila., PA. **Exhibited:** PAFA Ann., 1879 (flower paintings & still life in water color). **Sources:** Falk, *Exh. Record Series.*

WEAVER, Lewis *[Engraver] b.c.1830, Germany.*
Addresses: Philadelphia in 1860. **Comments:** He and his German wife had one child, born in Pennsylvania about 1858. **Sources:** G&W; 8 Census (1860), Pa., LII, 960.

WEAVER, Lillie *[Painter] mid 20th c.*
Exhibited: Salons of Am., 1934. **Sources:** Marlor, *Salons of Am.*

WEAVER, Margarita (Weigle) (Mrs. John) *[Painter] b.1889.*
Addresses: Brandon, VT. **Studied:** Forsyth, in Indianapolis; Paris, with L. Simon, H. Morriset, Bourdelle. **Member:** Hoosier Salon; Chicago AC. **Exhibited:** Hoosier Artists, Marshall Field's, 1925 (prize); AIC, 1928. **Sources:** WW33.

WEAVER, Marshall I. *[Painter] mid 20th c.*
Exhibited: AIC, 1929. **Sources:** Falk, *AIC.*

WEAVER, Martha Tibbals (Mrs. Arthur F.)
[Craftsperson] b.1859, Cleveland.
Addresses: Cleveland, OH. **Studied:** F. Thompkins; I. Wiles; J. De Camp; M. Fry; A.W. Dow; C. F. Binns; Cleveland Sch. A. **Member:** Am. Ceramic Soc.; Cleveland Women's AC; AFA. **Comments:** Specialty: ceramics. **Sources:** WW40.

WEAVER, Mary W. K. (Mrs.) *[Painter] d.1908, Wash., DC.*
Addresses: Wash., DC. **Exhibited:** Soc. of Wash. Artists, 1892. **Sources:** McMahan, *Artists of Washington, DC.*

WEAVER, Matthias Shirk *[Portrait painter] d.1848, Springfield, Summit County (OH).*
Addresses: Canton, OH, 1839-48. **Studied:** Philadelphia, 1829. **Sources:** Hageman, 123.

WEAVER, Persis See: **ROBERTSON, Persis Weaver (Mrs. Albert J.)**

WEAVER, Rene *[Landscape painter, commercial artist] b.1897, Pocatello, ID / d.1984, San Francisco, CA.*
Addresses: San Francisco, CA. **Studied:** Univ. Idaho; with Emil Jacques, Portland, OR. **Member:** Bohemian Club, San Francisco; Soc. Western Artists (pres.); Calif. WCS; American WCS. **Exhibited:** CPLH; de Young Mus.; Oakland Mus.; Gump's, San Francisco; American WC Soc annuals. **Awards:** first place & gold med., Oakland WC annual, 1944; special award, Soc. of Western Artists, 1948; prize, Abercrombie & Fitch show, 1965. **Comments:** Specialty: watercolors. Position: commercial artist, advertising agencies, Portland, OR & San Francisco, CA. **Sources:** Hughes, *Artists in California,* 593.

WEAVER, Robert *[Illustrator] b.1924, Pittsburgh, PA.*
Addresses: NYC. **Studied:** CI; ASL; Accademia Delle Belle Arti, Venice. **Exhibited:** D'Arcy Galleries; American Inst. of Graphic Arts; SI, gold medal, 1964; Art Dir. Club, NYC, Wash, DC & others; School of Visual Arts Mus., 1977 (retrospective). **Comments:** Positions: teacher, School Visual Arts, NYC; visiting faculty, Syracuse Univ. Illustrator: *Fortune, Life, Look,* and others. **Sources:** W & R Reed, *The Illustrator in America,* 309.

WEAVER, Robert E(dward) *[Painter] b.1914, Peru, IN / d.1991.*
Addresses: Peru, IN. **Studied:** John Herron AI, F.A. **Member:** Indiana Art Club; Hoosier Salon; Indiana Artists. **Exhibited:** NAD, 1938 (prize); Am. Acad., Rome, 1937 (prize); CGA, 1940; PAFA Ann., 1943; GGE, 1939; Corcoran Gal biennials, 1939, 1943; Hoosier Salon, 1940; Indiana Artists, 1946; Indiana Art Club; AIC, 1938; Chaloner prize, 1937. **Work:** Nat. Cash Register Corp.; John Herron AI; murals, Indianapolis Methodist Hospital; Alameda (CA) Naval Air Station; Eli Lilly Co.; Knightstown (IN) Soldiers and Sailors Children's Home. **Comments:** Position:

instructor, John Herron Art Sch., Indianapolis, IN. **Sources:** WW59; WW47; Falk, *Exh. Record Series.*

WEAVER, William J. *[Portrait painter] b.c.1759, England / d.1817, Savannah, GA.*
Addresses: Active in NYC, 1794 until at least 1815; Charleston, SC; Salem, MA. **Work:** Old Dartmouth Hist. Soc.; Nantucket Hist. Assn. **Comments:** He came from London where he painted inexpensive copies of famous portraits for the Polygraphic Society (1784-92). His attempt to sell these copies in America failed, and he became an itinerant portraitist who traveled along the Eastern seaboard from Nova Scotia to Charleston, SC, and up the Hudson River to Ontario. He painted in oil, usually on tin or wood. He died of a fever in a Savannah poor house. **Sources:** *New Bedford City Directory,* 1836; Blasdale, *Artists of New Bedford,* 203-204 (w/repros.); add'l info. courtesy Nantucket Hist. Assn.

WEAVER-LONG, Gladys *[Painter] mid 20th c.*
Exhibited: Soc. Indep. Artists, 1940. **Sources:** Marlor, *Soc. Indp. Artists.*

WEBB, A. C. *[Painter] b.1862, Nashville, TN.*
Addresses: NYC. **Studied:** AIC, ASL. **Member:** BAID; Paris, AAA; Chicago SE. **Exhibited:** Munic. Arts in Arch. NY, 1917 (prize); Kennedy & Co., NYC. **Work:** etchings, owned by City of Paris; French Govt. **Sources:** WW40.

WEBB, Aileen Osborn *[Painter, patron, collector] b.1892, Garrison, NY / d.1979.*
Addresses: NYC. **Studied:** Calif. College Arts & Crafts (hon. D.F.A., 1960). **Exhibited:** Awards: sustaining member award, Jr. League NYC, 1963; Trail Blazer Award, New York Chapt., Nat. Home Fashions League, 1964. **Comments:** Positions: chmn. board, Am. Craftsmen's Council; pres., World Crafts Council; pres., Am. House, NYC. Collection: modern art. **Sources:** WW73; WW47.

WEBB, Albert J(ames) *[Painter, etcher, lithographer] b.1891, NYC.*
Addresses: Brooklyn, NY. **Studied:** ASL. **Work:** MMA; CCNY; Brooklyn Mus. **Sources:** WW40.

WEBB, Charles A. *[Painter] early 20th c.*
Addresses: Saranac Lake, NY. **Studied:** Académie Julian, Paris with J.P. Laurens, 1904. **Member:** NYWCC. **Sources:** WW24.

WEBB, Clifford *[Painter] mid 20th c.*
Exhibited: AIC, 1928. **Sources:** Falk, *AIC.*

WEBB, Ebenezer R. *[Wood engraver] mid 19th c.*
Addresses: NYC, 1846. **Comments:** Of Wells & Webb (see entry). **Sources:** G&W; NYBD 1846.

WEBB, Edith Buckland (Mrs.) *[Painter, writer] b.1877, Bountiful, UT / d.1959, Los Angeles.*
Addresses: Los Angeles, from 1901. **Studied:** Hammond Hall, Salt Lake City. **Comments:** Active in Calif. by 1901. Author: *Indian Life at the Old Missions.* **Sources:** Petteys, *Dictionary of Women Artists.*

WEBB, Edna Dell See: **HINKELMAN, Edna Webb (Mrs. Edward)**

WEBB, Edward J. *[Architect] mid 19th c.*
Addresses: NYC. **Exhibited:** Am. Inst., 1842 (watercolors). **Sources:** G&W; Am. Inst. Cat., 1842; NYCD 1842.

WEBB, Eliza(beth) (Holden) *[Craftsperson] b.Geneva, Switzerland / d.1942, Mystic, CT.*
Addresses: Mystic, CT. **Studied:** E. Johnston, in England. **Member:** Mystic AA; NAC. **Exhibited:** Salons of Am. **Work:** illuminated baptismal service book, Cathedral of St. John the Divine; St. George's Mortuary Chapel, Stuyvesant Sq., NYC; Memorial Houses, Vassar Col., Poughkeepsie, NY; Webster Mem. Chapel, Newport, RI. **Comments:** Specialties: illuminating; lettering. **Sources:** WW40.

WEBB, F.R. *[Painter] late 19th c.*
Addresses: Phila., PA. **Exhibited:** PAFA Ann., 1876. **Sources:**

Falk, *Exh. Record Series.*

WEBB, Garl *[Painter] b.1908, Peru, IN.*
Addresses: Indianapolis, IN. **Studied:** Art Sch. John Herron. **Member:** Indiana Artists Club. **Exhibited:** Indiana Artists Club, Indianapolis, 1935 (prize), 1936 (prize). **Sources:** WW40.

WEBB, Grace (Agnes) (Parker) *[Painter, craftsperson, graphic artist, teacher, lecturer, writer] b.1888, Vergennes, VT.*
Addresses: Burlington, VT. **Studied:** ASL; PIA Sch.; Univ. Vermont; Univ. California; Simmons College; & with Barse Miller, Paul Sample, Rex Brandt, John Carlson, Charles Allen. **Member:** Phila. WCC; NAWA; AEA; AAPL; ASL; Santa Barbara (CA) AA; Lg. Vermont Writers; Northern Vermont AA; Vermont Hist. Soc. **Exhibited:** PAFA, 1940-44; NAWA, 1944, 1946, 1958; AWCS, 1943; Soc. for Sanity in Art, Boston, 1941; High Mus. Art, 1944; Northern Vermont Artists, annually; Fleming Mus. Art, Burlington; Phila. WCC, 1944-46, 1958; AAPL, 1958 (gold medal); Nat. Lg. Am. Pen Women, 1958 (prize). Other awards: Vermont Fed. Women's Club, 1954. **Work:** Fleming Mus. Art, Burlington, VT; Shelburne (VT) Mus. Art. **Comments:** Position: pres., Green Mt. Branch, Nat. Lg. Am. Pen Women, 1958-60; Vermont art chmn., 1956, 1958. Lectures: historical & contemporary art. **Sources:** WW59; WW47; Muller, *Paintings and Drawings at the Shelburne Museum,* 136.

WEBB, H. T. *[Portrait painter] mid 19th c.*
Addresses: Wilton, CT, 1840. **Work:** Shelburne (VT) Mus. **Sources:** G&W; Lipman and Winchester, 181; Muller, *Paintings and Drawings at the Shelburne Museum,* 137 (w/repros.).

WEBB, Herbert C. *[Painter] early 20th c.*
Addresses: Seattle, WA. **Sources:** WW24.

WEBB, J(acob) Louis *[Painter] b.1856 / d.1928.*
Addresses: NYC, 1883-84. **Member:** SAA, 1888; ANA, 1906. **Exhibited:** NAD, 1883-84; Boston AC, 1885, 1886; AIC, 1890. **Sources:** WW27.

WEBB, James *[Engraver] b.c.1810, England.*
Addresses: Philadelphia in 1850. **Sources:** G&W; 7 Census (1850), Pa., LII, 978.

WEBB, James *[Engraver] b.c.1820, England.*
Addresses: NYC Alms House, 1860. **Sources:** G&W; 8 Census (1860), N.Y., LXI, 156.

WEBB, James Elwood *[Painter, bookplate designer] b.1884, Hamorton, Chester County, PA / d.1940.*
Addresses: Los Angeles, CA/Hermosa Beach, CA. **Studied:** W.E. Schofield, N. Fechin, P. Lauritz, J.W. Smith, E. Payne. **Member:** PSC, Los Angeles. **Exhibited:** PSC, Los Angeles (traveling). **Work:** Univ. Southern Calif. **Sources:** WW40.

WEBB, Julie *[Painter] mid 20th c.*
Addresses: Royal Oak, MI. **Exhibited:** PAFA Ann., 1960. **Sources:** Falk, *Exh. Record Series.*

WEBB, Margaret Ely *[Painter, engraver, illustrator, writer, designer, teacher] b.1877, Urbana, IL / d.1965, Santa Barbara County, CA.*
Addresses: New Jersey; Boston; Santa Barbara, CA, from 1925. **Studied:** ASL; CUA School; & with Kenyon Cox, Arthur Dow, George Bridgman, John Twachtman, J. Alden Weir. **Member:** Boston Soc. Arts & Crafts; Am. Soc. Bookplate Collectors & Des.; Calif. Bookplate Soc. **Exhibited:** Soc. Women P&S; Soc. Indep. Artists; Oakland Art Gal.; Boston AC; Copley Soc.; Madonna Festival, Los Angeles; Santa Paula, CA; Santa Barbara AA; Faulkner Mem. Gal., Santa Barbara, CA; Bowers Merit, Mus., Santa Ana. Awards: prizes, Am. Bookplate Soc., 1924, 1925; Madonna Festival, Los Angeles, 1955. **Work:** Bookplates, Am. Antiquarian Soc.; Huntington Lib.; Santa Barbara Natural Hist. Mus.; Wilshire Methodist Church, Los Angeles; Mount Calvary Monastery, Santa Barbara, CA; Liverpool (England) Pub. Lib.; British Mus., London; Solvang (CA) Episcopal Church; St. Mary's Church, Santa Barbara. **Comments:** Illustrator: "The House of Prayer," "Aldine First Reader," "Under Greek Skies,"

other books. Contributor: *Saint Nicholas, Churchman, Dutch Ex Libris Journal.* **Sources:** WW59; WW47.

WEBB, Minna Grumbt (Mrs. Edward O.) *[Painter]*
b.1885, Germany / d.1969, Middleboro, MA.
Addresses: New Bedford, MA area, 1906-52. **Studied:** Swain Free School Design, 1929. **Exhibited:** Swain Free School Design, 1929; Easy Street Gall., Nantucket, MA, 1940. **Comments:** Came to the U.S. at age 6. Specialty: flowers. **Sources:** Blasdale, *Artists of New Bedford,* 204 (w/repro.).

WEBB, Paul *[Cartoonist]* b.1902, Towanda, PA.
Addresses: New Canaan, CT; Newtown, CT. **Studied:** PMSchIA; PAFA. **Member:** SI; Cart. Soc. **Exhibited:** Awards: two traveling scholarships, 1927-28. **Comments:** Author: "Comin' Round the Mountain," 1938, "Keep "Em Flyin'," 1942. Cartoonist: *Esquire, Life, Collier's, Saturday Evening Post;* comic strip, "The Mountain Boys." **Sources:** WW66; WW47.

WEBB, Robert, Jr. *[Painter]* early 20th c.
Addresses: Methuen, MA. **Exhibited:** PAFA Ann., 1918 (landscape). **Sources:** WW19; Falk, *Exh. Record Series.*

WEBB, Thelma N. *[Painter]* mid 20th c.
Addresses: St. Louis, MO. **Exhibited:** PAFA Ann., 1950-51. **Sources:** Falk, *Exh. Record Series.*

WEBB, Thomas *[Painter]* mid 20th c.
Addresses: NYC. **Member:** GFLA. **Sources:** WW27.

WEBB, Todd *[Photographer]* b.1905, Detroit.
Addresses: Bath, ME (1985). **Studied:** Ansel Adams; largely self-taught. **Exhibited:** Guggenheim Fellowship, 1953, 1956; Mus. City of NY, 1946 (solo); ACM, 1965. **Work:** Smithsonian; Columbus (GA) Mus. Art; AIC; Univ. Louisville; WMA; BMA; Univ. Michigan; Newark Mus.; MoMA; NYPL; IMP; PMA; ACM. **Comments:** Specialty: Best known for his post-WWII scenes of NYC and Paris, ghost towns of the Old West; frequent trips to France and England.

WEBB, Vonna Owings (Mrs.) *[Landscape and marine painter]* b.1876, Sunshine, CO / d.1964, Manhattan Beach, CA.
Addresses: Laguna Beach, CA, c.1930. **Studied:** Lillian Hudson; College of Montana; with Chris Jorgensen in San Francisco; Smith Academy, Chicago; AIC; Prang Summer School; with William A. Griffith. **Member:** Calif. AC; Laguna Beach AA. **Exhibited:** Laguna Festival of Arts, 1933-64. **Comments:** Position: teacher, in Indiana and Montana, early 1900s. Married in 1905, lived in Chicago and settled in Oregon. Moved to California, c.1930. Specialty: seascapes and desert landscapes in oil and watercolor. **Sources:** Hughes, *Artists in California,* 593; P&H Samuels, 515.

WEBB, W. B. (Mrs.) *[Artist]* late 19th c.
Addresses: Active in Jackson, MI. **Exhibited:** Michigan State Fair, 1887 (prize). **Sources:** Petteys, *Dictionary of Women Artists.*

WEBB, William N. *[Shade painter]* mid 19th c.
Addresses: Boston in 1850. **Comments:** In partnership with Charles Ellenwood (see entry), 1850. **Sources:** G&W; Boston CD 1850.

WEBBER, Carl See: WEBER, Carl

WEBBER, Catharine T. (Mrs. Carl E.) *[Sculptor]* b.1909, Seattle, WA.
Addresses: Seattle, WA. **Studied:** Univ. Wash.; BMFA Sch.; École des Beaux Arts, France. **Member:** Women Painters Wash. **Exhibited:** École des Beaux Arts, 1932; SAM, 1936, 1938 (solo), 1939. **Sources:** Trip and Cook, *Washington State Art and Artists.*

WEBBER, Charles T. *[Portrait, historical, and landscape painter; sculptor, teacher]* b.1825, Eastshore of Cayuga Lake, NY / d.1911, Cincinnati, OH.
Addresses: Springfield, OH in 1844; Cincinnati, 1858. **Member:** Cincinnati Sketch Cl., 1860 (charter mem.); McMicken Sch. Art, 1869 (founder); Cincinnati A. Cl., 1890 (founder).

Exhibited: Boston AC, 1882, 1886, 1892; Paris Salon, 1888; AIC. **Work:** Cincinnati AM. **Comments:** He was a leader in Cincinnati art circles during the latter half of the 19th century. Aside from his numerous portraits, he was best known for his historical painting, "The Underground Railroad," and his group portrait of Major Daniel McCook and his nine sons. He visited Santa Fe in 1886. **Sources:** G&W; Rodabaugh, "Charles T. Webber"; Cincinnati CD 1860+; WW10; P&H Samuels report alternate birthplace of Cincinnati, OH, 515; *Cincinnati Painters of the Golden Age,* 109-111 (w/illus.); Fink, *American Art at the Nineteenth-Century Paris Salons,* 403.

WEBBER, Elbridge Wesley See: WEBBER, Wesley

WEBBER, Florence C. *[Painter, teacher]* 19th/20th c.
Addresses: Tacoma, WA, 1892, 1898. **Member:** Annie Wright Seminary AC, Tacoma, 1889; Tacoma Art League, 1892. **Exhibited:** Western Wash. Indust. Expo, 1891. **Sources:** Trip and Cook, *Washington State Art and Artists.*

WEBBER, Frederick W. *[Curator, writer]* b.1847 / d.1922.
Comments: Position: curator, Herkscher Park Art Mus., Huntington, NY. Webber died in an auto accident.

WEBBER, John *[Landscape painter]* b.1752, London, England / d.1793, London, England.
Studied: studied painting in Bern, Switzerland; Johan Aberli, 1767-70; and Paris, with Jean-Georges Wille, 1770; Royal Acad., 1775. **Member:** Royal Academy, 1791. **Exhibited:** Royal Academy, 1776. **Work:** Nat. Library of Australia; State Library of NSW, Australia; Bernice P. Bishop Mus., Honolulu; Turnbull Library, New Zealand. **Comments:** The son of a Swiss sculptor, he spent much of his childhood in Bern. After his return to England he was employed as a decorative painter, but in 1776 he went as artist on Captain James Cook's last voyage to the Pacific. During this four-year voyage, Webber made many sketches, including some on the coast of the present states of Hawaii, Washington and Oregon, and after his return to England in 1780 he developed them into paintings which were used to illustrate the report of the expedition. Subsequently Webber painted landscapes in Great Britain, Switzerland, and Italy and published between 1787-92 sixteen views of places he had visited with Cook, etched and colored by himself. **Sources:** G&W; DNB; Rasmussen, "Art and Artists in Oregon" (courtesy David C. Duniway); *American Processional,* 237; Gould, *Beyond the Shining Mountains,* opp. 54, 59; P&H Samuels, 515-16; Forbes, *Encounters with Paradise.*

WEBBER, (Mrs.) *[Lithographer]* mid 19th c.
Comments: Drew on stone a view of Bellows Falls (VT) which was published by the Pendletons of Boston, probably sometime in the 1830's. **Sources:** G&W; Peters, *America on Stone.*

WEBBER, Wesley *[Landscape and marine painter]* b.1839, Gardiner, ME / d.1914, Wollaston, MA.
Addresses: Boston, MA (1870-90)/NYC (1892-on). **Studied:** self-taught. **Member:** Boston AC. **Exhibited:** Leonard Auction Rooms, 1873, 1876; Boston AC, 1874-1891; Mechanics Inst., Boston, 1882-83; NAD, 1890; Brooklyn AA, 1891. **Work:** Peabody Mus., Salem; Boston Athenaeum; Brooklyn Mus.; Portland MA. **Comments:** Webber served in the Civil War and was present at General Lee's surrender at Appomattox. His original sketches made at the surrender, along with his finished illustrations, were shown at the Boston Art Club and brought him his first public recognition. They were also published as wood engravings in *Harper's Weekly,* and as a lithograph published by J.H. Bufford in Boston. Thereafter, Webber earned a good reputation as a marine and landscape painter, but he became an alcoholic. He kept studios until his death: one in Boston (in 1876, he shared his Boston studio with William P. Stubbs), and the other in NYC. **Sources:** Campbell, *New Hampshire Scenery,* 171, who states his birth date as 1841; Wright, *Artists in Virginia Before 1900.*

WEBER, Albert Jacob *[Painter, educator] b.1919, Chicago, IL.*
Addresses: Ann Arbor, MI. **Studied:** AIC (B.F.A.); Mexico City
College (M.A.A.). **Member:** Ann Arbor AA. **Exhibited:** Univ.
Michigan, 1956-69 (5 shows); Soc. Wash. Printmakers, 1957 &
1960; Detroit Inst. Art, 1957, 1960 & 1966; Bloomfield AA, 1957
& 1967; AFA Traveling Exhibs., 1958-60; PAFA Ann., 1950,
1960. Awards: Prize, Grand Rapids Art Gal., 1958; purchase
prizes, Butler Inst. Am. Art, 1959-61; purchase prize, Graphic Art
& Drawing Exhib., Olivet College, MI, 1962. **Comments:**
Teaching: instructor, Mexico City College; art professor, Univ.
Michigan, Ann Arbor, 1955-69. **Sources:** WW73; Falk, *Exh.
Record Series.*

WEBER, Albert L. *[Painter] mid 20th c.*
Addresses: Columbus, OH. **Member:** Columbus PPC. **Sources:**
WW25.

WEBER, Alfons *[Sculptor, craftsperson] b.1882.*
Addresses: Chicago, IL. **Studied:** Art Sch., Nuremberg; State
Sch., Munich. **Work:** woodcarvings, Century of Progress Expo,
Chicago; GGE, 1939; AIC; Hist. Soc. Mus., Chicago. **Sources:**
WW40.

WEBER, August James *[Painter] b.1889.*
Addresses: Marietta, OH. **Studied:** F. Duveneck; L.H. Meakin;
H.H. Wessel. **Exhibited:** AIC, 1920; Corcoran Gal biennial, 1923.
Sources: WW40.

WEBER, C. Phillip *[Painter] b.1849, Darmstadt, Germany /
d.1921.*
Addresses: Germantown, PA; Phila., PA, 1880-81. **Studied:**
Kreling, in Nuremburg; P. Weber, in Munich. **Member:** Phila.
Artists Fund Soc. **Exhibited:** London, 1873 (medal); PAFA Ann.,
1876-91; Boston AC, 1879-81; NAD, 1880-81; Sydney, Australia
(medal); Melbourne, Australia (medal); AAS, 1902 (prize); AIC.
Sources: WW06; Falk, *Exh. Record Series.*

WEBER, Carl *[Landscape painter] b.1850, Phila. / d.1921.*
Addresses: Phila., PA, 1881-93. **Studied:** his father Paul; Becker,
in Frankfort; Steinle, in Vienna; Raupp, in Munich; Paris.
Member: Phila. Artists Fund Soc.; AAS; Phila. AC. **Exhibited:**
London, 1873 (medal); PAFA Ann., 1876-90, 1905; NAD, 1881-
93; Boston AC, 1885, 87; Columbian Expo, Chicago, 1893
(prize); Atlanta Expo, 1859 (prize); AAS, 1902 (gold); AIC.
Sources: WW19; Falk, *Exh. Record Series.*

WEBER, Caroline *[Artist, painting teacher] mid 19th c.*
Addresses: Buffalo, NY in 1857. **Sources:** G&W; Buffalo BD 1857.

WEBER, Carrie May *[Painter] mid 20th c.*
Addresses: Toledo, OH. **Exhibited:** Ohio WCC; Ohio State Fair;
Boston Soc. Indep. Artists; TMA, 1936, 1940. **Sources:** WW40.

WEBER, Cecilia Audrey *[Painter] mid 20th c.*
Addresses: Chicago area. **Exhibited:** AIC, 1936. **Sources:** Falk,
AIC.

WEBER, Charles F. *[Painter] late 19th c.; b.Cincinnati, OH.*
Exhibited: Paris Salon, 1881. **Sources:** Fink, *American Art at
the Nineteenth-Century Paris Salons,* 403.

WEBER, Edward *[Lithographer] mid 19th c.; b.Germany?.*
Addresses: Baltimore, 1835 to c.1851. **Comments:** The brothers
Hoen (see entry) were his nephews and August Hoen (see entry)
was his partner for some years before 1848 when Hoen set up his
own lithographic business. **Sources:** G&W; Peters, *America on
Stone;* Baltimore CD 1837-51. Examples of Weber's work are
found in Abert, *Journal;* Owen, *Report of a Geological
Exploration of Part of Iowa, Wisconsin, and Illinois;* Cross,
Journey from Fort Leavenworth to Fort Vancouver; and Frémont,
Report.

WEBER, Elsa *[Etcher] 20th c.; b.Columbia, SC.*
Addresses: NYC. **Studied:** F. T. Weber. **Sources:** WW40.

WEBER, F. *[Painter] late 19th c.*
Addresses: NYC, 1886. **Exhibited:** NAD, 1886. **Sources:**
Naylor, *NAD.*

WEBER, F. W. *[Painter] late 19th c.*
Addresses: Woodridge, NJ; Old Mystic, CT, 1895. **Exhibited:**
PAFA Ann., 1895; NAD, 1895. **Sources:** Falk, *Exh. Record
Series.*

WEBER, Fred W. *[Painter, writer, lecturer, critic] b.1890,
Phila.*
Addresses: Philadelphia 22, PA. **Studied:** Temple Univ.; Drexel
Inst.; Earl Horter; Paul Martell. **Member:** Sketch Club, Art Club
& Art All., Phila.; Pen & Pencil Club. **Exhibited:** PAFA; Sketch
Club, Art Club & Art All., Phila.; Woodmere Art Gal.; Univ.
Puerto Rico (solo). **Work:** Mural, Franklin Inst., Phila.
Comments: Positions: bd. gov., PM School IA, PMA; art ed./crit-
ic, *Phila. Record,* 1947; tech. dir., F. Weber Co., Phila., 1916-.
Auth.: "Artists' Pigments," 1923. Contrib.: *Art Digest,
Encyclopaedia Britannica.* **Sources:** WW53.

WEBER, Frederick T(heodore) *[Painter, sculptor, etcher,
writer] b.1883, Columbia, SC / d.1956, Astoria (Queens), NY.*
Addresses: Jackson Heights, NY; NYC. **Studied:** Acad. Julian,
Paris, with J.P. Laurens, 1907-09; École des Beaux-Arts, Paris;
Paul Richer; Muller-Schoenfeld in Berlin. **Member:** SAE;
AWCS; NAC; Phila. SE; NYWCC; New Haven PCC. **Exhibited:**
Corcoran Gal. biennial, 1912; NAD; Soc. Wash. Artists; Peabody
Inst.; CAM; Detroit Inst. Art; PAFA Ann., 1917-18; New Haven
PCC; AIC; AWCS; Wash. WCC; Balt. WCC; Phila.WCC; Phila.
Pr. Club; U.S. Nat. Mus., 1930 (solo); High Mus. Art, 1931 (solo);
Columbia AA, 1931 (solo). **Work:** MMA; BM; LOC; U.S. Nat.
Mus.; NYPL; Bibliothèque Nat., Paris; Mus. City of NY;
Winthrop College, SC.; Univ. South Carolina; City Hall,
Charleston, SC; Univ. Vermont; Virginia House, Richmond.
Comments: Auth.: article on portrait painting in *Encyclopaedia
Britannica,* 14th ed. **Sources:** WW53; WW47; Falk, *Exh. Record
Series.*

WEBER, Hugo *[Painter] b.1918, Basel, Switzerland / d.1971.*
Addresses: Chicago (immigrated 1940s); Basel and Paris (1955-
60); Chicago, early 1960s; NYC (1960s-on). **Studied:** sculpture
apprenticeship with Ernst Suter in Basel, 1937-39; and with
Gimond, Maillol and Arp in France. **Exhibited:** AIC, 1947, 1949,
1951 (solo), 1953; TMA, 1947; Salon des Réalitiés, Paris, 1948,
1958-59; Colorado Springs FAC, 1950 ("Energetic Figures and
Vision in Flux"); Galerie 16, Zurich, 1952; Inst. Design, Chicago,
1952; Galerie Parhass, Wuppertal, Germany, 1952; Allan Frumkin
Gal., Chicago, 1953, 1955; Betty Parsons Gal., NYC, 1953, 1955,
1959; Galerie Hutter, Basel, 1953; American Univ., Beirut,
Lebanon, 1954; WMAA, 1956; Guggenheim Mus., 1955;
Neuchatel, Winterthur, Berlin, 1956-58; Galerie Creuze, Paris,
1957; Galerie Arnaud, Paris, 1957; Corcoran Gal biennial, 1957;
Charleroi, Belgium, 1958; Kunsthaus, Zurich, 1960; Salon de
Mai, Paris, 1961; American Acad., Paris, 1961; Holland Gal.,
Chicago, 1961; Gres Gal., Chicago, 1962; PAFA Ann., 1966.
Work: AIC; CM. **Comments:** Teaching: Inst. Design ("Chicago
Bauhaus"), 1949-55. Films by the artist: "Vision in Flux", 1951;
"Process Documentation by the Painter", 1954. **Sources:** WW66;
American Abstract Art, 201; Falk, *Exh. Record Series.*

WEBER, Idelle Lois *[Painter, sculptor] mid 20th c.;
b.Chicago, IL.*
Addresses: Brooklyn, NY. **Studied:** Scripps College; Univ. Calif,
Los Angeles (A.A., B.A. & M.A.). **Exhibited:** MOMA, 1956;
Bertha Schaefer Gal., New York, 1962-1964; Guggenheim Mus,
1964; Providence Mus. Fine Arts, RI, 1965; Albright-Knox Gal.,
1963. Awards: Nat. Scholastic Art Awards, Scripps Col., 1950.
Work: Albright-Knox Gal., Buffalo. **Comments:** Preferred
media: oils, plexiglass. **Sources:** WW73; "Notiziario: Arte,"
Domus (1964); Douglas MacAgy, "The City Idyll," *Lugano Rev.*
(1965); Lucy R. Lippard, *Pop Art* (Praeger, 1966).

WEBER, Jean M. *[Art administrator, educator] b.1933,
Boston, MA.*
Addresses: Sag Harbor, NY. **Studied:** Brown Univ.; RISD (B.A.);
Edinburgh Univ.; State Univ. Iowa. **Member:** Am. Assn. Mus.;
AFA; Nat. Art Educ. Assn.; Int. Council Mus.; NY State Assn.

Mus. **Exhibited:** Awards: Danforth Foundation fellowship, 1954-55; Int. Mus. Sem. award, NY State Council Art, MMA, 1972. **Comments:** Positions: director, Jr. Art Gallery, Louisville, KY, 1966-69; asst. & acting director, Parrish Art Mus., Southampton, NY, 1969-70, director, 1970-. Teaching: adjunct professor, Southampton College, 1970-. Collections arranged: The Summer Place, 1970; American Impressions, 1970; Commedia dell'Arte, 1971; Objects and Images, 1971; Tantric Art of Tibet, 1972. **Sources:** WW73.

WEBER, J.F. (Mrs.) [Painter] late 19th c.
Addresses: Camden, NJ. **Exhibited:** PAFA Ann., 1879 (flower painting in water color). **Sources:** Falk, Exh. Record Series.

WEBER, John [Art dealer] mid 20th c.
Addresses: NYC. **Comments:** Positions: pres., John Weber Gallery. Specialty of gallery: contemporary art. **Sources:** WW73.

WEBER, John S. [Engraver] mid 19th c.
Addresses: St. Louis, 1859. **Sources:** G&W; St. Louis BD 1859.

WEBER, John, Jr. [Painter] b.1900, Des Moines, IA.
Addresses: Des Moines, IA. **Studied:** Cumming Art School, 1912 with Charles Cumming. **Exhibited:** Des Moines, Cedar Rapids, etc. with traveling exhibit; Iowa Art Salon, 1931 (hon. men., fourth place); Iowa Federation Women's Clubs Exhibit, 1932. **Comments:** Instructor, Architectural Design, Iowa State College. **Sources:** Ness & Orwig, Iowa Artists of the First Hundred Years, 216.

WEBER, Kem [Designer, painter] b.1889, Berlin / d.1963, Santa Barbara, CA.
Addresses: Los Angeles, CA. **Studied:** Berlin Acad. Applied Art, 1908-12. **Exhibited:** Calif. AC, 1926; Mod. Art Workers Los Angeles, 1926; Oakland Art Gallery, 1927. **Comments:** Came to San Francisco, c.1913. Position: art director, Bullock's Department Store, Los Angeles; teacher, Occidental College, Los Angeles; teacher, Los Angeles AC, 1931-41. **Sources:** Hughes, Artists in California, 594.

WEBER, Lou K. [Painter, teacher] b.1886 / d.1947.
Addresses: Dayton, OH. **Studied:** Univ. Chicago; Columbia. **Exhibited:** Women's Nat. Expo, Cincinnati, 1934 (prize). **Comments:** Contributor: articles, Design. Position: teacher, Oakwood H.S. **Sources:** WW40.

WEBER, Max [Painter, blockprint-er, sculptor, writer, teacher] b.1881, Bialystok, Russia / d.1961, Great Neck, NY. *MAX WEBER '17*
Addresses: Brooklyn in 1891; NYC, 1909-20; Garden City, Long Island, 1920; Great Neck, Long Island, NY. **Studied:** PIA Sch., with Arthur Dow, 1898-1900; Acad. Julian, Paris with Jean Paul Laurens, 1905-06; Acad. Colarossi, 1906-07; helped organize class under Henri Matisse, 1907-08; again Acad. Colarossi, 1908. **Member:** NIAL; Soc. Am. PS&S; Am. Artists Congress (chmn., 1937). **Exhibited:** Salon des Indépendants, 1906-07; Salon d'Automne 1907-09; Stieglitz' "291" gallery, 1911 (solo); Newark Mus., 1913 (solo); Montross Gal., 1915 (solo); Corcoran Gal biennials, 1916-61 (12 times; incl. bronze medal, 1941); Soc. Indep. Artists, 1917-19, 1936; AIC, 1928 (gold medal); La Tausca Pearls Comp., 1928, 1946 (prizes); PAFA Ann., 1930-60 (gold medal 1941; prize 1938, 1956); Pepsi-Cola Comp., 1945, 1946 (prizes); AIC, 1928 (med); MoMA, 1930 (retrospective); Santa Barbara Mus. Art, 1947; WMAA, 1949; Walker AC, 1949; PIA Sch., 1959; Newark Mus., 1959; AAAL, 1962; Boston Univ., 1962; Univ. Calif., Santa Barbara, 1968; Salons of Am. Other awards: hon. degree, D.H.L., Brandeis Univ., 1957. **Work:** MMA; WMAA; MoMA; NMAA; Jewish Mus., NYC; NGA; Jewish Theological Seminary Am.; Tel-Aviv Mus.; AIC; LACMA; CPLH; Santa Barbara Mus. Art; Wichita Art Mus.; Newark Mus.; Walker AC; Univ. Nebraska; BM; CMA; Phillips Collection; Vassar; Brandeis Univ. **Comments:** One of the most important American artists of the early decades of the 20th century, he played a significant role in introducing avant-garde art to America. He returned to NYC from Paris in 1909, having been

been a part of the European avant-garde community and having familiarized himself with Post-Impressionism, Fauvism, Cubism, Primitivism, and Expressionism. He produced his first nonobjective paintings and pastels between 1911 and 1914 and in 1915 he extended these experiments to sculpture. In the 1920s Weber's work became less abstract and more representational, and he began exploring Jewish themes, a subject he would return to often throughout the rest of his career. Around 1940 his paintings, both religious and secular, became especially expressionistic. Max Weber is also significant as a writer, having published important statements on modernist aesthetics. His seminal essay, "The Fourth Dimension from a Plastic Point of View" appeard in Camera Work in July 1910. Weber's book, Essays on Art (1916) influenced numerous students. Other writings include Primitives (1926) and Cubist Poems (1914). Positions: teacher, Minnesota Normal Sch., Duluth, 1903-05; Clarence White Sch. Photography, NYC, 1914-18; ASL, 1920-. **Sources:** WW59; WW47; Lloyd Goodrich, Max Weber (1949); Percy North and Susan Krane, Max Weber: the Cubist Decade, 1910-20 (exh. cat., Brooklyn Mus., 1993) [a review of the exh. by Roberta Tarbell appears in Amerian Art Review, Winter 1993]; Percy North, Max Weber (exh. cat., Jewish Mus., 1982); W. Homer, Avant-Garde Painting and Sculpture in America; A. Davidson, Early American Modernist Painting; Baigell, Dictionary; Falk, Exh. Record Series.

WEBER, Otis S. [Painter] late 19th c.
Addresses: NYC, 1887; Boston, MA. *O.S. WEBER*
Exhibited: Boston AC, 1879, 1880-90; NAD, 1887. **Sources:** The Boston AC.

WEBER, Paul [Landscape and por-trait painter] b.1823, Darmstadt, Germany / d.1916, Philadelphia, PA. *Paul Weber*
Addresses: Philadelphia, PA, 1848; Germany, 1869. **Studied:** Frankfurt, Germany. **Exhibited:** PAFA Ann., 1849-69, 1876-84, 1905; NAD, 1850-1893; Wash. AA, 1857, 1859; Boston Atheaneum, 1864; Brooklyn AA, 1861, 1869, 1873, 1884; Paris Salon, 1865, 1868. **Work:** CGA. **Comments:** Came to the U.S. at the age of 25. In 1857 he toured Scotland and Germany and in 1860 he returned to Darmstadt where he was appointed court painter. Positions: teacher, Phila. (one of his students was Edward Moran). **Sources:** G&W; Clement and Hutton; Fielding; Rutledge, PA; Swan, BA; Rutledge, MHS; Cowdrey, NAD; Cowdrey, AA & AAU; NYBD 1856-60; 8 Census (1860), Pa., LIV, 261; Washington Art Assoc. Cat., 1857, 1859. More recently, see Campbell, New Hampshire Scenery, 171; Falk, Exh. Record Series.

WEBER, Robert [Cartoonist] b.1924, Los Angeles, CA.
Addresses: New York 25, NY. **Studied:** Art Center Sch., Los Angeles; PIASch.; ASL. **Comments:** Contributor cartoons to Saturday Evening Post, Look, True and others. **Sources:** WW59.

WEBER, Rosa [Painter] early 20th c.
Addresses: Ft. Wayne, IN. **Studied:** Ft. Wayne Art School. **Sources:** WW17.

WEBER, Roy [Sculptor] mid 20th c.
Addresses: NYC. **Exhibited:** PAFA Ann., 1951; WMAA, 1952. **Sources:** Falk, Exh. Record Series.

WEBER, Rudolph [Illustrator] b.1858, Switzerland / d.1933, NY.
Comments: Came to U.S. in 1888. Illustrator: scientific books. Position: teacher, Princeton Univ.

WEBER, Sarah S. Stil(l)well (Mrs.) *S-SSW*
[Illustrator] b.1878, Phila., PA / d.1939, Phila.
Addresses: Phila. **Studied:** Drexel Inst., with Howard Pyle (also attended his summer classes at Chadds Ford, PA). **Exhibited:** Pan-Am. Expo, Buffalo, 1901 (bronze medal). **Comments:** Illustrator of national magazines as well as children's books. Author/illustrator: The Musical Tree. **Sources:** WW25; W & R Reed, The Illustrator in America, 75; Petteys, Dictionary of Women Artists.

WEBER, Sybilla Mittell *Sybilla Mittell Weber 1938.*
[Painter, etcher] b.1892, NYC / d.1957, NYC.
Addresses: NYC. **Studied:** A. Purtescher, in Munich; Pennell, in NY; France. **Member:** SAE; Wash. WCC. **Exhibited:** Milch Gals., NYC, 1932 (solo); Kleeman Gals., NYC, 1937 (solo); Phila. Print Club, 1937 (prize); Salons of Am.; AIC. **Work:** Westminster Kennel Club, NY; BM; Berlin Mus.; New Pinakothek, Munich; LOC; Smithsonian; Penn. Mus. Art; Honolulu Acad. Art. **Comments:** Preferred media: oil, watercolor. Also did etchings of animals. **Sources:** WW47; Petteys, *Dictionary of Women Artists.*

WEBER, Wally *[Painter] mid 20th c.*
Addresses: NYC. **Exhibited:** Soc. Indep. Artists, 1943-44. **Sources:** Marlor, *Soc. Indp. Artists.*

WEBER, Wilhelmine *[Painter] mid 20th c.*
Exhibited: Salons of Am., 1924. **Sources:** Marlor, *Salons of Am.*

WEBER, William *[Painter, teacher] b.1865, Germany / d.1905.*
Addresses: Kansas City, MO. **Studied:** Royal Acad., Berlin. **Comments:** Came to U.S. as a child. Position: teacher, Kansas City Central H.S.

WEBER-DITZLER, Charlotte *[Illustrator] b.1877, Phila.*
Addresses: NYC. **Studied:** Munich, with Schmidt & Fehr. **Sources:** WW13.

WEBERG, John *[Painter] mid 20th c.*
Addresses: Pittsburgh, PA. **Member:** Pittsburgh AA. **Sources:** WW21.

WEBORG, Arild *[Painter] mid 20th c.*
Addresses: Chicago. **Exhibited:** AIC, 1921-25. **Sources:** Falk, *AIC.*

WEBSTER, Anna Cutler *[Painter, craftsperson] b.1888, Portland, ME / d.1975, San Francisco, CA.*
Addresses: San Francisco, CA. **Studied:** BMFA School; Calif. Sch. FA. **Work:** Vedanta Soc., San Francisco. **Comments:** Position: teacher, Peninsula School, Menlo Park, 1925-32. **Sources:** Hughes, *Artists in California,* 594.

WEBSTER, Ben *[Painter] mid 20th c.*
Addresses: NYC. **Exhibited:** Soc. Indep. Artists, 1924. **Comments:** Possibly Webster, Ben, b.1865, London, England-d.1947, Hollywood, CA. **Sources:** Marlor, *Soc. Indp. Artists.*

WEBSTER, Bernice M. *[Painter, lecturer] b.1895, Northfield, MA.*
Addresses: Croton Falls, NY; Northfield, MA; Brattleboro, VT. **Studied:** Mass. Sch. Art; Teachers College, Columbia Univ. (B.S. in art), and with Henry B. Snell, Arthur Woelfle. **Member:** Albany Inst. Hist. & Art; So. Vermont AC; NAC. **Exhibited:** All. A. Am., 1941; NAC, 1931-48; Vendome Gal., 1941; Tomorrow's Masterpieces, 1943; Springfield Art Lg., 1947; Baer Gal., 1948-1950; So. Vermont AC, 1954-58; Artists Upper Hudson, 1948-50; Albany Inst. Hist. & Art, 1948 (solo); Bedford, NY, 1948, 1950, 1952; Greenfield, MA, 1948, 1957; Pawling, NY, 1949; New Canaan, CT, 1949; Ridgefield, CT, 1950-52; Northfield, MA, 1931 (solo), 1950; Northfield Sch. Girls, 1955. **Comments:** Lectures on art and travel. **Sources:** WW59; WW47.

WEBSTER, Daniel C. *[Copper and steel engraver] mid 19th c.*
Addresses: Boston, 1844-after 1860. **Sources:** G&W; Boston CD and BD 1844-60+.

WEBSTER, Daniel H. *[Sculptor] b.1880, Frankville, IA.*
Addresses: Westport, CT. **Studied:** pupil of Barnard, MacNeil, F. C. Jones and Du Mond in New York. **Work:** State Capitol, Pierre, SD; American National Bank, Austin, TX; Campo Beach, CT. **Sources:** Ness & Orwig, *Iowa Artists of the First Hundred Years,* 216.

WEBSTER, David S. *[Art administrator] mid 20th c.*
Addresses: Shelburne, VT. **Comments:** Positions: asst. director, Shelburne Mus. **Sources:** WW73.

WEBSTER, E. Ambrose *[Painter, lecturer, teacher] b.1869, Chelsea, MA / d.1935.*
Addresses: Provincetown, MA (1900-35)/NYC. **Studied:** BMFA Sch. with Benson & Tarbell; Acad. Julian, Paris, with J.P. Laurens & Benjamin-Constant, 1896-98; A. Gleizes in Paris. **Member:** Provincetown AA. **Exhibited:** Boston AC; PAFA Ann., 1907-09, 1915, 1924; Armory Show, 1913; Corcoran Gal. biennials, 1914-28 (4 times); AIC; Soc. Indep. Artists, 1930. **Comments:** Author of a booklet on color. Lectures: modern art. Position: dir./teacher, Webster Art Sch., Provincetown. He visited Bermuda frequently from 1913 on. **Sources:** WW33; Provincetown Painters, 130; Falk, *Exh. Record Series;* Brown, *The Story of the Armory Show.*

WEBSTER, Eleanor A. *[Painter] mid 20th c.*
Exhibited: Soc. Indep. Artists, 1939. **Sources:** Marlor, *Soc. Indp. Artists.*

WEBSTER, Erle *[Painter, etcher] mid 20th c.*
Addresses: Los Angeles, CA. **Exhibited:** Artists Fiesta, Los Angeles, 1931; Calif. WCS, 1931, 1932; Oakland Art Gal., 1933. **Comments:** Prefesrred medium: watercolor. **Sources:** Hughes, *Artists in California,* 594.

WEBSTER, Esther Barrows (Mrs. C. N.) *[Painter, printmaker] b.1902, Portland, OR / d.1985, Port Angeles, WA.*
Addresses: Port Angeles, WA, 1954. **Studied:** Univ. Washington; PAM; ASL; with George Gross. **Exhibited:** SAM, 1937, 1938, 1939 (solo); Henry Gallery, 1951. **Sources:** Trip and Cook, *Washington State Art and Artists.*

WEBSTER, Ethel Felder *[Painter] early 20th c.*
Addresses: Westport, CT. **Exhibited:** AIC, 1914. **Sources:** WW15.

WEBSTER, Eva *[Painter] late 19th c.*
Addresses: Chicago, IL, 1891. **Exhibited:** AIC, 1889, 1891; NAD, 1891. **Sources:** Falk, *AIC.*

WEBSTER, Frank V. *[Illustrator] early 20th c.*
Comments: From 1911-15, he produced illustrations for juvenile series books, most for the Stratemeyer Syndicate. **Sources:** info courtesy James D. Keeline, Prince & the Pauper, San Diego.

WEBSTER, Frederick Rice *[Sculptor] b.1869, Grand Rapids, MI.*
Addresses: Evanston, IL. **Studied:** RA, Munich. **Member:** Chicago WCC; Chicago SA. **Exhibited:** AIC, 1906-09. **Sources:** WW19.

WEBSTER, H. Daniel *[Sculptor] b.1880, Frankville, IA / d.1912.*
Addresses: Westport, CT. **Studied:** ASL, with Barnard, MacNeil, F.C. Jones, DuMond. **Member:** Silvermine Group. **Work:** statues, near Saugatuck, CT; State Capitol, Pierre, SD; bronze doors, American National Bank Bldg., Austin, TX. **Sources:** WW13.

WEBSTER, Harold Tucker *[Cartoonist] b.1885, Parkersburg, WV / d.1952.*
Addresses: Stamford, CT/Meddybemps, ME. **Member:** SI; Dutch Treat Club. **Work:** Huntington, Lib., San Marino, CA. **Comments:** Author/illustrator: "Our Boyhood Thrills and other Cartoons," "Boys and Folks," "Our Boyhood Ambitions," "The Thrill Comes Once in a Lifetime," "Life's Darkest Moment," "The Beginning of a Beautiful Friendship," "How to Torture Your Wife"; cartoon, "The Timid Soul." **Sources:** WW47.

WEBSTER, Helen Cornelia *[Sculptor] early 20th c.*
Addresses: Chicago. **Exhibited:** AIC, 1923. **Sources:** Falk, *AIC.*

WEBSTER, Herman Armour
[Etcher, painter] b.1878, NYC / d.1970, NYC.
Addresses: Paris, France. **Studied:** Yale Univ.; Académie Julian, Paris with J.P. Laurens, 1904. **Member:** Royal Soc. P&E, London; SAE; Société Nationale des Beaux-Arts, France; London AC; Paris AA; Chelsea AC; "Société des Amis des Vieux Moulins" (organization for the preservation of old windmills in France) (founder); Legion d'Honneur, France; Paris Salon, 1937.

Exhibited: AIC; NAD; Royal Acad., London; Venice, Italy; SAE; Salon des Beaux-Arts; Chicago; Pittsburgh; Wash., DC; Pan-Pacific Expo, San Francisco, 1915 (gold); SAE, 1932 (prize), 1934 (prize); Brooklyn SE, 1930 (Prize). **Work:** AIC; LOC; FMA; NYPL; Yale; Bibliothèque Nationale, Paris; Victoria & Albert Mus., London; Luxembourg, Paris; South Kensington, London; British Mus.; Darmstadt; MMA; Prints of the Year, 1932, 1933, 1934. **Sources:** WW47.

WEBSTER, Howard *[Painter] mid 20th c.*
Exhibited: AIC, 1936. **Sources:** Falk, *AIC.*

WEBSTER, Hutton, Jr. *[Painter, etcher, teacher, writer, lecturer, illustrator] b.1910, Lincoln, NE / d.1956, Tucson, AZ.*
Addresses: Tucson, AZ. **Studied:** Univ. Nebraska; Princeton Univ. **Member:** Southern Printmakers; SAE; Calif. Printmakers; Calif. SE. **Exhibited:** Carnegie Inst.; NAD; Univ. Nebraska; MMA; TMA; GGE, 1940; Kansas City, MO; Lincoln, NE; numerous regional exhib. **Awards:** fellowship, Tiffany Fnd., 1932; Pulitzer prize, 1933; 100 Prints of the Year, 1941. **Work:** MMA; LOC; Princeton Univ.; Stanford Univ.; NGA; NYPL; Joslyn Mem.; Univ. Nebraska. **Comments:** Lectures: history of Greek art. **Sources:** WW53; WW47.

WEBSTER, Ira *[Lithographer?] mid 19th c.*
Comments: "Confiding Monkeys Crossing a Stream," entered by him at Hartford (CT) in 1844. **Sources:** G&W; Peters, *America on Stone.*

WEBSTER, Larry Russell *[Designer, painter] b.1930, Arlington, MA.*
Addresses: Topsfield, MA. **Studied:** Massachusetts College Art (B.F.A.); Boston Univ. (M.S.). **Member:** AWCS; All. A. Am.; Soc. Printers, Boston; Boston WCS. **Exhibited:** NAD, 1968 & 1970 (Obrig Prize for watercolor, each yr.); All. A. Am., 1971 (gold medal); AWCS, New York, 1968 (silver medal), 1972 (silver medal); Watercolor USA. **Work:** De Cordova Mus., Lincoln, MA; Grand Rapids (MI) Art Mus.; Munic. Gal., Davenport, IA; Springfield (MO) Art Mus. **Comments:** Preferred media: watercolors. Positions: package designer, Union Bay & Paper Corp., 1953-54; illustrator, USA, 1954-56; graphic designer, vice-pres. & director, Thomas Todd Co., Boston, 1956-. Teaching: asst. professor, typographic design, hist. type & watercolor painting, Mass. College Art, 1964-65. **Sources:** WW73.

WEBSTER, Margaret Leverich *[Painter, craftsperson, teacher] b.1906, Belleville, NJ.*
Addresses: Elizabeth, NJ. **Studied:** Newark Art Sch.; A. Fisher. **Member:** NAWPS. **Exhibited:** NAWPS, 1929 (prize), 1936-38. **Sources:** WW40.

WEBSTER, Marjorie *[Painter] mid 20th c.*
Addresses: Stockton, CA. **Studied:** Calif. College of Arts & Crafts. **Exhibited:** Oakland Art Gallery, 1938. **Sources:** Hughes, *Artists in California,* 594.

WEBSTER, Mary H(ortense) *[Sculptor, painter] b.1881, Oberlin, OH / d.1964.*
Addresses: Chicago, IL. **Studied:** Cincinnati Art Acad., with Barnhorn & Nowottny; Académie Julian, Paris with Verlet; also with Injalbert and Waldmann in Paris; Geo. Hitchcock in Holland; C.W. Hawthorne in Provincetown; AIC with L. Taft. **Exhibited:** Paris Salon, 1906; Cincinnati AM, 1916; PAFA Ann., 1916; AIC, 1918-32. **Comments:** Teaching: Lock Haven, PA & Owatonna, MN, 1907-10; Portland Art Mus. School, 1910-13. **Sources:** WW33; Falk, *Exh. Record Series.*

WEBSTER, Sarah A. *[Artist] late 19th c.*
Addresses: Boston, MA, 1875. **Exhibited:** NAD, 1875. **Sources:** Naylor, *NAD.*

WEBSTER, Stokely *[Painter, designer] b.1912, Evanston, IL.* *S. Webster*
Addresses: Heampstead, NY.
Studied: Yale Univ.; Univ. Chicago; Columbia Univ.; NAD; Wayman Adams; Lawton Parker in Paris. **Member:** Chicago AC; All. A. Am. **Exhibited:** Corcoran Gal biennial, 1937; AIC; NAD,

1941 (prize); O'Toole Gal., NY, 1940 (solo); Rouillier Gal., Chicago, 1940. **Sources:** WW53; WW47.

WEBSTER, W. A. (Miss) *[Artist] late 19th c.*
Addresses: Active in Detroit, MI. **Studied:** Maud Mathewson. **Exhibited:** Mathewsons studio, Detroit, 1894. **Sources:** Petteys, *Dictionary of Women Artists.*

WEBSTER, Walter *[Wood engraver] b.c.1836, Massachusetts.*
Addresses: Boston in 1860. **Sources:** G&W; 8 Census (1860), Mass., XXVII, 432.

WEBSTER, William J. *[Painter] b.1895, Kirkman, IA / d.1983, Wash., DC.*
Addresses: Wash., DC, 1935 and after/ Kent Island, MD. **Studied:** Oberlin College. **Member:** Kent Island Art League. **Comments:** Specialty: oil. Started his career as a painter in 1950. **Sources:** McMahan, *Artists of Washington, DC.*

WECHSLER, Abraham F. (Mr. & Mrs.) *[Collectors] 20th c.*
Addresses: NYC. **Sources:** WW66.

WECHSLER, Arabella Kelly *[Painter, designer, etcher] b.1875, Waterford, NY / d.1970, Renton, WA.*
Addresses: Seattle, WA. **Comments:** Many of her paintings and etchings have been copyrighted. **Sources:** Trip and Cook, *Washington State Art and Artists.*

WECHSLER, Henry Benjamin *[Painter] b.1860, New York.*
Addresses: Munich, Bavaria, 1890; NYC, 1898-99. **Studied:** Académie Julian, Paris with Constant, Lefebvre, and Doucet, 1889-90. **Member:** SC 1898. **Exhibited:** PAFA Ann., 1889, 1892; Paris Salon, 1891; NAD, 1890-99; NYSF; Soc. Indep. Artists. **Sources:** WW13; Fink, *American Art at the Nineteenth-Century Paris Salons,* 403; Falk, *Exh. Record Series.*

WECHSLER, Herman J. *[Art consultant, writer] b.1904, NYC / d.1976.*
Addresses: NYC. **Studied:** New York Univ. (B.S.); Harvard Univ. (M.A.); École Louvre, Paris; also with Paul S. Sachs, John Shapley, Adolf Goldschmidt, Meyer Shapiro. **Comments:** Positions: founder, pres. & director, FAR Gallery, New York, 1934-. Publications: author, "Pocket Books of--Old Masters & Gods and Goddesses in Art and Legend"; author, "Lives of Famous French Painters," Wash. Square Press; author, "Introduction to Prints and Printmaking"; author, "Great Prints and Printmakers," 1968. Specialty of gallery: graphic art of nineteenth and twentieth centuries. **Sources:** WW73.

WECHTER, Vivienne Thaul *[Educator, painter] mid 20th c.; b.NYC.*
Addresses: Bronx, NY. **Studied:** Jamaica Teachers College, with Hunter (B.P.); Columbia Univ.; New York Univ.; Pratt Inst.; Sculpture Center, New York; ASL; with Robert Beverly Hale & de Creeft; Morris Davidson School Mod. Art. **Member:** Soc. Esthetics; College Art Assn.; Fed. Mod. P&S (exec. committee, 1971-); Am. Soc. Artists; Am. Assn. Univ. Prof. **Exhibited:** Art: USA; Provincetown AA; MoMA; Riverside Mus., New York (prize); Fed. Mod. P&S. Other awards: Am. Soc. Artists; Jersey City Mus. **Work:** CGA; Berkeley, CA; Rose Mus., Brandeis, MA; Jewish Mus., New York; Mus. Fine Art, Houston & Fort Worth, TX. **Comments:** Positions: director, Urban Arts Corps., 1968-; chmn.university coalition, Bronx Council Arts, 1970-; director, Bronx Mus. Arts, 1971-. Publications: illustrator, "The Park of Jonas," 1967; editor, "Five Museums Come to Fordham," 1968; editor, "Visual Fordham," 1969 & 1970; author, "A View from the Ark," Barlenmir House, 1972; contributor, "Reconsidering the Non-Figurative in Painting." Teaching: artist-in-residence, Fordham Univ., 1964-, chmn. acquisitions & exhibs., 1964- & professor fine arts, 1967-. **Sources:** WW73; G. Brown, article (1968) & R. Gurin, article (1968), *Arts Magazine.*

WECKERLY, Charles A. *[Engraver] 19th/20th c.*
Addresses: Wash., DC, active 1892-1920. **Comments:** Position: staff, U.S. Geological Survey. **Sources:** McMahan, *Artists of Washington, DC.*

WEDDA, John A. *[Designer, painter, illustrator, teacher]* b.1911, Milwaukee, WI.
Addresses: Larchmont, NY. **Studied:** Reginald O. Bennett. **Member:** Art Dir. Club; Adcraft Club, Detroit. **Exhibited:** AIC traveling exhib., 1942-46; WMAA, 1943-45; Detroit Inst. Art, 1936, 1938-145; Art Dir. Club, 1945, 1946. Awards: prizes, Detroit, MI, 1943. **Comments:** Contributor: *Pageant, Seventeen.* **Sources:** WW53; WW47.

WEDDELL, Iris *[Etcher]* mid 20th c.
Addresses: Hinsdale, IL. **Member:** Chicago SE. **Sources:** WW27.

WEDDERBURN, Alexander *[Engraver]* mid 19th c.
Addresses: Lowell, MA, 1835-37. **Sources:** G&W; Belknap, *Artists and Craftsmen of Essex County,* 5.

WEDDERSPOON, Richard G. *[Painter, educator]* b.c.1889, Red Bank, NJ.
Addresses: Chicago, IL; Syracuse, NY; Yardley, PA. **Studied:** Carnegie Inst.; Corcoran Sch. Art; PAFA (European scholarship, 1915, 1916). **Member:** Florida Art Group; Chicago AC; Syracuse SA. **Exhibited:** PAFA, 1915 (prize), 1916 (prize); Corcoran Gal biennial, 1916; PAFA Ann., 1920; Peabody Inst., Baltimore, MD; AIC, 1922 (prize); Syracuse MA, 1926-46 (prizes, 1937, 1944, 1946). **Work:** Chicago Munic. Collection; Vanderpoel Collection; De Pauw Univ. **Comments:** Position: professor, painting, Syracuse Univ., 1923-49 (retired). **Sources:** WW59; WW47; Falk, *Exh. Record Series.*

WEDDIGE, Emil *[Lithographer, educator, painter, designer, lecturer]* b.1907, Sandwich, Ontario.
Addresses: Ann Arbor, MI. **Studied:** Eastern Michigan Univ. (B.S.); Univ. Michigan (M.Des.); ASL; also with Emil Ganso, J.P. Slusser, Morris Kantor & E. Desjobert, France. **Member:** Scarab Club; AFA; Am. Color Print Soc.; Print Club; Print Council Am.; Int. Platform Assn. (special advisor to art chmn., 1968-). **Exhibited:** NAD, 1945; CI, 1945; TMA, 1946; VMFA, 1945; Assn. Am. Art; Alger House, Detroit; Ann Arbor Artists; Joseph Pennel Exhib., 1934-68; Am. Color Print Soc., 1948-71; Print Club, 1948-71; Biennial Color Print Exhib., 1952 & 1954; Van Gogh Mem. Exhib., Pontoise, France, 1960; Birmingham (MI) Gal., 1970s. Awards: Founders prize, Detroit IA, 1937, 1942; Butler AI; Woodstock (NY) Gal.; Akron AI; San Fran. AA; SFMA, 1939 WFNY, 1939; best print award, Am. Color Print Soc., 1956; James Cleating Print Prize, Michigan Exhib., 1964. **Work:** Univ. Michigan; MMA; Cape Kennedy, FL; LOC; PMA; Detroit AI. Commissions:lithography in color, Chrysler Motor Car Co., 1955; suite of lithographs in color, Parke, Davis & Co., 1956; History of Paper (suite), Dow Chem Co., 1957; portrait of a city, Detroit Edison Co., 1958; Sesquicentennial Suite, Univ. Michigan, 1966. **Comments:** Publications: author, "Lithography," 1966. Teaching: teacher, Univ. Michigan; art instructor, Eastern Michigan Univ., 1936-37; art professor, Univ. Michigan, Ann Arbor, 1937-. Art interests: stone lithography, 1966. **Sources:** WW73; WW47; article, *Statesman* (India, 1960); Joy Hakanson, "Art," *Detroit News,* 1969; William Tall, "Art," *Detroit Free Press,* 1969.

WEDEPOHL, Theodor *[Painter]* b.1863, Exter, Westphalia / d.1931.
Addresses: NYC. **Studied:** Imperial Acad., Berlin; Munich; Paris; Rome. **Exhibited:** Imperial Acad., Berlin (prizes). **Work:** portraits of many notables. His landscapes included some of the first ever painted in Iceland.

WEDIN, Elof *[Painter]* b.1901, Sweden.
Addresses: Minneapolis, MN. **Studied:** Minneapolis School Art; AIC. **Exhibited:** AIC; San Francisco World's Fair; Minneapolis IA 1937 (prize); Walker AC, 1945 (prize)Minneapolis; Minnesota State Fair (prize). Other awards: Texas Centenn., 1936; CGE, 1930. **Work:** Minneapolis Inst Arts; Univ Minn, Minneapolis; Smith Col.; Minneapolis Women's C.; WPA murals, USPOs, Litchfield, MN, Mobridge, SD. **Comments:** Preferred media: oils. **Sources:** WW73; WW47.

WEDO, Georgette *[Painter, printmaker, teacher]* b.1911.
Addresses: Sausalito, CA. **Exhibited:** SFMA, 1943, 1945-46; SAE, 1944; LOC, 1946; Oakland A. Gal., 1942-44; de Young Mem. Mus., 1945; Crocker Art Gal., Sacramento, CA, 1944; Paul Elder Gal., San Francisco; College Puget Sound, Tacoma, WA, 1944; Calif. SE (prize). **Comments:** Position: teacher, Good Samaritan Community Center, San Fransciso, from 1945. **Sources:** WW47.

WEDOW, Rudolph *[Painter]* b.1906 / d.1965, Clinton, NY.
Addresses: Williamsville, NY. **Exhibited:** Buffalo SA, 1937; Albright Art Gal., Buffalo. **Sources:** WW40.

WEDSTER, Herman A. *[Etcher, painter, draughtsman]* b.1878, NYC.
Addresses: Paris, France. **Studied:** St. Pauls Sch.; Yale Univ. (Ph.D.), and in Paris with I. P. Laurens. **Member:** Royal Soc. Painters, Etchers & Engravers, London; SAGA; Société National des Beaux-Arts, Paris; Société des Peintures-Graveurs Français. **Exhibited:** NAD; Royal Acad., London; Venice, Italy; SAGA; Salon de la Société Nationale des Beaux Arts, Paris; Int. Expo of Engraving, Yugoslavia, 1955; and in leading U.S. museums and galleries. Awards: gold medal, Pan-Pacific Expo, 1915; prize, SAGA, 1932; Officer, Legion d'Honneur, France; Grand Prix de Gravure, Paris Int. Expo, 1937. **Work:** AIC; LOC; FMA; NYPL; Yale Univ.; Bibliothèque Nationale, Paris; Victoria & Albert Mus., London; AIC; Carnegie Inst.; Chalcographic tin Louvre, Paris, etc. **Comments:** Contributor to *The Century, L'Illustration, Bulletin of the Soc. for the Preservation of Ancient Buildings, London,* and others. **Sources:** WW59.

WEEBER, Gretchen *[Painter]* mid 20th c.; b.Albany, NY.
Addresses: Nantucket, MA. **Studied:** Albany Inst. Hist. & Art; Inst. Allende, San Miguel Allende, Mexico; also with Betty Warren. **Member:** Nantucket AA (bd. mem., 1972). **Exhibited:** New York State Expos, Syracuse, 1964; Eastern States Expos, Springfield, MA, 1965; Berkshire Ann., Pittsfield, MA, 1968; Artists of the Upper Hudson, Albany Inst. Hist. & Art, 1970; Nantucket AA, Kenneth Taylor Galleries, MA, 1972; Main Street Gallery, Nantucket, MA, 1970s. Awards: Raymond Scofield Prize for best watercolor, Albany Artists Group, 1964; first prize, Rennselaer Co. Hist. Soc, 1968; first prize for Nantucket Subjects, Nantucket AA, 1969. **Work:** Rennselaer Co. Hist. Soc., Troy, NY; Home Savings Bank, Albany; New York State Conf. Mayors, Albany; First Lutheran Church, Albany; Robert Appleton Collection, Albany. **Comments:** Preferred media: watercolors. **Sources:** WW73.

WEED, Alice *[Painter, teacher]* mid 20th c.; b.Boston, MA.
Addresses: Boston, MA/Rockport, MA. **Studied:** BMFA School; Mass. School Art; with Stanley Woodward; Sears Gallagher; Marion P. Sloane. **Member:** Rockport AA; North Shore AA; Wellesley Soc. Artists; Copley Soc., Boston; Newton AA; New Hampshire AA. **Comments:** Position: teacher, Wellesley. **Sources:** *Artists of the Rockport Art Association* (1956).

WEED, C. Bronson *[Photographer]* mid 20th c.
Addresses: New Haven and Hamden, CT (1950s-60s). **Comments:** A modernist photographer who exhibited frequently (and won awards) during the 1950s-60s at many of the national salons sponsored by the pictorialist photography organizations. **Sources:** PHF files.

WEED, Clive R. *[Painter, cartoonist]* b.1884 / d.1936, NYC.
Addresses: Phila., PA/NYC. **Studied:** PAFA, with Anshutz. **Comments:** Married Helen Torr in 1913. Illustrator of newspaper and magazines in Phila. and New York. **Sources:** WW19.

WEED, Edwin A. *[Wood engraver]* b.c.1828, New York.
Addresses: NYC from about 1850 at least until 1860. **Sources:** G&W; 7 Census (1850), N.Y., L, 690; 8 Census (1860), N.Y., XLIV, 543; NYCD 1850; NYBD 1854, 1860.

WEED, Helen See: **TORR, Helen**

WEED, R. M. (Mrs.) *[Painter]* 19th/20th c.
Member: Tacoma Art League, 1891, 1892. **Exhibited:** Western

Wash. Indust. Expo, 1891. **Sources:** Trip and Cook, *Washington State Art and Artists.*

WEED, Raphael A. *[Patron, painter] d.1931, NYC.*
Addresses: Lived mostly in Newburgh and Wilton, NY. **Studied:** D. Volk; K. Cox. **Member:** NAC; Munic. AS, NYC; Player's Club. **Work:** in 1929 presented to the NY Hist. Soc. a collection of rare theatrical photographs.

WEEDELL, Hazel (Elizabeth) (Mrs. Gustav F. Goetsch) *[Painter, etcher, craftsperson, teacher] b.1892, Tacoma, WA / d.1984, St. Louis, MO.*
Addresses: Minneapolis; Kirkwood, MO; Glendale, MO. **Studied:** G. F. Goetsche; R. Koehler; E. Batchelder; Minnesota School Art. **Member:** St. Louis AG. **Sources:** WW31.

WEEDEN, Eleanor Revere *[Portrait painter, illustrator] b.1898, Colchester, CT.*
Addresses: New York 23, NY. **Studied:** Wheaton College; BMFA Sch.; Fenway Sch. Illus.; ASL; Paris. **Member:** All. Artists Am.; NAWA, 1938. **Exhibited:** All. Artists Am.; Portraits, Inc., NY; Doll & Richards Gal., Boston, 1931 (solo); Argent Gal., NYC, 1937 (solo). **Work:** many portrait commissions. **Comments:** Preferred media: oil, pastel. **Sources:** WW53; WW47; *Art by American Women:.the Collection of L.and A. Sellars,* 129.

WEEDEN, Howard (Miss Maria Howard) *[Painter, illustrator] b.1847, Huntsville, AL / d.1905, Huntsville.*
Addresses: Huntsville. **Studied:** Huntsville Female Sem.; Tuskegee Female Methodist College; mainly self-taught. **Exhibited:** Columbia Expo, Chicago, 1893; Edward Schulte Gal., Berlin, 1896; Tennessee Centennial, Nashville, 1897; Burit Mus., 1959. **Work:** Historic New Orleans Collection. **Comments:** Specialty: Southern subjects. Author/illustrator of several books of poetry with drawings of African Americans: "Shadows on the Wall," "Bandanna Ballads," "Songs of the Old South," and "Old Voices." **Sources:** WW08; *Complementary Visions,* 90; Petteys, *Dictionary of Women Artists.*

WEEDEN, William Nye *[Silver engraver, amateur artist] b.1841, New Bedford, MA / d.1891, New Bedford, MA.*
Addresses: New Bedford, MA, 1880-91. **Work:** New Bedford (MA) Free Public Library. **Comments:** Also traveled to Europe. **Sources:** Blasdale, *Artists of New Bedford,* 205.

WEEDER, F. Ellsworth *[Painter] early 20th c.*
Addresses: Philadelphia, PA. **Sources:** WW10.

WEEDING, Nathaniel *[Painter] mid 19th c.*
Addresses: NYC. **Exhibited:** Am. Inst., 1849 (painting of a dog's head). **Sources:** G&W; Am. Inst. Cat., 1849.

WEEGE, William *[Printmaker, educator] mid 20th c.; b.Milwaukee, WI.*
Addresses: Barneveld, WI. **Studied:** Univ. Wisc.-Milwaukee; Univ. Wisc.-Madison (M.A., 1967; M.F.A., 1968). **Exhibited:** U.S. Pavillion, World's Fair, Japan, 1970; Seventh Int. Biennial Exhib. Prints, Tokyo, 1970; Beyond Realism, Assoc. Am. Artists, NYC, 1970; Mechanics in Printmaking, 1970 & Artists as Adversary, 1970, MoMA; Large Print Show, WMAA, 1971. **Work:** Akron AI; BM; AIC; Frankfurt (Germany) Library; MoMA. **Comments:** Positions: director, photo-offset area project, Univ. Wisc.-Madison, 1967-68, graphics area specialist, 1968; director exp. workshop for Smithsonian Inst., 35th Venice Biennale, summer 1970; director, Shenanigan Press, Ltd., Venice, Italy. **Teaching:** from instructor in lettering to asst. professor of art, Univ. Wisc.-Madison, 1967-. **Sources:** WW73.

WEEGEE, (Arthur Fellig) *[Photographer] b.1899, Zloczew, Poland / d.1968.*
Addresses: NYC (immigrated, 1909). **Exhibited:** ICP, 1997 (retrospective). **Work:** Center for Creative Photography, Tucson (142 prints); MEM; MoMA; IMP. **Comments:** Epitome of the cigar-chewing, flash-popping news photographer, he recorded NYC crime, disasters and street life of the 1940s. His book *Naked City*

inspired a movie and TV series of the same name. **Sources:** Miles Barth, *Weegee's World* (ICP, 1997); Witkin & London, 266.

WEEK, Cora A. *[Painter] 19th/20th c.*
Addresses: NYC, 1900. **Exhibited:** SNBA, 1895; AIC; NAD, 1900. **Sources:** Fink, *American Art at the Nineteenth-Century Paris Salons,* 403.

WEEKES, Stephen *[Wood engraver] mid 19th c.*
Addresses: NYC from 1844 to about 1855. **Exhibited:** Am. Inst., 1844-45, 1847. **Sources:** G&W; NYCD 1844-48; Am. Inst. Cat., 1844-45, 1847; Hamilton, *Early American Book Illustrators and Wood Engravers,* 109.

WEEKLEY, Arizona Celeste *[Painter] mid 20th c.*
Addresses: NYC. **Exhibited:** Soc. Indep. Artists, 1932. **Sources:** Marlor, *Soc. Indp. Artists.*

WEEKS, Edward M. *[Engraver] b.1866 / d.1950, Wash., DC.*
Addresses: Wash., DC, active 1900-59. **Comments:** Position: staff, Bureau of Engraving and Printing. **Sources:** McMahan, *Artists of Washington, DC.*

WEEKS, Edwin Lord *[Genre painter, illustrator, photographer, writer] b.1849, Boston, MA / d.1903, Paris, France.*
Addresses: Boston, MA, 1873; Paris, France (1873-on). **Studied:** École des Beaux-Arts with Gérôme, 1869; also with Bonnât, in Paris. **Member:** SC, 1897; Secession, Munich; Paris SAP; Boston AC. **Exhibited:** NAD, 1873, 1890; Boston AC, 1873-84; Centennial Expo, Phila., 1876; Paris Salon, 1878, 1880-82, 1884-92, (prize, 1884; and gold medal, Paris Expo, 1889), 1894-99; PAFA Ann., 1882-83, 1892-93, 1899, 1901; Phila. AC, 1891 (gold); Berlin Int. Expo, 1891 (prize); World's Columbian Expo, Chicago, 1893; AIC; London Expo, 1896 (medal); Dresden, 1897 (medal); Munich, 1897 (medal); Pan-Am. Expo, Paris, Buffalo, 1901 (medal). **Award:** Chevalier of the Legion of Honor, France, 1896; Officer of the Order of St. Michael of Bavaria. **Work:** MMA; PAFA; AIC; Corcoran Gal; Brooklyn Mus.; Cercle Volney, Paris. **Comments:** An expatriate painter, Weeks was a disciple of Gérôme who became America's most prominent painter of North African orientalist genre. After living in Morocco from 1873-80, he established his studio in Paris. He continued to travel extensively in the Middle East, painting (and photographing) in Jerusalem, Damascus and Tangier. His illustrations and accompanying narratives of one of his trips appeared serially in *Harper's* and *Scribner's* from 1893-95. He also made an excursion through Turkey, Persia, and India, which resulted in the publication of *From the Black Sea through Persia and India* (1896). He is also known to have produced some paintings of Native Americans. In 1905, a group of 277 of his paintings was sold at the Am. Art Gal., NYC, for $47,500. **Sources:** WW03; P & H Samuels, 516; Fink, *American Art at the Nineteenth-Century Paris Salons,* 403; *300 Years of American Art,* vol. 1, 439; Falk, *Exh. Record Series.*

WEEKS, Harold *[Painter] mid 20th c.*
Addresses: Oakland, CA, 1928-32. **Exhibited:** Santa Cruz Statewide, 1928; Oakland Art Gal., 1928. **Sources:** Hughes, *Artists in California,* 594.

WEEKS, Isabelle May Little *[Painter] b.1851, Kalamazoo, MI / d.1907, Yankton, SD.*
Addresses: Yankton. **Sources:** Petteys, *Dictionary of Women Artists.*

WEEKS, James (Darrell) (Northrup) *[Painter] b.1922, Oakland, CA.*
Addresses: Bedford, MA. **Studied:** Calif. School Fine Arts, 1940-42 & 1946-48; Hartwell School Design, 1947; Escuela Pintura, Mexico City. **Exhibited:** Corcoran Gal. Invitational, 1963; CI, 1964; SFMA, 1965 (solo) & Boston Univ. Art Gal., 1971 (solo); PAFA Ann., 1966; Expo 1970, Osaka, Japan, 1970; Poindexter Gal., NYC, 1970s. **Work:** CGA; San Francisco MA; AFA; Howard Univ., Wash., DC; Oakland Mus. **Comments:** Teaching: painting instructor, San Francisco AI, 1958-67; painting

instructor, Univ. Calif., Los Angeles, 1967-70; instructor grad. painting & chmn. dept., Boston Univ., 1970-. **Sources:** WW73; A. Ventura, "James Weeks: The Plain Path," *Arts Magazine* (February, 1964); *James Weeks, Paintings* (Felix Landau Gallery, 1964); Falk, *Exh. Record Series*.

WEEKS, John *[Painter] b.1855, Germany.*
Addresses: New Orleans, active 1891-1900. **Sources:** *Encyclopaedia of New Orleans Artists*, 405.

WEEKS, Karolyn C. *[Painter] mid 20th c.*
Addresses: South Bend, WA, 1949. **Exhibited:** SAM, 1949; Henry Gallery, 1951. **Comments:** Preferred medium: oil. **Sources:** Trip and Cook, *Washington State Art and Artists*.

WEEKS, Leo Rosco *[Painter, illustrator] b.1903, La Crosse, IN / d.1977.*
Addresses: Chicago, IL; Fanwood, NJ. **Studied:** Am. Acad. Art; also with Glen Sheffer. **Member:** Hoosier Salon; All-Illinois SFA; Wawasee Art Gal.; Palette & Chisel Acad. Fine Arts (secretary, 1944-47; pres., 1948); Westfield AA. **Exhibited:** Hoosier Salon, Indianapolis, 1940s; Palette & Chisel Acad. Fine Arts, Chicago, 1942-62; All Illinois SFA, Chicago, 1942-62; Wawasee Art Gal.; Garden State Watercolor Soc., Princeton, NJ, 1970; Scotch Plains-Fanwood AA, 1971 & 72; Westfield AA, Union College, Cranford, 1965-67 & 1972; NJ State Shows. Awards: gold medal for oils, Palette & Chisel Acad. Fine Arts, 1943, 1944; first prize for watercolor, All-Illinois SFA, 1946 & 1952; Honeywell prize for Still Life in oil painting, Hoosier Salon, 1948. **Work:** public schools in Cairo, Herrin, Downers Grove & Rock Island, IL. **Comments:** Preferred media: oils, watercolors. Positions: asst. art director, *Popular Mechanics Magazine*, Chicago, 1943-62, New York, 1962-68; retired. Publications: illustrator of miscellaneous Western books for children, 1930-43; illustrator, "Penny Wise," 1942; illustrator, *Popular Mechanics Magazine*, 1943-68. **Sources:** WW73; WW47.

WEEKS, Lore Lucile *[Painter] early 20th c.*
Addresses: Chicago, IL. **Exhibited:** AIC, 1902. **Sources:** WW04.

WEEKS, Percy (Mrs.) *[Painter] 19th/20th c.*
Addresses: Oakland, CA, 1900-02. **Exhibited:** San Francisco AA, 1900. **Sources:** Hughes, *Artists in California*, 594.

WEEKS, William *[Architect, stone and wood carver, sculptor] b.1813, Martha's Vineyard, MA / d.1900, Los Angeles, CA.*
Addresses: Nauvoo, IL, c.1841; Utah; Los Angeles. **Work:** Historian's Office Mormon Church, Salt Lake City (architectural drawings). **Comments:** He became a builder and after various wanderings in the Middle West joined the Mormon Church. He was the chief architect of the Mormon Temple in Nauvoo and did some of the ornamental carving for it. He joined the trek to Utah in 1847 but broke with the church in 1848. **Sources:** G&W; Arrington, "Nauvoo Temple."

WEEMS, Benjamin *[Listed as "artist"] 19th/20th c.*
Addresses: Wash., DC, active 1920-35. **Exhibited:** Greater Wash. Indep. Exh., 1935. **Sources:** McMahan, *Artists of Washington, DC*.

WEEMS, Katharine Ward Lane *[Sculptor, medalist] b.1899, Boston, MA / d.1989.*
Addresses: Manchester, MA. **Studied:** May School, Boston; BMFA Sch., with Charles Grafly; also with Anna Hyatt Huntington, Brenda Putnam, & George Demetrios. **Member:** ANA; NA; NAWA; NSS (council mem., 1949); Arch. Lg.; CAFA; PBC; Gld. Boston A.; North Shore AA; Boston SS; Grand Central AG; AAPL; Boston AC; Mass. State Art. Comm.; NIAL; Guild Boston Artists. **Exhibited:** PAFA Ann., 1922-31, 1939-47 (gold 1927); Sesqui-Centenn. Expo, Phila, 1926 (med. for "Pygmy African Elephant"); AIC, 1926-30; Paris Salon, 1928 (prize); NAWA, 1928 (gold), 1931 (prize), 1933, 1944, 1946 (prize); North Shore AA, 1929 (prize); Grand Central Gal., 1929 (prize); Doll & Richards Gal., Boston, 1930 (solo), 1932 (solo); Boston Tercentenn. Exh., 1930 (prize); NAD, 1931 (prize), 1932 (prize),

1941, 1944, 1946, 1960 (Saltus Gold Medal for Merit), 1972 (Speyer Prize); Arch. Lg., 1942, 1944; Inst. Mod. A., Boston, 1943; Guild of Boston Artists, Boston, MA, 1970s. **Work:** BMFA; Mus. Science, Boston (a gallery devoted to her work); Reading (PA) Mus.; PAFA; BMA; Calgary Mus., Alta; Brookgreen Gardens, SC. Commissions: brick carvings of geographical distribution of animals of world, entrance doors, and two free-standing rhinoceroses, Biology Labs, Harvard Univ.; Lotta Fountain, Esplanade Plaza, Boston; U.S. Legion of Merit & Medal For Merit, U.S. Govt.; Goodwin Medal, MIT, Cambridge, MA. **Comments:** Animal sculptor. Exhibited as Katherine Ward Lane; married Carrington Weems in 1947. **Sources:** WW73; WW47 (as Lane); Rubinstein, *American Women Sculptors*, 168-170; Petteys, *Dictionary of Women Artists*; Falk, *Exh. Record Series*;"From Clay to Bronze" (film), Harvard Univ. & BMFA, 1930; Patricia Barnard, *The Contemporary Mouse* (Coward, 1954); Tatiana Browne, *A Bevy of Bears* (Heredities Inc., 1972).

WEESE, Myrtle A. *[Painter] b.1903, Roslyn, WA.*
Addresses: Tucson, AZ. **Studied:** Los Angeles Co. Art Inst.; also with George Flower & Ejnar Hansen. **Member:** Scand.-Am. Soc.; Am. Inst. Fine Arts; Las Artistas Art Club; Prof. Artists Los Angeles. **Exhibited:** Bowers Mem. Mus., Santa Anna (solo); Sierra Madre City Hall (solo); Los Angeles City Hall (solo); Descanso Gardens, 1961 (solo) & Sierra Madre, 1967 (solo). Awards: prizes, Brea Women's Club, 1961 & Las Artistas, 1961, gold medal, Greek Theatre, Los Angeles, 1961. **Sources:** WW73.

WEGENROTH, Stow *[Lithographer] mid 20th c.*
Addresses: NYC. **Exhibited:** WMAA, 1933-42. **Sources:** Falk, *WMAA*.

WEGER, Marie (Mrs. Ernest Kleinbardt) *[Painter] b.1882, Murten, Switzerland / d.1980, Harrison, NY.*
Addresses: Brooklyn, Mt. Vernon & Harrison, NY, 1930-75. **Studied:** in Munich, Germany, with her father Max Weger, Paul Nauen & Wilhelm von Dietz; in Paris. **Member:** All. Artists Am.; Beaux Arts Soc., Munich & Paris; Queensboro SA. **Exhibited:** Munich, 1907-30; Vienna; Paris; S. Indp. A., 1932; Salons of Am.; BM; AAPL; Queensboro SA; Meinhard-Taylor Gals., Houston; Harris (NY) Library; Hudson Valley AA; White Plains, NY; Kennedy Gals., NYC; Rose Cummings Gal., NYC; Peikin Gals., NYC; All. Artists Am., NYC; Wolfe Art Club, NYC; Tricker Gals., CA; Civic Club, NYC, 1931 (solo); Garden City (NY) Gals.,1970 (solo). **Work:** City Hall, Munich. **Comments:** Best known for her floral and fruit still life paintings, although she also painted portraits of notable world figures. Her husband Ernest Kleinbardt was also an artist. **Sources:** WW59; WW47; Petteys, *Dictionary of Women Artists*; Falk, *Exh. Record Series*.

WEGGELAND, Daniel F. *[Painter] early 20th c.*
Addresses: Salt Lake City, UT. **Sources:** WW15.

WEGGELAND, Danquart Anthon *[Portrait and landscape painter, teacher] b.1827, Christiansand, Norway / d.1918, Salt Lake City, UT.*
Addresses: Salt Lake City, UT from 1862-. **Studied:** Royal Acad., Copenhagen, 1848; landscape painting in Norway, 1949; NAD, with Daniel Huntington and G.P.A. Healy, 1861. **Exhibited:** Centennial Expo, Phila., 1876; World's Columbian Expo, Chicago, 1893. **Work:** Brigham Young Univ.; Springville AM; Latter Day Saints Temples. **Comments:** Came to NYC in 1861, having been persecuted in Norway and England for his conversion to the Mormon Church. Founder: Deseret Acad. FA, 1863. Position: teacher of Utah painters such as Harwood, Evans, Hafen and Lorus Pratt. **Sources:** P&H Samuels, 516-17.

WEGMAN, William *[Photographer, painter, video artist] b.1943, Holyoke, MA.*
Addresses: NYC, 1999. **Studied:** Mass. College Art, Boston, 1965; Univ. Illinois, Urbana-Champaign (M.F.A., 1967). **Exhibited:** WMAA; Kunsthalle, Switzerland. **Work:** BMFA; WMAA; BM; Chrysler Mus., NYC; MoMA, NY and Paris; Walker AM; CI. **Comments:** Known best for his witty, ironic, anthropomorphic photographs of his Weimaraner dogs--the first of

whom was Man Ray in the early 1970s. Teaching: Univ. Wisconsin, 1968-70, Calif. State Univ., Long Beach, CA, 1970. Author: "Pathetic Readings," *Avalanche Magazine,* 1974. **Sources:** Martin Kunz, *William Wegman, Paintings, Drawings, Photographs, Videotapes* (NYC: Harry Abrams, 1990).

WEGNER, Harry M. *[Painter] b.1851, Pittsburgh, PA.* **Addresses:** Virginia, 1885; Wash., DC, active 1898-1902. **Studied:** with his father Augustus. **Work:** Univ. Virginia; College William & Mary; Virginia State Lib., Richmond. **Comments:** Specialty: portraits. **Sources:** McMahan, *Artists of Washington, DC.*

WEGNER & BUECHNER *[Lithographers] mid 19th c.* **Addresses:** Pittsburgh, PA, before 1859. **Comments:** *Cf.* Charles Wagoner **Sources:** G&W; Drepperd, "Pictures with a Past," 96.

WEHLE, Fannie *[Painter] early 20th c.* **Addresses:** Louisville, KY. **Member:** Louisville Art Lg. **Sources:** WW04.

WEHN, James A. *[Sculptor] b.1882, Indianapolis, IN.* **Addresses:** Seattle, WA/Crescent Beach, WA. **Studied:** R.N. Nichols. **Member:** Am. Numismatic Soc. **Work:** mon., Seattle; relief, Court House, Chehalis, Wash.; medallions, Univ. Washington, Yesler Lib., Garden C., Northern Life Tower; Zeta Psi Fraternity, Seattle; seals of U.S./stone eagles, USPO, Longview, WA; bust, Skagway, AK; seal, City of Seattle; mon., Univ. Washington campus; bust, Harbor View Hospital, Seattle; medallions, Columbus Hospital, Seattle. **Sources:** WW40.

WEHNER, Carl Herman *[Sculptor] b.c.1847 / d.1921, Memphis, MI.* **Addresses:** Detroit, MI. **Studied:** H. K. Brown in Newburg-On-the Hudson; with J.Q.A. Ward, NYC. **Comments:** He settled in Detroit in 1854 and executed many statues of prominent people there. **Sources:** Gibson, *Artists of Early Michigan,* 238.

WEHNERE [?], Edward *[Listed as "artist"] b.c.1810, Maryland.* **Addresses:** Baltimore in 1850. **Comments:** No artist of this name appears in the Baltimore directories, but there was an Edward Wellmore (see entry), portrait and miniature painter, possibly the same man. **Sources:** G&W; 7 Census (1850), Md., V, 474; Baltimore CD 1837-67.

WEHR, Paul Adam *[Illustrator, designer, painter, graphic artist] b.1914, Mount Vernon, IN / d.1973.* **Addresses:** Indianapolis, IN. **Studied:** John Herron Art Inst. (B.F.A.). **Member:** Indiana A. Cl. **Exhibited:** Indiana Artists, 1937, 1942 & 1943; Indiana State Fair, 1936; PAFA, 1940 & 1943; Indiana A. Cl., 1944; Advertising Art Exhib., NY, 1945; Art Dirs. Cl., Chicago, 1945 & 1954. Awards: Indiana State Fair, 1940, 1941; prizes, Indiana Artists, 1942, 1944, 1951 & 1956 & Hoosier Salon, 1943, 1944 & 1969; Art Dir. Cl., Chicago, 1945 (prize); first award, Indiana Sesquicentennial Design Competition, Seal & Commemorative Stamp, 1965. **Work:** Herron Art Inst. **Comments:** Positions: hd. commercial art dept., John Herron Art Inst., Indianapolis, IN, 1937-45; illustrator, Stevens, Gross Studios, Inc., Chicago. Publications: illustrated covers for *Popular Mechanics, Sports Afield, Coronet & Country Gentleman Magazine;* illustrator, *Collier's* & others. **Sources:** WW73; WW47.

WEHR, Wesley Conrad *[Painter] b.1929, Everett, WA.* **Addresses:** Seattle, WA. **Studied:** Univ. Washington (B.A. & M.A.); also with Mark Tobey. **Exhibited:** Washington State Art Mobile, State Capitol Mus., Olympia, 1969-70; Expo 1970, Washington State Pavilion, Osaka, Japan, 1970; Gov. Invitational, State Capitol Mus., Olympia, 1970; Whatcom Mus. Hist. & Art, Bellingham, WA, 1970 (retrospective); Northwest Drawings, Henry Art Gal., Univ. Washington, Seattle, 1972; Francine Seders Gal., Seattle, WA & Humboldt Galleries, San Francisco, CA, 1970s. Awards: painting award, Arts & Crafts Festival, Bellevue, WA, 1966; painting award, Arts Festival, Anacortes, WA, 1967; first place & hon. men., Tacoma Art League, 1969. **Work:** Munic.

Gal. Mod. Art, Dublin, Ireland; Art Gal. Greater Victoria, BC; Lyman Allyn Mus., Connecticut Col., New London, CT; Carpenter Art Galleries, Dartmouth College, Hanover, NH; Henry Art Gal., Univ. Washington, Seattle. **Comments:** Preferred media: mixed media. Publications: illustrator, "Poetry Northwest," Seattle, 1966; contributor, "People/The Arts/The City," Munic. Art Commission Report, Seattle, 1966; contributor, "The Artist and His Environment," Univ. Press, Seattle, 1973. **Sources:** WW73; Mary Randlett, "Portraits by Mary Randlett," *Seattle Times,* 1971; Elizabeth Bishop, *The Artist and His Environment,* monograph (Univ. Press, Seattle, 1973).

WEHRLE, Fred J. *[Painter] b.1882, Murten, Switzerland.* **Exhibited:** Soc. Indep. Artists, 1940, 1942-43. **Sources:** Marlor, *Soc. Indp. Artists.*

WEHRMAN, H. *[Lithographer] mid 19th c.* **Addresses:** New Orleans, active 1868. **Exhibited:** Grand State Fair, 1858 (hon. men.). **Comments:** Possibly either Henry or Hermann Wehrmann (see entries). **Sources:** *Encyclopaedia of New Orleans Artists,* 405.

WEHRMANN, Charlotte Marie Clementine Bohne (Mrs. Henry) *[Engraver] b.1830, Paris, France / d.1911, New Orleans, LA.* **Addresses:** New Orleans, active c.1852-85. **Exhibited:** World's Indust. & Cotton Cent. Expo, 1884-85; Grand State Fair, 1867 (medal). **Comments:** She and Henry Wehrmann (see entry) married in 1848 and arrived in New Orleans in 1849. She engraved sheet music for her husband's company and together they printed over 8000 individual compositions and were commissioned by all major music houses in the city. She also engraved the first plates published by her son, Henry W. Wehrmann (see entry). Her son Valentine won a prize for his crayon drawing at age 16. **Sources:** *Encyclopaedia of New Orleans Artists,* 405.

WEHRMANN, Henrietta Termier (Mrs. Hermann) *[Lithographer] b.1834, Germany / d.1901, New Orleans, LA.* **Addresses:** New Orleans, active 1893-1901. **Comments:** Worked in the family business together with her husband Hermann and sons Adolph and Frederick. **Sources:** *Encyclopaedia of New Orleans Artists,* 406.

WEHRMANN, Henry *[Engraver, lithographer, printer] b.1827, Germany / d.1905, New Orleans, LA.* **Addresses:** New Orleans, active 1852-1905. **Comments:** Husband of Charlotte M. Wehrmann (see entry), father of Henry W. and Valentine Wehrmann. **Sources:** *Encyclopaedia of New Orleans Artists,* 406.

WEHRMANN, Henry W. *[Painter, sketch artist] b.1871, New Orleans, LA / d.1956, New Orleans, LA.* **Addresses:** New Orleans, active 1896-1903. **Comments:** Accomplished musician and composer, he sketched portraits of his favorite composers and maintained a studio. Son of Henry and Charlotte T. Wehrmann (see entries). **Sources:** *Encyclopaedia of New Orleans Artists,* 406.

WEHRMANN, Hermann *[Lithographer, engraver, printer] b.1840, Minden, Germany / d.1905, New Orleans, LA.* **Addresses:** New Orleans, active 1867-1905. **Comments:** Established his firm in New Orleans in 1867. Husband of Henrietta T. Wehrmann (see entry), father of Adolph and Frederick Wehrmann, who both worked in the family business. **Sources:** *Encyclopaedia of New Orleans Artists,* 407.

WEHRSCHMIDT, Daniel A. *[Painter, etcher] early 20th c.* **Addresses:** London, England. **Exhibited:** Pan-Pacific Expo, San Francisco, 1915 (medals); St. Louis Expo, 1904 (medals for paintings and mezzotints). **Sources:** WW17.

WEIBLEN, Albert *[Designer, stone carver] b.1857, Metzingen, Germany / d.1957, New Orleans, LA.* **Addresses:** New Orleans, active c.1885-1957. **Studied:** Stuttgart, Germany. **Comments:** Came to the U.S. c.1883 and worked in Chicago, San Francisco and Cleveland. Settled in New Orleans in 1885 and in 1887 bought the granite and marble works company

he had started out with. His company did the majority of work in Metairie Cemetery and his corporation in GA was responsible for the early work on the monumental carving on Stone Mountain. He designed numerous other monuments, tombs, fountains and wading pools in other cities. **Sources:** *Encyclopaedia of New Orleans Artists,* 407.

WEICKUM, Louis *[Painter] mid 20th c.*
Addresses: Astoria, NY. **Exhibited:** Soc. Indep. Artists, 1924-25. **Sources:** Marlor, *Soc. Indp. Artists.*

WEIDENAAR, Reynold Henry *[Etcher, painter, illustrator, lecturer] b.1915, Grand Rapids, MI / d.1985, Grand Rapids.*
Addresses: Grand Rapids, MI. **Studied:** Kendall School Design, 1935-36; Kansas City AI, scholarship, 1938, 1938-40; W. Rosenbauer; J. Meert; M. Hammon. **Member:** NAD; SAGA; AWCS; SAE; Chicago SE; Wash. SE; Calif. SE; CAFA; AAPL; Wash. WCC; Bridgeport AL; North Shore AA; Gloucester AA; New Orleans AA; Carmel AA; Springfield AL; Inst. Mod. Art, Boston; Palm Beach AL; Wash. AC. **Exhibited:** regular exhibitor, NAD, Detroit IA, 1943 & LOC; Wash. WCC, 1946; Irvington Art & Mus. Assn., 1943; CAFA, 1943; Hefner Galleries, Grand Rapids, MI, 1970s. **Awards:** SAE, 1942 (prize), 1945 (prize); LOC, 1944 (prize); P&S Soc., NJ, 1945 (prize); New Orleans AA, 1945 (prize), 1946 (prize); Guggenheim Foundation award, 1944; Tiffany Foundation scholarship, 1948. **Work:** LOC; Detroit IA; Nat. Gal. South Wales, Liverpool, England; U.S. Nat. Mus.; Honolulu Acad. FA; CAFA; Wadsworth Atheneum; W.R. Nelson Gal.; Hackley Art Gal., Muskegon, MI; PMA; Grand Rapids Art Gal. Commissions: murals, church history, La Grave Ave. Christian Reformed Church, 1965 & Urban Renewal, Michigan Consolidated Gas Co., Grand Rapids. **Comments:** Preferred media: watercolors, casein. Publications: author, "Our Changing Landscape," Wake-Brook House, 1970. Teaching: instructor, life drawing & painting, Kendall School Design, 1956; private instructor. Illustrator: "The Street," 1945, "The March of Truth," 1944, &other books. **Sources:** WW73; WW47.

WEIDENBACH, Augustus *[Landscape painter] mid 19th c.*
Addresses: Baltimore, MD (act. 1853-73). **Exhibited:** Maryland Hist.l Soc., as early as 1853; Brooklyn AA, 1872-74. **Comments:** His view of Harper's Ferry (WV) was lithographed by Edward Sachse & Co. between 1860-63. **Sources:** G&W; Lafferty; Rutledge, MHS; Stokes, *Historical Prints.*

WEIDENBACH, Henry *[Listed as "artist"] 19th/20th c.*
Addresses: Wash., DC, active c.1886-1905. **Sources:** McMahan, *Artists of Washington, DC.*

WEIDENMAN, Marguerite *[Painter] mid 20th c.*
Addresses: NYC. **Exhibited:** Soc. Indep. Artists, 1934. **Sources:** Marlor, *Soc. Indp. Artists.*

WEIDHAAS, Ralph Oscar *[Painter] mid 20th c.*
Addresses: NYC. **Exhibited:** Soc. Indep. Artists, 1932. **Sources:** Marlor, *Soc. Indp. Artists.*

WEIDHAAS, Ted *[Designer, decorator] mid 20th c.*
Addresses: NYC. **Work:** contour curtain, Radio City Music Hall, NYC; decorative masks, theatre sets, metal murals. **Sources:** WW40.

WEIDLICH, Raymond J. *[Painter] b.1910, Minneapolis, MN.*
Studied: Univ. Minnesota, College Arch. **Member:** Puget Sound Group Northwest Painters; Northwest WCS. **Exhibited:** Dayton (OH) Art Mus.; SAM, 1947. **Sources:** Trip and Cook, *Washington State Art and Artists.*

WEIDNER, Carl A. *[Miniature painter] b.1865, Hoboken, NJ.*
Addresses: NYC, 1888-89. **Studied:** NAD; ASL; P. Nauen, in Munich. **Exhibited:** NAD, 1888-89; Pan-Am. Expo, Buffalo, 1901 (prize); PAFA Ann., 1901-03. **Sources:** WW10; Falk, *Exh. Record Series.*

WEIDNER, Doris Kunzie *[Painter, screenprinter, lithographer] b.1910.*
Addresses: Phila., PA. **Studied:** Barnes Fnd.; PAFA. **Exhibited:** PAFA, 1938-1952 (1948 solo); PAFA Ann., 1944-54 (prize 1944, 1946); Audubon Artists; NAD; VMFA; Corcoran Gal biennial, 1951; Phila. Pr. Club; Woodmere Art Gal.; Newark Mus.; Asbury Park, NJ; MMA (AV), 1945; Phila., 1953. Other awards: Oklahoma Lith. Exhib., 1941; Pepsi-Cola, 1945. **Work:** Woodmere Art Gal., Phila.; PAFA; LOC; Oklahoma AC. **Sources:** WW59; WW47; Falk, *Exh. Record Series.*

WEIDNER, Roswell Theodore *[Painter, instructor, lithographer] b.1911, Reading, PA.*
Addresses: Phila., PA. **Studied:** PAFA, country school at Chester Springs, PA, 1930-33, and Phila., 1934-36 (Cresson Schol., 1936); Barnes Foundation, Merion, PA, 1934-36. **Member:** PAFA (fellow; pres., 1954-67; vice-pres., 1967-); Phila. WCC (bd. dirs., 1965-); AEA; Print Club Phila.; Int. Inst. Conserv. Hist. & Artistic Works; Ephrata Cloister Assoc. (hon. mem.). **Exhibited:** PAFA Ann., 1934-68 (Toppan prize, 1936; Fellowship prize, 1943; Granger award, 1959); PAFA solos, 1948, 1960; Phila. Sketch Club, 1936 (prize); WFNY, 1939; Corcoran Gal biennials, 1939-43 (3 times); Penn. Athletic Club, Phila., 1941 (solo); Directions Am. Painting, Carnegie Inst., 1943; Tarry (FL) Art Assoc., 1952 (hon. men.); Beryle Lush Gal., Phila., 1953 (solo); Miami Beach (FL) Art Center, 1957 (solo); Cosmo. Club, Phila., 1959 (solo); Reading Art Mus., 1961 (solo); Phila. Art All., 1962 (solo); Peale House at PAFA, 1965 (solo); Phila. WCC at PAFA, 1965, 1972, 1975, 1976; Wm. Penn Mem. Mus., Harrisburg, PA, 1966 (solo); McCleaf Gal., Phila., 1970 (solo); Drawing Soc. 2nd Eastern Cent. Exhib., PMA, 1970; 24th Am Drawing Biennial, Norfolk (VA) Mus. Arts & Sciences & Smithsonian Traveling Exhib., 1971; Kutztown State Teachers College; Woodmere Art Gal.; NAD; AIC; MMA (AV); Pepsi-Cola. **Work:** Reading Mus. Art; PAFA; PMA; Penn. State Univ.; MMA; LOC; Free. Lib., Phila.; Kutztown (PA) State Teachers College; AIC; Newark (NJ) Mus. Art; St. Louis Mus. Art; Santa Barbara (CA) Mus. Art; Washington Co. Mus. Art, Hagerstown, MD; and many corporate collections. Portrait commissions: Herman Beerman for Univ. Penn., Phila., 1968; Robert C. Sale for Connecticut State Library, Hartford, 1969; Clair R. McCollough for Nat Assoc. Broadcasters, Wash., DC, 1970. **Comments:** Preferred media: oils, charcoal, pastels. Positions: WPA, 1936-38; member exhib. committee, Phila. Art All., 1965-70. Teaching: PAFA, 1938-96; Phila. College Art, 1949-51. Special awards: Percy Owens Award for Distinguished Penn. Artist, 1966; Dean's Award for Distinguished Service to PAFA, 1996. **Sources:** WW73; WW47; Falk, *Exh. Record Series.*

WEIFFENBACH, Elizabeth *[Painter, teacher] early 20th c.*
Addresses: Buffalo, NY. **Sources:** WW21.

WEIFORD, Richard P. (Corp.) *[Painter] mid 20th c.*
Addresses: Chanute Field. **Exhibited:** Soc. Indep. Artists, 1942. **Sources:** Marlor, *Soc. Indp. Artists.*

WEIGHT, Christopher *[Painter] mid 19th c.*
Addresses: NYC, 1865. **Exhibited:** NAD, 1865. **Sources:** Naylor, *NAD.*

WEIGLEY, M. W. *[Painter] 19th/20th c.*
Addresses: Paris. **Exhibited:** Phila. AC, 1898. **Sources:** WW01.

WEIGMANN, Fritz *[Painter] mid 20th c.*
Exhibited: AIC, 1934. **Sources:** Falk, *AIC.*

WEIHS, Erika *[Painter] mid 20th c.*
Addresses: NYC. **Exhibited:** WMAA, 1948-49. **Sources:** Falk, *WMAA.*

WEIL, Alexander *[Lithographer] b.c.1818, Baden.*
Addresses: NYC from c.1854. **Comments:** He was associated with David Weil (see entry) in 1857. **Sources:** G&W; 8 Census (1860), N.Y., XLIX, 137; NYBD 1857, 1859; NYCD 1863.

WEIL, Arthur *[Artist] b.1883, Strassbourg.*
Addresses: Evanston, IL. **Studied:** Italy. **Exhibited:** AIC, 1916-

17, 1920. **Work:** Canadian Govt. **Sources:** WW19.

WEIL, Carrie H. (Mrs.) *[Sculptor] b.1888, NYC.*
Addresses: NYC. **Studied:** P. Hamaan in NYC; Académie Julian, Paris with Landowski. **Member:** NAWPS. **Comments:** Specialty: portrait busts. **Sources:** WW33.

WEIL, David *[Lithographer] mid 19th c.*
Addresses: NYC in 1857-59. **Comments:** In 1857 associated with Alexander Weil (see entry). **Sources:** G&W; NYBD 1857, 1859.

WEIL, Gertrude *[Painter] d.c.1900, Paris.*
Addresses: Phila., PA. **Exhibited:** PAFA Ann., 1891-92.
Comments: An art student from a wealthy Philaelphia family, her body was found in the Seine river, an apparent suicide by drowning. **Sources:** Falk, *Minerva J. Chapman* (Madison, CT: Sound View Press, p.16); Falk, *Exh. Record Series.*

WEIL, John *[Listed as "artist"] b.c.1810, New York.*
Addresses: NYC in 1850. **Sources:** G&W; 7 Census (1850), N.Y., LII, 263.

WEIL, Josephine Marie *[Painter] early 20th c.*
Addresses: NYC. **Studied:** ASL. **Exhibited:** Soc. Indep. Artists, 1917-19; PAFA Ann., 1919. **Sources:** WW19; Falk, *Exh. Record Series.*

WEIL, L. *[Sculptor] 19th/20th c.*
Exhibited: Paris Salon, 1898. **Sources:** Fink, *American Art at the Nineteenth-Century Paris Salons*, 404.

WEIL, Otilda *[Painter] early 20th c.*
Addresses: NYC. **Sources:** WW13.

WEIL, Richard K. (Mr. & Mrs.) *[Collectors] mid 20th c.*
Addresses: St. Louis, MO. **Sources:** WW73.

WEIL, Sibyl L. *[Artist] b.1944.*
Addresses: NYC. **Exhibited:** WMAA, 1975. **Sources:** Falk, *WMAA.*

WEIL, Susan Cooper *[Painter] b.1922.*
Sources: *Rediscovery: A Tribute To Otsego County Women Artists,* exh. brochure (Hartwick Foreman Gallery, 1989), 29-30.

WEIL, Yvonne *[Painter] mid 20th c.*
Exhibited: Soc. Indep. Artists, 1938. **Sources:** Marlor, *Soc. Indp. Artists.*

WEILAND, James G. *[Portrait painter] b.1872, Toledo, OH / d.1968.*
Addresses: Brooklyn, NY/Lyme, CT. **Studied:** NAD; ASL; Royal Acad., Munich; Acad. Delecluse & Acad. Colarossi, both in Paris. **Exhibited:** NAD; PAFA Ann., 1919; All. Artists Am.; Brooklyn SA; Lyme AA; AIC; Soc. Indep. Artists. **Work:** Conn. State Capitol; Florence Griswold Mus., Old Lyme, CT; U.S. Nat. Mus.; Conn.t State Lib.; Conn. Supreme Court; Court Houses at New London, Putnam, Willimantic, Bridgeport, Hartford, CT; Cleveland Pub. Lib.; Western Reserve Univ.; Granby (CT) Lib. **Sources:** WW59; WW47; Falk, *Exh. Record Series;* add'l info. courtesy Florence Griswold Mus., Old Lyme, CT.

WEILER, Louis *[Painter] b.1893, Bavaria, Germany.*
Addresses: Seattle, WA, 1916; Quincy, WA, 1941. **Studied:** Würzburg, Germany; with Prof. Wertheimer. **Exhibited:** Soc. Indep. Artists, 1930; Wenatchee, WA, 1928-32. **Sources:** Trip and Cook, *Washington State Art and Artists.*

WEILL, Edmond *[Painter, etcher, lithographer] b.1877, NYC.*
Addresses: Brooklyn, Brewster, NY. **Studied:** NAD, with Edgar M. Ward. **Member:** SC; Brooklyn SA; Putnam County AA; Brooklyn PS; Brooklyn WCC; AWCS. **Exhibited:** NAD, 1898; Carnegie Inst.; PAFA Ann., 1901-10 (5 times); Corcoran Gal biennials, 1907-23 (3 times); AIC; BMFA; WMAA; Boston AC, 1907; Salons of Am.; Soc. Indep. Artists. **Work:** BM; CCNY; Middletown (NY) Lib. **Sources:** WW53; WW47; Falk, *Exh. Record Series.*

WEILL, Erna *[Sculptor, instructor] 20th c.; b.Frankfurt-am-Main, Germany.*
Addresses: Teaneck, NJ. **Studied:** Univ. Frankfurt, with Helen von Beckerath; also with John Hovannes, NYC. **Member:** AEA; NY Soc. Artists Craftsmen; Mod. Artists Guild, NJ. **Exhibited:** New York World's Fair; NJ State Mus., Trenton; Brooklyn Mus.; Montclair Mus.; Newark Mus.; plus solos in NY & NJ, 1951-72. Awards: Mem. Foundation Jewish Cultural grant for religious sculpture. **Work:** Georgia Mus. Art, Athens; Birmingham (AL) Mus.; Jewish Mus., New York; Hyde Park Library, New York; Israel Mus., Hebrew Univ., Jerusalem. Commissions: bronze arch. sculptures, Teaneck Jewish Center, NJ, 1955, White Plains Jewish Center, NY, 1958 & Temple Har El, Jerusalem, Israel, 1963; bronze portrait sculptures, Linus Pauling, Portola Valley, CA, Martin Buber, Hebrew Univ. & Leonard Bernstein. **Comments:** Preferred media: stone, metal, concrete. Publications: author, "Any Child Can Model in Clay," *Design*; co-author, article, *Crisis*, 10/1965; contributor, *Library Journal &NJ Educ. Review.* Teaching: sculpture instructor, Brooklyn Mus., Forest Hills Public Schools, Forest Hills Jewish Center & Teaneck Jewish Center; sculpture instructor, Adult Educ. Program, Ft. Lee, NJ; private sculpture instructor, lecturer, Fairleigh Dickinson Univ., lecturer, various clubs & temples, NJ. **Sources:** WW73; Bernard Buranelli, "World of Erna Weill," *Rec. Magazine* (1964); Avram Kampf, *Contemporary Synagogue Art*, Union Am. Hebrew Congregations , 1965.

WEILL, Milton (Mr. & Mr.) *[Collectors] b.1891, NYC.*
Addresses: Sarasota, FL. **Studied:** Mr. Weill, Columbia Univ. (A.B., 1913). **Member:** Art Collectors Club. **Sources:** WW73.

WEILLER, Lee Green (Mrs. Eugene W.) *[Painter] b.c.1901, London, England.*
Addresses: Elkins Park, PA. **Studied:** Moore AI; H.B. Snell; R.S. Bredin; Philadelphia Sch. Design for Women; PAFA (fellowship); Acad. de la Grande Chaumière, Paris, France. **Member:** Phila. Art All.; Phila. MA; Moore Inst. College Art; Woodmere Art Gal. **Exhibited:** Phila. Art All.; Phila. Sketch Club; Corcoran Gal biennial, 1937; AFA traveling exhib. 1937; Moore IA, Phila.; Woodmere Art Gal. Awards: John Frederich Louis Medal; Pearl Aiman Van Sciver Prize. **Work:** Cheltenham Township, England. **Comments:** Preferred media: oils. Teaching: Wharton Center & Janette Whitehill Rosebuam AC, Phila., 1958-64. **Sources:** WW73; WW47.

WEIMER, B. *[Painter, designer] b.1890.*
Addresses: Akron, OH. **Exhibited:** Akron AI, 1924 (prize).
Comments: Position: art director, indust. designer, Miller Rubber Co., Akron. **Sources:** WW40.

WEIMER, Charles Perry *[Illustrator, writer, lecturer] b.1904, Elkins, WV.*
Addresses: New York 19, NY. **Studied:** Univ. Pittsburgh; Carnegie Inst.; AIC; H. Dunn. **Member:** SI; Artists Gld., NY; Chatham AC; Art Center of the Oranges, NJ. **Exhibited:** Montclair AM; Artists Gld., NYC; Art Dir. Club; SI. **Comments:** Contributor to art & photography magazines. Lectures: modern drawing; "Cavalcade of South America and Caribbean"; illustrated color photography moving pictures on 20 Latin American countries. **Sources:** WW53; WW47.

WEIN, Albert W. *[Sculptor, painter] b.1915, Bronx, NY / d.1991.*
Addresses: NYC, 1929-on; Encino, CA, early 1950s-1965; Hudson River area, 1975. **Studied:** his mother, Elsa, who was a staff artist for the *Baltimore-American*; Maryland Inst., 1927-29; NAD with Ivan Olinsky, 1929; Beaux Arts Inst. with Sidney Waugh and others, 1932; Hans Hofmann Sch. Art; Leo Friedlander (assisted, late 1930s); Am. Acad.; Grand Central Sch Art; Rome, 1940, 1947. **Member:** NSS, 1942 (fellow); Am. Acad. Rome, 1947 (fellow); IIAL; Huntington Hartford Fndtn. (fellow); Tiffany Fndtn., 1949 (fellow); Rockefeller Fndtn., 1989 (fellow). **Exhibited:** Atlantic Terra Cotta Comp., 1934 (prize); APEX comp., 1937; Metropolitan Life Insurance Comp., 1938 (2nd

prize); Municipal AG, NYC, 1938 (first prize); NAD, 1940-42, 1978 (Artists Fund prize), 1979 (gold medal), 1980 (prize), 1982 (prize), 1983 (gold med), 1989 (prize); WMAA, 1945,1950; MMA, 1944, 1951 (*American Sculpture* exhib.); Arch. L., 1942-46 (prize, 1944); NSS, prizes in 1941, 1984, 1986, 1988-89; Prix de Rome, Am. Acad. Rome, 1947 & 1948; Tiffany Foundation fellowship, 1949; PAFA Ann., 1950; Huntington Hartford Foundation fellowship, 1955; SFMA Ann., 1957; Jewish Mus., 1958 (solo); Palm Springs Desert Mus., 1969 (retrospective); The Gal., Palm Springs, CA; Dalzell Hatfield Galleries, Los Angeles, CA; Libbey Dam comp., 1973 (NSS prize); Childs Gal., Boston, 1989 (solo). **Work:** Gramercy Park Mem. Chapel, NY; USPO, Frankfort, NY, 1941; Vatican Mus. Numismatic Collection, Vatican City, New York Univ. Hall of Fame; Jewish Mus., New York; Brookgreen Gardens, SC; Palm Springs Desert Mus., CA. **Commissions:** exterior sculptures, Hillside Mem. Park, Los Angeles, 1960-68; exterior, St. Michael's Episcopal Church, Anaheim, CA, 1967; bas-relief panels, Univ. Wyoming Physical Sciences Center, 1968; 25th Anniversary Medal, U.N., 1970; exterior sculpture, Canton (OH) Jewish Community Center, 1970. **Comments:** Preferred media: bronze, marble. Teaching: Univ. Wyoming, 1965-67. **Sources:** WW73; WW47;J. Lovoos, "The Art of Albert Wein," *Am. Artist* (Jan., 1963); review, *Christian Science Monitor*, April, 1967; F. Sleight, *Retrospective Review* (Palm Springs Desert Mus., December, 1969); exh. cat., Childs Gal., Boston (1989); Falk, *Exh. Record Series*.

WEIN, Sophie A. *[Painter] mid 20th c.*
Exhibited: Salons of Am., 1931. **Sources:** Marlor, *Salons of Am.*

WEINBAUM, Jean *[Painter, sculptor] b.1926, Zurich, Switzerland.*
Addresses: San Francisco, CA. **Studied:** Zurich School Fine Arts, 1942-46; Acad. Grande Chaumière; École Paul Colin; Acad. Andre Lhote, 1947-48. **Exhibited:** Musée d'Art Moderne, Paris, 1962, 1963 & 1965; solos: Galerie Smith-Andersen, Palo Alto, CA, 1970, 1971 & 1973, CPLH, 1971, Musée Arts Décoratifs, Lausanne, Switzerland, 1972 & Bildungszentrum, Gelsenkirchen, Germany, 1972. **Work:** Musée d'Art Moderne, Paris, France; Nat. Collection Fine Arts, Wash., DC; Univ. Art Mus., Berkeley, CA; Stanford (CA) Univ. Mus.; CPLH. **Commissions:** eleven stained glass windows, Chapelle de Mosloy, 1951; rosette stained glass, Berne sur Oise, 1955; twenty-two stained glass windows, St. Pierre du Regard, 1957; Wall of Light (monumental stained glass window), Escherange, 1962; eight windows, Lycée de Jeunes Filles, Bayonne, France, 1966. **Comments:** Preferred media: watercolors, oils, stained glass. **Sources:** WW73; Francois Mathey & others, "Le Vitrail Français," chapter, *Tendances Modernes* (Ed. Deux Mondes, Paris, 1958); Robert Sowers, *Stained glass: An Architectural Art* (Universe Books, New York, 1965); Shuji Takashina, "Stained Glass Works by Jean Weinbaum," *Space Design* (Tokyo, Sept., 1967).

WEINBAUM, Judith *[Abstract painter] b.1895, NYC / d.1992, Bethesda, MD.*
Addresses: Wash., DC, active early 1940s. **Studied:** Hunter College. **Exhibited:** CGA; Howard Univ.; BMA. **Sources:** McMahan, *Artists of Washington, DC.*

WEINBERG, David *[Sculptor] b.1924.*
Addresses: NYC. **Exhibited:** WMAA, 1964. **Sources:** Falk, *WMAA.*

WEINBERG, Elbert *[Sculptor, educator] b.1928, Hartford, CT / d.1991, Avon, CT.*
Addresses: immigrated to U.S., 1886. **Studied:** Hartford Art Sch. with Henry Kreis; RISD with Waldemar Raemisch; Yale Univ. Sch FA. **Member:** Sculptors Guild, New York. **Exhibited:** WMAA, 1957-66; Carnegie Int., Pittsburgh, PA, 1958 & 1961; Sculpture USA, MoMA, 1959; 64 Americans Exhib., AIC, 1961; Hirshhorn Collection; Guggenheim Mus., 1962; PAFA Ann., 1962; Borgenicht Gal, NYC, 1970s. **Awards:** Prix de Rome, Am. Acad. Rome, 1951-53; Guggenheim fellowship, 1959; sculpture award, Am. Inst. Arts & Letters, 1969. **Work:** MoMA; WMAA;

Jewish Mus.; BMFA; Wadsworth Athenaeum, Hartford. **Commissions:** bronze procession (sculpture), Mr. & Mrs. Albert List, Jewish Mus., 1959; Jacob Wrestling with Angel (sculpture), Brandeis Univ., Waltham, MA, 1964; Revelation (bronze relief), chapel house, Colgate Univ., Hamilton, NY, 1964; Eagle (bronze), Fed. Res. Bank, Atlanta, GA, 1964; Shofar (bronze), Rockdale Temple, Cincinnati, OH, 1969. **Comments:** Preferred media: wood, bronze, marble. Teaching: sculpture, Cooper Union, 1956-69; visiting prof. sculpture, Boston Univ., 1970-. **Sources:** WW73; Falk, *Exh. Record Series.*

WEINBERG, E(milie) Sievert (Mrs. Isador G.) *[Portrait, landscape and mural painter] b.1882, Chicago, IL / d.1958, Piedmont, CA.*
Addresses: New Mexico, 1918; Berkeley, CA. **Studied:** AIC; with W.M. Chase in NYC; with H. Hofmann at Univ. Calif. **Member:** Oakland AA; San Francisco Soc. Women Artists; Mural Soc. Calif.; San Francisco AA; Calif. AC. **Exhibited:** AIC, 1905, 1915-18; San Francisco AA, 1916, 1925; Oakland Art Gal., 1917; Calif. Liberty Fair, 1918; Calif. AC, 1919; Acad. Western Painters, 1922; San Francisco Soc. Women Artists, 1918, 1927, 1931; Soc. Indep. Artists, 1920; Bohemian Club, 1928 (hon. men.); Calif. State Fair, 1933 (prize); GGE, 1939; SFMA, 1937-39 (solo), 1940-42 (solo), 1947; Montalvo Foundation, Los Gatos, 1941 (solo); de Young Mus., 1959; Salem AA, 1984 (solo); Western Oregon College of Education, 1985 (solo). **Work:** Oakland Mus.; Fresco, Univ. Elementary Sch., Berkeley; Vanderpoel AA, Chicago; Mills College, Oakland, CA. **Sources:** WW40; Hughes, *Artists in California*, 594.

WEINBERG, Florence C. *[Painter] early 20th c.*
Addresses: NYC. **Exhibited:** Soc. Indep. Artists., 1917-21. **Sources:** Marlor, *Soc. Indp. Artists.*

WEINBERG, Hortense *[Painter, sculptor] early 20th c.*
Addresses: Baltimore, MD. **Sources:** WW25.

WEINBERG, Louis *[Painter] b.1885 / d.1964, Bridgeton, ME.*
Addresses: NYC. **Exhibited:** Soc. Indep. Artists, 1917. **Sources:** Marlor, *Soc. Indp. Artists.*

WEINBERG, Louis *[Sculptor, educator, designer, craftsperson, teacher] b.1918, Troy, KS / d.c.1959.*
Addresses: Tulsa, OK; Madison, WI. **Studied:** Univ. Kansas (B.F.A., M.S.). **Member:** AEA; AAUP; CAA; NAEA; Western AA; Am. Cer. Soc. **Exhibited:** PAFA; Delgado MA; Syracuse MFA; Denver AM; DMFA; Philbrook AC; SFMA; Creative Gal., NY; Forum Gal., NY. **Work:** Philbrook AC; Univ. Wisconsin. **Comments:** Position: teacher, Univ. Tulsa; instructor, Univ. Wisconsin, dept. art educ., Madison, WI. **Sources:** WW59.

WEINBERG, Mark *[Painter] mid 20th c.*
Addresses: NYC. **Member:** Bronx AG. **Sources:** WW27.

WEINBERG, Martha See: **MILLER, Martha Weinburg**

WEINBERG-LOBEL, Florence *[Painter] mid 20th c.*
Exhibited: Salons of Am., 1927, 1930. **Sources:** Marlor, *Salons of Am.*

WEINBERGER, Albert See: **WHITE, Albert**

WEINBERGER, Amelie *[Painter] early 20th c.*
Addresses: New Orleans, active c.1915-16. **Exhibited:** NOAA, 1915-16. **Sources:** *Encyclopaedia of New Orleans Artists*, 408.

WEINCEK, Alicia *[Painter] mid 20th c.*
Addresses: NYC. **Work:** WPA mural, USPO, Mooresville, N.C. **Sources:** WW40.

WEINDORF, Arthur *[Painter, illustrator, teacher, educator, cartoonist, writer] b.1885, Long Island City, NY.*
Addresses: Long Island City 6, NY. **Member:** Soc. Indep. Artists. **Exhibited:** Soc. Indep. Artists, 1920-21, 1924-44; LOC, 1943; NAD, 1944-45; Phila. Pr. Club, 1942-43; Wash. WCC, 1942; Brooklyn SA, 1944; Oakland Art Gal., 1943; Portland SA, 1941-42; Bridgeport Art Lg., 1942; Irvington Art & Mus. Assn., 1943; Salons of Am. **Comments:** Contributor to builders' & designers'

magazines, with architectural & design articles. Specialist in scale models. **Sources:** WW59; WW47.

WEINDORF, Paul Friedrich *[Painter] b.1887, Germany / d.1965, Los Angeles, CA.*
Addresses: Los Angeles, CA. **Member:** Calif. AC; P&S Los Angeles. **Exhibited:** Calif. AC, 1936; CPLH, Soc. for Sanity in Art, 1945. **Sources:** Hughes, *Artists in California*, 595.

WEINEDEL, Carl *[Portrait and miniature painter] b.1795 / d.1845, NYC.*
Addresses: NYC from 1834-45. **Member:** ANA, 1839. **Comments:** He advertised in Richmond (VA) as early as 1821. **Sources:** G&W; Cummings, *Historic Annals of the NAD*, 186; Cowdrey, NAD; Bolton, *Miniature Painters; Richmond Portraits*, 243; Stauffer, no. 2041.

WEINER, Abe *[Painter, instructor] b.1917, Pittsburgh, PA.*
Addresses: Pittsburgh, PA. **Studied:** Carnegie Inst. Technology (certificate in painting & design, 1941), with Robert Gwathmey & Samuel Rosenberg. **Member:** Pittsburgh AA. **Exhibited:** Pittsburgh AA, 1940-72 & Shows, 1946-49, Carnegie Inst.; Carnegie Int., Carnegie Library, Pittsburgh, 1950; Contemporary Soc. Exhib., AIC, 1952; 50 Most Promising Artists U.S., MMA, 1953. **Awards:** first prize & second prize, 1941 & 45 Judge's Prize, 1959, Pittsburgh AA; Three Rivers Festival Purchase Award, 1968. **Work:** Hillman Library, Univ. Pittsburgh. Commissions: painting & mosaic on aluminum Alcoa Co., Pittsburgh; painting, PPG Industs. **Comments:** Preferred media: acrylics, egg tempera. Teaching: painting instructor, Arts & Crafts Center, 1957-60; painting & drawing instructor & asst. director, Ivy School Prof. Art, 1961-; painting instructor, Irene Kaufman Center, 1965-. **Sources:** WW73.

WEINER, A(braham) S. *[Painter, designer] b.1897, Vinnitza, Ukraine, Russia / d.1982.*
Addresses: Santa Monica, CA. **Studied:** Univ. Michigan (B.A. in Arch., 1922); AIC with Victor Poole; Studio Sch. Art, Chicago; & with Alexander Archipenko, John Norton. **Member:** Calif. WCS; Los Angeles AA. **Exhibited:** AIC, 1931, 1934; Northwestern Univ. 1931; Cornell Univ. 1933; Denver Mus., 1943; UCLA,, 1943; UCLA, 1943; solo exh.: SFMA, 1943; Santa Barbara MA, 1944; Denver AM, 1944, 1945; Los Angeles Artists & Vicinity Exhib., 1944 (hon. men.); Oakland Art Gal., 1944-46; LACMA, 1944-46, 1951; Chaffey College, 1945; SFMA, 1945; NAD, paintings of the year, 1946; Pepsi-Cola, 1946, 1949; A.S. Cowie Galleries, Los Angeles, 1947, 1950, 1954; Univ. Illinois, 1948; Santa Monica Pub. Lib.; Santa Barbara MA, 1946 (solo). **Awards:** Du Page County (IL) Artists, 1935 (prize); Glendale (CA) AA, 1944, (hon. men.), 1945 (first prize). **Comments:** Positions: set designer, 20th-Century Fox Film Corp; architectural draftsman. **Sources:** WW59; WW47.

WEINER, Dan *[Photographer] b.1919, NYC / d.1959.*
Studied: PIA School. **Member:** Photo League. **Exhibited:** Int'l Center of Photography, 1980 (retrospective); MoMA, 1989 (retrospective); Howard Greenberg Gal., NYC, 1998. **Comments:** A post-war photojournalist, he is best known for his images of the 1950s. In 1954, he was commissioned by *Collier's* to illustrate articles on African-Americans, which led to a book. He influenced the younger generation of photographers such as Robert Frank, Gary Winogrand, and Lee Friedlander. He died at age 39 in a plane crash over Kentucky while on assignment. **Sources:** press release, Howard Greenberg Gal. (NYC, May, 1998).

WEINER, Edwin M. R. *[Painter, lecturer, teacher] b.1883, Kingston, NY.*
Addresses: Beloit, WI. **Studied:** Cornell Univ.; ASL; & with Wayman Adams, George Bridgman. **Member:** Rockford Art Lg.; Beloit Art Lg.; Chicago Galleries Assn. **Exhibited:** Rockford Art Lg., 1936-46; Chicago Galleries Assn., 1943-46 prizes, 1942); Beloit Art Lg., annually; Davenport Mun. Art Gal.; Evansville (IN) Mun. Gal. **Work:** Many portrait commissions. **Comments:** Positions: instructor, Beloit College, Beloit Vocational Sch., Beloit, WI. Demonstration lectures on portrait painting, Tulsa,

OK. **Sources:** WW53; WW47.

WEINER, Egon P. *[Sculptor, educator, craftsperson, lecturer] b.1906, Vienna, Austria.*
Addresses: Chicago, IL; Evanston, IL. **Studied:** School Arts & Crafts, Acad. Fine Arts, Vienna & with E. Steinhof, J. Huelnner, A. Hanak. **Member:** Int. Inst. Arts & Letters (life fellow); Munic. Art League, Chicago (dir., 1961-64); Cliff Dwellers of Chicago; Alumni Assn. School of AIC (hon. life mem.); NIAL (advisory council, 1968-70). **Exhibited:** AIC (art rental, juried), 1940, 1942-46, 1960-70; PAFA Ann., 1941, 1947-51; Oakland A. Gal., 1942, 1946; Newport AA, 1945; Univ. Chicago, 1943, 1945; Pokrass Gal., Chicago, 1943 (solo); Art Inst. Oslo Juried Ann Exhib, 1971; U.S. Info Service Library, Am Embassy, Oslo, 1972-73. **Awards:** Int. Exhib. Arts & Crafts, Paris, 1925 (prize); Vienna, 1932-34 (prize); Oakland Art Gal., 1945 (medal); prize, 1948 & gold medal, 1969, Munic. Art League, Chicago; medal, 1959 & prize, 1959, AIC; prize, 1955 & citation, 1962, Am. Inst. Architects; Gold Medal, Soc. Arts & Letters, 1970. **Work:** Syracuse MFA; Augsburg Col., Minneapolis; Augustana Col., Rock Island, IL. Commissions: mem. portrait busts of architects Sullivan & Adler for Lobby of Auditorium Theater of Chicago, 1969; Polyphone #2 (bronze monument), St. Joseph Hospital, Chicago, 1969-70; Flame (bronze monument), Oslo, Norway, 1971; portrait bust of Sen. Beuton (bronze) for Encyclopedia Britanica, Chicago, 1970; portrait bust of Dr. Eric Oldberg (bronze) for Medical Center, Chicago, 1972. **Comments:** Preferred media: bronze. Positions: educ. consultant, film of Del Prado Mus., Madrid, Spain, 1969; educ. consultant, Int. Film Bureau, Chicago. Teaching: lecturer, U.S. & abroad; professor, sculpture & life drawing, AIC, 1945-1971, professor emeritus as of 1973; visiting professor art, Augustana College, 1956. **Sources:** WW73; WW47; Falk, *Exh. Record Series.*

WEINER, Elsie Ruth Deutsch (Mrs. Harry) *[Painter] b.1920, Seattle, WA.*
Addresses: Bellevue, WA. **Studied:** Univ. Washington; AIC; Cornish Art School; with Richard Yip, Emile Morse, Ray Brose, Sergie Bongart. **Member:** Women Painters of Wash.; Northwest WC Soc.; Gray's Harbor, WA, Art League. **Exhibited:** Frye Mus., Seattle; Mus. of Hist. and Industry; Northwest WC Soc.; SAM, 1945. **Sources:** Trip and Cook, *Washington State Art and Artists.*

WEINER, Harry Anton *[Painter] mid 20th c.*
Addresses: Chicago area. **Exhibited:** AIC, 1940-48, 1945 (prize). **Sources:** Falk, *AIC.*

WEINER, Irving *[Painter] mid 20th c.*
Member: AIC, 1942-43. **Sources:** Falk, *AIC.*

WEINER, Isadore *[Painter, graphic artist, teacher] b.1910, Chicago / d.After 1940.*
Addresses: Chicago, IL. **Studied:** AIC. **Member:** United Am. Artists. **Exhibited:** Fed. Art Gal., Chicago, 1939; AIC, 1939. **Comments:** Position: teacher, Hull House, Chicago. Committed suicide after 1940, perhaps in Chicago. **Sources:** WW40.

WEINER, Louis *[Painter] b.1892, Vinnitza, Russia.*
Addresses: Chicago, IL. **Studied:** Reynolds; Higgins; Poole; Norton; Krehbiel. **Member:** Palette & Chisel Club; Chicago Acad. FA; Chicago SA; Around the Palette; Am. Artists Congress; Chicago Artists Union. **Exhibited:** AIC, 1927-48. **Sources:** WW40.

WEINER, Samuel (Mrs.) *[Collector] late 20th c.*
Addresses: NYC. **Sources:** WW73.

WEINER, Ted *[Collector, patron] b.1911, Fort Worth, TX / d.1979.*
Addresses: Fort Worth, TX. **Exhibited:** Awards: Cultural Award, West Texas Chamber Commerce, 1967. **Comments:** Positions: director, Palm Springs Desert Mus., CA, 1967-; member, Nat. Committee, Univ. Art Mus., Univ. Calif., Berkeley, 1969-; mem., President's Advisory Committee Arts, John F. Kennedy Center Performing Arts, 1970-. Art interest: experimental art class for gifted children, Fort Worth. Collection: contemporary paintings

and sculpture, including works by Henry Moore, Maillol, Marino Marini, Modigliani, Lipchitz, Picasso, Callery, Voulkos, Chadwick, Noguchi, Calder, Laurens, Marchs, de la Fresneye, de Steal, Tamayo, Parker & Kline; selection exhibit at University of Texas at Austin, 1966 & Palm Springs Desert Museum, 1969. **Sources:** WW73.

WEINER-BLONDHEIM, Adolphe See: **BLONDHEIM, Adolphe (Wiener)**

WEINERT, Albert *[Sculptor] b.1863, Leipzig, Germany / d.1947, NYC.*
Addresses: San Francisco, CA; NYC, 1904-47. **Studied:** École des Beaux-Arts, Brussels. **Member:** NSS, 1909; Soc. Indep. Artists. **Exhibited:** San Francisco AA, 1889; Pan-Pacific, San Francisco, 1915 (arch. sculpture); AIC; Soc. Indep. Artists, 1917-18. **Work:** Plaza Park, Sacramento, CA; Lake George, NY; Toledo, Baltimore; Hall of Records, NYC; Detroit; tablets, Sons of the Revolution, Soc. Colonial Wars; arch. sculpture, LOC. **Sources:** WW33; Hughes, *Artists in California,* 595.

WEINERT, Marguerite *[Painter] mid 20th c.*
Addresses: Harrison, NY. **Exhibited:** Soc. Indep. Artists, 1931. **Sources:** Marlor, *Soc. Indp. Artists.*

WEINGAERTNER, Adam *[Lithographer] mid 19th c.*
Addresses: NYC, 1849-56. **Comments:** Of Nagel & Weingaertner (see entry). **Sources:** G&W; NYCD 1849-56.

WEINGAERTNER, Hans WEINGAERTNER
[Painter] b.1896, Krailburg, Germany / d.1970.
Addresses: Lynhurst, NJ; Belleville, NJ. **Studied:** Royal Acad., Munich, Germany, and with Ludwig Klein, Moritz Hyman, A. Jank. **Member:** Mod. Artists, New Jersey; Soc. Indep. Artists; New Haven PCC; New Jersey AA; Audubon Artists; New Jersey WCS. **Exhibited:** Soc. Indep. Artists, 1929-40; BM, 1932; New Haven PCC, 1934-39; AIC, 1936; traveling exhib., 1936-37; Corcoran Gal biennial, 1939; Montclair AM, 1938, 1939; New Jersey State Mus., Trenton, 1939; Newark Mus., 1940, 1944; Carnegie Inst., 1941; VMFA, 1946; Penn. State Teachers College, 1944, 1946; PAFA Ann., 1951; WMAA; NAD; CAFA; Salons of Am. Awards: prizes, Montclair AM, 1949, 1950; New Haven PCC, 1950; Newark Art Club, 1951; Bamberger purchase, 1964. **Work:** Newark Mus.; Rutgers Univ.; Jefferson H.S., Elizabeth, NJ. **Comments:** Teaching: Newark Sch. Fine & Indust. Art, Newark, NJ. **Sources:** WW66; WW47; Falk, *Exh. Record Series.*

WEINGARTEN, Hilde (Mrs. Arthur Kevess) *[Painter, printmaker] mid 20th c.; b.Berlin, Germany.*
Addresses: Brooklyn, NY. **Studied:** ASL, with Morris Kantor; Cooper Union Art School, with Morris Kantor, Robert Gwathmey & Will Barnet, certificate, 1947; Pratt Graphics Center. **Member:** AEA (bd. dirs., 1964-72); NAWA (asst. chmn. foreign exhibs., 1971-72); League Present Day Artists (bd. dirs., 1970-); Am. Soc. Contemporary Artists; Painters & Sculptors Soc. NJ. **Exhibited:** Jewish Tercentennary Exhib., 1955; Brooklyn & Long Island Artists, Brooklyn Mus., 1958, Graphics '71 Print Exhib., Western New Mexico Univ., Silver City, 1971; Audubon Artists, NAD, 1971. Awards: hon. mention, Silver Jubilee, Caravan Gallery, 1954; Patrons of Art prize for oil painting, Painters & Sculptors Soc. NJ, 1970; Winsor & Newton Award for oil painting, Am. Soc. Contemporary Artists, 1971. **Work:** Bezalel Nat. Mus., Jerusalem, Israel; Summit Medical Group, NJ; Arwood Corp., NYC; Western Electric, NJ; Gen. Reinsurance Corp. **Comments:** Publications: illustrator, *The Tune of the Calliope,* 1958 & *German Folksongs,* 1968. **Sources:** WW73.

WEINHARDT, Carl Joseph, Jr. *[Museum director] b.1927, Indianapolis, IN.*
Addresses: Indianapolis, IN. **Studied:** Harvard Univ.(A.B., magna cum laude, 1948; M.A., 1949; M.F.A., 1955); Christian Theological Sem., Indianapolis, HH.D. 1967. **Member:** Assn. Art Mus. Dirs.; Nat. Soc. Arts & Letters (nat. advisor); Drawing Soc. (nat. committee); Olana Preservation (trustee); Clowes Hall

Advisory Committee. **Comments:** Positions: staff member, MMA, 1955-58, assoc. curator prints & drawings, 1959-60; director, Minneapolis IA, 1960-62; director, Gallery Modern Art, New York, 1962-65; director, Indianapolis MA, 1965-. Publications: author, "The Etchings of Canaletto," MMA, 1956; author, "Beacon Hill," Bostonian Soc., 1958; author, "The James Ford Bell American Wing," Minneapolis IA, 1963; author, "Newport Preserved," *Art Am.,* 1965; author, "A Catalogue of European Paintings in the Indianapolis Museum of Art," 1971. Teaching: lecturer on architecture, Boston Arch. Center, 1954-55; lectures on fine art, Columbia Univ., 1958-60. Collections arranged: 5 Centuries German Prints, 1956 & 18th Century Design, 1960, MMA; 4 Centuries American Art, Minneapolis Inst. Arts, 1963; Pavel Tchelitchew, 1964 & Lovis Corinth, 1965, Gallery Modern Art; Treasures from th Metropolitan, Indianapolis Mus. Art, 1970s. **Sources:** WW73; Caroline Geib, "A Challenge Accepted," Time-Life Broadcasts, 1971.

WEINIK, Sam(uel) *[Painter, block printer] b.1890, Newark, NJ.*
Addresses: NYC. **Member:** Cyasan Artists. **Exhibited:** WMAA, 1951. **Sources:** WW33.

WEINMAN, Adolph Alexander *[Sculptor, medalist] b.1870, Karlsruhe, Germany / d.1952.*
Addresses: NYC; Forest Hills 75, NY. **Studied:** CUA School; ASL, 1889; & with Philip Martiny, Augustus Saint-Gaudens; assistant to Niehaus, Warner and French. **Member:** SAA, 1903; ANA, 1906; NA, 1911; NSS, 1900; Arch. League, 1902; Am. Numismatic Soc.; NIAL; Am. Acad. Arts & Letters, 1932; Century Assn.; AFA; Int. Jury for Sculpture, Pan-Pacific Expo, San Francisco, 1915; NYC Art Comm., 1924-27; Nat. Comm. FA, 1929-33. **Exhibited:** nationally; PAFA Ann., 1901-48. Awards: Pan-Am. Expo, Buffalo, 1901 (prize); St. Louis Expo, 1904 (medal); Brussels Int. Exhib., 1910 (medal); Arch. League, 1913 (gold); Am. Numismatic Soc., 1920 (medal); PAFA, 1924 (gold); AIA, 1929; AIC, 1930 (medal); NAD, 1946. **Work:** Memorials, Madison, WI; Detroit; MMA; CI; Kansas City Mus.; NYC; Houston MFA; Missouri State Capitol Grounds; frieze, Elks Nat. Mem. Hdq. Bldg., Chicago; tower/facade, Mun. Bldg., NYC; des., "Liberty" half-dollar and "Mercury" dime; Victory button, U.S. Army and Navy; statue/monumental frieze, Louisiana State Capitol; U.S. Supreme Court Room; Brooklyn Inst. Arts & Sciences; Herron AI; Norton Gal.; Brookgreen Gardens, SC; CGA; Municipal Mus., Baltimore, MD; monuments, statues, groups: Hodgenville, KY; Pennsylvania Terminal, NY; Baton Rouge, LA; pediment, Wisconsin State Capitol; designed all sculpture for P.O. Dept. Bldg., Wash., DC; pediment, U.S. Archives Bldg., Wash., DC; bronze doors, Am. Acad. Arts & Letters, NYC. **Comments:** Came to America in 1880. Position: trustee, chairman of art committee, Brookgreen Gardens, SC, 1937-. **Sources:** WW53; WW47; Falk, *Exh. Record Series.*

WEINMAN, Howard K(enneth) *[Sculptor] b.1901 / d.1976, Milton, VT.*
Addresses: NYC, Garden City, NY. **Member:** NSS. **Exhibited:** PAFA Ann., 1940-41. **Comments:** Son of Adolph Weinman; brother of Robert. **Sources:** WW47; Falk, *Exh. Record Series;* add'l info courtesy D.W. Johnson, *Dictionary of American Medalists* (pub. due 2000).

WEINMAN, R. *[Lithographer] mid 19th c.*
Addresses: New Orleans, 1854-59. **Comments:** In 1857, because of illness, he offered for sale his three-press lithographic plant. **Sources:** G&W; New Orleans CD 1854-56, BD 1858-59; Delgado-WPA cites *Bee,* Jan. 1, 1857.

WEINMAN, Robert Alexander *[Sculptor, painter] b.1915, NYC.*
Addresses: Forest Hills, NY; Bedford, NY. **Studied:** NAD; ASL; Hobart Sculptor's Welding Course; also sculpture with A. A. Weinman, Lee Lawrie, Paul Manship, E. McCartan, C. Jennewein & J.E. Fraser. **Member:** ANA; NSS (fellow; secy., 1962-65; first vice-pres., 1965-68 & 1970-); Soc. Animal Artists; Collectors Art

Medals (charter dir., 1971). **Exhibited:** NAD Ann., 1937, 1938, 1949 & 1953; PAFA Ann., 1939; All. A. Am. 1946, Sculpture Int., Phila., 1949; Albany Inst. Hist. & Art, 1939; NAC, 1941; NSS, 1952, 1960, 1965, 1969, 1970. Awards: hon. mention for sculpture, All. A. Am., 1946; Mrs. Louis Bennett Prize, NSS, 1952. **Work:** Bessie The Belligerent (bronze) & Great Blue Heron (watercolor), Brookgreen Gardens, SC. Commissions: limestone tympana, Our Lady Queen of Martyrs Church, Forest Hills, NY, 1939; bronze elk, Benevolent & Protective Order Elks, Walla Walla, 1948; bronze doors, Armstrong Library, Baylor Univ., Waco, TX, 1951; athletic medals, Nat. Collegiate Athletic Assn., 1952; Morning Mission (bronze), Bulsa, OK, 1962. **Comments:** Preferred media: bronze, stone, wood, metals. Publications: contributor *Nat. Sculpture Review,* 1962-71. **Sources:** WW73; WW47; Falk, *Exh. Record Series.*

WEINMANN, Albert *[Sculptor] b.1860 / d.1931, East Rockaway, NY.*

WEINRIB, David *[Sculptor] mid 20th c.*
Addresses: NYC. **Exhibited:** WMAA, 1962, 1966, 1968. **Sources:** WW66.

WEINRICH, Agnes *[Abstract painter, etcher, block printer] b.1873, Burlington, IA / d.1946, Provincetown, MA.*
Addresses: Provincetown, MA. **Studied:** AIC; ASL; with Albert Gleizes, Paris; in Berlin, Rome & Florence; Hawthorne & Blanche Lazzell, Provincetown. **Member:** NY Soc. Women Artists (organizer; director); New England Soc. Contemporary Art; Provincetown AA. **Exhibited:** Brown-Robinson Gal., NYC; Phila. Acad.; Boston MFA; PMG; Boston AC; Harley Perkins Gal., Boston (solo); Provincetown AA, 1915; Soc. Indep. Artists, 1917-23; Salons of Am.; AIC, 1928, 1941; PAFA Ann., 1929; Corcoran Gal biennial, 1939. **Work:** PMG. **Comments:** Weinrich was a cubist, and a reviewer in the *Christian Science Monitor,* Nov. 11, 1937, found her to be "in harmony with the Parisian spirit, indifferent to imitation." She was the sister-in-law of Karl Knaths. **Sources:** WW40; Ness & Orwig, *Iowa Artists of the First Hundred Years,* 217; Provincetown Painters, 160; Falk, *Exh. Record Series.*

WEINRICH, Leo L. *[Painter] early 20th c.*
Addresses: Bound Brook, NJ. **Sources:** WW15.

WEINSTEIN, David *[Painter] mid 20th c.*
Exhibited: Salons of Am., 1930. **Sources:** Marlor, *Salons of Am.*

WEINSTEIN, Eleanor *[Painter] mid 20th c.*
Exhibited: Soc. Indep. Artists, 1935. **Sources:** Marlor, *Soc. Indp. Artists.*

WEINSTEIN, Florence *[Artist] b.1895 / d.1989.*
Member: Woodstock AA. **Sources:** Woodstock AA.

WEINSTEIN, Joseph (Mr. & Mrs.) *[Collectors, patrons] b.1899, NYC.*
Addresses: NYC. **Studied:** Mr. Weinstein, Harvard Univ.; Mrs. Weinstein, Simmons College. **Comments:** Collection: Picasso, Cezanne, Renoir, Rouault, Soutine, Max Weber, Balcomb Greene, Rodin, Zogbaum, Zorach and others; also African sculpture. **Sources:** WW73.

WEINSTEIN, Joyce *[Painter] mid 20th c.*
Exhibited: PAFA Ann., 1954. **Sources:** Falk, *Exh. Record Series.*

WEINSTEIN, Sylvie L. *[Craftsperson] mid 20th c.; b.NYC.*
Addresses: Brooklyn, NY. **Member:** Am. Guild Craftsmen. **Exhibited:** Syracuse Mus., 1932 (prize). **Work:** Paris Expo, 1937; Phila. AI. **Sources:** WW40.

WEINSTOCK, Carol *[Painter, graphic artist, teacher] b.1914, NYC / d.1971.*
Addresses: NYC. **Studied:** ASL. **Member:** United Am. Artists. **Exhibited:** WFNY, 1939; GGE, 1939; ACA Gal., NYC, 1939; MoMA (solo); Smithsonian (solo); Nat. Gal.; AIC; PAFA; MMA; WMAA; "NYC WPA Art" at Parsons School Design, 1977. Awards: Nat. Award Watercolor Competition, Fine Arts Section of Public Building Admin., Washington, DC. **Work:** Univ.

Minnesota; Public Library, Brooklyn; Queen's College, NYC; PMA. **Comments:** WPA artist, Teaching and Easel Divisions. Specialty: gouaches, 1930s, collages, 1960s-70. **Sources:** WW40; *New York City WPA Art,* 93 (w/repros.).

WEINSTOCK, Saul *[Painter] mid 20th c.*
Addresses: NYC. **Exhibited:** WMAA, 1952. **Sources:** Falk, *WMAA.*

WEINTRAUB, Frances See: **LIEBERMAN, Frances Beatrice**

WEIR, Anna See: **BAKER, Anna**

WEIR, Caroline Alden See: **ELY, Caroline Alden Weir (Mrs. G. Page Ely)**

WEIR, Charles E. *[Portrait and genre painter] b.c.1823 / d.1845, NYC.*
Exhibited: National Acad.; Am. Art-Union, as early as 1841. **Comments:** Brother of Robert W. Weir (see entry). **Sources:** G&W; Cummings, *Historic Annals of the NAD,* 188; N.Y. *Evening Post,* June 21, 1845 (Barber); Cowdrey, NAD; Cowdrey, AA & AAU.

WEIR, Dorothy (Mrs. Mahonri Young) *[Painter, block printer] b.1890, NYC / d.1947, NYC/Ridgefield, CT?.*
Addresses: NYC/Ridgefield, CT. **Studied:** her father Julian; NAD; ASL with Louise Cox. **Member:** NAWPS. **Exhibited:** PAFA Ann., 1927; NAWPS, 1928 (medal); Stockbridge AA, 1929 (prize). **Comments:** Published the letters of her father, J. Alden Weir (see entry). **Sources:** WW40; Falk, *Exh. Record Series.*

WEIR, Edith Dean (Mrs. J. DeWolf Perry) *[Minature and portrait painter, writer] b.1875, New Haven, CT / d.1955.*
Addresses: Providence, RI/Princeton, MA; Charleston, SC; New Haven, CT, 1900. **Studied:** Yale Sch. FA, and with her father, John F. Weir; Lucia Fairchild Fuller; Adele Herter. **Member:** Providence AC. **Exhibited:** Soc. Am. Artists, 1898; PAFA Ann., 1899, 1901, 1903; NAD, 1900; Royal Acad., London, 1900; New Haven PCC, 1900 (charter exh.); Pan-Am. Expo, Buffalo, 1901; ASMP, NYC, 1902; AIC. **Work:** St. Paul's Church, New Haven, CT; Christ Church, West Haven, CT. **Comments:** Specialist in portrait miniatures. Author: *Under Four Tudors; Manual of Altar Guilds; Set Apart.* **Sources:** WW53; WW47; Petteys, *Dictionary of Women Artists;* Falk, *Exh. Record Series.*

WEIR, Ella See: **BAKER, Ella**

WEIR, Irene *[Painter, etcher, poster illustrator, art critic, lecturer] b.1862, St. Louis, MO / d.1944, Yorktown Heights, NY.*
Addresses: NYC/Katonah, NY. **Studied:** J. A. Weir; J. Pennell; Yale Univ.; ASL; Acad. Julian, Acad. Colarossi, and École des Beaux-Arts, all in Paris; Fontainebleau Sch. FA. **Member:** NYWCC; NAWPS; Salon of Am.; Coll. AA; SAE. **Exhibited:** Brooklyn Mus.; Corcoran Gal.; in London; Salons of Am.; AIC; Soc. Indep. Artists, 1917, 1928-30. **Work:** Houston MFA; Univ. Georgia; Rollins College; West Point. **Comments:** Granddaughter of Robert Walter Weir, whose biography she wrote in 1947; niece of J. Alden Weir & John Gerguson Weir.Painted flowers, landscapes, portraits, murals & religious subjects in oil & watercolor. Art teacher/founder/director, School Design & Liberal Arts, NYC, 1917-29. Author: "Greek Painters" and other articles in *Art Digest.* **Sources:** WW40; Petteys, *Dictionary of Women Artists.*

WEIR, John F(erguson) *[Painter, sculptor, teacher, lecturer, writer] b.1841, West Point, NY / d.1926.* *John F. Weir.*
Addresses: Providence, RI; NYC, 1864-67; West Point, NY, 1868; Europe, 1869; New Haven, CT, 1872-1900. **Studied:** his father Robert W., at West Point; NAD. **Member:** ANA, 1864; NA, 1866; CAFA; Century Assn.; Providence AC; New Haven PCC (founder). **Exhibited:** NAD, 1864-1900; Brooklyn AA, 1864, 1866-67, 1876, 1887; Boston AC, 1883-1906; New Haven PCC, 1900 (charter exh.); PAFA Ann., 1900-06; AIC. **Work:** MMA; BMFA; CGA; statues, Yale Univ.; fountain, New Haven

(CT) Green; portraits, Yale; Putnam Hist. Soc., Cold Springs, NY. **Comments:** While he achieved fame in the 1860s for his dynamic industrial interior scenes, his importance lies more in his role as an influential teacher and the founding director of the Yale Art School (1869-1913), the first in the country at a university. Weir also served as a commissioner of the art exhibition at the Philadelphia Centennial Expo. in 1876. He was overshadowed later by his famous younger brother, Julian, the Impressionist painter. His father was artist/teacher Robert W. Weir. **Author:** *John Trumbull and His Works.* **Sources:** WW24; Art in Conn.: Early Days to the Gilded Age; Baigell, *Dictionary;* Falk, *Exh. Record Series.*

WEIR, J(ulian) Alden
[Painter, etcher, teacher]
b.1852, West Point, NY /
d.1919, NYC.
Addresses: Paris, 1875-77; NYC, 1878-98/Windham and Branchville, CT, 1882-1918; Cos Cob, 1892-93. **Studied:** his father Robert; NAD, 1868-73; École des Beaux-Arts, Paris, with Gérôme, 1873. **Member:** Cornish (NH) Colony; SAA; AAPS, 1911-13; ANA, 1885; NA, 1886 (pres., 1915-17); AWCS; Ten Am. Painters (a founder); New York Etching Club; CAFA; Lotos Club; Artists Aid. Soc.; Century Assn.; NIAL; Tile Club. **Exhibited:** NAD, 1875-98, 1906 (gold med, 1906); Paris Salon, 1875-76; 1881-83 (prize 1882); Brooklyn AA, 1878, 1881-85, 1912; SAA, 1878-; PAFA Ann., 1879-80, 1888-1920 (prize 1910; gold medal 1913; medal 1918); Boston AC, 1882-1909; SNBA,1895; Paris Expo, 1889 (medal), 1900 (medal); Am. Artists Assn., 1889 (prize); World's Columbian Expo., Chicago, 1893 (mural); CI, 1897 (medal); NY Etching Club; St. Louis Expo, 1904 (gold medal); Pan-Am. Expo, Buffalo, 1901 (medal); AIC, 1912 (medal); Armory Show, 1913; Corcoran Gal. biennials, 1907-19 (8 times; incl. gold medal, 1914); Pan-Pacific Expo, San Francisco, 1915 (prize); MMA, 1924 (memorial); Parrish AM, 1984 ("Painter-Etchers" exh.). **Work:** MMA; AIC; BMFA; NMAA; NGA; Phillips Col.; Albright Art Gal., Buffalo; RISD; WMA; PAFA; Brooklyn Inst.; CI; CGA; Montclair (NJ) AM; Cincinnati Mus.; Wadsworth Atheneum, Hartford; Luxembourg Mus., Paris; Huntington Lib. & Art Gal., San Marino, CA. **Comments:** One of the leading American Impressionists, he was a member of the "Ten American Painters." His home and grounds in Branchville, CT are a National Historic Site. He was a close friend of Twachtman, Carlsen, Chase among others, and was one of the founders of the AAPS, which organized the 1913 Armory Show in NYC. He was elected president of the AAPS, but resigned due to its anti-NAD stance. Positions: teacher, summer classes at Cos Cob, CT (with Twachtman), 1892-93; ASL and CUA Sch., 1877-98; summer classes at Branchville, CT, 1897-1901. He was the brother of John F. Weir, and son of Robert W. Weir. His first wife, Anna Baker (d. 1892), and his second, Ella Baker, were both artists (see entries). **Sources:** WW15; Dorothy Weir Young, "The Life and Letters of J. Alden Weir (1960); *Connecticut and American Impressionism* 177-78 (w/repro.); *American Painter-Etcher Movement* 51; Doreen Bolger, *J. Alden Weir: An American Impressionist* (Univ. of Delaware Press, 1983); Gerdts. *American Impressionism,* 161-67; Fink, *American Art at the Nineteenth-Century Paris Salons,* 404; Art in Conn.: The Impressionist Years; Falk, *Exh. Record Series.*

WEIR, Lillian *[Painter] b.1883, Ft. Wadsworth, NY.*
Addresses: NYC. **Studied:** Ida Stroud; Douglas Volk. **Sources:** WW15.

WEIR, Robert W. (Mrs.) *[Artist] late 19th c.*
Addresses: NYC, 1880. **Exhibited:** NAD, 1880. **Sources:** Naylor, *NAD.*

WEIR, Robert Walter
[Landscape, portrait, genre and religious painter; illustrator; teacher] b.1803, NYC / d.1889, NYC.
Addresses: New Rochelle, NY, 1811; NYC, 1817, 1880-81; Westpoint, NY, 1864-74; Hoboken, NJ, 1877-79. **Studied:** John

Wesley Jarvis, NYC; Robert Cox, NYC, 1818; Am. Acad. FA, c.1821; Florence, 1824-27, with P. Benvenuti, Florence, Italy. **Member:** NA, 1829. **Exhibited:** Brooklyn AA, 1864, 1868, 1870, 1872; NAD, 1827-51, 1864-81; West Point Mus., 1976 (retrospective). **Work:** MMA; BMFA; West Point Mus.; NGA; NYC Hall; New York Hist. Soc.; Weir's best-known work, "The Embarkation of the Pilgrims" is in the Rotunda of the Capitol at Washington. **Comments:** One of the most versatile of America's 19th century painters, he is today best remembered as an influential teacher. He became a professional artist about 1821 and was a portraitist, genre painter, and an early member of the Hudson River School of landscape painters. Like John Quidor, he often drew his inspiration from the literary works of Washington Irving and James Fennimore Cooper. In 1827, after studying in Florence, Italy, he opened a studio in NYC. In 1834, he became an instructor of drawing at the U.S. Military Academy, West Point, NY, succeeding Charles R. Leslie, and in 1846 he was made professor. His most famous artist students were J.A.M. Whistler and two of his sons, John F. and Julian A. (he had 13 other children). He also taught Union Generals U.S. Grant, P. Sheridan, W.T. Sherman, and Confederates R.E. Lee and Jefferson Davis. After more than 40 years of teaching, he retired to NYC in 1876 where he had a studio. He was born in NYC, not New Rochelle, as frequently stated. **Sources:** G&W; The standard biography of Weir is *Robert W. Weir, Artist,* by his grand-daughter Irene Weir. See also: DAB; CAB; Clement and Hutton; Dunlap, *History;* Tuckerman, *Book of the Artists;* Webber, "The Birthplace of Robert Weir;" Cowdrey, NAD; Cowdrey, AA & AAU; Swan, BA; Rutledge, PA; Rutledge, MHS; Karolik Cat.; Met. Mus., *Life in America.* More recently, see Gerdts, *Robert Weir: Artist and Teacher of West Point* (exh. cat., West Point Mus., 1976); P & H Samuels, 517-18; Baigell, *Dictionary; 300 Years of American Art,* vol. 1, 130.

WEIR, Robert Walter, Jr. *[Illustrator] b.1836, West Point, NY / d.1905, Montclair, NJ.*
Exhibited: NAD, 1867. **Comments:** At age 19 he ran away to become a sailor on a whaler for 3 years, then joined the Navy during the Civil War. In 1864, his illustrations appeared in *Harper's.* He later became a construction engineer. Son of Robert, Sr.

WEIR, William Joseph *[Painter, illustrator, etcher] b.1884, Ballina, Ireland.*
Addresses: Chicago, IL. **Studied:** AIC; Chicago Acad. FA; Académie Julian, Paris. **Member:** Chicago Palette & Chisel Acad. FA. **Exhibited:** AIC, 1930. **Work:** State Mus., Springfield, IL. **Sources:** WW40.

WEIS, Anthonie E. *[Painter] mid 20th c.*
Exhibited: Soc. Indep. Artists, 1939-41. **Sources:** Marlor, *Soc. Indp. Artists.*

WEIS, Bernard J(ackson) *[Painter, illustrator, craftsperson] b.1898, McKeesport, PA.*
Addresses: Homestead, PA. **Studied:** C.J. Taylor. **Member:** Pittsburgh AA. **Sources:** WW25.

WEIS, Fred *[Painter] early 20th c.*
Addresses: Houston, TX. **Sources:** WW24.

WEIS, George *[Sculptor and gilder] mid 19th c.*
Addresses: New Orleans in 1830. **Comments:** There was also a George Weis, artist, at Baltimore from 1830-35. **Sources:** G&W; Delgado-WPA cites *Courier,* Nov. 20, 1830; Lafferty.

WEIS, John E(llsworth) *[Painter, teacher] b.1892, Higginsport, OH.*
Addresses: Cincinnati, OH. **Studied:** F. Duveneck; Meakin; Hopkins; Wessel. **Member:** Cincinnati AC; Cincinnati MacD. Club; Jafa Soc. **Exhibited:** PAFA Ann., 1925-27, 1930, 1933; AIC, 1926, 1928, 1930; Corcoran Gal biennials, 1928, 1932. **Comments:** Teaching: Art Acad., Cincinnati. **Sources:** WW40; Falk, *Exh. Record Series.*

WEIS, Marie E. *[Painter] mid 20th c.*
Addresses: S. Nyack, NY. **Exhibited:** Soc. Indep. Artists, 1928-29, 1936-40; Salons of Am., 1929, 1933. **Sources:** Falk,

Exhibition Record Series.

WEIS, S(amuel) W(ashington) *[Painter, sketch artist]*
b.1870, Natchez, MS / d.1956, Chicago, IL.
Addresses: New Orleans, active c.1915-36; Chicago, IL/Glencoe, IL. **Member:** NOAA; SC; Business Men's AC, Chicago; Palette & Chisel Club, Chicago; North Shore AL, Winnetka. **Exhibited:** NOAA, 1915, 1917. **Comments:** Amatuer artist and cotton broker who spent his later life in the Chicago area. **Sources:** WW27; *Encyclopaedia of New Orleans Artists,* 408.

WEISBECKER, Clement *[Painter] mid 20th c.*
Addresses: NYC. **Member:** Soc. Animal Artists. **Comments:** Animal paintings and drawings have been shown in museums and galleries throughout the country, and are included in the permanent collections of six museums as well as in a number of other public and private collections. **Sources:** WW66.

WEISBRODT, H. W. *[Engraver]* b.1856 / d.1827, Cincinnati.

WEISBROOK, Frank S. *[Painter] mid 20th c.*
Addresses: Davenport, IA. **Exhibited:** Davenport Art Gallery, 1933 (solo); St. Paul Inst., 1918 (bronze medal for watercolor); AIC. **Sources:** WW31; Ness & Orwig, *Iowa Artists of the First Hundred Years,* 217.

WEISE, Charles *[Miniature painter] 19th/20th c.*
Addresses: Wash., DC, active 1906-07; Baltimore, MD. **Work:** Maryland Hist. Soc. **Sources:** WW10; McMahan, *Artists of Washington, DC.*

WEISE, Paul *[Painter] early 20th c.*
Addresses: Dallas, TX. **Sources:** WW24.

WEISEL, Deborah Delp *[Painter, lithographer, writer, etcher, lecturer]* b.Doylestown, PA / d.1951.
Addresses: Springfield, MO/Moorestown, NJ. **Studied:** PM School IA; PAFA; Columbia; H. Breckenridge; C. Martin; De Voll. **Member:** AFA; AA Mus.; SSAL; Ozark AA; Missouri State Teachers Assn.; Friends of Art, Springfield; Western AA; Springfield Art Commission. **Exhibited:** Springfield AM; Ozark AA; SSAL. **Comments:** Position: art professor, Southwest Missouri State College, 1921-. **Sources:** WW47.

WEISENBERG, Helen Mills *[Painter] mid 20th c.*
Addresses: Phila., PA. **Member:** New Century Club; Plastic Club, Phila., 1924. **Exhibited:** PAFA Ann., 1927, 1929-31. **Sources:** WW25; Falk, *Exh. Record Series.*

WEISENBORN, Rudolph *[Abstract painter]* b.1881, Chicago / d.1974.
Addresses: Colorado; Chicago, IL, 1913-on. **Studied:** Students' Sch. Art, Colorado. **Member:** Chicago No-Jury Int. Exhib. (founder); Am. Abstract Artists, 1937. **Exhibited:** Soc. Indep. Artists, 1924, 1926, 1934; Fed. Art Project, AIC, 1938; "Half Century Am. Painting" Exhib., AIC, 1939. **Work:** WPA murals, Crane Tech. H.S. and Nettlehorst Sch., Chicago. **Comments:** Teaching: Chicago Acad. FA; Weisenborn Art Sch. **Sources:** WW40; *American Abstract Art,* 201.

WEISENBURG, George W. *[Painter] mid 20th c.*
Addresses: Oak Park, IL. **Exhibited:** AIC, 1910-35. **Sources:** WW19.

WEISENBURG, Helen M(ills) *[Painter] mid 20th c.*
Addresses: Baltimore, MD. **Studied:** Phila. Sch. Indust. Art; PAFA, with Breckenridge. **Member:** Plastic Club; Phila. Art All.; Balt. Friends Art. **Exhibited:** PAFA, 1927 (prize); Plastic Club, Phila., 1929 (gold). **Sources:** WW33.

WEISENBURGER, Sadie *[Painter]* d.1915, Indianapolis, IN.
Addresses: Indianapolis. **Studied:** Steele & Forsyth. **Sources:** WW13; Petteys, *Dictionary of Women Artists.*

WEISGARD, Leonard Joseph *[Illustrator, writer, designer, lecturer]* b.1916, New Haven, CT.
Addresses: Danbury, CT; Denmark. **Studied:** Pratt Inst. Art School; New School Soc. Res.; also with Alexei Brodovich. **Exhibited:** MMA; MoMA; Worcester Mus.; Waterbury Mus.; many libraries; throughout the Soviet Union. **Awards:** 50 Best Books of the Year, 1942-45 (prize); Caldecott Award, Am. Library Assn.; award, Am. Inst. Graphic Arts. **Comments:** Positions: exhibs. director, Mattatuck Hist. Soc.; member, greeting card art selection, UNICEF; scenic & costume designer. Author: "Water Carrier's Secret"; children's books, 1936-46. Contributor: *New Yorker, American Home, Ladies Home Journal,* & others. Publications: author or more than thirteen books; illustrator of over 250 books for children. Teaching: art instructor, Booth Free School. **Sources:** WW73; WW47; articles, *Horn Book Magazine.*

WEISGLASS, I. Warner (Mr. & Mrs.) *[Collectors] mid 20th c.*
Addresses: NYC. **Sources:** WW73.

WEISHAUPT, Frederick W. H. *[Fresco painter] 19th/20th c.*
Addresses: Wash., DC, active 1892-1920. **Sources:** McMahan, *Artists of Washington, DC.*

WEISMAN, Clara *[Listed as "artist"] 19th/20th c.*
Addresses: Wash., DC, active, 1920-25. **Studied:** ASL; Paris, London, Holland, Belgium. **Sources:** McMahan, *Artists of Washington, DC.*

WEISMAN, Joseph *[Portrait painter] mid 19th c.*
Addresses: Easton, PA, 1824. **Exhibited:** PAFA, 1822 (self-portrait). **Sources:** G&W; Rutledge, PA; *Easton Gazette,* Dec. 11, 1824.

WEISMAN, Joseph *[Painter, designer, illustrator, teacher, lithographer]* b.1907, Schenectady, NY / d.1977, La Jolla, CA.
Addresses: Los Angeles, CA. **Studied:** Chouinard AI; Los Angeles Art Center School; & with Barse Miller, Millard Sheets, Clarence Hinkle, Murphy & S. Reckless. **Member:** Los Angeles AA; P&S Los Angeles; Calif. WCS; Laguna Beach AA; AFA. **Exhibited:** PAFA, 1936-37; Laguna Beach AA, 1938; LACMA, 1930-31, 1933, 1937-39; San Diego FA Soc., 1931, 1933, 1940; Oakland Art Gal., 1933, 1936-38; Santa Barbara Mus. Art, 1944; Los Angeles AA, 1945-46, 1953; Santa Cruz Art Lg., 1933-38, 1946; Calif. State Fair, 1932-36, 1938 (prize), 1939 (prize); Los Angeles County Fair, 1929-31, 1936, 1938; GGE 1939; Santa Paula, CA, 1945; Madonna Festival, 1955. **Work:** Manual Arts H.S., Metropolitan H.S., Los Angeles; Los Angeles AA. **Comments:** Position: instructor, Hollywood AC School, 1954-55; Adult Educ., Los Angeles Board of Educ., 1954-. **Sources:** WW59; WW47; Hughes, *Artists in California,* 595.

WEISMAN, Robert R. *[Painter] mid 20th c.*
Addresses: Chicago, IL. **Member:** Chicago NJSA. **Exhibited:** AIC, 1927. **Sources:** WW25.

WEISMAN, W. H. *[Painter] mid 19th c.*
Addresses: Phila., PA, 1877. **Exhibited:** PAFA Ann., 1876; NAD, 1877. **Sources:** Falk, *Exh. Record Series.*

WEISMAN, Winston Robert *[Educator, writer]* b.1909, NYC.
Addresses: University Park, PA. **Studied:** Ohio Univ. (B.A., journalism & art history, cum laude, 1932); Univ. Paris, (certificate art history, summer 1934); New York Univ. Inst. Fine Arts (M.A. art history, 1936); Mills College, fellowship, 1939; Ohio State Univ. (Ph.D. art history & studio art, 1942). **Member:** College Art Assn. Am.; Soc. Arch. Historians; Victorian Soc. Am.; Friends of Cast Iron Arch. **Exhibited:** Awards: Ins. Univ. grant, 1940-42; Am. Council Learned Soc. scholarship, 1952-53; Am. Philos. Soc. award, 1954-55. **Comments:** Positions: visiting professor, New York Univ. Inst. Fine Arts, 1957; visiting professor, Univ. Penn., 1959; director, Penn. State Study Abroad Program, Univ. Cologne, summer 1963; Concora visiting lecturer, Northwestern Univ., spring 1969; director, Center Study Renaissance & Baroque Art, Penn. State Univ. Teaching: instructor in art history & photography, Mills College, 1937-39; instructor in art history, Univ. Kentucky, 1939-40; instructor in art history, Indiana Univ., 1947-50; art instructor, Univ. Texas, 1950-52; research professor art history, Penn. State Univ., 1953-, chmn. dept. art & arch. history, 1957-64, head dept. art history, 1964-71. Art interests: commercial architecture in the USA & Europe.

Publications: author, "The Emergence of the American Mode in Architecture," *Am. Review*, 5/1962, "Skyscraper," *Encyclopedia Britannica*, 1964, The Origins of the Skyscraper," *Soc. Ingegneri Bulletin*, 4/1970, "The Early Commercial Architecture of George B. Post," *Journal Soc. Arch. His.*, 10/1972 & "Cast Iron Building Technology: The Laing Stores," *Monumentum*, 1972. **Sources:** WW73.

WEISMANN, Barbara Warren (Mrs.) *[Designer, graphic artist, teacher]* b.1915, Milwaukee.
Addresses: St. Paul, MN. **Studied:** Milwaukee State Teachers College. **Exhibited:** Milwaukee AI, 1935 (prize), 1936 (prize); Wisc. Salon Artists, Univ. Wisc.; WPA Exhib. (traveling), Minnesota; AIC. **Comments:** Position: teacher, Univ. Minnesota. **Sources:** WW40.

WEISMANN, Donald Leroy *[Educator, painter, lecturer, block printer]* b.1914, Milwaukee, WI.
Addresses: Wauwatosa, WI; Austin, TX. **Studied:** Univ. Wisc.-Milwaukee (B.S.); Univ. Minnesota; Univ. Wisc.-Madison (Ph.M.); St. Louis Univ.; Harvard Univ., Carnegie Corp. scholarship, 1941; Ohio State Univ. (Ph.D.). **Member:** Wisc. Soc. Applied Art; Minnesota Art Soc.; Am. Assn. Univ. Prof.; Nat. Educ. Assn.; Wisc. P&S; Nat. Council Arts; Nat. Humanities Fac.; Am. Studies Assn.; Texas FAA. **Exhibited:** Milwaukee AI; Wisc. Mem. Union Gal.; Dayton AI; Monte Carlo Gal., Jalisco, Mexico, 1946; Rockefeller Center, NY, 1935; Wisc. Salon Artists, 1938, 1939; Ann. Exhib. Am. Art, 1940-41 & Int. Watercolor Exhib., 1942; AIC,1938-40; Ann. Exhib. Art U.S. & Territories, Butler IA, 1957-58; Gulf-Caribbean Exhib., Houston (TX) MFA, 1958; WFNY, 1964-65; Carlin Galleries, Fort Worth, TX, 1970s. Awards: Wisc. P&S, 1934 (prize); Wisc. Salon Artists, 1939 (prize); Harvard, 1941 (prize); purchase award for painting, Butler IA, 1957; Bromberg Award for Excellence in Teaching, Univ. Texas, Austin, 1965; letter of commendation for enhancement of arts in America, President of U.S., 1972. **Work:** Wisc. Artists Calendar, 1937; Butler IA; Chrysler Mus, Provincetown, MA; Columbia (SC) Mus. Art; D.D. Feldman Collection, Humanities Research Center, Univ. Texas, Austin; Witte Mus, San Antonio, TX. Commissions: mural, Illinois Centennial Bldg., Springfield, 1941; videotape service, Mirror of Western Art, Nat. Educ. TV, 1960 & The Visual Arts, Ford Foundation & U.S. Off. Educ., 1961; films, Terlingua, 1971 & Station X, 1972, Public Broadcast Corp. **Comments:** Preferred media: collage, film. Teaching: assoc. professor, North Texas State Univ., summer 1940; asst. professor of art & art history, Illinois State Normal Univ., 1940-42 & 1946-48; asst. professor of art history, Wayne State Univ., 1949-51; professor art & head dept., Univ. Kentucky, 1951-54; professor art, Univ. Texas, Austin, 1954-, chmn. dept., 1954-58, grad. professor of art history, 1958-, univ. professor in arts, 1964-, chmn. comp. studies, 1967-. Collections arranged: Ulfert Wilke Retrospective, 1953 & Victor Hammer Retrospective, 1954, Univ. Kentucky, Lexington. Research: creative process in art and science; language and visual form. Publications: author/illustrator, "Some Folks Went West," 1960; author, "Jelly Was the World," 1965; author/illustrator, "Language and Visual Form," 1968; contributor,"The Collage as Model," *Psychology Issues,* Vol. 6, No. 2; author, "The Visual Arts as Human Experience," 1970. **Sources:** WW73; WW47.

WEISS, Bernard See: **WEIS, Bernard J(ackson)**

WEISS, Dorothea Patterson *[Painter]* b.1910, Phila.
Addresses: Mesilla Park, NM. **Studied:** Moore Inst. Art; Yale Sch. FA (B.F.A.). **Exhibited:** San Francisco AA, 1937; El Paso Sun Carnival, 1951, 1952, 1953, 1958; Mus. New Mexico Fiesta Exhib., 1948-57; Rio Grande Valley Exhib., Mus. New Mexico Art Gal., 1956; New Mexico Artists, 1954. Award: prize, El Paso AA. **Work:** Mus. New Mexico, Santa Fe; Texas Western Univ.; Stations of the Cross, Our Lady of the Valley, Ysleta, TX; Christo Rey Church, Santa Fe; mural, St. Joseph's Church, El Paso. **Comments:** Position: incorporator & member, Mesilla Design Center. **Sources:** WW59.

WEISS, Edith *[Painter]* mid 20th c.
Addresses: Chicago area. **Exhibited:** AIC, 1951. **Sources:** Falk, AIC.

WEISS, Edward H. *[Painter]* mid 20th c.
Addresses: Chicago area. **Exhibited:** AIC, 1949. **Sources:** Falk, AIC.

WEISS, Fred *[Painter]* mid 20th c.
Exhibited: Soc. Indep. Artists, 1937. **Sources:** Marlor, *Soc. Indp. Artists.*

WEISS, Harvey *[Sculptor]* b.1922, NYC.
Addresses: NYC; Greens Farms, CT. **Studied:** NAD; ASL; also with Ossipe Zadkine, Paris. **Member:** Sculptors Guild (pres., 1970-71); Silvermine Guild Artists (board trustees, 1968-70); Authors Guild. **Exhibited:** Paul Rosenberg & Co., 1959-70 (5 solos); PAFA Ann., 1964, 1966; Silvermine Guild, 1968 (solo); Fairfield Univ., 1970 (retrospective); Am Inst. Arts & Letters, 1970; Sculptor's Guild Ann. Shows. Awards: Three Ford Foundation purchase awards; Olivetti Award, New England Ann. Exhib., 1969; NIAL grant, 1970. **Work:** Albright-Knox Art Gal.; Krannert Mus.; Silvermine Guild Collection; Nelson Rockefeller Collection; Joseph H. Hirshhorn Collection. Commissions: menorah, Temple B'nai Zion, Shreveport, LA, 1967; relief, Mt. Vernon Synagogue, NY, 1969; relief, Conn. Office Bldg., Westport, 1971. **Comments:** Preferred media: bronze, welded brass. Publications: author/illustrator, "Ceramics" (1964), "Paint Brush & Palette" (1966), "Collage and Construction" (1970), "The Gadget Book" (1971) & "Lens and Shutter" (1971). **Sources:** WW73; Falk, *Exh. Record Series.*

WEISS, Hugh *[Painter]* mid 20th c.
Addresses: Phila., PA. **Exhibited:** PAFA Ann., 1951. **Sources:** Falk, *Exh. Record Series.*

WEISS, Jacob *[Lithographer and engraver]* mid 19th c.
Addresses: Philadelphia, 1859 and after. **Sources:** G&W; Phila. CD 1859-60+.

WEISS, Jacob *[Painter]* mid 20th c.
Addresses: Brooklyn, NY. **Exhibited:** Salons of Am., 1923, 1934; Soc. Indep. Artists, 1925, 1927-28. **Sources:** Falk, *Exhibition Record Series.*

WEISS, Jean Bijur *[Painter, collector]* b.1912, NYC.
Addresses: Chappaqua, NY. **Studied:** New York School Design (certificate); Columbia Univ.; NY Univ.; MMA; NY School Social Res.; Kunstgewerbe Schule, Vienna; Silvermine, MoMA; ASL; Pratt Graphic Arts Center, New York, also with Arshile Gorky, George Grosz & Joseph Binder. **Member:** Silvermine Guild Art; Westchester Art Soc.; Yonkers AA; Katonah Gal. Lending Gallery. **Exhibited:** New England Ann., Silvermine, CT, 1956; AWCS, New York; Northern Westchester Ann.; Westchester Ann.; Katonah Gallery, 1971 (solo). Awards: Antiques award, New England Ann., Silvermine, 1956; Lobster Buoy's award, Westchester Co. Arts Festival; Croton Gothic award, Katohah Gal., NY. **Work:** Nat. Collection Fine Arts, Wash., DC; New York Hospital Collection, NY; Inst. Rehab., NY. **Comments:** Preferred media: acrylics, watercolors, ink. Teaching: adult educ. instructor, drawing & painting, Chappaqua Public Schools, NY, 1963-66. Collection: Arshile Gorky painting and drawings. **Sources:** WW73.

WEISS, John E. See: **WEYSS, John E.**

WEISS, Julius *[Painter, graphic artist]* b.1912, Portland, ME / d.1978, Portland, ME.
Addresses: Boston, MA. **Studied:** H. Giles; C. Hopkinson. **Member:** Artists Union, Boston. **Exhibited:** Provincetown AA; Springfield, Mass., MFA; Fed. Art Project Exhib. (traveling), MA. **Sources:** WW40.

WEISS, Lee (Elyse) C. (Mrs.) *[Painter]* b.1928, Inglewood, CA.
Addresses: Madison, WI. **Studied:** Calif. College Arts & Crafts, 1946-47; also with N. Eric Oback, 1957 & Alexander Nepote,

1958. **Member:** AWCS; Calif. Nat. WCS; Phila. WCC; Wisc. P&S; Wisc. WCS. **Exhibited:** AWCS, 1965-; PAFA, 1965, 1968; The Landscape as Interpreted by Twenty-Two Artists, Minneapolis Inst. Fine Arts, 1966; Am. Artist & Water Reclamation, Nat. Gal. Art, Wash., DC, 1972; Franz Bader Gal., Wash., DC & Oehlschaeger Gals., Chicago, IL, 1970s. **Awards:** medal of honor for watercolor, Knickerbocker Artists, 1964; five awards, 1965-71 & purchase award, 1967, Watercolor USA, Springfield Mus.; Emily Lowe Award, 1966 & Henry Ward Ranger Fund purchase award, 1967, AWCS. **Work:** Nat. Collection Fine Arts, Smithsonian Inst.; NAD; Exec. Residence, State Wisc.; Springfield (MO) Mus. Art; Dimock Gal., George Washington Univ., Wash., DC. **Commissions:** Am. Artist & Water Resources, one of 40 Am. artists chosen for Bur Reclamation Art Project, U.S. Dept. Interior, 1971. **Comments:** Preferred media: watercolors. Publications: co-author, "Lee Weiss Watercolors," College Printing & Publishing, 1971; author, article, "The Watercolor Page," *Am. Artist,* 9/1972. **Sources:** WW73.

WEISS, Lillian R. *[Painter] mid 20th c.*
Exhibited: Soc. Indep. Artists, 1941, 1943. **Sources:** Marlor, *Soc. Indp. Artists.*

WEISS, Marie E. *[Painter] mid 20th c.*
Exhibited: Soc. Indep. Artists, 1941. **Sources:** Marlor, *Soc. Indp. Artists.*

WEISS, Mary L. (Mrs. William H.) *[Painter] early 20th c.; b.Mauch Chunk, PA.*
Addresses: Bethlehem, PA, c.1905-09; East Gloucester, MA. **Studied:** PAFA, with Chase. **Member:** Plastic Club; NAWPS. **Exhibited:** Boston AC, 1904-07; AIC; PAFA Ann., 1906, 1909, 1921, 1924. **Sources:** WW25; Falk, *Exh. Record Series.*

WEISS, Ray (Miss) *[Painter, etcher, lecturer] mid 20th c.; b.New Haven, CT.*
Addresses: New Haven, CT. **Studied:** E. Leon; PIA School. **Member:** New Haven PCC; Phila. Print Club; AAPL. **Exhibited:** Salon Société des Artistes Français, 1930 (prize); New Haven PCC, 1932 (prize). **Work:** Etching, British Mus., London; Bibliothèque Nationale, Paris; MMA, 1932. **Sources:** WW40.

WEISS, Robert *[Sculptor, coppersmith] b.c.1843, Berlin, Germany.*
Addresses: New Orleans, active 1898. **Studied:** Potsdam, Germany. **Comments:** Designed and made the copper eagle on top of the *Daily Picayune* building. **Sources:** *Encyclopaedia of New Orleans Artists,* 409.

WEISS, Rudolph *[Landscape painter] b.c.1826, Hesse-Cassel, Germany.*
Addresses: Philadelphia at least from 1855. **Comments:** He may have been the artist of two marines by "Weiss" exhibited at the Pennsylvania Academy in 1851. **Sources:** G&W; 8 Census (1860), Pa., LII, 245; Rutledge, PA.

WEISS, S. Herberton *[Painter] mid 20th c.*
Addresses: Indiannapolis, IN. **Exhibited:** PAFA Ann., 1950. **Sources:** Falk, *Exh. Record Series.*

WEISS, Samuel A. *[Landscape painter] b.1874, Warsaw, Poland.*
Addresses: NYC; Coytesville, NJ. **Studied:** NAD; H. Mosler. **Exhibited:** PAFA Ann., 1905-06; Soc. Indep. Artists, 1917. **Comments:** Came to U.S. in 1886. **Sources:** WW17; Falk, *Exh. Record Series.*

WEISS, William Lentz *[Painter] early 20th c.*
Addresses: East Gloucester, MA; Phila. PA. **Member:** SC. **Exhibited:** AIC, 1906; PAFA Ann., 1907, 1924. **Sources:** WW25; Falk, *Exh. Record Series.*

WEISSBERG, S.M. *[Painter] mid 20th c.*
Addresses: NYC. **Exhibited:** PAFA Ann., 1954. **Sources:** Falk, *Exh. Record Series.*

WEISSBUCH, Oscar *[Painter, graphic artist, teacher, lecturer, block printer, etcher] b.1904, NYC / d.1948, Utica, NY.*
Addresses: Utica, NY. **Studied:** ASL; BAID; E.C. Taylor; E.Savage; D. Keller; L. York; Yale. **Exhibited:** MoMA, 1936; WFNY, 1939; MMA (AV), 1942; CI, 1941; Phila. Pr. Club, 1938, 1940, 1942, 1946; BM, 1940; British Mus., London, 1937; SFMA; LACMA; Albright Art Gal., 1943; LOC, 1944-45; Yale MFA (solo); Fine Prints of the Year, 1937; 60 Prints of the Year, 1942-42; 100 Am. Block Prints, 1941-42; Norway; Sweden; Denmark. **Work:** Wesleyan Univ.; Albright Art Gal.; Yale; Princeton; LOC; Queensboro Pub. Lib.; Brooklyn Pub. Lib.; Hunter College; State Dept. of Insurance, NY; Washington Irving H.S., NY; Louisiana State Univ.; Univ. Wisc.; Rochester Pub. Lib.; M. Proctor Inst.; Queens College; Westminster Church, Buffalo; Post Graduate Hospital, U.S. Naval Hospital, NY; Univ. Minnesota. **Comments:** Positions: teacher, Munson-Williams-Proctor Inst., Utica, NY (1941-), Mod. Painters Group, Cooperstown, NY (1945-). **Sources:** WW47.

WEISSENBERG, M. *[Painter] mid 20th c.*
Addresses: NYC. **Exhibited:** Soc. Indep. Artists, 1925. **Sources:** Marlor, *Soc. Indp. Artists.*

WEISSENBORN, G. *[Lithographer] mid 19th c.*
Addresses: NYC, 1861. **Comments:** Working with Henry Bruckner (see entry) in NYC, 1861. **Sources:** G&W; *Portfolio* (Feb. 1954), 126.

WEISSER, Leonie Oelkers (Mrs. Fred W.) *[Painter] b.1890, Guadalupe County, TX.*
Addresses: San Antonio & New Braunfels, TX. **Studied:** College Indust. Art, TX; Southwestern Univ., Georgetown, TX; M. Stanford; J.E. Jenkins; R.J. Onderdonk. **Member:** SSAL; San Antonio Art Lg. **Exhibited:** San Marcos, TX, 1921; Hays County (TX) Fairs, 1922-24 (prizes); Texas Artists 1926-34; Edgar B. Davis San Antonio Art Lg., 1927-29; San Antonio Artists, 1927, 1931, 1933, 1934; Exhib., San Antonio, 1929 (prize); SSAL, 1929-35; Texas Fed. Women's Club, 1931 (prize); Soc. Indep. Artists, 1931. **Work:** Witte Mem. Mus. **Comments:** Also appears as Weister. **Sources:** WW47; WW59.

WEISSLER, William, Jr. *[Painter] early 20th c.*
Addresses: Cincinnati, OH. **Member:** Duveneck Soc. **Sources:** WW25.

WEISSMAN, Charles M. *[Painter] mid 20th c.*
Exhibited: Soc. Indep. Artists, 1933; Salons of Am., 1934. **Sources:** Falk, *Exhibition Record Series.*

WEISSMAN, Polaire *[Executive director] mid 20th c.*
Addresses: New York 28, NY. **Sources:** WW66.

WEIST, E. A. *[Painter] 20th c.*
Exhibited: Oakland Art Gallery, 1928. **Sources:** Hughes, *Artists of California,* 595.

WEISTER, Jacob *[Lithographer] b.c.1810, France.*
Addresses: Southwark, a suburb of Phila., in 1850. **Comments:** His wife and children were also born in France, all before 1843. **Sources:** G&W; 7 Census (1850), Pa., LV, 409.

WEISTER, Leonie See: **WEISSER, Leonie Oelkers (Mrs. Fred W.)**

WEISTROP, Elizabeth N. *[Painter] mid 20th c.*
Addresses: NYC. **Exhibited:** PAFA Ann., 1954. **Sources:** Falk, *Exh. Record Series.*

WEISZ, Eugen *[Painter, printmaker, sculptor] b.1890, Hungary / d.1954, Tucson, AZ.*
Addresses: Wash., DC. **Studied:** Corcoran Sch. Art (gold medal, 1921); PAFA; Albright Sch. FA. **Member:** Soc. Wash. Artists; Wash. WCC. **Exhibited:** CGA biennials, 1926-53 (13 times); Soc. Wash. Artists, 1927 (medal), 1944 (prize), 1958 (prize); PAFA Ann., 1928; AIC; Greater Wash. Independent Exhib., 1935; NYWF, 1939; Wash. WCC, 1944 (prize); CGA, 1954 (memorial); American Univ., 1963 (memorial). **Work:** CGA. **Comments:** He came to the U.S. in 1906 with Buffalo Bill's Wild West Show, served in WWI, and worked in a number of jobs, including as a professional wrestler, prize fighter, sign painter and merchant sea-

man. As an artist he worked in a variety of media, covering portraiture, figure, still life and landscape subjects. As a teacher, he taught, guided and influenced many artist, with more than 150 of them endowing the Eugen Weisz Memorial Scholarship in his memory at the CGA. Position: teacher, vice principal (1935-1954), Corcoran Sch. Art; lecturer, George Washington Univ., 1925-38. **Sources:** WW40; McMahan, *Artists of Washington, DC;* Falk, *Exh. Record Series.*

WEISZ, George Gilbert, Jr. *[Lithographer, screenprinter, painter, educator] b.1921, Leroy, OH.*
Addresses: Akron 8, Ohio; R.F.D. 2, Seville, OH. **Studied:** Miami Univ., Oxford, OH (B.F.A.); & with Edwin L. Fulwider. **Exhibited:** LOC, 1943, 1946; Elisabet Ney Mus., 1942; Oklahoma AC, 1942; Wichita, Kansas, 1945; Providence, RI, 1946; Northwest Printmakers, 1946; Mint Mus. Art; Laguna Beach AA, 1946; Butler AI, 1946; Parkersburg FAC, 1946; Akron AI, 1946; Massillon Mus., 1945 (solo); North Canton Little Gal., 1945 (solo). **Work:** Elisabet Ney Mus., Austin, TX; Akron AI. **Comments:** Position: instructor, Akron (Ohio) AI, 1946-. **Sources:** WW53; WW47.

WEITENKAMPF, Frank (Dr.) *[Curator, writer] b.1866 / d.1962, NYC?.*
Addresses: NYC. **Work:** Important curator of prints at NYPL. **Comments:** Author: "American Graphic Art." 1924, "Manhattan Kaleidoscope," 1927.

WEITH, Simon *[Lithographer] b.c.1835, France.*
Addresses: Philadelphia in 1860. **Comments:** He lived with his father, Joseph, and brother, Stephen Weith (see entry). **Sources:** G&W; 8 Census (1860), Pa., LII, 437.

WEITH, Stephen *[Lithographer] b.c.1837, France.*
Addresses: Philadelphia in 1860. **Comments:** He lived with his father, Joseph, and brother, Simon Weith (see entry). **Sources:** G&W; 8 Census (1860), Pa., LII, 437.

WEITZ, Anna *[Painter] late 19th c.; b.New York.*
Exhibited: SNBA, 1890. **Sources:** Fink, *American Art at the Nineteenth-Century Paris Salons,* 404.

WEITZEL, Frank *[Sculptor] mid 20th c.*
Addresses: San Francisco, CA. **Exhibited:** San Francisco AA, 1925. **Sources:** Hughes, *Artists in California,* 595.

WEITZEL, Roswell F. *[Painter] mid 20th c.*
Addresses: Yonkers, NY, 1931. **Exhibited:** Soc. Indep. Artists, 1931. **Sources:** Marlor, *Soc. Indp. Artists.*

WEITZENHOFFER, A. Max *[Art dealer] b.1939, Oklahoma City, OK.*
Addresses: NYC. **Studied:** Univ. Oklahoma (B.F.A.). **Member:** Art Dealers AA. **Comments:** Positions: director, Gimpel & Weitzenhoffer Ltd. Specialty of gallery: twentieth century American and European paintings and sculpture. **Sources:** WW73.

WEITZMAN, J. Daniel (Mr. & Mrs.) *[Collectors] mid 20th c.*
Addresses: NYC. **Sources:** WW66.

WEITZMANN, Kurt *[Educator, art historian] b.1904, Almerode, Germany.*
Addresses: Princeton, NJ. **Studied:** Univ. Munster; Univ. Wurzburg; Univ. Vienna; Univ. Berlin (Ph.D., 1929). **Member:** Medieval Acad. Am. (fellow); German Archaeology Inst.; Am. Philos. Soc.; College Art Assn. Am.; Archaeol. Inst. Am. **Exhibited:** Awards: Univ. Heidelberg, 1967 (Dr. honoris causa); Univ. Chicago, 1968 (Dr. honoris causa); Prix Gustave Schlumberger, Acad. Inscriptions & Belles Lettres, Paris, France, 1969. **Comments:** Positions: stipend, German Archaeology Inst., Greece, 1932 & Berlin, 1932-34; permanent member, Inst. Advanced Study, 1935-72; consulting curator, MMA. Teaching: assoc. professor art & archaeology, Princeton Univ., 1945-50, professor art & archaeology, 1950-72, emer. professor, 1972-; visiting lecturer, art & archaeology, Yale Univ., 1954-55; visiting professor

of art & archaeology, Univ. Alexandria, 1960; guest professor, art & archaeology, Univ. Bonn, 1962; visiting scholar, Dumbarton Oaks, Washington, DC. Research: late classical, Byzantine & Medieval art; expeditions to Mount Athos & Mount Sinai. Publications: co-author, "Die Byzantinischen Elfenbeinskulpturen des X-XIII Jahrhunderts," Vols. I & II, 1930 & 1934; author, "Illustrations in Roll & Codex," 1947, revised edition, 1970; author, "Greek Mythology in Byzantine Art," 1951; co-author," A Treasury of Icons," 1967; author, "Studies in Late Classical & Byzantine Manuscript Illumination," 1971. **Sources:** WW73.

WELBORN, C. W. *[Painter] early 20th c.*
Addresses: Oklahoma City, OK. **Sources:** WW19.

WELBY, Adlard *[Amateur sketch artist] early 19th c.; b.England.*
Comments: An English gentleman of South Rauceby (Lincolnshire) who visited the United States from May 1819 to May 1820 and published a rather unfavorable account of his experiences and observations in 1821. The book was illustrated with views of the places he visited, presumably based on his own sketches. **Sources:** G&W; Welby, *A Visit to North America and the English Settlements in Illinois.*

WELCH, Clarissa Isabel Roberts *[Painter] b.1869, England / d.1961, Fort Bragg, CA.*
Addresses: San Francisco Bay area, active 1920s; Fort Bragg, CA, 1940s-1961. **Exhibited:** Oakland Art Gallery, 1928. **Sources:** Hughes, *Artists in California,* 595.

WELCH, Guy M. *[Painter] 19th/20th c.*
Addresses: California, active, 1870-1910. **Exhibited:** Duvannes Gallery, Los Angeles, 1975. **Sources:** Hughes, *Artists in California,* 595.

WELCH, Harold K. *[Painter] mid 20th c.*
Addresses: Chicago area. **Exhibited:** AIC, 1946. **Sources:** Falk, *AIC.*

WELCH, Jack *[Illustrator] b.1905, Cleburne, TX.*
Studied: W.L. Evans Correspondence Course Cartooning; Southern Methodist Univ. **Exhibited:** NY Art Dir. Club (awards). **Comments:** Worked as a newspaper artist in Texas, California, Seattle, Chicago, Phila., and NYC, also for national advertising campaigns, and did covers for *The Saturday Evening Post* and other magazines. **Sources:** W & R Reed, *The Illustrator in America,* 248.

WELCH, James Henry *[Collector] b.1931, Cleveland, OH.*
Addresses: Canton, OH. **Studied:** Western Penn. Horological Inst., Pittsburgh, certified watchmaker; College Wooster, B.A. **Member:** Nat. Assn. Watch & Clock Collectors (pres., Ohio Valley Chapter, 1964-65). **Comments:** Collection: seventeenth, eighteenth and early nineteenth century decorative watches including enamel automation repousse and complicated watches; eighteenth century English musical clocks; American paintings, Hudson River, nineteenth century portraits and still lifes; British nineteenth century landscapes and portraits; French Barbizon School landscapes. **Sources:** WW73.

WELCH, John *[Ship and ornamental carver and chairmaker] b.1711, Boston / d.1789, Boston.*
Work: He is believed to have carved the codfish which still hangs in the House of Representatives, Old State House, Boston. **Sources:** G&W; Brown, "John Welch, Carver," repros.; Swan, "Boston's Carvers and Joiners, Part I," 198-99.

WELCH, John *[Portrait painter] mid 19th c.*
Addresses: Baltimore in 1849. **Sources:** G&W; Baltimore CD 1849.

WELCH, John T. *[Engraver] mid 19th c.*
Addresses: NYC, 1856-59. **Sources:** G&W; NYBD 1856-59.

WELCH, Joseph *[Wood engraver and designer] mid 19th c.*
Addresses: Utica, NY, 1859. **Sources:** G&W; N.Y. State BD 1859.

WELCH, Katherine G. *[Painter] early 20th c.*
Addresses: NYC; Spring Station, KY. **Member:** NAWPS.
Exhibited: AIC, 1916. **Sources:** WW27.

WELCH, L. T. *[Engraver] mid 19th c.*
Addresses: Bainbridge, IN in 1860. **Sources:** G&W; Indiana BD
1860.

WELCH, Livingston *[Sculptor, painter] b.1901, New
Rochelle, NY / d.1976.*
Addresses: NYC. **Studied:** Hunter College. **Exhibited:** solos:
Wellons Gal., NYC, 1948, Caravan Gal., NY, 1956, World House
Gal., NYC, 1962-65, Shuster Gal., NYC, 1965-69 & Galeria Int.,
NYC. **Work:** Notre Dame Univ. Mus.; Casanova Col.; Hunter
Col. **Comments:** Preferred media: lead, brass. **Sources:** WW73.

WELCH, Ludmilla Pilat (Mrs.) *[Landscape painter] b.1867,
Ossining, NY / d.1925, Santa Barbara, CA.*
Addresses: Marin County, CA. **Studied:** Thaddeus Welch. **Work:**
Santa Barbara Hist. Soc. **Comments:** Married Th. Welch (see
entry) at age 16 and went to California in 1893. Specialty: Calif.
adobes, coastal scenes and landscapes. **Sources:** Hughes, *Artists
in California*, 595.

WELCH, Mabel R. *[Miniature painter, teacher] b.1871, New
Haven, CT / d.1959, West Springfield, MA.*
Addresses: NYC, 1899/North Wilbraham, MA. **Studied:** ASL
with Cox, Reid; in Paris, with Garrido, Lazar, Scott, Van der
Weyden, Courtois. **Member:** ASMP; NAWA; Brooklyn SMP;
Penn. SMP; Grand Central AG. **Exhibited:** SNBA, 1898; NAD,
1899; Pan-Pacific Expo, 1915 (medal); Soc. Indep. Artists, 1917;
Penn. SMP, 1920; ASMP, 1935, 1940; Calif. SMP, 1937 (medal);
Brooklyn SMP, 1933 (prize); NAWA, 1938 (prize); PAFA; 1938
(prize); Salons of Am.; AIC. **Work:** BM; PMA; CGA. **Sources:**
WW59; WW47; Fink, *American Art at the Nineteenth-Century
Paris Salons*, 404.

WELCH, Robert G. (Mr. & Mrs.) *[Collectors] b.1915,
Kewanee, IL.*
Addresses: Cleveland, OH. **Studied:** Stanford Univ. (A.B., 1937).
Member: CMA; MoMA; Cleveland Soc. Contemp Art. **Sources:**
WW73.

WELCH, Sophie Wilhelmine Koerfrer *[Painter] b.1865,
Aix La Chappelle / d.1945, Los Angeles, CA.*
Addresses: Los Angeles, CA. **Exhibited:** SFMA, 1937. **Sources:**
Hughes, *Artists in California*, 595.

WELCH, Stuart Cary *[Museum curator] mid 20th c.*
Addresses: Cambridge, MA. **Comments:** Positions: hon. curator,
Indian & Islamic mss. in Harvard College Library. Teaching: lec-
tures in fine arts, Harvard Univ. **Sources:** WW73.

WELCH, Thaddeus *[Landscape painter] b.1844, La Porte, IN
/ d.1919, Santa Barbara, CA.*
Addresses: Marin County, CA; *T. Welch, 1882.*
Santa Barbara, CA (since 1905).
Studied: worked for a printer in Portland, OR, 1863; with Virgil
Williams, San Francisco 1866; Royal Acad., Munich, 1874 (where
he befriended Twachtman, Chase, and Duveneck); Paris, 1878-81,
with Duveneck. **Member:** Bohemian Club, San Francisco; San
Francisco AA. **Exhibited:** Munich Academy, 1876 (bronze
medal); Paris Salon, 1880, 1881; Boston AC, 1882. **Work:** CPLH;
Oakland Mus. Art; San Diego AG; Frye Mus., Seattle.
Comments: Welch returned from Europe in 1881 and painted in
the Hudson River Valley area. There he met his second wife,
Ludmilla P. Welch (see entry), whom he married in 1883. He
worked in NYC, Boston, and Philadelphia. He traveled to the
Southwest, 1888-89; Australia in 1889; and finally settled in Calif.
in 1891. There he found financial success painting bucolic scenes
of Marin County. Some of his works were distributed as chro-
molithographs by Prang in Boston. **Sources:** Hughes, *Artists in
California*, 596; P&H Samuels, 518; Fink, *American Art at the
Nineteenth-Century Paris Salons*, 404.

WELCH, Thomas B. *[Engraver and portrait painter] b.1814,
Charleston, SC / d.1874, Paris.*

Addresses: Philadelphia. **Studied:** J.B. Longacre; Sully.
Exhibited: PAFA, Artists' Fund Society, American Academy and
Apollo Association, from 1832, (portraits and ideal subjects);
Paris Salon 1868, 1870. **Sources:** G&W; Stauffer; Rutledge, PA;
Rutledge, *Artists in the Life of Charleston;* Cowdrey, AA & AAU;
Phila. CD 1837-60+; 7 Census (1850), Pa., LI, 486; 8 Census
(1860), Pa., LXII, 343; Fink, *American Art at the Nineteenth-
Century Paris Salons*, 404.

WELCH, W. H. *[Engraver] mid 19th c.*
Addresses: NYC, 1850-51. **Sources:** G&W; NYBD 1850-51.

WELCHER, F. *[Listed as "artist"] mid 19th c.; b.German.*
Addresses: St. Louis in 1854. **Comments:** Assisted Edward
Robyn in the painting of a panorama of the Eastern Hemisphere in
St. Louis. **Sources:** G&W; Letter of Charles van Ravenswaay, St.
Louis, to J. Earl Arrington, Jan. 12, 1955 (G&W has information
courtesy J. Earl Arrington).

WELD, Isaac *[Topographical artist and writer] b.1774, Dublin
(Ireland) / d.1856, Ravenswell, near Bray (Ireland).*
Member: Royal Dublin Society. **Comments:** Weld traveled in the
United States (from New York to Virginia) and Canada during the
years 1795-97 and published an account of his experiences in
1799, illustrated with engravings after his own sketches. In 1807
his *Illustrations of the Scenery of Killarney,* appeared. Most of his
life was spent in Dublin, where he was prominent in the Royal
Dublin Society, though in his later years he spent much time in
Rome. **Sources:** G&W; DNB; Weld, *Travels Through the United
States.*

WELD, Virginia Lloyd *[Painter] b.1915, Cedar Rapids, IA.*
Addresses: Cedar Rapids. **Studied:** Coe College, Iowa; Univ.
Iowa; Marvin Cone. **Exhibited:** Little Gallery, Cedar Rapids; Coe
College Library; Iowa Artists Exh., Mt. Vernon, 1938; Killians
Local Artists Exhibit. **Comments:** Affiliated with D.C. Cook Pub.
Co., Elgin, IL, 1939. **Sources:** WW40; Ness & Orwig, *Iowa
Artists of the First Hundred Years*, 217.

WELDING, Henry *[Engraver] b.c.1841, Pennsylvania.*
Addresses: Philadelphia in 1860. **Comments:** Living in
Philadelphia in 1860 with his father, Charles Welding, alderman.
Sources: G&W; 8 Census (1860), Pa., LII, 633.

WELDON, C(harles) D(ater) *[Illustrator, painter]* **ω**
b.1855, Ohio / d.1935, East Orange, NJ.
Addresses: NYC, 1883-89, 1896-1900; Yokohama, Japan, 1893.
Studied: W. Shirlaw, in NY; Munkacsy, in Paris. **Member:** ANA,
1889; NA, 1897; AWCS; Century Assn. **Exhibited:** PAFA Ann.,
1883, 1887-88, 1896-97; NAD, 1883-1900; Charleston Expo,
1902 (bronze medal); Boston AC, 1903; AIC. **Comments:**
Influenced by Japanese art, Weldon often painted Japanese chil-
dren and other Japanese motifs; he spent several years in Japan
illustrating books. Weldon also lived in Iowa for a time. **Sources:**
WW33; Ness & Orwig, *Iowa Artists of the First Hundred Years,*
218; Falk, *Exh. Record Series.*

WELDON, Walter A. *[Ceramic craftsman, designer, lecturer]
b.1890, Rochester, NY.*
Addresses: Baltimore 29, MD. **Studied:** Johns Hopkins Univ.
Member: Am. Ceramic Soc. (fellow); Kiln Club, Wash., DC.
Exhibited: Syracuse MFA; extensively in ceramic exhibs. in U.S.
Award: Charles Fergus Binns medal, 1953 for ceramic art.
Comments: Position: member, United Nations Tech. Assistance
Admin. Mission to India, 1952 and to Yugoslavia, 1953. High-fire
porcelain; Chinese art in porcelain. Contributor: *Ceramic
Industry, Am. Ceramic Soc. Bulletin.* Lectures: The Art of the
Potter. Author *No Potter's Corner.* **Sources:** WW59; WW47.

WELFARE, Daniel *[Portrait and still life painter] b.1796,
North Carolina / d.1841, Salem, NC.*
Studied: studied with Thomas Sully (see entry) in Philadelphia.
Exhibited: PAFA, 1825. **Sources:** G&W; Fielding; Rutledge, PA.

WELL, David *[Lithographer] mid 19th c.*
Addresses: San Francisco, 1858. **Comments:** *Cf.* David Weil.
Sources: G&W; San Francisco BD 1858.

WELLA, H. Emily (Mrs.) *[Painter, teacher] b.1846, Delaware, OH / d.1925, Rochester, NY.*
Addresses: Rochester. **Member:** Rochester AC. **Sources:** WW24.

WELLAND, Thomas *[Engraver and die sinker] b.c.1806, England.*
Addresses: NYC, 1850-59. **Comments:** His wife also was English, but their children were born in the United States, one in Massachusetts about 1836, two in New Jersey about 1842-43, and two in Pennsylvania between 1844-47. Welland was first listed as a calico printer and paper embosser (1851) and subsequently simply as an engraver. **Sources:** G&W; 7 Census (1850), N.Y., LIII, 181; NYBD 1851; NYCD 1851-59.

WELLENS, Helen Miller (Mrs. Jules C.) *[Portrait, landscape & flower painter, illustrator, teacher] b.1879, Phila. / d.1924.*
Addresses: Ardmore, PA. **Studied:** NAD; ASL; with her father H. Miller; PAFA, with W.M. Chase. **Member:** NAWPS; C.L. Wolfe Art Cl. **Exhibited:** NAD, 1898; PAFA Ann., 1900 (as Miller), 1903 (as Wellens). **Comments:** Also appears as Helen Miller Dubbs and Helen Welsh Miller. **Sources:** WW10; WW01; Petteys, *Dictionary of Women Artists;* Falk, *Exh. Record Series.*

WELLER, Allen Stuart *[Educator, art historian, writer, lecturer] b.1907, Chicago, IL.*
Addresses: Columbia, MO; Urbana, IL. **Studied:** Univ. Chicago (Ph.B., 1927; Ph.D, 1942); Princeton Univ. (M.A., 1929); Indiana Central College (hon. LL.D., 1965). **Member:** College Art Assn. Am. (bd. directors); Soc. Arch. Historians; Nat. Assn. Schools Art (bd. directors); Assn. Fine Arts Deans. **Exhibited:** Awards: Legion of Merit, USAF, 1946; Royal Soc. Arts (fellowship); Nat. Assn. Schools Art (fellowship). **Comments:** Teaching: art history prof., Univ. Missouri-Columbia, 1929-47; art history prof., hd. dept., dean college of fine & applied arts & director mus., Univ. Illinois, 1947-71; visiting prof., Univ. Minnesota; visiting prof., Univ. Colorado; visiting prof., Univ. Calif.; visiting prof., Univ. Rhode Island; visiting prof., Oregon State Univ. Collections arranged: contemporary American painting & sculpture, Krannert Art Mus., 1948-53, biennially, 1955-69. Served in U.S. Army Air Force, 1942-45. Research: Italian Renaissance; contemporary American painting and sculpture. Publications: author, *Francesco de Giorgio, 1439-1501,* 1942; author, *Abraham Rattner,* 1956; co-author, *Art USA Now,* 1962; author, *The Joys and Sorrows of Recent American Art,* 1968. Contributor: *Art Digest, Art in America, Magazine of Art.* **Sources:** WW73; WW47.

WELLER, Carl F. *[Painter] b.1853, Stockholm, Sweden / d.1920, Wash., DC.*
Addresses: Wash., DC, active 1892-1920. **Studied:** Royal Acad. Art, Stockholm; Kensington A. Sch., London; ASL-Washington. **Member:** Soc. Wash. Artists (gov. board; treasurer); Wash. WCC (gov. board; treasurer); Wash. SFA. **Exhibited:** ASL exhib. at the Cosmos Club, 1902; Soc.Wash. Artists & Wash. WCC Inaugurals to 1920. **Sources:** WW19; McMahan, *Artists of Washington, DC.*

WELLER, Don *[Illustrator] b.1937, Colfax, WA.*
Addresses: Los Angeles, CA. **Studied:** Wash. State Univ. **Exhibited:** Art Dir. Clubs, Los Angeles and NYC (awards); Lifetime Achievement Award, SI, Los Angeles, 1982. **Comments:** First published a cartoon for *Western Horseman* magazine. Later he contributed to *Time, TV Guide,* and many other national publications. **Sources:** W & R Reed, *The Illustrator in America,* 348.

WELLER, Edwin J. *[Lithographer and engraver] b.c.1822, New York State or Phila.*
Addresses: Boston, active 1848-62. **Work:** Boston Athenaeum (see Powers & Weller). **Comments:** Partner with James T. Powers in Powers & Co., followed by Powers & Weller, from 1852-62 (see entry for Powers & Weller). He was also likely the Weller of Weller & Green, engravers, in 1852. **Sources:** G&W; Boston CD 1848 [as John E.], 1849-60+ [as Edwin J.]; 7 Census (1850), Mass., XXIV, 615 (indicates he was born in New York State about 1822); 8 Census (1860), Mass., XXVII, 456 (indicates he was

born in Philadelphia). More recently, see Pierce and Slautterback, 148.

WELLER, H. F. *[Painter] late 19th c.*
Addresses: Stapleton, Tompkinsville, NY, 1880s. **Exhibited:** NAD, 1882, 1884. **Sources:** Naylor, *NAD.*

WELLER, Howard *[Painter] mid 20th c.*
Addresses: NYC. **Exhibited:** Soc. Indep. Artists, 1941-42, 1944. **Sources:** Marlor, *Soc. Indp. Artists.*

WELLER, John S. *[Artist] mid 20th c.*
Addresses: Columbia, MO. **Exhibited:** PAFA Ann., 1962. **Sources:** Falk, *Exh. Record Series.*

WELLER, M. Bea(trice) *[Painter] mid 20th c.*
Exhibited: Soc. Indep. Artists, 1941-42. **Sources:** Marlor, *Soc. Indp. Artists.*

WELLER, Paul *[Painter, lithographer, designer, photog, illustrator] b.1912, Boston, MA.*
Addresses: New York 21, NY. **Studied:** NAD; Am. Artists Congress. **Member:** Art Lg. Am.; United Am. Arrtists (vice-pres.); Soc. Magazine Photographers. **Exhibited:** AIC, 1936; PAFA, 1936; MoMA, 1939; Phila. Art All.; WFNY, 1939; BM, 1952-53 (solo). **Work:** MMA; Springfield (MA) Mus. Art; BM; WPA mural, USPO, Baldwinsville, NY. **Comments:** Position: art director, *Infinity Magazine,* 1953-. **Sources:** WW59; WW47.

WELLER, Reinhardt *[Artist] late 19th c.*
Addresses: NYC, 1892. **Exhibited:** NAD, 1892. **Sources:** Naylor, *NAD.*

WELLER & GREEN *[Engravers] mid 19th c.*
Addresses: Boston, 1852. **Comments:** The partners were most likely Edwin J. Weller and Henry F. Greene (see entries). **Sources:** G&W; Boston BD and CD 1852.

WELLES, Carol *[Painter] early 20th c.*
Addresses: NYC. **Exhibited:** Soc. Indep. Artists, 1925. **Sources:** Marlor, *Soc. Indp. Artists.*

WELLES, C(harles) Stuart (Dr.) *[Painter] d.1927, London, England.*
Addresses: NYC. **Exhibited:** Soc. Indep. Artists, 1917. **Sources:** Marlor, *Soc. Indp. Artists.*

WELLES, Clara Barck *[Silversmith, designer] b.1868, Ellenville, NY / d.1965, San Diego, CA.*
Addresses: Oregon City, OR, 1880-90; Portland OR, 1894-97; Chicago, IL, 1899-1940; San Diego, CA, 1940-65. **Studied:** AIC, dept. decorative design. **Member:** Cordon Club. **Exhibited:** ASL, 1899, 1901, 1902; Alumni Retrospective Exhib., 1922, AIC; "Contemporary Industrial and Handwrought Silver," The Brooklyn Mus., 1937; MMA, 1937. **Work:** AIC; BM; Chicago Hist. Soc.; DMA; Evanston Hist. Soc.; Grand Rapids Art Mus.; Henry Ford Mus. and Greenfield Village Dearborn, MI; High Mus. Art, Atlanta, GA; Huntington Library, Art Collections, Botanical Gardens, San Marino, CA; BMFA; MMA; St. Louis Art Mus.; Yale Univ. Art Gal. New Haven, CT. The Kalo Shop received commissions for large trophies, bowls and trays. **Comments:** Welles was an important contributor to the American Arts and Crafts Movement in metal work. He founded the Kalo Shop in Chicago in 1900 and designed most of the wares produced there.The shop produced works in paper, copper, and burnt leather goods prior to 1905 at which point they adopted silversmithing and began producing jewelry and silver table items. Later there were as many as twenty-five silversmiths, male and female, employed in the "school in a workshop" (as many of them were also students). Welles advocated the active participation of women in the arts. She managed the retail and craft community shop and its various retail outlet locations until 1940 when she retired. She died in 1964 and the Kalo Shop closed in 1970. Also known as C.B. Wells. **Sources:** Info courtesy of Stanley W. Hess, Silverdale, WA; Sharon Darling, *Chicago Silversmiths* (Chicago: Chicago Hist. Soc., 1977).

WELLGE, Henry *[Lithographer, artist, architect, draftsman, publisher] b.1850, Germany / d.1917.*
Comments: First listed in the directories in Milwaukee in 1878, he began work that year when he drew and published a view of Chilton, WI. His career spanned more than three decades, showing partnerships with J. Bach, J. Stoner and George E. Norris (see separate entries). His association with Stoner lasted from 1880 until his retirement in 84. At least forty of Wellge's views were published in that time. He went into partnership with George Norris, Brockton, MA in 1884 and in 1885 the firm became "Norris, Wellge & Co." of Milwaukee. In 1887 Norris returned to New England and Wellge continued publishing as Henry Wellge & Co. until 1888. In 1888 he established the "American Publishing Co."and published large folio prints of thirteen Midwestern towns, eight mountain states, two cities in Texas and seven places in Virginia. He stayed in business until 1902, producing only a few later lithographs. **Sources:** Reps, 213-14 (pl.7).

WELLHAUSEN, Margaret *[Landscape painter, teacher] late 19th c.; b.Germany.*
Addresses: Norfolk, VA. **Exhibited:** Norfolk, VA, 1886. **Sources:** Wright, *Artists in Virginia Before 1900.*

WELLING, Gertrude Nott *[Painter] early 20th c.*
Addresses: NYC. **Exhibited:** AIC, 1918. **Sources:** WW19.

WELLING, William *[Engraver] b.c.1828, New York.*
Addresses: NYC in 1850. **Sources:** G&W; 7 Census (1850), N.Y., L, 794.

WELLINGTON, Annie F. (Miss) *[Painter] late 19th c.*
Addresses: Brookline, MA, 1889; Paris, France. **Exhibited:** Boston AC, 1886, 1890, 1891; NAD, 1889; PAFA Ann., 1891. **Comments:** Active 1856-91. **Sources:** Falk, *Exh. Record Series.*

WELLINGTON, Duke *[Painter] b.1896, Kansas / d.1987.*
Addresses: Ranchos de Taos, NM. **Studied:** Kansas State College; Los Angeles AC; ASL; also with Eliot O'Hara, Edgar A. Whitney, Hayward Veal, Doel Reed, Alice Harold Murphy, Reed Schmickle & Joseph Fleck. **Member:** Spiva AC; Scene & Pictorial Painters Int. (life mem.); Wichita Art Mus. **Exhibited:** Kansas City (MO) AA, Kansas City Mus., 1957; Kansas Painters Show, Kansas State College, Pittsburgh, 1958; Ozark Artist Guild, Joplin, MO, 1958 (award for "Clown Lou Jacobs"); Spiva AC, Joplin, 1959 (award for "The Hens"); Wichita Art Mus., 1968; Reynolds Gallery, Taos, NM, 1970s. Awards: award for "Finitude," Kansas Painters Show, 1959. **Work:** Graphica, Sage Brush Inn, Taos, NM; in many private collections, including Maurice Chevalier, Paris, Irving Berlin, NY & Gustav S. Eyssell, NY. Commissions: Christ in Kansas mural & 30 religious paintings, Diocese of Wichita, KS, 1958. **Comments:** Preferred medium: oils. Positions: art director, Texas Theatre, San Antonio, 1924-26; art director, Paramount Theatres, 1927-36; art director, Nat. Screen Serv., Los Angeles, 1946-56; art demonstrator, NBC/KOAM Educ.TV, Pittsburgh, 1966-67. Publications: author, "Theatre Poster Service," Publix Theatres Publ., 1929-36; author, *Theory and Practice of Poster Art*, Signs of Times Publ. Co., 1934. **Sources:** WW73; Robert Kelly, "San Antonio Boy Promoted," *San Antonio Evening News,* May 25, 1928; George Britt, "Lure Movie Fans," *New York World Telegram,* October 7, 1932; R.E. Breniver, "Duke, Artist Deluxe," *Signs of the Times* (Cincinnati, Ohio, February, 1932).

WELLINGTON, Frank H. *[Illustrator, miniaturist] b.1858, Brooklyn, NY / d.1911, Passaic, NJ.*
Addresses: NYC, 1884; Pasaic, NJ, 1890. **Exhibited:** Brooklyn AA, 1882, 1884; NAD, 1884, 1890; Pan-Am. Expo, Buffalo, 1901 (medal); PAFA Ann., 1903. **Comments:** Although he was a specialist in wood engraving, he did exhibit paintings at the Brooklyn AA. **Sources:** WW10; *Brooklyn AA;* Falk, *Exh. Record Series.*

WELLINGTON, John L. *[Painter] mid 20th c.*
Addresses: Cumberland, MD. **Exhibited:** PAFA, 1938; Am. WCC, 1938; Wash. WCC, 1936-39. **Sources:** WW40.

WELLIVER, Les *[Woodcarver, sculptor, painter] b.c.1920, North Dakota.*
Addresses: Kalispell, MT in 1969. **Comments:** Raised on ranches in Montana and served in the Navy, 1943-47. **Sources:** P&H Samuels, 318.

WELLIVER, Neil G. *[Painter] b.1929, Millville, PA.*
Addresses: Lincolnville, ME. **Studied:** Phila. Mus. College Art; Yale Univ., with Albers, Diller, Brooks & Relli. **Exhibited:** NAC, 1959; Am. Fedn. Arts Traveling Exhib., 1960 & 1968; PAFA Ann., 1962, 1966-68; WMAA, 1963, 1972-73; Realism Now, Vassar Col., 1968; Four Views, NJ State Mus., 1970; The New Landscape, Boston Univ., 1972; John Bernard Myers Gal., NYC, 1970s. Awards: Morse fellowship, 1960-61. **Work:** WMAA; Vassar Col. Mus. Art. **Comments:** Positions: painting critic, Cooper Union Art School, 1954-57; painting critic, Yale Univ. & Univ. Pennsylvania. Publications: contributor, *Art News, Craft Horizons, Perspecta.* **Sources:** WW73; "Welliver's Travels," *Art News* (1968); Rudolph Burckhardt (producer & director), "Green Wind" (film), 1970; Falk, *Exh. Record Series.*

WELLMAN, Betsy *[Painter] mid 19th c.*
Comments: Painter of a watercolor equestrian portrait about 1840. **Sources:** G&W; Lipman and Winchester, 182.

WELLMORE, Edward *[Engraver, portrait and miniature painter, and crayon portraitist] mid 19th c.*
Addresses: Baltimore, 1837-67; NYC. **Studied:** engraving under James B. Longacre (see entry) of Philadelphia. **Work:** Maryland Historical Society. **Comments:** He engraved several plates for Longacre's *National Portrait Gallery* (1834-35). He was in Baltimore as a portrait and miniature painter. Stauffer states that he later worked in NYC and is thought to have become a clergyman. Cf. Edward Wehnere [?] (see entry). **Sources:** G&W; Stauffer; Baltimore CD 1837-67; Dunlap, *History;.*

WELLS, A. Newton (Miss) *[Painter] late 19th c.*
Studied: Laurens, Constant. **Exhibited:** Paris Salon, 1897, 1898 (drawings). **Sources:** Fink, *American Art at the Nineteenth-Century Paris Salons,* 404.

WELLS, Albert *[Painter] b.1918, Charlotte, NC.*
Studied: Morehouse Col., with Hale Woodruff. **Exhibited:** Inst. Modern Art, Boston, 1943; Atlanta Univ., 1942, 1944; American Negro Expo, Chicago, 1940; Dillard Univ., 1941; Smith Col., 1943. **Sources:** Cederholm, *Afro-American Artists.*

WELLS, Alice Rushmore (Mrs. Henry C.) *[Painter, miniature painter] b.1877, Westbury, LI, NY.*
Addresses: Plainfield, NJ. **Studied:** ASL; R. Collin; Mme. Debillemont-Chardin. **Member:** NAWPS. **Exhibited:** AIC, 1905, 1911. **Sources:** WW40; WW10; Falk, *Exh. Record Series.*

WELLS, Alma (Mrs. Horace C. Levinson) *[Painter] b.1899.*
Addresses: Chicago, IL/Kennebunk, ME. **Studied:** J. Norton; H. de Waroquier, in Paris. **Member:** Arts Club, Chicago. **Exhibited:** Ogunquit (ME) Art Center 1935 (prize); AIC. **Sources:** WW40.

WELLS, Amy Watson See: **FELL, Amy Watson Wells**

WELLS, Anna M. *[Painter, teacher] mid 19th c.; b.Boston, MA.*
Addresses: Santa Cruz, CA. **Work:** Soc. of Calif. Pioneers ("Ruins of the Adobe Mission Church after the Earthquake," 1859). **Comments:** Specialty: watercolors. **Sources:** Hughes, *Artists in California,* 596.

WELLS, Benjamin B. *[Painter] early 20th c.*
Addresses: Hackensack, NJ. **Member:** SC. **Sources:** WW25.

WELLS, Cady *[Painter] b.1904, Southbridge, MA / d.1954, Santa Fe, NM.*
Addresses: Santa Fe, NM in 1935. **Studied:** Harvard Univ.; Univ. Arizona; & with Andrew Dasburg, 1932; brushwork and flower arranging in Japan; in France in 1953. **Member:** AFA; Springfield (MA) AL; San Diego AG. **Exhibited:** AIC, 1935-49; San Diego AF, 1936 (prize); State Fair, NM, 1939 (prize); Rio Grande Painters, Santa Fe, 1934; Heptagon Gal., Taos, 1934; WMAA,

1941-53; Mus. New Mexico, 1956 (retrospective); Univ. New Mexico, 1967 (retrospective). **Work:** FMA; Avery Mem., Hartford, CT; San Diego FA Soc.; San Diego AG; AIC; Mus. New Mexico; Amon Carter Mus. **Comments:** Went to Taos at age 28 to study with Dasburg and thereafter determined to make art his career. Studied and traveled widely. Specialties: watercolors; gouache abstractions. **Sources:** WW53; WW47; P&H Samuels, 518-19; Eldredge, et al., *Art in New Mexico, 1900-1945*, 209.

WELLS, Carrie Carter (Mrs. Charles J.) *[Painter] early 20th c.*
Addresses: Mattituck, NY. **Member:** NAWPS. **Sources:** WW24.

WELLS, Charles Arthur, Jr. *[Sculptor] b.1935, NYC.*
Addresses: Lucca, Italy. **Studied:** Leonard Baskin. **Exhibited:** Awards: John Taylor Arms Award, 1963; NIAL, 1964; Am. Acad. Rome, 1964-66. **Work:** WMAA; Nat. Portrait Gallery, Wash., DC; Penn. State Univ. Mus.; Smith Col. Mus. Art, Northampton, MA; Princeton Univ. Art Mus. **Comments:** Art interests: stone carving, etching. **Sources:** WW73; C. Chetham, article, *Mass. Review* (1964).

WELLS, Charles R. *[Designer] b.c.1832, Pennsylvania.*
Addresses: Philadelphia in 1860. **Comments:** He lived in the same house with William Livasse, lithographer (see entry). **Sources:** G&W; 8 Census (1860), Pa., LII, 951.

WELLS, Charles S. *[Sculptor, teacher] b.1872, Glasgow, Scotland.*
Addresses: Minneapolis, MN. **Studied:** K. Bitter; A. Saint-Gaudens; G.G. Barnard. **Work:** fountain, Gateway Park, Minneapolis; Anna T. Lincoln Mem.; Northfield, MN. **Sources:** WW40.

WELLS, Darius *[Wood engraver] mid 19th c.*
Addresses: NYC, 1846. **Comments:** Of Wells & Webb (see entry), wood engravers and printers' furnishing warehouse. **Sources:** G&W; NYBD and NYCD 1846.

WELLS, Edna M. *[Painter] early 20th c.*
Exhibited: Salons of Am., 1922, 1923. **Sources:** Marlor, *Salons of Am.*

WELLS, Eloise Long *[Sculptor, graphic artist, designer] b.1875, Alton, IL.*
Addresses: St. Louis, MO. **Studied:** St. Louis Sch. FA; Chouinard AI. **Member:** St. Louis Art Gld.; AC, Chicago. **Exhibited:** Soc. Indep. Artists, 1922-27; PAFA Ann., 1923; Kansas City AI, 1923 (gold); Salons of Am. **Sources:** WW40; Falk, *Exh. Record Series.*

WELLS, Emily (Mrs.) *[Painter] early 20th c.*
Addresses: Rochester, NY. **Member:** Rochester AC. **Sources:** WW21.

WELLS, F(rancis) Marion *[Sculptor] b.1848, Louisiana / d.1903, San Francisco, CA.*
Addresses: San Francisco, CA, c.1870-1903. **Member:** Bohemian Club (co-founder). **Exhibited:** Calif. State Fair, 1886; San Francisco AA & Mechanics Inst. Fairs, 1880s & 1890s. Awards: Mechanics Inst. Fair, 1883 (premium), 1890 (silver medal). **Work:** Mechanics' Inst., San Francisco; Statue of Liberty on City Hall, San Fran.; Marshall Mon. at Coloma. **Sources:** Hughes, *Artists in California*, 596.

WELLS, Fred N. *[Executive director] b.1894, Lincoln, NE.*
Addresses: Lincoln, NE. **Studied:** Univ. Calif., Berkeley; Univ. Nebraska (A.B.). **Member:** Sigma Delta Chi; Nebraska AA (pres., 1963-64; exec. secy., 1973); Nebraska Hall Fame Commission, 1973. **Comments:** Positions: chmn., Nebraska State Capitol Murals Commission, 1951-65; director, Lincoln Community Arts Council, 1973; treasurer & director, Nebraska Arts Council, 1973. **Sources:** WW73.

WELLS, Henrietta M. *[Painter] early 20th c.*
Addresses: Morristown, NJ, 1919. **Exhibited:** Soc. Indep. Artists, 1919. **Sources:** Marlor, *Soc. Indp. Artists.*

WELLS, Henry *[Ship carver] 18th/19th c.*
Addresses: Norfolk, VA. **Comments:** Carved figureheads for the brigs *Norfolk* and *Tetsworth.* He was active from 1748 to 1800. **Sources:** G&W; Pinckney, *American Figureheads and Their Carvers*, 82, 202.

WELLS, Jacob *[Artist and draftsman] mid 19th c.*
Addresses: NYC, 1851-58. **Comments:** After 1858 listed as bookseller. He may have been the J. Wells who designed three illustrations for the *American Missionary Memorial* (New York, 1853). **Sources:** G&W; NYCD 1851-60+; Hamilton, *Early American Book Illustrators and Wood Engravers*, 491.

WELLS, James Lesesne *[Painter, lithographer, etcher, illustrator, teacher] b.1902, Atlanta, GA.*
Addresses: Wash., DC. **Studied:** Lincoln Univ.; Teachers College, Columbia Univ. (B.S. & M.A.); NAD, with Frank Nankivell. **Member:** AFA; Washington WCC. **Exhibited:** NYPL, 1921; Harmon Fnd., 1931 (gold), 1933 (prize); Delphic Studios, 1932 (solo); Brooklyn Mus., 1932 (solo); NJ State Mus, Trenton, 1935; American Negro Expo, Chicago, 1940; Dillard Univ., New Orleans, 1941; Inst. of Modern Art, Boston, 1943; NAD, 1946; LOC, 1944, 1946; Phila. Pr. Club, 1943-46; Albany Inst. Hist. & Art, 1945; PMG, 1945; Int. Pr. Soc., 1944; Newport AA, 1944; Howard Univ., 1937, 1945; Nat. & Int. Group Show; Soc. Washington Printmakers; Prints of Two Worlds, Stampe di Due Mondi; Temple Univ; Rome, Italy; Wash. WCC, 1959 (award); Smithsonian Inst., 1961 (award); AFA, 1964 (purchase award for Talladega College); Exhib. & Symposium on Black Arts, CMA, 1967; Carl Van Vechtan Gal. A., Fisk Univ., 1967; Smith-Mason Gal., Wash., DC, 1969 (solo); group show, Afro-American Images, State Armory, Wilmington, DE, 1969; Paintings & Prints, Van Vechtan Gal. Art, 1972 (solo). **Work:** PMG; IBM Collection; Hampton Inst.; Thayer Mus., Univ. Kansas; Valentine Mus. Art, Richmond, VA; Howard Univ. Gal. Art; Lincoln Univ.; Fisk Univ.; Spelman College, Atlanta; Atlanta Univ.; Smithsonian Inst. **Comments:** Teaching: art professor, Howard Univ., retired, 1968. **Sources:** WW73; WW47; Cederholm, *Afro-American Artists.*

WELLS, Jane McClintock (Mrs. F. H.) *[Block printer, designer] b.1903, Charleston, SC.*
Addresses: Smithfield, VA. **Studied:** A. Hutty; A. H. Smith; BMFA Sch. **Comments:** Author/illustrator: "Collecting Ship Models in China," in the Mariner, 1930; "Chinese Lines of Communication," 1934. **Sources:** WW40.

WELLS, John *[Engraver] b.c.1820, Pennsylvania.*
Addresses: Philadelphia in 1850. **Sources:** G&W; 7 Census (1850), Pa., LV, 542.

WELLS, Joseph L. *[Painter] late 19th c.*
Addresses: Phila., PA, 1881. **Exhibited:** PAFA Ann., 1881 (landscape). **Comments:** *Cf.* Joseph R. Wells of Philadelphia. **Sources:** Falk, *Exh. Record Series.*

WELLS, Joseph R. *[Engraver] b.c.1821, Pennsylvania.*
Addresses: Philadelphia in 1850. **Comments:** *Cf.* Joseph L. Wells of Philadelphia in 1881. **Sources:** G&W; 7 Census (1850), Pa., LII, 662.

WELLS, Lewis I. B. *[Artist, "operative," chemist] early 19th c.*
Addresses: Philadelphia, 1814-20. **Sources:** G&W; Brown and Brown.

WELLS, Lucy Dolling (Mrs. William A.) *[Painter, teacher, printmaker] b.1881, Chicago / d.1962, Seattle, WA.*
Addresses: Seattle, 1932-62. **Studied:** AIC; Vanderpoel; R. Clarkson; R. Davey; E.Lawson. **Member:** SAM; NAWA; Pacific Coast PS&W, 1936 (prize); Women Painters of Wash. **Exhibited:** Soc. Indep. Artists, 1930; SAM, 1935-38; Tulsa Art Mus.; St. Louis; NYC; Pacific Coast PS&W, 1936 (prize). **Comments:** Position: teacher, Ballard Art Inst., WA. **Sources:** WW40; Trip and Cook, *Washington State Art and Artists.*

WELLS, Lynton *[Painter] b.1940.*
Addresses: NYC. **Exhibited:** WMAA, 1973. **Sources:** Falk,*WMAA.*

WELLS, Mac *[Painter]* b.1925, Cleveland, OH.
Addresses: NYC. **Studied:** Oberlin College (B.A., 1948); Cooper Union, 1948-49; also with Nahum Tschacbasov & Yasuo Kuniyoshi. **Member:** Am. Abstract Artists. **Exhibited:** solos: Aegis Gal., New York, 1963, A. M. Sachs Gal., New York, 1965 & 1967; PAFA Ann., 1968; Max Hitchinson Gal., New York, 1970 & 1972. **Work:** Michener Collection, Univ. Texas, Austin; Aldrich Mus., Ridgefield, CT; Herron Mus. Art, Indianapolis; Purdue Univ., West Lafayette; Univ. Massachusetts, Amherst. Commissions: three-dimensional card, MoMA, 1965. **Comments:** Preferred media: acrylics, watercolors, oils. Teaching: instructor in general studio, Hunter College, 1966-; instructor in painting & design, Moore College Art, Philadelphia, 1966-72; painting instructor, Skowhegan (ME) School Painting & Sculpture, 1969. **Sources:** WW73; article, "New Talent," *Art in Am.* (July & August, 1965); Lucy Lippard, "New York Letter," *Art Int.* (November 20, 1965); Falk, *Exh. Record Series.*

WELLS, Marjorie W. (Mrs. Robert D.) *[Painter]* mid 20th c.
Addresses: Seattle, WA. **Exhibited:** SAM, 1935. **Sources:** Trip and Cook, *Washington State Art and Artists.*

WELLS, Morris *[Engraver]* b.1839, Washington, DC.
Addresses: Wash., DC. **Comments:** Living in 1860 with his father, Thomas Wells, police officer. **Sources:** G&W; 8 Census (1860), D.C., II, 427.

WELLS, Newton A(lonzo) *[Painter, sculptor, illustrator, architect, craftsperson, teacher]* b.1852, Lisbon, St. Lawrence County, NY / d.1915, Urbana, IL?.
Addresses: Syracuse, NY, 1884, 1892; Cleveland, OH, 1891; Urbana, IL. **Studied:** Académie Julian, Paris with J.P. Laurens and Constant, 1886-95. **Member:** Mur. Painters, 1925; Arch. Lg. Am. (vice-pres); Chicago SE; Paris AAA. **Exhibited:** NAD, 1884, 1891; PAFA Ann., 1892, 1911; Boston AC, 1893; Paris Salon, 1896-98; AIC. **Work:** mural dec., Univ. Illinois Lib.; Sangamon County Court House, Springfield, IL; Colonial Theater, Boston; Englewood H.S. Chicago. **Comments:** Teaching: Univ. Illinois, 1889-20s. **Sources:** WW21; Fink, *American Art at the Nineteenth-Century Paris Salons*, 404; Falk, *Exh. Record Series.*

WELLS, Rachel Lovell *[Wax portraitist]* d.1795.
Addresses: Bordentown, NJ; Philadelphia. **Comments:** Sister of Patience Lovell Wright (see entry). The Lovells lived in Bordentown (NJ), but after her marriage Rachel moved to Philadelphia. Her only known work in wax was a full-length figure of the Rev. George Whitefield, modeled before his death in 1770 and later given to Bethesda College (GA). It was soon after destroyed in a fire. **Sources:** G&W; Bolton, *American Wax Portraits*, 22, 61.

WELLS, Rhea *[Painter]* early 20th c.
Addresses: NYC. **Member:** GFLA. **Exhibited:** AIC, 1922. **Sources:** WW27.

WELLS, Sabina Elliott *[Craftsperson, painter]* b.1876 / d.1943.
Addresses: Charleston, SC; New Orleans, active 1902-04; Baltimore, MD; Charleston, SC. **Studied:** Newcomb Col., 1902-04. **Exhibited:** Louisiana Purchase Expo, 1904; Newcomb Col.,1909; NOAA, 1910, 1914; Pan-Pacific Int. Expo, 1915. **Sources:** WW13; *Encyclopaedia of New Orleans Artists*, 409.

WELLS, Thomas W. *[Marine painter]* b.1916, Menominee, MI.
Addresses: Seattle, WA. **Studied:** Northwestern Military and Naval Academy; Yale Univ. **Member:** Puget Sound Group of Northwest Painters, 1947. **Exhibited:** Henry Gallery, 1951; SAM, 1953. **Sources:** Trip and Cook, *Washington State Art and Artists.*

WELLS, William B. *[Engraver]* b.1874 / d.1942, Wash., DC.
Addresses: Wash., DC, active 1920-42. **Comments:** Position: staff, Bureau of Engraving and Printing. **Sources:** McMahan, *Artists of Washington, DC.*

WELLS & WEBB *[Wood engravers and printers' furnishings warehouse]* mid 19th c.
Addresses: NYC, 1846. **Comments:** Partners were Darius Wells and Ebenezer R. Webb (see entries). **Sources:** G&W; NYBD and NYCD 1846.

WELLSTOOD, John Geikie *[Banknote engraver]* b.1813, Edinburgh, Scotland / d.1893, Greenwich, CT.
Comments: He came to America in 1830 with his family and went to work for Rawdon, Wright & Company (see entry). In 1847 he left to form his own banknote firm which was active in NYC for a decade under the names, Wellstood, Benson & Hanks; Wellstood, Hanks, Hay & Whiting; and Wellstood, Hay & Whiting (see entries). In 1858 Wellstood was one of the leaders in the formation of the American Bank Note Company (see entry) and he remained with the new firm until 1871 when he left to establish the Columbian Bank Note Company in Washington (DC). He returned to the American in 1879 and was still active as late as 1889. William Wellstood (see entry) was his brother. **Sources:** G&W; CAB; Fielding; Smith; NYCD 1836-60+.

WELLSTOOD, William *[Portrait, historical, and landscape engraver and etcher]* b.1819, Edinburgh, Scotland / d.1900, NYC.
Addresses: NYC, c.1845-1900. **Exhibited:** NAD, 1880.
Comments: Brother of the banknote engraver John G. Wellstood (see entry). He was brought to NYC by his parents at the age of eleven and began his career with the Western Methodist Book Concern in the early forties and also did some work for NYC publishers, but he was best known for his landscape engravings. His son James (1855-80) (see entry) also was an engraver. **Sources:** G&W; Stauffer; CAB; NYCD 1847+.

WELLSTOOD & PETERS *[Portrait, historical, and landscape engravers]* mid 19th c.
Addresses: NYC, 1854. **Comments:** Partners were William Wellstood, engraver, and Henry Peters, plate printer (see entries). **Sources:** G&W; NYBD and NYCD 1854.

WELLSTOOD, BENSON & HANKS *[Banknote engravers]* mid 19th c.
Addresses: NYC, 1848-51. **Comments:** The partners were John G. Wellstood, Benjamin W. Benson, and Owen G. Hanks (see entries). After 1851 the name was changed to Wellstood, Hanks, Hay & Whiting (see entry). **Sources:** G&W; NYCD 1848-51.

WELLSTOOD, HANKS, HAY & WHITING *[Bank note engravers]* mid 19th c.
Addresses: NYC, 1852-55. **Comments:** Partners were John G. Wellstood, Owen G. Hanks, De Witt Clinton Hay, and William H. Whiting (see entries). After 1855 it became Wellstood, Hay & Waiting (see entry). **Sources:** G&W; NYCD 1852-55.

WELLSTOOD, HAY & WHITING *[Banknote engravers]* mid 19th c.
Addresses: NYC, 1856-58. **Comments:** Members were John G. Wellstood, De Witt Clinton Hay, and William H. Whiting (see entries). One of the firms which merged in 1858 to form the American Bank Note Company (see entry). **Sources:** G&W; NYCD 1856-58; Toppan, *100 Years of Bank Note Engraving*, 12.

WELMAN, Val *[Artist]* mid 20th c.
Addresses: Seattle, WA. **Exhibited:** PAFA Ann., 1960. **Sources:** Falk, *Exh. Record Series.*

WELMHURST, O. *[Illustrator]* early 20th c.
Addresses: NYC. **Comments:** Position: illustrator with Appleton & Co. **Sources:** WW10.

WELMORE, J. *[Artist]* mid 19th c.
Addresses: Philadelphia. **Exhibited:** Artists' Fund Soc., 1835 (copy in miniature of an unidentified portrait of George Washington). **Sources:** G&W; Rutledge, PA.

WELP, George L. *[Illustrator, art director]* b.1890, Brooklyn, NY.
Addresses: Flushing, NY. **Studied:** ASL; PIA School; W. Biggs. **Member:** SI; SC; Art Dir. Club. **Sources:** WW29.

WELPLEY, Charles *[Painter, etcher]* *b.1902, Wash., DC.*
Addresses: Wash., DC. **Studied:** B. Baker; D. Garber. **Sources:** WW29.

WELPTON, Bonnie Jewett (Mrs. Hugh G.) *[Painter]* *b.1872, Des Moines, IA.*
Addresses: Des Moines, IA. **Studied:** Cumming School Art; Univ. Southern California Art School; Clarence E. Baldwin, Cahrles A. Cumming, Mrs. Alice McKee Cumming, W. L. Judson. **Member:** Delta Phi Delta Art Fraternity. **Exhibited:** Des Moines; Iowa Art Salon (first prize in watercolor). **Comments:** Art department chairman and art custodian for the Des Moines Women's Club, Welpton compiled an art catalogue of paintings in Hoyt Sherman Place. **Sources:** Ness & Orwig, *Iowa Artists of the First Hundred Years,* 218.

WELSCH *[Listed as "artist"]* *mid 19th c.*
Addresses: New Orleans, 1837. **Sources:** G&W; New Orleans CD 1837 (Delgado-WPA).

WELSCH, Paul *[Painter]* *b.1889, Strasbourg.*
Addresses: Paris, France. **Studied:** M. Denis; C. Guerin; B. Naudin, in Paris. **Work:** AIC; Musée de Mulhouse, Musée de Chateau des Rohans, both in Strasbourg. **Sources:** WW33.

WELSCH, Theodore Charles *[Landscape and genre painter]* *mid 19th c.*
Addresses: Syracuse, NY, 1858; Cincinnati, OH, 1860-61. **Exhibited:** National Academy, 1858, 1860; NAD, 1861; Paris Salon, 1859, 1865, 1866. **Sources:** G&W; Cowdrey, NAD; Fink, *American Art at the Nineteenth-Century Paris Salons,* 404.

WELSH, Charles *[Banknote engraver]* *b.c.1815, Pennsylvania.*
Addresses: Philadelphia. **Comments:** Active from about 1841 to after 1860. In 1851 he joined the firm of Draper, Welsh & Company (see entry) which was absorbed into the American Bank Note Company (see entry) in 1858. **Sources:** G&W; Phila. CD 1841-60+; 7 Census (1850), Pa., LV, 593; 8 Census (1860), Pa., LI, 211.

WELSH, Devitt See: **WELSH, H(orace) Devitt**

WELSH, Edward *[Engraver]* *b.c.1814, Ireland.*
Addresses: NYC in 1860. **Comments:** One of his children was born in Ireland c.1833 and two were born in NYC c.1838 and 1840. **Sources:** G&W; 8 Census (1860), N.Y., XLV, 933.

WELSH, Herbert *[Painter]* *b.1851.*
Addresses: Germantown, PA. **Studied:** PAFA; Bonnât, in Paris; F. A. Ortmanns, at Fontainebleau Sch. FA; O. Carlandi, in Rome. **Exhibited:** PAFA Ann., 1877, 1880. **Sources:** WW25; Falk, *Exh. Record Series.*

WELSH, H(orace) Devitt *[Illustrator, etcher, painter, block printer, drawing specialist, lecturer]* *b.1888, Phila. / d.1942, NYC.*
Addresses: Phila., PA; NYC. **Studied:** T. Anshutz; W.M. Chase; J. Pennell. **Member:** Phila. Sketch Club; PAFA (fellow); Phila. WCC; Phila. Art Week Assn.; Soc. Allied Artists. **Exhibited:** PAFA Ann., 1927; AIC, 1930. **Work:** Widener College, Phila.; etching of White House for Pres. Wilson; Elkins College, Phila.; LOC; Free Lib., Phila.; NYPL; British Mus. **Comments:** Positions: assistant, Div. Pictorial Publicity, WWII; chmn., Joseph Pennell Mem. Exh., Phila., 1926. **Sources:** WW40; Falk, *Exh. Record Series.*

WELSH, Isaac *[Engraver]* *b.c.1823, England.*
Addresses: NYC in 1860. **Sources:** G&W; 8 Census (1860), N.Y., XLV, 906.

WELSH, Laura See: **CASEY, Laura Welsh (Mrs. Thomas L.)**

WELSH, Owen *[Painter]* *mid 20th c.*
Addresses: San Jose, CA. **Exhibited:** GGE, 1939; San Francisco AA, 1940. **Sources:** Hughes, *Artists in California,* 596.

WELSH, Roscoe *[Painter]* *b.1895, Laclede, MO.*
Addresses: Chicago, IL. **Studied:** E. Califano. **Sources:** WW24.

WELSH, William P. *[Portrait painter, illustrator, muralist]* *b.1889, Lexington, KY.*
Addresses: Chicago, IL; Lexington, KY. **Studied:** Mary Kinkead, 1904-06; ASL with F.V. DuMond; Académie Julian, Paris with Baschet and Royer, 1906-07; Acad. Delecluse, 1909-10. **Member:** SI. **Exhibited:** H.P. Whitney Mural Competition, 1910 (prize); AIC, 1920-41; First Int. Water Color Exhib., 1921 (prize); Tribune Mural Competition, 1922 (prize); Int. Poster Competition, Chicago World's Fair poster (prize); Annal Exhib. Adv. Art for black and white drawing, 1930 (medal); Poster NY, 1931 (prize); Chicago Soc. Typog. Arts, 1936 (medal); J. B. Speed A. Mus., 1956 (retrospective); Cadet Library, U.S. Military Academy, West Point. **Work:** AIC; mural dec., Men's Café, Palmer House Hotel, Chicago; Univ. Kentucky Art Mus., Lexington. **Comments:** Served in France during WWI and became an instructor, College of Fine and Applied Arts, Beaune, Côte d'Or. Worked in Chicago from 1919-42 and re-entered the military until the end of WWII. Illustrator: covers, *Woman's Home Companion.* **Sources:** WW40; Jones and Weber, *The Kentucky Painter from the Frontier Era to the Great War,* 70 (w/repro.).

WELSHANS, Lotan *[Painter]* *b.c.1900.*
Addresses: Chicago area. **Exhibited:** Soc. Indep. Artists, 1927; AIC, 1929 (prize), 1930-31. **Sources:** Falk, *AIC.*

WELTON, Elise (Mrs. James B.) See: **ELISE, (Elise Cavanna Seeds Armitage)**

WELTON, Grace B. *[Artist]* *late 19th c.*
Addresses: Active in Detroit, MI. **Studied:** Maud Mathewson. **Exhibited:** Mathewsons studio, 1894. **Sources:** Petteys, *Dictionary of Women Artists.*

WELTON, Roland *[Painter]* *b.1919, San Francisco.*
Studied: ASL; Otis AI; Chouinard AI. **Exhibited:** Art West Assoc., Los Angeles, 1962-on; Inst. of Soviet-American Relations in the Soviet Union, 1966-67. **Sources:** Cederholm, *Afro-American Artists.*

WELTSCHEFF, George *[Painter]* *early 20th c.*
Addresses: Stamford, CT. **Exhibited:** Soc. Indep. Artists, 1924. **Sources:** Marlor, *Soc. Indp. Artists.*

WELTY, Magdalena *[Painter]* *early 20th c.*
Addresses: Active in Ft. Wayne, IN, c.1913. **Sources:** Petteys, *Dictionary of Women Artists.*

WEMMEL, Charles W. *[Artist and collector]* *b.c.1839, Brooklyn, NY / d.1916, Brooklyn.*
Addresses: Brooklyn. **Comments:** Served in the Civil War. **Sources:** G&W; *Art Annual,* XIII, obit.

WEMMER, N. J. *[Listed as "artist"]* *mid 19th c.*
Addresses: Philadelphia, 1850-52. **Sources:** G&W; Phila. CD 1850-52.

WENBAN, Sion L. *[Landscape painter, etcher]* *b.1818, Cleveland / d.1897.*
Addresses: Rockville, CT. **Exhibited:** Boston AC, 1884, 1889; Paris Salon, 1886. **Sources:** WW17; Fink, *American Art at the Nineteenth-Century Paris Salons,* 404.

Sion L. Wenban.

WENCK, Paul *[Painter, illustrator, graphic artist]* *b.1892, Berlin, Germany.*
Addresses: Living in New Rochelle, NY in 1941. **Studied:** Berlin, with Hancke, Boese, Friederich, Herwarth, Schaeffer. **Member:** Artists Guild; Deutscher Werkbund, Berlin. **Sources:** WW40; P&H Samuels, 519.

WENDEL, Theodore M.
[Landscape painter] b.1859, Midway, OH / d.1932, Ipswich, MA.

Th. Wendel.

Addresses: Newport, RI, 1890; Boston, MA, 1895; Ipswich, MA (1899-on). **Studied:** McMicken Sch. Art (where he formed friendship with J. DeCamp, c.1876); Royal Acad., Munich, 1878 (along with DeCamp); Académie Julian, Paris, 1886-87. **Member:** Boston GA. **Exhibited:** PAFA, 1881; NAD, 1890, 1895; PAFA Ann., 1906-20 (10 times; medal, 1909); Williams & Everett Gal., Boston, 1892 (duo with Theodore Robinson); Boston AC; Boston Guild Artists; Corcoran Gal biennials, 1907-26 (6 times); Pan.-Pac. Expo, San Francisco, 1915 (medal). **Work:** Cincinnati Mus.; PAFA; BMFA. **Comments:** He was one of most successful Impressionist landscape painters of Boston — and America. As a boy (aged 15-17) he joined the circus as an acrobat. After studying in Munich, he and his friends became known as the "Duveneck Boys" in Munich, Polling, Florence, and Venice, 1878-80. From 1882-85, he was in NYC, Boston, and Newport; and from 1886-87 he returned to Paris to study, spending his summers at Giverny. He was one of the few Americans whose works Monet chose to praise. During the 1890s he taught at Wellesley College and the Cowles Art School in Boston. His landscapes of Ipswich and Gloucester from c.1900-15 represent his strongest works. Despite being one of the most important American Impressionists, in 1917 a mysterious and protracted illness curtailed his career and he gradually slipped into obscurity. **Sources:** WW29; Danly, *Light, Air, and Color,* 88; *300 Years of American Art,* vol. 2: 535; exh. cat., *Painters of the Harcourt Studios* (Lepore FA, Newburyport, MA, 1992); Falk, *Exh. Record Series.*

WENDELL, E. *[Artist] late 19th c.*
Addresses: Active in Detroit, MI. **Exhibited:** Detroit AA, 1876. **Sources:** Petteys, *Dictionary of Women Artists,* suggests this may be Mrs. Emory Wendell.

WENDELL, Margaret See: **HUNTINGTON, Margaret W. Wendell**

WENDELL, Raymond John *[Artist] mid 20th c.*
Addresses: Jackson Heights, NY. **Exhibited:** WMAA, 1951. **Sources:** Falk, *WMAA.*

WENDEROTH, August See: **WENDEROTH, Frederick August**

WENDEROTH, Frederick August *[Historical, animal, landscape, and portrait painter, lithographer] b.c.1825, Kassel, Germany / d.1884.*
Addresses: Brooklyn, NY, 1848; San Francisco, by 1854; Charleston, SC, 1857; Philadelphia, PA, 1869. **Studied:** Kassel Academy. **Exhibited:** NAD, 1869; PAFA Ann., 1876, 1880. **Comments:** The son of the painter Carl Wenderoth. In 1845 he went to Paris and also visited Algeria. In partnership in San Francisco with the lithographer and painter Charles C. Nahl (see entry), also from Kassel. Wenderoth married Laura Nahl in 1856 and soon returned East. With Jesse Bolles (see entry) in Charleston (SC) *Cf.* August Wenderoth. He was active at least until 1863, since he painted a picture of the Battle of Gettysburg. His works are rare. **Sources:** G&W; Peters, *America on Stone;* Met. Mus., *Life in America,* no. 150; Nègler; Cowdrey, AA & AAU; San Francisco CD 1854; Peters, *California on Stone;* Phila. BD 1858; *Magazine of Art* (May 1944), 188, repro. *Cf.* Frederick A. Wenderoth; Rutledge, *Artists in the Life of Charleston,* 165, 224; Phila. CD 1860+. More recently, see Hughes, *Artists in California,* 596, who states his year of birth to be 1819; Falk, *Exh. Record Series.*

WENDEROTH, Harriet (Henrietta, Nettie) *[Wood carver, pottery decorator, designer] late 19th c.*
Studied: Cincinnati School Design. **Exhibited:** Columbian Expo, Chicago, 1893. **Comments:** Worked at Rookwood Pottery, Cincinnati, 1881-85. **Sources:** Petteys, *Dictionary of Women Artists.*

WENDT, Julia M. Bracken (Mrs. William) *[Sculptor, painter] b.1871, Apple River, IL / d.1942, Laguna Beach, CA.*
Addresses: Los Angeles/Laguna Beach. **Studied:** AIC, with Taft, 1887-92 (later his assistant). **Member:** Soc. Western Artists; Chicago SA; Chicago Munic. AL; Los Angeles FA; Calif. AC; NAC; Three Arts Club, Los Angeles, Laguna Beach AA. **Exhibited:** World's Columbian Expo, Chicago, 1893; Chicago, 1898 (prize); PAFA, 1899; Chicago Munic. AL, 1905 (prize); AIC, 1899-1910, 1921; St. Louis Expo, 1904; Pan-Pacific Expo, San Francisco, 1915 (gold); Calif. AC, 1918 (gold); LACMA, 1918, 1939 (solo); Calif.-Pacific Expo, San Diego, 1935; GGE, 1939; NSS. **Work:** LACMA; Lincoln Park, Los Angeles, 1924; New Ebell Club; Hollywood High School; Capitol, Springfield, IL. **Comments:** Married William Wendt (see entry) in 1906 and moved to Calif. Position: teacher, Otis AI, 1906-13. Preferred media: bronze, wood, marble. She achieved a national reputation as one of America's finest sculptors during her lifetime. **Sources:** WW40; Hughes, *Artists in California,* 597; Petteys, *Dictionary of Women Artists;* John Alan Walker, *William Wendt's Pastoral Visions and Eternal Platonic Quests* (priv. printed, Big Pine, CA, 1988); and, John Alan Walker, *Documents on the Life and Art of William Wendt* (priv. printed, Big Pine, CA, 1992), which includes chronology and bibliography on both William and Julia Wendt).

WENDT, William *[Landscape painter] b.1865, Bentzen, Prussia / d.1946, Laguna Beach, CA.*
Addresses: Chicago, IL

•WILLIAM WENDT.

(immigrated 1880); Los Angeles/Laguna Beach, CA from 1906. **Studied:** AIC (evening school); mostly self-taught. **Member:** ANA, 1912; Chicago SA; NAC; Soc. Western Artists; Calif. Laguna Beach AA; AFA; Calif. Art Club (pres., 1911). **Exhibited:** Chicago, 1893 (prize); AIC, prizes in 1897, 1904, 1910, 1913, 1922; SNBA, 1899; Pan-Am. Expo, Buffalo, 1901 (medal); St. Louis Expo, 1904 (medal); Chicago SA, 1905 (prize); Wednesday Club, St. Louis, 1910 (medal); Corcoran Gal biennials, 1910-41 (5 times); PAFA Ann., 1911-12, 1916-18, 1933; SWA, 1912 (prize); Pan-Pacific Expo, San Francisco, 1915 (medal); San Diego Expo, 1915 (prize); Calif. AC, 1916 (prize); Pan.-Am. Exhib, Los Angeles, 1925 (prize); Stendahl Gal. Los Angeles, 1926 (first solo); Pacific Southwest Expo, Long Beach, 1928 (gold, prize); Pasadena AI, 1930 (prize); Laguna Beach MA, 1977 (retrospective). **Work:** LACMA; Laguna Art Mus.; Oakland Mus.; Cincinnati Mus.; AIC; Herron AI; H.S., Richmond, IN; Cliff Dwellers Club., Chicago; Des Moines (IA) Assn. FA; Univ. Club, Seattle. **Comments:** He was a good friend of Gardner Symons (see entry) in Chicago and in 1894 took the first of several trips to California with him. In 1906, he married the sculptor Julia Bracken Wendt (see entry), and they settled in Los Angeles that year. In 1918, he built a studio in Laguna Beach. He was of a modest, religious, and even melancholy nature, but his firm belief in faithfully rendering the shapes and colors of nature served as inspiration and guideline for many other *plein-air* painters. **Sources:** WW40; Hughes, *Artists in California,* 597; *300 Years of American Art,* 596; Falk, *Exh. Record Series.* For discussion of religious and Neo-Platonic elements in Wendt's work, see John Alan. Walker, *William Wendt's Pastoral Visions and Eternal Platonic Quests* (priv. printed, Big Pine, CA, 1988); and, John Alan Walker, *Documents on the Life and Art of William Wendt* (priv. printed, Big Pine, CA, 1992; includes bibliography and catalogue raisonné).

WENG, Siegfried R. *[Museum director, educator, graphic artist, lecturer, block printer, teacher] b.1904, Oshkosh, WI.*
Addresses: Dayton, OH; Newburgh, IN. **Studied:** Oshkosh State Teachers Col.; AIC; Univ. Chicago (M.A.); Fogg Mus. Art, Harvard Univ. **Member:** AFA; AAMus.; Midwest Mus. Assn. (pres., 1948; vice-pres., 1954-55). **Exhibited:** Award: hon. Doctor of Humanities, Evansville College, 1960. **Comments:** Position: lecture asst. to Lorado Taft, Chicago, 1928; director, Dayton AI & Sch. Art, 1929-50; director, Evansville Mus. Arts & Science, Evansville, IN, 1950-. **Sources:** WW66; WW40.

WENGENROTH, Isabelle S. (Mrs. F. W.) *[Craftsperson, designer]* b.1875, Toledo, OH.
Addresses: Bayport, NY. **Studied:** W. Reiss; A. Heckman; J. Carlson; G.P. Ennis. **Member:** Keramic Soc., NYC; Design Guild, NYC; Baltimore WCC; NAWPS. **Exhibited:** Salons of Am. **Comments:** Specialty: textiles. **Sources:** WW40.

WENGENROTH, Stow *[Printmaker]* b.1906, Brooklyn, NY / d.1978, Rockport, MA.
Addresses: NYC; Greenport, NY. **Studied:** ASL, with W. Adams, G.P. Ennis, J. Carlson, G. Bridgman, 1923-27; Grand Central School Art. **Member:** ANA, 1938; NAD, 1941; Providence WCC; CAFA; SC; Prairie PM; NIAL; Soc. Am Graphic Artists; Philadelphia WCC; Albany Print Club. **Exhibited:** Phila. WCC, 1933 (gold), 1943 (gold), 1943 (Pennel Mem. Medal); Phila. Pr. Club, 1934 (prize), 1935 (prize), 1937 (prize), 1939 (prize); SC, 1937 (prize); AV, 1942 (prize); Northwest PM, 1943 (prize); CAFA, 1943 (prize), 1946 (prize); Mint Mus. Art, 1944 (prize); Audubon Artists, 1945 (gold), 1949 (medal of honor); NAC, 1933 (prize); NAD (1968, SFB Morse Medal); Kennedy Galleries, NYC, 1970s; SAGA, NYC. **Work:** Boston Public Lib. (large collection); MMA; LOC; BMFA; MoMA; BMA; Syracuse MFA; AGAA; NYPL; WMAA; Denver AM; Milwaukee AI; LACMA; SAM; FMA; PAFA; CI; Albany Inst. Hist. & Art. **Comments:** A superb draughtsman and craftsman, Wengenroth began lithography in 1929; and spent his life exploring the range of the lithographic stone, working commercially and as a fine printmaker. He made studies in dry-brush drawing, then line drawing, before commiting the subject to stone. His subjects include views of harbors, coves, lighthouses, buildings, and the plant and animal life of the Northeast. Painting locations include Monhegan Island (ME). Publications: author, *Making a Lithograph*, 1936; co-author, *Stow Wengenroth's New England*, 1969. **Sources:** WW73; Curtis, Curtis, and Lieberman, 51, 73, 187; Baigell, *Dictionary*; Ronald and Joan Stuckey, *The Lithographs of Stow Wegenroth* (1974).

WENGER, John *[Painter, designer]* b.1887, Elizabeth, Russia / d.1976, NYC.
Addresses: New York 23, NY. **Studied:** early training in Russia; NAD. **Member:** Audubon Artists; AWCS; Un. Scenic Artists; Nat. Soc. Painters in Casein; SC; Arch. Lg., NYWCC. **Exhibited:** Soc. Indep. Artists, 1917; PAFA Ann., 1917-18, 1933; Salons of America; Corcoran Gal biennial, 1932; NAD; AIC; WMAA; AWCS; Audubon Artists, 1945, 1953, 1954, 1956; Rochester Mem. Art Gal.; MMA, 1949; BM; MoMA; Mus. City of New York: Stendahl Gal., Los Angeles; Nat. Soc. Painters in Casein, 1954, 1955; Ferargil Gal., 1925 (solo); Montross Gal., 1931-34; Grand Central Art Gal., 1929, 1935, 1938, 1940, 1944, 1950, 1956; Staten Island Inst., 1945. Awards: prizes, Florida Southern College, 1952; Tel-Aviv Mus., Israel; medal, Sesqui-Centennial Expo, Phila., 1956. **Work:** Tel-Aviv Mus.; Mus. City of NY. **Comments:** Designer of stage productions & scenic designer for movie "Paramount on Parade." Position: art director, Roxy Theatre, NYC. **Sources:** WW59; WW47 (birth date listed as 1891); Falk, *Exh. Record Series*.

WENGER, Lesley *[Art dealer]* b.1941, NYC.
Addresses: San Francisco, CA. **Studied:** New York Univ. (B.A.), 1963). **Comments:** Positions: director, Wenger Gal., 1969-. Collections arranged: (exhibitions) Glass Sculpture/John Anderson, Bruce George, Kim Newcomb, Wenger Gal., San Francisco, 1971; Judith Foosaner--Painting, Wenger Gal., 1971; Laya Brostoff--Woven Canvases, Wenger Gal., 1972; Ceramic Sculpture/Dan Snyder, Butterfield, Shannonhouse, Buck, Billick, 1972; Ceramic Sculpture/Unterseher, McNarama, Greenley, Cooper Arrizabalaga, Williamson, Dewey, 1972; Sculpture/Mary Gould Quinn and Charlotte Wax, 1972. **Sources:** WW73.

WENGER, Sigmund *[Art dealer, lecturer]* b.1910, Brooklyn, NY.
Addresses: San Ysidro, CA. **Studied:** New York Univ., 1929-31.

Comments: Positions: director, Galerias Carlota, Tijuana, Baja California, Mex; co-director, Wenger Gal., San Francisco & La Jolla, CA. Teaching: consultant/lecturer, La Jolla (CA) Mus. Contemporary Art, 1965-69; consultant/lecturer, Fine Arts Gallery San Diego, CA, 1965-; consultant/lecturer, Nat. Inst. Fine Arts, Mexico City, Mexico, 1966-70. Specialty of gallery: Mexican and contemporary art. **Sources:** WW73.

WENGLER, John B. *[Landscape artist]* mid 19th c.; b.Austria.
Addresses: Wisconsin, 1850-51. **Exhibited:** American Art-Union, 1851. **Work:** Museum at Linz. **Sources:** G&W; Butts, *Art In Wisconsin*, 63-64; Cowdrey, AA & AAU.

WENIGE, G. *[Lithographer]* mid 19th c.
Addresses: Boston in 1860. **Sources:** G&W; New England BD 1860.

WENIGER, Maria P. *[Sculptor]* b.1880, Bevensen, Germany.
Addresses: NYC. **Member:** Soc. Indep. Artists. **Exhibited:** Salons of Am.; Soc. Indep. Artists, 1921, 1936; PAFA Ann., 1924. **Sources:** WW25; info. courtesy Peter C. Merrill, who cites 1890 as birth date; Falk, *Exh. Record Series*.

WENLEY, Archibald Gibson *[Museum director]* b.1898, Ann Arbor, MI / d.1962.
Addresses: Washington 7, DC. **Studied:** Univ. Michigan (A.B.); École des Langues Orientales Vivantes, Institut des Hautes Études Chinoises, and College de France, Paris. **Member:** Am. Oriental Soc.; Smithsonian Art Comm.; Chinese Art Soc. Am.; Far Eastern Assn. **Work:** Freer Gal. Art, Wash., DC. **Comments:** Position: director, Freer Gal. Art, Wash., D.C., 1943-; research professor, Oriental Art, Univ. Michigan. Co-author: "China," Smithsonian Inst. War Background Studies, No. 20; author, Freer Gal. Art Occasional Papers, No. 1: "Grand Empress Dowager Wen Ming and the Northern Wei Necropolis at Fang Shan," 1947; co-author," A Descriptive and Illustrative Catalogue of Chinese Bronze Acquired During the Administration of John Ellerton Lodge," Freer Gal. Art Oriental Studies No. 3, 1946. Contributor to *Journal of Am. Oriental Soc*. Lectures on arts of China, Japan and Korea. **Sources:** WW59.

WENTLAND, Frank A. *[Painter, etcher, lecturer, teacher]* b.1897, Rolling Prairie, IN.
Addresses: Michigan City, IN. **Studied:** A.C. Winn; A.H. Krehbiel. **Member:** Hoosier Salon; La Porte Brush & Palette Club; Michigan City AL. **Sources:** WW40.

WENTWORTH, Adelaide E. *[Etcher, craftsperson, teacher, lecturer]* mid 20th c.; b.Wakefield, NH.
Addresses: Cincinnati, OH/Kittery Depot, ME, from c.1915. **Studied:** D.W. Ross; W.S. Robinson; A. Dow. **Member:** Cincinnati Women's AC; Crafters Club. **Sources:** WW31.

WENTWORTH, Almond Hart (Mr.) *[Painter, teacher]* b.1872, Milton Mills, NH / d.1953.
Addresses: St. Petersburg, FL/East Lebanon, ME. **Studied:** Cowles Art Sch., Boston; ASL, Buffalo, NY; with Denman Ross; Harvard. **Member:** Eastern AA; New Haven PCC; St. Petersburg (FL) AC. **Exhibited:** New Haven PCC, 1910-40; St. Petersburg AC, 1944-52 (prize, 1945); Bridgeport AL. **Comments:** Position: director, art educ., Public School, New Haven, CT, 1904-40. **Sources:** WW53; WW47.

WENTWORTH, Catherine Denkman (Mrs.) *[Portrait painter, art collector, patron]* b.1865, Rock Island, IL / d.1948, Santa Barbara, CA.
Addresses: NYC; Paris, France. **Studied:** Paris, with Bouguereau & Robert-Fleury. **Exhibited:** Salon de la Soc. des Artistes Français; Hotel Jean Charpentier, 1925 (solo). **Sources:** WW15; Petteys, *Dictionary of Women Artists*.

WENTWORTH, Cecile Smith De (Mrs. Josiah Winslow) *[Painter]* b.NYC / d.1933, Nice, France.
Addresses: Paris, France/NYC, 1887-90; Peekamose, NY. **Studied:** Sacred Heart Convent; Paris, with Cabanel & Detaille. **Exhibited:** Tours (gold); Lyon (gold); Turin (gold); Paris Salon,

1886, 1888-99 (prize, 1891); NAD, 1887-90; Paris Expo, 1900 (medal). Other awards: Chevalier of the Legion of Honor, France, 1901; Officer of Public Instruction in France; Order of Holy Sepulchre from Pope Leo XIII. **Work:** MMA; Luxembourg Mus., Senate Chamber, both in Paris; Vatican Mus.; Catholic Univ.; CGA. **Comments:** (Marquise de Wentworth). Painted portraits of presidents and dignataries in the U.S. and Europe. **Sources:** WW10; WW17; Fink, *American Art at the Nineteenth-Century Paris Salons*, 404-405; Petteys, *Dictionary of Women Artists*.

WENTWORTH, Claude *[Landscape painter] mid 19th c.*
Addresses: NYC. **Exhibited:** NAD, 1859. **Sources:** G&W; Cowdrey, NAD.

WENTWORTH, (Daniel) F. *[Painter] b.1850 / d.1934.*
Addresses: New Milford, CT. **Studied:** Munich; largely self-taught. **Member:** CAFA. **Exhibited:** Brooklyn AC; AWCS; Boston AC, 1884-1907; CAFA, 1922 (prize). **Work:** Storrs (CT) College. **Sources:** WW33.

WENTWORTH, F. See: **WENTWORTH, (Daniel) F.**

WENTWORTH, Harriet Marshall (Mrs. Robert S.)
[Portrait & miniature painter] b.1896, New Hope, PA.
Addresses: Mamaroneck, NY; New Hope, PA. **Studied:** PAFA; Grande Chaumière, Acad. Colarossi, Paris, and with Daniel Garber, William Lathrop, A. Margaretta Archambault, Cecilia Beaux, F. Luis Mora, A. Favori. **Member:** AFA; Int. Inst. Arts & Letters (fellow); Int. Platform Assoc., Wash, DC (member, art committee). **Exhibited:** PAFA, 1933, 1934, 1942; Smithsonian Inst.; Ainslie Gal., NY (solo); Phillips Mill, New Hope, PA. **Work:** PAFA; Smithsonian Inst. **Sources:** WW59; WW47.

WENTWORTH, Jerome Blackman *[Listed as "artist" (probably amateur)] b.1820 / d.1893, Boston, MA.*
Exhibited: Boston Athenaeum, 1842. **Comments:** Married Catherine Rogers Motley Clapp in 1848. **Sources:** G&W; Swan, BA; Watkins, *The Residuary Legatees of the Will of Mrs. Eliza Ann (Blackman) Colburn*, 12, 14; Wentworth, *The Wentworth Genealogy*, gives the date of birth as December 18, 1818.

WENTWORTH, Margaret *[Painter] b.1914, Berkeley, CA.*
Addresses: California. **Studied:** Radcliffe Col.; with Roi Partridge, Mills Col., Oakland, CA; AIC; Fogg Mus. **Member:** Carmel AA; San Francisco AA. **Exhibited:** Santa Barbara Mus. (solo); Mills Col. (solo); Stanford Art Gal. (solo); Labaudt Gal., San Francisco (solo); Carmel AA Gal. (solo); de Young Mus. (solo). **Comments:** Also appears as Millard. **Sources:** Hughes, *Artists in California*, 597.

WENTWORTH, Murray Jackson *[Painter, instructor] b.1927, Boston.*
Addresses: Norwell, MA. **Studied:** Art Inst. Boston. **Member:** ANA; AWCS; All. A. Am.; Boston WCS (vice-pres., 1971-); Salmagundi Club. **Exhibited:** MMA, 1966; Mexico Art Inst. & Watercolor Mus., Mexico City, 1968; Butler IA, 1969; Brockton (MA) Fuller Mem. Mus., 1970; Farnsworth Mus, 1972 (solo). Awards: Ranger Fund Purchase Prize, NAD, 1965; Nat. Arts Club Bronze Medal Honor, 1968; AWCS Bronze Medal Honor, 1969. **Work:** Farnsworth Mus. Art, Rockland, ME; Springfield (MO) Mus. Art; First Nat. Bank, Boston; Mech. Nat Bank, Worcester, MA; Utah State Univ., Logan. **Comments:** Preferred media: watercolors. Publications: contributor, watercolor page, *Am. Artist Magazine*, 1970. Teaching: watercolor instructor, Art Inst. Boston, 1957-. **Sources:** WW73.

WENTWORTH, Thomas Hanford *[Folk portrait, miniature & landscape painter; profilist; aquatint engraver & lithographer] b.1781, Norwalk, CT / d.1849, Oswego, NY.*
Addresses: Utica, NY; Oswego, NY, 1806-49. **Comments:** He was sent as a youth to an uncle in St. John's, New Brunswick, for business experience and in 1805 to England. An itinerant portraitist, he is primarily known for his small pencil portraits painted in Mass., Conn., and New York from 1822-26. He also published several lithographs of Niagara Falls. William Henry Wentworth (see entry) was his son. **Sources:** G&W; Wentworth, *The*

Wentworth Genealogy, II, 21-22; Bolton, *Miniature Painters;* Sherman, "American Miniatures by Minor Artists," 424; Vanderpoel, *Chronicles of a Pioneer School*, opp. 220, 224, 228; *Antiques* (Jan. 1937), 10, (June 1937), 291, (July 1937), 7-8.

WENTWORTH, William Henry *[Portrait painter] b.1813, Oswego, NY.*
Addresses: Oswego, NY, 1859. **Comments:** Son of Thomas Hanford Wentworth (see entry) of Oswego (NY). **Sources:** G&W; Wentworth, *The Wentworth Genealogy*, II, 22; N.Y. State BD 1859.

WENTWORTH-ROBERTS, Elizabeth See: **ROBERTS, Elizabeth W(entworth)**

WENTZ, Henry Frederick *[Painter, craftsperson, lecturer, teacher] mid 20th c.; b.The Dalles, OR.*
Addresses: Portland, OR/Nehalem, OR. **Studied:** ASL. **Work:** Portland AA. **Sources:** WW40.

WENZEL, Edward *[Engraver] mid 19th c.*
Addresses: San Francisco, 1859 and after. **Sources:** G&W; San Francisco CD 1859-64.

WENZEL, Max *[Painter] mid 20th c.*
Exhibited: Soc. Indep. Artists, 1928. **Sources:** Marlor, *Soc. Indp. Artists.*

WENZEL, William *[Lithographer] mid 19th c.*
Addresses: San Francisco, 1860 and after. **Sources:** G&W; San Francisco CD 1860-64.

WENZEL, William Michael (Bill) *[Cartoonist, illustrator] b.1918, Union, NJ.*
Addresses: Atlantic Highlands, NJ. **Studied:** CUA School. **Member:** Nat. Cartoonists Soc. **Comments:** Illustrator/editor: "Love Ledger," 1946; "Off Limits," 1952; "Flimsey Report," 1953. Contributor cartoons to *Colliers, Saturday Evening Post, True, Cavalier, This Week, Saga; Argosy, NY Journal-American,* and other national magazines and newspapers. **Sources:** WW59.

WENZELL, A(lbert) B(eck)
[Illustrator, still life, landscape and mural painter] b.1864, Detroit, MI / d.1917, Englewood, NJ.
Addresses: Detroit, MI, 1888; NYC; Englewood, NJ.
Studied: Munich with Stahuber and Loefft; Académie Julian, Paris with Boulanger and Lefebvre, 1888. **Member:** SI (co-founder; pres., 1902); Arch. Lg., 1913; Mural Painters. **Exhibited:** Paris Salon, 1887; NAD, 1888; Boston AC, 1888, 1905; Paris Expo., 1890; PAFA Ann., 1893, 1901; Pan-Am. Expo, Buffalo, 1901 (medal); St. Louis Expo, 1904; AIC. **Work:** New Amsterdam Theatre, NYC. **Comments:** Master of drawing room subjects, his works represent a historic record of fashionable society at the turn of the century. Author: *Vanity Fair, The Passing Show,* and books for various publishers. Illustrator: *Harper's, Life, Ladies Home Journal, Saturday Evening Post.* **Sources:** WW15; Gibson, *Artists of Early Michigan*, 239; Fink, *American Art at the Nineteenth-Century Paris Salons*, 405; Falk, *Exh. Record Series.*

WENZLAWSKI, Henry C. *[Portrait painter] mid 19th c.*
Addresses: NYC, 1854. **Sources:** G&W; NYBD and NYCD 1854.

WENZLER, Anthony Henry *[Portrait, miniature, still life, genre, and landscape painter] b.Denmark / d.1871, NYC.*
Addresses: NYC, 1838-67. **Member:** ANA, 1848-60; NA, 1860. **Exhibited:** Apollo Assoc.; PAFA; NAD, 1838-67; Brooklyn AA, 1861-63, 1872 (landscapes in Maine). **Sources:** G&W; Cowdrey, NAD; Cowdrey, AA & AAU; Rutledge, PA; NYCD 1838-40, 1845-48, 1851-53, 1855-60+; Bolton, *Miniature Painters;* Clark, *History of the NAD*, 274; Washington Art Assoc. Cat., 1859. More recently, see Campbell, *New Hampshire Scenery*, 171.

WENZLER, H. See: **WENZLER, Sarah Wilhelmina (Miss)**

WENZLER, John Henry *[Listed as "artist"] mid 19th c.*
Addresses: NYC, 1846-53. **Sources:** G&W; NYCD 1846-47 as Henry, 1849 and 1851-53 as John Henry.

WENZLER, S. W. See: **WENZLER, Sarah Wilhelmina (Miss)**

WENZLER, Sarah Wilhelmina (Miss) *[Still- life painter] d.c.1871.*
Addresses: NYC, 1863-72. **Exhibited:** NAD, 1860-72; Boston Athenaeum, 1864-68; Brooklyn AA, 1864, 1868-72; PAFA, 1868-69. **Comments:** Active 1861-72. **Sources:** G&W; Swan, BA; Cowdrey, NAD; Rutledge, PA [as S.W. Wenzler]; *For Beauty and for Truth,* 91 [as Sarah Wilhelmina Wenzler] (w/repro.).

WENZLER, William *[Listed as "artist"] mid 19th c.*
Addresses: NYC, 1843. **Sources:** G&W; NYCD 1843.

WEOFLE, Arthur *[Portrait painter] b.1873 / d.1936.*
Addresses: Brooklyn, NY, 1899. **Exhibited:** NAD, 1899.
Sources: Naylor, *NAD.*

WERBE, Anna Lavick (Mrs. David B.) *[Painter, teacher, illustrator, lecturer, designer] b.1888, Chicago, IL.*
Addresses: Detroit, MI. **Studied:** AIC, with Vanderpoel, F. Freer; M. Baker. **Member:** Detroit FA All.; Detroit Mus. Art Founders Soc.; AIC Alum. Assn.; Detroit Art Market; Michigan WCS.
Exhibited: LACMA; Butler AI; Detroit Inst. Art, 1948 (prize); Grand Central Art Gal.; Soc. Indep. Artists; PAFA, 1925; Flint Inst. Art; Ann Arbor Mus. Art; AIC (retrospective); Scarab Club; Arthur Newton Gal., NY (solo). Awards: medal, Michigan State Fair, 1934; Michigan Artists, 1952. **Work:** Detroit Inst. Art.
Comments: Position: founder/director, Jewish Community Center Art School. **Sources:** WW59; WW47.

WERCK, Alfred *[Painter] mid 20th c.*
Exhibited: Salons of Am., 1931. **Sources:** Marlor, *Salons of Am.*

WERFT, Herman *[Painter] mid 20th c.*
Addresses: Brooklyn, NY. **Exhibited:** Soc. Indep. Artists, 1927, 1929. **Sources:** Marlor, *Soc. Indp. Artists.*

WERHEIM, Roland *[Painter] mid 20th c.*
Addresses: NYC. **Exhibited:** GGE, 1939. **Sources:** WW40.

WERLEY, Beatrice B. *[Painter, illustrator, commercial artist] b.1906, Pittsburgh, PA.*
Addresses: Eau Gallie, FL. **Studied:** Cleveland College; Huntington Polytechnic Inst.; and with Henry Keller, Frank Wilcox, W. Combs. **Member:** Melbourne AA (pres., 1951-53).
Exhibited: Awards: Cleveland Clinic (medal). **Work:** three animated medical movies for educational purposes; Am. Med. Assn. exhibits, San Francisco, 1946, Cleveland, 1946. **Comments:** Illustrator: "The Extremities," 1945. Lectures: medical art. Position: staff artist, Cleveland (OH) Clinic, 1935-49; illustrator, Patrick Air Force, FL, 1955-56. **Sources:** WW59.

WERNER, Alfred *[Critic, writer] b.1911 / d.1979.*
Addresses: NYC. **Studied:** Univ. Vienna; New York Univ. Inst. Fine Arts. **Member:** Int. Assn. Art Critics. **Exhibited:** Awards: Prof. Honoris Causa, Austrian Govt., 1967; officer's cross, German Order Merit. **Comments:** Positions: U.S. correspondent, Pantheon, Munich, Germany; book review editor, *Am. Artist,* New York. Publications: twenty books published including works on Modigliani, Pascin, Chagall & Barlach; contributor to *Arts Magazine, Art Journal, Am. Artist, Kenyon Review & Antioch Review.* Teaching: lecturer, history of modern art, Guggenheim Mus., MoMA, Nat. Gallery of Art, Jewish Mus.; instructor, Wagner College, City College, NYC. **Sources:** WW73.

WERNER, Charles George *[Cartoonist, lecturer] b.1909, Marshfield, WI.*
Addresses: Indianapolis, IN. **Studied:** Oklahoma City Univ.; Northwestern Univ. **Member:** Nat. Cartoonists Soc. **Exhibited:** Nat. Cartoonists Soc. Awards: Pulitzer prize, 1938; Sigma Delta Chi, 1943; Nat. Headliners Club, 1951; Freedom Fnd., 1951, 1952. **Work:** Huntington Lib.; LOC; White House, Wash. DC. **Comments:** Position: cartoonist, *Daily Oklahoman,* 1935-41; *Chicago Sun,* 1941-47; *Indianapolis Star,* 1947-.Lectures: history of cartooning. **Sources:** WW66.

WERNER, Donald (Lewis) *[Painter, designer] b.1929, Fresno, CA.*
Addresses: NYC. **Studied:** Fresno State College (B.A.), with Adolf & Ella Odorfer & Jane Gale; Chouinard Art Inst., Los Angeles; also costuming with Marjorie Best. **Member:** Gallery 1984; Yonkers AA. **Exhibited:** Gallery 1984, New York, 1959-72 (solos); Fresno A. Gal., 1967 (solo); Focus Gal., San Francisco, 1968 (solo); Hudson River Mus., 1969 & 1972 (solo); St. Paul (MN) Civic Center, 1970. Awards: first prize for watercolor, Fresno AC, 1960. **Work:** murals, Dan River Mills, NYC; Wellington Sears, New York; Martex, New York; Fresno (CA) Art Center; Hudson River Mus., Yonkers, NY. Commissions: collage murals, New York World's Fair. **Comments:** Preferred media: watercolors, collage. Positions: display designer, *Seventeen Magazine,* 11 years; store designer & displayer, Gimbels, 1968-69; mus. artist & designer, Hudson River Mus., 1968-69. Collections arranged: Art in Westchester, 1969; African Art, 1971; Light, Motion, Sound, 1971; Sky, Sand & Spirits, 1972; 20th Century Sculpture, 1972; James Renwick Brevoort, 1972, Hudson River Mus. **Sources:** WW73; Beeching, "Theatrical Displays and Display Techniques" (film), Scope Productions, 1969.

WERNER, Ernest *[Fresco painter] b.c.1821, Saxony.*
Addresses: Philadelphia in 1860. **Comments:** His wife was from Maryland, while one child (16) was born in Saxony and the other (10) in Maryland. **Sources:** G&W; 8 Census (1860), Pa., LIII, 507.

WERNER, Frank A. *[Painter] early 20th c.*
Addresses: Chicago, IL. **Member:** Chicago SA. **Exhibited:** AIC, 1909-19; PAFA Ann., 1914-15. **Sources:** WW21; Falk, *Exh. Record Series.*

WERNER, Fritz *[Portrait painter] b.1898, Vienna, Austria.*
Addresses: NYC. **Studied:** H. Tichy, in Vienna; H. von Haberman, in Munich; German Nat. Acad. **Member:** Woodstock AA. **Exhibited:** Austrian Nat. Acad., 1920-21 (prize); Corcoran Gal biennial, 1937. **Sources:** WW40; addit. info. courtesy Woodstock AA.

WERNER, Geraldine See: **PINE, Geri (Geraldine) (Mrs. Werner)**

WERNER, Gertrude *[Painter] early 20th c.*
Addresses: Long Island City, NY. **Exhibited:** Soc. Indep. Artists, 1927-28. **Sources:** Marlor, *Soc. Indp. Artists.*

WERNER, Hans *[Painter] mid 20th c.*
Addresses: Chicago area. **Exhibited:** AIC, 1938. **Sources:** Falk, *AIC.*

WERNER, Nat *[Sculptor, lecturer] b.1908, NYC / d.1991.*
Addresses: NYC. **Studied:** CCNY (B.A.); Columbia Univ. (M.A.); ASL, with Robert Lourent. **Member:** Sculptors Guild (pres., 1963-65); ; Am. Artists Congress; Guild Hall, Easthampton. **Exhibited:** ACA Gal., 1937-38, 1941-42, 1944, 1952, 1960, 1962-63, 1970s; WMAA, 1936-63; WFNY, 1939 (hon. men.); MoMA, 1940; MMA, 1941; AIC, 1942-43; PAFA Ann., 1942-53; Brussels Int.; 1946; Fairmount Park Int., Phila., 1950; Sculptors Guild Show, 1951 (solo); Johannesburg Int., South Africa; CI; Art USA, New York, 1958-59; Gladstone Gal., Woodstock, NY 1962, 1964-66 (all solo); Selected Artists Gal., NYC, 1965; Vincellette Gal., Bridgeport, CT, 1965; Benson Gal, Bridgehampton, NY, 1975 (solo), 1978 (solo). Awards: New Orleans Sculpture, 1942 (hon. men.); Guild Hall, Easthampton, NY, 1953-54 (first prize). **Work:** WMAA; Lyman Allyn Mus., New London, CT; Mt. Sinai Hospital, Detroit; Tel Aviv Mus., Israel; Howard Univ. Gal., Wash., DC. Commissions: bas-relief, Fowler (IN) Post Office; sculptures, Artus Res., New York, bronze, New York Eng. Soc., wood, James Madison H.S., New

York; New York Engineering Club. **Comments:** Teaching: sculpture instructor, Stuyvesant Adult Center, 1960-. WPA artist. **Sources:** WW73; WW47; *American Scene Painting and Sculpture*, 64 (cites alternate birthdate of 1910); Falk, *Exh. Record Series.*

WERNER, Otto *[Lithographer] b.c.1833, Prussia.*
Addresses: Baltimore in 1860. **Comments:** Living with his wife Dora, a native of Hanover, in 1860. **Sources:** G&W; 8 Census (1860), Md., V, 802.

WERNER, Reinhold *[Engraver and die sinker] mid 19th c.*
Addresses: NYC, 1857-59. **Sources:** G&W; NYBD 1857-59.

WERNER, Saale *[Painter] b.1939.*
Addresses: Houston, TX. **Exhibited:** WMAA, 1973. **Sources:** Falk, *WMAA.*

WERNER, Simon *[Painter] 19th/20th c.*
Addresses: NYC. **Studied:** Académie Julian, Paris, 1893-94. **Sources:** WW10; Fehrer, The Julian Academy.

WERNIGK, Reinhart *[Flower painter] mid 19th c.*
Exhibited: Illinois State Fair, Chicago, 1855 (first prize for flower painting). **Sources:** G&W; *Chicago Daily Press*, Oct. 15, 1855.

WERNTZ, Carl N(ewland) *[Painter, illustrator, teacher] b.1874, Sterling, IL / d.1944, Mexico City.*
Addresses: Chicago, IL. **Studied:** J.H. Vanderpoel; R. Freer; L. Parker; J. Pratt; O. Lowell; A. Mucha; R. Reid; R.Miller, Paris; O. Carlandi, Rome: Japan, with S. Mizuno, K. Kawatika. **Member:** AFA; Western AA; Arts Club, Chicago. **Exhibited:** AIC, 1913-1927; Soc. Indep. Artists, 1918-19; PAFA Ann., 1918. **Comments:** Contributor: covers/illustrations to *Red Book, Life, Century, Harper's, New York Times, Art and Archeology, Asia, Illustrated London News, Japan Travel Bulletin, B. P. Australian Quarterly.* Positions: cartoonist, *Chicago Record;* founder/director/president, Chicago Acad. FA. **Sources:** WW40; Falk, *Exh. Record Series.*

WERRBACH, William H. *[Painter] b.1925, Seattle, WA.*
Addresses: Seattle, WA. **Studied:** ASL. **Member:** Puget Sound Group of Northwest Painters, 1949; ASL; Seattle Art Director's Soc.; Wash. State Arts Comm. **Exhibited:** SAM; Frye Mus.; Northwest WC Soc., 1960. **Sources:** Trip and Cook, *Washington State Art and Artists.*

WERTEMBERGER, Godfrey S. *[Sign and ornamental painter, portrait painter and cycloramist] mid 19th c.*
Addresses: Springfield, OH about 1840; Cincinnati, OH. **Comments:** A portrait painter and cycloramist at Cincinnati. **Sources:** G&W; Knittie, *Early Ohio Taverns*, 44. Hageman, 123.

WERTEN, Maya *[Illustrator] mid 20th c.* **M W**
Sources: Falk, *Dict. of Signatures.*

WERTENBAKER, Charles (Mrs.) *[Painter] mid 20th c.*
Exhibited: Salons of Am., 1933. **Sources:** Marlor, *Salons of Am.*

WERTH, Kurt *[Illustrator] mid 20th c.; b.Leipzig, Germany.*
Addresses: Bronx, NY. **Studied:** State Acad. Graphic Arts, Leipzig, with Walter Tiemann (grad.). **Work:** Mus. Fine Arts, Leipzig Commissions: murals for canteens in many factories in Germany, 1930-34. **Comments:** Preferred media: wood, inks. Publications: illustrator, *Shakespeare: Troillus & Cressida* (1925), *The Merry Miller* (1952), & *One Mitten Lewis* (1955); author/illustrator, *The Monkey, the Lion, & the Snake* (1967) & *Lazy Jack* (1970). **Sources:** WW73.

WERTHEIM, Alma M. *[Painter] mid 20th c.*
Addresses: NYC. **Studied:** ASL. **Exhibited:** Soc. Indep. Artists, 1932-33. **Sources:** Marlor, *Soc. Indp. Artists.*

WERTHEIM, Josephine *[Painter] mid 20th c.*
Exhibited: Salons of Am., 1926. **Sources:** Marlor, *Salons of Am.*

WERTHEIM, Maurice (Mrs.) *[Collector] d.1974.*
Addresses: NYC. **Member:** Art Collectors Club. **Sources:** WW73.

WERTMÜLLER, Adolph Ulrich
[Portrait, miniature, historical, and figure painter] b.1751, Stockholm (Sweden) / d.1811, New Castle County, DE.
Addresses: Philadelphia, 1794-1796 and 1800-04; New Castle, DE, 1804-11. **Studied:** Stockholm, Sweden; with Joseph Marie Vien and at the Acad. Royale, Paris, 1772; Rome. **Exhibited:** Columbianum, 1795; his "Danae" was shown in Phila., 1806-14, and in NYC, 1810. **Work:** National Mus., Stockholm, Sweden; LOC has a copy of his diary; most of his personal papers are in Stockholm. **Comments:** After studying in Paris with Vien, Wertmüller went to Rome (with Vien), remaining there until 1779. He then became first painter to Gustavus III, King of Sweden, and for him painted his most famous work, "Danae" (Natl. Mus. Stockholm). Wertmüller lived in Spain from 1790 to 1794, after which he came to Philadelphia, remaining until 1796. He returned in 1796 to Sweden but settled permanently in America in 1800, living for several years in Philadelphia before moving to a farm in Delaware in 1804. Wertmüller was very involved in the cultural life of Philadelphia and in 1806 created a sensation when he exhibited his erotic "Danae." The work was exhibited for several years, drawing great crowds (men and women) and much comment in the press (in the form of letters and criticism) about the picture's fitness for public viewing. The work was shown in New York in 1810 and Wertmüller made several replicas of it, and also painted similarly sensual nude paintings of Ariadne and Venus. He also painted many portraits, including one of George Washington, in 1794. **Sources:** G&W; Bolton, *Miniature Painters;* Benisovich, "Roslin and Wertmüller"; Benisovich, "The Sale of the Studio of Adolph Ulrich Wertmüller"; Cowdrey, AA & AAU; Rutledge, PA; CAB; Morgan and Fielding, *Life Portraits of Washington*, 203-06; *Portraits in Delaware, 1700-1850*, 119; Flexner, *The Light of Distant Skies.* More recently, see William Gerdts, *The Great American Nude: A History in Art* (New York: Praeger Pub., 1974), pp. 40-40 (he also discusses the interesting history of the Danae's ownership); Gerdts, *Art Across America*, vol. 1: 303, 385 (note 2); Baigell, *Dictionary*

WESCHLER, Anita *[Sculptor, painter, writer, lecturer] b.1903, NYC.*
Addresses: NYC. **Studied:** NY School Fine & Applied Art; Parsons School Design, graduated 1925; NAD with Charles Hinton; PAFA, with Albert Laessle; Columbia Univ.; Barnes Foundation; ASL with Edward McCartan, Robert Laurent and William Zorach. **Member:** Arch. Lg.; Fed. Modern P&S; NAWA (juror); Sculptor's Guild (founding mem., exec. board); Artist-Craftsmen New York (juror); Soc. Indep. Artists; Am. Artists Congress. **Exhibited:** WMAA; MMA; PMA; MoMA; BM; AIC; Soc. Indep. Artists; PAFA Ann., 1934-53 (7 times); PMA; CI; AFA traveling exhib.; SFMA; Weyhe Gal., 1937 (solo), 1940 (solo); Hudson Park Branch, NYPL, 1938 (solo); Robinson Gal., 1940 (solo); Levitt Gal., 1947 (solo); also 25 solo shows nationwide since 1964. **Awards:** Montclair AM, 1935 (medal); Salons of Am.; Soc. Wash. Artists, 1936 (medal); SFMA, 1938 (medal); Friends Am. Art, Grand Rapids, 1943 (prize); prizes, Corcoran Gal. & SFMA; Audubon Artists Medal of Honor. **Work:** WPA work, USPO, Elkin, NC; numerous portraits; WMAA; Norfolk Mus. Arts & Sciences; Mus. Amherst; Alliance Republic Turkey; Mus. Tel-Aviv. Commissions: sculpture, U.S. Treasury Dept. **Comments:** Used her work to express political views. Preferred media: stone, aluminum, plastic, wood, terra-cotta, bronze. Teaching: faculty, Acad. Allied Arts, NYC, 1936. Positions: delegate to U.S. Comt. Int. Assn. Art; delegate to Fine Arts Fed, New York; delegate to Conf. Am. Artists. Publications: author, *Nightshade*, Colony Press; author, *A Sculptor's Summary.* Contributor: *Magazine of Art.* **Sources:** WW73; WW47; Fort, *The Figure in American Sculpture*, 230 (w/repro.); Falk, *Exh. Record Series.*

WESCOTT, Alison Farmer (Mrs. Paul) See: **FARMER, Al(l)ison**

WESCOTT, Harold (George) *[Designer, decorator, painter, block printer, craftsperson, teacher, lecturer] b.1911.*
Addresses: Milwaukee, WI. **Studied:** H. Thomas; R. von Neumann; F.L. Wright; Milwaukee State Teachers College. **Member:** Milwaukee PM; Wisc. Soc. Applied Art. **Exhibited:** Wisc. Salon Art, Madison, 1936 (prize); Wisc. P&S, 1936. **Work:** Milwaukee AI. **Comments:** Position: teacher, Milwaukee State Teachers College. Specialties: furniture & interior design; typographical layouts. **Sources:** WW40.

WESCOTT, P. B. *[Watercolorist] mid 19th c.*
Comments: Memorial painting in watercolors, Greenfield (MA), 1835. **Sources:** G&W; Lipman and Winchester, 182.

WESCOTT, Paul *[Painter, designer, teacher] b.1904, Milwaukee, WI / d.1970, Wilmington, DE.*
Addresses: Pottstown, PA, 1934-52; West Chester, PA, 1953-70; summers in Friendship, ME. **Studied:** AIC, 1925; PAFA, 1927 (Cresson traveling scholarship, 1930). **Member:** ANA, 1968; NA, 1970; PAFA (life); Chester County AA (life, director); Phila. Art All.; AFA; Wilmington Soc. FA; Portland MA (life). **Exhibited:** PMA, 1928-45; PAFA Ann., 1929-66 (Toppan prize, 1930; Lambert Fund prize, 1943); Chester County AA, 1930-45 (prize, 1941); Phila. Sketch Club, 1933-45 (prizes, 1933-35); NAD, 1936-70 (Ranger Fund prize, 1953; Obrig prize, 1954; Palmer prize, 1956, 1965, 1967; Altman prize, 1959; Carnegie Prize, 1969); Phila. Art Club, 1937 (prize); Woodmere Art Gal., 1940-45, 1950; Butler IA, 1941-45 (purchase prize, 1959); MMA, 1942, 1944, 1950, 1952; Phila. Artists Gal.; Phila. A. All.; BMA; Corcoran Gal biennials, 1951, 1957; AIC; Detroit IA; TMA; CAM; Portland MA, 1959 (prize); Art: USA, 1958 (prize); Huston Prize, Miami, 1963; Lehigh Univ., 1965 (solo); Univ. Pennsylvania, 1965 (solo); Farnsworth MA, 1966 (solo); Newman Gal., Phila., 1989 (solo); Brandywine River Mus, 1989 (retrospective, traveled to Farnsworth MA). **Work:** PAFA; NAD; Reading Mus.; Scranton Mus.; Farnsworth MA; Rockland, ME. **Comments:** Best known for his coastal scenes painted from 1946 -on at his 1779 summer home, "Innisfree" on Friendship Island, ME. His wife, Alison Farmer, was also an artist. Position: instructor/director, arts & crafts, The Hill School, Pottstown, PA, 1933-52; freelance, 1952-. **Sources:** WW47 (sometimes his name appears incorrectly as Westcott, as in WW.66 and WW.53); more recently, see Stark Whiteley, *Paul Wescott* (Brandywine River Mus., 1989); Falk, *Exh. Record Series.*

WESCOTT, Sue May See: **GILL, Sue May Wescott (Mrs. Paul)**

WESCOTT, William See: **WESTCOTT, William Carter**

WESLEY, Elaine *[Painter] mid 20th c.*
Addresses: NYC. **Exhibited:** PAFA Ann., 1964. **Sources:** Falk, *Exh. Record Series.*

WESLEY, Gwendolyn (Mrs. Charles) See: **WESSEL, Bessie Hoover (Mrs. Herman)**

WESLEY, John *[Painter] b.1928.*
Addresses: NYC. **Exhibited:** WMAA, 1967, 1969. **Sources:** Falk, *WMAA.*

WESNER, Janet Eldrige *[Painter] mid 20th c.*
Addresses: Chevy Chase, MD. **Exhibited:** Corcoran Gal biennial, 1945. **Sources:** Falk, *Corcoran Gal.*

WESSEL, Bessie Hoover (Mrs. Herman) *[Painter] b.1889, Brookville, IN.*
Addresses: Cincinnati 6, OH. **Studied:** Cincinnati Art Acad. with Frank Duveneck. **Member:** Cincinnati Prof. Artists; Cincinnati Woman's AC. **Exhibited:** CM, 1939, 1944; annually at Cincinnati Prof. Artists, Cincinnati Women's AC (prizes, 1937, 1939, 1940, 1948, 1950) & Hoosier Salon (prizes, 1943, 1945, 1947); Ohio State Fair, 1934, 1935. **Work:** Christian College, Columbia, MO; NAD; Anderson House, Wash., DC; Am. Legion Auxiliary Hdqtrs., Indianapolis, IN. **Comments:** Painted still lifes, miniatures & portraits. Also appears as Gwendolyn Wesley. **Sources:** WW59; WW47.

WESSEL, Henry *[Wood engraver] mid 19th c.*
Addresses: NYC, 1848. **Sources:** G&W; NYBD 1848.

WESSEL, Herman Henry *[Painter, teacher, educator] b.1878, Vincennes, IN.*
Addresses: Cincinnati 6, Ohio. **Studied:** Cincinnati Art Acad. with Frank Duveneck; Académie Julian, Paris with J.P. Laurens, 1906. **Member:** Cincinnati AC; Cincinnati Prof. Artists. **Exhibited:** Soc. Western Artists, 1915 (prize); Corcoran Gal biennial, 1916; PAFA Ann., 1919-20; Atlanta, 1920 (prize); Columbus, 1922 (prize); AIC. **Work:** CM; WPA murals, Scioto County Court House, Fed. Reserve Bank, Holmes Hospital, West Hills H.S., all in Cincinnati; Ohio State Office Bldg., Columbus; USPO, Springfield, OH. **Comments:** Teaching: Cincinnati Art Acad. **Sources:** WW59; WW47; Falk, *Exh. Record Series.*

WESSEL, Sophie *[Painter] mid 20th c.*
Addresses: Chicago area. **Exhibited:** AIC, 1949. **Sources:** Falk, *AIC.*

WESSELHOEFT, Mary Fraser *[Craftsperson, designer, illustrator, painter] b.1873, Boston, MA / d.1971, Santa Barbara, CA.*
Addresses: Cambridge, MA; NY; Santa Barbara, CA (from late 1920s). **Studied:** BMFA Sch., with D. Ross, C. H Woodbury, Boston and Ogunquit; von Habermann, in Munich. **Member:** Calif. WCS; Santa Barbara AA; Copley Soc., 1982; Soc. Indep. Artists; Am. Artists Congress; Salons of Am. **Exhibited:** Boston AC, 1897-99; Berlin, 1912; Soc. Indep. Artists, 1921-24; WMAA, 1922-25; Calif. State Fair; Calif. WCS, Los Angeles. **Work:** stained glass window, Grace Church, Kansas City; rose window, Unitarian Church, Santa Barbara; Nat. Hist. Mus.; Fogg Mus. Art. **Comments:** Designer and craftsman of ecclesiastical stained glass windows. **Sources:** WW40; *Charles Woodbury and His Students.*

WESSELLS, Helen E. *[Painter] mid 20th c.*
Exhibited: WMAA, 1927-28. **Sources:** Falk, *WMAA.*

WESSELMANN, Tom *[Painter, sculptor] b.1931, Cincinnati, OH.*
Addresses: NYC. **Studied:** Hiram College; Univ. Cincinnati (B.A.); cartooning at Cincinnati Art Acad., 1950s; Cooper Union Art School (cert.). **Exhibited:** WMAA biennials, 1965-72; solos: Tanager Gal., 1961, Green Gal., 1962, 1964 & 1965 & Sidney Janis Gal., NYC, 1966, 1968, 1970 & 1972; Mus. Contemp Art, Chicago, 1969; De Cordova Mus., Lincoln, MA, 1969; Sidney Janis Gal., NYC, 1970s. **Work:** Albright-Knox A. Gal., Buffalo, NY; MoMA; WMAA; Suermondt Mus., Aachen, Germany; Atkins MFA, Kansas City, MO. **Comments:** Pop artist. His first important series of paintings, the Great American Nudes (beginning c. 1961), paid homage to the commercialized nude and evolved out of his student interest in cartooning. In the Nudes he often fragmented the female figure, focusing on erotic body parts and filling the canvas with breasts, mouths, or genitalia. **Sources:** WW73; Baigell, *Dictionary*; William Gerdts, *The Great American Nude: A History in Art* (New York: Praeger Pub., 1974), 201; Slim Stealingworth, *Tom Wesselman* (Abbeville, 1981).

WESSELS, Glenn Anthony *[Painter, educator, mural painter, designer, writer] b.1895, Cape Town, South Africa / d.1982, Placerville, CA.*
Addresses: Berkeley, CA; Placerville, CA. **Studied:** Univ. Calif. (A.B., psychology, 1919); Calif. Col. A. & Cr. (B.F.A., 1926); Hans Hofmann Schule der Bildenden Kunst, Munich, 1928-30; Univ. Calif., Berkeley (M.A. in Art, 1932); also with Andre Lhote & Karl Hofer; Acad. Colarossi, Paris. **Member:** San Francisco AI (bd. trustees, 1963-72); San Francisco AA; Friends of Photography, Carmel (bd. trustees, 1968-72); Oakland Mus. (bd. trustees); Calif. WCS. **Exhibited:** Oakland Art Gal., 1935 (hon. men.); San Francisco AA, 1935-46, 1950-56 (first prize),1957-68; SAM, 1944 (hon. men.); Santa Barbara MA, 1946 (solo), 1955 (solo); Richmond AC, 1956 (hon. men.); Oakland Art Festival, 1956 (prize); St. Mary's Col., 1956 (solo); Rotunda Gal., San Francisco, 1956 (solo); de Young Mus., 1959 (solo); Gump's, San Francisco, 1959 (solo); San Jose State Col., 1961 (solo); Berkeley

Pub. Lib., 1961 (solo); Univ. Nevada, 1963 (solo); Oakland Art Mus. Exhibs., 1950-57 (purchase prize), 1958-68; Chrysler Mus., Provincetown; Univ. Illinois. Other awards: grant, 1965 & citation, 1971, Univ. Calif., Berkeley; first award for painting, San Francisco Mus. Ann., San Francisco AA, 1955. **Work:** SFMA; Oakland AM; Univ. Calif., Berkeley AM; Mus. Art, Washington State Univ., Pullman; Oakland Civic Auditorium (mural); Laguna Honda Home for the Aged, San Francisco (murals). **Comments:** Came to the U.S. in 1902. Preferred media: oils, acrylics. Became Hans Hofmann's assistant and interpreter in the U.S. in 1930. Positions: California Commissioner of Fine Arts; art critic, *San Francisco Fortnightly,* 1931-33; art editor, *San Francisco Argonaut,* 1934-40; supervisor, WPA, 1935-39; regional gen. chmn., Nat. Art Week, 1941. Teaching: professor, compos. materials art, Calif. Col. Arts & Crafts, 1931-42; Mills Col., Oakland, CA, 1932; Wash. State Col., 1940-46; professor, drawing, painting & art philosophy, Univ. Calif., Berkeley, 1946-63, emeritus professor, 1963-67. **Sources:** WW73; WW47; exh. cat., Annex Gal. (Santa Rosa, CA, n.d., c.1988); add'l. info courtesy Martin-Zambito Fine Art, Seattle, WA.

WESSENBERG, Jule *[Painter] mid 20th c.*
Addresses: Los Angeles, CA. **Exhibited:** Oakland Art Gallery, 1939. **Sources:** Hughes, *Artists inCalifornia,* 598.

WESSER, Ethelyn H. *[Painter] early 20th c.*
Addresses: Brooklyn, NY. **Sources:** WW21.

WESSON, Grace Edwards *[Painter, illustrator] early 20th c.*
Addresses: Orange, NJ. **Sources:** WW24; Petteys, *Dictionary of Women Artists,* suggests this may be the same as Grace D. Edwards of Montclair, NJ (see entry).

WEST, Alta See: **SALISBURY, A(lta) West (Mrs. William)**

WEST, Anne Warner *[Painter] mid 20th c.*
Addresses: Centerville, MD. **Exhibited:** Corcoran Gal biennial, 1947; PAFA Ann., 1949. **Sources:** Falk, *Exh. Record Series.*

WEST, Benjamin *[Historical, portrait, religious, genre, and landscape painter] b.1738, Springfield, PA / d.1820, London, England.*

Addresses: Philadelphia area, until 1760; Italy, 1760-63; London, England from 1763. **Studied:** William Williams (who also lent West books on art and art theory), c.1750-52; Italy, 1760-63, with stops at Rome, Florence, Bologna, and Venice. **Member:** Royal Academy (charter mem.; succeeded Sir Joshua Reynolds as pres. in 1792, serving, with one year's interruption, until 1820). **Exhibited:** Royal Academy, London; PAFA Ann., 1811-19 (and posthumously); AIC; Brooklyn AA, 1872. **Work:** PAFA; PMA; Yale Univ.; MMA; NGA, London; NGA, Wash., DC; NPG, Wash., DC; Royal Collection, London; Nat. Gallery Canada, Ottawa; BMFA (large collection of his drawings); Wadsworth Athenaeum, Hartford, CT; Herron Institute, Indianapolis; Smith College, Northampton, MA; Kensington Palace, London. **Comments:** One of the earliest American-born painters to study abroad, he was an influential expatriate painter and teacher to American artists. West's birth house is located on what is now the grounds of Swarthmore (PA) College. West's talent was recognized early, and between 1752, the date of his earliest painting, and 1760, when he left for Italy, he painted nineteen portraits in the Philadelphia area and in Lancaster, and one in New York (1759). His American work shows the influence of his teacher Williams, as well as John Valentine Haidt and especially John Wollaston [note: West's American portraits can be found at the Hist. Soc. of Penn. and PAFA]. He went to Italy in 1760 and while there became part of the circle of Neoclassicists which included Anton Raphael Mengs and Gavin Hamilton. After settling permanently in London in 1763, he established a studio and within a short time had moved to the front rank of British artists, receiving the attention and patronage of English nobility and royalty. Among the first of his neoclassical historical paintings was "Agrippina with the Ashes of Germanicus" (Yale Univ. Art Gal.), painted in 1768 for the Archbishop of York. His "Death of General Wolf" of 1770 (there are two versions, one at Royal Collection, London and National Gallery of Canada, Ottawa) was considered revolutionary and a landmark in history painting because of his decision to dress the figures, not in the classical garb of tradition, but in modern, and thus authentic, costume. In 1772 he was appointed historical painter to King George III. West's subject matter was of the widest variety: portraiture, mythology, the Bible, ancient and modern history, landscape, and genre, reflecting the aesthetic ideas of Gavin Hamilton, Shaftesbury, Burke, and Payne Knight and the demands of his patrons: King George III, Sir George Beaumont, Archbishop Drummond, Alderman Beckford, Lord Elgin and others. Included among his important works are "Penn's Treaty with the Indians" (PAFA) and "Saul and the Witch of Endor" (Wadsworth Athenaeum). His late works, such as "Death on a Pale Horse" of 1787 (there are several versions, the most well known is at PAFA; sketch at PMA), grew increasingly grand and dramatic in subject and style, linking him with the Romantic movement. Besides his painting, West's significance lies in his role as a teacher and symbol to young American artists. His London studio was an important training ground for art theory and technique, attracting numerous young Americans, including Gilbert Stuart, John Trumbull, Charles Willson Peale, Rembrandt Peale, Thomas Sully, and Samuel F.B. Morse. **Sources:** G&W; Farington, *The Farington Diary,* 8 vols. (London, 1922-28); Flexner, *America's Old Masters;* Flexner, *The Light of Distant Skies;* Galt, *Life, Studies and Works of Benjamin West,* 2 vols. (London, 1820), based on West's own account; Moses, *The Gallery of Pictures Painted by Benjamin West* (London, 1811); Phila. Museum of Art, *Catalogue of Benjamin West Exhibition* (Phila., 1938); Robins, *A Catalogue Raisonné of Historical Pictures by Benjamin West to be sold at Auction* (London, 1829); Waterhouse, *Painting in Britain 1530-1790* (London, 1953); von Erffa, "West's Washing of Sheep," *Art Quarterly,* XV (1952), 160-65; Flexner, "Benjamin West's American Neo-Classicism," NYHS *Quarterly,* XXXVI (1952), 5-41; Mitchell, "Benjamin West's Death of General Wolfe," *Journal of Warburg and Courtauld Institutes,* VII (1944), 20-33; Sawitzky, "The American Work of Benjamin West," *Penn. Magazine of History and Biography,* vol. 62, no. 4 (Oct. 1938): 433-62. More recently, see Baigell, *Dictionary;* Helmut von Erffa and Allen Staley, *The Paintings of Benjamin West* (New Haven, CT, and London, 1986); Ann Uhry Abrams, *The Valiant Hero: Benjamin West and Grand-Style History Painting* (Wash., DC: Smithsonian Inst. Press, 1985); Dorinda Evans, *Benjamin West and His American Students* (Wash., DC: National Portrait Gallery, 1980).

WEST, Benjamin Franklin *[Marine and ship painter] b.1818, Salem, MA / d.1854, Salem, MA.*
Work: Essex Institute (copy of Hogarth's "Columbus and the Egg"); Peabody Museum (whaling scene). **Sources:** G&W; Belknap, *Artists and Craftsmen of Essex County,* 14; letter from the Marine Society of Salem to FARL, Jan. 27, 1940; Robinson and Dow, *Sailing Ships of New England,* I, 64; *American Processional,* 126; *Antiques* (Oct. 1922), 162.

WEST, Bernice (Mrs. Robert A. Beyers) *[Sculptor, lecturer] b.1906, NYC / d.1986.*
Addresses: Bronxville, NY; Dallas, TX. **Studied:** Alexander Archipenko, Edmond Amateis, Lu Duble, William Zorach, Winold Reiss. **Member:** NAWA; Pen & Brush Club; CAFA; Southern Vermont Artists; SSAL; Studio Guild; Art Lg., Mt. Dora, FL. **Exhibited:** Soc. Indep. Artists, 1927, 1929; NAD, 1941; CAFA, 1941-43 (prize), 1944-52; Mint MA, 1940-41, 1945-46; Southern Vermont Artists, 1926-58; NAWA, 1932 (medal); SSAL, 1938-40 (prize), 1941; Westport Art Market, 1932-35; City Gardens Club, NY, 1932 (medal); Mt. Dora (FL) Art Lg., 1935-40; Fed. Artists 1955 (prize); DMFA, 1958; Salons of Am.; Contemporary Artists, 1931 (solo); Midtown Gal., 1932 (solo); Ferargil Gal., 1933. **Work:** monument, Silver Springs (FL); Mead Botanical Gardens,

Winter Park (FL); Wadsworth Atheneum; Mint. MA; High Point (NC) Mus.; Swarthmore College; mural, Charlotte (NC) Little Theatre; Manning House, Dallas; garden sculpture, Rockefeller Center, NYC; bronze plaque, Venice, Nokomis Bank (FL). **Comments:** Also appears as Bernice Gratz (Mrs. C.M. Gratz). **Sources:** WW59; WW47.

WEST, Bruce F. *[Sculptor] mid 20th c.*
Addresses: Philadelphia, PA?. **Exhibited:** PAFA Ann., 1968. **Sources:** Falk, *Exh. Record Series.*

WEST, Charles Massey, Jr. *[Painter, teacher, sculptor] b.1907, Centreville, MD.*
Addresses: Centreville, MD. **Studied:** PAFA, 1934 (Cresson traveling scholarship, 1934); Univ. Iowa; John Herron AI (B.F.A.). **Member:** Wilmington Soc. FA. **Exhibited:** Corcoran Gal biennials, 1941-47 (3 times); PAFA Ann., 1941, 1948; AIC, 1942; BMA, 1941; Delaware A., 1939-1946; CM, 1942; Indiana AA, 1940-41 (prizes); Hoosier Salon, 1942 (prize); Delaware Artists, 1942-43 (prizes). **Comments:** Teaching: John Herron AI, Indianapolis, 1939-43. **Sources:** WW53; WW47; Falk, *Exh. Record Series.*

WEST, Charles S. *[Painter] mid 20th c.*
Addresses: Rochester, NY. **Exhibited:** Salons of Am., 1931, 1933; Soc. Indep. Artists, 1931. **Sources:** Falk, *Exhibition Record Series.*

WEST, Clifford Bateman *[Painter, film maker, teacher, lecturer] b.1916, Cleveland, OH.*
Addresses: Bloomfield Hills, MI. **Studied:** Cleveland School Art; Adams State Teachers Col., Alamosa, CO (B.A.); Colorado Springs FAC; Cranbrook Acad. Art (M.A.); also with Boardman Robinson, Arnold Blanch. **Exhibited:** AIC, 1937, 1939, 1943-45; MMA (AV), 1942; Detroit AI, 1937-38, 1940-45; CMA, 1934, 1937; Butler AI, 1938, 1943, 1946; Denver AM, 1937, 1939, 1943, 1946; Milwaukee AI, 1946; Int. Watercolor, Exhib, Chicago, 1940; PAFA Ann., 1948-49; NAD, 1948; Premier of Eduard Munch Films, Guggenheim Mus., New York, 1968; Premier of Nesch Films, Detroit MA, 1972. **Awards:** Prix de Rome, Alumni prize, 1939; cine golden eagle award for film Harry Bertoia's Sculpture, 1969; gold medal Michigan Acad. Arts, Sciences & Literature, 1969; Flint AI (prize). **Work:** Massillon MA; Iowa State Teachers's College; Cranbrook MA. Commissions: murals, Rackham Mem. Bldg., Detroit, Casa Contenta Hotel, Guatemala, Vet. Mem. Bldg., Detroit, Colorado State Hist. Soc., Denver, Alamosa Nat. Bank, CO & City Bank, Detroit. **Comments:** Preferred medium: oil. Positions: co-founder/president, Ossabow Island Project, 1961-. Teaching: head dept. art, Kingswood School, 1940-54; instructor, drawing anatomy, Cranbrook Acad. Art, 1940-54. **Sources:** WW73; WW47; Falk, *Exh. Record Series.*

WEST, Corrine Michael See: **WEST, Michael**

WEST, Dick See: **WEST, Walter Richard ("Dick") (Wapah Nayah)**

WEST, Fannie A. *[Painter, teacher] b.1846, Vermont / d.1925, Phila.*
Addresses: Reading, PA. **Studied:** drawing and painting at Goddart's Seminary in Vermont; studies in Boston. **Comments:** In 1890, West opened a studio in Reading, PA, where she offered lessons in landscape and still life painting. **Sources:** Malmberg, *Artists of Berks County,* 41.

WEST, Frederick H. *[Engraver] b.1825, Germany.*
Addresses: Wash., DC, active 1860-c.1901. **Comments:** His wife was from Pennsylvania and their son Frederick (born c.1859) was born in Maryland. **Sources:** G&W; 8 Census (1860), D.C., I, 867. More recently, see, McMahan, *Artists of Washington, DC.*

WEST, G. *[Listed as "artist"] mid 19th c.*
Comments: One of the artists of Thomas Sinclair's lithographs illustrating *The North American Sylva,* 1846. **Sources:** G&W; McClinton, "American Flower Lithographs," 362.

WEST, George R. *[Topographical artist, panoramist, painter of oriental scenes] d.1860, New Zealand.*
Addresses: Wash., DC, active 1856-60. **Member:** Washington AA (founding mem.). **Exhibited:** Washington AA, 1857 (oriental scenes). **Comments:** Traveled to China with Caleb Cushing (American Minister to China) in the late 1840s. His sketches from that trip were used by William Heine (Commodore Perry's official artist on the Japan expedition), Joseph Kyle, and Jacob Dallas in the creation of a panorama, "China and Japan Illustrated," which was shown at Academy Hall, NYC, in 1856. West was to decorate several of the Committee rooms in the House and Senate wings of the Capitol building, but resigned and destroyed the work he had already completed after a dispute over the scenes. Appointed commissioner of New Zealand, he died shortly after his arrival. **Sources:** G&W; N.Y. *Herald,* Jan. 27, 1856 (courtesy J. Earl Arrington); Washington Art Association Cat., 1857. More recently, see, McMahan, *Artists of Washington, D.C.;* Brewington, 409; Gerdts, *American Artists in Japan,* 4.

WEST, George William *[Portrait and miniature painter] b.1770, St. Andrew's Parish, MD / d.1795.*
Studied: Benjamin West (not a relative) in London, 1788-90. **Comments:** His father, the Rev. William West was then rector of that parish, but in 1779 he became rector of St. Paul's in Baltimore. The son began painting portraits before he was fifteen. Having contracted tuberculosis in London, young West returned to his Baltimore home early in 1790. During the next few years he continued to paint portraits but his career was cut short in his twenty-sixth year. **Sources:** G&W; Pleasants, "George William West--A Baltimore Student of Benjamin West," with checklist and 14 repros.; Pleasants, *250 Years of Painting in Maryland,* 37; Prime, II, 38; represented at MHS.

WEST, Gladys M. G. *[Painter, teacher] b.1897, Phila., PA.*
Addresses: Phila. **Studied:** PAFA, with Breckenridge, Hale, Merriman, Pearson, Vonnoh. **Member:** Phila. Alliance. **Exhibited:** Soc. Indep. Artists, 1926. **Work:** St. Michael and All Angels, Phila.; Church of the Nativity, Phila.; Oak Lane Review Club, Phila. **Sources:** WW40.

WEST, Harold Edward *[Painter, illustrator, craftsperson, designer, graphic artist, block printer] b.1902, Honey Grove, TX.*
Addresses: Living in Santa Fe, NM in 1962. **Exhibited:** Mus. New Mexico, Santa Fe; Fiesta Show, 1958; WFNY, 1939; AIC. Award: Southwest Annual, 1957. **Comments:** Illustrator: *Broadside to the Sun,* 1946. Author/illustrator: *Cowboy Calendar,* 1946 (hand-blocked prints). **Sources:** WW59.

WEST, Hebilly *[Sculptor] mid 20th c.*
Addresses: Chicago area. **Exhibited:** AIC, 1935-37. **Sources:** Falk, *AIC.*

WEST, Helen *[Landscape painter] b.1926, Melbourne, Australia.*
Addresses: Living in Cody, WY in 1975. **Studied:** Montana State College; Minneapolis AI; AIC. **Comments:** Moved back to the U.S. when she was four years old; she lived in the East and spent summers in Wyoming. Teacher, Sunlight, WY. **Sources:** WW15; P&H Samuels, 520.

WEST, Isabelle Percy (Mrs.) See: **PERCY, Isabelle Clark (Mrs. George Parsons West)**

WEST, James *[Painter] mid 20th c.*
Addresses: San Rafael, CA, 1920s, 1930s. **Exhibited:** Oakland A. Gal., 1928. **Sources:** Hughes, *Artists in California,* 598.

WEST, James G. *[Painter] mid 20th c.*
Addresses: Cleveland, OH. **Member:** Cleveland SA. **Exhibited:** PAFA Ann., 1933. **Sources:** WW27; Falk, *Exh. Record Series.*

WEST, Jean Dayton (Mrs. Leonard A.) *[Portrait painter, educator, drawing specialist, teacher] b.c.1895, Salt Lake City, UT.*
Addresses: Des Moines, IA; Langley Field, VA. **Studied:** State Univ. Iowa (B.A., M.A.); NAD with Charles Hawthorne; C.A.

Cumming. **Member:** Iowa Artists Guild; American Women, 1938-39. **Exhibited:** Iowa Artists Exhibit, Mt. Vernon, 1938; Women's Club, 1938; Chicago Women's Club; solo shows, Iowa City, and Younkers, Des Moines; Joslyn Memorial, Omaha, NE; **Awards:** Iowa State Fair, 1918 (gold medal), 1920 (gold medal); Des Moines Woman's Club, 1931(gold), 1934 (medal), 1935 (medal). **Work:** Owen Collection, Des Moines; St. John's General Public Hospital, St. John, NB, Canada; Lamoni (IA) College. **Comments:** Specialized in children's portraits. Provided illustrations for *Sign Posts to Music,* by Alvaretta West and frontispiece in *Good Morning, Doctor,* by W.A. Rohlf, M.D. **Sources:** WW53; WW47; Ness & Orwig, *Iowa Artists of the First Hundred Years,* 218.

WEST, John B. *[Miniaturist] early 19th c.*
Addresses: Lexington, KY. **Exhibited:** PAFA, 1814. **Sources:** G&W; Rutledge, PA.

WEST, Joy Griffin *[Artist] d.1951.*
Member: Woodstock AA. **Sources:** Woodstock AA.

WEST, Levon *[Etcher, painter, photographer, writer, teacher] b.1900, Centerville, SC / d.1968, NYC.*
Addresses: NYC/Mayville, ND. **Studied:** J. Pennell, 1925-26; Univ. Minnesota, 1920-24; ASL, 1925. **Member:** SAE; AIGA; Print Collectors Club. **Exhibited:** Philadelphia, 1928 (prize); Salons of Am.; AIC, 1937. **Work:** PMA; NYPL; BM; Hispanic Mus, NYC; Havemeyer Collection, MMA; BMFA; LOC; Univ. Minnesota Art Gal.; Inst. Geographical Expo, Harvard; Honolulu Acad. Art; "Prints of the Year," 1931, 1933-34. **Comments:** Illustrator: "Vivid Spain," 1926; "Bald-Headed Aft," 1928; "Masters of Etching," No. 24, 1930; "Catalogue of the Etchings of Levon West," 1930, "Making an Etching," "How-to-Do-it," 1932. He visited Spain in 1926 and made 32 etchings there. He was the official artist of the World Press Congress in Geneva. In 1932 he was the guest artist for the State of Colorado and in 1935 he visited Bermuda. Represented by: Kennedy Gal., NYC. As a photographer, he used the name "Ivan Dmitri;" contributing photos to *The Saturday Evening Post, Rodeo, Dude Ranching,* etc. **Sources:** WW40; P&H Samuels, 520-21.

WEST, Libbie *[Listed as "artist"] mid 19th c.*
Exhibited: Mechanics' Inst., San Francisco, 1871. **Sources:** Hughes, *Artists in California,* 598.

WEST, Louise *[Painter, teacher] mid 20th c.; b.Baltimore.*
Addresses: Baltimore, MD/Gloucester, MA. **Studied:** H. Snell; F. Brangwyn. **Sources:** WW25.

WEST, Lowren *[Painter, illustrator, graphic designer] b.1923, NYC.*
Addresses: NYC; living in Phoenix, AZ in 1976. **Studied:** Pratt Inst. Art School; Hans Hofmann School Fine Arts; Columbia Univ.; ASL; The New School. **Exhibited:** NAC, 1960 & 1962; MoMA, 1960; Riverside Mus., 1964; Art in America Exhib., 1967-69; Monogram Art Gal., New York, 1967; Stable Gal., Scottsdale, AZ, 1970s. **Awards:** NAC, 1962. **Work:** commissions: graphic designs for General Electric, Westinghouse & *Life Magazine.* **Comments:** Preferred media: mixed media and collage. Publications: contributed illustrations for *New Yorker Magazine, Fortune Magazine & Graphis.* **Sources:** WW73; P&H Samuels, 521.

WEST, Margaret W. *[Painter] b.1872, Peoria, IL.*
Addresses: Chicago, IL. **Studied:** Académie Julian, Paris. **Exhibited:** PAFA Ann., 1896-97; AIC, 1897-99. **Sources:** WW01; Falk, *Exh. Record Series.*

WEST, Maud S. (Mrs.) *[Painter] mid 20th c.*
Addresses: Houston, TX. **Member:** Southwest Artists, Houston; SSAL; Texas FAA. **Exhibited:** Artists S.E. Texas, 1938; Houston Artists Ann., 1939; Houston MFA. **Sources:** WW40.

WEST, Michael *[Painter, poet] b.1908, Chicago, IL / d.1991, NYC.*
Addresses: NYC, 1939-91/second residences in Stonington, CT, 1950s & Montclair, NJ, weekends. **Studied:** Cincinnati Conservatory Music, 1920s; Cincinnati Art Acad., 1927-30, with Kate Reno Miller, Herman Wessel, John Weis, Frank Meyers; ASL, 1931-34, with Hans Hofmann, Raphael Soyer; A. Gorky, 1932-46 (mentor); R. Pousette-Dart, 1946-48. **Exhibited:** Rochester AC, 1935 (solo); Rochester Mem. Gal., 1935, 1939, 1941, 1943; Pinacotheca Gal., NYC, 1945; Rose Fried Gal., NYC, 1948; Stable Gal., NYC, 1953; Uptown Gal., NYC, 1957 (solo); Dominoe Gal., NYC, 1957 (solo), 1964; Lincoln Center, NYC, 1975; Pollock-Krasner House, East Hampton, LI, 1996 (solo). **Work:** Pollock-Krasner House, East Hampton, LI; WMAA. **Comments:** Was part of the New York School of Abstract Expressionists and a close associate of Gorky. Her work of the 1940s and 1950s used form as a way of expressing energy. Her full name was Corrine Michael West; she was known as Corinne West through 1935; Mikael West, 1936-40; and Michael West from 1941 until her death. During the 1950s, she was sometimes known as Michelle Lee. **Sources:** info, including clippings, courtesy Stuart Friedman, Granite Springs, NY.

WEST, Mikael See: **WEST, Michael**

WEST, Mildred *[Painter] mid 20th c.*
Exhibited: Soc. Indep. Artists, 1940. **Sources:** Marlor, *Soc. Indp. Artists.*

WEST, (Mrs.) *[Portrait painter] early 19th c.*
Addresses: Attleborough, MA, c.1820. **Sources:** G&W; Fielding.

WEST, Pennerton *[Painter, craftsperson, sculptor, etcher] b.1913, NYC.*
Addresses: New York 11, NY; Mohegan Lake, NY. **Studied:** ASL; CUA Sch.; Hans Hoffmann Sch. FA, and with William Hayter. **Member:** Silvermine Gld. Artists; AEA. **Exhibited:** PAFA Ann., 1938; U.S. State Dept. traveling exhib., Europe, 1953; BM, 1950; AFA traveling exhib., 1951, 1960; Mus. Mod. Art, Paris, 1951; Atelier 17 group exhibs., 1951; Kootz Gal., 1950; Stable Gal., 1955; East Hampton Gal., NYC, 1963; de-Nagy Gal., NYC, 1953 (solo); Condon Riley Gal., NYC, 1958; Lucien Gal., 1960; New Gal., Provincetown, 1962. **Work:** MoMA; NYPL. **Sources:** WW66; Falk, *Exh. Record Series.*

WEST, Peter B. *[Landscape painter, painting restorer] b.1837, Bedford, England / d.1913, Albion, NY.*
Addresses: New Orleans, LA, 1863; Cleveland, OH, 1878; Albion, NY. **Studied:** Bedford, England; Lees Sch. of Arts, London; with his father Robert West, England. **Exhibited:** Phila. Centenn., 1875 (prize); Columbian Expo, Chicago, 1893 (prize). **Comments:** Came to U.S. in 1863 and worked as a picture restorer in New Orleans and other cities before turning his attention of horse painting (while working in Cleveland). Later painted landscapes. **Sources:** Clement and Hutton; Benezit.

WEST, R. C. *[Engraver] mid 19th c.*
Comments: Engraver of two illustrations in *Benjamin Franklin: His Autobiography* (New York, 1849). **Sources:** G&W; Hamilton, *Early American Book Illustrators and Wood Engravers,* 172.

WEST, Raphael Lamarr *[Painter and lithographer] b.1769, London, England / d.1850, England.*
Addresses: New York, 1800-02. **Studied:** studied with his father. **Comments:** The elder son of Benjamin West (see entry), Raphael was born in London in 1769. He was an intimate friend of William Dunlap (see entry) while the latter was studying in London. He was well known for his painting of Orlando rescuing his brother from the lioness in *As You Like It* published in Boydell's *Shakespeare Gallery* and for his skill in drawing trees and figures. He came to America in 1800, intending to settle in Western New York, but returned to England two years later. In his later years he did some lithographic work. **Sources:** G&W; Dunlap, *History;* Thieme-Becker.

WEST, Russell W. *[Painter] b.1910, Haverhill, MA.*
Addresses: Boston, MA. **Studied:** E.L. Major; Massachusetts Sch. Art; NY Sch. Fine & Applied Art, Paris. **Exhibited:** AIC, 1935. **Sources:** WW40.

WEST, S. *[Painter(s)] early 20th c.; b.Berks County, PA.*
Addresses: Berks County, PA. **Comments:** There are several paintings from the Berks County area that bear the signature, S. West. It is thought that these paintings are the work of more than one painter. These paintings are attributed to Arthur B. Shearer, his brother, Victor Shearer, and their cousin, George C. Rohrbach. Several of the known examples are dated between 1900-16. **Sources:** Malmberg, *Artists of Berks County*, 40.

WEST, Samuel S. *[Portrait painter] mid 19th c.*
Addresses: Philadelphia. **Exhibited:** PAFA, 1818, 1829-30. **Sources:** G&W; Rutledge, PA.

WEST, Sarah Jesse *[Painter, teacher] 19th/20th c.; b.Toledo, OH.*
Addresses: Lake Erie, OH. **Studied:** ASL; Delecluse Acad., Paris. **Exhibited:** SNBA, 1895. **Work:** TMA. **Comments:** Position: instructor, TMA, summer school at Put-in-Bay Island, Lake Erie, c.1900-19. **Sources:** WW19; Fink, *American Art at the Nineteenth-Century Paris Salons*, 405.

WEST, Sophie (Mrs.) *[Landscape painter] b.1825, Paris, France / d.1914, Pittsburgh, PA.*
Comments: Came to U.S. in 1845 at the age of twenty; died at the home of a son in Pittsburgh (PA). *Cf.* Mrs. Sophie Anderson. **Sources:** G&W; *Art Annual*, XI, obit.

WEST, Theoris *[Painter, graphic artist] mid 20th c.*
Exhibited: Smith-Mason Gallery, 1971; Lee Cultural Center, Phila. **Sources:** Cederholm, *Afro-American Artists*.

WEST, Virgil Willam *[Painter] b.1893, Benkelman, NE / d.1955, Sonora, CA.*
Addresses: Sonora, CA. **Studied:** Calif. School of FA. **Work:** Sonora Inn; Tuolumne County Mus. **Comments:** Specialty: cowboy and Wild West genre. **Sources:** Hughes, *Artists in California*, 598.

WEST, W. R. *[Listed as "artist"] mid 19th c.*
Addresses: Philadelphia. **Exhibited:** Artists' Fund Society, 1841 (landscape after Thomas Doughty). **Comments:** This might be the William West, artist, of the 1841 directory or the William R. West, carpenter, of the 1840 and 1843 directories. **Sources:** G&W; Rutledge, PA; Phila. CD 1840-43.

WEST, W. Richard See: **WEST, Walter Richard ("Dick") (Wapah Nayah)**

WEST, Walter Richard ("Dick") (Wapah Nayah)
[Painter, craftsperson, teacher, lecturer] b.1912, Darlington, OK.
Addresses: Phoenix, AZ, 1947; living in Lawrence, KS, in 1976. **Studied:** Haskell Col., 1935; Bacone Col., Muskogee, OK, 1938; Univ. Oklahoma (B.A. 1941; M.F.A.); Univ. Redlands, CA; Olaf Nordmark in 1941-42. **Exhibited:** Kansas City, 1937 (prize); Tulsa, 1938; Dept. Interior, Wash., DC, 1940; Chappell Art Gal., 1941; Am. Indian Art Exh., Philbrook AC, 1946, 1958 (prize), 1960 (first place for sculpture); Esquire Theater A. Gal., Chicago, 1956; Bacone Col., OK, 1967; Civic Center, Muskogee, OK, 1969; Kansas City Mus. Hist. & Science, MO, 1971. **Awards:** citation of Indian arts & crafts, 1960; Waite Philips Award, 1964. **Work:** W.R. Nelson Gal.; U.S. Dept. Interior, Wash., DC; Chappell Art Gal., Pasadena, CA; Phoenix Indian H.S.; Joslyn AM; Mus. Am. Indian; Smithsonian Inst.; Joslyn Mem. Art Mus., Omaha, NE; Philbrook Art Center, Tulsa, OK; Gilcrease Inst., Tulsa; Bacone Col., OK. Commissions: mural, Okemah (OK) P.O., 1941; bas-relief panels, Univ. Redlands, CA, 1960s; Crucifixion (sculpture), North Am. Indian Center, Chicago, IL, 1960s. **Comments:** Cheyenne painter. Indian name was Wapah Nayah or Lightfooted Runner; also known as Dick West. Painted in traditional Indian-school style as well as in contemporary art styles. Illustr.: book jacket, *The Cheyenne Way*, 1941. Teaching: Phoenix Indian Sch., 1941-46; Bacone Col., 1947-70; Haskell

Indian Jr. Col., 1970-. Research: Indian art. Art interests: religious paintings & woodcarvings. Work published beginning in 1941: *National Geographic,* 1955; *Life International,* 1959; *Today,* 1963; *Saturday Review,* 1963. **Sources:** WW73; WW47; Ed. Shaw, "Another Face of Jesus" (filmstrip of life & works), produced by Am. Baptist Films, 1969; Charles Waugaman, *Cheyenne Artist* (Friendship Press, 1970); Dorothy Elliot, *Dick West, Artist* (Kansas, 1971); P&H Samuels, 510, 521.

WEST, Wilbur Warne *[Educator] b.1912, Indiana.*
Addresses: Mount Vernon, IA. **Studied:** Ohio State Univ. (B.S.), with Arthur Baggs, Edgar Littlefield; Columbia Univ. (M.A.); Woodstock, NY. **Member:** NAEA; Western AA; Northern Indiana Artists; AAUP; CAA. **Exhibited:** Nat. Ceramics Exh.; Butler IA; Midland Gal.; South Bend; Hoosier Salon; Northern Indiana Artists; Columbus Art Lg.; Indiana State Fair; Akron AI; Kent Univ.; Des Moines AC; Cornell College Art Gal. **Awards:** Midland Gal., 1935; scholarship, AIA, 1946. **Comments:** Positions: head of art dept./gallery director, Cornell College, Mount Vernon, IA; coordinator of Foreign Study Programs. Lectures: Art & Architecture of Europe; Design Today. **Sources:** WW66.

WEST, William *[Portrait and landscape painter] mid 19th c.*
Addresses: Philadelphia. **Exhibited:** PAFA, 1827, 1829 (portraits & watercolor landscapes including views of Durham Cathedral, Sterling Castle, & a Welsh scene). **Comments:** His address was given as 32 North 4th Street when he exhibited at PAFA. The directory for 1823 lists William and John West, painters and glaziers, at 30 North 4th and that for 1825 lists William alone at the same address. From 1829-33 William was listed at 1 Loxley Court. There was a William West, artist, listed in 1841 and the same year a W.R. West of Philadelphia exhibited at the Artists' Fund Society a landscape after Thomas Doughty. **Sources:** G&W; Rutledge, PA [included in the entry for William Edward West, who was in London from 1825 to 1838]; Phila. CD 1820-33.

WEST, William *[Painter] b.1922, Pittsburgh, PA.*
Addresses: Williamsville, NY. **Studied:** Art Inst., Buffalo, 1948-55 with Charles Burchfield, Robert Blair, David Pratt, James Vullo, Catherine Catanzaro Koenig; Empire State College, Buffalo (B.A., 1977-80). **Comments:** Came to Buffalo in 1927. Positions: board of director, Art Inst., Buffalo, 1950-55. **Sources:** Krane, *The Wayward Muse*, 197.

WEST, William Edward
[Portrait and figure painter]
b.1788, Lexington, KY / d.1857, Nashville, TN.
Addresses: Itinerant in Phila. and South through 1819; Europe; Baltimore, 1838; NYC, 1841-55; Nashville, TN. **Studied:** Phila. with Thomas Sully, 1807; Academia delle Bella Arte, Florence, Italy, c.1819-24. **Member:** NA, 1832. **Exhibited:** Royal Academy, London, 1826-33; London, 1834-37. **Work:** Univ. Kentucky Art Mus., Lexington; Shelburne (VT) Mus.; Tulane Univ., New Orleans. **Comments:** Began his career as an itinerant miniature painter, traveling to Natchez, MS, and New Orleans as early as 1802. It is believed he remained around Philadelphia from c.1807 until c.1816, when he went to New Orleans and then to Natchez, MS, returning to both places c.1818 and also painting portraits in Cincinnati, OH, and Nashville, TN, through the summer of 1819. Traveling to Italy in the fall of 1819, he remained for about four years, during which time he painted his well-known portraits of Byron, the Countess Guiccioli, Shelley, and Trelawney. In 1824 he went to Paris where he became friendly with Washington Irving. By this time he had begun to create allegorical and religious subjects in addition to portraits. From 1825-38 he had a studio in London. Having lost his money in an unfortunate investment, West returned to America and opened a studio in Baltimore, and then one in NYC. His last years were spent in Nashville (TN). **Sources:** G&W; DAB; Dunn, "Unknown Pictures of Shelley"; Dunn, "An Artist of the Past"; Richardson, "E.J. Trelawney by William Edward West"; Rutledge, PA; Brown

and Brown; Graves, *Dictionary;* Cowdrey, NAD; Cowdrey, AA & AAU; Swan, BA; NYCD 1840-52; *Album of American Battle Art.*; *Encyclopaedia of New Orleans Artists,* 409; Jones and Weber, *The Kentucky Painter from the Frontier Era to the Great War,* 70-71 (w/repros.); Muller, *Paintings and Drawings at the Shelburne Museum,* 137 (w/repro.); Gerdts, *Art Across America,* vol. 2: 87, 139.

WEST, William J. *[Painter] 19th/20th c.*
Addresses: New Orleans, active 1878-1905. **Comments:** He was also active in West & St. Clair in partnership with Andrew St. Clair. **Sources:** *Encyclopaedia of New Orleans Artists,* 410.

WESTABY, Dorothy *[Painter] mid 20th c.*
Addresses: Chicago area. **Exhibited:** AIC, 1940-41. **Sources:** Falk, *AIC.*

WESTALL, Lottie V. *[Painter] mid 20th c.*
Exhibited: Soc. Indep. Artists, 1941. **Sources:** Marlor, *Soc. Indp. Artists.*

WESTBROOK, Clara *[Painter] 20th c.*
Addresses: Brooklyn, NY. **Sources:** WW10.

WESTBROOK, Frances *[Painter] mid 20th c.*
Addresses: Chicago area. **Studied:** ASL. **Exhibited:** Soc. Indep. Artists, 1938; AIC, 1941-42. **Sources:** Falk, *AIC.*

WESTBROOK, (Lieutenant) *[Sketch artist] mid 19th c.*
Comments: A view of the NYC fire of 1835, sketched by Lt. Westbrook, was lithographed by A. Picken. **Sources:** G&W; Peters, *America on Stone.*

WESTBROOK, Lloyd Leonard *[Painter] b.1903, Olmsted Falls, OH / d.1987, Cleveland, OH.*
Addresses: Olmsted Falls, OH. **Studied:** Oberlin Col.; Cleveland Sch. Art; & with Henry Keller, Frank N. Wilcox. **Exhibited:** Carnegie Inst., 1941; VMFA, 1946; Cleveland Artists & Craftsmen Ann., CMA, 1932 (prize), 1933 (prize), 1934 (prize), 1935 (prize), 1939 (prize). **Work:** CMA. **Sources:** WW59; WW47.

WESTBROOK, M. (Mrs.) *[Painter on glass] late 19th c.*
Addresses: Active in Kalamazoo, MI. **Exhibited:** Michigan State Fair, 1885. **Sources:** Petteys, *Dictionary of Women Artists.*

WESTCHILOFF, Constantin A. *[Landscape and marine painter] b.1877, Russia / d.1945.*
Studied: Royal Acad., St. Petersburg, Russia, with Repin, 1898 (traveling scholarship, 1905-06). **Exhibited:** First Free State Exhib., Petrograd, 1919. **Work:** Khabarovsk AG, Astrkhan AG, and Gorky AG, all in Russia. **Comments:** (Veshchilov, Konstantin Alexandrovitch). He was active in theatre design by 1913, and directed a group of artists for the "Agitprop" decorations at the Petrograd Tech. Inst., 1918. An enigmatic character, he painted coastal scenes in Capri and in Maine.

WESTCOAST, Wanda *[Sculptor] b.1935.*
Addresses: Venice, CA. **Exhibited:** WMAA, 1975. **Sources:** Falk, *WMAA.*

WESTCOTT, George *[Illustrator] mid 20th c.*
Addresses: Waterville, NY. **Member:** SI. **Sources:** WW47.

WESTCOTT, John (J.B.) *[Painter] early 20th c.*
Addresses: Brooklyn, NY. **Exhibited:** Soc. Indep. Artists, 1920. **Sources:** Marlor, *Soc. Indp. Artists.*

WESTCOTT, Paul See: **WESCOTT, Paul**

WESTCOTT, Robert J. *[Painter] mid 20th c.*
Exhibited: Soc. Indep. Artists, 1940. **Comments:** Possibly Westcott, R.J., ASL. **Sources:** Marlor, *Soc. Indp. Artists.*

WESTCOTT, Rowena *[Landscape painter] early 20th c.*
Studied: Fine Art Dept., State Normal School, CA, 1915. **Sources:** Petteys, *Dictionary of Women Artists.*

WESTCOTT, Sarah E. Melendy *[Painter] late 19th c.; b.Milwaukee, WI.*
Studied: Duprée; Laugée; Bouguereau; Robert-Fleury. **Exhibited:**

Paris Salon, 1894, 1898. **Sources:** Fink, *American Art at the Nineteenth-Century Paris Salons,* 405.

WESTCOTT, Sue May (Mrs.) *[Painter] mid 20th c.*
Addresses: Phila., PA. **Exhibited:** Soc. Indep. Artists, 1926. **Sources:** Marlor, *Soc. Indp. Artists.*

WESTCOTT, William Carter *[Sculptor] b.1900, Atlantic City, NJ.*
Addresses: NYC/Devon, England. **Studied:** Sorbonne, Paris, France; ASL. **Member:** NSS; Royal Soc. Art, London (fellow). **Exhibited:** nationally. **Awards:** Earle award for sculpture (2). **Work:** Lou Gehrig Mem. bust, Boy's Town; monuments, busts. mem, Staunton, VA; Virginia Military Acad.; Mayfield, PA; St. Lo, France; Bush Terminal, Brooklyn, NY; Northwestern Military and Naval Acad.; many portrait busts of prominent persons. **Sources:** WW59 and WW53, as William Westcott; his name appeared as William Wescott in WW47 (living in NYC, member NSS).

WESTERBERG, John *[Painter] early 20th c.*
Addresses: Rockport, MA. **Sources:** WW13.

WESTERFIELD, J(oseph) Mont *[Painter, illustrator] b.1885, Hartford, KY.*
Addresses: Louisville, KY. **Studied:** F.G. Walker; P.A. Plasohke. **Member:** Louisville AL. **Sources:** WW15.

WESTERL, Robert *[Engraver] mid 19th c.*
Addresses: Lowell, MA, 1834-35. **Sources:** G&W; Belknap, *Artists and Craftsmen of Essex County,* 6.

WESTERLIND, A. *[Painter] mid 20th c.*
Addresses: Chicago, IL. **Member:** Chicago NJSA. **Sources:** WW25.

WESTERLUND, Stirling C. *[Painter] b.1904, Lynn Center, IL / d.1944, Long Beach, CA.*
Addresses: Long Beach, CA. **Exhibited:** P&S Los Angeles, 1936, 1938. **Comments:** Medium: watercolor and oil. **Sources:** Hughes, *Artists in California,* 598.

WESTERMAN, Harry J(ames) *[Cartoonist, painter, illustrator, teacher, writer] b.1877, Parkesburg, WV / d.1945.*
Addresses: Columbus, OH. **Studied:** Columbus Art Sch. **Member:** Columbus Pen & Brush Club; Lg. Columbus Artists; Soc. Indep. Artists; Chicago NJSA; Lg. Am. Artists. **Comments:** Position: cartoonist, *Ohio State Journal,* Columbus. **Sources:** WW40.

WESTERMANN, H(orace) C(lifford) *[Sculptor] b.1922, Los Angeles, CA / d.1981.*
Addresses: Brookfield Center, CT, 1973. **Studied:** AIC, 1947-50, 195; also with Paul Weighardt. **Exhibited:** Surrealist Art, MoMA, 1960; Eight Sculptors, The Ambiguous Image, Walker Art Ctr., Minneapolis, 1966; LACMA, 1968 (retrospective); Mus. Contemporary Art, Chicago, 1969; Documenta, Germany, 1970 & 1972; WMAA. **Awards:** Nat. Arts Council, 1967. **Work:** WMAA; AIC; LACMA. **Comments:** An eclectic artist and master carpenter whose work shares ideas and forms found in Dada/Surrealism, Primitivism, and Minimalism. In 1952 Westermann began his carved Death Ship series, also making other war-related pieces that dealt with death and violence (he served in the Pacific in WWII and in the Korean War). Beginning in 1955 he made the first of many miniature houses in wood, with glass, mirror, metal, or found-object additions. In his glass-front box constructions and cabinets, he has often juxtaposed and transformed odd forms and ideas and explored visual parodoxes and puns. Preferred media: laminated woods, metals. **Sources:** WW73; Baigell, *Dictionary; Two Hundred Years of American Sculpture,* 319-20; Max Kozloff, *H. C. Westermann* (exh. cat. LACMA, 1968).

WESTERMEIER, Clifford Peter *[Painter, educator, designer, lecturer, decorator, teacher] b.1910, Buffalo, NY.*
Addresses: Boulder, CO. **Studied:** Buffalo School Fine Arts; Pratt Inst. Art School; New York School Fine & Applied Arts; Univ. Buffalo (B.S.); Univ. Colorado (Ph.D.). **Member:** Buffalo

SA. **Exhibited:** Albright-Knox Art Gal., 1937-43; AWCS, 1939; Syracuse MFA, 1941; Boulder, CO; Paris, London; Tucson, AZ (solo). **Awards:** The Patteran, 1939 & 1940; Artists Western NY Ann., 1939 (prize); Boulder, CO. **Work:** Albright-Knox Art Gal.; Nat. Cowboy Hall Fame & Western Heritage, Oklahoma City, OK. **Comments:** Teaching: art instructor, Buffalo School Fine Art, 1935-44; art instructor, Univ. Buffalo, 1935-44; history instructor, Univ. Colorado, 1944-46; asst. history professor, Saint Louis Univ. & Maryville College, 1946-52; history professor, Univ. Arkansas, Fayetteville, 1952-64; guest lecturer, Univ. Texas, 1954; guest lecturer, Univ. Colorado, Boulder, 1957 & 1959, history professor, 1964-. Publications: author, *Man, Beast & Dust: The Story of Rodeo*, 1947; author/illustrator, *Trailing the Cowboy*, 1955 & *Who Rush to Glory*, 1958; author, *Colorado's First Portrait*, Univ. New Mexico Press, 1970; contributor, *Britannica Jr.*, & *Encyclopedia Britannica*. **Sources:** WW73; WW47.

WESTERN, A. S. *[Painter] early 19th c.*
Comments: Landscape in oils, painted at Boston about 1820. **Sources:** G&W; Lipman and Winchester, 182.

WESTERN, Theodore B. *[Sign and ornamental painter] mid 19th c.; b.England.*
Addresses: Cincinnati in the 1840s. **Comments:** He is said to have painted banners and badges for the Harrison campaign in 1840. **Sources:** G&W; Knittle, *Early Ohio Taverns*, 44; Cincinnati CD 1840-44.

WESTFALL, Samuel Henry *[Painter] b.1865, Newark / d.1940, Monterey, CA.*
Addresses: Monterey, CA. **Exhibited:** San Francisco AA, 1916; P&S Los Angeles, 1925. **Comments:** Married to Tulita Westfall (see entry). **Sources:** Hughes, *Artists in California*, 599.

WESTFALL, Tulita (Gertrude) Bennett Davis *[Mural painter, draftsperson, etcher] b.1894, Monterey, CA / d.1962, Pacific Grove, CA.*
Addresses: Monterey, CA. **Studied:** with H.V. Poor, F. Van Sloun, P.J. de Lemons, R. Schaeffer, L. Randolph, E.A. Vysekal, Calif. Sch. FA, Otis AI, Los Angeles; ASL. **Member:** Carmel AA; Monterey AA. **Exhibited:** Calif. Artists, Golden Gate Park Mus., 1916; Calif. State Fair, Sacramento, 1926 (prize); Oakland A. Gal., 1928, 1932; Santa Cruz Art Lg., 1931 (hon. men.); Calif. State Fair, Sacramento, 1926 (prize); Calif. State-Wide Exhib., Santa Cruz, 1939; GGE, 1939. **Work:** Pub. Library, Grammar Sch., both in Monterey. **Comments:** Preferred medium: watercolor. **Sources:** WW40; Hughes, *Artists in California*, 598, who cites a birth date of 1889.

WESTFALL Y DE BORONDA, Gertrude Bennett See: **WESTFALL, Tulita (Gertrude) Bennett Davis**

WESTFELDT, Martha Jefferson Gasquet (Mrs. George G.) *[Craftsperson, bookbinder, potter] b.1884, New Orleans, LA / d.1960, New Orleans, LA.*
Addresses: New Orleans, active 1916-25. **Studied:** Newcomb College; Alfred Univ., NYC. **Exhibited:** New Orleans AA, 1916-18. **Comments:** Civic leader and art patron who was also a pottery maker. During World War II she gave the profits from her novelty shop to the French Resistance. Patrick McLoskey Westfeldt (see entry) was her husband's uncle. **Sources:** *Encyclopaedia of New Orleans Artists*, 410.

WESTFELDT, Patrick McLoskey *[Painter] b.1854, NYC / d.1907, Charlotte, NC.*
Addresses: Asheville, NC; lived mostly in New Orleans, LA. **Studied:** Carl Hecker; William Prettyman, in NYC. **Member:** New Orleans AA, 1885 (pres., 1890, 1899; treasurer, 1901-03; exec. committee, 1904-07). **Exhibited:** New Orleans AA, 1887, 1890-92, 1894, 1896-97, 1899-1905, 1907, 1910; Tulane Univ., 1892-93; NWCS, 1897; PAFA Ann., 1902-03; AIC. **Comments:** Commission merchant and importer, also painter of watercolor landscapes. His nephew was married to Martha J. Westfeld (see entry). **Sources:** WW04; *Encyclopaedia of New Orleans Artists*, 410; Falk, *Exh. Record Series*.

WESTGATE, George Atwood *[Amateur artist] b.1858, Fairhaven, MA / d.1914, Fairhaven.*
Addresses: Fairhaven, MA, active 1878-1914. **Sources:** Blasdale, *Artists of New Bedford*, 205.

WESTLAVER *[Engraver] b.c.1836, Pennsylvania.*
Addresses: Philadelphia in 1860. **Comments:** Lived in Philadelphia in 1860 with his father, John A. Westlaver, jeweler. **Sources:** G&W; 8 Census (1860), Pa., L, 598.

WESTNEDGE, M. B. (Mrs.) *[Painter] late 19th c.*
Addresses: Active in Kalamazoo, MI, 1885-99. **Exhibited:** Michigan State Fair, 1885. **Sources:** Petteys, *Dictionary of Women Artists*.

WESTNEYE, M. B. (Mrs.) See: **WESTNEDGE, M. B. (Mrs.)**

WESTON, Brett *[Photographer, sculptor] b.1911, Los Angeles, CA / d.1993.*
Addresses: Carmel Valley, CA (1947-on). **Studied:** with his father, Edward, in Mexico, 1925. **Member:** Carmel AA. **Exhibited:** P&S Los Angeles, 1936; San Francisco AA, 1938. **Work:** WPA artist. **Comments:** Best known as a photographer in the style of his famous father. **Sources:** Hughes, *Artists in California*, 599.

WESTON, Carol Caskey *[Painter, printmaker] mid 20th c.*
Addresses: El Monte, CA. **Exhibited:** Calif WCS, LACMA, 1927. **Comments:** Preferred medium: watercolor. Specialty: birds and flowers. **Sources:** Hughes, *Artists in California*, 599.

WESTON, Delight *[Painter] mid 20th c.*
Exhibited: Salons of Am., 1934. **Sources:** Marlor, *Salons of Am.*

WESTON, Edward
[Photographer] b.1886, Highland Park, IL / d.1958. *EW 1941*
Addresses: California (1906-on); Carmel, CA (since 1928). **Studied:** self-taught. **Member:** f/64 Group. **Exhibited:** MoMA, 1946 (retrospective); Paris, 1950 (retrospective). **Award:** Guggenheim Fellowship, 1937-38. **Work:** MoMA, MMA: AIC; IMP: Amon Carter Mus.; Univ. N. Mex.; NOMA; Oakland MA; major mus. worldwide. **Comments:** One of the great masters of "straight" photography, he was renowned for both the originality of his vision, sharp focus, and ultimate craftsmanship. His best known images are nudes and still-life studies, such as "Pepper No. 30," 1930. His early platinum prints are very rare, and he produced his vintage silver prints in small numbers. By 1946 he had become incapacitated by Parkinson's disease and became dependent upon his son, Brett, to print his images. Beginning in 1958, Brett began a project to print about 800 of Edward's negatives in editions of 8. Edward's youngest son, Cole, printed his father's negatives after 1958. Publications: *California and The West* (1940; rev. ed., Millerton, NY: Aperture, 1978). **Sources:** the best source on his life are his journals (1923-43): *The Daybooks* (ed. Beaumont Newhall: Vol. 1., 1961; Vol. 2, 1966); see also Nancy Newhall, *The Photographs of Edward Weston* (1946); Witkin & London, 269-71.

WESTON, Frances M. *[Painter] early 20th c.*
Addresses: Haddonfield, NJ. **Exhibited:** PAFA, 1922. **Sources:** WW24.

WESTON, H. *[Painter] mid 19th c.*
Comments: Landscape in oils, painted in Virginia about 1850. **Sources:** G&W; Lipman and Winchester, 182.

WESTON, Harold *[Painter] b.1894, Merion, PA / d.1972, Alexandria, VA?.* *Weston*
Addresses: Alexandria, VA; New York 14, NY; St. Hubert's, NY (1920-on). **Studied:** Harvard Univ. (B.F.A.), 1916). **Member:** Am. Artists Congress; Fed. Mod. P&S (pres., 1953-55, 1955-57); Int. AA (U.S. delegate, 1954, 1957, 1960, 1963; liaison officer, 1859, 1960; vice-pres., 1960-61; pres., 1962-63; hon. pres., 1963-); World Academy of Art & Science (fellow); Nat. Council Arts & Govt. (vice-chmn., 1954-58; chmn., 1960-65;

pres., 1961-65). **Exhibited:** Montross Gal., NYC, 1920s; Salons of Am., 1923, 1930, 1932, 1934; PAFA Ann., 1923-53; WMAA, 1926, 1932, 1934, 1940; Corcoran Gal biennials, 1930-53 (11 times); AIC, 1931-42; GGE, 1939 (prize); PMG, 1950s; Atea Ring Gal., Westport, NY, 1997 (solo). **Work:** Rochester Mem. Art Gal.; PMG; PAFA; PC; Yale Univ.; SFMA; Columbia Univ. Lib.; MoMA; CGA; Smithsonian Inst.; General Services Admin. Bldg.; Munson-Williams-Proctor Inst., Utica.; American Univ., Wash., DC; PA Hist. Soc.; NYU; Butler IA; Oakland AM; Syracuse Univ. AM; Fogg MA; WMAA; London War Mus.; Evansville (IN) Mus. Arts & Sciences. **Comments:** Positions: art consultant in Europe for USIA, 1957; consultant, NY State Council on the Arts. Marlor gives place of death as New York City. **Sources:** WW66; WW47; Falk, *Exh. Record Series.*

WESTON, Harry Alan *[Painter, teacher] b.1885, Springfield, IL / d.1931.*
Addresses: NYC/Oakdale, NY. **Studied:** AIC; Grand Central Sch. Art; G.E. Browne; A. Mucha. **Member:** SC; AWCS; NYWCC; AAPL; All. A. Am. **Exhibited:** SC, NYC, 1928; AWCS, NYWCC, 1929; AIC. **Sources:** WW29.

WESTON, Henry W. *[Engraver] early 19th c.*
Addresses: Philadelphia from 1800-06. **Comments:** In 1800 he was a partner of Edward C. Trenchard (see entry). **Sources:** G&W; Stauffer; Brown and Brown.

WESTON, J. B. (Mrs.) *[Sketch artist] late 19th c.*
Exhibited: Woman's Building, Columbian Expo, Chicago, 1893 (sketch). **Sources:** Petteys, *Dictionary of Women Artists.*

WESTON, J. G. *[Engraver] late 18th c.*
Comments: Engraver of woodcut frontispiece (from an English original) of a story in *The Children's Miscellany* (Boston, 1796). **Sources:** G&W; Hamilton, *Early American Book Illustrators and Wood Engravers,* 72.

WESTON, James *[Wood and seal engraver] mid 19th c.*
Addresses: NYC, 1858-60. **Sources:** G&W; NYBD 1858, 1860.

WESTON, James L. *[Painter] b.1845 / d.1922.*
Addresses: Roxbury, MA. **Exhibited:** PAFA Ann., 1895-97; Boston AC, 1896, 1900. **Sources:** WW01; Falk, *Exh. Record Series.*

WESTON, M. Leipold (Mrs.) *[Painter] early 20th c.*
Addresses: Fort Gibson, OK. **Exhibited:** Soc. Indep. Artists, 1917. **Sources:** Marlor, *Soc. Indp. Artists.*

WESTON, Mary Bartlett Pillsbury (Mrs.) *[Portrait and landscape painter] b.1817, Hebron, NH / d.1894, Lawrence, KS.*
Addresses: Hartford, CT; NYC; Lawrence, KS. **Studied:** Hartford, CT. **Exhibited:** NAD,1842; World's Columbian Expo, 1893. **Comments:** The daughter of a Baptist minister. As a young woman she is said to have run away from home to study painting in Hartford (CT). Her early work was in miniature, but she later turned to oil portraits, landscapes, and religious subjects. She married Valentine W. Weston and went to live in NYC, where he had a looking glass business in the early forties. Mr. Weston died in 1863. **Sources:** G&W; Pilsbury and Getchell, *The Pillsbury Family,* 163; French, *Art and Artists in Connecticut,* 175-76; Bolton, *Miniature Painters;* Cowdrey, NAD; NYCD 1842; Lipman and Winchester, 182. More recently, see Campbell, *New Hampshire Scenery,*171-172; Trenton, ed. *Independent Spirits,* 246.

WESTON, Mary Coburn *[Painter] b.1839 / d.1913.*
Work: Colby College, Waterville, ME (painting, c.1870). **Sources:** Petteys, *Dictionary of Women Artists.*

WESTON, Mathilde L. *[Painter] mid 20th c.*
Addresses: Carlsbad, Pasadena, San Diego, CA. **Exhibited:** GGE, 1939. **Sources:** Hughes, *Artists in California,* 599.

WESTON, Morris *[Painter, sculptor, writer, teacher] b.1859, Boston, MA.*
Addresses: NYC/Essex, CT. **Exhibited:** Soc. Indep. Artists,

1917; PAFA Ann., 1919, 1925. **Sources:** WW27; Falk, *Exh. Record Series.*

WESTON, Otheto (Mrs.) *[Painter] b.1895, Monterey, CA.*
Addresses: Columbia, CA. **Studied:** self-taught. **Exhibited:** Kingsley AC, Sacramento, 1942-46; Haggin Gal., Stockton; Crocker Art Gal., Sacramento. **Sources:** Hughes, *Artists in California,*599.

WESTOVER, Russell Channing (Russ) *[Cartoonist] b.1886, Los Angeles, CA / d.1966, Ross, CA.*
Addresses: New Rochelle, NY; California. **Studied:** Mark Hopkins AI. **Exhibited:** Emil Alvin Hartman Sch. Des., NYC (medal). **Work:** Huntington Lib., San Marino, CA. **Comments:** Position: cartoonist, San Francisco *Bulletin, Chronicle.* Creator/cartoonist: "Tillie the Toiler" and "The Van Swagger" for King Features Syndicate, since 1921. **Sources:** WW40; Hughes, *Artists in California,* 599; *Famous Artists & Writers* (1949).

WESTOVER, Virginia *[Artist] mid 20th c.*
Addresses: Bay City, MI. **Exhibited:** PAFA Ann., 1960. **Sources:** Falk, *Exh. Record Series.*

WESTPHAHL, Conrad *[Painter] mid 20th c.*
Exhibited: AIC, 1928, 1934-35. **Sources:** Falk, *AIC.*

WESTPHAL, Katherine V. *[Painter] mid 20th c.*
Addresses: Seattle, WA. **Exhibited:** SAM, 1946; Henry Gallery, 1950. **Sources:** Trip and Cook, *Washington State Art and Artists.*

WESTROM, Walter E. *[Painter] b.1910, Lake View, IA.*
Addresses: Lake View, IA. **Studied:** pupil of Mrs. T. C. Marsh and L. Laurie Wallace in Lake View and Omaha. **Exhibited:** Sac County Fair; Iowa Art Salon, 1935, 1937; Joslyn Memorial in Five States Exhibition, 1935. **Sources:** Ness & Orwig, *Iowa Artists of the First Hundred Years,* 219.

WESTWATER, Eunice *[Artist] early 20th c.*
Addresses: Active in Los Angeles, 1911-14. **Sources:** Petteys, *Dictionary of Women Artists.*

WESTWOOD, H. (Ellen) G. *[Artist] 19th/20th c.*
Addresses: Active in Los Angeles, 1891-1903. **Sources:** Petteys, *Dictionary of Women Artists.*

WETERRAU, Rudolf *[Designer, painter] b.1891, Nashville, TN.*
Addresses: Bronxville, NY. **Studied:** ASL; SI; Art Dir. Club. **Sources:** WW47.

WETHERALD, Harry H. *[Painter, designer, illustrator] b.1903, Providence, RI / d.1955.*
Addresses: Providence 3, RI. **Studied:** RISD; NAD; & with Charles W. Hawthorne, John R, Frazier. **Member:** Providence AC; SC; Providence WCC; Boston Art Dir. Club. **Exhibited:** Phila. WCC; AIC; BMA; AFA traveling exhib., 1924-27. **Comments:** Position: trustee, RISD, Providence, RI. **Sources:** WW53; WW47.

WETHERALD, Samuel B. *[Portrait artist] mid 19th c.*
Exhibited: Maryland Historical Society, 1848 (heads of J.C. Jones and G.B. Cook, medium not indicated). **Work:** Maryland Historical Society (wash drawing of Thomas McKean, after Stuart, and iron bas-relief of Zachary Taylor). **Comments:** Samuel B. Wetherald, of Resin & Wetherald, was in the Baltimore directories for 1853 and 1855, but the nature of his business was not given. **Sources:** G&W; Rutledge, MHS; Rutledge, "Portraits in Varied Media"; Baltimore CD 1853, 1855.

WETHERALL, Samuel H. *[Engraver] b.c.1834, Maryland.*
Addresses: Baltimore in 1860. **Sources:** G&W; 8 Census (1860), Md., VI, 393; Baltimore CD 1860.

WETHERBEE, Alice Ney *[Sculptor] early 20th c.; b.NYC.*
Addresses: Paris, France. **Studied:** Larroux, in Paris. **Sources:** WW10.

WETHERBEE, Bertha C. *[Painter] late 19th c.*
Addresses: active in Detroit, MI. **Studied:** Maud Mathewson.

Exhibited: Mathewsons studio, 1894. **Sources:** Petteys, *Dictionary of Women Artists.*

WETHERBEE, Dora H. *[Painter] mid 20th c.*
Addresses: Ithaca, NY. **Exhibited:** Salons of Am., 1925-26; Soc. Indep. Artists, 1925-26. **Sources:** Falk, *Exhibition Record Series.*

WETHERBEE, Frank Irving *[Painter] b.1869, Hyde Park, MA.*
Addresses: Boston, MA. **Exhibited:** AIC, 1901. **Sources:** WW04.

WETHERBEE, George Faulkner *GF Wetherbee.*
[Painter] b.1851, Cincinnati, OH / d.1920.
Addresses: NYC; London. **Studied:** Royal Acad., London; Antwerp. **Member:** Royal Inst. Painters in Watercolor; Royal Inst. Painters in Oil. **Exhibited:** Paris Salon, 1895; PAFA Ann., 1896-97, 1905-09; St. Louis Expo, 1904 (medal); Chicago; Paris. **Work:** Albright Art Gal., Buffalo. **Sources:** WW21; Fink, *American Art at the Nineteenth-Century Paris Salons,* 405; Falk, *Exh. Record Series.*

WETHERBY, Isaac Augustus *[Portrait and ornamental painter; photographer] b.1819, Providence, RI / d.1904, Iowa City, IA.*
Addresses: Norway, ME, 1834; Boston, 1835-46; Milton, MA, 1848-54; Iowa City. **Studied:** In Charlestown and Stow (MA). **Comments:** He began his career as a portrait painter at Norway (ME) in 1834. From 1835-46 he had his studio in Boston, although he made a trip to Louisville (KY) in 1844. After his marriage in 1846, he moved to Roxbury and in 1848 to Milton (MA). In 1854 he went out to Iowa and set up a daguerreotype studio in Iowa City, but after a few months he went to Rockford (IL) where he had a daguerreotype studio until 1857. After two years at Eureka (IA), Wetherby and his family finally settled in Iowa City. He retired from his photographic business in 1874. **Sources:** G&W; Holloway, "Isaac Augustus Wetherby (1819-1904) and His Account Books"; WPA (MA), *Portraits Found in N.H.,* 28 [as J.A. Weatherby].

WETHERBY, Jeremiah Wood *[Portrait painter] b.1780, Stow, MA.*
Sources: G&W; Sears, *Some American Primitives,* 285; *Vital Records of Boxborough.*

WETHERELL, Grace *[Painter] 19th/20th c.*
Addresses: Oakland, CA. **Exhibited:** San Francisco Sketch Club, 1897; Mechanics' Inst., San Francisco, 1899. **Comments:** Preferred medium: pastel. **Sources:** Hughes, *Artists in California,* 599.

WETHERILL, Edith B. *[Painter] mid 20th c.*
Addresses: Haverford, PA. **Exhibited:** PAFA Ann., 1932. **Sources:** Falk, *Exh. Record Series.*

WETHERILL, E(lisha) Kent K(ane) *[Painter in oil and watercolor, etcher] b.1874, Philadelphia, PA / d.1929, Aberdeen, SC.*
Addresses: Phila., PA; NYC/Phoenicia, NY. **Studied:** Univ. Penn.; PAFA with Anshutz, late 1890s and 1906-09; Académie Julian, Paris with J.P. Laurens, 1902; also with Whistler in Paris. **Member:** ANA, 1927; Sketch Club; SC; Allied AA; Brooklyn SE. **Exhibited:** PAFA Ann., 1906-10, 1921-27; Corcoran Gal biennials, 1907-26 (6 times); Pan-Pacific Expo, San Francisco, 1915; Sesqui-Centenn. Expo, Phila., 1926 (medal); Salons of Am.; AIC. **Work:** PAFA; Art Club Phila.; Luxembourg Mus., Paris. **Comments:** Spec. in seascapes, views of New York, and figural works. His death was the result of injuries received in WWI. **Sources:** WW27; Danly, *Light, Air, and Color,* 89; Falk, *Exh. Record Series.*

WETHERILL, Isabelle (Isabella) Macomb *[Painter] 19th/20th c.*
Addresses: Phila., PA. **Exhibited:** Phila. Art Club, 1898. **Sources:** WW01.

WETHERILL, Maria Lawrence See: **LAWRENCE-WETHERILL, Maria**

WETHERILL, Roy *[Teacher, painter] b.1880, New Brunswick, NJ.*
Addresses: Kansas City, MO. **Studied:** C.A. Willimovsky; R.L. Lambdin; N. Tolson. **Comments:** Position: teacher, Kansas City AI. **Sources:** WW25.

WETHEY, Harold Edwin *[Art historian, etcher, lecturer, writer] b.1902, Port Byron, NY / d.1984.*
Addresses: Ann Arbor, MI. **Studied:** Cornell Univ. (A.B.); Harvard Univ. (M.A., Ph.D.). **Member:** College Arts Assn. Am.; Hispanic Soc. Am.; Soc. Arch. Historians; Acad. de S. Fernando; Soc. Peruana Historia; Rockefeller Fnd., 1944-45; Sheldon Fellow, Harvard Univ., 1932-33. **Exhibited:** Awards: Am. Council Learned Soc., 1936 & 1963-64 (fellowships); Russel lectureship, 1964-65 & Guggenheim fellowship, 1971-72, Univ. Michigan, Ann Arbor. **Comments:** Positions: contributing editor, *Handbook of Latin-Am. Studies,* 436-59; member editorial staff, *Art Bulletin,* 1965-71. Teaching: from instructor to asst. professor of art history, Bryn Mawr College, 1934-38; asst. professor of art history, Wash. Univ., St. Louis, 1938-40; assoc. profesor of art history, Univ. Michigan, Ann Arbor, 1940-46, professor of art history, 1946-; visiting professor of art, Univ. Tucaman, Argentina, 1943; U.S. State Dept. visiting professor of art, Univ. Mexico, summer 1960. Art interests: Spanish & Latin American art; Italian Renaissance & Baroque art. Publications: author, *Gil de Siloe and His School,* 1936; author, *Alonso Cano, Painter, Sculptor and Architect,* 1955, *El Greco and His School,* 1962, *Titian, the Religious Paintings,* 1960 & *Titian, Vol. II, The Portraits,* 1971; plus many others including contributions to leading encyclopedias & magazines. **Sources:** WW73; WW47.

WETHLI, Mark Christian *[Painter] b.1949.*
Addresses: NYC. **Exhibited:** WMAA, 1975. **Sources:** Falk, *WMAA.*

WETMORE, C. F. *[Portrait painter] mid 19th c.*
Addresses: Providence, RI in 1824; Boston in 1829. **Comments:** Cf. C.G. Wetmore. **Sources:** G&W; Swan, BA.

WETMORE, C. G. *[Portrait and miniature painter] early 19th c.*
Addresses: Charleston, SC in 1822. **Comments:** He was also agent for the Baltimore Floor Cloth Manufactory. Cf. C.F. (or J.) Wetmore. **Sources:** G&W; Rutledge, *Artists in the Life of Charleston.*

WETMORE, Helen *[Artist] late 19th c.*
Addresses: Active in Ann Arbor, MI, 1897. **Sources:** Petteys, *Dictionary of Women Artists.*

WETMORE, Mary Minerva *[Painter, teacher] early 20th c.; b.Canfield, OH.*
Addresses: Chicago & Urbana, IL. **Studied:** Cleveland Art Sch.; ASL, with W.M. Chase, Fox, Mowbray; Phila. Sch. Des. for Women.; Hopkins AI; Académie Julian, Paris with J.P. Laurens and Constant; Acad. Colarossi, with Collin and Courtois; W.M. Chase summer classes in Madrid, 1905 & Carmel, CA, 1914. **Member:** Chicago SA; Chicago AC; Paris Women's AA; NY Women's AC. **Exhibited:** AIC, 1901-15; Chicago Soc. Artists; PAFA Ann., 1904; Cleveland, NYC, San Francisco; Paris Salon. **Comments:** Art instructor, Univ. Illinois. **Sources:** WW33; Petteys, *Dictionary of Women Artists;* Falk, *Exh. Record Series.*

WETTER, Gladys Mock See: **MOCK, Gladys (Gladys Mock Wetter)**

WETTER, Pierce Trowbridge (Mrs.) See: **MOCK, Gladys (Gladys Mock Wetter)**

WETTERAU, Margaret Chaplin *[Painter] early 20th c.*
Addresses: Chicago, IL. **Member:** Woodstock AA. **Exhibited:** AIC, 1916-17. **Work:** Woodstock AA. **Sources:** WW17; addit. info courtesy Woodstock AA.

WETTERAU, Rudolf *[Advertising designer, painter] b.1891, Nashville, TN / d.1953, Woodstock, NY.*
Addresses: Bronxville, NY. **Studied:** ASL. **Member:** SI; Art Dir. Club; Woodstock AA. **Exhibited:** AIC, 1924; Soc. Indep. Artists, 1925-28. **Work:** Woodstock AA. **Comments:** Position: vice pres., Kiesewetter, Wetterau & Baker Advertising, NYC. **Sources:** WW53; Woodstock AA cites birth date of 1890.

WETTERSTEN, Harold T. *[Painter] early 20th c.*
Exhibited: AIC, 1920. **Sources:** Falk, *AIC.*

WETZEL, Anton *[Painter] mid 20th c.*
Addresses: Woodside, NY. **Exhibited:** Soc. Indep. Artists, 1930. **Sources:** Marlor, *Soc. Indp. Artists.*

WETZEL, Charles *[Engraver] mid 19th c.*
Addresses: NYC, 1852-58. **Comments:** Of Wetzel & Schleich (see entry). **Sources:** G&W; NYBD 1852-58.

WETZEL, George J(ulius) *[Painter] b.1870, NYC / d.1936.*
Addresses: NYC, 1898; Douglastown, NY. **Studied:** ASL, with Mowbray; Beckwith; Cox; Chase. **Member:** SC, 1898; Nat. FAS; AFA; Nassau County AL. **Exhibited:** PAFA Ann., 1896-97; NAD, 1898; Phila. AC (prize); SC (prize); Boston AC, 1899; Soc. Indep. Artists, 1927. **Sources:** WW35; Falk, *Exh. Record Series.*

WETZEL, Patricia See: **SAUBERT-WETZEL, Patricia**

WETZEL & SCHLEICH *[Engravers] mid 19th c.*
Addresses: NYC, 1852-58. **Comments:** Partners were Charles Wetzel and Charles Schleich (see entries). **Sources:** G&W; NYBD 1852-58.

WETZLER, Ernest *[Lithographer] mid 19th c.*
Addresses: NYC, 1857-60. **Comments:** Of Seibert & Wetzler, 1859-60 (see entry). **Sources:** G&W; NYBD 1857-60.

WEVER, Adolph *[Listed as "artist"] mid 19th c.*
Comments: Proposed to take four views of Cleveland (OH) in May 1844 for the purpose of lithographing and selling them. **Sources:** G&W; WPA (Ohio), *Annals of Cleveland.*

WEVIL, George, Jr. *[Engraver] mid 19th c.*
Addresses: Phila. from 1850-57; Cincinnati, 1859-60. **Sources:** G&W; Phila. CD 1852-57; Phila. BD 1850-56; Ohio BD 1859; Cincinnati BD 1859-60; Hamilton, *Early American Book Illustrators and Wood Engravers,* 464.

WEXEL, C. *[Artist] late 19th c.*
Exhibited: NAD, 1878. **Sources:** Naylor, *NAD.*

WEXLER, George *[Painter, educator] b.1925, Brooklyn, NY.*
Addresses: New Paltz, NY. **Studied:** Cooper Union School Art; New York Univ. (B.A.); Michigan State Univ. (M.A.). **Exhibited:** Landscape in America, New School Soc. Res., 1963; Angeleski Gal., New York, 1961 (solo); Albany (NY) Inst. Art, 1966 (solo); First St; Gal., New York, 1970s (solo); Schenectady (NY) Mus. Art, 1972 (solo). **Awards:** hon. mention, Michiana, South Bend, IN, 1954; hon. mention, Ball State Ann. Drawing Exhib., IN, 1962; painting prize, Mid-Hudson Ann., Albany Inst. Art, 1963-65. **Work:** Norfolk (VA) Mus. Art; Walter P. Chrysler Collection, NYC; State Univ. NY Albany; Schenectady (NY) Mus. Art; New York Univ. Collection. **Commissions:** murals, Detroit, Michigan, 1955 & Milwaukee, WI, 1956, Victor Gruen Assocs. **Comments:** Preferred medium: oil. **Publications:** author, book review, *Journal Aesthetic Educ.,* 1970. **Teaching:** asst. professor of design, Michigan State Univ., 1950-57; painting professor, State Univ. NY College New Paltz, 1957-. **Sources:** WW73; Gussow, "A Sense of Place," *Saturday Review* (1972).

WEXLER, Hannah Paipert *[Painter] mid 20th c.*
Addresses: Arlington, VA. **Exhibited:** Corcoran Gal biennials, 1937. **Sources:** Falk, *Corcoran Gal.*

WEYAHOK, Sikvoan *[Painter, sculptor] mid 20th c.*
Addresses: Pt. Hope, AK. **Studied:** Univ. Washington. **Exhibited:** SAM, 1938. **Sources:** Trip and Cook, *Washington State Art and Artists.*

WEYAND, Charles L. *[Painter] mid 20th c.*
Addresses: NYC. **Exhibited:** Salons of Am., 1923-27; Soc. Indep. Artists, 1924-25, 1927. **Sources:** Falk, *Exhibition Record Series.*

WEYDEN, Harry van der See: **VAN DER WEYDEN, Harry**

WEYGERS, Alexander G. *[Sculptor, painter] b.1901, Java.*
Addresses: Berkeley, Carmel, CA. **Exhibited:** Oakland Art Gallery, 1937; San Francisco AA, 1938. **Sources:** Hughes, *Artists in California,* 599.

WEYGOLD, Frederick P. *[Painter, writer] b.1870, St. Charles, MO / d.1941, Louisville, KY.*
Studied: PAFA; Europe. **Comments:** Specialty: painting and writing about Am. Indian life, especially the Sioux.

WEYHE, Erhard (Mrs.) *[Art dealer] mid 20th c.*
Addresses: NYC. **Sources:** WW73.

WEYL, Elinor G. *[Painter] mid 20th c.*
Exhibited: AIC, 1935; Corcoran Gal biennial, 1941. **Sources:** Falk, *Exhibition Records Series.*

WEYL, Lillian *[Painter, teacher] b.1874, Franklin, IN.*
Addresses: Indianapolis, IN. **Studied:** PIA School; W. Sargent; A.W. Dow; A. Hibbard; G. Wiggins; G.E. Browne. **Member:** Western AA; Friends Art, Nelson Gal.; Kansas City AI. **Comments:** Position: art director, Public Schools, in Indianapolis & Kansas City. **Sources:** WW40.

WEYL, Max *[Landscape painter] b.1837, Mühlen-am-Neckar, Germany / d.1914, Wash., DC.*
Addresses: Williamsport, PA; Wash., DC, c.1853, 1883, 1887-96. **Member:** Soc.Wash. Artists (pres.); Wash. WCC; Wash. AC (founding mem.). **Exhibited:** NAD, 1883-96; Brooklyn AA, 1884; Am. Gals., 1883; Boston AC, 1887; Soc. Wash. Artists, 1891 (first prize),1901 (prize), 1904 (prize); PAFA Ann., 1901-03; Corcoran Gal annuals/biennials, 1907-12 (4 times); Phila.; Chicago; National Mus. Am. Art, 1983-94; other Corcoran Gal exh., 1982. **Work:** Corcoran Gallery; NGA; Cosmos Club, Wash., DC; Albright-Knox AG, Buffalo; Virginia Military Inst.; Georgetown Univ.; National Trust Historic Preservation. **Comments:** One of the most popular landscapes painters of Wash., DC, he worked in the Barbizon style and was often referred to as the "American Daubigny." He came to the U.S. as a boy, was an intinerant watch repairman, and in 1861 opened a jewelry shop in Wash., DC. Shortly thereafter, he also began painting, and by 1878 had achieved enough success to list himself as an artist in the city directory. An 1879 trip to Europe attached him to the Barbizon style, and for the next two decades his landscapes of the Potomac River and Rock Creek valley won him renown. **Sources:** G&W; *Art Annual,* XI, obit.; CAB; WW13; McMahan, *Artists of Washington, DC; 300 Years of American Art,* vol. 1, 288; Falk, *Exh. Record Series.*

WEYLAND, Peter *[Painter] mid 20th c.*
Addresses: Chicago area. **Exhibited:** AIC, 1927. **Sources:** Falk, *AIC.*

WEYMAN, (Miss) *[Teacher of monochromatic painting] mid 19th c.*
Addresses: Charleston, SC, 1844-45, 1847-48. **Comments:** Taught in a young ladies' seminary at Charleston (SC), 1844-45, 1847-48. **Sources:** G&W; Rutledge, *Artists in the Life of Charleston.*

WEYMOUTH, George A. *[Painter, collector, preservationist] b.1936, Philadelphia.*
Studied: Yale Univ. (Amer. Studies); privately with Deane Keller, New Haven CT. **Exhibited:** Brandywine River Mus., 1991 (retrospective) **Work:** Brandywine River Mus. **Comments:** Brandywine River Valley artist working in the tradition of Andrew Wyeth. Specialist in egg tempera. In addition to landscapes and

figural works, Weymouth has painted many portraits. Founder of the Brandywine Conservancy. **Sources:** *George A. Weymouth: A Retrospective,* with essay by Richard J. Boyle (Chadds Ford, PA: Brandywine River Museum, 1991).

WEYRICH, Joseph Lewis *[Painter] early 20th c.*
Addresses: Baltimore, MD. **Exhibited:** PAFA Ann., 1915.
Sources: WW17; Falk, *Exh. Record Series.*

WEYSS, John E. *[Topographical artist] b.c.1820 / d.1903, Washington, DC.*
Comments: Served with Emory's Mexican Boundary Survey from 1849-55 and contributed many illustrations to his three-volume report (1857-59). He subsequently served as a major in the Union Army and after the war was again connected with Western surveys. **Sources:** G&W; Taft, *Artists and Illustrators of the Old West,* 277; Jackson, *Gold Rush Album,* 81-82; P&H Samuels, 522.

W. G. See: **GIBBS, William W.**

WHAITES, Edward P. *[Engraver] mid 19th c.*
Addresses: NYC, active 1837-after 1860. **Comments:** In 1850 he had the same business address as John L. Whaites (see entry).
Sources: G&W; NYCD 1837-60+.

WHAITES, John A. *[Engraver] mid 19th c.*
Addresses: NYC, 1850. **Sources:** G&W; NYCD 1850.

WHAITES, John L. *[Engraver and printer] d.Before 1852.*
Addresses: NYC, active 1827-50. **Comments:** Listed as "late engraver" in 1852-53. His business address in 1850 was the same as Edward P. Whaites's (see entry). **Sources:** G&W; NYCD 1827-52.

WHAITES, William *[Engraver] mid 19th c.*
Addresses: NYC, 1852. **Comments:** Probably the same as William C. Whaites, printer active from 1826-50; last listed, without occupation, in 1853. **Sources:** G&W; NYCD 1826-53.

WHAITES, William N. *[Lithographer] mid 19th c.*
Addresses: NYC, 1853. **Comments:** In 1845 he was listed as a printer at the same address as William C. Whaites (see William Whaites). **Sources:** G&W; NYCD 1845, 1853.

WHALEN, John W(illiam) *[Painter, illustrator, teacher] b.1891, Worcester, MA.*
Addresses: Pittsfield, MA/Madrid, NY. **Studied:** Boston, with E. Pape, Chase, Emerson, H. Brett, A. Spear. **Member:** Pittsfield AL. **Sources:** WW25.

WHALEY, E(dna) Reed (Mrs. M. S. Whaley) *[Painter, illustrator, writer, teacher] b.1884, New Orleans.*
Addresses: Columbia, SC. **Studied:** Newcomb College, Tulane Univ. **Member:** Columbia (SC) AA; AAPL; SSAL. **Exhibited:** Art Gld. of Columbia. **Awards:** Columbia AA, 1924 (prize); SSAL, 1921 (prize); South Carolina Art Gld., 1951. **Work:** Vanderpoel Collection. **Comments:** Illustrator: *The Old Types Pass,* M.S. Whaley. **Sources:** WW53; WW47.

WHALEY, M. J. (Miss) *[Painter] early 20th c.*
Addresses: NYC. **Exhibited:** NAD, 1884; Soc. Indep. Artists, 1917. **Sources:** Marlor, *Soc. Indp. Artists.*

WHALTER, R. *[Portraitist] 18th/19th c.*
Comments: Painter of oil portraits of James Madison and Col. John Armstrong about 1800. **Sources:** G&W; courtesy Robert B. Campbell, Boston.

WHARTON, Carol Forbes (Mrs. James P.) *[Miniature painter, writer] b.1907, Baltimore, MD / d.1958.*
Addresses: Baltimore 10, MD. **Studied:** Bryn Mawr Sch.; Corcoran Sch. Art; Maryland Inst.; Peabody Inst.; Nat. Sch. Fine & Applied Art, Wash., DC. **Comments:** Position: columnist, feature writer, art critic, *Baltimore Sun* Papers. **Sources:** WW53; WW47.

WHARTON, Elizabeth *[Painter] b.1882, Berona, NJ.*
Addresses: NYC. **Member:** NAWPS. **Exhibited:** Argent Gals., 1940 (solo). **Sources:** WW40.

WHARTON, James Pearce *[Educator, painter, educator, illustrator, lithographer] b.1893, Waterloo, SC / d.1963.*
Addresses: Takoma Park, MD. **Studied:** École des Beaux-Arts, Dijon, France; Lander Col.; Wofford Col.; Duke Univ. (A.B.); Univ. Guanajuato, Mexico (M.F.A.); Maryland AI, and with Wayman Adams, Leon Kroll, Robert Brackman, Maurice Davidson. **Member:** SSAL; Georgia AA; Balt. WCC; Balt. Charcoal Club. **Exhibited:** SSAL; Wash. Art Club; High Mus. Art, 1937 (prize); Columbus (GA) Art Club; San Miguel de Allende, Mexico; Manila, Philippines; BMA, 1944 (prize); Maryland AI; Balt. Charcoal Club; Balt. WCC, 1954 (prize). **Work:** Lib., Fort Benning; paintings, Nat. Radio Inst. Am.; St. Mary's (MD) College; Univ. Maryland. **Comments:** Positions: head, Manila Art Sch., 1938-40; Columbus Sch. Art, 1934-38; art professor/head, art dept., Univ. Maryland, College Park, 1948-. Contributor to magazine section, feature page, "It Happened in Georgia," Sunday Magazine Section, *Atlanta Journal,* from 1936; *Balt. Sunday Sun, Life* magazine, Army publications, covers for *Infantry Journal.* **Sources:** WW66; WW40.

WHARTON, Joseph *[Engraver] b.c.1833, Pennsylvania.*
Addresses: Phila. in 1850. **Comments:** In 1850 he lived with his mother, Margaret Wharton, and was the eldest of seven children. **Sources:** G&W; 7 Census (1850), Pa., LIV, 688.

WHARTON, Philip Fishbourne
[Landscape and genre painter, illustrator] b.1841, Phila. / d.1880, Media, PA. *Wharton.*
Addresses: Primarily in Phila.; also painted in Florida & Nassau. **Studied:** Paris, France; PAFA. **Exhibited:** Centennial Exh., Phila., 1876; PAFA Ann., 1876, 1878. **Comments:** Worked as a combat artist during the Civil War. His drawing of Sheridan's troops in the Shenandoah Valley, Nov.5, 1864, was published by *Harper's Weekly.* **Sources:** Clement and Hutton; Wright, *Artists in Virginia Before 1900;* Falk, *Exh. Record Series.*

WHARTON, Thomas Kelah *[Landscape painter and lithographer, architect and builder] b.1814, Hull, England / d.1862, New Orleans, LA.*
Addresses: Ohio, 1830-32; New York City, 1832; New York State; Holly Springs, MS, 1844; New Orleans, 1844-62.
Exhibited: NAD, 1834-35 (landscapes-two of them scenes in the Hudson Highlands around West Point). **Work:** Stokes Collection at the New York Public Library (two pencil views of Natchez, MS about 1850; two of his diaries, 1830-34 &1853-54; and a sketch book). **Comments:** He came to America with his parents in 1830 and settled in Ohio. In 1832 he entered the office of the NYC architect Martin E. Thompson. About 1838 he drew and lithographed a view of Reading (PA). He eventually moved to New Orleans and worked for the U.S. Treasury Department in various positions. A talented sketch artist, he made drawings of the progress and changes in the building of the Custom House and of scenes around the city and illustrated his N.O. diary, 1853-62. **Sources:** G&W; Stokes, *Historical Prints,* 86, 107; Cowdrey, NAD. Hageman, 104-106, incl.repros.; *Encyclopaedia of New Orleans Artists,* 411.

WHATELEY, H. *[Delineator] mid 19th c.*
Comments: Delineator of a view of Mount Vernon, the home of Washington, lithographed by Thomas Sinclair and published in 1859. **Sources:** G&W; Stokes, *Historical Prints,* 123.

WHEAT, Corydon *[Painter] b.1888, Farmdale, VA / d.1943, Geneva, NY.*
Exhibited: Soc. Indep. Artists, 1939. **Sources:** Marlor, *Soc. Indp. Artists.*

WHEAT, John Potter *[Painter, teacher] b.1920, NYC.*
Addresses: Darien, CT. **Studied:** Yale Univ. (B.F.A.). **Member:** NSMP; AWCS; CAFA; Silvermine Gld. Artists. **Exhibited:** MMA, 1942; AIC, 1943; NAC, 1946 (prize); NAD, 1943, 1946 (prize),1949 (prize), 1952 (prize), 1953-54; NWMP, 1944 (prize); Audubon Artists, 1953, 1954; All. Artists Am., 1953, 1954; CAFA, 1953-55 (prize, 1948); AWCS, 1954; Conn. WCS, 1953-55; PAFA Ann., 1962. **Awards:** Abbey Mem. Scholarship, 1946-

47; NSMP, 1944; Silvermine Gld. Artists, 1955. **Work:** murals, Mamaronek Jr. HS; Emanual Women's Club, San Francisco, CA. **Sources:** WW59; Falk, *Exh. Record Series.*

WHEATER, J. H. *[Illustrator] early 20th c.*
Addresses: Leonia, NJ. **Sources:** WW19.

WHEATLEY, T(homas) J(efferson) *[Painter, craftsperson] b.1853, Cincinnati.*
Addresses: Cincinnati, OH. **Studied:** T.C. Lindsay; C. Arter. **Member:** Cincinnati AC; Cincinnati Arts & Crafts Club; NSC (Ceramic Guild). **Comments:** Specialty: pottery. **Sources:** WW13.

WHEATON, Daniel *[Portrait painter] early 19th c.*
Addresses: Greenville, SC in 1827. **Sources:** G&W; courtesy Miss Anna Wells Rutledge.

WHEATON, Francis *[Painter, teacher] b.1849, Valparaiso, Chile / d.1942, Viola, NY.*
Addresses: NYC, 1891, 1900; Park Ridge, NJ, 1893-98; Suffern, NY. **Studied:** AIC; NAD. **Member:** Copley Soc., 1891. **Exhibited:** NAD, 1891-1900; Boston AC, 1893-1900; PAFA Ann., 1895-98; Salons of Am.; AIC. **Comments:** Specialty: sheep. **Sources:** WW13; Falk, *Exh. Record Series.*

WHEATON, Miles K. *[Engraver] mid 19th c.*
Addresses: NYC, 1851. **Sources:** G&W; NYBD 1851.

WHEDON, Harriet (Fielding) *[Painter] b.1879, Middletown, CT / d.1958, Burlingame, CA.*
Addresses: Los Angeles, Pasadena, San Francisco, CA; NYC; Chicago; Burlingame, CA. **Studied:** Calif. Sch. FA, and with Otis Oldfield, Ray Boynton, Randolph. **Member:** San Francisco AA; San Francisco AC; Fnd. Western Artists, Los Angeles. **Exhibited:** San Francisco AC, 1934; SFMA, 1935, 1939 (solo); San Francisco AA, 1939 (merit award); GGE, 1939; Oakland Art Gal., 1932, 1939; Santa Barbara MA; LACMA; CPLH. **Sources:** WW53; Hughes, *Artists in California*, 599.

WHEELAN, Albertine Randall (Mrs.) *[Painter, illustrator, cartoonist] b.1863, San Francisco, CA / d.1954, Litchfield, CT.*
Addresses: Paris, France; Litchfield, CT. **Studied:** William Keith and with V. Williams at San Fran. Sch. Des. **Member:** AFA. **Exhibited:** Columbian Expo, Chicago, 1893; San Francisco Sketch Club. **Comments:** Designer: character and costume sketches for C. Belasco; bookplates; stained glass windows. Originator: newspaper cartoon "The Dumbunnies." Illustrator for *St. Nicholas* and other children's publications. **Sources:** WW29; Hughes, *Artists in California*, 455.

WHEELER, Alice A. *[Painter] b.Canada / d.1930.*
Addresses: Boston, MA, 1879-85. **Exhibited:** NAD, 1879-85; Boston AC, 1880, 1884; Royal Canadian Acad., 1888. **Sources:** *The Boston AC;* Petteys, *Dictionary of Women Artists.*

WHEELER, Anna Norton *[Listed as "artist"] b.c.1869 / d.1962.*
Addresses: New Orleans, active 1891. **Exhibited:** NOAA, 1891. **Sources:** *Encyclopaedia of New Orleans Artists*, 411.

WHEELER, Asa H. *[Writing teacher, amateur artist] mid 19th c.*
Exhibited: Am. Inst., NYC, 1848-50 (monochromatic paintings). **Sources:** G&W; NYCD 1847-50; Am. Inst. Cat., 1848-50.

WHEELER, C. W. *[Painter] mid 20th c.*
Addresses: Chicago area. **Exhibited:** AIC, 1935. **Sources:** Falk, AIC.

WHEELER, Candace Thurber (Mrs. Thomas) *[Designer & writer on household decoration] b.1828, Delhi, NY / d.1923.*
Addresses: NYC, 1882. **Member:** Soc. Dec. Arts; Assoc. Artists. **Exhibited:** NAD, 1882. **Comments:** Well-known authority on home decoration, founder of the Society of Decorative Arts, and director of the Woman's Building at the World's Columbian Exposition, Chicago, 1893. She married Thomas M. Wheeler of NYC in 1846. Her daughter, Dora Wheeler, born in 1858, was also an artist and designer. **Sources:** G&W; *Art Annual*, XX, obit.; *Who's Who in America* (1922).

WHEELER, Charles H. *[Designer, lecturer] b.1865, New Haven, CT.*
Addresses: Longmeadow, MA. **Studied:** J. Niemeyer, at Yale. **Member:** Springfield AL; Springfield AG. **Exhibited:** Springfield MFA, 1929 (prize), 1937 (prize). **Work:** des./execution, special lighting fixtures, railings etc., St. Peter's Episcopal Church, Springfield; Chapel, South Kent Sch. for Boys, South Kent, Conn.; art metal work. **Sources:** WW40.

WHEELER, Christabel *[Painter] mid 20th c.*
Addresses: Chicago area. **Exhibited:** AIC, 1938. **Sources:** Falk, AIC.

WHEELER, Cleora Clark *[Designer, collector, engraver, painter, illuminator, writer] mid 20th c.; b.Austin, MN.*
Addresses: Saint Paul, MN. **Studied:** Univ. Minnesota (B.A. & cert. eng. drafting & advanced eng. drafting, 1943); NY School Fine & Applied Art; J. Gauthier. **Member:** Nat. Lg. Am. Pen Women (pres. Minnesota Branch, 1940-42; state pres., 1942-44; nat. chmn. design, 1944-46; nat. chmn. heraldic art, 1954-56 & nat. chmn. illum. & inscriptions, 1964-66); Am Soc. Bookplate Collectors & Des.; Bookplate Assn. Int. **Exhibited:** Am. Bookplate Soc. Ann., 1916-25; Avery Lib., Columbia, 1916-25; Grolier Club, NYC, 1916-25; Bookplate Assn. Int. 1926-36; Lg. Am. Pen Women, 1936, 1938, 1940, 1942, 1944, 1946, 1950; New York Times Book Fair, 1937; U.S. Nat. Mus., 1946; St. Paul Inst.; Minneapolis Inst. Art, 1922, 1923; St. Paul Pub. Lib., 1937 (solo); Paul Elder Gal., San Francisco, 1926 (solo); Nat. Collection Fine Arts, Smithsonian Inst., 1946-66; Bookplates, 14th Ann. Int. Congress Int. Ex Libris Soc. Elsinore, Denmark, 1972. **Awards:** first award in design, Minnesota State Soc., 1913; Univ. Minnesota, 1937; Nat. Lg. Am. Pen Women, 1942, 1950; silver chalice achievement award, Kappa Kappa Gamma, 1952. **Work:** LOC; Yale Club, NYC; Minnesota State Hist. Soc.; Minneapolis Inst. Art; brass wall plaque, library, Kappa Kappa Gamma House, Univ. Minnesota, Minneapolis; complete collection of bookplates in library at Brown Univ.; Columbia Univ.; Harvard Univ.; NYPL; pub. libs., St. Paul, Minneapolis, Los Angeles; Am. Lib., Paris; Am. Assn. Univ. Women, Wash., DC; Am. Soc. Bookplate Collectors and Des.; Bookplate Assn. Int.; Hist. Soc., St. Paul, MN; bookplate reproduced in "The Book of Artist's Own Bookplates," by R.T. Saunders. **Comments:** Publications: author, *On Behalf of Accuracy, Americans Society of Bookplate Collectors and Designers Yearbook,* 1933; author, series of six articles on bookplates, *Minnesota Med.* (July-Dec.,1957), reprinted in *Univ. Minnesota Bulletin* (July, 1972). Collection: bookplates. **Sources:** WW73; WW47.

WHEELER, Clifton A. *[Painter, teacher] b.1883, Hadley, IN / d.1953.*
Addresses: Indianapolis 19, IN. **Studied:** John Herron Art Inst.; Columbia Univ.; Butler Univ.; & with William Forsyth, William Chase, Robert Henri; Europe. **Member:** Indiana AC. **Exhibited:** AWCS; PAFA Ann., 1926, 1929; GGE 1939; WFNY 1939; VMFA, 1938; Indiana Art Club; Hoosier Salon; John Herron AI; Swope Gal. Art; annually in local & regional exhibs. **Awards:** Richmond (IN), 1917 (prize); Herron AI, 1921 (prize), 1923 (prize); Indiana AA, 1924 (prize); Franklin College, 1926 (prize); Rector Mem. prize, 1927, 1932; Indiana Univ., 1928 (prize). **Work:** John Herron AI; Swope Art Gal.; Purdue Univ.; De Pauw Univ.; Indiana Univ.; Ball State College: murals, Indianapolis City Hospital, Arsenal Tech. H.S., Nancy Hanks Hall, Indianapolis, IN; Thorntown (IN) Public Library; Mooresville (IN) Public Library; Rose Polytechnic Inst., Terre Haute; Syracuse (IN) Public Library; St. Joseph's Convent, Tipton (IN); Circle Theatre, Indianapolis. **Comments:** Married daugher of art director for *Century Magazine* and lived in Irvington section of Indianapolis which was an art colony in the 1930s. Positions: instructor, John Herron Art Inst.; teacher, Shortridge H.S., Indianapolis. **Sources:** WW53; WW47; Gerdts, *Art Across America,* vol. 2: 270; Falk, *Exh. Record Series.*

WHEELER, Dora See: **KEITH, Dora Wheeler (Mrs. Boudinot)**

WHEELER, E. Kathleen See: **CRUMP, Kathleen Wheeler**

WHEELER, Edith *[Painter] early 20th c.*
Addresses: Long Branch, NJ. **Exhibited:** Soc. Indep. Artists, 1917-18. **Sources:** Marlor, *Soc. Indp. Artists.*

WHEELER, Frances *[Painter] b.1879, Charlottesville, VA.*
Addresses: Wash., DC, active 1928-c.1948. **Member:** New Haven PCC; Wash. AC; Soc. Wash. Artists; Wash. WCC. **Exhibited:** Soc. Wash. Artists; Wash. Art Lg.; Wash. WCC; Maryland Inst.; Wash. AC; Greater Wash. Independent Exhib., 1935. **Sources:** WW40; McMahan, *Artists of Washington, DC.*

WHEELER, George Bernard *[Painter] mid 20th c.*
Exhibited: Salons of Am., 1933. **Sources:** Marlor, *Salons of Am.*

WHEELER, Gertrude *[Painter] late 19th c.*
Addresses: NYC, 1886. **Exhibited:** NAD, 1886. **Sources:** Naylor, *NAD.*

WHEELER, Gervase *[Listed as "artist" (probably amateur)] mid 19th c.*
Addresses: Philadelphia. **Exhibited:** PAFA, 1850 (view near Tarrytown, NY). **Sources:** G&W; Rutledge, PA; not listed in Phila. CD 1849-55.

WHEELER, Harry *[Painter] mid 20th c.*
Exhibited: Corcoran Gal biennial, 1959. **Sources:** Falk, *Corcoran Gal.*

WHEELER, Helen Cecil *[Painter] b.1877, Newark, NJ / d.1928.*
Addresses: Newark, NJ/Edgartown, MA. **Studied:** J.C. Johansen; ASL. **Exhibited:** PAFA Ann., 1923; Corcoran Gal biennial, 1926. **Sources:** WW25; Falk, *Exh. Record Series.*

WHEELER, Hilah Drake (Mrs. Clifton) *[Painter] b.c.1878, Newark, NJ / d.1970, Daoylestown, PA.*
Addresses: Indianapolis, IN. **Studied:** ASL; with Frank Du Mond, Walter Appleton Clark & Lathrop; Chase in Europe. **Exhibited:** AWCS; John Herron AI. **Comments:** Painted portraits & silhouettes in watercolor; also gardens, still lifes & home interiors. **Sources:** WW24; Petteys, *Dictionary of Women Artists.*

WHEELER, Hughlette ("Tex") *[Sculptor] b.c.1900, Texas / d.1955, Christmas, FL.*
Addresses: Active in Alhambra, CA, 1930s; Santa Monica, CA, 1940s. **Studied:** Chicago. **Work:** Amon Carter Mus.; Will Rogers State Park, Santa Monica; Santa Anita Racetrack, Arcadia, CA. **Comments:** Sculptor of Western subjects whose work is rare. He was a friend of C. M. Russell, E. Borein, D. Cornwell, and took over F.T. Johnson's studio, 1939. **Sources:** P&H Samuels, 522-23.

WHEELER, James *[Painter] late 19th c.*
Studied: Foxcroft Cole; Keith. **Exhibited:** Paris Salon, 1891. **Sources:** Fink, *American Art at the Nineteenth-Century Paris Salons,* 405.

WHEELER, Janet Derrinda (Miss) *[Portrait painter] b.1866, Detroit, MI / d.1945, Phila., PA.*
Addresses: Phila., 1889-1931, Long Beach, CA, 1930s; Phila., c.1939-45. **Studied:** O'Connor Art School, Detroit; PAFA (won Mary Smith Prize); Académie Julian, Paris with Bouguereau and T. Robert-Fleury; also with Courtois in Paris. **Member:** Plastic Club; Phila. Art All.; AFA; Am. Woman's Club, London; Lyceum Club & Cosmopolitan Club, Phila.; Soc. Hist. Art, Paris. **Exhibited:** Paris Salon, 1890; PAFA Ann., 1889-1915 (prize 1889, 1901); Phila, AC, 1902 (gold medal); St. Louis Expo, 1904 (silver medal); Corcoran Gal annuals, 1907-08; AIC. **Comments:** Known for her portraits of children. It appears that she stopped painting about 1915. **Sources:** WW40; Hughes, *Artists in California,* 599; Fink, *American Art at the Nineteenth-Century Paris Salons,* 405; Falk, *Exh. Record Series.*

WHEELER, Kathleen (Mrs. W. R. H. Crump) See: **CRUMP, Kathleen Wheeler**

WHEELER, Laura See: **WARING, Laura Wheeler**

WHEELER, Mamie C. *[Artist] late 19th c.*
Addresses: Helena, MT, 1891-94. **Exhibited:** NAD, 1891, 1894. **Comments:** Or Mary Cecilia Wheeler. **Sources:** Naylor, *NAD.*

WHEELER, Mary Cecilia See: **WHEELER, Mamie C.**

WHEELER, Mary Colman *[Painter] b.1846, Concord, MA / d.1920, Providence, RI.*
Addresses: Providence, RI. **Studied:** May Alcott & Dr. Rimer, Boston; Jacquesson in Paris; J. de la Chevreuse; hon. degree, Brown Univ. **Member:** Providence AC; Int. Congress Drawing Teachers (delegate). **Exhibited:** Paris Salon, 1880; Officier d'Acad., French govt. **Comments:** Painted flowers, portraits & still lifes. Taught painting, drawing, art history & languages at her studio in Providence. Her biography was written by Blanch E. Wheeler Williams, her niece. **Sources:** WW19; Fink, *American Art at the Nineteenth-Century Paris Salons,* 405; Petteys, *Dictionary of Women Artists.*

WHEELER, Monroe *[Art administrator, collector] b.1900, Evanston, IL.*
Addresses: Rosemont, NJ. **Studied:** France, England & Germany. **Member:** Grolier Club (trustee); New York Genealogical & Biog. Soc. (vice-pres. & trustee); Int. Graphic Arts Soc. (pres. & trustee); French Inst. U.S. (life member); Am. Inst. Graphic Arts (trustee). **Exhibited:** Awards: Chevalier, French Legion of Honor, 1951. **Comments:** Positions: director, Am. sect., Salon Int. de Livre, Paris, France, 1932; chmn. library committee, MoMA, 1935, member advisory committee, 1937, membership director, 1938, director of publs., 1939, director of exhibs., 1940, trustee, 1945-66, hon. trustee for life, 1966, chmn. comn. drawings & prints, 1967; trustee, Ben Sahn Foundation, 1969. Author/co-author for various publications, MoMA. Collections arranged at MoMA: Modern Bookbinding by Prof. Ignatz Wiemeler, 1935; Modern Painters & Sculptors as Illustrators, 1936; Prints of George Rouault, 1938; Britain at War, 1941; 20th Century Portraits, 1942; Airways to Peace, 1943; Modern Drawings, 1944; Chaim Soutine, 1950; Georges Rouault Retrospective, 1953; Textiles and Ornaments of India, 1956; The Last Works of Henri Matisse, 1961; Bonnard & His Environment, 1964. **Sources:** WW73.

WHEELER, N. *[Miniature painter] early 19th c.*
Addresses: Boston (in 1809) and Portsmouth, NH (April 1810). **Comments:** *Cf.* Nathan W. Wheeler. **Sources:** G&W; Boston CD 1809; *Antiques* (Sept. 1944), 158.

WHEELER, Nathan W. *[Portrait painter] b.Massachusetts / d.1849, New Orleans, LA.*
Addresses: Cincinnati, OH active 1818-31; New Orleans, active1844. **Studied:** Benjamin West. **Work:** Ohio Hist. Soc., Columbus (portrait of Martin Baum, 1819). **Comments:** Born in MA c.1789-94. He was a veteran of the War of 1812 according to the 1844 newspaper notice. He advertised an exhibition of his oil paintings in 1818 in Cincinnati; his work is also known through an engraving of his portrait of Sam Houston, President of Texas. *Cf.* N. Wheeler. **Sources:** G&W; *Antiques* (March 1932), 152; Delgado-WPA cites *Courier,* Jan. 24, 1844; Fielding's supplement to Stauffer, no. 1176. Hageman, 123; *Encyclopaedia of New Orleans Artists,* 411.

WHEELER, Nina Barr *[Painter] mid 20th c.*
Addresses: NYC. **Studied:** Fontainebleau Sch. FA, France. **Exhibited:** Fontainebleau Alumni, 1935-36; NAWPS, 1935-38; 48 States Comp., 1939. **Sources:** WW40.

WHEELER, Orson Shorey *[Sculptor, lecturer] b.1902, Barnston, PQ.*
Addresses: Montreal, PQ. **Studied:** Bishop's Univ. (B.A.); RCA classes (honors), Montreal; Cooper Union; Nat. Inst. Arch. Educ.; NAD; also study in Europe. **Member:** Sculpture Soc. Canada (treasurer, 1952-67). **Exhibited:** NAD, 1940; Smith College, 1945; Ottawa, 1950; Quebec City, PQ, 1951 & 1960; Montreal MFA, 1952-57. **Awards:** Dominican Govt. Centennial Medal, 1967. **Work:** commissions: bust, Canada Pacific Railways; bust,

Court House, Montreal, PQ; Supreme Court, Ottawa; Robinson Residence for Retired Teachers, Cowansville, PQ; sculpture, Dow Chemical Chan, Ltd. **Comments:** Positions: chmn. permanent collection, Canada Handicrafts Guild, 1944-64, co-chmn., 1964-. Teaching: lecturer in fine arts, Sir George William Univ., 1931-; seasonal lecturer arch., McGill Univ., 1949-. Art interests: made over 150 scale models of world famous buildings to illustrate the history of architecture, models exhibited at Montreal MFA, 1955. **Sources:** WW73; "Quebec Arts 1958," film produced by CBC, "Madones et Abstractions" (French version), shown at Brussels World's Fair, 1958.

WHEELER, Ralph D. *[Painter] early 20th c.*
Addresses: Chicago, IL. **Sources:** WW19.

WHEELER, Ralph Loring *[Craftsperson] b.1895, Allston, MA.*
Addresses: Newton Centre, MA. **Studied:** BMFA. **Member:** Boston SAC. **Comments:** Specialty: dyeing. **Sources:** WW40.

WHEELER, Robert G. *[Art administrator] b.1917, Kinderhook, NY.*
Addresses: Detroit, MI. **Studied:** Syracuse Univ.; Columbia Univ.; NY State College Teachers. **Member:** Am. Assn. Mus. (pres., Northeastern Conf., 1953-54, 1967-68); AFA. **Comments:** Teaching: instructor, Am. art history & appreciation, Russell Sage Col., Albany Div., 1950-56. Positions: asst. dir., Albany Inst. History & Art, 1947-49, dir., 1949-56; dir. res. & publ., Sleepy Hollow Restorations, 1956-68; dir. crafts, Henry Ford Mus., 1968-69, vice-pres., 1969-71; director mus. & interpretation, 1971-. Publications: contributor, *Antiques Magazine, Am. Collector, New York Historical Soc. Bulletin, New York History, New York Sun & New York World-Tel. & Sun.* Art interests: lectures on 17th-, 18th- & 19th-century arts & crafts of the Hudson Valley. **Sources:** WW73.

WHEELER, Steve *[Abstract painter] b.1912, Czechoslovakia / d.1991, NYC.*
Addresses: Western PA mining town, 1913; NYC, 1932-on. **Studied:** AIC, 1931; ASL, 1932-36, with Miller, Sternberg, Brooks, DuMond, Grosz, and Vytlacil; Hans Hoffman Sch., 1936-38. **Exhibited:** Bessamer Gal., Pittsburgh, 1939 (solo); Pinacotecha Gal., NYC, 1942 (solo); Milwaukee AI, 1943; WMAA, 1943-47, 1949; Ferargil Gal., NYC, 1944 (solo); MMA, 1942; Univ. Illinois, 1944; St. Louis AM, 1944; PAFA Ann., 1944; Minnesota AI, 1945; AIC, 1943-46, 1947-48; New Art Circle, 1942, 1946-47; Newhouse Gal., NYC, 1945; Cincinnati AM, 1946; Santa Barbara Mus., 1948; Brooklyn Mus., 1947-51 (purhase prize for print, 1949); Richmond (VA) Mus.; AFA traveling exhibs., 1947-51; New Gal., NYC, 1951 (solo); Town Gal., NYC, 1954 (solo); Baruch College, 1991 ("Indian Space Painters"); Snyder FA, NYC, 1992, 1994, 1997 (solos); Montclair AM, 1997 (retrospective); R. York Gal., 1998. **Work:** Addison Gal. Am. Art; WMAA; Cranbrook MA; Brooklyn Mus.; MMA. **Comments:** In the midst of the Abstract Expressionist movement, he developed a unique style of abstraction that extracted elements of cubism and combined the playful images of Paul Klee with the pictographic images and space of the Indians of the Northwest Coast, the Southwest, and Peru. His work influenced a group of the 1940s known as the "Indian Space Painters" and their movement was sometimes referred to as "Semiology." Independent and difficult, he withdrew from exhibiting after the 1950s. Teaching: Cooper Union, 1946-55 & Alfred Univ., 1949. **Sources:** exh. cat., Snyder FA (NYC, 1994); exh. review in *New York Times* (Oct. 19, 1997, p.39); *American Abstract Art*, 203; Falk, *Exh. Record Series.*

WHEELER, Stewart *[Painter, printmaker] b.1906 / d.1975, Phila., PA.*
Addresses: Phila., PA. **Exhibited:** PAFA Ann., 1935; Anne Smith Antiques, Saugerties, NY; Salons of Am. **Sources:** info. courtesy of Charles Semowich, Rensselaer, NY; Falk, *Exh. Record Series.*

WHEELER, Sylvia A. *[Artist] mid 19th c.*
Comments: A fire screen of about 1830 has a drawing of the Baltimore Battle Monument, with the inscription: "Drawn by Sylvia A. Wheeler." **Sources:** G&W; *Antiques* (July 1934), cover and p. 5.

WHEELER, T. M. (Mrs.) *[Painter] late 19th c.*
Addresses: NYC, 1871-84 (Long Island, NY, 1879). **Exhibited:** NAD, 1871-84; PAFA Ann., 1882. **Sources:** Falk, *Exh. Record Series.*

WHEELER, Tex See: **WHEELER, Hughlette ("Tex")**

WHEELER, Warren *[Painter] mid 20th c.*
Exhibited: Salons of Am., 1934. **Sources:** Marlor, *Salons of Am.*

WHEELER, William R(uthven) *[Portrait, miniature and landscape painter] b.1832, Scio, MI / d.c.1894, Hartford, CT.*
Addresses: Detroit, MI; Hartford, CT, 1855-on. **Studied:** received some instruction from an itinerant miniaturist in Michigan; Alvah Bradish, c.1850-51, Detroit. **Exhibited:** Boston Athenaeum, 1859; Hartford AA (later, Conn. Sch. Design), 1872-; Detroit AA, 1876. **Work:** Lyman Allyn Mus., New London, CT; Conn. Hist. Soc.; Wadsworth Atheneum, Hartford. **Comments:** Wheeler was born into a Connecticut family and began painting professionally at the age of fifteen (1847). He specialized in elaborate children's portraits, although he also painted portraits of civic leaders and liked to do landscapes. He died between 1893-96, when his widow was listed in the Hartford directory. **Sources:** G&W; French, *Art and Artists in Connecticut*, 143; Hartford CD 1862-96; Bolton, *Miniature Painters.* More recently, see Campbell, *New Hampshire Scenery*, 172; *Art in Conn.: Early Days to the Gilded Age;* Gerdts, *Art Across America*, vol. 1: 107; Art in Conn.: Early Days to the Gilded Age.

WHEELER, Zona Lorraine *[Painter, designer, illustrator, educator, engraver, lithographer] b.1913, Linsborg, KS.*
Addresses: Wichita 8, KS. **Studied:** Bethany College (B.F.A.), with Birger Sandzen; Am. Acad. Art, Chicago; Wichita AA Sch. **Member:** Wichita Art Gld.; Nat. Lg. Am. Pen Women; Wichita AA; NSMP; Altrusa Int.; Int. Inst. Arts & Letters (fellow); Prairie WCC. **Exhibited:** CGA, 1934; Phila. Pr. Club, 1935; Kansas City AI, 1935, 1938, 1939; Rocky Mountain PM, 1935; Joslyn Mem., 1936-39; Wichita AG, 1937-46; Wichita 20th Century Club, 1937-46; Kansas Fair, 1938-39 (prize), 1942; Topeka AG, 1939-41; Oklahoma AC, 1940; SFMA, 1946; Kansas Fed. Art Traveling Exhib.; San Francisco AA; Corpus Christi *Caller-Times;* Wash. WCC; Denver Art Mus.; Springfield (MO) Mus. Art; Joslyn Art Mus.; Assoc. Am. Artists, NY; Wichita AA (solo); Wustum Mus. Art (solo); Rutgers Univ. (solo); and in England. Awards: prizes, Prairie WCC, 1946, 1950; Wichita Women Artists, 1936; Naftziger award, 1947; Printing Indus. Am.; Direct Mail Adv. **Work:** Wichita AA; Wichita Mun. Mus.; Bethany Col.; Kansas State Col.; Women's Fed. Clubs Kansas; Altarpiece, U.S. Veterans Hospital, Wichita; mural-dec., Hotel Lassen, Wichita; Woodcut Soc., Kansas City. **Comments:** Position: advertising designer & illustrator McCormick Armstrong Co., Wichita, KS, 1943-. Contributor of layouts & illus. to *Saturday Evening Post, Colliers, New Yorker, Fortune, Direct Mail Advertising.* **Sources:** WW59; WW47.

WHEELOCK, Adelaide *[Painter] early 20th c.*
Addresses: Minneapolis, MN. **Sources:** WW17.

WHEELOCK, Beatrice (McLeish) *[Painter] 19th/20th c.; b.Denver, CO.*
Addresses: Wash., DC, active 1940s; La Jolla, CA. **Studied:** Calif. State Col. **Exhibited:** Smithsonian; CGA; Wash. WCC; Wash. SMP; Wash. Lg. Women Voters, 1944 (prize). **Sources:** McMahan, *Artists of Washington, DC.*

WHEELOCK, Ellen *[Painter] early 20th c.*
Addresses: St. Paul, MN. **Sources:** WW17.

WHEELOCK, J. Adams *[Illustrator] late 19th c.*
Addresses: Brooklyn, NY. **Member:** B&W Club. **Sources:** WW98.

WHEELOCK, Lila Audubon (Mrs. Howard) *[Sculptor] b.1890, Passaic Park, NJ.*

Addresses: NYC. **Studied:** ASL. **Member:** NAWPS. **Exhibited:** PAFA Ann., 1909-10; Whitney Studio Club, NYC, 1922; NAWPS; Soc. Indep. Artists, 1917. **Sources:** WW21; Falk, *Exh. Record Series.*

WHEELOCK, Mabel L. *[Painter] mid 20th c.*
Addresses: Chicago area. **Exhibited:** AIC, 1927. **Sources:** Falk, *AIC.*

WHEELOCK, May Coverly *[Painter] b.1874.*
Addresses: NYC, 1877. **Exhibited:** NAD, 1877-78; AIC, 1900. **Sources:** Falk, *AIC.*

WHEELOCK, Merrill G. *[Portrait and landscape painter in watercolors; architect] b.1822, Calais, VT / d.1866, Chelsea, MA.*
Addresses: Boston, MA. **Exhibited:** Boston AC, 1874; Boston Atheaneum, 1859,1860; Mass. Charitable Mechanic Assoc., 1874; North Conway Lib. Exhib., 1965. **Comments:** He was working in Boston as an architect in 1853 and as a portrait painter in watercolors from 1858-61. He probably was the Wheelock who illustrated Thomas Starr King's *The White Hills,* published in Boston in 1860. **Sources:** G&W; Waite, *The Wheelock Family of Calais, Vermont,* 97; Boston CD 1858-61; King, *The White Hills;* more recently, see Campbell, *New Hampshire Scenery,* 172-73.

WHEELOCK, Walter W. *[Portrait painter] mid 19th c.*
Addresses: NYC, 1842-43. **Exhibited:** NAD. **Sources:** G&W; Cowdrey, NAD; NYCD 1843.

WHEELOCK, Warren (Frank) *[Painter, sculptor, illustrator, craftsperson, teacher, writer] b.1880, Sutton, MA / d.1960, Albuquerque, NM.*
Addresses: NYC; Santa Fe, NM, 1949. **Studied:** PIA School. **Member:** Sculptors Gld.; An Am. Group; Am. Artists Congress; Am. Abstract Artists; Soc. Indep. Artists (a founder); Woodstock AA. **Exhibited:** Soc. Indep. Artists, 1921-33, 1936-41; Woodstock, NY, 1925 (solo); Western Mus. Assoc. traveling exhib., 1925; Ehrich Gal., 1927 (solo); Corcoran Gal biennial, 1928; PAFA Ann., 1928-35, 1944-48; An Am. Group, 1932 (solo); WMAA, 1932-47; Musée du Jeu de Paume, Paris, 1938; BM, 1938; MoMA, 1939; CI, 1941; PMA, 1940; Robinson Gal., 1940 (solo); Darmouth College, 1940 (solo); Denver AM, 1941; MMA (AV), 1942; AIC, 1942; Sculptors Gld., annually; Salons of Am. Awards: Pan-Am. Exhib., Los Angeles, 1925 (prize). **Work:** WMAA; AIC; IBM Collection; Mus. New Mexico; BM; AIC; Los Angeles MA; WMAA; PMA; Corporation of Glasgow, Scotland; Bartlett H.S., Webster, MA. **Comments:** Preferred direct carving; worked with geometric shapes to create nonobjective figures. Position: drawing instructor, PIA School, Brooklyn, NY, 1905-10; sculpture instructor, CUA School, New York, NY, 1940-45. Contributor to: *American Artist* magazine. **Sources:** WW59; WW47; Fort, *The Figure in American Sculpture,* 231 (w/repro.); Woodstock AA; Falk, *Exh. Record Series.*

WHEELON, Homer *[Painter, physician] b.1888, San Jose, CA.*
Addresses: Seattle, WA. **Studied:** self-taught. **Member:** Seattle FA Soc. **Exhibited:** SAM, 1934-1937; Am. Physicians AA, 1938, 1939. **Sources:** Trip and Cook, *Washington State Art and Artists.*

WHEELRIGHT, Louise *[Painter] early 20th c.*
Addresses: Boston, MA. **Sources:** WW19.

WHEELWRIGHT, Edward *[Painter] b.1824 / d.1900.*
Exhibited: Boston Athenaeum, c.1858. **Comments:** An American painter. **Sources:** G&W; Swan, BA.

WHEELWRIGHT, Elizabeth S. *[Teacher, engraver, painter, illustrator, craftsperson] b.1915, Boston, MA.*
Addresses: Chesham, NH; Keene, NH. **Studied:** Child-Walker Sch. Art; Newton College Sacred Heart (B.A.); in Italy & with Eliot O'Hara. **Member:** New Hampshire AA; Copley Soc., Boston; Catholic AA; Sharon AC. **Exhibited:** Boston AC; Boston Soc. Indep. Artists; Southern Printmakers; New England Pr. Assn.; Catholic AA; Sharon AC; New Hampshire AA. **Comments:** Position: teacher, Cambridge Sch., Belmont Day Sch., MA; instructor, Newton College of the Sacred Heart, Newton, MA;

Keene Jr. H.S. **Sources:** WW59.

WHEELWRIGHT, Ellen duPont (Mrs. Robert) *[Painter, sculptor] b.1889.*
Addresses: North Haven, ME. **Studied:** H. Breckenridge; C. Hawthorne; R. Bridgeman; C. Sawyer. **Member:** Wilmington SFA; Phila. WCS. **Exhibited:** PAFA, 1938, 1939; Wilmington AC. **Sources:** WW40.

WHEETE, Glenn *[Block printer] b.1884, Carthage, MO / d.1965, Tulsa, OK?.*
Addresses: Tulsa, OK. **Member:** Prairie PM; Calif. PM Soc.; Soc. Etchers; Canadian Soc. GA; Woodcut Soc.; Color Block PM. **Exhibited:** Int. PM Exhib., Los Angeles, 1934 (medal); Midwestern Artists, Kansas City AI, 1937 (prize). **Sources:** WW40.

WHEETE, Treva (Mrs. Glenn) *[Printmaker (woodcuts, block prints), graphic artist, sculptor] b.1890, Colorado Springs.*
Addresses: Tulsa, OK. **Member:** Prairie PM; Calif. PM, Soc. Etchers; Canadian Soc. GA; Woodcut Soc.; Color Block PM. **Exhibited:** Int. PM Exhib., Los Angeles, 1934 (medal), 1936 (prize); Grand Central Art Gals., NYC, 1937 (jointly with her husband). **Sources:** WW40.

WHELAN, Blanche *[Painter] b.1889, Los Angeles / d.1974, Los Angeles.*
Addresses: Los Angeles, active 1918-62. **Studied:** Stanford Univ. (A.B.); Los Angeles Sch. Art & Des.; ASL; B. Robinson; N. Haz. **Member:** Calif. AC; Laguna Beach AA; Women Painters West. **Exhibited:** Calif. Liberty Fair, 1918; Kanst Gallery, Los Angeles, 1918; Calif. AC, 1918-37; WMAA, 1921; Calif. State Fair, 1930; Arizona State Fair, 1931 (first prize). **Sources:** WW59; WW47; mre recently, see Hughes, *Artists in California,* 600.

WHELAN, Henry, Jr. *[Patron] d.1907.*
Addresses: Devon, Clovelydale, PA. **Comments:** Position: pres., PAFA.

WHELPLEY, Philip M. *[Engraver and landscape painter] mid 19th c.*
Addresses: NYC, active 1845-52. **Exhibited:** American Art Union (landscapes). **Comments:** He engraved mezzotint portraits of William H. Seward, Robert Toombs, and Richard Yeadon for *The Whig Portrait Gallery* (1852). **Sources:** G&W; Stauffer; *The Whig Portrait Gallery;* Cowdrey, AA & AAU.

WHELPLEY, Thomas *[Delineator] mid 19th c.*
Comments: Delineator of two views of Cleveland (OH) in 1833, engraved by M. Osborne and published in 1834 by Whelpley, a resident of Cleveland. **Sources:** G&W; Stokes, *Historical Prints,* 75.

WHERRY, Elizabeth F. *[Painter] mid 20th c.*
Addresses: Phila., PA. **Sources:** WW25.

WHETSEL, Gertrude P. (Mrs.) *[Marine & landscape painter] b.1886, McCune, KS / d.1952, Orange County, CA.*
Addresses: Los Angeles. **Studied:** C.L. Keller. **Member:** Oregon AS. **Exhibited:** Oregon State Fair, 1922 (prizes); P&S Los Angeles, 1936. **Sources:** WW33; Hughes, *Artists in California,* 600.

WHETSTONE, John S. *[Portrait sculptor] mid 19th c.*
Addresses: Cincinnati, OH, 1837-41. **Sources:** G&W; Cist, *Cincinnati in 1841,* 141.

WHETTEN, Alice *[Painter] mid 19th c.*
Sources: Falk, *Dict. of Signatures.*

WHETTING, John *[Painter] b.c.1812, Germany.*
Addresses: Cincinnati in 1850. **Sources:** G&W; 7 Census (1850), Ohio, XX, 766.

WHIDDEN, William Marcy *[Painter] late 19th c.; b.Boston.*
Studied: Vaudremer. **Exhibited:** Paris Salon, 1880. **Comments:** Exhibited a drawing at the Paris Salon. **Sources:** Fink, *American Art at the Nineteenth-Century Paris Salons,* 405.

WHIFFEN, Lloyd Dundas *[Painter, sketch artist] b.1885, India / d.1951, Alameda, CA.*
Addresses: England; Alameda, CA. **Studied:** England; Italy. **Member:** Carmel AA. **Exhibited:** Bay Region AA, 1935. **Comments:** Immigrated to California c.1912 and painted missions and historical buildings, which were reproduced on postcards and stationary. Other subjects include landscapes, marines, garden and farm scenes from Palm Springs to Yosemite. **Sources:** Hughes, *Artists in California*, 600.

WHINSTON, Charlotte (Mrs. Charles N.) *[Painter, sculptor, printmaker] b.c.1894, NYC / d.1976, NYC.*
Addresses: Mt. Vernon, NY; NYC. **Studied:** NY School Fine & Applied Arts, scholarship; NAD, with George Maynard & sculpture with Fredrick Roth; CUA School; ASL with George Luks. **Member:** Soc. Indep. Artists; Yonkers AA; Westchester Art & Crafts Gld; Audubon Artists (treasurer, 1963-64 & 1971-73); All. A. Am.; NAWA (vice-pres., pres. & advisor); Am. Soc. Contemporary Artists; Nat. Soc. Painters Casein & Acrylic (chmn. traveling exhibs., 1960-61; director chmn. awards, 1971-72); PBC. **Exhibited:** Soc. Indep. Artists; Yonkers AA; Westchester Arts & Crafts Gld.; NAWA, 1946-61; Contemporary Club, White Plains, NY, 1947 (solo); Pen & Brush Club, 1949, 1955; Engineering Women, NY, 1950; New York Soc. Women Artists, Riverside Mus. Ann., 1956, 1958 & 1962; Brooklyn Soc. Artists, 1957-61; Assn. Greek Women Artists & U.S. Info Service, Am. Gallery, Athens, Greece, 1957; Munic. Mus. Uneo Park Tokyo, 1960; Audubon Artists Ann. & All. A. Am. Ann., NAD Gals., 1960-72; Arg. Exhib., Mus. Nac. Artes, Buenos Aires & Rio de Janeiro, 1964. Awards: NAD, 1917 (medal); CUA School, 1917 (prize); first prize for watercolor, Indiana (PA) Univ., 1949; first grand prize for watercolor & silver medal, Seton Hall Univ., 1958; bronze medal for oil, NAWA, 1969. **Work:** Smith College, Northampton, MA; Univ. Wisconsin-La Crosse; Riverside Mus. Collection, Rose Art Mus., Brandeis Univ.; Seton Hall Univ., NJ; Norfolk (VA) Mus. Commissions: Urban Bldg. (exterior mural, porcelain enamel on steel), commissioned by Henry Goelet, 1956. **Comments:** Positions: director/chmn. nominations, New York Soc. Women Artists, 1968-71. Publications: contributor, *Today's Art*, summer 1960; co-author, article, *Art Am.*, 1961. **Sources:** WW73; WW47; Margaret Harold, *Prize Winning Art* (Allied Publ., 1968 & 1969).

WHIPPLE *[Artist?] mid 19th c.*
Comments: Proprietor and possibly the artist of a series of dissolving views shown in Baltimore in 1851. **Sources:** G&W; Baltimore *Sun*, Jan. 26, 1851 (G&W has information courtesy J. Earl Arrington).

WHIPPLE, Barbara (Mrs. Grant Heilman) *[Printmaker, writer] b.San Francisco, CA / d.1989.*
Addresses: Lititz, PA. **Studied:** Swarthmore College (B.A., 1943); Rochester Inst.Technology (B.S., 1956); Tyler School, Temple Univ. (M.F.A., 1961). **Member:** Phila. WCC; Phila. Art All.; Phila. Print Club; AEA; Swarthmore College Board Mgrs. **Exhibited:** Swarthmore (PA) College, 1964 (solo); Oak Ridge (TN) Art Center, 1966 & Asheville Art Mus., 1967; Elizabethtown (PA) College, 1971 (solo) & Lebanon Valley College, Annville, PA,1973 (solo). Awards: best of show & purchase prize, Library Religious Art Exhib., Denver, CO, 1967; first prize, Lancaster (PA) Open Award, 1968; juror's award, Reading (PA) Regional, 1969. **Work:** Newark (NJ) Public Library; Elizabethtown (PA) College; Lancaster (PA) Country Day School. Commissions: woodcut prints, Jr. League Lancaster, PA. **Comments:** Teaching: art instructor, Mem. A. Gal., Univ. Rochester, 1955-58; art instr., Rochester School Deaf, 1956-58; assoc. prof. of art, Geneseo State Teachers Col., 1958-59. Publications: author, "Art for the Child from 6 to 9," *Instr.,* 1956; author, "Another Key: Art," *Volta Review,* 1958; author, "Luigi Rist: Printmaker," 1971, "William E. Sharer, Painter," 1973 & "Ford Ruthling, Master of the Ball Point Pen," 1973, *Am. Artist.* **Sources:** WW73; "Barbara Whipple, Printmaker," *La Révue Moderne* (January, 1966).

WHIPPLE, Beatrice F(ranklin) *[Painter] mid 20th c.*
Addresses: Cranford, NJ. **Exhibited:** Soc. Indep. Artists, 1931-32, 1934-44; Salons of Am., 1934, 1936. **Sources:** Falk, *Exhibition Record Series.*

WHIPPLE, C(harles) Ayer *[Portrait painter, mural painter] b.1859, Southboro, MA / d.1928, Wash., DC.*
Addresses: NYC. **Studied:** Normal Art Sch.; BMFA Sch.; Académie Julian, Paris with Bouguereau, Robert Fleury, and Ferrier, 1889. **Work:** Republican Club, NYC; State Dept., War Dept., Post Office Dept., Navy Dept., all in Wash., DC; West Point, NY; State Hist. Bldg., Des Moines; Ottawa, Canada. **Comments:** He was engaged in retouching the famous Burmidi paintings at the Capitol, 1921-28. **Sources:** WW17.

WHIPPLE, Dorothy Wieland *[Painter, teacher] b.1906, Sandusky, OH.*
Addresses: Toledo, OH. **Studied:** Cleveland Sch. Art. **Member:** Toledo Women's AL; Western AA. **Comments:** Contributor: article, "Clay Modeling Stimulates Visual Senses," *Design* magazine, 1937. **Sources:** WW40.

WHIPPLE, Elsie R. *[Painter] 20th c.*
Addresses: Pittsburgh, PA. **Member:** Pittsburgh AA. **Sources:** WW21.

WHIPPLE, Enez Mary *[Art administrator] mid 20th c.; b.Syracuse, NY.*
Addresses: East Hampton, NY. **Studied:** Syracuse Univ. (B.S., journalism). **Member:** AFA; Am. Assn. Mus.; NY State Assn. Mus. **Comments:** Positions: exec. director, Guild Hall East Hampton, 1948-. Teaching: adjunct professor, humanities, Southampton College, Long Island Univ., 1971. **Sources:** WW73.

WHIPPLE, Georgia Morgan (Miss) *[Painter] 19th/20th c.*
Addresses: Tacoma, WA, 1896. **Member:** Tacoma Art League, 1891, 1892. **Exhibited:** Western Wash. Indust. Expo, 1891. **Sources:** Trip and Cook, *Washington State Art and Artists.*

WHIPPLE, John Adams *[Daguerreotypist, photographer] b.1822, Grafton, MA / d.1891, Boston.*
Exhibited: London, 1851 (Council medal); NYC, 1853-54 (silver medal). **Comments:** A pioneer daguerreotypist, in 1844 he invented the first glass wet-plate negatives for making albumen photographs on paper (although in 1848 his announcement was beaten by the Frenchman, Niépce). He later developed the "Crytalotype" print. In Boston, he was a partner in galleries with Albert Litch (1844-46), Wm. B. Jones (1849), and J.W. Black (1856-59). He was among the very first to photograph the moon (1849), a star (1850), and to photograph through the microscope. In 1863 in Boston, he took the first photographs illuminated by electric light outside at night. He quit photography in 1874 when he began publishing religious books. **Sources:** Welling; Newhall, *The Daguerreotype in America,* 155.

WHIPPLE, Mary H. *[Painter] late 19th c.*
Addresses: Greenfield, MA. **Exhibited:** PAFA Ann., 1896-97. **Sources:** Falk, *Exh. Record Series.*

WHIPPLE, Seth Arca *[Marine painter] b.1855, New Baltimore, MI / d.1901, Detroit, MI.*
Addresses: Detroit, MI, from 1871. **Exhibited:** Michigan State Fair, 1880; Great Art Loan, 1883; Detroit Mus. of Art, 1886; Art Club of Detroit, 1895; commercial galleries in Detroit during the 1880s and 1890s. **Work:** Dossin Great Lakes Mus., Belle Isle, MI. **Comments:** Specialty: ship portrait painter, active around Great Lakes Region. **Sources:** Gibson, *Artists of Early Michigan,* 243; Brewington, 412; Gerdts, *Art Across America,* vol. 2: 237.

WHIPPLE, W. *[Portrait painter] mid 19th c.*
Addresses: Rossville, OH, active 1842. **Sources:** Hageman, 123.

WHISENHUNT, Mina Price *[Painter] mid 20th c.*
Addresses: Syosset, LI, NY. **Exhibited:** Soc. Indep. Artists, 1934. **Sources:** Marlor, *Soc. Indp. Artists.*

WHISH, Lilian J. *[Painter] mid 20th c.*
Addresses: Albany, NY. **Member:** New Haven PPC. **Sources:** WW25.

WHISHNER, G. Arthur *[Painter] mid 20th c.*
Addresses: Columbus, OH. **Member:** Columbus PPC. **Sources:** WW25.

WHISLER, Howard F(rank) *[Painter] b.1886, New Brighton, PA.*
Addresses: NYC. **Studied:** ASL; PAFA, with Breckenridge, McCarter, Cresson European Sch., 1910-12. **Member:** Arch. Lg.; Northshore AA. **Sources:** WW33.

WHISTLER, George Washington *[Drawing teacher] b.1800, Fort Wayne, IN / d.1849, St. Petersburg, Russia.*
Studied: West Point, 1814-19, graduated. **Comments:** Served as assistant professor of drawing at West Point during the winter of 1821-22. He became a prominent civil engineer, helping to build the Baltimore and Ohio and other railroads. Retiring from the army in 1833, he settled in Lowell (MA), where his famous son, James Abbott McNeill Whistler (see entry), was born in 1834. In 1842 the elder Whistler went to Russia to build a railroad between St. Petersburg and Moscow for the Russian Government.
Sources: G&W; DAB; Pennell, *The Life of James McNeill Whistler.*

WHISTLER, James Abbott McNeill *[Portrait, figure, and landscape painter; etcher; lithographer, writer, teacher] b.1834, Lowell, MA / d.1903, London, England.*

Whistler.

Addresses: London, England (since 1859). **Studied:** probably with his father, George Washington Whistler [1800-49] who had taught drawing at West Point [1821-22]; Imperial Acad. FA, St. Petersburg, Russia, 1845; Pomfret, CT, 1849-51; West Point, 1851-54 (flunked out); Paris, under Gleyre, 1855 (briefly). **Member:** Officer, Legion of Honor; Acad. St. Luke, Rome; Royal Acad. Bavaria; Soc. British Artists, 1884 (pres., 1886; resigned after dispute, 1888); Int. Soc. PS&G, London (pres./founder) 1898; Royal Acad., Dresden; RSA; Soc. Nat. Beaux-Arts, Paris. **Exhibited:** NAD, 1868, 1874; Paris Salon, 1859-1900 (medal, 1883, gold 1889, medal1900); Munich Int. Expo, 1892 (medal); AIC; PAFA, 1893-1894 (gold), 1896-1903 (and posthumously); London FA Soc., 1883; Copley Soc., Boston, 1904; Armory Show, 1913. In 1863 his "Symphony in White" (NGA, Wash., DC) was refused at the Paris Salon but was hung at the Salon des Refusées, where it created a sensation. **Work:** MMA; NMAA; NGA; BMFA; AIC; PMA; Tate, London; Louvre, Paris; Freer Gal. Art, Wash., DC (the "Peacock Room," which he decorated to hold the Oriental porcelains of Frederick R. Leyland); Detroit IA; Glasgow AM; Shelburne (VT) Mus.; Taft Mus., Cincinnati. **Comments:** Whistler spent his childhood in the U.S. and Russia (1842-49). After leaving West Point in 1854, he worked for a year in the Coast and Geodetic Survey as a draftsman. In 1855 he left for Europe, never to return to the United States. He spent four years in Paris as part of the café society of avant-garde artists, writers, and poets that included his close friends Henri Fantin-Latour and Alphonse Legros, as well as Manet, Degas, Charles Baudelaire and Stephane Mallarme. He was among the earliest artists to incorporate the decorative design elements of Japonisme to manipulate two-dimensional space rather than offer a window to reality. By 1859 Whistler had settled permanently in London, but continued to visit Paris and traveled extensively throughout Europe and North Africa. He opened his Académie Carmen in Paris, 1889 (briefly called "Académie Whistler") and enlisted the help of his friend, Frederick MacMonnies. The new school immediately drew hundreds of students away from the other schools in Paris. However, Whistler's diminishing appearances resulted in the school closing in 1901. Among his leading American students

were F. Frieske and H.S. Hubbell. Witty and caustic, his fascinating personality kept him constantly before the public. In 1878, he sued John Ruskin for libeling his work. Whistler won the case — and one farthing — then went bankrupt. Ruskin had a mental breakdown. The pervasive and lasting influence of Whistler cannot be overemphasized. even the artistic way in which exhibitions are hung today owes a debt to this exacting master. He is also ranked with Rembrandt as the greatest of etchers, and his "Nocturne" lithographs are among the best the medium has ever offered. Even his frame designs were of great influence, for he perceived the frame as an extension of the art. His fluted reed mouldings have come to be known as "Whistler frames." Signature note: He typically signed his oils as "Whistler," but frequently applied his famous butterfly symbol in many variations. Author: "Ten O'Clock Lecture;" *The Gentle Art of Making Enemies* (1890). **Sources:** G&W; WW01; an early biography is *The Life of James McNeill Whistler* by Elizabeth and Joseph Pennell (1908). See also Park, *Mural Painters in America,* Part I; James Warren Lane, *Whistler* (New York, 1942); *Whistler Journal* (1921); Stanley Weintraub, *Whistler: A Biography* (New York: Weybright and Talley, 1974); Andrew McLaren Young, *The Paintings of James McNeill Whistler* (Yale Univ. Press, 1980); David P. Curry, "Whistler and Decoration" *Antiques* (Nov. 1984, p.1186); Linda Merill, *The Peacock Room: A Cultural Biography* (Freer Gallery, with Yale Univ. Press, 1998); *The Lithographs of James McNeill Whistler* (2-vol. catalogue raisonné, Chicago: AIC, 1998); Baigell, *Dictionary; American Painter-Etcher Movement* 52; Muller, *Paintings and Drawings at the Shelburne Museum,* 138 (w/repro.); frame info courtesy Eli Wilner Co., NYC; Falk, *Exh. Record Series.*

WHISTLER, Joseph Swift *[Craftsperson] b.1860, Baltimore / d.1905.*
Addresses: Lenox, MA. **Studied:** Harvard; abroad. **Comments:** Nephew of James McNeill Whistler.

WHISTLER, Rex *[Painter] mid 20th c.*
Exhibited: AIC, 1937. **Sources:** Falk, *AIC.*

WHITAKER, Alice J. *[Artist] late 19th c.*
Addresses: Active in Big Rapids, MI, 1891-93. **Sources:** Petteys, *Dictionary of Women Artists.*

WHITAKER, Charles *[Engraver] mid 19th c.*
Addresses: NYC, 1842. **Comments:** Of Bingley & Whitaker(see entry). **Sources:** G&W; NYCD 1842.

WHITAKER, Edward H. *[Painter] b.1808, New Hampshire / d.After 1862.*
Addresses: Boston, 1850. **Exhibited:** Boston Athenaeum, 1830, 1831(still lifes). **Comments:** Was listed as a fresco painter in Boston in the 1850 census. Swan states that he was active until 1862. **Sources:** G&W; Swan, BA; BA Cat., 1831; 7 Census (1850), Mass., XXVI, 705. More recently, see Campbell, *New Hampshire Scenery,* 173.

WHITAKER, Eileen (Mrs. Frederic) See: **MONAGHAN, Eileen**

WHITAKER, Ethel *[Painter] b.1877, Southbridge, MA / d.1901.*
Addresses: Winthrop, MA. **Studied:** BMFA; A. Graves, A. Palmer. **Exhibited:** Boston AC, 1900. **Sources:** WW01.

WHITAKER, Evelyn L. *[Painter] mid 20th c.*
Addresses: NYC. **Studied:** ASL. **Exhibited:** Soc. Indep. Artists, 1927-29. **Sources:** Marlor, *Soc. Indp. Artists.*

WHITAKER, Frederic *[Painter, writer] b.1891, Providence, RI / d.1980.*
Addresses: Cranston, RI; living in La Jolla, CA, 1976. **Studied:** RISD, with Cyrus Farnum, 1907-11. **Member:** AWCS (pres., 1949-56); SC; All. Artists Am; NAD, 1951 (vice-pres., 1956-57); Royal Soc. Arts, London (fellow); Audubon Artists (pres., 1943-46); Int. Assn. Plastic Arts (vice-pres., 1954-61); Providence AC; Wash. WCC; Providence WCC; South County AA. **Exhibited:**

Oakland Art Gal., 1942-44 (prizes); Audubon Artists, annually; Wash. WCC, annually; All. A. Am., annually; PAFA, 1946; AWCS, 1938-72; NAD, 1945-72; Royal WCS, London, 1962; Watercolor USA Ann., Springfield, MO, 1962-72; MMA Centennial AWCS, 1966; Grand Central Art Galleries, NYC, 1970s. **Awards:** Wash. WCC,1942 (prize); All. Artists Am., 1944 (prize); SC, 1944 (prize); Bridgeport, CT, 1944 (prize); Gloucester, MA, 1944 (prize); Parkesburgh (WV) FA Center, 1945 (prize); AWCS, 1949 (silver medal); AAPL Grand Nat., 1969 (best in show); Springville (UT) Art Assn., 1970 (best in show for all media). **Work:** Cayuga Mus. Hist. & Art; Neilson Mus., Pocatello, ID; Lawrence Gal., Atchison, KS; Providence AC; IBM Collection; MMA; BMFA; Hispanic Mus., New York; Frye Mus., Seattle, WA; Salt Lake City (UT) Art Mus. **Comments:** Positions: designer, Gorham Co., Providence, 1916-21; designer, Tiffany Co., New York, 1922. Teaching: private instructor in watercolors, 1958-64. Publications: author, "85 Monographs," *Am. Artist,* 1956-72; author, *Whitaker on Watercolor,* 1963 & *Guide to Painting Better Pictures,* 1965, Van Nostrand Reinhold; author, *Illus. Autobiography,* 1976. **Sources:** WW73; Norman Kent, *Watercolor Methods* (1955) & Susan Meyer, *Twenty-Four Watercolorists* (1972), Watson-Guptill; Janice Lovoos, *Frederic Whitaker* (Northland, 1972).

WHITAKER, George William *[Landscape painter, marine painter]* b.1841, Fall River, MA / d.1916, N. Providence, RI.

G.W.WHITAKER.

Addresses: NYC, 1867; Providence, RI, 1879. **Studied:** apprenticed to his uncle, and engraver, in NYC; encouraged by Inness and A.H. Wyant; in Paris privately with Laszlo De Paal (although some accounts state that he studied at the Académie Julian, he is not listed in Fehrer). **Member:** Providence AC; Providence WCC (founder). **Exhibited:** Brooklyn AA, 1867-70; NAD, 1867, 1879; RISD; Doll & Richards Gal., Boston; Providence AC; Boston AC, 1882-80; PAFA Ann., 1882-83. **Work:** RISD Mus.; Providence AC; Rhode Island Hist. Soc.; Kresge Art Center, MI. **Comments:** Best known for his Tonalist landscapes, evocative of his years at Barbizon and Fontainebleau. He was a key figure (with E.M. Bannister, Sydney Burleigh, and C.W. Stetson) in the founding of the Providence AC (1880) and its flourishing over the next several decades. In 1895 he moved into Burleigh's "Fleur de Lys" studio building. Upon his death, he was called the "Dean of Providence Artists." Teacher: RISD (first instructor in oil painting). **Sources:** WW15; exh. cat., *Painters of Rhode Island* (Newport AM, 1986); C. Bert, *Sketches* (Providence, No.1, Dec. 1990); Falk, *Exh. Record Series.*

WHITAKER, Irwin A. *[Educator, craftsman]* b.1919, Wirt, OK. **Addresses:** Okemos, MI. **Studied:** San Jose State College (B.A.); Claremont College (M.F.A.), with Richard Pettersen. **Member:** Midwest Designer-Craftsmen Council (bd. mem., 1958-60). **Exhibited:** many national & regional exhibs. **Awards:** first award for ceramics, Calif. State Fair, 1949; purchase award for ceramics, Univ. Nebraska, 1959; purchase award for enamel, Detroit Inst. Art, 1962. **Work:** Detroit Art Inst. **Comments:** Preferred media: ceramics, enamels, plastics. Publications: author, *Crafts and Craftsmen,* 1967. Teaching: ceramics instructor, Southern Oregon College, 1949-50; ceramics professor, Michigan State Univ., 1950-. Research: contemporary Mexican pottery. **Sources:** WW73.

WHITAKER, John *[Painter]* 20th c. **Addresses:** Phila., PA. **Sources:** WW04.

WHITAKER, Lawrence Leroy *[Painter]* b.1889, Reynoldsville, PA. **Addresses:** Windber, PA. **Studied:** Emile Walters. **Member:** All. Artists Johnstown; Pittsburgh AA. **Exhibited:** All. A. Am.; Indiana State Teachers Col.; PMG; Penn. State Col.; Carnegie Inst.; All. Artists Johnstown; Butler AI; Soc. Indep. Artists. **Awards:** prizes, All. Artists Johnstown, 1933-36, 1938; Ebensburg Fair, 1938, 1939; Bedford Fair, 1938; Carnegie, 1939, 1943.

Work: PMG; Penn. State College; Indiana State Teachers College; Pittsburgh Pub. Sch.; Somerset Pub. Sch. **Sources:** WW53; WW47.

WHITAKER, Ruth Townsend *[Painter]* early 20th c. **Addresses:** Ocean Beach, CA, 1916-35. **Member:** Calif. WC Soc.; San Diego Moderns, 1933. **Exhibited:** Calif.-Pacific Int. Expo, San Diego, 1935. **Sources:** Hughes, *Artists in California,* 600; Trenton, ed. *Independent Spirits,* 76.

WHITAKER, Stella Trowbridge (Mrs.) *[Painter]* early 20th c. **Addresses:** Cambridge, MA. **Studied:** ASL. **Member:** Soc. Indep. Artists. **Sources:** WW24.

WHITAKER, William *[Painter]* late 19th c. **Work:** Shelburne (VT) Mus. **Comments:** Active in 1871. **Sources:** Muller, *Paintings and Drawings at the Shelburne Museum,* 139 (w/repro.).

WHITCOMB, Jon *[Painter, illustrator]* b.1906, Weatherford, OK / d.1988. **Addresses:** Darien, CT. **Studied:** Ohio Wesleyan Univ., 1923-27; Ohio State Univ. (A.B., 1928). **Exhibited:** Art Dir. Club, 1946; SI, 1946. **Comments:** Best known for his portraits of glamorous women. Positions: poster artist, RKO Theatres, Chicago, 1928-29; art advertising, Cleveland, OH, 1930-34; vice-pres., Charles E. Cooper, Inc., NYC, 1935-64. Teaching: Famous Artists Sch., 1973. Publications: illustrator & author of articles, *Cosmopolitan, Illustrator, Ladies Home Journal, McCall's, Redbook.* **Sources:** WW73; WW47.

WHITCOMB, L. (Miss) *[Flower painter]* late 19th c. **Comments:** Active in the late 1870s. **Sources:** Petteys, *Dictionary of Women Artists.*

WHITCOMB, Raymond Everett *[Painter]* b.1903, Winterset, IA. **Addresses:** Adel, IA. **Studied:** Charlotte Fairbanks. **Exhibited:** Iowa Art Salon. **Work:** murals in businesses and other work in priv. colls. **Sources:** Ness & Orwig, *Iowa Artists of the First Hundred Years,* 219.

WHITCOMB, Susan *[Amateur artist]* mid 19th c. **Addresses:** Brandon, VT. **Work:** Rockefeller Folk Art Center. **Comments:** In 1842 she painted a view of Mount Vernon, Washington's home, after A. Robertson (probably Archibald Robertson, see entry). **Sources:** G&W; *Antiques* (July 1946), 41.

WHITCRAFT, Dorothea Fricke *[Painter]* b.c.1896, Fairmont, NE. **Addresses:** Active in Albuquerque, NM from c.1925. **Studied:** AIC. **Member:** New Mexico Art Lg., 1928 (a founder). **Exhibited:** NYC; New Mexico. **Comments:** Established first art dept., Univ. New Mexico; and opened a gallery in Albuquerque in 1945. **Sources:** Petteys, *Dictionary of Women Artists.*

WHITE, A. S. (Mrs.) See: **COX, Julia Mary**

WHITE, Agnes Baldwin Hofman *[Portrait and mural painter, illustrator]* b.1897, Columbus, OH. **Addresses:** Marietta, OH. **Studied:** Columbus Art Sch.; PAFA; École des Beaux-Arts, Fontainebleau, France. **Member:** Nat. Soc. Arts & Letters; Soc. Four Arts, Palm Beach, FL; Marietta Art Lg.; Nat. Soc. Arts & Letters (pres., Ohio River Valley Chapter); Columbus AL. **Exhibited:** AWCS, 1941; Soc. Four Arts, 1942-45; Columbus Gal. FA, 1941-46; Marietta Art Lg., 1956-58; Ogleby Inst., 1958. **Work:** portrait, Marietta College; murals, Hobe Sound, FL; Airport, Stuart, FL. **Sources:** WW59; WW47.

WHITE, Albert *[Artist]* b.c.1898, Denver, CO / d.1972, Los Angeles. **Addresses:** Active in Brooklyn, NY, 1938-41. **Comments:** Changed his name from Weinberger to White. **Sources:** BAI, courtesy Dr. Clark S. Marlor.

WHITE, Alden *[Etcher] b.1861, Acushnet, MA / d.1942, Acushnet.*
Addresses: New Bedford, MA, active 1914-20. **Studied:** V. Preissig; Haskell. **Member:** Chicago SE. **Exhibited:** New Bedford Art Club, 1914-20. **Comments:** Encouraged in his art by his cousin, Clifford Ashley (see entry). **Sources:** WW31; Blasdale, *Artists of New Bedford*, 205-206 (w/repro.).

WHITE, Alice Mary *[Painter] early 20th c.*
Addresses: Chicago. **Exhibited:** AIC, 1919, 1921, 1923. **Sources:** Falk, *AIC*.

WHITE, Alma Glascow (Mrs. J. D.) *[Painter] b.1840, Washington, IA / d.1884.*
Studied: Brooklyn, NY. **Exhibited:** World's Fair, Chicago, 1893; AIC. **Work:** State Historical Bldg., Des Moines (portraits). **Comments:** Daughter of Hon. Robert Glascow, member of House of Representatives of State of Iowa, and Mary Finley White. **Sources:** Ness & Orwig, *Iowa Artists of the First Hundred Years*, 219.

WHITE, Alma Glasgow *[Painter] mid 20th c.*
Addresses: San Francisco. **Member:** Soc. Indep. Artists. **Exhibited:** Stanford Univ., 1930; Salons of Am., 1932. **Comments:** Not to be confused with Alma Glascow White (see entry). **Sources:** Hughes, *Artists in California*, 600.

WHITE, Ambrosia Chuse (Mrs. John C.) *[Painter, teacher, writer] b.1894, Belleville, IL.*
Addresses: Madison, WI; Rockford, IL. **Studied:** Notre Dame Acad.; St. Louis Sch. FA; Univ. Wisconsin (B.S.); & with Frederic Taubes; Wash. Univ., St. Louis. **Member:** Madison Artists Gld. **Exhibited:** St. Louis Artists Gld., 1935; All-Illinois Soc. FA, 1936-38; Milwaukee AI, 1938; Wisc. Salon Art, 1943; Madison Artists Gld., 1935-46. **Comments:** Position: art teacher, Jr. H.S., Beloit, WI, 1945-46; art supervisor, Dane County Rural Schools, 1947-49; art teacher, St. James Parochial Schools, Madison, WI, 1949-52; primary teacher, Dist. 122, Rockford, IL, 1953-55. Author: *Holiday Story Book.* **Sources:** WW59.

WHITE, Amos *[Portrait painter] mid 19th c.*
Addresses: Hanover, NY, 1859. **Sources:** G&W; N.Y. State BD 1859.

WHITE, Antoinette G. *[Artist] late 19th c.*
Addresses: NYC, 1885; Norwolk, CT, 1886. **Exhibited:** NAD, 1885, 1886. **Sources:** Naylor, *NAD*.

WHITE, Belle Cady *[Painter, drawing specialist, teacher] b.1868, Chatham, NY / d.1945, Hudson, NY.*
Addresses: Brooklyn, NY/Chatham Center, NY. **Studied:** PIA School; Snell; Woodbury; Hawthorne. **Member:** AAPL; AWCS; Brooklyn WCC. **Exhibited:** Brooklyn SA, 1932 (prize); NAD; Salons of Am.; AIC. **Work:** Rollins College, FL; public schools, St. Louis. **Comments:** Author/illustrator: article "Everyday Art." Position: teacher, PIA School. **Sources:** WW40; *Charles Woodbury and His Students.*

WHITE, Benjamin *[Listed as "artist"] b.c.1828, Ireland.*
Addresses: Philadelphia. **Exhibited:** PAFA, 1850 (landscape). **Comments:** He was listed in the 1850 directory as a sculptor. **Sources:** G&W; 7 Census (1850), Pa., LI, 376; Rutledge, PA; Phila. CD 1850.

WHITE, Benny *[Painter, sculptor, graphic artist] b.1937, Detroit, MI.*
Studied: Soc. Arts & Crafts, 1961-64. **Exhibited:** Detroit IA. **Sources:** Cederholm, *Afro-American Artists.*

WHITE, Bob *[Painter] mid 20th c.*
Addresses: Sioux City, IO. **Exhibited:** WMAA, 1938. **Sources:** Falk, *WMAA.*

WHITE, Bruce Hilding *[Sculptor] b.1933, Bay Shore, NY.*
Addresses: Chicago, IL. **Studied:** Univ. Maryland (B.A.); Columbia Univ. (M.A. & Ph.D.). **Exhibited:** Chicago & Vicinity Artists 72nd & 73rd Ann., AIC, 1969 & 1971; Sculpture Nat., Purdue Univ., 1970; Large Sculpture 4th Ann., Blossom Kent Festival, OH, 1971; 12th Midwest Biennial, Joslyn AM, Omaha, NE, 1972. **Work:** Indiana Mus. Arts & Sciences, Evansville; Western Illinois Univ.; Columbia Univ.; Northern Illinois Univ. Commissions: stainless steel sculpture, Rogers Library & Mus. Art, Laurel, MS. **Comments:** Preferred media: aluminum, steel. Teaching: prof. of sculpture & area chairman, sculpture & crafts, art dept., Northern Illinois Univ., 1968-. **Sources:** WW73.

WHITE, C. Bolton *[Painter] mid 20th c.*
Addresses: Los Altos, CA, 1930s. **Exhibited:** Oakland A. Gal., 1932; Bohemian Club, 1939. **Sources:** Hughes, *Artists in California*, 600.

WHITE, Carrie Harper (Mrs. John) *[Watercolorist, teacher] b.1875, Detroit, MI.*
Studied: Cleveland School Art; Arch. Lg., NY; NY School Applied Design; José Arpa, Texas. **Comments:** Married in 1900 and did not resume painting until she moved to Legion, TX in 1925. **Sources:** Petteys, *Dictionary of Women Artists.*

WHITE, Charles F. *[Painter] mid 20th c.*
Addresses: Chicago area. **Exhibited:** AIC, 1946. **Sources:** Falk, *AIC.*

WHITE, Charles Henry *[Illustrator, etcher] b.1878, Hamilton, Ontario / d.1918, Nice, France.*
Addresses: NYC; New Orleans, active 1906. **Studied:** ASL; Joseph Pennell; Acad. Julian, Paris with J.P. Laurens & Benjamin Constant, 1894, 1898; Whistler in Paris. **Exhibited:** St. Louis Expo, 1904 (medal); AIC. **Comments:** Produced six etchings for his article "New Orleans" for *Harper's Monthly*, 1906. **Sources:** WW10; *Encyclopaedia of New Orleans Artists*, 411.

WHITE, Charles (Wilbert) *[Painter, graphic artist, educator, lithographer] b.1918, Chicago, IL / d.1979, Los Angeles, CA.*
Addresses: NYC; Los Angeles, CA. **Studied:** AIC; ASL; Taller Grafica Mex; (hon. D.F.A.), Columbia College (IL) and with Harry Sternberg, Briggs Dyer, George Neal. **Member:** ANA; Artists Lg. Am.; AEA; Assn. War Veteran Artists of Am.; Black Acad. Arts & Letters (exec. bd. mem.); Nat. Conf. Artists; Otis AA; Pasadena Soc. of Artists; National Center of Afro-American Artists. **Exhibited:** American Negro Expo., Chicago, 1940 (award); AIC, 1942; LOC, 1941; Atlanta Univ., 1942-45, 1953 (award), purchase awards in 1946, 1951,1959, 1961; SFMA, 1946; in Japan, India, France; ACA Gal., NYC, 1942, 1946, 1948, 1951 (solos); BMFA, 1943; BM; Smith College, 1943; MMA, 1952 (prize); Oakland Mus., 1966; Howard Univ, 1967; Morgan State College, 1967; Palace of Culture, Warsaw, 1967; Fisk Univ., 1968; Univ. of Dayton, 1968; Central State Col., 1968; Wilberforce Col., 1968; Wright State Univ., 1968; Dayton AI, 1968; Otis AI, 1968; Kunstnernes Hus, Oslo, 1968; Pushkin Mus., Moscow, 1968; Hermitage Mus., Leningrad, 1968; Heritage Gal., Los Angeles, 1968, 1971; Jackson State Col., 1968; Florida A & M Univ., 1968; Johnson C. Smith Univ., 1968; Dartmouth Col., 1968; WMAA, 1950-56,1968, 1971; Charles Bowers Mus., Santa Ana, CA, 1969; "Am. Drawings of the Sixties," New School AC, New York, 1969; Bowdoin Col., 1969; Ludwigshafen, Germany, 1969; Chaffey Col., 1969; Riverside AA, 1969; Claremont Col., 1969; Wisconsin Univ., 1969; Univ. of Calif., 1969-70; "Five Famous Black Artists," BMFA, 1970; Krannert AM, Champaign, IL, 1971; "Three Graphic Artists," LACMA, 1971; NAD, 1972; Clark AI, Williamstown, MA, 1998 ("Progress of the American Negro" mural). Awards: Julius Rosenwald fellow, 1942, 1944; Edward Alford award, 1946; NIAL Grant, 1952; WMAA fellow, 1955; International Shows, Germany, 1960, 1965 (medals); Childe Hassam Award, Am. Acad. Art, 1965; City Council Award, Los Angeles, 1968; Tamarind Fellowship, 1970. **Work:** Newark Mus.; MMA; WMAA; LACMA; Howard Univ.; Atlanta Univ.; Barnett Aden Gal.; Oakland Mus.; Tuskegee Inst.; AFA; Academy of Arts & Letters; Long Beach MA; LOC; Hirshhorn Mus.; IBM; National Archives; Syracuse Univ.; Golden State Ins. Co.; Illinois Bell Tel. Co.; Bakersfield Col.; Boston Black United Front Foundation; Flint, MI, Community Schools; Taller de Grafica, Mexico City; Deutsche Acad. der Künste, Berlin; Dresden MA,

Germany; Govt of Ghana. Commissions: murals: Assoc. Negro Press, 1940; "Five Great American Negroes," Chicago Pub. Lib., 1940; Hampton Inst., VA, 1943. **Comments:** Among the best-known African-American artists of the 20th century. White's early work, concerned with issues of race and suffering, was part of the social realist tradition. His later work was more inward in nature, while still dealing with the struggles of humanity. Teacher: Southside AC, Chicago, 1939-40; Geo. Washington Carver Sch., NYC, 1943-45; Howard Univ., 1945; Workshop School Art, 1950-53; Otis AI, 1965-. At one time he was married to artist Elizabeth Catlett. Illustrator: *Four Took Freedom* 1967; and *Black History* 1968. Doubleday. **Sources:** WW73; A. Locke, *The Negro in Art* 1940; B. Horowitz, *Images of Dignity, Drawings of Charles White* 1967; Cederholm, *Afro-American Artists;* Driskell, *Hidden Heritage,* 76-77.

WHITE, Cherry Ford (Mrs.) *[Portrait, landscape and still life painter, muralist] 19th/20th c.*
Addresses: Wash., DC, active 1918-1940s. **Studied:** Maryland Inst. Art, Baltimore (4 years). **Member:** Wash. AC. **Exhibited:** Soc. Wash. Artists; Greater Wash. Indep. Exhib., 1935. **Work:** mural, Walkers Chapel Methodist Church, Virginia. **Sources:** McMahan, *Artists of Washington, DC.*

WHITE, Clara C. *[Artist] early 20th c.*
Addresses: Active in Wash., DC, 1906-23. **Sources:** Petteys, *Dictionary of Women Artists.*

WHITE, Clarence Hudson II *[Photographer] b.1907.*
Addresses: NYC. **Member:** Pictorial Photographers of Am. **Comments:** Son of Clarence, Sr. **Sources:** WW30.

WHITE, Clarence Hudson, Sr. *[Photographer, teacher] b.1871, Carlisle, OH / d.1925, Mexico City.*
Addresses: NYC/Canaan, CT. **Studied:** self-taught. **Member:** Photo-Secession, 1902 (founder); Pictorial Ph. Am. (first Pres., 1916); NY Camera Club; Vienna Camera Club. **Exhibited:** 1st Phila. Salon, 1898; Boston; Dresden; Paris; NYC; Soc. Indep. Artists, 1917; Vienna; MoMA, 1971 (retrospective); Glasgow Expo (medal); Turin Expo. **Work:** Princeton AM (largest collection); MoMA (mostly platinum prints); IMP; MMA; LOC; Royal Photo. Soc.; CMA. **Comments:** One of the most important leaders of the Pictorialist movement, he was a highly influential teacher at Columbia Univ. (1907-14) and at his own Clarence H. White School of Photography (1914-on). His platinum prints (now rare) show the influence of Whistler, the Impressionists, and Japanese prints. Other teaching: Brooklyn AI; Summer Sch. Photography, Seguinland, ME. His wife, Jane Felix White (see entry), continued his school after his death. **Sources:** Witkin & London, 271.

WHITE, Clarence (Mrs.) See: **WHITE, Jane Felix (Mrs. Clarence H. White)**

WHITE, (Clarence) Scott *[Painter, illustrator] b.1872, Boston, MA / d.1965.*
Addresses: Belmont, MA. **Studied:** Charles Herbert Woodbury. **Member:** Copley Soc., Boston; SIA; Boston Soc. WC Painters; Odd Brushes Club; Boston AC. **Exhibited:** AIC; BMFA; Boston AC, 1899-1909; Soc. Indep. Artists, 1919-20; Boston Soc. WC Painters; Northeast Harbor, ME, annually, (solos). **Comments:** Preferred media: watercolor. Illustrator: *Pilgrim Trails,Bermuda Journey.* About 1925 he spent time in Bermuda. **Sources:** WW59; WW47; *Charles Woodbury and His Students;.*

WHITE, Constance *[Painter, etcher] 19th/20th c.*
Addresses: Wash., DC, active 1903-20. **Exhibited:** Soc. Wash. Artists; Wash. WCC. **Work:** National Mus. Am. Hist. **Comments:** Specialty: animals. **Sources:** WW10; McMahan, *Artists of Washington, DC.*

WHITE, Della S. *[Painter] mid 20th c.*
Exhibited: Oakland Art Gallery, 1929. **Sources:** Hughes, *Artists in California,* 600.

WHITE, Donald A. *[Artist] mid 20th c.*
Addresses: Indianapolis, IN. **Exhibited:** PAFA Ann., 1953.

Sources: Falk, *Exh. Record Series.*

WHITE, Doris A. *[Painter] mid 20th c.; b.Eau Claire, WI.*
Addresses: Jackson, WI. **Studied:** AIC. **Member:** NA; Calif. WCS; Am. WCS; Phila. WCC; Wisconsin WCS. **Exhibited:** Butler IA; AWCS, NYC (grand award); Art All. Phila.; Inst. Arte Mexico; Illinois Mus., Springfield. Other awards: NAD (Ranger Fund Purchase Award); Lowe Gallery (RCA Victor Purchase Award); All. A. Am. (Assoc. Member Award). **Sources:** WW73.

WHITE, Dorothy M. *[Sculptor] mid 20th c.*
Addresses: Los Angeles, CA, 1926-28. **Exhibited:** P&S Los Angeles, 1926. **Sources:** Hughes, *Artists in California,* 600.

WHITE, Duke *[Scenery painter] early 19th c.*
Addresses: NYC, 1828-32. **Comments:** He worked at the Bowery Theatre. In 1836 he painted a drop-scene of Mount Vernon for the dioramists Henry and William J. Hanington. **Sources:** G&W; N.Y. *Evening Post,* Nov, 28, 1828, and Jan. 13, 1830, and N.Y. *Herald,* Dec. 7 and 22, 1836 (citations courtesy J. Earl Arrington); Odell, *Annals of the New York Stage,* III, 571.

WHITE, Ebenezer Baker *[Portrait painter] b.1806, Sutton, MA / d.1888, Providence, RI.*
Addresses: Boston, active late 1830's; Providence, RI, c.1844-88. **Exhibited:** Boston Athenaeum, 1837. **Sources:** G&W; *Vital Records of Sutton, Mass.;* Swan, BA; Boston CD 1839; Providence CD 1844-88; *Providence, Births, Marriages and Deaths;* Sears, *Some American Primitives,* 113; Lipman and Winchester, 182.

WHITE, Edith *[Landscape and floral painter] b.1855, near Decorah, IA / d.1946, Berkeley, CA.*
Addresses: Pasadena, CA (from 1893). **Studied:** Mills Seminary; San Francisco Sch. Design, late 1870s; ASL, 1892. **Exhibited:** San Francisco AA, 1890; Calif. Midwinter Int. Expo, 1894; Denver Artists' Club, 1898. **Work:** San Diego Hist. Soc.; Santa Fe RR Collection; Calif. Hist. Soc.; Mills College, Oakland; Mt. Holyoke College; Denver Public Library. **Comments:** Came to California in 1859 and opened a studio in Los Angeles in 1882. Well-known for her realistic renditions of roses. **Sources:** Hughes, *Artists in California,* 600-601; Trenton, ed. *Independent Spirits,* 42-44.

WHITE, Edward B. *[Sketch artist] mid 19th c.*
Addresses: Charleston, SC. **Comments:** Designer of the membership certificate of the Washington Light Infantry of Charleston (SC), of which he was apparently colonel. The certificate was engraved in 1857 by Thomas B. Welch (see entry). **Sources:** G&W; Rutledge, *Artists in the Life of Charleston.*

WHITE, Edwin *[Genre, historical, and portrait painter] b.c.1817, South Hadley, MA / d.1877, Saratoga Springs, NY.*
Addresses: Bridgeport, CT, 1840; NYC, 1840s, 1861-68, 1876; Saratoga Springs, NY. **Studied:** Düsseldorf, Paris, Rome, Florence (1850-58 and 1869). **Member:** ANA, 1848; NA, 1849. **Exhibited:** NAD,1840-76; Brooklyn AA, 1861-75; PAFA Ann., 1877; Am. Art-Union; Boston Athenaeum; Washington AA. **Work:** MMA. **Comments:** He began to paint at the age of twelve and became known for his historical subjects. He also lived in Antwerp, Belgium in 1869, and in Florence, Italy in 1875. **Sources:** G&W; Smith; NY *Herald,* June 9, 1877, obit.; Clement and Hutton; Tuckerman; CAB; Cowdrey, NAD; Cowdrey, AA & AAU; Swan, BA; Rutledge, PA; Falk, PA, vol. II; Washington Art Assoc. Cat., 1857, 1859; Providence *Almanac* 1849; *Portfolio* (March 1955), 166, repro.

WHITE, Elizabeth *[Etcher, painter, illustrator, teacher, lecturer] b.1893, Sumter, SC.*
Addresses: Sumter, SC. **Studied:** Columbia Univ.; PAFA; and with Alfred Hutty, Wayman Adams. **Member:** Tiffany Fnd.; MacDowell Colony; Carolina AA; SSAL. **Exhibited:** SSAL, Houston, 1926 (prize); Florence (SC) Mus.; Columbus (SC) Mus.; Smithsonian Inst. Print Gal., 1939 (solo); WFNY, 1939; Venice (Italy) Biennale, 1940; Chapin Mem. Library; Asheville MA; Univ. North Carolina; Tryon, NC; Gibbes Art Gal., Charleston,

SC; Duke Univ.; Univ. North Carolina; Mint Mus. Art. **Work:** LOC; Carnegie Library, Sumter, SC. **Comments:** Illustrator: *Crossin' Over* and historical pamphlets. **Sources:** WW59; WW47.

WHITE, Elizabeth A. *[Miniature painter] mid 20th c.*
Addresses: Atlantic City, NJ, c.1917-25. **Exhibited:** PAFA, 1925. **Sources:** WW25; Petteys, *Dictionary of Women Artists.*

WHITE, Emily H. *[Painter, miniature painter] b.1862, Norris, IL / d.1924, Laguna Beach, CA.*
Addresses: Peoria, IL; Los Angeles & Laguna Beach, CA from 1905. **Studied:** AIC, with J. Guerin; C.H. Woodbury, Ogunquit, ME. **Member:** Laguna Beach AA. **Exhibited:** Blanchard Gal., Los Angeles, 1906; Peoria; Royars Gal., Los Angeles. **Work:** Laguna Beach Mus. **Comments:** Sister of Nona White (see entry). **Sources:** WW24; Hughes, *Artists in California,* 601; *Charles Woodbury and His Students.*

WHITE, Emma Chandler (Mrs.) *[Craftsperson] b.1868, Pomfret, VT.*
Addresses: Saltville, VA. **Member:** Boston SAC (Master Craftsman). **Comments:** Specialty: weaving. **Sources:** WW40.

WHITE, Emma Locke Reinhard (Mrs. F. W.) *[Painter] b.1871, New Brighton, SI, NY / d.1953.*
Addresses: Staten Island, NY/Kent Hollow, New Preston CT. **Studied:** ASL, and with Mowbray, Cox, Chase, Twachtman, Brandegee, and others. **Member:** AEA; Kent AA; AAPL; NAWA; Staten Island Mus. Arts & Sciences. **Exhibited:** Staten Island Mus. Arts & Sciences, 1943 (solo); in Calif., Maine, Conn. **Sources:** WW53; WW47.

WHITE, Ethelbert *[Painter] mid 20th c.*
Exhibited: AIC, 1928-29. **Sources:** Falk, *AIC.*

WHITE, Ethyle Herman (Mrs. S. Roy) *[Painter, illustrator, writer] b.1904, San Antonio, TX.*
Addresses: Anahuac, TX. **Studied:** San Antonio AI; in Europe; and with Frederick Taubes, Etienne Ret, Paul Schuman, and others. **Member:** Texas FAA; Artists, Composers & Authors; Nat. Lg. Am. Pen Women. **Exhibited:** Texas FAA; San Antonio River Artists; Delgado MA; Beaumont Art Lg.; Houston Art Lg.; FA Center of Houston; Caller-Times Exhib.; Gates Library, Port Arthur (solo); Anahuac, TX, 1943, 1957. **Comments:** Author/illustrator: "Arabella," 1954. **Sources:** WW59.

WHITE, Eugene B. *[Painter] b.1913, Middle Point, OH / d.1966.*
Addresses: Bradenton, FL; Sarasota, FL. **Studied:** Ft. Wayne Art Sch.; Ringling Sch. Art. **Member:** Florida Artists Group; SC; Florida Fed. Art; Sarasota AA; Art Lg. of Manatee. **Exhibited:** Sarasota AA, 1950-55 (prize), 1956-57 (prize), 1958-60 (prize)-1964; Ft. Lauderdale, FL, 1955; Ohio Valley, 1952-55; Florida Artists Group, 1953-61; Ft. Wayne MA, 1955 (prize), 1956-57; Sarasota Nat., 1955 (prize); Montpelier, OH, 1956 (prize)-57 (prize); Ft. Lauderdale, 1956 (prize); Longboat Key, 1958 (prize); Ringling MA, 1957, 1959-61; TMA, 1957 (prize); Knickerbocker Artists, 1957 (prize); Columbus, OH, 1957 (prize); Van Wert, OH, 1957 (prize)-58 (prize); Art Lg. of Manatee, 1958-60 (prizes); Columbus Gal. FA; Detroit IA; Tampa AI, 1958, 1964; Univ. Ohio, 1956; Rowland's traveling exhib., 1958, 1959-61; SC, 1959-64; Delgado MA, 1959; Florida Fed. Arts, 1959-64 (prize); SC, 1960 (prize); Pinellas Park, 1960 (prize), 1964 (prize); Festival of States, 1964 (prize); solos: Sarasota AA; Orlando AI; Lima, Ohio; TMA; Bellair AC; St. Petersburg AA; Miami Art Gal. **Work:** Ringling Sch. Art; Bradenton AC; Chrysler Motors, Detroit; Milwaukee County Stadium; Art Lg. of Manatee. **Comments:** Position: instr., Art Lg. of Manatee, Bradenton, FL. **Sources:** WW66.

WHITE, Frances (Mrs.) *[Painter, illustrator, craftsperson] early 20th c.*
Addresses: NYC. **Sources:** WW13.

WHITE, Francis Robert *[Painter, graphic artist, teacher, lecturer] b.1907, Oskaloosa, IA / d.1986, Chicago, IL.*

Addresses: Sioux City, IA/Clear Lake, IA. **Studied:** Principia Acad., 1925; PAFA; ASL, St. Louis; K. Cherry; Rome and Paris. **Member:** Am. Artists Congress; Guggenheim, 1930 (fellow); Cooperative Mural Painters, 1935 (organizer). **Exhibited:** Younker Bros. Tea Room Galleries, 1934, Des Moines (solo); AIC; Corcoran Gal.; MMA; WMAA; Iowa Art Salon, Des Moines, 1933 (hon. men., fourth prize), 1934, 1935, 1937 (two first prizes, two second prizes, sweepstakes); WFNY, 1939; Kansas City AI, 1936 (second prize in watercolor). **Work:** WMAA; Univ. Illinois; AIC Library; Little Gallery, Cedar Rapids; WPA murals, USPO, Missouri Valley, Iowa; Post Office at Courthouse, Cedar Rapids; Russian Inn, Philadelphia. **Comments:** Went to stained glass factory in Wilkes Barre and stayed until he learned the craft; opened a studio in NYC. Subsequently studied as Guggenheim fellow in England, France and Italy, 1930-31. Position: director; Clear Lake Summer School of Art; director, Little Gallery, Cedar Rapids; director, Federal Art projects WPA for Iowa; Specialty: stained glass. **Sources:** WW40; Ness & Orwig, *Iowa Artists of the First Hundred Years,* 219-220.

WHITE, Frank M. *[Sculptor] early 20th c.*
Addresses: Phila., PA. **Exhibited:** PAFA Ann., 1906 (relief). **Sources:** WW08; Falk, *Exh. Record Series.*

WHITE, Franklin *[Sculptor] mid 19th c.*
Addresses: Philadelphia, 1852. **Sources:** G&W; Phila. CD 1852.

WHITE, Franklin *[Portrait painter, daguerreotypist] mid 19th c.*
Addresses: Springfield, MA. **Studied:** Chester Harding (before 1832). **Comments:** He gave advice and criticism to Joseph Whiting Stock (see entry). Listed as a daguerreotypist in 1849, with a shop in Springfield. **Sources:** *Springfield and Chicopee Almanac, Directory, and Business Advertiser,* (1849), 95; mentioned in Juliette Tomlinson, ed., *The Paintings and the Journal of Joseph Whiting Stock* (Middletown, CT: Wesleyan Univ. Press, 1976); Vlach, 45-46, 53.

WHITE, Franklin *[Painter] b.1943.*
Exhibited: James A. Porter Gallery, 1970; State Armory, Wilmington, DE, 1971; WMAA, 1971. **Sources:** Cederholm, *Afro-American Artists.*

WHITE, Fritz *[Sculptor] mid 20th c.*
Addresses: Active in Denver, CO. **Member:** CAA. **Comments:** Worked as a commercial artist; started sculpting in 1962. **Sources:** P&H Samuels, 523.

WHITE, Gabriella Eddy (Mrs. Thomas E. M.) *[Painter] b.1843, Island of Fayal, Azores / d.1932, North Conway, NJ.*
Addresses: Active in New Bedford, MA area, 1865-76; North Conway, NH. **Studied:** William Morris Hunt and R. Swain Gifford. **Member:** Quittacas Club. **Exhibited:** Centennial Fair, Philadelphia, 1876; Brooklyn AA, 1878 ("Marsh Mallow"); Boston AC, 1878-81; Lawton's Book Store & Art Gal., New Bedford, 1878; BMFA, 1879; Columbian Expo, Chicago, 1893; New Bedford AC Loan Exhib., 1908. **Sources:** Campbell, *New Hampshire Scenery,* 173; Blasdale, *Artists of New Bedford,* 205-6.

WHITE, George *[Engraver] mid 19th c.*
Addresses: Philadelphia, 1839. **Comments:** Cf. George I., George R., or George T. White. **Sources:** G&W; Phila. CD 1839.

WHITE, George *[Drawing master] early 19th c.*
Addresses: Philadelphia, 1807-09. **Sources:** G&W; Brown and Brown.

WHITE, George Fleming *[Painter and commercial artist] b.1868, Des Moines, IA.*
Addresses: Des Moines, IA. **Studied:** with several teachers in Des Moines, including Richter, Henry Steinbach, C.E. Baldwin, C.A. Cumming; ASL, with Carol Beckwith and Kenyon Cox; Munich, with A. Azbe, R. Frank. **Member:** Iowa Artists Club. **Exhibited:** Des Moines Women's Club, 1926 (gold, silver and bronze medals); Iowa Art Salon, 1927 (first in watercolor), 1928 (fourth in watercolor), 1929 (hon. men.), 1930-31; Water Color

Show, PAFA; Philadelphia WCC Exhibit; Iowa Artists Club; Iowa Federation Women's Clubs Exhibit, 1932; Iowa State Fair, almost every year from 1884-1900. **Sources:** WW25; Ness & Orwig, *Iowa Artists of the First Hundred Years,* 220.

WHITE, George Gorgas *[Wood engraver and illustrator] b.c.1835, Philadelphia, PA / d.1898, NYC.* **Addresses:** Philadelphia,1854-61; NYC,1898. **Studied:** Phila., with J. Cassin, late 1850s. **Comments:** A Quaker, he came to NYC during the Civil War as an illustrator of war articles. He contributed illustrations to almost all the leading magazines for over a quarter of a century. Also illustrated "Beyond the Mississippi," 1867. **Sources:** G&W; *Art Annual,* I, obit.; Phila. CD 1854, 1856, 1860-61; Hamilton, *Early American Book Illustrators and Wood Engravers,* 493-94.

WHITE, George Irwine *[Engraver] mid 19th c.* **Addresses:** Phila., 1850-55, c.1861. **Comments:** Cf. George, George R., and George T. White. **Sources:** G&W; Phila. CD 1850-55 [as G. Irwine White], 1861 [as George I. White, artist]; Stauffer.

WHITE, George Merwangee *[Marine painter] b.1849, Salem, MA / d.1915, Salem, MA.* **Work:** Peabody Mus., Salem, MA; Lynn (MA) Hist. Soc. **Comments:** The son of a shipmaster, he sailed to the West Indies and Europe. From 1877-98 he was employed by Louis Pay as a designer. **Sources:** Brewington, 412.

WHITE, George R. *[Engraver] b.c.1811, Pennsylvania.* **Addresses:** Philadelphia, active 1848-60. **Comments:** In 1860 he owned real property valued at $25,000 and personal property to the value of $1,500. Cf. George, George I., and George T. White. **Sources:** G&W; 7 Census (1850), Pa., LIII, 265; 8 Census (1860), Pa., LXII, 311; Phila. CD 1848.

WHITE, George T. *[Listed as "artist"] mid 19th c.* **Addresses:** Philadelphia, 1846. **Comments:** Cf. George, George I., and George R. White. **Sources:** G&W; Phila. CD 1846.

WHITE, George W. *[Engraver] mid 19th c.* **Addresses:** NYC, 1843-58. **Comments:** He was of White & Vander[h]oef (see entry), 1857. **Sources:** G&W; NYCD 1843-58.

WHITE, George W. *[Portrait, figure, and landscape painter] b.1826, Oxford, OH / d.1890, Hamilton, OH.* **Addresses:** Cincinnati, 1843 and1847; Hamilton, OH, 1857 and after. **Studied:** Samuel Swan Walker (c.1840). **Comments:** He went to Cincinnati in 1843 intending to open a studio but met with little encouragement. For the next few years he traveled with a minstrel show as a blackface singer. Returning to Cincinnati, in 1847 he resumed his painting career and shared a studio with the landscape painter, William L. Sonntag (see entry). His first real success came in 1848 when he painted two views of Powers' statue, *The Greek Slave.* Until 1857, White worked in Cincinnati and lived in Covington (KY), except for a year in NYC. In 1857 he moved to Hamilton (OH) where he spent the rest of his life, except for the Civil War years when he lived in Cincinnati. **Sources:** G&W; *History and Biographical Encyclopedia of Butler County, Ohio,* 364-65; Bartlow *et al., Centennial History of Butler County,* 921-22; Cist, *Cincinnati in 1851,* 127; Cincinnati BD 1848; Ohio BD 1859; Hamilton CD 1873; Hageman, 123.

WHITE, George W. See: **FOX, R. Atkinson**

WHITE, Gerald See: **WHITE, Victor (Gerald)**

WHITE, Gilbert See: **WHITE, (Thomas) Gilbert**

WHITE, Gordon J. *[Painter, teacher, designer] b.1903, Granville, NY.* **Addresses:** Trenton 8, NJ. **Studied:** Cornell Univ. (B.F.A.), with Olaf Brauner, Walter K. Stone; Inst. Des., Chicago, with Moholy-Nagy; Columbia Univ. (M.A.). **Member:** New Jersey Art Educ. Assn.; Southern Vermont Artists; Mid-Vermont Artists; Morrisville-Trenton Art Group. **Exhibited:** Boston Soc. Indep.

Artists; Middlebury, VT; Mid-Vermont Artists, annually; Southern Vermont Artists, annually; Morrisville-Trenton Art Group, annually; Contemp. Club, Trenton, 1948, 1955; State Mus., Trenton, 1954. **Awards:** Sands medal, 1926, Sampson prize, 1927, Cornell Univ. **Work:** murals, Ajax Eng. Corp., Trenton, NJ. **Comments:** Position: instr., FA, Cornell Univ., 1927-28; head, art dept., Trenton Junior College, Sch. Indus. Art, Trenton, NJ, 1952-. **Sources:** WW59.

WHITE, H. P. *[Painter] 19th/20th c.* **Addresses:** Brookline, MA, active 1900-01. **Exhibited:** Boston AC, 1900. **Sources:** WW01.

WHITE, H(élène) Maynard *[Sculptor, portrait & mural painter] b.1870, Baltimore, MD.* **Addresses:** Phila., PA/Bar Harbor, ME. **Studied:** PAFA, with Moran, Chase, C. Beaux, Grafly; Charles Tefft & Rodin, Paris. **Member:** Plastic Club; Lyceum Club; Int. Sculptors. **Exhibited:** PAFA Ann., 1901, 1906; St. Louis Expo, 1904 (prize); Int. Sculptors (silver medal); AC Philadelphia (prize); California (medal); Phila. Sesquicentennial Expo, 1926. **Work:** Roosevelt, AZ; Union Nat. Bank; Univ. Pennsylvania; Bethany Col. Church; Mohican Lodge, Red Bank, NJ; San Francisco; murals, St. Andrew's, Philadelphia. **Sources:** WW17; Falk, *Exh. Record Series.*

WHITE, Henry Cooke *[Painter, etcher, writer, teacher] b.1861, Hartford, CT / d.1952, Waterford, CT.* **Addresses:** Waterford, CT; Hartford, CT, 1892-96. **Studied:** D.W. Tryon, 1875, 1880s; ASL, with K. Cox; G. DeF. Brush, 1884-86. **Member:** fellow, NAD; CAFA, 1919 (a founder, officer); NYWCC. **Exhibited:** NAD, 1892-96; PAFA Ann., 1893-99, 1907-10; AIC; AWCS; CAFA; The Pastellists; in Hartford, Springfield, New London, CT; Lyman Allyn Mus., 1954 (mem. exhib.); Florence Griswold Mus., Old Lyme, CT (three generations of White family painters), c.1988. **Work:** PMG; Wadsworth Atheneum; Florence Griswold Mus., Old Lyme, CT. **Comments:** A Tonalist. Traveled to England, France, Holland, Belgium, Germany and Italy, 1896-97. White painted until he was nearly 80 years old. Positions: drawing teacher, Hartford H.S., 1889; teacher, Art Soc. Hartford, briefly; private drawing teacher; trustee, Lyman Allyn Mus., New London, CT. Author: *Life and Art of Dwight William Tryon,* 1930. Contributor : "Art in America." **Sources:** WW53; WW47; *Connecticut and American Impressionism* 178 (w/repro.); Art in Conn.: The Impressionist Years; Falk, *Exh. Record Series.*

WHITE, Henry F. *[Genre and still life painter] mid 19th c.* **Addresses:** NYC, 1857-68. **Exhibited:** NAD, 1857-68. **Sources:** G&W; Cowdrey, NAD.

WHITE, Henry William *[Painter] mid 20th c.* **Addresses:** Danbury, CT. **Exhibited:** Soc. Indep. Artists, 1934-36, 1943-44. **Sources:** Marlor, *Soc. Indp. Artists.*

WHITE, Ian McKibbin *[Art administrator, designer] b.1929, Honolulu.* **Addresses:** San Francisco. **Studied:** Cate School; Harvard College (B.A., architecture, 1951); Harvard Univ. Grad. School Design, 1951-52; Univ. Calif., Los Angeles, 1957-58. **Member:** U.S. Nat. Committee Int. Council Mus.; Am. Assoc. Mus. (advisory council, 1964-); Am. Assoc. Mus. Dir. (committee chmn., 1969-); AFA (trustee, 1971-). **Exhibited:** Awards: Cate School, 1947 (silver medal for oil painting). **Work:** Commissions: designed Frieda Shiff Warburg Sculpture Garden, Brooklyn Mus., New York, NY, 1966; designed Peary-McMillan Arctic Mus., Bowdoin College, Brunswick, ME, 1967. **Comments:** Positions: asst. director, Brooklyn Mus., NYC, 1964-67; director, CPLH, San Francisco, CA 1968; director of mus., CPLH & M.H. de Young Mem. Mus, San Francisco, 1970-. Author: articles, *Curator,* Vol. 1910, No. 1; *San Francisco Examiner,* 1967. **Sources:** WW73.

WHITE, Inez Mary Platfoot *[Painter, lecturer] b.1889, Ogden, UT.*
Addresses: Omaha, NE. **Studied:** A. Dunbier in Omaha.
Member: Nebraska Artists; Omaha AC; Omaha Art Guild; Friends of Art. **Exhibited:** Joslyn Art Mus.; Kansas City AI, 1930; Nebraska Artists & Omaha Art Guild, 1928-31. **Work:** Windsor Sch., Field Sch., Our Lady of Lourdes Sch., all in Omaha, NE. **Comments:** Art lectures: color. **Sources:** WW53; WW47.

WHITE, J. *[Amateur painter] late 18th c.*
Addresses: Flemington (NJ?), active c.1788. **Comments:** In 1788 he made a copy in oils of an engraving after a painting by the English animal painter George Stubbs (1724-1806). **Sources:** G&W; *Antiques* (March 1939), 150, repro.; *Antiques* (May 1940), 258.

WHITE, Jack *[Sculptor] b.1940, NYC.*
Studied: New School for Social Research; ASL. **Exhibited:** Ruder & Finn Gal., 1969; Manhattan Counterpoints; Lever House, NY; Minneapolis IA; Nordness Galleries, NYC, 1969; High MA, Atlanta, GA; Flint (MI) Inst. Arts, 1969; Everson Mus., 1969; IBM, 1966; RISD, 1969; Mem. Art Gal., Rochester, 1969; Contemporary AM, 1970; SFMA, 1969; BMFA, 1970; NJ State Mus., 1970; Roberson Center, 1970; UC, Santa Barbara, 1970. **Awards:** MacDowell Art Colony Fellowship; Allen B. Tucker Memorial Fellowship. **Sources:** Cederholm, *Afro-American Artists.*

WHITE, J(acob) C(aupel) *[Designer, painter, etcher, illustrator, commercial artist, lecturer, teacher] b.1895, NYC.*
Addresses: Oakdale, LI, NY; NYC, 1865-66; Deal, NY, 1869. **Studied:** NAD; Académie Julian, Paris, 1919. **Member:** Advertising Club, NY. **Exhibited:** AIC; NAD, 1865-69; Salon de Tunis; Salons of Am. **Awards:** Tiffany Fnd. fellowship; Cartoon Competition, *Liberty* magazine (prize). **Work:** Tiffany Foundation. **Comments:** Position: art director, Am. Merrilei Corp., Brooklyn, NY. **Sources:** WW59; WW47.

WHITE, Jane Felix (Mrs. Clarence H. White)
[Photographer] b.1872 / d.1943, Ardmore, OH.
Comments: Following her husband's death in 1925, she continued the Clarence White Sch. of Photography in NYC until 1940.

WHITE, Jessie Aline (Mrs. George R. Angell) *[Painter, writer, craftsperson] b.1889, Wessington, SD.*
Addresses: Dallas, 1919; Fort Worth, TX. **Studied:** Minneapolis Sch. Art; AIC; ASL. **Member:** Dallas AA; Texas FAA; SSAL. **Exhibited:** Allied Arts Exhib., Dallas, 1930 (prizes), 1931 (prize); SSAL, 1937 (prize); Joseph Sartor Art Gals., Dallas, 1933 (solo); Dallas MFA. **Comments:** Painted industrial subjects, still lifes & landscapes in watercolor. **Sources:** WW40; Petteys, *Dictionary of Women Artists.*

WHITE, Jo *[Painter] mid 20th c.*
Addresses: Indianapolis, IN. **Exhibited:** PAFA Ann., 1947. **Sources:** Falk, *Exh. Record Series.*

WHITE, John *[Watercolor painter] b.c.1550, England / d.After 1593, probably Ireland.*
Work: British Museum, London (over seventy of White's original watercolors). **Comments:** One of the earliest European artists to work in North America (see also Jacques Le Moyne). In 1585 he was part of a group sent by Sir Walter Raleigh to Roanoke Island (then Virginia, now part of North Carolina) in order to investigate the possibility of establishing a colony. There he made drawings and watercolors of the flora, fauna, and native inhabitants of the region before returning with his party to England. In 1587 he was named governor of the colony and sent back to Virginia, along with a group of settlers that included his married daughter, who soon gave birth to Virginia Dare, the first English child born in America. Later in 1587 White went back to England for supplies; but because of England's war with Spain was not able to return to Virginia until 1590. When he finally arrived he found the site deserted and no trace of "the lost colony." Nothing is known of his later life except that he was living in Newtowne in Kylmore,

Ireland, in February 1593. Twenty-three of his Virginia views were engraved by the German engraver Theodore De Bry and published in the latter's *A Briefe and True Report of the New Found Land of Virginia* (Frankfurt-am-Main, 1590). **Sources:** G&W; DAB; Lorant, *The New World; the First Pictures of America.*, reproduces many of White's watercolors in color. See also, Bushnell, "John White." More recently, see Baigell, *Dictionary;* Gerdts, *Art Across America,* vol. 2: 11; P&H Samuels, 524.

WHITE, John *[Painter] mid 19th c.*
Addresses: Cheshire, CT, 1850. **Comments:** Painted landscape in oils. **Sources:** G&W; Lipman and Winchester, 182.

WHITE, John Blake *[Historical, portrait, and miniature painter] b.1781, Eutaw Springs, SC / d.1859, Charleston, SC.*
Addresses: Charleston, SC (for most of his career, although he lived briefly in Columbia, SC, c.1831). **Studied:** Benjamin West, London, 1800-03. **Member:** South Carolina Acad. FA (director); NAD, 1837 (hon. member). **Exhibited:** NAD; Boston Athenaeum; Apollo Assoc.; South Carolina Inst. (medal for best historical painting); "General Marion Inviting a British Officer to Share His Meal" toured cities from New Orleans to NYC. **Work:** U.S. Capitol Bldg., Washington (Revolutionary War scenes). **Comments:** While studying in London 1800-03, he became a friend to Washington Allston and like him became ambitious to paint history pictures. White returned to the U.S. and painted portraits in Charleston and Boston (1804), but finding little patronage, he decided to study law. He began practicing in Charleston in 1808 but continued to paint, specializing in scenes from American history. Among his major works was "The Unfurling of the United States Flag in Mexico" (1834), one of many White paintings destroyed when the capital at Columbia, SC, was burned during the Civil War. White's most well-known work "General Marion Inviting a British Officer to Share His Meal," was replicated many times by the artist (a replica, along with three other Revolutionary scenes by White, now hangs at the Capitol in Wash., DC). He also wrote essays and a number of plays which were performed in Charleston and elsewhere. **Sources:** G&W; DAB; Rutledge, *Artists in the Life of Charleston;* Clement and Hutton; White, "Journal"; Clark, *History of the NAD,* 274; Cowdrey, NAD; Cowdrey, AA & AAU; Swan, BA; Cummings, *Historic Annals of the NAD,* 143-44; Dunlap, *History; Portfolio* (Aug. 1947), 8. More recently, see Gerdts, *Art Across America,* vol. 2: 50-51 (w/repro.).

WHITE, Joseph *[Engraver] b.c.1844, Pennsylvania.*
Addresses: Philadelphia, 1860. **Comments:** He lived in the home of Joshua Bering (see entry). **Sources:** G&W; 8 Census (1860), Pa., LVIII, 429.

WHITE, Joseph P. *[Painter] b.1938.*
Addresses: NYC. **Exhibited:** WMAA, 1967, 1972. **Sources:** Falk, *WMAA.*

WHITE, Josiah *[Listed as "artist"] early 19th c.*
Addresses: Philadelphia, active 1811. **Comments:** Wire manufacturer, 1813-20. **Sources:** G&W; Brown and Brown.

WHITE, Juliet M. See: **GROSS, Juliet White (Mrs. John Lewis)**

WHITE, Katherine *[Painter] mid 20th c.*
Studied: ASL. **Exhibited:** Soc. Indep. Artists, 1936. **Comments:** Possibly White, Katherine F. (Mrs. Trumbull White). **Sources:** Marlor, *Soc. Indp. Artists.*

WHITE, L. E. (Miss) *[Artist] 19th/20th c.*
Addresses: Active in Los Angeles, 1894, 1909. **Sources:** Petteys, *Dictionary of Women Artists.*

WHITE, Lawrence Eugene *[Educator] b.1908, Abilene, TX.*
Addresses: Malibu, CA. **Studied:** Abilene Christian College (B.A.); Univ. Southern Calif. (M.A.). **Comments:** Positions: owner, Eugene White Ceramics Studios, 1941-48. **Publications:** author, *Art for the Child,* 1950. **Teaching:** instructor of art, Abilene Christian College, 1932-36; instructor of art, Pepperdine

College, 1939-44, prof. art & chmn dept., Pepperdine Univ., 1944-. **Sources:** WW73.

WHITE, Lemuel *[Portrait painter] early 19th c.*
Addresses: Philadelphia, 1813-17. **Exhibited:** Society of Artists, 1812-13 (profiles of ladies and several copies of figure paintings). **Comments:** Philadelphia directories, 1819-33, list Lemuel White, professor of elocution, and 1837-39, Lemuel G. White, teacher. **Sources:** G&W; Rutledge, PA [erroneously as Lorenzo White]; Society of Artists, Cats. 1812 and 1813 [as L. White]; Phila. CD 1814-39.

WHITE, Leo *[Cartoonist] b.1918, Holliston, MA.*
Addresses: Quincy, MA. **Studied:** School Practical Art, Boston; Evans School Cartooning, Cleveland. **Comments:** Positions: sports & editorial cartoonist, *Patriot-Ledger*, Quincy, MA. Author/illustrator, "Hockey Stars," Toronto Television News Service, "TV Starscramble," Columbia Features, New York; "Little People's Puzzle," United Features; "Crosswords for Kids," Fawcett. **Sources:** WW73.

WHITE, Lily F. (Mrs. A. Ruppell) *[Painter] early 20th c.*
Addresses: New Orleans, active c.1915. **Exhibited:** NOAA, 1915. **Sources:** *Encyclopaedia of New Orleans Artists*, 411.

WHITE, Lorenzo *[Portrait painter] d.1834.*
Addresses: Boston, 1829-34. **Exhibited:** Boston Athenaeum, 1829-32. **Comments:** He was listed in the directories as a musician 1829-32, and portrait painter, 1833-34. **Sources:** G&W; Swan, BA; Boston CD 1829-34.

WHITE, Lucy Schwab *[Painter] mid 20th c.*
Addresses: New Haven, CT. **Member:** New Haven PCC. **Sources:** WW25.

WHITE, M. *[Portrait painter] mid 19th c.*
Addresses: Boston, 1847. **Sources:** G&W; Boston BD 1847.

WHITE, Mable Dunn (Mrs. Edgar R.) *[Painter] b.1902, Charlotte, NC.*
Addresses: Jacksonville 7, FL. **Studied:** Greenville (SC) College for Women. **Member:** St. Augustine AA; Jacksonville AA; SSAL; AAPL; FA Lg. of the Carolinas. **Exhibited:** Nat. Exh. Am. Artists, NY, 1941; SSAL, 1941, 1943; Mint MA (prize); Gibbes Art Gal.; Blue Ridge AI; St. Augustine, Jacksonville, FL; Greenville (SC) Civic Art Gal., 1942 (solo); Asheville (NC) Civic Art Gal., 1942 (solo). **Sources:** WW59; WW47.

WHITE, Margaret C. *[Painter] mid 20th c.*
Addresses: NYC. **Studied:** ASL. **Exhibited:** Soc. Indep. Artists, 1929, 1932. **Comments:** Possibly White, Margaret (Mrs. Fitzhugh White). **Sources:** Marlor, *Soc. Indp. Artists*.

WHITE, Margaret Wood (Mrs. Victor Gerald) *[Portrait painter] b.1893, Chicago.*
Addresses: Woodmere, NY; Baltimore, MD. **Studied:** Geo. Bridgman; E. Blumenschein; J. Johansen; Bileul and Humbert in Paris. **Member:** NAWPS. **Exhibited:** Corcoran Ga. biennial, 1916 (as Wood); Salons of Am.; Soc. Indep. Artists, 1917; PAFA Ann., 1918. **Work:** portrait, Pres. F.D. Roosevelt, Harvard Club, NYC. **Sources:** WW40; WW38; Petteys, *Dictionary of Women Artists;* Falk, *Exh. Record Series*.

WHITE, Marie *[Decorator] b.1903.*
Addresses: Kansas City, MO. **Studied:** Kansas City AI. **Sources:** WW40.

WHITE, Mary *[Illustrator, craftsperson] b.1869, Cambridge, MA.*
Addresses: Brooklyn, NY. **Studied:** CUA School; ASL. **Sources:** WW08.

WHITE, Mary Jane *[Painter, lecturer, teacher] b.1907, Columbia City, IN.*
Addresses: Columbia City. **Studied:** R.E. Burke; H. Engel; C.B. Taylor; C.C. Bohm; AIC. **Member:** Midland AS; Indiana Artists; Hoosier Salon; Western AA; AAPL. **Exhibited:** Midland Acad., South Bend, IN, 1934 (prize), 1936 (prize), 1938 (prize). **Work:**

St. Mary's Acad., South Bend; Spink-Wawasee Hotel, Wawasee, IN. **Comments:** Position: fine arts director, Plymouth (IN) City Schools. **Sources:** WW40.

WHITE, Mazie J(ulia Barkley) (Mrs.) *[Painter, etcher, block printer] b.1871, Ft. Scott, KS / d.1934.*
Addresses: Clifton, NJ. **Studied:** C.G. Martin; G.J. Cox; A.R. Young; E. Graecen; W. Adams. **Member:** NJ Chapter, AAPL. **Sources:** WW33.

WHITE, Minor *[Photographer, teacher, critic, writer] b.1908, Minneapolis / d.1976.*
Addresses: Cambridge, MA. **Studied:** Univ. Minnesota, 1928-33; Columbia, 1944. **Member:** Soc. Ph. Educ. 1962. **Exhibited:** MoMA, 1941; Portland AM, 1942; IMP, 1959; PMA, 1970 (traveling exh.); SFMA, 1948; Photography Lg., NYC, 1950. **Work:** MOMA; George Eastman House, Rochester, NY; MIT. **Comments:** A highly influential teacher and critic influenced by Zen philosophy. He was the founding editor of *Aperture* magazine, 1952-76. Teaching: Portland, OR, 1937; La Grande AC, OR (WPA), 1940-41; Calif. Sch. FA., 1946-53; Rochester Inst. Tech., 1955-60; MIT, 1965-75. Curator of photography, Intl. Mus. of Photography, George Eastman House, Rochester, NY. **Sources:** his life in photography is best recounted in his *Mirrors, Messages, Manifestations* (1969); Witkin & London, 272; Baigell, *Dictionary*.

WHITE, Nathan F. *[Wood engraver] mid 19th c.*
Addresses: Troy, NY, 1851-53. **Sources:** G&W; Troy CD 1851-53.

WHITE, Nelson *[Portrait and landscape painter] mid 20th c.; b.Connecticut.*
Addresses: Florence, Italy, 1954-89; Florence, Italy/Waterford, CT, from 1989. **Studied:** Florence, Italy, from 1954. **Exhibited:** Florence Griswold Mus., Old Lyme, CT, c.1988 (three generations of White family painters). **Work:** Florence Griswold Mus., Old Lyme, CT. **Comments:** Son of Nelson Cooke White.

WHITE, Nelson Cooke *[Landscape painter, writer] b.1900, Waterford, CT / d.c.1990.*
Addresses: Waterford, CT. **Studied:** with his father, ~~NELSON C. WHITE~~ Henry Cooke White; NAD. **Member:** CAFA. **Exhibited:** AIC; NAD; AWCS; Florence Griswold Mus., Old Lyme, CT, c.1988 (three generations of White family painters). **Work:** Florence Griswold Mus., Old Lyme, CT. **Comments:** Position: trustee, Lyman Allyn Mus., New London, CT; Wadsworth Atheneum, Hartford, CT. Author: *The Life and Art of J. Frank Currier* (1936); *Abbott H. Thayer — Painter and Naturalist* (1951). Contrib.: *Art in America; Art & Archaeology*. **Sources:** WW66; WW47; Art in Conn.: The Impressionist Years (cites deathdate as 1989).

WHITE, Nona L. *[Painter, lecturer, writer, critic] b.1859, Illinois / d.1937.*
Addresses: Pasadena, CA. **Studied:** AIC. **Member:** Pasadena SA; Laguna Beach AA; Women Painters of the West. **Exhibited:** locally. **Comments:** Sister of Emily White (see entry). Position: art critic, *Los Angeles Evening News*. **Sources:** WW33.

WHITE, Norman Triplett *[Sculptor] b.1938, San Antonio, TX.*
Addresses: Toronto, Ontario. **Studied:** Harvard College with T. Lux Feininger, 1955-59 (B.A.). **Exhibited:** Some More Beginnings, Exp. in Art & Technology Show, Brooklyn Mus., 1968; Exp. in Art & Technology Show, High MA, 1969; The Canadian Electric Company, Carmen Lamanna Gallery, Toronto, Ontario, 1969; Norm White at the Electric Gallery, Electric Gallery, Toronto, 1971; New Media Art, Canadian Nat. Exhib., Art Gallery Ontario, 1971. **Awards:** Canadian Council bursaries, 1969-71. **Work:** Nat. Gallery Canada, Ottawa. **Comments:** Preferred media: electronics, plastics. Art interests (as stated in 1973): to mimic in as unarbitrary a way as possible the efficiency, flexibility and diversity of biological systems. **Sources:** WW73.

WHITE, Orrin A(ugustine) *[Landscape painter] b.1883, Hanover, IL / d.1969, Pasadena, CA.*
Addresses: Pasadena, CA, since 1923. **Studied:** Notre Dame Univ., 1902; Phila. Sch. Applied Art, 1906. **Member:** Calif. AC; Acad. Western Painters. **Exhibited:** Panama-Calif. Expo, San Diego, 1915 (silver medal); Battey Gal., Pasadena, 1916 (solo); Stendahl Gal., Los Angeles; Calif. AC, 1921 (Huntington prize); GGE, 1939; LACMA, 1940 (solo); AIC. **Work:** LACMA; State Mus., Springfield, IL; Montclair Mus.; CMA. **Comments:** Best known for his Calif. landscapes, particularly Monterey oaks and eucalyptus trees. Painted camouflage during WWI. **Sources:** WW40; Hughes, *Artists in California*, 601; P&H Samuels, 525.

WHITE, Owen S(heppard) *[Painter, teacher] b.1893, Chicago.*
Addresses: Mayaguez, Puerto Rico/Petoskey, MI. **Studied:** Amherst; CI; Columbia; ASL; École des Beaux-Arts, Fontainebleau, France; Cape Cod Sch. Art. **Exhibited:** Soc. Indep. Artists, 1936; All. Artists Am., 1938, 1939; WFNY, 1939; Newton Gal., NY, 1939 (solo). **Sources:** WW40.

WHITE, Peter W. *[Illustrator] early 20th c.*
Addresses: Rochester, NY. **Member:** Rochester AC. **Sources:** WW17.

WHITE, Ralph Ernest, Jr. *[Educator, painter, designer, illustrator] b.1921, Minneapolis, MN.*
Addresses: Austin 4, TX. **Studied:** Minneapolis Sch. Art; Univ. Minnesota; PIA Sch. **Exhibited:** Nelson Gal. Art, Kansas City, 1951; Denver AM, 1953; Butler IA, 1956, 1957; D.D. Feldman Exhib., 1956; AFA traveling exh., 1957; Texas annual, 1947, 1948, 1949 (prize), 1950, 1953-57; Texas WCS; Texas FAA, annually (prize, 1955); NOMA, 1957-58; Austin State College, 1956; Kansas State College, 1954. Awards: Vanderlip Fellowship, Minneapolis, 1942; prizes & purchase awards: Twin Cities annual, 1942; Corpus Christi, TX, 1948; Minnesota Centennial Exh., 1949; DMFA, 1947; Austin, TX. **Work:** Minneapolis IA; Witte Mem. Mus.; Texas A&I College, Kingsville; Corpus Christi Mem. Mus.; D.D. Feldman Coll.; Texas FAA; Laguna Gloria Mus., Austin. **Comments:** Positions: consulting art dir., DGB Adv. Co. (10 years); Clark Printing Co., San Antonio (3 years); art prof., Univ. Texas, 1959. Illustr.: *In a Scout's Boot*, (1957), *Sam Bass*, (1958), *Big Foot Wallace*, (1957). **Sources:** WW59.

WHITE, Richard *[Sculptor] late 19th c.; b.Cincinnati, OH.*
Exhibited: SNBA, 1893. **Sources:** Fink, *American Art at the Nineteenth-Century Paris Salons*, 406.

WHITE, Robert (Bob) *[Painter] mid 20th c.*
Addresses: Brooklyn, NY. **Studied:** ASL. **Exhibited:** Soc. Indep. Artists, 1933. **Sources:** Marlor, *Soc. Indp. Artists.*

WHITE, Robert H. *[Painter] b.1868, Phila., PA / d.1947, Phila.*
Addresses: Camden, NJ; Phila. **Studied:** PAFA, 1923-29. **Exhibited:** PAFA Ann., 1891; Artists Gal., Philip Ragan Assoc., Inc., Phila., 1946. **Comments:** White had a long-time ambition to become a painter but was not able to afford formal art instruction until the 1920s. During the Depression he supported himself as a door-to-door salesman but devoted all free time to painting. He produced over 100 works depicting one particular view along Twining Road near his home. In 1946, at the age of 78, he was given a solo show at Artists Gallery in Philadelphia, the first time his works were ever exhibited. A New York show was planned for the following year but was cancelled after his death in 1947. **Sources:** Falk, *Exh. Record Series;* info. courtesy Roy Wood, Jr.

WHITE, Robert W(inthrop) *[Sculptor, educator] b.1921, NYC.*
Addresses: St. James, NY. **Studied:** Joseph Weisz & Hans Grad, Munich, 1932-34; John Howard Benson, RI, 1934-38; RISD, 1938-42 & 1946. **Exhibited:** PAFA Ann., 1950-51, 1960; Int. Exh. Religious Art, Stazione Marittima, Trieste, Italy, 1958; Continuing Tradition of Realism in Am. Art, Hirschl & Adler Galleries, New York, 1962; Eight Americans, Amsterdam, Breda, Nymegen, Holland, 1969; Representational Spirit, Univ. Art Gallery, Albany, NY, 1970; James Graham & Sons, NYC, 1970s.

Awards: Am. Acad. in Rome fellowship, 1952-55; NAD Proctor Mem. Prize, 1962; Farfield Foundation grant, 1969. **Work:** BM; RISD; Springfield (MA) Mus. Commissions: life size bronze fountain, Mr. & Mrs. Amyas Ames, Martha's Vinyard, MA, 1957; bronze of St. Anthony on Padua, St. Anthony of Padua School, Northport, NY, 1959; A.E. Verrill Silver Medal, Peabody Mus. Natural History, Yale Univ., 1960; three wooden & metal figures, Mrs. Hester Pickman, St. Michael's Roman Catholic Church, Bedford, MA, 1960-66; bronze relief portrait of Joseph Wilson, Xerox Corp., Stamford, CT, 1972. **Comments:** Preferred media: bronze, terra-cotta, stone, wood, tempera, watercolors. Positions: sculptor-in-residence, Am. Acad. in Rome, Italy, 1969-70. Illustrator: *The Enchanted,* Pantheon, 1951; "The Confessions of Nat Turner," *Harper's Magazine,* 1967. Teaching: Parsons School Design, NYC, 1949-52; State Univ. NY, Stony Brook, 1962-. **Sources:** WW73; Falk, *Exh. Record Series.*

WHITE, Roger Lee *[Painter, educator] b.1925, Shelby, OH.*
Addresses: Oklahoma City, OK. **Studied:** Miami Univ. (B.F.A.); Univ. Denver (M.A.); Univ. Colorado; Univ. Oklahoma; also study with Mark Rothke, Jimmie Ernst, Wendell H. Black, Carl Morris & Richard Diebenkorn. **Member:** Oklahoma AA; Oklahoma Printmakers Soc. (executive bd.). **Exhibited:** Philbrook AC, Tulsa, OK, 1956-72; Oklahoma AC, 1956-72; Southwest Painters & Sculptors, Houston, TX, 1963; Nelson Gallery Art, Kansas City, MO, 1964; Oklahoma Univ. MA, Norman, 1970; Silver Mountain Art Studio, Empire, CO, 1970s. Awards: Philbrook MA, 1959-60; 20th Ann. Exhib. Oklahoma Artists, 1960; Oklahoma Printmakers 5th Nat. Exhib. Contemporary Art, 1963. **Work:** Oklahoma AC, Okla. City; Oklahoma City Univ.; Miami Univ. School Art, Oxford, OH; Univ. Okla. MA, Norman; Okla. Printmakers Soc., Okla. City. **Comments:** Preferred media: oils, watercolors. Positions: dir., Silver Mountain Summer Art School, Empire, 1959-72; dir., C.&W. Art Gallery, 1965-68; dir., Silver Mountain Art Gal., Georgetown, CO, 1969-72; producer, cinematographer & artist, Focal Point Assoc., Oklahoma City, 1971-. Teaching: asst. prof. & chmn. art dept., College of the Ozarks, 1957-58; spec. instructor, studio courses, Oklahoma Science & Arts Foundation, 1958-69; assoc. prof. studio courses & chmn. art dept., Oklahoma City Univ., 1958-69. **Sources:** WW73; Betty Neukom, *Silver Mountain* (Silver Mountain Art Studios).

WHITE, Roswell N. *[Wood engraver] mid 19th c.*
Addresses: NYC, 1832-37; Chicago, 1846-48; Cincinnati, c.1851. **Comments:** He may also have worked in Cincinnati, when a book containing some examples of his work was published there. There was a Roswell M. White, lumber dealer, in Cincinnati in the mid-fifties. **Sources:** G&W; NYCD 1832-37; Chicago CD 1846, BD 1848; Hamilton, *Early American Book Illustrators and Wood Engravers;* Cincinnati CD 1853+.

WHITE, Ruby Zahn *[Painter] b.1899, San Jose, CA / d.1986, San Diego, CA.*
Addresses: Stockton, CA. **Studied:** Calif. School FA. **Member:** Stockton Art Lg. (pres., 1939-40, 1948-49); Nat. Lg. Am. Pen Women; Soc. Western Artists. **Exhibited:** Smithsonian Inst., 1954, 1956; Calif. State Fair, 1954, 1958, 1962; Soc. Western Artists; Kingsley AC, Sacramento, 1952, 1960; Oakland Mus., 1953; Springfield (MA) MFA, 1961; Haggin Mus., Lodi Community AC & Univ. of the Pacific (retrospectives). **Work:** Haggin Mus., Stockton, CA; Univ. of the Pacific; Stockton Pub. Lib.; Stockton Record; Bank of Stockton; Lodi Community AC. **Comments:** Primarily a *plein air* landscape painter. Teaching: high schools in Sebastopol and Stockton, CA; College of the Pacific. **Sources:** Hughes, *Artists in California*, 601.

WHITE, Ruth *[Art dealer, collector] 20th c.; b.NYC.*
Addresses: NYC. **Studied:** Kurt Seligmann. **Comments:** Owner: Ruth White Gallery. Collections: Kurt Seligmann; Ozenfant; paintings & sculpture by various young American artists. Specialty of gallery: contemporary paintings, sculpture & graphics. **Sources:** WW73.

WHITE, Ruth C. *[Painter] mid 20th c.*
Exhibited: Soc. Indep. Artists, 1931. **Comments:** Possibly White, Ruth M., living in 1973. **Sources:** Marlor, *Soc. Indp. Artists.*

WHITE, Scott See: **WHITE, (Clarence) Scott**

WHITE, Stanford *[Architect, frame designer] b.1853 / d.1906.*
Comments: One of the most important Beaux-Arts architects of the 19th century, he was also an important frame designer. His dynamic designs often included classic architectural elements or featured delicate reeding in a grill pattern. Among his friends for whom he designed frames were Saint-Gaudens, W.M. Chase, T.W. Dewing, J. La Farge, Geo. DeF. Brush, A. Thayer, J.S. Sargent, J.H. Twachtman, and many others. The best selection of his frames may be seen at the Freer Gallery., Wash, DC. **Sources:** info. courtesy Eli Wilner Co., NYC.

WHITE, Theodore B. ("Theo") *[Lithographer, etcher, illustrator, drawing specialist, architect, writer, lecturer] b.1902, Norfolk, VA / d.1978, Ardmore, PA?.*
Addresses: Ardmore, PA. **Studied:** Univ. Pennsylvania. **Work:** series of lithographs, Williamsburg, VA; drawings and lithographs, Boulder Dam; Richmond Mus. **Comments:** Author/illustrator: "Colonial Mansions of Fairmount Park, "Richmond, Twelve Lithographs of the City on the James." **Sources:** WW40.

WHITE, Theresa *[Painter] mid 19th c.*
Exhibited: Michigan State Fair, 1858. **Sources:** Petteys, *Dictionary of Women Artists.*

WHITE, (Thomas) Gilbert *[Painter, decorator, lecturer, teacher, writer] b.1877, Grand Haven, MI / d.1939, Paris, France.*
Addresses: Paris/Les Andelys, France. **Studied:** ASL with Twachtman; Académie Julian, Paris with J.P. Laurens & Constant, 1898, École des Beaux-Arts; Whistler & F. MacMonnies in Paris. **Member:** AAPL (pres. European Chapter); Société Int.; Anglo-Am. Group, Paris; Commander, Legion of Honor; Am. Mission to Peace. **Exhibited:** Hanover Sq. Gal., NYC, 1987. Awards: Commander de la Légion d'Honneur: Officer de l'Académie; Order of the Purple Heart. **Work:** murals, Capitol, KY; Federal Bldg., Gadsen, AL; Capitol, Utah; County Court House, New Haven, CT; Peninsula Club, Grand Rapids, MI; portrait, Pan-Am. Bldg., Wash., DC; murals, Capitol, OK; McAlpin Hotel, NYC; murals: Dept. Agriculture Bldg., Wash., DC; Locust Club, Phila.; Houston MFA.; Brooklyn Mus.; Luxembourg Gal.; Gal. du Journal Paris; Univ. Club; Carnegie Found., Paris; Musée de St. Quentin; drawings, Univ. Utah; Univ. Oklahoma, Norman; drawings, CGA; Musée Luxembourg, Paris; Musée de la Cité de Paris. **Comments:** An expatriate painter who lived in Paris most of his life. **Sources:** WW38; article, *Antiques & Arts Weekly* (May 1, 1987, p.58).

WHITE, Vera M. (Mrs. Samuel S. III) *[Flower painter, lithographer, designer, art collector] b.1888, St. Louis, MO / d.1966, Bryn Mawr, PA.*

VERA WHITE

Addresses: Phila., Ardmore & Downingtown, PA. **Studied:** Earl Horter; Arthur B. Carles. **Member:** Phila. Artists All.; Phila. WCC; Chester County AA. **Exhibited:** Soc. Indep. Artists, 1926; PAFA Ann., 1934, 1943-45; PAFA, 1951; WMAA; Phila. Pr. Club; LOC; Chester County AA, 1955 (prize); Phila. Artists All.; Edward Side Gal., McClees Gal., Carlen Gal., Phila.; Columbus Gal. FA; Honolulu Acad. Arts; Reld & Lefevre Gal., London; Ferargil (solo); Marie Sterner (solo); Durand-Ruel(solo); Seligmann Gal., NY (solo); Bryn Mawr AC, 1954; Sessler Gal., Phila., 1955, 1956, 1957; Salons of Am.; AIC. **Work:** Temple Univ.; PMA; PAFA. **Comments:** The art collection of Mr. & Mrs. White was at the Phila. Mus. Art. **Sources:** WW59; WW47; Petteys, *Dictionary of Women Artists; Falk, Exh. Record Series.*

WHITE, Verner Moore *[Painter] b.1863, Lunenburg, VA / d.1923, Chautauqua, NY.*
Addresses: Deland, FL, 1884-85; Mobile, AL, 1885-87; Europe, 1887-95; Texas, 1895-1902; St. Louis, MO, 1902-23. **Studied:**

Southwestern Presbyterian Univ., Clarksville, TN; Paris, France, Brussels, Antwerp, Rotterdam, Liege, Rouen, Biarritz and Pau. **Member:** National Arts, NYC; St. Louis Art League. **Exhibited:** St. Louis World's Fair, 1902 (prize for still life), 1903 (twelve paintings, depicting the history, life, scenic beauty and resources of Texas). **Work:** Capitol Building, Montgomery, AL. **Comments:** Preferred medium: oil. Specialty: blooming trees in spring. **Sources:** info. courtesy of Edward P. Bentley, Lansing, MI.

WHITE, Victor (Gerald) *[Painter] b.1891, Dublin, Ireland / d.1954, Cedarhurst, LI, NY.*
Addresses: Cedarhurst. **Studied:** ASL with Bellows, R. Henri & W.M. Chase; Académie Julian, Paris with J.P. Laurens; Acad. Grande Chaumière, Paris; L. Simon & Billou in Paris. **Member:** Mural Painters. **Exhibited:** Soc. Indep. Artists, 1917; Portraits, Inc.; Arch. Lg., 1945. **Work:** Murals, Waldorf-Astoria Hotel, IT&T Bldg., NY; Grumman Corp.; WPA mural,USPO, Rockville Centre, NY; frieze, Theater Guild, NY. **Sources:** WW53; WW47.

WHITE, Wade *[Painter, sculptor] b.1909, Waterbury, CT.*
Studied: Yale Univ. (1933, B.A.); ASL; Columbia Univ. with O. Maldorelli; privately with C. Scarvaglione, NYC. **Member:** Rockport AA; Gloucester Soc. Artists (secy., 1941; pres., 1942). **Exhibited:** Jumble Shop, NYC; Mattatuck Hist. Soc., 1937 (solo); Rockport AA; Gloucester Soc. Artists 1941-42 (sculpture); J. Marqusee, NYC, 1989 (1930s paintings); Salons of Am. **Comments:** A Precisionist painter who only painted during the 1930s. Positions: slide librarian at the BMFA and art history teacher at the New England Conservatory of Music, 1943-46; cur., Mattatuck Mus., 1947-53; archivist, Fogg AM, Cambridge, MA, 1953-70; archivist, Victorian Soc. in Am.; 1970-on. **Sources:** exh. cat., J. Marqusee, NYC (1989).

WHITE, Walter Charles Louis *[Painter, teacher, lecturer] b.c.Sheffield, England / d.1964.*
Addresses: St. Albans, LI, NY/Woodstock, NY. **Studied:** Teachers College, Columbia Univ. (B.S.; M.A.); PIA Sch.; Carlson; Dow; Hawthorne. **Member:** SC; AWCS; New Haven PCC; NYWCC; AAPL; Mississippi AA; Long Island Soc. Arch. (hon.); Brooklyn Soc. Artists (pres.); Art Lg. of Nassau (pres.); AWC (sec.). **Exhibited:** WFNY 1939; Sesqui-Centennial Expo, Phila., PA, 1926; Wash. WCC; BM; TMA; New Haven PCC; AWCS, 1948-51; AFA traveling exh.; SC, 1948-51; Mississippi AA; Art Lg. Nassau County; Brooklyn Soc. Artists, 1950; NAC, 1950-52; CM; Columbus Gal. FA; Dayton AI; AIC. Awards: Art Lg. Nassau County, 1929, 1934, 1937 (prizes); Mineola Fair, 1938; Mississippi AA, 1926 (gold medal). **Work:** Vanderpoel Coll.; John Adams H.S., St. Albans, NY. **Sources:** WW59; WW47.

WHITE, Warren C. *[Landscape painter] late 19th c.*
Addresses: Virginia, active 1860s. **Comments:** Some of his sketches of Virginia appeared as illustrations in Edward Pollard's *The Virginia Tourist*, published in 1870. **Sources:** Wright, *Artists in Virginia Before 1900.*

WHITE, William *[Lithographer] b.c.1843, Pennsylvania.*
Addresses: Philadelphia, 1860. **Comments:** He was the son of John White, bricklayer, with whom he was living in 1860. **Sources:** G&W; 8 Census (1860). Pa., LV, 567.

WHITE, William *[Listed as "artist"] b.c.1843, New York.*
Addresses: NYC, 1860. **Comments:** He lived with his father John White, "shoefinder". **Sources:** G&W; 8 Census (1860), N.Y., XLV, 8.

WHITE, William Davidson *[Mural painter, illustrator, drawing specialist] b.1896, Wilmington.*
Addresses: Wilmington, DE. **Studied:** PAFA. **Exhibited:** Wilmington SFA, 1932 (prize). **Work:** CGA; Phila. MA; Univ. Pennsylvania; Wilmington SFA, Harlan Sch., Wilmington; WPA mural, USPO, Dover, DE. **Sources:** WW40.

WHITE, William G. *[Engraver] mid 19th c.*
Addresses: NYC, active 1843. **Comments:** Partner in Neale & White (see entry). **Sources:** G&W; NYCD 1843.

WHITE, William James *[Engraver, lithographer, seal cutter]*
mid 19th c.
Addresses: Chicago, active 1850's. **Sources:** G&W; Chicago BD 1852-53, CD 1855-59.

WHITE & VANDER[H]OEF *[Engravers] mid 19th c.*
Addresses: NYC, 1857. **Comments:** Partners were George W. White (see entry) and John J. Vander[h]oef. **Sources:** G&W; NYBD and NYCD 1857.

WHITE BEAR *[Watercolor painter] b.1869.*
Work: Mus. Am. Indian; Southeast Mus. of North Am. Indian, Marathon, FL. **Comments:** Early Hopi painter, active in 1899, at which time J. W. Fewkes asked him to make drawing representing the Hopi gods, published in 1903. **Sources:** P&H Samuels, 525.

WHITE BEAR, (Oswald Fredericks) *[Painter, craftsperson, teacher] b.1906, Old Oraibi, AZ.*
Addresses: Oraibi, AZ in 1968. **Studied:** Bacone College & Haskell, 1933-37; self-taught. **Work:** Mus. Am. Indian; Southeast Mus. North Am. Indians; New Jersey YMCA (mural). **Comments:** Hopi painter, Kachina carver. Also known as Oswald Fredericks. Teaching: New Jersey YMCA, 15 years. **Sources:** P&H Samuels, 525.

WHITECHURCH, Robert *[Portrait and banknote engraver, painter] b.1814, London, England / d.c.1880.*
Addresses: Philadelphia,1848-72; Washington, DC, 1872. **Exhibited:** PAFA Ann., 1876. **Comments:** He did not take up engraving until he was about thirty. He went to Washington to work for the Treasury Department. His widow was listed in the Philadelphia directory for1881. **Sources:** G&W; Stauffer; Phila. CD 1850-72, 1881; Rutledge, PA; Falk, PA, vol. II.

WHITE CORAL BEADS See: **PENA, Tonita (Quah Ah)**

WHITEFIELD, Edwin
[Viewmaker, lithographer, teacher, landscape & flower painter] b.1816, Ludworth, Dorset, England / d.1892, Dedham, MA.

E. Whitefield

Addresses: Itinerant, later settled in Boston. **Studied:** medicine & law; England. **Exhibited:** NAD, 1852-54. **Work:** Boston Athenaeum ("View of the Public Garden & Boston Common," printed by J.H. Bufford in 1866, engraved by Charles W. Burton); Minnesota Hist. Soc.; BMFA; Shelburne (VT) Mus. **Comments:** Prolific viewmaker of towns and cities. Came to the U.S. about 1836. During his first years he is believed to have been an agent for *Godey's Magazine,* traveling to Troy (NY), and Baltimore (MD). He was also a teacher and added to his income by sketching and painting watercolor views of Hudson Valley estates. Whitefield began to experiment with lithography in 1842; and in 1845 published his first views, two large lithographic prints of Albany and Troy, NY. That same year, illustrations by Whitefield appeared in Emma C. Embury's *American Wild Flowers in Their Native Haunts.* Two years later he issued a series of views under the title, *North American Scenery,* consisting of 28 views of rural landscapes and country estates. This became part of his larger series *Whitefield's Original Views of (North) American Cities (and Scenery).* From 1847 to 1852 he traveled through Canada and across the northern states collecting views which he published as part of the aforementioned *Views of American Cities* series. From 1856-59 he made several trips to Minnesota to promote his real estate interests there; from this period date a number of watercolor landscapes (Minn. Historical Society), sketches and lithographic views which he published in his *Series of Minnesota Scenery.* He and his family lived in Chicago 1860-63; while there he made *Views of Chicago* which was printed by a local firm. Back in Boston by 1866, he produced a drawing manual, drew a number of street maps, as well as a second drawing manual, issued as a series. From 1870-88, Whitefield lived in Reading (MA), where he continued to produce views of New England towns. During these years he did the illustrations for his three-volume *The Homes of Our Forefathers,* a seminal work recording, for history,

the early houses of New England. **Sources:** G&W; Heilbron, "Edwin Whitefield's Minnesota Lakes"; NYCD 1844; McClinton, "American Flower Lithographs," 363; G&W cited Bertha L. Heilbron of the Minnesota Historical Society as providing information. More recently, see Reps, 214-216 and cat. entries; Pierce & Slautterback, 182 and fig. 111; Campbell, *New Hampshire Scenery,* 173; Muller, *Paintings and Drawings at the Shelburne Museum,* 139 (w/repro.).

WHITEFIELD, Emma Morehead See: **WHITFIELD, Emma M(orehead)**

WHITEFIELD, F. Edith *[Landscape painter] 19th/20th c.*
Addresses: San Francisco, CA. **Exhibited:** San Francisco AA, 1903; Oakland Art Fund, 1905. **Sources:** Hughes, *Artists of California,* 602.

WHITEFIELD, R(aisse) (Mrs. R.) *[Painter] early 20th c.*
Studied: ASL. **Exhibited:** Soc. Indep. Artists, 1924-27. **Sources:** Marlor, *Soc. Indp. Artists.*

WHITEHAM, Edna May See: **WHITEHAN, (Edna) May**

WHITEHAN, (Edna) May *[Painter, illustrator] b.1887, Scribner, NE.*
Addresses: Nebraska; Takoma Park, MD; Virginia. **Studied:** Sara Hayden & Seymour, Univ. Nebraska; AIC. **Member:** Lincoln AC. **Exhibited:** Nebraska State Fair (prizes). **Work:** U.S. Nat. Arboretum. **Comments:** Positions: illustr., U.S. Dept. Agriculture, later at the Smithsonian Inst. **Sources:** WW25; McMahan, *Artists of Washington, DC.*

WHITEHAN, May See: **WHITEHAN, (Edna) May**

WHITEHEAD, Deborah *[Artist] late 19th c.*
Addresses: Active in Lansing, MI, 1890s. **Studied:** Maud Mathewson; Joseph Gies & Francis Paulus, Detroit Art Acad. **Sources:** Petteys, *Dictionary of Women Artists.*

WHITEHEAD, E. *[Painter] late 19th c.*
Addresses: NYC, 1889-90. **Exhibited:** NAD, 1889-90. **Sources:** Naylor, *NAD.*

WHITEHEAD, Edith H. *[Painter, primarily of miniatures] early 20th c.*
Addresses: Wash., DC. **Exhibited:** Wash. WCC, 1922. **Sources:** WW25; McMahan, *Artists of Washington, DC.*

WHITEHEAD, Florence *[Painter] early 20th c.*
Addresses: Phila., PA. **Sources:** WW17.

WHITEHEAD, James Louis *[Art administrator, designer] b.1913, Demopolis, AL.*
Addresses: Poughkeepsie, NY. **Studied:** Birmingham-Southern College (B.A., 1933); Vanderbilt Univ. (M.A., 1934); Univ. Pennsylvania (Ph.D., 1942). **Member:** Am. Assoc. Mus.; Int. Council Mus. **Comments:** Positions: dir., Staten Island Inst. Arts & Sciences, 1951-61; asst. to pres., Pratt Inst., 1961-63; dir., Monmouth Mus., 1963-67; cur., Franklin D. Roosevelt Lib. & Mus., 1967-. **Sources:** WW73.

WHITEHEAD, Margaret Van Cortlandt *[Painter] mid 20th c.*
Addresses: Pittsburgh, PA; Greenwich, CT; Rye, NY. **Studied:** ASL. **Member:** NAWPS. **Exhibited:** PAFA Ann., 1912-13; NAWPS, c.1923-38; Pittsburgh AA, 1912 (prize). **Sources:** WW40; Falk, *Exh. Record Series.*

WHITEHEAD, Philip Barrows *[Educator, writer, lecturer, museum curator] b.1884, Janesville, WI.*
Addresses: Beloit, WI. **Studied:** Beloit College (B.A.); Yale Univ. (Ph.D.); Am. Acad. in Rome. **Comments:** Contrib.: *American Journal of Archaeology.* Lectures: American painting & architecture. **Sources:** WW59.

WHITEHEAD, Ralph Radcliff *[Ceramicist, writer] b.1854, Yorkshire, England / d.1929, Santa Barbara, CA.*
Addresses: Woodstock, NY. **Studied:** Balliol College, Oxford, England; Académie Julian, Paris, 1896. **Comments:** Immigrated

to the U.S. in 1892. Author: *Grass of the Desert, Dante's Vita Nuova.* Member/founder: Byrdcliffe, the Utopian arts-and-crafts settlement in Woodstock, a colony intended to foster the ideals of John Ruskin and William Morris. Specialty: pottery.

WHITEHEAD, Walter *[Painter, illustrator] b.1874, Chicago / d.1956.*
Addresses: Dare, VA. **Studied:** AIC; Howard Pyle.
Member: SI, 1911; Art Dir. Club; SC. **Sources:** WW53.

WHITEHEAD, Walter Muir *[Writer, art historian, curator] b.1905, Cambridge, MA / d.1978.*
Addresses: North Andover, MA. **Studied:** Harvard Univ. (A.B., 1926; A.M., 1929) with A. Kingsley Porter; Courtald Inst., Univ. London (Ph.D, 1934) with WG Constable & Alfred Clapham. **Member:** College AA Am.; Boston Soc. Architects (hon. mem.); Am. Inst. Architects (hon. mem.). **Comments:** Positions: asst. dir., Peabody Mus., Salem, 1936-46; dir. & librarian, Boston Atheneum, 1946-72, emeritus, 1972-; trustee, Mus. Fine Arts, Boston, 1953-. Teaching: tutor fine arts, Harvard Univ., 1926-28, Allston Burr senior tutor, Lowell House, 1952-56, lecturer history, 1956-57. Research: Spanish Romanesque architecture of the Eleventh Century. Author: "Spanish Romanesque Architecture of the Eleventh Century,"1941 & 1968; "Salem East India Society and Peabody Museum of Salem: A Sesquicentennial History," 1949; "Boston Public Library: A Centennial History," 1956; "Boston, A Topographical History," 1959 & 1968; "Museum of Fine Arts, Boston: A Centennial History," 1970. **Sources:** WW73; L.H. Butterfield, ed. *Walter Muir Whitehill, A Record* (Atheonsen Press, 1958); complete bibliography, *Bulletin Bibliography* (F.W. Faxon, Co., 1973).

WHITEHILL, Clayton *[Artist] mid 20th c.*
Addresses: Phila., PA?. **Exhibited:** PAFA Ann., 1953. **Sources:** Falk, *Exh. Record Series.*

WHITEHILL, Donald J. *[Painter, illustrator] mid 20th c.; b.Newton, MA.*
Studied: BMFA Sch.; Mass. Sch. Art; Maryland Inst.; Max Brodel (medical illustration). **Exhibited:** Parc Layautry Exh., Casablanca, 1943 (first prize). **Comments:** Position: medical illustr., Army Gen. Hospital. **Sources:** *Artists of the Rockport AA* (1956).

WHITEHILL, Florence (Fitch) *[Painter] mid 20th c.; b.Hillsdale, NY.*
Addresses: NYC. **Studied:** Mass. College Art, Boston; Grand Central School Art. **Member:** Catharine Lorillard Wolfe AC (pres., 1953-56; corresp. secy., 1959-71); AAPL; Acad. Artists Assoc.; Nat. Lg. Am Pen Women (state art chmn., 1964-66; NY branch treasurer, 1972-73); Royal Soc. Arts, London (life fellow). **Exhibited:** All. Artists Am., NAD, 1944-52; AAPL Grand Nat., New York, 1947-72 (9 shows); Catharine Lorillard Wolfe AC Ann., 1949-72 (best in show, 1953 & best watercolor, 1968); Acad. AA, Fine Arts Mus., Springfield, MA, 1956-58, 1964 & 1967; Nat. Lg. Am. Pen Women Biennial, SI, Wash., DC, 1958 (award of honor for watercolor). **Work:** New York Hist. Soc.; East Hampton (NY) Soc.; Tamassee DAR School, SC. **Comments:** Preferred medium: watercolors. **Sources:** WW73; Mary Barbara Reinmuth, *The Pen Woman* (New York Branch, Nat. L. Am. Pen Women, winter 1957-58).

WHITEHORN, Edna May See: **WHITEHAN, (Edna) May**

WHITEHORNE, James A. *[Portrait and miniature painter] b.1803, Wallingford, VT / d.1888, NYC.*
Addresses: NYC, entire career. **Studied:** NAD, c.1826. **Member:** ANA, 1829; NA, 1833 (recording secretary 1838-44). **Exhibited:** Am. Acad.; Apollo Assoc.; NAD, 1828-81; Brooklyn AA, 1867; PAFA, 1837-42; Am. Inst. **Comments:** Prolific portrait painter, his exhibition record at the National Academy spanned a remarkable 53 years. **Sources:** G&W; CAB; Cowdrey, NAD; Cowdrey, AA & AAU; Rutledge, PA; Am. Inst. Cat., 1856.

WHITEHOUSE, James Horton *[Seal engraver and jewel cutter] b.1833, Staffordshire (England) / d.1902, NYC (Brooklyn).*
Addresses: NYC (Brooklyn), 1857-1902. **Work:** MMA. **Comments:** He was a member of the firm of Tiffany & Co., NYC, and an authority on art and engraving on precious metals. Some of his most notable works are the William Cullen Bryant silver vase, presented to the poet in 1874, and now in the MMA; the silver casket presented to the late Bishop Horatio Potter, in 1879, and the Third Seal of the United States Government. **Sources:** G&W; *Art Annual,* VI, obit.

WHITEHURST, Camelia *[Portrait painter] b.1871, Baltimore, MD / d.1936, Baltimore, MD.*
Addresses: Baltimore, MD. **Studied:** Charcoal Club with S. Edwin Whiteman; PAFA with Chase & Beaux. **Member:** PAFA; SSAL; NAWA; Grand Central Art Gal.; North Shore AA; Springfield AL; Soc. Wash. Artists. **Exhibited:** Corcoran Gal. biennials, 1914-26 (3 times); PAFA Ann., 1916-25, 1929; All Southern Exh., Charleston, SC, 1921 (prize); NAWA, 1920 (prize), 1921 (hon. mention), 1923 (prize); Memphis, 1922 (prize); New Orleans, 1923 (prize); Wash. SA, 1925 (medal), 1929 (prize); Springfield, MA, 1929 (prize); Jackson, MS, 1929 (gold); Baltimore MA, 1931 (solo). **Work:** Delgado MA; Baltimore Friends of Art; Maryland Hist. Soc., Baltimore; Univ. North Carolina, Chapel Hill, NC. **Comments:** Following her studies, she traveled in Europe and had a studio in Paris, France. Specialty: children's portraits. **Sources:** WW33; Falk, *Exh. Record Series;* addit. info. courtesy of Stephanie A. Strass, Reston, VA.

WHITELAW, Norma *[Miniature painter] early 20th c.*
Addresses: NYC. **Exhibited:** AIC, 1916. **Sources:** WW17.

WHITELAW, Robert N. S. *[Etcher] early 20th c.*
Addresses: Charleston, SC. **Sources:** WW25.

WHITELEY, Rose (Mrs.) *[Painter] early 20th c.*
Addresses: Salt Lake City, UT. **Sources:** WW15.

WHITELOCK, Samuel West *[Portrait and miniature painter] mid 19th c.*
Addresses: Baltimore, 1831-40. **Sources:** G&W; Lafferty.

WHITEMAN, Edward R. *[Painter] b.1938.*
Addresses: New Orleans. **Exhibited:** WMAA, 1975. **Sources:** Falk, *WMAA.*

WHITEMAN, Frederick J. *[Abstract painter] b.1909, Pennsylvania.*
Addresses: NYC; Lansdale, PA. **Studied:** Carnegie Inst., 1929, with Alex. Kostellow; ASL with J. Matulka & Eugene Fitch. **Member:** Am. Abstract Artists, 1937 (founder). **Exhibited:** Am. Abstract Artists, 1938; WMAA; Salons of Am. **Work:** NMAA. **Comments:** Teaching: formed art school with Alex. Kostellow; WPA/FAP in Greensboro, NC and Greenville, MS, 1937-39; Pratt Inst., NYC, 1939-74. **Sources:** Diamond, *Thirty-Five American Modernists* p.26; *American Abstract Art,* 202.

WHITEMAN, Leona Curtis See: **CURTIS, Leona (Mrs. Leona Curtis Whiteman)**

WHITEMAN, Mary H. *[Painter] late 19th c.*
Addresses: Phila., PA. **Exhibited:** PAFA Ann., 1882-83. **Sources:** Falk, *Exh. Record Series.*

WHITEMAN, S(amuel) Edwin *[Landscape painter, teacher] b.1860, Philadelphia, PA / d.1922.*
Addresses: Roxborough, PA, 1890; Baltimore, MD, 1893-99. **Studied:** Académie Julian, Paris with Boulanger, Constant, Lefebvre, 1883-89; École des Beaux-Arts. **Member:** Charcoal Club. **Exhibited:** Paris Salon, 1886-87, 1889; Paris Expo, 1889 (prize); PAFA Ann., 1890-1901, 1906-13; NAD, 1890-99; Boston AC, 1896, 1898-99; Corcoran Gal. annuals/biennials, 1907-12 (3 times); AIC; Soc. Indep. Artists, 1922. **Comments:** Teaching: Charcoal Club, 25 years; John Hopkins Univ. **Sources:** WW21; Fink, *American Art at the Nineteenth-Century Paris Salons,* 406;

Falk, *Exh. Record Series.*

WHITEMAN, Sarah W. *[Sculptor] late 19th c.*
Exhibited: SNBA, 1895. **Sources:** Fink, *American Art at the Nineteenth-Century Paris Salons,* 406.

WHITEMARSH, Katherine *[Painter] early 20th c.*
Exhibited: Salons of Am., 1924, 1926. **Sources:** Marlor, *Salons of Am.*

WHITENER, Paul (Austin) W(ayne) *[Museum director, painter, lecturer, teacher] b.1911, Lincoln County, NC / d.1959.*
Addresses: Hickory, NC. **Studied:** Duke Univ.; Ringling Sch. Art; Wilford Conrow; Donald Blake; Frank Herring. **Member:** AAPL; North Carolina State Art Soc.; SC; Kappa Pi (hon.); Duke Univ. Arts Council. **Exhibited:** Mint MA, 1944; Hickory MA, 1943-1946; SSAL, 1942; Duke Univ., 1945 (solo). **Work:** Duke Univ.; Lenoir Rhyne College, Hickory, NC; Hickory MA; many portrait commissions. **Comments:** Positions: dir., Hickory MA, 1943; teacher, Hickory H. S., 1945-46; nat. dir., AAPL Honor Roll. Lectures: art appreciation. **Sources:** WW59; WW47.

WHITESIDE *[Portrait painter] mid 19th c.*
Comments: Painted a portrait of Mrs. John W. Forney of Philadelphia in 1850. **Sources:** G&W; Lancaster County Hist. Soc., Portraiture in Lancaster County, 141.

WHITESIDE, Dorothy M. (Mrs. Leland W.) *[Painter] mid 20th c.*
Addresses: Seattle, WA, 1951. **Exhibited:** SAM, 1947. **Sources:** Trip and Cook, *Washington State Art and Artists, 1850-1950.*

WHITESIDE, Forbes J. *[Educator] mid 20th c.*
Addresses: Oberlin, OH. **Studied:** Univ. Minnesota (B.A., 1941; M.F.A., 1951); Minnesota School Art, cert., 1948. **Comments:** Teaching: Oberlin College, 1951-70s. **Sources:** WW73.

WHITESIDE, Frank Reed *[Landscape painter, teacher, writer] b.1866, Philadelphia, PA / d.1929, Philadelphia, PA.*

FRANK REED WHITESIDE

Addresses: Phila./Ogunquit, ME. **Studied:** PAFA; Académie Julian, Paris with J.P. Laurens and Constant, 1893. **Member:** Phila. Sketch Club; Fellow, PAFA (board); Phila. WCC; Phila. Art Alliance. **Exhibited:** PAFA Ann., 1887-98, 1905-06, 1915 (prize 1888); AIC, 1896-1915; Corcoran Gal. annual, 1907; Phila. Sketch Club 1929 (memorial); Phoenix AM (retrospective) 1971. **Comments:** Whiteside visited the Zuni Indians beginning in 1890 until 1920. He was mysteriously shot down at his home when he answered the door. Teaching: R.C. High School, Phila., 1899-96; Germantown Acad., 1907. **Sources:** WW27; P&H Samuels cite alternate birthdate of 1867; Falk, *Exh. Record Series.*

WHITESIDE, Henry Leech See: **WHITESIDE, Henryette Stadelman**

WHITESIDE, Henryette Stadelman *[Painter] b.1891, Brownsville, PA.*
Addresses: Wilmington, DE. **Studied:** PAFA; in Italy with Donati; Thomas Anschutz; Hugh Breckenridge; Charles Hawthorne. **Member:** Phila. WCC; Phila. Artists All.; Wilmington Soc. FA. **Exhibited:** PAFA Ann., 1931; NAD; AIC; WFNY 1939; Delaware AC; Ogunquit AC; Nat. Lg. Am. Pen Women (prize); Univ. Delaware, 1938. **Work:** State House, Dover, DE; Wilmington Soc. FA. **Comments:** Position: founder/director, Wilmington Acad. Art, until merged with Delaware AC, 1942. **Sources:** WW59; WW47 (listed as Henry Leech Whiteside in 1933 edition); Falk, *Exh. Record Series.*

WHITFIELD, E. *[Listed as "artist"] b.1820, Massachusetts.*
Addresses: Philadelphia, 1850. **Sources:** G&W; 7 Census (1850), Pa., LII, 341.

WHITFIELD, Emma M(orehead) *[Portrait painter, teacher] b.1874, Greensboro, NC / d.1932, Richmond, VA.*
Addresses: Richmond, VA. **Studied:** ASL; R. Collin in Paris; Maryland Inst. School Art & Design. **Work:** portraits, State Lib., Richmond, VA; Univ. Richmond, VA; Carnegie Lib., Greensboro,

NC; Capitols, Raleigh, NC, Jackson, MS; Guildford County Court House, Greensboro; Confederate Battle Abbey, Confederate Mem. Mus., Executive Mansion, all in Richmond; Women's Club, Raleigh; Mississippi College, Clinton; port., Boy's Indust. Sch., Birmingham, AL. **Comments:** Teaching: Woman's College, Richmond. **Sources:** WW31; Petteys, *Dictionary of Women Artists.*

WHITFIELD, John S. *[Portrait painter, sculptor & cameo portraitist] mid 19th c.*
Addresses: Cambridge, MA, 1828; Philadelphia, 1829; Paterson, NJ, 1848; NYC, 1849 -51. **Sources:** G&W; Swan, BA; Rutledge, PA; Cowdrey, NAD; NYBD 1849-50; NYCD 1851.

WHITFIELD, Robert Parr *[Illustrator] mid 19th c.*
Comments: Position: illustr., Smithsonian Inst., 1856-76. **Sources:** McMahan, *Artists of Washington, DC.*

WHITFORD, William Garrison *[Craftsman, educator, writer] b.1886, Nile, NY.*
Addresses: Chicago 37, IL; Olympia Fields, IL. **Studied:** C.F. Binns, Alfred Univ. (Ph.B.); D.F.A.); AIC; H.F. Staley, Iowa State College (S.M.). **Member:** Am. Ceramic Soc. (fellow); Nat. Educ. Assn.; Western AA. **Work:** Univ. Chicago (set of dishes). **Comments:** Position: adv. ed., *School Arts* magazine; head, dept. des. & ceramics, Maryland Inst., 1911-13; dir., workshop in art & crafts, & teacher training, Univ. Chicago, 1913-52; prof. emeritus of art educ., Univ. Chicago, 1952-. Author: *Introduction to Art,* 1937; co-author: *The Classroom Teacher,* Vol. I, II, III, 1933-35; *Art Stories* Books 1, 2 & 3, 1933-35; *High School Curriculum Reorganization,* 1933, & other books on art education. Contributor: *School Arts, School Review, Design; Dictionary of Education,* 1945; *Encyclopaedia of the Arts,* 1946. **Sources:** WW59; WW47.

WHITIES-SANNER, Glenna *[Painter] b.1888, Kalida, OH.*
Addresses: Findlay, OH. **Studied:** Leon Pescheret; Mrs. Vance Whities. **Member:** Ohio WCS; AEA; AWS; Toledo Art Club. **Exhibited:** TMA, 1943, 1944; Taft Mus.; Ohio WCS traveling exh., 1942-43; Findlay, OH, 1943; Kent State Univ.; Dayton AI; CMA; Butler AI; Columbus Gal. FA; Ohio Univ.; Canton AI; Fort Recovery Hist. Mus. Lib., 1951 (solo); Findlay College, 1956 (solo). **Work:** Veterans Hospital, Dayton, OH; Fort Recovery (OH) Hist. Mus. **Comments:** Teaching: Findlay College & cur., College Mus., 1953-. Author/illustrator: *The Book of Orchids.* Illustrator of biology and botany textbooks, 1956. **Sources:** WW59; WW47.

WHITING, Almon Clark *[Painter, etcher, designer] b.1878, Worcester, MA.*
Addresses: Wash., DC, active 1911-12, 1954; NYC; Paris, France, 1930. **Studied:** Mass. Normal Art Sch.; Académie Julian, Paris with J.P. Laurens and Constant, 1899; Whistler in Paris. **Member:** SC; ARA Assn.; Paris AA; Tile Club, Toledo; SWA. **Work:** TMA. **Comments:** Position: founder/director, Toledo (OH) Mus. Art, 1901-03. **Sources:** WW59; WW47; more recently, see, McMahan, *Artists of Washington, DC.*

WHITING, Daniel Powers *[Listed as "artist"] mid 19th c.*
Addresses: NYC. **Work:** NYHS. **Comments:** Artist of F. Swinton's lithograph, "The Heights of Monterey from the Saltillo Road Looking Towards the City, September 21, 1846." Whiting was an infantry captain who graduated from West Point in 1832 and was brevetted major for gallantry at the Battle of Cerro Gordo (Mexico) in 1847. He retired as a lieutenant colonel in 1863. **Sources:** G&W; *American Processional,* 242; Heitman, *Historical Register of the U.S. Army,* 691; Jackson, *Gold Rush Album,* 124-25; Peters, *America on Stone* [as D.W. Whiting].

WHITING, F. H. *[Listed as "artist"] late 19th c.*
Exhibited: Boston Athenaeum, 1859. **Comments:** He was active as late as 1883. **Sources:** G&W; Swan, HA.

WHITING, Fabius *[Portrait painter] b.1792, Lancaster, MA / d.1842, Lancaster.*
Studied: Gilbert Stuart (Lancaster, MA). **Comments:** He had

only a brief career as an artist. He entered the U.S. Army in time to hold a lieutenant's commission during the War of 1812 and subsequently rose to the rank of brevet major (1829). Whiting is said to have been the first instructor of James Frothingham (see entry). **Sources:** G&W; Morgan, *Gilbert Stuart and His Pupils*, 70-71.

WHITING, Florence Standish *[Mural painter, etcher, decorator] b.c.1888, Phila., PA / d.1947, Phila.*
Addresses: Phila. PA/Wildwood, NJ. **Studied:** PAFA with E. Horter, H. McCarter (Cresson traveling scholarship, 1918-19); Phila. School Design Women. **Member:** Phila. Alliance; Plastic Club. **Exhibited:** PAFA Ann., 1919-20, 1933-39, 1943-44; Plastic Club, 1931 (gold medal); Corcoran Gal. biennials, 1937-41 (3 times); Phila. Sketch Club, 1939 (gold medal); Golden Gate Expo, San Francisco, 1939. **Work:** murals, Brègy Sch., Phila.; PAFA; FA Bldg., Univ. Penn.; Allentown Mus. **Comments:** Her floral still life paintings are influenced by the Breckenridge and Carles in the fauvist style. **Sources:** WW40; Petteys, *Dictionary of Women Artists;* Falk, *Exh. Record Series.*

WHITING, Frank *[Etcher] mid 20th c.*
Addresses: Cooperstown, NY. **Member:** SAE. **Sources:** WW47.

WHITING, Gertrude *[Craftsperson] mid 20th c.*
Addresses: NYC. **Studied:** Inst. Neuchatelois des Dentelles. **Member:** Needle & Bobbin Club (founder); NYSC; Boston SAC (Master Craftsman); Embroiderers Guild, London; Les Amis du Louvre, Paris; Paris Chapt. AFA; MMA (hon. fellow). **Work:** indexed sampler 145 lace grounds, MMA; made 100 models of original stitches based on native des. for 130 East Indian schools. **Comments:** Author: *A Lace Guide for Makers and Collectors, The Spinster, Tools and Toys of Stitchery.* Position: lacemaker to Indian Govt. and United British and inter-denominational Am. Missions. **Sources:** WW40.

WHITING, Gertrude McKim (Mrs. John A. Proctor) *[Painter, art instructor] b.1898, Milwaukee, WI.*
Addresses: NYC; Old Lyme, CT; Woods Hole, MA. **Studied:** BMFA Sch.; ASL; Philip Hale; W. Adams. **Member:** All. Artists Am.; AAPL; Cape Cod AA; North Shore AA; CAFA; Soc. for Sanity in Art, Chicago; Marblehead AA. **Exhibited:** NAD; All. Artists Am.; Palm Beach Art Club; Oakland Art Gal.; New Haven PCC; Montclair Art Mus.; Ogunquit AC, 1937; North Shore AA; CAFA; Argent Gal. (solo). **Award:** prize, All. Artists Am., 1950. **Work:** Univ. Georgia; Princeton Univ.; war mem., Australia; Marine Biological Laboratory, Woods Hole, MA; Mus. of the City of NY; mem., Australia. **Comments:** Teaching: Chatham (VA) Hall, from 1959. **Sources:** WW59; WW47.

WHITING, Giles *[Painter, craftsperson] b.1873, NYC / d.1937.*
Addresses: NYC. **Studied:** Columbia, 1895 (Arch. sch.). **Member:** Artists Aid Soc.; NY Mun. AS; Arch. Lg. 1899; SCUA, 1895 (charter); Japan Soc. London; Art-in-Trades Club; Artists Fellowship; Am. Acad., Rome. **Exhibited:** Award: Friedsam medal for promotion of art in industry. **Sources:** WW13.

WHITING, John Downes *[Painter, illustrator, writer, lecturer] b.1884, Ridgefield, CT.*
Addresses: New Haven, CT. **Studied:** Yale Sch. (B.F.A.) with J. H. Niemeyer, G. A. Thompson; Clifton S. Carbee; Lucius Hitchcock. **Member:** New Haven PCC; CAFA; Rockport AA; Meriden Arts & Crafts Soc. **Exhibited:** New Haven PCC; Rockport AA; CAFA ; Conn. WCS; Meriden Arts & Crafts Soc.; Hartford, CT (solo). **Work:** Nat. Lib. Color Slides, Wash., DC; Munic. Collection, New Haven, CT; State Armory; Stephen's College, Columbuia, MO. **Comments:** Author/illustrator: *Practical Illustration*, 1920; *Fighters*, pub. Bobbs-Merrill; *S.O.S., The Trail of Fire*, pub. Bobbs; *Light and Color for the Vacation Painter*, 1958. Covers & illus. for book & magazine publishers. **Sources:** WW59; WW47.

WHITING, Lillian V. *[Painter, ceramist, teacher] b.1876, Fitchburg, MA / d.1949, Laguna Beach, CA.*
Addresses: Laguna Beach, CA. **Studied:** Boston Art School; ASL with Will H. Foote; Univ. Calif., Los Angeles, with John Hubbard Rich. **Member:** Laguna Beach AA (charter member); Women Painters West; Southern Calif. Art Teachers Assoc. **Work:** Laguna Beach Mus. Art. **Comments:** Position: art supervisor, public schools, Brattleboro, VT; teacher, Los Angeles. Specialty: landscapes and seascapes. **Sources:** WW24; Hughes, *Artists of California*, 602.

WHITING, Mildred Ruth *[Educator, painter, illustrator, designer] 20th c.; b.Seattle, WA.*
Addresses: Charleston, IL; Lincoln, NE. **Studied:** Univ. Nebraska (B.F.A.; Ph.D.); Univ. Minnesota. **Member:** Eastern Illinois Art Gld. (pres., 1951-52); Western AA; Nat. Art Educ. Assn.; Illinois Art Educ. Assn.; Midwestern College Art Conf.; AAPL; Lincoln AG. **Exhibited:** All-Illinois Soc. FA, 1942, 1943; Eastern Illinois Art Gld., annually; Nebraska State Fair, 1929 (prize), 1930 (prize); Bus. Prof. Women's Club, Lincoln, 1932 (prize); Eastern Illinois State Teachers College, 1939; Lincoln AG, 1939; All State Exh., Lincoln, 1939; Faculty Exhibs., 1949, 1951; Swope Gal. Art; Charleston (IL) H.S., 1950 (solo); Wabash Valley Exhib., 1948, 1949. **Comments:** Teaching: Eastern Illinois State College, Charleston, IL, 1936-. **Sources:** WW59; WW47.

WHITING, William H. *[Banknote engraver] mid 19th c.*
Addresses: Albany, NY, c.1835; NYC, 1837 and after. **Comments:** From 1852-58 he was a partner in Wellstood, Hanks, Hay & Whiting and Wellstood, Hay & Whiting (see entries). He co-founded the American Bank Note Co. in 1858 and was its secretary from 1860-62. **Sources:** G&W; Albany CD 1835; NYCD 1837-62.

WHITLATCH, Howard J. *[Educator] mid 20th c.*
Addresses: Fayetteville, AR. **Sources:** WW59.

WHITLEY, Philip Waff *[Sculptor] b.1943, Rocky Mount, NC.*
Addresses: Greenville, SC. **Studied:** Univ. North Carolina (B.A. & M.F.A.). **Member:** Guild SC Artists; Greenville Art Guild. **Exhibited:** Southern Sculpture: 1968, Southern Assn. Sculptors, Columbia, SC, 1968; Ann. Springs Mills Art Show, 1969; Ann. Piedmont Painting & Sculpture Exh., Charlotte, NC, 1970; Greenville Co. Mus. Art, 1971. **Work:** Mint Mus. Art, Charlotte, NC; Greenville Co. (SC) Mus. Art; Vardell Gallery, St. Andrews Presbyterian College, Laurinburg, NC; Springs Mills, Lancaster, SC. **Comments:** Preferred media: steel, bronze. Teaching: St. Andrews Presbyterian College, 1969-70; Greenville (SC) Mus. Art School, 1971-. **Sources:** WW73.

WHITLEY, Thomas W. *[Landscape and figure painter] mid 19th c.; b.England.*
Addresses: Paterson, NJ, c.1835-39; NYC, 1839-42; Cincinnati, 1848; NYC, 1849; Hoboken, NJ, 1861-63. **Exhibited:** NAD, 1835-63; Apollo Assoc. & Art-Union, 1841, 1848-49. **Comments:** After living in New York, he may have spent some time in Italy. He became superintendent of Edwin Forrest's farm at Covington (KY), across the river from Cincinnati. After losing that job, he returned in 1849 to NYC where he became a writer on the arts and drama for the New York *Herald*. He was the prime mover in the attack on the legality of the American Art-Union's lottery which resulted in the dissolution of that organization in the early fifties. **Sources:** G&W; Bloch, "The American Art-Union's Downfall"; Cowdrey, NAD; Cowdrey, AA & AAU; NYCD 1839-42; NYBD 1844, 1850-51, 1857; Essex, Hudson, and Union Counties (NJ) BD 1859.

WHITLOCK, Frances J(eanette) *[Painter, craftsperson, teacher] b.1870, Warren, IL / d.1952, Los Angeles.*
Addresses: Los Angeles from 1919. **Studied:** Arthur Dow; Charles Martin. **Member:** Calif. AC. **Exhibited:** Southern Calif. exhs. **Comments:** Teaching: Normal Sch., Fresno, CA, 1932. **Sources:** WW25.

WHITLOCK, John Joseph *[Art administrator, educator]* b.1935, South Bend, IN.
Addresses: Memphis, TN. **Studied:** Ball State Univ. (B.S., 1957; M.A., 1963); Indiana Univ. (Ed.D.). **Member:** Am. Assn. Mus.; Am. Assn. Univ. Prof.; Am. Craftsmen's Council; Nat. Art Educ. Assn. **Exhibited:** Drawings & Small Sculpture Show, Ball State Univ., 1957; Hanover College, 1963 (solo) & 1967-69 (solos); Guild Gallery, Louisville, KY, 1964 (solo); Indiana Univ. Matrix Gallery, Bloomington, IN, 1969 (solo); Franklin (IN) College, 1969 (solo). **Awards:** Ball State Univ. Fine Arts Purchase Award, 1957. **Work:** Ball State Univ., Muncie, IN; Hanover College, IN. **Comments:** Positions: director/curator, Burpee Art Mus., Rockford, IL, 1970-72; director, Brooks Mem. Art Gallery, Memphis, TN, 1972-. Publications: author, "Art in the Small College," Midwest Art Educ Conference, Houston, TX, 1965; author, "The Reproduction Was Better Than The Painting," *Art Educ.*, 1971. Teaching: Hanover College, 1964-69; Indiana Univ., Bloomington, 1969-70. Collections arranged: The Senufo Door/A Study of its Iconography, 1970; The Ghana Door/A Study of its Origin, 1970; A Return to Humanism, 1971. **Sources:** WW73.

WHITLOCK, Mary Ursula *[Miniature & portrait painter]* b.1860, Great Barrington, MA / d.1944, Riverside, CA.
Addresses: NYC, 1890, 1895; Brooklyn, NY, 1893, 1898, 1904; Riverside, CA. **Studied:** ASL with J. A. Weir; Académie Julian, Paris with Bouguereau and R.T. Fleury. **Member:** Calif. SMP; Penn. SMP; Riverside AA; NAWPS. **Exhibited:** Brooklyn AA, 1891; NAD, 1890-98; PAFA Ann., 1903-04; Soc. Indep. Artists, 1917. **Work:** White House (portrait of Dolly Madison); LACMA; BMFA. **Comments:** She was a friend of Cecilia Beaux (see entry). **Sources:** WW40; Falk, *Exh. Record Series.*

WHITLOCK, Miriam *[Painter]* early 20th c.
Addresses: NYC. **Exhibited:** Soc. Indep. Artists., 1934. **Sources:** Marlor, *Soc. Indp. Artists.*

WHITLOW, Tyrel Eugene *[Painter, instructor]* b.1940, Lynn, AR.
Addresses: Oglesby, IL. **Studied:** Arkansas State Univ. with Dan F. Howard (B.A.); Inst. Allende, San Miguel Allende, Mexico with James Pinto (M.F.A.). **Member:** AFA; Rockford AA; Lakeview AC; Nat. AA; Soc. Art Historians. **Exhibited:** 13th Ann. Mid-South Exh., Brooks Mem. Art Gallery, Memphis, TN, 1968; 5th Monroe Ann., Masur Mus. Art, Monroe, LA, 1968; Contemporary Southern Art Exh., Memphis, 1968 (top award); 10th Ann. Delta Art Exh., Arkansas AC, Little Rock, 1968; Print & Drawing Nat., Northern Illinois Univ., 1970; Illinois State Fair, Springfield, 1972; Burpee Mus. Art, Rockford, IL & The Collection Gallery, Princeton, IL, 1970s. **Awards:** purchase award, Arkansas Arts Festival, Pulaski Fed. Loan & Savings, Little Rock, 1968; watercolor award, Arkansas State Watercolor Exh., 1968. **Work:** Pulaski Savings & Loan Assn. Religious Collection, Little Rock, AR. **Comments:** Preferred media: oils. Teaching: Illinois Valley Community College, 1968-. **Sources:** WW73.

WHITMAN, Charles Thomas III *[Illustrator]* b.1913, Phila., PA.
Addresses: Phila. **Studied:** PM School IA. **Member:** Phila. Alliance; Phila. Sketch Club; Phila. WCC. **Work:** Roosevelt Jr. H.S., Phila. **Sources:** WW40.

WHITMAN, Frank S. *[Artist]* late 19th c.
Exhibited: NAD, 1886. **Sources:** Naylor, *NAD.*

WHITMAN, Jacob *[Portrait and sign painter]* d.1798, Phila.
Addresses: Phila., 1792; Reading, 1795. **Member:** Columbianum, 1795 (co-founder). **Exhibited:** PAFA, 1827 (copy of West's *Penn's Treaty,* painted in 1790). **Sources:** G&W; Prime, II, 38-39; Columbianum Cat., 1795; Rutledge, PA [as Witman].

WHITMAN, John Franklin, Jr. *[Illustrator, designer]* b.1896, Phila.
Addresses: Philadelphia 7, PA; Lebanon, PA. **Studied:** Univ. Pennsylvania; PAFA; École des Beaux-Arts, Fontainebleau, France; McCarter; Despujols; Carlu. **Exhibited:** Soc. Indep.

Artists, 1934; Art Dir. Club, 1928 (medal); Modern Packaging Exh., 1937 (prize). **Comments:** Designing and illus. for books and advertising. Position: art director/illustrator, Winston Co., Publishers. **Sources:** WW59; WW47.

WHITMAN, John Pratt *[Painter, graphic artist, lecturer]* b.1871, Louisville, KY.
Addresses: Tamworth, NH. **Studied:** Mass. Sch. Art. **Exhibited:** Grace Horne Gal., Boston; Currier Gal. Art, Manchester, NH; AGAA; Argent Gal., 1940 (solo). **Work:** "Utopia Dawns," Utopia Pub. Co., Boston. **Sources:** WW40.

WHITMAN, Paul *[Etcher, lithographer, painter, illustrator, mural painter]* b.1897, Denver, CO / d.1950, Pebble Beach, CA.
Addresses: Pebble Beach, CA. **Studied:** Washington Univ., St. Louis, MO; A. Hansen, Monterey. **Member:** Calif. SE; Carmel AA; Lithographers Technical Found. **Exhibited:** Int. SE, Los Angeles, 1928 (prize). **Work:** Stanford Univ.; Del Monte (CA) Hotel; Calif. State Lib.; Courvoisier Gallery, San Francisco; Maxwell Galleries, San Francisco; Smithonian Inst. **Comments:** Teaching: Douglas Sch., Pebble Beach. Specialty: watercolors of the Monterey area, fishing boats, Mexico. **Sources:** WW53; WW47.

WHITMAN, Ray Belmont *[Painter]* mid 20th c.
Exhibited: Soc. Indep. Artists, 1935. **Comments:** Possibly Whitman, Ray Belmont, b. 1889-d. 1946, Greenwich, CT. **Sources:** Marlor, *Soc. Indp. Artists.*

WHITMAN, Sarah (de St. Prix) Wyman (Mrs. Henry) *[Painter, writer, craftsperson]* b.1842, Baltimore / d.1904, Boston, MA.
Addresses: Boston, 1877-91. **Studied:** W.M. Hunt; Villiers-le-Bel with Couture, 1877. **Member:** BMFA Sch. (comt. mem., 1885-04); SAA, 1880; U.S. Pub. Art Lg., 1897; Copley Soc. (hon. mem.). **Exhibited:** NAD, 1877-91; PAFA Ann., 1879, 1883, 1892-1901; Williams & Everett Gal., Boston, 1888; Columbian Expo, (medal), Chicago, 1893; Pan-Am. Expo, 1901 (medal); widely in Boston galleries, including Boston AC and St. Botolph Club; AIC. **Work:** BMFA (her legatee); "Brooks Mem. Window" at Trinity Church, Boston, 1895. **Comments:** Known for her flower paintings, portraits, and landscapes. Concentrated on stained glass in the 1890s. Traveled to England and France in 1894, meeting Whistler; went again to Europe in 1900 and 1902, meeting John Sargent and Henry James. Author of a tribute to William M. Hunt in *International Review,* 1879; also, "The Making of Pictures: Twelve Short Talks with Young People," 1886; "Robert Browning in his Relation to the Art of Painting," 1889; article, "Stained Glass," *Handicraft* vol.2, no.6 (Sept., 1903): 117-31. **Sources:** WW04; *Letters of Sarah Wyman Whitman,* (Cambridge, Mass., 1907); Hoppin, "Women Artists in Boston," 17-46; Petteys, *Dictionary of Women Artists,* cites alternate birth date of 1843; Falk, *Exh. Record Series.*

WHITMAN, Thelma (Mrs. Charles S.) See: **GROSVENOR, Thelma Cudlipp (Mrs. Charles S. Whitman)**

WHITMAR, Julia *[Listed as "artist"]* b.c.1830, Pennsylvania.
Addresses: Phila., 1860. **Sources:** G&W; 8 Census (1860), Pa., LIV, 165.

WHITMER, Helen Crozier (Mrs.) *[Painter, lecturer, teacher]* b.1870, Darby, PA.
Addresses: Harrisburg, PA; Columbia, MO, 1900; La Grangeville, NY. **Studied:** Phila. Sch. Des. for Women; PAFA; Breckenridge; Anshutz; Henri; Thouron; Vonnoh. **Member:** Pittsburgh AA; Dutchess County AA. **Exhibited:** PAFA Ann., 1899-1900; Pittsburgh AA; Dutchess County AA; Soc. Indep. Artists. **Sources:** WW59; WW47; Falk, *Exh. Record Series.*

WHITMER, Jane Chandler *[Painter]* mid 20th c.
Addresses: Chicago area. **Exhibited:** AIC, 1947. **Sources:** Falk, AIC.

WHITMIRE, La Von *[Painter, graphic artist, teacher]* 20th c.; b.Hendricks County, IN.
Addresses: Indianapolis, IN. **Studied:** W. Forsyth; F. Fursman; E. O'Hara; F. Chapin. **Member:** Indiana Art Club; Prattlers Club, Indianapolis; Western AA. **Exhibited:** Herron AI, 1937 (prize), 1939, 1939. **Work:** Herron AI. **Comments:** Teaching: Wash., H.S., Indianapolis. **Sources:** WW40.

WHITMORE, Charlotte *[Landscape painter]* 19th/20th c.
Addresses: NYC, 1897. **Studied:** CUA School; G.H. Smillie. **Exhibited:** PAFA Ann., 1891 (landscape); NAD, 1897. **Sources:** WW01; Falk, *Exh. Record Series.*

WHITMORE, Coby *[Painter, illustrator]* b.1913, Dayton, OH / d.1988.
Addresses: NYC; Hilton Head Island, SC. **Studied:** Dayton AI; AIC. **Member:** SI (Hall of Fame, 1978); MoMA. **Exhibited:** SI, 1948 (solo). Awards: certificate distinctive merit, Art Dirs. Club, Philadelphia, 1954; award for merit, 33rd Ann. Nat. Exh. Adverting & Ed. Art & Design, 1954; ann. award for outdoor adverting, Art Dirs. Club, Chicago. **Work:** The Pentagon, Wash., DC; U.S. Air Force Acad.; New Britain (CT) Mus. Am. Art; Syracuse (NY) Univ. **Comments:** Full name is M. Coburn Whitmore. Positions: apprentice, Haddon Sundblom, Chicago, 1932-35; artist with Carl Jensen, Cincinnati, 1938-39; artist, Grauman Studios, Chicago, 1939-43; artist, Charles E. Cooper, Inc., New York, 1942-. Publications: illustr. of cover page, *Saturday Evening Post, Good Housekeeping, Ladies Home Journal, McCalls, Cosmopolitan.* **Sources:** WW73; WW47; W&R Reed, *The Illustrator in America,* 279.

WHITMORE, J. *[Wood engraver]* mid 19th c.
Addresses: Media, OH, 1853. **Sources:** G&W; Ohio BD 1853.

WHITMORE, Lenore K. *[Painter]* b.1920, Lemont, PA.
Addresses: Ridgewood, NJ. **Studied:** Penn. State Univ. (B.S.); Herron School Art; Provincetown Workshop; Garo Antresian; Will Barnet; Edward Manetta; Victor Candell; Leo Manso. **Member:** NAWA; Pen & Brush Club; Mod. Artists Guild; Indianapolis Art League; Indiana Artists Club. **Exhibited:** Hoosier Salon, 1962, 1963 & 1967; Eastern Michigan Nat. Polymer Exh., 1968; Audubon Artists Exhs.; Int. de Femme, 1969; Painters & Sculptors Soc. NJ. Awards: Motorola Nat. Art Exh. Awards, 1961 & 1962; Mark A. Brown Award in Composition, Hoosier Salon, 1963; permanent pigments award, Painters & Sculptors Soc. NJ, 1968. **Work:** John Calvert Coll.; G.D. Sickert Coll.; Indianapolis Foundation; DePauw Univ., Jerone Picker Coll. **Comments:** Preferred media: mixed media. Positions: pres., Indianapolis Art League Found., 1959-64. Teaching: Ridgewood School Art, 1969-70. **Sources:** WW73.

WHITMORE, M. Coburn See: **WHITMORE, Coby**

WHITMORE, Olive *[Painter]* early 20th c.
Addresses: NYC. **Sources:** WW19.

WHITMORE, Robert Houston *[Painter, etcher, engraver, craftsperson, illustrator, block printer, teacher]* b.1890, Dayton, OH.
Addresses: Yellow Springs, OH. **Studied:** AIC; Cincinnati Art Acad.; H.M. Walcott; James R. Hopkins. **Member:** Dayton Soc. P&S; Dayton SE. **Exhibited:** NAD, 1944; LOC, 1944; Phila. Pr. Club, 1945; Ohio Pr. traveling exh., 1935-52; Springfield AA, 1953-55; Dayton AI, 1936-55; Northwest PM, 1947; Wichita, KS, 1947; Terry AI, 1952; Butler AI, 1942; Dayton SE, 1921-42. Awards: prize, AIC, 1915, 1921; Springfield AA, 1950-52; Int. PM Exh., Los Angeles, 1924; prize, ASL, Chicago, 1920. **Work:** Los Angeles MA; Dayton AI; Steele H.S., Normal Sch., both in Dayton; Coshocton (OH) Pub. Lib.; Antioch College, Yellow Springs, OH; Vanderpoel Collection; Dayton Mus.; Pub. Lib., Lima, OH. **Comments:** Teaching: Antioch College, Yellow Springs, OH, 1925-50s. **Sources:** WW59; WW47.

WHITMORE, William R. *[Painter]* 19th/20th c.
Addresses: NYC, 1889; Farmington, CT, 1893; Springfield, MA, 1896-99. **Exhibited:** NAD, 1889-99. **Sources:** WW01.

WHITNEY, Alberta Ogden *[Painter]* early 20th c.
Exhibited: Salons of Am., 1934. **Sources:** Marlor, *Salons of Am.*

WHITNEY, Anne *[Sculptor]* b.1821, Watertown, MA / d.1915, Boston.
Addresses: Watertown, MA 1860; Belmont, MA, 1865; Europe c.1867-72; Boston,1872-1915. **Studied:** briefly with W. Rimmer, 1862; Munich. Paris, and Rome, 1867-71. **Exhibited:** Boston & NYC, 1860s ("Godiva" and "Africa"); NAD, 1860-65; Boston AC, 1873, 1877; Phila. Centennial, 1876; Woman's Bldg., Columbian Expo, Chicago, 1893. **Work:** statues: Samuel Adams for Capitol, Wash., DC; Adams Square, Boston; Watertown (MA) Free Pub. Lib. ("Senator Ch. Sumner"); "Leif Eriksen," in Boston and Milwaukee; others in Albany, St. Louis, and Newton, MA; Calla Fountain, Franklin Park, Phila.; Smith College ("Chaldean Shepherd"); Newark Mus. ("Lotus Eater"); BMFA; Wellesley (MA) College Art Mus.; NMAA (bust of Laura Brown); Boston Public Lib.;. **Comments:** Whitney taught school in Salem, MA, from 1847-49; traveled by boat to New Orleans via Cuba in 1850-51; and wrote poetry — all prior to her taking up sculpture in 1855. She taught herself for several years before seeking instruction in New York and Philadelphia. Feeling too advanced for classes at PAFA, she learned anatomy at Brooklyn hospital and studied privately with William Rimmer. Whitney studied in Europe for several years (1867-71), executing some ideal pieces, including "Roma" (1869, Wellesley Col. Art Mus.). She opened a studio in Boston on her return to the U.S. in 1871 and received many commissions, among them a statue of Samuel Adams for the U.S. Capitol, and portraits of college presidents in the Boston area. In 1875 she won first place in an anonymous competition for a commission of a statue of senator Charles Sumner. (The commission was revoked when the judges found out the winner was a woman; the statue, however, was put up in Harvard Square in 1902). Whitney was an active feminist and an Abolitionist, and throughout her life executed a number of sculptures reflecting her social ideals. These include the colossal figure of "Africa" (1863-64, Wellesley Col. Art Mus) and a statue of the Haitian leader Touissant L'Ouverture (1870). Later in her life she executed busts and full-length portaits of social reformers such as William Lloyd Garrison (1880, Smith College), Lucy Stone (1893, Boston Pub. Lib.), and Harriet Martineau (1883, later destroyed in a fire at Wellesley College). Position: teacher, modeling, Wellesley College, Mass., 1885. Publications: *Poems* (1959). **Sources:** G&W; DAB; Taft, *History of American Sculpture;* Gardner, *Yankee Stonecutters; Art Annual,* XII, obit.; Cowdrey, NAD; Rutledge, MHS. More recently see Rubinstein *American Women Artists,* 82-83; Tufts, *American Women Artists,* cat. no. 109-113; Petteys, *Dictionary of Women Artists; Two Hundred Years of American Sculpture,* 320-31; Craven, *Sculpture in America,* 228-32.

WHITNEY, Beatrice (Mrs. Van Ness) *[Painter]* b.1888, Chelsea, MA / d.1981.
Addresses: Boston, Brookline, MA. **Studied:** BMFA Sch. with Tarbell, Benson, Hale; Pratt; Woodbury, Ogunquit Sch., 1914. **Exhibited:** NAD, 1914 (prize); Pan-Pacific Expo, San Francisco, 1915 (medal); PAFA Ann., 1915 (as Whitney), 1917, 1924 (as Van Ness); Copley Gal., Boston, Poland Spring; Abbot Acad.; AIC; Newport (RI) AA; Duxbury (MA) AA; Phila. Art Club; Corcoran Gal. biennial, 1914; PCC; Boston Art Club; NAD; "Charles H. Woodbury and His Students," Ogunquit Mus. Am. Art, 1998. **Work:** Beaver Country Day Sch.; Colby College; Farnsworth Mus. **Comments:** Positions: faculty, Mus. Sch., Boston, MA; Abbot Academy with Marion Pooke; Walnut Hill School; founder, art dept., Beaver Country Day Sch., Chestnut Hill, MA. Developed art study program called "Eight Year Plan." Author of articles on art education. **Sources:** WW33; *Charles Woodbury and His Students;* Falk, *Exh. Record Series.*

WHITNEY, Betsey Cushing Roosevelt *[Collector, patron]* b.1909 / d.1998.
Comments: She and her husband, John Hay Whitney, amassed the world's greatest private collection of modern masters, which

included masterpieces by Picasso, Toulouse-Lautrec, van Gogh, Braque, Vlaminck, Renoir, and Matisse. She bequeathed more than $300 million-worth of her collection to the NGA, WMAA, and MoMA. In 1999, her estate (and the balance of her collection) was sold through several auctions at Sotheby's, NYC. **Sources:** obit., *New York Times* (Mar. 31, 1998, p.B6; and, Jan 13, 1999, E1).

WHITNEY, Charles Frederick *[Drawing specialist, lecturer, teacher]* b.1858, Pittston, ME.
Addresses: Danvers, MA/Tamworth, NH. **Studied:** Mass. Sch. Art; BMFA Sch. **Comments:** Author: *Blackboard Sketching, Blackboard Drawing, Indian Designs and Symbols, Chalk Talks for the Teacher.* Teaching: The Wheelock Sch., Boston. **Sources:** WW40.

WHITNEY, Daniel Webster *[Painter]* b.1896, Catonsville, MD.
Addresses: Catonsville. **Studied:** C.Y. Turner; D. Garber; H. Breckenridge; J. Pearson. **Sources:** WW31.

WHITNEY, Douglas B. *[Painter]* early 20th c.
Addresses: NYC. **Sources:** WW15.

WHITNEY, E. B. (Mrs.) *[Painter]* early 20th c.
Studied: ASL, Wash. **Exhibited:** ASL Exh., Cosmos Club, 1902. **Sources:** McMahan, *Artists of Washington, DC.*

WHITNEY, Edgar Albert *[Painter, instructor, writer]* b.1891, NYC.
Addresses: Jackson Heights, NY. **Studied:** Cooper Union; ASL; NAD; Columbia Univ.; Grand Central Sch. Art; Jay Comaway; Eliot O'Hara; Charles W Hawthorne. **Member:** AWCS (treasurer, 1954-60); Phila. WCC; ASL (life member); Southwestern WCS (hon. life member); Louisiana WCS (hon. life member). **Exhibited:** all AWCS Exhs. 1950-58; Phila. WCC, 1956-58; Knickerbocker Artists, 1956; Art Lg., Long Island, 1955-58 (prizes, 1956-58); Brick Store Mus., 1956-58 (prizes, 1957-58); Audubon Artists, 1958 (award); JAD, 1957; Hudson Valley AA, 1958 (prize); All Nat. Art League Shows (awards, 1952-58); NAD, 1971 & 1972; Downtown Gallery, New Orleans, LA & Schram Galleries, Fort Lauderdale, FL, 1970s. **Awards:** NAD Ranger Fund Purchase Prize, 1969. **Work:** Farnsworth Mus., Rockland, ME; NAD; Art Club St. Petersburg; Lake Worth AA; Lawrence Rockefeller Coll.; Art Lg. Long Island. **Comments:** Preferred media: watercolors. Positions: art director, McCann Erickson, NYC; contributing editor, *Am. Artist Magazine.* Publications: author, *Watercolor: The Hows and Whys,* 1958 & *Complete Guide to Watercolor,* 1965, Watson-Guptill; author, watercolor & casein articles, *Grolier Encyclopedia.* Teaching: Pratt Inst., 1938-52; NY Botanical Gardens; Whitney Watercolor Tours, 1948-. **Sources:** WW73; David Clark, "Watercolor Holiday," Universal Films, Hollywood, CA.

WHITNEY, Elias James *[Wood engraver & genre painter]* b.1827, NYC / d.After 1879.
Addresses: Brooklyn, NY, 1861. **Exhibited:** Am. Inst., 1842 (pencil drawing); NAD, 1854-61 (wood engravings & genre paintings); Brooklyn AA, 1864-79. **Comments:** After his marriage in 1847 he moved to Brooklyn. From 1852-57 he was associated with the firms of Whitney & Annin; Whitney, Jocelyn & Annin; and Whitney & Jocelyn. John Henry Ellsworth Whitney (see entry) was his brother. **Sources:** G&W; Phoenix, *The Whitney Family of Connecticut,* I, 865; Am. Inst. Cat., 1842, 1845, 1848; Cowdrey, NAD; NYCD 1848-57; Linton, *History of Wood Engraving in America;* Hamilton, *Early American Book Illustrators and Wood Engravers,* 496-97.

WHITNEY, Elwood *[Illustrator]* mid 20th c.
Addresses: NYC. **Member:** SI. **Sources:** WW47.

WHITNEY, Frank *[Painter, sculptor, illustrator]* b.1860, Rochester, MN.
Addresses: Hubbardwoods, IL. **Studied:** Académie Julian, Paris, with Puech, Bouguereau & Ferrier, 1892. **Exhibited:** AIC, 1897. **Comments:** Specialty: animals. **Sources:** WW10.

WHITNEY, George Gillett *[Painter]* early 20th c.
Addresses: Westtown, PA. **Sources:** WW24.

WHITNEY, Gertrude Vanderbilt *[Sculptor, patron]* b.1875, NYC / d.1942, NYC.
Addresses: NYC/Old Westbury, NY. **Studied:** privately with Hendrick Christian Anderson in 1900; ASL with James E. Fraser, 1903; with A. O'Connor and Rodin in Paris. **Member:** NAWA; NSS; Portrait Painters; Newport AA; New SA; NAC. **Exhibited:** Buffalo Expo., 1901; St. Louis Fair, 1904; AIC; PAFA Ann., 1909-42 (10 times); NAD (solo); Paris Salon, 1913 (hon. men.); NAWA, 1914 (prize); Fountain of El Dorado, Pan-Pacific Expo, 1915 (bronze medal); Soc. Indep. Artists, 1917, 1919-24, 1941; WMAA, 1918-41; Am. Art Dealers Assn., 1932 (medal); WFNY, 1939 (sculpture, "To the Morrow"); Salons of Am. **Award:** Grand Order of King Alfonso II of Spain. **Work:** WMAA; Victory Arch, NYC (1919); Washington Heights War Mem., 168th St., NYC (1922); Aztec Fountain, for Pan-Am. Union in Wash., DC (1912); fountain, McGill Univ., Montreal; Titanic Memorial statue, Wash., DC (1931); Fountain of El Dorado, Lima, Peru; Columbus Mem., Palos, Spain (1929); Buffalo Bill Cody, Cody, Wyoming (1924). **Comments:** Sculptor of public monuments and a major art patron. Gertrude Vanderbilt was born into a wealthy family and became interested in watercolor and drawing after the birth of her children (she married Harry Payne Whitney in 1896). As a sculptor, she was greatly influenced by Rodin, while Fraser and O'Connor encouraged her in the area of public monuments for which she is best known. Because of her famous name, she worked under pseudonyms until receiving a medal from the NAD for her statue "Immortal" in 1910. About this time, she also became a pivotal sponsor of American art, allowing artists to use part of her Greenwich Village studio to publically exhibit their work, and helping to finance the 1913 Armory Show. Her studio became a place where young artists gathered, and in 1914 she expanded into an adjoining building, hiring an assistant (Juliana Force). Whitney began exhibiting and buying the work of young artists and in 1918 the Whitney Studio grew into the Whitney Studio Club and then the Whitney Studio Galleries, resulting finally in the establishment of the Whitney Museum in 1931. In 1934 she won custody of her niece Gloria Vanderbildt in a sensational court case. Publications: novel, *Walking in the Dusk,* under pseudonym, E.J. Webb, 1932. **Sources:** WW40; Rubinstein, *American Women Artists,* 186-90 (cites 1875 as birthdate); Pisano, *One Hundred Years.the National Association of Women Artists,* 85; Fort, *The Figure in American Sculpture,* 232 (w/repro.) cites 1875 as birthdate; Falk, *Exh. Record Series.*

WHITNEY, Helen Jones *[MIniature painter]* early 20th c.
Addresses: Active in Moylan, PA, c.1915. **Comments:** Cf. Helen Reed Whitney. **Sources:** Petteys, *Dictionary of Women Artists.*

WHITNEY, Helen Reed (Mrs. P. R.) *[Painter, designer]* b.1878, Brookline, MA.
Addresses: Moyland, PA; Nantucket, MA; Evanston, IL. **Studied:** BMFA Sch.; Frank W. Benson; Edmund C. Tarbell; Fred Wagner; P. Hale. **Member:** Plastic Club, Art All., WCC, Print Club, all of Phila. **Exhibited:** Wanamaker Exh., 1915 (prize); PAFA Ann., 1918; Newtown Sq., PA, 1935 (prize); AIC. **Work:** Women's Club, Media, PA; Pennsylvania State College. **Sources:** WW53; WW47; Petteys, *Dictionary of Women Artists;* Falk, *Exh. Record Series.*

WHITNEY, Ida H. (Mrs. Fernald) *[Artist]* b.1884 / d.1962.
Addresses: Active in Brooklyn, NY, 1889-93. **Exhibited:** NAD, 1890. **Sources:** BAI, courtesy Dr. Clark S. Marlor.

WHITNEY, Isabel Lydia *[Mural painter, designer, illustrator]* b.1884, Brooklyn, NY / d.1962, NYC.
Addresses: NYC. **Studied:** A. Dow; H. Pyle; H. Lever; Kaiser Frederick Mus., Berlin; in France, Great Britain, Italy & Russia; Pratt Inst. **Member:** Brooklyn WCC; NAD; Brooklyn Soc. Mod. Art; Fifteen Gal. **Exhibited:** Soc. Indep. Artists, 1917-24, 1941; WMAA, 1926-28, 1936; Salons of Am.; AIC; PAFA Ann., 1937; MMA; Ainslee Gals.; Fifteen Gal.; Arch. Lg.; Nat. Arts Club; Barbizon Plaza Civic Club; Brooklyn Mus.; Tower Art Gal., Eastbourne, England, 1961 (solo); Pen & Brush Club, NYC, 1962

(memorial). **Work:** BM. **Comments:** Specialty: watercolor. Also painted in oil and fresco (murals, still lifes, landscapes, Taos Indians). Whitney restored wallpaper at Williamsburg and did fresco work at the Brooklyn Mus. and other locations. **Sources:** WW40; Petteys, *Dictionary of Women Artists;* Falk, *Exh. Record Series.*

WHITNEY, John Hay *[Art administrator, collector]* b.1904, Ellsworth, ME / d.1982.
Addresses: NYC. **Studied:** Yale Univ., 1922-26 (hon. M.A.); Oxford Univ., 1926-27; Kenyon College (hon. L.HD.); Colgate Univ. (hon. LL.D., 1958); Brown Univ. (hon. LL.D., 1958); Exeter Univ. (hon. LL.D., 1959); Colby College (hon. LL.D., 1959); Columbia Univ. (hon. LL.D., 1959). **Exhibited:** Awards: Benjamin Franklin Medal, Royal College Art, England; Legion Merit; Chevalier, French Legion Honneur. **Comments:** Positions: board directors & vice pres., Saratoga Performing AC; trustee, MoMA; trustee & vice pres., Nat. Gallery of Arts. **Sources:** WW73.

WHITNEY, John Henry Ellsworth *[Wood engraver]* b.1840, NYC / d.1891.
Addresses: Brooklyn, until 1870; Chappaqua, NY, 1870 and after. **Comments:** He was a younger brother of Elias James Whitney (see entry). He enlisted in the Union Army in 1861, was wounded at Antietam, and was mustered out in 1863. Auth.: *The Hawkins Zouaves (Ninth N.Y.V.): Their Battles and Marches.* **Sources:** G&W; Phoenix, *The Whitney Family of Connecticut,* I, 866; Smith; Hamilton, *Early American Book Illustrators and Wood Engravers,* 457.

WHITNEY, John P. *[Engraver]* mid 19th c.
Addresses: Boston, 1854-after 1860. **Comments:** Possibly the John Whitney, engraver, 24, born in Maine, listed in the 1860 census. **Sources:** G&W; 8 Census (1860), Mass., XXVI, 403.

WHITNEY, Josepha Newcomb *[Painter, teacher]* b.1872, Wash., DC.
Addresses: NYC; New Haven, CT/Woodstock, NY. **Studied:** CGA; E.C. Messer; Chase; Ennis. **Member:** New Haven PCC; NAWA; AWCS. **Exhibited:** Wash. WCC, 1896. **Sources:** WW40.

WHITNEY, J(osiah) D(wight) *[Topographical artist]* b.1819, Northhampton, MA / d.1896, Lake Sunapee, NH.
Comments: He assisted Charles T. Jackson during the winter of 1840-41 in a geological survey of New Hampshire. Jackson's *Final Report* (1844) and his *Scenery and Views of New Hampshire* (1845) were illustrated with many views by Whitney. Through his work with Jackson he developed an interest in geology and in 1842 he went abroad to study geology and chemistry for several years. Returning in 1847 he worked at several geological jobs and served as California's state geologist from 1860 to 1874. **Sources:** G&W; Jackson, *Final Report on the Geology and Mineralogy of the State of New Hampshire;* Jackson, *Views and Map Illustrative of the Scenery and Views of New Hampshire.;* Campbell, *New Hampshire Scenery,* 174.

WHITNEY, Katharine *[Painter]* early 20th c.
Addresses: Minneapolis, MN. **Sources:** WW15.

WHITNEY, Leonard M. *[Painter]* early 20th c.
Addresses: NYC. **Exhibited:** Soc. Indep. Artists, 1920. **Sources:** Marlor, *Soc. Indp. Artists.*

WHITNEY, Lewis *[Sculptor, craftsperson]* 20th c.
Addresses: Rockport, MA. **Member:** Rockport AA. **Exhibited:** Worcester Art Mus.; Baltimore Art Mus.; Cincinnati Art Mus.; Phila. Art All. **Sources:** *Artists of the Rockport Art Association* (1946, 1956).

WHITNEY, Lisa *[Painter]* mid 20th c.
Addresses: NYC; New Haven, CT (1937). **Exhibited:** PAFA Ann., 1934; AIC, 1937; Corcoran Gal. biennial, 1937. **Sources:** Falk, *Exh. Record Series.*

WHITNEY, Lois *[Painter]* mid 20th c.
Addresses: Chicago area. **Exhibited:** AIC, 1937. **Sources:** Falk, *AIC.*

WHITNEY, Margaret See: **THOMPSON, Margaret Whitney (Mrs. Randall)**

WHITNEY, Marjorie Faye *[Educator, painter, designer, decorator, craftsperson]* 20th c.; b.Salina, KS.
Addresses: Lawrence, KS. **Studied:** Kansas Wesleyan Univ.; Univ. Kansas (B.F.A.); Calif. College Arts & Crafts; Frank G. Hale; R. Ketcham; G. Lukens; H. Dixon. **Member:** CAA; Galveston Art Club; Western AA; Altrusa Club; Kansas Fed. Art; Kansas Art Teachers Assn.; MacD. Assn. **Exhibited:** Galveston, Texas, 1950, 1953-61; Wichita Art Mus., 1951, 1953-61; Topeka, KS, 1951, 1953-55; Manhattan, KS, 1952. **Work:** Bell Mem. Hospital, Kansas City; Gage Park Sch., Topeka; Watkins Mem. Hospital & Pickney Sch., Lawrence, KS. **Comments:** Extensive study and research in Sweden, Japan, Southeast Asia, England, Greece, Egypt and Mexico. Teaching: Univ. Kansas, Lawrence, 1928-61. Illustr.: *Boys of the Bible.* **Sources:** WW66; WW47.

WHITNEY, Mary *[Artist]* late 19th c.
Addresses: Active in Detroit, MI, 1891-93. **Sources:** Petteys, *Dictionary of Women Artists.*

WHITNEY, May *[Painter]* mid 20th c.
Exhibited: Salons of Am., 1934-36; Soc. Indep. Artists, 1936, 1941. **Sources:** Marlor, *Salons of Am.*

WHITNEY, Morgan *[Painter, photographer]* b.1869, New Orleans, LA / d.1913.
Addresses: New Orleans, active 1891-1901. **Studied:** Albert Herter, École des Beaux Arts, Paris. **Member:** New Orleans AA, 1905. **Exhibited:** New Orleans AA, 1891, 1901; Tulane Univ., 1893. **Comments:** Member of a prominent N. O. family and brother of the founder of the Whitney National Bank. He was an amateur painter and photographer as well as a noted private collector. **Sources:** *Encyclopaedia of New Orleans Artists,* 411-12.

WHITNEY, Olive E. *[Flower painter, illustrator, designer]* late 19th c.
Comments: Worked for Louis Prang & Co., chromolithographers, c.1974-86. **Sources:** Petteys, *Dictionary of Women Artists.*

WHITNEY, Philip Richardson *[Painter, craftsperson, teacher, architect]* b.1878, Council Bluffs, IA / d.c.1960.
Addresses: Swarthmore, PA; Moylan, PA. **Studied:** MIT (B.S. in Arch.); Fred Wagner. **Member:** Phila. AC; Phila. WCC; Swarthmore Players Club; Balt. WCC. **Exhibited:** Phila. WCC; PAFA Ann., 1918, 1920; Boston Art Club; Swarthmore Ann.; Baltimore WCC; Phila. Art Club. **Work:** Pennsylvania State College. **Comments:** Teaching: School FA, Univ. Pennsylvania, retired 1936. **Sources:** WW59; WW47; Ness & Orwig, *Iowa Artists of the First Hundred Years,* 220; Falk, *Exh. Record Series.*

WHITNEY, Sara Center See: **ROBINSON, Sarah (Center) Whitney (Mrs. Boardman)**

WHITNEY, Sarah H. *[Painter]* late 19th c.
Addresses: Baltimore, MD, 1878. **Exhibited:** NAD, 1878. **Sources:** Naylor, *NAD.*

WHITNEY, Stanley *[Painter, educator]* b.1946, Phila., PA.
Studied: Kansas City AI (B.F.A.; scholarship); Yale Univ. (M.F.A.; scholarship). **Exhibited:** Illinois Bell Telephone, Chicago, 1969; Univ. Iowa, 1971-72; Yale Art Gallery, 1972; Yale at Norfolk, 1972; Univ. Rhode Island, 1972 (solo). **Sources:** Cederholm, *Afro-American Artists.*

WHITNEY, Thomas Richard *[Engraver, author]* b.1807, Norwalk, CT / d.1858, NYC.
Addresses: NYC after 1827. **Comments:** After his marriage in 1827 he settled in NYC. In 1830 he published *The Young Draftsman's Companion.* Later he became the editor of *The Republic* and *The Sunday Times,* a State Senator (1854-55), Congressman (1855-57), and the author of a volume of poetry. **Sources:** G&W; Phoenix, *The Whitney Family of Connecticut,* I, 383; Union Cat., LC; NYCD 1828+.

WHITNEY, William *[Abstract painter]* mid 20th c.
Addresses: Alexandria, VA. **Exhibited:** Corcoran Gal. biennial,

1945. **Sources:** Falk, *Corcoran Gal.*

WHITNEY, William K. *[Engraver] b.c.1839, Massachusetts.*
Addresses: Boston, 1860. **Comments:** He lived with his father, Nahum Whitney, undertaker. **Sources:** G&W; 8 Census (1860), Mass., XXVI, 520; Boston CD 1860.

WHITNEY-HELMS, May See: **HELMS, May Whitney (Mrs.)**

WHITNEY & ANNIN *[Wood engravers] mid 19th c.*
Addresses: NYC, 1852. **Comments:** Partners were Elias J. Whitney and Phineas F. Annin (see entries). The firm became Whitney, Jocelyn & Annin in 1853 and Whitney & Jocelyn in 1856. **Sources:** G&W; NYBD 1852; Hamilton, *Early American Book Illustrators and Wood Engravers.*

WHITNEY & JOCELYN *[Wood engravers] mid 19th c.*
Addresses: NYC, 1856-58. **Comments:** Elias J. Whitney and Albert H. Jocelyn, successors to Whitney, Jocelyn & Annin (see entries). **Sources:** G&W; NYCD 1856-58; Am. Inst. Cat., 1856; Hamilton, *Early American Book Illustrators and Wood Engravers.*

WHITNEY, JOCELYN & ANNIN *[Wood engravers] mid 19th c.*
Addresses: NYC, 1853-55. **Comments:** The partners were Elias J. Whitney, Albert H. Jocelyn, and Phineas F. Annin. The firm grew out of Whitney & Annin and in 1856 became Whitney & Jocelyn (see entries). **Sources:** G&W; NYCD 1853-54; Hamilton, *Early American Book Illustrators and Wood Engravers.*

WHITON, Kate L. *[Painter] late 19th c.*
Addresses: Athens, NY, 1873. **Exhibited:** NAD, 1873. **Sources:** Naylor, *NAD.*

WHITON, S. J. *[Painter] 19th/20th c.*
Addresses: Hingham, MA. **Sources:** WW01.

WHITREDGE, William *[Sign, house & portrait painter] early 19th c.*
Addresses: Cincinnati, Oh, active 1829-34. **Sources:** Hageman, 124.

WHITSIT, Elon *[Painter] early 20th c.*
Addresses: NYC. **Sources:** WW13.

WHITSIT, Jesse (E.) *[Painter] b.1874, Decatur, IL.*
Addresses: NYC. **Exhibited:** Corcoran Gal. annual, 1908; AIC, 1913; Soc. Indep. Artists, 1917; PAFA Ann., 1918. **Sources:** WW21; Falk, *Exh. Record Series.*

WHITSON, C. F. (Miss) *[Artist] early 20th c.*
Addresses: active in Los Angeles, 1911-12. **Sources:** Petteys, *Dictionary of Women Artists.*

WHITSON, Peter (Peter Whitson Warren) *[Drawer, educator] b.1942, Concord, MA.*
Addresses: Billings, MT. **Studied:** Univ. New Hampshire with Christopher Cook (B.A., 1963); Univ. Iowa with James Lechay & Hans Breder (M.A. & M.F.A., 1967). **Exhibited:** All Iowa Show, Des Moines, 1967; 13th Ann. North Dakota Art Show, Univ. North Dakota, 1969, Hopper Show, AIC, 1969; Western Dakota Junk Co., Show, Eastern Montana College, 1969. **Work:** Univ. Iowa. **Comments:** Positions: co-pres., Western Dakota Junk Co., Billings, MT, 1969-; pres., Lost Lady Mining Co., Billings, 1970-; pres., Al's Ham-'N'-Egger & Body Shop, Billings, 1971-. **Publications:** auth., *The Western Dakota Junk Co. Junker Flyer,* 1970-72; auth., *The Lost Lady Newsletter,* 1970-72; auth. &contrib. to many other free art publications, 1969-72. Teaching: Univ. Iowa, 1965-67; Eastern Montana College, 1967-70s. **Sources:** WW73.

WHITTAKER, John Bernard *[Portrait painter, sculptor, illustrator] b.1836, Templemore, Ireland / d.1926, Brooklyn, NY.*
Addresses: Brooklyn, NY, 1861-84. **Member:** SC, 1897. **Exhibited:** NAD, 1859-84; Brooklyn AA, 1859-86, 1892. **Comments:** Position: art director, Adelphi College. **Sources:** G&W; Mallett; Brooklyn BD 1857-58; Cowdrey, NAD; WW10; BAI, courtesy Dr. Clark S. Marlor.

WHITTAKER, Lil(l)ian See: **WHITTEKER, Lilian E.**

WHITTAKER, M(ary) Wood (Mrs. John Bernard) *[Painter, teacher] b.1848, Ohio / d.1926, Brooklyn, NY.*
Addresses: Brooklyn, NY, 1882-1926. **Exhibited:** NAD, 1882, 1886; Brooklyn AA, 1874-86 (as Mary Wood), 1898; Soc. Indep. Artists, 1917. **Comments:** Teaching: Adelphi Acad., Brooklyn. **Sources:** WW24; BAI, courtesy Dr. Clark S. Marlor.

WHITTEKER, Lilian E. *[Painter] early 20th c.*
Addresses: Cincinnati, OH, 1907-27. **Member:** Cincinnati Women's AC; Soc. Women Artists. **Exhibited:** PAFA Ann., 1917. **Sources:** WW27; Petteys, *Dictionary of Women Artists;* Falk, *Exh. Record Series.*

WHITTEMORE, Charles E. (Mrs.) *[Painter] 19th/20th c.*
Addresses: NYC. **Sources:** WW01.

WHITTEMORE, Charles E. *[Illustrator, etcher] b.1856.*
Addresses: NYC. **Exhibited:** PAFA Ann., 1885-88, 1892; Boston AC, 1888-99; AIC. **Sources:** WW04; Falk, *Exh. Record Series.*

WHITTEMORE, Frances D(avis) (Mrs. L. D.) *[Painter, writer, lecturer, teacher] b.1857, Decatur, IL / d.1951, Topeka, KS.*
Addresses: Topeka. **Studied:** ASL with J. A. Weir; K. Cox; W. Shirlaw; AIC. **Member:** Topeka AG; Kansas State Fed. Art. **Comments:** Positions: art instructor, Washburn College; founder/director, Mulvane Art Mus., Topeka, KS. Author: *George Washington in Sculpture* (Marshall Jones Co., 1933). **Sources:** WW40.

WHITTEMORE, Grace Conner (Mrs. George A.) *[Painter] b.1876, Columbia County, PA.*
Addresses: East Orange, NJ. **Studied:** Moore Inst., Phila. Sch. Des. for Women; PAFA; Daingerfield; Snell. **Member:** Essex WCC; Art Center of the Oranges; Bloomfield AL. **Exhibited:** Art Center of the Oranges; Essex WCC; Montclair Art Mus., 1936; Woman's Club, Orange, NJ (prize). Other awards: prizes, NJ State Fed. Women's Club, 1942, 1943. **Sources:** WW59; WW47.

WHITTEMORE, Helen Simpson (Mrs. William J.) *[Painter] b.Horsham, England / d.c.1958.*
Addresses: NYC from c.1909; East Hampton, NY. **Studied:** Chase; Colin; Merson; Garrido in Paris. **Member:** AWCS; All. Artists Am.; NYWCC; NAWPS. **Exhibited:** AIC, 1909. **Work:** Guild Hall, East Hampton, NY. **Sources:** WW53; WW47.

WHITTEMORE, Margaret Evelyn *[Writer, graphic artist, illustrator, block printer] b.1897, Topeka, KS.*
Addresses: Topeka; Short Hills, NJ; Sarasota, FL. **Studied:** Washburn College (A.B.) in Topeka; AIC; Taos (NM) Art Colony. **Member:** Nat. Lg. Am. Pen Women; Nat. Soc. New England Women. **Work:** Univ. Kansas, Lawrence; Clay Center Lib. & Wichita Pub. Lib.; Kansas State Hist. Soc., Pub. Lib., both in Topeka. **Comments:** Author/illustrator: *Historic Kansas,* 1954; *Adventures in Thrift,* 1946; woodcuts, *Trees,* pub. Bruce Humphries; *Bird Notes,* by H.L. Rhodes, 1932. Contributor: *Audubon, Scholastic, Am. Magazine Art, Christian Science Monitor.* **Sources:** WW59; WW47; Petteys, *Dictionary of Women Artists.*

WHITTEMORE, William J(ohn) *[Painter, miniature painter, teacher] b.1860, NYC / d.1955.*
Addresses: East Hampton, LI; NYC (1885-on). **Studied:** NAD with W.M. Hart, L. Wilmarth, 1882-86; ASL with J.C. Beckwith, 1885; Académie Julian, Paris with B. Constant & J. Lefebvre, 1888-89. **Member:** ANA, 1897; AWCS; NYWCC; ASMP; Calif. SMP; SC, 1890 ; Lotos Club; Brooklyn AC; Allied AA; SPNY; Century Assn. **Exhibited:** NAD, 1884-1949 (prize 1917); Brooklyn AA, 1884-86; PAFA Ann., 1885-1908, 1917, 1921; Boston AC, 1886-1908; Paris Salon, 1889; Paris Expo, 1889 (medal); AIC,1890-1928; Atlanta Expo, 1895 (medal); Charleston Expo, 1902 (medal); Corcoran Gal.

annuals/biennials, 1907, 1910; AWCS, 1927 (prize); SC, 1927 (prize); Baltimore, 1928 (prize); Penn. SMP, 1934 (prize); Calif. SMP, 1942 (prize). **Work:** Lotos Club, NYC; Columbia Univ.; State House, Montpelier, VT; State House, Trenton, NJ; Franklin Inst., Phila.; BM; Boston AC; Essex Club, Newark, NJ; San Diego FA Soc.; Detroit Club; MMA; Guild Hall, East Hampton, NY. **Comments:** A classic realist painter, his exhibition record at the National Academy spanned an incredible 65 years. **Sources:** WW53; WW47; Fink, *American Art at the Nineteenth-Century Paris Salons,* 406; Falk, *Exh. Record Series.*

WHITTEMORE, William R. See: **WHITMORE, William R.**

WHITTEN, Alice E. *[Painter] mid 20th c.*
Addresses: Phila., PA. **Exhibited:** PAFA Ann., 1939. **Sources:** Falk, *Exh. Record Series.*

WHITTEN, Jack *[Painter, educator] b.1939, Bessemer, AL.*
Studied: Tuskegee Inst.; Southern Univ., Baton Rouge; CUA Sch. (B.F.A.). **Exhibited:** WMAA, 1969, 1972; Allan Stone Gallery, 1970 (solo). **Awards:** Whitney Fellowship, 1964. **Comments:** Teaching: Pratt Inst. **Sources:** Cederholm, *Afro-American Artists.*

WHITTIER, William *[Plate engraver] b.c.1843, Massachusetts.*
Addresses: Boston, active 1860. **Sources:** G&W; 8 Census (1860), Mass., XXVII, 433.

WHITTINGHAM, Bonnie *[Figure and landscape painter]; b.New England.*
Studied: PAFA; Barnes Found. **Exhibited:** Art All. Phila.; PAFA (3 prizes); Shore Gals., Boston, MA & Provincetown, MA; Boston Fine Arts Festival. **Work:** Irvin Felt Collection, Kidder, Peabody & Co.

WHITTINGHAM, William H. *[Illustrator] b.1932, Detroit.*
Addresses: NYC. **Studied:** Univ. Michigan; BM Sch. with Reuben Tam. **Exhibited:** SI; NY City Center (first prize). **Comments:** Illustrator: *The Saturday Evening Post, TV Guide, Ski,* and other national magazines, also many women's magazines in England. **Sources:** W & R Reed, *The Illustrator in America,* 310.

WHITTLE, B. *[Painter] early 19th c.*
Addresses: NYC, active 1837. **Work:** New York Hist. Soc. (a view of the Bloomingdale Flint Glass Works near NYC, c.1837). **Sources:** G&W; *American Collector* (Jan. 23, 1934), 3.

WHITTLE, Charles *[Painter] early 20th c.*
Exhibited: Golden Gate Park Memorial Mus., 1916. **Sources:** Hughes, *Artists of California,* 602.

WHITTLE, DeQuetteville *[Painter] early 20th c.*
Addresses: Chicago. **Exhibited:** AIC, 1921. **Sources:** Falk, *AIC.*

WHITTLE, Joseph I. *[Painter] 19th/20th c.; b.London, England.*
Addresses: San Francisco, CA, active 1860s. **Exhibited:** Hawaiian Soc. Artists, 1917. **Work:** Bancroft Lib., Univ. Calif., Berkeley. **Comments:** Position: scene painter, Tivoli Opera House, San Francisco. **Sources:** Hughes, *Artists of California,* 602; Forbes, *Encounters with Paradise,* 208.

WHITTLESEY, Caroline H. *[Painter] 19th/20th c.*
Addresses: Cleveland, OH. **Exhibited:** NYWCC, 1898. **Sources:** WW01.

WHITTLESEY, Chauncey (Mrs.) See: **BACON, Mary Ann**

WHITTLESEY, Gertrude S. *[Artist] early 20th c.*
Addresses: Active in Wash., DC, 1909-11. **Sources:** Petteys, *Dictionary of Women Artists.*

WHITTLETON, Anna Goodheart See: **HOWLAND, Anna Goodheart (Whittleton)**

WHITTREDGE, Thomas Worthington *[Landscape and portrait painter] b.1820, Springfield, OH / d.1910, Summit, NJ.*
Addresses: Cincinnati, c.1840-49; Indianapolis,1842; Europe, 1849-59; NYC, 1859-80; Summit, NJ,1880-1910. *W Whittredge*
Studied: Cincinnati, 1838-39; London; Antwerp; Paris, 1849; Düsseldorf (Germany) with A. Achenbach, 1849-54; Rome (Italy), 1854-59. **Member:** ANA, 1860; NA, 1861 (pres., 1874-77); Artists Fund Soc.; Century Assn., 1862. **Exhibited:** AIC; Cincinnati Art Acad., 1839 (landscapes), 1841; NAD, 1846, 1860-1911 (1st prize, 1883); Am. Art-Union, 1847; Brooklyn AA, 1861-87; Centenn. Expo, Phila., 1876 (bronze medal); PAFA Ann., 1853-67, 1879, 1904; Paris Expo, 1889 (prize); Pan-Am. Expo, Buffalo, 1901 (silver medal); St. Louis Expo, 1904 (medal); Exh. of 125 paintings, Century Assn., 1904 (solo of 125 paintings); Corcoran Gal. annuals, 1907-08; Macbeth Gal., NYC, 1944 (solo); Munson-Wms.-Proctor Inst., 1969 (retrospective, traveled to Cincinnati AM & Albany Inst.); Kennedy Gal., NYC, 1970 (solo); Morris Mus., Morristown, NJ, 1982 (solo); Adams Davidson Gal., Wash., DC, 1982 (solo). **Work:** WMA; NMAA; Cincinnati AM; BM; MMA; Newark Mus.; Amon Carter Mus.; CGA; The Century Assoc., NYC; Denver Art Mus.; Joslyn Mus.; Shelburne (VT) Mus.; Amon Carter Mus. **Comments:** (Known as Worthington Whittredge) Important landscape painter of the Hudson River School. In 1838 he was painting portraits in Cincinnati, but in 1840 he went to Indianapolis and formed a partnership in a daguerreotype studio. The business soon failed, and in 1841 he returned to portraiture, forming a partnership in Charleston, WV (possibly with B.W. Jenks), but that also failed. In 1844, he returned to Cincinnati and concentrated on landscapes. In 1849, he traveled to Europe, and befriended E. Leutze (and posed for his famous "Washington Crossing the Delaware" of 1851). In 1855, he began signing his oils "W. Whittredge" whereas he had previously signed as "T.W. Whitredge" and "T.W. Whitridge." By 1857, he had settled in Rome with Bierstadt and S.R. Gifford as his companions. In 1859, he returned to the U.S., taking a studio at the "10th Street Studio" building, and spending summers in Newport, RI. He was in the Rockies and New Mexico for the first time in 1866, and again in 1870 with friends S.R. Gifford and J.F. Kensett. He made a third trip, to the Platte River region of Colorado, probably in 1871. Newport, RI, remained his favorite summer haunt during the 1870s-80s. In 1880 he moved into his permanent home, "Hillcrest," in NJ, which was designed by Calvert Vaux. Thereafter, his sketching trips were mostly in the Northeast, but he was probably in Mexico in 1893, and again in 1896 with F.E. Church. In 1887, Ortigies' Art Gal. auctioned 75 of his oils. **Sources:** his autobiography was publ. by John I.H. Baur in 1942 (reprinted 1969), the full hand-written version (1905) of which is now in Whittredge Papers, Archives of Am. Art, Wash., DC; see also WW10; G & W; DAB; Karolik Cat., 509-19; Sweet, *Hudson River School;* Met. Mus., *Life in America;* Cowdrey, NAD; Cowdrey, AA & AAU; Rutledge, PA; Rutledge, MHS; Peat, *Pioneer Painters of Indiana,* 159-60; Hageman, 123; Gerdts, *Art Across America,* vol. 2: 258; P&H Samuels, 526-27; *Cincinnati Painters of the Golden Age,* 111-113 (w/illus.); Cheryl Cibulka, *Quiet Places, The Am. Landscapes of Worthington Whittredge* (Adams Davidson Gal., Wash., DC, 1982); Baigell, *Dictionary;* Muller, *Paintings and Drawings at the Shelburne Museum,* 139 (w/repro.); Robert Workman, *The Eden of America* (RISD, 1986, p.51); Falk, *Exh. Record Series.*

WHITTREDGE, Worthington See: **WHITTREDGE, Thomas Worthington**

WHITTRIDGE, Effie *[Painter] late 19th c.*
Addresses: Summit, NJ. **Exhibited:** PAFA Ann., 1895-97. **Sources:** Falk, *Exh. Record Series.*

WHITWELL, Mary Hubbard *[Painter] b.1847, Boston, MA / d.1908, probably Boston.*
Studied: W.M. Hunt, early 1870s; T. Couture in Paris, c.1877; Acad. Julian, Paris with T. Robert-Fleury, Bouguereau &

Giacomotti, 1885. **Exhibited:** Boston AC, 1880, 1884, 1888; Paris Salon, 1885, 1886; Williams & Everett Gal., Boston, 1888; SNBA, 1899. **Sources:** Fink, *American Art at the Nineteenth-Century Paris Salons,* 358, 406.

WHOOLLEY, Jay *[Sculptor] b.1942.*
Addresses: NYC. **Exhibited:** WMAA, 1973. **Sources:** Falk, *WMAA.*

WHORF, John *[Painter] b.1903, Winthrop, MA / d.1959, Provincetown, MA.* *John Whorf*
Addresses: Brookline, MA/Provincetown, MA (permanently, 1937-on). **Studied:** with his father, Harry C. Whorf; St. Botolphe Studio with Sherman Kidd, 1917 (age 14); BMFA Sch. with Wm. James and Philip Hale, 1917; in Provincetown, 1917-18, with C.W. Hawthorne; M. Bohm; R. Miller; G. Beneker, G.E. Browne & E.A. Webster; Acad. de la Grande Chaumière, École des Beaux-Arts & Acad. Colarossi, all in Paris, c.1919; J.S. Sargent in Boston, 1925-26. **Member:** ANA; NA, 1947; AWCS; Florida WCS; The Beachcombers; Provincetown AA. **Exhibited:** Grace Horne Gal., Boston, 1924 (first solo); AWCS; PAFA Ann., 1930; Oakland Art Gallery, 1930 (solo); Mills College, Oakland, 1931 (solo); Calif. WCS, 1934, 1939; AIC, 1939 (prize), 1943 (prize); WMAA; Kansas City AI; BMFA; Boston Soc. Watercolor Painters; Brooklyn Mus.; Phila. WCC; Albright-Knox Gal., Buffalo; Milwaukee AI; NOMA; New Rochelle AA;19th Venice Bienale; M.H. deYoung Mus.; Worcester AM; Cincinnati AM; Milch Gal., NYC (32 solos); Arvest Gal., Boston, 1984 (solo). Other awards: hon. degree, M.A., Harvard Univ., 1938. **Work:** BMFA; WMAA; MMA; MoMA; BM; LACMA; MIT; Fogg MA; Addison Gal. Am. Art; Amherst College AM; John Herron AI; TMA; Montclair Art Mus.; AIC; RISD; CAM; Univ. Illinois; New Britain Mus. Art; William Rockhill Nelson Gal. Art, Kansas City; St. Louis MA; Univ. of Miami (OH); Nat. Mus., Stockholm, Sweden; Pitti Palace, Florence, Italy; NOMA; Yale Univ.; Baltimore MA; Butler IA. **Comments:** After his full recovery from a paralyzing fall at age 18, he left for Europe, and painted throughout France, Portugal and Morocco, working in watercolor rather than oil. From 1924-on, he was a highly-regarded watercolorist; his style was most influenced by John Singer Sargent. **Sources:** WW53; exh. cat. Arvest Gal. (Boston, 1984); WW47; Falk, *Exh. Record Series;* info. courtesy North Shore AA.

WHORF, Nancy See: **KELLY, Nancy Whorf**

WHORRAL, Jeanne *[Sculptor] mid 20th c.*
Addresses: NYC?. **Exhibited:** PAFA Ann., 1966. **Sources:** Falk, *Exh. Record Series.*

WHOWELL, John E. *[Painter] mid 20th c.*
Addresses: Chicago area. **Exhibited:** AIC, 1935. **Sources:** Falk, *AIC.*

WHYMPER, Frederick *[Painter, author] b.1838, England.*
Addresses: San Francisco, active until 1882. **Member:** Bohemian Club, 1872 (charter member); San Francisco AA, 1871 (charter member; first sec./treas.). **Exhibited:** Mechanics' Inst. Fair, 1869; Arriola Relief Fund, San Francisco, 1872. **Work:** Oakland Mus. **Comments:** Member of the Russian-American Telegraph Exploring Expedition from San Francisco to Alaska in 1865. Auth.: *Travels and Adventures in the Territory of Alaska.* Specialty: watercolors. **Sources:** Hughes, *Artists in California,* 603.

WHYTE, Garrett *[Painter] late 20th c.*
Exhibited: Oak Park (IL) Lib.; Smith-Mason Gal., 1971. **Work:** Johnson Pub. Co. **Sources:** Cederholm, *Afro-American Artists.*

WHYTE, Isaiah *[Painter] early 19th c.*
Addresses: Boston, MA, 1814. **Work:** Peabody Mus., Salem, MA; FDR Lib., Hyde Park, NY (a marine watercolor and reverse oil painting on glass). **Sources:** Brewington, 413.

WHYTE, James *[Painter] early 20th c.*
Addresses: NYC. **Member:** Soc. Indep. Artists. **Exhibited:** Soc. Indep. Artists, 1920-21. **Sources:** WW25.

WHYTE, Martha A. *[Painter, illustrator] early 20th c.; b.Phila., PA.*
Addresses: Phila. **Member:** Plastic Club. **Sources:** WW10.

WHYTE, Raymond A. *[Painter] b.1923, Canmore, Alberta.*
Addresses: Kinnelon, NJ. **Studied:** ASL with Edwin Dickinson; Venice; Paris; Madrid; Univ. Toronto. **Exhibited:** NAD 1949-; Galerie DeTours, San Francisco, 1962-72 (solos); De Saisset Art Mus., Santa Clara, CA, 1967 (solo); Crocker Art Mus., Sacramento, CA 1967 (solo); E. Kuhlik Gallery, New York, 1972 (solo). **Work:** Crocker Art Mus., Sacramento, CA; De Beers Mus., South Africa. Commissions: triptych, Richard Hamilton, 1961; mural, Austral Oil Co., Houston, TX, 1965; triptych, Gerald B. Kara, NYC, 1968; memorabilia, oil, Bernard G Cantor, Beverly Hills, CA, 1970. **Comments:** Preferred media: oils. **Sources:** WW73; Jane Allison, "Painter in New York," *Indianapolis Star,* March 9, 1961; Doug Scott, "Profiles in Progress," *San Francisco Examiner,* August 2, 1964; Kevin Sanders, "Contemporary Surrealists," ABC TV Art Review, February 3, 1972.

WHYTE, Ruth *[Painter] early 20th c.*
Addresses: NYC. **Exhibited:** Soc. Indep. Artists, 1920. **Sources:** Marlor, *Soc. Indp. Artists.*

WIBOLTT, Aage Christian See: **WIBOLTT, (Jack) Aage Christian**

WIBOLTT, (Jack) Aage Christian *[Portrait and mural painter, illustrator] b.1894, Denmark / d.1952, Los Angeles, CA.*
Addresses: Los Angeles, 1948. **Studied:** Royal Acad., Copenhagen. **Member:** Am. Artists Congress. **Exhibited:** Royal Acad., 1913; Danish Art Gallery, 1917 (first solo); GGE, 1939; WFNY, 1939. **Work:** Fox Theatre, Los Angeles; Los Angeles Jr. College. **Sources:** WW40; Hughes, *Artists in California,* 603; P&H Samuels, 527.

WICHER & PRIDHAM *[Sign, ornamental, and steamboat painters] mid 19th c.*
Addresses: Cincinnati, 1844. **Comments:** Possibly Lawrence S. Wicker (painter, 1846) and Henry Pridham (see entry). **Sources:** G&W; Knittle, *Early Ohio Taverns,* 44; Cincinnati CD 1846.

WICHERTS, Arend *[Landscape painter, teacher] b.1876, Matteson, IL / d.1965, Birmingham, MI.*
Addresses: Detroit, MI. **Studied:** AIC; R.S. Robbins. **Exhibited:** AIC, 1903. **Comments:** Position: owner, art school, Royal Oak, MI. **Sources:** WW04; Gibson, *Artists of Early Michigan,* 245.

WICHERTS, Arend, Jr. See: **WICHERTS, Arend**

WICHT, John Von See: **VON WICHT, John G. F.**

WICK, James L. *[Painter] b.1883, Youngstown, OH.*
Addresses: Youngstown/ Rockport, MA. **Studied:** MIT (grad., 1906). **Member:** Buckeye AC, Mahoning Soc. of Painters, both in Youngstown; Rockport AA. **Exhibited:** Akron, Canfield, Mansfield, Youngstown, all Ohio. **Comments:** Position: vice-pres., Butler Art Inst., Youngstown, OH. **Sources:** *Artists of the Rockport Art Association* (1946).

WICK, Peter Arms *[Curator] b.1920, Cleveland, OH.*
Addresses: Boston. **Studied:** Yale Univ. (B.A., B.Arch.); New York Univ. Inst. FA; Fogg Art Mus., Harvard Univ. (M.A.). **Comments:** Positions: asst. cur., dept. prints & drawings, Boston Mus. FA, 1962-64; dir., Print Council Am., 1965; gov., Gore Place, Waltham-Watertown, MA, 1965; asst. dir., Fogg Art Mus., Harvard Univ., 1966-67, asst. cur., Houghton Lib., 1967-70, cur. printing & graphic arts, 1970-. Publications: editor, *Maurice Prendergast, Watercolor Sketchbook,* 1899, New York Graphic Soc., 1960; author, *Jacques Villion: Master of Graphic Art* (exhib catalogue) & *Honore Daumier Anniversary* exhibition catalogue, 1958, Boston Mus. Fine Arts; author, *A Summer Sketchbook by David Levine,* 1963; co-author, *Arts of the French Book, 1900-65: Illustrated Books of the School of Paris,* Southern Methodist Univ. Press, 1967; author, *Toulouse-Lautrec,* book covers and brochures, Harvard Univ. Library, 1972. **Sources:** WW73.

WICKARD, J. Murray *[Painter] early 20th c.*
Addresses: Indianapolis, IN. **Exhibited:** AIC, 1927, 1932.
Sources: WW25.

WICKENDEN, Robert J. *[Portrait, genre & landscape*
painter, lithographer, writer] b.1861, Rochester, England /
d.1931, Brooklyn, NY.
Addresses: Quebec, Canada; France; NYC, 1886. **Studied:**
Hébert; Merson. **Exhibited:** NAD, 1886; Paris Salon 1888, 1890;
Europe; PAFA Ann., 1891; AIC. **Work:** two portraits of King
Edward VII, Parliament Building, Ottawa, Ontario, Halifax, NS;
Detroit Inst. of Arts. **Comments:** Born of American parents; came
to U.S. at age 13. Specialty: Montreal snow scenes. Teaching:
Detroit, MI, c.1880. He painted portraits of many notables in the
U.S. and Europe. **Sources:** WW01; Gibson, *Artists of Early*
Michigan, 245; Fink, *American Art at the Nineteenth-Century*
Paris Salons, 406; Falk, *Exh. Record Series.*

WICKER, August *[Designer] b.c.1832, France.*
Addresses: Phila., 1860. **Sources:** G&W; 8 Census (1860), Pa.,
LII, 42.

WICKER, John Palmer *[Portrait painter, teacher] b.1860,*
Ypsilanti, MI / d.1931, Detroit, MI.
Addresses: Detroit, 1890-1900 and after. **Studied:** Paris with
Bougereau, Robert-Fleury & Cormon (seven years). **Exhibited:**
Paris Salon, 1893, 1894; Louisiana Purchase Centennial Expo, St.
Louis, 1904; Hopkin Club, Detroit, 1911; Scarab Club, 1925
(medal). **Comments:** Teaching: Detroit Mus. Art Sch., with J.
Gies; Detroit FA Acad. (later, Wicker Sch. FA). **Sources:** Gibson,
Artists of Early Michigan, 245; Fink, *American Art at the*
Nineteenth-Century Paris Salons, 406.

WICKER, Mary H. (Mrs.) *[Painter, sculptor] 20th c.;*
b.Chicago.
Addresses: Chicago, IL; NYC. **Studied:** in England with
Brangwyn; C.W. Hawthorne; H. Pushman; L. Gaspard; Geo. E.
Browne; Szukalski; Acad. Julian, Paris. **Member:** NAC; AAPL;
Chicago P&S; Chicago AC; Hoosier Salon. **Exhibited:** Am.
Artists Exh., AIC, 1923 (prize), 1924 (prize); PAFA Ann., 1926,
1930. **Sources:** WW40; Falk, *Exh. Record Series.*

WICKERSHAM, Marguerite H. *[Painter] early 20th c.*
Addresses: Phila., PA. **Exhibited:** AIC, 1906. **Sources:** WW08.

WICKERSHAM, Thomas *[Portrait painter] mid 19th c.*
Addresses: Cincinnati, 1858-60. **Comments:** Listed as W.
Wickersham in the Ohio business directory for 1859. **Sources:**
G&W; Cincinnati CD 1858, BD 1859-60; Ohio BD 1859.

WICKERTS, Arend See: **WICHERTS, Arend**

WICKES, Carrie *[Painter] late 19th c.*
Addresses: NYC, 1882. **Exhibited:** NAD, 1882. **Sources:**
Naylor, *NAD.*

WICKES, Ethel Marian *[Painter, mural painter] b.1872,*
Hempstead, LI, NY / d.1940, San Francisco, CA.
Addresses: San Francisco, from 1880. **Studied:** Paris, France.
Exhibited: Seattle AA, 1911; San Francisco AA, 1916; Worden
Gallery, 1927. **Work:** Shasta State Hist. Monument; CPLH;
Huntington Library, San Marino, CA. **Comments:** Specialty:
watercolors of wild geese and Calif. wild flowers. **Sources:**
Hughes, *Artists of California,* 603.

WICKES, William Jarvis *[Painter, sculptor] b.1897,*
Saginaw, MI.
Addresses: Saginaw. **Studied:** AIC. **Member:** Alliance.
Sources: WW33.

WICKEY, Harry Herman
[Etcher, teacher, lithographer]
b.1892, Stryker, OH / d.1968,
Cornwall Landing, NY.
Addresses: Cornwall Landing, NY. **Member:** NA; ANA, 1939;
Am. Soc. PS&G; Woodstock AA. **Exhibited:** WMAA, 1933-45;
AIC, 1939-40; PAFA Ann., 1939-41, 1947. **Awards:** SC, 1925
(prize); SAE, 1934 (prize); Chicago SE (prize); Sesqui-Centennial

Expo, Phila., 1926 (medal); Guggenheim Fellowship, 1939, 1940.
Work: MMA; AIC; Newark Mus.; BMFA; WMAA; AGAA;
NYPL; LOC; Fifty Prints of the Year, 1933, 1938; Fine Prints of
the Year, 1934. **Sources:** WW53; WW47; Woodstock AA; Falk,
Exh. Record Series.

WICKEY, Maria Rother (Mrs. Harry) *[Painter] b.1897,*
Warsaw, Poland / d.1955.
Addresses: Cornwall Landing, NY. **Studied:** NAD with F. C.
Jones; ASL; G. Bellows; G. Bridgman; A. Covey. **Member:**
Woodstock AA. **Exhibited:** WMAA, 1938; PAFA Ann., 1941.
Work: murals, Manhattan Trade Sch., NYC. **Sources:** WW40;
Falk, *Exh. Record Series;* addit. info. courtesy Woodstock AA.

WICKHAM, Enoch *[Sculptor] d.1971.*
Addresses: Buckminster Hollow, near Palmyra, TN. **Studied:** self
taught. **Work:** Buckminster Hollow, near Palmyra, TN (as of
1975); Heritage Hall, Fort Campbell, KY. **Comments:** Folk artist
who, prior to 1952, had spent his life as a farmer; he had invented
his own wheat thrasher, was a well-known surveyor, and had
reforested area waste-land. At the age of 69, he began his project
to create a sculptural complex (on his own land) devoted to God
and country. Over the next twenty years he used sixty tons of con-
crete to construct a series of fifty statues of national heroes and
religious scenes. All of the concrete figures are life size and larger
and placed on concrete pedastols inscribed with the artist's com-
ments on the story being told. In the mid 1960s Wickham began
to receive some public attention and was commissioned by the
curator of Heritage Hall, an army museum at Fort Campbell, KY,
to complete two statues. **Sources:** *American Art Review* 2, no. 6
(Sept.-Oct., 1975): 90-103.

WICKHAM, Julie M. *[Painter] early 20th c.*
Addresses: Cutchogue, LI, NY, from c.1915. **Member:** NAWPS.
Exhibited: NAWPS, 1935-38; Soc. Indep. Artists, 1935.
Sources: WW40.

WICKHAM, Nancy (Mrs. W. A. Boyd, Jr.) *[Craftsman]*
b.1923, Ardsley, NY.
Addresses: Woodstock, VT. **Studied:** Sacker Sch., Boston; Alfred
Univ. Sch. Ceramics; New Sch. Soc. Research with Schanker; BM
Sch. Art, with Candell. **Exhibited:** Syracuse MFA, 1947-48
(prize), 1949 (prize), 1954 (prize); Young Americans Exh., NY,
1951 (prize); WMA, 1955; Int. Exh. Ceramics, Cannes, France,
1955 (prize). **Comments:** Contributor to *Ceramic Age, Craft*
Horizons. **Sources:** WW59.

WICKHAM, Reginald *[Photographer] b.1931.*
Exhibited: WMAA, 1971; Addison Gallery, 1971. **Sources:**
Cederholm, *Afro-American Artists.*

WICKISER, Ralph Lewanda *[Painter, teacher writer,*
graphic designer, screenprinter, lithographer] b.1910, Greenup,
IL / d.1998, Riverhead, NY.
Addresses: Baton Rouge, LA; New Paltz, NY; Brooklyn, NY.
Studied: AIC, 1928-31; Eastern Illinois Univ. (B.A., 1934; hon;
Ph.D., 1956); Vanderbilt & Peabody (Tiffany fellowship, 1934-35;
M.A., 1935; Ph.D., 1938). **Member:** College AA Am.; Am. Soc.
for Aesthetics; Woodstock AA. **Exhibited:** SFMA, 1941-43,
1946; Assoc. Am. Artists, 1944, 1946; Woodstock AA; Wash.
WCC, 1943-44; New Orleans, 1946 (prize); Louisiana Exh., 1946
(prize); LOC, 1946, 1948; PAFA Ann., 1951; George Vinet travel-
ing exh. religious prints, 1952-58; AFA traveling exh.; CM, 1952;
Univ. Louisville (solo); WMAA, 1953; State Dept Exh. Color
Lithographs travel through Europe, 1954-56; New Realism,
Suffolk Mus., Stony Brook, NY, 1971. **Awards:** Ford grant, 1952-
53. **Work:** New Orleans MA; Lehigh Univ, Bethlehem, PA;
Currier Gal. Art; Louisiana Art Commission, Baton Rouge; Mint
Mus., Charlotte, NC; Atlanta AA; High Mus., Atlanta; Eastern
Illinois State Teachers College. **Comments:** An abstract painter,
he founded the graduate fine arts program at Pratt Institute in
1962, and his faculty included Kline, Pearlstein, Lichtenstein, and
J. Lawrence. **Author:** *An Introduction to Art Activities,* 1947; *An*
Introduction to Art Education, 1957; *Higher Education & the*
Arts. **Contributor:** *The Education of the Artist,* 1951; *A*

Contemporary Painter's Attitude Toward Tradition, 1955. Teaching: Louisiana State Univ., 1937-56; director art educ., State Univ. NY College, New Paltz, 1956-59; director/chmn., Pratt Inst., 1959-75. **Sources:** WW73; obit., *New York Times;* Woodstock AA; Falk, *Exh. Record Series.*

WICKS, Alden M. *[Painter] mid 20th c.*
Addresses: Princeton, NJ, 1942; New Hope, PA. **Exhibited:** PAFA Ann., 1942, 1951-52. **Sources:** Falk, *Exh. Record Series.*

WICKS, Eugene Claude *[Painter, instructor] b.1931, Coleharbor, ND.*
Addresses: Champaign, IL. **Studied:** Univ. Colorado (B.F.A.; M.F.A., 1959). **Member:** Nat. Assn. School Art. **Exhibited:** LOC, 1959; BM Print Exh., 1960, 1962 & 1964; Northwest PM Ann. Exh., 1960-68; Phila. Acad. 185th Ann., 1963; 1961-70 (solos). **Work:** AIC; Phila. Print Club; Lakeview AC, Peoria, IL; Decatur (IL) Art Center; AFA Overseas Collection. **Comments:** Preferred medium: oil. Positions: visiting artist, dept. art, Univ. Colorado, summer 1963. Teaching: Univ. Illinois, Urbana, 1959-70s. **Sources:** WW73.

WICKS, Heppie En Earl *[Portrait painter, lecturer, teacher] b.1869, Leroy, NY.*
Addresses: Leroy, NY. **Studied:** L.M. Wiles; I.R. Wiles; C.Y. Turner; C. Beaux; Acad. Julian & École des Beaux-Arts, Paris. **Exhibited:** Soc. Indep. Artists, 1917-18, 1920-21. **Sources:** WW33.

WICKS, James *[Painter] mid 20th c.*
Addresses: Indianapolis, IN. **Exhibited:** PAFA Ann., 1950. **Sources:** Falk, *Exh. Record Series.*

WICKS, Katharine See: **GIBSON, Katharine (Mrs. Frank S. C. Wicks)**

WICKSON, Guest *[Painter, teacher] b.1888, Berkeley, CA / d.1970, Palo Alto Veterans Hospital.*
Addresses: Berkeley, CA. **Member:** San Francisco AA. **Exhibited:** San Francisco AA, 1916, 1923-25; Oakland Art Gal., 1917; Berkeley Lg. FA, 1924; GGE, 1939. **Work:** SFMA. **Comments:** Teaching: Univ. Calif. & Calif. College Arts & Crafts. **Sources:** WW25; Hughes, *Artists in California,* 603.

WICKSTROM, Axel *[Painter] early 20th c.*
Addresses: Duluth, MN. **Sources:** WW17.

WICKWIRE, Jere R(aymond) *[Painter] b.1883, Cortland, NY / d.1974, Cortland.*
Addresses: NYC. **Studied:** W.M. Chase; ASL. **Member:** ANA, 1936; All. Artists Am. **Exhibited:** PAFA Ann., 1912, 1933; Soc. Indep. Artists, 1917; Allied AA, 1934 (prize); AIC. **Work:** Vassar College. **Sources:** WW47; Falk, *Exh. Record Series.*

WICZOEK, Max *[Painter] early 20th c.*
Exhibited: AIC, 1925. **Sources:** Falk, *AIC.*

WIDDEMER, Margaret *[Painter] early 20th c.*
Exhibited: Salons of Am., 1933. **Sources:** Marlor, *Salons of Am.*

WIDEL, Edith MacFarland (Mrs. Glen) *[Painter, printmaker] b.1908, Anglin, WA.*
Addresses: Brewster, WA, 1941. **Studied:** Cooper School, Spokane; Univ. Washington; AIC. **Exhibited:** SAM, 1934; Northwest PM, 1938. **Sources:** Trip and Cook, *Washington State Art and Artists,* 1850-1950.

WIDELL, Alma (B.) *[Painter] mid 20th c.*
Addresses: Hartford, CT, 1944. **Exhibited:** Soc. Indep. Artists, 1944. **Sources:** Marlor, *Soc. Indp. Artists.*

WIDEMAN, Florence P. See: **WIDEMAN, Florice (Florence P.)**

WIDEMAN, Florice (Florence P.) *[Painter, designer, teacher, etcher] b.1893, Scranton, PA.*
Addresses: Palo Alto, CA. **Studied:** Calif. Sch. FA; ASL; Parsons Sch. Art; F. Van Sloun; E. Scott, in Paris. **Member:** Calif. WCS; San Fran. Women Artists; Palo Alto AC; Soc. Western Artists. **Exhibited:** Riverside Mus. Art; BM; Phila. Print Club; SFMA; Santa Barbara Mus.; San Jose State College. **Comments:**

Illustrator: articles for *New York Times, New York Herald Tribune.* Positions: designer, modern pottery, Amberg Hirth Studio, San Francisco; Palo Alto Pub. Sch. **Sources:** WW47; Hughes, *Artists in California,* 603, where birth date is stated to be 1895.

WIDEMAN, Fred *[Painter] late 19th c.*
Addresses: Gonzales, CA. **Exhibited:** Calif. State Fair, Sacramento, 1881. **Sources:** Hughes, *Artists in California,* 603.

WIDEN, Carl W. *[Painter] early 20th c.*
Addresses: Sherman Oaks, CA, 1924, 1932. **Member:** P&S Los Angeles. **Sources:** Hughes, *Artists in California,* 603.

WIDENER, Peter A. B. *[Patron] b.1834, Phila. / d.1915.*
Addresses: Elkins Park, PA. **Comments:** His collection included such masterpieces as the "Cowper Madonna" by Raphael, "The Mill" by Rembrandt, the "Moresini" helmet and valuable pieces of Chinese porcelain. He had made a fortune in the meat business before entering politics in Phila.

WIDER, Charles *[Engraver] b.c.1828, Prussia.*
Addresses: NYC, 1860. **Comments:** His eldest child, aged 9, was born in Germany, but three younger ones, aged 1 to 5, were born in NYC. **Sources:** G&W; 8 Census (1860), N.Y., LIV, 165.

WIDEVELD See: **WYDEVELD, A(rnoud) (or Arnold)**

WIDFORSS, G(unnar Mauritz) *[Landscape painter, illustrator] b.1879, Stockholm, Sweden / d.1934, Grand Canyon, AZ.*

Widfory – 1923

Addresses: San Francisco, CA/studio on the rim of Grand Canyon. **Studied:** Stockholm Inst. Tech., 1896-1900. **Member:** Calif. WCS; Scandinavian-Am. Artists. **Exhibited:** Calif. WCS, 1928 (prize); State Fair, 1930 (prize); AIC, 1928, 1930; Mus. Northern Arizona, 1969 (retrospective). **Work:** NGA (collection of studies of Grand Canyon); First Nat. Bank of Arizona. **Comments:** Traveled to Russia, in Europe, Africa and from 1905-08 in the U.S., where he was unsuccessful. He returned to Sweden but finnally settled in California in 1921. Illustrator: "Songs of Yosemite," 1923. Specialty: views of the Grand Canyon, since 1922. **Sources:** WW33; P&H Samuels, 527.

WIDGERY, Julia Cornelia See: **SLAUGHTER, Julia Cornelia Widgery**

WIDLIZKA, Leopold *[Painter] early 20th c.*
Addresses: NYC. **Sources:** WW24.

WIDMANN, Frederick Jacques *[Printmaker] late 19th c.; b.New York.*
Studied: Ch. Barbant. **Exhibited:** Paris Salon, 1891, 1895 (woodcuts). **Sources:** Fink, *American Art at the Nineteenth-Century Paris Salons,* 406.

WIDNEY, G(ustavus) C. *[Illustrator, painter] b.1871, Polo, IL.*
Addresses: Chalfont, PA. **Studied:** AIC with Von Saltza; Académie Julian, Paris with J.P. Laurens and Constant, 1899. **Member:** Chicago SA; SI, 1911; Nat. Press Club, Wash., DC. **Exhibited:** AIC, 1901-06. **Sources:** WW13.

Widney 06

WIDSTROM, Edward Frederick *[Sculptor, craftsperson] b.1903, Wallingford, CT / d.1989.*
Addresses: Meriden, CT. **Studied:** Detroit School Art; ASL. **Member:** NSS; AAPL; Hudson Valley AA; CAFA; Meriden Arts & Crafts Assn.; New Haven PCC. **Exhibited:** CAFA, 1934-46; New Haven PCC, 1939-46; PAFA Ann., 1939-40; Fairmont Park, Phila. 1940; NAD, 1940-72; NSS, 1960-72 (silver medal); Hudson Valley AA, White Plains, NY, 1960-72; AAPL, 1969-71 (Pres. Award, 1970); Council Am. Artists, New York (Dir. Award. 1064). Other awards: Meriden Arts & Crafts Assn., 1937 (prize), 1939 (prize), 1946 (prize). **Work:** New Haven (CT) PCC; Meriden (CT) Art & Crafts Assn. Commissions: 33 Presidents of U.S., Int. Silver Co., Meriden, 1939-70; portrait reliefs, St. Stevens School, Bridgeport, CT, 1950, Munic. Bldg., Meriden,

1966 & Marionist School, Thompson, CT, 1968. **Comments:** Preferred media: bronze, metals. Position: staff, International Silver Co., Meriden. **Sources:** WW73; WW47; Falk, *Exh. Record Series.*

WIEBKING, Edward *[Painter] early 20th c.*
Addresses: Cincinnati, OH. **Sources:** WW15.

WIECHMANN, Margaret H(elen) *[Sculptor] b.1886, NYC.*
Addresses: Wainscott, NY. **Studied:** A. Proctor: ASL; NAD. **Comments:** Specialty: small bronzes of animals. **Sources:** WW21.

WIECZOREK, Max *[Painter]*
b.1863, Breslau, Germany / d.1955, Pasadena, CA.

MAX WIECZOREK

Addresses: NYC; Pasadena. **Studied:** in Italy & Germany; Ferdinand Keller; Max Thedy. **Member:** Calif. AC; Laguna Beach AA; Calif. WCS; AWCS; Painters of the West; Chicago Galleries Assn.; Int. Bookplate Artists; AFA; Fnd. Western Artists (pres.); NYWCC; Painters & Sculptors Club; Artland Club. **Exhibited:** AIC, 1919. Awards: medal, Pan-California Expo, 1915; Calif. AC, 1918, 1920; Arizona State Fair, 1920, 1922; Laguna Beach AA, 1920; Calif. WCS, 1923; Int. Bookplate Artists, 1926; Calif. State Fair, 1927; gold medal, Pacific Southwest Expo, Long, Beach, 1928. **Work:** Chaffey H.S., Ontario, CA; Engineer's Club, NY; Denishawn Sch.; Los Angeles Mus. Art; Virgil Jr. H.S., City Hall, Los Angeles; Los Angeles Athletic Club. **Comments:** He had already worked as an artist and exhibited landscapes in Europe when he came to America in 1893. Until 1908 he worked as a glass designer for Louis C. Tiffany, moving to Los Angeles that year. There he attained recognition by executing charcoal and pastel portraits of the local elite. **Sources:** WW53; WW47; more recently, see Hughes, *Artists in California*, 604.

WIEDERSEIM, Grace See: DRAYTON, G(race) **Wiederseim G(ebbie)(Mrs. W. H.)**

WIEDHOPF, Etta L(ea) W. *[Painter] early 20th c.*
Addresses: NYC. **Studied:** ASL. **Member:** Soc. Indep. Artists. **Exhibited:** Soc. Indep. Artists, 1921-22, 1941. **Sources:** WW25.

WIEGAND, Gustave Adolph *[Landscape painter] b.1870, Bremen, Germany / d.1957, Old Chatham, NY.*

GUSTAVE WIEGAND

Addresses: Brooklyn, NY, 1894-1900; Summit, NJ; Old Chatham. **Studied:** Royal Acad., Berlin, Dresden, Germany; William M. Chase, Eugen Bracht. **Member:** NAC; All. Artists Am.; NY Soc. Painters; SC. **Exhibited:** NAD, 1894-1900 (prize, 1905); AIC; PAFA Ann., 1900-10, 1916; Corcoran Gal. annuals, 1907-08; St. Louis Expo, 1904 (medal); Soc. Indep. Artists, 1917; Allied AA, 1937 (prize); World's Fair, St. Louis (medal); Salons of Am. **Work:** BM; NAC; Newark Mus. **Sources:** WW59; WW47; Falk, *Exh. Record Series.*

WIEGAND, Henry H. *[Patron] b.1861 / d.1943, Baltimore, MD.*
Comments: Trustee of the BMA, and its secretary for many years.

WIEGAND, Robert *[Painter] b.1934, Mineola, NY.*
Addresses: NYC. **Studied:** Albright Art School, Buffalo, NY; State Univ. NY Buffalo (B.S. art educ.); New York Univ. **Exhibited:** 10 Downtown, New York, 1968; Brooklyn Mus., 1968; MoMA, 1969; Jewish Mus., 1970; Newark Mus., 1972. Awards: New York Board Trade, 1970. **Work:** Murals, NY Dept. Parks, Astor Place, NY, Lever Bros. Co., 53rd & Park Ave., Noble Found, Church & Reade Sts. & Reliance Savings Bank, Jamaica Ave. & Union Hall St. **Comments:** Positions: vice-pres., City Walls, Inc. Teaching: Staten Island Acad.; Lehman College. **Sources:** WW73.

WIEGHARDT, Paul *[Painter, educator] b.1897, Germany / d.1969, Chicago?.*
Addresses: Chicago; Wilmette, IL. **Studied:** Sch. FA, Cologne, Germany; Bauhaus, Weimar with Klee; Acad. Fine Arts, Dresden,

Germany. **Exhibited:** AIC; Salon des Indépendants, Salon d'Automne, Salon des Tuileries, Paris Salon, all in Paris; AIC, 1946; PAFA Ann., 1946, 1950-54, 1962; LOC; Soc. Contemporary Art, Chicago; Knoedler Gal. (solo); PMG (solo); St. Paul Gal. Art (solo); Berkshire Mus. (solo); Springfield (MA) Mus. Art (solo). **Work:** Albright-Knox Art Gallery, Buffalo, NY; Barnes Foundation, Merion, PA; Berkshire Mus., Pittsfield, MA; Rosenwald Collection; Smith College Mus. Art, Northampton, MA. **Comments:** Teaching: AIC, 1946-63; Evanston AC, 1948-; Illinois Inst. Technology, 1950-. **Sources:** WW73; WW47; Falk, *Exh. Record Series.*

WIEGHORST, Olaf *[Painter, illustrator, sculptor] b.1899, Viborg, Jutland, Denmark / d.1988.*

O-Wieghorst 2C

Addresses: NYC in 1918; living in El Cajon, CA, 1945-75. **Studied:** probably with his father, who was an illustrator & engraver. **Work:** Amon Carter Mus.; Nat. Cowboy Hall of Fame; Eisenhower Library, Abilene; mainly private collections. **Comments:** Wieghorst began painting in 1916. He worked as a sailor, in the U.S. Cavalry, and as a ranch hand at the Quarter Circle 2C Ranch (whose brand became his insignia), before becoming a mounted policeman in NYC, 1925-44. Moved to El Cajon in 1945 and by the 1950s was well known for his specialty, horses. **Sources:** P&H Samuels, 527-28; The Cœur d'Alene Art Auction, July 25, 1998.

WIEGNER, Dorothy *[Landscape painter] b.1918 / d.1997.*
Addresses: Vermont (1960s-on). **Studied:** ASL, 1964-74; Skowhegan Sch. Painting; MacDowell Colony, NH. **Member:** Vermont Studio Center. **Exhibited:** Red Mill Gal., Vermont Studio Center, Johnson, VT (memorial). **Comments:** She was also a mother and race car driver. **Sources:** press release, Vermont Studio Center (April, 1997).

WIEHLE, Paul *[Sculptor] early 20th c.*
Addresses: NYC. **Member:** Arch. Lg., 1901. **Sources:** WW04.

WIELAND, Frederick (Albert Joseph) *[Stained glass designer, mural painter] b.1889, Würzburg, Germany / d.1967, San Diego, CA.*
Addresses: San Diego, CA, from 1923. **Studied:** frescoe painting, NY Trade Sch.; NAD; ASL; SI Sch. **Member:** San Diego Art Guid. **Sources:** Hughes, *Artists in California*, 604.

WIELAND, Joyce *[Painter, film maker] b.1931, Toronto, Ontario.*
Addresses: Toronto. **Studied:** Central Tech. School, grad. **Exhibited:** The Wall-Art for Architecture, traveling exh., Art Gallery Ontario, 1969 & Rothmans Art Gallery, Stratford, Ontario, 1970; Oberhausen Film Festival, Austria, 1969; Survey 1970-Realism(e)s, Montreal MFA & Art Gallery Ontario, 1970; Eight Artists from Canada, Tel-Aviv Mus., Israel, 1970; Directors' Fortnight, Cannes Film Festival, France, 1970; Isaacs Gallery, Toronto, 1970s. Awards: Canadian Council grant, 1966 & 1968; two prizes for Rat Life & Diet in North American, Third Independent Filmmakers' Festival, New York, 1968. **Work:** Nat. Gallery Canada; Montreal MFA; Philadelphia MA; MoMA Film Archives, New York, NY; Royal Belgian Film Archives. Commissions: Bill's Hat (mixed media), Art Gallery Ontario, 1967. **Sources:** WW73.

WIELGUS, Raymond John *[Sculptor] mid 20th c.*
Addresses: Chicago area. **Exhibited:** AIC, 1950. **Sources:** Falk, *AIC.*

WIEMAN, Verna See: WIMAN, Vern (Verna) (Miss)

WIENER, Alma *[Painter] mid 20th c.*
Exhibited: PAFA Ann., 1946. **Sources:** Falk, *Exh. Record Series.*

WIENER, B. C. *[Painter] mid 19th c.*
Addresses: New Orleans, active 1871. **Exhibited:** Grand State Fair, 1871 (best flower painting). **Sources:** *Encyclopaedia of New Orleans Artists*, 412.

WIENER, Dmitry *[Painter] early 20th c.*
Addresses: Paris, France, 1931; Stratford, CT, 1932. **Exhibited:** Soc. Indep. Artists, 1931-32; Salons of Am., 1932. **Sources:** Falk, *Exhibition Record Series.*

WIENER, Ernest H. *[Painter] early 20th c.*
Exhibited: Salons of Am., 1932. **Sources:** Marlor, *Salons of Am.*

WIENER, George *[Art dealer] mid 20th c.; b.NYC.*
Addresses: NYC. **Comments:** Positions: owner, Wiener Gallery. Specialty of gallery: late 19th-20th c. French and American. **Sources:** WW73.

WIENER, Paul Lester *[Designer, decorator, architect, lecturer] b.1895.*
Addresses: NYC. **Studied:** art schools in Leipzig. **Comments:** Contributor: *Architectural Forum, Architectural Record, Arts and Decoration, Spur, House & Garden, American Architect.* Specialties: industrial designs and models; architectural designs, modern interiors and exteriors. **Sources:** WW40.

WIENER, Rosalie Roos (Mrs. A. Lee) *[Craftsperson] early 20th c.*
Addresses: New Orleans, LA. **Studied:** E. Woodward; M.W. Butler; W. Stevens; X. Gonzales; Newcomb College. **Member:** SSAL. **Exhibited:** Newcomb College, 1930 (prize), (Master Craftsman) 1930; NOAA, 1933 (prize); SSAL, 1936 (prize). **Sources:** WW40.

WIENER, Samuel G. *[Painter] b.1896.*
Addresses: Shreveport, LA. **Studied:** Univ. Michigan (B.S.); Atelier Corbett-Gugler, NY; Atelier Gromort-Expert, Paris; Eliel Saarinen. **Member:** Am. Inst. Arch. (fellow); Shreveport AA; Men's Art Guild. **Exhibited:** Louisiana State Exh. Bldg. (solo); 14 States Regional Exh., Monroe, LA; 13 States Regional Exh., City Mus., Shreveport, LA; City Mus., Monroe (solo); Women's Dept. Club, Shreveport. **Comments:** Publications: auth./illust., "Venetian Houses and Details," *Architectural,* 1925. **Sources:** WW73.

WIENERS, Arthur (G.) *[Painter] early 20th c.*
Addresses: NYC. **Exhibited:** Soc. Indep. Artists, 1924-27.

WIENS, Aurelia M. *[Painter] early 20th c.*
Addresses: Milwaukee, WI. **Sources:** WW24.

WIER, Gordon D. (Don) *[Designer, painter, teacher, illustrator] b.1903, Orchard Lake, MI.*
Addresses: Stratford, CT; Chevy Chase, MD. **Studied:** Univ. Michigan (A.B.); Chicago Acad. FA; Grand Central School Art; J. Scott Williams. **Exhibited:** Baltimore WCC; Delaware River AA; Decorators Club, 1942; Soc. Decorators; Bridgeport, CT (2 solos). Awards: Cert. of Excellence, Inst. Graphic Arts, 1950 & 1951. **Work:** Detroit Inst. Art; Mus. Rouaux Art et Histoire, Brussels, Belgium; J. B. Speed Mem. Mus., Louisville, KY; also in private collections of King H. M. Baudouin I, Belgium, King Frederick IX & Queen Ingrid, Denmark, Crown Prince Akihito, Japan & others. **Comments:** Illustrator: "Adventures par la Lecture," 1932, "The Victors," 1933. Positions: designer, Steuben Glass, 1945-51, art designer, 1952-69; designer, Corning Glass Works, 1949-950. Teaching: Grand Central School Art, 1928-35. **Sources:** WW73; WW47.

WIER, Mattie *[Painter] mid 20th c.*
Addresses: Houston, TX. **Exhibited:** Houston MFA, 1938, 1939. **Sources:** WW40.

WIERS, Edgar *[Painter] early 20th c.*
Addresses: Brooklyn, NY. **Exhibited:** Soc. Indep. Artists, 1928. **Sources:** Marlor, *Soc. Indp. Artists.*

WIESE, Kurt *[Illustrator, writer] b.1887, Minden, Germany / d.c.1974, Idell, NJ.*
Addresses: Frenchtown, NJ. **Studied:** abroad. **Member:** Phila. WCC; Hunterdon County Art All. **Exhibited:** Int. Expo, Paris, 1937 (prize). **Comments:** Illustrator of over 300 children's books, and also an author. Author/Illustrator: *The Chinese Ink Stick; Liang and Lo; Karoo the Kangaroo; Ella, The Elephant; The*

Rabbit's Revenge; The Parrot Dealer; Fish in the Air; The Dog, The Fox and The Fleas; Happy Easter; The Cunning Turtle; The Groundhog and His Shadow; Rabbits Bros. Circus; A Thief in the Attic. Illustrator: *Quest of the Snow Leopard,* by Roy Chapman Andrews; *Bambi.* **Sources:** WW66; WW40.

WIESE, Lucie *[Art critic, writer, lecturer] mid 20th c.; b.Russia.*
Studied: Simmons College; New England Law School; Harvard Univ.; Sorbonne; Staley College (hon. Ph.D. Art Oratory). **Exhibited:** Awards: Bellingen Recognition & William Lyon Phelps Recognition. **Comments:** Position: writer & editor on the arts; counsel to collectors; editorial counsel to research & development info offices. Publications: editor, "The Emergence of an American Art"; editor, "Paul Rosenfeld: Voyager in the Arts"; author, "Mr. Butterfly" (play); author of exhib. catalogs. Research: American art and artists; twentieth century innovators. **Sources:** WW73.

WIESELT(H)IER, Vally (Miss) *[Designer, drawing specialist, sculptor, teacher, craftsperson] b.1895, Vienna, Austria / d.1945.*
Addresses: NYC. **Studied:** Vienna with J. Hoffman & Hafnermeister. **Exhibited:** Expo des Arts Décoratifs, Paris, 1925 (medal); Barcelona (prize); WMAA, 1945. **Work:** MMA; Cincinnati Mus.; Vienna Mus. Art; Grassi Mus., Liepsizg. **Comments:** Contributor: Am. and European magazines, papers. Position: affiliated with General Ceramics Co., NY. **Sources:** WW40.

WIESEN, George William, Jr. *[Illustrator, painter, lecturer, teacher] b.1918, Phila., PA.*
Addresses: Home, PA. **Studied:** Indiana (PA) State Teachers College. **Exhibited:** Indiana (PA) State Teachers College. **Sources:** WW40.

WIESENBERG, Louis *[Painter] d.1943.*
Addresses: NYC. **Exhibited:** Salons of Am., 1931; Soc. Indep. Artists, 1931, 1936, 1938-41, 1944. **Sources:** Falk, *Exhibition Record Series.*

WIESENBERGER, Arthur *[Collector, patron] 20th c.; b.NYC.*
Addresses: NYC; Pound Ridge, NY. **Studied:** Columbia College (B.A.). **Member:** MMA (life mem.); PMA (patron); WMAA. **Comments:** Position: member, Advisory Council, Dept. of Art & Arch., Columbia Univ. Collection: abstract painting; Impressionist painting; Tibetan painting; Tibetan and Indian sculptures. **Sources:** WW66.

WIESENFELD, Betsey Straub *[Painter, etcher, teacher] b.1912, Perth Amboy, NJ.*
Addresses: Berkeley, CA; Piedmont, CA. **Studied:** Mills College, Oakland; Univ. Calif., Berkeley; UCLA; Yasuo Kuniyoshi; Glenn Wessels; Peter Blos. **Member:** Oakland AA; San Francisco Women Artists; Richmond AA; Walnut Creek Civic AC; Fort Mason PM; East Bay WCS. **Sources:** Hughes, *Artists of California,* 604.

WIESENFELD, Paul *[Painter] b.1942, Los Angeles.*
Addresses: Munich?, Germany. **Studied:** Chouinard AI, Los Angeles (B.F.A., 1959); Kunstakademie, Munich, Germany, 1966; Indiana Univ., Bloomington (M.F.A., 1968). **Exhibited:** Awards: first Julius Hallgarten Prize, NAD, 1972; Nat. Endowment for the Arts grant, 1976. **Comments:** Moved to Buffalo in 1969. Teaching: State Univ. College at Buffalo, 1969-73. **Sources:** Krane, *The Wayward Muse,* 197.

WIESER, Louis *[Listed as "artist"] b.1837, Germany.*
Addresses: Wash., DC, active 1868-1904. **Sources:** McMahan, *Artists of Washington, DC.*

WIESSLER, William *[Painter, teacher] b.1887, Cincinnati, OH.*
Addresses: Cincinnati. **Studied:** F. Duveneck; L.H. Meakin; V. Nowottny. **Comments:** Teaching: Ohio Mechanics Inst. **Sources:** WW40.

WIEST, Don *[Landscape painter, teacher]* b.c.1920, Wyoming.
Addresses: living in Laramie, WY in 1974. **Studied:** Delaware; Colorado State College of Educ., Denver Univ.; Univ. Wyoming. **Comments:** Teaching: Univ. Wyoming, 1958. **Sources:** P&H Samuels, 528.

WIEST, Van Elmendorf K. *[Painter, teacher, commercial artist, designer, illustrator]* b.1915, Little Rock, AR.
Addresses: Santa Fe, NM. **Studied:** Am. Acad. Art, Chicago; AIC with Louis Ritman; Royal Acad. Art, London, with Middleton Todd; École des Beaux-Arts, Paris, France, Marquette Univ.; Northwestern Univ.; Univ. New Mexico. **Member:** Nat. Lg. Am. Pen Women (first pres., Corralles Branch); Santa Fe AA. **Exhibited:** NGA, 1950-1952; Mus. New Mexico, Santa Fe, 1948-50, 1952, 1953; Layton Art Gal., Milwaukee, 1940; Newton Art Gal., NY, 1946; Fishers Art Gal., NY; and in Santa Fe, Albuquerque, Carlsbad, Gallup and Taos, NM. Awards: prizes, Paris, France, 1945; Botts Mem. Gal., Albuquerque, 1953, 1956. **Work:** murals, Veterans of Foreign Wars, Albuquerque; many port. commissions U.S. and abroad. **Comments:** Position: instructor in portraiture, Univ. New Mexico (evening course); St. Michael's H.S.; assoc., Albuquerque Mod. Mus.; asst. to Cart Albach, consulting electrical engineer, Santa Fe; engineering asst. to various firms, 1942-. Illustrator/designer, statistical charting, visual aid and exhib. material for the New Mexico State Land Office, dept. of game & fish and the Economic Development Comm. **Sources:** WW59.

WIGAND, Adeline Albright (Mrs. Otto) *[Portrait painter]* b.Madison, NJ / d.1944.
Addresses: Mt. Vernon, NY, 1892; NYC, 1896-1900; Cedar Rapids, IA; Staten Island, NY/Wilmington, NY. **Studied:** W.M. Chase; Académie Julian, Paris with Bouguereau and T. Robert-Fleury. **Member:** NAWPS (one of first pres.); SPNY; Staten Island Inst. Arts & Sciences; Staten Island AA. **Exhibited:** NAD, 1892-1909 (prize, 1909); PAFA Ann., 1899, 1905; AIC, 1905, 1911; Paris Salon; New York Women's AC, 1905 (prize), 1908 (prize); Corcoran Gal biennials, 1908-37 (4 times); NAC, 1910 (prize), 1912 (prize); NAWPS, 1920 (prize). **Work:** RISD; Little Gallery, Cedar Rapids, Iowa; Staten Island Inst. Arts & Sciences. **Comments:** Mainly painted portraits and figures. **Sources:** WW40; Ness & Orwig, *Iowa Artists of the First Hundred Years,* 220; Falk, *Exh. Record Series.*

WIGAND, Otto Charles *[Painter]* b.1856, NYC / d.1944, Stapleton, SI, NY.
Addresses: NYC, Staten Island, NY/Wilmington, NY. **Studied:** ASL; Académie Julian, Paris with Boulanger and Lefebvre, 1884-87. **Member:** SC, 1899; NYWCC; S.I. Inst. Arts & Sciences; Staten Island AA (pres.). **Exhibited:** NAD, 1881-1900; Paris Salon, 1886-87; 1889-1900; PAFA Ann., 1891, 1898-99; AIC. **Work:** Boston AC. **Sources:** WW40; Fink, *American Art at the Nineteenth-Century Paris Salons,* 406; Falk, *Exh. Record Series.*

WIGFALL, Benjamin Leroy *[Painter, graphic artist]* b.1930.
Studied: Iowa State Univ.; Yale-Norfolk Summer Sch.; Yale Sch. Des., New Haven. **Exhibited:** AFA Traveling Exh., 1951-53; Norfolk Mus. Arts & Sciences; Jewish Community Center, Newport, CT; Addison Gallery, Andover, MA; Nat. Rehabilitation Service Exh.; VMFA; Virgina Artists Show, 1951 (1st prize); Hampton (VA) Inst., 1953 (purchase prize); Iowa State Univ., 1954; Brooklyn Mus., 1955; Lever House, NYC; Yale Univ. (solo). Fellowships: VMFA, 1949, 1951-53; Men's Council of Hampton Inst., 1952; General Education Board, 1953-54; Yale-Norfolk Summer Art School, 1954; Yale School of Des., 1954-55. **Sources:** Cederholm, *Afro-American Artists.*

WIGGAM, W. M. *[Painter]* early 20th c.
Addresses: Toledo, OH. **Member:** Artklan. **Sources:** WW25.

WIGGIN, Alfred J. *[Portrait painter]* mid 19th c.
Addresses: Cape Ann, MA, 1850. **Sources:** G&W; Lipman and Winchester, 182.

WIGGINS, Bill *[Painter]* b.1917, Roswell, NM.
Addresses: Roswell. **Studied:** New Mexico Military Inst., Roswell; Abilene Christian College; Am. Shrivenham Univ., England, with Francis Speight; FAP, WPA, Roswell. **Member:** Artists Equity Assn. **Exhibited:** Newport (RI) 43rd Ann., 1954; Low Ruins Nat., Tubac, AZ, 1965; 5th Juried Arts Nat., Tyler, TX, 1968; Mainstreams 1968, Marietta (OH) College, 1968; Arkansas State Univ. Nat., Jonesboro, 1970. **Work:** Roswell Mus. & Art Center. **Comments:** Preferred medium: oil. Teaching: Roswell Mus. & AC, 1955-63. **Sources:** WW73; Elena Montes, "Bill Wiggins of Roswell," *New Mexico Magazine* (October, 1965); "United States Art," *La Révue Moderne* (Paris, France, December, 1965).

WIGGINS, Carleton *[Landscape painter]* b.1848, Turner's Orange County, NY / d.1932.
Addresses: Brooklyn, NY, 1866-76, 1879, 1883-86; NYC, 1877, 1880-82; Old Lyme, CT (1915-on). **Studied:** NAD with Geo. Inness, 1870; Carmeincke in Brooklyn; Paris, 1880-81. **Member:** ANA, 1890; NA, 1906; SAA, 1887; AWCS; SC, 1898 (pres., 1911-12); Lotos Club; Brooklyn AC; Artists Fund. Soc.; Artists Aid Soc.; Am. Soc. Animal P&S; CAFA; Lyme AA; AFA. **Exhibited:** NAD, 1866-1900; Brooklyn AA, 1865-92; PAFA Ann., 1880; Paris Salon, 1881; Boston AC, 1882-1909; PAFA Ann., 1888-1907 (6 times); AIC; Prize Fund Exhib. NYC, 1894 (gold); Pan-Am. Expo. Buffalo (medal), 1901; Royal Acad., London; Corcoran Gal biennial, 1910; New Britain Mus. Am. Art, 1979 (trio with Guy C. and Guy A.); Lyme Acad. FA, 1996 (trio with Guy C. and Guy A.); Joan Whalen FA, 1998 (trio with Guy C. and Guy A.). **Work:** NGA, MMA; AIC; CGA; Lotos Cllub, NYC; Hamilton College, Brooklyn; Brooklyn Inst. Mus.; Newark Mus. **Comments:** One of the early artists of the colony at Old Lyme, CT, he was best known for his bucolic landscapes, especially those featuring cows. His more famous son was Guy Wiggins (see entry). He also painted in East Hampton, Long Island, in the 1890s. **Sources:** WW31; *East Hampton: The 19th Century Artists' Paradise;* Fink, *American Art at the Nineteenth-Century Paris Salons,* 406; Falk, *Exh. Record Series.*

WIGGINS, Eleanor D(u Bois) *[Painter]* early 20th c.
Addresses: Brooklyn, NY. **Exhibited:** Soc. Indep. Artists, 1931-32; Salons of Am., 1934. **Sources:** Falk, *Exhibition Record Series.*

WIGGINS, Emma J. *[Artist]* late 19th c.
Addresses: Active in Washington, DC, 1892. **Sources:** Petteys, *Dictionary of Women Artists.*

WIGGINS, George E. C. *[Illustrator, teacher]* mid 20th c.
Addresses: Phila., PA. **Exhibited:** PAFA, 1938. **Sources:** WW40.

WIGGINS, Gloria *[Painter]* b.1933, NYC.
Addresses: Staten Island, NY. **Exhibited:** Mariners Harbor Art Festival, 1967, 1970; Harlem Art Festival, 1968-69; Staten Island Community Col., 1969-71; Olatunji Center for African Culture, 1968-69; Richmond Col., 1971-72. Awards: resident artist award, Staten Island Community Col., 1971. **Sources:** Cederholm, *Afro-American Artists.*

WIGGINS, Guy A. *[Painter]* b.1920, Brooklyn, NY.
Addresses: Old Lyme, CT; NYC/Stockton, NJ. **Studied:** with his father, Guy C. Wiggins; Corcoran School Art, 1968-69; ASL; NAD. **Member:** NA; SC; CAFA; Lotos Club; NAC; Lyme AA; Kit Kat Club; New Haven PCC. **Exhibited:** Lyme Acad. FA, 1996 (trio with Carleton and Guy C.); Joan Whalen FA, 1998 (trio with Carleton and Guy C.). Awards: prizes, CAFA, 1916, 1918, 1926, 1931, 1933; SC, 1916, 1919; AIC, 1917; RISD, 1922; New Haven PCC, 1930; Lotos Club, 1938. **Work:** MMA; NGA; Brooklyn Inst. Mus.; Hackley Art Gal., Muskegon, MI; AIC; Dallas AA; Lincoln (NE) AA; Newark Mus.; Lotos Club, Wadsworth Atheneum, Hartford, CT. **Comments:** In 1976, after retiring from the U.S. Foreign Service, he began to paint professionally. His

subjects include cityscapes, still lifes, and country scenes. Lectures to art museum and art club audiences nationally. **Sources:** WW59; press release, Lyme Acad. FA (Oct., 1996).

WIGGINS, Guy C. *[Painter, teacher] b.1883, Brooklyn, NY / d.1962, on vacation in St. Augustine, FL.* **Addresses:** NYC , until 1920s/Lyme, CT, 1905-37/Essex, CT, 1937-62. **Studied:** with his father Carleton; Brooklyn Polytechnic Inst. (arch.); NAD, W.M. Chase & later R. Henri. **Member:** ANA, 1916; NA, 1935; SC, 1907; CAFA (pres., 1927-30s); NAD; Lyme AA; Kit Kat Club; New Haven PCC; NAC. **Exhibited:** Corcoran Gal. biennials, 1908-23 (5 times); PAFA Ann., 1912-34 (9 times); SC, 1916 (prize); 1919 (prize); AIC, 1917 (Norman Wait Harris Bronze Medal); CAFA, prizes in 1916, 1918, 1926, 1931, 1933; RISD, 1922 (prize); New Rochelle Soc., 1929 (prize); New Haven PCC, 1930 (prize); Lotos Club, 1938 (prize); Lyme Acad. FA, 1996 (trio with Carleton and Guy A.); Joan Whalen FA, 1998 (trio with Carleton and Guy A.). **Work:** MMA; NGA; Brooklyn Inst. Mus.; Hackley Art Gal., Muskegon, MI; AIC; Dallas AA; Lincoln (NE) AA; Newark (NJ) Mus.; Lotos Club; NAC; Wadsworth Atheneum; Beach Mem. Gal., Storrs, CT; Detroit Athletic Club; Denton College, TX; Cincinnati (OH) Club; New Britain (CT) Inst.; Heckscher Park Art Mus., Huntington, NY; Syracuse MFA; Reading Mus.; City College, Richmond, IN; Amherst College; Univ. Nebraska Art Gal. **Comments:** An important Impressionist member of the Old Lyme art colony, he was best known for his landscapes of Connecticut and NYC snow scenes. He was the son of Carleton (see entry) and father of Guy A. (see entry). Position: director, Guy Wiggins Art Sch., Essex, CT. Signature note: His middle initial, C, appears in his early signature; thereafter he consistently signed as "Guy Wiggins" in a mix of upper/lower case letters. **Sources:** WW47; *Connecticut and American Impressionism* 178-79 (w/repro.); Falk, *Exh. Record Series.*

WIGGINS, John Carleton See: **WIGGINS, Carleton**

WIGGINS, John Gregory *[Craftsperson] b.1890, Chattanooga, TN.* **Addresses:** Pomfret, CT/North Belgrade, ME. **Member:** Boston SAC. **Work:** St. Paul's Sch., Concord, NH; Trinity College Chapel, Hartford, CT; anthropological models, Peabody Mus., Andover, MA; models, Marine Room, BMFA. **Comments:** Specialties: woodcarving; models. **Sources:** WW40.

WIGGINS, M. Katherine *[Painter] mid 20th c.* **Exhibited:** Corcoran Gal. biennial, 1947. **Sources:** Falk, *Corcoran Gal.*

WIGGINS, Michael *[Painter, graphic artist] b.1954, Brooklyn, NY.* **Exhibited:** Mariners Harbor Art Festival, 1967; Brooklyn Mus., 1968; Harlem Art Festival, 1969; Olatunji Center for African Culture, 1969. Awards: Sklenar Art Award, 1967; prize, PS 18, NYC; Pininzolo Art Award, 1969. **Sources:** Cederholm, *Afro-American Artists.*

WIGGINS, Myra Albert (Mrs.) *[Painter, photographer, designer, writer, teacher] b.1869, Salem, OR / d.1956, Seattle, WA.* **Addresses:** Seattle, WA. **Studied:** Willamette Univ., Salem, OR; Mills College; with Dudley Pratt and F. H. Varley; ASL, 1891 with William M. Chase, Kenyon Cox, Frank DuMond, G. deF. Brush; W. Metcalf; J.H. Twachtman; F.V. Dumond; New York Sch. Art. **Member:** AAPL; AFA; Women Painters of Wash. State (founder; pres.); NAWA; Am. Art Group; Pacific Coast Assn. P&S; Nat. Lg. Am. Pen Women; Women Painters of Washington (1930, co-founder);. **Exhibited:** Albright Gallery, Buffalo (Secessionists' exh.), 1910; Vancouver, BC Art Gallery (solo); Dana Point, CA; New Orleans; Los Angeles; Argent Gal., NY, 1946 (solo); DeYoung Mus., San Francisco, SAM, 1953 (retrospective); photography exhibs.: AIC, Spokane, Yakima, WA (all solo); Salons of Am.; salons, Boston, Philadelphia, Albright Art

Gal., Rochester Mem. Art Gal., Portland Art Mus., Toronto, Canada, London, England, Paris, France, and others. Awards: prizes, AIC, 1933; San Francisco, 1939; Lg. Am. Pen Women, 1939 (prize); first nat. award for achievement in art, Washington, DC, 1948, 1952; Gen. Fed. Women's Club; Seattle, WA, 1951. **Work:** State Lib., Pub. Lib., both in Olympia, WA; YMCA, YWCA, both in Yakima, WA; Portland Art Mus.; Getty Mus.; Nat. Gal. of Am. Art, Smithsonian Inst. **Comments:** Wiggins was among the first artists of the northwestern United States to receive international recognition. She was known as "the Dean of Northwest women painters." Exhibiting her photographs while developing her painting abilities, in 1902 she was admitted into the Photo-Secession, Alfred Steiglitz's group of photographers. Steiglitz exhibited her work in many exhibitions and publications. She made a now-famous portrait of William Merritt Chase with his students at the Art Students League. Wiggins was encouraged in her art by Chase and made a transition from landscape photography to photographing the figure. She was very interested in Dutch genre scenes, whose light-and-shade features were a good match for the hues of gelatin and silver prints. George Eastman (of Eastman-Kodak) gave her financial support that allowed her to travel overseas; she moved to Washington State in 1907 (Toppenish, Wash., and Seattle, in 1930), where she continued to paint until her death at age 86. **Sources:** WW53; WW47; P&H Samuels, 528; addl info courtesy of Martin-Zambito Fine Art, Seattle, WA; Trenton, ed. *Independent Spirits,* 108 (w/repro.).

WIGGINS, Samuel A. *[Engraver] b.c.1834, New Brunswick.* **Addresses:** Detroit, MI, 1860. **Sources:** G&W; 8 Census (1860), Mich., XX, 110; Detroit CD 1861.

WIGGINS, Sidney M(iller) *[Decorator, designer, painter] b.1883, New Haven, CT / d.1940, Yonkers, NY.* **Addresses:** NYC, Yonkers, NY. **Studied:** R. Henri; E. J. Sloane; ASL. **Member:** SC; Yonkers AA; NYWCC; AWCS; Allied AA. **Exhibited:** AIC, 1920, 1932; Soc. Indep. Artists, 1920; PAFA Ann., 1922. **Sources:** WW40; Falk, *Exh. Record Series.*

WIGGLESWORTH, Frank *[Painter, sculptor] b.1893, Boston, MA.* **Addresses:** Boston. **Studied:** C. Grafly. **Member:** Boston SS; Boston AC; North Shore AA; Gloucester SA. **Exhibited:** Salons of Am. **Sources:** WW33.

WIGGLEWORTH, Isabella C. *[Painter] early 20th c.* **Addresses:** Cambridge, MA. **Exhibited:** PAFA Ann., 1931. **Sources:** Falk, *Exh. Record Series.*

WIGHT, Dick *[Painter] early 20th c.* **Addresses:** Oakland, CA, 1930s. **Studied:** Calif. College Arts & Crafts. **Exhibited:** Oakland Art Gallery, 1938. **Sources:** Hughes, *Artists of California,* 604.

WIGHT, Frank *[Printmaker] b.1910, Inglewood, CA.* **Addresses:** Hayward, CA. **Studied:** ASL; Univ. Calif., Berkeley; Calif. College Arts &Crafts; Fernand Leger in Paris; Felipe Orlando in Mexico City. **Exhibited:** de Young Mus, 1960; nationally. **Sources:** Hughes, *Artists in California,* 604.

WIGHT, Frederick S. *[Painter, art administrator] b.1902, NYC / d.1986.* **Addresses:** Los Angeles. **Studied:** Univ. Virginia (B.A.); Harvard Univ. (M.A.). **Member:** Int. Assn. Art Critics; Univ. Calif., Los Angeles Art Council. **Exhibited:** M. H. de Young Mem Mus., San Francisco, 1956 (solo); Pasadena Art Mus., 1956 (solo); Fine Arts Gallery San Diego, 1960 (solo); Esther Robles Gallery, Los Angeles, 1960 (solo); Long Beach Mus. Art, 1961 (solo); Palm Springs Desert Mus., 1969 (solo). **Comments:** Positions: asst. director, Inst. Contemporary Art, Boston, MA; director, Frederick S. Wight Galleries, Univ. Calif., Los Angeles, 1953-. Publications: author, *Morris Graves,* 1956, *Hans Hofmann,* 1957, *Arthur G. Dove,* 1958, *Richard Neutra,* 1958 & *Modigliani,* 1961. Teaching: art history instructor, Univ. Michigan, 1950; art history instructor, Harvard Univ., 1951; art history instructor, Univ. Calif, Los Angeles, 1953-60, chmn. dept. art, 1963-66. Collections arranged:

Jacques Lipchitz Retrospective, 63 Kurt Schwitters, 1965, Henri Matisse Retrospective, 1966, Negro in American Art, 1966, Jean Arp Memorial, 1968 & Gerhard Marcks Retrospective, 1969. **Sources:** WW73.

WIGHT, Moses *[Portrait and genre painter] b.1827, Boston, MA / d.1895.*
Addresses: Boston, c.1845-51; Europe, 1851-54; Boston, 1854-73; Paris (France), 1873 and after. **Studied:** Europe, 1851-54; Hébert; Bonnat. **Exhibited:** NAD, 1865-85; PAFA Ann., 1877, 1881-83, 1888; Boston AC, 1878-85; Brooklyn AA, 1879; Paris Salon, 1882-84; 1890, 1891. **Work:** Am. Antiquarian S. **Comments:** An expatriate, his first important work was a portrait of Alexander von Humboldt, 1852. He made two trips to Paris, in 1860 and in 1865. In 1873 he settled permanently in Paris and began to specialize in interiors. **Sources:** G&W; Wight, *The Wights,* 191-92; Smith; Clement and Hutton; Tuckerman; Boston BD 1845-60; Swan, BA; represented at American Antiquarian Society; Fink, *American Art at the Nineteenth-Century Paris Salons,* 406; Falk, *Exh. Record Series.*

WIGHT, P. B. *[Artist] late 19th c.*
Addresses: NYC, 1866-68. **Exhibited:** NAD, 1861-68. **Sources:** Naylor, *NAD.*

WIGHT, W. *[Portrait painter] 19th c.*
Work: Dartmouth College (portrait of Richard Fletcher, 1788-1869). **Comments:** Possibly Moses Wight. **Sources:** G&W; WPA (Mass.), *Portraits Found in N.H.,* 8.

WIGHTMAN, Emilie M. *[Listed as "artist"] 19th/20th c.*
Addresses: Wash., DC, active 1911-24. **Exhibited:** Soc. Wash. Artists, 1911. **Sources:** McMahan, *Artists of Washington, DC.*

WIGHTMAN, Francis P. *[Painter] early 20th c.*
Addresses: Baltimore, MD. **Sources:** WW13.

WIGHTMAN, George D. *[Wood engraver] late 19th c.*
Addresses: Buffalo, NY, active 1848-96. **Comments:** He may have been the George Wightman of 74 Fulton Street, NYC, who exhibited a wood engraving at the American Institute in 1847. **Sources:** G&W; Buffalo CD 1848-96; Am. Inst. Cat., 1847.

WIGHTMAN, N. *[Lithographer] early 19th c.*
Comments: Portrait of Bishop John Henry Hobart (1775-1830) of NYC. **Sources:** G&W; Peters, *America on Stone.*

WIGHTMAN, Thomas *[Engraver] early 19th c.; b.England.*
Addresses: Massachusetts, after 1800; Boston, active 1805-10 and possibly 1818. **Comments:** He did 25 copperplate illustrations for Dean's *Analytical Guide to Penmanship,* published at Salem in 1802, and in 1806 he did some plates for two books published in Boston. In 1814 he was working for Abel Bowen (see entry). **Sources:** G&W; Fielding; Hamilton, *Early American Book, Illustrators and Wood Engravers;* Boston CD 1805, 1809-10, 1818.

WIGHTMAN, Thomas *[Portrait and still life painter] b.1811, Charleston, SC / d.1888.*
Addresses: Charleston, SC, 1811-1841; NYC, 1841. **Studied:** Henry Inman, NYC, 1841. **Member:** ANA, 1849. **Exhibited:** NAD, 1836-54. **Comments:** In June 1841 he left Charleston to complete his studies in NYC where he seems to have stayed, except for visits to Charleston in 1843 and 1844, until about the time of the Civil War when he returned to the South. Of his later career nothing is known, except that he had a son Horace who was also a painter (see entry). **Sources:** G&W; *Art Annual,* X, 402; Rutledge, *Artists in the Life of Charleston;* Cowdrey, NA; Brooklyn CD 1843-52; Stillwell, "Some Nineteenth Century Painters," 82, 84, 85 (repro.), 87 (repro.).

WIGLE, Arch P. *[Painter] early 20th c.*
Addresses: Detroit, MI. **Sources:** WW24.

WIIG, Lars Haug *[Painter] early 20th c.*
Exhibited: Salons of Am., 1929; Soc. Indep. Artists, 1938. **Sources:** Falk, *Exhibition Record Series.*

WIIG-HANSEN, Maia *[Painter] mid 20th c.*
Exhibited: Soc. Indep. Artists, 1938. **Sources:** Marlor, *Soc. Indp. Artists.*

WIKEN, Dick *[Sculptor, craftsperson, designer, writer, teacher, lecturer] b.1913, Milwaukee, WI.*
Addresses: Milwaukee. **Studied:** Univ. Wisc. Ext. Div.; mostly self-taught. **Member:** Wisc. P&S. **Exhibited:** Milwaukee AI, 1934 (prize), 1935 (prize); Wisc. P&S, 1934, 1935 (prize) 1937, 1939-1941; Madison Salon Art, 1935 (prize), 1937 (prize), 1939, 1940; Wash., DC, 1936, 1937; Rockefeller Center, NY, 1934, 1938; WFNY 1939; PAFA, 1940; Mississippi Valley Artists, 1941; AIC, 1941; Syracuse Mus. FA, 1939; Nat. Exh. Am. Art, NY, 1937, 1938. **Work:** Pub. Sch., Milwaukee, WI; Soldier's Field, Administration Bldg., Chicago; many sculptured portraits. **Comments:** Lectures: woodcarving, ceramic sculpture, etc. **Sources:** WW53; WW47.

WIKSTROM, Bror Anders *[Painter, teacher, etcher, designer, illustrator] b.1839, Stora Lassana, Sweden / d.1909, NYC.*
Addresses: New Orleans, active 1883-1909. **Studied:** Acad., Stockholm; E. Persens; Julien Colarossi, Paris. **Member:** New Orleans AA (founder/treas., 1890; pres., 1892, 1895-96; secretary, 1899-1903); New Orelans AA, 1904-08 (board of dir.), 1909; Nashville Expo., c.1904 (art commissioner to Europe). **Exhibited:** Seebold's, NO, 1886; New Orleans AA, 1886-87, 1890-92, 1894, 1896-99, 1901-02; Tennessee Cent. Expo., 1897; NOAA, 1904-05; E. Curtis' Exchange, 1902; Louisiana Historical Soc., 1903; Louisiana Purchase Expo., 1904. **Comments:** Went to sea as a boy and is said to have attained the rank of a captain. He decided to pursue his interests in art when still in Sweden and became a magazine illustrator there. About 1881 he decided to draw scenes on voyages between Holland and NYC, eventually staying in Florida for about a year. His earliest recorded work in New Orleans were cartoons in 1883 and 1884. He returned to N.O. and designed floats used in the Mardis Gras carnivals for about 35 years. His marine paintings were also highly sought after during his life. **Sources:** WW08; *Encyclopaedia of New Orleans Artists,* 412-413, where his year of birth is recorded as 1854.

WILB See: **SNYDER, James Wilbert (WILB)**

WILBANKS, W. H. *[Art director] mid 20th c.*
Addresses: Portland, OR. **Sources:** WW59.

WILBAUX, Madame *[Sculptor] late 19th c.*
Addresses: Brooklyn, NY, 1878. **Exhibited:** NAD, 1878. **Sources:** Naylor, *NAD.*

WILBER, John *[Painter] mid 20th c.*
Addresses: Chicago area. **Exhibited:** AIC, 1940. **Sources:** Falk, *AIC.*

WILBERFORCE, Thomas C. *[Painter] 19th/20th c.*
Addresses: NYC, 1886; Glen Ridge, NJ, 1898. **Exhibited:** NAD, 1886, 1898. **Sources:** WW01; Naylor, *NAD.*

WILBERFOSS, Thomas S. See: **WILBERFORCE, Thomas C.**

WILBERG, Theodore L. *[Painter] early 20th c.*
Addresses: Cincinnati, OH. **Member:** SWA. **Sources:** WW15.

WILBERT, Robert John *[Painter, educator] b.1929, Chicago, IL.*
Addresses: Detroit, MI. **Studied:** Univ. Illinois (B.F.A., 1951; M.F.A., 1954). **Exhibited:** American Watercolors, Drawings & Prints, MMA, 1952; Butler IA 25th Midyear Ann., 1960; PAFA 156th Ann., 1961; Donald Morris Gallery, Detroit, 1962-72 (4 solos); A Survey of Contemporary Art, J.B. Speed Art Mus., Louisville, KY, 1965; Donald Morris Gallery, Detroit, MI, 1970s. **Awards:** 4th Biennial Michiana Regional Award, South Bend AC, 1966; gallery award, Michigan State Fair, 1967; Werbe Award, 57th Exh. Michigan Artists, Detroit IA, 1969. **Work:** Saginaw (MI) Mus.; South Bend (IN) Art Center; Kalamazoo (MI) Art Center; Macomb Co. Community College, Warren, MI; Wayne State Univ., Detroit. **Comments:** Preferred media: oils, watercol-

ors. Teaching: Flint (MI) Inst. Arts, 1954-56; Wayne State Univ., 1956-. **Sources:** WW73.

WILBUR, Dorothy Thornton *[Painter, illustrator, sculptor]* *early 20th c.; b.Fincastle, VA.*
Addresses: St. Paul, MN, active early 1920s; Wash., DC, c.1929 until at least 1956. **Studied:** Frederick Fursman, Julius Golz, Alice Schille. **Exhibited:** Minnesota SA, 1924 (prize); Wash. DC Soc. Artists, 1929-56. **Comments:** Specialty: book illustrations. **Sources:** WW59; WW47. More recently, see, McMahan, *Artists of Washington, DC.*

WILBUR, Eleanor(e) E. *[Painter] b.c.1844 / d.1912, Cambridge, MA.*
Addresses: Boston, MA. **Exhibited:** Boston AC, 1898. **Sources:** WW01.

WILBUR, Elvira A. *[Artist] late 19th c.*
Addresses: Active in Detroit, MI, 1889-91. **Sources:** Petteys, *Dictionary of Women Artists.*

WILBUR, Ernest C. *[Cartoonist] early 20th c.*
Addresses: Oak Park, IL. **Sources:** WW19.

WILBUR, Isaac E. *[Portrait painter] mid 19th c.*
Addresses: Rochester, NY, 1843. **Sources:** G&W; Ulp, "Art and Artists in Rochester," 32.

WILBUR, Lawrence L. *[Illustrator] early 20th c.*
Addresses: NYC. **Exhibited:** Nat. Preparedness, 1917 (prize for best Army poster). **Sources:** WW17.

WILBUR, Lawrence Nelson *[Painter, etcher, engraver, designer] b.1897, Whitman, MA / d.1988.*
Addresses: New York 25, NY. **Studied:** Massachusetts Normal Art School; Otis AI; Grand Central School Art; N.C. Wyeth. **Member:** SAE; SAGA; AWS; SC; Chicago SE; All. Artists Am.; Audubon Artists (exh. chmn., 1953). **Exhibited:** MMA; Nat. Gal., Wash., DC; PMA; Royal Soc. British Painters, Etchers & Engravers; Fairleigh Dickinson Univ.; Montclair (NJ) Mus.; AA Artists; New Britain (CT) Mus Art; Nat. Mus., Poland; Soc. Indep. Artists; LOC; Am. WCC, 1936, 1937, 1938; PAFA, 1938; AWCC; NYWCC, 1939; NAD, 1941, 1943; SAGA; SAE; AWS, 1943 (prize), 1951 (medal); Chicago SE; All. Artists Am., annually. 1052 (bronze medal); Audubon Artists; Argent Gal., 1938 (solo); New Jersey P&S Soc. (prize); SC, 1941 (prize), 1943 (prize). Awards: *Am. Artist* magazine, 1958 (bronze medal). **Work:** LOC; NGA; PMA. **Sources:** WW59; WW47; *American Scene Painting and Sculpture,* 64 (w/repro.).

WILBUR, Margaret Craven *[Sculptor] mid 20th c.; b.Detroit.*
Addresses: NYC. **Studied:** Detroit Sch. FA; A. Polasek; AIC. **Member:** NAWPS. **Comments:** Affiliated with Phoenix AI. **Sources:** WW40.

WILBUR, Ruth *[Painter] b.1915, Lake Forest, IL.*
Addresses: Chicago, IL. **Studied:** AIC. **Exhibited:** AIC, 1940 (prize). **Sources:** WW40.

WILBUR, Ruth Ann *[Illustrator] early 20th c.*
Addresses: perhaps from Calif. **Comments:** Illustrated a series of articles, "Seen at the Bon Marché," *Graphic,* (October, 1917). **Sources:** Petteys, *Dictionary of Women Artists.*

WILBUR, S. *[Wood engraver] mid 19th c.*
Comments: His work appeared in *The Lumiere* (New York, 1831). **Sources:** G&W; Hamilton, *Early American Book Illustrators and Wood Engravers,* 97.

WILBY, Margaret Crowinshield *[Portrait painter] b.1890, Detroit, MI.*
Addresses: Detroit 14, MI. **Studied:** AIC; ASL; Ontario College Art, Canada; Eliot O'Hara; J. P. Wicker; Vanderpoel; C.W. Hawthorne; A. Tucker; T.H. Benton. **Member:** Deerfield Valley (MA) Art Assoc.; Detroit Soc. Women Painters; Michigan Acad. Science, Arts & Letters; NAWA. **Exhibited:** NAWA, 1932-34, 1939-40; Detroit IA, 1939, 1942-43; Detroit Women Painters,

1934-58; Detroit WCS, 1946; Rockport AA, 1931; Gloucester AA, 1934; Deerfield Valley AA, 1933-34, 1937-38; Michigan Acad. Science, Arts & Letters, 1947-54; Greenfield, MA, 1948. **Sources:** WW59; WW47.

WILBY, Martha *[Painter] 20th c.*
Addresses: Cincinnati, OH. **Studied:** Cincinnati Art Acad. **Sources:** WW10.

WILBY, Richard *[Painter] b.1850, Cincinnati, OH / d.1936, Detroit, MI.*
Addresses: Detroit, 1873 and after. **Member:** Detroit AA; Detroit WCS. **Exhibited:** locally. **Sources:** Gibson, *Artists of Early Michigan,* 245.

WILCOCKS, Edna Marrett *[Portrait painter, teacher, writer] b.1887, Portland, ME / d.1969, Altadena, CA.*
Addresses: Arcadia & Altadena, CA. **Studied:** Vassar College; BMFA Sch.; ASL; Frank Benson; Edmund Tarbell; Philip Hale; Pratt; Harrison. **Member:** Women Painters of the West; Nat. Soc. Arts & Letters, Pasadena Chapt. (chmn., art committee). **Exhibited:** Soc. Indep. Artists, 1925; Calif. WCS, 1928-35; Pasadena SA, 1930-34; Women Painters of the West, 1933-55; Griffith Park, Los Angeles; Pasadena AA; Santa Barbara; Denver. **Work:** Court House, Wilkes-Barre, PA; Bowdoin College, Burnswick, ME; Court House, Edmonton, Alberta. **Comments:** Teaching: Flintridge Sch. for Girls, Pasadena, 1934; Anoakia Sch., Arcadia, CA, 1936-56. **Sources:** WW59; WW47.

WILCOTT, Frank *[Painter] early 20th c.*
Addresses: Chicago, IL. **Sources:** WW08.

WILCOX, Beatrice C. *[Painter] 19th/20th c.; b.Geneva, IL.*
Addresses: Chicago, IL, active 1898-1903. **Studied:** AIC. **Member:** SWA. **Exhibited:** PAFA Ann., 1895-97; Boston AC, 1896; AIC; Trans-Mississippi Expo, Omaha, NE, 1898; Chicago Artists, 1898. **Sources:** WW01; Petteys, *Dictionary of Women Artists;* Falk, *Exh. Record Series.*

WILCOX, Cora H. *[Painter] b.1882, Pennsylvania / d.1964, Laguna Beach, CA.*
Addresses: Laguna Beach, CA. **Studied:** Chicago Acad. FA. **Exhibited:** P&S Los Angeles, 1930; Laguna Festival of the Arts, 1941. **Sources:** Hughes, *Artists of California,* 604.

WILCOX, (David) Urquhart *[Painter, teacher] b.1876, New Haven, CT / d.1941, Buffalo, NY.*
Addresses: Buffalo. **Studied:** Yale Univ., New Haven; ASL with George Bridgman; ASL, Buffalo, with Lucius Hitchcock; in Europe, 1907. **Exhibited:** Buffalo SA, 1906 (prize), 1911 (prize), 1913 (prize). **Work:** Albright Art Gal., Buffalo. **Comments:** Teaching: Buffalo Sch. FA, 1904-08; Sch. FA, Albright Art Gal., 1910-40. **Sources:** WW40.

WILCOX, E. W. *[Painter] mid 20th c.*
Exhibited: Soc. Indep. Artists, 1940. **Comments:** Possibly Wilcox, Miss Elva W., d.1951 Forest Hills, LI, NY. **Sources:** Marlor, *Soc. Indp. Artists.*

WILCOX, Frank Nelson *[Painter, graphic artist, screenprinter, teacher, writer, lecturer, etcher, illustrator] b.1887, Cleveland, OH / d.1964, East Cleveland.*
Addresses: East Cleveland 12, Ohio, 1962. **Studied:** Cleveland Sch. Art, 1910; Henry Keller; F.C. Gottwald; L. Rohrheimer; H. Potter. **Member:** Cleveland Soc. Artists; AWS; Phila. WCC. **Exhibited:** AIC; PAFA Ann., 1927, 1929; Paris Salon and regionally in the U.S. including five retrospectives. Awards: Penton medal, Cleveland, 1920. **Work:** CMA; TMA; BM; dioramas, Western Reserve Hist. Soc.; San Diego Gal. FA; Tennessee State Mus. **Comments:** Traveled in Europe, on the eastern seabord of the U.S.; in Louisiana, Tennessee, Kentucky, and the Carolinas; and in the Southwest and on the Gulf Coast. Teaching: John Huntington Polytechnic Inst., 1918-53; Cleveland Inst. Art, until 1957. Author/illustr.: "Ohio Indian Trails," among others. **Sources:** WW59; WW40; Kelly, "Landscape and Genre Painting in Tennessee, 1810-1985," 118 (w/repro.); Falk, *Exh. Record Series.*

WILCOX, Harriet Elizabeth *[Painter, decorator] early 20th c.*
Addresses: Cincinnati, OH, 1886-1930s. **Work:** Victoria & Albert Mus., London; R. Indust. Art Mus., Berlin. **Comments:** Worked at Rookwood Pottery, Cincinnati. **Sources:** WW10; Petteys, *Dictionary of Women Artists.*

WILCOX, Hattie M. *[Artist] late 19th c.*
Addresses: Active in Washington, DC, 1880-82. **Sources:** Petteys, *Dictionary of Women Artists.*

WILCOX, John Angel James *[Steel engraver and etcher, portrait painter] b.1835, Portage, NY.*
Addresses: Boston, active 1860-1913. **Studied:** Jarvis Griggs Kellogg, Hartford (CT), mid-1850s (engraving). **Member:** Boston AC. **Exhibited:** Boston AC, 1882, 1895. **Comments:** He worked in line, stipple, and mezzotint, etched, and painted some portraits. **Sources:** G&W; WW10; Fielding's supplement to Stauffer; Hartford CD 1858-61; Boston CD 1866-1913; repro., *Ohio State Archaeological and Historical Quarterly* (Jan. 1948), opp. 4.

WILCOX, Joseph P. *[Sculptor and marble cutter] mid 19th c.*
Addresses: Newark, NJ. **Exhibited:** Am. Inst., 1856 (two marble reliefs); NAD, 1859 (one bust). **Sources:** G&W; Newark CD 1857-60; Am. Inst. Cat., 1856; Cowdrey, NAD.

WILCOX, L. Geer *[Painter] mid 20th c.*
Addresses: NYC. **Exhibited:** Salons of Am., 1936; PAFA Ann., 1940. **Sources:** Falk, *Exh. Record Series.*

WILCOX, Lois *[Painter, lithographer, cartoonist, craftsperson, teacher, writer] b.1889, Pittsburgh, PA / d.1958, Woodstock, NY?.*
Addresses: Wellesley, MA; Woodstock, NY. **Studied:** ASL with F. V. DuMond; BMFA Sch. with P. Hale; W. Metcalf, C. Hawthorne; also in Paris; in Rome with Galemberti and Venturini-Papari. **Member:** CAA; Woodstock AA. **Exhibited:** Detroit Mus. ARt, 1913 (solo); WMAA, 1926, 1928; Arch. Lg.; Fifty Prints of the Year, 1939; NAD; Corcoran Gal biennials, 1935, 1937 (as "Louis Wilcox"); Century of Progress, Chicago; Salons of Am.; many nat. exhib. of lithographs. **Comments:** Position: instructor, drawing & painting, Sweet Briar (VA) College, 1933-46. Contributor to *Magazine of Art.* **Sources:** WW53; WW47; Woodstock AA.

WILCOX, Ray *[Painter, illustrator, writer] b.1883, Elmira, NY / d.1959, Tenafly, NJ.*
Addresses: Tenafly, NJ. **Studied:** Rochester Athenaeum; ASL; Colorossi Acad., Paris. **Member:** AAPL; SC. **Exhibited:** Kresge Gal., Newark, NJ, 1933 (prizes); AAPL, 1935 (prize); Montclair AA, 1936 (prize); SC, 1936; Corcoran Gal. biennial, 1937; Salons of Am. **Work:** historic murals, Fashion Park, Rochester, NY; Finchley, New York, Chicago and Palm Beach; Knickerbocker Country Club, Tenafly, NJ. **Comments:** Author/illustrator: "Feathers in a Dark Sky," 1941. **Sources:** WW59; WW47.

WILCOX, Ruth *[Art librarian] b.1889, Cleveland, OH / d.1958.*
Addresses: Cleveland 6, Ohio. **Studied:** Oberlin College (A.B.); Western Reserve Univ., Sch. Lib. Science; NY State Lib. Sch. (B.L.S.). **Comments:** Position: head, FA Division, Cleveland (OH) Pub. Lib., 1917-. Lectures: book selection in the field of fine arts. **Sources:** WW53.

WILCOX, Ruth (Mrs. James L. Dawes) *[Painter, craftsperson, commercial artist] b.1908, NYC.*
Addresses: Closter, Tenafly, NJ. **Studied:** ASL; NY Sch. Fine. & Applied Art; PAFA; Académie Julian, Paris. **Member:** AAPL; NAWA. **Exhibited:** NAD, 1931-33; PAFA Ann., 1932; NAWA, 1933, 1935-46; Carnegie Inst.; CAFA, 1934; Montclair Art Mus., 1933-46; Rochester, Poughkeepsie, both in NY; Jersey City, Newark, Hackensack, Trenton, all in NJ; Salons of Am. Awards: prizes, NAWA, 1932, 1934; NAD, 1934; Ridgewood (NJ) AA, 1935, 1947, 1948; Wichita Art Mus., 1937; Fitzwilliam, NH, 1938-41; medal, Montclair Art Mus., 1936, 1939. **Work:** Maugham Sch., Tenafly, NJ; Grammar Sch., Leonia, NJ.; Palisades Interstate Park Comm.; murals, Provident Institution for Savings, Jersey City; Colonial Life Ins. Co., East Orange, NJ.;

Knickerbocker Country Club, Tenafly, NJ. **Comments:** Also known as Ruth Wilcox Dawes. **Sources:** WW59; WW47; Falk, *Exh. Record Series.*

WILCOX, Ruth Turner (Mrs. Ray) *[Painter, craftsworker, illustrator, writer, lecturer] b.1888, NYC.*
Addresses: Tenafly, NJ. **Studied:** ASL; Académie Julian, Paris; also in Munich, Germany. **Member:** NAWA; AAPL. **Exhibited:** NAD; PAFA; CI; CAFA; NAWA; Wichita Mus. Art; Delgado Mus. Art; Montclair (NJ) Art Mus.; New Jersey State Exhib., Montclair, 1934 (prize). **Comments:** Author/illustrator: "The Mode in Hats and Headdress," 1945; "The Mode in Footwear," 1948; "The Mode in Furs," 1951; "The Mode in Costume," 1942, 2nd rev. ed., 1948, 3rd rev. ed., 1958. **Sources:** WW59; Petteys, *Dictionary of Women Artists,* reports alternate birth date of 1908.

WILCOX, Urquhart *[Painter] b.1876 / d.1941.*
Addresses: Buffalo, NY (1908); Madison, CT (1908-09). **Exhibited:** AIC, 1906, 1912; Corcoran Gal. annuals, 1907-08; PAFA Ann., 1909. **Sources:** Falk, *Exh. Record Series.*

WILD, Alexander *[Lithographer] b.c.1814, Germany.*
Addresses: NYC, 1860. **Sources:** G&W; 8 Census (1860), N.Y., XLVIII, 949.

WILD, Hamilton G. See: **WILDE, Hamilton Gibbs**

WILD, John Caspar *[Landscape painter and lithographer] b.1804, Zurich, Switzerland / d.1846, Davenport, IA.*
Addresses: Phila.,1831; Cincinnati, c.1833-37; Phila., 1838; St. Louis,1839; Davenport,1845. **Work:** Yale Univ. Art Gal.; Missouri Historical Soc., St. Louis; Mercantile Lib., St. Louis; Minnesota Hist. Soc., St. Paul; Davenport Public Mus.; LOC (lithograph collection); Chicago Hist. Soc. (litho collection). **Comments:** As a young man Wild lived in Paris for fifteen years, specializing in townscapes and panoramas of Paris and Venice, but came to the United States about 1830. He established a brief partnership with the lithographer J.B. Chevalier (see entry); their chief work was a set of twenty views of Philadelphia and vicinity after drawings by Wild. His work in the Midwest included *Views of St. Louis* (1840), *The Valley of the Mississippi Illustrated in a Series of Views* (1841), and numerous paintings and lithographs of towns and scenic spots in Illinois, Iowa, and Minnesota. **Sources:** G&W; McDermott, "J.C. Wild, Western Painter and Lithographer," 12 repros.; McDermott, "J.C. Wild and Fort Snelling," one repro.; Wilkie, *Davenport Past and Present,* 307-10; Phila. CD 1838; *Portfolio* (Jan. 1946), 120; *Antiques* (Aug. 1946), 109; Stokes, *Historical Prints;* Rutledge, PA (as C. Wild). More recently, see Reps, 216-17; Peggy and Harold Samuels, cite alternate birthdate of 1806, 529.

WILD & CHEVALIER *[Lithographers] mid 19th c.*
Addresses: Philadelphia, 1838-39. **Comments:** Partners were John Caspar Wild and J.B. Chevalier (see entries. In 1838 they published twenty lithographed views of Philadelphia after drawings by Wild. **Sources:** G&W; *Portfolio* (Jan. 1946), 120; Phila. CD 1839; Drepperd, "Pictures with a Past," 96.

WILDE, David *[Engraver] b.c.1830, France.*
Addresses: San Francisco, 1860. **Sources:** G&W; 8 Census (1860), Cal., VII, 1374.

WILDE, Elsie *[Portrait, landscape & flower painter] 20th c.*
Studied: ASL; Parsons Sch. Des. **Member:** Rockport AA. **Exhibited:** Rockport AA (prizes). **Comments:** Position: fashion artist, NYC. **Sources:** *Artists of the Rockport Art Association* (1956).

WILDE, Hamilton Gibbs *[Portrait, genre & landscape painter] b.1827 / d.1884.*
Addresses: Boston, MA, 1863, 1871; Rome, Italy, 1862; Phila., PA, 1867. **Studied:** Europe, 1846 and again c.1859. **Exhibited:** Boston Athenaeum; NAD, 1863, 1871; PAFA Ann., 1853-80 (7 times); Boston AC. **Comments:** His father, James C. Wilde or Wild, was a bank cashier. **Sources:** G&W; Swan, BA; 8 Census (1860), Mass., XXVI, 684; Champney, *Sixty Years' Memories of Art and Artists,* 79; Boston CD 1852-57, BD 1853-54; Cowdrey,

NAD; Rutledge, PA; Falk, PA, vol. II.

WILDE, Ida M. *[Miniature painter] mid 20th c.*
Addresses: Brooklyn, NY. **Exhibited:** Brooklyn SMP, 1934, 1935; Penn. SMP, PAFA, 1934, 1935, 1939; Wash. SMP, 1939. **Sources:** WW40.

WILDE, Jennie (Virginia Wilkinson) *[Painter, commercial artist, designer, teacher] b.1865, Augusta, GA / d.1913, Measden, England.*
Addresses: New Orleans, active 1882-1913. **Studied:** Henriette Winant, Southern Art Union, 1882-83; Southern Art Union, 1885; J. Carroll Beckwith, NYAL, 1886. **Member:** NYAL, 1886-1913; Five or More Club, 1892; Artist's Assoc. of N.O.,1896; NOAA, 1905. **Exhibited:** Southern Art Union, 1883 (hon. mention). **Comments:** (Married Eugene Giraud, c.1895). Painted landscapes, genre, portraits. Position: teacher, Southern Academic Inst., 1886-92; teacher, Home Inst., 1893-97. Later had her own studio and designed floats for carnival organizations. She executed murals for the interior of the Church of Notre Dame, 1903 and was also a well-known author and poet. At her death she was considered the most distingushed woman artist in N.O. Her sister Emily Wilde was also a commercial artist and working with her. **Sources:** *Encyclopaedia of New Orleans Artists,* 414.

WILDE, John *[Painter, educator] b.1919, Milwaukee, WI.*
Addresses: Evansville, Madison, WI. **Studied:** Univ. Wisconsin (B.S. & M.S.). **Exhibited:** AIC; PAFA Ann., 1941-62 (7 times); Contemporary Am. Art, Univ. Illinois Biennial, 1948-65; several exhibs., Contemporary Am. Painting & Drawing, WMAA, 1950-68; Corcoran Gal biennial, 1953; Contemporary Drawing USA, MoMA, 1958; Art USA Now, U.S., Europea & Eastern mus., 1962-66; Milwaukee AC, 1967 (retrospective); Lee Nordness Gallery, NYC, 1970s. Awards: Lambert Purchase Award, PAFA, 1963; Childe Hassam Purchase Award, NAD, 1965; purchase award, Butler IA, 1968. **Work:** WMAA; PAFA; AIC; Detroit IA; Wadsworth Atheneum, Hartford, CT. **Comments:** Preferred media: oils, pencil, silverpoint. Teaching: Alfred Sessler Distinguished Professor of Art, Univ. Wisc.-Madison. **Sources:** WW73; Ed Nordness, *Art USA Now* (Viking Press, 1963); *Great Modern Drawings* (1967); "The Wildeworld" (film), Milwaukee Art Center, Univ. Wisc. Press & Channel 1910, Milwaukee, 1968; Falk, *Exh. Record Series.*

WILDE, L. B. *[Painter] mid 20th c.*
Exhibited: Soc. Indep. Artists, 1935. **Sources:** Marlor, *Soc. Indp. Artists.*

WILDE, Lois (Lois W. Hartshorne) *[Portrait painter] b.1902, Minneapolis, MN.*
Addresses: Minneapolis. **Studied:** C. Booth; Angorola; A. Kanoldt; Lhote, in Paris. **Member:** Minnesota Art Un. **Exhibited:** Minnesota State Fair, 1936 (prize). **Sources:** WW40.

WILDEN, Jim *[Sculptor] early 20th c.*
Addresses: NYC. **Sources:** WW17.

WILDEN, Spence *[Illustrator, industrial designer] b.1906 / d.1945, New Rochelle, NY.*
Studied: ASL. **Member:** SI. **Comments:** Position: art editor, *Woman's Home Companion,* 1945.

WILDENHAIN, Frans *[Potter, educator] b.1905, Leipzig, Germany / d.1980.*
Addresses: Pittsford, NY. **Studied:** Weimar Bauhaus; Acad. Amsterdam, Holland. **Member:** Am. Crafts Council; World Crafts Council. **Exhibited:** Mus. Contemporary Crafts, 1956 & 1962-64; Miami Nat., 1957 & 1958; Brussels World's Fair, 1958; Syracuse Invitational, 1971; Am. Crafts Council Gallery, NYC. Awards: Fairchild award (2), Rochester; Brussels World's Fair. **Work:** Smithsonian Inst.; Rochester Mem. Art Gallery, NY; Everson Mus., Syracuse, NY; Stedeljik Mus., Amsterdam; Boymans Mus., Rotterdam. Commissions: mural, Strasenburgh Lab., Rochester, NY; Nat. Library Medicine, Bethesda, MD; Summit Hospital, Overlook, NY; Rochester Inst. Technology, Rochester Students League. **Comments:** Publications: contributor, *Am. Artist*

Magazine & Crafts Horizons. Teaching: School Am. Craftsman, Rochester Inst. Technology. **Sources:** WW73; article, *Craft Horizons.*

WILDENRATH, Jean A(lida) (Jim Wilden) *[Painter, sculptor] b.1892, Denmark.*
Addresses: NYC; Wash. DC., 1929. **Studied:** G.F. Morris; J. Dupont; Cooper Union; NAD. **Exhibited:** PAFA Ann., 1929 (sculpture); Salons of Am. **Sources:** WW33; Falk, *Exh. Record Series.*

WILDENSTEIN, Daniel *[Gallery director, art historian] mid 20th c.; b.Verrières-le-Buisson (Seine), France.*
Addresses: NYC. **Studied:** Sorbonne, Paris. **Comments:** Positions: group sec. French Pavillon, World's Fair, 1937; director (with the late Georges Wildenstein) Arts, weekly French newspaper and also Gazette des Beaux-Arts, 1951-; director, activities, Musée Jacquemart-Andre, Paris, and Musée Chaalis, Institut de France, Paris; vice-pres., 1943-63, pres. & chmn. of board, 1963-, Wildenstein & Company, NYC. Specialty of gallery: Old Masters, French 18th century paintings, drawings, sculpture, 19th century French paintings. **Sources:** WW66.

WILDENSTEIN, Nathan *[Art dealer] b.1852 / d.1934, Paris.*
Comments: Founder: Wildenstein and Co., NY, 1903, a branch of his Paris firm.

WILDER, Arthur B. *[Landscape painter] b.1857, Poultney, VT / d.1949.*
Addresses: Woodstock, VT; Bristol, TN, 1886. **Studied:** ASL; Brooklyn Art Gld. School; T. Eakins. **Member:** AFA; Mid. Vermont AA, Rutland. **Exhibited:** NAD, 1886; Boston AC; AIC. **Work:** murals, Woodstock (VT) Inn. **Sources:** WW40.

WILDER, Bert *[Painter, etcher, teacher] b.1883, Taunton, MA.*
Addresses: NYC/Homer, NY. **Studied:** Massachusetts Sch. Art; BMFA Sch.; Cooper Union; Acad. Julian, Paris, with J.P. Laurens, 1900. **Member:** Kit Kat Club. **Exhibited:** Puerto Rico, 1933 (prize). **Comments:** His brush name was "Gil Parché.". **Sources:** WW40.

WILDER, Emil *[Portrait painter] b.c.1820, Germany.*
Addresses: Boston, 1850. **Comments:** He lived with his wife Nina. **Sources:** G&W; 7 Census (1850), Mass., XXV, 586.

WILDER, Ethel H. See: **ERNESTI, Ethel H. (Mrs. Richard)**

WILDER, F. H. *[Itinerant portrait painter] mid 19th c.*
Addresses: Fitchburg and Leominster, MA, active 1846. **Sources:** G&W; Sears, *Some American Primitives,* 287; Lipman and Winchester, 182.

WILDER, H. S. *[Painter] 20th c.*
Addresses: Newton, MA. **Member:** Boston AC. **Sources:** WW25.

WILDER, Herbert Merrill *[Illustrator] b.1864, Hinsdale, NH.*
Addresses: NYC/Hinsdale. **Studied:** T. Juglaris, in Boston. **Comments:** Specialty: comic subjects. **Sources:** WW10.

WILDER, Louise (Hibbard) (Mrs. Bert) *[Sculptor, etcher, teacher] b.1898, Utica, NY.*
Addresses: NYC/Homer, NY; Paterson, NJ. **Studied:** G.T. Brewster. **Member:** NAWPS; Soc. Med. **Exhibited:** Nat. Garden Show, NYC, 1929 (prize); PAFA Ann., 1929, 1931; AIC. **Work:** Court House, Newark; mem. fountain, Home for Indigent Aged, Wash., DC. **Comments:** Teaching: School Sculpture & Painting, Paterson, NJ. **Sources:** WW40; Falk, *Exh. Record Series.*

WILDER, M. E. (Mrs.) *[Artist] late 19th c.*
Addresses: NYC, 1871. **Exhibited:** NAD, 1871. **Sources:** Naylor, *NAD.*

WILDER, Matilda *[Amateur watercolorist] early 19th c.*
Addresses: Massachusetts, 1820. **Studied:** self-taught. **Sources:** G&W; Lipman and Winchester, 182.

WILDER, Mitchell Armitage *[Art administrator] b.1913, Colorado Springs, CO / d.1979.*
Addresses: Colorado Springs; Fort Worth, TX. **Studied:** McGill Univ. (A.B., 1935); Univ. Calif., Berkeley. **Member:** Assn. Art Mus. Dirs. **Comments:** Positions: asst. editor, Santos' "Religious Folk Art of New Mexico"; director, Colorado Springs FAC, 1945-53; director, Abby Aldrich Rockefeller Collection, Williamsburg, VA, 1954-58; director, Chouinard AI, Los Angeles, 1958-61; director, Amon Carter Mus., Fort Worth, 1961-. **Sources:** WW73; WW47.

WILDER, Ralph (Everett) *[Caricaturist] b.1875, Worcester, MA.*
Addresses: Morgan Park, IL. **Studied:** AIC; Chicago Acad. FA. **Comments:** Position: staff, *Chicago Record-Herald*, from 1903. **Sources:** WW21.

WILDER, Tom Milton *[Painter, block printer] b.1876, Coldwater, MI.*
Addresses: Ravinia, IL. **Studied:** AIC. **Member:** North Shore AL; Lake County AL; Southern PM Soc. **Exhibited:** Southern PM Soc., 1937 (prize); AIC. **Sources:** WW40.

WILDERSON, Bernice *[Painter] mid 20th c.*
Addresses: Chicago area. **Exhibited:** AIC, 1944, 1946. **Sources:** Falk, *AIC*.

WILDHABER, Paul, Jr. *[Painter, mural painter] b.1874, Switzerland / d.1948, Sacramento, CA.*
Addresses: NYC; Detroit, MI; Hollywood, CA. **Studied:** FA Acad., Munich, Germany. **Exhibited:** Artists Fiesta, Los Angeles, 1931; GGE, 1939; Calif. WCS, 1942-44. **Work:** murals: Hotel Pasadena; Goodwill Indust. Chapel. **Sources:** Hughes, *Artists in California*, 605.

WILDHACK, Robert J. *[Illustrator, painter] b.1881, Pekin, IL / d.1940, Montrose, CA.*
Addresses: La Crescenta, CA. **Studied:** R. Henri, NY; O. Stark, Indianapolis. **Member:** SI, 1910; SC; Artists Gld. **Comments:** Specialties: posters; humorous line drawings. **Sources:** WW31; Hughes, *Artists in California*, 605.

WILDINSON, M. J. (Miss) *[Landscape painter] late 19th c.*
Addresses: active in Kalamazoo, MI. **Exhibited:** Michigan State Fair, 1871. **Sources:** Petteys, *Dictionary of Women Artists*.

WILDMAN, Caroline Lax *[Painter] b.Hull, England / d.1949.*
Addresses: Bellaire, TX. **Exhibited:** Mus. FA, Houston, 1938, 1939, 1944 (prize); SSAL, 1938; San Antonio, TX, 1939. **Sources:** WW47.

WILDMAN, Edith Lavette *[Painter, photographer, decorator] b.1888, Cortland, Trumbull County, OH.*
Addresses: Cincinnati, OH. **Studied:** Cincinnati Art Acad., with K. R. Miller, H. Wessel, Grace Young, L. H. Meakin. **Exhibited:** from 1950 throughout the U.S. including Butler IA; Iron Whale Gal., Cortland, OH, 1972 (solo). **Comments:** Worked at Rookwood Pottery, 1910-12. Married Charles S. Fee in 1912 and did not paint again until age 62. **Sources:** Petteys, *Dictionary of Women Artists*.

WILDMAN, M. *[Painter] early 20th c.*
Addresses: Active in Phila., c.1917-25. **Comments:** *Cf.* Mary Frances Wildman. **Sources:** Petteys, *Dictionary of Women Artists*.

WILDMAN, Mary Frances *[Etcher] b.1899, Indianapolis, IN / d.1967, Monterey Peninsula, CA.*
Addresses: Palo Alto, CA. **Studied:** Stanford Univ. (A.B.; Ph.D.). **Member:** Phila. Pr. Club; Calif. SE; Palo Alto AC. **Exhibited:** PAFA, 1928-31; Phila. Pr. Club; Calif. SE, 1926-1932; Palo Alto AC, 1929, 1930; GGE, 1939. **Sources:** WW53; WW47.

WILENCHICK, Clement (S.) *[Painter] b.1900, NYC / d.1957, Los Angeles, CA.*
Addresses: NYC. **Studied:** A.B. Carles; H. McCarter; ASL. **Exhibited:** WMAA, 1922-27; Salons of Am.; Soc. Indep. Artists, 1925, 1932-33. **Sources:** WW25.

WILES, Bertha Harris *[Educator, writer] b.1896, Sedalia, MO.*
Addresses: Chicago 37, Ill. **Studied:** Univ. Illinois (B.A.); Univ. Wisconsin (M.A.); Am. Acad. in Rome; Radcliffe College (M.A.; Ph.D.). **Member:** CAA. **Exhibited:** Awards: Carnegie Fellowship, 1927, 1928; traveling scholarship, 1929; Am. Council Learned Soc. grant, 1931; Sachs Fellowship, Harvard Univ., 1936. **Comments:** Teaching: Radcliffe College, 1930-35; art instr., 1940-, cur., Max Epstein Archive, 1933-, art lib., 1939-43, Univ. Chicago. Auth.: "Fountains of Florentine Sculptors," 1933. Contrib. to art magazines & museums bulletins. Lectures: Florentine Fountains (sculpture). **Sources:** WW59; WW47.

WILES, Gladys Lee (Mrs. W. R. Jepson) *[Painter] b.1894, NYC / d.1984.*
Addresses: NYC/Peconic, NY. **Studied:** K. Cox; W.M. Chase (in Florence & Calif.); Johansen; her father Irving Wiles. **Member:** ANA, 1934; AAPL; All. Artists Am.; Audubon Artists; NAWPS, 1913; NYSP. **Exhibited:** AIC; NAWA, 1919 (med.); French Inst. U.S (med., "Lady in a Striped Dress"); NAD. **Comments:** She was the granddaughter of landscape painter Lemuel Wiles, and the daughter of Irving Ramsey Wiles, who used her as a model in many of his paintings. She began as a talented musician but ultimately pursued a career as a painter. Wiles began exhibiting her work in about 1914 and became a successful portraitist in the manner of Chase and Irving Wiles. **Sources:** WW59; WW47.

WILES, Irving R(amsay) *[Painter, illustrator, teacher] b.1861, Utica, NY / d.1948.*
Addresses: NYC; Peconic, NY. **Studied:** his father L.M. Wiles; W.M. Chase; ASL with J.C. Beckwith, 1880-82; Carolus-Duran, in Paris, 1882; Académie Julian, Paris with Lefebvre. **Member:** ANA, 1889; NA, 1897; SAA, 1887; AWCS; NIAL; All. AA; Paris AAA; AAPL; Artists Fund Soc.; Por. Painters; Pastelists; Arch. Lg., 1897; NYWCC, 1904. **Exhibited:** Brooklyn AA, 1881-85, 1891, 1912; PAFA Ann., 1881-85, 1893-1933 (prize, 1922); Boston AC, 1883-1906; Paris Salon, 1884; NAD, 1897-1900 (prizes, 1886, 1889, 1913, 1919, 1931, 1936); Knoedler Gal., NYC, 1900s (first solo show); Paris Expo, 1889 (prize), 1900 (medal); Col. Expo, Chicago, 1893 (medal); AWCS, 1897 (prize); Tenn. Centenn., Nashville, 1897 (medal); SAA, 1900 (medal); Pan-Am. Expo, Buffalo, 1901 (gold); Soc. Wash. Artists, 1901 (prize); St. Louis Expo, 1904 (gold); Corcoran Gal. biennials, 1907-35 (11 times); Appalachian Expo, Knoxville, 1910 (medal); Buenos Aires Expo, 1910 (gold); Pan-Pacific Expo, San Francisco, 1915 (gold); Newport AA, 1917 (prize); Duxbury AA, 1921 (prize); AIC. **Work:** Hotel Martinique, NY; City Hall, Brooklyn; CGA; NGA; West Point Military Acad.; MMA; Butler AI; Univ. Berlin, Germany; State Dept., Wash., DC; Chase Bank; Banker's Club, NY; Columbia Univ.; Lotos Club. **Comments:** Durig his early career in the 1880s, he was an illustrator for *Harper's, Scribner's,* and *Century.* Later, he became an influential teacher and recognized as the successor to Wm. M. Chase. In 1898 he bought a cottage in Peconic, with the bay and docks of Greenport being among his favorite subjects. Teaching: ASL, 1890s-1900s; Chase Sch. Art; Wiles Summer Sch., Peconic, 1890s. **Sources:** WW47; Pisano, *The Long Island Landscape,* n.p.; Fink, *American Art at the Nineteenth-Century Paris Salons,* 406; Falk, *Exh. Record Series.*

WILES, L. M. (Mrs.) *[Artist] late 19th c.*
Exhibited: NAD, 1880. **Sources:** Naylor, *NAD.*

WILES, Lemuel Maynard *[Landscape painter, teacher] b.1826, Perry, NY / d.1905, NYC.*
Addresses: Morrisania, NY, 1864-66; NYC, 1867-83, 1891, 1894-1900; Le Roy, NY, 1884-86; Perry, NY, 1892. **Studied:** New York State Normal College, 1847; Ingham Univ., LeRoy, NY (M.A., 1848); Albany Acad. with W.M. Hart from 1848; NYC with J.F. Cropsey, early 1850s. **Exhibited:** NAD, 1864-1900;

Brooklyn AA, 1865-81; PAFA Ann., 1881, 1901-04; Boston AC, 1883; AIC. **Work:** Perry, NY Pub. Lib.; Ingham, Univ., NY; LACMA; Bancroft Lib., UC Berkeley. **Comments:** A second generation member of the Hudson River School. After 1851 he taught and painted in Wash., DC, Albany and Utica, NY, until moving to NYC in 1861. By 1864, he had established his own studio at Washington Square. In 1873-74, he visited Panama, California, and Colorado making sketches upon which he based the larger works for which he was best known. His summers were spent at Ingham, NY, where he founded and directed his Silver Lake Art School. His son, Irving (see entry), became more famous. Positions: director, Ingham College FA, 1876-88; director, art dept., Univ. Nashville, 1893; teacher, Washington, DC, Albany, NY. **Sources:** G&W; Clement and Hutton; *Art Annual,* V, obit.; Rutledge, PA; Falk, PA, vol. II; Hughes, *Artists of California,* 605; P & H Samuels, 529-30; *300 Years of American Art,* vol. 1, 217.

WILES, William *[Ornamental painter] early 19th c.*
Addresses: Lebanon, OH, 1813. **Sources:** G&W; Knittle, *Early Ohio Taverns,* 44.

WILEY, Annie L. *[Painter] late 19th c.*
Addresses: Lancaster, PA. **Exhibited:** PAFA Ann., 1880.
Sources: Falk, *Exh. Record Series.*

WILEY, Catherine *[Painter] early 20th c.*
Addresses: Knoxville, TN. **Exhibited:** PAFA Ann., 1923.
Sources: WW25; Falk, *Exh. Record Series.*

WILEY, Dick (Pvt.) *[Painter] mid 20th c.*
Addresses: Fort Belvoir. **Exhibited:** Soc. Indep. Artists, 1942.
Sources: Marlor, *Soc. Indp. Artists.*

WILEY, Fred *[Painter] b.1916, Hartford, CT.*
Addresses: Monhegan Island, ME (year-round resident). **Studied:** trained as a scientist; studied art at Hartford (CT) Art School; studied painting in France, Italy and Greece. **Sources:** Curtis, Curtis, and Lieberman, 152, 187.

WILEY, Frederick J. *[Painter] early 20th c.*
Addresses: NYC. **Member:** Century Assn.; Lotos Club; Mural Painters. **Exhibited:** St. Louis Expo, 1904 (medal). **Sources:** WW33.

WILEY, Gertrude *[Portrait painter, teacher] 19th/20th c.*
Addresses: active in Detroit. **Comments:** Teaching: Detroit (MI) Art Acad., 1897-1900. **Sources:** Petteys, *Dictionary of Women Artists.*

WILEY, H. S. *[Painter] early 20th c.*
Addresses: NYC. **Exhibited:** Soc. Indep. Artists, 1931. **Sources:** Marlor, *Soc. Indp. Artists.*

WILEY, Hedwig *[Painter, teacher] 20th c.; b.Phila.*
Addresses: Philadelphia 7, PA. **Studied:** PAFA; Univ. Pennsylvania (B.S.); Columbia Univ.; Harvard Summer School; William M. Chase; Cecilia Beaux; Henry Snell; Dow; Breckenridge. **Member:** Plastic Club; Art All., Phila.; Pr. Club, Phila; PAFA. **Exhibited:** PAFA Ann., 1930; Phila. AC; Phila. Pr. Club; Phila. Plastic Club. **Sources:** WW59; WW47; Falk, *Exh. Record Series.*

WILEY, Hugh Sheldon *[Painter] b.1922, Auburn, IN.*
Addresses: Darby, Phila., PA; Bronxville, NY. **Studied:** PAFA (Cresson traveling scholarship, 1948); Mexico City. **Member:** NSMP. **Exhibited:** PAFA, 1947; PAFA Ann., 1952-54, 1962; Mexico City, 1952, 1953; Bertha Schaefer Gal., 1956-58; Ball State Teachers College, 1958; Bertha Schaefer Gal., 1955 (solo), 1956 (solo), 1957 (solo). Awards: prize, Rome Comp., 1949. **Work:** murals in homes and office bldgs., in Mexico City; New York; Wash., DC; Beach Haven, NJ; Phila.; Newark Prudential Life Ins. Co.; Ball State Teachers College. **Comments:** Position: visiting artist, Ball State Teachers College, 1957; PM School Art,

1958. Contributor to *Architectural Record, Design* (Bombay, India), *Architectural Forum.* **Sources:** WW59; Falk, *Exh. Record Series.*

WILEY, James (Mrs.) *[Painter] mid 19th c.*
Exhibited: PAFA Ann., 1877. **Sources:** Falk, *Exh. Record Series.*

WILEY, Katherine See: **WILEY, Catherine**

WILEY, Lucia *[Mural painter] 20th c.; b.Tallamook, OR.*
Addresses: Minneapolis, MN/Camp Danworthy, Walker, MN. **Studied:** Univ. Oregon. **Member:** Mur. Painters; Minnesota AA. **Exhibited:** PAFA Ann., 1940; AIC, 1943. **Work:** Univ. Oregon, Eugene; Miller Vocational H.S., Minneapolis; Armony, Minneapolis; SAM; USPO, Int. Falls, Long Prairie, MN. **Comments:** WPA artist. **Sources:** WW40; Falk, *Exh. Record Series.*

WILEY, Nan K. *[Painter, sculptor, teacher] b.1899, Cedar Rapids, IA.*
Addresses: Cheney, WA, 1941. **Studied:** Chicago Acad. FA; Univ. Oregon; Cranbrook Academy, MI; Académie de la Grand Chaumière, Paris. **Exhibited:** Port Huron, MI, 1933; NYC, 1936; SAM, 1937. **Comments:** Teaching: Eastern Washington Univ., Cheney. **Sources:** Trip and Cook, *Washington State Art and Artists, 1850-1950.*

WILEY, William T. *[Painter] b.1937, Bedford, IN.*
Addresses: Woodacre, CA. **Studied:** San Francisco Art Inst. (B.F.A., 1960; M.F.A., 1962). **Exhibited:** WMAA; Univ. Nevada Ann. Art Festival, Reno, 1969; Looking West, Joslyn Art Mus., Omaha, NE, 1970; Kompas IV Exhib., Stedelijk van Abbemuseum, Eindhoven & Dortmund, Netherlands, 1970 & Kunsthalle, Berne, Switzerland, 1970; Studio Marconi, Milan, Italy, 1971; AIC, 1972 (solo); CGA, 1972 (solo); Hansel Fuller Gallery, San Francisco, 1970s. Awards: sculpture purchase award, LACMA, 1967; purchase prize, WMAA, 1968; Nealie Sullivan Award, San Francisco Art Inst., 1968. **Work:** SFMA; WMAA; Univ. Calif. Mus., Berkeley; LACMA; Oakland (CA) Mus. **Comments:** Publications: co-author, "The Great Blondino" (film), shown Belgian Film Festival, 1967; contributor, "Over Evident Falls" (theater event), Sacramento State College, 1968; author, "Man's Nature" (film), shown Hansen Fuller Gallery, 1971. Teaching: Univ. California, Davis, 1962-. **Sources:** WW73; James R. Mellow, "Realist William Wiley," *New York Times,* October 11, 1970; John Perrault, "Toward a New Metaphysics," *Village Voice* (October 15, 1970); Cecile Mc Cann, "Probing the Western Ethic," *Artweek* (May 15, 1971).

WILF, Andrew *[Painter] b.1949.*
Addresses: Lynwood, CA. **Exhibited:** WMAA, 1975. **Sources:** Falk, *WMAA.*

WILFORD, Loran Frederick
[Painter, teacher, illustrator] b.1893, Wamego, KS / d.1972, Stamford, CT?.
Addresses: Stamford, Springdale, CT; Sarasota, FL. **Studied:** Kansas City AI; Charles Wilimovsky; George Pearse Ennis. **Member:** Soc. Indep. Artists; Artists Gld.; Salons of Am.; New York AG; NYWCC; AWCS (life); Audubon Artists; SC; Sarasota AA; Bradenton Art Lg. **Exhibited:** NAD; AIC; Soc. Indep. Artists; Palm Beach; PAFA Ann., 1925, 1931-32; Salons of Am.; NYWCC,1929; AWCS, 1929, 1932, 1961, 1962; SC, 1930; Phila. WCC, 1931; SC, 1930, 1953; Florida Fed. Artists, Miami, 1937; GGE, 1939; Corcoran Gal. biennial, 1941; Audubon Artists, 1945; CI, 1946; Sarasota AA, 1954, 1959, 1961, 1965; Bradenton Art Lg., 1965; Ft. Lauderdale, 1954. Awards: Calif. PM, 1922 (prize); Kansas City AI, 1922 (medal). **Work:** TMA; NY Pub. Sch.; Holmes Pub. Sch., Darien, CT. **Comments:** Teaching: Ringling Sch. Art, Sarasota, FL. **Sources:** WW66; WW47; Falk, *Exh. Record Series.*

WILGHORST, Olaf *[Painter] early 20th c.*
Exhibited: Soc. Indep. Artists, 1936. **Sources:** Marlor, *Soc. Indp. Artists.*

WILGUS, William John *[Portrait painter]* b.1819, Troy, NY / d.1853, Buffalo, NY.
Addresses: NYC,1833-c.1841; Buffalo, 1841-53. **Studied:** Samuel F.B. Morse, NYC, 1833-36. **Member:** NA (hon. mem., 1839). **Exhibited:** Centennial Exh. NAD, 1925. **Work:** CGA; Yale Univ. **Comments:** He traveled as far afield as Georgia, Missouri, and the West Indies, returning to Buffalo in 1847. **Sources:** G&W; Sellstedt, *Life and Works of William John Wilgus;* Cowdrey, NAD; Swan, BA; Met. Mus., *Life in America;* Cummings, *Historic Annals of the NAD,* 233; Peggy and Harold Samuels, 530.

WILHELM, Adolph L. *[Painter]* early 20th c.
Addresses: St. Paul, MN. **Sources:** WW24.

WILHELM, Arthur L. *[Painter]* b.1881, Muscatine, IA.
Studied: C.C. Rosenkranz; AIC. **Exhibited:** Minnesota State Exh., 1916 (special mention). **Sources:** Ness & Orwig, *Iowa Artists of the First Hundred Years,* 221.

WILHELM, Arthur Wayne *[Landscape painter, lithographer]* b.1901, Marion, OH.
Addresses: NYC; Woodstock, NY. **Studied:** B. Robinson; C. Rosen; C. Hawthorne; W. Von Schlegell; R. Reid; Matulka. **Member:** Woodstock AA. **Exhibited:** PAFA Ann., 1932, 1935. **Sources:** WW40; ·Falk, *Exh. Record Series.*

WILHELM, Aug[ust] *[Wood engraver]* b.c.1837, Hesse, Germany.
Addresses: Phila., 1860. **Sources:** G&W; 8 Census (1860), Pa., LV, 642.

WILHELM, E(duard) Paul *[Mural painter, teacher]* b.1905, Königsberg, East Prussia, Germany.
Addresses: Dayton, OH. **Studied:** State Art Sch., Königsberg. **Exhibited:** Soc. Indep. Artists, 1931. **Work:** Dayton AI. **Comments:** Teaching: U.S. Indust. Reformatory, Chillicothe, OH. **Sources:** WW40.

WILHELM, Lillian See: **SMITH, Lil(l)ian Wilhelm (Mrs.)**

WILHELM, R(oy) (E.) *[Painter, designer, teacher, block printer, illustrator]* b.1895, Mt. Vernon, OH.
Addresses: Akron 2, OH; Cuyahoga Falls, OH. **Studied:** John Huntington Inst., Cleveland; John Carlsen; Elmer Novotny; Henry Keller; Cleveland Sch. Art; S. Vago; E. Gruppe. **Member:** Akron Soc. Art; North Shore AA; SC; AWS; Rockport AA; Buffalo SA; Ohio WCC. **Exhibited:** Awards: prizes, Canton AI, 1945, 1946; Akron AI, 1946; North Shore AA, 1946; Canton AI, 1945, 1946; Akron AI, 1946; Rockport AA, 1948; AWS, 1952. **Work:** Ohio Bell Telephone Co. Coll.; Akron AI; Ohio Fed. Women's Clubs. **Sources:** WW53; WW47.

WILHELMS, The *[Painters]* early 20th c.
Addresses: Alamose, CO. **Exhibited:** Soc. Indep. Artists, 1926. **Sources:** Marlor, *Soc. Indp. Artists.*

WILIMOVSKY, Charles A. *[Etcher, engraver, painter, teacher, block printer]* b.1885, Chicago, IL / d.1974, Los Angeles County, CA.
Addresses: Chicago; Kansas City, MO; Los Angeles. **Studied:** AIC with J. C. Johansen, William M. Chase; Académie Julian, Paris, France. **Member:** Chicago SE; SAGA; Prairie PM; SAE, Chicago SA. **Exhibited:** PAFA Ann., 1916; nationally & in Paris, Brussels, Florence, Rome. Awards: prizes, Kansas City AI, 1916, 1920, 1923; Rosenwald, Carr, Clussman prizes, AIC, 1924, 1929, 1937; medal, Univ. Oklahoma; medal, Oklahoma Artists, 1917. **Work:** Kansas City AI; AIC; Springfield (MA) Pub. Lib.; Honolulu Acad. Art; Modern Gal., Prague; Lindsborg (KS) Univ.; Kansas City Club; City of Chicago Collection; Cedar Rapids, AA; Bibliothèque Nat., Paris. **Comments:** Teaching: Kansas City AI, 1915; AIC; Am. Art Acad.; Art Center Sch., Los Angeles. **Sources:** WW59; WW47; Falk, *Exh. Record Series.*

WILKE, Hannah *[Sculptor]* b.1940.
Addresses: NYC. **Exhibited:** WMAA, 1973. **Sources:** Falk, *WMAA.*

WILKE, Ulfert S. *[Painter, art administrator]* b.1907, Bad Tölz, Germany / d.1988.

Ulfert. 1964

Addresses: Iowa City, IA.
Studied: Willy Jaeckel, 1923; Arts & Crafts School, Brunswick, 1924-25; Acad. Grande Chaumière, 1927-28; Acad. Ranson, Paris, 1927-28; Harvard Univ., 1940-41; State Univ. Iowa (M.A., 1947). **Member:** Assn. Am. Mus. Dirs. **Exhibited:** AIC, 1945; Younger Am. Artists, Solomon R. Guggenheim Mus., 1954; Italy Rediscovered, Smithsonian Traveling Exh., 1955-56; Lettering By Modern Artists, MoMA, 1964; Tokyo Biennial, tour Japan, 1967; Ulfert Wilke, Recent Works, Des Moines AC, Columbus Gal. FA, Joslyn Art Mus. & SFMA, 1970-71. Awards: Albrecht Dürer Prize, Germany, 1927; Guggenheim Found. fellowship for study in Europe, 1959-60 & 1960-61. **Work:** Phila. Mus.; Solomon R. Guggenheim Mus., New York; CMA; WMAA; Mus. Tel Aviv, Israel. **Comments:** Preferred media: oils, acrylics. Positions: head dept. art & director, Kalamazoo (MI) College & Inst. Arts, 1940-42; art & educ. director, Springfield (IL) AA, 1946-47; director, Univ. Iowa Mus. Art, 1968-. Publications: illustrator, portfolios, *Music to Be Seen,* 1956, *Fragments from Nowhere,* 1958 & *One, Two and More,* 1960. Teaching: Univ. Louisville, 1948-55; Univ. Georgia, 1955-56; Rutgers Univ., New Brunswick, 1962-67. Collections arranged: Oscar Kokoschka, Kalamazoo Inst. Arts, 1940; As Found, Inst. Contemporary Art, Boston, 1966; Very Small Paintings, Objects & Works On Paper, Univ. Iowa Mus. Art, 1972. **Sources:** WW73; J. Langsner, *Art* (November, 1961) & G. Nordland, "Calligraphy and the Art of Ulfert Wilke," *Art Int.,* (April, 1971).

WILKE, William H(ancock) *[Designer, etcher, illustrator, block printer]* b.1879, San Francisco / d.1958, Palo Alto, CA.
Addresses: Berkeley, CA. **Studied:** Mark Hopkins Inst. Art, San Francisco with A. F. Mathews; Académie Julian, Paris with J.P. Laurens, 1900, 1902; Blanche in Paris. **Member:** Calif. SE; San Fran. Fed. Arts; Calif. SMP; Calif. PM; Bohemian Club.
Exhibited: Mark Hopkins Inst., 1906; Pan-Pacific Expo, San Fran., 1915 (gold); Santa Cruz Statewide, 1928; GGE, 1940. **Work:** Mills College Art Gallery, Oakland; Soc. Calif. Pioneers; de Young Mus.; "Fifty Best Books," Am. Inst. Graphic Art; etchings in privately printed books. **Comments:** Position: designer/manager, Shreve & Co., Silversmiths; illustrator/indust. designer, Henry Kaiser Co. **Sources:** WW53; WW47; more recently, see Hughes, *Artists in California,* 605.

WILKENS, John G. *[Painter]* early 20th c.
Exhibited: AIC, 1924. **Sources:** Falk, *AIC.*

WILKES, Charles *[Topographical artist]* b.1798, NYC / d.1877, Washington, DC.
Comments: He went to sea at age seventeen, and entered the U.S. Navy as a midshipman in 1818. From 1838-42 he was in command of the U.S. Exploring Expedition which visited the Oregon coast, some of the Pacific islands, and the coast of Antarctica, and from 1843-61 he was in Washington preparing for publication the various reports of the expedition. Wilkes's *Narrative* contains some illustrations after his own sketches. John Skirving also used some of his drawings for a panorama of Frémont's overland journey to California (1849). Wilkes was on active service at sea during the early part of the Civil War but was placed on the retired list in 1863. **Sources:** G&W; DAB; Rasmussen, "Artists of the Explorations Overland," 57-58; Boston *Evening Transcript,* Sept. 26, 1849 (courtesy J. Earl Arrington).

WILKES, Max S. *[Painter]* mid 20th c.
Addresses: NYC. **Exhibited:** PAFA Ann., 1949 (prize for best figurative oil painting). **Sources:** Falk, *Exh. Record Series.*

WILKES, Susan H. *[Painter]* early 20th c.
Addresses: White Bluff, TN. **Sources:** WW15.

WILKEVICH, Eleanor (Mrs. Proto A.) *[Painter, teacher]* b.1910, NYC / d.1969, San Diego, CA.
Addresses: San Diego, CA. **Studied:** Grand Central Sch. Art; ASL; George Pearse Ennis; Henry B. Snell; Aldro Hibbard.

Member: San Diego Art Gld.; La Jolla AC; San Diego County Art Council; La Jolla Art Lib. Assn. **Exhibited:** GGE 1939; La Jolla AC (solo); Laguna Beach AA (solo); Admiral Hotel Gal., San Diego; La Jolla Art Gld., (solo).; San Diego Art Gld.(solo); Cedar City, UT (solo). Awards: prizes, San Diego FA Soc., 1943, 1946, 1952; San Diego County Fair; Carlsbad-Oceanside Gld.; Spanish Village Assn. **Work:** San Diego FA Gal.; Russell Art Mus., Great Falls, MT; mural, San Diego County Hospital. **Comments:** Teaching: San Diego City Schools, dept. adult educ. **Sources:** WW59; WW47; more recently, see Hughes, *Artists in California*, 605.

WILKIE, D. *[Artist] late 19th c.*
Exhibited: NAD, 1878. **Sources:** Naylor, *NAD*.

WILKIE, John *[Portrait painter] mid 19th c.*
Addresses: Schenectady, NY, active 1840. **Work:** Union College, portrait of DeWitt Clinton. **Comments:** His portrait of Moncrieff Livingston of Columbia County (NY), painted in 1840, is owned by a private collector. **Sources:** G&W; info courtesy Mrs. Laurence Barrington; Lipman and Winchester, 182.

WILKIE, Robert D. *[Landscape, genre, still life & bird painter, illustrator, teacher] b.1828, Halifax, NS / d.1903, Swampscott, MA.* **R.D. Wilkie**
Addresses: Halifax, active 1849; Boston and Roxbury, 1856-1902; Swampscott, MA, 1902-03. **Exhibited:** Vose Galleries, Boston, 1948 (120 of his paintings; rediscovery). **Comments:** By 1853 he had begun to contribute landscape views to *Gleason's Pictorial Drawing Room Companion.* In 1863-65 he was Boston artist-correspondent for *Frank Leslie's Illustrated Weekly;* in 1868 and later he was doing work for the Boston lithographer, Louis Prang. During the seventies he made a number of painting trips to the White and Adirondack Mountains and taught painting in Boston. Probably between 1896-99 he painted over a hundred watercolor scenes from Dickens' novels. His health failing, he moved to Swampscott (MA) and died there at the home of his son. **Sources:** G&W; Vose Galleries, "Robert D. Wilkie, 1828-1903, Rediscovery of a 19th Century Boston Painter," based on information from Miss Ruth K. Wilkie, the artist's granddaughter. The Vose Galleries published at the same time two catalogues, one of 98 Dickens scenes and the other of 22 miscellaneous oils and watercolors.

WILKIE, Thomas *[Portrait painter] mid 19th c.*
Addresses: Albany, NY, 1859-60. **Sources:** G&W; Albany CD 1859-60.

WILKIN, Eloise *[Illustrator] mid 20th c.*
Comments: Her illustrations appeared in a number of Little Golden Books (Simon and Schuster) during the 1950s and 1960s.

WILKIN, Mildred Pierce (Mrs.) *[Painter, teacher] b.1896, Kansas.*
Addresses: Chino & Corona, CA. **Studied:** Los Angeles State Normal Sch.; San Francisco Sch. FA; Columbia Univ.; A.A. Hills; Univ. Calif., Los Angeles. **Member:** Laguna Beach AA; Calif. WCS. **Exhibited:** Calif. WCS, 1925-32, 1936; Laguna Beach AA, 1925-32; Ontario, CA, 1941, 1945. **Sources:** WW53; WW47.

WILKINS, Elizabeth Waller *[Painter, designer, illustrator, teacher, decorator] b.1903, Wheeling, WV.*
Addresses: Wytheville, VA, 1940; Philadelphia 3, PA. **Studied:** Detroit Sch. FA; PM Sch IA; John P. Wicker; John J. Dull. **Member:** SSAL; Detroit Art Market. **Exhibited:** Awards: prize, Times-Herald Art Fair, Wash., DC, 1946. **Comments:** Position: statistical drafting, WPB, 1945; cartographic section, U.N.R.R.A., 1946. **Sources:** WW53; WW47.

WILKINS, Emma Cheves *[Painter, teacher] b.1871, Savannah, GA.*
Addresses: East Savannah, GA. **Studied:** Telfair Acad., Savannah, with C. L. Brandt; Colarossi Acad., Paris, with Courtois, Girardot. **Comments:** Position: principal, art school, Savannah. **Sources:** WW25.

WILKINS, George W. *[Portrait painter] mid 19th c.*
Addresses: NYC, active 1840. **Exhibited:** NAD, 1840. **Sources:** G&W; NYBD 1840; Cowdrey, NAD.

WILKINS, Gladys M(arguerite) *[Block printer, craftsperson, designer, etcher, painter, teacher] b.1907, Providence.*
Addresses: Providence, RI/Broadway, Rockport, MA. **Studied:** RISD. **Member:** Providence WCC; South County AA; Providence AC; AAPL; Rockport AA; AFAA; Southern PM Soc. **Comments:** Position: teacher, RISD. **Sources:** WW40.

WILKINS, James F. *[Portrait, miniature, and panorama painter] b.1808, England / d.1888, near Shobonier, IL.*
Addresses: London, before 1832; New Orleans, 1832-43; St. Louis, c.1844. **Studied:** Royal Acad., London. **Member:** Soc. Study of Hist., Poetical & Rustic Figures, Paris. **Exhibited:** Royal Acad., London, 1835-36. **Work:** Missouri Hist. Soc.; Huntington Lib., CA; State Hist. Soc. Wisc. **Comments:** In 1850-51 he exhibited a panorama of the overland route to California from sketches he made in 1849. **Sources:** G&W; Graves, *Dictionary;* New Orleans CD 1842; New Orleans *Picayune,* Jan. 27, 1843 (courtesy Delgado-WPA); St. Louis *Intelligencer,* Oct. 20, 1850, and March 6, 1851 (courtesy J. Earl Arrington); Butts, *Art in Wisconsin,* 54; McDermott, "Gold Rush Movies." More recently, see *Encyclopaedia of New Orleans Artists,* 414; Hughes, *Artists of California,* 605; P&H Samuels, 530.

WILKINS, Margaret *[Painter] early 20th c.*
Addresses: Newton Center. **Sources:** WW19.

WILKINS, Muriel See: **FRANCIS, Muriel (Wilkins)**

WILKINS, Ralph Brooks *[Painter, designer, illustrator] 20th c.; b.San Jose, CA.*
Addresses: NYC. **Studied:** Calif. Sch. FA. **Exhibited:** Calif. Industries Expo, San Diego, 1926; best non-fiction book jacket of year, "The American Adventure," Muzzey, 1928 (prize); Salons of Am. **Comments:** Designer: book jackets, Harper's, Scribner's, Dodd Mead, Morrow, Appleton-Century, Farrar and Rinehart. **Sources:** WW40; Hughes, *Artists in California,* 606.

WILKINS, Ruth Lois *[Art administrator, art historian] b.1926, Boston, MA.*
Addresses: Fort Worth, TX. **Studied:** Wellesley College (A.B.). **Member:** College AA Am.; Am. Assn. Mus. **Exhibited:** Awards: Woman of Achievement in Arts, Post Standard, 1968. **Comments:** Positions: registrar, Everson Mus. Art, 1960-62, editor of publ., 1963-70, curator collections, 1966-70; consult, Mus Am China Trade, 1971; cur educ, Kimbell Art Mus, 1971-. Publications: editor, *American Painting from 1830,* 1965; editor, *Chinese Art from the Cloud Wampler & Other Collections,* 1968; author, *What is an Art Museum?,* 1968; editor, *American Ship Portraits & Marine Painting,* 1970; co-author, *China Trade Silver, 1790-1870,* 1972; plus others. Collections arranged: Chines Export Porcelain, 1965; American Painting from 1830, 1965; Some Recent Images in American Painting, 1968; Chinese Art from the Cloud Wampler Collection, 1968; American Ship Portraits & Marine Painting, 1970. Collection: American silver of the Colonial period. Research: Chinese gold & silver from the T'ang Dynasty; Chinese export silver for the Anglo-American market; classical studies, particularly Western Greek foundations of Sicily and Magna Graecia. **Sources:** WW73.

WILKINS, Sarah *[Painter in watercolors] mid 19th c.*
Addresses: Massachusetts, active 1830. **Comments:** She did a memorial painting in watercolors. **Sources:** G&W; Lipman and Winchester, 182.

WILKINS, Timothy *[Painter, sculptor] b.1943, Norfolk, VA.*
Studied: Pratt AI; with John Rudge. **Exhibited:** Starker Art Gallery, Provincetown, MA, 1967; Flynn Gallery, NY, 1969; Acts of Art Gallery, NYC, 1971. **Comments:** Specialty: mixed media. Position: guest instructor, MMA. **Sources:** Cederholm, *Afro-American Artists.*

WILKINSON *[Engraver] mid 18th c.*
Addresses: Philadelphia, 1766. **Sources:** G&W; Prime, I, 31-32.

WILKINSON, A(lbert) S. *[Painter] early 20th c.*
Exhibited: Salons of Am., 1923, 1924, 1934. **Sources:** Marlor, *Salons of Am.*

WILKINSON, Charles K. *[Museum curator] b.1897, London, England.*
Addresses: Sharon, CT. **Studied:** Slade School & Univ. College, Univ. London, 1915-17 & 1919-20. **Member:** Am. Oriental Soc.; British Inst. Persian Studies; Archaeology Inst. Am.; Century Assn. **Comments:** Positions: member, Egyptian expedition, MMA, 1920-32, Iranian expedition, 1932-1940, senior research fellow, 1942-47, assoc. curator, Near Eastern archaeoogy, 1947-53, curator, 1953-63, curator emer., 1963-; Hagop Kevorkian curator, Middle East art & archaeology, Brooklyn Mus., 1969-; trustee, Am. Schools Oriental Research; director, Colt Archaeology Inst.; member, Council British School Archaeology in Iraq. Teaching: adjunct professor, Columbia Univ., 1964-69; adjunct professor, New York Univ., 1966-67. **Sources:** WW73.

WILKINSON, Edith L. *[Painter] early 20th c.*
Addresses: Provincetown, MA. **Exhibited:** Salons of Am. **Comments:** Affiliated with Lovell Studio, Provincetown. **Sources:** WW24.

WILKINSON, Edward *[Painter, sculptor, architect, decorator, teacher, writer] b.1889, Manchester, England.*
Addresses: Garden Villas, TX/Houston, TX. **Studied:** J. Chillman; J. C. Tidden; Rice Inst. **Work:** hist. dioramas for mus. in Houston and Huntsville, TX; Capitol, TX; Houston Pub. Lib. **Comments:** Articles: "Texas Historical Buildings," Texas papers and "Journal." **Sources:** WW40.

WILKINSON, Elizabeth Armitage See: **ARMITAGE, Elizabeth Duntley (Mrs. James H.)**

WILKINSON, Ella F. *[Painter] b.1855.*
Addresses: Phila., PA. **Exhibited:** PAFA Ann., 1885. **Sources:** Falk, *Exh. Record Series.*

WILKINSON, F. A. *[Painter] early 20th c.*
Addresses: Surrey, England. **Sources:** WW10.

WILKINSON, Fritz *[Illustrator, cartoonist] mid 20th c.*
Addresses: NYC. **Comments:** Illustrator: *New Yorker,* 1939. **Sources:** WW40.

WILKINSON, Gaylord F. Hardwick *[Painter] early 20th c.*
Addresses: Chicago area. **Exhibited:** AIC, 1926, 1929, 1930. **Sources:** Falk, *AIC.*

WILKINSON, Georgia *[Painter] early 20th c.*
Addresses: NYC. **Exhibited:** Soc. Indep. Artists, 1923. **Sources:** Marlor, *Soc. Indp. Artists.*

WILKINSON, Hilda See: **BROWN, Hilda**

WILKINSON, J. (Mrs.) *[Teacher of drawing & languages] early 19th c.*
Addresses: New Orleans, 1826. **Sources:** G&W; Delgado-WPA cites *La. Gazette,* April 18, 1826.

WILKINSON, John *[Painter] mid 19th c.*
Addresses: New York, active 1839. **Exhibited:** NAD, 1839 (view of Niagara Falls, a cattle piece after Jackson; "Taking a Comfortable Nap."). **Sources:** G&W; Cowdrey, NAD.

WILKINSON, John ("Jack") *[Painter, teacher] b.1913, Berkeley, CA / d.1973, East Hampton, NY.*
Addresses: Eugene, OR. **Studied:** Univ. Oregon; Calif. Sch. FA; in Paris; Maurice Sterne. **Member:** San Francisco AA; Oregon Gld. P&S. **Exhibited:** AIC, 1937; San Francisco AA, 1937 (prize); 48 States Comp., 1940 (prize); Portland Art Mus., 1945 (solo). **Work:** SFMA; murals, Univ. Oregon; Eagles Lodge, Eugene, OR; USPO, Burns, OR. **Comments:** Teaching: Louisiana State Univ.; Univ. Oregon, 1941-. WPA artist. White gives year of death as 1974. **Sources:** WW53; WW47.

WILKINSON, Kirk Cook *[Art dealer, painter] b.1909, NYC.*
Addresses: Wellfleet, MA. **Studied:** Parson's School Design;

watercolor painting with Felice Waldo Howell. **Member:** AFA; SI; Century Assn.; Dutch Treat Club; Provincetown AA. **Exhibited:** Art Dir. Club New York, 1934-; Art Dir. Club Phila., 1954 & 1956; Jr. League Westchester Ann., 1966-69; Westchester AA Ann., 1969; Cape Cod AA Ann., 1970-72; Scarborough Art Gallery, Scarborough, NY, 1970s. Awards: gold medal, New York Art Dir. Club, 1954; gold medal, Philadelphia Art Dir. Club; second prize watercolor, Jr. League Westchester Show, 1969. **Work:** Scarborough Art Gal., NY; Pocker Art Gal., New York; Kendall Art Gal., Wellfleet, MA. **Comments:** Preferred media: watercolor, casein, acrylic. Positions: art director,*Country Life, Am. Home Magazine,* NY, 1935-36; art director, *House Beautiful Magazine,* New York, 1936-37; art director, Condé Nast, New York, 1937-39; art director, *Women's Day Magazine,* New York, 1938-70; pres. & organizer, Parson's School Design Alumni Council, 1944; owner, Kendall Art Gallery. Publications: author, "Let's Talk About Your Pictures," *Popular Photography,* 4/1954; author, "Lighting is the News," 10/1959 & "The New Thinking Man," 2/1962, *Art Direction.* Teaching: graphics instructor & ann. lecturer, Parson's School Design, 1931-52. Specialty of gallery: contemporary art, sculpture and ceramics. **Sources:** WW73; Charles Coiner, "Commentary on the Art and Layout of Women's Day," *Art Direction Magazine* (April, 1954).

WILKINSON, R. *[Painter] early 20th c.*
Addresses: Newburgh, NY. **Sources:** WW13.

WILKINSON, Rhoda *[Painter] early 20th c.*
Addresses: NYC. **Sources:** WW13.

WILKINSON, Robert *[Portrait painter] mid 19th c.*
Addresses: Phila., PA. **Exhibited:** PAFA Ann., 1876, 1878-79. **Sources:** Falk, *Exh. Record Series.*

WILKINSON, Ruth Lucille *[Painter] b.1902, Des Moines, IA.*
Addresses: Iowa City, IA; Des Moines. **Studied:** C.A. Cumming; Provincetown, MA, with C. W. Hawthorne; worked with a group of artists at Louis C. Tiffany Fondation, Oyster Bay. **Member:** Iowa Art Guild. **Exhibited:** Iowa Art Salon, 1927; 105th Ann. Exh. NAD, 1936; Iowa Art Guild, 1935; All Iowa Exh., Carson Pirie Scott, Chicago, 1937. **Work:** Iowa Memorial Union, Iowa City. **Comments:** Instructor of drawing and painting, Dept. of Graphic and Plastic Arts, State Univ. Iowa, Iowa City, IA. **Sources:** WW40; Ness & Orwig, *Iowa Artists of the First Hundred Years,* 221.

WILKINSON, Sarah R. *[Listed as "artist"] 19th/20th c.*
Addresses: Wash., DC, active c.1915-33. **Member:** Wash. AC. **Sources:** McMahan, *Artists of Washington, DC.*

WILKINSON, Stephanie See: **BIGOT, Stephanie Wilkinson (Mrs.Toussaint François)**

WILKINSON, Tom *[Painter, illustrator] early 20th c.*
Addresses: NYC. **Member:** GFLA. **Sources:** WW27.

WILKS, Louis *[Sculptor] mid 20th c.*
Addresses: NYC. **Exhibited:** "NYC WPA Art" at Parsons School Design, 1977. **Comments:** WPA artist. **Sources:** *New York City WPA Art,* 94 (w/repros.).

WILL, August *[Landscape & portrait painter] b.1834, Weimar, Germany / d.1910, Jersey City, NJ.*
Addresses: NYC, active 1855, 1893-98; Jersey City, 1855 and after. **Exhibited:** NAD, 1858, 1893, 1898; Brooklyn AA, 1863-64, 1870; AIC, 1894. **Comments:** In 1855 he made a pen-and-ink drawing of the NYC Post Office. He later exhibited crayon portrait heads, landscapes, and even some genre scenes. **Sources:** G&W; *Art News,* Jan. 29, 1910; Stokes, *Iconography,* pl. 28; Stokes, *Historical Prints;* NYCD 1857-60+.

WILL, Blanca (Biance) *[Sculptor, painter, teacher, designer, graphic artist] b.1881, Rochester, NY.*
Addresses: NYC; Winstow, AR; Blue Hill, ME. **Studied:** Rochester Mechanics Inst.; Hans Hofmann Sch. FA; Grande Chaumière, Paris; H. Adams; J. Fraser; G G. Barnard; D.W.

Tryon; J. Alexander; Tyrohn in Karlsruhe; Luhrig in Dresden; Castellucho, in Paris. **Exhibited:** PAFA Ann., 1913, 1927; Soc. Indep. Artists, 1917, 1920; NAD; traveling exh. bronzes, U.S. & Canada; Coronado, CA; Univ. New Mexico; Albuquerque; Mus. New Mexico, Santa Fe (solo); Rochester, NY (solo); Univ. Arkansas (solo); MFA Little Rock, 1958 (retrospective). Awards: prizes, Rochester Mem. Art Gal., 1932, 1933; Fairchild award, Rochester, 1934; MFA Little Rock, AR; New Mexico State Fair, 1938-40. **Work:** Rochester Mem. Art Gal.; Univ. Arkansas; CPLH; numerous sculptured busts, oil portraits; Univ. Rochester; New Sch. Soc. Res. **Comments:** Sculpted in bronze; painted in oil and portraits in oil and watercolor. Teaching: Memorial Art Gal., Rochester. **Sources:** WW59; WW47; Falk, *Exh. Record Series.*

WILL, John A. *[Printmaker, painter] b.1939, Waterloo, IA.*
Addresses: Calgary, Alberta T2N 1N4. **Studied:** Univ. Iowa (M.F.A., 1964); Rijsacadamie von Beeldende Kunston, Amsterdam, 1964-65; Tamarind, Albuquerque, NM (Ford Found. grant, 1970-71). **Exhibited:** LOC Nat. Print Exh., 1966; Drawings 1970 Nat. Drawing Exh., St. Paul, MN, 1968; Drawings USA Fourth Biennial Nat. Drawing Exh., SFMA, 1970; Colorprint USA Nat. Print Exh., Lubbock, TX, 1971; West 1971, Edmonton Art Gallery, Alberta, 1971. Awards: Fulbright fellowship to Holland, 1964-65. **Work:** NYPL; AIC; Univ. Calgary, Alberta; Hamline Univ., Minneapolis, MN; Mus. New Mexico, Santa Fe. **Comments:** Preferred media: graphics. Teaching: asst. professor drawing, Univ. Wisconsin-Stout, 1965-70; artist-in-residence, Yale Univ., summer 1966; artist-in-residence, Peninsula School Art, Fish Creek, WI, summer 1968; asst. professor lithography, Univ. Calgary, 1971-. **Sources:** WW73.

WILL, John M. August See: **WILL, August**

WILLARD, Archibald M. *AM Willard.*
[Painter] b.1836, Bedford, OH / d.1918.
Addresses: Cleveland, OH. **Studied:** NYC, 1873. **Exhibited:** NAD, 1875-81; Centennial Expo, Phila., 1876; Brooklyn AA, 1877. **Work:** Abbot Hall, Marblehead, MA; Fayette County Hist. Soc.; Washington Court House, OH. **Comments:** Willard began as a carriage painter but was catapulted to fame with a single painting. His "The Spirit of '76," a patriotic painting of two drummers and a fife player, marching before troops with the American flag, quickly became an iconic image in American culture. Originally titled "Yankee Doodle" when exhibited at the Centennial Expo. of 1876, the image was soonafter distributed as a chromolithograph. Willard painted at least four more versions. **Sources:** G&W; Pope, *Willard Genealogy,* 567; Daywalt, *The Spirit of '76; Art Annual,* XVI, 225, obit.; *300 Years of American Art,* vol. 1, 279.

WILLARD, Asaph *[Copperplate, steel & wood engraver] b.1786, Wethersfield, CT / d.1880, Hartford, CT.*
Addresses: Albany, NY in 1816; Hartford, 1817-80. **Studied:** engraving with Deacon Abner Reed of East Windsor. **Comments:** Member of the Hartford Graphic and Bank Note Engraving Co. James D. Willard (see entry) was his son. **Sources:** G&W; Pope, *Willard Genealogy,* 171; *American Art Review,* I (1880), 455; Stauffer; Rice, "Life of Nathaniel Jocelyn"; Dunlap, *History;* Hamilton, *Early American Book Illustrators and Wood Engravers,* 94; Peters, *America on Stone.*

WILLARD, Beatrice Ruth *[Painter] mid 20th c.*
Exhibited: Soc. Indep. Artists, 1940. **Sources:** Marlor, *Soc. Indp. Artists.*

WILLARD, Charlotte *[Writer, art critic] mid 20th c.*
Addresses: NYC. **Studied:** New York Univ; Columbia Univ. (B.A.); New School Social Res. with Jose de Creeft. **Exhibited:** Awards: MacDowell Colony fellowship, 1971-72. **Comments:** Positions: art editor, *Look,* 1950-955; contributing editor, *Art Am.,* 1958-68; art critic, *New York Post,* 1964-68. Publications: contributor, "Story Behind Painting," 1960, "Moses Soyer," 1961, "What

is a Masterpiece," 1964, "Cezanne to Op Art," 1971 & "Frank Lloyd Wright," 1972. Research: Renaissance painting. **Sources:** WW73.

WILLARD, F. W. *[Amateur artist] mid 19th c.*
Addresses: NYC, active c.1856. **Exhibited:** Am. Inst., 1856 (oil painting of Pomona, Goddess of Fruit). **Sources:** G&W; Am. Inst. Cat., 1856.

WILLARD, Frank Henry *[Cartoonist] b.1893 / d.1958.*
Addresses: Tampa, FL. **Studied:** Chicago Acad. FA. **Comments:** Creator: "Moon Mullins." Affiliated with *Chicago-Tribune, New York News* Syndicate. His work includes contributions to 238 newspapers; 7 books; reproductions of strips "The Plushbottom Twins," "Moon and Kayo." **Sources:** WW40.

WILLARD, Henry *[Portrait, miniature & genre painter] b.1802 / d.1855.*
Addresses: Boston, active c.1833 and after. **Exhibited:** Boston Athenaeum, 1834 -42 (a self-portrait, among others); NAD, 1833; Washington AA, 1859. **Sources:** G&W; Swan, BA; Cowdrey, NAD; Washington Art Assoc. Cat., 1859; Boston CD 1833-56; Stauffer, no. 2508.

WILLARD, Howard W. *[Llithographer, illustrator] b.1894, Danville, IL / d.1960.* *HW*
Addresses: California; NYC. **Studied:** ASL. **Member:** Artists Gld. **Exhibited:** Fifty Best Books of the Year, 1931. **Comments:** Illustr.: "The Silverado Squatters," "The Colophon," 1931. Position: illustr., *Readers Digest.* Specialty: lithographs of Chinese. **Sources:** WW40.

WILLARD, James Daniel *[Engraver] b.1817, Hartford, CT.*
Addresses: Hartford, active 1850s. **Comments:** In 1860 he was active in association with his father, Asaph Willard (see entry). **Sources:** G&W; Pope, *Willard Genealogy,* 171; Hartford BD 1851, 1857-60.

WILLARD, Jessie *[Painter] early 20th c.*
Addresses: Oakland, CA. **Studied:** AIC with Vanderpoel. **Exhibited:** Oakland Art Fund, 1905. **Comments:** Teaching: Calif. College of Arts & Crafts, 1908-10. Specialty: watercolors. **Sources:** Hughes, *Artists in California,* 606.

WILLARD, L. L. (Miss) *[Painter, writer, teacher] b.1839, New York.*
Addresses: Salt Lake City, UT. **Sources:** WW17.

WILLARD, Marie T. *[Painter] early 20th c.*
Addresses: NYC. **Sources:** WW25.

WILLARD, Mary Livingston *[Painter] early 20th c.*
Addresses: NYC. **Studied:** ASL. **Exhibited:** Soc. Indep. Artists, 1919-20. **Sources:** Marlor, *Soc. Indp. Artists.*

WILLARD, Rodlow *[Cartoonist, illustrator, designer, writer] b.1906, Rochester, NY.*
Addresses: NYC. **Studied:** Univ. California (B.A.). **Member:** Art Gld.; Nat. Cartoonists Soc. **Exhibited:** Cartoonists' Gld. traveling exh., 1938-40. **Comments:** Position: staff cartoonist, *Digest* magazine, "Review of Reviews," 1936-37; art director, Condé Nast business magazines, 1938-40; editor, juvenile magazines, Dell Publications, 1939-40; staff artist, King Features Syndicate, 1941-45. Illustrator: "Word Magic." 1939, "Hungry Hill," 1943 (King Features Syndicated version). Contributor to: national magazines & newspaper syndicates. Creator, "Scorchy Smith," daily and Sunday syndicated adventure feature, Assoc. Press News Features 1945-54. Story Boards, "Cinerama Holiday," 1955. Creator of "Jo and Jill," "Gal Friday," "Aunt Teek," newspaper comics, 1954-56. **Sources:** WW59; WW47.

WILLARD, Solomon *[Carver in stone & wood, architect, teacher of drawing & sculpture] b.1783, Petersham, MA / d.1861, Quincy, MA.*
Addresses: Boston, 1804-c.1842; Quincy, c.1842-61. **Studied:** learned the carpenter's trade in Petersham, MA. **Comments:** After

moving to Boston, Willard took up wood carving in 1809. He began carving figureheads in 1813, producing his most notable work in the figure for the frigate *Washington*. He visited Richmond in 1817 in order to study Houdon's bust of Washington, and designed a clay model himself. His plans to put the work into marble were ended when the model was accidentally destroyed. After 1820 he became a leading architect in Boston, but he also taught drawing and sculpture. His most well-known work, the Bunker Hill Monument, occupied him from 1825-42. Willard is also significant for having discovered the Quincy granite quarries and for the development of machinery for the cutting and handling of large slabs of stone. **Sources:** G&W; DAB; Pickney, *American Figureheads and Their Carvers;* Craven, *Sculpture in America,* 101; Milton Brown, et al, *American Art* (New York: H.N. Abrams, 1979) p. 167.

WILLARD, Theodora *[Painter] 19th/20th c.; b.Boston.*
Addresses: Cambridge, MA. **Studied:** A.F. Graves; A.W. Bühler. **Member:** Copley Soc., 1892. **Exhibited:** Boston AC; AIC. **Sources:** WW25.

WILLARD, Virgil *[Painter] early 20th c.*
Addresses: Seattle, WA, 1934. **Exhibited:** SAM, 1934. **Sources:** Trip and Cook, *Washington State Art and Artists,* 1850-1950.

WILLARD, William *[Portrait painter] b.1819, Sturbridge, MA / d.1904, Sturbridge.*
Addresses: Boston, active during the 1850s; Sturbridge, MA, 1882. **Exhibited:** Boston Athenaeum Gal., 1850s; NAD, 1882. **Work:** Am. Antiquarian Soc. (self-portrait and portraits of Charles Sumner, Daniel Webster, and George Frisbie Hoar). **Comments:** He also painted a panorama of Boston from Bunker Hill. **Sources:** G&W; Weis, *Checklist of Portraits;* Boston CD 1851-60; Swan, BA; Boston *Evening Transcript,* May 2, 1849 (courtesy J. Earl Arrington).

WILLCOX, Anita See: **PARKHURST, Anita (Mrs. Willcox)**

WILLCOX, Anne Lodge See: **PARRISH, Anne Lodge Willcox (Mrs. Thomas)**

WILLCOX, Arthur V. *[Painter] early 20th c.*
Addresses: Glendalough House, County Galway, Ireland. **Member:** Phila. AC. **Sources:** WW25.

WILLCOX, Harriet Elizabeth See: **WILCOX, Harriet Elizabeth**

WILLCOX, James M. *[Painter] early 20th c.*
Addresses: Lisnabrucka Recess, County Galway, Ireland. **Sources:** WW25.

WILLCOX, William H. *[Landscape painte, illustrator] b.c.1831, New York State.*
Addresses: Williamsburgh (LI), 1849; Phila., active c.1850-69; Germantown, PA. **Member:** Artists Fund Soc. **Exhibited:** Am. Inst., 1849 (two pencil drawings); PAFA Ann., 1850-68 (views in New Hampshire, Vermont, New York, and Pennsylvania), 1880-1917 (portraits & landscapes); NAD, 1867-69. **Comments:** In 1849 he sold two landscapes to the American Art-Union. **Sources:** G&W; 7 Census (1850), Pa., LIII, 661; Am. Inst. Cat., 1849; Cowdrey, AA & AAU; Rutledge, PA; Falk, PA, vol. II; Phila. CD 1856; WW17.

WILLE, Anna *[Painter] early 20th c.*
Exhibited: Salons of Am., 1930-32. **Sources:** Marlor, *Salons of Am.*

WILLE, Gertrude Tiemer (Mrs.) See: **TIEMER, Gertrude**

WILLE, O. Louis *[Sculptor] b.1917.*
Addresses: Aspen, CO. **Studied:** Univ. Minnesota (M.A.). **Exhibited:** Minneapolis AI; Walker AC; Denver AM; SFMA; Everson Mus., Syracuse. **Work:** Univ. Minnesota Gal.; Sculpture Center, NYC. **Comments:** Preferred media: wood, stone, bronze. **Sources:** WW73.

WILLENBECHER, John *[Sculptor] b.1936, Macungie, PA.*
Addresses: NYC. **Studied:** Brown Univ. (B.A., 1958); New York Univ. Inst. Fine Arts, 1958-61. **Exhibited:** Mixed Media & Pop Art, Albright-Knox Art Gal., Buffalo, 1963; Paintings & Constructions of the 60s, RISD, Providence, 1964; WMAA, 1964-66; Kunst-Lucht-Kunst, Stedelijk Mus., Eindhoven, Holland, 1966; Painting & Sculpture Today, Indianapolis Mus. Art, 1970. **Work:** WMAA; Albright-Knox Art Gal., Buffalo, NY; James A. Michener Found. Coll., Univ. Texas, Austin; Aldrich Mus. Contemp. Art, Ridgefield, CT; Solomon R. Guggenheim Mus., New York. **Sources:** WW73; David Bourdon (author), "Out There with Willenbecher," *Art Int.,* 9/20/1968. **Teaching:** lectures on painting, Phila. College Art, 1972-73.

WILLER, Jim *[Sculptor, painter] b.1921, Fulham, England.*
Addresses: West Vancouver, BC, Canada. **Studied:** Hornsey School Art, London, England; Royal Acad., Amsterdam; Winnipeg School Art & Univ. Manitoba, B.A., 1952. **Member:** Canadian Artists (rep.). **Exhibited:** Canadian Scholar Winner's Abroad Exh., Nat. Gallery Ottawa, 1956; Canadian Biennial, 1956-57; Univ. Manitoba Exh. Winnipeg Artists, 1961; Sculpture 1967, Toronto City Hall, 1967; 3D into the '70s, East Canada on Tour, 1970; Bau-xi Gallery, Vancouver, BC, Canada, 1970s. **Awards:** Canadian Govt. overseas grant, 1954; Canadian award to Netherlands, Imp. Tobacco, 1967-68; Greenwin Awards Arts, Al Latner, Toronto, 1969. **Work:** Nat. Gallery Canada, Ottawa; Winnipeg Art Gallery, Manitoba; Univ. Winnipeg; Univ. Manitoba, Winnipeg. **Commissions:** sun dial & two hanging screens, Polo Park Shopping Center, Winnipeg, 1959; sculpture, Charleswood Hotel, Winnipeg, 1961; marble portrait, Mrs. William Morton, Sackville, NB, 1963; red square, Greenwin Award for Arts, Toronto, 1969; five murals for Image I, Vancouver, 1970-71. **Comments:** Publications: author, *Paramind,* McClelland, 1972. **Teaching:** design instructor, Vancouver School Art, 1964-65. **Sources:** WW73; interview, CBC-TV, 1959; "Polo Park Sculpture," *Canadian Art,* 1959; "3 Part Sculpture," *Art Int.,* 1968.

WILLET, Anne Lee (Mrs. William) *[Craftsperson, decorator, designer, painter, teacher, lecturer] b.1867, Bristol, PA / d.1943, Atlanta, GA.*
Addresses: Phila. **Studied:** PAFA; Anshutz; Richardson; W. Willet. **Member:** Stained Glass Assn. Am.; MacD. Club. **Exhibited:** MMA; Arch. Lg., NYC; Boston Acad. FA; BMFA; AIC; CI; High Mus. Art; New Mus., Austin, TX. **Work:** stained glass windows, Cadet Chapel, U.S. Military Acad.; Chicago Theological Sem.; all windows, including Hilton Devotional Chapel, Journeys of the Pilgrims, Students' Lounge, Graham Taylor Chapel Lib.and Hall, First Presbyterian Church, Church of the Atonement, College of Surgeons, Chicago; Grosse Point Mem. Presbyterian Church, MI; Blessed Sacrament Church, Jefferson Ave. Presbyterian Church, Metropolitan Episcopal Church, Wash., DC; Greenwood Cemetery Chapel, Brooklyn, NY; St. Paul's Cathedral, Calvary Protestant Episcopal Church, Pittsburgh; DuPont mem. front windows, St. John's Episcopal Cathedral, Wilmington, DE; sanctuary window, St. John's Protestant Episcopal Church, Locust Valley, NY; All Saint's Chapel, Univ. Texas, Austin; Colonial Dames, Whitefield Mem., Bethesda, at Savannah, GA; Church of the Resurrection, Rye, NY; Princeton Graduate Colege.; Harrison Mems., Holy Trinity, Calvary Protestant Episcopal Church, Phila.; Trowbridge Mem., Santa Fe, NM; Wilson Mem. **Comments:** Articles: art and archaeology. **Sources:** WW40; Petteys, *Dictionary of Women Artists,* reports alternate birth date of 1866.

WILLET, Henry Lee *[Craftsman, lecturer] b.1899, Pittsburgh, PA / d.1983.*
Addresses: Phila. **Studied:** Princeton Univ.; Univ. Pennsylvania; with his father, William Willet; European study & travel; Lafayette College (hon. ArtD., 1951); Geneva College (hon. LH.D., 1966); Ursinus College (hon. LH.D., 1967); St. Lawrence Univ. (hon. D.F.A., 1972). **Member:** AFA; PAFA;T Square Club; Phila. Art All.; Pennsylvania Mus. Art; Medieval Acad. Am.;

Fairmount Park Assn.; Am. Inst. Architects (hon. member); Arch. Lg.; Stained Glass Assoc. Am. (fellow; pres., 1942-44); Royal Soc. Arts, London (fellow); Guild Religious Arch.; Am. Soc. Church Arch. (fellow). **Exhibited:** Columbia (SC) Mus. Art, 1961(solo); Atlanta(GA) Art Assn, 1961 (solo); Taft Mus., Cincinnati, OH, 1969 (solo); Mus. Am. Art, New Britain, CT, 1971 (solo); Arch. Glass, Mus. Contemporary Crafts, New York, 1968. Awards: medal of achievement, Phila. Art Alliance, 1952; Conover Award, Guild Religious Arch., 1963; Frank P. Brown Medal, Franklin Inst., 1971. **Work:** Children's Gallery, MMA. Stained glass commissions: Cadet Chapel, West Point Military Acad., 1910-72, Nat. Cathedral, Washington, DC; Randolph Field, San Antonio, TX; Chicago Theological Seminary; Northwestern Univ.; Berea, KY; Wilmington, DE; Longport, NJ; Muskegon, MI; Columbia, SC; Grosse Pointe, MI; Buffalo, NY; Pittsburgh; Ardmore, PA; Atlanta; Baltimore; Palmer, MA; Jackson, MS; Winter Park, FL; San Juan, Puerto Rico; Pelham, NY; great west window, St. Mary's Sch., Glen Falls; St. Paul's Episcopal Cathedral, Detroit; chancel rose; Martin Luther Church, Youngstown; epic windows, McCartney Lib., Geneva College, Beaver Falls, PA; Valley Forge Military Acad.; Trinity Episcopal Church, Swarthmore, PA; St. Peter's Episcopal Church, Phoenixville, PA; First Unitarian Church, New Orleans; Presbyterian Church, Rye, NY; Church Episcopal Church, Greensburg, PA; St. Paul's Episcopal Cathedral, Erie, PA; Am. Lutheran Church, Oslo, Norway, 1966, Hall of Science, New York World's Fair, 1967 & Nat. Presbyterian Church Center, Washington, DC, 1968; stained glass & tower window, San Francisco Grace Cathedral, 1966. **Comments:** Preferred media: glass, gold. Positions: pres., Willet Stained Glass Studios, 1930-65; chmn. board, 1965-. Publications: co-author, "Stained Glass," *Encyclopedia Americana,* 1948. Contrib.: *Architectural Forum, Stained Glass Quarterly, Religion in Life,* and other magazines. Teaching: instructor, history stained glass, Phila. School Apprentices Stained Glass, 1963-; instructor, sem. symbolism & color, Nantucket School Ecclesiastical Needlery, summer 1971. **Sources:** WW73; article, *Time* (October 11, 1937); "A New Luster in Churches," *Life* (April 11, 1955); Anne Hoene, "Stained Glass — What Future?," *Art Gallery* (December, 1968).

WILLET, William *[Mural painter, craftsperson, lecturer, writer] b.1868, NYC / d.1921.*
Addresses: Phila., PA. **Studied:** Mechanics & Tradesmens Inst., NY; Van Kirk; Chase; J. La Farge; France; England; Whittaker. **Member:** Mur. Painters; Arch. Lg., 1910; Boston SAC; St. Dunstan's Club, Boston; Phila. Art All. **Exhibited:** PAFA Ann., 1903. **Work:** stained glass windows, churches at West Point Military Acad.; Proctor Hall, Post Graduate Col., Princeton; Trinity Cathedral, Cleveland; St. John's Church, Locust Valley; St. Paul's Cathedral, Pittsburgh; Calvary Church, Germantown; St. Alvernia's Convent, Presbyterian Hospital Chapel, Third Presbyterian Church, all in Pittsburgh; Greenwood Cemetery Chapel, NY; Trinity Church, Syracuse; St. Paul's Church, Halifax, Nova Scotia. **Comments:** Author: "Stained Glass in Our Churches." **Sources:** WW19; Falk, *Exh. Record Series.*

WILLETS, Anita See: **BURNHAM, Anita Willets**

WILLETS, Mary T. (Miss) *[Artist] late 19th c.*
Addresses: Skeneateles, NY, 1871. **Exhibited:** NAD, 1871. **Sources:** Naylor, *NAD.*

WILLETT, Arthur Reginald *[Mural painter, decorator] b.1868, England.*
Addresses: NYC. **Studied:** E.H. Blashfield; H.S. Mowbray; F. Lathrop; London. **Member:** Mural Painters; Arch. Lg.; Art Fellowship. **Exhibited:** Soc. Indep. Artists, 1929, 1936. **Work:** capitol, St. Paul, MN; Courthouse, Youngstown, OH; Foreign Relations Committee Room, U.S. Capitol. **Sources:** WW40.

WILLETT, Donald C. *[Painter] mid 20th c.*
Addresses: Southfield, MI. **Exhibited:** PAFA Ann., 1960. **Sources:** Falk, *Exh. Record Series.*

WILLETT, J(acques) (I. W.) *[Painter] b.1882, Petrograd, Russia / d.1958, NYC.*
Addresses: NYC. **Studied:** Imperial Acad. Art, Petrograd; Munich; Paris. **Member:** Allied AA; Brooklyn SA; P&S; Salons of AM.; Soc. Indep. Artists; Contemp. Artists. **Exhibited:** Salons of Am.; Soc. Indep. Artists, 1917, 1923-25, 1935-36, 1938, 1940-41. **Work:** Newark Mus.; Univ. Club, Chicago; Acad. Allied Artists, NY. **Sources:** WW40.

WILLETTE, Charles E. *b.1899, Caribou, ME / d.1979.*
Addresses: Sandy Point, ME. **Studied:** ASL with M. Soyer, M. Cantor & Robert Brackman, mid 1930s; Brooklyn Mus. **Member:** Waldo (ME) County Artists. **Exhibited:** Ross AG, Newark, NJ, 1949 (solo); Maine State House, Augusta, 1949 (solo); A.U. Newton Gal., NYC, 1949 (solo); Opus 71 Gal., Hollis, NH, 1989 (solo). **Work:** murals, Lincoln Hotel, NYC. **Comments:** After a career as chief commercial artist for Whelan Drug Co., NYC, he returned to Maine, painting scenes around his native state. **Sources:** exh. flyer, Opus 71 Gal. (Hollis, NH, 1989).

WILLEY, Betty *[Lithographer] mid 20th c.*
Comments: WPA printmaker in California, 1930s. **Sources:** exh. cat., Annex Gal. (Santa Rosa, CA, n.d., c.1988).

WILLEY, Edith M(aring) (Mrs. N. C.) *[Painter, etcher, teacher, writer, lecturer] b.1891, Seattle, WA.*
Addresses: North Seattle, WA/Union, WA; Bremerton, WA. **Studied:** C.C. Maring; Eustace Paul Ziegler; Peter Camfferman; Edgar Forkner; May Marshall; Mark Tobey; L. Annin; A.C. Foresman. **Member:** Pacific Coast PS&W; Nat. Lg. Am. Pen Women; Women Painters of Washington. **Exhibited:** SFMA; CM; BM; Portland (OR) Art Mus.; Frye Mus. Art, Seattle; Sears-Roebuck Gal., Washington, DC; Art Lg. of Wash.; Frederick & Nelson Gal., Seattle, 1937-42 (solos); Northwest Gal., 1933. **Work:** Law Lib., State Capitol, Olympia, WA; John Hay Sch., King County Court House, First Nat. Bank, Scottish Rite Temple, all of Seattle; Puget Sound Hospital, Bremerton. **Sources:** WW59.

WILLEY, Jane G. D. (or G. O.) *[Painter] mid 19th c.*
Addresses: Richmond, VA, active 1854. **Exhibited:** Fair of the Mechanics Inst., Richmond, VA, 1854 (prize). **Sources:** Wright, *Artists in Virginia Before 1900;* Petteys, *Dictionary of Women Artists.*

WILLGOOSE, Peter *[Painter] early 20th c.*
Exhibited: Salons of Am., 1927. **Sources:** Marlor, *Salons of Am.*

WILLIAM, Eleanor Palmer (Mrs. Carroll R.) *[Painter] mid 20th c.; b.Baltimore.*
Addresses: Rye, NY. **Studied:** PM Sch IA; Maryland Inst., Baltimore; G.H. Smillie; B.W. Clinedinst; H. Newell; M. Lippincott, in Phila. **Member:** Phila. WCC (life); Plastic Club (life); Phila. All. (life); Phila. Print Club. **Work:** Phila. WCC. **Sources:** WW40.

WILLIAM, Meyvis Frederick *[Painter] early 20th c.*
Addresses: Rochester, NY. **Sources:** WW10.

WILLIAMS *[Scene painter] early 19th c.*
Addresses: Charleston, SC, active 1837. **Comments:** He worked at the New Theatre, along with J. Sera and D. Nixon. **Sources:** G&W; Rutledge, *Artists in the Life of Charleston.*

WILLIAMS, A. *[Painter] mid 19th c.*
Comments: Oil painting of a ship *c.* 1850. **Sources:** G&W; Lipman and Winchester, 182.

WILLIAMS, Abigail Osgood *[Painter, drawing teacher] b.1823, Boston, MA / d.1913.*
Addresses: Boston, MA, 1873; Salem, MA, 1913 and before. **Studied:** Rome, 1860-61. **Exhibited:** NAD, 1873; St. Botolph Club, Boston, 1891 (with her sister). **Comments:** She and her younger sister, Mary Elizabeth Williams (see entry), spent most of their lives together in Salem and were teachers of drawing in the Salem schools. In 1860 they went to Rome to study painting for eighteen months. Mary Elizabeth died in 1902. **Sources:** G&W;

Belknap, *Artists and Craftsmen of Essex County,* 15-16; Swan, BA.

WILLIAMS, Ada G. (Mrs.) *[Painter] early 20th c.*
Addresses: Cincinnati, OH. **Member:** Cincinnati Women's AC, 1915-23. **Sources:** WW24.

WILLIAMS, Adèle *[Portrait, landscape and still life painter]* b.1858, Richmond, VA / d.1942, Richmond.
Addresses: Richmond, c.1888-1945. **Studied:** Woman's Art School of Cooper Union; Gotham Art School; ASL; Paris, France in 1892; Charles Hawthorne in Provincetown; W.M. Chase & Rhoda H. Nicholls (watercolor); Bouguereau; Ferrier. **Member:** AWCS; NYWCC. **Exhibited:** NAD, 1888-95; PAFA Ann., 1890-1937 (8 times); AWCS, regularly; NYWCC; Paris Salon, 1894; Boston AC, 1892-98; Pittsburgh AA, 1912 (prize); NAWA, 1936-38; Corcoran Gal biennials, 1916, 1919; AIC; Baltimore & Richmond, VA. **Work:** Virginia Military Inst.; Univ. of Virginia; Virginia Hist. Soc. **Comments:** (Dates possibly 1868-1952) **Sources:** WW47; Wright, *Artists in Virgina Before 1900;* Fink, *American Art at the Nineteenth-Century Paris Salons,* 406.; Petteys, *Dictionary of Women Artists,* reports birth date as 1868; Falk, *Exh. Record Series.*

WILLIAMS, Adele Fay *[Painter, illustrator, writer]* b.1860, Joliet, IL / d.1937, Joliet.
Addresses: Pittsburgh, PA; NYC; Joliet. **Studied:** AIC; ASL; PAFA; Paris with Camille Pissaro; Acad. Colarossi with Lasar. **Exhibited:** Illinois Soc. FA; Pittsburgh AA, 1913; CI; AIC. **Comments:** Position: staff artist & art critic, *Washington DC Times,* and newspapers in Pittsburgh and NYC. **Sources:** Petteys, *Dictionary of Women Artists.*

WILLIAMS, Alfredus *[Painter]* b.1875.
Exhibited: Merino Galleries, NYC. **Comments:** Began painting in the primitive style late in life and had his first exhibit in the 1940s. **Sources:** Cederholm, *Afro-American Artists.*

WILLIAMS, Alice L. *[Painter] mid 20th c.*
Addresses: Phila., PA. **Exhibited:** Int. WC Ann., AIC, 1934, 1939. **Sources:** WW40.

WILLIAMS, Allen *[Wood engraver] mid 19th c.*
Addresses: NYC, 1860. **Sources:** G&W; NYBD 1860.

WILLIAMS, Alyn (Mr.) *[Miniature painter, writer, lecturer, teacher]* b.1865, Wrexham, Wales / d.1955.
Addresses: Wash. DC/Barrack's Hill, Plimpton, Sussex, England. **Studied:** Slade Sch. Art, London; Paris, with Laurens, Constant. **Member:** Royal Brit. Colonial Soc. Artists; Royal Soc. Min. PS&G (pres.); Imperial AL; Min. PS&G Soc., Wash., DC; Royal Cambrian Acad., Wales; AFA. **Exhibited:** Royal Acad., London; New WCS, London; Paris Salon; most active exhibiting in U.S., 1890-1914; AIC. **Work:** miniatures of King Edward VII, and Queen Alexandra in Guildhall (London) Art Gal.; Queen Mary; in Rome of Pope, Cardinal Garquet, Cardinal Archbishop Bourrie, Premier Mussolini; H.R.H. Princess Marie Jose of Belgium; Cardinal Gibbons; Pres. Taft, Pres. Coolidge, in Smithsonian. **Comments:** One of the most successful miniature painters at turn-of-the-century. **Sources:** WW33.

WILLIAMS, Ann *[Painter, teacher]* b.1906, Clinton, KY.
Addresses: Memphis, TN/Clinton, KY. **Studied:** Univ. Kentucky; Univ. Wisconsin with W.H. Varnum, Zozzora; Chicago Acad. FA. **Member:** Tennessee SA; Palette & Brush Club, Memphis; Western AA; SSAL. **Comments:** Teaching: Messick H.S., Memphis; Memphis Acad. Art. **Sources:** WW40.

WILLIAMS, Anne Huntington See: **HOWELL, Anne Huntington (Williams)**

WILLIAMS, Arthur S. (Mrs.) (Marie K. Berger) *[Portrait & mural painter]* b.1906, Gretna, VA.
Addresses: NYC. **Studied:** H.B. Snell; L. Kroll; E.C. Clark; C.C. Curran. **Member:** Lynchburg AC; Virginia Art All.; SSAL; Artists Gld., Lynchburg. **Work:** Campbell County Bd. Educ. **Sources:** WW40.

WILLIAMS, Benjamin Forrest *[Museum curator, art historian]* b.1925, Lumberton, NC.
Addresses: Raleigh, NC. **Studied:** Corcoran School Art with Eugene Weisz; George Washington Univ. (A.A.); Univ. North Carolina (A.B.); Columbia Univ., Paris Extension, École du Louvre; Netherlands Inst. Art History; ASL. **Member:** Am. Assn. Mus.; Southeastern Mus. Conf.; College AA Am. **Exhibited:** Virginia Intermont, Bristol; Weatherspoon Gallery, Greensboro; Person Hall Gallery, Chapel Hill, NC; Asheville Art Mus.; AFA traveling exhs. **Awards:** Ronsheim Mem. award, Corcoran School Art, 1946; Washington Soc. Arts, 1947; prizes, Southeastern Ann., 1947. **Work:** Atlanta AA; North Carolina Mus. Art; Duke Univ.; Greenville Civic Art Gallery, NC; Knoll Assoc., NYC. **Comments:** Positions: in charge of Ann NC Artists' Exhib; principal invesestor, Black Mountain College Research Project; gen. curator, North Carolina Mus. Art in 1973. **Publications:** contributor of articles on 19th c. American painting & sculpture to *North Carolina Mus. Art Bulletin* & *North Carolina Hist. Review.* Collections arranged: Francis Speight — Retrospective, Sculptures of Tilmann Riemenschneider; Carolina Charter Tercentenary Exhibition; Young British Art; North Carolina Collects; The Retrospectives for Joseph Albers, Hobson Pittman, Jacob Marling, Victor Hammer, Fedor Zakharov, Henry Pearson, & the collections of the North Carolina Mus. Art; assisted with, Rembrandt & His Pupils & E.L. Kirchner. **Sources:** WW73.

WILLIAMS, Berkeley, Jr. *[Painter]* b.1904, Richmond, VA / d.1938.
Addresses: Richmond, VA/Eccleston, MD. **Studied:** PAFA; B. Grigoriev. **Member:** SSAL. **Exhibited:** Salons of Am.; Soc. Indep. Artists, 1934. **Sources:** WW40.

WILLIAMS, C. D. *[Illustrator] mid 20th c.*
Addresses: Englewood, NJ. **Member:** SI. **Sources:** WW47.

WILLIAMS, C. Louise *[Painter] 19th/20th c.*
Addresses: Hartford, CT. **Exhibited:** AWCS, 1898. **Sources:** WW01.

WILLIAMS, Caroline Greene (Mrs.) *[Painter, etcher]* b.1855, Fulton, NY.
Addresses: East Cleveland, OH. **Studied:** Cleveland Sch. Art with H. Keller; C. Yates; C. McChesney; M. Jacobs. **Member:** Cleveland Women's AC. **Sources:** WW31.

WILLIAMS, Caryl F. *[Painter, blockprinter] early 20th c.*
Addresses: Los Angeles, CA. **Member:** P&S Los Angeles. **Exhibited:** Artists Fiesta, Los Angeles, 1931. **Sources:** Hughes, *Artists in California,* 606.

WILLIAMS, Catherine Stewart *[Painter] early 20th c.*
Addresses: Columbus, OH. **Exhibited:** AIC, 1928. **Sources:** WW25.

WILLIAMS, Charles *[Listed as "artist"]* b.1828, Ohio.
Addresses: Cincinnati, OH, 1850. **Sources:** G&W; 7 Census (1850), Ohio, XX, 901.

WILLIAMS, Charles David *[Illustrator]* b.1880, NYC / d.1954.
Addresses: New Rochelle, NY.
Member: SI (pres., 1927-1929); Artists Gld. **Comments:** Illustrator: Booth Tarkington (auth), *Monsieur Beaucaire;* national magazines. **Sources:** WW33; W & R Reed, *The Illustrator in America,* 146. Reed cite a birth date of 1875.

WILLIAMS, Charles Sneed *[Painter]* b.1882, Evansville, IN.
Addresses: Chicago 5, IL; Louisville, KY. **Studied:** Allan Fraser Art College, Arbroath, Scotland; G. Harcourt, in London. **Member:** Chicago P&S; Cercle de L'Union Artistique, Paris; Louisville AA (hon. life); AIC (life); Hoosier Salon; Chicago Gal. Art. **Exhibited:** Paris Salon; Royal Soc. Portrait Painters, London; Glasgow Inst.; Belfast, Ireland. Art Mus.; PAFA Ann., 1924; NAD; Corcoran Gal. biennial, 1937; NGA; AIC; Soc. Indep. Artists; solos in Paris, London, New York, Chicago. **Awards:** Hoosier Salon, 1935 (prize), 1938 (prize); SSAL, 1936 (prize). **Work:** U.S. Capitol, Wash., DC; Kentucky State Capitol; Am.

College of Surgeons; Confederate Mus., Richmond, VA; Kentucky State Hist. Soc.; Speed Mem. Mus., Louisville, KY; Northwestern Univ., Evanston, IL; Vanderpoel AA, Chicago; Am. Legion Auxiliary Headquarters, Indianapolis; Royal Ophthalmic Hospital, London; Shomberg House, London. **Sources:** WW53; WW47; Falk, *Exh. Record Series.*

WILLIAMS, Charles Warner See: **WILLIAMS, Warner**

WILLIAMS, Chester R. *[Painter, writer, lecturer, illustrator]* b.1921, Lewiston, ID.
Addresses: London, S.W. 3, England. **Studied:** Lukits Acad. FA; Courtald Inst., London; Venice, Italy. **Member:** Calif. WCS; Soc. Western Artists; Nat. Soc. Arts & Letters; Hesketh Hubbard Art Soc. **Exhibited:** Bordighera, Italy, 1953; Calif. WCS, 1953; Nat. Orange Flower Show, 1955; Soc. Western Artists, 1955; Britain In Water-Colour, 1956-1958; Nürnberg, Germany, 1953 (solo); London, England, 1954. **Work:** Italian Govt. **Comments:** Contrib.: *Music of the West* magazine. **Sources:** WW59.

WILLIAMS, Clara See: **PECK, Clara Elsene Williams**

WILLIAMS, Clara Louise *[Painter] late 19th c.*
Addresses: Hartford, CT. **Exhibited:** AIC, 1895, 1897. **Sources:** Falk, *AIC.*

WILLIAMS, Cliff S. (Y2C, U.S.N.R.) *[Cartoonists] mid 20th c.*
Exhibited: Soc. Indep. Artists, 1942. **Sources:** Marlor, *Soc. Indp. Artists.*

WILLIAMS, Clifford See: **WILLIAMS, (Edith) Clifford**

WILLIAMS, Connie *[Painter] early 20th c.*
Addresses: NYC. **Exhibited:** Soc. Indep. Artists, 1928. **Sources:** Marlor, *Soc. Indp. Artists.*

WILLIAMS, David Luccoc(k) *[Painter] early 20th c.*
Addresses: NYC. **Exhibited:** Soc. Indep. Artists, 1917, 1930. **Sources:** Marlor, *Soc. Indp. Artists.*

WILLIAMS, Delarue *[Painter] early 20th c.*
Addresses: Brooklyn, NY. **Sources:** WW10.

WILLIAMS, Dick See: **WILLIAMS, Richard F.**

WILLIAMS, Dora (Deborah) Norton (Mrs. Virgil)
[Painter] b.1829, Livermore, ME / d.1915, Berkeley, CA.
Addresses: Boston, MA; San Francisco, CA. **Studied:** San Francisco Sch. Design with Virgil Williams. **Exhibited:** San Francisco AA, 1882, 1885; World's Columbian Expo, Chicago, 1893; Calif. Midwinter Int. Expo, 1894; GGE, 1939 (Calif. Art Retrospective). **Comments:** Married Virgil Williams (see entry) in 1871 and went to San Francisco with him that year. *Cf.* Dora Norton. **Sources:** Hughes, *Artists of California,* 606.

WILLIAMS, Dorothy (Dorothea) A. *[Artist] late 19th c.*
Addresses: Active in Detroit, MI, 1889-97. **Comments:** May be related to Kate E. Williams (see entry) who lived at the same address. **Sources:** Petteys, *Dictionary of Women Artists.*

WILLIAMS, Dwight *[Landscape painter, teacher] b.1856, Camillus, Onondaga County, NY / d.1932, Cazenovia, NY.*
Addresses: Cazenovia, NY. **Studied:** J.C. Perry. **Member:** AFA; Central AA; New York Soc. Artists. **Exhibited:** Phillips Mem. Gal., Wash., DC; Soc. Wash. Artists; NAD, 1880; St. Louis Expo, 1904; Atlanta Expo; Salons of Am. **Work:** Colonial Williamsburg Coll.; Nat. Mus. Am. Art; Wash., DC Hist. Soc. **Comments:** Restorer of Old Master paintings. Teaching: Utica Seminary; art director, Norfolk College, 1889-92; National Park Sch., Washington, DC, 1894-98. **Sources:** WW31; Wright, *Artists in Virginia Before 1900;* McMahan, *Artists of Washington, DC.*

WILLIAMS, E. *[Listed as "artist"] mid 19th c.*
Addresses: New Orleans, 1849. **Sources:** G&W; Delgado-WPA cites New Orleans CD 1849.

WILLIAMS, E. F. See: **EDMONDS, Francis William**

WILLIAMS, (Edith) Clifford *[Painter] b.c.1880, Ithaca, NY / d.1971, Barbados.*
Addresses: NYC, c.1914-c.1918; Ithaca, NY; Barbados. **Studied:**

Yale Sch. FA, 1903-04; London, 1906; Acad. Julian, 1906, with Laurens. **Exhibited:** Soc. Indep. Artists, 1917-18. **Work:** Her letters to Alfred Stieglitz and several paintings and sketches are at Yale Univ.'s Beinecke Lib. **Comments:** After studying at Yale Sch. FA (her father, Henry Shaler Williams, taught geology at Yale) and in London and Paris, she emerged about 1914 as a member of the circle of artists associated with A. Stieglitz's 291 Gallery in NYC. She was also involved with the Dada periodical *Rongwrong.* Not much is known of her life after 1918. She appears to have moved back to Ithaca and given up painting, destroying much of her work. Williams lived her last years in Barbados. She was popularly known as Clifford Williams. Author: "A Letter," *Camera Work* (July 1914), 59. **Sources:** Betsy Fahlman, "Women Art Students at Yale, 1869-1913," *Woman's Art Journal* vol. 12, no. 1 (Spring/Summer, 1991), 21 (Fahlman gives birthyear as 1885); Margaret Burke Clunie, in Homer, *Avant-Garde Painting and Sculpture in America,* 148-49; Marlor, *Soc. Indp. Artists* (gives birthyear as 1880).

WILLIAMS, Edith M. Bates See: **BATES-WILLIAMS**

WILLIAMS, Edward B. *[Artist] late 19th c.*
Addresses: Phila., PA, 1882. **Exhibited:** NAD, 1882. **Sources:** Naylor, *NAD.*

WILLIAMS, Edward K. *[Painter] b.1870, Greensburg, PA.*
Addresses: Nashville, IN. **Studied:** AIC. **Member:** Chicago Gal. Assn.; Indiana AC; Brown County AA; Hoosier Salon, Chicago SA. **Exhibited:** AIC,1928 (prize); Hoosier Salon, 1930 (prize), 1932 (prize), 1934 (prize), 1937 (prize), 1940 (prize), 1941 (prize); Brown County AA, 1939 (prize); Indiana AC,1939 (prize), 1940 (prize), 1941 (prize); Chicago Gal. Assn., 1940 (prize). **Sources:** WW47.

WILLIAMS, Eleanor Palmer *[Painter] 19th/20th c.; b.Baltimore.*
Addresses: Phila., PA, 1903-33; Rye, NY. **Studied:** Maryland Inst.; G.H. Smilie, B. West Clinedinst, Hugh Newell in NY; Margaret Lippincott in Phila. **Exhibited:** PAFA Ann., 1891-92; AIC, 1903, 1906, 1912. **Sources:** Petteys, *Dictionary of Women Artists;* Falk, *Exh. Record Series.*

WILLIAMS, Elizabeth *[Still life & portrait painter] b.1844, Pittsburgh, PA / d.1889, Oakland, CA.*
Addresses: San Francisco. **Studied:** Aime Nicholas Morot in Paris. **Exhibited:** San Francisco AA, 1873, 1879; Snow & May's Gallery, San Francisco, 1878; Morris & Kennedy Gal., San Francisco, 1880; Paris Salon, 1887. **Sources:** Hughes, *Artists in California,* 606; Fink, *American Art at the Nineteenth-Century Paris Salons,* 406.

WILLIAMS, Elizabeth D. *[Painter] mid 20th c.*
Addresses: Atlantic Highlands, NJ. **Exhibited:** Soc. Indep. Artists, 1928-30; Salons of Am., 1931. **Sources:** Falk, *Exhibition Record Series.*

WILLIAMS, E(merson) Stewart *[Painter, architect, teacher] b.1909.*
Addresses: Annadale-on-Hudson, NY/Dayton, OH. **Studied:** C. Midjo; G. Harding; P.P. Cret; Cornell; Univ. Pennsylvania. **Member:** Dutchess County AA. **Exhibited:** Am. Acad., Rome, 1934 (prize); Am. WCC,1938 (prize); AIC. **Work:** Cornell Univ. **Comments:** Teaching: Bard College. **Sources:** WW40.

WILLIAMS, Esther *[Painter, designer, decorator, commercial artist] b.1901, Lime Springs, IA.*
Addresses: NYC (1930s-40s); Lime Springs, IA. **Studied:** Cumming School Art, Des Moines; Charles A. Cumming; Alice McKee Cumming; Marrenda Sheldahl. **Member:** AAPL. **Exhibited:** WMAA, 1933-46; AIC, 1937-45, 1938 (prize); Lime Springs & Cresco, IA (solos); Great Hall, Iowa State College; Washington State Fair; Fed. Clubs of Cresco, IA; Woman's Club, Tacoma, WA; Univ. Idaho; J. K. Gill Galleries, Portland, OR; Salem Arts League, Salem, OR; Denver Art Mus.; College Art Club, Santa Maria, CA; Graphic & Plastic Arts, Iowa State Fair, 1936 (gold); Central Iowa Fair, Marshalltown, 1936 (second

prize); Iowa Fed. Woman's Club (traveling), 1936-37; AFA (traveling), 1937-38; Minnesota State Fair; Des Moines Women's Club (art scholarship); scholarship to Cooper's Union, NY; Nat. Art Exh., NYC, 1935; Five States Exh., Joslyn Memorial, Omaha, 1937; Iowa Art Salon (prizes). **Work:** Younkers Bros. Studios, Des Moines, IA. **Comments:** WPA artist. Positions: judge, Fine and Applied Arts, Minnesota State Fair, 1935 and Missouri State Fair, 1936; designer and interior decorator, Darwin Studios, Des Moines; art class supervisor, Eastman Kodak Co., Des Moines; supervisor of applied art classes, Business Women's Home, Chamber of Commerce, YMCA and Jewish Community House. **Sources:** WW40; Ness & Orwig, *Iowa Artists of the First Hundred Years,* 221-22.

WILLIAMS, Esther Baldwin (Mrs. Oliver H.) *[Painter, lithographer] mid 20th c.; b.Boston, MA.*
Addresses: Boston; West Danville, VT; NYC/Rockport, MA. **Studied:** BMFA Sch.; in Paris; Philip Hale; Lhote. **Member:** Rockport AA; Copley Soc., 1899; New York Women's AC. **Exhibited:** Paris Salon, 1892; PAFA, 1893, 1898; PAFA Ann., 1901, 1927-52; Boston AC, 1894-95, 1897; NAD, 1895; Corcoran Gal. biennials, 1930-45 (7 times); WMAA, 1933, 1936, 1938, 1940-44; Dallas Mus. FA, 1933, 1940, 1942; AIC, 1935, 1937, 1938 (prize), 1940-43, 1945; WMA, 1935 (prize), 1936, 1938, 1945; CI, 1936, 1939-40, 1943-46; VMFA, 1938, 1940, 1942, 1944, 1946; GGE, 1939; WFNY, 1939; CM, 1940, 1941; TMA, 1940-45; Kraushaar Gal., 1941, 1944; MMA (VA), 1942; PMG, 1942; de Young Mem. Mus., 1943; NIAL, 1944 (prize); Am. Acad. Arts & Letters & NIAL grant, 1944; Rockport AA, 1955 (prize). **Work:** PAFA; WMAA; WMA; BMFA; AGAA; MMA; New Britain (CT) Art Mus. **Sources:** WW59; Petteys, *Dictionary of Women Artists; Artists of the Rockport Art Association* (1946,1956); Fink, *American Art at the Nineteenth-Century Paris Salons,* 318; Falk, *Exh. Record Series.*

WILLIAMS, Etta M. *[Artist] 19th/20th c.*
Addresses: active in Grand Rapids, MI, 1889-1900. **Sources:** Petteys, *Dictionary of Women Artists.*

WILLIAMS, Ewart Lyle *[Painter] early 20th c.*
Addresses: Chicago area. **Exhibited:** AIC, 1927. **Sources:** Falk, *AIC.*

WILLIAMS, Florence O. *[Painter] early 20th c.*
Addresses: Phila., PA. **Exhibited:** AIC, 1915. **Sources:** Falk, *AIC.*

WILLIAMS, Florence White *[Painter, designer, writer, lecturer, teacher, illustrator] b.Putney, VT / d.1953.*
Addresses: Greenfield, MA. **Studied:** Chicago Acad. FA; AIC; Henry B. Snell; John F. Carlson; Ames Aldrich; F. Grant; K. Krafft. **Member:** Deerfield Valley AA; Assn. Chicago P&S; South Side AA, Chicago; Chicago Gal. Assn.; Illinois Acad. FA; AFA. **Exhibited:** Illinois Fed. Women's Club (prize); ASL, 1924 (prize); Boston Line Greeting Card Contest, Boston (prize); Chicago Gal., 1927 (prize); All-Illinois SFA, 1932 (medal); AIC; CGA; Baltimore WCC; Detroit Inst. Art; Milwaukee AI. **Work:** Springfield Mus. Art; Commission for Encouragement of Local Art; Chicago Public School. **Comments:** Illustr., children's books and magazines. Des. wallpaper for leading manufacturers. **Sources:** WW53; WW47.

WILLIAMS, Franklin *[Painter, sculptor] b.1940, Ogden, UT.*
Addresses: Petaluma, CA. **Studied:** Calif. College Arts & Crafts (B.F.A. & M.F.A.). **Exhibited:** Some New Art in the Bay Area, San Francisco Art Inst., 1963; Lithographs by Bay Area Artists, SFMA, 1964; Funk Art Show, Univ. Calif., Berkeley, 1967; WMAA, 1967-68; Marc Moyens, Washington, DC, 1970s. **Awards:** Spencer Macky Mem. scholarship, 1965-66; Ford Found. grant, 1966; Nat. Endowment Arts Award, 1968. **Work:** Oakland Art Mus.; Univ. Calif. Mus.; Lytton Center Visual Arts. **Comments:** Preferred media: acrylics. Publications: author, articles, *Art Int.,* 1963, *Artforum,* 1963, 1967 & 1969, *Art Magazine,* 1968 & *Art News,* 1972. Teaching: San Francisco Art Inst., 1966-; Calif. College Arts & Crafts, 1971-. **Sources:** WW73.

WILLIAMS, Frederic Allen *[Sculptor lecturer, writer, teacher] b.1898, West Newton, MA / d.1958.*
Addresses: NYC/Taos, NM. **Studied:** Columbia Univ.; NAD; BAID; Robert Aitken. **Member:** AAPL; Am. Veterans Soc. Art (pres.). **Exhibited:** NAD, 1922 (prize), 1926, 1928, 1931-36, 1942-44; BAID, 1921 (prize); PAFA Ann., 1926-27; Arch. Lg., 1929, 1936; NSS, 1929; Am. Veterans Soc. Art, 1938-45; Artists of the Southwest, Santa Fe, NM, 1926-45; BM, 1930; Jersey City Mus.; MMA, 1942. **Work:** Arkell Mus., Canajoharie; Columbia Dental College, Medical Center, NY; Am. Acad. Arts & Letters; Heye Fnd., NY; New York Public Library; Historic Arts Gal.; Town Hall, Friedrichshafen, Germany. **Comments:** Contrib.: Western magazines, with articles & photographs. Specialties: Indians; life in the Southwest. **Sources:** WW53; WW47; Falk, *Exh. Record Series.*

WILLIAMS, F(rederick) Ballard *[Landscape and figure painter] b.1871, Brooklyn, NY / d.1956, Glen Ridge, NJ.* *Frank Ballard Williams*
Addresses: Glen Ridge, NJ, 1895-1900. **Studied:** Cooper Union; J.W. Stimson; NAD with C.Y. Turner, W.H. Gibson, E.M. Ward; England; France. **Member:** ANA, 1907; NA, 1909; NYWCC; Lotos Club; SC,1898 (pres., 1914-19); NAC; NYC Soc. Painters; Montclair AA (pres., 1924-25; chmn., art comt., 35 years); AAPL (founding pres., 1928; nat. chmn., 22 years). **Exhibited:** NAD, 1895-1909 (Isadore gold medal, 1909); PAFA Ann., 1893-1909, 1916, 1921-24; Boston AC, 1896, 1898, 1900, 1902; Pan-Am. Expo, Buffalo, 1901 (bronze medal); SC, 1898 (Inness Prize),1907 (prize); Corcoran Gal. biennials, 1907-26 (5 times); AIC, 1927; AAPL, 1949 (gold Medal of Honor); Montclair AM, 1949 (retrospective);London, Paris, Venice, Rome & Lima, Peru. **Work:** NGA; MMA; Albright Art Gal., Buffalo; Brooklyn Inst. Mus.; Montclair AM; Hackley Art Gal., Muskegon, MI; City AM, St. Louis; Dallas AA; Lotos Club; Quinnipiac Club, New Haven; NAC; Milwaukee AI Coll.; AIC; Grand Rapids AA; Los Angeles MA; New Britain (CT) AA; Engineers Club, NY; Nat. Gal., Lima, Peru; Drexel Inst., Phila; CAM; Lures Club; NAD; Arnot Art Gal. **Comments:** Best known for his landscapes which incorporate nymphs dancing in fields by the woods. He studied nature, but did not paint from it, choosing to create in his studio. **Sources:** WW53; WW47; P&H Samuels, 530; *300 Years of American Art,* 646; Falk, *Exh. Record Series.*

WILLIAMS, Frederick Dickinson *F.D.Williams*
[Portrait, landscape & figure painter, teacher] b.1829, Boston, MA / d.1915, Brookline, MA.
Addresses: Boston, active 1850s-60s, 1867-96; Brookline, MA. **Studied:** Harvard, 1850. **Exhibited:** Boston Atheneum; NAD, 1867-96; Boston Art Club; Paris Salon, 1878-82, 1884; PAFA Ann., 1881; AIC. **Comments:** He taught drawing in the public schools of Boston, but in the mid-1870s he went to Paris for a number of years. His wife (née Lunt), a native Bostonian, also was a painter and crayon artist (see entry). **Sources:** G&W; *Art Annual,* XII, obit.; Clement and Hutton; Boston BD 1856-60; 8 Census (1860), Mass., XXVIII, 876; Washington Art Assoc. Cat., 1859; Swan, BA. More reecntly, see Campbell, *New Hampshire Scenery,* 175-176; Falk, *Exh. Record Series.*

WILLIAMS, Gaar B. *[Cartoonist, illustrator] b.1880, Richmond, IN / d.1935, Chicago.* *Gaar Williams 3-11-35.*
Addresses: Glencoe, IL. **Studied:** Cincinnati Art Sch.; AIC. **Sources:** WW25.

WILLIAMS, Garth Montgomery *[Illustrator, designer, sculptor, painter, cartoonist] b.1912, NYC.*
Addresses: NYC; Guanajuato, Mexico. **Studied:** Westminster Sch. Art, London, England; Royal College Art, London, spec. talent scholarship painting & exten. scholarship, ARCA. **Exhibited:** Royal Acad. Arts Ann., London, 1933-35, 1938, 1941; Exh. Original Textile Designs, Cotton Bd., Cent. Gallery, Manchester, England, 1941; Am.-British AC, 1942. **Awards:** Prix de Rome for sculpture, Soc. Rome Scholarship, London, 1936. **Comments:**

Publications: illustr., *Stuart Little*, 1945, *Charlotte's Web,*1952 & *The Little House* books, 1953, Harper & Row; author & illustr., *The Adventures of Benjamin Pink*, 1951 & *The Rabbit's Wedding*, 1958, Harper & Row. Cartoonist: *New York, Tomorrow.* **Sources:** WW73; WW47.

WILLIAMS, George Alfred *[Painter, illustrator, craftsperson]* *b.1875, Newark, NJ / d.1932, Kennebunk, ME.*
Addresses: Kennebunkport, ME. **Studied:** Chase; Cox; ASL. **Member:** NY Soc. Keramic Art. **Exhibited:** PAFA Ann., 1901, 1910; Pan-Pacific Expo, San Francisco, 1915 (medal); AIC; Soc. Indep. Artists, 1917; Corcoran Gal. biennial, 1923. **Work:** AIC; Newark Mus. **Comments:** Illustr.: Dicken's characters. **Sources:** WW31; Falk, *Exh. Record Series.*

WILLIAMS, George Monier *[Landscape painter, architect]* *b.1815, Bombay, India / d.1898, Casanova, VA.*
Studied: England (arch.). **Comments:** Williams sketched views of Middlesex County, VA, during many visits to his son and family, on the last of which he died. **Sources:** Wright, *Artists in Virginia Before 1900.*

WILLIAMS, George P. *[Engraver]* *b.c.1834, Ireland.*
Addresses: Phila., PA, from 1850. **Exhibited:** PAFA Ann., 1881-87. **Sources:** G&W; 7 Census (1850), Pa., LIII, 828; Falk, *Exh. Record Series.*

WILLIAMS, George W. *[Painter] early 20th c.*
Exhibited: Salons of Am., 1934. **Sources:** Marlor, *Salons of Am.*

WILLIAMS, Gerald *[Sculptor, potter] b.1926, Asansol, India.*
Addresses: Goffstown, NH. **Studied:** Cornell College; Notre Dame College of NH (hon. D.F.A., 1971). **Member:** New Hampshe AA; Lg. New Hampshire Craftsmen. **Exhibited:** Am. Studio Pottery, 1967 & Ceramic Int., 1972, Victoria & Albert Mus., London, England; Syracuse Ceramic Nat., 1970; solos: Contemporary Crafts Mus., New York, 1969 & Currier Gallery Art, Manchester, 1970. **Work:** Currier Gallery Art, Manchester, NH; Fitchburg Art Mus., MA; Syracuse Univ., NY; Objects USA, Johnson Collection. Commissions: ceramic mural, Sunapee & resin mural, Laconia, State of NH; resin mural, Int. Paper Box Machine Co., Nashua, NH; ceramic mural, Sheen, Finney, Bass & Green Law Offices, Manchester. **Comments:** Preferred media: clays. Positions: trustee, Soc. Arts & Crafts, Boston, MA, 1967-72; member, advisory board, New Hampshire Commission Arts. Publications: author, "Textiles of Oaxaca, "1964; contributor, *Craft Horizons,* 1969; editor, *The Studio Potter,* 1972. Teaching: Currier Gallery School Art, 1952-72; Dartmouth College, 1964-65; Haystack School Crafts, 1966 & 1969-. Research: wet-firing process; photo-resist process. **Sources:** WW73; Nordness, *Objects: USA* (1970).

WILLIAMS, Gerald *[Painter] late 20th c.; b.Chicago, IL.*
Member: AFRICOBRA. **Exhibited:** Howard Univ., 1970, 1972; Nat. Center Afro-Am. Artists, 1970, 1972; Studio Mus., Harlem, 1970, 1972. **Work:** Johnson Pub. Co. **Sources:** Cederholm, *Afro-American Artists.*

WILLIAMS, Gluyas *[Illustrator, cartoonist, writer]* GW *b.1888, San Francisco, CA.*
Addresses: West Newton, MA/Deer Isle, ME. **Studied:** Harvard Univ. (A.B., 1911). **Exhibited:** BMFA, 1946. **Work:** LOC. **Comments:** Author: *The Gluyas Williams Book,* 1929; *Fellow Citizens,* 1940; *The Gluyas Williams Gallery,* 1957. Illustrator: *Daily Except Sunday,* 1938; *People of Note,* 1940; *A Tourist in Spite of Himself & Father of the Bride,* 1949 (books by Robert Benchley). Contributor, cartoons, *New Yorker* & other magazines. **Sources:** WW73; WW47.

WILLIAMS, Guy *[Painter] b.1932, San Diego, CA.*
Addresses: Claremont, CA. **Studied:** Chouinard Art School. **Exhibited:** New Modes in Calif. P&S, La Jolla Mus., 1966; Tokyo Int. Exh., Japan, 1967; AFA Traveling Exh., 1968 (prize); Long Beach Mus. Art, 1969 (purchase award); WMAA, 1972; James Phelan awards, 1961-63. **Work:** Long Beach (CA) Mus. Art; La Jolla (CA) Mus. Art. **Comments:** Publications: author,

"Art & Technology," *Artforum,* 2/1969; author, *Random Notes on Painting,* Pomona College Publishing, 1971. Teaching: Chouinard Art School, Calif. Inst. Arts, 1965-67; Pomona College, 1967-; Claremont Grad. School, 1967-. **Sources:** WW73; Barbara Rose, "California Art," *Art in America* (January, 1966); Carter Ratcliff, "Whitney Annual," *Artforum* (June, 1972).

WILLIAMS, H. D. *[Illustrator] early 20th c.*
Addresses: NYC. **Sources:** WW19.

WILLIAMS, Helen *[Painter] late 19th c.*
Addresses: Norwich, CT, 1895. **Exhibited:** PAFA Ann., 1895 (flower painting in watercolor). **Comments:** *Cf.* Helen L. Williams. **Sources:** Falk, *Exh. Record Series.*

WILLIAMS, Helen F. *[Ceramic craftsman, educator] b.1907, Syracuse, NY.*
Addresses: Syracuse 8, NY. **Studied:** Syracuse Univ. (B.F.A.). **Member:** Syracuse AA; AAPL; Lg. Am. Pen Women. **Exhibited:** Syracuse MFA, 1932-41, 1946-58; Syracuse AA, 1937 (prize), 1946-51 (prizes); WFNY 1939; Paris Salon, 1937; BMA, 1944; Lg. Am. Pen Women, 1946, 1955, 1956 (prize); Syracuse Ceramic Gld. **Work:** IBM Corp. Mus., Endicott, NY; Syracuse MFA. **Comments:** Teaching: Univ. Syracuse, NY. **Sources:** WW59; WW47.

WILLIAMS, Helen L. *[Painter] late 19th c.*
Addresses: NYC, 1876-86. **Exhibited:** NAD, 1876-86. **Comments:** *Cf.* Helen Williams of Norwich, CT in 1895. **Sources:** Naylor, *NAD.*

WILLIAMS, Helen P. *[Painter] mid 20th c.*
Addresses: Hastings-on-Hudson, NY. **Exhibited:** Am. WCC, 1938; NYWCC, 1939. **Sources:** WW40.

WILLIAMS, Henrietta F. *[Painter] early 20th c.*
Addresses: Crafton, PA. **Member:** Pittsburgh AA. **Exhibited:** PAFA Ann., 1927. **Sources:** WW25; Falk, *Exh. Record Series.*

WILLIAMS, Henry *[Portrait & miniature painter, profile cutter, wax modeler, engraver] b.1787, Boston, MA / d.1830, Boston.*
Addresses: Boston, 1787-1830. **Work:** Worcester Art Mus. **Comments:** A versatile artist, he was also listed as an anatomist in the Boston directories in the 1920s. Most likely he was the Henry Williams, who published *Elements of Drawing,* in 1814. From c.1810-12 he seems to have been in partnership with miniature painter William M.S. Doyle, as works during this period are signed by both. **Sources:** G&W; Bolton, *Miniature Painters;* Stauffer; Jackson, *Silhouette,* 153; Boston *Independent Chronicle,* 1808, cited by Dr. Clarence L. Brigham; Drepperd, "American Drawing Books"; Swan, BA; Dunlap, *History;* WPA (Mass.), *Portraits Found in N.H.,* 14, 20; *Antiques* (Oct. 1928), 325-26, repros.; *Antiques* (Aug. 1940), 54, repro.; *Art in America* (July 1940), 120, repro.; Strickler, *American Portrait Miniatures,* 115-16.

WILLIAMS, Henry A. (Mrs.) *[Still life painter] 19th/20th c.*
Member: Richmond AC. **Exhibited:** Richmond AC, 1896-1902. **Sources:** Wright, *Artists in Virginia Before 1900.*

WILLIAMS, Henry Dudley *[Art dealer] d.1907.*
Addresses: Boston. **Studied:** Brown Univ. **Member:** Bostonian Soc.; Brown Univ. Club; Boston AC. **Comments:** Position: head, firm of Williams & Everett Gallery.

WILLIAMS, Hermann Warner, Jr. *[Art administrator, writer] b.1908, Boston, MA / d.1975.*
Addresses: Washington, DC. **Studied:** Harvard Univ. (Prince Greenleaf & Burr scholarship; A.B. (cum laude), 1931; Univ. scholarship, 1931; M.A., 1933); Courtald Inst., Univ. London, student asst. (Ph.D., 1935); Inst. Fine Arts, New York Univ. (Carnegie Tuition fellowships, 1935-41). **Member:** Am. Assn. Mus.; Co. Mil. Historians (fellow; gov.); Assn. Art Mus. Dirs.; AFA; Am. Soc. Arms Collectors. **Comments:** Positions: docent, Fogg Mus. & Mus. Fine Arts, Boston; student asst., Oriental Study Room, Fogg Mus.; asst. to George Stout, restoration work,

Royal Ont. Mus. Art & Archaeology, Toronto; asst., dept. arms & armor, MMA; Rockefeller Found. intern, BM, 1935, asst. cur. of Renaissance & modern art, 1936; from asst. to asst. cur. paintings, MMA, 1937-46; asst. dir., CGA, 1945, dir. & secretary, 1947-68, emer. dir., 1968-; juror, Baltimore Mus. Art, Virginia Mus. Art. **Publications:** co-author, *William Sidney Mount*, 1944; author, *The Civil War: The Artists' Record*, 1961; author, *Mirror to the American Past; A Survey of American Nineteenth Century Genre Painting*, 1972. **Teaching:** lecturer, MMA, Mus. Fine Arts, Boston, College Art Assn. Am., NGA, Norton Gallery Art, Dayton Art Mus., Brooks Mem. Mus., Toledo Mus. Art, Florida Art League, Norfolk Mus., Washington Co. Mus. Art & Montgomery Mus. Fine Arts. **Collections arranged:** Biennial Exh. Contemporary Am. Painting, 1947-68, Visionaries & Dreamers, 1956, Am. Stage, 1957, Civil War; The Artists' Rec., 1961 & Past & Present: 250 Years Am. Art, Corcoran Gallery Art. **Collection:** 19th & 20th c. American art; pre-Civil War American military items. **Sources:** WW73; WW47.

WILLIAMS, Hiram Draper *[Painter, educator] b.1917, Indianapolis, IN.*
Addresses: Gainesville, FL. **Studied:** Williamsport Sketch Club with George Eddinger; Penn. State Univ. (B.S.) with Victor Lowenfeld & (M.Ed.) with Hobson Pittman & Lowenfeld. **Exhibited:** Art USA: Painting, MoMA, 1961; Art USA II; PAFA Ann., 1962, 1964; Corcoran Gal. biennials, 1963, 1965; Carnegie Int., Pittsburgh, 1964; Art Across Am. 1965; Art: USA: Now, 1966; Nordness Gals., NYC, 1970s. **Awards:** D.D. Feldman Award, 1958; Guggenheim Found. fellowship, 1963. **Work:** MoMA; WMAA; Milwaukee AC; Nat. Art Coll., Wash., DC; CGA. **Comments:** Preferred media: oils. Author: *Notes for a Young Painter*, Prentice-Hall, 1963; co-author, *Forms*, Univ. Texas Pres, 1969. Teaching: Univ. Southern Calif., 1953-54; Univ. Texas, Austin, 1954-60, research grant, 1958; Univ. Florida, 1960-70s. **Sources:** WW73; Donald Weisman, "Recent Painting of Hiram Williams," *Univ. Texas Quarterly* (1959); William B. Stephens, "On Creating and Teaching," *College Art Journal* (summer, 1971); Falk, *Exh. Record Series.*

WILLIAMS, Hobie *[Painter, educator] mid 20th c.; b.Bainbridge, GA.*
Studied: Fort Valley State College (B.S.); Univ. Wisconsin (M.S.); Pennsylvania State Univ.; Temple Univ.; Univ. Pittsburgh. **Exhibited:** Hortt Exh., FL (hon. men.); Beaux Arts Exh., Tuskegee Inst.; Xavier Univ., 1963; Atlanta Univ. (hon. men.). **Comments:** Teaching: Florida A&M Univ. **Sources:** Cederholm, *Afro-American Artists.*

WILLIAMS, Howe *[Painter] b.1871, Massillon, OH / d.1955, Santa Barbara, CA.*
Addresses: San Diego, CA, 1914-37; Tempe, AZ. **Studied:** Univ. Michigan; W. Shirlaw; A. Hibbard. **Member:** Phoenix FAA; San Diego FAA; Laguna Beach AA. **Exhibited:** Oakland Art Gallery, 1927; P&S Los Angeles, 1929; Arizona State Fair, 1926 (prize), 1930 (prize); Mus. Northern Arizona, 1932 (prize). **Work:** Mus. New Mexico, Santa Fe; Municipal Coll., Phoenix. **Sources:** WW40; Hughes, *Artists in California*, 607.

WILLIAMS, Irving Stanley *[Portrait painter, illustrator] b.1893, Buffalo.*
Addresses: Buffalo, NY. **Studied:** Albright Art Gal.; BMFA Sch.; Paris. **Member:** Buffalo SFA; Patteran AC; Prof. Artists Guild. **Sources:** WW40.

WILLIAMS, Isaac L. *[Portrait, landscape, and figure painter] b.1817, Phila. / d.1895, Phila.*
Addresses: Phila., PA, active 1837, 1877; Lancaster, PA, 1854-55; Europe, 1866; Phila., 1867-95. **Studied:** John R. Smith & John Neagle, Philadelphia. **Member:** Artists Fund Soc., 1860 (president). **Exhibited:** Phila. ,1837; PAFA Ann., 1836-66, 1876-88, 1905; NAD, 1876-77; Boston AC, 1883, 1891; later also in NYC, Baltimore, Washington. **Comments:** Until 1844 he painted chiefly portraits, but after that he became primarily a landscape painter. Most of his life was spent in Phila. **Sources:** G&W;

Lancaster County Hist. Soc., *Papers,* XVI (1912), 261-69; Clement and Hutton; 8 Census (1860), Pa., LVIII, 133; Rutledge, PA; Rutledge, MHS; Cowdrey, NAD; Cowdrey, AA & AAU; Swan, BA; Washington Art Assoc. Cat., 1859; Phila. CD 1846, 1852, 1857; Falk, PA, vol. II.

WILLIAMS, Ivor *[Painter] early 20th c.*
Exhibited: San Francisco AA, 1924. **Sources:** Hughes, *Artists in California,* 607.

WILLIAMS, J. *mid 19th c.*
Addresses: Phila. **Exhibited:** Apollo Assoc., 1838-39 ("Joan of Arc in Prison" and "The Sailor Boy's Return"). **Comments:** Possibly the same as James W., Isaac L., or John C. Williams. **Sources:** G&W; Cowdrey, AA & AAU.

WILLIAMS, J. A. *[Illustrator] early 20th c.*
Addresses: NYC. **Sources:** WW08.

WILLIAMS, J. Leon *[Painter] early 20th c.*
Addresses: NYC. **Exhibited:** Soc. Indep. Artists, 1920. **Sources:** Marlor, *Soc. Indp. Artists.*

WILLIAMS, Jack *[Painter] early 20th c.*
Addresses: Alhambra, CA. **Exhibited:** Oakland Art Gallery, 1927. **Sources:** Hughes, *Artists of California,* 607.

WILLIAMS, James Robert *[Painter, sculptor, cartoonist] b.1888, Halifax, Nova Scotia / d.1957, probably San Marino, CA.* **J.R.WILLIAMS**
Addresses: Prescott, AZ, since 1931. **Studied:** Mt. Union College, Alliance, OH. **Comments:** Cowboy-cartoonist who had a 45,000 acre cattle ranch. Best known for his cartoon "Out Our Way," which appeared in more than 700 papers from 1922. **Sources:** WW40; P&H Samuels, 530-31.

WILLIAMS, James W. *[Engraver] b.c.1816, Pennsylvania.*
Addresses: Phila., 1860. **Comments:** All his children, ages 7 to 16, were born in Pennsylvania. **Sources:** G&W; 8 Census (1860), Pa., LIV, 451.

WILLIAMS, James W. *[Portrait, miniature & marine painter] b.1787, England.*
Addresses: Phila., 1823-37, 1847-68. **Exhibited:** PAFA, 1829-44 (marine paintings). **Comments:** He had settled in Phila., when he was listed as a coach and sign painter. From 1825-33 he appears as a sign and ornamental painter, but thereafter as miniature painter, artist, and "artists' emporium." In February 1843 and December 1845, he was in New Orleans; in 1844, he visited Danville (KY). **Sources:** G&W; 8 Census (1860), Pa., LII, 659; Phila. CD 1823-37, 1847-68; Rutledge, PA; Delgado-WPA cites *Picayune,* Feb. 10, 1843, and Dec. 9, 1845; info courtesy Mrs. W.H. Whitley, Paris (KY).

WILLIAMS, John *[Lithographer] b.1835, New York.*
Addresses: NYC, 1860. **Sources:** G&W; 8 Census (1860), N.Y., XLVI, 478.

WILLIAMS, John Alonzo *[Painter, illustrator] b.1869,* **John Alonzo Williams** *Sheboygan, WI / d.1951.*
Addresses: NYC. **Studied:** ASL; MMA School. **Member:** ANA; NA, 1947; SC; AWCS; SI; AAPL; Artists Gld.; NYWCC; Artists Fund Soc. **Exhibited:** SC,1937 (prize), 1939 (prize); AWCS-NYWCC (prize). **Comments:** Preferred medium: watercolor. **Sources:** WW47.

WILLIAMS, John C. *[Listed as "artist"] mid 19th c.; b.Phila.*
Exhibited: Artists Fund Soc., 1837 (portrait). **Comments:** Possibly the same as J. C. Williams, portrait painter of San Francisco, 1860-65, who was a native of Pennsylvania. **Sources:** G&W; Rutledge, PA.

WILLIAMS, J(ohn) C(aner) *[Portrait painter] b.1814, Pennsylvania.*
Addresses: San Francisco, 1860-65. **Exhibited:** Calif. Art Union, 1865. **Comments:** Possibly the same as John C. Williams. **Sources:** G&W; 8 Census (1860), Cal., VII, 521; San Francisco

CD 1860-61, 1865. Bibliography: Hughes, *Artists in California*, 607.

WILLIAMS, John Insco *[Portrait & panorama painter]* b.1813, Oldtown, OH / d.1873, Dayton, OH.
Addresses: Indiana, 1832-35; Phila., 1835-38; Richmond, IN, 1840-41; Cincinnati, OH, 1841-69; Dayton, 1869-73. **Studied:** Cincinnati before 1832; Russell Smith & Thomas Sully, Philadelphia 1835-40. **Comments:** Apprenticed to a carriage painter in 1828 and worked in Ohio for the next seven years, apparently taking painting lessons at some point in Cincinnati. Began working as a professional itinerant portrait painter about 1832, traveling through central Indiana for three years. After studying for several years in Philadelphia, he returned to Indiana and opened a studio in Richmond, where he befriended Samuel Swan Walker (see entry), in 1841. The same year he moved to Cincinnati and stayed there for the next twenty-eight years, although he traveled periodically, visiting Louisville, KY, in 1845, and Richmond in 1847. While in Louisville, he met John Banvard (see entry), from whom he learned about the painting of panoramas. Williams soon became an accomplished and renowned panoramist himself. His 1849 "The Grand Moving Panorama of the Bible" was a great success, traveling to Cincinnati, Dayton, Baltimore, Washington, and Boston, before it was destroyed by the fire at Independence Hall, Philadelphia, in March 1851. A second version of this panorama was exhibited all over the country between 1856-71. A third panorama, "The Great Painting of the American Rebellion," was also widely exhibited and apparently brought Williams financial security. He also painted still lifes and landscapes. His wife (Mary Roberts Forman Williams, see entry) and two daughters also were painters. **Sources:** G&W; Peat, *Pioneer Painters of Indiana*, 86-91; Clark, *Ohio Art and Artists*, 111; Rutledge, PA; Rutledge, MHS. More recently, see Hageman, 107-111; Gerdts, *Art Across America*, vol. 2: 257.

WILLIAMS, John Insco (Mrs.) See: **WILLIAMS, Mary Roberts Forman (Mrs. John Insco Williams)**

WILLIAMS, John L. *[Listed as "artist"]* mid 19th c.
Addresses: Phila., 1853-58. **Comments:** The 1860 Census lists a John Williams, artist, born in England about 1822, living in Phila. with his wife and two children (11 and 9), all born in Maine. **Sources:** G&W; Phila. CD 1853-56, 1858; 8 Census (1860), Pa., LIV, 242.

WILLIAMS, John L. S. *[Painter]* b.1877.
Addresses: Chicago, 1904; Rutherford, NJ. **Exhibited:** AIC, 1904. **Sources:** WW10.

WILLIAMS, (John) Nelson *[Painter, designer]* b.1912, Brazil, IN.
Addresses: NYC. **Studied:** John Herron AI; DePauw Univ.; Corcoran Sch. Art; ASL. **Exhibited:** Rockport AA, 1942; Soc. Wash. Artists, 1937; AWS, 1945, 1950; Albany Inst. Hist. & Art, 1945; SFMA, 1945; Missisippi AA, 1945 (prize), 1946 (prize); Audubon Artists, 1946, 1948; John Herron AI, 1946 (prize), 1948 (prize); Alabama WCS, 1948 (prize)-1950; Butler AI, 1946, 1947, 1950; Portland Soc. Artists, 1946; Phila. WCC, 1948-50, 1955. **Sources:** WW59; WW47.

WILLIAMS, John Scott *[Mural painter, teacher, craftsperson]* b.1897, Liverpool / d.1976. *J. Scott Williams.*
Addresses: Leonia, NJ; NYC. **Studied:** AIC with Fred Richardson. **Member:** ANA, 1935; NA, 1937; NYWCC; AWCS; NSMP; SC; Arch. Lg. **Exhibited:** PAFA Ann., 1911, 1913; AIC, 1924 (prize); AWCS, 1925 (prize), 1927 (prize); SC, 1928 (prize); WFNY, 1939. **Work:** AIC; Indianapolis; Johns Hopkins Univ.; USPO, Newcastle, DE; four murals and five stained glass windows, Indiana State Lib. & Hist. Bldg., Indianapolis. **Comments:** Teaching: NYU. Illustr. of 20 different American magazines. WPA artist. **Sources:** WW47; Falk, *Exh. Record Series*.

WILLIAMS, John Skelton (Mrs.) *[Landscape & still life painter]* 19th/20th c.
Addresses: Richmond, VA. **Exhibited:** Richmond, VA, 1896-1901. **Sources:** Wright, *Artists in Virgina Before 1900*.

WILLIAMS, José *[Printmaker]* b.1934, Birmingham, AL.
Studied: Univ. Illinois (B.F.A., 1972); Chicago Teachers College, 1959-61; Am. Academy Art, 1955-57. **Member:** Nat. Conf. Artists. **Exhibited:** Atlanta Univ., 1967; Milikin Univ., Decatur, IL, 1969; South Side Community AC, Chicago, 1971; Illinois State Univ., 1971; Black Expo, Chicago, 1971; Sears & Roebuck Stores, Chicago & Gary, IN, 1972. **Comments:** Positions: dir., South Side AC, Chicago; advisor, House of Afam; founder; Afam Gallery. **Sources:** Cederholm, *Afro-American Artists*.

WILLIAMS, Julia Tochie *[Painter]* b.1887, Americus, GA / d.1948.
Addresses: Dawson, GA. **Studied:** Wesleyan College, Macon, GA; Daytona Beach Art Sch.; Emma Wilkins; Mrs. J.A. Varnedo. **Member:** Atlanta AA; Georgia AA. **Exhibited:** High Mus. Art, 1944-46; Georgia AA; Bristol, VA, 1946. **Sources:** WW47.

WILLIAMS, Julian Evans *[Painter, mural painter]* b.1911, Houston, MI.
Addresses: Central City, CO; San Francisco, CA; Mill Valley, CA. **Studied:** Calif. Sch. FA; Chappell House, Univ. Colorado Ext. **Exhibited:** P&S Los Angeles, 1934; SFMA, 1935; San Francisco AA, 1936; GGE, 1939. **Work:** mural: Fullerton Jr. College. **Comments:** He did restoration, frescoe and mural work with Charles Kassler (see entry) in Colorado and Calif. **Sources:** Hughes, *Artists in California*, 607.

WILLIAMS, Kate A. *[Painter]* d.1939.
Addresses: NYC. **Member:** NAWPS; Wash. WCC; AWCS; NAC; AAPL; AFA. **Exhibited:** AIC, 1916, 1918-20. **Sources:** WW33. *Kate A. Williams*

WILLIAMS, Kate E. *[Artist, china painter]* late 19th c.
Addresses: active in Detroit, MI, 1889-97. **Comments:** Lived at the same address as Dorothy Williams (see entry). **Sources:** Petteys, *Dictionary of Women Artists*.

WILLIAMS, Katharine Foote *[Artist]* early 20th c.
Addresses: active in Los Angeles, 1902-26. **Sources:** Petteys, *Dictionary of Women Artists*.

WILLIAMS, Katherine *[Painter]* early 20th c.
Addresses: Glastonbury, CT. **Member:** CAFA. **Sources:** WW25.

WILLIAMS, Keith Shaw *[Painter, etcher, teacher]* b.1905, Marquette, MI / d.1951, Cambridge, NY.
Addresses: NYC. **Studied:** NAD; PAFA; I. Olinsky; D. Garber; C. Hawthorne; Acad. Colarossi, Paris. **Member:** SC; SAE; AWCS; All. Artists Am.; Chicago SE; Artists Fellowship; ANA, 1939; NA, 1942. **Exhibited:** NAD, 1935 (prize); PAFA Ann., 1935-37, 1948; SC,1936-40 (prize); LOC,1946 (prize); Allied Artists Am., 1938 (medal), 1940 (medal); Montclair AM, 1941 (medal); AAPL, 1941 (medal); NAC,1928 (prize); Junior Artists, 1930 (prize), 1931 (prize), 1932 (prize); Corcoran Gal. biennial, 1937; AIC. **Work:** New York Hist. Soc.; NAD; SC; LOC; Rollins Mus. Lib.; Cornell Club, NYC. **Comments:** A protegé of the etcher, Ernest D. Roth, he also painted figures, landscapes, and still life. Teaching: Grand Central Sch. Art. **Sources:** WW47; Falk, *Exh. Record Series*.

WILLIAMS, L. Gwendolen *[Sculptor]* early 20th c.
Addresses: NYC. **Exhibited:** PAFA Ann., 1931. **Sources:** Falk, *Exh. Record Series*.

WILLIAMS, L. L. *[Painter]* late 19th c.; b.Boston, MA.
Exhibited: Paris Salon, 1881-86. **Sources:** Fink, *American Art at the Nineteenth-Century Paris Salons*, 407.

WILLIAMS, Laurence P. *[Painter]* early 20th c.
Addresses: Norman, OK. **Exhibited:** S. Indp. A., 1928. **Sources:** Marlor, *Soc. Indp. Artists*.

WILLIAMS, L(awrence) S. *[Painter] b.1878, Columbus.*
Addresses: Tenafly, NJ. **Studied:** C. Beckwith; W.M. Chase; F.V. DuMond. **Member:** SC. **Sources:** WW33.

WILLIAMS, Leah Frazer (Mrs. Ramond H.)
[Craftsperson] b.1903, Beaver, UT.
Addresses: Lubock, TX. **Studied:** Univ. Utah; M. Frazer; J.T. Harwood. **Member:** Lincoln Artists Gld.; Utah Art Gld.; Nebraska AA. **Sources:** WW40.

WILLIAMS, Lewis W. II *[Art historian] b.1918, Champaign, IL / d.1990.*
Addresses: Beloit, WI. **Studied:** Univ. Illinois (B.F.A., 1946; M.F.A., 1958); Univ. Chicago (Ph.D., 1958). **Member:** College AA Am.; Am. Assn. Univ. Prof. (pres. local chapt., 1967). **Exhibited:** Awards: Teacher of Year, Beloit College, 1966. **Comments:** Positions: dir., Assoc. College Midwest Arts London & Florence, Florence, Italy, 1971-72. Teaching: Univ. Missouri-Columbia, 1948-50; Northwestern Univ., Evanston, 1953-55; Beloit College, 1955-. Research: Am. sculpture. **Sources:** WW73.

WILLIAMS, Lois Katherine *[Painter] b.1901, Morristown, NJ.*
Addresses: New York 21, NY. **Studied:** Raymond P.R. Neilson; Ellen Emmet Rand. **Member:** NAWA. **Exhibited:** NAD, 1934; NAWA; All. Artists Am., 1935-1940; Ferargil Gal., 1933, 1935, 1937, 1940 (solos); PAFA Ann., 1936. **Work:** many portrait commissions. **Sources:** WW53; WW47; Falk, *Exh. Record Series.*

WILLIAMS, Louis Sheppard *[Wood engraver] b.1865, Bridgeton, NJ.*
Addresses: Wash., DC. **Studied:** with his brother George P. Williams; H. Simon; H. Helmick, 1895-99. **Comments:** Position: in charge of illustr., U.S. Dept. Agriculture. **Sources:** WW17; McMahan, *Artists of Washington, DC.*

WILLIAMS, Louisa A. *[Painter, sculptor] 19th/20th c.; b.Georgia.*
Addresses: New Orleans, active 1896-1902; Augusta, GA, c.1903-10. **Studied:** Prof. Hart, NYC; William Ordway Partridge, NYC; Moody & Fisher, Wash., DC; Balt. Conservatory. **Exhibited:** Grunewald's Music Store, New Orleans, 1896; New Orleans, 1902; Charleston Expo. **Comments:** Specialized in animal paintings. She maintained a studio in Baltimore, MD, c.1901, where she created and sold sculptures and other works. **Sources:** WW10; *Encyclopaedia of New Orleans Artists,* 415.

WILLIAMS, Louise *[Painter, sculptor] b.1913, Pittsburgh, PA.*
Studied: Wayne State Univ.; Charles McGee School; Soc. Arts & Crafts. **Exhibited:** Detroit Inst. Arts, 1969; Scarab Club, Detroit, 1969, 1972; Mt. Clemons, MI, 1972; Russel Woods Festival (2nd prize); Afro-American Mus., 1969, 1970 (prize); Wayne State Univ.; Normacel Gallery, Detroit, 1970. Awards: Army Special Service Award & Cash Prize. **Sources:** Cederholm, *Afro-American Artists.*

WILLIAMS, Louise *[Water colorist] late 19th c.*
Addresses: Hartford, CT. **Exhibited:** PAFA Ann., 1895-97. **Sources:** Falk, *Exh. Record Series.*

WILLIAMS, Louise H(ouston) *[Painter, lithographer, block-printer, teacher] b.1883, Garnett, KS.*
Addresses: Anacortes, WA. **Studied:** R. Davey; A. Gross; E. Forkner; Kansas City AI; Kansas Univ. **Member:** Pacific Coast Artists; Am. Soc. Arts & Sciences. **Exhibited:** Women Painters of Wash. & SAM, 1931, 1934, 1938; Boston AC; Western Wash. Fair. **Comments:** Teaching: Union Jr. College, Mount Vernon; private school, Anacortes. **Sources:** WW40; Trip and Cook, *Washington State Art and Artists, 1850-1950.*

WILLIAMS, Lowell C. *[Engraver] b.1866 / d.1928.*
Addresses: Wash., DC, active c.1887 until at least 1920. **Comments:** This may be L.C. Williams, who was an illustrator for the U.S. Dept. Agriculture, 1897-1900. **Sources:** McMahan, *Artists of Washington, DC.*

WILLIAMS, Lucille Kaltenbach See: **KALTENBACH, Lucile A.**

WILLIAMS, Lucy O. *[Painter, teacher] b.1875, Forrest City, AR.*
Addresses: Forrest City. **Studied:** ASL; AIC; J.H. Twachtman; D. Volk; W.M. Chase; R. Reid. **Member:** Arkansas WCC. **Work:** Forrest City Public School; Courthouse, Forrest City. **Sources:** WW40.

WILLIAMS, Mamie A. *[Artist, engraver] late 19th c.*
Addresses: active in Grand Rapids, MI, 1894-99. **Sources:** Petteys, *Dictionary of Women Artists.*

WILLIAMS, Margaret R. *[Artist, teacher] 19th/20th c.*
Addresses: active in Detroit, MI, 1895-1900. **Sources:** Petteys, *Dictionary of Women Artists.*

WILLIAMS, Marian E. *[Painter] mid 20th c.*
Addresses: Trenton, NJ. **Studied:** PAFA, 1936 (scholarship). **Sources:** WW40.

WILLIAMS, Marie *[Painter] mid 20th c.*
Studied: ASL. **Exhibited:** Soc. Indep. Artists, 1938. **Sources:** Marlor, *Soc. Indp. Artists.*

WILLIAMS, Marie English *[Painter] mid 20th c.*
Addresses: Vallejo, Kelseyville, CA. **Exhibited:** Bay Region AA, 1935. **Sources:** Hughes, *Artists in California,* 607.

WILLIAMS, Martha A. *[Painter]; b.Muncie, IN.*
Addresses: Indiana, early 1900s. **Studied:** J. Ottis Adams, Forsyth; Cincinnati Art Acad. **Exhibited:** Muncie AA. **Sources:** Petteys, *Dictionary of Women Artists.*

WILLIAMS, Mary *[Amateur artist] late 19th c.*
Addresses: active in Kalamazoo, MI, 1871. **Exhibited:** Michigan State Fair, 1871. **Sources:** Petteys, *Dictionary of Women Artists.*

WILLIAMS, Mary *[Still life painter] early 19th c.*
Addresses: Phila., active 1811-14. **Exhibited:** PAFA, 1811, 1814. **Sources:** G&W; Rutledge, PA.

WILLIAMS, Mary See: **REED, Mary Williams (Mrs. John A.)**

WILLIAMS, Mary Belle *[Painter (flowers & portraits)] b.1873, Massilon, OH / d.1943, Los Angeles, CA.*
Addresses: San Diego, CA. **Studied:** ASL. **Member:** San Diego Art Guild (charter member, 1915). **Exhibited:** Panama Calif. Int. Expo, 1915 (silver, bronze medals); Western Painters Traveling Exh., 1923-24; San Diego FA Gallery, 1927; California-Pacific Int. Expo, San Diego, 1935. **Work:** San Diego Public Library. **Sources:** Hughes, *Artists in California,* 607.

WILLIAMS, Mary Elizabeth *[Painter and drawing teacher] b.1825, Boston, MA / d.1902, Salem, MA.*
Addresses: Boston, MA, 1873; Salem, MA, 1902 and before. **Studied:** Rome, Italy, 1860-61. **Exhibited:** NAD, 1873; Boston AC, 1874-88; St. Botolph Club, Boston, 1891 (jointly with her sister). **Comments:** She was the younger sister of Abigail Osgood Williams (see entry), with whom she lived in Salem (MA) almost all her life. They taught drawing in the Salem schools. **Sources:** G&W; Belknap, *Artists and Craftsmen of Essex County,* 15-16.

WILLIAMS, Mary Frances *[Art historian, lecturer] b.1905, Providence, RI.*
Addresses: Lynchburg, VA. **Studied:** Radcliffe College (B.A.; M.A.; Ph.D). **Member:** Nat. Lg. Am. Penwomen; College AA Am.; MoMA; Lynchburg FAC; Lynchburg Art Club. **Exhibited:** Awards: Jonathan Fay Prize, 1927 & Caroline Wilby Prize, 1931, Radcliffe College; Gillie A. Larew distinguished teaching award, Randolph-Macon Woman's College, 1972. **Comments:** Positions: member, Virginia State Art Commission, 1956-70. Publications: author, "Catalogue of the Collection of American Painting at Randolph-Macon Woman's College," 1965; author, "Time Makes Ancient Good Uncouth," *Randolph-Macon Alumnae Bulletin,* 1972. Teaching: Hollins College, 1936-39; Mt. Holyoke College, 1939-42; & curator, Randolph-Macon Woman's College, 1952-.

Collections arranged: 41st-61st Annual Loan Exhibition of American Art, Randolph-Macon Woman's College. **Sources:** WW73.

WILLIAMS, Mary H. *[Sculptor] mid 20th c.*
Addresses: Peterborough, NH. **Exhibited:** PAFA Ann., 1939. **Sources:** Falk, *Exh. Record Series.*

WILLIAMS, Mary Octavia *[Painter] late 19th c.*
Addresses: Chicago. **Exhibited:** AIC, 1894, 1898. **Sources:** Falk, *AIC.*

WILLIAMS, Mary Roberts Forman (Mrs. John Insco Williams) *[Amateur painter] b.1833.*
Addresses: Cincinnati, OH, 1849-69; Dayton, OH, 1869-?. **Comments:** Born Mary Forman, she was living with foster parents at Richmond (IN) when she first met John Insco Williams (see entry). They married two years later, in 1849. She painted ideal pictures, including one called "Bleeding Kansas." **Sources:** G&W; Peat, *Pioneer Painters of Indiana,* 90; Clark, *Ohio Art and Artists,* 111. More recently, see Hageman, 108.

WILLIAMS, Mary Rogers *[Landscape painter, pastellist, teacher] b.1856, Hartford, CT / d.1907, Florence, Italy.*
Addresses: Hartford, CT; Northampton, MA. **Studied:** J.W. Champney; W.M. Chase; D.W. Tryon. **Member:** NY Women's AC. **Exhibited:** PAFA Ann., 1895-97, 1902; SNBA, 1899; NYWCC. **Comments:** Position: teacher, Smith College. **Sources:** WW04; Fink, *American Art at the Nineteenth-Century Paris Salons,* 407; Falk, *Exh. Record Series.*

WILLIAMS, Max *[Art dealer] b.1874 / d.1927, NYC.*
Comments: For forty years he was a collector of prints, and since 1905 made a specialty of gathering fine examples of ship models. He secured the figurehead of the frigate Constitution, a likeness of Andrew Jackson. In 1926 his collection of naval and marine prints, paintings, and relics was sold for $19,235.

WILLIAMS, May *[Painter, designer, teacher] mid 20th c.; b.Pittsburgh, PA.*
Addresses: Pittsburgh 13, PA. **Studied:** Carnegie College FA; Univ. Pittsburgh FA & Crafts; New York Sch. Fine & Applied Art; École des Beaux-Arts, Fontainebleau, France. **Member:** AFA; Pittsburgh AA; Florida Craftsmen's Gld.; Pittsburgh AC; AFA. **Work:** Carnegie Inst.; Pittsburgh AC. **Comments:** Teaching: Shady Side Acad. & Winchester-Thurston Schools, Pittsburgh, PA. **Sources:** WW59; WW47.

WILLIAMS, Micah *[Portraitist in pastels] b.1782 / d.1837, New Brunswick, NJ.*
Addresses: Monmouth County and Middlesex Counties, NJ, active c.1814-30; NYC, 1827-30. **Studied:** self-taught. **Work:** Abby Aldrich Rockefeller Folk AC, Williamsburg, VA; Monmouth County Hist. Assoc., Monmouth, NJ; Rutgers Univ., New Brunswick, NJ; Passaic County Hist. Soc., Paterson, NJ. **Comments:** For a number of years, the identity of the artist of a group of about sixty pastel portraits housed at the Monmouth County Hist. Soc. had remained a mystery. Some of the works had been misattributed to a Henry Conover, but eventually the group was identified as being by a Williams (first name unknown). Subsequent research led to the current conclusion that the pastellist's full name was Micah Williams, an artist known to have worked in and around New Brunswick, NJ, between 1815-30. Not much further is known of his life. A native of Essex County, records indicate that he was married in New Brunswick in 1806 and that between 1827-37 he worked in New York City. Because his late work (c.1830) shows an improvement in the treatment of hands and poses, it has been suggested that some of his time in NYC may have been devoted to study. **Sources:** G&W; Cortelyou, "A Mysterious Pastellist Identified," *Antiques* (August, 1957); Cortelyou, "Henry Conover:

Sitter, Not Artist;" *American Provincial Painting,* no. 12; Lipman and Winchester, 182; *300 Years of American Art,* vol. 1: 92-93; Baigell, *Dictionary.*

WILLIAMS, Michael *[Lithographer] mid 19th c.*
Addresses: NYC, active 1826-34. **Sources:** G&W; Peters, *America on Stone; American Collector* (June 1942), 10.

WILLIAMS, Mildred Emerson *[Painter, lithographer] b.1892, Detroit, MI.*
Addresses: Detroit; Birmingham, MI; NYC. **Studied:** PAFA; ASL; Henry McCarter; Robert Henri; Charles Locke; John Sloan; George Luks; Paris. **Member:** Detroit Soc. Women Painters; Birmingham Soc. Women Painters; Michigan Acad. Sciences, Arts & Letters. **Exhibited:** Soc. Indep. Artists, 1922-23, 1926-33, 1936-38; PAFA Ann., 1926-28; AIC, 1935; Corcoran Gal. biennial, 1937; AFA traveling exh.; Carnegie Inst., 1941; AIGA, 1935; Detroit Inst. Art, 1956, 1957 (several awards); Mich. Acad. Sciences, Arts & Letters, Ann Arbor. Awards: prizes, PAFA, 1928; Detroit Inst. Art, 1934, 1939, 1940. **Work:** NYPL; PAFA; McGregor Lib., Highland Park, MI; Detroit Inst. Art; Children's Mus., Detroit. **Comments:** WPA printmaker in NYC, 1930s. **Sources:** WW59; exh. cat., Annex Gal. (Santa Rosa, CA, n.d., c.1988); WW47; Falk, *Exh. Record Series.*

WILLIAMS, Milton (Franklin) *[Painter, designer, wood sculptor] b.1914, Burlingame, CA.*
Addresses: Seattle, WA; Monterey, CA. **Studied:** California Sch. FA; Matteo Sandona. **Exhibited:** Oakland Art Gal.; California State Fair; Santa Cruz Art Lg., 1936 (prize); Little Gal., Seattle, WA, 1946; Univ. Washington, 1943; SAM, 1942, 1943. **Sources:** WW53; WW47.

WILLIAMS, Moses *[Silhouettist/profile cutter] early 19th c.*
Addresses: Philadelphia, active 1813-20. **Comments:** Williams was a slave of Charles Willson Peale. Through his profile cutting at the Library Company of Phila. he earned enough money to buy his freedom. **Sources:** G&W; Brown and Brown; Philadelphia Mus. of Art, educational brochure related to 1997 exhibition, "The Peale Family: Creation of a Legacy, 1770-1870".

WILLIAMS, Myra T. *[Amateur artist] 19th/20th c.*
Addresses: active in Detroit, MI, 1899-1902. **Sources:** Petteys, *Dictionary of Women Artists.*

WILLIAMS, Neil *[Painter, film maker] b.1934, Bluff, Utah.*
Addresses: New York, NY. **Studied:** Calif. School Fine Arts (B.F.A., 1959). **Exhibited:** WMAA, 1967, 1973; solos: Green Gal., 1964, Dwan Gal., 1966, Andre Emmerich Gal., New York, 1966, 1968 & Logiudice Gal., 1972; Walter Kelly Inc., Chicago, 1970s. **Work:** WMAA; Richmond (CA) Mus.; MIT, Cambridge. **Sources:** WW73; Richard Hirsch, "Private Affinities & Public Users," *Arts Magazine,* Vol. 1940, No. 7; John Perreault, "Systematic Painting," *Artforum* (November, 1966); Lucy Lippard, "Perverse Perspectives," *Art Int.* (March, 1967).

WILLIAMS, Nelly Miller *[Painter] early 20th c.*
Addresses: Fort McPherson, GA. **Sources:** WW25.

WILLIAMS, Nelson See: **WILLIAMS, (John) Nelson**

WILLIAMS, Nick *[Painter] b.1877, Odessa, Russia.*
Addresses: Port Angeles, WA, 1941. **Exhibited:** Assoc. of S. Russia Artists, Odessa. **Sources:** Trip and Cook, *Washington State Art and Artists.*

WILLIAMS, Norton *[Painter] mid 20th c.*
Addresses: Oakland, CA, 1930s. **Studied:** Calif. College Arts & Crafts with Perham Nahl; Maurice Logan. **Exhibited:** Oakland Art Gallery, 1939; GGE, 1940. **Sources:** Hughes, *Artists in California,* 607.

WILLIAMS, O. L. (Miss) *[Artist] early 20th c.*
Addresses: active in Los Angeles, 1907-10. **Sources:** Petteys, *Dictionary of Women Artists.*

WILLIAMS, Olga C. *[Painter, craftsperson, teacher] b.1898, Sweetwater, TN.*
Addresses: Hot Springs, AR. **Studied:** I.J. Crawley; M.C. Forbes; C. Hill; A. Montgomery; I. Coulter. **Sources:** WW25.

WILLIAMS, Olive E. *[Painter] mid 20th c.*
Addresses: Franklin Park, IL. **Exhibited:** Salons of Am., 1927; AIC, 1927, 1934. **Sources:** Marlor, *Salons of Am.*

WILLIAMS, Otey *[Painter] early 20th c.*
Addresses: Phila., PA. **Sources:** WW24.

WILLIAMS, Otis *[Landscape & figure painter, sculptor, photographer] mid 20th c.*
Addresses: NYC. **Studied:** ASL; Beaux Arts Inst.; Los Angeles School Art & Design. **Member:** Calif. AC; P&S Los Angeles. **Exhibited:** Artists Fiesta, Los Angeles, 1931. **Sources:** WW17; Hughes, *Artists in California*, 607.

WILLIAMS, Patricia Gertrude *[Painter] b.1910.*
Addresses: Oakland, CA. **Studied:** Univ. Calif. **Member:** San Francisco AA; San Francisco Soc. Women Artists. **Exhibited:** San Francisco AA, 1936; Oakland Art Gallery, 1937; S. Indp. A., 1941. **Sources:** WW40; Hughes, *Artists in California*, 607.

WILLIAMS, Pauline Bliss (Mrs. Ronald Croft) *[Painter, illustrator, designer, lecturer] b.1888, Springfield, MA / d.1969, Daytona Beach, FL.*
Addresses: Rockport, MA. **Studied:** ASL; Henri Sch. Art; Frank DuMond; F. Luis Mora; George Bellows; H. Miller. **Member:** NAWA; North Shore AA; Springfield Art Lg.; Penn. SMP. **Exhibited:** NAWA; Soc. Indep. Artists; NSMP; North Shore AA; Brooklyn SMP; Penn. SMP; North Shore AA traveling exh., 1957-59; NAWPS,1926 (prize); Springfield AG, 1932 (prize); Springfield, MA, 1926 (prize), 1928 (prize); Soc. for Sanity in Art, Chicago, 1941; AIC, 1941; Salons of Am. **Comments:** Lectures: History of Miniature Painting. **Sources:** WW59; WW47.

WILLIAMS, Peggy Dodds (Mrs. Henry A.) See: **DODDS, Peggy (Williams)**

WILLIAMS, Philome F. (Mrs.) *[Painter] late 19th c.*
Addresses: Orange, NJ, 1884; NYC, 1885. **Exhibited:** NAD, 1884-85. **Sources:** Naylor, *NAD.*

WILLIAMS, Phoebe M. (Mrs.) *[Painter] 19th/20th c.*
Addresses: Seattle, WA, 1916. **Exhibited:** Wash. State Arts & Crafts, 1909. **Sources:** Trip and Cook, *Washington State Art and Artists.*

WILLIAMS, R. Ruskin *[Painter] early 20th c.*
Exhibited: AIC, 1921; Salons of Am., 1929. **Sources:** Marlor, *Salons of Am.*

WILLIAMS, Ramond Hendry *[Painter, sculptor, lecturer, writer, teacher] b.1900, Ogden, UT.*
Addresses: Lubbock, TX. **Member:** Utah AG; Lincoln AG. **Exhibited:** Delta Phi Delta Nat. Exh., Kansas City, 1936 (prize). **Work:** Logan Jr. H.S.; Logan H.S.; Joslyn Mem. **Comments:** Contributor: articles, *Design*, 1933, 1935, 1938. **Sources:** WW40.

WILLIAMS, Reed *[Etcher, commercial artist] early 20th c.; b.Pittsburgh.*
Addresses: Los Angeles, CA. **Member:** Los Angeles PM. **Exhibited:** Los Angeles PM, 1918. **Sources:** WW24; Hughes, *Artists in California*, 608.

WILLIAMS, Richard F. *[Painter, illustrator] b.1908, Buffalo, NY / d.1981, Crestwood, Yonkers, NY.*
Addresses: Buffalo, NY; Crestwood, Yonkers, NY. **Studied:** Buffalo Sch. FA; Am. Art Sch.; Robert Brackman. **Member:** Hudson Valley AA; Allied Artists Am. **Exhibited:** Hudson Valley AA, (Archer Milton Huntington Award); Beaux Arts Exh., (prizes for portraits); New Rochelle AA, 50th anniv., (Grumbacher Award), 1965 (prize); Fairleigh Dickinson Univ. Galleries, NJ; Mus. FA, Springfield, MA; Mystic, CT; AAPL; Knickerbocker Artists; Allied Artists Am. **Work:** Fairleigh Dickinson Univ.

Galleries, NJ; Mus. FA, Springfield, MA. **Comments:** Preferred media: watercolor, oil, pen & ink, gouache. Illustrator: *Colliers, Harpers,* and other national magazines. **Sources:** info courtesy of Terry Tunick, Bedford, NY.

WILLIAMS, Robert F. *[Painter] early 20th c.*
Addresses: Staten Island, NY. **Exhibited:** AIC, 1905; Boston AC, 1906; PAFA Ann., 1906; Salons of Am.; S. Indp. A., 1944. **Sources:** WW08; Falk, *Exh. Record Series.*

WILLIAMS, Robert T. *[Painter]*
Addresses: Chicago, IL. **Member:** Chicago NJSA.

WILLIAMS, Roy *[Painter] early 20th c.*
Addresses: NYC. **Studied:** ASL. **Exhibited:** S. Indp. A., 1917. **Comments:** Possibly Williams, Roy Lewis, b. 1874-d. 1938. **Sources:** Marlor, *Soc. Indp. Artists.*

WILLIAMS, Ruskin *[Painter] early 20th c.*
Addresses: Woodstock, NY. **Exhibited:** S. Indp. A., 1917. **Sources:** Marlor, *Soc. Indp. Artists.*

WILLIAMS, Ruth Moore *[Painter, etcher] b.1911, NYC.*
Addresses: NYC. **Studied:** C.S. Chapman; I. Olinsky; K. Anderson; NAD. **Member:** NAC. **Exhibited:** NAC,1934 (prize), 1937 (prize). **Sources:** WW40.

WILLIAMS, S. *[Engraver] mid 19th c.*
Comments: Engraver of one illustration in Harper's illustrated edition of Benjamin Franklin's *Autobiography* (New York,1849). *Cf.* T. Williams. **Sources:** G&W; Hamilton, *Early American Book Illustrators and Wood Engravers*, 172.

WILLIAMS, Scott J. *[Painter, craftsperson, designer] b.1887, Liverpool, England.*
Addresses: Scarsdale, NY. **Studied:** ATC. **Member:** NA; AWCS; NSMP; SC; Arch. Lg. **Exhibited:** Awards: prizes, AIC, 1924; AWS, 1925, 1927; SC, 1928. **Work:** AIC; Indiana State Library & Historical Bldg., Indianapolis; Johns Hopkins Univ.; USPO, Newcastle, DE. Completed 102 maps in porcelain enamel for American Battle Monuments Commission; stained glass window to coordinate with two murals, Arsenal Technical H.S., Indianapolis. **Sources:** WW59.

WILLIAMS, Shirley *[Artist] early 20th c.*
Member: NAWA (pres., 1910-11). **Sources:** Petteys, *Dictionary of Women Artists.*

WILLIAMS, Shirley C. *[Sculptor] b.1930, Hackensack, NJ.*
Addresses: Rockland Lake, NY. **Studied:** ASL with Sidney Dickenson, Gene Scarpantoni & William Dobbin; Frank Reilly School Art, NY, with Jack Faragasso; Craft Student League, NY, with Domenico Facci; John C. Campbell Folk Art School, NC. **Member:** AAPL (fellow); Int. Wood Collectors Soc.; Nat. Wood Carvers Assn.; Am. Forestry Assn.; Northeastern Loggers Assn. **Exhibited:** Catharine Lorillard Wolfe Art Club 70th Annual, Gramercy Park, NY, 1967; Vermont Lumberjack Roundup, State of Vermont, Lake Dunmore-Killington, 1968-71; Int. Wood Collectors Exhib., U.S. Nat. Arboretum, Wash., DC, 1971; AAPL Grand Nat., NY, 1972 (honorable mention); Northeastern Loggers Exhib. Hall, 1972. **Work:** Northeastern Loggers Exh. Hall, Old Forge, NY. Commissions: William of Orange coat of arms, Dutch Reformed Church, Spring Valley, NY, 1967; symbol, Smokey Bear, in the round, State of Vermont, 1969; Arabian show horse portrait, John R. Zehner, Nyack, NY, 1970; Audubon owl accoutrements, Tippy Arnold, Ho-Ho-Kus, NJ, 1971; regional estate carving, Lakewood School, Congers, NY, 1971. **Comments:** Preferred media: wood. Publications: author, "Introduction to Wood Sculpture," *Int. Wood Collectors Soc. Bulletin*, 1970. **Sources:** WW73; Sybil C. Harp, "The Lady Woodcarver," *Creative Crafts Magazine* (Fall, 1967); Ed. Gallenstein, "Profile of Shirley C. Williams," *Chip Chats Nat. Wood Carvers Magazine* (Winter, 1968); George Fowler, "Woodcarving with the Feminine Touch," *Northern Logger Magazine* (December, 1971).

WILLIAMS, T. *[Engraver] mid 19th c.*
Comments: Engraver of several illustrations in Harper's illustrated edition of Benjamin Franklin's *Autobiography* (New York, 1849). *Cf.* S. Williams. There was a Thomas Williams, engraver, working in NYC between 1869 and 1871; examples of his work have been found in books published as late as 1879. **Sources:** G&W; Hamilton, *Early American Book Illustrators and Wood Engravers*, 172-73, 237, 432, 501; NYCD 1869-71.

WILLIAMS, Thomas *[Professor of drawing & painting] early 19th c.*
Addresses: New Orleans, 1835. **Sources:** G&W; Delgado-WPA cites *Courier*, Jan. 5, 1835.

WILLIAMS, Todd *[Sculptor] b.1939, Savannah, GA.*
Studied: School of Visual Arts, NYC, 1961-65. **Exhibited:** School Visual Arts, 1964-65; AFA, 1965-66; 1st World Festival of Negro Arts, Dakar, Senegal, 1966; Dickson AC, 1966; WMAA, 1971. **Awards:** Whitney fellowship, 1965; Visual Arts scholarship; J. Clawson Mills fellowship. **Sources:** Cederholm, *Afro-American Artists*.

WILLIAMS, Tommy Carroll *[Art historian, painter] b.1940, Childress, TX.*
Addresses: San Marcos, TX. **Studied:** Lubbock Christian College (A.A.); West Texas State Univ. (B.S.); Univ. Oklahoma (M.Ed.). **Member:** College AA Am.; Kappa Pi. **Exhibited:** The Cutting Edge, Oklahoma City, 1967; St. Luke's Methodist Church Cutting Edge, Statewide Painting & Sculpture, Oklahoma City, 1967 (first place); Statewide Faculty Show, Central State Univ., Edmond, 1968. **Work:** Oklahoma Christian College, Oklahoma City; Central Art Galleries, NYC; Southwest Texas State Univ., San Marcos. **Comments:** Preferred media: acrylics. Publications: author, "Notebook for art appreciation courses," 1965 & 1967; illustrator, *Oklahoma Oil Journal*, 1968. Teaching: art instructor, Oklahoma Christian College, 1962-67, asst. prof. art, 1967-69; asst. prof. art history & gallery director, Southwest Texas State Univ., 1970-. Research: nineteenth-twentieth century European & American art. **Sources:** WW73; articles, local newspapers, Texas & Oklahoma, 1962-.

WILLIAMS, Virgil *[Landscape, genre, and portrait painter] b.1830, Dixfield, ME / d.1886, near St. Helena, CA.*
Addresses: Boston, 1860-62 and 1862-71; San Francisco, CA, 1862 and 1871-86. **Studied:** Brown University; NYC under Daniel Huntington; in Rome with Wm. Page, 1853-60. **Member:** SFAA (cofounder); Bohemian Club (cofounder & pres., 1875-76). **Exhibited:** PAFA, 1861; California Art Union, 1865; Boston AC, 1875, 1880, 1889. **Work:** Oakland Art Mus.; Silverado Museum, St. Helena, CA; CHS, Bancroft Library, Univ., Calif., Berkeley. **Comments:** Williams was married to Mary Page, daughter of William Page (see entry), Williams' close friend. He divorced Mary, however, about 1860. He had a studio in Boston until 1862, when he was commissioned to design and install an art gallery at Woodward's Gardens in San Francisco. He returned to Boston and taught drawing at Harvard and the Boston School of Technology. In 1871 Williams married Dora Norton, and returned with her to San Francisco, where he directed the newly formed School of Design until his death. He taught many artists who later became of the nation's most renowned painters. He was a member of the California Landscape School of the 1870s although his paintings of California are rare. Williams died on his ranch near St. Helena. **Sources:** G&W; WPA (CA), *Introduction to California Art Research*, II, 138-57, biblio., repros.; Rutledge, PA; *Antiques* (May 1947), 307, repro.; *Panorama* (Jan. 1946), 46, and (Aug. 1948), back cover. More recently, see Hughes, *Artists in California;* P&H Samuels, cite alternate birthplace of Taunton, MA, 531.

WILLIAMS, W. N. (Mrs.) *[Painter] early 20th c.*
Addresses: Pittsburgh, PA. **Member:** Pittsburgh AA. **Sources:** WW21.

WILLIAMS, W. S. *[Illustrator] early 20th c.*
Addresses: NYC. **Sources:** WW19.

WILLIAMS, Walter (Henry) *[Painter, printmaker] b.1920, Brooklyn, NY.*
Addresses: NYC 1950s-60s; Copenhagen, Denmark. **Studied:** Brooklyn Mus. Art School, 1951-55; Skowhegan School Painting & Sculpture, summer 1953 (scholarship); also with Ben Shahn, spring 1952. **Member:** Billed Kunstnernes Forbund, Denmark. **Exhibited:** WMAA Ann., 1953-63 (5 shows); Roko Gallery, NYC, 1954 (solo), 1962 (solo), 1963 (solo); Gallery Noa Poa, Copenhagen, 1956 (solo); Portland MA, 1958; Instituto Nacional de Dellas Artes, Mexico, 1958; Texas Southern Univ., 1962 (solo); Mexican-North American Cultural Inst., Mexico City, 1963 (solo); Int. Watercolor Biennial, Brooklyn Mus., 1963; Corner, Charlottenborg, Copenhagen, Denmark, 1963; Gallery Brinken, Stockholm, 1965 (solo); Studio 183, Sydney, Australia, 1965 (solo); Musée D'Art et D'Histoire, Geneva, Switzerland, 1965; The Little Gallery, Phila., 1966 (solo); PAFA Ann., 1966; Alabama Academy of Arts, 1966; White House, Wash., DC, 1966; Univ. Calif., Los Angeles Gals., 1966; Rochester Memorial Art Gallery; Dartmouth College, 1967; Albright-Knox Mus., Buffalo, 1967; Syracuse Univ., 1967; New Britain (CT) Mus. Am. Art, 1967; 50 Years of Afro-Am. Art, Phila.; Gallery Marya, Copenhagen, 1967 (solo); Fisk Univ., 1967-68, 1969 (solo); Stephens College, Columbus, MO, 1968; St. Augustine College, Raleigh; Utica (NY) College; Talladega (AL) College, 1968; Jarvis Christian College, Hawkins, TX, 1968; Univ. Cincinnati, 1969; Xavier Univ., 1969; Jackson State College, 1969 (solo); Lane College, Jackson, TN; Shaw Univ., Raleigh; Smithsonian Inst.; Brooks Memorial Art Gallery, TN; Illinois Bell traveling show, 1971; Berea (KY) College (solo); NAD, 147th Ann., 1972; Terry Dintenfass Inc., NYC, 1970s. **Awards:** John Hay Whitney Foundation fellowship, 1955; NIAL grant, 1960; Silvermine Award, 1963; Adolph & Clara Obrig Prize, NAD, 1972. **Work:** WMAA; Brooklyn Mus.; Riverside Mus., New York; MMA; Cincinnati Art Mus.; Walker Art Center, Minneapolis; Nat. Gallery Arts, Washington, DC; Texas Southern Univ., Houston; Mexican American Inst., Mexico City; PMA; Syracuse Univ.; Lowe Art Center, NYC; School of FA, PA; Univ. Georgia; Tucson, AZ, Public Schools; Oberlin (OH) College; Bellarmine College Lib., KY; Dartmouth College; Print Council of America, NYC; Skowhegan (ME) School of Painting & Sculpture; Howard Univ.; Smithonian Inst.; Univ.Redlands, CA. **Comments:** Teaching: artist-in-residence, Fisk Univ., 1968-69. **Sources:** WW73; Cedric Dover, *American Negro Art* (Studio, London, 1958); Janet Erickson & Adelaide Sproul, *Printmaking without a Press* (Reinhold, 1967); Cederholm, *Afro-American Artists;* Falk, *Exh. Record Series.*

WILLIAMS, Walter J., Jr. *[Painter, illustrator] b.1922.*
Studied: Meinzinger Art School; Soc. Arts & Crafts, Detroit. **Member:** Michigan Acad. Arts, Science & Letters; Detroit Soc. Adv. Culture & Educ. (exec. board; visual arts coordinator; art director). **Exhibited:** Detroit Inst. of Arts Mus., 1968; Scarab Club, Detroit, 1968; Atlanta Univ.; Wayne State Univ., 1969 (award); TMA, 1969; Grand Rapids Mus., 1970; Rackham Memorial Mus., Ann Arbor, MI, 1967 (prize)-69; Russell Woods Outdoor Exh., Detroit, 1967-69 (prizes); Univ. of Fl; Mich. Artists Ann., Detroit; Mich. State Fair; Invitational, Mich. State Fairgrounds, Detroit; Pontiac Cultural Arts Center; Lester Arwin Gallery, Detroit; Detroit Artist Market; Hannamura Gallery, Detroit; Bloomfield Hills, MI, Ann.; Lafayette Park Outdoor Exh., Detroit. **Sources:** Cederholm, *Afro-American Artists.*

WILLIAMS, Walter Reid *[Sculptor] b.1885.*
Addresses: Chicago, IL. **Studied:** C. Mulligan; B. Pratt; P. Bartlett; Académie Julian, Paris with Mercié. **Exhibited:** AIC, 1918-32. **Work:** Women's Athletic Club, Chicago. **Comments:** Position: director, Clay Arts Studio, Ridge Park Field House, Chicago. **Sources:** WW40.

WILLIAMS, Warner *[Sculptor, designer, lecturer, painter, teacher] b.1903, Henderson, KY / d.1982.*
Addresses: Culver, IN. **Studied:** Berea College; Herron Art Inst.;

AIC (B.F.A.); Polasek; Zettler; Inaelli. **Member:** Chicago Art Club; Chicago AA; Hoosier Salon; NSS; Illinois SFA. **Exhibited:** AIC, Century of Progress, Chicago, 1932; Herron AI, 1925 (prize); Hoosier Salon, 1928-42 (prizes, 1928, 1930-32); City of Chicago, 1938 (award); North Shore AA, 1937-38 (prizes); AIC, 1939, 1941 (prizes). **Work:** Martin Luther King bas-relief portrait, King Mem., Atlanta, GA; Albert Schweitzer medallion, Schweitzer Mem. Mus., Switzerland; Queen Marie medal, Vienna Diplomatic Acad & Theresianische Acad.; Thomas Edison Commemorative Medal, Smithsonian Inst. & Edison Mus., East Orange, NJ; Helen Keller medallion, 35 schools for blind, US; other memorials & bas-reliefs: Court House, Frankfort, KY; Berea College; Indiana Univ.; City Church, Gary, IN; Purdue Univ., Bradwell Sch., Chicago; Francis Parker Sch.; Univ. Pittsburgh. **Comments:** Positions: artist-in-residence, Culver Military Acad., Indiana, 1940-68. Contributor: *Design* magazine. **Sources:** WW73; WW47.

WILLIAMS, Watkins [*Painter*] *early 20th c.*
Addresses: Chicago, IL. **Exhibited:** AIC, 1909, 1911. **Sources:** WW13.

WILLIAMS, Wayland Wells [*Painter*] *b.1888, New Haven, CT / d.1945.*
Addresses: New Haven/Salisbury, CT. **Studied:** I. Weir; Yale. **Member:** New Haven PCC. **Comments:** Author: "The Whirligig of Time," "Goshen Street," "The Seafares." Position: state director, Connecticut WPA. **Sources:** WW40.

WILLIAMS, Wellington [*Copperplate and steel engraver*] *mid 19th c.*
Addresses: Phila., 1850-after 1860. **Sources:** G&W; Phila. CD 1850-60+. See also, Wellington Williams, *Appleton's Northern and Eastern Traveller's Guide.* (New York and Philadelphia, 1850).

WILLIAMS, Wheeler [*Sculptor, painter, lecturer, writer, teacher, architect*] *b.1897, Chicago, IL / d.1972, Madison, CT.*
Addresses: NYC/Madison, CT. **Studied:** Yale Univ.; Harvard Univ. Sch. Arch. (M. Arch.); with J. Coutan, École des Beaux-Arts, Paris, France; with J. Wilson, in Boston. **Member:** ANA, 1939; NA; NSS; Arch. Lg.; Audubon Artists; Am. Inst. FA (fellow); FA Fed. NY (pres.); Munic. Art Soc., NY; AAPL (pres.); Am. Veterans Soc. Artists; New York Soc. Ceramic Artists; BAID. **Exhibited:** Salon des Artistes Français, 1923-27; PAFA Ann., 1936-43, 1950; AIC; WFNY, 1939; NAD; GGE, 1939; CPLH; NSS; Ferargil Gal. (solo); Arden Gal., Guild Hall, East Hampton, LI, NY; Soc. Four Arts. Awards: prize, NAD, 1936; gold medal, NAC, 1956; AAPL, 1957; Salon d'Automne, Paris, 1937 (medal). **Work:** San Diego FA Soc.; Brookgreen Gardens, SC; Four Arts Gal., Palm Beach, FL; Norton Gal. Art, West Palm Beach, FL; AIC; Hackley Art Gal.; Chapel, West Point; U.S. Naval Acad., Annapolis; over-entrance, Parke Bernet Gal., NY; bust of Clifford Holland, entrance to Holland Tunnel, NY; Am. Battle Monument, Cambridge, England; statue of Sen. Taft, Taft Memorial Carillon, Wash., DC; garden façade, Brooks Mem. Art Gal., Memphis, TN; bust of Othmar Ammann, des. & engineer of George Washington Bridge, NY; other major works 1962-65: "Pioneer Mother of Kansas," Liberal, KS; Bust of Admiral Hewitt, U.S. Naval Acad.; "Muse of the Missouri Fountain", Kansas City; bronze bust of Admiral Luis de Florez, U.S. Naval Training Center, Port Washington; many architectural & monumental works, portrait busts, relief, medals, garden sculptures, ecclesiastic statues, throughout U.S., South Africa, & Canada. **Comments:** Specialty: garden sculpture. WPA artist. Lectures: garden sculpture; portrait sculpture; methods & techniques. Author: monograph on sculpture, 1947. Position: teacher, BAID. **Sources:** WW66; WW47; Falk, *Exh. Record Series.*

WILLIAMS, William [*Portrait painter, decorative and scenic artist, drawing and music teacher, novelist*] *b.1727, Bristol (England) / d.1791, Bristol.*
Addresses: Phila., 1747-60; Jamaica, 1760-63; Phila., 1763-75; England, 1776-91. **Studied:** self-taught. **Work:** NPG, Wash., DC;

BM; Newark (NJ) Mus.; Winterthur Mus., Wilmington, Del.; Yale Univ. Art Gal. **Comments:** Noteworthy as being as the first teacher of Benjamin West, Williams came to Phila. in 1747 as a mariner, established himself as a portrait painter, reportedly helped build the first theatre in the city, and also did theatrical scene painting for the city's Hallam theatre company. He met West about 1750 at the request of patron Samuel Shoemaker, who asked that Williams show the boy one of his paintings. This he did, also giving West some instruction and books, including his own unpublished manuscript "Lives of the Painters." Williams' portraits are tightly detailed, with the figures usually posed within elaborate stage-like settings that show his associations with the theatre. Among his most well-known works are his portraits of Deborah Hall (Brooklyn Mus.) and Benjamin Lay (NPG), the latter of which was commissioned by Benjamin Franklin. Williams also painted several fine full-length figural group portraits or "conversation pieces." In 1760, he traveled to Jamaica, returning in 1763 to Philadelphia. He was still painting in the Colonies as late as 1775, but about 1776 went back to Bristol (England), where he posed for a figure in West's "The Battle of La Hogue." Williams spent his last years in the Merchants' and Sailors' almshouse in Bristol, and on his death left a patron the manuscript of his adventure novel, *The Journal of Llewellyn Penrose, a Seaman* (which was loosely based on his own life at sea). Although Williams recorded that he had painted 141 works in his lifetime, only fourteen have been located (as of 1987). **Sources:** G&W; Sawitzky, "William Williams" and "Further Light on. William Williams"; Flexner, "The Amazing William Williams" and "Benjamin West's American Neo-Classicism with Documents on West and William Williams"; Prime, II, 13; Gottesman, I, 7. More recently, see David Howard Dickason, *William Williams, Novelist and Painter of Colonial American, 1727-1791* (Bloominton, IN, 1970); Saunders and Miles, 207, 225-26; Baigell, *Dictionary; 300 Years of American Art,* 48.

WILLIAMS, William [*Wood engraver, printer, bookseller*] *b.1787, Framingham, MA / d.1850, Utica, NY.*
Addresses: Utica, NY, 1800-35; Tonawanda, NY, 1835. **Comments:** He served as apprentice in a print shop in Utica until 1807 when he became a partner in the business. Hamilton lists two books containing wood engravings by him. **Sources:** G&W; Williams, *An Oneida County Printer, William Williams;* Hamilton, *Early American Book Illustrators and Wood Engravers,* 502.

WILLIAMS, William [*Amateur sketcher*] *b.1796, Westmoreland County, PA / d.1874, Fort Dodge, IA.*
Addresses: Westmoreland County, 1796-1850; Fort Dodge, 1850-74. **Comments:** He spent the greater part of his life in business in Westmoreland County (PA). In 1850 he went out to Iowa and established a provisions store at Fort Dodge, then a military installation, of which he made a drawing in 1852. When the troops were removed in 1854, Williams bought the military buildings and laid out the town of Fort Dodge. In 1869 he was elected first mayor of the incorporated city and he held the office for two years. **Sources:** G&W; Pratt, *History of Fort Dodge and Webster County, Iowa,* I, 155, repros. opp. 72 and 82; *Iowa Journal of History* (April 1951), cover and 169.

WILLIAMS, William George [*Topographical engineer, amateur portrait painter*] *b.1801, Phila. / d.1846.*
Studied: West Point, graduating in 1824. **Member:** NAD (hon. member). **Exhibited:** NAD, 1840, 1843-45 (portraits). **Comments:** During the 1830s-40s he worked for the U.S. Army on surveys of canal routes and harbor installations on the Great Lakes and elsewhere. He was chief of engineers under General Taylor during the Mexican War and was killed at the Battle of Monterey. **Sources:** G&W; CAB; Cowdrey, NAD.

WILLIAMS, William Joseph [*Portrait and miniature painter*] *b.1759, NYC / d.1823, Newbern, NC.*
Addresses: NYC, 1779-92; Virginia,1792; Phila., 1793-97; Newbern, NC, 1804-07; 1817-23. **Work:** Colonial Williamsburg Collection. **Comments:** Believed to be a nephew of the painter John Mare (see entry). He was christened William

Williams but on his conversion to the Roman Catholic faith about 1821, he adopted the name Joseph. He emerged as an artist in NYC in 1779. His work includes a portrait of George Washington as a Mason, painted in Philadelphia. **Sources:** G&W; Williams, *William Joseph Williams and His Descendants;* Smith, "John Mare. with Notes on the Two William Williams," 375-85; Prime, II, 38; NYCD 1813-17; Morgan and Fielding, *Life Portraits of Washington,* 201; Rutledge, *Artists in the Life of Charleston.*

WILLIAMS, William T. *[Printmaker, painter, educator]* b.1942, Cross Creek, NC.
Studied: NYC Community College (A.A.S., 1962); Pratt Inst. (B.F.A., 1966); Yale Univ. (M.F.A., 1968). **Exhibited:** Waterford (CT) Pub. Lib.; Hillcrest Inn, Ogunquit, ME; Wilkes Col., Wilkes-Barre, PA; Terra Mar Yacht Club, Saybrook, CT; Mystic (CT) AA; Mitchell Col., New London, CT; State Univ. Stonybrook, 1969; Ridgefield, CT, 1969; Studio Mus., Harlem, 1969; Fondation Maeght, St. Paul, France, 1970; Critics Choice Traveling Exhib., 1969-70; American Embassy, Moscow, 1969-70; Indianapolis Mus. Art, 1972; Utah MFA, 1972; MoMA, 1969, 1972; WMAA, 1969, 1971, 1972; Reese Palley, NY, 1971, (also solo); DeMenil Fnd., Houston, 1971; Kölner Kunstmarkt, Germany, 1971; Rice Univ., 1971. Awards: National Endowment for the Arts Traveling Grant, 1966; National Endowment for the Arts, 1970. **Work:** MoMA; Univ.Maine; State of NY, Albany Mall; Chase Manhattan Bank; Fisk Univ.; WMAA; Rice Univ. **Sources:** Cederholm, *Afro-American Artists.*

WILLIAMS-LYOUNS, H. F. *[Painter] early 20th c.*
Exhibited: Salons of Am., 1925. **Sources:** Marlor, *Salons of Am.*

WILLIAMSON *[Painter, panoramist] mid 19th c.*
Exhibited: NYC and Ohio, bef. 1849; Louisville, KY, 1849. **Comments:** Painter(?) of a panorama of the bombardment of Vera Cruz during the Mexican War. **Sources:** G&W; Louisville *Courier,* June 7 and 13, 1849 (courtesy J. Earl Arrington).

WILLIAMSON, A. W. (Mrs.) *[Painter] early 20th c.*
Addresses: Cincinnati, OH. **Member:** Cincinnati Women's AC, 1915-27. **Sources:** WW27.

WILLIAMSON, Ada Clendinin *[Painter, illustrator, printmaker (etchings, engravings, drypoints)] b.1880, Camden, NJ / d.1958, Ogunquit, ME.*
Addresses: Ongunquit. **Studied:** Drexel Inst.; PAFA (six years) with William Chase, Cecilia Beaux; Cresson traveling scholarships in Europe; Europe again in 1922, Costaluchi's Art School; Spain. **Member:** Phila. Pr. Club; Ogunquit AA; Phila. Art All.; Phila. Soc. Etchers (founding member). **Exhibited:** PAFA Ann., 1912, 1918-24, 1930-46; Pan-Pacific Expo, San Francisco, 1915; AIC, 1916, 1927; Art Club, Carlisle, PA, 1925 (solo); Phila. Art All., 1927; traveling exhib., Phila. Soc. Etchers, 1927; Pasadena AI, 1929 (solo); P&S Los Angeles, 1929; Woodmere Gal., 1941. Awards: PAFA fellowship, 1945; Cosmopolitan Club, 1945 (prize); Phila. Plastic Club, 1913 (gold medal); PAFA, 1922 (gold), 1945 (prize); Spaulding prize, 1948. **Comments:** Daughter of artihtect, T. Roney Williamson. Member of the "Phila. Eight," who exhibited in the 1920s. Illustrator: *St. Nicholas, Women's Home companion, Todays Magazine, Harper's Magazine.* **Sources:** WW53; WW47; Petteys, *Dictionary of Women Artists;* Falk, *Exh. Record Series.*

WILLIAMSON, Charles *[Listed as "artist"] b.c.1822, New York.*
Addresses: NYC, 1850. **Sources:** G&W; 7 Census (1850), N.Y., XLIV, 583.

WILLIAMSON, Charters *[Landscape painter] b.1856.*
Addresses: Brooklyn; NYC, 1882-86; NY. **Exhibited:** Brooklyn AA, 1882-86; NAD, 1882-86; PAFA Ann., 1882-83; Boston AC, 1884-86. **Sources:** *Brooklyn AA;* Falk, *Exh. Record Series.*

WILLIAMSON, Clara McDonald (Mrs.) *[Painter] b.1875, Iredell, TX / d.1976.*
Addresses: Dallas, TX. **Studied:** S.M.U.,

Dallas, 1943; Dallas MFA; mainly self-taught. **Exhibited:** Dallas Mus. Fine Arts, 1948 (solo); American Painting of Today, 1950, MMA,1950; Dallas MFA, 1948 (solo); Betty McLean Gal., Dallas; MMA; NAD; Am. Contemporary Natural Painters, 1953-54; Am. Primitive Painting Exhib., 1958-59, Smithsonian Inst., Washington, DC; Int. Exhib. Primitive Art, Bratislava, Czechoslovakia, 1966; Amon Carter Mus., Ft. Worth, 1967 (retrospective). Awards: Raiberto Comini Purchase Award, 1945 & 1947; Dealey Purchase Award, 1946 & Summerfield G. Roberts Award, 1954, Dallas Mus. Fine Arts. **Work:** Dallas Mus. Fine Arts, Inc.; Amon Carter Mus., Fort Worth, TX; Valley House Gallery, Dallas; MoMA; Wichita (KS) Art Mus. **Comments:** Preferred media: oils. Began painting in 1943 and continued until she was 91; known for over 160 works, depicting in many of them her experiences as a child of early settlers in the area. **Sources:** WW73; Vogel, *The Paintings of Aunt Clara* (Univ. Texas Press, 1966); Dewhurst, MacDowell, and MacDowell, 173-74; Trenton, ed. *Independent Spirits,* 191-95; Petteys, *Dictionary of Women Artists.*

WILLIAMSON, Clarissa *[Painter, teacher] early 20th c.*
Addresses: Logansport, IN. **Comments:** Position: art supervisor, Public Schools, Logansport. **Sources:** WW24.

WILLIAMSON, Curtis *[Painter] 19th/20th c.*
Addresses: NYC. **Studied:** Académie Julian, Paris, 1889-98; R. Henri in NYC (1907). **Exhibited:** PAFA Ann., 1906. **Sources:** WW08; Falk, *Exh. Record Series.*

WILLIAMSON, Edward L. (Mrs.) *[Painter] early 20th c.*
Addresses: Carmel, CA. **Member:** Women P&S. **Sources:** WW15.

WILLIAMSON, Elizabeth Dorothy (Mrs. Ten Broeck Williamson IV) *[Sculptor, craftsperson] b.1907, Portland, OR.*
Addresses: Old Albuquerque, NM, 1940. **Studied:** Mus. School, Portland; Otis Art Inst.; R. Allen. **Member:** New Mexico AA. **Work:** Los Angeles Mus. Hist., Science & Art; State Expo Bldg., Los Angeles. **Comments:** Position: teacher, State Vocational Educ., Old Albuquerque. **Sources:** WW40.

WILLIAMSON, Elizabeth M. *[Painter] early 20th c.*
Addresses: Richmond, VA. **Sources:** WW13.

WILLIAMSON, Frank *[Painter] 19th/20th c.*
Addresses: NYC. **Exhibited:** AIC, 1897-98; PAFA Ann., 1899. **Sources:** WW01; Falk, *Exh. Record Series.*

WILLIAMSON, Frank G. *[Painter] early 20th c.*
Addresses: San Francisco & Los Angeles, 1910-39. **Exhibited:** San Francisco Inst. Art, 1910; San Francisco AA, 1939. **Sources:** Hughes, *Artists in California,* 608. *Cf.* Frank Williamson.

WILLIAMSON, H. G. *[Painter] 19th/20th c.*
Addresses: NYC, 1898; Baltimore, MD. **Member:** SI, 1910; SC,1905. **Exhibited:** NAD, 1898. **Sources:** WW25.

WILLIAMSON, Harry Grant *[Painter] late 19th c.*
Addresses: Indianapolis, IN; New Jersey, by 1898. **Studied:** early pupil of T.C. Steele; in Munich, 1887; Indiana School of Art, 1891-94, with Steele and Forsyth. **Comments:** Painted landscapes and worked in New Jersey as an illustrator. **Sources:** Gerdts, *Art Across America,* vol. 2: 266.

WILLIAMSON, Howard *[Illustrator] mid 20th c.*
Addresses: NYC. **Member:** SI. **Sources:** WW47.

WILLIAMSON, Irene D. *[Artist] late 19th c.*
Addresses: NYC, 1890-93. **Exhibited:** NAD, 1890-93. **Sources:** Naylor, *NAD.*

WILLIAMSON, J. Maynard, Jr. *[Painter, illustrator] b.1892, Pittsburgh, PA.*
Addresses: Pittsburgh, PA. **Studied:** F. V. DuMond. **Member:** Pittsburgh AA. **Exhibited:** Pittsburgh AA, 1911 (prize); PAFA Ann., 1915. **Sources:** WW21; Falk, *Exh. Record Series.*

WILLIAMSON, James W. *[Illustrator]* b.1899, Omaha, NE.
Addresses: Greenwich, CT. **Studied:** Yale College; self-taught as an artist. **Member:** SI (Hall of Fame, 1984). **Exhibited:** Awards: medal & prizes, Art Dir. Club. **Comments:** Illus., *Saturday Evening Post, Life, Look, Woman's Home Companions,* & other national magazines. He sold his first work to *Life* magazine, while still in college. **Sources:** WW53.

WILLIAMSON, John *[Landscape painter]* b.1826, Toll Cross, near Glasgow, Scotland / d.1885, Glenwood-on-the-Hudson, NY.
Addresses: Brooklyn, NY, 1861-68; NYC, 1869-81; Glenwood-on-the-Hudson, c.1879-on; Yonkers, NY, 1883-85. **Studied:** Graham Art School, Brooklyn Inst. **Member:** ANA, 1861; Brooklyn AA, 1861 (a founder; secretary, 1861-68; resigned after a falling out with the group); Brooklyn and Long Island Fair, 1864 (art committee). **Exhibited:** NAD, 1850-85; AAU, 1852, 1853; Brooklyn AA, 1861-82; Washington and Boston; Utica AA. **Comments:** Williamson came to America in 1831 and spent most of his life in Brooklyn. A Hudson River School painter, he traveled up the Hudson River to Lake George, painting in the Adirondack and Catskill Mountains, and into New England, especially in the Berkshire Mountains (MA), the White Mountains (NH), the Green Mountains (VT), and in Connecticut. In the early 1860s, he developed an interest in still life, favoring lilacs, morning glories, cherries, and raspberries. **Sources:** G&W; CAB; Clement and Hutton; Cowdrey, NAD; Cowdrey, AA & AAU; Swan, BA; Washington Art Assoc. Cat., 1857; NYBD 1850+; *Art Digest* (May 1, 1945), 2, repro.; Campbell, *New Hampshire Scenery*, 176; P&H Samuels, 532; *For Beauty and for Truth*, 92 (w/repro.).

WILLIAMSON, Lama Belle *[Painter, art teacher]* b.1859, Sioux City, IA.
Addresses: Grundy Center, IA. **Studied:** John Herron AI; extension courses, Portland (OR) Mus. Art. **Exhibited:** Iowa State and county fairs; in Indianapolis. **Sources:** Petteys, *Dictionary of Women Artists.*

WILLIAMSON, Laura (Mrs.) *[Painter]* mid 20th c.
Addresses: NYC. **Exhibited:** S. Indp. A., 1930; Salons of Am., 1934. **Sources:** Falk, *Exhibition Record Series.*

WILLIAMSON, M. B. *[Artist]* late 19th c.
Addresses: Dobbs Ferry, NY, 1882. **Exhibited:** NAD, 1882. **Sources:** Naylor, *NAD.*

WILLIAMSON, Mabel See: **DWIGHT, Mabel**

WILLIAMSON, Margaret T. *[Painter]* early 20th c.
Addresses: Pittsburgh, PA. **Member:** Pittsburgh AA. **Sources:** WW21.

WILLIAMSON, Mayme E. *[Painter]* mid 20th c.
Addresses: San Francisco, CA, 1924-32. **Exhibited:** San Francisco AA, 1924, 1925; S. Indp. A., 1925. **Comments:** Specialty: watercolors. **Sources:** Hughes, *Artists in California*, 608.

WILLIAMSON, Minnie D. (Mrs. O. C.) *[Painter]* 19th/20th c.
Addresses: Seattle, WA. **Exhibited:** Wash. State Arts & Crafts, 1909. **Sources:** Trip and Cook, *Washington State Art and Artists.*

WILLIAMSON, Paul Broadwell *[Painter]* b.1895, NYC.
Addresses: San Francisco. **Studied:** Ohio Mechanics Inst., Cincinnati; & with Frank Duveneck. **Member:** AAPL (California State chmn., 1940-42; chmn. board directors, 1943-46; member, nat. board directors, 1947-)); Am. Veterans Soc. Art. **Exhibited:** Smithsonian Inst., 1940; Mus. New Mexico, Santa Fe, 1941; Am. Veterans Soc. Art, 1941-43, 1946; Springfield Mus. Art, 1945; Soc. for Sanity in Art, 1940; Army-Navy Exhib., San Francisco, 1942; AAPL, 1943, 1946. **Work:** St. Mary's College, Moraga, CA; Univ. Club, San Francisco. **Comments:** Author: *El Camino*

Real. **Sources:** WW53; WW47.

WILLIAMSON, Shirley (Mrs. Edward L.) *[Craftsperson, designer, teacher, blockprinter]* early 20th c.; b.NYC.
Addresses: NYC, c.1905-13; Palo Alto, CA. **Studied:** ASL with A.W. Dow & W.M. Chase; Académie Julian, Paris with Constant; also with Rodin in Paris. **Member:** Palo Alto AC; NY Women's AC,1904; San Francisco AA. **Exhibited:** Boston AC, 1906, 1907; PAFA Ann., 1906; San Francisco AA, 1916; Berkeley League of FA, 1924; Golden Gate Expo, 1939; AIC; Palo Alto AC; San Francisco SA. **Comments:** Position: teacher, Palo Alto H.S. **Sources:** WW40; Hughes, *Artists in California*, 608; Falk, *Exh. Record Series.*

WILLIAMSON, Thomas *[Landscape painter, architect]* b.1776 / d.1846.
Addresses: Portsmouth, VA. **Sources:** Wright, *Artists in Virgina Before 1900.*

WILLIAMSON, Thomas Hoones *[Landscape painter, architect]* b.1813 / d.1888.
Comments: Son of Thomas Williamson (see entry). Position: prof., Virginia Military Inst. **Sources:** Wright, *Artists in Virgina Before 1900.*

WILLIAMSON, Thomas N. *[Landscape and still life painter]* late 19th c.
Addresses: Richmond, VA. **Exhibited:** Richmond, VA, 1896-97. **Sources:** Wright, *Artists in Virgina Before 1900.*

WILLIAMSON, William *[Engraver]* b.c.1829, Pennsylvania.
Addresses: Phila., 1850. **Sources:** G&W; 7 Census (1850), Pa., LI, 504.

WILLIAMSON, William Harvey *[Painter, designer]* b.1908, Denver, CO.
Addresses: Carmel, CA. **Studied:** Chouinard AI; Art Center School, Los Angeles, and with Will Foster, F. Tolles Chamberlin. **Member:** NSMP; Arch. Lg.; Carmel AA; Soc. Western Artists; Oakland Mus. Assn. **Exhibited:** PAFA, 1925, 1926, 1928; AIC, 1935; CGA, 1936; NSMP; Arch. Lg., 1956; deYoung Mem. Mus.; Oakland Art Mus.; Stockton, CA; Calif. State Fair; Santa Cruz Art Lg.; Fresno Art Lg.; Laguna Beach AA; College Marin; Santa Paula, CA; Carmel AA; Maxwell Gal., San Francisco; Harrison Mem. Lib., Carmel; Maxwell Gal., San Francisco, 1958 (solo); AIA exhib., Monterey, CA, 1958. **Work:** Oakland Art Mus.; Douglas Aircraft Corp.; murals, Am. Automobile Assn. Office Bldg., San Francisco; Salinas (CA) Airport Terminal Bldg.; costume and mural sketches for 20th Century-Fox, Hollywood. **Comments:** Contributor to *Christian Science Monitor, Monterey Peninsula-Herald.* **Sources:** WW59.

WILLIAMSON, William M. *[Museum curator]* mid 20th c.
Addresses: New York 29, NY. **Sources:** WW59.

WILLICH, Adelheid *[Painter]* early 20th c.
Addresses: Willich Embroidery Studios, NYC. **Exhibited:** S. Indp. A., 1918. **Sources:** Marlor, *Soc. Indp. Artists.*

WILLING, Jessie Gillespie See: **GILLESPIE, Jessie (Mrs. J. G. Willing)**

WILLING, J(ohn) Thomson *[Painter, craftsperson, writer, lecturer]* b.1860, Toronto, Ontario / d.After 1934.
Addresses: Germantown, PA/Henryville, PA. **Studied:** Ontario Sch. Art. **Member:** AIGA; Royal Canadian Acad.; Art Dir. Club; SI; SC 1897. **Exhibited:** Brooklyn AA, 1886 ("Hibiscus Blooms"). **Comments:** Positions: art manager, The North American (since 1900); editor, Gravure Service Corporation. **Sources:** WW27.

WILLIS, A. V. See: **WILLIS, Edmund Aylburton**

WILLIS, Albert Paul *[Landscape painter, teacher]* b.1867, Phila., PA.
Addresses: Phila./Casco Bay, ME. **Studied:** PM School IA; F.V. DuMond. **Member:** Phila. WCC; Phila. Sketch Club; Providence WCC. **Exhibited:** PAFA Ann., 1896-98; AIC, 1898, 1900, 1902-

04; Boston AC, 1902. **Sources:** WW33; Falk, *Exh. Record Series.*

WILLIS, Alice M. *[Painter] b.1888, St. Louis, MO.*
Addresses: St. Louis. **Studied:** Rhoda H. Nicholls. **Member:** St. Louis AG. **Exhibited:** AIC, 1913. **Comments:** Specialty: watercolors. **Sources:** WW17.

WILLIS, Brooks *[Painter] mid 20th c.*
Exhibited: AIC, 1932. **Sources:** Falk, *AIC.*

WILLIS, Edmund Aylburton *[Landscape painter] b.1808, Bristol (England) / d.1899, Brooklyn (NYC).*
Addresses: NYC and Brooklyn, from c.1852-99. **Exhibited:** NAD, early 1852-62 (as A. Van Willis), 1862 (as A. V. Willis). **Comments:** His name appears as Edmund Aylburton Willis, A. Van Willis, A.V. Willis, and Edmund Van Willis **Sources:** G&W; *Art Annual,* 1899, obit.; Cowdrey, NAD; NYCD 1857, 1860.

WILLIS, Elizabeth Bayley *[Art historian, collector] b.1902, Somerville, MA.*
Addresses: Bainbridge Island, WA. **Studied:** Univ. Washington (A.B.) with Lyonel Feininger, Mark Tobey & Morris Graves. **Exhibited:** SAM, 1938. **Comments:** Positions: assoc., Willard Gallery, New York, 1943-46; curator, Henry Gallery, Univ. Washington, 1946-48; curator, San Francisco Mus. Art, 1948-50; acting asst. director, CPLH, 1950-51; consultant decorative arts, production & marketing, Mingei Kan, Tokyo, 1951-52; member UN Tech. Asst. Board for Taiwan, Vietnam, India & Morocco, 1952-59; consultant textile export, India, 1955-57. Research: tribes of India's Northeast frontier, especially their arts and textiles; textile arts of India; folk arts of Japan. Collection: artifacts, pottery and textiles from Tibet, Bhutan, Japan & Morocco, now in the Permanent Collection of the Smithsonian Institution; costumes and textiles from the same countries now in Permanent Collections of the University of Washington and the Washington State Museum; Ming and Ch'ing paintings in a private collection. **Sources:** WW73.

WILLIS, Eola *[Painter, craftsperson, writer, lecturer] mid 20th c.; b.Dalton, GA.*
Addresses: Charleston, SC. **Studied:** ASL, with Mrs. J.S.D. Smillie, Chase; Paris. **Member:** Carolina AA; Soc. for Preservation of Old Bldgs. (historian). **Exhibited:** Charleston Expo, 1902 (prize). **Work:** Gibbes Mem. Art Gal., Charleston. **Comments:** Author: *The Charleston Stage in the XVIII Century, Henrietta Johnston, First Woman Painter in America.* **Sources:** WW40.

WILLIS, Eveline F. *[Primitive watercolorist] late 19th c.*
Addresses: Active in Castleton, VT, c.1880. **Sources:** Petteys, *Dictionary of Women Artists.*

WILLIS, Frederick *[Listed as "artist"] b.c.1824, England.*
Addresses: Phila., 1860. **Comments:** His wife Clarissa and son William, aged 2, were both born in Pennsylvania. **Sources:** G&W; 8 Census (1860), Pa., LX, 740.

WILLIS, J. R. *[Painter, photographer, journalist] b.1876, Sylvania, GA.*
Addresses: Atlanta, GA; California; Gallup, NM; Albuquerque, NM, 1930s. **Studied:** Robert Henri and Wm. Merritt Chase, beginning 1902. **Exhibited:** Sante Fe, NM, during the 1930s. **Work:** Sante Fe Public Lib.; Denver Public Lib. **Comments:** Worked as a reporter for the Atlanta *Constitution* before beginning his art studies in 1902. He next worked in motion pictures and the newspaper business in California, afterward moving to New Mexico where he established a photography studio in Gallup. Willis spent his summers painting on the Reservations of Arizona and New Mexico. He moved to Albuquerque, NM, in the early 1930s, spending his winters in New Orleans or Atlanta. Painted a historical mural for Gallup, NM, under the WPA program. **Sources:** Dawdy, vol. 2; info courtesy Ingeborg Gal., Northfield, MA.

WILLIS, John *b.c.1810, New Jersey.*
Addresses: NYC, 1860. **Sources:** G&W; 8 Census (1860), N.Y.,

LXI, 844.

WILLIS, Katherine *[Painter] 19th/20th c.*
Addresses: Omaha, NE. **Studied:** J.L. Wallace. **Exhibited:** Trans-Mississippi Expo, Omaha, NE, 1898. **Sources:** WW01; Dawdy, vol. 2.

WILLIS, Louise Hammond *[Portrait painter, architect, musician, poet, teacher] b.1870, Charleston, SC.*
Studied: with E. Whittock McDowell in South Carolina; Beckwith & Mowbray, NYC. **Sources:** Petteys, *Dictionary of Women Artists.*

WILLIS, Mary Tallman See: **HAWES, Mary Tallman Willis**

WILLIS, Patty *[Painter, designer, lithographer, craftsperson, lecturer, block printer, sculptor] b.1879, Summit Point, WV.*
Addresses: Charles Town, WV. **Studied:** AIC; PIA School; Académie Moderne, Paris, with F. Leger. **Exhibited:** Corcoran Gal biennials, 1923, 1930; Carnegie Inst., 1925; Soc. Indep. Artists, 1928, 1937-38; Cumberland Valley Artists, 1935-1946; Nat. Exhib. Am. Art, NY, 1936, 1938; All. Artists West Virginia, 1937, 1945; Washington County MFA, Hagerstown, MD (prize). **Work:** Charles Town (WV)High School. **Comments:** Lectures: religion in art. **Sources:** WW53.

WILLIS, R(alph) T(roth) *[Mural painter, etcher, illustrator, sculptor] b.1876, Leesylvania, Freestone Point, VA. / d.1955, Encinitas, CA.*
Addresses: NYC; Westport, CT; Encinitas, CA. **Studied:** Corcoran Sch. Art; ASL; Académie Julian, Paris, 1899. **Member:** Mural Painters; Calif. AC. **Work:** 22nd Regiment Armory, NYC; LOC; Pomona (CA) Bldg. & Loan Assn.; Angeles Temple, Los Angeles; Brock Jewelry Store, Los Angeles. **Sources:** WW40.

WILLIS, Robert *[Painter] mid 20th c.*
Studied: Corcoran Gal Sch. Art. **Exhibited:** Corcoran Gal biennial, 1945. **Sources:** Falk, *Corcoran Gal.*

WILLIS, Thomas *[Marine painter] b.1850, Connecticut / d.1912, NYC.*
Work: Mariner's Mus.; Mystic Seaport Mus.; Peabody Mus., Salem. **Comments:** He used silk or satin for the sails in his ship paintings. Signature note: He signed with a simplified "T" atop a "W" monogram. **Sources:** Brewington.

WILLIS, Verda Lee *[Painter] mid 20th c.*
Addresses: Rosswell, NM. **Exhibited:** S. Indp. A., 1932. **Sources:** Marlor, *Soc. Indp. Artists.*

WILLIS, William H. *[Landscape painter] mid 19th c.*
Addresses: NYC, active 1847. **Exhibited:** NAD, 1847, 1856. **Comments:** In 1847 his address was the same as the 1842-46 address of William Henry Willis, merchant, but there is no William H. Willis listed in the directories around 1856. **Sources:** G&W; Cowdrey, NAD; NYCD 1842-57.

WILLIS, William R. *[Lithographer] mid 19th c.*
Addresses: NYC, active 1838-49. **Comments:** In 1844 he was with Willis & Probst (see entry). **Sources:** G&W; NYCD 1838.

WILLIS & PROBST *[Lithographers] mid 19th c.*
Addresses: NYC, 1844. **Comments:** The partners were William R. Willis and John Probst (see entries). **Sources:** G&W; NYBD and NYCD 1844.

WILLISON, Gertrude D. *[Miniature portrait painter, craftsperson] b.1873, Indiana.*
Addresses: NYC; Seattle, WA, 1907. **Studied:** Annie Wright Seminary, Tacoma; Mead's School, CT; with Harriett Foster Beecher; San Francisco; NYC; Chicago. **Exhibited:** Alaska Yukon Pacific Expo, 1909; Mark Hopkins Inst., San Francisco, 1905; Regional Painters of Puget Sound, 1870-1920, Mus. of Hist. & Industry, Seattle, 1986. **Comments:** Member of a pioneer Washington State family; her father was one of the framers of the State Constitution. **Sources:** WW10; Trip and Cook, *Washington State Art and Artists.*

WILLISTON, Constance Bigelow *[Painter] 19th/20th c.; b.Cambridge, MA.*
Studied: Smith College; Radcliffe; with Herbert Barnett, Samuel F. Hershey, W. Lester Stevens; Roy Morse and John M. Buckley. **Member:** Rockport AA; Copley Soc. of Boston; Cambridge AA. **Exhibited:** Rockport AA; Boston AC; Copley Soc., Boston; Cambridge AA; Soc.Indep. Artists; Speed Memorial Mus., Louisville, KY. **Comments:** Positions: teacher, private schools, Boston & Cambridge, 1896-1928. **Sources:** *Artists of the Rockport Art Association* (1946, 1956).

WILLITS, Alice *[Painter, illustrator, craftsperson] b.1885, Illinois.*
Addresses: Friendwood, TX. **Studied:** Cincinnati Art Acad. **Member:** Cincinnati Women's AC. **Sources:** WW10.

WILLITTS, E. *[Painter] late 19th c.*
Addresses: Phila., PA. **Exhibited:** PAFA Ann., 1876. **Sources:** Falk, *Exh. Record Series.*

WILLITTS, S. C. *[Listed as "artist"] mid 19th c.*
Addresses: Phila., active c.1840. **Exhibited:** Artists' Fund Society, 1840 ("Portrait of an Artist"). **Comments:** The painting "Portrait of an Artist" was owned by the artist Robert Street (see entry) and Willitts may have been one of his pupils; both were living on Vine Street at the time. **Sources:** G&W; Rutledge, PA.

WILLMAN, Joseph George *[Painter] b.1862.*
Addresses: Phila., PA. **Exhibited:** PAFA Ann., 1889-90, 1898. **Sources:** WW10; Falk, *Exh. Record Series.*

WILLMAN, T. *[Painter] mid 20th c.*
Exhibited: Salons of Am., 1934. **Sources:** Marlor, *Salons of Am.*

WILLMARTH, Arthur F. *[Illustrator, cartoonist] late 19th c.*
Addresses: Denver, CO. **Member:** Denver AC. **Comments:** Position: cartoonist, *Denver Republican.* **Sources:** WW98.

WILLMARTH, Elizabeth J. *[Painter] 19th/20th c.*
Addresses: Chicago, IL. **Sources:** WW01.

WILLMARTH, Kenneth L. *[Painter, illustrator] mid 20th c.*
Addresses: Omaha, NE. **Exhibited:** Nebraska Artists, Omaha, 1932; Kansas City AI, 1939. **Sources:** WW40.

WILLMARTH, William A. *[Designer] b.1898, Chicago, IL.*
Addresses: Omaha, NE. **Studied:** Chicago Acad. FA; Armour Inst., Chicago. **Member:** Omaha AG. **Sources:** WW40.

WILLNER, William Ewart *[Painter, designer, etcher, writer] b.1898, Duluth, MN.*
Addresses: Atlanta, GA. **Studied:** Univ. Minnesota (B.S. in Arch.); Univ. Pennsylvania (M.Arch.); ASL, with William von Schlegell. **Member:** AWCS; Brooklyn SA; Georgia Artists. **Exhibited:** PAFA; AWCS; BM; AIC; High Mus. Art; Georgia Artists. **Sources:** WW53; WW47.

WILLOUGHBY, Adeline See: **MCCORMACK, Adeline C. Willoughby**

WILLOUGHBY, Alice Estelle *[Painter] b.Groton, NY / d.1924, Wash., DC.*
Addresses: Wash., DC. **Studied:** Wash. ASL; Corcoran Art Sch. **Member:** Wash. WCC; Wash. AC; Wash. SFA (affiliate). **Exhibited:** ASL, Wash., at the Cosmos Club, 1902; Wash. WCC, 1896-1924. **Comments:** Specialty: landscapes, coastal scenes. Preferred media: oil and watercolor. **Sources:** WW24; McMahan, *Artists of Washington, DC.*

WILLOUGHBY, Annie *[Painter] late 19th c.*
Addresses: Phila., PA. **Exhibited:** PAFA Ann., 1887 (flowers & fruits). **Sources:** Falk, *Exh. Record Series.*

WILLOUGHBY, Edward C. H. *[Landscape painter] mid 19th c.*
Addresses: Chicago, 1859. **Sources:** G&W; Chicago CD 1859.

WILLOUGHBY, Sarah Cheney (Mrs. Charles) *[Painter, teacher] b.1841, MA / d.1913, Port Townsend, WA.*
Addresses: Seattle, WA; Port Townsend, WA. **Work:** Univ. Wash.

Library. **Comments:** A member of the pioneering Mercer Party, she moved to Seattle in 1862 to teach at the Territorial Univ. In 1865 she married Capt. Charles Willoughby, who was appointed Indian Agent for coastal Native American tribes. **Sources:** Trip and Cook, *Washington State Art and Artists.*

WILLOUGHBY, Walter *[Painter] mid 20th c.*
Addresses: Germantown, PA. **Exhibited:** PAFA Ann., 1929 (portrait). **Sources:** Falk, *Exh. Record Series.*

WILLS, B. *[Sculptor] early 20th c.*
Addresses: NYC. **Exhibited:** AIC, 1912. **Sources:** Falk, *AIC.*

WILLS, Edwina Wheeler (Mrs. L. Max) *[Painter, sculptor] b.1915, Des Moines, IA.*
Addresses: Waitsburg, WA, 1941. **Studied:** Grinnell College; Wash. State Univ.; Des Moines Univ. **Exhibited:** Iowa Art Salon, Des Moines, 1930-37; SAM, 1938; AIC. **Sources:** Trip and Cook, *Washington State Art and Artists.*

WILLS, Helen *[Painter] early 20th c. (act. 1920s)* **Sources:** Falk, *Dict. of Signatures.*

WILLS, J. R. *[Engraver] mid 19th c.*
Addresses: Philadelphia, 1849. **Sources:** G&W; Phila. BD 1849.

WILLS, Mary Motz (Mrs.) *[Painter] b.c.1895, Wytherville, VA.*
Addresses: Abilene, TX. **Studied:** W.M. Chase; J. Twachtmann; ASL; Phila.; Boston. **Member:** SSAL. **Exhibited:** Am. Mus. Nat. Hist.; Witte Mus., San Antonio; SSAL. **Work:** 350 Texas wildflowers in watercolor, Univ. Texas, Austin. **Sources:** WW40.

WILLS, Olive *[Painter, teacher] b.c.1890.*
Addresses: Cheyenne, WY. **Studied:** AIC; NY School Fine & Applied Arts; École d'Art, Paris. **Comments:** Art teacher in Cheyenne (WY) schools. Editor/author: *Artists of Wyoming,* 1932. **Sources:** Petteys, *Dictionary of Women Artists.*

WILLSEYK, Patricia *[Painter] mid 20th c.*
Exhibited: S. Indp. A., 1942-43. **Sources:** Marlor, *Soc. Indp. Artists.*

WILLSIE, Addie G. *[Painter] mid 20th c.*
Addresses: Kansas City, MO. **Sources:** WW24.

WILLSON, Edith Derry *[Painter, etcher] b.1899, Denver, CO.*
Addresses: Los Angeles. **Studied:** J. Pennell; ASL. **Member:** Chicago SE; NY Soc. Women P&S. **Work:** Nat. Gal., Munich; Cincinnati Lib.; Los Angeles Lib.; CMA; AIC; Detroit Mus. Art. **Sources:** WW31.

WILLSON, Frances (Mrs.) *[Painter] mid 20th c.*
Exhibited: Salons of Am., 1934. **Sources:** Marlor, *Salons of Am.*

WILLSON, James Mallory *[Painter, etcher, teacher] b.1890, Kissimmee, FL.*
Addresses: Palm Beach; West Palm Beach, FL. **Studied:** Acad. Colarossi, Paris; Rollins College; NAD; ASL; & with Henri, Bridgman, Johansen, Maynard, Fogarty. **Member:** Chicago Soc. Etchers; Florida Artists Group. **Exhibited:** SAGA, 1940, 1945; AV, 1942; NAD, 1944-1946; LOC, 1943, 1945; Soc. Four Arts, 1939, 1941 (prize), 1946; Palm Beach Art Lg., 1939, 1946; Norton Gal., 1944-45; Florida Artists Group traveling exhib., 1955-56. **Work:** LOC. **Comments:** Position: instructor, drawing & painting, Norton Sch. Art, West Palm Beach, FL, 1946-. **Sources:** WW59; WW47; WW53.

WILLSON, Joseph *[Cameo cutter, die sinker, and sculptor] b.1825, Canton, NY / d.1857, NYC.*
Addresses: Canton, NY, 1825-42; NYC, 1842-48; Washington, 1848-51; Italy, 1851-54; NYC, 1954-57. **Studied:** Salathiel Ellis, Canton, NY; portrait painting; Italy, 1851-54. **Comments:** He followed S. Ellis to NYC and there took up cameo cutting and die sinking. In Washington he was again associated with Ellis. **Sources:** G&W; Loubat, *Medallic History of the United States;* NYBD 1856-57; Cowdrey, NAD; Washington Art Assoc. Cat., 1857.

WILLSON, Martha B. See: **DAY, Martha Buttrick Willson (Mrs. Howard)**

WILLSON, Mary Ann *[Primitive watercolorist] early 19th c.* **Addresses:** Greenville, Greene County, NY, early 19th c. **Exhibited:** Harry Stone Gallery, NYC, 1944 (first solo, posthumous); Mus. Am. Folk Art, 1998 (solo). **Work:** NGA; BMFA; NY Hist. Assn., Cooperstown. **Comments:** She was active in upstate New York, 1800-25. Her decorative and brightly colored visionary works often feature Biblical historical and literary themes, and only about twenty are documented. Originally from New England, she settled in Greenville, Greene County (NY) where she lived "for many years" with a friend, Miss Brundage, who managed the farm while Miss Willson painted her primitive watercolors for sale. She used crude paints, made from berry juice, brick dust and the like. Her work became popular with local farmers and it has been said that her paintings were sold as far away as Canada and Alabama. After the death of Miss Brundage (with whom she shared a "romantic attachment") Miss Willson left Greenville and was not heard of again. **Sources:** G&W; Lipman, "Miss Mary Ann Willson," three repros.; Lipman, "Miss Willson's Watercolors," five repros.; Lipman, "Mermaids in Folk Art." More recently see CH. Rubinstein, *American Women Artists,* 32-33, with repro.; *NY-PA Collector* (review, June, 1998, p.26A); Finch, *American Watercolors,* 54 (w/repro.).

WILLSON, Robert *[Sculptor, educator] b.1912, Mertzon, TX.* **Addresses:** Miami, FL. **Studied:** Univ. Texas (B.A.); Univ. Bellas Artes, Guanajuato, Mexico (M.F.A.); also with Jose Clemente Orozco. **Member:** College Art Assn. Am.; Am. Assn. Mus. **Exhibited:** Painting & Sculpture Nat., SFMA, 1957; Int. Glass Sculpture, 1964, 1966 & 1968, Venice, 1968; Robert Willson Glass Sculpture, Mus. Correr, 1968 (solo); Ringling Art Mus., Sarasota, FL, 1970 (solo); Corning Mus. Glass, NY, 1971 (solo); Biennale Exhib., Venice, Italy, 1972; Galerie 1999, Miami, FL & Harmon Art Gallery, Naples, FL, 1970s. **Awards:** nat. hon. mention for sculpture, SFMA, 1957; Shell Co. Foundation grant for glass sculpture, 1971; grand medal award winner for sculpture, Garden Modern Art, Miami, 1972. **Work:** Mus. Correr, Venice, Italy; Nat. Glass Mus., Murano, Italy; Nat. Mus., Auckland, NZ; Witte Art Mus., San Antonio, TX; Lowe Art Mus., Coral Gables, FL. Commissions: glass sculptures, commissioned by Harmon Gallery, Naples, FL, 1969; ceramic sculptures, commissioned by Mrs. Robert Hoffman, Naples, 1970; glass sculpture doorway, commissioned by Herbert Martin, Miami, FL, 1972; enamel sculpture, Exec. Plaza, Miami, 1972. **Comments:** Preferred media: glass, enamel, ceramics. Positions: director, Council Ozark Artists, 1950-52; president & director, Florida Craftsmen, 1952-58. Publications: editor, *Kress Collection,* 1961 & author,*Art Concept in Clay,* 1967, Univ. Miami Press; author, *College-Level Art Curriculum in Glass,* Dept. Health, Educ. & Welfare, 1968. Teaching: chmn. dept art., Texas Wesleyan College, 1940-48; assoc. professor art, Univ. Miami, 1952-. Collections arranged: 3500 Years Colombian Art, Lowe Art Mus., 1960; Fragments of Egypt, Peoria Art Mus., 1969. Research: history of glass as sculpture. **Sources:** WW73; Roland Gleischer, *Some Recent Experiments in Glass,* 1965; Paul Perrot, "Robert Willson Glass Sculpture," *Mnemosyne,* 1968.

WILLSON, Rosalie S. *[Painter] early 20th c.* **Addresses:** NYC. **Member:** NAWPS. **Exhibited:** AIC, 1916-17. **Sources:** WW27.

WILLSON, Susan B. (Mrs.) *[Painter, craftsperson] b.Pennsylvania / d.1944, Seattle, WA.* **Addresses:** Seattle, WA. **Studied:** Univ. Washington; with E. Frokner, G. Galling, F. Bishoff. **Member:** Women Painters Washington. **Exhibited:** Women Painters of Wash. & SAM, 1931-38. **Sources:** Trip and Cook, *Washington State Art and Artists.*

WILLYS, Isaac *[Painter] early 19th c.* **Addresses:** Boston, 1810. **Work:** Yale Univ. Art Gal. (marine watercolor). **Sources:** Brewington, 416.

WILMARTH, Christopher Mallory *[Sculptor, instructor] b.1943, Sonoma, CA.* **Addresses:** NYC. **Studied:** Cooper Union (B.F.A., 1965). **Exhibited:** WMAA; Graham Gal., New York, 1968 (solo); Art Vivant États Unis, Dore Ashton Foundation, Maeght, France, 1970; Paula Cooper Gal., New York, 1971 -72 (solos); AIC, 1972. **Awards:** Nat. Council Arts grant, 1969; John Simon Guggenheim Mem. fellowship, 1970-71; Howard Foundation fellowship, 1972. **Work:** MoMA; Phila. Mus.; AIC; Woodward Foundation, Wash., DC; Lannan Foundation, Palm Beach, FL. **Comments:** Preferred media: glass, steel, wood. Teaching: adjunct professor sculpture, Cooper Union, 1969-; visiting critic sculpture, Yale Univ., 1971-72. **Sources:** WW73; Dore Ashton, "Radiance & Reserve," *Arts Magazine* (March, 1971); Robert Pincus Witten, "C. Wilmarth, a Note on Pictorial Sculpture" (May, 1971) & Joseph Masheck, review (June, 1972), *Artforum.*

WILMARTH, Effie B. See: **WILMARTH, Euphemia B.**

WILMARTH, Euphemia B. *[Still life and landscape painter] b.c.1856 / d.1906, Pasadena, CA.* **Addresses:** New Rochelle, NY, 1881-83, 1886; NYC, 1884. **Exhibited:** NAD, 1881-86; PAFA Ann., 1882. **Comments:** Her paintings at the NAD were all floral still lifes, particularly chrysanthemums. She listed her first name as "Effie." She had gone to California to paint landscapes when she died. **Sources:** PHF files; Falk, *Exh. Record Series.*

WILMARTH, L(emuel) E(verett) *[Genre and still life painter, teacher] b.1835, Attleboro, MA / d.1918, Brooklyn, NY.* *Lemuel E Wilmarth* **Addresses:** Paris, France, 1867; Brooklyn, NY, 1868-69; NYC, 1871-on. **Studied:** PAFA, 1850s; NAD; Kaulbach in Munich, 1859-62; École des Beaux-Arts, Paris, 1863-67 (apparently the first American to study with Gérôme). **Member:** ANA, 1871; NA, 1873; Artists Aid Soc. **Exhibited:** NAD, 1866-93; Brooklyn AA, 1869-73, 1877-78, 1884; PAFA Ann., 1876. **Comments:** Wilmarth was a highly skilled and meticulous genre painter, and his still lifes are usually of fruit. In 1868, shortly after returning from study in Europe, he became director of the schools of the Brooklyn Academy of Design, and two years later he was appointed professor of the free schools of the National Academy. He was in charge of the NAD's schools until 1890 but stopped exhibiting in their annuals in 1893. Twenty-five years later, he committed suicide. **Sources:** G&W; WW17; DAB; CAB; Clement and Hutton; *Art Annual,* XV, 284; Rutledge, PA; Falk, PA, vol. II; Swan, BA; death info courtesy Betty Krulick, Spanierman Gal., NYC.

WILMER, George *[Painter] mid 20th c.* **Addresses:** Los Angeles. **Studied:** Art Center School, Los Angeles. **Exhibited:** CGA; Am. Artists Congress, Hollywood; 48 Sts. Competition, 1939. **Sources:** WW40.

WILMER, William A. *[Stipple engraver of portraits] d.c.1855.* **Comments:** He had been a pupil of James B. Longacre of Philadelphia and did some engraving for Longacre's *National Portrait Gallery.* **Sources:** G&W; Stauffer.

WILMERDING, John *[Art historian] b.1938, Boston, MA.* **Addresses:** Princeton, NJ. **Studied:** Harvard Col. (AB, 1960); Harvard Univ. (A.M., 1961, Ph.D., 1965). **Comments:** Teaching: Dartmouth Col., 1965-77; Princeton Univ., 1988-on. Areas of expertise: 19th century landscape and marine paintings. Publications: *A History of American Marine Painting* (Little, Brown, Boston, 1968); *Fitz Hugh Lane* (New York, 1971); *Winslow Homer* (New York, 1972); *American Art* (Pelican-Penguin, 1976); *American Light: The Luminist Movement* (exh. cat., 1980); *The Art of John F. Peto* (exh. cat., 1983); *Andrew Wyeth, The Helga Pictures* (Abrams, 1987); *The Paintings of Fitz Hugh Lane* (coauthored, exh. cat., NGA, Wash. DC., 1988); *Winslow Homer in the 1870s* (coauthored, exh. cat., Art Mus. Princeton Univ., 1990); *American Views: Essays on American Art*

(Princeton, 1991). Positions: cur. & deputy dir., NGA, Wash. DC., 1977-88. **Sources:** *Who's Who In American Art* (1993-94).

WILMES, Frank *[Painter, craftsperson] b.1858, Cincinnati.* **Addresses:** Cincinnati, OH. **Studied:** L.H. Meakin; V. Nowottny; F. Duveneck. **Member:** Cincinnati AC. **Sources:** WW33.

WILMETH, Claire P. *[Painter] b.1900, Riverton, NJ.* **Addresses:** New York 22, NY. **Studied:** ASL, with George Bridgman, Wayman Adams; and in France, Italy and South America. **Member:** All. Artists Am. **Work:** Vanderpoel Collection, Chicago. **Sources:** WW59.

WILMETH, Hal Turner *[Art historian, painter] b.1917, Lincoln, NE.* **Addresses:** Lincoln, NE; Novato, CA. **Studied:** Kansas City Art Inst., with Thomas Hart Benton (B.F.A.); Univ. Chicago, with W. Middeldorf & O. Von Simson (M.A.); Univ. degli Studii, Florence, Italy, with Longhi & Salmi. **Member:** Am. Assn. Univ. Prof.; College Art Assn. Am. **Exhibited:** Kansas City AI, 1938, 1939. Awards: Fulbright grant, Italy, 1949-51. **Work:** Univ. Oklahoma. **Comments:** Positions: director, Gumps Art Gallery, San Francisco, 1954-60. Teaching: art history instructor, Univ. Nebraska, 1948-54; dean students, art history & humanities, California College Arts & Crafts, 1955-60; chmn. dept. art history, Dominican College, 1961-. **Sources:** WW73; WW40.

WILMOT, Alta E. (Miss) *[Miniature painter, teacher] late 20th c.; b.Ann Arbor, MI.* **Addresses:** NYC, 1884, 1888. **Studied:** J A. Weir; Paris with G. Courtois, Prinet, Blanc, Rixens. **Member:** SPNY; Penn. SMP; AFA. **Exhibited:** NAD, 1884, 1888; Paris Salon, 1890; AIC, 1894-96; PAFA Ann., 1903; Soc. Indep. Artists, 1918. **Sources:** WW29; Fink, *American Art at the Nineteenth-Century Paris Salons,* 407; Falk, *Exh. Record Series.*

WILMOT, Anna C. *[Artist] late 19th c.* **Addresses:** Active in Grand Rapids, MI, 1899. **Sources:** Petteys, *Dictionary of Women Artists.*

WILNER, Marie Spring *[Painter] mid 20th c.; b.Paris, France.* **Addresses:** Bronx, NY. **Studied:** Hunter College (B.A.); ASL; New School Social Res., with Camillo Egas & Samuel Adler. **Member:** Royal Soc. Art, London (life fellow); Int. Arts Guild, Monaco; Nat. Assoc. Arts & Letters; NAWA (gallery chmn., 1962; jury member, 1965; chmn. jury awards, 1967); Soc. Encouragement Progress, Paris (chevalier, 1968; officer, 1971). **Exhibited:** PAFA, 1961; Butler IA, 1963; Sheldon Swope Mus., 1968; Tweed Mus., Univ.Minnesota, 1969; Salon Autumn, Paris, 1972; Dickson Gal., Wash., DC & Sue Fischman, Fort Lauderdale, FL, 1970s. Awards: gold medal, Ann. Exhib. AAPL; Grumbacher purchase prize, NAWA; bronze medal, Third Biennale LA, Ancona, Italy. **Work:** Tweed Mus., Univ. Minnesota; Norfolk (VA) Mus.; Mus. Georgia; Bridgeport (CT) Mus.; Birmingham (AL) Mus. **Comments:** Preferred media: oils, watercolors, collage, plastic. **Sources:** WW73; Vallobra, "De l'Honneur et du Deshonneur des Hommes," article & cover, *Design* (1962).

WILNER, R. *[Painter] mid 20th c.* **Exhibited:** S. Indp. A., 1935. **Sources:** Marlor, *Soc. Indp. Artists.*

WILSHIRE, Florence L. B. *[Painter] mid 20th c.* **Addresses:** New Haven, CT. **Member:** New Haven PCC. **Sources:** WW29.

WILSON *[Painter] late 18th c.* **Comments:** Painted a view of Niagara Falls which was copied by Lt. William Pierrie (see entry) and subsequently engraved and published in 1774. **Sources:** G&W; Kelby, *Notes on American Artists,* 11.

WILSON *[Portrait painter] b.c.1824, Canada.* **Addresses:** Boston, 1860. **Comments:** He was boarding at the Hancock House in Boston. He was deaf from birth. **Sources:** G&W; 8 Census (1860), Mass., XXVIII, 172.

WILSON *[Painter] mid 19th c.* **Addresses:** Philadelphia, c.1850s. **Exhibited:** Washington AA, 1859. **Comments:** This might be Jeremy, Stephen D., or Samuel Wilson, portrait painters active in Philadelphia in the fifties. **Sources:** G&W; Washington Art Assoc. Cat., 1859.

WILSON *[Landscape painter] mid 19th c.* **Addresses:** Boston, active c.1850. **Exhibited:** Maryland Hist. Soc., 1850. **Comments:** No artist of this name was listed in the Boston directories 1849-51, and only William F. Wilson, portrait painter, from 1852-54. **Sources:** G&W; Rutledge, MHS; Boston CD 1849-51, BD 1852-54.

WILSON, Ada Buehere *[Painter] mid 20th c.* **Addresses:** Pensacola, FL. **Exhibited:** S. Indp. A., 1931. **Sources:** Marlor, *Soc. Indp. Artists.*

WILSON, Agnes E. *[Painter] 19th/20th c.* **Addresses:** San Francisco, CA. **Exhibited:** San Francisco AA, 1879. **Comments:** Specialty: landscapes, still lifes and portraits; her works are rare. Mother of Charles Theller Wilson (see entry). **Sources:** Hughes, *Artists in California,* 609.

WILSON, Albert *[Ship and ornamental carver] b.1828, Newburyport, MA / d.1893, Newburyport.* **Addresses:** Newburyport, 1828-93. **Comments:** He was a son of Joseph Wilson (see entry) and worked with his father and brother (James Warner Wilson) from about 1850 until his death. **Sources:** G&W; *Vital Records of Newburyport,* I, 416; Newburyport CD 1850-91, 1894 (date of death given); Pinckney, *American Figureheads and Their Carvers,* 141; Swan, "Ship Carvers of Newburyport," 81.

WILSON, Albert Leon *[Sculptor, illustrator] b.1920, Jamaica, NY.* **Addresses:** Rochester, NY. **Member:** Am. Craftsmen's Council; New York State Craftsmen; Lake Country Craftsmen; Sculpt-Your-Own-Bronze Club; Nantucket AA. **Exhibited:** York State Craft Fair, Ithaca College, NY; Northeast Craft Fair, Am. Craftmen's Council, Mount Snow, VT, 1967; Finger Lakes Exhib., 1971, Univ. Rochester Mem. Art Gallery; New American Sculpture, U.S. Info Agency touring exhib. to Europe, Asia & Africa, 1971-72. Awards: over twenty graphic art awards, Rochester Soc. Communicating Artists, 1957-67. **Work:** Men & Minotaurs (sculpture & print), Roberson AC, Binghampton, NY; "Our Man on the Moon" (sculpture), Strassenburg Planetarium, Rochester, NY; "Busted Bike," Roy Neuberger Collection to NY State Mus., Albany; also in collection of Gov. Nelson A. Rockefeller. Commissions: Phoenix, Allendale School, Rochester, 1968; baptismal font, Faith Lutheran Church, Webster, NY, 1969; main alter, Faith Lutheran Church, Webster, 1969; Eagle, Munic. Bldg. Courtroom, Fulton, NY, 1970; "Comet" ("Busted Bike"), Kaufman Bldg, NYC, 1972. **Comments:** Positions: layout artist & designer, J. C. Penney Co., New York, 1946-54; art director, Sibley, Lindsay & Curr, Rochester, 1956-58; art director, illustrator & free lance photographer, 1958-59; art group supervisor, Rumrill-Hoyt, Inc., 1958-67. Art interests: originator of box-beam sculpture and sculpture printing. **Sources:** WW73; "Iron Man," *Upstate* (1968); David Spengler, "He Unleashes His Art on the Steel Girder," *New Jersey Papers* (1971); article, *U.S. Info Service Photography* Bulletin (Sept., 1972).

WILSON, Alexander *[Ornithologist and sketcher] b.1766, Paisley, Scotland / d.1813, Phila.* **Comments:** Wilson worked as a weaver and peddler in Scotland until 1794 when he emigrated to America. For about ten years he taught school in New Jersey and Pennsylvania, but in 1802, after meeting the naturalist William Bartram, he began to collect material and make sketches for a work on American birds. The first volume of his classic *American Ornithology* appeared in 1808, with engravings by Alexander Lawson after Wilson's drawings, and the eighth volume was in the press at the time of Wilson's death. While working on his book Wilson had traveled widely through-

out the United States, east of the Mississippi. In 1804 he made a sketch of Niagara Falls which was engraved for *Port Folio,* March 1810. Wilson also tried his hand at engraving and etching, but with little success. **Sources:** G&W; DAB; Stauffer; Weitenkampf, "Early American Landscape Prints," 42.

WILSON, Alfred F. *[Portrait painter] b.c.1829, Pennsylvania.* **Addresses:** Phila., 1850. **Sources:** G&W; 7 Census (1850), Pa., L, 607.

WILSON, Alice See: **VITACCO, Alice Pratt (L. Alice Wilson)**

WILSON, Anna *[Portrait painter] mid 20th c.; b.San Francisco, CA.* **Addresses:** Hollywood, CA, 1930s. **Member:** Laguna Beach AA. **Exhibited:** Acad. Western Painters, 1936-38; Soc. for Sanity in Art, 1940; Oakland Art Gallery, 1940. **Sources:** Hughes, *Artists in California,* 609.

WILSON, Anna E. *[Painter] mid 20th c.* **Exhibited:** Salons of Am., 1928. **Sources:** Marlor, *Salons of Am.*

WILSON, Anna Keene (Mrs. Edward C.) *[Painter] mid 20th c.* **Addresses:** Baltimore, MD. **Sources:** WW25.

WILSON, Annie B. *[Painter] late 19th c.* **Addresses:** Trenton, NJ, 1894-95. **Exhibited:** PAFA Ann., 1894-95 (landscapes). **Sources:** Falk, *Exh. Record Series.*

WILSON, Annie L. *[Artist] late 19th c.* **Addresses:** Active in Detroit, MI. **Studied:** Maud Mathewson. **Exhibited:** at Mathewson's studio, 1893. **Sources:** Petteys, *Dictionary of Women Artists.*

WILSON, Arthur Russell *[Painter, etcher, architect] b.1893, Fergus Fall, MN / d.1966, San Francisco, CA.* **Addresses:** San Francisco. **Studied:** printmaking with Max Reno, Arthur Millier, Millard Sheets. **Exhibited:** GGE, 1939. **Comments:** Position: architect, C.W. Wilson & Sons, Hollywood, 10 years. Specialty: drypoints, marines and landscapes in oil. **Sources:** Hughes, *Artists in California,* 609.

WILSON, Ashton (Miss) *[Painter] b.1880, Charleston, WV / d.1952, NYC.* **Addresses:** NYC/White Sulphur Springs, WV. **Studied:** Chase; Hawthorne; Beaux; Twachtman; Borglum; F. Howell; ASL; Acad. Colarossi Paris. **Member:** NAWPS; PBC. **Exhibited:** PAFA Ann., 1925; Soc. Indep. Artists, 1926-27. **Work:** Capitol, WV; Wash., DC. **Comments:** Illustrator: *Gardens of Virginia.* **Sources:** WW40; Falk, *Exh. Record Series.*

WILSON, Beatrice Hope *[Painter] mid 20th c.* **Addresses:** NYC. **Studied:** ASL. **Member:** Soc. Indep. Artists. **Exhibited:** Soc. Indep. Artists, 1921. **Sources:** WW25.

WILSON, Ben *[Painter, lecturer, teacher] b.1913, Phila.* **Addresses:** Ridgefield, NJ; Woodside, NY. **Studied:** NAD, 1931-33; City College New York, with Eggers (B.S.S., 1935); Acad. Julien, Paris, France, 1953-54; K. Anderson; L. Kroll. **Member:** Art Lg. Am.; Soc. Indep. Artists; Hetero Art Group; Modern Artists Guild (vice-pres., 1963); New Jersey AA. **Exhibited:** Riverside Mus., 1942, 1955; Am.-British AC, 1943; Soc. Indep. Artists, 1944; Audubon Artists, 1945; Norlyst Gal., 1945; Pepsi-Cola, 1946; PAFA Ann., 1946; Newark Mus., 1956, triennial, 1961; Montclair Mus., 1956-72 (nine exhibs.); Everhart Mus., 1965 & 1966; New Jersey Pavilion, New York World's Fair, 1965-66; Galerie AG, Paris, France, 1970s. **Awards:** CCNY, 1933 (prize); NAD, 1932 (medal); Agnes B. Noyes Award for watercolor, 1959 & Skinner award for abstract oils, 1963, Montclair Mus.; Ford Foundation artist-in-residence, Everhart Mus., 1965. **Work:** Everhart Mus., Scranton, PA; Fairleigh Dickinson Collection Self Portraits; Norfolk (VA) Mus.; Fabergé Collection, Ridgefields, NJ; Almeras Collection, Paris. **Comments:** Preferred media: oils. Publications: author, *Cobra,* Artists Proof, 1966. Teaching: instructor painting & drawing, City College New York, 1946-48; instructor life drawing, Jamesine Franklin School Art, 1950; lec-

turer modern art, New York Univ., 1962-68. **Sources:** WW73; Bugatti, *International Encyclopedia of Artists* (Univ. Europa, 1970-71); WW47; Falk, *Exh. Record Series.*

WILSON, Bryan *[Painter] mid 20th c.* **Exhibited:** PAFA Ann., 1966. **Sources:** Falk, *Exh. Record Series.*

WILSON, Carolyn Haeberlin See: **HAEBERLIN, Carolyn (Mrs. R. Wilson)**

WILSON, Carrington *[Painter] mid 19th c.* **Addresses:** NYC, active 1840-45. **Exhibited:** NAD, 1841 ("Landing of Columbus"). **Comments:** He was a sign painter by trade. **Sources:** G&W; Cowdrey, NAD; NYCD 1840-45.

WILSON, Charles *[Painter] mid 20th c.* **Addresses:** NYC. **Member:** Soc. Indep. Artists; Bronx AG. **Exhibited:** Salons of Am.; Soc. Indep. Artists, 1917-21, 1926-27. **Sources:** WW27.

WILSON, Charles *[Sculptor] b.1937.* **Addresses:** Branford, CT. **Exhibited:** WMAA, 1964. **Sources:** Falk, *WMAA.*

WILSON, Charles Banks *[Painter, lithographer, illustrator, writer] b.1918, Springdale, AR.* **Addresses:** Miami, OK in 1976. **Studied:** AIC, lithography with Francis Chapin, painting with Louis Riman & Boris Anisfeld & watercolor with Hubert Ropp. **Exhibited:** AV, 1944; 1945; NAD, 1942-46; LOC,1943-46; SFMA, 1943-46; SAM, 1943-46; Philbrook Art Ctr., 1944-46; Int. Watercolor Exhib., AIC, 1939; Am. Watercolor Exhib., Springfield, MO, 1970; some 200 nat. & regional exhibs. **Awards:** Arkansas Exhib., 1946 (prize); Chicago Soc. Lithographers & Etcher Award, 1939; first prize for prints, Brooklyn Mus., 1943, 1944; LOC Purchases, Nat. Print Exhib., 1944-54; Oklahoma Artists, 1945 (prize); NGA, 1946 (prize). **Work:** MMA; CGA; Gilcrease Inst. Am. Hist. & Art, Tulsa, OK; Joslyn Art Mus., Omaha, NE; Smithsonian Inst., Wash., DC; LOC. Commissions: 50 watercolors, Ford Motor Co., 1951-69; oil mural, commissioned by J.D. Rockefeller, Jr., Jackson Lake Lodge, WY, 1955; portraits, of Thomas Gilcrease, Gilcrease Inst. Am. Hist. & Art, 1957 & Will Rogers, Oklahoma Press Assn., Oklahoma City, 1961; rotunda murals, Oklahoma State Legislature, 1970. **Comments:** Preferred media: egg tempera. Publications: illustrator, *Treasure Island,* 1948; *Company of Adventures,* 1949; *The Mustangs,* 1952 & *Geronimo,* 1958; author, *Indians of Eastern Oklahoma,* 1957. Teaching: head art dept., Northeastern Oklahoma Agriculture & Mechanical College, 1947-60. **Sources:** WW73; WW47; "An Indian Party," *Collier's Magazine,* 7/25/1942; "Hold Before the Young," *Oklahoma Today,* 1969; "Painting Mural Portraits," *Am. Artists,* 11/1969; P&H Samuels, 532.

WILSON, Charles J. A. *[Etcher, painter, illustrator] b.1880, Glasgow, Scotland / d.1965, Newtonville, MA?.* **Addresses:** Duluth, MN, 1881; Newtonville, MA. **Studied:** self-taught. **Member:** Boston Soc. Printmakers; PAFA, 1929; Int. Printmakers, 1930; Currier Gal. Art, 1932; Lyman Allyn Mus., 1934; SAE, 1931; LOC,1943, 1944. **Exhibited:** Soc. Indep. Artists, 1928; PAFA, 1929; Int. Printmakers, 1930; Currier Gal. Art, 1932; Lyman Allyn Mus., 1934; SAE, 1931; LOC, 1943, 1944; Boston Soc. Printmakers, 1948-50. **Work:** Marine Mus., Boston; New Haven R.R.; U.S. Coast Guard Acad., New London, CT; Mun. Mus. of Baltimore; U.S, Naval Acad., Annapolis, MD; Mariner's Mus., Newport News, VA; Peabody Mus., Salem, MA; MIT. **Comments:** He worked for the Bethlehem Shipbuilding Co., etching their ships from blueprints. During WWII he worked for the U.S. Coast Guard in Boston. Signature note: he signed his etchings with a monogram "W" atop an anchor. **Sources:** WW59; WW47; Brewington, 417.

WILSON, Charles Theller *[Landscape painter] b.1885, San Francisco, CA / d.1920, NYC.* **Addresses:** Eureka, CA. **Studied:** with his mother; with Jules

Tavernier. **Exhibited:** Calif. State Fair, 1888. **Work:** Clarke Mem. Mus., Eureka; Eureka Court House. **Comments:** Specialty: Calif. redwoods. Son of Agnes E. Wilson (see entry). **Sources:** Hughes, *Artists in California,* 609.

WILSON, Claggett *[Painter] b.1887, Wash., DC / d.1952, NYC.*
Addresses: Boston, MA. **Studied:** ASL; F.L. Mora; R. Miller; Acad. Julian, Paris, with J. P. Laurens, 1909. **Member:** Soc. Indep. Artists; Salons of Am. **Exhibited:** PAFA Ann., 1912; Armory Show, NY, 1913; Soc. Indep. Artists, 1917-1934; WMAA, 1920-28; Salons of Am.; AIC. **Work:** BM; MMA. **Comments:** Auth./Illustr.: *The War Pictures of Claggett Wilson* (Sears Pub, NYC, 1928). **Sources:** WW40; McMahan, *Artists of Washington, DC; Falk, Exh. Record Series.*

WILSON, Clara Powers *[Painter, sculptor] late 19th c.*
Addresses: Chicago, IL; NYC, 1893. **Exhibited:** PAFA Ann., 1893; NAD, 1893. **Sources:** WW19; Falk, *Exh. Record Series.*

WILSON, D. W. *[Engraver] early 19th c.*
Comments: Engraved a ball ticket and a bookplate, Albany, about 1825-30. *Cf.* David West Wilson. **Sources:** G&W; Stauffer.

WILSON, David Philip *[Painter] mid 20th c.*
Exhibited: AIC, 1930, 1938. **Sources:** Falk, *AIC.*

WILSON, David West *[Miniaturist] b.c.1799 / d.1827, NYC.*
Addresses: NYC, 1827 and before. **Member:** NA (cofounder). **Comments:** His miniature of Kosciuzko was stolen from the Academy. *Cf.* D.W. Wilson. **Sources:** G&W; N.Y. *Evening Post,* April 28, 1827, obit. (Barber); N.Y. *Mirror,* Dec. 24, 1825, p. 175 (courtesy Mary Bartlett Cowdrey); Cowdrey, AA & AAU.

WILSON, Della Ford *[Educator, craftsperson, writer] b.1888, Hartsell, AL.*
Addresses: Madison 3, WI. **Studied:** James Milliken Univ. (B.S.); Peoples Univ., St. Louis, with Frederick Rhead; Alfred Univ., with Charles F. Binns; Teachers College, Columbia Univ. (M.A.). **Member:** Nat. Educ. Assn.; Wisconsin Teachers Assn.; Western AA; Nat. Lg. Am. Pen Women; Madison AA. **Exhibited:** Wisconsin Salon Artists, 1942; Madison AA, 1941. **Comments:** Position: professor, art educ., 1915-54, prof. emeritus, 1954-, chmn., art educ. dept., 1943-46, Univ. Wisconsin, Madison, WI. Author/ illustrator: *Primary Industrial Arts,* 1927-35. **Sources:** WW59; WW47.

WILSON, Donald Roller *[Painter] b.1938.*
Addresses: Fayetteville, AK. **Exhibited:** WMAA, 1975. **Sources:** Falk, *WMAA.*

WILSON, Donna A. See: **CRABTREE, Donna**

WILSON, Dorothy Gilbert *[Artist] b.1889 / d.1988.*
Member: Woodstock AA. **Sources:** Woodstock AA.

WILSON, Douglas *[Painter, graphic artist] mid 20th c.*
Addresses: Chicago, IL. **Exhibited:** AIC, 1937-38, 1942; Int. WC Ann. (1937, 1938), Int. Li.-En Ann. (1937, 1938), Artists Chicago, Vicinity (1938), Fed. Art Project Exhib., 1938, all at AIC. **Sources:** WW40.

WILSON, E. *[Itinerant portrait painter] mid 19th c.*
Comments: He painted portraits of Rev. and Mrs. Frank Cooper of Antrim (NH). **Sources:** G&W; Sears, *Some American Primitives,* 286; Lipman and Winchester, 182; more recently, see Campbell, *New Hampshire Scenery,* 176, who states that he may be the same as E. T. Wilson.

WILSON, E. H. *[Sign and ornamental painter] mid 19th c.*
Addresses: Wooster (OH), 1820-50. **Sources:** G&W; Knittle, *Early Ohio Taverns,* 44.

WILSON, E. M. *[Painter] late 19th c.*
Addresses: NYC, 1880-86. **Exhibited:** NAD, 1880-86. **Sources:** Naylor, *NAD.*

WILSON, E. (Miss) *[Portrait painter] mid 19th c.*
Addresses: Chicago, 1855. **Sources:** G&W; *Chicago Almanac,* 1855.

WILSON, E. (Mrs.) *[Artist] late 19th c.*
Addresses: Active in Grand Rapids, MI. **Exhibited:** Michigan State Fair, 1880. **Sources:** Petteys, *Dictionary of Women Artists.*

WILSON, Ed *[Artist] mid 20th c.*
Addresses: Durham, NC. **Exhibited:** PAFA Ann., 1960. **Sources:** Falk, *Exh. Record Series.*

WILSON, Edgar *[Sculptor] b.1886 / d.1941, Phila.?.*
Addresses: Phila., PA. **Exhibited:** PAFA Ann., 1925. **Sources:** WW25; Falk, *Exh. Record Series.*

WILSON, Edith L. *[Painter] mid 20th c.*
Addresses: Chicago area. **Exhibited:** AIC, 1940, 1942. **Sources:** Falk, *AIC.*

WILSON, Edward *[Sculptor] late 19th c.*
Addresses: Princeton, NJ, 1899. **Exhibited:** PAFA Ann., 1898, 1900 (religious subjects); NAD, 1899. **Sources:** Falk, *Exh. Record Series.*

WILSON, Edward Arthur *[Illustrator, lithographer, painter, educator, designer, block printer] b.1886, Glasgow, Scotland / d.1970, Dobbs Ferry, NY.*
Addresses: Truro, MA. **Studied:** AIC; & with Howard Pyle. **Member:** SC; ANA; Royal Soc. Artists (fellow); Century Assn.; AIGA; SI, 1912; Artists Guild; AI Graphic Artists; Players Club. **Exhibited:** SI, 1954 (solo); RISD, 1953; Pratt Inst., 1954. **Awards:** medal, Art Dir. Club, NY, 1926, 1930; prizes, SC, 1926, 1942; Bookplate International, Los Angeles, 1923; Phila. Pr. Club, 1936 (prize); Limited Editions Club, silver medal, 1954. **Work:** LOC; NYPL; MMA; Princeton Pr. Club. **Comments:** Illustrator: *Iron Men and Wooden Ships; The Hunting of the Snark,* 1932; *A Shropshire Lad,*1935; *The Tempest,* 1940; *Jane Eyre,* 1944; *Westward Ho!,* 1946; *Ivanhoe; Dr. Jekyll and Mr. Hyde; The Book of Edward A. Wilson; The Seven Voyages of Sinbad the Sailor; By These Words,* 1954; *Twenty Thousand Leagues Under The Sea,* 1955 (over 60 books in all). Contributor to advertising campaigns. **Sources:** WW59; WW47.

WILSON, Edward N. *[Sculptor, educator] b.1925, Baltimore, MD.*
Addresses: Binghamton, NY. **Studied:** Univ. Iowa (B.A., M.A.); Univ. North Carolina. **Member:** College Art Assn. Am. (board dirs., 1970, secretary & chmn. artists commission, 1971-); State Univ. NY-Wide Committee Arts. **Exhibited:** Univ. Iowa, 1951, 1954; North Carolina A&T College, Greensboro, 1955; North Carolina Artists Ann., Raleigh, 1955; North Carolina Mus. Art, Raleigh, 1955, 1961 & 1962; Duke Univ., Durham, NC, 1956; BMA, 1956 (award for sculpture), 1962; Madison Square Garden, NYC, 1958; Silvermine Guild Artists, New Canaan, CT, 1959; Chapel Hill (NC) Art Gal., 1959; Cecile Art Gal., NY, 1959 (1st award, sculpture); Allied Arts Durham, NC, 1960; 155th Ann. Exhib. Am. Painting & Sculpture, PAFA & Detroit Inst. Arts, 1960; Univ. North Carolina, Greensboro, 1961-62; Howard Univ., 1961(purchase prize for sculpture, New Vistas in Am. Art), 1970; Mint Mus., Charlotte, NC, 1962; Am. Negro Art, Univ. Calif., Los Angeles, 1966 Univ. Calif., Davis, 1966, San Diego & Oakland, CA, 1967; State Univ. New York at Binghampton, 1966; Fine Arts Gal. San Diego, 1967; Oakland Art Mus., 1967; Colgate Univ., Hamilton, NY, 1967; Artists Central New York, Munson-Williams-Proctor Mus., 1966-68; 30 Contemporary Black Artists, nat. circulated, 1968-70. **Awards:** Carnegie Research Grant; fellowship, State Univ. New York, 1966-68. **Work:** Howard Univ. **Commissions:** mem. in bronze, Duke Univ., Durham, NC, 1965; JFK (park design & sculpture), City of Binghamton & Sun Bull Fund, NY, 1966-69; Second Genesis (aluminum sculpture), City of Baltimore for Lake Clifton School, MD, 1970-71; mem. in bronze, Harlem Commonwealth Council, 1972; Middle Passage (concrete & bronze), City of New York, Brooklyn, NY, 1972-73.

Comments: Preferred media: metals, concrete. Positions: artists-in-residence, humanities div., Western Michigan Univ., 1969. Publications: author, *Contemporary Sculpture; Some Trends & Problems*, 1963; author, "Statement,"*Arts in Society*, fall-winter 1968-69; author, "CAA & Negro Colleges," *Arts in Soc*, winter 1968-69. Teaching: professor sculpture, State Univ. NY Binghamton, 1964-, chmn. dept. art & art history, 1968-72. **Sources:** WW73; Cedric Dover, *American Negro Art* (NY Graphic Soc., 1960); "Art & Rebuttal," *Christian Science Monitor*, April 21, 1971; H. Hope, article, *Art Journal* (spring) Vol. 31, No. 3; Cederholm, *Afro-American Artists*.

WILSON, Edwin *[Painter, block-printer, illustrator] mid 20th c.* **Sources:** Falk, *Dict. of Signatures.*

WILSON, Eleanor Hubbard *[Painter] mid 20th c.* **Addresses:** NYC. **Exhibited:** S. Indp. A., 1932. **Sources:** Marlor, *Soc. Indp. Artists.*

WILSON, Ellen Louise Axon (Mrs. Woodrow) *[Painter] b.Savannah, GA / d.1914, White House, Wash., DC.* **Addresses:** Princeton, NJ. **Studied:** Women's College, Rome; ASL. **Member:** NAWA. **Exhibited:** NAD; NAWA; AIC, 1912; PAFA Ann., 1913. **Comments:** (Ellen Louise Axon). Wife of the President of the U.S. **Sources:** Falk, *Exh. Record Series.*

WILSON, Ellis *[Painter, illustrator] b.1900, Mayfield, KY.* **Addresses:** NYC. **Studied:** Kentucky State College; X. Barile; AIC. **Member:** United Am. Artists. **Exhibited:** AIC, 1923 (prize); American Negro Expo, Chicago, 1940; Caresse Crosby Gal., Barnett Aden Gal., both in Wash., DC; WFNY, 1939; Atlanta Univ., 1946 (prize); Mechanics' Inst., NYC (prize); Downtown Gal., Contemporary Art Gal., Int. Pr. Gal., Vendôme Gal., all in NYC; Harmon Fnd. Traveling Exh.; Terry AI, 1952 (prize), 1953 (prize); Kentucky So. Indiana Exhib., 1954 (prize); I. B. Speed Mus. Art (solo); Murray State College, KY; Mayfield Pub. Lib.; South Side AC, Chicago. Awards: Guggenheim Fellowship, 1944-46; Charles S. Peterson Prize for African Poster. **Work:** NYPL, Schomburg Collection. **Sources:** WW59; Cederholm, *Afro-American Artists*, Cederholm cites a birth date of 1899.

WILSON, Eloise H. *[Block printer] mid 20th c.* **Addresses:** Edgewood, MD. **Exhibited:** Northwest Printmakers, 1936. **Sources:** WW40.

WILSON, Emily L(oyd) *[Painter] b.1868, Altoona, PA.* **Addresses:** Beach Haven, NJ/St. Augustine, FL; Phila., PA, 1895. **Studied:** Phila. Sch. Design for Women; W. Sartain. **Member:** Plastic Club. **Exhibited:** NAD, 1895. **Work:** St. Augustine Hist. Soc. Mus. **Sources:** WW31.

WILSON, Ernest M(arius) *[Painter, graphic artist, illustrator, commercial artist] b.1885, Goteborg, Sweden / d.1969, Los Angeles.* **Addresses:** Occanside, CA; Vista, CA. **Studied:** Germany; California AI; Art Center Sch., Los Angeles; Univ. California (B.A.), and with Carl Oscar Borg. **Member:** Santa Monica AA; Westwood Village AA; Carlsbad-Occanside Art Lg.; Vista Art Gld. **Exhibited:** Sweden, 1932; Montana State Fair, 1918 (prize), 1919 (prize),1920; Goteborg, Sweden, 1920 (prize); Pomona County Fair, 1922, 1924; Santa Monica AA, 1946 (prize)-1948 (prize); Westwood Village AA, 1949; Santa Monica Lib., 1948-50; San Diego Fair, 1955; Carlsbad Acad. Exhib., 1955; LACMA, 1925, 1930. **Comments:** Position: teacher, Thomas Edison High School. Contributed covers to *California Classroom Teacher.* **Sources:** WW59.

WILSON, Esther (Hester) *[Painter] late 19th c.; b.Richmond, VA.* **Studied:** Fantin La Tour; Mathieu. **Exhibited:** Paris Salon, 1869, 1870. **Sources:** Fink, *American Art at the Nineteenth-Century Paris Salons*, 407.

WILSON, Estol *[Painter] b.1879.* **Addresses:** Hastings, NY. **Exhibited:** AIC, 1899-1900, 1908, 1922. **Sources:** WW19.

WILSON, Fannie Holmes (Mrs.) *[Portrait painter] late 19th c.* **Addresses:** NYC, 1879; Brooklyn, NY, 1880. **Exhibited:** NAD, 1879-80. **Sources:** Naylor, *NAD.*

WILSON, Floyd *[Painter] early 20th c.* **Addresses:** Portland, OR. **Comments:** Affiliated with Portland Pub. Lib. **Sources:** WW15.

WILSON, Floyd *[Artist] b.1887 / d.1945.* **Member:** Woodstock AA. **Work:** Woodstock AA. **Sources:** Woodstock AA.

WILSON, Francis Vaux *[Illustrator] b.1874, Phila., PA / d.1938.* **Addresses:** Old Lyme, CT. **Studied:** PAFA; Henri. **Member:** Phila. AC; Salmagundi Club. **Sources:** WW31.

WILSON, Frederick *[Painter, illustrator, craftsperson] b.1858, Great Britain.* **Addresses:** NYC; Phila., PA. **Studied:** C. Wilson, in England. **Member:** Arch. Lg., 1911; AC Phila. **Exhibited:** PAFA Ann., 1893; Paris, 1900 (gold). **Work:** murals/stained glass: Cuyahoga County Court House, Cleveland, OH; St. Clement's Church, Phila.; Manchester Cathedral, England; cartoons/mosaic, Clevelands; cartoons, Staten Island, N.Y.; U.S. Naval Acad., Annapolis. **Sources:** WW21; Falk, *Exh. Record Series.*

WILSON, Frederick Francis *[Cartoonist] b.1901, Aurora, MO.* **Addresses:** San Diego, CA. **Studied:** W.L. Evans School of Cartooning, Cleveland. **Work:** Huntington Library Art Gal., San Marino, CA; Franklin Inst., Phila. **Comments:** Position: staff cartoonist, *San Diego Union-Tribune.* **Sources:** WW40.

WILSON, George L. *[Painter] b.1930, Windsor, NC.* **Studied:** Pittsburgh AI; School of Visual Art, NYC; National Academy Sch. of Fine Arts. **Exhibited:** Uptown Gal., NYC, 1964; Harlem's 1st Outdoor Show (Tucker Award); Carl Van Vechten Gal.; Fisk Univ.; New York Bank for Savings; Bowery Savings Bank; Brooklyn Mus.; Oakland Mus.; Nat. Academy of Art Gals.; Studio Mus., Harlem, 1969; Smith-Mason Gal., 1971. Awards: Emily Lowe Award, 1963. **Sources:** Cederholm, *Afro-American Artists.*

WILSON, George W. *[Listed as "artist"] b.c.1830, Virginia.* **Addresses:** Cincinnati, 1860. **Comments:** Mulatto artist, residing with Robert Duncanson. He had a photographic gallery there in 1861, but he may also have been a painting pupil of Duncanson. **Sources:** G&W; 8 Census (1860), Ohio, XXV, 255; Cincinnati CD 1861.

WILSON, Gilbert Brown *[Painter, sculptor, illustrator] b.1907, Terre Haute, IN.* **Addresses:** Terre Haute. **Studied:** Indiana State. Teachers College; AIC; Yale Sch. FA. **Member:** Am. Artists Congress; Art Lg. Am. **Exhibited:** Hoosier Salon, 1929 (prize), 1933 (prize); BAID, 1930 (prize); Indiana State Kiwanis (prize). **Work:** murals, Woodrow Wilson Jr. H.S., Terre Haute, IN; Indiana State Teachers College; Antioch College, Yellow Springs, OH; hotel, Lake Wawasee, IN. **Sources:** WW53; WW47.

WILSON, Gladys Lucille *b.1906, Texas.* **Studied:** Univ. Chicago; Columbia Univ. (M.A.); AIC. **Exhibited:** Chicago Art League, 1928; Harmon Fnd., 1933. **Sources:** Cederholm, *Afro-American Artists.*

WILSON, Grace (Mrs.) *[Painter] mid 20th c.* **Addresses:** Pittsburgh, PA. **Member:** Pittsburgh AA. **Sources:** WW25.

WILSON, H. & O. *[Painters] mid 19th c.* **Exhibited:** Illinois State Fair, 1855. **Comments:** Second prize winners at the Illinois State Fair for animal painting in oils. Probably Henry and Oliver Wilson (see entries) who had a marble works in Chicago at that time under the name of H. & O. Wilson. **Sources:** G&W; Chicago *Daily Press*, October 15, 1855; Chicago CD 1855.

WILSON, Harold Morris *[Commercial artist] b.1912, Des Moines, IA.*
Addresses: Des Moines. **Studied:** with Harriet Macy; Cumming School Art, with Alice McKee Cumming. **Comments:** Position: editor, art dept., *Register* and *Tribune.* **Sources:** Ness & Orwig, *Iowa Artists of the First Hundred Years,* 222.

WILSON, Harriet (Mrs. William E.) *[Painter] b.1886, NYC.*
Addresses: West Orange, NJ. **Member:** AWCS; New Jersey WC Soc.; All. Artists Am.; Art Center of the Oranges. **Exhibited:** AWCS,1934, 1936, 1939 (prizes); Newark Art Club (prizes, 1949, 1952); Art Center of the Oranges (prizes, 1948-52, 1954, 1955); New Jersey WC Soc. (prize, 1954; All. Artists Am., 1948-54 (prize, 1953). **Sources:** WW59; WW47.

WILSON, Hazel Marie *[Painter] b.1899, Chicago.*
Addresses: Living in Union, NM, 1915. **Studied:** AIC; with Xavier Gonzales, San Antonio; Cyril Kay-Scott in El Paso, TX; with Dey de Ribcowsky. **Exhibited:** El Paso, Denver, Las Cruces and Santa Fe. **Sources:** Petteys, *Dictionary of Women Artists.*

WILSON, Helen *[Painter, teacher] b.1884, Lincoln, NE / d.1974, NYC.*
Addresses: Lincoln, NE; NYC. **Studied:** AIC; C. W. Hawthorne; H. Breckenridge; D. Garber; W. Adams; Fountainebleau Sch. FA. **Member:** Lincoln AG. **Exhibited:** Soc. Indep. Artists; St. Paul, MN, 1917; Kansas City, 1923; PAFA Ann., 1952; Nebraska AA, regularly; Lincoln AG. **Comments:** Position: teacher, H.S., Lincoln, NE. **Sources:** WW40; Falk, *Exh. Record Series.*

WILSON, Helen Frances *[Painter] b.1850, Portland, ME / d.1910, Berkeley, CA.*
Addresses: San Francisco; Berkeley. **Studied:** San Francisco. **Member:** San Francisco AA. **Exhibited:** San Francisco AA, 1885; Mechanics' Inst., 1893. **Work:** Calif. Genealogical Soc., San Francisco. **Sources:** Hughes, *Artists in California,* 610.

WILSON, Helen Louise *[Sculptor] mid 20th c.; b.Chicago.*
Addresses: NYC. **Studied:** Wellesley College (B.A.), and with Bourdelle, Lantchansky, in Paris, France. **Member:** Sculptors Gld.; Audubon Artists; NAWA; Arch. Lg. **Exhibited:** WFNY 1939; WMAA, 1949; NAWA, annually; Sculptors Gld., annually; Audubon Artists, annually; PAFA, 1952; Salon d'Automne, Salon des Independentes, Paris; Argent Gal., 1950 (solo); Riverside Mus., 1957. **Awards:** Nat. Comm. FA, Wash., DC, 1940; NAWA, 1949, 1957; Arch. Lg., 1952; Audubon Artists, 1957. **Work:** relief, USPO, Lowville, NY. **Sources:** WW59.

WILSON, Henrietta *[Painter, teacher] 19th/20th c.; b.Cincinnati, OH.*
Addresses: Norwood, OH; Cincinnati, OH, 1896. **Studied:** Cincinnati Art Acad. **Member:** Cincinnati Women's AC (pres., 1902); Crafters Club; Ohio-Born Women Painters. **Exhibited:** NAD, 1896; AIC, 1896-1902; Soc. Western Artists, 1898. **Comments:** Position: teacher, Cincinnati Art Acad., c.1910-40. **Sources:** WW40.

WILSON, Henry *[Listed as "artist"] b.c.1835, Pennsylvania.*
Addresses: Phila., 1860. **Sources:** G&W; 8 Census (1860), Pa., LV, 210.

WILSON, Henry *[Portrait painter] mid 19th c.*
Addresses: Brooklyn, NY, 1857. **Sources:** G&W; Brooklyn BD 1857.

WILSON, Henry *[Marble cutter] mid 19th c.*
Addresses: Chicago, active 1849-60. **Exhibited:** Illinois State Fair (prize for animal painting in oils). **Comments:** He was listed as a sculptor in 1851 and in 1855, with Oliver Wilson (see entry). **Sources:** G&W; Chicago CD 1849-60; Chicago *Daily Press,* Oct. 15, 1855.

WILSON, Hilda Loveman *[Writer] b.1915, Chattanooga, TN.*
Addresses: New York 68, NY. **Studied:** Barnard College, Columbia Univ. (A.B.). **Comments:** Position: art editor, *Newsweek,* 1942-47; freelance writer, 1947-. Contributor:

Newsweek weekly department containing news of art events & personalities. **Sources:** WW59.

WILSON, Holt C. *[Painter] b.1855.*
Addresses: Portland, OR. **Exhibited:** AIC, 1895. **Sources:** Falk, *AIC.*

WILSON, Howell *[Painter] early 20th c.; b.Phila.*
Addresses: Phila., PA. **Studied:** PAFA; London. **Member:** Phila. AC. **Exhibited:** AIC, 1902-03. **Sources:** WW08.

WILSON, Isabella Maria *[Painter] early 19th c.*
Comments: Known for still life on velvet, dated 1826. **Sources:** Petteys, *Dictionary of Women Artists.*

WILSON, J. *[Portrait and miniature painter] mid 19th c.*
Addresses: NYC, 1844. **Comments:** *Cf.* John Wilson (artist, 1850) and John T. Wilson (portrait painter, 1860). **Sources:** G&W; NYBD 1844, 1860; NYCD 1850.

WILSON, J. B. *[Portrait painter] early 19th c.*
Addresses: South Carolina, active 1804. **Comments:** Painted a portrait of James B. Richardson, Governor of South Carolina, 1802-04; signed and dated 1804. **Sources:** G&W; Information courtesy the late William Sawitzky.

WILSON, J. Coggeshall *[Painter] 20th c.; b.NYC.*
Addresses: NYC. **Exhibited:** Paris Salon, 1902 (prize); PAFA Ann., 1903. **Sources:** WW04; Falk, *Exh. Record Series.*

WILSON, J. G. *[Portrait painter] mid 19th c.*
Addresses: New Orleans, 1838-42. **Sources:** G&W; New Orleans CD 1838, 1841-42; more recently, see *Encyclopaedia of New Orleans Artists,* 416, where it is stated that this was possibly John Graham Wilson, born c.1818 and died in New Orleans, 1879.

WILSON, James *[Copperplate engraver] early 19th c.*
Addresses: Bradford, VT. **Comments:** He was associated in 1813 with Isaac Eddy of Wethersfield. **Sources:** G&W; Stauffer.

WILSON, James *[Listed as "artist"] b.c.1826, England.*
Addresses: NYC, 1860. **Comments:** His wife and three children (aged 2 to 8) were born in New York. Possibly the same as James Claudius Wilson. **Sources:** G&W; 8 Census (1860), N.Y., LIV, 361.

WILSON, James Claudius *[Marine painter] mid 19th c.; b.Scotland.*
Addresses: NYC, active 1855 and after. **Exhibited:** Am. Inst., 1856 (oil painting, "National Guard"). **Comments:** He was brought to America at the age of ten by his father and uncle, who were employed as commercial copyists in NYC. During the latter fifties and the sixties he painted pictures of ships in the NYC area. Possibly the same as James Wilson. **Sources:** G&W; Peters, "Paintings of the Old `Wind-Jammer,'" 31-32, repro.; NYCD 1855-57; Am. Inst. Cat., 1856.

WILSON, James Perry *[Landscape painter, dioramist] b.1892, Bordenton, NJ / d.1976.*
Studied: trained as a designer-artist at a noted architectural firm. **Work:** Dioramas for the Am. Mus. Nat Hist, NYC. **Comments:** Painting locations include Monhegan Island (ME), where, in 1932, he met a man who suggested he submit work to the American Museum of Natural History's preparation department. Wilson went on to work for the Museum for over 20 years, creating more than thirty dioramas. **Sources:** Curtis, Curtis, and Lieberman, 114, 187.

WILSON, James Warner *[Ship and ornamental carver] b.1825, Newburyport, MA / d.1893, Newburyport.*
Comments: He was a son of Joseph Wilson (1779-1857)(see entry), and worked in Newburyport (MA) all his life, first with his father and later with his brother Albert (see entry). **Sources:** G&W; *Vital Records of Newburyport,* I, 417; Newburyport CD 1850-91, death date in CD 1894; Swan, "Ship Carvers of Newburyport," 81; Pinckney, *American Figureheads and Their Carvers,* 141.

WILSON, Jane *[Painter] b.1924, Seymour, IA.*
Addresses: NYC. **Studied:** Univ. Iowa (B.A., M.F.A.). **Member:** NA, 1979. **Exhibited:** Hansa Gal, NYC, 1953 (first solo); WMAA, 1961-68; Corcoran Gal biennial, 1963; PAFA Ann., 1964, 1966; Graham Gal, NYC, 1968-75; Smithsonian traveling exhib., 1968; Newport Festival Art, 1968; Univ Iowa, 1969; Finch College, NY, 1969; Fischbach Gal, NYC, 1978-on; NAD, 1985 & 1987 (Adolph and Clara Obrig Prize), 1990 (Altman Prize). Awards: Tiffany grant, 1967. **Work:** MoMA; WMAA; Wadsworth Atheneum, Hartford, CT; New York Univ.; Rockefeller Inst., New York. **Comments:** Teaching: art history instructor, Pratt Inst., 1967-70; Mellon Professor, Cooper Union, 1976-77; teacher, Parsons Sch. Des., 1973-83; assoc. professor, Columbia Univ., 1975-88; visiting artist at eight schools, including Univ. Wisconsin, 1971 & Univ. of Richmond, VA, 1990; chmn., Skowhegan School of Painting & Sculpture, 1984-86. **Sources:** WW73; Falk, *Exh. Record Series.*

WILSON, Jean Douglas *[Painter] early 20th c.*
Addresses: Bronxville, NY. **Sources:** WW25.

WILSON, Jeremy (Jeremiah) *[Portrait and landscape painter] b.1824, Illinois / d.1899.*
Addresses: Phila.,1853-56; Rome (Italy), 1859; Phila., 1861-62; Harrisburg, PA, 1863. **Studied:** with Albert Bierstadt in Italy. **Exhibited:** PAFA, 1853-63. **Work:** Blair County (PA) Hist. Soc.; Oakland Art Mus.; Maryland Hist. Soc. (view of the Shenandoah Valley, painted in 1860). **Comments:** Wilson was on the Middle Fork of the American River in 1850. **Sources:** G&W; Rutledge, PA; more recently, see Hughes, *Artists in California,* 610; P&H Samuels, 532; Wright, *Artists in Virgina Before 1900.*

WILSON, John *[Painter] b.1821, Scotland / d.1870, Oakland, CA.*
Addresses: San Francisco. **Comments:** Specialty: marines and landscapes. **Sources:** Hughes, *Artists in California,* 610.

WILSON, John *[Engraver] b.c.1833, Ireland.*
Addresses: Phila., 1860. **Sources:** G&W; 8 Census (1860), Pa., LIV, 251.

WILSON, John *[Listed as "artist"] b.c.1832, Pennsylvania.*
Addresses: Phila., 1860. **Sources:** G&W; 8 Census (1860), Pa., LIV, 333.

WILSON, John *[Engraver] mid 19th c.*
Addresses: St. Louis, 1859. **Sources:** G&W; St. Louis BD 1859.

WILSON, John *[Listed as "artist"] mid 19th c.*
Addresses: NYC, 1850. **Comments:** *Cf.* J. Wilson and John T. Wilson. **Sources:** G&W; NYCD 1850.

WILSON, John A(lbert) *[Sculptor] b.1878, New Glasgow, Nova Scotia.*
Addresses: Boston, MA; NYC. **Studied:** H.H. Kitson; B.L. Pratt. **Exhibited:** PAFA Ann., 1950. **Sources:** WW13; Falk, *Exh. Record Series.*

WILSON, John Graham See: **WILSON, J. G.**

WILSON, John Howell *[Painter] b.1849.*
Addresses: Phila., PA, 1878-79; St. Louis, MO, 1885. **Exhibited:** PAFA Ann., 1878-79, 1885 (landscapes in watercolor). **Sources:** Falk, *Exh. Record Series.*

WILSON, John Louis *[Draftsman, architect] b.1899, New Orleans, LA.*
Studied: New Orleans Univ.; Columbia Univ. **Exhibited:** Harmon Fnd., 1928, 1935; New Orleans Univ., 1930; Atlanta Univ., 1944. **Sources:** Cederholm, *Afro-American Artists.*

WILSON, John T. *[Engraver] mid 19th c.*
Addresses: NYC, 1856. **Comments:** African American artist. **Sources:** G&W; NYCD 1856.

WILSON, John T. *[Portrait painter and colorist] mid 19th c.*
Addresses: NYC, 1859-60. **Comments:** *Cf.* John Wilson, artist, NYC, 1850. **Sources:** G&W; NYCD 1859-60; NYBD 1860.

WILSON, John Woodrow *[Painter, lithographer, illustrator, teacher] b.1922, Roxbury, MA.*
Addresses: Roxbury, MA. **Studied:** BMFA Sch.; Tufts College (B.S. in Educ.); in Paris with Fernand Leger and in Mexico. **Member:** Nat. Center Afro-American Artists, Roxbury, MA (board directors). **Exhibited:** Nat. Negro Art Exhib., Atlanta Univ., 1943-52; CI, 1944-946; Albany Inst., 1945; LOC, 1945-46, 1953; Smith College, 1941; Wellesley College, 1943; Inst. Mod. Art, 1943-45; Springfield Mus. Art, 1945-46; Boris Mirski Gal., Boston, 1944-56; AGAA, 1946; MMA, 1950; Brooklyn Mus.; NAD; Am. Printmakers, Paris, France; SAGA, 1953, 1955; CM, 1953; MoMA, 1954; Art Wood Gal., Boston, 1954 (solo); Exch. Exh. Am. Prints, Italy, 1955; NY City College, 1967; BMFA, 1970; Newark Mus., 1971; American Internat. College, Springfield, MA, 1971 (solo); Boston Pub. Lib., 1973. Awards: prizes, BMFA Sch.; Atlanta Univ., 1954, 1955; Inst. Mod. Art, Boston, 1943 (prize), 1945 (prize); Pepsi-Cola, 1946 (prize); Paige traveling scholarship, BMFA Sch., 1946; John Hay Whitney Fellowship, 1950-51; International Inst. of Exchange Fellowship, for study in Mexico, 1952. **Work:** Smith College; MoMA; NYPL; Boston Pub. Lib.; Atlanta Univ.; CI; Howard Univ.; Pepsi-Cola Collection; Dept. FA, French Govt.; Bezalel Mus., Jerusalem; Brandeis Univ.; Tufts Univ. **Comments:** Position: teacher, Pratt Inst., 1958; Boston Univ.; art faculty, BMFA; board directors, Elma Lewis School Fine Arts. **Sources:** WW59; WW47; Cederholm, *Afro-American Artists.*

WILSON, Joseph *[Ship and ornamental carver] b.1779, Marblehead, MA / d.1857.*
Addresses: Chester, NH, active 1796-98; Newburyport, MA, 1798-1857. **Comments:** He carved a number of portrait statues and animal figures for the grounds of "Lord" Timothy Dexter's house in Newbury, including figures of Washington, Adams, and Jefferson, Dexter himself, Napoleon and Lord Nelson, and other prominent persons, as well as four lions, an eagle, lamb, unicorn, dog, horse, Adam and Eve, Fame, and a traveling preacher. After about 1850 he was assisted by his sons, Albert and James Warner Wilson (see entries). **Sources:** G&W; Swan, "Ship Carvers of Newburyport," 78-81; Pinckney, *American Figureheads and Their Carvers,* 141; *Antiques* (Aug, 1945), 80, repro.

WILSON, Joseph *[Banknote engraver] mid 18th c.*
Addresses: Cecil County (MD), 1749. **Comments:** Counterfeitor of banknotes who broke out of the Cecil County (MD) jail, where he was awaiting execution, in November 1749. **Sources:** G&W; Prime, II, 32.

WILSON, Joseph C. *[Lithographer] b.c.1845, Pennsylvania.*
Addresses: Phila., 1860. **Comments:** He was the son of William Wilson, a steamfitter of English birth. **Sources:** G&W; 8 Census (1860), Pa., XLIX, 217.

WILSON, Joseph Miller *[Painter, architect] early 20th c.*
Addresses: Phila., PA. **Sources:** WW04.

WILSON, Josephine Davis *[Painter] early 20th c.*
Addresses: West Phila., PA. **Sources:** WW04.

WILSON, Karan Rose *[Painter, educator] b.1944, Hartford, CT.*
Studied: Univ. Hartford (B.F.A.). **Exhibited:** Univ. Hartford, 1971; Hartford Civic & Arts Festival, 1971; Wadsworth Atheneum, 1971, 1972; American Internat. College, Springfield, MA, 1971, 1972. Award: graphics award, "Through Young Black Eyes," Hartford, CT, 1971. **Sources:** Cederholm, *Afro-American Artists.*

WILSON, Kate *[Painter, teacher, sculptor] 19th/20th c.; b.Cincinnati.*
Addresses: Norwood, OH, active from c.1897. **Studied:** Louis Rebisso, Cincinnati Art Acad. **Member:** Cincinnati Women's AC. **Exhibited:** AIC, 1896; PAFA Ann., 1896-97. **Sources:** WW31; Falk, *Exh. Record Series.*

WILSON, L. Alice See: **VITACCO, Alice Pratt (L. Alice Wilson)**

WILSON, Laura K. *[Painter] late 19th c.*
Exhibited: NAD, 1885. **Sources:** Naylor, *NAD*.

WILSON, Louis W. *[Painter] b.1872.*
Addresses: Chicago, IL. **Studied:** Académie Julian, Paris, 1898.
Member: Chicago SA. **Exhibited:** AIC, 1897-1908. **Sources:**
WW10.

WILSON, Lucy Adams (Mrs.) *[Painter] b.1855, Warren, OH.*
Addresses: Miami, FL/Asheville, NC. **Studied:** Herron AI,
Indianapolis; ASL; W. Forsyth; T. C. Steele. **Member:** Miami Art
Lg.; AFA. **Work:** Herron AI; Zion Park Inn, Asheville, N.C.
Sources: WW40.

WILSON, M. Sinclair *[Painter] mid 20th c.*
Addresses: Chicago area. **Exhibited:** AIC, 1940. **Sources:** Falk,
AIC.

WILSON, Margery N(ewcomb) *[Painter] mid 20th c.*
Addresses: Pawling, NY. **Exhibited:** Salons of Am., 1929-34;
Soc. Indep. Artists, 1927-28. **Sources:** Falk, *Exhibition Record
Series.*

WILSON, Marie Crilley *[Painter] mid 20th c.*
Addresses: New Brunswick, NJ. **Exhibited:** Soc. Indep. Artists,
1929. **Sources:** Marlor, *Soc. Indp. Artists.*

WILSON, Martha See: **DAY, Martha Buttrick Willson
(Mrs. Howard)**

WILSON, Mary *[Artist] b.1934 / d.1989.*
Member: Woodstock AA. **Exhibited:** Woodstock AA. **Sources:**
Woodstock AA.

WILSON, Mary Priscilla See: **SMITH, Mary Priscilla
Wilson (Mrs.)**

WILSON, Mary R. *[Painter] early 19th c.*
Addresses: Massachusetts, 1820. **Comments:** Painted a still life
in watercolor. **Sources:** G&W; Lipman and Winchester, 182.

WILSON, Matthew *[Copperplate printer, engraver] mid 19th c.*
Addresses: Boston, 1853-60. **Comments:** He was with the print-
ing firm of Wilson & Daniels (see entry) from 1853-58 and with
the engravers William M. Miller & Co. from 1859 (see entry).
Sources: G&W; Boston CD 1853-60+.

WILSON, Matthew Henry *[Portrait & miniature painter,
crayon & pastel portraitist] b.1814, London, England / d.1892,
Brooklyn, NY.*
Addresses: Phila., 1832; Columbus, OH, 1840; Brooklyn,
NY,1843, 1863-92. **Studied:** Henry Inman in Philadelphia, 1832-
35; with Claude Marie Dubufe in Paris, 1835. **Member:** ANA,
1844-92. **Exhibited:** NAD, 1841-44, 1846, 1861, 1867, 1870-72,
1882, 1885; Brooklyn AA, 1867-72, 1912; PAFA Ann., 1878,
1880. **Work:** Peabody Institute; Speed Museum, Louisville (por-
trait of Abraham Lincoln); Connecticut Hist. Soc., Hartford; New
Bedford Free Public Library. **Comments:** He emigrated to the
U.S. in 1832. He visited New Orleans in the spring of 1845, and
in 1847 he went to Baltimore for at least two years. From 1856-
60, he worked in Boston while living in New Bedford. From
1861-63, he had a studio in Hartford, after which he settled per-
manently in Brooklyn. During the Civil War he spent some time
in Washington painting portraits of prominent men, including one
of Lincoln two weeks before the assassination. **Sources:** G&W;
CAB; Cowdrey, NAD; Brooklyn CD 1843-45; Swan, BA;
Delgado-WPA cites New Orleans *Daily Topic*, May 15, 1845;
Lafferty; Pleasants, *250 Years of Painting in Maryland*, 56;
Rutledge, PA; Falk, PA, vol. II; New England BD 1856; Boston
CD 1858-60; French, *Art and Artists in Connecticut*, 162;
Hageman, 124; *Encyclopaedia of New Orleans Artists*, 416;
Blasdale, *Artists of New Bedford*, 207-08 (w/repro.); BAI, cour-
tesy Dr. Clark S. Marlor.

WILSON, Maude *[Painter] 19th/20th c.; b.Chicago.*
Addresses: Chicago, IL. **Studied:** AIC. **Exhibited:** AIC, 1892-
99; NYWCC, 1897-98; Chicago Artists; PAFA; Trans-Mississippi
Expo, PAFA Ann., 1895, 1898; Omaha, NE, 1898.

WILSON, May *[Sculptor] b.1905, Baltimore, MD.*
Addresses: NYC. **Exhibited:** Salons of Am.; New Idea, New
Media Show, Martha Jackson Gal., NYC, 1960; MoMA Traveling
Assemblage, NYC, 1962; AFA Patrioitic Traveling Show, NYC,
1968; WMAA; Gimpel & Weitzenhoffer, NYC, 1970s. **Awards:**
Baltimore Mus. Art Shows, 1952 & 1959. **Work:** WMAA; BMA;
Goucher College, Baltimore; CGA; Dela Banque de Pariset,
Brussels, Belgium. **Sources:** WW73; Bill Wilson, "Grandma
Moses of the Underground," *Art & Artists* (May, 1968); "Woo
who? May Wilson" (film), Amalie Rothschild, 1970; "May
Wilson" (videotape), Lee Ferguson, July 14, 1971.

WILSON, Melba Z(eller) *[Sculptor] b.1896, Missouri /
d.1959, Los Angeles, CA.*
Addresses: Los Angeles. **Exhibited:** Calif. AC, 1925-30; P&S
Los Angeles, 1926; San Diego FA Gallery, 1927; Los Angeles
County Fair, 1929. **Sources:** WW25; Hughes, *Artists in
California*, 610.

WILSON, Melva Beatrice *[Sculptor, mural painter, lecturer,
poet] b.1866, Madison, IN / d.1921, NYC.*
Addresses: NYC/Hempstead, NY. **Studied:** Cincinnati Art Acad.,
with Nobel, Nowottny, Rebisso; Rodin, in Paris. **Exhibited:** St.
Louis Expo; Cincinnati Art Mus.; Paris Salon, 1897. **Work:**
Farley Mem. Chapel, Calvary Cemetery, NY; St. Louis Cathedral.
Comments: Specialty: decorative religious subjects; animals;
equestrian statues. **Sources:** WW08.

WILSON, Mortimer, Jr.
[Illustrator, cartoonist, painter] *Mortimer Wilson jr*
b.1906.
Addresses: Lincoln, NE; NYC; Arizona, 1956-on. **Studied:** ASL.
Member: SI. **Exhibited:** PAFA Ann., 1930. **Comments:**
Contributed illustrations to *Good Housekeeping* (1939) & other
national magzines. **Sources:** WW47; Falk, *Exh. Record Series.*

WILSON, (Mrs.) *[Amateur portrait sculptor] mid 19th c.;
b.Cooperstown, NY.*
Addresses: Cincinnati, active in the early 1850s. **Comments:**
Went to Cincinnati with her parents (names unknown) and mar-
ried a Dr. Wilson. (The 1853 Cincinnati directory lists three doc-
tors named Wilson: Israel, Singleton C., and T. Wilson). She
apparently became interested in sculpture after visiting a studio in
Cincinnati and thereafter began to model and to carve in stone.
Sources: G&W; Lee, *Familiar Sketches of Sculpture and
Sculptors*, 216-18; Gardner, *Yankee Stonecutters*, 73.

WILSON, Nathalie K. *[Painter] mid 20th c.*
Addresses: NYC. **Studied:** ASL. **Exhibited:** S. Indp. A., 1924.
Sources: Marlor, *Soc. Indp. Artists.*

WILSON, Nelson (D.) *[Painter, designer, teacher] b.1880,
Leopold, IN.*
Addresses: Evansville, IN. **Studied:** Chicago Acad. FA.
Exhibited: Hoosier Salon, 1929-46 (prize); John Herron AI,
1926-1939; Evansville Art Mus., 1930 (solo). **Work:** Culver
Grade Sch., Bosse H.S., Evansville, IN; State House, Indianapolis;
murals, Vanderburg County Coliseum, Evansville. **Sources:**
WW53; WW47.

WILSON, Nevada *[Landscape painter] mid 20th c.*
Addresses: Los Angeles, CA, 1916-1940s. **Member:** Los Angeles
Art Lg. **Exhibited:** Los Angeles Art Lg.; Los Angeles City Hall,
1941. **Sources:** Hughes, *Artists in California*, 610.

WILSON, Norman Badgley *[Painter, engraver] b.1906,
Arcadia, IN.*
Addresses: Indianapolis 5, IN. **Member:** Indiana AA; Indiana
Soc. Printmakers. **Exhibited:** PAFA, 1937; John Herron AI, 1937,
1939, 1942, 1944, 1946, 1948-52; Butler AI, 1945, 1946, 1948,
1949; TriState Print Exh., 1944, 1945, 1948; Milwaukee AI, 1946;
South Bend AA, 1950-52; Ft. Wayne AI, 1951; Carnegie Inst.; J.
B. Speed Mem. Mus.; Phila. Pr. Club. **Awards:** prizes, South Bend
AA, 1951; Ft. Wayne, AI, 1951; John Herron, AI, 1952. **Sources:**
WW59; WW47.

WILSON, Oliver *[Marble cutter] mid 19th c.*
Addresses: Chicago, 1850s. **Exhibited:** Illinois State Fair, 1855. **Comments:** He was in partnership with Henry Wilson (see entry). Together they won a prize for animal painting in oils at the Illinois State Fair in October 1855. **Sources:** G&W; Chicago CD 1853-55; Chicago *Daily Press*, Oct. 15, 1855.

WILSON, Oregon *[Portrait and genre painter] late 19th c.; b.Pittsburgh, PA.*
Addresses: active in Pittsburgh, Phila.; NYC, 1869-1872. **Studied:** Europe. **Exhibited:** Brooklyn AA, 1869-73; NAD, 1869, 1872; PAFA Ann., 1876. **Comments:** Painted portraits along the Monongahela River in Brownsville, PA, before traveling to Europe for study. On his return he focused on figurative painting, sometimes exploring historical subject matter. He was the teacher of William Rhoads (see entry). **Sources:** G&W; Gerdts, *Art Across America,* vol. 1: 290; Falk, *Exh. Record Series.*

WILSON, Orme *[Patron] b.1885, NYC / d.1966.*
Addresses: NYC. **Studied:** Harvard University (A.B.). **Comments:** Position: 1st vice-pres. and trustee, Corcoran Gallery of Art, Washington, D.C. **Sources:** WW66.

WILSON, Paul *[Painter] early 20th c.*
Exhibited: Salons of Am., 1923. **Sources:** Marlor, *Salons of Am.*

WILSON, Ralph L. *[Collector] mid 20th c.*
Addresses: Canton 9, OH. **Sources:** WW66.

WILSON, Raymond C. *[Painter] b.1906, Oakland, CA / d.1972.*
Addresses: San Francisco. **Studied:** Calif. College Arts & Crafts; with Maurice Logan. **Member:** Bay Region AA; San Francisco AA. **Exhibited:** Oakland Art Gal., 1934-40; AIC Nat. Traveling Exhib., 1936; SFMA, 1936-40; GGE, 1939; Phelan Exhib., CPLH, 1939. **Work:** Oakland Mus. **Comments:** He suffered a mental breakdown at the height of his career, but nevertheless left a legacy of 225 watercolors painted over a period of seven years. **Sources:** Hughes, *Artists in California,* 610.

WILSON, Reginald *[Painter, portrait painter] b.1909, Butler, OH / d.1993, Woodstock, NY.*
Addresses: NYC; Woodstock, NY, 1945-93. **Studied:** Chicago; Cleveland, OH; ASL, 1929 (he was friends with Arnold Blanch, who introduced him to Woodstock in 1939). **Member:** Woodstock AA (board directors). **Exhibited:** WMAA; AIC; BM; PAFA Ann., 1949; Woodstock AA Gallery; Ganso, Perls & Ferargil galleries, NYC; "Twenty Years of Painting, 1965-85, Woodstock, NY (together with his wife); Woodstock School of Art, 1998 (retrospective). **Awards:** Woodstock Fnd. Award, 1952; Sallie Jacobs Award, 1973. **Comments:** WPA artist. Married to painter Carolyn Haeberlin (see entry) in 1942, shortly after he was drafted into the U.S. Air Force. After WWII, they settled in Woodstock, NY, where he painted portraits, mostly of his family, and everyday objects and scenes in a geometric-constructivist style. **Sources:** Falk, *Exh. Record Series;* info. courtesy of Peter Bissell, Cooperstown, NY.

WILSON, Robert Burns *[Portrait painter, marine painter, poet, novelist] b.c.1851, Parker, PA / d.1916, Brooklyn, NY.*
Addresses: Virgina; Pittsburgh, PA; Louisville, KY, 1872-75; Frankfort, KY (c.30 yrs); NYC, 1904-16. **Studied:** Pittsburgh, PA, 1871. **Exhibited:** PAFA Ann., 1881; SSAL, at Henderson, KY, c.1900 (medal); AIC, 1908. **Work:** Owensboro (KY) Mus. FA; Univ. Kentucky Art Mus., Lexington. **Comments:** Wilson spent much of his childhood in Virginia and West Virginia. In 1869 he left home to work as an artist and spent about a year with a circus. He had a studio with John W. Alexander (see entry) in Pittsburgh and in 1871 went to Union County, KY. In the 1880s he began to paint landscapes. Specialty: animals, landscapes (early 1880s on). Also occasionally painted religious subjects. Preferred media: watercolor, oil, charcoal, pastel. Author, "Remember the Maine," *New York Herald,* 1898. **Sources:** WW15; add'l info. courtesy of Francis Smith, Bardstown, KY; Jones and Weber, *The Kentucky Painter from the Frontier Era to the Great War,* 71-72 (w/repros.);

Falk, *Exh. Record Series.*

WILSON, (Ronald) York *[Painter] b.1907, Toronto, Ontario.*
Addresses: Toronto 176, Ontario. **Studied:** Cent. Tech. School, Toronto; Ontario College Art. **Member:** Royal Canadian Acad.; Ontario Soc. Artists (pres., 1946-49); Canadian Group Painters (pres., 1968). **Exhibited:** New York World's Fair, 1939; CI, 1952; Biennial São Paulo, Brazil, 1963; Main Gallery, Mus. Galliera, 1963; Bellas Artes, Mexico, 1969 (solo); Roberts Gallery, Toronto, Ontario, 1970s. **Awards:** Winnipeg Show Award, 1956; Baxter Award, Toronto, 1960; Canadian Centennial Medal, 1967. **Work:** Nat. Gallery Canada; Nat. Mus. Art Mod., Paris; MOMA, Mexico; Birla Acad. Mus., Calcutta, India; Art Gallery Ontario. Commissions: murals, McGill Univ., Montreal, 1954, Imp. Oil, Toronto, 1957, O'Keefe Center, Toronto, 1959 & Gen. Hospital, Port Arthur, 1965; mosaic, Carleton Univ., Ottawa, 1970. **Comments:** Publications: illustrator, *Face at the Bottom of the World,* Hagiwara Sukitaro Publ., Tokyo. **Sources:** WW73; "Mural" (film), Crawley Films, 1957; Michael Foytenay, "York Wilson" (film), Nat. Film Board, 1962; Michel Seuphor, *York Wilson,* catalog (1964).

WILSON, Rose O'Neil(l) (Mrs. Harry L.) See: **O'NEILL, Rose Cecil**

WILSON, Rowland *[Cartoonist] b.1930, Dallas, TX.*
Addresses: North Ozone Park, NY. **Studied:** Univ. Texas (B.F.A.); Columbia Univ. **Comments:** Contributed cartoons to *Saturday Evening Post, Colliers, True, Esquire, American, Ladies Home Journal, American Legion* magazines. **Sources:** WW59.

WILSON, S. Alice *[Painter] mid 20th c.*
Exhibited: Salons of Am., 1934. **Sources:** Marlor, *Salons of Am.*

WILSON, S. M. *[Portrait painter] late 19th c.*
Addresses: NYC, 1868. **Exhibited:** NAD, 1868. **Sources:** Naylor, *NAD.*

WILSON, Samuel *[Engraver] d.19.*
Addresses: Holmesburg, PA, 1856-60+. **Sources:** G&W; Phila. CD 1856-60+.

WILSON, Samuel *[Listed as "artist"] mid 19th c.*
Addresses: Phila., 1859. **Sources:** G&W; Phila. CD 1859.

WILSON, Sarah C. *[Miniature painter] early 20th c.*
Addresses: Beaver, PA, c.1907-10. **Member:** Pittsburgh AA.

WILSON, Scott *[Industrial designer, painter] b.1903, Vigan, Luzon, Philippines.*
Addresses: New York 21, NY. **Studied:** Harvard Univ. (A.B.). **Member:** IDI (fellow); Nat. Soc. for Decoration Des.; Arch. Lg. **Comments:** Position: nat. director, Inter-Society Color Council, 1954-56; vice-pres., Nat. Soc. for Decoration Design, 1955-56; owner, Scott Wilson Designs, NYC. Author/illustrator: *Tommy Tomato and the Vegets,* 1936; *Tommy Tomato Saves the Garden,* 1937. Contributor to trade and scientific publications. **Sources:** WW59; WW47.

WILSON, Sol(omon) *[Painter, screenprinter, teacher] b.1896, Vilno, Russia (now Poland) / d.1974, New York, NY.* **Sol Wilson**
Addresses: NYC (immigrated 1901)/Provincetown, MA. **Studied:** Cooper Union, 1918; NAD, 1920-22; BAID; also with George Bellows, Robert Henri, G. Olinsky, and G. Maynard; ASL. **Member:** NAD; Provincetown AA; Beachcombers Club; Nat. Ser. Soc.; Boston AC; Am. Artists Congress; Audubon Artists; Artists Equity Assn.; An Am. Group; Art Lg. Am. **Exhibited:** S. Indp. A., 1928-29; PAFA Ann., 1934-66; NAD, 1938, 1940, 1945, 1946, 1968; AIC,1935, 1943, 1945; MMA, AV, 1943; Pepsi-Cola exh., 1944; VMFA, 1942, 1944, 1946; Critics Choice, NY, 1945; Nebraska AA 1945, 1946; LOC,1944; Provincetown AA, 1957 (prize); Corcoran Biennial, 1947 (prize); Univ. Iowa, 1945, 1946; CAM, 1939; WFNY, 1939; Carnegie Inst. Int., 1929-50 (prize,1947); Corcoran Gal biennials, 1935-53 (8 times; incl. 3rd hon men, 1947); Inst. Arts & Letters Ann., 1950; Butler Inst. Am.

hon men, 1947); Inst. Arts & Letters Ann., 1950; Butler Inst. Am. Art, 1965; Salons of Am.; WMAA. Other awards: Am. Red Cross, 1942; grant, Am. Acad. Arts & Letters. **Work:** MMA; WMAA; LOC; Brooklyn Mus; Telfair Acad.; Lincoln H.S., NY; Brooklyn College; Am. Red Cross; LOC; BMA; SAM; St. Louis AM; Newark Mus; Westhampton, NY; Biro-Bidjan Mus., U.S.S.R.; Youngstown (OH) Mus. Art; Tel-Aviv Mus, Israel. Commissions: WPA murals in USPOs in NY at Delmar (1944) and Westhampton Beach (1946). **Comments:** He called himself an "expressionistic realist" painter. During the summers he painted first in Rockport, MA (c.1927-46), and then across the Cape Cod Bay in Provincetown, MA (1947-on). In Provincetown, he was best known as the painter of the "Blessing of the Fleet." Preferred media: oils, casein, watercolors. Teaching: Am. Artists School, NYC, 1936-40; School Art Studies, 1945-49; ASL, 1968-69. **Sources:** WW73; Earnest Watson, *American Drawing* (1957) & *Landscape Painting* (1962); "Sol Wilson," *Horizon Magazine* (1961); Crotty, 71; Provincetown Painters, 185; Falk, *Exh. Record Series.*

WILSON, Sophie (Mrs. Wins) *[Portrait painter, block printer, illustrator, drawing specialist]* b.1887, Falls Church, VA. **Addresses:** Richmond, VA. **Studied:** PM School IA; Corcoran School Art; Berkshire Summer School Art. **Member:** Richmond Acad. Art; VMFA. **Comments:** Illustrator: cover drawings, *Etude, Country Life, Peoples Popular* magazines. **Sources:** WW40.

WILSON, Stanley Charles *[Sculptor, graphic artist, illustrator, weaver, educator]* b.1947, Los Angeles, CA. **Studied:** Otis AI (B.F.A. & M.F.A.). **Member:** Am. Assn. Univ. Prof.; NAEA; Am. Crafts Council. **Exhibited:** Brockman Gal., Los Angeles; Municipal Art Gal., San Pedro; Otis AI Gal.; LACMA; Allied Arts Council, San Bernardino (prize); Watts Art Festival, 1971 (hon. mention, Citus Award); Galeria del Sol, Santa Barbara, 1972; Pacific Grove AC, 1972. **Work:** Otis AI; Brockman Gal., Los Angeles. **Comments:** Position: professor, Southwestern College, San Diego, CA. **Sources:** Cederholm, *Afro-American Artists.*

WILSON, Stella *[Artist]* early 20th c. **Addresses:** Active in Los Angeles, 1907-08. **Sources:** Petteys, *Dictionary of Women Artists.*

WILSON, Stephen D. *[Portrait painter]* b.c.1825, Pennsylvania. **Addresses:** Phila., active from 1847-60 and after. **Sources:** G&W; 7 Census (1850), Pa., LII, 390; Phila. CD 1847-60+; Phila. BD 1850 [as L.D. Wilson].

WILSON, Susan Colston *[Painter]* mid 20th c. **Addresses:** Saranac Lake, NY. **Comments:** Affiliated with American Red Cross. **Sources:** WW25.

WILSON, Sybil *[Painter, designer]* b.1923, Tulsa, OK. **Addresses:** Bridgeport, CT. **Studied:** ASL, with Ernes Fiene; Yale Univ. School Art & Arch., with Josef Albers (B.F.A. & M.F.A.); also with Anni Albers. **Exhibited:** Grand Central Mod. Gallery, NYC, 1962 (solo) & 1965 (solo); Retinal Art in US Traveling Exhib., 1966; East Hampton Gallery, New York, 1970 (solo); Woods, Gerry Gallery, RISD, 1972 (solo). **Awards:** Am. Inst. Graphic Arts 50 Best Award, 1960. **Work:** New York Univ. Collection; Univ. Kentucky Collection; Univ. Massachusetts Collection; Univ. Bridgeport Collection; Chase Manhattan Bank Collection. **Comments:** Preferred media: acrylics. Publications: editor, *Anni Albers: On Designing*, Pellango Press, New Haven, 1960. Teaching: art professor, Univ. Bridgeport, 1954-; adjunct professor art, RISD, 1970-72. **Sources:** WW73.

WILSON, T. P. *[Painter]* late 19th c. **Addresses:** Chicago. **Exhibited:** AIC, 1889. **Sources:** Falk, *AIC.*

WILSON, Thomas *[Coach and ornamental painter]* early 19th c. **Addresses:** Phila. **Comments:** John Neagle (see entry) served his apprenticeship under Wilson from c.1813-18. During this time Wilson was himself taking lessons in painting from Bass Otis (see entry). **Sources:** G&W; Dunlap, *History*, II, 372-73.

WILSON, Tom Muir *[Designer]* b.1930, Bellaire, OH. **Addresses:** Burnsville, MN. **Studied:** West Virigina Inst. Technology; Cranbrook Acad. Art (B.F.A.); Rochester Inst. Technology (M.F.A.). **Exhibited:** Rochester, NY (solo) & Wheeling, WV, 1957, 1959 & 1961 (all solos); Boston Art Festival, 1961; Photography Exhib., George Eastman House, Rochester, NY, 1963; Western NY Ann., Buffalo, 1963 & 1964; Art of Two Cities, Minneapolis, 1965. **Awards:** award for sculpture, Art Inst. Am. Inst. Architects, 1956; prize, Phila. Print Club, 1961. **Comments:** Preferred media: graphics. Positions: designer exhib. galleries, George Eastman House Mus. Photography, 1961-62; freelance photographer & graphic designer, New York, Rochester & Minneapolis, 1961-. Teaching: art professor & instructor in photography & graphic design, Minneapolis School Art; photography instructor, Rochester Inst. Technology; instructor in sculpture & design, Nazareth College Rochester. **Sources:** WW73.

WILSON, Vaux *[Illustrator]* 20th c. **Addresses:** Elmhurst, NY. **Sources:** WW21.

WILSON, Virginia Rohm *[Portrait painter]* b.1851, Beallsville, PA / d.1930, Urbana, IL. **Studied:** Springfield (OH) Female Acad.; with Jacob Cox in Indianapolis. **Comments:** Married Clayton Todd. **Sources:** Petteys, *Dictionary of Women Artists.*

WILSON, Vylla (Poe) *[Painter, journalist]* early 20th c. **Addresses:** Wash., DC, active 1930s, 1940s. **Exhibited:** Greater Wash. Independent Exh., 1935. **Comments:** Sister of Elizabeth E. Poe (see entry). **Sources:** McMahan, *Artists of Washington, DC.*

WILSON, W.O. *[Illustrator, painter, designer]* 19th/20th c. **Sources:** Falk, *Dict. of Signatures.*

WILSON, W. Reynolds, Jr. *[Portrait painter]* b.1899, Phila. / d.1934. **Addresses:** Phila. **Studied:** PAFA; Grand Central Art Sch., NYC; Académie Julian, Paris. **Member:** Phila. AC; Phila. Sketch Club.

WILSON, William *[Portrait painter]* b.Yorkshire, England / d.1850, Charleston, SC. **Addresses:** Charleston, SC by 1840; NYC, 1842-43; New Orleans, 1845. **Comments:** Worked principally in Georgia and South Carolina, 1840-51. **Sources:** G&W; Rutledge, "Early Painter Rediscovered," with checklist and two repros.; Rutledge, *Artists in the Life of Charleston*, 167.

WILSON, William *[Engraver]* mid 19th c. **Addresses:** NYC, 1850. **Sources:** G&W; NYCD 1850.

WILSON, William E. *[Painter]* mid 20th c. **Addresses:** Phila., PA, 1930. **Exhibited:** PAFA Ann., 1930. **Sources:** Falk, *Exh. Record Series.*

WILSON, William F. *[Portrait painter]* mid 19th c. **Addresses:** Boston, 1852-54. **Sources:** G&W; Boston BD 1852-54.

WILSON, William J. *[Painter, etcher, illustrator]* b.1884, Toledo, OH. **Addresses:** Long Beach, CA. **Member:** Long Beach AA (pres.); Los Angeles P&S (dir.); Laguna Beach AA; Spectrum Club. **Exhibited:** Spectrum Club, Long Beach, 1932 (prize), 1933 (prize). **Work:** Bilge Club, San Pedro, CA. **Sources:** WW40.

WILSON, William W. *[Copperplate engraver and printer]* mid 19th c. **Addresses:** Boston, 1832 until after 1860. **Comments:** In 1834 he was a member of the firm of Pollock & Wilson (see entry). **Sources:** G&W; Boston CD 1832-60+, BD 1841-60; Stauffer.

WILSON, Winifred *[Painter]* mid 20th c. **Addresses:** Chicago area. **Exhibited:** AIC, 1929. **Sources:** Falk, *AIC.*

WILSON, Woodrow (Woody) See: **BIG BOW, Woodrow ("Woody") Wilson**

WILSON, York See: **WILSON, (Ronald) York**

WILSTACH, George L. *[Painter, designer, craftsperson]* b.1892.
Addresses: Lafayette, IN/Gloucester, MA. **Studied:** AIC; ASL. **Member:** Hoosier Salon; Indiana Art Club; North Shore AA. **Work:** Lafayette AM, Ind. **Comments:** Position: des./manufacturer, hand-carved picture frames. **Sources:** WW40.

WILT, Ellen Bonar *[Painter] mid 20th c.*
Addresses: Ann Arbor, MI. **Exhibited:** PAFA Ann., 1960; Corcoran Gal biennial, 1961. **Sources:** Falk, *Exh. Record Series.*

WILT, Richard *[Painter, educator] b.1915, Tyrone, PA.*
Addresses: Ann Arbor, MI. **Studied:** Penn. State Univ.; Carnegie Inst.; New School Social Research, NY; Univ. Pittsburgh, M.A. **Exhibited:** PAFA Ann., 1949, 1958-62; Arts & Crafts Center, Pittsburgh, 1950 (solo); Grand Rapids Art Mus., 1950; Inst. Contemporary Art, 1951, circulated by AFA, 1952; Butler IA, 1951; Detroit IA, 1952; Sioux City AC, 1952; Rackharn Gal., Ann Arbor, 1955; AIC. Awards: prizes, Pittsburgh AA, 1947-49, 1951, 1953, 1954; Michigan Artists, 1949, 1951-54, 1956; Old Northwest Terr. Exhib., 1950, 1951; Butler IA, 1953; Michiana Exhib., 1955; Michigan State Fair, 1955, 1957; Michigan Acad., 1956, 1957. **Work:** Detroit IA; Butler IA; Illinois State Mus.; Indiana State Teachers College; South Bend Mus. Art. **Comments:** Position: assoc. professor art, College of Arch. & Des., Univ. Michigan, Ann Arbor. **Sources:** WW59; Falk, *Exh. Record Series.*

WILTBERGER, And[rew?] *[Listed as "artist"] b.c.1821.*
Addresses: Phila. in 1860. **Comments:** He was from Bavaria, but his wife and children were born in Pennsylvania, the latter between 1842-50. **Sources:** G&W; 8 Census (1860), Pa., LIV, 688.

WILTON, Anna Keener See: **KEENER, Anna Elizabeth (Mrs. Wilton)**

WILTON, Bernard *[Painter] mid 18th c.; b.England.*
Addresses: Phila. in 1760. **Comments:** He painted a sign for the Bull's Head Tavern in 1760, long attributed to Benjamin West (see entry). **Sources:** G&W; Barker, *American Painting*, 162; Scharf and Westcott, *History of Philadelphia.*

WILTSIE, Loura S. *[Painter] late 19th c.*
Addresses: Newburg, NY, 1886. **Exhibited:** NAD, 1886. **Sources:** Naylor, *NAD.*

WILTZ, Arnold *[Painter, engraver] b.1889, Berlin, Germany / d.1937, Kingston, NY.*
Addresses: NYC, 1914, 1930; Woodstock, NY, 1923-. **Studied:** NAD (evenings); Hamilton Easter Field. **Member:** Brooklyn Soc. Modern Art; Woodstock AA. **Exhibited:** Macys Gal., NYC, 1926, 1933; Grand Central Art Gal., NYC, 1927; Dudensing Galleries, NY, 1927-30, 1932 (all solo); NAD, 1927; Albright-Knox Art Gal., Buffalo, NY, 1928, 1929; Corcoran Gal biennials, 1928-37 (4 times); PAFA Ann., 1930-31, 1934-35; Jones Little Gal., Woodstock, NY, 1930; Frank Rehn Gal., NYC, 1931; Welden Gal, Chicago, 1931 (solo); Karl Freund Arts, Inc., NYC, 1937 (solo); Woodstock (NY) Gal., 1937; Paradox Gal., Woodstock, NY, 1977, 1978, 1981, 1982; Salons of America, Autumn Salon,1922; Salons of American Art, Spring Salon, 1929-30; Soc. Modern Artists, 1923; Woodstock AA, 1929, 1932-34, 1936, 1969, 1978, 1980; Brooklyn Mus., 1933; AIC, 1929; CI, 1930, 1933, 1935-37; St. Louis Art Mus., 1930; CMA, 1931; WMAA, 1932-36; Wanamaker Reg., NYC, 1934; Municipal Art Exhib., Rockefeller Center, NYC, 1934; Venice Bienniale, Italy, 1934; de Young Mus., San Francisco, 1935; MoMA, 1936; Vassar College Art Gal., 1977; Columbia-Greene Com. College, Hudson, NY, 1980; College Art Gal., State Univ. NY, New Paltz, 1983; Woodstock Hist. Soc., 1984;. **Work:** Woodstock AA; Cincinnati Mus.; Helena Rubenstein Collection; Paris, France; PMG, WMAA; private collections. **Comments:** Wiltz's work can be related to both Precisionism and Surrealism. Son of a painter, he displayed an early talent for art, but went to sea at age 16 and traveled about the world for the next seven years. In 1914, at the outbreak of WWI, he settled in NYC and enrolled in art classes. Married Eva Madeline Shiff (see entry) in 1922 and in 1923 they settled in Woodstock, NY. In 1928 he worked for a time in France and critics regarded his work in this period as a turning point. His life ended prematurely after a bout with pneumonia. **Sources:** WW33; *Woodstock's Art Heritage,* 144-145; *American Scene Painting and Sculpture,* 64 (w/repro.); Woodstock AA; Falk, *Exh. Record Series.*

WILTZ, Emile *[Portrait painter] b.1812, New Orleans, LA / d.1891, New Orleans.*
Addresses: New Orleans in 1841-42. **Comments:** He was listed as a tax collector in 1846 and translator for the Louisiana Senate, 1844. **Sources:** G&W; New Orleans CD 1841-42, 1846. More recently, see *Encyclopaedia of New Orleans Artists,* 416.

WILTZ, Leonard, Jr. *[Marble sculptor] b.c.1815, New Orleans, LA / d.1861, New Orleans.*
Addresses: New Orleans, 1846-53. **Sources:** G&W; New Orleans CD 1846, 1852-53. More recently, see *Encyclopaedia of New Orleans Artists,* 417.

WILTZ, Madeline See: **SHIFF, E. Madeline (Mrs. Arnold Wiltz)**

WILVERS, Robert *[Painter] 20th c.*
Addresses: Milwaukee, WI. **Exhibited:** PAFA Ann., 1953. **Sources:** Falk, *Exh. Record Series.*

WILWERDING, Walter J(oseph) *[Painter wildlife), illustrator, teacher, writer, lecturer, photographer] b.1891, Winona, MN.*
Addresses: Old Greenwich, CT ; Minneapolis, MN in 1966. **Studied:** Minneapolis School Art; landscape with Edwin M. Dawes, 1919-15; R. Koehler; G. Doetsch; L. M. Phoenix; M. Cheney. **Member:** Soc. Animal Artists (charter member); Assn. of Professional Artists, Minneapolis. **Exhibited:** Old Greenwich (CT) Artists; Minneapolis and St. Paul annually; Northwestern Artists Annual; many solo shows in New York, Chicago, St. Paul, Minneapolis, Beverly Hills and elsewhere nationally. **Work:** Explorers Club Bldg., Chicago, and in the collections of prominent American collectors. **Comments:** Positions: instructor, animal drawing, 1926-32, 1941-48, vice-pres. & dir. educ., 1948-61, Art Instruction Schools, Minneapolis, MN; member, Nat. Advisory Council for Art Instruction Schools. Author/illustrator: *Animal Drawing and Painting,* 1946, rev. 1956; *The Cats in Action,* 1962; *How to Draw and Paint Hoofed Animals,* 1963; *How to Draw and Paint Textures of Animals,* 1965; *Jangwa, The Story of a Jungle Prince, Keema of the Monkey People, Punda, the Tiger-Horse.* Illustrator: *True Bear Stories,* J. Miller; *King of the Grizzlies,* A. Richardson, *Under Western Heavens,* Olai Aslagsson; *Indian Moons,* Winona Blanche Allen. Contributor as author and/or illustrator to *Sports Afield, This Week Magazine, Boy's Life, Blue Book, Nature, Fauna, Red Cross Magazine, Western Sportsman, True West, Audubon Magazine, Bulletin of New York Zoological Soc.* **Sources:** WW66; WW40.

WIMAN, Vern (Verna) (Miss) *[Caricaturist, illustrator, etcher, painter] b.1912, San Francisco / d.1977, San Francisco.*
Addresses: San Francisco. **Studied:** Calif. Sch. FA with Maurice Sterne; Schaeffer Sch. Des. **Member:** Calif. SE. **Exhibited:** Carnegie Inst., 1944; William Rockhill Nelson Gal., 1944; CAM, 1944; Portland Art Mus., 1939, 1944; CM, 1944; SFMA, 1940, 1941, 1944-46; de Young Merit. Mus., 1943; Calif. SE, 1945; Dorian Art Gal., 1945; Raymond Gal., 1945, 1946; Workshop Gal., 1945; Calif. Sch. FA, 1938 (prize), 1939 (prize). **Work:** Portland AM. **Comments:** Sometimes signed as simply "Vern." Last name sometimes appears as Wieman. Position: caricaturist, *San Francisco Chronicle,* 1939-. **Sources:** WW53; WW47, as Wiman.

WIMAR, Charles Ferdinand
[Portrait and historical painter]
b.1828, Siegburg, near Bonn,
Germany / d.1862, St. Louis, MO.
Addresses: Came to America in 1843, settling in St. Louis, MO.
Studied: Leon Pomarede in St. Louis, c.1846-50; Josef Fay and
Emanuel Leutze in Düsseldorf, 1852-56. **Member:** Western Acad.
Art. **Exhibited:** PAFA, 1862; St. Louis annual exhibitions during
his lifetime; St. Louis AM, 1946 (retrospective). **Work:** Amon
Carter Mus.; Noonday Club, St. Louis; St. Louis AM; Univ.
Michigan; Washington Univ.; Missouri Hist. Soc.; Peabody Mus.,
Harvard; murals, St. Louis Court House. **Comments:** Best known
as a painter of frontier life and buffalo on the Great Plains. He
grew up in St. Louis and from c.1846 to 1850 worked with the
panoramist Leon Pomarede, accompanying him on a trip up the
Mississippi in 1849. Wimar opened a painting shop with Edward
Boneau in St. Louis in 1851, but the following year traveled to
Düsseldorf, remaining there until 1856. After returning to the
U.S., Wimar took at least three trips up the Missouri River and in
1858 trekked 300 miles up the Yellowstone River. Wimar depicted
Indian ceremonies and buffalo herds, as well as hunting and war
scenes. He also made many photographs of Native Americans.
Wimar painted some portraits as well, and in 1861 executed the
mural decorations for the rotunda of the St. Louis Court House.
Four of his American sketchbooks have been preserved. **Sources:**
G&W; Rathbone, "Charles Wimar," biographical sketch, bibliog-
raphy, and illustrated catalogue of an exhibition at the City Art
Museum of St. Louis in 1946; P & H Samuels, 533-34; Baigell,
Dictionary; 300 Years of American Art, vol. 1, 224.

WIMAR, Karl Ferdinand See: **WIMAR, Charles
Ferdinand**

WIMBERLEY, Frank Walden *[Painter, sculptor] b.1926,
Pleasantville, NJ.*
Addresses: Corona, NY. **Studied:** Howard Univ., with Lois M.
Jones, James Wells & James Porter. **Member:** Guild Hall, East
Hampton, Long Island. **Exhibited:** C. W. Post College, NY, 1969;
Whitney Rebuttal, Acts of Art Gallery, New York, 1971;MoMA;
Hudson River Mus., Yonkers, NY, 1971; Seton Hall Univ., NJ,
1971; Dutchess Co. College, NY, 1972. **Work:** MoMA; Storefront
Mus., New York. **Comments:** Preferred media: collage. **Sources:**
WW73; Cederholm, *Afro-American Artists.*

WIMBUSH, J. L. *[Painter] late 19th c.*
Addresses: Phila., PA. **Exhibited:** PAFA Ann., 1876, 1878-79
(portraits). **Sources:** Falk, *Exh. Record Series.*

WIN *[Painter] mid 20th c.*
Addresses: Mac-Win Studio, NYC. **Exhibited:** S. Indp. A., 1929.
Sources: Marlor, *Soc. Indp. Artists.*

WINANS, Walter *[Painter, sculptor, illustrator] b.1852, St.
Petersburg, Russia / d.1920, London, England.*
Addresses: Kent, England/Brussels, Belgium. **Studied:** Volkoff;
Paul; Geroges; Corboult. **Member:** Peintres et Sculpteurs du
Cheval; Allied AA. **Exhibited:** Award: Chevalier of the Imperial
Russian Order of St. Stanislaus. **Work:** Marble Palace, St.
Petersburg; Hartsfeld House, London. **Comments:** Born in
Russian of American parents. Specialty: horses. **Sources:** WW13;
P&H Samuels, 534.

WINANS, William O. *[Wood engraver] b.c.1830, New York.*
Addresses: Cincinnati during the 1850's. **Sources:** G&W; 7
Census (1850), Ohio, XXII, 437; Cincinnati CD 1851-56.

WINANT, H. *[Painter] late 19th c.*
Addresses: NYC, 1885. **Exhibited:** NAD, 1885. **Sources:**
Naylor, *NAD.*

WINBRIDGE, Edward *[Sculptor] late 19th c.*
Addresses: NYC, 1878. **Exhibited:** NAD, 1877-78. **Sources:**
Naylor, *NAD.*

WINCHELL, Elizabeth Burt (Mrs. John P.) *[Painter,
craftsperson, decorator, teacher, designer, graphic artist, lectur-
er] b.1890, Brooklyn, NY.*

Addresses: Freeport, ME; Yarmouth, ME. **Studied:** Moore Inst.
Des., Phila.; PAFA; PM School IA; & with Henry Snell, Samuel
Murray, & E. Daingerfield, D. Garber, W.W. Gilcrist, Jr., H.
Sartain. **Member:** Freeport AC; Maine Craft Gld.; Portland WC
Soc; Haylofters, Portland, Maine; AAPL. **Exhibited:** PAFA; BM;
Portland SA; Freeport AC, 1940-46; Walker Art Center;
Lincolnville, ME; Providence, RI; Maine WC Soc.; St. Augustine,
FL; Hooked rugs exhibited Ogunquit AC; Massachusetts House
Workshop; Farnsworth Mus.; Portland Art Mus.; Wanamaker
Exhib., Phila., 1910-11 (prize); Flower Show Exh., Phila., 1911
(prize), 1928 (prize); C.L. Wolfe AC, NYC,1928 (prize). **Work:**
Moore Inst. Des.; Brunswick (ME) Savings Banks; Camden (ME)
Munic. Collection. **Comments:** Position: teacher, Bailey Sch.,
Bath, ME, 1939-46, **Sources:** WW59; WW47.

WINCHELL, Fannie *[Painter] early 20th c.*
Addresses: Laguna Beach, CA. **Member:** Laguna Beach AA.
Sources: WW25.

WINCHELL, Paul *[Graphic artist, illustrator, teacher, gilder]
mid 20th c.*
Addresses: Minneapolis, MN. **Studied:** AIC; L. Kroll; B.
Anisfeld; D. Garber; C. Woodbury; G. Oberteuffer; E. Forsberg.
Exhibited: Midwestern AA , Kansas City AI, 1938. **Comments:**
Position: teacher, Minneapolis Sch. Art. **Sources:** WW40;
Charles Woodbury and His Students.

WINCHELL, Ward (Philo) *[Painter] b.1859, Chicago, IL /
d.1929, Los Angeles County, CA.*
Addresses: Los Angeles, CA. **Member:** Calif. AC. **Sources:**
WW25; Hughes, *Artists in California*, 610.

WINCHESTER, Alice *[Art editor] b.1907, Chicago.*
Addresses: Newtown, CT. **Studied:** Smith College (B.A., 1929).
Member: Am. Assn. Mus.; Soc. Arch. Historians; Furniture Hist.
Soc.; Assn. Preservation Technology; Am. Ceramic Circle.
Comments: Positions: editor, *Magazine Antiques*, 1938-72; tem-
porary curator, WMAA, 1972-74. Publications: co-editor,
Primitive Painters in America 1750-1950, 1950; author, *How to
know American Antiques*, 1951; editor, *The Antiques Treasury of
Furniture and Other Decorative Arts*, 1959, *Collectors and
Collections*, 1961 & *Living with Antiques*, 1963. Research:
American decorative arts; American folk art. **Sources:** WW73.

WINCKLER-SCHMIDT, Adele (Mrs.) *[Miniature painter]
early 20th c.; b.St. Louis, MO.*
Addresses: NYC; London, England (1910-13). **Studied:** St. Louis
Sch. **Exhibited:** St. Louis Expo, 1904 (bronze medal); Corcoran
Gal biennial, 1910. **Sources:** WW13.

WINDEAT, William *[Portrait painter] mid 19th c.*
Addresses: NYC. **Exhibited:** NAD, 1849. **Sources:** G&W;
Cowdrey, *NAD.*

WINDETT, Villette See: **OVERLY, Villette Windett**

WINDFOHR, Robert F. *[Collector] late 20th c.*
Addresses: Fort Worth, TX. **Comments:** Positions: chmn. board,
Fort Worth (TX) Art Center. **Sources:** WW73.

WINDHAM, Edmund *[Painter] 19th/20th c.*
Addresses: Brooklyn, NY. **Sources:** WW01.

WINDHAM, R. *[Painter] mid 20th c.*
Exhibited: AIC, 1938. **Sources:** Falk, *AIC.*

**WINDISCH, Marion L(inda) (Mrs. Alden Cody
Bentley)** *[Sculptor] b.1904, Cincinnati.*
Addresses: NYC. **Studied:** C.J. Barnhorn; E. McCartan.
Exhibited: Three AC (prizes); Women's City Club, Cincinnati
(prize). **Sources:** WW33.

WINDLEY, A. C. *[Painter] mid 20th c.*
Addresses: NYC. **Exhibited:** S. Indp. A., 1930. **Sources:**
Marlor, *Soc. Indp. Artists.*

WINDRAS, Cedric Wilford *[Painter] b.1888, Australia /
d.1966, Hermosa Beach, CA.*
Addresses: Los Angeles, CA. **Exhibited:** WPA, Southern Calif.,

1934. **Comments:** Specialty: sailing ships. **Sources:** Hughes, *Artists in California,* 611.

WINDREM, Robert C. *[Painter, printmaker, commercial artist]* *b.1905, Madera, CA / d.1985, Vancouver, WA.* **Addresses:** California; Vancouver, WA. **Studied:** Univ. Calif., Berkeley. **Member:** San Francisco AA. **Exhibited:** GGE, 1939; Gump's, San Francisco, 1940s. **Sources:** Hughes, *Artists in California,* 611.

WINDUST, Marjorie *[Painter] b.1908, Paris, France.* **Addresses:** Provincetown, MA, from 1930. **Studied:** ASL, with Thomas Benton, V. Vytlacil; Hawthorne. **Member:** Provincetown AA; NAWA; AEA; ASL. **Exhibited:** S. Indp. A., 1935; HCE Gal., Provincetown, 1957 (solo), 1958-66; Art USA, Madison Square Garden, NYC, 1958; Wiener Gal., Provincetown, 1959 (solo); James Gal., NYC, 1959; Area Gal., NYC, 1960-65 (solos, 1962, 1964); Westerly Gal., NYC, 1963-66; Royal Scottish Acad., Edinburgh, Scotland, 1963; Royal Birmingham (England) Soc., 1964; 50th Anniv. Show, Provincetown AA, 1964; NAWA traveling exh., 1965-67; La Napoule, France, 1965; Musée de Cognac, France, 1966; Cultural Center, Cannes, 1966. **Work:** Provincetown AA & Mus.; Provincetown Heritage Mus.; Chrysler Mus., Norfolk, VA. **Comments:** She and her husband (Mr. Halper) owned and operated the HCE Gallery in Provincetown from 1953 to c.1968. **Sources:** info courtesy Arthur B. Lane, MA.

WINEBRENNER, Harry Fielding *[Painter, sculptor, teacher, author, illustrator] b.1885, Summersville, WV / d.1969.* **Addresses:** Chatsworth, CA. **Studied:** Univ. Chicago; AIC; British Acad., Rome, Italy; Grande Chaumière, Académie Julian, France; with Taft, Mulligan, Sciortino. **Member:** Calif. AC; Society for Sanity in Art; Sculptors Gld., Southern Calif. **Exhibited:** AIC, 1914; Oakland Art Gal., 1948; Paris, France, 1950 (solo). **Work:** Hist. Society, Oklahoma City, OK; Carmel Sch., Avranches, France; Munic. Art Gal., Oklahoma City, OK; Oklahoma Art Mus.; murals, Northern Oklahoma Jr. College; Venice (CA) H.S. **Comments:** Author/illustrator: "Practical Art Education." Position: teacher, Venice (CA) H.S., 1917-45. **Sources:** WW59; WW47.

WINEGAR, A. L. *[Painter] early 20th c.* **Addresses:** New Haven, CT. **Sources:** WW04.

WINEGAR, Anna *[Painter] b.1867, Plainville, MN / d.1941, Tucson, AZ.* **Addresses:** Bronxville, NY. **Studied:** ASL. **Member:** NAWPS. **Sources:** WW27.

WINEGAR, Samuel Perry, Jr. *[Marine and portrait painter] b.1845, Harwich, MA / d.1917, New Bedford, MA.* **Addresses:** New Bedford, MA (1869-on). **Work:** Kendall Whaling Mus. **Comments:** A sailor who was listed as a nightwatchman in 1869 but, from 1881-1900 he was listed as an artist in the *New Bedford City Directory.* **Sources:** Blasdale, *Artists of New Bedford,* 208-09 (w/repro.); Brewington, 418.

WINER, Arthur Howard *[Sculptor, educator] b.1940, Lowell, MA.* **Addresses:** Marietta, OH. **Studied:** Univ. Massachusetts (B.A., 1962); Univ. Chicago (M.F.A., 1963); Hobart School Welding, Troy, OH, 1970; also with Hiroaki Morino & Katherin Nash. **Member:** College Art Assn. Am.; Am. Assn. Univ. Prof.; Nat. Council Educ. Ceramic Arts; Am. Crafts Council; World Crafts Council. **Exhibited:** 27th & 29th Int. Concorso Ceraminca Arte, Faenza, Italy, 1969 & 1971; Butler IA, 1969-71; USA Nat., Mobile, AL, 1970; Metal Show, Am. Soc. Metals, Cleveland, OH, 1970; Appalachian Corridors 3, Charleston, WV, 1972; Park Avenue Gal., Mount Kisco, NY, 1970s. **Awards:** Shell Oil-Marietta College grants, 1968-71. **Work:** Univ. Massachusetts, Amherst; Rock Valley College, Rockford, IL; Art Inst. Zanesville, OH; Cherryvale Shopping Center, Rockford, IL; Hobart School Welding. **Commissions:** concrete relief, Mr. Addison, Marietta, OH, 1970; relief, James Mills, Marietta, 1970; welded steel relief,

Franklin Lee, Marietta, 1971; free standing welded steel, Dr. & Mrs. G. Krivchenia, Marietta, 1971; welded steel relief & free standing, First Bank Marietta, 1971 & 1972. **Comments:** Preferred media: steel. Positions: juror, Mainstreams Int. Exhib, Marietta, 1968-72; director, Marietta College Crafts Regional, 1972. Teaching: art instructor, Rock Valley College, 1965-66; asst. professor, sculpture & ceramics, Marietta College, 1966-. Publications: contributor, *Contemporary American Ceramics* (catalogue), 1969. **Sources:** WW73.

WINER, Donald Arthur *[Museum curator, instructor] b.1927, St. Louis, MO.* **Addresses:** Harrisburg, PA. **Studied:** Univ. Missouri (B.S., M.A.). **Member:** Am. Assn. Mus.; Northeastern Mus. Conf.; Penn. Guild Craftsmen; Mid-State Artists. **Comments:** Preferred media: ceramics. Positions: curator, Springfield (MO) Art Mus., 1954-57; asst. director, Brooks Art Gallery, Memphis, TN, 1957-59; director, Montgomery (AL) Mus. Fine Arts, 1959-62; director, Everhart Mus. Art & Science, 1962-66; curator, Penn. Collection Fine Arts, Penn. History & Mus. Commission, 1966-. Teaching: instructor of painting, drawing & art history, Elizabethtown College, 1969-. Collections arranged: William Singer, Jr. Retrospective, 1967; Edwin W. Zoller Retrospective, 1968; Pennsylvania, 1971; George Hetzel Retrospective, 1972; Pennsylvania Heritage, 1972. Research: Pennsylvania painters; pottery of Pennsylvania. Collection: American earthenware, especially slip decorated red ware. **Sources:** WW73.

WINER, Flossie A. *[Painter] mid 20th c.* **Addresses:** Chicago area. **Exhibited:** AIC, 1939. **Sources:** Falk, *AIC.*

WINES, James N. *[Sculptor] b.1932, Oak Park, IL.* **Addresses:** NYC. **Studied:** Syracuse Univ. School Art (B.A., 1955). **Member:** Arts & Bus. Co-op Council, NY, 1971; Fed. Design Assembly, Wash., DC, 1972; Bicentennial Celebration, Wash., DC, 1972 (arts advisory council). **Exhibited:** WMAA, 1958-68; American Sculpture, São Paulo Biennial, Brazil, 1963; Pittsburgh Int., 1964; PAFA Ann., 1964, 1968 (prize); American Sculpture, Walker AC, Minneapolis, 1964; International Sculpture, Tate Gal., London, 1965; Marlborough Gal., NYC, 1970s. **Awards:** Design in Steel, Iron & Steel Inst., 1971. **Work:** Albright-Knox Art Gal., Buffalo, NY; Stedelijk Mus., Amsterdam, Holland; WMAA; Tate Gal., London, England; Walker AC, Minneapolis, MN. **Commissions:** plaza sculpture, Hoffman-La Roche Res. Center, Nutley, NJ, 1964; plaza sculpture for library, Univ. Wisconsin-Milwaukee, 1965; lobby sculpture, Dana ArC, Colgate Univ., Hamilton, NY, 1967; sculpture for mall, State Capital Bldg, Albany, NY, 1968; sculpture for lobby, Treadwell Corp., New York, 1968. **Comments:** Position: director, Site, Inc., New York, 1969-. Teaching: instructor in environmental art, School Visual Art, 1965-; instructor environmental workshop, New York Univ., 1965-71.Publications: author, "The Case for Site-Oriented Art," *Landscape Arch.,* 7/1971; author, *Site, Art & Artists,* London, 10/1971; co-author, "Street Art," TA/BK, Holland, 1/1972; co-author, "Peekskill Melt," Art Gallery, 3/1972; author, "The Case for the Big Duck," *Arch. Forum,* 4/1972. **Sources:** WW73; David Sellin, *James Wines--Sculpture* (Colgate Univ. Press, 1966); Falk, *Exh. Record Series.*

WINFIELD, Arthur M. *[Illustrator] early 20th c.* **Comments:** From 1912-26, he produced illustrations for juvenile series books, including *Rover Boys* for the Stratemeyer Syndicate. **Sources:** info courtesy James D. Keeline, Prince & the Pauper, San Diego.

WINFIELD, Rodney M. *[Painter] mid 20th c.* **Addresses:** Glen Gardner, NJ. **Exhibited:** PAFA Ann., 1951. **Sources:** Falk, *Exh. Record Series.*

WING See: **TSE, Wing Kwong**

WING, Anna See: **TRNKA, Anna Belle Wing (Mrs.)**

WING, Florence Foster (Mrs.) *[Designer] b.1874, Roxbury, MA.*
Addresses: Newton Centre, MA. **Studied:** BMFA Sch. **Member:** Copley Soc.; Boston SAC. **Exhibited:** BMFA (prize). **Work:** Bookplate. BMFA Lib.; Elmwood Pub. Lib., Providence, RI. **Comments:** Specialty: bookplates. **Sources:** WW40.

WING, Francis (Frank) Marion *[Cartoonist, teacher] b.1873, Elmwood, IL.*
Addresses: Minneapolis, MN. **Studied:** Grinnell College, Iowa. **Comments:** Positions: cartoonist, *Minneapolis Journal* (1900); St. Paul *Dispatch* and *Pioneer Press*; Chicago *Tribune* Syndicate; chief instructor, cartoon division, Federal School, Minneapolis. Author/illustrator, "The Fotygraft Album," 1917; "Yesterdays," (material syndicated by Des Moines *Register* and *Tribune*, 1930). **Sources:** WW40; Ness & Orwig, *Iowa Artists of the First Hundred Years*, 222-223.

WING, George F. *[Painter] b.1870, Massachusetts.*
Addresses: NYC, 1901-02; Wareham/South Dartmouth, active, 1908-14 ; Melrose, MA, 1930. **Exhibited:** PAFA Ann., 1901-02, 1930; New Bedford Art Club, 1908-14; New Bedford Free Public Library, 1921. **Work:** Dartmouth (MA) H.S. **Comments:** Most likely the same as G. F. Wing, Jr. listed in WW04 and living in NYC. **Sources:** Blasdale, *Artists of New Bedford,* (w/repro.); Falk, *Exh. Record Series.*

WING, Leota McNemar *[Painter] b.1882, Wilmington, OH.*
Addresses: Cedar Falls, IA. **Studied:** Univ. Kansas, Univ. Nebraska; Bethnay College, Lindsborg, KS; State Normal, San Diego, CA; William H. Griffith, Berger Sandzen. **Exhibited:** North Central Kansas Fair, Belleville, KS; Des Moines, IA (prizes). **Sources:** Ness & Orwig, *Iowa Artists of the First Hundred Years*, 224.

WINGATE, Arline (Mrs. Clifford Hollander) *[Sculptor, lecturer, teacher] b.1906, NYC.*
Addresses: East Hampton, NY. **Studied:** A. Faggi; J. Hovannes; A. Archipenko; Smith College. **Member:** Fed. Mod. P&S; NAWA; NY Soc. Women AC. **Exhibited:** S. Indp. A., 1935; NAD 1939; GGE, 1939; WFNY, 1939; Riverside Mus., 1938, 1941; Midtown Gal., 1938-46; Clay Club, 1938; NY Soc. Women AC,1939; PAFA Ann., 1940, 1945-46, 1950, 1954; Wildenstein Gal., 1941-46; NAWA, 1941-46; BM, 1944; MMA; WMAA, 1940-49; Smith College, 1942; AIC,1942; Wadsworth Atheneum Mus., 1944; Durand-Ruel Gal., 1944; Salons of Am.; SFMA; BMA; Frank Rehn Gal., NYC,1970s. **Work:** Syracuse (NY) Univ. Mus.; Nat. Mus. Stockholm, Sweden; Ghent Mus.Belgium; Farnsworth Mus, Rockland, ME; Parrish Mus, Southampton, NY. **Sources:** WW73; WW47; Falk, *Exh. Record Series.*

WINGATE, Carl *[Painter, illustrator, etcher, writer] b.1876.*
Addresses: Milton, MA/Marblehead, MA. **Studied:** W. Shirlaw. **Work:** 14 drypoints of ships, Mus., City of NY. **Sources:** WW40.

WINGATE, Curtis *[Painter, sculptor] b.1926, Dennison, TX.*
Addresses: probably Phoenix, AZ in 1971. **Studied:** William Schimmel. **Member:** CAA (assoc. mem.). **Work:** banks and businesses. **Comments:** Specialty: rodeo subjects. **Sources:** P&H Samuels, 534.

WINGERD, Loreen *[Graphic artist, craftsperson, teacher] b.1902.*
Addresses: Indianapolis, IN. **Studied:** W. Forsyth; J. Herron AI. **Member:** Indiana Artists Club; Indiana Soc. Printmakers. **Sources:** WW40.

WINGERT, Edward Oswald *[Painter, sculptor] b.1864.*
Addresses: Phila., PA. **Studied:** PAFA, with Anshütz, Hovenden, Porter. **Member:** AAPL. **Exhibited:** Spring Garden Inst. (medals); PAFA Ann., 1919-20; Soc. Indep. Artists, 1924. **Work:** Graphic Sketch Club, Phila.; Youngstown AI. **Sources:** WW40; Falk, *Exh. Record Series.*

WINGERT, Paul Stover *[Educator, writer, lecturer] b.1900, Waynesboro, PA / d.1974.*
Addresses: NYC; Montclair, NJ. **Studied:** Columbia College (A.B.); Columbia Univ.(M.A. & Ph.D.); Univ. London; Sorbonne, Paris. **Member:** College Art Assn. Am.; Am. Ethnology Soc.; Polynesian Soc.; Am. Anthropology Assn.; AAAS (fellow). **Exhibited:** Awards: Wenner-Green grant South Seas, 1952; Guggenheim Foundation fellowship, 1955. **Comments:** Publications: author, *The Sculpture of W. Zorach,* 1938, *An Outline Guide to the Art of the South Pacific,* 1946, *Arts of the South Seas,* 1946, *The Sculpture of Negro Africa,* 1950, *Art of the South Pacific Islands,* 1953 & *Primitive Art,* 1962 & 1965; co-author, *The Tsimshian: Their Arts and Music,* 1951; contributor, articles & review, *Art Bulletin, Am. Anthropologist, Transactions of New York Acad. Sciience, College Art Journal, Art Digest, Saturday Review* & others. Teaching: curator fine arts & archaeology, 1934-42, Columbia Univ., instructor, 1942-49, asst. professor fine arts & archaeology, 1949-54, assoc. professor, 1954-58, professor, 1958-66, professor emer., 1966-. Collections arranged: Arts of South Seas, MoMA, 1946; African Negro Sculpture, De Young Mem. Mus., 1948; Prehistoric Stone Sculpture of the Pacific Northwest, Portland AM, 1951; Melanesian Art War Mem. Mus., Auckland, NZ, 1952; South Pacific Art, 1953; African Sculpture, BMA, 1955-56. **Sources:** WW73.

WINGERT, Richard (Dick) *[Cartoonist] b.1919, Cedar Rapids, IA.*
Addresses: Westport, CT, 1949. **Studied:** John Herron Art Sch., Indianapolis, 1940. **Comments:** In 1942, he created "Hubert" (King Features Syndicate). **Sources:** *Famous Artists & Writers* (1949).

WINHOLTZ, Caleb *[Painter] mid 20th c.*
Addresses: St. Paul, MN. **Exhibited:** Salons of Am.; AIC, 1924-36. **Sources:** WW19.

WINICK, Sari *[Painter] mid 20th c.*
Exhibited: AIC, 1943. **Sources:** Falk, *AIC.*

WINKEL, Nina *[Sculptor] b.1905, Borken, Westfalen, Germany / d.1990, Keene Valley, NY.*
Addresses: immigrated to NYC, 1942; Keene Valley, NY. **Studied:** Staedel Mus. School, Frankfurt, Germany. **Member:** Clay Club Sculpture Center; NSS (fellow; secy., 1965-68); ANA; Sculptors Guild; Sculpture Center (pres., 1970-). **Exhibited:** Clay Club Gal., 1944 (solo); Newark Mus. 1944; PAFA Ann., 1946-58; Nebraska AA, 1946; Int. Fairmount Park Exhib.; Am. Acad. Arts & Letters; Univ. Notre Dame, 1954 (solo); WMAA; many shows, NAD; Sculpture Center, 1972 (retrospective). Awards: E. Watrous Gold Medal, 1945 & Samuel F.B. Morse Gold Medal, 1964, NAD; bronze medal, NSS, 1967-71. **Work:** wall panel, Keene Valley Library, NY. Commissions: Lassiter Mem., Lassiter Family, Charlotte, NC; Early Moravians (wall panels), Hanes Corp., Winston-Salem, NC; War Mem., Seward Park High School, NYC; Group of Children, City of Wiesbaden, Albert Schweitzer School. **Comments:** Preferred media: copper, terra-cotta. Publications: author of articles on sculpture & mosaics in periodicals. Teaching: sculpture, Clay Club Servicemen Canteen, 1942-46. Research: antiques, Byzantine mosaics. **Sources:** WW73; WW47; Nancy Dryfoos, "Nina Winkel," *Nat. Sculpture Review* (1971); Falk, *Exh. Record Series.*

WINKLE, Emma Skudler (Mrs. Vernon M.) *[Painter, craftsperson, designer, illustrator, lecturer, teacher] b.1902, Stuart, NE.*
Addresses: Lincoln 2, NE. **Studied:** Univ. Nebraska (B.F.A.); Columbia Univ.; & with J. Upjohn, Howard Church, Mrs. H.M. Brock, H. Stellar, L. Mundy, Paul Grummann. **Member:** Lincoln Art Gld.; Topeka Art Gld.; Am. Assn. Univ. Women; Nebraska AA. **Exhibited:** Lincoln Art Gld., 1924-1945; Topeka Art Gld., 1945; Lincoln State Fair; Univ. Nebraska, 1922-40. **Comments:** Position: art instructor, Univ. Nebraska, Lincoln, NE, 1921-32. Illustrator, "In-Service Education of Elementary Teachers," 1942; "In-Service Education of Teachers & Rural Community Building," 1940. **Sources:** WW53; WW47.

WINKLER, Agnes Clark (Mrs. G. A. M.) *[Painter, illustrator, craftsworker, writer]* b.1864, Cincinnati, OH / d.1945. **Addresses:** Chicago. **Studied:** L. Lundmark; E. James at AIC; F. Timmons; Watson; Mary Helen Stubbs. **Member:** All-Illinois SFA; Hoosier Salon; Cincinnati Women's AC; Chicago NJSA. **Exhibited:** PAFA Ann., 1910. **Comments:** Contributor: Paris magazines. **Sources:** WW40; Petteys, *Dictionary of Women Artists,* cites alternate birth date of 1893; Falk, *Exh. Record Series.*

WINKLER, Arthur John *[Landscape painter, etcher]* b.1883, Richmond, IN / d.1933, Victorville, CA. **Addresses:** Long Beach, CA. **Member:** P&S Los Angeles. **Exhibited:** Pasadena Art Inst., 1928. **Comments:** *Plein air* painter, who went on painting excursions into the desert with his friend H. Puthuff (see entry). **Sources:** Hughes, *Artists in California,* 611.

WINKLER, John William Joseph (Mrs.) See: **GINNO, Elizabeth de Gebele**

WINKLER, John W(illiam Joseph) *[Etcher, painter]* b.1894, Vienna, Austria / d.1979, El Cerrito, CA. ~W'193z~ **Addresses:** San Francisco, CA; Berkeley, CA. **Studied:** Calif. School FA, with Stanton and Van Sloun, 1910. **Member:** ANA, 1936; NA; Chicago SE; Am. Soc. Etchers; Société des Graveurs in Noir, Paris; Calif. Soc. PM; San Francisco AA; SAGA (life member). **Exhibited:** Chicago SE, 1918 (prize); Calif. SE, 1919 (prize); SAE, 1937 (prize); Concord AA, 1920 (prize); LACMA, 1920 (solo); Minneapolis, MI, 1921 (solo); NYC, 1923 (solo); Galeria Guiot, Paris, 1924 (solo); Keppels Gal., NYC, (solo); NYPL, (solo); BMFA (solo); AIC (solo); Fine Arts Soc., London (solo); Calif. State Lib., 1940 (solo), 1952 (solo); de Young Mus., 1951 (solo); San Francisco Pub. Lib., 1955 (solo); Korea, 1966 (solo); Triton Mus., Santa Clara, 1971 (solo); Van Straaten Gal., Chicago, 1972, (solo); CPLH, 1973, (solo), 1974 (solo); Richmond AC, 1973-74, (solos); Walton Gal., San Francisco, 1974 (solo); June 1 Gal., Wash., CT, 1975, (solo); Bank of Am. Gal., San Francisco, 1975, (solo); Brooklyn Mus, 1979 (solo). **Work:** AIC; NYPL; MMA; LOC; Luxembourg Mus., Paris; Calif. State Lib.; Soc. Calif. Pioneers; CPLH; SFMA: Bibliothèque Nationale, Paris; Boston Pub. Lib.; Smithsonian Inst.; MM; Oakland Mus.; Bancroft Lib., Univ. Calif., Berkeley; Victoria & Albert Mus., London; Brooklyn Mus.; Cleveland Mus.; Nat. Mus. Isreal; Oakland Mus.; San Francisco Pub. Lib. **Comments:** Immigrated to the U.S. in 1907, at first as a ranch hand and gold miner. After studying in San Francisco, around 1912 he concentrated on etchings of the city, producing many views of Telegraph Hill, Chinatown, the wharfs, the East San Francisco Bay area, and the Sierra Nevada mountains. His edition sizes were usually about 50, and he produced his etchings into the 1970s. **Sources:** WW47; Hughes, *Artists in California,* 611; *Journal of the Print World Newsletter* (vol. 1, no.4 (n.d., c.1988).

WINKS, Lucile Condit *[Painter, lithographer, block printer, drawing specialist]* b.1907, Des Moines, IA. **Addresses:** Salisbury, NC/Columbia Univ., NYC. **Studied:** B. Sandzen; A. Shannon; Margaret Wittemore; C. Henkle; A. Young. **Member:** Lg. Am. Pen Women; North Carolina Prof. Artists Club. **Sources:** WW40; Ness & Orwig, *Iowa Artists of the First Hundred Years,* 224.

WINN, Alfred *[Glass-stainer]* b.c.1813, England. **Addresses:** NYC in 1850. **Sources:** G&W; 7 Census (1850), N.Y., XLIII, 39; NYCD 1850.

WINN, Alice Collingbourne *[Painter]* early 20th c. **Addresses:** La Porte, IN. **Studied:** Sinibaldi at Capri and Eivert Pietut at Amsterdam. **Member:** Chicago ASL. **Exhibited:** AIC, 1912; Soc. Indep. Artists, 1924. **Sources:** Falk, *AIC;* Petteys, *Dictionary of Women Artists.*

WINN, Edna *[Painter]* mid 20th c.; b.Provincetown, MA. **Addresses:** Cambridge, MA/ Rockport, MA. **Studied:** Somerville; Boston; with Alma LeBrecht; BMFA Sch.; Aldro T. Hibbard School of Painting; with Lester Stevens. **Member:** Rockport AA; Cambridge AA; Winchester AA; Copley Soc., Boston. **Sources:** *Artists of the Rockport Art Association* (1946).

WINN, Emile W. *[Painter, printmaker]* mid 20th c. **Addresses:** San Francisco/Ross, CA. **Member:** San Francisco AA. **Exhibited:** San Francisco Soc. Women Artists, 1931; SFMA, 1935. **Sources:** Hughes, *Artists in California,* 611.

WINN, James Buchanan, Jr. *[Mural painter, decorator]* b.1905, Celina, TX. **Addresses:** Dallas/Wimberley, TX. **Studied:** O.E. Berninghaus; F. Carpenter, Wash. Univ.; Académie Julian, Paris. **Work:** bas relief, City Park, murals, Texas State Bldg., Village Theatre, Burrus Mills, Power and Light Bldg., all in Dallas; ceiling and dec., Univ. Texas, Austin; dec., Blackstone Hotel, Ft. Worth; State Mem., Gonzales; bas-reliefs, Ripley Fnd.; dec., River Oaks Theatre, Houston; murals, Medical Arts Bldg., dec., Hillcrest Mausoleum, both in Dallas. **Sources:** WW40.

WINN, James H. *[Jeweler, craftsperson, designer, engraver, sculptor, lecturer, teacher, writer]* b.1866, Newburyport, MA. **Addresses:** Pasadena, CA. **Studied:** H. Resterich; E. Rose; C. Mulligan. **Exhibited:** AIC, 1910 (price); Women's Conservation Expo, Knoxville, TN, 1913 (gold, prize); Calif. State Fair, Pomona, 1931 (prize). **Sources:** WW40.

WINN, Joseph *[Painter]* b.1890, Monroe County, NY. **Addresses:** Wash., DC, active, 1923- at least 1977. **Studied:** Corcoran Art Sch. **Member:** Landscape Club of Wash. **Comments:** He took painting excursions with Robert E. Motley. **Sources:** McMahan, *Artists of Washington, DC.*

WINN, S. A. (Miss) *[Illustrator, designer]* late 19th c. **Comments:** Employed by Prang & Co., chromolithographers, c.1891. **Sources:** Petteys, *Dictionary of Women Artists.*

WINNER, Charles H. ("Doc") *[Cartoonist]* b.1885, Perrysville, PA. **Comments:** He began as a cartoonist for the *Pittsburgh Post,* and in 1917 moved to the Newark (NJ) *Star-Eagle.* In 1926, he created the popular comic strip, "Elmer" (King Features Syndicate). **Sources:** *Famous Artists & Writers* (1949).

WINNER, Margaret F. *[Portrait painter, miniature painter, illustrator]* b.1866, Phila. / d.1937. **Addresses:** Phila. **Studied:** PAFA; H. Pyle. **Member:** Phila. Alliance; Plastic Club. **Work:** Dickinson College, Carlisle, PA; County Medical Soc., Phila. **Sources:** WW38.

WINNER, William E. *[Portrait, genre, historical, and religious painter]* b.c.1815, Phila. / d.1883. **Addresses:** Phila., 1836-83. **Member:** NA (hon. member). **Exhibited:** PAFA Ann., 1836-69, 1876-81; NAD, 1865-75; Boston Athenaeum; Apollo Assoc.; Am. Art-Union. **Comments:** He visited Charleston in 1848. **Sources:** G&W; 7 Census (1850), Pa., LI, 322, as Wenner; Rutledge, PA; Falk, PA, vol. II; Cowdrey, NAD; Swan, BA; Cowdrey, AA & AAU; Phila. CD 1839-60+; Rutledge, *Artists in the Life of Charleston; Portfolio* (Nov. 1944), 54, repro.

WINNEWISSER, Emma Louise *[Painter]* 19th/20th c.; b.Bellows Falls, VT. **Addresses:** Boston, MA. **Studied:** A. W. Bühler, in Boston. **Exhibited:** Boston AC, 1905; AIC, 1905. **Sources:** WW04.

WINNINGHAM, Alma M. *[Painter]* early 20th c. **Addresses:** Wash., DC, active 1920-35. **Exhibited:** Greater Wash. Independent Exh., 1935. **Sources:** McMahan, *Artists of Washington, DC.*

WINOGARD, Helen *[Painter]* mid 20th c. **Addresses:** NYC. **Exhibited:** S. Indp. A., 1927-28. **Sources:** Marlor, *Soc. Indp. Artists.*

WINOGRAND, Gary *[Photographer] b.1928 / d.1984.*
Studied: City College NY (painting); Columbia Univ.; New School Soc. Resarch, NYC, with Alexey Brodovitch (photojournalism). **Work:** MoMA; IMP/GEH. **Comments:** A photographer who captured America's social landscape of the 1950s-70s, often in a humorous way. Teacher: Univ. TX, Austin, 1973-on. **Sources:** Witkin & London, 274.

WINOKUR, James L. *[Collector, patron] b.1922, Phila.*
Addresses: Pittsburgh, PA. **Studied:** Univ. Pennsylvania (B.S., econ., 1943). **Comments:** Positions: trustee & member mus. art committee, Carnegie Inst., 1967-; vice pres. & gov., Pittsburgh Plan for Art, 1967-; fellow, Mus. Art, Carnegie Inst., 1968-; bd. dirs., Arts & Crafts Center, Pittsburgh, 1969-; trustee, Sara Mellon Scaife Foundation, 1972-. Art interests: Joseph Goto, American sculptor in welded steel. Collection: cobra paintings, drawings and sculpture including Carl-Henning Pedersen, Jorn, Corneille, Alichinsky, Ubac, Reinhoud and others; twentieth century American paintings, drawings and sculpture including John Kane, Dove, Avery, Joan Mitchell, Feininger, Wines, Sam Francis, Joseph Goto and others; prints from Old Masters to the twentieth century. **Sources:** WW73.

WINQUIST, Erik H. *[Painter] b.1907, Sweden.*
Addresses: Seattle, WA. **Studied:** Stockholm, Sweden. **Member:** Puget Sound Group of Northwest Painters. **Exhibited:** SAM, 1936-1940. **Sources:** Trip and Cook, *Washington State Art and Artists.*

WINSEY, A. Reid *[Painter, illustrator, cartoonist, writer, educator, lecturer] b.1905, Appleton, WI.*
Addresses: Greencastle, IN. **Studied:** Univ. Wisconsin (B.S., M.S.); Yale Univ.; Am. Acad. A., Chicago; & with Elmer Taflinger, Thomas Hart Benton. **Member:** Hoosier Salon; Indiana AC; Indiana Fed. AC; Chicago SE. **Exhibited:** Wisconsin Salon. **Work:** Layton Art Gal.; Wisconsin General Hospital, Madison, WI; Central Nat. Bank, Greencastle, IN; Art Educ. Bldg., Madison, WI; Atwater Training Sch., New Haven, CT. **Comments:** Position: hd., Dept. Fine & Applied Art, De Pauw Univ., Greencastle, IN, 1935-. Conducted art tours to Europe each summer for college credit. Author/illustrator, "Freehand Drawing Manual"; "Drawing Simplified." Contributor: school & art magazines. **Sources:** WW66; WW47.

WINSHIP, Florence Sarah *[Illustrator, writer, designer] late 20th c.; b.Elkhart, IN.*
Addresses: Chicago; Deerfield, IL. **Studied:** Chicago Acad. Fine Arts; AIC. **Comments:** Publications: illustrator, "Counting Rhymes," 1941, "Fuzzy Wuzzy Puppy," 1946, "The A-B-C Book," 1940, "Sounding Rhymes," 1942, "Sir Gruff," 1946, "Woofus," 1944, "Animal A-B-C," 1945, "Woofus & Miss Sniff," "Santa's Surprise," "The Night before Christmas," "The Bird Book;" plus many other books for children. **Sources:** WW73; WW47.

WINSHIP, John S. *[Engraver] 19th/20th c.*
Addresses: Wash., DC, active c.1865-1905. **Comments:** Lived at the same address as William W. Winship (see entry). **Sources:** McMahan, *Artists of Washington, DC.*

WINSHIP, W. W. *[Engraver] b.c.1834, District of Columbia.*
Addresses: Georgetown, DC in 1860. **Sources:** G&W; 8 Census (1860), D.C., I, 67.

WINSLAR, C. See: **HALL, C. Winslar (Mrs.)**

WINSLOW, Arthur G. *[Painter] mid 20th c.; b.Indiana.*
Studied: Purdue Univ.; with Maurice Utrillo. **Exhibited:** Harmon Fnd., 1930-31; Smithsonian Inst., 1930; South Side Community AC, Chicago, 1941. **Sources:** Cederholm, *Afro-American Artists.*

WINSLOW, C. *[Artist] mid 19th c.*
Comments: Made an early drawing of the Mormon Temple at Nauvoo (IL), probably about 1845. **Sources:** G&W; Arrington, "Nauvoo Temple," Chap. 8.

WINSLOW, Earle B. *[Illustrator, lithographer, teacher, painter, illustrator] b.1884, Northville, MI / d.1969.*
Addresses: Woodstock, NY. **Studied:** Sch. FA, Detroit, Mich.; AIC; ASL. **Member:** SI (chairman, exhib. committee, 1940-44); Artists Gld. (pres., 1940-44); Woodstock AA. **Exhibited:** S. Indp. A., 1920, 1926-27; PAFA Ann., 1920; Int. WC Soc., 1928-40; AIC, 1931-32; CAA; SI; 1931-45; Macbeth Gal. (solo); Audubon Artists; Nat. Soc. Painters in Casein; Artists of the Upper Hudson. **Comments:** Position: instructor, PIA School, 1946-48; cartoonist & Illustrator, Sch. FA New York, 1949-51. Illustrator, "Robbin's Journal," 1931; "Gospel of St. Mark," 1932; "Fire Fighters," 1939; & other books. Lectures: illustration. **Sources:** WW59; WW47; Woodstock AA; Falk, *Exh. Record Series.*

WINSLOW, Edward Lee *[Landscape painter] b.1871, Tescola, IL.*
Addresses: Indianapolis, IN. **Member:** Indiana AC; Hoosier Salon. **Work:** Shortridge H.S., Indianapolis. **Sources:** WW40.

WINSLOW, Eleanor C. A. (Mrs.) *[Painter, illustrator] b.1877, Norwich, CT.*
Addresses: NYC. **Studied:** ASL; Whistler, in Paris. **Member:** CAFA; NAWPS; Norwich AA. **Exhibited:** NAD, 1907 (Third Hallgarten Prize); Corcoran Gal annuals, 1907; Boston AC, 1908; PAFA Ann., 1908; AIC. **Sources:** WW40; Falk, *Exh. Record Series.*

WINSLOW, Henry *[Painter, etcher, critic, poet] b.1874, Boston, MA / d.After 1953, London, England?.*
Addresses: NYC after 1900; London, England. **Studied:** Whistler, in Paris. **Member:** Chicago SE; AIGA. **Exhibited:** Paris Salons; Royal Acad., London; AIC. **Work:** British Mus., London; Bibliothèque Nationale, Paris; NYPL; London Port Authority. **Comments:** He was the first artist to produce etchings in Cos Cob, CT, 1906, and was in South Norwalk, CT in 1908. Author: "The Etching of Landscapes" (Chicago SE, 1914). **Sources:** WW40; *Connecticut and American Impressionism* 179 (w/repro.).

WINSLOW, Henry J. *[Engraver and copperplate printer] mid 19th c.*
Addresses: NYC, 1832-40. **Sources:** G&W; *Am. Adv. Directory,* 1832; NYBD 1837, 1840.

WINSLOW, Leo *[Painter] mid 20th c.*
Addresses: Logansport, IN. **Sources:** WW25.

WINSLOW, Leon Loyal *[Teacher, writer] mid 20th c.; b.Brockport, NY.*
Addresses: Baltimore, MD. **Studied:** PIA School. **Member:** AFA. **Comments:** Author: "Organization of Art," "Elementary Industrial Arts." "Essentials of Design". **Sources:** WW31.

WINSLOW, Louisa See: **ROBINS, Louisa Winslow (Mrs. Thomas)**

WINSLOW, Marcella (Mrs. Randolph) See: **COMES, Marcella**

WINSLOW, Mina L. *[Painter] mid 20th c.*
Exhibited: AIC, 1932. **Sources:** Falk, *AIC.*

WINSLOW, Morton G. *[Painter] mid 20th c.*
Exhibited: Great Lakes Exh., The Patteran, Buffalo, 1938; AIC,1939; WFNY, 1939. **Sources:** WW40.

WINSLOW, Vernon *[Painter, illustrator] mid 20th c.; b.Dayton, OH.*
Exhibited: Atlanta Univ., 1942, 1943, 1944 (prize); South Side Community AC, Chicago, 1941; Albany Inst. of History & Art, 1945; Fort Huachuca, AZ, 1943. **Work:** Atlanta Univ. **Sources:** Cederholm, *Afro-American Artists.*

WINSOR, V. Jacqueline *[Sculptor] b.1941, Newfoundland, Canada.*
Addresses: NYC. **Studied:** Yale Summer School Art & Music, 1964; Massachusetts College Art (B.F.A., 1965); Rutgers Univ. (M.F.A., 1967). **Exhibited:** Am. Women Artists, Hamburg Kunsthaus, Germany, 1972; Nova Scotia College Art & Design, Halifax, 1972 (solo); Virginia Commonwealth Univ., Richmond, 1972; Paula Cooper Gal., NYC, 1972; WMAA. **Comments:**

Teaching: instructor art introd. & ceramics, Douglass Col., 1967; instructor art introd., Middlesex Co. Col. & Newark State Teachers' Col., 1968 & 1969; instructor ceramics, Mills Col. Educ., 1968 & 1971; instructor graphics, Loyola Univ., New Orleans, summer 1969; instructor ceramics, Greenwich House Pottery School, New York, 1969-72; instructor sculpture, School Visual Arts, New York, spring 1971; instructor art introd., Hunter Col., 1972-73. **Sources:** WW73; Grace Glueck, "Art Notes," *New York Times*, May 30, 1971; Elizabeth Bear, "Rumbles" (Sept, 1971) & interview with Jackie Winsor (spring, 1972), *Avalanche*.

WINSTANLEY, John Breyfogle See: **BREYFOGLE, John Winstanley**

WINSTANLEY, William *[Landscape and portrait painter] 18th/19th c.; b.England / d.After England.*
Addresses: Wash., DC, c.1792-94; NYC, 1795-99; Boston, 1801; England, 1806. **Exhibited:** Brooklyn AA, 1872 (portrait of Pres. John Adams). **Work:** Mt. Vernon (VA) Ladies Assoc.; Smithsonian Inst. **Comments:** He was one of the earliest landscape painters in America. Only three others — George Beck, Francis Guy, and Wm. Groombridge — were dedicated to the landscape at the turn of the 18th century. Winstanley came to the U.S. as a youth, just prior to 1793, and soon sold two Hudson River landscapes to President Washington (Mt. Vernon Ladies Assoc.). He next visited the newly-created District of Columbia where he painted several views of the Potomac River, selling two views to the President. He also painted several romantic landscapes "Genessee Falls, New York" and "Grotto Scene by Moonlight" (Smithsonian Inst.). From 1795-99, Winstanley's studio was in NYC, where he exhibited panoramas of London (1795) and Charleston (1797). He also took up portrait painting and made copies of one of Gilbert Stuart's Washington portraits, which some sources say Winstanley then tried to sell as his own (see discussion in Pleasants). The Washington portrait in the White House is said to be one of these copies. In 1801 Winstanley published a play, *The Hypocrite Unmask't,* in NYC. The last indication of his American residence is a prospectus which appeared in a Boston newspaper in Nov., 1801 (advertising a series of eight American views, to be engraved in aquatint). He is known to have returned to England, exhibiting several landscapes at the British Institution in London in 1806. **Sources:** G&W; Pleasants, *Four Late Eighteenth Century Anglo-American Landscape Painters,* 301-24, three repros. and checklist (reprinted 1970); NYCD 1795, 1798-99; Cowdrey, AA & AAU; Odell, *Annals of the New York Stage,* I, 443; Vail, "A Dinner at Mount Vernon," 79; Gottesman, *Arts and Crafts in New York,* II, nos. 58-60; Dunlap, *History;* Flexner, *The Light of Distant Skies,* biblio., 269. More recently, see Baigell, *Dictionary.*

WINSTANLEY-BREYFOGLE, Evelyn (Mrs. John) *[Artist] early 20th c.*
Addresses: Wash., DC, active 1917. **Exhibited:** Wash. AC (benefit of Am. Red Cross, Willard Hotel), 1917; WMAA, 1921. **Comments:** Married artist John Winstanley Breyfogle (whose name also appears as John Breyfogle Winstanley). **Sources:** McMahan, *Artists of Washington, D.C.*

WINSTEN See: **WINSTON, Nell A(rcher)**

WINSTEN, Dik *[Painter] mid 20th c.*
Exhibited: S. Indp. A., 1924. **Sources:** Marlor, *Soc. Indp. Artists.*

WINSTEN, Sheila (Mrs. Archer) See: **RALEIGH, Sheila (Mrs. Archer Winsten)**

WINSTON, Annie Stegar *[Portrait and decorative painter] late 19th c.*
Addresses: Richmond, VA. **Exhibited:** Richmond, VA, 1896, 1897, 1899. **Sources:** Wright, *Artists in Virginia Before 1900.*

WINSTON, Dudley (Mrs.) *[Painter] late 19th c.*
Addresses: Chicago. **Exhibited:** AIC, 1898. **Sources:** Falk, *AIC.*

WINSTON, Grace Falwell (or Farwell) *[Painter] early 20th c.*
Addresses: Chicago. **Exhibited:** AIC, 1905. **Sources:** Falk, *AIC.*

WINSTON, Lydia K. (Mrs. Harry Lewis) *[Collector, patron] mid 20th c.; b.Detroit, MI.*
Addresses: Birmingham, MI. **Studied:** Vassar College, B.A.; Cranbrook Academy of Art, M.A. **Exhibited:** Awards: Doctor of Humanities, Wayne State University, 1961; Cranbrook Award in Ceramics, 1944. **Comments:** Positions: member, Detroit Commissioners of Art; trustee, Founders Soc., Detroit Inst. Arts; chmn., art policy committee of the trustees, Detroit Inst. Arts; chmn., arts policy committee, as a trustee of Bennington College; mem., nat. Advisory committee, Washington Gal. Modern Art; mem., committee on 20th Century painting & sculpture, AIC; mem., advisory committee, Skowhegan (ME) School of Art; mem., int. council, MoMA. Collection: 20th century art collection (formed with the late Mr. Harry Lewis Winston) of European and American painting, sculpture, graphics, drawings, from cubism, futurism, Dada, constructivism, and surrealism to works by Pollock, Tobey, Stella, Noland, and Morris Louis; numerous articles have been published about the collection, including an article in "Great Private Collections", and articles in *Arts, Art News,* European journals, and other magazines and books; collection was exhibited as a whole in 1957-58 in Detroit and other cities. **Sources:** WW66.

WINSTON, Mildred (Mrs. Fisher) See: **ATKIN, Mildred Tommy (Mrs. Fisher Winston)**

WINSTON, Naomi Raab *[Painter, teacher] b.1894, Evergreen, AL / d.1979, Virginia Beach.*
Addresses: NYC; Wash., DC, 1930s; Virginia Beach. **Studied:** Central College, AL; Taylor School of Heraldry, Chicago, IL; Corcoran Art Sch. **Sources:** McMahan, *Artists of Washington, DC.*

WINSTON, Nell A(rcher) *[Painter] mid 20th c.*
Exhibited: Salons of Am., 1934. **Comments:** (Last name also appears as Winsten). **Sources:** Marlor, *Salons of Am.*

WINSTON, Richard *[Painter] b.1927, Orange, NJ.*
Member: Conn. Classic Art, Inc.; Boston Negro Artists Assn. **Exhibited:** Arnot Art Gal., 1956; Cameron Gal., 1965; Winston Gal., 1965-66; Elmira Col., 1966 (award); Fairfield Univ., 1970; Sacred Heart Univ., 1970; Westport Bank & Trust, 1972; Greenwich Village, NYC; New Haven Regional Center Art Gal., 1972. **Comments:** Specialty: mixed media. **Sources:** Cederholm, *Afro-American Artists.*

WINTER, Alice Beach (Mrs. Charles A.) *[Painter, sculptor, illustrator, teacher] b.1877, Green Ridge, MO / d.c.1970, Gloucester, MA.*
Addresses: St. Louis; `ALICE BEACH → WINTER` NYC; East Pasadena, CA, 1932; East Gloucester, MA, from c.1930. **Studied:** St. Louis School FA; ASL, & with George de Forest Brush, Joseph De Camp, J. Fry, C. Von Saltza, J. Twachtman. **Member:** NAWA; North Shore AA; Business & Prof. Women's Club, Gloucester; Gloucester SA. **Exhibited:** St. Louis Expo., 1897; AIC; NAD; PAFA Ann., 1910-13, 1921; CI; Soc. Indep. Artists; CAM; LACMA; NAWA; North Shore AA; Contemp. New England Artists; Gloucester Festival Art. Awards: medal, St. Louis Sch. FA; prize, Gloucester Chamber of Commerce, 1954. **Work:** many portraits of children. **Comments:** Illustrations for stories and covers of child-life for national magazines. Contributor: illustrations/covers, *Delineator.* Specialty: children. **Sources:** WW59; WW47; Falk, *Exh. Record Series.*

WINTER, Andrew *[Painter] b.1893, Sindi, Estonia / d.1958, Brookline, MA.* `A. WINTER`
Addresses: NYC in 1929-40; Monhegan Island, ME, 1953. **Studied:** NAD, 1921; Cape Cod Sch. Art; Tiffany Fnd.; Am. Acad, Rome; NAD, Mooney traveling scholarship, 1925. **Member:** AWCS; NAC; SC; A. Fellowship; Tiffany Fnd.; ANA; NA, 1938; Allied AA; AAPL. **Exhibited:** PAFA Ann., 1929-50 (9 times); AIC; Corcoran Gal biennials, 1932-51 (7 times); VMFA; CI; AFA Traveling Exhib.; GGE, 1939; WFNY, 1939; AV; SC;

Pepsi-Cola; Montclair AM; Herron AI; TMA; ATC; Carnegie Inst.; Currier Gal. Art; NAC; Herron AT; TMA; NAD, 1924 (medal), 1931 (medal), 1935 (medal), 1940-42 (prizes); NAC,1931 (prize); Allied AA, 1933 (prize), 1939 (prize); SC,1934 (prize), 1937 (prize), 1938 (prize), 1940 (prize), 1941 (prize), 1942 (prize), 1945 (prize),1948, 1949; Buck Hills Falls, PA, 1940 (prize); Currier Gal., 1941 (prize); Ogunquit AC, award, 1948; Salons of Am. **Work:** Marine Mus., Newport News, VA; NAD; PAFA; Cranbrook Acad. Art; Winchester (MA) Pub. Lib.; Buck Hills Falls, PA; Wake Forest (IL) College; NAC; IBM Collection; High Mus. Art; Hickory (NC) Mus.; Claremont H.S., NC; Mint Mus. Art; Wesleyan College, Macon, GA; Mt. Holyoke College; Rochester Mem. Art Gal.; WPA mural, USPO, Wolfeboro, NH. **Comments:** Frequently visited Monhegan Island, ME, before he and his wife, Mary Taylor, became full-time residents for a number of years. **Sources:** WW53; WW47; Curtis, Curtis, and Lieberman, 144, 170, 187; Falk, *Exh. Record Series.*

WINTER, C. *[Listed as "artist"] mid 19th c.*
Addresses: Philadelphia, PA, c.1840. **Work:** Karolik Collection (painting of an early minstrel show scene). **Sources:** G&W; Karolik Cat., 520, 521 (repro.).

WINTER, Charles *[Portrait painter] b.c.1822, Louisiana.*
Addresses: NYC in 1860. **Comments:** His wife was from New Jersey; one child (age12 in 1860) was born in Pennsylvania, and two others (5 and 9 in 1860) were born in New York State. **Sources:** G&W; 8 Census (1860), N.Y., LIII, 168.

WINTER, Charles Allan *[Painter, illustrator, decorator, drawing specialist, lecturer, teacher] b.1869, Cincinnati, OH / d.1942.*
Addresses: East Gloucester, MA. **Studied:** Cincinnati Art Acad., with Nobel, Nowottny; Académie Julian, Paris with Bouguereau and Ferrier, 1894-96; Rome. **Exhibited:** Paris Salon, 1896, 1898; AIC. **Work:** murals, City Hall, H.S., both in Gloucester, MA; Univ. Wyoming. **Comments:** Contributor: illustrations/covers, Elbert Hubbard's "Little Sermons" in *Cosmopolitan* and *Hearst's* magazines; illustrations/covers, *Collier's*; work for American Bank Note Co. **Sources:** WW40; Fink, *American Art at the Nineteenth-Century Paris Salons,* 407.

WINTER, Clark *[Sculptor, teacher, lithographer, lecturer] b.1907, Cambridge, MA.*
Addresses: NYC; Corte Madera, CA. **Studied:** Harvard Univ. (A.B.); ASL; Cranbrook Acad. Art; R. Laurent; W. Zorach; Indiana Univ. (M.F.A.); Fontainebleau Acad. Art. **Exhibited:** Soc. Indep. Artists, 1940-42; PAFA Ann., 1942; Fontainebleau Sch. Alumni Assn., 1943 (prize); Vendôme Gal., 1943; Am. Sculpture Exhib., MMA, 1951; WMAA, 1954; SFMA, 1954; Third Int., PMA; Soc. Sculptors. **Work:** Mus. Art, Carnegie Inst.; Aldrich Mus. Contemporary Art; Carnegie-Mellon Univ.; Pittsburgh Hilton Hotel. **Comments:** Teaching: teacher, PIA School, 1945-47; instructor, Indiana Univ., 1947-49; hd., dept. sculpture, Kansas City AI, 1949-53; visiting assoc. prof., UCal., Berkeley, 1953 & 1955; assoc. prof. sculpture, Carnegie-Mellon Univ., 1955-70, emer. prof., 1972-. **Sources:** WW73; WW47; Falk, *Exh. Record Series.*

WINTER, Ezra (Augustus) *[Painter, illustrator, mural painter] b.1886, Manistee, MI / d.1949.*
Addresses: Falls Village, CT. **Studied:** Chicago Acad. FA; Am. Acad, Rome, schol, 1911-14. **Member:** NSMP; SC; AFA; Arch. Lg.; Am. Acad. Arts & Letters; ANA, 1924; NA, 1928; Players Club. **Exhibited:** Arch. Lg., 1922 (medal); NY Soc. Arch., 1923 (gold); AIC. **Work:** Cunard Bldg., NY; Cornell; NY Cotton Exchange; Nat. Chamber of Commerce, Wash., DC; Union Trust Bldg., Detroit; Music Hall, Rockefeller Center; Kilbum Hall, Eastman Theatre, Rochester, NY; Pub. Lib., Birmingham, AL; Savings Bank, Rochester, NY; Industrial Trust Bldg., Providence, RI; stained glass window, Straus Bank, Chicago; NY Life Bldg., Restaurant, NYC; Bank of Manhattan Trust Co.; George Rogers Clark Mem., Vincennes, IN. **Sources:** WW47.

WINTER, George *[Portrait, landscape, and historical painter; dioramist] b.1810, Portsea, England / d.1876, Lafayette, IN.*
Addresses: NYC, 1830-c.1835; Cincinnati, c.1835; Logansport, IN, c.1836-51; Lafayette, IN, 1851-76. **Studied:** London; NAD, three years. **Exhibited:** NAD, 1832-35 (portraits and miniatures); Cincinnati, OH, 1846 and 1848-49; Logansport, IN ,1850 (dioramas); held annual raffles for his paintings in Lafayette, IN, from 1851-73, in Indianapolis, 1852; Toledo, OH, 1851 & 1858; Burlington, IA, 1856; and La Porte, IN, 1858. **Work:** Indiana State Mus. and Historic Sites, Indianapolis; Earlham College, Richmond, IN; State Hist. Soc. Wisconsin, Madison, WI. **Comments:** Painted miniatures and portraits in NYC before going to Cincinnati in 1835. Moving to Indiana in 1836, he became the state's most important pioneer artist, painting numerous portraits of the local Indians and early settlers, as well as romantic landscapes. Winter also created and exhibited large dioramas of foreign and historical scenery. He worked in both watercolor and oil. The best known of his pupils was John Insco Williams (see entry). **Sources:** G&W; George S. Cottmnan, "George Winter, Artist," *Indiana Magazine of History* vol. 1 (3rd Quarter, 1905); *The Journals and Indian Paintings of George Winter 1837-1839,* with essays by Wilbur D. Peat ("Winter, the Artist") and Gayle Thornbrough ("Biographical Sketch"), along with Winter's autobiography and journals and 31 repros. (Indianapolis: Indiana Historical Society, 1948); Peat, *Pioneer Painters of Indiana;* Burnet, *Art and Artists of Indiana;* and *American Heritage* (August 1950), 34-39; Hageman, 124; Gerdts, *Art Across America,* vol. 2: 255-56 (with repro.); P&H Samuels, 534.

WINTER, Gerald *[Painter] mid 20th c.*
Exhibited: Corcoran Gal biennial, 1963 (bronze medal). **Sources:** Falk, *Corcoran Gal.*

WINTER, H. Edward *[Craftsperson, designer] b.1908, Pasadena, CA.*
Addresses: Cleveland, OH. **Studied:** Cleveland Sch. Art; Kunstgewerbe Schule, Vienna, Austria. **Member:** Cleveland SC; NYSC. **Exhibited:** CMA, 1933 (prize), 1934 (prize), 1936 (prize); Robineau Mem. Ceramic Exhib., Syracuse NY Mus., 1934 (prize), 1936 (prize); Canadian Nat. Exhib., 1933 (prizes); Nat. Ceramic Exhib., Syracuse MFA, 1937 (prize)-38 (prize). **Work:** 25 porcelain enamel murals, for the Ferro Enamel Corp., Cleveland; CMA, Am. Ceramic Tour of Europe, 1937. **Sources:** WW40.

WINTER, Helen Cecil *[Painter] early 20th c.*
Exhibited: S. Indp. A., 1917. **Sources:** Marlor, *Soc. Indp. Artists.*

WINTER, John *[Painter of landscapes, coaches, coats of arms, and ornamental work of all kinds] mid 18th c.*
Addresses: Phila. **Comments:** First advertised in Philadelphia in March 1739/40 and was still there in 1771. Sometime before 1755 he was in business with Gustavus Hesselius (see entry). In 1761 he may have been one of the artists of a view of the Pennsylvania Hospital, by Winters and Montgomery (see entry), for the engraver Robert Kennedy. **Sources:** G&W; Brown and Brown; Prime, I, 13.

WINTER, Joseph *[Painter] mid 20th c.*
Addresses: NYC. **Exhibited:** PAFA Ann., 1954; WMAA, 1958. **Sources:** Falk, *Exh. Record Series.*

WINTER, Lumen Martin *[Sculptor, painter, illustrator, designer, lecturer, teacher, cartoonist] b.1908, Ellery, IL / d.1982, New Rochelle, NY.*
Addresses: Cincinnati; New Rochelle. **Studied:** Cleveland Sch. Art; NAD; Grand Central Sch. Art; BAID; Olinsky; Biggs; Pape; Grand Rapids (MI) Jr. College; also study in France & Italy. **Member:** Cincinnati Prof. Artists; Cincinnati AC; Art Dir. Club, Chicago; Art Gld., NY; FA; Salmagundi Club (committees & juries, 1950-); AWCS; Nat. Soc. Mural Painters (vice-pres., 1953-55); New Rochelle AA (pres., 1952-54); Arch. Lg. NY (vice-pres., 1955-57). **Exhibited:** Salon of Am., 1933; Asbury Park SA, 1939-40; AV, 1943; Butler AI, 1943-44; CM, 1937-46, 1944 (prize, "Int. Color Lithography");

Ohio WCS,1944-45; Cincinnati Prof. Artists, 1943-45; Grand Rapids Art Gal., 1929-31; Cincinnati AC,1937-45; Hackley Art Gal., 1929 (solo); Grand Rapids Pub. Lib., 1932; Brown Gal., Cincinnati, 1940; Detroit AI; Grand Central Art Gal.; Hotel Gibson, Cincinnati (solo); AWCS Annuals & traveling shows, 1950-; Int. Watercolor, PAFA, 1951; Geneva, Switzerland, 1955; NAD, 1965 (purchase award); Salmagundi Club, 1969 (Peterson Award); Bicentennial, Am. Numismatic Soc., 1972 (medallion). **Work:** Union H.S. and Union Jr. College, both in Grand Rapids, MI; Univ. Cincinnati; Friar's Club, Cincinnati; murals: Fed. Bldg., Fremont, MI; Hutchinson, KS; WPA murals: USPOs, Fremont, MI, Wellston Public School, St. Louis; Washington Co. Mus., Hagerstown, MD; LOC; Mus. Contemporary Art, Dallas, TX; Columbus Mus. Arts & Crafts, Georgia; Vatican, Rome, Italy. Commissions: Lady of the Thruways (bronze figure), Knights of Columbus for Lady of Good Counsel College, White Plains, NY, 1959; mosaic & bas-relief sculpture for chapels, U.S. Air Force Acad., Colorado Springs, CO, 1960-61; Apollo 13 official medallion for Capt. James A. Lovell, Jr., Houston, TX, 1970; Titans mural (oil on linen), United Nations, NYC, 1972; space age mosaic, AFL-CIO Hq Bldg, Wash., DC, 1972. **Comments:** Position: art juror, various art shows. Research: art works of Leonardo da Vinci. Art interests: reconstruction of full size Last Supper. Publications: co-author: "Epics of Flight" (1932), "Can It Be Done?" (1933); co-author, *The Last Supper of Leonardo da Vinci* , (Coward McCann, 1953). Contributor: covers, *Liberty*, 1935. **Sources:** WW73; WW47; Norman Kent & Ernest Watson, "Lumen Martin Winter," *Am. Artist Magazine* (1950, 1952, 1959 & 1966); Ralph Fabri, "Lumen Martin Winter," *Today's Art* (1966).

WINTER, Margaret C. *[Printmaker] mid 20th c.*
Exhibited: Kingsley AC, Sacramento, CA, 1939-54; GGE, 1940. **Sources:** Hughes, *Artists in California*, 612.

WINTER, Mary Taylor See: **TAYLOR, Mary**

WINTER, Milo *[Illustrator] b.1888, Princeton, IL.*
Addresses: NYC. **Studied:** AIC. **Member:** Chicago AC; Caxton Club, Chicago. **Comments:** Author/illustrator: "Billy Popgun." Illustrator: "Aesop's Fables"; "Arabian Nights"; "Alice in Wonderland"; "Gulliver's Travels"; "Bible Story Book"; "Animal Inn," and others; numerous text books. Illustrated 18 film strips for "Then and Now in the U.S.A.," for Silver Burdett Co. Position: art editor, *Childcraft*, 1947-49; art editor, film strip div., Silver Burdett Co., NYC, 1949-. **Sources:** WW53.

WINTER, Milo Kendall, Jr. *[Painter, designer, teacher] b.1913, Chicago, IL / d.1956.*
Addresses: Chicago/Goose Rock Beach, ME. **Studied:** AIC; Cranbrook Acad.; E. O'Hara. **Exhibited:** AIC,1939; PAFA; AFA, 1938, 1939 (traveling). **Work:** CAM. **Comments:** Positions: teacher, RISD; O'Hara WC School (summer). **Sources:** WW40.

WINTER, Olive E. *[Painter] mid 20th c.*
Addresses: MIles City, MT. **Exhibited:** S. Indp. A., 1930, 1932. **Sources:** Marlor, *Soc. Indp. Artists*.

WINTER, R. *[Painter of chemical dioramas, crystalline views, chromatropes and metamorphoses] mid 18th c.*
Exhibited: NYC (Nov. 1843), St. Louis (Feb. 1845), Charleston (Nov. 1845), Richmond (March 1846), Nashville (April 1847), Philadelphia (June 1847), Baltimore (Oct.-Nov. 1847), Brooklyn (1847), Nashville (Feb.-March 1850), Cincinnati (Feb.-March 1853), Baltimore (December 1856), and Philadelphia (April 1857). **Comments:** His work included European views and "The Death of Napoleon." *Cf.* Robert Winter. **Sources:** G&W; Odell, *Annals of the New York Stage*, V, 409.

WINTER, Raymond *[Painter] mid 20th c.*
Addresses: Fairhaven, PA. **Member:** Pittsburgh AA. **Sources:** WW25.

WINTER, Robert *[Portrait painter, daguerreotyper] b.1821, England.*
Addresses: Phila., 1860; San Francisco, 1866- c.1887. **Sources:**

G&W; Phila. CD 1860. More recently, see Hughes, *Artists in California*, 612.

WINTER, Roger *[Painter, educator] b.1934, Denison, TX.*
Addresses: Dallas, TX. **Studied:** Univ. Texas (B.F.A., 1956); Univ. Iowa (M.F.A., 1960); Brooklyn Mus. School, Beckmann scholarship, 1960. **Exhibited:** Texas Painting & Sculpture, 20th Century, Dallas, 1971-72; White Mus., San Antonio, TX, 1967; Pollock Gal., 1968 (solo) & One I at a Time, 1971 (solo), Southern Methodist Univ., Dallas & Delgado Mus. Art, New Orleans, LA, 1968 (solo); Cranfill Gal., Dallas, TX, 1970s. Awards: purchase award, Univ. Oklahoma Art Mus., 1962; top award, Dallas Ann., Dallas Mus. Fine Arts, 1964. **Work:** Mus. Art, Univ. Oklahoma, Norman; Dallas Mus. Fine Arts; Pollock Gal., Southern Methodist Univ., Dallas; Nicholson Mem. Library & Mus., Longview, TX; Oak Cliff Savings & Loan, Dallas. **Comments:** Preferred media: oils, pencils. Positions: installation asst., Dallas Mus. Contemporary Arts, 1962-63; gallery tours & lecturer, Dallas Mus. Fine Arts, 1963-. Teaching: painting instructor, Fort Worth AC, 1961; painting instructor, Dallas Mus. Fine Arts, 1962-68; assoc. professor painting, Southern Methodist Univ., 1965-. **Sources:** WW73; Douglas McAgy, *One i at a Time*, exhib. catalogue (Southern Methodist Univ. Press, 1971); film on work produced on KERA-TV, Dallas, 1971.

WINTER, Ruth *[Painter] b.1913, NYC.*
Addresses: Rego Park, NY. **Studied:** New York Univ. (B.S., 1931; M.A., 1932); ASL, with Corbino, Bosa & Morris Kantor, 1957-61. **Member:** NAWA; ASL (life mem.); Mahopac Art Lg. **Exhibited:** Am. Art at Mid-century, Orange, NJ, 1957; Nat. Assn. Women Artists, 1957-68; Art USA, Provincetown, Mass., 1958; Brooklyn Mus., 1960; NAD, 1960. Awards: Marcia Brady Tucker Prize, NAWA, 1957; Max Low Award, 1959; Mr. & Mrs. Gomes Award, Mahopac Art Lg., 1959. **Work:** in collections of Reginald Cabral, Provincetown, MA, Marlo Lewis, Scarsdale, NY, Mr. Frantz, Great Neck, NY, Lawrence Koenisberg, South Lawrence, NY & Seymour S. Alter, West Hempstead, NY. **Comments:** Preferred media: oils. **Sources:** WW73; Robert M. Coates, "The Art Galleries," *New Yorker* (May, 1957); Stuart Preston, "Art: A Game of Styles," *New York Times* (May, 1957); painting televised, Boston, July, 1958.

WINTER, T. *[Portrait painter] b.c.1831, Germany.*
Addresses: New Orleans in 1850. **Comments:** His wife Mary, born c.1831, was a native of France. **Sources:** G&W; 7 Census (1850), La. VII, 331.

WINTER, William *[Miniature painter] mid 19th c.*
Addresses: Cincinnati, 1856. **Sources:** G&W; Cincinnati CD 1856.

WINTERBOTHAM, Rue See: **CARPENTER, Rue Winterbotham (Mrs. John Alden)**

WINTERBURN, Georg T. *[Landscape painter, bookplate designer] b.1865, Leamington Spa, England / d.1953, Los Angeles, CA.*
Addresses: Los Angeles. **Studied:** Merson, Thaulow, LeRoy. **Exhibited:** Southern Calif. Art Teachers Assoc., 1922. **Comments:** Position: asst. instructor, industrial art, Univ. Calif., Berkeley, 1896-1901; teacher, Polytechnic H.S., Los Angeles, after 1906. **Sources:** Hughes, *Artists in California*, 612.

WINTERBURN, Phyllis *[Painter, teacher, designer, block-printer] b.1898, San Francisco, CA / d.1984, San Francisco.*
Addresses: Sausalito, CA. **Studied:** Calif. Sch. FA, with Spencer Macky, Isabelle Percy West, K. Gillespie, Norman Edwards; Schaeffer Sch. Des.; Univ. Calif.; Dominican College. **Member:** San Fran. Soc. Women Artists; Marin SA; San Fran. AA; Northwest PM. **Exhibited:** Calif. State Fair, 1937. **Work:** SFMA; Marin AA; CPLH. **Comments:** Position: director of art, Katharine Branson Sch., Ross, CA. **Sources:** WW40; Hughes, *Artists in California*, 612.

WINTERHALDER, Erwin *[Sculptor] b.1879, Zürich, Switzerland / d.1968, Santa Clara County, CA.*
Addresses: San Francisco, CA. **Studied:** Paris, 1903-05; Italy, 1905-07; Munich and Zürich, 1908-13; with Sterling Calder, 1914-15. **Comments:** Settled in San Francisco in 1913 and worked as a commercial artist through the early 1930s. **Sources:** WW17; Hughes, *Artists in California*, 612.

WINTERHALDER, Joseph *[Portrait and landscape painter] b.c.1820, Germany / d.1867, New Orleans.*
Addresses: New Orleans, 1852-56. **Comments:** Itinerant painter who was the brother of Franz X. Winterhalder, a noted portrait painter in Paris and England. Joseph Winterhalder was first recorded in the U. S. in Montgomery, Al, 1849, married and settled in New Orleans in 1851. From 1858-66 the directories list J. Winterhalder, bakery, and J. Winterholder, wheelwright. Father of Louis Adolph Winterhalder (see entry). **Sources:** G&W; New Orleans CD 1852-66. More recently, see *Encyclopaedia of New Orleans Artists*, 417.

WINTERHALDER, Louis (Ludwig) Adolph *[Painter, cartoonist, commercial artist] b.1862, New Orleans, LA / d.1931, New Orleans.*
Addresses: New Orleans, active 1882-1931. **Studied:** Andres Molinary; Achille Perelli; William H. Buck. **Exhibited:** Southern Art Union, 1882; Acad. Fine Arts, Chicago. **Comments:** Credited with drawing the first political cartoon in a New Orleans newspaper. Son of Joseph Winterhalder (see entry). **Sources:** *Encyclopaedia of New Orleans Artists*, 417.

WINTERICH, Joseph *[Sculptor] b.1861, Neuweid, Germany / d.1932, Koblenz, Germany.*
Addresses: Cleveland, OH. **Work:** church dec., St. Ignatius, St. Cyril, St. Methodine & Our Lady of Good Counsel, all in Cleveland. **Comments:** Came to U.S. in 1907. In 1920, he joined his son in church furnishing & dec. firm in Cleveland.

WINTERMOTE, Mamie W(ithers) (Mrs.) *[Portrait painter] b.1885, Liberty, MO / d.1945, Hollywood, CA.*
Addresses: Hollywood, CA. **Studied:** Kansas City AI; with R. Davey, N. Facine. **Member:** Calif. AC; Women Painters of the West. **Sources:** WW40; Hughes, *Artists in California*, 612.

WINTERMUTE, Marjorie *[Painter] mid 20th c.*
Addresses: Berkeley, CA. **Member:** Carmel AA. **Exhibited:** GGE, 1939. **Sources:** Hughes, *Artists in California*, 612.

WINTERS, A. (Mrs.) *[Painter] late 19th c.*
Addresses: Phila., PA, 1876. **Exhibited:** PAFA Ann., 1876 (landscapes). **Sources:** Falk, *Exh. Record Series.*

WINTERS, Ann *[Painter] mid 20th c.*
Addresses: Chicago area. **Exhibited:** AIC, 1944. **Sources:** Falk, AIC.

WINTERS, Denny (Denny Winters Cherry) *[Painter, lithographer, designer, craftsperson, printer] b.1907, Grand Rapids, MI / d.1985, Woodstock, NY?.*
Addresses: Los Angeles, CA; Woodstock, NY, 1947; Rockport, ME, 1973. **Studied:** AIC; Chicago Acad. Fine Arts; with Weisenborn; Académie Julian, Paris; with Diego Rivera in Mexico. **Member:** Los Angeles WCS; Woodstock AA.
Exhibited: WMAA; MoMA; AIC,1936-37, 1945; SFMA, 1939-41 (prize), 1942-43 (prize); PAFA Ann., 1941-42, 1950-52, 1960-64; Denver Mus. Ann. Art Show, 1941 (first prize); Colorado Springs FAC, 1943; LACMA, 1939-45, 1944 (solo); Perls Gal., 1942; Levitt Gal., 1945 (solo); CI, 1945, 1946; Butler IA (purchase prize); Woodstock AA. Awards: Guggenheim fellowship, 1948. **Work:** Woodstock AA; PMA; SFMA; dioramas, Century of Progress, sponsored by Univ. Chicago. **Comments:** Denny Sonke Winters spent several years in Woodstock with first artist husband Herman Cherry, later maintaining a permanent home in Rockport, ME, with second husband Lew Dietz, a writer. Preferred media: oil, watercolor, acrylic. Publications: illustrator, *Full Fathom Five & Savage Summer*; jacket design, *Wilderness River*. **Sources:** WW73; WW47; Falk, *Exh. Record Series*; add'l info courtesy of Peter Bissell, Cooperstown, NY.

WINTERS, Ellen *[Painter, sculptor] mid 20th c.*
Addresses: NYC. **Member:** NAWA. **Exhibited:** NAWA, 1935-38. **Sources:** WW40.

WINTERS, Helen H. *[Painter] early 20th c.*
Addresses: Newark, NJ. **Sources:** WW15.

WINTERS, Irma J. *[Painter] mid 20th c.*
Exhibited: S. Indp. A., 1941-43. **Sources:** Marlor, *Soc. Indp. Artists.*

WINTERS, John L. *[Painter, printmaker] b.1935, Zalite, Latvia.*
Addresses: University, MS. **Studied:** RI Sch. Design (B.F.A.); Tulane Univ. (M.F.A.); Inst. Allende, San Miguel Allende, Mexico. **Member:** Col. Art Assn. Am. **Exhibited:** Artist's Ann., 1967 & Artists of the Southeast & Texas, 1969, Delgado Mus., New Orleans, LA; 57th Nat., Jackson, MS, 1967; Memphis Sesquicentennial, Brooks Art Gal., Memphis, TN, 1969; The Arts: The 8th Decade, Georgia Col., Milledgeville, 1971; Dos Patos Gal., Corpus Christi, TX, 1970s. **Work:** Mississippi State Col. Women Art Gallery, Columbus. **Comments:** Preferred media: oils, intaglio. Teaching: instr. drawing, painting & printmaking, Mississippi State Col. Women, 1965-70; asst. prof. drawing, painting & printmaking, Univ. Mississippi, 1970-. **Sources:** WW73.

WINTERS, John (Richard) *[Painter, sculptor, block printer] b.1904, Omaha, NE.*
Addresses: Springfield, PA. **Studied:** Chicago Acad. FA; AIC; & with Frederick Poole, J. Allen St. John. **Exhibited:** CGA, 1934; Denver A. Mus.; Wichita AA; Kansas State Col.; Tulsa AA; Topeka A. Gld.; Salina (KS) AA; AIC, 1935-36, 1938, 1940, 1944; Springfield (MA) Mus., A., 1938; Little Gal., Chicago; Carson Pirie Scott Co., Chicago; Chicago Woman's Cl., 1938; Springfield, PA, 1955; Wallingford, PA, 1956. **Work:** murals, Steinmetz H.S., Chicago; Northwest Airlines, Seattle; Cook County Hospital, IL; Hatch Sch., Oak Park, I.; Brookfield (IL) Zoo; WPA mural, USPO, Petersburg, IL. **Comments:** Position: instr., Layton Sch. A., Milwaukee, Wis., 1946-47; Kansas State Col., 1947-48; chief des., Display Dept., John Wanamaker's, Philadelphia, PA, 1949-on (designed Christmas Cathedral, Grand Court, 1955). **Sources:** WW59; WW47.

WINTERS, Paul Vinal *[Sculptor, painter, decorator, designer, teacher] b.1906, Lowell, MA.*
Addresses: Norwood, MA. **Studied:** Massachusetts State Sch. Art; & with Raymond A. Porter, Leo Toschi, C. Dallin.
Exhibited: Robbins Mem. Town Hall, Arlington, MA, 1932; Pub. Lib., Children's Mus., Boston; Peabody Mus., Cambridge. **Work:** Statue, Monohoi, PA; bust, Boston Pub. Lib.; Pub. Lib., Children's Mus., Boston. **Comments:** Position: teacher, Dorchester House. **Sources:** WW53; WW47.

WINTERSTEEN, Bernice McIlhenny *[Art administrator, collector] b.1903, Phila. / d.1986.*
Addresses: Villanova, PA. **Studied:** Smith College (B.A.); Ursinius College (hon. LH.D., 1965); Villanova Univ (hon. D.F.A., 1967); Wilson College (D.F.A., 1968); Moore College Art (D.F.A., 1968). **Member:** Phila. Art Commission; Phila. Center Performing Arts (hon. mem.). **Exhibited:** Awards: Distinguished Daughter of Penn., 1964. **Comments:** Positions: bd. of gov. & trustee, womens committee, PMA, 1947-64, pres., 1964-68; organizer & first chmn. visiting committee, Smith College Art Mus., 1951; bd. of gov., Phila. Mus. College Art, 1955-64; advisory council member, Princeton Univ. Mus. Art, 1958-; member visiting committee design & visual arts dept., Harvard Uni., 1964-; hon. chmn., Nat. Trust Preservation Conference, Phila. Friends Am. Mus. Britain; member mayor's committee for 1976 Bicentennial Observation & 1976 World's Fair Committee. Collection: 19th- & 20th-century French painting & sculpture; French Impressionist & Post-Impressionist paintings, including fifteen paintings by Picasso & Matisse's "Lady in Blue.". **Sources:** WW73.

WINTHROP, Emily *[Sculptor] mid 20th c.*
Addresses: NYC. **Member:** NAWA. **Sources:** WW27.

WINTHROP, Grenville L. *[Patron] b.1865 / d.1943.*
Addresses: NYC. **Work:** His collections, left to Harvard, included early American portraits, drawings by English and French artists, and Chinese sculpture.

WINTHROW, E. R. (Mrs.) *[Painter] mid 20th c.*
Exhibited: Salons of Am., 1934. **Sources:** Marlor, *Salons of Am.*

WINTLE, William Watkin *[Painter] b.1911, Johannesburg, South Africa / d.1970, San Francisco, CA.*
Addresses: Volcano, CA; San Francisco, CA. **Studied:** South Africa; Calif. College of Arts and Crafts. **Member:** Soc. of Western Artists. **Exhibited:** locally; American WC Soc. **Comments:** Specialty: watercolors. **Sources:** Hughes, *Artists in California*, 612.

WINTON, William *[Listed as "artist"] b.c.1840, Ohio.*
Addresses: NYC in June 1860. **Sources:** G&W; 8 Census (1860), N.Y., XLVI, 397.

WINTRINGHAM, Frances M. *[Painter] b.1884, Brooklyn, NY.*
Addresses: NYC. **Studied:** ASL, with G. Bellows; K.H. Miller; R. Henri; J. Sloan; C. Hawthorne. **Member:** Soc. Indep. Artists; Lg. AA; Whitney Studio Club. **Exhibited:** Soc. Indep. Artists, 1917-21; WMAA, 1921, 1923. **Sources:** WW33; Falk, *WMAA.*

WINZENREID, Henry E. *[Painter, lithographer, illustrator, designer, block printer] b.1892, Toledo, OH.*
Addresses: New York 17, NY; Woodstock, NY. **Studied:** John F. Carlson; Southern Pr.M. Soc. **Exhibited:** AIC, 1928-29 & nationally. **Sources:** WW53; WW47.

WIPER, Thomas William *[Art administrator, painter] b.1938, San Francisco, CA.*
Addresses: Tucson, AZ. **Studied:** Univ. Ariz., with Charles Littler (B.F.A. & M.F.A.); Univ. Calif., Berkeley, with Carl Kasten. **Member:** Am. Fedn. Arts; Tucson Coun. Arts. **Exhibited:** Regional exhibs., 1964-. **Comments:** Preferred media: mixed media, watercolors, acrylics, film. Positions: dir. educ., Tucson Art Ctr., Ariz., 1968-. Teaching: instr., Foothill Col., 1965-66; instr., Univ. Ariz., 1966-68. **Sources:** WW73.

WIRE, Melville T(homas) *[Painter] b.1877, Austin, IL / d.1966, Salem, OR.*
Addresses: Albany, OR. **Studied:** M.C. Le Gall; Mrs. E. Cline-Smith. **Member:** AAPL; Oregon SA. **Exhibited:** PPE, 1915; Oregon SA, 1931 (prize); Meier & Frank, Portland, 1936-38. **Work:** Cleveland Mus.; LOC. **Sources:** WW33; Hughes, *Artists in California*, 612.

WIREMAN, Eugenie M. *[Painter, illustrator] mid 20th c.; b.Phila., PA.*
Addresses: Phila. **Studied:** PAFA; H. Pyle. **Member:** Phila. Alliance. **Sources:** WW33.

WIRES, Alden Choate (Mrs.) *[Painter] b.1903, Oswego, NY.*
Addresses: Rockport, MA. **Member:** Tiffany Fnd.; Rockport AA. **Sources:** WW33.

WIRES, Hazel Kitts *[Painter, designer] b.1903, Oswego, NY.*
Addresses: Haworth, NJ. **Studied:** Corcoran Sch. Art; with A.T. Hibbard; R. Hammond; H. Breckenridge; S.B. Baker; W.L. Stevens, John Chetcuti. **Member:** Bergen County Artists Guild; New Jersey Art Council; Hackensack AC; Rockport AA; North Shore AA; Ridgewood AA; Soc. Wash. Artists; AAPL. **Exhibited:** Soc. Wash. Artists, 1937 (medal). **Comments:** Position: teacher, Englewood Art Gal., NJ, from 1943; director, North Jersey Art Sch., Teaneck, NJ. **Sources:** WW47; *Artists of the Rockport Art Association* (1956).

WIRSUM, Karl *[Painter] b.1939.*
Addresses: Chicago, IL. **Exhibited:** WMAA, 1967. **Sources:** Falk, *WMAA.*

WIRTH, Anna M(aria) Barbara *[Illustrator, painter, writer] b.1868, Johnstown, PA / d.c.1939, Los Angeles, CA.*
Addresses: Altadena, CA. **Studied:** PAFA; Phila. Sch. Des. for Women; Phila. School Min. Painters. **Member:** Calif. SMP. **Exhibited:** AIC, 1916. **Comments:** Illustrator: "Progressive Pennsylvania," by J.M. Swank. Author/Illustrator: The King's Jester." Contributor: articles, *Los Angeles Saturday Night*; poems, *Davis Anthologies.* **Sources:** WW38.

WIRTH, Colvert & Robert *[Engravers] mid 19th c.; b.Prussia.*
Addresses: NYC, 1860. **Comments:** Living together in NYC in June 1860. Colvert was 29 and Robert 25. **Sources:** G&W; 8 Census (1860), N.Y., XLIV, 815.

WIRTZ, Carel *[Sculptor] early 20th c.*
Addresses: NYC. **Exhibited:** PAFA Ann., 1917. **Sources:** WW17; Falk, *Exh. Record Series.*

WIRTZ, William *[Portrait, painter, sculptor, lithographer, lecturer, teacher] b.1888, The Hague, Holland / d.1935.*
Addresses: Baltimore, MD. **Studied:** F. Jansen; W. A. van Konijnenburg, in The Hague; Düsseldorf. **Comments:** Came to Baltimore in 1912. **Sources:** WW27.

WISBY, Jack *[Landscape painter] b.1870, London, England / d.1940, San Rafael, CA.*
Addresses: San Francisco; Marin County, CA, after 1906. **Studied:** self-taught. **Exhibited:** Torrance Gallery, San Anselmo, CA, 1960. **Work:** San Mateo County Hist. Soc. **Comments:** Arrived in San Francisco in 1897 and married Mary A. Fossey Wisby (see entry) that same year. For a short time he worked as an engraver, but made a living with his soft, poetic landscapes thereafter. **Sources:** Hughes, *Artists in California*, 612-613.

WISBY, Mary Anne Fossey *[Painter] b.1875, Sussex, England / d.1960, San Francisco, CA.*
Addresses: San Francisco. **Comments:** Came to San Francisco in 1897 and married Jack Wisby (see entry) that same year. Position: teacher, Chinese Mission School, San Francisco, until 1906. Her works are rare. **Sources:** Hughes, *Artists in California*, 613.

WISE, C. *[Engraver of portraits in stipple] b.England / d.1889.*
Addresses: Boston in 1852. **Comments:** Did work for publishers in NYC and Philadelphia. **Sources:** G&W; Stauffer; Boston BD 1852.

WISE, Ella G. *[Painter] late 19th c.*
Addresses: Phila., PA. **Exhibited:** PAFA Ann., 1887-89. **Sources:** Falk, *Exh. Record Series.*

WISE, Ethel Brand (Mrs. L. E.) *[Sculptor] b.1888, NYC / d.1933, Syracuse, NY.*
Addresses: Wash., DC, 1915; Syracuse, 1931. **Studied:** J.E. Fraser; H. Trasher; A. Lee. **Member:** Syracuse AA; Syracuse ACG. **Work:** memorial, Masonic Temple, Syracuse; memorial, Wichita Falls, TX; Univ. Missouri, Columbia; St. Johns Military Acad., Manlius; Central H.S.; Marshall Mem. Home, Syracuse; Macon, GA. **Sources:** WW31; WW15 (as Ethel Brand).

WISE, Florence B(aran) (Mrs.) *[Painter, illustrator] b.1881, Farmingdale, LI, NY.*
Addresses: Cranston, RI. **Studied:** NAD, with F.C. Jones, G.W. Maynard, G. Bridgman; RISD. **Member:** Providence WCC. **Work:** Ambassador Hotel, Chicago; Vacation Home for Crippled Children, Spring Valley, NY; Rhode Island Post 23, Providence; Temple Beth-El, Providence. **Comments:** Illustrator: covers for periodicals. **Sources:** WW40.

WISE, George *[Listed as "artist"] mid 19th c.*
Addresses: Baltimore, 1849-50. **Sources:** G&W; Lafferty.

WISE, Howard *[Art dealer] b.1903, Cleveland, OH / d.1989.*
Addresses: NYC. **Studied:** Clare College, Cambridge Univ. (B.A., honors); Western Reserve Univ.; Cleveland Inst. Art. **Comments:** Positions: established Howard Wise Gallery of

Present Day Painting & Sculpture, Cleveland, 1957; director, Howard Wise Gallery, NYC, 1960-. Specialty of gallery: kinetic and light art. **Sources:** WW73.

WISE, James *[Portrait and miniature painter] mid 19th c.* **Addresses:** New Orleans in May 1843; Charleston, SC in 1844 and 1845; Virginia; St. Joseph, MO. **Comments:** His portrait of John C. Calhoun was engraved by Sartain (see entry). A James H. Wise, possibly the same man, was listed as a portrait painter at San Francisco from 1856-60. **Sources:** G&W; Delgado-WPA cites N.O. *Picayune,* May 3, 1843; Rutledge, *Artists in the Life of Charleston;* Willis, "Jefferson County Portraits and Portrait Painters"; San Francisco BD 1856, 1858-60.

WISE, John *[Painter] late 19th c.* **Addresses:** Phila., PA. **Exhibited:** PAFA Ann., 1881-82 (landscapes). **Sources:** Falk, *Exh. Record Series.*

WISE, Louise Waterman (Mrs. Stephen S.) *[Portrait painter, sculptor, writer] b.NYC / d.1947.* **Addresses:** NYC. **Studied:** ASL, with K. Cox, R. Henri, K.H. Miller, G. Bellows. **Exhibited:** PAFA Ann., 1920-21, 1936; NAD, 1925; Corcoran Gal biennials, 1919, 1928; NAWA. **Work:** Columbia, Tel-Aviv Mus., Palestine. **Comments:** Translator: works from French. **Sources:** WW47; Falk, *Exh. Record Series.*

WISE, Roland *[Painter] b.1923, San Francisco, CA.* **Addresses:** Buffalo, NY. **Studied:** ASL, 1949; Univ. Manitoba, Winnipeg, Canada (B.F.A., 1955); New York Univ. (M.A., 1958). **Member:** Patteran Soc., 1966-68. **Comments:** Came to Buffalo in 1955 to teach at State University College. He received a CAPS grant, New York State Council on the Arts, 1976. **Sources:** Krane, *The Wayward Muse,* 197.

WISE, Sallie Aubrey *[Landscape painter] b.1868 / d.1935.* **Studied:** Female Inst., Greensboro, NC. **Work:** Valentine Mus., Richmond, VA (Pratt's Castle, Richmond, and Natural Bridge). **Sources:** Wright, *Artists in Virginia Before 1900.*

WISE, Samuel C. *[Engraver] b.c.1826, Connecticut.* **Addresses:** NYC in July 1850. **Comments:** His wife and daughter were both born in New York State. **Sources:** G&W; 7 Census (1850), N.Y., XLVIII, 128.

WISE, Sarah Morris See: **GREENE, Sarah Morris**

WISE, Vera *[Painter, lithographer, educator] mid 20th c.; b.Iola, KS.* **Addresses:** El Paso, TX. **Studied:** Willamette Univ., Salem, OR (B.A.); Chicago Acad. FA; Kansas City AI. **Member:** NAWA; SSAL; Texas FAA; California WC Soc.; Texas FA Assn.; Texas WC Soc. **Exhibited:** AWCS, 1937, 1939, 1947, 1954; NAWA, 1938, 1942-43, 1945; CM, 1935; Jackson (MS) Mus. FA, 1943, 1951; SSAL, 1943, 1945; Wash. WC Club, 1942-43; Texas FA Assn., 1943, 1946, 1949-61; West Texas Exh., 1942-46; Texas Pr. Exh., 1945; Denver A. Mus., 1934-37, 1943, 1944, 1949; Texas P. & S., 1949-52; Texas WC Soc., 1950-58; Kansas City AI, 1933, 1935, 1939; Phila. WC Club, 1949; William Rockhill Nelson Gal. A., 1951; Cal. WC Soc., 1958, 1959; Art: USA, 1958; Beaumont Mus. A., 1958; Northwest Pr. M., 1954; Romano Gal., Biblioteca Nacional, Mexico, 1951; El Paso Mus., 1960; Texas Des.-Craftsmen, 1961; Santa Barbara (Cal. WC Soc.), 1960; Des.-Craftsmen, Little Rock, 1960; solo traveling exh. Texas museums and colleges, 1955-60; Roswell Mus., 1957; El Paso Pub. Lib., 1958; Laguna Gloria Mus., Austin, 1958. **Awards:** prizes, Ft. Worth, Texas, 1942; Abilene Mus. A., 1946, 1950-51; Texas WC Soc., 1951, 1957; Beaumont Mus., 1954; Chautauqua Nat., 1958; Texas FA Assn., 1953, 1955; Chalmont Exh., El Paso, 1961; El Paso area, 1961. **Work:** Idaho State Col.; Texas FA Assn.; So. Methodist Univ. **Comments:** Paintings reproduced, article, *Ford Times,* 1960, 1961. Position: teacher, College Mines, El Paso, 1939-46; professor/head, art dept., Texas Western College, El Paso. **Sources:** WW66; WW47.

WISE, William G. *[Painter] early 20th c.* **Addresses:** Phila, PA. **Studied:** PAFA. **Sources:** WW25.

WISELTIER, Joseph *[Painter, craftsperson, teacher] b.Paris, France / d.1933.* **Addresses:** West Hartford, CT. **Studied:** Dow; Bement; Snell. **Member:** Alliance; EAA (pres.); Conn. AA; Hartford ACC; AFA; AAPL. **Exhibited:** Hartford; NYC. **Comments:** Positions: teacher, state director, Art Educ., CT. **Sources:** WW31.

WISELY, John Henry *[Sculptor, teacher, craftsperson] b.1908, Woodward, OK.* **Addresses:** Champaign, IL; New Brunswick, NJ. **Studied:** Kansas City AI; with Wallace Rosenbauer, Ross Braught, Mildred Hammond. **Exhibited:** WFNY, 1939; GGE 1939; Kansas City AI, 1936-40; St. Louis, MO, 1939; Tulsa, OK., 1938, 1939; St. Joseph, MO, 1938, 1939; Missouri State Fair, 1936-40; PAFA Ann., 1947. **Awards:** San Francisco AC, 1940; Kansas City AI, 1941. **Work:** IBM Collection. **Sources:** WW53; WW47; Falk, *Exh. Record Series.*

WISEMAN, Robert *[Painter] mid 20th c.* **Studied:** ASL. **Exhibited:** S. Indp. A., 1940-42. **Comments:** Possibly Wiseman, Robert C. **Sources:** Marlor, *Soc. Indp. Artists.*

WISEMAN, Robert Cummings *[Painter, etcher, architect] b.1891, Springfield, OH.* **Addresses:** New York 3, NY. **Studied:** Kenyon College, Gambier, OH; MIT; Columbia Univ. (B. Arch.). **Member:** AIA. **Exhibited:** Hudson River AA, 1940; Springfield AA, 1945; ACA Gal., 1938; Barzansky Gal., 1943 (solo). **Work:** Mus. City of New York. **Sources:** WW53; WW47.

WISEMAN, Robert R. (or W.) *[Painter] late 19th c.* **Addresses:** NYC, 1878. **Exhibited:** NAD, 1878; Boston AC, 1882. **Comments:** Active 1877-82. **Sources:** *The Boston AC.*

WISER, Angelo *[Listed as "artist"] b.c.1841, Pennsylvania.* **Addresses:** Phila. in 1860-61; New Orleans, active 1871-72. **Sources:** G&W; 8 Census (1860), Pa., LIII, 172; Phila. CD 1861. More recently, see *Encyclopaedia of New Orleans Artists,* 418.

WISER, Guy Brown *[Painter, illustrator, writer, teacher] b.1895, Marion, IN / d.1983, San Diego County, CA.* **Addresses:** Columbus, OH; Los Angeles, CA. **Studied:** Despujols; Gorguet; H.H. Breckenridge; C. Hawthorne; J.R. **Member:** Hoosier Art Patrons Assn.; Columbus AL; AAPL. **Exhibited:** PAFA Ann., 1927 (prize), 1929-30; Northern Indiana AL, 1927 (prize); Hoosier Salon, Chicago, prizes in 1927, 1929-34; Richmond (IN) AA, 1928 (prize); Columbus AL, 1929 (prize); Herron AI, 1930 (prize); Corcoran Gal biennial, 1930; AIC. **Work:** Muskingum College, New Concord, OH; Hospital &d Law College, Ohio State Univ. **Comments:** Illustrator: "Rambles in Europe," pub. American Book Co., "Prose and Poetry," pub. L.W. Singer Co., "Ourselves and the World," pub. Whittlesey House. **Sources:** WW40; Falk, *Exh. Record Series.*

WISER, John *[Panorama and scenery painter] b.c.1815, Pennsylvania.* **Addresses:** Phila. **Exhibited:** Artists' Fund Society at PAFA, 1841 (two landscapes, "Ruins of the Convent of the Carmelites at Bruges" and "Ruins of the Temple of Peace"); in Phila.,1853 (panorama of the Creation, Paradise, and the Flood). **Comments:** He may have studied in Europe, since he exhibited European landscapes. In November 1841 he was a scene painter at the Walnut Street Theatre in Phila., along with Charles Lehr and Peter Grain, Jr.(see entries). In April 1850 he was scene painter at the Chestnut Street Theatre. He was still in Phila. in July 1860. **Sources:** G&W; 8 Census (1860), Pa., LII, 693; Rutledge, PA; Phila. CD 1841; Phila. *Public Ledger,* Nov. 6, 1841, Dec. 4 and 14, 1849, April 8, 1850, and April 25, 1853.

WISH, Oliver P. T. *[Curator, photographer] b.Portland, ME / d.1932.* **Addresses:** Portland, ME. **Member:** Portland Camera Club; Portland SA. **Comments:** Position: curator: Sweat Mem. Art Mus., Portland.

WISHAAR, Grace N. See: **PEEKE, Grace N. Wishaar**

WISMER, Frances Lee *[Painter, illustrator, blockprinter, teacher, curator, collector] b.1906, Pana, IL / d.1997, Seattle, WA.*
Addresses: Seattle, WA. **Studied:** W. Isaacs, A. Patterson, H. Rhodes; Univ. Wash. (B.A. Fine Arts, 1935); special studies in weaving, jewelry, pottery, printmaking. **Member:** Northwest PM. **Exhibited:** Northwest PM, Seattle, 1929 (prize); SAM, 1935 (prize). **Work:** Henry Art Gallery; SAM. **Comments:** Also known as a philanthropist, she worked in Japan in the commercial art field beginning in 1935 and drew weekly sketches for *Japan News Week*. She also did murals. She depicted working people In her prints, which she sent to Seattle for exhibition, winning many prizes. Produced cartoons for leaflet newspaper while working for the "Office of War Information" in Honolulu during WWII. Married attorney Thomas Blakemore and returned to Japan where she promoted the work of contemporary Japanese printmakers, opening a gallery in Tokyo. (Name also appears as Blakemore and as Baker). Publications: auth., illustr., "We the Blitzed" (c. 1940-45); auth., "Who's Who in Modern Japanese Prints." **Sources:** WW40; add'l. info. courtesy Martin-Zambito Fine Art, Seattle, WA.

WISNIEWSKA, Benedicta *[Painter] mid 20th c.*
Addresses: Buffalo, NY. **Exhibited:** Great Lakes Exh., The Patteran, 1938; Albright Art Gal., 1938-40. **Sources:** WW40.

WISNOSKY, John G. *[Painter, educator] b.1940, Springfield, IL.*
Addresses: Honolulu, HI. **Studied:** Yale Univ. Summer School Art, 1961; Univ. Illinois, Urbana (B.F.A., 1962; M.F.A., 1964). **Member:** Honolulu Printmakers (pres., 1969-70); Hawaii P&S League (pres., 1969-70). **Exhibited:** Northwest Printmakers Int., Seattle, WA, 1965; SAGA, NYC, 1965; Presentation Artist Show in conjunction with Boston Printmakers, BMFA, 1966; Drawings-USA, Saint Paul AC, MN, 1967; Am. Printmakers Exhib., Otis Art Inst., 1968; Downtown Gal., Honolulu, HI, 1970s. **Awards:** Henry B. Shope Prize, SAGA, 1965; purchase award, Honolulu Acad. Arts, 1970. **Work:** Honolulu Acad. Arts; Southern Illinois Univ., Carbondale; Contemporary AC Hawaii, Honolulu; State Hawaii Foundation Culture & Arts; Mint Mus., Charlotte, NC. Commissions: Pan. Pac. hall design, Hawaii Pavilion, Expo 1970, Osaka, Japan, 1970; sculpture, Ewa Beach Public Library, Oahu, HI, 1971; flora pacifica design, Ethnobotanical Expos, 1971. **Comments:** Preferred media: acrylics, intaglio, mixed media. Positions: owner, J. Wisnosky Design Services, 1970-. Teaching: instructor, painting & design, Virginia Polytech Inst. & State Univ., 1964-66; asst. professor, painting, design, printmaking & advanced drawing, Univ. Hawaii, 1966-. **Sources:** WW73; Jean Charlot, review, *Honolulu Star-Bulletin*, Sept. 13, 1967, Jan. 12, 1971 & July 1, 1971; Webster Anderson, review, *Honolulu Advertiser*, March 9, 69 & June 30, 1971.

WISONG, W. A. *[Portraitist] mid 19th c.*
Comments: Painter of a portrait of Christian B. Herr of Lancaster County (PA) in 1852. **Sources:** G&W; Lancaster County Hist. Soc., *Portraiture in Lancaster County*, 142.

WISSLER, Jacques *[Engraver and lithographer; portraitist in crayons and oils] b.1803, Strasbourg (Alsace) / d.1887, Camden, NJ.*
Addresses: NYC, 1860; Richmond, 1861; Macon, MS; Camden, NJ. **Studied:** Paris. **Comments:** He was trained as a lithographer and engraver in Paris. He emigrated to America in 1849. In 1860 he was in NYC with the firm of Dreser & Wissler (see entry), but when the Civil War broke out in 1861 he was working in Richmond. His services were commandeered by the Confederate Government to engrave the plates for the paper currency and bonds of the Confederate States. At the close of the war he moved to Macon (MS) and later to Camden (NJ). Though primarily an engraver, he was also a successful portrait artist. **Sources:** G&W; Stauffer; CAB; NYBD and NYCD 1860; Boston *Transcript*, Nov. 28, 1887, obit.

WISSLER, Jessie Louisa *[Painter] early 20th c.; b.Duncannon, PA.*
Addresses: Williamsburg, PA; Thurmont, MD. **Studied:** Phila. Sch. Des. for Women; Drexel Inst. **Exhibited:** PAFA Ann., 1901. **Comments:** Specialty: watercolors. **Sources:** WW08; Falk, *Exh. Record Series*.

WITHAM, Marie Alis *[Painter] early 20th c.*
Addresses: Cincinnati, OH. **Sources:** WW19.

WITHAM, Vernon Clint *[Painter, collector] b.1925, Eugene, OR.*
Addresses: Eugene, OR. **Studied:** Univ. Oregon; Calif. School Fine Arts, San Francisco. **Exhibited:** Under 25, Seligmann Gal., NYC, 1949; Artists of Oregon, Portland Art Mus., 1953; CPLH, 1960 (solo); Maxwell Gal., San Francisco, 1961; The Am. Landscape, Peridot Gal., New York, 1968; Grandtour Gal., Eugene, OR, 1970s. **Awards:** purchase award, Northwest Painting Ann., 1972. **Work:** Univ. Oregon Mus. Art, Eugene; Univ. Wyoming Mus. Art, Laramie. **Comments:** Preferred media: mixed media. Publications: co-author, *12 New Painters* (serigraph folio), 1953; contributor, insert 4, *The Written Palette*, 1962. Teaching: artist-in-residence, Univ. Wyoming, 1971-. Collection: antique primitive art from around the world. **Sources:** WW73.

WITHENBURG, Virginia Thomas (Mrs.) *[Painter] mid 20th c.*
Addresses: Glendale, OH, c.1915-27. **Member:** Cincinnati Women's AC. **Sources:** WW27.

WITHERS, Caroline *[Miniaturist] mid 19th c.*
Addresses: Charleston, SC before the Civil War. **Comments:** She was presumably one of the Misses Withers mentioned in Mrs. E.F. Ellet's *Women Artists in All Ages and Countries* (reviewed in *Russell's Magazine*, VI (Jan. 1860), 384). She painted in oil & watercolor and also cut cameos. **Sources:** G&W; Carolina Art Assoc. Cat., 1935, 1936; Rutledge, *Artists in the Life of Charleston*, 167.

WITHERS, Celeste (Mrs. Nieuwenhuis) *[Painter] early 20th c.*
Addresses: Los Angeles, 1919; Hollywood, CA, 1924. **Member:** Laguna Beach AA; Calif. AC. **Exhibited:** Laguna Beach AA, 1918; SFAA, 1919; Calif. AC, 1918-24; San Diego FA Gal., 1927; P&S Los Angeles, 1938. **Comments:** Wife of Jan Domela (see entry). Both were also known by the last name of Domela Nieuwenhuis. **Sources:** WW19; WW24 (under Nieuwenhuis); Hughes, *Artists in California*, 613.

WITHERS, Ebenezer *[Portrait painter] mid 19th c.*
Addresses: NYC from 1835-39. **Exhibited:** NAD; Apollo Assoc. **Sources:** G&W; Cowdrey, NAD; Cowdrey, AA & AAU; NYCD 1837.

WITHERS, Edward *[Painter] mid 20th c.; b.New Zealand.*
Addresses: Los Angeles, CA, 1930s, 1940s. **Studied:** Wellington College, New Zealand; Royal Academy & Slade School, both in London; Académie Julian, Paris. **Member:** Calif. AC (pres.); P&S Los Angeles. **Exhibited:** Southern Calif. shows, many awards & prizes. **Work:** Gardena, CA, High School; Mus. of Archaeology and Art, Gunnison, CO. **Sources:** Hughes, *Artists in California*, 613.

WITHERS, Frederick C. *[Artist] late 19th c.*
Addresses: NYC, 1863-76. **Exhibited:** NAD, 1863-77. **Sources:** Naylor, *NAD*.

WITHERS, George (K., Jr.) *[Painter, illustrator] b.1911, Wichita, KS.*
Addresses: Kansas City, MO. **Studied:** A. Bloch; R.J. Eastwood; K. Mattern. **Sources:** WW33.

WITHERS, Loris Alvin *[Painter, designer, teacher, craftsperson, decorator] b.1891, Phila.*
Addresses: Port Washington, LI, NY. **Studied:** Carnegie Inst. (A.B.); ASL; NAD; Grande Chaumière, Delecluse Acad., Casteluchio, Morisset, all in Paris; R. Miller. **Member:** SC

Exhibited: Arch. Lg.; Salon des Tuileries, Paris; SC. **Work:** Haskell Mem., Palm Beach, FL.; Cornell Univ.; Church of the Holy Family, Columbus, GA; many ports.; windows, Bethesda-by-the-Sea Church, Palm Beach, FL; Cathedral St. John the Divine, New York. **Comments:** Positions: art instructor, Hunter College, 1926-33; Brooklyn (NY) College, 1933-43; designer, stained glass windows, Heinigke & Smith, NYC; Froderick L. Leuchs, Inc., 1956-58. **Sources:** WW59; WW47.

WITHERS, W. C. (Miss) *[Still life and portrait painter] 19th/20th c.*
Addresses: Richmond, VA. **Exhibited:** Richmond, VA, 1897-1903. **Sources:** Wright, *Artists in Virginia Before 1900.*

WITHERSPOON, F. V. (Mrs.) *[Artist] early 20th c.*
Addresses: Active in Los Angeles, c.1900-03. **Sources:** Petteys, *Dictionary of Women Artists.*

WITHERSPOON, M(ary) Eleanor *[Miniature painter, painter] b.1906, Gainesville, TX.*
Addresses: Ft. Worth, TX. **Member:** Brooklyn SMP. **Sources:** WW33.

WITHERSTINE, Donald Frederick *[Etcher, painter] b.1896, Herkimer, NY / d.1961, Provincetown, MA?.*
Addresses: Provincetown, MA. **Studied:** AIC; PAFA; G.E. Browne. **Exhibited:** AIC, 1925. **Work:** Peoria (IL) AI; Bloomington (IL) AA; Univ. Illinois; wood blockprint selected by Allied Artists of Am. as society's gift to its members, Christmas, 1933. **Sources:** WW40.

WITHINGTON, Elizabeth R. *[Painter] mid 20th c.*
Addresses: Rockport, MA.
Member: AWCS.
Exhibited: AWCS, 1933, 1934, 1936-39; AIC, 1936.
Sources: WW47.

WITHJACK, Edward *[Painter] mid 20th c.*
Exhibited: S. Indp. A., 1939-41. **Sources:** Marlor, *Soc. Indp. Artists.*

WITHROW, E. A. See: **WITHROW, Eva (Evelyn) Almond**

WITHROW, Eva (Evelyn) Almond *[Portrait and genre painter] b.1858, Santa Clara, CA / d.1928, San Diego, CA.*
Addresses: San Francisco, CA; Munich, Germany, 4 years; London, England, 7 years; San Diego, CA. **Studied:** San Francisco School of Des.; with J. Frank Currier in Munich; Paris, two years; with Cormon, Delacluze. **Member:** San Francisco AA; American Soc. Women Artists; San Francisco Soc. Women Artists (first pres.). **Exhibited:** San Francisco AA annuals from 1870s; Kunstverein München; Calif. State Fair, 1888, 1891 (medal); Paris Salon, 1893; Calif. Midwinter Int. Expo, 1894; Royal Academy, London, 1898; Paris Salon; Alaska-Yukon Expo., Seattle, 1909; de Young Mus., 1915, 1916; Hobart Gal., San Francisco, 1926. **Work:** Louvre, Paris; Mills College, Oakland; Oakland Mus.; Calif Hist. Soc.; de Young Mus.; Palais du Luxembourg, Paris. **Comments:** Specialty: portraits, still lifes, scenes of Native American life in the Southwest and Southern Calif. Painted portraits of prominent San Franciscans and Londoners. She signed her works in various ways, as "Evelyn Almond Withrow," "E.A. Withrow," "Eva Withrow," "E. A. W.," E. Almond Withrow" and" Withrow." **Sources:** Hughes, *Artists in California,* 613-14; Fink, *American Art at the Nineteenth-Century Paris Salons,* 407; Petteys, *Dictionary of Women Artists,* says Withrow died in San Francisco.

WITHROW, William J. *[Art administrator] b.1926, Toronto, Ontario.*
Addresses: Toronto 133, Ontario. **Studied:** Univ. Toronto (B.A., 1950; B.Ed., 1955 ; M.Ed., 1958; M.A., 1960). **Member:** Canadian Mus. Assn.; Am. Assn. Mus.; Am. Assn. Art Mus. Dirs.; Canadian Art Mus.Dirs. Org.; Canadian Nat. Committee for Int. Council Mus. **Exhibited:** Awards: Canadian Centennial Medal, 1967. **Comments:** Positions: director, Art Gallery Ontario,

Toronto, 1960-. Teaching: hd. art dept., Earl Haig College, 1951-59. Publications: author, *Sorel Etrog Sculpture,* 1967 & *Contemporary Canadian Painting,* 1972. **Sources:** WW73.

WITKEWITZ, Solomon *[Painter] mid 20th c.*
Exhibited: AIC, 1918-19; Salons of Am., 1929. **Sources:** Marlor, *Salons of Am.*

WITKIN, Jerome Paul *[Painter, educator] b.1939, Brooklyn, NY.*
Addresses: Syracuse, NY. **Studied:** Cooper Union Art School, 1957-60; Skowhegan School Painting & Sculpture; Berlin Acad., Germany, Pulitzer traveling fellowship, 1960; Univ. Penn. (M.F.A., 1970). **Exhibited:** Morris Gal., NYC, 1962-64 (solos); A History of Collage, Grosvenor Gal., London, 1966; The Transatlantic, U.S. Artists in England, U.S. Embassy, London, 1966; Drawings USA, Minnesota Mus. Art, 1971; Drawings, Kraushaar Gal., New York, 1971. **Awards:** Guggenheim Foundation fellowship painting, 1963-64. **Work:** Minnesota Mus. Art, Saint Paul; Univ. New Hampshire, Durham; B. K. Smith Gal., Lake Erie College, Painesville, OH. **Comments:** Preferred media: oils. Teaching: drawing instructor, Maryland Inst. Art, Baltimore, 1963-65; lecturer painting, Manchester College Art, England, 1965-67; visiting professor, design, drawing & painting, Moore College, 1968-71; assoc. professor art, Syracuse Univ., 1971-. **Sources:** WW73.

WITKOWSKI, Karl *[Portrait and genre painter] b.1860, Austria or Poland / d.1910.*
Addresses: Newark, NJ, until mid-1890s; Irvington, NJ, from mid-1890s. **Studied:** Czartkow AA with Matejko; Académie Julian, Paris, 1887-88. **Exhibited:** NAD, 1899. **Work:** Newark Pub. Lib. **Comments:** A popular genre painter who specialized in pictures of newsboys and street urchins, painting in a style similar to that of J.G. Brown. **Sources:** Gerdts, *Art Across America,* vol. 1: 250 (w/repro.).

WITKUS, William *[Painter] mid 20th c.*
Exhibited: Salons of Am., 1934. **Sources:** Marlor, *Salons of Am.*

WITMAN, George F. *[Painter] late 19th c.*
Addresses: Philadelphia, 1876. **Exhibited:** PAFA, 1876 ("Crossing the Alleghanies: Before Railroads;" "Under the Gaslight"). **Sources:** Falk, PA, vol. 2: 527, 575.

WITMAN, Jacob See: **WHITMAN, Jacob**

WITMAN, Mabel Foote *[Painter] mid 20th c.*
Addresses: Wash., DC, active 1924-35. **Exhibited:** Soc. Wash. Artists, 1924; Soc. Indep. Artists, 1924-29; Greater Wash. Indep. Exhib., 1935; Salons of Am. **Sources:** WW25; McMahan, *Artists of Washington, DC.*

WITMEYER, Stanley Herbert *[Art administrator, designer] b.1913, Palmyra, PA.*
Addresses: Rochester, NY. **Studied:** School Art & Design, Rochester Inst. Technology (diploma); State Univ. NY College Buffalo, (B.S.); Syracuse Univ. (M.F.A.); Univ. Hawaii, with Ben Norris. **Member:** Rochester Torch Club (pres., 1952); Nat. Art Educ. Assn.; Rochester Art Club (pres., 1956); Rochester Inst. Technology Alumni Assn. (pres., 1952); NY State Art Teachers Assn. **Exhibited:** Rochester Mem. Art Gal.; Albright-Knox Gal., Buffalo; Honolulu Acad. Fine Arts; Everson Mus., Syracuse. **Awards:** Distinguished Alumni Awards, State Univ. NY College Buffalo, 1968 & Rochester Inst. Technology, 1971; Athletic Hall of Fame Award, Rochester Inst. Technology, 1971. **Comments:** Preferred media: watercolors, mixed media. Positions: director, School Art & Design, Rochester Inst. Technology, 1952-68, assoc. dean College Fine & Applied Arts, 1968-. Publications: author, articles, *Everyday Art, Design Magazine, School Arts, Nat. Art Educ. Journal & NY Art Teachers Bulletin.* Teaching: art instructor, Cuba Public Schools, NY, 1939-44; professor, painting & design, School Art & Design, Rochester Inst. Technology, 1946-52. Collection: American printmakers and painters. **Sources:** WW73.

WITT, Christopher (Dr.) *[Physician and amateur artist] b.1675, England / d.1765, Germantown, PA.*
Addresses: Germantown, PA, 1704-65. **Work:** Hist. Soc. of Pennsylvania (Kelpius portrait). **Comments:** Witt (or DeWitt) came to America in 1704 to join the little colony of Pietistic mystics at Germantown (PA). In 1705 he painted an oil portrait of the leader, Johannes Kelpius (1673-1708). This is probably the earliest portrait painted in Pennsylvania. Groce & Wallace report that Witt had a reputation as a sorcerer in Germantown. **Sources:** G&W; Welsh, "Artists of Germantown," 235-36; Hocker, *Germantown 1683-1933,* 51; Pennypacker, *The Settlement of Germantown,* 226 (repro. opp.). More recently, see Gerdts, *Art Across America,* vol. 1: 264.

WITT, John Henry (or Harrison) *[Portrait and landscape painter] b.1840, Dublin, IN / d.1901, NYC.*
Addresses: Ohio, 1877; NYC, 1878-99. **Studied:** Cincinnati, with Joseph O. Eaton, 1858. **Member:** ANA, 1885; Artists Fund Soc. **Exhibited:** NAD, 1877-99; Brooklyn AA, 1878-83; AIC, 1888, 1894-96. **Comments:** At eighteen he went to Cincinnati to study art with Joseph O. Eaton (see entry) and from 1862 to about 1879 he had a studio in Columbus (OH), where he painted portraits of a number of early Ohio governors as well as other prominent citizens. In 1873 he spent some time in Washington (DC). In 1879 he moved to NYC. Fairman, Burnet, and Clark (*History of the NAD*) give Harrison as the middle name, but he is listed as John Henry in *Museum Echoes* (May 1951) and as J. Henry in the Columbus directory for 1867. **Sources:** G&W; WW01; Fairman, *Art and Artists of the Capitol,* 353; *Museum Echoes* (May 1951), 37 and cover; Peat, *Pioneer Painters of Indiana,* 99-100; Clark, *Ohio Art and Artists,* 114; Clark, *History of the NAD,* 274; Columbus CD 1867-77; NYCD 1880-99; Borough of Manhattan, *Deaths Reported in 1901,* 401.

WITT, Marie *[Painter] mid 20th c.*
Exhibited: S. Indp. A., 1942. **Sources:** Marlor, *Soc. Indp. Artists.*

WITT, Marion *[Painter] mid 20th c.*
Addresses: Chicago area. **Exhibited:** AIC, 1944-51. **Sources:** Falk, *AIC.*

WITT, Nancy Camden *[Sculptor, painter] b.1930, Richmond, VA.*
Addresses: Ashland, VA. **Studied:** Randolph-Macon Woman's College; Old Dominion Univ. (B.A.); Virginia Commonwealth Univ., (M.F.A.). **Exhibited:** Virginia Mus. Biennial, 1961-69 (5 exhibs.); Ringling Mus., FL, 1963; Miami Nat. Painting Exhib., Coral Gables, FL, 1964; Southeastern Exhib., Atlanta, GA, 1964; Southeastern Exhib. Prints & Drawings, Jacksonville, FL, 1965; Eric Schindler Gal., Richmond, VA, 1970s. **Work:** Valentine Mus., Richmond; Chrysler Mus., Norfolk, VA; Mint Mus., Charlotte, NC; Univ. Virginia, Charlottesville; Virginia Military Inst., Lexington. Commissions: portrait, Ferrum College, VA, 1969; mobile construct, Philip Morris Tobacco Co., Richmond, 1969-70; mural, Security Fed. Savings & Loan Co., Richmond, 1971. **Comments:** Teaching: acting chmn., art dept., Richard Bland College, College William & Mary, 1961-63 & 1964-65. **Sources:** WW73.

WITT, Victoria Engalnd *[Painter] late 19th c.*
Addresses: NYC, 1891-95. **Exhibited:** NAD, 1891-95. **Sources:** Naylor, *NAD.*

WITTE, Martha Luella Clementz *[Painter] b.1886, Iowa / d.1976, Long Beach, CA.*
Addresses: Long Beach. **Exhibited:** San Diego FA Gallery, 1927. **Sources:** Hughes, *Artists in California,* 614.

WITTEN, Bunty *[Painter] mid 20th c.*
Exhibited: Salons of Am., 1934. **Sources:** Marlor, *Salons of Am.*

WITTEN, Thomas *[Painter] mid 20th c.*
Addresses: Chicago area. **Exhibited:** AIC, 1929, 1930 (prize). **Sources:** Falk, *AIC.*

WITTENBER, Jan *[Painter] mid 20th c.*
Addresses: Chicago, IL. **Member:** Chicago NJSA. **Exhibited:**

AIC, 1931, 1936. **Sources:** WW25.

WITTENBERG, Theodore C. *[Listed as "artist"] b.c.1820, New York.*
Addresses: NYC in 1860. **Comments:** He, his wife, and their three children were all born in New York State. **Sources:** G&W; 8 Census (1860), N.Y., XLIV, 357; NYCD 1863.

WITTENBORN, George *[Collector, art dealer] b.1905, Germany / d.1974.*
Addresses: Scarsdale, NY. **Member:** MoMA; MMA. **Comments:** Positions: president, art import & export co.; publisher & distributor books & periodicals on fine & applied arts. Publications: editor, *Nelson Howe: Body Image & Paul Klee: Nature of Nature.* Collection: contemporary and experimental art. Specialty of gallery: ultra modern art and statements. **Sources:** WW73.

WITTER, Ella Marie *[Painter] mid 20th c.; b.Storm Lake, IA.*
Addresses: Storm Lake, IA; Minneapolis, MN. **Studied:** AIC; Minneapolis School Art; Hofmann School, Munich; Capri, Italy; summers in Gloucester, Marblehead and Mexico; Hans Hofmann, Diego Rivera, Ernest Thurn, & Hayley Lever. **Member:** Minnesota AA (bd. of directors, treasurer); Delta Phi Delta Art Fraternity; Lg. Am. Pen Women. **Exhibited:** Twin City (annually), 1927 (first prize), 1928 (fourth prize), numerous honorable mentions; Minnesota State Fair; AIC; Am. Women Painters; Boston Art School; traveling exhibits; solo shows; Buena Vista College, Storm Lake (annually). **Comments:** Positions: hd. of art dept., Central H.S., Minneapolis, MN; lecturer on modern art. **Sources:** WW24; Ness & Orwig, *Iowa Artists of the First Hundred Years,* 224.

WITTERS, Nell *[Painter, craftsperson, illustrator, educator, designer] early 20th c.; b.Grand Rapids, MI.*
Addresses: New York 31, NY. **Studied:** AIC; PAFA; J.C. Johansen; ASL; Teachers College, Columbia Univ., and with Eliot O'Hara, George Elmer Browne. **Member:** ASL; Pen & Brush Club; Wolfe Art Club; York State Craftsmen; Village AC; 8th St. Art Assn.; Little Studio Art Gal.; Brooklyn Soc. Art; AAPL; NAWA. **Exhibited:** Salons of Am.; AIC, 1919 (prize); Alliance, 1919 (prize); Soc. Indep. Artists, 1932-33, 1940, 1942; NAWA, 1933 (prize); Wolfe Art Club, 1935 (prize); Pen & Brush Club, 1937 (prize); Brooklyn Soc. Art (prize). **Comments:** Taught art in Minnesota, Michigan & Iowa. **Sources:** WW59; WW47.

WITTICH, Julius Henry *[Painter] b.1875, Chicago, IL / d.1948, Berkeley, CA.*
Addresses: Berkeley, CA. **Exhibited:** Oakland Art Gallery, 1936, 1939; Calif. State Fair, 1937. **Sources:** Hughes, *Artists in California,* 614.

WITTKOWER, Rudolf *[Educator, historian, writer, lecturer] b.1901, Berlin, Germany.*
Addresses: New York 27, NY. **Studied:** Univ. Munich; Univ. Berlin (Ph.D.). **Member:** Soc. Arch. Historians; Renaissance Soc. Am.; Archaeological Inst. Great Britain & Ireland; Am. Acad. Arts & Sciences (fellow); Accademia di Belli Arti, Venice; Accademia dei Lincei, Rome; British Acad., 1958 (fellow); Warburg Inst., London, 1958 (hon. fellow); Max-Planck Gesellschaft, Göttingen (foreign member). **Exhibited:** Awards: Serena Medal, British Acad., 1957; Banister Fletcher Prize, 1959. **Comments:** Positions: Bibliotheca Hertziana, Rome, 1923-33; Warburg Inst., Univ. London, 1934-56; prof. Hist. A., Univ. London, 1949-56; prof., Columbia Univ., NYC, 1956-. Author: "British Art and the Mediterranean," 1948; "Architectural Principles in the Age of Humanism," 1949; "The Drawings of Carracci," 1952; "The Artist and the Liberal Arts," 1952; "Gian Lorenzo Bernini," 1955; "Art and Architecture" in Italy, 1600-1750," 1958; "Born Under Saturn", 1963; "The Divine Michelangelo", 1964. Editor: "Studies in Architecture"; "Columbia University Studies in Art History and Archaeology." Contributor to *Art Bulletin, Burlington Magazine, Warburg and Courtauld Inst. Journal, Archaeological Journal,* etc. **Sources:** WW66.

WITTMACK, Edgar Franklin *[Illustrator, painter] b.1894, NYC / d.1956.*
Addresses: New York 23, NY. **Member:** SC; SI. **Comments:** Illustrator: Westerns for pulp magazines, 1920s; cover of *Saturday Evening Post*, 1930s. **Sources:** WW53; WW47; P&H Samuels, 535.

WITTMANN, Otto *[Museum director, art administrator] b.1911, Kansas City, MO.*
Addresses: Toledo, OH. **Studied:** Harvard Univ. **Member:** Assn. Art Mus. Dir. (pres., 1971-72); Am. Assn. Mus. (council); Nat. Collection Fine Arts Commission; College Art Assn. Am. (dir.); Int. Council Mus. (glass committee; secy. gen.). **Exhibited:** Awards: Chevalier, Legion d'Honneur, France; Commander, Order or Merit, Italy; Off. Order of Orange-Nassau, Netherlands. **Comments:** Positions: curator, Hyde Collections, Glens Falls, NY, 1938-41; asst. dir., Portland (OR) Mus. Art, 1941; assoc. dir., TMA, 1953-59, dir., 1959-, editor *Museum News,* 14 years; member, Nat. Endowment Arts Mus. Advisory Panel.Teaching: art history instructor, Skidmore College, 1938-41. Collections arranged: The Splendid Century, Masterpieces from France; Painting in Italy in 18th Century; The Age of Rembrandt; The Art of Van Gogh. Publications: co-author, *Travellers in Arcadia;* and numerous articles in art magazines. **Sources:** WW73.

WITTMER, Henry *[Painter] early 20th c.*
Addresses: Pittsburgh, PA. **Member:** Pittsburgh AA. **Sources:** WW21.

WITTRUP, John Severin *[Painter] b.1872, Stavanger, Norway.*
Addresses: Chicago 11, IL. **Studied:** AIC; & with Waiter Clute, C. Bothwood. **Member:** A.Gld.; Soc. for Sanity in Art; Illinois SA; Chicago P&S. **Exhibited:** Chicago P.&S.; Art Gld. (solo); Babcock Gal. (solo); Findlay Gal., Chicago; Johannesburg, South Africa, 1936, 1938 (solo); BM; Paris Salon, 1937; AIC, 1942. **Work:** BM; Pretoria (South Africa) Art Mus. **Sources:** WW53; WW47.

WIX, (Henry) Otto See: **WIX, Otto**

WIX, Otto *[Landscape painter] b.1866, Germany / d.1922, Santa Barbara, CA.*
Addresses: NYC; Hawaii, HI, 1907; San Francisco, CA, c.1910; Santa Barbara, CA, c.1920-22. **Studied:** NYC. **Exhibited:** PAFA Ann., 1898; San Francisco AA, 1902; Kilohana Art League, 1907; Honolulu Art Soc., 1920. **Work:** Santa Fe Railroad Collection. **Comments:** Painted mostly in Kauai. Preferred medium: watercolor and oil. **Sources:** WW01; Hughes, *Artists in California,* 614; Forbes, *Encounters with Paradise,* 209, 239-40 (w/repro.); Falk, *Exh. Record Series.*

WOBORIL, Peter P. *[Painter] 20th c.*
Addresses: Milwaukee, WI. **Sources:** WW24.

WOEDRICK, Gertrude Smith *[Painter] 20th c.*
Addresses: Brazoria, TX, 1918. **Exhibited:** S. Indp. A., 1918. **Sources:** Marlor, *Soc. Indp. Artists.*

WOELFFER, Emerson S. *[Painter, sculptor, graphic artist, lecturer] b.1914, Chicago, IL.*
Addresses: Chicago; Los Angeles. **Studied:** AIC; Inst Design, Chicago (B.A. & hon. D.F.A.). **Member:** Un. Am. Artists. **Exhibited:** Int. WC Ann., 1936; Int. Lith.; Wood Eng. Ann., 1937-38; PS Ann., 1937, 1938; Artists Chicago Vicinity Ann., 1936-39; AIC; WMAA; PS Ann., PAFA Ann., 1939, 1952-54, 1968 (prize); Corcoran Gal biennial, 1941; Gallery 1916, Graz, Austria, 1965; solos: Santa Barbara Mus., CA, 1964 , David Stuart Gal, Los Angeles, 1965 & 1969, Quay Gal, San Francisco, 1968; Jodi Scully Gal, Los Angeles, 1972; California Inst. Arts Invitational, 1972. Awards: Guggenheim Foundation fellowship, France, Italy, Spain & England, 1967-68; purchase award, All City Art Festival, 1968. **Work:** AIC; WMAA; MoMA; Univ. Illinois. **Comments:** Preferred media: oils, acrylics. Positions: topography draftsman, USAAF, 1939-40; artist-in-residence, Honolulu Acad. Arts, Hawaii, 1970. Teaching: School Design,

Chicago, 1942; Black Mountain College, 1949; Colorado Springs FAC, 1950; Chouinard Art Inst., 1959; Univ. Southern California, summer 1962. Collection: African, New Guinea & pre-Columbia works; surrealist paintings. **Sources:** WW73; WW40; Falk, *Exh. Record Series.*

WOELFLE, Arthur W. *[Painter, lecturer, teacher] b.1873, Trenton, NJ / d.1936, Brooklyn, NY.* ARTHVR W. WOELFLE
Addresses: Brooklyn and NYC. **Studied:** ASL with H.S. Mowbray, C. Beckwith, K. Cox, Twachtman; NAD with W. Low, C. Y. Turner; in Paris; C. Marr and Diez in Munich (on Brooklyn Inst. scholarship). **Member:** ANA, 1929; NAC; SC 1902; Artists Guild; Grand Central Art Gal. **Exhibited:** Munich 1897 (prize); Boston AC, 1903, 1905; NAD, 1923-36; PAFA Ann., 1925-30; Allied AA, 1928 (medal); Corcoran Gal biennial, 1932; Montclair(NJ) Art Mus., 1934 (prize); NAC,1935 (medal); Salons of Am.; AIC. **Work:** murals/portraits, Court House, Youngstown, Ohio; Court House, Coshocton, NH; murals, AC Gal., Erie, PA. **Comments:** Teaching: Kingsley Sch.; Mechanics Inst.; Castle Sch.; Grand Central Sch. Art, 1928-36. **Sources:** WW33; Falk, *Exh. Record Series.*

WOELTZ, Julius *[Painter, teacher] b.1911, San Antonio, TX.*
Addresses: New Orleans. **Studied:** AIC. **Member:** AC Club, New Orleans. **Exhibited:** WFNY, 1939; Mississippi AA, Jackson, 1935 (prize); AC Club, New Orleans, 1936 (prize); AIC; WMAA. **Work:** WPA murals, USPO, Elgin, Amarillo, TX. **Comments:** Position: teacher, New Orleans Art Sch. **Sources:** WW40.

WOELTZ, Russell *[Painter] 20th c.*
Addresses: Chicago, IL. **Exhibited:** Artists Chicago, Vicinity, 1937, 1938 (prize), Fed. Art Project, 1938, AIC. **Sources:** WW40.

WOERNER, Karl S. *[Painter] 20th c.*
Exhibited: Salons of Am., 1934. **Sources:** Marlor, *Salons of Am.*

WOESSNER, Henriette English (Mrs. Frank) *[Painter, printmaker, teacher] b.1905, Colfax, WA.*
Addresses: Seattle, WA. **Studied:** Calif. School FA; Wiggens School, Los Angeles; Cornish Art School, Seattle; with Ken Callahan, Joan Bloedel, Yoshi Yoshita. **Member:** Women Painters Wash.; Northwest WC Soc.; Nat. Lg. Am. Pen Women. **Work:** priv. collections in Japan, England, Denmark and South Africa; SAM. **Comments:** Co-owner, Woessner Gallery, Seattle. **Sources:** Trip and Cook, *Washington State Art and Artists,* 1850-1950.

WOFFORD, Philip *[Painter, waiter] b.1935, Van Buren, AR.*
Addresses: Hoosick Falls, NY. **Studied:** Univ. Arkansas, B.A., 1957; Univ. Calif., Berkeley, 1957-58. **Exhibited:** San Francisco Mus. Ann., 1958; WMAA, 1969 , 1972-73; CGA; Andre Emmerich Gallery, NYC, 1970s. **Work:** WMAA; Michener Foundation Collection, Austin, TX; RISD. **Sources:** WW73; Carter Ratcliff (author), "The New Informalists," *Art News,* 2/1970; Peter Scheldajl (author), "Return to the Sublime," *New York Times,* 4/18/1971. Publications: author, article, *Art Now: New York,* 1970; author, "Grand Canyon Search Ceremony," *Barlenmire House,* 1972. Teaching: art instructor, New York Univ. Extension, 1964-68; art instructor, Bennington College, 1969-.

WOGRAM, Frederick *[Lithographer] mid 19th c.*
Addresses: NYC, 1854-59. **Sources:** G&W; NYBD 1854, 1857, 1859.

WOHLBERG, Ben *[Illustrator] b.1927.*
Addresses: NYC. **Studied:** Kansas City College (arch.); Chicago Acad. FA; Art Center School, Los Angeles. **Exhibited:** American WC Soc.; SI, Award of Excellence, 1962. **Comments:** Illus., *Redbook,* beginning 1960, and other national magazines, paperback covers and hardcover illustrations for *Reader's Digest,* and the Franklin Library. **Sources:** W & R Reed, *The Illustrator in America,* 310.

WOHLBERG, Meg *[Illustrator] 20th c.*
Addresses: New York 16, NY. **Member:** SI. **Sources:** WW53; WW47.

WOHLGEMUTH, Daniel *[Painter] 20th c.*
Addresses: NYC. **Exhibited:** Salons of Am., 1924; S. Indp. A., 1924. **Sources:** Marlor, *Salons of Am.*

WOICESKE, Elizabeth Bush (Mrs. Ronau Wm.)
[Painter, sculptor, block printer, designer, teacher] b.1883, Phila. / d.1958, Woodstock, NY?.
Addresses: Woodstock, NY. **Studied:** St. Louis Sch. FA; J. Banks. **Member:** Woodstock AA. **Work:** Woodstock AA. **Comments:** Specialty: flowers. **Sources:** WW40; Woodstock AA.

WOICESKE, R(onau) W(illiam) *[Painter, etcher, painter, designer, teacher] b.1887, Bloomington, IL / d.1953, Woodstock, NY.*
Addresses: Woodstock, NY.
Studied: St. Louis Sch. FA.; J. Carlson. **Member:** SAE; Calif. Pr. Club; Philadelphia Pr. Club; Chicago SE; CAFA;Woodstock AA. **Exhibited:** SAE; California Pr. Club; Phila. Pr. Club; Chicago SE; Carnegie Inst.; several solo exhibs., New York. **Awards:** prize, Southern Printmakers, 1936; prize, St. Louis AL. **Work:** Woodstock AA; Los Angeles MA; LOC; NYPL; stained glass windows & murals in many churches; Contemporary Prints of the Year, 1931; Fifty Prints of the Year, 1933; Fine Prints of the Year, 1935. **Comments:** Most of his prints were etchings, drypoints, and aquatints — produced in editions of 50 to 100. His favorite subject was winter scenes. **Sources:** WW53; WW47; Woodstock AA.

WOISERI, J. L. Bouquet *[Painter, printmaker] early 19th c.*
Addresses: active in New Orleans (1803) and in Boston (1810). **Work:** Mariners Mus., Newport News, VA (watercolor, aquatint). **Sources:** Brewington, 419.

WOISKY, Jan S. *[Painter] 20th c.*
Addresses: NYC. **Exhibited:** S. Indp. A., 1924. **Sources:** Marlor, *Soc. Indp. Artists.*

WOJCIK, Gary Thomas *[Sculptor] b.1945, Chicago, IL.*
Addresses: Ithaca, NY. **Studied:** School Art Inst.Chicago, B.F.A.; Univ. Kentucky, M.A. **Exhibited:** WMAA, 1968; Univ. Illinois Biennial Painting & Sculpture Exhib., 1969; Soc. Contemporary Art 29th Ann., AIC, 1969; Viewpoints Painting & Sculpture Invitational, Colgate Univ., 1970; Painting & Sculpture 1972, Storm King AC, Mountainville, NY, 1972; Kornblee Art Gallery, NYC, 1970s. **Awards:** AIC traveling fellowship. **Work:** High Mus. Art, Atlanta, GA; New York Port Authority; Chicago Park District, Hyde Park. **Comments:** Preferred media: welded metal. Teaching: part-time asst. professor sculpture, Ithaca College, 1969- **Sources:** WW73; review, *New York Times*, November 29, 1970, *Art News Magazine* (January 29, 1971) & *Art Int.* (February 20, 1971).

WOJINSKI, Francis Ann O. P. *[Printmaker, educator] b.1910, Detroit, MI.*
Addresses: Las Vegas, NV. **Studied:** Siena Heights College, B.A.; De Paul Univ., M.A.; Univ. Southern California, with Jules Heller & Carlton Ball, M.F.A. **Member:** Int. Graphic Art Soc.; Print Council Am.; Pratt AC Contemporary Prints; Nat. Catholic AA. **Exhibited:** Rochester Festival Relig Arts, 1965; Bay Artist-Educator Asn, Oakland Art Mus, California, 1966; Incarnate World Col Fine Arts Gallery, San Antonio, Teasx, 1969; 40th San Antonio Artists Exhib., 1970; Retrospective Exhib., Texas Univ. Medical School, San Antonio, 1971. **Awards:** Rochester Festival Religious Arts, 1965; 40th Ann. Artists Exhib. San Antonio, 1970. **Work:** Colgate Rochester Divinity School, Rochester, NY; St. John Fisher College, Rochester; Siena Heights College, Adrian, MI; Univ. Texas Mus., Austin. **Comments:** Preferred media: intaglio. Publications: author/illustrator, *Reading Readiness Book for First Grade*,1940, *Art Course of Study for Primary Grades*,1942,*Art Course of Study for Elementary Grades,*1944 & *Art Course of Study for High School*, 1960. Teaching: instructor, all subjects & art, St. Edmund School, Oak Park, IL, 1930-40; instructor, social sciences & art, St. Scholastica School, Detroit,

MI, 1940-50; instructor, Latin & art, Holy Cross H.S., Santa Cruz, CA, 1950-60; instructor, Latin & art, Bishop O'Dowd H.S., Oakland, 1960-65; instructor graphics, Siena Heights College, 1965-68; instructor graphics, Incarnate Word College, 1969-71. **Sources:** WW73.

WOKAL, Louis Edwin *[Designer, craftsperson] b.1914, Astoria, NY.*
Addresses: New York 14, NY; College Point, NY. **Member:** Un. Scenic Artists. **Work:** models & dioramas, WFNY 1939; New York Mus. Sc. & Indst. **Comments:** Position: modelmaker, John C. Stark Indust. Models, NYC; U.S. Army Engineers, 1941-45. **Sources:** WW53; WW47.

WOLBERG, Fred *[Sculptor] 20th c.*
Addresses: Chicago area. **Exhibited:** AIC, 1949. **Sources:** Falk, *AIC.*

WOLBERG, Marvin *[Painter] 20th c.*
Addresses: Chicago area. **Exhibited:** AIC, 1950-51. **Sources:** Falk, *AIC.*

WOLCHONOK, Louis *[Painter, etcher, designer, teacher, craftsperson, writer, lecturer] b.1898, NYC / d.1973.*
Addresses: New York 23, NY. **Studied:** CUASch.; NAD; CCNY (B.S.); Julian Acad., Paris; Brooklyn Acad. FA. **Member:** New York Soc. Craftsmen (1st vice-pres., 1951-53); SAE; Woodstock AA. **Exhibited:** WMAA, 1934; AIC, 1930-1932; NAD; PAFA; Los Angeles MA; Tate Gal., London; Milch Gal. (solo); ACA Gal.; Newhouse Gal.; Ainslie Gal. **Work:** CMA; Univ. Nebraska; Bibliothèque Nationale, Paris. **Comments:** Teaching: drafting, CCNY, 1930-; design, etching, painting, Craft Students League of the YWCA, NYC, 1932-. Contributor: articles, *Creative Design*, 1934. Lectures: appreciation & history of art. Author/illustrator: "Design for Artists and Craftsmen," 1954. **Sources:** WW59; WW47; Woodstock AA.

WOLCOTT, Alexander Simon *[Daguerreotypist] d.1844, Stamford, CT.*
Comments: One of the first Americans to make a daguerreotype, he was successful on Oct. 6, 1839, one month before Daguerre's agent François Gouraud (see entry) came to the U.S. In 1840, he opened a portrait gallery with John Johnson in NYC. **Sources:** Newhall, *The Daguerreotype in America*, 156.

WOLCOTT, Elizabeth Tyler *[Illustrator] b.1892, Brookline, MA.*
Addresses: NYC from 1918. **Studied:** Mass. Normal Art School, Boston; one year in France. **Sources:** Petteys, *Dictionary of Women Artists.*

WOLCOTT, Frank *[Painter, sculptor, etcher, craftsperson] 20th c.; b.McLeansboro, IL.*
Addresses: Chicago, IL. **Studied:** AIC. **Exhibited:** AIC, 1906-15; PAFA Ann., 1910, 1913. **Sources:** WW25; Falk, *Exh. Record Series.*

WOLCOTT, H. P. *[Artist] late 19th c.*
Addresses: NYC, 1879. **Exhibited:** NAD, 1879. **Sources:** Naylor, *NAD.*

WOLCOTT, Helen *[Painter] 20th c.*
Addresses: Provincetown, MA. **Sources:** WW25.

WOLCOTT, John Gilmore (Fra Angelo Bomberto)
[Mural painter, cartoonist, lecturer, teacher, writer] b.1891, Cambridge, MA.
Addresses: Lowell, MA. **Studied:** Harvard Univ., A.B., Ed.M.; & with Denman Ross, Charles Woodbury, W. Churchill. **Member:** NSMP (pres.); AAPL (Massachusetts State Chm., 1941-46); Lowell AA (pres., 1944-46); St. Botolph's Club, Boston; Whistler Guild, Boston. **Exhibited:** WFNY 1939; numerous regional exhibs. **Work:** Whistler Mus., Lowell, MA; murals, Park Square Bldg., Boston; Gardner, Mass. **Comments:** Positions: teacher, Greenhalge Sch., Lowell, MA; manager, Nat. Masters Studios. Auth./illus.: "Fra Angelo Bomberto in the Underworld of Art," 1946. Contributor to art & educational magazines. **Sources:**

WW53; WW47; *Charles Woodbury and His Students.*

WOLCOTT, Josiah *[Portrait painter] mid 19th c.*
Exhibited: Boston Athenaeum, 1837. **Comments:** New England painter, active from 1835 to 1857. He painted portraits of Mr. and Mrs. Abel Houghton, owned in 1941 by Theodore S. Houghton of St. Albans (VT). **Sources:** G&W; WPA (MA), *Portraits Found in VT;* Swan, BA.

WOLCOTT, Katherine *[Painter] b.1880, Chicago.*
Addresses: Chicago, IL. **Studied:** AIC; Acad. FA, Chicago; V. Reynolds; L. Parker; H.B. Snell; F. Grant; O. White; Académie Julian, Paris with Mme. Laforge and Constant. **Member:** Assn. Chicago PS; Chicago AC; The Cordon; Chicago Gal. Assn.; North Shore AL; South Side AA; Chicago SMP. **Exhibited:** AIC, 1906-1915; Pan-Pacific Expo, San Francisco, 1915. **Sources:** WW40.

WOLCOTT, Marion Post *[Photographer] b.1910.*
Studied: NYU; Univ. Vienna. **Work:** LOC; Univ. Minnesota; MMA; SFMA. **Comments:** Best known as one of the leading WPA photographers for the Farm Security Admin., 1938-43. **Sources:** Witkin & London, 275.

WOLCOTT, Roger Augustus *[Painter, educator, designer, craftsperson, sculptor] b.1909, Amherst, MA.*
Addresses: Agawam, MA; Arlington, VA. **Studied:** Massachusetts College Art; Cornell Univ.; NY Sch. Fine & Applied Art; & with Richard Andrew, Joseph Cowell, Ernest Major. **Member:** Rockport AA; Springfield Art Gld.; Am. Assn. Agricultural College Editors; A. Univ. Western Massachusetts. **Work:** Springfield Mus. Natural Hist. **Comments:** Positions: art instructor, Springfield (MA) Mus. FA, 1933-40; indust. design research, Angler Research, Inc., Framingham, MA, 1940-43; des. research, Nikor Products, Springfield, MA, 1943-46; indust. des. consultant, 1946-51; asst. professor, visual educ., Univ. Massachusetts, Amherst, MA; audio-visual advisor, Int. Cooperation Admin., Panama City, CZ, 1956-58. **Sources:** WW59; WW47.

WOLCOTT, Stanley (Mrs.) See: **ROBERTS, Dean (Mrs. Stanley H. Wolcott)**

WOLDEN, Matt *[Painter] 20th c.*
Addresses: Duluth, MN. **Sources:** WW24.

WOLEVER, Adeleine *[Painter, illustrator, teacher] b.1886, Belleville, Ontario, Canada.*
Addresses: Boston, MA. **Studied:** Tarbell; Benson; Hale; Paxton; Woodbury; Noyes. **Work:** theatre drawings for the *Boston Evening Transcript.* **Sources:** WW21; *Charles Woodbury and His Students.*

WOLF, Allen *[Painter] 20th c.*
Addresses: NYC. **Exhibited:** PAFA Ann., 1953. **Sources:** Falk, *Exh. Record Series.*

WOLF, Amanda *[Sculptor] 20th c.*
Addresses: Cincinnati, OH. **Exhibited:** Cincinnati AM, 1937,1939; AIC. **Sources:** WW40.

WOLF, Ben *[Painter, critic, writer, illustrator, teacher, lecturer, graphic artist] b.1914, Philadelphia, PA.*
Addresses: Wellfleet, MA; Philadelphia, PA. **Studied:** With Carl H. Nordstrom, Justin Pardi, Hans Hofmann. **Member:** Phila. WCC; Phila. Sketch Club; Franklin Inn; AEA; AAUP; Phila. Art All.; Phila. Pr. Club. **Exhibited:** Philadelphia Pr. Club; Grace Horne Gal., Boston; Arch. Lg., 1944; Provincetown AA; PMA, 1955; other exhibitions, 1962-65: FAR Gal., NY; Little Gal., Philadelphia; Newman Gal., Philadelphia; East End Gal., Provincetown; Golden Anniversary Exhib. of Provincetown AA, circulated by AFA; Santa Barbara Mus. Art, 1947 (solo); Minnesota State Fair, 1947; Mus. New Mexico, Santa Fe, 1949; Babcock Gal., 1950; Delgado Mus. Art, 1950: Bijou Theatre, New York, Cyrano Exhib., 1950; Carriage House, Phila., 1955; Phila. Art All., 1959; Newman Gal., Phila., 1960; Karlis Gal., 1960; East End Gal., 1961, both Provincetown; PAFA Ann., 1968. **Comments:** Positions: teacher, Wellfleet (MA) Sch. Art; U.S.

Coast Guard Combat Artists, 1942-44; assoc. editor, *Art Digest,* 1944-47; assoc. editor, *Picture on Exhibit,* 1947; art critic, *Santa Fe New Mexican,* 1948-49; panelist, Provincetown AA, 1959, 1961; asst. professor, PMA College Art, as of 1966. Illustrator: "Memoirs of C. N. Buck," 1941; "The King of the Golden River," 1945. Contributor to "Art in the Armed Forces," 1944; "G.I. Sketch Book," 1944; *Life magazine, Art Digest, Child Life, Art in America, National Observer, Pennsylvania Magazine of History and Biography, Philadelphia Bulletin* magazines. Author: monograph on Raymond Jonson, in *Artists of New Mexico,* Univ. New Mexico Press; monograph on Morton Livingston Schamberg, Univ. Pennsylvania Press. **Sources:** WW66; Falk, *Exh. Record Series.*

WOLF, Eva M. Nagel (Mrs. Addison) *[Painter, illustrator, craftsperson] b.1880, Chicago.*
Addresses: Phila. **Studied:** Maryland Inst., Baltimore; PAFA. **Sources:** WW24.

WOLF, Fay Miller *[Painter] 20th c.*
Addresses: Woodmere, NY. **Member:** S. Indp. A. **Sources:** WW25.

WOLF, Galen R. *[Painter] b.1889, San Francisco, CA / d.1976, San Francisco.*
Addresses: San Francisco. **Studied:** with Gertrude Boyle; Europe. **Member:** Soc. of Western Artists; Sierra Morena Club. **Exhibited:** Soc. of Western Artists; The Gallery, Burlingame; Oakland Mus.; SFMA; Half Moon Bay Lib.; San Mateo Arts Council, 1977 (solo). **Work:** Millbrae City Hall; San mateo County Lib.; Wells Fargo Bank Collection. **Comments:** Specialty: landscapes and Calif. missions. Preferred medium: watercolor. **Sources:** Hughes, *Artists of California,* 614.

WOLF, Hamilton (Achille) *[Painter, illustrator, educator] b.1883, NYC / d.1967, Oakland, CA.*
Addresses: Oakland, CA. **Studied:** NAD; ASL, with W. M. Chase, R. Henri; Columbia; BAID; Acad. Colarossi. **Member:** Carmel AA; San Francisco AA (hon. member). **Exhibited:** Seattle AS, 1917 (prize); S. Indp. A., 1918; LACMA, 1922; Galerie Beaux Arts, San Francisco, 1928; Oakland Art Gal., 1929 (prize), 1932, 1939, 1950 (prize); Calif. State Fair Exhib., 1930 (prize), 1934 (prize),1940 (prize); SFMA (prize); Bakersfield, CA (prize); Pomona, CA, 1938 (prize); San Francisco AA, 1939 (prize), 1944 (prize); WFNY 1939; GGE 1939; Western Mus. Assn.; CPLH, 1945, 1946, 1948; CI, 1941; deYoung Mem. Mus., 1943; Roerich Mus.; Riverside Mus.; Mills College; Stanford Univ.; Rotunda Gal., San Francisco; Fnd. Western Artists, Los Angeles; solos: Macbeth Gal.; Delphic Studios; Rutgers Univ.; Oakland Art Mus. (retrospective); Seattle Art Soc.; Gumps Gal.; Mexico City; Instituto de Allende, Mexico; Chase Gal., NY, 1960. **Work:** Huntington Lib. and Gallery, San Marino; Washington County Mus., Hagerstown, MD; Georgia Mus. Art, Athens; Univ. Maine; Long Beach (CA) Mus. Art; Henry Gal., Univ. Washington, mural, Shell Laboratories, Emeryville, CA. **Comments:** Positions: teacher, Los Angeles Sch. Art, 1911-16; Univ. Washington, 1916-18; Univ. California, 1929-38; California College Arts & Crafts, Oakland, from 1929; Acad. Adv. Art, San Francisco, from 1935. **Sources:** WW66; WW47; more recently, see Hughes, *Artists in California,* 614-15.

WOLF, Henry *[Painter] 20th c.*
Addresses: Brooklyn, NY. **Exhibited:** S. Indp. A., 1933; Salons of Am., 1935. **Sources:** Falk, *Exhibition Record Series.*

WOLF, Henry *[Wood engraver] b.1852, Eckwersheim, Alsace / d.1916, New York, NY.*
Addresses: NYC. **Studied:** J. Levy, in Strasbourg. **Member:** ANA, 1905; NA, 1908; Int. Soc. SP&G; Lotos C.; Union Int. des Beaux-Arts et des Lettres, Paris; Jury, Paris Expo, 1889, 1900; Jury Selection and Awards, Pan-Am. Expo, Buffalo, 1901; Jury of Awards, St. Louis Expo, 1904. **Exhibited:** PAFA Ann., 1879, 1894-1903; Paris Salon, 1887, 1888 (prize), 1889, 1895 (gold), 1898, 1899; Paris Expo, 1889 (prize), 1900 (medal); Columbian Expo, Chicago, 1893 (medal); Boston AC, 1896; Rouen Expo,

1903 (medal); St. Louis, 1904 (prize); Pan-Pacific Expo, San Francisco, 1915 (prize). **Work:** series for Century; portraits, *Harper's*; LOC; NYPL. **Comments:** Came to NYC in 1871. Exhibited wood engravings in the Paris Salon. With T. Cole and W. J. Linton formed the great triumvirate of American wood engravers. **Sources:** WW15; Fink, *American Art at the Nineteenth-Century Paris Salons*, 407; Falk, *Exh. Record Series.*

WOLF, Jacob J., Jr. *[Commercial artist, engraver] b.1888, New Orleans, LA.*
Addresses: New Orleans, active 1907-60. **Comments:** Worked at several firms as an engraver and later was art director with advertising agencies. **Sources:** *Encyclopaedia of New Orleans Artists*, 418.

WOLF, Joseph C. *[Painter] 20th c.*
Addresses: Brooklyn, NY. **Studied:** ASL. **Exhibited:** S. Indp. A., 1924. **Sources:** Marlor, *Soc. Indp. Artists.*

WOLF, Leon *[Painter] 20th c.*
Addresses: NYC; Allendale, NJ, 1931. **Studied:** ASL. **Exhibited:** Armory Show, 1913; S. Indp. A., 1931. **Sources:** WW15; Brown, *The Story of the Armory Show.*

WOLF, Max (Dr.) *[Painter, etcher] b.1885, Vienna, Austria.*
Addresses: NYC/Millwood, NY. **Member:** Physicians AC; Am. Bookplate Soc. **Sources:** WW29.

WOLF, May V. *[Painter] 19th/20th c.*
Addresses: NYC, 1896-97, 1917-22; Washington, DC, 1910-16; 1927-37. **Exhibited:** NAD, 1896-97; Wash. DC art groups. **Sources:** Petteys, *Dictionary of Women Artists.*

WOLF, Peggy (Pegot) *[Sculptor] 20th c.*
Addresses: Active Chicago, 1935; California, 1939; NYC, 1948. **Exhibited:** Chicago, 1935; P&S Los Angeles, 1938; All Calif. Exh., 1939; WFNY, 1939; AIC. **Sources:** WW40; Hughes, *Artists in California*, 615.

WOLF, Sarah K. *[Painter] d.1953, New Orleans, LA.*
Addresses: New Orleans, active c.1890-94. **Studied:** Mrs. F. Moore, 1894. **Exhibited:** Mrs. Moore's Studio, 1894. **Comments:** Painted a 116-piece set of china with scenes of LA and other places. Because of its delicacy she refused to exhibit it at the Columbian Expo, Chicago, 1893. Also painted in oil and watercolor. **Sources:** *Encyclopaedia of New Orleans Artists*, 418.

WOLFE, Ada A. *[Painter, teacher] 20th c.; b.Oakland, CA.*
Addresses: Minneapolis MN. **Studied:** Minneapolis Sch. FA; NY Sch. Art, with Chase. **Exhibited:** Minnesota State Art Soc., 1914 (prize). **Comments:** Position: teacher, Minneapolis Sch. FA. **Sources:** WW33.

WOLFE, Ann (Mrs. Graubard) *[Sculptor, instructor] b.1905, Mlawa, Poland.*
Addresses: Washington, DC; Minneapolis, MN. **Studied:** Hunter College, B.A.; studied sculpture in Manchester, England & Paris, France; Acad. Grande Chaumière, with Despiau & Vlerick. **Member:** AG, Wash. **Exhibited:** AGAA, 1942; AG, Wash., 1942-45; WMA, 1939 (solo), 1940, 1946; Grace Horne Gal., 1940; Soc. Wash. Artists, 1944; Whyte Gal., 1946; Third Sculpture Int., Phila. Mus. Art, 1949; PAFA Ann., 1951; Fifth Six-State Sculpture Show, 1951; Biennial From the Upper Midwest, 1956 & 1958, Walker AC, Minneapolis, MN; "Sculpture 54," Sculpture Center, New York, 1954; Adele Bednarz Galleries, Los Angeles, 1970s. **Awards:** Allied Artists Am., 1936; Soc. Washington Artists, 1944 & 1945; Minneapolis Inst. Arts, 1951. **Work:** Morris Raphael Cohen Library, City Univ. NYC; Jerusalem Mus. Art, Israel; Nat. Mus. Korea, Seoul; Mus. Western Art, Moscow, Russia; Wangensteen-Phillips Medical Center, Univ. Minnesota. **Commissions:** Children's Hospital, St. Paul, MN, 1957; welded relief in steel & bronze, Mt. Zion Temple, St. Paul, 1965. **Comments:** Preferred medium: bronze. Teaching: private studio instruction, 1962-70; sculpture instructor, Minnesota Center Arts & Educ. 1971-. Publications: contributor, *Worcester (MA) Tel-Gazette*, 1940-1960; art book reviews. **Sources:** WW73; WW47; Falk, *Exh. Record Series.*

WOLFE, Anne L. *[Painter] late 19th c.*
Addresses: Active in Indianapolis, 1881-84. **Sources:** Petteys, *Dictionary of Women Artists.*

WOLFE, Byron ("By") B. *[Painter, illustrator] b.1904, Parsons, KS / d.1973, Colorado Springs.*
Studied: Univ. Kansas. **Member:** CAA. **Work:** Whitney Gall., Cody, WY; Montana Hist. Soc., Helena; W.R. Nelson Gal., Kansas City; Wyoming State Art Gallery, Cheyenne; Eisenhower Library, Abilene, KS; William Rockhill Nelson Gall., Kansas City. **Comments:** Illustrator: covers, *Western, Western Horseman, Kansas Historical Society.* **Sources:** P&H Samuels, 535-36.

WOLFE, Claudia Kayla *[Landscape painter] 20th c.*
Addresses: San Francisco, CA, 1930s. **Exhibited:** SFMA, 1935. **Sources:** Hughes, *Artists of California*, 615.

WOLFE, Duesbury H. *[Portrait painter] 19th c.*
Addresses: San Jose, CA, active 1890s. **Work:** San Jose Hist. Mus. **Sources:** Hughes, *Artists of California*, 615.

WOLFE, Edward *[Painter] 20th c.*
Exhibited: AIC, 1932. **Sources:** Falk, *AIC.*

WOLFE, George E. *[Illustrator] 20th c.*
Addresses: NYC. **Sources:** WW21.

WOLFE, Jack D. *[Craftsmen, designer, teacher, lecturer] b.1915, NYC.*
Addresses: New York 14, NY; Flushing, LI, NY. **Studied:** with Ruth Canfield, Maija Grotel, Alexander Couard, Peter Muller Munk. **Member:** NY Soc. Ceramic Artists; Long Island Art Lg. **Exhibited:** WMAA, 1957; Long Island Art Lg.; NY Soc. Ceramic Artists, 1948 (prize). **Work:** MoMA. **Comments:** Position: ceramics instructor, NY Univ.; Universal Sch. of Handicrafts; Henry St. Settlement; freelance consultant and designer for factories and individuals. **Sources:** WW59.

WOLFE, John C. *[Portrait, landscape, and panorama painter] mid 19th c.*
Addresses: Cincinnati and Dayton, OH, 1843 -51; Chicago, 1859. **Comments:** He was the artist of a panorama of *Pilgrim's Progress* and, with William L. Sonntag (see entry), of a panorama of *Paradise Lost.* **Sources:** G&W; Cincinnati CD 1843, 1851; Chillicothe *Daily Scioto Gazette*, April 24, 1850; Chicago CD 1859; Baltimore *Sun*, June 3, 1850 (G&W has information courtesy J. Earl Arrington); Hageman, 124.

WOLFE, John K. *[Painter and draftsman] b.c.1835, Pennsylvania.*
Addresses: Phila., 1860. **Exhibited:** PAFA, 1861 ("Sleepy Hollow"). **Comments:** Son of William B. and Mary K. Wolfe of Philadelphia, with whom he was living in 1860. His father was fairly well-to-do, owning personal property valued at $40,000. He was listed as "drawing" in the 1871 directory. **Sources:** G&W; 8 Census (1860), Pa., LX, 975; Rutledge, PA; Phila. CD 1871.

WOLFE, Karl (Ferdinand) *[Painter, educator, craftsperson] b.1904, Brookhaven, MS.*
Addresses: Jackson 6, MS. **Studied:** AIC, traveling scholarship, 1929; William M. R. French. **Member:** Mississippi AA; SSAL; NOAL; NOAA; Chicago Gal. Art. **Exhibited:** Corcoran Gal biennial, 1932; PAFA Ann., 1933; AIC, 1935; Carnegie Inst., 1941; Mississippi AA, 1932-55 (gold medals, 1932, 1951); Delgado Mus. Art, 1934-42; Art Along the Mississippi, 1942; SSAL, 1932-42. **Awards:** Brooks Mem. Art Gal., 1935; prizes, SSAL, 1933, 1934, 1937. **Work:** Montgomery Mus. FA; Governor's Mansion, Jackson, MS; WPA mural USPO, Louisville, KY; Municipal Art Gal., Jackson; Mississippi State College for Women; Lib. Bldg., Mississippi A&M College, Starkville, MS. **Comments:** Teaching: Milsaps College, Jackson, MS, 1947-; Allison's Wells Art Colony, Way, MS. Specialty: woodcarving. **Sources:** WW59; WW40; Falk, *Exh. Record Series.*

WOLFE, Meyer R. *[Painter, lithographer, illustrator] b.1897, Louisville, KY / d.1985, Nashville, TN.*
Addresses: New York 19, NY; Frenchtown, NJ. **Studied:** Chicago

Acad. FA with DeVoe; ASL with J. Sloan; Académie Julian, Paris with Laurens. **Exhibited:** PAFA Ann., 1935, 1946; AIC, 1938; NAD, 1941, 1945; Carnegie Inst., 1948, 1949; LOC, 1944, 1948-50; WFNY 1939; Salons of Am. **Work:** Univ. Minnesota. **Sources:** WW59; WW47; Falk, *Exh. Record Series.*

WOLFE, Mildred Nungester (Mrs. Karl Wolfe) *[Painter, sculptor]* b.1912, Celina, OH.
Addresses: Decatur, AL, 1940; Jackson, MS, 1959. **Studied:** Athens Col.; Alabama State Col. for Women (A.B.); Colorado Springs FA Center (M.A.); AIC; ASL; J.K. Fitzpatrick; Boardman Robinson. **Member:** Mississippi AA; Atlanta Art Lg.; Alabama Art Lg.; SSAL. **Exhibited:** Montgomery (AL) Mus. FA, 1935 (prize); Alabama Art Lg., prizes, 1935, 1940; SSAL, 1938 (prize); McDowell Gal., 1938 (prize); WFNY 1939; CGA, 1939, 1949; Mississippi AA, 1945-56; Alabama Art Lg., 1935-40, 1952; Jackson, MS, prizes, 1947, 1949-51, 1953, 1955; Birmingham Mus. Art, 1956. **Work:** Montgomery Mus. FA; Munic. Art Gal., Jackson; Mississippi State Col.; Alabama Polytechnic Inst.; LOC; murals, St. Andrew's Episcopal Day School, Jackson, MS; Jacksonian Highway Hotel; Stevens Dept. Store, Richton, MS; Leila Cantwell Seton Hall, Decatur; Montgomery MFA; Alabama Polytech. Inst., Auburn. **Comments:** Position: art history instr., Milsaps College, Jackson, MS, 1957-. **Sources:** WW59; WW40.

WOLFE, Natalie (Mrs. D. D. Michel or Michael) *[Sculptor]* b.1896, San Francisco, CA / d.1936.
Addresses: San Fran. **Studied:** Ferrea; Calif. Sch. FA. **Member:** Nat. Lg. Am. Pen Women (FA dept.). **Exhibited:** Pan-Pacific Expo, San Fran., 1915 (gold medal); AIC. **Work:** bust, De Young Mem. Mus.; portrait, Masonic Home, Dacota, CA; portrait reliefs, Hadassah Sculpture, George Washington H.S., San Fran. **Sources:** WW38; Petteys, *Dictionary of Women Artists.*

WOLFE, Townsend Durant *[Painter, art administrator]* b.1935, Hartsville, SC.
Addresses: Little Rock, AR. **Studied:** Georgia Inst. Technology; Atlanta Art Inst., B.F.A.; Cranbrook Acad. Art, M.F.A.; Inst. Art Admin., Harvard Univ., cert. **Member:** Am. Assn. Mus.; AFA; Southeastern Assn. Mus. **Exhibited:** Ball State Teacher's College Drawing Nat., Muncie, IN, 1959-67 (4 shows); Mead Painting of Yearr Exhib., Atlanta, GA, 1962; Watercolors USA, Springfield, MO, 1963-64; Bucknell Ann. Drawing Nat., Lewisberg, PA, 1965; Audubon Artist Nat., NYC, 1968. **Awards:** M. J. Kaplan Painting Award, Nat. Soc. Casein Painters, 1965; Silvermine Guild Award Painting, 18th Am. New England Exhib., 1967; award merit & purchase prize, 57th Nat. Painting Exhib., Mississippi AA, 1967. **Work:** Ark Arts Ctr, Little Rock; Mint Mus Art, Charlotte, NC; Okla Arts Ctr, Oklahoma City; Mississippi AA, Jackson; Carroll Reece Mem. Mus., East Tenn. State Univ., Johnson City. **Comments:** Preferred media: oils, bronze. Positions: director, Wooster Community AC, Danbury, CT, 1965-68; art director, Upward Bound Project, Danbury, summers 1966-68; exec. director, Arkansas AC, 1968-. Teaching: instructor, painting & drawing, Memphis (TN) Acad. Art, 1959-64; instructor, painting & drawing, Scarsdale Studio Workshop, NY, 1964-65. **Sources:** WW73.

WOLFE-PARKER, Viola *[Painter, sculptor, screenprinter, craftsperson]* b.1904, Minneapolis, MN.
Addresses: Minneapolis 11, MN. **Studied:** Univ. Minnesota; Minneapolis Sch. Art, and with B. J. O. Nordfeldt, Paul Burlin, Charles Burchfield. **Member:** Calif. WC Soc.; Minnesota AA (pres., 1956-68); AEA (board of directors, recording secretary, Twin City Chapt., 1952-58); Provincetown AA; Minnesota Centennial Committee (visual arts & arch. committee, 1958). **Exhibited:** Riverside Mus., 1948; Grand Central Art Gal., 1948; Los Angeles County Fair, 1947-49; de Young Mem. Mus., 1947; Pasadena AI, 1945-49; Santa Barbara, CA, 1945-49; San Diego, CA, 1945-1949; Seattle, WA, 1945-49; Joslyn Art Mus., 1948, 1950, 1951; Terry AI, 1952; numerous traveling exhibs., 1945-50; Minnesota State Fair, 1940-51, 1956, 1958; Harriet Hanley Gal., 1940; Minneapolis Inst. Art, 1941-52; Minneapolis Woman's Club, 1942-52, 1954, 1956; St. Paul Art Gal., 1946-49; Walker AC, 1947, 1954; Minneapolis Aquatennial, 1947-52; Five Twin

City Artists, 1949; Minneapolis AA, 1949, 1955, 1956; Minn. Women Artists, 1950; Swedish-Am. Inst. Art, 1952, 1954 (solo), 1958; Carleton College, 1954; Wisc. State Teachers College, 1954; St. Paul Carnival Exhib., 1955, 1958; AEA, 1952; Centennial Expo, 1958; Minnesota AA, 1955, 1956. **Awards:** prizes, Minneapolis Inst. Art, 1947, 1949; Minnesota State Fair, 1947, 1949; Woman's Club, 1949. **Work:** Minneapolis Woman's Cl.; Minneapolis Chamber of Commerce; work included in Minn. Centennial Commission's film "Art in Minnesota," 1958. **Comments:** Position: art chmn., St. Paul Winter Carnival Art Exhib., 1957-58. **Sources:** WW59.

WOLFF *[Listed as "artist"]* mid 19th c.
Addresses: NYC. **Exhibited:** NAD, 1850 (several still lifes of birds and fruit). **Sources:** G&W; Cowdrey, NAD.

WOLFF, Adolf *[Sculptor]* b.1887, Brussels, Belgium.
Addresses: NYC. **Studied:** NAD, briefly; Fernando Miranda; Royal Acad., Brussels; Charles van der Stappen and Constantin Meunier. **Member:** Sculptors Gld.; Am. Artists Congress. **Exhibited:** Modern Gal., 1915, 1916; Sculptors Gld., 1938, 1939; BM; WMAA; Am. Artists Congress; Musée Moderne, Brussels (prize); S. Indp. A., 1924, 1931-33. **Work:** State Mus. Birobidzhan, Russia, 1936. **Comments:** Combined radical political philosophy with avant-garde sculpture; experimented with cubist and non-objective form. Associated with Ferrer School in NYC, c.1910. **Sources:** WW40; Fort, *The Figure in American Sculpture,* 232 (w/repro.).

WOLFF, Carrie *[Artist]* late 29th c.
Addresses: Active in Indiana, c.1880. **Studied:** Indiana School Art. **Comments:** Married Samuel Richards. **Sources:** Petteys, *Dictionary of Women Artists.*

WOLFF, Edna *[Painter]* 20th c.
Addresses: Chicago area. **Exhibited:** AIC, 1936. **Sources:** Falk, AIC.

WOLFF, Elsie K. *[Painter]* 20th c.
Studied: ASL. **Exhibited:** S. Indp. A., 1941, 1943. **Sources:** Marlor, *Soc. Indp. Artists.*

WOLFF, Gustav(e) (H.) *[Painter]* b.1863, Germany / d.1935, Berlin, Germany.
Addresses: NYC (since 1866); St. Louis, MO. **Studied:** St. Louis Sch. FA, with P. Cornoyer; Europe. **Member:** Buffalo SA. **Exhibited:** Portland, OR, 1905; PAFA Ann., 1905, 1912; Competitive Exhib., St. Louis, 1906; SWA, 1907 (medal); Salons of Am.; AIC; S. Indp. A., 1920-21, 1929. **Work:** CAM. **Sources:** WW40; Falk, *Exh. Record Series.*

Gustave Wolff

WOLFF, Isabel (Mrs. Harold G.) See: **BISHOP, Isabel (Mrs. Harold G. Wolff)**

WOLFF, Martial *[Painter]* 20th c.
Addresses: NYC. **Exhibited:** S. Indp. A., 1934-35. **Sources:** Marlor, *Soc. Indp. Artists.*

WOLFF, Otto *[Painter, illustrator, craftsperson, writer, lecturer, teacher]* b.1858, Cologne, Germany / d.1965.
Addresses: Chicago, IL; NYC, 1882-93. **Studied:** Paris, with Bonnat, Cormon, Ferrier. **Member:** Chicago SA; Chicago AC. **Exhibited:** Paris Salon, 1881, 1883-84, 1888 (prize); NAD, 1882-93; PAFA Ann., 1883; AIC; S. Indp. A., 1921. **Sources:** WW24; Fink, *American Art at the Nineteenth-Century Paris Salons,* 407; Falk, *Exh. Record Series.*

WOLFF, Robert Jay *[Painter, writer, designer, sculptor, lecturer, teacher]* b.1905, Chicago, IL / d.1977, New Preston, CT.
Addresses: Paris (1926-31); Chicago (1931-45); NYC (1945); New Preston, CT. **Studied:** Yale Univ., 1926; briefly at École Beaux Arts with Georges Mouveau. **Member:** Am. Abstract Artists, 1937. **Exhibited:** AIC, 1934, 1935 (sculpture solo), 1938, 1946; Am. Abstract Artists, 1937-50; K. Kuh Gal., Chicago, 1930s-40s (solos); Reinhardt Gal., NYC (solo), Nierendorf Gal, NYC (solo); Kleeman Gal., NYC (solo); galleries in Denver, San

Francisco, Cincinnati, Topeka; Realities Nouvelles, Paris & other European cities, 1948-51; Guggenheim Mus., 1951 (solo); traveling exhib. to France, Italy, Germany & Switzerland, 1956; PAFA Ann., 1958; CGA, 1958; WMAA, 1958; plus nine solos, New York, 1939-58. **Work:** AIC; Brooklyn Mus.; Wadsworth Atheneum, Hartford, CT; Tate Gallery, London; Guggenheim Mus; RISD; Brooklyn Mus; Brooklyn Col, CUNY. **Comments:** A geometric abstract painter. After teaching at the Chicago Bauhaus he implemented the first Bauhaus-derived arts program in a liberal arts college in America — at Brooklyn College. Author: "Toward a Direct Vision" in Am. Abstract Artists cat., 1938; *Elements of Design: Educational Portfolio,* MoMA, 1946; *Education of Vision,* Brazilier, 1965 (contrib.); *Seeing Red, Feeling Blue & Hello Yello,* Scribners, 1968; *On Art & Learning,* Grossman, 1971. Teaching: Dean, School of Design, Chicago, 1938-42; chmn., professor art, Brooklyn College, CUNY, 1946-71; visiting professor design, MIT, 1961. **Sources:** WW73; Sidney Janis *Abstract Art in America* (Reynal & Hitchcock ,1944); L Moholy-Nagy, *Vision in Motion* (Theobold-Chicago, 1948); M. Seuphor, *Dictionary of Abstract Art* (Tudor, 1957). More recently, see *American Abstract Art,* 202; Falk, *Exh. Record Series.*

WOLFF, Ruth Mitchell *[Painter] 20th c.; b.Herkimer, NY.*
Addresses: Montclair & Verona, NJ. **Studied:** Rochester Athenaeum Fine & Applied Arts; with Charles S. Charman, Anna Scott. **Member:** Verona-West Essex AA (pres.); Sorelle Club (pres.); New Haven PCC. **Exhibited:** Rochester Athenaeum Fine & Applied Arts (Wiltie prize for watercolors); widely in the NYC area. **Work:** Maryland Fed. Womens Clubs. **Sources:** *Art by American Women:.the Collection of L. and A. Sellars,* 14.

WOLFF, Solomon *[Painter] b.1841, Mobile, AL / d.1911.*
Addresses: NYC. **Studied:** CCNY; Free Acad., 1859.
Comments: Settled in NYC, c.1844. Position: teacher, CCNY, 1860-1903.

WOLFORD, Charles *[Portrait painter] b.c.1811, Pennsylvania.*
Addresses: Louisville, KY, 1843-58. **Comments:** From 1865-67 he was a clerk in a Louisville stationery store and in 1870 he was listed as Capt. Charles Wolford, president of the Arctic Mining & Manufacturing Company. **Sources:** G&W; 7 Census (1850), Ky., XI, 346; Louisville CD 1843-70.

WOLFROM, Philip H. *[Painter] 19th/20th c.*
Addresses: NYC. **Studied:** Académie Julian, Paris, 1894.
Sources: WW04.

WOLFS, Wilma Diena *[Sculptor, painter, graphic artist, educator, illustrator, lecturer] 20th c.; b.Cleveland, OH.*
Addresses: Lakewood 7, Ohio. **Studied:** Western Reserve Univ., B.A., B.S.; Cleveland Sch. A.; traveling schol., 1928; Univ. Minnesota; Radcliffe College, A.M.; NYU; Univ. Pennsylvania; École des Beaux-Arts, Paris; & with Henry Keller, Rolf Stoll, & L. Simon, F. Humbert, Prinet, Baudoin, Ducos de la Haille, Laguillermie, Hans Hofmann, W. Eastman; Univ. Chicago. **Member:** Am. Assn. Univ. Women; Ohio WC Soc.; Arkansas WC Soc.; Soc. Indep. Artists; New Hampshire Arts & Crafts Soc. **Exhibited:** CGA; CMA; Butler AI; Mus. FA, Little Rock, AR; Wichita Art Mus.; Philbrook AC; Studio Gld.; Soc. Indep. Artists; Univ. Arkansas; Brooks Gal., Cleveland; Akron AI; Columbus Gal. FA; Dayton AI; Massillon Mus.; Ohio Univ.; Zanesville AI; Toledo Mus. Art. Awards: prizes, Mus. FA, Little Rock, AR, 1939; medal, Arkansas WC Soc., 1938; Carnegie Scholarships for study in Paris, France, & at NY Univ., Harvard Univ., Univ. Pennsylvania. **Work:** Univ. Arkansas; Hendrix College., Conway, AR; sculpture, Catholic Church, Winter Park, FL; Research Studio, Maitland, FL. **Comments:** Position: head, art dept., Hendrix College, Conway, AR, 1936-37; State Teachers College, Keene, NH, 1937-38; art instructor, MacMurray College, Jacksonville, IL, 1938-39; asst. professor art, Florida State College for Women, Tallahassee, FL, 1939-40. **Sources:** WW59; WW47.

WOLFSKILL, José Guillermo *[Painter] b.1844, Los Angeles / d.1928, Los Angeles.*
Addresses: Los Angeles. **Exhibited:** World's Columbian Expo, Chicago, IL, 1893 (2 oils of Spanish homes in Southern Calif.). **Sources:** Hughes, *Artists in California,* 615.

WOLFSKILL, Joseph William See: **WOLFSKILL, José Guillermo**

WOLFSON, Frances *[Painter] 20th c.*
Exhibited: S. Indp. A., 1938. **Sources:** Marlor, *Soc. Indp. Artists.*

WOLFSON, Henry Abraham *[Portrait painter] b.1891, Leningrad, Russia.*
Addresses: NYC. **Member:** NAD. **Exhibited:** Salons of Am. **Sources:** WW40.

WOLFSON, Irving *[Painter, etcher, teacher] b.1899.*
Addresses: NYC. **Sources:** WW29.

WOLFSON, Sidney *[Painter, sculptor] b.1911, NYC / d.1973.*
Addresses: Salt Point, NY. **Studied:** ASL; Pratt Inst; Cooper Union. **Exhibited:** Six Am. Abstract Painters, Arthur Tooth Gallery, London, 1961; Carnegie Int., Pittsburgh, 1962; Geometric Abstraction, WMAA, 1962; solo show, Bennington College, VT, 1963; New Acquisitions, 1971 & Retrospective, 1972, Vassar College. **Work:** WMAA; Wadsworth Atheneum; Herbert F. Johnson Mus., Cornell Univ.; Vassar College; Columbia Univ. **Comments:** Preferred medium: oil. Teaching: artist-in-residence, Creative Arts Acad, New York, summer 1968; asst. professor art, Dutchess Community College, Poughkeepsie, NY, 1969-70. **Sources:** WW73.

WOLFSON, William *[Lithographer, painter, designer, illustrator, educator, writer] b.1894, Pittsburgh, PA / d.1966, Los Angeles.*
Addresses: Forest Hills, LI, NY. **Studied:** Carnegie Inst.; NAD; ASL; A. W. Sparks; G. W. Maynard; DuMond. **Member:** Pittsburgh AA. **Exhibited:** 50 Prints of the Year, 1928-29, 1931; WMAA, 1933; Salons of Am. **Work:** Bibliothèque Nationale, Paris; NYPL. **Comments:** Contributor: *Readers Digest, Coronet* magazines. Author/illustrator: "Going Places," 1940. **Sources:** WW53; WW47.

WOLGAMUTH, H. *[Sculptor] mid 19th c.*
Addresses: San Francisco, 1856. **Sources:** G&W; San Francisco BD 1856.

WOLHAUPTER, Helen Phillips *[Landscape painter] b.c.1897.*
Addresses: Santa Monica, CA, Hollywood, CA, 1920s, 1930s. **Exhibited:** Calif. WC Soc., 1927; Los Angeles County Fair, 1929. **Comments:** She married writer Maurice Knox McKee Kelly, Jr. in 1932. **Sources:** Hughes, *Artists of California,* 615.

WOLINS, Joseph *[Painter] b.1915, Atlantic City, NJ.*
Addresses: NYC. **Studied:** Dr. Henry Fritz; NAD, 1931-35, with L. Kroll; in Europe, 1937. **Member:** Artists Equity Assn. **Exhibited:** WFNY, 1939; J. B. Neumann, NY; TMA; Corcoran Gal biennial, 1947; Univ. Illinois; PAFA Ann., 1949; WMAA Ann., 1949-53; MOMA Ann., São Paulo, Brazil, 1962; Norfolk (VA) Mus.; Smithsonian Inst.; Butler Inst. Am. Art Ann., Youngstown, OH, 1965; Contemporary Arts, NY (solo); Bodley, NY (solo); Silvermine, Norwalk, CT (solo); Agra, Washington, DC (solo); "NYC WPA Art" at Parsons School Design, 1977. Awards: Mark Rothko Foundation award for painting, 1971; Audubon Artists, 1976; NIAL, 1976; Am. Soc. Contemporary Artists, 1976. **Work:** MMA; Norfolk (VA) Mus. Arts & Sciences; Albrecht Mus., St. Joseph, MO; Fiske Univ. Art Gal, Mobile, AL; Butler AI; Ein Harod Mus., Israel. **Comments:** Preferred media: oils. WPA artist, 1935-41. **Sources:** WW73; *New York City WPA Art,* 94 (w/repros.); Falk, *Exh. Record Series.*

WOLINSKY, Joseph *[Painter] b.1873.*
Addresses: Sydney, Australia. **Studied:** Royal Art Soc., New South Wales; Colarossi, in Paris. **Member:** Royal AS, New South Wales. **Work:** Nat. Art Gal., New South Wales. **Sources:** WW27.

WOLKER, Mark *[Painter] 20th c.*
Exhibited: S. Indp. A., 1917. **Sources:** Marlor, *Soc. Indp. Artists.*

WOLKIN, Harry *[Painter] 20th c.*
Addresses: Pittsburgh, PA. **Member:** Pittsburgh AA. **Sources:** WW25.

WOLLASTON, John
[Portrait painter] mid 18th c.; b.England.
Jno Wollaston Pinx 1750
Studied: in London under a noted drapery painter, perhaps Joseph van Aken (who painted draperies for artists such as Thomas Hudson and Allan Ramsay). **Work:** MMA; Mus.City of NY; NYHS; NGA, Wash., DC; Washington and Lee Univ., Lexington, VA; Worcester (MA) Art Mus.; Shelburne (VT) Mus. **Comments:** Son of London portrait painter John Wollaston (1672-1749). The family name has been at times spelled as Woolaston. The younger Wollaston's earliest firmly dated work is of 1742. He came to America in 1749 and remained for almost ten years, during which time he produced at least three hundred portraits in NYC (1749-52), Annapolis (and elsewhere in Maryland, 1753-54), Virginia (c. 1755-58), and Phila. (1759). He brought to the colonies the latest in English portrait fashion and was highly sought after and praised in his day. His faces are distinguished by certain mannerisms — the slight turn of the head, the almond-shaped eyes and the small, sweet smile; and he excelled at the painting of lace, satin, and pearls. Wollaston, like Blackburn, exerted a strong influence on his American contemporaries, including Benjamin West, Matthew Pratt, John Mare, and John Hesselius (see entries). He left the colonies in 1759 and eventually went to the West Indies, where he is recorded as living on the Island of St. Christopher in 1765 or 1765. Between September of 1765 and March of 1767 he was working in Charleston, SC, where he painted at least 17 portraits. It was noted in the *South Carolina Gazette* that he had left for England in May of 1767. Of his later career nothing is recorded although it is known that he was living in England in 1775. **Sources:** G&W; Groce, "John Wollaston (fl. 1736-67): A Cosmopolitan Painter in the British Colonies," is the most complete account; see also Bolton and Binsse, "Wollaston, An Early American Portrait Manufacturer"; Morgan, "Wollaston's Portraits of Brandt and Margaret Van Wyck Schuyler"; and Groce, "John Wollaston's Portrait of Thomas Appleford, Dated 1746." More recently, see Baigell, *Dictionary;* Craven, *Colonial American Portraiture,* 304-06 and 371-73; Saunders and Miles, 176-182; NYHS (1974); Muller, *Paintings and Drawings at the Shelburne Museum,* 140 (w/repro.).

WOLLE, Muriel (Vincent) Sibell *[Painter, writer, teacher, illustrator, lithographer] b.1898, Brooklyn, NY / d.1977, Boulder, CO?.*
Addresses: Boulder, CO in 1976. **Studied:** NY School Fine & Applied Art, two diplomas; New York Univ., B.S., 1928; Univ. Colorado, M.A., 1930; F.W. Howell; ASL. **Member:** AFA; Am. Colle. S. PM; Topeka PM; NAWA; Delta Phi Delta (second vice pres., first vice pres. & national alumni pres.); Boulder Artists Guild; Colorado Authors League, Denver; Woman's Press Club. **Exhibited:** Denver Art Mus. Ann., 1928-47; Boulder AG, 1927-46; Colorado State Fair, 1930 (prize), 1932 (prize); NAWA, 1930-48; Kansas City AI, 1932-38, 1934 (prize), 1935 (prize); Joslyn Mem., 1932-40; Artists West of the Mississippi, 1939; Denver Art Mus., 1956 (solo); Iowa State Univ. Gallery, Mem. Union, 1967 (solo). **Awards:** Denver Art Mus. (prize, 1928); Norlin Medal, 1957 & Stearns Award, 1966, Univ. Colorado; Laureate Key, Delta Phi Delta, 1958. **Work:** Denver AM; Springfield (MO) Art Mus.; Montana State Mus., Helena; Univ. Colorado. **Comments:** Preferred media: lithographic crayon, watercolors. Positions: teacher, Texas State College for Women, 1920-23; instructor of art, College Industrial Art, 1920-23; instructor of art, New York Sch. Fine & Applied Art, 1923-26; from instructor to prof. art & head dept., Univ. Colorado, Boulder, 1926-66, emer. prof., 1966-.

Publications: author/illustrator, *Ghost Cities of Colorado,* 1933; *Cloud Cities of Colorado,* 1934; *Stampede to Timberline,* 1949; *The Bonanza Trail,* 1953 & *Montana Pay Dirt,* 1963. Contributor: illustrations, *Theatre Arts Monthly;* article, *Design* magazine. Art interests: visiting, sketching & collecting historic ghost mining town data of the twelve western states. **Sources:** WW73.

WOLLENBERG, Gertrude Arnstein See: **ARNSTEIN, Gertrude**

WOLO See: **TRUTZSCHLER, Wolo**

WOLPERT, Elizabeth Davis *[Painter, instructor] b.1915, Fort Washington, PA.*
Addresses: Ambler, PA. **Studied:** Moore College Art, B.F.A.; Penn. State Univ., M.A.Ed.; also with Hobson Pittman. **Member:** Artists Equity Assn.; Phila. Art Alliance; Phila. Mus. Art; Woodmere Art Gal.; Nat. Art Educ. Assn. **Exhibited:** PAFA, 1948; Phila. Mus. Art, 1962; Butler IA, 1965; many shows, Woodmere Art Gallery; Cheltenham AC, 1966. **Awards:** Charles K. Smith First Prize & first mem. Prize, Woodmere Art Gal., 1953; first purchase prizes, Junto, Phila., 1958-59. **Work:** Woodmere Art Gal., Phila.; Penn. State Univ., University Park; Temple Univ., Phila.; Bob Jones Univ., Greenville, SC; Univ. Miami, Coral Gables, FL. **Comments:** Preferred medium: oil. Teaching: art instructor, public & private schools, 1938-. **Sources:** WW73.

WOLPERT, Samuel *[Artist] 20th c.*
Addresses: Phila., PA. **Exhibited:** PAFA Ann., 1950. **Sources:** Falk, *Exh. Record Series.*

WOLSKY, Milton Laban *[Illustrator, painter] b.1916, Omaha, NE.*
Addresses: Omaha. **Studied:** Univ. Nebraska, Omaha; AIC; also with Julian Levi & Hans Hofmann, NYC. **Member:** SI. **Exhibited:** AWCS, New York, 1953; Joslyn Art Mus., Omaha, 1960 (solo); Nebraska Centennial, Sheldon Art Gal., Lincoln, 1967. **Awards:** first award & purchase prize, Gov. Art Show, 1964. **Work:** Gov. Mansion, State of Nebraska; U.S. Embassy, Lebanon; Air Force Hist. Soc.; U.S. Nat. Bank, Omaha. **Comments:** Preferred medium: oil. Positions: art director, Bozell & Jacobs, Inc. Publications: author, *Basic Elements of Painting,* 1959; author/illustrator, *Rock People,* 1970. Teaching: painting instructor, Joslyn Art Mus., 1958-62. Collection: Wolsky Collection of contemporary paintings; donation to Joslyn Art Mus., 1967. **Sources:** WW73.

WOLTER, Adolph G. (Adolph Gustav Wolter van Ruemelin) *[Sculptor, educator, lecturer, craftsperson] b.1903, Reutlingen, Germany.*
Addresses: Indianapolis 20, IN. **Studied:** Kunstbewerbe Schule, Acad. FA, Stuttgart, Germany; John Herron AI; D.K. Rubins. **Member:** Indiana Art Club (dir.); John Herron Alumni Assoc.; the 20s. **Exhibited:** Nat. Exhib. Am. Art, NY, 1938; Indiana State Fair, 1935-40 (prizes), 1951; Herron AI, 1938 (prize), 1943, 1945; Hoosier Salon, 1946 (prize). **Work:** sculpture, Indiana State Library; room, Detroit, MI; American Legion Office Bldg., Washington, DC; *Indianapolis Star;* portrait busts, reliefs, Wood County Court House, Wisconsin Rapids, WI; Indiana Nat. Bank, Indianapolis; Indianapolis Speedway Trophy; Mem. Center & Life Science Bldg., Purdue Univ.; Tennessee State Capitol; Wabash College; Ball State University.; De Pauw Univ.; Indiana State House. **Comments:** Lectures on art appreciation. Position: gallery asst., Herron AI, 1945-46. **Sources:** WW59; WW47.

WOLTER, H. J. *[Painter] 19th/20th c.*
Addresses: Amersfoort, Holland. **Exhibited:** AIC, 1929. **Sources:** WW01.

WOLTMAN, Ethel *[Painter] 20th c.*
Addresses: Piedmont, CA. **Exhibited:** Oakland Art Gallery, 1929. **Sources:** Hughes, *Artists of California,* 615.

WOLTMAN, Nancy Coldwell (Winslow) *[Painter] b.1913, East Lynn, MA.*
Addresses: New York 21, NY. **Studied:** ASL; Farnsworth Sch.

Art; Amagansett Art Sch. **Member:** NAWA; Copley Soc., Boston; New Jersey P&S; AEA; Woodstock AA. **Exhibited:** Audubon Artists, 1949; New Jersey P&S, 1951, 1952; Sarasota, FL, 1951; NAWA, 1952-57 (prize, 1953); New England annual, 1949, 1950; Provincetown AA, 1948, 1949; Copley Soc., 1950, 1951; Caravan Gal., 1953-55; Woodstock AA, 1955; Michigan, 1951 (prize); New York, 1957 (2 solos); Massachusetts, 1956 (solo). **Sources:** WW59.

WOLTZ, George W. *[Painter] 20th c.*
Addresses: NYC. **Member:** SC. **Sources:** WW25.

WOLTZE, G. See: **WOLTZE, Peter**

WOLTZE, P. See: **WOLTZE, Peter**

WOLTZE, Peter *[Painter] 19th c.; b.Weimar.*
Addresses: Milwaukee, WI, and possibly New Orleans, 1880s.
Comments: There is some confusion over whether the Peter Woltze who painted in Milwaukee in the 1880s is the same as the P. Woltze who painted in New Orleans at about the same time. In *Art Across America,* William Gerdts refers to a Peter Woltze, watercolor specialist, who came to Milwaukee from Weimar and "painted a portrait of Viandon in 1882 and also wrote criticism for German language publications before returning to his native city." It is quite possible that is the same artist who painted in New Orleans and signed as P. Woltze. The latter artist is discussed in *The South on Paper: Line, Color, and Light* as producing watercolors of genre and street scenes in New Orleans and the rural south. It is also possible that the G. Woltze listed in the *Encyclopaedia of New Orleans,* is actually P. Woltz and that someone may have misread the "P" as a "G." The *Encyclopaedia* descibes two watercolors ("Hauling Cotton at the Levee" and "Street Scene, New Orleans"), signed as "G" Woltze, with the latter work inscribed "New Orleans, 1889." The fact that these are of similar subject matter to that of P. Woltze makes the link possible. **Sources:** Gerdts, *Art Across America,* vol. 2: 333; *Encyclopaedia of New Orleans,* 418; add'l info., including citation from *The South on Paper: Line, Color, and Light,* courtesy Arthur J. Phelan, Jr., Chevy Chase, Md.

WOLVERTON, Annabelle *[Painter] 20th c.*
Addresses: Kansas City, MO. **Exhibited:** S. Indp. A., 1924. **Sources:** Marlor, *Soc. Indp. Artists.*

WOLVERTON, Jean *[Painter] 20th c.*
Exhibited: S. Indp. A., 1941. **Sources:** Marlor, *Soc. Indp. Artists.*

WOMELSDORF, Joyce *[Painter] 20th c.*
Exhibited: AIC, 1946. **Sources:** Falk, *AIC.*

WOMRATH, A(ndrew) K(ay) *[Painter, illustrator, designer] b.1869, Frankford, Phila.*
Addresses: Kent, CT. **Studied:** ASL with Twachtman and J. A. Weir; Académie Julian, Paris, 1893; also with Grasset and Merson in Paris; Westminster Sch. Art, London. **Member:** Arch. Lg., 1902; NAC. **Exhibited:** SNBA, 1895; PAFA Ann., 1895-1901. **Sources:** WW33; Fink, *American Art at the Nineteenth-Century Paris Salons,* 407-408; Falk, *Exh. Record Series.*

WONDENBERG, C. M. I. *[Painter] 20th c.*
Addresses: Paterson, NJ. **Sources:** WW24.

WONG, Frederick *[Painter, instructor] b.1929, Buffalo, NY.*
Addresses: NYC. **Studied:** Univ. New Mexico, B.F.A., M.A. **Member:** AWCS; Allied Artists Am. **Exhibited:** LACMA, 1959; Butler IA, 1960; AWCS, NYC, 1960-69; Watercolor USA, Springfield, MO, 1963; Mainstreams '69, Marietta, OH, 1969; Kenmore Galleries, Phila., 1970s. Awards: bronze medal, Butler Midyr Ann., Butler IA, 1960; gold medal, Nat. Arts Club, 1961; award of excellence, Mainstreams, 1969, Marietta College, 1969. **Work:** Butler IA; Atlanta AA; Reading Mus. Art; Philbrook ArC; Neuberger Collection, Purchase, NY. **Comments:** Preferred medium: watercolor. Teaching: instructor, form & structure, Pratt Inst., 1966-69; instructor, painting, drawing & design, Hofstra Univ., 1970-. **Sources:** WW73.

WONG, George *[Painter] 20th c.*
Exhibited: S. Indp. A., 1937. **Sources:** Marlor, *Soc. Indp. Artists.*

WONG, Harry *[Painter] 20th c.*
Addresses: NYC. **Exhibited:** S. Indp. A., 1944. **Sources:** Marlor, *Soc. Indp. Artists.*

WONG, Jason *[Executive director] b.1934, Long Beach, CA.*
Addresses: Tucson, AZ. **Studied:** Long Beach City College, A.A., 1954; Univ. Calif., Los Angeles, B.A., 1963. **Member:** Am. Assn. Mus, Western Assn. Art Mus. (vice-pres.); AFA. **Exhibited:** Awards: Nat. Educ. Assn. grant for research in museological studies, 1972. **Comments:** Positions: asst. curator, Long Beach Mus. Art, 1959-64; art director, Audiorama Corp., Am.-Quest Int., 1964-65; curator, Long Beach Mus. Art, 1965, director, 1965-72; director, Tucson AC, 1972-. Collections arranged: 7 Decades of Design, organized through Calif. Arts Commission grant for state tour, 1967-68; The Art of Alexander Calder - Gouaches, western states tour, 1970; Max Beckmann Graphics, Nat. Tour, 1973. **Sources:** WW73.

WONG, Nanying Stella *[Painter, teacher, poet, writer] b.1914, Oakland, CA.*
Addresses: Oakland. **Studied:** Calif. College Arts & Crafts; Cornell Univ.; Mexico City College; Univ. Dublin. **Exhibited:** GGE, 1939. Award: Bay Area Art Lovers Assoc., 1961. **Comments:** Position: teacher, public schools. **Sources:** Hughes, *Artists in California,* 615.

WONG, Tyrus *[Painter, designer, etcher, lithographer, illustrator] b.1910, Canton, China.*
Addresses: Sunland, CA. **Studied:** Otis AI. **Member:** Calif. WC Soc.; AWS; Motion Picture Set Des.; Los Angeles Mus. Assn.; Los Angeles AA; Motion Picture Illustrators. **Exhibited:** Calif.-Pacific Int. Expo, San Diego, 1935; PAFA, 1948, 1951, WFNY 1939; AWCS, 1947-49, 1955; Calif. WC Soc., 1948-55; LC, 1951, 1952; Denver Art Mus., 1948, 1954, 1955; Los Angeles Mus. Art, 1950, 1952, 1954 (prize), 1955 (prize); Calif. State Fair, 1950-52; Butler AI, 1955; Oakland Art Mus., 1955. **Work:** Honolulu Acad. FA; Santa Barbara Mus. Art; Los Angeles AA; Los Angeles Mus. Art. **Comments:** Illustrator: "Footprints of the Dragon," 1949; text & illustrations, "Watercolor Portraiture," 1949; cover illlustraions, *Los Angeles Times Home Magazine,* 1954, 1955. Contributor: illustrations, *Arts & Architecture, Coronet, Western Art Review* magazines. Positions: production des., Walt Disney Studios, 1937-40; production illus., Warner Bros. Studio, 1941-; California Artists card designer. **Sources:** WW59.

WONNER, Paul (John) *[Painter] b.1920, Tucson, AZ.*
Addresses: Montecito, CA. **Studied:** Calif. College Arts & Crafts; Univ. Calif., Berkeley, M.A., M.L.S. **Exhibited:** CI, 1958 & 1964; WMAA, 1959, 1967; AIC, 1961 & 1964; Univ. Illinois, 1961, 1963 & 1965; MoMA, 1962. **Work:** Guggenheim Mus., NYC; San Francisco Mus. Art; Nat. Collection Fine Arts, Smithsonian Inst., Washington, DC; Oakland (CA) Mus.; Joseph H. Hirshhorn Foundation. **Comments:** Teaching: painting instructor, Univ. Calif., Los Angeles, 1963-64; painting instructor, Otis Art Inst., 1966-68. **Sources:** WW73.

WONSETLER, John Charles *[Painter, illustrator, writer, designer, decorator] b.1900, Camden, NJ.*
Addresses: Chatham, NJ. **Studied:** PM School Art, with Thornton Oakley. **Exhibited:** Phila. Art All., 1930, 1939; Wanamaker Gal., Phila., 1929; PM School Art, 1931. Awards: prize, PM School Art,1925. **Work:** murals, Franklin & Marshall College, Lancaster, PA; murals for theatres: Colonel Drake Theatre, Oil City, PA; Holmes Theatre, Holmesburgh, PA; Hotel Warwick, Forum Theatre, Apollo Theatre, and Iris Theatre, Phila.; Embassy Theatre, Reading, PA; Norris Theatre, Norristown, PA; Collingswood Theatre, Collingswood, NJ; Reed Theatre, Alexandria, VA; Rivoli Theatre, Wilmington, DE; St. John's Church, Tamaqua, PA; Church of St. Mary Magdalene de Pazzi, Philadelphia; Hotel Belvedere, Baltimore, MD; theatre, York, PA; Tyson, Byrd Theaters, Phila. **Comments:** Co-author/illustrator, "Me and the General"; "Liberty for Johnny." Author/illustrator:

"Yanks in Action." Illustrator: "Lambs's Tales from Shakespeare"; "Our Lusty Forefathers"; "Treasure Island"; "Up the Trail from Texas"; "Rogers Rangers"; "Buffalo Bill and the Great Wild West Show." Illustrator of children's books and magazines. **Sources:** WW59; WW47.

WOO, Jade Fon *[Painter] b.1911, San Jose, CA / d.1983, Bakersfield, CA.*
Addresses: San Fran., CA. **Studied:** Univ. New Mexico; ASL, Los Angeles. **Member:** Calif. WCS; Soc. Western Artists; AWCS; West Coast WCS; Alameda AA; Concord AA; Diablo AA. **Exhibited:** San Francisco AA, 1937; de Young Mus.; Oakland Mus.; LACMA; American WC Soc. traveling shows. Awards: more than 200. **Comments:** Position: scenic artist, movie studios, 1930s; teacher, Diablo Valley College, 1954-83. **Sources:** Hughes, *Artists in California,* 616.

WOOD, Alma *[Painter] 20th c.*
Addresses: NYC. **Sources:** WW15.

WOOD, Annie A. (Nan) (Mrs. Chas. M.) *[Painter] b.1874, Dayton, OH.*
Addresses: Tucson, AZ. **Studied:** ASL; Lhote, in Paris. **Member:** Palette & Brush Club, Tucson; Tucson AA. **Exhibited:** S. Indp. A., 1930; State Mus., Tucson, 1943-46. **Work:** Dayton AI. **Sources:** WW40.

WOOD, Beatrice (Beato) *[Craftsperson, portrait painter, lecturer] b.1893, San Francisco / d.1998, Ojai, CA.*
Addresses: NYC; Ojai, CA (1948-98).
Studied: Univ. Southern California; Académie Julian, Paris; with Shipley, Finch, Glen Lukens; ceramics in Austria with Gertrud & Otto Natzler. **Exhibited:** MMA; Soc. Indep. Artists, 1917; MoMA; Syracuse Mus. FA; San Diego FA Soc. Many solo shows, including America House, 1949; LACMA; Honolulu Acad. Arts, 1951; Am. Gal., Los Angeles, 1955; Takishamaya Gal., Tokyo, 1962; Pasadena Art Mus., 1959; Warren Hadler Gal., NYC, 1978; Everson Mus. Art, Syracuse, NY, 1978; Clark Gals., Los Angeles, 1891. Also: M. Diamond FA, 1982; Calif. State Univ. Art Gal., 1983; Am. Crafts Mus., NYC, 1997; Lake Worth Mus., FL, 1998. Traveling exhibs.: CPLH, 1964; Phoenix Art Mus., 1973. **Work:** San Diego FA Soc. **Comments:** The "Mama of Dada," she is best known as a ceramicist and potter. Born into an affluent family, she was an early nonconformist and went to Paris at the age of 18. Back in NYC, she befriended the adventurous Marcel Duchamp and his friend Henri-Pierre Roché. The three of them founded the magazine *Blind Man,* which was one of the earliest manifestations of the Dada art movement in NY. Her life inspired at least two movie characters, one in François Truffaut's "Jules & Jim," and the character of Rose in the 1998 movie "Titanic," directed by James Cameron, who was a neighbor in CA. She developed her own version of the luster glaze technique in pottery and worked at the wheel until two years before her death at age 105. In 1994, she was named by the Smithsonian as an "Esteemed American Artist," and declared a "California Living Treasure" by Gov. Pete Wilson. Wood's signature appears also as Beato and Bea. **Sources:** WW53; WW47. More recently, see Petteys, *Dictionary of Women Artists; NY Times,* 14 March, 1998; Trenton, ed. *Independent Spirits,* 75.

WOOD, Catherine *[Painter] 19th c.*
Addresses: Malone, NY. **Exhibited:** PAFA Ann., 1891 (watercolor). **Sources:** Falk, *Exh. Record Series.*

WOOD, Charles *[Lithographer] mid 19th c.*
Addresses: NYC. **Exhibited:** Am. Inst., 1844 ("specimens of lithography"). **Sources:** G&W; Am. Inst. Cat., 1844.

WOOD, Charles *b.c.1833, New York.*
Addresses: Cincinnati in September 1850. **Sources:** G&W; 7 Census (1850), Ohio, XX, 711.

WOOD, Charles *b.c.1836, Massachusetts.*
Addresses: Boston, 1860. **Comments:** Living with his parents, Mr. and Mrs. John H. Wood, in Boston in 1860. **Sources:** G&W;

8 Census (1860), Mass., XXVI, 214.

WOOD, Charles C. *[Painter] early 19th c.*
Comments: Painter of two watercolors depicting the "perilous situation" of the U.S. Frigate *Macedonian* in a North Atlantic hurricane, September 27, 1818. Wood, who made drawings on the spot, may have been a member of the ship's company. **Sources:** G&W; *Portfolio* (June 1952), 235, repros.

WOOD, Charles Erskine Scott *[Painter] b.1852, Erie, PA.*
Addresses: Portland, OR. **Exhibited:** AIC, 1895-1911; PAFA Ann., 1895. **Sources:** WW13; Falk, *Exh. Record Series.*

WOOD, Christopher *[Painter] b.1901 / d.1930.*
Exhibited: AIC, 1932. **Sources:** Falk, *AIC.*

WOOD, Daniel *[Listed as "artist"] b.c.1821, New Hampshire.*
Addresses: New Orleans in October 1850. **Sources:** G&W; 7 Census (1850), La., IV (1), 597.

WOOD, Doris Olson (Mrs.) *[Watercolorist and dress designer] b.1896, Fort Dodge, IA.*
Addresses: Fort Dodge, IA. **Studied:** with her father, Evan Olson. **Exhibited:** Denver, Five States Show; Joslyn Memorial, Omaha; Iowa Artists Exhibit; Blanden Gallery, Fort Dodge (watercolors); Iowa Artists Club, 1934, 1935. **Comments:** Spent the summer of 1935 painting in Norway and Denmark. **Sources:** Ness & Orwig, *Iowa Artists of the First Hundred Years,* 224.

WOOD, E. (Miss) *[Painter] 19th c.*
Addresses: Active in East Windsor, CT. **Comments:** Painted panels of birds and flowers. **Sources:** Petteys, *Dictionary of Women Artists.*

WOOD, E. Shotwell Goeller See: **GOELLER-WOOD, Emily Shotwell**

WOOD, Edith Longstreth (Mrs. William S.) *[Painter, lithographer] b.1885, Phila.,PA / d.1967.*
Addresses: Philadelphia 3, PA. **Studied:** Bryn Mawr College (A.B.); PAFA (Cresson traveling scholarship); England; H. Breckenridge; Scandinavian Art Acad., Paris; H. Hoffman. **Member:** Phila. Art All. (fellow); Phila. Pr. Club; The Phila. Ten; Southern Vermont Artists; Plastic Club; North Shore AA; Phila. WCC. **Exhibited:** NAD; PAFA Ann., 1927-48; Corcoran Gal. biennials, 1930-39 (3 times); PAFA Fellowship, 1956-58; Phila. Plastic Club, 1933 (med.); Southern Vermont Artists, 1956-58; others in New England, New Mexico & Calif.; Moore College Art & Des., Phila., 1998 (retrospective, "The Phila. Ten."). **Work:** PAFA; La France Inst., Phila.; Phila. Art All. **Sources:** WW59; WW47; Talbott and Sidney, *The Phila. Ten;* add'l info. courtesy of Peter Bissell, Cooperstown, NY; Falk, *Exh. Record Series.*

WOOD, Edmund *[Painter] b.1854, New Bedford, MA / d.1935, New Bedford.*
Addresses: New Bedford. **Studied:** Brown Univ., A.B., 1876. **Member:** New Bedford Art Club (pres.). **Exhibited:** New Bedford Art Club, 1907. **Sources:** Blasdale, *Artists of New Bedford,* 210.

WOOD, Ella Miriam *[Portrait & mural painter, teacher] b.1888, Birmingham, AL / d.1976, New Orleans.*
Addresses: New Orleans, active 1911-71. **Studied:** Newcomb College, Tulane Univ.; PAFA; & with Henry McCarter, Charles Hawthorne, Daniel Garber. **Member:** NOAA; New Orleans Arts & Crafts Club. **Exhibited:** NOAA, 1911, 1913-14, 1916-17, 1932, 1939; Mississippi State Fair, 1913 (purchase prize); Delgado Mus. Art, 1935, 1940; New Orleans Arts & Crafts Club; Louisiana State Exh., Baton Rouge, LA. Awards: prize, Newcomb Art Sch., 1907-08 (Fannie Estelle Holley Mem. Medal). **Work:** mural, altarpieces, St. Augustine Church, New Orleans; portrait, Newcomb College, Charity Hospital, New Orleans. **Sources:** WW59; WW47; more recently, see *Encyclopaedia of New Orleans Artists,* 419.

WOOD, Eloise *[Etcher, painter, educator, lecturer, designer] b.1897, Geneva, NY / d.1966, Geneva, NY?.*
Addresses: Geneva. **Studied:** Albright Art Sch.; Farnsworth Sch.

Art; ASL; William Smith College, Geneva, NY; Teachers College, Columbia Univ.; H. Wickey; A. Lewis; C. Locke. **Member:** AAUP. **Exhibited:** Phila. SE, 1931; NAC, 1930; Brooklyn SE, 1931; Chicago SE, 1931; Calif. Printmakers 1931; Phila. Pr. Club, 1931; Kennedy Gal., NY, 1932 (solo). **Work:** MMA; altarpiece, St. John's Chapel, Hobart College; windows, Sampson Air Base, NY; 41 Heraldic Shields, Coxe Hall, Hobart College. **Comments:** Position: assoc. professor & chmn., art dept., Hobart & William Smith College, Geneva, NY. **Sources:** WW59; WW53; WW47.

WOOD, Ethelwyn A. *[Painter] b.1902, Germantown, PA.*
Addresses: Lake Worth, FL. **Studied:** Penn. Sch. Indust. Art; PAFA. **Member:** F., PAFA; West Palm Beach AL. **Work:** PAFA. **Sources:** WW33.

WOOD, Ezra *[Wood-turner and liquor seller] b.1798, Buckland, MA / d.1841, Buckland.*
Addresses: Buckland. **Comments:** Also executed hollow-cut profiles. **Sources:** G&W; Robinson, "Ezra Wood, Profile Cutter," 3 repros.

WOOD, F. *[Still life painter] 19th c.*
Sources: Falk, *Dict. of Signatures.*

WOOD, Frances *[Painter] mid 20th c.*
Addresses: NYC, Woodstock, NY; Santa Fe, NM; France. **Studied:** ASL, 1922-26 with Boardman Robinson, Max Weber, Nicolaides, Thomas Benton. **Member:** Brooklyn Soc. Artists. **Exhibited:** Paris; Brooklyn Mus.; Santa Fe Mus.; New York City (solos); Helene (MT) Mus.; "NYC WPA Art" at Parsons School Design, 1977. **Comments:** WPA artist. **Sources:** *New York City WPA Art*, 95 (w/repros.).

WOOD, Frances Raiff *[Painter] b.1899, Brooklyn, NY.*
Addresses: Paris, France. **Exhibited:** Gal. Neuf, NYC, 1943 (solo). **Sources:** Petteys, *Dictionary of Women Artists.*

WOOD, Franklin Tyler *[Painter, etcher, teacher] b.1887, Hyde Park, MA / d.1945, Rutland, VT.*
Addresses: Rutland, VT. **Studied:** Cowles Art School; ASL; abroad. **Member:** Chicago SE; SAE. **Exhibited:** Pan-Pacific Expo, San Francisco, 1915 (medal). **Work:** AIC; BMFA; LOC; Smithsonian. **Sources:** WW40.

WOOD, George Albert *[Landscape painter] b.1845 / d.1910.*
Exhibited: Barridoff Gal., Portland, ME, 1984. **Comments:** Impressionist painter whose titled works show that he was active in Annisquam (MA), Monhegan (ME), Boothbay (ME), Yarmouth (MA), and North Carolina. **Sources:** exh. cat. Barridoff Gal. (Portland, ME, 1984).

WOOD, George Bacon, Jr.
[Landscape and genre painter, silhouettist] b.1832, Philadelphia, PA / d.1910.
Addresses: Phila., PA, 1861-67, 1879-85; Germantown, PA, 1869, 1875-78; Elizabethtown, NY, 1871-74. **Studied:** PAFA, with C. Schussele. **Member:** Philadelphia Sketch Club.; Artists Fund Soc. Phila. **Exhibited:** PAFA Ann., 1858-69, 1876-87, 1905; NAD, 1861-85; Brooklyn AA, 1866. **Comments:** Exhibition records indicate that he primarily worked and lived in Germantown, PA; however, his address during the early 1870s was Elizabethtown, NY, in the Adirondacks. **Sources:** G&W; Rutledge, PA; Falk, PA, vol. II; London, *Shades of My Forefathers,* 79, 185 (repro.); WW10.

WOOD, Grace Mosher *[Painter] 19th/20th c.*
Addresses: Paris, c.1897-1900. **Exhibited:** Salon Nat. Beaux-Arts, 1898. **Sources:** WW01; Fink, *American Art at the Nineteenth-Century Paris Salons,* 408.

WOOD, Grace S. *[Painter] 20th c.*
Addresses: NYC. **Exhibited:** S. Indp. A., 1931. **Sources:** Marlor, *Soc. Indp. Artists.*

WOOD, Grant *[Painter, teacher, graphic artist] b.1892, Anamosa, IA / d.1942, Iowa City, IA.*

GRANT WOOD

Addresses: Cedar Rapids, Iowa City, IA. **Studied:** Minneapolis School Design, with E. Batchelder, summers 1910-11; Iowa State Univ.; AIC; Académie Julian, Paris, 1923; Univ. Wisconsin, (hon Litt.D., 1935); Lawrence College, (hon Litt.D., 1938). **Member:** Mural Painters; Cedar Rapids AA; NAD. **Exhibited:** Galerie Carmine, Paris, 1926 (solo); Iowa Federation Women's Clubs, 1928 (first prize); Iowa Art Salon, 1929 (first prize), 1930 (first prize for portrait and landscape, sweepstakes), 1931 (sweepstakes in oil), 1932 (sweepstakes); Toledo Mus. Ann. Exhibit, 1929; National Acad. Art, Chicago, 1930 (solo); AIC, 1930 (Norman Wait Harris bronze medal), 1942 (retrospective); PAFA Ann., 1931, 1937; Corcoran Gal biennials, 1937, 1957; WMAA. **Work:** Art Inst. Chicago ("American Gothic"); Cedar Rapids (Iowa) AA; Cincinnati AM; Amon Carter Mus.; Memorial Hall of Cedar Rapids, Memorial Coliseum; Joslyn Art Mus., Omaha, NE; Nebraska AA, Lincoln; Omaha (NE) AI; Dubuque (IA) AA; WMAA; MMA. **Comments:** Important figure in the Regionalist art movement of the 1930s, along with Thomas Hart Benton and John S. Curry. Wood advocated that American artists should turn inward and explore American themes by looking to their own environment for subject matter. Wood's own subject was the rural midwest, particularly Iowa, and in his work he reflected both his respect for rural life and a commentary that at times could be ironic, witty, and critical. His philosophy is exemplied in his most famous work "American Gothic," which was meant as a satirical commentary on Puritan repression, and by his own words: "Your true Regionalist is not a mere eulogist; he may even be a severe critic" ("Revolt Against the City," essay, 1935). In stylistic terms his work can be divided into two phases: works prior to 1928, which are rendered in a somewhat impressionistic, picturesque manner; and those after, which were influenced by his interest in 16th-century Northern German and Flemish art (Wood had traveled to Munich with Marvin Cone in 1928). In these works, clarity prevails, as Grant combines precisely contoured, stylized forms and high color in simple, ordered compositions. Wood, together with several other artists, including Adrian Dornbush, founded the Stone City art colony and school in 1932. It was located three miles from Anamosa on the Wapsipinicon River. The colony and school flouished for two years but the expense was too great and it was abandoned in 1934. Illustrator: "Main Street," by Sinclair Lewis. Positions: teacher, Stone City Art School (founder) 1932; Univ. Iowa, from ca. 1933; WPA Dir. for Iowa, 1933-34. **Sources:** WW40; Baigell, *American Scene Painting;* Wanda Corn, *Grant Wood, the Regionalist Vision* (New Haven: Yale Univ. Press, 1983); Joseph S. Czestochowski, *John Steuart Curry and Grant Wood: A Portrait of Rural America* (Columbia, MO: University of Missouri Press, 1981); Cécile Whiting, "American Heroes and Invading Barbarians: The Regionalist Response to Fascism," *Prospects,* vol.13, 1988: 295-325; Ness & Orwig, *Iowa Artists of the First Hundred Years,* 225-26.

WOOD, Gretchen Kratzer (Mrs. L. R.) *[Painter, decorator] 20th c.; b.Clearfield, PA.*
Addresses: San Juan. **Studied:** PM School IA; ASL; A. Sotomayor, in Madrid; E. Pape; C. Beaux. **Member:** Studio Guild; AAPL (chmn., Puerto Rico). **Exhibited:** Indep. Artists Exhib., NY, 1938; Studio Guild; Salons of Am. **Work:** Washington College, Chestertown, MD; Polytech Inst., San German, PR; murals, Hotel Candado, San Juan, PR. **Sources:** WW40.

WOOD, Hanna *[Primitive watercolorist (portraits)] late 19th c.*
Addresses: Active in New Hampshire, c.1870. **Sources:** Petteys, *Dictionary of Women Artists.*

WOOD, Harrie (Morgan) *[Painter, illustrator] b.1902, Rushford, NY.*
Addresses: NYC/Bethel, CT. **Studied:** PIA School; ASL. **Member:** NWCC; AWCS; Mystic AA. **Exhibited:** PAFA Ann.,

1930; AIC, 1931. **Work:** Lyman Allyn Mus., New London, CT. **Comments:** Illustrator: "The Boy Who Was," '"Made in America," "Something Perfectly Silly," "Lucian Goes A-Voyaging," "Made in England," 1932. **Sources:** WW40; Falk, *Exh. Record Series.*

WOOD, Harry *[Cartoonist, illustrator] b.1871 / d.1943.* **Addresses:** Kansas City, MO. **Comments:** Creator: comic strip "The Intellectual Pup," which ran in the *Kansas City Star* from 1907.

WOOD, Harry Emsley, Jr. *[Educator, painter, critic, writer, sculptor] b.1910, Indianapolis, IN.* **Addresses:** Tempe, AZ. **Studied:** Univ. Wisconsin, B.A., M.A.; Ohio State Univ., M.A., Ph.D.; Acad. Belli Arti, Florence, Italy, with Ottono Rosai; also with John Frazier, Provincetown, MA & Emil Bisttam, Taos, NM. **Member:** College Art Assoc. Am.; Nat. Art. Educ. Assn. (nat. council, 1958-62); Pacific AA (pres., 1958-60); Am. Soc. Aesthetics; Arizona Art Educ. Assn. (pres., 1954-55). **Exhibited:** Columbus, OH, 1941 (solo); Peoria, IL, 1944; Decatur, IL, 1945; Galesburg, IL, 1946; Beloit, WI, 1947; Illinois State Mus., 1949; Indiana Art Retrospective, John Herron, AI, 1953; Arizona Artists, Tucson, 1956, 1957; Florence, Italy, 1950; Phoenix Art Mus., 1961; Phoenix & Tucson Ann., 1961; Arizona State Univ., Tempe; Northern Arizona Univ., Flagstaff. Awards: purchase prize, Artist Guild, 1959. **Work:** Mem. Union, Arizona State Univ., Tempe; Phoenix (AZ) Art Mus. Commissions: murals, Great Cent. Ins. Co., Peoria, IL; plus many portraits of prominent people. **Comments:** Positions: vice-pres., Mind Commun. Group, 1971-. Publications: author, *Lew Davis, 25 years of Painting in Arizona,* 1961, *Soul, An Interpretation of That Which Might Have Been,* Birmingham, 1963, *A Sculpture by John Waddell & The Faces of Abraham Lincoln,* 1970. Teaching: art professor, Illinois Wesleyan Univ., 1942-44; dean, college fine arts, Bradley Univ., 1944-50; art professor, Arizona State Univ., 1954-, chmn. dept. art, 1954-66. **Sources:** WW73.

WOOD, Helen (Mrs. Duncan Bell) *[Painter, teacher] late 19th c.* **Addresses:** Colorado Springs, CO, late 1800s. **Comments:** Specialized in painting Colorado flowers on china and taught flower painting in Zanesville, OH. **Sources:** Petteys, *Dictionary of Women Artists.*

WOOD, Helen Snyder *[Painter] b.1905, Berkeley, CA / d.Berkeley.* **Addresses:** Berkeley. **Studied:** Calif. College Arts & Crafts. **Member:** Soc. Western Artists; San Francisco Women Artists Soc.; Marin Soc. Artists; Oakland AA (charter member); Alameda AA. **Exhibited:** locally. **Sources:** Hughes, *Artists of California,* 616.

WOOD, Henry Billings *[Portrait painter] mid 19th c.* **Addresses:** Boston in 1853. **Sources:** G&W; Boston BD 1853.

WOOD, J. *[Engraver] early 19th c.* **Comments:** Engraved aquatint views of Philadelphia and the penitentiary at Richmond (VA) and a conchological plate for Rees' *Encyclopedia,* first decade of the 19th century. Cf. James Wood, and Joseph Wood. **Sources:** G&W; Groce and Willet, "Joseph Wood," 154, 157.

WOOD, J. *[Miniaturist & profilist; teacher of drawing, painting & mathematics] early 19th c.* **Comments:** Advertised in Richmond (VA) as a miniaturist and profilist in October 1803 and as a teacher of drawing, painting, & mathematics in December 1804. Cf. John Wood. **Sources:** G&W; *Richmond Portraits,* 243.

WOOD, J. G. (Mrs.) *[Listed as "artist"] mid 19th c.* **Addresses:** Cincinnati, 1841-42. **Sources:** G&W.

WOOD, J. Ogden See: **WOOD, Ogden**

WOOD, James *[Engraver] b.c.1803, Providence, RI / d.1867, Providence.* **Addresses:** Providence, active 1847-67. **Comments:** Worked chiefly as engraver for calico printers. In 1856 he was working with Robert Ralston (see entry) at Wood and Ralston, and from 1859 with his son, James R. Wood (see entry). **Sources:** G&W; Providence CD 1847-67; *Providence, Births, Marriages and Deaths;* Vol. III: Deaths, 1851-70.

WOOD, James *[Engraver] mid 19th c.* **Addresses:** Charleston, SC. **Comments:** He became a Director of the South Carolina Academy of Fine Arts in 1821. It was probably James rather than Joseph Wood (see entry), who engraved a view of the South Carolina Medical College in 1826. In 1828 he made a plaster cast of the medal presented to Lafayette by the National Guards of Paris. **Sources:** G&W; Rutledge, *Artists in the Life of Charleston;* Groce and Willet, "Joseph Wood," 157-58.

WOOD, James Arthur (Art) *[Cartoonist, lecturer] b.1927, Miami, FL.* **Addresses:** Rockville, MD. **Studied:** Washington & Lee Univ., B.A.; Michigan State Univ. **Member:** Assn. Am. Ed. Cartoonist (board member, 1959-63); Nat. Cartoonists Soc.; Nat.Press Club. **Exhibited:** Brussels World's Fair, 1958; Pittsburgh Press, 1959 (solo); The Great Challenge, Int. Cartoon Exhib., 1959-60; Cartoon Show, Nat. Portrait Gallery, 1972. Awards: Freedoms Foundation awards, 1953, 1954 & 1958-60; Christopher Award, 1954; Golden Quill Awards, 1960 & 1962. **Work:** LOC; Alderman Library Permanent Collection, Univ. Virginia, Charlottesville; Univ. Akron (OH) Collection; William Allen White Collection, Univ. Kansas; Truman Library Collection. **Comments:** Positions: editorial cartoonist, *Richmond Newsleader,* 1950-56; chief political cartoonist, Pittsburgh Press Club, 1956-63; cartoonist & info director, U.S. Indep. Tel. Assn., 1963-. **Sources:** WW73.

WOOD, James F. (Mrs.) *[Painter] 19th c.* **Addresses:** Camden, NJ, 1881; Phila., PA, 1888-90. **Exhibited:** PAFA Ann., 1881, 1888, 1890. **Sources:** Falk, *Exh. Record Series.*

WOOD, James L. *[Painter, teacher, lecturer] b.1863, Phila. / d.1938.* **Addresses:** Phila., PA. **Studied:** T. Eakins, in Phila.; Gérôme, in Paris. **Exhibited:** PAFA Ann., 1893, 1896-99; AIC, 1901. **Comments:** Position: teacher, Drexel Inst., Phila. **Sources:** WW04; Falk, *Exh. Record Series.*

WOOD, James Nowell *[Art historian, art administrator] b.1941, Boston, MA.* **Addresses:** Buffalo, NY. **Studied:** Williams College, B.A.; Inst. Fine Arts, New York Univ., M.A. **Comments:** Positions: asst. to director, MMA, 1967-68, asst. curator, dept. 20th century art, 1968-70; curator, Albright-Knox Art Gallery, Buffalo, NY, 1970-. Publications: author, *Rockne Krebs,* 1971 & *Six Painters,* 1971. Research: nineteenth and twentieth century American and European painting, sculpture and decorative arts. **Sources:** WW73.

WOOD, James R. *[Engraver] b.c.1833, Providence, RI / d.c.1887, Providence.* **Addresses:** Providence, 1859-87. **Comments:** He was the son of James Wood (see entry) and, like his father, was principally employed as a calico engraver. **Sources:** G&W; Providence CD 1859-87; *Providence, Births, Marriages and Deaths:* (Death listed between 1881 and 1890).

WOOD, Jessie Porter *[Painter, illustrator, craftsperson, teacher] b.1863, Syracuse, NY / d.1941, Wash., DC.* **Addresses:** Virginia and Rhode Island until 1898; Wash., DC, late 1898-1941. **Studied:** George Washington Univ.; J.C. Beckwith; G. deF. Brush; W. Shirlaw; J.W. Stimson. **Member:** Wash. WCC, 1898-c.1922. **Exhibited:** Wash. WCC. **Comments:** Positions: teacher, Charlottesville, VA, Providence, RI; staff, LOC, 1898-1932. **Sources:** WW25; McMahan, *Artists of Washington, DC.*

WOOD, Jessie Sartell *[Painter] 19th c.* **Addresses:** Malone, NY. **Exhibited:** PAFA Ann., 1885. **Sources:** Falk, *Exh. Record Series.*

WOOD, John *[Limner and teacher]* *early 19th c.*
Addresses: NYC, 1801. **Comments:** He made a wash drawing of NYC from Long Island, which was engraved by William Rollinson and published in 1801. *Cf.* the J. Wood who was at Richmond (VA) in 1803-04. **Sources:** G&W; McKay, "Register of Artists."; Stokes, *Iconography*, pl. 74.

WOOD, John Stedman *[Painter, engraver]* *b.1894, Tacoma, WA / d.1983, Tacoma.*
Addresses: Tacoma. **Studied:** Calif. School FA; mostly self-taught. **Member:** Tacoma FAA; Puget Sound Group Northwest Painters. **Exhibited:** Brush & Palette Club, Tacoma, 1921; Tacoma FAA, 1922, 1923. **Comments:** Position: co-owner, Tacoma Engraving Co.; advertising consultant, American Plywood Assoc., Tacoma. **Sources:** WW25; Trip and Cook, *Washington State Art and Artists, 1850-1950.*

WOOD, John T. *[Painter]* *d.1919.*
Addresses: Portland, ME. **Member:** Brushians (later group). **Comments:** Position: worked at N. & T.J. Wood, makers of patent medicines. In the Brushians group he was given the nickname, "The Silent Man." **Sources:** Casazza, *The Brushians*, 15-16.

WOOD, John Z. *[Painter]* *20th c.*
Addresses: Rochester, NY. **Exhibited:** Boston AC, 1888. **Sources:** WW08.

WOOD, Joseph *[Miniature and portrait painter]* *b.c.1778, on a farm near Clarkstown, NY / d.1830, Washington, DC.*
Addresses: NYC, c. 1793-1813; Phila., 1813-16; Washington, DC, 1816-30. **Studied:** apprenticed to a silversmith, NYC, c. 1793. **Exhibited:** NAD. **Work:** Virginia Hist. Soc., Richmond; PAFA; Walters Art Gallery, Baltimore, MD. **Comments:** Moved to NYC at the age of 15 and apprenticed with a silversmith while painting miniatures on the side. Opened a studio in 1801 and one year later formed a partnership with John Wesley Jarvis (see entry). They worked together until about 1810, when Jarvis went South. Wood continued to work in NYC for three more years before moving to Phila. and then to Washington, DC, where he spent the rest of his career, except for occasional professional visits to Baltimore and Phila. In Washington, he gained the patronage of prominent leaders, including Pres. James Madison and his wife, Dolly. In his last years, Wood made drawings for patent applications. **Sources:** G&W; Groce and Willet, "Joseph Wood: A Brief Account of His Life and the First Catalogue of His Work"; Rutledge, PA; Cowdrey, AA & AAU; Pleasants, *250 Years of Painting in Maryland*, 41. More recently, see Gerdts, *Art Across America*, vol. 1: 343; McMahan, *Artists of Washington, DC.*

WOOD, Josephine *[Painter]* *late 19th c.*
Addresses: NYC, 1891-92. **Exhibited:** NAD, 1891-92; Woman's Art Club; Klackner Gal., NYC, 1894. **Sources:** Petteys, *Dictionary of Women Artists.*

WOOD, Julia Smith (Mrs. Richmond) *[Painter]* *b.1890, New Bedford, MA / d.1958, New Bedford.*
Addresses: New Bedford. **Studied:** Swain Free School Design with Harry Neyland and others. **Member:** Boston AC; Providence AC. **Exhibited:** New Bedford Art Club, 1916; Swain free School Design, 1929; Providence Art Club. **Comments:** Specialty: landscapes and seascapes in oil; pen and ink drawings. A friend of Ora Maxim (see entry). Position: teacher, Betsy B. Winslow School. **Sources:** WW40; Blasdale, *Artists of New Bedford*, 210-11 (w/repro.).

WOOD, Justin *[Painter]* *20th c.*
Addresses: Cleveland, OH. **Member:** Cleveland SA. **Sources:** WW27.

WOOD, K. E. (Mrs.) *[Craftsperson]*
Addresses: New Orleans, active 1888. **Member:** Tulane Decorative Art Lg. Women, 1888. **Exhibited:** Tulane Decorative Art Lg. Women, 1888. **Sources:** *Encyclopaedia of New Orleans Artists*, 419.

WOOD, Katharine Marie *[Miniature painter, painter]* *b.1910.*
Addresses: Staten Island, NY. **Studied:** Sch. Applied Des. for Women, NY; ASL; E. D. Pattee; A. Schweider. **Exhibited:** ASMP, 1938; Penn. SMP, PAFA, 1938. **Sources:** WW40.

WOOD, Kath(e)ryn Leone *[Miniature and portrait painter, writer]* *b.1885, Kalamazoo, MI / d.c.1936, Los Angeles.*
Addresses: Kalamazoo; Los Angeles from 1915. **Studied:** AIC, with F. Freer, Lawton Parker. **Member:** AFA. **Exhibited:** Pan-Pacific Expo, San Francisco, 1915; P&S Los Angeles, 1920; Detroit Inst. Art, 1930. **Work:** miniature of Mrs. J.C. Burrows, Continental Mem. Hall, Wash., DC; U.S. District Court, Cincinnati, OH. **Sources:** WW35; Hughes, *Artists in California*, 616.

WOOD, Kenneth A. *[Painter]* *mid 20th c.*
Exhibited: Corcoran Gal biennial, 1951. **Sources:** Falk, *Corcoran Gal.*

WOOD, Leona *[Painter, printmaker, craftsperson]* *b.1921, Seattle, WA.*
Addresses: Seattle. **Studied:** San Francisco School Des.; with R. Schaeffer. **Exhibited:** Western Wash. Fair, 1937; SAM, 1938-949. **Sources:** Trip and Cook, *Washington State Art and Artists, 1850-1950.*

WOOD, Lilla Sorrenson See: **WOODS, Lilla Sorrenson (Mrs. E. B. Woods)**

WOOD, Lillian Lee *[Portrait painter]* *b.1906, Richmond, VA.*
Addresses: Richmond 20, VA. **Studied:** Sweet Briar College, B.A.; ASL, with Kenneth Hayes Miller, Kimon Nicolaides; D. Romanovsky. **Member:** VMFA; Acad. Science & FA, Richmond. **Exhibited:** VMFA; Richmond Acad. Art. **Awards:** Virginia Mechanics Inst., 1932 (prize); Richmond Acad. Art, 1932 (prize). **Work:** Richmond (VA) Armory. **Sources:** WW59; WW47.

WOOD, M. Louise See: **WRIGHT, (M.) Louise Wood (Mrs. John)**

WOOD, Margaret See: **WHITE, Margaret Wood (Mrs. Victor Gerald)**

WOOD, Mary *[Artist]* *early 20th c.*
Addresses: Active in Washington, DC, 1900. **Sources:** Petteys, *Dictionary of Women Artists.*

WOOD, Mary A. See: **WHITTAKER, M(ary) Wood (Mrs. John Bernard)**

WOOD, Mary Braman *[Still life painter]* *b.1893.*
Addresses: Swansea, MA. **Studied:** with Abbie Luella Zuill. **Sources:** Petteys, *Dictionary of Women Artists.*

WOOD, Mary Earl *[Painter]* *20th c.; b.Lowell, MA.*
Addresses: Boston, MA, 1907-31. **Studied:** BMFA Sch., with Tarbell, Benson, De Camp. **Member:** Copley Soc. **Sources:** WW33.

WOOD, Memphis (Miss) *[Painter, teacher]* *b.1902, Dacula, GA.*
Addresses: Mandarin 7, FL; Jacksonville 7, FL. **Studied:** Univ. Georgia, M.F.A.; Univ. Florida. **Member:** Southeastern AA; Flordia Art Group; Florida Craftsmen; Jacksonville AA. **Exhibited:** High Mus. Art, 1951-53; Florida Art Group, 1956, 1958; Jacksonville Mus. Art, bi-annually; Ringling Mus. Art, 1955; solo: Gainesville (FL) AA, 1955; Jacksonville Mus. Art, 1950; Stetson Univ., 1956. **Work:** Univ. Georgia; Murray State Teachers College; Stetson Univ. **Sources:** WW59.

WOOD, Mireille Piazzoni *[Painter]* *b.1911, San Francisco.*
Addresses: San Francisco. **Studied:** with her father; Calif. School FA with Macky, Albright, Randolph and Stackpole. **Member:** San Francisco AA; San Francisco Soc. Women Artists. **Exhibited:** SFMA; CPLH; de Young Mus.; San Francisco AA, 1927-37; San Francisco Women Artists; GGE, 1939. **Comments:** Daughter of Gottardo Piazzoni (see entry), she married Philip R. Wood (see entry) in 1937. **Sources:** Hughes, *Artists in California*, 616.

WOOD, Molly Wheeler *[Painter] 20th c.*
Exhibited: AIC, 1935. **Sources:** Falk, *AIC*.

WOOD, Nan (Mrs. Charles M.) *[Painter] b.1874, Dayton, OH.*
Addresses: Tucson , AZ. **Studied:** ASL; & with Andre L'Hote, in Paris, France. **Member:** Tucson AA; Palette & Brush Club, Tucson. **Exhibited:** State Mus. Tucson, 1943-1946; Boston AC. **Work:** Dayton AI. **Sources:** WW53; WW47.

WOOD, Nelson D. *[Artist] 20th c.*
Addresses: Wayne, PA. **Exhibited:** PAFA Ann., 1940. **Sources:** Falk, *Exh. Record Series.*

WOOD, Norma Lynn *[Painter] 20th c.*
Addresses: Houston, TX. **Exhibited:** MFA, Houston, 1938, 1939. **Sources:** WW40.

WOOD, Norman (Mrs.) *[Painter] 20th c.*
Addresses: Knoxville, TN. **Sources:** WW13.

WOOD, Ogden *[Landscape painter] b.1851, NYC / d.1912.*
Addresses: NYC, 1876-80; Paris (c.1881-on). **Studied:** E. Van Marcke. **Member:** Artists Fund Soc. **Exhibited:** Brooklyn AA, 1875-81; NAD, 1876-83; Paris Salon, 1882-90, 1898-99; PAFA Ann., 1889; St. Louis Expo, 1904 (medal). **Comments:** (also known as J. Odgen Wood) Wood lived in NYC until about 1881 when he left for Paris, and apparently remained there as an expatriate landscape painter. **Sources:** WW10; Fink, *American Art at the Nineteenth-Century Paris Salons*, 408; Falk, *Exh. Record Series.*

WOOD, Orison *[Decorative wall painter] b.1811 / d.1842.*
Addresses: West Auburn, Lewiston, and Webster Corner, ME about 1830. **Studied:** said to have learned the technique of painting on plaster from his father, Solomon Wood (see entry), who worked as a plaster figure maker in Boston. **Sources:** G&W; Little, *American Decorative Wall Painting*, 126 (repro.), 127, 132.

WOOD, Philip Reeve *[Painter] b.1913, Oakland, CA.*
Addresses: San Francisco. **Studied:** Calif. School FA, with Macky, Boynton, Blanch, Poole & Stackpole. **Exhibited:** GGE, 1939; San Francisco AA, 1940. **Comments:** Speciality: landscapes of Northern Calif. Married to M. Piazzoni Wood (see entry), he was greatly influenced by his father-in-law Gottardo Piazzoni (see entry). **Sources:** Hughes, *Artists of California*, 616.

WOOD, Remsen V. *[Painter] 20th c.*
Addresses: Rochester, NY. **Exhibited:** Salons of Am., 1928-29; S. Indp. A., 1927. **Sources:** Falk, *Exhibition Record Series.*

WOOD, Robert *[Landscape painter] b.1889, Kent, England / d.1979.*
Addresses: Carmel, CA; Laguna Beach, CA; High Sierras of Calif. **Studied:** England. **Comments:** Popular landscape painter whose work was always in great demand; his paintings were often reproduced lithographically and mass distributed through retailers such as Sears, Roebuck, and Co., in the form of prints, wall murals, and place mats. He came to U.S. in 1911 and traveled throughout the country before settling in California. His most popular landscapes are of the Texas hills and fields of bluebonnets, the California coast, and the Rockies. He also painted in Mexico and Canada. **Sources:** *300 Years of American Art*, vol. 2: 836.

WOOD, Robert E. *[Painter, teacher] b.1926, Gardena, CA.*
Addresses: Living in Green Lake Valley, CA in 1976. **Studied:** Pomona College; Claremont Graduate School. **Member:** ANA, 1971; NA, 1974; Nat. Cowboy Acad. Western Art. **Exhibited:** more than 60 solos. **Comments:** Specialty: watercolor. Teaching: Univ. Minnesota, Otis Art Inst.; Scripps College; annual summer school, San Bernardino Mountains, CA. **Sources:** P&H Samuels, 536.

WOOD, Robert W. *[Painter] early 20th c.*
Addresses: Baltimore, MD. **Sources:** WW17.

WOOD, Samuel M. *[Wood engraver] b.c.1831, Pennsylvania.*
Addresses: NYC in August 1850. **Sources:** G&W; 7 Census (1850), N.Y., XLIV, 222.

WOOD, Shotwell E. See: **GOELLER-WOOD, Emily Shotwell**

WOOD, Silas *[Landscape painter, monochromatic artist, teacher] mid 19th c.*
Addresses: Cleveland, OH, 1841; Charleston, SC, 1848; Cincinnati, 1850; Cleveland, 1851; NYC, 1854-60. **Exhibited:** NAD, 1854-58; American Institute, NYC, 1856-60. **Comments:** Itinerant artist who worked in Cleveland in 1841 as a painting teacher; then at Charleston in 1848 as a landscape painter; at Cincinnati in 1850 as a monochromatic artist (this is a technique in which charcoal on paper is covered with a marble dust); and again at Cleveland in June 1851 as a landscape painting teacher. Wood settled in NYC by 1854, after which he exhibited landscapes and monochromatic paintings at the National Academy and the Amer. Institute. Susan D. Wood (see entry) who lived at the same NYC address, was probably his wife or daughter. **Sources:** G&W; WPA (Ohio), *Annals of Cleveland*; Rutledge, *Artists in the Life of Charleston*; Cincinnati CD 1850; Cowdrey, NAD; Am. Inst. Cat., 1856; NYCD 1859-60. More recently, see article on sandpainting and the monochromatic technique in *Antiques* September 1996.

WOOD, Solomon *[Plaster figuremaker] early 19th c.*
Studied: learned plaster technique in Boston, early 19th. century. **Comments:** His son, Orison Wood (see entry), who was a wall painter at Auburn (ME) about 1830 is said to have learned the technique of painting plaster from his father. **Sources:** G&W; Little, *American Decorative Wall Painting*, 127.

WOOD, Stacy H. *[Painter] 20th c.*
Addresses: NYC. **Sources:** WW17.

WOOD, Stan *[Painter] 20th c.*
Addresses: Cleveland, OH. **Member:** Cleveland SA. **Exhibited:** AIC, 1926-27. **Sources:** WW27.

WOOD, Stanley *[Painter, lithographer] b.1894, Bordentown, NJ.*
Addresses: Carmel, CA in 1940. **Member:** Carmel AA; Calif. WC Soc. **Exhibited:** Berkeley Lg. FA, 1924; NYC galleries, 1925; San Francisco AA, 1923, 1924 (gold)-1925, 1930 (Anne Bremer prize); Santa Cruz, 1928 (prize); WMAA, 1932; de Young Mus., 1935. **Work:** BM; Mills College Art Gal., Oakland, CA. **Sources:** WW40; Hughes, *Artists of California*, 617.

WOOD, Stanley L. *[Western painter, illustrator] b.1866 / d. 1928*
Comments: English artist active in the American West, 1888. Illus: *A Waif in the Plains* by Brette Harte (1890); illustrator for *The Graphic*. **Sources:** P&H Samuels; *Dict. British Artists, 1880-1940.*

WOOD, Susan D. *[Monochromatic painter] mid 19th c.*
Addresses: NYC, 1856. **Exhibited:** Am. Inst., 1856 (monochromatic painting). **Comments:** Her address was the same as that of Silas Wood (see entry) in 1856. **Sources:** G&W; Am. Inst. Cat., 1856.

WOOD, Thomas *[Lithographer, stationer, and publisher] mid 19th c.*
Addresses: Active in NYC from 1843-60. **Sources:** G&W; Peters, *America on Stone*; NYCD 1843-59; Am. Inst. Cat., 1844; *Antiques* (July 1945), 33 (repro.).

WOOD, Thomas Hosmer *[Amateur painter] b.1798, Massachusetts / d.1874, Paris.*
Addresses: Utica, NY about 1837. **Comments:** He became a prosperous merchant in Utica and took an active part in forming the Utica AA and promoting its exhibitions, while some of his own paintings are said to have "adorned the homes of many citizens in the vicinity." He died while on a tour of the art centers of the continent. **Sources:** G&W; Bagg, *Memorial History of Utica*, 233-34.

WOOD, Thomas Waterman *[Genre and portrait painter, etcher, illustrator] b.1823, Montpelier, VT / d.1903, NYC.*

T. W. WOOD. 1880.

Addresses: Nashville, TN, and Louisville, KY, 1860-67; NYC, 1867-1903. **Studied:** Boston, with Chester Harding, 1846-47; Düsseldorf, with Hans Gude, 1858-60; London. **Member:** ANA, 1869; NA, 1871 (pres., 1890-1900); AWCS (pres., 1878-87); New York Etching Club (founder); NAC; Artists Aid Soc. (founder/pres., 1869-03); Century Club. **Exhibited:** NAD, 1858-59, 1861-99; NY Etching Club; Brooklyn AA, 1868-84; Boston AC, 1875, 1884, 1891; PAFA Ann., 1889; Parrish AM, 1984 (Painter-Etchers exhib.); AIC. **Work:** Wood Art Gallery, Montpelier, VT (more than 200 oils and watercolors); MMA; Tennessee State Mus.; Univ. Kentucky Art Mus., Lexington; Shelburne (VT) Mus.; J.B. Speed Mus., Louisville; NY State Hist Soc. **Comments:** After his study with Harding, Wood worked as a portrait painter in Quebec; Wash., DC; NYC (1854-57); and Baltimore (1856-58). In 1858, he went to Europe for further study, and from 1860-67 he worked in Nashville, TN, and Louisville, KY, and painted several works related to the Civil War. In 1867, he settled permanently in NYC and became a popular genre painter of rural life, specializing in anecdotal scenes of African-Americans, and was prominent in several of the city's art organizations. **Sources:** G&W; CAB; *Art Annual,* IV, obit.; Pleasants, *250 Years of Painting in Maryland,* 58; MacAgy, "Three Paintings."; NYBD 1854-57; Lafferty; New England BD 1860; Cowdrey, NAD; *Art Digest* (April 1, 1935), 32 (repro.). Bibliography: WW01; Kelly, "Landscape and Genre Painting in Tennessee, 1810-1985," 42-43 (w/repro.); Jones and Weber, *The Kentucky Painter from the Frontier Era to the Great War,* 72-73 (w/repros.); Muller, *Paintings and Drawings at the Shelburne Museum,* 141; *American Painter-Etcher Movement* 53; Baigell, *Dictionary;* Falk, *Exh. Record Series.*

WOOD, Trist (Julien Bringier) *[Cartoonist, teacher, sketch artist] b.1868 / d.1952, New Orleans, LA.*
Addresses: New Orleans, active 1880-1935. **Studied:** Tulane Univ. **Comments:** From a prominent New Orleans family, he began sketching, making drawings in Mexico in 1882. He studied and taught art at Tulane and lived in Europe for 15 years, as a student, critic and author. After returning to N.O. he was mainly a cartoonist for various publications. **Sources:** *Encyclopaedia of New Orleans Artists,* 419-20.

WOOD, Virginia *[Painter] 20th c.*
Exhibited: S. Indp. A., 1935. **Comments:** *Cf.* Virginia Hargraves Wood and Virginia Hargraves Goddard. **Sources:** Marlor, *Soc. Indp. Artists.*

WOOD, Virginia Hargraves See: **GODDARD, Virginia Hargraves Wood (Mrs. Charles Franc)**

WOOD, Virginia Hargraves *[Painter] 20th c.; b.Wash., DC.*
Addresses: NYC/Leeton Forest, Warrenton, VA. **Studied:** CUA School; Yale. **Member:** Nat. Soc. Mural Painters. **Exhibited:** Nat. Assn. Women PS, 1935-38; Liturgical Art Soc., NY, 1937 (prize). **Work:** WPA murals, Fed. Court Room, Scranton, PA; Liturgical Art Soc., NY; USPO, Farrell, PA. **Comments:** *Cf.* Virginia Hargraves Wood Goddard. In the 1940 Art Annual, there were entries for Virginia Hargraves Wood Goddard, b. 1873, near St. Louis, MO, living in Mattituck, NY, 1940; and one for a Virginia Hargraves Wood, born in Wash., DC (no year given) and living in NYC and Leeton Forest, Warrenton, VA, 1940. Based on the education and memberships listed it would seem that they are two individual artists, although this is not certain. Petteys combined all the information into one listing for Virginia Hargraves Wood Goddard. **Sources:** WW40; Petteys, *Dictionary of Women Artists.*

WOOD, Virginia M. (R.) *[Painter] 20th c.*
Addresses: Clarksburg, WV. **Exhibited:** S. Indp. A., 1932. **Sources:** Marlor, *Soc. Indp. Artists.*

WOOD, W. Homer *[Miniature painter] 20th c.*
Addresses: Yeadon, Delaware County, PA. **Exhibited:** PAFA

Ann., 1903. **Sources:** WW04; Falk, *Exh. Record Series.*

WOOD, W. T. *[Painter] 19th/20th c.*
Addresses: Wash., DC, active 1935. **Exhibited:** Greater Wash. Independent Expo., 1935. **Sources:** McMahan, *Artists of Washington, DC.*

WOOD, Waddy B. *[Painter, architect] b.St. Louis, MO / d.1944, Warrentown, VA.*
Addresses: Wash., DC, 1892-1940; Warrentown, VA, 1940-44. **Studied:** Virginia Polytechnic Inst. **Member:** Wash. Soc. Fine Arts. **Exhibited:** Wash. WCC, 1917, 1926, 1927 (scenes of Paris and Bermuda). **Comments:** Born in 1864 or 1869. Mainly an architect, he designed many buildings in the Wash., DC area, including Alice P. Barney's Studio House. **Sources:** WW21; McMahan, *Artists of Washington, DC.*

WOOD, Wallace *[Patron] b.1850, Jamestown, NY / d.1916, NYC.*
Studied: abroad. **Comments:** While in Europe he made a collection of pictures, costumes, and other objects illustrating the history of civilization, which is now at NYU. He was for many years holder of the Samuel E B. Morse Chair of Art at NYU.

WOOD, William D. *[Painter] d.1915, Albany, NY.*
Comments: Position: head decorator, NY Central's car shops, West Albany, NY. Wood died in an automobile accident.

WOOD, William F. *[Listed as "artist"] b.c.1805, England.*
Addresses: Phila., in 1850. **Comments:** His wife and two oldest children (ages 18 and 16 in 1850) were also born in England, but the four younger children were born in Pennsylvania between 1840 and 1847, except for one born in New York state about 1844. **Sources:** G&W; 7 Census (1850), Pa. LII, 237.

WOOD, W(illiam) R(euben) C(lark) *[Landscape painter] b.1875, Wash., DC / d.1915.*
Addresses: Baltimore, MD/Prudence Island, RI. **Studied:** S.E. Whiteman, in Baltimore. **Member:** Charcoal Club, Baltimore; Baltimore WCC (pres.); Baltimore Mun. AC. **Exhibited:** Boston AC, 1905-07. **Sources:** WW17.

WOOD, William S. *[Painter] 20th c.*
Addresses: Phila., PA. **Studied:** PAFA. **Sources:** WW21.

WOOD, Worden *[Marine illustrator] early 20th c.*
Addresses: active 1912-37. **Work:** Mystic Seaport Mus.; Peabody Mus., Salem. **Comments:** Illustrator: *Yachting,* 1927. **Sources:** Brewington, 420.

WOOD-THOMAS, Alan *[Painter] 19th/20th c.*
Studied: in France. **Exhibited:** WMAA, 1950; Carlebach Gallery, 1948 (solo); John Heller Gallery, 1955. **Sources:** info courtesy of Charles Semowich, Rensselaer, NY.

WOOD & RALSTON *[Calico engravers] mid 19th c.*
Addresses: Providence, RI, active 1856. **Comments:** The partners were James Wood and Robert Ralston (see entries). **Sources:** G&W; Providence CD 1856.

WOODAMS, Helen Chase *[Sculptor, painter] b.1899, Rochester, NY.*
Addresses: Rochester, NY. **Studied:** ASL; AIC; Académie Julian, Paris. **Exhibited:** WFNY, 1939; MoMA; Finger Lakes Exh., Rochester, NY; Albright Art Gal., 1939 (prize). **Sources:** WW40.

WOODARD, A. *[Painter] 20th c.*
Addresses: Toledo, OH. **Member:** Artklan. **Sources:** WW25.

WOODARD, Beulah Ecton *[Sculptor, painter] b.1895, Frankfort, OH / d.1955, Los Angeles, CA.*
Addresses: Los Angeles (Vernon), CA. **Studied:** Otis Art Inst.; Los Angeles Art School; USC. **Member:** Los Angeles Negro AA (co-founder 1937). **Exhibited:** LACMA, 1935 (solo); Stendahl Galleries, Los Angeles Negro AA, 1937 (first prize); Municipal Mus., Munich, Germany, 1964. **Comments:** Specialty: African subjects. Preferred media: clay, plaster, wood, copper, metal, oils, paper-maché. **Sources:** Hughes, *Artists of California,* 617; Cederholm, *Afro-American Artists;* Hughes cites a death date of

1955 in Los Angeles, while Cederholm states 1964.

WOODARD, Lee L. *[Designer] b.1884, Owosso.*
Addresses: Owosso, MI. **Studied:** AIC; Kirkpatrick Sch. Furniture Des., Grand Rapids, MI. **Comments:** Designer: furniture, for Marshall Field & Co. & Carson, Pirie, Scott in Chicago; W. & J. Sloane, Wanamaker's, Lord & Taylor, Macy's, NYC; Lammert's, St. Louis. Position: designer, Woodard Furniture Co., L. J. Woodard Sons' Wrought Iron Furniture Co., Owosso, MI. **Sources:** WW40.

WOODARD, Leroy Reynolds *[Portrait painter, etcher] b.1903, Brockton, MA.*
Addresses: Randolph, NH. **Studied:** BMFA Sch. **Sources:** WW40.

WOODARD, Lillian Esther *[Painter] b.1920, Iowa City, IA.*
Addresses: Des Moines, IA. **Studied:** Cumming School Art; Alice McKee Cumming, V. B. Arnold. **Exhibited:** Iowa Art Salon, 1935; Rockefeller Center; City Library, Des Moines. **Sources:** Ness & Orwig, *Iowa Artists of the First Hundred Years*, 226.

WOODARD, M. P. *[Painter] 20th c.*
Addresses: Short HIlls, NJ. **Exhibited:** S. Indp. A., 1944. **Sources:** Marlor, *Soc. Indp. Artists*.

WOODBERRY, Robert *[Painter, illustrator, teacher] b.1874, Centreville, MA.*
Addresses: Somerville, MA. **Studied:** W. D. Hamilton, Boston; Académie Julian, Paris with J.P. Laurens and Constant, 1897. **Exhibited:** Paris Salon, 1898, 1899. **Sources:** WW08; Fink, *American Art at the Nineteenth-Century Paris Salons*, 408.

WOODBRIDGE, John J. *[Listed as "artist"] mid 19th c.*
Addresses: NYC, 1848-49. **Sources:** G&W; NYCD 1848-49.

WOODBURN, Thomas *[Painter] 20th c.*
Addresses: Wash., DC. **Work:** recruiting posters, U.S. Army. **Sources:** WW40.

WOODBURY, C. O. *[Illustrator] 20th c.*
Addresses: NYC. **Sources:** WW19.

WOODBURY, Charles H(erbert) *[Marine painter, etcher, teacher, writer] b.1864, Lynn, MA / d.1940, Jamaica Plain (Boston), MA.*
Addresses: Boston, MA, 1887-97/Ogunquit, ME. **Studied:** Cobbett Sch., 1875-77; MIT, 1882-86 (an engineering major, he was largely self-taught, but took informal watercolor class with Ross S. Turner; Académie Julian, Paris, with Boulanger and Lefebvre, 1890-91). **Member:** Boston AC, 1884 (became the Club's youngest member at the age of 17); SAA, 1899; ANA, 1906; NA 1907; Boston SWCP; NYWCC; Boston GA; Ogunquit AA. **Exhibited:** Lynn Art Exhib., 1880 (2nd prize) Boston AC, 1882, 1884 (prize), 1895 (prize); J. Eastman Chase Gal., Boston, 1887 (first solo; sold out show); NAD, 1887-97,1932 (prize, 1932); 1888 (solo), 1891 and 1896 (both joint exhibs. with wife Marcia); Klackner Gal, 1889 (etchings); PAFA Ann., 1890-1938; PAFA, 1924 (gold); New Salon, Paris, 1891 (etching); SNBA, 1891; AIC, 1892-1939; Paris Salon, 1894 (painting); Atlanta Expo, 1895 (gold); Tenn. Centenn., Nashville, 1897 (prize); Mechanics' Fair, Boston (medals); Paris Expo, 1900 (med); Pan-Am. Expo, Buffalo, 1901 (med); WMA, 1903 (prize), 1907 (prize); St. Louis Expo, 1904 (med); CI, 1905 (prize); Corcoran Gal biennials, 1907-37 (15 times; incl. silver med, 1914); Buenos Aires Expo, 1910 (med); AWCS, 1911 (prize); W.A. Clark Prize, 1914; Pan.-Pac. Expo, San Fran., 1915 (medals); Brooklyn, 1931 (prize); SAE, 1933 (prize); Vose Gal., Boston, 1978, 1980; "Charles H. Woodbury and His Students," Ogunquit Mus. of Amer. Art, 1998. **Work:** BMFA; AGAA; AIC; Berkshire Athenaeum; Boston Pub. Lib.; CI; St. Louis AM; CGA; Danforth MA; Detroit IA; FMA; Gardner Mus., Boston; Herron AI; Joslyn AM, Omaha; MMA; RISD; Utah Collection; Telfair Acad., Savannah; WMA; Colby College; Ogunquit Mus. Amer. Art;

Portland (ME) MA; SFMA; Peabody Mus., Salem; Wellesley College; Adler Planetarium & Astronomical Mus., Chicago (six paintings made in Ogunquit showing the solar eclipse of Aug. 31, 1932). **Comments:** A highly influential teacher of many students, most of whom were women, who flocked to his summer classes held at Ogunquit, Maine, from 1898-1934 (teaching hiatus during WWI). He produced his first etching in 1882, and during his early career was an illustrator for *Century* and *Harper's,* 1888-89. He traveled extensively in Europe and made at least eighteen trips to the Caribbean from 1901-39. He also taught classes at his Boston studio; at Worcester AA (1895); Wellesley Col. (1899-06; 1913-14); and Pine Hill Sch. (1907-10). In his teaching and in his own work, he was concerned with conveying a true sense of movement, and instructed his students "to paint in verbs, not in nouns" (quoted in *Charles Woodbury and His Students.*). His wife Marcia Oakes Woodbury was also an artist. Publications: Author, *Painting and Personal Equation* (1919); Co-author, with Elizabeth W. Perkins, *The Art of Seeing* (1925). **Sources:** WW38; *Charles H. Woodbury* (exh. cat., Boston: Vose Galleries, 1978). *Charles H. Woodbury and Marcia Oakes Woodbury* (exh. cat., Boston: Vose Galleries, 1980); biography by George M. Young, *Force Through Delicacy* (Randall Pub., Portsmouth, NH, 1998); *Charles Woodbury and His Students;* Falk, *Exh. Record Series.*

WOODBURY, Emma A. *[Painter] 19th c.*
Addresses: NYC. **Exhibited:** AIC, 1896. **Sources:** Falk, *AIC.*

WOODBURY, J. C. *[Painter] 20th c.*
Addresses: Providence, RI. **Member:** Providence WCC. **Sources:** WW29.

WOODBURY, J. O. *[Painter] 20th c.*
Addresses: Madison, WI. **Exhibited:** PAFA Ann., 1966 (oil collage). **Sources:** Falk, *Exh. Record Series.*

WOODBURY, Lillian E. Morgan (Mrs. George) *[Painter] b.1851, Sparta, WI.*
Addresses: Aurora Station, OH; Taylor County, IA, c.1860; Corning, IA. **Studied:** Corning public schools; Cleveland, OH. **Comments:** Painted mostly landscapes and still lifes. Taught for a while at Hiram College in Ohio and in the Corning schools. **Sources:** Ness & Orwig, *Iowa Artists of the First Hundred Years*, 226.

WOODBURY, M. A. *[Engraver] mid 19th c.*
Addresses: Chicago, 1859. **Sources:** G&W; Chicago BD 1859.

WOODBURY, Marcia Oakes (Susan Marcia) (Mrs. Charles H.) *[Painter] b.1865, South Berwick, ME / d.1913.*
Addresses: Boston, MA/Ogunquit, ME/Holland. **Studied:** Chas. H. Woodbury, 1888; Lazar, Paris; studied on her own in Holland. **Member:** NY Women's AC; NYWCC; Boston WCC. **Exhibited:** J. Eastman Chase Gal., Boston, 1891, 1896 (both joint exhibs. with husband Charles); Boston AC, (prize); NY Women's A. Cl.; NYWCS; Boston WCC; AIC; Mechanics' Fair, Boston (medal); Atlanta (GA) Exposition, 1895; PAFA Ann., 1896-97; Tenn. Centennial, Nashville, 1897; BMFA, 1914 (retrospective); Vose Gal., 1980; "Charles H. Woodbury and His Students," Ogunquit Mus. Art, 1998. **Comments:** After marrying Charles Woodbury in 1890, the couple honeymooned in Europe, visiting a number of places, including Holland, the latter of which became a significant source of inspiration in the development of her style. She visited Holland frequently thereafter, staying for long periods of time, studying the old masters, and earning praise for her depictions of Dutch children. In Holland, she also wrote commentaries (in Dutch) on Flemish painters. After her death at the age of 48, her husband organized a critically acclaimed exhibition of her work at the BMFA. **Sources:** WW13; *Charles Woodbury and His Students; Charles H. Woodbury and Marcia Oakes Woodbury* (exh. cat., Boston: Vose Galleries, 1980); Falk, *Exh. Record Series.*

WOODCOCK, Francis *[Painter] b.1906, Oakland, CA / d.1983, San Rafael, CA.*
Addresses: San Francisco. **Studied:** Calif. College Arts & Crafts, with Martinez, Nahl, Logan. **Member:** Oakland AA (pres.); Soc. Western Artists (vice-pres.); Hayward AA (pres.); West Coast WC. Soc. (pres.). **Exhibited:** de Young Mus.; CPLH; SFMA; San Francisco Art Festival; Kaiser Center; Jack London Square. **Sources:** Hughes, *Artists in California,* 617.

WOODCOCK, Hartwell L. *[Painter, craftsperson] b.1852, Scarsmour, ME / d.1929.*
Addresses: Belfast, ME. **Studied:** F.E. Wright, in Boston; Colarossi Acad., Paris. **Exhibited:** Portland SA, 1885 (medal); Boston AC, 1898-1908. **Comments:** Specialty: scenery of Maine coast, oil and watercolors. Some of his works relate to Bermuda. **Sources:** WW08.

WOODCOCK, Percy *[Painter] late 19th c.*
Addresses: NYC, 1889. **Exhibited:** NAD, 1889, 1893. **Sources:** Naylor, *NAD.*

WOODCOCK, T. S. *[Engraver and inventor] mid 19th c.; b.England.*
Addresses: Came to America (from Manchester, England), c.1830; Philadelphia, 1836; Brooklyn, NY, 1842. **Comments:** May have been connected with the firm of Woodcock & Harvey in Brooklyn (see entry), although his address in 1842 was not the same as the firm's. It is believed that he returned to England sometime in the 1840s after inheriting some money. **Sources:** G&W; Stauffer; Brooklyn CD 1842, 1844.

WOODCOCK & HARVEY *[Engravers and copperplate printers] mid 19th c.*
Addresses: Brooklyn, NY, 1838-45. **Comments:** The partners were Frederick Woodcock, listed separately as a "print block cutter," and John Q. Harvey , copperplate printer (see entries). In 1845 the firm also included T. Woodcock, possibly the same as T. S. Woodcock (see entry). Frederick Woodcock had an oil cloth manufactory in Brooklyn from 1846-59. **Sources:** G&W; Brooklyn CD 1838-59.

WOODEN, Carrie *[Artist] late 19th c.*
Addresses: Active in Stony Point, MI, 1899. **Sources:** Petteys, *Dictionary of Women Artists.*

WOODEN, Howard Edmund *[Museum director, art critic] b.1919, Baltimore, MD.*
Addresses: Terre Haute, IN. **Studied:** Johns Hopkins Univ., B.S. & M.A. **Member:** College Art Assn. Am.; Am. Assn. Mus.; Soc. Arch.Historians; Archaeology Inst. Am. **Exhibited:** Awards: Fulbright grant, U.S. Dept. State, 1951-52. **Comments:** Positions: director, Sheldon Swope Art Gallery, Terre Haute, 1966-. Publications: author, *Architectural Heritage of Evansville,* 1962; author, *The Rose Hulman Institute Collection of British Watercolors,* 1969; author, *Fifty Paintings and Sculptures from the Collection of the Sheldon Swope Art Gallery,* 1972. Teaching: Fulbright instructor, Athens College, 1951-52; lecturer art history, Univ. Evansville, 1955-63; assoc. professor, Univ. Florida, 1963-66; assoc. professor art history, Indiana State Univ., Terre Haute, 1967-. Collections arranged: The Rose Hulman Institute Collection of British Watercolors, 1967-72; Sculptures by Ernst Eisenmayer, 1967-68; B. M. Jackson: oils, 1970; John Silk Deckard: 1960-70, 1970-71. Research: British watercolor painting of the eighteenth and nineteenth centuries; American architecture of the nineteenth century; meaning in contemporary art. **Sources:** WW73.

WOODHAM, Derrick James *[Sculptor] b.1940, Blackburn, England.*
Addresses: Iowa City, IA. **Studied:** S. E. Essex Technology College School Art, intermediate diploma design; Hornsey College Arts & Crafts, nat. diploma design; Royal College Art, diploma. **Exhibited:** New Generation, 1965, Whitechapel Gallery, London, 1965; Paris Bienalle, Mus. Art Moderne, 1965; Primary Structures, Jewish Mus., NYC, 1966; British Sculpture of the 60's, Nash House Gallery, London, 1970; Der Geist Surrealismus, Baukunst Galerie, Köln, Germany, 1971; Richard Feigen & Co., NYC, 1970s. Awards: Stuyvesant Found bursary, 1965; Prix de la Ville, Sculpture, Paris Bienalle, 1965. **Work:** Tate Gallery, London, England; Mus. Contemporary Art, Nagaoka, Japan. Commissions: Sculpture J. Meeker, Fort Worth, TX, 1969; sculpture, S. P. Steinberg, Newlett, NY, 1971. **Comments:** Preferred media: mixed media. Teaching: sculpture instructor, Phila. College Art, 1968-70; asst.professor art forms found, Univ. Iowa School Art, 1970-. **Sources:** WW73; Grace Gluek (author), "British Sculptures," *Art in Am.,* 1966; Robert Kudielka, "Abscheid vom Object," *Kunstwerke,* 10/1968; Otto Kulturman (author), *The New Sculpture,* Praeger, 1969.

WOODHAM, Jean *[Sculptor, lecturer] b.1925, Midland City, AL.*
Addresses: NYC; Westport, CT. **Studied:** Auburn Univ. (B.A. 1947); Sculpture Center, NYC; Univ. Illinois, Kate Neal Kinley Mem. fellowship. **Member:** Sculptors Guild (treasurer, 1960-65; exec. board, 1966-68; secretary, 1972; pres., 1990-92); Arch. Lg.; Audubon Artists (juror, 1964); Artists Equity; NAWA (juror, 1960-61,1963-66; chmn. sculpture, 1965-66). **Exhibited:** Alabama Art Lg. , Montgomery MFA, 1948; PAFA Ann., 1950-54; Womens Int. Art Club, New Burlington Gal., London, 1955; Silvermine Guild (CT), 1955-60 (prize, 1960); U.S. Info Agency exhibs. in Argentina, Brazil, Chile, & Mexico, 1963; WFNY, 1964; Audubon Artists, 1962 (medal); NAWA, 1966 (prize); Sculptors Guild, Albright-Knox Gal., Buffalo, 1971; WMAA; BMFA; Cooper Union; Smith College MA; Benton MA, Univ. Conn.; Rochester Mem. AG; NYU; Wadsworth Atheneum; Auburn Univ. AM, 1996 (retrospective); Stamford Mus. (CT), 1998 (retrospective). **Work:** Massillon Mus.; Telfair Acad., Savannah, GA; Norfolk MA. Commissions: "The River" (welded steel wall piece), Int. Bank Reconstruction & Develop Co., NYC, 1964; "Menorah" (welded bronze), Jewish Community Center, Harrison, NY, 1966; "Wings" (welded bronze), Alabama State Univ., Montgomery, 1967; fountain sculptures, Flintkote Corp, White Plains, NY, 1968-69; fountain pieces, Gen. Electric Credit Corp., Stamford, CT, 1971-72; Southern Conn. State Univ. **Comments:** A woman pioneer in monumental abstract sculpture in welded metals. Positions: chmn. sculpture, New York Fed. Women's Clubs, 1950-51; member, board managers, Silvermine Guild Artists, 1958-60; member, exec. board, Rowayton AC, CT, 1966-67. Teaching: head dept. sculpture, Silvermine Guild Artists, 1955-56; sculpture instructor, Stamford Mus., 1967-69; visiting asst. professor sculpture, Auburn Univ., 1970. **Sources:** WW73; Jacques Schnier, *Sculpture in Modern America* (Univ. Calif. Press, 1948); *Jean Woodham, Sculptress* (Veritas Corp., 1966); Margaret Harold, *Prize-Winning Sculpture* (Allied Publ., 1967, book 7); Falk, *Exh. Record Series.*

WOODHOUSE, Betty See: **BURROUGHS, Betty (Mrs. Betty Burroughs Woodhouse)**

WOODHOUSE, Harry Valentine *[Portrait and figure painter] b.1865, Villa Nova, Ontario / d.1939, Detroit, MI.*
Addresses: Detroit. **Studied:** Paris, France, with Bougereau and Robert-Fleury; Royal Academy, Munich. **Exhibited:** Detroit Inst. Art; Canada; Europe. **Work:** Atlanta, GA; New Orleans, LA; Mobile, AL; Oklahoma State Capitol. **Sources:** Gibson, *Artists of Early Michigan,* 248.

WOODHOUSE, John *[Painter] 20th c.*
Addresses: Phila., Frankford, PA. **Exhibited:** PAFA Ann., 1894 (landscape in water color). **Sources:** WW04; Falk, *Exh. Record Series.*

WOODHOUSE, Nellie *[Painter] 19th c.*
Addresses: Monterey, CA, 1870s. **Work:** Monterey Peninsula Mus. Art. **Sources:** Hughes, *Artists of California,* 617.

WOODIN, J. A. *[Watercolor portraits] mid 19th c.*
Addresses: Palmyra, NY, 1830. **Sources:** G&W; Lipman and Winchester, 182.

WOODIN, Lillian G. *[Artist] late 19th c.*
Addresses: Active in Detroit MI, 1895. **Sources:** Petteys, *Dictionary of Women Artists.*

WOODIN, Thomas *[Carver and cabinet maker; also taught drawing] mid 18th c.*
Addresses: Charleston, SC, 1767. **Comments:** His daughter Rebecca taught young ladies "in the different branches of 'polite education'," presumably including the arts of design. She was still in Charleston in 1778. **Sources:** G&W; Rutledge, *Artists in the Life of Charleston,* 120.

WOODING, B. Riker *[Painter] late 19th c.*
Addresses: Brooklyn, NY, 1885. **Exhibited:** NAD, 1885. **Sources:** Naylor, *NAD.*

WOODING, Jennie James *[Painter] 19th/20th c.*
Addresses: Belfast, ME; NYC, 1898. **Exhibited:** NAD, 1898; PAFA Ann., 1902. **Sources:** WW01; Falk, *Exh. Record Series.*

WOODLAMS, Leonore *[Sculptor] b.1914, San Francisco.*
Addresses: San Francisco. **Studied:** with Bufano. **Member:** Carmel AA. **Work:** Grace Cathedral, San Francisco. **Sources:** Hughes, *Artists in California,* 618.

WOODLEIGH, Alma *[Painter] 19th c.*
Exhibited: Calif. State Fair, Sacramento, 1880. **Sources:** Hughes, *Artists of California,* 617.

WOODLOCK, Ethelyn Hurd *Ethelyn Hurd Woodlock*
[Painter] b.1907, Hallowell, ME.
Addresses: Midland Park, NJ.
Studied: Copley School Commercial Art, Boston. **Member:** NAWA; Wolfe Art Club; AAPL; Allied Artists Am. **Exhibited:** 64th Am. Show, AIC, 1961; Contemporary Portraits, Fitchburg Art Mus., MA, 1962; Awards Artists Exhib., Montclair Art Mus., 1966; Contemporary Am. Realism, Hammond Mus., Salem NY, 1968; Bergen Community Mus., 1971. Awards: purchase award, Ringwood Manor State Exhib., 1968; purchase award, Bergen Mall, Paramus, NJ, 1971; judge's choice, AAPL, 1971. **Work:** Valley Hosp, Ridgewood, NJ; The Carlson Collection, Ramsey, NJ; Board Trades Bldg., Nassau, Bahamas; Hickory Art Mus., SC; Fort Lauderdale Public Library. **Comments:** Preferred medium: oil. **Sources:** WW73; Rodger, "Non-Verbal Communication," *Am. Soc. Clinical Hypnosis* (1972).

WOODMAN, Edith See: **BURROUGHS, Edith Woodman (Mrs Bryson Burroughs)**

WOODMAN, Edwin Wright *[Painter] 20th c.*
Addresses: Chicago, IL. **Exhibited:** AIC, 1909. **Sources:** WW10.

WOODMAN, Florence *[Painter] 20th c.*
Addresses: Chicago, IL. **Exhibited:** AIC, 1909. **Sources:** WW21.

WOODMAN, George (Mrs.) *[Amateur artist] mid 19th c.*
Addresses: NYC. **Exhibited:** NAD, 1859 ("Study from Nature"). **Comments:** Her maiden name was Durand and her husband was a NYC lawyer. **Sources:** G&W; Cowdrey, NAD; NYCD 1859.

WOODMAN, L. M. D. *[Artist] late 19th c.*
Addresses: NYC, 1878. **Exhibited:** NAD, 1878. **Sources:** Naylor, *NAD.*

WOODMAN, Lucy *[Artist] late 19th c.*
Addresses: Active in Grand Rapids, MI, 1892-93. **Sources:** Petteys, *Dictionary of Women Artists.*

WOODMAN, Selden James *[Portrait painter] b.1834, Maine / d.1923, Oakland, CA.*
Addresses: NYC, 1863; Rochester, NY; Chicago; Topeka, KS; Portland, OR; San Francisco, CA. **Studied:** Chicago; Paris, with Thomas Couture. **Exhibited:** NAD, 1863. **Work:** Bidwell Mansion, Chico, CA: Oregon Hist. Soc.; Kansas State Hist. Soc. **Comments:** Traveled as a sailor, shipwrecked on the coast of Labrador and worked on the NYC docks; he also practiced law for two years in Rochester before studying art. **Sources:** Hughes, *Artists of California,* 617.

WOODNER, Ian *[Collector] 20th c.*
Addresses: NYC. **Member:** Art Collectors Club. **Sources:** WW73.

WOODRING, Gaye *[Painter] 20th c.*
Addresses: Chicago. **Member:** GFLA. **Sources:** WW27.

WOODRING, Merle (Crisler) Foshag *[Painter, teacher] b.1899, Spokane, WA / d.1977, Bethesda, MD.*
Addresses: Wash., DC. **Studied:** Los Angeles Inst.; Corcoran School Art; with Eliot O'Hara; Diego Rivera. **Member:** Wash. WCC; Wash. AC; AWCS; Wash. SMP. **Exhibited:** AWCS; Smithsonian Inst.; CGA, 1949 (award); Wash. WCC; NAC. **Work:** Smithsonian Inst.; Dumbarton Oaks. **Comments:** Specialty: water-color landscapes, city scenes, still lifes. She often accompanied her first husband, Smithsonian curator Wm. Foshag, on field trips to Mexico, where she painted outdoors. After his death she married Dr. Woodring, also of the Smithsonian. **Sources:** McMahan, *Artists of Washington, DC;* Petteys, *Dictionary of Women Artists.*

WOODROFFE, Eleanor G. *[Painter] 20th c.*
Addresses: Niantic, CT/NYC. **Member:** NAWPS. **Exhibited:** S. Indp. A., 1917. **Sources:** WW29.

WOODROOFE, Louise M. *[Painter, educator] 20th c.; b.Champaign, IL.*
Addresses: Urbana, IL. **Studied:** Univ. Illinois; Syracuse Univ., B.P.; & with Hugh Breckenridge. **Member:** NAWA; North Shore AA. **Comments:** Position: art professor, Univ. Illinois, Urbana, IL. **Sources:** WW59; WW47.

WOODRUFF, B. D. *[Painter] 20th c.*
Addresses: Toledo, OH. **Member:** Artklan. **Sources:** WW25.

WOODRUFF, Bessie Hadley *[Painter] 20th c.*
Addresses: Jersey City, NJ. **Sources:** WW13.

WOODRUFF, Claude Wallace *[Illustrator, painter] b.1884, Hamilton, MI.*
Addresses: Pittsburgh, PA. **Studied:** G. Bridgman; T. Fogarty; E. Penfield; C. B. Falls, C. Rosen. **Member:** SI. **Exhibited:** AIC, 1926. **Comments:** Author/illustrator: *The Life of Shep, the Farmer's Dog.* Illustrator: children's books, pub. Harpers. Position: teacher, Pittsburgh AI. **Sources:** WW40.

WOODRUFF, Corice (Mrs. Henry S.) *[Painter, sculptor] b.c.1878, Ansonia, CT.*
Addresses: Minneapolis, MN. **Studied:** Minneapolis Sch. FA, with R. Koehler; K. Akerberg; ASL. **Member:** AG, Chicago; Attic C. **Exhibited:** Minnesota State Art Soc. (prize), 1914 (prize); St. Paul, 1916 (prize); S. Indp. A., 1927, 1929; PAFA Ann., 1927. **Comments:** Specialties: small sculpture; bas-relief portraits; portrait busts. **Sources:** WW33; Falk, *Exh. Record Series.*

WOODRUFF, Eugenie G. *[Painter] 20th c.*
Addresses: NYC, 1923. **Exhibited:** PAFA Ann., 1923 (still life). **Sources:** Falk, *Exh. Record Series.*

WOODRUFF, F. Charles *[Sculptor] 20th c.*
Addresses: Chicago area; NYC. **Exhibited:** AIC, 1947; PAFA Ann., 1954. **Sources:** Falk, *Exh. Record Series.*

WOODRUFF, Fannie P. *[Painter] 19th/20th c.*
Addresses: Boston, MA. **Exhibited:** Boston AC, 1894, 1898-99. **Sources:** WW01.

WOODRUFF, Hale Aspacio *[Painter, printmaker, educator, lecturer] b.1900, Cairo, IL / d.1980, NYC.*
Addresses: Atlanta, GA, 1931-45; NYC, 1945-80. **Studied:** John Herron Art Inst., Indianapolis; AIC; Fogg Art Mus., Harvard Univ.; Paris, with H. O. Tanner, 1931; Acad. Scandinave & Acad. Moderne, Paris; Morgan State College, hon. D.F.A.; also fresco painting with Diego Rivera, Mexico City, 1936. **Member:** NJ Soc. Artists; Soc. Mural Painters; Committee Art Educ.; MoMA; NY State Council Arts. **Exhibited:** Harmon Fnd., 1926 (bronze award & hon men.), 1928-29, 1931, 1933, 1935; AIC, 1927; Smithsonian Inst., 1929; Texas Centennial, 1936; Georgia AA,

1938; WFNY, 1939; BMA, 1939; Diamond Jubilee Expo, Chicago, 1940 (awards); High Mus. Art (prize), 1935, 1938, 1940; VMFA, 1944; Atlanta Univ., 1951 (purchase prize); WMAA, 1953; Galerie Jeune Peinture, Paris; Int. Print Soc., State Mus. North Carolina (solo); Kansas City Art Inst. (solo); Univ. Michigan, Ann Arbor (solo); Hampton Inst. & Univ. North Carolina, Chapel Hill & Greensboro (solo); Xavier Univ., 1963; Rockford (IL) College, 1965; Newark Mus., 1971; Bertha Schaefer Gallery, NYC, 1970s; Studio M, Harlem, 1979 (retrospective). Awards: Julius Rosenwald fellowship for Continued Creativity in Art, 1943-45; Great Teacher Award, NY Univ., 1966; honorary doctorate, Morgan State College, Baltimore, 1968. **Work:** Newark (NJ) Mus.; LOC; IBM Collection; Howard Univ., Washington, DC; Lincoln Univ., Jefferson City, MO; Atlanta Univ.; Spelman College; Harmon Fnd.; Jackson College; NY State Univ.; Savery Lib., Talladega College, AL (Amistad murals); Howard H.S., Atlanta; murals, Atlanta School Soc. Work. **Comments:** While in Paris in the late 1920s Woodruff painted landscapes before turning to a cubist style. Returning to the U.S. in 1931, he began painting scenes of African-American life in the South and in 1938 completed a series of murals for Talladega College relating the history of the mutiny aboard the slave ship *Amistad,* and the subsequent trial. About this time he was also making expressive, realistic woodcuts about such subjects as lynching. In the mid 1940s Woodruff began working in a more abstract style and by the 1950s was totally devoted to abstraction, incorporating hieroglyphics and African art symbolism into his work. As an educator for over 40 years, Woodruff had a strong impact on young African-American artists. Positions: art dir and teacher, Atlanta Univ., 1931-45 (he also helped organize the Atlanta Annuals, which served as an important venue for African-American artists); professor, art educ., New York Univ. (1945-68), emer. professor, 1968-. Lectures, "The Negro as Artist," at Drew Univ, Denver Mus., Univ. Massachusetts, Amherst, Queensboro Jewish Center, Vassar College, Univ. Colorado, Boulder & many other clubs, schools & art groups throughout U.S. **Sources:** WW73; Baigell, *Dictionary; Hale Woodruff* (exh. cat., NYC: Studio Mus., Harlem, 1979); Cederholm, *Afro-American Artists; 300 Years of American Art,* 891.

WOODRUFF, James *[Portrait painter, glazier and furniture maker] b.1911.*
Addresses: Ohio, active 1836-37 and again 1844-46. **Sources:** Hageman, 124.

WOODRUFF, John B. *[Landscape painter] b.1876, Ypsilanti, MI.*
Addresses: Detroit, MI. **Studied:** AIC; Munich, Germany. **Member:** Pallette & Chisel Club, Chicago (pres., 1914-15); Scarab Club, Detroit. **Exhibited:** AIC, 1914. **Sources:** Gibson, *Artists of Early Michigan,* 248.

WOODRUFF, John Kellogg *[Painter, sculptor, graphic artist, teacher] b.1879, Bridgeport, CT / d.1956, Nyack, NY.*
Addresses: Nyack, NY. **Studied:** Yale School FA; Artist-Artisan Inst., NY; Teachers College, Columbia Univ.; & with John Niemeyer, Walter Shirlaw, Arthur Dow, C. J. Martin, W. S. Robinson, Curran; ASL. **Member:** Woodstock AA. **Exhibited:** Marie Sterner Gal., Babcock Gal., Dudensing Gal., Argent Gal., Findlay Gal. (all solos); BM; Salons of Am.; AIC; S. Indp. A. **Work:** BM. **Sources:** WW53; WW47; Woodstock AA.

WOODRUFF, Julia S. (Miss) *[Painter, minature painter] 19th/20th c.*
Addresses: Seattle,WA, 1924. **Exhibited:** Soc. Seattle Artists, 1908. **Sources:** WW21.

WOODRUFF, Linda *[Painter] late 19th c.; b.Bridgeton, NJ.*
Addresses: Paris, France. **Exhibited:** Salon Nat. Beaux-Arts, 1898. **Sources:** WW98; Fink, *American Art at the Nineteenth-Century Paris Salons,* 408.

WOODRUFF, Louise Lentz *[Sculptor] 20th c.*
Addresses: Chicago. **Exhibited:** AIC, 1923-37. **Sources:** Falk, *AIC.*

WOODRUFF, M. *b.c.1832, Pennsylvania.*
Addresses: Phila. in June 1860. **Sources:** G&W; 8 Census (1860), Pa., LV, 507.

WOODRUFF, (Miss) *[Painter] mid 19th c.*
Addresses: Active in Detroit, 1868-72. **Exhibited:** Michigan State Fair, 1868. **Sources:** Petteys, *Dictionary of Women Artists.*

WOODRUFF, Porter *[Painter] 20th c.*
Exhibited: Salons of Am., 1934. **Sources:** Marlor, *Salons of Am.*

WOODRUFF, S. *[Artist] mid 19th c.*
Exhibited: NAD, 1844 (portrait), 1849 ("Crystallized Minerals, Sparta, NJ"). **Comments:** In 1844, address of the artist not given. In 1849 he gave Sparta as his address. **Sources:** G&W; Cowdrey, NAD.

WOODRUFF, William *[Engraver and copperplate engraver] mid 19th c.*
Addresses: Phila., 1817-24; Cincinnati, 1831-32. **Sources:** G&W; Stauffer; *Am. Adv. Directory,* 1831-32.

WOODRUFF, William E. A. *b.c.1827, Kentucky.*
Addresses: Louisville in 1850. **Comments:** Possibly the William E. Woodruff who was listed as a law student in 1852 and as an attorney-at-law in 1855. **Sources:** G&W; 7 Census (1850), Ky., XI, 447; Louisville CD 1852, 1855.

WOODRUFFE, F. *[Artist] late 19th c.*
Addresses: NYC, 1889. **Exhibited:** NAD, 1889. **Sources:** Naylor, *NAD.*

WOODS, Alice See: **ULLMAN, Alice Woods (Mrs. Eugene P.)**

WOODS, Beatrice *[Portrait painter, drawing specialist] b.1895, Cincinnati.*
Addresses: Cincinnati, OH. **Studied:** Cincinnati Art Acad.; Slade Sch., London; Royal Acad., London. **Member:** Women's AC, Cincinnati; Cincinnati MacD. Soc.; Cincinnati Print & Drawing Circle; Cincinnati Assn. Prof. Artists; AEA; Nat. AC; Studio Guild; NAWPS. **Comments:** Specialty: medical illustration. **Sources:** WW40.

WOODS, David Holmes *[Landscape and portrait painter, photographer] b.1830, Ohio / d.1911, Sacramento, CA.*
Addresses: San Francisco, CA. **Studied:** Calif. State Fair, 1881. **Work:** Calif. Hist. Soc. **Comments:** Painter of *Blackhawk,* a famous Irish racehorse. He also operated a gallery in San Francisco during the 1890s. **Sources:** Hughes, *Artists of California,* 617.

WOODS, E.E. *[Painter] 20th c.*
Addresses: Baltimore, MD. **Exhibited:** PAFA Ann., 1929. **Sources:** Falk, *Exh. Record Series.*

WOODS, Gurdon Grant *[Sculptor, educator] b.1915, Savannah, GA.*
Addresses: Warrenton, VA; Santa Cruz, CA. **Studied:** ASL; Brooklyn Mus. School; San Francisco Art Inst., hon. D.Arts, 1966. **Member:** San Francisco Art Inst. (exec. director, 1955-64); College Art Assn. Am.; San Francisco Mus. Council. **Exhibited:** PAFA Ann., 1941; San Francisco Art Inst. Ann.; San Francisco Art Festivals; Denver Mus. Ann.; São Paulo Biennial; Southern Sculpture Ann.; WMAA; Bolles Gallery, San Francisco, CA, 1970s. Awards: four purchase awards, San Francisco Ann. & Festivals; also foundation grants & citations. **Work:** City of San Francisco. Commissions: steel fountain & concrete relief panels, IBM Corp., San Jose, CA; aluminum fountain, Paul Masson Winery, Saratoga, CA; concrete panels, McGraw-Hill, Novato, CA. **Comments:** Preferred medium: concrete. Positions: director, College San Francisco Art Inst., 1955-65; sculptor member, San Francisco Art Commission, 1954-56; sculptor member, Santa Cruz Art Commission, 1970-. Teaching: sculpture instructor, San Francisco Art Inst., 1955-65; assoc. professor art, Univ. Calif., Santa Cruz, 1966-, chmn. dept., 1966-70. **Sources:** WW73; Falk, *Exh. Record Series.*

WOODS, Ignatius *[Listed as "artist"] b.c.1827, Scotland.* **Addresses:** Cincinnati in August 1850. **Sources:** G&W; 7 Census (1850), Ohio, XX, 743.

WOODS, Jeanne *[Painter] 20th c.* **Addresses:** Richmond, VA. **Exhibited:** S. Indp. A., 1934. **Sources:** Marlor, *Soc. Indp. Artists.*

WOODS, Lilla Sorrenson (Mrs. E. B. Woods) *[Painter] b.1872, Portage, WI.* **Addresses:** Hanover, NH. **Studied:** L. Ely in Kilburn, WI; AIC; Corcoran Sch. Art; H. T. Hammond; Miss Hawley, in Rijsvard, Holland; Académie Julian, Paris with J.P. Laurens. **Member:** Gloucester SA. **Exhibited:** S. Indp. A., 1918. **Sources:** WW40.

WOODS, Lily Lewis (Mrs.) *[Painter] 20th c.* **Addresses:** Cambridge, MA. **Member:** Cincinnati Women's AC. **Sources:** WW17.

WOODS, Marcy S. *[Painter] 20th c.* **Addresses:** Lodi, CA. **Exhibited:** Bohemian Club, San Francisco, annual, 1922; San Francisco AA, 1924; Calif.-Pacific Industries Expo., San Diego, 1926; Calif. State Fair, 1930. **Sources:** Hughes, *Artists of California*, 618.

WOODS, Marian A. *[Painter] 20th c.* **Addresses:** Phila., PA. **Exhibited:** PAFA Ann., 1934. **Sources:** Falk, *Exh. Record Series.*

WOODS, Rip *[Painter, educator] b.1933, Idabel, OK.* **Addresses:** Phoenix, AZ. **Studied:** Arizona State Univ., M.A.E., 1958. **Exhibited:** Drawing USA, CPLH, 1960; Phoenix Art Mus., 1968 (solo); Art on Paper, Weatherspoon Gallery, NC, 1969; Illinois Bell Travelling Exhib., Chicago, 1970-71; 73rd Western Ann., Denver, CO, 1971. **Work:** Phoenix Art Mus.; Arizona State Univ., Tempe; Arkansas State Univ., Jonesboro; Yuma (AZ) FA Center; Arizona Western College, Yuma. **Commissions:** relief-assemblage mural (with Ray Fink), Nat. Housing Indusis., Phoenix, 1970; mosaic & bas relief painting (with Ray Fink), Greyhound-Armour, Phoenix, 1971. **Comments:** Preferred media: mixed media Teaching: assoc. professor, painting, drawing & printmaking, Arizona State Univ., 1965-; assoc. professor painting, Colorado Springs FA Center, summer 1967. **Sources:** WW73.

WOODS, Roosevelt See: **WOODS, Rip**

WOODS, Sarah Ladd *[Collector, patron] b.1895, Lincoln, NE / d.1980.* **Addresses:** Lincoln, NE. **Studied:** Wellesley College, B.A.; Univ. Nebraska, LH.D. **Member:** Nebraska AA (patron, pres. & life trustee). **Comments:** Art interests: Thomas C. Woods Collection, Sheldon Gal., Univ. Nebraska. Collection: contemporary American. **Sources:** WW73.

WOODS, Stedman See: **WOOD, John Stedman**

WOODS, Theodore Nathaniel III *[Sculptor] b.1948, Akron, OH.* **Addresses:** Phoenix, AZ. **Studied:** Arizona State Univ., with Ben Goo, B.F.A. & M.F.A. **Member:** L'Assemblage; Tempe Five. **Exhibited:** Southwest Fine Arts Biennial, Santa Fe, NM, 1970; First Four Corners Biennial, Phoenix, AZ, 1971; Yuma (AZ) Fine Arts Invitational, 1972; Dimensions '72, Phoenix Art Mus. Exhib, 1972. Awards: third place crafts, Fine Arts, 1970; first place sculpture, First Four Corners Biennial, 1971; merit award sculpture, Dimensions '72. **Work:** Arizona State Univ. **Comments:** Preferred media: plastics, wood. **Sources:** WW73.

WOODS, Willis Franklin *[Museum director] b.1920, Washington, DC.* **Addresses:** Detroit, MI. **Studied:** Brown Univ., A.B.; American Univ.; Univ. Oregon. **Member:** Soc. Arts & Crafts (trustee, 1962-); Arch. Am. Art (trustee, 1962-); Art Quarterly (editorial board, 1962-); Am. Assn. Mus.; Am. Assn. Mus. Dirs. **Comments:** Positions: asst. director, CGA, 1947-49; director, Norton Gallery & School Art, West Palm Beach, FL, 1949-62; director, Detroit Inst.Arts, 1962-. Teaching: art instructor, Palm Beach Jr. College,

1958-62. **Sources:** WW73.

WOODSIDE, Abraham *[Portrait, historical, genre, and religious painter] b.1819, Phila. / d.1853, Phila.* **Addresses:** Phila., 1844-53. **Exhibited:** PAFA, 1843-61; Brooklyn AA, 1872; Maryland Hist. Soc.; Am. Art-Union. **Comments:** The younger son of John Archibald Woodside, Sr. (see entry); had his studio in Phila. from 1844 until his death. His best-known work was "Hagar and Ishmael in the Desert." **Sources:** G&W; Jackson, "John A. Woodside," 64-65; Trenton *State Gazette*, Aug. 17, 1853, obit.; Phila. CD 1844-54; Rutledge, PA; Rutledge, MHS; Cowdrey, AA & AAU.

WOODSIDE, Anna Jeannette *[Painter, craftsperson, etcher, teacher] b.1880, Pittsburgh, PA.* **Addresses:** Pittsburgh 13, PA. **Studied:** Pittsburgh Sch. Des. for Women, and with Christian Walter, Henry Keller, Jonas Lie, F. Clayter, C. Hawthorne. **Member:** Pittsburgh AA; AFA; AAPL. **Exhibited:** Awards: prizes, Pittsburgh AA, 1930; Russell Mem.prize, 1930. **Sources:** WW53; WW47.

WOODSIDE, Gordon William *[Art dealer, collector] 20th c.; b.Seattle, WA.* **Addresses:** Seattle. **Studied:** Univ. Washington. **Comments:** Positions: director, Gordon Woodside Galleries, Seattle. Specialty of gallery: artists of the Pacific Nortwest. Collection: representative works by prominent artists of the Northwest. **Sources:** WW73.

WOODSIDE, John Archibald, Jr. *[Wood engraver] mid 19th c.* **Addresses:** Phila. **Comments:** Elder son of John A. Woodside, Sr. (see entry). He was listed in Phila. only from 1837-40, though his work has been found in a book published in 1852. **Sources:** G&W; Jackson, "John A. Woodside," 64; Phila. CD 1837-40; Hamilton, *Early American Book Illustrators and Wood Engravers*, 100, 151, 505.

WOODSIDE, John Archibald, Sr. *[Sign and ornamental painter; still life and animal pictures] b.1781, Phila. / d.1852, Phila.* **Addresses:** Phila., 1805-52. **Studied:** may have learned the trade of sign painting from Matthew Pratt (see entry). **Member:** Artists' Fund Soc. **Exhibited:** PAFA , 1817-36. **Work:** MMA; Ins. Co. of North Am.; Hist. Soc. Penn.; Phila. MA. **Comments:** He was one of the most celebrated art-sign painters of the Federal period, and his work was greatly admired by his contemporaries, including William Dunlap (see entry) who wrote in his *History of the Rise and Progress of the Arts of Design in America* (1834) that Woodside "paints signs with talent beyond many who paint in higher branches." Woodside's sons, Abraham and John A. Woodside, Jr., were also artists (see entries). **Sources:** G&W; Jackson, "John A. Woodside, Philadelphia's Glorified Sign-painter"; Trenton *State Gazette*, March 1, 1852, obit.; Phila. CD 1805-52; Rutledge, PA; Swan, BA; Dunlap, *History*, II, 471; *Antiques* (Sept. 1946), 158, repro.; *Art Digest* (Aug. 1, 1950), 8, repro.; *Connoisseur* (April 1953), 68; Sherman, "Some Recently Discovered Early American Portrait Miniaturists," 295, repro.; McCausland, "American Still-life Paintings," repro.; Chamberlain, "A Woodside Still Life"; Flexner, *The Light of Distant Skies;* P&H Samuels, 537; *300 Years of American Art*, vol. 1, 90.

WOODSON, Marie L. *[Mural painter, craftsperson, teacher] b.1875, Selma, AL.* **Addresses:** Denver, CO. **Studied:** AIC; Ochtman; NY Sch. Fine & Applied Art. **Member:** Denver AA; Art Commission, City & County of Denver. **Exhibited:** Denver (prize). **Work:** murals, Denver Pub. Lib. **Comments:** Illustrator: "Tunes for Tiny Tots," by A. Freneauff. Position: director, art educ., Denver Public Schools, c.1910-40. **Sources:** WW40.

WOODSON, Maud See: **CASSEDY, Maud Woodson (Mrs. Morton))**

WOODSON, Max Russell *[Painter] 20th c.*
Addresses: Guilford, CT. **Exhibited:** S. Indp. A., 1930. **Sources:** WW17.

WOODVILLE, Richard Caton *[Genre painter] b.1825, Baltimore, MD / d.1855, London, England.*
Studied: drawing at St. Mary's *1848 R.C.W.* Coll., Baltimore, 1830s (as a young boy); possibly from Alfred Jacob Miller; Karl F. Sohn in Düsseldorf, 1845-50. **Exhibited:** NAD, 1845 (prior to his leaving for Düsseldorf); PAFA, 1847; Brooklyn AA, 1872; Corcoran Gal., 1967. **Work:** Corcoran Gal.; Walters AG, Baltimore (includes some of his earliest work); NAD; NMAA. **Comments:** Expatriate genre painter. Woodville briefly attended Univ. of Md. as a medical student (1842-43) and while there produced a group of sketches of his college friends and the inmates of an almshouse. These drawings are highly finished and indicate his skill at an early age. Deciding to dedicate himself to painting, Woodville left for Düsseldorf in 1845 and remained there for five years. During this time, he sent some paintings to America for exhibition, and the American Art-Union reproduced and distributed several of them as engravings. From 1851-on, Woodville lived chiefly in Paris and London. Woodville's most popular genre pictures were those relating to contemporary American life. These include "War News From Mexico" (1848, NAD) and "Politics in an Oyster House" (1848, Walters Gallery). Woodville died from an "accidental" overdose of laudanum (morphine). His son, Richard, Jr. (see entry), became a popular illustrator for the *Illustrated London News.* **Sources:** G&W; Cowdrey, "Richard Caton Woodville"; Pleasants, *250 Years of Painting in Maryland;* Cowdrey, NAD; Cowdrey, AA & AAU; Rutledge, MHS; Rutledge, PA; *Antiques* (July 1941), 48, repro.; *Art Digest* (June 1, 1939), 42, repro; More recently, see Francis Grubar, *Richard Caton Woodville* (exh. cat., Corcoran Gal., 1967); Baigell, *Dictionary; 300 Years of American Art,* vol. 1, 210.

WOODVILLE, Richard Caton, Jr. *[Painter, illustrator] b.1856, London, England / d.1937, St. John's Wood, England.*
Studied: Royal Acad. in DüsseldoRoyal Acad., London, 1876. **Exhibited:** Royal Acad., London. **Work:** Russell Foundation, Montana. **Comments:** Son of Richard C. Woodville, Sr. (see entry). Illustrated the American West in 1884 but did not visit there until 1890, when he was assigned by the *Illustrated London News* to depict American and Canadian outdoor life. He also covered the Sioux Indian War, 1890-91 and depicted the final military defeat of the Plains Indians. He was the most prolific Western illustrator in Europe for a time. **Sources:** P&H Samuels, 537-38.

WOODWARD, Angelo *[Portrait painter] late 19th c.*
Addresses: NYC, 1883. **Exhibited:** NAD, 1883. **Sources:** Naylor, *NAD.*

WOODWARD, Anna *[Painter, writer] 20th c.; b.Pittsburgh, PA.*
Addresses: Pittsburgh, PA/Paris, France. **Studied:** Académie Julian, Paris with Robert-Fleury, Lefebvre, and Bouguereau; Geo. Hitchcock, Holland. **Member:** Pittsburgh AA; Femmes Peintres et Sculpteurs. **Exhibited:** Paris Salon, 1898; Int. Expo, Rheims, France, 1903 (silver medal). **Sources:** WW10; Fink, *American Art at the Nineteenth-Century Paris Salons,* 408.

WOODWARD, Cleveland Landon *[Marine and landscape painter, illustrator] b.1900, Glendale, OH / d.1986, Westminster Village, Spanish Fort, AL.*
Addresses: Fairhope, AL; Truro, MA, 1934-53. **Studied:** Cincinnati Art Acad., scholarship, 1923-26; Charles Hawthorne's Cape Cod School Art, summer 1924; British Art Acad., Rome Italy, 1928-29. **Member:** Eastern Shore Art Assn. (board dirs., 1971-74); Cape Cod AA (co-founder & member first boar dirs.); Advisory Committee, Eastern Shore Acad. Fine Arts. **Exhibited:** Cincinnati Art Mus. Spring Exhib., 1925; Traxel Art Gallery, Cincinnati, 1929 (solo); Mobile Art Mus, 1968 (solo); Percy Whiting Mus., Fairhope, AL, 1969 (solo), 1971 (solo); Mobile Art Gallery, 1971 (solo); Orleans Art Gallery, Cape Cod, MA, 1970s.

Work: BMFA; Fine Arts Mus. of the South, Mobile, AL; Mobile Art Gallery, Langan Park, AL; Arctic Mus., Brunswick, ME; Boardman Press, Nashville, TN; United Lutheran Publ. House, Phila.; Christian Board Publ., Saint Louis, MO. **Commissions:** Samuel and Eli (mural), Seventh Presbyterian Church, Cincinnati, OH, 1949; painting for Donald B. MacMillan of Arctic Mus., Brunswick, ME, 1952; sixteen watercolor illus. for World Bible, World Publ. Co., 1962; Peter and John (mural), West End Baptist Church, Mobile, AL, 1972. **Comments:** Preferred media: oils, watercolors. He shared an interest in marine and landscape painting with his friend and neighbor of Truro, MA, Frederick Waughn (see entry). Publications: illustrator, *By An Unknown Disciple,* Harper Bros., *The Other Wise Man,* Harper Bros., *Painting Christ Head,* Abingdon Press, *Kudla And His Polar Bear,* Dodd Mead & Co. Teaching: lectures on Biblical art, schools, colleges & museums, many years; instructor in oil painting, Eastern Shore Acad. Fine Arts, 1972-. **Sources:** WW73; add'l info courtesy of Peter Bissell, Cooperstown, NY.

WOODWARD, David Acheson *[Portrait painter] b.1823 / d.1909.*
Addresses: Phila., 1842; Baltimore, 1849 and later. **Exhibited:** Artists' Fund Society, 1842. **Work:** Princeton University (Egbert). **Sources:** G&W; Rutledge, PA; Baltimore CD 1849-60+; Rutledge, MHS.

WOODWARD, Dewing (Miss) See: **DEWING-WOODWARD, (Miss)**

WOODWARD, E. F. *[Engraver] mid 19th c.*
Addresses: Hartford, CT in 1839; Phila., 1844-53. **Comments:** Engraver of maps and historical vignette for a school atlas published in Hartford (CT) in 1839 and subsequently an engraver at Philadelphia. **Sources:** G&W; Stauffer; Phila. BD 1844, CD 1845-53.

WOODWARD, Ellsworth *[Painter, etcher, teacher, sculptor] b.1861, Seekonk, MA / d.1939, New Orleans, LA.*
Addresses: New Orleans, active 1885-1939. **Studied:** RISD; C. Marr, Samuel Richards, Richard Fehr in Munich. **Member:** NOAL; Artist's Assoc. of N.O.; Arts Exhib. Club; NOAA (pres.); SSAL (pres.); Providence AC (hon.); Round Table Club; AFA; College AA; Int. Union of Fine Arts & Letters, Paris; LA Art Teacher's Assoc.; Minnesota State Art Soc.; Soc. Western Art; Royal Soc. for Encouragement of Art, London; Philad. AG; Nat. Soc. of Craftsmen. **Exhibited:** Artist's Assoc. of N.O., 1887, 1890, 1892, 1896-97, 1899, 1901-02; Tulane Decorative Art Lg. Women, 1888; NOAL, 1889; Tulane Univ., 1890, 1892-93; PAFA Ann., 1894, 1896-99; Tennessee Cent. Expo, Nashville, 1897; Newcomb College, 1899, 1905, 1910 (medal); Louisiana Historical Soc., 1900; E. Curtis' Exchange, 1902; NOAA, 1904-05, 1907, 1910 (gold), 1913-18, 1935 (prize); Fine Arts Club, 1909; Mississippi AA (gold); Boston SAC (medal); SSAL (prize); LOC, 1937; AIC. **Work:** Mun. Court House, Delgado Mus. Art, Newcomb College Art Gal., all in New Orleans; Jackson (MS) AA; Charleston Mus., SC; BM; MFA, Houston; Historic New Orleans Collection. **Comments:** Position: asst. professor, professor of art, director, Tulane Univ., Newcomb College; pres., board of admin., Delgado Mus. Came to New Orleans to teach at Tulane under his brother, William Woodward (see entry). He and William were two of the most influential figures in the New Orleans art world in the 19th century. Ellsworth became Newcomb's first professor of art and introduced the school's successful art pottery program as well as the expansion of the art program into embroidery, metalwork and china painting. He remained active as an artist, even in retirement and helped form many art organizations. He was frequently honored for his contribution to the arts and in 1934 President Roosevelt appointed him to the directorship of the Gulf States Public Works of Art Project. His special talent was watercolor painting and in 1936 the Fine Arts Cl. established a prize in his name. Husband of Mary Belle J. Woodward (see entry). **Sources:** WW38; *Encyclopaedia of New Orleans Artists,* 420-22; *Complementary Visions,* 43, 90; Falk, *Exh. Record Series.*

WOODWARD, Ethel (Edith) Willcox (Mrs. H. E.)
[Painter] b.1888, Andover, MA.
Addresses: Penns Grove, NJ. **Studied:** P. Hale; WMA Sch.
Exhibited: Delphic Studios, NYC, 1940 (solo). **Sources:** WW40.

WOODWARD, Helen M. *[Painter, designer] b.1908, Newton Stewart, IN / d.1986.*
Addresses: Indianapolis 5, IN. **Studied:** John Herron AI; Butler Univ.; Indiana Univ.; & with Charles Hawthorne, Eliot O'Hara, Wayman Adams; Cape Cod Sch. Painting; R. Miller. **Member:** Indiana AC; Contemporary Club, Indianapolis; Hoosier Salon. **Exhibited:** Ball State College, Muncie, IN (solo); Indiana Univ.; H. Lieber Gal., Indianapolis; Hoosier Salon, 1928, 1929 (prizes); Herron AI, 1939 (prize); Indiana AC (prize). **Sources:** WW53; WW47.

WOODWARD, Henry *[Portrait painter] mid 19th c.*
Addresses: Worcester, MA, 1848-52. **Exhibited:** Boston AC, 1875, 1881-82. **Comments:** In 1857 he was listed as treasurer of the Mechanics' Savings Bank, Worcester. **Sources:** G&W; New England BD 1849; Worcester CD 1848-57.

WOODWARD, Hildegard H. *[Painter, illustrator, author] b.1898, Worcester, MA.*
Addresses: Boston, MA; Brookfield, CT, 1969. **Studied:** Boston MFA School; travel-study in Europe and Mexico. **Exhibited:** Worcester (MA) Mus.; MMA; Hartford Atheneum; Marie Sterner Gal., NYC, 1932 (solo). **Comments:** Painted portraits, still lifes, flowers, figures, drawings. Wrote and illustrated children's books. **Sources:** WW25; Petteys, *Dictionary of Women Artists.*

WOODWARD, John Douglas *[Painter, illustrator] b.1848, Monte Bello, Middlesex County, VA / d.1924.*
Addresses: Kentucky; Richmond, VA; NYC, 1868, 1885-94; South Orange, NY, 1882, 1895; New Rochelle, NY. **Studied:** with Edward V. Valentine, William L. Sheppard and John A. Elder in Richmond; CUA School; Cincinnati, with F.C. Welsh. **Member:** SI; New Rochelle AA. **Exhibited:** NAD, 1867-95; Brooklyn AA, 1882-86; Boston AC, 1882, 1894; PAFA Ann., 1883-87, 1892. **Comments:** Illustrator: Hayden's U.S. Geological Survey Report, 1872, Appleton's *Picturesque America* and *Picturesque Europe* series. **Sources:** WW24; Wright, *Artists in Virginia Before 1900.* Wright cites a birthdate of 1846; Falk, *Exh. Record Series.*

WOODWARD, Laura (or Lana) *[Landscape, marine & still life painter] late 19th c.*
Addresses: Mt. Desert Island, ME; NYC (active 1872-89).
Exhibited: Am. Art Gal.; NAD, 1872-89; Brooklyn AA, 1872-85; PAFA Ann., 1877, 1880-82; Louisville, KY Indust. Expo, 1878. **Comments:** Exhibited works indicate she painted in the Catskills, Adirondacks, and White Mountains, and in Connecticut, New Jersey, and Pennsylvania. **Sources:** Campbell, *New Hampshire Scenery,* 176; Petteys, *Dictionary of Women Artists;* Falk, *Exh. Record Series.*

WOODWARD, Leila Grace *[Painter, illustrator, teacher] b.1858, Coldwater, MI.*
Addresses: Paris, 1898-99; Minneapolis, early 1900s; Wash., DC area, 1911 until c.1928. **Studied:** Chicago; England; Holland; Rome; Venice; DuMond in Boston; Merson, Collin, Whistler, all in Paris. **Exhibited:** Paris Salon, 1897-99; Soc. of Wash. Artists; Wash. WCC; AIC. **Sources:** WW29; McMahan, *Artists of Washington, DC;* Fink, *American Art at the Nineteenth-Century Paris Salons,* 408.

WOODWARD, Louise Amelia Giesen (Mrs.William)
[Painter, sculptor, craftsperson] b.1862, New Orleans / d.1937, Biloxi, MS.
Addresses: New Orleans, active 1888-1912. **Member:** NOAL, 1889; Artist's Assoc. of N.O., 1896; Arts Exh. Club, 1901.
Exhibited: Tulane Dec. Art Lg. Women, 1888; NOAL, 1889; Artist's Assoc. of N.O., 1891-92, 1896-97, 1902; Newcomb Art School, 1892; Tulane Univ., 1892-93; Delgado Mus., 1912.

Sources: WW15; *Encyclopaedia of New Orleans Artists,* 422.

WOODWARD, (M.) Dewing See: **DEWING-WOODWARD, (Miss)**

WOODWARD, Mabel May *[Painter] b.1877, Providence, RI / d.1945.*
Addresses: Providence, RI/Ogunquit, ME. **Studied:** RISD, 1896; ASL with W. M. Chase, F. V. DuMond, K. Cox, and Geo. Bridgman; A. W. Dow; Chas. H. Woodbury, Ogunquit School. **Member:** Providence AC; Providence WCC; South County AA; Ogunquit AC. **Exhibited:** Boston AC, 1908; Providence AC, 1939 (solo); Vose Gals., Boston (solo); El Paso (TX) Mus. Art, 1972 (solo); Chicago AI; Providence WCC; South County AA; NAD; AIC (gold medal, 1908); "Charles H. Woodbury and His Students," Ogunquit Mus. Am. Art, 1998. **Work:** Providence AC, RISD Mus. **Comments:** Impressionist painter best known for her summer garden and beach scenes painted along the New England shore, especially in Ogunquit, Maine. She was the first woman president of the Providence AC. Position: faculty, RISD. **Sources:** WW40; exh. cat., *Charles H. Woodbury and His Students* (Ogunquit Mus., ME, 1998); exh. cat., *Painters of Rhode Island* (Newport AM, 1986, p.27); Petteys, *Dictionary of Women Artists.*

WOODWARD, Martha D. *[Portrait painter, miniaturist] 19th c.*
Addresses: Baltimore, MD. **Studied:** Women's College, Baltimore. **Exhibited:** PAFA Ann., 1889, 1891. **Sources:** Falk, *Exh. Record Series.*

WOODWARD, Mary Belle Johnson (Mrs. Ellsworth)
[Painter, sculptor] b.1862, NYC / d.1943, New Orleans.
Addresses: New Orleans, active 1886-1939. **Studied:** Tulane Univ., 1886; Newcomb College, 1887-91. **Member:** Tulane Decorative Art Lg. Women, 1888; Newcomb Art Alumni Assoc., 1895 (sec.); Arts Exhib. Club, 1901; NOAA, 1905, 1913, 1916. **Exhibited:** Tulane Decorative Art Lg. Women, 1888; NOAA, 1905. **Sources:** *Encyclopaedia of New Orleans Artists,* 422.

WOODWARD, Norah Bisgood *[Painter] b.1893, Kew, England / d.1988, San Diego, CA.*
Addresses: San Diego, CA. **Studied:** Richmond, England. **Member:** San Diego Art Guild; Wednesday Club. **Exhibited:** GGE, 1939. **Work:** San Diego Mus. **Sources:** Hughes, *Artists of California,* 618.

WOODWARD, Robert Strong *[Painter] b.1885, Northampton, MA / d.1957.*
Addresses: Shelburne Falls, MA; Buckland, MA. **Studied:** BMFA Sch.; & with Edmund Tarbell, Philip Hale; mostly self-taught. **Member:** SC; Boston AC; Old Boston Artists; Springfield (MA) Art Lg.; Pittsfield (MA) AL; AFA; NYWCC; Deerfield Valley AA. **Exhibited:** NAD; Carnegie Inst.; AIC; PAFA Ann., 1921, 1928-37; Corcoran Gal biennials, 1930-41 (5 times); BMFA; WFNY 1939; GGE 1939; Deerfield Valley AA; Williston Acad.; Springfield AA; Salons of Am. Awards: prizes, NAD, 1919; Springfield A. Lg., 1927; Albany Inst. Hist. & Art, 1937; gold medal, Tercentenary Expo, Boston, 1930; Ogunquit AC, 1948; Boston AC, 1932; prize, Concord AA, 1920. **Work:** Springfield Art Mus.; Canajoharie Art Gal.; Syracuse MFA; BMFA; Williston Acad., Easthampton, MA; Stockbridge Pub. Lib.; Yale Univ.; Pasadena AI; San Diego FA Soc.; Northfield (MA) Seminary; Mount Holyoke College; Putnam Mem. Hospital, Bennington, VT; Lib., Northampton, MA; Massachusetts State College, Amherst; H.S., Gardner, MA. **Comments:** Marlor gives year of death as 1960. **Sources:** WW59; WW47; Falk, *Exh. Record Series.*

WOODWARD, Stanley Wingate *[Painter, etcher, writer, illustrator, teacher]* b.1890, *Stanley W. Woodward* Malden, MA / d.1970, Rockport, MA?.
Addresses: Boston, Rockport, MA. **Studied:** Eric Pape Sch. Art; BMFA Sch.; PAFA. **Member:** Gld. Boston Artists; AWS (Life); Int. Platform Assn.; Phila. WCC; Wash. WCC; CAFA; Boston Soc. WC Painters; SAGA; Audubon Artists; All. Artists Am.; Rockport AA; North Shore AA (pres.); SC; F.I.A.L.; Springfield AL; Chicago SE; NYWCC; Grand Central AG. **Exhibited:** PAFA Ann., 1924-33; Corcoran Gal biennials, 1926-51 (5 times); AIC; BMFA; CAM; NAD; Pepsi-Cola. Awards: prizes, NAD, 1925; AWS, 1927; Balt. WCC, 1927; Springfield Art Lg., 1928; Stockbridge AA, 1931; New Haven PCC, 1940; Rockport AA, 1940, 1948, 1955, 1959, 1960; Wash. WCC, 1940; North Shore AA, 1941; Meriden AA, 1950; Springfield Academic Artists, 1959; Boston Tercentenary, 1930 (gold med); Concord AA, 1919 (prize); Jordan Marsh, Boston, 1949, 1959. **Work:** BMFA; Bowdoin Col.; Converse Mem. Gal., Malden, Mass.; Ft. Worth Mus. A.; Ball State University; Mem. Gal, New Haven, CT; Univ. Michigan; Ft. Worth AM; Amherst Coll.; Wheaton College; Washington County Mus., Hagerstown, MD; BM; Vanderpoel Collection; Holyoke Art Mus.; Framingham (MA) Lib.; Wilton (NH) Lib.; Wellesley Hills Lib.; Springville (UT) Art Mus.; Lehigh Univ. Art Mus.; Concord AA; St. Mark's Sch., Southboro; BM; Converse Mem Gal., Malden, MA. **Comments:** Teaching: Woodward Outdoor Painting Sch., 1935-; Ringling Art Sch., Sarasota, FL, 1937-38; Laguna Beach School Art & Des., 1963. Illustrator: *Collier's* and *Ford Times* magazines. Author: *Adventures in Marine Painting* (1948); *Marine Painting in Oil and Water Color* (1961). Contributor: *American Artist.* **Sources:** WW66; WW47; *Artists of the Rockport Art Association* (1956); Falk, *Exh. Record Series.*

WOODWARD, Wilbur Winfield *[Painter]* late 19th c.; b.Indiana.
Studied: Royal Acad. Anvers; Robert-Fleury. **Exhibited:** Paris Salon, 1879, 1880. **Sources:** Fink, *American Art at the Nineteenth-Century Paris Salons*, 408.

WOODWARD, William *[Painter, teacher, sketch artist, craftsperson, etcher, architect]* b.1859, Seekonk, MA / d.1939, New Orleans, LA.
Addresses: New Orleans, active 1885-1923; Biloxi, MS, 1924-39. **Studied:** RISD; Mass. Normal Art Sch., Boston; Académie Julian, Paris with Boulanger and Lefebvre, 1875-76. **Member:** Providence Art Club; Tulane Decorative Art Lg. Women (founder, pres.); NOAL; New Orleans Art Pottery; Louisiana Chapter AIA; NOAA; AIA, 1897; SSAL; Gulf Coast AA; Miss. AA; AFA; Laguna Beach AA. **Exhibited:** RI Indus. Expo, 1881 (medal); Am. Expo, 1885-86; Columbian Expo, Chicago, 1893; Artist's Assoc. of N.O., 1887, 1889-92, 1896-97, 1899, 1901-02; Tulane Decorative Art Lg. Women, 1888; NOAL, 1889; Tulane Univ., 1890, 1892-93; Art League Pottery Club, 1892; Tennessee Cent. Expo, 1897; Newcomb College, 1899; E. Curtis' Exchange, 1902; Gulf Coast AA, 1927 (gold), 1929 (gold); Mississippi Fed. Women's Club, 1931 (prize); NOAA, 1904-05, 1907, 1909 (medal), 1910-11, 1913-18, 1932 (prize), 1936 (prize); Nat. Assoc. Newspaper Artists, 1905; Pan-Pacific Expo, 1915; S. Indp. A., 1918-20, 1927; SSAL, 1936 (prize). **Work:** NOAA; Delgado AM; United Fruit Co.; Tulane Univ.; High Mus., Atlanta; Rogers Art Gal., Laurel, MS; Historic New Orleans Collection. **Comments:** William and his brother Ellsworth Woodward (see entry) were the two of the most influential figures in the New Orleans art world in the 19th century. William became interested in art after visiting the Centenn. Expo. in Philadelphia, 1876. Following his training he moved to New Orleans in 1884 and taught at Tulane Univ. and Newcomb College until his retirement in 1922. He brought his brother Ellsworth to Tulane and was instrumental in the organization of Newcomb College. Also an architect, he designed buildings on the university's campus, and was the founder of the Tulane School of Architecture, 1907. He made numerous draw-ings of French Quarter buildings in order to record their appearance and associated himself with the Vieux Carré commission for the preservation of the historical district. In an accident while painting a mural, he damaged his spine in 1921, and was confined to a wheelchair for the rest of his life. He moved to Biloxi and continued to paint and invented fiberloid, a simplified etching process. He created prints based on his earlier paintings. Husband of Louise Ameila G. Woodward (see entry). Anthony R. White gives place of death as Biloxi, MS. **Sources:** WW38; *Encyclopaedia of New Orleans Artists*, 422-424; *Complementary Visions*, 34, 43.

WOODWARD, William (Mrs.) See: **WOODWARD, Louise Amelia Giesen (Mrs.William)**

WOODWELL, Elizabeth *[Painter]* 20th c.
Addresses: Pittsburgh, PA. **Member:** Pittsburgh AA. **Sources:** WW21.

WOODWELL, Johanna Knowles See: **HAILMAN, Johanna K. Woodwell (Mrs. James D.)**

WOODWELL, Joseph (or James) R. *[Landscape painter]* b.1843, Pittsburgh, PA / d.1911, Pittsburgh.
Addresses: Pittsburgh, PA, 1879-80; Magnolia, MA. **Studied:** Paris and Munich, early 1860s-66. **Exhibited:** NAD, 1879-80; Pittsburgh AA, 1859; Brooklyn AA, 1867; St. Louis Expo (medal), 1904; PAFA Ann., 1861-62, 1865, 1869, 1877-79, 1899, 1900, 1907-10; Corcoran Gal annuals, 1907-08; Carnegie Inst.; AIC; also in Paris. **Comments:** He was part of the group of painters who worked at "Scalp Level," a summer retreat similar to the Barbizon art colony. Exhibited works indicate he painted in Yosemite, Florida, Canada, France, and England. Position: chmn., FA Comm., CI. **Sources:** WW10; Chew, ed., *Southwestern Pennsylvania Painters*, 150-154; Falk, *Exh. Record Series.*

WOODWELL, W. E. *[Painter]* 20th c.
Addresses: Pittsburgh, PA. **Member:** Pittsburgh AA. **Sources:** WW21.

WOODY, Howard See: **WOODY, (Thomas) Howard**

WOODY, Solomon *[Portrait and landscape painter]* b.1828, near Fountain City, Wayne County, IN / d.1901, Fountain City, IN.
Addresses: Cincinnati, OH, 1840s; Fountain City, IN. **Studied:** Cincinnati, 1840s briefly. **Comments:** He received some informal art training in Cincinnati, where he worked as men's clothing salesman and throughout his life painted for amusement, gaining his living from a general store he conducted in Fountain City. **Sources:** G&W; Peat, *Pioneer Painters of Indiana*, 95-96, 241.

WOODY, Stacy H. *[Illustrator]* b.1887 / d.1942, Mt. Vernon, NY.
Studied: PIA School; AIC. **Member:** New Rochelle AA.

WOODY, (Thomas) Howard *[Sculptor, educator]* b.1935, Salisbury, MD.
Addresses: Columbia, SC. **Studied:** Richmond Prof. Inst., B.F.A.; Eastern Carolina Univ., M.A.; Univ. Iowa; AIC; Kalamazoo Art Ctr; Univ. Kentucky. **Member:** Southern Assn. Sculptors (pres., 1965-70); Nat. Sculpture Center (advisor, 1966-); Guild South Carolina Artists (board member, 1969); SC Craftsmen (board member, 1968); Southeastern College Art Conf. **Exhibited:** Smithsonian Touring Sculpture Exhib., 1969; Art in Embassies Int. Program, U.S. Dept. State, 1969; Ball State Nat. Small Sculpture Exhib., Muncie, IN, 1971; Atmospheric One-man Presentations, De Waters AC, Flint, MI, 1972 & Akron Art Inst, 1972. Awards: special citation award, Atlanta Festival Sculpture, 1968; South Carolina State Art Collection Award, SC Arts Commission, 1971. **Work:** Miami (FL) MOMA; Mint Mus. Art, Charlotte, NC; Birmingham (AL) Mus. Art; Columbus (GA) Mus. Arts & Crafts; Royal Ontario Mus., Toronto. **Comments:** Preferred media: bronze, assemblage. Teaching: sculpture instructor, Roanoke (VA) Fine Art Center, 1959-61; assoc. professor sculpture, Pembroke State Univ., 1962-67; professor sculpture,

Univ. South Carolina, 1967-, Russell Creative Research Award, 1972. **Sources:** WW73; J. A. Morris, *Contemporary Artists of South Carolina* (Greenville Co. Mus. Art, 1970).

WOOF, Maija (M Gegeris Zack Peeples) *[Painter] b.1942, Riga, Latvia.*
Addresses: Sacramento, CA. **Studied:** Univ. Calif., Davis (B.A., 1964; M.A., 1965); also with William T. Wiley, Robert Arneson & Wayne Thiebaud. **Exhibited:** Candy Store Gallery, Folsom, CA, 1965-72 (solos); Grotesque Show, San Francisco, Boston & Phila., 1969; Sacramento Sampler 1, Crocker Art Gallery, Oakland Mus. & Brazil, 1971-72; The World of Woof, throughout Arizona, 1971-72; Beast Retrospective, Univ. California Gallery, Davis, 1972. **Work:** Crocker Art Gallery, Sacramento, CA; La Jolla (CA) Mus. Art; Matthews AC, Tempe, AZ; SFMA; Norman Mackenzie Art Gal., Regina, Sask. Commissions: Beast rainbow painting, City of San Francisco, Civic Center, 1967; Rainbow House, San Francisco, 1967-68; crocheted, woven & sewn beast curtains, Univ. California Art Bldg., Davis, 1971. **Comments:** Preferred media: oils, acrylics, clay, watercolors, dye. Teaching: art instructor, Laney College, Oakland, CA, 1968-69; art instructor, Univ. California, Davis, 1971-72; art instructor, Sierra College, Rocklin, CA, 1971-. Collections arranged: The Nut Show, for Kaiser-Aetna, Tahoe Verdes, CA, 1972. **Sources:** WW73; Andrew Gale, "An Art Original," *Sacramento Bee,* 1971.

WOOLASTON, John See: **WOLLASTON, John**

WOOLDRIDGE, Julia *[Painter, teacher] 20th c.*
Addresses: Richmond, VA. **Studied:** M. de Tarnovsky; Dow. **Comments:** Position: art supervisor, Richmond Public Schools. **Sources:** WW17.

WOOLDRIDGE, Peter Holze *[Painter] 20th c.*
Exhibited: S. Indp. A., 1941. **Sources:** Marlor, *Soc. Indp. Artists.*

WOOLEY, Joseph *[Engraver] b.c.1815, England.*
Addresses: Frankford, PA, 1850. **Comments:** He, his wife, and their elder daughter (born c.1848), were born in England, but their younger daughter was born in Pennsylvania, around September 1849. **Sources:** G&W; 7 Census (1850), Pa., LVI, 263.

WOOLF, Fae *[Painter] b.1901, Providence, RI / d.1985, Providence.*
Addresses: Providence/Narragansett. **Studied:** locally, in Providence. **Exhibited:** Providence AC; Newport AA; Rhode Island Art Festival; NYC; Chicago, IL. Awards: blue ribbon, National Competition, sponsored by Motorola Co.; many other prizes locally. **Work:** priv. colls. **Comments:** Preferred media: watercolor, oils, pen & ink. Starting to paint at age 40, when her family gave her an easel and paint kit for Mother's Day, she produced over 200 still-lifes, seascapes, landscapes and genre pictures. **Sources:** info. courtesy of her son, Sheldon M. Woolf, Barnstable, MA.

WOOLF, Michael Angelo *[Actor, illustrator, and genre painter, wood engraver] b.1837, London (England) / d.1899.*
Addresses: NYC, 1881-87. **Studied:** Paris; Munich. **Exhibited:** NAD, 1881-87; PAFA Ann., 1885. **Comments:** He was brought to America as an infant, c.1838. He was well known for his humorous illustrations in black-and-white. Specialty: children of the slums in comic vein. **Sources:** G&W; WW98; *Art Annual,* I, obit.; Bénézit; Müller, *Allgemeines Künstler Lexikon;* Falk, *Exh. Record Series.*

WOOLF, Samuel Johnson *[Portrait painter, printmaker, writer, illustrator] b.1880, NYC / d.1948, NYC?.*
Addresses: NYC. **Studied:** CCNY; ASL; NAD, with Cox, Brush. **Exhibited:** NAD, 1904 (prize); St. Louis Expo, 1904 (prize); PAFA Ann., 1904-15, 1921-23; S. Indp. A., 1917; Paris Salon, 1937 (prize); PAFA; CI; Corcoran Gal biennials, 1907-21 (3 times); AIC; Mus. City NY, 1946; Appalachian Expo, Knoxville, 1910 (medal). **Work:** U.S. Capitol, Wash., DC; MMA; NYPL; CCNY; Brook Club; Normal College; Catholic Club, NYC; Hunter College, NYC; Univ. Michigan. **Comments:** Author/illustrator: "Drawn from Life, 1932; "Here Am I," 1942. **Sources:**

WW47; Falk, *Exh. Record Series.*

WOOLFE, Annette Marguerite Shipper (Mrs. Raymond F.) *[Painter] b.1889.*
Addresses: NYC. **Member:** NAWA. **Exhibited:** NAWA, 1935, 1937, 1938; Salons of Am.; S. Indp. A., 1935. **Sources:** WW40.

WOOLFENDEN, William Edward *[Art administrator, art historian] b.1918, Detroit, MI.*
Addresses: NYC. **Studied:** Wayne State Univ., B.A., M.A. **Member:** Am. Assn. Mus.; College Art Assn.; Soc. Arch. Historians; Nat. Trust Hist. Preservation. **Comments:** Positions: asst. curator Am. art, Detroit Inst. Arts, 1945-49, director educ., 1949-60; asst. director, Archives Am. Art, Detroit, MI, 1960-62, exec. director, 1962-64, director, 1964-70, director, Archives Am. Art, Smithsonian Inst., NYC, 1970-; member visiting committee, dept. Am. paintings & sculpture, MMA; adv. drawings, Minnesota Mus. Art, St. Paul. Research: American art & American drawings. **Sources:** WW73.

WOOLFOD, Eva Marshall (Mrs.) *[Painter] 19th/20th c.*
Addresses: Paris, France. **Studied:** Académie Julian, Paris with Adler; also with Collin in Paris. **Sources:** WW04; Fehrer, The Julian Academy.

WOOLFSON, Fannie *[Artist] 20th c.*
Addresses: NYC. **Exhibited:** PAFA Ann., 1947. **Sources:** Falk, *Exh. Record Series.*

WOOL(L)ETT, Anna Pell (Mrs. Sidney) *[Sculptor, painter] 20th c.; b.Newport, RI.*
Addresses: Jamaica Plain, MA. **Studied:** BMFA Sch., with Bela Pratt. **Sources:** WW13.

WOOLLETT, Sidney W. *[Sculptor] 20th c.*
Addresses: Jamaica Plain, MA. **Sources:** WW17.

WOOLLETT, William *[Painter, etcher, architect, lithographer] b.1901, Albany, NY / d.1988, Montecito, CA.*
Addresses: Montecito, CA. **Studied:** Univ. Minnesota (arch.); Atelier Hirons, NYC. **Member:** Calif. Soc. Etchers; Santa Barbara AA; Los Angeles Cultural Heritage Board (co-founder); Calif. AC; American Inst. Arch. **Exhibited:** Calif.-Pacific Int. Expo, 1935; LACMA, 1935. **Comments:** Son of W. Lee Woollett (see entry). Specialty: etchings and lithographs of the bulding of the Hoover Dam. Auth., book about Hoover Dam, and *California's Golden Age,* 1989. **Sources:** Hughes, *Artists in California,*618.

WOOLLETT, William *[Portrait painter] 19th c.*
Addresses: In and around Phila., 1819-24. **Work:** Princeton Univ. (portrait of Pres. Ashbel Green, 1762-1848). **Sources:** G&W; Phila. CD 1819-24; Egbert, *Princeton Portraits,* 56.

WOOLLETT, William Lee *[Painter, mural painter, sculptor, architect] b.1874, Albany, NY / d.1955, Hollywood, CA.*
Addresses: Los Angeles, CA. **Studied:** MIT (arch.). **Member:** Santa Barbara AA; Los Angeles AA. **Exhibited:** Grauman's Theater, Los Angeles, 1918; Artists Fiesta, Los Angeles, 1931. **Comments:** Father of William Woollett (see entry). **Sources:** Hughes, *Artists of California,* 618.

WOOLLEY, A. B. *[Painter] 20th c.*
Addresses: Avalon, PA. **Member:** Pittsburgh AA. **Sources:** WW25.

WOOLLEY, Fred Henry Curtis *[Painter, designer] b.1861 / d.1936, Boston, MA.*
Addresses: Malden, MA. **Sources:** Brewington, 420.

WOOLLEY, Virginia *[Painter, etcher, teacher] b.1884, Selma, AL / d.1971, Orange County, CA.*
Addresses: Atlanta, GA, until 1923; Laguna Beach, CA, since 1923. **Studied:** AIC, and in Paris, France; with J. Blanche, L. Simon, R. Miller, F. W. Freer. **Member:** SSAL; Laguna Beach AA; Nat. Lg. Am. Pen Women. **Exhibited:** Paris Salon; Laguna Beach AA; Pasadena Art Inst., 1928. **Work:** High Mus. Art, Atlanta. **Comments:** Painted arch. subjects & landscapes. She

was curator of the art gallery which later became the Laguna Beach Art Mus. **Sources:** WW59; WW40; Petteys, *Dictionary of Women Artists.*

WOOLLEY, William *[Portrait painter and mezzotint engraver] 18th/19th c.; b.England.*
Addresses: Came to America c.1797 and was active in NYC and Phila. for several years. **Work:** Princeton Univ. owns a portrait of Rev. Ashbel Green, signed "Wooley," which may be by him, although Groce & Wallace reported that the portrait had been dated c.1825. **Comments:** Painted and engraved portraits of George and Martha Washington which were published about 1800 by David Longworth of NYC. **Sources:** G&W; Dunlap, *History,* II, 63; Stauffer; Egbert, *Princeton Portraits,* 56.

WOOLNOTH, T. *[Engraver] mid 19th c.*
Exhibited: Ame. Acad., 1833 (engraving of J.W. Jarvis's portrait of Daniel D. Tompkins for Herring and Longacre's *National Portrait Gallery,* 1834). **Comments:** Groce and Wallace believed that this was probably the English engraver Thomas Woolnoth (1785-?), noted for his theatrical portraits, many of which were published in London between 1818-33. **Sources:** G&W; Dunlap, *History,* II, 469; Cowdrey, AA & AAU; Redgrave, *Dictionary of Artists of the English School;* Hall, *Catalogue of Dramatic Portraits.*

WOOLRYCH, Bertha Hewit (Mrs. F. Humphry W.) *[Painter, illustrator] b.1868, Ohio / d.1937.*
Addresses: St. Louis, MO. **Studied:** St. Louis Sch. FA; Paris, with Morot, Collin, Courtois. **Member:** St. Louis AG; St. Louis Art Students Assn. **Exhibited:** Lewis & Clark Expo, Portland, 1905 (bronze medal); St. Louis Sch. FA (silver & gold medals); St. Louis District, Gen. Fed. Women's Club (medal). **Sources:** WW38.

WOOLRYCH, F. Humphry W. *[Painter, illustrator] b.1868, Sydney, Australia.*
Addresses: St. Louis, MO. **Studied:** Royal Acad., Berlin; École des Beaux-Arts, Colarossi Acad., Collin, Courtois, Puvis de Chavannes, all in Paris. **Member:** Hellas AC, Berlin; St. Louis AG; 2x4 Soc. **Exhibited:** AIC, 1908. **Work:** St. Louis Pub. Lib.; Mus. Nat. Resources, Univ. Missouri; Columbia, MO; murals, Leschen Rope Co., MO; Athletic Assn. Bldg., Delmar Baptist Church, both in St. Louis; Capitol, Jefferson City, MO; Capitol, Montgomery, AL. **Sources:** WW40.

WOOLSEY, C(arl) E. *[Painter] b.1902, Chicago Heights, IL.*
Addresses: Taos, NM; Martinsville, IN. **Studied:** self-taught. **Exhibited:** Hoosier Salon, 1928 (prize), 1929 (prize), 1937; PAFA Ann., 1932; Corcoran Gal biennials, 1932, 1935; Block Mem. prize, 1937; NAD, 1931 (Hallgarten prize). **Work:** Kokomo (IN) AA. **Comments:** Brother of Wood Woolsey (see entry). **Sources:** WW40; Falk, *Exh. Record Series.*

WOOLSEY, Constance *[Painter] 20th c.*
Addresses: Oakland, CA. **Studied:** Univ. Calif., Berkeley, with John E. Gerrity. **Exhibited:** Oakland Art Gallery, 1939. **Sources:** Hughes, *Artists of California,* 618.

WOOLSEY, Natalie Sherburne *[Painter] b.1903, Oakland, CA / d.1985, Pebble Beach, CA.*
Addresses: Pebble Beach, CA. **Studied:** Calif. College Arts & Crafts. **Member:** Carmel AA. **Comments:** Specialty: rural scenes of Contra Costa County. **Sources:** Hughes, *Artists of California,* 618.

WOOLSEY, Wood W. *[Painter] b.After 1899, Danville, IL / d.1970, Laredo, TX.*
Addresses: Taos, NM; Stroudsburg, PA. **Studied:** Self-taught. **Exhibited:** NAD, 1930, 1932, 1934; Hoosier Salon; Evansville AI; Phoenix AA. **Awards:** prizes, Hoosier Salon, 1931, 1932; Phoenix AA, 1932; Evansville, AI, 1935. **Work:** Fed. Women's Club, Kokomo, IN; Mus. FA, Evansville, IN; Lafayette (IN) AI; Danville, IL; high schools in Terre Haute, Evansville, and Columbus, IN. **Comments:** Brother of Carl (see entry). **Sources:** WW53; WW47.

WOOLSON, Ezra *[Portrait painter] b.1824 / d.1845, Fitzwilliam, NH.*
Addresses: Active in Fitzwilliam, NH; was in Boston in 1843. **Sources:** G&W; Norton, *History of Fitzwilliam, N.H.,* 208 (repro.), 209; Lipman and Winchester, 182.

WOOLTIDGE, Powhattan *[Painter] 19th/20th c.*
Addresses: Louisville, KY. **Member:** Louisville AL. **Sources:** WW01.

WOOLWAY, Will *[Painter] 20th c.*
Addresses: Barrington, IL. **Exhibited:** AIC, 1951; PAFA Ann., 1962. **Sources:** Falk, *Exh. Record Series.*

WOOLWORTH, Charlotte A. *[Primitive pastelist] mid 19th c.*
Addresses: Active in New Haven, CT, 1865. **Sources:** Petteys, *Dictionary of Women Artists.*

WOOLYDIE, M. *[Lithographer] b.c.1820, Germany.*
Addresses: NYC in 1850. **Comments:** He left Germany with his wife and two children after 1846. **Sources:** G&W; 7 Census (1850), N.Y., XLII, 15.

WOOSTER, Austin C. *[Painter] 19th/20th c.; b.Chartiers Valley, PA.*
Addresses: Pittsburgh, PA, active 1864-1913. **Comments:** Specialty: landscapes and still lifes. **Sources:** Chew, ed., *Southwestern Pennsylvania Painters,* 155-56.

WOOTON, Clarence *[Painter, decorator, teacher] b.1904, Dry Hill, KY.*
Addresses: Norfolk 2, VA. **Studied:** Detroit City College, & with Ernest Lawson; G. Ignon. **Member:** Spectrum Club, Long Beach, CA; Professional Art Gld., Norfolk, VA. **Exhibited:** Irene Leach Mem. Mus., Norfolk, VA, 1944, 1945; VMFA, 1945; Pepsi-Cola, 1945; Pub. Libs., Miami Beach, Coral Gables, FL. **Awards:** prizes, Univ. Kentucky, 1940. **Work:** Collins Mem. Lib., Miami Beach, FL. **Comments:** Position: teacher, Miami Beach AC. **Sources:** WW53; WW47.

WOOTTEN, Leon *[Painter] mid 20th c.*
Exhibited: Corcoran Gal biennial, 1959. **Sources:** Falk, *Corcoran Gal.*

WORCESTER, Albert *[Painter, etcher] b.1878, West Compton, NH / d.1935.*
Addresses: Paris, France; Detroit, MI; New Orleans, active 1918. **Studied:** Maud Mathewson in Detroit; NYC; Italy; Académie Julian, Paris with J.P. Laurens, 1908; also with Merson in Paris. **Exhibited:** PAFA Ann., 1905-06, 1918; Corcoran Gal biennial, 1916; NOAA, 1918; Delgado Mus. Art, 1919; AIC. **Comments:** Worcester came to New Orleans in 1918 to exhibit three paintings of landscape and genre scenes. He died as the result of a fall in Barcelona, Spain. **Sources:** WW21; *Encyclopaedia of New Orleans Artists,* 424; Gibson, *Artists of Early Michigan,* 249; Falk, *Exh. Record Series.*

WORCESTER, Eva *[Painter, sculptor, writer, lecturer] b.1892, Erie, MI / d.1970.*
Addresses: Grosse Pointe Shores 36, MI. **Studied:** BMFA Sch.; and with Elliot O'Hara, Hobson Pittman, Emile Gruppe, Margaret F. Browne, and others. **Member:** Michigan WC Soc.; Grosse Pointe Artists; Desert AC, Palm Springs, CA; Copley Soc., Boston; Chicago Art Club; Michigan Artists; Pen & Brush Club; Int. Platform Assn.; NAWA; Fed. Am. Artists. **Exhibited:** Nat. Lg. Am. Pen Women, 1953, 1954; Detroit Inst. Art, annually; Michigan Acad. Arts & Letters; Thieme Gal., Palm Beach, 1963; NAD, 1965; Copley Gal., Boston, 1952 (solo); Washington Gal., Miami Beach, 1954; Detroit War Mem., 1956; Palm Springs, CA, 1957, 1958; Galerie Bernheim, Paris, France, 1959-60; Desert Mus., Palm Desert, CA, 1963. **Awards:** prizes, Grosse Pointe Artists, 1955; Nat. Lg. Am. Pen Women, 1953. **Work:** War Mem. Collection, Detroit; Grosse Pointe Garden Center; Nat. Fed. Women's Club, Boston; Lobby, Detroit TV-Radio Station Bldg. **Sources:** WW66.

WORCESTER, Fernando E. *[Wood engraver] b.c.1817, New Hampshire.*
Addresses: Active in Boston from about 1836-52. **Comments:** He was connected with the firms of Brown & Worcester (1846-47) and Worcester & Pierce (1851-52) (see entries). **Sources:** G&W; 7 Census (1850), Mass., XXVI, 305; Boston CD and BD 1842-52.

WORCESTER & PIERCE *[Wood engravers] 19th c.*
Addresses: Boston, active 1851-52. **Comments:** Partners were Fernando E. Worcester and William J. Pierce (see entries). **Sources:** G&W; Boston CD 1851-52.

WORDEN, Laicita Warburton (Mrs. Kenneth Gregg) *[Painter, sculptor, illustrator] b.1892, Phila., PA.*
Addresses: Greenwich, CT/Phila. **Studied:** PAFA. **Sources:** WW25.

WORDEN, Sara See: **LLOYD, Sara A. Worden (Mrs. Hinton S.)**

WORDEN, Willard E. *[Painter, photographer] b.1868, Smyrna, DE / d.1946, Palo Alto, CA.*
Addresses: San Francisco, CA. **Studied:** PAFA. **Exhibited:** Louvre, Paris. **Work:** Oakland Museum. **Comments:** Official photographer for the PPE, 1915. Specialty: hand-painted photographs of Chinatown and San Francisco before the earthquake of 1906. **Sources:** Hughes, *Artists of California*, 619.

WORES, Lucia *[Painter] 19th c.*
Addresses: San Francisco; Los Angeles. **Studied:** with her brother; with Fred Yates, Emil Carlsen, Arthur Mathews. **Member:** San Francisco Sketch Club; San Francisco AA; Sequoia Club. **Exhibited:** Calif. Midwinter Int. Expo, 1894; San Francisco Sketch Club, 1895-98. **Comments:** Sister of Theodore Wores (see entry). Specialty: interiors, figures, hay barges on San Francisco Bay. **Sources:** Hughes, *Artists of California*, 619.

WORES, Theodore *[Landscape and portrait painter, illustrator, teacher] b.1859, San Francisco, CA / d.1939, San Francisco.*

Theodore Wores.

Addresses: Munich, 1881; NYC, 1891-99; San Francisco. **Studied:** with Joseph Harrington, 1871 (at age 12); San Francisco School of Des., with Virgil Williams, 1874; Royal Acad., Munich, with Alex. Wagner and Ludwig Loefftz, 1875; also privately with Tobey Rosenthal and Frank Duveneck in Munich. **Member:** San Francisco AA; Bohemian Club; Century Assn.; SC; Art Soc. of Japan; New English AC, London. **Exhibited:** Royal Acad., Munich, 1876 (medal), 1878 (medal); PAFA Ann., 1884; NAD, 1881-99; Royal Acad., London; Paris Salon, 1890; Dowdeswell Gal., London, 1889 (solo); World's Columbian Expo, Chicago, IL, 1893; Calif. Midwinter Expo, 1894; Bohemian Club, 1894 (solo), 1920; Knoedler Gal., NYC, 1894; St. Louis Exp, 1895 (medal); Boston AC, 1898; Kilohana Art Lg. Hawaii, 1902; Century Club, NYC, 1904 (Spanish paintings); de Young Mus.; Alaska-Yukon Expo, 1909 (gold medal); PPE, 1915 (gold medal); Stanford Mus., 1922; Cosmos Club, Washington, DC; GGE, 1939; AIC; Spanierman Gal., NYC, 1997 (solo). **Work:** Bohemian Club; Oakland Mus.; CPLH; de Young Mus.; SFMA: St. Francis Hospital, San Francisco; LACMA; White House, Washington, DC; Bancroft Library, Univ. Calif., Berkeley; Crocker Mus., Sacramento; Calif. Hist. Soc.; Monterey Peninsula Mus. Art; Honululu Acad. Arts; Amon Carter Mus., Fort Worth, TX; Triton MA, Santa Clara, CA. **Comments:** An Impressionist who traveled widely, he was also the best known artist working in San Francisco during the late 19th to early 20th century. From 1879-81, he was one of the "Duveneck Boys" in Venice. He returned to San Francisco in 1881, painting portraits and scenes in Chinatown, and by 1884 was teaching at the San Francisco ASL. From 1885-87, he was one the first Americans to paint in Japan, and lived near Tokyo. In 1888, he had a studio at the Tenth Street Studio Bldg. in NYC, next to W.M. Chase. In 1892, he held an auction of his paintings to fund his return to Japan, where he painted more than 100 new works during the next two years. His articles on Japan appeared in *Century* and *Scribner's.* From 1901-02, he traveled and painted in Hawaii and Samoa; and in 1903 he was in Spain painting with Philp L. Hale. He returned to San Fran. in 1905, and from 1907-12, was director of the San Fran. Art Inst. (former Mark Hopkins IA). The great San Francisco Fire of 1906 destroyed his home, studio, and much of his earlier work. In 1913 he was painting in the Canadian Rockies; and from 1915-17 he painted the Southwest Indians in Taos, NM. In 1926 he moved to Saratoga near San Francisco and continued to paint vivid Impressionist landscapes. **Sources:** WW33; Hughes, *Artists of California,* 619, more recently, Wm. H. Gerdts, exhib. brochure for Spanierman Gal. (Apr., 1998); Forbes, *Encounters with Paradise,* 223; *For Beauty and for Truth,* 93 (w/repro.); Fink, *American Art at the Nineteenth-Century Paris Salons,* 408; Falk, *Exh. Record Series.*

WORK, J. Clark *[Illustrator] 20th c.*
Addresses: Westport, CT. **Member:** SI. **Sources:** WW47.

WORK, Marylou *[Artist] 20th c.*
Addresses: Doylestown, PA. **Exhibited:** PAFA Ann., 1958. **Sources:** Falk, *Exh. Record Series.*

WORKMAN, David Tice *[Mural painter] b.1884, Wahpeton, Dakota Territory (now ND).*
Addresses: Excelsior, MN. **Studied:** Hamline Univ., St. Paul, MN; BMFA Sch.; with Philip Hale, Frank Benson, Howard Pyle, and in London, England with Frank Brangwyn. **Work:** Murals, Pub. Lib., Hibbing, MN; Marshall Auditorium, Roosevelt Auditorium, Central Lutheran Church, all in Minneapolis; St. George's Church, St. James' Church, St. Mary's Hospital, all in St. Louis, MO; Pub. Lib., Ely, MN; Franklin Auditorium, Mankato, MN. **Sources:** WW53; WW47.

WORKS, Donald Harper *[Painter] b.1897, Huron, SD / d.1949, San Anselmo, CA.*
Addresses: St. Louis, MO; San Francisco; San Anselmo, CA. **Studied:** Minnesota Univ. (arch.); Calif School FA. **Exhibited:** San Francisco AA annuals from 1920s; San Francisco Modern Gallery, 1926; Blanding Sloan Gallery, San Francisco, 1930 (solo). **Comments:** Married to Katherine S. Works (see entry). An architect by profession, he painted landscapes, industrial scenes and waterfront activities in oil and watercolor. In 1928 he assisted James Hewlett (see entry) with murals in NYC, and in 1929 shared studios with J. Schnier (see entry) and Rinaldo Cuneo (see entry) in San Francisco. **Sources:** Hughes, *Artists of California,* 619.

WORKS, Katherine S. *[Painter, mural painter, printmaker] b.1904, Conshohocken, PA.*
Addresses: San Anselmo, CA. **Studied:** ASL, with Bridgman, Benton, Kuhn. **Member:** Marin Soc. Artists; Marin Arts Guild; San Francisco AA; Artists Equity Assoc.; San Francisco Women Artists. **Exhibited:** San Francisco Bay area. **Work:** Marin General Hospital, Children's Ward (mural); WPA mural, USPO, Woodland, CA. **Comments:** Married to Donald Works (see entry), she often signed her paintings Kay Works. **Sources:** WW40; Hughes, *Artists of California,*619.

WORLDS, Clint *[Painter] b.1922, Kernville, CA.*
Addresses: Living in Orogrande, NM in 1968. **Comments:** Influenced by Will James and received advice from Norman Rockwell and Bill Bender. **Sources:** P&H Samuels, 538.

WORLEY, George *[Lithographer] mid 19th c.*
Addresses: Phila., active 1846-after 1860. **Comments:** In 1846 he was one of the artists employed by Thomas Sinclair (see entry) to illustrate *The North American Sylva.* In 1859 he became senior partner in the firm of Worley, Bracher & Matthias (see entry), later known as Worley & Bracher. **Sources:** G&W; McClinton, "American Flower Lithographs," 362; Phila. CD 1849-60+.

WORLEY, BRACHER & MATTHIAS *[Lithographers] mid 19th c.*
Addresses: Phila., 1859-60. **Comments:** Partners were George Worley, William Bracher, and Benjamin Matthias (see entries).

The firm was known as Worley & Bracher after 1860. **Sources:** G&W; Phila. CD 1859-61. Note: Phila. BD 1859 erroneously listed the firm as Morley, Brorher & Matthias.

WORMAN, Eugenia A. Hutchinson (Mrs. Wm.)
[Painter] b.1871, Oshkosh, WI / d.1944, Seattle, WA.
Addresses: Seattle. **Exhibited:** Seattle SFA, 1922 (prize). **Comments:** Position: faculty, Univ. of Wash., 1922-42. **Sources:** WW24; Trip and Cook, *Washington State Art and Artists, 1850-1950.*

WORMHOUDT, Sarah *[Painter] b.1914, Pella, IA.*
Addresses: Pella, IA. **Studied:** Minneapolis School Art; Walt Killam. **Exhibited:** Iowa Art Salon; Memorial Union, Iowa State College, 1938. **Sources:** Ness & Orwig, *Iowa Artists of the First Hundred Years,* 226.

WORMLEY, Edward J. *[Designer] b.1907, Oswego, IL.*
Addresses: NYC. **Studied:** AIC. **Member:** AID (fellow); IDI; Arch. Lg. **Exhibited:** MoMA, 1947-49, 1950 (award), 1951 (award),1952 (award),1954; Arch. Lg., 1947-49; AID, 1950 (Elsie De Wolfe Award), 1951 (award); BMA, 1951; Akron AI; RISD,1948; Albright-Knox Art Gal., 1947; Dayton AI. **Comments:** Positions: visiting consultant and lecturer, Cornell University, 1955; board directors, American Craftsmen's Council; America House, Inc.; Int. Graphic Arts Society; Virginia Mills, Inc.; designer, indust. furniture, textile & interior ; design director, Dunbar Furniture Corporation, 1931-42, 1947 and on. Lectures on furniture design & modern design, Harvard Univ., John Herron AI, BMA, Parsons Sch. Des., Pratt Inst., School of the AIC. **Sources:** WW66; WW59.

WORMLY, (Mrs.) *[Engraver] 19th c.*
Addresses: Active in Columbus, OH. **Comments:** Engraved her husband's work. **Sources:** Petteys, *Dictionary of Women Artists.*

WORMS, Edward J. *[Engraver] 20th c.; b.NYC.*
Addresses: Paris, France. **Studied:** Gérôme. **Sources:** WW13.

WORMS, Ferdinand *[Marine painter] b.1859 / d.1939.*
Sources: Brewington, 420.

WORMSER, Amy J. Klauber *[Painter] b.1903, San Diego, CA.*
Addresses: San Diego, CA. **Studied:** Mills College, Oakland, CA, with Roi Partridge, 1920-23; Calif. Sch. FA, 1923-29; Kunstgewerbeschule Wien, Austria, 1929-31. **Member:** San Diego Mus. Art; Asian Arts Committee. **Exhibited:** Artists Cooperative Gal., San Fran., 1934 (solo); San Fran. Acad. Sciences, mid-1950s; San Diego Pub. Lib.; San Diego FA Gal. **Work:** San Diego Natural Hist. Mus. **Comments:** Specialty: fabric & wallpaper design. Daughter of Amy Salz Klauber (see entry) and Melville Klauber. **Sources:** Hughes, *Artists in California,* 619-620.

WORMSER, Ella Klauber *[Painter, photographer] b.1863, Carson City, NV / d.1932, San Francisco.*
Addresses: San Francisco; Deming, NM, 1888-98; San Francisco. **Studied:** San Fran. Sch. Des., with Virgil Williams; ASL, San Fran. **Exhibited:** Mark Hopkins Inst., 1898, 1906; GGE, 1939 (retrospective). **Comments:** Sister of Leda and Alice Klauber (see entries). While living in Deming, she concentrated on photographing pioneer life in New Mexico. Specialty: portraits and still lifes. **Sources:** Hughes, *Artists of California,* 620.

WORONIECKI, Helen *[Painter] 20th c.*
Addresses: Seattle, WA. **Exhibited:** SAM, 1940. **Sources:** Trip and Cook, *Washington State Art and Artists, 1850-1950.*

WORRALL, Clarence Augustus *[Painter, etcher] 19th c.*
Addresses: Phila., PA, 1894. **Exhibited:** PAFA Ann., 1882-89; NAD, 1894. **Sources:** Falk, *Exh. Record Series.*

WORRALL, Henry *[Illustrator and painter] b.1825, Liverpool (England) / d.1902, Topeka, KS.*
Addresses: Buffalo, 1835; Cincinnati; Topeka, KS, late 1860s. **Studied:** self-taught. **Comments:** Brought to America at the age of ten, Worrall spent his youth mainly in Buffalo and Cincinnati and became well known in the latter city during the 1850s as a professional musician. In the late sixties he moved to Topeka (KS) where he soon became prominent both as a musician and as an artist. Though he painted some portraits and gave humorous illustrated lectures, it was as a delineator of Western scenes that he made his greatest reputation. His work appeared in *Harper's Weekly* and *Frank Leslie's Illustrated Newspaper* between 1877 and 1893 and he also illustrated several books of Western history. He signed variously as H. Worrall, Worrall, H. W., W, or monogram. **Sources:** G&W; Taft, *Artists and Illustrators of the Old West,* 117-28; P&H Samuels, 538-39.

WORRALL, Rachel *[Miniature painter] 20th c.*
Addresses: NYC. **Sources:** WW10.

WORRALL, William Henry *[Painter] b.1860, Poughkeepsie, NY / d.1939, White Plains, NY.*
Studied: ASL. **Exhibited:** S. Indp. A., 1932. **Sources:** Marlor, *Soc. Indp. Artists.*

WORRELL, Charles *[Amateur artist] b.1819.*
Comments: He depicted the battle between the *Merrimac* and the *Monitor* in Hampton Roads (VA) in November 1862. He was then a lieutenant in the 20th New York Volunteers, stationed at Fort Monroe (VA). He resigned his commission December 29, 1863. **Sources:** G&W; *Album of American Battle Art,* 173-74, pl. 217; War Dept. records, Adjutant General's Office, at National Archives.

WORRELL, James *[Engraver] b.c.1831, Phila.*
Addresses: Phila. in 1860. **Comments:** He was the son of Isaac, musician, and Eliza Worrell. An older brother, Francis, was listed as a painter. **Sources:** G&W; 8 Census (1860), Pa., LI, 355.

WORRELL, John *[Scenery painter] early 19th c.; b.England.*
Addresses: Providence, RI c.1809; Boston, c.1811-13. **Work:** Rhode Island Hist.l Soc. (view of Providence, used as a drop curtain at the old Providence Theatre). **Sources:** G&W; Yarmolinsky, *Picturesque United States of America,* 41; *Antiques* (Nov. 1943), 236, repro.

WORRET, Charles See: **WORRELL, Charles**

WORSHAM, Bell *[Painter] 20th c.*
Addresses: Richmond, VA. **Exhibited:** PAFA Ann., 1934. **Sources:** Falk, *Exh. Record Series.*

WORSHAM, Janet *[Painter] 20th c.*
Addresses: Lynchburg, VA. **Studied:** ASL. **Exhibited:** S. Indp. A., 1917. **Sources:** WW17.

WORSHIP *[Engraver] early 19th c.*
Comments: Engraved plans for machinery, Philadelphia, 1815-20. **Sources:** G&W; Stauffer.

WORST, Edward F. *[Craftsperson, lecturer, teacher, writer] 20th c.; b.Lockport, IL.*
Addresses: Lockport, IL. **Studied:** Lowell Textile Inst.; Chicago Normal Sch.; Germany; Sweden. **Comments:** Author: "Foot Power Loom Weaving," "How to Weave Linen." Position: teacher, Edward E. Worst Craft House, Penland, NC. **Sources:** WW40.

WORSWICK, Lloyd *[Sculptor, craftsperson, teacher] b.1899, Albany.*
Addresses: NYC/Washington, NY. **Studied:** Urich; Cedarstrom; Brewster; Olinsky; Weinman; Bufano. **Exhibited:** PAFA Ann., 1924. **Sources:** WW33; Falk, *Exh. Record Series.*

WORTH, Beatrice B. *[Painter] 20th c.*
Addresses: Lakewood, NJ. **Exhibited:** S. Indp. A., 1918. **Sources:** Marlor, *Soc. Indp. Artists.*

WORTH, David G. *[Miniaturist and mechanical profilist] mid 19th c.*
Addresses: Nantucket, MA in November 1826. **Sources:** G&W; Nantucket *Inquirer,* Nov. 18, 1826 (G&W has information courtesy Miss Helen McKearin).

WORTH, Herman *[Sculptor] 19th/20th c.*
Studied: Académie Julian, Paris with Mercié. **Sources:** Fehrer, *The Julian Academy.*

WORTH, Peter John *[Sculptor, art historian]* b.1917, *Ipswich, England.*
Addresses: Lincoln, NE. **Studied:** Ipswich School Art, 1934-37; Royal College Art, London, 1937-39, ARCA, 1946, with E. W. Tristram, Paul Nash, Edward Bawden, Douglas Cockerell, Roger Powell. **Member:** Egypt Explor. Soc., London; College Art Assn. Am. **Exhibited:** SFMA, 1950; Nelson Gal. Art, 1950, 1953, 1954 & 1957; AIC, 1951; Walker AC, 1951, 1952 & 1956; Denver AM, 1952, 1953, 1955-57 & 1960-63. **Work:** Denver Art Mus.; Joslyn Art Mus.; Permanent Collection, Sheldon Gallery Art, Univ. Nebraska. **Comments:** Publications: photographer, *Life Library of Photography*, 1970 & Bilder, Stuttgart, 1970. Teaching: art history professor, Univ. Nebraska, Lincoln, 1959-. Research: stylistic transformations in late antique and early medieval art, especially in iconography. **Sources:** WW73.

WORTH, Thomas *[Comic and genre artist]* b.1834, NYC / d.1917, Staten Island, NY. *Worth pecit*
Addresses: Islip, Long Island; Staten Island. **Exhibited:** NAD, 1874; Brooklyn AA, 1884. **Comments:** Worth sold his first comic sketch to Nathaniel Currier (see entry) in 1855 and later became one of the most popular of the artists whose work was lithographed by Currier & Ives (see entry). Though best known for his comics, he also did many racing scenes. His home for many years was at Islip, Long Island, but in his later years he lived on Staten Island. **Sources:** G&W; CAB; Merritt, "Thomas Worth, Humorist to Currier & Ives"; Peters, *Currier & Ives*, I, 70-91; *Antiques* (Sept. 1946), 184.

WORTH, Viola I. *[Painter]* 20th c.
Exhibited: S. Indp. A., 1939. **Sources:** Marlor, *Soc. Indp. Artists.*

WORTHAM, (C)lyde H(arold) See: **WORTHAM, Harold**

WORTHAM, Harold *[Painter, art consultant]* b.1909, *Shawnee, OK / d.1974.*
Addresses: Madrid 6, Spain. **Studied:** Yard School Fine Arts, Washington, DC; ASL, with K. H. Miller, Brackman & Dickinson; San Fernando Acad. Fine Arts, Madrid, Spain, with Gregorio Toledo & Francisco Nuñez Losada. **Member:** ASL; Int. Inst. Arts & Letters, Switzerland; Int. Council Mus. (conservation), Rome. **Exhibited:** Metropolitan Arts, Washington, DC, 1936; Rosenberg Library, Galveston, 1942 & 1953; Casa Am., Madrid, 1952; Prado Sala, Madrid, 1959; Galeria Fortuny, Madrid, 1964; Jasper Galleries, Houston, TX, 1970s. Awards: purchase prize award, Independent Artists, Metrop. Exhib., 1936; Famous Amateurs Award first prize for oils, UNICEF Exhib., 1951; hon. awards for restoration, San Fernando Acad., 1953-54. **Work:** Rosenberg Library, Galveston, TX. Commissions: restoration work in Mus. Santa Cruz, Toledo, Spain; Mus. Pontevedra, Spain; Monasterio Nuestra Señora de Guadalupe, Spain; Cathedral, Murcia, Spain; Iglesia, Zumaya & Parrochial Church, Arenillas, Zamora, Spain. **Comments:** Preferred medium: oil. Positions: consultant, restoration & conservation paintings, Spanish Govt., Cent. Inst. Restoration, Govt. Spain, Madrid, 1964-. **Sources:** WW73; WW59.

WORTHEN, William Marshall *[Sculptor]* b.1943, *Wellsberg, WV.*
Addresses: Albuquerque, NM. **Studied:** Univ N Mex, BS. **Exhibited:** New Mexico Professional Invitational, Albuquerque, 1968 & 1972; Mainstreams, Marietta, Ohio, 1971 & 1972; The West Artists & Illustrators, Tucson Art Ctr, Ariz, 1972; Gallery A, Taos, NM. Awards: Award for Falcon, 1967, Falcon on Gauntlet & Buffalo, 1971, N Mex State Fair. **Comments:** Preferred media: steel, bronze. **Sources:** WW73.

WORTHINGTON, Beatrice Maude *[Sculptor]* 20th c.
Addresses: Boston, MA. **Sources:** WW15.

WORTHINGTON, Eric *[Painter]* 20th c.
Studied: ASL. **Exhibited:** S. Indp. A., 1940-41. **Sources:** Marlor, *Soc. Indp. Artists.*

WORTHINGTON, Margaret *[Silhouette cutter]* early 19th c.
Addresses: Phila. & Lancaster, PA, c.1803-05. **Comments:** A Quaker, who signed "M. Worthington" in pencil on silhouettes which she cut free hand. **Sources:** Petteys, *Dictionary of Women Artists.*

WORTHINGTON, Mary E. *[Painter]* early 20th c.; *b.Holyoke, MA.*
Addresses: Denver, CO, 1915-30. **Studied:** F.V. DuMond; Académie Julian, Paris with J.P. Laurens and Constant; H. Read at Denver AM. **Exhibited:** Denver Artists Club, from mid-1890s. **Sources:** WW31.

WORTHINGTON, Pearl See: **HILL, Pearl L. (Mrs. G. E. Worthington)**

WORTHINGTON, Virginia Lewis *[Painter, craftsperson]* 20th c.
Addresses: San Antonio, TX. **Studied:** Newcomb Col., New Orleans. **Member:** SSAL. **Exhibited:** SSAL, Montgomery, Ala., 1938; Southeastern Tex. AA, 1938; Cincinnati AM, 1939. **Sources:** WW40.

WORTHLEY, Caroline Bonsall (Mrs. Irving T.) *[Painter, craftsperson]* b.1880, Cincinnati / d.c.1944.
Addresses: Phoenixville, PA. **Studied:** Cincinnati Art Acad.; PM School IA; F Wagner; J.F. Copeland; PAFA (Chester Springs Summer Sch.); Chautauqua Summer Sch. Appl. Arts. **Member:** Plastic Club; Phila. Art Alliance. **Sources:** WW40.

WORTLEY, David *[Engraver and die sinker]* mid 19th c.
Addresses: NYC, 1856-59. **Sources:** G&W; NYBD 1856-59.

WORTMAN, Denys, Jr. *[Cartoonist, illustrator, painter]* b.1887, Saugerties, NY / d.1958, NYC?. *Wortman*
Addresses: Martha's Vineyard, MA. **Studied:** Rutgers Univ.; Stevens Inst. Tech.; NY Sch. Fine & Applied Art; Kenneth Hayes Miller; Robert Henri. **Member:** ANA; NA; SI (pres.); NIAL; Woodstock AA. **Exhibited:** Armory Show, 1913; WMAA, 1936, 1938; AIC. **Work:** complete file of proof, MMA & NYPL. **Comments:** A political cartoonist best known for depicting life among NYC's lower classes. Position: cartoonist, *New York World, New York World-Telegram*, & syndicated newpapers, 1924-. Auth.: "Metropolitan Movies," c.1927, "Mopey Dick and the Duke," c.1952. **Sources:** WW53; WW47; Woodstock AA; Brown, *The Story of the Armory Show.*

WOSE, Beatrice Ely (Mrs. Richard V. Smith) *[Painter, educator]* b.1908, Syracuse, NY.
Addresses: Syracuse, NY. **Studied:** Syracuse Univ., B.F.A.; & with George Luks. **Member:** Assoc. A. Syracuse. **Exhibited:** GGE 1939; Finger Lakes Exh., Rochester, NY, 1939-1944; Syracuse Mus. FA, 1933-1946. Awards: Hiram Gee F., Syracuse Univ., 1930. **Work:** Syracuse Mus. FA. **Comments:** Position: L., 1943-44. Asst. Prof. A., Chm. A. Dept., 1944-, Col. FA, Syracuse Univ., Syracuse, NY. **Sources:** WW53; WW47.

WOSTREY, Carlo *[Painter, mural painter]* b.1865 / d.1930, *Trieste, Italy.*
Addresses: NYC; Los Angeles, CA. **Work:** murals, Church of St. Vincent, Trieste; Church of Madonna of Loudres, NYC; St. Andrews Church, Pasadena. **Comments:** Painted murals in Europe at the turn of the century and immigrated to the U.S. shortly after WWI. **Sources:** Hughes, *Artists of California ,*620.

WOTHERSPOON, William Wallace *[Landscape painter]* b.1821 / d.1888.
Addresses: NYC, 1844-48, 1852-1883. **Member:** A.N.A. , 1848. **Exhibited:** NAD, 1844-45, 1847-57, 1863, 1866-67, 1870, 1883; Brooklyn AA, 1871; AAU; PAFA, 1855; Washington Art Association, 1857 (Scottish scene). **Comments:** From 1844 until 1848 his landscapes were mainly of the White Mountains. He must have traveled abroad in 1849, as several Scottish landscapes were shown at the NAD in 1849 and 1850; in 1851 he was listed as living in Rome. He was back in NYC in 1852 and in the years to follow showed many Italian landscapes at the National

Academy. **Sources:** G&W; Mallett; Muller, *Allgemeine Kunstler Lexikon;* Cowdrey, NAD; Cowdrey, AA & AAU; Rutledge, PA; Washington Art Assoc. Cat., 1857. More recently, see Campbell, *New Hampshire Scenery,* 177.

WOY, Leota *[Painter, illustrator] b.1868, New Castle, IN / d.1962, Glendale, CA.*
Addresses: Denver, CO; Laguna Beach, CA. **Studied:** self-taught; Cory Sch. Indust. Art, NYC. **Member:** Denver AC; Ex Libris Soc., Berlin; Laguna Beach AA. **Comments:** Specialty: bookplates. Woy also designed wallpaper, stained glass, embroidery, and art needlework. **Sources:** WW25; Petteys, *Dictionary of Women Artists.*

WOZECH, Anthony See: **VOZECH, Anthony**

WRAAI, Gustav *[Mural painter] 20th c.*
Addresses: NYC. **Sources:** WW13.

WRAGG, Eleanor T. *[Painter, miniature painter, wood engraver] early 20th c.*
Addresses: NYC; Texas; Stony Creek, CT. **Studied:** ASL. **Member:** Carolina AA. **Exhibited:** actively in Texas; NYSMP; Phila. SMP; Wash., DC. **Comments:** Also painted portraits and landscapes. **Sources:** WW25; Petteys, *Dictionary of Women Artists.*

WRAIGHT, Katherine Severance *[Craftsperson]*
Addresses: New Orleans, active c.1911-17. **Studied:** Newcomb College, 1902-06, 1916-17. **Exhibited:** NOAA, 1911. **Sources:** *Encyclopaedia of New Orleans Artists,* 424.

WRAMPE *[Painter] 20th c.*
Exhibited: AIC, 1936. **Sources:** Falk, *AIC.*

WRAY, Dick *[Painter] b.1933, Houston, TX.*
Addresses: Houston, TX. **Studied:** Univ. Houston. **Exhibited:** Mus. Contemporary Art, Houston, 1961; Southwest Painting & Sculpture, Houston, 1962; Hemisfair, Houston, 1968; Homage to Lithography, MoMA, 1969. Awards: purchase prizes, Ford Foundation, 1962 & MFA, Houston, 1963. **Work:** Albright-Knox Art Gallery, Buffalo, NY; MFA, Houston. **Sources:** WW73.

WRAY, Henry Russell *[Painter, etcher, illustrator, writer] b.1864, Phila. / d.1927, Colorado.* **H.R.WRAY**
Addresses: NYC/Colorado Springs, CO.
Member: SC; Players Club. **Exhibited:** Soc. Indep. Artists, 1918. **Sources:** WW27.

WRENCH, Arthur *[Painter] 20th c.*
Exhibited: Salons of Am., 1934. **Sources:** Marlor, *Salons of Am.*

WRENCH, Polly (Mary) *[Miniaturist] late 18th c.; b.Eastern Shore of Maryland.*
Addresses: Phila., 1772. **Studied:** Charles Willson Peale.
Comments: Sister-in-law of James Claypoole (see entry). She is known to have been active in Phila. in 1772, painting miniatures to support her widowed mother and younger brother. She later married Jacob Rush, brother of Benjamin (see entry), and gave up painting. **Sources:** G&W; Sellers, *Charles Willson Peale,* I, 110-11; Bolton, *Miniature Painters;* Wharton, *Heirlooms in Miniatures;* Petteys, *Dictionary of Women Artists.*

WRENN, Charles L(ewis) *[Portrait painter, illustrator] b.1880, Cincinnati.*
Addresses: NYC/Norwalk, CT. **Studied:** W. Chase; ASL. **Member:** SI; SC. **Sources:** WW33.

WRENN, Elizabeth J(encks) (Mrs. Harold) *[Sculptor] b.1892, Newburgh, NY.*
Addresses: Baltimore, MD/Wellfleet, MA. **Studied:** A. Eberle; ASL; Maryland Inst., Baltimore; G. Bridgman; M. Young; A. Dazzi, in Rome. **Member:** Munic. Art Soc., Baltimore; Baltimore Artists Un.; AAPL. **Exhibited:** WFNY, 1939. **Work:** City Hall, Baltimore. **Sources:** WW40.

WRENN, Harold Holmes *[Painter, teacher, drawing specialist, architect] b.1887, Norfolk, VA.*
Addresses: Baltimore 10, MD. **Studied:** Norfolk (VA) Acad.; Univ. Virginia; Columbia Univ. **Member:** AFA; Balt. AG (pres.); Balt. Artists Un.; Provincetown AA; Munic. Artists Soc., Balt. **Exhibited:** AFA traveling exhib., 1935; Corcoran Gal biennial, 1939; WFNY 1939; MoMA; VMFA, 1939 (prize); Pepsi-Cola traveling exhib., 1945; Balt. Munic. Mus., 1943 (prize); BMA, annually (prize, 1939); Phila. Art All. **Work:** Phila. Art All.; Norfolk Mus. Art & Sc.; VMFA; BMA; Balt. Munic. Mus. **Comments:** Position: head, art dept., Gilman School, Baltimore, MD. **Sources:** WW59; WW47.

WRENTZ, George III *[Painter, graphic artist, architect] b.1941, Valdosta, GA.*
Studied: Florida A&M Univ.; Int. Professional College. **Exhibited:** Miami Pub. Lib., 1972; Univ. of Miami, 1971, 1972; Theater Afro-Arts, 1971, 1972; Coral Gables H.S., 1971, 1972; Miami Black Arts, 1971, 1972; Perrine AC, 1971; St. Paul A&M Church, 1972. **Sources:** Cederholm, *Afro-American Artists.*

WRIGHT *[Portrait painter]*
Comments: An oil portrait of one Seward of Hurdtown (VA) is signed "Wright of Sparta" (owned in 1940 by W.P. Hill, dealer, of Richmond). **Sources:** G&W; G&W has information courtesy H.W. Williams, Jr., Corcoran Gallery.

WRIGHT, Alice Morgan *[Sculptor, writer] b.1881, Albany, NY / d.1975, Albany.*
Addresses: NYC, 1914-20; Albany, NY, 1920-75. **Studied:** Smith College, A.B., 1904; St. Agnes Sch., Albany, NY; Russell Sage College, L.H.D.; ASL with Hermon MacNeil, James Earle Fraser; Academie Colarossi with Injalbert, École des Beaux-Arts, Paris, France, 1909; and with Gutzon Borglum, Injalbert. **Member:** NSS (fellow); NAWA; Am. Assoc. Univ. Women; Soc. Independent Artists, 1917 (a founder). **Exhibited:** NAD, 1909-31(prize, 1909); Royal Acad., 1911, 1918, 1927; Soc. Nat. des Beaux-Arts, 1912; PAFA Ann., 1912-31; TMA, 1913; Salon d'Automne, 1913; Modern Gal., 1916; AIC, 1916-31; NYC at Milch, Ferargil, Arden, Arlington, Gorham & Macbeth Gals.; S. Indp. A., 1917, 1920-33, 1941; NAWA, 1919-30 (prizes); Whitney, 1940; NSS; Marie Sterner Gal., NYC, 1937 (solo); Albany Inst. Hist. & Art, 1936, 1978; NGA (prize); NAC (prize); Folger Shakespeare Mus. (prize); Newark Mus. (prize); Smith College (prize). **Work:** Folger Shakespeare Mus., Wash., DC; U.S. Nat. Mus., Wash., DC; Newark Mus.; Bleecker Hall, Albany, NY; London Mus., Kensington Palace; Bay Ridge H.S., Brooklyn, NY; John M. Greene Hall, College Hall and Smith College Library, Northampton, MA; Brookgreen Gardens, SC. **Comments:** One of the first American sculptors to explore Cubist and Futurist forms (1916-21). She also produced more conventional pieces. Wright was also a political activist, participating in suffrage demonstrations and helping found the New York State League of Women Voters in 1921. After 1930 she devoted most of her time to writing and organizing for various causes. Contributor to *Harper's* and *Bookman* magazines; wrote first acting version in the U.S. of "Sakuntala," performed at Smith College. **Sources:** WW59; Rubinstein, *American Women Sculptors,* 220-23; Fort, *The Figure in American Sculpture,* 233 (w/repro.); Petteys, *Dictionary of Women Artists;* Falk, *Exh. Record Series.*

WRIGHT, Alma Brockerman (Mr.) *[Portrait & landscape painter, muralist, teacher] b.1875, Salt Lake City, UT / d.1952, Le Bugue, Dordogne, France.*
Addresses: Dordogne, France. **Studied:** LDS College, 1892-95; Univ. Utah, 1895-96 with Haag and Harwood; Académie Julian, Paris with J.P. Laurens, 1902; Académie Colarossi and École des Beaux-Arts, Paris, 1902-04, with Bonnât. **Member:** Soc. Utah Artists; Paris AAA; AAPL; Laguna Beach AA. **Exhibited:** Utah AI, 1904 (prize), 1905 (medal). **Work:** murals, panels, LDS Temples in Honolulu, & in Cardston, Alberta, Canada; Utah State Capitol; Mormon Temple, Mesa, AZ; Springville AM. **Comments:** Teaching: Utah colleges, 1896-, 1904-37. Spent WWII in a German prison camp. **Sources:** WW53; WW47; P&H

Samuels, 539.

WRIGHT, Almira Kidder *[Amateur painter in watercolors on silk]* early 19th c.
Addresses: Vermont, early in the 19th century. **Sources:** G&W; Lipman and Winchester, 182.

WRIGHT, Ambrose *[Engraver]* b.c.1838, Connecticut.
Addresses: NYC in June 1860. **Sources:** G&W; 8 Census 1860), N.Y., XLIV, 727.

WRIGHT, Angie Weaver (Mrs.) *[Portrait painter, designer, decorator, teacher, lecturer]* b.1890, Leesburg, OH.
Addresses: Honolulu, HI. **Studied:** Corcoran School. **Member:** Soc. Wash. Artists; Columbus AL; Hudson Highlands AA; Honolulu AA; Am. Lg. Pen Women. **Work:** dec., Cadet Gymnasium, U.S. Military Acad.; stage settings, West Point Players, 1935-37. **Comments:** Position: teacher, YWCA, Honolulu. **Sources:** WW40.

WRIGHT, Annie See: **ROGERS, Annah Barkeley Wright (Mrs. Philip)**

WRIGHT, Barton Allen *[Painter, illustrator]* b.1920, Bisbee, AZ.
Addresses: Flagstaff, AZ. **Exhibited:** First Regional Art Exhib, Phoenix, AZ, 1967; Calif. Centennial Exhib, San Diego, 1969; La Jolla AA, 1969; Festival of Arts, Lake Oswego, 1971. **Work:** Commissions: display, Wupatki Nat. Monument, Flagstaff, 1962. **Comments:** Preferred media: scratchboard, acrylics. Positions: curator arts & exhibs., Mus. Northern Arizona, 1955-58, mus. curator, 1958-. Publications: illustrator, *San Caetano del Tumacacori*, 1955, *Throw Stone*, 1961 & *Little Cloud*, 1962; author, *This is a Hopi Kachina*, 1964 & illustrator, *Dinosaurs of Northern Arizona*, 1968, Mus. Nothern Arizona. Collections arranged: M. R. F. Colton, 1958; G. E. Burr, 1959; Indian Artists, 1960; Western Artists, 1962; Paul Dyck, 1964; Am. Art, 1965; Flagstaff Art 1966; Southwest Art, 1968; Widforss, 1969; Santa Fe Indian Art, 1970; Nat. Park Illusr., 1971; N. Fechin, 1972. **Sources:** WW73.

WRIGHT, Bernard *[Painter, sculptor]* b.1928, Pittsburgh, PA.
Studied: self-taught. **Exhibited:** Los Angeles area; "Graphics of American Negro Artists Exhibit," Soviet Union. **Sources:** Cederholm, *Afro-American Artists*.

WRIGHT, Bertha Eugenie Stevens (Mrs. Lawrence W.) *[Painter]* 20th c.; b.Astoria, LI, NY.
Addresses: Merrick, NY, 1920s-30s. **Studied:** self-taught. **Member:** AAPL; Soc. Indep. Artists. **Exhibited:** Salons of Am. **Sources:** WW40.

WRIGHT, C. K. (Mrs.) *[Artist]* early 20th c.
Addresses: Active in Los Angeles, 1905-13. **Sources:** Petteys, *Dictionary of Women Artists*.

WRIGHT, Cameron See: **WRIGHT, (Philip) Cameron**

WRIGHT, Catharine Wharton Morris (Mrs.) *[Painter, writer]* b.1899, Phila. / d.1988.
Addresses: Phila., Glenside, Wyncote, PA; Jamestown, RI. **Studied:** Phila. School Design Women, 1917-18; Henry B. Snell; Leopold Seyffert. **Member:** AWCS; Audubon Artists; Balt. WCC; Wash. WCC; All. Artists Am; Phila. WCC (vice-pres., 1949-57); Phila. SMP; CAFA; Phila. Art All.; Newport AA; ANA; NAD; Authors Lg. Am.; NYWCC. **Exhibited:** PAFA Ann., 1920, 1925 (as Morris), 1926-54; Corcoran Gal. biennials, 1921-41 (8 times); NAD, 1930-52; AIC, 1921-42; AWCS; CI; All. Artists Am., 1938-45; Audubon Artists, 1945; Newport AA, 1918-46; Woodmere Art Gal., 1941-46; Phila. Art All., 1918-46; Vose Gals., Boston, MA, 1970s. **Awards:** medals, Springside (PA) Sch., 1937, 1940; prize, Phila. AC, 1924; prize, PAFA, 1933; Second Hallgarten prize, NAD, 1933; prize, Newport AA, 1933; prize, Allied Artists Am., 1941; prize, Silvermine Guild Artists, 1955. **Work:** PAFA; Allentown Mus.; Moore Inst. Des. for Women; PMA; Woodmere Art Gal.; Univ. Pennnsylvania; Pennsylvania State Univ.; NAD. **Comments:** Painted marines, landscapes, por-

traits in oils & watercolors. **Auth.:** *The Simple Nun*, 1929, *Seaweed, Their Pasture*, 1946, *The Color of Life*, 1957; plus prose & verse in national magazines including *Atlantic Monthly*, *Saturday Evening Post*. Teaching: Fox Hill Sch. Art, 1950-70s (founder). **Sources:** WW73; WW47; Falk, *Exh. Record Series*.

WRIGHT, Charles Clifford *[Painter]* 20th c.
Addresses: Seattle, WA, 1944. **Exhibited:** SAM, 1945; WMAA, 1948. **Sources:** Trip and Cook, *Washington State Art and Artists*, 1850-1950.

WRIGHT, Charles Cushing (Mrs.) See: **WRIGHT, Lavinia Dorothy Simons (Mrs. Charles Cushing)**

WRIGHT, Charles Cushing *[Medallist and engraver]* b.1796, Damariscotta, ME / d.1854, NYC.
Member: NA (founder). **Exhibited:** NAD; American Art-Union. **Comments:** He took up engraving while working for a silversmith in Utica (NY) about 1817 and worked briefly in Albany and NYC before going to Savannah (GA) in 1819. In 1820, after losing all his possessions in the great fire at Savannah, he moved to Charleston (SC) where he remained for four years. In Charleston he married Lavinia Dorothy Simons (see Lavinia Dorothy Wright). In 1823 he moved to NYC where he spent the rest of his life. Though best known as a medalist, he was also a member of the following engraving firms: Durand & Wright (1826-27), Bale & Wright (1829-33), and Wright & Prentiss (1835-38) (see entries). His son, Charles Washington Wright (see entry), also became an engraver. **Sources:** G&W; A manuscript biography of Charles Cushing and Lavinia Dorothy Wright by their great-grandson, Charles Lennox Wright II is at the NYHS. See also: Loubat, *Medallic History of the U.S.*; Stauffer; Cummings, *Historic Annals of the NAD*, 262; Dunlap, *History*; Cowdrey, NAD; Cowdrey, AA & AAU; NYCD 1826-53; Rutledge, *Artists in the Life of Charleston*.

WRIGHT, Charles H. (Mr. C.H.) b.1870, Knightstown, IN / d.1939.
Addresses: NYC. **Studied:** ASL. **Member:** SI, 1914; SC; NYWCC; New Rochelle AA. **Exhibited:** AIC, 1911-12, 1916, 1918; S. Indp. A., 1918, 1920-21. **Sources:** WW40.

WRIGHT, Charles J. *[Artist]* late 19th c.
Addresses: Yonkers, NY, 1872; NYC, 1886. **Exhibited:** NAD, 1872, 1886. **Sources:** Naylor, *NAD*.

WRIGHT, Charles Lennox *[Painter, illustrator, teacher]* b.1876, Boston, MA.
Addresses: Bayside, NY/West Rockaway, NY. *Charles L. Wright Jr 1891*
Studied: ASL; Académie Julian, Paris, 1896; Dagnan-Bouveret and Merson, in Paris. **Exhibited:** Paris Salon, 1896. **Sources:** WW25; Fink, *American Art at the Nineteenth-Century Paris Salons*, 408.

WRIGHT, Charles Washington *[Medallist and wood engraver]* b.1824, Washington, DC / d.1869, NYC.
Addresses: NYC, c.1844-69. **Comments:** Son of Charles Cushing and Lavinia Dorothy Wright (see entries). He was active as an engraver in NYC and did work for *Harper's* and *Frank Leslie's Illustrated Weekly*. His son, Charles Lennox Wright I (1852-1901) (see entry)became an engraver and was the pioneer of zinc etching, and his grandson was also an artist. **Sources:** G&W; Wright, "The Pioneer of Zinc Etching," 201; Wright, "Charles Cushing Wright--Lavina Dorothy Wright," 152; Am. Inst. Cat., 1844.

WRIGHT, Chauncy *[Wood engraver]* b.c.1834, Connecticut.
Addresses: NYC in 1860. **Sources:** G&W; 8 Census (1860), N.Y., XLIII, 51.

WRIGHT, Chester *[Illustrator]* 20th c.
Addresses: NYC. **Sources:** WW19.

WRIGHT, Christina *[Painter]* b.c.1886, U.S.? / d.1917, NYC.
Comments: Drowned in the North River. **Sources:** Petteys, *Dictionary of Women Artists*.

WRIGHT, Cora Bernice *[Painter] b.1868, Martinez, CA / d.1948, Eureka, CA.*
Addresses: Eureka, CA. **Studied:** with Manuel Valencia.
Exhibited: PPE, 1915; GGE, 1939. **Sources:** Hughes, *Artists of California,* 620.

WRIGHT, Cornelia E. *[Painter] 20th c.*
Exhibited: WMAA, 1922. **Sources:** Falk, *WMAA.*

WRIGHT, Daisy Thayer *[Painter] 20th c.; b.Providence, RI.*
Studied: with Amy T. Dalrymple, John F. Carlson, Jerry Farnsworth, Anthony Thieme, Jane Freeman, Emile Gruppe.
Member: Rockport AA; North Shore AA; Yonkers Mus.; Scarsdale AA; Hudson Valley AA. **Exhibited:** National AC, NYC; Ogunquit AC; Contemporary Club, White Plains; White Plains County Center. **Sources:** *Artists of the Rockport Art Association* (1946, 1956).

WRIGHT, Dimitri *[Painter] b.1958, Newark, NJ.*
Studied: Newark School of Fine & Industrial Arts; Brooklyn Mus.; CUA School. **Exhibited:** Newark Mus., 1969, 1971, 1972; Brooklyn Mus., Little Gallery, 1971; Blum Gallery, 1971; Gallery 9 (prize); Fairleigh Dickinson Univ. (1st prize); Millowbrook Mill Art Show (1st prize, graphics). Other awards: Max Beckman Memorial Scholarship. **Work:** Newark Mus.; Newark Lib.; Urban Life Center, Columbia, MD. **Sources:** Cederholm, *Afro-American Artists.*

WRIGHT, Edna D. *[Painter] 20th c.*
Addresses: Norfolk, VA. **Studied:** PAFA, 1936,1937 (Cresson traveling scholarship). **Sources:** WW40.

WRIGHT, Edna Lowe *[Miniature painter] d.20.*
Addresses: San Francisco, CA. **Exhibited:** Mark Hopkins Inst., 1904-05. **Sources:** Hughes, *Artists of California,* 620.

WRIGHT, Edward *[Wood engraver] mid 19th c.*
Addresses: Boston, 1835-53. **Comments:** During most of this time he was connected with the firm of Chandler, Wright & Mallory and its successor Wright & Mallory (see entries).
Sources: G&W; Boston CD 1835-53; Hamilton, *Early American Book Illustrators and Wood Engravers,* 171, 192.

WRIGHT, Edward Harland *[Portrait painter] mid 19th c.*
Addresses: Norwich, CT, 1850. **Sources:** G&W; Lipman and Winchester, 182.

WRIGHT, Elizabeth *[Wax modeler] b.c.1750, Bordentown, NJ / d.London, England.*
Addresses: NYC, 1772. **Comments:** The eldest daughter of Patience Lovell Wright (see entry). After 1772 she followed her mother to London and took up wax work. She married Ebenezer Platt and lived in London until her death. Her younger brother Joseph Wright (see entry) was a noted portrait painter and one of her sisters, Phebe, married the English artist John Hoppner.
Sources: G&W; Perrine, *The Wright Family of Oyster Bay,* 89-92.

WRIGHT, Elva M. *[Painter, teacher] b.1886, New Haven, CT.*
Addresses: Long Branch, NJ. **Studied:** Columbia Univ.; ASL; H. L. McFee; Y. Kuniyoshi. **Member:** NAWA; AAPL; Asbury Park Soc. FA. **Exhibited:** AAPL, 1937-52; Asbury Park Soc. FA, 1935-52; Newark Mus., 1938; WFNY 1939; ASL, 1950; State House, Trenton, NJ, 1951; Montclair Art Mus., 1953; NAC, 1954, 1955; NAWA, 1933, 1939, 1941-46, 1955; Old Mill Annual, Tinton Falls, NJ, 1953, 1954. Awards: prizes, New Jersey Art Gal., Newark, 1938, 1940; Asbury Park Soc. FA, 1939, 1942-44; AAPL, 1942, 1950, 1951, 1952, 1953; Deal, NJ, 1954, 1955.
Sources: WW59; WW47.

WRIGHT, Emma R. *[Painter] 19th/20th c.*
Addresses: NYC, 1886-92; New Haven, CT. **Member:** New Haven PCC. **Exhibited:** NAD, 1884-92; Boston AC, 1891-96; New Haven PCC, 1900 (charter exh.). **Comments:** Among her works are "Gloucester Harbor" and "A Lifting Fog" (both 1900).
Sources: WW25.

WRIGHT, F. E. *[Portrait painter] b.1849, South Weymouth, MA / d.1891.*
Addresses: Boston, MA, 1879-80. **Studied:** Académie Julian, Paris with Chapu, Boulanger, and Lefebvre; also with Bonnât in Paris. **Exhibited:** Boston AC, 1873-81; NAD, 1879-80. **Sources:** Fehrer, The Julian Academy; *The Boston AC.*

WRIGHT, F. Harriman *[Painter] 20th c.*
Addresses: NYC. **Exhibited:** Salons of Am.; S. Indp. A., 1917.
Sources: WW24.

WRIGHT, Frances Pepper *[Painter, graphic artist] b.1915, Philadelphia, PA.*
Addresses: Phila./Kittery Point, ME. **Studied:** PAFA; J. J. Capolino. **Member:** Plastic Club, Phila. **Exhibited:** PAFA, 1937.
Sources: WW40.

WRIGHT, Frances R. *[Painter] mid 20th c.*
Addresses: Homestead, PA. **Exhibited:** Corcoran Gal biennial, 1941. **Sources:** Falk, *Corcoran Gal.*

WRIGHT, Frank *[Painter, printmaker] b.1932, Wash., DC.*
Addresses: Chevy Chase, MD. **Studied:** American Univ., B.A., 1954; Univ. Illinois, Urbana, M.A., 1957; Fogg Mus., Harvard Univ., 1960-61 (fellowship). **Exhibited:** Watkins Gallery, Washington, DC, 1959 (solo); Mickelson Gallery, Washington, DC, 1965 (solo); Galeria Nice, Buenos Aires, Argentina, 1965 ; Atelier 17 et Son Maitre S. W. Hayter, Bibliothèque Nat., 1966; Gallery Marc, Washington, DC, 1971 (solo).Awards: Nat. Soc. Arts & Letters scholarship, 1950-54; Leopold Schepp Foundation fellowship for European studies, 1956-58; Paul J. Sachs fellowship in graphic arts, Print Council Am., 1959-62. **Work:** Bibliothèque Nat., Paris, France; Nat. Collection Fine Arts, Washington, DC; Univ. Seattle Law School. Commissions: deep-bite etching demonstration plate & ed., Lessing J. Rosenwald, Jenkintown, PA, 1968. **Comments:** Preferred media: oils, graphics. Teaching: instructor, master drawing, Corcoran School Art, Washington, DC, 1966-70; asst. professor design & graphics, George Washington Univ., 1970-. **Sources:** WW73; Rafael Squirru, "Washington Mannerists or the Foresight to Look Backward," *Americas* (Jan., 1957).

WRIGHT, Frank Cookman *[Painter, instructor] b.1904, Cincinnati, OH.*
Addresses: NYC. **Studied:** Yale Univ., A.B., with Sydney Dickenson & Eugene Soragu; Grand Central School Art, with Edmund Graecen; NAD School, with Dean Cornwell; also with Dimitry Romanovsky. **Member:** AAPL (pres., 1967-); Council Am. Artist Soc. (pres., 1968-); Hudson Valley AA (pres., 1931-37; director); Am. Inst. Fine Arts (fellow); Copley Soc. Boston. **Exhibited:** Macbeth Galleries, 1935; solo shows: Copley Soc. Boston; Newport AA; AAPL Grand Nat.; Hudson Valley AA. Awards: first prize for portraits, Hudson Valley AA, 1935; hon. mention for oil landscapes, AAPL, 1962. **Work:** Hammond Mus., North Salem, NY; Tarrytown (NY) Public Library; also in private collections in 42 states & 16 countries. Commissions: Gateway Arch--Saint Louis, Nat. Marine Service, 1966. **Comments:** Preferred media: oils, acrylics. Positions: editor, *News Bulletin,* 1959-. Publications: contributor of many editorials, articles & reviews. Teaching: private instructor; lecturer & demonstrator, radio & TV programs. **Sources:** WW73.

WRIGHT, Frank Lloyd *[Architect, designer] b.1869, Richland Center, WI / d.1959.*
Comments: Internationally influential for his "Prairie Houses,' built 1900-10, which were analogous to cubism in painting. His domestic architecture also reflected the influence of Japan and Meso-America. He designed the total living environment, including furniture and stained glass.

WRIGHT, Fred William *[Portrait painter] b.1880, Crawfordsville, IN.*
Addresses: NYC/Cambridge, MD; St. Petersburg Beach, FL.

Studied: John Herron AI; ASL; CUA School; and Académie Julian, P. Marcel-Baronneau, both in Paris; J. 0. Adams; ASL; R. Reid, NYC. **Member:** SC. **Work:** State Capitol and Law Sch., Albany, NY; State Capitol, Annapolis, MD; Union, Catholic, and Nat. Democratic Clubs, NYC; New York County Lawyers' Assn., Haverstraw, NY; Law School, Albany, NY; Waldorf Astoria Hotel; Libby Owens Bd. Room, Toledo, OH; Hill Reference Lib., St. Paul, MN; College Indust. Art, Denton, TX; DuPont, Wilmington, DE; Dun and Bradstreet; Univ. Delaware; Columbia Univ.; Brown Univ.; Harvard Univ.; CM; Haverstraw (NY) Hospital; College of Surgeons, Chicago. **Sources:** WW59; WW40.

WRIGHT, Fredda Burwell (Mrs. William) *[Painter, sculptor, teacher]* *b.1904, Orleans, NE.*
Addresses: Topeka, KS. **Studied:** ASL; M. Huntoon; L. T Hull. **Exhibited:** Women Painters Am., Wichita AM; Midwestern Artists Ann., Kansas City AI. **Comments:** WPA artist. Position: teacher, Topeka Community AC. **Sources:** WW40.

WRIGHT, Frederick *[Painter]* *late 19th c.; b.Boston, MA.*
Studied: With Bonnat. **Exhibited:** Paris Salon, 1887. **Sources:** Fink, *American Art at the Nineteenth-Century Paris Salons,* 408.

WRIGHT, Frederick William *[Etcher, painter, craftsperson]* *b.1867, Napanee, Ontario, Canada / d.1946, Freeport, LI, NY.*
Addresses: Freeport, NY. **Studied:** Montreal AA; Académie Julian, Paris with J.P. Laurens, 1906, 1909. **Member:** SAE; Nassau County AL; Indiana Soc. Printmakers; Soc. Indep. Artists; Salons of Am. **Exhibited:** Soc. Indep. Artists, 1921-22, 1924-25. **Sources:** WW40.

WRIGHT, G. Alan *[Sculptor]* *b.1927, Seattle, WA.*
Addresses: Renton, WA. **Studied:** Honolulu School Art; also with Willson Stamper & Ralston Crawford. **Exhibited:** Northwest Ann. Show, Seattle Art Mus., 1962-65; Gov. Invitational Exhib., Washington, 1967; Sara Roby Gallery, Racine, WI, 1968; WMAA, 1968; Lee Nordness Gallery, New York, 1968 & 1969. Awards: First prizes, Renton Art Festival, 1962 & 1964; first prize, New Arts & Crafts Fair, Bellevue, WA, 1963; Ford Foundation Purchase Award, 1964. **Work:** Johnson Wax Collection; Seattle Art Mus.; Denver Art Mus. Commissions: The Great Gull in Bronze, D. E. Skinner, Seattle Science Pavillion, World's Fair, 1962; bronze lion cub, First Nat. Bank, Spokane, WA, 1963; bronze owl, City Hall, Renton, WA, 1968; bronze crane, Seattle First Nat. Bank, 1969; crane, First Nat. Bank, Tacoma, WA, 1969. **Comments:** Preferred media: bronze, stone. Positions: serigraph artists, Honolulu Acad. Arts, Hawaii; board directors & founding member, Allied Art, Renton, 1962-964; pres., Renton Art Festival, 1962-64; commissioner, Mayor's Art Commission, Renton, 1962-65. **Sources:** WW73; article, *Christian Science Monitor,* 1962 & 1964; J. Canaday, article, *New York Times,* 1968; M. Randlett, *Living Artists of the Pacific Northwest* (1972).

WRIGHT, George *[Genre and seascape painter]* *late 19th c.*
Addresses: Phila., PA. **Exhibited:** PAFA Ann., 1876-83 (genre and seascapes); NAD, 1882-94 (genre scenes). **Comments:** There has been some confusion between three Philadelphia artists with the name of George Wright. These include George Hand Wright (1871-1952, see entry), George Wright (portrait painter, see entry) and the George Wright who exhibited genre and seascape paintings between 1876-94. He lived at these Philadelphia addresses: 1334 Chestnut St in 1879-80 (see Falk, PA, Vol. 2) and 1520 Chestnut St. in 1882-94 (Naylor, NAD). **Sources:** Falk, PA, Vol. 2 ; Naylor, NAD.

WRIGHT, George *[Portrait painter]* *mid 19th c.*
Addresses: Phila. **Comments:** Listed in Groce & Wallace as active 1854-60, based on Census of 1860. There was another George Wright (see entry) of Philadelphia who exhibited genre paintings, 1872-94, in Philadelphia and New York. It does not seem likely that they are the same person, but they may have been related. In addition, there was artist George Hand Wright (1872-1951), also of Philadelphia, who was probably a relative. **Sources:** G&W.

WRIGHT, George *[Sculptor]* *20th c.*
Exhibited: Rockford (IL) College, 1965; Walker AC, Minneapolis; Minneapolis IA; Mus. Contemporary Crafts, NY. **Sources:** Cederholm, *Afro-American Artists.*

WRIGHT, George Frederick *[Portrait painter]* *b.1828, Washington, CT / d.1881, Hartford, CT.*
Addresses: Hartford. **Studied:** NAD, c.1848; Baden, Germany and Rome, Italy, c.1857-59. **Exhibited:** NAD, 1851-59; Brooklyn AA, 1882. **Comments:** After taking up painting professionally, he settled in Wallingford (CT) and was custodian of the Wadsworth Athenaeum Gallery at Hartford for a short time. He studied at the NAD in NYC about 1847 but returned to Hartford one year later. About 1857 he went abroad for two years, studying in Baden and Rome. In September, 1860, after returning from a study trip to Europe, he went to Springfield (IL) to paint the portrait of the Republican nominee for the presidency, Abraham Lincoln. He painted a second portrait of Lincoln at Washington later that year. Wright also worked in the South, but most of his time was spent in Hartford. **Sources:** G&W; French, *Art and Artists in Connecticut,* 137; Wilson, *Lincoln in Portraiture;* New England BD 1849; Hartford BD 1851, CD 1855; Cowdrey, NAD; Met. Mus., *Life in America; Antiques* (Feb. 1948), 93, repro.; *Mag. of Art* (Feb. 1948), 71, repro. More recently, see Gerdts, *Art Across America,* vol. 1: 105, 106, 107.

WRIGHT, George Hand *[Graphic artist, illustrator, etcher, painter]* *b.1872, Fox Chase, Phila., PA / d.1951, Westport, CT.*
Addresses: Westport, CT (1907-on). **Studied:** Spring Garden Inst.; PAFA. **Member:** NA, 1939; SC; SAE; Westport AA; SI, 1901; Dutch Treat Club. **Exhibited:** NAD; LOC; AIC; CI; SC; Grand Central Art Gal.; Harlow Gal.; Ferargil Gal.; Westport AA, 1912. **Comments:** Early in his career he was in NYC, illustrating for *Harper's, Century, Scribner's,* and *Saturday Evening Post.* He attracted a number of artists to live in Westport, CT, which became a colony for artists and illustrators. Not to be confused with the genre painter, George Wright, of Phila. (exhibited 1876-94, see entry). **Sources:** WW47; Gerdts, *Art Across America,* vol. 1: 129; *Community of Artists,* 11-14.

WRIGHT, Gladys Yoakum *[Painter]* *20th c.*
Addresses: Fort Worth, TX. **Sources:** WW19.

WRIGHT, Grace Latimer *[Painter]* *early 20th c.*
Addresses: Brooklyn, NY. **Studied:** ASL. **Exhibited:** PAFA Ann., 1913; S. Indp. A., 1917; Corcoran Gal biennial, 1928. **Sources:** WW15; Falk, *Exh. Record Series.*

WRIGHT, Grant *[Painter, illustrator]* *b.1865, Decatur, MI / d.1935.*
Addresses: Weehawken, NJ. **Studied:** NAD; E. Ward. **Member:** Bronx Artists Gld. (founder); NJ Art Group. **Work:** Mus. City NY. **Comments:** Illustrated: "Yazzo Valley Tales," by E.E Younger. **Sources:** WW33.

WRIGHT, H. B. *[Painter]* *20th c.*
Addresses: Portville, NY. **Sources:** WW08.

WRIGHT, H. E. (Mrs.) *[Artist]* *early 20th c.*
Addresses: Active in Los Angeles, 1884-88, 1902. **Sources:** Petteys, *Dictionary of Women Artists.*

WRIGHT, Hattie Leonard (Mrs.) *[Portrait painter]* *b.c.1860.*
Addresses: Iowa; San Diego, CA. **Studied:** Fort Wayne, IN; Adrian, MI with Eldridge, a portrait artist. **Exhibited:** Iowa County Fairs; Iowa Art Salon, 1927-34. **Work:** Fort Wayne (IN) Historical Mus.; Fort Dodge (IA) Historical Mus. **Comments:** Also a poet and writer; contributed to local Indiana and Iowa papers; also *Harper's Weekly, Ladies Home Journal, Union Signal, Children's Activities.* **Sources:** Ness & Orwig, *Iowa Artists of the First Hundred Years,* 226.

WRIGHT, Helen *[Librarian, writer] b.Columbus, OH / d.1935.*
Addresses: Wash., DC. **Member:** Ohio State Archaeological Soc.; Arts Club, Archaeological Soc., Literary Soc., AFA, all in Wash., DC. **Comments:** Author: biographical sketches of artists in the "Dictionary of American Biography." Contributor: *American Art News.* Position: staff, LOC, for 30 years.

WRIGHT, Helen Elizabeth See: **ROWE, Helen Wright (Mrs. H. R.)**

WRIGHT, (Helen) Jeannette *[Painter and sculptor] b.1901, Marshalltown, IA.*
Addresses: Waverly, IA. **Studied:** AIC, 1923; studied oil painting with William Owen, medeling with Mr. Meserindino and pencil sketching in 1926 with Everett Watson in the Berkshires; traveled in Europe, 1928-30. **Member:** Iowa Artists Club. **Exhibited:** Little Gallery, Cedar Rapids, IA; Iowa Artists club, 1933, 1934, 1935, 1936; All Iowa Exhibition, Carson Pirie Scott, Chicago, 1937. **Comments:** Position: art instructor, Wartburg College. **Sources:** Ness & Orwig, *Iowa Artists of the First Hundred Years,* 227.

WRIGHT, Hortense *[Painter in pastel] late 18th c.*
Addresses: Active in Bordentown, NJ, 1798. **Sources:** Petteys, *Dictionary of Women Artists.*

WRIGHT, J. (or I.) Dunbar *[Painter] b.1862 / d.1917, Port Jervis, NY.*
Addresses: NYC. **Member:** SC. **Exhibited:** Corcoran Gal biennial, 1910; AIC, 1910; PAFA Ann., 1911; S. Indp. A., 1917. **Sources:** WW15; Falk, *Exh. Record Series.*

WRIGHT, James *[Painter] 20th c.*
Addresses: NYC. **Sources:** WW17.

WRIGHT, James *[Banknote engraver] mid 19th c.*
Comments: With the firm of Danforth, Wright & Company, NYC, 1853-59. In 1857 his home was in Orange (NJ). **Sources:** G&W; NYCD 1853-59.

WRIGHT, James Couper *[Painter, teacher, lecturer, designer, craftsperson] b.1906, Kirkwall, Orkney Islands, Scotland / d.1969, Los Angeles.*
Addresses: Los Angeles; Pasadena, CA. **Studied:** Edinburgh College Art, Scotland, D.A.; Mills College, Oakland, CA; Germany; France; Austria; London; England. **Member:** California WC Soc.; Pasadena Soc. Art; AWS; Los Angeles AA; AFA. **Exhibited:** nationally & with numerous solo exhibs: AIC, 1936-38; Phila. WCC, 1936-38; California WCS, 1931 (prize), 1932-46 (prize, 1937); Ebell Club, Los Angeles, 1933; SFMA, 1935; LACMA, 1936; GGE, 1939; Pottinger Gallery, Pasadena, 1939; San Fran. AA, 1937-44; Oakland Art Gal., 1938-45, 1942 (prize); San Diego FA Soc., 1934 (prize); Denver, 1941 (prize); Santa Cruz, 1944; Los Angeles AA, 1934 (prize); California State Fair, 1935 (prize), 1936 (prize); 48 awards for watercolors. **Work:** SFMA; Oakland Art Mus.; Santa Barbara Mus. Art; LACMA; Pasadena Art Mus.; San Diego FA Gal.; Int. Exhib. Hygiene, Dresden, Germany, 1930. **Comments:** Position: teacher, Univ. Georgia, 1939-41; instructor, Pasadena City College; summer at Los Angeles Harbor. Specialty: stained glass. **Sources:** WW66.

WRIGHT, James D. *[Portrait painter] mid 19th c.*
Addresses: Xenia, OH, active 1840; Terre Haute, IN, 1860, 1868; Zionsville, IN, c.1860. **Exhibited:** Indiana State Fair, 1857. **Sources:** G&W; Peat, *Pioneer Painters of Indiana,* 42; Indiana BD 1860. Hageman, 124.

WRIGHT, James Henry *[Still life, landscape, marine, and portrait painter] b.1813, New York / d.1883, Brooklyn, NY.*
Addresses: New Orleans, 1836; in and around NYC, 1842-on. **Exhibited:** NAD, 1842-71; Brooklyn AA, 1863, 1869, 1877, 1879; American Art-Union. **Comments:** The earliest notice of his activity was at New Orleans in July 1836. **Sources:** G&W; D'Otrange, "James H. Wright, 19th Century New York Painter," one repro.; Smith; Delgado-WPA cites *Bee,* July 6, 1836; 8 Census (1860), N.Y., XLIX, 984; Cowdrey, NAD; Cowdrey, AA

& AAU; *Art Digest* (Sept. 1945), 12.

WRIGHT, Jeannette See: **WRIGHT, (Helen) Jeannette**

WRIGHT, Jennie E. (Mrs.) *[Painter] 19th/20th c.*
Addresses: Phila., PA; Portland, OR. **Exhibited:** PAFA Ann., 1889. **Comments:** Painted mountain scenery and Mt. Hood. **Sources:** WW04; Petteys, *Dictionary of Women Artists;* Falk, *Exh. Record Series.*

WRIGHT, John *[Engraver] b.c.1818, New York.*
Addresses: NYC in 1860. **Sources:** G&W; 8 Census (1860), N.Y., L. 183.

WRIGHT, John *[Painter] 20th c.*
Addresses: London, England. **Member:** Concord AA. **Sources:** WW27.

WRIGHT, John H. *[Painter] mid 20th c.*
Addresses: Philadelphia, PA. **Exhibited:** PAFA Ann., 1941, 1943; Corcoran Gal biennial, 1941. **Sources:** Falk, *Exh. Record Series.*

WRIGHT, Joseph *[Portrait painter, modeler in clay and wax, medallist, die sinker and etcher] b.1756, Bordentown, NJ / d.1793, Philadelphia.*
Addresses: Philadelphia, 1783-86; NYC, 1786-90, Phila., 1790-93. **Studied:** learned to model in wax with his mother Patience Lovell Wright; painting under Benjamin West and Wright's brother-in-law John Hoppner, London. **Exhibited:** Royal Academy, 1780, 1782. **Work:** Pa. Hist. Soc.; PAFA; Md. Hist. Soc.; Cleveland Mus; Winterthur (DE) Mus. owns a bas-relief portrait of Washington. **Comments:** Son of Joseph and Patience Lovell Wright (see entry). Moved to NYC after his father's death in 1769. When his mother traveled to England in 1772, Joseph and his sisters remained in America, later joining her in London where he studied art with his mother, and with Benjamin West and John Hoppner. He visited Paris in 1782, returning to America in 1783 and settling in Philadelphia. Wright is best known for his portraits of Washington, one of which he painted at Princeton. Of his Washington portraits, there are two main types: a three-quarter length bust (Md. Hist. Soc. and Pa. Hist. Soc.) and a profile bust of c.1790 (example in the Cleveland Mus.). He also modeled a clay bust of Washington. In 1792 he became a designer and die sinker for the U.S. Mint, designing medals and coins. He died in Phila. during the yellow fever epidemic of 1793. **Sources:** G&W; DAB; Kimball, "Joseph Wright and His Portraits of Washington," ten repros.; Perrine, *The Wright Family of Oyster Bay,* 89-92; Loubat, *Medallic History of the U.S.,* pl. 6; Dunlap, *History;* Prime, II, 39; Gottesman, II, 60a, 108, 1286; Storer, "The Manly-Washington Medal"; Swan, BA; Rutledge, PA; Graves, *Dictionary;* Morgan and Fielding, *Life Portraits of Washington.* More recently, see Baigell, *Dictionary.*

WRIGHT, Josephine M. *[Miniature painter] early 20th c.*
Addresses: Active in Alhambra, CA. **Exhibited:** PAFA, 1925; Southern Calif. **Sources:** Petteys, *Dictionary of Women Artists.*

WRIGHT, Jud *[Cartoonist] 20th c.*
Addresses: Los Angeles, 1918-41. **Exhibited:** P&S Los Angeles, 1941. **Sources:** WW19; Hughes, *Artists of California,* 621.

WRIGHT, Julia E. See: **MANSON, Julia Elizabeth Wright**

WRIGHT, Julian Chapman *[Painter, teacher] b.1904, Texas / d.1978, Los Angeles.*
Addresses: Los Angeles. **Exhibited:** Artists Fiesta, Los Angeles, 1931. **Sources:** Hughes, *Artists of California,* 621.

WRIGHT, Lavinia Dorothy Simons (Mrs. Charles Cushing) *[Amateur still life and portrait artist] b.1805, Charleston, SC / d.1869, NYC.*
Addresses: NYC. **Comments:** Lavinia Dorothy Simons was married to the engraver Charles Cushing Wright (see entry) at Charleston in 1820 and spent most of her life in NYC. She became an educator and pioneer advocate of women's rights. **Sources:** G&W; Wright, "Charles Cushing Wright--Lavinia

Dorothy Wright," manuscript biography at NYHS.

WRIGHT, Lawrence (Mrs.) *[Painter] 20th c.*
Addresses: Lawrence, LI, NY. **Exhibited:** S. Indp. A., 1919-22, 1925, 1927, 1934; Salons of Am., 1925. **Sources:** Falk, *Exhibition Record Series.*

WRIGHT, Leon *[Painter] mid 20th c.*
Exhibited: American Negro Expo, Chicago, 1940; South Side Community AC, Chicago, 1945. **Sources:** Cederholm, *Afro-American Artists.*

WRIGHT, Louis Booker *[Museum director, historian]*
b.1899, Greenwood, SC.
Addresses: Washington 9, DC. **Studied:** Wofford College, A.B.; Univ. North Carolina, M.A., Ph.D. **Member:** Mod. Language Assn.; Am. Hist. Assn.; Am. Antiquarian Soc.; Am. Philosophical Soc.; Grolier Cl.; Colonial Soc. Massachusetts; Mass. Hist. Soc. **Exhibited:** Award: Guggenheim Fellowship, 1928-29, 1930. **Comments:** Positions: professor, Am. history, bibliography, research methods, Univ. North Carolina, Emory Univ., Univ. Michigan, Univ. Washington, UCLA, and others; member, permanent research group & chmn., committee on fellowships, Huntington Lib., 1932-48; director, Folger Shakespeare Library, Washington, DC, as of 1966. Author: "Middle-Class Culture in Elizabethan England," 1935; "The First Gentlemen of Virginia," 1940; "Culture on the Moving Frontier," 1953; "The Cultural Life of the American Colonies," 1957; "Shakespeare for Everyman," 1964. Contributor to many learned journals. Lectures: British and American colonial history. **Sources:** WW66.

WRIGHT, (M.) Louise Wood (Mrs. John) *[Painter, illustrator, teacher] b.1875, Phila.*
Addresses: London, England. **Studied:** PAFA; Académie Julian, Paris; also with Whistler in Paris; F. W. Jackson in England. **Member:** Phila. WCC; NYWCC; Concord AA. **Exhibited:** PAFA Ann., 1889 (prize)-1905 (6 times); St. Louis Expo, 1904 (medal); Boston AC, 1905; Pan-Pacific Expo, San Francisco, 1915; Beaux Arts Gal. & Royal Acad., London, 1924-30; AIC. **Sources:** WW33; Falk, PAFA, vol. II. which gives the date of her birth as 1865; Petteys, *Dictionary of Women Artists.*

WRIGHT, Margaret *[Painter] b.1885 / d.1958.*
Studied: self-taught; some instruction with W.B. Romeling. **Sources:** *Rediscovery: A Tribute To Otsego County Women Artists,* exh. brochure (Hartwick Foreman Gallery, 1989), 15.

WRIGHT, Margaret Hardon (Mrs. James H.) *[Etcher, illustrator] b.1869, Newton, MA / d.1936, Brookline, MA.*
Addresses: Newton, MA. **Studied:** MIT; Wellesley; W. H. W. Bicknell; Paris, with Merson, Cavaille-Call. **Member:** Chicago SE; Copley Soc.; Boston SE; AAPL. **Exhibited:** Boston AC, 1902-03; PAFA Ann., 1903; Pan-Pacific Expo, San Francisco, 1915. **Work:** NYPL; LOC; M. Carnavalet, Paris; Margaret H. Wright Room, Lipscomb Lib., Randolph-Macon Woman's College, Lynchburg, VA. **Comments:** Specialties. bookplates; etchings; Christmas cards. **Sources:** WW27; Petteys, *Dictionary of Women Artists;* Falk, *Exh. Record Series.*

WRIGHT, Marian Lois *[Painter] late 19th c.*
Addresses: New Haven, CT, 1881; NYC, 1882-83; South Bethlehem, PA, 1884-85; Cambridge, MA. **Studied:** with Muller, Hennessy. **Exhibited:** Paris Salon, 1880; NAD, 1881-85; Brooklyn AA, 1883-84; PAFA Ann., 1883; Boston AC, 1888. **Comments:** Also known as Marian L. Wright Cohn. **Sources:** WW25; Fink, *American Art at the Nineteenth-Century Paris Salons,* 408; Falk, *Exh. Record Series.*

WRIGHT, Marsham E(lwin) *[Painter, craftsperson, block printer] b.1891, Sidcup, Kent, England / d.1970, Seattle, WA.*
Addresses: South Minneapolis, MN. **Studied:** L.A. Henkora; C. Booth; Minneapolis Sch. Art. **Member:** AAPL. **Exhibited:** Minneapolis Inst. Art, 1929 (prize), 1931 (prize); Soc. Indep. Artists, 1929; Minnesota State Fair, 1931 (prize), 1932 (prize). **Sources:** WW40.

WRIGHT, Martha *[Artist] late 19th c.*
Addresses: NYC, 1876. **Exhibited:** NAD, 1876. **Sources:** Naylor, *NAD.*

WRIGHT, Mary Catherine *[Painter] 19th/20th c.*
Addresses: NYC. **Sources:** WW01.

WRIGHT, Mildred G. *[Painter] b.1888, New Haven, CT.*
Addresses: Long Branch, NJ. **Studied:** Cape Ann Art Sch.; Woodstock Sch. Painting; & with Charles Rosen, Judson Smith, & others. **Member:** NAWA; AAPL; Asbury Park Soc. FA. **Exhibited:** NAWA, 1938-46; AAPL, 1939-46; Spring Lake, NJ, 1940-46; Asbury Park Soc. FA, 1938-40; Asbury Park Women's Club, 1940; Long Branch Women's Club, 1939-42; Long Branch Teachers Assn., 1944. Awards: prizes, New Jersey Art Gal., Newark, 1939, 1942. **Sources:** WW53.

WRIGHT, Milton *[Painter] mid 20th c.*
Exhibited: Corcoran Gal biennial, 1951. **Sources:** Falk, *Corcoran Gal.*

WRIGHT, Miriam Noel *[Sculptor, writer] d.1930, Milwaukee, WI.*

WRIGHT, Morris *[Photographer, writer] b.1910, Nebraska.*
Work: MoMA; BMFA; other major collections. **Comments:** Best known as a writer, in 1935 he began to photograph landscapes and interiors that are people-less but suggest their small-town inhabitants. **Sources:** Witkin & London, 197.

WRIGHT, N. H. (Mrs.) *[Painter] late 19th c.*
Addresses: San Francisco; Los Angeles, 1884. **Comments:** Painted flowers & portraits. **Sources:** Petteys, *Dictionary of Women Artists.*

WRIGHT, Nellie B. *[Painter] 19th/20th c.*
Addresses: Portville, NY. **Exhibited:** PAFA Ann., 1896-97; AWCS, 1898. **Sources:** WW01; Falk, *Exh. Record Series.*

WRIGHT, Neziah *[Banknote engraver] b.c.1804, New Hampshire.*
Addresses: NYC. **Comments:** He was with Rawdon, Wright & Company and its successors from 1828 to 1858 and then with the American Bank Note Company (see entries). **Sources:** G&W; NYCD 1828-60; 7 Census (1850), N.Y., LV, 423.

WRIGHT, Nina Kaiden *[Art consultant] b.1931, NYC.*
Addresses: NYC. **Studied:** Emerson College, B.A. **Comments:** Positions: member, nat. advisory council, Mus. Graphic Art, New York; member, art advisory council, New York Boar Trade; consultant to Philip Morris for Two Hundred Years of North American Indian Art & When Attitudes Become Form; consultant to Mead Corp. for European Painters Today; consultant to Am. Motors Co., Gulf & Western Industries, Bristol-Myers, Coca-Cola, J. C. Penney, Capital Res. & others; pres., Ruder & Finn Fine Arts in 1973. **Sources:** WW73.

WRIGHT, Norman B. *[Painter] 20th c.*
Addresses: Chicago, IL. **Exhibited:** AIC, 1937 (prize). **Sources:** WW40.

WRIGHT, Patience Lovell (Mrs.) *[Wax modeler] b.1725, Bordentown, NJ / d.1786, England.*
Addresses: Bordentown, NJ; NYC; London. **Studied:** self-taught (she initially modeled in breaddough). **Work:** "Lord Chatham," Westminster Abbey Mus. (her only surviving work). **Comments:** Patience Lovell, her eight sisters and one brother were the children of a prosperous but fanatically idealistic Quaker farmer in Bordentown (NJ). At twenty she ran away to Philadelphia but in 1748 returned to Bordentown and married Joseph Wright. They had four children: Elizabeth, who became a wax modeler (see entry); Joseph, who became a modeler and painter (see entry); Phoebe, who married the English artist John Hoppner; and Sarah. After her husband's death in 1769, Patience Wright needed to support herself and her children and began modeling small bas-relief portraits in wax. She soon had a thriving business and moved to NYC, where she developed a waxworks show with her sister, Rachel Wells (see entry), also exhibiting the works in Charleston

and Philadelphia. She modeled full-length figures of famous people, painting and clothing the figures and setting them into a tableau. In 1772 Wright went to England in order to open a waxworks museum. It quickly became very popular, as did Wright herself. Her wax busts and figures were much admired and her wax statue of Lord Chatham was placed in Westminster Abbey. An outspoken patriot, Wright acted as a spy for America during the Revolution. She was planning to return to the States to make portraits of George Washington and the nation's new leaders, when she was injured in a fall and died. **Sources:** G&W; Lesley, "Patience Lovell Wright, America's First Sculptor," four repros.; DAB; Hart, "Patience Wright, Modeller in Wax"; Bolton *American Wax Portraits;* Wall, "Wax Portraiture," 5-13. More recently see Ch. Rubinstein, *American Women Artists,* 23-26; Baigell, *Dictionary.*

WRIGHT, Pauline [*Painter, teacher*] *b.1889, Senatobia, MS / d.1983, Baton Rouge, LA.*
Addresses: New Orleans, active 1911-18. **Studied:** Newcomb College, 1911; AIC, 1916. **Exhibited:** NOAA, 1913, 1915-17. **Comments:** Taught art for a year in Jackson, MS after graduating. She returned to Newcomb College to teach until 1918 when she married and moved to Baton Rouge. There she worked as a professional artist privately and in the community. **Sources:** WW17; *Encyclopaedia of New Orleans Artists,* 425-26.

WRIGHT, Persis (Stevens) (Miss) [*Painter*] *20th c.*
Addresses: Merrick, LI, NY. **Exhibited:** Soc. Indep. Artists, 1924; Salons of Am., 1925. **Sources:** Falk, *Exhibition Record Series.*

WRIGHT, (Philip) Cameron [*Illustrator, designer*] *b.1901, Phila.*
Addresses: Jackson Heights, NY. **Studied:** M. Herman; Pratt Inst.; W. de-Leftwich Dodge; G.B. Bridgman; ASL; E. Arcioni, at British Acad. Art, Rome. **Member:** Artists Guild. **Comments:** Illustrator: *Two Fables,* by C. Morley; book jackets, Century Co., Longmans, Green & Co., Bobbs Merrill; covers, *Country Life,* 1925, *Christmas,* 1926; *Plymouth, 1620,* by W. P. Eaton, *Stonewall,* by J. D. Adams, *Lucinda, The Boy Who Had No Birthday,* by M. L. Hunt; children's books, pub. William Morrow, H. C. Kinsey, Harcourt Brace and Co., and Random House, 1937. **Sources:** WW40.

WRIGHT, Redmond Stephens [*Etcher, painter*] *b.1903, Chicago, IL.*
Addresses: NYC; Pasadena 2, CA. **Studied:** Harvard Univ.; AIC, and with Edouard Leon, in Paris. **Member:** SAGA; Chicago Art Club; Société Int. de la Gravure Originale en Noir. **Work:** LOC; mural of Red Cross history presented at Conference to the Japanese Red Cross in Tokyo, 1934. **Comments:** Position: instructor, Pasadena AI; San Gabriel Valley AC, CA. **Sources:** WW53; WW47.

WRIGHT, Robert Murray [*Painter*] *19th/20th c.* ₁₉ R M W₀₁
Sources: Falk, *Dict. of Signatures.*

WRIGHT, Rufus [*Portrait, genre, figure & still life painter, lithographer, teacher*] *b.1832, Cleveland, OH / d.1900.*
Addresses: NYC, 1860; Brooklyn; Washington, DC in 1865; probably in San Francisco, 1880s. **Studied:** NAD and with George Augustus Baker, Jr., in NYC. **Exhibited:** NAD,1862-80; Brooklyn AA, 1865-80. **Work:** Oakland MA; Chicago Hist. Soc. **Comments:** He apparently made a trip West during the 1850s, for in 1859 Sarony, Major & Knapp (see entry) published a view of Davenport (IA) drawn by Wright, and he seems also to have painted a panorama of the Mormons about this time. Position: teacher, Brooklyn Acad. Des., 1866-72. **Sources:** G&W; CAB; *Portfolio* (Oct. 1946), 41; Schick, *Early Theatre in Eastern Iowa,* 270 (G&W has citation courtesy J. Earl Arrington); NYBD 1860; P&H Samuels, 540; McMahan, *Artists of Washington, DC.*

WRIGHT, Russel [*Designer, sculptor, decorator*] *b.1904, Lebanon, OH / d.1976.*
Addresses: NYC. **Studied:** Cincinnati Acad. Art, with Frank Duveneck; ASL, with Kenneth Hayes Miller & Lentelli; Princeton Univ., 1922-24; School Architecture, Columbia Univ., 1923; School Architecture, New York Univ., 1938-39. **Member:** Am. Soc. Indust. Designers (founder/pres., 1952-53); Harlem School Arts (founding member, board directors). **Exhibited:** Focal Food & Fashion Exhibits, WFNY 1939; home furnishings designs exhibited MMA, MoMA, Good Design Show & others in US & Europe. Awards: Tiffany Award for sculpture; two Trail Blazer Awards, 1951; Good Design Awards, MoMA, 1950 & 1953. **Work:** Commissions: styling electrical appliances, merchandising wood & basket products, Japan, 1957-58; design, Dragon Rock (experimental home & arboretum), Garrison-on-Hudson, NY, 1960; designed dinnerware & glassware, Japan, 1964; design, Shun Lee Dynasty (Chinese restaurant), 1966. **Comments:** Wright's modern industrial design for furniture and household objects for easier living is the hallmark of middle-class consumerism in the 1940s-50s. His designs for easier living included furniture, lamps, floor coverings, tableware, wallpaper, textiles, metalware, pianos, radios, and others for leading manufacturers. Positions: stage manager & designer stage production, with Norman Bel Gedes, The Theatre Guild Neighborhood Playhouse & Group Theatre; owner, Russel Wright Assocs., 1954-; consultant in master planning & programming of parks, Nat. Park Service, 1967-; director, Summer in Parks Program, Washington, DC, 1968; consultany on developing handicrafts, Govt. Barbados, 1970. Publications: co-author, "Easier Living," 1951. **Sources:** WW73.

WRIGHT, Ruth S. [*Painter*] *mid 20th c.*
Exhibited: Salons of Am., 1934. **Sources:** Marlor, *Salons of Am.*

WRIGHT, Samuel B. [*Engraver*] *19th/20th c.*
Addresses: Wash., DC, active c.1901-05. **Comments:** Position: staff, Bureau of Engraving and Printing. **Sources:** McMahan, *Artists of Washington, DC.*

WRIGHT, Sarah Jane [*Painter*] *20th c.*
Addresses: Wash., DC, active 1908-35. **Exhibited:** Soc. Wash. Artists; Wash. WCC; Greater Wash. Indep. Exhib., 1935. **Sources:** WW19; McMahan, *Artists of Washington, DC.*

WRIGHT, Sarah Morris See: **GREENE, Sarah Morris**

WRIGHT, Stanley Marc [*Painter, instructor*] *b.1911, Irvington, NJ / d.1996.*
Addresses: Stowe, VT. **Studied:** School Fine Art, Pratt Inst., grad. (highest honors), 1933; Jerry Farnsworth School Art, Tiffany Foundation fellowship, 1935. **Member:** Salmagundi Club; Audubon Artists; Int. Inst. Arts & Letters (life fellow); Northern Vermont Artists (director, 1951); Vermont Council Arts; AAPL; Montclair AA; New Hope AA; Provincetown AA. **Exhibited:** Solos: U.S. Capitol Bldg.; Clarke Gal., Stowe, VT; Fleming MA, Burlington; Wood Art Gal., Montpelier; Montclair (NJ) Mus.; Newark (NJ) AC; Backus Gal., Stowe; Helen Day AC, Stowe; AWCS; NYWCC; Art Center Oranges, NJ; Kresge Gal.; Brooklyn Mus.; Pratt Inst.; NAC; Corcoran; MMA; Grand Central Gal.; NJ State Mus.; Jersey City Mus.; NAD; SC; Phila. Mus. **Work:** Portraits of Gov. Deane C. Davis & Sen. George D. Aiken, State House, Montpelier, VT; Joe Kirkwood, Golf Hall of Fame, Foxberg, PA; George A. Wolf Medical Center, Univ. Kansas; A.G. Mackay, Medical Center, Burlington, VT; Newark (NJ) Mus.; Montclair Mus.; Fleming Mus., Univ. Vermont; U.S. House of Representatives. **Comments:** WPA artist, 1934. Served in U.S. Army and earned Bronze Star, 1942-44. Moved to Stowe, VT in 1949 and opened Wright School Art. Preferred media: oils, watercolors, acrylics. Teaching: head portrait & landscape, Newark Sch. Fine Arts, 1944-50; instructor portrait & landscape & director, Wright School Art, Stowe, VT, 1950-; lecturer, demonstrator & instructor painting, many organizations. **Sources:** WW73; articles in *Cue Magazine, Vermont Life Magazine, Times, Newark News, Free Press* & others. Bibliography: addit. info courtesy Clarke

Galleries, Palm Beach, FL.

WRIGHT, Stanton MacDonald See: **MACDONALD-WRIGHT, Stanton**

WRIGHT, Sylvia B. *[Painter] 20th c.*
Exhibited: AIC, 1939, 1944. **Sources:** Falk, *AIC.*

WRIGHT, Thomas ("Jeff") Jefferson *[Portrait painter]*
b.1798, probably Mount Sterling, KY / d.c.1846, Mount Sterling, KY.
Addresses: Kentucky, early 1830s; Culpeper, VA, 1831-33; Houston, TX (and areas north), from 1837. **Studied:** There is unconfirmed speculation that he studied with Matthew Jouett, in Lexington, KY, and Sully in Phila. (1822). **Work:** Texas State Archives, Austin; Univ. Kentucky Art Mus., Lexington. **Comments:** Active in Kentucky in the early 1830s as a portrait and sign painter and carpenter. Painted portraits in Virginia until 1833. Arrived in Texas about 1837 and painted in the areas around Houston, Huntsville and Nacogdoches for the remainder of his life. He was a leading Texas painter in his day, receiving many commissions through his friendship with Sam Houston (president of the Texas Republic), whom Robertson painted several times. Wright died while in Kentucky for a visit, probably from yellow fever. **Sources:** G&W; Willis, "Jefferson County Portraits and Portrait Painters"; O'Brien, *Art and Artists of Texas* (cited in Barker, *American Painting,* 454); Williams and Barber *Writings of Sam Houston,* II, 190-91, and III, 236. More recently, see Peggy and Harold Samuels, 540; Jones and Weber, *The Kentucky Painter from the Frontier Era to the Great War,* 73 (w/repro.); Gerdts, *Art Across America,* vol. 2: 113.

WRIGHT, W. Lloyd *[Painter] 20th c.*
Addresses: NYC. **Member:** SI. **Sources:** WW31.

WRIGHT, Willard Huntington *[Art critic, writer, aesthetician] b.1888 / d.1939.*
Addresses: NYC. **Comments:** Articulate, confrontational advocate for modern art; produced important early writings on modernist movement. He was the chief organizer of the important "Forum Exhibition of Modern American Painters," held at Anderson Galleries, NYC, 1916. Author: *Modern Painting: Its Tendencies and Meaning* (New York: John Lane Co., 1915); co-author (with his brother, Stanton MacDonald-Wright): *The Creative Will: Studies in the Philosophy and Syntax of Aesthetics* (John Lane Co., 1916); author, *The Future of Painting* (B.W. Huebsch, Inc., 1923); also, author of articles: "The Aesthetic Struggle in America," *Forum* LV (January-June, 1916), and many others. Later created the Philo Vance detective series under the pseudonym S.S. Van Dine. **Sources:** Rose, *Readings in American Art,* 27-30; H. Wayne Morgan, *New Muses: Art in American Culture, 1865-1920,* 152-54, 219-20 (bib); John Loughery, "Charles Caffin and Willard Huntington Wright, Advocates of Modern Art," *Arts* 59 (Jan., 1987): 103-09.

WRIGHT, William *[Painter] 20th c.; b.Pittsburgh, PA.*
Addresses: Pittsburgh. **Member:** Pittsburgh AA. **Sources:** WW21.

WRIGHT, William B. *[Painter] 20th c.*
Addresses: NYC. **Exhibited:** S. Indp. A., 1918. **Sources:** WW15.

WRIGHT, William H. (Mr. & Mrs.) *[Collectors] 20th c.*
Addresses: Los Angeles, CA. **Comments:** Collection: modern paintings & watercolors; Pre-Columbian sculpture, mostly from Colima, Mexico. **Sources:** WW73.

WRIGHT & BALE *[Engravers] mid 19th c.*
Addresses: NYC, 1829-33. **Comments:** Partners were Charles Cushing Wright and James Bale (see entries). **Sources:** G&W; NYCD 1829-33.

WRIGHT & MALLORY *[Wood engravers] mid 19th c.*
Addresses: Boston, 1840-52. **Comments:** Successors to Chandler, Wright & Mallory (see entry). The partners were Edward Wright and Richard P. Mallory (see entries). **Sources:** G&W; Boston CD 1836-51, BD 1841-52.

WRIGHT & PRENTISS *["Xylographic" wood and copper-plate engravers and printers] mid 19th c.*
Addresses: NYC, 1835-38. **Comments:** The partners were Charles Cushing Wright and, probably, Nathaniel Smith Prentiss (see entries). **Sources:** G&W; NYCD 1835-38.

WRIGHTSMAN, Charles Bierer *[Collector] b.1895, Pawnee, OK.*
Addresses: Houston, TX. **Studied:** Stanford Univ., 1914-15; Columbia Univ., 1915-17. **Comments:** Positions: trustee, MMA; chmn., board trustees, Inst. Fine Arts. **Sources:** WW73.

WRIGHTSON, A. *[Landscape painter] mid 19th c.*
Addresses: NYC in 1857. **Exhibited:** NAD, 1857. **Sources:** G&W; Cowdrey, NAD.

WRIGHTSON, Phyllis *[Painter] b.1907, Berkeley, CA.*
Addresses: San Francisco, CA, 1930s; Santa Barbara, CA, since 1961. **Studied:** Univ. Calif., Berkeley; with Frank Fletcher. **Exhibited:** GGE, 1939. **Sources:** Hughes, *Artists in California,* 621.

WRIGLEY, Harry E. *[Sketch artist] mid 19th c.*
Comments: Served as captain in the Topographical Engineers for Union forces during the Civil War. Views of Libby Prison and Richmond, VA, were published in *Harper's Weekly,* 1863.

WRIGLEY, Viola Blackman (Mrs. Roy F.) *[Painter, lithographer] b.1892, Kendallville, IN.*
Addresses: White Plains, NY. **Studied:** Oberlin College; Univ. Kansas; Teachers College, Columbia Univ.; & with Charles Martin; H. B. Snell; Grand Central Art Sch. **Member:** NAWA; Hudson Valley Artists Guild; Pen & Brush Club; Westchester Artists Guild; Chappaqua Guild. **Exhibited:** NAWA; Westchester Art Guild; Toronto, Canada, 1941. **Sources:** WW59; WW47.

WRISTON, Barbara *[Educator, art historian] b.1917, Middletown, CT.*
Addresses: Chicago, IL. **Studied:** Oberlin College, A.B.; Brown Univ., A.M. **Member:** Soc. Arch. Historians (pres., 1960-61); Furniture Hist. Soc.; Victorian Soc. Am.; U.S. Nat. Committee Int. Council Monuments & Sites; Am. Nat. Committee Educ. & Cultural Action, Int. Council Mus. (chmn., 1966-70). **Comments:** Positions: director of music educ., AIC, 1961-. Publications: author, "When Does Architecture Become History," *Inland Architect,* 1962; author, "Who Was the Architect of the Indiana Cotton Mill, 1849-1850?," *Journal Soc. Arch. Historians,* 5/1965; author, "Joiner's Tools in The Art Institute of Chicago," 1967 & "The Howard Van Doren Shaw Memorial Collection in The Art Institute of Chicago," 1969, *Museum Studies;* author, *Visual Arts in Illinois,* 1968. Research: seventeenth and eighteenth century English and American architecture and furniture. **Sources:** WW73.

WRIT, R. W. *[Portrait painter]*
Work: Dartmouth College, Hanover (NH) (oil portrait of Sylvanus Thayer). **Sources:** G&W; WPA (Mass.), *Portraits Found in N.H.,* 22.

WROEBEL, Joseph *[Painter] 20th c.*
Addresses: Chicago area. **Exhibited:** AIC, 1945. **Sources:** Falk, *AIC.*

WU, Ching-Hu *[Painter] 20th c.*
Addresses: China. **Exhibited:** S. Indp. A., 1924. **Sources:** Marlor, *Soc. Indp. Artists.*

WU, (George) Seckwah *[Painter] 20th c.*
Addresses: NYC. **Exhibited:** S. Indp. A., 1929. **Sources:** Marlor, *Soc. Indp. Artists.*

WUERMER, Carl *[Painter, etcher, fine art appraiser]* b.1900, Munich, Germany / d.1983, Woodstock, NY?. *Carl Wuermer*
Addresses: NYC, Woodstock, NY. **Studied:** AIC, 1920-24; W.J. Reynolds; ASL. **Member:** Grand Central Art Gal.; Allied Artists Am.; Artists Fellow (pres., 1957-59); Hudson Valley AA; Springfield AL; Illinois Acad. FA; CAFA; Woodstock AA. **Exhibited:** S. Indp. A., 1924; Anderson Gal., Chicago, 1925 (solo), 1926 (solo); AIC, 1926 (prize), 1927 (prize); PAFA Ann., 1927-29, 1931-35; NAD, 1928 (J. Francis Murphy Mem. prize); Springfield (MA) Art Lg., 1928 (prize); Salons of Am., 1929; Grand Central Art Gal., 1929 (prize), 1930, 1934 (solo), 1938 (solo), 1943 (solo),1945 (prize); O'Brien Art Gal., Chicago, 1931 (solo); Am. Painting & Sculpture; Corcoran Gal biennials, 1928-32 (3 times); Buck Hill Falls (PA) AA, 1943 (prize); Painting In U.S., Carnegie Inst., 1946-49 (Popular Vote Prize); Allied Artists Am. 58th Ann., 1971(hon. men.); Fifth Ann. Painting & Sculpture, Grover M. Hermann Fine AC, Marietta, OH, 1972. **Work:** Amherst College; High Mus. Art, Atlanta, GA; IBM Corp. Art Collection, Endicott, NY; Encycopedial Britannica Collection Am. Art; Royal Globe Ins. Co., London, England; Syracuse Univ. Art Collection, NY. **Comments:** Immigrated to Chicago in 1915. Preferred media: oils. He used a technique similar to French pointillism. Research: for the appraisal of the Frick Collection, New York, High Museum of Art Collection, Eleutherian Mills-Hagley Foundation Collection, Wilmington, DE and others. Woodstock Art Association gives year of death as 1981. **Sources:** WW73; G. Pagano, *The Encyclopedia Britannica Collection of American painting* (1946); WW47; Woodstock AA cites death date of 1981; Falk, *Exh. Record Series.*

WUERNER, Carl See: **WUERMER, Carl**

WUERPEL, Edmund Henry *[Painter, educator, writer, lecturer]* b.1866, St. Louis, MO / d.1958.
Addresses: Clayton 5, St. Louis, MO. **Studied:** Washington Univ., St. Louis; Académie Julian, Paris with Bouguereau, Robert-Fleury, Ferrier, and Doucet, 1889-92; École des Beaux-Arts, Paris; also in Paris with Aman-Jean, Gérôme, and Whistler in Paris. **Member:** Am. Artists Assn., Paris; St. Louis Art Lg.; St. Louis Art Gld.; 2 x 4 Soc., St. Louis. **Exhibited:** AIC; CGA; Carnegie Inst.; PAFA Ann., 1896-1905, 1910-1923, 1932; Pan-Pacific Exp., 1915, hor concours; CAM; St. Louis A. Gld.; 2 x 4 Soc.; Chicago, Portland, St. Louis Exp. Author: numerous monographs. Awards: med., Lewis & Clark Exp.; prizes, St. Louis A. Gld.; St. Louis A. Lg.; Hon. degree, D.F.A. Washington Univ. **Work:** murals, Missouri State Capitol; Church of Unity, St. Louis, MO; CAM; Pub. Lib., St. Louis; Herron AI, Indianapolis; Missouri Athletic Club and Lib.; Buenos Aires Mus.; Sch. of Orthodontia, Pasadena; Burroughs Sch., St. Louis. **Comments:** Position: dean emeritus, Washington Univ., St. Louis, MO; instructor, acting director, dean, St. Louis School FA. **Sources:** WW53; WW47; Falk, *Exh. Record Series.*

WUERST, Emile See: **WUERTZ, Emil H. (or Wuerst)**

WUERTZ, Emil H. (or Wuerst) *[Sculptor, teacher]* b.1856, St. Albans, VT (or Germany) / d.1898.
Addresses: NYC, 1891. **Studied:** Académie Julian, Paris with Chapu and Mercié, 1884-90; also in Paris with Rodin. **Exhibited:** NAD, 1891; AIC, 1894-98; Paris Salon, 1887-88, 1890; World's Columbian Expo, 1893 (med); Tennessee Centenn. Expo, 1897 (medal); NSS, 1898. **Comments:** He taught at the AIC, but went down with the "Bourgogne" off Nova Scotia. **Sources:** WW98.

WUESTE, Louise Heuser *[Portrait painter]* b.1803, Gummersbach-on-Rhine (Germany) / d.1875, Eagle Pass, TX.
Studied: Conrad Lessing and Adolph Schroedter (her brothers-in-law); Düsseldorf; with August Sohn, after 1821. **Work:** Witte Mus., San Antonio. **Comments:** She came to Texas with her husband, Leopold Wueste, and settled at San Antonio about 1852. She advertised in 1860 in San Antonio as a portrait painter and teacher. After 1870 she moved to her son's home in Eagle Pass,

where she painted genre scenes of Mexicans. **Sources:** G&W; O'Brien, *Art and Artists of Texas*, 19; P&H Samuels, 540; Trenton, ed. *Independent Spirits*, 186; add'l info. courtesy Peter C. Merrill, who cites 1874 as death date.

WUHL, Edna Dell *[Painter]* 20th c.
Addresses: Troy, NY. **Sources:** WW21.

WUJCIK, Theo *[Printmaker, educator]* b.1936, Detroit, MI.
Addresses: Tampa, FL. **Studied:** Soc. Arts & Crafts Art School, Detroit, MI, diploma; Creative Graphic Workshop, NYC; Tamarind Lithography Workshop, CA, Ford Foundation grant, 1967-68. **Exhibited:** Int. Original Prints, CPLH, 1964; Boston Printmakers 19th Ann., Mus. Fine Arts, Boston, 1967; 17th Print Nat., Brooklyn Mus, NY, 1970; Prints by Seven, WMAA, 1970; Int. Miniature Print Exhib., Pratt Graphic AC New York, 1971; Brooke Alexander Inc., NYC, 1970s. Awards: Louis Comfort Tiffany Foundation Award Graphics, 1964. **Work:** MoMA; LACMA; Amon Center Mus. Western Art, Fort Worth; Pasadena (CA) Art Mus.; LOC. **Comments:** Preferred media: graphics. Positions: co-founder, Detroit Lithography Workshop, 1968-70; shop director, graphics studio, Univ. South Florida, 1970-. Teaching: graphics instructor, Soc. Arts & Crafts Art School, 1964-70; asst. professor lithography, Univ. South Florida, 1972-. **Sources:** WW73.

WULF, Lloyd William *[Painter, graphic artist, teacher, lithographer, etcher]* b.1913, Avoca, NE / d.1965, San Francisco, CA?.
Addresses: San Francisco. **Studied:** Univ. Nebraska; Calif. Sch. FA. **Exhibited:** Int. Lithographers, Wood Engravers, AIC, 1937; SFMA, 1937 (prize); San Francisco AA, 1937 (Parilla purchase prize); de Young Mus., 1939. Awards: Calif. School FA, Phelan scholarship, 1936; San Francisco AA, 1941, Rosenberg scholarship. **Work:** SFMA; WPA artist. **Comments:** WPA printmaker in California, 1930s. **Sources:** WW40; exh. cat., Annex Gal. (Santa Rosa, CA, n.d., c.1988); Hughes, *Artists of California*, 621.

WULFF, Auguste *[Commercial artist]* b.1853, Germany.
Addresses: New Orleans, active 1876-1900. **Comments:** Immigrated to the U.S. in 1872. **Sources:** *Encyclopaedia of New Orleans Artists*, 425.

WULFF, Lloyd William See: **WULF, Lloyd William**

WULFF, Timothy Milton *[Portrait painter]* b.1890, San Francisco / d.1960, San Francisco.
Addresses: San Francisco. **Studied:** Calif. School FA, with F. Van Sloun; École des Beaux-Arts, Paris, 1922-25. **Member:** San Francisco AA. **Exhibited:** San Francisco AA, annuals, 1916, 1924, 1925. **Work:** Palace FA, San Francisco. **Sources:** WW33; Hughes, *Artists in California*, 621-22.

WULSER, Adolphe *[Painter]* 20th c.
Addresses: NYC. **Exhibited:** S. Indp. A., 1928-31. **Sources:** Marlor, *Soc. Indp. Artists.*

WULZEN, Edgar Franklin *[Painter]* 20th c.
Addresses: Brooklyn, NY. **Exhibited:** Soc. Indep. Artists, 1929-30. **Sources:** Marlor, *Soc. Indp. Artists.*

WUNDER, Adalbert *[Portraitist in oils, crayon, and india-ink]* b.1827, Berlin (Germany).
Addresses: Hartford, CT, 1855; Hamilton (Ontario), 1869. **Studied:** Berlin and Dresden Academy. **Comments:** He began his art studies in Berlin at the age of sixteen, later spending two years at the Dresden Academy. He came to America in 1855 and settled in Hartford (CT) where he was well known for his portraits in crayon and ink. In 1869 he left Hartford for Hamilton (Ontario). **Sources:** G&W; French, *Art and Artists in Connecticut*, 136; Hartford CD 1856-57; Cowdrey, NAD; Bolton, *Crayon Draftsmen.*

WUNDER, Richard Paul *[Art historian, art administrator]* b.1923, Ardmore, PA.
Addresses: Orwell, VT. **Studied:** Harvard Univ. (A.B., 1949; M.A., 1950; Ph.D., 1955). **Member:** College Art Assn. Am.;

Drawing Soc. (director, 1964-72); Soc. l'Histoire l'Art Français; Archives Am. Art (advisory board, 1968-); Art Quarterly (advisory board, 1967-). **Exhibited:** Awards: John Thornton Kirkland fellowship, Harvard Univ., 1954. **Comments:** Positions: asst. to director, Fogg Art Mus., Harvard Univ., 1953-54; curator, drawings & prints, Cooper Union Mus., 1955-64; curator & asst. director, Nat. Collection Fine Arts, Smithsonian Inst., 1964-69; director, Cooper-Hewitt Mus. Design, 1969-70. Publications: author, *Extravagent Drawings of the 18th Century,* Lambert-Spector, 1962; author, *Architectural & Ornament Drawings,* Univ. Michigan Mus., 1965; author, *Hiram Powers,* Smithsonian Inst., 1973. Collections arranged: The Architect's Eye, Cooper Union Mus, 1962; Theater Drawings from the Donald Oenslager Collection, Minneapolis Inst. Arts & Yale Univ. Art Gallery, 1963-64; Frederic Edwin Church, Nat. Collection Fine Arts, Smithsonian Inst., 1966. Research: Italian & French drawings of the seventeenth & eighteenth centuries; American painting, sculpture & drawings of the nineteenth century. **Sources:** WW73.

WUNDERLICH, George *[Historical and landscape painter]* *b.c.1826, Pennsylvania.*
Addresses: Phila. (1850s-60s). **Exhibited:** PAFA, 1853-68. **Comments:** An 1854 broadside announced the exhibition of his "Gigantic Illustrations of American History," representing all the early events in the country's history from Columbus to the Revolution. This "moving picture" was a "28,000 sq. ft. mechanical illusion," operated by the artist's brother controlling a steam engine. It was shown regularly at the Assembly Buldings in Phila., and the price of admission was 25 cents. **Sources:** G&W; 7 Census (1850), Pa., LII, 609 [as George Wonderly]; Phila. CD 1852-61; Rutledge, PA; Phila. *Public Ledger,* Dec. 13 and 22, 1854 (G&W has citation courtesy J. Earl Arrington); PHF files (broadside, 1854).

WUNDERLICH, Rudolf G. *[Art dealer] b.1920, Tarrytown, NY.*
Addresses: NYC; Chicago. **Studied:** New York Univ. **Comments:** Positions: director, Kennedy Galleries, Inc., 1970s, thereafter Mongerson-Wunderlich Gal., Chicago. Specialty of gallery: early American eighteenth, nineteenth & twentieth century paintings, drawings & watercolors; also Western American. **Sources:** WW73.

WUNDERLY, August *[Painter] 20th c.*
Addresses: Pittsburgh, PA. **Member:** Pittsburgh AA. **Sources:** WW21.

WUNDT, Claire *[Painter] 20th c.*
Exhibited: S. Indp. A., 1938-39. **Sources:** Marlor, *Soc. Indp. Artists.*

WURDEMANN, Frank G. *[Engraver] 19th/20th c.*
Addresses: Wash., DC, active c.1892-1920. **Comments:** Position: U.S. Coast Survey. **Sources:** McMahan, *Artists of Washington, DC.*

WURMS, Gottlieb *[Engraver] b.c.1826, Germany.*
Addresses: Phila. in 1860. **Comments:** From Württemberg; lived in 1860 with his German-born wife and three children (aged two to eight) born in Pennsylvania. **Sources:** G&W; 8 Census (1860), Pa., LIV, 306.

WURMSKI, (General) *[Silhouettist] mid 19th c.*
Addresses: Phila. in the 1840s. **Comments:** He is said to have been an emigré Polish patriot. **Sources:** G&W; *Antiques* (March 1949), 216, repros.

WURSTER, William *[Painter] 20th c.*
Addresses: Seattle, WA, 1951. **Member:** Puget Sound Group of Northwest Painters, 1944. **Exhibited:** SAM, 1947. **Comments:** Position: adv. producer, Frederic E. Baker and Assoc., 1951. **Sources:** Trip and Cook, *Washington State Art and Artists, 1850-1950.*

WURTELE, Isobel Keil *[Painter] b.1885, McKeesport, PA / d.1963, Los Angeles.*
Addresses: Rochester, MN; Los Angeles. **Studied:** Artzberger Art School, Allegheny, PA; Calif. College Arts & Crafts; with Hugh Breckenridge, 1929. **Member:** Women Painters of the West; Laguna Beach AA; Calif. AC. **Exhibited:** Northshore AA, Gloucester, MA, 1929; Calif. AC, 1930, 1933; Pittsburgh Expo. **Sources:** WW19; Hughes, *Artists of California,* 622.

WURTH, Herman *[Sculptor] 20th c.; b.NYC.*
Addresses: NYC. **Studied:** Paris, with Falguière, Mercié. **Exhibited:** PAFA Ann., 1911. **Sources:** WW13; Falk, *Exh. Record Series.*

WÜRTTEMBERG, Paul-Fredéric-William (Duke of) *[Topographical artist, explorer] b.1797, Carlsruhe, Germany / d.1860, Mergentheim, Germany.*
Comments: Brought up in Stuttgart, he gave up a military career and devoted himself to travel and the study of natural history. Visited the Western Hemisphere four times: 1822-24, Mississippi and Missouri Valleys and Cuba; 1829-32, Mexico; 1849-56, North, Central, and South America, including Oregon and Florida; 1857, Mississippi Valley. During the course of these trips he visited New Orleans in 1822, 1829 (under alias Baron von Hohenberg), 1850, and 1852. His only published work was an account of his first voyage (Stuttgart, 1835). A drawing by him made on this first trip was the basis for the lithograph "The Balize, Louisiana" (listed by Stokes). Also known as Paul-Fredéric-William. **Sources:** G&W; Larousse, *Grand Dictionnaire Universel du XIXième Siecle;* Stokes, *Historical Prints.* More recently, see *Encyclopaedia of New Orleans Artists,* 425, under "Württemberg, Prince Paul of.".

WURTZ, Edith M. B. *[Painter] 20th c.*
Addresses: Englewood, NJ. **Sources:** WW24.

WURTZBURGER, Janet E. C. *[Collector, patron] b.1908, Cleveland, OH.*
Addresses: Stevenson, MD. **Member:** Walters Art Gallery (vice-pres., 1973); Baltimore Mus. (trustee); Maryland Inst. College Art (trustee); MoMA (int. council); Am. Acad. at Rome (trustee). **Comments:** Collection: modern sculpture from Rodin to Calder; primitive art collection, exhibited at Baltimore Mus. in 1973. Art interests: contemporary sculpture. **Sources:** WW73.

WURZBACH, W. *[Wood engraver] mid 19th c.*
Addresses: Boston, 1853-54; NYC, 1858. **Comments:** Hamilton records examples of his work in books published between 1854-81. **Sources:** G&W; Boston BD 1853-54; NYCD 1858; Hamilton, *Early American Book Illustrators and Wood Engravers,* 160, 179, 432, 487.

WÜST, Alexander *[Landscape painter] b.1837, Dordrecht (Netherlands) / d.1876, Antwerp (Belgium).*
Addresses: NYC (1858 until at least 1869). **Member:** ANA, 1861. **Exhibited:** NAD, 1861-62, 1867, 1881; PAFA Ann., 1858-69, 1877; Brooklyn AA, 1861, 1867-75. **Work:** his "Morning in the Catskills" is in the Pawtucket Club, Haverhill (MA). **Comments:** Wust came to America in the late 1850s and had a studio in NYC from 1858 at least until 1869. Exhibited works indicate he painted in the Adirondacks and all over New England; and, by 1872 was exhibiting landscapes of Norway. **Sources:** G&W; Mallett; NYBD 1858; Cowdrey, NAD; Rutledge, PA; more recently, see Campbell, *New Hampshire Scenery,* 177, who states that there is some confusion about his death date, since his work was exhibited at the NAD in 1881 (but no address given); Falk, *Exh. Record Series.*

WUST, Ferdinand Alexander See: **WÜST, Alexander**

WÜST, Louis *[Portrait painter] mid 19th c.*
Exhibited: NAD, 1867. **Sources:** Naylor, *NAD.*

WÜST, Theodore *[Portrait painter] late 19th c.*
Addresses: NYC, 1865. **Studied:** with Cogniet. **Exhibited:** NAD, 1865; Paris Salon, 1882, 1884. **Comments:** Exhibited drawings at the Paris Salon. **Sources:** Fink, *American Art at the Nineteenth-Century Paris Salons,* 408.

WYAND, D. E. *[Painter]* 19th c.
Sources: Falk, *Dict. of Signatures.*

WYAND, George *[Engraver]*
b.c.1840, Pennsylvania.
Addresses: Pennsylvania Hospital for the Insane, Phila., in October 1860. **Sources:** G&W; 8 Census (1860), Pa., LX, 796.

WYANT, Alexander Helwig
[Landscape painter] b.1836, Evans
Creek, Tuscarawas County, OH /
d.1892, NYC.
Addresses: NYC, from 1866; Arkville, NY. **Studied:** apprenticed to a harness maker before the age of 21; NAD, c.1864; Karlsruhe, Germany, with F. Gude (a Düsseldorf-trained artist), 1865-66.
Member: NA, 1869; Century Assoc., 1875. **Exhibited:** NAD, 1865-92; Brooklyn AA, 1867-92; Boston AC, 1877-82; PAFA Ann., 1879-81, 1893, 1902; AIC; MMA, 1917, 1965, 1970; WMAA, 1938; Utah Centennial Expo, 1947; Univ. Utah, 1968 (retrospective). **Work:** NMAA; BM; Montclair Mus.; MMA; TMA; Tennessee State Mus.; Univ. Kentucky Art Mus., Lexington; Worcester AM. **Comments:** A member of the second generation of the Hudson River School painters, his landscapes are often poetic, moody, and atmospheric — alligning him more closely with the American Barbizon movement. Wyant's earliest known painting dates from 1854. In 1857, after seeing George Inness's paintings in Cincinnati, he was inspired to visit the master in NYC. With encouragement from Inness and the financial support of Nicholas Longworth of Cincinnati, he was able to study for a year at the National Academy and travel to Germany in 1865. Before returning to NYC in 1866, he visited England, where he was influenced by the landscapes of Constable and Turner. In 1873, at age 37, he suffered a paralytic stroke which forced him to learn to paint with his left hand. After this, he spent his winters in NYC and summers in the Adirondacks at Keene Valley, NY. By 1880, he was spending more time at Keene Valley and in 1889, with his condition worsening, he bought a home in the Catskills, at Arkville, NY, an important center for American Barbizon painters. **Sources:** G&W; Clark, *Alexander Wyant;* DAB; Swan, BA; Rutledge, PA; *Panorama* (Jan. 1947), 55, repro.; *Magazine of Art* (Nov. 1946), 289, repro.; *Art Digest* (Aug. 1, 1936), 10, repro. More recently, see Campbell, *New Hampshire Scenery,* 178; *Keene Valley: The Landscape and Its Artists,* fig. 7, 17, and essay; Baigell, *Dictionary;* Gerdts, *Art Across America,* vol. 1: 164-65, 182-83; Kelly, "Landscape and Genre Painting in Tennessee, 1810-1985," 66-68 (w/repro.); Jones and Weber, *The Kentucky Painter from the Frontier Era to the Great War,* 73-74 (w/repros.); Falk, *Exh. Record Series.*

WYANT, Arabella L. (Mrs. Alexander H.) *[Painter]*
d.1919, Arkeville, NY.
Addresses: NYC/Arkville, NY. **Studied:** her husband. **Member:** NAWPS; NAC; NY Woman's Art Club. **Exhibited:** Brooklyn AA, 1884; NAD, 1896; PAFA Ann., 1896-98; AIC, 1896, 1899, 1900, 1909. **Sources:** WW15; Falk, *Exh. Record Series.*

WYATT, A(ugustus) C(harles) *[Landscape painter]* b.1863, England / d.1933, Montecito, CA.
Addresses: Montecito. **Exhibited:** Royal WCS (golds); Royal Int. Horticultural Exh., London, 1912 (prize). **Comments:** Painted in the New England states, South Carolina & Hawaii.

WYATT, Edward (Mrs.) See: **DAVIS, Helen S(tewart Foulke)**

WYATT, Mary Lyttleton *[Miniature painter]* early 20th c.; b.Baltimore.
Addresses: Paris. **Studied:** Paris with Mme. Debillemont-Chardon, Collin. **Sources:** WW10.

WYATT, Stanley *[Painter, educator]* b.1921, Denver, CO.
Addresses: Grand View-on-Hudson, NY. **Studied:** Columbia College with Frank Mechau (B.A., 1943); AIC, 1946; Columbia Univ. with Meyer Shapiro (M.A., 1947); Brooklyn Mus. with Rufino Tamayo, 1948. **Member:** Royal Soc. Arts, London (fel-

low); Salmagundi Club; Newcomer Soc. North Am.; United Fed. College Teachers. **Exhibited:** Barnard College, NYC, 1959; Regis College, Denver, 1961; La Galeria Collectionistas, Mexico City, 1962; North Am.-Mexican Cultural Inst., Mexico City, 1963; Casa Italiana, Columbia Univ., New York, 1971. **Awards:** Brainard Sr. prize, Columbia College, 1943; distinction in illustration, Am. Assn. Alumni Magazines, 1957; gold ribbon for prints, Fifth Ann. Bergen Mall Exhs., 1966. **Work:** North Am.-Mexican Cultural Inst., Mexico City; Packaging Inst., Toronto, Canada; Nyack (NY) Pub. Lib. Commissions: illustrations, *Nat. Educ. Assn. Journal,* 1952-65, *Columbia Univ. Alumni News,* 1953-57, *New York Times Magazine,* 1957-61, *College Entrance Board Review,* 1959-72 & *Rockefeller Univ. Review,* 1968. **Comments:** Preferred media: oils, tempera, graphite. Positions: director, dept. art, Del Piombo AC, 1959-61; art dept. rep., Baruch Ach, 1961-69; supervisor art dept., evening division, City College New York, 1969-72. Publications: editor, *Jester,* Columbia Univ., 1943; author, *Thanks to Shanks,* 1958; illustrator, *Poetry of the Damned,* Peter Pauper, 1960; illustrator, *20th Century Views & 20th Century Interpretations,* 1960-72 & *The Great American Forest,* 1965, Prentice Hall. Teaching: Waynesburg College, 1949-51; Columbia Univ., 1952-60; City College New York, 1960-; Rockland Community College, 1961-63. **Sources:** WW73.

WYBRANT *[Portrait painter in watercolors]* mid 19th c.
Addresses: Gloucester, MA, c.1850. **Sources:** G&W; Lipman and Winchester, 182.

WYBRANT, Edna See: **SMITH, Edna Wybrant**

WYCISLAK, Eugene *[Sculptor]* mid 20th c.
Addresses: Chicago area. **Exhibited:** AIC, 1951. **Sources:** Falk, *AIC.*

WYCKOFF, Florence Richardson *[Sculptor, ceramist]* b.1905, Berkeley, CA.
Addresses: San Francisco; Watsonville, CA. **Studied:** Univ. Calif., Berkeley; Calif. College Arts & Crafts; Académie Julian, Paris; Kunstgewerbeschule, Wien, Austria. **Member:** San Francisco Women Artists. **Exhibited:** San Francisco Women's City Club, 1930; CPLH, 1935. **Sources:** Hughes, *Artists in California,* 622.

WYCKOFF, Isabel Dunham (Mrs. George V.) *[Flower painter]* mid 19th c.
Addresses: NYC, c.1840; Sun Prairie, WI, 1855. **Exhibited:** Delphic Studios, NYC, 1933 (along with O'Keeffe sisters). **Comments:** She was the maternal grandmother of the artists Ida, Catherine, and Georgia O'Keeffe (see entries). **Sources:** G&W; *Art Digest* (April 1, 1933), 27; Petteys, *Dictionary of Women Artists.*

WYCKOFF, Jane Brown (Mrs. Walter) *[Painter]* b.1905, Sault St. Marie, MI / d.1990, Seattle, WA.
Addresses: Seattle, WA. **Studied:** Univ. Washington; ASL. **Exhibited:** SAM, 1934-1946. **Comments:** Contributor: *Vogue Magazine.* **Sources:** Trip and Cook, *Washington State Art and Artists,* 1850-1950.

WYCKOFF, Joseph *[Painter, teacher]* b.1883, Ottawa, KS.
Addresses: NYC. **Studied:** AIC; PAFA; J. Hambridge; H. Giles; ASL; NY Sch. Fine & Applied Art. **Member:** AAPL. **Exhibited:** AIC, 192, 1914, 1917-19; S. Indp. A., 1921-22. **Sources:** WW33.

WYCKOFF, Marjorie Annable *[Sculptor]* b.1904, Montreal, Quebec.
Addresses: Buffalo, NY. **Studied:** A. Lee. **Sources:** WW33.

WYCKOFF, Maud E. *[Painter]* early 20th c.
Addresses: Brooklyn, NY. **Sources:** WW13.

WYCKOFF, Sylvia Spencer *[Painter, educator]* b.1915, Pittsburgh, PA.
Addresses: East Syracuse, NY; Syracuse, NY. **Studied:** College Fine Arts, Syracuse Univ. (B.F.A., 1937; M.F.A., 1944). **Member:** NAWA; Nat. Lg. Am. Pen Women; Syracuse AA; Daubers Club Syracuse. **Exhibited:** Daubers Club; Eight Syracuse

Watercolorists, 1943-46; Munson-Williams-Proctor Inst., Utica, NY; Mem. Art Gallery, Rochester, NY; Everson Mus. Art, Syracuse; Cooperstown (NY) AA.; NAWA. **Awards:** Onondaga Hist. Exh., 1945 (prize); Syracuse AA, 1943 (prize); first prize for watercolor, Syracuse Regional, 1945; League Prize for watercolor, Nat. Lg. Am. Pen Women Nat. Show, 1948; Gordon Steele Award, Syracuse AA, 1968. **Work:** Radio Station WSYR, Syracuse, NY; R E. Dietz Co., Syracuse. **Comments:** Preferred medium: watercolors. Teaching: Syracuse Univ., 1942-. **Sources:** WW73; WW47.

WYDEFELDT See: **WYDEVELD, A(rnoud) (or Arnold)**

WYDEFIELD See: **WYDEVELD, A(rnoud) (or Arnold)**

WYDEVELD, A(rnoud) (or Arnold) *[Still life & genre painter]* b.1823, Nijmegen, Holland / d.After 1888. **Addresses:** NYC, 1862-88. **Exhibited:** Washington AA, 1857, 1859; NAD, 1859-67, 1873, 1884, 1888; PAFA, 1862; Brooklyn AA, 1867, 1874. **Comments:** Although his earliest work is in genre, he primarily painted fruit and flower still lifes. He also did numerous paintings of fish beginning in the early 1870s. Emigrated to U.S. in 1853, returning to Nijmegen in 1864 and then back to America about 1866. He died at an unknown date after 1888 in New York City or Baltimore. He exhibited at the Washington Art Association in 1857 as Wydefield, and in 1858 as Wydefeldt; at the National Academy in 1859 as Wideveld; and at the Pennsylvania Academy in 1862 as A. Wydevelde. NAD later lists his name occasionally as Wyderveld. **Sources:** G&W; NYCD 1855-58; Washington Art Assoc. Cat., 1857, 1859; Cowdrey, NAD; Rutledge, PA; addl info. courtesy of David Stewart Hull, NYC.

WYDEVELDE, A. See: **WYDEVELD, A(rnoud) (or Arnold)**

WYER, Raymond *[Painter, writer, lecturer]* early 20th c.; b.London. **Addresses:** Worcester, MA. **Studied:** Académie Julian, Paris with Bouguereau and Benjamin-Constant; Académie Delecluse, Paris; London and Brussels. **Member:** Artists Soc., London; Langham Club, London; Archaeological Inst. Am.; Am. Assn. Mus.; NAC; St. Botolph Club, Boston; Royal Soc. Arts, London (fellow). **Comments:** Positions: dir., Hackley Gal., Muskegon (1912-16), WMA (1918). **Sources:** WW21.

WYETH, Andrew Newell *[Landscape, marine and figure]* b.1917, Chadds Ford, PA. **Addresses:** Chadds Ford, PA/Port Clyde, ME (1985); NYC. **Studied:** with his father, N.C. Wyeth; Harvard Univ. (hon. D.F.A., 1955); Colby College (hon. D.F.A., 1955); Dickinson College (hon. D.F.A., 1958); Swarthmore College (hon. D.F.A., 1958). Peter Hurd taught Wyeth to paint with egg tempera. **Member:** NA, 1945; Audubon Artists (director); Nat. Acad. Arts & Letters; Am. Acad. Arts & Letters; AWCS; Phila. WCC (director). **Exhibited:** Macbeth Gal., NYC, 1937 (first solo exh.); AIC (solo); MoMA; Corcoran Gal. biennials, 1939-57 (6 times); PAFA Ann., 1938-1952 (prize), 1956-62; traveling exh. to England; traveling exh. to PAFA, Baltimore, NYC, Chicago, 1966; de Young MA, 1973; first living American to receive a retrospective at MMA, 1976; Wilmington (DE) Mus. (prize); Butler AI (prize); AAAL, 1947 (prize); AWCS, 1952 (gold); award: *Art in America Magazine*, 1958; Currier Gallery Art, Manchester, NH; Fogg Art Mus., MA; Univ. Arizona, Tucson; Mus. FA, Boston; WMAA; Carnegie Inst. (award). **Work:** MMA; MoMA; BMFA; PMA; LACMA; AIC; CPLH; Phillips Acad., Andover; Wadsworth Atheneum; Farnsworth Mus., Rockland, ME; Canajoharie Art Gal.; Univ. Nebraska; AGA; New Britain Mus.; Butler AI; Wilmington Mus. Art; Lincoln Mus., England; mural, Delaware Trust Bank, Wilmington; Dallas MFA; Houston MFA; Shelburne (VT) Mus. **Comments:** Internationally recognized by early 1940s for paintings such as "Christina's World" (1948, MoMA); his is a

household name since the 1950s. His watercolor style has attracted countless followers, and he was the first artist to appear on the cover of *Time* magazine. His name has long been associated with Cushing, ME, and he has been drawn to Monhegan Island, ME to paint. Some of his works relate to Bermuda. His father was N. C. Wyeth. Preferred media: tempera, watercolors. Author: "The Nub," "The Smugglers' Sloop," 1935. **Sources:** WW73; WW47; P&H Samuels, 540-41; Wanda Corn, *The Art of Andrew Wyeth* (exh. cat., de Young Museum, San Francisco, 1973); John Wilmerding, *Andrew Wyeth: The Helga Pictures* (H.N. Abrams, 1987); Muller, *Paintings and Drawings at the Shelburne Museum*, 141; Curtis, Curtis, and Lieberman, 123, 187; Richard Merryman, *Andrew Wyeth*, Houghton Pub.; Falk, *Exh. Record Series*.

WYETH, Caroline *[Painter]* b.1909, Chadds Ford. **Addresses:** Chadds Ford, PA/Port Clyde, ME. **Studied:** N.C. Wyeth. **Member:** Wilmington SFA; Chester County AA; Phila Art All. **Exhibited:** Wilmington Soc. FA, 1932 (prize), 1937 (prize). **Sources:** WW40.

WYETH, Francis *[Lithographer]* mid 19th c. **Addresses:** Boston, 1832-33. **Sources:** G&W; Peters, *America on Stone*.

WYETH, Henriette Zirngiebel (Mrs. Peter Hurd) *[Painter]* b.1907, Wilmington, DE. **Addresses:** Chadds Ford, PA/San Patricio, NM, 1980. **Studied:** Normal Art School, Boston; PAFA; R. Andrew; PAFA with H. McCarter & A.B. Carles; also with her father, N.C. Wyeth. **Member:** Wilmington Soc. FA; Chester County AA; ANA, 1974. **Exhibited:** PAFA Ann., 1927, 1936-44 (prize, 1937); Corcoran Gal. biennial, 1937; CI; AIC; MMA; Roswell Mus. Art, NM; NYC. **Awards:** four first prizes, Wilmington Soc. FA, 1933-36; Chester County AA, 1934. **Work:** Wilmington Soc. FA; Roswell Mus. Art; New Britain (CT) Mus. Art; Lubbock (TX) Mus. Art; Texas Tech Univ. **Comments:** Older sister of Andrew (see entry). **Sources:** WW73; WW40; P&H Samuels, 540; Falk, *Exh. Record Series*.

WYETH, James (Jamie) Browning *[Painter]* b.1946, Wilmington, DE. **Addresses:** Chadds Ford, PA. **Studied:** with his Aunt, Caroline & his father, Andrew, in the Wyeth family tradition. **Member:** NAD; AWCS; Nat. Endowment Arts. **Exhibited:** numerous solos in NYC. **Work:** MoMA; National Portrait Gallery; William Farnsworth Lib. & Art Mus., Rockland, ME; Brandywine River Mus., Chadds Ford, PA; Delaware Art Mus., Wilmington. **Comments:** Preferred media: oils, watercolors. For years Wyeth maintained a studio on Monhegan Island, ME, where he explored many aspects of the island in paint. **Sources:** WW73; Joseph Roody, "Another Wyeth," *Look Magazine* (April 2, 1968); "Wyeth Phenomenon" (film), CBS TV 1969; Richard Meryman, "Wyeth Christmas," *Life Magazine* (Dec. 17, 1971); Curtis, Curtis, and Lieberman, 57, 165, 187.

WYETH, John Allan *[Painter]* mid 20th c. **Addresses:** NYC. **Exhibited:** CI, 1938; Corcoran Gal. biennial, 1939-43 (3 times); PAFA Ann., 1939; GGE 1939. **Sources:** WW40; Falk, *Exh. Record Series*.

WYETH, N(ewell) C(onvers) *[Painter, illustrator, mural painter, decorator, teacher]* b.1882, Needham, MA / d.1945, Chadds Ford, PA. **Addresses:** Chadds Ford, PA/Port Clyde, ME. **Studied:** Mechanics Art Sch., Boston, 1899; Massachusetts Normal Art Sch. with R. Andrew; Eric Pape Sch. Art, Boston, with G.L. Noyes, C. W. Reed; H. Pyle, 1902-11. **Member:** SI, 1912; Wilmington Soc. FA; Phila. All.; Chester County AA; NA, 1941. **Exhibited:** Phila. WCC, 1910 (prize); PAFA Ann., 1911, 1920-46; Pan-Pacific Expo, San Francisco, 1915 (gold); Wash. SA, 1931 (medal); Corcoran Gal. biennials, 1930-45 (7 times); incl. 4th prize, 1932); Macbeth Gal., NY, 1939 (solo); AIC. **Work:** murals, Capitol, MO; Hotel Traymore, Atlantic City; Reading Mus. FA;

Fed. Reserve Bank, First Nat. Bank, both in Boston; NYPL; Franklin Savings Bank, NYC; First Mechanics Bank, NYC; First Mechanics Nat. Bank, Trenton; Roosevelt Hotel dining room, NYC; Penn Mutual Life Insurance Bldg., Phila.; Wilmington Savings Fund Soc., DE; altar in Chapel of the Holy Spirit, Nat. Cathedral, Washington, DC. **Comments:** Howard Pyle's greatest student, he produced more than 3,000 illustrations for hundreds of articles, numerous posters, and more than 100 books. He began illustrating for *Saturday Evening Post,* and by 1904 his work (mostly cow-punching westerns) was accepted by *Scribner's;* however, his breakthrough work came in 1911 when he illustrated Robert Louis Stevenson's *Treasure Island* for Scribner's. He continued to illustrate other books in the Scribner's Illustrated Classics series, including *Kidnapped, The Boy's King Arthur, Black Arrow, The Mysterious Island, Westward Ho!, Deerslayer, The Last of the Mohicans, Robin Hood, Robinson Crusoe, Drums* and others. His works assumed a child's-eye view and featured characters in exacting detail, often dramatized by long shadows — a style that clearly had an effect on the epic movies of the 1940s. He spent many summers painting on Monhegan Island (ME) where he accompanied the fishermen on their trips. In 1945 his car stalled (or he stopped it) on a railroad track and an onrushing milk train killed him, his daughter-in-law, and his grandson. Of his painter-children, Andrew became the most famous. **Sources:** P&H Samuels, 541-42; Curtis, Curtis, and Lieberman, 140, 187. More recently, see David Michaelis *N.C. Wyeth* (first biography on the artist; Knopf pub., 1998); Falk, *Exh. Record Series.*

WYETH, P. C. *[Portrait painter] mid 19th c.*
Addresses: NYC in 1846; Cincinnati, 1849-51; Brooklyn, 1858. **Exhibited:** NAD, 1846, 1858. **Comments:** In 1852 he painted a group portrait of the children of Charles L. Shrewsbury at Madison (IN). The last record of him is in 1858. **Sources:** G&W; Cowdrey, NAD; Peat, *Pioneer Painters of Indiana,* 61 and pl. 23.

WYHOFF, Julius *[Painter] mid 20th c.*
Addresses: Yonkers, NY. **Work:** WPA mural, USPO, Mt. Gilead, OH. **Sources:** WW40.

WYKES, Adeline Gaylor *[Painter] early 20th c.*
Exhibited: Salons of Am., 1922-26. **Sources:** Marlor, *Salons of Am.*

WYKES, Frederic Kirtland *[Painter, illustrator, teacher] b.1905, Grand Rapids, MI.*
Addresses: Grand Rapids 6, MI. **Studied:** John B. Stetson Univ.; Univ. Michigan (A.B.); AIC; Frederic Fursman; Jean Paul Slusser. **Exhibited:** S. Indp. A., 1931; AIC, 1937. **Work:** IBM Coll.; Grand Rapids Art Gal.; Michigan Nat. Bank; mural, Orthopedic Sch., Grand Rapids, MI. **Comments:** Illustr.: "Wings in the Sun," "History of Allegan County, Michigan." **Sources:** WW59; WW47.

WYLAND, Edith Varian See: **COCKCROFT, Edith Varian (Edith Varian Wyland)**

WYLE, Florence *[Sculptor, poet] b.1881, Trenton, IL / d.1968, Toronto, Canada.*
Addresses: Chicago & Oak Park, IL, 1907-c.1911; Greenwich Village, NYC, c. 1912; Toronto, Canada, 1913-68. **Studied:** Univ. Illinois; AIC with Charles Mulligan and Lorado Taft, 1907 >ed); Ontario Soc. Artists. **Exhibited:** AIC, 1908-1911; PAFA Ann., 1911; Paris, 1927; Tate Gal., London, 1938; medal from Queen Elizabeth, 1953; Art Mus., London, Ontario, 1962 (retro., with Frances Loring); Pollack Gal., Toronto, 1965 (retro. with Loring), 1969 (memorial); Ontario Soc. Artists; Royal Canadian Acad;. **Work:** Art Gallery of Ontario, Toronto; Nat. Gallery Canada; Winnipeg AG. Commissions: bronze statuettes for Canadian War Records Organization, 1919. **Comments:** (Compare with Florence Wyle, appearing in WW10 as painter). Became a leading sculptor in Toronto after moving there in 1913 with friend and fellow sculptor Frances Loring (1887-1968). The two women met at the AIC and opened a Greenwich Village studio together before settling in Toronto, where they shared a stu-

dio/home until 1968. They also remodeled a church building that became a popular meeting place in Toronto for Canadian intellectuals during the 1920s and 1930s. Known as "The Church," it is now a Canadian landmark. Wyle specialized in figures, portraits, and studies of animals, in bronze & marble. **Sources:** Rubinstein, *American Women Sculptors,* 205-06; Petteys, *Dictionary of Women Artists;* P&H Samuels, 542; Falk, *Exh. Record Series.*

WYLE, Florence *[Painter] early 20th c.*
Addresses: Oak Park, IL, 1910. **Comments:** *Cf.* Florence Wyle, sculptor. **Sources:** WW10.

WYLEY, Frank A. *[Painter, printmaker] b.1905, Long Beach, MS.*
Exhibited: Texas Centennial, 1936; Dillard Univ., 1941; Atlanta Univ., 1942-44; Xavier Univ., 1963. **Sources:** Cederholm, *Afro-American Artists.*

WYLIE, J(ohn) C. *[Painter, teacher] b.1918, El Paso, TX.*
Studied: Univ. Minnesota; New Mexico Highland Univ. (B.A.); Cranbrook Acad. Art (M.F.A.) with Zoltan Sepechy; AIC; Richard Neutra. **Exhibited:** Newport AA, 1946; DMFA, 1947; Brooks Mem. Mus., 1949; Detroit Art Gal., 1949; Cranbrook Acad. Art, 1949 (prize); BM, 1951; Mus. New Mexico, 1946 (prize), 1948, 1951 (prize); Philbrook AC, 1947 (prize), 1952 (prize); AWCS, 1952 (prize); St. Paul Art Gal., 1953; Minneapolis Inst. Art, 1952, 1953; Mulvane Art Mus., 1954; Univ. Nebraska, 1954; Univ. New Mexico, 1948 (solo); Baldwin-Kingrey, Chicago, 1949; Bressler Art Gal., Milwaukee, 1949; Harriet Hanley Gal., Minneapolis, 1953; Walker AC, 1953; John Heller Gal., NY, 1953. **Work:** Cranbrook Acad. Art; Philbrook AC. **Comments:** Teaching: Memphis Acad. Art, 1950-51; Minneapolis Sch., 1952-54. **Sources:** WW59.

WYLIE, John Edward *[Landscape and floral painter] late 19th c.; b.New Haven, CT.*
Addresses: Hartford, CT. **Exhibited:** Brooklyn AA, 1876. **Sources:** *Brooklyn AA.*

WYLIE, Marion See: **STIRRETT, Wylie**

WYLIE, Robert *[Genre painter, sculptor] b.1839, Isle of Man (England) / d.1877, Brittany (France).*
Studied: PAFA, 1859-62; Penn. Beaux-Arts Acad.; Barye. **Exhibited:** PAFA Ann., 1859-60 (work in ivory and clay), 1884, 1905; Paris Salon, 1869, 1870, 1872, 1873, 1875. **Work:** Corcoran Gal.; Peabody Inst. **Comments:** In 1839 he was brought to America as a child. In 1863 he went to France where he spent the rest of his life. He was known chiefly as a painter of Breton peasant scenes. **Sources:** G&W; CAB; Clement and Hutton; Rutledge, PA; Fink, *American Art at the Nineteenth-Century Paris Salons,* 408-409; Falk, *Exh. Record Series.*

WYLIE, Samuel B. *[Painter] b.1900 / d.1957.*
Addresses: Woodstock, NY. **Studied:** ASL. **Member:** SC; Woodstock AA. **Work:** Woodstock AA. **Sources:** WW21; addit. info. courtesy Woodstock AA.

WYMA, Peter Edward *[Cartoonist] b.1922, Chicago, IL.*
Addresses: St. Clair, MI. **Studied:** School of Visual Arts, NY. **Member:** Nat. Cartoonists Soc. **Exhibited:** Awards: best published cartoon of the Year, 1950, 1951, Sch. of Visual Arts. **Work:** daily cartoon panel, General Features Syndicate; "Senator Caucus," *Washington Evening Star* and others; freelance cartoons to all major publications. **Sources:** WW66.

WYMAN, Dorothy Churchill (D. Wyman Martin) *[Painter] 20th c.*
Studied: BMFA Sch.; privately with George E. Browne in Provincetown & Europe. **Exhibited:** Grace Horne Gal., Boston (first solo); All. Artists Am., 1935; Boston SIA; Copley Soc.; Provincetown AA; Bakker Gal., Boston, 1993 (retrospective).

WYMAN, Florence See: **IVINS, Florence W. (Mrs. W. M., Jr.)**

WYMAN, Geraldine See: **SPALDING, Geraldine Wyman**

WYMAN, John *[Artist] b.c.1820, New York.*
Addresses: Phila. in 1860. **Comments:** The Philadelphia directories list him as a ventriloquist (1852-54), daguerreotypist (1855), and artist (1856-61). **Sources:** G&W; 8 Census (1860), Pa., LVIII, 114; Phila. CD 1852-61.

WYMAN, Lois Palmer (Mrs.) *[Painter] mid 20th c.*
Addresses: Cincinnati, OH. **Member:** NAWA. **Exhibited:** NAWPS, 1935-38. **Sources:** WW40.

WYMAN, Lucile Palmer *[Etcher, sculptor, lecturer, teacher] b.1910, NYC.*
Addresses: Gardnerville, NV. **Studied:** F.V. Guinzburg; E. Fraser; M. Young; G. Lober; H. Raul; A. Piccirilli; E. Morahan; M. Gage; G. Luken. **Member:** AAPL; Art Center of the Oranges; San Fran. Soc. Women Artists; Santa Monica AS. **Sources:** WW40.

WYMAN, Luke (Jr.) *[Landscape painter] 19th c.*
Exhibited: Brooklyn AA, 1867-69. **Comments:** The works he exhibited indicate he painted along the shoreline of Cape Ann, MA, and up the Hudson River. **Sources:** Brooklyn AA.

WYMAN, May Cornelia *[Painter] late 19th c.*
Addresses: Chicago. **Exhibited:** AIC, 1899. **Sources:** Falk, AIC.

WYMAN, Sarah See: **WHITMAN, Sarah (de St. Prix) Wyman (Mrs. Henry)**

WYMAN, William *[Craftsman] b.1922, Boston / d.1980.*
Addresses: East Weymouth, MA. **Studied:** Mass. College Art (B.S.); Columbia Univ. (M.A.); Alfred Univ. **Member:** Am. Crafts Council; Am. Assn. Univ. Prof. **Exhibited:** work exhibited in every major ceramic exh. nat. & int. including MMA, Inst. Contemp. Arts, Boston, Victoria & Albert Mus., London, World Ceramic Exh., New York, Brussels World's Fair. Awards: Rhode Island Festival Arts; Smithsonian Inst.; Am. Crafts Council. **Work:** Des Moines AC; Saint Paul Gallery Art; Mus. Contemp. Crafts; Everson Mus. Art; Smithsonian Inst. Commissions: ceramic monument, Weymouth H.S., 1965. **Comments:** Preferred medium: ceramics. Positions: operator, Herring Run Pottery, East Weymouth. Teaching: workshops & lectures, many univs., colleges & art organizations, nat. & in Canada; instructor, ceramic & sculpture, Boston MFA School in 1973. **Sources:** WW73.

WYNKOOP, Emma T. *[Amateur landscape painter] mid 19th c.*
Addresses: active in Penn., c.1870. **Sources:** Petteys, Dictionary of Women Artists.

WYNKOOP, Richard J. *[Painter] early 20th c.*
Addresses: Bridgeport, CT. **Exhibited:** Soc. Indep. Artists, 1927. **Sources:** Marlor, Soc. Indp. Artists.

WYNN, Donald James *[Painter, lecturer] b.1942, Brooklyn, NY.*
Addresses: Brooklyn, NY. **Studied:** Pratt Inst. (B.F.A., 1967); Indiana Univ. (M.F.A., 1969). **Exhibited:** Hofstra Ann., Hempstead, NY, 1967; Indiana Artists, Herron Mus., Indianapolis, 1968; Poetic American Realism, Gallerie R.P. Hartmann, Munich, Germany, 1969; 22 Realists, WMAA, 1970; The Realist Revival, AFA Traveling Exh., New York Cultural Center, 1972. Awards: Herron Mus. Art Award, 1968; Elizabeth T. Greenshields Found. Mem. grant, 1970; FA Work Center residence grant, Provincetown, MA, 1971. **Work:** Pratt Inst.; Indiana Univ.; Greenshields Fed., Montreal. **Comments:** Positions: guest artist, Yale Univ., New Haven, CT, 1970; guest artist, Skidmore College, Saratoga Springs, NY, 1971; visiting artist, AIC, 1972-73; visiting artist, Ohio Univ., 1972. Teaching: Indiana Univ., Bloomington, 1967-69; Eastern Michigan Univ., 1972. **Sources:** WW73; Muller-Mellis, Poetic American Realism (Gallerie R. P. Hartmann, 1969); James Monte, 22 Realists (WMAA, 1970); Carter Ratcliff, "New York," Art Int. (April, 1970).

WYNNE, Albert Givens *[Painter, instructor] b.1922, Colorado Springs, CO.*
Addresses: Colorado Springs. **Studied:** Univ. Denver; Iowa Wesleyan College (B.A.); Univ. Iowa (M.A.); S. Carl Fracassini; Boardman Robinson; James Lechay. **Exhibited:** Corcoran Gal.

biennial, 1961; Joslyn Art Mus.; Butler Inst. Am. Art; Anchorage Alaska AC (prize); Des Moines AC (prize); AFA traveling exh.; Roswell, NM. **Comments:** Teaching: hon. instructor, Univ. Colorado, Colorado Springs FAC. **Sources:** WW73.

WYNNE, Evelyn B. *[Printmaker, commercial artist, teacher, painter, educator] b.1895, NYC.*
Addresses: Chevy Chase, MD, 1940-65. **Studied:** ASL; Royal College Engraving, London, England; Univ. Michigan; Corcoran Art Sch.; Malcolm Osborn; Avard Fairbanks; Eugene Weiss. **Member:** Lg. Am. Pen Women; Wash. WCC; Wash. PM; Corcoran Alumni. **Exhibited:** Corcoran Art Sch. 1942 (prize); LOC, 1943, 1949, 1952; Wash. SE, 1944-54, 1958; Wash. SMP, 1946; Soc. Wash. Artists, 1946, 1947, 1958; Smithsonian Inst. **Sources:** WW59; WW47.

WYNNE, Leslie Bernard, Jr. *[Painter, craftsperson, illustrator] b.1920, Indianapolls, IN.*
Addresses: Sierra Madre, CA. **Studied:** Pasadena City College; Pasadena AI; Claremont College; Einar Hansen; S. MacDonald-Wright; James Chapin; Norman Rockwell; Alfred Dewey. **Member:** Calif. WCS; Artists of the Southwest. **Exhibited:** Pasadena AI; Los Angeles County Fair; Greek Theatre, Los Angeles; John Herron AI; Ebell Club, Lafayette, LA (solo.). **Sources:** WW59.

WYNNE, Madeline Yale (Mrs.) *[Painter, craftsperson] b.1847, Newport, NY / d.1918, Asheville, NC.*
Addresses: Chicago/Deerfield, MA. **Studied:** BMFA Sch.; George Fuller. **Member:** Copley Soc., 1879; Chicago Arts & Crafts Soc.; Deerfield Arts & Crafts Soc. **Exhibited:** AIC, 1898; Chicago Artists, 1898. **Comments:** Specialty: metal work. **Sources:** WW10.

WYNNE, Milton *[Painter] mid 20th c.*
Addresses: NYC. **Exhibited:** PAFA Ann., 1949. **Sources:** Falk, Exh. Record Series.

WYNNE, Peter H. *[Painter] b.1858, Dublin, Ireland / d.1907, New Orleans.*
Addresses: New Orleans, active c.1896-1907. **Exhibited:** Artist's Assoc. of N.O., 1896. **Sources:** Encyclopaedia of New Orleans Artists, 425.

WYNNYK, Beryl McCarthy *[Sculptor, painter, craftsperson] b.1902.*
Addresses: San Francisco. **Exhibited:** San Francisco AA, 1939; GGE, 1939. **Comments:** Third wife of Ray Boynton (see entry). **Sources:** Hughes, Artists of California, 622.

WYNSHAW, Frances *[Art dealer] mid 20th c.; b.NYC.*
Addresses: NYC. **Comments:** Positions: dir., Avanti Gals., New York. Specialty of gallery: contemp. Am. and European art. **Sources:** WW73.

WYNTREE, Sonia *[Painter] mid 20th c.*
Exhibited: S. Indp. A., 1938. **Sources:** Marlor, Soc. Indp. Artists.

WYRICK, Pete (Charles Lloyd Wyrick, Jr.) *[Art critic, writer] b.1939, Greensboro, NC.*
Addresses: Richmond, VA. **Studied:** Davidson College (B.A.); Univ. North Carolina (M.F.A.); Univ. Missouri. **Member:** Am. Assn. Mus.; College AA Am.; Soc. Arch. Hist.; Am. Acad. Consults. **Exhibited:** Corcoran Biennial Exh. Am. Painting, 1967; North Carolina AA Ann., 1968; Univ. Virginia Print Exh., 1968. **Comments:** Positions: artmobile coordinator & asst. head programs division, Virginia MFA, Richmond, 1966-68; exec. dir., Assn. Preservation Virginia Antiques, 1968-70; pres., FA Consults, Richmond, 1971-; art critic, Richmond News Leader, 1971-. Publications: auth.,"Art and Urban Aesthetics" (weekly column), Richmond News Leader; auth.," A Wyeth Portrait," 1967 & "Contemporary Art at the Virginia Museum," 1972 Arts in Virginia; co-auth., "Richmond's 17th Street Market"; auth., "A Richmond Guide." Teaching: literature instr., Stephens College, 1964-66. Collections arranged: Art from the Ancient World, The Human Figure in Art, A Wyeth Portrait & Light as a Creative Medium, Virginia MFA, 1966-68. Research: contemporary Am.

painting; 18th-20th c. Am. architecture. **Sources:** WW73.

WYSE, F. H. *[Engraver] mid 19th c.*
Addresses: NYC, 1846. **Comments:** Possibly the H. Wyse of Albany who exhibited two specimens of engraving at the American Institute in 1849. **Sources:** G&W; NYBD 1846; Am. Inst. Cat., 1849.

WYSONG, Marjorie Eudora MacMonnies (Mrs.)
[Painter] early 20th c.
Studied: NAD. **Exhibited:** Salons of Am., 1934. **Comments:** Daughter of Frederick MacMonnies and Mary Low (see entries). **Sources:** Marlor, *Salons of Am.;* Petteys, *Dictionary of Women Artists.*

WYSZYNSKI, Eustace *[Lithographer] mid 19th c.*
Addresses: NYC, 1845-52. **Comments:** In 1845-46, with Rudolph Dolanowski (see entry). **Sources:** G&W; NYCD 1845-52; NYBD 1846.

WYTHE, J. *[Portrait painter] mid 19th c.*
Addresses: NYC. **Exhibited:** NAD, 1852. **Sources:** G&W; Cowdrey, NAD.

Aaron Sopher: *Couple viewing geometric abstract painting* (1960's)

X

XÁNTUS, János *[Topographical artist] b.1825, Csokonya, Hungary / d.1894, Budapest, Hungary.*
Addresses: Active 1851-60. **Comments:** Studied law and served in the ill-fated Rebellion of 1848. Escaped to the United States in 1851, where he became a topographer with one of the Pacific Railroad Surveys in 1852 and again in 1855. He also served with the U.S. Coast Survey in California and was stationed at Fort Tejon and Cape St. Lucas. While he was in California, he made important contributions to the study of Western birds and several new species were named for him. He was U.S. Consul at Manzanillo, Mexico from 1861-64, and afterwards returned permanently to Hungary. In his native country he became keeper of the ethnographical division of the National Museum in Budapest, a position he held until his death. He published two books on his American experiences, illustrated with his own sketches: *Levelei Ejszakamerikából* (Pest, 1858) and *Utazás Kalifornia déli Részeiben* (Pest, 1860). **Sources:** G&W; DAB; more recently, see Hughes, *Artists in California,* 623.

XAVIER, K. *[Painter] mid 20th c.*
Addresses: Seattle, WA, 1946. **Exhibited:** SAM, 1946. **Sources:** Trip and Cook, *Washington State Art and Artists.*

XCERON, Jean *[Painter] b.1890, Isari, Likosouras, Greece / d.1967.*
Addresses: NYC (immigrated 1904); Wash. DC (1910s); NYC (1920-27); Paris (1927-37); NYC (1937-on). **Studied:** Corcoran School Art, 1910s; École des Beaux-Arts, Paris, 1927. **Member:** Am. Abstract Artists; Fed. Mod. P&S; Soc. Indep. Artists.
Exhibited: S. Indp. A., 1921-22, 1925; Gal. de France, Paris, 1931 (1st solo); Gal. Percier, Paris, 1933; Gal. Pierre, Paris, 1934; Garland Gal., NY, 1935; Nierendorf Gal., 1938; Bennington College, 1944; Fed. Mod. P&S, 1945; New Orleans Arts & Crafts Club, 1931; GGE, 1939; Sao Paulo, Brazil, 1939; CI, 1942-44; CPLH, 1945; Soc. Indep. Artists, 1921-24; Guggenheim Mus., 1939-52, 1954-56, 1962, 1963; Am. Abstract Artists, 1941-44, 1951-58, 1964; NAC, 1942; Carnegie Inst., 1942-44, 1946-50; United Nations, San Fran., 1945; WMAA, 1946-65; traveling solo: New Mexico, Calif., Wash., 1948-49; Univ. Illinois, 1948-50, 1952, 1955, 1957, 1963 (prizes); Sidney Janis Gal., NYC, 1950, 1964; Newcomb College, 1957; WAC, 1953; Montreal Mus. FA., 1955; Rose Fried Gal., 1955, 1957, 1960-64; Yale Univ., 1957; BM, 1957; AFA, 1958; MoMA traveling exh., South America, 1963-64; AIC, 1964; NY World's Fair, 1964; Lever House, NYC, 1964; Gal. Dalmau, Barcelona, Spain; Brussels; Goldwach Gal., Chicago, 1963. **Work:** MoMA; PC; PMG; Mus. Non-Objective Painting (Guggenheim Mus.); Univ. Georgia; Univ. Illinois; Berkshire Mus. Art; Brandeis Univ.; Smith College; Washington Univ., St. Louis; Cahiers d'Art, Paris; Staatliche Kunsthalle, Karlsruhe, Germany; WPA mural for Assembly Room Chapel, Riker's Island, NY. **Comments:** Position: consult., Guggenheim Mus., 1939-67. **Sources:** WW66; WW47; *American Abstract Art,* 203.

XELA See: **SCHOMBURG, Alex**

XERON, John (or Jean) See: **XCERON, Jean**

XIQUES, Antonia *[Listed as "artist"] b.New Orleans,LA / d.1930, New Orleans.*
Addresses: Active in New Orleans, 1889-91. **Sources:** *Encyclopaedia of New Orleans Artists,* 426.

Dawson-Watson: *My Studio, Field & Sky.*
From *The Illustrator* (1893)

YABE, Yosuke *[Painter] early 20th c.*
Addresses: NYC. **Exhibited:** Salons of Am., 1929; S. Indp. A.,
1929. **Sources:** Falk, *Exhibition Record Series.*

YACOBOVITZ, Elias *[Painter] early 20th c.*
Addresses: Brooklyn, NY, 1931. **Exhibited:** S. Indp. A., 1931.
Sources: Marlor, *Soc. Indp. Artists.*

YACOE, Donald Edward *[Painter, teacher] b.1923, Chicago.*
Addresses: Alhambra, CA. **Studied:** AIC (traveling scholarship,
1948; B.F.A.; M.F.A. **Exhibited:** AIC, 1947-52 (Logan Prize,
1952); PAFA, 1949; BM, 1949; Rochester Mem. Art Gal., 1948;
SAM, 1949; NAD, 1948; MoMA, 1956; Los Angeles Mus. Art,
1954-55, 1958; Denver Art Mus., 1954-55; SFMA, 1955, 1956;
Pasadena Art Mus., 1956-58 (purchase prize, 1957); Santa
Barbara Art Mus., 1955; Long Beach, CA, 1957; Calif. State Fair,
1957 (purchase prize), 1958; Babcock Gal., NY, 1946 (solo);
Elizabeth Nelson Gal., Chicago, 1952; Palmer House Gal.,
Chicago, 1953; Landau Gal., Los Angeles, 1954, 1956. **Work:**
murals, Hotels Sherman & Chicagoan, Chicago; Clock Country
Club, Whittier, CA; Turf Club, Las Vegas, Nev., Hotel Fremont,
Las Vegas. **Comments:** Teaching: Pasadena (CA) City College.
Sources: WW59.

YAEGER, Edgar Louis *[Painter] b.1904, Detroit, MI.*
Addresses: Detroit 15, MI. **Studied:** Univ. Detroit; Univ.
Michigan; Wayne Univ.; John P. Wicker; Andre L'Hote, Marcel
Gromaire & O. Friesz in Paris (on Anna Scripps Whitcomb trav-
eling scholarship, 1934). **Member:** Scarab Club, Detroit; Wayne
Univ. AC. **Exhibited:** Detroit Inst. Aer, 1932, 1939 (prizes); AIC,
Carnegie Inst.; PAFA Ann., 1931, 1934; Corcoran Gal. biennial,
1930; CAA; MoMA; Angell Mus., Ann Arbor, MI (solo); Weyhe
Gal., NY (solo). **Work:** Detroit Inst. Art; murals, Receiving
Hospital, U.S. Naval Armory, Detroit; Ford Sch., Highland Park,
MI; Grosse Pointe Pub. Lib.; City of Detroit Pub. Lighting
Comm.; Univ. Michigan. **Comments:** WPA muralist. **Sources:**
WW53; WW47.

YAEGER, William L. *[Painter] early 20th c.*
Addresses: Phila., PA. **Member:** Phila. AA. **Sources:** WW25.

YAEXA, Thomas *[Painter] mid 20th c.; d.20.*
Addresses: Phila., PA. **Exhibited:** WMAA, 1958. **Sources:** Falk,
WMAA.

YAFFEE, Edith Widing (Mrs. Herman) *[Portrait painter]*
b.1895, Helsingfors, Finland / d.1961, Freeport, ME.
Addresses: Wash., DC. **Studied:** W. Paxton; P. Hale; PAFA
(European traveling scholarship, 1921). **Exhibited:** Chaloner
Paris-Am., 1920 (prize); PAFA Ann., 1921; Corcoran Gal. bienni-
al, 1923. **Sources:** WW33.

YAFFEE, Herman A. *[Painter] b.1897.*
Addresses: Cousins Island, ME. **Studied:** BMFA Sch.; PAFA;
Paris; Spain. **Sources:** WW29.

YAGHJIAN, Edmund (K.) *[Painter, educator, lecturer,*
writer] b.1903, Harpoot, Armenia.
Addresses: Columbia, SC. **Studied:** RISD (BFA); ASL with
Stuart Davis; J.R. Frazier; I.G. Olinsky; W. Von Schlegell.
Member: AFA; College AA; Southeastern College AA (pres.);
ASL (life mem.); SC Artists Guild (pres. & founder). **Exhibited:**
NY World's Fair; San Francisco World's Fair; S. Indp. A., 1932;
Carnegie Int., Pittsburgh, PA, 1936; WMAA, 1936,1940-41;
MMA, 1941-42; Corcoran Gal. biennials, 1937, 1947; PAFA Ann.,
1934-53 (7 times); NAD, 1934, 1936; MMA (AV), 1942; Pepsi-
Cola, 1944; WMAA, 1936, 1939, 1942; GGE, 1939; CI, 1936,
1941, 1945; Salons of Am.; Univ. South Carolina, 1972 (retro-
spective). **Work:** Duke Univ.; Ossining (NY) Mus.; Montpelier
(VT) Mus.; numerous H.S. and hospitals; NYU; Jr. H.S. 93, Beth
El Hospital, both in NYC; Commerce Bldg., Wash., DC; Newark
Educ. Bldg.; Mt. Morris Hospital, Farm Colony Hospital, NY;
NYPL; New York Univ.; High Mus. Art, Atlanta, GA; Gibbes Art
Mus., Charleston, SC; West Point Mus., NY. **Comments:**
Preferred medium: acrylics. Teaching: ASL, 1938-42; Univ.
Missouri, 1944-45; head dept. art, Univ. South Carolina, 1945-66;
artist-in-residence, 1966-72; Columbia Mus. Art, 1970s. **Sources:**
WW73.

YAKOVLEV, Yasha *[Photographer] b.1912, Russia / d.1970.*
Addresses: NYC. **Member:** Photo. Soc. Am. **Comments:** A
dancer, he performed Tartar and Caucasian dances in theatres in
the US and abroad for 30 years. He then turned to photography
and cinematography, studying under Sergei Eisenstein, and
exhibiting widely. **Sources:** flyer, G. Harris Auction Co.,
Marshalltown, IA.

YALE, (Charlotte) Lilla *[Painter, teacher] b.1855, Meriden,*
CT / d.1929.
Addresses: Meriden, CT. **Studied:** D.F. Wentworth in Hartford;
G. deF. Brush; ASL; W.M. Chase, R.H. Nicholls, both in
Shinnecock, Long Island. **Member:** Meriden Arts & Crafts Assn.
(charter member). **Exhibited:** S. Indp. A., 1918. **Comments:**
Primarily a plein-air artist, she painted landscapes as well as por-
traits. Marlor cites a birthplace of Cheshire, CT, and place of
death as Meriden, CT. **Sources:** WW27; Pisano, *The Students of*
William M. Chase, 24.

YALE, Leroy Milton (Dr.) *[Painter, etcher] b.1841, Holmes'*
Hole (now Vineyard Haven, MA) / d.1906, Quisset, MA.
Addresses: active in New Bedford, MA area, 1881-1906.
Studied: Columbia College, 1862; Bellevue Hospital Medical
College, 1866; primarily self-taught in art. **Member:** NYEC (a
founder,1877; pres., 1877-79). **Exhibited:** Boston AC, 1882;
Brooklyn AA, 1883. **Work:** Print Dept., NYPL has selection of
his best work, with a manuscript catalogue of his etchings as well
as original plates and tools illustrating the technique of the art;
Old Dartmouth Hist. Soc. **Comments:** Yale came to Nonquitt,
MA, every summer, and was a friend of R. Swain Gifford. He
made several hundred etchings, mostly landscapes, and later
turned to pastels. **Sources:** Blasdale, *Artists of New Bedford,* 211-
212 (w/repro.).

YALE, Lilla See: **YALE, (Charlotte) Lilla**

YAMA, Sudzuki Shinjiro *[Block printer, decorator, lecturer]*
b.1884, Japan.
Addresses: Syracuse, NY. **Work:** Mus. FA, Syracuse. **Sources:**
WW40.

YAMAGISHI, Teizo *[Painter] b.1898, Japan.*
Addresses: Seattle, WA, 1941. **Studied:** Tokyo FA College.
Exhibited: SAM, 1937-38. **Sources:** Trip and Cook, *Washington State Art and Artists,* 1850-1950.

YAMAGUCHI, Toshihiko *[Painter] early 20th c.*
Addresses: Summerville, MA, 1928. **Exhibited:** S. Indp. A.,
1928. **Sources:** Marlor, *Soc. Indp. Artists.*

YAMAMOTO, Taro *[Painter] b.1919, Hollywood, CA.*
Addresses: Brooklyn 1, NY/Provincetown (1951-on). **Studied:**
Santa Monica City College; ASL with Kuniyoshi, Kantor,
Browne, Vytlacil, 1950-51; Hans Hoffman Sch. FA, NYC, 1951-
53. **Member:** Beachcombers Club; Provincetown AA. **Exhibited:**
PAFA Ann., 1951; Provincetown AA, 1952, 1954-58; Contemp.
Art Gal., NY, 1953; Sun Gal., Gal. 256, and Little Gal., all
Provincetown, 1955-57; ASL, 1955 (solo); Galerie 8, Paris, 1953
(solo); ACA Gal., NYC, 1953 (solo); Provincetown Art Gal.,
1958. Scholarships & fellowships: Hans Hofmann Sch. FA, 1951;
ASL, 1952 (John Sloan Mem. fellow); McDowell traveling fel-
low, 1953; McDowell Colony, 1954, 1956-57. **Work:** Methodist
Church, Los Angeles; Walter Chrysler Coll. (60 paintings).
Comments: Abstract painter. **Sources:** WW59; Crotty, 143;
Provincetown Painters, 255.

YAMANAKA, H. *early 20th c.*
Exhibited: Salons of Am., 1926, 1928. **Sources:** Marlor, *Salons
of Am.*

YAMANAKA, Sadajiro *[Patron] b.1866, Japan / d.1936.*
Comments: Came to U.S. c.1896 and opened New York branch
of his firm. Oriental and occidental circles knew him as one of the
foremost connoisseurs of Asiatic art. The governments of Japan,
France, and Germany conferred honors upon him.

YAMANARI, Kozen *[Painter] early 20th c.*
Addresses: NYC. **Exhibited:** S. Indp. A., 1919. **Sources:**
Marlor, *Soc. Indp. Artists.*

YAMAZOE, Keechi *[Painter] early 20th c.*
Addresses: NYC. **Exhibited:** S. Indp. A., 1920. **Sources:**
Marlor, *Soc. Indp. Artists.*

YAMMERINO, Aurelio James *[Painter, teacher] b.1912,
New Rochelle, NY.*
Addresses: Port Chester, NY; New Rochelle, NY. **Studied:** NAD;
Leon Kroll; Gifford Beat; George Picken. **Member:** Westchester
Arts & Crafts Gld.; Mamaroneck Art Gld.; SC; AAPL; Wash.
Square AA. **Exhibited:** NAD, 1951; AWCS, 1951; Audubon
Artists, 1951; All. Artists Am., 1950; NAC, 1952; AAPL, 1949-
52; SC, annually; Creative Art Gal.; A.F.I. Gal.; Village Art Cert.;
Hudson Valley AA; Hudson Soc. Indep. Artists; Little Studio, NY;
Quaker Ridge Sell., Scarsdale, NY, 1954-58; Westchester County
Center, White Plains, NY, 1955; Travis Gal., NY, 1955; Greene
Gal., New Rochelle; Sidin-Harris Gal., Hartsdale, NY;
Mamaroneck Lib., 1958 (solo); Greenwich (CT) AA, 1958 Cos
Cob, CT, 1958. Awards: prizes, Hudson Valley AA, 1948;
Hudson Valley Indep. Artists, 1949; White Plains, NY, 1948;
Wash. Square AA, 1948-50; Westchester Arts & Crafts Gld.,
1958; Women's Club, Portchester, NY. **Comments:** Teaching:
Westchester County Workshop, White Plains, NY; Jewish
Community Center, Port Chester, NY. **Sources:** WW59.

YAMPOLSKY, Oscar *[Painter, sculptor, teacher] b.1892 /
d.1944.*
Addresses: Chicago, IL. **Studied:** AIC; Europe. **Exhibited:** AIC,
1912-13, 1916-17, 1923. **Comments:** Teaching: Fort Wayne (IN)
Art Sch.; Wash. State College. **Sources:** WW17.

YANCEY, Terrance L. *[Painter, graphic artist] b.1944,
Boston, MA.*
Studied: BMFA Sch. **Member:** Boston Negro AA; Art Dir. Club
of Boston. **Exhibited:** Boston Univ., 1963; MIT, 1963; Boston
Pub. Lib., 1964, 1965; Univ. Mass., 1968; Boston City Hall, 1969,
1970, 1972; Int. Whole World Celebration, Commonwealth
Armory, Boston, 1971; Black Acad., NYC, 1972; other public
bldgs., churches & galleries in the 1960s-70s. Awards: Safety

Poster Award, 1961, 1962; Red Cross Poster Award, 1961-63;
Boston Globe Scholastic Art Award, 1961-65; Clean Up Boston
Poster Award, 1962, 1963; Boston Negro AA (1st Award); Sunday
in the Park, Boston (prize). **Sources:** Cederholm, *Afro-American
Artists.*

YANDELL, Charles R. *[Painter, craftsperson] 19th/20th c.*
Addresses: NYC. **Member:** NAC. **Sources:** WW01.

YANDELL, Enid *[Sculptor, teacher] b.1870, Louisville, KY /
d.1934, Boston, MA.*
Addresses: Boston, MA/Edgartown, MA; NYC, 1899. **Studied:**
Cincinnati Art Sch. with Ben Pitman & Louis T. Rebisso; assisted
Lorado Taft, Chicago, 1891; P. Martiny in NY; assisted Karl
Bitter, NYC, 1893; MacMonnies & Rodin in Paris, 1894.
Member: NSS, 1898 (one of the first women elected); NY
Municipal AS; NYWCC; Boston SS. **Exhibited:** AIC, 1891,
1916; statue of Daniel Boone for Kentucky pavilion, caryatids for
the Woman's Bldg., and other work, Columbian Expo, Chicago,
1893 (Designer's medal); SNBA, 1896; Tennessee Expo,
Nashville, 1897 (medal); Paris Salon, 1897-99; NAD, 1899;
PAFA Ann., 1899-1911 (6 times); Pan-Am. Expo, Buffalo, 1901
(prize); St. Louis Expo, 1904 (medal); Officier de l'Académie,
French Government, 1906; Armory Show, 1913. **Work:** Mus. of
Art, RISD; Carrie Brown mem. fountain, Providence, RI; Daniel
Boone statue, Louisville, KY; College Physicians & Surgeons,
NY; Emma Willard Mem., Albany, NY; Hogan fountain/monu-
ment, Louisville, KY; fountain, Watch Hill, RI; Mayor Lewis
Mon., New Haven, CT. **Comments:** Yandell was one of the group
of women assisting Lorado Taft in the preparation of architectural
sculptures for the World's Columbian Expo. in Chicago. She also
produced her own work for the Exposition. Yandell built a suc-
cessful career as a sculptor of public monuments and portrait
busts, but she also worked on smaller commissions — making
decorative sculpture for private homes and gardens. She worked
primarily in a Beaux-Arts style, but occassionally produced works
that show the influence of Symbolist aesthetics and Rodin (as in
her "Kiss Tankard," produced for Tiffany's, c. 1899, now at
RISD). An organizer of the Branstock School Art, Edgartown,
1907. Produced little work following WWI. Co-auth.: *Three Girls
in a Flat* 1892 (autobiographical story about the experiences of
three unmarried professional women). **Sources:** WW33; Fink,
Am. Art at the 19th C. Paris Salons, 409; Fort, *The Figure in
American Sculpture,* 234 (w/repro.); Rubinstein, *American Women
Artists,* 100-01.

YANEZ, Alvaro See: **FERNANDEZ-YANEZ, Alvaro**

YANG, Edith *[Painter] early 20th c.*
Addresses: China. **Exhibited:** S. Indp. A., 1924. **Sources:**
Marlor, *Soc. Indp. Artists.*

YANKOWITZ, Nina *[Painter] b.1946.*
Addresses: NYC. **Exhibited:** WMAA, 1973. **Sources:** Falk, *WMAA.*

YAP, Violet *[Painter] mid 20th c.*
Addresses: NYC. **Exhibited:** PAFA Ann., 1946. **Sources:** Falk,
PAFA, Vol. 3.

YARBROUGH, Vivian Sloan *[Painter] b.1893, Whitesboro,
TX / d.1978, Santa Fe, NM.*
Addresses: Ft. Worth, TX. **Studied:** R. Davey; E. Lawson; J.
Sloan. **Member:** S. Indep. A.; SSAL; Texas FAA. **Exhibited:**
Denver AM; S. Indep. A., 1930, 1931, 1933; Qgunquit(ME) AC;
Salons of Am. **Sources:** WW33.

YARD, Margaret See: **TYLER, Margaret Yard**

YARD, Sydney Jones *[Painter] b.1855, Rockford, IL / d.1909,
Monterey Peninsula, CA.*
Addresses: NYC; Monterey Peninsula, CA. **Studied:** NYC;
Sutton Palmer, British Isles. **Work:** Monterey Peninsula Mus. Art.
Comments: Position: newspaper publisher, Monterey. Specialty:
watercolor landscapes and coastals. **Sources:** Hughes, *Artists of
California,* 624.

YARDE, Richard *[Painter, educator] b.1939.*
Studied: BMFASch; Boston Univ. (B.F.A., 1962; M.F.A., 1964).
Exhibited: Fort Wright College, Spokane, 1968 (solo); Boston City Hall, 1969; Brandeis Univ., 1969; BMFA, 1970; Nat. Center of Afro-Am. Artists, Boston, 1971; Studio Mus., Harlem; Rose Art Mus., 1970; Thayer Acad., 1972; Boston Univ.; Inst. Contemporary Art; Rhode Island Arts Festival; Emancipation Proclamation Centennial; Boston Pub. Lib., 1973; Carl Siembab Gal.; Yaddo; Windsor School, Boston. **Awards:** Blanche E. Colman Award, 1971; Invitation to Yaddo Corp., 1964, 1966, 1970; McDowell Colony, 1968, 1970; Artist-in-residence, Harlem Art Project, 1968; Boston Univ., 1962 (grand prize); summer study in Ibadan, Nigeria. **Work:** Boston Univ.; Fort Wright College, Spokane; 1st Nat. Bank of Boston; Windsor School, Boston. **Comments:** Teaching: Boston Univ. **Sources:** Cederholm, *Afro-American Artists.*

YARDLEY, Caroline S. *[Miniature painter] early 20th c.*
Addresses: NYC; St. Paul, MN. **Member:** Penn. SMP.
Exhibited: PAFA Ann., 1903. **Sources:** WW10.

YARDLEY, Ralph O. *[Cartoonist] b.1878, Stockton, CA / d.1961, Stockton, CA.*
Addresses: Stockton, CA; Carmel, CA. **Studied:** Mark Hopkins Art Inst.; Partington Art School. **Work:** Huntington Lib., San Marine, CA; Haggin Mus., Stockton. **Comments:** Positions: quick-sketch artist, *San Francisco Examiner*, 1898, *Honululu Advertiser*, 1900; staff, *NY Globe*, 1905-07, *San Francisco Call*, 1907-1909; staff cartoonist, Stockton Record, Stockton, CA, 30 years. **Sources:** WW59; WW47. More recently, see Hughes, *Artists of California*, 624.

YARNELL, Agnes *[Painter, sculptor, author] mid 20th c.; b.Drifton, PA.*
Addresses: Ardmore, PA. **Studied:** Liberty Tadd School of Modeling; PAFA. **Exhibited:** PAFA Ann., 1930-43 (4 times); Union League, Phila. (war soldier figures). **Work:** White House Coll., Wash., DC; (bronze bust of President Ronald Reagan, presented 1986); Franlin Inst. Laboratories, Phila. **Commissions:** life size figure of Benjamin Franklin for Franklin Inst. **Comments:** Worked with Boris Blai, Paul Manship, and Archipenko. Author: *Circus World* (1982); *An Attempted Evocation of the Civil War.* **Sources:** PAFA, vol. 3; info. courtesy Mary Ann Ruggiero, Westwood, NJ.

YARNELL, D. F. *[Sign painter ("fancy sign painter")] mid 19th c.*
Addresses: Shreve (OH) in 1847. **Sources:** G&W; Knittle, *Early Ohio Taverns*, 45.

YARON, Alexander A. *[Painter, commercial artist, illustrator] b.1910, Tallinn, Estonia.*
Addresses: Forest Hills 75, NY; Kew Gardens 15, NY. **Studied:** V. Podgoursky, V. Zasipkin, F.H. Hindle, in Shanghai. **Member:** Shanghai Art Club. **Exhibited:** Cathay Mansions, Shanghai, 1943; Dominico-American Inst., 1950; Hotel Prado, Tegucigalpa, Honduras; San Salvador, 1951; New Orleans, LA, 1952; Shelbourne Hotel, Miami, 1953. **Work:** mural, Presidential Palace, El Salvador. **Comments:** Position: illustr., J.C. Martin, Inc., NYC. **Sources:** WW59.

YARROW, William H(enry) K(emble) *[Painter, writer] b.1891, Glenside, PA / d.1941, NYC.*
Addresses: Redding Ridge, CT. **Studied:** PAFA; Acad. Grand Chaumière & Colarossi, both in Paris. **Member:** Arch. Lg.
Exhibited: PAFA Ann., 1910-19 (8 times); Pan.-Pac. Expo, 1915 (medal); Phila. AC, 1916 (gold); S. Indp. A., 1917, 1919, 1921; Corcoran Gal. biennials, 1910-16 (3 times); Ferargil Gal., NY, 1938; AIC. **Work:** PAFA; WMAA; Phila. AC. **Comments:** Author: "Robert Henri," 1921. Editor: *American Art Library.* **Sources:** WW40.

YATER, George David *[Painter, photographer art administrator, designer, writer] b.1910, Madison, IN.*
Addresses: Provincetown, MA; Truro, MA (1931-on). **Studied:** John Herron Art Sch, 1928-32; Cape Sch. Art, Provincetown with

Henry Hensche, summers 1931-34; Edwin Dickinson; Richard Miller; W. Forsyth. **Member:** Phila. WCC; Provincetown AA; Indianapolis AA. **Exhibited:** NAD, 1934, 1940; PAFA, 1934, 1937, 1939, 1943-45; Hoosier Salon, 1931 (prize), 1932, 1934, 1936 (prize), 1940, 1941, 1945, 1946 (prize), 1954 (first prize); AWCS, 1938, 1945; WFNY, 1939; Hanover Col. Inc., 1939 (solo); Currier Gal. Art, Manchester, NH, 1940; Univ. Illinois, 1939; Inst. Mod. Art, Boston, 1939; Paper Mill Playhouse, Millburn, NJ, 1939; Provincetown AA, 1934-46; Indianapolis MA, 1931-46; Chrysler Art Mus., Provincetown, MA; John Herron AM, 1953 (Alumni prize, Indiana Artists Ann.); Falmouth Artists Guild, 1961, 1969 (1st prizes). **Work:** Chrysler Collection, Norfolk Art Gallery, VA; Ford Motor Co, Dearborn, MI; Paper Mill Playhouse, Millburn, NJ; Indiana Univ., Bloomington; De Pauw Univ., Greencastle, IN. **Comments:** Preferred media: oils, watercolors. Positions: dir., Provincetown AA, 1947-61; dir., Sarasota AA, 1955-66; dir. & instr., Middletown FA Center, 1970-71. Photographs: *Rudder, Motor Boating, Yachting* magazines; more than 75 watercolors have been used as illustrations in *Ford Times, Lincoln-Mercury Times, New Eng Journeys*, 1952-60. **Sources:** WW73; WW47; Ernie Pyle, article, *Scripps-Howard Feature* (1936); Jack Stinnet, *In New York* (AP Feature, 1936); Robert Hatch, "At the Tip of Cape Cod," *Horizon Magazine* (1961); Crotty, 117; Provincetown Painters, 149.

YATES, Charles E. *[Printmaker] b.1940, Tennessee.*
Studied: Univ. Pennsylvania. **Exhibited:** Phila. Civic Center Mus.; Brand Lib. of Art & Music, Glendale, CA; UCLA; Los Feliz Jewish Community Center; Dickson AC, Univ. Calif. **Work:** Oakland Mus. **Sources:** Cederholm, *Afro-American Artists.*

YATES, Cullen Bryan *[Landscape painter, framemaker] b.1866, Bryan, OH / d.1945.*
Addresses: NYC, 1898; Shawnee-on-Delaware, Monroe County, PA, summers, from 1910, permanently from 1923. **Studied:** NAD, W.M. Chase, L. Ochtman, all in NYC; École des Beaux-Arts, Colarossi Acad., both in Paris; Académie Julian, Paris with J.P. Laurens & B. Constant. **Member:** ANA, 1908; NA, 1919; AWCS; NYWCC; Lotos Club; SC, 1899; NAC (life member); Allied AA; SPNY; New York Century A.rtists. **Exhibited:** SNBA, 1896; NAD, 1898; PAFA Ann., 1898-1935 (13 times); Boston AC, 1903-1909; St. Louis Expo, 1904 (medal); Corcoran Gal. annuals/biennials, 1907-08, 1910; SC, 1907 (prize), 1921 (prize); Buckwood Inn, Shawnee, PA, 1912; NAC, 1932 (medal); AIC. **Work:** NGA; City Art Mus., St. Louis; Seattle Gal.; Brooklyn Mus.; Montclair (NJ) AM; Butler AI; Seattle AM; Nat. AC; Lotos Club; Newark (NJ) AM. **Comments:** Known for his landscapes around Shawnee and his paintings of the Maine coast at Monhegan. **Sources:** WW40; Fink, *American Art at the Nineteenth-Century Paris Salons*, 409; Art in Conn.: The Impressionist Years; Gerdts, *Art Across America*, vol. 1: 281-83.

YATES, Edna Roylance *[Block printer, etcher, wood engraver, lithographer, teacher, lecturer] b.1906, NYC.*
Addresses: NYC/La Grangeville, NY. **Studied:** A. Gorky; A. Lewis; H. Wickey. **Member:** AA of Syracuse. **Exhibited:** Syracuse Mus. FA, 1937 (prize). **Comments:** Teaching: Adults & Children's Sch. AC, NY. **Sources:** WW40.

YATES, Elizabeth M. *[Painter, teacher] b.1888, Stoke-on-Trent, Staffordshire, England.*
Addresses: Buffalo, NY. **Studied:** PIA Sch. **Member:** Buffalo GAA. **Sources:** WW31.

YATES, Floyd Buford (Bill) *[Cartoonist] b.1921, Samson, AL.*
Addresses: Westport, CT. **Studied:** Corcoran School Art; Univ. Texas (B.J.). **Member:** Nat. Cartoonists Soc.; Artists & Writers. **Comments:** Positions: author of lesson on magazine cartooning for cartoon course, Art Instruction, Inc.; ed. of humor publications for Dell Publ. Co.; *1000 Jokes magazine; Ballyhoo; For Laughing Out Loud*, 1950-60. Illustr.: "Dear Doctor," 1958; "Dear Justice," 1960. Ed.: "Laughing on the Inside," 1953; "Too Funny for Words," 1954; "Forever Funny," 1956; "The other Woman," 1959; "Nervous in the Service," 1961. Contrib. cartoons to: *Sat. Eve.*

Post; Look; True; This Week; Ladies Home Journal; Esquire; Better Homes & Gardens, Argosy; Sports Illustrated; King Features Syndicate; McNaught Syndicate; Chicago Tribune-New York News Syndicate, and others. **Sources:** WW66.

YATES, Frederick *[Portrait painter] b.1854, England / d.1919, England.*
Addresses: San Francisco, CA, 1886-1900; England. **Studied:** Bonnat, Boulanger, Lefebvre in Paris. **Member:** Bohemian Club. **Exhibited:** Paris Salon; Royal Acad., London; ASL of San Francisco, 1886; Mark Hopkins Inst., 1897. **Work:** Bohemian Club. **Comments:** Teaching: San Francisco ASL. **Sources:** Hughes, *Artists of California*, 624.

YATES, Ida Perry *[Craftsman, textile restorer, museum curator] b.1876, Charles Town, WV.*
Addresses: Washington, DC. **Work:** Textile Mus., Wash. D.C.; NGA; Dumbarton Oaks, Wash. D.C.; Smithsonian Inst.; Walters A. Gal., Balt.; Yale Univ. Mus. **Comments:** Position: cur., Textile Mus., Washington, DC, 1929-retired. Specialist in preserving ancient textiles. **Sources:** WW53.

YATES, Jack *[Painter] mid 20th c.*
Exhibited: AIC, 1938. **Sources:** Falk, *AIC.*

YATES, Julian E. *[Painter] b.1871, Williams Mills, NC / d.1953, Nantucket, MA.*
Addresses: Nantucket (1935-on). **Studied:** Wake Forest College; Univ. Chicago (Divinity). **Exhibited:** K. Taylor Gal., Nantucket; Nantucket Hist. Assn. **Work:** Nantucket Hist. Assn. **Comments:** An active member of Nantucket's summer artist colony, he was an amateur of considerable talent who devoted much of his time to painting during his 18 years of retirement on the island from 1935-53. Previously an Army Colonel, he was Chief of Chaplains, 1929-35. **Sources:** info. courtesy Nantucket Hist. Assn.

YATES, Julie Chamberlain Nicholls (Mrs. Halsey E.) *[Sculptor] b.St. Louis, MO / d.1929, Governor's Island, NY.*
Addresses: Governor's Island, NY. **Studied:** Rodin and Bourdelle in Paris; St. Louis FA Sch. with Zolnay. **Member:** NAC, 1920. **Exhibited:** S. Indp. A., 1917; WMAA, 1921, 1927-28; Paris Salon; NAC; St. Louis Artists' Guild. **Comments:** Portraits and garden figures. **Sources:** Petteys, *Dictionary of Women Artists.*

YATES, Julie T. *[Sculptor] early 20th c.*
Addresses: NYC. **Comments:** *Cf.* Julie C. Yates. **Sources:** WW17.

YATES, (Mrs.) *[Miniature painter] mid 19th c.*
Addresses: Philadelphia. **Exhibited:** Artists' Fund Soc., 1835 (several originals and copies). **Sources:** G&W; Rutledge, PA.

YATES, Ruth *[Sculptor, teacher] b.1896, Greenville, OH.*
Addresses: NYC. **Studied:** Cincinnati Art Acad.; ASL; Grand Central Art Sch.; Académie Julian, Paris with P. Landowski; J. de Creeft. **Member:** ASL; AEA; Pen & Brush Club; Westchester Clay & Chisel Club (founder, pres.); Westchester Arts & Crafts Gld.; NSS (rec. sec., 1943-46, 1949-50); NAWA (pres., 1949-51; treas., 1952-); Hudson Valley AA. **Exhibited:** NAD, 1931; NAWA, 1931, 1932, 1938, 1939 (prize), 1945, 1946, 1949, 1951 (prize), 1952; NY, 1939 (solo); PAFA Ann., 1942-43; NSS, 1940, 1949, 1952; MMA, 1942; Pen & Brush Club, 1945-49 (prize, 1945); Argent Gal., 1950-52; Artists for Democratic Living award, 1951. **Work:** Norfolk Mus. Arts & Sciences; Brookgreen Gardens, SC. **Comments:** Positions: dir., New York City Center Gal., 1953-. Teaching: Westchester Workshop, White Plains, NY. **Sources:** WW59; WW47.

YATES, Sharon Deborah *[Painter] b.1942, Rochester, NY.*
Addresses: Rome, Italy. **Studied:** Syracuse Univ. (scholarship to Florence, Italy, 1963; B.F.A., 1964); Tulane Univ. (M.F.A., 1966). **Exhibited:** Am Fedn Arts Traveling Exhib, New York, 1967-; Okla Art Ctr Tenth Ann, 1968; Mainstreams '70, Marietta (OH) College FA Center, 1970; Exh. Contemp. Realists, Cleveland (OH) Inst., 1972; Univ. Louisville, KY, 1967 (solo). Awards: seed grant as artist-in-residence, Am. Beautiful Fund of Natural Area Council, 1970; grand prize, Mainstreams, 1970; Prix de Rome,

1972. **Work:** Oklahoma AC, Oklahoma City. **Comments:** Preferred medium: oils. Publications: contrib., *A Sense of Place, The Artist & The American Land,* 1972. Teaching: Univ. Louisville, 1966-68; Maryland Inst. College Art, 1968-. **Sources:** WW73; Barbara Gold, "Art!?," film produced on Channel 2, Baltimore, MD, March, 1972.

YAVNO, Max *[Photographer] b.1911, NYC / d.1985, Los Angeles, CA.*
Studied: City College, NY (B.B.S., 1972); CCNY Grad. Sch.; Columbia Univ; Univ. Calif., Los Angeles (cinematography). **Member:** Photo League (pres., 1938-39); Conde Nast. **Exhibited:** Award: Guggenheim Fellowship. **Work:** MoMA; George Eastman House; Frances Lehman Loeb AC; Herbert F. Johnson Mus. Art; MMA; Minnesota Inst. Arts; Center for Creative Photography (AZ); North Light Gallery, Univ. Arizona Art Mus,; TMA; CMA; Univ. Michigan Mus. Art; Detroit (MI) Inst. Arts; New Orleans (LA) Mus, Art, Indiana Univ. Art Mus.; Amon Carter Mus. ; Mus. FA Houston; Mus. Photographic Arts, CA; Grunwald Center for the Graphic Arts, CA; Calif. Mus. Photography; Stanford Univ. Art Mus.; LACMA; San Fran. Mus. Mod. Art; Oakland (CA) Mus. Art; Santa Barbara (CA) Mus. Art; PMA; Fogg Art Mus., Harvard Univ.; Virginia Mus. FA; Portland (OR) Mus. Art; Univ. New Mexico Art Mus.; Yale Univ. Art Gal.; Gal. FA, Center for Graphic and Photographic Studies, FL. **Comments:** Positions: Los Angeles Studio for Commercial Photography, 1954-75; WPA, 1936-42; social worker, NYC Home Relief Bureau, 1935. Publications: with Lee Shippey, *The Los Angeles Book,*1950; with Herb Caen, *The San Francisco Book,* 1948; with M.K. Fisher, *The Wine Book,* 1962. **Sources:** info courtesy Selma Koss Holtz, Waban, MA.

YAWORSKI, Alex F. *[Painter] mid 20th c.*
Addresses: Chicago area. **Exhibited:** AIC, 1949-50. **Sources:** Falk, *AIC.*

YAZZIE, James Wayne *[Painter] b.1943.*
Addresses: living in Sheep Springs, NM in 1967. **Work:** Tamerind Found., Dragoon, AZ; Mus. Am. Indian; Mus. New Mexico. **Sources:** P&H Samuels, 543.

YBARRA, Alfred C. *[Painter] mid 20th c.*
Addresses: Los Angeles, CA, 1930s, 1940s; NYC. **Member:** NY WCC. **Exhibited:** GGE, 1939; Artists of Los Angeles, LACMA, 1943. **Sources:** Hughes, *Artists in California*, 624.

YCRE, Marthe *[Painter] mid 20th c.*
Addresses: NYC. **Exhibited:** WMAA,1920-28; S. Indp. A., 1928, 1930; Salons of Am., 1934. **Sources:** Falk, *Exhibition Record Series.*

YEAGER, Charles George *[Craftsperson, block printer, painter, teacher] mid 20th c.*
Addresses: Indianapolis, IN. **Studied:** M. Thompson; O. Richey; W. Forsyth; P. Harley; A. Heckman; C. Martin; W. McBride; C. Wheeler; A. Young. **Member:** Ind. AC; Ind. Soc. PM. **Exhibited:** Ind. Artists' Ex. 1929 (prize); Ind. State Fair, 1937 (prize); Hoosier Salon, 1937 (prize). **Work:** Ind. Univ. **Comments:** Position: teacher, Emmerich H.S., Indianapolis. **Sources:** WW40.

YEAGER, Edward *[Portrait, historical, and map engraver on copper, steel, and wood] mid 19th c.*
Addresses: Philadelphia, active during the 1840's and 1850's. **Sources:** G&W; Phila. CD 1840-59.

YEAGER, Joseph *[Engraver, printseller, publisher] b.c.1792, Philadelphia (probably) / d.1859, Philadelphia.*
Addresses: Philadelphia, active 1809-c.1849. **Comments:** Of his known works, half consist of etched portraits and the other half of line-engraved views of scenery and buildings. He also sold prints and published children's books. In 1848 he became president of the Harrisburg & Lancaster Railroad, which was later absorbed into the Pennsylvania system. **Sources:** G&W; DAB; Stauffer; Phila. CD 1816-47; *Antiques* (Aug. 1928), 130, repro.

YEAGER, Walter Rush *[Illustrator, religious artist, designer] b.1852, Philadelphia, PA / d.1896, Philadelphia, PA.*

Studied: PAFA. **Comments:** Joined staff of *Leslie's*, c. 1874 and accompanied the Frank Leslie party to the West in 1877. **Positions:** head of lithographic art dept., Philadelphia,,1880; freelance artist and illustrator, 1885. **Sources:** P&H Samuels, 543.

YEARGANS, Hartwell *[Painter, printmaker] b.1925.*
Exhibited: WMAA, 1971. **Work:** Oakland Mus. **Sources:** Cederholm, *Afro-American Artists.*

YEARGANS, James Conroy *mid 20th c.*
Studied: NAD. **Member:** Spiral Group. **Exhibited:** Newark Mus.; SFMA; Rhode Island Mus.; ACA Gallery; McGill Univ., Montreal. **Sources:** Cederholm, *Afro-American Artists.*

YEARSLEY, Joseph *[Lithographer] b.c.1834, Delaware.*
Addresses: Philadelphia in 1860. **Comments:** His wife and two small children were born in Pennsylvania. **Sources:** G&W; 8 Census (1860), Pa., XXVI, 221.

YEATMAN, George W. *mid 20th c.*
Exhibited: Salons of Am., 1934; S. Indp. A. 1936. **Sources:** Falk, *Exhibition Record Series.*

YEATMAN, Sue *[Landscape artist] late 19th c.*
Addresses: Norfolk, VA. **Exhibited:** Norfolk, VA, 1885. **Sources:** Wright, *Artists in Virgina Before 1900.*

YEATS, Jack Butler *[Painter] b.1871, Sligo, Ireland / d.1957, Dublin, Ireland.*
Addresses: Dublin, Ireland. **Exhibited:** Armory Show, 1913; S. Indp. A., 1921-26. **Sources:** Marlor, *Soc. Indp. Artists;* Brown, *The Story of the Armory Show.*

YEATS, John *[Portrait painter, writer] b.1839, Ireland / d.1922.*
Addresses: NYC. **Studied:** S. Indp. A.; Hibernian Acad. **Comments:** Father of poet William Butler Yeats and of artist Jack B. Yeats. Author: "Essays, Irish and American." **Sources:** WW17.

YECKLEY, Norman *[Painter] b.1914, Douglas, AZ.*
Addresses: Glendale, CA. **Studied:** Otis Art Inst.; San Francisco ASL; with Dana Bartlett. **Member:** Glendale AA; Laguna Beach AA. **Comments:** Known for his desert landscapes. **Sources:** Hughes, *Artists in California,* 624.

YEE, Frank *[Sculptor] mid 20th c.*
Addresses: Wash., DC. **Exhibited:** PAFA Ann., 1952 (prize), 1953. **Sources:** Falk, *PAFA, Vol. 3.*

YEISER, Mary *[Painter] b.1905.*
Studied: Académie Julian, Paris, 1928. **Sources:** Fehrer, The Julian Academy.

YEKTAI, Manoucher *[Painter] b.1922, Tehran, Iran.*
Addresses: NYC. **Studied:** Univ. Tehran; Ecole Superior des Beaux Arts, Paris, with Ozenfant, 1945-47; ASL, 1947-48. **Exhibited:** Poindexter Gal, NYC, 1957-64 (5 solos); Gumps Gal, San Francisco, 1959, 1964-65; Piccadilly Gal, London, 1961 & 1970; Anderson-Meyer Gal, Paris, 1962; PAFA Ann., 1962; Corcoran Gal biennial, 1963; Gertrude Kasle Gal., Detroit, 1965-70. **Comments:** Preferred media: oils. **Sources:** WW73.

YELLAND, Raymond Dabb *[Landscape painter] b.1848, London, England / d.1900, Oakland, CA.*
Addresses: NYC; Oakland, CA, 1874-1900. **Studied:** NAD, with W. Page, L.E. Wilmarth, J.R. Brevoort, 1868-72; Paris, with Merson, 1877. **Member:** San Francisco AA, 1874. **Exhibited:** NAD, 1882-88; San Francisco AA, 1874-1900; Paris Salon, 1877; Mechanics' Inst., 1875-96; World's Columbian Expo, Chicago, 1893; Calif. Midwinter Int'l Expo, 1894; Mark Hopkins Inst., 1897. **Work:** Calif. Hist. Soc.; Oakland Mus.; First Congregational Church, Oakland; Bancroft Library, UC Berkeley; Monterey Peninsula Mus. of Art; Chicago Hist. Soc.; Garzolli Gal., San Rafael, CA. **Comments:** Came to the U.S. in 1851 and grew up in NYC and painted for a time in Gloucester Harbor. He served under Sheridan in the Civil War and sailed around Cape Horn to San Francisco in 1874 with his new bride. Yelland's coastal scenes display his special mastery of depicting light at sunset. **Positions:** instructor, Mills College, Oakland, CA, 1874; asst. director, Calif. Sch. Design, 1877; director, 1888; drawing teacher, UC Berkeley; perspective instructor, Mark Hopkins IA. Many important artists count among his students, incl. Homer Davenport, Alexander Harrison and Maynard Dixon (see entries on each). **Sources:** WW98; Hughes, *Artists in California,* 624-625; P&H Samuels, 543; Gerdts, *Art Across America,* vol. 3: 245-46.

YELLAND, William Raymond *[Landscape painter, architect] b.1889, Los Gatos, CA / d.1966, Milan, Italy.*
Addresses: Oakland, CA. **Studied:** UC Berkeley (arch.) with John G. Howard; Univ. of Pennsylvania. **Member:** American Inst. of Architects; Athenian-Nile Club, Oakland, CA. **Exhibited:** Oakland Art Gallery, 1929-34. **Award:** A.I.A., 1927. **Comments:** Nephew of R. D. Yelland (see entry), he was mainly an architect, who painted and exhibited in the San Francisco Bay area in his free time. **Sources:** Hughes, *Artists in California,* 625.

YELLENTI, Nicholas *[Painter] b.1894, Pittsburgh.*
Addresses: NYC (Old Lyme, CT, in 1924). **Studied:** Swain Sch.Des., with C. Riddell, I. Caliga, P. Little. **Member:** SC. **Exhibited:** Toledo Fed. A. Exh., 1920 (prize), 1921 (prize); Corcoran Gal biennial, 1937. **Sources:** WW40.

YELLIN, Samuel *[Craftsperson, teacher] b.1885, Poland / d.1940, NYC.*
Addresses: Wynnewood, PA. **Studied:** PM Sch IA; Europe. **Member:** AIA; Arch. Lg.; Arch. C., Chicago; Boston SAC; Phila. Alliance; Am. Assn. Mus.; Fairmount Park AA.; Phila. Sketch C.; T. Square; Medieval Acad. of Am.; AFA; Am. Inst. Iranian A. & Archaeology; BAID; Royal Soc. A., London; Armor & Arms Soc. **Exhibited:** Art Exh. Phila. 1916 (prize); AIC, 1918 (med); AIA, 1920 (med); Arch. Lg., 1922 (gold); PM Sch IA, 1930 (prize). **Work:** Harkness Mem. Quadrangle, Yale; Carillon Tower, Mountain Lake, Fla.; National Cathedral, Wash., D.C.; Cathedral of St. John the Divine, Fed. Reserve Bank, Equitable Trust Co., Central Savings Bank, J.P. Morgan Lib., Columbia, Jewish Theological Seminary, St. Thomas Church, all in NYC; Goodhart Hall, Bryn Mawr Col., Pa.; Wash. Mem. Chapel, Valley Forge, Pa.; Princeton Univ. Chapel; Hall of Fame, NYU; Sterling Mem. Lib., Yale; McKinlock Mem., Northwestern; Harvard; SAM; AIC; Ohio State Univ., Columbus; Oberlin Col.; St. George's Chapel, Newport, R.I.; Grace Cathedral, San Fran.; Cloisters, MMA; Univ. Pittsburgh. **Comments:** Award: Phila. Civic Book Award, 1925. Contributor: articles, Encyclopaedia Britannica. Position: advisor in metalwork, Phila. MA. Specialty: metalwork. **Sources:** WW40.

YENA, Donald *[Painter and illustrator] mid 20th c.*
Addresses: Living in San Antonio in 1971. **Comments:** Painted seriously since 1960. Specialty: Old West, historic sites and buildings of Texas. Illustrator, "Battles of Texas," "Six Flags of Texas," and "Antique Arms Annual," 1971. **Sources:** P&H Samuels, 543-44.

YENS, Karl Julius Heinrich *[Muralist, painter, etcher, teacher] b.1868, Altona, Germany / d.1945.*
Addresses: Los Angeles and Pasadena, CA, 1910-18; Laguna Beach, CA, from 1918. **Studied:** M. Koch, in Berlin; Acad. Julian, Paris, with J.P. Laurens & Constant, 1900. **Member:** Laguna Beach AA; AAPL; Los Angeles AA (hon. life); Acad. West Painters; Calif. AC; Calif. WCC; Long Beach AA; San Diego FAS; Int. Bookplate Assn.; Scandinavian-Am. Artists Soc. of West; Modern Art Soc. (co-founder); Teachers Assoc.; Calif. SMP; San Diego FA Soc. **Exhibited:** Boston AC, 1903; PAFA Ann., 1904; Pan-Calif. Int. Expo, San Diego, 1915 (med.); LACMA, 1918, 1922, 1929; Calif. AC, 1919 (prize); Laguna Beach AA, 1921 (prize), 1922 (prize), 1924 (med.), 1925 (prize), 1927 (prize), 1935 (prize); Calif. WCS, 1922 (prize); Southern Calif. Fair, Riverside, 1922 (prize), 1928 (prize); Southwest Mus., 1922 (prize); Los Angeles P&S, 1923 (prize), 1928 (med.); Arizona State Fair, Phoenix, 1923 (prize), 1927 (prize), 1928 (prize); SFAA, 1925; Orange County (CA) Fair, 1923 (prize),

1925 (prize), 1927 (prize); Los Angeles County Fair, 1924 (prize), 1928 (prize); Artists Southern Calif., San Diego, 1926 (prize); Biltmore Salon, Los Angeles, 1926 (med.); Int. Bookplate Assn., 1927 (prize); Sacramento State Fair, 1927 (prize), 1934 (prize); FA Gal.; San Diego, 1928 (prize); Pacific SW Expo, Long Beach, 1928 (gold); Second Ann. Statewide Art Exh., Santa Cruz, 1929 (prize); Ann. Exh., Springville, UT, 1931 (prize); Oakland Art Gal., 1932; Calif. State Fair, Sacramento, 1935 (prize); Laguna Beach AA, 1935 (prize); Aeronautical Art Exh., T.W.A., 1937 (prize); GGE, 1939; AIC. **Work:** City Hall, Altona, Germany; Country Club House, Brookline, MA; Duquesne Club, Pittsburgh; Astor Theatre, NYC; LACMA; Calif. State Expo Bldg., Los Angeles; Univ. Calif., Los Angeles; Clearwater H.S.; Laguna Beach H.S.; FA Gal., San Diego, San Pedro H.S.; U.S.S. *California*; John H. Vanderpoel AA, Chicago; Bowers Mem. Mus., Santa Ana. **Comments:** Was a muralist in Germany and Scotland before coming to U.S. in 1901 and executing mural commissions in NYC and Wash., DC. Settled in Southern Calif. in 1910, where he painted portraits, landscapes, genre scenes, and figurative works for the next thirty-five years. He was also known as Karl Jens. **Sources:** WW40; WW06; Hughes, *Artists in California, 625.*

YEOMAN, Arthur Charles *[Painter, commercial artist] b.1904, NYC / d.1964, Los Angeles, CA.*
Addresses: Los Angeles, CA, 1928-64. **Member:** P&S of Los Angeles. **Exhibited:** Artists of Los Angeles, LACMA, 1946. **Sources:** Hughes, *Artists in California, 625.*

YEOMANS, George *[Sketch artist] mid 19th c.*
Comments: Delineator of a view of Williamstown (Mass.) lithographed by P.S. Duval & Co. (see entry) at Philadelphia, about 1855-56. **Sources:** G&W; Stokes, *Historical Prints.*

YEOMANS, Walter Curtis *[Printmaker, commercial artist, painter, educator, illustrator] b.1882, Avon, IL / d.1972, Jacksonville, FL.*
Addresses: St. Augustine, FL; Cornwall Bridge, CT/Rockport, MA. **Studied:** Univ. Illinois; with Fursman; Senseney; Bicknell; AIC; with Aldro T. Hibbard, Bate, Farnsworth. **Member:** Chicago SE; Boston Pr. M.; St. Augustine AA; Kent AA; Rockport AA. **Exhibited:** Chicago Soc. Et.; Boston Pr. M.; Rockport AA; Kent AA; Springfield A. Lg.; Albany Pr. Cl.; Buffalo Pr. Cl.; LOC; SAGA; Laguna Beach AA; WFNY 1939; Victoria & Albert Mus., London; Salons of Am. **Awards:** Irvington A. & Mus. Assn.; Chicago Soc. Et. **Sources:** WW59; WW47; add'l info. courtesy Anthony R. White, Burlingame, Ca.

YEPEZ, Dorothy *[Art administrator, painter] b.1918, Philadelphia, PA.*
Addresses: Saranac Lake, NY. **Studied:** Univ. Pa.; Temple Univ.; New York Univ.; Cooper Union; New Sch. Soc. Res.; also privately. **Member:** charter mem. New York State Coun. Arts; Smithsonian Assocs.; Am. Fedn. Arts; Am. Assn. Mus.; MoMA. **Exhibited:** Dorothy Yepez Galleries, Saranac Lake, 1959, 1962, 1967 & 1972; Pen & Pallette Ann. Exhib., Saranac Lake, 1965 & 1966. **Awards:** Grumbacher award, 1957. **Work:** Amistad Res. Ctr., New Orleans, La.; Saranac Lake Free Libr., NY. **Comments:** Preferred media: pastels. Positions: dir.-adminstr., Dorothy Yepez Galleries, 1952-. Collections arranged: Leon Slwinski, Warsaw, Poland, 1961; The Gay 90's 1961; Military Lore (Civil War), 1962; Arts & Crafts from the Clinton Prison Hobby Shop, Dannemora, NY, 1962; Dolls of all Nations & Original Christmas Cards, 1963; Stamp Show: Vatican Series from the collection of His Eminence Cardinal Spellman, 1963; Meet the Artists: Naomi Lorne, Lilly Shiff, May Heiloms, Montifore Hosp Libr, NY. Collection: 150 yr. old sch. house; furniture, glassware, crockery, tinware & other antiques. **Sources:** WW73.

YERBYSMITH, Ernest Alfred (Ernst Alfred Schmidt) *[Sculptor] b.1876, Saxony, Germany / d.1952, Laguna Beach, CA.*
Addresses: NYC; San Francisco, CA. **Studied:** San Francisco. **Member:** Laguna Beach AA. **Work:** Presbyterian Church, Laguna; Los Angeles Times Bldg. Lobby; Bowers Memorial

Mus.; Queen of Angels Hospital, Los Angeles; Paris Inn, Los Angeles. **Comments:** Immigrated to the U.S. in 1886. Worked as a ship cabin boy, on a cattle ranch and fought in the Spanish-American War. He mined for gold and c.1906 he decided to become a sculptor. He worked for the PPE in 1915 and later constructed sets for many years for Hollywood movie studios. **Sources:** Hughes, *Artists in California, 625.*

YERE, Marthe See: **YCRE, Marthe**

YERKES, Charles T. *[Patron] b.1837, Phila. / d.1905.*
Addresses: NYC. **Comments:** Urban transportation magnate who was on the board of directors of the Worlds Columbian Expo, Chicago, 1893, to which he loaned his collection of paintings.

YERKES, David Norton *[Designer, painter, architect] b.1911, Cambridge, MA.*
Addresses: Wash., DC. **Studied:** Harvard, Yale. **Member:** AIA. **Exhibited:** Wash, WCC, CGA, 1939; Smithsonian. **Sources:** WW40.

YERKES, Mary Agnes *[Painter] early 20th c.*
Addresses: Oak Park, IL. **Exhibited:** AIC, 1912-15. **Sources:** WW17.

YERUSHALMY, David *[Sculptor] b.1893, Jerusalem, Palestine.*
Addresses: Chicago, IL. **Studied:** Franz-Barwig, J. Mullner, F. Zelzny, all in Vienna. **Member:** Around the Palette; All-Ill. SFA. **Exhibited:** Ann. Exh. Artists Chicago Vicinity, AIC, 1931 (prize); PAFA Ann., 1932-33. **Sources:** WW33.

YERXA, Thomas *[Painter] mid 20th c.*
Addresses: Philadelphia (?). **Exhibited:** PAFA Ann., 1951-62 (3 times); Corcoran Gal biennials, 1953-61 (4 times). **Sources:** Falk, *Exhibition Records Series.*

YETO, Genjiro See: **KATOAKA, Genjiro**

YEWELL, George Henry *[Portrait and genre painter, etcher, cartoonist] b.1830, Havre-de-Grace, MD / d.1923, Lake George, NY.*
Addresses: NYC, 1862-67, 1879-99/Lake George, NY. **Studied:** NAD, with T. Hicks,1851-56; in Paris with Thomas Couture,1856. **Member:** A.N.A., 1862; N.A., 1880; A. Fund S.; Century. **Exhibited:** NAD, 1852-1916; PAFA, 1862; Brooklyn AA, 1862-84; Paris Salon, 1872, 1874; NY Etching Cl, 1888; Parrish AM, 1984 ("Painter-Etchers" exh.). **Work:** MMA; Louisville (KY) Art Gal.; Wadsworth Athenaeum, Hartford; Hist. Dept., Des Moines; Acad. Med., NYC; Presbyterian Bldg., NYC; Univ. Iowa. **Comments:** Although he painted genre and architectural subjects, he was best known as a portrait painter. In 1841, when he was eleven, his widowed mother brought him to Iowa. During the 1850s, he studied in Paris, and in 1862 returned to settle in NYC. On his next extended European trip, he was living in Rome from 1871-78, visiting Egypt in 1875. He returned to NYC in 1878 and during the early 1880s began summering at Lake George, NY. **Sources:** G&W; WW04; Ness and Orwig, *Iowa Artists of the First Hundred Years,* 227; Cowdrey, NAD; Naylor, NAD; Falk, NAD; Clark, *History of the NAD;* Swan, BA; Rutledge, PA; *American Painter-Etcher Movement* 54; Fink, *American Art at the Nineteenth-Century Paris Salons,* 409.

YIP, Richard D. *[Painter, teacher, lecturer] b.1919, Canton, China.*
Addresses: Stockton, CA. **Studied:** Cal. Col. A. & Crafts; Col. of the Pacific (B.A.); Univ. California, Berkeley (M.A.). **Member:** Cal. WC Soc.; Marin Soc. A. **Exhibited:** AWCS, 1951; PAFA, 1953; Butler AI, 1954; Cal. WC Soc., 1948; Denver A. Mus., 1954; SAM, 1955. **Awards:** prizes, San F. A. Festival, 1951; AWCS, 1952; Outdoor Festival, Bloomfield Hills, Mich., 1954 (purchase); Cal. State Fair, 1955. **Work:** Marin Soc. A.; Col. of the Pacific. **Comments:** Position: special art instr., Col. of the Pacific, Stockton, Cal., 1949-. **Sources:** WW59.

YOAKUM, Delmer J. *[Painter, designer] b.1915, Saint Joseph, MO.*

Addresses: Sedona, AZ. **Studied:** Chouinard Art Inst. & Jepson Art Inst., Los Angeles, Calif.; Kansas City Art Inst.; Univ. Southern Calif. **Member:** Calif. Nat. Watercolor Soc. (past pres.); Inglewood Art League (hon. life mem.); Sedona Arts Ctr. **Exhibited:** LACMA, 1947-58; Butler Inst. Am. Art, 1953-71; Calif. Nat. WC Soc., Los Angeles, 1954-72; Watercolor USA, Springfield, Mo., 1966-72; NAD, 1970; The Martin Gallery, Scottsdale, AZ, 1970s. Awards: Edouvard Manet Award, Frye Art Mus., 1958 & 1963; best of show, City of Avalon, Calif., 1967; John Marin Mem. Award, Watercolor USA, 1971. **Work:** Butler Inst. Am. Art, Youngstown, OH; San Diego Art Mus., Calif.; Calif. Nat. WC Soc.; Las Vegas Art League; Glendale Savings & Loan, Calif. **Comments:** Preferred media: oils, watercolors. Positions: scenic artist, Motion Picture Studios, Hollywood, Calif, 1952-72. Teaching: instr. art, Sedona, Ariz. **Sources:** WW73.

YOAKUM, Joseph *[Painter] b.1886, Arizona / d.1972.*
Addresses: Chicago, IL. **Comments:** Born on a Navajo reservation in Arizona, Yoakum claims to have run away from home as a teenager and to have worked with a number of circuses. After serving in France during WWI, he lived the life of an itinerant, working in various places until settling in Chicago. He began painting in 1962, creating visionary-like landscapes (in watercolor and pen) which he described as portraits of places he had visited. **Sources:** Finch, *American Watercolors,* 57; Jane Livingston and John Beardsley, Black Folk Art in America, 1930-1980 (Jackson, MS, 1982), 163.

YOCHIM, Louise Dunn *[Educator, painter] b.1909, Jitomir, Ukraine.*
Addresses: Chicago, IL; Evanston, IL. **Studied:** AIC (cert.1932, B.A.E., 1942, M.A.E., 1952); Univ. Chicago, 1956. **Member:** A. Lg. Chicago; Am.-Jewish AC; Chicago NJSA; Chicago Soc Artists (pres, 1972); Renaissance Soc. Art; Nat. Art Educ. Assn.; Nat. Comt. Art Educ. **Exhibited:** Detroit Inst. A., 1945; Chicago FA Ga, 1945; Univ. Chicago. 1946; Omaha, Nebr., 1936; Sioux City, Iowa, 1935; Chicago NJSA, 1934; AIC, 1935-44; Chicago Soc. Artists Exhib., Riverside Mus., NYC, 1951; Nat. Exhib., Terry Mus. Art, Fla., 1952; Assoc. Artists Gal., Wash., DC, 1962; one-woman show, Northeastern Ill. Univ., 1972 (solo); Four Arts Gallery, Evanston, IL, 1970s. Awards: Todros Geller Award for painting, Am. Jewish Arts Club, 1948 & 1961; award, Chicago Soc. Artists, 1953. **Work:** Bir-Bejan, Russia; Eilat Mus, Israel; Bernard Horwich Ctr., Chicago, Ill.; Northeastern Ill. Univ., Chicago; A. Werbe Gal., Detroit, Mich. **Comments:** Preferred media: oils, watercolors. Positions: teacher, Chicago H.S., 1938-46; art supvr., Chicago Pub. Schs., 1950-71; consult art, elem. & high schs., 1971-; consult. art, Rand McNally Publ., 1967-; consult. art, Encycl. Britannica, 1968-. Publications: auth., "Building Human Relationship through Art," 1954; "Perceptual Growth in Creativity," 1967 & "Art in Action," 1969. Teaching: instr. art, Chicago Pub. HS, 1934-50; instr. art, Chicago Acad. Fine Arts, 1951-52; instr. art, Chicago Teachers Col., 1960-61. **Sources:** WW73; Frank Holland, "Renaissance Unit's Show to Cap Season," *Chicago Sun Times* (1957); Doris Lane Butler, "Winnetka to open Art Fair Season," *Chicago Daily News* (1957); Frank Getlein, "Associated Artists," *Sunday Star* (Wash., DC, 1962).

YOCHIM, Maurice *[Painter, graphic artist, teacher] b.1908, Russia.*
Addresses: Chicago, Il. **Studied:** AIC. **Member:** Around the Palette, Chicago (pres.); Chicago NJSA. **Exhibited:** Chicago NJSA, 1934; Ar. Chicago Vicin. Ann., AIC, 1936. **Comments:** Position: teacher, Waller H.S. Chicago. **Sources:** WW40.

YOCUM, Helen M. See: **QUAINTANCE, Helen M.** **(Yocum)**

YOFFE, Vladimir *[Sculptor] mid 20th c.*
Addresses: NYC. **Exhibited:** WMAA, 1947-48; PAFA Ann., 1948, 1953. **Work:** USPO, Derry, N.H. WPA artist. **Sources:** WW40; Falk, *Exhibition Records Series.*

YOHN, F(rederick) C(offay) *FC YOHN*
[Illustrator] b.1875, Indianapolis, IN / d.1933, Norwalk, CT.
Addresses: Norwalk, CT. **Studied:** Indianapolis Art School; ASL, with Mowbray. **Member:** SI, 1901; Artists Gld.; SC, 1901. **Work:** 100 drawings, LOC; Indiana Hist. Soc.; Massachusetts Hist. Soc. **Comments:** He was prominent for a generation as an illustrator of books and magazines, noted especially for his spirited battle scenes, although he never witnessed a battle. He illustrated a series of frontier sketches by Theodore Roosevelt; General Funston's "Memoirs of Two Wars"; John Lodge's "Story of the Revolution"; he drew extensively for *Scribner's* and *Collier's.* In 1930 he was commissioned to paint several large historical canvases for the Mass. Bay Tercentenary. **Sources:** WW31; P&H Samuels, 544.

YOKOI, Teruko *[Painter] mid 20th c.*
Exhibited: PAFA Ann., 1958; Corcoran Gal biennial, 1959. **Sources:** Falk, *Exhibition Records Series.*

YOLDASSIS, Demetris *[Painter] mid 20th c.*
Addresses: NYC. **Exhibited:** S. Indp. A., 1925. **Sources:** Marlor, *Soc. Indp. Artists.*

YON, Thomas *[Engraver, gold- and silversmith, jeweler] mid 18th c.*
Addresses: Charleston, SC, 1764-68. **Comments:** He engraved views of St. Michael's Church and St. Philip's Church. **Sources:** G&W; Prime, I, 33 [as Yon]; Rutledge, *Artists in the Life of Charleston* [as You].

YONAN, Solomon D *[Painter] b.1911, Persia.*
Addresses: Chicago, IL. **Studied:** AIC. **Exhibited:** AIC, 1931 (prize). **Sources:** WW40.

YONGE *[Miniature painter] late 18th c.*
Addresses: Active in South Carolina. **Comments:** Artist of a portrait of a Mrs. Hopton, presumably of South Carolina, dated 1771. **Sources:** G&W; Carolina Art Assoc. Cat., 1935.

YONKERS, Richard *[Painter, gallery director, lecturer] b.1919, Grand Rapids, MI.*
Addresses: Grand Rapids 3, MI. **Studied:** Grand Rapids A. Gal. Sch.; Cranbrook Acad. A. **Exhibited:** Detroit Inst. A., 1944 (prizes), 1945. **Work:** Grand Rapids A. Gal.; Detroit Inst. A. **Comments:** Position: dir., Grand Rapids (Mich.) A. Gal., 1946-; artist-in-residence, Hope Col., Holland, Mich., 1945. **Sources:** WW53.

YONT, Lily *[Painter, sculptor, teacher] early 20th c.; b.otoe County, NE.*
Addresses: Lincoln, NE. **Studied:** BMFA School, 1910; Calif. School Arts & Crafts, 1925; with Sara Hayden. **Exhibited:** Omaha Soc. FA, Kansas City, 1907 (prize)-28; Lincoln (NE) Art Guild. **Sources:** Petteys, *Dictionary of Women Artists.*

YOORS, Jan *[Craftsman, designer, painter, writer] b.1922, Antwerp, Belgium / d.1977.*
Addresses: New York 17, NY. **Studied:** in Belgium; Univ. Col., London; Sch. Oriental & African Studies, London. **Member:** AEA. **Exhibited:** tapestries, Montclair A, Mus., 195657; DMFA, 1958; solo: London, 1948; Brussels, 1949; New York, 1953-55; Denver, 1956. Des. weaver specializing in modern tapestries. **Work:** mural, North Queens Medical Center. **Sources:** WW59.

YORE, Martha A. *[Painter] mid 20th c.*
Exhibited: S. Indp. A., 1936. **Sources:** Marlor, *Soc. Indp. Artists.*

YORESKA, Marion A. *[Miniature painter] mid 20th c.*
Addresses: Hollywood, CA, 1931; San Francisco, CA, 1939. **Exhibited:** P&S of Los Angeles, 1931; GGE, 1939. **Sources:** Hughes, *Artists in California,* 625.

YORK, Holcomb *[Painter] mid 20th c.*
Exhibited: WMAA, 1927. **Sources:** Falk, *WMAA.*

YORK, John Devereux *[Painter] b.1865, Nashville, TN.*
Addresses: Chicago, IL. **Studied:** Ecole des Beaux-Arts, paris,

with R. Collin. **Exhibited:** Tokyo, Japan, 1901 (prize); AIC,1905. **Sources:** WW08.

YORK, Lewis E. *[Abstract painter] mid 20th c.*
Comments: When Daniel V. Thompson rediscovered the art of egg tempera painting at the Courtauld Institute, and revived the medium with his book, *The Practice of Tempera Painting* (1936), his disciple, Lewis York, produced the step-by-step illustrations for the book. York went on to teach the technique to Reginald Marsh, Paul Cadmus, Jared French, and George Tooker. York taught at the Mattatuck School of Art during the 1920s, then taught at the Yale School of Fine Art in the 1930s, later becoming the head of its Fine Arts Dept. At Yale, he conducted extensive experiments with color field relationships, using squares within squares to teach his students. His eventual successor at Yale, Josef Albers, observed York's experiments and soon thereafter developed his famous "Hommage to the Square" series. **Sources:** PHF files, interviews with Andrew Petryn, 1990s (a York student).

YORK, Robert *[Cartoonist] b.1909, Minneapolis, MN / d.1975.*
Addresses: Louisville, KY. **Studied:** Cummings Sch. A.; Drake Univ.; Chicago Acad. FA. **Member:** Sigma Delta Chi (Journalistic Fraternity); Am. Assn. Editorial Cartoonists. **Exhibited:** Awards: Pulitzer Prize, 1956. **Sources:** WW66.

YORKE, William G(ay) *[Marine painter] b.1817, England / d.After 1892.*
Work: Mystic (CT) Seaport Mus.; New-York Hist. Soc.; Peabody Mus., Salem; Sailors' Snug Harbor, Staten Island, NY; Phila. Maritime Mus. (owns latest known oil, dated 1892). **Comments:** Father of William H. Yorke, he left Liverpool, England, in 1870 to continue his career in ship portraiture in Brooklyn. He lived aboard his sailboat, which explains why many of his works are inscribed verso with different addresses. Later, his boat sank in a collision with a steamboat, and the accident caused him to lose an eye. Having lost all belongings, he was impoverished, and lived in a shanty he built on a canal boat in Brooklyn. The owner of the steamship which had rammed his sailboat eventually provided lodging for him and his family on one of his boats docked at Staten Island. **Sources:** article, A.J. Peluso, in *Maine Antique Digest* (Aug., 1990, p.28E); *300 Years of American Art,* 176.

YORKE, William H(oward) *[Marine painter] b.1847 / d.1921.*
Addresses: Liverpool, England (active 1858-1909). **Comments:** English marine painter who, although he did not follow his father, William G. Yorke, to America, is listed here because these two ship painters are often confused. **Sources:** article, A.J. Peluso, in *Maine Antique Digest* (Aug., 1990, p.28E).

YOSHIDA, Fuji *[Painter] early 20th c.*
Addresses: Boston, MA. **Exhibited:** AIC, 1904. **Sources:** Falk, *AIC.*

YOSHIDA, Hiroshi *[Painter] b.1876 / d.1950.*
Addresses: Boston, MA. **Exhibited:** Boston AC, 1900; AIC, 1904. **Sources:** WW01.

YOSHIDA, Ray Kakuo *[Painter, educator] b.1930, Kauai, Hawaii.*
Addresses: Chicago, IL. **Studied:** AIC Sch. (B.A.); Syracuse Univ. (M.F.A.); Univ. Chicago; Univ. Hawaii; also with A.D. Reinhardt. **Member:** AIC. **Exhibited:** Spirit of the Comics, Inst. Contemp. Art, Univ. Pa., 1969; Chicago & Vicinity Exhibs., AIC, 1969 & 1971; Am. Painting 1972, Indianapolis Mus. Art, 1972; Mus. Contemp. Art, Chicago; Brooklyn Mus.; Phyllis Kind Gal., Chicago, IL, 1970s. Awards: Thomas C. Thompson Purchase Prize, Everson Mus., 1953; Walter M. Campana Prize, 1960 & Frank G. Logan Medal & Prize, 1971, AIC. **Work:** Everson Mus., Syracuse, NY; AIC; NOMA. **Comments:** Preferred media: oils, acrylics. Teaching: prof. painting, AIC School, 1960-on. **Sources:** WW73; Franz Schulze, *Chicago Art* (Follett, 1972); article In: *Art;* article, In: *Art News.*

YOSHIHARU See: **HIGA, (Yoshiharu)**

YOST, David *[Portrait painter] mid 19th c.*
Addresses: Shenandoah County, VA. **Work:** Shenandoah County Courthouse. **Sources:** Wright, *Artists in Virginia Before 1900.*

YOST, Eunice Fite (Mrs. F.) *[Painter] mid 20th c.*
Addresses: Ann Arbor, MI. **Comments:** Affiliated with Univ. MI. **Sources:** WW27.

YOST, Frederick J. *[Painter, lithographer, teacher, lecturer] b.1888, Berne, Switzerland / d.1968, Akron, OH.*
Addresses: Youngstown, OH; Akron, OH. **Studied:** Mt. Union Col., Alliance, OH; ASL, and with Homer Boss, John Sloan, Robert Henri, R. Lahey. **Member:** Ohio WC Soc. (pres.). **Exhibited:** S. Indp. A., 1928, 1930-33; MMA, 1945; AIC; Butler AI, 1947-1951; Ohio WC Soc.; PAFA, 1948-1950; Akron AI, 1947-1951, 1958; Fla. Southern Col., 1952; Ohio Univ., 1950; Columbus Gal. FA, 1947-50; AWCS, 1958; Salons of Am.; 3 solo: Canton AI; Akron AI, Springfield Mus. A. Contributor to Ford Times, 1958-59. **Awards:** prizes, Massilon Mus., 1944; Ohio WC Soc., 1944, 1948; Indianapolis, Ind., 1944; Tri-State Pr. M., 1945, 1946; Butler AI, 1946 ; Youngstown Pub. Schools, 1946 (prize); Ohio Univ., 1950; Ethel Printz award, 1950; Fla. Southern Col., 1952; Akron AI, 1952, 1956-1958; Canton AI, 1961, 1963; medal, Phila. Pa., 1950. **Work:** Massillon Mus.; Youngstown Pub. Sch. Coll.; Butler AI; Akron AI; Kennedy & Co., NY; Beaver Col., Beaver Falls, Pa.; Block Gal., Indianapolis; Prospect Park, NY; murals, Sioux City Steak House; Sioux City A. Center; City Hall, Sioux City; Akron AI; Evangelical Church, Akron; Rockefeller Center; Radio City, NY; Brooklyn Zoological Park. Affiliated with NYC Park Dept. Mural Projects. **Comments:** Came to U. S. in 1889. Position: teacher, Butler AI; Akron AI; instr., Akron AI, Akron, Ohio; cur. Historical House of Refuge, 1955. **Sources:** WW66; WW47.

YOST, Jenette Evelyn *[Sculptor] mid 20th c.*
Addresses: Chicago area. **Exhibited:** AIC, 1931-32. **Sources:** Falk, *AIC.*

YOST, Philipp Ross *[Teacher, designer, painter, writer] b.1914, Auburn, NE.*
Addresses: Columbus, OH. **Studied:** Cleveland Sch. A.; AIC; Univ. Kansas. **Member:** The Patteran. **Exhibited:** Carnegie Inst., 1941; AIC, 1933; Kansas City AI, 1931, 1934 (prize)-36; Albright A. Gal., 1936 (prize)-41; Great Lakes Exh., 1939. **Work:** Albright A. Gal.; Patteran Soc., Buffalo. **Comments:** Position: instr. des., Albright A. Gal., 1936-42; U.S. Army, in charge of Arts & Skills, 21st General Hospital; chief clerk, Sub-Com. of Monuments & FA, Allied Control Comm., Rome City Planning; in charge, Visual Aids Section, Shrivenham Am. Univ., England, 1942-45; ed. asst., *Design* (from 1945). **Sources:** WW53; WW47.

YOUMANS, Edna Mary *[Painter] b.1906, near Assian, IA.*
Addresses: Decorah, IA. **Studied:** Federal Art School, Minneapolis. **Exhibited:** County Fairs (many first premiums); Tri-County Fair, MT; Iowa Artists, Cedar Rapids. **Sources:** Ness & Orwig, *Iowa Artists of the First Hundred Years,* 228.

YOUNG, Alexander *[Maker of terra-cotta figures and architectural forms] mid 19th c.*
Addresses: NYC. **Exhibited:** American Institute, 1851: "one figure, one corbel and Gothic cap [and] one full-trimmed Elizabethan window". **Sources:** G&W; Am. Inst. Cat., 1851; NYCD 1851.

YOUNG, Alfred *[Sculptor] b.1936.*
Addresses: Albuquerque, NM. **Exhibited:** WMAA, 1967. **Sources:** Falk, *WMAA.*

YOUNG, Andrew *[Apprentice lithographer] b.c.1840, Pennsylvania.*
Addresses: Philadelphia, 1860. **Comments:** His parents, James and Mary Young, were both Irish. **Sources:** G&W; 8 Census (1860), Pa., LIV, 253.

YOUNG, Anna E. *[Painter] 19th/20th c.*
Exhibited: Wash. State Arts and Crafts, 1909; Wash. State Commission of FA, 1914. **Sources:** Trip and Cook, *Washington State Art and Artists.*

YOUNG, Aretta *[Painter, teacher, writer] b.1864, Idaho / d.1923, Provo, UT.*
Studied: Columbia, with A. W. Dow. **Comments:** Position: teacher, Brigham Young Univ.

YOUNG, Art(hur) (Henry)
[Cartoonist, writer] b.1866, Orangeville, IL / d.1943, NYC.
Addresses: Bethel, CT. **Studied:** Vanderpoel at AIC; ASL; Acad. Julian, Paris, with Bouguereau. **Member:** Am. Artists Congress. **Exhibited:** Armory Show, 1913; S. Indp. A., 1917-18; WMAA, 1938, 1941. **Comments:** Young was a radical socialist whose cartoons appeared in *New Masses; The Nation; Saturday Evening Post; Collier's; Life; New Yorker.* Auth.: *Trees at Night; On My Way; Art Young's Inferno; The Best of Art Young;* and *Art Young, His Life and Times.* **Sources:** WW40; Thomas Craven, ed. *Cartoon Cavalcade* (New York: Simon and Schuster, 1943).

YOUNG, Arthur M. *[Painter] mid 20th c.*
Addresses: Radnor, PA. **Exhibited:** PAFA Ann., 1933. **Sources:** Falk, *PAFA, Vol. 3.*

YOUNG, Arthur Raymond *[Painter, graphic artist, educator, lithographer, lecturer, writer, teacher] b.1895, NYC / d.1943, NYC?.*
Addresses: New York 27, NY. **Studied:** NAD; ASL. **Exhibited:** BM; Weyhe Gal. (solo); Daniels Gal. (solo); Pan-Hellenic Engineers Cl. (solo). **Work:** British Mus., London; Fifty Prints of the Year, 1929, 1931. **Comments:** Teaching: T. Col., Columbia Univ., 1927-. Contributor to: *Art Education Today.* Lectures: graphic arts; painting. **Sources:** WW59; WW47.

YOUNG, August(us) *[Portrait and historical painter, landscape painter] b.1837, Germany (or NYC) / d.1913.*
Addresses: Brooklyn, NY, active 1860-1913. **Studied:** c.1850 with Junius Brutus Stearns, Theodore Kaufman, National Academy. In Munich and Paris, 1853-c.1855. Watercolors from J.B. Wandesforde, c.1856. **Exhibited:** NAD, 1856; Brooklyn AA, 1863-81. **Comments:** He was born in NYC of German parents (Stiles), or in Germany (*Art Annual* and *N.Y. Times*). **Sources:** G&W; Stiles, *History of King's County,* II, 1160-61; *Art Annual,* XI, obit.; N.Y. *Times,* Nov. 9, 1913, obit.; Brooklyn *Eagle,* Nov. 7, 1913, obit.; Cowdrey, NAD; NYCD 1856, 1858; Brooklyn CD 1904.

YOUNG, B. *[Portrait painter] mid 19th c.*
Comments: Portrait of a hunter, inscribed on the back: "J.G. Henry [?] by B. Young 1838." **Sources:** G&W; Sherman, "Newly Discovered American Portrait Painters," 235.

YOUNG, Beckford *[Painter, mural painter] b.1905, Petaluma, CA / d.1979, Berkeley, CA.*
Addresses: El Cerrito, CA. **Studied:** UC Berkeley; Munich, with Hans Hofmann, Italy, with Vaclav Vytlacil. **Member:** San Francisco AA; Am. Abstract Artists. **Exhibited:** GGE, 1939; San Fran. Mus. A, 1937 ("Mural Conceptualism" exh.); NJ State Mus., 1983 ("American Constructions, 1930-65"); NMAA, 1990. **Work:** NMAA; Privates Club, Fort Ord; Government Island, Alameda (frescoe). **Comments:** Hwe was a WPA artist, and produced abstract constructions during the 1930s-40s. **Sources:** Hughes, *Artists in California,* 626; Diamond, *Thirty-Five American Modernists* p.38.

YOUNG, Beth Powlen (Mrs. E. Marvin) *[Painter] b.1908, Logansport, IN.*
Addresses: Des Moines, IA. **Studied:** Pratt Inst., Brooklyn, NY; Indiana Univ., B.S. **Exhibited:** Des Moines Public Library; Des Moines Women's Club; Iowa Art Salon. **Sources:** Ness & Orwig, *Iowa Artists of the First Hundred Years,* 228.

YOUNG, Betty *[Painter, graphic artist] b.1946, Brooklyn, NY.*
Studied: NY City Col. (B.A.); City Univ. of New York Graduate Center. **Exhibited:** High School of Music & Art, 1962-65; Children's Aid Soc. Show, 1967; Nyumba Ya Sanaa Gallery, 1967-71; Vocational Guidance & Workshop Center Ann., 1967-72; Holyoke Col., 1972. **Awards:** *Scholastic Magazine* Award for Art,

1965. **Comments:** Position: assist. teacher, Queens College, SEEK Program. **Sources:** Cederholm, *Afro-American Artists.*

YOUNG, C. L. V. *[Painter] mid 20th c.*
Addresses: Syracuse, NY. **Sources:** WW24.

YOUNG, Celestia *[Primitive painter] mid 19th c.*
Addresses: Active in Plymouth, MI, c.1856. **Work:** Greenfield Village and Henry Ford Mus. ("Adam's Mill"). **Comments:** As a school girl, she painted a sawmill in Plymouth, MI, documenting a major industry in early Michigan. **Sources:** Dewhurst, MacDowell, and MacDowell, 174.

YOUNG, Charles A. (Chuck) *[Painter, printmaker, educator] b.1930, NYC.*
Studied: NY Univ. (M.A.). **Exhibited:** Hampton Inst., 1951; Richmond, VA, Mus. of Art, 1952; NY Univ., 1959; Fayetteville, NC, State Univ., 1960-62 (solos); Honeycutt Art Exh., Fayetteville, NC, 1962; Ann. Art Exh., Fayetteville, NC, 1962 (prizes); Weatherspoon Gal., Greensboro, NC, 1962; NC Artists Open Exh., 1963; Tenn. A &I. State Univ., 1964 (solo); Voice of America, Wash., DC, 1965 (solo); Unitarian Church, Nashville, TN, 1965 (solo); Tyco Gal., Nashville, 1966 (solo); Parthenon Gal. of Art, Nashville, 1967; Sheraton Hotel, Phila., 1968; Fisk Univ., 1969; Smith-Mason Gal., Wash., DC, 1969 (solo), 1971; Wilmington, DE, 1971; Agra Gal., Wash., DC, 1972 (solo); NJ State Mus., Trenton, 1972. **Work:** Scottish Bank, Fayetteville, NC; Fisk Univ.; Fayetteville State Univ.; Tenn. A & I State Univ., Nashville; Kennedy Inst., Wash., DC; Tyco Gal., Nashville, TN; Smith-Mason Gal., Wash., DC. **Comments:** Position: prof., chairm., Federal City Col., Wash., DC. **Sources:** Cederholm, *Afro-American Artists.*

YOUNG, C(harles) Jac(ob) *[Etcher, painter] b.1880, Rodenbach, Bavaria, Germany / d.1940, Weehawken Heights, NJ?.*
Addresses: NYC, 1915; West Hoboken, NJ, 1919; Wehawken Heights, NJ, 1938. **Studied:** NAD, with E.M. Ward, C.Y. Turner; Henri. **Member:** SAE; SC; Chicago CE; Brooklyn SE. **Exhibited:** PAFA Ann., 1913, 1916, 1918 (as Jung); Corcoran Gal., 1916 (as Jung); S. Indp. A., 1917 (as Jung); Brooklyn SE, 1928 (prize); Paterson, NJ, 1928, 1930 (prize); Newark AC, 1931 (med), 1933 (prize), 1935 (prize); Northern N.J. Artists, Newark, 1932 (prize), 1933 (prize); Montclair AA, 1922 (prize), 1933 (prize); Phila. Pr. C., 1933 (prize); Contemp. C., Newark, 1934 (prize), 1935 (prize); NJ Gal., 1934 (prize)-35 (prize); Yonkers AA, 1928 (prize); SAE 1929 (prize); SC, 1929 (prize); Albany Pr. C., 1935 (prize). **Work:** LACMA; Newark Pub. Lib.; Toronto A. Gal., Ontario; NYPL; etchings, Univ. Nebr.; Peoria (Ill.) AI; Milwaukee AI; CGA; Hackley Gal. Art, Muskegon, Mich.; LOC; Phila. Pr. C.; Smithsonian; SAE; Chicago SE; Honolulu Acad. A.; Mus. Sc. & A.; Yonkers, NY; AIC; BM; AGAA, Andover (Mass.); Am. Fed. Labor, Wash., DC; Pub. Lib., Hasbrouck Heights, NJ; Bd. Edu., Kearney, NJ; Dept. Pub. Instruction, Hunterdon County, NJ; etchings, Albany Inst. Hist. & A. **Comments:** Born Charles Jacob Jung, he exhibited under that name through at least 1919. Came to U. S. c.1881. **Sources:** WW38 (as Young); WW19 (as Jung); WW15 (as A. Jac Jung); Falk, *Exh. Record Series.*

YOUNG, Charles Morris
[Painter, etcher] b.1869, Gettysburg, PA / d.1964.
Addresses: Phila., PA, 1890s; Radnor, PA, 1947; Drifton, PA, 1959. **Studied:** PAFA, with Chase, Anshutz, and Vonnoh; Acad. Colarossi, Paris, France, 1897. **Member:** ANA; Phila. A. Cl. **Exhibited:** PAFA, frequently, 1891-1944 (50 times; incl. prize, 1925); NAD, 1892, 1897; AIC, 1896-1923; SNBA, 1898; Boston AC, 1902, 1907; St. Louis Expo., 1904 (prize); Pan-A. Expo, Buffalo. 1901; Phila. A. Cl., 1908; CI, 1910 (prize); Buenos Aires Expo., 1910; Corcoran Gal biennials, 1907-41 (14 times); Pan-Pacific Expo., San Francisco, 1915; PAFA, 1921, 1925; Amsterdam, Holland, 1929 (gold). **Work:** PAFA; CGA; Nat. Gal.; Budapest; Albright A. Gal.; Rochester Mem. A. Gal.; Nat. Gal.,

Santiago, Chile; Reading Mus. A.; PMA; PAFA; Allentown A. Gal.; Boston A. Cl.; St. Louis A. Cl.; Sandhurst Military Acad., England, and in priv. colls. **Comments:** Pennsylvania Impressionist, known for his snowy landscapes. While studying in France, he spent time at Giverny in 1903. Signature note: Early works are signed "C.M. Young" in upper/lower case with the tail of the "Y" re-curving under the "C.M." Later signatures are variants of this earlier form, with "Chas." and "Morris" often employed, so that the most common form is "Chas. Morris Young." **Sources:** WW59; WW47; Danly, *Light, Air, and Color,* 90.

YOUNG, Chic (Murat Bernard Young) *[Cartoonist, illustrator] b.1901, St. Louis, MO / d.1973.*
Addresses: NYC. **Comments:** In 1924, he created a popular comic strip, "Dumb Dora," and in 1930 created his internationally famous comic strip, "Blondie" (King Features Syndicate). "Blondie" became so popular that even a sandwich, the "Dagwood," was named after one of the principal characters. **Sources:** WW59; WW40; *Famous Artists & Writers* (1949).

YOUNG, Chu W. *[Painter] mid 20th c.*
Exhibited: Salons of Am., 1934. **Sources:** Marlor, *Salons of Am.*

YOUNG, Clara Huntington See: **HUNTINGTON, Clara Leonora (Peggy)**

YOUNG, Clarence K. *[Engraver] 19th/20th c.*
Addresses: Wash., DC, active c.1904-20. **Comments:** Possibly the same Clarence Young who, from 1912-16, produced illustrations for juvenile series books, including *Racer Boys* for the Stratemeyer Syndicate. **Sources:** McMahan, *Artists of Washington, DC;* add'l info courtesy James D. Keeline, Prince & the Pauper, San Diego.

YOUNG, Cliff(ord) See: **YOUNG, (F.) Cliff(ord)**

YOUNG, Dorothy See: **WEIR, Dorothy (Mrs. Mahonri Young)**

YOUNG, Dorothy O. (Mrs. Jack J. Sophir) *[Sculptor, painter, teacher, craftsperson] b.1903, St. Louis, MO.*
Addresses: University City, MO; Crestwood 23, MO. **Studied:** St. Louis Sch. FA, Washington Univ.; ASL. and with E. Wuerpel, Leo Lentelli, George Bridgman; Victor S. Holm. **Member:** St. Louis Art Gld.; County AA; Soc. Indep. Artists, St. Louis; Am. Artists All. **Exhibited:** St. Louis Art Gld., 1925 (prize), 1926-29 (prize), 1930-46 (solo), 1947-52; Kansas City AI, 1928-32, 1934; St. Louis AL, 1924-30, 1931 (prize), 1933-34; Soc. Indep. Artists, St. Louis, 1930-55 (prizes: 1937, 1940, 1943, 1944, 1945, 1947-1949, 1950, 1952, 1953, 1955) ; Joslyn Art Mus., 1939, 1941, 1944; Springfield Art Mus., 1943; CAM, 1939-46, 1949; William Rockhill Nelson Gal. Art, 1947; Am. Artists All., 1946-55; Missouri Fed. Club traveling exhib., 1947-48, 1952-55; St. Louis Art Festival, 1950; Peoples' Art Center Assn. Fair, 1955; St. Louis Artists, 1924-34. Other awards: Henry Shaw Cactus Soc., 1955; St. Louis County Fair, 1947. **Work:** Office, St. Louis Council, Boy Scouts of Am.; Rockwoods (MO) Mus.; Jackson Park Sch., St. Louis. **Sources:** WW59; WW47.

YOUNG, E. R. See: **YOUNG, Eleanor R.**

YOUNG, Edward C. *[Marine painter] b.1806, Hanover, NJ / d.1856, Boston, MA.*
Work: Mystic Seaport Mus.; Naval Hist. Fndtn, Wash., DC. **Comments:** A career naval officer with the U.S. Marine Corps, he sailed aboard a number of warships including the U.S.S. Constitution. **Sources:** Brewington, 424.

YOUNG, Eleanor R. *[Painter, drawing specialist] b.1908, Red Bluff, CA.*
Addresses: NYC. **Studied:** ASL; Archipenko. **Member:** NAWPS. **Exhibited:** Salons of Am., 1927 (as E.R. Young). **Sources:** WW40; Marlor, *Salons of Am.*

YOUNG, Eliza Middleton Coxe (Mrs. C. M.) *[Painter] b.1875, Phila.*
Addresses: Jenkinstown, PA (1919); Radnor, PA (1939). **Studied:**

PAFA with T. Anshutz and Charles M. Young (her husband). **Exhibited:** AIC, 1904, 1907; PAFA Ann., 1905-06; Corcoran Gal biennial, 1939. **Sources:** WW19.

YOUNG, Ellsworth *[Painter and illustrator] b.1866, Albia, IA / d.1952, Evanston, IL.*
Addresses: Oak Park, IL. **Studied:** AIC; John H. Vanderpoel and Oliver Dennett Grover. **Member:** Chicago PS; Chicago Galleries Assoc.; Austin, Oak Park, River Forest Art League (board of directors); Illinois Soc. FA. **Exhibited:** AIC; Chicago Galleries Assoc.; Marshall Field's Galleries; Carson Pirie Scott Galleries; Illinois Fine Art Soc.; American Fine Arts Soc. Galleries, NY. **Work:** State Mus., Springfield, IL; Tolleston Public School, Gary, IN; Illinois State Teachers College, H.S., both in Bloomington, IL; State Teachers College, Macomb and DeKalb, IL; Park College, Parkville, MO. **Comments:** Illustrated many books and magazines. Position: illustrator, *Times,* Denver, CO; art staff, Chicago *Tribune.* Illustrator, *Poems You Ought to Know.* Work used by U.S. Government to advertise Liberty Loan; appeared later in "Ladies Home Journal." **Sources:** WW40; Ness & Orwig, *Iowa Artists of the First Hundred Years,* 228.

YOUNG, Elmer E. *[Painter] mid 20th c.*
Addresses: Minneapolis, MN. **Member:** AWCS. **Exhibited:** AIC, 1925. **Sources:** WW53; WW47.

YOUNG, Esther Chistensen (Mrs. Charles J. Young) *[Illustrator, drawing specialist, craftsperson, writer] mid 20th c.; b.Milwaukee, WI.*
Addresses: Van Hornesville, NY. **Studied:** Groom; Aiken; Sinclair; Milwaukee-Downer College; ASL. **Exhibited:** Wisc. PS, 1924 (prize); Women's Arts and Industries Expo, NY, 1925 (prize). **Sources:** WW40.

YOUNG, Eunice E. *[Painter] early 20th c.*
Addresses: Active in Los Angeles, 1913-26. **Studied:** C.A. Fries and J.H. Farnham in San Diego. **Exhibited:** Los Angeles studio exhib., 1914. **Sources:** Petteys, *Dictionary of Women Artists.*

YOUNG, Eva H. *[Miniature painter] early 20th c.*
Addresses: NYC and Highwood, NJ, c.1913-19. **Exhibited:** PAFA, 1922. **Sources:** WW19; Petteys, *Dictionary of Women Artists.*

YOUNG, (F.) Cliff(ord) *[Illustrator, writer, painter, lecturer, teacher] b.1905, New Waterford, OH / d.1985.*
Addresses: New York 19, NY. **Studied:** Pittsburgh AI; AIC; NAD; ASL; Charles Schroeder; Leon Kroll; Harvey Dunn; G. Oberteuffer; J. Norton; J. Wellington Reynolds & Harvey Dunn. **Member:** A. Gld.; AAPL; NSMP; Fifty Am. A.; Nat. Soc. Painters in Casein; NAC; Archit. League New York; Salmagundi Club (chmn. art comt., 1970-71); Nat. Soc. Mural Painters (treas., 1971-72); Soc. Illusr.; Artist Guild (pres., 1972). **Exhibited:** Corcoran Gal biennial, 1932; NAC, 1933 (prize), 1934 (prize), 1936 (prize); S. Indp. A., 1933. **Work:** US Navy Art Gal. & US Marine Corps Coll., Wash., DC; Fed. Hall, NYC. Commissions: WPA murals, St. Francis Monastery, Utuado, PR, 1958, Berkshire Life Ins. Co, Pittsfield, Mass., 1961, Church of Our Lady of Victory, NYC, 1962, Norweg Children's Home, Brooklyn, NY, 1963 & Pub. Sch. 232, Queens, NY, 1965. **Comments:** Preferred media: oils, acrylics. Teaching: Central Park Sch. A., NYC; chmn. found. courses, Phoenix Sch. Design, NYC, 1967-; instr. painting Salmagundi Club, NYC, 1970-on. Publications: auth./illus., "Figure Drawing Without a Model," 1946; auth, "Drawing Drapery from Head to Toe," 1947; auth., "Figure Construction," 1966. **Sources:** WW59; WW47; WW73 (as Cliff Young).

YOUNG, Florence Upson *[Painter, engraver, teacher] b.1873, Fort Dodge, IA / d.1974, Alhambra, CA.*
Addresses: Iowa (55 years); Alhambra, CA. **Studied:** AIC, with John Vanderpoel; ASL, with Kenyon Cox, Carol Beckwith, Frank DuMond, William M. Chase, Wilbur Reaser, Nicolai Fechin. **Member:** Women Painters of the West; Soc. for Sanity in Art. **Exhibited:** local clubs and galleries; Younkers, Des Moines; J.W. Robinson Co.; Sketch Show, San Gabriel Artists Guild; GGE,

1939; LACMA; Los Angeles Pub. Lib.; Ebell Club; Friday Morning Club; City Hall, Los Angeles; Greek Theatre; San Diego, Santa Paula, CA. **Awards:** Palos Verde Library, 1938 (first prize); California State Building, Expo Park, Los Angeles, 1938 (first prize); LACMA, 1943 (prizes); Greek Theatre, 1955; Artists of the Southwest, 1951. **Work:** Pomona College. **Comments:** Ness & Orwig quote a Los Angeles paper, writing of Young: "Art for art's sake and labor for humanity's sake might well be given as the deepest motives underlying her service in the field of art." Contributor to *Widening Horizons in Creative Art.* **Sources:** WW59; WW47; Ness & Orwig, *Iowa Artists of the First Hundred Years,* 228-29; Petteys, *Dictionary of Women Artists,* reports birth date of 1972.

YOUNG, Frances Gamblin Price (Mrs. W.) *[Painter, teacher] b.1901, Winterset, IA.*
Addresses: Hibbing, MN. **Studied:** pupil of Charles W. Hawthorne, Charles A. Cumming, Richard Miller. **Member:** Iowa Art Guild. **Exhibited:** Iowa Art Salon, 1927 (first in oil); 1928 (second in oil), 1929 (hon. men. and third in watercolor), 1930 (hon. men. in oil); Iowa Art Guild, 1934, 1936; Arrowhead Art Exchange, Duluth, MN, 1931 (first prize). **Work:** priv. colls. **Comments:** Instructor, Cumming School Art; instructor, Dept. Graphic and Plastic Arts, State Univ. Iowa. **Sources:** WW40; Ness & Orwig, *Iowa Artists of the First Hundred Years,* 229.

YOUNG, Frank Herman *[Designer, writer, teacher] b.1888, Nebraska City, NE.*
Addresses: Chicago 3, IL. **Studied:** AIC. **Member:** A. Dir. C., Chicago; SI; Chicago Gld. Free Lance A. **Comments:** Position: founder, pres., Young & Timmins Advertising Art Studios, Chicago, Ill.; founder and dir., Am. Acad. A., Chicago, Ill. Author: "Advertising Layout," 1928; "Modern Advertising Art," 1931; "Technique of Advertising Layout," 1935. Contributor to: trade publications. Lectures: Advertising Layout. **Sources:** WW59; WW47.

YOUNG, Gertrude M. *[Painter, curator] b.1862, London, England / d.1930, Tucson, AZ.*
Addresses: NYC (1887-24; immigrated 1887); Tucson, AZ (1924-on). **Studied:** England; ASL, 1890-94. **Member:** Tucson FA Assn; Palette & Brush Cl. **Exhibited:** Palette & Brush Cl. (4th annual exh., her last). **Comments:** She worked as the governess for Theodore Roosevelt's children when he was Governor of NY. In 1919, she joined the Brooklyn Museum and became an assistant curator. From 1924-on, she painted Arizona subjects such as the San Xavier Mission. **Sources:** info courtesy Wayne Kielsmeier, Tucson, AZ.

YOUNG, Gertrude Yates (Mrs. Victor E.) *[Painter] b.1904, Springfield, MO.*
Addresses: Des Moines, IA. **Studied:** Kansas City Art Inst. **Exhibited:** Park College, Parkville, MO; Kansas City Art Inst.; Mus. Springfield, MO; Iowa Art Salon; New Ocean House Hotel, Swampscott, MA. **Sources:** Ness & Orwig, *Iowa Artists of the First Hundred Years,* 229.

YOUNG, Gladys G. *[Painter, graphic artist] b.1897, Vevey, Switzerland / d.1974, NYC.*
Addresses: NYC. **Studied:** ASL; & in Paris with Andre Lhote. **Member:** Audubon A.; Soc. Women A. (pres.). **Exhibited:** Salons of Am.; Corcoran Gal biennial, 1941; Gal. 460 Park Ave., NYC, 1941 (solo); Ferargil Gal., 1945 (solo); Riverside Mus., NYC, 1938; Provincetown AA, 1937, 1938; Shaw Gal., NYC, 1939; Soc. Women A. Award: prize, NAWA, 1951, 1958. **Sources:** WW59; WW47.

YOUNG, Grace *[Painter, decorator] b.1869, Covington, KY / d.1947, Montclair, NJ.*
Addresses: Cincinnati, OH. **Studied:** Cincinnati Art Acad.; with Friedrich Fehr and Carl Marr, Munich; Acad. Colarossi with Privet and Girodet, Paris. **Exhibited:** Frame House Gal., Louisville, KY, 1971 (posthumous). **Comments:** Worked for Rookwood Pottery. **Sources:** Petteys, *Dictionary of Women Artists.*

YOUNG, Grace Alexandra *[Painter] mid 20th c.*
Exhibited: S. Indp. A., 1935. **Sources:** Marlor, *Soc. Indp. Artists.*

YOUNG, Grace S. *[Ceramicist, batik, painter] b.1874, Brooklyn.*
Addresses: Brooklyn, NY/Orient, NY. **Studied:** A. Heckman; W. Reiss; G. Cornell; K. Williams: V. Raffo; Sally Stevens; Maude Robinson. **Member:** NYSC; Keramic Soc. and Des. Guild, NYC. **Exhibited:** Keramic Soc. and Des. Guild, 1930 (prize); AIC. **Sources:** WW40.

YOUNG, Gustav *[Artist] early 19th c.*
Addresses: Baltimore, 1812. **Sources:** G&W; Lafferty.

YOUNG, Harvey B. See: **YOUNG, Harvey Otis**

YOUNG, Harvey Otis
[Landscape painter, teacher] b.1840, Post Mill, VT / d.1901, Colorado Springs, CO.

HARVEY YOUNG 73

Addresses: Paris, 1879; Colorado (Manitou Springs, Aspen, and Denver), 1879-98; Colorado Springs, 1899-on. **Studied:** Acad. Julian, Paris, 1876; privately with Carolus-Duran in Paris; in Munich, 1870s. **Member:** Denver AA (co-founder, 1893). **Exhibited:** Mechanics Inst., San Fran., 1868, 1875-78; Brooklyn AA, 1876-79; Indust. Expo., Paris Salon, 1878, 1879; Chicago, 1875; NAD, 1879; PAFA Ann., 1879. **Work:** Oakland Mus.; Denver AM; Bancroft Lib., Univ. Calif., Berkeley; CGA; Colorado College, Colorado Springs; Penrose Pub. Lib., Colorado Springs. **Comments:** Young is best known for his Rocky Mountain landscapes and mining scenes, many of which are painted in gouache. In 1859, he joined the California Gold Rush, sailing from NYC to San Francisco via Panama. While panning for gold he also made many sketches of the Salmon River area. After serving in the Civil War, he returned to San Francisco in 1866 and established a studio. From 1869-79, he made six trips to study in Europe, but also returned to the West on sketching trips, finalizing paintings in his NYC studio. In 1879, he was bitten by the mining bug again, and settled in Colorado where he dropped painting for many years while he pursued mining silver. Young won a fortune in mining, but when he lost it all, he returned to painting. In his later years, he painted scenes along the route of the Denver and Rio Grande Railroad for the company's advertising brochures. Young's name is sometimes mistakenly given as Harvey B. Young due to an error in family records. **Sources:** G&W; *Art Annual,* IV. obit.; Clement and Hutton. More recently, see Hughes, *Artists in California,* 626; P & H Samuels, 544, report Lyndon, VT as an alternate birthplace; *300 Years of American Art,* vol. 1, 305.

YOUNG, Helen *[Painter] b.1888, South Otselic, NY.*
Addresses: Mt. Vernon, NY. **Studied:** C.J. Martin. **Member:** N.Y. Soc. Women Artists; Woodstock AA. **Exhibited:** S. Indp. A., 1917-18, 1922, 1924, 1929; NAWA, 1933 (prize), 1936, 1937; N.Y. Soc. Women Artists, 1939; Art Center, NYC, 1923 (prize); Salons of Am.; AIC. **Work:** City Hall, Dinan, France. **Sources:** WW40; addit. info. courtesy Woodstock AA.

YOUNG, Helen (Walcott) *[Painter] 19th/20th c.*
Addresses: Wash., DC, active, early 1920s; NYC. **Exhibited:** Wash. WCC, 1921; CGA, 1924 (solo); Soc. Wash. Artists. **Comments:** Her work includes seascapes and scenes of South America, where she did field work with an expedition of the American Museum of Natural History. Helen Young. **Sources:** McMahan, *Artists of Washington, DC.*

YOUNG, Henry DeMerritt *[Painter] late 19th c.*
Addresses: Boston, MA. **Exhibited:** Boston AC, 1878, 1884, 1896, 1897. **Sources:** *The Boston AC.*

YOUNG, J. Donald *[Educator] b.1897, NYC.*
Addresses: Los Angeles, CA; Pasadena, CA. **Studied:** Columbia Univ. (A.B.); Princeton Univ. (MA., M.F.A.); Am. Sch. Classical Studies, Athens, Greece. **Member:** CAA; Archaeological Inst. Am.; Am. Soc. for Aesthetics. **Comments:** Position: instr., 1923-25, asst. prof., 1925-36, Columbia Univ., NY; asst. prof., 1936-38, assoc. prof., 1938-40, prof., 1940-, chm. art dept., 1937,

Occidental Col., Los Angeles, Cal. Contributor to: *American Journal of Archaeology; Art Bulletin; College Art Journal.* **Sources:** WW59.

YOUNG, J. H. A. *[Engraver] b.c.1830, Prussia.*
Addresses: Wash., DC in 1860. **Comments:** His wife was from New York and their son John, aged 2, was born in Washington. **Sources:** G&W; 8 Census (1860), D.C., I, 599.

YOUNG, J. James, Jr. *[Painter] mid 20th c.*
Addresses: Ossining, NY, 1931. **Exhibited:** S. Indp. A., 1931. **Sources:** Marlor, *Soc. Indp. Artists.*

YOUNG, J. Shepard *[Painter] mid 20th c.*
Addresses: Chicago area. **Exhibited:** AIC, 1939, 1941. **Sources:** Falk, *AIC.*

YOUNG, James H. *[Engraver] mid 19th c.*
Addresses: Philadelphia, 1817-66. **Comments:** He was associated in business with William Kneass (1818-20) and George Delleker (1822-23, as Delleker & Young). **Sources:** G&W; Brown and Brown; Phila. CD 1817-66.

YOUNG, James Harvey *[Portrait painter] b.1830, Salem, MA / d.1918, Brookline, MA.*
Addresses: Boston. **Member:** Boston AC. **Exhibited:** Boston AC, 1878, 1884, 1893. **Work:** American Antiquarian Society; Essex Institute (self-portrait). **Comments:** He studied architecture but as early as 1848 opened a portrait studio in Boston where he spent most of his life. **Sources:** G&W; Essex Institute, *Cat. of Portraits*, 258; Swan, BA; Sears, *Some American Primitives*, 85-86, repro. p. 68; 8 Census (1860), Mass., XXVI, 488; Rutledge, PA; Boston BD 1858-60; Essex Institute *Historical Collections,* LXXXVI (April 1950), 172-74. Bibliography: WW17.

YOUNG, Janet Todd *[Painter, mural painter] b.1908.*
Addresses: Italy; San Francisco, CA, 1937. **Studied:** Evanston, IL, Art Academy; with Hans Hofmann, Debshitz School of Arts, Munich, 1931. **Member:** Am. Abstract Artists (founding mem.). **Exhibited:** SFMA, 1938; GGE, 1939; de Young Mus., 1956; American Abstract Painters of NY Nat'l Tour. **Sources:** Hughes, *Artists in California*, 626; Diamond, *Thirty-Five American Modernists* p.37.

YOUNG, Jean Lorell *[Painter] b.1933, Nebraska.*
Addresses: California; Woodstock, NY. **Studied:** Wallace Berman, Hollywood, 1950-54, Emil Bisttram, Los Angeles, 1952, Chouinard A. Sch., 1953, with Judith Rothschild, 1953-1957, Monterey; Hans Hoffmann School, 1955; with Karl Knaths. **Exhibited:** Lucien Labaudt A. Gal., San Francisco, CA, 1956, 1958 (solo); Sun Gal., Provincetown, MA, 1958; Provincetown AA, 1959; Schuster Gallery, NYC, 1960, 1962 (solo); 1963 (solo); The Studio, Woodstock, NY, 1962-66; Springfield Mus. of Art, MA, 1963; Rudolf Gallery, Woodstock, NY, 1963-74; Ann Leonard Gallery, Woodstock, 1966-68; Marist College, Poughkeepsie, NY, 1970 (solo); July and August Gallery,1970-74, Woodstock AA, 1978, Bluestone Gallery,1982, Fletcher Gallery,1994, 1996, all Woodstock, NY; Shirley Fiterman Gallery, NYC, 1994. **Work:** Commission: mural, Woodstock Festival, 1994. **Comments:** Preferred medium: oil, acrylic, gouache, collage. Auth. *Woodstock Craftsmans Manual,* Praeger, 1971; *Woodstock Craftsmans Manual 2,* Praeger, 1972. **Sources:** info. courtesy of J. Young, Woodstock, NY.

YOUNG, John Chin *[Painter, collector, blockprinter, craftsperson] b.1909, Honolulu, Hawaii.*
Addresses: Honolulu, HI. **Studied:** mostly self-taught. **Member:** Assn. Honolulu Artists; Calif. WCS; Hawaii Painters & Sculptors League (pres.); Tennent Art Foundation (trustee, 1972). **Exhibited:** GGE, 1939; Corcoran Gal biennial, 1941; Am. Artists Exhib., Rockefeller Center, NYC; Am. Art Today, MMAA & VMFA, 1950 & 1958; LACMA (solo); CPLH (solo); Calif. Acad. Arts (solo); Honolulu Acad. Arts (solo); Pacific Heritage Traveling Exhib., Berlin. **Awards:** Honolulu Acad. Arts, 1938, 1939, 1950 (first prize in watercolors), 1954 (first prize in oil painting) &1955 (best in show). **Work:** Hawaii State Found.

Culture & Arts, Honolulu Acad. Arts; Smithsonian Inst. Art in Embassy Program, Washington, DC; Dept. Educ. Hawaii State Artmobile Program, Honolulu. **Commissions:** oil mural painting, Hana Ranch, Maui, HI. **Comments:** Preferred media: oils. Positions: art critic, *Honolulu Star Bulletin,* 1965-66; chairman, cultural activities committee, East West Center, Honolulu, 1971-72; director, John Young Gal. Teaching: Honolulu Acad. Art, 1960-61. Collection: Oriental, pre-Columbia, African and Oceanic art works. **Sources:** WW73; WW40; Forbes, *Encounters with Paradise,* 270.

YOUNG, John H. *[Designer] b.1858, Grand Rapids, MI / d.1944.*
Addresses: North Pelham, NY. **Exhibited:** AIC, 1899. **Work:** scenic work in Chicago, NYC. **Comments:** (Brother of Louis C.).

YOUNG, John J. *[Survey artist, topographical draftsman, and painter] b.1830, Prussia / d.1879, Wash., DC.*
Addresses: Wash., DC, active from 1860s. **Work:** National Archives; Amon Carter Mus. **Comments:** Accompanied the Williamson-Abbot railroad survey of Northern California and Oregon in 1855. The report of this expedition, Vol. VI of *Reports of Explorations and Surveys,* contains a number of illustrations from his drawings (including 14 landscape scenes, 1 geologic scene, and 10 drawings of trees). As staff artist with the War Department, he also illustrated, from the drawings of others, several other reports of surveys of the late fifties. These included Lt. Ives' exploration of the Colorado River (drawings by Mollhausen and Von Egloffstein); Capt. Macomb's exploration from Santa Fe to Colorado (drawings by John Strong Newberry); and Capt. Simpson's exploration in Utah (drawings by Von Beckh). During the 1860s and 1870s Young lived in Washington, DC and his name appears in directories as draftsman for the War Department, topographical engineer, and engraver. In 1877 he was listed as an engraver for the U.S. Coast Survey. **Sources:** G&W; Taft, *Artists and Illustrators of the Old West,* 267-68. More recently, see McMahan, *Artists of Washington, D.C.;* P & H Samuels, 545.

YOUNG, John L. *[Listed as "artist"] b.1821, Maryland.*
Addresses: Baltimore, 1850. **Sources:** G&W; 7 Census (1850), Md., V, 832.

YOUNG, John T. *[Landscape artist] b.c.1814 / d.1842, Rochester.*
Addresses: Working in and around Rochester, NY from c.1835-42. **Comments:** Iillustrated Henry O'Reilly's *Sketches of Rochester* (1838) and also drew a view of the upper Genesee Falls which was lithographed. **Sources:** G&W; Taft, *Artists and Illustrators of the Old West,* 268; Ulp, "Art and Artists of Rochester"; Stokes, *Historical Prints* and Peters, *America on Stone* list him as J. Young [not to be confused with John J. Young].

YOUNG, Joseph Louis *[Sculptor, art administrator] b.1919, Pittsburgh, PA.*
Addresses: Los Angeles, CA. **Studied:** Westminister Col. (A.B., 1941, hon L.L.D., 1960); BMFA Sch. (hon. grad., 1951); Carnegie Inst. Technol.; Mass. Inst. Technol.; Cranbrook Acad. Art; ASL; also with Karl Zerbe, David Aronson, Mitchell Siporin, Oskar Kokoschka & Gyorgy Kepes. **Member:** fel., Int. Inst. Art & Lett.; Nat. Sculpture Ctr., Lawrence, Kans.; Nat. Soc. Mural Painters. **Exhibited:** Ten Year Retrospective, Art in Architecture, Palm Springs Desert Mus., 1963; Int. Exhib. Muralists, Brussels, Belg., 1965; solo shows, Archit. League New York, 1951 & Falk Raboff Gal., Los Angeles, 1953. **Awards:** Edwin Austin Abbey scholar, 1950; Am. Acad. Rome, Italy, 1951; Huntington Hartford Found. fel., 1952. **Work:** commissions: granite bas-relief, Los Angeles Co. Hall Record, Los Angeles Civic Ctr., Calif., 1964; sixteen stained glass windows, Congregation Beth Sholom, San Francisco, Calif., 1965; West apse, Nat. Shrine Immaculate Conception, Wash., DC, 1967; history of math. (mosaic mural), Math. Sci. Bldg., UCLA, 1970; The Triforium (multi-media tower), Los Angeles Mall, 1973; plus over forty major archit. commissions throughout the USA. **Comments:** Preferred media: multi-media. Positions: designer 400th Anniversary of

Michelangelo, Italian Trade Comn.; nat. v. pres., AEA, 1961-62; nat. v. pres. Nat. Soc. Mural Painters, 1971-72; owner, Art in Archit. Teaching: dir., Mosaic Workshop, 1955-; artist-in-residence, Brandeis Inst., 1962-; chmn. dept. archit. arts, Santa Barbara Art Inst., 1970; lectr., "Art in Architecture," at various institutions of higher learning. Art Interests: sound-light in architectural environments. Publications: auth., "Bibliography of Mural Painting in USA," 1946; "A plan for Mural Painting in Israel," 1952; "The World of Mosaic" (film), produced by Univ. Calif., Los Angeles, 1957; "Arts & Crafts in Architecture," Reinhold, 1963; "Dialogue in Art," KNBC-TV, 1967. **Sources:** WW73.

YOUNG, Joseph S. *[Painter] mid 20th c.*
Addresses: Chicago area. **Exhibited:** AIC, 1945 (prize), 1947, 1951. **Sources:** Falk, *AIC.*

YOUNG, Kate *[Painter] late 19th c.*
Addresses: NYC, 1886. **Exhibited:** NAD, 1884, 1886. **Sources:** Naylor, *NAD.*

YOUNG, Kathryn I. *[Craftsperson, teacher, lecturer, writer] b.1902, Babylon, NY.*
Addresses: Hartsdale, NY. **Studied:** N.Y. Sch. F. & Appl. A.; Columbia Univ. **Member:** EAA; Westchester A. & Cr. Gld.; Chappaqua A. & Cr. Gld. **Comments:** Position: dir., Westchester Workshop, County Ctr., White Plains, N.Y. **Sources:** WW40.

YOUNG, Kenneth Victor *[Painter, designer] b.1933, Louisville, KY.*
Addresses: Wash., DC. **Studied:** Ind. Univ.; Univ. Louisville (B.S.). **Exhibited:** Speed Mus., Louisville, 1963; Inst. Contempt. Arts, Wash., DC, 1967; BMA, 1969; Ill. Bell Co., Chicago, 1971; State Armory, Wilmington, DE, 1971; Univ. of Iowa, 1972; Indianapolis Mus, Ind., 1972; A.M. Sachs Gal.; Studio Gallery, Wash., DC, 1970s. **Work:** CGA; Va. Nat. Bank, Alexandria; Johnson Publ. Co., Chicago, IL. **Comments:** Positions: designer, Smithsonian Inst., 1964-. Teaching: instr. painting, Louisville Pub. Sch., 1962-63; instr. design & painting, Corcoran Sch. Art, 1970-. Collections arranged: Music Machines, Hall of Graphic Arts, Women and Politics, Gandhi Centennial Exhib., Explorers N.Z. **Sources:** WW73; B. Rose, "Black Artist in America," *Art Am.* (1970); Cederholm, *Afro-American Artists.*

YOUNG, Laura E. *[Painter] b.1879, Newark, NJ / d.1939, Verona, NJ.*
Exhibited: Montclair AM, 1931. **Sources:** Petteys, *Dictionary of Women Artists.*

YOUNG, Louis C. *[Scenic painter] b.1864, Grand Rapids, MI / d.1915.*
Addresses: Pelham, NY. **Comments:** (Brother of John H.).

YOUNG, Louise E. *[Painter] mid 20th c.*
Addresses: NYC. **Studied:** ASL. **Exhibited:** S. Indp. A., 1929. **Sources:** Marlor, *Soc. Indp. Artists.*

YOUNG, Louise K. *[Painter] mid 20th c.*
Addresses: Dayton, OH. **Exhibited:** PAFA Ann., 1932. **Sources:** Falk, *PAFA, Vol. 3.*

YOUNG, Lyman *[Cartoonist] b.1893, Chicago, IL.*
Addresses: Clearwater, FL (1949). **Studied:** AIC.
Comments: The brother of cartoonist Chic Young, in 1928 he created the adventure strip, "Tim Tyler's Luck" (King Features Syndicate). **Sources:** *Famous Artists & Writers* (1949).

YOUNG, Mahonri ("Hon") Mackintosh *[Sculptor, painter, graphic artist, writer, teacher, educator] b.1877, Salt Lake City, UT / d.1957, Norwalk, CT.*
Addresses: NYC/Ridgefield, CT. **Studied:** drawing with James Harwood, 1895-97, in Salt Lake City; ASL, 1899-1900 with Bridgeman, Kenyon Cox & Walter A. Clark; Acad. Julian, Paris, with J.P. Laurens & Verlet, 1901-05; briefly at Acad. Delecluse & at Acad. Colarossi with Injalbert. **Member:** ANA, 1912; NA, 1913; NSS, 1910; SAE; NAC; AWCS; Century Assn.; AM Soc. PS&G; SAW, NIAL. **Exhibited:** Am. Art Assoc., Paris, 1903 (prize); Salon d'Automne, 1905; PAFA Ann., 1906-41 (11 times);

NAD, 1908-34 (Barnett prize, 1911; Maynard prize, 1932); AIC, 1909-42; Berlin Photographic Co., 1913 (solo); Armory Show, 1913; Pan-Pacific Expo, 1915 (silver medal); WMAA, 1920-41; Rehn Gal., 1928 (solo); Olympic Games, Los Angeles, CA, 1932 (prizes); Corcoran Gal. biennials, 1935, 1937; SAE; Utah AI; AGAA, 1940 (retrospective). **Work:** large collection, Brigham Young Univ.; MMA; Hopi, Navaho & Apache groups, AMNH; Newark Mus.; NYPL; Peabody Inst., Baltimore; RISD; Salt Lake City AI; LDS Gymnasium, Salt Lake City; BM; Los Angeles Mus. Hist., Science & Art; monument, Protestant Cathedral, Paris; WMAA; BM; Providence Mus. Art; BMA; CGA; PMG; Brookgreen Gardens, SC; AGAA; WMA; CMA; Salt Lake City (UT) Mus. Art; Sea Gull Monument, Salt Lake City; This Is The Place Monument, Salt Lake City; monument, Tucson, AZ; statue of Brigham Young, Statuary Hall, U.S. Capitol, Wash, DC.
Comments: Pioneer social-realist sculptor, he was the grandson of Mormon leader Brigham Young. His subjects paralleled those of The Eight, and included laborers and boxers. He also favored western genre subjects and visited the Southwest three times (the first trip being to Arizona in 1912), modeling groups of the Hopi, Apache, and Navajo Indians for dioramas at the Amer. Mus. of Natural History. Among his best known public works is "This is the Place" monument, 1947, at Emigration Canyon, Salt Lake City. Young was also recognized for his drawings, prints, and painting, and taught all of these at the ASL in New York. Teaching: Am. School Sculpture, NYC; instructor sculpture, drawing, etching, ASL, early 1920s. Auth.: article, "Modeling" in *Encyclopaedia Britannica.* **Sources:** WW53; WW47; Frank Jewett Mather, Jr. *Mahonri Young* (exh. cat., Addison Gal., 1940); Roberta Tarbell, "Mahonri Young's Sculptures of Laboring Men, French and American Realism, and Walt Whitman's Poetics for Democracy," *Mickle Street Review* vol. 12 (1990): 114-212; Baigell, *Dictionary;* P&H Samuels, 545-46; Fort, *The Figure in American Sculpture,* 235.

YOUNG, Mahonri S. *[Art administrator] b.1911, NYC.*
Addresses: Columbus, OH. **Studied:** Dartmouth College (A.B.); New York Univ. (M.A.). **Member:** Assn. Art Mus. Directors. **Comments:** Positions: acting dir., Munson-Williams-Proctor Inst., 1951-53; dir., Columbus Gal. FA, 1953-. Publications: Am. correspondent, *Apollo Magazine.* Teaching: Sarah Lawrence College, 1941-50. Collections arranged: Howald, Wildestein & British collections. **Sources:** WW73.

YOUNG, Marjorie Ward *[Painter, instructor] b.1910, Chicago, IL.*
Addresses: Phoenix, AZ. **Studied:** with Florence Reed, Chicago, 1924; AIC Sat. Sch., 1925-27, Day Sch., 1928-32; with William B. Schimmel, 1955-56, Jossey Bilan, 1958-62, Edgar A. Whitney, 1969 & 1971, Richmond Yip, 1970 & J. Douglas Greenbowe & Milford Zornes, 1972. **Member:** Ariz. Artists Guild (pres., 1961-66); Ariz. Watercolor Assn. (pres., 1968); Nat. League Am. Pen Women (br. art chmn., 1972); Phoenix Art Mus. Fine Arts Assn.; Contemp. Watercolorist Ariz. **Exhibited:** Low Ruins Spring Nat., Tubac, Ariz., 1965 (second in watercolor for "Filibusters"); 16th Ann. Tucson Festival Art, Ariz., 1966; Fine Arts Festival S. Dak. State Univ., 1969; 2nd Ariz. Watercolor Biennial, Phoenix Art Mus., 1970; Nat. League Am. Pen Women, Wash., DC, 1971 (best of show for watercolor), Nat. Diamond Biennial 1972 (hon. men. for "A Study in Brief"); Camelback Galleries, Scottsdale, AZ, 1970s. **Work:** Ariz. Bank, Phoenix; First Nat. Bank Ariz., Phoenix; Water Bimson Coll., Phoenix; Phoenix Country Cl. **Comments:** Preferred media: watercolor, pen & pencil. Positions: background artists, Fleischer, Famous & Paramount Studios, Miami, Fl, 1938-42; gal. dir., Phoenix YWCA, 1970-72. Teaching: instr. drawing & watercolor, Phoenix Art Mus., 1970-72; instr. watercolor, Creative Living Found., 1972. Publications: illusr., "Many Lives of the Lynx," 1964; illusr., "Functional Spanish," 1968. **Sources:** WW73.

YOUNG, Mary E. *[Artist] late 19th c.*
Addresses: Brooklyn, NY, 1886. **Exhibited:** NAD, 1886.

Sources: Naylor, *NAD.*

YOUNG, Mary L(ouise) *[Painter] mid 20th c.; b.St. Louis.*
Addresses: Connecticut; Massachusetts; Long Island, NY; Worcester, MA. **Studied:** Twachtman. **Member:** Greenwich SA. **Sources:** WW25.

YOUNG, Mattie *[Painter] early 20th c.*
Addresses: San Fran., CA. **Sources:** WW15.

YOUNG, May Belle *[Painter, teacher] b.1891, Charleston, SC.*
Addresses: Jackson Heights, NY; Mexico City, D.F. **Studied:** NAD; ASL; PIASch.; Grand Central Sch. Art. **Member:** NAWA; Gotham Painters; Wolfe AC. **Exhibited:** NAWA, 1939, 1944; Town Hall Club, NY; Studio Gld.; Gotham Painters, 1943-45; Phila. WCC, 1938; AWCS, 1938; Thos. E. Cook Travel Bureau, NY (solo); Jacksonville AC, 1950; Barbizon Hotel, NY, 1949; St. Augustine (FL) AA, 1955. **Work:** Victoria (BC) Pub. Lib. **Comments:** Position: teacher, Newtown H.S., Elmhurst, NY. **Sources:** WW59; WW47.

YOUNG, Milton *[Painter, sculptor] b.1935, Houston, TX.*
Studied: Los Angeles City Col.; Calif. State Col., Los Angeles (B.F.A.). **Member:** Los Angeles AA. **Exhibited:** Brockman Gal.; LACMA, 1965; Los Angeles Tower Gal., 1969; Ankrum Gal., 1970; Los Angeles Ann. Art Exh.; UCLA A. Gal., 1971; Ill. Bell Tel. Co., 1971; Univ. of Iowa, 1972. **Work:** Malcolm X Col., Chicago; priv. colls. **Sources:** Cederholm, *Afro-American Artists.*

YOUNG, (Miss) *[Landscape painter] mid 19th c.*
Addresses: Chicago, 1856. **Comments:** Could be the Miss Young from New York State, aged 18, who was listed as an engraver in the 1850 Census of Cleveland (Ohio). **Sources:** G&W; Chicago CD 1856; 7 Census (1850), Ohio, XI, 450.

YOUNG, Myrtle M. *[Painter] mid 20th c.*
Addresses: San Fran., CA. **Sources:** WW24.

YOUNG, N. M. *[Painter] early 20th c.*
Addresses: NYC. **Sources:** WW19.

YOUNG, Oregon *[Painter] d.1873, Santa Barbara, CA.*
Exhibited: San Francisco, CA, 1873. **Sources:** Hughes, *Artists in California,* 627. Hughes states that the entire collection of paintings, on exhibit at the time of Young's death, was bought by Senator J.P. Jones of Nevada.

YOUNG, Pat B. (Mrs. Judson) *[Landscape painter] b.1908, Tacoma, WA.*
Addresses: Lake Oswego, OR, 1984. **Studied:** Robert Wood, G. Post, Rex Brandt. **Exhibited:** Wash. State Hist. Soc., 1968. **Comments:** Signed her name PA/NG. **Sources:** Trip and Cook, *Washington State Art and Artists.*

YOUNG, Peter *[Painter] b.1940.*
Addresses: NYC. **Exhibited:** WMAA, 1967, 1969. **Sources:** Falk, *WMAA.*

YOUNG, Philip *[Listed as "artist"] mid 19th c.*
Addresses: Cincinnati, 1836. **Sources:** G&W; Cincinnati CD 1836 (G&W cited information as courtesy Edward H. Dwight, Cincinnati Art Museum).

YOUNG, Phineas Howe *[Landscape and portrait painter] b.1847, Winter Quarters (Florence), NE / d.1868, Salt Lake City, UT.*
Studied: Dan Weggeland, Salt Lake City. **Comments:** Nephew of Brigham Young, and a pioneer Utah painter before his death from pneumonia. **Sources:** P&H Samuels, 546.

YOUNG, (Rev.) *[Watercolor and ink portraitist] mid 19th c.*
Addresses: said to have been active in Center County, PA from c.1825-40. **Sources:** G&W; Lipman and Winchester, 182.

YOUNG, Richard Carr *[Painter, illustrator, craftsperson, teacher] mid 20th c.; b.Chicago.*
Addresses: Chicago, IL. **Exhibited:** AIC, 1925-26. **Sources:** WW25.

YOUNG, Rose *[Painter] early 20th c.*
Addresses: Phila., PA. **Studied:** PAFA. **Exhibited:** S. Indp. A., 1917. **Sources:** WW15.

YOUNG, Stark *[Painter] mid 20th c.*
Addresses: NYC. **Exhibited:** WMAA, 1944; PAFA Ann., 1945-46. **Sources:** Falk, *Exhibition Records Series.*

YOUNG, Susanne Bottomley B. (Mrs. Benjamin Swan Young) *[Painter, decorator] b.1891, NYC.*
Addresses: Oyster Bay, NY. **Studied:** Alexander; G. deF. Brush. **Work:** frieze, Club Royal, NYC. **Sources:** WW40.

YOUNG, Thomas *[Portrait and miniature painter] early 19th c.*
Addresses: Providence, RI. **Comments:** Painted portraits of several prominent citizens of Providence (RI) between 1817-40. **Sources:** G&W; Fielding; information provided G&W courtesy Dr. H.W. Williams, Jr., Corcoran Gallery.

YOUNG, Thomas A. *[Landscape painter] b.1837, London, England / d.1913.*
Addresses: Flatbush, Brooklyn, NY, 1863-1913. **Comments:** Not to be confused with August Young (1837-1913), also a Brooklyn artist. **Sources:** G&W; *Art Annual,* XI, obit.; Brooklyn CD 1890, 1904, 1912.

YOUNG, Thomas S. *[Sculptor] mid 20th c.*
Addresses: NYC. **Exhibited:** PAFA Ann., 1964. **Sources:** Falk, *PAFA, Vol. 3.*

YOUNG, Tobias *[Painter] early 19th c.*
Comments: Painted two views in NYC c.1824. **Sources:** G&W; Stokes, *Iconography,* VI, pl. 96a-b.

YOUNG, Walter N. *[Illustrator, designer, teacher] b.1906, Brooklyn, NY.*
Addresses: New York 19, NY; Goldens Bridge, NY. **Studied:** PIA Sch. **Member:** A.Dir.Cl. **Comments:** Position: instr., PIA Sch., Brooklyn, NY, 1936-42. Illustr.: *McCall's, Woman's Home Companion, House & Garden, Better Homes & Gardens.* **Sources:** WW53; WW47.

YOUNG, Webb *[Painter] b.1913, Covington, KY.* Webb Young
Addresses: Santa Fe, NM. **Studied:** AIC; Famous Artists Sch.; Gerald Cassidy, 1925-27; Inst. San Miguel Allende, Mexico. **Work:** New Mexico State Fair Permanent Art Coll. **Comments:** Preferred media: watercolors, oils. Publications: auth., "Student Steps to Watercolor Painting"; "Mexico Sketches" & A Sketchbook of Southwestern Life." Art interests: painting the Southwest. **Sources:** WW73.

YOUNG, William Crawford *[Illustrator] b.1886, Cannonsburg, MI.*
Addresses: Norwalk, CT. **Studied:** AIC; Chicago Art Acad. **Member:** Silvermine GA. **Comments:** Position: staff, *Judge, King Features Syndicate.* **Sources:** WW40.

YOUNG, William Thomas (Tom) *[Painter, etcher, lithographer, educator, lecturer] b.1924, Huntington, WVA.*
Addresses: Staten Island 1, NY. **Studied:** Univ. Cincinnati; Univ. Alabama (B.F.A., M.A.); Ohio State Univ.; Univ. So. California; Columbia Univ.; John Herron AI; Chouinard AI; Hans Hofmann Sch. FA; Cincinnati Acad. A. **Member:** Comm. on A. Edu. **Exhibited:** Alabama WC Soc., 1949; PMA, 1950; BM, 1950; Canton A. Mus., 1951; Birmingham, 1953, 1954; NY City Center, 1956-57; Wagner Col., 1957, 1959; CM, 1946; Mich. State Univ., 1947; Montgomery Mus. FA, 1950; A. Lg. of Long Island, 1954; Pietrantonio Gal., NY, 1956, 1959; Artzt Gal., NY, 1959; Univ. Alabama, 1957; Nonagon Gal., NY, 1958 (5-man); Univ. So. Illinois, 1960; Brata Gal., NY, 1960; Toronto, Canada, 1960; Kansas City AI, 1960; Kauffman Gal., 1956; Tanager Gal., 1957; Davida Gal., 1957; March Gal., 1957-58, 1959-60; Marino Gal., 1958; solo: Univ. Alabama, 1948-50, 1961; Jackson Mun. A. Mus., 1961; Little Rock A. Center, 1961; Brata Gal., NY, 1962; Univ. So. Illinois 1961; Univ. Mississippi, 1961; Allison's A. Colony, Way, Miss., 1961. Awards: prizes, scholarship, John Herron AI, 1940; Alabama WC Soc., 1954; Staten Island Mus.

Hist. & A., 1955; NY City Center Gal., 1956. **Work:** Univ. Alabama; Army Air Force Base, Okla. (mural); Univ. So. Ill. Mus.; Wagner Col., Staten Island; mural, Hayden Publ. Co., NY, 1963; work in numerous priv. colls. **Comments:** Positions: instr. art, Univ. Alabama, 1949-50; prof., Alabama State Col., 1950-52; hd. art dept., Wagner Col., Staten Island, NY, 1953-. Juror, annual Staten Island Mus. Exh., 1964; and for 14th annual Festival of Arts, Birmingham Art Mus., 1965; dir., special seminars "Exploring Art in New York," 1964-65. **Sources:** WW66.

YOUNG-HUNTER, Eva Hatfield *[Painter] early 20th c.*
Addresses: NYC. **Sources:** WW24.

YOUNG-HUNTER, John *[Portrait and landscape painter]* b.1874, Glasgow, Scotland / d.1955.
Addresses: NYC, 1913; Taos, NM, c.1942. **Studied:** Royal Acad. Sch. & Univ. London, with his father Colin Hunter, Alma-Tadema, W. Orchadson, J.S. Sargent. **Member:** Allied Artists Am.; AWCS; CAFA; SC; Chelsea Artists, London. **Exhibited:** Royal Acad. Art, London, 1900-13; Paris Salon, 1910 (prize), 1914 (medal); Corcoran Gal. biennial, 1923; Nat. Gal., London; Hartford, CT, 1925 (prize); Luxembourg Mus., Paris (prize); Allied Artists Am., 1932 (prize); Allied AA, 1933 (gold); Oakland Ann., 1937 (prize); NAD; Allied Artists Am.; AIC; Kansas City AI; Oklahoma City, OK; Mus. New Mexico, Santa Fe; Audubon Artists, 1948-52; Albuquerque, NM; Harwood Found., Taos, 1956 (retrospective). **Work:** Nat. Gal., London; Walker Art Gal., Liverpool, England; WMA; Oberlin, OH; Princeton Univ.; Harvard Univ.; Johns Hopkins Univ.; Texas Tech. Univ.; Dayton AI; Art Mus., Wellington, New Zealand; Gov. House, Ottawa, Canada; Art Mus., Dundee, Scotland; Tate Gallery, London; Musée de Luxembourg, Paris; Mus. New Mexico. **Comments:** Painter of Indians and landscapes in the West, society portraits in NYC. First visited New Mexico in 1917. Auth.:"Reviewing the Years." **Sources:** WW53; WW47; P&H Samuels, 546.

YOUNG-HUNTER, Mary Towgood *[Portrait and landscape painter]* b.1872, Napier, New Zealand / d.1947, Carmel, CA.
Addresses: Scotland; England; NYC; Taos, NM; Berkeley, CA; Carmel, CA. **Studied:** Florence, Italy; Royal Acad., London. **Exhibited:** Berkeley Lg. FA, 1924; City of Paris, San Fran., 1924; San Fran. AA, 1924; Calif. State Fair, 1930. **Comments:** Married to John Young-Hunter (see entry) in 1899. **Sources:** Hughes, *Artists of California*, 627.

YOUNG & DELLEKER *[Engravers] early 19th c.*
Addresses: Philadelphia, 1822-23. **Comments:** James H. Young and George Delleker (see entries). Also known as Delleker & Young. **Sources:** G&W; Phila. CD 1822-23.

YOUNGERMAN, Jack *[Painter]* b.1926, Louisville, KY.
Addresses: NYC. **Studied:** Univ. North Carolina, Chapel Hill, 1944-46; Univ. Missouri-Columbia (grad., 1947); Ecole des Beaux Arts, Paris, 1948. **Exhibited:** Corcoran Gal. biennials, 1959-67 (3 times); "American Prints Today,' Munson-Williams-Proctor Inst., Utica, NY, 1968; WMAA biennials, 1967, 1969; "L'Art Vivant aux Etats-Unis," Fondation Maeght, Paris, 1970; Carnegie Int., 1971; Pace Gal., NYC, 1970s. **Awards:** Nat. Council Arts & Sciences Award, 1966. **Work:** MoMA; WMAA; Guggenheim Mus.; Albright-Knox Art Gallery, Buffalo, NY; AIC; CGA, NMAA, Phillips Collection, Hirshhorn Mus., all Wash., DC; VMFA; Wadsworth Atheneum, Hartford, CT. **Comments:** Modernist painter whose bold, reductive abstractions have been compared to both Georgia O'Keeffe and Matisse. His works contain suggestions of leaves, plants and flames, forms which he increasingly simplified and flattened, using stark colors. Positions: designer stage set & costumes, Histoire de Vasco, Paris, 1956 & Death Watch, New York, 1958. **Sources:** WW73; *300 Years of American Art*, 991; "Portrait—Jack Youngerman," *Art in Am.* (Sept.-Oct., 1968); "Drawings by Jack Youngerman," *Harpers* (Oct., 1968); Barbara Rose, "Getting it Physical," *Vogue* (Feb., 1971).

YOUNGERMAN, Reyna Ullman *[Painter, lecturer teacher]* b.1902, New Haven, CT / d.1992.
Addresses: Miami Beach, FL. **Studied:** Yale Sch. FA (B.F.A.); ASL; Wayman Adams; Alexander Brook; Jerry Farnsworth. **Member:** CAFA; Blue Dome Fellow; Florida Artists Group; Sarasota AA; NAWA; AEA; Open Forum Speaker's Bureau, Boston; Miami WCS; Des.-Dec. Gld.; New Haven PCC; Brush & Palette Club; Meriden SA; F.I.A.L.; Palm Beach Art Lg.; Conn. WCS. **Exhibited:** NAWA, 1932-46; BMFA; Morgan Mem.; Avery Mus.; Yale Gal. FA; NAD; CAFA; New Haven PCC; Brush & Palette Club; Copley Soc., Boston; Ogunquit AC; Palm Beach Art Lg.; Ft. Lauderdale, FL; Norton Gal. Art; Soc. Four Arts; Miami AC; Barzansky Gal.; Butler AI; Argent Gal.; Audubon Artists; Mayo Hill Gal., Wellfleet; Provincetown Art Gal.; Sarasota AA; Lowe Gal. Art; Rockport Art Gal.; Hartford Atheneum; Montreal, Canada; PAFA; Oelschlager Gal., Chicago; Worth Ave. Gal., Palm Beach (solo); Miami Mus. Mod. Art; Nationale Palazio des Artes, Cuba. **Awards:** fellowship, Tiffany Found., 1926-27; prizes, New Haven PCC, 1942; Meriden SA, 1934, 1945, 1946; Miami Artists; Blue Dome Fellowship; Pan-American portrait award; AAPL; Lowe Gal.; CAFA; Yale Sch. FA; Florida Painters Group; medal, Beaux Arts (4). **Work:** Tiffany ouFnd.; Superior Court, New Haven, CT. **Comments:** Positions: hd. art dept., New Haven College, 1940; chmn., City of Miami Beach Music & Art Board; leader, Brandeis Art Appreciation Study; chmn., Miami Beach Art Festival. **Sources:** WW66; WW47.

YOUNGLOVE, Elbridge G. *[Listd as "artist"] mid 19th c.*
Addresses: Buffalo, NY, 1856-59. **Sources:** G&W; Buffalo BD 1856, CD 1857-59.

YOUNGLOVE, Mary Golden *[Miniature painter, craftsperson, teacher] 19th/20th c.; b.Chicago, IL.*
Addresses: Chicago, IL, active c.1897-1915. **Studied:** AIC with F. Freer, Johansen. **Member:** ASL, Chicago; Lake View AC, Chicago. **Exhibited:** AIC, 1895-1910. **Sources:** WW15.

YOUNGLOVE, Ruth Ann (Mrs Benjamin Rhees Loxley) *[Painter, craftsperson, teacher, lecturer, block printer]* b.1909, Chicago, IL.
Addresses: Pasadena, CA. **Studied:** Univ. Calif., Los Angeles (B.E.); Orrin A. White; Marion K. Wachtel; Bessie Hazen; Helen Chandler; B. Whitice. **Member:** Pasadena Soc. Artists (patron chmn., 1958-68); Pasadena AA (secy., 1961-64); Laguna Beach AA (life member); Calif. Nat. WCS; AWCS (assoc.). **Exhibited:** Pasadena SA; Laguna Beach AA Gal.; Los Angeles County Fair, 1936-41 (prizes); Calif. Nat. WCS, Los Angeles, 1967 & Laguna Beach; 1971; Flintridge Prep. School, La Cañada, 1972 (solo) & Community Service Center, Pasadena, 1972 (solo). **Awards:** second prize for landscape, Artists Lg. Seal Beach, 1968. **Work:** Bank of Am., Pasadena, CA; El Tovar Hotel, Grand Canyon, AZ. **Comments:** Preferred media: watercolors. Teaching: private instr., 1955-65. Art interests: landscape painting. **Sources:** WW73; WW47.

YOUNGMAN, Willis B. *[Painter] late 19th c.*
Exhibited: Boston AC, 1874, 1877. **Sources:** *The Boston AC.*

YOUNGQUIST, John *[Draftsman]* b.1918, Crookston, MN.
Addresses: Moorhead, MN. **Studied:** Univ. Minnesota (B.A.); Minn. Sch. Art; Univ. Iowa (M.F.A.); ASL; Slade Sch., Univ. London; Inst. Allende, San Miguel, Mexico; NY Univ. **Member:** College AA Am. **Exhibited:** Drawing USA, St. Paul, 1971; Manisphere Int., Winnipeg, 1971; Red River Ann., Moorhead, 1972; Ball State Drawing Exh., Muncie, IN; Minneapolis Art Inst. Biennial. **Awards:** Seagram Award for Drawing, Manisphere Exh., 1971; purchase award, Drawings USA, St. Paul, 1971. **Work:** Minn. Inst.Art, Minneapolis; Minn. Mus. Art, St. Paul; North Dakota State Univ., Fargo; Moorhead State College, MN; Univ. Iowa, Iowa City. **Comments:** Positions: bd. dirs., Red River AC, Moorhead, 1966-68. Teaching: Minn. Sch. Art, 1954-59; Univ. Minn., Ext., 1957-1958; Moorhead State College, 1961-. **Sources:** WW73.

YOUNGS, Amelia Loretta L. *[Painter] d.1920, Wash., DC.*
Addresses: Wash., DC, active 1865-1920. **Exhibited:** Soc. Wash. Artists, 1892. **Sources:** McMahan, *Artists of Washington, DC.*

YOUNGS, Maude B. *[Painter] 19th/20th c.*
Addresses: Seattle, WA. **Member:** Women Painters of Wash., 1932. **Exhibited:** SAM, 1934, 1938. **Sources:** WW24; Trip and Cook, *Washington State Art and Artists, 1850-1950.*

YOUNKIN, William LeFevre *[Architect, painter] b.1885, Iowa City, IA.*
Addresses: Lincoln, NE. **Studied:** Maurice Braun; Columbia School Arch. **Member:** Lincoln Artists Guild; Nebraska AA; AAPL. **Comments:** Supervising architect, Nebraska State Capitol Bldg. **Sources:** WW40; Ness & Orwig, *Iowa Artists of the First Hundred Years,* 229.

YOUSE, Margaret *[Painter] late 19th c.*
Addresses: Oakland, CA. **Exhibited:** Calif. Midwinter Int. Expo., 1894. **Sources:** Hughes, *Artists of California,* 627.

YOVITS, Esther *[Painter, teacher] b.1916.*
Addresses: NYC. **Studied:** S. Brecher. **Member:** NAWPS; PS&G, NYC. **Exhibited:** PAFA Ann., 1938; NAD, 1938; Argent Gal., NYC; Contemp. Art Gal., NYC. **Sources:** WW40.

YOW, Rose Law *[Painter] early 20th c.*
Addresses: Seattle, WA. **Sources:** WW24.

YOWELL, Alex J. *[Artist, photographer] early 20th c.*
Addresses: Wash., DC, active 1905-14. **Sources:** McMahan, *Artists of Washington, DC.*

YPHANTIS, George (Andrews) *[Painter, engraver, teacher, graphic artist] b.Kotyora, Turkey / d.1899.*
Addresses: Berkeley, CA. **Studied:** Univ. Toronto (B.A.); Yale Sch. FA (B.F.A.). **Member:** Am. Assn. Univ. Prof. **Exhibited:** GGE 1939; PAFA, 1942; Mont. State Univ. (solo); Univ. British Columbia (solo); Seattle AM (solo); Los Angeles, 1939-40; Salons of Am. **Work:** Seattle Art Mus.; Montana State Univ. **Comments:** Teaching: Montana State Univ., 1934-42; Calif. College Arts & Crafts, Oakland, CA, 1946-. Lectures: History of Art. **Sources:** WW53; WW47. More recently, see Hughes, *Artists of California,* 627.

YRISARRY, Mario *[Painter] b.1933, Manila, Philippines.*
Addresses: NYC. **Studied:** Queens College (NY) (B.A.); Cooper Union. **Exhibited:** Am. Painting & Sculpture, Indianapolis Mus. Art, 1970; Using Walls (indoors), Jewish Mus., New York, 1970; WMAA, 1969-71 ; Grids Inst. Contemp. Art, Univ. Penn., 1972; Painting & Sculpture 1972, Storm King AC, 1972; OK Harris Gallery, NYC, 1970s. **Work:** WMAA; Balti. Mus. Art; Indianapolis Mus. Art; Rose Art Mus., Brandies Univ.; MIT Mus. Art. Commissions: poster, Albert A. List Found., Lincoln Center, New York, 1972. **Comments:** Preferred medium: acrylics. Publications: auth., *The New Work, First Person Singular-2,* Art Gallery, CT, 5/1971. **Sources:** WW73; Donald Judd, review, *Arts Magazine* (Oct., 1964); Carter Ratcliff, review, *Art News* (Dec., 1969); Robert Pincus-Witten, "New York," *Artforum* (Feb., 1970).

YU-HO, Tseng *[Painter] mid 20th c.*
Exhibited: Corcoran Gal. biennial, 1963; PAFA Ann., 1964. **Sources:** Falk, *Exhibition Records Series.*

YUDIN, Carol *[Printmaker, painter] 20th c.; b.Brooklyn, NY.*
Addresses: Belleville, NY. **Studied:** Pratt Graphic Center with Sid Hammer, Michael Ponce de Leon, Roberto di Lamonica, Andrew Stasik & painting with Michael Lenson. **Member:** NAWA (graphic juror, 1972-75); Painters & Sculptors Soc. NJ (secy., 1962-70; pres., 1971-73); Artists Equity NJ; Art Exh. Council; Hunterdon AC. **Exhibited:** Art from NJ, NJ State Mus., 1969; Fourth Int. Miniature Print Exh., 1971; Seventh Triennial NJ Artists, Newark (NJ) Mus., 1971; 31st Ann. Painters & Sculptors Soc. NJ, 1971; NAWA, Jersey City & New York, 1971; Pratt Graphic Center Gallery, NYC & Korby Gallery, Cedar Grove, NJ, 1970s. Awards: Purchase awards, NJ State Mus., 1969, Painters & Sculptors Soc. NJ, 1969 & Nat. Miniature Art

Soc. Exh., 1970. **Work:** NJ State Mus., Trenton; Jersey City Mus., NJ; St. Peters College, Jersey City; Miniature Art Soc. NJ, Paramus; Belleville Pub. Lib., NJ. Commissions: "Tree of Life," Congregation Ahavath Achim, Belleville, 65. **Comments:** Teaching: Nutley Adult Sch., NJ, 1966-; Temple Emanuel, Peterson, NJ, 1966-69. **Sources:** WW73.

YUDITSKY, Cornelia R. *[Painter, designer, teacher] b.1895 / d.1980, Upper Marlboro, MD.*
Addresses: Wash., DC. **Studied:** Calif. Sch. FA; Corcoran Gal. Sch.; Univ. Utah; Grace Cornell; John Butler. **Member:** Wash. AC. **Exhibited:** Soc. Wash Artists, 1935, 1939; Greater Wash. Independent Exh., 1935; Landscape Club of Wash., 1939; CGA, 1939; LOC; Allocations Gal., WPA, Wash., DC, 1939. **Comments:** Teaching: Jewish Community Center, Wash., DC. **Sources:** WW40; McMahan, *Artists of Washington, DC.*

YUILL-THORNTON, Alexander *[Painter, architect] b.1917, Manila, PI / d.1986, San Francisco, CA.*
Addresses: San Diego, CA, c.1933; Boulder City, NV; San Francisco, CA. **Studied:** Army & Navy Academy; Univ. Calif., Berkeley (arch.); San Francisco Art Inst., 1960s (etching). **Exhibited:** San Francisco AA, 1939. **Comments:** Specialty: watercolors. **Sources:** Hughes, *Artists of California,* 627.

YUNCKER, Lillian *[Painter, china painter] b.1882, Indiana / d.1980, Tacoma, WA.*
Addresses: Tacoma, WA. **Studied:** Visitation Acad., Tacoma; Holy Angles Academy, Minneapolis. **Member:** Tacoma FA Assoc.; Tacoma Art League. **Exhibited:** Alaska Yukon Pacific Expo, 1909; Wash. State Hist. Soc., 1945; Tacoma Art League, 1951. **Sources:** Trip and Cook, *Washington State Art and Artists, 1850-1950.*

YUNKERS, Adja *[Painter, educator] b.1900, Riga, Latvia / d.1983, NYC.*
Addresses: NYC. **Studied:** Leningrad, Paris, Berlin & Rome. **Exhibited:** Corcoran Gal. biennial, 1959, 1961; WMAA, 1958-73; "Abstract Expressionists & Imagists," Guggenheim Mus., 1961; PAFA Ann., 1962; "The New American Painting & Sculpture: The First Generation," MoMA, 1969; "Etats Unis," Fondation Maeght, Saint Paul de Venice, France; plus over forty solo shows at galleries; incl. Emmerich Gal., NYC, 1960s. Awards: Guggenheim fellowship, 1949-50, 1954-55; Ford Found. grant, 1960. **Work:** MoMA; Guggenheim Mus.; WMAA; MMA; Albright-Knox Art Gal., Buffalo. Commissions: "A Human Condition" (mural), Syracuse Univ., 1966; tapestry for student union, SUNY Stony Brook, 1967. **Comments:** Preferred media: graphics, pastels, oils, acrylics. Positions: ed., *Creation, Ars & Ars-Portfolio,* Stockholm, 1942-45; visiting critic, Columbia Univ., 1967-69. Publications: ed., "Prints in the Desert," 1950. Teaching: New Sch. Social Res., 1947-56; Cooper Union, 1956-67; Barnard College, 1969-; summer sessions at several western universities. **Sources:** WW73.

YURA, Solomon *[Painter] mid 20th c.*
Studied: ASL. **Exhibited:** S. Indp. A., 1940-41, 1943. **Sources:** Marlor, *Soc. Indp. Artists.*

YUSCHOK, Pablo *[Painter] early 20th c.*
Addresses: Woodbine, NJ. **Exhibited:** PAFA Ann., 1932. **Sources:** Falk, *PAFA, Vol. 3.*

YUST, David E *[Painter, educator] b.1939, Wichita, KS.*
Addresses: Fort Collins, CO. **Studied:** Birger Sandzen; Wichita State Univ.; Kansas State Univ.; Univ. Kansas (B.F.A.), 1963; Univ. Oregon (M.F.A.), 1969. **Exhibited:** Artists Choice, Nelson Gal. Art, Kansas City, 1965-66; Am. Embassy Arts Prog., State Dept traveling exh., 1966-68; Artists Choice, Friends of Contemp. Art, Denver, 1970; Selected Artists, Mulvane AC, 1970-71; 73rd Western Ann., Denver AM, 1971; Fountain Gal. Art, Portland, OR, 1970s. Awards: Purchase awards, Selected Artists, Mulvane AC, 1970, 11th Biennial, Kansas State Univ., 1970 & Colorado State Univ. Centennial, 1970. **Work:** Denver (CO) Art Mus.; Mulvane AC, Topeka, KS; Colorado State Univ., Fort Collins;

Kansas State Univ., Manhattan; Univ. Oregon, Eugene.
Comments: Preferred medium: acrylics. Teaching: Colorado State
Univ., 1965-70s. **Sources:** WW73.

YUTZEY, Marvin Glen *[Designer, craftsperson, lecturer]*
 b.1912, Canton, OH.
Addresses: Moundsville, WV. **Studied:** Cleveland Sch. Art.
Member: ADI; Am. Ceramic Soc. **Exhibited:** CMA, 1933-34.
Comments: Position: des. dir., Fostoria Glass Co., Moundsville,
WV, 1936-. Specialty: pressed glass. **Sources:** WW59; WW47.

Charles S. Reinhart: *Sketch of F. Hopkinson Smith.*
From *The Illustrator* (1894)

Aaron Sopher: *Artist at her easel* (1960s)

Z

ZABARSKY, Melvin Joel *[Painter, educator]* b.1932, Worcester, MA.
Addresses: Durham, NH. **Studied:** School Worcester Art Mus., Ruskin School Drawing & Fine Arts, Univ. Oxford; School Fine & Applied Arts, Boston Univ. (B.F.A.); Univ. Cincinnati (M.F.A.). **Exhibited:** Boris Mirski Gal., Boston, 1962 (solo); Tragos Gal., Boston, 1966 (solo); De Cordova Mus., 1970 (solo); Surreal Images, De Cordova Mus., 1968; New England Painters Traveling Exhib., Ringling Mus., Sarasota, FL, 1969. Awards: painting prize, Boston Arts Festival, 1962; Ford Foundation grant in humanities, 1968. **Work:** MoMA; De Cordova Mus., Lincoln, MA; Addison Gal. Am. Art, Andover, MA; Wiggins Coll., Boston (MA) Pub. Lib.; Currier Gal. Art, Manchester, NH. **Comments:** Preferred media: oils. Teaching: painting instructor, Swain School Design, New Bedford, MA, 1960-64; asst. professor of painting, Wheaton Col., 1964-69; assoc. professor of painting, Univ. New Hampshire, 1969-. **Sources:** WW73; C. Goldstein, *Zabarsky,* catalogue (De Cordova Mus., 1970); B. Schwartz, *Humanism in Twentieth Century Art* (Praeger, 1973).

ZABEL, Augusta L. *[Landscape painter]* early 20th c.
Addresses: Oakland, CA, 1902-05; San Francisco, CA, 1910-13. **Exhibited:** San Francisco AA, 1902, 1903; Oakland Art Fund, 1905. **Sources:** Hughes, *Artists in California,* 628.

ZABOLY, Bill (Bela Pal) *[Painter, illustrator, etcher]* b.1910, Cleveland, OH / d.1985, Cleveland?.
Addresses: Cleveland, 1940; Westport, CT, 1949. **Exhibited:** CMA, 1932 (Work by Cleveland Artists & Craftsmen); World's Fair, Chicago, 1933 (etchings). **Work:** CMA. **Comments:** In 1939 he took over the drawing of the famous comic strip, "Popeye" (King Features Syndicate). **Sources:** WW40; *Famous Artists & Writers* (1949).

ZABRISKIE, Virginia M. *[Art dealer]* mid 20th c.; b.NYC.
Addresses: NYC. **Studied:** Washington Square College, New York Univ. (B.A.); New York Univ. Inst. Fine Arts (M.A.). **Member:** Art Dealers Assn. **Comments:** Positions: director, Zabriskie Gal., 1954-. Specialty of gallery: twentieth century American art. **Sources:** WW73.

ZABRISKIE, William B. *[Painter]* b.1840 / d.1933.
Addresses: Hackensack, NJ. **Exhibited:** Brooklyn AA, 1879. **Sources:** *Brooklyn AA.*

ZACCHINI, Hugo *[Painter, lecturer, teacher, writer]* b.1898, Peru, South America / d.1975, Fontana, CA.
Addresses: Tampa, FL. **Studied:** Francesco Michetti in Rome, Italy. **Work:** Cathedral, Alexandria, Egypt; des./arch., Temple of Music, Tampa, FL; Hertzberg Mus., San Antonio, TX. **Comments:** He was born into a touring Italian circus family, the projectile Zacchinis, human cannonballs shot out of a cannon designed by their father Ildebrando. Hugo was the most famous of his siblings and was affiliated with Ringling Brothers Barnum & Bailey Circus for many years. He stayed with the circus until he was sixty years old, using his free time to paint and study art. In Paris, he became a friend of Picasso, Dali and Monet; in Alexandria, Egypt, he decorated the Roman Catholic Cathedral. Specialty: circus and nocturnal scenes, landscapes. Position: director, Art and Nature Inst., Tampa; teacher, Chaffey College, Fontana, CA, c.1958-on. **Sources:** WW40; info. courtesy of Joel L. Fletcher, Fletcher/Copenhaver Fine Art, Fredericksburg, VA.

ZACCONE, Fabian F. *[Painter, designer, lithographer, teacher, lecturer, muralist, portrait painter]* b.1910, Valsini, Italy / d.1992, Demarest, NJ?.
Addresses: West New York, NJ. **Studied:** PIA School; New York Univ. (M.A.); Da Vinci Art School. **Member:** Salons of America; Soc. Indep. Artists; Knickerbocker Artists; Assoc. Artists New Jersey. **Exhibited:** Soc. Indep. Artists, 1929, 1934-35; LOC; WFNY, 1939; Riverside Mus., 1944; Artists of Today, 1943, 1944 (solo); BM; Kennedy Gal.; NAD; NAC; Salons of America; Sweden; Venice, Italy. Awards: Montclair Art Mus., 1934 (med.), 1936 (med.), 1939 (med.),1952 (prize); N.J.A. Group, Newark, 1934 (prize); Newark, 1938 (prize); Audubon Artists, 1951 (prize); Jersey City Mus., 1952 (prize); NAC, 1955 (prize); New Jersey P&S (prize). **Work:** mural, public library, West New York, NJ; stained glass windows and mosaic mural, Mother Cabrini Shrine, NYC. **Comments:** Position: art supervisor, West New York & New Jersey, public schools. Illustrator: "Behold Your King," 1946. **Sources:** WW59; WW47.

ZACHARIAS, Athos *[Painter]* b.1927, Marlborough, MA.
Addresses: NYC. **Studied:** ASL, summer, 1952; RISD (B.F.A., 1952); Cranbrook Acad. Art (M.F.A., 1953). **Exhibited:** Art USA, New York, 1959; North Carolina Mus. Art, Raleigh, 1959; Pan-Pacific Show, Kyoto, Japan, 1961; Gal. Mayer, New York, 1961 (solo) & Louis Alexander Gal., New York, 1963 (solo). Awards: best in show award, Guild Hall, 1961; grant, Longview Foundation, 1962; festival arts purchase award, Southampton College, 1968. **Work:** Mus. Art, Providence, RI; Inst. Contemporary Art, Boston, MA; Kalamazoo (MI) Inst. Art; Phoenix (AZ) Art Mus.; Westinghouse Corp. Pittsburgh, PA. Commissions: decor for Manhattan Festival Dancers, commissioned by Robert Ossorio, NYC, 1963. **Comments:** Preferred media: acrylics. Publications: illustrator, cover, *Science & Technology,* 1963. Teaching: instructor of painting, Brown Univ., 1953-55; instructor of painting, Parsons School Design, 1963-65; instructor of painting Wagner College, 1969-. **Sources:** WW73.

ZACK, Leon *[Painter]* early 20th c.
Exhibited: AIC, 1928. **Sources:** Falk, *AIC.*

ZACK, Louis *[Sculptor]* mid 20th c.
Addresses: Los Angeles, CA. **Exhibited:** P&S Los Angeles, 1936. **Work:** WPA artist. **Sources:** Hughes, *Artists in California,* 628.

ZADIG, Bertram *[Illustrator, block printer]* b.1904, Budapest, Hungary.
Addresses: NYC. **Member:** SI. **Work:** NYPL. **Comments:** Illustrator: "Critical Woodcuts," by Stuart P. Sherman; "Hunger Fighters," by Paul de Kruif; "Twelve Portraits of the French Revolution," by Henri Beraud; "The History of the America

Nation," by Mason W. West. **Sources:** WW47.

ZADKINE, Ossip *[Sculptor] b.1890, Smolensk, Russia/moved to Paris in 1909 / d.1967, Paris.*
Addresses: Spent his career in Paris with the exception of 1940-45, when he lived in NYC. **Exhibited:** PAFA Ann., 1944-45; WMAA, 1946. **Work:** Hirshhorn Mus., Wash., DC; Mus. Nat. D"Art, Paris; Stedelijk Mus., Amsterdam. **Comments:** French sculptor who combined Cubism and Expressionism in his work. Included here because he was in the U.S. during the war years, 1940-1945/46. Zadkine was an important teacher for American direct carvers of the 1950s, many of whom studied with him in Paris in the late 1940s and 1950s. Among these artists were Israel Levitan, Sidney Geist, Gabriel Kohn, Hugh Townley, and George Sugarman. **Sources:** C. Calo, "Aspects of Wood Sculpture in America," 22-24; Bénézit; Falk, *PAFA, Vol. 3.*

ZADOK, Charles (Mr. & Mrs.) *[Collectors] late 20th c.*
Addresses: NYC. **Sources:** WW73.

ZAGORIN, Honoré See: **SHARRER, Honoré Desmond (Mrs. Perez Zagorin)**

ZAHN, Carl Frederick *[Designer, art administrator] b.1928, Louisville, KY.*
Addresses: Boston, MA. **Studied:** Harvard Univ. (A.B., 1948). **Member:** Am. Inst. Graphic Arts (bd. of directors, 1968-71). **Exhibited:** Fifty Books Exhibition, Am. Inst. Graphic Arts, 1960-72; Dreitzer Gal., Brandeis Univ., 1969 (solo). **Comments:** Positions: graphics designer, BMFA, 1956- & editor-in-chief, 1971-. **Sources:** WW73; William Seitz, *Carl Zahn,* catalogue of exhib at Brandeis Univ. (1969).

ZAHN, Edward *[Lithographer] mid 19th c.*
Addresses: NYC, 1854. **Sources:** G&W; NYBD 1854.

ZAHN, Otto *[Craftsperson, bookbinder] b.1906, Arnstadt, Thuringia.*
Addresses: Wash., DC. **Studied:** Otto Dorfner, in Weimar, Germany. **Comments:** Position: bookbinder, Bliss Library, Wash., DC. **Sources:** WW40.

ZAHN, Ruby See: **WHITE, Ruby Zahn**

ZAHNER, Ralph *[Listed as "artist"] b.1825, Prussia.*
Addresses: NYC. August 1850. **Sources:** G&W; 7 Census (1850), N.Y., XLIV, 270.

ZAIDENBERG, Arthur *[Painter, wood-block printer] b.1903 / d.1990.*
Studied: ASL. **Member:** Woodstock AA. **Exhibited:** Soc. Indep. Artists, 1927. **Work:** Woodstock AA. **Sources:** Woodstock AA.

ZAIKINE, Eugene A. *[Painter, sculptor, decorator] b.1908, Russia.*
Addresses: NYC. **Studied:** NAD; ASL; Grand Central Art Gal. **Member:** Mural Artists Gld.; Soc. Indep.t Artists. **Exhibited:** Cooperstown AA, NY; Soc. Indep. Artists, 1934; murals, WFNY, 1939. **Work:** Russian Greek Catholic Cathedral of Transfiguration, Brooklyn; Sts. Peter & Paul Church, Granville, NY; Half Moon Hotel, Brooklyn; Mayflower Hotel, Plymouth, MA. **Sources:** WW40.

ZAINO, Constantino *[Painter] 20th c.*
Addresses: NYC. **Exhibited:** Soc. Indep. Artists., 1931. **Sources:** Marlor, *Soc. Indp. Artists.*

ZAISS, Leonard *[Painter, sculptor] b.1892 / d.1933, Harrison, NY.*
Addresses: White Plains, NY. **Studied:** ASL. **Exhibited:** Salons of Am.; Soc. Indep. Artists, 1932-33. **Sources:** Falk, *Exhibition Record Series.*

ZAJAC, Jack *[Sculptor, painter] b.1929, Youngstown, OH.*
Addresses: Fontana, CA, 1951; Rome, Italy, 1973. **Studied:** Scripps College, 1949-53; also with Millard Sheets, Henry McFee & Sueo Serisawa; Am. Acad. in Rome. **Exhibited:** PAFA Ann., 1951, 1962; WMAA, 1959-60; Drawings by Sculptors, Smithsonian Inst., circulated in the US, 1961-63; Am. Painting,

VMFA, 1962; MoMA, 1962-63; Newport Harbor Art Mus., Balboa, CA, 1965 (retrospective) & Temple Univ., Rome, 1969 (retrospective); Fairweather Hardin Gal., Chicago, 1970s. **Awards:** Prix de Rome, 1954, 1956 & 1957; Am. Acad. Arts & Letters grant, 1958; Guggenheim fellowship, 1959. **Work:** MoMA; LACMA; PAFA; Milwaukee AI; Nelson Gal. Art, Kansas City, MO. Commissions: Reynolds Metals Co., 1968. **Comments:** Teaching: instructor, Pomona College, 1959. **Sources:** WW73; Henry J. Seldis & Ulfert Wilke, *The Sculpture of Jack Zajac,* Gallard Press, 1960; Allen S. Weller, *The Joys and Sorrows of Recent American Art,* Univ. Illinois, 1968.

ZAK, Karel J. *[Painter] early 20th c.; b.Elgin, IL.*
Exhibited: AIC, 1910. **Sources:** WW13.

ZAKANYCH, Robert. *[Painter] b.1935, Elizabeth, NJ.*
Addresses: NYC. **Exhibited:** WMAA, 1967, 1969, 1973, 1981; Int. Drawing Show, Darmstadt, Germany, 1971; New York Painting, J.L. Hudson Gal., Detroit, MI, 1971; Intimate Selection Am. Spirit I, Miriam Willard Gal., New York, 1971; Reese Palley, New York, 1971 (solo). **Work:** WMAA; Blue Cross, Blue Shield, Chicago, IL; Solomon, Cordwell, Buenz, Assoc., Chicago; Munich MoMA, Germany. **Sources:** WW73.

ZAKHAROFF, Feodor *[Painter] b.1882, Russia / d.1968, NYC.*
Addresses: NYC. **Studied:** Moscow School Painting, Sculpture & Arch. **Exhibited:** PAFA, 1928 (prize), 1936; Corcoran Gal biennials, 1935, 1937. **Work:** museums in Russia. **Sources:** WW40; Falk, *Exhibition Records Series.*

ZAKHAROR, Feodor See: **ZAKHAROFF, Feodor**

ZAKHEIM, Bernard Baruch *[Painter, sculptor, craftsperson, designer, teacher] b.1898, Warsaw, Poland / d.1985, San Francisco, CA.*
Addresses: San Francisco, CA; Sebastopol, CA. **Studied:** Calif. School FA; Art Acad., Warsaw; Politechnikum, Danzig; Kunstgewerbeschule München; Mexico; France. **Member:** Calif. Soc. Mural Artists; Am. Artists Congress; San Francisco AA; Artists Un. **Exhibited:** Mills College, Oakland, 1930; CPLH, 1932; SFMA, 1935 (first prize), and annually; San Francisco AA, 1935 (medal)-36, 1940 (medal); GGE, 1939; San Diego traveling exhib., 1940; U.S. Treasury Dept., 1940; Wash. State Fair, 1946; Rome, Italy, 1958; Atrium Gallery, Santa Rosa, 1964 (Artist's Fund prize); San Francisco Arts Festival, 1984 (sculpture award). **Work:** SFMA; frescoes, Coit Mem. Tower, Jewish Community Center, Univ. Calif. Medical School, Univ. Calif. Hospital, all in San Francisco; WPA murals, USPO, Mineola, TX; Rusk, TX; Alemany Health Center, San Francisco. **Comments:** Came to San Francisco in 1920. Position: instructor, adult dept., San Francisco Public Schools; instructor, occupational therapy, Presidio, San Francisco, CA. **Sources:** WW59; WW47; Hughes, *Artists in California ,*628 (birth date cited as 1896).

ZAKRESKI, Alexander *[Lithographer and topographical draftsman] mid 19th c.*
Addresses: San Francisco, 1850-58. **Comments:** In 1850 he was associated with someone named Hartman, perhaps J.W. Hartman. In 1858 he was listed as a draftsman with the Surveyor General's Office. **Sources:** G&W; Peters, *California on Stone;* San Francisco CD 1850-58.

ZALCE, Alfredo *[Painter] mid 20th c.*
Exhibited: AIC, 1938-44. **Sources:** Falk, *AIC.*

ZALLINGER, Franz X. *[Painter] b.1894, Salzburg, Austria / d.1962.*
Addresses: Seattle, WA, 1941. **Studied:** School of FA, Bavaria, Germany; with Fritz Kraus, Vienna; with H. Danzinger. **Member:** Puget Sound Group of Northwest Painters, 1933. **Exhibited:** SAM. **Comments:** Father of Rudolph F. Zallinger (see entry). **Sources:** Trip and Cook, *Washington State Art and Artists.*

ZALLINGER, Rudolph F. *[Painter, illustrator, etcher] b.1919, Irkutsk, Siberia / d.1994, Branford, CT.*
Addresses: Seattle, WA (emigrated there in 1924); New Haven,

CT, 1941-on. **Studied:** Cornish Art School, Seattle; Yale Univ. (M. A.); with his father, Franz Zallinger, E. Ziegler, John Butler. **Member:** Puget Sound Group of Northwest Painters. **Exhibited:** NYC; SAM; Gal. FA, New Haven, CT, 1938-39 (solos). **Comments:** The son of Franz X. Zallinger (see entry), he taught at Yale Univ. from 1942-50, and was artist-in-residence at Yale's Peabody Mus. from 1952. In 1947, he painted the popular "The Age of Reptiles," a 110-ft. mural of dinosaurs at the Peabody, which was featured as a U.S. postage stamp in 1970. In 1967, he completed his 60-ft. mural "The Age of Mammals," also at the Peabody. **Sources:** Trip and Cook, *Washington State Art and Artists;* obit. clipping, 1994.

ZALONE, Cyril See: **SLOANE, Cyril**

ZALOUDEK, Duane *[Painter] b.1931.*
Addresses: Portland, OR. **Exhibited:** WMAA, 1969. **Sources:** Falk, *WMAA.*

ZALSTEM-ZALESSKY, Alexis (Mrs.) *[Collector] late 20th c.*
Addresses: New Milford, CT. **Comments:** Collection: contemporary art. **Sources:** WW73.

ZAMMITT, Norman *[Sculptor] b.1931, Toronto, Ontario, Canada.*
Addresses: Moved to U.S. in 1943; New Mexico, 1964-65; Los Angeles, CA, 1973. **Studied:** Pasadena City College (scholarship), A.A., 1957; Otis Art Inst. (scholarship, M.F.A., 1961). **Exhibited:** Young West Coast Artists, 1965 & Show of New Acquisitions, 1967, MoMA; Am. Sculpture of the Sixties, LACMA & PMA, 1967; Felix Landau at Studio Marconi, Milan, Italy, 1970; solo shows in Beverly Hills & Los Angeles, CA, and NYC, 1962-72 (solos). **Awards:** Tamarind fellowship, 1967; purchase prize, 50th Ann. Sculpture Exhib., Otis Art Inst., 1968; Guggenheim fellowship, 1968. **Work:** MoMA; Hirshhorn Mus.; LOC; Otis Art Gal., Los Angeles; Larry Aldrich Mus., CT. **Comments:** Grew up on Mohawk Indian Reservation across the river from Montreal. Teaching: instructor of drawing & painting, Calif. Inst. Arts, 1967; visiting professor of design, school architecture, Univ. Southern Calif., 1968-69; lecturer design, Univ. Calif., Los Angeles, 1971-72. **Sources:** WW73; *The Spiritual in Art,* 419.

ZAMPARELLI, Mario Armond *[Designer, collector] late 20th c.; b.NYC.*
Addresses: Los Angeles, CA. **Studied:** Pratt Inst.; Univ. Paris. **Work:** commissions: murals in acrylics, Trans World Airlines; graphic works & environmental designs for Kimberly-Clark, Union Bank, Hughes Airwest & Summa Corp. **Comments:** Awards: J.W. Alexander Medal, City of New York; Haskel traveling fel., Pratt Inst.; Paul Hoffman Gold Medal. Positions: owner, Mario Armond Zamparelli & Co.; pres., Art Index, Inc. Collection: Renaissance art, contemporary and ethnic art. Specialty of gallery: international art curatorial and exhibition service. **Sources:** WW73; articles, *Esquire Magazine, Sundancer Magazine & Los Angeles Times.*

ZANCK, Gerald Joseph *[Painter] mid 20th c.*
Exhibited: AIC, 1944. **Sources:** Falk, *AIC.*

ZANDER, Jack *[Illustrator] mid 20th c.*
Addresses: Long Island City, NY. **Member:** SI. **Sources:** WW47.

ZANE, Edna B. *[Painter] late 19th c.*
Addresses: Philadelphia, PA. **Exhibited:** PAFA Ann., 1895 (watercolor). **Sources:** Falk, *PAFA, Vol. 2.*

ZANETTA, Clotilda *[Painter] early 20th c.*
Addresses: Cincinnati, OH. **Comments:** Associated with Art Acad., Cincinnati. **Sources:** WW25.

ZANG, John J. *[Landscape painter] late 19th c.*
Addresses: Yosemite. **Work:** Wadsworth Atheneum, Hartford. **Comments:** Active in Calif., 1883; also painted along Hudson River.

ZANTMAN, Hans *[Art dealer] b.1919, Sumbawa, Dutch East Indies.*
Addresses: Carmel, CA, 1973. **Studied:** private instruction, Netherlands. **Comments:** Positions: director, Zantman Art Galleries, Ltd., Carmel, CA. Specialty of gallery: living artists from USA & Europe, especially France. **Sources:** WW73.

ZAPKUS, Kestutis Edward *[Painter] b.1938, Dabikine, Lithuania.*
Addresses: NYC. **Studied:** AIC (B.F.A., 1960); Syracuse Univ. (Ryerson fellowship, 1960; M.F.A., 1962). **Exhibited:** Six Americans Signal, Paris, 1964; WMAA Ann., 1969; solos: Gres Gal., Chicago, 1962, Stable Gal., 1968 & Paula Cooper Gal., NYC, 1971. **Awards:** Invitational first prize, Chicago Arts Festival, 1963. **Work:** AIC. **Comments:** Preferred media: acrylics, oils. **Sources:** WW73.

ZARETSKY, Shulamith *[Painter] mid 20th c.*
Addresses: Brooklyn, NY. **Exhibited:** Soc. Indep. Artists, 1941, 1943-44. **Sources:** Marlor, *Soc. Indp. Artists.*

ZARICK, Alexander *[Painter] b.1930 / d.1983.*
Addresses: Plymouth, CT. **Studied:** Maryland IA, Baltimore; AIC. **Comments:** Abstract figurative painter who, with his painter-wife, Joye, ran the Zarick Gallery in Farmington, CT, during the 1950s-60s. **Sources:** article in *Danbury News-Times* (Jan. 18, 1987, p.F2); obit. clipping.

ZARICK, Joye *[Painter] b.c.1930, Chicago, IL / d.1990.*
Addresses: Plymouth, CT. **Studied:** Maryland IA with Jacques Marger, 1945; AIC, 1950. **Exhibited:** Trinity College (solo); Univ. Hartford (solo); New Britain Mus. Am. Art; Wadsworth Atheneum; Mattatuck College, 1977 (solo); Housatonic Art Lg., 1987 (retrospective). **Comments:** Abstract/symbolist figurative painter who, with her painter-husband, Alex, ran the Zarick Gallery in Farmington, CT, during the 1950s-60s. **Sources:** article, *Danbury News-Times* (Jan. 18, 1987, p.F2); obit. clipping.

ZARIFI, L. (Miss) *[Painter] mid 20th c.*
Addresses: Nicosea, Cyprus. **Exhibited:** Soc. Indep. Artists, 1931. **Sources:** Marlor, *Soc. Indp. Artists.*

ZARING, Louise E(leanor) A. (Mrs.) *[Landscape painter, sculptor, craftsperson] b.c.1875, Cincinnati, OH / d.c.1945.*
Addresses: Greencastle, IN (c.1884). **Studied:** ASL; Académie Vitti, Paris, with J. Twachtman and F. MacMonnies; L.O. Merson and L.R. Garrido, also in Paris; C.W. Hawthorne in Provincetown. **Member:** Paris Women's AA; Provinceton AA; ASL; Wash. AC; Indiana Soc. Artists; North Shore AA. **Exhibited:** Richmond AA, 1900 (prize), 1919 (prize); Hoosier Salon; Acad. Vitti. **Sources:** WW33.

ZARINI, E. Mazzoni *[Etcher] mid 20th c.*
Addresses: Niccolo, Florence. **Member:** Chicago SE. **Sources:** WW27.

ZARSKY, Ernest *[Painter, lithographer, engraver] b.1864.*
Addresses: Cleveland, OH. **Studied:** F. C. Gottwalt; H. Keller; H.R. Poore; Cleveland Sch. Art. **Member:** Cleveland SA. **Sources:** WW40.

ZASTROW-KUSSOW, Berndt H. W. *[Lithographer] b.c.1839 / d.1906.*
Addresses: Milwaukee, WI; Chicago. **Comments:** He and his colleague Franz Doniat (see entry) took over Louis Lipman's firm in 1869 and ran it until 1871, when they moved to Chicago. They lithographed the earliest known bird's-eye views by noted artist H.H. Bailey. **Sources:** info courtesy of Thomas Beckman, Delaware.

ZAUGG, Zola *[Painter] b.1897 / d.1975, Colorado Springs, CO.*
Addresses: Colorado Springs. **Comments:** Painted architectural and genre subjects, landscapes. **Sources:** Petteys, *Dictionary of Women Artists.*

ZAUNER, Leslie *[Illustrator] b.1890, Perry, TX.*
Addresses: Rochelle, NY. **Sources:** WW29.

ZAVA, Robert *[Painter, printmaker] b.1905, Venice, Italy / d.1988, Laguna Beach, CA.*
Addresses: NYC; Laguna Beach. **Studied:** ASL. **Member:** Laguna Beach, AA. **Exhibited:** Laguna Beach Art Gallery, 1937; LACMA, 1940; San Francisco AA, 1941 (award); Nat. Painting & Drawing Exhib., 1943; Laguna Beach AA, 1944. **Sources:** Hughes, *Artists in California*, 628.

ZAVADIL, Florence G. *[Painter] mid 20th c.*
Addresses: Baltimore, MD. **Exhibited:** PAFA Ann., 1964. **Sources:** Falk, *PAFA, Vol. 3.*

ZAVEL, (Zavel Silber) *[Sculptor, painter] b.1910, Latvia.*

zavel

Addresses: NYC. **Studied:** Vicar Art School, Detroit, MI, 1929-32; AIC with L. Ritman; Univ. Southern Calif. with Carlton Ball; with Charles Despiau in Paris; Vira Muckuna and William Sherwood, in Russia. **Exhibited:** Salon Carnot, Paris, 1936; Detroit IA, 1949-55 (annuals); Am. Ceramic Soc., Los Angeles, 1958; Greenburg Hebrew Center, Dobbs Ferry, NY, 1950-62; Am. Art, Orange, NJ, 1962; Old Print Center, NYC, 1970 (solo). Awards: grant, New School Social Research, NYC, 1963. **Work:** U.S. Embassy, Moscow. Commissions: abstract sculpture, commissioned by Mr. & Mrs. Albert Miller, Detroit, 1954; metal sculpture & fireplace, commissioned by Mr. & Mrs. George Hall, Pittsburgh, PA, 1965; metal centerpiece, commissioned by Mr. & Mrs. Leonard Epstein, Paramus, NJ, 1967; bronze centerpieces, commissioned by Mr. & Mrs. Phil Brant, Detroit, 1969 & Dr. & Mrs. Leonard Brant, Port Richmond, CA, 1970. **Sources:** WW73; PHF files.

ZAVYTOWSKY, A. *[Listed as "artist"] b.c.1826, Poland.*
Addresses: New Orleans in 1850. **Comments:** Living in 1850 with his English wife and another couple, Mr.&Mrs. B. DeBar (see B. DeBar). **Sources:** G&W; 7 Census (1850), La., IV, 465.

ZAYAS, Marius de *[Art dealer, caricaturist, illustrator, writer] b.1880, Veracruz, Mexico / d.1961.*
Addresses: NYC, from 1907. **Exhibited:** "291" Gal, NYC, 1909, 1910, 1913 (solos). **Work:** MMA (Alfred Stieglitz Collection). **Comments:** Shortly after moving to NYC in 1907, De Zayas became part of the Stieglitz circle and in 1909 and 1910 exhibited caricatures (depicting New York personalities) at Stieglitz's gallery. De Zayas exhibited there again in 1913 (in solo show entitled "Caricature: Absolute and Relative"), showing highly original caricature portraits in which he depicted, not external characteristics, but instead described the subject by a combination of curved lines, geometric shapes, and mathematical symbols and formula that he believed symbolized the spirit of the individual. De Zayas called these "geometric equivalents" and over the next two years made a number of portraits of various people, including Stieglitz, Picabia, the artist Katharine N. Rhoades, and Theodore Roosevelt. The works have a particular historical importance because they predate Picabia's "machinist portraits" and may have influenced them. De Zayas's main significance to early 20th-century American art, however, lies in his activities as an art dealer and his writings for several important avant-garde publications. He opened two galleries of his own: The Modern Gallery (1915-18) and the De Zayas Gallery (1919-1921), showing the most progressive of European artists, Picasso, Braque, Picabia, Van Gogh, Derain, Brancusi, Modigliani, and Cezanne; and American modernists, Marin, Dove, Walkowitz, Paul Strand, Sheeler, and Schamberg; and also African and Pre-Columbian sculpture. After the De Zayas Gallery closed, he acted as an advisor to other New York galleries, organizing exhibitions of modern art. His own collection of African art was an important visual source for American artists. In addition, he contributed several articles to *Camera Work,* in 1911-14 and was an editor at the short-lived avant-garde publication *291.* Books: co-author, with Paul Haviland, *A Study of the Modern Evolution of Plastic Form* (1913); author, *African Negro Art: Its Influence on Modern Art* (1916). **Sources:** W. Homer, *Avant-Garde Painting and Sculpture in America,* 62; A. Davidson, *Early American Modernist Painting,* 77-79, 178, 189, 261.

ZBYTNIEUSKI, Stan L. *[Painter] early 20th c.*
Exhibited: Soc. of Wash. Artists, 1918. **Sources:** McMahan, *Artists of Washington, DC.*

ZDASIUK, Maxim M. *[Painter] b.1897, Grodno, Poland / d.1945, San Francisco.*
Addresses: San Francisco. **Member:** Soc. for Sanity in Art. **Sources:** Hughes, *Artists in California,* 628.

ZEABOWER, Margaret *[Artist] late 19th c.*
Addresses: Active in Wash., DC, 1884. **Sources:** Petteys, *Dictionary of Women Artists.*

ZEARING, Henry *[Sculptor] late 19th c.*
Addresses: Chicago. **Exhibited:** AIC, 1888. **Sources:** Falk, *AIC.*

ZECKENDORF, Guri Lie (Mrs.) *[Collector] late 20th c.*
Addresses: NYC. **Member:** Art Collectors Club. **Sources:** WW73.

ZECKWER, Emilie See: **DOONER, Emilie Zeckwer**

ZEELER, Arthur *[Painter] early 20th c.*
Addresses: St. Louis, MO. **Sources:** WW15.

ZEEVEN, Evert Burema *[Collage artist, painter, critic] b.1909, Holland.*
Comments: Founded the Royal Dutch Art Gallery in Provincetown, 1957, with Lodewijk Bruckman (see entry). **Sources:** Crotty, 25.

ZEHR, Connie *[Sculptor] b.1938.*
Addresses: Chatsworth, CA. **Exhibited:** WMAA, 1975. **Sources:** Falk, *WMAA.*

ZEIDLER, Avis *[Painter, sculptor, etcher] b.1908, Madison, WI.*
Addresses: San Francisco. **Studied:** Labault, Boynton, Stackpole, E. Neuhaus, DuMond. **Member:** San Francisco Soc. of Women Artists. **Exhibited:** SFMA, 1935, 1942 (solo); GGE, 1939. **Sources:** WW40; Hughes, *Artists in California,* 628.

ZEIG, E. Anschutz *[Painter] early 20th c.*
Addresses: Pittsburgh, PA, 1925. **Exhibited:** Soc. Indep. Artists, 1925. **Sources:** Marlor, *Soc. Indp. Artists.*

ZEIGLER, Albert Lee See: **ZEIGLER, Lee Woodward**

ZEIGLER, E. P. *[Painter] early 20th c.*
Addresses: Cordova, AK. **Sources:** WW19.

ZEIGLER, John Arvin *[Designer] b.1930, Cincinnati.*
Addresses: Cincinnati 1, OH; Milford, OH. **Studied:** College of Applied Art, Univ. Cincinnati (B.S.). **Member:** Cincinnati Art Directors Club (vice-pres.). **Comments:** Position: asst. art director, Procter & Gamble Co., Cincinnati. Illustrator: "Training for Fun and Profit," 1946. Contributed cartoons to *Saturday Evening Post.* **Sources:** WW59.

ZEIGLER, Lee Woodward *[Mural painter, illustrator, lecturer] b.1868, Baltimore, MD / d.1952, "Fanewood," Newburgh, NY.*
Addresses: Baltimore, until 1885; NYC, 1886-1910; St. Paul, MN, 1910-18; Newburgh, NY, 1918-52. **Studied:** Maryland Inst., 1886; self-taught. **Member:** Charcoal Club, Baltimore (1885, funding mem.); Hudson Highland AA; AFA; Mural Painters; SC, 1905; NYWCC, 1906; Lg. Am. Artists, Inc.; NSMP; Medieval Acad. Am.; Royal SA, London (fellow). **Exhibited:** School of Five Arts, Univ. Kansas, 1909; St. Paul Inst., 1915 (gold); Maryland Inst., 1925 (medal); NAD; Northwestern Artists, St. Paul, 1915 (medal); AIC. **Work:** Maryland Inst. ("Maryland" mural); St. Paul (MN) Inst.; Church of St. John, NYC; Trinity Church, Ft. Wayne, IN; St. James-by-the-Sea, Monticito, CA; Chapel of the Transfiguration, Glendale, OH; Enoch Pratt Free Lib., Baltimore, MD ("The Faerie Queene"); Art Mus., Wilmington, DE; St. Michael's Church, Church of St. Mary Magdelene, both in NYC; Calvary Church, Cincinnati; equestrian portrait, Gen. Anthony Wayne, Stony Point Mus., NY; portrait of Washington, West Point. Commissions: Elmira Correctional Facility, Elmira, NY; Stony Point Mus., NY; St. Thomas Church, New Windsor, NY; St Paul (MN) Library; Roman Catholic Church, W 34th St., NYC; many churches, now painted over.

Comments: (Before 1886 he was known as Albert Lee Zeigler) Known especially for his murals depicting historical, literary, and narrative subjects. From 1889 to 1904, he drew for *Life* magazine, and in 1905 began concentrating on illustrations for historical novels. From 1910 to 1918 he served as director of the St. Paul (MN) Inst Sch. of Art. When he returned to the east coast in 1918, he began painting murals, and by 1930 was in great demand. Ziegler's major project was the "The Faerie Queene," an eighteen-panel mural depicting the Age of Chivalry, covering 1800 square feet of wall space at the Enoch Pratt Free Library (Baltimore, MD), a work that took 12 years to complete (1933-45). The mural, now in need of restoration, reflected his life-long interest in the pageantry and poetry of the Middle Ages. Zeigler himself wrote poetry and was a friend of Edward Arlington Robinson. Illustrator: deluxe editions of Jane Austen (27 volumes); Kingsley (4 vols.); Gauthier; Balzac. **Sources:** WW40; *The Zeigler Memorial Art Exhibition* (Maryland Institute, 1954); info courtesy of Audrey Z. Archer-Shee, Easton, MD.

ZEIL, William Francis Von *[Painter, engraver, historian, educator, graphic artist, writer] b.1914, Harrisburg, PA.*
Addresses: Philadelphia, PA. **Studied:** Villanova College (A.B.); Webster College, St. Louis Univ. (M.A.); & with Carl Shaffer, Morris Blackburn. **Member:** Phila. Print Club; Phila. Art All.; Medaeval Acad. Am. **Exhibited:** Phila. Print Club, 1945-46, 1953-55, 1957-58; Phila. Art All., 1944-45; Phila. Sketch Club, 1943; Ragan Gal., 1943; C. Shaffer Gal., Phila., 1958. **Awards:** Hon. degree. LL.D., White, College, 1945; medal, Villanova College, 1934. **Comments:** Author: "The Development of Christian Symbolism in Western Art," 1945. Position: artist-in-residence, Girard College, Philadelphia, PA. **Sources:** WW59; WW47.

ZEIS, Joseph *[Cartoonist] b.1923, Trenton, NJ.*
Addresses: Morrisville, PA. **Exhibited:** Int. Exhib., Bordighera, Italy, 1955, 1956, 1957. **Comments:** Contributor of cartoons to *Saturday Evening Post, Redbook, True, American Weekly,* and other national publications. **Sources:** WW59.

ZEISEL, Eva S. *[Designer, teacher, lecturer] b.1906, Budapest, Hungary.*
Addresses: New York 25, NY. **Studied:** Acad. FA, Budapest, Hungary. **Exhibited:** Phila., PA, 1926; Paris Salon, 1937; WFNY, 1939; MoMA, 1936 (solo), 1944. **Comments:** Position: instructor, indust. design, PIA School, Brooklyn, NY, 1939-. Contributor to *Interiors* magazine. Lectures: functional design. **Sources:** WW53; WW47.

ZEISLER, Claire B. *[Painter] mid 20th c.*
Addresses: Chicago area. **Exhibited:** AIC, 1951. **Sources:** Falk, *AIC.*

ZEISLER, Richard Spiro *[Collector, patron] b.1916, Chicago, IL.*
Addresses: NYC. **Studied:** Amherts College (B.A.); Harvard Univ. **Member:** MoMA (committee painting & sculpture); Brandeis Univ. (fine arts award advisory committee); Mount Holyoke College (art advisory committee); Assocs. Fine Arts, Amherst College (exec. committee); Pierpont Morgan Library (fellow). **Comments:** Collection: European painting of the twentieth century. **Sources:** WW73.

ZEITLIN, Alexander *[Sculptor] b.1872, Tiflis, Russia / d.1946, NYC.*
Addresses: NYC. **Studied:** Falquiere, Beaux-Arts, Paris. **Member:** Alliance; PS; Brooklyn SA. **Exhibited:** PAFA Ann., 1920, 1926; Salons of Am.; Soc. Indep. Artists, 1924-25, 1927, 1935. **Work:** statue, La Valence, France; R. Hudnut's monument, Woodlawn Cemetery, NY; G. Backer's monument, Betholom Fields Cemetery, Brooklyn. **Sources:** WW33; Falk, *Exhibition Records Series.*

ZELANSKI, Paul John *[Painter] b.1931, Hartford, CT.*
Addresses: Storrs, CT. **Studied:** Cooper Union (certificate, 1955); Yale Univ. (B.F.A., 1957); Bowling Green State Univ. (M.A., 1958). **Member:** Mystic AA (bd. directors, 1962-); CAFA;

Springfield Art League; New England Art Today (bd. directors, 1964, 1966 & 1968); Texas Men Art. **Exhibited:** Turn Toward Peace, Boston, MA; New England in Five Parts, De Cordova Mus., Lincoln, MA; CREIA, Hartford Univ. Carpenter Center, Boston; New Direction in Painting, Univ. Mass., Amherst; Hard Eye, Amel Gallery, NYC. **Awards:** award for painting, 1969 & best in show, 1971, Slater Mus.; plaza seven, New England Framing Corp., 1969. **Work:** Univ. Mass., Amherst; Slater Mus., Norwich, CT; Manchester (CT) Community College; Hampshire College, Northampton, MA. **Comments:** Preferred media: acrylics, plexiglass. Teaching: instructor of painting, drawing & design, North Texas State Univ., 1958-61; instructor of painting, Fort Worth, TX, 1961-62; assoc. professor art, Univ. Connecticut, 1962-. **Sources:** WW73; Alan Graham Collier, *Form, Space & Vision* (Prentice-Hall); Barnard Chaet, *Artists at Work* (Webb).

ZELDIS, Malcah *[Primitive painter] b.c.1932, Detroit, MI.*
Addresses: NYC. **Comments:** Began painting historical events and figures, Jewish religious themes, family scenes and personal memories of the past when she was in her late thirties. She is said to have created close to two hundred paintings, many of which were self-portraits or portraits of her family. **Sources:** Dewhurst, MacDowell, and MacDowell, 174.

ZELENKA, Maxine P. *[Painter] b.1915, Chicago, IL.*
Addresses: St. Louis, IL. **Studied:** Univ. Illinois; AIC; NAD; C. Pugialis. **Exhibited:** Indep. Artists Exhib., NYC, 1938; AIC, 1939; Vendôme Gal., NYC. **Sources:** WW40.

ZELIFF, A. E. *[Painter] mid 19th c.*
Addresses: Essex County, NJ, about 1850. **Comments:** Subjects: genre and still life. **Sources:** G&W; Lipman and Winchester, 182; repro., Garbisch Collection, Catalogue, 103.

ZELL, Amelie *[Painter] mid 20th c.*
Addresses: Philadelphia, PA. **Exhibited:** PAFA Ann., 1944. **Sources:** Falk, *PAFA, Vol. 3.*

ZELL, Christian *[Lithographer] mid 19th c.*
Addresses: Philadelphia, 1859. **Sources:** G&W; Phila. BD 1859.

ZELL, Ernest N(egley) *[Painter] b.1874, Dayton, OH.*
Addresses: Columbus, OH. **Studied:** Columbus Art School; Cincinnati Art Acad.; Shinnecock Summer School; Ohio State Univ., Columbus; Chase, in Holland. **Member:** Columbus AL. **Comments:** Position: art director, School for the Deaf, Columbus, OH. **Sources:** WW33.

ZELLA, Newcombe See: **BOHM, Zella**

ZELLAR, Magnus *[Painter] mid 20th c.*
Exhibited: AIC, 1931. **Sources:** Falk, *AIC.*

ZELLER, Arthur *[Painter] early 20th c.*
Addresses: St. Louis, MO. **Member:** St. Louis AG. **Sources:** WW27.

ZELLER, August *[Sculptor, teacher] b.1863, Bordentown, NJ / d.1918.*
Addresses: Pittsburgh, PA. **Studied:** Franklin Inst.; PAFA, with Eakins; École des Beaux-Arts, Paris, with Thomas; Paris, with Rodin. **Member:** Pittsburgh AA. **Exhibited:** PAFA Ann., 1885, 1907; AIC, 1908. **Work:** Episcopal Church, Fox Chase, PA; Schuykill Co. military mon., Pottsville, PA. **Comments:** Teaching: arch. sculpture, Carnegie Inst. **Sources:** WW17.

ZELLNER, Minna Weiss (Mrs. Carl Sina Zellner) *[Etcher, teacher] b.1889, New Haven, CT.*
Addresses: Phila., PA. **Studied:** E. Horter; Leon, in Paris. **Member:** Phila. Print Club; Phila. Alliance; Phila. Art Teachers Assn.; New Haven PCC; APPL; Société de la Gravure Originale en Noir, Paris. **Work:** etching, British Mus.; Chicago Lib.; Newark Mus.; Univ. Nebraska; NYPL; MMA; dry point, Bibliothèque Nationale, Paris. **Sources:** WW40.

ZELOZ, Nicolas *[Painter] mid 20th c.*
Exhibited: Salons of Am., 1934. **Sources:** Marlor, *Salons of Am.*

ZELTZER, John E(rnest) *[Painter] mid 20th c.*
Studied: ASL. **Exhibited:** Salons of Am., 1924; Soc. Indep. Artists, 1924-28. **Sources:** Falk, *Exhibition Record Series.*

ZEMAN, Leon *[Teacher and painter] mid 20th c.*
Addresses: Cedar Rapids, IA. **Studied:** AIC, with John Norton and Wellington J. Reynolds. **Exhibited:** Iowa Art Salon, 1930 (hon. mention, third prize); Iowa Fed. Women's Clubs, 1932. **Comments:** Painted on Tama Indian Reservations. Position: supervisor of art, Cedar Rapids, IA. **Sources:** Ness & Orwig, *Iowa Artists of the First Hundred Years,* 230.

ZEMER, Yigal *[Sculptor, printmaker] b.1938, Israel.*
Addresses: NYC. **Studied:** Am. Inst., Tel Aviv, Israel, 1958; study in Bezalel, Jerusalem, 1963-64; study in London, England, 1969; ASL, 1970-71; Pratt Graphics Center, 1972. **Exhibited:** Young Artists From Around the World, Union Carbide Bldg., NYC, 1971; Gallery Zzo, 1966 (solo) & Old Gaffa Gallery, 1969, Tel Aviv (solo). **Work:** AIC; LACMA; Univ. Minnesota, Minneapolis; SFMA; LOC. Commissions: Open Garden (sculpture monument), Messilot, Israel, 1967; mem. area sculpture, Niroz, Israel, 1967. **Comments:** Positions: print editor, Int. Graphic Art Soc., NYC, 1972; editor, Pratt Inst., New York, 1972; editor, Nabis Fine Art, New York, 1972. **Sources:** WW73.

ZEMSKY, Illya (Ellya) *[Painter] mid 20th c.*
Addresses: NYC. **Exhibited:** Soc. Indep. Artists, 1921-22; Salons of Am., 1930. **Sources:** Falk, *Exhibition Record Series.*

ZENK, Josef *[Painter, blockprinter] b.1904, NYC.*
Addresses: Utica, NY (1926-30s); Palisades, NJ (1940s). **Studied:** NAD Sch. (3 years); ASL; Munson-Wms-Proctor Inst., Utica, NY, 1930; New Sch. Social Research, NYC with Louis Schanker, c.1945. **Exhibited:** Salons of Am., 1936; Albany Inst.; Allentown Mus. Art (PA); Brooklyn Mus; BMA; Cranbrook Acad.; NOMA; Indiana Univ.; LOC; Munson-Wms.-Proctor Inst., 1937 (solo); Univ. Michigan; NAD (prize for woodcut); NJ State Mus.; Newark Mus.; NYPL; Phila Print Club; Principia College, IL; Portland MA; Rochester Mem. Gal; Syracuse MA; SAM; Speed AM, Louisville; St. Louis AM; San Diego Gal FA; Tweed Gal, Duluth; NMAA; "Best Prints of the Year" (AFA traveling exh.); Pederson Gal., Lambertville, NJ, 1998 (solo). **Work:** Munson-Wms.-Proctor Inst., Utica, NY. **Comments:** Progressed from stylized naturalism to a dramatic abstract style. **Sources:** Marlor, *Salons of Am;* add'l info courtesy Jim Alterman, Lambertville, NJ.

ZENNECK, Adolph *[Engraver, commercial artist] b.1851, Germany / d.1887, New Orleans, LA.*
Addresses: New Orleans, active 1873-84. **Comments:** Came to the U. S. c.1870 and worked in NYC for several publications, including *Frank Leslie'e.* In New Orleans he had his own engraving business with different partners and at the time of his death was in the newspaper business, publishing the *Mascot.* He was shot and killed by a disgruntled subject of a *Mascot* story. **Sources:** *Encyclopaedia of New Orleans Artists,* 426.

ZENNER, Rose *[Painter] early 20th c.*
Addresses: Cincinnati, OH. **Member:** Cincinnati Women's AC. **Sources:** WW29.

ZENON, Gora *[Art teacher] mid 19th c.*
Addresses: Louisiana. **Comments:** Professor of drawing at Mandeville College, Louisiana, in 1844. **Sources:** G&W; New Orleans *Bee,* March 22, 1844 (Delgado-WPA).

ZENOR, Virgil DeForest *[Painter] b.1904, Missouri / d.1962, Hawthorne, CA.*
Addresses: Hawthorne, CA. **Exhibited:** P&S Los Angeles, 1932-34; Oakland Art Gal., 1933. **Work:** mural, Leuzinger High School, Lawndale, CA. **Comments:** WPA artist. Position: indus. illustrator, Douglas Aircraft, 11 years. **Sources:** Hughes, *Artists in California,* 628.

ZENSKY, J. *[Painter] early 20th c.*
Addresses: NYC. **Member:** Soc. Indep. Artists. **Sources:** WW21.

ZERAN, William *[Painter] mid 20th c.*
Addresses: Los Angeles, CA, 1930s. **Exhibited:** Calif. AC, 1930, 1931; P&S Los Angeles, 1931-34; GGE, 1939. **Sources:** Hughes, *Artists in California,* 628.

ZERBE, Karl *[Painter educator] b.1903, Berlin, Germany / d.1972, Tallahassee, FL.*
Addresses: Boston, MA; Tallahassee, FL. **Studied:** in Germany and Italy. **Member:** AEA (pres., 1957-59); CAA; SAGA. **Exhibited:** GGE, 1939; MoMA, 1938, 1963; Rio de Janeiro; Art USA (Johnson Collection), traveling exhib., 1962-65; Harvard Univ., 1934 (solo); Corcoran Gal biennials, 1941-61 (10 times); Berkshire Mus., 1943 (solo), 1947 (solo); AIC, 1935-49; CI, 1949 (prize); PAFA Ann., 1944-66 (16 times; incl. prize, 1949); other PAFA exh, 1947 (prize), 1951 (prize); Phila. Art All., 1949, Munson-Williams-Proctor Inst., 1950; Inst. Contemp. Art, Boston, 1951; Currier Gal. Art, 1951; MIT, 1952; BMA, 1952; deYoung Mem. Mus., 1952; Colorado Springs FAC, 1952; Ford Fnd., 1960 (retrospective); WMAA. Other awards: John Barton Paine award, Richmond, VA, 1942; Blair award, Chicago, 1944; Harris award, Chicago, 1946; citation, Boston Univ., 1957; D.F.A., Florida State Univ., 1963. **Work:** NIAL; MMA; WMAA; BM; Albright Art Gal.; AIC; Butler AI; CAM; Cranbrook Acad. Art; FMA; Harvard Univ.; Ft. Worth AA; John Herron AI; LACMA; MIT; Munson-Williams-Proctor Inst.; Newark Mus.; New Britain AI; PMG; RISD; San Diego FA Gal.; VMFA; Walker AC; Tel-Aviv Mus.; Universities of Georgia, Illinois, Iowa, Nebraska, Minnesota, Oklahoma, Rochester, Washington; IBM; Des Moines AC; Nat. Gal., Berlin. **Comments:** Position: head, dept. painting, BMFA Sch., 1937-54; art professor, Florida State Univ., Tallahassee, 1954-60s. **Sources:** WW66; WW40.

ZERBO, Valerio J., Jr. (Bill) *[Designer, commercial artist] b.1905, NYC.*
Addresses: New York 21, NY; Riverside, CT. **Studied:** ASL; NY Acad. FA; and in Rome, Italy. **Member:** SI; Art Writers. **Sources:** WW59.

ZEREGA, Andrea Pietro de *[Painter, educator, lecturer, teacher, portrait painter] b.1917, De Zerega, Italy.*
Addresses: Wash., DC. **Studied:** Corcoran School Art, with Richard Lahey, Hobart Nichols, Mathilde Mueden Leinsenring; in Italy, with Dr. Gaspare Biggio; Tiffany Foundation. **Member:** Artists Gld. Washington; Soc. Wash. Artists; Wash. WCC; SSAL; Landscape Club, Wash.; Corcoran Alumni Assn.; Georgetown Artists Group; Third Order Secular of St. Francis of Assisi, Mt. St. Sepulchre Fraternity. **Exhibited:** Corcoran Gal biennials, 1939-57 (6 times); other Corcoran Gal exhs, 1942 (solo), 1952 (restrospective); PAFA Ann., 1940; Carnegie Inst., 1941; NAD; MMA; VMFA, 1942; Times Herald Exhib., 1943 (prize); VMFA; PMG; Landscape Club, Wash., 1944-46, 1952-53 (prizes); Ferargil Gal., NYC; Wash. Art Club; Univ. Kentucky; Catholic Univ. of Am.; BMA; Minnesota State Fair; Richmond AA; Brooks Mem. Art Gal.; Currier Gal. Art; Vassar Col.; Muehlenberg Col.; Speed Mem. Mus.; Munson-Williams-Proctor Inst.; U.S. Nat. Mus.; Barnett Aden Gal.; Univ. Illinois; Soc. Wash. Artists, 1936-39, 1942, 1945 (medal); Graham Gal., NYC, 1961; USIA traveling exhib. to Europe, 1959; Wash. Pub. Lib., 1941 (solo); Catholic Univ. of Am.; Whyte Gal.; Playhouse Gal., Wash., DC; BMA, 1952; "Religious Art Exhib.," Wash., DC, 1958 (prize); Franz Bader Gal., Wash., DC, 1960, 1964. Other awards: fellowship, Tiffany Fnd., 1938. **Work:** PMG; Barnett Aden Gal.; Tiffany Fnd.; Butler Inst. Am. Art; TMA; concrete-mosaic "The Way of the Cross," Chapel of the Holy Spirit, Ursuline Acad., Bethesda, MD; stained glass windows and "The Way of the Cross", Church of the Epiphany, Georgetown, Wash., DC, 1965. **Comments:** Position: director, Studio San Luca, Georgetown, DC; chairman, art dept., Marymount College, Arlington, VA. **Sources:** WW66; WW47.

ZERLIN, Robert *[Sculptor] mid 20th c.*
Exhibited: AIC, 1940; PAFA Ann., 1941. **Sources:** Falk, *Exhibition Records Series.*

ZESTER, Mica See: **HEIDEMANN, Mica Zester (Mrs. Otto)**

ZETTEL, Josephine Ella [Draftswoman, decorator] b.1874, Cincinnati, OH / d.1954, Cincinnati, OH.
Comments: Worked at Rookwood Pottery, Cincinnati, 1892-1904. **Sources:** Petteys, Dictionary of Women Artists.

ZETTERLUND, John [Painter] b.1879, Sweden / d.1963, Fresno, CA.
Addresses: Berkeley, CA. **Exhibited:** San Francisco AA, 1917; Calif. State Fair, 1937. **Sources:** WW17; Hughes, Artists in California, 629.

ZETTLER, Emil Robert [Designer, teacher] b.1878, Karlsruhe, Germany / d.1946, Chicago.
Addresses: Deerfield, IL. **Studied:** AIC; Royal Acad., Berlin; Académie Julian, Paris. **Exhibited:** AIC, 1912 (prize), 1915 (medal), 1916 (gold), 1917 (medal), 1921 (prize), 1925 (gold); PAFA Ann., 1914-25 (8 times); Chicago SA, 1915 (medal); Pan-Pacific Expo, San Francisco, 1915 (medal). **Work:** Munic. Art Collection, Chicago; BM; designed & executed official medal, Century of Progress Expo, 1933; Gov. Bldg., Chicago. **Comments:** Teaching: industrial arts, AIC. **Sources:** WW40.

ZEUS, Carl Christian [Painter, teacher] b.1830, Germany / d.1915, Berkeley, CA.
Addresses: San Jose, CA. **Exhibited:** World's Columbian Expo, Chicago, 1893. **Comments:** Specialty: watercolors. Position: director, his own art school. **Sources:** Hughes, Artists in California, 629.

ZEVON, Irene [Painter] b.1918, NYC.
Addresses: NYC. **Studied:** Nahum Tschacbasov. **Member:** NAWA. **Exhibited:** Kenosha (WI) Public Mus.; St. Louis Public Library; Long Island Univ., NY; NAD; NAWA, 1972 (Marion K. Haldenstein Mem. Prize). **Work:** Butler IA; La Jolla (CA) Art Center; Kenosha (WI) Public Mus.; Mary Buie Mus., Oxford, MS; Univ. Georgia Mus., Athens. **Comments:** Preferred media: oils. **Sources:** WW73.

ZEVY, Hyman [Painter] early 20th c.
Exhibited: Salons of Am., 1929. **Sources:** Marlor, Salons of Am.

ZIB, Tom See: **ZIBELLI, Thomas A. (Tom Zib)**

ZIBELLI, Thomas A. (Tom Zib) [Cartoonist] b.1916, Mt. Vernon, NY.
Addresses: Mt. Vernon, NY. **Studied:** Grand Central Art School; Commercial Illustration Studios. **Exhibited:** OWI Exhib., Am. FA Soc., NY, 1943, 1944; El Paso, TX, 1945. **Comments:** (Known as Tom Zib) Freelance adv. cartoons & filmstrip illus. Contributor: King Features Syndicate, 1950-; Look, 1950-60s; Parade, 1970-; Med. Econ., 1970-; Wall Street Journal, 1970-. Also, cartoons to Colliers; Saturday Evening Post, Ladies Home Journal, American, This Week, Argosy, and many other national magazines. Publications: contributor cartoons to "Best Cartoons of the Year," 1947-56, inclusive; "Best From Yank;" "Honey, I'm Home"; "You've Got Me on the Hook"; "But That's Unprintable"; "Teensville, USA"; "You've Got Me in the Nursery"; "Lady Chatterly's Daughter," etc. Cartoon illus. for book, "Why Not?," 1960-61. **Sources:** WW66; WW73.

ZIC, Zivko [Landscape painter] b.1924, Krk, Yugoslavia.
Addresses: Buenos Aires, 1947-62; Chicago, 1962-89; Tucson, AZ, 1989-on. **Studied:** Scuola di Medicina, Univ. di Roma, and Acad. di Delle Arti, 1945-47; Salvador Serra, Buenos Aires, 1950-53. **Exhibited:** Gal. Van Riel, Buenos Aires, 1955-57 (first solos); Collectors Gal., Chicago, 1963 (solo); Union Lg. Club, Chcago, 1963, 1965; Rizzoli Gal., Chicago, 1985 (solo); Mitchell-Brown Gal., Tucson, 1990 (solo). **Work:** municipal museums of Arrecifes, Parana, and Bahia Blanca, all in Argentina. **Sources:** exh. cat., Mitchell-Brown Gal. (Tucson, 1990).

ZICKEL, Beulah Luce [Painter] mid 20th c.
Addresses: Santa Cruz, CA. **Exhibited:** Calif. State Fair, 1937. **Sources:** Hughes, Artists in California, 629.

ZIEDSES DES PLANTES, Arnold Marcus [Landscape painter] b.1890, Holland / d.1949, Pasadena, CA.
Addresses: Pasadena, CA. **Comments:** Specialty: San Jacinto & Santa Rosa mountains, desert scenes. Also appears as Des Plantes. **Sources:** Hughes, Artists in California, 629.

ZIEG, Elsa Anshutz [Painter] early 20th c.
Addresses: Pittsburgh, PA. **Member:** Pittsburgh AA. **Exhibited:** Soc. Indep. Artists. **Sources:** WW25.

ZIEGFELD, Edwin [Educator, writer] b.1905, Columbus, OH.
Addresses: NYC. **Studied:** Ohio State Univ. (B.S. & B.S. educ.); Harvard Univ. (M.L.A.); Univ. Minnesota (Ph.D.). **Exhibited:** Awards: outstanding achievement award, Univ. Minnesota, 1956; award for distinguished service to art & education, Nat. Gallery Art, Wash., DC, 1966. **Comments:** Positions: pres., Nat. Art Educ. Assn., 1947-51; council mem., Nat. Committee on Art Educ., 1948-51, 1953-56; pres., Int. Soc. for Educ. through Art, 1954-60. Teaching: chmn. & professor emerit., art educ. dept., Teachers College, Columbia Univ. Publications: co-author, Art Today, 1941, rev. edition, 1949, 5th edition, 1969; co-author, Art for Daily Living, 1944; editor, Art and Education, (a symposium), 1953; author, Art for the Academically Talented Student, 1962. **Sources:** WW73.

ZIEGLER, Eustace Paul ~~[signature] 1906~~
[Painter, mural painter, etcher, lithographer, teacher] b.1881, Detroit, MI / d.1969, Seattle, WA.
Addresses: Alaska, 1909-1930s; Seattle, WA, from 1940s (with summers in Alaska). **Studied:** Detroit Sch. FA; Detroit Mus. Art, with Ida M. Perrault and Francis Paulis. **Member:** Puget Sound Group Painters; Pacific Northwest Acad. **Exhibited:** Ann. Northwest Art Exh., 1926 (prize), 1927 (prize), 1929 (prize), 1931 (prize), 1932 (prize), 1934 (prize); Frye Mus., Seattle, 1969 (solo of 63 oils). **Work:** Anchorage (AL) Hist. and Fine Arts Mus.; Univ. of Alaska Mus., Fairbanks; SAM; Charles and Emma Frye Art Mus., Seattle; murals on the steamship "Alaska"; Olympic Hotel, Public Library, Broadway H.S., all in Seattle; Capitol, Washington; Dayton Clinic, Ohio, Public Library, Jersey City Art Mus.; Baranof Hotel, Juneau, AK; CPLH. **Comments:** Specialist: paintings of Alaska – the landscape and people. A prolific artist, he once estimated that he had painted over 50 paintings a year for 60 years. **Sources:** WW40; 300 Years of American Art, vol. 2: 777; Trip and Cook, Washington State Art and Artists; P & H Samuels, 547; 300 Years of American Art, 777; obit., PHF files (unident., Jan. 1969).

ZIEGLER, Frank [Painter] mid 20th c.
Exhibited: AIC, 1934. **Sources:** Falk, AIC.

ZIEGLER, George Frederick [Engraver] mid 19th c.
Addresses: NYC, 1857-58. **Sources:** G&W; NYBD 1857-58.

ZIEGLER, H. [Painter] mid 19th c.
Comments: Watercolor portraits c.1840. **Sources:** G&W; Lipman and Winchester, 182.

ZIEGLER, Henry ~~HENRY ZIEGLER. 1927.~~
[Etcher, illustrator]
b.1889, Sherman, TX / d.1968, NYC.
Addresses: Richmond, NY. **Studied:** J. Pennell; W.R. Leigh. **Member:** ASL. **Exhibited:** Salons of Am. **Comments:** Illustrator: "Cowboy Stuff;" de luxe edition illus. with fifty original etchings owned by various public libraries. **Sources:** WW32.

ZIEGLER, Laura (Belle) [Sculptor] mid 20th c.; b.Columbus, OH.
Addresses: Rome, Italy; Columbus 6, OH. **Studied:** Columbus Art Sch.; Ohio State Univ. (B.F.A.); Cranbrook Acad. Art; in Italy. **Member:** Sculptors Gld. **Exhibited:** Biennale, Venice, Italy, 1956, 1958; Schneider Gal., Runic, 1955 (solo); O'Hara Gal., London, England, 1956; Duveen-Grahani Gal., NY, 1956; Inst. Contemporary Art, Boston, 1957; Columbus Gal. FA, 1957. Awards: prize, Columbus Art Lg., 1947-49; Fulbright grant,

Rome, Italy, 1950. **Work:** MoMA; Columbus Gal. FA; 18-foot cross, St. Stephens Episcopal Church, Columbus, OH. **Sources:** WW59.

ZIEGLER, Mary *[Associate museum director]* mid 20th c.
Addresses: Seattle, WA. **Sources:** WW59.

ZIEGLER, Matthew E. *[Painter]* b.1897.
Addresses: Genevieve, MO. **Studied:** AIC. **Exhibited:** 48 States Comp., 1939 (prize); Artists Gld., City Art Mus., St. Louis. **Work:** USPO, Flandreau, SD. **Comments:** WPA artist. **Sources:** WW40.

ZIEGLER, Nellie Evelyn *[Painter]* b.1874, Columbus, OH / d.1948, Pasadena, CA.
Addresses: Pasadena, CA. **Studied:** France. **Exhibited:** Pasadena Soc. of Women P&S, 1925; Pasadena Soc. of Artists, 1934-37. **Sources:** Hughes, *Artists in California*, 629.

ZIEGLER, Samuel P. *[Painter, lithographer, etcher, teacher, graphic artist]* b.1882, Lancaster, PA / d.1967, Fort Worth, TX.
Addresses: Fort Worth, TX. **Studied:** PAFA, with Chase, Anshutz, Breckenridge; Texas Christian Univ. (B.A.; M.A.); traveled and studied in Europe, 1913. **Member:** AFA; AAPL; SSAL; Texas FAA; Ft. Worth AA; Ft. Worth City Art Comm. (1925-38). **Exhibited:** Dallas, 1924 (medal); SSAL, annually in regional & local exh., 1929 (prize); Cresson traveling scholarship, PAFA, 1912. **Work:** Carnegie Lib., Ft. Worth; Univ. Club; Texas Christian Univ.; Ft. Worth MA; Stirling & Polytechnic H.S., Ft. Worth. **Comments:** Teaching: Texas Christian Univ., 1919-50s. **Sources:** WW47; WW59; P&H Samuels, 547.

ZIEGLER, Siegfried *[Painter, graphic artist]* b.1894, Munich, Germany.
Addresses: New York 23, NY. **Studied:** Munich Acad. FA, with Angelo Jank, Huge von Habermann. **Member:** Audubon Artists. **Exhibited:** Soc. Indep. Artists, 1942; Audubon Artists, annually. Awards: govt. prize, Munich, 1915; silver medal, Int. Exh., Munich, 1921. **Work:** State College, Munich; Lafayette Mus., Paris, France; Kaiser Friedrich Mus., Berlin; Newcomen Soc., London; Warwick, PA; Anheuser-Busch Co. **Comments:** Contrib.: *La Révue Moderne*, Paris; *St. Paul Pioneer Press*; *Die Jugend*, Munich. **Sources:** WW59.

ZIEMANN, Richard Claude *[Printmaker, educator]* b.1932, Buffalo, NY.
Addresses: Chester, CT. **Studied:** Albright Art School; Yale Univ. (B.F.A. & M.F.A.); painting with Albers & Brooks; printmaking with Peterdi; drawings with Chaet. **Member:** SAGA. **Exhibited:** American Prints Today, touring exhib. to most major print exhibs., 1958-65, 24 mus., 1962-63 & Paris Biennale, 1963; solos: Springfield College, 1966, Allen R. Hite Art Inst., Univ. Louisville, 1967, Alpha Gal., Boston, 1967 & Univ. Connecticut Art Gal., 1968; oversize prints, WMAA; Jane Haslem Gal., Wash., DC & Alpha Galleries, Boston, MA, 1970s. Awards: Fulbright grant to the Netherlands, 1958-59; NIAL grant, 1966; Tiffany Foundation grant, 1960-61. **Work:** Brooklyn Mus., NY; Silvermine Guild Art; SAM; De Cordova & Dana Mus.; LOC & NGA, Wash., DC. Commissions: print editions for Int. Graphic Arts Soc., 1958 & 1960, Yale Univ. Alumni Assn., 1960 & Pan-Am Airlines, 1962. **Comments:** Positions: supervisor, Graphic Workshop in Graphic Arts USA, exhib. touring the Soviet Union, 1963-64; artist-in-residence, Dartmouth College, summer 1971. Teaching: asst. professor art, Hunter College, 1966; instructor printmaking, Yale Univ. Summer School, 1966-67; assoc. professor art, Lehman College in 1973. **Sources:** WW73.

ZIERAND, G. A. *[Sculptor]* late 19th c.
Addresses: NYC, 1886. **Exhibited:** NAD, 1886. **Sources:** Naylor, *NAD*.

ZIERING, Robert M. *[Illustrator, teacher]* b.1933, Brooklyn, NY.
Addresses: NYC. **Studied:** NYU; Sch. Visual Arts, NYC. **Exhibited:** MoMA; SI; Art Dir. Club, NYC; A.I.G.A.; Alonzo Gal., NYC; Heritage Arts, NJ; Butler Inst.; East Tennessee State Univ. **Comments:** Illustr.: *Coronet, Time, Life*, and other national magazines. Teaching: high schools; Sch. Visual Arts, NYC. **Sources:** W&R Reed, *The Illustrator in America*, 348.

ZIERLER, William *[Art dealer]* b.1928, NYC.
Addresses: NYC. **Studied:** Washington & Jefferson College. **Comments:** Positions: pres. & dir., William Zierler Gal., 1968-. Specialty of gallery: 20th c. paintings an sculpture, representing Malcolm Bailey, Paul Camacho, Ken Danby Stephen Greene, Budd Hopkins, Alvin Loving and Matt Phillips. Publications: contrib., *Art Magazine*, 4/1971. **Sources:** WW73.

ZIGLER, John *[Engraver]* b.c.1827, Pennsylvania.
Addresses: Philadelphia in 1850. **Sources:** G&W; 7 Census (1850), Pa., XLIX, 583.

ZIGROSSER, Carl *[Writer, museum curator, critic]* b.1891, Indianapolis, IN / d.1975, Montagnola, Switzerland.
Addresses: Phila., PA; Switzerland, 1972. **Studied:** Columbia Univ. (A.B.); Temple Univ. (hon. Litt.D., 1961). **Member:** Phila. Art All.; Phila. PM; Print Council Am. (vice-pres., 1956-70). **Exhibited:** Curatorial Retrospective, PMA, 1964. Awards: Guggenheim fellowship, 1939-40; achievement medal, Phila. Art All., 1959. **Comments:** Positions: dir., Weyhe Gal., New York, 1919-40; cur. of prints & drawings, PMA, 1941-63, vice- dir., 1955-63, hon. trustee, 1972-; trustee, Guggenheim Mus., New York. 1951. Collections arranged: "Between Two Wars, Prints by American Artists 1914-41," WMAA, 1942; "Alfred Stieglitz: 291 & After, selections from the Stieglitz Collection," 1944 & "Masterpieces of Drawing in America," 1950, PMA. Contrib.: *Print Collector's Quarterly, Creative Art*. Author: *Twelve Prints by Contemporary American Artists*, 1919; *The Artist in America*, 1942; *Käthe Kollwitz*, 1946; *The Expressionists, a Survey of Their Graphic Art*, 1957; *The Complete Etchings of John Marin, a Catalogue Raisonné*, 1969, *Prints & Drawings of Käthe Kollwitz*, 1969; *The Appeal of Prints*, 1970; *My Own Shall Come to Me*, 1971. **Sources:** WW73; WW47.

ZILKEN, Lorenz *[Painter]* mid 20th c.
Exhibited: AIC, 1936. **Sources:** Falk, *AIC*.

ZILLICOUX, F. J. (Mrs.) *[Artist]* late 19th c.
Addresses: active in Jackson, MI. **Exhibited:** Michigan State Fair, 1887. **Sources:** Petteys, *Dictionary of Women Artists*.

ZILLIG, Fritz *[Painter, caricaturist]* b.1885, Cologne, Germany / d.1950, Monterey, CA.
Addresses: Dubuque, IA; Chicago, IL; Los Angeles; Seattle, WA, 1945. **Studied:** Dresden. **Member:** Puget Sound Group of NW Painters, 1947. **Exhibited:** P&S Los Angeles, 1931; SAM, 1945; AIC. **Comments:** Ness & Orwig describe Zillig's drawings as "character sketches which express terrific emotion, both of tragic and the happy kind." Also did landscapes. His caricatures appeared in national magazines. **Sources:** WW15; Ness & Orwig, *Iowa Artists of the First Hundred Years*, 230; Hughes, *Artists in California*, 629; Trip and Cook, *Washington State Art and Artists*.

ZILVE, Alida *[Sculptor]* b.Amsterdam, Holland / d.1935.
Addresses: Brooklyn, NY. **Studied:** A.G. Newman; E. Stetson; Crawford. **Exhibited:** PAFA Ann., 1924-25. **Work:** bas-reliefs: Seaman's Savings Bank, NY; YMCA, Little Falls, NY; Canastota Mem. Hospital, NY; Macon, GA; YWCA, Bayonne, NJ; Independence Mem. Bldg., United Daughters of the Confederacy, Independence, MO; Elks Club, Paterson, NJ; Roselle H.S., NJ; Hempstead, NY; Elizabeth (NJ) Jr. H.S.; Vocational Sch., Perth Amboy, NJ. **Sources:** WW33.

ZILVERSERG, Jim *[Cartoonist, commercial artist, writer]* b.1918, Tripp, SD.
Addresses: Minneapolis, MN; Hopkins, MN. **Studied:** Northern State Teachers College, Aberdeen, SD. **Exhibited:** Minnesota Outdoor Award for contribution to conservation through cartooning. **Work:** political cartoons, Secy. of Agriculture Coll., Wash., DC; Nat. Red Cross Campaign. **Comments:** Contrib. to cartoon anthologies; magazine covers and illustr.; sport features and illustr. to *Minneapolis Star, Farm Journal, Sports Afield, Farmers Union*, etc. Creator of new comic strip, "The Tillers" as well as

"Hired Hiram." Lectured on art and cartooning. **Sources:** WW59.

ZILZER, Gyula *[Printmaker, painter, designer, illustrator]* *b.1898, Budapest, Hungary / d.1969, NYC?.*
Addresses: Hollywood, CA; NYC. **Studied:** Royal Acad. Art, Budapest; Decorative Art Sch. & Hans Hofmann Sch. Art, Munich; Royal Polytech Univ., Budapest; Acad. Colorossi & Acad. Moderne, Paris. **Exhibited:** Assn. Am. Artists, 1937 (solo); Mellon Gal., Phila., 1933 (solo); New Sch. Soc., Res., 1932 (solo); AIC, 1932, 1937; London, 1931; Amsterdam, 1931; Moscow, 1927; Paris, 1926; Bloomsbury Gal., London, England; Mellon Gal., Phila.; Los Angeles AM, 1943 (solo); San Diego FA Soc., 1943 (solo); M.H. de Young Mem Mus, 1944 (solo). **Awards:** purchase prize, Int. Exh., Moscow, 1927; Int. Exh., Bordeaux, France, 1927; French Govt. Scholarship, 1928. **Work:** Graphische Cabinet, Munich; Mus. Mod. Art, Rotterdam; Mus. Western Art, Moscow; British Mus., London; MOMA, Budapest; MoMA, MMA & NYPL; Los Angeles Mus. Art; Luxembourg Mus. & Bibliothèque Nat., both in Paris. **Commissions:** portraits of U.S. District Court for Southern District New York. **Comments:** Positions: production des. & art dir., major films, Hollywood, CA, 1938-48, Cinerama, 1958. Contrib.: U.S. & European Production; numerous films, including "Sahara," 1943, "The Short and Happy Life of Francis Macomber," 1946. Publications: illustr., Poe's "The Black Cat," 1927; "Gas Attack," a portfolio of lithographs, 1932; "The Mechanical Man," 1961; "Kaleidoscope,"1932. **Sources:** WW73; WW47.

ZIM See: **ZIMMERMAN, Eugene ("Zim")**

ZIM, Marco *[Painter, sculptor, etcher]* *b.1880, Moscow, Russia / d.1963, NYC.*
Addresses: NYC; San Diego, CA. **Studied:** ASL with G.G. Barnard; NAD with E. Ward, Maynard; École des Beaux-Arts, Paris with Bonnât. **Member:** SAE; Calif. AC. **Exhibited:** Panama- Calif. Int. Expo, San Diego, 1915 (bronze & silver medals); San Fran. AA, 1917, 1919; PAFA Ann., 1905, 1920-30 (5 times); Artists of Southern Calif., 1927; Salons of Am.; AIC. **Work:** LOC; NYPL; AIC. **Comments:** (Born Marco Zimmerman) Came to U.S. in 1885. **Sources:** WW47; Hughes, *Artists of California*, 629; add'l info. courtesy Anthony White, Burlingame, CA, who gives year of birth as 1883.

ZIMBAL, Mathilde M. *[Painter] mid 20th c.*
Exhibited: Soc. Indep. Artists, 1936. **Sources:** Marlor, *Soc. Indp. Artists.*

ZIMBEAUX, Frank Ignatius Seraphic *[Painter] b.1861, Pittsburgh, PA / d.1935, Salt Lake City, UT.*
Addresses: NYC, 1914; Carthage, MO; Salt Lake City, 1924. **Studied:** London; Paris. **Comments:** Raised in Europe. Father of Francis Zimbeaux also an artist. Specialty: romantic landscapes and figures. **Sources:** P&H Samuels, 547.

ZIMDARS, Gertrude M. *[Painter] b.1868, Germany / d.1930, Sonoma, CA.*
Addresses: San Francisco, CA. **Exhibited:** San Francisco AA, 1898. **Sources:** Hughes, *Artists of California*, 629.

ZIMILES, Murray *[Painter, educator] b.1941, NYC.*
Addresses: NYC. **Studied:** Univ. Illinois (B.F.A.); Cornell Univ. (M.F.A.); École Nat. Superieure Beaux-Arts, Paris, France. **Exhibited:** Prints from Portfolios & Invitational, BM, 1970; Fourth Bienal Am. Grabado, Santiago, Chile, 1970; Zingale Gal., New York, 1971 (solo) & Kunstnerforbundet Gal., Oslo, Norway, 1972 (solo); Assoc. Am. Artists Gal., NYC, 1970s. **Awards:** Found. États-Unis fellowship, Paris, France, 1965-66; Royal Norwegian Govt. fellowship, 1971. **Work:** BM; NYPL; Rosenwald Coll.; Nat. Coll. FA; U.S. Embassy, Bogota, Colombia. **Comments:** Teaching: Pratt Graphics Center, New York, 1968-71; Silvermine College Art, New Canaan, CT, 1968-71; State Univ. NY, New Paltz, 1972-. Publications: co-auth., *The Technique of Fine Art Lithography* (1970), *Early American Mills & The Lithographic Workshop* (1973). **Sources:** WW73; "New Talent," *Artist Proof Ann. 1971.*

ZIMM, Bruno Louis *[Sculptor, architect] b.1876, NYC / d.1943.*
Addresses: Woodstock, NY, 1913 and after. **Studied:** J.Q.A. Ward; A. Saint-Gaudens; K. Bitter. **Member:** NSS; Woodstock AA. **Exhibited:** Arch. Lg., 1913 (prize); Paris Expo, 1900 (medal). **Work:** Woodstock AA; Slocum Mem. and Mem. Fountain, NY; Finnegan Mem., Houston; mem., Wichita; sculpture, Art Bldg., San Francisco; bust, Baylor College, Belton, TX; Seaboard Nat. Bank, NYC; First Nat. Bank, Jersey City; statue, St. Louis; sculpture, St. Pancras Church & St. Thomas Church, Brooklyn; St. Clement's Church, Phila. **Comments:** Productive sculptor in a traditional, classicizing style. **Sources:** WW40; *Woodstock's Art Heritage,* 147; Woodstock AA.

ZIMMELE, Margaret Scully (Mrs. Harry B. Zimmele) *[Painter, illustrator, teacher] b.1872, Pittsburgh, PA / d.1964, Kenwood, MD.*
Addresses: Wash., DC/Berkshire Heights, Great Barrington, MA. **Studied:** Penn. College for Women; Pittsburgh Sch.Design; Chase; Shirlaw; Whittenmore Lathrop; Carlson; Hawthorne. **Member:** Soc. Wash. Artists; Pittsburgh AA; Wash. AC (charter mem.); Nat. Lg. Am. Pen Women. **Exhibited:** Soc. Wash. Artists, 1910-35 (prize), 1936-c.1940; Greater Wash. Indep. Exh., 1935; Wash. AC, 1962 (solo); Pittsburgh AA; Maryland Inst.; Nat. Lg. Am. Pen Women, 1925 (prize), 1934 (prize). **Sources:** WW40; McMahan, *Artists of Washington, DC.*

ZIMMER *[Lithographer] mid 19th c.*
Addresses: New Orleans in 1833. **Comments:** Of Zimmer & Droz, lithographers and engravers at New Orleans in 1833. Zimmer was the lithographer and A. Droz (see entry), the engraver. **Sources:** G&W; New Orleans *Courier,* Jan. 25, 1833, and *Bee,* June 3, 1833. Additional contemporary references are included in *Encyclopaedia of New Orleans Artists,* 427.

ZIMMER, Eli *[Painter] mid 20th c.*
Addresses: Chicago area. **Exhibited:** AIC, 1942-48. **Sources:** Falk, *AIC.*

ZIMMER, Fred *[Painter] mid 20th c.*
Addresses: Columbus, OH. **Exhibited:** PAFA Ann., 1960. **Sources:** Falk, *PAFA, Vol. 3.*

ZIMMER, Marion Bruce (Mrs. Gerald H. Zimmer) *[Portrait painter, teacher] b.1903, Battle Creek, MI.*
Addresses: Syracuse, NY/Amber, NY. **Studied:** Syracuse Univ. **Member:** AA of Syracuse; NAWPS; Nat. Lg. Am. Pen Women. **Exhibited:** Syracuse Mus., 1935 (prize), 1936 (prize); Lg. Am. Pen Women, 1936 (prize); Syracuse MFA, 1938 (prize). **Comments:** Teaching: Syracuse Univ. **Sources:** WW40.

ZIMMERER, Frank J. *[Painter, commercial artist] b.1882, Nebraska City, NE / d.1965, Los Angeles, CA.*
Studied: AIC; Glasgow Sch. Art, Scotland; Paris, France. **Member:** Calif. AC. **Comments:** Position: administrator, Northwest Missouri Normal. **Sources:** Hughes, *Artists of California*, 629.

ZIMMERLI, Ruth B. (Mrs.) *[Painter] mid 20th c.*
Addresses: NYC. **Studied:** ASL. **Exhibited:** Soc. Indep. Artists, 1944. **Sources:** Marlor, *Soc. Indp. Artists.*

ZIMMERMAN, Alice E. *[Craftsman] mid 20th c.; b.Mount Vernon, IN.*
Addresses: Gatlinburg, TN. **Studied:** DePauw Univ. (B.M.); Columbia Univ. (M.A.); Universal Sch. Crafts; AIC; Ringling Sch. Art; Univ. Tennessee Craft Workshop; Craft Study Tour of Scandinavia; San Miguel de Allende, Mexico; Univ. Tennessee. **Member:** Am. Craftsmens Council; Delta Kappa Gamma; Kappa Pi.; Southern Highland Handicraft Gld. **Exhibited:** Am. Jewelry & Related Objects Exh., 1955, 1956, 1958; Louisville AC, 1955; Indianapolis Hobby Show, 1954; Southern Highlands Handicraft Gld., annually; Am. Craftsmens Council, 1959; World Agricultural Fair, New Delhi, India, 1958-60; Tri-State Ann., 1950-58; Univ. Minnesota, Tweed Gal.; Wilmington College. **Comments:** Teaching: Hanover H.S., 1928-33; Reitz H.S., 1934-58;

Evansville (IN) College,1947-58. Member of the 12 Designer Craftsmen of the Southern Appalachians who founded a shop in Gatlinburg, TN. Contrib.: *School Arts* magazine. Lectures: crafts. Produced set of craft slides in connection with Ford Foundation-sponsored Survey of the Southern Appalachian Studies, 1959. Reproductions of the artist's jewelry used in various books on jewelry-making. Tour of duty with USIS in Fed. States of Malaya, 1960-61, assisting in instruction & establishing craft workshops. **Sources:** WW66.

ZIMMERMAN, Carl John *[Mural painter, portrait painter]* b.1900, Indianapolis, IN.
Addresses: Loveland, OH. **Studied:** Herron AI; Chicago Acad. FA; Cincinnati Art Acad.; Jean Marchand in Paris; J. Weis; Audubon Tylor; William Forsyth. **Member:** Cincinnati AC; Prof. Artists, Cincinnati; MacDonald Soc., Cincinnati. **Exhibited:** regional & local exhd. **Work:** murals, Cathedral of St. Monica, Cincinnati; St. Paul's Church, Marry, SD; Saints Peter & Paul Church, Norwood, OH; Cincinnati Club. **Comments:** Teaching: Cincinnati Art Acad., 1940. **Sources:** WW59; WW47.

ZIMMERMAN, Carolyn (Mrs. Carl Zimmerman) *[Sculptor]* b.1903, Walton, IN.
Addresses: Loveland, OH. **Studied:** W. Forsyth; M.R. Richards; W. Hentschell; C.J. Barnhorn; Cincinnati Art Acad.; Antoine Bourdelle, Madame Levy-Ginsborg, both in Paris. **Member:** Women's AC of Cincinnati; MacDowell Soc.; Cincinnati Crafters Co.; Cincinnati Assn. Prof. Artists; Cincinnati Ceramics Gld. **Sources:** WW40.

ZIMMERMAN, Catherine *[Painter]* mid 20th c.
Exhibited: Corcoran Gal. biennial, 1967. **Sources:** Falk, *Corcoran Gal.*

ZIMMERMAN, Elinor Carr *[Painter, miniaturist]* b.1878, St. Louis, MO.
Addresses: NYC; Lakeland, FL. **Studied:** Washington Univ., B.S., B.Arch.; PAFA; A.M. Archambault; Mabel R. Welch; Wayman Adams; Gertrude Whiting; ASL. **Member:** Penn. SMP; AAPL; Phila. Plastic Club. **Exhibited:** PAFA, 1936, 1949; Soc. Indep. Artists, 1942; AAPL, 1945, 1948; miniature exhs., Chicago, Los Angeles, Washington, New York; Asbury Park, NJ (solo); Kansas City (solo); San Diego FA Gal.(solo). Awards: Florida Southern College, 1952. **Work:** PMA; many miniature commissions. **Sources:** WW59; WW47.

ZIMMERMAN, Ella A. *[Watercolorist, ceramist, china painter, teacher]* early 20th c.
Addresses: Colorado Springs, CO, early 1900s. **Studied:** Kathryn Cherry at St. Louis Art Sch. **Exhibited:** Antlers Hotel & Perkin Hall, Colorado Springs, 1914; Colorado State Fair, 1923 (prize); Denver. **Sources:** Petteys, *Dictionary of Women Artists.*

ZIMMERMAN, Elyn *[Photographer]* b.1945.
Addresses: Berkely, CA. **Exhibited:** WMAA, 1975. **Sources:** Falk, *WMAA.*

ZIMMERMAN, Eugene ("Zim") *[Caricaturist]* b.1862, Basel, Switzerland / d.1935.
Addresses: Elmira, NY. **Comments:** Auth.: "This and That about Caricature," "Cartoons and Caricatures," "Home Spun Philosophy". Illustr.: books and articles for Bill Nye and James Whitcomb Riley. Position: staff, *Puck* (since 1882), *Judge* (1884-1913); dir., Correspondence Sch. Caricature, Cartooning & Comic Art. **Sources:** WW27.

ZIMMERMAN, Frank M. *[Painter]* mid 20th c.
Exhibited: Salons of Am., 1926-30. **Sources:** Marlor, *Salons of Am.*

ZIMMERMAN, Frederick A. *[Painter, critic, teacher, sculptor, lecturer]* b.1886, Canton, OH / d.1974, Arcadia, CA.
Addresses: Pasadena, CA. **Studied:** Univ. Southern California; Victor Brenner. **Member:** Pasadena SA (life mem.; pres., 1946-47); Pasadena FA Club; NIAL (advisory bd.); Pasadena AA; Scarab Club; Calif. AC; Laguna Beach AA; Southern Calif. SAC; AFA; AAPL. **Exhibited:** Pasadena Beach AI, 1931 (prize); Pasadena SA, annually; Los Angeles Mus. Art; Sacramento State

Fair; San Diego FA Soc.; Detroit IA. **Work:** John Muir Pub. Sch., Seattle, WA; Pasadena Pub. Lib.; Monrovia (CA) H.S. **Comments:** Teaching: Pasadena (CA) AI, Pasadena (CA) City College, adult classes. **Sources:** WW59; WW47.

ZIMMERMAN, George R. *[Painter]* mid 20th c.
Exhibited: Salons of Am., 1934, 1936; Soc. Indep. Artists, 1935-37. **Sources:** Falk, *Exhibition Record Series.*

ZIMMERMAN, Harold S. *[Painter]* early 20th c.
Addresses: Orrville, OH. **Exhibited:** PAFA Ann., 1934. **Sources:** Falk, *PAFA, Vol. 3.*

ZIMMERMAN, Herman *[Painter]* mid 20th c.
Addresses: NYC. **Work:** WPA murals, USPOs, Wilmington, DE & Tipp City, OH. **Sources:** WW40.

ZIMMERMAN, Jane *[Painter, portrait painter]* b.1871, Frederick, MD / d.c.1955.
Addresses: Frederick, MD. **Studied:** CUA Sch.; NAD; Chase Sch. Art; ASL; F. Luis Mora; Robert Henri; C.Y. Turner. **Exhibited:** BMA; Maryland Inst.; Hagerstown MA; CUA Sch. (medal). **Work:** Lee Hospital & Lee Hotel, Frederick, MD. **Sources:** WW53; WW47.

ZIMMERMAN, L(illian) H(ortense) *[Sculptor]* early 20th c.; b.Milwaukee, WI.
Addresses: Milwaukee. **Studied:** AIC; ASL. **Member:** Wisc. P&S. **Exhibited:** Milwaukee AI, 1924 (medal, prize); AIC. **Sources:** WW33.

ZIMMERMAN, Marco See: **ZIM, Marco**

ZIMMERMAN, M(ason) W. *[Painter, block printer]* b.1860, Phila., PA.
Addresses: Rydal, PA. **Studied:** J.W. Little; Acad. Julian, Paris. **Member:** Phila. WCC; Phila. Sketch Club; Phila. Alliance; AWCS; Wash. WCC; Balt. WCC; Phila. SE. **Exhibited:** PAFA, 1920 (gold); Sesqui-Centenn., Phila., 1926 (medal); Phila. Print Club, 1931 (prize); AIC. **Sources:** WW40; Fehrer, The Julian Academy cites 1861 birth date.

ZIMMERMAN, Max *[Painter]* mid 20th c.
Exhibited: Salons of Am., 1934. **Sources:** Marlor, *Salons of Am.*

ZIMMERMAN, Paul Warren *[Painter, educator]* b.1921, Toledo, OH.
Addresses: Hartford, CT. **Studied:** John Herron Art School (B.F.A.). **Member:** NAD; CAFA; Conn. WCS (pres., 1952-53). **Exhibited:** Corcoran Gal. biennials, 1955, 1959; "Indiana Artists Exh.," John Herron AM, Indianapolis, 1957; "Am. Painting & Sculpture," Univ. Illinois, 1961; PAFA Ann., 1946-62 (5 times); Conn. WCS, 1964 (1st prize); 144th Ann. Exh., NAD, 1967 (2nd Altman Landscape Prize), 1969 (1st Altman prize); Midyear Show, Butler IA, 1970; J. Seligmann & Co., NYC. 1970s. **Work:** PAFA; Houston MFA; Butler IA; Springfield (MA) Mus. FA; Wadsworth Atheneum, Hartford, CT. Commissions: mural, First New Haven (CT) Nat. Bank, 1965. **Comments:** Preferred media: oils. Teaching: Univ. Hartford Art Sch., 1947-70s. **Sources:** WW73; Henry Pitz, "Paintings of Paul Zimmerman," *Am. Artist Magazine* (Jan., 1960).

ZIMMERMAN, Walter *[Sculptor, teacher]* b.Switzerland / d.1937, Vincennes, IN.
Addresses: Oak Park, IL. **Comments:** Came to the U.S. as a young man. Position: assoc. of Lorado Taft at AIC for 25 years.

ZIMMERMAN, William Albert *[Craftsperson]* b.1888, Leighton, PA.
Addresses: Brookline, Delaware County, PA. **Studied:** PM School IA. **Member:** T Square Club. **Comments:** Specialty: metalwork. Designer: "The Iron-Craftsmen," Phila. **Sources:** WW40.

ZIMMERMAN, William Harold *[Painter, illustrator]* b.1937, Dillsboro, IN.
Addresses: Dillsboro, IN. **Studied:** Cincinnati Art Acad. **Member:** Soc. Animal Artists. **Exhibited:** Cincinnati Animal Art Show, 1966 (prize); Soc. Animal Artists ann., NYC, 1967; solos:

New York, San Francisco, Chicago & Cincinnati; Frame House Gal., Louisville, KY, 1970s. **Work:** Cincinnati (OH) Mus. Natural Hist.; Pomona (CA) College. **Comments:** Publications: co-auth./illustr., "Topflight, Speed Index to Waterfowl," 1966; auth., "North American Waterfowl. " **Sources:** WW73; Oscar Godbout, "Wood, Field and Stream," *New York Times,* Oct. 18, 1964; Bill Thomas, "Dillsboro's Audubon," *Nat. Observer,* Nov. 12, 1965; Jay Shuler, "A Real Artist Has to Work for Himself," *Carolina Outdoors* (Sept., 1971).

ZIMNERER, Frank J. *[Painter, designer, teacher] early 20th c.; b.Nebraska City.*
Addresses: Lincoln, NE. **Studied:** AIC; Paris. **Comments:** Specialty: stage design. Teaching: Univ. Nebraska, Lincoln. **Sources:** WW27.

ZINER, Feenie *[Sculptor] mid 20th c.*
Addresses: Chicago area. **Exhibited:** AIC, 1948-51. **Sources:** Falk, *AIC.*

ZINER, Zeke *[Sculptor, painter, printmaker] b.1919, NYC.*
Addresses: Branford, CT. **Studied:** Pratt Inst.; ASL; Univ. Chicago; Illinois Inst. Tech. **Exhibited:** AIC; Hudson Mus., Yonkers, NY; Benton Museum, Univ. Connecticut, 1982 (solo). **Work:** AIC; MoMA; WMAA; Arts Club, Chicago; SI; Am. Inst. Graphic Arts; LOC; Tyler Sch. Art, Temple Univ; Canton (OH) AI; Wash. Univ., St. Louis; Albany AI; Arnot AG, Elmira, NY; Rochester Mem Gal.; Univ. Wisconsin; Mus. Science & Indust., Chicago (installation); US Court House, White Plains, NY (installation).

ZINGALE, Santos *[Painter, educator, block printer] b.1908, Milwaukee, WI.*
Addresses: Madison 5, WI. **Studied:** Milwaukee State Teachers College; Univ. Wisconsin; G. Moeller; R. Von Nueman; H. Thomas. **Member:** Madison AA; Wisc. P&S. **Exhibited:** Wisc. P&S, 1931-43, 1946, 1955 (prizes, 1935, 1937); Madison Salon, 1937-46, 1951-55 (prizes, 1937, 1942); PAFA Ann., 1949-50, 1952; Gimbel's Centennial Exh., Milwaukee, 1949-52; Minnesota Centennial, 1949; Assoc. Am. Artists, Chicago, 1949; Walker AC, 1949, 1954; AIC; AFA traveling exh.; Birmingham Mus. Art, 1954; BM, 1958; Butler IA, 1956; Wichita AA, 1957; LC, 1957. **Awards:** Wisc. Salon Art, Madison, 1935 (prize); Wisc. State Fair, 1929 (prize), 1930 (prize); Madison AA, 1951; Midwest Landscape Exh., 1953. **Work:** murals, Marquette Univ.; Henry Mitchell H.S., Racine, WI; Univ. Wisconsin; WPA mural, USPO, Sturgeon Bay, WI; Milwaukee State Teachers College. **Comments:** Teaching: Layton Sch. Art; Univ. Wisconsin, Madison, 1946-50s. **Sources:** WW59; WW47.

ZINGG, Jules Emile *[Painter] mid 20th c.*
Exhibited: AIC, 1935. **Sources:** Falk, *AIC.*

ZINK, Eugenia *[Sculptor] early 20th c.*
Addresses: Los Angeles, CA. **Exhibited:** P&S Los Angeles, 1931; Los Angeles County Fair, 1931. **Sources:** Hughes, *Artists of California,* 629.

ZINK, John (R.) *[Painter] early 20th c.*
Addresses: Boonton, NJ. **Exhibited:** Soc. Indep. Artists, 1918. **Sources:** Marlor, *Soc. Indp. Artists.*

ZINN, Doris M. *[Painter] b.1900, NYC.*
Exhibited: Soc. Indep. Artists, 1936. **Sources:** Marlor, *Soc. Indp. Artists.*

ZINNER, Marion R. *[Painter] mid 20th c.*
Addresses: Syracuse, NY. **Exhibited:** PAFA Ann., 1936. **Sources:** Falk, *PAFA, Vol. 3.*

ZINSER, Frank *[Painter] early 20th c.*
Addresses: Cincinnati, OH. **Member:** Cincinnati AC. **Sources:** WW27.

ZINSER, Paul R. *[Painter, sculptor, illustrator, craftsperson] b.1885, Wildbad.*
Addresses: Chicago, IL. **Studied:** J.H. Adam. **Member:** Cincinnati AC. **Work:** Cincinnati AM. **Sources:** WW24.

ZINSSER, Handforth *[Painter, sculptor] mid 20th c.*
Addresses: Boston, MA/Dover, MA. **Studied:** ASL; MIT; G. Demetrois; Kunstgewerbe Schule, Vienna. **Sources:** WW40.

ZIOLKOWSKI, Korczak *[Sculptor, painter, architect] b.1908, Boston, MA / d.1982.*
Addresses: Hartford, CT; Custer, SD. **Member:** NSS. **Exhibited:** CAFA, 1938, 1939; New Haven PCC, 1938; Symphony Hall, Boston, 1938; Romanian Pavilion Contemp. Art, WFNY, 1939 (1st sculptural prize for marble portrait of Paderewski); PAFA Ann., 1940-41. **Work:** SFMA; Judge Baker Guidance Center, Boston; Symphony Hall, Boston; Vassar College; marble portraits of Paderewski, Georges Enesco, Artur Schnable, Wilbur L. Cross, John F. Kennedy & Crazy Horse at Crazy Horse Mem. Commissions: Noah Webster statue (marble), Town Hall Lawn, West Hartford, CT; granite portrait of Will Bill Hickok, Deadwood, SD; Chief Sitting Bull (granite portrait), Mobridge, SD; Robert Driscoll, Sr. (marble), First Nat. Bank Black Hills, Rapid City, SD; carving mountain into equestrian figure of Sioux Chief Crazy Horse at request of Indians as memorial to Indians of North America, Custer, SD, 1948-. **Comments:** Positions: chmn. bd., Crazy Horse Found.; asst. to Gutzon Borglum, Mount Rushmore Nat. Mem., SD. **Sources:** WW73; WW47.

ZION, Ben See: **BEN-ZION**

ZION, Harry *[Painter] mid 20th c.*
Addresses: Philadelphia, PA. **Exhibited:** PAFA Ann., 1937. **Sources:** Falk, *PAFA, Vol. 3.*

ZIPIN, Martin Jack *[Painter, graphic artist, teacher] b.1920, Phila., PA / d.1991.*
Addresses: Phila., PA. **Studied:** Graphic Sketch Club, Phila.; Tyler Sch. FA, Phila; M.B. Gottlieb; F. Watkins; E. Horter; F. Fincke; M. Sharpe. **Member:** Graphic Sketch Club. **Exhibited:** Graphic Sketch Club, 1936 (prize, medal); PAFA WC Ann., 1938; PAFA Ann., 1948. **Work:** Graphic Sketch Club. **Sources:** WW40.

ZIPKIN, Jerome R. *[Collector] mid 20th c.; b.NYC.*
Addresses: NYC. **Studied:** Princeton Univ. **Member:** Art Collectors Club. **Comments:** Collection: contemporary paintings and sculpture. **Sources:** WW73.

ZIRINSKY, Julius *[Painter] mid 20th c.*
Addresses: NYC. **Exhibited:** Soc. Indep. Artists, 1934, 1937, 1941. **Sources:** Marlor, *Soc. Indp. Artists.*

ZIRKER, Joseph *[Graphic artist, lecturer] b.1924, Los Angeles, CA.*
Addresses: Palo Alto, CA. **Studied:** Univ. Calif, Los Angeles, 1943-44, 1946-47; Univ. Denver (B.F.A., 1949); Jules Heller & Francis de Erdely, Univ. Southern Calif. (M.F.A., 1951). **Member:** College AA Am. **Exhibited:** Artists of Los Angeles & Vicinity, LACMA, 1952; 7th Nat. Print Ann., BM, 1953; Young Am. PM, MoMA, 1953-54; New Dimensions of Lithograph, Tamarind Lithographs, Univ. Southern Calif., 1964; Calif. PM, Achenbach Found., CPLH, 1971; Gal. Smith-Anderson, Palo Alto, CA, 1970s. **Awards:** 3rd Nat. Print Exh., Bradley Univ., Illinois, 1952; 2nd Nat. Exh. of Prints, Univ. Southern Calif., 1952; 7th Ann. Print Exh., BM, 1953. **Work:** BM; Tamarind Archives, Tamarind Lithography Workshop (printer fellowship, 1962-63, research fellowship, 1965); Stanley Freenean Coll., LACMA; Martin Gluck Coll., San Diego Mus., La Jolla AC; Achenbach Found., CPLH. **Comments:** Positions: dir., Joseph Press, Venice, CA, 1963-64. Publications: cover designs for *Baja California 1533-1950,* 1951; *Embryo,* a literary quarterly, 1954-55; "Art Is One" exhibition catalogue, 1961. Teaching: Univ. Southern Calif., 1963; Chouinard Art Inst., Los Angeles, 1963; San Jose City College, 1966-. **Sources:** WW73.

ZIRNBAUER, Franz (Seraph) *[Painter, teacher] b.1860, Pittsburgh.*
Addresses: Paris, France/Carthage, MO. **Studied:** Académie Julian, Paris, with J.P. Laurens & Gervaix; Blanche & R.E. Miller in Paris; London; Dublin. **Exhibited:** S. Indp. A., 1919-20.

Sources: WW21.

ZIROLI, Andrew *[Painter] mid 20th c.*
Addresses: Chicago, IL. **Exhibited:** PAFA Ann., 1941. **Sources:** Falk, *PAFA, Vol. 3.*

ZIROLI, Angelo Gerardo *[Sculptor] b.1899, Montenegro / d.1948.*
Addresses: Wyandotte, MI. **Studied:** AIC; Italy; A. Polasek; A. Sterba; V. Gigliotti. **Member:** Chicago Gal. Assn.; Illinois Acad. FA; All-Illinois SFA; Soc. Med. **Exhibited:** AIC, 1923 (prize); Soc. Wash. Artists, 1928 (prize); NAD, 1931 (prize), 1935, 1940; PAFA Ann., 1929, 1931; Chicago Gal. Assn.; Detroit IA, 1941. **Work:** mem., Randhill Park Cemetery, Arlington Heights, IL; mem., East Chicago. **Comments:** Auth.: "The Life of a Chicago Sculptor." **Sources:** WW47.

ZIROLI, Nicola Victor *[Painter, educator, etcher, lithographer] b.1908, Montenegro, Italy.*
Addresses: Urbana, IL. **Studied:** AIC (grad., 1930); L. Ritman; G. Oberteuffer. **Member:** Audubon Artists; AWCS; Int. Platform Assn.; Nat. Soc. Painters in Casein; Phila. WCC. **Exhibited:** Albright-Knox Art Gal., Buffalo; VMFA, Richmond, 1938, 1940, 1942, 1946; Corcoran Gal. biennials, 1930-59 (10 times; incl. 2nd hon. men., 1939); Los Angeles Mus. Art; PAFA Ann., 1937-62 (10 times); Soc. Wash. Artists, 1934 (prize); AIC, 1936, 1937, 1938 (prize), 1939 (prize); San Fran. AA, 1939 (medal); Springfield (MO) Art Mus., 1945 (prize), 1946 (prize); Decatur (IL) Art Center, 1945 (prize); Ohio Univ., 1946 (prize); Mint Mus. Art, 1946 (prize); CI, 1942, 1944; NAD, 1932, 1934, 1940-41, 1944; SFMA, 1935, 1937-44; CPLH, 1946; CM, 1933, 1939, 1940; WMAA, 1938; Albright Art Gal.; Kansas City AI; Oakland Art Gal., 1938, 1941; Denver AM, 1938; Rochester Mem. Art Gal.; TMA; CMA; Detroit IA; MMA; El Paso Mus. Art (1st prize for oil painting); 7th Ann. Nat Exh., Mead Comp. Watercolor Prize; Evansville Mus. FA (1st prize oils for still life). **Work:** MMA & WMAA; Chicago Pub. Lib.; Butler IA; New Orleans Mus. Art. **Comments:** Teaching: Univ. Illinois, 1973. **Sources:** WW73; WW47.

ZISKA, Helene F. (Baroness) *[Illustrator, sculptor] b.1893, NYC.*
Addresses: Valley Stream, NY. **Studied:** Acad. Munich; Acad. Vienna; Creighton Univ. **Member:** Nassau County AL. **Work:** restoration drawing of Baluchitherium (largest fossil mammal found), AMNH. **Comments:** Illustr.: "From Fish to Men," "Man's Place Among the Anthropoids," "Fish Skulls," "Surgery," "Garden Cinderellas," "Scientific Results of the Cruises of the Yatch 'Eagle'." Position: scientific illustr., dept. comparative anatomy, AMNH. **Sources:** WW40.

ZISLA, Harold *[Painter, educator] b.1925, Cleveland, OH.*
Addresses: South Bend, IN. **Studied:** Cleveland Inst. Art; Western Reserve Univ. (B.S. Educ. & A.M.). **Member:** Assn. Prof. Artists Indiana (bd. mem.). **Exhibited:** Cleveland Mus. Art; South Bend Michiana; John Herron Art Mus.; Fort Wayne Art Mus.; Kalamazoo Art Inst. **Comments:** Positions: dir. & bd. mem., South Bend AC, 1957-. Teaching: South Bend AC, 1953-; Indiana Univ. Ext., South Bend, 1955-70s. **Sources:** WW73.

ZITOMER, Daniel *[Painter] mid 20th c.*
Addresses: Brooklyn, NY. **Exhibited:** S. Indp. A., 1944. **Sources:** Marlor, *Soc. Indp. Artists.*

ZIZKONSKY, N. *[Painter] early 20th c.*
Exhibited: Salons of Am., 1924. **Sources:** Marlor, *Salons of Am.*

ZLATKOFF, Charles *[Sculptor] mid 20th c.*
Addresses: Los Angeles, CA. **Exhibited:** PAFA Ann., 1966. **Sources:** Falk, *PAFA, Vol. 3.*

ZOELLER, Robert (Fredric) *[Painter] b.1894, Pittsburgh, PA.*
Addresses: Mt. Sinai, LI, NY. **Studied:** Corcoran Sch. Art; Carnegie Inst.; Pittsburgh AI; Gordon Grant. **Member:** Douglaston Art Lg.; Art Lg. of Long Island; Am. Veterans Soc. Artists; NSMP; Old Town Arts & Crafts, Southold, LI. **Exhibited:** Douglaston Art Lg., 1930-37, 1938-40 (prize), 1941-44, 1945

(prize), 1946; Mineola Fair, 1944 (prize); Grand Central Art Gal., 1940; Am. Inst. Sporting Art, New York & Chicago, 1940, 1941; Am. Veterans Soc. Artists,1938-45; 8th St. Gal., NY, 1940; Art Lg. of Long Island (prize); Long Island Art Festival, 1946; Suffolk County Mus., Stony Brook, LI, Parrish Mus.; St. James, 1951 (prize) & Southold, LI; Mineola Fair (prize). **Work:** murals, Union Savings Bank, Brookhaven Town Hall, Patchogue, LI. **Sources:** WW59; WW47.

ZOELLER, Sara See: **OLDS, Sara Whitney (Mrs. Robert Zoeller)**

ZOELLIN, Roy T. *[Sculptor] b.1892, Redding, CA / d.1940, Pacific Grove, CA.*
Addresses: San Francisco, CA, 1930s. **Studied:** Stackpole; Piazzoni. **Member:** Carmel AA; Monterey Guild. **Exhibited:** Oakland Art Gal., 1932; San Fran. AA, 1932 (hon. men.); SFMA, 1935; GGE, 1939. **Work:** Devendorf Plaza, Carmel. **Sources:** Hughes, *Artists in California*, 630.

ZOELLNER, Louis *[Cameo carver] b.1852, Idar, Germany / d.1934, Brooklyn, NY.*
Addresses: Brooklyn, NY (1871-on). **Exhibited:** Brooklyn AA, 1879; NAD, 1879-80. **Comments:** In 1868 he studied cameo carving under German masters in Berlin, and soon developed a special technique. (The region of Berkenfold, Germany, had been for centuries the source of semi-precious stones used by cameo artists for their carvings.) He served in the Franco-Prussian War; when it was over, he sailed for New York, arriving in 1871. For fifty years, Zoellner was recognized as an outstanding exponent of his art and was reputed to be the last notable cameo carver in the U.S. He did cameos of William Cullen Bryant, Henry W. Longfellow, Peter Cooper, Commodore Cornelius Vanderbilt, President and Mrs. Hayes, Edwin Booth, Robert Louis Stevenson and President James A. Garfield. He spent three to five years on some of the more delicate cameos. His largest pieces were "Caesar," "Paris and Helen of Troy," "Mount Olympus" and "Venus" Festival," said to be the largest carved by a cameo master. **Sources:** WW35.

ZOELLNER, Richard Charles *[Printmaker, painter, mural painter, portrait painter, teacher] b.1908, Portsmouth, OH.*
Addresses: Cincinnati, OH (1940); Tuscaloosa, AL (1947). **Studied:** Cincinnati Art Acad; Tiffany Found. **Member:** Nat. Soc. Mural Painters; SAGA; Am. Color Print Soc. **Exhibited:** PAFA Ann., 1934-52 (4 times); Indiana Soc. PM, 1944 (prize); Northwest PM, 1945 (prize); Alabama AL, 1945 (prize); Alabama WCS, 1946 (prize); Birmingham AC (prize); LOC, 1943, 1945; AIC, 1941; 1942; WFNY, 1939; SAM, 1944; SFMA, 1944; Dayton AI, 1942, 1943; CM, 1941-43; Intermont College, WV, 1944; SSAL, 1945; First & Fifth Nat. Print Ann., Brooklyn Mus, 1948 & 1953; Birmingham Festival Arts, Birmingham (AL) Mus. Art, 1963; Am. Color Print Soc., Phila., 1963; 18th Ann. Piedmont Graphic Exh., Mint Mus., Charlotte, NC, 1971; Franz Bader Gal., Wash., DC. **Awards:** Ann. Arts Club Print Exh., Auburn Univ., 1966; award for Images on Paper, Mississippi AA, 1971; award, 13th Dixie Ann., Montgomery Mus. FA, 1972. **Work:** murals, Univ. School, Cincinnati; U.S. Govt.; Reptile House, Zoo, Cincinnati, Community Bldg., Greenhills, Cincinnati; USPO, Hamilton, OH; Portsmouth, OH; Cleveland; Medina, OH; Georgestown, OH; oil paintings, Gov. House, Charlotte Amalie, Virgin Islands; MoMA, ; PMA; BM; PAFA; Andover (MA) Mus. Am. Art. **Comments:** WPA artist. Preferred media: intaglio. Teaching: Cincinnati Art Mus , 1945-48; Univ. Alabama, 1948-; visiting artist, May Washington College, 1951, Univ. Mississippi, 1952-53 & Univ. Florida, 1953-54. **Sources:** WW73; WW40; WW47.

ZOGBAUM, Helène *[Floral still life painter] late 19th c.*
Addresses: Philadelphia, PA. **Exhibited:** PAFA Ann., 1885-91 (4 times). **Sources:** Falk, *PAFA, Vol. 2.*

ZOGBAUM, R(ufus) F(airchild) *[Naval painter, illustrator]*

b.1849, Charleston, SC / d.1925, NYC.
Addresses: NYC; Highland Falls, NY, 1889. **Studied:** Univ. Heidelberg; ASL, 1878-79; Paris, with Bonnât, 1880-82. **Member:** AWCS; Century Assn. **Exhibited:** Brooklyn, AA, 1877, 1884; PAFA Ann., 1879, 1883; Boston AC, 1888, 1893, 1902; NAD, 1889; Columbian Expo, Chicago, 1893 (medal); Brooklyn AA; Avery Gal., NYC, 1889; AIC. **Work:** murals: State Capitol, St. Paul, MN; Federal Bldg., Cleveland, OH; Woolworth Bldg., NYC; portraits, Naval War College, Newport; Williams College, Williamstown, MA; Flower Hospital, NY. **Comments:** Zogbaum was a popular illustrator who specialized in depicting idealized army life and life in the West, including cowboys, cattle drives, stagecoaches, and river boats. In 1882-83, he visited England, and in 1883, went to Germany. In 1884, he was in Montana, sketching military life on the frontier. He also toured Oklahoma in 1888, preparing sketches for a series that appeared in *Harper's Weekly* and in books such as *Horse, Foot and Dragoons, Ships and Sailors,* and *All Hands.* In the 1890s, he concentrated on naval and military subjects, and was a leading artist-correspondent during the Spanish-American War in the Caribbean, Puerto Rico and Cuba. He was author-illustrator of "War and the Artist," *Scribner's,* 1915. **Sources:** WW24; P&H Samuels, 548.

ZOGBAUM, Wilfrid *[Painter, sculptor, photographer] b.1915 / d.1965.*
Addresses: NYC (1930s); San Francisco, CA (1960s). **Studied:** RISD (summer classes); Yale Sch. Art, 1933; NYC with John Sloan, 1934; Hans Hofmann, 1935; in Paris (1937-39) under Guggenheim fellowship. **Member:** Am. Abstract Artists, 1937-40s (founder). **Exhibited:** S. Indp. A., 1936 (as W. M. Zogbaun); WMAA, 1960, 1962, 1964. **Comments:** After studying with Hofmann he became committed to abstract painting. He was a photographer with the U.S. Army Signal Corps in the Pacific theater during WWII, and after the war he became a commercial and fashion photographer. In 1948, he dropped photography and resumed painting, as an Abstract Expressionist. He switched to sculpture in the mid 1950s, and is best known for his works in that medium. He was the grandson of Rufus F. Zogbaum (see entry). Teaching: Univ. Calif.; Univ. Minnesota; So. Illinois Univ.; Pratt Inst, NYC. **Sources:** WW66; Diamond, *Thirty-Five American Modernists; American Abstract Art,* 203; Marlor, *Soc. Indp. Artists.*

ZOGBAUN, W. M. See: **ZOGBAUM, Wilfrid**

ZOLA, Bernard *b.1894, Italy.*
Studied: ASL. **Exhibited:** S. Indp. A., 1925-26; Salons of Am., 1934. **Sources:** Falk, *Exhibition Record Series.*

ZOLBIUS See: **BELZONS, Jean**

ZOLINE, Esther N. *[Miniature & watercolor painter] d.1948.*
Addresses: active in Los Angeles, CA, 1909. **Studied:** ASL. **Exhibited:** Salons of Am.; S. Indp. A., 1937. **Sources:** Petteys, *Dictionary of Women Artists.*

ZOLL, Victor Hugo *[Painter] early 20th c.*
Addresses: Paris. **Sources:** WW08.

ZOLLER, Edwin W. *[Painter] mid 20th c.*
Addresses: Du Bois, PA (1940); Tyrone, PA (1954). **Member:** Pittsburg AA; AFA; DuBois Civic Art Soc. **Exhibited:** Pittsburg AA, 1937 (prize); PAFA Ann., 1954. **Work:** 100 Friends Pittsburg. **Comments:** Teaching: Penn. State College. **Sources:** WW40.

ZOLNAY, George Julian *[Sculptor, teacher] b.c.1863, Bucharest, Romania / d.1949, NYC.*
Addresses: NYC (immigrated 1892); Wash., DC, 1913; St. Louis, MO, c. 1940; NYC. **Studied:** Imperial Acad. FA, Vienna; Nat. Acad., Bucharest; E. Hellmer; C. Kundmann. **Member:** NAC; St. Louis AG; Wash. AC; Cosmos Club; Union Int. des Arts et Sciences, Paris; Soc. Wash. Artists; Circolo Artistico, Rome; Tineremia Romana, Bucharest; Arch. Lg., 1900; SWA; Missouri Comm. to Portland Expo (chmn.). **Exhibited:** Portland Expo, 1904 (gold), 1905 (gold); Vienna Acad. (prize); PAFA Ann., 1915;

National Sculpture Soc. Other awards: Order "Bene Merenti," by King of Romania. **Work:** mon., St. Louis; Richmond, VA; Nashville, TN; Savannah, GA; Owensboro, KY; Univ. Virginia, Charlottesville; City Gates, Univ. City, MO; U.S. Customs House, San Fran., CA; New Bedford, MA; statue, U.S. Capiitol; Bucharest Royal Inst.; City AM, St. Louis; Herron AI. **Comments:** Positions: teacher, St. Louis School FA, before 1940; cur. of sculpture, St. Louis AM, before 1940. **Sources:** WW40; McMahan, *Artists of Washington, DC.*

ZOLOTT, Esther *[Sculptor] mid 20th c.*
Addresses: Chicago area. **Exhibited:** AIC, 1935. **Sources:** Falk, *AIC.*

ZONA, Rinaldo A. *[Painter, sculptor] b.1919, NYC.*
Addresses: Huntington, NY. **Exhibited:** Childe Hassam Fund Exh., Am. Acad Arts & Letters, New York, 1967; East Hampton Gal., New York, 1966-68 (solo) & 1970 (solo). **Work:** Rose Art Mus. & Riverside Mus. Coll., Brandeis Univ., Waltham, MA; Finch College Mus., New York. **Comments:** Preferred media: oils, acrylics. **Sources:** WW73.

ZOOK, Gertrude *[Painter, teacher] mid 20th c.*
Addresses: Ft. Wayne, IN. **Studied:** Columbia; AIC; Indiana Univ. **Member:** Hoosier Salon; Western AA. **Comments:** Teaching: North Side H.S., Ft. Wayne, IN. **Sources:** WW40.

ZORACH, Dahlov See: **IPCAR, Dahlov (Mrs.)**

ZORACH, Marguerite Thompson (Mrs. William) *[Painter, craftsperson, mural painter] b.1887, Santa Rosa, CA / d.1968, Brooklyn, NY.*
Addresses: Greenwich Village, NYC; Brooklyn, NY/Robinhood, ME. **Studied:** Stanford Univ., 1908; Grande Chaumière, Paris, with F. Auburtin, 1908; La Palette sch., with John Duncan Fergusson, Paris, 1908-11. **Member:** NY Soc. Women Artists (founder, 1st pres.), 1925; Am. Soc. PS&G. **Exhibited:** Salon d'Automne, 1908, 1911; Soc. Indep. Artists, Paris, 1911; Soc. Indep. Artists, NYC, 1917-18, 1921-24, 1941; Royar Gals., Los Angeles, 1912 (solo) & 1913; Armory Show, NY, 1913; Contemporaries, NYC, 1913 (solo); Playhouse, Cleveland, 1913; Daniel Gal., NYC, 1915, 1916, 1918 (embroideries); Pan-Pacific Expo, San Fran.,1915 (medal); Forum Exh., NYC, 1916 (only woman to exhibit); Soc. Indep. Artists, 1917, 1918; AIC, 1920 (Logan medal); Dayton MA, 1922; Salons of Am.; 1922-36; Montross Gal., NYC, 1923 (solo) (traveling); Downtown Gal., NYC, 1928 (solo), 1930 (solo), 1934 (solo); Corcoran Gal. biennials, 1930-45 (4 times); PAFA Ann., 1930-64 (12 times); Brummer Gal., NYC, 1935 (solo); Knoedler Gals., NYC, 1944 (solo); WMAA, 1932, 1940, 1951-52; Kraushaar Gals., NYC, 1953, 1957, 1962, 1968 (all solos); "Zorach Day," Bowdoin College, 1958; Bates College, 1964; Maine Art Gal., Wiscasset, 1968 (traveling); Brummer Gal.; Colby College, 1968; CPLH, 1956, 1969 (solo); Nat. Coll. FA, Washington, DC, 1973-74; Farnsworth Lib. & Art Mus., Rockland, ME, 1980. Awards: hon. D.F.A. **Work:** NMAA; MMA; WMAA; MoMA; Newark Mus.; BM; Colby College; Speed Mus.; Massillon Mus. WPA murals, USPO, Peterborough, NH; Ripley, TN; Monticello, IL. **Comments:** Pioneer American modernist, one of the first to introduce Fauvist and Cubist styles in the U.S. between 1910-20. After studying in Paris (1908-11) and visiting Egypt, Palestine, India, and Japan (1911), she returned to her Fresno home, where she produced brilliantly colored Fauvist landscapes (some depicting the Sierras and Yosemite, a favorite subject throughout her career), using orange, crimson, and purple as her palette and enclosing her forms in thick black outlines. She married William Zorach in December of 1912 (they had met in Paris) and the couple moved to Greenwich Village. Marguerite continued painting in a Fauvist style until 1915 when she began imposing a Cubist structure on her landscapes. After the birth of her two children in 1915 (Tessim) and 1917 (Dahlov, who later became an artist — see Dahlov Ipcar) she had less time for painting and began making embroideries in brilliant colors, often depicting stylized arcadian scenes (first shown in 1918 at the

M. ZORACH 1910

Daniel Gal.). These large tapestries became her main artistic focus after 1920, although she continued to paint and also assisted her husband on some of his large projects. In the 1930s, M. Zorach completed two WPA murals for the Fresno post office and court house, depicting farmworkers picking grapes; the murals were rejected, however, by officials who wanted something more traditional. Note: upon leaving Calif. in 1912, M. Zorach had thrown out a large group of drawings and paintings, bringing with her only a small group that remained rolled up until 1968 when she gave them to her son Tessim. These were subsequently restored and exhibited (see Tarbell, *Marguerite Zorach*). Author: newspaper articles, written and illustrated during her stay in Paris for her hometown newspaper. **Sources:** WW66; WW47; W. Homer, *Avant-Garde Painting and Sculpture in America;* Rubinstein, *American Women Artists,* 172-76; A. Davidson, *Early American Modernist Painting,* 166-67, 249-51; Roberta Tarbell, *Marguerite Zorach: The Early Years, 1908-1920* (Wash. DC: Natl Coll. of Fine Arts, Smithsonian Inst, 1973); P&H Samuels, 548; Petteys, *Dictionary of Women Artists.*

ZORACH, William *[Sculptor, painter, blockprinter, writer, teacher] b.1887, Eurburick-Kovno, Lithuania / d.1966, Bath, ME.*

Addresses: Greenwich Village, NYC, 1912-37; Brooklyn, NY/Robinhood, ME. **Studied:** apprenticed at the Morgan Lithograph Co., Cleveland, 1903-06; painting at night with Henry Keller at Cleveland Sch. Art, c.1903-05; ASL, 1908-09; NAD, 1908-09; La Palette Sch., with John Duncan Fergusson, Paris, 1909-11. **Member:** Sculptors Gld. (a founder); Am. Soc. PS&G; Am. Soc. Sculptors; Cornish (NH) Colony. **Exhibited:** Salon d'Automne, 1911 (exh. as "William Finkelstein"); Taylor Art Gal., Cleveland, 1912 (solo); Armory Show, 1913; S. Indp. A., 1917-18, 1922, 1929, 1941; Dayton AI, 1922 (solo); Univ. Rochester, 1924 (solo), 1941 (solo); C.W. Kraushaar, 1924 (1st solo sculp. exh.); AIC Ann., 1926-49 (Logan Prize, 1931 & 1932); WMAA biennials, 1928-66; Downtown Gal., NYC, 1931; PAFA Ann., 1933-66 (21 times; incl. Widener medal, 1962); Arch. Lg., 1937 (prize), 1958 (prize); AIC, 1938 (solo); WFNY, 1939; Dallas Mus. FA, 1945 (solo); CPLH, 1946; ASL, 1950 (retrospective) McNay AI, 1956 (solo); Bowdoin College Mus. Art, 1958 (solo), 1959-60 (retrospective), traveling to WMAA; Lowe AC; Queens College, NY, 1961; Columbus Gal. FA; Cincinnati Contemp. AC; Downtown Gal., NY (solo); Salons of America. Other awards: hon. M.F.A., Bowdoin College, 1958; citation, Bates College, 1958; hon. D.F.A., Colby College, 1961; gold medal, NIAL, 1961. **Work:** MMA; MoMA; BMFA; BM; CMA; WMAA; AIC; PMG; Berkshire Mus.; Newark (NJ) Mus.; "The Spirit of Dance," Radio City Music Hall, NYC; Shelburne (VT) Mus.; Wichita AM; Norton Gal. Art; Swope Art Gal.; Munson-Williams-Proctor Inst.; Los Angeles Mus. Art; WPA statue, U.S.P.O. Bldg., Wash., DC; figures, facade, Mayo Clinic. **Comments:** Pioneer direct carver. Came to the U.S. at age four and grew up in Port Clinton, OH. He met Marguerite Thompson (see entry) while studying in Paris and they were married in NYC in Dec., 1912. Zorach did not begin exploring modernist styles until 1912, and over the next several years painted Fauvist landscapes. From 1917 until 1920, his paintings--including a group of landscapes painted in the Yosemetes — combine Cubist fragmentation and Klee-like fantasy elements. In 1917 he carved his first wood relief and by 1922 had decided to dedicate himself primarily to sculpture. Zorach worked chiefly in stone from 1923. After 1922, his forms grew round, volumetric and monumental. Zorach described his influences to be the primitive carving of the past, particularly African art, and the sculpture of the Persians, the Mesopotamians, the archaic Greeks and the Egyptians. In his work Zorach stressed universal themes, especially the relationship between mother and child, man and woman, and children and animals. A pioneer in the revival of direct carving, he helped to popularize the technique through his teaching. Positions: sculpture instructor, ASL, NYC, 1929-59; vice-pres., NIAL, NYC. Contrib.: *Magazine of Art, Creative Arts, National Encyclopaedia.* Lectures: "History of Sculpture from Primitive to

Modern Times." Auth.: *Zorach Explains Sculpture: What if Means and How It Is Made* (New York: Amer. Artists Grp., 1947); *Art is My Life* (New York: World Publishing Co., 1967). **Sources:** WW47; WW66; John I.H. Baur, *William Zorach* (exh. cat., WMAA, 1959); Roberta K. Tarbell, "A Catalogue Raisonné of William Zorach's Carved Sculpture," 2 vols. (Ph.D dissertation, Univ. of Delaware, 1976); Joan Marter, et al., *Vanguard American Sculpture, 1913-1939* (New Brunswick, NJ: Rutgers Univ. Art Gallery, 1979); Fort, *The Figure in American Sculpture,* 235-36 (w/repro.); Baigell, *Dictionary;* Craven, *Sculpture in America,* 576-80; A. Davidson, *Early American Modernist Painting,* 245-49; P&H Samuels, 548-49.

ZORETICH, George S. *[Painter] mid 20th c.*
Addresses: State College, PA. **Exhibited:** PAFA Ann., 1949-66 (4 times); Corcoran Gal. biennials, 1953-61 (4 times). **Sources:** Falk, *Exhibition Records Series.*

ZORN, Helen A. *early 20th c.*
Exhibited: Salons of Am., 1931. **Sources:** Marlor, *Salons of Am.*

ZORNES, James Milford *[Painter, designer, illustrator, teacher, lecturer] b.1908, Camargo, OK.*
Addresses: Nipomo, CA; Mt Carmel, UT. **Studied:** F. Tolles Chamberlin & Millard Sheets, 1935-38; Otis Art Inst., 1938; Pomona College, 1946-50. **Member:** ANA; AWCS; Calif. WCS (pres.); West Coast WCS(vice-pres.); Southern Pr. Club; San Diego FA Soc.; Laguna Beach AA; Riverside AA (bd. dir., 1966-67). **Exhibited:** Los Angeles County Fair, 1933 (prize), 1936 (prize); Calif. WCS, 1935 (prize); Beverly Hills H.S., 1939 (prize); Chicago Int. Watercolor Exh., AIC, 1938; San Francisco World's Fair, 1938-40; MMA, 1941; 96th Ann. AWCS, 1963; Watercolor USA, 1972; MMA, 1941 (prize); Allied Services Exh., Bombay, India, 1944 (prize); Pomona College, 1946 (prize); CGA; AIC; GGE, 1939; Riverside Mus., 1938; Found. Western Artists; Los Angeles Mus. Art; SFMA, 1946; San Diego FA Soc., 1934 (prize); Denver AM; Santa Barbara Mus. Art. Awards: award for In the Cove, NAD; William Tuthill Prize for Well at Guadalupe, 1938; Am. Artist Medal for Beach Party, 1963. **Work:** MMA; LACMA; San Diego FA Soc.; Butler IA; NAD; White House Coll., Wash., DC. Commissions: murals for post offices at El Campo, TX, 1937 & Claremont, CA, 1938, U.S. Govt.; Glendale (CA) H.S. **Comments:** WPA artist. Preferred medium: watercolors. Positions: official Army artist, U.S. Govt., 1943-45. Teaching: Polytechnic Jr. H.S., Pasadena, 1940; Otis Art Inst., 1938-46; Pomona College, 1946-50; Univ. Calif., Santa Barbara, 1948-49. **Sources:** WW73; article, *Am. Artist Magazine* (Nov., 1963); Edgar A. Whitney, *Complete Guide to Watercolor Painting* (1965); *One Hundred Watercolor Techniques* (Watson-Guptill, 1968).

ZOROMSKIS, K. *[Painter] mid 20th c.*
Addresses: NYC. **Exhibited:** PAFA Ann., 1964. **Sources:** Falk, *PAFA, Vol. 3.*

ZORTHIAN, Jirayr H(amparzoom) *[Painter, craftsperson, designer, lecturer, printmaker, teacher] b.1912, Kutahia, Armenia.*
Addresses: Altadena, CA; New Haven, CT in 1940. **Studied:** Yale Sch. FA (B.F.A.); in Italy. **Member:** AAPL; Pasadena AA; Pasadena Soc. Artists; AEA. **Exhibited:** New Haven PCC, 1936, 1938-41; BMA, 1943-45; Wash. County MFA, 1945; Calif. State Fair; PAFA Ann., 1947; CPLH; Los Angeles Mus. Art; Los Angeles County Fair; Pasadena Art Mus., 1954 (solo), 1955; Nat. Orange Show, 1954; Sierra Madre Lib. (solo). **Work:** murals, State Capitol, Nashville, TN; United Illuminating Co., New Haven, CT; New Plaza Hotel, Harrisburg, PA; Camp Ritchie, MD; WPA mural, USPO, St. Johnsville, NY. **Comments:** Positions: artist, *Pasadena Independent Star News,* 1953-58; art instr., Tom Chandler Sch., Pasadena, CA, 1958. Contrib.: *Pencil Points, Life, G.I. Sketch Book.* **Sources:** WW47.

ZOTOM, Paul Caryl *[Artist] b.c.1853 / d.1913, Oklahoma.*
Studied: Hampton Inst., Hampton, VA; Paris Hill, near Utica, NY. **Exhibited:** Heard Mus., Phoenix, AZ; Colorado Springs FA

Center, CO; Oklahoma Mus. Art; "Native Am. Paintings,"organized by Joslyn Art Mus., 1979-80; "Indianische Künstler,"organized by Philbrook Mus. Art, Tulsa, OK, 1984-85; "Beyond the Prison Gates: The Fort Marion Experience and its Artistic Legacy," organized by the Nat. Cowboy Hall of Fame & Western Heritage Center, Oklahoma City, OK; "Visions of the People," The Minneapolis Inst. Arts, 1992-93. **Work:** Colorado Springs FA Center; Hampton Inst., College Mus. & Huntington Lib., Hampton, VA; Nat. Mus. Am. Indian, Smithsonian Inst.; Yale Univ., New Haven, CT. **Comments:** A member of the Kiowa tribal nation, his native name was Podaladalte (Snake head). He was also called, Zo Tom, or The Biter or Hole Biter. In addition to being an artist, Zotom was also said to have been an Episcopalian deacon, missionary and warrior. Preferred media: colored pencil. **Sources:** info. courtesy of Donna Davies, Fred Jones Jr. Mus. Art, Univ. of Oklahoma.

ZOTZMANN, Richard *[Painter] mid 20th c.*
Exhibited: S. Indp. A., 1937-38. **Sources:** Marlor, *Soc. Indp. Artists.*

ZOUTÉ, Leon *[Painter] mid 20th c.*
Addresses: North Rose, NY. **Exhibited:** S. Indp. A., 1941; PAFA Ann., 1942; WMAA, 1947. **Sources:** Falk, *PAFA, vol. 3;* Falk, *WMAA;* Marlor, *Soc. Indp. Artists* (gives alternate last name of Salter).

ZOX, Larry *[Painter] b.1936., Des Moines, IA.*
Addresses: NYC. **Studied:** Univ. Oklahoma; Drake Univ.; Des Moines AC with George Grosz. **Exhibited:** Riverside (CA) Mus., 1968; First Indian Triennale, 1968; The Direct Image, Worcester (MA) Art Mus., 1969; WMAA, 1965-73; Indianapolis Mus. Art, 1972; Kornblee Gal., NYC, 1970s. **Awards:** Guggenheim fellowship, 1967; Nat. Council Arts Award, 1969. **Work:** WMAA; Oberlin (OH) College; Joseph H. Hirshhorn Coll.; Des Moines AC; MoMA. **Comments:** Teaching: artist-in-residence, Juniata College, 1964; guest critic, Cornell Univ., 1967; artist-in-residence, Univ. North Carolina, Greensboro, 1967; art instr., Sch. Visual Arts, 1967-; art instr., Dartmouth College, winter 1969. **Sources:** WW73.

ZOZZORA, Frank *[Painter, illustrator, lecturer, teacher, writer] b.1902, Sassano, Italy.*
Addresses: Madison, WI/New London, CT. **Studied:** E. Savage; F. Bicknell; C.J. Taylor; E.M. Ashe; T.W. Stevens. **Member:** Wisc. P&S; Madison AA. **Sources:** WW33.

ZSCHAEBITY, Richard *[Artist] b.1860, Dresden, Germany / d.1912, Jersey City, NJ.*
Addresses: active in Brooklyn, NY, 1886. **Sources:** BAI, courtesy Dr. Clark S. Marlor.

ZSCORSCH, Walter *[Sculptor] early 20th c.*
Addresses: Chicago area. **Exhibited:** AIC, 1926-28 (prize). **Sources:** Falk, *AIC.*

ZSHINGA HEKA See: **STANDINGBEAR, George Eugene**

ZSISSLY, Malvin See: **ALBRIGHT, Malvin M. (Zsissly)**

ZSOLDOS, Julius *[Painter] early 20th c.*
Addresses: NYC. **Sources:** WW04.

ZUBER, Elizabeth Wilson Howard (Mrs. Frank)
[Amateur painter of landscapes, china painter] b.1864, Ohio / d.1931, Los Angeles.
Addresses: Active in NYC & Calif. **Comments:** Married Mr. Howard and then Frank Zuber in 1916. **Sources:** Petteys, *Dictionary of Women Artists.*

ZUCCARELLI, Frank Edward *[Painter, illustrator] b.1921, PA.*
Addresses: Somerset, NJ. **Studied:** Newark Sc. Fine & Indust. Art with William J. Aylward & John Grabach; ASL with Robert Philip; Newark State Teachers College (B.A.). **Member:** Naval Art Coop. & Liaison Committee (combat artists); Salmagundi Club (resident artist, juror); AAPL (fellow); Am. Vet. Soc. Artists; Bur Artists. **Exhibited:** Newark Sch. Indust. & FA Alumni Show,

Newark Mus., NJ; Westfield AA State Show, 1968; Am. Vet. Soc. Artists, Salmagundi Club, New York, 1970; AAPL Grand Nat., 1970; U.S.N. Combat Art Coll., Salmagundi Club, New York, 1972. **Awards:** purchase award, Westfield AA, 1969; Salmagundi Prize, 1969 & hon. men., 1971, Salmagundi Club. **Work:** U.S. Navy & Marine Mus., Wash., DC; Marine Corps Base, Barstow, CA; Abraham Sharpe Found., NY; Malcolm Forbes Coll., NY. **Commissions:** paintings for U.S. Navy, Newport RI, 1971; Dahlgren Weapons Lab., VA, 1971 & Mediterranean Sixth Fleet, 1972. **Comments:** Preferred media: oils. Positions: illustr., Ruffa Advertising Agency & Street & Smith Publ. **Publications:** illustr, *Catholic Home Messenger.* Teaching: private instructor oils, 1958-; Spectrum Inst., Somerville, NJ, 1972-. **Sources:** WW73; Doris Brown, "New England — Artists' Forte," *New Brunswick Home News* (1968) & "Artist's Assignment Pays Off," *Sun Home News* (New Brunswick, 1971); Colleen Zirnite, "Artist Speaks of Many Things," *Spectator* (1972).

ZUCKER, Anna *[Illustrator, etcher] early 20th c.*
Addresses: Los Angeles, CA. **Studied:** College of FA, Garvanza, CA; ASL, 1908, with F. Luis Mora & C. H. White. **Exhibited:** Blanchard Hall, Los Angeles, 1909. **Comments:** Her illustrations appeared in national magazines. **Sources:** Hughes, *Artists of California,* 630; Petteys, *Dictionary of Women Artists.*

ZUCKER, Jacques
[Painter, writer] b.1900, Radom, Poland / d.1981. **J.ZUCKER.**
Addresses: NYC, 1977. **Studied:** Bezalel Art School, Jerusalem; Acad. Julian, Acad. Grande Chaumière & Colarossi Acad., all in Paris. **Member:** Artists Equity Assn.; Fed. Artists & Sculptors. **Exhibited:** MMA; MoMA; CI; PAFA Ann., 1929-60 (8 times); AIC; Smith College; Springfield Mus. Art; BM; Inst. Modern Art, Boston; WMA; WMAA; Assn. Am. Artists, 1940, 1944; Bignou Gal., 1946; Wadsworth Atheneum; Yale Univ.; Dudensing Gal.; Ferargil Gal.; Reinhardt Gal.; Wildenstein Gal.; Paris; Schoeneman Gals., NYC, 1970s; "NYC WPA Art" at Parsons Sch. Des., 1977. **Work:** Bezaleel Art Mus., Jerusalem; MoMA Tel-Aviv, Israel; Helena Rubenstein Mus., Tel-Aviv; MoMA Paris. **Comments:** WPA artist. Preferred media: oils, pastels, gouache, sanguine. Collection: paintings in oils, watercolors, gouache & pastels; drawings in charcoal, sepia & sanguine. Contrib.: articles, *L'Art Vivant* (Paris), *Esquire.* Publications: illustr. of many stories. **Sources:** WW73; WW47; *New York City WPA Art,* 95 (w/repros.); Harry Salpeter, article, *Esquire Magazine,* 1938; articles, *Menorah Magazine.*

ZUCKER, Murray Harvey *[Painter, sculptor] b.1920, NYC.*
Addresses: NYC. **Member:** Artists Equity Assn. New York; Am. Soc. Contemp. Artists; Am. Vet. Soc. Artists. **Exhibited:** 10th Ann., Ball State Teachers College, Muncie, IN, 1964; 16th Ann., Silvermine Guild Artists, CT, 1965; 161st Ann., PAFA, 1966 (hon. men.); 25th Ann., Audubon Artists, NYC, 1967; Am. Soc. Contemp. Artists, 1971 (hon. men.); "Artists New York — 1972," NYC, 1972. **Work:** AFL-CIO Hdqtrs., Wash., DC: Community Blood Council, New York; Omaha (NE) Nat. Bank. Commissions: painting, Atlantic Richfield Co., New York, 1968; painting, Technicon Corp., Ardsley, NY, 1969; painting, Police Benevolent Assn., New York, 1970. **Comments:** Preferred media: acrylics, collage. **Sources:** WW73; C. Crane, "Contemporary Collages," *Interiors* (May, 1970).

ZUCKER, Paul *[Educator, critic, writer] b.1890, Berlin, Germany.*
Addresses: NYC. **Studied:** Univ. Berlin & Munich; Inst. Tech., Berlin & Munich (Ph.D.). **Member:** CAA; Am. Soc. Arch. Hist.; Am. Soc. for Aesthetics. **Comments:** Awards: prizes, Arch. Comp., Germany, 1933; Arnold W. Brunner Scholarship, AIA, 1953. Teaching: Cooper Union, NYC, 1938-64; New Sch. for Social Research, NYC. Auth.: *Stage Setting at the Time of the Baroque; Stage Setting at the Time of the Classicism; Architecture in Italy at the Time of the Renaissance; American Bridges and Dams;* also, *Styles in Painting* (1950, paperback edition, 1962); *Town and Square — From the Agora to the Village Green* (1959).

Ed.: "The Music Lover's Almanac" (with William Hendelson); *New Architecture and City Planning, A Symposium*. **Sources:** WW66.

ZUCKER, Philip *[Painter] mid 20th c.*
Exhibited: S. Indp. A., 1941. **Sources:** Marlor, *Soc. Indp. Artists*.

ZUCKERKANDL, Gertrud (Gertrude?) *[Painter] mid 20th c.*
Exhibited: AIC, 1930. **Sources:** Falk, *AIC*.

ZUCKERMAN, Beatrice See: **ULLRICH, B(eatrice)**

ZUCKERMAN, Evelyn *[Painter] early 20th c.*
Addresses: Brooklyn, NY. **Exhibited:** S. Indp. A., 1929.
Sources: Marlor, *Soc. Indp. Artists*.

ZUCKERMAN, Jack *[Painter] b.1920, Chicago, IL.*
Addresses: Elmhurst, NY. **Studied:** AIC; ASL. **Member:** AEA.
Exhibited: WMAA, 1952-53, 1956; Audubon Artists, 1951;
Indiana State Teachers College, 1951; Hacker Gal., 1950.
Awards: Long Island Art Festival, 1950. **Work:** WMAA.

ZUCKERMAN, Milton *[Painter] early 20th c.*
Addresses: Brooklyn, NY. **Exhibited:** S. Indp. A., 1929.
Sources: Marlor, *Soc. Indp. Artists*.

ZUELECH, C(larence Edward) *[Etcher, illustrator] b.1904, Cleveland.*
Addresses: Cleveland, OH. **Studied:** Keller. **Member:** Cleveland
PM. **Exhibited:** CMA, 1932 (prize); 48 Sts. Competition, 1939.
Work: Cleveland Print Club; CMA. **Sources:** WW40.

ZUELOW, Franz *[Printmaker] mid 20th c.*
Exhibited: AIC, 1941. **Sources:** Falk, *AIC*.

ZUGOR, Sandor *[Painter] b.1923, Brod, Yugoslavia.*
Addresses: NYC. **Studied:** Acad. FA, Budapest, 1941-45, with
Istvan Szonyi; Hungarian Acad. Rome (fellowship) 1946-48,
graphics with Varga Nandor Lajos. **Exhibited:** Exh. Hist. Siena,
Municipal Mus., Italy, 1948; Budapest Nat. Exhs., Nat. Gal. Art,
1954 & 1955; Young Americans, Mus. Contemp. Crafts, New
York, 1962; Brooklyn Heights Artists, BM, 1969; Palacio Bellas
Artes, Mexico City, 1972. **Awards:** first prize for Peace War, Fed.
Hungarian Artists, 1954. **Work:** Mus. FA Budapest; Munic. Mus.
Budapest, Ministry Cultural Affairs, Vienna. **Comments:**
Preferred media: graphics, polymers, acrylics, oils. Positions: dir.,
Westbeth Graphics Workshop, 1971-. Teaching: Brooklyn College
Adult Educ., 1966-71. **Sources:** WW73.

ZUILL, Abbie Luella *[Painter] b.c.1855, Fall River, MA / d.1921.*
Addresses: Fall River, MA. **Studied:** Robert Spear Dunning,
probably late 1880s (she finished many of his works after he died
in 1905). **Comments:** Specialty: fruit and flower still lifes. Zuill
was a member of Fall River (MA) School of Still Life Artists.
Teaching: private classes in still life painting, Somerset, MA,
c.1912. **Sources:** *For Beauty and for Truth*, 95 (w/repro.);
Petteys, *Dictionary of Women Artists*.

ZUKOVIC, Marko *early 20th c.*
Exhibited: Salons of Am., 1934. **Sources:** Marlor, *Salons of Am.*

ZULA See: **BARCONS, Zulema (Zula) (Mrs. Ora I. Bussart)**

ZUMSTEG, Vera Collings *[Painter] b.1906, Washington State.*
Addresses: San Francisco, CA. **Studied:** Univ. Oregon; Victor
DeWilde, San Francisco. **Exhibited:** GGE, 1939. **Comments:**
Specialty: watercolor. **Sources:** Hughes, *Artists of California*, 630.

ZUMWALT, Bernice *[Painter, teacher] b.1904, Bakersfield, CA.*
Addresses: Oakland, CA. **Studied:** Calif. College Arts & Crafts.
Member: Pacific AA; Humboldt AC, 1934. **Comments:**
Preferred medium: watercolor. Specialty: coastal landscapes.
Teaching: Humbodt County public schools, 1926-66. **Sources:**
Hughes, *Artists of California*, 630.

ZUMWALT, Gail Delaney (Mr.) *[Lithographer] b.1917, Modesto, CA / d.1976, San Jose, CA.*

Addresses: San Jose, CA. **Studied:** Calif. Sch. FA. **Exhibited:**
GGE, 1939. **Comments:** Position: partner, advertising art firm,
San Jose, CA. Part of a group of twenty artists who produced lith-
ographs for the "Chronicle Contemporary Graphics" project of
1940. **Sources:** exh. cat., Annex Gal. (Santa Rosa, CA, n.d.,
c.1988); Hughes, *Artists of California*, 630.

ZUNIGA, Francisco *[Sculptor] b.1911, San Jose, Costa Rica.*
Addresses: Mexico City, Mexico. **Exhibited:** Third Sculpture
Int., Phila. Mus. Art, 1949; Expos F. Zuniga, Mus. Nac., San Jose,
Costa Rica, 1954; Kunst Mexikaner, Köln, Germany, 1959; Expos
Zuniga, FA Gals. San Diego & Phoenix Art Mus., 1971; Galeria
Tasende, Guerrero, Mexico, 1970s. **Awards:** Primer Escultura,
Costa Rica, Expos Art Centro Americano, 1935; premio for Diego
Rivera, Second Biennial Inter-Am. Art, 1960; premio adquisicion
Inst. Nac. Bellas Artes. **Work:** Middelhiem Mus., Antwerpen,
Belgium; Fogg Art Mus., Cambridge, MA; FA Gals. San Diego,
CA; Mus Arte Mod., Mexico City, Mexico; Phoenix (AZ)Art
Mus. **Commissions:** mMonument, Nuevo Laredo, Mexico, 1958;
Monument to a Cuauhtemoc, Quito, Ecuador, 1961; Fuentes
Monumentales, Chapultepec, Mexico City, 1962; reliefs, Edigicio
Secretaria de Communicaciones; Estatua a Benito Juarez,
Gobierno de Michoacan, Morelia, MI. **Comments:** Preferred
media: bronze, marble. **Sources:** WW73; Rosa Gonzales,
Dictionnaire de la Sculpture Moderne (Paris, 1960); Ali
Chumxcero, *Zuniga* (Misrachi, Mexico, 1969); Toby Joysmith,
Zuniga (FA Gals. San Diego, 1971).

ZUNSER, (Miriam) Shomer *[Painter] mid 20th c.*
Exhibited: AIC, 1942; S. Indp. A., 1942. **Sources:** Falk,
Exhibition Record Series.

ZUPPKE, Robert C. *[Painter] early 20th c.*
Addresses: Chicago, IL. **Exhibited:** AIC, 1912. **Sources:** WW15.

ZUR CANN-BOSCOWITZ, Alice *[Painter] mid 20th c.*
Exhibited: S. Indp. A., 1939. **Sources:** Marlor, *Soc. Indp. Artists*.

ZURCHER, Suzette Morton (Mrs.) *[Collector, typographic designer] b.1911, Chicago, IL.*
Addresses: Chicago, IL. **Studied:** Vassar College (A.B.); School
of AIC. **Exhibited:** Awards: AIGA, 1941-65 (five awards).
Comments: Positions: pres., Women's Bd., 1960-63, hon. trustee,
1964-, AIC; des. of publications, 1950-60, AIC; owner/proprietor,
The Pocahontas Press, 1937-. Collection: 17th century paintings;
19th century English painting and drawing; pre-Columbian and
African gold; Ashanti gold weights. **Sources:** WW66.

ZURFLICH, Frances *[Painter] mid 20th c.*
Exhibited: Corcoran Gal. biennial, 1951. **Sources:** Falk,
Corcoran Gal.

ZUSSIN, Harold *[Painter, printmaker] mid 20th c.*
Addresses: Chicago area. **Exhibited:** AIC, 1941, 1946. **Sources:**
Falk, *AIC*.

ZUTZ, Adolf *[Painter] early 20th c.*
Exhibited: AIC, 1932. **Sources:** Falk, *AIC*.

ZUTZ, Carl *[Painter] late 19th c.*
Exhibited: PAFA Ann., 1878. **Sources:** Falk, *PAFA, Vol. 2*.

ZVRKOFF, John *[Painter] early 20th c.*
Addresses: NYC. **Exhibited:** S. Indp. A., 1925, 1927.
Comments: (his last name is alternately spelled Zwerkoff)
Sources: Marlor, *Soc. Indp. Artists*.

ZWAAN, Cornelius Christiaan *[Portrait & genre painter] b.1882, Amsterdam, Holland / d.c.1964.*
Studied: Ryks Acad. voor Beeldende Kunsten, Amsterdam.
Exhibited: Indianapolis Mus. Art, 1973 (memorial exh.).
Comments: His works were first introduced in the U.S. in 1909,
and he was active in Chicago and Indianapolis in the 1930s-40s.
Sources: unident. brochure and photographs of Indianapolis Mus.
Art installation, PHF files.

ZWEERTS, Arnold *[Painter, educator] b.1918, Bussum, Netherlands.*

Addresses: Downers Grove, IL. **Studied:** Sch. for Arts & Crafts, Amsterdam; Sch. for Art Teacher Training, Royal Acad. Art, Amsterdam; Royal Acad. Art, Copenhagen, Denmark; Acad. Belli Arti, Ravenna, Italy; Inst. Allende, Univ. Guanajuato, Mexico (M.F.A.); Jos Rovers, Riseby; Oselli; Signoriny; Kortlang. **Member:** Midwest Designer Craftsmen. **Exhibited:** Amsterdam, Netherlands, 1948 (first solo); London, England, 1953; Chicago Merchandise Mart, 1960 (first U.S. solo); St. Paul (MN) Gal. Art, 1962; AIC, 1966. **Work:** Stedelijk Mus., Amsterdam; Coll. of the State, The Hague, Netherlands. Commissions: mosaics, Hengelo, Netherlands, 1954, Lockhorst, Koldewyn, Van Eyck, Rotterdam Architects, 1955-56, Chicago Process Gearr Co., 1961, Boulder (CO) Medical Arts Bldg., 1963-64 & Dr. Snider, Chicago, 1969-70. **Comments:** Preferred media: oils, woodcuts, mosaic. Teaching: Kingston Upon Thames, Surrey, England, 1951-53; Stedelijk Mus., Rijkmus, Amsterdam, 1954-57; AIC, 1957-; Loyola Univ., Chicago, 1968. Publications: auth., articles about art, *Bussumsche Courant,* 1950; auth., "A Renaissance in Architectural Art?," *Delphian Quarterly,* vol. 1943, No. 4. **Sources:** WW73; Pieter Scheen, *Lexicon Nederlandse Beeldende Kunstenaars 1750-1950, Part II.*

ZWERKOFF, John See: **ZVRKOFF, John**

ZWICK, Rosemary Goldfein *[Sculptor, printmaker] b.1925, Chicago, IL.*
Addresses: Evanston, IL. **Studied:** Univ. Iowa with Phillip Guston & Abrizio (B.F.A., 1945); AIC with Max Kahn, 1945-47; De Paul Univ., 1946. **Member:** Renaissance Soc., Univ. Chicago; Am. Craftsmen Soc. **Exhibited:** Ceramic Nat., Everson Mus. Art, Syracuse, NY, 1960, 1962 & 1964; Soc. Wash. PM, Nat. Mus., Wash., DC, 1964; Mundelein College, Chicago, 1964-71; AIC,1949, 1964-72; Twentieth Wichita, Wichita AA, KS, 1968; Truro (MA) Art Gal. & Naples (FL) Art Gal., 1970s. **Work:** Oak Park (IL) Lib. Coll.; Albion (MI) College Print Coll.; Rearis Sch. Coll., Chicago; Phoenix (AZ) Pub. Schs. Coll.; Crow Island Sch., Winnetka, IL. Commissions: two sculpture animal forms, Wonderland Shopping Center, Livonia, MI, 1960; wall relief, Motorola Co., Chicago, 1962; sculpture, Temple B'Nai Jenoshua, Morton Grove, IL, 1968; large seated figure, Blue Island (IL) Lib., 1971. **Comments:** Preferred medium: ceramics. Positions: staff artist, *Jr. Arts & Activities Magazine,* 1945-47; assoc., 4 Arts Gallery, Evanston, IL 1962-. Specialty of gallery: Japanese prints, Midwestern artists & craftsmen. **Sources:** WW73; John B. Kenny, *Ceramic Design* (Chilton, 1963); Wesley Buchwald, *Craftsmen in Illinois* (Illinois Art Education Assn., 1965).

ZYLINKSI, Andrew *[Painter, teacher] b.1869, Zaile, Lithuania.*
Addresses: Wash., DC, active 1898; Ebenezer, NY. **Studied:** Wojciech; Gerson; Warsaw (Poland) Sch. Design. **Member:** St. Louis AL. **Work:** Delgado AM; Commercial Club, Hannibal, MO. **Sources:** WW21; McMahan, *Artists of Washington, DC.*

Lester G. Hornby:
Fiacre, Paris, (c.1910)

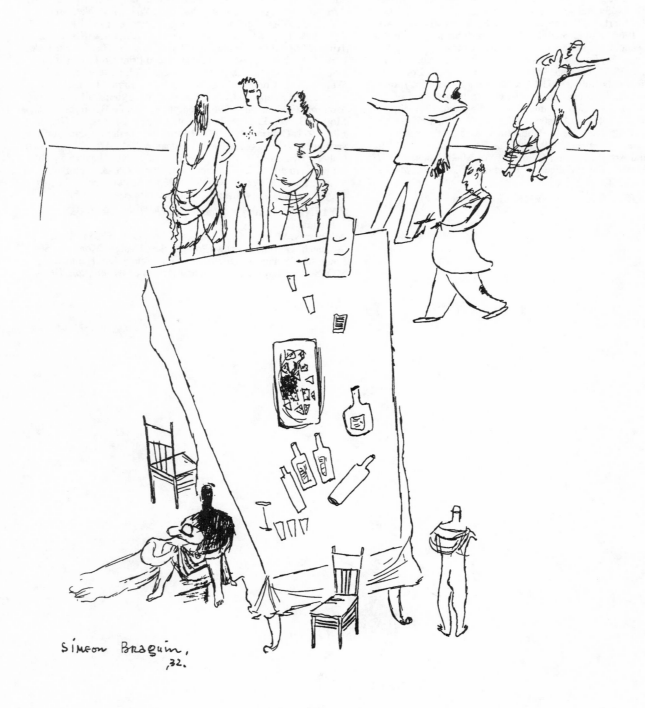

Simeon Braguin: *Party* (1932)

SOURCES
KEY TO CITATIONS OF BIBLIOGRAPHICAL SOURCES

All bibliographical sources are listed alphabetically. If not listed here, monographs and articles on individual artists are cited in full within the artist's biographical entry. For a discussion of the Sound View Press *Exhibition Record Series,* see the end of this section.

Individuals who have contributed information used in the dictionary have been included in the Acknowledgments, and/or cited within the particular artist's entry (cited as: add'l info courtesy . . .).

City and Business Directories, although not listed here, are cited in individual entries by the abbreviations "CD" and "BD" which follow the name of the city or state (for example: NYCD; Boston BD). These directories can be found in the Library of Congress, or in local historical societies and town libraries.

In using all types of published sources, the editors have relied on their accuracy and checked discrepancies wherever possible. However, the citation of a source does not guarantee its accuracy. Reseachers should consult original source material wherever possible and, like the authors listed in this bibliography, must exercise their own critical judgment.

A

Abraham, Evelyn. "David G. Blythe, American Painter and Woodcarver," *Antiques,* XXVII, May 1935, 180-3.

Adams, Adeline V. *John Quincy Adams Ward: An Appreciation.* New York, 1912.

Addison, Agnes, ed. *Portraits in the University of Pennsylvania.* Philadelphia, 1940.

Addison, Julia DeWolf. "Henry Sargent, a Boston Painter." *Art in America* 17 (Oct. 1929): 279-84.

Admiralty-Office. *List of the Flag Officers and Other Commissioned Officers of His Majesty's Fleet.* London, 1818.

Agate, Grace B. "Joseph Jefferson, Painter of the Teche," *National Historical Magazine,* 22 (Nov. 1938): 23-25.

Alabama Legislature Declares Nicola Marschall Designer First Confederate Flag. Montgomery, 1931; Historical and Patriotic Series No. 12.

Albee, John. *Henry Dexter, Sculptor.* Cambridge, 1898.

Album of American Battle Art, 1755-1918. Washington, 1947.

Alden, H. M. "Charles Parsons." *Harper's Weekly* LIV (Nov. 19, 1910): 21.

Alexander, Constance G. *Francesca Alexander.* Cambridge, 1927.

Allen, Charles Dexter. *A Classified List of Early American Book Plates.* New York, 1894.

Allen, Edward B. *Early American Wall Paintings, 1710-1850.* New Haven, 1926.

Allen, Virginia W. "Winged Skull and Weeping Willow," *Antiques* 29 (June 1936): 250-53.

Allison, Anne. "Peter Pelham, Engraver in Mezzotinto." *Antiques* LII (Dec. 1947): 441-3.

American Abstract Art of the 1930s and 1940s: The J. Donald Nichols Collection. Exh. cat. Harry N. Abrams, New York, Inc., for Wake Forest University, Winston-Salem, N.C., 1998

American Academy of Fine Arts (New York), annual exhibition catalogues, 1816-35 [indexed in Cowdrey, *American Academy of Fine Arts and American Art-Union,* II].

American-Anderson Art Galleries, Sales Cat., April 2-3, 1937. Catalogue No. 4314.

American Art at Amherst, A Summary Catalogue of the Collection at the Mead Art Gallery. Amherst, Mass.: Amherst College, 1977.

American Art-Union [New York] publications include the *Bulletin* (1848-53), the *Transactions* (1844-52), and annual exhibition catalogues (1844-52). These are listed in full in Cowdrey, *American Academy and American Art-Union,* I, 246-85, and the catalogues indexed in Vol. II of the same work.

American Battle Painting, 1776-1918. Exh. cat., with text by Lincoln Kirstein. National Gallery of Art, Washington, and Museum of Modern Art, New York, 1944.

American Folk Art; A Collection of Paintings and Sculpture . . . the Gift of Mrs. John D. Rockefeller, Jr., to Colonial Williamsburg. Williamsburg, 1940.

American Institute of the City of New York: catalogues of the annual fairs, New York, 1842, 1844-51, 1856; *Fifth Annual Report.* Albany, 1847; *List of Premiums Awarded by the Managers of the 24th Annual Fair.* New York, 1852; *Transactions for the Year 1856.* Albany, 1857.

American Painter-Etcher Movement. Exh. cat., with essays by Maureen C. O'Brien and Patricia C. F. Mandel. Southampton, N.Y.: Parrish Art Museum, 1984.

American Paintings in the Corcoran Gallery of Art. Comp. by E. B. Swenson, Washington, 1947.

American Primitive Painting, Nineteenth Century: The Chicago Historical Society's Collection. Chicago, 1950.

American Processional. U. S. National Capitol Sesquicentennial Commission, *American Processional, 1492-1900.* Washington, 1950.

American Provincial Paintings, 1680-1860, from the Collection of J. Stuart Halladay and Herrel George Thomas. Pittsburgh, 1941.

American Scene Painting and Sculpture: Dominant Style of the 1930s and 1940s. New York: D. Wigmore Fine Art Inc., 1988

Amesbury, Mass. *Vital Records of Amesbury, Mass., to the End of the Year 1849.* Topsfield, Mass., 1913.

Anderson, Edward P. "The Intellectual Life of Pittsburgh, 1786-1836: VIII, Painting," *Western Pennsylvania Historical Magazine,* XIV, Oct. 1931, 288-93.

Andes, Martin L. "Augustus Neynabor, Chester County Folk Artist," *Chester County* [Pa.] *Collections.* No. 9, Jan. 1938, 335-6.

Andrews, Wayne. "The Baroness Was Never Bored: The Baroness Hyde de Neuville's Sketches of American Life 1807-1822," *New-York Historical Society Quarterly,* XXXVIII, April 1954, 105-17.

Angle, Paul M., "Jevne and Almini," *Chicago History,* I, Spring 1948, 313-16.

Annals of San Francisco, by Frank Souls, John H. Gihon, and James Nisbet. New York, *1855.*

Apollo Association [New York], annual exhibition catalogues, 1839-43 [described and indexed in Cowdrey, *American Academy and American Art-Union].*

———— *Transactions,* 1839-43 [described in Cowdrey, *American Academy and American Art-Union,* I, 243-6].

Armstrong, David M. *Day Before Yesterday.* New York, 1920.

Arnold, John N. *Art and Artists in Rhode Island.* Providence, 1905.

Arrington, I. Earl. "Henry Lewis's Moving Panorama of the Mississippi River," *Louisiana History* 6 (Summer, 1965), 245-49.

———— "Leon D. Pomarede's Original Panorama of the Mississippi River," *Missouri Historical Society Bulletin,* IX, April 1953, 261-73.

———— "Nauvoo Temple." Unpublished manuscript.

———— "Samuel A. Hudson's Panorama of the Ohio and Mississippi Rivers," *Ohio Historical Quarterly* 66 (October 1957), 355-74.

———— "Samuel B. Stockwell and His Mississippi Panorama," unpublished manuscript.

———— "The Story of Stockwell's Panorama," *Minnesota History,* XXXIII, Autumn 1953, 284-90.

"Art and Artists in Manchester," *Manchester* [N.H.] *Historic Association Collections,* IV, Part I (1908), 109-28.

Art and Artists of the Mystic, Connecticut Area, 1700-1950. Exh. cat., with essays by B. MacDonald Steers and Barbara Reed. Mystic, Conn.: Mystic Art Association Gallery, 1976.

Art by American Women: Selections from the Collection of Louise and Alan Sellars. Exh. cat., with introduction by Louise and Alan Sellars. Gainesville, Ga.: Brenau College, 1991.

Art in Connecticut: Between World Wars. Exh. material. William Benton Museum of Art, University of Connecticut, Storrs, Conn., 1994.

Art in Connecticut: Early Days to the Gilded Age. Exh. material. William Benton Museum of Art, University of Connecticut, Storrs, Conn., 1992.

Art in Connecticut: The Impressionist Years. Exh. material. William Benton Museum of Art, University of Connecticut, Storrs, Conn., 1993.

Arthur, Helen. "Thomas Sparrow, an Early Maryland Engraver," *Antiques,* LV, Jan. 1949, 44-5.

Artistic Heritage of Newport and the Narragansett Bay. Exh. cat. Newport, R.I.: William Vareika Fine Arts, 1990.

Artists of the Rockport Art Association. Rockport, Mass.: Rockport Art Assoc., 1956.

Artists of the Rockport Art Association. Rockport, Mass.: Rockport Art Assoc., 1946.

Artists Year Book; A Handy Reference Book Wherein May Be Found Interesting Data Pertaining to Artists. Ed. by Arthur N. Hosking, Chicago, 1905.

Association of the Graduates of the U.S. Military Academy, *Annual Reunion,* 1896.

Audubon, John Woodhouse. *Audubon's Western Journal: 1849-50.* Cleveland, 1906.

Audubon, Maria Rebecca. *Audubon and His Journals.* New York, 1897.

Averill, Esther C. "Early Weathervanes Made in Many Styles and Forms," *American Collector,* II, Aug. 9, 1934, 7.

Avery, Lillian Drake. *A Genealogy of the Ingersoll Family in America, 1629- 1925.* New York, 1926.

B

Bachman, C. L., ed. *John Bachman, the Pastor of St. John's Lutheran Church, Charleston.* Charleston, 1888.

Bagg, M. M., ed. *Memorial History of Utica, N.Y.* Syracuse, 1892.

BAI (Brooklyn Artists Index). Compiled by Dr. Clark S. Marlor, database available at the Brooklyn Museum, Art Reference Library.

Baigell, Matthew. *Dictionary of American Art.* 1979. Reprint, New York: Harper & Row, 1982.

———— *The American Scene, American Painting of the 1930s.* New York, 1974.

Baker, C. H. Collins. "Notes on Joseph Blackburn and Nathaniel Dance," *Huntington Library Quarterly,* IX, Nov. 1945, 33-47.

Baker, Charles E. "The Story of Two Silhouettes," *New-York Historical Society Quarterly,* XXXI, Oct. 1947, 218-28.

Baker, George Holbrook.. "Records of a California Journey," *Society of California Pioneers Quarterly,* VII, Dec. 1930, 217-43.

———— "Records of a California Residence," *Society of California Pioneers Quarterly,* VIII, March 1931, 39-70.

Baker, Mary E. *Folklore of Springfield.* Springfield, Vt., 1922.

Baker, William S. *American Engravers and Their Works.* Philadelphia, 1875.

———— *The Engraved Portraits of Washington, with Notices of the Originals and Brief Biographical Sketches of the Painters.* Philadelphia, 1880.

Baldwin. Christopher Columbus. *Diary of Christopher Columbus Baldwin, Librarian of the American Antiquarian Society, 1829-1835.* Worcester, 1901.

Ball, Thomas. *My Three Score Years and Ten.* Boston, 1891.

Ballou, Adin. *An Elaborate History and Genealogy of the Ballous in America.* Providence, 1888.

Bancroft, Hubert Howe. *History of the Pacific States of North America.* Vol. XVII: *California, 1846-48.* San Francisco, 1886.

Banvard; or, the Adventures of an Artist. Paternoster Road, London, nd.

"Baptisms from 1639 to 1730 in the Reformed Dutch Church, N.Y.," *Collections of the New York Genealogical and Biographical Society,* II (1901), 228.

Barba, Preston A. *Balduin Molihausen, the German Cooper.* Philadelphia, 1914.

Barber, Gertrude A. "Deaths Taken from the New York Evening Post, Nov. 16, 1801-Dec. 31, 1890," typed manuscript, 1933-47, a copy of which is in the library of the New-York Historical Society.

———— "Index of Letters of Administration of New York County from 1743 to 1875." Typed manuscript, 1950-51, a copy of which is in the library of the New-York Historical Society.

Barber, John W. *The History and Antiquities of New England, New York, New Jersey, and Pennsylvania.* Hartford, 1856.

Barck, Dorothy C. "John Rogers, American Sculptor," *Old-Time New England,* XXIII, Jan. 1933, 99-114.

Barker, Virgil. *American Painting, History and Interpretation.* New York, 1950.

Barnouw, Adriaan Jacob. "A Life of Albertus Van Beest," *Rotterdam Year Book,* Rotterdam, Neth., 1919.

Barr, Lockwood. "William Fans, Annapolis Clockmaker," *Antiques,* XXXVII, April 1940, 174-6.

Bartholomew, George W., Jr. *Record of the Bartholomew Family.* Austin, 1885.

Bartholomew, Henry S. K. *Pioneer History of Elkhart, Ind.* Goshen, 1930.

Bartlett, Joseph G. *Simon Stone Genealogy: Ancestry and Descendants of Deacon Simon Stone of Watertown, Mass., 1320-1926.* Boston, 1926.

Bartlett, John Russell. *Personal Narrative of Explorations and Incidents in Texas, New Mexico, California, Sonora, and Chihuahua.* New York and London, 1854.

Bartlett, Truman Howe. *The Art Life of William Rimmer, Sculptor, Painter and Physician.* Boston, 1882.

Bartlow, Bert S., and others. *Centennial History of Butler County, Ohio.* B. F. Bowen & Co., 1905.

Bassett, John Spencer, ed. *Correspondence of Andrew Jackson.* Washington, 1926-35.

Bates, Albert Carlos. *An Early Connecticut Engraver and His Work.* Hartford, 1906.

Bathe, Greville and Dorothy. *Jacob Perkins, His Inventions, His Times, and His Contemporaries.* Philadelphia, 1943.

Baur, John I. H. *An American Genre Painter: Eastman Johnson, 1824-1906.* Brooklyn Museum, 1940.

———— ed. "The Autobiography of Worthington Whittredge, 1820-1910," *Brooklyn Museum Journal,* I (1942), 5-68.

———— "Eastman Johnson, Artist-Reporter," *American Collector,* IX, Feb. 1940, 6-7.

———— *John Quidor, 1801-1881.* Brooklyn Museum, 1942.

———— "The Peales and the Development of American Still Life," *Art Quarterly,* III, Winter 1940, 81-92.

———— "A Romantic Impressionist: James Hamilton," *Brooklyn Museum Bulletin,* XII, Spring 1951, 1-9.

———— "A Tonal Realist: James Suydam," *Art Quarterly,* XIII, Summer 1950, 221-27.

———— "Unknown American Painters of the 19th Century," *College Art Journal,* VI, Summer 1947, 277-82.

———— "American Luminism," *Perspectives USA* no. 9 (Autumn 1954): 90-98.

Bayley, Frank W. "An Early New England Limner-Some Account of the Recently Discovered Portraits of Mr. and Mrs. Jeremiah Dummer, Painted by Him," *Old-Time New England,* XII, July 1921, 3-5.

———— *Little Known Early American Portrait Painters,* Boston, 1915-17; five pamphlets issued "with the compliments of the Copley Gallery, Boston."

BD Business Directory (see discussion at beginning of BIB-LIOGRAPHY section)

Bearden, Romare, and Harry Henderson. *A History of African-American Artists, from 1792 to the Present.* New York: Pantheon Books, 1993.

Beardsley, Eben E. *Life and Times of William Samuel Johnson.* New York, 1876.

Beardsley, William A. "An Old New England Engraver and His Work: Amos Doolittle," *Papers of the New Haven Colony Historical Society,* VIII (1914), 132-50.

Beckwith, Lt. E. G. "Report of Exploration of a Route for the Pacific Railroad from the Mouth of the Kansas to Sevier River, in the Great Basin," 33 Cong., 1 Sess., *House Exec. Doc.* 129.

Beckwith, Hiram Williams. *History of Montgomery County* [Ind.]. Chicago, 1881.

Beers' *History of York County, Pa.,* by George R. Prowell, Chicago, J. H. Beers & Co., 1907.

Belknap, Henry W. *Artists and Craftsmen of Essex County, Mass.* Salem, 1927.

Belknap, Waldron Phoenix, Jr. "The Identity of Robert Feke," *Art Bulletin,* XXIX, Sept. 1947, 201-7.

Bender, Horace. see Horatio Greenough.

Bénézit, E. *Dictionnaire des Peintres, Sculpteurs, Dessinateurs et Graveurs.* Rev. & enl. ed. Paris: Librarie Gründ, 1976.

Benisovich, Michel N. "Roslin and Wertmüller, Some Unpublished Documents," *Gazette des Beaux Arts,* VI Ser., XXV, April 1944, 221-30.

———— "The Sale of the Studio of Adolph Ulrich Wertmüller," *Art Quarterly,* XVI, Spring 1953, 21-39.

Benjamin, Samuel G. W. "Fifty Years of American Art, 1828-1878," *Harper's New Monthly Magazine,* LIX, July 1879, 241- 57; Sept. 1879, 481-96; Oct. 1879, 673-88.

———— *Our American Artists.* Boston, 1879.

Bennet, James O'Donnell. *The Mask of Fame; The Heritage of Historical Life Masks Made by John Browere, 1825 to 1833.* With Everett L. Millard, Highland Park, Ill., 1938.

Bennett, H. Selfe. "The Story of Two Old Prints," *Art in America,* VI, Aug. 1918, 240-8.

Bentley, William. *The Diary of William Bentley* [1784-1819], Salem, 1905-14.

Bermuda Historical Society, *Loan Exhibition of Portraits. XVII, XVIII, and XIX Centuries.* Hamilton, Bermuda, 1935.

Bernard du Hautcilly, Auguste. *Voyage Autour du Monde, Principalement à la Californie et aux Iles Sandwich, Pendant les Années 1826, 1827, 1828, et 1829.* Paris 1834-35.

Bert, Catherine. *Sketches, An Art Journal (of The Providence Art Colony)* No. 1 (Dec. 1990).

———— *Sketches, An Art Journal (of The Providence Art Colony)* No. 2 (Dec. 1991).

Biddle, Edward, and Mantle Fielding. *The Life and Works of Thomas Sully.* Philadelphia, 1921.

Bigot, Marie (Healy). *Life of George P. A. Healy, by His Daughter Mary (Madame Charles Bigot) followed by a Selection of His Letters* (np., nd.).

Bingham, George Caleb. "Letters of George Caleb Bingham to James S. Rollins," edited by C. B. Rollins, *Missouri Historical Review,* XXXII (1937-38), 3-34, 164-202, 340-77, 484-522; XXXIII (1938-39), 45-78, 203-29, 349-84, 499-526.

Biographical Record of Clark County, Ohio. New York and Chicago, 1902.

Biographie Universelle. Paris, Mechaud Frères, 1811-62, 85 vols.

Bishop, Edith. *Oliver Tarbell Eddy 1799- 1868. A Catalogue of His Works . . . in Connection with an Exhibition Shown at The Newark Museum, March 28-May 7, 1950, The Baltimore Museum of Art, May 28-June 25, 1950.*

Blanchard, Julian. "The Durand Engraving Companies," *Essay Proof Journal,* Nos. 26-8, April and July 1950, Jan. 1951.

Bland Galleries [New York]. *Exhibition of Southern Genre Paintings by William Aiken Walker.* Exh. catalogue, Feb.-March 1940.

Blasdale, Mary Jean. *Artists of New Bedford, A Biographical Dictionary.* New Bedford, Mass.: New Bedford Whaling Museum, with the Old Dartmouth Historical Society, 1990.

Blaugrund, Annette. *Paris 1889: American Artists at the Universal Exposition.* Pennsylvania Academy of the Fine Arts, Philadelphia, in assoc. with Harry N. Abrams, New York, 1989.

Bloch, E. Maurice. "The American Art-Union's Downfall," *New-York Historical Society Quarterly,* XXXVII, Oct. 1953, 331-59.

Bodley Book Shop, Catalogue No. 80: "Books with a Selection of Autograph Material" (1945).

Boggs, William E. *The Genealogical Record of the Boggs Family, the Descendants of Ezekiel Boggs.* Halifax, 1916.

Bolton, Charles Knowles. *The Founders; Portraits of Persons Born Abroad Who Came to the Colonies in North America before the Year 1701.* Boston, 1919-26.

———— "Workers with Line and Color in New England," manuscript volume at the Boston Athenaeum.

Bolton, Ethel Stanwood. *American Wax Portraits.* Boston, 1929.

———— *Wax Portraits and Silhouettes.* Boston, 1914.

Bolton, Theodore. "Benjamin Trott," *Art Quarterly,* VII, Autumn 1944, 257-90.

———— "The Book Illustrations of F. O. C. Darley," *Proceedings of the American Antiquarian Society,* LXI, Part I,

April 1951, 136-82.

———— "Charles Loring Elliott; An Account of his Life and Work" and "A Catalogue of the Portraits Painted by Charles Loring Elliott," *Art Quarterly*, V, Winter 1942, 59-96.

———— *Crayon Draftsmen*. Full title: *Early American Portrait Draughtsmen in Crayons*. New York, 1923.

———— "Henry Inman, an Account of His Life and Work" and "Catalogue of the Paintings of Henry Inman," *Art Quarterly*, III, Autumn 1940, 353-75, and Supplement, 401-18.

———— "James Sharples," *Art in America*, XI, April 1923, 137-43.

———— "John Hazlitt," *Essex Institute Historical Collections*, LVI, Oct. 1920, 293-6.

———— "John Watson of Perth Amboy, Artist," *Proceedings of the New Jersey Historical Society*, LXXII, Oct. 1954, 233-47.

———— "Manasseh Cutler Torrey," *Essex Institute Historical Collections*, LVII, April 1921, 148-9.

———— *Miniature Painters*. Full title: *Early American Portrait Painters in Miniature*. New York, 1921.

———— *Peale Family Exhibition, Century Association, 1953*. New York, 1953.

———— "Portrait Painters in Oil." Full title: "Early American Portrait Painters in Oil," unpublished manuscript at New-York Historical Society.

———— "Saint-Mémin's Crayon Portraits," *Art in America*, IX, June 1921, 160-7.

———— and Harry L. Binsse. "Robert Feke, First Painter to Colonial Aristocracy," *Antiquarian*, XV, Oct. 1930, 32-7, 74-82.

———— and Harry L. Binsse. "Wollaston, an Early American Portrait Manufacturer," *Antiquarian*, XVI, June 1931, 30-3, 50, 52.

———— and Irwin F. Cortelyou. *Ezra Ames of Albany, Portrait Painter, Craftsman, Royal Arch Mason, Banker, 1768-1836 and a Catalogue of His Works*. New York, 1955.

———— and George C. Groce. "John Hesselius, an Account of His Life and the First Catalogue of His Portraits," *Art Quarterly*, II, Winter 1939, 77-91.

———— and George C. Groce. "John Wesley Jarvis, an Account of His Life and the First Catalogue of His Work," *Art Quarterly*, I, Autumn 1938, 299-321.

———— and Ruel P. Tolman. "Catalogue of Miniatures by or Attributed to Benjamin Trott," *Art Quarterly*, VII, Autumn 1944, 278-90.

Born, Wolfgang. *American Landscape Painting; An Interpretation*. New Haven, 1948.

———— "The Female Peales: Their Art and Its Tradition," *American Collector*, XV, Aug. 1946, 12-14.

———— "Notes on Still Life Painting in America," *Antiques*, L, Sept. 1946, 158-60.

———— *Still-Life Painting in America*. New York, 1947.

Borneman, Henry S. "Thomas Buchanan Read, The Odyssey of an Artist, 1822- 1872," in *Yesterday in Chester County Art*, by Henry J. Pleasants and others, West Chester, Pa., 1936.

Borneman, Richard R. "Franzoni and Andrei: Italian Sculptors in Baltimore, 1808," *William and Mary Quarterly*, 3d Ser., X, Jan. 1953, 108-11.

Borough of Manhattan. *Deaths Reported in 1901*. New York, Dep't of Health, 1902.

Borthwick, J. D. *Three Years in California*. Edinburgh and London, 1857; republished in New York, 1927, as *The Gold Hunters*, ed. by Horace Kephart.

Boston Art Club. (see Chadbourne, Janice)

Boston Athenaeum, annual exhibition catalogues, 1827-30,

1833-48, 1850-51, 1853, 1856-60.

Boston Marriages, 1752-1809.

Boston, Mass., Registry Dept. *Records Relating to the Early History of Boston*, Vol. XXX, Boston, 1903.

Boston. Museum of Fine Arts. *Catalogue of Paintings*. Boston, 1921.

Bowditch, Harold. "Early Water-Color Paintings of New England Coats of Arms," *Publications of the Colonial Society of Massachusetts*, XXXV (Boston, 1951), 172-210.

———— "The Gore Roll of Arms," *Rhode Island Historical Society Collections*, XXIX (1936), 11-30, 51-64, 92-6, 121-8; XXX (1937), 28-32, 54-64, 88-96, 116-28; XXXI (1938), 24-32, 56-64, 90-6, 124-8.

———— "Heraldry and the American Collector," *Antiques*, LX, Dec. 1951, 538-41.

Bowen, Clarence W., ed. *History of the Centennial Celebration of the Inauguration of George Washington*. New York, 1892.

Bowen, Clarence W. *History of Woodstock, Conn*. Norwood, Mass., 1926-43.

Bowen, John T. *The United States Drawing Book*. Philadelphia, 1839.

Bowes, Frederick P. *The Culture of Early Charleston*. Chapel Hill, 1942.

Bowyer, Campbell T. *Harvey Mitchell, Virginia Painter*. Bedford Democrat, 1952.

Boxborough, Mass. *Vital Records of Boxborough, Mass., to the Year 1850*. Boston, 1915.

Brackenridge, H. M. *Recollections of Persons and Places in the West*. 2nd ed., Philadelphia, 1868.

Bradbury, Anna R. *History of the City of Hudson, New York*. Hudson, 1908.

Brainard, Newton C. "Isaac Sanford," *Connecticut Historical Society Bulletin*, XIX, Oct. 1954, 122.

Brandywine River Museum. *Catalogue of the Collection, 1969-89*. Chadds Ford, Pa.: Brandywine Conservancy, 1991.

Brewington, Dorothy E.R. *Dictionary of Marine Artists*. Peabody Museum of Salem, Mass., and Mystic Seaport Museum, Mystic, Conn., 1982

"Brief Notes on Some Deceased Artists." *Publications of the Rhode Island Historical Society*, New Ser., III (1895), 107-11.

Brief Sketch of the Life of Mary Smith, the Painter. Philadelphia, 1878.

Brigham, Clarence S. "Notes on the Thomas Family Portraits," *Proceedings of the American Antiquarian Society*, LVI (Worcester, 1947), 49-54.

———— *Paul Revere's Engravings*. Worcester, 1954.

Brigham, Willard I. T. *The Tyler Genealogy*. Plainfield, N.J., 1912.

Brinton, Christian. "Gustavus Hesselius," in Philadelphia Museum of Art, *Gustavus Hesselius, 1682-1755*. Exh cat., 1938.

Brooklyn Art Association. (see Marlor, Clark S. *A History of the Brooklyn Art Association with an Index of Exhibitions*)

Brockway, Jean Lambert. "The Miniatures of James Peale," *Antiques*, XXII, Oct. 1932, 130-4.

Brooklyn Museum of Art. *The New Path: Ruskin and the American Pre-Raphaelites*. Brooklyn, N.Y.: Brooklyn Museum of Art, 1985.

Brooks, Alfred M. "Fitz Lane's Drawings," *Essex Institute Historical Collections*, LXXXI, Jan. 1945, 83-6.

Brown, Alexander. *The Cabells and Their Kin*. Boston and New York, 1895.

Brown, Bruce. "Two Versions of the Arkansas Traveler," *American Collector*, VI, May 1937, 6.

Brown, H.Glenn and Maude O. *A Directory of the Book-Arts and Book Trade in Philadelphia to 1820, Including Painters and Engravers*. New York, 1950; reprinted from *New York Public Library Bulletin*, May 1949-March 1950.

Brown, Jennie Broughton. *Fort Hall on the Oregon Trail, a Historical Study.* Caldwell, Idaho, 1932.

Brown, Mary Louise. "John Welch, Carver," *Antiques,* IX, Jan. 1926, 28-30.

Brown, Milton. *The Story of the Armory Show.* 2nd. ed. New York: Abbeville Press and the Joseph Hirshhorn Foundation, 1988.

Brown, Ralph Hall. *Mirror for Americans; Likeness of the Eastern Seaboard 1810.* New York, 1943.

Brown, Roscoe C. E. *Church of the Holy Trinity, Brooklyn Heights in the City of New York, 1847-1922.* New York, 1922.

Brown, William Henry. *Portrait Gallery of Distinguished American Citizens.* Hartford, 1845; reissued at Troy, N.Y., in 1925 and at New York in 1931.

Brown, William Wells. *The Rising Sun; or, The Antecedents and Advancement of the Colored Race.* 13th ed., Boston, 1882.

Brunet, Pierre. *Descriptive Catalogue of a Collection of Water-Colour Drawings by Alfred Jacob Miller (1810-1874) in the Public Archives of Canada.* Ottawa, 1951.

Bryan, Michael. *Bryan's Dictionary of Painters and Engravers.* Ed. by George C. Williamson, London, 1903-05.

Buffet, Edward P. "William Sidney Mount, A Biography," published serially in *The Port Jefferson* [N.Y.] *Times,* 1923-24.

"Burial Records of Philadelphia Board of Health, 1807-1814," manuscript, Genealogical Society of Pennsylvania, Philadelphia.

"Burials in the Dutch Church, N.Y.," *Year Book of the Holland Society, 1899* (New York, 1899), 139-211.

Burke, William. *Mineral Springs of Western Virginia, with Remarks on Their Use.* New York, 1842.

Burnaby, Andrew. *Travels Through the Middle Settlements in North-America, in the Years 1759 and 1760.* 3d ed., London, 1798.

Burnet, Mary Q. *Art and Artists of Indiana.* New York, 1921.

Burnham, Roderick H. *The Burnham Family.* Hartford, 1869.

Burr, Frederick M. *Life and Works of Alexander Anderson.* New York, 1893.

Burroughs, Alan. *John Greenwood in America, 1745-1752.* Andover, Mass., 1943.

——— "A Letter from Alvan Fisher," *Art in America,* XXXII, July 1944, 117-26.

——— *Limners and Likenesses; Three Centuries of American Painting.* Cambridge, 1936.

——— "Paintings by Nathaniel Smibert," *Art in America,* XXXI, April 1943, 88-97

Burroughs, Clyde H. "Painting and Sculpture in Michigan," *Michigan History Magazine,* XX, Autumn 1936, 395-409; XXI, Winter 1937, 39-54.

Burroughs, Louise. "An Inscription by John Hesselius on a Portrait in the Metropolitan Museum of Art," *Art Quarterly,* IV, Spring 1941, 110-14.

Bury, Edmund. "Raphaelle Peale (1774-1825), Miniature Painter," *American Collector,* XVII, Aug. 1948, 6-9.

Bushnell, David I., Jr. "Drawings by George Gibbs in the Far Northwest, 1849-1851," *Smithsonian Miscellaneous Collections,* XCVII, No. 8, Dec. 30, 1938.

——— "Friedrich Kurz, Artist-Explorer," Smithsonian Institution *Annual Report,* 1927 (Washington, 1928), 507-27.

——— "John Mix Stanley, Artist-Explorer," Smithsonian Institution *Annual Report,* 1924 (Washington, 1925): 507-12.

——— "John White; The First English Artist to Visit America, 1585," *The Virginia Magazine,* XXXV, Oct. 1927, 419-30; XXXVI, Jan. 1928, 17-26, April 1928, 124-34.

——— "Seth Eastman, Master Painter of the North American Indian," *Smithsonian Miscellaneous Collections,* LXXXVII, No. 3, April 1932.

Butts, Porter. *Art in Wisconsin.* Madison, 1936.

Bye, Arthur E. "Edward Hicks," *Art in America,* XXXIX, Feb. 1951, 25-35.

——— "Edward Hicks, Painter-Preacher," *Antiques,* XXIX, Jan. 1936, 13-16.

C

CAB. *Appleton's Cyclopaedia of American Biography.* Ed. by James Grant Wilson and John Fiske, New York, 1887-89.

——— (rev. ed.). *Appleton's Cyclopaedia of American Biography.* Edited by James Grant Wilson and John Fiske, rev. ed., New York, 1898-1900.

Cabinet of Genius Containing All the Theory and Practice of the Fine Arts, No. I, New York, 1808.

Cabot, Mary R. *Annals of Brattleboro, 1681-1895.* Brattleboro, Vt., 1921-22.

Cahill, Holger. "Artisan and Amateur in American Folk Art," *Antiques,* LIX, March 1951, 210-11.

Caldwell, Henry Bryan. "John Frazee, American Sculptor." Master's Thesis, New York University, Graduate School, 1951.

Calo, Carole Gold. "Aspects of Wood Sculpture in America During the 1950s." Ph.D. diss., Boston University, 1986.

Campbell, Catherine H. *New Hampshire Scenery: A Dictionary of Nineteenth-Century Artists of New Hampshire Mountain Landscapes.* Canaan, N.H.: Phoenix Publishing for the New Hampshire Historical Society, 1985.

Campbell, Orson. *Treatise on Carriage, Sign and Ornamental Painting.* Scott, N.Y., and De Ruyter, N.Y., 1841.

Campbell, Patrick. *Travels in the Interior Inhabited Parts of North America in the Years 1791 and 1792.* Edinburgh, 1793; republished, with introduction and notes by H. H. Langton and W. F. Ganong, by The Champlain Society, Toronto, 1937.

Carlock, Grace Miller. "William Rickarby Miller (1818-1893)," *New-York Historical Society Quarterly,* XXXI, Oct. 1947, 199-209.

Carolina Art Association, *Cat.* 1935. Carolina Art Association, *Exhibition of Miniatures from Charleston and Its Vicinity Painted Before the Year 1860.* Charleston, Gibbes Memorial Art Gallery, 1935.

——— *Cat.* 1936. Carolina Art Association, *An Exhibition of Miniatures Owned in South Carolina and Miniatures of South Carolinians Owned Elsewhere Painted Before the Year 1860.* Charleston, Gibbes Memorial Art Gallery, 1936.

——— *Catalogue with a Short Sketch of Charles Fraser and List of Miniatures Exhibited Jan./Feb. 1934.* Charleston, 1934.

——— manuscript on miniatures. Unpublished *catalogue raisonné* of American miniatures of South Carolinians, prepared by Anna Wells Rutledge for the Carolina Art Association.

Carpenter, Helen G. *The Reverend John Graham of Woodbury, Ct., and His Descendants.* Chicago, 1942.

Carr, Cornelia, ed. *Harriet Hosmer: Letters and Memories.* New York, 1912.

Carrick, Alice V. L. "Novelties in Old American Profiles," *Antiques,* XIV, Oct. 1928, 322-7.

——— "The Profiles of William Bache," *Antiques,* XIV, Sept. 1928, 220-4.

——— "Profiles Real and Spurious," *Antiques,* XVII, April 1930, 320-4.

——— *Shades of Our Ancestors; American Profiles and Profilists.* Boston, 1928.

——— "Silhouettes," *Antiques,* VI, Aug. 1924, 84-9; VIII,

Dec. 1925, 341-4.

Carroll, Dana H. *Fifty-eight Paintings by Homer D. Martin.* New York, 1913.

Carvalho, Solomon N. *Incidents of Travel and Adventure in the Far West.* New York and Cincinnati, 1857.

Casazza, Elaine Ward. *The Brushians.* Privately published. Liminton, Maine, 1996.

Catalogue of the Belknap Collection. Full citation is John Marshall Phillips, Barbara N. Parker, and Kathryn C. Buhler, eds. *The Waldron Phoenix Belknap, Jr., Collection of Portraits and Silver, with a Note on the Discoveries of Waldron Phoenix Belknap, Jr., Concerning the Influence of the English Mezzotint on Colonial Painting.* Cambridge, 1955.

Catalogue of the Works of Art Exhibited in the Alumni Building, Yale College, 1858. New Haven, 1858.

Catesby, Mark. *The Natural History of Carolina, Florida and the Bahama Islands.* London, 1731-43.

Catlin, George. *Letters and Notes on the Manners, Customs, and Condition of the North American Indians.* London, 1841

CD City Directory (see discussion at beginning of BIBLI-OGRAPHY section).

Cederholm, Theresa Dickason, ed. and compiler. *Afro-American Artists, A Bio-bibliographical Directory.* Boston: Boston Public Library, 1973.

Centennial Exhibition, 1889-1989 By Members Past and Present of the National Association of Women Artists. Selections from the Collection of Louise and Alan Sellars. Exh. cat., Gainesville, Ga.: Brenau College, 1990.

Chadbourne, Janice (with Karl Gabosh, and Charles O. Vogel, compilers & eds.). *Boston Art Club: Exhibition Record, 1873-1909.* Madison, Conn.: Sound View Press, 1991.

Chadwick, Whitney. *Women, Art, and Society.* Rev. ed. London: Thames and Hudson, 1997.

Chamberlain, Georgia S. "Bas-Relief Portraits by Salathiel Ellis," *Antiques Journal,* IX, Oct. 1954, 23, 39.

———— "John Reich, Assistant Engraver to the United States Mint," *The Numismatist,* LXVIII, March 1955, 242-9.

———— "Medals Made in America by Moritz Furst," *The Numismatist,* LXVII, Sept. 1954, 937-43; Oct. 1954, 1075-80.

———— "Moritz Furst, Die-Sinker and Artist," *The Numismatist,* LXVII, June 1954, 588-92.

———— "Salathiel Ellis: Cameo-Cutter, Sculptor, Artist of Nineteenth Century America," *Antiques Journal,* IX, Feb. 1954, 36-7.

———— "A Woodside Still Life," *Antiques,* LXVII, Feb. 1955, 149.

Chamberlain, George Walter, and Lucia Glidden Strong. *The Descendants of Charles Glidden of Portsmouth and Exeter, N.H.* Boston, 1925.

Chambers, Bruce W. *The World of David Gilmour Blythe.* Exh. cat. Washington, D.C.: National Museum of American Art, 1980.

Champlin, John D., and Charles C. Perkins, eds. *Cyclopedia of Painters and Paintings.* New York, 1886-87.

Champney, Benjamin. *Sixty Years' Memories of Art and Artists.* Woburn, Mass., 1900.

Chandler, George. *The Chandler Family; The Descendants of William and Annis Chandler.* Worcester, 1883.

Chapin, Howard M. *Cameo Portraiture in America.* Providence, 1918.

———— "George Oliver Annibale," *Rhode Island Historical Society Collections,* XXII, Oct. 1929, 119-28.

Charles Woodbury and His Students. Exh. cat. Ogunquit, Maine: Ogunquit Museum of American Art, 1998.

Chatterton, Elsie B. "A Vermont Sculptor," *News and Notes* (Vermont Historical Society), VII, Oct. 1955, 10-14.

Cheney, Ednah Dow, ed. *Louisa May Alcott, Her Life, Letters, and Journals.* Boston, 1889.

———— *Memoir of John Cheney, Engraver.* Boston, 1889.

———— *Memoir of Seth W. Cheney, Artist.* Boston, 1881.

Chew, Paul, A. ed. *Southwestern Pennsylvania Painters, 1800-1945.* Greensburg, Pa.: The Westmoreland County Museum of Art, 1981.

Childs, Cephas G. *Views of Philadelphia from Original Drawings Taken in 1827-1830.* Philadelphia, 1827-30.

Childs, Charles D. "Robert Salmon, a Boston Painter of Ships and Views," *Old-Time New England,* XXVIII, Jan. 1938, 91-102.

———— "Thar She Blows: Some Notes on American Whaling Pictures," *Antiques,* XL, July 1941, 20-3.

Chinard, Gilbert, ed. *Houdon in America: A Collection of Documents in the Jefferson Papers in the Library of Congress.* Baltimore, 1930.

Chittenden, Hiram M., and Alfred T. Richardson. *Life, Letters and Travels of Father Pierre-Jean De Smet, S.J.* New York, 1905.

Christ-Janer, Albert. *George Caleb Bingham of Missouri, the Story of an Artist.* New York, 1940.

Cist, Charles. *Cincinnati in 1841.* Cincinnati, 1841.

———— *Sketches and Statistics of Cincinnati in 1851.* Cincinnati, 1851.

———— *Sketches and Statistics of Cincinnati in 1859.* Cincinnati, 1859.

City Art Museum of St. Louis (see Saint Louis Art Museum)

City Life Illustrated, 1890-1940. Exh. cat. Wilmington, Del.: Delaware Art Museum, 1980.

Clark, Alvan. "Autobiography of Alvan Clark," by Hon. Win. A. Richardson, *New-England Historical and Genealogical Register,* CLXIX, Jan. 1889, 52-8.

Clark, Edna M. *Ohio Art and Artists.* Richmond, Va., 1932.

Clark, Eliot C. *Alexander Wyant.* New York, 1916.

———— *History of the National Academy of Design, 1825-1953.* New York, 1954.

———— *Theodore Robinson: His Life and Art.* Chicago: R.H. Love Galleries, 1979.

Clarke, Hermann Frederick, and Henry Wilder Foote. *Jeremiah Dummer, Colonial Craftsman and Merchant, 1645-1718.* Boston, 1935.

Clarke, John Lee, Jr. "Joseph Whiting Stock," in Lipman and Winchester, *Primitive Painters in America, 1750-1950.* New York, 1950.

Clarke, Thomas Wood. *Emigrés in the Wilderness,* New York, 1941.

Cleland, Robert G. *A History of California; The American Period.* New York, 1922.

Clement, Clara Erskine, and Laurence Hutton. *Artists of the Nineteenth Century and Their Works.* 4th ed., revised. Two volumes. Boston: Ticknor and Company, 1879, 1884.

Cline, Isaac M. "Art and Artists in New Orleans Since Colonial Times," in Louisiana State Museum, *Biennial Report of the Board of Curators for 1920-21,* 32-42.

Coad, Oral Sumner. *William Dunlap, a Study of His Life and Works and of His Place in Contemporary Culture.* New York, 1917.

Coburn, Frederick W. "The Johnstons of Boston," *Art in America,* XXI, Dec. 1932, 27-36; Oct. 1933, 132-8.

———— "Mather Brown," *Art in America,* XI, Autumn 1923, 252-60.

———— "More Notes on Peter Pelham," *Art in America,* XX, June-Aug. 1932, 143-54.

———— *Thomas Bayley Lawson; Portrait Painter of Newburyport and Lowell, Mass.,* Salem, 1947.

———— "Thomas Child, Limner," *American Magazine of Art,*

XXI, June 1930, 326-8.

Cody, Edmund R. *History of the Coeur d'Alene Mission of the Sacred Heart.* Caldwell, Idaho, 1930.

Coe, Benjamin. *Easy Lessons in Landscape Drawing.* Hartford, 1840.

Coffin, Charles C. *The History of Boscawen and Webster* [N.H.] *from 1733 to 1878.* Concord, N.H., 1878.

Cohen, Hennig. "Robert Mills, Architect of South Carolina," *Antiques,* LV, March 1949, 198-200.

Coke, Edward Thomas. *A Subaltern's Furlough, Descriptive of Scenes in Various Parts of the United States, Upper and Lower Canada, New Brunswick, and Nova Scotia, During the Summer and Autumn of 1832.* London, 1833.

Colbert, Edouard Charles Victurnien, comte de Maulevrier. *Voyage dans l'Intérieur des Etats-Unis et au Canada,* with introduction and notes by Gilbert Chinard, Baltimore, 1935.

Colden, Cadwallader D. *Memoir Prepared at the Request of the Committee of the Common Council of the City of New York and Presented to the Mayor of the City, at the Celebration of the Completion of the New York Canals.* New York, 1825.

Cole, Gertrude S. "Some American Cameo Portraitists," *Antiques,* L, Sept. 1946, 170-1.

Cole, Thomas. "The Late Mr. Ver Bryck," in Cummings, *Historic Annals of the National Academy of Design* (Philadelphia, 1865), 182-4.

Coleman, J. Winston, Jr. "Joel T. Hart; Kentucky Sculptor," *Antiques,* LII, Nov. 1947, 367.

———— "Samuel Woodson Price, Kentucky Portrait Painter," *The Filson Club Historical Quarterly,* XXIII, Jan. 1949, 5-24.

Colonial Laws of New York. Albany, 1894.

Colton, Walter. *Three Years in California.* New York and Cincinnati, 1850.

Columbianum Cat. Exhibition of the Columbianum, or American Academy of Painting, Sculpture and Architecture, &c., Established at Philadelphia, 1795. Philadelphia, 1795.

Commemorative Biographical Record of Hartford County, Conn. Chicago, 1901.

Comstock, Helen. "American Watercolors Before 1860," *Panorama,* II, Aug-Sept. 1948, 3-12.

———— "The Complete Work of Robert Havell, Jr.," *Connoisseur,* CXXVI, Nov. 1950, 127.

———— "An 18th Century Audubon," *Antiques,* XXXVII, June 1940, 282-4.

———— "The Hoff Views of New York," *Antiques,* LI, April 1947, 250-2.

Community of Artists, Westport-Weston, 1900-85. Essays by Dorothy Tarrant and John Tarrant. Westport, Conn.: Westport-Weston Arts Council, 1985.

Complementary Visions of Louisiana Art: The Laura Simon Nelson Collection at the Historic New Orleans Collection. Essays by William H. Gerdts, George E. Jordan, and Judith H. Bonner. New Orleans: Historic New Orleans Collection, 1996.

Concerning Expressionism: American Modernism and the German Avant-Garde. Exh. cat., with introductory essay by Patricia McDonnell. New York: Hollis Taggart Galleries, 1998.

Cone, Bernard H. "The American Miniatures of Walter Robertson," *American Collector,* IX, April 1940, 6-7, 14, 20; May 1940, 24.

Connecticut Artists Collection. Waterbury: Mattuck Historical Society, 1968.

Connecticut and American Impressionism. Exh. cat, with essays by Jeffrey W. Anderson, Susan Larkin, and Harold Spencer. William Benton Museum of Art, University of Connecticut, Storrs, Conn. 1980.

Connecticut Historical Society. *Annual Report,* Hartford, May 1950.

Connecticut Historical Society. *Kellogg Prints.* Exh. catalogue, Hartford, 1952.

Cooke, George. "Sketches of Georgia," by G. C., *Southern Literary Messenger,* VI, 1840, 775-7.

Corcoran Cat. Corcoran Gallery of Art, *Handbook of the American Paintings in the Collection of the Corcoran Gallery of Art.* Comp. by E. B. Swenson. Washington, 1947.

Corcoran Gallery of Art, *150th Anniversary of the Formation of the Constitution; Catalogue of a Loan Exhibition of Portraits . . . Nov. 27, 1937 to Feb. 1, 1938.*

Corey, Deloraine P. *The Waite Family of Malden, Mass.* Malden, 1913.

Corn, Wanda M. *The Color of Mood: American Tonalism, 1880-1910.* San Francisco: M.H. de Young Memorial Museum, 1972.

Corning, A. Elwood. "Hoyle's Painting of Washington's Headquarters," Historical Society of Newburgh Bay and the Highlands, *Publication* No. XXX (1944), 17-18.

———— "Washington's Headquarters, Newburgh, N.Y.: A Painting," Historical Society of Newburgh Bay and the Highlands, *Publication* No. XXIX (1943), 5-7.

Cortelyou, Irwin F. "Henry Conover: Sitter, Not Artist," *Antiques,* LXVI, Dec. 1954, 481.

———— "A Mysterious Pastellist Identified," *Antiques,* LXVI, Aug. 1954, 122-4.

Cortissoz, Royal. *John LaFarge: A Memoir and a Study.* Boston and New York, 1911.

Cortland Academy [Homer, N.Y.], *Catalogue of the Trustees, Instructors and Students.* Homer, N.Y., 1836 and 1837.

Cowdrey, Mary Bartlett. *American Academy of Fine Arts and American Art-Union.* New York, 1953. Cited as Cowdrey, AA & AAU.

———— "Arthur Fitzwilliam Tait, Master of the American Sporting Scene," *American Collector,* XIII, Jan. 1945, 5, 18.

———— "Asher Brown Durand, 1796-1886," *Panorama,* II, Oct. 1946, 13-23.

———— "The Discovery of Enoch Wood Perry," *Old Print Shop Portfolio,* IV, April 1945, 169-81.

———— "Edward Lamson Henry, An American Genre Painter," *American Collector,* XIV, July 1945, 6-7, 12, 16.

———— *George Henry Durrie, 1820-1863, Connecticut Painter of American Life, Special Loan Exhibition, March 12-April 13, 1947.* Hartford, Wadsworth Athenaeum, 1947.

———— "Jasper F. Cropsey, 1823-1900, The Colorist of the Hudson River School," *Panorama,* I, May 1946, 85-94.

———— "Lilly Martin Spencer, 1822-1902, Painter of the American Sentimental Scene," *American Collector,* XIII, Aug. 1944, 6-7, 14, 19.

———— *The Mount Brothers: An Exhibition.* Stony Brook, N.Y., Suffolk Museum, 1947.

———— *National Academy of Design Exhibition Record, 1826-1860.* New York, 1943. Cited as Cowdrey, NAD.

———— "A Note on Emanuel Leutze," *Antiques,* XLIX, Feb. 1946, 110.

———— "The Return of John F. Kensett," *Old Print Shop Portfolio,* IV, Feb. 1945, 121-36.

———— "Richard Caton Woodville, An American Genre Painter," *American Collector,* XIII, April 1944, 6-7, 14, 20.

———— "Seth Eastman, Soldier and Painter, 1808-1875," *Panorama,* I, Feb. 1946, 50-6.

———— "The Stryker Sisters by Ralph Earl," *Art in America,* XXXVI, Jan. 1948, 55-7.

———— "William Henry Bartlett and the American Scene," *New York History,* XXII, Oct. 1941, 388-400.

———— *Winslow Homer: Illustrator.* Northampton, Mass., Smith College Museum of Art, 1951.

———— and Herman W. Williams, Jr., *William Sidney Mount, 1807-1868; An American Painter.* New York, 1944.

Cox, Kenyon. *Winslow Homer.* New York, 1914.

Cragsmoor Artists' Vision of Nature. Exh. cat., with essay by Kaycee Benton. Cragsmoor, N.Y.: Cragsmoor Free Library, 1977.

Cramer, Maurice B. "Henry FewSmith, Philadelphia Artist, 1821-1846," *Pennsylvania Magazine of History and Biography,* LXV, Jan. 1941, 31-55.

Crane, Ellery B. *Historic Homes and Institutions and Genealogical and Personal Memoirs of Worcester County, Mass.* New York and Chicago, 1907.

Craven, Thomas, ed. *Cartoon Cavalcade.* New York: Simon and Schuster, 1943.

Craven, Wayne. *Colonial American Portraiture.* Cambridge, England: Cambridge University Press, 1986.

———— *Sculpture in America, from the Colonial Period to the Present.* New York: Thomas Y. Crowell Co., 1968.

Crosby, Everett U. *Eastman Johnson at Nantucket; His Paintings and Sketches of Nantucket People and Scenes.* Nantucket, 1944.

Cross, Osborne. "Journey from Ft. Leavenworth, Kansas, to Ft. Vancouver," 31 Cong., 2 Sess., *Senate Exec Doc. 1,* 126-244; reprinted in Settle, *March of the Mounted Riflemen,* Glendale, Cal., 1940.

Crotty, Frank. *Provincetown Profiles and Others on Cape Cod.* Barre, Mass.: Barre Gazette, 1958.

Crouse, Russel. *Mr. Currier and Mr. Ives, A Note on Their Lives and Times.* Garden City, 1930.

Cullum, George W. *Biographical Register of the Officers and Graduates of the U. S. Military Academy . . . from Its Establishment in 1802 to 1890.* 3d ed., Boston and New York, 1891.

Cuming, Fortescue. *Cuming's Tour to the Western Country, 1807-09.* Reprinted in Thwaites, *Early Western Travels* (Cleveland, 1904), Vol. IV.

Cummings, Thomas S. *Historic Annals of the National Academy of Design.* Philadelphia, 1865.

Cunningham, Henry W. *Christian Remick, An Early Boston Artist.* Boston, 1904.

Currier, John J. *History of Newburyport, Mass., 1764-1909.* Newburyport, 1906-09.

Curtis, Jane, Will Curtis, and Frank Lieberman. *Monhegan: The Artists' Island.* Camden, Maine: Down East Books, 1995.

Czestochowski, Joseph S. *The American Landscape Tradition: A Study and Gallery of Paintings.* New York: E.P. Dutton, Inc., 1982.

D

DAB. *Dictionary of American Biography.* Ed. by Allen Johnson and Dumas Malone, New York, 1928-36.

Daingerfield, Elliott. *George Inness; The Man and His Art.* New York, 1911.

Dana, Charles A., ed. *The United States Illustrated; in Views of City and Country.* New York, c. 1855.

Danly, Susan. *Light, Air, and Color: American Impressionist Paintings from the Collection of the Pennsylvania Academy of the Fine Arts.* Exh. cat. Philadelphia: Pennsylvania Academy of Fine Arts, 1990.

Danvers, Mass. *Vital Records of Danvers, Mass., to the End of the Year 1849.* Salem, 1909-10.

Danvers [Mass.] Historical Society, *Historical Collections.* Danvers, 1913-.

Darrach, Charles G. "Christian Gobrecht, Artist and Inventor," *Pennsylvania Magazine of History and Biography,* XXX, July 1906, 355-8.

Dartmouth College, *General Catalogue of Dartmouth College and the Associated Schools, 1769-1900.* Hanover, N.H., 1900.

Davidson, Abraham. *Early American Modernist Painting, 1910-1935.* New York: Harper & Row, 1981.

———— *The Eccentrics and Other American Visionary Painters.* New York: E.P. Dutton, 1978.

———— *Ralph Albert Blakelock.* University Park, Pa: Pennsylvania State Univ. Press, 1996.

Davidson, Marshall. *Life in America.* Boston, 1951.

Davis, Curtis Carroll. "Fops, Frenchmen, Hidalgos, and Aztecs; Being a Survey of the Prose Fiction of J. M. Legaré of South Carolina (1823-1859)," *North Carolina Historical Review,* XXX, Oct. 1953, 524-60.

———— "Poet, Painter, and Inventor: Some Letters by James Mathewes Legaré," *North Carolina Historical Review,* XXI, July 1944, 215-31.

———— "The Several-sided James Mathewes Legaré: Poet," *Transactions of the Huguenot Society of South Carolina,* No. 57 (Charleston, 1952), 5-12.

Davis, Edw. Morris III. *A Retrospective Exhibition of the Work of John Adams Elder 1833-1895.* Richmond, Virginia Museum of Fine Arts, 1947.

Davis, William W. H. *History of Doylestown, Old and New, 1745-1900.* Doylestown, Pa., c. 1904.

Davisson, G. D. "William Keith," *Bulletin of the California Palace of the Legion of Honor Museum,* III, July 1945, 34-9.

Dawdy, Doris Ostrander. *Artists of the American West.* 3 vols. Chicago, Ill.: Sage Books, 1974.

Daywalt, Alberta T. "The Spirit of '76," *Antiques,* XL, July 1941, 24.

Decatur, Stephen. "The Conflicting History of Henry Dawkins, Engraver," *American Collector,* VII, Jan. 1939, 6-7.

———— "Richard Morell Staigg," *American Collector,* IX, Aug. 1940, 8-9.

———— "William Rollinson, Engraver," *American Collector,* IX, Dec. 1940, 8-9.

DeKay, Charles. *Illustrated Catalogue of Oil Paintings by the Late Alfred Cornelius Howland, NA., to be Sold.* New York, 1910.

Delafield, John. *An Inquiry into the Origin of the Antiquities of America.* New York, 1839.

Delafield, John Ross. *Delafield, The Family History.* New York, 1945.

Delgado-WPA. Isaac Delgado Museum of Art [now the New Orleans Museum of Art], Delgado Art Museum Project, W.P.A., "New Orleans Artists Directory, 1805-1940," unpublished.

de Mare, Marie. *G. P. A. Healy, American Artist; an Intimate Chronicle of the Nineteenth Century.* New York, 1954.

Demuth, C.B. "Aaron Eshleman," *Historical Papers and Addresses of the Lancaster County [Pa.] Historical Society,* XVI (1912), 247-50.

Descriptive Catalogue of Paintings with a Memoir of George Cooke [Prattville, Ala.?] 1853.

Detroit Institute of Arts. *The Quest for Unity: American Art Between World's Fairs, 1879-1893.* Exh. cat. Detroit: Founders Society, Detroit Institute of Arts, 1983.

———— *The French in America, 1520-1880.* Detroit, 1951.

De Voto, Bernard A. *Across the Wide Missouri.* Boston, 1947.

Dewhurst, C. Kurt, Betty MacDowell, and Marsha MacDowell. *Artists in Aprons: Folk Art by American Women.* New York: E. P. Dutton, in association with the Museum of American Folk Art, 1979.

Dexter, Arthur. "The Fine Arts in Boston," in Justin Winsor, *Memorial History of Boston.* (Boston, 1880-81), Vol. IV.

Dexter, Elizabeth W. A. *Career Women of America, 1776-1840.* Francestown, N.H., 1950.

Dexter, Franklin B. *Biographical Sketches of the Graduates of Yale College.* New York, 1885-1912.

Dexter, Orrando P. *Dexter Genealogy, 1642-1904*. New York, 1904.

Dialogues with Nature: Works by Charles Salis Kaelin 1858-1929. Exh. catalogue, with essays by Carol Lowrey and Richard J. Boyle. New York: Spanierman Gallery, 1990.

Diamond, Martin. *Who Were They? My Personal Contact With Thirty-Five American Modernists Your Art History Course Never Mentioned*. 1995. Photocopy; the author has also donated the manuscript to the Archives of American Art, National Museum of American Art, Washington, D.C.

Dickinson, Henry W. *Robert Fulton, Engineer and Artist; His Life and Works*. London and New York, 1913.

Dickinson, Thomas A. "Rufus Alexander Grider," *Proceedings of the Worcester* [Mass.] *Society of Antiquity*, XVII, March-April 1900, 110-13.

Dickson, Harold E. "The Case Against Savage," *American Collector*, XIV, Jan. 1946, 6-7, 17.

——— *John Wesley Jarvis, American Painter, 1780-1840*. New York, 1949.

——— "A Misdated Episode in Dunlap," *Art Quarterly*, IX, Jan. 1946, 33-6.

——— "A Note on Jeremiah Paul, American Artist," *Antiques*, LI, June 1947, 392-3.

——— ed. *Observations on American Art; Selections from the Writings of John Neal*. State College, Pa., 1943.

Diers, Herman H. "The Strange Case of Alonzo Chappel," *Hobbies*, XLIX, Oct. 1944, 18-20, 28.

Dintruff, Emma J. "The American Scene a Century Ago," *Antiques*, XXXVIII, Dec. 1940, 279-81.

DNB. *Dictionary of National Biography*. London, 1921-22.

Dods, Agnes M. "A Check List of Portraits and Paintings by Erastus Salisbury Field," *Art in America*, XXXII, Jan. 1944, 32-40.

——— "Connecticut Valley Painters," *Antiques*, XLVI, Oct. 1944, 207-9.

——— "More About Jennys," *Art in America*, XXXIV, April 1946, 114-16.

——— "Nathan Negus," *Antiques*, LVIII, Sept. 1950, 194.

——— "Newly Discovered Portraits by J. William Jennys," *Art in America*, XXXIII, Jan. 1945, 5-12.

——— "Sarah Goodridge," *Antiques*, LI, May 1947, 328-9.

Doggett's Repository of Arts [Philadelphia], *Original Cabinet Paintings Now Arranged at . . . Nov. 22, 1821* [copy at Frick Art Reference Library, New York City].

Doolittle, William F. *The Doolittle Family in America*. Cleveland, 1901-08.

Dorchester Births, Marriages, and Deaths. A Report of the Record Commissioners of the City of Boston, Containing Dorchester Births, Marriages, and Deaths to the End of 1825. Boston, 1890.

Dorchester, Mass. *Vital Records of the Town of Dorchester from 1826 to 1849*. Boston, 1905.

d'Otrange, Marie-Louise. "James H. Wright, 19th Century New York Painter," *American Collector*, XII, Feb. 1943, 5, 19.

Doughty, Howard N. "Life and Works of Thomas Doughty." Unpublished manuscript at the New-York Historical Society.

Dow, Charles M. *Anthology and Bibliography of Niagara Falls*. Albany, 1921.

Dow, George F. "Old-Time Ship Pictures," *Antiques*, II, Oct. 1922, 161-4.

——— *The Arts and Crafts in New England, 1704-1775*. Topsfield, Mass., 1927.

Downes, William H. "An American Painter: Mark Waterman," *Magazine of Art* (1895), 269-73.

——— "George Fuller's Pictures," *International Studio*, LXXV, July 1922, 265-73.

——— *The Life and Works of Winslow Homer*. Boston, 1911.

Draper, Benjamin P. "American Indians, Barbizon Style: The Collaborative Paintings of Millet and Bodmer," *Antiques*, XLIV, Sept. 1943, 108-10.

——— "John Mix Stanley, Pioneer Painter," *Antiques*, XLI, March 1942, 180-2.

——— "Karl Bodmer, an Artist Among the Indians," *Antiques*, XLV, May 1944, 242-4.

Drayton, John. *The Carolinian Florist of Governor John Drayton of South Carolina, with Water-Color Illustrations from the Author's Original Manuscript*. Edited by Margaret B. Menwether, Columbia, S.C., 1943.

——— *Memoirs of the American Revolution*. 2 vols., Charleston, 1821.

Dreier, Dorothea A. "Walter Shirlaw," *Art in America*, VII, Autumn 1919, 206-16.

Drepperd, Carl W. "American Drawing Books," *New York Public Library Bulletin*, XLIX, Nov. 1945, 795-812.

——— "New Delvings in Old Fields—Found: A 'New' Early American Engraver," *Antiques*, XLII, Oct. 1942, 204-5.

——— "Pictures with a Past," *American Collector*, IV, June 1927, 88-97.

——— "Rare American Prints, Drawn from a Drawing Book," *Antiques*, XVI, July 1929, 26-8.

——— "Three Battles of New Orleans," *Antiques*, XIV, Aug. 1928, 129-31.

Dresser, Louisa. "Christian Gullager; An Introduction to His Life and Some Representative Examples of His Work," *Art in America*, XXXVII, July 1949, 105-79.

——— "Edward Savage, 1761-1817," *Art in America*, XL, Autumn 1952, 157-212.

——— ed. *XVIIth Century Painting in New England*. Worcester, Mass., Worcester Art Mus., 1935.

——— "The Thwing Likenesses, A Problem in Early American Portraiture," *Old-Time New England*, XXIX, Oct. 1938, 45-51.

Driskell, David C. *Hidden Heritage: Afro-American Art, 1800-1950*. Exh. cat. San Francisco: Art Museum Association of America, 1985.

Dumont de Montigny. Louis François Benjamin, "L'Etablissement de la Province de la Louisiane," Societe des Américanistes de Paris, *Journal*, New Ser. XXIII (1931), 273-440.

——— *Memoires Historiques sur la Louisiane*. Paris, 1753.

Dunlap, William. *Diary of William Dunlap (1766-1839)*. Edited by Dorothy C. Barck, New York, 1930.

——— *A History of the American Theatre*. New York, 1832.

——— *History of the Rise and Progress of the Arts of Design in the United States*. New York, 1834; rev. ed., Boston, 1918. [cited as Dunlap, *History*].

Dunn, N. P. "An Artist of the Past: Wilham Edward West and His Friends at Home and Abroad," *Putnam's Monthly*, II, Sept. 1907, 658-69.

——— "Unknown Pictures of Shelley," *The Century Magazine*, LXX, Oct. 1905, 909-17.

Dunshee, Kenneth H. *As You Pass By*. New York, 1952.

Durand, John. *The Life and Times of A. B. Durand*. New York, 1894.

Durrie, Mary C. "George Henry Durrie, Artist," *Antiques*, XXIV, July 1933, 13-15.

Dwight, Edward H. "Aaron Houghton Corwine: Cincinnati Artist," *Antiques*, LXVII, June 1955, 502-4.

——— "John P. Frankenstein," *Museum Echoes*, XXVII, July 1954, 51-3.

——— "Robert S. Duncanson," *Museum Echoes*, XXVII, June 1954, 43-5.

———— "Robert S. Duncanson," *Bulletin of the Historical and Philosophical Society of Ohio*, XIII, July 1955, 203-11.

E

Earle, Pliny. *The Earle Family; Ralph Earle and His Descendants.* Worcester, 1888.

East Hampton: The 19th Century Artists' Paradise. Exh. cat., with essay by Katharine Cameron. East Hampton, N.Y.: Guild Hall Museum, 1991.

Eastman, Mary H. *American Aboriginal Portfolio . . . Illustrated by S[eth] Eastman, U. S. Army.* Philadelphia, 1853.

Eaton, Cyrus. *History of Thomaston, Rockland, and South Thomaston, Maine.* Hallowell, Me., 1865.

Ecclesiastical Records, State of New York, Albany, 1901-16.

Eckhardt, George H. "Early Lithography in Philadelphia," *Antiques,* XXVIII, Dec. 1935, 249-52.

Eckstorm, Fannie Hardy. "Jeremiah Pearson Hardy: A Maine Portrait Painter," *Old-Time New England,* XXX, Oct. 1939, 41-66.

Edmonds, Francis W. "Frederick S. Agate," *The Knickerbocker or New-York Monthly Magazine,* XXIV, Aug. 1844, 157-63.

Edwards, Edward. *Anecdotes of Painters Who Have Resided or Been Born in England.* London, 1808.

Edwards, Lee M. *Domestic Bliss: Family Life in American Painting, 1840-1910.* With contributions by Jan Seidler Ramirez and Timothy Anglin Burgard. Yonkers, N.Y.: Hudson River Museum, 1986.

Egbert, Donald D. *Princeton Portraits.* With the assistance of Diane Martindell Lee. Princeton, 1947.

Eisen, Gustavus A. "A Houdon Medallion," *Antiques,* XVII, Feb. 1930, 122-5.

Eldredge, Charles, Julie Schimmel, & William H. Truettner. *Art in New Mexico, 1900-1945: Paths to Taos and Santa Fe.* Exh. cat., Abbeville Press, New York, for the National Museum of American Art, Washington, D.C., 1986.

Eldridge, Charles W. "Journal of a Tour Through Vermont to Montreal and Quebec in 1833," *Vermont Historical Society Proceedings,* New Ser. II, June 1931, 53-82.

Ely, Lydia. "Art and Artists of Milwaukee," in Howard Louis Conard, ed., *History of Milwaukee County.* Chicago, 1898.

Elzas, Barnett A. *The Jews of South Carolina from the Earliest Times to the Present Day.* Philadelphia, 1905.

Emmet, Thomas Addis. *The Emmet Family.* New York, 1898.

Emory, William H., *United States and Mexican Boundary Survey, Report of William H. Emory.* Washington, 1857-59.

Encyclopaedia of New Orleans Artists, 1718-1918. New Orleans: Historic New Orleans Collection, 1987.

Encyclopedia Britannica. 11th ed., Cambridge, England, 1910-11.

Endicott, Frederic, ed. *Record of Births, Marriages and Deaths . . . [in Stoughton, Canton and Dorchester, Mass.]* Canton, Mass., 1896.

Erffa, Helmut von. "An Oil Sketch by Benjamin West," *The Register of the Museum of Art of the University of Kansas,* No. 7, May 1956, 1-8.

———— "West's Washing of Sheep," *Art Quarterly,* XV, Summer 1952, 160-5.

Essex Institute [Salem, Mass.], "Additions to the Catalogue of Portraits in the Essex Institute," *Essex Institute Historical Collections,* LXXXVI. April 1950, 155-74.

———— *Catalogue of Portraits in the Essex Institute.* Salem, 1936.

Evans, Charles. *American Bibliography.* Chicago, 1903-34.

Evans, Elliot. "Some Letters of William S. Jewett," *California Historical Society Quarterly,* XXIII, June 1944, 149-77, and Sept. 1944, 227-46.

———— "William S. and William D. Jewett," *California Historical Society Quarterly,* XXXIII, Dec. 1954, 309-20.

Evans, Richard X., ed. "Letters from Robert Mills," *South Carolina Historical and Genealogical Magazine,* XXXIX, July 1938, 110-24.

Evert, Marilyn. *Discovering Pittsburgh's Sculpture.* Photos by Vernon Gay. Pittsburgh, Pa.: Univ. of Pittsburgh Press, 1983.

Ewers, John C. "Charles Bird King, Painter of Indian Visitors to the Nation's Capital," *Annual Report of the Board of Regents of the Smithsonian Institution 1953,* 463-73.

———— "Gustavus Sohon's Portraits of Flat-head and Pend d'Oreille Indians, 1854," *Smithsonian Miscellaneous Collections,* CX, No. 7, Nov. 1948.

F

Faguani, Emma E. *The Art Life of a XIXth Century Portrait Painter, Joseph Fagnani.* Paris, 1930.

Fahlman, Betsy. "Women Art Students at Yale, 1869-1913," *Woman's Art Journal* vol. 12, no. 1 (Spring/Summer, 1991): 15-23.

Fairman, Charles E. *Art and Artists of the Capitol of the United States of America.* Washington, 1927.

Falk, Peter Hastings, ed. *Exhibition Record Series.* (see below and the complete list of titles following bibliography section).

———— *Record of the Carnegie Institute's International Exhibitions: 1896-1996.* Madison, Conn.: Sound View Press, 1998.

———— *The Annual & Biennial Exhibition Record of the Whitney Museum of American Art: 1918-1989.* Madison, Conn.: Sound View Press, 1991.

———— *Biennial Exhibition Record of the Corcoran Gallery of Art, 1907-1967.* Madison, Conn.: Sound View Press, 1991.

———— *Annual Exhibition Record of the Art Institute of Chicago, 1888-1950.* Madison, Conn.: Sound View Press, 1990.

———— *Annual Exhibition Record of the National Academy of Design, 1901-1950.* Madison, Conn.: Sound View Press, 1990.

———— *Annual Exhibition Record of the Pennsylvania Academy of Fine Arts. Volume 2: 1876-1913.* Madison, Conn.: Sound View Press, 1989

———— *Annual Exhibition Record of the Pennsylvania Academy of Fine Arts. Volume 3: 1914-1968.* Madison, Conn.: Sound View Press, 1989.

———— *Dictionary of Signatures and Monograms of American Artists.* Madison, Conn.: Sound View Press, 1988.

Famous Artists and Writers of King Features Syndicate. King Features Syndicate Inc., 1949.

Farington, Joseph. *The Farington Diary,* ed. by James Greig, London, 1923-28.

FARL. Frick Art Reference Library, New York City.

Farmer, Silas. *The History of Detroit and Michigan.* Detroit, 1884.

Farquhar, Francis P. *Edward Vischer: His Pictorial of California.* San Francisco, 1932.

Fay, Theodore S. *Views in New York and Its Environs.* New York and London, 1831.

Felt, Joseph B. *Annals of Salem.* Salem and Boston, 1845-49.

Fenton, William N. "The Hyde de Neuville Portraits of New York Savages in 1807-1808," *New-York Historical Society Quarterly,* XXXVIII, April 1954, 119-37.

Fehrer, Catherine. *Julian Academy: Paris, 1868-1939.* Exh. cat. New York: Shepard Gallery, 1989.

Fielding, Mantle. *Dictionary of American Painters, Sculptors, and Engravers.* Philadelphia, Pa., 1926; plus rev. and enl. ed., by Glenn B. Opitz. Poughkeepsie, N.Y.: Apollo Books, 1986.

Finch, Christopher. *American Watercolors.* New York:

Abbeville Press, 1986.

Fincham, Henry W. *Artists and Engravers of British and American Book Plates.* London, 1897.

Fink, Lois Marie. *American Art at the Nineteenth-Century Paris Salons.* Washington, D.C.: National Museum of American Art, 1990

Finn, Matthew D. *The Theorematical System of Painting.* New York, 1830.

First Fifty Years of Cazenovia Seminary 1825-1875. Cazenovia, N.Y., 1877.

First German Reformed Church, New York City, records of, at New-York Historical Society.

Fisher, Philip A. *The Fisher Genealogy.* Everett, Mass., 1898.

Fisk, Frances B. *A History of Texas Artists and Sculptors.* Abilene, 1928.

Flagg, Jared B. *The Life and Letters of Washington Allston.* New York, 1892.

Flagg, Norman Gershom and Lucius C. S. *Family Records of the Descendants of Gershom Flagg.* Quincy, Ill., 1907.

Fleming, George Thornton, ed. *History of Pittsburgh and Environs.* New York and Chicago, 1922.

Fletcher, Edward H. *Fletcher Genealogy.* Boston, 1871.

Fletcher, Robert S. "Ransom's John Brown Painting," *Kansas Historical Quarterly,* IX, Nov. 1940, 343-6.

Flexner, James T. "The Amazing William Williams: Painter, Author, Teacher, Musician, Stage Designer, Castaway," *Magazine of Art,* XXXVII, Nov. 1944, 242-6, 276-8.

———— *America's Old Masters; First Artists of the New World.* New York, 1939.

———— "Benjamin West's American NeoClassicism, with Documents on West and William Williams," *New-York Historical Society Quarterly,* XXXVI, Jan. 1952, 5-41.

———— *First Flowers of Our Wilderness.* Boston, 1947.

———— *Gilbert Stuart; A Great Life in Brief.* New York, 1955.

———— *John Singleton Copley.* Boston, 1948.

———— *The Light of Distant Skies, 1760- 1835.* New York, 1954.

———— "Winthrop Chandler: An 18th-Century Artisan Painter," *Magazine of Art,* XL, Nov. 1947, 274-8.

Folsom, Elizabeth K. *Genealogy of the Folsom Family.* Rutland, Vt., 1938.

Folsom, Joseph F. "Jacob C. Ward, One of the Old-Time Landscape Painters," *Proceedings of the New Jersey Historical Society,* New Ser. III, April 1918, 83-93.

———— ed. *Bloomfield, Old and New.* Bloomfield, N.J., 1912.

Foote, Abram W. *Foote Family.* Rutland, Vt., 1907.

Foote, Henry Wilder. "Charles Bridges: 'Sergeant-Painter of Virginia,' 1735- 1740," *Virginia Magazine of History and Biography,* LX, Jan. 1952, 1-55.

———— *John Smibert, Painter.* Cambridge, 1950.

———— *Robert Feke, Colonial Portrait Painter.* Cambridge, 1930.

For Beauty and for Truth: The William and Abigail Gerdts Collection of American Still Life. Exh. cat., with essays by Susan Danly and Bruce Weber, introduction by William H. Gerdts. Mead Art Museum, Amherst, Mass., and Berry-Hill Galleries, New York, 1998.

Forbes, David W. *Encounters with Paradise: Views of Hawaii and Its People, 1778-1941.* Honolulu: Honolulu Academy of Fine Arts, 1992.

Forbes, Esther. *Paul Revere and the World He Lived In.* Boston, 1942.

Forbes, Harriette M., "Early Portrait Sculpture in New England," *Old-Time New England,* XIX, April 1929, 159-74.

Ford, Alice. *Edward Hicks, Painter of The Peaceable Kingdom.* Philadelphia, 1952.

———— *Pictorial Folk Art, New England to California.* New York, 1949.

Ford, Alice E. "Some Trade Cards and Broadsides," *American Collector,* XI, June 1942, 10-13.

Ford, Henry A. and Mrs. Kate B. *History of Cincinnati, Ohio.* Cleveland, 1881.

Ford, Worthington C. *British Officers Serving in the American Revolution 1774- 1783.* Brooklyn, 1897

———— "Broadsides, Ballads etc. Printed in Massachusetts 1639-1800," *Massachusetts Historical Society Collections,* LXXV, Boston, 1922.

Forrer, Leonard. *Biographical Dictionary of Medallists.* London, 1902-30.

Fort, Susan Ilene. *The Figure in American Sculpture: A Question of Modernity.* Exh. cat., with contributions by Mary L. Lenihan, Marlene Park, Susan Rather, and Roberta K. Tarbell. Los Angeles County Museum of Art in association with University of Washington Press, Seattle, Wash., 1995.

1440 Early American Portrait Artists, see W.P.A. Historical Records Survey, New Jersey.

Foshay, Ella M. *Jasper F. Cropsey: Artist and Architect.* Exh. cat. New York City: New-York Historical Society, 1987.

Frankenstein, Alfred V. *After the Hunt: William Harnett and Other American Still Life Painters, 1870-1900.* Berkeley and Los Angeles, 1953.

———— "J. F. Francis," *Antiques,* LIX, May 1951, 374-7, 390.

———— and Arthur K. D. Healy. *Two Journeymen Painters.* Sheldon Museum, Middlebury, Vt., 1950; reprinted from *Art in America,* XXXVIII, Feb. 1950.

Frankenstein, John. *American Art: Its Awful Altitude.* Cincinnati, 1864.

Frary, I. T. "Ohio Discovers Its Primitives," *Antiques,* XLIX, Jan. 1946, 40-1.

Fraser, Charles. *Reminiscences of Charleston.* Charleston, 1854.

Frazee, John. "The Autobiography of Frazee, the Sculptor," *North American Magazine,* V, April 1835, 395-403; VI, July 1835, 1-22.

Freeman, James E. *Gatherings from an Artist's Portfolio.* New York, 1877.

———— *Gatherings from an Artist's Portfolio in Rome.* Boston, 1883.

Frémont, John Charles. *Memoirs of My Life.* New York, 1887.

———— *Report of the Exploring Expedition to the Rocky Mountains in the Year 1842, and to Oregon and North California in the Years 1843-'44.* Washington, 1845.

French, Henry W. *Art and Artists in Connecticut.* Boston, 1879.

French, Hollis. *Jacob Hurd and His Sons, Nathaniel and Benjamin, Silversmiths, 1702-1781.* Cambridge, 1939.

From Colony to Nation: An Exhibition of American Painting, Silver and Architecture from 1650 to the War of 1812. Art Institute of Chicago, 1949.

Fulton, Eleanor J. "Robert Fulton as an Artist," *Papers of the Lancaster County* [Pa.] *Historical Society,* XLII, No. 3 (1938), 49-96.

G

G & W. *See* Groce, George C. and David H. Wallace.

Gage, Thomas H. *An Artist Index to Stauffer's American Engravers,* Worcester, 1921; reprinted from *Proceedings of the American Antiquarian Society,* 1921.

Gaillard, William. *The History and Pedigree of the House of Gaillard or Gaylord.* Cincinnati, 1872.

Gallagher, H. M. Pierce. "Robert Mills, 1781-1855, America's First Native Architect," *Architectural Record,* LXV, April 1929, 387-93; May 1929, 478-84; LXVI, July 1929, 67-72.

Galt, John. *The Life, Studies, and Works of Benjamin West.*

London, 1820.

Gammell, R.H. Ives. *The Boston Painters: 1900-1930*. Ed. by Elizabeth Ives Hunter. Orleans, Mass.: Parnassus Imprints, 1986.

Garbisch Collection catalogue. U. S. National Gallery of Art, *American Primitive Paintings from the Collection of Edgar William and Bernice Chrysler Garbisch*. Washington, 1954.

Gardner, Albert T. E. "Fragment of a Lost Monument: Marble Bust of Washington," *Metropolitan Museum of Art Bulletin*, VI, March 1948, 189-97.

———— "Hiram Powers and William Rimmer, Two 19th Century American Sculptors," *Magazine of Art*, XXXVI, Feb. 1943, 43-7.

———— "Hudson River Idyl," *Metropolitan Museum of Art Bulletin*, VI, April 1948, 232-6.

———— "Ingham in Manhattan," *Metropolitan Museum of Art Bulletin*, X, May 1952, 245-53.

———— *Yankee Stonecutters; The First American School of Sculpture 1800-1850*. New York, 1944.

Garraghan, Gilbert J. *The Jesuits of the Middle United States*. New York, 1938.

Garretson, Mary N. W. "Thomas S. Noble and His Paintings," *New-York Historical Society Quarterly Bulletin*, XXIV, Oct. 1940, 113-23.

Gass, Patrick. *Gass's Journal of the Lewis and Clark Expedition*. Chicago, 1904.

Gegenheimer, Albert F. "Artist in Exile: The Story of Thomas Spence Duché," *Pennsylvania Magazine of History and Biography*, LXXIX, Jan. 1955, 3-26.

The Gem, or Fashionable Business Directory for the City of New York. New York, 1844.

Genealogy of the Descendants of John Sill. Albany, 1859.

Genin, Sylvester, *Selections from the Works of the Late Sylvester Genin, Esq., in Poetry, Prose, and Historical Design, with a Biographical Sketch*. New York, 1855.

Geske, Norman A. "A Pioneer Minnesota Artist," *Minnesota History*, XXXI, June 1950, 99-104.

Gerdts, William H. *American Artists in Japan*. Exh. cat. New York: Hollis Tagart Galleries, Inc., 1996.

———— *American Impressionism*. New York: Abbeville Press, 1984.

———— *Art Across America: Two Centuries of Regional Painting*. 3 vols. New York: Abbeville Press, 1990.

———— *Monet's Giverny: An Impressionist Colony*. New York: Abbeville Press, 1993.

———— *Painters of the Humble Truth: Masterpieces of American Still Life, 1801-1939*. Columbia, Mo.: Philbrook Art Center with Univ. of Missouri. Press, 1981

———— *The White Marmorean Flock: Nineteenth Century American Women Neo-Classical Sculptors*. Exh. cat. Poughkeepsie, NY: Vassar College Art Gallery, 1972.

———— (see also *For Beauty and for Truth*)

———— and Russell Burke. *American Still-Life Painting*. New York: Praeger Publishers, 1971.

Ghent, William J. *The Road to Oregon, a Chronicle of the Great Emigrant Trail*. London, 1929.

Gibbes, Robert W. *A Memoir of James De Veaux*. Columbia, S.C., 1846.

Gibson, Arthur Hopkin. *Artists of Early Michigan*. Detroit: Wayne State Univ. Press, 1975.

Gideon, Samuel E. "Two Pioneer Artists in Texas," *American Magazine of Art*, IX, Sept. 1918, 452-6.

Gilchrist, Agnes A. *William Strickland, Architect and Engineer, 1788-1854*. Philadelphia, 1950.

Gillingham, Harrold E. "Notes on Philadelphia Profilists," *Antiques*, XVII, June 1930, 516-18.

Gilman, Margaret E. "Studies in the Art of Drawing and Painting by Members of the Dep't of Fine Arts," *Fogg*

Museum Bulletin, X, March 1945, 74-80.

Girodie, Andre. *Un Peintre Alsacien de Transition; Clement Faller*. Strasbourg, 1907.

Gladding, Henry C. *The Gladding Book*. Providence, 1901.

Glassburn, Dorothy E. "Artist Reports on the Fire of 1845; Two Paintings by Wilham Coventry Wall," *Carnegie Magazine*, XVIII, March 1945, 300-2.

Goetzmann, William H., and William N. Goetzmann. *The West of the Imagination*. New York: W.W. Norton & Co., 1986.

Golden Age: Cincinnati Painters of the Nineteenth Century Represented in the Cincinnati Art Museum. Exh. cat., with essays by Denny Carter and Bruce Weber. Cincinnati: Cincinnati Art Museum, 1980.

Goodrich, Lloyd. *American Watercolor and Winslow Homer*. Walker Art Center, Minneapolis, 1945.

———— "Ralph Earl," *Magazine of Art*, XXXIX, Jan. 1946, 2-8.

———— "Robert Feke," in *Robert Feke*, catalogue of an exhibition at the Whitney Museum, Heckscher Art Museum, and Boston Museum of Fine Arts, 1946.

———— *Winslow Homer*. New York, 1944.

Goodwin, Hermon C. *Pioneer History; or, Cortland County and the Border Wars of New York*. New York, 1859.

Gordon, William S. "Gabriel Ludlow (1663-1736) and His Descendants," *New York Genealogical and Biographical Record*, L, Jan. and April 1919, 34-55, 134-56.

Gosman, Robert. "Life of John Vanderlyn." Unpublished; two typed drafts at the New-York Historical Society.

Goss, Charles F. *Cincinnati, the Queen City, 1788-1912*. Chicago and Cincinnati, 1912.

Goss, Elbridge H. *The Life of Colonel Paul Revere*. Boston, 1891.

Gottesman, Rita S. *The Arts and Crafts in New York, 1726-1776*. New York, 1938; cited as Gottesman, I.

———— *The Arts and Crafts in New York, 1777-1799*. New York, 1954; cited as Gottesman, II.

Gould, Dorothy F. *Beyond the Shining Mountains*. Portland, Ore., 1938.

Graffenried, Thomas P. de. *History of the de Graffenried Family from 1191 A.D. to 1925*. Binghampton and New York, 1925.

Grande Encyclopedie, Inventaire Raisonné des Sciences, des Lettres et des Arts. Paris, 1886-1902.

Grant, Maurice H. *A Dictionary of British Landscape Painters from the 16th Century to the Early 20th Century*. Leigh-on-the-Sea, 1952.

Graves, Algernon. *A Dictionary of Artists Who Have Exhibited Works in the Principal London Exhibitions of Oil Paintings from 1760 to 1880*. London, 1884.

———— *The Royal Academy of Arts: A Complete Dictionary of Contributors and Their Work, from Its Foundation in 1769 to 1904*. London, 1905. Reprint, Kingsmead Reprints and Hilmarton Manor Press, 1989.

Green, Samuel Abbott, *John Foster, The Earliest American Engraver and the First Boston Printer*. Boston, 1909.

Green, Samuel M. "Uncovering the Connecticut School," *Art News*, LI, Jan. 1953, 38-41, 57.

———— "Charles Caleb Ward, the Painter of the 'Circus is Coming,' " *Art Quarterly*, XIV, Autumn 1951, 231-51.

Greenough, Frances Boott, ed. *Letters of Horatio Greenough to His Brother, Henry Greenough*. Boston, 1887.

Greenough, Horatio [Horace Bender, pseud.]. *The Travels, Observations, and Experience of a Yankee Stonecutter*. New York, 1852.

Greve, Charles T. *Centennial History of Cincinnati and Representative Citizens*. Chicago, 1904.

Griffin, Grace Gardner, *Writings on American History* [1906-40]. Washington and New Haven, 1908-49.

Groce, George C. "John Wollaston (fl. 1736-1767): A Cosmopolitan Painter in the British Colonies," *Art Quarterly*, XV, Summer 1952, 133-48.

———— "John Wollaston's Portrait of Thomas Appleford, Dated 1746," *New-York Historical Society Quarterly*, XXXIV, Oct. 1950, 261-8.

———— "New York Painting before 1800," *New York History*, XIX, Jan. 1938, 44-57.

———— "Who Was J[ohn?] Cooper (b. *ca.* 1695-living 1754?)," *Art Quarterly*, XVIII, Spring 1955, 73-82.

———— "William John Coffee, Long-lost Sculptor," *American Collector*, XV, May 1946, 14-15, 19-20.

———— *William Samuel Johnson; A Maker of the Constitution.* New York, 1937.

———— and David H. Wallace. *The New York Historical Society's Dictionary of Artists in America, 1564-1860.* New Haven: Yale University Press, 1957. [Cited as G & W.]

———— and J. T. Chase Willet, "Joseph Wood: A Brief Account of His Life and the First Catalogue of His Work," *Art Quarterly*, III, Spring 1940, 149-61, and Supplement 1940, 393-418.

Grolier Club, *The United States Navy, 1776 to 1815, Depicted in an Exhibition of Prints.* New York, 1942.

Gudde, Erwin G. "Carl Nahl, California's Pioneer of Painting," *American-German Review*, VII (1940), 18-20.

Guide to Hanington's Moving Dioramas. New York, 1837.

Guignard, Philippe. *Notice Historique sur Ia Vie et les Traveaux de M. Fevret de Saint-Mémin.* Dijon, 1853.

H

Haberly, Loyd. *Pursuit of the Horizon; A Life of George Catlin, Painter and Recorder of the American Indian.* New York, 1948.

Hageman, Jane Sikes. *Ohio Pioneer Artists: A Pictorial Review.* Cincinnati, Ohio: Ohio Furniture Makers, 1993.

Ham, Harry H. *History of Perry County, Pa.* Harrisburg, 1922.

Hale, Edward Everett. "The Early Art of Thomas Cole," *Art in America*, IV, Dec. 1915, 22-40.

Hale, Susan. *Life and Letters of Thomas Gold Appleton.* New York, 1885.

Hall, Lillian A. *Catalogue of Dramatic Portraits in the Theatre Collection of the Harvard College Library.* Cambridge, 1930.

Hall, Martha K. "James Long Scudder, Artist," *The Long Island Forum*, XVIII, March 1955, 43-4, 56.

Hamersly, Thomas H. S., *General Register of the United States Navy and Marine Corps.* Washington, 1882.

Hamilton, Sinclair. *Early American Book Illustrators and Wood Engravers, 1670-1870.* Princeton, 1950.

———— "Homer Martin as Illustrator," *New Colophon*, I, July 1948, 256-63.

Hamlin, Talbot. *Benjamin Henry Latrobe.* New York, 1955.

———— "Benjamin Henry Latrobe, 1764-1820," *Magazine of Art*, XLI, March 1948, 89-95.

———— "Benjamin Henry Latrobe: The Man and the Architect," *Maryland Historical Magazine*, XXXVII, Dec. 1942, 339-60.

Harding, Chester. *My Egotistography.* Boston, 1866.

Hardy, Harrison Claude and Rev. Edwin N. *Hardy and Hardie, Past and Present.* Syracuse, 1935.

Harlow, Alvin F. *The Serene Cincinnatians.* New York, 1950.

Harlow, Thompson R. "William Johnston, Portrait Painter, 1732-1772," *Connecticut Historical Society Bulletin*, XIX, Oct. 1954, 97-100, 108.

Harlow, Thompson R. "Some Comments on William Johnston, Painter, 1732-1772," *Connecticut Historical Society Bulletin*, XX, Jan. 1955, 25-32.

Harris, Charles X. "Henri Couturier, an Artist of New Netherland," *New-York Historical Society Quarterly Bulletin*, XI, July 1927, 45-52.

———— "Peter Vanderlyn, Portrait Painter," *New-York Historical Society Quarterly Bulletin*, V, Oct. 1921, 59-73.

Harris, Edward D. *A Genealogical Record of Thomas Bascom and His Descendants.* Boston, 1870.

Harshberger, John W. *The Botanists of Philadelphia and Their Work.* Philadelphia, 1899.

Hart, Charles H. *Browere's Life Masks of Great Americans.* New York, 1899.

———— "The Earliest Painter in America," *Harper's New Monthly Magazine*, XCVI, March 1898, 566-70.

———— "Gustavus Hesselius," *Pennsylvania Magazine of History and Biography*, XXIX, April 1905, 129-33.

———— "The Last of the Silhouettists," *Outlook*, LXVI, Oct. 1900, 329-35.

———— "Life Portraits of Andrew Jackson," *McClure's Magazine*, IX, July 1897, 795-804.

———— "Life Portraits of Daniel Webster," *McClure's Magazine*, IX, May 1897, 619-30.

———— "Life Portraits of George Washington," *McClure's Magazine*, VIII, Feb. 1897, 291-308.

———— "Life Portraits of Henry Clay," *McClure's Magazine*, IX, Sept. 1897, 939-48.

———— "Life Portraits of Thomas Jefferson," *McClure's Magazine*, XI, May 1898, 47-55.

———— "Patience Wright, Modeller in Wax" *Connoisseur*, XIX, Sept. 1907, 18-22.

———— "Portrait of John Grimes, Painted by Matthew Harris Jouett," *Art in America*, IV, April 1916, 175-6.

———— "Portrait of Thomas Dawson, Viscount Cremorne, Painted by Mather Brown," *Art in America*, V, Oct. 1917, 309-14.

———— ed., *A Register of Portraits Painted by Thomas Sully, 1801-1871.* Philadelphia, 1909.

———— "Unknown Life Masks of Great Americans," *McClure's Magazine*, IX, Oct. 1897, 1053-60.

———— and Edward Biddle, *Memoirs of the Life and Works of Jean Antoine Houdon, the Sculptor of Voltaire and of Washington.* Philadelphia, 1911.

Hartigan, Lynda Roscoe. *Sharing Traditions, Five Black Artists in Nineteenth-Century America.* Washington, D.C.: Smithsonian Institution Press, 1985.

Harvard University, *Harvard Tercentenary Exhibition Catalogue.* Cambridge, 1936.

———— *Quinquennial Catalogue of the Officers and Graduates.* Cambridge, 1890.

Harvey, George. *Harvey's Scenes of the Primitive Forest of America.* New York, 1841.

Hastings, George E. *The Life and Works of Francis Hopkinson.* Chicago, 1926.

Hastings, Mrs. Russell. "Pieter Vanderlyn, a Hudson River Portrait Painter (1687-1778)," *Antiques*, XLII, Dec. 1942, 296-9.

Hatch, John Davis, Jr. "Isaac Hutton, Silversmith," *Antiques*, XLVII, Jan. 1945, 32-5.

Havell, Harry P. "Robert Havell's 'View of the Hudson from Tarrytown Heights,'" *New-York Historical Society Quarterly*, XXXI, July 1947, 160-2.

Hawthorne, Julian. *Nathaniel Hawthorne and His Wife: A Biography.* Boston, 1885.

Hawthorne, Nathaniel. *Mosses from an Old Manse.* New York, 1846.

Hayner, Rutherford. *Troy and Rensselaer County, New York.* New York and Chicago, 1925.

Hazard, Samuel, ed. *The Register of Pennsylvania.* Philadelphia, 1828-35.

Healy, George P. A. *Reminiscences of a Portrait Painter.* Chicago, 1894.

Heilbron, Bertha L. "Documentary Panorama," *Minnesota*

History, XXX, March 1949, 14-23.

————— "Edwin Whitefield's Minnesota Lakes," *Minnesota History,* XXXIII, Summer 1953, 247-51.

————— "Making a Motion Picture in 1848; Henry Lewis on the Upper Mississippi," *Minnesota History,* XVII (1936), 131- 58, 288-301, 421-36.

————— "A Pioneer Artist on Lake Superior," *Minnesota History,* XXI, June 1940, 149-57.

————— "Pioneer Homemaker, Reminiscences of Mrs. Joseph Ullmann," *Minnesota History,* XXXIV, Autumn 1954, 96-105.

————— "Seth Eastman's Water Colors," *Minnesota History,* XIX, Dec. 1938, 419-23.

————— "The Sioux War Panorama of John Stevens," *Antiques,* LVIII, Sept. 1950, 184-6.

Heitman, Francis B. *Historical Register and Dictionary of the United States Army.* Washington, 1903.

Held, Julius S. "Edward Hicks and the Tradition," *Art Quarterly,* XIV, Summer 1951, 121-36.

Hemenway, Abby Maria, ed. *Vermont Historical Gazetteer.* Burlington, 1868-91.

Henderson, Helen W. *The Pennsylvania Academy of the Fine Arts and Other Collections of Philadelphia.* Boston, 1911.

Hendrickson, Walter B. *David Dale Owen, Pioneer Geologist of the Middle West.* Indianapolis, 1943.

Hennig, Helen K. *William Harrison Scarborough, Portraitist and Miniaturist.* Columbia, S.C., 1937.

Hensel, William U. "An Artistic Aftermath," *Lancaster County* [Pa.] *Historical Society Papers,* XVII (1913), 106-11.

————— "Jacob Eichholtz, Painter." *Lancaster County* [Pa.] *Historical Society Papers,* XVI (1912), Supp.

Heraldic Journal; Recording the Armorial Bearings and Genealogies of American Families. Boston, 1865-68.

Herberman, Charles G. *The Sulpicians in the United States.* New York, 1916.

Herrick, Francis H. *Audubon the Naturalist: A History of His Life and Time.* New York and London, 1917.

Herring, James. Autobiography, manuscript at New-York Historical Society; a portion of it published as " 'The World Was All Before Me': A New Jersey Village Schoolmaster, 1810," by Charles E. Baker, in *Proceedings of the New Jersey Historical Society,* LXXII, Jan. 1954.

Hewins, Amasa. *Hewins's Journal. A Boston Portrait-painter Visits Italy.* Ed. by Francis H. Allen, Boston, 1931.

Heywood, William S. *History of Westminster, Mass.* Lowell, 1893.

Hicks, Edward. *Memoirs of the Life and Religious Labors of Edward Hicks, Written by Himself,* Philadelphia, 1851.

Hicks, George A. "Thomas Hicks, Artist, a Native of Newtown," *Bucks County* [Pa.] *Historical Society Papers,* IV (1917), 89-92.

Hildeburn, Charles R. "Records of Christ Church, Philadelphia, Baptisms, 1709- 1760," *Pennsylvania Magazine of History and Biography,* XIII (1889), 237-41.

Hill, John Henry. *John William Hill, An Artist's Memorial.* New York, 1888.

Hill, Nola. "Bellamy's Greatest Eagle," *Antiques,* LI, April 1947, 259.

Hillard, George S. "Thomas Crawford: A Eulogy," *Atlantic Monthly,* XXIV, July 1869, 40-54.

Hills, Patricia. *The Genre Painting of Eastman Johnson: The Sources and Development of his Style and Themes.* New York: Garland Publ., 1977.

Hines, Harvey K. *An Illustrated History of the State of Oregon.* Chicago, 1893.

Hinton, John H. *The History and Topography of the United States of North America.* Boston, 1857.

Historic Minnesota, A Centennial Exhibition. Minneapolis

Institute of Arts, 1949.

History and Biographical Cyclopaedia of Butler County, Ohio. Cincinnati, 1882.

History of Edwards, Lawrence and Wabash Counties, Ill. Philadelphia, 1883.

History of Monroe County, N.Y. Philadelphia, 1877.

History of the Longacre-Longaker-Longenecker Family. Philadelphia, *c.* 1902.

Hitchcock, Margaret R. "And There Were Women Too," *Amherst Graduate Quarterly,* XXVI (1937), 191-4.

Hocker, Edward W. *Germantown 1683-1933.* Germantown, Pa., 1933.

Holloway, H. Maxson. "Isaac Augustus Wetherby and His Account Books," *New-York Historical Society Quarterly Bulletin,* XXV, April 1941, 55-72.

Holmes, William H. *Smithsonian Institution, The National Gallery of Art, Catalogue of Collections,* Washington, 1922.

Home Authors and Home Artists; or, American Scenery, Art, and Literature New York, 1852. Aso known as *The Home Book of the Picturesque.*

Home Book of the Picturesque, see *Home Authors and Home Artists.*

Homer, William Innes. *Alfred Stieglitz and the Photocession.* Boston: Little, Brown, & Co., 1983.

————— *Alfred Stieglitz and the American Avant-Garde.* Boston: New York Graphic Society, 1977.

————— *Avant-Garde Painting and Sculpture in America, 1910- 1925.* Wilmington, Del.: Delaware Art Museum, 1975.

————— *Robert Henri and His Circle.* Ithaca and London: Cornell University Press, 1969.

————— *Pictorial Photography in Philadelphia: The Pennsylvania Academy's Salons, 1898-1901.* Exh. cat., Philadelphia: Pennsylvania Academy of the Fine Arts

Hopkins, John Henry, Jr. *The Life of the Late Right Reverend John Henry Hopkins.* New York, 1873.

Hopkins, Timothy. *The Kelloggs in the Old World and the New.* San Francisco, 1903.

Hoppin, Martha J. "Women Artists in Boston, 1870-1900: The Pupils of William Morris Hunt." *American Art Journal* (Winter 1981): 17-46.

Hosmer, Herbert H., Jr. "John G. Chandler," *Antiques,* LII, July 1947, 46-7.

Howat, John K. *The Hudson River and Its Painters.* New York: American Legacy Press, 1983.

Howe, Gilman Bigelow. *Genealogy of the Bigelow Family of America.* Worcester, 1890.

Howell, Ethel. "Joseph B. Smith, Painter," *Antiques,* LXVII, Feb. 1955, 150-1.

Howell, Warren R. "Pictorial Californiana," *Antiques,* LXV, Jan. 1954, 62-5.

Howell's *California in the Fifties.* Ed. by Douglas S. Watson, San Francisco, John Howell, 1936.

Howells, Mildred, ed. *Life in Letters of William Dean Howells.* Garden City, 1928.

Howland, Garth A. "John Valentine Haidt, a Little Known 18th Century Painter," *Pennsylvania History,* VIII, Oct. 1941, 304-13.

Howlett, D. Roger. *The Lynn Beach Painters: Art Along the North Shore, 1880-1920.* Lynn, Mass.: Lynn Historical Society, 1998.

Hubbard, Geraldine H. "The Hopkins Flower Prints," *Antiques,* LV, April 1949, 286-7.

Hudson, Charles. *History of the Town of Lexington, Middlesex County, Mass.* Boston and New York, 1913.

Hughes, Edan Milton. *Artists in California, 1786-1940.* 2nd ed., San Francisco: Hughes Publishing, 1989.

Hughes, John T., *Doniphan's Expedition.* Cincinnati, 1848.

Hume, Edgar E. "Nicola Marschall. . . the German Artist Who Designed the Confederate Flag and Uniform,"

American-German Review, VI (1940), No. 6, 6-9, 39-40.

Hunter, Wilbur H., Jr. "The Battle of Baltimore Illustrated," *William and Mary Quarterly,* 3d Ser. VIII, April 1951, 235-7.

———— "Joshua Johnston: 18th Century Negro Artist," *American Collector,* XVII, Feb. 1948, 6-8.

———— *The Paintings of Alfred Jacob Miller, Artist of Baltimore and the West.* Baltimore, 1950.

———— "Philip Tilyard," *William and Mary Quarterly,* 3d Ser. VII, July 1950, 393-405.

Hyer, Richard. "Gerritt Schipper, Miniaturist and Crayon Portraitist," *New York Genealogical and Biographical Record,* LXXXIII, April 1952, 70-2.

I

Ide, John Jay. "A Discovery in Early American Portraiture," *Antiques,* XXV, March 1934, 99-100.

———— *The Portraits of John Jay.* New York, 1938.

In This Academy: The Pennsylvania Academy of the Fine Arts, 1805-1976. Philadelphia, 1976.

Innes, John H. *New Amsterdam and Its People.* New York, 1902.

Inness, George, Jr. *Life, Art and Letters of George Inness.* New York, 1917.

Ireland, Joseph N. *Records of the New York Stage.* New York, 1866-67.

Irving, Pierre M. *Life and Letters of Washington Irving.* New York, 1864.

Irving, Washington. *Journals of Washington Irving.* Ed. by William P. Trent and George S. Hellman, Boston, 1919.

Ivankovitch, Michael. *Collector's Value Guide to Early 20th Century American Prints.* Paducah, KY: Collector Books, 1998.

Ives, Joseph C. *Report Upon the Colorado River of the West Explored in 1857 and 1858.* Washington, 1861.

J

Jackson, Charles T. *Final Report on the Geology and Mineralogy of the State of New Hampshire.* Concord, 1844.

———— *Views and Map Illustrative of the Scenery and Geology of the State of New Hampshire.* Boston, 1845.

Jackson, Emily N. *Ancestors in Silhouette, Cut by August Edouart.* London and New York, 1921.

———— *Silhouette; Notes and Dictionary.* London, 1938.

Jackson, Joseph. "Krimmel, 'The American Hogarth,' " *International Studio,* XCIII, June 1929, 33-6, 86, 88.

———— "John A. Woodside, Philadelphia's Glorified Sign-Painter," *Pennsylvania Magazine of History and Biography,* LVII, Jan. 1933, 58-65.

Jackson, Joseph H. ed., *Gold Rush Album.* New York, 1949.

———— "Jacob Marling, an Early North Carolina Artist," *North Carolina Booklet* X, April 1910, 196-9.

Jacobson, Margaret E. "Olaf Krans," in Lipman and Winchester, *Primitive Painters in America, 1750-1950; An Anthology.* (New York, 1950), 139-48.

James Eddy . . . Biographical Sketch. Providence, 1889.

James, Edwin, comp. *Account of an Expedition from Pittsburgh to the Rocky Mountains, Performed in the Years 1819, '20.* London, 1823; reprinted in Thwaites, *Early Western Travels,* XIV-XVII.

James, Henry. *William Wetmore Story and His Friends, from Letters, Diaries, and Recollections.* Boston, 1903.

Jameson, Ephraim O. *The Jamesons in America, 1647-1900.* Boston, Mass., and Concord, N.H., 1901.

Jefferson, Thomas. *The Writings of Thomas Jefferson.* Monticello Edition, Washington, 1904-05.

Jenkins, Lawrence W. "William Cook of Salem, Mass.," *Proceedings of the American Antiquarian Society,* XXXIV, April 1924, 27-38.

Jewett, Frederick C., *History and Genealogy of the Jewetts of America.* New York, 1908.

Johns, Elizabeth. *American Genre Painting: The Politics of Everyday Life.* New Haven: Yale University Press, 1991.

Johnson, Charlotte B. "The European Tradition and Alvan Fisher," *Art in America,* XLI, Spring 1953, 79-87.

Johnson, Jane T. "William Dunlap and His Times," *Antiques,* XXXVII, Feb. 1940, 72-4.

Johnson, Malcolm. *David Claypoole Johnston.* Exh. cat. Worcester, Mass.: American Antiquarian Society, 1970.

Johnston, Joseph E. "Reports of the Secretary of War, with Reconnaissances of Routes from San Antonio to El Paso," 31 Cong., 1 Sess., *Senate Exec. Doc.* 64, 1850.

Jonas, Edward A. *Matthew Harris Jouett, Kentucky Portrait Painter.* Louisville, 1938.

Jones, Arthur F., and Bruce Weber, *The Kentucky Painter from the Frontier Era to the Great War.* Lexington, Ky.: Univ. of Kentucky Art Museum, 1981

Jones, Emma C. B. *The Brewster Genealogy, 1566-1907.* New York, 1908.

Jones, Harvey L. *Mathews: Masterpieces of the California Decorative Style.* Exh. cat. Layton, Utah: Gibbs M. Smith, Inc., in assoc. with the Oakland Museum, 1985.

Jones, J. Wesley. "Jones' Pantoscope of California," *California Historical Society Quarterly,* VI, June 1927, 109-29, and Sept. 1927, 238-53.

"Joseph Steward and The Hartford Museum, *Connecticut Historical Society Bulletin,* XVIII, Jan.-April 1953.

Josephson, Marba C. "What Did the Prophet Joseph Smith Look Like," *The Improvement Era,* May 1953, 311-13, 374.

K

[Kaelin, Charles S.] (see *Dialogues with Nature*)

Kaplan, Milton, comp. *Pictorial Americana; a Select List of Photographic Negatives in the Prints and Photographs Division of the Library of Congress.* Washington, 1945.

Karolik Cat. Full citation is *M. and M. Karolik Collection of American Paintings 1815 to 1865,* Cambridge, 1949.

Karr, Louise. "Paintings on Velvet," *Antiques,* XX, Sept. 1931, 162-5.

Katlan, Alexander W. *American Artists' Materials.* 2 volumes: Vol. 1, *Suppliers Directory, Nineteenth Century: New York, 1810-1899 and Boston, 1823-1887.* Madison, Conn.: Sound View Press, 1987. Vol. 2, *A Guide to Stretchers, Panels, Millboards, and Stencil Marks.* Madison, Conn.: Sound View Press, 1992.

Katz, Irving I. "Jews in Detroit, Prior to and Including 1850," *Detroit Historical Society Bulletin,* VI, Feb. 1950, 4-10.

Keating, William H. *Narrative of an Expedition to the Source of St. Peter's River in 1823.* London, 1825.

Keene Valley: The Landscape and its Artists. Exh. cat., with essay by Robin Pell. New York: Gerald Peters Gallery, 1994.

Kelby, William. *Notes on American Artists 1754-1820.* New York, 1922.

Keller, I. C. "Thomas Buchanan Read," *Pennsylvania History,* VI, July 1939, 133-46.

Kellner, Sydney, "The Beginnings of Landscape Painting in America," *Art in America,* XXVI, Oct. 1938, 158-68.

Kelly, James C. "Landscape and Genre Painting in Tennessee, 1810-1985." Exh. cat. published as special issue of *Tennessee Historical Quarterly* 49, no. 2 (Summer 1985).

Kendall, John S. *The Golden Age of the New Orleans Theater.* Baton Rouge, 1952.

Kende Galleries [New York], Catalogue No. 228, Feb. 9, 1946.

Kent, Alan E. "Early Commercial Lithography in Wisconsin," *Wisconsin Magazine of History*, XXXVI, Summer 1953, 247-51.

Kentucky Tradition in American Landscape Painting: From the Early 19th Century to the Present. Owensboro, Ky.: Owensboro Museum of Fine Art, 1983.

Keyes, Homer E. "A. F. Tait in Painting and Lithograph," *Antiques*, XXIV, July 1933, 24-5.

———— "The Boston State House in Blue Staffordshire," *Antiques*, I, March 1922, 115-20.

———— " 'The Bottle' and Its American Refills," *Antiques*, XIX, May 1931, 386-8, 390.

———— "Coincidence and Henrietta Johnston," *Antiques*, XVI, Dec. 1929, 490-4.

———— "Doubts Regarding Hesselius," *Antiques*, XXXIV, Sept. 1938, 144-6.

Kidder, Mary H. *List of Miniatures Painted by Anson Dickinson, 1803-1851.* Hartford, 1937.

Kieffer, Elizabeth C. "David McNeely Stauffer," *Papers of the Lancaster County [Pa.] Historical Society*, LVI, No. 7 (1952), 161-75.

Kimball, Sidney Fiske. "Furniture Carvings by Samuel Field McIntire," *Antiques*, XXIII, Feb. 1933, 56-8.

———— "Joseph Wright and His Portraits of Washington," *Antiques*, XV, May 1929, 376-82; XVII, Jan. 1930, 35-9.

———— *The Life Portraits of Jefferson and Their Replicas*, Philadelphia, 1944; Vol. LXXX VIII of the *Proceedings of the American Philosophical Society*.

———— *Mr. Samuel McIntire, Carver, the Architect of Salem.* Portland, Me., 1940.

King, Thomas Starr. *The White Hills; Their Legends, Landscapes, and Poetry.* Boston, 1860.

Kingston, Mass. *Vital Records of Kingston, Massachusetts, to the Year 1850.* Boston, 1911.

Kinietz, William V. *John Mix Stanley and His Indian Paintings.* Ann Arbor, 1942.

Kirstein, Lincoln. "Rediscovery of William Rimmer," *Magazine of Art*, XL, March 1947, 94-5.

Knittle, Rhea M. *Early Ohio Taverns, Tavern-sign, Stage-coach, Barge, Banner, Chair and Settee Painters*, No. 1 of The Ohio Frontier Series, Aug. 1, 1937.

———— "The Kelloggs, Hartford Lithographers," *Antiques*, X, July 1926, 42-6.

Knoedler, M. and Company, *Life Masks of Noted Americans of 1825, by John I. H. Browere*, New York, Feb. 1940.

Knowlton, Helen M. *Art Life of William Morris Hunt.* Boston, 1899.

Knox, Dudley W. *A History of the U. S. Navy.* New York, 1936.

Knox, Katharine McCook. "A Note on Michel Felice Corné," *Antiques*, LVII, June 1950, 450-1.

———— *The Sharples.* New Haven, 1930.

Knubel, Helen M. "Alexander Anderson; a Self Portrait," *Colophon*, New Graphic Series, I, No. 1 (New York, 1939), 8-11.

Köhler, Karl. *Briefe aus Amerika.* Darmstadt, 1854.

Koehler, Sylvester R. *Catalogue of the Engraved and Lithographed Work of John Cheney and Seth Wells Cheney.* Boston, 1891.

Koke, Richard J. "Milestones Along the Old Highways of New York City," *New-York Historical Society Quarterly*, XXXIV, July 1950, 165-234.

Kouwenhoven, John A. *The Columbia Historical Portrait of New York.* New York, 1953.

———— "Th. Nast as We Don't Know Him," *Colophon*, New Graphic Series, I, No. 2 (New York, 1939), 37-48.

Kovinick, Phil, and Marian Yoshiki-Kovinick. *An Encyclopedia of Women Artists of the American West.* Austin, TX: University of Texas Press, 1998.

Krane, Susan. *The Wayward Muse: A Historical Survey of Painting in Buffalo.* Exh. cat., with contributions by William H. Gerdts and Helen Raye. Buffalo, N.Y.: Albright-Knox Museum, 1987.

Kristiansen, Rolf H. and John J. Leahy, Jr. *Rediscovering Some New England Artists, 1875-1900.* Dedham, Mass.: Gardner-O'Brien Associates, 1987.

Kuchta, Ronald, and Dorothy Gees Seckler. *Provincetown Painters, 1890s-1970s.* Exh. cat. Syracuse, N.Y.: Everson Museum of Art, 1977.

Kultermann, Udo. *The History of Art History.* Norwalk, CT: Abaris Books, 1993.

Kunstchronik und Kunstmarkt. Leipzig, 1866-1926.

Kurz, Frederick. *Journal . . . 1846 to 1852*, Washington, 1937; Bulletin 115 of the Bureau of American Ethnology, Smithsonian Institution.

L

Ladies Garland and Family Wreath. Philadelphia, 1837-50.

Lafferty, S. E. "Artists Who Have Worked in Baltimore, 1796-1880." Unpublished manuscript compiled c.1934.

Lambert, John. *Travels Through Canada and the United States of North America in the Years 1806, 1807, and 1808.* London, 1813.

Lancaster, Clay "Primitive Mural Painter of Kentucky: Alfred Cohen," *American Collector*, XVII, Dec. 1948, 6-8, 19.

Lancaster County [Pa.] Historical Society, *Historical Papers and Addresses of the.* Lancaster, 1896-.

———— *Loan Exhibition of Historical and Contemporary Portraits Illustrating the Evolution of Portraiture in Lancaster County . . . November 23 to December 13, 1912.* Lancaster, 1912.

Landauer, Bella C., *My City, 'Tis of Thee; New York City on Sheet-music Covers.* New York, 1951.

Landgren, Marchal E. "Robert Loftin Newman, *American Magazine of Art*, XXVIII, March 1935, 134-40.

Lane, Gladys R. "Rhode Island's Earliest Engraver," *Antiques*, VII, March 1925, 133-7.

Lane, James Warren. *Whistler.* New York, 1942.

Lanman, Charles. *Haphazard Personalities; Chiefly of Noted Americans.* Boston and New York, 1886.

Larkin, Oliver W. *Samuel F. B. Morse and American Democratic Art.* Boston and Toronto, 1954.

Larousse, Pierre. *Grand Dictionnaire Universel du XIXème Siecle.* Paris, 1866-90.

Larsen, Ellouise B. *American Historical Views on Staffordshire China.* New York, 1939.

Lassiter, William L. "James Eights and His Albany Views," *Antiques*, LIII, May 1948, 360-1.

Latrobe, Benjamin Henry. *Impressions Respecting New Orleans.* Ed. by Samuel Wilson, Jr., New York, 1951.

———— *The Journal of Latrobe*, with an introduction by J. H. B. Latrobe. New York, 1905.

Lee, Cuthbert. "John Smibert," *Antiques*, XVIII, Aug. 1930, 118-21.

Lee, Hannah F. *Familiar Sketches of Sculpture and Sculptors.* Boston, 1854.

Leng, Charles W. and William T. Davis, *Staten Island and Its People, A History, 1609-1933.* New York, 1930-33.

Lesley, Everett Parker. "Patience Lovell Wright, America's First Sculptor," *Art in America*, XXIV, Oct. 1936, 148-54, 157.

———— "Some Clues to Thomas Cole," *Magazine of Art*, XLII, Feb. 1949, 42-8.

———— "Thomas Cole and the Romantic Sensibility," *Art Quarterly*, V, Summer 1942, 199-220.

Leslie, Charles R. *Autobiographical Recollections.* Boston and London, 1860.

Lester, C. E. "Charles Loring Elliott," *Harper's New Monthly Magazine*, XXXVIII, Dec. 1868, 42-50.

———— *Letters and Papers of John Singleton Copley and Henry Pelham, 1739-1776*, Boston, 1914; Vol. LXXI of the *Collections* of the Massachusetts Historical Society.

Lethève, Jacques. *Daily Life of French Artists in the Nineteenth Century*. New York: Praeger, 1971.

Levering, Joseph M. *A History of Bethlehem, Pa., 1741-1892*. Bethlehem, 1903.

Levin, Gail. *Synchromism and American Color Abstraction, 1910-1925*. New York: Braziller, 1978.

Levinge, Richard G. A. *Echoes from the Backwoods*. London, 1846.

Lewis, Charles L. "Alonzo Chappell and His Naval Paintings," *Proceedings of the United States Naval Institute*, LXIII (1937), 359-62.

Lewis, Henry. "Journal of a Canoe Voyage from the Falls of St. Anthony to St. Louis," *Minnesota History*, XVII (1936), 149-58, 288-301, 421-36.

Lewis, James O. *The Aboriginal Portfolio*. Philadelphia, 1835.

Libhart, Antonio C. "John Jay Libhart, Artist," *Historical Papers and Addresses of the Lancaster County [Pa.] Historical Society*, XVI (1912), 241-6.

Linton, William J. *The History of Wood Engraving in America*. Boston, 1882.

Lipman, Jean. *American Folk Art in Wood, Metal and Stone*. New York, 1948.

———— "American Townscapes," *Antiques*, XLVI, Dec. 1944, 340-1.

———— "Benjamin Greenleaf, New England Limner," *Antiques*, LII, Sept. 1947, 195-7.

———— "Deborah Goldsmith, Itinerant Portrait Painter," *Antiques*, XLIV, Nov. 1943, 227-9.

———— "Eunice Pinney, An Early Connecticut Water-colorist," *Art Quarterly*, VI, Summer 1943, 213-21.

———— "I. J. H. Bradley, Portrait Painter," *Art in America*, XXXIII, July 1945, 154-66.

———— "Joseph H. Hidley (1830-1872): His New York Townscapes," *American Collector*, XVI, June 1947, 10-11.

———— "Mary Ann Willson," in Lipman and Winchester. *Primitive Painters in America*. New York, 1950.

———— "Mermaids in Folk Art," *Antiques*, LIII, March 1948, 211-13.

———— "Miss Willson's Watercolors," *American Collector*, XIII, Feb. 1944, 8-9, 20.

———— "Peaceable Kingdoms by Three Pennsylvania Primitives," *American Collector*, XIV, Aug. 1945, 6-7, 16.

———— "Rufus Porter, Yankee Wall Painter," *Art in America*, XXXVIII, Oct. 1950, 135-200.

———— "William Verstille's Connecticut Miniatures," *Art in America*, XXIX, Oct. 1941, 229.

———— and Alice Winchester. *Primitive Painters in America, 1750-1850; An Anthology*. New York, 1950.

———— *List of All the Officers of the Army and Royal Marines*. London, War Office, March 13, 1815.

———— "List of Portraits Painted by Ethan Allen Greenwood," *Proceedings of the American Antiquarian Society*, LVI, April 1946, 129-53.

Little, Nina Fletcher. *American Decorative Wall Painting, 1700-1850*. Sturbridge, 1952.

———— "An Unusual Painting," *Antiques*, XLIII, May 1943, 222.

———— "Dr. Rufus Hathaway, Physician and Painter of Duxbury, Mass., 1770-1822," *Art in America*, XLI, Summer 1953, 95-139.

———— "Earliest Signed Picture by T. Chambers," *Antiques*, LIII, April 1948, 285.

———— "Itinerant Painting in America, 1750-1850," *New York History*, XXX, April 1949, 204-16.

———— "J. S. Blunt, New England Landscape Painter," *Antiques*, LIV, Sept. 1948, 172-4.

———— "Joseph Shoemaker Russell and His Water Color Views," *Antiques*, LIX, Jan. 1951, 52-3.

———— "Recently Discovered Paintings by Winthrop Chandler," *Art in America*, XXXVI, April 1948, 81-97.

———— "T. Chambers, Man or Myth," *Antiques*, LIII, March 1948, 194-6.

———— "Thomas Thompson, Artist-Observer of the American Scene," *Antiques*, LV, Feb. 1949, 121-3.

———— "William Matthew Prior, the Traveling Artist, and His In-laws, the Painting Hamblens," *Antiques*, LIII, Jan. 1948, 44-8.

———— "Winthrop Chandler," *Art in America*, XXXV, April 1947, 77-168.

———— and Tom Armstrong, eds. *American Folk Painters of Three Centuries*. New York, 1980.

Livingston, Jane, and John Beardsley. *Black Folk Art in America, 1930-1980*. Jackson, Miss., 1982.

Locke, Alain LeRoy. *The Negro in Art*. Washington, 1940.

Lockley, Fred. *Oregon Trail Blazers*. New York, 1929.

Lockridge, Ross F. *The Old Fauntleroy House*. New Harmony, Ind., 1939.

London, Hannah R. *Portraits of Jews by Gilbert Stuart and Other Early American Artists*. New York, 1927.

———— *Shades of My Forefathers*. Springfield, Mass., 1941.

Longacre, James B. "Diary," *Pennsylvania Magazine of History and Biography*, XXIX, April 1905, 134-42.

Loomis, Elias and Elisha S. *Descendants of Joseph Loomis in America*. Beria, Ohio, 1909.

Looney, Ben Earl. "Historical Sketch of Art in Louisiana," *Louisiana Historical Quarterly*, XVIII (1935), 382-96.

Lorant, Stefan. *The New World; The First Pictures of America, Made by John White and Jacques Le Moyne and Engraved by Theodore De Bry*. New York, 1946.

Lord, Jeanette M. "Some Light on Hubard," *Antiques*, XIII, June 1928, 485.

Lossing, Benson J. "The National Academy of the Arts of Design and Its Surviving Founders," *Harper's New Monthly Magazine*, LXVI, May 1883, 852-63.

Loubat, Joseph F. *The Medallic History of the United States of America 1776-1876*. New York, 1878.

Lovejoy, Edward D. "Poker Drawings of Ball-Hughes," *Antiques*, L, Sept. 1946, 175.

Lowell, Mass. *Vital Records of Lowell, Mass., to the End of the Year 1849*. Salem, 1930.

Lucas, Fielding. *Progressive Drawing Book*. Baltimore, 1827.

Lyman, Grace A. "William Matthew Prior, the 'Painting Garret' Artist," *Antiques*, XXVI, Nov. 1934, 180.

Lyman, Horace S. *History of Oregon*. New York, 1903.

Lyman, Lila Parrish. "William Johnston (1732-1772), a Forgotten Portrait Painter of New England," *New-York Historical Society Quarterly*, XXXIX, Jan. 1955, 63-78.

Lynch, Marguerite. "John Neagle's Diary," *Art in America*, XXXVII, April 1949, 79-99.

The Lynn Beach Painters: Art Along the North Shore, 1880-1920. By D. Roger. Howlett. Lynn, Mass.: Lynn Historical Society, 1998.

M

M.A.D. Maine Antique Digest. Waldoboro, Maine

Mabee, Carleton. *The American Leonardo; A Life of Samuel F. B. Morse*. New York, 1943.

MacAgy, Jermayne. "Three Paintings by Thomas Waterman Wood (1823-1903)," *California Palace of the Legion of Honor Bulletin*, II, May 1944, 9-15.

McCausland, Elizabeth. *A. H. Maurer.* New York, 1951.
———— "American Still-life Paintings in the Collection of Paul Magriel," *Antiques,* LXVII, April 1955, 324-7.
———— "The Early Inness," *American Collector,* XV, May 1946, 6-8.
———— *George Inness, An American Landscape Painter, 1825-1894.* New York, 1946; catalogue of exhibition at Springfield, Mass.
———— *The Life and Work of Edward Lamson Henry.* Albany, 1945.
McClinton, Katharine. "American Flower Lithographs," *Antiques,* XLIX, June 1946, 361-3.
Macomb, John N. *Annual Report, Chief Topographical Engineer, 1860 and 1861. His Expedition from Santa Fe to the Portion of the Grand and Green Basin of the Colorado of the West, in 1859.* Washington, 1876.
McCormack, Helen G. "The Hubard Gallery Duplicate Book," *Antiques,* XLV, Feb. 1944, 68-9.
———— *William James Hubard, 1807-1862.* Valentine Museum, Richmond, Va., 1948.
McCormick, Gene E. "Fitz Hugh Lane, Gloucester Artist, 1804-1865," *Art Quarterly,* XV, Winter 1952, 291-306.
McCracken, Harold. *Portrait of the Old West.* New York, 1952.
McCreery, Emilie. "The French Architect of the Allegheny City Hall," *Western Pennsylvania Historical Magazine,* XIV, (1940), July 1931, 237-41.
McDermott, John F. "Charles Deas: Painter of the Frontier," *Art Quarterly,* XIII, Autumn 1950, 293-311.
———— "Early Sketches of T. R. Peale," *Nebraska History,* XXXIII, Sept. 1952, 186-9.
———— "Gold Rush Movies," *California Historical Society Quarterly,* XXXIII, March 1954, 29-38.
———— "Indian Portraits," *Antiques,* LI, May 1947, 320-2; LV, Jan. 1949, 61.
———— "J. C. Wild and Fort Snelling," *Minnesota History,* XXXII, Spring 1951, 12-14.
———— "J. C. Wild, Western Painter and Lithographer," *Ohio State Archaeological and Historical Quarterly,* LX, April 1951, 111-25.
———— "Leon Pomarede, 'Our Parisian Knight of the Easel,'" *Bulletin of the City Art Museum of St. Louis,* XXXIV, Winter 1949, 8-18.
———— "Likeness by Audubon," *Antiques,* LXVII, June 1955, 499-501.
———— *The Lost Panoramas of the Mississippi.* Chicago: University of Chicago Press, 1958.
———— ed., "Minnesota 100 years Ago, Described and Pictured by Adolf Hoeffler," *Minnesota History,* XXXIII, Autumn 1952, 112-25.
———— "Newsreel–Old Style; or, Four Miles of Canvas," *Antiques,* XLIV, July 1943, 10-13.
———— "Peter Rindisbacher: Frontier Reporter," *Art Quarterly,* XII, Spring 1949, 129-45.
———— "Samuel Seymour: Pioneer Artist of the Plains and the Rockies," *Annual Report of the Smithsonian Institution,* 1950, 497-509.
———— ed., *Travels in Search of the Elephant: The Wanderings of Alfred S. Waugh, Artist, in Louisiana, Missouri, and Santa Fé in 1845-1846.* St. Louis, 1951.
MacDonald, Colin S. *A Dictionary of Canadian Artists.* 7 volumes. Ottawa, Canada, 1967-97.
MacFarlane, Janet R. "Hedley, Headley, or Hidley, Painter," *New York History,* XXVIII, Jan. 1947, 74-5.
M'Ilvaine, William, Jr. *Sketches of Scenery and Notes of Personal Adventure in California and Mexico.* Philadelphia, 1850.
McIntyre, Robert G. *Martin Johnson Heade, 1819-1904.* New York, 1948.

McKay, George L. "A Register of Artists, Booksellers, Printers and Publishers in New York City," *New York Public Library Bulletin:* [1801-10], XLIII (1939), 711-24, 849-58; [1811-20], XLIV 351-7, 415-28, 475-87; [1781-1800], XLV (1941), 387-95, 483-99.
Maclay, Edgar S. *Reminiscences of the Old Navy from the Journals and Private Papers of Captain Edward Trenchard and Rear-Admiral Stephen Decatur Trenchard.* New York and London, 1898.
McMahan, Virgil E. *Artists of Washington, D.C., 1796-1996.* Vol. 1, *An Illustrated Directory of Painters, Sculptors, and Engravers Born Before 1900.* Washington, D.C., 1995.
MacMinn, George R. *The Theater of the Golden Era in California.* Caldwell, Ida., 1941.
M.A.D. Maine Antique Digest. Waldoboro, Maine
"Maine Artists," *Maine Library Bulletin,* XIII, July-Oct. 1927, 3-23.
Maine Historical Society [Portland]. "Catalogue of Oil Portraits in the Library," typed manuscript (1938) at Frick Art Reference Library, New York.
Maine Register, for the Year 1855 with a Complete Business Directory of the State. Boston, 1855.
Maine Register and Business Directory for the Year 1856. South Berwick, Me., 1856.
Mallett, Daniel T., *Mallett's Index of Artists.* New York, 1935.
———— *Supplement to Mallett's Index of Artists.* New York, 1940.
Malmberg, Valerie L. *Artists of Berks County: An Overview, 1850-1920.* Boyertown, Pa.: Greshville Antiques, 1989.
Manchester Historic Association, *Collections of the.* Manchester, N.H., 1897- 1912.
Marblehead, Mass. *Vital Records of Marblehead, Mass., to the End of the Year 1849.* Salem, 1903-08.
Marceau, Henri. *William Rush, 1756-1833, the First Native American Sculptor.* Philadelphia, 1937.
Marcy, Randolph B. *Exploration of the Red River of Louisiana.* (Washington, 1853); also in 32 Cong., 2 Sess., *Senate Exec. Doc. 54.*
Markens, Isaac. *The Hebrews in America, a Series of Historical and Biographical Sketches.* New York, 1888.
Marlor, Clark. S. *Salons of America, 1922-1936.* Madison, Conn.: Sound View Press, 1991.
———— *Society of Independent Artists: The Exhibition Record, 1917-1944.* Madison, Conn.: Sound View Press, 1984.
———— *A History of the Brooklyn Art Association with an Index of Exhibitions.* New York: James F. Carr, 1970.
———— , compiler. BAI (Brooklyn Artists Index). Database available at the Brooklyn Museum, Art Reference Library.
Marryat, Francis S. ("Frank"). *Mountains and Molehills; or, Recollections of a Burnt Journal.* New York, 1855.
Marter, Joan M., et al. *Vanguard American Sculpture, 1913-1939.* New Brunswick, N.J.: Rutgers University Art Gallery, 1979.
Martin, Elizabeth G. *Homer D. Martin, a Reminiscence.* New York, 1904.
Martin, Mary. "Profiles of Our Early American Forebears Painted on Glass," *House and Garden,* LVI, Dec. 1929, 82-3, 126, 130, 146.
———— "Some American Profiles and Their Makers," *Connoisseur,* LXXIV, Feb. 1926, 87-98.
Martin, Oscar T. "The City of Springfield: Fine Arts," in *The History of Clark County, Ohio.* Chicago, 1881, 489-96.
Martin, Mrs. William H. *Catalogue of All Known Paintings by Matthew Harris Jouett.* Louisville, 1939.
Marvin, Abijah P. *History of the Town of Lancaster, Mass. 1643-1879.* Lancaster, 1879.
Marzio, Peter C. *The Democratic Art: Pictures for a Nineteenth-Century America.* Boston: David R. Godine, in association

with the Amon Carter Museum of Western Art, Fort Worth, Texas, 1979.

Mason, George C. *Reminiscences of Newport*. Newport, 1884.

Mason, J. Alden. "Grand Moving Diorama, a Special Feature," *Pennsylvania Archaeologist*, Jan. 1942, 14-16.

Massachusetts Historical Society, *Collections of the*. Boston, 1792-.

———— *Proceedings of the*. Boston, 1859-.

Masterson, James R. *Tall Tales of Arkansaw*. Boston, 1943.

Mather, Frank Jewett, Jr. *Homer Martin, Poet in Landscape*. New York, 1912.

Maude, John. *Visit to the Falls of Niagara in 1800*. London, 1826.

Mayer, Francis B. *Drawings and Paintings by Francis B. Mayer*. Baltimore, 1872.

———— *With Pen and Pencil on the Frontier in 1851; The Diary and Sketches of Frank Blackwell Mayer*. Ed. by Bertha L. Heilbron. Publications of the Minnesota Historical Society, Narratives and Documents, Vol. I, St. Paul, 1932.

Mayo. Unpublished notes on Washington and Baltimore artists by the late J. F. H. Mayo of Washington, D.C., and Bethesda, Md., as cited in Groce & Wallace.

Mc (all names beginning "Mc" are alphabetized as if spelled "Mac")

Meares, John. *Voyages Made in the Years 1788 and 1789, from China to the Northwest Coast of America*. London, 1790.

Mecklenburg, Virginia M., Rebecca Zurier, and Robert W. Snyder. *Metropolitan Lives: the Ashcan Artists and their New York*. Wash., D.C.: National Museum of American Art, 1995.

Mellon, Gertrude A., and Elizabeth F. Wilder, eds. *Maine, its Role in American Art, 1740-1963*. New York: Viking Press, 1963.

"Memoirs of James Peller Malcolm, F.S.A.," *Gentleman's Magazine*, LXXXV, May 1815, 467-9.

Meredith, Roy. *Mr. Lincoln's Camera Man: Mathew B. Brady*. New York, 1946.

Merrill, Arch. *The White Woman and Her Valley*. Rochester, 1955.

Merrill, Peter. *German Immigrant Artists in America: A Biographical Dictionary*. Lanham, Md. Scarecrow Press, 1997.

———— *German-American Artists in Early Milwaukee: A Biographical Dictionary*. Madison, Wis.: Max Kade Inst. for German-American Studies, University of Wisconsin–Madison, 1997.

———— *German-American Painters in Wisconsin: Fifteen Biographical Essays*. Stuttgart, Germany: Verlag Hans-Dieter Heinz, 1997.

Merritt, Jesse. "Thomas Worth, Humorist to Currier & Ives," *American Collector*, X, Aug. 1941, 8-9.

Metropolitan Museum of Art. *American Paradise: The World of the Hudson River School*. New York: The Metropolitan Museum of Art, 1986.

———— *Life in America*. New York: The Metropolitan Museum of Art, 1939.

———— *William Sidney Mount and His Circle*. New York: The Metropolitan Museum of Art, 1945.

Middlebrook, L. F. "A Few of the New England Engravers," *Essex Institute Historical Collections*, LXII, Oct. 1926, 359-63.

Middlefield, Mass. *Vital Records of Middlefield, Mass., to the Year 1850*. Boston, 1907.

Middleton, Margaret S. *Henrietta Johnston of Charles Town, South Carolina, America's First Pastellist*. Columbia, S.C., 1966.

———— *Jeremiah Theus, Colonial Artist of Charles Town*. Columbia, S.C., 1953.

———— "Thomas Coram, Engraver and Painter," *Antiques*, XXIX, June 1936, 242-4.

Millar, Bruce. "Stettinius, Pennsylvania Primitive Portraitist," *American Collector*, VIII, May 1939.

Millard, Everett L. "The Browere Life Masks," *Art in America*, XXXVIII, April 1950, 69-80.

Miller, Dorothy. *The Life and Work of David G. Blythe*. Pittsburgh, 1950.

Miller, F. de Wolfe, *Christopher Pearse Cranch and His Caricatures of New England Transcendentalism*. Cambridge, 1951.

Miller, John. *A Twentieth-Century History of Erie County, Pa*. Chicago, 1909.

Miller, Lillian B., ed. *The Peale Family: Creation of a Legacy, 1770-1870*. Exh. cat. New York: Abbeville Press in association with The Trust for Museum Exhibitions and the National Portrait Gallery, Smithsonian Inst., 1997.

Millet, Josiah B., ed. *George Fuller, His Life and Works*. Boston and New York, 1886.

Miner, George L. *Angell's Lane: The History of a Little Street in Providence*. Providence, 1948.

Minick, Rachel. "Henry Ary, an Unknown Painter of the Hudson River School," *Brooklyn Museum Bulletin*, XI, Summer 1950, 14-24.

Minutes of the Common Council of the City of New York, 1784-1831, Vol. XIX, May 3, 1830, to May 9, 1831, New York, 1917.

Minutes of the Provincial Council of Pennsylvania. Philadelphia and Harrisburg, 1852.

Mirror of the Times: Newburyport Painters Around the Turn of the Century. Exh. cat. Lepore Fine Arts, Newburyport, Mass., 1995.

Mitchell, C. H. "Benjamin West's Death of General Wolfe," *Journal of the Warburg and Courtauld Institutes*, VII (1944), 20-33.

Mitchell, Lucy B. "James Sanford Ellsworth, American Miniature Painter," *Art in America*, XLI, Autumn 1953, 151-84.

Monaghan, Frank. "The American Drawings of Baroness Hyde de Neuville," *FrancoAmerican Review*, II, Spring 1938, 217-20.

Montgomery, Morton L. *History of Berks County in Pennsylvania*. Philadelphia, 1886.

Mook, Maurice A. "S. Roesen, 'The Williamsport Painter,' " *The Morning Call* [Allentown, Pa.], Dec. 3, 1955.

Moravian Church Records, New York City, 1744-1805. Births, deaths, etc. Copy at New-York Historical Society.

Morgan, Charles H. and Margaret C. Toole, "Benjamin West: His Times and His Influence," *Art in America*, XXXVIII, Dec. 1950, 205-78.

Morgan, H. Wayne *Keepers of Culture: The Art Thought of Kenyon Cox, Royal Cortissoz, and Frank Mather, Jr*. Kent, Ohio: Kent State University Press, 1989.

———— *New Muses: Art in American Culture, 1865-1920*. Norman, Okla.: University of Oklahoma Press, 1978.

Morgan, John Hill. *Early American Painters*. New York, 1921.

———— *Gilbert Stuart and His Pupils*. New York, 1939.

———— "John Wollaston's Portraits of Brandt and Margaret Van Wyck Schuyler," *Antiques*, XXI, Jan. 1932, 20-2.

———— *A Sketch of the Life of John Ramage, Miniature Painter*. New York, 1930.

———— and Mantle Fielding, *The Life Portraits of Washington and Their Replicas*. Philadelphia, 1931.

———— and Henry W. Foote, "An Extension of Lawrence Park's Descriptive List of the Works of Joseph Blackburn," *Proceedings of the American Antiquarian Society*,

XLVI, April 1936, 15-81.

Morman, John F. "The Painting Preacher: John Valentine Haidt," *Pennsylvania History*, XX, April 1953, 180-6.

Morris, Harrison S. *Masterpieces of the Sea: William T. Richards, a Brief Outline of His Life and Art*. Philadelphia and London, 1912.

Morrison, Leonard A. and Stephen P. Sharples, *History of the Kimball Family in America, from 1634 to 1897*. Boston, 1897.

Morse, Edward L. *Samuel F. B. Morse, His Letters and Journals*. Boston and New York, 1914.

Moses, Henry. *The Gallery of Pictures Painted by Benjamin West*. London, 1811.

Moure, Nancy Dustin Wall. *Southern California Art*. With three sections previously published as individual books: The California Watercolor Society Index to Exhibitions, 1921-54; Artists' Clubs and Exhibitions in Los Angeles Before 1930; and Dictionary of Art and Artists in Southern California Before 1930. Glendale, Calif.: Dustin Publications, 1984.

Mulkearn, Lois. "Pittsburgh in 1806," *Carnegie Magazine*, XXII, May 1949, 322.

Müller, Hermann A. *Allgemeines KünstlerLexikon*. Frankfurt-am-Main, 1895-1901.

Muller, Nancy C. *Paintings and Drawings at the Shelburne Museum*. Shelburne, Vt.: Shelburne Museum, 1976.

Mumford, James G. *Mumford Memoirs; Being the Story of the New England Mumfords from the Year 1655 to the Present Time*. Boston, 1900.

Mundy, Ezra F. *Nicholas Mundy and Descendants Who Settled in New Jersey in 1665*. Lawrence, Kans., 1907.

Munger, Jeremiah B. *The Munger Book*. New Haven, 1915.

Municipal Museum of Baltimore, *The Paintings of Philip Tilyard*. Baltimore, 1949.

Munsell, Joel. *The Annals of Albany*. Albany, 1850-59.

——— *Collections on the History of Albany*. Albany, 1865-71.

Munson, Myron A. *The Munson Record*. New Haven, 1895.

Murphy, Henry C., ed. *Journal of a Voyage to New York and a Tour in Several of the American Colonies in 1679-80, by Jaspar Dankers and Peter Sluyter*. Brooklyn, 1867.

Murrell, William. *A History of American Graphic Humor*. New York, 1933-38.

Museum of Modern Art, *American Folk Art: The Art of the Common Man in America*. New York, 1932.

N

NAD Cat. Individual catalogues of annual exhibitions, National Academy of Design.

Nägler, Georg K. *Neues allgemeines Künstler-Lexikon*. Munich, 1835-52.

National Academy of Design, for a convenient series of indexes to these annual exhibition catalogues, see Cowdrey [1826-60], Naylor [1861-1900], and Falk [1901-50].

——— *Catalogue of the Permanent Collection*. New York, 1911.

——— *A Century and a Half of American Art, 1825-1975*. New York: National Academy of Design, 1975

——— *Artists by Themselves: Artists' Portraits from the National Academy of Design*. New York: National Academy of Design, 1983.

National Gallery of Art. *American Battle Painting 1776-1918*. Washington, 1944.

Navy Register. Register of the Commissoned and Warrant Officers of the Navy of the United States . . . for the year. Washington, 1859-61.

Naylor, Maria K., ed. *The National Academy of Design Exhibition Record, 1860-1900*. 2 vols. New York: Kennedy Galleries, 1973.

Nelson, Helen C. "A Case of Confused Identity; Two Jewetts Named William," *Antiques*, XLII, Nov. 1942, 251-3.

——— "The Jewetts, William and William S.," *International Studio*, LXXXIII, Jan. 1926, 39-42.

Nelson's Biographical Dictionary and Historical Reference Book of Erie County, Pa. Erie, 1896.

Nerney, Helen. "An Italian Painter Comes to Rhode Island," *Rhode Island History*, I, July 1942, 65-71.

Ness, Zenobia B., and Louise Orwig. *Iowa Artists of the First Hundred Years*. Wallace-Homestead Co., Iowa, 1939.

Neuhaus, Eugen. *The History and Ideals of American Art*. Stanford, Cal., 1931.

Nevins, Allan. *Fremont, Pathmaker of the West*. New York, 1939.

——— and Frank Weitenkampf. *A Century of Political Cartoons; Caricature in the United States from 1800 to 1900*. New York, 1944.

"The New Art of Lithotint," *Miss Leslie's Magazine*, April 1843, 113-14.

New Haven, Conn. *Vital Records of New Haven, 1649-1850*. Hartford, 1917.

New York As It Is [date]. New York, 1833-37.

New York City WPA Art. Exh. cat. New York City WPA Art Inc., for Parsons School of Design, New York, 1977.

New York Colonial Documents. E. B. O'Callaghan, ed., *Documents Relating to the Colonial History of the State of New York*. Albany, 1856-61.

New-York Historical Society. *A Catalogue of American Portraits in the New-York Historical Society*. 2 volumes. New Haven: Yale Univ. Press, for the The New-York Historical Society, 1974. [cited in entries as NYHS Catalogue (1974) to distinguish from the below listed 1941 NYHS Catalogue.]

——— *A Catalogue of American Portraits in The New-York Historical Society*, by Donald A. Shelley. New York, 1941.

——— *Collections*, I-IV (New York, 1809- 29); 2d Ser., I-IV (New York, 1841-59); Publication Fund Series, I-LXXXI (New York, 1868-1948).

——— *Annual Report* [for 1944]. New York, 1945.

New York State Historical Association, *Life Masks of Noted Americans of 1825, by John I. H. Browere* (New York, 1940), catalogue of an exhibition at M. Knoedler & Co., New York, Feb. 1940.

——— "List of American Paintings in the Fenimore House Collection," *Art in America*, XXXVIII, April 1950, 125-8.

Newburyport, Mass. *Vital Records of Newburyport, Mass., to the End of the Year 1849*. Salem, 1911.

Newhall, Beaumont. *The Daguerreotype in America*. 3rd rev. ed. New York, Dover Publications, 1976.

——— *The History of Photography*. 4th ed. New York: Museum of Modern Art, 1964.

Newton, Judith Vale, and William H. Gerdts. *The Hoosier Group: Five American Painters*. Indianapolis, Ind.: Eckert Publications, 1985.

Nichols, Mary E. "Abel Nichols, Artist," *Historical Collections of the Danvers Historical Society*, XXIX (1941), 4-31.

1912 Revisited: The 75th Anniversary Exhibition. Newport, R.I.: Newport Art Museum, 1987.

Noble, Louis L. *The Course of Empire, Voyage of Life, and Other Pictures of Thomas Cole, N.A., with Selections from His Letters and Miscellaneous Writings, Illustrative of His Life, Character, and Genius*. New York, 1853.

Nolan, J. Bennet. "A Pennsylvania Artist in Old New York," *Antiques*, XXVIII (1935), 148-50.

Norfleet, Fillmore. *Saint-Mémin in Virginia*. Richmond, 1942.

North, James W. *History of Augusta*. Augusta, Me., 1870.

Norton, John F. *The History of Fitzwilliam, N.H., from 1752 to 1887*. New York, 1888.

Novak, Barbara. *American Painting of the Nineteenth Century: Realism, Idealism, and the American Experience*. New York: Harper & Row, 1979.

Now and Then, Muncy, Pa., Muncy Historical Society, 1868-.

Noyes, Emily L. *Leavitt, Vol. IV. Descendants of Thomas Leavitt, the Immigrant, 1616-1696, and Isabella Bland*. Tilton, N.H., 1953.

Nute, Grace Lee. "Peter Rindisbacher, Artist," *Minnesota History*, XIV, Sept. 1933, 283-7.

———— "Rindisbacher's Minnesota Water Colors," *Minnesota History*, XX, March 1939, 54-7.

O

Oakes, William. *Scenery of the White Mountains*. Boston, 1848.

O'Brien, Esse F. *Art and Artists of Texas*. Dallas, 1935.

O'Connor, John, Jr. "David Gilmour Blythe, 1815-1865," *Panorama*, I, Jan. 1946, 39-45.

———— "Reviving a Forgotten Artist; A Sketch of James Reid Lambdin, the Pittsburgh Painter of American Statesmen," *Carnegie Magazine*, XII (1938), 115-18.

Odell, George C. D. *Annals of the New York Stage*. New York, 1927-45.

Oertel, John F. *A Vision Realized: A Life Story of Rev. J. A. Oertel, D.D., Artist, Priest, Missionary*. Milwaukee, 1917.

Old Family Portraits of Kennebunk. Kennebunk, Me.: The Brick Store Museum, 1944.

On the Edge, 40 Years of Painting in Maine. Exh. cat. Rockland, Maine: Farnsworth Museum of Art, 1992.

Ormsbee, Thomas H., "Christian Meadows, Engraver and Counterfeiter," *American Collector*, XIII, Jan. 1945, 6-9, 18.

———— "Robert Fulton, Artist and Inventor," *American Collector*, VII, Sept. 1938, 6-7, 16-17.

———— "The Sully Portraits at West Point," *American Collector*, IX, Sept. 1940, 6-7, 14, 20.

Osgood, Ira, and Eben Putnam. *A Genealogy of the Descendants of John, Christopher, and William Osgood*. Salem, Mass., 1894.

Owen, David Dale. *Report of a Geological Exploration of Part of Iowa, Wisconsin and Illinois . . . in Autumn 1839*. Washington, 1844.

———— *Report of a Geological Survey of Wisconsin, Iowa, and Minnesota*. Philadelphia, 1852.

Owen, Hans C. "America's Youngest Engraver, *Antiques*, XXVI, Sept. 1934, 104-5.

———— "John Cheney, Connecticut Engraver, *Antiques*, XXV, May 1934, 172-5.

Owen, Richard. *Report of a Geological Reconnaissance of Indiana Made During the Years 1859 and 1860*. Indianapolis, 1862.

P

PA Cat., *see* Pennsylvania Academy.

PAFA. *In This Academy: The Pennsylvania Academy of the Fine Arts, 1805-1976*. Philadelphia, 1976.

Pageant of America, a Pictorial History of the United States. Ed. by Ralph H. Gabriel, New Haven, 1925-29.

Paine, Albert Bigelow. *Th. Nast: His Period and His Pictures*. New York and London, 1904.

Painters of Rhode Island: Eighteenth to the Twentieth Centuries. Newport, R.I.: Newport Art Museum, 1986.

Painters of the Harcourt Studios. Lepore Fine Arts, Newburyport, Mass., 1992.

Painting in the South, 1564-1980. Compiled by David S. Bundy. Richmond, Va.: Virginia Museum, 1983.

"Paintings of Grove S. Gilbert," *Rochester* [N.Y.] *Historical Society Fund Series*, XIV (1936), 54-60.

Panorama, New York, Harry Shaw Newman Gallery, 1945-.

Parish Register of St. Anne's Church, Lowell, Mass. Lowell, 1885.

Park, Esther A. *Mural Painters in America:* Part I. Pittsburg, Kans., 1949.

Park, Lawrence. "An Account of Joseph Badger, and a Descriptive List of His Work," *Proceedings of the Massachusetts Historical Society*, LI, Dec. 1917, 158-201.

———— *Gilbert Stuart, an Illustrated Descriptive List of His Works*. Ed. by William Sawitzky, New York, 1926.

———— "Joseph Badger of Boston, and His Portraits of Children," *Old-Time New England*, XIII, Jan. 1923, 99-109.

———— "Two Portraits by Blackburn," *Art in America*, VII, Feb. 1919, 70-9.

Parker, Barbara N. "The Dickinson Portraits by Otis A. Bullard," *Harvard Library Bulletin*, VI, Winter 1952, 133-7.

———— "George Harvey and His Atmospheric Landscapes," *Bulletin of the Museum of Fine Arts*, Boston, XLI, Feb. 1943, 7-9.

———— "The Identity of Robert Feke Reconsidered in the Light of W. Phoenix Belknap's Notes," *Art Bulletin*, XXXIII, Sept. 1951, 192-4.

———— and Anne B. Wheeler, *John Singleton Copley; American Portraits in Oil, Pastel, and Miniature*. Boston, 1938.

Parks, Frank S. *Parks Records, Volume 3*. Washington, 1925.

Parrish, Philip H. *Historic Oregon*. New York, 1937.

Patrick, Ransom R. "John Neagle, Portrait Painter, and Pat Lyon, Blacksmith," *Art Bulletin*, XXXIII, Sept. 1951, 187-92.

Peabody, Robert S. and Francis G. *A New England Romance: The Story of Ephraim and Mary Jane Peabody*. Boston and New York, 1920.

Peabody, Selim H. *Peabody (Paybody, Pabody, Pabodie) Genealogy*. Boston, 1909.

Peabody Institute [Baltimore], *List of Works of Art in the Collection of the*. Baltimore, 1949.

Peabody Museum of Salem, Mass., *A Catalogue of the Charles H. Taylor Collection of Ship Portraits*. Comp. by Lawrence W. Jenkins, Salem, 1949.

Peach, A. W., ed. "From Tunbridge, Vermont, to London, England: The Journal of James Guild . . . from 1818 to 1824," *Proceedings of the Vermont Historical Society*, New Ser. V, Sept. 1937, 249-314.

Peale, Rembrandt. "Reminiscences," *The Crayon*, I-III, 1855-56.

Pease, David. *A Genealogical and Historical Record of the Descendants of John Pease*. Springfield, Mass., 1869.

Peat, Wilbur D. *Pioneer Painters of Indiana*. Indianapolis, 1954.

———— "Preliminary Notes on Early Indiana Portraits and Portrait Painters," *Indiana History Bulletin*, XVII, Feb. 1940, 77-93.

Peck, William F. *Semi-Centennial History of the City of Rochester*. Syracuse, 1884.

Peckham, Stephen F. *Peckham Genealogy*. New York, 1922.

Pedersen, Roy, and Barbara A. Wolanin. *New Hope Modernists, 1917-1950*. Exh. cat., New Hope: New Hope Modernist Project, Inc., for the James A. Michener Art Museum, Doylestown, Pa., 1991.

Peet, Phyllis. *American Women of the Etching Revival*. Atlanta, Ga.: High Museum of Art, 1988.

Pendleton, Everett H. *Brian Pendleton and His Descendants*. East Orange, N.J., 1910.

Pennell, Elizabeth R. and Joseph. *The Life of James McNeill Whistler*. Philadelphia and London, 1908.

Pennsylvania Academy of the Fine Arts, catalogues of the annual exhibitions, 1812-1968 (For a convenient series of indexes to the Academy's exhibition records, see EXHIBITION RECORD SERIES at the end of the BIBLIOGRAPHY).

——— *Catalogue of the Memorial Exhibition of Portraits by Thomas Sully*. Philadelphia, 1922.

"A Pennsylvania Primitive Painter," *Antiques*, XXXV, Feb. 1939, 84-6.

Pennypacker, Samuel W. *The Settlement of Germantown, Pa., and the Beginning of German Immigration to North America*. Lancaster, 1899.

Perkins, George A. *The Family of John Perkins of Ipswich, Mass.* Salem, 1889.

Perley, Sidney. *History of Salem, Mass.* Salem, 1928.

——— *The Plumer Genealogy*. Salem, 1917.

Perrine, Howland D. *The Wright Family of Oyster Bay*. New York, 1923.

Perry, Matthew Calbraith. *Narrative of the Expedition of an American Squadron to the China Seas and Japan*. New York and London, 1856.

Peters, Edmond F. and Eleanor B. *Peters of New England, a Genealogy and Family History*. New York, 1903.

Peters, Fred J. *Clipper Ship Prints*. New York, 1930.

——— "Paintings of the Old 'Wind-Jammer,'" *Antiques*, III, Jan. 1923, 30-2.

Peters, Harry T. *America on Stone*. Garden City, 1931.

——— *California on Stone*. Garden City, 1935.

——— *Currier & Ives, Print Makers to the American People*. Garden City, 1929-31.

——— "George Henry Durrie, 1820-1863," *Panorama*, I, Dec. 1945, 27-9.

Petteys, Chris. *Dictionary of Women Artists: An International Dictionary of Women Artists Born Before 1900*. Boston: G.K. Hall & Co., 1985

Philadelphia Museum of Art. *Benjamin West, 1738-1820*. Philadelphia, 1938.

Phillips, Hazel S. "Marcus Mote, Quaker Artist," *Museum Echoes*, XXVII, Feb. 1954, 11-14.

Phillips, John M. "Ralph Earl, Loyalist," *Art in America*, XXXVII, Oct. 1949, 187-9.

Phoenix, Stephen W. *The Whitney Family of Connecticut*. New York, 1878.

Pierce, Bessie L. *A History of Chicago*. New York and London, 1937-40.

Pierce, Catharine W. "Francis Alexander," *Old-Time New England*, XLIV, Oct.-Dec. 1953, 29-46.

Pierce, Sally, and Catharina Slautterback. *Boston Lithography, 1825-1880: The Boston Athenaeum Collection*. Boston: Boston Athenaeum, 1991.

Piercy, Frederick. *Route from Liverpool to Great Salt Lake Valley*. Liverpool, 1855.

Piers, Harry. "Artists in Nova Scotia," *Nova Scotia Historical Society Collections*, XVIII (1914), 101-65.

Piers, Harry. *Robert Field, Portrait Painter in Oils, Miniature, and Water-Colours and Engraver*. New York, 1927.

Pilsbury, David B., and Emily A. Getchell. *The Pillsbury Family*. Everett, Mass., 1898.

Pinckney, Pauline A. *American Figureheads and Their Carvers*. New York, 1940.

Pipes, Nellie B. "John Mix Stanley, Indian Painter," *Oregon Historical Quarterly*, XXXIII, Sept. 1932, 250-8.

Pisano, Ronald G. *One Hundred Years: A Centennial Celebration of the National Association of Women Artists*. Exh. cat. Nassau County Museum of Fine Art, Roslyn Harbor, N.Y., 1988.

——— *The Long Island Landscape, 1865-1914, the Halcyon Years*. Exh. cat. Southampton, N.Y.: Parrish Art Museum, 1981.

——— *The Students of William Merritt Chase*. Exh cat. Huntington, N.Y.: Hecksher Museum, 1973.

Pleasants, Henry, Jr. *Four Great Artists of Chester County*. West Chester, Pa., 1936.

——— and others. Chester County Art Association, *Yesterday in Chester County Art*. West Chester, Pa., 1936.

Pleasants, J. Hall. *An Early Baltimore Negro Portrait Painter, Joshua Johnston*. Windham, Conn., 1940.

——— "Four Late Eighteenth Century Anglo-American Landscape Painters," *Proceedings of the American Antiquarian Society*, LII, Oct. 1942, 187-324.

——— "Francis Guy, Painter of Gentlemen's Seats," *Antiques*, LXV, April 1954, 288-90.

——— "George Beck, an Early Baltimore Landscape Painter," *Maryland Historical Magazine*, XXXV (1940), 241-3.

——— "George William West, a Baltimore Student of Benjamin West," *Art in America*, XXXVII, Jan. 1949, 77.

——— "Justus Engelhardt Kühn, an Early Eighteenth Century Maryland Portrait Painter," *Proceedings of the American Antiquarian Society*, XLVI, Oct. 1936, 243-80.

——— *Saint-Mémin Water Color Miniatures*. Portland, Me., 1947.

——— *250 Years of Painting in Maryland*. Baltimore Museum of Art, 1945.

——— and Howard Sill, *Maryland Silversmiths 1715-1830*. Baltimore, 1930.

Plowden, Helen H. *William Stanley Haseltine, Sea and Landscape Painter*. London, 1947.

Pope, Charles H. *The Cheney Genealogy*. Boston, 1897.

——— *A History of the Dorchester Pope Family*. Boston, 1888.

——— ed., *Willard Genealogy, Sequel to Willard Memoir*. Boston, 1915.

Porter, Edward G. "The Ship Columbia and the Discovery of Oregon," *The New England Magazine*, New Series VI, Old Series XII, June 1892, 472-88.

Porter, James A. *Modern Negro Art*. New York, 1943.

——— "Robert S. Duncanson, Midwestern Romantic-Realist," *Art in America*, XXXIX, Oct. 1951, 99-154.

——— "Versatile Interests of the Early Negro Artist: A Neglected Chapter of American Art History," *Art in America*, XXIV, Jan. 1936, 16-27.

Portrait and Biographical Record of Western Oregon. Chicago, 1904.

"Portraits Found in Vermont." WPA Historical Records Survey, Mass., *Portraits Found in Vermont*.

Portraits in Delaware, 1700-1850, a Check List. Wilmington, 1951.

Potts, Thomas M. *Historical Collections Relating to the Potts Family*. Canonsburg, Pa., 1901.

Powel, Mary E. "Miss Jane Stuart *Bulletin of the Newport* [RI.] *Historical Society*, XXXI, Jan. 1920, 1-16.

Powell, Mary M. "Three Artists of the Frontier," *Bulletin of the Missouri Historical Society*, V, Oct. 1948, 34-43.

Powers, Amos H. *The Powers Family*. Chicago, 1884.

Prairie Print Makers. Exh. cat., with essays by Barbara Thompson O'Neill and George C. Foreman. Wichita, Kans.: Gallery Ellington, 1981.

Pratt, Harlow M. *History of Fort Dodge and Webster County, Iowa*. Chicago, 1913.

Pratt, Waldo. *A Forgotten American Painter: Peter Baumgras* (np., nd.).

Price, Prentiss. "Samuel Shaver: Portrait Painter," *The East Tennessee Historical Society's Publications*, No. 24 (1952), 92-105.

Price, Samuel W. *The Old Masters of the Bluegrass*. Louisville, Filson Club Publications, XVII, 1902.

Prime, Alfred C. *The Arts and Crafts in Philadelphia, Maryland, and South Carolina, 1721-1785*. Topsfield, Mass., 1929; cited as Prime, I.

——— *The Arts and Crafts in Philadelphia, Maryland, and South Carolina, 1786- 1800*. Topsfield, Mass., 1932; cited as

Prime, II.

Princeton University. *General Catalogue, 1746-1906.* Princeton, 1908.

Pringle, Ashmead F., Jr. "Thomas Coram's Bible," *Antiques,* XXX, Nov. 1936, 226-7.

Providence, R.I. *Alphabetical Index of Births, Marriages, and Deaths Recorded in Providence.* Providence, 1879-.

Provincetown Painters, 1890s-1970s. Exh. cat., with essays by Ronald Kuchta and Dorothy Gees Seckler. Syracuse, N.Y.: Everson Museum of Art, 1977.

Prown, Jules David. *John Singleton Copley.* Two volumes, Cambridge, Mass.: Harvard Univ. Press, 1966.

———— *American Paintings: From Its Beginnings to the Armory Show.* Cleveland, Ohio: World Publishing, 1969.

R

RA Cat. See Graves, *Royal Academy.*

Ramsay, David. *The History of South Carolina.* Charleston, 1809.

Ramsay, John. "The American Scene in Lithograph: The Album," *Antiques,* LX, Sept. 1951, 180-3.

Randall, Alice S. "Connecticut Artists and Their Work; Fidelia Bridges in Her Studio at Canaan," *Connecticut Magazine,* VII, No. 5, Feb.-March 1902, 583-8.

Randolph, Robert I. *The Randolphs of Virginia.* Chicago, c.1936.

Les Raretés des Indes, "Codex Canadiensis," Album Manuscrit de la Fin du XVIIe Siecle Contenant 108 Dessins. Paris, 1930.

Rasmussen, Louise. "Art and Artists of Oregon, 1500-1900." Unpublished manuscript, Oregon State Library.

———— "Artists of the Explorations Overland, 1840-1860," *Oregon Historical Quarterly,* XLIII, March 1942, 56-62.

Rathbone, Perry T. "Charles Wimar," in City Art Museum of St. Louis, *Charles Wimar 1828-1862, Painter of the Indian Frontier* (St. Louis, 1946), 8-30.

———— "Itinerant Portraiture in New York and New England." Master's Thesis, Harvard University, 1933, copy at Frick Art Reference Library, New York.

———— ed. *Mississippi Panorama.* City Art Museum of St. Louis, 1949.

Ravenel, Beatrice St. J. "Here Lyes Buried; Taste and Trade in Charleston Tombstones," *Antiques,* XLI, March 1942, 193-5.

Read, George W. and Ruth Gaines, ed. *Gold Rush: The Journals, Drawings, and Other Papers of J. Goldsborough Bruff April 2, 1849-July 20, 1851.* New York, 1944.

Read, J. A. and D. F. *Journey to the Gold-Diggins by Jeremiah Saddlebags.* New York, 1849; reprinted, with introduction by Joseph Henry Jackson, Burlingame, Cal., 1950.

Réau, Louis. "A Great French Sculptor of the 18th Century, Jean-Antoine Houdon," *Connoisseur,* CXXI, June 1948, 74-7.

Recherches Historiques, Levis, Que., Société des Etudes Historiques, 1895-1925.

"Records of Christ Church Burials, 1785-1900," manuscript, Genealogical Society of Pennsylvania, Philadelphia.

Redgrave, Samuel. *A Dictionary of Artists of the English School.* London, 1878.

Reed Papers. Manuscript correspondence of General Joseph Reed, 1757-95, in 12 volumes, New-York Historical Society.

Reed, Walt, and Roger Reed. *The Illustrator in America, 1880-1980: A Century of Illustration.* New York: Madison Square Press, for The Society of Illustrators, 1984.

Reese, Albert. "A Newly Discovered Landscape by Ralph Earl," *Art in America,* XXXVI, Jan. 1948, 49-53.

Reichel, William C. *History of the Rise, Progress, and Present Condition of the Moravian Seminary for Young Ladies at Bethlehem, Pa.* 2d ed., Philadelphia, 1874.

Reid, Robert R. *Washington Lodge, No. 21, F. and AM., and Some of Its Members.* New York, 1911.

Reid, Robert W. "Some Early Masonic Engravers in America," *Transactions of the American Lodge of Research, Free and Accepted Masons,* III, No. 1 (1938-39), 97-125.

———— and Charles Rollinson. *William Rollinson, Engraver.* New York, 1931.

Reiter, Edith S. "Charles Sullivan (1794-1867)," *Museum Echoes,* XXVII, Jan. 1954, 3-5.

———— "Lily Martin Spencer," *Museum Echoes,* XXVII, May 1954, 35-8.

———— "Sala Bosworth," *Museum Echoes,* XXVII, March 1954, 19-21.

Remarks upon the Athenaeum Gallery of Paintings, for 1831, August 17. Boston, 1831.

Report of the United States National Museum . . . for the Year Ending June 30, 1897. Washington, 1899.

Reps, John W. *Views and Viewmakers of Urban American.* Columbia, Mo.: University of Missouri Press, 1984.

Revue Louisianaise, Société Litteraire et Typographique de la Nouvelle-Orleans, 1846-58.

Reynolds, John H. "Papers and Documents of Eminent Arkansans," *Publications of the Arkansas Historical Association,* I (1906), 230-52.

Reznikoff, Charles, and Uriah Z. Engelman. *The Jews of Charleston: A History of an American Jewish Community.* Philadelphia, 1950.

Rice, Foster W. "Life of Nathaniel Jocelyn," unpublished manuscript.

———— "Nathaniel Jocelyn, Painter and Engraver,' *American Collector,* XVI, Dec. 1947, 6-9.

Rice, Howard C., Jr. "An Album of Saint Mémin Portraits," *Princeton University Library Chronicle,* XIII, Autumn 1951, 23-31.

Rice, William H. *In Memoriam: Amadeus Abraham Reinke.* New York, 1889.

Richardson, Edgar P. *American Romantic Painting.* New York, 1944.

———— "E. J. Trelawney by William Edward West," *Art Quarterly,* XIV, Summer 1951, 157-60.

———— "Gustavus Hesselius," *Art Quarterly,* XII, Summer 1949, 220-6.

———— "Portraits by Jacob Eichholtz," *Art in America,* XXVII, Jan. 1939, 14-22.

———— "Two Portraits by William Page," *Art Quarterly,* I, Spring 1938, 91-103.

———— *Washington Allston, a Study of the Romantic Artist in America.* Chicago, 1948.

———— "Winslow Homer's Drawings in *Harper's Weekly,"* *Art in America,* XIX, Dec. 1930, 38-47.

Richmond Portraits in an Exhibition of Makers of Richmond 1737-1860. Richmond: Valentine Museum, 1949.

Rimmer, William. *Art Anatomy.* Boston, 1877.

———— *Elements of Design.* Boston, 1864.

Roberts, W. "Thomas Spence Duché," *Art in America,* VI, Oct. 1918, 273-4.

Robertson, Archibald. *Archibald Robertson, Lieutenant-General of Royal Engineers, His Diaries and Sketches in America, 1762-1780.* Ed. by H. M. Lydenburg, New York, 1930.

Robertson, Emily, ed. *Letters and Papers of Andrew Robertson.* London, 1895?.

Robie, Virginia. "Waldo Portraits by Smibert and Blackburn," *American Society Legion of Honor Magazine,* XX, Spring 1949, 43-52.

Robins, George. *A Catalogue Raisonné of Historical Pictures . . . [by] Benjamin West . . . [to] be Sold at Auction.* London, 1829.

Robinson, Francis W. "Early Houses on the Detroit River and Lake Erie in Watercolors by Catherine Reynolds," *Bulletin of the Detroit Institute of Arts*, XXXIII, No. 1 (1953-4), 17-20.

Robinson, Frederick B. "Erastus Salisbury Field," *Art in America*, XXX, Oct. 1942, 244-53.

Robinson, John. *A Description of and Critical Remarks on the Picture of Christ Healing the Sick in the Temple Painted by Benjamin West, Esq.* Philadelphia, 1818.

Robinson, John, and George F. Dow. *The Sailing Ships of New England, 1607-1907.* Salem, 1922.

Robinson, Mary T. "William Allen Wall of New Bedford," *Magazine of Art*, XXX, Feb. 1937, 108-10, 128.

Robinson, Olive C. "Ezra Wood, Profile Cutter," *Antiques*, XLII, Aug. 1942, 69-70.

Rochester Historical Society, *Scrapbook*, Vol. I, 1950. Rochester, N.Y., 1950.

Rodabaugh, James H. "Charles T. Webber," *Museum Echoes*, XXVII, Aug. 1954, 59-62.

Roden, Robert F. "Seventy Years of Book Auctions in New York," *New York Times Book Review*, March 19, 1898.

Roos, John Frederick Fitzgerald De. *Personal Narrative of Travels in the United States and Canada in 1826.* London, 1827.

Root, Edward W. *Philip Hooker: A Contribution to the Study of the Renaissance in America.* New York, 1929.

Rose, Barbara. *American Painting: Twentieth Century.* New York: Rizzoli, 1986.

———, ed. *Readings in American Art Since 1900: A Documentary Survey.* New York: Praeger Pub., 1968.

Rosenthal, Albert. "Two American Painters: West and Fulton," *The Antiquarian*, XII, July 1929, 43.

Ross, Marvin C. "A List of Portraits and Paintings from Alfred Jacob Miller's *Account Book,*" *Maryland Historical Magazine*, XLVIII, March 1953, 27-36.

——— *The West of Alfred Jacob Miller.* Norman, Okla., 1951.

——— "William Birch, Enamel Miniaturist," *American Collector*, IX, July 1940, 5, 20.

Ross, Robert Budd. "Detroit in 1837," a series of articles published in the [Detroit] *News Tribune*, Aug. 12, 1894-Sept. 15, 1895.

Rotterdam Year Book or *Rotterdamsch Jaarboek*, for 1919. Rotterdam, Neth., 1919.

Rowell, Hugh Grant. "Washington Irving the Artist," *American Collector*, XIV, April 1945, 6-7, 16, 19.

Royer, Kathryn M. "Narrative Painting in Nineteenth Century America." Master's Thesis, Pennsylvania State College, 1941.

Rubinstein, Charlotte Streifer. *American Women Artists.* Boston: G. K. Hall & Co., 1982.

——— *American Women Sculptors.* Boston: G. K. Hall & Co., 1990.

Rudkin, W. Harley. "George Inness, American Landscape Painter," *Art in America*, XXXIV, April 1946, 109-14.

Runk, Emma Ten Broeck. *The Ten Broeck Genealogy.* New York, 1897.

Runnels, Moses T. *History of Sanbornton, N.H.* Boston, 1881-82.

Runyan, Alice. "John Andre, the Artist," *American Collector*, XIV, June 1945, 5, 18.

Rushford, Edward A. "Lewis Prang, Engraver on Wood," *Antiques*, XXXVII, April 1940, 187-9.

Rusk, Fern H. *George Caleb Bingham, the Missouri Artist.* Jefferson City, 1917.

Rusk, William S., ed. "New Rinehart Letters," *Maryland Historical Magazine*, XXXI, Sept. 1946, 225-42.

Rusk, William S. *William Henry Rinehart, Sculptor.* Baltimore, 1939.

Rutledge, Anna Wells. "Another American Caricaturist," *Gazette des Beaux Arts*, XLVII, April 1955, 221-6.

——— *Artists in the Life of Charleston, through Colony and State from Restoration to Reconstruction.* Philadelphia, American Philosophical Society, *Transactions*, XXXIX, Part 2, Nov. 1949.

——— "Charleston's First Artistic Couple," *Antiques*, LII, Aug. 1947, 100-2.

——— "Cogdell and Mills, Charleston Sculptors," *Antiques*, XLI, March 1942, 192-3, 205-7.

——— "A Cosmopolitan in Carolina," *William and Mary Quarterly*, 3d Ser., VI, Oct. 1949, 637-43.

——— "Early Painter Rediscovered: William Wilson," *American Collector*, XV, April 1946, 8-9, 20-1.

——— "A French Priest, Painter, and Architect in the United States: Joseph-Pierre Picot de Limoëlan de Clorivière," *Gazette des Beaux Arts*, XXXIII, March 1948, 159-76.

——— "Handlist of Miniatures in the Collections of the Maryland Historical Society," *Maryland Historical Magazine*, XL, June 1945, 119-36.

——— "Henry Benbridge (1743-1812?) American Portrait Painter," *American Collector*, XVII, Oct. 1948, 8-10, 23; Nov. 1948, 9-11, 23.

——— "Henry Bounetheau (1797-1877), Charleston, S.C., Miniaturist," *American Collector*, XVII, July 1948, 12-15, 23.

——— "A Humorous Artist in Colonial Maryland," *American Collector*, XVI, Feb. 947, 8-9, 14-15.

——— MHS. "Cross File of Maryland Historical Society Catalogues." Unpublished manuscript by Anna Wells Rutledge.

——— PA (or PAFA). Originally published as Rutledge, Anna Wells. *Cumulative Record of Exhibition Catalogues, The Pennsylvania Academy of the Fine Arts, 1807-1870, the Society of Artists, 1800-1814, the Artists' Fund Society, 1835-1845.* Philadelphia: American Philosophical Soc., 1955. Reprint, with revisions, published as Rutledge and Peter Hastings Falk., eds. *Annual Exhibition Record of the Pennsylvania Academy of Fine Arts. Volume 1: 1807-1950.* Madison, Conn.: Sound View Press, 1988.

——— "Portraits in Varied Media in the Collections of the Maryland Historical Society," *Maryland Historical Magazine*, XLI, Dec. 1946, 282-326.

——— "Portraits Painted Before 1900 in the Collections of the Maryland Historical Society," *Maryland Historical Magazine*, XLI, March 1946, 11-50.

——— "Who Was Henrietta Johnston?" *Antiques*, LI, March 1947, 183-5.

——— "William Henry Brown of Charleston," *Antiques*, LX, Dec. 1951, 532-3.

——— "William John Coffee as a Portrait Sculptor," *Gazette des Beaux Arts*, XXVIII, Nov. 1945, 297-312.

S

Safford, Victor. "John Haley Bellamy, the Woodcarver of Kittery Point," *Antiques*, XXVII, March 1935, 102-6.

[Saint Louis Art Museum] City Art Museum of St. Louis, Mo., *Charles Wimar, 1828-1862, Painter of the Indian Frontier.* Exhibition catalogue, St. Louis, 1946.

Samuels, Peggy and Harold. *The Illustrated Biographical Encyclopedia of Artists of the American West.* Garden City, N.Y.: Doubleday & Co., Inc., 1976.

Sanborn, Franklin B. *Henry David Thoreau.* New York and Boston, 1882.

——— "Thomas Leavitt and His Artist Friend James Akin," *Granite Monthly*, XXV, Oct. 1898, 224-34.

Sartain, John. *The Reminiscences of a Very Old Man, 1808-*

1897. New York, 1899.

Saunders, Richard H., and Ellen G. Miles. *American Colonial Portraits: 1700-1776.* Exh. cat. Washington, D.C.: Smithsonian Institution Press for the National Portrait Gallery, 1987

Saunier, Charles. *Bordeaux.* Paris, 1909.

Sawitzky, Susan, "The Portraits of William Johnston, a Preliminary Checklist," *New-York Historical Society Quarterly,* XXXIX, Jan. 1955, 79-89.

Sawitzky, William. "The American Work of Benjamin West," *Pennsylvania Magazine of History and Biography,* LXII, Oct. 1938, 433-62.

———— *Catalogue, Descriptive and Critical, of the Paintings and Miniatures in the Historical Society of Pennsylvania.* Philadelphia, 1942.

———— "Further Light on the Work of Willam Williams," *New-York Historical Society Quarterly Bulletin,* XXV, July 1941, 101-12.

———— "Further Notes on John Hesselius," *Art Quarterly,* V, Autumn 1942, 340-1.

———— "Lectures." Mimeographed syllabus, based on notes taken by Alice L. Moe, of thirteen lectures on Early American Painting delivered by Mr. Sawitzky in 1940-41 at The New-York Historical Society under the sponsorship of the Society and New York University under a grant from the Carnegie Foundation.

———— *Matthew Pratt, 1734-1805.* New York, 1942.

———— *Ralph Earl 1751-1801.* New York, 1945; catalogue of an exhibition at the Whitney Museum and the Worcester Art Museum.

———— "William Williams, First Instructor of Benjamin West," *Antiques,* XXXI, May 1937, 240-2.

———— and Susan Sawitzky, "Portraits by Reuben Moulthrop, a Checklist by William Sawitzky Supplemented and Edited by Susan Sawitzky," *New-York Historical Society Quarterly,* XXXIX, Oct. 1955, 385-404.

———— and Susan Sawitzky, "Thomas McIlworth *New-York Historical Society Quarterly,* XXXV, April 1951, 117-39.

Sawyer, Ray C. "Deaths Published in The Christian Intelligencer of the Reformed Dutch Church from 1830 to 1871." Typed manuscript in seven vols., New-York Historical Society.

Schafer, Joseph. "Trailing a Trail Artist of 1849," *Wisconsin Magazine of History,* XII, Sept. 1928, 97-108.

Scharf, John T. *The Chronicles of Baltimore.* Baltimore, 1874.

———— and Thompson Westcott, *History of Philadelphia 1609-1884.* Philadelphia, 1884.

Scharff, Maurice R. "Collecting Views of Natchez," *Antiques,* LXV, March 1954, 217-19.

Schetky, Lawrence O. *The Schetky Family.* Portland, Ore., 1942.

Schick, Joseph S. *The Early Theater in Eastern Iowa.* Chicago, 1939.

Schimmel, Julie. *Stark Museum of Art: The Western Collection.* Orange, Tex.: Stark Museum of Art, 1978.

Schmitt, Evelyn L. "Two American Romantics: Thomas Cole and William Cullen Bryant," *Art in America,* XLI, Spring 1953, 61-8.

Schmitz, Marie L. "Henry Lewis: Panorama Maker," *Gateway Heritage, Journal of Missouri Historical Society* Vol. 3 (Winter, 1982-83): 36-48.

Schoolcraft, Henry R. *Information Respecting the History, Condition, and Prospects of the Indian Tribes of the United States.* Philadelphia, 1851-57.

———— *Scenes and Adventures in the Semi-Alpine Region of the Ozark Mountains of Missouri and Arkansas.* Philadelphia, 1853.

Schoonmaker, Marius. *The History of Kingston, N.Y.* New

York, 1888.

———— *John Vanderlyn, Artist, 1775-1852.* Kingston, N.Y., 1950.

Schutz, Gaza. "Old New York in Switzerland," *Antiques,* XXXIII, May 1938, 260-1.

Schwartz, Ellen Halteman, comp. *Northern California Art Exhibition Catalogues (1878-1915): A Descriptive Checklist & Index.* La Jolla, Calif.: Laurence McGilvery, 1990.

Scituate, Mass. *Vital Records of Scituate, Mass., to the Year 1850.* Boston, 1909.

Scott, Kenneth. "Abijah Canfield of Connecticut," *Antiques,* LIX, March 1951, 212.

Scott, Leonora Cranch. *The Life and Letters of Christopher Pearse Cranch.* Boston and New York, 1917.

Scribners [New York], "Rare Books in Science and Thought, 1490-1940," Catalogue 138, 1952.

Sears, Clara E. *Highlights among the Hudson River Artists.* Boston, 1947.

———— *Some American Primitives.* Boston, 1941.

Sears, Robert. *A New and Popular Pictorial Description of the United States.* New York, 1848.

Seebold, Herman Boehm de Bachelle. *Old Louisiana Plantation Homes and Family Trees.* New Orleans, 1941.

Sellers, Charles Coleman. *Charles Willson Peale.* Philadelphia, 1947.

———— "James Claypoole: A Founder of the Art of Painting in Pennsylvania," *Pennsylvania History,* XVII, April 1950, 106-9.

———— *Portraits and Miniatures by Charles Willson Peale.* Philadelphia, 1952.

———— "Sellers Papers in the Peale-Sellers Collection," *Proceedings of the American Philosophical Society,* XCV, No. 3, June 12, 1951, 262-5.

Sellstedt, Lars G. *From Forecastle to Academy, Sailor and Artist; Autobiography by Lars Gustaf Sellstedt.* Buffalo, 1904.

———— *Life and Works of William John Wilgus, Artist, 1819-1853.* Buffalo, 1912.

Semmes, John E. *John H. B. Latrobe and His Times, 1803-1891.* Baltimore, 1917.

Semon, Kurt M. "Who Was Robert Street?" *American Collector,* XIV, June 1945, 6-7, 19.

Senate House Museum, Kingston, N.Y., "Exhibition of Paintings by Joseph Tubby." Exh. cat., Dec. 1953-Jan. 1954.

Settle, Raymond W., ed. *The March of the Mounted Riflemen.* Glendale, Cal., 1940.

Sewall, Samuel. *Diary of Samuel Sewall.* Boston, Massachusetts Historical Society Collections, 5th Ser., V-VII, 1878-82.

Shannon, Martha A. S. *Boston Days of William Morris Hunt.* Boston, 1923.

Shapley, Fern Rusk. "Bingham's 'Jolly Flatboatmen,' " *Art Quarterly,* XVII, Winter 1954, 352-6.

Shaw, Joshua. *A New and Original Drawing Book.* Philadelphia, 1816.

———— *Picturesque Views of American Scenery.* Philadelphia, c.1820-21.

———— *United States Directory for the Use of Travellers and Merchants.* Philadelphia, 1822.

Sheeler, Robert L. "The Strange and Cryptic Picture Diary of Charles DeWolf Brownell," [Providence, RI.] *Sunday Journal,* June 8, 1947.

Sheirr, Rodman J. "Joseph Mozier and His Handiwork," *Potter's American Monthly,* VI, Jan. 1876, 24-8.

Shelley, Donald A. "Addendum: William R. Miller," *New-York Historical Society Quarterly,* XXXI, Oct. 1947, 210-11.

———— "American Painting in Irving's Day," *American Collector,* XVI, Oct. 1947, 19-21, *50.*

————— "Audubon to Date," *New-York Historical Society Quarterly*, XXX, July 1946, 168-73.

————— "George Harvey and His Atmospheric Landscapes of North America," *New-York Historical Society Quarterly*, XXXII, April 1948, 104-13.

————— "George Harvey, English Painter of Atmospheric Landscapes in America," *American Collector*, XVII, April 1948, 10-13.

————— "John James Audubon, Artist," *Magazine of Art*, XXXIX, May 1946, 171-5.

————— "William Guy Wall and His Watercolors for the Historic *Hudson River Portfolio*," *New-York Historical Society Quarterly*, XXXI, Jan. 1947, 25-45.

————— "William R. Miller, Forgotten 19th Century Artist," *American Collector*, XVI, Nov. 1947, 16, 23.

Shelton, Henry. *The Salmagundi Club; A History.* Boston: Houghton Mifflin Co., 1918.

Shepard, Lee. "Last Man's Society," *Bulletin of the Historical and Philosophical Society of Ohio*, V. Sept. 1947, 25-9.

Sherman, Frederic F. "American Miniatures by Minor Artists," *Antiques*, XVII, May 1930, 422-5.

————— "American Miniatures of Revolutionary Times," *Art in America*, XXIV, Jan. 1936, 39-43.

————— "American Miniaturists of the Early 19th Century," *Art in America*, XXIV, April 1936, 76-83.

————— "Asher B. Durand as a Portrait Painter," *Art in America*, XVIII, Oct. 1930, 309-16.

————— *Early American Painting.* New York, 1932.

————— "Four Figure Pictures by George Fuller," *Art in America*, VII, Feb. 1919, 84-91.

————— "James Sanford Ellsworth," in Lipman and Winchester, *Primitive Painters in America.*

————— "Nathaniel Jocelyn, Engraver and Portrait Painter," *Art in America*, XVIII, Aug. 1930, 251-8.

————— "Nathaniel Rogers and His Miniatures," *Art in America*, XXIII, Oct. 1935, 158-62.

————— "Newly Discovered American Miniaturists," *Antiques*, VIII, Aug. 1925, 96-99.

————— "Newly Discovered American Portrait Painters," *Art in America*, XXIX, Oct. 1941, 234-5.

————— "Pierre Henri's American Miniatures," *Art in America*, XXVIII, April 1940, 78, 81.

————— "The Portraits of Washington from Life," *Art in America*, XVIII, April 1930, 150-62.

————— "Ralph Earl, Biographical and Critical Notes," *Art in America*, XXIII, March 1935, 57-68.

————— "Samuel L. Waldo and William Jewett, Portrait Painters," *Art in America*, XVIII, Feb. 1930, 81-6.

————— *Richard Jennys, New England Portrait Painter.* Springfield, Mass., 1941.

————— "Robert Loftin Newman: An American Colorist," *Art in America*, IV, April 1916, 177-84.

————— "Robert Loftin Newman," *Art in America*, XXVII, April 1939, 73-5.

————— "Some Recently Discovered Early American Portrait Miniaturists," *Antiques*, XI, April 1927, 293.

————— "Three New England Miniatures," *Antiques*, IV, Dec. 1923, 275-6.

————— "Two Newly Discovered Watercolor Portraits by Robert Field," *Art in America*, XX, Feb. 1932, 85-6.

————— "Two Recently Discovered Portraits in Oils by James Peale," *Art in America*, XXI, Oct. 1933, 114-21.

————— "Unrecorded American Miniaturists," *Art in America*, XVI, April 1928, 130, 133.

————— "Unrecorded Early American Painters," *Art in America*, XXII, Oct. 1934, 145-50; XXXI, Oct. 1943, 208.

————— "Unrecorded Early American Portrait Painters,"

Art in America, XXII, Dec. 1933, 26-31.

Sherman, Thomas T. *Sherman Genealogy.* New York, 1920.

Shertzer, Abram Trego. *A Historical Account of the Trego Family.* Baltimore, 1884.

Shettleworth, Earle G., Jr. and W. H. Bunting. *An Eye for the Coast: The Maritime and Monhegan Island Photographs of Eric Hudson.* Gardiner, Maine: Tilbury House, Pub., 1998.

Shinn, Josiah H. *The History of the Shinn Family in Europe and America.* Chicago, 1903.

Shipp, Steve. *American Art Colonies, 1850-1930: A Historical Guide to America's Original Art Colonies and their Artists.* Westport, Conn.: Greenwood Press, 1996.

Shoemaker, Alfred L. "Reading's First Artist, a Painter of Butterflies," *Historical Review of Berks County* [Pa.], XIII, April 1948, 89-90.

Sill, Howard, compiler. "Sill Abstracts;" "Miscellaneous Abstracts from Maryland Gazette 1730-1775; Source Material Relating Chiefly to Craftsmen," typed transcripts, two volumes, New-York Historical Society.

Simkin, Cohn, ed. *Currier & Ives' America: A Panorama of the Mid-Nineteenth Century Scene.* New York, 1952.

Simpson, Corelli C. W. *Leaflets of Artists.* Bangor, Me., 1893.

Simpson, James H. *Report of Explorations Across the Great Basin.* Washington, 1876.

————— "Report . . . of an Expedition into the Navajo Country," 31 Cong., 1 Sess., *Senate Exec. Doc. 64* (Washington, 1850), 55-168.

Siple, Walter H. "A Romantic Episode in Cincinnati," *Bulletin of the Cincinnati Art Museum*, XI, April 1940, 42-52.

Sitgreaves, Lorenzo. "Report of an Expedition down the Zuni and Colorado Rivers," 32 Cong., 2 Sess., *Senate Exec. Doc. 59*, Washington, 1853.

Sizer, Theodore, ed. *The Autobiography of Colonel John Trumbull, Patriot-Artist, 1756-1843.* New Haven, 1953.

Sizer, Theodore. *The Works of Colonel John Trumbull, Artist of the American Revolution.* New Haven, 1950.

Slade, Denison R. "Henry Pelham, the Half-Brother of John Singleton Copley," *Publications of the Colonial Society of Massachusetts*, Vol. V, *Transactions, 1897, 1898* (Boston, 1902), 193-211.

Slafter, Edmund F. *Slafter Memorial of John Slafter, with a Genealogical Account of His Descendants.* Boston, 1869.

Slocum, Charles E. *A Short History of the Slocums, Slocumbs and Slocombs of America.* Vol. I, Syracuse, N.Y., 1882; Vol. II, Defiance, Ohio, 1908.

Smet, Pierre Jean de. *Oregon Missions and Travels over the Rocky Mountains in 1845-46.* New York, 1847; reprinted in Thwaites, *Early Western Travels*, XXIX, 103-424.

Smith, Albert D. *A Loan Exhibition of the Works of Shepard Alonzo Mount, 1804-1868.* Heckscher Art Museum, Huntington, L.I., 1945.

Smith, Alice E. "Peter Rindisbacher: A Communication," *Minnesota History*, XX, June 1939, 173-5.

Smith, Alice R. H. and D. E. H. *Charles Fraser.* New York, 1924.

————— ed., *A Charleston Sketch Book, 1796-1806.* Charleston, 1940.

Smith, Mr. and Mrs. Chetwood. *Rogers Groups; Thought and Wrought by John Rogers,* Boston, 1934.

Smith, Edward S. "John Rubens Smith, an Anglo-American Artist," *Connoisseur*, LXXXV, May 1930, 300-7.

Smith, Helen Burr. "John Mare . . . New York Portrait Painter, with Notes on the Two William Williams," *New-York Historical Society Quarterly*, XXXV, Oct. 1951, 355-99.

Smith, Jerome I. "Cerracchi and His American Visit," *American Collector*, V, Aug. 1936, 3, 19.

——— "New York's Fire of 1845 in Lithography," *Antiques*, XXXVIII, Sept. 1940, 119-20.

——— "Painted Fire Engine Panels," *Antiques*, XXXII, Nov. 1937, 245-7.

Smith, John Chaloner. *British Mezzotint Portraits*. London, 1883.

Smith, Olive C., and Addison J. Throop, ed. *Ancestral Charts of George Addison Throop, Deborah Goldsmith*. East St. Louis, Ill., 1934.

Smith, Ophia D. "Charles and Eliza Leslie," *Pennsylvania Magazine of History and Biography*, LXXIV, Oct. 1950, 512-27.

——— "Frederick Eckstein, the Father of Cincinnati Art," *Bulletin of the Historical and Philosophical Society of Ohio*, IX, Oct. 1951, 266-82.

Smith, Ralph C. *A Biographical Index of American Artists*. Baltimore, 1930.

Smith, S. Winifred. "James Henry Beard," *Museum Echoes*, XXVII, April 1954, 27-30.

Smith, Todd D. *American Art from the Dicke Collection*. Exh. cat., with essays by Todd D. Smith; James F. Dicke, II; Nancy E. Green; and Eli Wilner. Dayton, Ohio: Dayton Art Institute, 1997.

Smith, William Henry. *The History of the State of Indiana*. Indianapolis, 1897.

Smithsonian Institution. *Carl Bodmer Paints the Indian Frontier; A Traveling Exhibition*. Washington, 1954.

Sniffen, Harold S. "James and John Bard, Painters of Steamboat Portraits," *Art in America*, XXXVII, April 1949, 51-66.

Snow, Christopher L. *An Exhibition of 19th and 20th Century Newburyport Area Artists*. Exh. cat., Newburyport, Mass., 1981.

Snow, Julia D. S. "Delineators of the Adams-Jackson American Views, Part I, Thomas Cole," *Antiques*, XXX, Nov. 1936, 214-19; ". . . Part II, Alexander Jackson Davis," *Antiques*, XXXI, Jan. 1937, 26-30; ". . . Part III, C. Burton and W. Goodacre, Jr.," *Antiques*, XXXII, July 1937, 22-6; ". . . Part IV, Miscellany," *Antiques*, XXXVI, July 1939, 18-21.

——— "King *versus* Ellsworth," *Antiques*, XXI, March 1932, 118-21.

Society of Artists, annual exhibition catalogues, Philadelphia, 1811-14.

Solon, Louis M. *The Art of the Old English Potter*. London, 1883.

Somebody's Ancestors: Paintings by Primitive Artists of the Connecticut Valley. Springfield, Mass., Museum of Fine Arts, 1942.

Spaulding, Charles W. *The Spalding Memorial*. Chicago, 1897.

Spencer, Robert C. *Spencer Family History and Genealogy*. Milwaukee, 1889.

Spendlove, F. St. George. "The Canadian Watercolours of James Pattison Cockburn. *Connoisseur*, CXXXIII, May 1954, 203-7.

Spieler, Gerhard G. "A Noted Artist in Early Colorado; The Story of Albert Bierstadt," *American-German Review*, XI, June 1945, 13-17.

Spielmann, M. H. "Francesca Alexander and 'The Roadside Songs of Tuscany,' " *Magazine of Art* (1895), 295-9.

Spinney, Frank O. "J. Bailey Moore," *Old-Time New England*, XLII, Jan-March 1952, 57-62.

——— "Joseph H. Davis, New Hampshire Artist of the 1830's," *Antiques*, XLIV, Oct. 1943, 177-80.

——— "Joseph H. Davis," in Lipman and Winchester, *Primitive Painters in America*, 97-105.

——— "The Method of Joseph H. Davis," *Antiques*, XLVI, Aug. 1944, 73. "William S. Gookins, Portrait Painter of Dover, N.H.," *Old-Time New England*, XXXIV, April 1944, 61-6.

The Spiritual in Art, 1890-1985. Exh. Cat., Los Angeles County Museum of Art, 1986.

Sprague, Henry W. "Lars Gustav Sellstedt," *Publications of the Buffalo Historical Society*, XVII (Buffalo, 1913), 37.

Sprague, Warren V. *Sprague Families in America*. Rutland, Vt., 1913.

Stackpole, Everett S. *History of Winthrop, Maine*. Auburn, Me., 1925.

Stanger, Frank M., ed. *Off for California; the Letters, Log, and Sketches of William H. Dougal, Gold Rush Artist*. Oakland, Calif., 1949.

Stanley, John Mix. "Portraits of North American Indians." *Smithsonian Miscellaneous Collections*, II, Washington, 1862.

Stansbury, Howard. *Exploration and Survey of the Valley of the Great Salt Lake*. Philadelphia, 1852.

Stanton, William A. *A Record . . . of Thomas Stanton of Connecticut and His Descendants*. Albany, 1891.

Stauffer, David McN. *American Engravers upon Copper and Steel*. New York, 1907.

Stebbins, Theodore E., Jr. *The Life and Works of Martin Johnson Heade*. New Haven: Yale University Press, 1975.

Stechow, Wolfgang. "Another Signed Bradley Portrait," *Art in America*, XXXIV, Jan. 1946, 30-2.

Steinman, George. "Benjamin West Henry, a Lancaster Artist," *Historical Papers and Addresses of the Lancaster County Historical Society*, XVI, No. 9, Nov. 1, 1912, 270-2.

Stephens, Stephen D. *The Mavericks, American Engravers*. New Brunswick, N.J., 1950.

Sterling, Albert M. *The Sterling Genealogy*. New York, 1909.

Stern, Madeleine B. *Louisa May Alcott*. Norman, OkIa., 1950.

Stewart, Rick. *Lone Star Regionalism: The Dallas Nine and their Circle, 1928-45*. Dallas: Dallas Museum of Art, with Texas Monthly Press, 1985.

Stewart, Robert. *Henry Benbridge, 1743-1812: American Portrait Painter*. Wash., DC: Smithsonian Inst. Press for the National Portrait Gallery, 1971.

Stiles, Frederick G. "Jeremiah Stiles, Jr.," *Collections of the Worcester Society of Antiquity*, VI, *Proceedings for 1884* (Worcester, 1885), 205-9.

Stiles, Henry R., ed. *The Civil, Political, Professional, and Ecclesiastical History of the County of Kings and the City of Brooklyn, N.Y.* New York, 1884.

——— *The History of Ancient Wethersfield, Conn.* New York, 1904.

Stillman, William J. *The Autobiography of a Journalist*. Boston and New York, 1901.

Stillwell, John E. "Archibald Robertson, Miniaturist, 1765-1835," *New-York Historical Society Quarterly Bulletin*, XIII, April 1929, 1-33.

——— "Some 19th Century Painters," *New-York Historical Society Quarterly Bulletin*, XIV, Oct. 1930, 79-93.

Stokes. *Historic Prints*. I. N. Phelps Stokes and Daniel C. Haskell, *American Historical Prints; Early Views of American Cities, Etc., from the Phelps Stokes and Other Collections*. New York Public Library, 1933.

Stokes, I. N. Phelps. *The Iconography of Manhattan Island 1498-1909*. New York, 1915-28.

Stone, R. B. "Not Quite Forgotten, a Study of the Williamsport Painter, S. Roesen," *Proceedings and Papers of the Lycoming County [Pa.] Historical Society*, No. 9, 1951.

Storer, Malcolm. "The Manly Washington Medal," *Proceedings of the Massachusetts Historical Society*, LII (1918-19), 6-7.

Stout, Herald F. *Stout and Allied Families*. Dover, Ohio. 1943.

Stowe, Lyman Beecher. "The First of the Beechers," *Atlantic Monthly*, CLII, Aug. 1933, 209-20.

Street, Mary E. A. *The Street Genealogy*. Exeter, N.H., 1895.

Streeter, Milford B. *A Genealogical History of the Descendants of Stephen and Ursula Streeter*. Salem, 1896.

Strickland, Walter G. *A Dictionary of Irish Artists*. Dublin and London, 1913.

Strickler, Susan E. *American Portrait Miniatures: The Worcester Art Museum Collection*. With the assistance of Marianne E. Gibson. Worcester, Mass.: Worcester Art Museum, 1989.

——— ed. *American Traditions in Watercolor: The Worcester Art Museum Collection*. New York: Worcester Art Museum with Abbeville Press, 1987.

Stryker, Peter, "Journal of Peter Stryker from New York City to Saratoga, 1788, and in New York State and New Jersey, 1815-1816." Transcript at New-York Historical Society.

Sully, Thomas. "Recollections of an Old Painter," *Hours at Home*, X (Philadelphia, 1873), 69ff.

Sutton, Mass. *Vital Records of Sutton, Mass., to the End of the Year 1849*. Worcester, 1907.

Svin'in, Pavel Petrovich. *Picturesque United States of America, 1811-13*. Ed. by Abraham Yarmolinsky, New York, 1930.

Swan, Mabel M. *The Athenaeum Gallery 1827-1873*. (Boston, 1940); cited as Swan, BA.

——— "Boston's Carvers and Joiners, Part I, Pre-Revolutionary," *Antiques*, LIII, March 1948, 198-201; ". . . Part II, Post-Revolutionary," *Antiques*, LIII, April 1948, 281-5.

——— "Early Sign Painters," *Antiques*, XIII, May 1928, 402-5.

——— "The Goddard and Townsend Joiners," *Antiques*, XLIX, April 1946, 228-31.

——— "Gilbert Stuart in Boston," *Antiques*, XXIX, Feb. 1936, 65-7.

——— "John Ritto Penniman," *Antiques*, XXXIX, May 1941, 246-8.

——— "Master Hubard, Profilist and Painter," *Antiques*, XV, June 1929, 496-500.

——— "Moravian Cabinetmakers of a Piedmont Craft Center," *Antiques*, LIX, June 1951, 456-9.

——— "A Neglected Aspect of Hubard," *Antiques*, XX, Oct. 1931, 222-3.

——— "A Revised Estimate of McIntire," *Antiques*, XX, Dec. 1931, 338-43.

——— "Ship Carvers of Newburyport," *Antiques*, XLVIII, Aug. 1945, 78-81.

——— "Simeon Skillin, Senior, the First American Sculptor," *Antiques*, XLVI, July 1944, 21.

——— and Louise Karr, "Early Marine Painters of Salem," *Antiques*, XXXVIII, Aug. 1940, 63-5.

Sweet, Charles F. *A Champion of the Cross, Being the Life of John Henry Hopkins*. New York, 1894.

Sweet, Frederick A. "Asher B. Durand, Pioneer American Landscape Painter," *Art Quarterly*, VIII, Spring 1945, 140-60.

——— *The Hudson River School and the Early American Landscape Tradition*. Exh. cat., Art Institute of Chicago and Whitney Museum of American Art, New York, 1945.

Swinth, Kirsten N. "Painting Professionals: Women Artists and the Development of a Professional Ideal in American Art, 1870-1920." Ph.D dissertation. New Haven, Conn.: Yale University, 1995.

T

Taft, Lorado. *The History of American Sculpture*. New York, 1925.

Taft, Robert. *Artists and Illustrators of the Old West, 1850-1900*. New York, 1953.

——— "The Pictorial Record of the Old West," fifteen articles in the *Kansas Historical Quarterly*, 1946 to 1952, subsequently revised and published as *Artists and Illustrators of the Old West, 1850- 1900*. New York, 1953.

Talbot, William S. *Jasper F. Cropsey (1823-1900)*. New York and London, 1977.

Talbott, Page, and Patricia Tanis Sydney. *The Philadelphia Ten: A Women's Artist Group, 1917-45*. Exh. cat. Philadelphia: Moore College of Art and Design, 1998.

Tappan, Daniel L. *Tappan-Toppan Genealogy*. Arlington, Mass., 1915.

Taylor, Agnes L. *The Longstreth Family Records*. Philadelphia, 1909.

Taylor, William C. *Memoirs of the House of Orleans*. London, 1849.

Ten American Painters. Exh. cat., with essays by William H. Gerdts, Sheila Dugan, Ronald Pisano, et al. New York: Spanierman Gallery, 1990.

Tenney, Martha I. *The Tenney Family*. Concord, N.H., 1904.

Terry, James. *Allyn Hyde of Ellington, Conn., Together with a Review of "An Early Connecticut Engraver and His Work."* Hartford, 1906.

Terry, Stephen. *Notes of Terry Families in the United States*. Hartford, 1887.

——— "Texas in Pictures," *Antiques*, LIII, June 1948, 453.

Tharp, Louise H. *The Peabody Sisters of Salem*. Boston, 1950.

Thayer, Bezaleel. *Memorial of the Thayer Name*. Oswego, N.Y., 1874.

Thieme/Becker. (Ulrich, Thieme, and Felix Becker). *Allgemeines Lexikon der Bildenden Kunstler*. Leipzig, 1907-08; and 20th-century volumes by Hans Vollmer, 1952. Rev. ed. by Wilhelm Engelmann, Leipzig: Deutscher Taschenbuch Verlag, 1992.

Things of Beauty: Floral Still-Lifes Selected from the Collection of Louise and Alan Sellars. Exh. cat., with introduction by curator Paul E. Sternbert, Sr. Gainesville, Ga: Brenau College, 1992.

Thomas, Isaiah. *The History of Printing in America*. 2d ed., Albany, 1874.

Thomas, Milton H., ed. *Elias Boudinot's Journey to Boston in 1809*. Princeton, 1955.

Thomas, Ralph W. "William Johnston, Colonial Portrait Painter," *New Haven Colony Historical Society Journal*, IV, March 1955, 4-8.

Thomas, Stephen. "The American Career of Albert Van Beest," *Antiques*, XXXI, Jan. 1937, 14-18.

Thomas, W. Stephen. "George Catlin, Portrait Painter," *Antiques*, LIV, Aug. 1948, 96-7.

Thompson, Charles H. *A Genealogy of the Descendants of John Thompson, of Plymouth*. Lansing, Mich., 1890.

Thompson, Thomas P. *Louisiana Writers Native and Resident . . . to Which Is Added a List of Artists*. New Orleans, 1904.

Thornburg, Opal. "The Panoramas of Marcus Mote, 1853-1854," *Art in America*, XLI, Winter 1953, 22-35.

Thorne, Thomas. "America's Earliest Nude?" *William and Mary Quarterly*, 3d Ser., VI, Oct. 1949, 565-8.

Thorpe, Thomas B. "New York Artists Fifty Years Ago," *Appleton's Journal of Literature, Science, and Art*, VII, May 25, 1872, 572-5.

——— "Reminiscences of Charles L. Elliot, Artist," [New York] *Evening Post*, Sept. 30, Oct. 1, 1868; *Semi-Weekly Post*, Oct. 6, 1868.

300 Years of American Art. Compiled by Michael David

Zellman. 2 vols. Seacaucus, N.J.: Wellfleet Press, 1987.

Thwaites, Reuben Gold, ed. *Early Western Travels, 1748-1846*. 32 vols., Cleveland, 1904-07.

Thwing, Leroy L. "The Four Carving Skillins," *Antiques*, XXXIII, June 1938, 326-8.

Ticknor, Caroline. *May Alcott, A Memoir*. Boston: Little, Brown, and Co., 1927.

Todd, Frederick P. "Huddy & Duval Prints, an Adventure in Military Lithography," *Journal of the American Military Institute*, III (1939), 166-76.

Tolles, Frederick B. "A Contemporary Comment on Gustavus Hesselius," *Art Quarterly*, XVII, Autumn 1954, 271-3.

Tolman, Ruel P. "Attributing Miniatures," *Antiques*, XIV, Nov. 1928, 413-16; Dec. 1928, 523-6.

———— "Boston City and Harbor, 1839, Painted by Robert W. Salmon," *Art in America*, IX, Feb. 1921, 81-2.

———— *Life of Edward Greene Malbone*. New York, 1957.

———— "The Technique of Charles Fraser, Miniaturist," *Antiques*, XXVII, Jan. 1935, 19-22; Feb. 1935, 60-2.

Toppan, Charles. "History and Progress of Banknote Engraving," *The Crayon*, I, Feb. 21, 1855, 116-17.

Toppan, Robert N. *A Hundred Years of Bank Note Engraving in the United States*. New York, 1896.

Torrence, Robert M. *Torrence and Allied Families*. Philadelphia, 1938.

Torrey, Frederic C. *The Torrey Families and Their Children in America*. Lakehurst, N.J., 1924-29.

Tower, Fayette B. *Illustrations of the Croton Aqueduct*. New York, 1843.

Towne, Edwin E. *The Descendants of William Towne*. Newtonville, Mass., 1901.

Trenton, Patricia, ed. *Independent Spirits: American Women Painters of the West, 1890-1945*. Los Angeles: Autry Museum of Western Heritage in association with University of Calif. Press, 1995.

Trip, Dode, and Sherburne F. Cook, Jr. *Washington State Art and Artists, 1850-1950*. Olympia, Wash.: Sherburne Antiques and Fine Art, Inc., 1992.

Trollope, Frances M. *Domestic Manners of the Americans*. New York, 1832.

Trotter, Jessie. "E. Hutchinson Miller (1831- 1921) the Artist," *Jefferson County [W. Va.] Historical Society Magazine*, V (1939), 38-40.

Tuckerman, Henry T. *Book of the Artists*. New York, 1867.

———— *A Memorial of Horatio Greenough*. New York, 1853.

Tufts, Eleanor. *American Women Artists, 1830-1930*. Washington, D.C.: National Museum of Women in the Arts, 1987.

Turner, Maria. "Early Artists in Nebraska," in *Nebraska Art and Artists*. Ed. by Clarissa Bucklin, Lincoln, 1932.

Twitchell, Ralph E. *Genealogy of the Twitchell Family*. New York, 1929.

200 Years of American Sculpture. Exh. cat. New York: Whitney Museum of American Art, in assoc. with David R. Godine, Publisher, 1976

U

Ulp, Clifford McC. "Art and Artists in Rochester," *Rochester Historical Society Publication Fund Series*, XIV (1936), 29-60.

Underwood, Lucien M. *The Ancestry and Descendants of Jonathan Pollard*. Syracuse, 1891.

United States Exploring Expedition, see Wilkes, Charles.

United States, War Dept. *Reports of Explorations and Surveys to Ascertain the Most Practicable and Economic Route for a Railroad from the Mississippi River to the Pacific Ocean*. 13 vols. Washington, 1855-60.

University of Pennsylvania. *Biographical Catalogue of the Matriculates of the College . . . 1749-1893*. Philadelphia, 1894.

V

Vail, Robert W. G. "The American Sketch-books of a French Naturalist, 1816-1837, a Description of the Charles Alexandre Lesueur Collection, with a Brief Account of the Artist," *Proceedings of the American Antiquarian Society*, XLVIII, April 1938, 49-155.

———— "A Dinner at Mount Vernon, from the Unpublished Journal of Joshua Brookes (1773-1859)," *New-York Historical Society Quarterly*, XXXI, April 1947, 72-85.

———— *Gold Fever: A Catalogue of the California Gold Rush Centennial Exhibition*. New-York Historical Society, 1949.

———— *Knickerbocker Birthday: A Sesquicentennial History of The New-York Historical Society, 1804-1954*, New York, 1954.

———— "The Last Meeting of the Giants," *New-York Historical Society Quarterly*, XXXII, April 1948, 69-77.

———— "Report of the Board of Trustees," *Annual Report* of The New-York Historical Society for 1952 (New York, 1953), 17-37.

———— "Storied Windows Richly Dight," *New-York Historical Society Quarterly*, XXXVI, April 1952, 149-59.

Valentine, Elizabeth G. *Dawn to Twilight; Work of Edward V. Valentine*. Richmond, 1929.

Valentine, David T., comp. *Manual of the Corporation of the City of New York for 1860*. New York, 1860.

Vanderpoel, Emily N., comp. *Chronicles of a Pioneer School from 1792 to 1833*. Cambridge, 1903.

Vanderpoel, George B. *Genealogy of the Vanderpoel Family*. New York, 1912.

Vann, Elizabeth C., and Margaret C. D. Dixon. *Denny Genealogy, Second Book*. Rutland, Vt., 1947.

Van Nostrand, Jeanne. "Thomas A. Ayres: Artist-Argonaut of California," *California Historical Society Quarterly*, XX, Sept. 1941, 275-9.

———— and Edith Coulter, *California Pictorial; A History in Contemporary Pictures, 1786-1859*. Berkeley and Los Angeles, 1948.

Van Ravenswaay, Charles. "Anna Maria von Phul," *Missouri Historical Society Bulletin*, X, April 1954, 367-84.

———— "The Forgotten Arts and Crafts of Colonial Louisiana," *Antiques*, LXIV, Sept. 1953, 192-5.

Van Rensselaer, Florence. *The Livingston Family in America and Its Scottish Origins*. New York, 1949.

Van Sickle, John W. *A History of the Van Sickle Family in the United States*. Springfield, Ohio, 1880.

Vedder, Elihu. *The Digressions of V.* Boston and New York, 1910.

Vermont, Edgar de Valcourt. *America Heraldica, a Compilation of Coats of Arms, Crests, and Mottoes of Prominent American Families*. New York, 1886-89.

Vignoles, Olinthus J. *Life of Charles Blacker Vignoles*. London and New York, 1889.

Vinton, John A. *The Richardson Memorial*. Portland, Maine, 1876.

Virginia Historical Portraiture, 1585-1830. Ed. by Alexander W. Weddell, Richmond, 1930.

Vlach, John Michael. *Plain Painters: Making Sense of American Folk Art*. Washington, D.C.: Smithsonian Inst. Press, 1988.

Von Hagen, Victor W. "F. Catherwood, Archt." *New-York Historical Society Quarterly*, XXX, Jan. 1946, 17-29.

———— *Frederick Catherwood, Archt*. New York, 1950.

Vose Galleries. *Mary Bradish Titcomb and Her Contemporaries: The Artists of Fenway Studios, 1905-1939*. Exh. cat. Boston: Vose Galleries, 1998.

———— "Robert D. Wilkie, 1828-1903, Re-discovery of a 19th Century Boston Painter," chronology and two catalogues of Wilkie paintings exhibited at the Vose Galleries, Boston, November 1948.

———— *Vose Galleries of Boston, Inc.: A Commemorative Catalogue.* Boston, 1987.

W

Wadsworth Athenaeum [Hartford]. *George Henry Durrie, 1820-1863, Connecticut Painter of American Life.* Comp. by Mary Bartlett Cowdrey, Hartford, 1947.

Wagner, Henry R., and Charles L. Camp. *The Plains and the Rockies, a Bibliography.* 3d ed. Columbus, Oh., 1953.

Wainwright, Nicholas B. *Philadelphia in the Romantic Age of Lithography.* Philadelphia: Historical Society of Pennsylvania, 1958.

Waite, Emma F. "Pioneer Color Printer: F. Quarré," *American Collector,* XV, Dec. 1946, 12-13, 20.

Waite, Marcus W. *The Wheelock Family of Calais, Vt.* North Montpelier, Vt., 1940.

Walker Art Galleries [Minneapolis]. *Illustrated Catalogue of Indian Portraits Painted by Henry H. Cross.* Minneapolis, 1927.

Walker, Ronald E. *Early California Impressionists.* Exh. cat. Reno, Nevada: Nevada Museum of Art, 1993.

Wall, Alexander J. "Joseph Valaperta, Sculptor," *New-York Historical Society Quarterly Bulletin,* XI, July 1927, 53-6.

———— "Wax Portraiture," *New-York Historical Society Quarterly Bulletin,* IX, April 1925, 3-26.

Walsh, James J. *American Jesuits.* New York, 1934.

Warren, Eliza S. *Memoirs of the West; The Spaldings.* Portland, Ore., 1916?.

Warren, William L. "A Checklist of Jennys Portraits," *Connecticut Historical Society Bulletin,* XXI, April 1956, 33-64.

———— "The Jennys Portraits," *Connecticut Historical Society Bulletin,* XX, Oct. 1955, 97-128.

———— "Mary Ann Hardy, an Appreciation," *Old-Time New England,* XLV, Winter 1955, 73-6.

———— "Richard Brunton, Itinerant Craftsman," *Art in America,* XXXIX, April 1951, 81-94; XLI, Spring 1953, 69-78.

Washbourn, John T. "The Work of David E. Cronin," *New-York Historical Society Quarterly Bulletin,* XXV, Jan. 1941, 17-25.

Washington, George. *The Diaries of George Washington, 1748-1799.* Ed. by John C. Fitzpatrick, Boston and New York, 1925.

Washington [D.C.] Art Association, catalogues to the annual exhibitions, 1857-on.

Waterhouse, Ellis K. *Painting in Britain 1530-1790.* London and Baltimore, 1953.

Watkins, Walter K. "John Coles, Heraldry Painter," *Old-Time New England,* XXI, Jan. 1931, 129-43.

———— *The Residuary Legatees of the Will of Mrs. Eliza Ann (Blackman) Colburn.* Boston, 1900.

Watlington, H. T. "The Incomplete Story of John Green, Artist and Judge," *Bermuda Historical Quarterly,* VI, May 1949, 65-76.

Watson, Douglas S., ed. *California in the Fifties.* San Francisco, 1936.

Watson, Forbes. *Winslow Homer.* New York, 1942.

Wayland, John W. *A History of Shenandoah County, Va.* Strasburg, Va., 1927.

Weaks, Mabel C. "A Miniature of Herman Melville's Mother," *Antiques,* LIV, Oct. 1948, *259.*

Webber, Richard. "The Birthplace of Robert Walter Weir, Artist," *New-York Historical Society Quarterly Bulletin,* XIV, Oct. 1930, 94.

Weber, Bruce *The Giverny Luminists: Frieseke, Miller, and Their Circle.* Exh. cat. New York: Berry-Hill Galleries, 1995.

Weber, Frederick P. *Medals and Medallions of the Nineteenth Century, Relating to England, by Foreign Artists,* London, 1894-1907.

Webster, J. Carson. "Junius R. Sloan, Self-taught Artist," *Art in America,* XL, Summer 1952, 103-52.

Wehle, Harry B. "A Portrait of Henry Clay, Reattributed," *Metropolitan Museum of Art Bulletin,* XX, Sept. 1925, 215-16.

———— and Theodore Bolton, *American Miniatures, 1730-1850.* New York, 1927.

Weimann, Jeanne Madeline. *The Fair Women: The Story of the Woman's Building, World's Columbian Exposition, 1893.* Chicago: Academy Chicago, 1981.

Weinberg, H. Barbara. "19th Century American Painters at the École des Beaux-Arts," *American Art Journal,* Autumn, 1981, pp. 71-84

———— *The Lure of Paris: Nineteenth-Century American Painters and Their French Teachers.* New York: Abbeville Press, 1991.

Weir, Irene. *Robert W. Weir, Artist.* New York, 1947.

Weis, Frederick L. *Check List of the Portraits in the Library of the American Antiquarian Society.* Worcester, 1947.

Weiss, Harry B. "The Growth of the Graphic Arts in Philadelphia 1663-1820," *Bulletin of the New York Public Library,* LVI, Feb. 1952, 76-83; March 1952, 139-45.

———— "The Number of Persons and Firms Connected with the Graphic Arts in New York City, 1633-1820," *Bulletin of the New York Public Library,* L, Oct. 1946, 775-86.

———— and Grace M. Zeigler, "Mrs. Thomas Say," *Journal of the New York Entomological Society,* XLI, Dec. 1933.

———— *Thomas Say, Early American Naturalist.* Springfield, Ill., and Baltimore, 1931.

Weitenkampf, Frank. *American Graphic Art.* New York, 1912; rev. ed., 1924.

———— "An Artist of Ante-Bellum Times," *The Independent,* XLVI, March 29, 1894, 395.

———— "Early American Landscape Prints," *Art Quarterly,* VIII, Winter 1945, 40-67.

———— "F. O. C. Darley, American Illustrator," *Art Quarterly,* X, Spring 1947, 100-13.

———— "The Intimate Homer; Winslow Homer's Sketches," *Art Quarterly,* VI, Autumn 1943, 307-21.

———— "John Greenwood; An American-born Artist in 18th Century Europe, with a Checklist of His Etchings and Mezzotints," *Bulletin of the New York Public Library,* XXXI, Aug. 1927, 623-34.

———— "John Hill and American Landscapes in Aquatint," *American Collector,* XVII, July 1948, 6-8.

———— *Political Caricature in the United States in Separately Published Cartoons; An Annotated List.* New York, 1953.

———— "A Swiss Artist among the Indians," *Bulletin of the New York Public Library,* LII, Nov. 1948, 554-6.

Welby, Adlard. *A Visit to North America and the English Settlements in Illinois.* London, 1821; reprinted in Thwaites, *Early Western Travels,* XII.

Weld, Isaac. *Travels through the States of North America, and the Provinces of Upper and Lower Canada during the Years 1795, 1796, and 1797.* London, 1800.

Weld, Ralph F. *Brooklyn Village 1816- 1834.* New York, 1938.

Weller, Allen. "A Note on Winslow Homer's Drawings in *Harper's Weekly,*" *Art in America,* XXII, March 1934, 76-8.

Welling, William. *Photography in America: The Formative Years, 1839-1900.* New York: Thomas Y. Crowell Co., 1978.

Welsh, Herbert. "Artists of Germantown," in *Germantown History* (Germantown Site and Relic Society, 1915), 233-47.

Wentworth, John. *The Wentworth Genealogy.* Boston, 1870.

Wechsler, Jeffrey. *Surrealism and American Art, 1931-1947.* Exh. cat. Rutgers, N.J.: Rutgers Univ. Gallery, 1977.

West Stockbridge, Mass. *Vital Records of West Stockbridge, Mass., to the Year 1850.* Boston, 1907.

Weston, Thomas. *History of the Town of Middleboro, Mass.* Boston and New York, 1906.

Westphal, Ruth Lilly, ed. *Plein Air Painters of California: The Southland.* 3rd printing, with some changes. Irvine, Calif.: Westphal Publishing, 1990.

———— *Plein Air Painters of California: The North.* Irvine, Calif.: Westphal Publishing, 1993.

———— and Janet Blake Dominik, eds. *American Scene Painting: California, 1930s and 1940s.* Irvine, Calif.: Westphal Publishing, 1991.

Wharton, Anne H. *Heirlooms in Miniatures.* Philadelphia, 1898.

———— *Salons Colonial and Republican.* Philadelphia, 1900.

———— *Whig Portrait Gallery.* New York, c. 1850.

White, D. Fedotoff. "A Russian Sketches Philadelphia, 1811-1813," *Pennsylvania Magazine of History and Biography,* LXXV, Jan. 1951, 3-24.

White, John Blake. "The Journal of John Blake White," ed. by Paul R. Weidner, *South Carolina Historical and Genealogical Magazine,* XLII (1941), 55-71, 99-117, 169-86; XLIII (1942), 34-46, 103-17, 161-74.

White, Leonard D. *The Jeffersonians; A Study in Administrative History, 1801- 1829.* New York, 1951.

White, Margaret E., ed. *A Sketch of Chester Harding, Artist, Drawn by His Own Hand.* Boston, 1890; new ed., 1929.

White, Philip L. *The Beekmans of New York in Politics and Commerce, 1647- 1877.* New York, 1956.

Whitehill, Walter M. "Portraits of American Ships," *American Collector,* X, April 1941, 6-8.

Whitley, William T. *Artists and Their Friends in England, 1700-1799.* London and Boston, 1928.

———— *Gilbert Stuart.* Cambridge, 1932.

Whitmore, William H., "Abel Bowen," *Bostonian Society Publications,* I (1886-88), 29-56.

———— *A Brief Genealogy of the Gore Family.* Boston, 1875.

———— *Notes Concerning Peter Pelham and His Successors Prior to the Revolution.* Cambridge, 1867.

Whitney, Edna. *Kentucky Ante-Bellum Portraiture.* The National Society of the Colonial Dames in the Commonwealth of Kentucky, 1956.

Wied-Neuwied, Maximilian Alexander Philipp, Prince of. *Maximilian, Prince of Wied's Travels in the Interior of North America, 1832-1834.* Cleveland, 1906. Vols. XXII-XXV of Thwaite, *Early Western Travels.*

Wight, William W. *The Wights.* Milwaukee, 1890.

Wilkes, Charles. *Narrative of the United States Exploring Expedition.* Philadelphia, 1844.

Wilkie, Franc B. *Davenport, Past and Present.* Davenport, Iowa, 1858.

"William Mackwitz, Wood Engraver," *Missouri Historical Society Bulletin,* VIII, Jan. 1952, 176-9.

Williams, Amelia W. and Eugene C. Barber, ed. *The Writings of Sam Houston 1813- 1863.* Austin, Tex., 1938-43.

Williams, John C. *An Oneida County Printer, William Williams.* New York, 1906.

Williams, John F. *William J. Williams, Portrait Painter, and His Descendants.* Buffalo, 1933.

Williams, Wellington. *Appleton's Northern and Eastern Traveller's Guide.* New York and Philadelphia, 1850.

Williams, William W. *History of Ashtabula County, Ohio.* Philadelphia, 1878.

Willis, Eola. *The Charleston Stage in the 18th Century, with Social Settings of the Time.* Columbia, S.C., 1924.

———— "Henrietta Johnston, South Carolina Pastellist," *The Antiquarian,* XI, Sept. 1928, 46-7.

Willis, Patty. "Jefferson County Portraits and Portrait Painters," *Magazine of the Jefferson County* [W. Va.] *Historical Society,* VI, Dec. 1940, 21-39.

Wilmerding, John. *American Light: The Luminist Movement, 1850-1875.* 1980. Reprint, Princeton: Princeton University Press and the National Gallery of Art, 1989.

———— *A History of American Marine Painting.* Peabody Museum, Salem, and Little, Brown, Boston, 1968.

Wilner, Eli, and Mervyn Kaufman. *Antique American Frames: Identification and Price Guide.* New York: Avon Books, 1995.

———— *The Art of the Frame: American Frames of the Arts and Crafts Period.* New York: Eli Wilner and Co., 1988

Wilson, Erasmus, ed. *Standard History of Pittsburgh, Pa.* Chicago, 1898.

Wilson, Francis. *Joseph Jefferson, Reminiscences of a Fellow Player.* New York, 1906.

Wilson, Robert. "Art and Artists in Provincial South Carolina," *Year Book, 1899, Charleston, South Carolina,* Appendix, 137-47.

Wilson, Rufus R. *Lincoln in Portraiture.* New York, 1935.

Wilson, Samuel M. "Matthew Harris Jouett, Kentucky Portrait Painter; A Review," *The Filson Club History Quarterly,* XIII, April 1939, 75-96; "Additional Notes" *ibid.,* XIV, 1940, 1-16, 65-102.

Winchester, Alice "A Painted Wall," *Antiques,* XLIX, May 1946, 310-11.

Winn, David W. and Elizabeth J. *Ancestors and Descendants of John Quales Winn and His Wife Mary Liscome Jarvis.* Baltimore, 1932.

Winter, George. *The Journals and Indian Paintings of George Winter 1837-1839.* Indianapolis, 1948.

Winter, William. *The Jeffersons.* Boston, 1881.

Winwar, Frances. *American Giant: Walt Whitman and His Times.* New York, 1941.

Wisconsin, State Historical Society of, *Historical Collections of the.* Madison, 1854-.

———— *Second Triennial Catalogue of the Portrait Gallery of the.* Madison, 1892.

Wiseman, Charles M. R. *Centennial History of Lancaster, Ohio, and Lancaster People.* Lancaster, 1898.

Witkin, Lee, and Barbara London. *The Photograph Collector's Guide.* Boston: New York Graphic Society, 1979.

Wood, Christopher. *Dictionary of British Art.* Volume IV, *Victorian Painters.* Suffolk, England: Antique Collectors Club Ltd., 1995.

Wood, Edmund. "William Bradford," *Old Dartmouth Historical Sketches,* XXVI (1909), 6-8.

Woodstock AA. Woodstock Artists Association, Woodstock, N.Y.

Woodstock's Art Heritage, The Permanent Collection of the Woodstock Artists Association. Woodstock, N.Y.: Overlook Press, 1987.

Woodward, E. M., and John M. Hageman. *History of Burlington and Mercer Counties, N.J.* Philadelphia, 1883.

Woolsey, Theodore S. "The American Vasari," *Yale Review,* III, July 1914, 778-89.

Worcester Art Museum. *Catalogue of Paintings and Drawings.* Worcester, Mass., 1922.

———— *Christian Gullager, 1759-1826, An Exhibition.* Worcester, Mass., 1949.

Worcester Society of Antiquity (later Worcester Historical Society), *Collections of the.* Worcester, Mass., 1881-1901.

———— "Works of William Marshall Swayne," *Chester County* [Pa.] *Collections,* XVI, Oct. 1939, 503-4.

Workman, Robert. *The Eden of America: Rhode Island Landscapes, 1820-1920.* Exh. cat., with essays by Lloyd Goodrich and John Wilmerding. Providence, RI:

Museum of Art, Rhode Island School of Design, 1986.

W.P.A. [Works Progress Administration] American Guide Series, *Alabama, A Guide to the Deep South.* New York, 1941.
——— *California, A Guide to the Golden State.* New York, 1939.
——— *Georgia, A Guide to Its Towns and Countryside.* Athens, Ga., 1940.
——— *Kansas, A Guide to the Sunflower State.* New York, 1939.
——— *Kentucky, A Guide to the Bluegrass State.* New York, 1954.
——— *Maine, A Guide "Down East."* Boston, 1937.
——— *Michigan, A Guide to the Wolverine State.* New York, 1941.
——— *Missouri, A Guide to the "Show Me" State.* New York, 1941.
——— *Montana, A State Guide Book.* New York, 1949.
——— *Nebraska, A Guide to the Corn-husker State.* New York, 1939.
——— *New Hampshire, A Guide to the Granite State.* Boston, 1938.
——— *Tennessee, A Guide to the State.* New York, 1949.
——— *Texas, A Guide to the Lone Star State.* New York, 1940.
——— *Wisconsin, A Guide to the Badger State.* New York, 1941.

W.P.A. (Ala.). Historical Records Survey, Alabama.

W.P.A. (Ark.). Historical Records Survey, Arkansas.

W.P.A. (Calif.). *Introduction to California Art Research,* I and II, San Francisco, 1936-37.

W.P.A. (Mass.). *Portraits Found in Maine.* Full citation: W.P.A., Historical Records Survey (Mass.). *American Portraits (1645-1850) Found in the State of Maine* (Boston, 1941).
——— *Portraits Found in Mass.* Full citation: W.P.A., Historical Records Survey (Mass.), *American Portraits 1620-1825 Found in Massachusetts* (Boston, 1939), 2 vols.
——— *Portraits Found in N.H.* Full citation: W.P.A., Historical Records Survey (Mass.), *Preliminary Checklist of American Portraits 1620-1860 Found in New Hampshire* (Boston, 1942).
——— *Portraits Found in N.Y.* Full citation: W.P.A., Historical Records Survey (Mass.), "American Portraits Found in New York." Manuscript volume, Library of Congress.
——— *Portraits Found in Vt.* Full citation: W.P.A., Historical Records Survey (Mass.), "Portraits Found in Vermont." Manuscript volume, Library of Congress.

W.P.A. (N.H.). Historical Records Survey, New Hampshire.

W.P.A. (N.J.). Historical Records Survey, New Jersey.

W.P.A., Historical Records Survey (New Jersey), *1440 Early American Portrait Artists.* Newark, 1940.

W.P.A., Historical Records Survey (Ohio), *Annals of Cleveland, 1818-1935.* (Cleveland, 1936+).

W.P.A., Historical Records Survey (Pa.), "Catalogue of the Early American Portraits in the Pennsylvania Academy of the Fine Arts." Manuscript volume, Library of Congress.

W.P.A., Historical Records Survey (Pa.), *Descriptive Catalogue of the Du Simitire Papers in the Library Company of Philadelphia.* Philadelphia, 1940.

W.P.A. (Texas). Historical Records Survey, Texas.

W.P.A. (Vt.). Historical Records Survey, Vermont.

Wright, Charles Lennox II. "Charles Cushing Wright— Lavinia Dorothy Wright— Their Life and Works." Manuscript biography, New-York Historical Society.
——— "The Pioneer of Zinc Etching, Introduction to the Charles Lennox Wright I Collection," *New-York Historical Society Quarterly,* XXXVI, April 1952, 195-209.

Wright, Edith A., and Josephine A. McDevitt. "Henry Stone, Lithographer," *Antiques,* XXXIV, July 1938, 16-19.

Wright, Nathalia. "Horatio Greenough, Boston Sculptor," *Old-Time New England,* XLV, Jan-March 1955, 55-60.

Wright, R. Lewis. *Artists in Virginia Before 1900: An Annotated Checklist.* Charlottesville, Va.: University Press of Virginia for the Virginia Historical Society, 1983.

Wroth, Lawrence C. *Abel Buell of Connecticut, Silversmith, Type Founder, and Engraver.* New Haven, 1926.

WW98-WW73. See discussion in Volume I, HOW TO READ AN ENTRY: SOURCES.

Wynne, Nancy, and Beaumont Newhall. "Horatio Greenough: Herald of Functionalism," *Magazine of Art,* XXXII, Jan. 1934, 12-15.

Y

Yale University Gallery of Fine Arts. *Connecticut Portraits by Ralph Earl, 1761- 1801.* With foreword by William Sawitzky, New Haven, 1935.

Yanaguana Society [San Antonio]. *Catalogue of a Loan Exhibition.* San Antonio, Texas, December 1933.

Yancey, Rosa F. *Lynchburg and Its Neighbors.* Richmond, 1935.

Yarmolinsky. *see* Svin'in.

Yesterday in Chester County Art. See under Pleasants, Henry, Jr.

Young, Andrew W. *History of the Town of Warsaw, New York.* Buffalo, 1869.

EXHIBITION RECORDS SERIES
SOUND VIEW PRESS, MADISON, CONN.

Art Institute of Chicago
Annual Exhibition Record of the Art Institute of Chicago, 1888-1950. Edited by Peter Hastings Falk, 1990.

Boston Art Club
Boston Art Club: Exhibition Record, 1873-1909. Compiled and edited by Janice H. Chadbourne, Karl Gabosh, and Charles O. Vogel, 1991.

Carnegie Institute
Record of the Carnegie Institute's International Exhibitions: 1896-1996. Edited by Peter Hastings Falk, 1998.

Corcoran Gallery of Art
Biennial Exhibition Record of the Corcoran Gallery of Art, 1907-1967. Edited by Peter Hastings Falk, 1991.

National Academy of Design
Annual Exhibition Record of the National Academy of Design, 1901-1950. Edited by Peter Hastings Falk, 1990.

Pennsylvania Academy of the Fine Arts
Annual Exhibition Record of the Pennsylvania Academy of the Fine Arts. Volume 1: 1807-1950. Reprint, with revisions, of the 1955 edition of Anna Wells Rutledge. Edited by Peter Hastings Falk, 1988.
——— *Annual Exhibition Record of the Pennsylvania Academy of Fine Arts. Volume 2: 1876-1913.* Edited by Peter Hastings Falk, 1989
——— *Annual Exhibition Record of the Pennsylvania Academy of Fine Arts. Volume 3: 1914-1968.* Edited by Peter Hastings Falk, 1989

Salons of America
Salons of America, 1922-1936. By Clark S. Marlor, 1991.

Society of Independent Artists
Society of Independent Artists: The Exhibition Record, 1917-1944. By Clark S. Marlor, 1984.

Whitney Museum of American Art
The Annual & Biennial Exhibition Record of the Whitney Museum of American Art: 1918-1989. Edited by Peter Hastings Falk, 1991.

FINIS